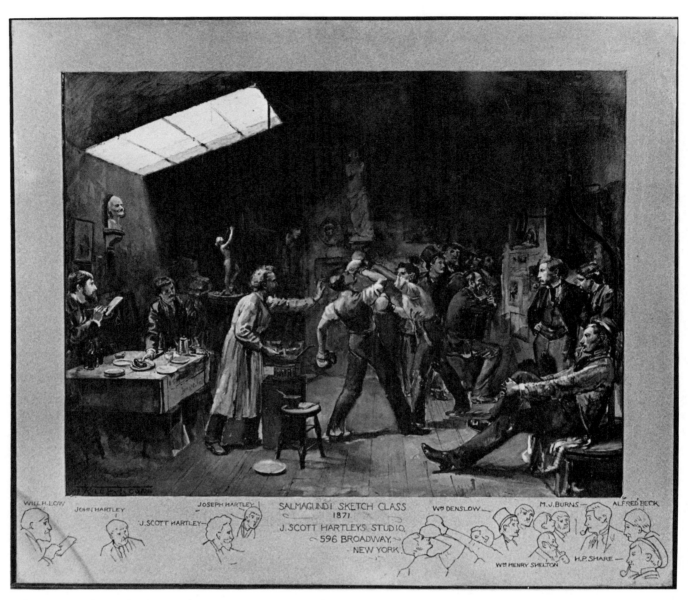

Will H. Low recreated one of the Salmagundi Sketch Club classes of 1871 in this 1879 illustration. Low has depicted himself at far right sketching boxing action while other members look on. Courtesy of Salmagundi Club, New York

WHO WAS WHO IN AMERICAN ART

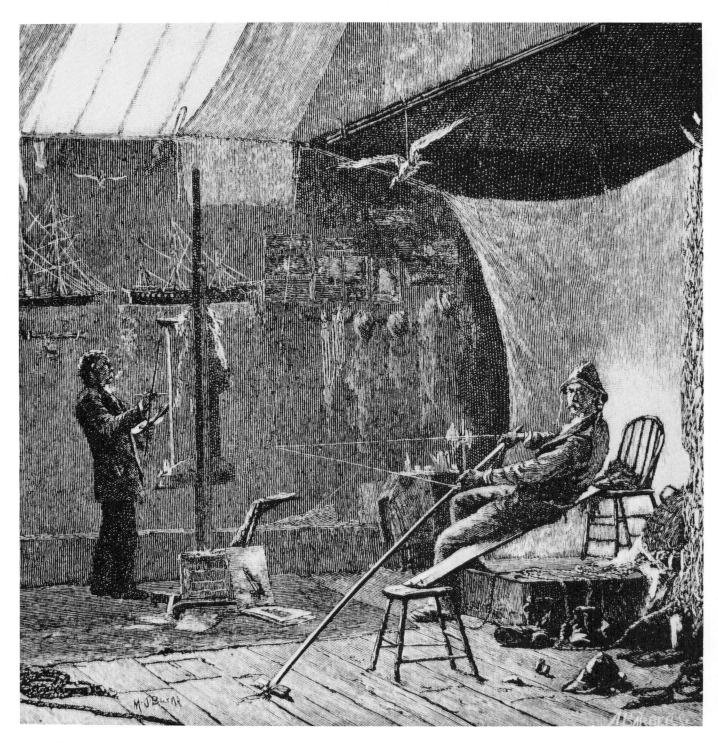

Milton J. Burns: *A Marine Artist's Studio in New York.* From *Scribner's Monthly* (January, 1880). Courtesy Mystic Seaport Museum

WHO WAS WHO IN AMERICAN ART

Compiled from the Original
Thirty-four Volumes of

AMERICAN ART ANNUAL: WHO'S WHO IN ART

Biographies of American Artists
Active from 1898–1947

EDITED BY

PETER HASTINGS FALK

SOUND VIEW PRESS

1985

In memory of my father
Wilbur Nelson Falk

Copyright ©1985 by Sound View Press.

All rights reserved. No part of this book may be reproduced or transmitted in any form or by any means, electronic or mechanical, including photocopying, recording, or by any information storage and retrieval system, without permission in writing from the publisher.

Published in the United States of America by Sound View Press
883 Boston Post Road, Suite 150, Madison, Connecticut 06443.

Library of Congress Catalog Card Number: 85-50119
ISBN 0-932087-00-0

Composition by The Publishing Nexus Incorporated
Post Office Box 195, Guilford, Connecticut 06437

Printed in the United States of America

CONTENTS

ACKNOWLEDGMENTS	ix
SOURCES	ix
PUBLISHER'S NOTE: On Rediscovering Forgotten American Artists	xi
WHY AND HOW THIS BOOK WAS CREATED	xiii
ABBREVIATIONS: Professional Classifications	xix
Museums, Exhibitions, Schools, Associations	xx
General Abbreviations	xxviii
HOW TO READ AN ENTRY	xxxi
EUROPEAN TEACHERS OF AMERICAN ARTISTS	xxxiii
A Note on the International Exhibitions	xxxv
WHO WAS WHO IN AMERICAN ART	1

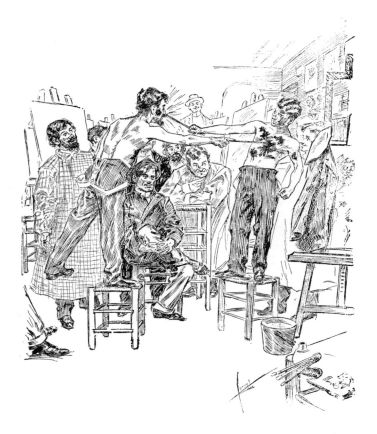

Edward Cucuel: *A Paint-Brush Duel at the Beaux-Arts*. From W.C. Morrow's *Bohemian Paris of Today*, 1899

ACKNOWLEDGMENTS

Since 1975 we have been researching forgotten American Artists with the intention of producing a major biographical dictionary. Our fellow researchers, Peggy and Harold Samuels, told us of a similar idea for using the old *American Art Annual* series and kindly suggested the title.

Most of the thirty-four volumes of the old *Annual* were photocopied at the Boston Public Library, and I am grateful to Theresa Cederholm and Janice Chadbourne for their cooperation. Several volumes from the Sterling Library at Yale University were also used to complete this task.

Many facts and dates that had not been included in the original *Annuals* have been added to make this book more useful. This part of our task would not have been as complete without the help of Raymond W. Smith of New Haven, the country's leading specialist in rare and hard-to-find American art books, who kindly put his large library at our disposal.

Compiling the thirty-four volumes of the old *Annual* entailed cross-checking more than 120,000 biographical entries. I am grateful to my assistant editor, Scott Shapleigh, for his careful assistance in every stage of the long editorial process and to Lee Ann Bellner, who assisted in the important first stage of sorting and cross-checking the master index cards.

For their encouragement and suggestions I am also thankful to Charles Eldredge, Director of the National Museum of American Art; Prof. William H. Gerdts, City University of New York; Donald Kelley, Curator of the Boston Athenaeum; Prof. Irma Jaffe, Fordham University; Prof. Clark S. Marlor, Adelphi University; Barbara Polowy, Librarian at the Rochester Institute of Technology, who wrote the very helpful "American Art Annual: A Guide to Biographical Information, Vol.1–Vol.30" in *Art Documentation* (ARLIS, Spring 1984); Peter Rathbone, Head of American Paintings at Sotheby's; Chalotte S. Rubenstein; S. Morton Vose II of the Vose Archives; and Assoc. Prof. H. Barbara Weinberg, City University of New York.

Finally, my appreciation and deep love belong to my wife Peggy, whose active participation and common sense approach helped steer this project. She continues by example to prove that the working mother, in her multi-faceted role, can accomplish more than many men would attempt.

SOURCES

This volume was compiled from the original thirty volumes of the rare *American Art Annual* (1898–1933) and its subsequent four volumes under the title of *Who's Who in American Art* (1935–1947). (See Introduction for a complete description of the compilation and editorial processes.

While this volume was originally intended as a compilation of historical data, we felt obliged to make it as complete as possible by adding biographical facts. For the era's forgotten artists of distinction this sometimes meant adding a new biography that did not appear in the original *Annuals*. In most cases the data on lesser known artists came from our own research files (heavily indebted to the Archives of American Art), or from the massive library of monographs and exhibition catalogues owned by Raymond W. Smith of New Haven.

A list of exhibition catalogues, monographs, and other books used to confirm or expand our original data would be far too long for us to include here; however, among the more useful sources for artists were Baigell's *Dictionary of American Art*; Brewington's *Dictionary of Marine Painters*; Groce&Wallace's *Dictionary of Artists in America: 1564–1860*; Morgan's *New Muses: Art in American Culture, 1865–1920*; Moure's *Southern California Art*; The National Academy of Design's *A Century and a Half of American Art*, and its *Artists by Themselves*; Parsons/WPA Artists' *New York City WPA Art*; Samuels' *Illustrated Biographical Encyclopedia of Artists of the American West*; The University of Connecticut's *Connecticut and American Impessionism*. For photographers the more useful sources were: Beaton&Buckland's *The Magic Image*; McQuaid & Wilson's *Index to American Photographic Collections*; Welling's *Photography in America: 1839–1900*; and Witkin&London's *The Photograph Collector's Guide*.

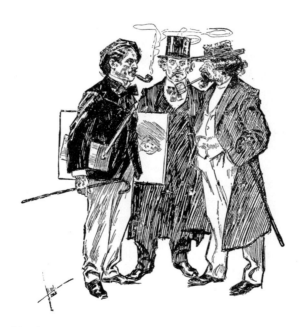

Edward Cucuel: *Typical Students of the Beaux-Arts*. From W.C. Morrow's *Bohemian Paris of Today*, 1899

PUBLISHER'S NOTE

On Rediscovering Forgotten American Artists and the Role of Sound View Press

> *"Beauty, like wit, to judges should be shown;*
> *Both are most valued where they are best known"*
> from the title page of American Art Annual

Scattered throughout old American art journals are illustrations of works by highly accomplished artists who have long since slipped into obscurity. Turning the pages, we see that they keep good company, for right there in the same journals are works by artists now highly esteemed, from Edwin Austin Abbey to William Zorach. As art historians, we are intrigued and challenged: why have these artists been forgotten? where are their works? how many other artists have slipped into obscurity? how many have been undeservedly overlooked? Without doubt the discovery (or rediscovery) of such talent is the most exciting part of our work.

Disappointingly, our research too often ends in the discovery that artists' works and letters have been permanently lost as a result of fire. Since the Civil War, it seems, fire has hit almost every major city in the United States: Portland, Maine, in 1866; Chicago, in 1871; Boston, in 1872; Milwaukee, in 1892; Minneapolis, in 1893; Baltimore, in 1904; San Francisco, in 1906–the list goes on.

Such disasters, however, are not the only reason for the eclipse of accomplished artists. Many artists never fully recovered from the long, difficult period of the Great Depression, despite the efforts of the WPA. Perhaps more of their works were stored away—or thrown out—during the Depression era than at any other time. The reasons for the disappearance of other artists are often more personal and complex. Some were so wealthy they did not need—or want—to have their work promoted. Some were reclusive by nature, withdrawing altogether from the museum and gallery scene—if, in fact, they ever had been a part of it. Some were irascible characters, at odds with the world. Some were alcoholics. We find that every one of the artists whose life and work we research has his or her own intriguing story.

As researchers and publishers, we use as a starting point biographical sketches (such as the nearly 25,000 in this book). From these we select and focus upon certain artists, researching their lives and objectively appraising their work. Then we delve more deeply, checking to see if enough work of high quality has survived to merit our full commitment to a more thorough appraisal. This procedure is most exciting when it culminates in our organizing retrospective exhibitions for museums and galleries, and in the preparing and publishing of illustrated monographs to promote the artists and their work.

We also work discreetly with owners who wish to sell their art collections as a whole or, perhaps, help them find the most appropriate museum to which they may donate their pieces.

Our satisfaction comes with the thrill of discovery, the exploration of artists' lives, and in serving as a catalyst for the long overdue (re)introduction of forgotten yet talented artists to the public. Always eager to be of assistance to others doing research in the field, we welcome all inquiries.

Peter Hastings Falk
Publisher

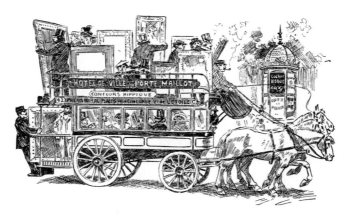

Edward Cucuel: *Judgment Day at the Salon . . . The Upper Decks of the Ominibuses Were Crowded With Artists*. From W.C. Morrow's *Bohemian Paris of Today*, 1899

WHY AND HOW THIS BOOK WAS CREATED

Who Was Who in American Art was born of a practical need for a comprehensive reference tool for our own research and of our desire to share that information with anyone interested in the history of American fine arts. Since the focus of our research is on the artists active from the last quarter of the nineteenth century to the mid-twentieth century, and since that period is also of great interest to a vast number of researchers, collectors, dealers, curators, and historians, we felt this book would also be a useful contribution to the field of American art. We found ourselves in agreement with the many researchers who considered the few existing biographical dictionaries of artists to be inadequate. Based primarily upon previous dictionaries, such works often repeat misspellings, wrong dates, and other inaccurate information.

The nearly 25,000 biographical entries in this book were compiled from the original thirty volumes of the *American Art Annual* (1898–1933) and its subsequent four volumes under the title of *Who's Who in American Art* (1935–1947). These thirty-four volumes have been regarded as our most accurate source of biographical data on American artists active from the late nineteenth century through the mid-twentieth century. The *Annual*'s reputation is based largely on the fact that it is the only source whose information has come directly from the artists themselves.

Florence N. Levy was the founding editor of the *American Art Annual* in 1898. She had the foresight to recognize the importance of gathering current biographical data on artists who had made their mark in various spheres of the American art world. Certainly the catalyst that sparked her vision in the 1890s was the flowering of numerous art schools, summer colonies, and societies across the nation. These were the culmination of a new belief in the inherent worth of American art, a belief that had been growing during the previous two decades. The Centennial Exhibition of 1876, in Philadelphia, had awakened America's senses and signaled the descent of thousands of American art students upon the academies of Europe. By 1893 the World's Columbian Exposition, in Chicago, would come to symbolize a nation whose artists and their patrons had finally gained a new confidence and earned a new respect, ensuring the future of American art.

Readers will notice the frequency with which the artists in this volume credit their art education to the schools in Paris and Munich. Most popular in Paris were the Académie Julian, the Académie Colarossi, the Ecole des Beaux-Arts, the Académie Delecluse, and the Académie de la Grand Chaumière. Even Whistler's short-lived Académie Carmen drew a large number of young Americans between 1898 and 1901. The lure of the art atmosphere of the *Quartier Latin* was inevitable, but, for the first time, American students could also find extensive and solid training on their own soil. In 1899 the school of the Art Institute of Chicago boasted 1,800 students. In the same year, the Pennsylvania Academy of Fine Arts had 375 students, and just a year earlier two of its leading instructors, Thomas Anshutz and Hugh

A nearly complete set of the *American Art Annual* from the Sterling Library at Yale University

Breckenridge, opened their Darby School of Painting in Fort Washington. Boston's Museum School claimed strong leadership in the persons of Edmund Tarbell and Frank Benson, two prominent members of *The Ten*. The Pape School and the Cowles School also drew large enrollments from the Boston region.

In 1899 the school of the National Academy of Design in New York registered 250 students. The Art Students League had enjoyed an active following ever since its founding in 1875. One of the most popular schools in New York was the Chase School of Art, founded by the illustrious William Merritt Chase in 1896 and renamed the New York School of Art in 1898. Chase also ran a summer school at Shinnecock on Long Island that, from 1891 to 1902, attracted students from all over the country.

In addition to the growth in art schools, the decades from 1890 to 1910 also witnessed the formation of many important art colonies that attracted mature artists. In Connecticut, Theodore Robinson, John Twachtman, and Childe Hassam settled in Cos Cob. Hassam later moved to the colony at Old Lyme, as did Henry Ward Ranger, Willard Metcalf, and many others. George Inness, Charles Curran, and Edward Lamson Henry were among those who founded a mountain-top colony at Cragsmoor, New York. Augustus Saint-Gaudens, Thomas Dewing, and Maxfield Parrish were early members of the colony at Cornish, New Hampshire. Birge Harrison and John F. Carlson were the founders of an art colony at Woodstock, New York, whose students were legion.

During the 1910s new colonies continued to be "discovered" in beautiful regions where artists enjoyed banding together. Provincetown, on Cape Cod, delighted Charles Hawthorne and he started his popular school there; Charles Davis settled into teaching at Mystic, Connecticut; and Abbott Thayer had a following in Dublin, New Hampshire. The rugged coast of Maine drew many artists, who tended to settle around Ogunquit, while many were won by the beautiful landscapes around New Hope, Pennsylvania and the Brandywine region of Delaware. Out West, colonies were growing in Taos and Santa Fe, and many eastern artists eventually settled on California's coast at Carmel. Later, in picturesque Rockport, Massachusetts, large classes were held in the summer by long-time residents Aldro Hibbard, Lester Hornby, and Anthony Thieme.

In addition to the schools and colonies, art societies began to spread to every major city in the country. Many were specialized, such as the National Society of Mural Painters (founded 1895), the National Sculpture Society (founded 1893), the American Society of Miniature Painters (founded 1899), and the Society of Illustrators (founded 1901). At the turn of the century the whole art world was alive with the beginnings of tumultuous change. Cycles of reaction gave birth to new radical styles and new "isms." In America, secessionist movements were also powerful forces on the course of American art. The work of the famous *Ten American Painters* (founded 1897) had come to epitomize the best American

Impressionism could offer. But by 1907 Robert Henri, William Glackens, and six others seceded from the art establishment of the Gilded Age to form a controversial group called *The Eight*, later known as the *Ashcan Group*. It was also during this period that Alfred Stieglitz formed the influential *Photo Secession* group (1902), which propelled photography as a fine art into the public view.

It is not within the scope of this introduction to offer a history of all the art schools, colonies, and societies that were founded from the close of the nineteenth century to World War I. The emergence and growth of various groups continued, only to be affected by the larger global importance of World War I, the Depression era, and World War II. The purpose for briefly citing the examples above is simply to illustrate why in 1898 it was historically important and appropriate for Florence Levy to begin publishing the *American Art Annual*.

In producing the *Who's Who in Art* sections of the *Annual*, Levy explained that thousands of "data blanks" were sent out to artists, filled out by them, and returned. Names of artists were secured from the membership rosters of the leading art societies in the nation and from the exhibition catalogues of those societies' annual exhibitions. Artists of the student or amateur class did not qualify for admission. Thus, the *Annual* never intended to include all artists, but rather a selected list of those who had attained a position of some prominence in their special fields.

Although the *Annual*'s publishing schedule was irregular, its *Who's Who in Art* sections were basically biennial. From 1898 to 1920 each contained 3,000 to 5,000 artists' biographies. The number of entries grew with each successive biennial. From the 1920s to 1947 each of the *Who's Who in Art* contained from 6,000 to 10,000 artists' biographies. The editors sought to update their information by mailing the artists their particular biographical entries for revision and inclusion in the next edition. Every effort was made to locate all artists. Some, particularly those who moved frequently, required several mailings. Gallery owners, museum directors, and officers of art organizations were also helpful in providing information. Previously listed artists who did not respond were dropped unless they were known to have exhibited during the previous two years or were members of an important art society. Obituaries appeared in every volume of the *Annual*, providing an additional source of information.

In creating *Who Was Who in American Art* it was our objective to devise a careful editing procedure that would effectively compile the original thirty-four volumes into one practical reference volume. As we knew from experience, the thirty-four volumes and the quantity of data contained in them present two inherent problems to researchers and readers. First, complete original sets are rarely found. (In fact, the only fairly complete set we have been able to locate for sale is owned by Ursus Books, Ltd., of New York. That set lacks four volumes and is currently priced at $2,500.) Second, the few incomplete sets that can sometimes be found in older, larger libraries are difficult to use in a practical way. For example: You are researching the artist Howard Brown. It has been your great good fortune to have found a complete set of the *American Art Annual*, and the thirty-four volumes sit before you. Guessing that one of the volumes toward the middle of the series would be a good place to start, you pick volume 18, whose title page reads 1921. You are pleased to have found Howard Brown's listing on the first try. But now you must look into successive volumes until you find the last one in which he is listed. It is logical to expect that the last listing was also the largest and the most complete. However, all facts about some artists' careers found in the early annuals do not necessarily reappear in the later annuals. You therefore have to be careful not to miss some data on Howard Brown that may not have been carried forward to his last listing. To do this you have to work backward chronologically through each annual, examining each of his entries until you come to his first listing. In addition, you must be aware that the last listing you found in the annuals may not be the *real* last listing. Sometimes an artist would be dropped from the annuals only to be included again many years later. To make matters worse, in this particular case there is a special problem: there are *two* artists named Howard Brown listed. You may have settled upon the Howard Brown whose last listing

appeared in 1925. But you may have missed the Howard Brown whose last listing appeared in 1947. In our new *Who Was Who in American Art* such confusion is eliminated since both artists' entries appear together (the entries are arranged in alphabetical order by surname) and can be distinguished at a glance.

From the example above it can be seen why, in our effort to compile the most complete biographical entries, our strategy was to implement a screening process that would catch all bits of relevant data from each of the annuals in which an artist appeared. The first step was to photocopy the thirty-four volumes of the *American Art Annual*. To accomplish this, incomplete sets from several institutions were used to create one complete photocopy set of nearly 6,000 pages.

For editing purposes, a system of checks and counter-checks was created, beginning with the last annual, published in 1947. Each biographical entry in the 1947 annual was compared to the entries in the preceding annual, that of 1940. Any "new" data was extracted and entered on one master index card for the particular artist. When this process was completed we were left with one set of "master cards," which included all of the artists active from 1940 to 1947. The year of the annual in which the artist last appeared was also noted.

Working backward chronologically, the next two annuals were published in 1938 and 1935. These were compared with each other. Again, the most complete entry was selected, and any additional bits of data added to it. The next step was to compare these 1938 and 1935 entries with our first set from 1940 to 1947. When this final step of "merging and purging" was completed, our set of "master cards" had grown considerably. It now included all of the artists from 1935 to 1947.

Continuing backward, the next two annuals were paired off for comparison with each other and, finally, with the "master cards." Again, the new entries were given index cards on which the year of their annual was marked. For artists already filed within the "master cards," regular comparisons were made to catch any "new" data in the earlier entries and carry it forward to the respective "master card." Working from 1947 back through 1898 entailed cross-checking more than 120,000 biographical entries, all of which were finally compiled into the nearly 25,000 complete entries that constitute this volume.

Inclusion of the obituaries that appeared in every annual was another important facet of the editing procedure. In many cases extra facts were extracted from the obituaries, making the master entries more complete—and often more colorful. What researcher could resist including the fact that Birtley Canfield (1866–1912) the sculptor who specialized in dogs, died from being bitten by one of his subjects! Or that the adventurous Charles Basing (1865–1933) died in Marrakesh, Morocco, from blood poisoning after a camel stepped on his foot! Some artists even had problems with the government that the obituaries found worth citing. Jefferson Chalfant (1856–1931) painted a $1-bill in such meticulous detail that it was confiscated by the government. Philippo Costagini (1839–1904), who spent most of his life painting a monumental historical fresco for the Capitol at the rate of $10 per day, retired only to discover that Congress had failed to make the appropriations with which to pay him.

The obituaries also included people who, though not artists, made important contributions to the American art world. Samuel Putnam Avery and Joseph Duveen were among the great art dealers who helped build some of the country's major private collections. Figuring prominently among the collectors are the familiar names of J. P. Morgan, Henry Clay Frick, Benjamin Altman, and Jules Bache. Although a French art dealer, Paul Durand-Ruel must be included, for it was he who first brought Impressionism to the American public, staging a hotly debated landmark exhibition in New York in 1886.

Although the focus of this book is upon artists who were most active from the 1890s through the 1940s, many who are listed actually reached the prime period of their artistic productivity during the 1860s, 1870s, or 1880s. Some of these earlier artists who were still active at the end of the century were William H. Beard (1825–1900), Albert Bierstadt (1830–1902), Eastman Johnson (1824–1906), William Trost Richards (1833–1905), Arthur F. Tait (1819–1905), Whistler (1834–1903), and Frederick E.

Church (1826–1900). The earliest artist in this book is John Sartain (1808–1897). At the other end of the spectrum, readers will discover the names of a few of our older modern masters, such as Georgia O'Keeffe (b. 1887). There are other examples of living artists who had attained enough prominence at a relatively young age to be included in our cut-off annual of 1947. Among them are abstract expressionist artists such as Robert Motherwell (b. 1915), who has outlived his contemporary Jackson Pollock (1912–1956). The great majority of the artists in this book, however, come from the period that saw both the American impressionists and the early abstract painters reach maturity. It was a period of great variety and constant change; one that included *The Ten*, the *Ashcan Group*, painters of the Old West, the great illustrators who followed a tradition begun in the 1870s, designers in both the *Art Nouveau* and *Art Deco* styles, the *Regionalists* of the Depression era; and, finally, the progenitors of the movement toward abstraction.

We are also pleased to include the period's most accomplished master craftspeople, photographers, cartoonists, curators, critics, and educators. How could we leave out Rube Goldberg, that zany cartoonist-inventor, who has delighted generations? How could we omit Rudolf Arnheim, whose studies on the psychology of perception are valuable aids in understanding works of art? And how could we bypass Frederic Goudy? The name may not be instantly recognizable, but it was he who designed the typeface in which this book is set. The famous and the forgotten are here, forming a roster of thousands who made their individual marks on American art history. We urge our readers to investigate their lives in greater depth.

While this volume was originally intended as a compilation of historical data, we felt obligated to add biographical facts. For the era's forgotten artists of distinction this sometimes meant adding a new biography that did not appear in the original *Annuals*. This final stage of editing utilized several private and institutional libraries acknowledged herein, as well as our own research files. Great care has been taken to avoid the errors and omissions that unfortunately may creep into a work of this size and complexity. In our endeavor to continue to improve the scope and accuracy of this volume, we shall always welcome corrections and any suggestions for the addition of new names.

PHF

Edward Cucuel: *A New Model at Gérôme's Atelier.* From W.C. Morrow's *Bohemian Paris of Today*, 1899

ABBREVIATIONS

PROFESSIONAL CLASSIFICATIONS

Adv. Des	Advertising Designer	E, Et	Etcher[1]	Min. P	Miniature Painter
Arch	Architect	Edu	Educator	Mur. P	Mural Painter
Arch-S	Architectural sculptor	Enam	Enameling	Mus. Assoc	Museum Associate[2]
Art Lib	Art Librarian[2]	En, Engr	Engraver[1]	Mus. Cur	Museum Curator[2]
B	Block Printer[1]	G	Graphic Artist[1]	Patron	Patron of The Arts[2]
Bkbind	Bookbinder	Genre P	Genre Painter	Ph, Photogr	Photographer
C	Craftsperson	Gr	Graver[1]	Por.P, Port.P	Portrait Painter
Caric	Caricaturist	Hist	Historian	Por.S, Port.S	Portrait Sculptor
Car, Cart	Cartoonist	I	Illustrator	Pub	Publisher[2]
Cer	Ceramicist	Indst. Des	Industrial Designer	S	Sculptor
Com.A, Comm.A	Commercial Artist	Int. Dec	Interior Decorator	Ser	Serigrapher[1]
Cr	Critic	J	Jeweler	T	Teacher
Cur	Curator[2]	L	Lecturer	Typ, Typogr	Typographer
Dealer	Art dealer[2]	Ldscp.P	Landscape Painter	W	Writer
Dec	Decorator[3]	Li, Lith	Lithographer[1]	WAA	Worker in Applied Arts (old term, now changed to "C")
Des	Designer[3]	Lib. Dir	Library Director[1]		
Dr	Drawing Specialist	Mar. P	Marine Painter	Wood En, Wood Engr	Wood Engraver[1]

 1. In the final volume on which this book is based (*Who's Who in American Art*, 1947) the editors sought to subsume the various specialties within the graphic arts into one category: [G]. We have tried to maintain the older more specific classifications wherever possible. A brief explanation of these various fields within the graphic arts may be helpful.

 [En, Engr] We doubt that the use of this classification in the old *Annuals* adheres strictly to the technical definition of engraving alone. For the purposes of this book an engraver was likely to be an artist working in any of the three basic intaglio printing methods: etching, engraving, or drypoint. The combination of all three methods was not unusual. Intaglio is the method of creating grooved lines in a metal plate (usually copper) which can then be inked and printed. From the founding of the New York Etching Club in 1877 to the early 1890s, etching enjoyed great popularity in America. After a quarter century of neglect, interest in printmaking was revived by the Painter-Gravers of America, established in 1917. Since printmakers, particularly etchers, were commonly refered to as "gravers," it is likely this is the context in which the old *Annuals* used the [Engr] and [Gr] designations.

 Wood engravers [Wood En] are similar to blockprinters [B] in that both made relief prints from wood blocks. However, wood engraving, like lithography, was a relatively young process in contrast to the blockprint (or woodcut), which is the oldest of all the relief processes. Wood engraving was the universal means of illustrating books and magazines from the mid-nineteenth-century until its replacement by the increased use of photomechanical halftones in the 1890s. This golden age of wood engraving illustrations was forged by artists and wood engravers working for publishers like Harper's, Scribner's, and Century, all frequently

cited herein. These publishers employed highly skilled masters of this forgotten craft to translate artists' drawings, paintings, or photographs into black-and-white wood engravings.

An artist designated as a blockprinter [B] is therefore clearly different from a wood engraver. Although the woodcut had been used to print pictures in Europe for six centuries, the beginnings of American appreciation for it as an art form can be traced only to the last quarter of the nineteenth century, when Japanese prints were introduced. American artists did not begin to exploit the woodcut as an expressive medium in its own right until the early twentieth century. Arthur Wesley Dow stands out as our most influential early proponent of the woodcut. During the era of World War I, the Provincetown Printers and other print clubs had given the woodcut a major place in their artistic ventures. Finally, by the 1930s both printmakers and illustrators came full cycle and revived another method, the original white-line wood engraving.

Designs for lithography [Li, Lith] are usually made with a grease pencil on a special lithographic stone or on a special paper later to be transferred to the stone. The stone is then wetted, leaving an even layer of water over its surface. The areas marked by the grease pencil repel the water but will accept a layer of ink. The stone is then ready for the printing press. It was not necessary for the artist to thoroughly understand the process as it was with intaglio, for most used the services of professional lithographic printers. Therefore, this designation [Li] does not imply that the artist was also the printer.

The serigraph [Ser] is simply a sophisticated synonym for the common silkscreen, a stencil process. The designation was coined in 1941 to distinguish artists' work from that of commercial silkscreen printers.

2. Non-artists were included if they made a significant contribution to the literature, promotion, or growth of art in America. For persons with institutional affiliations, such as museum curators, museum directors, art librarians, library directors, and educators, this meant having books or articles published. As in university life today, we abided by the dictum "publish or perish." Patrons were often both serious collectors and financial supporters of museums. In many cases they also bequeathed their art collections to a favorite museum.

Historically, certain art dealers combined their commercial interests with an instinct for promoting artists who have now become widely appreciated. Some, such as Alfred Steiglitz, William Macbeth, and Durand-Ruel mounted exhibitions that had major impact on the art world.

3. A designer [Des] is one who created the plan to produce a particular object although he or she may not have been the actual fabricator. A decorator [Dec] is one who applied his or her craftsmanship to adorning the art object. For example, a decorator of art pottery may or may not be the same person who designed its shape and conceived its decoration. In some cases the difference between the two may be minimal or nonexistent.

MUSEUMS, EXHIBITIONS, SCHOOLS, ASSOCIATIONS

AAAA
American Association of Allied Arts. Est. 1897 in NYC.

AAAL
American Academy & Institute of Arts and Letters. Est. 1904 by the National Institute of Arts and Letters. Membership limited to 50, chosen from NIAL membership.

AAC
See Chicago AA.

AAM
Art Association of Montreal.

AAPL
American Artists Professional League. Est. 1928.

AAPS
Association of American Painters and Sculptors. Sponsors of the "International Exhibition of Modern Art," better known as the "Armory Show," held in NYC in 1913, the most important event in the development of modern art in America.

A. Aid S.
See A. Fellowship.

AAS
American Art Society, Philadelphia.

A. Bookplate S.
American Bookplate Society.

A. Ceramic S.
American Ceramic Society. Est. 1899 in Columbus, OH.

ACM
Amon Carter Museum. Est. 1961 in Fort Worth, TX.

ACP or AC Phila.
See Phila. AC.

ADI
American Designers Institute.

AEF
American Expeditionary Forces of WWI. During 1918–19 a small group of artists were selected as official artist-correspondents for the U.S.

AFA
American Federation of Arts. Est. 1909 to circulate exhibitions throughout the U.S. Published the Magazine of Art.

AFAS
American Fine Arts Society. Est. 1889 in NYC, by the ASL, SAA and Arch. L. Its building on 57th Street has housed the ASL since 1892.

A. Fellowship
Est. 1869. Name changed to Artists' Aid Society in 1890; then changed back to Artists' Fellowship in 1924.

A. Fund S.
Artists Fund Society, NYC. (same as A. Aid S.?)

AG
Artists Guild. Unless preceded by another city name, refers to the Artists Guild of the Author's League of America in NYC. Est. 1920 as GFLA; became the Artists Guild in 1931. Purpose: act as a medium of contact between artists and clients.

AGAA
Addison Gallery of American Art. Est. 1931 by Phillips Academy.

AIA
American Institute of Architects. Est. 1867.

AIAL
See AAAL.

AIC
Art Institute of Chicago. The museum grew out of the old Chicago Academy of Design, a school started in 1866. This became the Chicago Academy of Fine Arts in 1879; and the name was

changed to the Art Institute of Chicago in 1882. Building erected 1893.

AIGA
American Institute of Graphic Arts. Est. 1914 in NYC. Sponsored annual exhibitions and published "Fifty Books of the Year."

Albany IA
Albany Institute of History and Art. Est. 1791 as the Society for Promotion of Useful Arts. Its Art School was formed in 1886 when it was joined by the Albany Gallery of Fine Arts (est. 1846).

Albany Sch. FA
Albany School of Fine Arts. Est. 1910.

Albright A. Gal.
Albright-Knox Art Gallery. Est. 1862 in Buffalo and called both the Albright Art Gallery Academy and the Buffalo Fine Arts Academy. The Art School of the Academy was established in 1887 and united with the Buffalo Students Art Club in 1891. Building erected in 1905.

Alfred Univ.
Alfred University (New York State School of Clay Working and Ceramics). Est. 1900.

All.A.Am.
See Allied AA.

Alliance
See Allied AA.

Allied AA.
Allied Artists of America. Est. 1914 in NYC as an exhibition cooperative, electing its own juries.

Am. Abstract A.
American Abstract Artists. Est. 1936 in NYC. An important avante-garde force up to 1940.

Am. Acad. AL
See AAAL.

Am. Acad. in Rome
American Academy in Rome. Est. 1894 as the American School of Architecture, it became the American Academy of Architecture, Painting, Sculpture, and Music. "The course of study is one of observation and research aiming to form correct taste."

Am. A. Cong.
American Artists Congress. Est. 1936 in NYC. Endorsed government support of art unions, and promoted the social-realist style in American scene painting. Its increasing ties to the Communist Party led many painters to abandon its cause and it was defunct by 1943.

Am. APL
See AAPL.

AMNH
American Museum of Natural History. Est. 1869 in NYC.

Am. Numismatic Assn.
American Numismatic Association Est. 1891 in NYC.

Am. Numismatic Society
American Numismatic Society Est. 1858 in NYC.

Am. Sch. Min. P.
American School of Miniature Painting. Est. 1914 in NYC by Lucia F. Fuller, E.D. Pattée, and M.R. Welch.

ANA
Associate member of the National Academy of Design.

ARCA
Associate member of the Royal Canadian Academy.

Arch. Lg.
Architectural League of New York. Est. 1880 in NYC. formerly the Sketch Club of NY.

Arch. Lg. of Am.
Architectural League of America. Est. 1899. Sponsored exhibitions at chapters of the AIA in major cities.

Armory Show
"The International Exhibition of Modern Art" sponsored by the Association of American Painters and Sculptors at the Armory in NYC in 1913. The most important exhibition of modern art in America, it had a major influence on the course of American art.

Artists Lg. of Am.
Artists League of America. Est. 1941 in NYC to circulate exhibitions and provide help to artists in emergencies. Also held classes.

ASL
Art Students League. Est. 1875 in NYC, it quickly became one of the country's most important art schools. Many art schools in major cities offered scholarships for study at the ASL in New York. By the 1880s the ASL was forming branches in other cities. Unless a city name follows ASL, reference is to the ASL of NYC. [ASL of Chicago est. 1893; ASL of Wash., D.C. est. 1884].

ASMP
American Society of Miniature Painters. Est. 1899 in NYC. Phased out during the Depression. A revival organization, the Miniature Artists of America, was est. 1985.

ATA
Art Teachers Association.

AUDAC
American Union of Decorative Artists & Craftsmen.

Audubon A.
Audubon Artists. Est. 1940 in NYC.

AV
American Artists for Victory. Est. 1942 in NYC. Represented 34 art associations around the U.S. Organized a colossal exhibition at the MET (1,418) in 1942. In 1944 organized a 200-work exhibition to tour the British Isles. Also sponsored the National War Poster Competition.

AWCS
American Watercolor Society. Est. 1866 in NYC. Exhibitions held at National Academy of Design. In 1941 it absorbed the New York Watercolor Club.

A. Women PS
See NAWA.

BAC
See Boston AC.

BAID
Beaux-Arts Institute of Design. Est. 1894 and called the Society of Beaux-Arts Architects until 1941. Members must have been pupils of the Ecole des Beaux-Arts in Paris, whose principles they wished to cultivate and perpetuate in the U.S.

Baltimore AS
Municipal Art Society of Baltimore. Est. 1899.

BC
See Brooklyn AA.

Black Mtn. Col.
Black Mountain College, North Carolina. Art Dept. est. 1933; headed by Josef Albers.

BM
Brooklyn Museum. Est. 1823 as the Brooklyn Institute of Arts & Science. Art School est., 1898.

BMA
Baltimore Museum of Art. Est. 1914.

Balt. WCC
Baltimore Watercolor Club. Est. 1892.

Beaux-Arts Inst.
See BAID.

BMFA
Boston Museum of Fine Arts. Est. 1870. Art School est. 1876. Building erected 1909.

Bohemian C.
Bohemian Club. Est. 1872 in San Francisco as a men's social club for those in the artistic, literary, or scientific professions. Held annual exhibitions. Any other Bohemian Club will be qualified by its city name, e.g., Bohemian AC, Chicago.

Boston AC
Boston Art Club. Est. 1840. Est. its school in 1898.

Boston A. Students Assoc.
Boston Art Students Association. Est. 1879 and housed in the Grundmann Studio building. It became the Copley Society in 1888.

Boston Athenaeum
Est. 1807. A large part of its collection is at the Boston Museum of Fine Arts. Held exhibitions regularly.

Boston GA
Boston Guild of Artists. Est. 1914.

Boston Inst. Mod. A.
: Boston Institute of Modern Art. est. 1936; became the Boston Museum of Modern Art in 1938. Today called the Institute of Contemporary Art.

Boston PCC
: Boston Paint & Clay Club. Est. 1879.

Boston AC
: Boston Art Club. Est. 1854. Held annual exhibitions and purchased art for its collection. Admission free to students recommended by members.

Boston SAC
: Boston Society of Arts & Crafts. Est. 1897 and housed in the Mechanics Charitable Association building.

Boston SWCP
: Boston Society of Watercolor Painters. Est. 1892.

Boston WCC
: Boston Watercolor Club. Began its annual exhibitions at the Boston Art Club in 1887.

Brigham Young Univ.
: Brigham Young University. College of Fine Arts est. 1875. Art Museum est. 1965.

Broadmoor A. Acad.
: Broadmoor Art Academy. Est. 1919. Became part of the Colorado Springs Fine Art Center in 1936. The school achieved national stature under the directorship of Boardman Robinson in the 1930s.

Brooklyn AA
: Brooklyn Art Association. Est. 1864.

Brooklyn SA
: Brooklyn Society of Artists. Est. 1917. Exhibited at Brooklyn Museum.

Brooklyn SE
: Brooklyn Society of Etchers. Est. 1915; became Society of American Etchers in 1931. Exhibitions held at National Academy of Design.

BSAC
: See Boston SAC.

BSWCP
: See Boston SWCP.

Buffalo FA Acad.
: See Albright A. Gal.

Buffalo SA
: Buffalo Society of Artists. Est. 1892. Exhibited at Albright Art Gallery and sponsored the annual exhibitions of Buffalo's Bohemian Sketch Club.

B&W Cl.
: Black & White Club. Est. 1898 in Brooklyn; held its first annual exhibition in 1899 at the National Sculpture Society, NYC. Not to be confused with the Black and White Society which, as part of the Salmagundi Club, held its first annual exhibition at National Academy of Design in 1877.

CA
: See Chicago AA.

Calif. Col. A&C
: California College of Arts & Crafts. Est. 1907 in Oakland, Calif.

CAD
: See CUASch.

CAFA
: Connecticut Academy of Fine Arts. Est. 1910 in Hartford. Annual exhibitions held at the Wadsworth Athenaeum.

CAM
: See St. Louis AM.

Calif. Pal. Leg. Honor
: Est. 1896 in San Francisco, now the San Francisco Museum of Art.

Calif. Sch. Des.
: California School of Design. Est. 1874 in San Francisco, a part of the Mark Hopkins Institute. Became affiliated with the Univ. of Calif. in 1893. Today called the California School of Fine Art.

Calif. Soc. Min. P.
: California Society of Miniature Painters. Est. 1912 in Los Angeles. Exhibited at Los Angeles Art Association.

Calif. AC
: California Art Club. Est. 1909 in Los Angeles by the Painters Club. Exhibited at the Los Angeles Museum of Art from 1913–38.

Calif. SE
: California Society of Etchers. Est. 1913.

Cape Cod Sch. A.
: Cape Cod School of Art. Est. by Charles W. Hawthorne in Provincetown, Mass. in 1899.

CCNY
: City College of the City University of New York.

CE
: Cincinnati Exhibition, Spring 1898.

Central AA
: Central Art Association. Formed the Truth and Beauty League for boys and girls under 18 years old.

Century
: Century Association (or Club). A prominent social club for men in NYC. Held exhibitions and built a collection.

CGA
: See Corcoran.

Char. C.
: Charcoal Club. Est. 1883 in Baltimore. Offered classes. There was also a Charcoal Club in Philadelphia organized as an alternative to the Pennsylvania Academy of the Fine Arts in early 1890s. R. Henri gave criticisms, but the club did not last long.

Chase Sch. A.
: Chase School of Art. Est. 1896 in NYC by William M. Chase; re-named the New York School of Art in 1898.

Chicago AA
: Chicago Art Association. Est. 1897.

Chicago Acad. FA
: Chicago Academy of Fine Arts. Est. 1902. Not to be confused with the Art Institute of Chicago, once known by the same name.

Chicago Gal. A.
: Chicago Galleries Association.

Chicago NJSA
: Chicago No-Jury Society of Artists. Est. 1922; held exhibitions of "No Jury, No Prize, No Profit."

Chouinard A. Sch. (or AI)
: Chouinard Art School. Est. 1921 by Nelbert Chouinard in Los Angeles. Became California Institute of the Arts, Valencia, in 1961.

CI
: Carnegie Institute. Est. 1896. College of Fine Arts est. 1905. Building erected 1907. Sponsored annual Carnegie International Exhibition of Paintings.

Cincinnati A. Acad.
: Cincinnati Art Academy. See description under its popular name, McMicken Sch. Des.

Cincinnati AC
: Cincinnati Art Club. Est. 1880.

Cincinnati AM
: Cincinnati Art Museum. Est. 1881. Building erected 1886. It grew out of the McMicken School of Design, which was est. 1868.

Cleveland AA
: Cleveland Art Association. Est. 1916.

Cleveland Sch. A.
: Cleveland School of Art. Est. 1882. Formed the Cleveland Museum of Art in 1900.

CLW Art C.
: See Wolfe AC.

CM
: See Cincinnati AM.

CMA
: Cleveland Museum of Art. Est. 1900, it grew out of its Art School (est. 1882). Building erected 1914.

Colorado Springs FA Center
: Colorado Springs Fine Art Center. See Broadmoor A. Acad.

Columbia
: Columbia University, NYC. See also T. Col., Columbia.

Columbus
: Columbus Museum of Art. Est. 1878, Columbus, Ohio, as the Columbus Gallery of Fine Art. The Columbus Art Association and Art School were est. 1879 as part of the museum.

Columbus PCC
: Columbus Paint and Clay Club. Est. 1898 in Columbus, Ohio, as an all-men's club.

Contemporary
: The Contemporary Group.

Cooper Union
: See CUASch.

Copley S.
: Copley Society. Est. 1879 as the Boston Art Students Association, whose name was changed in 1888.

Corcoran
: Corcoran Gallery of Art. Museum est. 1869; art school est. 1875. Building erected 1897.

Country Sketch C.
: Country Sketch Club. Est. 1897 by a group of students at the National Academy of Design for other students with little time or means. Located in Ridgefield, N.J. in 1899.

Cranbrook Acad. A.
: Cranbrook Academy of Art (and Museum) est. 1927 in Bloomfield Hills., Mich.

CSB
: See Copley S.

CUASch
: Cooper Union Art School. Est. 1859 in NYC. Operated the Women's Art School during the day separate from the Men's Night School. Its museum, est. 1897, is now the Cooper-Hewitt Museum, NYC, a part of the Smithsonian.

DAC
: See Denver AC.

Dallas AA
: Dallas Art Association. Est. 1902 as part of the Dallas Museum of Art.

Darby Sch. P.
: Darby School of Painting. Est. 1899 in Darby, Pa., by Thomas Anshutz and Hugh Henry Breckenridge. A special feature of the school was its year-round painting en plein air.

Delgado MA
: See NOMA.

Delta Phi Delta
: Est. 1909 as a chapter of the American Federation of Arts. By 1945 it had 7,000 members with chapters at 28 colleges and universities.

Denver AC
: Denver Art Club. Est. 1893, but had been informally active since the 1880s.

Deseret Acad. FA
: Deseret Academy of Fine Art. Est. 1863 in Salt Lake City by D. Weggeland, G. Ottinger, and A. Lambourne.

de Young Mem. Mus.
: de Young Memorial Museum. Est. 1895 in San Francisco.

Detroit A. Acad.
: Detroit Art Academy. Est. 1894.

Detroit IA
: Detroit Institute of Arts. Est. 1885 as the Detroit Museum of Arts (until 1888).

Detroit Sch. Des.
: Detroit School of Design. Est. 1911.

Drexel Inst.
: Drexel Institute Museum. Est. 1891. School of Art est. 1892. Now called Drexel University.

EAA
: Eastern Arts Association.

EA and MT Teacher
: Eastern Art and Manual Training Teachers Association. Est. 1899 to advance the interests of art education.

Edu. Alliance
: Educational Alliance Art School. Est. 1914 in NYC.

Encyc. Brit.
: Encyclopaedia Britannica Collection. Est. 1944. Sponsored traveling exhibitions of its collection of twentieth-century American art.

Everson MA
: See Syracuse MA.

FAP
: Federal Art Project. See WPA.

FAS
: Fine Art Society, NYC.

Fawcett Sch.
: Fawcett School of Industrial Art. Est. 1882 in Newark, N.J.

Fed. A. Proj.
: See WPA.

Fed. Mod. PS
: Federation of Modern Painters & Sculptors. A non-political alternative to the declining American Artists Congress. Est. 1940 in NYC to promote avante-garde art. Held annual exhibition at Wildenstein Gallery.

Fenway Sch.
: Fenway School of Illustration. Est. 1912 in Boston.

FMA
: Fogg Museum of Art. A part of Harvard Univ., est. 1895.

Fontainbleau Sch. FA
: Fontainbleau School of Fine Art. Est. 1923 in France; ceased 1939 due to WWII.

FRSA
: Fellow of the Royal Society of Artists, London.

FSA
: Farm Security Administration (1935–43). Employed a select group of photographers to document conditions during the Depression. See also WPA.

GFLA
: Guild of Free Lance Artists. Est. 1920 in NYC. See AG.

GGE
: Golden Gate Exposition, San Francisco, 1939.

Grand Central A. Gal.
: Grand Central Art Galleries. Est. 1923 in NYC as a non-profit gallery.

Guggenheim M.
: Solomon R. Guggenheim Museum. Est. 1937 in NYC as the Museum of Non-Objective Painting.

G.W.V. Smith AM
: George Walter Vincent Smith Art Museum. Est. 1889 in Mass. as part of the Springfield Library Association.

Hartford A. Sch.
: Hartford Art School. Est. 1877 in Hartford, Conn.

Herron AI
: John Herron Art Institute. Est. 1902 as part of the Indianapolis Art Association.

Hofmann Sch. A.
: Hans Hofmann School of Fine Art. Est. 1934 in NYC and Provincetown, Mass.

Hoosier Salon
: Est. 1926 to promote Indiana artists. Exhibitions often held at Art Institute of Chicago.

Hopkins IA
: Mark Hopkins Institute of Art. Est. 1874. Also known as the California School of Design. Affiliated with the San Francisco Art Association.

Houston AL
: Houston Art League. Est. 1900. Name changed to Houston Museum of Fine Arts in 1925.

Houston MFA
: Houston Museum of Fine Arts. Est. 1900 as the Houston Art League (until 1925). Its school was est. 1927.

IMP
: International Museum of Photography at George Eastman House. Est. 1947 in Rochester, NY.

Indianapolis AA
: See Indianapolis AM.

Indianapolis AM
: Indianapolis Art Museum. Est. 1883 by the Indianapolis Art Association. Its school, the John Herron Art Institute, was est. 1902. Building erected 1906.

Indianapolis SAC
: Indianapolis Society of Arts & Crafts. Est. 1898.

Intl. Soc. AL
: International Society of Arts & Letters (sometimes listed as Société Internationale des Beaux-Arts et des Lettres).

Intl. Soc. SP&G
: International Society of Sculptors, Painters & Gravers. Est. 1898 in London, with James A. McN. Whistler as its first president.

Kappa Pi
: Est. 1911. A national honorary art fraternity for both men and women students. By 1945 had 30 chapters and 3,000 members.

Kit Kat Cl.
: Kit Kat Art Club. Est. 1881 in NYC as

a meeting place for artists to informally draw and paint from a model.

KWM
Kendall Whaling Museum. Est. 1956 in Sharon, Mass.

LAL
See Louisville AL.

Layton A. Gal.
Layton Art Gallery. Est. 1888. See also Milwaukee AM.

Lg. of AA
League of American Artists.

LOC
Library of Congress. Est. 1800 in Wash., D.C.

Los Angeles MA
Los Angeles County Museum of Art. Est. 1907. Building erected 1913.

Los Angeles Sch. A.&Des.
Los Angeles School of Art & Design. Est. 1887 by Mrs. L.E. Garden MacLeod. Closed in 1919.

Lotos C.
Lotos Club. Est. 1870 as a men's social club, to which many prominent artists belonged.

Louisville AL
Louiseville Art League. Est. 1895 in Ky.

Lyme AA
Lyme Art Association. Est. 1902 in Conn.

Mac.D. C.
MacDowell Club. Est. 1907 in NYC by Edward MacDowell; disbanded in 1945. Today the MacDowell Association maintains a large summer colony for artists, writers, and musicians in Peterborough, N.H.

Mass. Mechanics A.
Massachusetts Charitable Mechanics Association. Est. 1795 in Boston. Sponsor of many exhibitions, including the first major exhibition of the French Impressionists in the U.S., in 1883.

Mass. Normal A. Sch.
Massachusetts Normal Art School. Est. 1873 in Boston to train teachers of the fine and industrial arts. Tuition was free to Mass. residents intending to teach drawing in the public schools. Now called the Massachusetts School of Art.

Mass. Sch. A.
See Mass. Normal A. Sch.

Mark Hopkins IA
See Hopkins IA.

McMicken Sch. Des.
McMicken School of Design. Est. 1868 in Cincinnati. Athough its name was changed to the Cincinnati Art Academy in 1881, it has been commonly referred to by its old name.

Md. Hist. Soc.
Maryland Historical Society. Est. 1844 in Baltimore. Now called Museum and Library of Maryland History.

Md. Inst. Sch. A.&Des.
Maryland Institute School of Art and Design. Est. 1826. Now called the Maryland Institute College of Art.

MET
See MMA.

MHI
See Hopkins IA.

Milwaukee AI
Milwaukee Art Institute. Est. 1888. Building erected 1911. Now the Milwaukee Art Museum.

Milwaukee AM
Milwaukee Art Museum. Est. 1888 as the Layton Art Gallery. Its School of Art was est. 1920.

Mineral P.
National League of Mineral Painters. Sponsored annual exhibitions since 1892. Affiliated with Ceramic and Pottery Clubs in major cities.

Minneapolis AL
Minneapolis Art League. Est. 1896.

Minneapolis IA
Minneapolis Institute of Arts. Est. 1883. Building erected 1914. Affiliated with the Minneapolis Society of Fine Arts.

Minneapolis Sch. FA
Minneapolis School of Fine Arts. Est. 1885. Affiliated with the Minneapolis Society of Fine Arts. Now called Minneapolis College of Art & Design.

Min. PS&G
See ASMP.

MIT
Massachusetts Institute of Technology.

MMA
Metroplitan Museum of Art. Est. 1870 in NYC. Building erected 1880.

Modern AA
See S. Mod. A.

MOMA
Museum of Modern Art. Est. 1929 in NYC.

Montclair AM
Montclair Art Museum. Est. 1911 in N.J.

Moore IA
Moore Institute of Art. Est. 1844 as the Philadelphia School of Design for Women.

Munson-Williams-Proctor Inst.
Est. 1919 in Utica, N.Y.

Munich Acad.
Royal Bavarian Academy, Munich.

Municipal AS of N.Y.
Municipal Art Society of New York. Est. 1893.

Mural P.
See NSMP.

Mus. N.Mex.
Museum of New Mexico. Est. 1909 in Santa Fe.

Mus. Non-Objective P.
See Guggenheim M.

Mystic SA
Society of Mystic (Conn.) Artists.

NA
Full member of the National Academy of Design. See also NAD.

NAAE
National Association for Art Education.

NAC
National Arts Club. Est. 1898 in NYC to foster the applied arts.

NAD
National Academy of Design. Est. 1825 in NYC. From 1865–99 its building was on 23rd St. From 1899–40 the NAD School was on 109th St. & Amsterdam Ave., while NAD exhibitions (for most of the artists of this dictionary's time frame) were held at the American Fine Arts Society's galleries on 57th St. The present building on Fifth Ave. was occupied in 1940. It also served as the headquarters for the Artists' Fellowship Inc.; American Watercolor Society, New York; Society of American Etchers, New York; and National Society of Mural Painters, New York. Many other organizations' exhibitions were held there. NAD's "Antique School" was free, but required a drawing exam for admission. Other courses, such as painting, had tuition.

Nat. AAI
National Alliance of Art & Industry.

Nat. Assn. Women PS
See NAWA.

Nat. Coll. FA
See NCFA.

Nat. Gal.
See NGA.

Nat. Soc. Mural P.
See NSMP.

NAWA or NAWPS
National Association of Women Artists. Est. 1889 in NYC. Exhibited at National Arts Club, New York and Argent Gallery, NYC. Also called National Association [sometimes "Academy"] of Women Painters and Sculptors.

NCFA
National Collection of Fine Arts. Est. 1906 in Wash., D.C. as part of the Smithsonian. Now called the National Museum of American Art.

Newark M.
Newark Museum. Est. 1909 in N.J. Housed in the Newark Public Library through the 1940s.

Newark Sch. FA
Newark School of Fine Art. Est. 1882 in N.J.

Newcomb A. Sch.
Newcomb Art School of Newcomb College. Est. 1887 in New Orleans.

Known for its training in pottery, ceramics, and arts & crafts.

New Haven PCC
New Haven Paint & Clay Club. Est. 1900 in New Haven, Conn.; now housed in the John Slade Ely House.

New Orleans AA
See NOAA.

Newport AA
Newport Art Association. Est. 1912 in R.I.; Art School est. 1913.

New School
The New School. Est. 1911, in Boston by Douglas J. Connah and Vesper E. George. In 1924 Vesper George est. an art school under his own name.

New Sch. Soc. Res.
New School for Social Research. Est. 1919 in NYC.

Newspaper AA
Newspaper Artists & Book Illustrators Association, NYC.

NGA
National Gallery of Art. Est. 1937 in Wash., D.C. (a federal museum independent of the Smithsonian).

NIAL
National Institute of Arts and Letters. Est. 1898. Limited to 250 members. Headquartered at American Academy of Arts and Letters in NYC, which it est. in 1904.

NJSA
No-Jury Society of Artists. Est. 1920s by the Salons of America. Similar to Society of Independent Artists.

NMAA
National Museum American Art. Est. 1906 in Wash., D.C., as the National Collection of Fine Arts.

NOAA
New Orleans Art Association. Est. 1880 as the New Orleans Art Union; became the New Orleans Art Association in 1885–86. Exhibitions held at Delgado Museum.

NOMA
New Orleans Museum of Art. Est. 1910 as the Delgado Museum of Art by Isaac Delgado.

Norwich A. Sch.
Norwich Art School. Est. 1890 in Conn.

North Shore AA
North Shore Artists Association, Gloucester, Mass.

NPG
National Portrait Gallery. Est. 1962 in Wash., D.C., as a branch of the Smithsonian.

NSC
National Society of Craftsmen, NYC.

NSMP
National Society of Mural Painters. Est. 1895 in NYC.

NSS
National Sculpture Society. Est. 1893 in NYC.

N.Y. Arch. Lg.
See Arch. Lg.

NYEC
New York Etching Club. Est. 1877 in the studio of G.&J. Smillie.

N.Y. Eve. Sch. Indst. A.
New York Evening School of Industrial Art. Est. 1913 in NYC.

NYPL
New York Public Library. Est. 1895.

NYSC
New York Society of Craftsmen. Est. 1906 as the National Society of Craftsmen; name changed in 1920.

N.Y. Sch. A.
New York School of Art. Est. 1896 in NYC as the Chase School of Art. Name changed in 1898 by the school's new director Douglas J. Connah. William M. Chase continued to teach there until 1907.

N.Y. Sch. Appl. Des. for Women
New York School of Applied Design for Women. Est. 1892 in NYC.

N.Y. Sch. FA
New York School of Fine and Applied Art. Est. 1909 in NYC. It later became part of Parsons School of Design and had a branch in Paris.

NYSF
New York State Fair of 1898.

N.Y. Soc. P.
New York Society of Painters. Est. 1916 in NYC.

N.Y. Soc. Women A.
See NYSWA.

N.Y. State Agric. Sch.
New York State Agricultural School. Est. 1840. Held exhibitions since 1840 and formed a collection.

NYSWA
New York Society of Women Artists. Est. 1925 in NYC. Exhibited at National Academy of Design.

NYU
New York University.

NYWCC
New York Watercolor Club. Est. 1890 in NYC. In 1941 it was absorbed by the American Watercolor Society, New York.

N.Y. Women's AC
See NAWA.

Oakland M
Oakland Museum. Est. 1910 in Calif. as the Oakland Art Gallery. Building erected 1916.

Ogunquit AA
Ogunquit Art Association. Est. 1930 in Maine; Summer School of Art est. 1935. Not to be confused with Charles H. Woodbury's Ogunquit Summer School of Art, operating from 1898 to 1917.

Omaha A. Workers' S.
Omaha Art Workers' Society. Est. 1898.

One Hundred Friends of Art, Pittsburgh
Est. 1916 by John L. Porter to encourage local artists to foster art appreciation among school children. Formed a collection.

OSA
Ontario Society of Artists. Est. 1872 in Toronto.

Otis AI
Otis Art Institute. Est. 1918 in Los Angeles as an art school.

OWI
Office of War Information. Agency of U.S. government (1942–45).

PA Soc. Min. P.
Pennsylvania Society of Miniature Painters. Est. 1901 in Philadelphia. Annual exhibitions held at Pennsylvania Academy of the Fine Arts.

PAFA
Pennsylvania Academy of the Fine Arts. Est. 1805. Building erected 1876.

Pal. Leg. Honor
See SFMA.

Pan.-P. Expo
See P.-P. Expo.

Pape Sch. A.
Eric Pape School of Art. Est. 1898 in Boston.

Paris AAA
American Art Association of Paris. Est. 1890.

Paris Expo
Universal Exposition, Paris, 1900. Most other years referred to as the Paris Salon.

Paris Groupe PSA
Groupe des Peintres et Sculpteurs American de Paris.

Paris Salon
See discussion on p. xxxv.

Paris SAP
Paris Society of American Painters.

Parsons Sch. Des.
Parsons School of Design. Est. 1904 in NYC.

Pastelists
Society of Painters in Pastel. Est. 1883 in NYC by William M. Chase and Robert Blum. Some of the members stamped their work "P.P.," for "Painters in Pastel." They apparently held only four exhibitions, the last being in 1890.

Patteran
The Patteran. Est. 1933 in Buffalo as an art & social club. Exhibitions held at Albright Art Gallery.

PBA
Public Buildings Administration. See WPA.

PBC
Pen & Brush Club. Est. 1894 in NYC for women artists, writers, and craftswomen.

Peabody Inst.
Peabody Institute, Baltimore. Est. 1857. Building erected 1866. Did not offer instruction, but its collection of casts were free for public drawing.

Pa. MA
See PMA.

People's AG
People's Art Guild. Est. 1915 in NYC by John Weischel as the first artists' cooperative in the U.S.

Pepsi Cola
Began its corporate collection and sponsored a national competition beginning in 1944, directed by Artists for Victory.

P-G
Painters-Gravers of America. Est. 1917 in Albert Sterner's studio in NYC. The first major revival of printmaking in America since the era of the New York Etching Club.

Phila. AC
Art Club of Philadelphia. Est. 1887. Held exhibitions and purchased art for its collection.

Phila. All.
Art Alliance of Philadelphia. Est. 1914.

Phila. Sch. Des. for Women
Philadelphia School of Design for Women. Est. 1844. Later called Moore Institute of Art; now called Moore College.

Phila. Sketch C.
Philadelphia Sketch Club. Est. 1860.

Phila. Soc. AL
Philadelphia Society of Arts & Letters.

Phila. WCC
Philadelphia Watercolor Club. Est. 1900. Collection housed at Pennsylvania Academy of Fine Arts.

Photo. Sec.
Photo Secession. Est. 1902 in NYC; led by Alfred Stieglitz, who published "Camera Work" and held exhibitions of members' works at his "Little Galleries of the Photo Secession," beginning in 1905.

PIASch
Pratt Institute Art School. Est. 1887 in Brooklyn.

Pittsburgh AA
Associated Artists of Pittsburgh. Est. 1910.

Pittsburgh AI
Pittsburgh Art Institute. Est. 1921 as a school.

Plastic C.
Plastic Club. Est. 1897 in Philadelphia as a women's art club, holding classes and exhibitions.

PMA
Philadelphia Museum of Art. Est. 1875 as the Pennsylvania Museum of Art until 1938. Building erected 1876.

PMG
Phillips Memorial Gallery. Est. 1918 in Wash., D.C., as a museum of modern art. Now called the Phillips Collection.

PMSchIA
Philadelphia Museum School of Industrial Art. Est. 1875. Building erected 1876.

Poland Spring A. Gal.
Poland Spring Art Gallery. Est. in South Poland, Maine; began annual exhibitions in 1894.

Por. P.
National Association of Portrait Painters. Est. in NYC.

Portland AA
See Portland AM.

Portland AM
Portland Art Museum. Est. 1892 in Oreg. by the Portland Art Association. Building erected 1905.

Portland MA
Portland Museum of Art. Est. 1882 in Maine by the Portland Society of Artists and called the Sweat Memorial Art Museum. Its Portland School of Fine Art est. 1911. Building erected 1911.

Portland SA
See Portland MA.

Port. P.
See Por. P.

P.-P. Expo
Panama-Pacific Exposition, San Francisco, 1915. A major exposition celebrating the completion of the Panama Canal. A similar exposition was held the same year in San Diego, the Panama-California Exposition.

Prairie PM
Prairie Printmakers. Est. 1931 in Kans.

Prang
Prang Normal Art Class. Est. 1900 in Boston by Louis Prang; shortly after also in NYC.

Pratt Inst.
See PIASch.

Princeton
Princeton University. Art Dept. est. 1882.

Print C., Phila.
Print Club of Philadelphia. Est. 1914.

Providence AC
Providence Art Club. Est. 1880 in R.I.

Providence Athenaeum
Est. 1831 in R.I.

Providence HC
Providence Handicraft Club. Est. in R.I.

Providence WCC
Providence Watercolor Club. Est. 1896 in R.I.; housed at the Providence Art Club.

PS
See Poland Springs A. Gal.

PS Fed. Bldgs.
Painting & Sculpture for Federal Buildings. See WPA.

PS Gal. Assn.
Painters & Sculptors Gallery Association, NYC.

PWA
See WPA.

RA
Royal Academy, London (unless other city specified).

RCA
Royal Canadian Academy.

RISD
Rhode Island School of Design (and Museum). Est. 1877 in Providence, R.I.

RIP
Royal Institute of Painters, London.

RIT
Rochester Institute of Technology. Est. 1830 in N.Y. as the Rochester Athenaeum & Mechanics Institute.

Rochester Athenaeum
See RIT.

Rockport AA
Rockport Art Association. Est. 1920 in Mass.

RSA
Royal Scottish Academy.

RWCS
Royal Watercolor Society, London.

SAA
Society of American Artists. Est. 1877 or 1878 in NYC. Merged into National Academy of Design in 1906.

SAE
Society of American Etchers. Est. 1915 as the Brooklyn Society of Etchers; became SAE in 1931. Exhibitions held at National Academy of Design.

Salma. C.
See SC.

Salons of Am.
Salons of America. Organized "No-Jury" exhibitions, such as Chicago No-Jury Society of Artists.

SAM
Seattle Art Museum. Est. 1906 in Wash. Building erected 1933.

San Fran. AA
San Francisco Art Association. Est. 1872. Founder of San Francisco Museum of Art, whose collection formed its nucleus. Affiliated with the Mark Hopkins Institute of Art since 1874.

SBA
Société des Beaux-Arts, Paris.

SBA Arch.
See BAID.

SC
Salmagundi Club. Est. 1871. An early important art club in NYC, it held regular exhibitions and formed a collection. Its influence waned by the 1940s.

Scarab C.
Scarab Club, Detroit.

Sculptors Gld.
Sculptors Guild. Est. 1937 in NYC to unite avante-garde sculptors.

Sect. FA, Fed. Works Ag.
See WPA.

SFMA
San Francisco Museum of Fine Arts. Est. 1896 by the San Francisco Art Association and known as the Calif. Palace of the Legion of Honor. Building erected 1907.

Shinnecock Sch.
Shinnecock Summer School of Art. Est. near Southampton, Long Island, N.Y. in 1891 by William M. Chase, and active through 1902.

SI
Society of Illustrators. Est. 1901 in NYC. (There was an Illustrators Club est. 1896 in NYC that may be related.)

S. Indp. A.
Society of Independent Artists. Est. 1917 in NYC. Held annual exhibitions with no jury and no prizes until 1944. Over 6,800 artists were exhibitors during its 27 years of operation.

SLP
See S. Ldscp. P.

S. Ldscp. P.
Society of Landscape Painters. Est. 1899 in NYC. Exhibitions held at American Art Galleries in NYC and at the Art Institute of Chicago.

S. Medalists
Society of Medalists. Est. 1928 in NYC. Exhibited at Architectural League of New York.

S. Mod. A.
Society of Modern Artists. Est. 1940 in NYC as an alternative to the declining American Artists Congress.

Smithsonian
Smithsonian Institution. Est. 1846 in Wash., D.C. Governing body of the National Museum of American Art, the National Portrait Gallery, the Freer Gallery, and the Hirschhorn Museum.

SMPF West
Society of Men Who Paint the Far West.

Soc. Am. E.
See SAE.

Soc. Anonyme
Société Anonyme. Est. 1920 in NYC by Katherine S. Drier and Marcel Duchamp for the promotion and study of progressive art in America. The Society's collection is now at Yale.

Soc. Med.
See S. Medalists.

Soc. Wood En.
Society of Wood Engravers. Est. 1882 in NYC.

So. Sts. A. Lg.
See SSAL.

Southwest M.
Southwest Museum. Est. 1907 in Los Angeles.

SPNY
See N.Y. Soc. P.

Springfield MA
See G.W.V. Smith AM.

SSAL
Southern States Art League. Est. 1921. Held annual exhibitions.

Stained Glass AA
Stained Glass Association of America. Est. 1903. Published "Stained Glass."

St. Botolph C.
St. Botolph Club. Est. 1880 in Boston as a men's club for art and literature. Held exhibitions and formed a collection.

St. Louis AM
St. Louis Art Museum. Est. 1879 in affiliation with Washington Univ. Building erected in 1904. Became the City Art Museum in 1912, a name later dropped.

St. Louis Expo
St. Louis Exposition. Est. 1883 to hold annual exhibitions. Best known for its major exposition of 1904.

St. Louis Sch. A.
St. Louis School of Art. Est. 1879 as a part of Washington Univ.

Studio C.
Studio Club. Est. 1904 in NYC as a branch of the YWCA.

S. Utah A.
Society of Utah Artists. Est. 1893 in Salt Lake City.

SWA
Society of Western Artists. Held annual exhibitions which traveled to Art Institute of Chicago, Cincinnati Art Museum, Detroit Institute of Art, Cleveland Museum of Art, St. Louis Art Museum and Indianapolis Art Museum.

Swain Sch. Des.
Swain School of Design. Est. 1881 in New Bedford, Mass.

S. Wash. A.
See Wash. SA

S. Wash. E.
See Wash. SE.

Sweat Mem. AM
See Portland MA.

SW Sculptors
Society of Western Sculptors.

Syracuse MA
Everson Museum of Art of Syracuse. Est. 1896 in N.Y. Building erected 1904 and 1937.

T. Col., Columbia
Columbia University, Teachers College. Est. 1890 in NYC for artists intending to become teachers. Directed by Arthur W. Dow, 1904–22.

Telfair Acad.
Telfair Academy of Arts & Sciences. Est. 1875 in Savannah, Ga.

Ten Am. P.
Ten American Painters. Held their first exhibition at Durand-Ruel Galleriers, NYC, in 1898. Members were: F.W. Benson, J.R. DeCamp, T.W. Dewing, C. Hassam, W.L. Metcalf, R. Reid, E.E. Simmons, E.C. Tarbell, J.H. Twachtman, and J.A. Weir. When Twachtman died he was replaced by William M. Chase. They were last active as a group in 1919. Not to be confused with groups of painters in other cities calling themselves "The Ten," such as the "Philadelphia Ten," or the "Chicago Ten."

Throop Polytech. Inst.
Throop Polytechnic Institute. Est. 1891 in Pasadena by Amos Throop. Taught manual arts until ca. 1907. Now called Calif. Institute of Technology.

Tiffany Fnd.
Louis Comfort Tiffany Foundation. Est. 1918 in Oyster Bay, Long Island, as a summer workshop for artists and craftsmen.

TMA
Toledo Museum of Art. Est. 1901 in Ohio. Building erected 1911. Its Museum School of Design est. 1919.

T-Square C.
T-Square Club. Est. 1883 in Philadelphia.

2x4 Soc.
2x4 Society, St. Louis.

Univ. Chicago
University of Chicago. Art School was est. 1882.

Univ. N.Mex.
University of New Mexico. Art Museum est. 1923 by the Harwood Foundation.

Univ. Nebr.
University of Nebraska School of Fine Arts. Est. 1912, but art instruction given since 1877.

Univ. Pa.
University of Pennsylvania. It coordinated its art classes with those of the Pennsylvania Academy of the Fine Arts and Philadelphia Museum School of Industrial Art.

Univ. Utah
University of Utah. Est. 1850 in Salt Lake City. Art Dept. est. 1905. Its

museum, Utah Museum of Fine Art est. 1951.

USPO
United States Post Office (usually cited with regard to the WPA).

VMFA
Virginia Museum of Fine Arts. Est. 1934 in Richmond.

WAA
Western Arts Association.

WAA of C
Women's Art Association of Canada.

Walker A. Ctr.
Walker Art Center. Est. 1875 in Milwaukee, Wis., by T.B. Walker.

WAM
See WMA.

Wadsworth Athenaeum
Est. 1844 in Hartford, Conn. First public museum in America. Connecticut Academy of the Fine Arts held annual exhibitions there.

Wash. SA
Society of Washington Artists. Est. 1891 in Wash., D.C. Held annual exhibitions at the Corcoran.

Wash. SE
Society of Washington Etchers. Est. 1934 in Wash., D.C.

Wash. SFA
Washington Society of Fine Arts. Est. 1905 in Wash., D.C.

Wash. Soc. Min. P.
Washington Society of Miniature Painters. Est. 1933 in Wash., D.C.

Wash. St. AA
Washington State Art Association. Est. 1906 in Seattle.

WFNY
World's Fair, New York, 1939.

Whitney M.
See WMAA.

WMA
Worcester Museum of Art. Est. 1896. Its School of Art est. 1898. Building erected 1898.

WMAA
Whitney Museum of American Art. Est. 1930 in NYC by Gertrude Vanderbilt Whitney for the advancement of contemporary American art.

Wolfe AC
Catherine Lorrillard Wolfe Art Club. Est. 1896 in NYC as a club for women artists, craftswomen, and musicians.

Women's AC
See NAWA.

Woodstock AA
Woodstock Art Association. Est. 1919 in N.Y. Not to be confused with the Woodstock Summer School of Painting, a branch of the Art Students League of NYC. est. 1906.

WPA
Federal Art Project of the Works Progress [later, Projects] Administration. For the purpose of this book WPA is used in its most common context: the large government programs set up during the Great Depression to provide jobs for artists. Although the WPA was the largest of the federal assistance projects for thousands of artists, there were many separate, if similar, projects operating from 1933–43. Among these were the Section of Fine Arts, Public Bldg. Administration of the Federal Works Agency (1934–43); the Index of American Design (part of the WPA); the Public Works of Art Project (1933–34); the Treasury Relief Art Project (1935–39); and the Farm Security Administration (1935–43). Due to WWII, all of these programs disbanded by 1943.

WWC
See Wash. WCC.

Yale
Yale University School of Fine Art. Est. 1864 in New Haven, Conn. Yale's Art Gallery was est. 1832 by John Trumbull.

YS
American League of Young Sculptors.

YWCA
Young Women's Christian Association, New York. Est. art classes in 1872.

GENERAL ABBREVIATIONS

A, Ar	Art, Arts, Artist	Am	American, America
AA	Art Association (preceded or followed by a city)	AM	Art Museum (preceded by city or name)
AC	Art Club (preceded or followed by a city)	Ann	Annual
A&C, A&Cr	Arts & Crafts	App, Appl	Applied
A&CC, ACC	Arts&Crafts Club (preceded or followed by city)	Ar	Art, Artists
Acad	Academy	Arch	Architects, Architectural
ACG	Arts & Crafts Guild (preceded or followed by a city)	Ar Gld, Artists G	see AG
		Assn	Association
		Assoc, Asscd	Associated
AD	Academy of Design	Asst	Assistant
Adv	Advertising	b.	born
AFA	Academy of Fine Arts (when preceded by a city)	Bien	Biennial
AG	Artists Guild (preceded by a city)	C, Cl	Club
		ca.	circa
A Gal	Art Gallery	cem	cemetery
AI	Art Institute	Cen, Ctr	Center
All	Alliance, Allied	Centenn	Centennial
Alum	Alumni	Cer	Ceramicist, Ceramics, Ceramic

Ch	Church	LDS	Latter Day Saints
Chm	Chairman	Let	Letters
Cinci	Cincinnati	Lg, L	League
Co	County, Company	MA	Museum of Art (preceded by city or name)
Col	College	med	medal
Coll	Collection	M.E.	Methodist Episcopal
Com, Comm	Commercial	mem	memorial
Com, Commit	Committee	MFA	Museum of Fine Arts (preceded by city of name)
Comm	Commission	Mod	Modern
Cnty	County	Mon	Monument
Cong	Congress	Mun, Munic	Municipal
Cr	Craft, Crafts (as part of an organization's name)	Mus, M	Museum
d.	died	Nat	National
Dec	Decoration, Decorator	PCC	Paint & Clay Club (preceded by city or name)
Deg	Degree	PM	Printmakers (preceded by city or name)
Des, D	Design, Designer	Polytech	Polytechnical
Dir	Director	Por, Port	Portrait
Ed	Editor	PPC	Pen & Pencil Club (preceded by city or name)
Edu	Educator, Education	Prof	Professional, Professor
Est	Established	Prog	Program
Exh	Exhibition, Exhibited	Pr.M	Printmakers (preceded by city or name)
Exec	Executive	PS, P&S	Painters and Sculptors (preceded by city or name)
Expo	Exposition		
F	Fellow (preceded or followed by organization)	PS&G	Painters, Sculptors and Gravers
FA	Fine Arts	Pub	Published by
Fed	Federation	Reg	Regional
Fnd, Found	Foundation	S	Society
Frat	Fraternity	SA	Society of Artists (preceded by city or name)
Gal	Gallery	Sal	Salon
G, Gl, Gld	Guild	Sc	Science(s), Scientific
Gr	Graver, Gravers	Sch	School
Hist. S	Historical Society	SE	Society of Etchers (preceded by city or name)
H.S.	High School	Sem	Seminary
Hon	Honorary Member	SMP	Society of Miniature Painters (preceded by city or name)
IA	Institute of Art (preceded by city)		
Illus, I	Illustrated, Illustrations	Soc	Society
Indp	Independent	T. Col, TC	Teacher's College (preceded by city or name)
Indst	Industrial, Industry	Text	Textile
Inst, In	Institute	Un	Union, United
Instr	Instructor	WCA	Watercolor Association
Int, Intl	International	WCC	Watercolor Club
Jr. Lg	Junior League	WCS	Watercolor Society

Edward Cucuel: *Gérôme Criticising Bishop's Work*. From W.C. Morrow's *Bohemian Paris of Today*, 1899

HOW TO READ AN ENTRY

Each entry may contain as many as eleven categories of information. With the exception of certain obituaries that we chose to keep intact, these categories flow in a natural sequence as illustrated and described below.

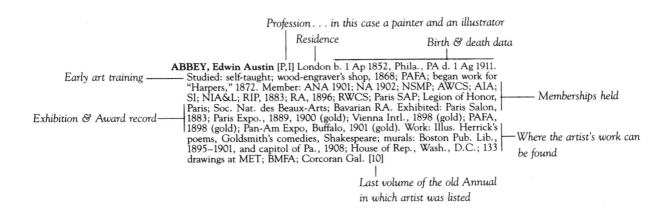

1. *Name:* Last name in capitals, followed by first and middle names or initial. Married names or brush names appear in parentheses following the proper name, and have also been cross-referenced. A woman's name may be followed by her husband's given names, as (Mrs. Harry Albert), if the entry is alphabetized under her married name. If confusion might have ensued because of the nature of the given names, the surname is repeated, as (Mrs. John Vance Smith).

2. *Profession Code:* Follows the person's name and is contained within brackets. See abbreviations, p. xix.

3. *Last Known Address:* City (and State or country) of the artist's last-known address. This is sometimes separated by a slash (/) from another address (usually a summer address). Look to the volume year at the end of each entry for the date when the artist last lived at this address. A date in parentheses following the address or a death date may provide more information.

4. *Birth Date:* Indicated after the b. The place of birth, if known follows the date. Months are shown in the standard abbreviations: Ja, F, Mr, Ap, My, Je, Jy, Ag, S, O, N, D.

5. *Death Date:* Indicated after the d. The place of death, if known, follows the date. However, if the previous last-known address was also the same as the place of death this information is not repeated. Any known unusual circumstances of death follow in parentheses.

6. *Studied:* Names of the artist's teachers and art schools attended. When known, the years of attendence are given. In the case of colleges and universities the year usually refers to the student's year of graduation. See abbreviations beginning p. xx. For a list of frequently cited foreign teachers see p. xxxiii.

7. *Member:* Associations and clubs. The artist's date of election, if known, follows.

8. *Exhibited:* Includes both exhibitions entered and awards won. If an artist won an award it is indicated in parentheses adjoining the name of the institution or exposition. Gold medals are cited as (gold) while silver and bronze medals are cited simply as (med). All other prizes, including honorable mentions, are cited as (prize). For abbreviations, and a brief description of some of the foreign Salons, see p. xxxv.

9. *Work:* Museums and other institutions that conserve the artist's work.

10. *Additional Support Information:* Preceded by a qualifier, e.g., Position:..., Author:..., Illustrator:..., Creator:....

11. *Volume Year:* The last volume of the old *Annuals* in which the artist was listed anchors each entry. Artists who were never listed but whose obituaries did appear in the *Annual* have no bracketed date following their entries. Additional biographies not appearing in the original *Annuals* are indicated by [*]. Some of the artists listed in [47] continued to be listed in *Who's Who in American Art*, the publication of which was taken over by the R.R. Bowker Co. beginning with the 1953 edition. The data in the 1953 edition largely repeats the [47] entries. However, if it is known that an artist was still active through the late 1950s, 1960s or possibly even the 1970s we suggest using this volume in conjunction with the more recent volumes.

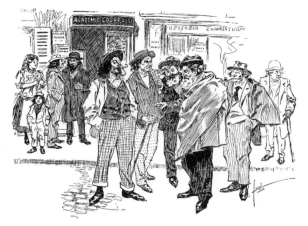

Edward Cucuel: *Italian Models in Front of Colarossi's*. From W.C. Morrow's *Bohemian Paris of Today*, 1899

EUROPEAN TEACHERS OF AMERICAN ARTISTS

From the 1870s through the 1920s ever-increasing numbers of American art students flocked to the European academies, particularly those in Paris, seeking to improve their technical skills as well as absorb emerging new art forms. By far the most popular of the art academies for Americans was the Académie Julian in Paris (often misspelled "Julien"). Its director Rodolphe Julian (1839-1907) was only a minor artist, but as an administrator he excelled, and his academy flourished. For what was an affordable tuition, an aspiring student could attend classes at the Académie Julian and benefit from the criticism of teachers from the Ecole des Beaux-Arts, who were persuaded by Julian to make regular appearances. Those teachers most frequently mentioned herein are Laurens, Constant, and Lefebvre. The Académie Julian was so popular among American and British students that by the 1890s Julian had to set up a number of studios around Paris, three of which were for women only.

After securing training at the Académie Julian or private instruction from a master, some students applied for admission to that mecca of art education, the Ecole des Beaux-Arts. It was here that students fortunate enough to be admitted would strive to win the coveted "Prix de Rome." (In the U.S. the Metropolitan Museum of Art would later sponsor an analogous competition of the same name.) This important prize was traditionally a prerequisite to fame; at the very least it could firmly launch an artist's career.

The five principal academies in Paris attended by Americans were the Académie Julian, Académie Colarossi, Académie de la Grand Chaumière, Académie Delecluse, and the Ecole des Beaux-Arts. As the avante-garde movements developed in the early part of the twentieth century, new schools such as the Académie Moderne and the Académie Scandinave were founded. Of the other European academies, the Royal Academy in Munich and the academies in Rome were the most popular. These were followed by the academies in Brussels, Düsseldorf, London, and Vienna.

The following list of European teachers is provided simply as a brief orientation. It is by no means a complete list of the European teachers cited herein; rather, it is a list of those teachers most frequently cited. Most of the teachers have very similar profiles. Most graduated from the Ecole des Beaux-Arts and went on to become members of the prestigious Institute des Beaux-Arts itself. Many won the "Prix de Rome," and all won awards at the important Salons. Most were jury memebers at the various expositions. Most were also members of the Legion d'Honneur, achieving stature as they rose from Chevalier to Officier to Commandeur. Should more extensive biographical information be required, we direct the reader to the *Dictionnaire des Peintres, Sculpters, Dessinateurs, Graveurs*, by Benezit, and the *Allgemeines Lexikon der Bildenden Kunstler*, by Thieme-Becker. Finally, the reader should keep in mind that some American teachers have in the past been mistakenly thought of as Europeans. Among them are Charles Lasar and William Dannat, both of whom taught many Americans in Paris, and Carl Von Marr, who was equally popular in Munich.

AMAN JEAN, Edmond [French/P,E,Li,W] b. 1860 d. ca. 1935. Juror of the old Salon from 1893, he quit to found the Salon des Tuileries with Albert Besnard.

BASTIEN-LEPAGE, Jules [French/P] b. 1848 d. 1884. Influential plein air painter.

BESNARD, Albert [French/P,E] b. 1849 d. 1834, Member of the old Salon; founder of the new Salon and later the Salon des Tuileries. Also a member of the Salon d'Automne. Became director of the Ecole des Beaux-Arts in 1922.

BLANCHE, Jacques [French/P,Cr] b. 1861 d. 1942. His studio was a favorite meeting place of the avante-garde.

BONNAT, Leon [French/P] b. 1838 d. 1922. Taught at Ecole des Beaux-Arts.

BOUGUEREAU, William Adolphe [French/P] b. 1825 d. 1905. With Cabanel he directed the old Salon. So strong was his influence that artists often called it "Bouguereau's Salon." Taught at Ecole des Beaux-Arts; Académie Julian.

BOULANGER, Gustave [French/P] b. 1824 d. 1888. Taught at Ecole des Beaux-Arts; Académie Julian.

BOURDELLE, Emile [French/S] b. 1861 d. 1929. Influential sculptor and close friend of Rodin. Taught at Académie de la Grande Chaumière.

BOUTET DE MONVEL, Bernard [French/P,E] b 1884 d. 1944.

BRANGWYN, Sir Frank [English/P,E,Li] b. 1867 d. 1956.

CABANEL, Alexandre [French/P] b. 1823 d. 1889. Juror of admissions and awards at the Ecole des Beaux-Arts, from 1863. Co-director, with Bouguereau, of the annual Salon.

CAROLUS-DURAN, Charles Emile [French/P,S] b. 1837 d. 1917. Founder, with Besnard, Meissonnier, and Puvis de Chavannes, of the new Salon in 1884 (Pres., 1898). Dir., Ecole Français in Rome, 1905.

CASTELUCHO, Claudio [Spanish/P] b. 1870 d. 1927. Dir. of his Académie Castelucho in Montparnasse, Paris. Also taught at Académie de la Grande Chaumière.

CAZIN, Jean Charles [French/Ldscp.P,E] b. 1841 d. 1901. One of the leading landscape painters during the last quarter of the nineteenth century. He taught many Americans at Grez-sur-Loing.

CHAPU, Henri [French/S] b. 1833 d. 1891. Taught at Académie Julian.

CHARPENTIER, Félix [French/S] b. 1858 d. 1924.

CHARRETON, Victor [French/P] b. 1864 d. 1936. One of the founders of the Salon d'Automne.

COLLIN, Raphael [French/P] b. 1850 d. 1916. Taught at Académie Julian.

CONSTANT, Benjamin [French/P] b. 1845 d. 1902. Taught at Académie Julian.

CORMON, Fernand [French/P] b. 1854 d. 1924. Taught at Ecole des Beaux Arts. Toulouse Lautrec was one of his students.

COTTET, Charles [French/P] b. 1863 d. ca. 1924. One of the founders of the Société Nationale des Beaux-Arts in 1884, and of the Société Nouvelle in 1900. Leader, with Prinet, of the "Black Group," analogous to the "Ashcan Group" in the U.S.

COURTOIS, Gustave [French/P] b. 1853 d. 1923. One of the most popular teachers at the Académie Colarossi.

COUTURE, Thomas [French/P] b. 1815 d. 1879. Influential teacher who counted among his students Manet, Millet, Puvis de Chavannes and Americans W.M. Hunt and J. Lafarge.

DAGNAN-BOUVERET, Pascal [French/P] b. 1852 d. 1929.

DAMPT, Jean [French/S] b. 1853 d. 1946.

DEBILLEMONT-CHARDIN, Gabrielle [French/Min.P] b. 1860 d. 1957. Important teacher in the revival period of miniature painting. Taught at Ville de Paris schools.

DELANCE, Paul [French/P] b. 1848 d. 1924.

DELAROCHE, Paul [French/P,S] b. 1797 d. 1856. Taught at Ecole des Beaux-Arts, from 1832.

DELECLUSE, Auguste Joseph [French/P] b. 1855 d. 1928. Dir. Académie Delecluse, probably in Montparnasse. Note: Some confusion exists regarding the Académies Delecluse and Delécluze, both believed to have been in Montparnasse. In our opinion, the académie cited in the *American Art Annual* is that of Auguste Joseph Delecluse and not Eugene Delécluze (q.v.). The two principal instructors other than Auguste Joseph at the Académie Delecluse were Georges Callot [1857–1903] and Paul Delance (q.v.).

DELECLUZE, Eugène [French/P,E] b. 1882. Dir. Académie Delécluze in Montparnasse. Note: See DELECLUSE for note on possible confusion regarding the académies of the two artists.

DESCHAMPS, Louis [French/P] b. 1846 d. 1902.

DESPIAU, Charles [French/S] b. 1874 d. 1946.

DESPUJOLS, Jean [French/P,Dec,W] b. 1886.

DIEZ, Wilhelm von [German/P,I] b. 1839 d. 1907. Taught at Royal Acad., Munich, from 1871. Influential for spreading the "Munich Style," based on Dutch genre and technique. W.M. Chase and F. Duveneck were his students.

DOUCET, Lucien [French/P] b. 1856 d. 1895.

DUPRÉ, Julien [French/Ldscp.P] b. 1851 d. 1910.

FALGUIERE, Alexandre [French/S,P] b. 1831 d. 1900. An influential proponent of realism in sculpture.

FERRIER, Gabriel [French/P] b. 1847 d. 1914. Taught at Ecole des Beaux-Arts.

FLAMENG, François [French/P,E] b. 1856 d. 1923. Taught at Ecole des Beaux-Arts; Académie Julian.

FLINT, Sir. W. Russell [Scottish/P,I] b. 1880 d. 1969.

FREMIET, Emmanuel [French/S] b. 1824 d. 1910.

FRIESZ, Othon [French/P,E] b. 1879 d. 1949. One of the Fauves.

GANDARA, (Antonio de la Gandara) [French/P] b. 1862 d. 1917.

GEROME, Jean Leon [French/P,S,E] b. 1824 d. 1904. Influential head of painting at the Ecole des Beaux-Arts, from 1863–1903. Known for his support of his students, although he was against Impressionism. T. Eakins was his student.

GIRARDOT, Louis [French/P,Li] b. 1856 d. 1933. Taught at Académie Colarossi.

GLEYRE, Marc [French/P] b. 1808 d. 1874. Delaroche's studio passed on to him, where he taught Gérôme.

GRASSET, Eugène [French/P,Des,Dec,I,Arch] b. 1841 d. 1917.

GUERIN, Charles [French/P] b. 1875 d. 1939. Anti-academic modernist teacher.

GYSIS, Nicholas [Greek/P] b. 1842 d. 1901. Taught in Munich.

HENNER, Jean Jacques [French/P] b. 1829 d. 1905. Taught at Académie Julian.

INJALBERT, Jean Antoine [French/S] b. 1845 d. 1933.

JOHN, Augustus [English/P] b. 1878 d. 1961. Taught at Liverpool Academy, from 1901.

KNAUS, Ludwig [German/P] b. 1829 d. 1910. Taught at Academy of Berlin, from 1865.

LAURENS, Jean Paul [French/P] b. 1838 d. 1921. Replaced Meissonnier as Dir. of Institute des Beaux-Arts. He also taught at the Académie Julian and Académie de Toulouse. His son Paul Albert Laurens [1870–34] taught at the Ecole Polytechnique, from 1898.

LAURENT, Ernest [French/P] b. 1859 d. 1929. Neo-impressionist.

LEFEBVRE, Jules [French/P] b. 1836 d. 1911. Taught at Académie Julian.

LEIBL, Wilhelm [German/P] b. 1844 d. 1900. Influential teacher in Munich. Many of his students were founders of the various secessionst movements of the early 1900s.

LHOTE, André [French/P,I,Cr] b. 1885 d. 1962. Influential modernist teacher of the twentieth century. Formed his school in 1922.

LOEFFTZ, Ludwig [German/P] b. 1845 d. 1910. Dir. of Royal Acad. in Munich.

MENARD, Emile [French/P] b. 1862 d. 1930. Taught at the Académie de la Grande Chaumière.

MERCIÉ, Marius Antonin [French/S,P] b. 1845 d. 1916. Pres. of Société des Artistes Français.

MERSON, Luc Olivier [French/P] b. 1846 d. 1920. Taught at Ecole des Beaux-Arts, from 1894.

MOROT, Aimé [French/P] b. 1850 d. 1913. Taught at Ecole des Beaux-Arts, from 1900. Specialized in portraits, history, and battles.

MUNKACSY, Michael [Hungarian/P] b. 1844 d. 1900. Taught in Paris.

PILOTY, Carl [German/P] b. 1826 d. 1886. Taught at the Royal Acad. in Munich, from 1858; Dir., from 1874.

PRINET, René [French/P] b. 1861 d. 1946. Directed a class for women at the Ecole des Beaux-Arts and gave free classes at his studio in Montparnasse. Also taught at Académie de la Grande Chaumière. Founder, with Besnard, Aman-Jean, and Bourdelle, of the Salon des Tuileries.

PUVIS DE CHAVANNES, Pierre [French/P] b. 1824 d. 1898. One of the Founders of the Société Nationale des Beaux-Arts, in 1884. He was an influential teacher of Degas, and the Nabi painters.

RAFFAELLI, Jean François [French/P,E,Li,S,I] b. 1850 d. 1924.

ROBERT-FLEURY, Tony [French/P] b. 1837 d. 1912. Like Laurens, a popular teacher at Académie Julian.

RODIN, Auguste [French/S] b. 1840 d. 1917. Influential sculptor who had many students at his Montparnasse studio.

SICKERT, Walter [German/P,E] b. 1860 d. 1942. Taught at Slade School of Art in London.

SIMON, Lucien [French/P] b. 1861 d. 1945. Taught at the Académie de la Grande Chaumière.

SOROLLA Y BASTIDA, Jaoquin [Spanish/P] b. 1863 d. 1923. Influential impressionist.

STEINLEN, Théophile Alexandre [French/P,Li,E,I,S,Des] b. 1859 d. 1923. Taught at Académie de la Grande Chaumière.

STUCK, Franz [German/P,S] b. 1863 d. 1928. Taught at the Royal Acad. in Munich. Influential proponent of the "Jugenstyle" ("Art Nouveau").

THAULON, Fritz [Norwegian/P,E] b. 1847 d. 1906, Holland.

VERLET, Charles Raoul [French/S] b. 1857 d. 1923.

A NOTE ON THE INTERNATIONAL EXHIBITIONS

Among the largest and most prestigious international exhibitions held in the U.S. that an artist could add to his exhibition record were: the Centennial Exposition in Philadelphia in 1876, the World's Columbian Exposition in Chicago in 1893, the Omaha Exposition of 1898, the Pan-American Exposition in Buffalo in 1901, the St. Louis Exposition in 1904, the Louisiana Purchase Exposition in New Orleans in 1904, the Armory Show in 1913, the Panama-Pacific Exposition in San Francisco in 1915, and the Century of Progress Exhibition in Chicago in 1933. Of course, important exhibitions were held annually at such institutions as the National Academy of Design, the Pennsylvania Academy of the Fine Arts, the Carnegie Institute, and the Art Institute of Chicago.

It was the goal of many American artists to have their works hung at one of the Salons in Paris. Sorting out the various Salons held in Paris from the 1870s to the 1920s has often been a problem for American researchers. Even the old *American Art Annuals* sometimes simply listed the designation "Paris Salon" when in fact this could refer to either the "old Salon" or the "new Salon." The original Salon,

which was largely controlled by the Institute des Beaux-Arts, chronically suffered from whatever political discontent was prevalent. Its annual Salon was held at the Palais de l'Industrie on the Champs-Elysées from 1857 until the building was destroyed in 1897.[1] Beginning with the great Universal Exposition in 1900, it was held at the new Grand Palais. A schism within the Salon led to the formation of the Société des Artistes Français in 1880. Soon, personality and internal disputes led to a further split within the Société des Artistes Français and in 1884 the rival Société Nationale des Beaux-Arts was formed. Many scholars refer to this as the "new Salon." Thus, after 1884, there were two large annual Salons. In many cases it appears that Americans listing "Paris Salon" in their exhibition record were referring to the "new Salon." Its annual exhibitions were sometimes referred to by its location as the "Salon du Champs de Mars."

After the 1880s there was no single official event upon which an artist's work would be judged. At the turn of the century, other expositions, such as the Salon d'Automne and the Salon des Indépendants, gained in prestige. In the first decades of the twentieth century, many independent or secessionist exhibitions and one-man shows sprang up in the midst of the then tumultuous changes in the art world.

[1] This and following facts on the Salons in Paris are from Jacques Letheve, *Daily Life of French Artists in the Nineteenth Century* (New York: Praeger, 1971).

WHO WAS WHO IN AMERICAN ART

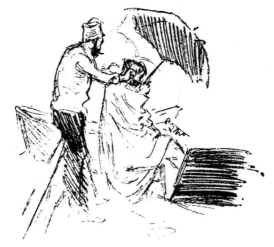

Charles S. Reinhart: *William M. Chase cutting John H. Twachtman's hair on an excursion of the Tile Club, ca. 1880.* From *The Illustrator* (1894)

AALBU, Olaf [G] Minneapolis, MN. Exhibited: Twin City Annual, Minneapolis Inst. A., 1938 (prize) [40]

AARON, May Todd (Mrs.) [P] Pawhuska, OK b. LaCelle, IA. Studied: AIC. Member: NAWA; SSAL; Phila. Pr. Cl.; Okla. AA; Southwest AA; Wichita AA. Exhibited: AIC; NAWA; AWCS; All.A.Am.; San Fran. AA; Mus. N.Mex., Santa Fe; CM; PAFA; Audubon A.; Kansas City AI; Wash. WCC; Univ. Okla. (one-man); SSAL 1931 (prize); WFNY, 1939; Phila. AC; Wichita AA (one-man). Work: PAFA; Vanderpoel Coll. [47]

AARONS, George [S] Brookline, MA b. 6 Ap 1896, Leningrad. Studied: BMFA Sch.; BAID; Richard Brooks; Solon Borglum. Member: NSS; Gld. Boston A.; North Shore AA; Boston SS; Am. A. Cong. Exhibited: PAFA, 1926, 1928; Phila. A. All., 1930; Am. A. Cong., 1937, 1938; PMA, 1940; NSS; WMAA, 1940; Gld. Boston A., 1945, 1946; Inst. Mod. A., 1945, 1946; Stuart A. Gal., Boston, 1946; Gloucester SA, 1944; North Shore AA, 1945, 1946. Work: Old Harbor Village, Boston; USPO, Ripley, Miss.; Fireman's Mem., Beverly, Mass.; mem. to Mitchell Frieman, Boston. Position: T., Fitchburg (Mass.) Art Centre [47]

ABBATE, Paolo S. [S] Torrington, CT b. 9 Ap 1884, Villarosa, Italy. Studied: USA; abroad. Member: NSS; Conn. A. & W.; Intl. FA Lg.; Ar. Council. Exhibited: NSS; Arch. Lg.; PAFA. Work: mem./mon., Newburgh, N.Y.; Providence, R.I.; Torrington; Fiume, Italy; NAC; Lib., Waterbury, Conn.; bust portraits of President Harding, John Burroughs, others. Position: Cur., Torrington Mus. A. [47]

ABBATT, A(gnes) D(ean) [P,I,C,T] b. 23 Je 1847, NYC. Studied: Cooper Union; NAD; James D. Smillie; R. Swain Gifford. Member: AWCS. Exhibited: Mass. Charitable Mechanics Assoc., Boston (med); San Antonio Expo (prize) [15]

ABBE, Alfriede Martha [S] Ithaca, NY b. 6 F 1919, Wash., D.C. Studied: Cornell; AIC; Harry P. Camden. Exhibited: Cornell, 1938, 1940 (med); Am. Acad., Rome, 1939; AIA, 1939 (prize); All.A.Am., 1940; New Haven PCC, 1940; Rochester Mem. A. Gal., 1941; Auburn Mus., 1942; IBM, 1942. Position: Scientific Illus., Cornell, 1942–46 [47]

ABBEY, Edwin Austin [P,I] London b. 1 Ap 1852, Phila., PA d. 1 Ag 1911. Studied: self-taught; wood-engraver's shop, 1868; PAFA; began work for "Harper's," 1872. Member: ANA 1901; NA 1902; NSMP; AWCS; AIA; SI; NIA&L; RIP, 1883; RA, 1896; RWCS; Paris SAP; Legion of Honor, Paris; Soc. Nat. des Beaux-Arts; Bavarian RA. Exhibited: Paris Salon, 1883; Paris Expo, 1889, 1900 (gold); Vienna Intl., 1898 (gold); PAFA, 1898 (gold); Pan-Am. Expo, Buffalo, 1901 (gold). Work: Illus. Herrick's poems, Goldsmith's comedies, Shakespeare; murals: Boston Pub. Lib., 1895–1901, and capitol of Pa., 1908; House Rep., Wash., D.C.; 133 drawings at MET; BMFA; Corcoran Gal. [10]

ABBEY, Iva L. [P,T] Des Moines, IA b. 25 Mr 1882, Chester, CT. Studied: Griffin; Hale; Benson; MacGilvary; C.J. Martin. Member: Alliance; Eastern AA; Hartford ACC; Hartford AS [25]

ABBEY, Mary Gertrude (Mrs. Edwin Austin) [P,I] d. 20 Je 1931, London. She bequeathed a trust fund of $100,000 to the National Academy of Design, New York, to form the Edwin Austin Abbey Trust Fund for Mural Paintings, the income to be employed to give commissions to "highly gifted trained artists to execute mural paintings...." Chelsea Lodge, the artist's home and studio in London, was left to the Royal Academy "for a museum for the people of Great Britain and the benefit of the public." The gift included the entire contents of the house, consisting of Mr. Abbey's paintings, drawings, studies, all his works of art and antiques, none of which were to be removed. The residue of the estate was to be divided between these beneficiaries for maintenance and endowment.

ABBOT, Agnes Anne [P] Harvard, MA b. 19 Ag 1897, Potsdam, Germany. Studied: Sch. FA&Crafts, Boston, with C. Howard Walker, Katherine B. Child; Aldro T. Hibbard; Charles H. Woodbury. Member: AWCS; NAWA; Gloucester SA; CAA; Boston AC; Boston SAC; College AA. Exhibited: WMA, 1935; Grace Horne Gal., Boston, 1931, 1937, 1939 (one-man); Margaret Brown Gal., 1946 (one-man). Work: BMFA; FMA. Position: T., Wellesley Col., 1943– [47]

ABBOT, Edith R. [Edu,P,W] NYC b. Hartford, CT d. 18 Je 1964. Studied: Norwich A. Sch., with Alice V.V. Brown; ASL, with W.M. Chase, Arthur W. Dow. Member: NAWA; CAA; AA Mus. Exhibited: NAWA, 1946; Southern Vt. A., 1941; Argent Gal., 1940, 1942, 1945 (one-man). Author: "The Great Painters," 1927. Positions: T., Wellesley Col. (1905–15), MMA (1915–41) [47]

ABBOT, Hazel Newnham [Ldscp.P] Colorado Springs, CO b. 31 O 1894, Montreal. Studied: Child-Walker Sch. Des., Boston. Member: NAWPS [40]

ABBOT, Lillian Elvira Moore (Mrs. Charles G.) [P] Wash., D.C./Mt. Wilson, CA b. Fairfax County, VA d. 1 Je 1944. Studied: E.C. Messer; Richard N. Brooke; Catherine C. Critcher; E.H. Miller; W.M. Chase. Member: Soc. Wash. Ar. Exhibited: CGA [40]

ABBOTT, Anne Fuller (Mrs. A. Lenox Uhler) [P] Wash., D.C. b. Brandon, VT. Studied: ASL; Corcoron Sch. A.; NAD; W.M. Chase; Douglas Volk; Francis Jones. Member: Wash. A. Cl.; Wash. WCC; Wash. SA; AFA; NAC; PBC. Work: Navy Dept., Wash., D.C. Position: Dir., Abbott Sch. A., Wash., D.C. [47]

ABBOTT, Berenice [Photogr] Maine b. 1898. Studied: Man Ray, in Paris. Work: portraits, 1920s; documentation of NYC, 1930s; science series, 1940s; Maine, 1960s, all in major U.S. museums [*]

ABBOTT, Edith Abigail [P] Rockport, MA b. Randolph, VT. Studied: Univ. Vt.; Mt. Holyoke Col.; T. Col., Columbia. Member: La Jolla A. Center; Daytona Beach AA; Rockport AA. Awards: Clearwater, Fla., 1941 (prizes); Rockport AA, 1942; Daytona Beach AA, 1944. Positions: T., Mt. Holyoke Col., T. Col., Columbia [47]

ABBOTT, Edith R. [P] NYC Member: NAWPS [27]

ABBOTT, Edward Roydon [P] Oklahoma City, OK b. 15 Mr 1897. Studied: Kansas City AI; Frank von der Lancken. Member: Assn. Okla. A. Exhibited: Assn. Denver A. Mus., 1943; Miss. AA, 1945; Assn. Okla. A., 1936–45 (prize), 1940–44; Ozark Exh., Springfield, Mo., 1941–44 [47]

ABBOTT, Elenore Plaisted (Mrs. C. Yarnall) [P,I] Moylan, PA d. 1935. Studied: PAFA; Phila. Sch. Des.; Simon, Cottet, in Paris. Member: Phila. WCC; Plastic Cl. [38]

ABBOTT, Emily Louise (Mrs. B.J.O. Nordfeldt) [P] Lambertville, NJ b. 22 O 1900, Minneapolis. Studied: Univ. Minn.; Minneapolis Sch. A.; B.J.O. Nordfeldt. Member: Minn. A. Assn. Exhibited: Minn. State Fair, 1937 (prize); Minneapolis Inst. A., 1938, 1944 (prizes); Twin City Ann., 1938 (prize); Midwestern Ar., 1938; San Fran. A. Assn.; Cincinnati

Ann.; CGA, 1941; AIC, 1937–40; PAFA, 1940; AV, 1942; SFMA; Walker A. Center; Univ. Minn.; Minneapolis Inst. A.; St. Paul Gal. [47]

ABBOTT, Francis R. [P] Phila., PA b. Phila. Studied: PAFA; Académie Julian, Paris. Member: Phila. AC; Phila. Sketch Cl. [25]

ABBOTT, Holker [P] b. 1858, Lowell, MA d. 30 Ap 1930 (at his country estate "The Hundreds" in Wellesley Hills, Mass). He was a member of the first class to be graduated from the Boston Museum of Fine Arts, and for some years occupied a studio with H.W. Bicknell, where he meant to specialize in ecclesiastical art. He decorated the Episcopal Church in Wellesley, but made his personal career of minor importance and devoted himself to the advancement of art in America. In the 1870s he was one of the organizers of the Boston Art Sudents Association. He soon became its president and changed the Association into the Copley Society of Boston, which society he served as president until the time of his death. Under his personal guidance the educational and exhibition policies of the Copley Society exerted a wide influence. He was a director of the Museum of Fine Arts in Boston, and had been secretary of the Tavern Club for twenty years. A wreath of laurel was placed before the portrait of Holker Abbott, painted by John Singer Sargent for the Tavern Club, which held the position of honor in the exhibition of the Copley Society closely following his death, at the Boston Museum of Fine Arts.

ABBOTT, John Evans [Lib.Dir] NYC b. 9 F 1908, Milford, DE d. 5 F 1952. Studied: Haverford Col.; Member: AA Mus.; Theatre Lib. Assn.; Soc. Am. Archivists; Intl. Fed. Film Archives. Positions: V.P.-Sec./Dir., Film Lib., MOMA, 1935–46, Trustee, 1939–46 [47]

ABBOTT, Katherine G. See Cox.

ABBOTT, Mary Ogden [P] Boston, MA. Member: Concord AA [25]

ABBOTT, Samuel Nelson [I] Kingston, NY b. 20 N 1874, Mechanicsville, IA d. ca. 1955. Member: SI 1913 [47]

ABBOTT, Sammie A. [P] Lackawanna, NY. Exhibited: Ar. Western N.Y., Albright A. Gal., 1939 (prize) [40]

ABBOTT, W.H. [S] NYC [21]

ABBOTT, William [I,T] Chicago, IL b. 9 N 1892, Minneapolis, MN. Studied: Chicago Acad. FA [25]

ABBOTT, Yarnall [P,T,L,W] Phila., PA/Rockport, MA b. Phila. d. 24 Je 1938. Studied: PAFA; Thomas Anshutz; Collin, Courtois, in Paris. Member: Phila. Sketch Cl.; North Shore AA; Phila. Alliance; Rockport AA; AFA. Author: two articles, Encyclopaedia Britannica. Contributor: magazines. Lectures: art appreciation [38]

A'BECKET, Maria [P] b. Portland, ME d. 6 S 1904, NYC. Studied: her father; W.M. Hunt; Daubigny, in France.

ABDY, Rowena Meeks (Mrs.) [P,Dr] San Fran., CA b. 24 Ap 1887, Vienna, Austria d. 18 Ag 1945. Studied: Arthur F. Mathews; Mark Hopkins AI. Member: San Fran. AA; Calif. WC Soc.; Carmel AA. Exhibited: Calif. Mus. A., San Fran., 1920 (med); Southwest Mus., Los Angeles, 1921 (prize); State Fair, Sacramento, 1922 (prize); Calif. WC Soc., Los Angeles, 1923; Ariz. State Fair, 1925, 1930 (prizes). Work: Mills Col. A. Gal., Calif.; Pal. Leg. Honor; Commercial Cl., San Fran.; Vanderpoel Coll., Chicago; Seattle A. Mus. Illustrator: "On the Ohio," "Old California," ten WC drawings (pub. John Henry Nash). She remodeled her big car into a studio. [40]

ABEL, Christine Jeannette (Jean) [P,W,T,C,L] Glendale, CA b. 21 N 1890, Maxwell, CA. Studied: Calif. Sch. FA; Schaeffer Sch. Des., San Fran.; Chouinard AI, Los Angeles; A. Hansen; X. Martinez. Member: ATA of Southern Calif.; San Fran. Soc. Women A.; Foothill Chap. ATA; Glendale AA; Pacific AA; AFA. Exhibited: Glendale AA, 1944; Golden Gate Expo, 1939; San Fran. Soc. Women A.; Los Angeles Mus. A., 1928; Calif. Ceramic Traveling Exh., San Fran. AA, 1924. Author: articles on Indst. Des. Positions: T. Glendale H.S. and Col. [47]

ABEL, Louise [S] Cincinnati, OH b. 7 S 1894, Württemberg, Germany. Studied: Cincinnati A. Acad.; ASL; Kunstgewerbe Schule, Stuttgart; Clement Barnhorn; Leo Lentelli; Boardman Robinson; Alfred Loercher, in Stuttgart. Member: Cincinnati Crafters; Pen and Pencil Cl., Cincinnati; Cincinnati Assn. Prof. A. Exhibited: Tiffany Fnd. (prize); CM, 1925, 1945; PAFA, 1925, 1945; AIC, 1926, 1940; Nat. Ceramic Exh., 1937, 1941; Getz & Brown Gal., Ohio, 1936; Andrews Gal., 1942; Dayton AI, 1936. Position: S./Des., Rookwood Pottery, 1921–32 [47]

ABEL, Myer [Li,P,T,L] Cincinnati, OH b. 5 Ja 1904, Cincinnati d. ca. 1948. Studied: Cincinnati A. Acad.; March, Lhote, in Paris. Exhibited: Mod. A. Soc., Cincinnati, 1940 (prize); IBM, 1940 (prize); 50 Prints of the Year, 1932; Intl. Lith. Exh., Chicago, 1932, 1934, 1936; PAFA, 1932, 1934, 1941; GGE, 1939; Los Angeles Mus. A., 1945; CM, 1930, 1941. Position: T., Cincinnati A. Acad., 1930–46 [47]

ABELE, Lanier Bradfield (Mrs. Alan Mason) [Min.P] Atlanta, GA b. 1 Ja 1909, Atlanta. Studied: Brenau Col., with John Weygandt; Corcoran Sch. A., with Eugen Weisz, Burtis Baker; Felix Mahony; Nat. Sch. F.&Appl. A. Member: Atlanta Studio Cl.; Atlanta AA; Assn. Ga. Artists; SSAL. Work: Oglethorpe Univ.; Brenau Col.; U.S. Naval Armory, Atlanta [40]

ABELL, Margaret Noel [S,Car,C] Georgetown, CT b. 3 D 1908, NYC. Studied: ASL, with Alexander Archipenko; Breckenridge Sch., Gloucester, Mass. Member: NAWA; AAPL. Exhibited: Provincetown AA; NAWA [47]

ABELL, Walter (Halsey) [Edu,L,W,C] East Lansing, MI b. 23 F 1897, Brooklyn, NY d. 28 F 1956. Studied: Univ. Pa.; Swarthmore Col.; Europe. Member: Am. Soc. Aesthetics. Contributor: Encyclopedia Americana; Encyclopedia of the Arts; articles for art magazines. Positions: Asst. Prof. A., Antioch Col., 1925–27; Prof. A. Acadia Univ. (Canada), 1928–43; Supv. Edu., Nat. Gal. (Canada), 1943–44; Assoc. Prof. A., Mich. State Col., East Lansing, 1944– [47]

ABELMAN, Ida [G,P] Brooklyn, NY b. 12 F 1910, NYC. Studied: Nat. Acad.; Des. Lab. Member: Am. Ar. Cong. Exhibited: Fed.A.Gal., N.Y., 1938; 48 Sts. Comp.; Whitney Mus.; MOMA; Phila. A. All.; Berkshire Mus. FA [40]

ABELS, Jean [S] Brooklyn, NY b. 14 O 1905, Pittsburgh, PA. Studied: Archipenko; Schweigardt, in Munich. Exhibited: WFNY, 1939 [40]

ABENDSCHEIN, Albert [P] NYC/Central Valley, NY b. 13 F 1860, NYC. Studied: Loefftz, Bavarian Royal Acad., both in Munich. Exhibited: Bavarian Royal Acad. (medals) [13]

ABERCROMBIE, Gertrude [P] Chicago, IL b. 17 F 1909, Austin, TX. Studied: Univ. Ill. Member: Chicago SA; Chicago NJSA. Exhibited: Chicago Ar., AIC, 1936 (prize); Chicago Soc. Ar., 1937 (med); AIC, 1938 (prize). Work: Burbank Sch., Chicago [40]

ABERNETHY, Inez [P] Phila., PA/Paris, France [05]

ABEYTA, Narciso Platero [P,I] Gallup, NM b. 1918, Canoncito, NM. Studied: Santa Fe Indian Sch., 1939; Somerset A. Sch., 1940. Work: in "Art in America," 1961; Philbrook AC; Univ. Okla.; Mus. N.Mex.; Ariz. State Mus. [*]

ABRACHEFF, Ivan [Edu,L,P,Mur.P] NYC b. 20 Ap 1903, Sliven, Bulgaria d. 21 Ag 1960. Studied: Nat. Acad. FA, Sofia and Rome; Giozepe Menato, in Rome. Exhibited: AIC, 1935; Grace Horne Gal., Boston, 1930–34; Indp. Gal. Mod. A., Boston, 1936. Author: articles as critic, Italy and Brazil. Position: T., Abracheff Sch. A., Boston [47]

ABRACHEFF, Nicolai (Nikolai) [Edu,W,L,P] NYC b. 22 Jy 1897, Sofia, Bulgaria. Studied: Nat. Acad. FA, Sofia; Antonio Mancini, Alfons Mucha, in Rome. Exhibited: Grace Horne Gal., Boston, 1931–35; Indp. Gal. Mod. A., Boston, 1937; Europe; South America. Editor: art magazine, "Zemja." Journalist and critic, in Bulgaria, Italy, Brazil. Position: Dir., Abracheff Sch. A., Boston [47]

ABRAHAMS, Helen [P] Phila., PA [13]

ABRAHAMS, Joseph B. [D,I,W] Mt. Kisco, NY/Katonah, NY b. 4 Jy 1884, Grodno, Russia. Studied: NAD; ASL. Work: Hebrew typefaces for classic series (Hebrew Press, Phila.); Hebrew inscriptions and symbols, Temple Emanuel, NYC; synagogue, church, theatre, and hotel ornament; illuminations for testimonial vols. to Louis Marshall and Mrs. Felix M. Warburg; ex libris for scholars, laymen, libraries, and museums in the U.S. and abroad. Contributor: art journals. Position: Dir., Graphic Arts Studio & Graphic Arts Press, NYC, 1910–46 [47]

ABRAHAMSEN, Christian [P] Chicago, IL b. 1887, Bergen, Norway. Exhibited: AIC, 1938 (prize); Ar. Chicago Vicinity Ann., AIC, 1936, 1939; "50 Years American Painting," AIC, 1939 [40]

ABRAMOFSKY, Israel [P,C] Toledo, OH b. 10 S 1888, Kiev, Russia. Studied: Académie Julian, Paris, with Jean Paul Laurens, Lucien Simon; Joseph Berges. Exhibited: AIC, 1938; Morgan A. Gal., 1938; Contemporary A. Gal., 1944; Youngstown AI, 1946. Work: Luxembourg Gal., Salon d'Automne, Nat. Beaux-Arts, all in Paris; AIC; Toledo Mus. A.; Akron AI; BM; Mus. Jaffe, Jerusalem [47]

ABRAMOVITZ, Albert [En,P] Brooklyn, NY b. 24 Ja 1879, Riga, Russia. Studied: Imperial A. Sch., Odessa; Grande Chaumière, Paris. Member: Societaire Salon d'Automne; A. Lg. Am.; SIA. Exhibited: Clichy, Paris, 1911 (prize); Universal Exh., Turin, Italy, 1911; New-Age Gal., 1943, 1946; AIC, 1938, 1940; ACA Gal., 1942; Bonestell Gal., 1940 (one-

man); Un. Am. A., 1940; NAD, 1946; Am. Assn. Univ. Women, 1946; Am. Ar. Congress. Work: NYPL; MMA; LOC; Brit. Mus., Victoria and Albert Mus., both in London [47]

ABRAMOWITZ, Benjamin [P,Li] Greenbelt, MD b. 4 Jy 1917, NYC. Studied: NAD. Exhibited: Wash. A. Fair, 1945 (prize); PMG, 1944, 1945; New Sch. Soc. Res., 1939; ACA Gal., 1938; BMA, 1945; Howard Univ., 1946 (one-man); Wash., D.C. Pub. Lib., 1945. Work: Howard Univ. [47]

ABRAMS, Arthur Rosskam [P,D,T] Elmira, NY b. 21 F 1909, Phila. Studied: PAFA; Pa. Mus. Sch. Indst. A.; Académie Julian, Paris. Member: DaVinci All., Phila.; Elmira A. Cl. Exhibited: State Dept., Harrisburg; AM, Reading; Allentown Mus. [40]

ABRAMS, Eleanor [P] Butler, PA b. Karns City, PA. Studied: Elliott Daingerfield; Henry B. Snell. Member: Pittsburgh AA [29]

ABRAMS, Lucien [P] Old Lyme, CT b. 10 Je 1870, Lawrence, KS d. 14 Ap 1941. Studied: ASL; Académie Julian, Paris, with Laurens, Constant, Collin, Whistler. Member: Lyme AA; San Antonio AA; AFA. Work: Dallas Mus. FA [40]

ABRAMSON, Maurice [P,Mur.P,Car,I,Li,D] Bayonne, NJ b. 4 Mr 1908, Bayonne. Studied: NAD, 1933, 1937 (prize); Irvington A.&Mus. Assn., N.J., 1941 (prize); Bayonne A. Exh., 1941. Work: mural, Bayonne Pub. Lib. Caricaturist: New Theatre and Film Magazine of New York [40]

ABRAMSON, Rosalind [P,E] NYC b. 14 Ja 1901, Norfolk, VA. Studied: ASL, with Bridgman, Bellows, Henri, DuMond; W.A. Levy. Member: GFLA; NAWPS [27]

ABRANZ, Lucien [P] NYC [09]

ABSTETAR, Stanley [P,Li,L] Sheboygan, WI b. 10 N 1916, Sheboygan. Studied: Milwaukee State T. Col.; Central Mich. Col. Edu.; Carl Holty. Exhibited: AIC, 1941; Wis. P&S, 1936-42; Wis. Exh., Madison, 1936-40; Wis. State Fair, 1937, 1938 (prize), 1939 (prize), 1940. Work: Pub. Bldgs., Wis. WPA artist. Positions: Asst. Supv., Milwaukee Pub. Mus., 1940-41; Wis. Visual Aids Program 1941-42 [47]

ACEE, Blue Eagle [P,B,Car,D,E,S,L,T] Muskogee, OK b. 17 Ag 1910, Anadarko, OK d. 1959. Studied: Okla. Univ. Member: Assn. Okla. Ar.; Tulsa AA. Exhibited: Nat. Exh. Am. Indian Painters, Philbrook AC, 1946 (prize); Xth Olympiad, Los Angeles Mus. Hist., Science, and Art, 1932 (prize); England; France. Work: Indian murals for U.S. Gov. in colleges of Okla., 1934; 12 paintings owned by Alfonso, former King of Spain; paintings in numerous galleries. Named "outstanding Indian in the U.S.," 1958. Position: Dir. A., Bacone Col., Okla. [47]

ACEVES, José [P,D,S] El Paso, TX b. 22 D 1909, Chihuahua, Mexico. Studied: Tech. Inst., El Paso; Audely Dan Nichols; Tom Lea, Jr. Exhibited: Dallas MFA; Tex. Centenn., 1936. Work: USPOs, Borger, Mart, both in Tex. WPA artist. [40]

ACHELIS, Margaret [S] NYC [17]

ACHENER, Maurice [E] Paris, France. Member: Chicago SE [17]

ACHERT, Fred [P] Cincinnati, OH. Member: Cincinnati AC [24]

ACHESON, Alice S(tanley) (Mrs. Dean) [P,I] Wash., D.C. b. 12 Ag 1895, Charlevoix, MI. Studied: Wellesley Col.; BMFA Sch.; Howard Smith; Richard Meryman. Member: NAWA; Soc. Wash. Ar.; A. Gld. Wash.; Wash. WCC; NYSWA. Illustrator: "New Roads in Old Virginia" [47]

ACHESON, Georgina Elliott [P] Ardsley-on-Hudson, NY [24]

ACHNING, Estellyn Allday (Mrs. Walter J.) [P,Li,I] San Antonio, TX b.12 Je 1909, Atlanta, TX. Studied: Colorado Springs FA Center; Univ. N.Mex.; Andrew Dasburg; Charle Rosen; Henry McFee. Member: Tex. FA Assn.; SSAL; NAWA. Exhibited: Tex. FA Assn., 1945 (prize), 1946; SSAL, 1945 (prize); NAWA 1941-46; Denver A. Mus., 1945; Midwestern A., 1942 [47]

ACKEN, Joe B. [P] Tampa, FL [24]

ACKER, Eleanor Beatrice [B,D,Dr,I,P] Collingswood, NJ b. 12 Je 1907, Camden, NJ. Studied: PMSchIA; Moore Inst., Pa. Sch. Des. for Women; Earl Horter; Graphic Sketch Cl. Member: Am. Ar. Prof. Lg. Exhibited: Graphic Sketch Cl., 1934 (prizes); Collingswood First Ann. Exh., 1935 (prizes); Studio Cl., Nashville, 1936 (prize); N.J. Ann. Exh., Camden, 1936 (prize). Illustrator: "Under a New Banner," by Estelle M. Grant. Work: Collingswood Pub. Lib.; Graphic Sketch Cl., Phila. [40]

ACKER, Geraldine D.N. (Mrs. Ernest R.) [Por.P] Poughkeepsie, NY b. 27 Je 1895, Wassiac, NY. Studied: NAD, with Hinton, Curran; ASL, with DuMond, Luks. Member: NAWA; Duchess County AA. Exhibited: NAWA, 1942, 1943, 1946; Syracuse Mus. FA, 1942; Albany Inst. Hist.&A., 1943, 1945, 1946; Poughkeepsie, 1940-46; Argent Gal., 1944 [47]

ACKER, Herbert V(an) B(larcom) [P] San Gabriel, CA b. 4 O 1895. Studied: NAD, with Douglas Volk, Francis Jones; ASL, with DuMond, F. Luis Mora; Grande Chaumière, Paris; Cecilia Beaux. Member: Pasadena SA; Laguna Beach AA; Pasadena AI; ASL. Exhibited: Pasadena AI, 1931 (prize), 1945, 1946; Paris Salon, 1924; Salon d'Automne, 1923; Los Angeles Mus. A., 1936-38; Pasadena SA, 1925-46 [47]

ACKER, Marjorie. See Phillips, Duncan, Mrs.

ACKER, William Reynolds Beal [Mus.Assoc,Edu] Wash., D.C. b. 17 O 1907, NYC. Studied: Harvard; Leiden, Holland. Co-translator: "Studies on the Wall Paintings of Horyuji." Positions: OWI, 1942-45; Assoc. Research, Freer Gal. A., 1940-46 [47]

ACKERMAN, Harry Gregory [P] NYC b. 2 N 1909, Romania. Studied: Yale; NAD; ASL; Am. Acad., Rome; Lake Forest Fnd. Arch. and Ldscp. Arch. Member: Grand Central AG; Am. A. Cong. [40]

ACKERMAN, Olga M. (Mrs.) [P] San Fran., CA [15]

ACKERMANN, John Joseph [P] NYC b. 12 Ap 1889, Lisowice, Austria d. 19 D 1950. Studied: Acad. A., Vienna; Columbia; ASL, with George Grosz; N.Y. Indst. A. Sch., with Hechenbleikner. Exhibited: Montross Gal. (one-man). Work: U.S. Treasury Dept, Wash., D.C. [47]

ACKERSON, F(loyd) G(arrison) [P] Wilkinsburg, PA b. 1 Ja 1889, Portage, MI. Studied: Carnegie Tech. Art Sch. Member: Pittsburgh AA; Palm Beach A. Center. Exhibited: Pittsburgh AA (prize); Pittsburgh Adv. Cl., 1928, (prize). Work: Vanderpoel Coll., Chicago. Research: pigment, color, light. Position: Ar., Westinghouse Electric and Mfg. Co., East Pittsburgh [40]

ACKLEY, Elting [I] NYC [19]

ACKLEY, Herbert Mayhew [P] Portland, OR b. 10 D 1905, Chicago. Studied: Portland AM Sch. Member: Am. Ar. Cong. Exhibited: 8th Ann. Exh., Portland Mus., 1939; Northwestern Ann., Seattle, 1936 (prize) [40]

ACKLEY, Telka [P,Gr,I] NYC b. 25 S 1918, NYC. Studied: ASL; Stow Wengenroth; Ogden Pleissner. Member: AWCS. Exhibited: AWCS, 1939. Work: illus., publications E.F. Ackley, Stokes Comp., 1937, 1939 [47]

ACRUMAN, Paul [Car,I] Texarkana, AR b. 22 Ag 1910, Mena, AK. Studied: Hendrix Col., Ark. Member: Am. Soc. Mag. Car.&I. Work: car., publications/syndicated features [47]

ADAIR, Ruby (Mrs.) [P] San Fran., CA b. 17 N 1899, Pescadero, CA. Studied: Calif. Sch. FA; Labaudt; Gertrude Partington Albright; Irvine. Member: San Fran. Soc. Women A.; San Fran. AA [40]

ADALINE, M. [S] Chicago, IL [15]

ADAM, David Livingston [Por.P] Chicago, IL b. 1883, Glasgow, Scotland d. Jy 1924. Studied: Glasgow Sch. A., with Jean Delville, M. Greiffenhagen; AIC; Brussels Royal Acad. Member: Chicago Palette & Chisel Cl.; Chicago SA. Exhibited: Chicago Palette & Chisel Cl. (gold)

ADAM, Wilbur G. [P] Chicago, IL b. 23 Jy 1898, Cincinnati, OH. Studied: Duveneck; L.H. Meakin; James R. Hopkins; H.H. Wessel; C.A. Lord. Member: Tiffany Fnd.; Cincinnati AC; Chicago Gal. A.; Soc. Chicago P.&S. Exhibited: AIC, 1925 (prize); Chicago Gal., 1931 (prize), 1932 (prize) [40]

ADAM, William [P,L,T] Pacific Grove, CA b. 29 Ag 1846, Tweedmouth, England. Studied: Delecluse, in Paris; Greenlees, Robert Brydall, in Glasgow. Member: Boston A. Soc.; Glasgow AC. Exhibited: Sacramento State Fair (gold). Work: Del Monte Gal., Calif. [31]

ADAMS, Ansel [Photogr] b. 1902 d. 1984, Carmel, CA. Studied: self-taught. Member: Group f/64 (founder); Friends of Photography (founder, 1966). Exhibited: An American Place, 1933. Author: numerous books on photography. Well known for his dramatic western landscapes. Work: major U.S. museums [*]

ADAMS, Arthur (Sandy) [Mar.P] Killingly, CT. Active 1906-41. Work: Mystic Seaport Mus.

ADAMS, Bertrand R. (Bert) [I,P,C] Ames, IA b. 29 N 1907, Webster City, IA. Studied: Federal Schools; Univ. Iowa; Charles Hawthorne; Sidney Dickinson; Grant Wood; Christian Peterson. Member: Coop. A. of Iowa. Exhibited: Iowa State Fair, 1934 (prize), 1935, 1936. Work: murals,

USPOs, Dubuque, Siloam Springs, both in Iowa. Author: "Design Correlation," Architectural Record, F 1937 [47]

ADAMS, Charles F. (Mrs.) [Patron] d. 1 O 1921, Hinsdale, IL. Through her efforts an art salon was established in Chicago, from which developed the annual exhibitions of Chicago artists at the Art Institute.

ADAMS, Charles L. [P,T] Jamaica Plain, MA b. 26 N 1857, NYC d. 16 S 1914, Antwerp, Belgium. Studied: Oudinot, in Paris. Member: Boston AC. Position: T., MIT [14]

ADAMS, Charles Partridge [Ldscp.P,T] Los Angeles, CA/Laguna Beach, CA b. 12 Ja 1858, Franklin, MA d. 15 O 1942, Pasadena, CA. Studied: self-taught. Member: Denver AC; Laguna Beach AA. Exhibited: Nat. Mining and Indst. Expo, Denver (gold); Pan-Am Expo, Buffalo, 1901 (prize). Work: State Univ., Boulder, Colo.; Kansas City, Mo.; San Diego; Women's Cl., Denver; Denver A. Assoc. [40]

ADAMS, Chauncey M. [P,E,T] Utica, NY/Unadilla Forks, NY b. 28 Mr 1895, Unadilla Forks. Studied: Daniel Garber; PAFA. Member: Utica ASL. Work: Converse Col., S.C. [33]

ADAMS, Clifton Emerson [S] Lohrville, IA b. 29 F 1904, La Place, IL. Studied: Victor S. Holm, Fred G. Carpenter; St. Louis Sch. FA. Member: AAPL; Iowa AC; Ft. Dodge AG; Soc. Sanity in A., Chicago. Exhibited: Art All., St. Louis, 1927 (prize); Des Moines AC, 1932–33 (prize); All-Iowa Exh. Art, Chicago, 1937 (prize); Iowa Centenn., 1938 (prize). Work: State College, Ames, Iowa [40]

ADAMS, E. [P] Park City, UT. Member: Soc. Utah A. [31]

ADAMS, Edgar F., Mrs. See Adams, Marjorie Nickles.

ADAMS, Edith Gordon [P] Shelbyville, IN b. 27 My 1870, Shelbyville d. 1938. Member: Ind. Ar. Cl. [33]

ADAMS, Edward S. (Mrs.) [P] Chicago, IL

ADAMS, Elizabeth Livingston [P] Paris, France. b. Albany, NY [06]

ADAMS, Florence Bowman [Edu,P,L] Woodbury, NJ b. 10 Ap 1902, Phila. Studied: Earl Horter; Luigi Spizzirre; Yarnall Abbott. Member: Phila. A. All.; Woodmere AA; A. T. Assn. Exhibited: PAFA, 1934, 1935, 1938; DaVinci Exh.; Phila. A. All.; Phila. A. T. Exh.; Wanamaker Reg., 1934; Phila. WCC Ann. Work: Lutheran Church, Woodbury, N.J. [47]

ADAMS, Frank [I] NYC [04]

ADAMS, H. Lawson, Jr. [P] Abroad

ADAMS, Harriette [P] Paris, France Studied: Richard E. Miller [10]

ADAMS, Harriet Dyer [Mus.Cur,T,L] Bloomfield Hills, MI b. 9 F 1910, Champaign, IL. Studied: Univ. Mich.; Radcliffe; NYU. Author: "Selective Bibliography of Hispano-Islamic Art in Spain and North Aftica," 1939. Cataloger: Rockefeller Pr. Coll., MOMA, 1939. Assembler: Picasso Pr. Exh., 1939. Mss. "Guide to Public Print Collections in New York City," 1940. Positions: Cur./Acting Dir., Person Hall A. Gal., Univ. N.C., 1940–44; Cur., Cranbrook Acad. A. Mus.; T., Kingswood Sch., Bloomfield Hills, 1945– [47]

ADAMS, Henry b. 1858, Duisberg, Germany d. 9 D 1929. President of Maryland Institute. He was associated with the Institute for forty-five years, becoming its president in 1920.

ADAMS, Herbert [S] NYC/Plainfield, NH b. 28 Ja 1858, West Concord, VT d. 21 My 1945. Studied: Mass. Normal A. Sch.; Mercié, in Paris. Member: ANA, 1898; NA, 1899; SAA, 1891; NSS, 1893; Arch. Lg., 1896; N.Y. Municipal AS; NAC; Century Assoc.; AAAL; Salma C.; Port. P.; AFA. Exhibited: Paris Salon, 1888, 1889; A.C.P., 1892 (med); Columbian Expo, Chicago, 1893 (med); Charleston Expo, 1902 (gold); St. Louis Expo, 1904 (med); P.-P. Expo, San Fran., 1915 (med); NAD, 1916 (gold); AAAL, 1926. Work: Fitchburg, MA; Winchester, MA; LOC; Fed. Res. Board Bldg.; Wash., D.C.; St. Bartholomew's Church, NYC; AAAL; MMA; Cleveland; NYC; Newark; Newport News, VA; Society of Medalists, N.Y. [04]

ADAMS, J. Howard [P] Providence, RI. Member: Providence AC [25]

ADAMS, Jean Crawford [P] Chicago, IL b. Chicago. Studied: AIC; George Bellows, John Vanderpoel. Member: Chicago AC; Chicago SA. Exhibited: Am. Exh., AIC, 1928 (prize), 1930–32, Chicago A., 1933 (prize), 1934–45; MOMA, WMAA, 1932, 1933; Toledo Mus. A.; PMA, 1932; BMA, 1938; Carnegie Inst., 1928–30; CAM, 1930; SFMA; Milwaukee AI; Dallas Mus. FA [47]

ADAMS, John Ottis [Ldscp.P,T] Brookville, IN/Leland, MI b. 8 Jy 1851, Amity, IN d. 28 Ja 1927. Studied: John Parker, in London; Benczur, Loefftz, both in Munich. Member: Indianapolis AA. Exhibited: St. Louis Expo, 1904 (med); FA Bldg., Chicago, 1907 (prize); Buenos Aires Expo, 1910 (prize). Work: Richmond, Ind. AA; Herron A. Inst., Indianapolis; AA, Muncie, Ind.; AA, Cedar Rapids, Iowa; Pub. libraries, Terre Haute, Anderson, Brookville, Bluffton, Evansville, Ft. Wayne, Marion (all in Ind.), Bay City, Mich. [25]

ADAMS, John Quincy [Por. P] b. 1875, Vienna, Austria d. 1933. A great-grandson of J.Q. Adams, sixth president of the U.S. He was greatly influenced professionally by Whistler, a personal friend. He painted many distinguished figures in pre-war Austrian society.

ADAMS, John Quincy d. 12 F 1919. Assistant Secretary of the Art Commission of the City of New York. He lectured and wrote extensively on art matters.

ADAMS, John Squire [Por.P,D] Cleveland Heights, OH b. 28 N 1912. Studied: Cleveland Sch. A. Member: Cleveland SA. Exhibited: Cleveland A. Mus., 1935 (prize), 1936 (prize). Work: mural, Hall of Progress, Great Lake Expo, Cleveland, for U.S. Coal Co. [40]

ADAMS, John Wolcott [I] b. 1874, Worcester, MA d. 3 Je 1925, NYC. Studied: ASL; Howard Pyle; Cox; Mowbray; Tarbell; Benson. Member: SI, 1910; Soc. Illus.; Players Cl. Illustrator: Scribner's, The Century. Set designer: Walter Hampden's productions. A member of the family which gave two presidents to the U.S. [25]

ADAMS, Katharine Langhorne (Mrs. Benjamin Pettengill) [P,L] Fairfield, CT b. Plainfield, NJ. Studied: ASL; Dumond. Member: NAWA; Soc. Brit. A. Exhibited: NAWA, 1936 (prize); Century Progress, Chicago; Detroit Inst. A.; CMA; PMA; Albright A. Gal.; AIC; Pittsburgh; Plainfield, N.J.; Old Lyme, Conn.; Buenos Aires. Work: PAFA; AIC [47]

ADAMS, Kenneth Miller [P,Li] Albuquerque, NM b. 6 Ag 1897, Topeka KS d. 1966. Studied: AIC; ASL; Kenneth Hayes Miller; George Bridgman; Maurice Sterne; Andrew Dasburg. Member: ANA, 1938; Prairie Pr.M.; Audubon A.; Taos SA; Am. A. Cong. Exhibited: NAD, 1928–46; PAFA; San Fran. AA, 1920, 1932; SFMA, 1942, 1946; AIC; CGA; Dallas Mus. FA; VMFA; Kansas City AI; Denver A. Mus., 1928 (prize), 1930 (prize); Exh. Am. Lith., Phila., 1932 (award); Carnegie Inst.; Mus. N.Mex., Santa Fe; Harwood Fnd. Work: Univ. N.Mex.; Colorado Springs FA Center; Kansas State Col.; Denver A. Mus.; Los Angeles Mus. A.; Honolulu Acad. A.; Dallas Mus. FA; NYPL; WMAA; Carnegie Inst.; Lib. Cong.; USPOs, Goodland, Kans., Deming, N.Mex. Illustrator: "Autobiography of Earth," by John H. Bradley. Position: T., Univ. N.Mex., Albuquerque [47]

ADAMS, Lawrence [Edu,P] Pineville, LA b. 20 D 1905, Charlotte, NC. Studied: ASL; Yale; Colorado Springs FA Center, with Boardman Robinson. Member: Am. A. Cong. Exhibited: AIC, 1940 (prize). Work: USPO, Sullivan, Mo. Position: T., Univ. Mo., Columbia [47]

ADAMS, Lillian [P,T] Montclair, NJ/East Gloucester, MA b. 21 Ap 1899, London. Member: A. Center of the Oranges. Exhibited: Jersey Ar. Exh., Newark, 1936 (prizes); Montclair MA; Rutgers Univ.; A. Center of the Oranges. Position: T., Art Center of the Oranges [40]

ADAMS, Loring [P] Saxonville, MA [09]

ADAMS, Louis S. [P] Melrose, MA [06]

ADAMS, Margaret Boroughs (Mrs. Wayman) [P,Li,G,C] NYC/Elizabethtown, NY b. Austin, TX d. 8 F 1965. Studied: Univ. Tex.; Newcomb Col.; Tulane; Columbia; N.Y. Sch. F.&Appl. A.; Ellsworth Woodward; W.M. Chase. Member: SSAL; Southern Pr.M.; PBC; NAWA; AWCS; SSAL; Pen and Brush Cl. N.Y. Exhibited: SSAL, 1938; NAWA, 1938; Corcoran Gal., 1938; AWCS, 1944; All. A.Am., 1945; PAFA, 1945; Univ. Tex., 1936 (one-man); Grand Central Gal., 1936 (one-man); CGA, 1939 (one-man); Harlow-Keppel Gal., 1943 (one-man). Illustrator: "Stars and their Stories" [47]

ADAMS, Marjorie Nickles (Mrs. Edgar F.) [P,C] Media, PA b. 11 O 1898, Shippensburg, PA. Studied: PMSchIA; Chester Springs Acad. FA; Daniel Garber; Hugh Breckenridge; PAFA. Member: Phila. A. All.; Am. Ar. Prof. Lg.; Woodmere AA. Exhibited: Phila. Plastic C., 1929 (prize); PAFA, 1922, 1923 [47]

ADAMS, Philip [P] Wash., D.C./Cambridge, MA b. 26 Je 1881, Honolulu. Studied: Bridgman; Paxton; Hale; Benson; Woodbury. Member: Copley S. [25]

ADAMS, Philip Rhys [Mus.Dir,L,W] Cincinnati, OH b. 19 N 1908, Fargo, ND. Studied: Ohio State Univ.; NYU; Princeton; Cook; Robinson; Mather. Member: Assn. A. Mus. Dir. Author: "The Sculpture of Erwin F. Frey," 1940, "Rodin," 1945. Contributor: art magazines. Positions: T.,

Newcomb Col., 1931–34; Asst. Dir., 1934–36, Dir., 1936–45, Columbus (Ohio) Gal. FA; Dir., Cincinnati Mus. Assn., 1945– [47]

ADAMS, Velma [Li,E,En,P,S] Los Angeles, CA b. 4 Ap 1902, Eiuita, CO. Studied: Otis AI; ASL; Grand Central Sch. A.; George Biddle; F. Tolles Chamberlin; Loren Barton; Leo Katz; Wayman Adams. Member: Callif. Pr.M.; Calif. SE; Council All. A.; Southern Pr.M.; Calif. AC; Women P. of the West. Exhibited: San Gabriel, AGI (one-man); ACI, 1938 (one-man); Ebell Salon, 1938; Southwest M., 1939; Calif. SE, 1939 (prizes); Calif. AC, 1940; Otis AI Alumn., 1941–43, 1945; GGE, 1939; Staten Island Inst.; Fnd. Western A., 1940–45; Laguna Beach AA; Los Angeles AA, 1943–46; Fillmore A. Barn, 1941–43; Los Angeles Mus. A., 1945. Work: Southwest Mus., Los Angeles; Appalachian Mus. A., Mt. Airy, Ga.; Los Angeles Mus. A.; U.S. Navy [47]

ADAMS, Walter Burt [P,I,Car] Evanston, IL b. 6 Jy 1903, Kenosha, WI. Studied: AIC; William Owen, Jr.; Elmer A. Forsberg; George Oberteuffer. Member: North Shore AL. Exhibited: AIC, 1930–46; PAFA, 1936–38; Evanston Women's Club, 1932–46. Work: WPA Federal Art Project [47]

ADAMS, Walter Langely [P,L,T] White Plains, NY b. 31 My 1897, NYC. Studied: Sorbonne, Paris; Univ. Pa.; ASL; NAD; Ten Brook; Coombs; Metcalf. Member: Albermarle AA; Westchester A.&Crafts; Soc.Am.A. Exhibited: Sorbonne, 1919; NAD, 1922–24; Albermarle AA, 1937, 1938; Westchester A.&Crafts, 1942–46; Contemporary Cl., 1946 [47]

ADAMS, Wayman [Por.P] NYC/Elizabethtown, NY b. 23 S 1883, Muncie, IN d. 8 Ap 1959. Studied: John Herron AI; W. Forsyth; William Chase; Robert Henri. Member: NA; AWCS; All.A.Am.; Nat. Inst. A.&Let.; Phila. WC Cl.; Phila. Sketch Cl.; N.Y. Soc. P.; Phila. AC; SC; Indiana A. Cl.; NAC; Nat. Assn. Port. P. Exhibited: Muncie AA, 1910 (prizes); NAD, 1914, 1926, 1932; Richmond AA, 1915; Indiana A. Cl., 1916; AIC, 1918 (prize,med); AWCS, 1930 (prizes); SC, 1931, 1940; Newport AA, 1918, 1925; Hoosier Salon, 1925, 1926, 1929, 1931, 1935; Springfield AA, 1926; PAFA, 1929, 1933; All.A.Am., 1930 (med); Holland Soc., N.Y., 1933 (prizes,med); Carnegie Inst., 1943 [47]

ADAMS, Wilbur Henry [D] Cleveland, OH b. 1 Je 1906, Erie, PA. Studied: MIT; Jacques Carlu; Raymond Hood. Member: AIA. Work: Designer: Republic Steel exh. rooms; Perfection Stove Company; Electromaster; motor-bus for Twin Coach [40]

ADAMS, Wills A. [P] b. 1854, Goshen, IN d. 1932, Salt Lake City, UT. Studied: self-taught; AIC. Produced western landscapes at his Park City, Utah studio. [*]

ADAMS, Winifred Brady (Mrs. J.O.) [P] Indianapolis, IN b. 8 My 1871, Muncie, IN d. 2 Ja 1955. Studied: Drexel Inst.; Douglas Volk, H. Siddons Mowbray, William Chase. Member: Indiana A. Cl.; NAC; Indianapolis AA; Cincinnati Women's AC; Portfolio Cl., Indianapolis; AFA. Exhibited: John Herron AI, 1926 (prizes); Hoosier Salon; Muncie AA; Richmond AA, 1943. Work: Indiana Univ.; John Herron AI; Richmond AA; Muncie AA [47]

ADAMS, Woodhull [P] Lyme, CT. Member: Salma. C.

ADAMSON, Penrhyn Stanley. See Stanlaws, Penrhyn.

ADAMSON, Sydney [I] NYC

ADDAMS, Charles [I,Car] NYC. Member: SI. Work: New Yorker [47]

ADDAMS, Clifford (Isaac) [P,E] NYC b. 25 My 1876, Woodbury, NJ d. 7 N 1942. Studied: Whistler; Belgium; Holland; Spain; France; Italy; British Isles; PAFA, 1899. Member: Chicago Soc. E.; Phila. Soc. E.; Soc. Am. Etchers. Exhibited: Panama-Pacific Expo, San Fran., 1915 (med); Chicago SE, 1917 (prize); AIC, 1922 (prize), 1926 (med); Phila. AC, 1922 (gold); NAD, 1924 (prize); PAFA, 1925 (gold). Work: PAFA; murals, Council Chamber, City Hall, Asheville, N.C.; etchings, AIC; MMA; Nat. Coll. Fine Art (Smithsonian); Lib. Congress [40]

ADDAMS, Inez (Mrs. Clifford) [P] London, England. Exhibited: P.-P. Expo, San Fran., 1915 (med) [21]

ADDAMS, J. Howard [P] d. 7 D 1924. Member: Providence AC

ADDISON, Agnes (Mrs. John M. Gilchrist) [Edu,W,L] Mt. Vernon, NY b. 25 D 1907, Phila. Studied: Wellesley Col.; Univ. Pa.; Harvard; Europe. Member: CAA; Am. Soc. Arch. Hist.; Phila. A. All. Exhibited: Phila. A. All.; Phila. Women's Univ. Cl. Author: "Early American Gothic," 1940, "Pennsylvania Portraits," 1940. Contributor: book reviews, articles to art magazines. Positions: T., Tex. State Col. for Women, 1931–32, Univ. Pa., 1934–41, Randolph-Macon Col., 1941–42 [47]

ADDISON, Julia de Wolf (Mrs. D.D.) [W,D,L,P] Brookline, MA/Marion, MA b. 24 F 1866, Boston. Studied: private schools in England and Boston; MIT; Amy M. Sacker. Member: Boston SAC; Copley Soc.; Soc. Sanity in A.; Authors' Cl., Soc. A.&Crafts. Work: Matapoisett, Beverly, Brookline, Swansea, Cambridge, Marion, Mass.; Bristol, Providence, R.I.; Meriden, Conn.; Lafayette, La.; Ontario, Calif.; France; China. Author: Art of the Pitti Palace; Art of the Dresden Gallery; Classic Myths in Art; Arts and Crafts of the Middle Ages; Florestane and the Troubadour. Illuminator on vellum, hearldic work, embroiderer [47]

ADDISON, Walter [P] NYC. Exhibited: Am.WC Soc., 1937; Nat. Acad., 1938; Ferargil Gal. [40]

ADDISON, Wilfred John [P,Li,D,B,E,I] Syracuse, NY b. 30 My 1890, Barrie, Ontario. Studied: Syracuse Univ.; NAD; ASL, with Frank DuMond, Thomas Fogarty; Mechanics Inst., Rochester. Member: Assoc. A. Syracuse; Syracuse Pr.M.; Syracuse Sketch Cl. Exhibited: Onandaga Hist. A. Exh., 1942, 1943, 1946; Cayuga Mus. Hist.&A., 1942–46; CAM, 1919; Albright A. Gal., 1921, 1922; Assoc. A. Syracuse, 1927–46, 1938 (prize), 1945 (prize); Onandaga Hist. A. Exh. 1942–46; Syracuse Mus. FA, 1945 (one-man). Inventor: Aquachrome printing [47]

ADELSPERGER, Mary P. (Mrs.) [P] Chicago, IL. Member: Chicago SA [25]

ADEN, Alonzo J. [L] Wash., D.C. b. 6 My 1906, Spartanburg, SC d. 1963. Studied: Howard Univ.; Buffalo Mus. Sc. Member: AA Mus.; AFA. Lectures: Negro in American Art. Positions: Cur., Howard Univ. Gal. A., 1930–43; Dir., Barnett Aden Gal., Wash., D.C., 1943–46 [47]

ADERENTE, Vincent [Mur.P] Jersey City, NJ b. 20 F 1880, Naples d. 13 Je 1941, Bayside, NY. Studied: Blashfield; Mowbray. Member: Mural P.; Arch.Lg., 1911. Work: U.S. Mint Bldg., Denver; Court House, Youngstown, Ohio; City Hall, Yonkers, N.Y.; Albany, N.Y.

ADES, Harold [D,I,P,E] NYC b. Turnbridge Wells, England. Member: AAPL. Exhibited: Salon Am., Anderson Gal., 1927. Illustrator: "Short Stories of Famous Men"; "Down to the Sea in Ships," 1946 [47]

ADLER, Elmer [Typ,T,L,W] Princeton, NJ b. 22 Jy 1884, Rochester, NY. Member: AIGA. Positions: Research Assoc. Gr. A., Princeton Univ. Lib.; Ed., "Colophon"; Managing Dir., Pynson Printers [47]

ADLER, J.C. [Por.P] Charleston, WV d. 2 O 1915. Painted portraits of many well-known Southerners, including former W.Va. Governor G.W. Atkinson. At one time, he lived in NYC.

ADLER, Ruth [En] NYC [21]

ADLER, Sam [P,D] Chicago, IL b. 2 Je 1901, Manchester, England. Studied: John Norton; William Owen, Jr. Member: Around the Palette, Chicago; Chicago NJSA [40]

ADLOW, Dorothy (Mrs. Nicolas Slonimsky) [Cr,L,Edu] Boston, MA d. 1964. Studied: Radcliffe Col. Positions: A.Cr., Christian Science Monitor; L., BMFA [47]

ADNEY, EdwinTappan [I] Woodstock, New Brunswick b. 13 Jy 1868, Athens, OH d. 1950. Studied: ASL. Specialties: Canadian military; canoe-making; heraldry. Artist and special correspondent for Harper's Weekly at Klondike, 1897–98 [25]

ADOLPH, Virginia (Mrs. R.E.) [P] Jamaica, NY. Studied: London Sch. A.; Pa. Acad. FA. Member: Queensboro Soc. Allied AC; Wolfe ACI; Am. Ar. Prof. Lg.; Studio Gld.; 1937; Queensboro Soc. All. AC, Nat. ACI, 1939 [40]

ADOLPHE, Albert J(ean) [P] Phila., PA b. 17 F 1865, Phila. d. 12 N 1940. Studied: Gérôme, Whistler, in Paris; De Vriendt, in Antwerp; Pa. Mus. Sch. Indst. A., with Eakins. Member: Alumni Assn. Pa. Mus. Sch. Indst. A.; Graphic Sketch C. Exhibited: Columbian Expo, Chicago, 1894 (prize); Paris Salon, 1899 (prize); Phila. AC, 1904 (gold), 1921 (prize); Phila., "Americanization Through Art" Exh., 1916 (prize). Work: dec., Marlborough-Blenheim Hotel, Atlantic City, N.J., and for steamships "St. Louis," "St. Paul," "New York" and "Paris" [40]

ADOMEIT, George G. [P] Cleveland, OH b. 15 Ja 1879, Memel, Germany. Studied: Cleveland Sch. A.; F.C. Gottwald. Member: AIGA; Cleveland SA; AI Graphic A.; Cleveland Print C. Exhibited: Ohio State Fair, 1922 (prize); Annual Exh., CMA (prizes); CAM, 1931; WMAA, 1937; Detroit Inst. A., 1925, 1926; Albright A. Gal., 1928; Toledo Mus. A., 1928, 1929, 1932, 1935; PAFA, 1925–36, 1941; CGA, 1928, 1931, 1933, 1935, 1937; Carnegie Inst., 1930. Work: CMA. Position: A. Dir., Caxton, Co., Cleveland, 1901–46 [47]

ADRIANCE, Mary Horton (Minnie) (Mrs. William A.) [P] NYC d. 26 Ag 1941, Lumberville, PA. Member: S.Indp.A.; NAC; PBC [24]

ADRIANI, Bruno [W] b. 18 Ag 1881, Werne, Germany. Studied: Kiel; Munich; Berlin. Member: CAA. Author: "Philipp Harth, Sculptor," 1939,

"Problems of the Sculptor," 1943, "Pegot Waring, Stone Sculptures," 1945 [47]

ADSIT, Mabel Lawson [P] Mt. Vernon, NY [17]

AF EKENSTAM, Marta [C,S] Pasadena, CA b. 3 My 1880, Mamlo, Sweden d. 4 Ag 1939. Studied: Sven Bengston; Max Pfeiffer-Quandt; Moritz Fritsch; Fritz Schmidt; Georg Buchner. Member: Pasadena SA. Exhibited: Salon d'Automne, Grand Palais, Paris (medals); Giovos A. Gal., London; Ar. Fiesta, Los Angeles, 1931 (gold). Specialties: metals and ivory, ebony and turtle shell sculpture [38]

AFROYIM, Beys (Ephraim Bernstein) [P,S,T] NYC b. 2 Ja 1893, Ryki, Poland. Studied: AIC; NAD; Boris Anisfeld. Member: A. Lg. Am. Work: Moscow Mus. A.; U.S. pub. bldgs. Position: Dir./T., Afroyim Experimental A. Sch., 1927–46 [47]

AGAFONOFF, Eugene Andrew [P] Seymour, CT b. 11 F 1879 Kharkov, Russia d. ca. 1955. Studied: Imperial Acad. A., St. Petersburg. Exhibited: Ekaterinoslav, Russia, 1910 (med); Indp. A., 1929; French A. Gal., N.Y., 1931; Stendahl Gal., 1932; Greenwich (Conn.) Pub. Lib., 1939; Derby (Conn.) Pub. Lib., 1943 [47]

AGA-OGLU, Mehmet [Edu,L,W] NYC b. 24 Ag 1896, Eriwan, Russia d. 1948. Studied: Univ. Moscow; Friedrich-Wilhelm Univ., Berlin; Lazarowski Inst.; Univ. Vienna. Member: CAA. Author: books on bookbinding, rugs & textiles. Lectures: Islamic Art. Positions: T., Univ. Mich, 1933-38, Princeton Univ., 1935, 1938; Ed., Ars Islamica, 1934–38 [47]

AGAR, John Giraud [Patron] b. 30 Je 1856, New Orleans, LA d. 20 S 1935, New Rochelle, NY. Positions: president, New York Municipal AS, 1908, 1909; treasurer, Grand Central Art Assoc.; president, Arts Council, NYC, 1927–29; president, National Arts Cl., N.Y., 1910–32 (honorary president of the latter until his death)

AGNEW, Chalmers, Jr. [P] Duluth, MN [17]

AGNEW, Clark M. [I] Westport, CT. Member: SI [47]

AHGUPUK, George [P] Shishmaref, AK. Exhibited: Nat. Exh. Am. Indian Painters, Philbrook A. Center, 1946 [47]

AHL, Eleanor Curtis (Mrs. Henry Hammond) [P] Boston, MA [24]

AHL, Henry Curtis [P,I,W] Newbury, MA b. 30 D 1905, Springfield, MA. Studied: Henry Hammond Ahl; Eleanor Curtis Ahl; Harvard. Member: Gloucester SA. Exhibited: Conn. Acad. FA; New Haven PCC; Springville (Utah) AA. Work: Vanderpoel Coll.; Springville AA. Author/Illustrator: booklets on literary shrines [47]

AHL, Henry Hammond [P,S] Newbury, MA b. 20 D 1869, Hartford, CT d. 1953. Studied: Royal Acad., Munich, with Alexander Wagner, Franz Stuck; Ecole des Beaux-Arts, Paris, with Gérôme; Peter Paul Müller. Member: Am. APL; Copley S.; SC; Conn. Acad. FA. Exhibited: Munich Royal Acad. (prize); NAD; AWCS; Wash A. Cl.; PAFA; BMFA; Boston A. Cl.; WMA; Hartford Atheneum; CGA; North Shore AA. Work: WMA; Springfield (Mass.) A. Mus.; Sweat Mem. Mus., Portland, Maine; Whistler Mem. Home, Lowell, Mass.; Vanderpoel Coll.; Wellesley Col.; church murals, Boston and Providence [47]

AHLBERG, Emil [P] Minnetonka Mills, MN b. 1865, Gothenburg, Sweden. Studied: A. Collmander [00]

AHLBERG, Florence Maria [P,G] San Fran., CA b. 10 Jy 1902, Homer, NE. Studied: Portland Acad. FA; Calif. Sch. FA. Member: Los Angeles A. Assn.; Chicago AC; N.J. Soc. Ar.; San Fran. Alumni Assn. Exhibited: Pal. Leg. Honor, San Fran., 1934, 1939; de Young Mus., San Fran. Work: WPA Fed. A. Program, Wash., D.C. [40]

AHLBORN, Emil [P] Boston, MA [13]

AHLFELD, Florence Tilton (Mrs. Fred) [P,L,W] North Manchester, IN b. 4 My 1894, Vermilion, SD. Studied: AIC; Columbia Univ.; Grant Wood. Member: All-Ill. SFA. Author: articles for Rural Education Year Book, National Education Association. Lectures published in NEA proceedings, 1936 [40]

AHLM, Gerda Maria [P] Chicago, IL b. 25 My 1869, Vesteros, Sweden. Studied: Royal Acad., Stockholm; Paris; Rome. Member: Swedish Ar. Soc., Stockholm [05]

AHNEMAN, Leonard J. [P,D,Edu,Mur.P] NYC b. 21 My 1914, NYC. Studied: CUASch, NYC. Exhibited: Honolulu Acad. A., 1942; Southwest Pacific Service Exh., 1944; WFNY, 1939; Nat. A. Soc., 1939; CGA, 1939; Saranac A. Lg., 1940. Work: USPO, Montpelier, Ohio. Position: T., mural painting, CUASch [47]

AHRENS, Ellen Wetherald [P,I,Min.P] Lansdowne, PA b. 6 Je 1859, Baltimore. Studied: Boston Mus. Sch., with Grundmann; PAFA, with Eakins; Drexel Inst., with Pyle. Member: Pa. S. Min. P.; Phila. All. Exhibited: CI, 1901 (prize,med); St. Louis Expo, 1904 (medals) [38]

AHRENS, Carl [P] Rockport, MA [00]

AID, George C(harles) [I,P,En] Tryon, NC b. 26 Ag 1872, Quincy, IL d. 12 My 1938. Studied: St. Louis Sch. FA; Académie Julian, Paris, with Laurens, Benjamin-Constant; Simon, Cottet, in Paris. Member: Chicago SE; St. Louis AG; Paris AAA; Soc. des Peintres-Graveurs Français. Exhibited: St. Louis Expo, 1904 (med). Work: Lib. Cong.; NYPL; Luxembourg, Paris; Royal Gallery, Dresden [38]

AIKEN, Charles Avery [P,Gr] Wellesley Hills, MA b. 29 S 1872, Georgia, VT d. 2 F 1965. Studied: BMFA Sch. Member: SC; NYWCC; Wellesley SA; AWCS; Phila. WC Cl.; All.A.Am.; New Haven PCC. Exhibited: All.A.Am., 1945 (med); CGA; PAFA; NAD; Carnegie Inst.; AIC; P.-P. Expo, 1915; WFNY, 1939; Wellesley SA; WMA; Newport AA. Work: Nat. Gal.; Worcester (Mass.) A. Mus.; Brooklyn Mus.; Dallas Mus. FA; Vanderpoel Coll; NCFA; Yale; New Haven PCC; Wesleyan Col., Macon, Ga.; San Diego FA Soc.; Steinert Hall, Boston [47]

AIKEN, John Dary [Edu,P,D,L] Wellesley Hills, MA b. 10 Ap 1908, Boston. Studied: Vesper George Sch. A.; Eliot O'Hara. Member: Boston S. Indp. A.; Wellesley SA; Gloucester SA. Exhibited: PAFA, 1937; Gloucester SA, 1937–39; Wellesley SA, 1936–46. Work: murals, bookplate designs. Positions: T., Boston Sch. Occupational Therapy, 1939–46, Browne & Nichols Sch., Cambridge, Mass., 1942–46 [47]

AIKEN, Frank A. [Min.P,P] b. 1859, NYC d. 9 Ag 1933, Mamaroneck, NY. Studied: NYC; Munich

AIKEN, Mary Hoover (Mrs. Conrad) [P] Rye, Sussex, England b. 11 D 1907, Cuba, NY. Studied: Corcoran Sch. A.; Charles W. Hawthorne; George Luks; Fontainebleau, France; Kunstgewerber Schule, Munich; Luis Quintanilla, in Madrid. Member: Women's Intl. A. Cl., London. Work: MMA [40]

AIKEN, May [P,I] North Sutton, NH [17]

AIKMAN, Walter M(onteith) [Wood En,E,Ldscp.P] Summerville, SC/Pigeon Cove, MA b. NYC d. 3 Ja 1939. Studied: engraving, Frank French and J.G. Smithwick, in New York; drawing and painting, Boulanger and Lefebvre, in Paris. Member: Brooklyn SA; Rockport AA. Exhibited: Paris Expo, 1889 (med); Columbian Expo, Chicago, 1893 (med); Pan-Am. Expo, Buffalo, 1901 (med). Work: Carnegie Inst.; NYPL; Brooklyn Inst. Arts & Sciences [38]

AIMAN, Pearl [P] Phila. PA. Member: NAWPS [24]

AINSLEY, Oliver [P] NYC [09]

AINSLIE, Maud [P,B] Louisville, KY/Provincetown, MA b. N 1870, Louisville d. 6 Jy 1960. Studied: A.W. Dow; William Zorach. Member: Louisville AA; Provincetown AA. Exhibited: A.R. Hite Inst., 1951; Louisville AC, 1954 [19]

AITKEN, Irene Anabel [C,W,L,S,T] Cleveland, OH b. 25 N 1907, Cleveland. Studied: Western Reserve Univ.; Ohio State Univ.; Cleveland Sch. A.; Russell B. Aitken; Arthur Baggs; Edgar Littlefield. Member: Columbus AL. Exhibited: Nat. Ceramic Exh., Syracuse, N.Y., 1933–42; CMA, 1937 (prize), 1939 (prize), 1940, 1942; Columbus, A. Lg., 1937 (prize) 1938 (prize); Columbus Gal. FA, 1938; Syracuse Mus. FA, 1939. Work: CMA. Author: "Methods of Weaving." Position: Instr., San Jose State Col., Calif. (summer) [47]

AITKEN, Peter [Wood En] Brooklyn, NY b. 16 Je 1858, Dundas, Canada. Studied: Timothy Cole; Europe. Exhibited: Columbian Expo, Chicago, 1893 (med); Pan-Am. Expo, Buffalo, 1901 (med) [19]

AITKEN, Robert I(ngersoll) [S] NYC b. 8 My 1878, San Fran., CA. Studied: Mark Hopkins Inst., with Arthur F. Mathews, Douglas Tilden. Member: ANA, 1909; NA, 1914; NSS, 1902; Arch. Lg., 1909; Port. P.; Allied AA; NAC. Exhibited: NAD, 1908 (prize); Arch. Lg., 1915 (med); Panama-Pacific Expo, San Fran., 1915 (med). Work: monuments, San Fran.; memorial, New Britain, Conn.; U.S. Supreme Court Bldg.; MMA; $50 coin for U.S.A., 1915; Columbus Gal. FA, Columbus, Ohio; Gettysburg, Pa. [47]

AITKEN, Russell Barnett [Cer] NYC b. 20 Ja 1906, Cleveland, OH. Studied: Cleveland Sch. A.; Michael Povolny; Josef Hofman; Kunstgewerbeschule, Vienna; Staatlicheporzellan, Berlin; Austria; Hungary; Africa (1937). Member: N.Y. Soc. Cer. A. Exhibited: CMA, 1931 (prize), 1932 (prize), 1934 (prize), 1935 (prize), 1938 (prize), enameling, copper, 1935 (prize), 1936 (prize), 1938 (prize); Robineau Exh., Syracuse,

Mass., 1932 (prize), 1933 (prize), 1936 (prize), enamels on copper, 1938 (prize). Work: CMA; WMAA; MOMA; Syracuse Mus. [40]

AJURIA, Gregorio De (Mrs.) [Min.P] NYC [00]

AKABA, Seppo [P] Atlantic City, NJ [15]

AKED, Aleen [P,C,S,L] Sarasota, FL/Tyrone, Ontario b. England. Studied: Ontario Col. A.; Ringling Sch. A.; Sydney March; Abbott Graves. Member: Sarasota AA; SSAL; Fla. Fed. A. Exhibited: Ontario Col. A. (prize); Ringling Mus. A., 1938 (prize); Canadian Nat. Exh., 1936-38; Royal Canadian Acad., 1938; All.A.Am., 1939; SSAL, 1938-40; Sarasota AA; Studio Gld., 1939, 1940; NYPL, 1940; St. George Pub. Mus., 1940; Ontario SA, 1938 [47]

AKELEY, Carl Ethan [S] b. 1864, Clarendon, NY d. 17 N 1926, Kabale, Uganda. Member: Nat. Sculpture Soc., 1914; Arch. Lg; Nat. Inst. Soc. Sciences; Franklin Inst. Work: bronzes, West Side Unitarian Church, NYC; Brooklyn Inst. Mus.; Am. Mus.Nat. Hist. A noted naturalist, collector and mounter of wildlife specimens, engineer and inventor, as well as sculptor; he became associated with the Am. Mus. Nat. Hist. in 1909 and was in Africa collecting specimens for that institution at the time of his death.

AKERS, Charles [S] NYC b. 15 O 1835, Hollis, ME d. 16 S 1906. Studied: his brother, Benjamin Paul Akers, in Rome, 1855.

AKERS, Vivian Milner (Mr.) [P] b. 6 D 1886, Norway, ME. Studied: ASL; John J. Enneking; Douglas Volk. Member: Soc. A., Wilmington, Del.; A. Assn., Plainfield, N.J. Exhibited: Nat. Acad., 1936 [40]

AKIN, Louis B. [P] Flagstaff, AZ b. 6 Je 1868 d. reported on 5 Ja 1913. Studied: Chase, DuMond, in NYC. The American Museum of Natural History had given him the commission to decorate its new room devoted to Indians of the Southwest. Specialty: Hopi Indian life, since 1903.

AKIN, Mary [P] New Bedford, MA. Member: F., PAFA [24]

AKLBORN, Emil [P] Paris, France [09]

ALAIN, D. A. [Car,L] NYC b. 11 S 1904, Mulhouse, France. Studied: Ecole des Beaux-Arts, Geneva. Work: New Yorker; Saturday Evening Post; Collier's; Life; Stage. Author: "Album of Cartoons," 1946 [47]

ALAJALOV, Constantin [I,P] NYC b. 18 N 1900, Rostov, Russia. Studied: Univ. Petrograd. Member: Phila. WC Cl. Work: BM; PMA; Mus. City N.Y.; MOMA; Soc. Anonyme; New Yorker [47]

ALAIN, Marie Barrett [D,P,I] Baltimore, MD. Studied: Md. Inst.; ASL. Work: Cone Coll., Baltimore [40]

ALAN, Jay (J. Alan Klein) [Car] NYC b. 24 Ap 1907, Beatrice, NE d. 17 Jy 1965. Studied: Univ. Nebr.; Chicago Acad. FA. Member: SI. Exhibited: Nat. Cartoon Exh. Creator: comic strip "Modest Maidens," Assoc. Press Syndicate. Position: Dir., Assoc. Press Feature Service [47]

ALBEE, Grace (Thurston) A(rnold) (Mrs. Percy F.) [En,L] Springtown, PA b. 28 Jy 1890, Scituate, RI. Studied: R.I. Sch. Des; Paul Bornet, in Paris. Member: NA; Conn. Acad. FA; Albany Pr. Cl.; Phila. WC Cl.; Lehigh A. All. Exhibited: Salon d'Automne, Beaux A., Am. Lib., all in Paris, 1931, 1932; NAD, 1938-46; AIC, 1935; PAFA, 1936, 1944; Nat. Exh. Contemporary Am. Prints, Sweden, 1937; 50 Am. Prints, AIGA, 1945, 1946; Southern Pr.M.; Providence AC; Albany Pr. Cl.; Lib. Cong.; CGA; Carnegie Inst.; Am.-Brit. A. Center; N.J. State Mus., Trenton, 1945; Phila. Pr. Cl., 1938-46; CMA, 1943; MMA, 1942. Work: MMA; Carnegie Inst.; CMA; Okla. A.&M. Col.; John Herron AI; R.I. Sch. Des.; Lib. Cong.; Nat. Mus., Stockholm; NAD; PMA; Cleveland Pr. Cl.; Marblehead AA. Kansas City Woodcut Soc. [47]

ALBEE, Percy F. [P] Hellerstown, PA b. 26 Je 1883 d. 26 N 1959. Studied: PAFA; R.I. Sch. Des. Member: ANA; SAE; Providence AC; Providence WCC; Salma. C. Exhibited: Allied Am., 1937 (prize). Work: dec., Mem. Hall, St. Paul's Chapel, Brown Univ.; Roger Williams Park Mus.; murals, R.I. Country Club, Providence [47]

ALBERS, Anni [C,Edu,W,L] Black Mountain, NC b. Berlin, Germany. Studied: A. Sch., Berlin; A. Acad., Hamburg; Bauhaus, Weimar, Dessau. Exhibited: Traveling Exh. Textiles, MOMA, 1945; Intl. Exhibition, Univ. N.C., 1945; Cranbrook Acad. A., 1946; MIT, 1946; MOMA Bauhaus Exh., 1938-39; Bauhaus Traveling Exh., 1939; Golden Gate Expo, 1939. Work: textile, M. Zwickau; Nat. M., Munich. Contributor: craft magazines; articles, "Work with Material," pub. Black Mountain College, 1938, "The Weaving Workshop," "Bauhaus, 1919-28," pub. MOMA, 1938. Position: T., Black Mountain Col., 1933-46 [47]

ALBERS, Josef [Edu,L,P,Gr] Black Mountain, NC b. 19 Mr 1888, Bottrop, Germany. Studied: Royal A. Sch., Berlin; Sch. Appl. A., Essen; A. Acad., Munich; Bauhaus, Weimar. Member: Am. Abstract A. Work: Yale Univ. A. Gal.; Weatherspoon Gal., Greensboro, N.C.; AGAA; Germany; Italy. Position: Hd., A. Dept., Black Mountain Col. [47]

ALBERT, Calvin [S,P,T] Chicago, IL b. 19 N 1918, Grand Rapids, MI Studied: AIC; Inst. Des., Chicago, with Moholy-Nagy; Archipenko Sch. Exhibited: AIC, 1941, 1945; VMFA, 1946; Detroit Inst. A., 1945. Work: Detroit Inst. A. Position: Instr., Sculpture & Life Drawing, Inst. Des., Chicago [47]

ALBERT, Drusilla [S] Seattle, WA b. 22 Ja 1909, Minneapolis, MN. Studied: Charles Grafly; Albert Laessle; Walker Hancock; Italo Griselli, in Florence. Member: Seattle A. Mus. Exhibited: Northwest Annual Exh., Seattle A. Mus., 1934 (prize), 1936 (prize) [40]

ALBERT, E. Maxwell [P,T] New Canaan, CT b. 1 Ag 1890. Studied: ASL. Member All. AA; Salma. C.; Lyme AA; New Rochelle AA. Exhibited: New Rochelle AA, 1921 (prize), 1922 (prize), 1923 (prize) [40]

ALBERT, Ernest [P] New Rochelle, NY b. Brooklyn, NY d. 25 Mr 1946. Studied: Brooklyn A. Sch. Member: ANA; NAC; All. AA; Salma. C.; AWCS; Grand Central Gal.; New Rochelle AA; Conn. Acad. FA; Lyme AA; New Haven PCC; Silvermine GA [40]

ALBERT, Mary (Mrs. M.A. Nelson) [P] Ridgewood, NJ b. 6 Jan 1910, Jackson, OH. Studied: Ohio Univ.; ASL, with Bernard Klonis, Jon Corbino; AIC, with Edmund Geisbert. Member: NAWA; Ill. FA Soc. Exhibited: NAWA, 1945, 1946; Audubon A., 1945; AWCS, 1946; Argent Gal., 1945 (one-man); Ill. FA Soc., 1944; Evanston A. Center; Ohio Univ. [47]

ALBERT, Virginia [P] Baltimore, MD [24]

ALBERTS, J(ohn) Bernhard Louisville, KY b. 9 Jy 1886. Studied: Cincinnati Acad., with Duveneck, Meakin; Tarbell, Benson; in Boston. Member: Louisville A. Lg. [24]

ALBIN, Edgar A. [Edu,P,En] Tulsa, OK b. 17 D 1908, Columbus, KS. Studied: Univ. Tulsa; Iowa State Univ.; Fletcher Martin; Philip Guston; Donald M. Mattison. Member: Prairie WC Painters Assn.; Southwestern AA; Okla. AA. Exhibited: Okla. State AA, 1946 (med); Tulsa AA, 1936-39; Philbrook A. Center, 1940, 1944 (one-man); Mus. N.Mex., Santa Fe, 1940; Prairie WC Painters Traveling Exh., 1940-46; Tulsa A. Gld., 1939-46; Bethany Col., 1941; Northwest Pr.M., 1942; Southern Pr.M. Traveling Exh., 1942; Tex. State AA, 1943; Saranac Lake A. Lg., 1943, 1944; Univ. Kans., 1944 (one-man). Work: IBM. Position: T., Univ. Tulsa, 1939-46 [47]

ALBINSON, Dewey [P] Minneapolis, MN b. 9 Mr 1898. Studied: Minneapolis Sch. A.; ASL; Paris; Italy. Member: Minn. AA. Exhibited: Minneapolis Inst. A., 1920 (prize), 1922 (prize), 1924 (prize) 1928 (prize), 1931 (prize); Minn. State Fair, 1922 (prize); 1925 (prize,med); 1928 (prize, med); Ann. Exh. Am. Paintings and Sculpture, AIC, 1925 (prize). Work: Minneapolis Inst. A.; Calif. Mus., San Diego [40]

ALBRECHT, Clarence John [S,L,T] NYC b. 28 S 1891, Waverly, IA. Studied: H.R. Dill; James A. Wehn; Charles Eugene Tefft. Work: grizzly bear group, Calif. Acad. Sciences; sea lion group, AMNH; deer, bear and goat groups, State Mus., Univ. Wash. [29]

ALBRECHT, Frederick E. [P,I] NYC b. Seattle, WA. Studied: N.Y. Sch. F.&Appl. A.; Seattle ASL; ASL, with John Sloan, Jean Charlot. Member: AAPL. Exhibited: All.A.Am., 1943; AWCS, 1942; Montross Gal., 1942. Position: Illus., Theatre Magazine [47]

ALBRIGHT, Adam Emory [P] b. 15 Ag 1862, Monroe, WI d. 13 S 1957. Studied: AIC; Munich; Paris. Member: F., PAFA; AWCS; SC; Assn. Chicago P.&S.; Chicago Gal. Assn. Exhibited: PAFA; AIC, 1907 (prize), 1908 (prize), 1914 (prize); Chicago Gal. Assn., 1927, 1931; Assn. Chicago P.&S., 1936. Work: CAM; Toledo Mus. A.; Mun. A. Lg., Chicago; Cedar Rapids (Iowa) Pub. Lib.; Topeka (Kans.) Pub. Lib.; Springfield (Ill.) State Mus. Specialty: child life [47]

ALBRIGHT, Floyd Thron [P] Dalhart, TX b. 1897, Cleborne, TX. Studied: Chicago AFA; Emil Bisttram, in Taos; Dunton, in Denver [*]

ALBRIGHT, Gertrude Partington (Mrs.) [P,E,T] San Fran., CA b. Heysham, England. Studied: J.H.E. Partington; G.X. Prinet. Member: San Fran. AA; San Fran. SWA; Club Beaux A. Exhibited: P.-P. Expo, San Fran., 1915 (med). Work: City of San Fran. [40]

ALBRIGHT, Henry James [P,C,S] Glenmont, NY b. 16 Jy 1887, Albany, NY. Studied: S.L. Huntley; William St. John Harper; Charles L. Hinton; John F. Carlson; Hawthorne [31]

ALBRIGHT, H. O(liver) [P] San Fran., CA b. 29 Ja 1876, Mannheim, Germany. Member: San Fran. AA; Berkeley Lg. FA; Club Beaux-Arts, San

Fran. Exhibited: San Fran. AA, 1920 (med), 1925 (gold), 1929 (prize); Springville, Utah, 1926 (prize); State Fair, Sacramento, 1933 (prize); San Fran. A. Assn., 1937 (prize) [40]

ALBRIGHT, Hedwig Evelyn Gertrude [S,P] San Fran., CA b. 16 My 1911, French Camp, CA. Studied: Calif. Sch. FA; Rudolph Schaeffer Sch. Des. Member: San Fran. Soc. Women Ar. Exhibited: San Fran. A. Assn. Ann., 1935; San Fran. A. Assn. WC Ann., 1939; GGE, 1939; Palace Legion Honor [40]

ALBRIGHT, Henry J. [Edu,C,D,P,S] Glenmont, NY b. 16 Jy 1887, Albany, NY d. Ja 1951. Studied: ASL, with Birge Harrison, John Carlson; Emma Willard A. Sch.; Samantha L. Huntley; Charles L. Hinton; Charles W. Hawthorne. Member: Albany Inst. Hist.&A.; Albany A. Group; New Haven PCC. Exhibited: Albany Inst. Hist.&A.; Schenectady Mus. A.; New Haven PCC; Ehrich Gal., 1936–46. Work: bronze seal, City of Albany; Mem. shield, N.Y. Police Dept.; mem. plaque, John Boyd Thatcher Park. Position: Dir./Instr., Troy AI, 1925–40 [47]

ALBRIGHT, Ivan Le Lorraine [P,S,Li] Warrenville, IL b. 20 F 1897, Chicago, IL. Studied: Northwestern Univ.; AIC; PAFA; NAD; Ecole des Beaux-Arts, Paris. ANA; AWCS; Phila. WC Cl.; Assn. Chicago Painters & Sculptors; Chicago SA; Laguna Beach AA; Chicago AC; Springfield (Mass.) A. Lg. Exhibited: AIC, 1926 (prize), 1928 (prize); Chicago Soc. A., 1930 (gold), 1931 (prize); PAFA, 1934 (prize); Springfield A. Lg., 1937. Work: Milwaukee AI; Hackley Gal. FA; Dept. Labor Bldg., Wash., D.C. [47]

ALBRIGHT, John J. b. 18 Ja 1848, near Natural Springs, VA d. 20 Ag 1931, Buffalo, NY. Donor of the Albright Art Gallery. Soon after taking up his residence in Buffalo, he became interested in the art life of the city and was made a director of the Buffalo Fine Arts Academy. Recognizing the need for a proper place in which to exhibit masterpieces of painting and sculpture, he presented the city, in 1902, with the Albright Art Gallery, which cost more than a million dollars. His interest in the world of art extended to Rome, where he was one of the incorporators of the American Academy. Among his other benefactions is the Albright Public Library in Scranton, Pa., which stands on the site of his father's homestead.

ALBRIGHT, Floyd Thron [P,D,B,C,Arch] Dalhart, TX b. 9 Ag 1897, Cleburne, TX. Studied: Chicago Acad. FA; Dunton; Bisttram. Member: SSAL; Tex. FA Acad. Work: Citizens State Bank, Midway Bank and Trust Co., First Nat. Bank, Dallam County Lib., Dallam County Court House, Loa Rita Theatre, all in Dalhart [40]

ALBRIGHT, Malvin Marr (Zsissly) [S] Warrenville, IL b. 20 F 1897, Chicago. Studied: BAID; Ecole des Beaux-Arts, Nantes, France; Albin Polasek; Charles Grafly. Member: NSS; Laguna Beach AA; Chicago Gal. Assn.; Chicago SA; F., PAFA. Exhibited: AIC, 1929 (prize); Chicago Gal. A. (prize); Chicago SA, 1930 (gold), 1934. Work: San Diego FA Gal.; Carnegie Lib., Marion, Ill.; statues, Omaha, Nebr., Chicago [47]

ALBRIZIO, Conrad Alfred [P,T,D] Baton Rouge, LA b. 20 O 1894, NYC. Studied: George Luks; ASL; St. Hubert, Fontainebleau Sch. FA; Venturini Papari, in Rome. Member: AFA. Exhibited: Rosenwald F., 1945–46, 1946–47; GGE, 1939; WMAA, 1937, 1944, 1945; Critics Show, Cincinnati, 1944; Critics Show, N.Y., 1945; Iowa Univ., 1946; Springfield, Mass., 1946; Passedoit Gal., 1946 (one-man). Work: frescoes, La. State Capitol, USPO, DeRidder, La.; murals, U.S. Treas., Russellville, Ala., Expo Bldg., Shreveport, La., Court House, New Iberia, La.; La. State Office Bldg., Baton Rouge; gesso panels, Church of St. Cecilia, Detroit. Position: T., La. State Univ. [47]

ALBRIZIO, Humbert [S] Iowa City, IA b. 11 D 1901, NYC. Studied: BAID; New Sch. Soc. Res.; Member: NSS; Minn. S. Group. Exhibited: NAD Ann., 1933, 1934; NSS, 1940 (med); Walker A. Center, 1945 (prize), 1946 (prize); Des Moines, 1946; MMA; WMAA; BM; PMA; Carnegie Inst.; PAFA; Albany Inst. Hist.&A.; AIC. Work: Walker A. Center; USPO, Hamilton, N.Y.; Midland, Pa. Position: Instr., Sculpture, State Univ., Iowa City [47]

ALBRO, Maxine [Mur.P,Li] Carmel, CA b. 20 Ja 1903, Iowa. Member: San Fran. AA; Am. A. Cong. Work: frescoes, Coit Tower, San Fran., All. A. Gld., Menlo Park; mosaic, State T. Col., San Fran. [40]

ALCOCK, William A. [P] NYC [23]

ALCORN, Gordon Dee, Mrs. See Lung, Rowena Clement.

ALDEN, Henri Vere [P,I] NYC/Catskill, NY b. 15 Jy 1897, Phila. Studied: NAD. Member: NYWCC; Bronx AG; AAPL [40]

ALDEN, Katharine L. [C,Edu,D,T] Plymouth, MA b. 8 Ja 1893, Boston. Studied: Mass. Sch. A. Member: Boston SAC. Exhibited: weaving, Boston SAC, 1936 (prize); Paris, 1937 (gold); WMA. Position: Plymouth Pottery Sch., 1936–46 [47]

ALDEN, Lowell Wavel [S,P,Edu,L] Houston, TX b. 16 Jy 1911, Jonesboro, LA. Studied: La. Polytech. Inst. Member: Assoc. A. Houston; SSAL. Exhibited: Mus. FA, Houston; Dallas Mus. FA; SSAL [47]

ALDERTON, H.H. [E] Palo Alto, CA. Member: Calif. SE [27]

ALDIS, Arthur T. d. 23 N 1933, FL. An honorary trustee of the Art Institute of Chicago and Secretary of the Friends of Am. Art. He was one of the most active of the trustees, serving on the Committee on Painting and Sculpture as well as the Goodman Theatre Committee.

ALDRICH, Annie E. Roxbury, MA [00]

ALDRICH, Adolf Degiani [P,S,G] Springfield, MA b. 17 O 1916, Springfield. Studied: Springfield Mus. FA. Member: Ar. U. Western Mass.; Springfield A. Lg. Exhibited: oil, Springfield A. Lg., 1939 (prize). Work: Springfield Mus. FA [40]

ALDRICH, Clarence Nelson [P,Arch] Long Beach, CA b. 21 F 1893, Milford, ME d. ca. 1955. Studied: Sherly Poor; Hans Hofmann. Member: Nat. Assn. Arch.; Los Angeles P.&S. Cl.; Long Beach AA; Arch. Cl., Long Beach. Exhibited: Long Beach AA, 1930 (prize), 1932 (prize), 1933 (prize), 1938 (prize); Spectrum C., 1932 (prize), 1934 (prize), 1936 (prize); Los Angeles Mus. A., 1935. Work: Mausoleum Park, Compton, Calif.; Pioneer Soc. Calif. [47]

ALDRICH, Cornelia Ward (Mrs.) [P,I] Richmond County, VA [21]

ALDRICH, F(rank) H(andy) [P,I,C,L,T] Toledo, OH b. 29 Mr 1866, Wauseon, OH. Studied: Metcalf; Twachtman; Knaufft. Member: Toledo Artklan; AFA; S.Indp.A. Designer/Sculptor: bronze tablets marking Gen. Knox Highway, Ticonderoga to Boston. Positions: Dir., Troy Art Inst.; Custodian, Ancient Books and Mss., Toledo Mus. A. [29]

ALDRICH, G(eorge) Ames [P,E] Chicago, IL b. 3 Je 1872, Worcester, MA d. 7 Mr 1941. Studied: ASL; MIT; Académie Julian, Paris; Colarossi Acad.; Aman-Jean; Whistler; Collin; Thaulow. Member: Chicago PS; Société des Artistes Français; Chicago Gal. A.; Hoosier Salon. Exhibited: Hoosier Salon, 1923 (prize), 1926 (prize), 1929 (prize), 1932 (prize); AIC, 1926 (prize). Work: Sioux City A. Soc.; Purdue Univ.; Univ. Ill.; Un. Lg. Cl., Aurora; Decatur Mus.; MFA, Houston; murals, Musée de Rouen, France; Ball State T. Col., Muncie, Ind.; War Mothers Bldg, Wash., D.C. [40]

ALDRICH, Harvey [P] Toledo, OH. Member: Artklan [24]

ALDRICH, John G. [P] Providence, RI. Member: Providence WCC; Providence AA [24]

ALDRICH, M. Azzi [P] NYC b. 19 Ag 1892, NJ. Studied: Royal Acad. A.&Let., Milan; Paris; Rome; New York. Member: NSS. Exhibited: Midtown Gal., 1938. Work: designed/executed fountain, Sesqui-Centennial Expo, Phila. [47]

ALDRICH, Mary Austin (Mrs. Malcolm Fraser) [S,C] Brookhaven, NY b. 22 F 1884, NYC. Studied: Partridge; Lober; Fraser. Member: N.A. Women PS; NAC; NYSC. Work: altar piece and panels, St. Anne's Convent, Kingston, N.Y.; bronze mem., Christ Child, Nat. Cathedral, Wash., D.C. [33]

ALDRICH, Talbot Balley [P] Boston, MA. Member: Boston AC [24]

ALDRICH, William T. [P] Boston, MA. Member: Providence AC [19]

ALDRIDGE, C. Clay [Mus.Dir] Scranton, PA b. 16 Mr 1910, Rome, NY. Studied: Cornell; Harvard. Member: AA Mus.; Am. Archaeological Soc. Position: Dir., Everhart Mus., Scranton, 1945– [47]

ALDRIN, Anders Gustave [P,B,Li] Los Angeles, CA b. 29 Ag 1889, Stjernsfors, Sweden. Studied: Otis Art Inst.; Santa Barbara Sch. FA; Calif. Sch. FA. Member: Calif. WCS. Exhibited: Los Angeles Mus. A., 1939; Calif. WC Soc., 1939. Work: Pomona County Fair, Calif. [40]

ALEGRE, A. Villamor [P] NYC b. 19 F 1909, Philippine Islands. Studied: AIC; Chicago Acad. FA; Northwestern Univ.; Univ. Chicago; Columbia. Member: Chicago NJSA; All-Ill. Soc. FA. Exhibited: Am. Service Forces Exh., London, 1944 (prize); AIC, 1936, 1937, 1946; Los Angeles Mus. A., 1939; CGA, 1941; portrait, Vigan, P.I., 1934 (prize). Work: stained-glass window, Coronado, Costa Rica [47]

ALEXANDER, A(rthur) H(adden) [E,Ldscp.P] Cleveland, OH b. 27 O 1892, Decatur, IL. Member: Am. Soc. Ldscp. A.; Cleveland SA; Cleveland Print Cl. [33]

ALEXANDER, Christine [W,L] NYC b. 10 N 1893, Tokyo. Studied: Cornell. Member: Archaeological Inst. Am. Author: "Greek Athletics," 1925,

"Jewelry, the Art of the Goldsmith in Classical Times," 1928, "Arretine Relief Ware," 1945. Contributor: MMA Bulletin; Am. Journal Archaeology. Lectures: Greek & Roman Antiquity. Positions: Dept. Greek & Roman Art, 1923, Assoc. Cur., 1931– , MMA [47]

ALEXANDER, Clifford Grear [C,P] Brighton, MA b. 15 Ag 1870, Springfield, MA. Member: Boston AC; SIA. Studied: BMFA Sch. Exhibited: Jordan Marsh Co., Boston [47]

ALEXANDER, (Sara) Dora Block (Mrs. Max) [P] Los Angeles, CA b. 1 Jy 1888, Suwalki, Poland. Studied: Charles Reiffel. Member: San Diego A. Gld. Exhibited: Denver A. Mus., 1936; Audubon A., 1943, 1944; Argent Gal., 1943 (one-man); San Diego FA Soc., 1930–40; Los Angeles Mus. A., 1935, 1938, 1942; Santa Cruz A. Lg., 1946; Oakland A. Gal., 1946 [47]

ALEXANDER, Elizabeth A. (Mrs. John W.) [Costume Des,Int.Dec] b. NYC d. 14 Ja 1947, Princeton, NJ. After her marriage to the painter (who later became president of NAD), she lived in Paris for many years. Mr. and Mrs. Alexander were close friends of Maude Adams, the actress, and designed settings and costumes for many of her productions. Actively interested in fostering talented young musicians and other artists. Member: Cosmopolitan Cl. Positions: Pres., Sch. A. Lg. of N.Y., 1923–25; Chm., Town Hall Club awards committee

ALEXANDER, Frances B. (Mrs.) [P,L] Lithonia, GA b. 28 Je 1911, Moreland, GA. Studied: Univ. Ga.; High Mus. Sch. A. Member: SSAL; NAWA; Ga. AA; Atlanta AA. Exhibited: High Mus. A., 1944 (prize); NAWA, 1945, 1946; Ga. AA, 1946; Mint Mus. A., 1945; Atlanta AA & Traveling Exh., 1945 [47]

ALEXANDER, Helen Douglas [P] NYC. Member: Am. WC Soc. Exhibited: Am. WC Soc., 1936–38; NYWCC, 1937 [47]

ALEXANDER, Jacques [P] NYC b. 15 D 1863, Berlin, Germany. Studied: Laurens, Constant, in Paris. Member: Soc. Deaf Ar. [31]

ALEXANDER, Johanna S. [P] Chicago, IL b. Strasburg, Germany. Studied: AIC. Member: ASL Chicago [17]

ALEXANDER, John White [Por.P,Mur.P] b. 7 O 1856, Allegheny, PA d. 31 My 1915, NYC. At the age of 17 he came to New York and worked for three years in the art department of Harper & Brothers. His ability attracted Abbey and Reinhart, working for the same firm, and it was at their suggestion that he went abroad in 1877. He studied for three months at the Munich Royal Academy, where he received the medal for drawing. From there he joined a small group of Americans in the little Bavarian village of Polling, painting in company with Frank Duveneck, J. Frank Currier, Joseph De Camp and others; he then went to Venice, where he met James McNeill Whistler; and later to Florence, returning to New York in 1879. Exhibited: Paris, Champ de Mars Salon (1893), elected "Sociètaire"; in 1901 he was made a chevalier of the Legion of Honor; PAFA, 1897 (gold), 1899 (prize); Paris Expo, 1900 (gold); Pan-Am. Expo, Buffalo, 1901 (gold); Soc. Am. Ar. N.Y., 1901 (prize); Soc. Washington Ar., 1903 (prize); St. Louis Expo, 1904 (gold); CI, 1911 (med); P.-P. Expo, San Fran., 1915 (med). At the time of his death he was president of the Nat. Acad. Des. (of which he had been president since 1909); the Sch. Art Lg. (since foundation in 1911); the Nat. Inst. A.&L.; the Mural Painters; he had been president of the MacDowell Cl. He was elected an associate of the Nat. Acad. Des. in 1901 and an academician in 1902; also member of the N.Y. Architectural Lg., 1901.; AAAL; Portrait Painters; SI; Am. Inst. Arch.; Am Fed. Arts; Sociètè Nationale des Beaux-Arts, Paris; Intl. Soc. Sculptors, Painters, and Gravers, London; Royal Soc. of Brit. Ar.; Munich Secession; Vienna Secession; and trustee of Am. FA Soc., NYPL, and MMA. Works: Luxembourg, Paris; MMA; BMFA; R.I. Sch. Des., Providence; Wilstach Gal., Phila.; PAFA; Cincinnati Mus.; Carnegie Inst.; St. Louis Mus.; A. Inst. Chicago; Harvard; Princeton; Columbia; Wheaton Seminary, Norton, Mass.; Radcliffe; Mt. Holyoke; Bowdoin; Nat. Gal., Wash., D.C.; Soc. FA, Minneapolis; Corcoran Gal.; LOC; Capitol, Harrisburg, Pa.

ALEXANDER, Jon H. [I,P,S] Rochester, NY b. 8 Dec 1905, Rochester. Studied: Mechanics Inst., Rochester; NAD, with Robert Aiken, Charles Hawthorne; Univ. Rochester, Sch. Medicine. Work: sculpture, Pittsford, N.Y.; Rochester Armory & Mem. Gal. Position: Diorama Ar.,Sculptor, Model Builder, Archaeology Div., Rochester Mus., 1941–46 [47]

ALEXANDER, Julia Standish [S,T] New Rochelle, NY b. Springfield, MA. Studied: ASL; Victor Brenner. Member: Keramic S. and Des. G. of N.Y.; AFA [40]

ALEXANDER, Leah Ramsey [Min.P] Phila., PA [23]

ALEXANDER, Margo (Mrs.) [P,G] Chicago, IL Exhibited: PAFA WC Ann., 1936; Chicago Ar.Ann., 1933, 1936, 1937; Intl. Exh. Lithography Wood Engraving, AIn.C., 1936; Intl. WC Exh. AIn.C., 1936, 1937; GGE, 1939 [40]

ALEXANDER, Marie Day (Mrs. Ernest R.) [P] Greenfield, MA b. 31 O 1887, Greenfield. Studied: Augustus Vincent Tack; Philip Hale; William Paxton. Member: Deerfield Valley AA; Palm Beach A. Cent.; N.A. Women PS. Work: Mass. Fed. Women's Cl., Boston; Deerfield Acad., Deerfield, Mass. [40]

ALEXANDER, Mary Louise [S,W,T] Cincinnati, OH. Studied: Meakin; Duveneck; Barnhorn; Grafly; Nowottny. Member: Cincinnati Women's AC; MacDowell Soc., Cincinnati; PBC. Work: Cincinnati Art Acad. [40]

ALEXANDER, William H(enry) S(nowdon) [I] Haddonfield, NJ b. 7 Ap 1883, Haddonfield d. 1938. Studied: Drexel Inst.; PAFA. Member: Phila. Soc. All. A.; Phila. Sketch Cl. [33]

ALEXANDERSEN, Genevieve Constance [S] Chicago, IL b. Bergen, Norway. Member: North Shore AA; All-Ill. Soc. FA. Exhibited: Norwegian Nat. Lg., 1929, (prize); AIC; Centenn. Bldg., Springfield, Ill. [47]

ALEXANDRE, Zeno [P] Paris b. 1873, Calif. Studied: Ecole des Beaux-Arts; Gustave Moreau, Laurens, in Paris [17]

ALEXEIEFF, Alexander A. [I] Mt. Vernon, NY b. 18 Ap 1901, Kazan, Russia. Studied: Soudeikine, André Delzers, in Paris. Member: Studio Alexeieff; Académie du Cinéma, Paris. Work: NYPL; Widener Lib., Cambridge, Mass.; Bibliothèque Nationale, Paris; stage des., Théâtre Pitoeff, Paris; Ballet Russe de Monte Carlo. Illustrator: "Russian Fairy Tales," Tolstoy's "Legends & Stories," and others. Contributor: art magazines. Lectures: Illustration [47]

ALFANO, Vincenzo [S] NYC b. 11 N 1854, Naples. Studied: Inst. FA, Naples; Domenico Morelli; Fillippo Palizzi. Member: NSS, 1903; Arch. Lg., 1901; Royal Acad., Naples. Exhibited: Naples Expo, 1877 (med); Paris Expo, 1878 (med); Naples, 1891 (prize); P.-P.Expo, San Fran., 1915 (prize) [19]

ALFEREZ, Enrique [S] New Orleans, LA. Exhibited: WFNY, 1939 [40]

ALFORD, (Edward) John (Gregory) [Edu,W,L,P] Providence, RI b. 3 Ap 1890, England. Studied: Cambridge Univ. Member: CAA; Am. Soc. Aesthetics. Exhibited: London Group, 1930; Canadian WC Soc., 1941, 1943; Canadian Soc. Gr. A., 1941, 1943. Contributor: art magazines & reviews. Positions: Prof. FA, Univ. Toronto, 1934–45; Prof. Aesthetics, R.I. Sch. Des., Providence, 1945 [47]

ALGER, John (Herbert) [P,T] NYC b. 25 F 1879, Boston. Studied: MIT. Member: AAPL; Brooklyn Soc. Mod.A. Exhibited: PAFA, 1935; AAPL, 1944. Work: WMAA [47]

ALGOREN, Lionel C. [D] Evanston, IL b. 14 N 1896, Minneapolis. Studied: Minneapolis Sch. FA; Ecole de Bellevue, Paris, with Leslie Cauldwell; Victoria & Albert Mus., London, with Oliver Brackett. Member: ADI. Exhibited: Minneapolis Inst. A., 1927 (prize). Work: des., Scott Radio Cabinets, Hammond Electric Organ Consoles, etc. [47]

ALKE, Elizabeth Heil [P] New Richmond, OH b. 3 Ag 1877, Columbus, OH d. 8 Ap 1938. Studied: T.S. Noble; Caroline Lord; Cincinnati A. Acad. Member: Cincinnati Women's AC; NAWPS. Exhibited: NAWPS, 1928 (prize) [38]

ALKE, Stephen [P] New Richmond, OH b. 14 My 1874, Augusta, KY d. 13 Ja 1941, Cincinnati. Studied: Frank Duveneck; T.S. Noble; Henry Sharp; Vincent Nowottny; L.H. Meakin; Cincinnati A. Acad. Member: Duveneck Soc. [40]

ALKINS, Anne Drayton [Min.P] Phila., PA [13]

ALKINS, Florence Elizabeth [P] San. Fran., CA [19]

ALLAIRE, Louise [P] NYC. Member: NAWPS. Exhibited: NAWPS, 1935–38 [40]

ALLAN, Amy Nicholson [P] Charleston, SC [23]

ALLAN, Charles Beach (Mrs.) [P] Kansas City, MO b. 9 O 1874, Detroit. Studied: AIC; Birger Sandzen; Souter, in Paris. Member: Laguna Beach AA [25]

ALLAN, James [P] Seattle, WA. Exhibited: Seattle FA Soc., 1922 (prize) [25]

ALLAWAY, Robert [P] NYC Exhibited: NYWCC, 1937. Work: USPO, Breckenridge, Minn. WPA artist. [40]

ALLCHIN, Harry [P,I] Catskill Station, NY [17]

ALLCOTT, John Volney [Mus.Dir,Edu,L] Chapel Hill, NC b. 30 My 1905,

St. Paul, MN. Studied: Univ. Wis., with Hagen; AIC, with Anisfeld, Giesbert; Royal Acad. FA, Florence; Univ. Chicago. Member: N.C. State A. Soc.; N.C. Edu. Assn. Exhibited: AIC, 1936, 1938. Positions: Head, Dept. A., Univ. N.C.; Dir., Person Hall A. Gal., Chapel Hill [47]

ALLEN, Agnes (Oliver) [P] Phila. PA b. 22 Je 1897, Phila. Studied: PAFA; BFA; Clinton Peters; Frank Linton. Member: Phila. A. All.; Phila. Pr. Cl.; Am. Assn. Univ. Women; F., PAFA. Exhibited: Portraits, Inc., 1945; A.Dir.Cl., 1945; PAFA, 1929, 1934; Harcum Col., Bryn Mawr, Pa., 1943 (one-man); Westchester AA, 1937; Wayne A. Center, 1940. Work: Westminster Theological Sem.; Jefferson Medical Col.; Bangor (Maine) Pub. Lib.; Episcopal Acad., Overbrook, Pa.; portrait, J. Somers Smith, "Fish House," Schuylkill, Pa. [47]

ALLEN, Alonzo W. [P] Prairie du Chien, WI. Exhibited: 48 Sts. Comp. [40]

ALLEN, Anna Elizabeth [P,I] Orange City, FL b. 18 F 1881, Worcester, MA. Studied: Mass. Sch. A.; Charles Woodbury; Hugh Breckenridge; A.G. Randal; Anson K. Cross. Member: Orlando AA; Fla. Fed. A.; SSAL; Gloucester AA. Exhibited: Boothbay Harbor, Maine; Daytona Beach, Fla., 1945. Work: Carnegie Lib., Turner Falls, Mass. Illustrator: "History of Montague" [47]

ALLEN, Anne Huntington (Mrs. Thomas Woodruff) [P] Cincinnati, OH b. 1858, NY. Studied: Cooper Inst.; Wyatt Eaton; Frank Duveneck; Carolus Duran, Henner, Acad. Colarossi, in Paris. Member: Cincinnati Women's AC

ALLEN, C.B. (Mrs.) [P] Kansas City, KS [21]

ALLEN, Charles [E,En] Kansas City, MO b. 18 Ap 1874, Great Bend, KS. Member: Kansas City SA; Kansas City Print Cl. [40]

ALLEN, Charles Curtis [P,Edu] Waban, MA b. 13 D 1886, Leominster, MA d. 28 Je 1950. Studied: WMA Sch., with Philip Hale, H.D. Murphy; Henry D. Rice. Member: ANA, 1933; Boston SWCP; Boston GA; Gloucester SA; Grand Cent. AG; NA; SC; Rockport AA; North Shore AA; Ogunquit AA; Phila. WCC; AWCS. Exhibited: Boston Tercentenary, 1930 (med); Boston AC, 1931; Carnegie Inst., 1945; Boston Soc. WC Painters. Work: BMFA; WMA; Brown Univ.; Clark Univ. Position: T., Summer Sch., Jeffersonville, Vt. [47]

ALLEN, Charles Edward [Car,I,P] Brooklyn, NY b. 23 Je 1921, Americus, GA. Studied: CCNY. Member: A. Gld.; Am. Soc. Magazine Car. Exhibited: CCNY, 1941 (prize). Illustrator: Collier's, Liberty, This Week, other magazines [47]

ALLEN, Clara Marie (Mrs. Frederic R.) [Edu,P,Ser,I,L] Lincoln, NE b. 15 D 1913, San Diego. Studied: San Diego State Col.; Univ. Calif. Member: Nebr. AA; Lincoln A. Gld. Exhibited: Nebr. AA, 1945; PAFA, 1946; Denver A. Mus., 1946; Joslyn Mem., Omaha, 1944 (prize), 1945. Position: T., Univ. Nebr., Lincoln, 1944– [47]

ALLEN, Clay (Mrs.) [P] Seattle, WA. Member: Seattle FA Soc. [25]

ALLEN, Colin [Car,I] Towaco, NJ. Illustrator: Collier's, Saturday Evening Post, other magazines [47]

ALLEN, Courtney [I,L] New Rochelle, NY b. 16 Ja 1896, Norfolk, VA. Studied: Corcoran Sch. A.; NAD; Hawthorne, C.C. Curran; Felix Mahony, W.H.W. Bicknell. Member: SI; New Rochelle AA. Exhibited: SI; New Rochelle AA. Illustrator: magazines, books. Lectures: Illustration [47]

ALLEN, Emma Lois Craig (Mrs. John H.) [P,T] Orange, NJ b. Vernon, IN d. 16 Mr 1946. Studied: St. Louis

ALLEN, Erma Paul [B,I,W] New Rochelle, NY/North Truro, MA b. Wash., D.C. Studied: Corcoran Sch. A.; Nat. Sch. F.&Appl. A.; Hawthorne. Member: SI; Ar. Gld.; New Rochelle AA [40]

ALLEN, Frances R. (Mrs. Nicholas D.) [P] NYC b. 3 My 1913, San Angelo, TX. Studied: Xavier Gonzales; Rudolph Staffel. Member: SSAL. Exhibited: SSAL, Montgomery, Ala., 1938; San Antonio, 1939 [40]

ALLEN, Frank Leonard [Edu,D,P,L,E] Needham, MA b. 19 N 1884, Portland, ME. Studied: Mass. Sch. A.; BMFA Sch., with Denman W. Ross; Tarbell; Major; Henry B. Snell; Richard Andrew. Member: EAA; SC; AWCS. Work: Cranbrook Mus., Bloomfield Hills, Mich.; Carl Milles Mus., Stockholm. Positions: T., PIASch (1912–30), Cranbrook Acad. A. (1930–32); Hd., Des. Dept., Mass. Sch. A., Boston (1934); Dir., Boothbay Studios, Summer Sch. A. [47]

ALLEN, Frederick B. [P] Boston, MA [25]

ALLEN, Frederick Hovey b. 1845, Lyme, NH d. 24 D 1926, NYC. An authority on art. In 1895 he began to write and lecture on art. Moved to NYC in 1901 and, in 1917, opened an art gallery at the Hotel Majestic, in which were hung the works of prominent artists. Author of sixteen books on art, numerous magazine articles; at the time of his death was working on an autobiography and a book, "Artists I Have Met."

ALLEN, Frederick Warren [S,T] Concord, MA b. 5 My 1888, North Attleboro, MA. Studied: Bela Pratt; Paul Landowski; Paul Bartlett. Member: NSS; Gld. Boston A.; Concord AA. Work: BMFA; Boston AC; Boston City Hall; MMA; Boston Pub. Lib.; N.Y. County Court House; war mem., Dedham, Mass.; Concord Mus; mem., Mount Hope Cemetery, Boston. Position: T., BMFA Sch. [47]

ALLEN, Gregory Seymour [P,S] Glendale, CA b. 8 Jy 1884, Orange, NJ d. 1935. Studied: Gutzon Borglum; H.M. Shrady; Philip Martini. Work: Los Angeles Mus. A. [35]

ALLEN, Greta (Mrs.) [P,T] Boston, MA b. 16 My 1881, Boston. Studied: Mass. Sch. A., with Joseph DeCamp; BMFA Sch., with Frank Benson; George Noyes. Member: Copley Soc.; Boston AC. Exhibited: Milwaukee AI, 1930 (one-man); Boston AC; Copley Soc.; Irving & Casson Gal.; PAFA [47]

ALLEN, Hazel Leigh [S] Milwaukee, WI b. 8 D 1892, Morrilton, AR. Studied: AIC; Ferdinand Koenig. Member: Wis. P.&S. Soc. Exhibited: PAFA, 1929; Milwaukee AI, 1923, 1929, 1931; Layton A. Gal., 1941 [47]

ALLEN, Hildur Peterson (Mrs.) [P] Seattle, WA b. 30 D 1888, Minneapolis. Studied: Edgar Forkner. Member: Seattle FAS. Exhibited: Northwest Exh., Seattle FA Soc., 1923 (prize) [25]

ALLEN, J.H. Dulles [D,Cer] Enfield, PA b. 11 F 1879, Phila. Member: T. Square Cl.; Phila. Alliance; AIA. Exhibited: AIA, 1938 (med). Work: tile and terra cotta, Patio and Annex, Pan-Am. Union, Wash., D.C.; Barnes Fnd., Merion, Pa.; Carson Col., Flourtown, Pa.; Detroit Inst. A.; polychrome tile grilles, The Carillon Tower, Lake Wales, Fla.; Folger Shakespeare Lib., Wash., D.C.; Hartford County Court House, Hartford, Conn.; Worcester A. Mus., Mass.; pools, Rittenhouse Square, Phila.; electric fountain, Italian Gardens, Pierre S. duPont, Del.; floors, Harvard Col. dormitories, Pa. Mus. A., U.S. Dept. Justice, Wash., D.C. Position: President/Chief Des., Enfield Pottery and Tile Works, Inc. [40]

ALLEN, James E. [E,Li,P,W] Larchmont, NY b. 23 F 1894, Louisiana, MO. Studied: AIC; ASL; Grand Central A. Sch.; Hans Hofmann; Joseph Pennell; Arshile Gorky; Harvey Dunn; Nicholas Fechin. Member: SAE; Chicago SE; Phila. SE; New Rochelle AA; SC. Exhibited: SC, 1932 (prize), 1939 (prize), 1946 (prize); NAC, 1932 (prize); Phila. Pr. Cl., 1933 (prize); SAE, 1940 (prize); Northwest Pr.M., 1942 (prize); Okla. WPA A. Center, 1942 (prize); NAD; PAFA; SAE; Phila. SE; Phila. Pr. Cl.; Chicago SE, 1932–46; LOC (one-man); New Rochelle Pub. Lib.; Charleston, W.Va., A. Gal., 1944. Work: BM; CM; CMA; SAM; AIC; Montclair A. Mus., Lib. Cong.; NYPL; PMA. Contributor: art magazines [47]

ALLEN, J.G. (Mrs.) [P] Muskogee, OK. Member: Okla. Assoc. Ar. [25]

ALLEN, Jane Mengel [P,B,Li] Glenview, KY b. 1 Ag 1888, Louisville, KY d. 23 Ap 1952. Studied: Hopkins; Hawthorne; Martin. Member: Louisville AC; Louisville AA; SSAL; Louisville A. Center; NAWPS. Exhibited: Jr. Lg. Nat. Exh. N.Y., 1929 (prizes); Cincinnati, 1931 (prize); Los Angeles, 1932 (prize); Jr. Lg., Louisville, 1932 (prizes); Jr. Lg., Phila. (prize); Jr. Lg., Los Angeles (prize); ACI, Louisville, 1935–36 (prize), 1937–38 (prize); NAWPS, 1938 (prize) [40]

ALLEN, Joel Nott [Por.P] NYC b. 29 Ja 1866, Ballston Spa, NY. Studied: Met. Sch. A.; ASL; Walter Satterlee; H. Siddons; Mowbray. Member: SC; Lotos Cl. Work: New York Chamber of Commerce [25]

ALLEN, John Donn (Jawne Allen) [P,B,D,T] Wash., D.C. b. 29 N 1893, Norfolk, VA. Studied: Hawthorne; Richard Miller; Felix Mahony; N.Y. Sch. F.&Appl. A. Member: Wash. WCC; Nat. Soc. Pastelists. Exhibited: Bal Boheme poster contests, Wash. AC, 1935 (prize). Position: T., Nat. A. Sch., Wash., D.C. [40]

ALLEN, John Howard [P] Cape Elizabeth, ME b. 10 My 1866, Brownfield, ME d. 13 Ja 1953. Studied: Charles H. Woodbury. Member: Portland SA; Ogunquit AA; N.Y. Physicians AC; Haylofters, Portland. Exhibited: SC; Sweat Mem. A. Mus., 1943; San Fran. Mus., 1938 (med) [47]

ALLEN, Josephine L. (Mrs. Herbert D.) [Mus.Cur] NYC b. 2 Jy 1893, Cairo, Egypt. Studied: Wellesley Col. Contributor: MMA Bulletin. Positions: Asst., Dept. Paintings, 1919–27, Asst. Cur., 1928– , MMA [47]

ALLEN, Junius [P] NYC b. 9 Je 1898, Summit, NJ d. 8 Jy 1962. Studied: N.Y. Sch. F.&App. A.; NAD; George Elmer Browne; Hawthorne; George W. Maynard; Woelfle. Member: ANA, 1934; SC; Montclair AA; NA,

1941; All.A.Am.; Audubon A.; Summit AA. Exhibited: Plainfield AA, 1931 (med); Montclair AA, 1931 (med); New Rochelle AA, 1932 (prize); AAPL; Contemporary Gal. (prize); NAD, 1933 (prize); N.J. Gal., Newark, 1934 (prize); SC, 1939, 1941, 1944; All.A.Am., 1943; Audubon A.; Pepsi-Cola Exh., 1944; WFNY, 1939. Work: MMA; State A. Col., Trenton; Gould Acad., Bethel, Maine; Montclair A. Mus. [47]

ALLEN, Lee [P] Iowa City, IA b. 16 S 1910, Muscatine, IA. Studied: Univ. Iowa; Grant Wood; Harriet Macy. Exhibited: Iowa A. Salon, 1931 (prize). Work: Iowa Mem. Union; Delta Upsilon Frat., Iowa City; murals, USPOs, Onawa, Emmetsburg, Iowa Medical Illus.; Univ. Iowa Hospitals [40]

ALLEN, Lennox [P,S,W] Glenview, KY b. 20 D 1911, Glenview. Studied: Rollins Col., with Jean Pfister, Able; Cincinnati A. Acad.; Frank Myers; Hentchel; Wessel; John Weiss. Member: SSAL; NAC. Exhibited: NAC; Cincinnati Ar., 1939; Louisville AC, 1945; Ky.-Ind. Exh., 1946 [47]

ALLEN, Louise (Mrs. A.H. Atkins) [S] Boston, MA/West Gloucester, MA b. Lowell, MA. Studied: R.I. Sch. Des., Providence; BMFA Sch. Member: NAWPS; Copley S.; NSS; Boston SS; North Shore AA. Work: CMA; Smith Col. A. Mus. [33]

ALLEN, Margo (Margaret Newton) (Mrs. Harry Hutchison Shaw) [P,Edu] Lafayette, LA/Cohasset, MA b. 3 D 1895, Lincoln, MA. Studied: BMFA Sch.; Naum Los Sch., Brit. Acad., Rome, with Naum Los; Frederick Allen; Charles Grafly; Bela Pratt. Member: NSS; Boston SS; St. Augustine AC. Exhibited: Jr. Lg., Boston, 1929 (prize); NAD; PAFA; Pal. Leg. Hon.; Phila. A. All.; AGA; Mus. FA, Houston (one-man); Dallas Mus. FA.; SAM; Joslyn Mem.; Currier Gal.; Clearwater A. Mus.; San Diego FA Soc., 1939-40. Work: portrait busts, bas-reliefs, U.S. Frigate "Constitution"; HMS "Dragon"; war mem., Cohasset, Mass.; church, Winchester, Mass.; Clearwater A. Mus.; Butler AI; CM; portraits, garden sculptures, civic memorials. Lectures: The Indians of Mexico. Position: T., Southwestern La. Inst., Lafayette, 1943– [47]

ALLEN, Marion Boyd (Mrs. William A.) [P] Boston, MA b. 23 O 1862 d. 28 D 1941. Studied: BMFA Sch., with Tarbell, Benson. Member: Copley S.; Conn. Acad. FA; NAWPS; New Haven PCC. Exhibited: Conn. Acad. FA, 1915 (prize), 1920 (prize), 1921 (prize); Newport AA, 1919 (prize); Buffalo SAC, 1920 (prize); French Inst., New York, 1920 (prize); Jordan Marsh Exh., Boston, 1932 (prize); New Haven PCC, 1932 (prize). Work: Pub. Lib., Barre, Mass.; Col. Lib., Brunswick, Maine; Harvard Cl.; Randolph-Macon Col., Lynchburg, Va.; Ill. Col., Jacksonville; Pub. Lib., Arlington, Mass; Christian Science Pub. House; Bostonian Soc. [40]

ALLEN, Marion Campbell [Edu,D,I,W] Bloomington, IL b. 21 Ap 1896, Albany, NY Studied: PIASch.; Chicago Acad. FA; AIC; Univ. Chicago; Columbia Univ. Member: Nat. Edu. Assn.; Central Ill. Edu. Assn.; Western AA, Bloomington A. Exhibited: North Shore AA. Positions: Instr. A., Indiana State T. Col., Indiana, Pa., 1920-23; Asst. Prof. A., Ill. State Normal Univ., Normal, Ill., 1927-46 [47]

ALLEN, Martha [C,S,Edu] Montevallo, AL b. 22 S 1907, Appleton, TN. Studied: Ala. Col.; T. Col., Columbia Univ., with Oronzio Malderelli. Member: Birmingham AC; Ala. WC Soc.; Ala. A. Lg. Exhibited: Ala. WC Soc.; Birmingham AC; Jr. Lg. Gal. (one-man). Position: T., Ala. Col. [47]

ALLEN, Mary Coleman [P] Troy, OH b. 9 Ag 1888, Troy. Studied: Cincinnati A. Acad., with Duveneck; Am. Soc. Min. P.; ASL. Member: ASMP. Work: BM; Dayton AI; Cathedral House, Cincinnati [47]

ALLEN, Mary G(ertrude) (Mrs.) [P,S,T,L] Lake Stevens, WA b. 7 O 1869, Mendota, IL. Studied: Anna Hills; Michel Jacobs; Dudley Pratt. Member: Seattle A. Mus.; Laguna Beach AA; Women P. of Wash.; Pacific Coast PS&W. Work: Whitman Col., Walla Walla; Trinity Church, Everett, Wash.; First Lutheran Church, Portland, Oreg.; Port Madison, Wash.; Cedarholme, Wash. [40]

ALLEN, Mary Rolfe (Mrs.) [I,P,T] Des Moines, IA b. 7 D 1887, West Phila. Studied: PAFA, with Chase, Poore, Anschutz, McCarter; Pa. Sch. Ind. A., with Deigendesch, Faber, Copeland [25]

ALLEN, Mary (Stockbridge) [P,S,Edu] Everett, WA b. 7 O 1869, Mendota, IL d. 22 Ja 1949. Studied: Anna Neills; Michel Jacobs. Member: Laguna Beach AA; Women P. Wash. [47]

ALLEN, Max I. [Edu] North Manchester, IN b. 19 Mr 1913, Markle, IN. Studied: Manchester Col., North Manchester, Ind. Position: T., Manchester Col., 1937-46 [47]

ALLEN, Nellie Wright [P] Jersey City, NJ [25]

ALLEN, Nicholas D., Mrs. See Raphael, Frances.

ALLEN, Orville S. [P] NYC. Member: S.Indp.A. [25]

ALLEN, P(earl) W(right) (Mrs. J.G.) [P,T] Muskogee, OK b. 9 Ap 1880, Kossuth, MS. Studied: Anna Hills; Walter Gotz; John F. Carlson. Member: Muskogee AC; Okla. AA. Work: Muskogee Pub. Lib.; with Nola Jean Sharp, Baptistry painting, First Baptist Church, Muskogee; First Baptist Church, First Christian Church, Bristow, Okla. [40]

ALLEN, Rebecca G. [P] Boston, MA [29]

ALLEN, T. Ellwood [P] Toledo, OH [24]

ALLEN, Thomas [P] Boston, MA/Princeton, MA b. 1849, St. Louis, MO d. S 1924, Worcester, MA. President BMFA. Studied: Royal Acad., Düsseldorf. In 1884 he became an associate of the Nat. Acad. Des., and was a member of the Soc. of Am. Ar., Boston A. Cl.; Boston PCC, Boston Soc. WC Painters; Copley Soc., and was chairman of the council and faculty of Boston Mus. Sch. of Drawing and Painting; president of the Intl. Jury of Award, St. Louis Expo, 1904; chairman, since 1910, of the Art Commission of the City of Boston. Work: BMFA; City A. Mus., St. Louis; Berkshire Athenaeum

ALLEN, W.S. Vanderbilt [P] Bronxville, NY [09]

ALLEN, Wilhelmina Frances. See Minna.

ALLEN, Willard [P,T] Woodstock, NY b. 15 Ag 1860, Oberlin, OH. Studied: Chase; Carlsen; Ahrens [21]

ALLENBACH, Anna Petrick [P] Cleveland, OH b. 30 Jy 1898, Austin, MN. Studied: Hinsdale, Ill. A. Center; Kansas City AI. Member: Kansas City Soc. Ar.; Ohio WC Soc.; Cleveland Women's A. Cl. Exhibited: Midwestern A. Exh., Kansas City AI, 1936 (prize); Midwestern A. Exh., 1937; Ohio WC Soc. Traveling Exh., 1938, 1939; Cleveland Women's A. Cl. Ann., 1938, 1939 [40]

ALLENBROOK, Charles Theodore [P,D,L] New Rochelle, NY b. 9 D 1905, London, England. Studied: St. Martin's Sch. A., Hornsey Sch. A., Cheltenham Sch. A., England. Member: New Rochelle AA. Exhibited: Am.-Brit. A. Center, 1941; AWCS, 1945, 1946; AMNH, 1946 (one-man); New Rochelle Pub. Lib., 1940-46. Work: murals, U.S., Europe [47]

ALLENDER, Nina E. (Mrs.) [P,I,T] Wash., D.C. b. Auburn, KS. Studied: PAFA, with Chase, Henri; Brangwyn, in London. Member: Wash. AC [33]

ALLER, Gladys (Mrs. G.A. Farber) [P] Los Angeles, CA b. 14 Jy 1915, Springfiled, MA. Studied: Otis AI; Chouinard AI; ASL; George Grosz; Richard Lahey; John Sloan. Member: Calif. WC Soc. Exhibited: Calif. WC Soc., 1936 (prize); Los Angeles Mus. A., 1941-43; PAFA, 1937-40; Calif. WC Soc., 1930-46. Work: MMA [47]

ALLINGTON, Grace [P] NYC b. Penn Yan, NY. Studied: Pratt Inst., Brooklyn, N.Y. [09]

ALLIS, C. Harry [P] NYC b. Dayton, OH d. 8 Je 1938. Studied: Detroit Mus. A. Sch.; Bay View Acad. Member: All. AA; Scarab C.; NAC; SC; Imperial AL, London; Munich; Soc. Amer. P.; Paris AAA; Southwestern Ar. Work: Ackerman Coll., San Fran.; "Pig 'n Whistle" Coll., Los Angeles; Univ. Oreg., Eugene; Ateneo, San Juan, Puerto Rico; Detroit Inst. A. [38]

ALLIS, Genevieve [P] Derby, CT b. 15 Mr 1864, Derby d. 9 F 1914 (suicide). Studied: J.H. Niemeyer; J. Alden Weir; Henry B. Snell; Ben Foster. Member: New Haven PPC; Bridgeport A. Lg. Exhibited: USA; Paris.

ALLISON, F.D. [P] St. John, New Brunswick. Member: AWCS [47]

ALLISON, John [P] Englewood, NJ b. 13 Ja 1893, Englewood, NJ. Studied: George Hart; Vandeering Perrine. Member: Palisade A. Assn.; Am. Ar. Prof. Lg.; Ar. Gld., Bergen County, N.J. Exhibited: PAFA Ann., 1934; Nat. Acad., 1937; Newark A. Cl.; Newark Mus.; Ferargil Gal. [40]

ALLISON, Margaret Prosser. See Prosser.

ALLISON, W(illiam) M(erle) [I] NYC b. 27 Ja 1880, KS. Studied: John Herron A. Inst.; Chicago A. Acad. Member: Ar. Gld.; SI. Illustrator: "Heroes of Liberty," "Women in American History," pub. Bobbs-Merrill Co. Specialties: historical/western subjects [33]

ALLMAN, Richard M. [Edu,P,D] San. Fran., CA b. 12 O 1901, Denver. Studied: Univ. Calif.; Claremont Col.; William Hekking; Hartley Burr Alexander; John R. Frazier; Spencer Macky; Maynard Dixon. Member: San Fran. AA; Riverside AA; Acad. Mod. A.; Am. A. Fnd. Exhibited: Los Angeles Mus. A., 1930 (prize); Calif. WC Soc., 1936, 1937; Riverside Mus., 1938; S.Indp.A., 1938; San Fran. AA, 1936; San Fran. Open Air Exh., 1940, 1941; Pal. Leg. Hon., 1939; Santa Cruz A. Lg., 1935-44. Work: windows, mural panels, Riverside Jr. Col. Positions: Hd., A. Dept., San Mateo Jr. Col., 1924-28; Riverside Jr. Col., 1928-35; San Fran. Jr. Col., 1935– [47]

ALLMOND, Katherine. See Hulbert, Charles A., Mrs.

ALLUISI, Joseph A. [P] Baltimore, MD

ALLWORTHY, Joseph [P] Chicago, IL b. 19 S 1897, Pittsburgh. Studied: AIC; Académie Julian, Paris. Member: All. Française de Chicago; Chicago AC. Exhibited: Municipal A. Lg., 1931 (prize), 1935 (prize); Chicago Gal. Assn., 1934 (prize); Findlay Gal., 1935 (med); Carnegie Inst.; Chicago Century of Progress, 1934; Tex. Centenn. Expo, 1936; Palacio de Bellas Artes, Mexico (one-man). Work: Eastman Mem. Gal., Laurel, Miss.; Union Lg. Cl., Chicago; City of Chicago Municipal Coll.; Pub. Lib., Chicago [47]

ALLYN, Grace E. [P] Portland, ME [25]

ALMENRAEDER, Frederick [S] Chicago, IL b. 1832, Wiesbaden, Germany. Studied: Stadel's Inst., Frankfort [06]

ALMQUIST, Olaf [E] Milwaukee, WI [24]

ALMY, Frank Atwood [Mus.Dir] Muskegon, MI b. 19 N 1900, Grinnell, IA d. 1956. Studied: Grinnell Col.; Harvard; AIC. Position: Dir., Hackley A. Gal., Muskegon [47]

ALQUIST, Clara [P] b. 18 D 1878. Member: Conn. Acad. FA; Deerfield Valley AA [40]

ALSCHULER, Alfred S. [P] Chicago, IL [21]

ALSOP, Rachel Griscom. See Carter, Mrs.

ALSRUHE, Henry [P] Baltimore, MD [24]

ALSTON, Frank Herman, Jr. [P,Li,E] Wash., D.C. b. 11 D 1913, Providence. Studied: R.I. Sch. Des.; Howard Univ. Member: AAPL; Dauber Cl. Exhibited: Atlanta Univ., 1945 (prize); AAPL, 1945 (prize); Soc. Wash. A., 1946 (med); WFNY, 1939; Lib. Congress, 1941; Corcoran Gal. A., 1941, 1946; Phillips Mem. Gal., 1941; Newport AA, 1945; Atlanta Univ., 1945; NAC, 1946; R.I. Sch. Des., 1946. Work: Howard Univ. A. Gal. [47]

ALSTON, Frederick Cornelius [P,I,T] St. Louis, MO b. 31 O 1895, Wilmington, NC. Studied: Phila. Sch. Industrial A.; Thornton Oakley; George Harding. Member: St. Louis Indp. A.; AFA; St. Louis Citizens' Art Com. Exhibited: St. Louis Citizens' Art Com., 1930-31 (prize), 1932 (prize). Work: mural, Tuskegee Inst. [40]

ALT, Lester H. [D] Buffalo, NY b. 21 Mr 1909, Buffalo. Studied: PIASch. Exhibited: Albright A. Gal. Specialty: adv. design [47]

ALT, Lillian [P] Chicago, IL b. Kokomo, IN d. ca. 1955. Studied: George Oberteuffer; F. DeForest Schook; Louis Ritman; Frederick Victor Poole. Member: Hoosier Salon; Ill. SA; Chicago Women's Salon [47]

ALTEN, Mathias J. [P] Grand Rapids, MI b. 13 F 1871, Gusenburg, Germany d. 8 Mr 1938. Studied: Constant; Laurens; Prinet; Girrardo; Whistler, in Paris. Member: Grand Rapids AA; All. AA; Scarab Cl.; NAC; Chicago Gal. Assn. Exhibited: Acad. Colarossi, Paris, 1899 (med); Grand Rapids AA, 1916 (prize); Detroit AI, 1919 (prize); Scarab Cl., 1920 (gold); Detroit AI, 1922 (prize); portrait, Grand Rapids AA, 1933 (prize). Work: Syracuse Mus. FA; U.S. Court of Appeals, Cincinnati; Mich. State Capitol, Lansing; Armory, Flint, Mich.; Lib. Port Huron, Mich.; Armory A. Assoc.; Calvin Col. [38]

ALTENBORG, John Alfred [C] Lindsborg, KS b. 23 Jy 1875, Linderos, Sweden d. 12 My 1946. Member: Smoky Hill AC. Exhibited: woodcarving, Kans. Fair, Topeka (prize), State Fair, Hutchinson, Kans., 1934 (prize) [40]

ALTENBURG, Alexander [P] NYC Member: S.Indp.A. [21]

ALTHOUSE, Lillian [P] Los Angeles, CA. Member: Calif. AC [25]

ALTIZER, Florence Sharman (Mrs.) [S] b. 27 Mr 1878, Bloomington, IL d. 21 Mr 1946, Fayetteville, AR. Studied: St. Louis Sch. FA

ALTMAN, Benjamin NYC b. 12 Jy 1840, NYC d. 7 O 1913. Left school at the age of twelve and helped his father in a small store, gradually building up his dry goods business until, at his death, the Altman store occupied an entire block on Fifth Avenue. During the last decade of his life he acquired a wonderful collection of paintings, Chinese porcelains, art objects and rugs, which he bequeathed to the Metropolitan Museum of Art—value: $15,000,000.

ALTMANN, Aaron [P,W,L,T,Edu] San Fran., CA b. 28 O 1872, San. Fran. Studied: A.F. Mathews, in San Fran.; Constant, Laurens, Gérôme, in Paris. Member: San Fran. AA. Position: Dir., A. Edu., public schools, San Fran. [40]

ALTSCHULE, Hilda (Mrs. H.A. Coates) [P,S] Rochester, NY b. Russia. Studied: Hunter Col.; Cornell. Exhibited: Rochester Mem. A. Gal., 1929-46, prizes: 1935, 1940, 1942, 1944; Great Lakes Exh., Cayuga Mus. Hist.&A.; Albright A. Gal., 1939. Work: Rochester Mem. A. Gal. [47]

ALVARO, or ALVARADO [P] Portuguese-Am. painter of fishing vessels in Boston and Provincetown. Active, early 1900s. [*]

ALVAREZ, Mabel [P,Li] Beverly Hills, CA b. Waialoua, HI. Studied: W.V. Cahill. Member: San Diego A. Gld.; Council All. A., Los Angeles; Calif. AC. Exhibited: Pan-Calif. Expo, San Diego, 1916 (med); Calif. AC, 1918 (prize), 1919 (prize); Fed. Women's Cl., 1923 (prize); Laguna Beach AA, 1928 (prize); Pasadena, Calif., 1929 (prize); Ebell Cl., prizes: 1933, 1934, 1935; Honolulu Pr.M., 1939 (prize); AIC, 1923; PAFA, 1923; MOMA, 1933; N.Y. Municipal Exh., 1938; GGE, 1939; Los Angeles Mus. A.; Oakland A. Gal.; San Diego FA Soc. [47]

ALVORD, Muriel [P] Hartford, CT b. Goshen, CT d. 22 N 1960. Studied: Ethel Walker Sch.; Yale; Wayman Adams; Arthur J.E. Powell; Eugene Savage; Edwin C. Taylor. Member: Springfield A. Lg.; Hartford Soc. Women Painters; New Haven PCC; North Shore AA. Exhibited: BAID (med); Meriden A.&Crafts Exh., 1944, (prize); All.A.Am., 1944; Min. P.S.&Gr., 1944, 1946; North Shore AA, 1944, 1945; Newport AA, 1944, 1945; Pa. Soc. Min. P., 1945; New Haven PPC; Conn. Acad. FA; Springfield A. Lg., Hartford Soc. Women Painters; Western Col. (one-man); Sweet Briar Col., Wells Col.; Argent Gal.; Doll & Richards, Boston [47]

AMATEIS, Edmond [S,Edu,W] Brewster, NY b. 7 F 1897, Rome, Italy. Studied: BAID; Académie Julian, Paris. Member: F., Am. Acad., Rome; NA; NSS; Century Assn.; A. Fellowship; ANA, 1936; Arch. Lg. Exhibited: Arch. Lg., 1929 (prize); PAFA, 1933 (prize); NAD; NSS. Work: Brookgreen Gardens, S.C.; Baltimore & Kansas City War Mem.; William M. Davidson Mem., Pittsburgh; USPO, Ilion, N.Y.; Commerce Bldg., Wash., D.C.; sculpture, Buffalo; Rochester. Author: articles on sculpture. Illustrator: Country Life, Town and Country, Pencil Points [47]

AMATEIS, Louis [S] Wash., D.C. b. 13 D 1855, Turin, Italy (came to U.S. in 1883) d. 18 Mr 1913. Studied: Royal Acad., Turin; Paris; Milan. Member: NSS; Soc. Wash. A.; Arch. Lg. Exhibited: Royal Acad., Turin (gold); Nat. Expo, Turin, 1880 (med). Works: monument to soldiers of the war of 1836, at Galveston, Tex.; Baldwin Mem., at Milford, Conn.; busts of President Chester A. Arthur, James G. Blaine, Andrew Carnegie, and others; monument, Turin; bronze doors, U.S. Capitol. In 1892, appointed head of the Dept. of Fine Arts at George Washington Univ.

AMBELLAN, Harold [S] NYC b. 24 My 1912, Buffalo, NY. Studied: William Ehrich. Member: United Am. Ar. Exhibited: Fed. A. Gal., 1938; MOMA. Work: Willerts Park Housing Proj., Buffalo; USPO, Metuchen, N.J. [47]

AMBERG, H. George [Mus.Cur,W,L] NYC b. 28 D 1901, Halle, Germany. Studied: Univ. Cologne. Member: Am. Soc. Aesthetics; Theatre Lib. Assn. Author: "Art in Modern Ballet," 1946; article on ballet in Encyclopedia Americana; article on theatre in Encyclopedia of the Arts. Lectures: Theatre History, Aesthetics & Design. Position: Cur., Dept. Theatre A., MOMA [47]

AMBERSON, Grace D. (Mrs.) [P] Cockeysville, MD b. 23 O 1894 d. 28 D 1957. Member: Ar. Un., Baltimore. Exhibited: BMA, 1941-46 [47]

AMBROSE, Lester J. [P] NYC b. 16 Ja 1879, Gardenville, NY. Studied: ASL, Buffalo; Chase Sch., N.Y., with William Chase, Robert Henri; Lucius Hitchcock; Kenneth Hayes Miller; Louis Mora. Member: AAPL; S.Indp.A.; Am. Veterans Soc. A. Exhibited: AIC, 1935; NAD, 1945; All.A.Am., 1944, 1945; S.Indp.A., 1938-44; CI, 1946; AAPL, 1945; NAC, 1946. Illustrator: American, Pearson's, Delineator, Woman's Home Companion, Chicago Tribune. Cartoonist: Rochester (N.Y.) Post-Express [47]

AMENDOLA, Robert [S] Natick, MA b. 24 Ap 1909, Boston. Studied: Mass. Sch. A.; Yale. Member: F., Am. Acad., in Rome; Liturgical A. Soc.; Wellesley SA. Exhibited: Mass. Sch. A., 1930 (med); Wellesley SA, 1930-42. Work: Yale Univ. Chapel; church sculpture, Braintree, Gloucester, Boston, Newton, all in Mass.; Avon, Conn. Positions: Engineering Illus., Chance Vought Aircraft Co., 1943-45; Instr. Sculpture, Army Rehab. Prog., 1945-46 [47]

AMENT, R(obert) S(elfe) [P,E,D] NYC b. Brooklyn, NY d. 1938. Studied: Ward; Chase; Henri. Member: SI; A. Dir. Cl.; Players; Dutch Treat [38]

AMERO, Emilio [P,Li] b. Mexico City. Studied: Nat. Sch. FA, Mexico City; Saldana; De La Torre. Member: Am. A. Cong. Work: lithographs, MMA; Central Sch. FA, Mexico; frescoes, Fed. Art Project, New York, Secretariat of Education, Mexico. Former professional connections with New York Herald-Tribune, Brooklyn Eagle, Theatre Magazine. Position: T., New Sch. Soc. Res. [40]

AMES, Blanche [P] Boston, MA [10]

AMES, Edwin Isaac [Min.P,W] Chicago, IL b. 3 My 1862, Lodi, IL. Studied: Cowles A. Sch., Boston; George Frost; Fred Freer, in Chicago [09]

AMES, Frances (Mrs. Linwood P.) [P] Fort Plain, NY b.1868, Massina, NY. Studied: Chase; Collin, Courtois, Renvir, all in Paris. Work: portraits, St. Lawrence Univ.; Republican Club, NYC

AMES, Jean Goodwin [C,P,Edu] Claremont, CA b. 5 N 1905, Santa Ana, CA. Studied: AIC; Univ. Calif., Los Angeles; Univ. Southern Calif. Exhibited: N.Y. Municipal Exh., 1937; Los Angeles Mus. A.; AIC; San Fran. Expo, 1938; Santa Barbara Mus. A., 1946; Dalzell Hatfield Gal., 1946. Work: mural, San Diego Civic Center. Position: T., Scripps & Claremont Col., 1940–46 [47]

AMES, Jessie T. [P] NYC. Exhibited: Am. WC Soc., 1933, 1934, 1936; WC Cl., Wash., D.C., 1936, 1938; WC Cl., New York, 1937 [40]

AMES, L. Lawrence [P] Orange, NJ

AMES, Lydia May [P,L,T] Cleveland, OH b. Cleveland. Studied: Cleveland Sch. A.; R.I. Sch. Des.; Johonnot; abroad. Member: Women's AC Cleveland. Work: Mt. Pleasant Sch., Cleveland; murals, Children's Tuberculosis Hosp., Cleveland. Designer: cover, "Moth and Butterfly," by Ellen Robertson Miller, pub. Scribner's [40]

AMES, (Polly) Scribner [P,T,S,L] NYC b. 16 F 1908, Chicago. Studied: AIC; Univ. Chicago; Chicago Sch. S.; José de Creeft; Hans Hofmann; Dubac, in Switzerland; Hans Schwegerle, in Munich. Exhibited: Bonestell Gal., 1939; Puma Gal., 1943; Kalamazoo AI, 1939; Eleanor Smith Gal., 1945; Creative A. Gal., 1943; Crosby Gal., Wash. D.C., 1946. Position: T., City & Country Sch., NYC, 1939–41 [47]

AMES, William L. [P] NYC. Member: Lg. AA [25]

AMFT, Robert E. [P,Li,D,T] Chicago, IL b. 7 D 1916, Chicago. Studied: AIC. Exhibited: AIC, 1938, 1940, 1941 [47]

AMICK, Robert Wesley [P,T,I] Old Greenwich, CT b. 15 O 1879, Canon City, CO. Studied: Yale; ASL. Member: Greenwich SA; Old Greenwich AA; SI, 1913. Specialty: western subjects [47]

AMINO, Leo [S,D] NYC b. 26 Je 1911, Formosa, Japan. Studied: NYU; Am. A. Sch. Member: A. Lg. Am. Exhibited: AIC; WFNY, 1939; Montross Gal. (one-man); Clay Cl.; Bonestell Gal. Work: MOMA; Massillon Mus., Ohio [47]

AMORE, John [S,Edu] NYC b. 28 F 1912, Genoa. Studied: BAID; Fontainebleau Sch. FA; NAD. Member: F., Am. Acad., Rome. Exhibited: BAID, 1935 (prize); 1937 (prize); Am. Acad., Rome, 1937 (prize) [47]

AMOROSO, Anthony [P,Edu] Woodside, NY b. 19 Ag 1877, Messina, Italy. Studied: Acad. FA, Messina; Brera Acad. FA, Milan. Exhibited: Messina, 1900 (prize); Milan, 1918 (prize); CGA, 1935, 1939 [47]

AMSDEN, Harriet [P] NYC [04]

AMSDEN, William King [P] Rockland Lake, NY. Member: AWCS [04]

AMYX, Leon Kirkman [P,Edu] Salinas, CA b. 20 D 1908, Visalia, CA. Studied: San Jose State Col.; Claremont Col.; Calif. Col. A.&Crafts. Member: Calif. WC Soc.; San Fran. AA. Exhibited: Oakland A. Gal, 1945 (med); SFMA, 1944, (prize); San Fran. AA, 1933, 1939–41; AWCS, 1943; NAD; San Diego FA Soc., 1941; Oakland A. Gal., 1933–36, 1940, 1944, 1945; Calif. WC Soc., 1945, 1946; Los Angeles Mus. A.; SFMA; Riverside Mus., NYC. Position: T., Salinas Jr. Col. [47]

ANARGEROS, Spero [S,C] NYC/Dryden, NY b. 23 Ja 1915, NYC. Studied: ASL; Master In. United A. Member: ASL. Exhibited: Nat. Acad., 1936, 1938. Work: USPO, Hammonton, N.J. WPA artist. [40]

ANDERECK, Kathleen Mason (Mrs.) [I,C] Brooklyn, NY/Hollywood, CA b. 30 N 1894, Phila. Studied: Phil. Sch. Ind. A.; Thornton Oakley. Member: Alliance [25]

ANDERS, Willi [P,S] Milwaukee, WI b. 19 Jy 1897, Hanover, Germany. Studied: Kunstgewerbe Schule, Hanover; Robert von Neumann; Myron Nutting. Member: Wis. P.&S. Exhibited: Wis. State Fair, 1938 (prize), 1939 (prize), 1945 (prize); Univ. Wis., 1934 (prize), 1935 (prize), 1938 (prize); Milwaukee AI, 1936 (prize), 1938 (prize); AIC, 1935; PAFA, 1939; Wis. Salon; Wis. P.&S.; Kansas City AI; Great Lakes Exh., 1938, 1939. Work: Milwaukee AI [47]

ANDERSEN, Andreas Storrs [Edu,P] Tucson, AZ b. 6 O 1908, Chicago d. 1974. Studied: CI; Brit. Acad., Rome; AIC. Member: Am. Assn. Univ. Prof.; Ariz. Soc. P.&S.; Palette & Brush Cl. Exhibited: GGE, 1939; N.Y. Mun. Lg.; Ariz. State Mus. Work: IBM; Univ. Ariz. Position: Assoc. Prof. A., Hd. Dept. A., Univ. Arizona [47]

ANDERSEN, Martinus [P,I] NYC b. 13 Ag 1878, Peru, IN. Studied: Herron A. Inst., Indianapolis, with J.O. Adams, Forsyth. Member: S.Indp.A.; SI. Exhibited: Richmond, Ind., 1913 (prize), 1914 (prize), 1915 (prize) [40]

ANDERSEN, Niels Yde [D,E] Kenmore, NY b. 4 Mr 1888, Copenhagen. Member: SAE; The Patteran, Buffalo; Buffalo Pr. Cl. Exhibited: Albright A. Gal., 1936 (prize), 1937 (prize). Work: Albright A. Gal.; Moscow Mus. Foreign A.; Danish-Am. Archives. Specialty: product design [47]

ANDERSEN, Norman [D,E,I] Chicago, IL b. 5 N 1894. Studied: AIC; Am. Acad. A. Member: Palette and Chisel Acad. FA. Work: advertising posters; magazine and booklet layouts [40]

ANDERSON, A(bram) A(rchibald) [Por.P] NYC b. 1847, NYC. Studied: Bonnât, Cabanel, Cormon, Collin, in Paris. Member: AWCS; Paris AAA

ANDERSON, Alice Sloane [P] Bedford Hills, NY. Exhibited: Fontainebleau Alumni, 1935; Studio Gld., 1936, 1938; A.Cent., Ogunquit, 1936 [40]

ANDERSON, Alma [Edu,L,P] de Kalb, IL b. Sweden. Studied: Univ. N.D.; Columbia Univ.; Univ. Iowa; Banff Sch. A.; AIC; Grant Wood; Charles Martin. Exhibited: Haish Lib., de Kalb; Northern Ill. State T. Col., de Kalb. Positions: Dir. A., City Sch., La Crosse, Wis., 1926–27; Asst. Prof. A., 1927–37, Hd. FA Dept., 1937– , Northern Ill. State T. Col. [47]

ANDERSON, Andreas [Por.P] Boston, MA b. 1869, Bergen, Norway d. 1 F 1903. Studied: Cowles A. Sch.; Académie Julian, Paris, 1891–94, with Laurens, Benjamin-Constant

ANDERSON, Anne [E,B,P] Chicago, IL b. Elgin, IL. Studied: AIC; Chicago Acad. FA; Charles Hawthorne; Hugh Breckenridge. Member: Chicago SE; Swedish-Am. AA; North Shore AL. Work: dry point, Vexio Mus., Sweden; etchings, Smithsonian Inst. [40]

ANDERSON, Arnold Nelson [E,D] Phila., PA/Brant Beach, NJ b. 24 Ag 1895, Camden, NJ. Studied: PMSchIA. Member: Phila. Print C. Exhibited: SAE; Phila. SE; Phila. Pr. Cl. Work: Univ. Nebr.; PMA; Pa. Hist. Soc.; Haverford, Col. [47]

ANDERSON, Bernard [P] St. Paul, MN [24]

ANDERSON, C. Stephen [D,P] West Orange, NJ b. 4 Ja 1896, Harrisburg, PA. Studied: Am. Acad. A., Chicago; William Mosby; Gillette Elvgren. Member: Art Center of the Oranges. Exhibited: Art Center of the Oranges, 1943–46; Maplewood (N.J.) A. Exchange Gal., 1945, 1946 [47]

ANDERSON, Carl (Thomas) [Car] Madison, WI b. 14 F 1865, Madison d. 4 N 1948. Studied: Pa. Mus. Sch. Ind. A. Work: Illus., Life, Judge, Saturday Evening Post, Collier's, American Kennel Gazette. Author: "Dusty, the Story of a Dog and His Adopted Boy," "Henry." Cartoonist: animated cartoons for the screen; The Carl Anderson Cartoon Course; "Henry," King Features Syndicate [47]

ANDERSON, Carlos [P] NYC. Exhibited: CGA, 1936; AIC, 1938 [40]

ANDERSON, Carroll [Cr,Art Dealer] Chicago, IL d. 24 S 1946. Pres., Anderson Art Galleries of Chicago until 1942, when they were closed after being in business for 70 years.

ANDERSON, Charles S. [P] Columbus, OH. Member: Columbus PPC [25]

ANDERSON, C(harles) Webster [Edu,P,C] Los Angeles, CA b. 13 N 1911, Constantinople. Studied: Occidental Col.; Univ. Calif.; Calif. Col. A.&Crafts; Vyclav Vytlacil; Worth Ryder. Member: Calif. WC Soc. Exhibited: Perls Gal.; Univ. Calif., Los Angeles, 1946; Los Angeles City Col., 1939. Position: T., Los Angeles City Col., 1935–46 [47]

ANDERSON, Clarence William [E,Li,I,W] Mason, NH b. 12 Ap 1891, Wahoo, Nebr. Studied: AIC. Member: SAE. Exhibited: Am. Soc. E., 1932 (prize). Author/Illus., "Thoroughbreds," 1942, "Big Red," 1943, "Tomorrow's Champion," 1946; and others. Specialty: horses [47]

ANDERSON, Claude J.K. [P,W] Riverton, NJ/Choteau, MT b. 10 F 1902, Hamilton Township, NJ. Studied: Princeton Univ.; Europe. Member: Phila. A. All.; AAPL [47]

ANDERSON, David I. [P] NYC [15]

ANDERSON, Dorothy Visju [P,T,S] Hollywood, CA b. Oslo. Studied: AIC; W.M. Chase. Member: Calif. AC. Exhibited: Springfield, Ill. (prize); Los Angeles Mus. A., 1937 (med); Salon D'Automne; AIC; San Diego FA Soc.; Tilton Sch., Chicago; Los Angeles Mus. A. Work: Vanderpoel Coll. [47]

ANDERSON, E.A. (Miss) [P] Louisville, KY. Member: Louisville A. Lg. [17]

ANDERSON, Edward S. [I] NYC. Member: SI [25]

ANDERSON, E(llen) Graham [P,I,E] NYC b. Lexington, VA. Studied: Académie Moderne, with Charles Guérin; E.A. Taylor, in Paris [25]

ANDERSON, Elmer G. [P] Phila., PA. Member: F., PAFA [21]

ANDERSON, Ernfred [S,T,D,L] Elmira, NY b. 28 Ag 1896, Esperod, Sweden. Studied: Société Industrielle de Lausanne. Member: Elmira AC. Exhibited: NSS, 1935–40; NAD, 1933–35. Work: mon., Elmira, Horseheads, NY. Author: "Public Art in Elmira," 1941. Positions: Dir., Arnot A. Gal., 1943–46; Inst. A., Elmira Col. [47]

ANDERSON, F.W. [P,S,C] Brooklyn, NY b. 28 Ag 1896, Sweden. Member: Brooklyn PS; Brooklyn SA; Scandinavian Am. A. [25]

ANDERSON, Florence (Ann) M(ewhinney) [P] El Paso, TX. b. 11 Nov 1874, Terre Haute, IN. Studied: AIC; Alice Mitchell; Elmer L. Boone; Berla Emeree; Leola Freeman. Member: Hoosier Salon Patrons' Assoc.; Tex. FA. Assoc. [33]

ANDERSON, Frank Hartley [B,En,P,Arch,L,T] b. 10 June 1890, Boston d. 17 Ap 1947. Studied: AIC; Harvard Univ.; Elmer Forsberg; Henry Turner Bailey; Henry Vincent Hubbard. Member: Northwest PM; Southern PM Soc.; Conn. Acad. FA. Exhibited: Am. Block Print Ann., Wichita, 1935 (prize); Southern PM Soc., 1936 (prize); SSAL, 1937 (prize); wood-engr., New Orleans A. Assn., 1939 (prize); WFNY, 1939. Works: prints, Md. Inst., Baltimore; Pub. Lib., East Chicago, Ind.; A. Mus., Wichita; Vanderpoel Coll.; Nat. Fire Prevention Soc., Boston; Butler A. Inst., Youngstown, Ohio; Springfield A. Mus. & State Col, Mo.; Pub. Lib., Birmingham; Mus. FA., Montevallo; Lehigh Univ.; High Mus., Atlanta; Mus. N.M., Santa Fe; Pub. Lib., El Paso; Nat. Mus., Stockholm; Delgado Mus., New Orleans; Milwaukee AIn., Wis.; Harvard Coll. Lib.; NYPL; mural, USPO, Fairfield, Ala., Sec. FA, Fed. Works Agency; Nat. Exh. Contemporary Am. Prints, to Sweden, Norway, etc., 1936; Am. Ar. Calendar, 1939. Author: articles, American Architect, Architectural Forum, American Magazine of Art, various newspapers. Co-author: "Manning's City Plan of Birmingham." Lectures: bookplates, graphic arts, etc. Position: Engineer, Regional Office, PWA, Atlanta [47]

ANDERSON, Frederic A. [I] Phila., PA. Member: SI [33]

ANDERSON, G. Adolph [P] Mt. Tremper, NY b. 21 My 1877, Rochester, MN. Studied: Jonas Lie; John Johansen; Robert Henri; Van Deering Perrine; Howard Giles; Académie Julian, Paris. Member: AFA. Work: murals, Mem. Lib., Ridgewood, N.J. [40]

ANDERSON, Genevieve Dillaye [P,C,T] Hartford, CT b. 15 Je 1900, Avon, NY. Studied: Skidmore Col.; Columbia Univ. Member: NAWA; Hartford Soc. Women P.; Conn. WC Soc.; Eastern AA; Conn. AA. Exhibited: NAWA, 1943–46; Hartford Soc. Women P.; Conn. WC Soc.; Meriden A.&Crafts Cl.; New Haven PCC. Postion: T., Supv. A., Pub. Sch., Bristol and Hartford [47]

ANDERSON, George M. [P] Cincinnati, OH [21]

ANDERSON, Gwen(dolyn) (Orsinger) [P,T] Lake Worth, FL b. 31 My 1915, Chicago. Studied: Univ. Calif., Los Angeles; Univ. Ill.; AIC; Norton Gal.&Sch. A.; Eliot O'Hara. Member: Palm Beach A. Lg.; Soc. Four A., Palm Beach. Exhibited: Norton Gal., 1946 (prize); AIC, 1945; Norton Gal., 1946; Palm Beach A. Lg., 1946; Strait Mus., Lake Worth, 1946; MacFadden-Deauville Gal., Miami, 1946. Position: T. A., Pekin H.S., Ill. [47]

ANDERSON, H(arold) E(dgerly) [B,Dec,D,Dr,E,I,P] Evanston, IL b. 29 Ja 1899, Boston. Studied: Mass. Normal A. Sch.; AIC, with Ernest Major, D.J. Connah; Vesper George; J. Allen St. John. Member: Soc. Typographic A.; Chicago Gld. A. [47]

ANDERSON, Harold N. [I] Old Greenwich, CT b. 26 Je 1894, Boston. Studied: Fenway A. Sch. Member: SI; A. Gld; New Rochelle AA; Old Greenwich AA. Exhibited: A. Dir. Cl., 1937 (prize) 1940 (prize) 1942 (prize), 1946 (prize). Illustrator: national magazines [47]

ANDERSON, Heath (Miss) [P,I] b. 1 Ja 1903, San Fran. Studied: Calif. Sch. A.&Crafts; Geneve Rixford Sargeant. Member: All Arts C., Berkeley; Calif. S. Women A. Exhibited: State Exh., Santa Cruz, 1928 (prize); Nat. Am. Humane Assoc., 1928 (prize) [40]

ANDERSON, Helen [P] Providence, RI [25]

ANDERSON, Helge [P] Boston, MA [21]

ANDERSON, Hendrik Christian [S,W] Rome, Italy b. 17 Ap 1872, Bergen, Norway (brought to U.S. in infancy; settled at Newport in 1873) d. 19 D 1940. Studied: Boston; Paris; Naples; Rome. Author: "Creation of a World Centre of Communication," "Legal and Economic Advantages of a World Centre of Communication," "League of Nations" [33]

ANDERSON, Herbert R. [P] Chicago, IL [25]

ANDERSON, Hildure E. [C,Edu] Las Cruces, NM b. 11 Ja 1894, Belgrade, MN. Studied: Univ. Minn.; Univ. Chicago; Columbia Univ.; John Shapley. Member: Am. Assn. Univ. Women; AFA; Am. Assn. Univ. Prof. Positions: Instru., Hist. A., Des., St. Olaf's Col., Northfield, Minn.; Assoc. Prof., N.Mex. Col. A.&M, State College, N.Mex. [47]

ANDERSON, Howard Benjamin [Li,P,Car] Chicago, IL b. 26 Je 1903, Racine, WI. Studied: Univ. Wis., with Chapin, Ritman; CGA Sch., with Eugene Weiss. Exhibited: Buffalo Pr. Cl., 1940; Denver A. Mus., 1941; Okla. Lith. Exh., 1940, 1941; Wis. Pr. Soc., 1936; Wis. Salon, 1940 [47]

ANDERSON, Jessica B. [P] Spartanburg, SC b. 16 S 1890, San Rafael, CA. Studied: Wis. Sch. FA.; Acad. de la Grande Chaumière, Paris. Member: FA Lg. Carolinas; Miss. A. Assn.; SSAL. Exhibited: SSAL Ann., Montgomery, Ala., 1938 [40]

ANDERSON, Joel Randolph [E,Li,P,D,T] Waterbury, CT b. 13 Jy 1905, South Britain, CT. Studied: ASL, with George Bridgman. Member: Conn. Acad. FA. Exhibited: NAD, 1941; Lib. Cong., 1943; Conn. Acad. FA, 1940, 1941, 1946. Work: MMA [47]

ANDERSON, John K. [S,P,Arch] Buffalo, NY b. 31 D 1904, Buffalo. Studied: Cornell Univ. Col. Arch. Member: Buffalo SA. Exhibited: Albright A. Gal., 1937–44; Buffalo SA, 1942–46 [47]

ANDERSON, Julia (Mrs. C.D. Doerfler) [P] Wauwatosa, WI b. 21 N 1871, Milwaukee d. 1944. Studied: Caleb Harrison; Dudley Crafts Watson. Member: Wis. PS; Seven Arts Soc. Milwaukee. Exhibited: water color, Wis. PS, 1924 (prize) [40]

ANDERSON, Karl [P,I] Westport, CT b. 13 Ja 1874, Oxford, OH d. 18 My 1956. Studied: AIC; Académie Julian, Paris; Colarossi Academy, in Paris; Holland; Italy; Madrid. Member: ANA, 1913; NA, 1923; NAC. Exhibited: Carnegie Inst., 1910 (med); PAFA, 1916 (prize); NAD, 1917; AIC, 1919; NAC, 1920 (prize); Armory Show, 1913; Westport Town Hall, 1984. Work: AIC; CAM; CMA; PAFA; Los Angeles Mus. A.; BMFA; High Mus. A.; Detroit Inst. A.; murals, USPO, New Haven, Conn.; Bedford, Ohio. His son was writer Sherwood Anderson. [47]

ANDERSON, Leslie E. [P,Dr] Byron, MN b. 1 Jy 1903, Trent, SD. Studied: Minn. Sch. A.; Cameron Booth. Member: Rochester AS. Exhibited: drawing, FA Exh., Minn. State Fair, 1934 [40]

ANDERSON, Lewis [P] Kansas City, MO. Exhibited: Midwestern SA, 1937, 1939; WFNY, 1939 [40]

ANDERSON, Loulie (Raymond) [P,T] Tampa, FL b. 14 Mr 1887, Brownsville, TN. Studied: AIC, with Wagoner, Inness; Ringling Sch. A. Member: Fla. Fed. A. Exhibited: Tampa AI (one-man). Position: Sec., Tampa AI, 1932–42, 1946– [47]

ANDERSON, Lyman (Matthew) [I] Bronxville, NY b. 4 My 1907, Chicago. Studied: AIC; Pruett; Carter; Wayman Adams; Naum Los. Member: SI. Exhibited: A. Dir. Cl., 1939, 1945; SI, 1939–46. Illustrator: fiction, covers, advertising in leading publications. Position: Sec., SI, 1942–45 [47]

ANDERSON, M.C. (Mrs.) [P] Ft. Worth, TX [25]

ANDERSON, Martha Fort (Mrs. Frank Hartley) [P,T,L] Mt. Airy, GA b. 22 Je 1885, Macon, GA. Studied: Piedmont Col.; BMFA Sch.; ASL, with Philip Hale, Frank Benson; Bela Pratt; ASL; Richard Miller; Edward Penfield; Colarossi Academy, in Paris. Member: N.A. Women PS; So. Pr. M. Soc. Exhibited: NAWA, SSAL, 1919–38; Assn. Ga. A.; Birmingham A. Cl. Work: Univ. Ala.; Univ. Pa.; St. Paul's Church, Richmond, Va.; Lakeview Lib., Birmingham, Ala.; Fed. Bldg., Fairfield, Ala.; Fulton Co. Court House; NYPL. Positions: T., Univ. Ala. Sch. FA, 1919–23, Ext. Div., 1934–38 [47]

ANDERSON, Martinus [P,I] Bridgeport, IN/Crawfordsville, IN b. 13 Ag 1878, Peru, IN. Studied: J. Ottis Adams; William Forsyth [25]

ANDERSON, Milo Elvyn [P,G,T] Sacramento, CA b. 28 Ja 1905, San Fran. Studied: Col. A.&Cr., Univ. Calif. Exhibited: Fed. A. Proj., San Fran., Oakland; Sacramento A. Center; Crocker A. Gal. Work: Grant Union High Sch.; Sacramento A. Center. Position: Instr., Sacramento A. Center [40]

ANDERSON, Norman J. [G] Wash., D.C. Exhibited: WCC, Wash. Print

Sect., 1933, 1936, 1937, 1938; WCC, Wash., 1938, 1939; Min. PS&G Soc. Wash., 1939 [40].

ANDERSON, Ollie Belle [L,T,P,D,C] Chicago, IL b. 31 Mr 1914, Memphis. Studied: AIC, with Louis Cheskin; Chicago Inst. Des., with Moholy-Nagy. Exhibited: South Side A., 1938–40. Work: T. Col., Nashville; State Nat. Parks, Ill. Position: T., South Side Community A. Center, Chicago, 1934–40 [47]

ANDERSON, Oscar [P] Gloucester, MA b. 31 Jy 1873, Gotland, Sweden. Studied: Charles Noel Flagg, in Hartford. Member: Conn. Acad. FA; Gloucester SA; North Shore AA; Boston AC. Exhibited: Conn. Acad. FA, 1917 (prizes), 1921 (prize); Swedish Cl. Chicago, 1929 (prize). Work: Beach Mem. Coll., Storrs, Conn.; Pub. Lib. Canaan, Conn.; decoration, Town Hall, Manchester, Mass. [40]

ANDERSON, Percy E. [I] NYC. Member: SC [25]

ANDERSON, Peter [C] Ocean Springs, MS b. 22 D 1901. Studied: E. de F. Curtis; Charles F. Binns. Specialty: pottery: throwing, glazing, and firing [40]

ANDERSON, Peter Bernard [S,T] St. Paul, MN b. 3 N 1898, Sweden. Studied: J.K. Daniels; Académie Julian, Paris, with Buchard, Landofski. Member: Minn. State AS. Exhibited: Minn. State AS, 1922 (prize); Twin City Art C. (prize); Minn. State Fair, 1920 (prize); 1921 (prize); 1922 (prize) [33]

ANDERSON, Ray(mond Henning) [P] Wilkinsburg, PA b. 16 Ap 1884, Bradford, PA. Studied: Stevenson A. Sch.; Cap Cod A. Sch. Member: Pittsburgh AA [25]

ANDERSON, Ronald [P,I,W] b. 1886, Lynn, MA d. 12 N 1926, South Norwalk, CT. Studied: AIC; Eric Pape; George Lawlor. Member: Gld. Free Lance Ar.; Soc. Illus. Designer: covers, Woman's Home Companion, Delineator, Saturday Evening Post, Collier's, McCall's, Literary Digest

ANDERSON, Ruth A. (Mrs. Samuel Temple) [P] Hatchville, MA b. Carlisle, PA. Studied: Anshutz; Breckenridge; Cecilia Beaux; Chase; Jonas Lie. Member: F., PAFA; North Shore Arts Assoc.; Boston GA.; Wash. SA.; Plastic C. Exhibited: N.A. Women PS, 1922 (prize); North Shore AA, 1930 (prize). Work: PAFA [40]

ANDERSON, Ruth Bernice [P,E] Indianapolis, IN b. 7 Jy 1914, Indianapolis. Studied: John Herron A. Sch. Member: Ind. A. Cl.; Hoosier Salon; Tucson FA Assn. Exhibited: All State Exh., Tucson, 1937 (prize); Hoosier Salon; Ind. A. Cl.; Tucson FA Assn. [47]

ANDERSON, S. McC. (Mrs.) [P] New Orleans, LA [21]

ANDERSON, Tennessee Mitchell [S] b. Jackson, MI d. 20 D 1929, Chicago. Member: Chicago A. Cl.; Chicago No-Jury Soc. Ar.; Romany Cl.

ANDERSON, Vera Stevens. See Stevens, Vera.

ANDERSON, Victor Coleman [P,I] White Plains, NY/Altamont, NY b. 3 Jy 1882, Peekskill, NY d. 9 Jy 1937, White Plains. Studied: Pratt Inst.; Birge Harrison; Hobart Nichols; Herman Dudley Murphy. Member: SC; Westchester A.&Crafts G.; Chappaqua A.&Craft G.; New Rochelle AA; Grand Central A. Gal. Exhibited: Buck Hill AA, Buck Hill Falls, Pa., 1934 (prize); SC Auction Exh., 1935 (prize) [38]

ANDERSON, V(iola) Helen [P] Attleboro, MA b. Redfield, SD. Studied: Fontainebleau Sch. FA; A.W. Heintzelman; C.W. Hawthorne. Member: Conn. Acad. FA. Exhibited: portrait, Kansas City AI, 1923 (prize); oil, Springfield, AL, 1937 (prize) [40]

ANDERSON, Walter Inglis [D,P,Dec,Cer,S] Ocean Spring, MS b. 29 S 1903, New Orleans. Member: F., PAFA. Work: murals, school, Ocean Springs, Miss. Designer: pottery and block prints for textiles [40]

ANDERSON, Zanna [P] NYC b. 10 F 1917, Holdrege, NE d. Ag 1955. Studied: NAD, with Karl Anderson, Charles C. Curran. Member: NAWA. Exhibited: All.A.Am., 1935–37; Swedish-Am. Exh., 1939, 1940, 1941, 1946; Phila. WC Cl., 1939; NAWA, 1946; NAD, 1940, 1943, 1944; Five-States Exh., Omaha, 1936, 1937; Nebr. AA, 1937, 1938. Work: Fed. Court Bldg., Lincoln, Nebr.; Columbia Univ. [47]

ANDRADE, Mary Fratz (Mrs.) [P,I,T] Jenkintown, PA b. Phila.. Studied: Robert Vonnah, Henry Thouron, Thomas Anshutz, Mucha, in Paris. Member: F., PAFA; Phila. All.; Art T. Phila. [33]

ANDRÉ, Renée (Miss) [P] NYC b. France. Studied: ASL; Robert Henri; George Bellows. Exhibited: Am. WC Soc., 1936. Work: MMA [40]

ANDREAE, Vera Romaine [S] Cincinnati, OH [09]

ANDREASEN-LINDBORG, Ingeborg (Mrs.) [P,E] Stockholm b. 10 Ag 1876, Hjörlunde, Denmark. Studied: AIC; Royal Acad. Denmark; Colarossi, in Paris. Member: Chicago SE; Danish and Swedish Graphical Societies. Exhibited: Royal Acad. Denmark (gold); Baltic Exh., (med). Work: Nat. Mus., Stockholm; Roy. Lib., Copenhagen [25]

ANDREEN, Axel A. [P] Chicago, IL [04]

ANDRES, Charles John [I] North Berwick, ME b. 1913, Hastings-on-Hudson, NY. Studied: H. Dunn, 1936–40; T. Fogarty; F. Reilly. Illustrator: Zane Grey novels [*]

ANDRESON, Carlos [P,Li,T] NYC b. 1 My 1905, Midvale, Utah. Studied: Académie Julian, Paris; Charles Fuetsch. Exhibited: WMAA, 1937, 1938; PAFA, 1937; BM, 1937; AIC, 1938; NGA, 1940; Lib. Cong., 1939, 1940; U.S. Navy Traveling Exh., 1941; Assoc. Am. A. Gal., 1939 (one-man). Work: MMA; Princeton; BM; Utah State Inst. FA; U.S. Navy Dept. Position: T., Utah State A. Center, 1938 [47]

ANDRESEN, Lois E. (Mrs.) [P,I,T] Brooklyn, NY [09]

ANDREW, Richard [P,T,L] East Gloucester, MA b. 9 Ja 1869, Belfast. Studied: Mass. Normal A. Sch.; Académie Julian, Paris; BAID, with J.L. Gérôme; Laurens. Member: Gld. Boston A.; Gloucester Soc. A. Exhibited: Albright A. Gal.; Lowell (Mass.) AA; PAFA; CAM; CGA; WMA; CM; BMFA. Work: mural, Hall of Valor, State House, Boston. Position: Hd. Dept. A., Mass. Sch. A. [47]

ANDREWS, Bernice. See B.P.A. Fernow, Mrs.

ANDREWS, Charles Sperry, 3rd [P,G,T] Bronxville, NY/Faust, NY b. 5 O 1917, NYC. Studied: Nat. Acad.; Tiffany Fnd. Member: Soc. Indp. A.; Allied Ar. Am.; Acad. All. A.; Bronxville ALg.; Saranac ALg. Exhibited: Nat. Acad., 1938; Am. Fed. A. Traveling Exh.; Acad. All. A. Spring Salon [40]

ANDREWS, Claude Y. [P] Peru, IN. Studied: Franklin Col.; Univ. Mich.. Exhibited: Hoosier Salon, 1945 [47]

ANDREWS, Edna Rozina [Edu,P,E] Syracuse, NY b. 6 Ap 1886, Pulaski, NY. Studied: Syracuse Univ. Member: Assoc. A. Syracuse; NAWA; Rockport AA; Eastern AA; Syracuse Pr.M.; Nat. Edu. Assn.; Daubers Cl. Exhibited: N.Y. State A. Exh., Cortland, 1945 (prize); SAE, 1945, 1946; NAWA, 1944–46; Assoc. A. Syracuse; Syracuse Pr.M.; N.Y. State A. Exh., 1945, 1946; Finger Lakes Exh., 1944. Work: Cornell Univ.; Cal. State Lib. Position: T., Syracuse Pub. Sch., 1938–46 [47]

ANDREWS, Ellen R. [P] Minneapolis, MN [21]

ANDREWS, Eliphalet Frazer [P] b. 1855, Steubenville, OH d. 19 Mr 1915, Wash. D.C. Studied: Marietta Col; Düsseldorf Acad.; Ludwig Knaus; Bonnât, in Paris. Member: Metropolitan Cl., Wash., D.C. Under the patronage of the late W.W. Corcoran he founded the Corcoran School of Art, of which he was the director from 1877 until 1902. He painted several of the portraits now in the White House.

ANDREWS, Gwynne M. [Patron] d. 10 Ag 1930, NYC. He bequeathed approximately $350,000 and eventually all of his works of art to the Metropolitan Museum of Art. The works include collections of Gothic, Greek, Roman and Italian sculpture and coins, Renaissance medals, an ancient manuscript of the Koran, and other art treasures. The "Gwynne Andrews Fund" will be established for the purchase of paintings of the Italian school.

ANDREWS, Helen F. [P,E] Farmington, CT b. 22 D 1872, Farmington. Studied: ASL; Académie Julian, Paris, with Jean Paul Laurens; Constant, in Paris. Member: Conn. Acad. FA; Deerfield Valley AA. Exhibited: Conn. Acad. FA, 1914 (prize) [47]

ANDREWS, Iris M. [I] Kenton, OH [19]

ANDREWS, J. Winthrop [P,T] Yonkers, NY/Chicopee, MA b. 31 Ag 1879, Newtonville, MA. Studied: Mass. Sch. A.; DuMond; Hamilton, De Camp. Member: Yonkers AA; Eastern AA. Position: Dir. A., Yonkers public schools [33]

ANDREWS, Marietta Minnegerode (Mrs.) [A,W] b. 11 D 1869, Richmond, VA d. 7 Ag 1931, near Alexandria, VA. Studied: Corcoran Sch. A, with Eliphalet Fraser Andrews (a former director of the school and the man she later married); William M. Chase; Luigi Chialiva, in Paris; Ernest Lieberman, Munich. Work: stained glass windows, St. Paul's Chuch, Steubenville, Ohio; Am. Soc. Psychical Res., NYC; Univ. Va., Charlottesville; Concordia Lutheran Church, George Washington Univ., Wash. D.C. Author/Illustrator: "The Memoirs of a Poor Relation," "My Studio Window," and other works, pub. Dutton; pageants; poems

ANDREWS, Martha Bailey Hawkins (Marnie) [S,T,W] Pensacola, FL / Raleigh, NC b. 7 Ag 1908. Studied: Meredith Col., N.C.; State College,

N.C.; So. Sch. Creative A. Member: Pensacola AIn.; Pensacola ACl. Exhibited: S.C. State Fair, 1931 (prize); N.C. Fed A., 1931 (prize); Pensacola A. Center. Work: bas-relief, St. John's Episcopal Church, Warrenton, Fla.; busts, Pensacola A. Center. Contributor: Pensacola "News-Journal" Position: Instr., Pensacola A. Center [40]

ANDRIEU, Jules [P,S] Pass Christian, MS b. Mr 1844, New Orleans. Studied: Ernest Ciceri [01]

ANDRUS, Alice [P] Cleveland Heights, OH. Member: Women's A. Club Cleveland [21]

ANDRUS, J. Roman [Edu,Li] Provo, UT b. 11 Jy 1907, St. George UT. Studied: Otis AI, with Eduard Vysekal, Roscoe Shrader; Brigham Young Univ.; Colorado Springs FA Center. Member: Assoc. Utah A. Exhibited: Brigham Young Univ., 1940-42 (prize); Utah State Inst. FA, 1945 (prize); Calif. State Fair, 1939; Otis AI, 1938, 1939 (prize); Assoc. Utah A., 1940-45; Springville (Utah) Exh., 1939-46; Cedar City Exh., 1943-46; Dixie Jr. Col., St. George, Utah, 1939-46. Work: Utah State Capitol Coll.; Dixie Jr. Col.; Brigham Young Univ. Position: Instr. A., Brigham Young Univ. [47]

ANDRUS, Vera [P,Li,I] Dobbs Ferry, NY b. 9 D 1896, Plymouth, WI. Studied: Univ. Minn.; St. Paul Sch. A.; Minneapolis AI; ASL, with Boardman Robinson, George Grosz. Member: NAWA; Gloucester SA; Creative A. Assoc.; Hudson Valley AA; Westchester G.; NAWPS; So. Pr.M. Soc.; Salons of Am. Exhibited: Minneapolis Inst. A., 1928 (prize); NAWA, 1941 (med); Hudson Valley AA, 1941 (prize) 1943 (prize), 1944 (prize); WMAA; PAFA; AIC; MMA. Work: MMA; Minneapolis Inst. A.; Lyman Allyn Mus., New London, Conn.; LOC. Author/Illustrator, "Sea-Bird Island," 1939. Position: staff, MMA, 1931-46 [47]

ANDRUS, Zoray (Mrs. Eric Kraemer) [P,S,Des,C,I] Virginia City, NV b. 27 Ap 1908, Alameda, CA. Studied: Calif. Col. A.&Crafts; Univ. Calif., with Hans Hofmann; Mills Col., with Alexander Archipenko. Member: Calif. WC Soc. Exhibited: Denver A. Mus., 1941, 1942 (prize); Virginia City, Nev., 1945; Reno, 1943; San Fran. AA, 1943-45; Calif. WC Soc., 1942-44. Costume Des., Fed. Theater Proj., San Fran. [47]

ANGAROLA, Anthony [P] Chicago b. 4 F 1893 d. 15 Ag 1929. Studied: A. Inst. Chicago. Exhibited: Chicago Soc. Ar., 1921 (prize), 1925 (med, prize); A. Inst. Chicago, 1921 (prize); Twin-City Exh., A. Inst. Chicago, 1925 (prize); Chicago A. Gld., 1926 (prize)

ANGEL, John [S,T,L,I] Sandy Hook, CT b. 1 N 1881, Newton Abbott, Devon, England d. 1960. Studied: Albert Mem., Cheltenham; Royal Acad. A. Schs.; George Frampton; Thomas Brock. Member: F., Royal Sch. Brit. S.; ANA; A. Workers Gld.; NSS; Arch. Lg.; Century Assn.; Mediaeval Acad. Am. Exhibited: sculpture, Royal Acad., London, 1911 (gold), 1912-27; PAFA, 1938. Work: busts, statues, panels, groups for churches in Oxford, Yorkshire, Exeter, Bridgewater, Rotherham; Albert Mem. Mus., Exeter; bronze, Inst. FA, Glasgow; sculpture, Cathedral St. John the Divine, NYC; East Liberty Presbyterian Church, Pittsburgh; statues, Houston, Austin, Tex.; Vincennes, Ind.; St. Louis, Mo.; Concord, N.H.; Chicago; Indianapolis; Phillip's Acad., Andover, Mass.; Yale Univ. Illustrator: article on cathedral sculpture in "The Cathedral Age." Lectures: sculpture [47]

ANGEL, Rifka [P] NYC b. 16 S 1899, Calvaria, Russia. Studied: ASL, with Boardman Robinson; Moscow A. Acad. Member: Chicago NJSA; Chicago SA; Am. A. Cong. Exhibited: AIC, 1931, 1933 (prize), 1935, 1939; MOMA, 1934; WMAA, 1934; WFNY, 1939; Honolulu Acad. A., 1941 (one-man); Nelson A. Gal.; Findlay Gal. (one-man); CAM, 1945 (prize); Chicago A. Soc., 1934 (med). Work: AIC; Honolulu Acad. A. [47]

ANGELA, Emilio [S] Chatham, NJ b. 12 Jy 1889, Italy. Studied: Columbia Univ.; Cooper Union; ASL; NAD; MacNeil; Calder; Weinman; Brenner. Member: NSS; Arch. Lg. [47]

ANGELL, Clare [I] NYC

ANGELL, George R., Mrs. See Whilte, Jessie Aline.

ANGELL, Louise M. [P,C,T] Fall River, MA b. 17 Ag 1858, North Providence, RI. Studied: R.I. Sch. Des; Eckhardt, in Dresden. Member: Providence AC

ANGELO, Emidio [Car] Phila., PA b. 4 D 1903, Phila. Studied: George Harding; Henry McCarter. Member: PAFA; DaVinci All.; Phila. All. Cartoonist: Saturday Evening Post, Collier's, Life, Judge, Ballyhoo, College Humor, serially in Sales Management, Bell Telephone News, Public Ledger, Philadelphia Inquirer; comic strip "Uncle Dominick." Lectures: animated cartoons, "Cartoons and Caricatures" [40]

ANGELO, Valenti [P,D,E,Dec,I] NYC b. Massarosa, Tuscany, Italy. Studied: self-taught. Member: AI Graphic A. Work: illustrations, woodcuts, "Leaves of Grass," Walt Whitman, pub. Grabhorn Press, other books; hand illuminations, Golden Cross Press, Bronxville, N.Y. [38]

ANGMAN, Alfons J(ulius) [P,S,W] New Orleans, LA b. 14 Ja 1883, Stockholm. Studied: self-taught. Member: NOAA; College AA, AFA [40]

ANGOOD, May LaBarre [P,E,Li,T] Omaha, NE b. Fremont, NE. Studied: AIC; Augustus Dunbier. Member: Nebr. ATA; Friends of Art, Omaha. Position: T., Univ. Omaha [40]

ANISFELD, Boris [S,Li,P,C,T] Chicago, IL/Central City, CO Member: Salon d'Automne, Paris. Exhibited: AIC, 1937 (prize). Work: BM; Gardner Mus., Boston; Albright A. Gal, Buffalo; AIC; Los Angeles A. Assn. Positions: Instr., Sch. AIC; Dir., Boris Anisfeld Summer Sch. A., Central City [40]

ANKENEY, John S(ites) [P,L,T,W] Columbia, MO/Estes Park, CO b. 21 Ap 1870, Xenia, OH d. 16 My 1946. Studied: Twachtman; Chase; DuMond; Saint Gaudens; Ross; Lefebvre, Aman-Jean, Menard, in Europe. Member: NAC; Am. APL; Col. AA; Am. Fed. A.; Chicago Gal. Assn. Exhibited: watercolor, NOAA, 1936 (prize). Work: Univ. Mo; Bethany Col., Lindsborg, Kans.; Lindenwood Col., St. Charles, Mo.; Carl Milles Coll., Cranbrook, Mich.; Christian Col., Columbia, Mo. [40]

ANKROM, Francis [P] San Antonio, TX. Work: USPO, Canyon, Tex. WPA artist. [40]

ANNAN, A. Hawthorne [P] NYC b. NYC. Studied: Henry B. Snell; Hugh Breckenridge. Member: Gloucester AA; North Shore AA [40]

ANNAN, Abel H. [P] NYC. Member: Chicago WCC

ANNAN, Alice H. [P] NYC b. NYC. Studied: ASL; Henry B. Snell; Ben Foster. Member: Chicago WCC; N.Y. Pen and Brush C.; North Shore AA. Work: Poland Spring Gallery

ANNAN, Sylvester Papin [P,C,Arch] Grove, MO b. 11 My 1865, St. Louis. Studied: Boulanger, Lefebvre, Luigi Loir, in Paris. Member: St. Louis Arch. C.; St. Louis AG

ANNEN, Helen Wann (Mrs. Peter J.) [Edu,P,I,W,L] Madison, WI b. 23 N 1900, Fairplay, MO. Studied: Univ. Okla., with Oscar Jacobson; Univ. Wis.; Calif. Sch. FA; Broadmoor Acad., with Birger Sandzen. Member: Wis. P.&S.; Madison AA; Am. A. Fed. Exhibited: Univ. Okla., 1919 (med); Madison AA, 1940 (prize); Wis. Salon, 1945 (prize); Wis. State Fair, 1940 (prize), 1942 (prize), 1943 (prize); Seven A. Cl.; Milwaukee AI. Work: Madison AA; Wis. State Journal Coll. Lectures: Techniques of Watercolor. Illustrator: children's books. Position: Assoc. Prof. A., Univ. Wis., 1925-46 [47]

ANNETT, Ina [P,B,Li,I] Norman, OK b. 4 Ag 1901, Cleveland, OK. Studied: O.B. Jacobson; George Bridgman; Romanoffsky. Member: Assn. Okla. A. Exhibited: graphic arts, Denver AC, 1931 (prize); watercolor, Okla. State Fair, 1933 (prize). Work: lithograph, Smoky Hill A. Cl., Lindsborg, Kans.; oil and batik, Univ. Okla. Illustrator: "Folk Say 1930," ed. Ben Botkin; cover and designs ,"Forgotten Frontiers," Alfred B. Thomas, pub. Univ. Okla. Press. Position: T., Univ. Okla. [40]

ANNIQUET, Charles [P] Woodstock, NY

ANNIS, John B. [P] Cleveland, OH. Member: Cleveland SA

ANNISON, Edward S. [I] NYC. Member: SI

ANNOT, [P,I,L,T,Dec] NYC b. 27 D 1894, Berlin. Studied: Louis Corinth; André Lhote. Member: NYSWA. Work: oils and watercolors, German museums. Author/Illustrator: German publications. Lectures: painting; radio talks [40]

ANSBACHER, Jessie [P,T] NYC b. Wilkes-Barre, PA d. 1964. Studied: N.Y. Sch. A., with William Chase, Joseph Pennell, McCartain; Auerbach-Levy. Member: NAWPS. Exhibited: Anderson Gal., 1921; Milch Gal., 1944 (one-man). Work: portrait, Guggenheim Fnd. Position: Dir. & T., Jessie Ansbacher A. Sch. 1933-46 [47]

ANSHUTZ, Thomas Pollock [P] Ft. Washington, PA b. 5 O 1851, Newport, KY d. 16 Je 1912. Studied: Nat. Acad. Des., New York; PAFA; Doucet, Bouguereau, in Paris. Member: F., PAFA; Phila. WC Cl.; New York WC Cl. Exhibited: A. Cl. Phila., 1901 (prize); St. Louis Expo, 1904 (med); PAFA, 1909 (gold,prize); Buenos-Aires Expo, 1910 (gold) Position: T., PAFA

ANSHUTZ, Elsa Martin [P,T] St. Petersburg, FL b. Pittsburgh, PA. Studied: Cleveland Sch. A.; BMFA Sch. Exhibited: Carnegie Inst.; A. All. Am. (one-man); NAD; Gloucester SA; St. Augustine AC (one-man); St. Petersburg AC (one-man); Fla. Fed. A.; Boston Conservatory (one-man); North Shore AA; Clearwater A. Mus.; Fla. Gulf Coast Group

Traveling Exh. Position: A. Dir., Sch. Creative Arts, East Gloucester, Mass. [47]

ANSLEY, Don L. [P] Chicago, IL. Member: Chicago NJSA

ANTHON, Jane Marie [Li,P] NYC b. 1 S 1924, Yakima, WA. Studied: Portland (Oreg.) Mus. A. Sch.; Cornish A. Sch., with Emelio Amero; ASL, with Will Barnet. Exhibited: Lib. Cong., 1945; Portland A. Mus., 1943; Cornish A. Sch., 1944, 1945 [47]

ANTHONY, Andrew V.S. [P] d. 1906. Member: Am. WC Soc. New York; Century Assoc.

ANTHONY, Elisabeth Mary [P,Des,T,W] Hackensack, NJ b. 7 N 1904, NYC. Studied: NYU; NAD, with Charles Hawthorne, Ivan Olinsky; In. United Ar. Member: Hackensack ACI; N.J. A. Professional Lg.; Englewood AC. Exhibited: Montclair A. Mus.; PAFA; Montross Gal.; Contemporary A. Gal.; Dec. Cl. Gal., New York (one-man); Position: T. A., Englewood & Paterson, N.J. schools [47]

ANTHONY, Ernest Edwin [P,I,T] Swampscott, MA b. 26 S 1894, Providence, R.I. Studied: R.I. Sch. Des. Member: Copley Soc. Position: T., BMFA Sch. [40]

ANTHONY, Hale Bower [P,T,L] Rockport, MA b. 2 N 1900, Chelsea, MA. Studied: Mass. Sch. A., BSE; Tufts Col., with Charles Martin. Member: North Shore AA; Rockport AA; Eastern AA. Exhibited: North Shore AA; Jordan-Marsh, 1945, 1946; Rand Gal.; Rockport AA. Work: murals, Rockport, Worcester, Mass. [47]

ANTHONY, Ripley O. [P] NYC

ANTLERS, Max H. [P,I,T] NYC b. 2 My 1873, Berlin. Studied: Lefebvre, Robert-Fleury, in Paris. Member: SC

ANTMAN, Jacob [P] Chicago, IL b. 23 D 1913, Poland. Studied: AIC, with Boris Anisfeld. Exhibited: AIC, 1938, 1940, 1946 [47]

ANTONIA, Tamara [P,Dec,L,T] Berkeley, CA b. Russia. Studied: Univ. Calif; Hans Hofmann, in Munich. Member: San Fran. Mural S.; Nat. Lg. Am. Pen W. Work: landscape, M.H. de Young Mem. Mus., San Fran. [47]

ANTREASIAN, Garo Zareh [P,I,Li] Indianapolis, IN b. 16 F 1922, Indianapolis. Studied: John Herron AI. Exhibited: Hoosier Salon, 1944 (prize); Wash. Herald Exh., 1945 (prize); Ind. A., 1946 (prize); SFMA, 1942; Tex. Pr.M., 1942; NAD, 1943; Kans. Pr.M., 1942; Armed Forces Exh., Albany, N.Y., 1944; Ohio Valley WC Soc., 1944; Hoosier Salon, 1944; Ind. A., 1944, 1946. Work: U.S. Coast Guard Acad., New London, Conn. [47]

ANTROBUS, John [P] d. 18 O 1907, Detroit, MI. He had lived in Chicago and Washington.

APEGIAN, Avides M. [P] Fitchburg, MA

APEL, Marie (Mrs.) [S] NYC. Member: NAWPS; Eclectics

APGAR, Nicolas Adam [P] Slingerlands, NY b. 8 Dec 1918, Gaillon, Eure, France. Studied: Syracuse Univ. Member: Albany A. Group. Exhibited: Oakland A. Gal., 1944; Albany Inst. Hist.&A., 1939–44; 1946; Schenectady, N.Y., 1945, 1946; Jackson, Miss., 1943 [47]

APOSTLE, James [P,I] Thompsonville, CT b. 17 F 1917, Thompsonville. Studied: Am. Intl. Col. Member: Springfield A. Lg. Exhibited: Springfield A. Lg., 1939–45; A. Gld., 1943–45; Little Gal., Springfield (one-man) [47]

APPEL, Charles P. [P] East Orange, NJ b. 11 Jy 1857, Brooklyn, NY. Studied: Chase; Mora. Member: SC, 1906

APPEL, Jack [S] NYC b. 28 O 1911. Studied: NYU; BAID; Cecere; Snowden; Manship; Piccirilli. Specialty: Australian animals [47]

APPEL, Marianne (Mrs. M.A. Mecklem) [P,I] Woodstock, NY b. 6 My 1913, NYC. Studied: Woodstock Sch. P.; Peppino Mangravite; B. Walter Tomlin; Henry Mattson; Charles Rosen; Henry Lee McFee; Judson Smith. Member: Woodstock AA. Exhibited: Woodstock AA, 1938 (prize); Carville, La., 1940 (prize); Dutchess County Fair, 1935 (prize); CGA, 1940, 1941; WMAA, 1938–44; AIC, 1938–42; Carnegie Inst., 1941–44; AFA Traveling Exh., 1942; Milch Gal. Work: MMA; Marine Hosp., Carville, La.; USPO, Middleporte, N.Y.; Wrangell Ala. Illustrator: commercial and art magazines [47]

APPEL, Viola [P] East Orange, NJ b. 27 Jy 1897, Jersey City Heights, NJ. Studied: Gustave Cimiotti; John Grabach. Member: NAWPS. Exhibited: Contemporary Gal., Newark, 1936 (prize), 1937 (prize), 1938 (prize); Municipal Exh., Irvington, N.J., 1937 (prize). Position: Asst. Dir., N.J. Gal., Kresge Dept. Store, Newark [40]

APPLEBEE, Frank Woodberry [P,E] Auburn, AL b. 2 Je 1902, Boston. Studied: Mass. Sch. A.; Ala. Polytech. Inst.; Charles Martin; Ralph Pearson; Ernest L. Major; Joseph Cowell; John Sharman. Member: Ala. A. Lg.; SSAL; Ala. EC Soc.; Scarab C.; Birmingham AC. Exhibited: Rockefeller Center, N.Y., 1936; Corpus Christi, Tex., 1946; Ala. Col. for Women, 1938 (prize), 1939; SSAL, 1939, 1945; Ala. AL, 1933 (prize), 1934–46. Work: Montgomery Mus. FA; Ala. Col. for Women; Ala. Polytech. Inst. Position: T., Ala. Polytech. Inst., Auburn, 1932–46 [47]

APPLEGATE, Frank G. [S,C] b. 9 F 1882, Atlanta d. 13 F 1931, Santa Fe, N.M.. Studied: PAFA, with Grafly; Verlet, in Paris. Member: N.M. Painters, 1923; Santa Fe Ar.

APPLETON, Eliza Haliburton (Mrs. Everard) [S] Providence, RI/Rumford, RI b. 9 N 1882, East Providence, RI. Studied: R.I. Sch. Des., with Atkins; Jane Hammond; Moses Ezekiel; Maccagnani, Bompiani, in Rome. Member: Providence AC [40]

APTHORP, Louise L. [P] Cambridge, MA/Georges Mills, NH b. 1 D 1878, Orange, NJ. Member: Copley S.; North Shore AA; Boston S.Indp.A.

AQUADRO, Frederica [P] St. Louis, MO

ARAPOFF, Alexis [P] Cambridge, MA b. 1904, St. Petersburg. Studied: Sch. FA, Saratov, Russia. Exhibited: Worcester M., 1938; In. Mod. A., Boston, 1939; WFNY, 1939. Work: Mus., Strasbourg, France; Works Progress, Adm., Cambridge, Mass. [40]

ARBUCKLE, Gladys [P] Indianapolis, IN

ARCHAMBAULT, Anna Margaretta [P,L,W,Por.P,Min.P,T] Middlebury, VA b. Phila. Studied: PAFA; Académie Julian, Paris; Debillemont-Chardôn, in Paris; Longstreth Sch., Phila. Member: Pa. Soc. Min. P.; Phila. Plastic Cl. Exhibited: Pa. Soc. Min. P., 1922 (med), 1925 (prize); PAFA, 1941 (prize); Royal Min. Soc., London. Work: Butler AI, Youngstown, Ohio; Univ. Pa.; U.S. Naval Acad.; Treasury Bldg., Wash., D.C.; Independence Hall, Phila. Author: "Art, Architecture, and Historic Interest in Pennsylvania." Lectures: History of Miniature Painting. Position: Dir., Phila. Sch. Miniature Painting [47]

ARCHBOLD, Geoffrey Charles [Des,B,I,W] NYC b. 1 O 1902, Decatur, IN d. 5 D 1938. Studied: AIC; Cleveland Sch. A. Member: Cleveland PM. Work: stencil prints in color, CMA. Author: articles in Magazine of Art, School Arts Magazine, Design, Popular Mechanics; headings and vignettes, New Yorker, Stage, Esquire, Life, Vanity Fair, other magazines [38]

ARCHER, Edmund Minor [P,T,L] Richmond, VA b. 28 S 1904, Richmond. Studied: Colarossi Acad., in Paris; Univ. Va.; ASL, with Kenneth Hayes Miller, Allen Tucker. Member: ASL; NSMP. Exhibited: CGA, 1930 (med); VMFA, 1936 (prize), 1941 (prize); Corcoran Gal., 1930 (med); PAFA; AIC; WMAA; WFNY, 1939; NAD. Work: BMFA; WMAA; VMFA; Fisk Univ. Mus.; Univ. Mich.; State Capitol, Richmond, Va.; USPO, Hopewell, Va. Positions: Asst. & Assoc. Cur., WMAA, 1930–40; Instr., Corcoran Sch. A.; Prof., George Washington Univ. [47]

ARCHIBALD, David Gray [P] NYC

ARCHIBALD, Julia Logan [P] NYC. Exhibited: Am. WC Soc. Ann., 1937, 1938; Nat. A. Cl.; Flower Paintings Exh., 1939 [40]

ARCHIPENKO, Alexander [S,T,L] NYC b. 30 My 1887, Kiev, Russia d. 1964. Studied: A. Schools in Kiev and Moscow; Ecole des Beaux-Arts, Paris. Exhibited: U.S.; Europe. Work: mon., Pub. Gardens, Cleveland; museums in Frankfort, Mannheim, Leipzig, Moscow, Essen, Hamburg (Germany), and Osaka, Japan; Vienna; Rotterdam; Kiev; Nat. Gal., Berlin; Brooklyn, N.Y. Author: 8 monographs. Inventor: "animated painting," known as "Archpentura." Founder: Ecole d'Art, NYC, 1923. Position: Dir./T., Archipenko Sch. A., NYC [47]

ARCIERI, Charles F. [P,I] Grantwood, NJ b. 11 N 1885, San Fran. Studied: Charles Judson; Frank Van Sloun; Theodore Wores

ARDISSON, Gaitan [S] b. France d. 19 Ag 1926, Wheatley Hills, NY

ARDOLINO, Ralph J. [S] b. 1876, Italy d. 15 Ja 1937, Long Branch, NJ. Work: mem., Wash., D.C.; altar, St. Thomas's Church, NYC; mon., Oyster Bay, N.Y.

ARELLANO, Juan M. [P] Phila., PA

AREND, Carl H. [P] Slingerlands, NY b. 19 F 1910, Brooklyn, NY. Member: Albany A. Group. Exhibited: Albany Inst. Hist.&A., 1942 (prize) [47]

ARENS, Egmont [Indst.Des,L,W] NYC b. 15 D 1887, Cleveland. Studied: Univ. N.M.; Univ. Chicago. Member: F., Soc., Indst. Des.; Art. Dir. C.; Adver. C.; Nat. Assn. Art Edu.; AFA. Work: WFNY, 1939; lamps for the

machine age, reproduced in House and Garden, Vogue, Good Housekeeping, Charm, Harpers Bazaar, etc. Author: "Consumer Engineering," pub. Harper's, and articles on design for trade and commercial publications. Lectures: package design, etc. Position: Pres., Plastic Boats, Inc. [47]

ARGYROPEDON, Emanuel [P] NYC. Member: S.Indp.A.

ARKELL, Bartlett [Patron] b. 1862, Canajoharie, NY d. 12 O 1946, Bennington, VT. Bought more than 200 American paintings for Canajoharie Museum.

ARLEDGE, Sara Kathryn [P,E] Pasadena, CA b. 28 S 1911, Mojave, CA. Studied: UCLA; Columbia; Barnes Fnd. Exhibited: PAFA, 1935; AV, 1942; AIC, 1943; GGE, 1939; Los Angeles Mus. A., 1936, 1937; Philbrook A. Center, 1943. Contributor: Ariz. Quarterly. Position: Asst. Prof., A. Univ. Okla, 1943-44; Univ. Ariz., 1945-46 [47]

ARLENT-EDWARDS, S. [Messotint En] NYC. Member: SC

ARLT, Emilie M. (Mrs.) [P] Alexandria, VA b. 1892, Phila. Studied: Sch. Des. for Women, Phila.; Corcoran Gal. Sch. Exhibited: WC.Cl., Wash., D.C., 1937; Phillips Gal., Wash., D.C., 1938; Soc. Wash. Ar., 1939; Alexandria Lib. (two-man show), 1939 [40]

ARLT, Paul Theodore [P,Des] Arlington, VA b. 15 Mr 1914, NYC. Studied: Colgate Univ., with Alfred Krakusin; CGA Sch.; PMG Sch. A., with C. Law Watkins; Eugen Weisz; Burtis Baker; Job Goodman. Member: Soc. Wash. A.; A.Gld. Wash.; Wash. Ldscp. Cl. Exhibited: Soc. Wash. A., 1939 (prize); CGA, 1939 (prize); PAFA, 1939; AIC, 1942; VMFA, 1946 (prize); A.Gld. Wash.; Marine Corps Exh.; SFMA; Honolulu Acad. A.; PMG. Work: PMG; VMFA; Watkins Mem. Coll.; U.S. Marine Corps Coll.; USPO, Enterprise, Ala. Position: A. Correspondent, U.S. Marine Corps, 1944-45 [47]

ARLT, William H. [Des,T,P,L] Brooklyn, NY b. 19 Ag 1868, Breslau, Germany d. ca. 1950. Studied: Columbia Univ.; CUASch; NAD; ASL. Member: ADI; A.All.Am.; Textile Des. Gld. Positions: Instr. Des., N.Y. Textile Sch., 1918-41; Instr., Des., Columbia Univ. 1933-41; Dir. Woodstock Sch. Des., N.Y., 1921-46 [47]

ARMBRUSTER, A.E. [Scenic P] Columbus, OH. Member: Pen and Pencil Cl., Columbus, 1914; Lg. Columbus Ar.

ARMBRUSTER, Otto Herman [P,T,I] NYC b. 28 Ag 1865, Cincinnati d. 15 Ag 1908. Studied: M. Armbruster. Member: SC, 1900; Kit-Kat C.

ARMER, Ruth [P] San Fran., CA. Exhibited: San Fran. A. Assn.; 1935; San Fran. A. Assn. Ann., 1935; San Fran. A. Assn. WC Ann., 1939 [40]

ARMES, Theo. C. [P] Wash., D.C.

ARMFIELD, Maxwell [P,I,C,W,L,T] Ringwood, Hants., England b. Ringwood. Studied: Birmingham; Paris; Italy. Member: Arch. Lg.; MacDowell Cl.; Mural P. Work: Luxembourg Gal. Illustrator: Century, Asia, other publications

ARMIN, Emil [P,B,S] Chicago, IL b. 1 Ap 1883, Radautz, Romania. Studied: AIC. Member: Chicago SA; Chicago NJSA; Ten Artists (Chicago). Exhibited: Chicago SA, 1932 (med), 1935 (med); AIC, 1922, 1923, 1953. Illustrator: "Thirty-five Saints and Emil Armin," by J.Z. Jacobson, pub. L.M. Stein, Chicago [40]

ARMINGTON, Caroline H(elena) (Mrs.) [P,E] Paris, France b. 11 S 1875, Brampton, Ontario d. 25 O 1939. Studied: Académie Julian, Paris. Member: AFA; Société Nationale des Beaux-Arts; Société de la Gravure Originale en Noir. Work: etchings, NYPL; LOC; Luxembourg, Petit Palais, Paris; Brit. Mus., South Kensington, Mus., both in London; Nat. Gal., Ottawa; A. Gal., Toronto; CMA; Syracuse Mus.; Dayton A. Inst.; Bibliographie de Belgique, Brussels; Bibliothèque Nationale, Paris; Musée Carnavalet, Paris; MMA; BM; Des Moines AA [33]

ARMINGTON, Frank Milton [P,E] NYC b. 28 Jy 1876, Fordwich, Ontario d. 21 S 1940. Studied: Académie Julian, Paris, with Jean Paul Laurens, Henry Royer. Work: paintings, Musée du Jeu de Paume (Annex of Luxembourg Gal.), other French gal.; BM; Des Moines Assoc. FA; Witte Mus., San Antonio; AA, Tulsa, Okla.; Univ. Tulsa; Women's Cl., Fort Worth, Tex.; triptych, Am. Church, Paris; etchings, Lib. Cong.; NYPL; Luxembourg Gal.; Bibliothèque Nationale, Petit Palais, Paris; Brit. Mus., South Kensington Mus., London; Bibliographie de Belgique, Brussels; Na. A. Gal., Ottawa; Toronto A. Gal. [40]

ARMISTEAD, Robert [E] NYC

ARMITAGE, Elise Seeds. See Cavanna, Elise.

ARMOUR, G.O. [I] NYC

ARMOUR, Samuel E. [P,S,T] Springfield, MA b. 4 F 1890, Kibburn, England. Studied: BMFA Sch.; Vesper George; Aldro Hibbard; Harry Leith-Ross. Member: Rockport AA; Melrose A.Lg.; Springfield A.Lg. Exhibited: Am. Legion, Springfield, 1931 (prize); Rockport AA, 1924-26; Boston, 1923; Westfield, 1920; Springfield, 1931, 1934; Cent. Progress, Chicago, 1933, 1934; Springfield Women's Cl., 1938 (one-man) [47]

ARMS, Eleanor M. Deerfield, MA b. 10 Je 1864, Old Deerfield d. 1938. Member: Soc. Deerfield Industries. Specialty: rugs [38]

ARMS, Jessie. See Botke, Mrs.

ARMS, John Taylor [E,W,I,L] Fairfield, CT b. 19 Ap 1887, Wash., D.C. Studied: Princeton; MIT. Member: NA; Canadian P. E.&En.; Royal Soc. P. E.&En.; SAE; NIAD; AFA; AAPL; SSAL; Audubon A.; Southern Pr.M.; Phila. A. All.; Arch. Lg.; Am. Color Pr. Soc.; North Shore AA. Exhibited: AIA (med); Chicago SE, 1932 (prize); SSAL, 1932 (prize), 1933 (prize), 1934 (prize), 1937, 1940, 1941, 1946 (prize); etching, Phila. Pr. C. (prize); Baltimore WC Cl., 1939; Brooklyn SE; Chicago SE; NAC, 1927; Northwest Pr.M., 1940; Paris Salon, 1937; PAFA, 1935; Phila. Pr. Cl., 1935; SC, 1927; Meriden, Conn., 1941, 1945 (prize); Bridgeport A. Lg., 1945 (prize), 1946 (prize); Irvington A.&Mus. Assn., 1945 (prize); Conn. Acad. FA, 1946 (prize); P.&S. Soc., 1946 (prize). Work: Brit. Mus., Victoria & Albert Mus., both in London; Toronto A. Gal.; MMA; PMFA; Detroit Inst. A.; BMFA; FMA; AIC; BM; IBM; SAM; Carnegie Inst.; Yale; de Young Mem. Mus.; CMA; CGA; Lib. Cong.; SAE. Author: "Hand-Book of Print Making and Print Makers." Illustrator: "Churches of France," "Hill Towns and Cities of Northern Italy. Lectures: Prints: Technique, History, Value, etc. Positions: Ed., Print Dept., Print Magazine; Visiting L., Wesleyan Univ., 1938-39 [47]

ARMSTRONG, Alice (Mrs. A. Washington Pezet) [P,I,Li] Greenwich, NY b. 8 Ap 1906, Elma, NY. Studied: Skidmore Col; ASL, with George Bridgman, George Luks; NAD, with Charles Hawthorne; Grand Central Sch. A., with Wayman Adams, Harvey Dunn; Jonas Lie. Exhibited: Anderson, Gal., 1931; NAD, 1936-38; PAFA, 1937, 1938; AIC, 1937-1938; WFNY, 1939; Lib. Cong., 1945; Florence Tricker Gal., 1939; Bronx Mus. 1945. Work: AIC; PAFA [47]

ARMSTRONG, Amos Lee [P] Shreveport, LA/Many, LA b. 25 Je 1899, Many. Studied: George Bridgman; Frank DuMond; Ivan Olinsky; Thomas Benton; Michel Jacobs. Member: SSAL; Shreveport AC; Houston Sketch C.; Natchitoches Art Colony; Sketch A., Monroe La.; Am. Ar. Prof. Lg.; Studio Gl.,; Am. Assn. M. Exhibited: Natchitoches Art Colony, 1927 (prize); La. State Exh., Baton Rouge, 1938 (prize). Work: Natchitoches Art Colony Coll.; Shreveport Mus. [40]

ARMSTRONG, Barbara [P] Canton, OH/Ogunquit, ME b. 26 S 1896, Bellaire, OH. Studied: Hamilton E. Field

ARMSTRONG, C.D. [P] Pittsburgh, PA. Member: Pittsburgh AA

ARMSTRONG, Carolyn Faught [P,T] Phila., PA b. 9 Jy 1910, Asbury Park, NJ. Studied: PMSchIA. Member: Woodmere AA. Exhibited: PAFA, 1940; Phila. A. All., 1941; Woodmere A. Gal., 1941-46; Phila. AC, 1942. Work: PAFA [47]

ARMSTRONG, Catherine B. [P] Indianapolis, IN/Staunton, VA b. Anaconda, MT. Studied: Lewiston Normal, Lewiston, Idaho; Univ. Chicago; A. Fairbanks; G. Brandt; R. LaS. Coats; W. Sargent; A. Tompkins. Member: Indst. Ar. Exhibited: Ind. A.Ann., John Herron AIn., 1937; Chicago A. Exh., Navy Pier, 1939 [40]

ARMSTRONG, Charles R. [P] New Orleans, LA

ARMSTRONG, David Maitland [P,C] NYC b. 1836, Newburgh, NY d. 26 My 1918. Studied: Trinity Col,; Rome; Merson, in Paris. Member: Soc. Am. Ar. (1879); Century Assoc.; Mur. P.; Arch. Lg. N.Y. (1887); ANA, 1906. Work: chapel at Biltmore, the George Vanderbilt estate in N.C. From 1869 to 1872 he was American Consul at Rome; in 1878, director of the American section of the Art Dept. at the Paris Expo, for which he received the Legion of Honor of France. Specialty: design of stained glass.

ARMSTRONG, Estelle (R.) M(anon) [Edu,P] Nutley, NJ b. 11 May 1884, Lincoln, IL. Studied: Calif. Sch. Des.; ASL; Sch. F.&Appl. A.; AIC; William M. Chase; Charles Hawthorne; Henry B. Snell. Member: NAWA; N.J. WC Soc.; Montclair AA; St. Joseph A. Lg. Exhibited: NAD; NAWA; AWCS; Montclair A. Mus.; BM. Positions: T., New York Univ., 1927-43, Montclair A. Mus., 1943-46 [47]

ARMSTRONG, James Tarbottom (Dr.) [P] b. 1848 d. 1933, Los Angeles. Also art connoisseur, writer, and inventor. Position: Cur., Univ. Southern Calif. Mus.

ARMSTRONG, Janet Lieb [Des] Cumberland, MD b. 2 F 1908, Farmington, MN. Studied: Univ. Minn. Member: ADI. Positions: Ed., Keystone Quarterly, 1943-46; Des., Bates Fabrics, Inc. 1939-44 [47]

ARMSTRONG, Louise (Mrs.) [P] Chicago, IL. Member: Chicago SA

ARMSTRONG, Margaret Neilson [I,W] b. 24 S 1867, NYC d. 18 Jy 1944, NYC. Studied: her father, David Maitland Armstrong

ARMSTRONG, Robert I. [P] Columbus, OH. Member: Columbus PPC

ARMSTRONG, Samuel (John) [P] Stellacoon Lake, WA b. 7 N 1893, Denver. Studied: Pa. Mus. Sch. Indst. A.; Mechanics Art Inst., Rochester; J.L.G. Ferris; Albert Herter. Member: Santa Barbara AL. Exhibited: Pac. Northwest Expo, Seattle, 1927 (prize); NW Independent Salon, Seattle, 1928 (prize). Work: murals, Fox Arlington Theatre, Santa Barbara, Calif., Edward L. Doheny, Jr. Mem. Lib., UCLA; portraits, Temple of Justice, Olympia, Wash. Founded: Armstrong Sch. A., Tacoma, 1923; art ed., Tacoma News Tribune, 1918-28 [40]

ARMSTRONG, Voyle Neville [P,I,W] Wichita Falls, TX b. 26 N 1891, Dobbin, WV. Studied: Cincinnati A. Acad., with Meakin, Eschenbach, Barnhorn, Duveneck; James R. Hopkins, H.H. Wessel. Member: Cincinnati AC; SSAL. Work: Cincinnati AC [40]

ARMSTRONG, William T.L. [P,Arch] Nutley, NJ b. 10 S 1881, Belfast d. 23 Je 1934. Member: AIA; N.Y. Arch. Lg.; Soc. Beaux-Arts Architects; AWCS; NYWCC. Exhibited: AWCS (prize); Montclair Mus., 1931-32 (prize); Plainfield (N.J.) AA, 1932 (prize); Newark AC, 1932 (prize), 1934 (prize). Work: Pub. Lib., Grace Episcopal Church, both in Nutley; Brooklyn Presbyterian Church. Positions: T., Sch. Arch., Columbia Univ., NYU [33]

ARMSTRONG, William W. [P] b. 1822, Dublin d. 1914, Canada. Topographical artist for Wolseley expedition, Canadian Northwest, 1870 [*]

ARNAUTOFF, Victor Michail [P,E,Mur.P] San. Fran., CA b. 11 N 1896, Mariupol, Ukraine. Studied: Calif. Sch. FA; Diego Rivera. Member: San Fran. AA; United Am. Ar. Exhibited: San. Fran. AA, 1937 (prize), 1938 (prize); GGE, 1939; WFNY, 1939; San Fran. AA, 1929-39; AIC; Pal. Legion Honor, 1946; Toledo Mus. A.; Fnd. Western A. Work: SFMA; Albert Bender Mem. Coll.; Edward Bruce Mem. Coll.; murals, USPOs, College Station and Linden, Tex., Richmond and Pacific Grove, Calif. WPA muralist. Positions: Instr. Sculpture, Fresco Painting, Calif. Sch. FA, San Fran.; Instr. P., Stanford Univ. [47]

ARNDT, Gunter G. [Arch,S,Des,C] New Rochelle, NY b. 19 S 1903, Berlin. Studied: Fed. Acad., Berlin; New Sch. Soc. Res. Work: Hudson River Mus. [47]

ARNDT, Paul Wesley [P,Mur.P] Woodstock, NY b. 30 S 1881, Jacksonville, IL. Studied: AIC; J. Francis Smith A. Acad.; Ecole des Beaux-Arts, Paris, with Gérôme, Ferrier. Work: murals for steamships, theatres and public bldgs. [47]

ARNEST, Bernard Patrick [P,Li] NYC b. 19 F 1917, Denver. Studied: Colorado Springs FA Center; Boardman Robinson. Member: F., Guggenheim, 1940. Works: War Dept. Permanent Coll.; murals, private bldgs., Denver, Rocky Ford, Colo.; USPO, Wellington Tex. Position: Chief, War Artists, Hist. Sec., ETO, 1944-45 [47]

ARNETT, Eleanor [P] Phila., PA/Gloucester, MA b. 13 Mr 1895, Phila. Studied: PAFA; Hugh Breckenridge; Hans Hofmann, in Munich. Member: Phila. Alliance [40]

ARNHEIM, Rudolf [Edu,W] Bronxville, NY b. 15 Jy 1904, Berlin. Studied: Univ. Berlin. Member: F., Guggenheim, 1941, 1942; CAA; Am. Soc. Aesthetics; Am.Assn. Advancement Sc. Positions: T., Sarah Lawrence Col., 1943— , New Sch. Soc. Res., 1943- [47]

ARNHOLT, Waldon Sylvester [Des,Li] Ashland, OH b. 1 Ja 1909, Nankin, OH. Studied: C. Fritz Hoelzer. Work: church murals. Position: Artist/Lith., A.L. Garber Co., 1941- [47]

ARNO, Peter (Curtis Arnoux Peters) [I,Car] NYC b. 1904 d. 22 F 1968. Studied: Yale. Exhibited: AIC, 1936; London; Paris. Work: New Yorker. Cartoonist: "Peter Arno's Parade," 1929, "Peter Arno's Circus," 1931, etc. [40]

ARNOLD, Aden F. [P,T] Jefferson, IA b. 3 D 1901, Jefferson. Studied: Univ. Iowa; NAD. Member: Iowa AG. Work: portraits, Univ. Iowa, Iowa City [40]

ARNOLD, Axel [P] Chicago, IL b. 1871, Sweden

ARNOLD, Clara Maxfield (Mrs.) [P] East Providence, RI b. 5 N 1879, East Providence. Studied: Providence artists. Member: Providence AC; Providence WCC

ARNOLD, Dorothy [P] Princeton, NJ. Member: NAWPS. Exhibited: Am. WC Soc., 1933; NAWPS, 1935, 1937, 1938 [40]

ARNOLD, Edward [P,Li] b. 1824, Württemberg, Germany d. 1866, New Orleans. Worked with James Guy Evans, 1850. Work: Peabody M., Salem Mass.; La. State M.; Mariners M., Va; Smithsonian. Specialty: watercolors of marine subjects [*]

ARNOLD, Frank McIntosh [Mar.P,I] b. 1867 d. 15 F 1832, Orlando, FL. Member: SC

ARNOLD, Fred Lathrop [P] Chicago, IL

ARNOLD, Grant [P,Li,T,W] Woodstock, NY b. 24 Ap 1904, Brooklyn, NY. Studied: ASL, with Max Weber, Kenneth Hayes Miller; Syracuse Univ.; Boardman Robinson; Charles Locke. Member: ASL; Southern PM Soc.; Northwest PM. Exhibited: Phila. Pr. Cl., 1938, 1939; WFNY, 1939; NAD, 1939-41. Work: LOC; Albany Inst. Hist.&A.; NYPL; MMA. Author: "Creative Lithography," 1941. Positions: Instr., Sch. Lith., Woodstock, N.Y., 1932-40; U.S. Coast & Geodetic Survey, 1940-43 [47]

ARNOLD, Harry [P,T] Waukegan, IL b. Penzance, Cornwall. Studied: Acad. Colorossi, Paris; London. Member: S.Indp.A.; All-Ill. SFA

ARNOLD, Howard Weston [I] Westfield, NJ. Member: SI [47]

ARNOLD, James Irza [Des,G,I] Jordan, NY b. 26 Je 1887, Warners, NY. Exhibited: Soc. Am. E.; Nat. A. Cl., 1934, 1935 [40]

ARNOLD, John Knowlton [Por.P] b. 1834 d. 31 May 1909, Providence. Several governors and other distinguished men of R.I. were among his sitters.

ARNOLD, Laura Elizabeth [P] Montgomery, AL b. 2 N 1916, Montgomery. Studied: State T. Col., Troy, Ala.; Montgomery Mus. FA, with J. Kelly Fitzpatrick, Warren C. LeBron. Member: SSAL; Ala. A. Lg. Exhibited: SSAL Ann., 1938; SSAL Circuit Exh., Ala. Work: State T. Col., Troy; Montgomery Mus. FA. Position: T., Lafayette Sch., Montgomery, 1941-46 [47]

ARNOLD, Lucetta [P] Pittsburgh, PA. Member: Pittsburgh AA, 1916

ARNOLD, Newell Hillis [S,C,T,E,Li] Minneapolis, MN b. 10 Jy 1906, Beach, ND. Studied: Univ. Minn.; Minneapolis Sch. A.; Cranbrook Acad. A., with Carl Milles. Member: St. Louis A. Gld.; Minn. S. Group; Arch. Lg.; Group 15, St. Louis. Exhibited: Arch. Lg., 1937; WFNY, 1939; Minn. S. Exh., 1944; Minneapolis Inst. A., 1934-37; CAM, 1938-45; Minn. State Fair, 1939-40, 1944. Work: CAM; Walker A. Center; Monticello Col.; Univ. Minn.; Minn. Dept. Health; USPO, Abingdon, Ill.; WWII Mem., St. Louis. Position: T., Monticello Col., Godfrey, Ill., 1938- [47]

ARNOLD, Paul B. [Edu,P] Oberlin, OH b. 24 N 1918, Taiyuanfu, China. Studied: Oberlin Col. Member: CAA; Ohio Valley AA. Exhibited: AWCS, 1942; Portland Soc. A., 1942; Ohio WC Soc., 1943, 1945, 1946; Allen A. Mus., 1946 (one-man). Position: T., Oberlin Col., 1941-43, 1946- [47]

ARONSON, Boris [P] NYC b. 15 O 1900, Kiev, Russia. Studied: Ilya Machkav, Moscow; Gov. Art Sch., Alexandra Exter, in Kiev. Work: Mus. Mod. A., Kiev; Stage Des., "Walk a Little Faster," "Three Men on a Horse," "Awake and Sing" [40]

ARONSON, Cyril (Miss) [P,S,Des,T,L] Detroit, MI b. 13 Je 1918, Boston. Studied: Wayne Univ. Member: Detroit Soc. Women P.&S.; Detroit WC Soc. Exhibited: Detroit Soc. Women P.&S., 1941 (prize); AIC, 1941; Mich. A., 1940, 1941, 1944, 1945; Detroit Soc. Women P.&S. 1941-45. Positions: T., Detroit Inst. A., Wayne Univ. [47]

ARONSON, David [P] Boston, MA b. 28 O 1923, Shilova, Lithuania. Studied: BMFA Sch. Exhibited: Inst. Mod. A., 1944 (prize); VMFA, 1946 (prize). Work: VMFA; AIC [47]

ARONSON, Harry Harold [P,E] Paris, France/NYC b. NYC. Studied: NAD; Laurens, in Paris. Member: Paris AAA

ARONSON, Joseph [Arch,Des,W,L] NYC b. 22 D 1898, Buffalo, NY. Studied: Univ. Buffalo; Columbia; Member: ADI; Arch. Lg. Author: "Furniture & Decoration," 1936; "Encyclopedia of Furniture," 1938. Contributor: Popular Science [47]

AROOTIAN, Baidzar H. (Mrs.) [E,P] NYC b. 14 N 1899, Dardanelles. Studied: William Auerbach-Levy; Harry Wickey; NAD; ASL. Member: ASL; NAWPS; Studio Gld., N.Y. [47]

AROUNI, Lynette [P] Great Falls, MT. Exhibited: 48 Sts. Comp. [40]

ARNOW, Matson [I] NYC [24]

ARNSTEIN, Gertrude [P] San Fran., CA [24]

ARNSTEIN, Helen [P] San Fran., CA [24]

ARPA, José [P,E,Mur.P,T] San Antonio, TX b. 19 F 1868, Carmona (Seville), Spain. Studied: Acad. FA, Seville, with Eduard Cano. Work: murals, Texas Theatre, San Anotnio; San Antonio A. Lg.; A. Acad., Seville [35]

ARQUIN, Florence [P,Li,T,W,L] Chicago, IL b. 10 Je 1900, NYC. Studied: AIC; Nat. Univ. Mexico. Member: Chicago SA; Photographic Soc. Am. Exhibited: AIC, 1934–38, 1942; Biblioteca Benjamin Franklin, Mexico City, 1943 (one-man); Kansas City, 1935–38; PAFA, 1936, 1937, 1939; Chicago SA, 1934–42; Riverside Mus., 1939, 1941; Ill. State Mus., 1942; David Porter Gal., 1945–46 (traveling exh.). Work: Watson Coll.; Diego Rivera Coll., Mexico City. Author: Tech. manuals with Kodaslide sequences, Am. Council Edu. Contributor: reviews, criticism for art magazines. Lectures: Art of Latin Am.; visual aids. Positions: Mus. Instr., AIC, 1939–42; Dir., Kodachrome Slide Proj., Wash., D.C., 1944–45; to photograph and lecture in South America for Dept. State, 1945–46 [47]

ARTER, Charles J. [P] b. Hanoverton, OH d. 29 D 1923, Alliance, OH. Studied: Cincinnati; Paris. Had studios in Venice, London, and New York. Painted portraits of many famous personages; decorated by the king and queen of Italy for portraits he had made of them.

ARTHUR, Revington [P,S,I,T] Glenbrook, CT b. Glenbrook. Studied: Grand Central Sch. A.; ASL; K. Nicolaides; G.P. Ennis; A. Gorki. Member: Silvermine Gld. A.; AWCS; Darien Gld. A. Exhibited: Carnegie Inst., 1931, 1943, 1944, 1945; PAFA, 1932, 1934, 1937; VMFA, 1944, 1946; WMAA, 1945; BM, 1931, 1943; CGA, 1939, 1941; Walker A. Center, 1943, 1944; Critics Armory Show, 1945; Critics Choice, Cincinnati, 1945; NAD, 1944. Work: BM; Telfair Acad. Position: Instr., A., NYU courses, Chautauqua, N.Y. [47]

ARTHUR, Robert [P] NYC b. 1850, Phila. d. 20 O 1914. Studied art in Antwerp and Paris, where he was an intimate friend of Robert Louis Stevenson. Summered at Ogunquit, Maine, where he had his studio. He was member of the Century Cl. and the Salma. Cl.

ARTHURS, Stanley (Massey) [Mur.P,I] Wilmington, DE b. 27 N 1877, Kenton, DE. Studied: Howard Pyle. Member: SC; Wilmington SFA. Work: Capitol, St. Paul, Minn.; Univ. Del., Newark; Capitol, Dover, Del.; Rochester (N.Y.) Athenaeum & Mech. Inst.; Wilmington Soc. FA; American Cl., Shanghai. Author: "On the Old Boston Post Road," "Early Steamboat Days," etc. Illustrator: "The Bigelow Papers," "The Children's Longfellow," historical works [40]

ARTINE. See Smith, Robin Artine.

ARTINGSTALL, Margaret [P] Chicago, IL. b. 1883. Studied: AIC

ARTZYBASHEFF, Boris [I,P,Des,En,W] NYC b. 25 My 1899, Kharkov, Russia d. 17 Jy 1965. Studied: Tenishev Sch., St. Petersburg. Member: Grolier Cl.; SI; AIGA. Illustrator: books by Edmund Wilson, Padriac Colum, Tagore, Balzac, others. Author/Illustrator: "Seven Simeons," pub. Viking, "Poor Shaydullah," pub. Macmillan, other books. Illustrator: Time, Life, Fortune [47]

ASANGER, Jacob [P,E,C] NYC/Browning, MT b. 20 Ja 1887, Altoetting, Bavaria. Studied: Munich art schools. Member: S.Indp.A. [25]

ASBJORSEN, Sigvald [S] Chicago, IL b. 1867, Christiana, Norway. Studied: B. Bergslieu, M. Skeibrok, in Middeltun, Norway [21]

ASCH(MEIER), Stan(ley) William Joseph [Car,L] NYC b. 31 Ag 1911, St. Paul, MN. Studied: Mills Acad., St. Paul; Rose Lyone; Lester Tournier. Member: Nat. Press Cl. Cartoonist: national magazines, 1931–46. Lectures: cartooning. Position: T., Univ. Minn, 1934–37 [47]

ASHBROOK, Carolyn S. [P] Indianapolis, IN [25]

ASHBROOK, Paul [P,I,E,Li,T] Cincinnati, OH b. 3 Ja 1867, NYC. Studied: ASL, with Frank Duveneck. Member: Cincinnati AC; Duveneck Soc. [47]

ASHBURTON, Mary (Mrs. M.A.P. Emmerich) [P] Hazelton, PA b. Staten Island, NY. Studied: Bertha Fanning Taylor; Stefan Courvenburg; Nina Alexandroviez. Member: S.Indp.A. [40]

ASHBY, Paul W(arren) [En,T,P,L] Kendallville, IN b. 9 S 1893, Gunnison, CO. Studied: Ind. Univ.; Evansville, Col.; Cincinnati Univ.; Ft. Wayne A. Sch. Member: Ind. Soc. Pr.M.; So. Pr.M.; Hoosier Salon; Northern Ind. A. Salon; Am. Monotype Soc. Exhibited: Ind. AC, 1938, 1939 (prize) 1940; Ft. Wayne A., 1942 (prize); A.&Models, 1944 (prize); Hoosier Salon, 1939–43, 1944 (prize); Northern Ind. A. Salon, 1946 (prize); Ind. Soc. Pr.M., 1938–43, 1944 (prize), 1945 (prize) 1946; Witchita AA, 1938; Phila. Press Cl., 1938, 1940; So. Pr.M. 1938–43; Mo. A., 1945; Lib. Cong., 1943; Calif. SE, 1945; San Fran. AA, 1945; Northwest Pr.M., 1946; Laguna Beach AA, 1946; Mint Mus. A., 1946; Albany Inst. Hist.&A., 1945; Am. Monotype Soc., 1940–42; Ind. A., 1937–43. Position: A. Supv., Kendallville (Ind.) Pub. Sch., 1944–47 [47]

ASHE, Edmund M. [P,I,T] Westport, CT. Member: NYWCC; SI, 1901; Pittsburgh AA

ASHE, Margaret L. Memphis, TN b. Brownsville, TN. Studied: Académie Julian, Paris; Henry Mosler. Member: Memphis A. Cl. Established school in 1881, for which she received medal and diploma at Columbian Expo, Chicago, 1893; Diploma, Tenn. Centenn. [04]

ASHELMAN, Walter A. [P] Columbus, OH. Member: Columbus PPC [21]

ASHER, Lila Oliver [P,Des,T] Arlington, VA b. 15 N 1921, Phila. Studied: PMSchIA; Frank B.A. Linton. Exhibited: PAFA, 1941. Work: murals, Rodeph Sholom Synagogue, Phila. Executed 3600 portraits of servicemen in army and navy hospitals for USO. [47]

ASHERMAN, Edward H. [P,A] NYC/Ogunquit, ME b. 20 Mr 1878, Milwaukee. Studied: Joseph Hoffmann, in Vienna; Académie Julian, Paris; Frank Alva Parsons; Robert Henri; Kenneth Miller. Member: NAC [33]

ASHFORD, Bette Beggs. See Beggs.

ASHFORD, Frank Clifford [P] Paris, France. Studied: Chase, in New York [25]

ASHIWARA, Ko [P] NYC [21]

ASHLEY, Anita C. [P] NYC. Member N.Y. Women's AC. [09]

ASHLEY, Clifford W(arren) [P,W,I,L] Westport, MA b. 18 D 1881, New Bedford, MA. Studied: Pape Sch. A., with Eric Pape; Pyle Sch. A.; George L. Noyes. Exhibited: Wilmington SFA, 1927 (prize); CGA; PAFA; AIC; P.-P. Expo, 1915. Work: Pub. Lib., Whaling Mus., New Bedford, Mass.; BM; MIT; Wilmington Soc. FA; Canajoharie A. Mus.; Mariner's Mus., Newport News, Va. Author/Illus., "The Yankee Whaler," 1926; "Whaleships of New Bedford," 1929; other books on whaling. Contributor: Harper's, Scribner's, other magazines [47]

ASHELY, L. Seymour [P] d. 27 O 1912

ASHTON, Ethel V. [Li,P] Phila., PA b. Phila. Studied: Moore Inst. A.Sc.&Indst.; PAFA; Phila. Sch. Des. for Women; ASL; Europe. Member: Phila. A. All.; S.Indp.A.; Am. Color Pr. Soc. Exhibited: DaVinci All., 1943 (prize); AIC, 1929–46; BM, 1931; Carnegie Inst., 1944; Am. Color Pr. Soc., 1943–46; Lib. Cong., 1943–46; NAD, 1946; Northwest Pr.M., 1946; PAFA, 1929–37; SFMA, 1941, 1946; Phila.A.All., 1930–46; Phila. Pr. Cl., 1939–46; DaVinci Gal., 1939–44; Phila. Sketch Cl., 1928–46 [47]

ASHTON, May Malone (Mrs.) [P] Wash., D.C. d. 1976. Member: S. Wash. A.; Wash. WCC; Wash. AC. Exhibited: Wash. SA, 1932 (prize) [40]

ASHWORTH, (George) Bradford [Des] NYC b. 29 F 1892, Fall River, MA. Studied: ASL, with George Bellows, Kenneth Hayes Miller. Exhibited: Am. WC Soc., 1933, 1936, 1938. Designer: "Mr. Whistler," "On Stage," USO camp shows, other theatrical prod. Position: Dir., Elitch Gardens Theatre, Denver [47]

ASHWORTH, G.B. [P] NYC [21]

ASKENAZY, Maurice [P] Hollywood, CA b. 22 F 1888, NYC d. 13 Jy 1951. Studied: NAD; Jones; Volk; Maynard. Exhibited: Pasadena Mus., 1929 (prize); Calif. State Exh., Sacramento, 1931 (prize); Los Angeles Mus. A., 1937 (prize) [40]

ASKIN, Jules [P,W,L] Montclair, NJ b. 19 Ap 1900, Baltimore. Studied: Johns Hopkins Univ.; PAFA; Md. Inst.; C.Y. Turner; Joseph Lauber; Charles Grafly. Contributor: fashion, theatre, art magazines [47]

ASKREN, Walter [P] Indianapolis, IN

ASKUE, Russell P. [P] Cleveland, OH. Member: Cleveland SA [25]

ASPELL, Lillian [E] b. NYC d. 17 My 1944, Tucson, AZ. Worked in London, 1929–44.

ASPELL, Seddie B. (Miss) [I] NYC. Member: SI [24]

ASPLUND, Tore [P] NYC. Member: AWCS. Exhibited: AWCS, 1938, 1939; PAFA, 1938 [47]

ASTIN, John H. [P] Bryan, TX. Exhibited: WFNY, 1939 [40]

ASTORI, K. Astafieff [P] NYC. Member: Russian AG [21]

ATCHISON, Joseph Anthony [S,P] Wash., D.C. b. 12 F 1895, Wash., D.C. Studied: George Julian Zolnay; Richard Edwin Brooks. Work: Nat. Mus., Catholic Univ., Nat. Shrine Immaculate Conception, all in Wash., D.C.; frieze, Cleveland Pub. Auditorium; Masonic Auditorium, Pittsburgh, Kans.; U.S. official inaugural medal, 1937; Corcoran Gal.; U.S. Capitol; painting, Church Holy Angels, Phila. Designer: sets, Metropolitan Opera. Inventor: cycloramic structure [40]

ATCHLEY, Whitney [Des,Dec,C] Wash., D.C. b. 16 Ap 1908, Des Moines. Studied: Cleveland Sch. A. Exhibited: May Exh., Cleveland, 1933 (prize);

Robineau Mem. Center, 1934; M. Mod. A. Gal, Wash., D.C. Work: CMA. Position: Assist. Dir. C., WPA Art Proj. [40]

ATENCIO, Gilbert [P] Santa Fe, NM. Exhibited: Nat. Exh. Am. Indian P., Philbrook A. Center, 1946 [47]

ATHANASIUS, (Brother) [Por.P,T] Brooklyn, NY b. 26 My 1893, Richmond, IA. Studied: Catholic Univ.; E.C. Bannister; Wintrhop Turney; I.M. Kimball. Work: Mt. St. Joseph's Col., Baltimore; Working Boys' Home, Newton Highlands, Mass.; St. Michael's Rectory, Holy Name Rectory, Brooklyn. Position: Supervisor A., various schools, Brooklyn [40]

ATHERTON, J. Carlton [Cer,T] Columbus, OH b. 17 Ja 1900, Taylor, PA d. 13 Je 1964. Studied: Syracuse Univ.; Pratt Inst.; Grace Hazen; Adelaide Alsop Robineau. Contributor: Keramic Studio, Design, Ceramic Age. Radio talks: Design in Industry, Pottery and Porcelain. Position: Asst. Prof., FA Dept., Ohio State Univ.; Vice-pres. and Assoc. Ed., Design [40]

ATHERTON, John [P,Des,I,W] Arlington, VT b. 7 Je 1900, Brainerd, MN d. 15 S 1952. Studied: Col. of the Pacific; Calif. Sch. FA. Exhibited: Berkeley A. Lg., 1924 (prize); San Fran. AA, 1925 (prize); Bohemian Cl., San Fran., 1926 (prize), 1928 (prize); A. Dir. Cl., 1931 (prize), 1936 (prize), 1937 (prize); Conn. WC Soc., 1940 (prize); AV, 1942 (prize); Carnegie Inst.; WMAA; PAFA; AIC; MOMA. Work: MMA; MOMA; WMAA; AIC; Hartford Atheneum; Albright A. Gal.; PAFA. Illustrator: national magazines. Advertising campaigns: Packard; Lincoln; General Motors; Cluett, Peabody; Socony-Vacuum [47]

ATHEY, Ruth C. [P,I,C,Des,T] Brooklyn, NY b. 26 Mr 1892, St. Louis, MO. Studied: Pratt Inst.; Mary Langtry; Ralph Johonnot; O.W. Beck; Ida Haskell; Ethelyn Schaurman; Ethel Traphagen. Illustrator: McCalls [40]

ATKIN, Mildred [P] NYC b. 23 Ag 1903, NYC. Studied: Metropolitan A. Sch.; Winold Reiss; Arthur Schweider. Exhibited: Montross Gal.; Bonestell Gal., 1945 (one-man) [47]

ATKINS, Alan [I] Oakland, CA b. 26 Je 1910, Piedmont, CA. Studied: Yale Sch. FA; W.P. Robins, in England. Work: poster, Univ. Calif. [40]

ATKINS, Albert Henry [S,P,T] Gloucester, MA b. Milwaukee, WI d. 10 Mr 1951. Studied: Cowles A. Sch.; Académie Julian, Académie Colarossi, both in Paris. Member: North Shore AA; Rockport AA; Providence AC; Arch. Lg.; NSS, 1911; SC; AFA; BMFA. Exhibited: Milwaukee AI, 1917 (med); North Shore AA, 1925 (prize); Garden C. Am.; Art All., 1931 (gold); Tercentenary Exh., Boston, 1931 (gold); NAD; PAFA; Providence Mus. FA; Toledo Mus. A.; Albright A. Gal.; Rockport AA; Providence AC; North Shore AA; Carnegie Inst. Work: R.I. Sch. Des.; arch. sculptures, churches in Wash., D.C., Conn., Mass., Minn., Pa., Cathedral St. John the Divine, St. Patrick's Cathedral, both in NYC; mem., Boston, Milwaukee, Providence; Toledo Mus. A. Position: Instr., R.I. Sch. Des., 1909–26 [47]

ATKINS, David [P,Li,L] NYC b. 28 N 1910, Waterbury, CT. Studied: ASL, with Kenneth Hayes Miller, William von Schlegel; NAD, with Sidney Dickinson, Leon Kroll; Edu. All. A. Sch., with Abbo Ostrowsky. Member: Lg. Present-Day A.; A. Lg. Am.; Audubon A.; S.Indp.A. Exhibited: MMA, 1936; Riverside Mus.; Lg. Present-Day A., 1944, 1946; Am.-British A. Center, 1943; Vendôme Gal., 1942; Contemporary A. Gal., 1945; Chapellier Gal., 1945; S.Indp.A., 1943, 1944 [47]

ATKINS, Florence Elizabeth [P] San Fran., CA b. Pleasant Hill, LA d. 25 S 1946. Studied: Newcomb Col., Tulane Univ.; Ellsworth and William Woodward; Hans Hofmann, in Munich; Mark Hopkins A. Sch., San Fran. Member: SSAL; New Orleans AA. Exhibited: San Fran. AA. Work: portfolio, American birds [47]

ATKINS, Louise Allen [S,Edu,L] West Gloucester, MA b. Lowell, MA. Studied: RISD; BMFA Sch. Member: NSS; North Shore AA; Rockport AA; Copley Soc.; Providence AC. Exhibited: North Shore AA, 1930 (prize); PAFA; AIC; NAD; Providence Mus. A.; BMFA; RISD; Lowell AA; CMA; Buffalo Mus. A. Work: CMA; Smith Col. A. Mus.; mem., Greenwich, R.I.; Annapolis, Md; Gloucester, Lowell, both in Mass. Lectures: Sculpture. Position: T., RISD 1925–46 [47]

ATKINSON, Alice [P] Indianapolis, IN [04]

ATKINSON, Alicia (Mrs. George Chychele Waterston) [P,T] North Andover, MA b. 10 D 1905, Brookline, MA. Studied: BMFA Sch.; ASL; Fontainebleau Sch. A.; Boardman Robinson; Henry Lee McFee. Member: ASL; NAWPS. Exhibited: Jr. Lg. Exh., Boston, 1929 (prize), 1931 (prize); PAFA, 1937; Salon des Beaux-Arts, Paris, 1938; Gal. Drouant, Paris 1938 (one-man); AGAA, 1939, 1944, 1945; Grace Horne Gal., Boston, 1939 (one-man). Jordan Marsh, 1943; 1945; South County AA, 1944, 1945; Lectures: French Impressionists and Cézanne. Positions: A. Dir., various schools, Boston area [47]

ATKINSON, Carla [P] Woodstock, NY. Member: Lg. A.A. [21]

ATKINSON, E.H. [P] Phila., PA. Studied: PAFA; Académie Julian, Paris [13]

ATKINSON, E. Marie. See Hull, A., Mrs.

ATKINSON, Florence [P] Montreal, Quebec [09]

ATKINSON, John Ingliss [P,C,G,S] NYC b. 29 Ag 1909, Brooklyn, NY. Studied: Pratt Inst.; ASL. Member: United Am. Ar. Union; Harlem Ar. Gld. Exhibited: Am. Ar. Sch.; Harlem A. Center. Work: WMAA [40]

ATKINSON, Leo F(ranklin) [P,Mur.P] Seattle, WA b. 23 S 1896, Sunnyside, WA. Studied: Seattle AC. Work: Columbian Theatre, Baton Rouge, La.; Seattle FA Gal; murals, American Theatre, Bellingham, WA [33]

ATKINSON, Natalie Johnson (Mrs. W.D.) [P] NYC/Southampton, NY b. 4 S 1898, Whitehall, MI. Studied: J. Johanssen; Robert Henri; C. Delvaille. Member: NAWPS. Exhibited: NAWPS, 1936–38. Work: Am. Hist. Soc., N.Y. [40]

ATKINSON, W.E. [P] Toronto, Ontario. Member: ARCA; OSA [06]

ATKINSON, William Osborn [S,L] Los Angeles, CA b. 3 S 1913, Los Angeles. Studied: Chouinard AI. Exhibited: S., Annual PS Exh., 1936 (prize), Southern Calif. Festival All. A., 1936 (prize), both at Los Angeles Mus. A. Work: San Diego Expo; bas reliefs, USPO, Santa Barbara [40]

ATKYNS, (Willie) Lee (Jr.) [P,T,Gr] Wash., D.C./Puzzletown, PA b. 13 S 1913, Wash., D.C. Studied: Auriel Bessemer. Member: Soc. Wash. A.; A. Cl., Wash., D.C.; Newport AA; SSAL; Ldscp. Cl., Wash., D.C.; Wash. WC Cl. Exhibited: A. Cl., Wash., D.C., 1946 (prize); BMFA; NAD; PMG; Sweat Mus. A.; Springfield A. Lg.; Utah State Inst. FA; Acad. Sc.&FA, Richmond, 1941 (one-man); Georgetown Gal., 1941 (one-man); A. Cl., Wash., D.C. (one-man); Alexandria Pub. Lib., 1945 (one-man); Pub. Lib., Wash., D.C., 1946 (one-man). Position: Dir., Lee Atkyns Studio Sch. A., Wash., D.C. & Puzzletown, Pa. [47]

ATTARDI, Thomas [P,T] NYC b. 10 S 1900, Italy. Studied: NAD; ASL; DaVinci Sch. A., with Lockman, Bernecker. Member: Springfield A. Lg.; A. Lg. Am. Exhibited: NAD, 1924 (prize); CGA; WFNY, 1939; Springfield A. Mus.; Seligmann Gal., 1932; Newark Mus., 1929; Midtown Gal., 1934, 1936 [47]

ATTERBURY, Etta [P] St. Joseph, MO. Member: St. Joseph A. Lg. [21]

ATTRIDGE, Irma Gertrude (Mrs.) [P] Beverly Hills, CA b. 21 N 1894, Chicago, IL. Studied: Chouinard AI. Member: Calif. AC; Calif. WC Soc.; Women P. of the West. Exhibited: Los Angeles Mus. A., 1944, (prize); Ebell Cl., 1943, (prize); Los Angeles Pub. Lib., 1943 (prize), 1946 (prize); SFMA, 1942; Oakland A. Gal., 1943; Los Angeles Mus. A., 1940, 1945; Sacramento Mus. Assn.; San Diego FA Soc. Work: USO portraits, Army hospital, Italy [47]

ATWATER, Grace E. [P] Wash., D.C. d. 14 O 1909, NYC. Studied: ASL; Corcoran Sch. A. Member: Wash. WCC. Position: T., Corcoran Sch. A.

ATWATER, Jean Howe. See Morse.

ATWATER, Mary [Des,T,W,L] Basin, MT b. 28 F 1878, Rock Island, IL. Studied: AIC; Chicago Acad. A.; Académie Julian, Académie Colarossi, both in Paris; Rafael Collin. Author: "Shuttle-Craft Book of American Hand Weaving," 1928. Publisher: Shuttle-Craft Guild Bulletin [47]

ATWELL, Julia Hill (Mrs.) [P,C,L,T] Denton, TX b. 8 Ag 1880, Silver City, ID d. 24 Mr 1930. Studied: Brangwyn; Carlson; Dow; Schumacker; Miller. Position: Dean, Sch. FA, Tex. State Col. for Women [29]

ATWELL, Thomas B. [I] Bayside, NY. Member: SI [47]

ATWOOD, Francis Gilbert [Caric] d. M 1900. Contributor: Life

ATWOOD, Annie K. (Mrs.) [P] Chelsea, MA [24]

ATWOOD, Clara E. See Fitts, F.N., Mrs.

ATWOOD, Helen [P,T] Phila., PA/New Haven, CT b. New Haven. Studied: ASL, Phila.; Yale; Acad. Colarossi, Acad. Grande Chaumière, both in Paris. Member: NAWPS. Work: New Haven A. Gal. [40]

ATWOOD, Lorena F. [P] Brooklyn, NY [24]

ATWOOD, Mary Hall [P,I,Des] Los Angeles, CA b. 25 F 1894, Chicago. Studied: Fleury; Millet; AIC. Member: Calif. WC Soc.; AIC. Exhibited: Tercentenary, Boston (prize). Specialty: maps [40]

ATWOOD, Robert [P,T,Des] Bartonsville, VT b. 23 My 1892, Orange, NJ. Studied: Faucett Sch. A.; PAFA. Member: Laguna Beach AA; Gloucester AA; AAPL; Vt. AA; PAFA. Exhibited: NAD, 1930; PAFA, 1930; Montclair A. Mus.; Northern Ariz. Mus. A.; Phoenix A. Center; Laguna Beach AA;

Tucson A. Center. Positions: A. in Residence, Ariz. State Col., 1938–41; Indst. Des., Western Electric Co., 1942–44 [47]

ATWOOD, William E(dwin) [P] East Gloucester, MA b. Killingly, CT. Member: SC; Boston AC; NAC; Copley Soc.; North Shore AA [33]

AUBREY, Mabel Kelley. See Reade, Roma.

AUCELLO, Salvatore L. [P,Mur.P,E,Li,T] Chicago, IL b. 12 D 1903, Italy. Studied: NAD, with Hawthorne, Robinson; Charles Curran; George Maynard; Arthur Crisp; Auerbach-Levy. Member: Tiffany Fnd.; Chicago SA; A. Lg. Am.; AAPL; South Side Community A. Center; SC; Westchester ACG. Exhibited: NAD, 1924, 1926, 1927, 1929; Oakland A. Gal., 1944, 1945; Milwaukee AI; Findlay Gal., 1945. Work: mural, Chrysler Bldg., NYC; Nelson A. Gal., Kansas City, Mo. [47]

AUCHIAH, James [P] Carnegie, OK b. 1906, Medicine Park, OK. Exhibited: 48 Sts. Comp. Member: "Five Kiowas," Univ. Okla., 1927 [40]

AUCHMOODY, Elaine Plishker [P,L] Great Neck, NY b. 8 Ap 1910, NYC. Studied: Traphagen Sch. Des.; Grand Central Sch. A.; ASL; Arthur Woelfle; Eric Pape; Frank Hazeil. Member: NAWA. Exhibited: Parkersburg FA Center, (prize); P.&S. Soc., (prize) N.J.; Douglaston A. Lg. (prize); Great Neck AA (prize); CGA; Carnegie Inst.; CAM; Butler AI; Chicago AC; Mint Mus. A.; Denver A. Mus.; Springfield Mus. A. [47]

AUDIBERT, Nelda M. [P] NYC. Member: NAWPS. Exhibited: NAWPS, 1936–38; Am. SC Soc., 1937–38; Argent Gal, 1938 (one-man) [40]

AUDIGIER, E.D. (Mrs. L.D.) [P] Rome, Italy [24]

AUER, Lili [S] Chicago, IL. Exhibited: Ar. Chicago Vicinity, AIC., 1939; WFNY, 1939 [40]

AUER, William [P] Toledo, OH. Member: Artklan [31]

AUERBACH, M.R. (Miss) [P] Montreal, Quebec [10]

AUERBACH-LEVY, William [E,I,L,P,T] NYC b. 14 F 1889, Russia d. 29 Je 1964, Ossining, NY. Studied: NAD; Académie Julian, Paris, with Jean Paul Laurens. Member: F., Guggenheim Mem. Fnd.; ANA; SC; Chicago SE; SAE; Phila. SE; Conn. Acad. FA; SC. Exhibited: Chicago SE, 1914 (prize), 1918 (prize); P.-P. Expo, San Fran., 1915 (med); NAD, 1921 (prize), 1925 (prize); Calif. PM, 1923 (med); SC, 1923 (prize), 1925 (prize), 1928 (prize); PAFA, 1924 (prize), 1927 (prize); Jewish Centre Exh., 1926 (prize). Work: AIC; BMFA; WMA; NYPL; Lib. Cong.; Honolulu Acad. A.; Detroit Inst. A.; Worcester Mus. Illustrator: Collier's, New Yorker, Vanity Fair, American, Woman's Home Companion, newspapers. Lectures: Etching; Caricature. Film: "Making of an Etching," for Paramount [47]

AUGUR, Caroline Patience [Edu,P] Hartford, CT b. 19 Ag 1918, Philippine Islands. Studied: Mt. Holyoke Col., T. Col., Columbia Univ.; Umberto Romano. Member: Springfield A. Lg.; Meriden Arts & Crafts Lg. Exhibited: Springfield A. Lg., 1944; Meriden Arts & Crafts Lg., 1945, 1946; Wheaton Col. A. Gal., 1944, 1946 (one-man). Position: T., Wheaton Col., 1942– [47]

AUKERMAN, Elizabeth [P] Brooklyn, NY [24]

AULICH, Emma [P] NYC [10]

AULL, Jess Brown [P] Dayton, OH b. 30 D 1884, Dayton, OH. Studied: Lucien Simon; Hawthorne. Member: Ohio P. [33]

AULMANN, Theodora [P] Des Moines, IA [24]

AULMANN, Theodore [P] Los Angeles, CA. Member: Calif. AC [31]

AULT, Charles H. [P] Cleveland, OH b. Iroquois, Canada. Member: NAC [10]

AULT, George Copeland [P] Woodstock, NY b. 11 O 1891, Cleveland d. 30 D 1948 (drowning). Studied: St. John's Wood Sch. A.; Slade Sch. A., London. Exhibited: WMAA, 1932, 1934; AIC, 1943; BM, 1935; Carnegie Inst., 1941, 1943, 1946; PAFA, 1931, 1934, 1944, 1946; NAD, 1945; VMFA, 1946; Pal. Leg. Honor, 1946; Montclair A. Mus., 1931, 1933; Albany Inst. Hist.&A., 1941–43. Work: Addison Gal. Am. A.; WPA Proj., 1934; Treasury Relief A. Proj., FAP, 1937, 1939; WMAA; Newark Mus.; N.J. Hist. Soc.; Albany Inst. Hist.&A.; Dartmouth; AGAA; Pal. Leg. Honor; Los Angeles Mus. A.; PAFA; Field Fnd. Specialty: cubist realism [47]

AUNSPAUGH, V(ivian) L(ouise) [P,T] Dallas, TX b. Bedford, VA. Studied: Fitz; Twachtman; Weld, in Rome; Mucha, in Paris. Position: Founder/Dir., Aunspaugh A. Sch., Dallas [33]

AURES, Victor [I] Buffalo, NY b. 22 Mr 1894, Buffalo. Studied: Buffalo Sch. FA; Daniel Carter Beard; Urquhart Wiley. Exhibited: Buffalo SA, 1935 (prize). Contributor/Illustrator: "Handbook of the Boy Scouts of America," 1937. Position: Affiliated with A.S. Weill Adv. Agency, Buffalo [40]

AURNER, Kathryn Dayton (Mrs. Robert R.) [En,P,W] Madison, WI b. 23 S 1898, Iowa City. Studied: Univ. Iowa; Carnegie Inst.; Univ. Wis.; Charles Cumming; Norwood McGilvary; Barse Miller; Hugh Breckenridge. Member: Wis. A. Fed.; Wis. P.&S.; Madison AA; Madison A. Gld. Exhibited: Madison AA, 1940 (prize); Lg. Am. Pen Women, 1944 (prize); Madison A. Gld., 1943 (prize); Wis. Salon; Wis. P.&S. Illustrator: "Land of the Aiowas," by Edwin Ford Piper. Contributor: art magazines; newspapers. Position: Dir., Soldier A. Prog., Truax Field, Madison, 1943–46 [47]

AUS, Carol [Por.P] Chicago, IL b. 27 Mr 1868, Bergen, Norway d. 19 My 1934. Studied: Académie Julian, Paris. Member: Chicago Gal. Assn.; AC, Chicago. Work: Capitol, Madison, Wis.; courthouses and libraries, Fort Wayne, Ind., Madison, Wis., Univ. Chicago, Northwestern Univ., Chicago. She maintained a studio in Paris and one in Chicago, making frequent trips back and forth until 1927, when she took up permanent residence in Chicago. She painted portraits of many celebrities. [33]

AUSTEN, Alice [S] Boston, MA [24]

AUSTEN, C(arl) (Frederick) [P,Car] St. Augustine, FL b. 21 Ap 1917, Chicago. Studied: Chicago Acad. FA; AIC, with Louis Ritman. Exhibited: AIC, 1941, 1945; SFMA, 1941; Contemporary A. Center, 1941; VMFA, 1946 [47]

AUSTIN, Amanda P. [P,S] b. 1856, Carrollton, MO d. 1917, NYC. Studied: San Fran. Sch. Des., with Virgil Williams; George Bingham, in Mo.; Bush, W.F. Jackson, in Calif.; Renard, Delecluse, in Paris, 1911–15 [17]

AUSTIN, Arthur Everett, Jr. [Edu,L,P,W] Hartford, CT/Windham NH b. 18 D 1900, Brookline, MA. Studied: Harvard, with Sachs, E.W. Forbes. Member: Assn. A. Mus. Dir. Exhibited: MOMA; Conn. WC Soc. Contributor: art magazines. Positions: Dir., Wadsworth Atheneum, 1927–44; Instr. A., Trinity Col., 1927–44; Dir., Ringling Mus. A., 1946– [47]

AUSTIN, Charles Percy [P,Des,I,Mur.P] Santa Monica, CA b. 23 Mr 1883, Denver d. 1948. Studied: Denver Sch. A.; ASL; Claudio Castelucho, in Paris; John T. Twachtman. Member: Calif. AC. Work: murals, Our Lady of Mount Carmel, Montecito; St. Peter's Church, Los Angeles; San Juan Capistrano. Illustrator: "Capistrano Nights," by Saunders and O'Sullivan, 1930. Specialty: posters [47]

AUSTIN, Darrel [P,Mur.P] NYC b. 25 Je 1907, Raymond, WA. Studied: Univ. Oreg. Exhibited: annual nat. exhibitions, 1941–46. Work: MMA; MOMA; Detroit Inst. A.; William Rockhill Nelson Gal. A.; Rochester Mem. A. Gal.; Albright A. Gal.; Smith Col. Mus.; BMFA; Clearwater A. Mus.; PMG; mural, Medical Col., Portland, Oreg. [47]

AUSTIN, Dorothy [S] Dallas, TX/Alexandria, MN b. 3 Ja 1911, Dallas. Studied: Arthur Lee; William Zorach. Exhibited: All. A. Exh., Dallas, 1932 (prize), 1933 (prize). Work: Dallas Mus. FA; Hall of State, Dallas [40]

AUSTIN, Edward C. [P] Phila., PA. b. Phila. [10]

AUSTIN, Howard B. [P] Cleveland, OH. Member: Cleveland SA [29]

AUSTIN, Louise M. [P,T] Lincoln, NE b. 20 D 1903, Shell, WY d. N 1936. Studied: Univ. Nebr.; Ambrose Webster; Kimon Nicolaides. Member: Lincoln A. Gld. Work: Univ. Nebr. [35]

AUSTIN, Margaret Baer [P] Baltimore, MD b. 16 O 1897, Baltimore. Studied: Hawthorne; Paul Baudorin; Robert Saint Hubert. Work: fresco, Palace, Fontainebleau, France [40]

AUSTIN, Mary Fisher [P] Boston, MA [24]

AUSTIN, Sarah [Min.P] b. 1843 d. 14 O 1909, NYC

AUSTRIAN, Ben [P] d. 9 D 1921, Kempton, Pa. Studied: self-taught. First achieved success with his depiction of barnyard subjects, later with his landscapes. He had a studio in Palm Beach, Fla.

AUSTRIAN, Florence H(ochschild) (Mrs. Charles R.) [P] Baltimore, MD b. 8 S 1889, Baltimore. Studied: Goucher Col.; Charles Hawthorne; S. Edwin Whiteman; Hugh Breckenridge; John Sloan; Leon Kroll. Member: NAWA; AFA; Baltimore WCC. Exhibited: Md. Inst., 1931 (prize); Municipal Mus., Baltimore, 1945 (prize); CGA, 1941; PAFA, 1932, 1933; PMG; NAWA; BMA, 1931 (one-man); Contemporary Gal. Work: Municipal Mus., Baltimore [47]

AUSUBEL, Sheva [P,C,T] NYC b. 1 My 1896, Austria d. 13 My 1957. Studied: NAD; Univ. Calif; ASL; Calif. Sch. FA; abroad. Member: NAWA; Brooklyn Soc. P.; N.Y. Soc. Women P. Exhibited: NAWA, 1938; N.Y. Soc. Women P.; BM. Position: Inst., weaving, Textile H.S., NYC [47]

AVENT, Mayna Treanor (Mrs. Frank) [P] Nashville, TN b. 17 S 1868, Nashville. Studied: Académie Julian, Paris; Lasar, in Paris. Member: Nashville MA; Studio Cl. Exhibited: Nashville AA (gold) [40]

AVERILL, Louise Hunt [Edu] Baltimore, MD b. 22 N 1915, Old Town, ME. Studied: Wellesley; Yale. Member: CAA. Positions: Docent, MMA, 1941; Instr., Hist. A., Duke Univ., 1943-45; Instr., Hist. A., Goucher Col., 1945-46 [47]

AVERY, Claire [I,C,T] Brookhaven, NY b. 31 Mr 1879, Sterling, NY. Member: Intl. Soc. A. Lg. [21]

AVERY, Faith [I] NYC [24]

AVERY, Frances (Mrs. James Penney) [P] NYC b. 23 Ag 1910, Kitchner, Ontario. Studied: Wicker's Sch. FA, Detroit; ASL. Member: NAWA; NSMP; N.Y. Soc. Women P.; Nat. Soc. Mural P.; ASL; United Scenic Ar. Exhibited: MOMA, 1938, 1941 (prize); PAFA, 1935; WFNY, 1939; Detroit IA, 1929; NAD, 1932; AIC, 1936; WMAA, 1941; NAWA, 1940-44; N.Y. Soc. Women P., 1945, 1946; Riverside Mus., 1935-45; reproductions, U.S. Camera Ann. Work: WPA Projects, Lincoln Hospital, Fordham Hospital, NYPL, Sch. No. 11, NYC [47]

AVERY, Harold [I,Wood En] b. 1858 d. 3 Ap 1927, East Elmhurst, N.Y. Illustrator: Collier's, Life, Cosmopolitan, Scientific American

AVERY, Henry A. [P,S] Chicago, IL b. 22 Ja 1902, Morganton, NC. Studied: So. Side Settlement House, Chicago. Member: United Am. Ar.; So. Side Community A. Cent. Exhibited: Am. PS ann., AIC, 1939; Navy Pier ann., Chicago, 1939; Evanston Pub. Lib., 1939. Work: murals, Cent. Masonic Temple and Regal Theater, Chicago; Civic Center, Alton, Ill. [40]

AVERY, Hope (Mrs. Nelson Mead) [P] NYC. Member: NAWPS. Exhibited: NAWPS, 1935-38 [40]

AVERY, Kenneth Newell [P] Hemet, CA b. 20 N 1883, Bay City, MI. Studied: Chase; J.P. Laurens. Member: Calif. PS; Calif. AC; Pasadena AA [40]

AVERY, Milton [P] NYC b. 7 Mr 1893, Altmar, NY d. 3 Ja 1965. Studied: Conn. Lg. A.; Charles Noel Flagg. Member: Fed. Mod. P.&S.; Soc. Indp. A. Exhibited: Conn. Acad. FA, 1930 (prize); AIC, 1932 (prize); PAFA, 1945; AIC; CGA; BM; Newark Mus.; Albright A. Gal.; Carnegie Inst., 1944, 1945. Work: Newark Mus.; BM; PMG; Albright A. Gal; PAFA; Barnes Fnd.; Phillips Mem. Gal. [47]

AVERY, Myrtilla [Mus.Dir,Edu] NYC b. Katonah, NY d. 4 Ap 1959. Studied: Wellesley Col.; Univ. State N.Y.; Radcliffe Col. Member: Mediaeval Acad. Am. Contributor: art magazines. Positions: Dir., Farnsworth A. Mus.; Prof. A., Wellesley Col., 1927-37 [47]

AVERY, Ralph H. [P,B] Rochester, NY b. 3 S 1906, Savannah, GA d. 1976. Studied: Charles H. Woodbury; Carl W. Peters; Hilda Belcher; Harry Leith-Ross. Member: Rochester AC; Buffalo SA; Prairie PM. Exhibited: "Picturesque Rochester" competition, 1929 (prize); Buffalo SA, 1936 (prize), 1939 (med). Work: Mem. A. Gal., Rochester; Newark Pub. Lib. Illustrator: The Instructor. Positions: Cur., Rundel A. Gal., Rochester Pub. Lib.; Instr., Sch. Applied A., Rochester [40]

AVERY, Samuel Putnam NYC b. 1822, N.Y. d. 11 Ag 1904. An engraver on wood and copper and a connoisseur, he knew, personally, all the American artists of the middle of the century and, finally, gave up commercial engraving to become a dealer in art works. It was through his advice that many of the important collections of the nineteenth century were formed. His specialty was old Dutch painters and romantic French landscape painters, and many paintings at the Metropolitan Museum were selected by him. The loss of one of his sons, a talented young architect, caused Mr. Avery to found in Columbia University the Avery collection of architectural and art books as a memorial. Another notable gift was a collection of engravings and etchings presented to the Print Dept. of the New York Public Library (Astor, Lenox and Tilden foundations), now housed in the Lenox building. He was a member of the Grolier Club (at one time president), Century Association, Union League, New York Architectural League, National Sculpture Society, and The Players.

AVERY, Samuel Putnam, Jr. b. 1847, Brooklyn, NY d. 25 S 1920. A prominent art dealer and son of the founder of the Avery Architectural Library of Columbia University. In 1886, he succeeded his father as head of one of the largest art houses in the United States.

AVEY, Martha [P,T] Oklahoma City, OK b. Arcola, IL d. 28 Ag 1943. Studied: J.H. Vanderpoel; Martha Walter; Cecilia Beaux; Maurice Braun; AIC; N.Y. Sch. F.&App. A.; Am. Sch. A., Fontainebleau, France. Member: Okla. AA; SSAL; Am. APL; C.L. Wolfe AC. Exhibited: C.L. Wolfe AC, 1937 (prize). Work: John H. Vanderpoel A. Assn.; Okla. A.Lg. Position: Head, A. Dept., Oklahoma City Univ. [40]

AVINOFF, Andrey [P,I,Mus.Dir,L] Locust Valley, NY b. 14 F 1884, Tulchin, Russia d. 1948. Studied: Univ. Moscow; Univ. Pittsburgh. Member: Pittsburgh AA; AWCS, 1922-46;AWCS. Exhibited: AWCS, 1922-46; AFA; England. Illustrator: Thibetan drawings, "A Modern Magic Carpet," Century Magazine, 1922; covers for Asia magazine. Designer: Commons Room, Nationality rooms, Univ. Pittsburgh. Lectures: Nature in Art; Imagery in Art; Russian, Persian, Flemish and Dutch art. Position: Dir. Emeritus, Carnegie Inst., Dept. FA; Asst. Prof. FA, Univ. Pittsburgh [47]

AVISON, George (Alfred) [I,W,P,Des,Mur.P] Rowayton, CT b. 6 My 1885, Norwalk, CT Studied: Chase Sch. A.; N.Y. Sch. A. Member: Silvermine Gld. A.; Westport AC; AAPL. Exhibited: Argent Gal.; Silvermine Gld. A.; Ogunquit A. Center. Illustrator: "The Scrapper,," 1946. Author/Illustrator: "Uncle Sam's Army," other books. Work: murals, Fairfield Town Hall, New Canaan, Conn. [47]

AVRAM, Nathaniel [S] b. 1884, Romania (came to U.S. in 1904) d. N 1907, New York. Worked with H.A. MacNeil and Karl Bitter.

AWA, Tsireh (Alfonso Roybal) [P] San Ildefonso Pueblo, NM b. 1895 d. 1955. Studied: self-taught; Soc.Ind.A., 1918. Leader of the San Ildefonso artists. [*]

AXELSON, Axel [I,P] Chicago, IL b. 29 Mr 1871, Stockholm. Studied: AIC; Tech. Sch., Stockholm. Specialties: illus. in pen and ink; coats of arms [40]

AXTELL, Mary E. [P] St. Paul, MN [19]

AYARS, Alice Annie [C,Cer,T] Cleveland Heights, OH b. 11 D 1895, Richburg, NY. Studied: N.Y. State Col. Cer.; Western Reserve Univ.; Charles F. Binns. Member: F., Am. Cer. Soc.; Women's AC Cleveland. Exhibited: Cleveland A.&Crafts, 1924 (prize), 1925 (prize), 1928 (prize), 1934 (prize), 1938 (prize), 1941-43 (prizes), 1946 (prize); Syracuse Mus. FA, 1933, 1935, 1936, 1938-41; Sweden, Denmark, Finland, 1936-37; CGE, 1939; CMA, 1923-46; Golden Gate Expo, 1939. Work: CMA; Cleveland Pub. Lib.; Children's Mus., Detroit. Author: articles on ceramics. Position: T., Cleveland Cer. Center [47]

AYER, G. Earle [P] Seattle, WA [24]

AYER, J(ames) C. [P] Glen Cove, NY b. 13 Oct 1862, Lowell, MA. Studied: Cullen Yates; L. Cahen Michel, in Paris. Member: N.Y. Physicians AC; Nassau Co. AL [33]

AYER, Margaret [I] NYC b. NYC. Studied: PMSchIA; Beloul, in Paris. Member: SI. Illustrator: children's books and magazines, 1930-46 [47]

AYER, Mary Lewis [P,T] Newton Center, MA/North Conway, NH b. 20 Ag 1878, Mattoon, IL. Studied: Wilbur D. Hamilton; Tarbell; Chase. Member: Copley S. [24]

AYER, Ralph Dwight [P,T] Woburn, MA b. 2 Ap 1909, Woburn. Studied: Mass. Sch. A., Boston; BMFA Sch., with Frederick Bosley. Member: Springfield A. Lg. Exhibited: Mass. Sch. A., 1930 (med); Palm Beach A. Center, 1933; Ogunquit A. Center, 1933, 1934; Irvington A.&Mus. Assn., 1945; Portland SA, 1937; Phila. Sketch Cl., 1945; Springfield A. Lg., 1945; Yonkers AA, 1945. Position: T., Mass. Sch. A. [47]

AYLWARD, Ida (Mrs. W.J.) [P,I,C] Port Washington, NY b. Fairport, NY. Studied: Kenyon Cox; Howard Pyle; Edmund Tarbell. Work: mosaic glass windows, Madison Ave. Methodist Episcopal Church, NYC; Pro-Cathedral of St. John, Milwaukee; illus., Woman's Home Companion; portrait, Butler Univ., Indianapolis [40]

AYLWARD, William James [P,I,T] Washington, NY b. 5 S 1875, Milwaukee d. ca. 1958. Studied: AIC; ASL; Howard Pyle Sch. A., Wilmington, Del. Member: AWCS; All.A.Am.; SC; AAPL; Phila. WCC; A. Fund. S.; Ship Model Soc., N.Y.; Artists Gld. Exhibited: SC, 1911 (prize); 1914 (prize); 1939 (prize); Phila. WCC, 1912 (prize); Official Artists, A.E.F. World War; Salon d'Automne, 1924; NAD, 1925; All.A.Am., 1925, 1929; AWCS; Chicago World's Fair; WFNY, 1939; Hempstead Centenn., 1944. Work: NCFA; Lib. Cong.; Wilmington Mus. A.; Peabody Mus. A. Illustrator: "Sea Wolf," "20,000 Leagues Under the Sea," other books on marine and naval subjects. Positions: T., PIASch, 1930-34, Newark Sch. F.&Indst. A., 1936- [47]

AYRAULT, F.A. [P] Lockport, NY [10]

AYRES, Helen [P] Phila., PA [24]

AYRES, L.J. (Mrs. W.J.) [P,T] St. Petersburg, FL b. 2 Jy 1874, Kentland, IN. Member: St. Petersburg AC [33]

AYRES, Martha Oathout [S] Inglewood, CA b. 1 Ap 1890, Elkader, IA. Studied: AIC; Lorado Taft; Mulligan; Ganiere. Member: Calif. AC. Exhibited: S.Dak. State Fair, 1916 (prize); ASL, Chicago (prize); Wyo. State Fair, 1918 (prize). Work: mem., Carleton Col., Northfield, Minn. [40]

AYTON, Charles William [S] Pau, France b. St. Louis, MO. Studied: Dubois, Gauquié, both in Paris; St. Gaudens. Exhibited: Paris Salon, 1903 (prize); St. Louis Expo, 1904 (med). Work: City A. Mus., St. Louis [24]

AZADIGIAN, Manuel [P] Phila., PA [24]

AZZI, Marius A. [S] NYC b. 19 Ag 1892, Hoboken, NJ. Studied: Royal Acad. FA, Milan; Carl Bitter; A.S. Calder [24]

B

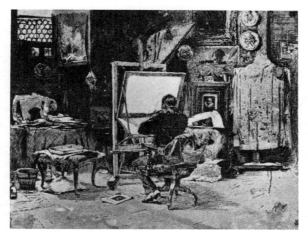

Robert Blum: *A Modern Etcher (self-portrait)*. From *The Illustrator* (1893)

BAAR, Marion (Mrs. M.B. Stanfield) [P,W,L,T] Westport, CT b. 22 S 1898, NYC. Studied: ASL, with Robert Henri, Johansen; A. and V. Charreton, Lhote, in France; Howard Giles. Member: NAWA; AFA; Westport AA; North Shore AA. Exhibited: NAD; CI; CGA. Contributor: art magazines [47]

BAART, Kitti [P] Wash., D.C. b. 8 D 1914, Holland. Studied: ASL; Norris Crandell. Member: Ar. U., Wash., D.C. Exhibited: New Sch. Soc. Res., 1937; Am. Ar. Sch., 1937; ACA Gal., 1938 [40]

BABB, George F. [P] NYC [13]

BABBIGE, James Gardner [P] b. 2 S 1844 d. 8 Ja 1919. Specialty: ship painter. Opened studio in 1875. [*]

BABBINGTON, Helen Brett [S,T] Detroit, MI b. 2 Je 1910, Cleveland. Studied: G. Rayner Hoff, in Sydney, Australia. Member: Detroit Soc. Women PS. Exhibited: Mich. State Fair, 1937 (prize); Detroit Inst. A., 1937 (prize); PAFA, 1939; ceramic, Syracuse M., 1939. Work: Hutchinson School, Detroit; Parramatta Theatre, Sydney Col., Sydney [40]

BABBOTT, Frank I. [Patron] b. 1854 d. 7 D 1933. President of Brooklyn Institute of Arts and Sciences from 1920 to 1928. Donated many pieces, which he helped to arrange, to the Italian Renaissance Hall in the Brooklyn Museum, which was opened in 1932.

BABCOCK, Catherine Evans (Cathie) [Li,I,P,Mur.P,Car] Bala-Cynwyd, PA b. 23 F 1921, Rydal, PA. Studied: Temple Univ.; Eliot O'Hara; Henry C. Pitz. Member: Phila.A.All. Exhibited: PAFA, 1939 (prize); Ohio Valley Exh., 1943 (prize); LOC, 1945; NAD, 1946; Phila. Pr. Cl.; Ohio Valley WC Exh., 1943, 1944; Phila. A. All., 1944 (one-man). Work: mural, Temple Univ. Hospital. Illustrator: "Mother Penny," 1946 [47]

BABCOCK, Dean [B,I] Long's Peak, CO b. 14 Ja 1888, Canton, IL d. 1969. Studied: John Vanderpoel; Robert Henri; Helen Hyde. Member: Denver AG; Gulf Coast AA. Exhibited: woodcuts, Denver Art Mus., 1934 (prize). Work: bookplates, N.Y. State Lib., Albany; Newark Pub. Lib.; Denver A. Mus.; Univ. Denver Lib. Illustrator: "Songs of the Rockies" (by C.E. Hewes), "Westering" (by Thomas H. Ferril, pub. Yale Press). Position: Research Assoc., Print Dept., Denver A. Mus. [38]

BABCOCK, Elizabeth Jones (Mrs.) [P] NYC b. 19 Jy 1887, Keokuk, IA. Studied: Cincinnati Acad. A.; ASL; Am. Sch. FA, Fontainebleau; Duveneck; Chase; Despujols, Miller. Member: NSMP; NAWPS; Mural P. Exhibited: NAWPS, 1935 (prize), decorative painting, 1936 (prize) [47]

BABCOCK, Eugenia [P] Grand Rapids, MI. Member: Grand Rapids AA [24]

BABCOCK, Ida Dobson [P] Redlands, CA b. F 1870, Darlington, WI. Studied: William Lippincott; George de Forest Brush; Charles Francis Brown. Member: San Bernardino County AA; Ar. Council, Los Angeles. Work: Univ. Nebr. Gal., Lincoln [40]

BABCOCK, Loren (Mrs. Perez R.) See Barton, Loren.

BABCOCK, R(ichard Fayerweather [Des,I,W,L,T,P] Evanston, IL b. 4 Je 1887, Denmark, IA d. 23 F 1954. Studied: AIC; Herron AI; Weinhold and Eisengraber Sch. Painting, Stätische Gewerbe Schule, both in Munich. Member: ASL, Chicago; Chicago WCC; Chicago A. Gld. Cliff Dwellers C. Exhibited: AIC (one-man); Hoosier Salon. Illustrator: natural history subjects; Encyclopaedia Britannica. Position: T., Chicago Acad. FA [47]

BABCOCK, Thomas d. announced 2 S 1899. Boston artist who lived in Europe forty years. Close friend of Millet.

BABCOCK, Viola Ward [P] Rumson, NJ b. 7 Ja 1919, Jersey City, NJ. Studied: Benton Spruance; Michel Jacobs. Member: AAPL; Asbury Park SFA. Exhibited: Acad. All. A., 1941, 1942; Jersey City, 1938–41; Montclair AM, 1941; Asbury Park SFA, 1942, 1946; AAPL, 1942, 1943 [47]

BACA, Lufina [C] Santa Clara Indian Pueblo, Espanola, NM d. ca. 1935

BACH, Alfons [Indst.Des] Stamford, CT b. 19 Je 1904, Germany. Studied: European schools. Member: ADI; Phila. A. All.; Silvermine Gld. A. Exhibited: ADI, 1942 (med); MMA, 1934, 1936, 1938; MOMA; N.J. State Mus., Trenton; Phila. A. Center; Riverside Mus.; Los Angeles A. Center; Newark Mus.; Rockford AA. Work: designs, General Electric, Heywood-Wakefield, Philco Radio, Bigelow-Sanford, Pacific Mills. Contributor: consumer/trade publications; cover des., national magazines [47]

BACH, Florence Julia [P,S] Buffalo, NY/Bethel, CT b. Buffalo. Studied: Albright Gal. A. Sch., with Chase, DuMond; Louis Lejeune, in Paris. Member: Buffalo SA, 1917, 1923. Exhibited: Buffalo SA, 1915 (prize), 1918 (prize), 1919 (prize), 1921 (prize), 1922 (prize), 1924 (prize); Buffalo Centenn., 1932 (med). Work: Buffalo FA Acad. Associated: Buffalo Sch. FA, Albright A. Gal. [40]

BACH, Oscar Bruno [Metalworker,L] NYC b. 13 D 1884, Germany. Studied: Royal A. Acad., Berlin. Member: Arch. Lg.; NYSC. Exhibited: Arch. Lg., 1928 (gold); Temple Emmanuel, 1929 (gold). Work: metalwork for Riverside Church (NYC), Temple Emmanuel (NYC), Christ Church (Cranbrook, Mich.), Williamsburgh Savings Bank (Brooklyn, N.Y.), Bank of New York (NYC), City Hall (Berlin); four exterior plaques for Rockefeller Center; plaques for Payne Whitney Gymnasium (N.Y.), SS. Washington, Empire State Bldg., Dept. Health (N.Y.), Toledo MA, Tel. Bldg. (Cincinnati). Position: Pres., Bach Studios, Inc., Bachite Development Corp. [40]

BACH, Otto Karl [Mus.Dir,T,Cr,W,L] Denver, CO b. 26 My 1909, Chicago. Studied: Dartmouth; Univ. Paris; Univ. Chicago. Member: AA Mus.; Western Assn. A. Mus. Dir.; Mich. Acad. A., Sc.&Let. Author: "A New Way to Paul Klee," 1946. Contributor: art magazines. Positions: Asst. Dir., Milwaukee AI, 1934; Dir., Denver (Colo.) A. Mus., 1944–46 [47]

BACH, Richard (Franz) [Edu,W,L] b. 29 Je 1887, NYC, d. 16 F 1968. Studied: Columbia. Member: AIA; Arch. Lg.; AID; NSMP; A. Dir. Cl.; Soc. Designer-Craftsmen; AA Mus.; Am. Indst. AA; Municipal A. Soc. of N.Y.; Century Assn.; A.All.Am.; AFA; Am. Handicraft Council; CUASch. Contributor: professional journals. Positions: Editor: Magazine of Art, 1930–32; Assoc. in Indst. A., MMA, 1918–29 [47]

BACH, Robert Otto [Des,P,Dec,L] San Francisco, CA b. 6 F 1917, San Fran. Studied: Calif. Sch. FA, with Joseph Sinel. Exhibited: Pal. Leg. Honor, 1939; A. Assn. Ann.; San Fran. MA, 1939; Seattle AM [40]

BACHARACH, Elsie W. [P] NYC/Woodstock, NY b. 20 Je 1899, NYC d. 8 Mr 1940. Studied: Winold Reiss A. Sch., N.Y.; Acad. Delecluse, Paris; Alexander Brook. Member: NAWPS. Exhibited: NAWPS, 1936, 1937, 1938 (prize); PAFA, 1939; GGE, 1939 [40]

BACHARACH, Herman Ilfeld [I,Gr] Phoenix, AZ b. 5 Ag 1899, Las Vegas, N.Mex. Studied: N.Mex. Normal Univ.; Univ. Pa; PMSchIA; Thornton Oakley. Exhibited: AIGA, 1927–28 (prize); PMSchIA, 1935 (med). Illustrator: children's books [47]

BACHE, Berta [P] NYC [04]

BACHE, Jules S. [Patron] NYC b. 1861, NYC d. 24 Mr 1944, Palm Beach, FL. He bequeathed his collection to MMA.

BACHE, Martha Moffett (Mrs.) [P,T,W] Wash., D.C. b. 26 O 1893, Flint, MI. Studied: PIASch, with Ernest Watson; AIC; Chicago Acad. FA, with Lester Stevens, Andrea Zerega. Member: Wash. AC; Wash. Soc. FA; AFA. Exhibited: Garfinckels, Wash., D.C., 1936 (prize); ASMP; Soc. Wash. A.; CGA; NCFA; Wash. AC; Georgetown Gal. Positions: T., Wash. D.C. Pub. Sch., Army hospitals [47]

BACHELDER, Jonathan Badger [G,Li] b. S 1825, Gilmanton, NH d. 22 D 1894, Hyde Park, NY. Published marine prints in Boston; views of Salem, Worcester, and Providence. [*]

BACHELDER, Oscar Louis [C] Candler, NC b. 14 Jy 1852, Menasha, WI d. 26 Je 1935. Studied: Calvin B. Bachelder. Member: BSAC; NYSC; Phila. ACG. Work: pottery, AIC, Newark (N.J.) Mus.

BACHELER, Frances Hope [P,T] Talcottville, CT b. 16 Je 1889, Lebanon, CT. Member: Eastern AA; Conn. AA; Hartford ACS; Hartford AC; AFA [33]

BACHER, Otto Devereux [C] Rock Tavern, Orange County NY b. 25 Je 1892, NYC. Studied: ASL, with Will Low Bacher. Member: Hudson Highland AA. Work: Hudson Highland AA. Position: associated with Pottery Division, White Cloud Farms [40]

BACHER, Otto Henry [P,E,I] Lawrence Park, Bronxville, NY b. 31 Mr 1856, Cleveland d. 16 Ag 1909, Lawrence Park. Studied: Duveneck; Carolus-Duran, Boulanger, Lefebvre, in Paris; Whistler, in Venice. Member: ANA; SAA; SI. Exhibited: Pan-Am. Expo, 1901 (prize); La. Purchase Expo, 1904 (med). Author: "With Whistler in Venice," 1908

BACHER, Will Low [Des,P,E] Rock Tavern, Orange County NY b. 9 Ja 1898, Broxville, NY. Studied: Bridgman; G. Maynard; DuMond, Othon Friesz, S. Calder. Member: Hudson Highland AA. Position: A. Dir./Des., White Cloud Pottery [40]

BACHMAN, Max [S] b. 1862, Brunswick, Germany d. 13 Ja 1921, NYC. Designer: allegorical figures of the continents for the Pulitzer Bldg., NYC

BACHOFEN, Max Albin [P] Castroville, TX/Alliance, OH b. 25 Ag 1903, Neubrunen, Switzerland. Studied: P.B. Travis. Exhibited: Cleveland, 1927 (prize), 1928 (prize), 1929 (prize), 1931 (prize). Work: City of Cleveland [40]

BACHRACH, David [P,Mur.P,T] Malden, MA b. 12 Mr 1906, Chelsea, MA. Studied: Boston Sch. Mod. A. Member: S.Indp.A., Boston; Chelsea A. Gld. Exhibited: S.Indp.A.; San Fran. MFA; Mercury Gal., N.Y.; Rockport Gal., Mass. Work: mural, Mt. Scopus Lodge of Masons, Malden, Mass. [40]

BACK, Joe [S,P,W] Dubois, WY b. 1899, Ohio. Studied: AIC (1925–27; 1930–31), with St.John, Poole, Philbrick, Obertauffer. Specialty: sculptures, horses/cowboys [*]

BACKUS, George J. (Mrs.) (Miss Fallis) [S] Minneapolis, MN b. Attic, IN. Studied: AIC; Minn. Sch. FA [08]

BACKUS, Josefa Crosby (Mrs. Grosvenor H.) [P] Sea Island, GA/Dublin, NH b. 13 O 1875, Brooklyn, NY. Member: Soc. Wash. Ar.; Union des Femmes Peintres et Sculpteurs, Paris. Exhibited: Argent Gal., 1938; Soc. Wash. Ar., 1939 [40]

BACKUS, Mary G. [P] Biltmore, NC [24]

BACKUS, Standish, Jr. [P,I,Des] Santa Barbara, CA b. 5 Ap 1910. Studied: Princeton; Univ. Munich; Eliot O'Hara. Member: Calif. WCS; San Diego FAS. Exhibited: Calif. WCS, 1940 (prize); Oakland A. Gal., 1939 (prize); AIC, 1940; Los Angeles MA, 1938–40; Navy Combat Exh., 1945, 1946; BM; Denver AM. Work: San Diego FA Soc.; Calif. WC Soc.; Los Angeles MA; U.S. Navy Dept., Wash. D.C. Position: Naval Combat A., Pacific area & Japan, 1945 [47]

BACON, Alice Sutton (Mrs.) [P] Cambridge, MA b. 23 Ap 1907. Studied: Radcliffe; BMFA Sch. Member: Boston AC; Cambridge AA; North Shore AA; Rockport AA. Exhibited: BMFA, 1930; Germanic Mus., Cambridge, 1946. [47]

BACON, Charles R(oswell) [Mur.P] Salem, NY b. 22 S 1868, N.Y. d. 9 O 1913. Studied: Constant, Lefebvre, Doucet, Collin, in Paris. Work: dec., Union Trust Co., Nineteenth Ward Bank, both in NYC. Many of his paintings were sold at the MMA A. Gal., 19 Ja 1914 [13]

BACON, Edith Jane [P] Winnetka, IL. Member: Wis. PS. Exhibited: AIC, 1938, 1939 [40]

BACON, Elizabeth (Beth) Driggs [P] Indianapolis, IN d. 15 Mr 1928, Indianapolis. Studied: AIC; ASL. Exhibited: Hoosier Sal., 1925, 1926, 1927, 1928; all large decorative, mythological compositions. Position: Staff, John Herron AI [21]

BACON, Francis H. [Des] Boston, MA [09]

BACON, Alice Marion (Mrs. George B.) See Sutton.

BACON, Henry [P] London b. 1839, Haverhill, MA d. 13 Mr 1912, Cairo, Egypt. Studied: Frère, Cabanel, in Paris. Noted for watercolor pictures of Normandy and of caravan life in Egypt. At eighteen he enlisted and became field artist for Leslie's Weekly.

BACON, Irving R. [P,S,I] Grosse Pointe, MI b. 29 N 1875, Fitchburg, MA d. 1962, El Cajon, CA. Studied: Chase Sch., N.Y., with F. Luis Mora; Royal Acad., Munich, with Carl von Marr, Heinrich von Zugel. Member: AAPL; Detroit A. Founders Soc. Exhibited: Royal Acad., Munich 1909 (med); NAD, 1910–12; PAFA, 1911, 1912; AIC, 1911, 1912; Western A., 1910–13. Work: Louisville A. Gal.; Edison Inst.; portraits, reproductions of early Ford inventions, in Ford coll. Designer: greyhound and quail radiator ornaments for Ford. Personal artist for Henry Ford. [47]

BACON, John Reuben [P,Des,T,L] Tarrytown, NY b. 5 Ap 1866, Tarrytown. Studied: William M. Chase. Member: NYSC; Gloucester SA; Hudson Valley AA; Deerfield Valley AS. Author: book on blockprinting. Contributor: N.Y. Times, Brooklyn Eagle, etc. [40]

BACON, Julia [P] Jamaica Plain, MA b. Boston d. 1901. Studied: E.C. Tarbell. Member: BASA, 1894 [01]

BACON, Kate L. See Kate B. Bond, Mrs.

BACON, Peggy (Mrs. Alexander Brook) [Edu,P,Por.P,Caric,I,Li,T,W] NYC/Cross River, NY b. 2 My 1895, Ridgefield, CT. Studied: Jonas Lie; John Sloan; K.H. Miller; Andrew Dasburg; George Bellows. Member: Am. Soc. PS&G; SAE; F., Guggenheim Fnd., 1934. Work: MET; BM; WMAA. Position: T., New Sch. Soc. Res., NYC [40]

BACON, Viola J.(P.) NYC b. 1878, Macon, GA. Studied: CUASch; W.J. Whittemore [04]

BADDERSTON, Stephanie [P] Phila., PA [17]

BADGER, Francis S. [P] Chicago, IL. Exhibited: AIC, 1933–37, 1939 [40]

BADIN, Ferdinand [P,G] Buffalo, NY b. 17 D 1897, Vienna, Austria. Studied: Hubert Zwickle, Vienna. Work: "Index American Design" [40]

BADUE, Daniel Serra. See Serra.

BADURA, Benjamin [P] Milwaukee, WI. Member: New Century Cl. [24]

BADURA, Bernard [P,C] New Hope, PA b. 22 S 1896 Milwaukee, WI. Studied: Milwaukee Normal A. Sch., with George Oberteuffer; PAFA, with Arthur Carles, Daniel Garber. Exhibited: CAFA, 1934 (prize); CGA; NAD; CM; VMFA; PAFA; Hartford Mus.; New Haven Mus. Work: PMA

BADURA, Faye Swengel. See Swengel.

BAEHR, Francine (Mrs.) [E,P,Des] NYC b. 21 Jy 1897. Studied: Univ. Chicago; Acad. Julian, Grande Chaumière, both in Paris; Casteluccio. Member: NSMP; Silvermine Gld. A. Exhibited: Brooklyn SE; Chicago SE. Work: WFNY, 1939 [47]

BAEHR, Frances Ernestine NYC [24]

BAEKELAND, Céline [P] Yonkers, NY b. Ghent, Belgium. Studied: Europe; Hobart Nichols. Member: NAWA; NAC; All.A.Am.; PBC; Soc. Four A.; SSAL; Springfield AA; Newport AA; East Hampton Gld.; Yonkers AG; Blue Dome Fellowship. Exhibited: NAWA; Soc. Four A.; Ogunquit A. Center; Hudson Valley AA; Newport AA; Albany Inst. Hist.&A.; Currier Gal.; Eastman Gal.; Purdue; Lyman Allyn Mus.; Slater Mem. Mus.; Speed Mus.; Brooks Mem. A. Gal.; High Mus. A.; AFA Traveling Exh. Illustrator: art magazines [47]

BAER, Arthur F. [P] Cleveland, OH. Member: Cleveland SA [24]

BAER, George [P] NYC. Exhibited: Ferargil Gal., 1937 (one-man); AIC; Kansas City AI [40]

BAER, Herbert M. [P,En,Arch] NYC/Westport, CT b. 13 N 1879, NYC. Studied: Ware; Columbia. Member: SBAA; Arch. Lg.; S.Indp.A. Exhibited: Paris Salon, 1905 (prize). Work: Park and Tilford's, NYC [33]

BAER, Howard [P,I,Car] NYC. Contributor: New Yorker, Esquire, other magazines [47]

BAER, John Miller [En,I] Washington, D.C. b. 29 Mr. 1886, Blackcreek, WI. Studied: Corcoran; Laurence Acad. A. [33]

BAER, Kurt [P,C,T] Los Angeles, CA b. 18 N 1905. Studied: Univ. Calif.; André Lhote, Fuerst, in Paris; Munich; Berlin. Member: Eagle Rock AA [33]

BAER, Lillian [S] NYC b. 30 Mr 1887, NY. Studied: A. Mucha; James E. Fraser [17]

BAER, Martin [P,E] Carmel, CA b. 3 Ja 1895, Chicago. Studied: Smiths A. Acad., Chicago; AIC; State Acad., Munich; Ecole des Beaux-Arts, Paris. Member: AAPL; Carmel AA. Exhibited: Pal. Leg. Honor, 1943, 1946; AIC, 1926–31; Durand-Ruel, Paris, 1926; Galerie Jeune Peinture, Paris, 1928; Newhouse Gal., 1929, 1936, 1941; Santa Barbara Mus. A., 1942; San Diego FAS, 1942; Taylor Gal., 1942; Galerie M. Benezit, Paris, 1936. Work: MOMA; Los Angeles MA; San Diego, FAS; Pal. Leg. Honor; Eastman Mem. Fnd.; Oshkosh Pub. Mus.; Ft. Worth MA; Luxembourg Mus.; Musée du Jeu de Paume; Casablanca Mus., Morocco [47]

BAER, William J(acob) [P] East Orange, NJ b. 29 Ja 1860 d. 21 S 1941. Studied: McMicken Sch. Des., Cincinnati; Royal Acad., Munich. Member: ANA; ASMP; Calif. S. Min. P.; Pa. S. Min. P. Exhibited: Paris Expo, 1900 (med); Pan-Am. Expo, Buffalo, 1901 (med); Charleston Expo, 1902 (med); P.-P. Expo, San Fran., 1915 (gold). Award: Hors Concours, St. Louis Expo, 1904 (Jury of Awards). Work: Jaffe Coll., Hamburg; BM; Walters Gal., Baltimore; Montclair (N.J.) AM [40]

BAERER, Henry [S] NYC b. 1837, Kirchlim, Hesse-Kassel, Germany d. 7 D 1908, Bronx, NY. Studied: Von Launitz; Acad. Munich. Member: NSS. Work: statues, Central Park, Ft. Green Park, Prospect Park, all in NYC

BAERMAN, L(ucius) E. [P] Copenhagen, NY b. 12 O 1879, Antwerp, NY. Studied: NAD [15]

BAESEMANN, Margaret Maassen. See Maassen.

BAGDATOPOULOS, W(illiam) S(pencer) [P,I,E,Li,B,T] Santa Barbara, CA b. 23 Jy 1888, Zante, Greece. Studied: Academie van Beeldende Kunsten en Technische Weetenschappen, Rotterdam. Member: Chicago SE; London Sketch Cl.; F., Royal Soc. A., London. Exhibited: South Kensington, London, 1913 (medals). Work: NGA; Srinagar, Kashmir; Nat. Pinakotec, Athens; Municipal Gal. A., Amsterdam; Boyman's Mus., Rotterdam; British Mus., London. Contributor: Times of India Ann., since 1911 (on design, stage sets, etc., pertaining to India). [40]

BAGG, Henry Howard [P,T] Lincoln, NE b. 1852, Wauconda, IL d. 1928. Specialty: Western life. Position: T., NE Wesleyan Univ. [*]

BAGG, Louise Eleanora [P,S,] Paris, France b. Springfield, MA. Studied: Desvergnes, in Paris. Exhibited: St. Louis Expo, 1904 (medals) [17]

BAGGS, Arthur E. [C,T] Columbus, OH/Marblehead, MA b. 27 O 1886, Alfred, NY. Studied: Charles F. Binns, N.Y. State Col. Ceramics. Member: F., A. Ceramic S., 1930; Boston SAC; Columbus AL. Exhibited: Chicago Exch. App. A., 1915 (prize); Boston SAC, 1925 (med); Charles F. Binns, 1928 (med); Cleveland, 1928 (prize); Robineau Mem. Cer. Exh., Syracuse, 1933 (prize), 1935 (prize), 1938 (prize). Work: MMA; BMFA; Newark Mus.; Columbus (Ohio) Gal. FA; Cranbrook Mus.; Syracuse Mus. FA. Position: T., Ohio State Univ., Columbus [40]

BAGLEY, James M. [P,Wood En] Denver, CO b. 1837, Maine d. 1910. Work: Denver Pub. Lib. Came to Denver 1872; by 1880 painting Colorado landscapes. [*]

BAGLEY, Ralph Leon [P,Li] Welch Cove, NC b. 14 My 1913. Studied: Flint AI, with Brozik; ASL, with Lee; CGA. Exhibited: Flint AI, 1931–33; Detroit AI, 1931, 1932 [47]

BAHLS, Ruth [P] Lafayette, IN b. 23 Mr 1901, Lafayette. Studied: Purdue; John Herron AI; Chales Hawthorne. Exhibited: Hoosier Salon, 1934; Indp. A. Exh. [47]

BAHM, Henry [P,Li] Roxbury, MA b. 26 F 1920. Studied: Mass. Sch. A., with Ernest Major; BMFA Sch., with Karl Zerbe. Member: Boston Inst. Mod. A. Exhibited: SFMA, 1945; Assoc. Am. A., 1946; Inst. Mod. A.; Boris Mirski Gal.; Stuart A. Gal. [47]

BAHNC, Salcia [P,E,Li,S,T] NYC b. 14 N 1898, Dukla, Poland. Studied: AIC; Chicago Acad. FA. Member: Chicago AC. Exhibited: Chicago, 1942 (prize); AIC, 1919–1929, 1942, 1943; Johnson Gal., Chicago, 1925, 1927, 1929, 1931 (one-man); Arch. Lg., 1925; Marie Sterner Gal., 1928; PAFA, 1922; Jeune Peinture, Paris, 1934 (one-man); Salon de Tuileries, Paris, 1930–1935; Sur. Indp., Paris, 1929 [33]

BAHR, Florence Riefle (Mrs. Leonard M.) [P,I] Baltimore, MD b. 2 F 1909, Baltimore. Studied: Dickinson Col.; Md. Inst., with Henry Roben. Exhibited: Md. Inst., 1936; BMA, 1936–46. Work: BMA. Illustrator: "Poems for Children," by John Shaw [47]

BAHR, Leonard Marion [P,T,I] Baltimore, MD b. 12 My 1905, Baltimore. Studied: Md. Inst. Member: AAPL. Exhibited: BMA, 1930, 1946. Work: Johns Hopkins Univ.; Univ. Md.; Mo. State T. Col.; Baltimore Aquarium; Fed. Land Bank, Catonsville, Md.; Md. Nat. Hist. Soc. Position: T., Md. Inst., Baltimore, 1930–46 [47]

BAILEY, Carden [P,T,G] Houston, TX b. 23 S 1911, Houston. Studied: PAFA; P. Lingan. Exhibited: Southeast Tex. Ar. Ann., Houston Mus., 1934–36, 1939; City Fed. Women's Cl., 1937 (one-man) [40]

BAILEY, Cora Louise (Corot) [Des,I] Boston, MA b. O, 1870, West Newton, MA. Studied: Mass. Normal A. Sch.; BMFA Sch. Member: B.A. Students' Assn., 1896. Designer: stained glass windows [17]

BAILEY, Caroline M.B. [Por.P] Covington, KY b. 1 Mr 1905, Baltimore. Studied: George Oberteuffer; Albert Krehbiel; William Owen; AIC. Member: Louisville AA [40]

BAILEY, Earl Clifford [T,P] Billings, MT b. 30 My 1909, Havre, MT. Studied: Mont. State Univ.; Colo. State Col. Edu.; ASL, with Harry Sternberg, Kenneth Hayes Miller. Exhibited: Mont. State Univ., 1937 (prize); Northern Mont. Fair, 1942 (prize); Northwest AA, 1944–46; Yellowstone A. Gal., Billings, 1944; Northern Mont. Fair, 1942. [47]

BAILEY, Evelyn [P] Berkeley, CA b. 1912, Seattle, WA. Studied: Col. A.&Crafts, Univ. Calif. Exhibited: Delta Epsilon exh. (prizes) [40]

BAILEY, G. Harold [P] Webster, MA [24]

BAILEY, Harry L. [P,I,E] Beverly Hills, CA b. 2 D 1879, St. Louis, MO d. late 1930s. Studied: St. Louis Sch. FA. Member: Calif. AC; Calif. PM

BAILEY, Helen Virginia. See Pett, Helen Bailey. [40]

BAILEY, Henrietta Davidson [Cer,Des,B] New Orleans, LA b. New Orleans. Studied: Newcomb Col.; Ellsworth Woodward; Arthur W. Dow. Member: NOAA. Exhibited: Newcomb A. Alum. Assn., 1931 (prize), 1932 (prize). Work: Delgado Mus.; City A. Mus., St. Louis, Mo.; Newcomb Col. [40]

BAILEY, Henry Lewis [E] Los Angeles, CA. Member: Calif. AC; Calif. PM [24]

BAILEY, Henry T(urner) [I,C,T,W,L] Cleveland, OH b. 9 D 1865, North Scituate, MA d. 26 N 1931, Chicago. Studied: Mass. Normal A. Sch., Boston; Europe. Member: Cleveland AA; College AA; Cleveland SA; Cleveland AIA; AFA; P.-P. Expo, San Francisco, 1915. Work: Vanderpoel Coll. Author: "Photography and Fine Art," "Symbolism for Artists." Positions: State Supv., Drawing, Mass. 1889–1900; Dir.: Chautauqua Summer Sch. A.&Cr., 1906–16; Cleveland Sch. A., 1917–30; John Huntington Polytechnic Inst., Cleveland, 1919–30

BAILEY, James E(dward) [P] Phila., PA b. 13 D 1885, Baltimore. Member: Phila. AL; Graphic Sketch Cl. Exhibited: Wanamaker's, Phila., 1915–16 (prize); World Fair Poster, Chicago, 1923 (gold) [33]

BAILEY, John Haynes [Mus. Dir] Davenport, IA b. 22 My 1909, Dansville, NY. Studied: Cornell. Member: AA Mus. Position: Dir., Davenport Public Mus., 1940– [47]

BAILEY, L.E. [P] Chicago, IL. Member: GFLA [24]

BAILEY, LaForce [P,Mur.P,T] Urbana, IL b. 17 Ap 1893, Joliet, IL. Studied: William M. Hekking; Charles Hawthorne; John R. Frazier. Member: AIA; Provincetown AA; AWCS; Wash. WCC; Phila WCC. Exhibited: AWCS, 1934 (med). Work: murals, Ill. Century Progress Expo, 1933. Position: T., Univ. Ill., Urbana [47]

BAILEY, Merrill A. [P,T] Cazenovia, NY b. 21 Jy 1909, Cazenovia. Studied: PIASch; Syracuse Univ.; Ogden Pleissner; Anna Fisher. Member: AWCS; Syracuse AA. Exhibited: Syracuse Mus. FA, 1938 (prize), 1940 (prize), 1944 (prize), AV, 1943 (prize); Rochester Mem. A. Gal., 1944 (prize), 1946; Syracuse AA, 1935, 1936, 1937 (prize), 1938–46; BM, 1941–45; AIC, 1942–46; MMA, 1942; Toledo Mus. A., 1943, 1946; AWCS, 1940–46. Work: Syracuse Mus. FA; Rochester Mem. A. Gal.; Munson-Williams-Proctor Inst., Utica, N.Y.; Toledo Mus. A. Contributor: art magazines. Position: T., Cazenovia Jr. Col. [47]

BAILEY, Minnie Moly [P,I] Southbridge, MA b. 29 O 1890, Oberlin, KS. Studied: Hawthorne; Connah; Pape [24]

BAILEY, Robert M. [P] Boston, MA. Studied: Boston AC [13]

BAILEY, R.O. [P] Cleveland, OH. Studied: Cleveland SA [24]

BAILEY, S.T. Brooklyn, NY [01]

BAILEY, Vernon Howe [P,I] NYC b. 1 Ap 1874, Camden, NJ d. O 1953. Studied: PAFA; PMSchIA; Acad. Biloul, Paris. Member: AWCS; Hispanic Soc. Am.; San Fernando Royal Acad. FA, Madrid. Work: Hispanic Mus., N.Y.; Smithsonian Inst.; French War Mus.; NYPL; Mus. City N.Y.; Nat. Lib., Madrid; Lib. Am. Studies, Rome; Vatican Lib. Illustrator: "Skyscrapers of New York," "Little Known Towns of Spain," magazines, New York Sun (1934–36) [47]

BAILEY, Walter Alexander [P,E,B,Li,T] Kansas City, MO b. 17 O 1894, Wallula, KS. Studied: Charles A. Wilimovsky; John D. Patrick; Randall Davey; Anthony Angarola; Ross Braught; Thomas Hart Benton. Member: F., Tiffany Fnd., 1924. Work: William Rockhill Nelson Gal. A.; Municipal Auditorium, Kansas City; Pub. Lib., Springfield, Mass. [40]

BAILEY, Weldon [Li] Phila., PA b. 14 D 1905, Phila. Studied: PAFA; Graphic Sketch Cl. Exhibited: Phila. Print Cl., 1934 (prize). Work: NYPL. Illustrator: magazines. Position: A. Cr., Philadelphia Record. [40]

BAILEY, William J. [Car,I,Des] Collingswood, NJ b. 26 My 1902, Phila. PA. Studied: PMSchIA; Spring Garden Inst. Member: Phila. A. Dir. Cl. Illustrator: Saturday Evening Post, Collier's [47]

BAILEY, Worth [Des,W,L,En] Alexandria, VA b. 23 Ag 1908, Portsmouth, VA. Studied: Col. William & Mary; Univ. Pa., with Virginia Morris, Glenna Latimer. Member: AA Mus; Am. Soc. Arch. Historians. Exhibited: Norfolk Soc. A., 1926–28 (prize); Norfolk, Williamsburg, Richmond, Va., 1928–38. Work: Univ. Pa.; Valentine Mus.; Col. William & Mary. Contributor: art/antique magazines [40]

BAILHACHE, Anne Dodge [P,Li] Saratoga, CA b., Lancaster, PA. Studied: Calif. Sch. FA. Member: San Fran. AA; San Fran. Soc. Women A. Exhibited: San Fran. Soc. Women A. (prize); SFMA; Pal. Leg. Honor; GGE, 1939. Position: Founder/Director, Montalvo Fnd., Saratoga, 1939–46 [47]

BAIN, Harriet F. [P] b. Kenosha, WI. Studied: John Vanderpoel; E.A. Webster; Collin; Garrido. Member: Wis. PS; Chicago AC; Provincetown AA; Salons of Amer. Work: Vanderpoel AA Coll., Chicago [40]

BAIN, Joan (Mrs. J.B. Nicodemus) [P,T] Memphis, TN b. 9 Mr 1910, Manila, Philippine Islands. Studied: Newcomb Col., Tulane Univ.; Robert Graham; John Lenhardt; Wayman Adams. Exhibited: S.C. AA, 1938; VMFA, 1939, 1940; CGA, 1941; James Lee A. Acad., 1941 (oneman); Brooks Mem. A. Gal., 1941 [47]

BAIN, Lillian Pherne [P,E,T] Portland, OR b. 14 Ag 1873, Salem, OR d. ca. 1950. Studied: ASL, with Frank DuMond, Guy Rose, Joseph Pennell. Member: ASL; Oreg. SA. Exhibited: NAD, 1923, 1924, 1927; Western A., 1936; Chicago SE; Newport AA; Brooklyn SE [47]

BAIN, Thomas James Coutts [P,S,T] Durham, NC b. 3 N 1896, Aberdeen, Scotland. Member: Phila. Fed. A. Work: White House; reconstructing statues for Joseph Widener, Phila. [40]

BAINBRIDGE, Mabel Foster (Mrs. John P.) [Dec,Des,L,W] Hingham, MA/Chatham, MA b. 22 N 1885, Boston, MA. Studied: Miss Sacker's Sch. of Dec. Des., Boston; lace-making schools, France and England. Member: N.Y. Needle and Bobbin C.; Boston SAC (Master Craftsman); Thread and Needleworker's Gld. Work: Exhaustive catalogue of all laces and embroideries in Isabella Stewart Gardner Mus., Boston. Contributor: House and Garden, Ladies' Home Journal, Handicrafter, other magazines [40]

BAINBRIDGE, F. Edith [P,I,T] NYC b. 8 Ap 1886, Brooklyn, NY. Studied: PIASch; Anna Fisher; Ernest Blumenschein. Member: Wolfe ASC [13]

BAINS, Ethel Franklin Betts [I] Phila., PA. Studied: PAFA. Member: Phila. WCC. Exhibited: P.-P. Expo, San Fran., 1915 (med) [40]

BAIR, Homer Franklin [P] Greensburg, PA b. 2 N 1896, Greensburg. Studied: self-taught. Member: Pittsburgh AA; Greensburg AC. Exhibited: Greensburg AC, 1933 (prize); Pittsburgh AA, 1935 (prize), 1936 (prize). Work: Greensburg; Pa. State Col. [40]

BAIRD, Coe Manning [Por.P] Verona, NJ b. Middletown, NY d. 24 F 1942

BAIRD, Eugene Q(uentin) [P] Orange, NJ b.6 My 1897, Straits Settlements, Asia. Studied: PIASch; ASL; Jane Peterson. Member: NYWCC; A. Dir. Cl.; Essex County WCC [40]

BAIRD, Louise S. Louisville, KY. Member: Louisville AL [01]

BAIRD, Myra H. Louisville, KY. Member: Louisville AL [01]

BAIRD, Ruth Llewellyn [P] Winnetka, IL b. 21 D 1888, Monticello, IL. Studied: AIC; Cleveland Sch. A.; A. Acad. Cincinnati; Archipenko. Member: Women's A. Cl., Cincinnati; North Shore A. Lg., Chicago. Exhibited: North Shore A. Lg., 1938 (prize), 1939 (prize); Cincinnati AM; Ar. Chicago Vicinity, AIC; Joslyn Mem., Omaha, Nebr., 1939 [40]

BAIRD, Will [P] St. Paul, MN [19]

BAIRD, William B. Paris b. Chicago. Studied: Adolphe Yvan, in Paris [98]

BAIRNSFATHER, Arthur L. [P,T] Birmingham, AL b. 14 Ap 1883, Kentucky. Studied: Frank Duveneck; Vincent Nowottny; Cincinati A. Acad.; AIC. Member: Salma. C.; SSAL; Rockport AA; Birmingham AC. Exhibited: SSAL, San Antonio, Tex., 1929 (prize); SSAL, Montgomery, Ala., 1938 (prize). Work: Univ. Ala., Tuscaloosa; USPO, Monroeville, Ala.; Burlington, N.C. Sect. FA, Fed. Works Agency; Mus. FA, Capitol, both in Montgomery, Ala.; Ala. Col., Montevallo; Capitol, Jackson, Miss. [48]

BAISDEN, Frank M. [Mur.P,L,T] Chattanooga, TN/Rising Fawn, GA b. 17 Je 1904, Atlanta. Studied: PAFA. Member: Tenn. SA; Chattanooga AA. Work: murals, Louis XV Salon, Château de la Coninnais, Dinan, France; Watkins Inst., Nashville; PAFA. Positions: Dir. A., Univ. Chattanooga; Dir. A., Bright's Sch., Chattanooga [40]

BAISLEY, Charles [P] New Orleans, LA [08]

BAIZERMAN, Saul L. [S] NYC. Member: S. Gld. Exhibited: AWCS; WMAA, 1934; PAFA Ann., 1934, 1936, 1937; Gld. A. Gal., N.Y., 1937 (one-man); WFNY, 1939; Mus. Mod. A. Gal., Wash., D.C., 1939 [40]

BAKER, Adelaide Clarissa [P,C] Cleveland, OH b. Cleveland. Studied: George Elmer Browne; Max Bohm; Cleveland Sch. A. Member: Wash. A. Center; Cleveland AA. [33]

BAKER, Alice C. [P] Baltimore, MD [24]

BAKER, Annabelle [P,S,Des,Gr] Hampton, VA b. 18 My 1925, St. Petersburg, FL. Studied: Hampton Inst.; Viktor Lowenfeld; Leo Katz. Exhibited: Hampton Inst., 1944 (prize). Exhibited: Atlanta Univ., 1944, 1945; MOMA, 1943; VMFA, 1944–46. Work: Des., books for U.S. Naval Edu. programs, 1944 [47]

BAKER, Bryant [S] NYC b. 8 Jy 1881, London. Studied: City & Glds. Tech. Inst.; Royal Acad., London. Member: Royal Soc. British Sculptors; Royal Soc. A.; AFA. Exhibited: Royal Acad., 1910 (gold; prize); NAD; PAFA; BMFA; CGA; NCFA; AIC; Paris Salon. Work: statues, mem., busts, England & U.S. Lectures: contemporary sculpture [47]

BAKER, Catherine (Isabelle). See Stuart, C.B.

BAKER, Charles [P,Cr] Brooklyn, NY b. 1844 d. 19 Ag 1906, Lake George, NY. Son of Charles Baker, one of the founders of the Art League.

BAKER, Charles Edwin [Ed,W] NYC b. 16 D 1902, Harlan, IA. Studied: Columbia. Member: Bibliogr. Soc. Am.; Am. Assn. State & Local Hist. Contributor: art magazines. Positions: Ed., Hist. Records Survey, NYC, 1937–41; N.Y. Hist. Soc., 1944– [47]

BAKER, Conn [P] Columbus, OH. Member: Columbus Pen & Pencil Cl. [24]

BAKER, Donald [P] Westerville, OH. Member: Columbus Pen & Pencil Cl.; S.Indp.A. [24]

BAKER, Elizabeth Gowdy (Mrs.) [P] NYC/Palm Beach, FLA/Lake Placid, NY b. Xenia, OH d. 11 O 1927. Studied: ASL; CUASch; N.Y. Sch. A.; PAFA; Cowles A. Sch., Boston; Rome; Florence; Paris. Member: NAC; Aquarellists; NAWPS. Work: Xenia Theological Seminary, St. Louis; Engineers Cl., NYC; Phillips Acad., Andover, Mass.; Ia. Hist. Soc.; Springfield (Mass.) A. Mus.; Univ. Cincinnati Lib. Specialty: portraits in pure aquarelle and in oil [24]

BAKER, Ellen Kendall (Mrs. Harry Thompson) [P] Puteaux, France b. Fairfield, NY d. 1913, St. Giles, England. Studied: Paul Soyer, Harry Thompson, both in Paris. Exhibited: PAFA; NAD; AIC; Pan-Am. Expo, Buffalo, 1901 (prize) [98]

BAKER, Emilie H. [P] NYC. Studied: Twachtman; Cox. Member: ASL. Specialty: watercolors [08]

BAKER, Ernest Hamlin [P] Carmel, NY. Work: USPO, Wakefield, R.I. WPA artist. [40]

BAKER, Eugene [I] Paris, France b. Baltimore, MD. Studied: Bouguereau, Blanc, in Paris [10]

BAKER, F.A. Fuller [P] Hempstead, NY. Member: S.Indp.A. [24]

BAKER, Frances Louise [P,W] Lake Forest, IL b. 1871, Chicago. Studied: Merson, Collin, both in Paris [08]

BAKER, Frederic Van Vliet [P,T] b. 6 N 1876. Studied: PIASch; Courtois, in Paris. Member: SC; Soc. Nat. des Beaux-Arts, 1901. Position: T., PIASch [33]

BAKER, G. (P.) NYC [04]

BAKER, George [P,I,W] Bedford Hills, NY b. 2 Ja 1882, Strother, MO. Studied: Westminster Col. Exhibited: Salon des Artistes Française, 1910, 1911; Salon des Beaux-Arts, 1911; NAD, 1910; Am. A. Chicago, 1910. Position: Pres., Nat. Adv. A. Center, N.Y. 1941– [47]

BAKER, George H(erbert) [P] Centerville, IN b. 14 F 1878 d. 11 N 1943. Studied: Cincinnati AA. Member: Richmond AA; Ind. AC; S.Indp.A.; Richmond Palette Cl. Exhibited: Muncie, Ind., 1910 (prize); Richmond, Ind., 1910 (prize), 1913 (prize), 1915 (prize), 1930 (prize); Hoosier Salon, 1925 (prize); Ind. State Fair, 1930 (prize) [40]

BAKER, George Holbrook [P,Li] San Fran., CA b. 1827, Medway, MA d. 1906. Studied: NAD. Set up lithography business in San Fran., 1862. [*]

BAKER, George O. [P,I] Chicago, IL b. 2 Ja 1882, Mexico, MO. Studied: Laurens, Richard Miller, both in Paris. Member: S. Lg. [24]

BAKER, Gladys M. [P] Douglaston, NY [24]

BAKER, Grace M. [P,T] Greeley, CO b. 18 O 1876, Annawan, IL. Studied: AIC. Member: Nat. Edu. A.; WAA. Position: Hd., Art Dept., Colo. State T. Col. [33]

BAKER, Helen Josephine [Min.P] Phila., PA b. 8 Ja 1869, Phila. Studied: Chase; PAFA. Member: Plastic Cl. [15]

BAKER, Helena Seymour [P] LaPorte, IN b. 1 Ap 1900. Studied: George Elmer Browne; Robert Henri; Sigurd Skou. Member: ASL; Hoosier Salon [33]

BAKER, Horace [Wood En] Great Neck, LI, NY b. 12 N 1833, North Salem, NY d. 2 Mr 1918, Great Neck. He was trained in his brother's engraving firm in Boston, of which he afterwards became a partner. For many years he was connected with the engraving department of Harper's Magazine and later with the publications of Frank Leslie.

BAKER, Ida Strawn (Mrs.) [C,Li,W] Indianapolis b. 24 S 1876, Gillett Grove, IA. Studied: AIC; John Herron AI; William Forsythe; Paul O'Higgen, in Mexico; Birger Sandzen. Member: Handicraft Gld. Ind. Author: "Batik and Other Pattern Dyeing," pub. Mentzer Bush & Co. Work: John Herron AI, Indianapolis. Position: Pres., Waldcraft Lab., Inc., Indianapolis [40]

BAKER, Jean [P,B] Los Angeles, CA b. 6 N 1903, Arcadia, NE. Studied: Rudolph Schaeffer; Alfonso Iannelli; Carl Sprinchorn. Member: Women P. of the West; Los Angeles AL. Exhibited: Intl. Bookplate Exh., U.S. Div., Los Angeles Mus. Hist., Sc.&A., 1933 (prize) [40]

BAKER, J. Elder NYC [01]

BAKER, Jessie E. [P] Wash., D.C. Member: Wash. SA [24]

BAKER, Lamar [E,Li,P,I] NYC b. 15 S 1908, Atlanta. Studied: Univ. Ga. High Mus.A.; ASL, with Kenneth Hayes Miller, Harry Sternberg. Member: Rosenwald F., 1942. Exhibited: NAD, 1940, 1941, 1943; MMA, 1942; High Mus. A., 1939 (one-man); Weyhe Gal., 1945 (one-man) [47]

BAKER, Margaret [P] Chicago, IL [17]

BAKER, M(aria) May [P,T] Norfolk, VA b. 25 S 1890, Norfolk. Studied: PAFA; Corcoran; Charles Hawthorne; C.C. Critcher; Webster. Member: Norfolk SA; Norfolk A. Corner. Work: Norfolk Soc. A. [40]

BAKER, Martha Susan [P,Min.P] Paris b. 25 D 1871, Evansville, IN. Studied: AIC. Member: Chicago SA; SWA. Exhibited: AIC, 1905 (prize, med); Arché Salon, Chicago, 1897 (prize); St. Louis Expo, 1904 (med); CI, 1904 (prize) [09]

BAKER, Mary F(rances) [P] New Orleans, LA b. 28 O 1879, New Orleans d. 24 Ag 1943. Studied: Newcomb A. Sch.; PAFA. Member: New Orleans AA; New Orleans ACC. Exhibited: New Orleans AA (med) [40]

BAKER, Mary Hofstetter [P,Des] Hammonton, NJ b. 4 Ja 1913, Phila. Studied: PAFA; PMSchIA; Barnes Fnd. Member: Phila. WCC. Exhibited: PAFA, 1942–44; CGA, 1943–45; Soc. Four A., 1942; Temple Univ., 1941; daVinci Gal., 1942; Cape May, N.J., 1941–45; Plastic Cl.; Phila. A. All., 1939. Work: PAFA [47]

BAKER, M(innie) (Mitchell) [T,P,S,L] Durant, OK b. 20 Jy 1901, Ardmore, OK. Studied: Southeastern State Col., Durant, Olka.; Univ. Iowa; Tarbell; Merryman; Guston. Member: Okla. AA; Okla. Edu. Assn. Exhibited: Okla. State Fair, 1929 (prize), 1930 (prize), 1931 (prize); CGA; Okla. A. Center; Philbrook A. Center Work: Okla. A. Center. Position: T., Southeastern State Col. [47]

BAKER, Oliver [[P]] Boston, MA [01]

BAKER, Oliver Mozart [P] Brooklyn, NY. Work: USPO, McRae, Ga. WPA artist. [40]

BAKER, Ora Phelps [P,T] Stevens, Point, WI b. 22 O 1898, Stevens Point. Studied: AIC. Member: Chicago ASL; Allied A. Soc. Ft. Worth, Tex. [33]

BAKER, Percy Bryant [S] Boston/East Gloucester, MA b. 8 Jy 1881, London. Studied: Royal Acad. A., London. Member: F., Royal Soc. Brit. Sculptors. Work: statue, Haddersfield, England; Queen of Norway; mem., Winchester, Va., Austin, Tex.; busts of President Wilson and Sen. H.C. Lodge, owned by Gen. P.C. March. [19]

BAKER, Raymond Nelson [Des,P] Hammonton, NJ b. 11 Je 1913, Phila., PA. Studied: PAFA; PMSchIA. Exhibited: PAFA; Phila. A. All.; Plastic Cl.; Cape May (N.J.) Exh. Positions: A. Dir., Webb Mfg. Co., Phila., 1946– ; Bd. Mgrs., PAFA, 1946–47 [47]

BAKER, Robert P [S] b. 29 Je 1886, London d. 5 S 1940, Hyannis, MA. Studied: England. Member: NSS; SC

BAKER, S(amuel) B(urtis) [P] Wash., D.C. b. 29 S 1882, Boston. Studied: Major; DeCamp; Edward H. Barnard; Charles H. Davis. Exhibited: 1921, Clark prize and Corcoran medal; Sesqui-Centennial Expo, Phila., 1926 (med); Copley Gal.; Corcoran Gal.; Gld. Boston Ar. Work: Macon A. Inst.; Mass. State House; Boston; Harvard Law Sch.; N. H. State House; U.S. Marine Corps Headquarters; Corcoran Gal.; Wash., D.C.; Va. Theological Seminary, Alexandria; Nat. Acad. Design, N.Y.; Wash. Loan and Trust Co.; Georgetown Univ. Law Sch.; Univ. Md. Positions: Instr./Vice-prin., Corcoran Sch. A., 1921–35; Adj. Prof. FA, George Wash. Univ., 1925–36 [40]

BAKER, S.H. [P] Boston, MA [01]

BAKER, Sarah M. [Edu,P] Wash., D.C. b. 7 Mr 1899, Memphis, TN. Studied: Md. Inst.; Tiffany Fnd.; Hugh Breckenridge; Arthur Charles; André Lhote. Member: Wash. A. Gld.; F., PAFA; F., PMG. Exhibited: Wash. Soc. Indp. A., 1935 (prize); BMA, 1945 (prize). Work: BM; Am. Univ. Positions: T., Bryn Mawr Sch. Girls, Baltimore (1929–37), St. Timothy's Sch., Catonsville, Md. (1931–45), Am. Univ. (1945–) [47]

BAKER, S. Oscar [P] Paris. Studied: Laurens, Richard Miller, in Paris [13]

BAKER, T. André [P] Columbus, OH. Member: Columbus PPC [24]

BAKER, Thomas S. [I,P] Boston/Manchester, MA b. 1 N 1907, Manchester, MA. Studied: Mass. Sch. A.; NAD; Allyn Cox. Member: Boston AC; Boston WCS; North Shore AA; Wash. WCC; AWCS [40]

BAKER, William Henry [Mur.P,Des,I,T] Dallas, TX b. 20 O 1899, Dallas. Studied: AIC; Frank Reaugh. Member: Allied A., Ft. Worth; AG Tex. Work: USPO, Ft. Worth [40]

BAKKE, Anton E.K. [Des,C] NYC b. 11 O 1911, North Mankato, MN. Studied: Minneapolis Sch. A.; Bavarian Acad. A., Munich. Position: Dir., Minic Display, N.Y. [47]

BAKKER, Gerhard H. [G,P,Des,T] Milwaukee, WI b. 30 O 1906, Solingen, Germany. Studied: Kunstgewerbe Schule, Solingen; Boardman Robinson; Ward Lockwood; Broadmoor A. Acad. Member: Wis. PS; Wis. PM; Prairie PM; Southern PM Soc. Exhibited: Milwaukee AI, 1932 (prize); Ann. Exh. Blockprints, Wichita, Kans., 1936 (prize) 1937 (prize); Denver AM, 1936 (prize); Wis. Salon of Art, 1936 (prize); Ann. Exh. Wis. PS, Milwaukee, 1936 (prize). Work: Milwaukee AI; wood cut, Wichita AM; woodcuts, prints, PWAP, 1934. Position: T., Layton Sch. A. [40]

BAKOS, Jozef G. [Edu,P] Santa Fe, NM (1976)b. 23 S 1891, Buffalo, NY. Studied: J.E. Thompson; Albright AS, Buffalo. Member: Los Cinco Pintores. Exhibited: Denver, 1932 (prize); Oakland A. Gal., 1930 (prize); Albuquerque, N.Mex., 1945 (prize); CGA, 1941; AIC; CI; 48 Sts. Comp., 1946; GGE, 1939; PAFA; Santa Barbara Mus. A., 1945, 1946 (one-man). Work: WMAA; BM; SFMA; Univ. Okla.; Denver AM; Santa Fe AM; Roerich Mus. Position: T., Univ. Denver, 1931–33 [47]

BAKOS, Teresa. See Teresa.

BALANO, Paula Himmelsbach (Mrs. Cosme) [P,C] Phila., PA b. 10 My 1878, Leipzig. Studied: PAFA; Chase; Cecilia Beaux; Walter Appleton Clark; Mucha, in Paris. Member: Phila. WCC; NYWCC; NAWPS; Phila. All.; Wash. AC; Plastic Cl.; Conshohocken AL. Exhibited: watercolors, Plastic Cl., 1916 (gold); oil, 1927 (medal). Work: PAFA. Position: T., Phila. Sch. Des. for Women [40]

BALCH, Edwin Swift d. 13 Mr 1927. A writer, scientist and explorer, he was the author of many scientific works and books on painting. His will provides for a $2,000,000 museum to be built in Philadelphia, at the death of his wife. This is to house his books and works of art.

BALCH, Georgia W. (Mrs.) [P] Johnson, VT b. 12 D 1888, Toronto. Studied: Kansas City AL, with Charles Wilimovsky; ASL, with Haley Lever; Harold Dunbar. Member: AAPL; Gloucester SA; Studio Gld. Exhibited: CGA, 1936; Rockefeller Center, NYC, 1936; Ogunquit, Maine; Gloucester, Mass.; Burlington, Vt. [47]

BALCH, Gertrude Howland [P,T,E] Wilmington, DE b. 27 D 1909, Flushing, NY. Studied: Wilmington Acad. A. Member: Wilmington SFA. Work: Delaware A. Center, 1938–45 [47]

BALCOM, Lowell L(eroy) [P,I,E] Westport, CT b. 22 O 1887, Kansas City, MO d. 12 Mr 1938. Studied: J.D. Patrick. Member: AG. Work: Kansas City Pub. Lib. [38]

BALDAUGH, Anni (Mrs. Von Westrum) [P] North San Diego, CA b. 1886, Holland. Studied: Arendsen, Holland; Zaschke, Vienna; von Kunowsky, Munich. Member: Conn. Acad. FA; Beaux-Arts, Paris; Bookplate Assn. Intl.; San Diego FAS; Calif. WC; Calif. Soc. Min. P.; Laguna Beach AA. Exhibited: Los Angeles Mus., 1922 (gold); watercolor, Phoenix, Ariz., 1923 (prize); Pomona, Calif., 1926 (prize); Riverside, Calif., 1927 (prizes); Santa Cruz, 1928 (prize); San Diego, 1928 (prize); Calif. Soc. Min. P., 1929 (prize); FA Gal., San Diego, 1930 (prize), 1934 (prize), 1935 (prize), 1936 (prize); Pasadena, 1932 (prize). Work: FA Gal., San Diego [40]

BALDERSTON, Anne [T] Phila. Member: F., PAFA [24]

BALDINGER, Wallace Spencer [Edu,Cr,W,L,P] Eugene, OR b. 19 Ap 1905, Springdale, PA. Studied: Oberlin Col.; PAFA, AM; Univ. Chicago; Univ. Paris. Member: CAA; Am. Soc. Aesthetics. Exhibited: Kans. Free Fair, 1935; Washburn Col., 1936; Lawrence Col., 1942. Contributor: art magazines on history of Am. art. Positions: Dir., Mulvane A. Mus., Washburn Col., 1932–40; T., Lawrence Col. (1940–44), Univ. Oreg., (1944–) [47]

BALDREY, Haynsworth [S,P,L,T,W] Newton, NJ b. 24 Ag 1885, Cortland, NY d. 6 Mr 1946. Studied: C.T. Hawley; Grafly; E. Keyser; J. Scott. Member: NSS; AAPL; Art Center of the Oranges; N.J. WC Soc. Exhibited: Baltimore, 1908 (prize), 1909 (prize), 1910 (prize); sculpture, Art Center of the Oranges, 1932 (prize), 1933 (prize); Montclair AA 1934 (med); Ridgewood, 1935 (prize); N.J. State Exh., Trenton, 1939 (prize). Contributor: magazines [40]

BALDRIDGE, Cyrus LeRoy [I,W,E,T] Santa Fe, NM b. 27 My 1889, Alton, NY. Member: Frank Holme Sch. I.; Univ. Chicago. Exhibited: Chicago SE, 1937 (prizes); Prairie PM, 1944 (prize). Work: Samuel Insull Coll., 300 sketches made in West Africa, Fisk Univ. Lib., Nashville, Tenn.; LOC; NYPL; Illustrator: "White Africans and Black," "Translations from the Chinese" (1941), "The Parables" (1942), other books [47]

BALDWIN, Barbara (Miss B.B. Smith) [S,P,W] NYC b. 13 Ja 1914, Portland, ME. Studied: Portland Sch. FA; PAFA; NAD; ASL; Alexander Bower; Leon Kroll; Frank DuMond. Exhibited: N.Y. Municipal Exh., 1936; Grand Central Pal., 1936; NAD, 1944; Sweat Mem. A. Mus., 1932–34; Soc.Indp.A., 1936; Hudson River Mus., 1942; Yonkers AA, 1942–44. Author: articles on art [47]

BALDWIN, Burton Clarke [I] Chicago, IL b. 1891, Danville, IL. Studied: Chicago Acad. FA. Member: Pallette and Chisel Cl. [33]

BALDWIN, Charles B(ooth) [P,I] Derby, CT b. 23 My 1897, Derby. Studied: Albert Sterner; Wayman Adams; Joseph Pennell; George Bridgman. [33]

BALDWIN, Clarence E(dgar) [P,I] Hoboken, NJ b. 16 Ap 1862, Hopewell, NY. Studied: Munich Acad., with Carl Marr; ASL, with Chase. Member: SC. Work: Capitol, Des Moines, Ia. [13]

BALDWIN, Clifford Park [I,P] Oceanside, CA b. 14 F 1889, Cincinnati, OH. Studied: George Demont Otis; Jean Mannheim. Exhibited: Southwest Mus.; Long Beach, La Jolla, Oceanside, Sacramento. Work: Southwest Mus., Los Angeles. Illustrator: books, periodicals. Position: Staff Artist/Photographer, Southwest Mus., Los Angeles, 1933–41 [47]

BALDWIN, Edith Ella [P,Bookbinder] Worcester, MA b. 19 N 1870, Worcester. Studied: Acad. Colarossi, Acad. Julian, T. Robert-Fleury, Gustav Courtois, Henry Mosler, Julius Rolshoven, in Paris [17]

BALDWIN, Esther. See Williams, Oliver H., Mrs. [15]

BALDWIN, Frances [P] San Fran., CA b. 18 O 1907, San Fran. Studied: Calif. Sch. FA; ASL, with Kuniyoshi. Member: San Fran. AA; San Fran. Women A. Exhibited: San Fran. AA, 1938–43; San Fran. Women A., 1937–43. Work: SFMA [47]

BALDWIN, Jane (Margaret) (Mrs. Warren) [P,En,T] Spokane, WA b. 3 Ag 1908, Spokane. Studied: Wash. State Col., with Glenn Wessels, George Laisner. Member: Wash. AA. Exhibited: Pacific Northwest A. Exh., Spokane (prize); PAFA, 1941, 1942; Phila. Pr. Cl., 1945, 1946; Lib. Cong., 1944–46; SFMA, 1943, 1944, 1946; SAM, 1942–44, 1946; Wichita AA, 1938, 1941; Laguna Beach AA, 1945, 1946; Portland (Oreg.) Mus. A., 1937, 1938; Oakland A. Gal., 1945; Denver A. Mus., 1945. Position: T., Wash. State Col., Spokane [47]

BALDWIN, Josephine K(night) (Mrs.) [P] Harrisburg, PA b. 4 Jy 1888, Harrisburg. Studied: PAFA. Member: Harrisburg AA [33]

BALDWIN, Mary M. [P] NYC. Member: NYWCC [24]

BALDWIN, Nixford [P,Mur.P,S,E] Springfield, MA b. Springfield. Member: Springfield AL; Stockbridge AA; North Shore AA; Gloucester SA; Provincetown AA. Exhibited: Springfield AL (prize); Stockbridge AA, 1936 (prize). Work: mural, USPO, Fayetteville, W.Va. WPA artist. [40]

BALDWIN, Polly. See Blackford.

BALDWIN, R. Roberts [I] NYC. Member: SI [47]

BALDY, J.M. [P] Devon, PA. Member: Phila. AC [24]

BALFOUR, Helen (Mrs.) [P,I] Los Angeles b. 11 Jy 1857, London. Studied: AIC. Member: Calif. AC; Calif. WCS; Laguna Beach AA. Illustrator: "Sunset Highways" [24]

BALFOUR, Roberta (Mrs.) [P,W] Carmel by the Sea, CA b. 30 Jy 1871, Yarmouth, Nova Scotia. Studied: Beatrice Irwin, in London; R.B. Brown, in Yarmouth; Hayward, in Paris; William Watts. Exhibited: S.Indp.A.; Kyoto A. Assn., 1928; Carmel A. Assn., Calif. Work: Vancouver Armory, B.C. [40]

BALINK, Hendricus C(ornelius) [P,Por.P,E] Santa Fe, NM b. 10 Je 1882, Amsterdam, Holland d. 1963. Studied: Nat. State Acad., Amsterdam, 1909–14; C.L. Dake; V. der Waay; Derkinderen; duPont; Arst. Member: Chicago SA. Work: Mus. N.Mex. Began painting Indian portraits, 1925 [21]

BALKAN, Maury [Por.P] Chicago, IL b. 25 Ap 1913, Chicago. Studied: Studio Sch. A.; AIC; Claude Buck. Member: AIC; Chicago NJSA; Swedish-Am. AA; North Shore AA. Illustrator: "Lights Out," by Arch Oboler, pub. Stokes, 1937 [40]

BALL, Alice Lynde Raymond (Mrs. Thomas W.) [P,J] Old Lyme, CT b. 1870 d. 16 Ja 1942, Old Lyme

BALL, Alice Worthington [P] Baltimore, MD b. Boston d. 22 Jy 1929, Gloucester, MA. Studied: Collin, Courtois, Hitchcock, in Paris. Member: NAWPS; CAFA; NAC; Baltimore WCC; S.Indp.A.; Phila. AC. Exhibited: CAFA, 1915 (prize); North Shore AA, 1929 (prize) [27]

BALL, Caroline Peddle (Mrs.) [S] Torrington, CT b. 11 N 1869, Terre Haute, IN d. 2 O 1938. Studied: Augustus Saint-Gaudens, Cox, in New York. Member: Ind. SS. Exhibited: Paris Expo, 1900 (prize). Work: "Victory," U.S. Bldg., Paris Expo, 1900; corbels, Grace Church, Brooklyn; fountains, Flushing, N.Y., Auburn, N.Y., Westfield, N.J. [38]

BALL, George Edward [Des,L,W] NYC/Edgewood, RI b. 6 S 1875, Birmingham, England. Member: Utopian Cl., Providence, R.I. Lectures: Silver Since the 16th Century, kindred subjects. Contributor: critical and historical articles, numerous publications. Specialty: Industrial designs for metal, glass, plastics [40]

BALL, Janet Woodward [P] Phila., PA. Exhibited: Phila. WCC Ann., 1934, 1936, 1938; Germantown A. Lg., 1937; PAFA Ann. PS., 1939 [40]

BALL, L. Clarence [P,I] b. 4 Jy 1858, Mt. Vernon, OH d. 10 O 1915. Studied: self-taught. Member: Chicago SA; Cliff Dwellers. Exhibited: Soc. Western Artists. Specialty: landscapes with cattle and sheep [15]

BALL, Linn (B.) [P,I,C] NYC/Landing, NJ b. 25 S 1891, Milwaukee, WI. Member: AG; SI [33]

BALL, Mary Roberts. See Price, Joseph, Mrs.

BALL, Mary Wilson [G] Wash., D.C. Exhibited: SSAL, 1932, 1933, 1938; WCC Wash., 1933, 1934, 1937; Min. PSG Soc., Wash., D.C., 1939 [40]

BALL, Percy B. [Des,P,L,W] North Attleboro, MA b. 29 My 1879, Birmingham, England. Studied: William C. Codman, II; Cyrus Farnum. Member: Utopian C. of Prov. Exhibited: Intl. Expo, Paris, 1937 (gold).

Radio talks: "Art in Everyday Life," "Art in Industry," etc. Position: Silver des., Watson Co., Attleboro [40]

BALL, Robert Edward, Jr. [P,Mur.P,I] Provincetown, MA b. 7 S 1890, Kansas City, MO. Studied: Richard Miller, in Paris and Brittany. Exhibited: Ar. of Kansas City and Vic., 1915 (prize). Work: mural, Capitol, Jefferson City, Mo. [40]

BALL, Ruth N(orton) [S] San Diego, CA b. Madison, WI. Studied: J. Liberty Tadd, Phila.; St. Louis Sch. FA; Cincinnati A. Acad. Member: San Diego AG. Exhibited: Calif. SA, San Diego, 1931 (prize). Work: fountains, Greenwood Cemetery; Lib. Park, Coronado, Calif.; bronze, FA Gal., San Diego; City AM, St. Louis; Cincinnati Mus.; bronze tablet, Boy Scout Headquarters, San Diego; Olympic medal, Amsterdam; Mayan tiles, Mexican bldg. and group ten figures, Palace of Edu., Calif. Pacific Intl. Expo, San Diego; emery tablet, Cincinnati Mus. [40]

BALL, Seymour Alling [I] NYC b. 19 N 1902, Springfield, MA. Studied: PIASch. Member: SI. Illustrator: national magazines [47]

BALL, Stanley Crittenden [P,T] New Haven, CT/North Plain, CT b. 19 N 1885, Shelburne Falls, MA. Studied: George Bruestle. Member: Lyme AA; New Haven PCC [33]

BALL, Thomas [S,P] Montclair, NJ b. 3 Je 1819, Charlestown, MA d. 11 D 1911, Montclair. Member: Handel and Haydn Soc. of Boston; NSS. Work: statues, Washington, D.C., Central Park, NYC. He lived in Florence, Italy, from 1865 to 1897. [09]

BALL, Thomas Watson [P,Mur.P,Mar.P,C] Old Lyme, CT b. 7 Jy 1863, NYC d. 25 Ja 1934. Studied: ASL, with Beckwith, Mowbray, DuMond. Member: NAC; SC; AIGA; Lyme AA; CAFA; SI. Work: ceiling decorations, Chapel of the Intercession, NYC, Trinity Chapel, Buffalo; figure panels, St. Thomas' Church, NYC. In addition to his murals, his marines and ship pictures are found in many collections. Position: A. Ed., Harper Brothers, 1894–1900 [33]

BALLANTINE, Edward James [P] NYC b. 8 D 1885, Edinburgh, Scotland. Member: S.Indp.A. [24]

BALLANTYNE, Kenneth M. [I] Baldwin, NY. Member: SI [47]

BALLANTYRE, K.M. [P] Chicago, IL [19]

BALLARD, Louise Elizabeth [Mus.Cur] San Fran. b. 15 My 1911, Lewisburg, WV. Studied: Occidental Col.; Chouinard AI; Carnegie F., Yale. Member: Am. Soc. Aesthetics; AFA. Author: articles on art, reviews. Positions: Ed., Los Angeles MA Quarterly; Cur., Los Angeles MA, 1940-43; Asst. Cur., SFMA, 1945–46 [47]

BALLATOR, John R. [P,Mur.P,Edu,L] Hollins College, VA b. 7 F 1909, Portland, OR. Studied: Portland Mus. A. Sch.; Univ. Oreg.; Yale. Work: murals, USPO, Portland, Oreg.; Dept. Justice, Wash., D.C.; Menninger Sanatorium, Topeka, Kans. Position: T., Hollins Col., Va. 1938– [47]

BALLERINI-BALL, N. [P,S,E] Hartford, CT/Gloucester, MA b. 21 F 1899, Pittsfield, MA. Studied: Philip Hale; Emil Fuchs; George Bridgman; Joseph Pennell. Member: Gloucester GA [33]

BALLET, Billie [P] NYC [15]

BALL-HUGHES, Georgiana [P] Dorchester, MA b. 1828 d. 10 O 1911. The daughter of the late Robert Ball-Hughes, the painter and sculptor, she studied in Europe and lived much of the time in London.

BALLIN, Florence. See Cramer, Mrs.

BALLIN, Hugo [P,Mur.P,W] Pacific Palisades, CA b. 7 Mr 1879, NYC d. 27 N 1956. Studied: ASL; Rome; Florence. Member: NA; NIAL. Exhibited: SAA, 1905 (prize), 1906 (prize); Arch. Lg., 1906 (med), 1907 (med), 1908 (prize), 1909 (prize); Buenos Aires Intl. Expo, 1910 (med); NAD, 1907 (medal,prize), 1940 (prize); AIA, 1933 (prize); Aero Art Exh. (prize); murals, Golden Gate Expo, 1939. Work: Montclair AM; murals, panels, interiors, San Fran., Los Angeles, Capitol, Madison, Wis., Annmary Brown Mem. Mus., Providence, R.I.; Edison Building, Los Angeles; Griffeth Planetarium. Author: books and motion picture continuities [47]

BALLINGER, H(arry) R(ussell) [P,I,T,L] New Hartford, CT b. 4 S 1892, Port Townsend, WA. Studied: Calif. IA; ASL; Harvey Dunn; Wayman Adams; Maurice Braun. Member: SC; All.A.Am.; Audubon A.; AAPL. Exhibited: SC, 1944 (prizes); Hartford Atheneum, 1944. Exhibited: Conn. WC Soc., 1944 (prize), 1945 (prize); Meriden A.&Crafts Assn., 1944 (prize); Audubon A., 1945; All.A.Am., 1940–45; Conn. Acad. FA, 1938–46; SC, 1923–46; Springfield AA, 1944; Jordan Marsh Exh., 1946; Conn. WC Soc., 1944, 1945. Work: Hartford Atheneum; New Britain AM. Illustrator: national magazines. Positions: Instr., T. Col., New Britain, Conn., 1945–46, Bristol (Conn.) A. Lg., 1945–46 [47]

BALLINGER, Louise Bowen [Edu,Mus.Cur] Phila., PA b. 9 F 1909, Palmyra, NJ. Studied: PMSchIA; Univ. Pa. Member: Phila. A. All.; Woodmere A. Gal. Positions: Cur./Instr., PAFA 1943– [47]

BALLINGER, Maxil [G,P,T,W] Bloomington, IN b. 30 Mr 1914, Walnut Grove, MO. Studied: Springfield (Mo.) State Col.; Harvard; Univ. N.C.; Iowa Univ. Member: Phila. Pr. Cl.; Am. Color Pr. Soc.; SSAL; Ozark AA. Exhibited: Northwest Pr.M., 1942, 1943, 1946; SFMA, 1942; Phila. Pr. Cl., 1942, 1943, 1946; Am. Color Pr. Soc., 1942, 1943, 1946; AIC; Des Moines MA; Lib. Cong. Position: T., Ind. Univ. [47]

BALLOU, Bertha [P,S,L] Spokane, WA b. 14 F 1891, Hornby, NY. Studied: ASL; CGA; BMFASch; DuMond; Tarbell; Meryman; Bosley; Grafly. Member: Assn. Wash. A.; Spokane AA. Exhibited: Spokane AA, 1929 (prize), 1930 (prize), 1933 (prize), 1934 (prizes); Inland Empire Fair (prizes); Northwest A. Exh. Work: Eastern Wash. Hist. Soc.; Spokane Pub. Lib.; Holy Trinity, Cath. St. John churches, Spokane [47]

BALLOU, P. Irving [P] Brooklyn, NY [24]

BALMER, Clinton [P] Brooklyn, NY. Member: SC [21]

BALSEIRO, Ernesto [P] Arecileo, Puerto Rico. Member: S.Indp.A [24]

BALTEKAL-GOODMAN, Michael [Arch,B,L] Berkeley, CA b. 7 Ja 1903, Russia. Studied: Univ. Calif. Member: San Fran. AA; Los Angeles SCC; Assn. Northern Calif. Arch. Work: Fifty Prints of the Year, 1931; NYPL; de Young Mem. Mus., San Fran. Position: T., Sch. Arch., Univ. Calif., Berkeley [40]

BALTZELL, Marjorie [S,T] Lyons, NY b. 7 O 1891, Lyons. Studied: Charles Martin; Robert Laurent; Syracuse Univ.; Columbia. Member: Tex. FAA. Position: T., Tex. State Col. for Women [40]

BALZER, Margaret (Mrs. M.B. Cantieni) [P,E,En,Edu] NYC b. 30 Ap 1914, Newton, KS. Studied: Carleton Col.; AIC; Lyonel Feininger; Josef Albers; William Stanley Hayter. Exhibited: AIC, 1944, 1946 (med,prize); Intermont Col., Bristol, Va., 1944, 1945 (prize); Lincoln A. Gld., 1941; Ohio Valley A., 1944, 1945; Berea Col., 1946; Univ. Louisville, 1946; Carleton Col., 1946. Position: Asst. Dir. A., Berea Col., Ky., 1937–45 [47]

BAMBERGER, Ruth [P] Newark, NJ [19]

BANASEWICZ, Ignatius [E,Li,P] Brooklyn, NY b. 5 D 1903, Leningrad. Studied: W.A. Levy; William Starkweather; Clinton Peters; C.C. Curran. Member: Chicago NJSA; Salons of Am.; S.Indp.A.; Buffalo SA; Phila. SE. Exhibited: Ogunquit A. Center, 1931 (prize) [40]

BANCEL, Henry A. [P] NYC b. 12 N 1885, NYC. Studied: NYU. Member: AWCS. Exhibited: AWCS, 1936–46 [47]

BANCROFT, Albert Stokes [P] Denver, CO b. 15 My 1890, Denver d. 1972. Studied: self-taught; Cornell. Member: Denver A. Gld. Exhibited: Denver AM, 1916, 1918, 1922–35, 1936 (prize), 1937, 1938 (prize), 1939–40, 1943–44; Municipal A. Exh., N.Y., 1936, 1937. Work: Denver AM [47]

BANCROFT, H. [P] Ithaca, NY [24]

BANCROFT, Hester (Mrs. Romeyn Berry) [S] Jacksonville, NY. Member: NAWPS. Exhibited: NAWPS, 1937–38 [38]

BANCROFT, Lena T. (Mrs.) [P] Portland, ME b. Maine. Studied: BMFA Sch.; ASL. Member: Copley S. 1893 [15]

BANCROFT, Milton Herbert [P] Sandy Spring, MD b. 1 Ja 1867, Newton, MA. Studied: Mass. Normal A. Sch., Boston; PAFA; Courtois, Callot, Delance, Girardot, all in Paris. Member: SC, 1904. Work: Park Bank, NYC; P.-P. Expo 1915. Positions: T., Swarthmore Col., 1886–92; Supt. Sch., PAFA, 1892–94 [40]

BANCROFT, Samuel, Jr. Wilmington, DE d. 22 Ap 1915. A director of the Pennsylvania Academy of Fine Arts in Philadelphia, he acquired a large collection of works by the Pre-Raphaelite painters.

BAND, Max [P,W] Hollywood, CA b. 21 Ag 1900, Lithuania. Studied: Acad. A., Berlin. Exhibited: U.S., Europe. Work: Musée de Luxembourg, Paris; French AI, Phila.; Riverside Mus.; PMG; Los Angeles MA. Author: "History of Contemporary Art," 1935 [47]

BANEVER, Gilbert [P,Des,T,L] New Haven CT b. 8 Je 1913, New Haven. Studied: Yale; Am. Acad. in Rome; Ferruccio Ferrazzi. Member: Conn. Acad. FA; Springfield A. Lg.; SSAL. Exhibited: Yale, 1933 (prize); Am. Acad. in Rome, 1933 (med), 1934 (med); Prix de Rome, 1934; Tenn. IBM Comp., 1942 (prize); PAFA, 1940; AIC, 1941; Conn. Acad. FA, 1937–42; Springfield A. Lg., 1939–42; SSAL, 1942, 1943. Work: Yale; New Haven Bd. Edu.; IBM; Grand Central A. Gal. Positions:

Dir./T., Memphis Acad. Art, 1938–43; Des., General Electric Co., 1943–45; MGM, 1945– [47]

BANG, Eleonore E. [C,T,L] Newton, MA b. Copenhagen, Denmark. Studied: Sweden; Berlin; Copenhagen A. Soc. Member: Boston Soc. A.&Crafts. Author: "Leather Craft for Amateurs" [47]

BANGE, Louis C. [P] NYC. Member: AG Authors Lg. A. [24]

BANHAM, Louis [P] Jersey City, NJ. Member: GFLA [21]

BANISTER, Mary W. See Redfield, Mrs.

BANKER, Grace [P] Detroit, MI. Member: S. Detroit Women P. [24]

BANKER, Grace Wood (Mrs. Paul) [Lib] NYC b. Gananoque, Ontario. Studied: Queens Univ.; PI, Sch. Lib. Sc. Member: Spec. Lib. Assn.; Bibliogr. Soc. Am. Position: Librarian, BM, 1940– [47]

BANKER, William Edwin [Des,I] West Carrollton, OH b. 16 Je 1908, Los Angeles. Studied: Dayton AI; Central Acad. Commercial A. Member: Dayton Adv. Cl. [47]

BANKS, James Francis [P,T] Richmond, VA b. 19 F 1900. Studied: H.I. Jewett; G.T. Pritchard, in Australia; Ferruci Ferracci, in Rome; G. Watson James. Member: Richmond Acad. A.&Sc. Exhibited: VMFA, 1938 (oneman); WFNY, 1939. Work: VMFA [40]

BANKS, J. Lisney [S] Toronto, Ontario [01]

BANKS, Jesse [P] NYC [13]

BANKS, Virginia [P,E,En,Edu] Iowa City, IA b. 12 Ja 1920, Norwood, MA. Studied: Smith Col.; Butera Sch. FA; St. Univ. Iowa; Colorado Springs FA Center; Eliot O'Hara; Philip Guston; Stuart Edie; Boardman Robinson. Exhibited: VMFA, 1946; Phila. Pr. Cl., 1946; AIC, 1946; Univ. Iowa, 1945, 1946; Assoc. Am. A., 1946; AFA; Weyhe Gal., 1945; Des Moines A. Center, 1946; Simpson Col., 1946; Rockford MA, 1946; Univ. Iowa Faculty Exh.; Iowa St. Col., 1946. Position: T., State Univ. Iowa, 1944– [47]

BANKSON, G(len) P(eyton) [P,Mur.P,C] Spokane, WA b. 7 S 1890, Mount Hope, WA. Work: murals, First National Bank, Spokane; mantelpiece, Univ. Idaho [40]

BANNARN, Henry Wilmer [S] NYC/Fayette, ME b. 17 Jy 1910, Hughes County, OK. Studied: B.J.O. Nordfeldt; George Oberteuffer; S. Chatwood Burton; Carl Mose; Ahron Ben-Schumel. Member: Am. A. Cong.; Artists U.; Harlem AG. Exhibited: sculpture, Minneapolis Inst. A., 1932 (prize). Work: Howard Univ. [40]

BANNING, Beatrice Harper (Mrs. Waldo) [E,C] Old Lyme, CT b. 5 D 1885, Staten Island, NY d. ca. 1960. Studied: CUASch; ASL; NAD; Gadda's, Florence. Member: SAE; Old Lyme AA; Conn. Acad. FA; NAWA; New Haven Paint & Clay Cl.; AAPL; Book Workers' Gld. of N.Y. Exhibited: Conn. Acad. FA, 1944 (prize), 1946; Bridgeport AL, 1945 (prize); NAD, 1946; SAE, 1946; NAWA, 1946; Old Lyme AA, 1945; Albright A. Gal.; PAFA; Newport AA; CMA; Lib. Cong., 1946; Women's Intl. Exh., London 1946; WFNY, 1939. Work: MMA; NYPL; Lib. Cong. [47]

BANNISTER, Edward M. [Ldscp.P,P] b. 1833, St. Andrews, New Brunswick d. 9 Ja 1901. Specialties: landscapes; cattle. He was one of the best known Black painters, though more familiar to an earlier generation than to this. Was a pupil of the Lowell Institute in Boston, and received a first class medal at the Centennial Expo, Phila., 1876. He lived in Providence, 1876–1901.

BANNISTER, Eleanor C(unningham) [P] Brooklyn, NY b. NYC d. 30 Ja 1939. Studied: Whittaker; Constant, Lefebvre, in Paris. Member: Brooklyn SA. Work: BM; Masonic Temple, San Fran. [38]

BANNISTER, James [En] Brooklyn, NY b. 1821, England d. 11 O 1901. An expert engraver, he was one of the founders of the Franklin Bank Note Engraving Company and one of its officers until a few years before his death. He was also a student of astronomy and the natural sciences.

BANNON, Laura [P,I,T] Chicago, IL b. Acme, MI. Studied: Laura Van Pappelendam; John Norton; AIC; Mich. State Col. Member: Chicago SA. Exhibited: AIC, 1939. Illustrator: books. Position: Hd., Juvenile Dept., AIC [40]

BARAGWANATH, John G., Mrs. See McMein, Neysa Moran.

BARANCEANU, Belle [Mur.P,Li,B,En,I,T] San Diego, CA b. 17 Jy 1905, Chicago, IL. Studied: Minneapolis Sch. A.; Anthony Angarola. Member: San Diego A. Gld.; La Jolla A. Center; Chicago SA; Chicago NJSA. Exhibited: AIC, 1926, 1928, 1931 (prize), 1938; Calif. Pac. Expo, 1935 (med); Kansas City AI, 1927; GGE, 1939; Carnegie Inst., 1943; Lib. Cong., 1943, 1945, 1946; NAD, 1943–46; AV, 1942; Denver A. Mus., 1945; Chicago SA, 1931; Los Angeles A. Mus., 1927, 1928; SFMA, 1941. Work: San Diego FA Soc.; Lib. Cong.; mural, USPO, La Jolla; FA Gal., Hall of Education, San Diego. Illustrator: "Gynecology," by Dr. George Huff, 1943. Position: T., FA Gal., San Diego [47]

BARATELLI, Charles [S] b. Italy d. 11 N 1925, Milford, CT. Studied: Milan. Work: State House, Columbia, S.C.; St. Patrick's Church, Waterbury, Conn.; entrance to Keeney Park, Hartford

BARBARIN, Francis S. [Mus.Cur] Wash., D.C. b. 1833, Newport, RI d. 29 Mr 1900. Position: Curator, Corcoran Gal. He was connected with the Gallery from the time it opened.

BARBARITE, James Peter [P,Edu] Brooklyn, NY b. 20 F 1912, Brooklyn. Studied: CUASch; Columbia; NAD, with Jonas Lie, Karl Anderson. Member: F. Tiffany Fnd., 1939–42. Exhibited: Am. WC Soc. Ann., 1938; Milch Gal; BM; All.A.Am., 1942–44. Award: Prix de Rome, 1942. Position: Prof. P., Biarritz Am. Univ., France, 1945–46 [47]

BARBARO, Charles [P] Boston, MA b. 21 Ag 1896, Italy. Studied: BMFA Sch.; John Singer Sargent; Aldro T. Hibbard. Member: Boston Ar. Un. [40]

BARBAROSSA, Theodore Cotillo [S] East Boston, MA b. 26 D 1906, Ludlow, VT. Studied: Mass. Sch. A.; Yale; Cyrus E. Dallin; Heinz Warneke; Raymond Porter; Robert Eberhard. Member: NSS; Clay Cl. S. Center. Exhibited: Mass. Sch. FA, 1927 (med); Yale, 1931 (prize); Rome Collab. Comp., 1931 (gold), 1933 (prize); New Rochelle AA, 1941 (med); AIC, 1938; PAFA, 1939; CGA, 1939; NAD, 1935, 1936, 1938; WFNY, 1939; Conn. Acad. FA, 1938; New Haven PCC. Work: reliefs/panels, USPOs, Geneva, Oakville, both in N.Y., Clinton, Mass. [40]

BARBER, Alice. See Stephens, Charles, Mrs.

BARBER, A.W. [P] Cleveland, OH. Member: Cleveland SA [24]

BARBER, Charles E. [En] Phila., PA b. 1842 d. F 1917. Associated with the Philadelphia mint for fifty years, he was also one of the country's most expert engravers and was widely known to medal makers in the U.S. and abroad. He engraved most of the presidential medals of the last fifty years. [40]

BARBER, Cornelia Cresson. See Cresson, Cornelia.

BARBER, Edwin A.T. Lee [Mus.Dir,W] b. 13 Ag 1851, Baltimore, MD d. 12 D 1916. Director of the Pennsylvania Museum of Industrial Art, he was an authority on ceramics, antiquities and glassware, writing extensively on all of these subjects. He was the organizer of the exhibition in Philadelphia, 1916, "Fakes and Reproductions," and he was one of the collaborators of the new edition of the "Century Dictionary."

BARBER, George (Rodgers) [P,T,Des] NYC b. 6 Ja 1910, Phila. Studied: Black Mountain Col, with Josef Albers, George Grosz. Exhibited: PAFA, 1941; Carnegie Inst., 1941, 1943. Position: Instr., CUASch, 1945–46 [47]

BARBER, John [Edu,P,E,I,L] NYC b. 19 O 1898, Galati, Romania. Studied: Europe. Member: Am. A. Cong. Exhibited: Golden Gate Expo, 1939; Salon d'Automne, 1923–46; Salon des Tuileries; NAD, 1938, 1943; Ministry FA, Lisbon. Work: Luxembourg Mus., Paris. Position: Prof. FA, Harcum Jr. Col., Bryn Mawr, Pa., 1944–46 [47]

BARBER, Mary D. [P] Bolinas, CA [13]

BARBER, William Sherman [P] Huntington, WV b. 20 N 1866, Sheridan OH. Studied: Cincinnati A. Acad. [05]

BARCHUS, Eliza R. (Mrs. John H.) [P] b. 1857, Salt Lake City, UT d. 1959, Portland, OR. Studied: Will Parrott. Exhibited: Portland, 1888; NAD, 1900. Specialty: mountain landscapes [*]

BARCLAY, Edith Lord [P] Brooklyn, NY. Member: NAWPS [24]

BARCLAY, Edward [P] Wash., D.C. [01]

BARCLAY, McClelland [P,I] NYC/East Hampton, NY b. 9 My 1891, St. Louis, MO. Studied: H.C. Ives; George Bridgman; Thomas Fogarty. Member: ASL; Chicago AC; Assn. A.&Industries; Ar. Gld. Illustrator: Cosmopolitan, Good Housekeeping. Posters: Navy poster, Committee on Nat. Preparedness, 1917 (prize); USMC recruiting poster (prize); allegorical painting of Commerce of Chicago, Chicago Assn. Commerce (prize). Missing in action after the landing ship tank on which he was a passenger was torpedoed, 18 Jy 1943. [40]

BARCLAY, McKee [Car,W] Baltimore, MD b. 1870, Louisville, KY d. 26 Ap 1947. Positions: Staff, several Ky. newspapers; political writer/cartoonist, Baltimore Sun, 1908–20

BARCONS, Zulema (Zula) [P,G] NYC b. Buenos Aires. Studied: Nat. Acad.; Paris. Member: NAWPS. Exhibited: Am. WC Ann., 1934; WC Cl. N.Y. Ann., 1934, 1936; Nat. Acad. Ann., 1936, 1937, 1938; Argent Gal., 1937 (one-man) [40]

BARD, James [P] b. 1815, Chelsea, NY d. 26 Mr 1897, White Plains, NY. Studied: self-taught, since 1827. Work: BM; Mariners Mus., Va.; Peabody, Mus., Salem, Mass. Shared studio with twin brother John (d. 1856) until 1849. Specialty: ship portraits [*]

BARD, Sara Foresman [P,T] Indianapolis, IN b. Slippery Rock, PA. Studied: Grand Central Sch. A.; AIC; Henry B. Snell; George Pearse Ennis; Sigourd Skou. Member: AWCS; Wash. WC Cl.; Baltimore WC Cl.; Studio Gld.; Springfield A. Lg.; NAWA; North Shore AA. Exhibited: Baltimore WC Cl., 1928 (prize); N.Y. WC Cl., 1928 (prize), 1929 (prize); NAWA, 1931 (med), 1934 (prize); Springfield A. Lg., 1939 (prize); Hoosier Salon, 1929, 1931, 1934, 1936 [47]

BARE, Arnold Edwin [I] NYC b. Je 1920, NYC. Exhibited: Yale Univ. Sch. FA. Illustrator: "Pierre Pidgeon," 1943, "Mooky & Tooky," 1946, other books [47]

BARELA, Patrocino [S] Taos, NM. Exhibited: WFNY, 1939. Work: Univ. Mus., Phila. [40]

BARER, Miriam Anne [P,I,Des,E,Li] NYC b. 3 Jy 1923, New Haven, CT. Studied: Yale. Exhibited: Audubon A., 1945; Mississippi AA, 1945; Santa Barbara Mus. A., 1944; Albany Inst. Hist.&A.; 1945; Conn. Acad. FA, 1946. Position: A., Schenley Affiliates, Inc., 1945–46 [47]

BARFOOT, Dorothy [Edu,P,C,Des,L] Manhattan, KS b. 7 O 1896, Decorah, IA. Studied: State Univ. Ia.; T. Col., Columbia; Bisttram Sch. A., Taos, N.Mex. Exhibited: NAWA, 1935–37; Kansas City AI, 1940; Joslyn Mem., 1938. Positions: Head, A. Dept., Drake Univ., 1923–30; Kans. State Col., Manhattan, Kans., 1935– [47]

BARFORD, George [G] NYC. Exhibited: Intl. Exh. Lith. Wood Engraving, AIn. C., 1937; Wis. Salon A., 1938 [40]

BARGER, Clara Wood [P] Phila., PA [05]

BARGER, Raymond [S] NYC b. 1906, Brunswick, MD. Studied: Carnegie Inst.; Yale Univ. Sch. FA. Member: F., Am. Acad., Rome, 1937; NSS. Work: WFNY, 1939; USPO, annex, Providence, R.I.; San Marino, Italy [47]

BARGEST, Frank G. [P] New Orleans, LA [17]

BARHYDT, Jean K. (Mrs. George Weed) [P,C] Hartford, CT b. Brooklyn, NY. Member: Conn. Acad. FA; New Haven PBC; Soc. Conn. C. [40]

BARILE, Xavier J. [P,T,L,E] NYC b. 18 Mr 1891, Tufo, Italy. Studied: CUASch.; ASL, with Victor Perard, William DeL. Dodge; Luis Mora; Charles Chapman; John Sloan. Member: S.Indp.A.; FA Soc.; Pueblo, Colo.; Am. Monotype Soc.; Audubon A.; St. Augustine AC. Exhibited: NAD, 1943; Am. Monotype Soc., Traveling Exh., 1940, 1944; Santa Fe Mus., 1944 (one-man); Whitney Studio Cl.; NAC; Lib. Cong.; S.Indp.A.; Denver A. Mus.; Colo. Springs FA Center; Audubon A. Illustrator: magazines and covers. Positions: Dir., Barile A. Sch., 1919–39; Head, A. Dept., Pueblo Jr. Col., 1939–45 [47]

BARKER, Agnes McMakin (Mrs.) [P] Media, PA [05]

BARKER, Albert Winslow [Li,T,W,L] Moylan, PA b. 1 Je 1874, Chicago, IL d. 5 D 1947. Studied: PAFA; Haverford Col.; Univ. Pa.; Bolton Brown. Exhibited: Calif. Pr.M. Soc., 1935 (gold); Intl. Expo, Paris, 1937. Work: Los Angeles Mus.; NYPL; Lib. Cong.; Corcoran Gal.; BMA; Pa. Mus. A., Phila.; BMFA; Pr. Cl., Rochester; Newark Mus.; Pub. Lib., Newark; Hackley A. Gal., Muskegon, Mich.; Gal. FA, Columbus, Ohio; Fogg Mus., Cambridge, Mass.; Henry A. Gal., Seattle; Addison Gal. Am. A., Andover, Mass.; Honolulu Mus. A.; Uffizi Gal.; Solothurn Mus., Switzerland. Contributor: American Journal of Archaeology. Author: technical notes on prints and lithography [47]

BARKER, Ethel N. [P] Chicago, IL [08]

BARKER, George [P,T,L,W] Pacific Palisades, CA b. 20 F 1882, Omaha, NE d. 1965. Studied: Grande Chaumière, André Lhote, in Paris; J. Lawrie Wallace; Edwin Scott. Member: Santa Monica AA; Calif. AC; Los Angeles P.&S. Cl. Exhibited: Los Angeles P.&S. Cl., 1940, 1941 (prize), 1942 (prize), 1944; Santa Monica AA, 1940 (prize), 1945 (prize); Pomona Col., 1946; Calif. AC 1935–44; Grant Gal., 1935 (one-man). Work: Joslyn A. Mus., Nebr. His wife was painter Olive R. Barker. [47]

BARKER, George, Jr. [P] Omaha, NE [17]

BARKER, Katherine [P,T] Phila., PA/Croton-on-Hudson, NY. b. 2 D 1891, Pittsburgh, PA. Studied: Breckenridge; Anshutz; Carlson; Hale; Beaux; Vonnoh; PAFA [21]

BARKER, Lucy Hayward (Mrs.) [Por.P] Presque Isle, ME b. 29 N 1872, Portage Lake, ME. Studied: BMFA Sch., with Philip Hale, Frank Benson, Edmond Tarbell; Alger V. Currier. Work: St. Luke's Cathedral, Portland, Maine; Wayland Pub. Lib., Maine [47]

BARKER, M(ary) C(hamberlain) [Por.P] NYC/Gilmanton, NH b. 7 My 1856, NYC d. 13 Ap 1914. Studied: Cox; Volk [13]

BARKER, May [P] Jersey City Heights, NJ [01]

BARKER, Olive (Ruth) (Mrs. George) [P] Pacific Palisades, CA b. Chicago, IL d. 1962. Studied: N.Y. Sch. F.&App. A.; F. Tolles Chamberlin; Millard Sheets; Paul Sample. Member: Calif. WC Soc.; Calif. AC; NAWA; Santa Monica AA; Women Painters of the West. Exhibited: Calif. AC, 1934 (prize), 1935 (prize), 1938 (prize), 1940 (prize); NAWA, 1939; Calif. WC Soc., 1940 Riverside Mus., 1940; GGE, 1939 [47]

BARKER, Virgil [Edu,W,L] Coconut Grove, FL b. 11 D 1890, Abingdon, VA d. 30 Ja 1964. Studied: Harvard Col.; Corcoran Sch. A. Author: "Henry Lee McFee," 1931. Contributor: art magazines. Positions: Cur., Carnegie Inst., 1919–20; Dir., Kansas City AI, 1920–21; Prof., Univ. Miami, 1931– [47]

BARKLEY, Howell [Min.P] NYC [13]

BARKSDALE, Ethel duPont, Jr. See Wack, J. de Blois, Mrs.

BARKSDALE, George Edward [P] Richmond, VA b. 13 Ag 1869, Charlotte County, VA. Studied: PAFA; William L. Shepherd; Herman Sodersten. Member: AFA; S. Indp. A.; Exhibited: Kenilworth AA, Asheville, N.C., 1928 (med). Work: Antioch Church, Henrico County, Va. [47]

BARLOGA, Viola H. [P] Rockford, IL b. 21 F 1890, Camden, NJ d. ca. 1960. Studied: AIC; Chicago Acad. FA; ASL; Rockford Col; Sidney Laufman; Oskar Gross; Briggs Dyer. Member: NAWA. Exhibited: Rockford AA, 1941 (prize); Montclair AA (prize); Carnegie Inst.; CGA; AIC; Burpee Gal.; Argent Gal. Work: Burpee A. Gal., Rockford [47]

BARLOW, Harriet May (Mrs.) b. 1844 d. 19 Ag 1934, Toledo, OH. One of the founders of the Toledo Museum of Art.

BARLOW, John Noble [P] b. 1861, Manchester, England d. 24 Mr 1917, St. Ives, Cornwall, England. Studied: Lefebvre, Delance, Constant, all in Paris. Member: Providence AC. Exhibited: Paris Salon, 1899 (med); Paris Expo, 1900 (med). Work: R.I. Sch. Des. Became a citizen of the U.S. in 1887. [17]

BARLOW, Marvin Kellogg (Tony) [Car,Des] NYC b. 11 Ap 1906, Bellingham, WA. Studied: Univ. Wash.; AIn. C; Am. Acad., Chicago. Contributor: Esquire, 1939 [47]

BARLOW, Mary Belle (Mrs. John T.) [C] Phila., PA b. 15 Ja 1885, NYC. Studied: Alfred Univ.; Charles F. Binns; Edward de F. Curtis; PMSchIA. Member: Phila. All.; Pa. Gld. C.; Woodmere A. Gal. Exhibited: Paris Expo, 1937; Phila. A. All., 1937, 1942, 1943; Woodmere A. Gal., 1939; Pa. Gld. C., 1946; Womens Univ. Cl., 1940. Work: Northern Ariz. Mus., Flagstaff [38]

BARLOW, Myron [P] Detroit, Mich./Etaples, France b. 1873, Ionia, MI d. 16 Ag 1937, Etaples (on his annual summer visit). Studied: AIC; Ecole des Beaux-Arts, Gérôme, in Paris. Member: Paris AAA; Paris SAP; Soc. Nat. BA, Paris; Phila. AC. Award: Knight of the Leg. of Honor, France. Exhibited: St. Louis Expo, 1904 (gold); P.-P. Expo, San Fran., 1915 (gold). Work: PAFA; Detroit Inst. A.; Palais des Beaux-Arts, Douai, France; Municipale Coll., Etaples [33]

BARLOW, Nina G. [P] Phila., PA [01]

BARLOW, (Walter) Jarvis, Jr. [Mus.Dir] Pasadena, CA b. 21 Je 1900, Berlin. Studied: Univ. Calif.; Univ. Georgetown. Position: Dir., Pasadena AI, 1944– [47]

BARNARD, Edward Herbert [P] Belmont, MA b. 10 Jy 1855, Belmont d. 16 Ap 1909, Westerly, MA. Studied: BMFA Sch.; John B. Johnston; Boulanger, Lefebvre, Collin, in Paris; arch., MIT. Member: St. Botolph Cl.; Boston WC Cl. Exhibited: Charitable Mechanics Assn., Boston (med); Tenn. Centenn., Nashville, 1897 (prize) [08]

BARNARD, Ellinor M. (Mrs. Manuel Komroff) [P] NYC b. 29 Ag 1872, London, England d. 16 Feb 1942. Member: NYWCC; NAWPS. Specialty: portraits in water colors

BARNARD, George Grey [S] NYC b. 24 My 1863, Bellefonte, PA d. 24 Ap 1938. Studied: AIC; Ecole des Beaux-Arts, Paris, with Carlier. Member: Assoc. Soc. Nationale des Beaux-Arts, France; Nat. Inst. A.&L.; Ind. SS.

Exhibited: Paris Expo, 1900 (gold); Pan-Am. Expo, Buffalo, 1901 (gold); St. Louis Expo, 1904 (gold). Work: MMA; AI Chicago; Capitol, Harrisburg, PA; Carnegie Inst.; Central Park, NYC; "Lincoln(s)," Lyttle Park (Cincinnati), Manchester (England), Louisville(Ky.), Luxembourg, UCLA, Lincoln Sch. (NYC) [38]

BARNARD, James M. [P,E,B] Bolton, MA b. 18 Ap 1910, Cambridge, MA. Studied: Philip L. Hale [40]

BARNARD, Josephine W. [P,T] Woodstock, NY b. Buffalo, NY. Studied: Dow; Snell; Carlson; Stanhope Forbes, in England. Member: NAWPS [40]

BARNARD, Julia E. [P] Stamford, CT [17]

BARNES, Burt [P,I,W,T] b. 30 Je 1879, Manitowoc, WI d. 1947. Studied: AIC. Member: Wis. PS. Exhibited: Milwaukee, 1925 (prize); Nat. Gal., Wash., D.C. Friend of W.E. Schofield

BARNES, Catherine [P] Phila., PA. Exhibited: WC Ann., PAFA, 1937, 1938 [40]

BARNES, Catherine J. [I,Des,T] Mantua, NJ b. 6 Je 1918, Phila. Studied: PMSchIA; ASL, with Eliot O'Hara. Member: Phila. WC Cl.; Plastic Cl.; Phila. A. All. Exhibited: PAFA; AIC; BM; Montclair A. Mus.; Butler AI; Phila. A. All. (one-man). Illustrator: "Favorite Tales," 1945, "Understood Betsy," 1946, other books, national travel and fashion magazines [47]

BARNES, Ernest Harrison [P,T] Detroit, MI/Mystic, CT b. Portland, NY. Studied: Hillsdale Col.; AIC; ASL, with Charles H. Davis, Will Howe Foote; Henry R. Poore. Member: Scarab Cl.; Boston AC; Conn. Acad. FA; SSAL; All.A.Am. Exhibited: Detroit Inst. A., 1916 (prize), 1917–21, 1922 (prize), 1923, 1926, 1928; SSAL, 1928 (prize); CGA, 1921, 1923, 1926, 1933; AIC, 1906, 1907, 1932; NAD, 1923, 1925, 1931, 1933; CM, 1909, 1910, 1911; WFNY, 1939; Mystic AA, 1920–45; Conn. Acad. FA, 1922–46; SSAL; Ann Arbor AA. Work: Unvi. Mich.; Hillsdale Col.; Vanderpoel Coll.; Detroit Inst. A. Position: Asst. Prof., A., Univ. Mich., 1929–43 [47]

BARNES, Fay M. [P] Chicago, IL. Studied: AIC [13]

BARNES, Gertrude J(ameson) (Mrs. Henry A.) [P] Minneapolis, MN b. 23 O 1865, Tyngsboro, MA. Studied: Minneapolis Sch. FA, with Douglas Volk; Cowles A. Sch., with Dennis M. Bunker; Snell; Lathrop; C.H. Woodbury. Member: Ar. Lg. Minneapolis; NAWPS. Exhibited: Minn. State Art Soc., 1904 (prize), 1908 (prize), 1910 (prize), 1914 (prize); Minneapolis AI, 1915 (prize); St. Paul Inst., 1916 (med); Minn. Art Commission, 1918 (prize), 1919 (prize). Work: Minn. State Art Soc., St. Paul [40]

BARNES, Helen Brooks [P] NYC b. 3 Ja 1889, Aberdeen, SD. Studied: Mary Baldwin Sem., Staunton, VA. Member: NAWA. Exhibited: NAWA, 1942, 1943, 1945, 1946; NAD, 1942; All.A.Am., 1945; Montross Gal., 1945; Am.-Brit. A. Center [47]

BARNES, Henry Burt [P] Glen Ellyn, IL. Member: Chicago NJSA [24]

BARNES, Hiram Putnam [I] Waltham, MA b. 1 Ap 1857, Boston. Studied: Fernand Lungren; Childe Hassam [13]

BARNES, John Pierce [P] Collingsdale, PA [24]

BARNES, Lee Carroll [S,C] Wash., D.C. b. 26 Je 1906, Des Moines, IA. Studied: Corcoran Sch. Exhibited: Mus. Mod. A., Wash., D.C., 1938; Feragil Gal. (one-man); Arden Gal., 1938; Corcoran Gal., 1940 [40]

BARNES, Matthew Rackham [P] San Fran., CA b. 26 N 1880, Scotland d. 1951. Exhibited: San Fran. AA, 1926 (prize), 1937 (prize) [40]

BARNES, Nevin C. (Mrs.) [P] Cleveland, OH. Member: Cleveland Women's AC [24]

BARNES, Renée [P] Indianapolis, IN b. 5 S 1886, Grand Rapids, MI d. 28 D 1940. Studied: John Herron Art Inst.; Will Vawter; William Forsyth; Clifton Wheeler. Member: Ind. Ar. C. [40]

BARNES, Roderic B. [P] NYC. Member: SC [24]

BARNES, Virginia [T,P,Ser] Montevallo, AL b. 19 My 1895, Livingston, AL. Studied: Ala. Col; AIC; Univ. Ga.; T. Col., Columbia Univ.; Dudley Crafts Watson. Member: Ala. A. Lg.; Ala. WC Soc.; Birmingham AC; SSAL. Exhibited: Birmingham AC; Ala. A. Lg.; Ala. WC Soc.; SSAL. Work: Montgomery Mus. FA; Huntington Col.; Ala. State T. Col.; Ala. Col.; capitol, Montgomery. Position: Asst. Prof., A., Ala. Col, Montevallo, 1939–46 [47]

BARNET, Will [P,T,Gr] NYC b. 25 My 1911, Beverly, MA. Studied: BMFA Sch., with Philip Hale; ASL, with Charles Locke; Harry Wickey. Member: Phila. Pr. Cl.; ASL; Am. A. Cong. Exhibited: Phila. Pr. Cl., 1942 (prize), 1945 (prize); Carnegie Inst., 1944, 1945; CGA, 1945; VMFA, 1944; PAFA, 1943–45; Univ. Ia., 1945, 1946; Walker Gal., 1938 (one-man); Gal. St. Etienne, 1943 (one-man); Schaefer Gal., 1946 (one-man). Work: MMA; FMA; Lib. Cong.; PMG; PMA; Carnegie Inst.; SAM; Honolulu Acad. A. Positions: Instr., ASL, 1936– ; CUASch., 1945–46; Birch Wathen Sch., 1944–46 [47]

BARNETT, Bion [P] NYC [21]

BARNETT, Eugene A. [P,S,I,E,W] NYC b. 18 Mr 1894, Atlanta, GA. Studied: Edward Penfield. Member: SI [47]

BARNETT, George J. [P] Buffalo, NY [17]

BARNETT, Herbert Phillip [P,T,L] Worcester, MA b. 8 Jy 1910, Providence, RI d. 1972. Studied: BMFA Sch.; R.I. Sch. Des.; Europe. Member: Inst. Mod. A., Boston; Eastern AA. Exhibited: PAFA, 1937 (prize); Carnegie Inst., 1943–46; Springfield Mus. A.; WMAA, 1945; PAFA, 1936–44; NAD; GGE, 1939; AIC; MMA; Inst. Mod. A., Boston; Rockport AA; R.I. Sch. Des.; Phila. A. All.; WMA. Work: WMA; PAFA; Univ. Ariz. Position: Instr., WMA Sch., 1940– [47]

BARNETT, Isa [I,T] Phila., PA b. 1924, Carbondale, PA. Studied: Phila. Mus. SA; Henry Pitz; R. Riggs; R. Fawcett. Position: T., Phila. Col. A. [*]

BARNETT, Leroy [P] b. 18 D 1884, Brooklyn, NY d. Mr 1920. Studied: Joseph H. Boston; Henri; Kenneth Hayes Miller [19]

BARNETT, Tom P. [P,Arch] St. Louis, MO b. 11 F 1870, St. Louis d. 23 S 1929. Studied: arch., with George I. Barnett; painting, with Paul Cornoyer. Member: Chicago AG; NAC; St. Louis AG; SC; 1920; Chicago Gal. A.; Allied AA. Exhibited: arch., La. Purchase Expo. St. Louis, 1904 (gold); Portland Expo, 1905 (med); St. Louis Ar. Gld, 1914 (prize), 1915 (prize), 1917 (prize), 1919 (prize); St. Louis AG, 1918 (prize); St. Louis Art Lg., 1921 (prize); AIC, 1922 (prize); St. Louis Chamber Commerce, Ar. Gld. Salon, 1922 (prize), 1925 (prize); St. Louis AL, 1926 (prize). Work: St. Louis Mus. FA; Capitol, Jefferson City; Cook County Courthouse, Chicago

BARNEY, Alice. See Christian Hemmick, Mrs.

BARNEY, Alice Pike (Mrs.) [P,W] Wash., D.C. b. 14 Ja 1860, Cincinnati, OH d. 12 O 1931, Los Angeles. An artist and playwright, she studied art in Paris with Carolus-Duran and Whistler. Her portrait of Whistler is considered one of the best. It was used in Joseph Conrad's book of "Noted Men," and has also been used in other books on Whistler. A portrait of Natalie Barney is owned by the French government and that of Hon. Calhoun by the State Department in Wash., D.C. A producer of original plays, her play "Lighthouse" won the Drama League of America Contest in 1927, and "False Values," the first prize of the Arts Club of Washington. [29]

BARNEY, Arthur L. [P] NYC. Member: SC [24]

BARNEY, Frank A. [P] Auburn, NY b. 7 D 1862, Union Springs, NY. Work: Syracuse Mus. FA; Binghamton Mus. A. [47]

BARNEY, J. Stewart [P,Arch,S,W] b. O 1869, Richmond, VA d. 22 N 1925. Member: Newport AA [24]

BARNEY, Maginel Wright [P,I] NYC d. 18 Ap 1966. Member: GFLA; SI. Illustrator: "This Way to Christmas," by Ruth Sawyer, pub. Harper Bros. [33]

BARNEY, Marian Greene (Mrs. W. Pope) [P] Moylan, PA b. St. Paul, MN. Studied: Cecilia Beaux; Violet Oakley; Emil Carlsen; Philip Hale; Pearson. Member: F., PAFA; Phila. All.; Pr. Cl. [33]

BARNEY, Walter, Mrs. See Stevens, Esther.

BARNHORN, Clement J(ohn) [S] Cincinnati, OH b. 1857, Cincinnati. d. 2 Ag, 1935. Studied: Académie Julian, Paris; Bouguereau, Peuch, Mercié, Ferrier, in Paris; Rebisso. Member: NSS, 1899; Cincinnati AC. Exhibited: Paris Salon, 1895 (prize); Paris Expo, 1900 (med); Pan-Am. Expo, Buffalo, 1901 (prize); St. Louis Expo, 1904 (med). The "Crucifixion Group" (1929), considered his finest work, is in the Church of Santa Monica, Cincinnati. Position: Hd., Sculpture Dept., Cincinnati A. Acad. [33]

BARNITZ, Henry Wilson [P,C,T] Glenview Park, IL b. 27 D 1864, Berwick, PA. Studied: PAFA, with Eakins, Hovenden; stained glass, Leon De Le Chaux. Member: F., PAFA; Chicago SA; Chicago WCC; SWA; Intl. Soc. AL [15]

BARNITZ, Myrtle Townsend [P,S,C,W,T] Glen View, IL b. Greensburg, PA. Studied: Charles Francis Browne; Thomas Hovenden; Thomas Eakins; William Gilchrist; Thomas P. Anshutz; Hugh Breckenridge. Member: F., PAFA; Chicago NJSA [40]

BARNOUW, Adriaan J. [P,L,Hist] NYC b. 9 O 1877, Amsterdam, Holland. Member: Century Assn. Exhibited: MMA, 1942; Buffalo A. Gal.; Amster-

dam, Holland, 1934 (one-man); Kley Kamp A. Gal., The Hague, 1934 (one-man). Author: Dutch Paintings Bulletin, MMA, 1944. Contributor: art magazines. Lectures: Dutch Art. Painted at Taos, N.Mex. [47]

BARNS, Cornelia [P,I] Berkeley, CA b. 25 S 1888, New York. Studied: Twachtman; Chase. Illustrator: Liberator [33]

BARNSLEY, James M. Montreal, Quebec b. Canada. Studied: St. Louis Sch. FA; Académie Julian, Paris. Member: NYWCC, 1900 [01]

BARNUM, Emily Keene [P,W] Lausanne, Switzerland b. 29 Mr 1874, NYC. Studied: J.G. Vibert, in Paris; Irving R. Wiles; ASL. Member: PBC. Founder/Editor, The Swiss Monthly, published at Lausanne [40]

BARNUM, Fayette (Miss) [P] Louisville, Ky. Member: Louisville AL [01]

BARNUM, J.H. [P,I] Norwalk, CT. Member: Ar. Gld.; SI [33]

BARONE, Antonio [P,E,T] NYC b. 20 My 1889, Valle Dolmo, Sicily. Studied: DuMond; Chase; Mora. Member: Chicago SE; Por.P. Exhibited: etching, P.-P. Expo, San Fran., 1915 (med); Phila. AC., 1917 (gold) [24]

BARR, Charles Hagan [C] b. Pittsburgh, PA d. 9 Ja 1947, Stratford, CT. Studied: Italy. Exhibited: NYC; Chicago; Boston. Specialty: bronze

BARR, Clayre [P,T] New Orleans, LA b. 26 O 1913. Studied: New Orleans A. C. Cl. A. Sch.; Newcomb Col.; Charles Brin; Enrique Alferez. Member: New Orleans A. C. Cl. Exhibited: water color, New Orleans Ar. Gld., Delgado Mus., 1934 (prize); New Orleans A. C. Cl., Grisham Gal.; WFNY, 1939. Work: WPA Project, New Orleans H.S. [40]

BARR, Howard [I,Car] Chicago, IL. Work: Esquire, 1939 [40]

BARR, Paul E. [Edu,P] Grand Forks, ND b. 25 N 1892, Tipton County, IN d. 1953. Studied: AIC; Univ. Chicago; Univ. Ind.; Sorbonne; Univ. Paris; Univ. N.Dak. Member: AAPL; AFA; Ind. A. Cl.; Hoosier Salon; Nat. Edu. Assn.; Am. Assn. Univ. Prof.; Nat. Inst. A.&L. Exhibited: N.Dak. A. Exh., 1940 (prize); Rockefeller Center, 1936, 1937, 1938; WFNY, 1939; IBM, 1940; Pasadena, Calif., 1946; AFA Traveling Exh., 1938, 1939; Kansas City AI, 1940; Rochester, N.Y., 1940; Ball State FA Gal., 1940; Dallas Mus. FA, 1943; Hoosier Salon, 1940, 1941; Delgado Mus. A., 1943; John Herron AI, 1945, 1946. Work: Pub. Lib., Tipton, Ind.; Univ. N.Dak.; IBM; capitol, Bismarck; Cottey Col., Nevada, Mo.; Municipal Univ., Wichita, Kan. Co-author: "Creative Lettering," 1938. Position: Head, A. Dept., Univ. N.Dak., Grand Forks, 1928– [47]

BARR, William [P,I] San Fran., CA b. 26 Ap 1867, Glasgow d. 25 F 1933. Studied: Glasgow Sch. A.; South Kensington, London; Académie Julian, Paris. Member: Glasgow A. Cl.; Paisley Art. Inst. Work: town of Paisley; City Hall, Union Lg. Cl., San Fran. Specialty: historical associations, which he depicted in his Calif. landscapes and portraits [33]

BARRATT, George W. [I] Wilmington, DE [13]

BARRATT, Louise Bascom [I] NYC. Member: SI. Illustrator: "The Bugaboo Men," Today's Housewife, 1919–21 [40]

BARRATT, Watson [Des,I] NYC b. 27 Je 1884, Salt Lake City, Utah. Studied: Robert Henri; William M. Chase; E. Penfield; Howard Pyle. Member: SI; Arch. Lg. Work: covers, Saturday Evening Post, Harpers Bazaar; illus., national magazines; des., Passing Shows, Shubert Revues, Ziegfield Follies, 1918–34; Ethel Barrymore's "Love Duel," Al Jolson's "Bombo." Positions: director, St. Louis, Detroit municipal operas, 1932–35; consultant, WFNY, 1939 [47]

BARRAUD, A.T. [P] Brookline, MA [98]

BARRE, Raoul [P] Montreal, Quebec [01]

BARREAUX, Adolphe [I] NYC/Merriewold Park, NY b. 9 Ja 1900, Orange, NJ. Studied: Sargeant Kendall. Member: Ar. Gld. Work: mural, Green Room Cl., NYC. Position: T., Barbizon Sch. Modeling, NYC [40]

BARRETT, Elizabeth Hunt (Mrs. Edward N.) [P] Amherst, VA b. 9 Ja 1863, NYC. Studied: NAD [24]

BARRETT, George H., Jr. [P] NYC [08]

BARRETT, Laura A. [P,I,E,C] NYC/New Brighton, NY b. West New Brighton d. 27 O 1928. Studied: Alfred Stevens, in Paris; Weir; Clarkson. Member: Art Workers' Cl. for Women; NAC. Work: Knoxville, Tenn. [33]

BARRETT, Lawrence (Lorus) [E,Li,T,I,W] Colorado Springs, CO b. 11 D 1897, Guthrie, Okla. d. 1973. Studied: Broadmoor A. Acad.; Colorado Springs FA Center; R. Reid; E. Lawson, J.F. Carlson. Member: F., Guggenheim, 1940. Exhibited: Midwest Exh., 1928 (med); Phila. Pr. Cl., 1941 (prize); AV, 1943 (prize); NAD; Lib. Cong.; MMA; Phila. Pr. Cl.; deYoung Mem. Mus., 1941 (one-man); Santa Barbara Mus., 1945 (one-man); Pas-adena Mus. A., 1946 (one-man). Work: MMA; Lib. Cong. Author: text on lithographs for Adolf Dehn monograph, 1946. Position: T., Colorado Springs FA Center, 1936– [47]

BARRETT, Lisbeth Stone (Mrs. Albert O.) [Min.P] Devon, PA b. 2 Ap 1904, Seattle, WA. Studied: Newcomb Col., Tulane Univ.; ASL; Grand Central Sch. A.; Académie Julian, Paris; PAFA. Member: Phila. All.; Pa. Soc. Min. P. Exhibited: Calif. S. Min. P., 1935 (prize), 1937 (prize) [47]

BARRETT, Oliver O'Connor [S,I,T] NYC b. 17 Ja 1908, London. Studied: Fircroft Col., England. Member: S. Gld. Exhibited: PAFA, 1945; Royal Acad., London, 1933; Audubon A., 1946; New Orleans AA, 1942, 1943. Illustrator: "Anything for a Laugh" (1946), Town & Country, other magazines [47]

BARRETT, Riva Helfond, Mrs. See Helfond.

BARRETT, Robert D. [P,C,Edu] NYC b. 23 N 1903, Fulton, NY. Studied: Syracuse Univ. Member: SC; All.A.Am.; N.Y. Soc. C. Exhibited: NAD, 1932, 1938; AFA Traveling Exh., 1939; All.A.Am., 1936, 1945, 1946; AWCS, 1946; WFNY, 1939; El Paso Mus., 1945; Paris Expo, 1937. Position: Instr., Brooklyn Col. [47]

BARRETT, Strait C. [P] NYC [19]

BARRETT, Thomas Weeks [P,Des,En] Poughkeepsie, NY b. 12 S 1902, Poughkeepsie d. 20 N 1947. Studied: BMFA Sch.; Henry Hunt Clark. Member: Carmel AA; Hudson Highlands A.; Am. A. Cong.; Dutchess County AA. Exhibited: PAFA, 1932, 1934, 1935. Work: PMG; Franklin D. Roosevelt Lib., Hyde Park, N.Y.; Woodcut Soc., Kansas City [47]

BARRETT, William S. [P] Brooklyn, NY b. 1 My 1854, Rockport, ME d. 1927, Rockport. Studied: Paris, NYC. Member: SC, 1902; Brooklyn AC; founder/member, "The Brooklyn Ten," 1902. Work: Schenectady Mus. Teacher: watercolor, 1886–1904 [09]

BARRETTO, Anna Appleton (Mrs. Larry) [Art Lib.] Goshen, NY b. 8 Ap 1891, Englewood, NJ. Studied: Beard's Sch. Illustrator: "Bright Mexico," 1935, "Hawaiian Holiday," 1938. Position: Staff, Frick Art Ref. Lib., NYC, 1920– [47]

BARRICK, Shirley Gordon (Mr.) [P,E,I,T] Cleveland, OH b. 8 Jy 1885, Cleveland. Studied: Cleveland Sch. A. Member: Cleveland SA. Exhibited: Cleveland Mus. A., 1919 (prize), 1923 (prize); Ohio State Fair, 1921 (prize). Position: A. Dir., Plain Dealer Pub. Co., Cleveland [40]

BARRIE, Erwin S. [P] Greenwich, CT b. 3 Je 1886, Canton, OH. Studied: AIC. Member: Chicago AC; Greenwich A. Soc; NAC. Work: Rockford AA; Joliet A. Lg. [47]

BARRINGTON, Amy L. [P,W,L] NYC b. Jersey City, NJ. Studied: Cox; Brush; Chase. Member: NAWPS; Worcester Gld. Ar.&Craftsmen. Contributor: articles on decoration, art objects, archaeology in current magazines [40]

BARRITT, Robert Carlyle [P,T] West Pittston, PA b. 23 Je 1898, West Pittston. Studied: PAFA; N.Y. Sch. A.; R. Sloan Bredin. Member: AAPL; Audubon A.; Am. Veterans Soc. A.; Buck Hill AA. Exhibited: Wanamaker Exh., 1920 (prize); Audubon A.; Am. Veterans Soc. A.; Hagerstown, Johnstown, Pa.; Norfolk (Va.) AM; MA, Scranton, Pa.; Butler AM, Youngstown, Ohio [47]

BARROLL, Nina L. [P] Elizabeth, NJ. Member: AWCS [04]

BARRON, Dorothy Lois Hatch [P,B,Des,T] San Diego, CA b. Escondido, CA. Studied: Albert Heckman; Belle Boas; Doris Rosenthal; Arthur Young; Charles Martin. Member: Western AA; FAS, San Diego. Work: batik hangings, State Col., Fargo, Alpha Phi house, Grand Forks, N.Dak. [40]

BARRON, Grace [P,T] NYC b. 7 D 1903, Buffalo, NY. Studied: Boston Sch. FA&Crafts; Fontainebleau, France. Member: The Patteran, Buffalo; Rockport AA. Exhibited: Albright A. Gal., 1933, 1934, 1935 (prize), 1936–40, 1941 (prize), 1942–44; Carnegie Inst., 1941; AFA Traveling Exh., 1941, 1942; U.S. Govt. Section FA, 1941; N.Y. State Exh., Syracuse, 1941. Work: Albright A. Gal. [47]

BARRON, Jane Carson (Mrs. Amos N.) [Metalwork,Enam] Cleveland, OH b. 26 Ja 1879, Cleveland. Studied: BMFA Sch.; Pratt Inst.; Lorin Martin; Amy M. Sacker; Louis Rorheimer. Member: Boston SAC. Exhibited: jewelry, St. Louis Expo, 1904 (med); Cleveland Mus. A, 1930, 1934. Specialty: jewelry [38]

BARROWS, Albert, Mrs. See Hamlin, Edith A.

BARROWS, Albert [P] Monterey, CA [24]

BARROWS, B.E. [P] Chicago, IL. Member: Chicago NJSA [24]

BARROWS, Elizabeth Bartlett (Mrs.) [P,I] NYC b. 1872, Boston. Studied: Denis Bunker; Kenyon Cox [04]

BARRY, Edith Cleaves [P,S,E,Mus.Dir] NYC b. Boston. Studied: ASL; N.Y. Inst. FA; Paris. Member: NAWA; All.A.Am.; NSMP. Exhibited: Whitney Studio (prize); CAFA, 1916 (prize), 1921 (prize), 1922 (prize), 1938 (prize), 1940; Montclair A. Mus., 1928 (med); Portland (Maine) SA, 1915; NAWA, 1916, 1922, 1926, 1932, 1942, 1945; Yale Mus. FA, 1916; Albright A. Gal., 1922; All.A.Am., 1942; AIC; CGA; NAD; Arch. Lg.; PAFA. Work: Dartmouth; Dyer Lib.; York Nat. Bank, Saco, Maine; USPO, Kennebunk, Maine; AAPL; Soldiers & Sailors Cl., NYC. Position: Dir., Brick Store Mus., Kennebunk, 1936–46 [47]

BARRY, Eleanor E. [T,P] Melrose, MA/Goose Rocks Beach, ME. Studied: BMFA; Eliot O'Hara. Exhibited: Argent Gal.; Currier Gal., Manchester, N.H., 1939. Positions: Instr., BMFA; summers, Chief Asst., Eliot O'Hara [40]

BARRY, Ethelred Breeze [I] Arlington Heights, MA. b. 1870, Portsmouth, N.H. Studied: Henry Sandham. Member: Copley S., 1897 [09]

BARRY, John J. [E,W] Toronto b. 21 Je 1885, Hamilton, Ontario. Studied: Los Angeles Sch. A.&Des.; ASL; Royal Col. A., London; Joseph Pennell; Sir Frank Short; Ernest Haskell. Member: Calif. Pr.M.; Rockport AA; North Shore AA. Exhibited: Conn. Acad. FA, 1946; LOC, 1943; Montreal AA. Contributor: travel articles, illus. for magazines. Lectures: Process of Etching. Author: "How to Make Etchings," 1930 [47]

BARRY, Marietta [P] Seattle, WA [21]

BARSCHEL, H(ans) J(oachim) [Adv.Des] NYC b. 22 F 1912, Berlin, Germany. Studied: Acad. Free & Appl. A., Berlin. Exhibited: AIGA, 1938 (prize); A. Dir. Cl., 1938, 1939; A-D Gal., 1946. Work: NYPL; Lib. Cong. Designer: book jackets & covers, "Ciba Symposia"; Fortune, Town & Country [47]

BARSE, George R(andolph), Jr. [P] Katonah, NY b. 31 Jy 1861, Detroit, MI d. 25 F 1938. Studied: Cabanel, Boulanger, Lefebvre, in Paris. Member: ANA, 1898; NA, 1900; SAA, 1899; Century Assn. Exhibited: NAD, 1895 (prize); SAA, 1898 (prize); Pan-Am. Expo, Buffalo, 1901 (med). Work: Lib. Cong.; Vanderpoel Coll.; Carnegie Inst.; Minneapolis Inst. A.; Kansas City A. Inst.; Mus. FA, Syracuse; Art Cl., Providence; Art Cl., Phila.; H.B. Speed Mem. Mus., Louisville, Ky. [38]

BARSOTTI, John Joseph [P,I] Columbus, OH b. 22 Ap 1914, Columbus. Studied: Ohio State Univ. Exhibited: Columbus A. Lg., 1938–41, 1946; Butler AI, 1939–41; WMAA, 1939; AIC, 1941, 1943; Oakland A. Gal., 1941; Denver A. Mus., 1941; Ohio Valley Exh., 1946; Parkersburg A. Center, 1941 [47]

BARSTOW, Marion Huse, Mrs. See Huse.

BARSTOW, S.M. [P] Sebago, ME [01]

BARTE, Eleanore [P,I] NYC/Rockport, MA b. Milwaukee. Member: Rockport AA [24]

BARTEL, Sarah N. (P.) [P] NYC. Member: Wash. WCC [04]

BART-GERALD, E(lizabeth) [P] NYC b. 8 S 1907, Cleveland. Studied: Cleveland Sch. A.; Hans Hoffman, in Capri; André Lhote, in Paris. Exhibited: Cleveland Mus. A., 1933 (prizes). Work: Cleveland Mus. A. Designer: wallpapers, fabrics [40]

BARTH, Eugene F(ield) [P,E] Beech Hurst, NY b. 4 Mr 1904, St. Louis. Studied: Fred C. Carpenter. Member: ASL. Exhibited: St. Louis Ar. Gld., 1928 (prize) [40]

BARTHE, Richmond [S] NYC b. 28 Ja 1901, Bay St. Louis, MS. Studied: AIC; ASL; Xavier Univ.; Charles Schroeder. Member: F., Guggenheim, 1940, 1941; F., Rosenwald, 1930, 1931; Am. Acad. &L.; S. Gld.; NSS; Audubon A. Exhibited: Audubon A., 1945 (med); Harmon Fnd., 1929, 1931, 1933; WMAA, 1933–36; 1940–42, 1944; BM, 1935, 1945; CGA, 1936; PAFA, 1938, 1940–44; Atlanta Univ., 1945, 1946; Montclair A. Mus., 1946; Hampton Inst., 1944; Carnegie Inst., 1938, 1941; MMA, 1942. Work: WMAA; Oberlin Col.; PAFA; VMFA; MMA; NYU [40]

BARTHOLD, Manuel Loyola [P] near San Sebastian, Spain; b. 9 S 1874, NYC. Studied: Cormon, Laurens, in Paris. Exhibited: Paris Salon, 1904 (med); Liège Expo, 1905 (med). Work: Luxembourg Mus., Paris [17]

BARTHOLOMEW, Charles L. (Bart) [Car,T,W,L,I] Minneapolis, MN b. 10 F 1869, Chariton, IA. Studied: Burt Harwood; Douglas Volk. Illustrator: children's books. Author: "Bart Chalk Talk System," Crayon Presentation Booklet. Cartoonist: magazines. Editor: textbooks on illustrating and cartooning. Position: Dean, Fed. Sch. Illus. & Car., Minneapolis [40]

BARTHOLOMEW, Donald C. [Car] White Plains, NY b. 1883 d. 20 D 1913. Position: Staff, Evening Globe, NYC

BARTHOLOMEW, William Newton [P,T,W] Newton Centre, MA b. 1822, Boston d. 1898. Studied: with daguerreotypist J. Wesley Jones, in Calif., 1850. Teacher of drawing, in Boston, 1852–71 [05]

BARTILOTTA, Samuel A. [P] Chicago, IL b. 22 Ag 1900, Villarosa, Italy. Studied: Piccinelli; AIC; Chicago Acad. FA. Member: Hoosier Salon; All-Ill. SFA; South Side AA. Work: A. Inst. Chicago [40]

BARTLE, George P. [Wood En,Ldscp.P] Phalanx, NJ b. 1853, Wash., D.C. d. 9 D 1918. Studied: H.H. Nichols. Work: Century Magazine

BARTLE, Grace M. [Ldscp.P] Dover Plains, NY b. 6 N 1889, Pittsburgh. Studied: J.E. Powell. Member: Dutchess County AA; Putnam County AA. Work: mural, Methodist Episcopal Church, Dover Plains [40]

BARTLE, Sara N(orwood) [Min.P] Wash., D.C. b. Wash., D.C. Studied: Carroll Beckwith; William Holmes [24]

BARTLESON, Malotte [Min.P] Paris, France b. Alabama. Studied: Debillemont-Chardon; Laforge; Castelucho [05]

BARTLETT, Charles W. [P] NYC. Member: Calif. PM [24]

BARTLETT, Clarence Drew [P] Amsterdam, Holland b. 1860, Athens, OH. Studied: Académie Julian, Paris; Carl Marr, in Munich. Member: Arti et Amicitae Soc., Amsterdam [01]

BARTLETT, Dana [P,E,T] Los Angeles, CA b. Ionia, MI d. Jy 1957. Studied: ASL; William M. Chase; Coussens, in Paris. Member: Calif. AC; Decorative AS; Western Acad. Work: Sacramento State Lib.; Los Angeles Mus. A.; Southwest Mus.; Huntington Coll., San Marino; Los Angeles Pub. Lib., Lafayette Park Branch; Boston Pub. Lib., Print Dept. Illustrator: "The Bush Aflame" [40]

BARTLETT, Elizabeth M.P. [P,T] Boston, MA b. Salisbury, MA. Studied: Mass. Sch. A; Webster; Woodbury; Comins; Breckenridge; Naum Los, in Rome. Member: Copley S. [33]

BARTLETT, Elwood Warren [En,I] Milwaukee, WI b. 11 S 1906, Walworth County, WI. Studied: self-taught. Exhibited: NAD, 1940–43, 1946; Phila. Pr. Cl., 1940–43; Northwest Pr.M., 1940–43, 1946; Milwaukee AI, 1940–43, 1946. Work: Lib. Cong.; NYPL; Milwaukee Pub. Lib. Illustrator: Chicago Tribune [47]

BARTLETT, Ethel G. [P] Arlington, MA [05]

BARTLETT, Evelyn [P] Beverly, MA. Exhibited: PAFA, 1935, 1937; Corcoran Biennial, 1935, 1937. Work: PAFA [40]

BARTLETT, Francis d. 23 S 1913, Beverly Farms, MA. A financier and a lawyer, he was a trustee of the BMFA for twenty-three years. His gifts to the Museum, including property and objets d'art, are valued at $2,500,000.

BARTLETT, Frederic Clay [P] Beverly, MA b. 1 Je 1873, Chicago. Studied: Gysis, in Munich; Collin, Aman-Jean, Whistler, in Paris. Member: All. AA; Chicago SA; Mural P.; AFA; Royal Acad., Munich. Exhibited: St. Louis Expo, 1904 (med); Carnegie Inst., 1908 (prize); AIC, 1910 (prize); P.-P. Expo, San Fran., 1915 (med). Work: Chicago Univ. Cl.; Univ. Chicago; Second and Fourth Presbyterian Churches, Chicago; City Hall, Chicago; AIC; Carnegie Inst.; Corcoran Gal. [40]

BARTLETT, Frederic Clay, Jr. [P,Arch] Manchester, VT b. 21 N 1907, Chicago. Member: Southern Vt. Ar. Inc., Manchester; A. Cl., Chicago. Exhibited: AIC, 1938; PAFA, 1938; WFNY, 1939. Work: Wood Gal., Montpelier, Vt.; BM; Addison Gal., Andover, Mass. [40]

BARTLETT, Frederick Eugene [P] Yonkers, NY b. 13 N 1852, West Point, NY d. Je 1911, Highland Falls, NY. Studied: NAD, with Wilmarth, Beckwith; Carolus-Duran, in Paris; Hypolite Michaud, in Beaume, France. Exhibited: St. Louis Expo, 1904 (med). Specialty: landscapes [09]

BARTLETT, Fred Stewart [Mus.Cur,T,W] Colorado Springs, CO b. 15 My 1905, Brush, CO. Studied: Univ. Colo.; Univ. Denver; Harvard Univ. Member: F., Carnegie Inst. Positions: Dir. Edu./Asst. to Dir., Denver A. Mus., 1935–43; Cur., Paintings, Colorado Springs FA Center, 1945– [47]

BARTLETT, G. Waldron [P,T] Bensonhurst, NY b. New York. Studied: L.L. Lowell; Paul Nefflen; T.S. Noble; William M. Chase [13]

BARTLETT, Grace Landell [P,C] Colorado Springs, CO b. 19 Ag 1907, Colorado Springs. Studied: Randall Davey. Exhibited: Colo. State Fair, Pueblo, 1932 (prizes). Work: woodcarving, Grace Episcopal Church, Colorado Springs. Position: T., Broadmoor Acad. [40]

BARTLETT, Gray [P] Los Angeles, CA b. 1885, Rochester, MN d. 1951.

Studied: Greeley (Colo.) Sch. A.; AIC. Work: Ariz. State Univ. Specialty: cowboys. Had studios in Calif. and Utah. [*]

BARTLETT, Helen B. [P] d. 24 O 1925, NYC. Wife of the artist Frederic Clay Bartlett.

BARTLETT, Ivan [Des,P,Li,Ser,I] Long Beach, CA b. 3 F 1908, Plainfield, VT. Studied: Chouinard AI. Exhibited: Calif. Festival All. A., 1935 (prizes); Long Beach Exh., 1937 (prize); Laguna Beach, 1938 (prize); Los Angeles County Fair, 1938 (prize), 1939, 1941 (prize); WFNY, 1939; GGE, 1939; SFMA, 1937, 1938; Oakland A. Gal., 1938; Los Angeles Mus. A., 1936–39; San Diego, 1937–39; Fnd. Western A., 1938, 1939; Zeitling Gal., 1938 (one-man); City of Paris, San Fran., 1944, 1945 (one-man). Work: Lib. Cong.; Los Angeles County Fair; USPO, Huntington Park, Redondo Beach, both in Calif. [47]

BARTLETT, Josephine Hoxie [P] Paris, France b. 1870, New York. Studied: G. Courtois, in Paris; Peter Graham. Member: Soc. Scottish Ar. [09]

BARTLETT, Julia M(cMahon) [P] NYC b. 4 My 1899, NYC. Studied: Robert Brandegee; Cecilia Beaux; Ralph Pearson. Member: All.A.Am. [40]

BARTLETT, Madeleine A(delaide) (Danforth) [S,W] Boston, MA b. Winchester MA. Studied: Cowles A. Sch.; Henry H. Kitson. Member: Boston Soc. S.; Conn. Acad. FA. Exhibited: Boston Tercentennary Exh., 1930 (med); PAFA, 1912, 1914, 1915, 1917, 1920, 1922, 1931; AIC, 1916, 1926; NSS, 1923, 1929, 1943; Boston Soc. S., 1925 [47]

BARTLETT, Minnie Ellsworth [P,I] Indianapolis, IN b. 29 Je 1890, Seymour, IN. Studied: Wheeler; Stark; Forsyth. Member: Ind. Ar. Assoc. [15]

BARTLETT, Otto [P] Paris, France b. New York [13]

BARTLETT, Paul [P,T] St. Petersburg, FL b. 8 Jy 1881, Taunton, MA. Studied: John Sloan. Member: S. Indp. A.; St. Petersburg ACl. Exhibited: Chicago SA, 1919 (prize), 1920 (prize); PAFA, 1932 (med). Work: Cincinnati Mus; WMAA; Luxembourg Mus., Paris [40]

BARTLETT, Paul W(ayland) [S] Paris b. 1865, New Haven, CT d. 20 S 1925. Studied: Cavelier, Frémiet, Rodin, in Paris. Member: NSS, 1893; Nat. Inst. AL; Am. Acad. A.&L; Paris AAA; Royal Acad., Belgium; Inst. France; ANA, 1917; NA, 1917; S. Wash. A.; Acad. des Beaux-Arts; Chicago SA; Lg. AA. Exhibited: Paris Salon, 1887 (prize); Pan-Am. Expo, Buffalo, 1901 (gold); St. Louis Expo, 1904 (prize); Liège Expo, 1905 (med). Work: MMA; Capitol, Hartford; mon., Boston, Phila., Duluth (Minn.), Waterbury (Conn.); NYPL; Square of the Louvre, Paris; PAFA; Chicago AI; Lib. Cong.; pediment, House of Rep., Wash., D.C. Son of T.H. Bartlett and an expatriot classical sculptor, he was named Chevalier of the Legion of Honor in 1895.

BARTLETT, Truman H. [S,W,L,T,] Jamaica Plain, MA b. 25 O 1835, Dorset, VT. Studied: Frèmiet, in Paris. Work: Hartford, Waterbury, Conn. Author: "Life of Dr. William Rimmer," "Physiognomy of Abraham Lincoln," "Epochal Portraits of Abraham Lincoln," essays on Frèmiet, Rodin, Aube, Millet, and others. Position: Instr. Modeling, MIT, for twenty-three years [21]

BARTO, Emily (Mrs.) [I,W,P] NYC b. 6 Ap 1896, Greenport, NY. Studied: CUASch.; NAD; George Bridgman; Charles Hawthorne; William Dodge. Member: AAPL. Exhibited: All.A.Am., 1944; NAC, 1945. Author/Illustrator: children's books [40]

BARTOL, Elizabeth Howard [P] Boston, MA/Rockport, MA b. 1842, Boston d. 1927. Studied: Boston Sch. Des., with S.S. Tuckerman; W. Rimmer; William M. Hunt; Couture, at Villiers-le-Bel. Exhibited: Williams & Everett Gal., Boston, 1888; Boston AC, 1870s, 1880s. Work: Lancaster (Mass.) Hist. Soc. One of Hunt's best students, she stopped painting ca. 1895, due to illness. In 1921 she gave the Swan Collection of European furniture to BMFA. [*]

BARTON, August Charles [Des,P,T,L] Bronxville, NY b. 15 N 1897, Szekesfehervar, Hungary. Studied: Royal Hungarian Univ. Tech. Sciences; Royal Hungarian Col. Inst. A. Member: Textile Des. Gld. Am.; AWCS. Lecture: Textile designing for modern fabrics. Position: Instr., Textile Des., Moore Inst., Phila. [47]

BARTON, Catherine Graeff [S] New Haven, CT b. 22 Jy 1904, Englewood, NJ. Studied: CUASch.; ASL; Archipenko; Despiau, Gimond, in Paris. Member: New Haven PCC; NAWA. Exhibited: FA Comm., Wash., D.C., 1930 (prize); NAWA, 1931 (prize); NAD, 1926; Arch. Lg., 1926; PAFA, 1927; NSS, 1940; New Haven PCC, 1944–46 [47]

BARTON, Cleon Douglas [P,T] Boscawen, NH b. 18 N 1912, Concord, NH. Studied: Inst. A.&Sciences, N.H.; Omer T. Lassonde. Exhibited: Concord A. Center, Mass.; Currier Gal., Manchester, N.H. Work: Univ. N.H.; Pub. Libs., Nashua and Somersworth, N.H. [40]

BARTON, Donald B(lagge) [P] Fitchburg, MA/Rockport, MA b. 23 Ag 1903, Fitchburg. Studied: Michael Jacobs; Philip Hale; A.T. Hibbard; Gifford Beal; Hans Hofmann; Henry Rice; Lester Stevens. Member: PAFA. Exhibited: AWCC (prize). Position: Hd., Barton Studio [40]

BARTON, Ethel Rose [P,Des] NYC/Cornish, NH b. Cornish. Studied: CUASch; NAD; ASL; Guy Pène duBois; Boardman Robinson. Exhibited: CUASch. (med); AWCS, 1927 [47]

BARTON, G. [P] Toledo, OH. Member: Artklan [24]

BARTON, Loren (Mrs. Perez R. Babcock) [E,I,T,L] Los Angeles, CA b. 16 N 1893, Oxford, MA. Studied: Univ. Southern Calif. Member: AWCS; NYWCC; PBC; SAE; Calif. WC Soc. Exhibited: Ariz. A Exh., 1922 (prize), 1923 (prize), 1926 (prizes), 1927 (prize); NAWA, 1928 (med); Arcadia Exh., Calif., 1924 (prize); NAWPS, 1926 (med); Pacific Southwest Expo, 1928 (prize); Pomona Fair, 1928 (prizes); AWCS, 1941; Santa Paula, Calif, 1941; Clearwater A. Mus., 1946; NAD, 1945; AIC, 1945. Work: AIC; Calif. State Lib.; Los Angeles Pub. Lib.; NYPL; BM; San Diego FA Soc.; Los Angeles Mus. A.; MMA; Nat. Lib., France; Wesleyan Col., Macon, Ga.; Pomona Col.; Phoenix Municipal Coll.; VMFA; NGFA. Illustrator: "The Little House," 1937, "California," 1938, "The Butterfly Shawl," 1940. Position: T., Chouinard AI, Los Angeles [47]

BARTON, Macena Alberta [P] Chicago, IL b. 7 Ag 1901, Union City, MI. Studied: AIC. Member: Chicago SA; South Side Community A. Center; Chicago P.&S.; Chicago AC. Exhibited: AIC, 1927 (prize), 1928, 1932, 1933, 1937, 1941–43; VFMA, 1946 [47]

BARTON, Minette (Mrs. Charles H.) [P] Colorado Springs, CO b. Minneapolis. Studied: Robert Reid; Birger Sandzen; Randall Davey; Jean Despujols; Paul Baudouin; John Sloan; Hans Hofmann; Boardman Robinson; Fontainebleau. Member: ASL. Exhibited: Denver A. Mus., 1932 (prize); Colo. State Fair, 1932 (prize); Kansas City A. Inst., 1933 (med) [40]

BARTON, Nancy E. [P] Worcester, MA [13]

BARTON, Ralph [P,I,C,W] NYC b. 14 Ag 1891, Kansas City, MO. Member: SI; GFLA. Illustrator: "Gentleman Prefer Blondes" (by Anita Loos, pub. Boni & Liveright), magazines [24]

BARTON, Robert M., Mrs. See Harris, Marian D.

BARTOO, Catherine R. [P,Mus.Dir] Binghamton, NY b. 3 Mr 1876, Williamsport, PA. Studied: N.Y. Sch. A. Member: N.Y. Soc. P.; Binghamton Soc. FA. Work: Binghamton Mus. FA. Position: Dir., Binghamton Mus. FA [47]

BARUCH, Anne Barbara [P] Wash., D.C. b. 21 Jy 1903, Boston. Studied: R.I. Col. Edu.; Bessie Kaufman; Francine Utrecht. Member: Soc. Four A.; Palm Beach A. Lg. Exhibited: AAPL; Soc. Four A.; Palm Beach A. Lg. [47]

BARWICK, Walt (W.) [P,C] Kansas City, MO b. 1 N 1895, Kansas City. Studied: Charles A. Willmovsky [24]

BARZUN, Jacques [W,T,Cr,L] NYC b. 30 N 1907, Crèteil, France. Studied: Lycée Janson de Sailly, Paris; Columbia. Member: F., Am. Council Learned Soc., 1933–34; F., Guggenheim Fnd., 1945; Am. Hist. Assn.; Soc. Am. Hist.; Authors Gld. Am.; Century Assn. Author: "Of Human Freedom," 1939, "Darwin, Marx, Wagner," 1941, other books. Contributor: art magazines. Position: T, Columbia , 1928– [47]

BASCOM, Whitney Dorus b. 1904 d. 18 Ap 1935, Ticonderoga, NY. He was curator of Fort Frederick Mus. at Crown Point, and had spent the winter in Haiti with an archaeological expedition.

BASEBE, Ernest [P] Chicago, IL [17]

BASINET, Victor Hugo [P,B,Des,Dec,I,L] Los Angeles, CA/Monterey, CA b. 14 Mr 1889, Providence. Studied: Hugo Bruel; Jean Goucher; Antonio Cremoninni; Angelo Carducci; Dalvid Alfaro Sigueiros, Mexico. Member: Soc. Rational Tech. Painting, Munich; Los Angeles AA; Am. A. Cong. Work: Univ. Calif.; Gaelic Sch., Dublin, Ireland [40]

BASING, Charles [P,Mur.P,Arch] NYC/Provincetown, MA b. 23 Jy 1865, Australia d. 3 F 1933, Marrakech, Morocco (the result of blood poisoning after a camel stepped on his foot). Studied: Bouguereau; Ferrier. Member: N.Y. WC Cl.; Salma. Cl.; Am. WC Soc.; Allied AA; Chicago WCC. Exhibited: Salma. Cl., 1921 (prize), 1926 (prize); Am. Inst. Arch., 1924, (med). Work: murals, Columbia Univ. C.; Carnegie Inst. Tech.; ceiling, Grand Central Station, NYC. [33]

BASKE, Yamada [P] Minneapolis, MN [15]

BASKERVILLE, Charles [P] NYC b. 16 Ap 1896, Raleigh, NC. Studied: Cornell Univ.; ASL; Acad. Julian, Paris. Member: NSMP; AAPL; SI. Exhibited: Carnegie Inst., 1941; WMAA, 1936; CGA, 1940; Soc. Four A., Palm Beach, Fla., 1938, 1940; NGFA; Albright A. Gal.; de Young Mem. Mus.; MMA. Work: MA, Moscow. Illustrator: Scribner's, Life, Vanity Fair, other magazines [47]

BASKY, L. Marie [P] Astoria, NY. Member: Am. Inst. GA; NAWPS. Exhibited: NAWPS, 1933, 1935–38. Position: T., N.Y. Sch. F.& Appl. A. [40]

BASS, Elizabeth Harrington [Cer,T] NYC/Southbury, CT b. 18 Je 1893, South Acton, MA. Member: Keramic Soc.; Des. Gld. Position: T., Little Red School House, NYC [40]

BASS, Nell Blaine. See Blaine.

BASSETT, Charles Preston [Des,P,Li,S,T,L,C] Pittsburgh, PA b. 27 Je 1903, Pittsburgh. Studied: Carnegie Inst.; Wilfred Readio; Joseph Bailey Ellis; Emil Grapin. Member: Assoc. A. Pittsburgh; Pittsburgh WC Soc. Exhibited: Westinghouse Electric Co., 1933 (prize); Brunswick-Balke Co., 1934 (prize); design, city of Pittsburgh, 1938 (prize); Assoc. A. Pittsburgh; CI, 1938–44; A.& Cr. Center, Pittsburgh, 1945 [47]

BASSETT, Frances Christine [P,I] Chicago, IL b. 16 O 1880, Elyria, OH. Studied: AIC [05]

BASSETT, Gertrude (Mrs.) [P] Boston, MA [24]

BASSETT, H. Ellsworth [P,I] Newark, NJ b. 1 F 1875, Wash., D.C. Studied: Laurens, Girardot, both in Paris [15]

BASSETT, Margaret Giffen (Mrs. Charles P.) [P,T,Des,L,C] Pittsburgh, PA b. 15 Ag 1904, Pittsburgh. Studied: CI; Wilfred Readio; Joseph Bailey Ellis; Norwood McGilvary. Member: Assoc. A. Pittsburgh. Exhibited: CI, 1942–45; A.& Cr. Center, Pittsburgh, 1945, 1946 [47]

BASSETT, Reveau Mott [P,E,T] Dallas, TX b. 9 Ja 1897, Dallas. Studied: ASL; J. Pennell; W.R. Leigh; B. Robinson. Exhibited: NAD, 1925; Houston MFA; Dallas MFA. Work: Hall of State, Dallas; Dallas MFA [47]

BASSETT, Richard [P,W] Boston, MA/Northampton, MA b. 21 F 1900, Durham, NC. Studied: Grande Chaumière, Paris; ASL; P. Tudor, in London. Member: Gloucester, Mass., Soc. A.; Boston S.Indp.A. Exhibited: Ferargil, Gal., N.Y., 1937; Gloucester, Soc. A., 1938, 1939; Grace Horne Gal., Boston, 1939, 1940; WFNY, 1939 [40]

BASSETT, Thomas Joseph [C,Des,W,L] Providence, RI b. Ashburnham, MA d. 2 S 1935. Studied: State T. Col., Fitchburg, Mass.; Brown Univ.; Harvard. Member: Utopian Cl., Providence. Work: R.I. Sch. Des. Mus. Designer: Bassett Toy Furniture. Author: "Art Metal Work" and "Mechanical Drawing," courses of study for Providence public schools. Position: T., R.I. Sch. Des. [40]

BASSFORD, Wallace [P,Des] St. Louis, MO b. St. Louis. Studied: Pennell; Hoke; von Schlegell; Wuerpel; Carpenter; Gleeson; Goetch; George Elmer Browne; St. Louis Sch. FA; Univ. Mo. Member: St. Louis A. Gld. Exhibited: Kansas City AI, 1933 (gold); CAM, 1937, 1938, 1945 (prize); St. Louis A. Gld. 1932 (prize), 1944 (prize); SFMA, 1941; All.A.Am., 1945; Joslyn Mem., 1943; Jackson, Miss., 1945; Ogunquit A. Center, 1939. Work: Capitol, Mo.; Univ. Mo. Designer: covers, Literary Digest [47]

BASTEDO, H.E. (Miss) [P] Toronto, Ontario [01]

BASTERT, S.E. [P] Amsterdam, Holland [01]

BASTIAN, Dorcas Cooke Doolittle [P,T] Phila., PA b. 1 O 1901, Phila. Studied: Sch. Des. for Women, Phila.; PAFA;. Hugh Breckenridge. Member: Plastic Cl.; Woodmere A. Gal. Exhibited: Plastic Cl., 1926 (med); PAFA, 1933 (prize). Work: PAFA. Position: T., summer sch., Gloucester, Mass. [47]

BASTIAN, Rufus A. [P,E,Li,T,W] Dumont, NJ b. 8 D 1908, Milwaukee. Studied: Boris Anisfeld; AIC; abroad. Contributor: art magazines. Positions: Instr., AIC, Chicago; Dir., Wyo. Summer Sch. A. [47]

BASTRUP, Leonard Hollis [Des,I] Wilton, CT b. 15 Mr 1907, St. Louis, Mo. Studied: Otis AI; AIC; ASL. Member: A. Dir. Cl. [47]

BATCHELDER, Alix [P] Pasadena, CA. Exhibited: WFNY, 1939 [40]

BATCHELDER, E.B.L., Mrs. See Longman, Evelyn.

BATCHELDER, Ernest A. [Des,W] Pasadena, CA b. 22 Ja 1875, N.H. d. Ag 1957. Author: "Principles of Design" (1904), "Design in Theory and Practice." Contributor: The Craftsman. [Related to Alix?] Positions: Minneapolis Handcraft Gld., 1903–08; Batchelder Sch. Handcraft & Des., Arroyo Seco, Calif., 1909 [*]

BATCHELDER, John L., Jr. [P,T] Boston, MA b. N 1907, Boston. Studied: Philip Hale; Abram Poole; Alexander Iacovieff. Member: North Shore AA. Position: T., BMFA [40]

BATCHELDER, Nathaniel Horton, Mrs. See Longman, Evelyn Beatrice.

BATCHELOR, Clarence D. [Car] NYC d. 1977. Award: Pulitzer prize, best cartoon, 1937. Work: Huntington Lib., San Marino, Calif. [40]

BATE, Rutledge [P] Brooklyn, NY b. 2 F 1891, Brooklyn. Member: BMFA Sch.; Abbott Thayer. Member: AWCS. Exhibited: Brooklyn SA, 1935; NYWCC Ann., 1936, 1937; AWCS, 1937 [47]

BATE, Stanley [Des,P] NYC b. 26 Mr 1903, Nashville, TN. Studied: ASL, with Bridgman. Member: SI. Exhibited: AWCS, 1939; Albany Inst. Hist.&A., 1946; SI, 1943–46. Illustrator: Outdoor Life. Position: A. Dir., Encyclopaedia Britannica, 14th Edition [47]

BATEMAN, Charles [P] South Salem, NY b. 18 N 1890, Minneapolis, MN. Studied: ASL; Kenneth Hayes Miller; Andrew Dasburg [33]

BATEMAN, John M. [S] Haddonfield, NJ b. 14 F 1877, Cedarville, NJ. Studied: PMSchIA; PAFA; Charles Grafly; Colarossi Acad., Paris. Exhibited: P.-P. Expo, San Fran., 1915 (prize). Work: Doylestown, Pa.; Pa. Bldg., Sesqui-Centenn. Expo [40]

BATES, Bertha Corson Day (Mrs. D.M.) [Dr,I] Greenville, DE b. 20 Ag 1875, Phila. Studied: Howard Pyle; Drexel Inst., Phila. Member: Plastic Cl.; Phila. Print Cl.; Phila. All. Exhibited: Colgate & Co. (prize); Phila. Export Expo (prize). Illustrator: Harper Bros.; Little Brown and Co.; R.H. Russell; other publishers [33]

BATES, Carol [P] Gardiner, ME b. 21 S 1895, Gardiner d. ca. 1958. Exhibited: PAFA, 1940–41, 1943–45; CGA, 1943; Univ. Pittsburgh, 1945 (one-man); Goose Rocks Beach, Maine; Ogunquit, Maine [47]

BATES, Clarence E. [S,C,T] Portland, OR b. 9 Je 1910, Cottage Grove, OR. Studied: Univ. Oreg. Work: San Fran. MA. Position: T., Salem Federal A. Center [33]

BATES, Earl Kenneth [P] Mystic, CT b. 28 O 1895, Haverhill, MA d. 1973. Studied: ASL; PAFA. Member: Allied AA; SC; ANA; New Haven PCC, 1928 (prize); Mystic AA; CAFA. Exhibited: PAFA, 1921 (prize), 1928 (med); CAFA, 1927 (prize); New Haven PCC, 1928 (prize); WFNY, 1939; Carnegie Inst., 1944, 1945; CGA; AIC, 1926 (prize); TMA; Contemporary A. Gal.; Grand Central Gal. (one-man). Work: PAFA; IBM; Beach Mem. Gal., Univ. Conn. [47]

BATES, Gladys (Bergh) [P,I] Brooklyn, NY b. 19 Jy 1898, London, England d. O 1944. Studied: N.Y. Sch. F.&Appl. A.; Emil Bistram; Felicie Waldo Howell; Howard Giles. Member: Alliance; NAWPS; North Shore AA; AWCS; Brooklyn S. Mod. A.; Nat. AAI [40]

BATES, Gladys Edgerly [S] Mystic, CT b. 15 Jy 1896, Hopewell, NJ. Studied: CGA; PAFA, with Charles Grafly; Albert Laessle. Member: NSS; NAWA; Mystic AA; PBC; CAFA. Exhibited: PAFA, 1931 (gold); CAFA, 1933 (prize); NAWA, 1934 (med,prize); AIC, 1935 (prize), 1939, AV, 1942 (prize); PBC, 1944 (prize); Century of Progress, 1934; Tex. Centenn., 1936; CI, 1938; AGAA, 1941; Phila. A. All.; PBC; Mystic AA, 1925–46. Work: MMA; PAFA [47]

BATES, Harry [S] b. 1850, Stevenage, England d. 31 Ja 1898. Member: ARA

BATES, Isaac Comstock b. 27 Jy 1843, Blackstone, MA d. 1 Ja 1913, Providence, RI. President of the Rhode Island School of Design. He took an active part in the building of the Providence A. Cl. and the R.I. Sch. of Des.; was elected Trustee of the Sch. of Des. in 1885, became Vice-Pres. in 1890, and Pres. in 1907. In his will, he left a collection of works of art and a generous sum of money to the R.I. Sch. of Des.

BATES, Isabel Miriam [P,T] NYC b. 27 O 1911, Newark, NJ. Studied: Newark Sch. F.&Indst. A.; Otis A. Inst., Los Angeles; Nat. Acad. Member: United Am. A. Exhibited: PAFA, 1938; Corcoran, 1939; 48 Sts. Comp., Corcoran, 1939. Position: T., Newark Sch. F.&Indst. A. [40]

BATES, John Everts [P,T] Ann Arbor, MI b. 22 D 1891, Brooklyn, NY. Studied: Henry Lee McFee [33]

BATES, Kenneth Francis [J] Euclid, OH b. 24 My 1904, Scituate, MA. Studied: Fontainebleau Sch. FA, with Carlu; Mass. Sch. A., with L.A. Martin. Member: Cleveland SA; Cleveland Craft Gld.; Cleveland AA; Cleveland Print C. Exhibited: CMA, 1927 (prize), 1929 (prize), 1930 (prize), 1932 (prize), 1934 (prize), 1936 (prize), 1938 (prize), 1939 (prize), 1941, 1943–46; Contemporary Am. Ceramics, 1937, 1938, 1940; Syracuse

Ceramic Exh., 1938–40; Toledo MA; Akron AI, 1939; Butler AI, 1940; Phila. A.All., 1941; CMA 1927–46. Work: CMA; WFNY, 1939. Specialties: metals and enamels. Positions: Instr. Des., Cleveland Sch. A., 1927–46, Western Reserve Univ. [47]

BATES, R.E. [P] Paris, France[09]

BATES, Waldo F., Jr. [Edu,L,P] Edinboro, PA b. 1 N 1889, Scituate, MA. Studied: Mass. Sch. A.; Pa. State Col.; Harvard. Member: Nat. Edu. Assn.; Pa. Acad. Sc. Position: Dir. Edu., State T. Col., Edinboro, Pa. 1920–46 [47]

BATHGATE, Joseph A. [Car] Yonkers, NY b. 1909 d. 8 N 1944, Yonkers

BATHURST, Clyde C. [S] Rockport, MA b. 8 Je 1883, Mount Union, PA d. 16 O 1938. Studied: Grafly. Member: F., PAFA; Rockport AA. Exhibited: PAFA, 1909 (prize); P.-P. Expo, San Fran., 1915 (prize) [38]

BATTAGLIA, Pasquale Michael [P,T] Phila., PA b. 5 Ja 1905, Phila. d. 26 S 1959. Studied: Univ. Pa.; PAFA; PMSchIA. Member: F. PAFA; Phila. WCC; Phila. A. T. Assn. Exhibited: PAFA 1929–45, (prizes); Westchester AA (prizes); Pa. Soc. Min. P., 1944, 1945; Phila. WCC; NCFA, 1944, 1945; Woodmere A. Gal.; Phila. A. All.; Cape May, N.J. Work: PAFA [47]

BATTAGLIA, Salvatore [P] NYC [19]

BATTAINI, Ambrose [S] Boston, MA. Exhibited: WFNY, 1939 [40]

BATTEN, McLeod [P] Mill Valley, CA [21]

BATTLES, D. Blake [P,C,T] Ferndale, MI b. 25 D 1887, Wellington, OH. Studied: Henry Keller; F.C. Gottwald; Herman Matzen. Member: Cleveland SA. Specialty: industrial des. [33]

BATZELL, Edgar A., Jr. [P,Des,T] Ballston Spa, NY b. 8 N 1915, Pittsburgh, PA. Studied: Syracuse Univ.; ASL, with Kantor, Walt Kuhn. Exhibited: Buffalo, N.Y., 1939 (prize); Syracuse AA, 1943, 1945; Albany A. Group, 1945; Schenectady MA, 1945, 1946. Position: A., General Electric Co., Schenectady, N.Y., 1940–43, 1946 [47]

BAUCH, Solomon Stan [P,L,W] NYC b. 7 S 1883, Romania. Studied: Robert Henri; George Bellows. Member: Physicians AC, N.Y.; Artists U. Exhibited: Portland AM, 1939; Buffalo Acad. FA, 1939; Albright Gal., 1939; Contemporary A. Inc. N.Y., 1939, 1940 [40]

BAUER, Henry W. [P] Phila. Member: Phila. AC [24]

BAUER, Sol A. [S,T] Cleveland, OH b. 11 Mr 1898, Cleveland. Studied: Cleveland Sch. A. Exhibited: CMA, 1928–46 (prizes, annually); PAFA, 1933–34; 1937–38, 1942, 1946; AIC, 1938, 1940; WFNY, 1939; Audubon A., 1945. Work: CMA. Position: Instr., Council Edu. All., Cleveland [47]

BAUER, Theodore [S] Member: NSS [01]

BAUER, W.C. [P] Elizabeth, NJ [01]

BAUER, William [P,Li,I,Des] Webster Groves, Mo. b. 13 Je 1888, St. Louis, Mo. Studied: St. Louis Sch. FA. Member: St. Louis A. Lg.; Am.A.All. Exhibited: St. Louis A. Gld., 1921 (prize), 1926 (prize); Kansas City AI, 1924 (prize); Mo. State Fair, 1926 (prize); St. Louis A. Lg., 1927 (prize); St. Louis Indp. A., 1931 (prize); Carnegie Inst., 1927; CAM, 1946; Am.A.All., 1946; Kansas City AI, 1924, 1925. Work: Kansas City AI; Governor's Mansion, Jefferson City, Mo.; St. Louis Pub. Lib. [40]

BAUGHER, Everett Earnest [S,C] Sedalia, MO b. 28 Ap 1906, Sedalia. Studied: Kansas City AI. Exhibited: Kansas City AI; Joslyn Mem., 1942, 1943; PAFA, 1942; CAM, 192; Denver AM, 1944 [47]

BAUGHMAN, Mary Barney [S,L,T] Richmond, VA. Studied: Michel de Tarnovsky; Acad. Colarossi. Member: Richmond AC [21]

BAUHAN, Louis [P] Jersey City, NJ. Member: GFLA [24]

BAUHAN, R. [P] Princeton, NJ [24]

BAULINSON, A.S. [P] NYC [15]

BAUM, Albert [P] Cincinnati, OH. Member: Cincinnati AC [01]

BAUM, Franz [P,E] Santa Cruz, CA b. 14 Ja 1888, Wiesbaden, Germany. Studied: A. Acad., Munich. Exhibited: SAM, 1939–41; SFMA, 1941; Crocker A. Gal., Sacramento, Calif., 1941. Work: Stadt Gal., Munich; Kunsthalle, Bremen; SAM [47]

BAUM, Mark [P] NYC b. 2 Ja 1903, Sanok, Poland. Studied: self-taught; NAD; CCNY. Member: Provincetown AA. Work: WMAA [47]

BAUM, Walter Emerson [P,Mus.Dir,T,Cr] Sellersville, PA b. 14 D 1884, Sellersville d. 12 Jy 1956. Studied: PAFA; W.T. Trego. Member: ANA; F.PAFA, 1939; Phila. A.All.; Phila. WCC; AAPL; Am. color Pr. Soc.; AWCS; A.Lg.Am.; Phila. AC. Exhibited: PAFA 1925 (med), 1939 (prize); Springville, Utah, 1932 (prize); ASMP, 1943 (prize); Phila. WCC, 1944 (med); AWCS, 1945 (prize); Buck Hill (Pa.) AA, 1945 (prize); Kemerer Mus., Bethlehem, Pa., 1984; NAD; Phila. AC; CGA; AIC; BM; BMA; Dayton AI; CAM; Detroit Inst. A.; Ft. Worth MA; Decatur A. Center. Work: PAFA; Pa. State Col.; Tuskegee Inst.; Allentown Mus.; Toledo MA; NAD; PMA; Franklin D. Roosevelt Coll. Positions: Cr., Phila. Evening Bulletin; Dir., Allentown MA, Kline-Baum A. Sch., Allentown, Pa. [47]

BAUMANN, Charles Hart [I,Des] Brooklyn, NY b. 20 Jy 1892, Phila. Studied: PAFA; Pa. Mus. Sch. Indst. A. Work: Illus./commercial des., nat. advertisers, chambers of commerce, etc. Position: Dir., Commercial Illus. Sch., N.Y., 1926– [40]

BAUMANN, Gustave [En,P,C,W] Santa Fe, NM b. 27 Je 1881, Magdeburg, Germany d. 8 O 1971, Santa Fe. Studied: Kunstgewerbe Schule, Munich; AIC. Exhibited: P.-P. Expo, 1915 (gold); Fifty books of the year, 1940 (prize); Los Angeles MA, 1926 (prize); CGA, 1930. Work: NGFA; BMFA; Nat. Gal., Toronto; AIC; MMA. Author/Illustrator: "Frijoles Canyon Pictographs," 1939 [47]

BAUMANN, Karl Herman [P,Des,Li] San Fran., CA b. 26 D 1911, Leipzig, Germany. Studied: Winkler, in Leipzig. Member: San Fran. AA. Exhibited: Oakland Mus.; Riverside Mus., 1940; Dayton AI, 1940; Palace Legion Honor, 1945; SFMA, 1940, 1942, 1945 (one-man); City of Paris, San Fran., 1945 [47]

BAUMBACH, Harold [P] Brooklyn, NY b. S 1903, NYC. Studied: PIASch. Member: Fed. Mod. P.&S.; Artists U. Exhibited: PAFA, 1945; AIC, 1942; CI, 1944, 1945; Iowa Univ., 1946; Wildenstein Gal.; Contemporary A. Gal. (one-man). Work: BM; Albright A. Gal.; Univ. Ariz.

BAUMER, Julius H. [Por.P] Chicago, IL b. 1848, Muenster, Westphalia d. My 1917

BAUMGARD, George [I] NYC [15]

BAUMGARDT, Paul E. [P] Kansas City, MO b. 25 My 1909, Kansas City. Studied: Ilah Marian Kibbey; Thomas Hart Benton. Exhibited: Kansas City SA, 1935 (prize), 1936 (prize); Sweepstake Show, Kansas City AI, 1936 [40]

BAUMGARTEN, Cecil [I] Member: SI [47]

BAUMGARTNER, Warren W. [I,P] Southport, CT b. 15 Mr 1894, Oakville, MO d. 1963. Studied: AIC, with Wellington J. Reynolds; Grand Central Sch. A., with Pruett Carter. Member: SI; AWCS. Exhibited: AWCS, 1940 (prize), 1946 (prize). Illustrator: national magazines [47]

BAUMGRAS, Peter [P] Wash., D.C. b. 1827, Bavaria, Germany d. 1904. Studied: Royal Acad., Munich, with Kaulbach, Schorn. Exhibited: NAD 1868 [04]

BAUMHOFFER, Walter M. [I] Northport, NY b. 1 N 1904, Brooklyn, NY. Studied: PIASch. Member: SI. Exhibited: SI, 1941–45. Illustrator: national magazines [47]

BAUR, John I.H. [Mus.Cur,L,W] New Rochelle, NY b. 9 Ag 1909, Woodbridge, CT. Studied: Yale. Member: Century Assn. Author: "An American Genre Painter, Eastman Johnson," 1940, "John Quidor," 1942. Contribututator: art magazines. Lectures: American Art. Positions: Supv. Edu., 1934–36; Cur., BM, 1936– [47]

BAUR, Meta Tiarks [P] Chicago, IL. Member: Chicago NJSA [24]

BRAUS, Paul Jean [S] Indianapolis, IN b. 2 N 1914, Indianapolis. Member: Hoosier Salon, Exhibited: Ind. A., Indianapolis, 1934 (prize); Hoosier Salon, 1935 (prize) [40]

BAUS, S(imon) P(aul) [P] Indianapolis, IN b. 4 S 1882, Indianapolis. Studied: Adams; Forsyth; Stark. Member: Ind. AA; Hoosier Sal. Exhibited: Wanamaker, Phila., 1909 (prize); Indianapolis AA, 1919 (prizes); Chicago Exh. Am. PS, 1923 (prize); Richmond, Ind. AA, 1924 (prize); Hoosier Salon, 1925 (prize); Muncie AL, 1926 (prize); Griffiths, 1927 (prize); Kittle, 1928 (prize); Ind. A., John Herron AI, 1934 (prize), 1936 (prize); Hoosier Sal., 1936 (prize). Work: John Herron AI; Capitol, Indianapolis; Richmond (Ind.) A. Gal. [40]

BAUSMAN, Marian D. See Walker, Otis L., Mrs.

BAUVIERE, A.M. de [P] Chicago, IL [15]

BAXLEY, Ellen Cooper (Mrs.) [P] Santa Barbara, CA b. 26 Ap 1860, Lancaster Co., PA. Studied: San Fran. A. Sch.; Paris. Member: Santa Barbara AL. Work: Court House, Santa Barbara [33]

BAXTER, Bertha [P] NYC/East Gloucester, MA b. Indianapolis, IN. Studied: N.Y. Sch. F. & Appl. A. Member: All. A. Am.; AWCS; NAWA; Ind. AC; North Shore AA. Exhibited: Hoosier Salon (prize) [47]

BAXTER, Elijah [P] Newport, RI b. 1 S 1849, Hyannis, MA d. Ag 1939. Studied: Acad. des Beaux Arts, Antwerp, Belgium, with Van Lerius, Van Luppen, Jacobs. Member: Boston AC; Providence AC; Newport AA. Exhibited: Boston, 1878 (med); Providence AC, 1929 (prize). Work: R.I. Sch. Des.; Boston AC; BMFA [33]

BAXTER, Martha Wheeler [P,T,Min.P,Por.P] Hollywood, CA b. Castleton, VT. Studied: Chardon, Schmidt, in Paris; Acad. Delecluse, Acad. Colarossi, Acad. Julian, Paris; Behenna, in London; Sartorelli, in Venice; BAID. Member: ASL; Pa. Soc. Min. P.; Calif. AC; NAWA. Exhibited: Women Painters of the West, 1938 (prize); Pacific Southwest Expo, 1928 (med); BAID, 1918 (medals); Calif. Soc. Min. P., 1918 (prize), 1919 (prize), 1922 (prize), 1923 (prize), 1929 (prize), 1932 (prize), 1936 (med), 1937 (prize); Los Angeles MA, 1936 (prize); AIC, 1940; PAFA; ASMP; Calif. Intl. Expo, 1935; GGE, 1939; Palace Legion Honor; Europe; South America. Work: Frick Coll.; PMA; Los Angeles MA; NCFA [47]

BAY, Howard [Des] Hollywood, CA b. 3 My 1912, Centralia, WA. Studied: Univ. Wash.; Univ. Colo.; Carnegie Inst. Member: F., Guggenheim, 1940–41; Un. Scenic A. Am. Exhibited: Donaldson Theatre Award, 1944 (prize), 1945 (prize); Smith Col., 1944 (one-man). Contributor: theatre magazines. Position: Pres., United Scenic Artists, 1941–46 [47]

BAYARD, Clifford Adams [P,E,Li,T] Wilmington, VT b. 12 D 1892, McKeesport, PA. Studied: CI. Member: Pittsburgh AA; AFA; Springfield AA; Deerfield Valley AA; Vermont A. Gl. Exhibited: Pittsburgh AA 1922 (prize), 1944 (prize); Stockbridge AA, 1936 (prize); CI, 1922; AWCS, 1939; NAD, 1938; WFNY 1939; Springfield A. Lg.; Deerfield Valley AA; Albany Inst. Hist. & A.; Southern Vt. A.; AFA 1938, 1939. Work: Fleming MA, Burlington, Vt.; Bennington MA; Williams Col.; CI; Pittsburgh Bd. of Edu. [47]

BAYARD, Donald D. [Des,P] Chicago, IL b. 3 N 1904, Duluth, MN. Studied: Yale, with Eugene Savage; Chicago Inst. Des., with Moholy-Nagy. Member: Kimball F., New Haven, 1932. Exhibited: BAID, 1932 (prize), CGA, 1935; Paris Expo, 1937; Butler AI, 1937; White House Exh., 1937. Work: Cleveland Municipal Coll. Position: Gr. Engineer, Fisher Body Co., 1943–45; Gr. Engineering Service, 1945– [47]

BAYARD, Eleanor [P] NYC. Member: NAWPS [24]

BAYARD, Lucie [P] NYC [17]

BAYHA, Edwin F. [I] Glenside, PA. Member: F. PAFA [24]

BAYLEY, Frank W. b. 1863 d. 24 Jy 1932, Plum Island, Newburyport, Mass. An authority on early American portraiture, he was the author of "The Life of John Singleton Copley" and "Five Colonial Artists," and was co-author with Charles E. Goodspeed of a revised edition of Dunlap's "American Art History," first published in 1833. Through his researches he rendered valuable service to the history of American art. He was proprietor of the Copley Galleries in Boston. (It was later discovered that Bayley was importing portraits and selling them as being by Copley and other American portraitists.)

BAYLEY-PAINE, Mahlon (Mrs. Paul T.) [P,C] Lebanon, IN b. Milwaukee, WI. Studied: John Herron AI; Cranbrook Acad. A., with Carl Milles; PAFA; Yale, with Eberhardt. Member: Ind. A. Exhibited: Hoosier Salon (prize); John Herron AI (prize); Ind. A. (prize); PAFA (prize); Cranbrook Acad. A.; Marshall Field Gal. Work: Carnegie Lib. [47]

BAYLINSON, A.S. [P,T] NYC b. 6 Ja 1882, Moscow, Russia d. 6 My 1950. Studied: NAD; Henri Sch. A.; Robert Henri; Homer Boss. Member: S.Indp.A. Exhibited: Nat. Gal., Canada, 1934, 1935; Detroit IA, 1977; CI, 1931–37; PAFA, 1932–46; AIC, 1942, 1943; Toledo MA, 1946; WMAA, 1933, 1935, 1937–38, 1940–41. Work: Newark Mus.; MMA; BMFA [47]

BAYLISS, Lilian (Mrs. A.R. Green) [Min.P] NYC b. 20 F 1875. Studied: Noemie Schmitt, in Paris, 1900; Lucius Fairchild Fuller, 1901 [05]

BAYLOR, Edna Ellis (Mrs. Armistead K.) [P] Ipswich, MA b. 9 My 1882, Hartford, CT. Studied: BMFA; Frank Benson; Edmund Tarbell; Ross Turner; Henry Rice. Exhibited: NAC; North Shore AA; Boston AC; Nat. Lg. Am. Pen Women; Am. APL; Copley S. Exhibited: Nat. Lg. Am. Pen Women, 1929 (prize), 1930 (prize), 1932 (prize), 1933 (prize) [40]

BAYLOS, Zelma U. [P,S,L,W] NYC b. Butka, Hungary d. ca. 1950. Studied: Courtois, Prinet, Girardot, in Paris; NAD, with Will Low, C.Y. Turner. Member: Putnam County AA. Exhibited: MMA; BM; NAD; PAFA; NAC. Work: 12th Reg. Armory, 71st Reg. Armory, Standish Hall, NYC [47]

BAYMAN, Leo [S] NYC [24]

BAYNE, Mary. See Bugbird, H.C., Mrs.

BAZ, Ben-Hur [L,P,T] NYC b. 7 N 1906. Studied: Nat. Acad., Mexico City. Fashion illustrator: McCall's, Woman's Home Companion [40]

BAZANT, George [I] Bronx, NY [19]

BAZE, Willi [P,Mur.P,L,T] Chickasha, OK b. 16 Mr 1896, Mason, TX. Studied: Norfeldt, John E. Thompson; Okla. Col. for Women; Broadmoor Acad.; Am. Sch. Research, Santa Fe. Work: murals, First Christian Church, First Baptist Church, both in Chickasha; Osler Bldg., Okla. City. Lectures: modern art. Author: "The Rhythm of Colour," "Six Great Moderns." Position: Teacher of Kiowa Indian students, 1922–27 [40]

BAZIOTES, William A. [P] NYC b. 11 Je 1912, Pittsburgh, PA d. Je 1963. Studied: NAD. Exhibited: PAFA, 1945; Univ. Iowa, 1946; WMAA, 1945. Work: MMA; Wash. Univ., St. Louis, Mo.; Art of this Century, N.Y. [47]

BEACH, Beata (Mrs. B.B. Porter) [P,Des,E,I] Thompkins Corners, NY b. 29 My 1911, Rome. Studied: Académie Julian, Paris; A. Lhote, in Paris; ASL; Grand Central Sch. A. Member: ASL. Exhibited: ASL, 1932 (prize); VMFA, 1939; PAFA, 1939; CAA, 1935; Riverside Mus. Work: USPO, Monticello, Ga. [47]

BEACH, Charles (Mrs.) [P] Dubuque, IA. Member: Dubuque AA

BEACH, Chester [S] NYC b. 23 My 1881, San Fran. d. 6 Ag 1956. Studied: Verlet, Roland, in Paris; Rome. Member: NA, 1924; NSS; Am. AAAL; NAC; Am. Numismatic Soc. Exhibited: Académie Julian, Paris, 1905 (gold); NAD, 1907 (prize), 1926 (gold); P.-P. Expo, 1915 (med); NAC 1923 (prize), 1926 (gold, prize); 1932 (med), 1934 (prize); Arch. Lg., 1924 (gold); AIC, 1925 (gold); NSS, 1938 (prize). Work: P.-P. Expo; AAAL; BM; AIC; CMA; Palace Legion Honor; Barnard Col.; Newark Mus.; WFNY, 1939. Specialties: portraits, coin design [47]

BEACH, D. Antoinette [P] Redfield, SD [09]

BEACH, Howard D(wight) [P,Photogr] Buffalo, NY b. 21 Mr 1867, New Britain, CT. Member: Buffalo SA; Royal Photographic Soc., England. Exhibited: Buffalo SA (prizes) [33]

BEACH, Sara Berman [P,Li] Sunnyside, NY b. 29 S 1897, Łódz, Poland. Studied: CUASch; DaVinci A. Sch.; Polish A. Acad. Member: A. Lg. Am. Exhibited: DaVinci A. Sch., 1927; Western Mus., Moscow, 1934; Indp. A., 1940–42; New Sch. Soc. Res., 1936, 1938; Audubon A., 1946; NAD, 1946; ACA Gal., 1935; A. Cong., 1936; A. Lg. Am., 1945; New-Age Gal., 1945, 1946. Work: New-Age Gal.; Aviation Cl., NY [47]

BEACH, Sarah E. [P] NYC [04]

BEACH, Warren [P,G,C] Minneapolis, MN b. 21 My 1914, Minneapolis. Studied: Yale; Charles Hawthorne; E. Dewey Albinson; Donald C. Greason. Exhibited: Grand Central Gal.; Yale Univ. Gal., New Haven; Inst. A., Minneapolis, 1939. Position: Associated with Addison Gal., Andover, Mass. [40]

BEACHAM, Harriet T. (Mrs.) [P] Baltimore, MD. Member: Baltimore WCC [24]

BEACHAM, Oliver C(onley) [P,E] Dayton, OH b. 4 O 1862, Xenia, OH. Member: Dayton SE; Dayton FA Gl.; AAPL [33]

BEADENKOPF, Anne [P] Baltimore, MD b. 6 Ag 1875, Baltimore. Studied: ASL; Henry Roben; Ivan Olinsky. Member: NAWA. Exhibited: NAWA, 1943, 1944, 1945; Am.-British A. Center; BMA; NAD [47]

BEAL, Gifford [P,Mur.P] NYC b. 1879, NYC d. 5 F 1956. Studied: Princeton, with Chase; ASL. Member: NA; NIAL; AWCS; NSMP; NAC; Century Assn.; Arch. Lg. Exhibited: NAD, 1910 (prize), 1919 (prize), 1931 (prize), 1932 (prize); NAC, 1913 (med), 1918 (gold, prize), 1941 (prize); CGA, 1914 (med), 1930 (medal, prize); P.-P. Expo, 1915 (gold); Newport AA, 1917 (prize); Phila. WCC, 1917 (prize); AIC, 1913 (prize), 1930; Paris Expo, 1937 (med). Work: MMA; AIC; Syracuse Mus. FA; Detroit Inst. A.; Los Angeles Mus. A. (Harrison Gal.); Newark Mus.; BM; PMG; WMAA; murals, Interior Bldg., Wash., D.C., USPO, Allentown, Pa.; etchings, Yale; Princeton; Honolulu Acad. A.; NYPL; Fifty Prints of the Year, 1931; Addison Gal., Andover, Mass. [47]

BEAL, Reynolds [P,E] Rockport, MA b. 11 O 1867, NYC d. D 1951. Studied: Chase. Member: ANA; AWCS; SAE; SC; NAC: Lotos Cl.; Century Assn.; Boston AC. Exhibited: SC, 1902 (prize); North Shore AA, 1929 (prize) [47]

BEAL, Thaddeus R. [P] Newburgh, NY [24]

BEALE, Bertha F. [P] Buncombe County, NC [09]

BEALES, Isaac B. [P,C,L,T] Hasbrouck Heights, NJ/Milford, CT b. 14 Ag 1866, Great Yarmouth, England. Studied: E.J. Poynter; Woodhouse Stubbs [24]

BEALES, J.B. [P] NYC [19]

BEALL, Cecil Calvert [I] Larchmont, NY b. 15 O 1892. Studied: ASL, with Bridgman. Member: SI; A. Gld. Illustrator: Collier's, American, other magazines [47]

BEALL, Leah [Des,Dec,Dr,C,I] Piedmont, CA/Yreka, CA b. 21 Ag 1910, San Fran. Studied: Calif. Sch. AC. Exhibited: Calif. State-wide Exh., Santa Cruz (prize); Oakland A. Gal., 1934 (prize) [40]

BEALL, Lester Thomas [Des,P,I,L] Ridgefield, CT b. 14 Mr 1903, Kansas City, MO d. 20 Je 1969. Studied: Lane Tech. Sch.; Univ. Chicago. Member: A. Dir. Cl.; SI. Exhibited: Chicago Soc. Typographic A., 1934 (prize), 1935 (prize); A. Dir. Cl. 1934 (prize), 1936 (prize), 1937 (medal,prizes), 1937 (medal), 1938 (prizes), 1939 (prizes), 1949 (prize); AIGA, 1935 (prizes), 1939 (prize); N.Y. Exh. Printing, 1941 (prize); Crowell-Collier Pub. Co., 1942 (prize); AIC, 1935, 1936; MOMA, 1937; Paris Expo, 1937; Royal Mus., London, 1937; Los Angeles AC. Contibutor: graphic arts magazines [47]

BEALS, Gertrude. See Bourne, Frank A., Mrs.

BEALS, Grace Romney [P] Buffalo, NY d. Je 1929. Member: Buffalo SA [24]

BEALS, Jessie Tarbox [Photogr] Hollywood, CA b. 1871, Hamilton, Canada d. 30 My 1942. Member: Pictorial Photographers Am.; Boston SAC. Published book of poems, "Songs of a Wanderer," 1928. Illustrative photographs for national magazines. Lived most of her life in NYC. [30]

BEALS, Victor [I] Tuckahoe, NY b. 20 F 1895, Wuhu, China. Studied: Munsell; Vesper George. Member: Artists Gld. Specializes in travel advertising for Cunard, I.M.M., Italian Line, Clyde-Mallory, Furness, Ward, Porto Rico and American Express Co. [40]

BEAM, Philip Conway [Mus.Dir,Edu,W] Brunswick, ME b. 7 O 1910, Dallas, TX. Studied: Harvard. Contributor: Art Journal, New England Quarterly. Expert on Winslow Homer. Positions: Dir., Bowdoin Col. MA; T., Bowdoin Col., 1938– [47]

BEAMAN, Robert P. (Mrs.) [P] Norfolk, VA. Member: Norfolk SA [24]

BEAMES, S(tephen) [S,T] Evanston, IL b. 3 Mr 1896, Multan, India. Studied: Boston Sch. FA&Crafts; Albin Polasek; BAID. Work: mem., Evanston, Ill.; sculpture, Chicago Theological Seminary. Position: T., Rockford Col., Ill. [33]

BEAN, Caroline van H. [P,E] Wash., D.C. b. Wash., D.C. Studied: Smith Col.; William M. Chase; B.J. Blommers; John Singer Sargent. Member: Soc. Wash. A.; Soc. Wash. Et.; Wash. AC. Exhibited: High MA; Closson Gal., Cincinnati; Bresler Gal., Milwaukee [47]

BEAN, Mary (Mrs. Richard Rogers) [P] Sunneytown, PA b. 20 Ag 1904, Norristown. Studied: Breckenridge Sch. P.; PAFA; PMSchIA. Member: Plastic Cl. [33]

BEAN, Nellie F. [Min.P] Vevey-la-Tour, Switzerland b. Boston, MA. Studied: Mme. Hortense Ricard [09]

BEAR, Donald [Mus.Dir,W,Cr,L,Edu] Santa Barbara, CA b. 5 F 1905, Seymour, IN d. 16 Mr 1952. Studied: Denver A. Acad.; Chappel Sch. A.; Europe. Member: F. Oberlander Fnd. Author: monographs. Contributor: art magazines; art criticism, newspapers. Positions: Cur. Paintings, Edu. Dir., 1930–35, Denver AM; Regional & Nat. Consultant, FAP, 1935–38; Dir., Schoenberg Festival, Denver, 1937; Dir., Denver AM, 1935–40; Dir., Santa Barbara (Calif.) Mus. A., 1940– [47]

BEAR, Reuben C. [Com.A] Phila., Pa b. 5 Jy 1905, Russia. Studied: PMSchIA. Member: Adv. Staff, Gimbels Dept. Store. [33]

BEARD, Adelia Belle [P,I] Flushing, NY b. Painesville, Ohio d. 16 F 1920. Studied: Cooper Union; ASL, with Wyatt Eaton, Chase. Author/Illustrator: with sister Lina, "Little Folks Handy Book," other books. Sister of Daniel C. Beard. [13]

BEARD, Alice [P,I] NYC/Bearsville, NY b. Cincinnati. Member: NAWPS. Exhibited: NAC, 1925 (prize). Co-author: with Frances Rogers, three books pub. F.A. Stokes Co. [40]

BEARD, Beatrice (Mrs. Allen Grover) [P] NYC. Member: NAWPS. Exhibited: Studio Gld. N.Y., 1936; NAWPS, 1933, 1935–37 [40]

BEARD, Daniel Carter ("Dan Beard") [Car,T,P,I,L,W] Suffern, NY/Hawley, PA b. 21 Je 1850, Cincinnati d. 11 Je 1941. Studied: Sartain; ASL, with Chase, Beckwith. Member: SI; ASL. Work: Lib. Cong. Author: books on nature subjects. Illustrator: national magazines, books. Founder: The Boy Scouts. Awards: Roosevelt Distinguished Medal, other awards. Mt. Beard named for him. Positions: ran depts. Ladies Home Journal, Woman's Home Companion, Pictorial Review, American Boy, New York Herald, The Press; Assoc. Ed., Boys' Life [40]

BEARD, Eva Rorty (Mrs. I.M.) [P,T] Longmeadow, MA b. Middletown, NY. Member: Hartford AS. Position: Dir. A., Longmeadow Sch. [24]

BEARD, Frank [I] Chicago, IL b. 1842, Cincinnati d. 28 S 1905, Chicago. He was a son of James Beard. During the Civil War he acted as special artist for Harper's and other publishers. For seventeen years he lectured at Chautauqua, and for a considerable period was Prof. FA, Syracuse Univ. He was the originator of "Chalk Talks," and for many years was connected with "The Ram's Horn," a religious publication. His cartoons directed against the evils of the liquor traffic were often extremely effective.

BEARD, George [P] Coalville, UT [15]

BEARD, James Carter [I] New Orleans, LA b. 6 Je 1837, Cincinnati d. 15 N 1913. Brother of Daniel C. Beard. Specialty, animals—"Billy Possum," etc. [13]

BEARD, Lina [I] Flushing, NY b. Cincinnati. Studied: Cooper Union; ASL. Author/Illustrator: with her sister Adelia, "Little Folks Handy Book," etc. Sister of Daniel C. Beard. [24]

BEARD, Mary Caroline [I,W] Flushing, NY b. 1852, Cincinnati d. 13 Ag 1933. She studied art at Cooper Union and the Art Students' League in New York and wrote and illustrated numerous short stories, magazine articles, and books for girls. She and her sister originated the first Girl Scout group in the United States. The sister of Daniel Carter Beard, originator of the Boy Scout movement in this country.

BEARD, William Holbrook [P] NYC b. 13 Ap 1825, Painesville, OH d. 20 F 1900, New York. Studied with his brother James Henry Beard [1812–93] and also in Rome, Düsseldorf and Switzerland. He settled in N.Y. in 1861. Elected NAD in 1862. He was noted for the intense expression and action that he gave animals in his humorous and satirical pictures; also for his allegorical and imaginative subjects. In 1885 he published a collection of sketches, "Humor in Animals," later a text book "Action in Art." He left ready for publication "Pictures Illustrated by Verse" and "Aphorisms, Philosophism, Sarcisms and other Isms." [98]

BEARDEN, Ed(ward) (Carpenter) [P,Mus.Dir,T,L] Dallas, TX b. 9 O 1919, Dallas. Studied: Southern Methodist Univ.; Colorado Springs FA Cl. Exhibited: Pasadena, Calif., 1946; Dallas All. A., Tex. Gen. Exh.; SSAL. Work: Dallas MFA. Positions: Asst. Dir., Dallas MFA, 1942– ; T., Southern Methodist Univ., 1944– [47]

BEARDSLEY, Nellie [P] Irvington, CA [19]

BEARDSLEY, Rudolph [P,I,Des] b. 1875 d. 15 Ag 1921, New York. He was a captain in the camouflage division during World War I, and trained artists in camouflage in Washington and in France. He designed the stage settings for "Scandals of 1921."

BEATIEN, Yazz (Jimmy Toddy) [P,I] Chambers, AZ b. 1928, Wide Ruins, AZ. Studied: Santa Fe Indian AS; Kuniyoshi, 1948 [*]

BEATO, B. See Wood, Beatrice.

BEATTIE, Kenneth P. [P] Ravenna, OH. Member: Cleveland SA [24]

BEATTY, Hetty Burlingame [S,Des,I,C] Gloucester, MA b. 8 O 1906, New Canaan, CT. Studied: BMFASch.; Charles Grafly; Albert Laessle; George Demetrios. Exhibited: Knoedler Gal., N.Y., 1936 (prize); PAFA, 1931–37; AIC, 1935–37; Macbeth Gal., 1934; WMA, 1941 (one-man). Work: USPO, Farmington, Maine [47]

BEATTY, John W(esley) [P,E] Pittsburgh, PA b. 1850, Pittsburgh d. 29 S 1924, Clifton Springs, NY. Studied: Royal Bavarian Acad., Munich. Member: Pittsburgh AS; Pittsburgh AA; Pittsburgh Photogr. Soc.; Boston GA; AI Gr. A.; Lotos Cl. Award: Cross of Knight of the Legion of Honor, 1921. Work: NGA; Lotos Cl. Author: "An Appreciation of Augustien Saint Gaudens," "Art of John Alexander," "The Relation of Art to Nature, a Philosophical Treatise," articles and brochures. Positions: Dir. Emeritus, Dept. FA Carnegie Inst.; Dir., AFA; Advisory Art Committee—Chicago Expo, 1893, Buffalo Expo, 1901, St. Louis Expo, 1904, San Fran. Expo, 1915. [24]

BEATTY, Richard R. [Li,T] Vineyard Haven, MA b. 28 Ja 1899, Wilkensburg, PA. Studied: CI; AIC. Member: Cleveland Pr. Cl. Exhibited: CMA (prize); Ohio Pr. M.; Sweden. Work: CMA. Position: T., East Tech. H.S., Cleveland [47]

BEATTY, Sarah Blythe [P] Wilkinsburg, PA. Member: Pittsburgh AA. Exhibited: Pittsburgh AA, 1914 (prize) [24]

BEATTY, W. Gedney [P] NYC. Member: SC [24]

BEAUCHAMP, John W. [P,E,Mur.P,Li] Provincetown, MA b. 22 Je 1906. Studied: R.E. Miller; L. Kroll; F.L. Schlemmer. Exhibited: PAFA, 1935 (prize). Work: WPA murals, USPOs, Millinocket (Maine), Muncy (Pa.) [40]

BEAUDOUIN, Frank [I,Des] Springfield, PA b. 11 S 1885, Elizabeth, NJ. Member: PMSchIA; Spring Garden Inst. Illustrator: "Ice Patrol" (1937), "Q-Boat" (1943), "Flight Into Danger" (1945), other books. Position: Starr A., Curtis Pub. Co.; Adv. A., N.W. Ayer & Son, Phila. [47]

BEAULAURIER, Leo James [P,Mur.P,I] Great Falls, MT b. 10 My 1912, Great Falls. Studied: Univ. Notre Dame; A. Center Sch., Los Angeles. Exhibited: GGE, 1939; Mont. State Fair; Civic Center Gal., Great Falls. Work: murals, USPOs, Langden (N.Dak.), Billings (Mont.). Specialty: paintings of famous Indians on black velvet [47]

BEAULEY, William Jean [P] NYC b. 15 S 1874, Joliet, IL. Studied: Henri, Maratta, in N.Y.; Yvon, in Paris. Member: Arch. Lg.; SC, 1908; Paris AAA; Phila. AC; Players Cl.; A. Fund S. Exhibited: Arch. Lg., 1912 (prize). Work: Vanderpoel AA Coll., Chicago [40]

BEAUMONT, Arthur Edwaine [P,E,Li,L,T,W] Los Angeles, CA b. 25 Mr 1890, Norwich, England. Studied: Russell Flint; Frank Brangwyn; Hunt Diederich; Académie Julian, Acad. Colarossi, both in Paris; Slade Coll.- Univ., London; Brussels; Amsterdam. Member: Calif. PS; Calif. WCS; Long Beach AA; Calif. AC; Acad. Western P.; Los Angeles Print Group; Laguna Beach AA. Exhibited: Long Beach AA 1931 (prize), 1932 (prize), 1936 (prize); Calif. AC 1936 (prize). Work: UCLA; White House, Navy Dept., Wash., D.C. Contributor: national magazines, newspapers [40]

BEAUMONT, Arthur J. [P] Stapleton, NY b. 7 Ap 1877, Bradford, England d. 3 Ap 1956. Studied: Académie Julian, Paris; Bouguereau; Olsson, in London. Member: SC; All. A. Am.; AWCA; North Shore AA. Exhibited: AWCS, 1924 (prize), 1928 (prize), 1946; SC, 1925 (prize); Staten Island Mus. A., 1942 [47]

BEAUMONT, Ernest [P] NYC b. 23 Ja 1871, Yorkshire, England d. 3 Ja 1933. Member: AWCS. Work: two backgrounds, Mus. of the City of N.Y., 1932 [33]

BEAUMONT, Henrietta (E.) (Mrs.) [P] NYC b. 19 F 1881, York, England. Studied: H. Locke, in England; A.J. Bagdanove; Lester Stevens; A.T. Hibbard. Member: NAWPS; Wolfe A. Cl.; Staten Island Inst. A.&Science [40]

BEAUMONT, Lilian A(dele) [P] Boston, MA b. Jamaica Plain, MA d. 1922. Studied: BMFA, with Benson, Tarbell, Philip Hale. Member: CSB [21]

BEAUPRÈ, Eugene [P] New Rochelle, NY. Member: SC [24]

BEAUREGARD, Donald [P] b. 1884, Fillmore, UT d. Ap 1915. Studied: Brigham Young Univ. 1903–06; Académie Julian, Paris, with Laurens, 1906–08. Work: Mus. N.Mex.; Louvre; Fillmore Mus.; Springville AG. Cowboy artist. [13]

BEAUX, Cecilia [P,T] NYC/Gloucester, MA b. Phila. d. 19 S 1942. Studied: William Sartain, in Phila.; Académie Julian, Lazar Sch., both in Paris. Member: ANA, 1894; NA, 1902; Por. P.; NAC; Soc. des Beaux-Arts, Paris; Phila. WCC; NAWPS; AFA; F. PAFA. Exhibited: AC Phila., 1893 (gold); NAD, 1893 (prize), 1914 (prize), 1915 (prize); CI, 1896 (med), 1899 (gold); PAFA, 1885 (prize), 1857 (prize), 1891 (prize), 1892 (prize), 1900 (gold); Paris Expo, 1900 (gold); Pan-Am Expo, Buffalo, 1901 (gold); St. Louis Expo, 1904 (gold); P.-P. Expo, 1915 (med); NAWPS, 1917 (prize); AIC, 1921 (med); AAAL, 1927 (gold); Chi Omega, 1933 (gold). Work: PAFA; Toledo MA; MMA; Chicago AI; CGA; BMFA; Luxembourg Gal., Paris; Uffizi, Florence, Italy [40]

BEAVER, Earle B. [P,S,L] Chicago, IL b. 8 S 1918. Studied: AIC. Exhibited: Ann. Am. P&S; AIC, 1938; Ar. Chicago Vic., 1939 [40]

BEBE, Debelle (Mrs.) [P] Asbury Park, NJ [04]

BECCARD, Helen Louise [P,B,T] St. Louis, MO b. 12 N 1903. Studied: St. Louis Sch. FA. Member: St. Louis AG; Shikari; Am. A. Cong. Exhibited: St. Louis AG, 1928 (prize), 1929 (prize), 1938 (prize). Illustrator: children's books, pub. Walter B. Simon, St. Louis. Position: T., Mary Inst., Clayton, Mo. [40]

BECHDOLT, Jack [P] NYC [24]

BECHER, Arthur E. [P,I] Ardsley, NY/Hopewell Junction, NY b. 29 Jy 1877, Freiberg, Germany. Studied: Louis Mayer; Howard Pyle; Otto Strützel, in Munich. Member: SI, 1910; SC; AG. Illustrator: books, magazines. Specialty: horses [40]

BECHTEL, David B. [P] Phila., PA. Exhibited: AAS, 1902 (med) [04]

BECK, Benjamin J. [P,Des,Dr,T] Chicago, IL b. York, NE. Studied: Frederic Grant; Stark Davis; Leon Lundmark; Jack Spelman. Member: All-Ill. SFA; Soc. for Sanity in A. Exhibited: All-Ill. SFA, 1938 (prize). Work: Century of Progress Expo, Chicago [40]

BECK, Carol H. (Miss) [P] Phila., PA b. 1859, Phila d 15 O 1908. Studied: PAFA; Dresden; Paris. Member: Plastic Cl. Exhibited: PAFA, 1899 (prize). Work: portraits of many prominent men; Swarthmore Col.; Univ. Pa. Her brother, the Hon. James M. Beck, established the Carol H. Beck Memorial Gold Medal for best portrait shown at the PAFA exhibition. Position: Ed., catalogue of the Wilstach Coll. Paintings, Mem. Hall, Phila. [08]

BECK, Dunbar [P,Dec,Mur.P,T] Sacramento, CA b. 16 S 1902. Studied: Ohio Wesleyan Univ.; Northwestern; Yale; Am. Acad., Rome. Member: F. PAFA. Exhibited: 48 States Comp., 1939 (prize). Award: Prix de Rome, 1927. Work: dec., East Room, White House, Wash., D.C.; altar, church paintings, N.Y., Phila., St. Paul, Minn., Sacramento; mural, USPO Danvers, Mass. [47]

BECK, Frank H. [Car] NYC b. 9 Ap 1893, Tacoma, WA. Creator: "Hem and Amy," "All in a Lifetime" [40]

BECK, H.K. [P] Elgin, IL [13]

BECK, Jay [I,S,C,P] Chicago, IL b. 20 S 1916, Chicago. Studied: Univ. Chicago. Exhibited: AIC. Illustrator: "Wild Bird Neighbors," 1946 [47]

BECK, Martha A. [P] Elgin, IL [13]

BECK, Martin A. [P] Elgin, IL [13]

BECK, Minna McL(eod) [P,W,T] NYC b. 18 My 1878, Atlanta, GA. Studied: Arthur W. Dow; Columbia. Member: SAAL. Position: Head, A. Dept., Ala. Col. [40]

BECK, Raphael [P,S,I] Buffalo, NY b. Lancaster, PA d. 29 My 1947, Lockport, NY. Studied: Weber, in Munich; Académie Julian, Paris. Member: Buffalo SA. Exhibited: Pan-Am. Expo, Buffalo, 1901 (prize); St. Louis Expo, 1904 (prize); Lewis and Clark Expo, Portland, 1905 (prize). Had a studio in Buffalo for more than 30 years. [21]

BECH, Rhea E. [P] Pittsburgh, PA. Member: Pittsburgh AA [24]

BECK, R.K. [I] Brooklyn, NY [19]

BECK, Walter (Otto) [P,S,E,W] Millbrook, NY b. 11 Mr 1864, Dayton, OH. Studied: I. Broome; Munich Acad., with Gysis, Loefftz; Rümann. Member: Arch. Lg., 1902; NAC; Wash. AC; AAPL. Exhibited: Nat. Mural Comp., 1897 (prize); Sesqui-Centenn. Expo, Phila., 1926 (med). Work: BM; NGA; Newark AA; Montclair Mus.; PMA [40]

BECK, William [P] Yonkers, NY [24]

BECK-BRONDUN, Hjilva [Por.P] NYC b. 1877 d. 12 F 1914 (suicide, in NYC). Came to U.S. in 1904.

BECKER, August H. [P,Mur.P] b. 1840, Cologne, Germany d. 1903, St. Louis, MO. Studied: Leon Pomarede. Work: Mo. Hist. Soc. Specialty: murals of Indian genre [*]

BECKER, Carl J. [P] Phila., PA [05]

BECKER, Charlotte [I] NYC. Member: SI [47]

BECKER, Emelle [P] Chicago, IL. Member: Chicago NJSA [24]

BECKER, Eulabee. See Dix.

BECKER, F. Otto [P,Li] b. 1854, Dresden, Germany d. 1945, Milwaukee. Studied: Royal Acad., Dresden. Lithographer: "Custer's Last Stand" [*]

BECKER, Florence [S] Denver, CO [01]

BECKER, Frederick W. [P] Palm Springs, CA b. 24 Mr 1888, Vermillion, S.Dak. Studied: Los Angeles Sch. A.&Des.; Mackey Sch. A., San Fran.; PAFA; ASL, Los Angeles; Hugh Breckenridge; Daniel Garber; Joseph T. Pearson; Hale; Robert Reid; Emil Carlsen. Member: Soc. Texas A.; SSAL; Okla. AA. Exhibited: Kansas City AI, 1932 (prize). Work: Univ. Okla.; Okla. City A. Lg.; Okla. Hist. Bldg. [47]

BECKER, Herman Albert [S,C] Miami, FL b. 7 O 1909, Essen, Germany. Studied: NAD; BAID; Columbia Univ., with Maldarelli. Member: Palm Beach A. Lg. Exhibited: NAD, 1939 (prize); BAID, 1939–41 (prizes); Palm Beach A. Lg., 1946 (prize) [47]

BECKER, Joseph [I,En] Brooklyn, NY b. 1841, Pottsville, PA d. 28 Ja 1910. Work: MMA. At seventeen, became an engraver for Leslie's Illustrated Newspaper; during the Civil War, went to the front as artist for the paper; manager of its art dept., 1875–1900.

BECKER, Joseph (Hubert) [Car,W,P,Des] Kansas City, MO b. 17 F 1905, Kansas City. Exhibited: Kansas City AI, 1945; CAM, 1945 [47]

BECKER, Kenneth P. [P] Hinsdale, IL. Exhibited: Intl. WC Ann., 1935, 1936, 1938; Am. PS; AIC, 1937, 1938 [40]

BECKER, Marion R. (Mrs. John W.) [Art Soc.Dir] Newton, OH b. 2 Ja 1903, St. Louis, MO. Studied: Vassar. Position: Dir., Cincinnati Mod. A. Soc., 1942– [47]

BECKER, Maurice [P,Car,I] NYC b. 4 Jan 1889, Russia. Studied: Robert Henri; Homer Boss. Member: A. Lg. Am.; S.Indp.A. Exhibited: WMAA, 1935, 1945, 1946; MMA, 1942; Pepsi-Cola, 1944; NAD, 1944, 1945; CI, 1945; Berkshire Mus., 1946 (one-man); AIC. Work: Woods Mus., Montpelier, Vt. [47]

BECKER, Richard [S] Union Hill, NJ [05]

BECKET, Marie A. [P] NYC. Member: Women's AC [01]

BECKETT, Marion H. [P] NYC [15]

BECKHOFF, Harry [I] Larchmont, NY. Member: SI. Work: Collier's [47]

BECKINGTON, Alice [Min.P,T] Scituate, MA b. 30 Jy 1868, St. Charles, MO d. 4 Ja 1942, Calif. Studied: ASL, with Beckwith; Constant, Lefebvre, Lazar, in Paris. Member: Am. S. Min. P.; Pa. Soc. Min. P.; AFA. Exhibited: Pan-Am. Expo, Buffalo, 1901 (prize); St. Louis Expo, 1904 (med); Brooklyn S. Min. P., 1935 (med). Work: MMA; Pa. Mus. A. [40]

BECKMAN, Jessie Mary [P,T] Los Angeles, CA/Laguna Beach, CA b. Upper Sandusky, OH. Studied: Académie Julian, Paris; Meakin; Satler; Chase; Henri; Webster. Member: Calif. AC; West Coast AC; MacDowell C. All. A. Exhibited: portraits, Tri State Fair (prizes)

BECKMANN, Max [P,G] b. 1884, Leipzig, Germany d. 1950, NYC. Studied: F. Smith, in Weimar; Paris; Florence. Exhibited: Contemporary German P., 1929; MOMA, 1947, 1950; Carnegie Intl. Exh., 1949 (prize). Important German expressionist. [*]

BECKWITH, Ada B. [P,T] Cleveland, OH b. 27 F 1886, Cleveland. Studied: Pratt Inst. Member: Cleveland Women's AC [24]

BECKWITH, Arthur [P] San Fran., CA/Marin County, CA b. 24 Ja 1860, London d. summer 1930. Studied: South Kensington schools. Member: San Fran. Inst. A.; Sequoia Cl.; Bohemian Cl.; Marin County AA. Work: Golden Gate Park Mus., Sequoia Cl., San Fran. [27]

BECKWITH, Bertha (Mrs.) d. 10 My 1925. The widow of painter Carroll Beckwith.

BECKWITH, E.F. [P] Ionia, MI [15]

BECKWITH, James [P,Des,C,T] Westport, CT b. 21 D 1907, Mt. Pleasant, IA. Studied: Yale. Member: Calif. WCS [40]

BECKWITH, J(ames) Carroll [P] NYC/Tannersville, NY b. 23 S 1852, Hannibal, MO d. 24 O 1917 (suicide). Studied: Ecole des Beaux-Arts, with Carolus-Duran; Nat. Acad. Des.; Walter Shirlaw. Member: ANA, 1886; NA, 1894; SAA, 1881; AWCS; ASL; A. Fund. C.; Century Assoc.; Nat. Inst. A.&L.; Lotos C. Exhibited: Paris Salon, 1887 (prize); Paris Expo, 1889 (med), 1900 (med); Atlanta Expo, 1895 (gold); Charleston Expo, 1902 (gold). Work: Nat. Mus., Wash., D.C.; Toledo Mus. A., AA, Indianapolis; Albright Gal.; Detroit Mus. A. Most of his paintings were sold at auction in NYC after his death. Position: Instr., ASL.

BEDEKIAN, Victoria N. [P] Montclair, NJ [25]

BE DELL, Dorothy Krippner (Mrs. A. Burr) [P] Green Bay, WI b. Green Bay. Studied: AIC; Lou Matthew Bedore; Lorado Taft, 1928. Member: Green Bay A. Colony. Exhibited: Wis. PS, 1928; Oshkosh M.; Neville Public M., Green Bay [40]

BEDFORD, Cornelia E. [I,W] Dresden, Germany b. 17 Je 1867, NYC d. 17 Ap 1935. Studied: PMSchIA; PAFA. Member: Sachsischer Kunst Verein zu Dresden. Author/Illustrator: "Views and Interviews in Germany." Position: Dresden correspondent, New York Herald (pub. in Paris) [40]

BEDFORD, Helen De Wilton [Edu] Cape Girardeau, MO b. 12 N 1904, Columbia, MO. Studied: Univ. Mo; T. Col., Columbia Univ. Member: Am. Assn. Univ. Prof.; Nat. Assn. A. Teachers; Nat. Edu. Assn. Position: Dir., Dept FA, State T. Col., Cape Girardeau [47]

BEDFORD, Henry E(dward) [P,S,W,L] Brooklyn, NY/Wiscasset, ME b. 3 Mr 1860, Brooklyn d. 29 O 1932. Studied: Heatherly Art Sch., London; William Anderson. Member: SC. Specialty: scenes of Maine. He designed the clock in Grand Central Station and several other large clocks. [33]

BEDNAR, Hermina Beidinger, Mrs. See Beidinger.

BEDNAR, John James [Edu,P,S,Des,Mur.P] South Bend, IN b. 1 Jy 1908, Cleveland. Studied: Univ. Notre Dame. Exhibited: Hoosier Salon, 1941, 1942, 1945 (prize). Work: murals, St. Edward's Univ.; Univ. Notre Dame. Positions: T., Univ. Notre Dame, 1943–45 [47]

BEDNO, Edward [Car,I,Des] Chicago, IL b. 8 Mr 1925, Chicago. Studied: AIC. Exhibited: Ill. State Mus.; North Miss. Valley A.; AIC. Illustrator: Mr. & Mrs. Magazine [47]

BEDORE, Sidney N. [S] Lake Geneva, WI b. 5 Mr 1883, Stephenson, MI d. 12 S 1955. Studied: AIC; BAID; Solon Borglum. Work: Lib., Neville Pub. Mus., Green Bay, Wis.; mon., Madison, Wis., Benton Harbor, Mich. [47]

BEDORE, Anna Lou Matthews, Mrs. See Matthews, Lou.

BEE, Lonie (Mr.) [I] Scarsdale, NY. Member SI [47]

BEEBE, Dee (Miss) [P,T] Brooklyn, NY b. New Orleans, LA. Studied: Chase; Cox; Snell; Duveneck. Member: NYWCC; Wash. WCC [40]

BEEBE, Elizabeth [P] NYC [13]

BEEBE, Grace H. (Mrs.) [P] Boston, MA. Member: Copley S., 1895 [04]

BEEBE, Katharine [C] NYC/Hyde Park, VT b. 6 D 1884, Brooklyn, NY. Studied: N.Y. Sch. Applied Des. for Women; John Hines; Floyd Ackley. Member: NYSC; Boston SAC [40]

BEEBE, Louise Oliver (Mrs. F.L.). See Oliver, Louise.

BEEBE, Robert [P] Cleveland, OH. Member: Cleveland SA [24]

BEECHER, Florence C. [Min.P] NYC. Exhibited: Brooklyn Soc. Min. P. Ann., 1934, 1935; Pa. Soc. Min. P. Ann., 1935, 1936, 1938; Wash. Soc. Min. PS&G, 1939 [40]

BEECHER, Genevieve Thompson [P] Los Angeles, CA b. 27 Ag 1888, Chicago d. 1955. Studied: N.Y. Sch. Appl. Des.; Chouinard AI; Otis AI, with Paul Lauritz. Member: Calif. AC; Women Painters of the West; Calif. Soc. Min. P. Exhibited: Hollywood Riviera, 1936 (prize); Calif. Soc. Min. P., 1944; Pal. Leg. Honor, 1940–42, 1944, 1945; Los Angeles Mus. A., 1944; Calif. AC, 1935–37; Santa Paula, Calif., 1942, 1944; Occidental Col., 1946; Calif. State Bldg., 1946 [47]

BEECHER, Mathew [I] Yonkers, NY. Member: SI [33]

BEECK, Kisa (Mrs.) [P,S] Berkeley, CA. Studied: Calif. Sch. FA. Member: San Fran. A. Assn.; San Fran. Soc. Women Ar. Exhibited: AM, Portland, Oreg., 1933; San Fran. Soc. Women Ar., 1938, 1939; San Fran. A. Assn.; Women P. Am., Wichita, Kans. [40]

BEEK, Alice D. Engley (Mrs.) [P,T,W,L] Tacoma, WA b. 17 Je 1876, Providence. Studied: R.I. Sch. Des.; Wheeler A. Sch.; Sidney Burleigh; Acad. Delecluse, Lazar, L'Hermitte, Puvis de Chavannes, Edward Ertz, in Europe. Member: Am. APL. Exhibited: Expositions Internationales Français (2 golds,med,prizes); Seattle Expo, 1909 (gold,prize). Work: European galleries. Position: Dir. A., Annie Wright Sem., Tacoma [40]

BEEKMAN, Henry Rutgers [P,E] NYC/West Hampton Beach, NY b. 18 N 1880, NYC d. 23 Ag 1938. Studied: Hawthorne; Bredin; Lathrop; Pennell. Member: Wash. WCC; All. Ar; Conn. Acad. FA; NYWCC [38]

BEEM, Frances [Min.P] Chicago, IL [19]

BEEM, Paul Edward [Des,I,P,Li,S] Chicago, IL b. 12 Ja 1908, Indianapolis. Studied: John Herron AI; AIC; Elmer Taflinger; George Bridgman; R.L. Coats. Member: Soc. Typographic A.; A. Dir. Cl. Exhibited: Herron AI, 1930–34 (prizes); Hoosier Salon, 1929–40 (prizes); CM, 1929 (prize), 1931, 1932; AIC, 1932 (prize), 1938 (prize); Dayton AI, 1932; Detroit Inst. A., 1933; Carnegie Inst., 1934; Delgado Mus. A. Work: Herron AI; Univ. N.Dak; Ind. Univ. Contributor: art magazines [47]

BEEMER, Edwin F. [P] NYC. Member: S.Indp.A. [24]

BEERBOHM, Marvin [P,Des,Mur.P] Detroit, MI b. 24 Jy 1909, Toronto. Studied: Detroit Soc. A.&Crafts; Samuel Halpert; John Carroll. Exhibited: Detroit Inst. A., 1940 (prizes); CGA, 1935, 1937; PAFA, 1939; VMFA, 1940; San Fran. AA, 1940; Carnegie Inst., 1940; AV, 1943; San Diego FA Soc., 1942; Milwaukee AI, 1945; Detroit Inst. A., 1932–42; Univ. Mich., 1936–38; Kansas City AI, 1937. Work: murals, USPOs, Knoxville (Iowa), Belding (Mich.); Detroit Pub. Lib. [47]

BEERS, Alexander Richard [P] Chicago, IL b. 1882, Titusville, PA. Studied: Phila. Textile Sch.; AIC. Member: Palette & Chisel Cl. [24]

BEESON, Betty Z(immerman) (Mrs. P.C.) [P] Chicago, IL/Silver Lake, WI b. 17 Je 1897, Atlanta. Studied: Frederick M. Grant. Member: All-Ill. SFA; Austin, Oak Park and River Forest AL [33]

BEETZ, Carl Hugo [Li,P,T,I] San Fran., CA b. 25 D 1911, San Fran. d. 1974. Studied: Calif. Sch. FA, with Spencer Macky; ASL, with George Bridgman; Chouinard AI, with Pruett Carter. Member: Calif. WC Soc. Exhibited: Redlands A. Gld., 1941 (prize); Pomona, Calif., 1937; AIC, 1941; Riverside Mus., 1940, 1944; San Diego, 1941; Lib. Cong., 1944, 1945; Phila. Pr. Cl., 1944; Indianapolis Pr. Show, 1946; Springfield Pr. Show, 1946; Calif. WC Soc., 1937, 1939, 1940, 1942, 1943; San Fran. AA, 1941, 1943, 1946; Fnd. Western A., Los Angeles, 1937, 1938, 1940, 1942, 1944. Illustrator: magazines. Positions: Instr., Chouinard AI (1935–44), Calif. Col. A.&Crafts, Oakland (1944–), Acad. Adv. A., San Fran. (1944–), San Fran. Jr. Col. (1945–) [47]

BEGAY, Apie ("Son of Milk") b. N.Mex. d. before 1936. Navaho crayon artist. [*]

BEGAY, Harrison [P,I] Granado, AZ (1968) b. 1917, White Cone, AZ. Studied: Fort Wingate Indian Sch.; Santa Fe Indian Sch. Exhibited: First Nat. Exh. Am. Indian P., Philbrook A. Center, 1946 (prize). Work: Mus. Am. Indian; Okla. Univ. Mus. A. [47]

BEGG, John (Alfred) [S,P,Des] Hastings-on-Hudson, NY b. 23 Je 1903, New Smyrna, FL d. 1974. Studied: Columbia; Arthur Wesley Dow; Charles Martin. Member: AIGA. Exhibited: WMAA, 1945; BM, 1935, 1937; Buchholz Gal., 1943, 1945; Wakefield Gal., 1942 (one-man); Nierendorf Gal., 1945. Work: Ind. Mus. Mod. A.; bronze plaque for Readerscope award, 1945. Author: technical book reviews. Positions: A. Ed., American Book Co., 1932–37; Dir., Oxford Univ. Press, 1939– [47]

BEGGS, Bette (Mrs. B.B. Ashford) [P,Des,I] Middletown, RI b. 13 N 1915, Phila. Studied: Yale; Fontainebleau, France; Wayman Adams; Eliot O'Hara. Member: Phila. A. All.; Phila. Pr. Cl. Exhibited: BAID, 1935 (med); PAFA, 1938–41; AIC, 1939; AWCS, 1938, 1939; CGA, 1939; MOMA, 1943; Phila. A. All., 1940; Norfolk Mus. A., 1941. Illustrator: Harper's Bazaar. Position: Illus./Des., Marshall Field & Co., 1944 [47]

BEGGS, Helene Warder [P] Elmhurst, IL [19]

BEGGS, Thomas Montague [Edu,P] Claremont, CA b. 22 Ap 1899, Brooklyn, NY. Studied: PIASch.; ASL; Yale; Ecole des Beaux-Arts, Fontainebleau, France. Member: Am. Soc. Aesthetics; Am. Assn. Univ. Prof; Calif. AC; FMA. Exhibited: Sch. A. Lg., 1917 (med); BAID, 1923. Work: Redlands Univ.; Nat. Central Univ., Chungking, China. Author/Illustrator: "Art Education." Position: T., Pomona Col., 1936– [47]

BEGIEN, Jeanne (Mrs. Jewett Campbell) [P,Edu] Richmond, VA b. 21 O 1913, Cincinnati. Studied: Richmond Professional Inst.; Colorado Springs FA Center, with Henry Varnum Poor, Boardman Robinson, Karfiol, Blanch. Exhibited: Acad. Sc.&FA, Richmond, 1939 (prize); VMFA, 1940, 1943, 1946; Butler AI, 1942; Mint Mus. A., 1943; Soc. Wash. A., 1940; WFNY, 1939; Richmond Acad. Sc.&FA, 1939. Position: T., Univ. Richmond [47]

BEHAR, Ely M(axim) [P,T] NYC/Rockport, MA/Paris b. 15 Ag 1890, Paris. Studied: John F. Carlson; C.W. Hawthorne. Member: Rockport AA. Illustrator: newspapers and magazines [21]

BEHENNA, Katherine Arthur (Mrs.) [Min.P,I,T] Etaples, France b. Scotland. Studied: Brush, in New York; Collin, Lefebvre, in Paris. Member: Royal Min. P., London; Royal WC Soc., London; ASL [13]

BEHL, Johann Wolfgang [S,Edu,C,L] Richmond, VA b. 13 Ap 1918, Berlin, Germany. Studied: Acad. FA, Berlin; Am. A. Sch., N.Y.; R.I. Sch. Des. Member: CAA. Exhibited: AIC, 1944 (prize); Milwaukee AI, 1945 (prize); Swarthmore Col. Position: T., Richmond Inst., Col. William & Mary, 1945– [47]

BEHM, Gustav [T,Woodcarver] b. 1856, Germany d. 4 My 1926, Chicago. He taught woodcarving at the Art Institute of Chicago (1890–95) and in Vienna. His most notable work is "The Resurrection Morn," on which he worked from 1895 to 1922. He came to America in 1885.

BEHNCKE, Gustav [P] b. 1853, Hamburg, Germany d. 21 Ja 1937, Oshkosh, WI. He came to this country in the early 1870s, journeyed across the great plains and joined the Gordon Stockade, a party of white men who went into the Black Hills in search of gold. In pioneer days it was the vogue to decorate residences of wealthy families. Most of these embellishments in Oshkosh were done by Behncke, and his decorations may still be found in about 175 churches in Wisconsin.

BEHNCKE, Nile Jurgen [Mus.Dir,P] Oshkosh, WI b. 4 Je 1894, Oshkosh d. 1954. Studied: State T. Col., Oshkosh; George Pearse Ennis. Member: Wis. P.&S. Exhibited: Wis. Fed. Women's Cl. (prize); Wis. A. (prize); Wis. P.&S.; PAFA; AIC; CGA. Work: Green Bay YMCA; Ripon Col.; Mount Mary's Col.; Oshkosh State T. Col; Kenosha Mus. A.; Oshkosh Pub. Mus.; Christian Science Bldg., Victoria, B.C.; Butler AI. A leading watercolorist in Wis. Position: Dir./Cur., Oshkosh Pub. Mus., 1925–54 [47]

BEHR, Ernest Theodore [P] Chicago, IL b. 1861, Saxony, Germany. Studied: Dresden A. Sch. Member: Chicago Arch. Cl.; Palette & Chisel Cl. Specialty: watercolors [09]

BEIDINGER, Hermina (Mrs. H.B. Bednar) [Des,P] South Bend, IN b. 13 Ap 1916, South Bend. Exhibited: Hoosier Salon, 1940, 1941, 1944. Positions: Staff A., Bendix Aviation Corp., 1943–44, Adv. A., 1944–45 [47]

BEIERLY, Marjorie C. [P,T] Milwaukee, WI b. 28 Ag 1912, Milwaukee. Studied: Mercer Orwig; Jens Jensen; Gerrit Sinclair; Nic Lenz. Exhibited: Kenosha Hist.&A. Mus., 1940(one-man); Wis. P.&S., 1941; Wis. State Fair, 1941; Machat's Gal., Milwaukee, 1946 (one-man) [47]

BEILER, (Ida) Zoe [P,T,L] Elida, OH b. 30 N 1889, Lima, OH. Studied: Lima Col.; Mich. State T. Col.; AIC; Univ. Chicago. Member: Nat. Edu. Assn.; Nat. Inst. A.&L. Exhibited: Fargo, N.Dak., 1938 (prize); GGE, 1939 (med); Nat. Exh. Am. Painting, 1936–38; CGA, 1942; Chicago World's Fair, 1933; N.Dak. State T. Col., 1935, 1936; Aberdeen, S.Dak., 1937; Bismarck, N.Dak., 1938, 1943; Glendive, Mont., 1945; Dickinson, N.Dak., 1933, 1935, 1942, 1945. Work: IBM; FA Cl., Fargo, N.Dak.; Mayville State Col.; Fargo Agricultural Col.; Dickinson Pub. Lib.; capitol, Bismarck; State Col., Dickinson, N.Dak. Position: T., State T. Col., Dickinson [47]

BEIMERS, M. Eugene, Mrs. See De Turck, Ethel Ellis.

BEIN, Arthur G. [Des] NYC [09]

BEIN, Charles W. [P] New Orleans, LA b. 1 Ag 1891, New Orleans. Member: New Orleans ACC [33]

BEISIEGEL, Albert [P] Rochester, NY. Member: Rochester AC [24]

BEKKER, David [P,Gr,T] Chicago, IL b. 1 My 1897, Vilna, Russia. Studied: Acad. A., Palestine; Antikolsky Sch. A.; Denver Acad. A.; Bezalel Sch. A.; Boris Schatz; Abel Panne. Member: A. Union Chicago; Chicago SE; Chicago NJSA; Conn. Acad. FA; Am. A. Cong. Exhibited: Jerusalem, 1911 (prize), 1912 (prize); AIC, 1942 (prize); Nat. Gal Prints, Wash., D.C.; Colo. State Fair, 1912 (prize), 1913 (prize); 1923 (prize). Work: Nat. Gal. Prints; Nat. Mus., Biro-Bidjan, USSR; Tel Aviv Mus.; State House, Boston; Romania; Palestine A. Mus. Author: "Myths and Moods," 1932, "Two Worlds." Positions: Instr., Hull House, Chicago; A. Ed., Pech & Schwebel magazine [47]

BEL GEDDES, Norman [Des,W] NYC b. 27 Ap 1893, Adrian, MI d. 8 My 1958. Studied: AIC; Cleveland Sch. A. Member: Authors Lg. Am.; Soc. Illuminating Engineers; Royal SA, London; Arch. L.; Stage Des. Cl.; ADI; Un. Scenic A. Exhibited: Arch. L., 1921; Int. Exh., Amsterdam, 1922; Victoria & Albert Mus., 1922; Vienna; Milan; U.S. Work: MOMA, Mus. City N.Y.; MMA; Univ. Mich.; Univ. Syracuse: Williams Col; Louvre. Designer: 200 theatrical prod., 1916–42; WFNY, 1939, "Toledo Tomorrow" (master city plan for Toledo, 1945), Pan-Am. Airways ship & plane identification, ocean liners, automobiles, airplane interiors, etc. Contributor: art magazines, Encyclopaedia Britannica. Author: "Horizons", 1932, "Magic Motorways," 1940 [47]

BELANSKE, William E. [I] Bellville, NJ [19]

BELASKI, Stephan [P] Bellows Falls, VT b. 25 Mr 1909, NYC. Studied: Vesper George Sch. A., Boston; Jean Despujols, André Strauss, Gaston Balande, all in France. Exhibited: PS. Fed. Bldgs., 1936. Work: USPO, Rutland, Vt. WPA artist. [40]

BELCHER, Hilda [P] Pittsford, VT b. 20 S 1881, Pittsford d. 27 Ap 1963. Studied: Chase Sch., with Henri, Chase; Bellows; Luks; K.H. Miller. Member: NA, 1932; AWCS; NAWA; Phila. WC Cl.; Conn. Acad. FA; Springfield A. Lg.; Southern Vt. A.; NAC. Exhibited: AWCS, 1909 (prize), 1915 (prize), 1918 (prize); NAD, 1926 (prize), 1931 (prize); PAFA, 1932 (prize); Ogunquit Cl., 1932 (prize); Newark A. Cl., 1933 (med); Phila. WC Cl., 1935 (gold); AIC; NAWA, 1917 (prize), 1926 (prize); Baltimore WCC, 1925 (prize); Southern Vt. A.; Wash. AC; Fleming Mus. A., 1933, 1945 (one-man); High Mus. A., 1935 (one-man); Bennington Hist. Mus., 1940 (one-man); Sweet Briar Col.; Palm Beach AA; Conn. Acad. FA, 1915 (prize); Newport AA, 1916 (prize); NYWCC, 1909 (prize), 1917 (prize). Work: Md. Inst.; PAFA; Houston Mus. FA; Montclair A.

Mus.; High Mus. A.; Williams Col.; Vassar Col.; Savannah Pub. Lib.; Dumbarton House, Wash., D.C. [47]

BELCHER, Martha Wood (Mrs.) [P,E,T] NYC/Pittsford, VT b. 17 Ag 1844, England. Studied: Cooper Inst.; Flügen, Lietzenmeyer, Lindenschmidt, in Munich. Member: NAWPS, NYWCC [24]

BELDEN, Ella Celeste [S,P] Chicago, IL b. 1873, Chicago. Studied: AIC [13]

BELDEN, Janet [P] NYC. Exhibited: 48 Sts. Comp. [40]

BELDEN, Louise [S] Minneapolis/Minnetonka, MN b. 23 Ja 1907, Minneapolis. Member: Lg. Am. Pen Women; Minn. AA. Exhibited: Twin Cities Ar. Exh., Minneapolis Inst. A., 1936 (prize) [40]

BELINE, George [P,S,T] NYC b. 23 Jy 1887, Minsk, Russia. Studied: Académie Julian, Paris; Ecole des Beaux-Arts, Paris; Ecole Place des Vosges, Paris; Jean Paul Laurens; NAD. Member: SC; All.A.Am. Exhibited: PAFA; NAD; Municipal Gal., N.Y.; AWCS [47]

BELING, Helen (Mrs. H.B. Kahn) [S] New Rochelle, NY b. 1 Ja 1914, NYC. Studied: CCNY; NAD, with C. Paul Jennewein, Lee Lawrie, Paul Manship; ASL, with William Zorach. Member: Hudson Valley A.; Westchester A. & Crafts Gld. Exhibited: NAD, 1934 (med), 1938 (med), 1939-41; Franklin, Inst., Phila., 1939; Hudson Valley AA., 1941 (prize); New Rochelle AA, 1944 (prize), 1946 (prize); P.&S. Soc., N.J., 1946 (prize); Arch. Lg., 1941; All.A.Am., 1944; NAC, 1945, 1946; Audubon A., 1943; New Haven PCC, 1942; Westchester A.&Crafts Gld., 1945. Work: Franklin Inst. [47]

BELIVEAU, Rene [P] Montreal, Quebec [01]

BELKNAP, Alice S. [P] Louisville, KY [05]

BELKNAP, Norman Fryberger [Des,T] Buffalo, NY b. 21 S 1921, Buffalo. Studied: PIASch. Exhibited: Buffalo A. Inst., 1945, 1946. Positions: Typographic Des., J.W. Clement Co., Buffalo, 1942-; T., Buffalo AI, 1944- [47]

BELL, A. David [P] Phila., PA. Member: AWCS [47]

BELL, Blanche Browne [P,I,E,C,W] San Antonio, TX b. 22 Ag 1881, Helena, TX. Studied: Arpa; Gonzales; de Young. Member: SSAL; Tex. FAA; San Antonio Palette & Chisel Cl.; San Antonio AL. Exhibited: Tex. Wildflower Contest, 1926 (prize); SSAL, 1929 (med, prize) [40]

BELL, Carl [S] Chicago, IL b. 1858, Germany d. 18 Je 1927. Studied: Acad. FA, Munich. He was commissioned by King Ludwig of Bavaria to superintend the building of castles in the Bavarian Alps. He directed the sculpture for the World's Fair in Chicago and was director of sculpture for the Buffalo and St. Louis Fairs and for the Paris Expo in 1900.

BELL, Caroline M. [P] Mattatuck, NY. Member: NAWPS. Exhibited: NAWPS, 1933, 1935-38 [40]

BELL, Cecil C. [P] Staten Island, NY. b. 15 Jy 1906, Seattle. Studied: ASL, with Harry Wickey; John Sloan; Harry Sternberg. Work: WMAA [47]

BELL, Charles E. [Car,I] b. 1874, Williamsport, PA d. 11 Je 1935, Avalon, NJ. Work: Capitol, Harrisburg, Pa. He had been associated with the Philadelphia Inquirer for thirty-six years, and was a member of the pen and Pencil Club of Philadelphia.

BELL, Clara Louise (Mrs. Béla Janowsky) [P,Min.P] NYC b. Newton Falls, OH. Studied: Cleveland Sch. A.; ASL; Henry G. Keller; Edith Stevenson Wright. Member: ASMP; NAWA; Brooklyn Soc. Min. P.; Studio Cl., N.Y. Exhibited: CMA, 1919 (prize), 1920-22, 1923 (prize), 1925 (prize), 1926; Studio Cl., 1926 (prize), 1927 (prize), 1928 (prize); NAWA, 1928, 1929, 1930 (med), 1931-33, 1936-39; PAFA, 1917, 1940; WFNY, 1939; ASMP, 1926-46; Butler AI, 1939; Brooklyn Soc. Min. P., 1928-38; BM, 1936; Syracuse Mus. FA, 1929; Montclair A. Mus., 1930; Vose Gal.; Un. Lg., 1930; Colony Cl., 1946; Rheinhardt Gal. Work: MMA; BM; Masonic Temple, Youngstown, Ohio; Butler AI; U.S. Coast Guard Bldg., Wash., D.C. [47]

BELL, Edith Marian [P,T] Mount Carroll, IL b. Cushing IA. Studied: NAD; Wayman Adams; George Pearse Ennis. Member: F., Tiffany Fnd.; Iowa A. Gld.; Chicago Gal. Assn. Exhibited: NAD, 1922 (prize); Town & Country A. Cl., Chicago, 1938 (prize); Exh. Iowa Paintings, Chicago, 1937 (prize); AWCS, 1934, 1936-38; NYWCC, 1935-37; Phila. WCC, 1937; Wash. WCC, 1937, 1938; All.A.Am., 1940, 1941; Chicago Gal. Assn., 1943 (one-man); Dickerson Gal., Frances Shimer Col., Mt. Carroll, Ill.,1946. Work: State Univ. Iowa; Frances Shimer Col. Position: Dir., A. Dept., Frances Shimer Col. [47]

BELL, Edward August [P] Peconic, NY b. 18 D 1862, NYC. Studied: NAD; Bavarian Royal Acad., in Munich. Member: ANA, 1901; SAA, 1898; SC, 1904. Exhibited: Paris Expo, 1889 (med); NAD, 1893 (prize); Pan-Am. Expo, 1901 (med); St. Louis Expo, 1904 (med). Work: Smith Col.; Cinncinati Mus.; Indianapolis AA [47]

BELL, Elizabeth Williams (Mrs.) [P] Wash. D.C. [01]

BELL, Enid (Mrs. E.B. Palanchian) [S,C,T,I,W] North Bergen, NJ b. 5 D 1904, London. Studied: Scotland; Sir W. Reid Dick, in London; ASL. Member: N.Y. Soc. C.; Assoc. A., N.J. Exhibited: Paris Int. Exh., 1937 (gold); AAPL, 1934 (prize); N.Mex. State Fair, 1940 (prize), 1941 (prize); Newark AC, 1933 (prize); PAFA; NAD; WFNY, 1939; MMA; BM; Mus., N.Mex, Santa Fe; Ferargil Gal., 1929 (one-man); Arden Gal., 1934. Work: Congressional medal for Lincoln Ellsworth; USPOs, Mt. Holly (N.J.), Boonton (N.J.), Hereford (Tex.). Illustrator: "Forsaking All Others," by Alice Duer Miller. Author/Illustrator: "Tin-work as a Hobby. Position: T., Newark Sch. F.&Indst. A., 1944- [47]

BELL, Hamilton d. 27 Mr 1929. He was acting director of the Pennsylvania Museum from December 1917 to January 1919, and was subsequently appointed curator of the Johnson Collection.

BELL, Helen K. [P] Franklin, PA b. Ja 1902, Franklin. Studied: Garber; B.E. Ward. Member: F., PAFA [33]

BELL, Jennie [P] Louisville, KY. Member: Louisville AL [01]

BELL, M.A. (Mrs. Eastlake) [P] Boston, MA. b. London, England [05]

BELL, Philip Fletcher [P] Wash., D.C. b. 6 Jy 1907, Kirksville, MO. Studied: George Washington Univ.; Yale; Corcoran A. Gal; Eugene Savage. Member: Ldscp. Cl., Wash., D.C. Exhibited: CGA, 1937; PMG; Whyte Gal.; Grand Central A. Gal. Positions: T., George Washington Univ., Acting Exhibits Officer, Lib. Cong., 1945- [47]

BELL, Samuel [S] NYC. Exhibited: 48 Sts. Comp. [40]

BELL, Sidney [P] Portland, OR [24]

BELL, Thomas Sloan [Ldscp.P,Mar.P] Arwada, CO. Member: Denver AC, 1897 [01]

BELL, Wenona Day [P,T] NYC b. Trenton, SC. Studied: Brenau Col.; PAFA; T. Col., Columbia; Hans Hofmann, in Munich. Exhibited: Ga.- Ala. Exh., Memphis (prize); PAFA, 1925, 1927; AIC, 1928; Detroit Inst. A., 1926. Work: Vanderpoel Coll.; Agricultural Bldg., Wash., D.C.; Court House, Columbus, Ga.; Court House, Greenville, Ga.; West Ga. State Col., Carrollton. Position: T., Parsons Sch. Des. [47]

BELL, W.E. (Mrs.) [P] NYC. Member: Lg. AA [24]

BELL, W(illiam) Wils [P] Terre Haute, IN b. 28 Ag 1864, Green County, IL. Member: Hoosier Salon; Ind. A. Cl. Exhibited: Hoosier Salon, 1941 (prize); Ind. A. Cl., 1943 (prize) [47]

BELLAMY, Edna [S] Norfolk, VA [17]

BELLE, Cécile (Mrs. Ralph M. Carson) [P] Pawling, NY b. 22 Jy 1900, Verdun, France. Studied: Caen; Rouen; Oxford Univ.; Sch. FA, Antwerp, Belgium. Exhibited: Carnegie Inst., 1944, 1945; Springfield Mus. A., 1941-45; Durand-Ruel Gal., 1945 (one-man); Bonestell Gal., 1944 (one-man). Work: IBM. Position: 1st Vice-Pres., Grosvenor Neighborhood House, NYC, 1946- [47]

BELLIN, Milton Rockwell [P,Des,I] NYC b. 6 Je 1913, New Haven, CT. Studied: Yale; New Sch. Soc. Res.; Brodovitch; Kuniyoshi. Member: Conn. WC Soc. Exhibited: MOMA, 1940 (prize); Springfield AA, 1928, 1937 (prize); Conn. WC Soc., 1940, 1944 (prize), 1945 (prize); Norwich AA, 1946 (prize); CGA, 1939; Conn. Acad. FA, 1941; AWCS, 1941, 1946; New Britain Inst., 1938 [47]

BELLING, Warren [P] Oak Park, IL. Exhibited: Am. Soc. PS. Ann., AIC, 1935; A. Chicago Vicinity, AIC, 1938 [40]

BELLIS, Daisy Maude [P,Des,W,L,Edu] Branford, CT b. 16 F 1887, Waltham, MA. Studied: Univ. Vt.; Mass. Sch. A.; Scott Carbee; Raymond P. Ensign; Hugh H. Breckenridge; Wilbur Dean Hamilton; Lhote Acad., Paris; Thurston Topham, in Montreal. Member: F., Royal Soc. A., London. Exhibited: Copley Soc.; Montreal A. Gal., 1925-33; Renault A. Gal., Montreal, 1928; Walker A. Gal., Liverpool, England, 1930; FAP Exh., 1936-39; Town House, Berkeley, Calif., 1939; San Fran. Gal. A., 1941. Contributor: magazines. Positions: Instr. A., MacDonald Col., McGill Univ., 1922-34; L., FAP, 1936-43 [47]

BELLOWS, George W(esley) [P] NYC b. 12 Ag 1882, Columbus, OH d. 8 Ja 1925. Studied: Maratta; Jay Hambidge; Henri. Member: ANA, 1908; NA, 1913; Am. PS; NAC; S.Indp.A.; Los Angeles Modern AS; Nat. Inst. AL; Boston AC; New SA; Lg AA. Exhibited: NAD, 1908 (prize), 1913 (prize),

1914 (prize), 1916 (med); PAFA, 1913 (med), 1917 (med), 1921 (gold); CI, Pittsburgh, 1913 (prize); 1914 (med), 1922 (prize); P.-P. Expo, San Fran., 1915 (gold); Newport AA, 1918 (prize); AIC, 1916 (med, prize), 1921 (med); NAC, 1922 (prize). Work: MMA; PAFA; Columbus (Ohio) AA; Toledo Mus.; Nat. A. Cl., N.Y.; Ohio State Univ.; R.I. Sch. Des.; AIC; Detroit Inst.; Carnegie Inst. St. Louis Mus.; Albright Gal. [24]

BELL-SMITH, Frederic M. [P,I,T] Toronto, Ontario b. 1846, London d. 1923. Studied: Acad. Colarossi, Paris. Member: Canada SA; RCA; OSA. Illustrator: "Picturesque Canada," 1882 [01]

BELLVILLE, Laura M. [P] Norwood, OH. Member: Cincinnati Women's AC [24]

BELMONT, I(ra) J(ean) [P,W] NYC b. 15 Je 1885, Kaunas, Lithuania d. ca. 1964. Studied: Königsberg; Paris; New York. Member: Salons of Am.; Les Artistes Musicalistes, Paris. Exhibited: Bryn Mawr A. Center, 1945; Belmont Gal., 1945; Phila. A. All., 1929; Renaissance Gal., Paris, 1932; Wildenstein Gal., 1933; Mus. Sc.&Indst., 1940. Work: BM; Crocker Coll., San Fran.; Heckscher Fnd.; Univ. Ga.; Musée du Jeu de Paume, Paris. Author: "Modern Dilemma in Art," 1944. Contributor, articles/illus., Art News, Art Digest, Gazette des Beaux-Arts. Originator: "Color-Music: Neo Expressionism" [47]

BELMONT, Lillian (Lu) [P,T] Ridgefield, CT b. 23 Je 1907 NYC. Studied: ASL, with Kenneth Hayes Miller, Kimon Nicolaides, Minna Citron. Member: NAWA; A. Lg. Am.; Ar. of Today. Exhibited: Ar. of Today, Newark, N.J. (one-man); Contemporary A. Gal.; Ferargil Gal.; NAC. Position: T., BM, 1946– [47]

BELO, Jane [Li,W] Bali, Dutch East Indies b. 3 N 1904, Dallas. Contributor: Scribner's, Bookman, Forum, "American Anthropologist" [40]

BELSKIE, Abram [S] Closter, NJ b. 24 Mr 1907, London. Studied: Glasgow Sch. A., with Alexander Proudfoot, Archibald Dawson. Member: NSS. Exhibited: Glasgow, 1925, 1926, 1927; NAD, 1936, 1946. Work: Brookgreen Gardens, S.C.; Jewish Theological Sem. of Am.; Mariners Mus., Newport News, Va.; AMNH; Field Mus.; Cleveland Health Mus.; N.Y. Acad. Medicine. Co-author: "Birth Atlas," 1940. Position: Sculptor Assoc., N.Y. Acad. Medicine, 1939–46 [47]

BELT, A. Elmer [Art Lib.Dir,L] Los Angeles, CA b. 10 Ap 1893, Chicago, IL. Studied: Univ. Calif. Member: CAA; AMA. Exhibited: AMA Exh., 1922 (med). Position: Dir., Elmer Belt Lib. of Vinciana, Los Angeles [47]

BELVILLE, Alice M. [P] NYC [17]

BEMAN, Jean. See Cook-Smith, Mrs.

BEMAN, Roff [P,T] Chicago, IL b. 6 F 1891, Chicago. Studied: Nodin, in Paris; Walcott; Sloan; Emil Armin. Member: Chicago A. Cong.; Chicago NJSA; United Am. Ar. Exhibited: WFNY, 1939. Work: WPA, Ill. [40]

BEMELMANS, Lampert [Des,S] Miami, FL b. 28 Ja 1871, Regensburg, Germany. Studied: Schenckenhoeer, in Germany; Rompatscher, in Italy; Cedarstrom, Brewster, in N.Y. Exhibited: WFNY, 1939. Work: Gesu Church, Miami [40]

BEMENT, Alon [Edu,Des,P,L,W] NYC b. 15 Ag 1876, Ashfield, MA d. 22 N 1954. Studied: BMFA Sch.; Ecole des Beaux-Arts, Paris; Sloyd Sch., Sweden; Académie Julian, Paris. Member: SC; AAPL; Lg. N.H. A.&Crafts. Exhibited: SC, 1935–37; Silvermine Gld., 1935–37. Author: "Figure Construction." Contributor: national magazines. Positions: Prof., T. Col., Columbia Uiv., 1908–20; Dir., Md. Inst., 1920–25; Dir. A. Center, N.Y., 1925–32; Dir., Nat. All. A.&Indst., 1932–38; Dean, Traphagen Sch. Fashion, 1946– [47]

BEMENT, Frank A. [P] NYC [08]

BEMIS, Waldo Edmund [Des,I] Oakdale, NY b. 26 Jy 1891, Covina, CA d. 9 S 1951. Studied: Los Angeles Sch. A.&Des.; Univ. Calif.; Grand Central A. Sch.; Harvey Dunn. Positions: A. Dir., Foster & Kleiser, Forbes Litho. Co., Pacific Railways [47]

BEMUS, Mary B. (Mrs.) [P,T] Santa Barbara, CA/Owensmouth, CA b. 17 Ag 1849, Leicester, NY. Studied: L.M. Wiles. Member: Laguna Beach AA [21]

BENDA, W(ladyslaw) T(heodor) [L,Des,I] NYC b. 1873, Poznań, Poland (came to U.S. in 1899) d. 30 N 1948. Studied: Acad. FA, Cracow, Poland. Member: SI. Exhibited: P.-P. Expo, 1915 (med). Designer/originator: Benda masks, used on stage. Naturalized, 1911. [47]

BENDER, Russell Thurston [P] Chicago, IL b. 1895, Chicago. Studied: Chicago Acad. FA. Member: Palette and Chisel Cl. [24]

BENDINER, Alfred [Car,Li,I,Arch] Phila., PA b. 23 Jy 1899, Pittsburgh. Studied: Pa. Mus. Sch. Indst. A.; Am. Acad., Rome; Univ. Pa.; Paul Cret. Member: AIA; Phila. WC Cl.; Phila. A. All. Exhibited: PAFA, 1946 (prize); Phila. Pr. Cl., 1938 (prize), 1944 (prize); Lib. Cong.; PMA; NAD, 1930–46; Phila. A. All.; Graphic Sketch Cl. Work: NGFA; Lib. Cong.; PMA; PAFA; Princeton; Univ. Pa.; Rosenwald Coll. Artist: Joint Assyrian Expedition, Iraq, 1936–37. Illustrator: "Tepe Gawra," Vol. II. Illustrator: Holiday, Scribner's. Author: travel articles, Pa. Gazette. Position: Caric., Phila. Evening Bulletin, 1938–46 [47]

BENEDICT, Augusta B(urke) (Mrs. Stewart B.) [S] Plainfield, NJ/Shelter Island, NY b. 21 Ja 1897, NYC. Studied: Victor Salvatori. Member: NAWPS; Plainfield AA. Exhibited: Jr. Lg. Exh., Newark Mus., 1931 (prize) [40]

BENEDICT, Enella [P] Chicago, IL b. Chicago. Studied: AIC; ASL; Académie Julian, Paris, with Lefebvre, Constant, Laurens [13]

BENEDICT, F.M. [P] Lawrence, KS [09]

BENEDICT, J.B. [P] Denver, CO [24]

BENEDICT, Milner [P,Edu,L] Atlanta, GA b. 5 Ja 1916, Birmingham, AL. Studied: Univ. Ala.; PAFA; Grand Central A.; José Rey. Member: SSAL; Assn. Ga. A.; Atlanta AA. Exhibited: Paris Salon, 1938–39; SSAL, 1944–46; Ga. AA, 1945, 1946; Atlanta AA, 1942–46. Position: Dir. A., Oglethorpe Univ. [47]

BENEDICT, Nina [P] Louisville, KY. Member: Louisville AL [01]

BENEDICT, Vida G. [C,T,L] Buffalo, NY b. 22 Ja 1888, Buffalo. Studied: Charles Pagnier, Ingeborg Borjeson, both in Paris; Giuglio Giannini, in Florence. Member: N.Y. Soc. Book Workers; Boston Soc. A.&Crafts; Buffalo Gld. All. A. Exhibited: GGE, 1939; Paris Salon, 1934, 1937; Gld. All. A.; Phila. AC. Lectures: Bookbinding [47]

BENEDUCE, Antimo [P] Chicago, IL b. 28 Mr 1900, Naples, Italy. Studied: Cleveland Sch. A.; NAD; Charles Hawthorne; Henry G. Keller. Member: Chicago AC; Phila. WC Cl.; AWCS; Cleveland SA; CGA, 1929 (one-man); Albany Inst. Hist.&A., 1933 (one-man); AIC, 1945; Akron AI, 1939 (one-man). Work: Akron AI; CM; Vanderpoel Coll. [47]

BENEKER, Gerrit A. [P,W,L] Truro, MA b. 26 Ja 1882, Grand Rapids, MI d. 23 O 1934. Studied: AIC; ASL; John Vanderpoel; Frederick Richardson; F.V. DuMond; Henry Reuterdahl; Charles W. Hawthorne. Member: SC; Provincetown AA; Beachcombers C.; Am. APL. Exhibited: Scarab Cl., Detroit, 1916 (prize); Cleveland Mus., 1919 (prize). Work: Provincetown AA; Butler A. Inst., Youngstown, Ohio; Grand Rapids A. Gal.; Victory Liberty Loan Poster, "Sure, We'll Finish the Job" [33]

BENEKER, Katharine [Mus.Cur,P,T] NYC b. 11 My 1909, Brooklyn, NY. Studied: PMSch.IA; Mass. Sch. A.; Richard Miller; Charles W. Hawthorne. Exhibited: AWCS, 1942–45; NAWA, 1943, 1944; Provincetown AA, 1938–41. Positions: T., Brewster, Mass., 1932-36; Supv. Exh., Am. Mus. Natural Hist., 1940– [47]

BENEPE, Katharine Buzzell [Por.P,T] Glendale, CA b. Fort Benton, MT. Studied: UCLA; J. Francis Smith; Nicolai Fechin; Elmer Schofield. Member: Los Angeles AA; Pasadena Assn. All. A.; San Diego AG; Los Angeles S.Indp.A.; Glendale A. Exhibited: Pasadena Civic A. Exh., 1936 (prize) [40]

BENESCH, Otto [Mus.Cur,Hist,W,L] Cambridge, MA b. 29 Je 1896, Ebenfurth, Austria d. 16 N 1964. Studied: Univ. Vienna. Member: F., Guggenhim; Austrian Univ. Lg. AM. Author: books on art and artists. Contributor: art magazines and periodicals. Lectures: history of painting, drawing, and graphic arts. Positions: Cur., Albertina Mus., Vienna, to 1938; T., Harvard [47]

BENGOUGH, William [P,I] Kiamesha, NY b. 14 O 1863, Whitby, Ontario d. 25 S 1932. Studied: Ontario Soc. Ar.; Toronto; ASL. Member: NAC. Work: Harper's, London Graphic, Collier's; "Cyclopaedia of American Biography." During the Spanish-American War his drawings made in the war zone in Cuba were widely published in the newspapers. [13]

BENGTZ, (Eric Algot) Ture [P,E,Li,T,Des,L] Melrose, MA b. 23 O 1907, Westansunda, Aland, Finland. Studied: BMFA Sch. Member: Gld. Boston A. Exhibited: Currier Gal., Manchester, N.H.; Mariehamn, Aland;NAD, 1941, 1942, 1943 (prize), 1944–46; AIC, 1946; Carnegie Inst.;CGA, 1941; Lib. Cong., 1944, 1946; Pal. Leg. Honor, 1946. Work: Vanner's Coll., Aland. Position: Head, Dept. Drawing, Graphic Arts & Anatomy, BMFA Sch. [47]

BENHAM, C.C. [P] NYC [01]

BENISOVICH, Michel N. [L,W,T] NYC b. 28 Je 1891, Russia. Studied: NYU, with W. Friedlaender, Offner, Weinberger; abroad. Member: CAA.

Author: "N.A. Taunay, 1753–1830, Undercurrents in French Paintings." Contributor: art magazines. Lectures: French 17th-century Painting [47]

BENJAMIN, Charles Henry [P,C,W,L,T] Altadena, CA b. 29 Ag 1856, Patten, ME d. 1 Ag 1937. Studied: self-taught. Member: Lafayette (Ind.) AA; Wash. WCC; Calif. WCS; AFA [38]

BENJAMIN, Gershon [P] NYC b. 6 Ja 1899, Romania. Studied: ASL; CUASch; Montreal AA; Educational All., N.Y.; Joseph Pennell. Member: Indp. A. Am. Exhibited: BM, 1939; AIC, 1939; Carnegie Inst., 1945; Contemporary A. Gal., 1937 (one-man); Uptown Gal., 1936 (one-man) [47]

BENJAMIN, Lucile J., Mrs. See Joullin.

BENJAMIN, Marguerite [I] b. 1897, Saginaw, MI d. 2 Ap 1936, Orleans, MA. The wife of Charles Taselau, portrait painter, she specialized in illustrations for children's books.

BENJAMIN, Nora [Li,I] NYC/Noroton, CT b. 4 Ja 1899, NYC. Studied: Boardman Robinson; Kimon Nicolaides; Charles Locke. Member: ASL. Work: New Yorker, children's books [47]

BENJAMIN, Paul [P] Arlington, VT b. 26 Je 1902, NYC. Studied: ASL; Gifford Beal; William McNulty; William von Schlegell. Member: Ar. Aid Committee, NYC, 1932–35. Work: White House; U.S. Gov. [40]

BENJAMIN, Samuel Green Wheeler [Mar.P,I,W,L] Burlington, VT/Charlotte, VT b. 13 F 1837, Argos, Greece (the son of an American missionary) d. 19 Jy 1914. Studied: Williams Col.; Carlo Brindesi; W.E. Norton; S.L. Gerry. Member: Boston A. Cl. Exhibited: Boston, 1884 (prize). Studio in Boston, 1870–1881. During the Crimean War he went to the front for the London Illustrated News. In 1883 he was appointed the first United States Minister to Persia, and served until 1886. Among his literary works are "Art in America," "Constantinople, Isle of Pearls and other Poems," "The Story of Persia." Position: Ed., American Dept., Magazine of Art [13]

BENN, Ben [P] NYC b. 27 D 1884, Russia. Studied: NAD. Member: Am. Soc. PS&G; Am. A. Cong. Work: MMA; Newark Mus.; Albany Inst. Hist.&A.; Mus. City of New York; Kröller Coll., The Hague; WMAA [47]

BENNERS, Ethel Ellis de T(urck) (Mrs. Alfred Eugene, Jr.) [P,Dec] Phila., PA/Pottersville, NY. Studied: Breckenridge; Anshutz; William M. Chase; Cecilia Beaux. Member: F., PAFA; Plastic Cl.; Phila. A. All. Work: dec., Congress Hotel ballroom, Baltimore; Hotel Wellington lounge, Phila.; co-painter with Lucile Howard, American Women's Assoc. Club House ballroom, New York [40]

BENNETT, Alfred H. [P] Pittsburgh, PA b. 19 D 1891, Pittsburgh. Studied: Univ. Pittsburgh; Christian Walter. Member: Assoc. A., Pittsburgh. Exhibited: Carnegie Inst., 1932 (prize), 1937 (prize). Work: Pa. State Col. [47]

BENNETT, Belle [S] NYC. Member: NAWPS [24]

BENNETT, Bertha (Mrs.) [P,E,Li] San Antonio, TX b. 5 Mr 1883, Eastland, TX. Studied: San Antonio Sch A., with Henry F. McFee; San Antonio AI, with Charles Rosen. Member: San Antonio A. Lg.; San Antonio Pr.M.; Tex. FA Acad.; Nat. Inst. A.&L. Exhibited: Denver A. Mus.; Tex. FA Acad., 1937–46; Jacksonville, Miss. (one-man); Borglum Studio, San Antonio (one-man) [47]

BENNETT, Bertha Forbes [P,I] Ridgewood, NJ b. 10 Jy 1886, Yokohama, Japan. Studied: PIASch.; DuMond [17]

BENNETT, Bessie [C,T,P] Chicago, IL b. Cincinnati. Member: SWA; BSA; Chicago A.&Crafts Cl. [09]

BENNETT, Charles A(lpheus) [C,W,T] Peoria, IL b. 28 Mr 1864, Holden, MA. Editor: Industrial Education Magazine. Author: "The Manual Arts" [21]

BENNETT, E(mma) (Dunbar) (Mrs. Harrison Bennett) [S] Paris, France b. New Bedford, MA. Studied: Brit. Acad., Rome. Member: Copley S.; MacD. Cl.; Lyceum Cl., Paris [33]

BENNETT, Emma-Sutton (Carter) (Mrs.) [P,I,E] St. Louis, MO b. 26 Ag 1902. Studied: Hayley Lever; ASL. Member: ASL; Three Arts Cl.; Salons of Am.; Indp. A., New York; Indp. A., St. Louis; Chicago No-Jury SA; SSAL; Miss. AA. Exhibited: etching/textiles, Chattanooga Inter-State Fair, 1930 (prizes); drawing, Miss. State Fair, 1930 (prize) [40]

BENNETT, Francis I. [P] Nutley, NJ/Normandy Beach, NJ b. 8 Mr 1876, Phila. Studied: Anshutz; Chase; Henri; Vonnoh. Member: AAPL [33]

BENNETT, Franklin [P,E] Oakland, CA b. 5 Ja, 1908, Greensport [no state given]. Studied: ASL. Member: NAC; AAPL; Bay Region AA, Oakland. Exhibited: NAC, 1928 (prize). Work: NAC; Randolph-Macon Col. [40]

BENNETT, Frederick [P] Rochester, NY. Exhibited: WC Ann., PAFA, 1935; Great Lakes Exh., The Patteran, 1938 [40]

BENNETT, Georgia E. [P,W] Worcester, MA b. Woodstock, OH. Studied: William E. Schumacher; Hans Hofmann; Eliot O'Hara. Exhibited: Ogunquit A. Assn., 1939 [40]

BENNETT, H(enry) H. [P,I,] Chillicothe, OH b. 5 Dec 1863, Chillicothe. Studied: ASL. Director of art and decorative features for the Ohio Columbus Centennial, Columbus [13]

BENNETT, Isabelle Jewel [P,T] Santa Monica, CA b. 5 Jy 1908, Covina, CA. Studied: UCLA. Member: Calif. WC Soc.; Los Angeles AA; A. T. Southern Calif. Exhibited: Calif. WC Soc., 1933 (prize). Position: T., Pasadena Jr. Col. [40]

BENNETT, John [S,C,I,W] Charleston, SC b. 17 My 1865, Chillicothe, OH. Studied: ASL; Cincinnati A. Acad. Member: S.C. AA. Work: Pub. Libs., Chattanooga, Charleston, both in S.C., Wilkes-Barre, Pa. Author: "Madame Margot," 1921, other books. Illustrator: "Primitive Man in Ohio," by Moorehead. Author/Illustrator: "Pigtail of Ah Lee Ben Loo," 1928 [40]

BENNETT, Joseph Hastings [E,P] Piedmont, CA b. 27 Mr 1889, San Diego. Studied: Armin Hansen. Member: Calif. SE; Calif. PM; Phila. Pr. Cl.; Carmel AA. Exhibited: dry points, Calif. State Lib. [40]

BENNETT, Louis (Mrs.) [P] NYC/Weston, WV. Member: NAWPS [24]

BENNETT, Lyle Hatcher (Mrs. Herman) [P,Li,T] North Hollywood, CA b. 24 Je 1903, Beckley, WV. Studied: Northwestern; W.Va. Univ.; ASL; Robert Brackman; Hans Hofmann. Member: All. A. W.Va.; San Fernando AC. Exhibited: Parkersburg FA Center, 1940, 1943 (prize); All. A. W.Va., 1935, 1936 (prize); 1937–38, 1939 (prize), 1940–45; IBM, 1937,1940 (prize); WFNY, 1939; VMFA, 1939; Butler AI, 1940, 1943; Ohio Valley A., 1943, 1944; Intermont Col., 1944, 1945; Los Angeles Mus. A., 1946 [47]

BENNETT, Mary Elizabeth [P,I] Middletown, CT b. 27 S 1877, Coventry, CT. Studied: PIASch; Berkshire Summer Sch. A. Member: Hartford Soc. Women P.; Hartford AC. Illustrator: Conn. state bulletin on geology of Middletown, Conn. and vicinity [47]

BENNETT, Rainey [P,Mur.P] Chicago, IL b. 1907. Studied: AIC; Grosz. Exhibited: Intl. WC Exh., AIC, 1936; 48 Sts. Comp., 1939. Work: murals, Peoples Gas Co. of Ill. (Chicago), Rushville, Ill., Dearborn, Mich., Sect. FA, Fed. Works Agency. Position: Supervisor, Chicago Fed. A. Proj., 1937 [40]

BENNETT, Reginald (Osborn) [P,T,Mur.P] Ferndale, MI b. 20 F 1893, Devils Lake, ND. Studied: J.P. Wicker; J. Despujols; Otehon Friez. Member: Scarab Cl. Exhibited: Detroit, 1929 (prize); Friends Mod. A., 1933 (prize). Work: murals, City Hall (Detroit), Fordson Board Edu. (Dearborn), Lansing. Position: Instr., Gen. Motors Styling Sect., Detroit [40]

BENNETT, Reo [P,I] NYC [01]

BENNETT, Richard [Wood En,I,T] New Rochelle, NY b. 22 Jy 1899, Ireland. Studied: Walter Isaacs; Ambrose Patterson. Member: Northwest PMA. Illustrator: New York Times Magazine, Bookman, Theatre Arts Monthly, Forum, Survey, Graphic, "England and Ireland—Twelve Woodcuts," 1927, pub. Univ. Wash. Press; Baltimore Mus.; NYPL [40]

BENNETT, Ruth H. [I] Dover, NJ b. 1883 d. 20 F 1947. Studied: CUASch. Illustrator: children's books. Position: Vice-pres., PBC, New York

BENNETT, Ruth M. [Cr,T,P] Hollywood, CA b. 11 F 1899, Momence, IL d. 21 Jy 1960. Studied: ASL; Otis AI; Chouinard AI; John Carlson; Emily Mocine; George Bridgman; Millard Sheets; Armin Hansen, Karoly Fulop; E. Vysedal. Member: Calif. WC Soc. Exhibited: Calif. AC, 1926 (prize); Los Angeles County Fair, 1926 (prize), 1927 (prize), 1929 (prize), 1930 (prize), 1932 (prize), 1933 (prize), 1936 (prize), 1937 (prize); Los Angeles Mus., 1925 (prize), 1934 (prize); Tri-Craft Gld., 1937 (prize). Teacher: woodcarving [47]

BENNETT, Virginia Davisson (Mrs. Francis L.) [P,W] Bloomfield, NJ d. 18 O 1944. Author: children's books

BENNEY, Robert L. [P,I,Des,L] NYC b. 16 Jy 1904, NYC. Studied: CUASch.; ASL; NAD; Grand Central Sch. A.; Frank Nankivell; Harvey Dunn; Bridgman; Biggs; Cornwell. Member: ASL; N.Y. S.Indp.A.; Am. Ar. Prof. Lg.; AAPL; A. Gld.; SI. Exhibited: PMA (prize); A. Dir. Cl. (Abbott Lab.), 1945 (med); CUASch. (prize); NAD; CGA, 1941; Currier Gal., 1940; VMFA, 1940; BMFA, 1944; AIC, 1944; Inst. Mod. A.; NGA, 1943, 1945; MMA, 1943; Carnegie Inst., 1943; BM; Montreal AA;

de Young Mem. Mus., 1945; Dallas Mus. FA, 1945; Portland Mus. A., 1945; Arch. Lg.; NYPL; Newspaper A. Exh., 1938; N.Y. S.Indp.A.; Phila. Pr. Cl.; NYWCC; Mus. City New York (one-man). Work: NYPL; Mus. City New York; Shell Oil Co.; RCA-Victor Co.; Abbott Lab.; U.S. Navy; U.S. Army; U.S. War Dept.; Standard Oil Co.; Chrysler Corp. Illustrator: "Naval Aviation," 1944, national magazines [47]

BENOLKEN, Leonore [P,L,T] Omaha, NE b. 14 Mr 1896, Saskatchewan, Canada. Studied: J. Laurie Wallace; Augusta Knight. Member: Omaha AG; AAPL; PBC. Exhibited: Five States' Exh., 1934–39; Blanden Mem. Gal., Fort Dodge, Iowa. Lectures: The Working Side of Art. Positions: Supervisor/Instr., Adult Art Dept., Omaha Univ. [40]

BENRIMO, Thomas D. [P,I,T] Taos, N.Mex. b. 1887, San Fran. d. 1958. Studied: self-taught; ASL. Work: Fort Worth AM; Mus. N.Mex.; Denver AM. Lived in NYC, 1906–39. Position: T., Pratt Inst., 1935–39 [15]

BENSCO, Charles J. [Por.P,L,T] Los Angeles, CA b. 19 F 1894, Austria Hungary d. N 1960, Phoenix. Studied: Milton Banckroff; George Bridgman; William Chase; Ernest Blumenschein. Member: Calif. AC. Exhibited: Ebell Exh., 1937 (prize). Lectures: art, painting [40]

BEN-SHMUEL, Ahron [S] NYC/Upper Black Eddy, PA b. 18 Ja 1930, NYC. Member: F., Guggenheim Mem.; NSS; Am. Soc. PS&G. Work: MOMA; BM; Smith Col. Mus. A. Contributor: articles, Studio News, Arts Weekly [40]

BENSING, Frank S. [I,P,Des] NYC/Woodstock, NY b. 29 O 1893, Chicago. Studied: AIC; De Forrest Schook; W.J. Reynolds; Walter Biggs. Member: AWCS; A.&W.; SI; SC; A. Gld.; A. Fellowship. Exhibited: NAD; All.A.Am.; SC; AWCS. Illustrator: national magazines [47]

BENSINGER, Anne Mosejiere [P,T] Los Angeles, CA b. 29 Jy 1906, Topeka, KS. Studied: UCLA; Chouinard Sch. A.; Edouard Vysekal; Millard Sheets; Guy de Bouthier; Alexander Archipenko. Member: Calif. WC Soc.; Calif. AC. Exhibited: Calif. WC Soc., Pomona, 1930 (prize); Calif. State Fair, 1931 (prize), 1933 (prize) [40]

BENSLEY, Martha S. [P,I,T,W] Chicago, IL b. Chicago. Studied: AIC; Chase; Duveneck; Wiles; Van Ingen [13]

BENSON, Agnes [P,I] Minneapolis, MN [17]

BENSON, Ben Albert [B,E,Wood En,I] Downers Grove, IL b. 23 Ja 1901, Bollnas, Sweden. Studied: AIC; ASL; Univ. Nebr.; Bridgman; Lewis. Member: Swedish A. Chicago; Phila. Pr. Cl.; The Westerners. Exhibited: Am. Leg., 1925 (prize); Swedish-Am. A., Chicago, 1946; Northwest Pr.M.; Wichita Pr. Exh.; Joslyn Mem., 1945 (one-man); Swedish Soc. A., Chicago [47]

BENSON, Eda Spoth [P,En,S,T,] West Palm Beach, FL b. 25 Mr 1898, Brooklyn, NY. Studied: ASL; BAID; Europe; Eugene Steinhof; Alexander Hofa; Leon Dabo. Member: Springfield AA; Palm Beach A. Lg.; Stockbridge A. Lg. Exhibited: Miami State Expo, 1929 (prize); Palm Beach A. Lg., 1933 (prize), 1934 (prize); Lime Rock AA, 1932; Lib. Cong., 1943–45; AFA Traveling Exh., 1943–45; BM, 1933–46; Palm Beach A. Lg., 1929–46; Springfield A. LG., 1940–45; NAD, 1942, 1943; Lime Rock AA, 1927–33; Stockbridge AA, 1927–33; Albany Inst. Hist.&A., 1932 (one-man); Fla. Fed. A., Miami, 1930 (prize). Work: Pub. Lib., Hartford [47]

BENSON, Frank W(eston) [P,E,T] Salem, MA b. 24 Mr 1862 d. 15 N 1951. Studied: BMFA Sch.; Boulanger, Lefebvre, in Paris. Member: ANA, 1897; NA, 1905; Ten Am. P.; Nat. Inst. A.&L.; Chicago SE; Por. P.; Boston GA; Soc. Am. E.; Am. Acad. A.&Sciences. Exhibited: NAD, 1889 (prize), 1891 (prize), 1906 (prize); Columbian Expo, Chicago, 1893 (med); Mechanics Assn., Boston (med); Cleveland A. Assn. (prize); Boston AC 1895 (prize), 1896 (prize); SAA, 1896 (prize); CI, 1896 (med), 1899 (med), 1903 (gold); Paris Expo, 1900 (med); Pan-Am. Expo, Buffalo, 1901 (med); PAFA, 1903 (prize), 1908 (gold); St. Louis Expo, 1904 (2 gold); Phila. AC, 1906 (gold); Corcoran Gal., 1907 (prize), 1919 (gold, prize); Chicago SE, 1918 (prize); AIC, 1909 (med), 1912 (med, prize), 1922 (prize); Phila. WC Soc., 1924 (gold); Sesqui-Centenn. Expo, Phila., 1926 (gold); Phila., 1929 (med). Work: Cincinnati Mus.; CI; Buffalo Acad. FA; R.I. Sch. Des.; BMFA; Worcester A. Mus.; Chicago AI; MMA; Corcoran Gal.; Detroit Inst. A.; Butler A. Inst.; Los Angeles Mus. A. [47]

BENSON, Hannah Nicholson (Mrs. Adolph B.) [P,W,L] New Haven, CT b. Pawtucket, RI. Studied: Brown; Henry Davenport; C. Gordon Harris. Member: CAFA; New Haven PCC. Exhibited: CAFA, 1934, 1935; New Haven PCC, 1928–46. Author: "The Craftsman," "Swedish Weaving." Lectures: Scandinavian art, Swedish art [47]

BENSON, John Howard [Des,S,W,L] Newport, RI b. 6 Jy 1901, Newport d. 23 F 1956. Studied: NAD; ASL, with Joseph Pennell, Lewis. Member: Providence AC; Newport AA. Work: sculpture, Cold Spring Harbor, N.Y.; South Natick, Mass.; Porstmouth, N.H. Co-author: "The Elements of Lettering," 1940. Author: "Lettering Portfolio," pub. BMFA. Lectures: lettering, theory of design. Positions: Instr., Lettering, 1931–44, Head, Dept. Sculpture, 1936–46, Head, Lettering Workshop, 1945– , R.I. Sch. Des. [47]

BENSON, John P. [Mar.P] Kittery, ME b. 8 F 1865, Salem, MA d. 16 N 1947. Member: AFA; Gld. Boston A. Exhibited: Jordan Marsh Exh., Boston, 1937 (gold, prize). Work: BMFA; Dayton AI; AMNH; Old Stone Bank, Providence; Peabody Mus., Salem [47]

BENSON, John William [P,E,T] Brooklyn, NY b. 12 O 1904, Brooklyn, NY. Studied: Eugene Savage; Edwin C. Taylor. Exhibited: NAD, 1931 (prize) [40]

BENSON, Leslie L(angille) [I] Norwalk, CT b. 15 Mr 1885, Mahone, Nova Scotia. Studied: BMFA Sch.; Eric Pape Sch.; Fenway Sch. Member: SC. Illustrator: commercial, also magazines [40]

BENSON, Nesbit [P] NYC. Member: SI, 1911 [19]

BENSON, Stuart [S,W] NYC b. 3 Ja 1877, Detroit. Studied: Gies Sch. A., Detroit. Member: NSS. Exhibited: NAD; CI; PAFA; WFNY, 1939; AIC; Salon d'Automne, Salon des Tuileries, Salon des Independents, all in Paris. Work: MMA; AIC; Nelson Gal. A.; Honolulu Acad. A. Contributor: national magazines [47]

BENSON, Tressa Emerson (Mrs. B.A.) [P,T] Downers Grove, IL b. 28 Je 1896, Bucksport, ME. Studied: Acad. Colarossi, Acad. de la Grande Chaumière, both in Paris; Hawthorne; C. Amborse Webster. Member: F., Syracuse Univ.; Lincoln A. Gld.; Chicago SA; NAWA. Exhibited: Kansas City AI, 1929 (med); AIC, 1931–36, 1937 (prize), 1938, 1941, 1942, 1944; Mandel Bros., Chicago, 1941 (one-man); Joslyn Mem., 1943 (one-man). Position: Dir. A., Avery Coonley Sch., Downers Grove, 1946– [47]

BENTHAM, George [I] b. 1850, Ireland d. 8 Ap 1914, Fordham (N.Y.) Home for Incurables. He did work for the Century Magazine, and was for several years an artist on the Chicago Post. He was prominent as a silverpoint artist, and was noted for his collection of books and curios. He came to the U.S. in 1889.

BENTLEY, Alfred [E] NYC. Member: Calif. PM [24]

BENTLEY, Claude Ronald [P,Li] Chicago, IL b. 9 Je 1915, NYC. Studied: Northwestern; Am. Acad. A., Chicago; AIC, with Louis Ritman, Max Kahn. Exhibited: Elgin Acad., 1941; Denver A. Mus., 1941; AIC, 1941; Assoc. Am. A., Chicago, 1946 [47]

BENTLEY, Harry H. [P] Evanston, IL [24]

BENTLEY, John William [P] Woodstock, NY b. 3 Ja 1880, Paterson, NJ. Studied: George Bridgman; DuMond; Robert Henri. Member: Ridgewood AA. Exhibited: Ridgewood AA, 1940 (prize); Buffalo SA, 1921 (prize); State Fair, Sacramento, Calif., 1924 (prize). Work: City Hall, Kingston, N.Y.; U.S. Gov. Bldgs., schools, N.Y.; WPA Fed. A. Project; Dutch Reformed Church, Woodstock [47]

BENTLEY, J.T. [I] Tenafly, NJ [19]

BENTLEY, Lester W. [P,Li,Mur.P] White Plains, NY b. 29 Mr 1908, Two Rivers, WI. Studied: AIC; Carl Buehr; Louis Ritman; Boris Anisfeld; Chapin; Valentine Vedauretta; abroad. Exhibited: Wis. Sal., 1937 (prize), 1939 (prize); Kansas City AI, 1938, 1939 (prize); Milwaukee AI, 1940 (prize), 1941 (prize); AIC; CGA; VMFA; CI; GGE, 1939; Wis. P.&S. Work: mural, USPO, DePere, Wis.; Neville Pub. Mus., Green Bay [47]

BENTLEY, Benedict [P] Merchantville, NJ. Member: Phila. AA [21]

BENTON, Harry Stacy [P,I] Norwalk, CT b. 11 O 1877, Saratoga Springs, NY. Studied: AIC. Member: Silvermine GA [33]

BENTON, Mary [P] NYC [05]

BENTON, Thomas Hart [P,Mur.P,T,W] Kansas City, MO b. 15 Ap 1889, Neosho, MO d. 1975. Studied: AIC, 1906–07; Académie Julian, Paris, 1908–11. Exhibited: Arch. Lg., 1933 (gold); Wanamaker's Exh., NYC, 1934 (prize). Work: MMA; Wanamaker Gal. Coll.; MOMA; BM; Capitol, Jefferson, Mo.; Ind. State Univ.; New Sch. Soc. Res.; WMAA. Author: "An Artist in America." Painted in NYC, 1912–32. Specialty: realistic murals and portraits representative of ordinary life and occupations of the Middle West. Position: Head, Dept. P., Kansas City AI [47]

BENTZ, John [P] Leonia, NJ b. Columbus, OH d. 1 Ag 1950. Studied: Robert Blum; Kenyon Cox, W.M. Chase. Member: ASL; Pa. S. Min. P.; Am. S. Min. P. Exhibited: Leonia AS, 1932 (prize); S. Min. P., 1937 (med) [47]

BENVENUTI, Robert [P] NYC. Member: Arch. Lg., 1899 [04]

BENZ, Mildred Wiggins [P] Toppinish, WA [24]

BENZ, Otto Charles [Des,P,L] Paterson, NJ b. 6 F 1882, Paterson. Studied: ASL; Chase Sch. A.; Harry Emmons; Carl Lenz. Member: Ridgewood AA; Paterson AA. Exhibited: Ridgewood, Montclair, Newark, East Orange, N.J.; New York; Rockport, Gloucester, Mass. Specialty: textile design [47]

BENZIGER, August [Por.P] NYC/Brunnen, Switzerland b. 2 Ja 1867, Einsiedein, Switzerland. Studied: Royal Acad., Vienna; Académie Julian, Paris; Ecole des Beaux-Arts, Paris, with Bonnât. Member: Union Artistique, Paris. Work: Chicago Hist. Soc. [21]

BENZINGER, Ruth [P] Jamestown, NY. Exhibited: NYWCC, 1937; Ar. Western N.Y., 1938 [40]

BEN-ZION [P,T] NYC b. 8 Jy 1897, Ukraine, Russia. Member: Am. Ar. Cong.; United Am. Ar. Exhibited: Passadoit Gal.; Bonestell Gal.; Ar. Gal., N.Y., 1936; Barbizon Plaza Gal., 1938; PAFA, 1940; CI, 1945; WMAA, 1946. Work: MOMA; Newark Mus. [47]

BERARDINELLI, Dennis [P,T,E,Li] Kingston, NY b. 25 Mr 1897, Italy. Studied: John B. Whittaker; Charles W. Hawthorne. Exhibited: NAD, 1926 (med), 1929 (med), 1946; AWCS, 1933; Lib. Cong., 1946; SAM, 1946; New Haven PCC, 1946; Phila. Pr. Cl., 1946; Conn. Acad. FA, 1946. Position: A. Dir., Kingston A. Lg. Sch. [47]

BERCKMANS, Elizabeth (Mrs.) [P] Brooklyn, NY b. 1842, Plainfield, NJ d. 17 Ap 1915

BERD, Morris [T,Li,P] Arden DE b. 12 Mr 1914, Phila., PA Studied: Phila. Graphic Sketch Cl.; PMSchIA. Exhibited: PAFA, 1939, 1941. Position: Instr., Adv. Des., PMSchIA [47]

BERDAN, Anna R. [P] New Haven, CT. Member: New Haven PCC [21]

BERDANIER, Paul F., Sr. [Car,E,P] Jackson Heights, NY b. 7 Mr 1879, Frackville, PA. Studied: Gustave Wolff; Sch. FA, St. Louis; Albert Gihon, in Paris. Member: Chicago SE; SAE; SC; All.A.Am. Exhibited: St. Louis A. Lg., 1919 (prize); SC, 1943 (prize); SAE, 1944 (prize). Work: Jefferson Mem., St. Louis, Mo.; Mus. Moret, France; Univ. Kans.; Howard Univ.; NGFA; NYPL; SC. Position: Cartoonist, United Features Syndicate, 1929– [47]

BEREND, Charlotte (Mrs. Corinth) [P] NYC. Member: NAWPS. Exhibited: NAWPS, 1936–38 [40]

BERENSON, Elizabeth [P] NYC [24]

BERESFORD, Helen Elizabeth [Edu,Des] Columbia, MO b. 5 Ja 1900, Vinton, Iowa. Studied: Iowa State Col.; N.Y. Sch. F.&App.A.; Univ. Iowa. Exhibited: Textile Des. Exh., Univ. Iowa, 1940, 1941; Hist. Costumes Exh., Univ. Mo., 1945, 1946. Position: Assoc. Prof., F.&App.A., Univ. Mo., Columbia, 1929–46 [47]

BERG, George Louis [P] La Jolla, CA b. 27 O 1868, McGregor, IA d. 1 Jy 1941, Los Gatos, CA. Studied: ASL. Member: Gld. Am. P.; New Haven PCC; SC; Silvermine GA; Gld. Seven Arts, Darien, Conn. Work: N.J. Fed. Women's Cl.; Hinckley A. Gal. Position: Chief, Dept. FA, Alaska-Yukon Pacific Expo, Seattle, 1909 [40]

BERG, Waldemar Gustave [P,Des,E] Minneapolis, MN/Bangor, WI b. 19 Ag 1915, Bangor. Studied: Robert Brackman; Glen Mitchell; Edmund Kopietz; Joseph Binder, in Vienna. Member: Minneapolis Inst. A. Exhibited: Interstate Fair, LaCrosse, Wis., 1935 (prizes), 1936 (prizes); Golden Gate Expo, 1939 [40]

BERGAMO, Dorothy Johnson (Mrs. Ralph) [P,Li,T,L] New Hope, PA b. 1 F 1912, Chicago, IL. Studied: Univ. Chicago; F., AIC; Northwestern Univ. Exhibited: AIC, 1938, 1940, 1941, 1943 (prize); San Antonio A. Exh., 1943, 1945, 1946; Cal. A. Exh., 1944; Texas FA Assn., 1945, 1946; Contemporary A. Gal., 1946. Work: Witte Mem. Mus., San Antonio; San Antonio AI. Lectures: modern art. Position: Instr., San Antonio AI, 1945–46, Bergen Jr. Col., Teaneck, N.J., 1946–47 [47]

BERGE, Edward [S] Baltimore, MD b. 3 Ja 1876, Baltimore d. 12 O 1924. Studied: Md. Inst.; Rinehart Sch. S., Baltimore; Académie Julian, Paris; Verlet, Rodin, in Paris. Member: Charcoal Cl.; NSS, 1908; NAC. Exhibited: Paris AAA (prize); Pan-Am. Expo, Buffalo, 1901 (med); St. Louis Expo, 1904 (med); P.-P. Expo, San Fran., 1915 (med). Work: monuments, Baltimore; Mus. Honolulu [21]

BERGE, (Edward) Henry [P] Baltimore, MD b. 29 My 1908, Baltimore. Studied: Md. Inst.; Rhinehart Sch. S., Baltimore, with J. Maxwell Miller; with his father, Edward Berge. Member: A. Un. Baltimore. Exhibited: NAD, 1933; PAFA, 1933, 1934; Baltimore Mun. AA; Md. A.; A. Un., Baltimore. Work: BMA; Zimmerman, Baker, Crozier mem. Position: Instr., S., Md. Inst. [47]

BERGE, Olaf A. [Des,P,C] St. Paul, MN b. 16 Ja 1898, St. Paul. Studied: Cameron Booth; Frederick Calhoun. Exhibited: Minn. State Fair, 1932 (prize), 1936 (prize). Specialty: commercial/industrial design [40]

BERGE, Stephens [P] Baltimore, MD/Snowville, NH b. 29 My 1908, Baltimore. Studied: Md. Inst. Member: Baltimore Ar. U. Work: Municipal A. Soc., Baltimore; Cone Coll., Baltimore. Position: Instr., Md. Inst. FA [40]

BERGEN, George [E] NYC/Stony Creek, CT. Member: SC [24]

BERGER, Anthony [Dr,T] NYC b. 1832, Frankfurt, MO. Studied: Staedelehe Inst. Member: Albrecht Dürer Soc., New York. Exhibited: Am. Inst., New York (med). Teacher: free-hand drawing [98]

BERGER, Frank W. [S,Cr] b. 1846 d. My 1916, Minneapolis. Architectural sculptor; wood carver; instructor in modeling, H.S., St. Paul. His works are in several Minneapolis churches.

BERGER, George [P] Cincinnati, OH [19]

BERGER, Marcia E. [P] Cincinnati, OH. Member: AWCS; Cincinnati Women's AC. Exhibited: AWCS, 1939; CM, 1939; Ohio State Fair, 1935 [47]

BERGER, Marie [P,C] Chicago, IL b. 4 O 1900, Chicago [24]

BERGER, Marie K. See Williams, Arthur S., Mrs.

BERGER, William Merritt [I] NYC b. 14 F 1872, Union Springs, NY. Studied: William M. Chase; George DeForest Brush; Bashet. Illustrator: Scribner's, Pictorial Review, Liberty, also "Joyous Travellers," "Joyous Guests," by Lindsay and Poulsson, pub. D. Lothrop [40]

BERGERE, Richard [P,Des,W] Flushing, NY b. 3 Jy 1912, Chicago. Studied: NYU; Columbia Univ.; ASL, wiith George Bridgman. Exhibited: Assoc. Am. A. Gal.; G Place Gal., 1943; Findlay Gal., 1941; Esquire Gal., 1943 (one-man); CGA, 1937; ASL, 1936; WMAA, 1946; AIC, 1942, 1944; Lib. Cong., 1943. Illustrator: "Treasure Island," 1946 [47]

BERGLUND, Amanda [P] Skokie, IL b. 22 Ja 1879, Stockholm. Studied: AIC; Carl R. Krafft; Increase Robinson. Member: Swedish-Am. AA; North Shore AA; Chicago Mun.A.Lg.; Evanston A. Center. Exhibited: AIC; Milwaukee AI; Century of Progress Expo, Chicago [47]

BERGLUND, Hilma L.G. [P,C] St. Paul, MN/Pine City, MN b. 23 Ja 1886, Stillwater, MN. Studied: St. Paul Sch. A. [24]

BERGMAN, Karola [P] San Fran., CA b. 16 Ap 1902, Prague. Studied: Berlin. Member: San Fran. Soc. Women Ar. [38]

BERGMANN, Franz W. [P,C,I,W] San Fran., CA b. 6 Ag 1898, Dimling, Austria. Studied: Acad. FA, Vienna; Jungwirth; Tichy; Delug. Member: San Fran. AA. Exhibited: Pal. Leg. Honor, 1946 (med), GGE, 1939; AIC; San Fran. AA; SFMA, 1946. Work: mural, USPO, Stockton, Calif., Dollar Steamship liners "President Hoover," "President Coolidge"; SFMA; Mills Col. Illustrator: "This Way to the Circus," 1938. Author/Illustrator: "San Francisco Flips," 1946, other children's books. Position: Instr., Calif. Sch. FA, San Fran. [47]

BERGNES, G. [P] NYC. Member: Phila. WCC [17]

BERGSTROM, Elizabeth T.B. [P] Chicago, IL b. Stockholm. Studied: Frederick M. Grant; Frederick V. Poole; Roy Ketcham; Arthur Gunther. Member: All-Ill. SFA [40]

BERKAN, Otto [Por.P] Passaic, NJ b. 1832 d. 3 O 1906. Work: Catholic Cathedral, Phila. Lived in Phila. for many years.

BERKE, Berenice (Yvette) [W,P,I] NYC b. 25 Ap 1920, NYC. Studied: N.Y. Sch. F.&Appl. A.; N.Y. Sch. Interior Decoration; Beaux-Arts, Fontainebleau, France. Member: NAWA. Exhibited: NAWA, 1944–46; Argent Gal., 1944–46; NAD, 1944–46; Assoc. Am. A., 1945. Author/Illustrator: "Latin American Costumes," 1946. Contributor: national magazines. Positions: Ed., Fontainebleau Alumni Bulletin; Co-producer, PAMAR Television Productions, 1946– [47]

BERKELEY, William Noland [Mus.Dir] Charlottesville, VA b. 1867 d. 25 N 1945. At one time, director of the Hudson River Museum, Yonkers, N.Y.

BERKEY, Ben B. [P] Cleveland, OH b. 6 My 1907, NYC. Studied: Cleveland Sch. A.; Huntington Inst., Cleveland. Work: WPA, Cleveland [40]

BERKMAN, Aaron [P,T,L] NYC b. 23 My 1900, Hartford. Studied: Hartford A. Sch.; BMFA Sch.; Europe. Exhibited: BM, 1941, 1943; AWCS, 1944; ACA Gal. (one-man); Assoc. Am. A. (one-man). Contributor: Art Forum, American Mercury, American Spectator. Position: Dir., YM-YWHA A. Center, New York, 1940– [47]

BERKMAN, Bernece [P,G,T] Chicago, IL b. 6 Ja 1911, Chicago. Studied: AIn. C.; Todros Geller; F. Weisenborn. Member: United Am. Ar., Chicago; Chicago Soc. Ar.; Am. Ar. Cong.; Women's Salon, Chicago; Chicago G. Group. Exhibited: Am. Ar. Cong., 1937; Denver AM; AIn. C., 1938 (Federal Art); Springfield (Mass.) MFA; WFNY, 1939. Work: Univ. Omaha [47]

BERKMAN, Jack [P] Wash., D.C. Studied: George Washington Univ.; Corcoran Sch. A. Member: Wash. A. Gld.; Soc. Wash. A. Exhibited: CGA, 1941, 1942, 1943; Miss. State A., Jackson, 1931; VMFA, 1940; Soc. Wash. A., 1937–46; Wash. A. Gld., 1942–46. Work: Barnett Aden Gal.; Hammond Coll. [47]

BERKMAN-HUNTER, Bernece [Li,Ser,P,T,Des] NYC b. 6 Ja 1911, Chicago, IL. Studied: AIC; New Sch. Soc. Res.; Rudolph Weisenborn; Stuart Davis. Member: A.Lg.Am.; Nat. Serigraph Soc. Exhibited: SAM, 1946 (prize); Denver A. Mus., 1938; AIC, 1938, 1940, 1941; WFNY, 1939; Springfield Mus. A., 1939; MOMA, 1940; MMA, 1942; Carnegie Inst., 1943; Univ. Iowa, 1943; Lib. Cong., 1945; SAM, 1946; Am.A.Cong., 1937; Riverside Mus.; Chicago SA; Ill. State Mus., 1940; Weyhe Gal., 1943. Work: AIC; Carnegie Inst.; SAM; Univ. Iowa; Univ. Mich. Position: T., Serigraphy, Hull House, Chicago [47]

BERLANDINA, Jane (Mrs. J.B. Howard) [Mur.P,Ldscp.P] San Fran., CA b. 13 Mr 1898, Nice, France. Studied: Cours Vivaudy; École Nationale des Arts Decoratifs, Nice; Raoul Dufy; Bernard Naudin. Member: San Fran. AA. Exhibited: CGA, 1935; AIC, 1943, 1944; WMAA, 1943; San Fran. AA. Work: murals, Paris Int. Expo; sets/costumes, San Fran. Opera; SFMA; MMA; GGE, 1939; Stage Door Canteen, San Fran. [47]

BERLENDIZ, Victor [S,C] St. Louis, MO b. 8 Ja 1867, Venice, Italy. Studied: Vincenzo Cadorin [13]

BERLIN, Harry [P,L] NYC b. 10 S 1886, NYC. Studied: NAD. Member: SC; Intl. Soc. AL [15]

BERMAN, Anni Radin [P] Syracuse, NY b. 18 F 1914, NYC. Studied: Am. Sch. Des.; Traphagen Sch. Fashion; Am.A. Sch.; Raphael Soyer. Member: Assoc. A., Syracuse. Exhibited: Indp. A.; Assoc. A., Syracuse; Rochester Mem. A. Gal. Position: Dir., Children's classes, Syracuse Mus. FA, 1939– [47]

BERMAN, Cotelle R. [P] Springfield, MA/Woodmont, CT b. Springfield. Member: Springfield AL; Silvermine Gld. Exhibited: Springfield MFA, 1938 (prize), 1939 [40]

BERMAN, Elliott Walter [P,En] Phila., PA b. 25 Je 1913, Phila. Member: F., PAFA; Lehigh A. All. Exhibited: Laguna Beach AA, 1944; Rittenhouse Square, 1941, 1942, 1944; Allentown Mus. A., 1942, 1943; Lehigh A. All., 1943, 1944; Muhlenberg Col., 1943, 1944 [47]

BERMAN, Eugene [Des,P] Los Angeles, CA b. 4 N 1899, St. Petersburg, Russia d. 1972. Studied: Russia; Germany; Switzerland; France. Exhibited: WMAA; AIC; PAFA; CAM; MOMA; MMA; PMG; Santa Barbara Mus. A.; Hartford Atheneum. Work: PMG; MMA; MOMA; BMFA; Hartford Atheneum; BMA; CAM; AIC; Vassar Col.; Smith Col.; CAD; Albertina Mus., Vienna. Designer: sets/costumes, Ballet Russe de Monte Carlo (1938, 1939, 1943), Am. Ballet Caravan (1941), Ballet Theatre (1942, 1943, 1946) [47]

BERMAN, H(arry) [P] Phila., PA b. 1 Je 1900, Phila. d. 19 N 1932, Mount Pocono, PA. Studied: PAFA; Fred Wagner. Member: F., PAFA. Works: Pa. State Col. A. Mus.; F., PAFA; Pa. Mus. [33]

BERMAN, Samuel [P] NYC [24]

BERMAN, Sarah [P] NYC/East Nassau, NY b. 25 D 1895, Russia. Member: S.Indp.A.; Salons of Am. [33]

BERMAN, Saul [P] NYC b. 18 Ap 1899, Russia. Studied: Charles W. Hawthorne. Exhibited: Am. P.&S, AIC, 1929 (prize); murals, USPOs, Calif., Pa., Thomspsonville, Conn., Sect. FA, Fed. Works Agency [40]

BERMUDEZ, Ramon B. [S,P] Phila., PA. Exhibited: S. Ann. PAFA, 1935; WFNY, 1939 [40]

BERNARD, David Edwin [Li,P,Edu] Maryville, TN b. 8 Ag 1913, Sandwich, IL. Studied: Univ. Ill.; Humbert Albrizio. Exhibited: Ala. WC Soc, 1943; Lib. Cong., 1945, 1946; Denver A. Mus., 1945; San Anotnio, 1945; Springfield, Mo., 1945; Albany Inst. Hist.&A., 1945. Position: Instru., Dept. A., Maryville Col, 1946–47 [47]

BERNARD, Sister Regina [T] b. 1879 d. 27 Mr 1947, Jersey City. Position: T., Art, St. Aloysius Acad.

BERNARDINI, Orestes [Des,P,I] Astoria, NY b. 3 Ag 1880, Lucca, Italy d. N 1957. Studied: Europe. Member: Un. Scenic A. Exhibited: Rome, 1906, 1907; Firenze, 1900–1908; Lucca, 1903. Designer: interiors, churches, theatres, hotels, etc.

BERNAT, Emile [Tapestry, Weaving, Embroidery] Brookline, MA b. Je 1868, Budapest, Hungary. Studied: Gobelin Looms, Paris. Member: Boston SAC. Exhibited: Boston SAC (med). Work: tapestry restorations, Royal Austrian Coll., BMFA, Isabella Stewart Gardner Mus., Boston; R.I. Sch. Des.; Yale Univ. Mus., and others [40]

BERNAT, Martha Milligan [S] Mansfield, OH b. 5 Ag 1912, Toledo, OH. Studied: Cleveland Sch. A., with Alexander Blazys. Member: Toledo AC Cl. Exhibited: CMA, 1935 (prize); Toledo Mus. A., 1936. Work: St. Peter's Church, Mansfield [47]

BERNATH, Sandor [P,I,T] NYC/Eastport, ME b. 30 D 1892, Hungary. Member: NYWCC; AWCS. Work: BM [24]

BERND-COHEN, Max [Mur.P,L,W,I] Lakeland, FL/West Chester, PA b. 7 My 1899, Macon, GA. Studied: Paris; Madrid. Exhibited: Chester County AA, 1934 (prize); Florida Bldg., Century of Progress Expo, Chicago; All States Exh., Herron AI, 1933. Contributor: New Hope Magazine. Founder: Fla. Southern A. Assn. Mus., Lakeland. Position: Hd., A. Dept., Stanley Jones Fnd., Fla. Southern Col., Lakeland [40]

BERNEKER, Louis F(rederick) [P,E,T] NYC/East Gloucester, MA b. 1872, Clinton, MO d. 27 Ja 1937, Gloucester. Studied: St. Louis Sch. FA; Laurens, in Paris. Member: ANA; NYWCC; AWCS; All. AA; SC; NAC; NYSP; North Shore AA. Exhibited: All. AA, 1930 (prize); NAD, 1930 (prize). Work: Church of St. Gregory the Great, NYC; Belmont Theatre, NYC; Chicago Theatre; Dallas AA. Position: Instr., Mechanics Inst. [33]

BERNEKER, Maud F(ox) (Mrs.) [P] NYC/East Gloucester, Mass. b. 11 Ap 1882, Memphis, TN. Studied: NAD. Member: NAWPS; All. AA; Gloucester AS [33]

BERNER, E. (Mrs.) [P] Brooklyn, NY. Member: S.Indp.A. [24]

BERNET, Otto b. 1881 d. 13 O 1945. One of the founders of the Parke-Bernet Galleries in New York City.

BERNEY, Bertram S. [P] Baltimore, MD b. 2 N 1884, Baltimore d. ca. 1950. Studied: Baltimore Polytechnic Inst.; Md. Inst. Exhibited: BMA, 1933–41, 1942 (prize); 1943–46; Municipal Mus., Baltimore, 1940–45; Cumberland Exh., 1937 [47]

BERNEY, Theresa [B,Dr,E,P] Baltimore, MD b. 4 Dec 1904, Baltimore. Studied: Henry A. Roben; C.H. Walther; C.W. Hawthorne; William Meyerowitz. Member: Baltimore WCC. Work: BMA [40]

BERNHARD, Joseph L. [P] Columbus, OH. Member: Columbus PPC [24]

BERNHARD, Lucian [Arch,Des,L,P] NYC b. 15 Mr 1883, Stuttgart. Member: AIGA; SI; A. Gld. Work: monograph, "Lucian Bernhard," NYPL; reproduced, Vogue, House and Garden, Arts and Decoration, Architectural Forum, Advertising Arts. Position: Instr., NYU, ASL [47]

BERNHARDT, Barbara [P,E,Car,L] Richmond, IN b. 22 Ap 1913, Richmond. Studied: Earlham Col; ASL; Diego Rivera; John Sloan; John M. King. Member: Palette Cl., Richmond; NAWPS. Exhibited: Richmond AA, 1922 (prize); 1925 (prize), 1942 (prize); NAWA, 1934; Springfield Mus. A., 1937; Richmond AA, 1922, 1925, 1931, 1932, 1934, 1935, 1936, 1941, 1942, 1943; Woodstock AA, 1937–39; Montross Gal.; Argent Gal.; Contemporary A. Center; ACA Gal. [47]

BERNHEIMER, Franz Karl [P,Edu,S] Sweet Briar, VA b. 16 My 1911, Munich. Studied: Munich; Hamburg; Rome; Zurich; Yale Univ. Member: CAA. Positions: Instr., Brooklyn Col., Dept. Des. (1946), Sweet Briar Col., Dept. A. (1946–47) [47]

BERNHEIMER, Richard [Edu,L,W] Bryn Mawr, PA b. 30 S 1907, Munich d. 28 My 1958. Studied: Univ. Munich; Univ. Rome; Univ. Berlin. Member: CAA. Author: "Romanesque Animal Sculpture," 1930. Contributor: art magazines. Positions: T., Univ. Pa (1933–38), Haverford Col. (1937–42), Bryn Mawr Col. (1933–) [47]

BERNI, Alan [Des] Jackson Heights, NY b. 16 My 1912, NYC. Studied: PIASch. Member: A. Dir. Cl. Author: "Modern Packaging. Specialty: package design [47]

BERNINGHAUS, Julius Charles [P] Taos, NM b. 19 My 1905, St. Louis, MO. Studied: St. Louis Sch. FA; AIC; ASL. Exhibited: St. Louis AG, 1925 (prize), 1926 (prize); Ariz. State Fair, 1929 (prize), 1931 (prize); Colo. State Fair, 1932 (prize). Work: Maryville (Mo.) State T. Col.; Pub. Lib., Raton, N.Mex. Son of Oscar Edmund Berninghaus. [47]

BERNINGHAUS, Oscar Edmund [P,Des,T] Taos, NM b. 2 O 1874, St. Louis, MO d. 27 Ap 1952. Studied: St. Louis Sch. FA. Member:

St. Louis A. Gld.; Taos SA; Taos AA; Soc. Western A.; ANA, 1926; SC. Exhibited: SWA, 1913 (prize); St. Louis A. Gld., 1915 (prize), 1917 (prize), 1918 (prize), 1919 (prizes), 1920 (prizes), 1921 (prizes), 1922 (prize), 1923 (prize), 1924 (prize), 1926 (prize); NAD; PAFA; AIC; CAM; CGA, 1927 (prize), 1930 (prize); GGE, 1939; WFNY, 1939. Work: CAM; Gilcrease Fnd.; murals, Capitol, Jefferson, Mo., USPO, Phoenix, Ariz.; Erie (Pa.) Mus.; Fort Worth Mus.: Los Angeles Mus. A.; San Diego FA Gal. Specialty: Pueblo Indians [47]

BERNSTEIN, Aline [P] NYC. Member: S.Indp.A. Specialty: theatrical design [24]

BERNSTEIN, Edna L. (Mrs. Milton L.) [P,S] NYC b. 6 Ja 1884, NYC. Studied: ASL; William Chase; Howard Chandler Christy; Winold Reiss. Member: NAWA. Exhibited: Palm Beach AA, 1935 (prize) [47]

BERNSTEIN, Ephraim. See Afroyim, Beys.

BERNSTEIN, Henry [P] Detroit, MI b. 1 Ap 1912, Detroit. Studied: Soc. AC, Detroit, with John Carroll. Exhibited: Rockefeller Center, 1936; AIC, 1937; CGA, 1940, 1943; Detroit Inst. A., 1930-44. Work: murals, USPO, East Lansing, Mich.; Mt. Sterling, Ill. [47]

BERNSTEIN, Michael [P] NYC. Member: S.Indp.A. [24]

BERNSTEIN, Saul [P] Baltimore, MD b. 4 Ap 1872, Poswol, Russia d. Ap 1905. Studied: Md. Inst., Baltimore; Académie Julian, Paris. Member: Paris AAA [05]

BERNSTEIN, Theresa F. (Mrs. William Meyerowitz) [P,E,W] NYC/East Gloucester, MA b. Phila. Studied: PAFA; ASL; Henry B. Snell; Eliott Daingerfield; Daniel Garber. Member: NAWA; North Shore AA; Audubon A.; Am. Color Pr. Soc.; SAE; Soc.Indp.A.; Gloucester SA; Conn. Acad. FA; Plastic Cl.; Ten Phila. P. Exhibited: Phila. Plastic Cl. (med); French Inst. A.&SC. (med); NAWA (prize); North Shore AA (prize); Am. Color Pr. Soc. (prize); Phila. Pr. Cl. (prize); GGE, 1939; Carnegie Inst.; MMA; CGA; PAFA, 1916-40; NAD, 1916-46; Dayton AI, 1930-38; WMAA, 1935-39; BMFA; BM; WMA, 1935-39. Work: AIC; Lib. Cong.; PMG; BM; Princeton Univ.; Harvard Univ.; Dayton AI; WMAA. Contributor: articles on art for newspapers and museum bulletins [47]

BERNSTROM, Victor [I,Wood En] Grand View-on-the-Hudson, NY b. 1845, Stockholm d. 13 Mr 1907, Europe. Studied: Royal Acad., Sweden. Member: Soc. Am. Wood En. Exhibited: Columbian Expo, Chicago, 1893 (med); St. Louis Expo, 1904 (med); Pan-Am. Expo, Buffalo, 1901 (med) [05]

BERRESFORD, Virginia [P] NYC/Chilmark, MA b. 1904, Rochelle Park, NY. Studied: Wellesley Col.; Charles Martin; Ozenfant. Work: Detroit Mus. [40]

BERRY, Annabel Sedlle (Mrs. Warren T.) [P] Newport, RI [24]

BERRY, Camelia (Mrs. Jack D.) [P,I] Stillwater, OK b. 28 D 1918, Wash., D.C. Studied: ASL; Barnard Col.; K. Williams; F. Luis Mora. Member: Okla. AA; Western AA. Exhibited: Norlyst Gal., 1944; Okla. A. Center, 1942-45; Philbrook A. Center, 1945. Work: Stillwater Lib. [47]

BERRY, Carroll Thayer [G,P,C] Wicasset, ME b. 4 S 1886, New Gloucester, ME. Studied: PAFA; Eric Pape. Member: F., PAFA; Maine Craft Gld. Exhibited: Ogunquit A. Center, 1937; Sweat Mem. Mus., Portland; Currier Gal., Manchester, N.H., 1939. Work: Univ. Wis. [40]

BERRY, Ellen McClung (Mrs. Thomas H.) [A.Dir] Fountain City, TN b. Knoxville, TN. Studied: Univ. Tenn. Member: AFA; SSAL. Position: Dir., Knoxville A. Center, 1942- [47]

BERRY, Erick (Mrs. Allena C. Best) [P,I,W,L,T] NYC b. 4 Ja 1892, New Bedford, MA. Studied: Eric Pape; Henry McCarter; PAFA; ASL; Paris; London. Illustrator: children's books [33]

BERRY, Helen Murrin (Mrs. Helen Berry Shanes) [T,P,C] Phila., PA b. 25 Ag 1900, Phila. Studied: PAFA. Member: F., PAFA; Pr. Cl.; Germantown AL; Phila. ATA. Exhibited: PAFA, 1933, 1935; NYWCC. Work: PAFA. Position: Teacher, A., Phila. Pub. Sch., 1928- [47]

BERRY, Martha (Mrs. Jay Datus) [P,L] Chicago, IL b. 31 My 1916, Fort Wayne, IN. Studied: AIC; Frederic M. Grant. Exhibited: Corcoran Gal., 1939; Beloit Col., 1939 [40]

BERRY, Nathaniel L. [P,T] Waltham, MA b. 20 D 1859, Lynn, MA. Member: Boston AC [13]

BERRY, Patrick Vincent [Ldscp.P] NYC b. 1852, Troy, NY d. 13 Jy 1922. Studied: Troy Acad.; St. John's Col., Fordham Univ.; William Hart; Albert Bierstadt. Position: Instr., A., Fordham Univ. [13]

BERRY, Phil [I,Car] NYC. Member: SI. Illustrator: national magazines. Cartoonist: Liberty, 1939 [47]

BERRY, Ruth Linnell [P,T] Lexington, MA b. 14 F 1909, Watertown, MA. Studied: Boston Univ.; Radcliffe Col.; Leslie Thompson; Richard Lahey. Member: N.H. AA; Springfield A. Lg.; North Shore AA. Exhibited: Wawasee A. Gal., 1945; Springfield AA, 1946; N.H. AA, 1943-46; Boston AC, 1932, 1933; Jordan-Marsh, 1946; North Shore AA, 1946 [47]

BERRY, Wils(on) (Reed) [P,I,L,T] Logansport, IN b. 22 Ap 1851, Cass County, IN. Work: "The Dominion Parliament Buildings at Ottawa, Canada," owned by the king of Great Britain [24]

BERRYMAN, Clifford Kennedy [Car,I,L] Wash., D.C. b. 2 Ap 1869, Clifton, KY d. 11 D 1949. Member: Wash. AC; Wash. Soc. FA; AFA. Exhibited: Lib. Cong., 1945 (one-man); AFA Traveling Exh., 1943-45; CGA, 1924, 1943 (one-man); Wash. D.C. Pub. Lib. (one-man). Work: Lib. Cong.; Brit. Mus.; NYPL; T. Roosevelt mem.; F.D. Roosevelt Mus.; Huntington Lib.; Univ. Idaho; Univ. Tex.; Columbia Univ.; Caldwell Coll. Illustrator: "Roosevelt and the Old Guard," and other books. Creator: "The Teddy Bear." Award: Pulitzer Prize for Cartoon, 1943. Specialty: political cartoons. Position: Car., The Evening & Sunday Star, Wash., D.C., 1907- [47]

BERRYMAN, Florence Seville [W,L,] Wash., D.C. b. Wash., D.C. Studied: George Washington Univ. Member: Wash. AC; Am. Newspaper Women's Cl.; Soc. Bookplate Coll. & Des. Exhibited: George Washington Univ., 1924. Author: monograph, "Early American Bookplates," 1925. Contributor: newspapers and art magazines. Positions: Cr., Washington Post, Evening Star; Staff, AFA, 1924- [47]

BERRYMAN, James Thomas (Jim) [Car,I,W] Wash., D.C. b. 8 Je 1902, Wash., D.C. Studied: George Washington Univ.; Corcoran Sch. A.; Will Chandlee. Exhibited: WFNY, 1939 (prize). Specialty: sports cartoons and illustrations. Position: Car., Washington Evening Star, King Features Syndicate, 1936- [49]

BERSON, Adolphe [P] San Fran., CA b. San Fran. Studied: Lefebvre, Robert-Fleury, in Paris [24]

BERTHELSEN, Johann [P,L,T] New Milford, CT b. 25 Jy 1883, Copenhagen. Member: SC; AWCS; All.A.Am.. Exhibited: Chicago, 1928 (Erskine prize); Indianapolis, 1946 (Holcombe prize). Work: Sembrich Mem., Lake George, N.Y.; Terre Haute Mus.; Tex. Tech. Col. [47]

BERTIERI, Pilade [P] NYC b. 1 Ag 1874, Turin, Italy. Studied: Grosso, Tallone, in Italy. Award: Chevalier de la Couronne d'Italie [05]

BERTOIA, Harry [P,C] Topanga Canyon, CA b. 10 Mr 1915, San Lorenzo, Italy. Studied: Cranbrook Acad. A.; Detroit Soc. A.&Crafts. Exhibited: Assn. Western Mus. Dir. Exh.; Peace Conference Exh., San Fran. Work: Mus. Non-Objective Painting; Cranbrook Acad. A.; Wadsworth Atheneum. Position: Instr., Metalcraft, Cranbrook Acad. A. [47]

BERTRAND, Jeanne [S] NYC b. France. Studied: C.S. Pietro, in New York. Work: Toledo Mus. [17]

BERTRAND, Raymond [P,Li,T] Taylorsville, CA b. 7 Ja 1909, San Fran. Studied: E. Spencer Macky. Member: San Fran. AA; San Fran. A. Center. Exhibited: San Fran. AA, 1935 (prize). Work: fresco, Coit Tower, San Fran. Position: Calif. Sch. FA, San Fran. [40]

BERTSCH, Fred S. [Des] Chicago, IL 1879, MI. Studied: AIC. Member: Palette & Chisel Cl. [24]

BERZEVIZY, J(ulius) [P] Buffalo, NY b. 14 D 1875, Homonna, Hungary. Studied: F. Ventz; Conrad Svestka; Sch. Portland (Oreg.) AA. Member: Rochester AC; Buffalo SA. Exhibited: Rochester AC, 1925 (med) [47]

BERVINCHAK, Nicholas [P,E,Dec] Pottsville, PA b. 4 D 1903, Black Heath, PA. Studied: Paul Daubner; Fed. Sch. Inc. Member: N.Y. S.Indp.A.; Phila. SE & Graphic A.; Soc. Am. E. Exhibited: Minn. State Expo, 1934 (prize); poster, Latham Found., 1935 (prize); Pub. Lib., Pottsville, Pa. Work: Our Mother of Sorrows Church, Phila.; Lib. Cong. [40]

BESIG, Walter [P] Suffern, NY [13]

BESNER, Frances [Des,S] Bronx, NY b. 15 Ap 1917, NYC. Studied: N.Y. Sch. F.&Indst. A.; Parsons Sch. Des. Exhibited: N.Y. Sch. F.&Indst. A., 1939 (med); New Sch. Soc. Res.; ACA Gal., 1940; Tribune A. Gal., 1946. Position: A. Dir., Flying Age Magazine, 1946- [47]

BESS, Forrest Clemenger [P,L] San Antonio, TX b. 5 O 1911, Bay City, TX. Studied: Academia de San Carlos, Mexico City; Tex. A.&M. Col.; Tex. Univ. Exhibited: Corcoran Gal., 1939; Witte Mem. Mus., San Antonio,

1946 (prize); CGA, 1940; Houston A., 1939, 1940; San Antonio A., 1946; Dallas Mus. FA, 1946. Work: Houston Mus. FA. Lectures: camouflage [47]

BESSELL, Evelyne Byers [P] Houston, TX. Exhibited: Dallas MFA, 1938; Houston MA, 1938 [40]

BESSEMER, Auriel [P,I,Des,Dec,L,T,W] Wash., D.C. b. 27 F 1909, Grand Rapids, MI. Studied: Howard Giles; Master Inst. Roerich Mus.; Loen Kroll; Arthur Covey; NAD. Member: Louis Comfort Tiffany Found.; AFA. Exhibited: Chaloner prize competition, 1931 (prize); 48 Sts. Comp., 1939. Work: Am. Mus. Nat. Hist.; F.A. Sterling Coll., Wash., D.C.; Western Reserve Acad., Hudson, Ohio; Roerich Mus.; USPOs, Hazelhurst, Miss., Winnsboro, S.C., Arlington, Va., Sect. FA, Fed Works Agency. Position: Dir., Gal of Modern Masters, Wash., D.C. [40]

BESSEY, Martha Davis [Des] NYC b. NYC d. 16 Ja 1901. She was specially proficient in flower painting, heraldic work, illuminating, and the designing of badges and medals. One of her designs for a badge won a prize at the Chicago World's Fair, 1893.

BESSINGER, Frederic [P] Santa Monica, CA b. 30 D 1886, Kansas City, MO [40]

BESSIRE, Dale Philip [P] Nashville, IN b. 14 My 1892, Columbus, OH. Studied: Univ. Chicago; John Herron AI. Member: Hoosier Salon; Ind. A. Cl.; Fla. Fed. A.; Brown Co. A. Gal. Assoc.; Chicago Gal. Assn. Exhibited: Ind. A. Cl. (prize); Ind. State Fair (prize); Century Progress, Chicago; John Herron AI, 1946; Hoosier Salon, 1922–46; Chicago Gal. Assn., 1936–46; Fla. Fed. A.; Palm Beach. Work: Ind. Univ.; DePauw Univ.; Rollins Col.; Ball State Col.; memorials, Duncan, Whiting, Gary, Ind.; Ind. Veteran's Home. Position: Pres., Ind. A. Cl., 1945–47 [47]

BESSOM, Florence [S] Hyattsville, MD b. 30 N 1905. Studied: Mass. Sch. A.; NAD. Member: Marblehead AA; Boston SAC. Exhibited: Rosenthal Competition, 1932 (prize). Work: St. James Church, Oldtown, Maine; USPO, Staunton, Va., Sec. FA, Fed. Works Agency; Hubbard Lib., Hallowell, Maine [40]

BEST, Alice M. (Mrs. Arthur) [P,T] San Fran., CA [17]

BEST, Arthur W. [P,T] b. 1865, Peterboro, Ontario d. ca. 1919, San Fran. Work: Oakland AM. Specialty: Grand Canyon. Position: Dir., Best Art Sch., 1897 [*]

BEST, H(arry) C(assie) [P] Yosemite National Park, CA b. 1863, Peterborough, Canada d. 14 O 1936, San Fran. Studied: Thad Welch. Member: AG Members of FA Soc., San Diego; San Fran. AA. Work: Cosmos Cl., Wash., D.C.; Jonathan Cl., Los Angeles; Yosemite Nat. Park Coll. Brother of Arthur Best. [33]

BEST, Jane Hayden (Mrs.) [P] Riverside, CA b. Pierceton, IN. Studied: Millard Sheets. Member: Riverside AA; Laguna Beach AA [40]

BEST, Margaret Callahan [P,G,T] Houston, TX b. 8 Ag 1895, Arima, Japan. Studied: Univ. Ark; Bertha L. Hellman: Julian Muench. Member: SSAL; Houston A. Mus. Exhibited: Houston A. Mus [40]

BEST, Nellie G. [P,C] Lynwood, CA b. 22 My 1906, Sterling WA. Studied: Univ. Oreg. Member: Minn. Ar. Assn. Exhibited: CGA, 1939; Howard Univ., 1942; Guatemala Fair, 1941; Minn. Inst. A.; Univ. Minn. Work: USPO, White Bear Lake, St. Paul, Minn.; Ontario, Calif. [47]

BEST, Willard Sewell [P] Chicago, IL/Fox Lake, IL b. 8 Ap 1872, Gentry Co. (near Albany), MO. Studied: AIC; Wellington J. Reynolds; Lawton Parker, in Chicago. Member: Palette & Chisel Cl. [19]

BETHEA, F. Elizabeth [Edu,P] Ruston, LA b. 11 My 1902, Birmingham, AL. Studied: Newcomb Col., Tulane Univ.; Columbia Univ. Member: Southeastern AA; SSAL. Exhibited: SSAL; Ala. A. Lg.; New Orleans A. Lg. Position: Prof./Head, Dept. A., La. Polytechnic Inst., Ruston [47]

BETHERS, Ray [En,P,Des,I] NYC b. 25 Ap 1902, Corvallis, Oreg. Studied: Univ. Oreg.; Calif. Sch. A.; Grande Chaumière; Morris Davidson; ASL. Member: SI; Calif. SE; San Fran. AA; Beachcombers Cl. Exhibited: Lib. Cong. (prize); Calif. SE, 1937 (prize). Work: SFMA; Lib. Cong. [47]

BETLATCH, J.W. [P] Minneapolis, Minn. [17]

BETSBERG, Ernestine (Mrs. Arthur Osver) [P] Long Island City, NY b. 6 S 1909, Bloomington, IN. Studied: AIC, with Boris Anisfeld. Exhibited: AIC, 1936, 1938, 1939, 1941, 1942; VMFA, 1946; NAD, 1945 [47]

BETTELHEIM, (Jolan) Gross [P,E,Li] Jackson Heights, NY b. 27 Ja 1900, Nitra, Czechoslovakia. Studied: Royal Hungarian Acad. FA; State Acad. FA, Berlin; Cleveland Sch. A., with Orlik, Hofer; Kunstgewerbe Schule, Vienna; Acad. Für Bildene Kunste, Berlin; L'Ecole des Beaux Arts, Grande Chaumière, Paris. Member: AFA; SAE; Conn. Acad. FA. Exhibited: CMA, 1928–37 (prizes); Northwest Pr.M., 1945 (prize), 1946 (prize); Conn. Acad. FA, 1945 (prize); AIC, 1932, 1934, 1935, 1937; PAFA, 1931, 1933, 1934, 1936, 1941, 1942; NAD, 1943–46; Santa Barbara Mus. A., 1944; SAE, 1944–46; Lib. Cong., 1943, 1944 (prize), 1945 (prize), 1946; Conn. Acad. FA, 1944, 1945 (prize), 1946; Denver A. Mus., 1944; WMAA, 1942; CGA, 1944; SFMA, 1944; BM, 1945; Montclair A. Mus., 1945; Durand-Ruel Gal., 1945 (one-man). Work: Cleveland Pr. Cl.; CMA; Lib. Cong.; SAM; BM; Everhart Mus., Scranton, Pa.; Munson-Williams-Proctor Inst.; PMA; Mus. Western A., Moscow, USSR [47]

BETTERSWORTH, Beulah R. [P] Woodstock, NY b. 22 Ag 1894, St. Louis, MO. Studied: ASL; Frank V. DuMond; Charles Hawthorne; John Sloan; John Carroll. Work: White House; USPO, Columbus, Indianola, Miss., Sec. FA Fed. Works Agency [40]

BETTERSWORTH, Howard Brown [P] Brooklyn, NY. Member: GFLA [24]

BETTINARDI, John [Li] Hasbrouck Heights, NJ b. 30 Ja 1885, Italy. Studied: Edward Stiefel, in Zurich; Hans Schuler [40]

BETTINGER, Hoyland B. [P,E,T] Newton Lower Falls, MA/Percé, Quebec b. 1 D 1890, Lima, NY. Member: Boston AC; Boston SAC; North Shore AA; Rockport AA; Boston Soc. WC P.; AWCS. Work: Pub. Lib., Yarmouth, Nova Scotia. Positions: Dir., The Hobby Sch., Newton Lower Falls, Gaspé Sch., Percé [40]

BETTIS, Charles Hunter [I,Des] Chicago, IL b. 1891, TX. Studied: AIC. Member: Palette & Chisel Cl.; Chicago Arch. Cl.; T Square & Palette Cl. [21]

BETTISON, David [P] Louisville, KY. Member: Louisville AL [01]

BETTS, Anna Whelan [I,P,C,T] Phila., PA b. Phila. Studied: Howard Pyle; Courtois, in Paris; Vonnoh. Member: F., PAFA; Phila. WCC. Exhibited: P.-P. Expo, San Fran., 1915 (med). Illustrator: Century, Harper's, other magazines [21]

BETTS, B.D. [P] NYC [17]

BETTS, Edwin C. [Ldscp.P,Int.Dec] b. 1857, Hillsdale, MI d. 1917 Denver. Studied: Met. AS. Began his career as a painter of frescoes. His last painting was "The Valley of the Housatonic."

BETTS, Edwin D(aniel), Sr. [P,I] Chicago, IL b. 1847 d. F 1915. Father of Edwin, Jr., Grace, Harold, and Louis Betts. [*]

BETTS, E(dwin) D(aniel), Jr. [P,I] Chicago, IL b. 1879, St. Louis, MO d. F 1915. Studied: his father, E.D. Betts, Sr. Best known for his idealized "Birth of Christ." Brother of Grace, Louis, and Harold Betts.

BETTS, Ethel Franklin [P] Phila., PA [09]

BETTS, Giovanna d. 19 Ag 1935, NYC. An artist and poet.

BETTS, Grace May [P] Chicago, IL b. 1885, NYC. Studied: her father, E.D. Betts, Sr.; AIC. Her brothers were Harold, Louis, and E.D. Betts, Jr. [15]

BETTS, Harold Harington [P,I] Chicago, IL. b. 1881, NYC. Studied: his father, E.D. Betts, Sr. Specialties: Grand Canyon; Pueblo Indians. Brother of Grace, Louis, and E.D. Betts, Jr. [17]

BETTS, Jack [I] NYC. Member: SI [47]

BETTS, John H. [P] Phila., PA [01]

BETTS, Louis [Por.P] NYC b. 5 O 1873, Little Rock, AR d. 1961. Studied: PAFA; William Chase. Member: F., PAFA; NA, 1915; Nat. Inst. AL; SC; Century Assn.; NAC; Un. Lg. Cl., Chicago. Exhibited: NAD, 1902 (prize), 1918 (prize), 1931 (gold), 1932 (prize), 1933 (prize), 1937 (prize); All.A.Am., 1931 (gold); AIC, 1920 (med); St. Louis Expo, 1904 (med); Carnegie Inst., 1910 (prize). Work: AIC; CGA; Richmond AA; Montclair A. Mus.; Ark. A. Mus.; Toledo Mus. A.; Corcoran Gal.; Chicago Univ.; Mayo Fnd., Rochester, Minn. Brother of Grace, Harold, and E.D. Betts, Jr. [47]

BETTS, Rostan (Miss) [P] Memphis, TN b. 25 Jy 1887, McMinville, TN. Studied: Cincinnati Acad.; N.Y. Sch. Applied Des. for Women [17]

BETZLMANN, Ferdinand, Mrs. See Irma Reisner.

BEURNERE, Moreon (Mrs. M.B. Boyd) [P,E] NYC/South Newbury, VT b. 26 Jy 1902, France. Studied: ASL. Member: Wash. WCC. Exhibited: CGA; AWCS. Work: portrait of Franklin Delano Roosevelt, owned by him [47]

BEURY, Gaston [S] Boulogne-sur-Seine, France b. 9 Jy 1859, San Jose, CA. Studied: Chapu. Member: Soc. des Artistes Français [09]

BEUST, Anton von [P] Orange, NJ [09]

BEUTLICH, Anton B. [Por.P] b. 1866, Stavanger, Norway d. 16 D 1929, Chicago. Studied: AIC. Member: Palette & Chisel Cl., Chicago

BEVANS, M.T. [I] NYC. Member: SI [21]

BEVANS, M.T. (Mrs.) [I] NYC. Member: SI [24]

BEVERIDGE, Kuhne. See W.B. Branson, Mrs.

BEVERLY-HAYNES, D(orothy) F(rances) [P,Des] Hartford, CT b. 22 D 1904, Hartford. Studied: Hartford Sch. A.; Rembski; Joseph C. Chase; H.H. Darnell. Member: Hartford Soc. Women P.; Meriden A.&Crafts. Exhibited: Travelers Insurance Co. Adv. Exh., 1938 (prize); Laguna Beach AA, 1943; AV Poster Traveling Exh., 1943; Conn. Acad. FA; Hartford Soc. Women P.; Meriden A.&Crafts. Work: portrait, dog mascot, U.S. Coast Guard [47]

BEVIN, Alice Conklin (Mrs. George J. Leewitz) [P] Paris/East Hampton, CT b. 21 Ag 1898, East Hampton. Studied: Philip Hale; Charles Hawthorne; George Bridgman; Frank DuMond; Raoul Tannelier. Member: Gloucester SA; Provincetown AA; NAWPS. Work: Pub. Lib., Utica, N.Y. [40]

BEW, Mattie Clover, Mrs. See Clover-Bew.

BEWKES, James [P] NYC. Member: GFLA [24]

BEWLEY, Hallie Samuel (Mrs. Murray P.) b. 1852, near Bowling Green, KY d. 21 Jy 1930, Long Beach, CA. She was president of the Fort Worth (Tex.) Art Association from its beginning in 1910 and did much to bring together the splendid collection of paintings owned by the Fort Worth Museum of Art. She was an officer and director of the Fort Worth Public School Art Society, life member, Board of Directors of the Texas Federation of Women's Clubs and served many years as chairman of its Art Dept.

BEWLEY, Murray Percival [P] Hollywood, CA b. 19 Je 1884, Fort Worth, TX. Studied: AIC; PAFA, with Chase, Henri; Beaux. Member: Mystic AC; SC; All.A.Am.. Exhibited: SC, 1921 (prize); Sacramento, Calif. 1943 (prize); Paris Salon, 1908, 1909, 1910 (prize), 1911–1914; PAFA; AIC; NAD. Work: Fort Worth Mus.; PAFA; A. Inst., Dayton; Mus. FA, Houston; Indst. Archives, New York [47]

BEYER, George Albert [P,Ser] Minneapolis, MN b. 30 Ag 1900, Minneapolis. Studied: Minneapolis Sch. A.; Vaclav Vytlacil; Sydney Dickson; Richard Lahey; Anthony Angarola; Cameron Booth. Member: A.Lg.Am.; Nat. Serigraph Soc. Exhibited: Minn. State Fair, 1944 (prize); Minn. Inst. A.; Elisabet Ney Mus., Austin, Tex., 1943 (prize); Nat. Serigraph Soc., 1941 (prize); MOMA. Work: Elisabet Ney Mus. [47]

BEYERS, Robert A., Mrs. See West, Bernice.

BEYHAN, Matthew W. [P] Newton Center, MA. Exhibited: 48 Sts. Comp. [40]

BEYMER, William Gilmore [P] NYC [08]

BIAFORA, Enea [S] Warwick, NY b. 25 O 1892, St. Giovanni, Italy. Studied: Inst. FA, Naples, Italy. Member: NSS; AAPL. Work: MMA [47]

BIAMONTE, Grace Houston [T,P,L] Indiana, PA b. Marysville, OH. Studied: Columbus A. Sch.; Ohio State Univ.; Columbia Univ.; N.Y Sch. App. Des.; Charles Hawthorne. Member: Assoc. A., Pittsburgh. Position: Instr. A., State T. Col., Indiana, Pa., 1933–46 [47]

BIANUCCI, Irene (Mrs. I.B. Soravia) [Des,P,I,Ser] Chicago, IL b. 16 D 1903, Lucca, Italy. Studied: James Millikin Univ.; George Oberteuffer; Boris Anisfeld; John W. Norton. Member: F., AIC; Chicago SA. Exhibited: James Millikin Univ., 1924 (prize); Un. Lg., Chicago, 1930 (prize); AIC, 1930, 1931; 1932, 1934, 1936, 1939, 1940, 1941; Chicago SA, 1934–45. Work: Juvenile Court, Chicago; USPO, Mt. Carroll, Ill. Position: Des./Illus., Container Corp. of Am., 1943– [47]

BIBERMAN, Edward [P] Hollywood, CA b. 23 O 1904, Phila., PA. Studied: Univ. Pa.; PAFA. Member: NSMP; Calif. Council All. A. Exhibited: PAFA, 1930, 1931 (prize); WMAA, 1931–33; MOMA, 1930, 1934; SFMA; Los Angeles Mus. A.; PMA; BMFA, 1930–46. Work: PAFA; Houston Mus. FA; Fed. Bldg., Los Angeles; USPO, Venice, Calif. Position: T., A., Center Sch., Los Angeles, 1938–46 [47]

BIBERSTEIN, Franz [P] Milwaukee, WI b. 1850, Munich d. 1930. Specialty: panoramas [*]

BICCHI, Silvio [P] NYC [09]

BICK, Alexander F. [C,Des,T,W] Milwaukee, WI/Fort Collins, CO b. 9 Ap 1890, Chicago. Studied: AIC. Positions: Instr. in metal arts, Shorewood Opportunity Sch; Milwaukee Public Schools; Inst., Des., summer, Colo. State Col., Fort Collins [40]

BICKFORD, Nelson Norris [P,S] NYC b. 15 Ap 1846, Quebec d. 5 D 1943. Studied: Bouguereau; Académie Julian, Lefebvre, Boulanger, F. Miralles, in Paris. Specialty: animals [17]

BICKNELL, Albion Harris [P,E,En] Malden, MA b. 18 Mr 1837, Turner, ME d. 23 Ap 1915. Studied: Boston; Ecole des Beaux-Arts, Thomas Couture, in Paris. Work: capitols and libs., New England, including pub. lib. in Malden. Specialties: portraits, historical scenes

BICKNELL, Evelyn M. [P] NYC b. 14 Jy 1857, NYC d. 5 Mr 1936. Member: NYWCC; SC, 1901; AWCS [33]

BICKNELL, Frank A(lfred) [P] Old Lyme, CT b. Augusta, ME. Studied: Albion H. Bicknell; Académie Julian, with Bouguereau, Robert-Fleury, in Paris. Member: ANA, 1913; Paris AAA; SC, 1907; NAC; Lotos Cl.; All. AA; MacD. Cl.; SPNY; Pittsburgh AA. Exhibited: Pittsburgh, AA., 1922 (prize). Work: Nat. Gal., Wash., D.C.; Montclair (N.J.) Mus.; Denver A. Mus.; Boston A. Cl.; Un. Lg. Cl., New York [40]

BICKNELL, W(illiam) H(arry) W(arren) [E] Winchester, MA/Provincetown, MA b. 12 Jy 1860, Boston. Studied: Otto Grundmann; Frederic Crowninshield; Boston Mus. Sch. FA. Member: Copley S., 1880 Chicago SE; Boston SE; Provincetown AA; Winchester AA. Exhibited: St. Louis Expo, 1904 (med). Work: AIC; Rochester Mem A. Gal.; BMFA; NYPL; LOC [40]

BIDDLE, Edward [Patron] b. 1851 d. 24 F 1933, Phila. Author: with Mantle Fielding, a vol. on Thomas Sully; also writings on art subjects. A connoisseur of art and member of a distinguished family, he was a lawyer by profession.

BIDDLE, George [P,S,Gr,W,Cr,L] Croton-on-Hudson b. 24 Ja 1885, Phila. d. 1973. Studied: Harvard; PAFA; Paris; Munich. Member: Am. Soc. PS&G; Mural P. Exhibited: MMA; WMAA; PAFA; BMFA; SFMA; San Diego FA Soc.; Los Angeles Mus. A.; Lib. Cong.; NYPL; PMA; one-man exhibits, Paris, Rome, Vienna, Mexico. Work: Dept. Justice, Wash., D.C.; Nat. Lib., Rio de Janeiro; Supreme Court, Mexico City; USPO, Brunswick, N.J.; MMA; WMAA; MOMA; PAFA; PMA; BMFA; SFMA; San Diego FA Soc.; Los Angeles Mus. A.; Lib. Cong.; NYPL; AIC; Newark Pub. Lib.; Pal. Leg. Honor; Kaiser Friedrich's Mus., Berlin; Galeria d'Arte Moderna, Venice; John Herron A. Inst.; Denver AM; Dallas Mus. FA. Author: "Adolphe Borie," "Boardman Robinson," "Green Island," "Artist at War," "George Biddle's War Drawings," etc. Contributor: national magazines [47]

BIDDLE, George, Mrs. See Sardeau, Helene.

BIDWELL, Raye [P] Cleveland, OH. Member: Cleveland SA [24]

BIDWELL, Watson [Mus.Cur,E,P,W,Cr,L] Briggsdale, CO b. 11 S 1904, Kinsley, KS d. ca. 1964. Studied: Univ. Denver; Cyril Kay-Scott; John E. Thompson; B.J.O. Nordfeldt; Walt Kuhn. Member: Denver A. Gld.; Colo. Edu. Assn. Exhibited: Denver A. Mus., 1933 (prize), 1934, 1935 (prize), 1936, 1937 (prize), 1938–41; WFNY, 1939; Denver A. Gld.; Univ. Kans. Work: Denver A. Mus. Author: reviews for art magazines. Lecture: History of Art. Positions: Docent, 1933–36, Cur., Oriental A., Denver A. Mus., 1936–39 [47]

BIE, Katrine Hvidt (Frolich) [L,T,P,C] Brooklyn, NY b. Oslo, Norway. Studied: PIASch.; ASL, with George Grosz, Gordon Samstag. Member: Norwegian A.&Crafts Cl. Exhibited: BM; Staten Island Mus. A.; Vendome Gal., 1940–43; Norwegian A.&Crafts Cl. Columnist: Brooklyn Eagle "Nursery Book Shelf." Lectures: Illustrations in Children's Books. Position: T., Woodward Sch. Brooklyn [47]

BIEBEL, Franklin Matthews [L,Mus.Asst.Dir] NYC b. 4 N 1908, La Grange, IL d. ca. 1968. Studied: Col. Wooster; Oberlin Col; Princeton Univ.; Univ. Paris. Member: F., Dumbarton Oaks Res. Lib.&Coll., Wash., D.C., 1942; CAA; Archaeological Inst.; Mus. Council, N.Y. Author: "The Mosaics of Gerasa", 1938. Contributor: art magazines. Lectures: Renaissance, Modern Art. Positions: Asst. Cur., CAM, 1935–37; Instr., Princeton Univ., 1937–38; Asst. Prof./Chm. A. Dept., Rutgers Univ., 1938–42; L., 1943, Asst. to Dir., 1944–46, Asst. Dir., 1946– Frick Coll. [47]

BIEDERMANN, Eduard [P,I] Louisville, KY [01]

BIEHL, Godfrey F. [P] Pittsburgh, PA. Member: Pittsburgh AA. Exhibited: Pittsburgh AA, 1936 (prize); Cincinnati AM; Butler AIn., Youngstown, Ohio; T. Col., Lock Haven, Pa. 1939 (one-man) [40]

BIEHLE, August [P] Cleveland, OH. Member: Cleveland SA [24]

BIEHN, Irving Lew [P] Milwaukee, WI b. 1 Ag 1900, Milwaukee. Studied:

Layton Sch. A., with Dudley Crafts Watson. Work: Milwaukee Pub. Mus. [47]

BIEL, Egon Vitalis [P,I,E,Li] NYC b. 27 N 1902, Vienna. Studied: Europe. Exhibited: Vienna (one-man); Berlin (one-man); Paris (one-man); London (one-man); New York (one-man). Work: Albertina Mus., Vienna; Mus. Prague; Mod. Mus., Paris. Illustrator: Saturday Review of Literature [47]

BIEL, Joseph [P] NYC b. 27 O 1891, Russia d. 23 Ap 1943. Studied: ASL; Russian Acad., Paris; Workman's Coll., Melbourne, Australia. Member: ASL; Ar. U.; Am. A. Cong. Exhibited: WFNY, 1939. Work: Mus. Western A., Moscow, Biro-Bidjan Mus., USSR; schools, Newark, N.J, Brooklyn, N.Y.; hospital, Mount Maurice, N.Y. [40]

BIEL, Lena Gurr. See Gurr, Lena.

BIELECKY, Stanley [P,T] East Chicago, IN. Studied: Minneapolis Inst. A.; AIC; PAFA, 1941; Grand Rapids, Mich., 1940; SFMA, 1938; Elgin Acad., 1941; AIC, 1935–41; Detroit Inst. A., 1941, 1942, 1945; John Herron AI, 1939–42, 1946. Positions: Instr., Ind. Univ. Ext. Div. (1937–43, 1946), Valparaiso Univ. (1941–43, 1946) [47]

BIELEFELD, Otto F. [P,E,B] Milwaukee, WI b. 12 D 1908, Milwaukee. Studied: Layton Sch. A. Exhibited: State Fair, Milwaukee, 1938 (prize); Wis. Salon A., 1937 [40]

BIELENBERG, George [P] Chicago, IL [13]

BIELETTO, Benedetto B. [P] Chicago, IL [15]

BIER, Justus [Edu,W,Cr] Anchorage, KY b. 31 My 1899, Nuremberg, Germany. Studied: Univ. Munich; Univ. Jena; Univ. Zurich. Member: CAA; Am. Soc. Aesthetics; Am. Assn. Univ. Prof.; Louisville A. Center. Author: books on sculpture, art, architecture. Positions: Asst, Prof, 1941–46, Prof./Head, Dept. FA, Univ. Louisville, 1946– ; Cr./A. Ed., Courier-Journal, Louisville, 1944– [47]

BIERACH, S.E. [I] Brooklyn, NY b. 27 Jy 1872, Jersey City. Exhibited: Pan-Am. Expo, Buffalo, 1901 [09]

BIERHALS, Otto [P,T] Tenafly, NJ/Woodstock, NY b. 5 S 1879, Nuremberg. Studied: Cooper Union; NAD; PAFA; Herman Gröber, in Munich; Paris; Italy. Member: All. AA. Exhibited: Am. AS, Phila., 1900 (prize); Montclair (N.J.) A. Mus. (prize); A. Center, Ogunquit, Maine, 1935 (prize); Ann. PS., Albany Mus. Hist.&A., 1937, 1938 [40]

BIERSTADT, Albert [Ldscp.P] NYC b. 7 Ja 1830, Düsseldorf, Germany d. 18 F 1902. Studied: Lessing, in Germany; Rome; U.S. Member: ANA, 1860; Boston A. Cl.; Nat. Inst. A.&L.; Century Assn.; Am. Geographical Soc.; Musical A. Soc.; Union Lg. Cl. Exhibited: Austria (med); Germany (med); Bavaria (med); Belgium (med). Work: capitol, Wash., D.C.; Hermitage, St. Petersburg; Imperial Palace, Berlin; NYPL; Acad. FA, Buffalo; Corcoran Gal. He came to New Bedford (Mass.) in 1831, though he made frequent trips to Europe, spending much time in Venice and Switzerland. He was named Chevalier of the Legion of Honor (1867), received the Order of St. Stanislaus of Russia (1869), and the Imperial Order of the Medjidi from the Sultan of Turkey (1886).

BIERSTADT, Mary F. Hicks Stewart b. 1837 d. 3 O 1916, NYC. Widow of the noted landscape painter, Albert Bierstadt.

BIESEL, Charles [P,G] NYC b. 20 O 1865, NYC d. 5 Ag 1945, Chicago. Member: Chicago Soc. Ar.; A. Cl., Chicago; "Ten Artists," Chicago. Exhibited: AIC, 1938 [40]

BIESEL, Fred [P,I] Chicago, IL b. 27 S 1893, Phila. Studied: RISD; AIC. Member: Chicago SA; Ten Artists. Exhibited: Chicago SA, 1934 (prize). Position: Asst. State Supervisor, Ill. A. Project, WPA [40]

BIESIOT, Elizabeth Kathleen Gall [S,Edu,C] Seattle, WA b. 8 O 1920, Seattle. Studied: Univ. Wash., with Maldarelli; Columbia Univ.; Archipenko; Paul Bonifas. Member: Northwest C. Workshop; Springfield A. Lg.; AAPL; Soc. Ceramic A.; Lincoln A. Gld. Exhibited: Craftsman Gld., 1940 (prize); Univ. Wash., 1942 (prize); Denver A. Mus., 1945 (prize); SAM, 1945 (prize); San Fran. AA, 1944, 1945; AAPL, 1945; Springfield A. Lg., 1944, 1945, 1946; Oakland A. Gal., 1945, 1946; Denver A. Mus., 1945; Mint Mus. A., 1946; Audubon A., 1945; SAM, 1940–45; Lincoln A. Gld., 1945. Work: sculpture, Bush Sch.; Clien Clinic, Seattle. Position: Instr., Univ. Nebr., 1945 [47]

BIESTER, Anthony [Por.P,Ldscp.P] b. 26 Ag 1837, Cleves, Germany d. 26 Mr 1917, Madisonville, OH. Studied: B.C. Koekkoek; Oswald Achenbach; Holland; Belgium; France. Member: Cincinnati AC; Exhibited: Ind. State Fair (gold) [17]

BIETZ, Hugo H. [Des,P,S,C] Ravenna, OH b. 2 F 1892, Akron, OH. Studied: AIC. Work: murals, Cleveland; bronze, Kent State Univ. [47]

BIG BOW, Woodrow Wilson [P] b. 1914, Carnegie, OK. Work: Mus. Am. Indian; Philbrook AC. Kiowa painter. [*]

BIGELOW, C(harles) B(owen) [P,I] Rockton, IL b. 19 S 1860, Buffalo, NY. Studied: AIC, with Vanderpoel; Académie Julian, Paris, with Constant. Member: Paris AAA [13]

BIGELOW, Charles C. [P,I] Buffalo, NY b. 20 F 1891, Buffalo. Studied: Albright A. Sch.; Syracuse Univ. Member: Buffalo AC. Work: Buffalo Consistory (AASR), Courier-Express Bldg., Sprenger's Dutch Tavern, all in Buffalo. Illustrator: magazines [40]

BIGELOW, Constance [P] Paris b. NYC [13]

BIGELOW, Daniel Folger [Ldscp.P] Chicago, IL b. 22 Jy 1823, Peru, NY d. Jy 1910. Member: Chicago SA. He was connected with the group of artists headed by G.P.A. Healy, and with them organized the Academy of Design, which later became the Art Institute of Chicago. [13]

BIGELOW, L. Seymour, Jr. [P] Phila., PA [21]

BIGELOW, Olive (Mrs. Herbert Pell) [P] Hopewell Junction, NY b. 12 My 1886, Mountain Station, NJ. Studied: ASL; Rafaelle Collin, in Paris; Carl Marr. Member: Grand Central AG; NAWA; Newport AA; Gloucester SA. Exhibited: Royal Drawing Soc., London, 1902 (prize), 1904 (prize); Newport AA, 1929 (prize), 1943; Knoedler Gal., 1920 (prize); Walker Gal., London, 1922; Ferargil Gal., 1927; Bernheim Jeanne, Paris, 1929; Lisbon, 1942. Work: Providence Mus. A.; Vienna Military Acad.; Norwich Mus. A., England. Illustrator: Vogue, Harper's [47]

BIGELOW, William Sturgis b. 1850, Boston d. 6 O 1926, Boston. A physician, art connoisseur, and author, he gave his collection of Oriental treasures to the Boston Museum of Fine Arts, and it is considered the finest collection of Chinese and Japanese art objects in America. He was a trustee of the Boston Museum of Fine Arts, and a Fellow of the American Academy of Arts and Sciences.

BIGGERS, Charles M. [P] St. Louis, MO [24]

BIGGERS, John Thomas [P,S] Hampton, VA b. 13 Ap 1924, Gastonia, NC. Studied: Hampton Inst., with Victor Lowenfeld. Exhibited: MOMA, 1943; CAM; SFMA; Portland A. Mus.; BMFA; SAM, 1945; VMFA Traveling Exh., 1945, 1946; Brooklyn Lib., 1946; Petersburg, Va., 1946 [47]

BIGGS, Geoffrey [I] Palatine Bridge, NY b. 6 Ap 1908, London. Studied: Grand Central Sch. A., with De Feo, Wolfle. Member: SI. Exhibited: SI; A.Dir.Cl. Illustrator: magazines, advertising [47]

BIGGS, Walter [I,T] NYC b. 4 Je 1886, Elliston, VA. Studied: Robert Henri; Kenneth Hayes Miller; Edward Penfield; F. Luis Mora. Member: ANA; AWCS; SI; SC. Exhibited: SC, 1939 (prize); A. Dir. Cl., 1939 (prize); AIC; AWCS. Illustrator: national magazines [47]

BIGLAND, Percy [P] Haverford, PA [08]

BIGLER, Mary Jane White [Edu,P] Detroit, MI b. Columbia City, IN. Studied: Ind. Univ.; Wayne Univ.; Taylor A. Sch.; Brown County Sch. Painting. Member: Ind. A. Cl.; Detroit A. Market; Detroit WC Soc. Exhibited: Ind. A. Cl., 1940, 1946; Hoosier Salon; Detroit Inst. A.; Detroit A. Market. Position: Instr., Wayne Univ., 1943–46 [47]

BIJUR, Nathan I. [P,E] NYC b. 2 Jy 1875, New York. Studied: A. Gorky. Member: Soc. Am. E. [40]

BILL, Carroll (M.) [Dec,L,P,I,W] East Weymouth, MA b. 28 D 1877, Phila. Studied: Harvard Univ. Member: Boston Soc. WC Painters; Copley Soc.; AWCS. Exhibited: NYWCC, 1928 (prize); Baltimore WC Cl.; PAFA; AWCS; Butler AI; Boston Soc. WC Painters. Work: Hispanic Soc., N.Y.; Herron AI; Univ. Mich.; Farnsworth Gal.; Rockland, Maine; MIT; murals, Boston Airport, Bethlehem Ship Co., Worcester, Springfield, Manchester, all in Mass. Illustrator: "Tempest over Mexico," 1935. Author/Illustrator: national magazines [47]

BILL, Sally Cross (Mrs. Carroll) [Min.P,Mur.P] East Weymouth, MA b. Lawrence MA. Studied: DeCamp; Ross Turner. Member: Boston Soc. WC Painters; North Shore AA; Gld. Boston A.; Pa. S. Min. P; NAWA; NYWCC. Exhibited: P.-P. Expo, San Fran., 1915 (med); Los Angeles Mus. A., 1932 (prize). Work: PMA; Women's City Cl., Boston; St. James Church, New Bedford; murals, three steamers of the Bethlehem Ship Co. [47]

BILLINGS, Henry [P,Li,T,Mur.P] NYC b. 13 Jy 1901, Bronxville, NY. Studied: ASL. Member: Nat. Soc. Mural P.; Mural Artists Gld.; Am. Soc. PS&G. Exhibited: Midtown Gal., 1946 (one-man); NAD; WMAA;

WFNY, 1939. Work: WMAA; Mus. Sc.&Indst., N.Y.; Music Hall, N.Y.; USPOs, Lake Placid, Wappinger Falls, N.Y., Columbia, Tenn., Medford, Mass. Positions: Instr., ASL, 1940–41, Bard Col. [47]

BILLINGS, Henry J. [Ldscp.P,B,L,W] Springfield, MA b. 20 Ja 1894, Skowhegan ME. Studied: George Pearse Ennis; W. Lester Stevens. Member: Springfield AL; Springfield AG; Conn. Acad. FA. Exhibited: oils, Springfield AG, 1932 (prize), 1933 (prize), 1934 (prize); print, 1934 (prize). Lectures: travel, illus. with paintings made on trips abroad [40]

BILLINGS, Mary H(athaway) [P] Brooklyn, NY/Northampton, MA b. Brooklyn, NY. Studied: Rhoda Holmes Nicholls; Cullen Yates; Pape; Whittaker. Member: NAC; Brooklyn SA; Deerfield Valley A. Assn. [40]

BILLINGTON, John J(ules) [P,T,Li,Ser,I] Los Angeles, CA b. 17 F 1900, Meadville, MO. Studied: Univ. Mo.; AIC; ASL. Member: Calif. WC Soc. Exhibited: San Fran. AA, 1939; 48 Sts. Comp.; Laguna Beach AA, 1938 (prize); San Diego FA Soc., 1941 (prize); Am. A. Cong., 1940 (prize); Douglas Aircraft Co., 1943 (prize); WFNY, 1939; CGA, 1939; San Diego FA Soc., 1941; AIC, 1940; Riverside Mus., 1940; Calif. WC Soc., 1945. Position: Tech. Illus., Lockheed Aircraft Corp., 1944–46 [47]

BILLMYER, Charlotte Post (Mrs. James I.) [I] Jackson Heights, NY b. 16 S 1901, Brooklyn, NY. Studied: Harvey Dunn; Ward. Illustrator: Cosmopolitan, Collier's, Country Home [40]

BILLMYER, James Irwin [I] NYC b. 1897, Union Bridge, MD. Studied: Harvey Dunn; George Luks. Member: SI. Illustrator: national magazines [47]

BILODEAU, Laura Du Barry [P,C,T] Brookline, MA/Nantasket, MA b. 21 Ja 1896, Brockton, MA. Studied: BMFA Sch.; Scott Carbee A. Sch., Boston. Member: Bay State Ar. Gld. Position: Instr., Dorchester House [40]

BILOTTI, A.G. Hesse [S] NYC [15]

BILOTTI, Salvatore F. [S] NYC/Summit, NJ b. 3 F 1879, Cosenza, Italy d. 22 Ja 1953. Member: Arch. Lg., 1914; NSS; F., PAFA. Exhibited: Arch. Lg., 1914 (prize); Lincoln Mem. Competition, Milwaukee, 1933 (prize); AIC, 1938; Montclair (N.J.) AA, 1938 [40]

BINDER, Carl F. [P,Li] Cleveland Heights, OH b. 10 F 1887, Germany. Studied: Knackfuss A. Acad., Düsseldorf. Member: Kokoon AC, Cleveland. Exhibited: CMA, 1924 (prize), 1925 (prize), 1926 (prize), 1927 (prizes), 1928 (prizes). Work: PAFA; CMA [40]

BINDER, Jacob [Por.P] Boston, MA b. 18 D 1887, Kreslavke, Russia. Studied: Vilna A. Sch.; Acad. A., Petrograd; Joseph DeCamp; John Singer Sargent. Member: Boston AC; North Shore AA; Am.A.Lg. Exhibited: New England A. Exh., 1929 (prize); AIC, 1919–21; PAFA, 1923, 1924, 1925, 1928; CAM; Ind. AA; Springfield A. Mus.; Copley Soc.; FA Mus., Harrisburg, Pa.; North Shore AA, 1920–45; East Gloucester AA; Ogunquit AA. Work: BMFA; Harvard Univ.; Northeastern Univ.; Boston Univ.; Pub. Lib. and State House, Boston; Concord (N.H.) State House [47]

BINDER, Joseph [Des,L] NYC b. 3 Mr 1898, Vienna. Studied: States Sch. A.&Crafts, Vienna. Member: SI. Exhibited: WFNY, 1939 (prize); A. Dir. Cl., 1939 (med), 1944 (med); MOMA, 1941, Traveling Exh.; 1946; AIC, 1933; Franklin Inst., 1937; Austrian Mus., Vienna, 1935. Work: BMFA; MMA; Franklin Inst.; Austrian Mus., Vienna; map mural, American Airlines; E.R. Squibb & Co. Author: "Color in Advertising," 1934. Contributor: art magazines [47]

BINDRUM, Elsie Spaney [P] Richmond Hill, NY/Stockbridge, VT b. 21 N 1906, Piermont, NY. Studied: ASL; Met. A. Sch. Work: Lothrop, Lee, Shepard Co. publications, 1938, 1939; New Yorker; McCall's; Delineator, 1936 [40]

BINDRUM, John L. [P,T] Piermont, NY b. 22 Ja 1907, Brooklyn, NY. Studied: ASL; Brooklyn Inst. A.&Sc.; J.R. Koopman; Richard Lahey; George Bridgman; M.G.L. Briem. Member: AWCS; Brooklyn A. Soc. Exhibited: PAFA, 1939, 1941; AIC, 1939, 1941; AWCS, 1936–46; WFNY, 1939; BM, 1941; Vienna, 1939; Toronto, 1939; Brooklyn A. Exh., 1940–46. Position: Instr., Brooklyn Mus., 1936–46 [47]

BINFORD, Julien [P,S] NYC. b. 25 D 1908, Fine Creek Mills, VA. Studied: Emory Univ.; AIC; Boris Anisfeld. Member: F., AIC, 1932; F., VMFA, 1940; Rosenwald Fnd. Exhibited: Audubon A.; Southern Mus. Circuit; CAM; VMFA; NAD; Carnegie Inst.; Los Angeles Mus. A.; Toledo Mus. A.; GGE, 1939; Gal. Jeanne Castel, Salon Des Tuileries, Paris; Phillips Mem. Gal; AIC, 1937, 1938. Work: PMG; IBM; BMFA; AGAA; VMFA; New Britain Mus.; Springfield Mus. A.; Oberlin Col.; Univ. Nebr; W.R. Nelson Gal. A.; Univ. Ga. [47]

BINGHAM, Harriette G. [S] NYC/Arlington, VT b. 6 Mr 1892, Cleveland. Member: NAWPS [24]

BINGHAM, Henry P. (Mrs.) [S] Cleveland [24]

BINGHAM, James R. [I] Scarsdale, NY. Member: SI [47]

BINNER, Leslie. See Buck, Leslie Binner.

BINNS, Charles Fergus b. 4 O 1857, Worcester, England d. 4 D 1934, Alfred, NY. An authority in the ceramic field. The son of Richard William Binns, director of the Royal Porcelain Works in Worcester, he was himself connected with the Porcelain Works from 1872 to 1896. In 1897, he became principal of the Technical School of Science and Art at Trenton, N.J., remaining until 1900. He was director of the former New York State School of Clay Working and Ceramics from the time of its establishment, in 1901, to 1931. Largely responsible for the building of the State College of Ceramics in Alfred, New York (completed in 1932), he was a member and founder of the American Ceramic Society, and a member of the Boston SAC, English Cer. S., and the N.Y. Soc. Cer. Art. He specialized in art pottery and covered his works with unusual glazes. Work: Met.: AIC; Detroit MA. Author: "Ceramic Technology," "The Story of the Potter," "The Potter's Craft." [30]

BINNS, Elsie [S,P]. Studied: Alfred Univ. [24]

BINSWANGER, Isidor [S] Phila., PA. Exhibited: PAFA, 1938; WFNY, 1939 [40]

BINTLIFF, Martha B(radshaw) (Mrs.) [P] La Jolla, CA b. 19 S 1869, Superior, WI. Studied: Giuseppe Ferrari, in Rome. Member: NAWPS; AFA [40]

BINYON, Algernon (Mrs.) See Bean, Caroline van Hook.

BIORN, Emil [P,I] Chicago, IL b. 7 Je 1864, Christiania, Norway. Studied: Christiania AI; AIC. Member: Palette & Chisel Cl., Chicago [17]

BIRCH, Geraldine (Mrs. G.R. Duncan) [P,E] Pasadena, CA b. 12 N 1883, Sussex, England. Studied: Slade Sch. A., London; London Univ.; Desvallieres, Menard, Prinet, in Paris; W.W. Russell. Member: Calif. PM; Calif. AC; Pasadena SA. Exhibited: Provincial Expo, Victoria, B.C., 1932 (prize); Brooklyn SE; Phila. SE; Los Angeles Mus. A.; Pasadena SA; Roswell (N.Mex.) Mus. A. Work: State Lib., Saramento; Oakland A. Gal.; San Juan Capistrano Mission [47]

BIRCH, Ranice (Mrs. Ranice W.V.B. Davis) [I,Edu] Baltimore, MD b. 26 Ap 1915, Regina, Saskatchewan. Studied: Conn. Col.; Johns Hopkins Medical Sch.; Robert Brackman; Max Brodel. Member: Assn. Medical I. Illustrator: medical handbooks. Contributor: medical journals. Positions: Asst. to Dr. N.J. Eastman, Johns Hopkins Hosp.; Dir., Dept. A. (as applied to medicine), Johns Hopkins Sch. [47]

BIRCH, Reginald [Des,En,I] NYC b. 1856, London, England d. 17 Je 1943. Studied: Munich; Italy. He came to America at the age of 16 and began work as a designer and engraver of theatrical posters in San Francisco. In 1881 he came to New York, becoming an illustrator for St. Nicholas (magazine). Among his principal works are illustrations for "Little Lord Fauntleroy" (1886), "Sarah Crewe," "Lady Jane," and "How Fauntleroy Really Occurred." [13]

BIRCHANSKY, Leo [P,Car,T] Sea Gate, NY b. 18 D 1887, Russia. d. 9 Mr 1949. Studied: Imperial Sch. FA, Odessa. Member: Salons of Am.; Miami A. Lg. Exhibited: Salons of Am., 1932–46; A. All., 1942; AV, 1943. Work: murals, Mercantile Bank Bldg., Miami Beach. Position: Car., New York American, Daily Mirror, Daily News, 1925–44 [47]

BIRCHMAN, Willis [I] NYC. Member: SI [47]

BIRD, E.J. [P] Salt Lake City, UT. Exhibited: WFNY, 1939 [40]

BIRD, Elisha Brown [Des] b. 4 N 1867, Dorchester, MA d. 9 Ap 1943, Phila. Member: All.A.Am.; Amer. Soc. Bookplate Collectors and Des. Specialty: bookplates. Position: Promotion Des., New York Times [40]

BIRD, F. [P] NYC b. 25 Mr 1869, London. Studied: R. Swain Gifford [01]

BIRD, Harry [Des] Pasadena, CA b. 12 Ja 1887, Milwaukee, WI. Designer: ceramic decorations. Originator: inlaid glazed method on commercial ware under trade name, "Bird Pottery." Associated: Vernon Potteries, Ltd., Los Angeles [40]

BIRD, L. Pern [I] Winchester, England [24]

BIRDSALL, Amos, Jr. [P] Tom's River, NJ b. 10 Je 1865, Waretown, NJ. Studied: self-taught. Member: SC; Wash. AC; AFA [33]

BIRDSALL, Harry, Jr. [Des] Hartsdale, NY b. 20 N 1909, Peekskill, NY. Position: A. Dir., Brisacher Van Norden & Staff, New York, N.Y. [47]

BIRDSEYE, Dorothy Carroll [P] Gloucester, MA b. NYC. Studied: George Bridgman; Hugh Breckenridge. Member: North Shore AA; F., PAFA. [33]

BIRGE, Mary Thompson (Mrs. Edward) [P] Bloomington, IN/Lake Waccabuc, NY b. 5 Je 1872, NY. Studied: Yale Sch. FA. Member: New Haven PCC [24]

BIRKENBERGER, William [P,Des,C] Waterbury, CT b. 11 Ja 1903, Germany. Studied: AFA. Exhibited: New Haven PCC, 1935 (prize) [47]

BIRNBAUM, Abe [P,Car,I] Croton-on-Hudson, NY b. 11 Je 1899, NYC. Studied: ASL. Member: Am. A. Cong. Exhibited: CI, 1944; Phila. A. All.; PMA; WFNY, 1939. Illustrator: "Listen to the Mocking Words," 1945; Harper's Bazaar, New Yorker [47]

BIRNBAUM, Adolph [Por.P] Brooklyn, NY b. 1865 d. 21 Mr 1943, Brooklyn

BIRNEY, William Verplanck [P] NYC b. 5 Jy 1858, Cincinnati d. 1909. Studied: Mass. Normal A. Sch., Boston; Royal Acad., Munich. Member: NYWCC; Brooklyn AC; SC, 1888; Phila Sketch C.; A. Fund S.; Lotos Cl., 1901. Exhibited: Pan-Am. Expo, Buffalo, 1901 (med); Intl. Expo, Munich (prize); St. Louis Expo, 1904 (med); ANA, 1900 [08]

BIRRELL, Verla Leone [P,L,Edu] Provo, UT b. 24 N 1903, Tacoma, WA. Studied: Univ. Utah; Claremont Col. Member: Utah Acad. Sc., A.&Let. Exhibited: Palace Legion Honor, 1936. Work: Ephraim A. Gal.; Capitol, Utah; St. George A. Gal.; Capitol, Utah; St. George A. Gal.; Brigham Young Univ. [47]

BIRREN, Joseph P. [P,L] Chicago, IL b. 1865, Chicago d. 5 Ag 1933, Milwaukee, WI. Studied: AIC; New York, Phil.; Paris; Munich. Member: Chicago AC; Palette & Chisel C.; Laguna Beach AA; All. AA; Ill. Acad. FA; Chicago PS; North Shore AA; Conn. Acad. FA; Romany Cl.; Chicago Gal. A.; Knight of the Oak Leaf Crown, decorated by Grand Duchy of Luxembourg. Work: Chicago A. Comm. Coll.; Union League Cl., Chicago; Bermuda Promotional Comm.; Ill. Women's Athletic Cl.; Rockford A. Cl.; Ill. State Mus.; Los Angeles Mus.; Wash. Univ. Mus.; Lauren Rogers Mus.; Pasadena A. Inst.; Vanderpoel AA Coll.; Col. Cl., Chicago [33]

BISBING, H(enry) Singlewood [P] Paris b. 31 Ja 1849, Phila., PA d. 26 N 1933, Conn. Studied: PAFA; Munich Acad.; De Hass, in Brussels; Vuillefroy, in Paris. Member: Paris SAP. Exhibited: Paris Salon, 1891 (med); PAFA, 1892 (gold); Columbian Expo, Chicago, 1893, (med); Paris Expo, 1900, (med); Pan-Am. Expo, Buffalo, 1901 (med); Chevalier, Legion of Honor, France, 1902; Weathersspoon AG, UNC, 1971. Work: PAFA; Hayden Survey, 1872-73. Specialty: animals. His painting of cattle won many awards. [17]

BISCHOF, Severin [P,C] Syracuse, NY b. 24 S 1893, Wenden, Germany. Studied: Syracuse Univ.; abroad. Exhibited: Syracuse MFA 1924, 1925 (prize), 1926-39, 1940 (prize), 1941 (prize); Rochester Mem. A. Gal.; Indp. A. [47]

BISCHOFF, Elmer Nelson [P,T] San Fran., CA b. 9 Jy 1916, Berkeley, CA. Studied: Univ. Calif. Member: San Fran. AA. Exhibited: SFMA, 1941 (prize), 1946 (prize); San Fran. AA, 1941-42, 1944, 1946. Position: Instr., Calif. Sch. FA, San Fran., 1946- [47]

BISCHOFF, Eugene Henry [P,T] Bennington, VT/Taos, NM b. 20 S 1880, Pfortzheim, Germany d. 1954. Studied: ASL, with George Bridgman; PIASch; Calif. Sch. FA. Member: Queensboro Soc. All. AC; Douglaston AL. Exhibited: Queensboro Soc. All. AC, 1934 (med). Work: Bennington Mus.. Position: A. Dir., Vt. Gravure [40]

BISCHOFF, Franz A. [P] South Pasadena, CA b. 1864, Austria (came to U.S. in 1884) d. F 1929. Member: Calif. AC. Specialty: landscapes

BISCHOFF, Herman E. [I] East Chatham, NY. Member: SI [47]

BISCHOFF, Ilse Martha [I,P,Gr] NYC b. 21 N 1903, NYC. Studied: ASL; Europe; Joseph Pennell; George Buchner. Member: ASL; Am. Inst. GA. Exhibited: Phila. Pr. Cl., 1927 (prize); AIGA, 1930 (prize); Pepsi-Cola, 1945 (prize). Work: BMFA; BMA; MMA; NYPL. Represented in Fifty Prints of the Year, 1929-1930; Fifty Books of the Year, 1931. Illustrator: children's books [47]

BISCHOFF, Marie Evangeline [P] Jamaica, NY [13]

BISHOP, Cortlandt Field [Patron] b. 1870, NY d. 30 Mr 1935, Lenox, MA. He was a noted collector of art and antiques and was principal owner and former president of the American Art Association, Anderson Galleries.

BISHOP, Emily Clayton [S] Smithsburg, MD b. 1892 d. 2 Mr 1912. She graduated from the Pa. Acad. of Fine Arts in Philadelphia in 1911 and was regarded as one of the most promising of America's younger sculptors. She was represented in the PAFA exhibition (1912) by three works.

BISHOP, Flora M(elissa) (Mrs.) [P] Seattle, WA b. Minneapolis, MN. Studied: Calif. Sch. FA; Clyde Leon Keller; Univ. Oreg. Member: Women Ar. Wash.; Seattle AI; Oreg. SA [33]

BISHOP, Harold S. [P,E,Li,T] Rochester, NY b. 25 Mr 1884. Studied: Cincinnati A. Acad; Frank Duveneck; L.H. Meakin. Member: Cincinnati AC; Rochester AC. Exhibited: Mem. A. Gal., 1922 (prize), 1927 (prize), 1929 (prize); Rochester Expo, 1926 (gold). Work: murals, Riviera Theatre, Syracuse, N.Y.; Oriental Theatre, Rochester, Pa.; Univ. Rochester, Colgate Rochester Divinity Sch., City Hall, Pub. Lib., Convent of the Sacred Heart, Rochester N.Y.; Lester Inst., London [40]

BISHOP, Hubert E. [P] Norwalk, CT b. 8 Mr 1869, Norwalk. Studied: self-taught. Member: Silvermine Group A.; S.Indp.A. [24]

BISHOP, Irene. See E.T. Hurley, Mrs.

BISHOP, Isabel (Mrs. I.B. Wolff) [P,E,T] Riverdale, NY b. 3 Mr 1902, Cincinnati, OH. Studied: Kenneth Hayes Miller; ASL; N.Y. Sch. App. Des.. Member: NA; NIAL; SAE; An. Am. Group. Exhibited: NAD 1936 (prize), 1943 (prize), 1945 (prize); SAE, 1939 (prize); Butler AI, 1941 (prize); CGA, 1945 (med); Lib. Cong., 1946 (prize); CI; VMFA; WFNY, 1939; GGE, 1939; AIC; WMAA; CAM. Work: WMAA; MMA; PAFA; AGAA; Springfield MA; Butler AI; PMG; BMA; CAM; NYPL; Lib. Cong.; CGA; mural, USPO, New Lexington, Ohio. Illustrator: "Pride and Prejudice" (Book-of-the-Month-Club Edition), 1946. Contributor: art magazines [47]

BISHOP, Katherine [P] San Fran., CA [13]

BISHOP, Marjorie (Cutler) [P] NYC 23 Ag 1904, Melrose, MA. Studied: New. Sch. Soc. Res.; ASL; Sol Wilson; Guy Pene DuBois. Exhibited: Walker A. Center, 1946 (prize); PAFA, 1945; Carnegie Inst., 1945; Pepsi-Cola, 1946; Levitt Gal., 1945 (one-man); Suffolk Mus., 1946; ACA Gal., 1943; Brandt Gal., 1943 [47]

BISHOP, Mattie White [Min.P] Brunswick, GA [17]

BISHOP, Morris, Mrs. See Kingsbury, Alison Mason.

BISHOP, R(ichard) E(vett) [E,P,C,W] Phila., PA b. 30 My 1887, Syracuse, NY. Member: Phila. Pr. Cl.; Chicago SE; Phila. SE; Soc. Am. E.; Phila. Sketch Cl.; Phila. WCC; Phila. All.; Pr.M. of Calif. Exhibited: Phila. Pr. Cl., 1924 (prize). Work: A. Mus., Honolulu; Mus. FA, Syracuse; Pa. Mus. A., Phila. Represented: Fine Prints of the Year, 1932, 1933, 1934. Author: "Bishop's Birds," 1936, Phila. J.B. Lippincott [40]

BISSELL, Cleveland [P] NYC. Exhibited: 48 Sts. Comp. [40]

BISSELL, Dorothy Pendennis [S] Williamsville, NY b. 17 My 1894, Buffalo, NY. Studied: Arthur Lee. Member: Buffalo SA. Specialties: animals, heads of children [47]

BISSELL, Edgar J(ulian) [P] St. Louis, MO b. 14 Mr 1856, Aurora, IL. Studied: Otto Grundmann; Boulanger, Lefebvre, Collin, Courtois, all in Paris. Member: St. Louis Soc. Ar. [21]

BISSELL, George E(dwin) [S] Mt. Vernon, NY b. 16 F 1839, New Preston, CT d. 30 Ag 1920. Studied: English Acad., Rome, 1876; Arts Decoratif, Paris, 1883-84. Member: NSS, 1893; Arch. Lg., 1899; Mt. Vernon Municipal AS. Exhibited: Paris Expo, 1900 (prize); St. Louis Expo, 1904 (med). Work: MMA; Waterbury, Conn.; Ayr, Scotland; Edinburgh, Scotland; Phila.; Hoboken, N.J.; Fultonville, N.Y.; Saratoga, N.Y.; LOC. Studio in Paris (six years); studio in Florence (four years). [19]

BISSELL, Helen Rathman (Mrs.) [P] Maplewood, MO [24]

BISSELL, S [P] Boston, MA [15]

BISSELL, Susan F. [P] d. 14 S 1920, Port Jefferson, NY. She was a student in the School of Applied Design for Women in 1896 when William M. Chase withdrew from the Art Students' League and established a class. She was one of the first members of the class, and when the school was reorganized as the New York School of Art she became the Secretary. [21]

BISSELL, Valetta Hawthorne [P] NYC [17]

BISTLINE, Edna (Marian) (Mrs.) [P] Phila., PA b. 14 Ag 1914, Elliottsburg, PA. Studied: PAFA, with McCarter, Chapin, Watkins; Barnes Fnd. Member: F., PAFA. Exhibited: DaVinci All., 1943, 1944 (prize); PAFA, 1945; Phila. Sketch Cl., 1944-46; Ragan Gal., 1945; Woodmere A. Gal., 1942, 1946 [47]

BISTTRAM, Emil [P,Des,L,T,] Taos, NM b. 7 Ap 1895, Hungary d. 1976. Studied: Howard Giles. Member: F., Guggenheim, 1931; NYWCC; AWCS; Phila. WCC; Fnd. Western Ar.; and founder, Taos SA, 1931. Exhibited: Phila. WCC, 1926 (prize); AWCS, 1927 (prize), 1930 (prize); 1931 (prize); Phila. WCC, 1931 (med). Work: Albright A. Gal; Roerich Mus., New York; Taos County Court House; murals, Dept. Justice, Wash., D.C.; USPO, Ranger, Tex. Position: Dir., Taos Sch. A. [47]

BITTENBENDER, Ben [P] Nescopeck, PA [24]

BITTER, C.B.R. [P] Toledo, OH. Member: Artklan [24]

BITTER, Karl (Theodore Francis) [S] NYC/Raquette Lake, NY b. 6 D 1867, Vienna, Austria (came to the U.S. in 1899) d. 10 Ap 1915 (after being struck by an automobile on leaving the Metropolitan Opera House). Studied: Vienna Acad. FA; Edmund Hellmer. Member: ANA, 1902; NA, 1903; NSS; Nat. Inst. A.&L.; N.Y. Arch. Lg.; Century Assoc. Exhibited: Comp. for Astor Mem. Gates, Trinity Church, New York (his design was chosen); Paris Expo, 1900 (med); Pan-Am. Expo, Buffalo, 1901 (gold); Arch. Lg. New York, 1914 (med); P.-P. Expo, San Fran., 1915 (med); Charleston Expo, 1902 (gold); ACP, 1903 (gold); St. Louis Expo, 1904 (gold). Work: Phila.; Trinity Church, New York; Ann Arbor, Mich.; Indianapolis AA; MMA. He was director of sculpture at three expositions—Buffalo (1901), St. Louis (1904), San Fran. (1915).

BITTERLY, L.P. (Mrs.) [P,S] Denver, CO [24]

BITTINGER, Charles [P] Wash., D.C. b. 27 Je 1879, Wash., D.C. Studied: ASL; Ecole des Beaux-Arts, Acad. Delecluse, Acad. Colarossi, Paris. Member: SC, 1908; ANA, 1912; NA, 1937; NAC; All.A.Am.; AFA; The Colorists; Gld., Boston A.; Wash. AC; Soc. Wash A.; Duxbury AA. Exhibited: St. Louis Expo, 1904 (med); NAD, 1909 (prize), 1912 (prize); P.-P. Expo, 1915 (med); Duxbury AA, 1919 (prize); Soc. Wash. A., 1925 (prize); Newport AA, 1938 (prize). Work: Ultra-violet mural, Franklin, Inst., Phila.; St. Louis A. Mus.; Allegheny Col.; NAC; CAM; MMA; Nat. Acad. Sc., Wash., D.C.; Montgomery (Ala.) Mus. FA [47]

BITTINGER, Ross Thomas [C,Des,T] Ann Arbor, MI/East Jaffrey, NH b. 6 N 1898, Madison, MI. Studied: BMFA Sch.; Cranbrook Acad. A.; Harvard Univ.; Univ. Mich.; MIT. Member: Boston Soc. A. Cr.; Ann Arbor A. Assn. Work: Fogg Mus., Cambridge, Mass.; St. Luke's Chapel, Ypsilanti, Mich. Position: Instr., Univ. Mich. [40]

BITTNER, Frank [P,I] NYC b. 30 My 1879, Akron, OH. Studied: William M. Chase; Robert Henri [09]

BITZ, Charlotte Kizer (Mrs. Arthur L.) [P,B,T] Port Chester, NY b. 8 Ja 1901, Lincoln, NE. Studied: Charles Martin; Columbia Univ.; Univ. Nebr. Sch. A. Member: Westchester A. Ce. Gld.; Port Chester FA Soc.; Eastern A. Assn. Exhibited: watercolor, Kansas City A. Inst., 1933 (prize). Work: Joslyn Mem., Omaha. Position: Dir., A.&Crafts, Westchester Workshop [47]

BIVA, Lucien [P] NYC. Member: S.Indp.A. [24]

BIXBEE, William J(ohnson) [P,I,T] Marblehead, MA b. 31 Ag 1850, Manchester, NH d. 14 Jy 1921, Lynn, MA. Studied: Lowell Inst.; Tommaso Juglaris; S.P. Rolt Triscott; Marcus Waterman. Member: Boston SWCP; S.Indp.A. Work: Poland Spring A. Gal., South Poland, Maine. Designer: seal of the City of Lynn [19]

BIXBY, William Keeney b. 2 Ja 1857, Adrian, MI d. 29 O 1931, St. Louis, MO. He retired from active business at the age of forty-seven and began collecting paintings and other rare objects. In 1918, he sold his manuscript collection, which included letters and autographs of Michelangelo, Napoleon, and Beethoven, and went to China, where he continued his collecting, bringing back jades, porcelains, and lacquers. He later placed most of his art objects as a loan collection in the St. Louis Museum. He bequeathed to the Museum $80,000 and art objects valued at $60,000. Bixby was president of the City Museum of St. Louis from 1904 until his death; he was also an honorary vice-president of the American Federation of Arts.

BJAREBY, (Alfred) Gunnar [P,S,I] Boston, MA b. 11 F 1899, Forslovsholm, Sweden. Studied: Académie Julian, Paris; BMFA Sch., with L. Thompson, Charles Grafly; Gotthard Sandberg, in Sweden. Member: North Shore AA. Exhibited: North Shore AA., 1939–41, 1942 (prize), 1943–46; Salon de Printemps, Paris, 1933; Swedish Cl., Chicago, 1946; Boston AC, 1933; Jordan Marsh, 1935–44, 1946. Work: murals, St. Joseph's Cathedral, Manchester, N.H. Illustrator: "Comrades in Snow," 1940 [47]

BJORKLUND, Lorence F. [I] Croton Falls, NY b. ca. 1914, Minnesota. Studied: PIASch. Specialty: western books and magazines [*]

BJORKMAN, Olaf [P,S] NYC b. 1887, Stockholm, Sweden d. 24 F 46 [15]

BJORNCRANTZ, Carl G. [Indst.Des] Evanston, IL b. 8 Ag 1904, Grand Rapids, MI. Studied: Colgate Univ. Member: ADI. Position: Chief Des., Sears Roebuck & Co., 1943– [47]

BJORVAND, Helen H. (Mrs. Bernt J.) [T,I] Elmira, NY b. 17 My 1902, Hartford, CT. Studied: Smith Col.; Yale. Illustrator: "Lucy Perhaps," 1935. Position: T., Elmira Col., 1933– [47]

BJURMAN, Andres [S,C,T] Alhambra, CA b. 4 Ap 1876, Sweden d. 17 My 1943. Studied: self-taught. Member: Calif. AC; Am. APL. Exhibited: San Diego Expo, 1915 (prize); Calif. Liberty Fair, 1918 (prize); Southwest Mus., 1923 (prize); Los Angeles Mus., 1924 (prize), 1927 (prize), 1939 (prize); Pomona, Calif., 1924 (prize), 1927 (prize), 1939 (prize); Southwest Expo, Long Beach, 1928 (gold). Work: John Morton Mem. Mus., Phila. [40]

BLACK, E.B. [P] St. Petersburg, FL d. Winter 1924

BLACK, Eleanor Simms (Mrs. Robert M.) [P] Pittsburgh, PA b. 9 Ja 1872, Wash., D.C. d. 13 N 1949. Studied: Corcoran Sch. A; Howard Helmick; Charles W. Hawthorne. Member: Pittsburgh AA. Exhibited: PAFA, 1924; NAD, 1925; CGA, 1926; SSAL, 1924–28; Pittsburgh AA, 1915, 1944 [47]

BLACK, H. Virginia [P] Bluefield, WV. Studied: Vivene A. Sch., Bluefield; Marshall Col. Member: AAPL; Mountaineer AA. Work: mural, Baptist Church, Bluefield [40]

BLACK, Harold [P,Des,T] NYC b. 13 D 1913, NYC. Studied: NAD; Leon Kroll; Gifford Beal. Member: Audubon A. Exhibited: NAD, 1936 (prize); MOMA, 1940, 1940 (prize); 48 Sts. Comp., 1940 (prize); WFNY, 1939; GGE, 1939; AIC, 1939–43; MMA, 1942; Arch. Lg., 1942. Work: murals, Fed. Court House, Salina Kans. Illustrator: "The Kaw," 1943. [47]

BLACK, J. Loren [P] Cleveland, OH. Member: Cleveland SA [24]

BLACK, John M(atthew) [P] Bayfield, WI b. 18 Je 1876, Crown Point, IN. Studied: J. Francis Smith; Sterba. Exhibited: AIC, 1906 (med) [17]

BLACK, Kate Eleanor (Mrs.) [P,C] South Norwood, OH b. 3 D 1855, London (came to U.S. in 1899). d. 14 D 1924. Studied: Cincinnati Acad. Member: Cincinnati Women's A. Council. Exhibited: Provincial Exh., New Westminster, British Columbia (med) [21]

BLACK, Laverne Nelson [P] Chicago, IL. Exhibited: PS Ariz., 1938. Work: USPO, Phoenix, Ariz. WPA artist. [40]

BLACK, Mary C.W. (Mrs. R. Douglas Morrison) [P] Monterey, CA b. Poughkeepsie, NY d. 4 D 1943. Studied: ASL, with W.L. Lathrop; F. Luis Mora; Glenn Newell. Member: NAWPS; Carmell AA; NAC; San Fran. AA. Exhibited: Santa Cruz AL, 1935 (prize). Work: Seattle AM; Santa Cruz (Calif.) Women's Cl.; Officers' Cl., Presidio, Monterey, Cal. [40]

BLACK, Norman I. [P,E] Paget, Bermuda/Casco Bay, ME b. 8 N 1883, Chelsea, MA. Studied: Eric Pape Sch., Boston; Acad. Julian and Beaux-Arts, Paris; Munich. Member: Calabash C., Bermuda [40]

BLACK, Norman I. (Mrs.) [P] Paget, Bermuda/Casco Bay, ME b. 15 Ap 1884, Providence, RI. Studied: Eric Pape Sch., Boston; Acad. Julian, Paris; Munich. Member: Providence AC; Calabash C., Bermuda [40]

BLACK, Olive P(arker) [Ldscp.P] NYC/South Egremont, MA b. 22 Jy 1868, Cambridge, MA. Member: ASL, with H. Bolton Jones; NAD; William Chase; Edwin Blashfield. Member: NAWPS; SPNY; AAPL; CSB, 1887 [40]

BLACK, Oswald Ragan [Car,I,L] Minneapolis, MN b. 29 O 1898, Neoga, IL. Studied: Walter L. Evans; Univ. Nebr. Member: Lincoln AG; Minn. AA; Minneapolis SFA. Exhibited: Nat. Lg. Women Voters, 1924 (prize). Position: Car., Minneapolis Star Journal and Tribune, 1940– [47]

BLACK, Richard Brown [P] Greenfield, IL b. 1888, Indiana d. 17 Ap 1915. Studied: Cormon, Paris; Germany. Spent two years painting in North Africa. Two paintings purchased by French Gov. [15]

BLACK, Robert M. (Mrs.) [P] Pittsburgh, PA. Studied: Pittsburgh AA [21]

BLACKBURN, J.B. (Mrs.) [P] San Fran., CA [13]

BLACKBURN, Morris (Atkinson) [P,Des,T] Phila., PA b. 13 O 1902, Phila. Studied: PAFA; Henry McCarter; Arthur B. Carles. Studied: Phila. A. All. Exhibited: Chester County AA (prize). Work: murals, PAFA, PWAP; watercolor, Wilmington (Del.) SFA; sketches PMA. Position: T., PMSchIA [40]

BLACKBURN, Oscar [P] Minneapolis, MN [19]

BLACKBURN, William Thomas [Des,P] Los Angeles, CA b. 3 O 1908, Hickory, NC. Studied: PAFA; Académie Julian, Paris; Nat. Acad., Florence. Position: Asst. to A. Dir., Bullock's Wilshire, Los Angeles [47]

BLACKFORD, Polly Baldwin [P] Norfolk, VA b. 2 Ap 1910. Studied: PAFA. Exhibited: Norfolk Chamber Commerce, 1929 (prize); Leach Mem. Comp., 1932 (prize), 1933 (prize). Work: U.S. Gov. [40]

BLACKMAN, Carrie Horton (Mrs. George) [P,W] Carmel, CA b. Cincinnati. Studied: St. Louis Sch. FA; Chaplin, in Paris. Member: St. Louis AG. Exhibited: Alaska-Yukon Expo, 1909 (med). Specialty: children's portraits [33]

BLACKMAN, Walter [Por.P] b. 1847 d. December 13, 1928, Chicago, IL. He was also a poet, and for the last fifteen years had lived in London and Paris.

BLACKMON, Thomas Lawson [P,L] Corpus Christi, TX b. 28 F 1901, Ennis, TX. Studied: AIC; Académie Julian, Paris. Exhibited: San Antonio, 1927 (prize). Work: Witte Mus., San Antonio [40]

BLACKMORE, Arthur E(dward) [P,C] NYC b. 8 F 1854, Bristol, England d. 15 D 1921. Studied: South Kensington Mus., London. Member: SC, 1897; A. Aid. S.; A. Fund S.; Arch. Lg., 1914; Wash. AC; S.Indp.A. [21]

BLACKOWL, Archie [P,T] Apache, OK (1967) b. 22 N 1911, Weatherford, OK. Studied: Nordmark; Seger Indian Sch.; Concho Indian Sch. Exhibited: Okla. A. Center; state colleges/univ. Work: murals, Indian Sch.; Officers Cl., Ft. Sill, Okla.; Haskell Inst.; Philbrook A. Center [47]

BLACKSHEAR, Annie Laura Eve [P,I,T,W,L] Athens, GA b. 30 O 1875. Studied: CUASch; Chase Sch. A.; ASL; PAFA; Twachtman; William Chase; R. Swain Gifford; Breckenridge; Garber; Women's AS. Member: SSAL; Ga. AA; Southeastern AA; Athens AA. Exhibited: SSAL; Ga. AA; Univ. Ga. Work: portraits, public officials; illus., Ga. Agric. Ext. Service. Author/Illustrator: "Charts for Visual Instruction." Contributor: magazines, newspapers. Position: I., Ga. Agric. Ext. Service, 1917–46 [47]

BLACKSHEAR, Kathleen [P,T,Des,Li,Ser,L] Chicago, IL b. 6 Je 1897, Navasota, TX. Studied: AIC; ASL; Baylor Univ. Member: Chicago SA; Chicago AC. Exhibited: Chicago SA, 1934 (med); Witte Mem. Mus. (one-man); Houston MFA; Dallas MFA; Delgado Mus. A. Illustrator: "An Artist's Calendar," 1937–47. Position: Instr., AIC, 1926–46 [47]

BLACKSTONE, Harriet [P] NYC b. 1864, New Hartford, NY d. 16 Mr 1939. Studied: Académie Julian, Paris; Chase summer schools; PIASch. Member: NAC; Chicago SA; Chicago AC. Exhibited: AIC; Paris Salon, 1907; Bennington Mus., 1984. Work: Vincennes AA; de Young Mem. Mus., San Fran.; NGA; BM; Layton AG, Milwaukee [38]

BLACKTON, J. Stuart [P] NYC. Studied: SC [21]

BLACKWELDER, Lucile [P] St. Louis, MO. Member: St. Louis AG [24]

BLACKWELL, Mary [P] Indianapolis, IN [24]

BLACKWELL, Wenonah [P] Seattle, WA [21]

BLACKWOOD, Gladys Rourke [I] Freeport, IL b. 13 Ap 1904, Sterling, IL. Studied: AIC. Illustrator: "Auno and Tauno," 1940, "The Cocoa Dancer," 1945, other books [47]

BLADEN, Thomas W. [Des] Jamaica, NY [09]

BLAGDEN, Thomas P. [P,T] Lakeville, CT b. 29 Mr 1911, Chester, PA. Studied: Yale; PAFA; Daniel Garber; Francis Speight; Henry Hensche. Member: Conn. WCS. Exhibited: CGA, 1937 (prize); PAFA, 1938, 1940; Albany Inst. Hist.&A., 1939, 1946; Conn. WCS, 1940, 1946. Work: Albany Inst. Hist.&A.; Wadsworth Atheneum, Hartford. Position: T., Hotchkiss Sch., Lakeville, 1935– [47]

BLAI, Boris [S,L,T] Phila., PA/Ocean County NJ b. 24 Jy 1893, Rowno, Russia. Studied: Rodin; Imperial Acad. FA, Leningrad. Member: Phila. A. All.; Fairmount Park AA; Grand Cent. A. Gal. Position: Founder–Dir., Stella Elkins Tyler Sch. FA [40]

BLAI, Isabel S. [S,C] New Brunswick, NJ b. 8 Ag 1919, Trenton, NJ. Studied: Temple Univ.; Boris Blai; Franklin Watkins; Furman Finck. Member: Wash. AG. Exhibited: PAFA, 1941, 1942; AV, 1942; Soc. Wash. A., 1941; Temple Univ., 1941; Wash. AG, 1942. [47]

BLAIN, Edgar H. [T,P] Medina, OH b. 20 S 1903, Greenfield, OH. Studied: Cincinnati A. Acad.; Wilmington Col.; Ohio State Univ. Member: Cincinnati AC. Exhibited: Florida Fed. A., 1941 (prize); Clearwater AM, 1941 (prize); Akron AI, 1944 (prize); Butler AI, 1939; Cincinnati AC; Akron AI; Florida Fed. A. Position: Dir. A., Medina County Sch., Medina, 1928– [47]

BLAIN, J(ulia) [T,P,C,L] Springfield, MO b. 3 Je 1893, Ozark, MO. Studied: Drury Col.; Charles Cagle; Omar Lassonde; Antonio Cortizas. Member: SSAL. Exhibited: SSAL, 1934; Springfield MA. Position: In charge of Art Classes & Exh., Springfield AM, 1944–45 [47]

BLAINE, Mahlon [P] San Fran., CA [17]

BLAINE, Nell (Mrs. N.B. Bass) [P] NYC b. 10 Jy 1922, Richmond, VA. Studied: Richmond Prof. Inst.; Richmond Sch. A.; Hans Hofmann. Member: F. VMFA, 1943, 1946; Jane St. Group; Am. Abstract A. Exhibited: Passadena AI, 1946; VMFA, 1944–46; AIC, 1944; Am. Abstract S., 1945, 1946; Art of this Century, 1945; Norfolk Mus. A., 1944–46; Jane Street Gal., 1945 (one-man) [47]

BLAIR, Dorothy L(illian) [Mus.Cur,T,W,L] Toledo, OH b. 10 S 1890, Webster Groves, MO. Studied: Mt. Holyoke Col.; Kyoto Imperial Acad., Japan; Univ. Mich. Member: Chinese A. Soc. Am., N.Y.; Soc. Japanese Studies, N.Y. Exhibited: Intl. Essay Contest, Kokusai Bunka Shunkokai, Tokyo, 1940 (prize). Author: "Survey of East Asiatic Art in the Museums of Europe," 1937. Contributor: mus. bulletins, art magazines. Lectures: Arts and cultures of East Asiatic countries. Position: Asst. Dir., John Herron AI, 1922–26; Asst. Cur., Oriental Art, Toledo Mus. A., 1928– [47]

BLAIR, E.R. [I] Cleveland, OH. Member: Cleveland SA [33]

BLAIR, James B. [P] Pittsburgh, PA. Member: Pittsburgh AA [24]

BLAIR, Lawrence Edson [T,I,W] Madison, WI b. 17 N 1892, Darlington, WI. Studied: AIC. Work: Galena Hist. Mus., Ill. Contributor: trade periodicals. Position: T., Univ. Wisconsin, 1926–46 [47]

BLAIR, Lee C. [P] Glendale, CA. Member: AWCS [47]

BLAIR, Lee Everett [P,Car,Des] NYC b. 1 O 1911, Los Angeles. Studied: David Alfaro Sequerios; Morgan Russell; Lawrence Murphy; Pruett Carter; Chouinard Sch. A., Los Angeles. Member: Laguna Beach AA; Calif. SCS; AWCS. Exhibited: AWCS, 1933 (prize), 1944 (med); Los Angeles MA, 1932 (prize); Calif. WCS, 1933 (prize), 1939 (prize); Ariz. State Fair, 1932 (prize). Work: Pal. Leg. Honor. Position: Animated Car., Color, Story Director, Walt Disney Studios [47]

BLAIR, Mary Robinson [Car,I,Textile Des] Los Angeles, CA b. 21 O 1911, McAllister, OK. Studied: Pruett Carter; Lawrence Murphy. Member: Calif. WCS. Exhibited: Calif. WCS, 1937 (prize). Work: Los Angeles AA. Position: Color Dir., MGM Car. Studio [40]

BLAIR, Preston Erwin [P,I,Car] Los Angeles CA b. 24 O 1910, Los Angeles. Studied: Otis AI; Chouinard AI. Member: AWCS; Calif. WCS. Exhibited: Laguna Beach AA, 1944, 1945 (prize); Los Angeles MA, 1945; AWCS, 1945, 1946; Calif. WCS, 1943–45. Position: Car. Dir., MGM Studios, Culver City, CA, 1940– [47]

BLAIR, Robert Ernest [S] Kansas City, MO. Exhibited: WFNY, 1939 [40]

BLAIR, Robert N. [P,S,E,Edu] Buffalo, NY b. 12 Ag 1912, Buffalo. Studied: BMFA Sch.; Buffalo AI. Member: Guggenheim F., 1946; AWCS; Buffalo Pr. Cl.; The Patteran; Buffalo SA; Alabama WCS. Exhibited: Albright A. Gal., 1940 (prize), 1942 (one-man), 1944 (prize); BM, 1939; AIC, 1942–44; NGFA, 1942; MMA; Riverside Mus.; Albany Inst. Hist.&A., 1934–46; BMA; Ala. WCS; Buffalo Mus. Sc., 1942 (one-man); Ala. Polytechnic Inst., 1944; Univ. Ala., 1944; Colgate Univ., 1939, 1941. Work: MMA; murals, chapel and hospital, Ft. McClellan, Ala. Illustrator: "Captain and Mate," 1940, other children's books. Position: Dir., Buffalo AI, 1946 [47]

BLAIR, Jeannette, Sister [Edu] Wash., D.C. Studied: Notre Dame; Western Reserve Univ.; Columbia; Ursuline Col.; Cleveland Sch. A. Contributor: liturgical magazines. Position: T., Dir. A. Dept., Catholic Univ. [47]

BLAIR, Walter D. [P] NYC [19]

BLAISDELL, Bertram (Mrs.) [P] Providence, RI. Member: Providence WCC [24]

BLAISDELL, Elinore [T,I,W] NYC b. Brooklyn, NY. Studied: ASL; Naum Los; Robert Brackman. Member: SI; A. Gld. Exhibited: Ford Fnd., 1939 (prize). Author/Illustrator: "Falcon, Fly Back," other books. Position: T., Art Career Sch., N.Y. [47]

BLAKE, Anne Dehon [P] Boston, MA b. Boston. Studied: BMFA, with F. Crowninshield; ASL; Alfred Stevens, in Paris. Member: A. Students Assoc., Boston [19]

BLAKE, Beth MacLafferty (Mrs. Frank O.) [S,P,Li,L] Berkeley, CA b. 10 Ag 1901. Studied: Perham Nahl; Ray Boynton; Hans Hofmann; Chiura Obata; Eugen Neuhaus; Millard Sheets; Univ. Calif. Member: NAWPS; Taos SA; Phoenix FAA; Delta Epsilon; Arizona SPS. Exhibited: Phoenix FAA, 1925 (prize), 1928 (prize); Mus. Northern Ariz., 1932 (prize), 1933 (prize); WC, Scottsdale Soc. Ar. Ann., 1938 (med). Work: U.S. Government, El Paso. Position: Dir. A., Jokake Sch., Ariz. [40]

BLAKE, Caroline [P] Brooklyn, NY [24]

BLAKE, Charles B. [P] NYC. Member: SC [24]

BLAKE, Charles George [P] St. Petersburg, FL/Chicago, IL b. 3 O 1866, Devonshire, England. Studied: Lorado Taft; John Vanderpoel; AIC, with Caroline Wade; Cowles A. Sch.; Am. A. Acad. Member: Fla. Fed. A.; AAPL; St. Petersburg AC; John H. Vanderpoel AA; CGA, 1938. Author: "Celtic Art," 1933, pub. Charles G. Blake and Co. Contributor: articles, magazines/newspapers [40]

BLAKE, Donald [T,Des,P] Sarasota, FL b. 26 Je 1889, Bushnell, FL. Studied: PAFA; Henry McCarter. Member: SSAL. Work: Tampa AI. Position: T., Ringling Sch. A., 1932–46 [47]

BLAKE, Edith Cotton (Mrs. John Wesley) [B,C,Des,T] Plymouth, NH b. 27 Je 1883, Warren, NH. Studied: Mary M. Atwater; C.C. Willard; Manchester Inst. A.&Sc. Member: Cr. Workers Gld.; BSAC. Exhibited: Manchester Inst. A.&Sc. (prizes). Position: T., League of New Hampshire A.&Cr. [40]

BLAKE, George W. [P] Nutley, NJ. Member: GFLA [24]

BLAKE, James Edward [P,T] Cincinnati, OH b. 8 Je 1864, Peru, IN d. 11 F 1912. Studied: L.H. Meakin; R.T. Clark; J.H. Sharp; Vincent Nowottny; F. Duveneck. Member: Cincinnati AC. Specialty, landscapes. [09]

BLAKE, James Henry [I,L] West Somerville, MA b. 8 Jy 1845, Boston. Studied: Hollingsworth; Rimmer; Moore. Illustrator: scientific books, magazines, gov. reports [40]

BLAKE, John W. [C] Plymouth, NH b. 26 Jy 1882, Warren, NH. Studied: Mary M. Atwater; Manchester Inst. A.&Sc. Member: Lg. New Hampshire A.&Cr. Exhibited: Phila. A. All., 1939; AFA, Paris Expo, 1937 [47]

BLAKE, Leo B. [P,T,L,I] Berkshire MA b. 7 Jy 1887, Galesburg, IL d. 1976. Studied: AIC; Alfred East; W.J. Reynolds; Birge Harrison. Member: SC; North Shore AA; CAFA; New Haven PCC. Exhibited: Ill. Acad. FA, 1931 (prize); New Haven PCC, 1942 (prize); CAFA, 1939 (prize); SC, 1942 (prize); Mass. Fed. Women's Cl., 1943 (prize), 1944 (prize); AIC, 1910, 1911; Chicago SA; North Shore AA; Syracuse Univ.; Williams Col.; Berkshire Mus. A.; Springfield AL; Phila. A. All. [47]

BLAKE, William Harold, Mrs.. See Stanton, Elizabeth C.

BLAKE, William Phipps [I] b. 1825, NYC d. 1910, Tucson, AZ. Railway survey sketch artist for Williamson's 1853 survey in Calif. [*]

BLAKELOCK, Clarence L. [P] Scarsdale, NY b. 1878, Mt. Vernon, NY d. 18 Ja 1947, Scarsdale. Member: SC, Scarsdale AA. A cousin of the noted painter, Ralph A. Blakelock.

BLAKELOCK, Ralph Albert [Ldscp.P] b. 15 O 1845, NY d. 9 Ag 1919 (in an asylum near Middletown, N.Y.) Studied: self-taught. Member: ANA, 1913; NA, 1916. Exhibited: Paris Expo, 1900 (prize). Work: CGA; Worcester AM; NGA; BM; MMA; Montclair (N.J.) Mus. A.; Hackley AG, Muskegon, Mich.; Cincinnati Mus.; CI. His daughter, Marian, painted in a similar style and some of her paintings bear the forged signature of her father. [17]

BLAKELY, Dudley Moore [P,C,Des,I,S,L] Bloomfield Hills, MI b. 13 O 1902, Harriman, TN. Studied: Worcester AM Sch.; ASL. Work: habitat backgrounds, AMNH. Illustrator: cover, color plates for magazines, journals. Position: Ar., Cranbrook Inst. Science, Bloomfield Hills [40]

BLAKELEY, Margaret [P] Paris, France. Member: SBA [98]

BLAKEMAN, Thomas Greenleaf [E,En,I,Dr,Li,P] North Truro, MA/Melville, MT b. 23 O 1887, Orange NJ. Studied: Hawthorne; W.H. W. Bicknell. Member: SC; Provincetown AA; Southern Pr.M. Soc. Work: Minneapolis Inst. A.; NYPL; N.Y. Bar Assoc.; Harvard; Duke; Boston Pub. Lib.; Wood Gal., Montpelier, Vt. [40]

BLAKESLEE, Horace W., Mrs. See Carey, Alice Inglis.

BLAKESLEE, Sarah Jane (Mrs. Francis Speight) [P] Phila., PA b. 13 Ja 1912, Evanston, ILL. Studied: Corcoran Sch. A.; PAFA. Exhibited: PAFA. Work: murals, USPO, Strasburg, Va. WPA artist. [40]

BLAKESLEE, Walter [P] New Haven, CT b. 1852 d. 15 Je 1902, New Haven. Studied: Yale. Specialty: scenic artist.

BLAKLEY, Catherine S. See Strode.

BLANCH, Arnold [P,E,Li,I,W,T,L] Woodstock, NY b. 4 Je 1896, Mantorville, MN d. 23 O 1968. Studied: Kenneth Hayes Miller; John Sloan; Henri; Minneapolis Sch. A.; ASL. Member: Guggenheim F., 1933; Am. Soc. PS&G; Salons of Am.; Woodstock AA. Exhibited: San Fran. AA, 1931 (prize); Pal. Leg. Honor, 1931 (prize); AIC, 1930-31, 1932 (med) 1933-43; PAFA, 1931-37, 1938 (med) 1939-45; CI, 1938 (prize); Domesday Press, 1945 (prize); CGA, 1931-45; WMAA, 1931-46; GGE 1939; WFNY 1939; MMA; Butler AI; Lib. Cong. Work: WMAA; MMA; CMA; Colorado Springs FA Center; Pal. Leg. Honor; Cranbrook Acad. A.; Detroit Inst. A.; Univ. Nebraska; CAM; Denver AM; Butler AI; Encyclopaedia Britannica Coll.; Univ. Arizona; Lib. Cong.; murals, USPOs, Fredonia (N.Y.), Norwalk (Conn.), Columbus (Wis.) Author: "Gouache," 1946. Illustrator: "The Humboldt River," 1943, other books. WPA artist. [47]

BLANCH, Lucille [P,Li,T] Spartanburg, SC/Woodstock, NY b. 31 D 1895, Hawley, MN. Studied: Goetsch; DuMond; Minneapolis Sch. FA; ASL. Member: Guggenheim F. 1933; Am. Soc. PS&G; Am. A. Cong.; Woodstock AA. Exhibited: San Fran. AA, 1931 (prize); Wanamaker Reg. Exh., N.Y., 1934 (prize). Work: WMAA; Wanamaker Gal., N.Y.; MMA; Minneapolis Inst. A.; Univ. Nebr.; murals, USPOs, Ft. Pierce, Fla., Appalachia, Va. WPA artist. Position: Resident Ar., Converse Col. [40]

BLANCHARD, Ethel C. See Leon Collyer, Mrs.

BLANCHARD, Helen [P] Chicago, IL [09]

BLANCHARD, Lyman Wallace [P,Dec] Pittsburgh, PA b. 12 Jy 1883, Abilene, KS. Member: Pittsburgh AA. Exhibited: Pittsburgh AA, 1933 (prize); Carnegie AI, 1933 (prize) [40]

BLANCHARD, Porter [C,Des,S] Pacoima, CA b. 28 F 1886, Littleton, MA. Member: Boston SAC. Specialty: handwrought silver [40]

BLANCHFIELD, Howard James [P,Des,Car,I] Schenectady, NY b. 12 S 1896, Buffalo, NY d. S 1957. Member: Albany A. Group; Albany Pr. Cl. Exhibited: Albany Inst. Hist. &A., 1936-46; Munson-Williams-Proctor Inst., 1945, 1946; Skidmore Col., 1944-46; Schenectady, N.Y., 1941, 1945, 1946; Albany A. Group, 1945, 1946. Position: Dir., Albany Pr. Cl., 1943-46 [47]

BLAND, Garnet William [Des,P,I] Detroit, MI b. 9 Je 1903, Manhattan, KS. Studied: Kansas City AI; Wicker Sch. FA, Detroit, Mich.; Fed. Sch. A., Minneapolis, Minn. Member: Am. Advertising A.&I. Exhibited: AIC; PAFA; Detroit Inst. A.; Soc.Indp.A.; MOMA [47]

BLANEY, Dwight [P] Boston, MA b. 24 Ja 1865, Brookline, MA. d. 2 F 1944. Member: CSB, 1892; Boston GA, Boston SWCP. Exhibited: P.-P. Expo, 1915 (med). Work: Cleveland MA [40]

BLANEY, Henry R(obertson) [P,I,E] Salem, MA b. 29 Ja 1855, Dedham, MA. Studied: self-taught. Exhibited: Pan-Am. Expo, Buffalo, 1901 (prize). Specialty: Oriental and tropical subjects [13]

BLANK, Frederick Charles [Des,En] Leominster, MA b. 10 My 1866, Rockville, CT. Studied: Fred Leigh. Member: Soc. Medalists; Am. Soc. Bookplate Collectors and Designers; AFA. Exhibited: P.-P. Expo, 1915 (gold); Bookplate Assn. Intl., 1929 (prize), 1932 (prize). Work: bookplates, Harvard Univ.; D.C. Chapter Daughters Am. Revolution; LOC; Am. Antiquarian Soc. (Worcester, Mass.); N.Y. Historical Soc.; Wis. Historical Soc. [40]

BLANK, Ida [P] Atlanta, GA b. 12 Ag 1913, NYC. Studied: High Mus. A., Atlanta; Alexander Abels. Member: SSAL. Exhibited: High MA; SSAL, 1938 [40]

BLANK, J(ohn) Philip [Des,P,Car] Ambler, PA b. 8 Ap 1916, Phila. PA. Studied: PMSchIA; H. Clinton Beagary. Member: Phila. A. Dir. Cl.; Phila. Pr. Cl.; Phila. A. All.; Fairmount Park AA; Woodmere A. Gal. Exhibited: PAFA, 1940, 1942; Ogunquit, Me., 1946; Cape May, N.J., 1944, 1945; Woodmere A. Gal., 1944-46. Position: Asst. A. Dir., Gray & Rogers, Phila., Pa., 1944-46 [47]

BLANKE, Esther [P,C] Chicago, IL/Nashotah, WI b. 2 F 1882, Chicago. Studied: AIC; London; Munich. Member: Chicago AG; Cordon C. [33]

BLANKE, Marie E. [P] Chicago, IL b. Chicago. Studied: AIC; Munich; London. Member: Chicago Gal. Assn.; Assn. Chicago PS; Chicago AC; Women A. Salon, Chicago. Exhibited: AIC, 1920 (prize), 1922 (prize); Chicago AC; Chicago Gal. Assn.; Women's Salon. Work: State Mus., Springfield, Ill. Position: Dir., Municipal A. Lg., Chicago. [47]

BLANKENBERG, Alice I. [P] Phila., PA [19]

BLANQUET, Louis [P] Kansas City, MO [24]

BLASH, Olin P. [P] Cambridge, MA b. Cambridge. Studied: H. Bolton Jones; William M. Chase; Blashfield; Mowbray; ASL [01]

BLASHFIELD, Albert Dodd [I] NYC b. 31 Jy 1860, NYC. Studied: ASL. Brother of E.H. Blashfield. [17]

BLASHFIELD, Edwin H(owland) [Mur.P,W,L] NYC/South Dennis, MA b. 15 D 1848 d. 12 O 1936. Studied: PAFA; Bonnât, in Paris. Member:

ANA, 1882; NA, 1888; Nat. Comm. FA; Mural P.; Arch. Lg., 1886; N.Y. Municipal AS; NSS; FAS; Century Assoc.; AIA; NIAL; AAL; Soc. Am. Ar.; N.Y. Fed. FA; SI; NAC; SC; Wash. AC; AFA. Exhibited: Paris Expo, 1900 (med); St. Louis Expo, 1904 (gold); Arch. Lg. 1911, 1911 (med); NAD 1911 (prize), 1934 (gold); NIAL, 1923 (gold); Paris Salon, 1874–1879. Work: MMA; Court House Baltimore; Cleveland Fed. Bldg.; Citizens Bank, Cleveland; Hudson County Court House, Jersey City; Capitol, Madison, Wis.; Essex County Court House, Newark; Appellate Court, N.Y.; CCNY; Church of the Saviour, Phila.; Capitol, Pierre, S.Dak.; Bank of Pittsburgh; Capitol, St. Paul, Minn.; Lib. Cong.; Luzerne County Court House, Wilkes-Barre, Pa.; Mahoning County Court House, Youngstown, Ohio; St. Matthew's Church, Wash., D.C.; First Presbyterian Church, Chattanooga, Tenn.; Pub. Lib., Detroit; MIT; Episcopal Church, Chappaqua, N.Y. Author: "Mural Painting in America," 1914, with Mrs. Blashfield, "Italian Cities." Co-editor: Vasari's "Lives of the Painters." From 1920 to 1926 he was president of NAD and of NIAL, 1915–16. Known as the dean of American mural painters. [33]

BLASHFIELD, Evangeline Wilbour Author and student of art; wife of Edwin Howland Blashfield. She was born in Little Compton, R.I. in 1881 and died in New York City, November 15, 1918.

BLASHKI, M. Evergood [P] NYC b. 10 Ja 1871, Melbourne, Australia. Member: SC, 1908 [13]

BLASINGAME, Frank Marvin [S,P] NYC/Atlantic Highlands, NJ b. 15 D 1903, San Fran. Member: Asbury Park SFA; Mod. Ar. N.J.; Contemporary A. Gal. N.Y. Work: sculpture, city and county of Honolulu; painting, Denver AM [40]

BLASINGAME, Marguerite Louis (Mrs.) [P,S,Dr] Honolulu. HI b. 2 F 1906, Honolulu. Studied: Stanford Univ.; Univ. Hawaii. Member: Hawaiian Mural G.; Honolulu AS; Assn. Honolulu Ar.; San Fran. A. Center; San Fran. Soc. Women A. Exhibited: Honolulu Ann., 1933 (prizes); Print Show, 1934 (prizes), 1936 (prize). Work: Kawananakoa Fountain, Lib. of Hawaii; Moana Park, Church of the Crossroads, Honolulu Academy of Art, Waikiki Theatre, all in Honolulu. Author: "A Course in Art Appreciation for the Adult Layman," pub. Stanford Univ. Press [40]

BLASINGHAM, Katherine Groh (Mrs. H. E.) [P] Indianapolis, IN b. 4 Ag 1893, Logansport, IN. Studied: E. O'Hara; J.F. Smith; Turman; Carl Graf; Wayman Adams; Herron AI; Ind. State T. Col. Member: Hoosier Salon; Ind. A. Cl.; Ind. Fed. AC. Exhibited: Canton AI, 1936 (prize), 1938 (prize); Hossier Salon; Ind. A. Cl.; John Herron AI [47]

BLASS, Charlotte L. [P] Flushing, NY b. 21 Ap 1908, Orange, NJ. Studied: NAD, with Hawthorne; ASL, with George Luks. Member: McDowell Colony. Exhibited: NAD; AIC; PAFA; Toledo MA; AWCS; Provincetown AA; BM. Work: BM; U.S. Military Acad., West Point, N.Y.; T. Col., Columbia [47]

BLATAS, Arbit [P] NYC b. 19 N 1908, Kaunas, Lithuania. Studied: Acad. Julian, Grande Chaumière, both in Paris. Member: Fed. Mod. P.&S. Exhibited: Salon d'Automne, 1935, 1939; WMAA, 1943–46; CI, 1943–45; Critic's Choice, N.Y., 1945; CGA, 1944; VMFA, 1943–44; Providence MA, 1944. Work: VMFA; Providence MA; BM; Wichita Mus. A.; MOMA; Musée de Grenoble, France [47]

BLATCHLY, W.D. [P] Toronto, Canada. Member: OSA [01]

BLATT, Louis [P,T] Brooklyn, NY b. 24 S 1911, Russia. Studied: NAD; ASL; NYU. Member: A. Lg. Am. Exhibited: Vendôme Gal. (one-man); ACA Gal.; BM; Roerich Mus. A. [47]

BLATTNER, Robert Henry [Des,I,T,L] Port Chester, NY b. 8 D 1906, Lynn, MA. Studied: Mass. Sch. A. Illustrator: magazines. Positions: A. Dir., Marschalk & Pratt, 1944–45; Foreign Editions, Reader's Digest, 1945– [47]

BLATTNER, Rose [P,T,Des,W] NYC b. 29 Mr 1900, Pittsburgh, PA. Studied: ASL, with Benton, Robinson; Léger; Hans Hofmann; J. Itten Kunstschule, Berlin; Acad. Moderne, Paris. Member: Comm. A. Edu., N.Y. Exhibited: BAID, 1934 (med); Bauhaus Exh., MMA, 1938; N.Y. Soc. Women P., 1942, 1943; Am.-British A. Center, 1940, 1942; Lillienfeld Gal., 1944, 1945 (one-man); Bonestell Gal., 1943, 1944 (one-man). [47]

BLAU, Daniel [P,E] Dayton, OH b. 2 F 1894, Dayton. Studied: Max Seifert; A. Acad. Cincinnati; Dayton AI. Member: Dayton SE [40]

BLAUROCK, Carlotta [P] Chicago, IL b. 1866, Prescott, WI. Studied: AIC; Charles Lasar, in Paris [04]

BLAUVELT, Charles F. [P] b. 1824, N.Y. d. 16 Ap 1900, Greenwich, CT. Studied: PAFA; NAD; Chas. L. Elliott. Member: A. Fund S., 1859; NA, 1859. Position: T., U.S. Naval Academy, Annapolis.

BLAZEK, Anton [P,C,S] b. Horepnik, Czechoslovakia. Studied: Md. Inst. Exhibited: Los Angeles Co. Fair, Pomona, 1938 (prize); San Diego Gal. FA (prize); Little Gal., Bullocks, Wilshire, Los Angeles, 1934; Stendahl Gal.; Los Angeles Gal. FA; Golden Gate Expo, 1939 [40]

BLAZEY, Lawrence [Des,P,C] Bay Village, OH b. 6 Ap 1902, Cleveland, OH. Studied: Cleveland Sch. A.; Univ. London, Slade Sch.; Cleveland SA; ADI. Exhibited: CMA, 1928–31, 1932 (prize), 1933 (prize), 1934, 1935 (prize), 1936 (prize), 1937–45, 1946 (prize); PAFA, 1930, 1932, 1934; AIC, 1941. Work: CMA. Position: Indst. Des. Dir., Designers for Industry, Inc. 1936–46 [47]

BLAZY, Sterling [P] NYC b. 20 Mr 1904, Cleveland, OH. Exhibited: CMA, 1931 (prize), 1933 (prizes) [40]

BLAZYS, Alexander [S,T] Cleveland, OH b. 16 F 1894, Lithuania. Studied: S. Volnuchin. Exhibited: CMA 1926 (prize), 1927 (prizes), 1928 (prizes), 1931 (prize), 1933 (prize). Work: CMA, Church of the Covenant, St. Luke's Hospital, Rockefeller Park, all in Cleveland [40]

BLECK, Mietzi [P,Des,T,En] Juneau, AK b. 11 My 1911, Oshkosh, WI. Studied: Robert von Neumann; Howard Thomas; Elsa Ulbrecht. Member: Wis. Pr.M.; Wis. A. Fed.; Alaskan A.&Cr. Exhibited: Wis. P.&S., 1937 (prize), 1938; Wis. Salon, 1938; CGA, 1939; Wis. MA; CGA, 1939. Author/Illustrator: "Crossed Roads," 1937 [47]

BLEIL, Charles George [E,P,T] San Fran., CA b. 24 D 1893. Studied: Calif. Sch. FA; Univ. Calif. Member: San Fran. AA; Calif. SE. Exhibited: San Fran. AA, 1924 (prize); Calif. SE, 1925 (prize) [47]

BLENNER, Carle John [Por.P] Orange, CT b. 1 F 1862, Richmond, VA. Studied: Yale; Bouguereau, Robert Fleury, Aman-Jean, in Paris. Member: All. A. Am.; New Haven PCC; SC; Newport AA; Wash. AC; AFA. Exhibited: Boston AC, 1891 (med); NAD, 1899 (med); Pan-Am Expo, 1901 (med); St. Louis Expo, 1904 (med); Charleston SC (med); Springfield AA (prizes); New Haven PCC, 1932 (prize). Work: Univ. Cl., N.Y.; Columbia Univ.; Univ. Vermont; Rutgers Univ.; Houston MFA; Ft. Worth MA [47]

BLESCH, Clara [P] Columbus, OH [19]

BLESCH, Rudolph [P] Oklahoma City, OK [17]

BLESSUM, Benjamin [P,E] Chicago, IL b. 4 N 1877, Norway. Studied: self-taught. Specialty: landscapes [09]

BLEY, Elsa W. [P,T] Dorset, VT b. 10 Mr 1903, NYC. Studied: ASL; Grand Central Sch. A.; George Luks; George Pearse Ennis; Wayman Adams; Henry Snell. Member: Southern Vt. A.; Scarsdale AA; Hudson Valley AA. Exhibited: Sch. A. Lg., 1919 (med); Scarsdale AA, 1931–35, 1936 (prize), 1937, 1938 (prize), 1939–43, 1944 (prize), 1945 (prize), 1946; Wash. WCC, 1936; AWCS, 1931, 1937; Montross Gal., 1933–42; NAC, 1936–39; Southern Vt. A., 1938–42, 1946. Position: Founder/ Dir., Scarsdale A. Gld. [47]

BLINN, Louise. See Gibson, L.B.

BLINN, R.W. [P] NYC b. 1909, Jacksonville, FL. Studied: PIASch. Exhibited: Wanamaker Regional, 1934; Corcoran Bienn., 1937; Am. PS, AIC, 1937–38 [40]

BLISS, Alma Hirsig (Mrs.) [Min.P] NYC b. 24 Je 1875, Berne, Switzerland. Studied: Willard Metcalf; Douglas Volk. Member: ASMP; NAWA. Exhibited: Pa. Soc. Min.P., 1931 (prize); ASMP, 1932 (prize); NAWA, 1932 (prize), 1937 (prize), 1941 (prize); Calif. Soc. Min. P., 1938 (med). Work: CGA; PMA; BM; Norfolk MA [47]

BLISS, Elizabeth Sturtevant. See Samuel Theobald, Jr., Mrs.

BLISS, Lizzie P. [Patron] b. 11 Ap 1864, Boston, MA d. 13 Mr 1931, NYC. A daughter of Cornelius N. Bliss, she was one of the champions of modern art. By her will the Museum of Modern Art in New York City, of which she was one of the organizers and vice-president, was bequeathed works by Cézanne, Matisse, and others. The MMA and CGA received bequests, along with other museums.

BLOCH, Albert [P,E,W,L,T] Lawrence, KS b. 2 Ag 1882, St. Louis, MO. Studied: St. Louis Sch. FA; "Blauer Reiter" group, Munich. Work: PMG; AIC; Columbus (Ohio) Gal. FA; Thayer Mus., Univ. Kans. Position: Dir., Dept. P., Sch. FA, Univ. Kans. [40]

BLOCH, Arthur [G] Phila., PA. Exhibited: NA Ann., 1936; Pr. Cl. Phila. Ann., 1938 [40]

BLOCH, E. Maurice [Hist,L,P,W] NYC b. 26 O 1916, NYC. Studied: NYU;

Harvard; NAD, with Gifford Beal, Charles Curran; ASL, with Robert Brackman. Member: Am. Assn. Univ. Prof.; CAA. Exhibited: NYU, 1937 (prize), 1938 (prize). Contributor: art magazines. Positions: T., Univ. Mo. (1943–44), NYU (1945–46) [47]

BLOCH, Julia (Mrs. Gustav Straus) [G,I,P,W] Phila., PA b. 2 D 1903, Phila. Studied: Phila. Sch. Des. for Women; PAFA; PMSchIA. Exhibited: PAFA, 1932–36; Lib. Cong., 1943–45; CI, 1943–45; Phila. Pr. Cl., 1935–41; Albright A. Gal., 1940–43; Oakland A. Gal., 1936, 1939, 1940; Wichita, Kans., 1936; Phila. A. All., 1934, 1939, 1943. Illustrator: "Matilda, the Old-Fashioned Hen," 1936. Contributor: Philadelphia Inquirer [47]

BLOCH, Julius (T.) [Li,T,P] Phila, PA b. 12 My 1888, Kehl, Germany d. Ag 1966. Studied: PAFA; PMSchIA. Member: Phila. Pr. Cl.; Phila. A. All.; AFA. Exhibited: Wanamaker Exh., 1934 (prize); WMA, 1933, (prize), 1934 (prize); Phila. Pr. Cl., 1933 (prize); Phila. A. All., 1939. Work: MMA; WMAA; PMA; PAFA; CGA; White House, Wash. D.C. Position: T., PMSchIA [47]

BLOCH, Lucienne [Mur.P,B,Des,Li,I,L] NYC b. 5 Ja 1909, Geneva, Switzerland. Studied: Antoine Bourdelle; André Lhote; Diego Rivera. Member: Mural P; Artists U. Exhibited: Beaux-Arts, Paris (prize); Nat. Soap Sculpture Competition, Rockefeller Center, 1936 (prizes); Sweden, 1937; WFNY, 1939. Work: Brussels Mus., Belgium; murals, Madison House, House of Detention for Women, New York [40]

BLOCK, Adolph [S] NYC b. 29 Ja 1906, NYC. Studied: Edward McCartan; BAID; Fontainebleau, France; Hermon MacNeil; Sterling Calder; Edward Sanford. Member: F., Tiffany Fnd., 1926; NSS. Exhibited: BAID, 1927 (med), 1927 (prize); Fontainebleau Alum. Assn., 1932, 1934, 1938; NAD; PAFA; Arch. Lg.; NSS; WMAA; NAC. Work: Bayonne, N.J. Pub. Lib. [47]

BLOCK, Fanny Rocker [P,Des,T,L] Woodstock, NY b. 2 Ja 1914. Studied: Educational All. A. Sch., New York [40]

BLOCK, Henry [P,En,E] b. 11 Mr 1875 d. 22 Ja 1938. Studied: ASL. Member: Plainfield AA; Westfield AA; AAPL; Newark AC; S.Indp.A.; Southern PM Soc.; Am. A. Cong. Exhibited: Newark AC, 1937 (prize). Work: NYPL; MMA; Denver MA; Los Angeles Mus. Science, Hist.&A.; Franklin Inst., Phila.; Lib. Cong. Originator: hand engraved wood block pictures in full color [38]

BLOCK, Herbert Lawrence (Herblock) [Car] Cleveland, OH b. 13 O 1907, Chicago. Member: Cleveland SA. Positions: Car., editorial, Chicago Daily News, NEA Service [40]

BLOCK, I.A. [P] Brooklyn, NY. Exhibited: 48 Sts. Comp. [40]

BLOCK, J. Mortimer [P] NYC [19]

BLOCK, Maurice [Mus.Cur] Pasadena, CA b. Galion, OH. Studied: Cincinnati A. Acad.; AIC; Univ. Chicago. Member: AAMus; Assn. A. Mus. Dir. Positions: Asst. Cur., AIC, 1910-20; Dir., Omaha AI, 1920–26; Cur., Huntington Lib. & A. Gal., San Marino, Calif. 1928– [47]

BLODGETT, Edmund Walton [P] Stowe, VT b. 23 D 1908, Cleveland, OH d. ca. 1964. Studied: George Luks; George Pearse Ennis. Member: AWCS. Work: Zanesville AI; Evansville (Ind.) Pub. Mus. Illustrator: national magazines [47]

BLODGETT, George Winslow [S] Santa Fe, NM b. 10 Mr 1888, Northfield, MN d. ca. 1958. Studied: Oregon State Col.; Académie Julian, Paris. Exhibited: BM; Arden Gal.; Grand Central Gal. Tulsa; PMA; Cranbrook Acad. A. Work: MMA; Brookgreen Gardens, S.C.; Cranbrook Acad. A.; Denver A. Mus.; SAM; Santa Fe, Albuquerque, N.Mex. [47]

BLODGETT, Walton [P] Stamford, CT b. 23 D 1908, Cleveland, OH. Studied: Ennis, Luks. Member: Am. WCS [33]

BLOGG, H.A. [P] Seattle, WA [24]

BLOMMERS, Bart [P] Pittsfield, MA [19]

BLOMMERS, Caroline Bean (Mrs.) [P] Smithtown, NY [15]

BLONDHEIM, Adolphe (Wiener) [P,E,Li,T] New Hope, PA b. 16 O 1888, Baltimore, MD. Studied: Md. Inst.; PAFA, with Chase, Beaux, Breckenridge. Member: Chicago SE. Exhibited: NAD, 1915, 1918 (med); AIC, 1920 (med); Chicago SE, 1920 (prize); Kansas City AI, 1926 (gold,med) PAFA, 1919, 1941 (prize); CGA, 1921; Milch Gal., 1928; Nierendorf Gal., 1938. Work: Calif. State Lib.; AIC; NGFA; Vanderpoel Coll.; mural, Capitol, Mo. [47]

BLOOD, B.H. (Mrs.) [Min.P] Hartford, CT [19]

BLOODGOOD, M(orris) Seymour [P,T] NYC b. 11 N 1845, NYC d. 12 F 1920. Studied: NAD; ASL; Blanc, Courtois, in Paris; CUASch. Member: Paris AAA. Position: T., NAD [15]

BLOODGOOD, Robert Fanshawe [P,S,I,E,T] NYC/Setauket, NY b. 5 O 1848, NYC d. 10 Ja 1930. Studied: NAD; ASL. Member: SC; Calif. SE; NAC (charter member) [25]

BLOOM, Elsie E. [P] Chicago, IL. Member: Chicago NJSA [24]

BLOOM, John Vincent [P] Davenport, IA b. 27 Mr 1906, DeWitt, IA. Studied: AIC; John W. Norton. Exhibited: Davenport (Iowa) Municipal A. Gal., 1929 (prize), 1931, 1932 (prize), 1933–36, 1939 (prize), 1940, 1941, 1946 (prize); Des Moines Assn. FA, 1932 (prize), 1934 (gold), 1935 (prize), 1936 (prize); Univ. Iowa, 1934 (prize); AIC, 1928; Dubuque AA, 1935; Little Gal., Cedar Rapids, Iowa, 1935; Carson Pirie Scott Gal., 1936 [47]

BLOOM, M.E. [P] Member: S.Indp.A. [24]

BLOOMER, Hiram Reynolds [P,I,E] Sausalito, CA b. 19 D 1845, NY. Studied: T. Hill; Carolus-Duran, G. Pelouse, in Paris. Member: San Fran. AA; Bohemian Club. Exhibited: Calif. State Fair (med) [09]

BLOOMFIELD, Elizabeth L. [P] Germantown, PA [04]

BLOOR, Henry Pritchard b. 1827, Edinburgh, Scotland d.18 Ap 1902, Brooklyn, N.Y. A designer and constructor of church windows, he studied the designing and coloring of windows in Scotland, then came to America and established a decorative glass plant in Brooklyn, which he conducted for forty years.

BLOS, May [I,T,P,C] Oakland, CA b. 1 My 1906, Sebastopol, CA. Studied: Univ. Calif. Exhibited: Oakland A. Gal. Position: Illus., Botany & Zoology, Univ. Calif., 1944–46 [47]

BLOS, Peter W. [P] Oakland, CA b. 29 O 1903, Munich. Studied: Hermann Groeber, Franz Von Stuck, in Munich. Exhibited: Oakland A. Gal., 1935–40, 1941 (prize), 1942–46; NAD, 1939; Critic's Choice, Cleveland, 1945; GGE, 1939; Los Angeles MA, 1942; Univ. Calif. A. Gal., 1944 [47]

BLOSER, Florence Parker [P] Los Angeles, CA b. 19 O 1889, Los Angeles. Studied: Los Angeles A. Sch; Arthur Gilbert; Millard Sheets; Alfredo Remos Martinez. Member: Calif. AC; Women Painters of the West [40]

BLOSSOM, Earl [I] Westport, CT. Member: SI [47]

BLOUNT, S. Ellis [P] Brooklyn, NY b. 22 Ap 1896, New Bern, NC. Studied: Xavier Barille [24]

BLOW, Richard [P] NYC b. 22 F 1904, LaSalle, IL. Studied: NA; ASL; AIC. Exhibited: Corcoran Bienn., 1939; GGE, 1939. Work: MMA [40]

BLOW, Thomas R. [G] St. Louis, MO b. 7 O 1897, St. Louis. Studied: Sch. FA, St. Louis; Breckenridge Summer Sch. A. Member: St. Louis AG. Exhibited: St. Louis AL, 1926, (prize); WCC Ann. Washington, 1936–39 [40]

BLOWER, David H(arrison) [P] Los Angeles, CA b. 18 S 1901, Fontanet, IN d. 1976. Studied: Wicker Sch. FA, Detroit. Exhibited: Mich. Ar., Detroit AI, 1930 (prize), 1931 (prize) [40]

BLUE EAGLE, Acee. See Acee, Blue Eagle.

BLUEMNER, Oscar Florianus [P] South Braintree, MA b. 21 Je 1867, Germany. d. 12 Ja 1938. Studied: Berlin. Exhibited: Royal Acad., Berlin, 1892 (med). Work: WMAA; PMA [38]

BLUE, A. Aladar [P] NYC [09]

BLUM, Alex A. [E,P] Rye, NY b. 7 F 1888, Budapest, Hungary. Studied: NAD; Cincinnati A. Acad.; Duveneck; Melatz. Member: Phila. Sketch Cl.; Phila. All. Exhibited: NAD, 1920 (med), 1924 (prize). Work: MMA; Lib. Cong.; Yale Univ.; BMFA [47]

BLUM, Edith C. [P] NYC. Member: NAWPS. Exhibited: NAWPS 1935–37; NA Ann., 1936; Corcoran Bienn., 1937, 1939 [40]

BLUM, Edward C. Brooklyn, NY b. 1863, NYC d. 20 N 1946. Studied: Europe. Chairman of the Brooklyn Inst. A.&Sciences, he received the gold medal of the Brooklyn Downtown Assn. in 1932, the Great Silver Cross of Merit for "aiding the art of Austria in America," the Chevalier of French Legion of Honor, and officer of the Order of Leopold I of Belgium.

BLUM, Helen A(brahams) (Mrs. Alex A.) [P] Phila., PA b. 17 Ag 1886, Phila. Studied: PAFA; Elliot Dangerfield; Henry Snell; Hugh Breckenridge [24]

BLUM, Jerome S. [P] New York (1934) b. 27 Mr 1884, Chicago. Studied:

Smith Art Acad.; AIC; Ecole des Beaux-Arts, Paris, with Merson. Exhibited: Salon d'Automne, 1909–10 [17]

BLUM, Lucile Swan [S] Chicago, IL [15]

BLUM, Robert Frederick [P,I,Mur.P] NYC b. 9 Jy 1857, Cincinnati, OH d. 8 Je 1903, NYC. Studied: Apprenticed at sixteen to lithographic house, he studied art in the evenings; McMiken A. Sch. Des., Cincinnati (1876). Member: ANA, 1892; NA, 1893; SAA; AWCS; S. Mural P. Exhibited: Paris Expo, 1889 (medals), 1900 (med); Pan-Am. Expo, Buffalo, 1901 (gold). In 1890 he went to Japan to prepare the illus. for Sir Edwin Arnold's "Japonica." Position: Illus., Scribner's, 1879

BLUMANN, Sigismund [Photogr] Fruitvale-Oakland, CA b. 13 S 1872, NYC. Studied: Royal Photogr. Soc. Gr. Britain. Position: Editor, "Camera Craft" [30]

BLUMBERG, Yuli (Feiga Blumberg-Kopman) [P,Li] Far Rockaway, NY b. 4 S 1894, Lithuania d. 12 N 1964. Studied: Europe. Exhibited: BM, 1929; J.B. Neumann Gal. (one-man); ACA Gal., 1946. Work: J.B. Neumann Gal. [47]

BLUME, Melita (Mrs.) [Ldscp.P] Brookhaven, NY b. Halle, Germany. Studied: ASL; NA, Munich. Member: NAWPS; Assoc. A. of Long Island [40]

BLUME, Peter [P] Gaylordsville, CT b. 27 O 1906, Russia. Studied: ASL. Member: F., Guggenheim Fnd., 1932, 1936; Am. Soc. PS&G; Am. A. Cong. Exhibited: CI, 1934 (prize); BMFA; WMAA; MMA; MOMA; Columbus Gal. FA. Work: BMFA; Columbus Gal. FA; MOMA; MMA; WMAA; USPOs, Cannonsburg (Pa), Rome (Ga.), Geneva (N.Y.). WPA artist. [47]

BLUMENFELD, Maurice [P] Brooklyn, NY b. France. Studied: ASL. Exhibited: NAD, 1936 (prize) [40]

BLUMENSCHEIN, Ernest Leonard [P,I] Taos, NM b. 26 My 1874, Pittsburgh, PA d. 1960. Studied: ASL; Académie Julian, Ecole des Beaux-Arts, both in Paris; Cincinnati A. Acad.; Constant, Laurens, Collin, in Paris. Member: ANA, 1910; NA, 1927; SI, 1901; AWCS; Audubon A.; Taos AA. Exhibited: NAD 1912 (med), 1921 (prize), 1923 (prize), 1925 (prize), 1929 (prize); NAC, 1923 (med) 1934 (med) 1936 (prize); SC, 1910 (prize), 1911 (prize), 1931 (prize); Grand Central AG, 1929 (prize); PAFA, 1910 (prize); Phila. WCC, 1909 (prize); P.-P. Expo, 1915 (med); AIC, 1917 (gold); CGA; CI; Canada; Europe; South America. Work: MOMA; MMA; NAC; CM; Dayton AI; BM; NCFA; John Herron AI; Los Angeles MA; PIASch; Milwaukee AI; murals, Capitol, Mo.; USPO, Walsenberg, Colo. WPA artist. [47]

BLUMENSCHEIN, Helen G. [Li,Ser,P,I] Santa Fe, NM (1975) b. 21 N 1909, NYC. Studied: her parents, Ernest Blumenschein and Mary Sheppard Greene; ASL, with Harry Sternberg; André Lhote, in Paris. Member: NAC; PBC; Taos AA. Exhibited: N.Mex. State Fair; Ariz. State Fair; Studio Cl., N.Y.; WFNY, 1939; Paris Salon, 1940; NAD, 1933–46; Kansas City; Denver; Santa Fe. Work: NYPL; Lib. Cong.; Newark Pub. Lib. Author/Illustrator: "Taos Calendar," pub. and des. in silk screen, 1942, 1943, 1947 [47]

BLUMENSCHEIN, Mary Greene (Mrs.) [P,C,I] Taos, NM b. 26 S 1869, NYC d. 24 My 1958. Studied: PIASch; Herberg Adams; Collin, in Paris. Member: ANA, 1913; SI, 1912; NAWPS. Exhibited: Paris Salon, 1900 (med), 1902 (med); St. Louis Expo, 1904 (med); NAD, 1915 (prize); Denver AM, 1934 (prize). Work: BM; PIASch [47]

BLUMENSTIEL, Helen Alpiner [P,Li,T,I] Salem, OR b. 3 S 1899, Rochester, NY. Studied: Univ. Rochester; Grand Central A. Sch.; Fontainebleau, France; Fritz Trautmann; Sigurd Skou. Exhibited: Rochester ACG, 1922 (prize), 1928 (prize), 1929 (prize); Studio Cl, N.Y., 1930 (prize); NAD, 1937; Mich., Conn., Okla., 1935–39 [47]

BLUMENTHAL, Margaret M. [Des,T] NYC b. 7 S 1905, Latvia. Studied: B. Scherz, Bruno Paul, both in Berlin. Exhibited: Monza, Italy, 1927; MMA, 1930; Pratt Inst. Gal., 1935. Position: Jewelry, Indst. & Textile Des., 1943–46 [47]

BLUMENTHAL, M(oses) L(awrence) [I,T] Elkins Park, PA b. 13 Jy 1879, Wilmington, NC. Studied: Pa. Mus. Sch.; Munich. Member: AG; Phila. Sketch Cl. Illustrator: Saturday Evening Post. Position: Instr., Illus., Graphic Sketch Cl., Phila. [40]

BLUMERT, J(ohanna) M(arie) [Des,Dr,P,T] Oakland, CA b. 22 Mr 1901, Fresno, CA. Studied: Hans Hofmann, Vytlacil, in Munich; Worth Ryder; Calif. Col. AC; Univ. Calif. Member: San Fran. S. Women A. Position: A. Instr., Willard Jr. High School, Berkeley, Calif. [40]

BLUMER, Marguerite Barnett (Mrs.) [P,T] Stillwater, OK b. 25 Jy 1901, Columbia, Mo. Studied: Univ. Mo. Member: Ozark AA. Exhibited: Ozark Empire Fair, 1940; Ozark AA, 1940–42, 1946; Joslyn Mem., 1941, 1942; Springfield AA, 1946; Mo. State Fair, 1940–42. Position: Instr., Okla. Agric.&Mech. Col., Stillwater [47]

BLUMLER, George [P] NYC. Member: GFLA [24]

BOAK, Milvia W. [P,G] San Fran., CA b. 24 Mr 1897, Oakland, CA. Studied: Calif. Sch. FA. Member: San Fran. AA; San Fran. Soc. Women Ar. Exhibited: San Fran. AA, 1939; Oakland AA; GGE, 1939 [40]

BOALL, Marian G. [P] Oakland CA [21]

BOARDMAN, Annette B. [P] Yonkers, NY [24]

BOARDMAN, Frank Crawford [P,S] New Haven, CT b. Hartford, CT. Studied: Yale; Ecole des Beaux-Arts, Paris. Member: New Haven PCC [07]

BOARDMAN, Rosina Cox [P,Min.P] Huntington, NY b. NYC. Studied: ASL; N.Y. Sch. App. Des.; Chase A. Sch., with Alice Beckington, William Chase. Member: ASMP; Pa. S. Min. P.; NAWA. Exhibited: ASMP, 1920–37, 1938 (prize), 1939–46; Pa. S. Min. P., 1923 (med); Los Angeles S. Min. P., (med); NAWA, 1919–35, 1936 (med); 1937–46; PAFA 1920–46. Work: BM; CGA; Fairmount Mus. A., Phila. Author/Illustrator: "Lillies and Orchids" [47]

BOAS, Belle [Mus.Cur,Edu,W] Baltimore, MD b. Providence, RI. Studied: RISD; Columbia; ASL. Member: Am. Soc. Aesthetics. Exhibited: Friends of A., Baltimore. Positions: A. Dir., Horace Mann Sch., 1918–43; Dir. Edu., BMA, 1943–46 [47]

BOAS, Simone Brangier [S] Baldwin, MD b. 3 F 1895, France. Studied: Bourdelle; Zorach; Univ. Calif.; San Fran. Sch. A.; Acad. de la Grande Chaumière, Paris. Member: Baltimore A. Union; Sculptors' Gld., N.Y. Exhibited: Municipal A. Soc., Baltimore, 1934–35 (prize); Contemporary A.; WFNY, 1939. Work: Municipal A. Soc.; Johns Hopkins Univ., Cone Coll., Baltimore. Art criticism: Maryland Spectator; Lecture: sculpture [40]

BOBBITT, Vernon L. [P,T] Pella, IA b. 27 Jy 1911, Pella. Studied: State Univ. Iowa; Emil Ganso; Fletcher Martin; Philip Guston. Member: F., Tiffany Fnd., 1940; AFA; CAA. Exhibited: Joslyn Mem., 1936, 1941, 1946; Kansas City AI, 1936; Iowa State Col., 1937; Weyhe Gal., 1945, 1946. Position: A.T., Central Col., Pella, 1937–42, 1945– [47]

BOBBS, Ruth Pratt (Mrs. William C.) [P] Indianapolis, IN b. 3 S 1884, Indianapolis. Studied: Académie Julian, Paris; Chase Sch. A.; ASL; BMFA Sch.; Charles Hawthorne. Member: Ind. AC; Hoosier Salon. Exhibited: Herron AI, 1926 (prize); Hoosier Salon (prize); Ind. AC, 1944 (prize), 1945 (prize). Work: Indianapolis AI [47]

BOBERTS, Carl [I] NYC. Member: SI [47]

BOBLETER, Lowell Stanley [Mus.Dir,E,Edu,L,W,P] St. Paul, MN b. 24 D 1902, New Ulm, MN d. 1973. Studied: St. Paul Gal. & Sch., with Cameron Booth, George Resler. Member: SAE; Chicago SE; Am. Assn. Mus. Dir.; Am. Assn. Univ. Prof.; Minn. AA; AFA. Exhibited: Minneapolis State Fair, 1931 (prize), 1933–36 (prizes), 1938 (prize); Minneapolis IA, 1933 (prize), 1935–37 (prizes), 1939–40 (prizes), 1942–43 (prizes), 1945 (prize); Minneapolis Women's Cl., 1940 (prize), 1941 (prize); SAE, 1931–46; Chicago SE; NAD; Lib. Cong.; PAFA; 50 Prints of the Year; 100 Best Prints; prints chosen by Walker A. Center, St. Paul Gal. & Sch. A., Collectors of Am. A., for "Presentation Print Prizes." Work: Smithsonian; Calif. State Lib.; SAE; Chicago SE; Parkersburg FA Center; Minneapolis Inst. A.; PAFA; NYPL; Lib. Cong.; Walker A. Center; NGA; Flint AI; Hamline Univ.; Minn. Fed. Women's Cl. Lectures: Art history. Position: Prof. A., Dir. Univ. Gal., Hamline Univ., St. Paul, 1943– [47]

BOCCINI, Manuel (Fiorito) [P,E,S,Li] Rye, NY b. 10 S 1890, Teco, Italy. Studied: Grande Chaumière, Paris; ASL; Grand Central A. Sch.; André Favory; André Derain. Exhibited: Anderson Gal., 1927; Gal. Barrero, Paris, 1929, 1930; Salon d'Automne; Boccini Gal., N.Y., 1938; S.Indp.A.; Salons Am. [47]

BOCK, Charles Peter [P] Manvel, TX b. 13 Ag 1872, Germany. Studied: AIC; Simon, in Paris. Member: Dallas Painters; Overland Landscape Outfit. Work: Dallas Pub. Lib. [21]

BOCK, Frederick William [E,P] St. Paul, MN b. 7 Je 1876, Manitowoc, WI. Studied: NAD; ASL. Member: Minn. AA. Exhibited: St. Paul AI (prize); Minn. State Fair (prize); Minneapolis Inst. A.; St. Paul Gal. & Sch. A.; Walker A. Center [47]

BOCK, Richard Walter [S] River Forest, IL b. 16 Jy 1865, Germany (came to U.S. in 1870). Studied: Berlin Acad., with Schaper; Ecole des Beaux-Arts, Paris, with Falguière. Member: AAPL. Exhibited: Columbian Expo, Chicago 1893 (med); AAPL, Portland, Oreg., 1932 (prize); St. Louis Expo,

1904. Work: mon., Shiloh, Ill.; Alton, Ill.; Pub. Lib., Indianapolis; Northwestern Univ. Dental Sch.; Chicago Dental Sch.; Villa Park, Ill.; Eugene (Oreg.) AM [40]

BOCK, Vera [Dec,I] NYC b. 1 Ap 1905, St. Petersburg, Russia. Member: AIGA. Exhibited: NYPL, 1942; A. Dir. Cl., 1946. Work: Mural decorations in private homes. Illustrator: "The Tangle-Coated Horse" (by Ella Young), "The Adventures of Maya the Bee" (by Waldemar Bonsels), "Metten of Tyre" (by Helena Carus), Life, other magazines [47]

BOCKMANN, Charles G. [P] . Member: Phila. AC [24]

BODE, Catherine Burnaby [P] Sierra Madre, CA. Exhibited: WC Ann.; PAFA, 1935; Calif. Soc. Min. P. Ann. 1938 [40]

BODEBENDER, Laura [P,T] New Orleans, LA b. 2 Jy 1900, New Orleans. Studied: Nicolaides; K.H. Miller. Member: ASL; SSAL; NOAA; Circolo Artistico Internazionale. Work: ASL; Italian Gov.; Vatican, Rome; Houston MFA; Montomera (Ala.) MFA; High Mus. A.; Municipal Cl. House, Jackson, Miss. [40]

BODELL, Mark Robinson [P] Glen Ellyn, IL b. 24 Ap 1891, Lafayette, IN. Studied: John Sloan; Forrest Shook. Member: Hoosier Salon [33]

BODFISH, Evelin. See Bourne.

BODINE, Helen [Min.P] Phila., PA b. Phila. d. ca. 1958. Studied: François Maene, in Paris; Herman Deigendesch. Member: Woodmere A. Gal. Exhibited: Milan, Italy, 1906 (gold); PAFA, 1939; Woodmere A. Gal. [47]

BODKIN, Sally Grosz [S] NYC b. 11 N 1900, Budapest, Hungary. Member: Clay Cl., N.Y. Exhibited: Clay Cl., 1942 (one-man); NAC, 1943; WMAA, 1944; Syracuse MFA, 1943; Rochester Mem. A. Gal., 1943; Bershire MA, 1943; Newark Mus., 1943; NAD, 1944; Mt. Holyoke Col., 1944 [47]

BODNAR, Thomas [P,E] Brooklyn, NY/East Branch, NY b. 23 My 1882, Hungary. Studied: Bridgman; Young. Member: Salons of Am.; S.Indp.A.; Brooklyn SA [24]

BOE, Olive [P] Minneapolis, MN [24]

BOEBINGER, Charles William [C,Des,En,I,T] Mt. Healthy, OH b. 17 Je 1876, Cincinnati, OH. Studied: Cincinnati A. Acad.; ASL; J.F. Carlson; Walter Crane, in England. Member: Western AA; Third Intl. A. Cong. at London, Fourth Cong. at Dresden. Position: Head, A. Dept., Ohio Mechanics Inst., Cincinnati [4]

BOECHE, Guy A. [P] Phila., PA [15]

BOECKER, Theodore A. [P] Oak Park, IL [17]

BOECKMAN, Carl L. [P] Minneapolis, MN b. Christiania, Norway. Studied: Christiania; Copenhagen; Munich. Exhibited: Columbian Expo, Chicago, 1893 (med). Work: Capitol, St. Paul, Minn. [33]

BOECKMAN, Helga [P] St. Paul, MN [13]

BOEHLER, Albin [P] NYC. Member: AG Authors Lg. A. [24]

BOEHM, Henry Richard [P,I] Briarcliffe, NY b. 1870, IL d. 1 F 1914 (suicide). He worked for Cosmopolitan and other magazines.

BOEHME, Hazel Fetterley [P,E] Los Angeles, CA b. 6 O 1900, Minneapolis, MN. Studied: Millard Sheets; Frank Zimmerer. Member: Calif. WCS; Calif. AC; Women P. of the West. Exhibited: Los Angeles County Fair, 1931 (prize) [40]

BOEHMER, Fritz [P] Toledo, OH b. 4 Je 1875, Czechoslovakia. Studied: Sch. FA, Dresden, Germany. Exhibited: Ohio State Fair, 1934, 1935. Work: Index Am. Des., Fed. A. Project [40]

BOEHNER, Margaret Huntington [P] Syracuse, NY. Member: NAWPS. Exhibited: NAWPS, 1935-37 [40]

BOERICKE, Johanna M(agdalene) [P,S] Phila., PA b. 13 F 1868, Phila. Studied: PAFA; Rome; Paris. Member: Plastic Cl.; Pa. S. Min. P.; Phila. A. All.; Baltimore WCC; Am. Ar. Prof. Lg. [17]

BOERICKE, Mildred McGeorge (Mrs. Gideon) [P] Wynnewood, PA. Member: F., PAFA [24]

BOERNER, Edward A. [P,Edu,S] Milwaukee, WI b. 26 Je 1902, Cedarburg, WI d. 1981. Studied: Univ. Wis., with Varnum, Colt; Minneapolis IA, with Cameron Booth; Univ. Iowa, with Grant Wood, L.D. Longman. Member: Wis. P&S; Wis. Edu. Assn.; Milwaukee A. T. Assn. Exhibited: Wis. P&S; All-Iowa Exh., 1940; AIC. Position: A. Instr., Univ. Wis., 1940- [47]

BOESCHENSTEIN, Bernice (Mrs. C.K.) [P,C,T] St. Louis, MO b. 19 My 1906, Louisburg, KS d. 22 Ag 1951. Studied: Univ. Ill.; Kansas State Col.; AIC; Wash. Univ.; Fred Conway. Member: Group 15, St. Louis. Exhibited: CAM, 1939-40, 1941 (prize); AIC, 1941; Kansas City AI, 1940. Work: CAM [47]

BOESSENECKER, J. Henri [Dr,Mur.P] NYC b. 14 O 1883, NYC. Studied: NAD; Robert Blum; Cooper Inst.; Royal Acad. FA, Munich. Exhibited: Royal Acad. FA, Munich, 1902 (prize), 1904 (prize), 1905 (prize) [40]

BOETHING, Marjory Adele (Mrs.) [P,T] Glendale, CA. Studied: Nicolai Fechin; Otis A. Inst.; Edouard Vysekal; Ralph Holmes; Roscoe Shrader. Member: Los Angeles AA; Calif. A. Cl. [40]

BOETTCHER, Clarence [P] Milwaukee, WI. Member: Wis. PS [24]

BOGART, George Hirst [P] b. 1864 d. 1923. Often confused with George Henry Bogert. [*]

BOGART, Harriet [T,P] Richmond, VA b. 26 Ap 1917, Charlotte, NC. Studied: Richmond Prof. Inst.; Col. William & Mary; ASL, with Harry Sternberg. Exhibited: VMFA, 1946; VMFA Traveling Exh., 1946. Position: Instr. A., Richmond Prof. Inst., 1946 [47]

BOGART, Maud Humphrey (Mrs.) [I] NYC [01]

BOGART, Stella M. (Mrs. Ernest L.) [P] NYC/Peacham, VT b. Terre Haute, IN. Studied: E.A. Vysekal, Colarossi, A.D. Gihon, in Paris; Schachinger, in Vienna. Member: AAPL; Studio Gld., N.Y. Work: Thomasboro, Ill. [47]

BOGATAY, Paul [Edu,S,Des,C] Columbus, OH b. 5 Jy 1905, Ava, OH. Studied: Cleveland Sch. A.; Ohio State Univ., with Arthur E. Baggs. Member: Columbus AL. Exhibited: CMA, 1930 (prize), 1931 (prize); Syracuse MFA 1934-41 (prize); IBM (prize); Phila. A. All., 1937; WMAA, 1937; Toledo MA, 1938-39; AFA, Paris, 1937; CAD, 1939; Columbus AL, 1930-45; CMA, 1930-32; Butler AI, 1940, 1946. Position: T., Ohio State Univ., 1936-46 [47]

BOGDANOVE, A.J. [P] NYC/Monhegan Island, ME b. 2 S 1888, Minsk, Russia d. 23 Ag 1946, Dunbarton, N.H. Studied: NAD, with George W. Maynard, F.C. Jones. Member: SC; All. AA. Work: portrait, CCNY; murals, various schools. Position: T., CCNY [40]

BOGDANOVICH, Borislav [P,W,L] NYC b. 3 Ap 1899, Ruma, Yugoslavia. Studied: Prague; Paris. Member: NAC. Exhibited: AIC, 1941; WMAA, 1945. Work: Ministry FA, Belgrade, Yugoslavia; Yugoslav Embassy, Wash., D.C. Author: articles on Yugoslavian art [47]

BOGER, Fred [P,I] Detroit, MI b. 12 O 1857, Baltimore. Studied: Frank Duveneck. Member: Cincinnati AC. Exhibited: Univ. Cincinnati [40]

BOGERT, George Henry [Ldscp.P] NYC b. 1864, NY d. 13 D 1944. Studied: NAD; Puvis de Chavannes; Aimé Morot, Boudin, both in Paris. Member: ANA, 1899; SAA, 1899; Lotos Cl.; SC, 1897; A. Fund S. Exhibited: PAFA, 1892 (prize); SAA, 1898 (prize); NAD, 1899 (prize); Paris Expo, 1900 (med); Pan-Am. Expo, Buffalo, 1901 (med); AAS, Phila., 1902 (gold), 1907 (gold); St. Louis Expo, 1904 (med). Work: MMA; CGA; Buffalo FA Acad.; NGA; PAFA; BM; BMFA, Huntington Mus., Calif.; Minneapolis Inst. A.; St. Louis Mus.; Chicago AI; Arnot A. Gal., Elmira, N.Y.; Montauk Cl., Brooklyn; Dallas A. Gal.; Edinburgh (Scotland) Mus.; Cl. of Shanghai, China; Newark Mus.; Detroit Inst. A.; Milwaukee AI; Detroit Cl.; Pittsburgh Athletic Cl.; Los Angeles Cl.; Quinnipiac Cl., New Haven [40]

BOGERT, Julia [P] NYC [13]

BOGGS, Frank M. [P] Meudon, France b. 1855, Springfield, OH d. 11 Ag 1926. Studied: Ecole des Beaux-Arts, Gérôme, in Paris. Exhibited: Exh., N.Y., 1885 (prize); Paris Expo, 1889 (med). Work: BMFA; MMA; Luxembourg Mus., Paris; Mus. Niort [17]

BOGGS, Franklin [P,I,Des,Edu] Beloit, WI b. 25 Jy 1914, Warsaw, IN. Studied: Ft. Wayne A. Sch.; PAFA. Exhibited: PAFA, 1939, 1940. Work: Abbott Lab. Coll.; U.S. War Dept.; USPO, Newton, Miss. Illustrator: "Men Without Guns." Co-illustrator: "Sally and the Rampatan." Army medical painting reproduced in art magazines. Positions: Illus., T.V.A.; War Artist, 1944; Artist-in-residence, Beloit Col., 1945-46 [47]

BOHAN, Ruth) H. [P,E,Li] Kansas City, MO. Exhibited: NAD; PAFA, 1934; CGA, 1937, 1937; VMFA; CAM; Oakland A. Gal. [47]

BOHLAND, Gustav [S,Des,C,P] Miami Beach, FL b. 26 Ja 1897, Austria d. 22 Ap 1959. Studied: CUASch; NAD; BAID; A.A. Weinman. Work: CGA; Miami Beach Pub. Lib. & A. Center; murals, Miami Beach hotels; First Nat. Bank, Miami; des., honor button for Dade County Blood Bank, Univ. Miami. Author: "Gumbie," 1944 [47]

BOHLAND, Gustav, Mrs. See Parnell, Eileen.

BOHLMAN, Edgar Lemoine [P,Dec,Des,I,W] Rabat, Morocco b. 2 Ja 1902, Cottage Grove, OR. Studied: Univ. Oreg. Work: Documentation of costumes of the Moroccan Sahara for archives of French Protectorate of Morocco; Honolulu Acad. A.; Mus. French Protectorate, Rabat. Author/Illustrator: "Moroccan Marriage," Town and Country Magazine, 1937 [40]

BOHLMAN, Herman T. [P] Portland, OR/Manzanita, OR b. 15 Ap 1872, Portland. Studied: Clyde Keller. Member: Oreg. SA. Exhibited: AAPL, 1932 (prize), 1933 (prize); Oreg. SA, 1934 (prize). Work: Portland City Hall [40]

BOHM, C. Curry [P,T] Nashville, IN b. 19 O 1894, Nashville, TN. Studied: AIC, with Edward Timmins. Member: Chicago P&S Assn.; Brown County A. Gal.; Ind. A. Cl.; Palette & Chisel Acad. FA; Hoosier Salon; Chicago Gal. Assn. Exhibited: Chicago Municipal A. Lg., 1931 (prize); Hoosier Salon, 1934 (prize), 1937 (prize), 1939 (prize), 1941 (prize), 1942 (prize) 1945 (prize); Brown County A. Gal. (prize); Ind. A. Cl., 1945 (prize) Chicago Palett & Chisel Acad. FA, 1931 (gold); AIC, annually. Work: Chicago Pub. Sch. Coll.; Ill. State Mus.; Swope Gal. A.; Muncie AA; Ind. Univ.; Davenport Municipal A. Gal. Position: Dir., Brown County Sch. Landscape P. [47]

BOHM, Max [P] Bronxville, NY b. 21 Ja 1868, Cleveland, OH d. 19 S 1923. Studied: Laurens; Guillemet, Constant, in Paris. Member: ANA, 1917; NA, 1920; SC; Mural P.; Provincetown Beachcombers' Cl.; Provincetown AA; Cleveland AC; Paris SAP; Paris AAA; Chelsea AC, United A. Cl., both in London. Exhibited: Paris Salon, 1898 (med); Paris Expo, 1900, (med); Pan-Am Expo, Buffalo, 1901 (med); St. Louis Expo, 1094 (med); P.-P. Expo, San Fran., 1915 (gold); NAD, 1917 (prize). Work: Luxembourg, Paris; Minn. State A. Soc.; mural, Court House, Cleveland, Ohio; portrait, Capitol, St. Paul, Minn.; NGA [21]

BOHNARD, William A(lfred) [P,A] Cleveland, OH b. 2 Jy 1877, Cleveland. Member: Cleveland AIA; Cleveland SA; AIA [24]

BOHNEN, Aloys L. [P] Minneapolis, MN [15]

BOHNEN, Carl [P] St. Paul, MN [15]

BOHNENBLUST, Eleanor [P,Li] Pasadena, CA b. California. Studied: ASL. Member: San Fran. AA. Exhibited: Phila. Pr. Cl., 1944, 1945; Northwest Pr.M., 1944; Laguna Beach AA, 1944 [47]

BOHNER, Marian A. (Mrs. C.B.) [P] Indianapolis, IN b. 30 Ag 1904, Decatur, IL. Studied: Taffinger's A. Sch., Indianapolis; Indianapolis ASL; Harold McDonald; Wayman Adams. Member: Indianapolis ASL; Hoosier Salon; Ind. A. All. Exhibited: Indianapolis ASL, 1941-43; Ind. A., 1944; Hoosier Salon, 1943-44 [47]

BOHNERT, Herbert [P,L] Hastings-on-Hudson, NY b. 19 My 1890, Cleveland, OH d. 19 Ag 1967. Studied: Cleveland Sch. A. Member: SI; Cleveland SA; SC; A. Gld. [47]

BOHNERT, Rosetta (Mrs. Herbert) [P] Hastings-on-Hudson, NY b. 1 D 1885, Brockton, MA d. 1980. Studied: R.I. State Normal Sch.; Sch. App. Des.; Olaf Olesen; Maud Mason. Member: NAWA; NAC; Hudson Valley AA; Westchester A.&Cr.; AAPL. Position: Pres., Hudson Valley AA [47]

BOHROD, Aaron [P] Chicago, IL b. 21 N 1907, Chicago. Studied: Crane Col., Chicago; AIC; ASL; John Sloan; Boardman Robinson; K.H. Miller; Charles Locke; Richard Lahey; Todros Geller. Member: F., Guggenheim Fnd. Exhibited: AIC, 1933-35 (prizes), 1937 (prize), 1945 (prize); GGE, 1939 (prize); CI, 1939 (prize); Calif. WCS, 1940 (prize); PAFA, MMA, 1942 (prize); CGA, 1943 (prize). Work: MMA; WMAA; AIC; BM; BMA; PAFA; CGA; Swope Gal. A.; Walker A. Center; Butler AI; Telfair Acad. A.; Cranbrook Acad. A.; murals, USPOs, Vandalia, Clinton, Galesburg, all in Ill. Position: A., War Correspondent (European Theater Operations), Life, 1943-45 [47]

BOILEAU, Philip [P,I] NYC b. 1864, Quebec (settled in New York in 1902) d. 18 Ja 1917, NYC. Originator: "Peggy Head." Painted many pictures of fashionable women. [08]

BOISSONNEAU, Marguerite [P] New Orleans, LA [01]

BOIT, Edward D. [P] b. 1842 d. 22 Ap 1916, Rome. Studied: Harvard; Europe. Exhibited: Paris Salon, 1876. He was an intimate friend of John S. Sargent, and they held several joint water color exhibitions in New York and Boston. [15]

BOK, Hannes Vajn [Li,P,I] NYC. Exhibited: Lib. Cong., 1945, 1946; Assoc. Am. A. Gal., 1943; Ferargil Gal., 1945. Illustrator: "Go South Young Man," 1946 [47]

BOLANDER, Karl S. [P,Des,L,T,W] Columbus, OH b. 3 My 1893, Marion, OH. Studied: PIASch, with Walter Beck; Columbia Univ., with Arthur W. Dow; Bershire Sch. of A., with Norwood MacGilvary; Univ. Chicago, with Walter Sargent; Pedro J. de Lemos; Ohio State Univ., with Thomas E. French. Member: Columbus AL; AAPL; EAA; Western AA; Southeastern AA; Ohio Edu. Assn.; SC. Author: "Lettering in Twelve Lessons," pub. Dobson-Evans. Official art lecturer, Great Lakes Expo, Cleveland, Ohio. Positions: Pres./Founder, Nat. A. Hobby Gld.; Dir., Columbus, Ohio A. Center, 1934-39 [40]

BOLDEN, Joseph E. [Li,I] Phila., PA b. 27 F 1902, Meyersdale, PA. Exhibited: Fourth Ann. Exh. Am. Lith. (prize) [33]

BOLEGARD, Joseph [P] Chicago, IL [19]

BOLEGARD, Joseph [I] NYC. Member: SI [47]

BOLINGER, Ethel King (Mrs. H.J.) [P] Lodi, CA b. 5 N 1888, Garnet, KS. Member: Northern Calif. A.; Stockton AL. Exhibited: Kingsley A. Cl., 1942-46; Northern Calif. A., 1946 [47]

BOLLAM, Catherine Jones, Mrs. See Jones, Catherine.

BOLLENDONK, Walter [P] Nanuet, NY [24]

BOLLES, Ida Randall (Mrs.) [P,Mar.P] Laguna Beach, CA. Studied: George C. Hopkins; Duveneck; Wash. ASL; Corcoran AS. Member: Laguna Beach AA. Exhibited: Southern Calif. Orange Assoc. Comp., 1923 (prize) [33]

BOLLES, R.F. [P] Boston, MA. Member: Boston AC [24]

BOLLIN, Leone C(obbum) (Mrs. Leon E.) [P] Coral Gables, FL b. 8 D 1893, Bluffton, IN. Studied: Chicago Acad. FA; Am. Acad. A., Chicago. Member: Miami AL; Florida Fed. A. Exhibited: Florida Fed. A., 1940 (prize), 1943 (prize), 1945 (prize). Position: Dir., Fla. State Fed. A. [47]

BOLLING, Leslie G(arland) [S] Richmond, VA b. 16 S 1898, Dendron, VA. Studied: Hampton Inst.; Virginia Union Univ.; William E. Young; Berkeley Williams. Exhibited: Harmon Fnd., 1933 (prize). Work: VMFA; Valentine Mus. A., Richmond [47]

BOLLMAN, Henry, Jr. [P,G] Junction City, KS b. 17 F 1909, Ft. Mead, SD. Studied: Kansas City AI; ASL. Exhibited: Sweepstake Show, Kansas City, Mo., 1937 (prize); Kansas City AI, 1938; Omaha, Nebr. Position: Li., Kansas City AI [40]

BOLMAR, Charles (Carl) Pierce [I,Car,W] Topeka, KS b. 28 Ag 1874, Topeka. Studied: PAFA; Spring Garden Inst.; G.M. Stone; G. Hopkins. Member: Topeka AG. Exhibited: Spring Garden Inst., 1896 (med). Illustrator: "Overland Stage to California," 1901, other books. Position: Staff A., Car., Topeka State Journal, 1901-41 [47]

BOLMER, Clinton [P] NYC [13]

BOLMER, M. De Forest [P] NYC b. 1854, Yonkers, NY d. 7 Je 1910. Studied: Paris; Munich. Member: SC, 1904. Specialty: landscapes. Many of his paintings were sold at auction, Feb. 2, 1911. [09]

BOLMERT, H.F. [I] Cleveland, OH. Member: F., Tiffany Fnd., 1929, 1930; Cleveland SA [15]

BOLOTOWSKY, Ilya [P,T] NYC b. 1 Jy 1907, Petrograd, Russia. Studied: Col. St. Joseph, Constantinople; NAD. Member: Am. Abstract A.; Fed. Mod. P.&S. Exhibited: NAD, 1929 (prize), 1930 (prize); CI, 1945; MOMA; WMAA, 1938; CGA, 1934; SFMA; Riverside Mus.; New A. Circle, 1946 (one-man); PMA: PMA; PMG; Mus. Non-Objective Painting; murals, Williamsburgh Housing Project; WFNY, 1939. Positions: T., Black Mountain Col., N.C. (1946-48), Univ. Wyo., 1948 [47]

BOLTON, Adelaide H. [P] Phila., PA. Member: F., PAFA [24]

BOLTON, Clarence [Li,P,Des,T] Woodstock, NY b. 16 S 1893, Wallingford, Conn. d. 1962. Studied: Yale; J.F. Carlson; L. Lawrie. Member: Woodstock AA; New Haven PCC; CAFA; Meriden A.&Cr. Soc. Exhibited: A. All., 1929 (prize); Southern Pr.M. (prize); Okla. A. Lg., 1939 (prize); New Haven PCC, 1942 (prize); NAD; CGA; Phila. Pr. Cl.; Northwest Pr.M.; Woodstock AA; Albany Inst. Hist.&A.; San Fran. A. Center; Denver A. Mus; LOC. Work: mural, USPO, Beacon, N.Y. [47]

BOLTON, Frances [P] Brooklyn, NY [13]

BOLTON, Hale W(illiam) [P] Dallas, TX/Los Angeles, CA b. 1885, Honey Grove, TX d. Fall, 1920. Studied: St. Louis Sch. FA; Holland; France; Frank Reaugh. Exhibited: Tri-State Exh., Memphis, 1907 (gold), 1910 (gold); Galveston, 1915 (med); Women's Forum, Dallas, 1916 (gold). Specialty: Western subjects [19]

BOLTON, Helen Stevens (Mrs.) [Des,T] NYC. Studied: Pratt Inst.; Traphagen Sch. Fashion; NYU. Member: Nat. Assn. Art Edu.; EAA. Position: T., Washington Irving H.S. [40]

BOLTON, Robert Frederick [P,Des,I] NYC/Verona Station, NY b. 19 Mr 1901. Studied: NAD; ASL; BAID. Exhibited: NAD, 1919 (med), 1920 (med), 1938; WFNY, 1939. Work: murals, Black Diamond Steamship Line [40]

BOLTON, Theodore [W,I,E,T] NYC b. 12 Ja 1889, Columbia, SC. Studied: Corcoran Sch.; PIASch; NYU; Harvard. Member: AAPL; Am. Lib. Assn. Exhibited: Indp. A., 1917; AIGA, 1917; Brooklyn SE, 1917–20; Wash. WCC, 1917, 1919, 1944; AWCS, 1932, 1933. Author: "Early American Painters in Miniature," "Early American Draughtsmen in Crayons," "American Book Illustrators." Contributor: art magazines. Position: Lib., Century Assn., 1926– [47]

BOLTZ, Joseph Kinnie [W,C,T] Franklin, MI b. 3 Ag 1897, Kent, IA d. ca. 1954. Studied: State T. Col., Warrensburg, Mo.; PIASch; Wayne Univ. Member: Nat. Edu. Assn.; WAA; Scarab C. Exhibited: Scarab C., Detroit, 1934, 1935. Position: Ed., Western AA Bulletin, 1940–46 [47]

BOMBERTO, Fra Angelo. See Wolcott, John.

BOMEISLER, Dorothy Topping (Mrs. Douglas) [P] Greenwich, CT. Member: NAWPS. Exhibited: NAWPS, 1935, 1936, 1937 [40]

BOMMER, Marie A. [P] Brooklyn, NY b. 2 N 1905, Brooklyn. Studied: Anna Fisher. Member: NAWPS; AWCS; NYWCC [40]

BONADE LA CHARME, Maud [P,T,Cr,L] New Hope, PA b. Paris, France. Studied: PAFA. Member: AAPL; All. Française; Plastic C. Exhibited: Columbia, 1932; Warwick Gal., Phila., 1935, 1937; Guenther A. Gal., 1939; Paris Salon; S.Indp.A.; CMA; CGA; Vendôme Gal.; Plastic C.; Indp. Gal., New Hope, Pa.; Acad. All. A.; abroad [47]

BONANNO, Alexander [P] NYC [15]

BONAR, Henry (H.G. Buettner-Bonar) [Des,L] Passaic, NJ b. 18 S 1896, Greiz-Thueringen, Germany. Studied: Acad. Graphic A., Leipzig, Germany. Member: A. Gld. Lectures: Type Design, Lettering [47]

BONAR, James [P,A,W] Pittsburgh, PA/Gibsonia, PA b. 3 Ap 1864, Dunfermline, Scotland. Member: Pittsburgh AA; Hundred Friends of Pittsburgh Art. [21]

BONAVENTURE, Edmond F. NYC b. 1844, Alsace, France. d. 10 S 1918. Studied: Sch. Engineers, Chalons. A well-known art dealer. He came to America in 1871 and in 1878 started a book store in NYC. He acquired many of the art objects for the J.P. Morgan, Robert Hoe, and other celebrated collections.

BONAWITZ, George (Owen) [P] NYC. Member: SC [21]

BOND, Byron L. [Des,P,E,I,C,G] Richmond, IN b. 8 My 1906, Richmond, IN. Studied: Ind. Univ.; John Herron AI; ASL, with R. Coates. Member: Chicago A. Center. Exhibited: Richmond AA; John Herron AI; Hoosier Salon. Designer: "Leland Line" bookplates. Position: Dir., Leland Commercial A.&Adv. Studios, Richmond [47]

BOND, Christiana [P] Baltimore, MD [24]

BOND, Dorothy K. [Dec,B,C] York, PA b. 14 Ag 1911, York, PA. Studied: Md. Inst. A. Member: York AC [40]

BOND, Gwen(doline) (Maplesden) (Mrs. E.P.) [E,P,T,W,L,S] NYC b. 3 S 1890, India. Studied: Columbia; NYU; N.Y. Sch. Appl. Des.; PAFA, with D. Garber; ASL, with DuMond, Bridgman. Member: NAC; NAWA; AFA. Exhibited: NAD, 1944; NAWA, 1946; NAC; SAE; N.Y. Soc. C. Work: T., New Dorp (N.Y.) H.S. [47]

BOND, Kate Lee Bacon [P,T] Winnetka, IL b. 18 N 1890. Studied: AIC. Member: Chicago SA; Chicago S. Min. P. [24]

BONER, Alice M. [P] Landsowne, PA [01]

BONGE, Arch [P] b. 1901 d. 21 Nov 1936, Biloxi, MS. Studied: AIC. Exhibited: NYC

BONGIORNO, Laurine Mack (Mrs.) [Edu] Oberlin, OH b. 17 Ap 1903, Lima, Ohio. Studied: Oberlin Col.; Radcliffe Col. Member: CAA. Contributor: College Art Bulletin. Position: T., Wellesley Col., 1930–44 [47]

BONHAJO, Val [P] Cincinnati, OH. Member: Cincinnati AC [24]

BONN, Mabel Muir [Min.P] Maplewood, NJ [13]

BONNAR, James King [P,Des] Newtonville, MA b. 12 My 1885, North Adams, MA d. 5 Jy 1961. Studied: Mass. Sch. A.; de Camp. Member: Rockport AA; North Shore AA; Copley Soc. Exhibited: Rockport AA, 1940–46; North Shore AA, 1935–46; SC at Bethel [47]

BONNDEY, Burton S. [P] Oconomowoc, WI [15]

BONNER, Mary [P,I,E,C] San Antonio, TX/Paris, France b. 1885, Bastrop, LA d. 26 Je 1935. Studied: R. Miller; B. Brown; E. Leon. Member: SSAL. Exhibited: Paris Salon, 1925 (prizes), 1926 (med). Works: Luxembourg Mus.; Brit. Mus.; NYPL. Awards: Palmes Académique, 1929, France; Colonial Exhibit, France, 1931 (hors concours). Work: etchings, French gov. [33]

BONNET, Leon Durand [Mar.P] Bonita, CA/Ogunquit, ME b. 12 S 1868, Phila. d. 22 Je 1936, San Diego. Studied: E. Clark; E. Potthast. Member: SC; All. AA; NAC; Calif. AC; Soc. Ogunquit P.; Contemp. A., San Diego; FAS, San Diego [33]

BONNEY, Edythe [P] W. Phila., PA [05]

BONSALL, Elizabeth F(earne) [P,I] Phila., PA b. 12 S 1861. Studied: PAFA, with Eakins, Pyle; Collin, Courtois, in Paris. Member: Plastic C.; Phila. All.; Print C. Exhibited: PAFA, 1885 (prize), 1888 (prize), 1897 (prize). Work: PAFA [40]

BONSALL, Mary W. [P,Min.P,Des] Phila., PA b. Fernwood, PA. Studied: C. Beaux; R. Vonnoh; W.M. Chase. Member: Plastic C.; F., PAFA; Pa. S. Min. P. Specialities: portraits in oil; miniatures; designs for seals [40]

BONSIB, Louis W. [P] Ft. Wayne, IN b. 10 Mr 1892. Member: Citizens AL, Ft. Wayne; Ft. Wayne Art Sch. Assoc.; Ind. AA; Hoosier Salon AA. Exhibited: Hoosier Salon, 1937 (prize); Ind. AA, 1939 (prize). Work: Ft. Wayne Women's Cl.; YWCA, Ft. Wayne; Hanover Col.; Univ. Ind. [40]

BONTA, Elizabeth B(rainard) [P,T] Brooklyn, NY b. Syracuse, NY. Studied: Pratt Inst., with A.W. Dow; J. Alden Weir; George De Forest Brush. Exhibited: St. Paul Inst., 1916 (med). Work: St. Paul Inst. [40]

BONTE, Charles Howard [Cr] Phila., PA b. 24 Ag 1880. Position: Cr., Philadelphia Inquirer, 1923– [47]

BONWIT, Ralph B. [Photogr] Baltimore, MD b. 1895 d. 18 D 1935. Exhibited: U.S.; abroad

BOOG, Carle Michel [P,I] Brooklyn, NY b. 27 Je 1877, Lucerne, Switzerland. Studied: ASL, Ecole des Baux-Arts, Paris; Leon Bonnât. Member: SC. Exhibited: NAD; PAFA; CGA; Rochester Mem. A. Gal; AWCS; Allied AA; BM. Work: Mus. City of N.Y.; Univ. Nebr.; Hist. Mus., Bennington, Vt. Illustrator: "Leather Stocking Tales," "How It Came about Stories," and others [47]

BOOGAR, William F. [S] Provincetown, MA b. 12 Ag 1893 d. 20 Jy 1958. Studied: PAFA; Charles Hawthorne. Exhibited: PAFA; NAD; Paris Intl. Exh., 1937. Specialty: bronze [47]

BOOK, Harry Martin [P] Millersville, PA b. 27 Je 1904, Millersville. Studied: Pa. State Col.; Columbia. Member: Phila. A. All.; AAPL. Exhibited: Reading AM; Argent Gal., 1939; Phila. AA, 1947 [47]

BOOKATZ, Samuel [P] Wash., D.C. b. 3 O 1910, Phila. Studied: John Huntington Inst., Cleveland; Cleveland Sch. A.; BMFA Sch.; Grande Chaumière, Paris; Am. Acad., Rome. Member: NSMP. Exhibited: CGA, 1944; CMA, 1930–46; VMFA, 1940; Work: Navy hospitals in Phila., Wash., D.C., Norfolk, Va., Bethesda, Md. [47]

BOOKBINDER, Jack [P,Li,T,L,W,] Phila., PA b. 15 Ja 1911, Odessa, Russia. Studied: PAFA, with H. McCarter, D. Garber; Tyler Sch. FA; Europe. Member: F., Barnes Fnd., 1938, 1939; Phila. A. All.; Phila. WC Cl.; Eastern AA; Phila. A. T. Assn. Exhibited: PAFA, 1944–53; LOC, 1945, 1946, 1949, 1951; CGA, 1945; Phila. Pr. Cl., 1944–52; DaVinci All., 1944, 1945; Woodmere A. Gal., 1944–52; Albany Inst. Hist.&.A., 1945. Work: PAFA. Author: articles on art education. Positions: L., Barnes, Fnd., 1936–44; Asst. to Dir., F.&Indst. A., Board Pub. Edu., Phila., 1945– [47]

BOOKER, Nell Battle [P,I] NYC b. 19 Ag 1918, Durham, NC. Studied: Univ. N.C.; ASL; F. Speight; R. Soyer; G. Grosz. Exhibited: ASL, 1942 (prize); N.C. State A. Soc., 1945 (prize); Assoc. Am. A., 1944, 1945; Mint Mus. A., 1945, 1946. Illustrator: "Jane Eyre," 1946 [47]

BOONE, Cora M. [P] Oakland, CA [24]

BOONSHAFT, Rochelle (Margolis) [I] Phila., PA b. 15 Ap 1919, Dayton, OH. Studied: Dayton AI; Rochester Inst. Tech. Exhibited: Cayuga Mus. Hist.&.A., Auburn, N.Y.; Rochester A. Cl.; PAFA. Illustrator: "Abahai, Child's ABC Book" [47]

BOORAEM, Hendrik [P] St. Michaels, MD b. 2 Ap 1886, Jersey City, NJ d.

5 O 1951. Exhibited: All.A.Am.; High Mus. A.; Soc. Four A., Palm Beach, Fla.; Ga. Traveling Exh. [47]

BOOT, Elizabeth. See Duveneck.

BOOTH, Cameron [P,T] NYC b. 11 Mr 1892, Erie, PA. Studied: AIC; Hans Hofmann, in Munich; H.M. Walcott; A. Lhote, in Paris. Member: F., Guggenheim, 1942, 1943. Exhibited: Minneapolis State AS, 1922 (prize); Twin City Ar., 1925 (prize), 1926 (prize); water color, Kansas City AI, 1937 (prize); CI, 1923, 1924, 1928, 1930, 1943, 1944, 1946; AIC, 1923, 1924, 1931, 1934-37, 1940, 1942-44, 1946; PAFA, 1924, 1925, 1943-46; Work: PAFA; Newark Mus.; Minneapolis Inst. A.; PMG; Denver A. Mus.; SFMA; MMA; AIC; Univ. Calif. Mus. A. Positions: T., ASL (1944–), Univ. Minn. (1950–)[47]

BOOTH, Eloise [P] St. Joseph, MO. Member: St. Joseph A. Lg. [24]

BOOTH, Eunice Ellenetta [P,T] Stockton, CA b. Goshen, NH d. 12 N 1942. Studied: Mass. Sch. A.; N.Y. Sch. F.&App. A.; Handicraft Gld., Minneapolis, with Batchelder; W. Chase; Acad. Julian, Acad. Delecluse, both inParis. Member: College AA; Boston AC; Calif. State AA. Contributor/Illustrator: magazines, newspapers. Position: Advisory Cr., Graphic Arts, Col. of the Pacific [40]

BOOTH, Franklin [I] NYC. Member: SI, 1911; SC; Ar. Gld. [24]

BOOTH, George Warren [I,P,T] Pasadena, CA b. 6 Jy 1917, Omaha, NE. Studied: Ohio Univ.; Dayton AI; Chouinard AI; Pruett Carter. Member: Calif. WC Soc. Exhibited: Los Angeles Mus. A., 1944; SSAL, 1942; Parkersburg, W.Va., 1942; Calif. WC Soc., 1943-45. Position: Dir., Animation, Motion Picture Unit, AAF, 1943– [47]

BOOTH, Hanson [I] Woodstock, NY b. 19 My 1885, Noblesville, IN d. 26 F 1944, Albany. Studied: Vanderpoel; Bridgman. Exhibited: SC, 1913 (prize). Work: Cincinnati Mus.; LOC; Ind. State Mus. Illustrator: Harper's, educational books, "The Little Lame Prince," by Miss Mullock, "Water Babies," by Charles Kingsley [40]

BOOTH, James Scripps [P,W] Grosse Pointe, MI b. 31 My 1888, Detroit. Studied: Europe. Member: Scarab C., Detroit. Exhibited: Mich. State Fair, 1916 (prizes); Detroit Inst. A., 1915 (prize); Scarab C., 1920, 1933. Work: Detroit Inst. A. [47]

BOOTH, Laura M. [P] NYC [09]

BOOTH, Nina Mason [P] Batavia, NY b. 25 Ag 1884, Gilbert Mills, NY d. ca. 1957. Studied: F.E. Mason. Member: Buffalo SA; Rochester AC. Work: N.Y. state [47]

BOOTH, Ralph Harman [Patron] Toronto, Ontario b. 29 S 1873, Toronto d. Je 1931. Member: Detroit A. Inst. (Pres.) He was one of the biggest factors in developing art in Detroit. Bequeathed $200,000 to Detroit Mus. A. Founders' Soc.

BOOTH, Zadie Cary [S,P,T] Crete, NE b. 7 D 1905, Crete, NE. Studied: Doane Col.; Univ. Nebr. Member: Nebr. A. T. Assn. Exhibited: Joslyn Mem., 1940-46; Lincoln A. Gld., 1942-45. Position: Chm., A. Dept., Doane (Nebr.) Col., 1938-51 [47]

BOOZ, Charles [P] Buffalo, NY [17]

BORATKO, André [P,S,T] El Cerrito, CA b. 5 Ja 1912, Austria-Hungary. Studied: St. Paul Sch. A.; Minneapolis Sch. A.; Dewey Albinson; Cameron Booth; Nicolai Cikovsky. Exhibited: Minneapolis Inst. A., 1930-35 (prizes); Minn. St. Fair, 1931-39; St. Paul AA, 1931; AIC, 1931; SFMA, 1939; GGE, 1939; CGA, 1941; San Fran. WC Soc., 1946; Univ. Wash. 1946. Work: IBM; Town Hall, Milaca, Minn.; Minneapolis Sch. Deaf; Am. Island Park, Chamberlain, S.Dak. Position: T., Calif. Col. A.&Cr., Oakland, 1946– [47]

BORCHARDT, Norman [Edu,I,P] Tampa, FL b. 21 Ja 1891, Brunswick, GA. Studied: AIC; Norton; Vanderpoel; Henri. Member: Freelance A. Group, N.Y.; Fla. Fed. A.; Brush & Palette C. Work: murals, Univ. Tampa. Illustrator: books; magazines; Encyclopaedia Britannica. Position: Hd. Dept. A., Univ. Tampa, 1934-46 [47]

BORDEN, E. Shirley [P] Media, PA b. 1867, Phila. Member: Phila. Sketch Cl. [04]

BORDEN, Garrick Mallory [T] d. 24 My 1912, Cambridge, MA. Studied: Cornell, 1899. Position: T., Harvard, 1909–

BORDEWISCH, Ferdinand F. [E,I] Dayton, OH b. 2 Je 1889, Kettlersville, Ohio. Studied: Bridgman; Fogarty; Mora. Member: Dayton SE; ASL [33]

BORDWELL, Georgine Graves [P] San Fran., CA [17]

BOREIN, (John) Edward [P,E,I,T] Santa Barbara, CA b. 21 O 1872, San Leandro, Calif. Studied: Hopkins' Art Sch., San Fran., 1891; ASL, 1915. Member: Soc. Am. E. Work: Harpers; Century; Gilcrease Col., Tulsa; NYPL. A true cowboy artist, he worked at ranches in Santa Barbara (1890s), Mexico (1897-99, 1903). Had a studio in Oakland, Calif., 1904. Friend of Will Rogers, Maynard Dixon, Russell, Seltzer and Borg. [40]

BOREN, Esther Jones [P] Grand Prairie, TX b. 17 Ag 1896, Memphis. Studied: Aunspaugh. Member: ASL, Dallas [24]

BORG, Carl Oscar [P,E,B,I] NYC b. 3 Mr 1879, Grinstad, Sweden d. 8 My 1947, Santa Barbara, Calif. Studied: self-taught. Member: ANA, 1938; Calif. AC; SC; Intl. Soc. AL; San Fran. SA; San Fran. SE; Calif. WCS; Calif. PM; P. of the West; Laguna Beach AA; AFA. Exhibited: Painters C., Los Angeles, 1909 (prize); Vichy, 1913 (prize); Versailles, 1914 (med); P.-P. Expo, San Fran., 1915 (med); San Diego, 1916 (gold); Phoenix, 1916 (prize); Calif. AC, 1918 (prize), 1920 (prize), 1923 (prize); Société Français, 1920 (med); Calif. WCS, 1923 (prize); P. of the West, 1924 (med), 1928 (gold); Pacific Southwest Expo, Long Beach, 1928, (med,prize); Sacramento (prize); Ebell C., Los Angeles, 1930 (prize); Láguna Beach AA, 1935 (prize); Acad. Western P., 1936 (prize). Work: Univ. Calif., Berkeley; Mun. Coll., Phoenix; de Young Mem. Mus.; Hearst Free Lib., Anaconda, Mont.; Calif. State Lib., Sacramento; Los Angeles Mus. A.; Los Angeles Pub. Lib.; Milwaukee AI; Montclair (N.J.) Art Mus.; Mills Col., Calif.; Oakland Art Gal.; LOC; Gothenberg Mus., Univ. Lund, both in Sweden; Bibliothèque Nationale, Paris. Published: etchings, "The Great South West," Los Angeles, 1936 [40]

BORGERSEN, Hans [P] Chicago, IL b. 17 S 1877, Christiana, Norway. Studied: Acad. Julian, Acad. Colarossi, both in Paris; Bouguereau; Ferrier; Thaulow [05]

BORGESON, J.W. [P] Chicago, IL [19]

BORGHI, Guido Rinaldo [P] NYC b. 29 Mr 1903, Locarno, Switzerland d. 1971. Studied: Europe; New York. Member: S.Indp.A. Exhibited: CGA, 1939; NAD, 1940; Roerich Mus., 1936; Salons of Am., 1934; Boise Mus., A., 1941; S.Indp.A., 1937; Municipal A. Gal., N.Y.; Contemp. A. Gal. Position: Tech. Dir., Hall of Art, NYC, 1943-45 [47]

BORGHI, Lillian Lewis [W,P,T,Cr] Sparks, NV b. 23 F 1899, Pueblo, CO. Studied: Univ. Utah; J. Howard; J.L. Fairbanks. Member: Pacific AA; Latimer AC. Exhibited: Rockefeller Center, 1937; Hawthorne, Nev., 1944; Univ. Nev., 1943; Reno A. Center, 1940, 1941. Position; Writer/Cr., Reno Evening Gazette, 1938-45 [47]

BORGLUM, Elizabeth [P] Venice, CA [19]

BORGLUM, (John) Gutzon (de la Mothe) [S,P,I,T] Stamford CT/ Mt. Rushmore, SD b. 25 Mr 1871, Idaho d. 6 Mr 1941, Chicago. Studied: V. Williams; San Fran. AA, with W. Keith, 1888; Académie Julian, Paris. Member: Soc. Nat. des Beaux-Arts, Paris; Arch. Lg., 1902; Am. PS; Royal Soc. British Ar.; SC. Exhibited: Western Art Assoc. (gold); St. Louis Expo, 1904 (gold). Work: mon., Wash., D.C.; colossal head of Lincoln, Wash., D.C.; MMA; war mem., Newark, N.J.; Univ. Va.; Sheridan equestrian, Chicago; N.C. War Mem.; figures, Cathedral St. John Divine, N.Y.; memorials, Rock Creek Cemetery (Wash., D.C.), Raleigh (N.C.), Poznań (Poland), Portland (Oreg.), San Antonio (Tex.); statue, Paris. He is best known for his monumental sculpting of Mt. Rushmore, S.Dak. [40]

BORGLUM, Solon H(annibal) [S] Norwalk, CT b. 22 D 1868, Ogden, Utah d. 30 Ja 1922 (war injuries). Studied: his brother, Gutzon Borglum; A. Acad., Cincinnati, with Rebisso, 1895-97; Frémiet, Puech, in Paris. Member: NSS, 1901; ANA, 1911; Silvermine Group A. Exhibited: Paris Salon, 1899 (prize); Paris Expo, 1900 (med); Pan-Am. Expo, 1901 (med); St. Louis Expo, 1904 (med); Buenos Aires Expo, 1910 (med). Work: statues, Atlanta (Ga.), Prescott (Ariz.), New Rochelle (N.Y.); mem. Packer Inst., Brooklyn, N.Y.; monuments, Danbury (Conn.), Topeka (Kans.); MMA; Brooklyn Inst. Mus.; Detroit Inst.; San Fran. Expo, 1915; St. Marks Church, NYC. Founder: Sch. Am. Sculpture, NYC. Served in France as YMCA Secretary in World War I; was awarded the Croix de Guerre for courage under fire. [21]

BORGMEYER, Charles L. [Cr] Chandler, AZ d. 1918

BORGO, Louis J. [P,Des,Dec] NYC/Washingtonville, NY b. 3 Ja 1876, Milan, Italy. Studied: Acad., Milan [40]

BORGORD, Martin [P,S] Riverside, CA b. 8 F 1869, Gausdal, Norway d. 25 Mr 1935. Studied: J.P. Laurens; W.M. Chase. Member: SC; Allied AA; AAPL; Am. AA, Paris; AFA. Exhibited: Paris Salon, 1905 (gold). Work: Luxembourg Mus., Paris; CI; NAD; Washington County Mus. FA, Hagerstown, Md.; Sweat Mem. Art Mus. [33]

BORGSTEDT, Douglas [Car,W] Bryn Mawr, PA b. 3 Ja 1911, Yonkers, NY. Studied: Haverford Col.; PMSchIA. Exhibited: Berkshire Mus. A. (one-

man); MOMA; MMA Traveling Exh. Illustrator: Saturday Evening Post, Collier's. Positions: Illus., U.S. Army, 1942–45; Photogr. Ed., Saturday Evening Post, 1946– [47]

BORIE, Adolphe [P] Phila., PA/Paris, France b. 5 Ja 1877, Phila. d. 14 My 1934. Studied: PAFA; Munich Acad. Member: ANA, 1917; NA, 1934; AC Phila.; Port. P.; Allied AA; Phila. New SA. Exhibited: PAFA, 1901 (gold); P.-P. Expo, San Fran., 1915 (med); NAD, 1917 (prize); CGA, 1926 (med,prize); Sesqui-Centenn. Expo, Phila., 1926 (med); Phila. AC, 1928 (gold); AIC, 1928 (med). Work: MMA; WMAA; Univ. Pa.; Pa. Mus. A., Phila. [33]

BORISS, M.E., Mrs. See Coker, Walton.

BORKMAN, Gustaf [En] Brooklyn, NY b. 1842, Sweden d. 19 F 1921. Work: old-time illustrations for the Graphic, Harper's Weekly, Harper's Monthly

BORN, Ernest (Alexander) [P,Li,Arch] San Fran., CA b. 21 F 1898, San Fran. Studied: J.G. Howard; A. Hansen; La Montagne St. Hubert; P. Baudouin. Member: N.Y. Soc. Mural P.; Exhibited: GGE, 1939 [40]

BORN, Wolfgang [Hist,W,L,I,P] Baton Rouge, LA b. 21 O 1893, Breslau, Germany d. ca. 1950. Studied: Europe. Member: CAA; Assn. Am. Arch. Hist.; Am. Assn. Univ. Prof. Exhibited: Germany (one-man); Austria (one-man); St. Louis Pub. Lib. Work: Albertina Mus., Vienna; Ciba Symposia, Ars Islamica; other art publications. Positions: T., Queens Col. (1944), La. State Univ., Baton Rouge (1945–) [47]

BORNARTH, Mary S. (Mrs.) [P] Niles Center, IL. Studied: Layton Sch., Milwaukee; Minneapolis Sch. F.&Appl. A.; AIC; Hawthorne; L. Seiffert; L. Kroll; W. Reynolds; F.V. Poole; F. Fursman. Member: North Shore A. Lg.; All. Ill. Soc. FA; AIC [40]

BORNE, Mortimer [E,P,S,L,En] Brooklyn, NY b. 31 D 1902, Rypin, Poland. Studied: NAD; ASL; BAID; Hinton; Hawthorne; F. Jones. Member: SAE. Exhibited: SAE, 1939 (prize), 1943 (prize); AIC, 1931; AIGA, 1937; Sweden, 1937; WFNY, 1939; 100 Prints, 1940; MMA, 1942; MOMA, 1940; CGA, 1949 (one-man); Montreal Mus. FA, 1942 (one-man); NYPL (one-man); NGA, 1944 (one-man); Currier Gal., 1945; CI, 1947; BM, 1950; Wichita AA, 1952. Work: LOC; NGA; NYPL; Syracuse Mus. FA; Rochester Mem. A. Gal; N.J. State Mus. [47]

BORON, Vivian Browne [P] Chicago, IL b. 16 My 1902, Harbor Beach, IL. Studied: Chicago Acad. FA; Balande, Lhote, in Paris. Member: Detroit S. Women PS. Work: Palais de Justice, Lyons, France; Mich. Hist. Mus. [40]

BORONDA, Beonne [S,T] NYC b. 23 My 1911, Monterey, CA. Studied: ASL; A. Lee; DuMond. Member: NSS; NAWA; Mystic AA; CAFA. Exhibited: NAWA, 1932–34, 1935 (prize), 1936, 1937, 1938 (prize), 1939–46; N.J. Soc. P.&S., 1945 (prize), 1946 (prize); PBC, 1944, 1945 (prize); Montclair A. Mus., 1944; WMAA, 1940; CAFA, 1933–46; PAFA, 1935–45; NAD, 1935, 1937, 1941, 1944, 1945; AIC, 1937, 1938, 1940; WFNY, 1939; MMA, 1942; Mystic AA, 1930–45; Arch. Lg., 1941, 1944. Specialty: soap sculpture. Position: T., Montclair A. Mus., 1944–45 [47]

BORONDA, Lester David [P,C,D] NYC/Mystic, CT b. 24 Jy 1886, Reno, NV. Studied: ASL; Académie Julian, Paris; DuMond. Member: Mystic AA; Carmel AA. Exhibited: CI, 1912; CGA, 1915; NAD; AIC, 1922 (prize); Rochester Mem. A. Gal. (one-man); BMA (one-man); Minneapolis Inst. A. (one-man). Work: PAFA; Mech. Inst., Rochester, N.Y. Specialty: wrought iron [47]

BOROW, Willard [P] Phila. Studied: PMSchIA; E. Horter; H. Pitz; P. Froelich. Exhibited: Phila. A. All., 1939 (prizes). Position: T., Pocono Mt. Camps, Pa. [40]

BORST, George H. [S] Wayne, PA b. 9 F 1889, Phila. Studied: PAFA; C. Grafly; Académie Julian, Paris; A. Laessle; Itallo Vagnetti, in Florence, Italy. Member: AAPL. Exhibited: PAFA, 1927 (prize), 1930–46; NAD; NSS; Phila. A. All., 1937 (one-man); Un. Lg., Phila., 1944. Work: Mem. Acad. Music, Phila.; sculpture, Plymouth, Pasquaney, Onaway, all in N.H.; Wayne, Pa. [47]

BORU, Sorcha (Mrs. Ellsworth Stewart) [Cer,S] San Carlos, CA b. 13 Ap 1906, San Fran. Studied: Univ. Calif. Member: NYSC; San Fran. AA. Exhibited: Robineau Mem. Cer. Exh., Syracuse, N.Y., 1936 (prize); Intl. Expo, Paris, 1937. Illustrator: "Elynor Rummynge," by John Skelton, pub. Helen Gentry Press. [40]

BORUM, Linwood Clarke [Mar.P] Baltimore, MD b. 20 My 1898, Gwynn, VA. Studied: Md. Inst.; H. Roben. Member: AAPL. Exhibited: Md. Inst., 1938 (med); SAM, 1944 (prize); NAD, 1945 (prize); Los Angeles Mus. A., 1944; Milwaukee AI, 1944, 1945; Norfolk Mus. A.&Sc., 1944; CGA, 1944; Newark Mus., 1945; BMA, 1945; NAD, 1945; Syracuse Mus. FA, 1945; Buffalo AI, 1945; W.R. Nelson Gal., 1945; Speed Mem., Mus., 1945; Traveling Exh., Merchant Seamen, United Nations, 1943–46. Work: San Fran. Mus. Sc.&Indst. [47]

BORZO, Karel [Por.P] Seattle, WA b. 3 Ap 1888, Hertogenbosch, Holland. Exhibited: Wash. State Fair, 1928 (prize); Oakland A. Gal.; SAM; SFMA. Work: St. Edward's Seminary, Kenmore, Wash. [47]

BOSA, Louis [P,T] NYC b. 2 Ap 1905, Cordoipo, Italy. Studied: ASL; John Sloan. Member: Audubon A. Exhibited: Wanamaker, 1938 (prize); Pepsi-Cola, 1942–43, 1944 (prize), 1945 (prize), 1946 (prize); NAD, 1944 (prize), 1937–46; Rockport AA (prize); AIC, 1937–46; CGA, 1937–46; CI, 1948–46; PAFA, 1938–46; Schneider-Gabriel Gal., 1941; Kleeman Gal. (one-man); PMA; MMA; BM; MOMA; WMAA; Springfield Mus. FA; TMA; BMFA; Clearwater Mus. A. Work: PAFA; Clearwater Mus. A.; Kansas City AI; Wilmington Mus. A.; Springfield (Mass.) Mus. FA; Pepsi-Cola Coll.; CI; Encyclopaedia Britannica Coll.; U.S. State Dept.; IBM [47]

BOSE, Neal [P,I,E] Chicago, IL/Evanston, IL b. 22 My 1894, Columbia, TN. Studied: L. Seyffert; A. Tyler; L. Kroll. Member: AG. Specialty: adv. illus. [33]

BOSE, Norma [P,T] Wash., D.C. b. San Fran. Studied: George Washington Univ.; Columbia; H. McFee; P. Sample. Member: Soc. Wash. A.; Wash. WCC. Exhibited: PAFA, 1934–37, 1940; AWCS; Wash. WCC, 1931–46. Soc. Wash. A., 1929–46. Position: T., Roosevelt H.S., Wash., D.C. [47]

BOSIN, F. Blackbear [P] Cement, OK. Studied: Okla. Univ.; J. Havard MacPherson. Exhibited: First Nat. Exh. Am. Indian Painters, Philbrook A. Center, 1946, (prize). Work: Philbrook A. Center; Gilcrease Fnd.; Honolulu Acad. A. [47]

BOSLEY, Frederick A(ndrew) [P,T] Concord, MA/Piermont, NH b. 24 F 1881, Lebanon, NH d. 22 Mr 1941. Studied: Tarbell, Benson, in Boston, 1900–06; Europe, BMFA Sch., 1906–08. Member: ANA, 1934; Boston Gld. A., 1918, 1924, 1926; St. Botolph C.; Am. Gld. AC; Concord Art Center; AFA. Exhibited: P.-P. Expo, San Fran., 1915 (med); CI, 1920 (prize); Locust C.; PAFA (gold). Work: BMFA; Locust C.; Diocesan House, Boston; Farnsworth Mus.; NAD; Winchendon (Mass.) Lib.; Concord Acad. Position: Dir., BMFA Sch., 1913 [40]

BOSS, Homer [P,T] Santa Cruz, NM b. 9 Jy 1882, Blandford, MA d. 15 Ja 1956. Studied: Chase; Anschutz; Henri. Member: NAC; Fifteen Group (along with Hopper and Bellows), 1905–10. Exhibited: Armory Show, 1913. Lectures: Anatomy. Position: T., ASL, 1922–41 [47]

BOSSERMAN, Lyman Webber [P,Dr,T] Glendale, CA b. 29 N 1909, La Porte, IN. Studied: Univ. Southern Calif; Otis A. Inst.; G.W. Carpenter; M. Smith; H. DeKruif; P. Sample. Member: Laguna Beach AA; Calif. WCS; Gendale AA [40]

BOSSERT, Walder J. [I] Brooklyn, NY [19]

BOSSERT, Edythe Hoy [P,T] Mill Hall, PA b. 18 Jy 1908, PA. Studied: CI; Lock Haven St. T. Col. Member: NAWA; North Shore AA; Lock Haven AC. Exhibited: NAD, 1944; Lock Haven Exh., 1946; North Shore AA, 1943, 1944; NAWA, 1945; Parkersburgh FA Exh., 1942, 1943; Bucknell Univ., 1951; Terry AI, 1952 [47]

BOSTELMANN, Else (Mrs.) [I,P] Darien, CT (1953) b. Leipzig, Germany. Studied: Univ. Leipzig; Academie FA, Germany; von Hoffman; Schneider; H. Giles. Illustrator: Ginn & Co., National Geographic, children's books [47]

BOSTICK, Alma [P,T] Wash., D.C. b. 1 O 1891, Monroe, LA. Studied: C. Critcher; E.A. Webster. Member: Wash. SA; SSAL. Specialty: portraits. Position: T., Critcher Sch. Painting [33]

BOSTICK, William Allison [P,I,Des,Li,Car] Detroit, MI b. 21 F 1913, Marengo, IL. Studied: CI; Cranbrook Acad. Art; Zoltan Sepeshy. Member: Scarab Cl., Detroit. Exhibited: Detroit Inst. A., 1943 (prize), 1945 (prize); Audubon A., 1945; Pepsi-Cola, 1945; Detroit Inst. A., 1936–46; Detroit WCC, 1946; Domesday Press Exh., 1945. Work: Cranbrook Acad. Art. Author/Illustrator: "England Under G.I. Reign," 1946. Illustrator: "Art in the Armed Forces," other books. Contributor: articles, marine publications. Positions: Supv., City of Detroit Printing Div.; A. Dir., Conjure House, Publishers [47]

BOSTOCK, Arthur W. [P] Worcester, MA [24]

BOSTOCK, Charles A. [P] Worcester, MA [21]

BOSTON, Frederick James [P] 18 F 1855, Bridgeport, CT d. 8 F 1932, Brooklyn, NY. Studied: Whittaker; Carolus-Duran, in Paris. Member: Brooklyn SA; SC. He was the first instructor of art at the Brooklyn Institute of Arts and Sciences, and at one time president of the Painters' and Sculptor's Club. One of the founders of the Brooklyn Art Guild

BOSTON, Joseph H. [P,T] NYC b. Bridgeport, CT Member: ANA, 1901; SAA, 1896; SC, 1898; All.A.Am.. Brooklyn AC; NAC. Exhibited: Pan-Am. Expo, 1901 (med). Work: Butler AI; Brooklyn Inst. A.&Sc. [47]

BOSTWICK, Jane W. [P,I] Pittsburgh, PA [04]

BOSWELL, Norman Gould [P,Des] Los Angeles, CA b. 10 S 1882, Halifax, Nova Scotia. Studied: Victoria Sch. A.&Des., Halifax; Otis AI, Los Angeles; H.W. Cannon. Exhibited: Santa Cruz, Calif.; Hollywood Pub. Lib.; Los Angeles A. Lg. Work: mural, Rosicrucian Oriental Mus., San Jose, Calif. [47]

BOSWELL, Peyton [Cr] Hopewell, NJ b. 25 My 1879, Wolf Creek, IL d. 18 D 1936, Trenton, NJ. He went to New York to report for the Herald, becoming its art critic in 1912. In 1918, he was art reviewer for the New York American, and, in 1921, obtained part ownership of The Art News. He acted as agent for William Randolph Hearst in acquiring The International Studio, which he edited until 1925. In 1926, he launched The Art Digest. His last work was a survey of "American Art as It Is Today," the lead article in the January, 1937, issue of The London Studio.

BOSWELL, Peyton, Jr. [W] Malverne, NY b. 22 S 1904, Chicago d. 23 Je 1950. Studied: Rutgers Univ. Author: "Modern American Painting" (1939), "Henry Varnum Poor" (1940), "George Bellows" (1941); "Review of the Year in Art" for the Encyclopedia Americana. Position: Ed., The Art Digest, 1936-46 [47]

BOSWORTH, George F. [P] Boston, MA. Member: Boston AC [24]

BOSWORTH, Winifred [P,E] Elgin, IL b. 1885, Elgin. Studied: AIC; BMFA; ASL; Laurens, in Paris; Eisenbrüber, in Munich. Member: Chicago WCC; Chicago SE; S.Indp.A. [21]

BOTH, Armand [I] New Rochelle, NY b. 8 Ja 1881, Portland, Me d. 1 F 1922. Studied: Albert E. Moore; Eric Pape. Member: New Rochelle AA; Portland AA; SI, 1913. Illustrator: Sir Gilbert Parker's works; novels (for Harpers); magazines [21]

BOTH, William C. [I] Chicago, IL b. 18 F 1880, Chicago. Studied: J. Francis Smith; Laurens. Member: Palette & Chisel Cl. [33]

BOTHWELL, Dorr [P,Des,T,L,Ser] San Fran., CA b. 3 My 1902, San Fran. Studied: Calif. Sch. FA; Univ. Oreg. Member: San Fran. Soc. Women A.; San Fran. AA. Exhibited: San Fran. Soc. Women A., 1926, 1928, 1929 (prize), 1930-31, 1941, 1942 (prize), 1943-45; San Diego A. Gld., 1927, 1932 (prize), 1934; San Diego FA Soc., 1931-33; San Fran. AA, 1944 (prize), GGE, 1939; Pal. Leg. Honor, 1946; SFMA, 1940-45; Los Angeles Mus. A., 1941; CGA, 1934; NGA, 1942; Denver A. Mus., 1945. Lectures: Samoan life. Position: Instr., Calif. Sch. FA, San Fran. [47]

BOTKE, Cornelius [E,P] Santa Paula, CA b. 6 Jy 1887, Leewarden, Holland d. 16 S 1954. Studied: Chris Le Beau; Sch. Appl. A., Haarlem, Holland; AIC. Member: Calif. AC; Chicago Gal. Assn.; SAE; Calif. SE; Calif. Pr.M.; Fnd. Western A. Exhibited: AIC, 1916 (prize), 1918 (prize), 1921, 1930 (prize); Calif. SE, 1934 (prize); SAE, 1935 (prize); Bookplate Assn. 1936 (prize); Los Angeles Mus. A., 1931 (prize), 1933 (prize), 1934 (prize), 1938 (prize), 1939 (prize), 1946; Paris Salon, 1923; Pepsi-Cola, 1946; Fnd. Western A., 1946. Work: Santa Monica Pub. Lib.; Lincoln (Nebr.) AA; AIC; LOC; Calif. State Lib.; NYPL; Los Angeles Pub. Lib. [47]

BOTKE, Jessie Arms [P] Santa Paula, CA b. 27 My 1883, Chicago, IL. Studied: AIC, with John Johanson, Charles Woodbury; Herter. Member: Calif. WC Soc.; Calif. AC; NAWA; Fnd. Western A. Chicago Gal. A.; Grand Central Gal. A. Exhibited: AIC, 1916, 1917 (prize), 1918 (prize), 1919 (prize), 1920-25, 1926 (prize); Peoria Soc. All. A., 1918 (med); NAWA, 1925 (prize), 1933 (prize); Southwest Expo, 1928 (med); Western Acad. Painters, 1935 (prize), 1936 (prize); Sanity in Art, 1938 (prize); NAD; PAFA; CGA; Los Angeles Mus. A.; GGE, 1939; Pal. Leg. Honor. Work: AIC; Nebr. AA; Mills Col.; mural, Univ. Chicago [47]

BOTKIN, Henry Albert [P,Des,W] NYC b. 5 Ap 1896, Boston, MA. Studied: Mass. Normal A. Sch.; ASL; E.R. Major; Bridgman; abroad. Member: Am. A. Cong. Exhibited: Audubon A., 1945 (prize); CGA; PAFA; Carnegie Inst.; AIC; WMAA; GGE, 1939; WFNY, 1939; MMA; BMA; Denver A. Mus.; Walker Gal.; Stendahl Gal.; Carstairs Gal.; Phillips Gal.; Harriman Gal. (one-man); Los Angeles Mus. A. (one-man); SFMA; Chicago AC; PMG; BMFA; Kansas City AI; Downtown Gal. Work: MMA; MOMA; PMG; Univ. Nebr.; BM; Newark Mus.; Univ. Okla. Illustrator: magazines [47]

BOTSFORD, Anna. See Comstock.

BOTT, Earle Wayne [P,Des,Li,En,I,Car,L] Brazil, IN b. 1 Ja 1894, Indianapolis. Studied: John Herron AI; A. Acad., Cincinnati; AIC; William Forsythe; James R. Hopkins; Frank Duveneck. Member: Ind. AC. Exhibited: Ind. State Fair, 1921 (prizes); Hoosier Salon, 1925, 1933; John Herron AI, 1914, 1921-23, 1932; Ind. AC, 1922, 1933, 1935; Richmond AA, 1922-24; Ind. A., 1932-34. Work: Am. Legion, Kokomo, Ind. Lectures: Lithography [47]

BOTT, Mabel Siegelin (Mrs. Earle Wayne) [T,C,P,Des] Brazil, IN b. 12 S 1900, Clay Co., IN. Studied: John Herron AI. Member: Ind. AC; Ind. Fed. AC; Boston SAC. Exhibited: Ind. State Fair, 1924 (prize), 1925 (prize), 1926 (prize), 1927-28, 1929 (prize), 1930 (prize), 1931 (prize), 1932 (prize), 1933 (prize), 1934-40; Kentucky State Fair, 1927 (prize), 1932 (prize); Ind. Fed. AC, 1936 (med); Hoosier Salon; Marshall Field Gal., 1926; John Herron AI, 1926, 1927, 1929, 1930; Ind. AC, 1933, 1935, 1936. Position: T., Van Buren Township H.S., Ind., 1944-46 [47]

BOTTIGHEIMER, Erna [P] Cincinnati, OH b. 23 Mr 1907. Studied: Cincinnati A. Acad.; Henry Lee McFee; George Grosz. Member: Cincinnati Assn. Prof. Ar.; Contemporary Ar., Cincinnati. Exhibited: Cincinnati Mus., 1938, 1939; GGE, 1939 [40]

BOTTO, Otto [P] North Bergen, NJ b. 15 Jy 1903, Ragaz, Switzerland. Studied: Switzerland. Exhibited: PAFA, 1941; MMA, 1941; MOMA, 1938; WMAA, 1939; BM, 1941, 1943, 1945; AIC, 1942, 1943, 1944; Carnegie Inst., 1946; La Tausca Pearl Exh., 1946; Fed. Mod. P.&S., 1946. Work: Brooklyn Lib. [47]

BOTTORF, Edna Annabelle [Edu,P,W,L] Lock Haven, PA b. 30 Ja 1901, Lock Haven. Studied: Lock Haven State T. Col.; NYU; Snow-Froehlich Sch. Indst. A.; Pa. State Col.; Emil Walters; Hobson Pittman. Member: Am. Assn. Univ. Prof.; Nat. Edu. Assn.; Eastern AA. Exhibited: Butler AI; Parkersburg, W.Va. Contributor: educational magazines and journals. Position: A. Dir., State T. Col., Lock Haven, 1935- [47]

BOTTS, Hugh (Pearce) [Pr.M,Des,P,Li,E] NYC b. 19 Ap 1903, NYC d. 25 Ap 1964. Studied: Rutgers Univ.; NAD; ASL; BAID; Hinton; Curran; Charles Hawthorne; Ivan Olinsky; William Auerbach-Levy; William Von Schlegell; Eugene Fitsch; Harry Sternberg. Member: F., Yaddo Fnd., 1929; ANA; SAE; SC; AAPL; Phila. WCC; Princeton Pr. Cl.; Southern Pr.M.; Northwest Pr.M.; North Shore AA; Springfield A. Lg.; New England Pr. Assn. Exhibited: Arch. Lg., 1934 (prize); BAID, 1937 (prize); SC, 1943 (prize); N.J. State Exh., Montclair A. Mus., 1941 (med), 1942 (prize), 1943 (prize), 1944 (prize); N.J. P.&S., 1946 (prize); MMA, 1940, 1943; WMAA, 1941; Carnegie Inst., 1941; CGA, 1939-42; AIC, 1938; LOC, 1941-43; MOMA, 1942; NAD, 1936-43; WFNY, 1939; Phila. Pr. Cl., 1936-46; Conn. Acad. FA, 1936-43; SAE, 1936-43; Oakland A. Gal., 1941-43; Southern Pr.M., 1936-40; 100 Prints, 1938-41. Work: LOC; MMA; FMA; BM; Boston Pub. Lib.; CM; Newark Mus.; Montclair A. Mus.; SAM; Queens Col.; NYPL [47]

BOUCHE, Louis [P,T] NYC b. 18 Mr 1896, NYC d. 7 Ag 1969, Pittsfield, MA. Studied: Grande Chaumière, Ecole des Beaux-Arts, Paris; ASL; Richard Miller, Simon, Ménard, J.P. Laurens, in Paris; Ossip Linde; DuMond; Luis Mora. Member: F., Guggenheim, 1933; An Am. Group; Audubon A. Am. Soc. PS&G; Am. A. Cong. Exhibited: CGA, 1937, 1939; PAFA, 1941, 1942, 1945. Work: MMA; WMAA; PMG; WMA; Blandon Mem. Gal.; PAFA; Univ. Nebr.; Encyclopaedia Britannica Coll.; Wichita Mus. A.; murals, Dept. Interior, Justice Bldgs., Wash., D.C.; USPO, Ellenville, N.Y.; Pa. R.R. lounges [47]

BOUCHE, Marian Wright [P,W] NYC b. 8 D 1895, NYC. Studied: Henri Matisse; Walt Kuhn. Member: Paris AAA; Penguin Cl.; S.Indp.A. [33]

BOUCHER, Graziella V. [P,W] Portland, OR b. 31 O 1906, Detroit, MI. Specialty: paintings of animals. Writer: newspapers and magazines. Position: Dir., national publicity campaigns and art exhibitions [33]

BOUDREAU, James Clayton [Edu,Li,L,W] NYC b. 25 D 1891, Framingham, MA. Studied: Mass. Normal A. Sch.; Columbia; Alfred Univ. Member: Nat. Edu. Assn.; Mun. A. Comm.; Eastern AA; Western A.; A. Dir. Cl.; AFA; SI. Author: "History of Coastal Patrol Base #17," 1944. Lectures: History of Art; Camouflage; Aviation. Positions: Dir., A., Pittsburgh Public Sch., 1920-28; Dean, PIASch., 1928- [47]

BOUGHTON, Alice [Por.P,Photogr] Brooklyn, NY b. 1865, Brooklyn d. 21 Je 1943, Bay Shore, NY. Opened studio in NYC, 1890. Portraits of many notables in the arts, including A.P. Ryder, Gorki, James Joyce, appear in her book "Photographing the Famous," 1928. Work: MMA; IMP; other major photography mus.

BOUGHTON, George Henry [P] London b. 1834, near Norwich, England (came to U.S. in 1837) d. 19 Ja 1905, London. Studied: self-taught; Albany, N.Y.; Paris, with Edouard Frère. Went to London in 1861. Member: NA, 1871; AWCS; A. Fund S.; Royal Acad., London, 1898. Specialty: landscapes [04]

BOUGHTON, William Harrison [P,T] Dubuque, IA b. 19 F 1915, Dubuque. Studied: Univ. Iowa, with Grant Wood, Fletcher Martin; Univ. Calif.,

with Earl Loran, Shaeffer Zimmern. Exhibited: SFMA, 1945; Univ. Calif., 1945 [47]

BOUGUEREAU, Elisabeth (Jane) Gardner (Mrs. W.A.) [P] Paris, France b. 1837, Exeter, NH d. Ja 1922. Exhibited: Paris Salon, 1879 (prize), 1887 (med); Paris Expo, 1889 (med) [21]

BOULTON, Frederick W(illiam) [P,C,I] Evanston, IL b. 18 Mr 1904, Mishawaka, IN. Studied: AIC; John Norton; Charles H. Woodbury; Joseph Allworthy; abroad. Member: Chicago A. Dir. Cl. Illustrator: commercial, magazines. Position: A. Dir., J. Walter Thompson Co., Chicago [40]

BOULTON, Jospeh Lorkowski [S,L] Redding, CT b. 26 My 1896, Fort Worth, TX. Studied: NAD; ASL; BAID; H.A. MacNeil. Member: All.A.Am.; Phila. A. All.; AAPL; SC. Exhibited: NAD, 1921 (prize), 1922–44; Hempstead, N.Y., 1945 (prize); PAFA, 1927–40; Danbury, Norwalk, Bridgeport, Conn. Work: D.A.R., Fort Worth, Tex.; Detroit Inst. A.; Fort Worth Mus. A.; Phila. Acad. Medicine; Univ. Pa. [47]

BOULWARE, I.W. (Mrs.) [P] St. Joseph, MO. Member: St. Joseph A. Lg. [21]

BOUNDEY, Burton S(hepard) [P,T,Mur.P] Monterey, CA b. 2 F 1879, Oconomowoc, WI d. 1962. Studied: AIC; Smith A. Sch., Chicago; Vanderpoel; Henri. Member: AAPL; Carmel AA. Exhibited: Santa Cruz A. Lg., 1933 (prize), 1935–46; Crocker A. Gal., 1935, 1937 (prize), 1938, 1939, 1940 (prize); AV, 1943 (prize); San Fran. AA, 1935, 1937; Oakland A. Gal., 1935, 1936, 1946; GGE, 1939; Dayton AI, 1943; Carmel AA. Work: Oconomowoc Pub. Lib.; Louise De Haven Coll., Monterey. Position: Instr., Carmel AI [47]

BOURDELLE, Pierre [P,S] NYC d. 6 Jy 1966, Oyster Bay, NY. Exhibited: Tex. Cetenn., 1936. Work: Chrysler Bldg.; USPO, Rockford, Mich. WPA artist. [40]

BOURGEOIS, Louise [P] NYC b. 25 D 1911, Paris. Studied: Ecole des Beaux-Arts, Paris; ASL; Fernand Léger. Exhibited: MOMA, 1941, 1943 (prize); LOC; MMA; WMAA, 1945, 1946; Los Angeles Mus. A., 1943; SFMA, 1944; Pal. Leg. Honor, 1950. Work: Albright A. Gal. [47]

BOURKE, Marian [P] NYC [13]

BOURKE-WHITE, Margaret [Photogr] b. 1904, NYC d. 1971. Studied: Clarence White Sch. Photography; Cornell, 1927. Work: IMP; MOMA; NOMA; LOC; BM; CMA. Positions: Staff Photojournalist, Fortune (1929–33; Fortune's first photojournalist), Life (1933–57); WPA [*]

BOURNE, Emma Cartwright (Mrs. R.D. Darrell) [E,P] Boston, MA b. 23 F 1906, Norwalk, CT. Studied: Richard Andrew [33]

BOURNE, Evelin Bodfish [P] Buzzards Bay, MA b. 10 Jy 1892, Wareham, MA. Studied: NAD. Member: Provincetown AA. Work: Vassar Col. [40]

BOURNE, Gertrude B. (Mrs. Frank A.) [P] Boston, MA b. Boston. Studied: Henry B. Snell; Henry W. Rice. Member: AWCS; Wash. WCC; NYWCC. Exhibited: Doll & Richards, Boston, 1939 [47]

BOURNE, Minerva [P] NYC. Member: AWCS [47]

BOURQUIN, J.E. [P] Yonkers, NY. Member: S.Indp.A.; Bronx AG [24]

BOURSCHEIDT, Dora [P] Peoria, IL [19]

BOUTWOOD, Charles Edward [P,T] Chicago, IL b. England. Studied: Royal Acad., London; Paris. Member: Chicago SA; Chicago WCC. Exhibited: Chicago SA, 1913 (med). Work: Vanderpoel Coll. [33]

BOUVE, Rosamond Smith (Mrs.) NYC. Member: Boston GA; Conn. Acad. FA; NAWPS. Exhibited: P.-P. Expo, San Fran., 1915 (med) [40]

BOWDEN, Beulah Beatrice [P,C,T,] Mars Hill, NC b. 21 Jy 1875, Townsville, NC. Studied: Meredith Col.; ASL; John Carlson; Harry Leith-Ross. Member: SSAL; Ar. Gld, Asheville, N.C. Exhibited: Birmingham, Ala.; Charlotte, N.C.; Asheville, N.C. Position: Instr., Mars Hill Col., 1904–06, 1914– [47]

BOWDEN, H(arry) [P,Des,Li,Ser] Sausalito, CA b. 9 F 1907, California. Studied: Univ. Calif.; J. Francis Smith; Hans Hofmann, in Munich. Member: Am. Abstract A. Exhibited: SFMA, 1945; Am. Abstract A., 1937–39; DeYoung Mus., 1948; Los Angeles, Mus. A., 1949. Work: mural, Williamsburg Housing Project, Williamsburg, N.Y. [40]

BOWDISH, Edward Romaine [P,I,E] Skaneateles, NY b. 26 My 1856, Richfield Springs, NY. Studied: his father; August Schwabe. Member: Yonkers AA; AFA; AAPL [33]

BOWDISH, Nelson S. [Ldscp.P] b. 1831, New Lisbon, NY d. 3 Ap 1916, Skaneateles, NY

BOWDITCH, Mary [S] Boston, MA. Member: NAWPS. Exhibited: NAWPS, 1935, 1936, 1937 [40]

BOWDOIN, Harriette [P] NYC b. Massachusetts d. 1947. Studied: Henry B. Snell; Elliott Daingerfield; Frank Brangwyn, in France. Member: AWCS; NAWA; N.Y. Soc. Painters [47]

BOWDOIN, William G. [Cr] Brooklyn, NY b. 1861, South Hadley, MA d. 22 Mr 1947. Art critic, N.Y. Evening World, 1915–24; art & make-up editor, The Independent, for 7 years; Author: "The Rise of the Bookplate," "James McNeill Whistler." Contributor: various publications. Authority: bookplates

BOWEN, Benjamin James [P] Kairouan, Tunisia. b. 1 F 1859 d. early in 1930, Lausanne, Switzerland. Studied: Lefebvre, Carriere, Robert-Fleury, in Paris. Work: Paris Salon. Although a resident in Europe since 1898, he had always retained a home in Boston. [10]

BOWEN, Ernest [P] NYC. Member: Bronx AG [24]

BOWEN, Ezra [P] b. 1891, Bethlehem, PA d. 26 D 1945, NYC

BOWEN, Irene [P,T] Los Angeles, CA b. 27 N 1892, South Bend, WA. Studied: John F. Carlson [21]

BOWER, Alexander [Mus.Dir,P,Des] Cape Elizabeth, ME b. 31 Mr 1875, NYC d. 6 Ag 1952. Studied: PMSchIA; PAFA, with Thomas P. Anshutz. Member: ANA; SC; AWCS; Phila. WCC; Boston Soc. WC Painters. Exhibited: Carnegie Inst.; NAD; PAFA; AIC; CGA. Work: Univ. Nebr.; Springfield (Mo.) A. Mus.; Butler AI; Sweat Mem. A. Mus.; Farnsworth Mus., Rockland, Maine. Positions: Dir., L.D.M. Sweat Mem. A. Mus.; Dir., Sch. F.&App.A., Portland, Maine [47]

BOWER, Frederick [P] Phila. PA [13]

BOWER, Helen (Carolyn) [Cr] Detroit, MI b. 7 Ja 1896, Buchanan, MI. Studied: Univ. Mich. Position: A. Cr., Detroit Free Press [47]

BOWER, Helen Lane [P,Des] Brooklyn, NY b. 16 D 1898, Lanesville, NY. Studied: PIASch.; George Pearse Ennis; Oscar Julius; Ann Fisher. Member: NAWA, PBC; Wolfe AC. Exhibited: Wolfe AC, 1939 (prize), 1944 (prize); NYWCC, 1937; 8th Street Gal., 1939; WFNY, 1939; NAWA; PBC [47]

BOWER, Lloyd D. [P] Columbus, OH. Member: Columbus PPC [24]

BOWER, Lucy Scott (Mrs.) [P] b. 18 Ja 1864, Rochester, IA d. 14 N 1934, Paris. Studied: Robert-Fleury, Lefebvre, Simon, Ménard, in Paris. Member: NYSA; All. AA; Gotham A.; NAWPS; PBC. Exhibited: Arc-en-Ciel Exh., Paris, 1917 (gold); Nat. Lge. Amer. Pen Women, 1929 (prize). Work: Mus. of Vitré, France; PBC; N.J. Fed. Women's Cl., Long Branch. Author: poetry, "In a Minor Vein." She spent the years from 1904 to 1934 in England and France. [33]

BOWER, Maurice L. [I] Phila., PA. Member: SI [40]

BOWER, Philip [P] NYC b. 15 Jy 1895 d. Winter 1935, Málaga, Spain. Studied: NAD; BAID. Member: F., Am. Acad., Rome, 1924–25; Mural P.; Arch. Lg. Work: Lib., Hamilton Col. [33]

BOWERS, Beulah Sprague [P,C,S,L] Meriden, CT b. 5 N 1892, Everett, MA. Studied: MIT, with W.F. Brown; South Boston A. Sch.; Mass. Sch. A.; CUASch.; Univ. N.H.; Joseph De Camp; Cyrus Dallin; William Felton Brown; Ethel Traphagen. Member: Meriden A.&Crafts Assn.; Conn. AA; Wichita AA; Wichita AG; Kans. Fed. A.; Prairie WCS. Exhibited: Meriden A.&Crafts Assn., 1939–46; Kans. WC Soc.; Kansas AA; A. Gld. Lectures: Color; Design. Positions: Asst. Prof., A., Univ. Wichita, 1929–37; Supv. A., Meriden Pub. Sch., 1939– [47]

BOWERS, Charles [Car] b. 1889, Cresco, IA d. 24 N 1946, Paterson, NJ. Cartoonist: Chicago Tribune, Chicago Star. A pioneer in animated movie cartoons. [47]

BOWES, A. Wentworth [P] Bronx, NY b. D 1890. Studied: J. Wentworth Bowes [40]

BOWES, Julian [S,L,W,T] Old Saybrook, CT b. 7 Mr 1893, NYC. Studied: Jay Hambidge. Member: F., Royal Hellenic Soc.; Assoc., Brit. Sch. Archaeology, Egypt. Work: MMA; WMAA; Columbia Univ.; Am. Mus. Nat. Hist.; Navy Yard, N.Y. Author: "Scripta Mathematica," 1934; "Proportions of the Ideal Human Figure," "Dynamic Symmetry— a Manual for Artists," "The Egyptian Cubit—the Quadrature of the Circle." Lectures: Ancient Egypt, Sculpture of Ancient Greece, Dynamic Symmetry in Composition. Position: Dir., School of Dynamic Symmetry, New York [47]

BOWLEN, William C. [E] Holyoke, MA/Gloucester, MA b. 10 My 1868, Newburyport, MA. Member: Chicago SE; Calif. PM [33]

BOWLES, Caroline (Mrs.) [P] Pasadena, CA. Member: Calif. AC [24]

BOWLES, Janet Payne (Mrs.) [C,W,T,Goldsmith] Indianapolis, IN b. 29 Je 1882, Indianapolis d. 18 Jy 1948. Studied: Radcliffe Col.; Columbia Univ.; William James, in Paris. Member: Ind. AA. Exhibited: Int. Goldsmiths, London, 1913 (prize); London & Paris Jewelers, 1912 (prize); P.-P. Expo, 1915 (prize); London & Paris Jewelers, 1912 (prize), 1920 (prize); Bossilini, Florence, Italy, 1924 (prize); New York; Boston; Chicago (one-man). Work: Morgan Coll.; chalices, churches in Italy, Paris, New York, Wash., D.C. Author: "Gossamer to Steel" (1917), "Complete Story of the Christmas Tree" (1918). Lectures: Russian Art [47]

BOWLES, M. André [P] b. 1864, New Orleans d. 14 My 1930, Chicago. Position: Art Dir., various publications, 1900–26

BOWLIN, Angela Clarke [Mus.L] NYC b. 5 My 1911, St. Paul, MN. Studied: Smith Col.; Univ. Minn., NYU. Lectures: Medieval, Renaissance Art. Position: Staff L., MMA, 1942–46 [47]

BOWLING, Charles T. [P] Dallas, TX. Exhibited: Allied Arts Exh., Dallas Mus. FA, 1937 (prize) [40]

BOWLING, Jack (Frank) [En,Li,C,I] Wash., D.C. b. 5 Jy 1903, Bonham, TX. Studied: U.S. Naval Acad. Member: Honolulu Pr.M. Exhibited: Honolulu Pr.M., 1934, 1935; SAE; Southern Calif. Pr.M.; Southern Pr.M. Work: LOC; Honolulu Acad. A. Illustrator: "Book of Navy Songs," "U.S. Naval Institute Proceedings," and others [47]

BOWMAN, Frances T. [P] Evanston, IL. Exhibited: Am. WC Soc., 1933, 1934, 1937; PAFA, 1936 [40]

BOWMAN, Martha Musser [T] Lancaster, PA. Member: F., PAFA [24]

BOWMAN, M.J. [P] Cleveland, OH. Member: Cleveland SA [25]

BOWMAN, Richard Irving [P,T] Chicago, IL b. 15 Mr 1918, Rockford, IL. Studied: AIC; Univ. Chicago. Exhibited: AIC, 1939–41, 1942 (med), 1944, 1945 (med), 1946; SFMA, 1941; CM, 1941; Pinacotheca, 1945 (one-man) [47]

BOWSER, Waldo [I] NYC [17]

BOYCE, Richard Audley [E,P,C,Des,I] Glen Rock, NJ b. 24 Jy 1902, Brooklyn, NY. Studied: Joseph Pennell. Work: furniture design; animated model building [40]

BOYD, Byron Bennett [P,Li] Des Moines, IA. b. 22 Ja 1887, Wichita, KS. Studied: Univ. Colo.; Columbia Univ.; Jean Manheim; NAD; Harry Leith-Ross. Member: Des Moines Assn. FA; Chicago Gal. Assn.; Iowa AC; Coop. A. Iowa; Am. APL. Work: murals, USPOs, Osceola and Pella, Iowa, Sec. FA, Fed. Works Agency;assistant to Boardman Robinson, murals, Colo. Springs FA Center, Dept. Justice Bldg., Wash., D.C. Author: plays, "An Amateur Hamlet," "The Strongest," etc. Position: Dir., A. Dept., Drake Univ. [40]

BOYD, Clare Shenehon (Mrs. Fiske) [P,T] Summit, NJ/Plainfield, NH b. 28 Jy 1895, Minneapolis, MN. Studied: Minneapolis Sch. A.; George Luks; Boardman Robinson; ASL; Inst. FA, NYU. Positions: Instr., Kent Pl. Sch., Summit; Co-director, Pinehaven Retreat for Ar. [40]

BOYD, Doris (Paulin) [P] Los Angeles, CA b. 7 N 1909, Hollywood, CA. Studied: J. Francis Smith; Theodore N. Lukits; Jack Wilkinson Smith. Member: Calif. AC; Laguna Beach AA; San Gabriel AG [40]

BOYD, E.M. (Mrs.) [P] NYC [17]

BOYD, Fiske [B,Dr,E,L,P] Summit, NJ/Plainfield, NH b. 5 Jy 1895, Phila., PA d. 1975. Studied: PAFA; Kenneth Hayes Miller; ASL. Member: Am. Soc. PS&G; Am. A. Cong. Exhibited: Print Cl., Phila., 1931 (prize). Work: MMA; WMAA; NYPL; BMFA; Herron A. Inst., Indianapolis; Addison Gal. Am. A., Andover, Mass. Phillips Mem. Gal., Wash., D.C.; Newark Mus.; USPO, Summit, N.J., Sec. FA, Fed. Works Agency. Position: Co-director, Pinehaven Retreat for Ar. [40]

BOYD, Helen E(dward) Walker (Mrs. Theodore E.) [Min.P,P] Wheaton, IL b. 11 Mr 1897 Chicago, IL. Studied: Bryn Mawr Col.; AIC; Cummings; Eda Nemoede Casterton; Kate Bacon Bond. Member: Chicago Soc. Min.P. Exhibited: PAFA, 1930, 1931, 1933; BMA, 1930; BM, 1931, 1932, 1934; AIC, 1930; ASMP, 1933, 1934; Chicago Soc. Min.P., 1932–44; CGA; Chicago Century Progress, 1933; Wheaton (Ill.) Exh., 1946 [40]

BOYD, Ida E. [P,T] Brooklyn, NY [09]

BOYD, Jeanie L. [P] Wash., D.C. [13]

BOYD, John Rutherford [I] NYC [09]

BOYD, Moreon Beurnère. See Beurnère, Moreon.

BOYD, Myra [Min.P] Paris/Chicago, IL b. Pittsburgh, PA. Studied: Debilliemont-Chardon; de la Valette; Bouguereau; Tudor-Hart. Member: Pittsburgh AA [08]

BOYD, Phoebe Amelia [P,S] Germantown, PA b. 29 D 1875, Phila., PA. Studied: William A. Hoffstetter; Antonio Cortizos. Work: Phila. AA (library) [33]

BOYD, Rutherford [P,Des,W,L] Leonia, NJ b. Phila., PA d. 13 F 1951. Studied: PAFA; ASL. Member: AWCS; SC; Arch. Lg. Exhibited: Dallas All. A., 1940 (prize); SSAL, 1941 (prize). Writer: research in design. Author: articles, various magazines [47]

BOYD, W.J. [P] Okla. City, OK. Member: Okla. AA [21]

BOYD, William [P,A] Sewickley, PA/Medomak, ME b. 24 Ag 1882, Glasgow, Scotland. Studied: Paul Cret; Univ. Pa.; M. Duquesne, in Paris. Member: F., AIA. Exhibited: Pittsburgh AA, 1921. Position: Assoc. with Ingham & Boyd, Arch. [40]

BOYDEN, Dwight Frederick [P,Ldscp.P] b. 1860, Boston d. 16 My 1933, Baltimore, MD. Studied: Boulanger, Lefebvre, both in Paris; MIT. Member: SC, 1902. Exhibited: Paris Salon, 1899 (med), 1900 (gold). Lived in Paris, 1882–98.

BOYE, Bertha M. [P] Ukiah, CA [19]

BOYER, Helen King [En,Des,P,L] Earleville, MD b. 16 D 1919, Pittsburgh. Studied: Samuel Rosenberg; Wilfred Readio; Boyd Hanna. Member: SAE. Exhibited: SAE, 1940–42, 1943 (prize), 1944; LOC, 1933, 1934, 1943 (prize); Buffalo Pr. Cl, 1943; Laguna Beach AA, 1945, 1946; NAD, 1942, 1943; Northwest Pr.M., 1941, 1944; Oakland A. Gal., 1941–43; PAFA, 1941, 1942; Southern Pr.M., 1942; Pittsburgh Assoc. A., 1942–45. Work: LOC; Carnegie Inst. Position: A., Pittsburgh Sun Telegraph, 1944–46 [47]

BOYER, Ida F. [P] Brooklyn, NY d. S 1915. Studied: Europe. Position: Instr., CUSch

BOYER, Jane Allen (Mrs. Murray) [P] Riverton, NJ. Member: F., PAFA; Plastic Cl. [21]

BOYER, Louise (Rivé-King) (Miller) [En,P,Des,L] Earleville, MD b. 30 O 1890, Pittsburgh. Studied: Carnegie Inst.; Pittsburgh Sch. Des.; Henry Keller; Arthur Sparks; Charles Hawthorne. Member: SAE. Exhibited: Assoc. A. Pittsburgh (prize); John Herron AI, 1946 (prize); LOC, 1943, 1944; SAE, 1940–45; Northwest Pr.M., 1941–45; SFMA, 1943–45; NAD, 1942–46; MMA, 1942; Carnegie Inst., 1941, 1944; Laguna Beach AA, 1945, 1946; PAFA, 1941, 1942; Wash. Soc. Min. P., 1942; Wash. WCC, 1942; Southern Pr.M., 1942; Am. Prints Today, Indianapolis, 1946. Lectures: Etchings; Drypoints [47]

BOYER, P.T. [P] Phila., PA [01]

BOYER, Ralph Ludwig [P,E] Westport, CT b. 23 Jy 1879, Camden, NJ d. 19 My 1952. Studied: PAFA; William Chase; Cecilia Beaux; Anshutz; Breckenridge [47]

BOYHAN, Matthew William [P] NYC. Studied: BMFA Sch.; Charles H. Woodbury. Award: Prix de Rome, 1936 [40]

BOYKO, Fred S. [P,T] NYC b. 30 Mr 1894, Vienna d. 5 Jy 1951. Studied: Vienna. Member: AAPL. Exhibited: P.&S. Soc., N.J., 1945 (prize); All.A.Am., 1944; Ogunquit A. Center, 1945 [47]

BOYLAN, W(illiam) [P] Brooklyn, NY b. 10 Ap 1879, Brooklyn. Studied: New York. Member: Brooklyn WCC; Brooklyn SA [21]

BOYLE, Alex [S] NYC [05]

BOYLE, Beatrice A. [I,P] Rocky River, OH b. 28 Mr 1906, Pittsburgh. Studied: Cleveland Col.; Huntington Polytechnic Inst.; Henry Keller; Frank Wilcox; W. Combs. Exhibited: Cleveland Clinic (med); San Fran., 1946; Cleveland, 1946. Work: medical movies for educational purposes. Illustrator: "The Extremities," 1945. Specialty: medical illustrations. Lectures: Medical Art. Position: Staff A., Cleveland Clinic, 1935–46 [47]

BOYLE, Charles W. [P,T] New Orleans, LA b. New Orleans d. 9 F 1925. Studied: Paul Poincy; A. Molinary; ASL. Member: NOAA; NAC. Work: Delgado Mus.; New Orleans AA [24]

BOYLE, Ferdinand Thomas Lee [Por.P] Brooklyn, NY b. 1820, Ringwood, England d. 2 D 1906. Studied: Henry Inman. Member: New York Sketch Club; Faust Cl., Brooklyn; Carlton Cl. Work: Denver AM; Union Lg. Cl.; portraits of Charles Dickens; Poe; U.S. Grant. In 1855 he settled in St. Louis, and there organized the Western Academy of Art; returned to

New York in 1866. Positions: Prof., A., Brooklyn Inst.; Hd., Sch. A., Adelphi Col.

BOYLE, Gertrude [S] NYC. Member: S.Indp.A. [21]

BOYLE, John J. [S] NYC b. 12 Ja 1852, NYC d. 10 F 1917. Studied: Eakins; Ecole des Beaux-Arts, with Dumont; Thomas, E. Millet, in Paris. Member: Société des Artistes Français; NSS, 1893; ANA, 1910; Phila. Sketch Cl.; AC Phila.; NAC; Arch. Lg., 1894; N.Y. Municipal AS; T Square Cl. Exhibited: Paris Salon, 1886 (prize); Columbian Expo, Chicago, 1893 (med); Paris Expo, 1900 (med); Pan-Am. Expo, Buffalo, 1901 (med); St. Louis Expo, 1904 (med); P.-P. Expo., San Fran., 1915 (med). Work: Fairmount Park, Phila.; Lincoln Park, Chicago; LOC; Wash., D.C. [15]

BOYLE, John Joseph [P,Mur.P] Paris, France/Germantown, PA b. 30 My 1874, Pittsburgh d. 25 Ap 1911, Ocean View, NJ. Studied: PAFA; Académie Julian, Paris, with Benjamin-Constant, Laurens. Member: Paris AAA. Works: churches in Phila., Baltimore, Wash., D.C. [05]

BOYLE, Sarah Yocum McF. (Mrs.) [Min.P] West Phila., PA b. Germantown, PA. Studied: Drexel Inst.; Pyle; Deigendesch; Herman Faber. Member: F., PAFA; Plastic Cl.; Phila. All.; Pa. Soc. Min. P.; AFA [40]

BOYNTON, George R(ufus) [P] NYC/Elizabethtown, NY b. Pleasant Grove, WI d. 6 Ja 1945. Studied: NAD; ASL; J.G. Brown; C.Y. Turner; Walter Shirlaw; William M. Chase. Member: Lotos Cl.; A. Fund S.; McD. Cl. Work: Union Lg. Cl.; U.S. Military Acad.; N.Y. Zoological Soc.; Genealogical and Biographical Soc.; NYU; U.S. District Court, 7th Regt. Armory, New York; Larchmont Yacht Cl.; N.Y. Yacht Cl.; Columbia Univ.; CCNY; Yale Univ.; St. Lawrence Univ. Known as "The Painter Laureate of Army and Navy Life." [40]

BOYNTON, Ray Scepter [Mur.P,C,T,W,] San Fran., CA b. 14 Ja 1883, Whitten, IA d. 1951, NM. Studied: AIC, 1904–07; Rivera, Orozco, in Mexico; Chicago Acad. FA; William P. Henderson; John W. Norton. Member: San Fran. AA; Mural P.; Calif. S. Mural P. Exhibited: San Fran. AA, 1935 (prize). Work: Mus. N.Mex.; Mills Col.; Univ. Calif.; Calif. Sch. FA; Canon Kip Mem., Bohemian Cl., Coit Mem. Tower, all in San Fran.; USPO, Modesto, Calif; Dollar Steamship Co., Portland, Oreg.; Pal. Leg. Honor; de Young Mem. Mus., San Fran. Illustrator: "Ordeal by Hunger." Position: T, Univ. Calif., Berkeley [40]

BOZA, Daniel [P,Dec,C] Cleveland, OH b. 6 Ja 1911. Studied: Cleveland Sch. A.; Am. Acad, Rome. Exhibited: Cleveland M., 1937 (prize); WFNY, 1939. Award: Prix de Rome, 1933, 1935. Developer: porcelain enamel [40]

BOZA, Louis [P] NYC. Exhibited: GGE, 1939 [[40]

BOZA, Oliver [P] Cleveland, OH. Exhibited: 48 Sts. Comp. [40]

BRABAZON, Thomas [P,L,T] Hartford, CT. Member: Conn. Acad. FA; Hartford Municipal AS [21]

BRACKEN, Charles W. [Des,I,P,S] Chicago, IL b. 21 D 1909. Studied: Univ. Wash.; Chicago Acad. Member: Chicago Free Lance A. Gld. Exhibited: AIC, 1946; SAM, 1938; Univ. Wash., 1930, 1931, 1946. Position: A. Dir., Bracken-Tyler, Chicago, 1943–46 [47]

BRACKEN, Clio (Hinton Huneker) (Mrs. William Barrie) [S] NYC b. 25 Jy 1870, Rhinebeck, NY d. 12 F 1925. Studied: Saint Gaudens; MacMonnies; Rodin. Work: statue, Gen. Fremont, Calif. [17]

BRACKEN, Julia M. See Wendt.

BRACKENRIDGE, Cornelia. See Talbot, M.W., Mrs.

BRACKENRIDGE, Henry M. [P] Pittsburgh, PA. Member: Phila. AC [21]

BRACKENRIDGE, Marian [S] Santa Barbara, CA/South Pasadena, CA b. 16 Ap 1903, Buffalo, NY. Studied: Ettore Cadorin [24]

BRACKER, Charles E. [I,Des,Car] Harrison, NY b. 16 O 1895, Rochester, NY. Studied: Syracuse Univ. Exhibited: A. Dir. Show, Radio City, 1938. Creator: cat "Chessie." Positions: Illus., Texaco, Beechnut, Chesapeake & Ohio [40]

BRACKER, M. Leone [I] NYC b. 1885 d. 26 Ag 1937, Rye, NH (drowned). Best known for his World War I posters, especially "Keep 'Em Smiling."

BRACKETT, Arthur Loring [P] Brookline, MA. Member: Boston AC [13]

BRACKETT, Edward Augustus [S] Winchester, MA b. 1 O 1818, Vassalboro, ME. Studied: self-taught [09]

BRACKETT, Sidney Lawrence [P] Boston, MA. Studied: John B. Johnson; Frederic P. Vinton. Member: BAC [09]

BRACKETT, Walter M. [P] Boston, MA b. 14 Je 1823, Unity, ME d. 8 Mr 1919. Studied: self-taught. One of the founders, Boston AC. Exhibited: Universal Expo, Vienna (med); Centenn. Expo, Phila., 1876 (med). Work: Crystal Palace, Buckingham Palace, London; War Dept., Wash., D.C. Specialties: portraits, fish and game [17]

BRACKMAN, Robert [P] Noank, CT b. 25 S 1898, Odessa, Russia. Studied: Francisco Ferrer Sch., with Robert Henri, George Bellows; NAD. Member: NA; All. AA; Mystic SA; Conn. Acad. FA; Wilmington SA. Exhibited: Conn. Acad. FA, 1920 (prize), 1932 (prize), 1936 (prize); NAD, 1932 (prize), 1940 (prize); abroad. Work: R.I. Sch. Des.; Brooklyn Mus.; Beach Coll., Storrs, Conn.; New Haven PCC; Honolulu Acad. A.; MMA; Newark Mus.; High Mus., Atlanta; Addison Gal., Andover, Mass.; Brooklyn Acad. A.&Sc.; Minneapolis Inst. A.; Rockford AA; Norton A. Gal.; Houston Mus. FA; IBM; Encyclopaedia Britannica Coll.; Yale Univ.; Princeton Univ.; Pentagon; Brooks Mem. A. Gal. Position: ASL, 1934– [47]

BRACKMIER, Herbert W. [B,C] Indianapolis, IN b. 29 Je 1909, Indianapolis. Member: Hoosier Salon; Ind. AC [40]

BRACONY, Leopold [S] NYC b. Rome, Italy [13]

BRADBURY, Charles Earl [P,E,W,L] Champaign,IL b. North Bay, NY. Studied: Syracuse Univ.; Académie Julian, Paris; Hugh Breckenridge. Exhibited: Salon des Beaux-Artes, 1927; PAFA, 1925; Univ. Ill. Work: Univ. Ill.; Syracuse Univ.; Southern Ill. Normal Univ. Position: T., Univ. Ill., 1913– [47]

BRADBURY, Edith M. [Edu,P] Waterloo, IA b. 22 F 1910, Onawa, IA. Studied: State Univ. Iowa; AIC. Exhibited: Waterloo AA; Cedar Falls A. Gal.; State Univ. Iowa; Iowa WC Soc. Position: A. Supv., Pub Sch., 1937–

BRADBURY, Harriet J. (Mrs.) [Patron] Boston, MA d. 4 A 1930. Gave between four and six million dollars to BMFA.

BRADDOCK, Effie Francis [S] Warren, PA b. 13 My 1866, Phila. Member: AFA; F., PAFA; Plastic Cl. [33]

BRADDOCK, Katherine (Mrs. Frederick M.) [P,C,W,L] Stockton, CA b. 19 S 1870, Mt. Vernon, OH. Studied: Cincinnati A. Acad., with Frank Duveneck; J.H. Sharp; Thomas Noble. Member: San Fran. AA. Exhibited: San Fran. AA, 1932, 1935; Oakland A. Gal., 1932; Haggin Mem. Gal., Stockton, Calif., 1936 (one-man), 1946. Work: Mus. FA, Little Rock, Ark.; Haggin Mem. Gal. Contributor: Art magazines/directories [47]

BRADDON, Charles Edwin [P] Cleveland, OH b. 19 Ag 1906, Cleveland. Studied: PAFA. Exhibited: Cleveland MA, 1938, 1939, AIC, 1939. [40]

BRADFIELD, Edward [P,En] Vicksburg, MS b. 1 Je 1892, Vicksburg. Studied: Mary Clare Sherwood; SSAL; New Orleans AA; Miss. AA; Shreveport AC; New Orleans A. Lg.; AFA. Exhibited: Miss. AA, 1939 (prize), 1940-43, 1944 (prize), 1945; Shreveport AC, 1941, 1942; New Orleans A. Lg., 1942–44; SSAL, 1943, 1945 [47]

BRADFIELD, Elizabeth Palmer (Mrs.) [P] Pontiac, MI. Member: Detroit S. Women P. [24]

BRADFIELD, Margaret (Mrs. John) [P,I,L,W] Ann Arbor, WI b. 2 Je 1898, Danville, IL. Studied: Northwestern Univ.; Columbia Univ.; AIC; Detroit Soc. A.&Crafts, with John Carroll. Member: Detroit Soc. Women P.; NAWA. Exhibited: Detroit Soc. Women P. (prize); Ann Arbor A. Exh. (prize); Gov. Carville Comp. 1941, (prize); PAFA, 1943; Mus. City of N.Y., 1942; All.A.Am., 1942; Detroit Inst. A., 1925–45; Illustrator: "Mr. Plum and the Little Green Tree," 1946 [47]

BRADFORD, Francis Scott [Mur.P,P,T] Cornwall Bridge, CT b. 17 Ag 1898, Appleton, WI d. 1 O 1961. Studied: Univ. Wis.; NAD; Europe. Exhibited: NAD; PAFA; New Haven PCC. Member: ANA; NSMP; Century Assn. Work: Cranbrook Cathedral, Mich.; Milwaukee County Court House; Int. Tel. & Tel. Co., N.Y.; murals, Consumers Bldg. WFNY, 1939. Award: Prix de Rome, 1923. Positions: Instr., NAD, 1932–37, U.S. Army Chemical Warfare Bd., 1942–44 [47]

BRADFORD, Harry [P] Wash., D.C. [01]

BRADFORD, John N. [P] Columbus, OH. Member: Columbus PPC [24]

BRADFORD, Martha Jane [P,T] Guntersville, AL b. 30 N 1912, Guntersville. Studied: Frank W. Applebee; Roy H. Staples; Ala. Polytechnic Inst. Member: SSAL; Ala. AL; Miss. AA; NOAA; Am APL. Exhibited: watercolor, Mus. FA, Montgomery, 1935 (prize) [40]

BRADFORD, Myrtle Taylor [P,W,L,T] Miami, FL b. 22 Ag 1860 Indianapolis, IN. Studied: Harvard; Lena Hinman; Sig. Compania, Italy. Member: AAPL; Miami A. Lg.; SSAL; Blue Dome F. Exhibited: Miami

Women's Cl., (med). Contributor: Biographical Dictionary of American Poets [47]

BRADFORD, Stella [P,Li] Providence, RI b. 21 Ag 1920, Providence. Studied: RISD; Colo. Springs FA Center. Member: Providence AC; R.I. Contemp. A. Exhibited: RISD, 1941 (prize); NAD, 1942; LOC, 1942, 1946; R.I. AC, 1941, 1942, 1946; Contemporary A., 1941, 1946 [47]

BRADISH, Alvah [Por.P] b. 4 S 1806, Sherburne, NY d. 20 Ap 1901, Detroit. Spent the early part of his life in the western part of New York State, but later went to Chicago, St. Paul and Detroit.

BRADISK, Ethelwyn C. [P,T,W,L] NYC b. 3 Je 1882, Springfield, IL. Studied: T. Col., Columbia. Exhibited: AWCS, 1915, 1934; Phila. WC Cl., 1916; AFA Traveling Exh., 1916; Ogunquit AA, 1943, 1944. Lectures: Decorative Arts [47]

BRADLEY, Anne Cary [P] Fryeburg, ME b. 19 Ag 1884, Fryeburg. Studied: Sch. F.&App. A., Portland, Maine.; George Elmer Browne; Henry Poore; Michel Jacobs. Member: N.Y. Soc. Indp. A.; Salons of Am. Exhibited: Ogunquit A. Center, 1946; Portland SA, 1946; West Oxford County Fair, Fryeburg, 1939 (prize) [47]

BRADLEY, Carolyn G. [P,T] Columbus, OH b. Richmond, IN. Studied: Earlham Col.; Herron AI; Columbia; Mexico; William Forsythe; Victor Julius; W. Lester Stevens. Member: AWCS; Ind. AC; NAWA; Wash. WC Cl.; Ohio WC Cl.; Columbus A. Lg.; Providence WC Cl.; Springfield (Mass.) A. Lg.; Cincinnati Women's AC. Exhibited: Hoosier Salon, 1927, 1939, 1935 (prizes); Herron AI, 1928, 1930 (prizes); Richmond AA, 1928, 1930, 1935 (prizes); NAWA, 1928, 1934 (prizes); AWCS, 1934, 1937 (prizes); Cincinnati Womens' AC, 1938 (prize). Work: Richmond AA. Position: T., Ohio State Univ. 1937–46 [47]

BRADLEY, Charles B. [Edu,W,L,C,P] Boston, NY b. 11 F 1883, Binghamton, NY. Studied: PIASch.; Cornell; State T. Col., Buffalo. Member: Eastern AA; Am. Assn. Univ. Prof. Author/Illustrator: "Design in the Industrial Arts," 1946. Lectures: Art History and Appreciation. Position: Dir. & Prof. A. Edu., State T. Col., Buffalo, N.Y., 1918–46 [47]

BRADLEY, Edson [Patron] b. 1852 d. 20 Je 1935. A collector of rare Chinese porcelain, he owned a large number of superb specimens.

BRADLEY, Edward Eugene [P] b. 29 N 1857 d. 1938 Stonington, CT. Work: Mystic Seaport Mus. [*]

BRADLEY, Florence A. [P] Chicago, IL b. 1853, Mt. Morris, NY. Studied: Ingham Univ.; Silver Lake A. Sch.; Irving R. Wiles; Rhoda Holmes Nicholls [04]

BRADLEY, Geroge P. [P] Cleveland, OH. Member: Cleveland SA; SWA; Cleveland WCS

BRADLEY, Joseph Crane [P,T] Madison, WI b. 23 Jy 1919, Woods Hole, MA. Studied: Univ. Wis., with Oskar Hagen, James Watrous. Member: AFA. Exhibited: SFMA, 1946 (med); Pal. Leg. Honor, 1946; Wis. Salon, 1937–1943, 1944 (prize) 1945; Milwaukee AI, 1946; Miss. AA, 1946. Work: Wis. Union; Univ. Wis. [47]

BRADLEY, Mabel D. [P] New Haven, CT [19]

BRADLEY, Mary [P] Rockville, MD. Exhibited: Corcoran Bienn., 1939; Soc. Wash. A. Exh., 1939 [40]

BRADLEY, Susan H. [Ldscp.P] Boston, MA b. 15 My 1851, Boston d. 11 Je 1929. Studied: Thayer; Edward Bolt; Chase; BMFA Sch.; PAFA. Member: Phila. WCC; Boston WCC; NYWCC; S.Indp.A.; Boston GA; Boston SWCP. Work: Herron Art Inst., Indianapolis; Hillyer A. Gal., Northampton, Mass.; BMFA [27]

BRADLEY, W.B. [P] NYC b. 16 N 1890, Pittsburgh, PA. Studied: Edward Trumbull [21]

BRADLEY, Will(iam) H. [I,W] South Pasadena, CA b. 10 Jy 1868, Boston MA. Member: SI, 1910; Arch. Lg., 1914; Players, 1905. Author/Illustrator: "Toymaker to the King," "The Wonder Box." Positions: A. Dir., Collier's 1907–09, Good Housekeeping, 1911–13, Metropolitan, 1914–16, Century, 1914–16 [47]

BRADSHAW, Alexandra Christine [P,Li,L,T] South Laguna, CA b. Nova Scotia. Studied: Stanford; UCLA; Columbia; W.T. Hedges; Hans Hofmann; Rex Slinkard; André Lhote. Member: Pacific AA; NAWA; Fresno AA; Cal. WC Soc.; Laguna Beach AA. Exhibited: SFMA, 1943; Laguna Beach AA, 1941–43, (prizes), 1944; NAWA, 1940, 1941; Calif. WC Soc., 1942–44; Riverside Mus., 1944, 1946 ; San Fran. AA, 1943, 1944; Crocker A. Gal. (one-man); Pasadena AI (one-man). Work: Fresno State Col.; East Bakersfield H.S. Position: Prof./Hd. A. Dept., Fresno State Col. [47]

BRADSHAW, George A. [E,Ser,T] Trenton, NJ b. 15 O 1880, Trenton, NJ. Studied: John Ward Stimson; Trenton Sch. Indst. A. Member: SAE; Chicago SE; Southern Pr.M.; North Shore AA; CAFA; SC. Exhibited: Los A. Mus. A., 1926; NAC, 1924, 1926, 1927, 1929, 1930; MMA, 1942; SAE, 1923–46; Chicago SE, 1926–46; North Shore AA, 1926–46; Montclair A. Mus., 1932–34, 1935 (med) 1936 (prize), 1937–46; Mint Mus. A., 1943–46; CAFA, 1943–46; LOC 1943–45; NAD, 1942, 1943, 1946; Buffalo Pr. Cl., 1936–43; Audubon A., 1945; Southern Pr.M.; SC, 1944–46; Phila. SE, 1930, 1934, 1937 Work: NGA; NYPL; Vanderpoel Coll.; Montclair A. Mus.; Newark Mus.; Univ. Nebr. Illustrator: pictorial history books on N. J. Position: T., Sch. Indst. A., Trenton, N.J. [47]

BRADSTREET, Edward D. [P] Meriden, CT b. 11 N 1878, Meriden d. 14 Ja 1921. Member: CAFA; New Haven PCC; Meriden A.&Cr. Assoc. [19]

BRADT, Delphine [P] Chattanooga, TN/Phila., PA. Member: F., PAFA [24]

BRADT, Josephine [P] Phila., PA. Member: F., PAFA [17]

BRADWAY, Florence [P,T] Phila., PA b. 16 O 1897, Phila. Studied: Phila. Sch. Des.; Henry B. Snell; Leopold Seyffert. Exhibited: Moore Inst., 1934 (prize); NAD, 1931; CGA, 1931; PAFA, 1917–22, 1926, 1938, 1940; Woodmere A. Gal., 1944–46; Phila. Sketch Cl. Position: Instr., Moore Inst. Sch. Des., Phila., 1918– [47]

BRADWELL, George W. [I] Brooklyn, NY. Member: B. & W.C. [01]

BRADY, John [I] NYC [13]

BRADY, Katherine [P] Baltimore, MD [24]

BRADY, Mabel Claire [C,T,S] NYC b. 28 O 1887, Homer, NY. Studied: PIASch.; N.Y. Sch. F. & Appl.A.; Winold Reiss, Henry B. Snell, Maude Robinson. Member: PBC; Keramic Soc. & Des. Gld. Exhibited: Des. Gld., 1930 (prize); PBC, 1941 (one-man), 1942–45; Argent Gal., 1945; Lectures: Creative Expression Through Medium of Clay. Position: Instr., Ceramics, Haaren H.S., NYC, 1930–46 [47]

BRADY, Mary C. [P] San Fran., CA [13]

BRAENDLE, Fred Joseph b. 1845, Switzerland d. 18 Mr 1934, Wash. D.C. An art authority. Started in the art business in Florence, Italy. In 1873 was in charge of the Italian Government's exhibit at the Vienna Exposition. He came to the U.S. to serve in a like capacity at the Phila. Centennial.

BRAGA, Alfred Maynard [P,T,Des] Hudson, MA b. 3 My 1911, Hudson, MA. Studied: Vesper George Sch. A.; Harvard; WMA Sch.; Eliot O'Hara. Member: North Shore AA; Rockport AA; AAPL; F., Tiffany Fnd. Exhibited: NAD; PAFA, 1939. Position: A.T., Hudson Pub. Sch. [47]

BRAGDON, Claude Fayette [Des,Arch,T,C,W] Rochester, NY b. 1 Ag 1866, Oberlin, OH. Member: AIA; Rochester A.&C. Soc.; Arch. Lg., 1896. Exhibited: Arch. Lg. (golds,medals)[10]

BRAGDON, Mabel D. East Boston, MA [01]

BRAGDON, Melvin F. [P] Member: Columbus PPC [24]

BRAGHETTA, Lulu H. [S,T] b. 1 Ja 1901, Santa Ana, CA. Studied: ASL; Choinard AI, Los Angeles; Grand Central Sch., NYC; Met. Sch, NYC. Member: San Fran. A. Assn. Exhibited: Oakland A. Gal., 1936 (med), 1939, (gold), 1939 (one-man); A. Center, Reno, Nev. (one-man); Syracuse Mus., 1939; Golden Gate Exp., 1939; Argello Mem., Benicia, Calif., 1939. Position: T., Calif. Col. AC [40]

BRAGIN, Ernest [I] NYC. Member: SI [47]

BRAGUIN, Simeon [Des,P,Dr,I] Essex, CT (1985)b. Ja 1907, Kharkov, Russia. Studied: Boardman Robinson. Member: Am. A. Cong. Illustrator: Condé Nast Publications, McCall Co., Delineator, Harper's [40]

BRAHAM, Irma (Mrs. Herbert J.) [P] Brooklyn, NY. Member: Nat. Assn. Women PS. Exhibited: NYWCC Ann., 1936; Nat. Assn Women PS, 1936–38 [40]

BRAIN, Elizabeth [P] Springfield, OH [04]

BRAINARD, Elizabeth Homes (Mrs.) [Por.P] Boston, MA b. Middleboro d. 1905, Boston. Studied: Italy; Boston. Work: Boston Col.

BRAINE, B.G. [P] Montclair, NJ [21]

BRAITHWAITE, T. R. [P] Chicago, IL. Member: Chicago NJSA [24]

BRAKKEN, Andrew [P] Arlington, WA [24]

BRALEY, Clarence E. [P] New Bedford, MA [17]

BRALL, Ruth [S,T] NYC b. 3 D 1906, NYC. Studied: N.Y. Sch. Indst. A.; Columbia; Charles Harner; Joseph Nicolosi; Oronzio Maldarelli. Member:

All.A.Am.; Lg. Present-Day A. Exhibited: All.A.Am., 1938–45; Swope Gal. A., 1942; Audubon A., 1945; NAD, 1941–45; Am-British A. Ctr.; MMA; Vendôme Gal.; Mattatuck A. Mus. [47]

BRAMMAR, Joseph Roxbury, MA. Member: BAC [01]

BRAMNICK, David [P] Phila., PA b. 17 My 1894, Kishineff, Russia. Studied: PAFA. Work: Graphic Sketch Club [24]

BRANCH, Grove R. [P,C,T] Worcester, MA. Member: Boston A.&Crafts Soc. Positions: Instr. Jewelry, Worcester Mus., Manual Arts, Worcester Acad., Lin-e-kin Bay Camp [21]

BRANCH, Veronese Beatty [P] Alexandria, VA. Exhibited: AIC, 1936, 1939; Soc. Wash. Ar., 1940 [40]

BRANCHARD, Emile Pierre [P] NYC b. 4 D 1881, NYC d. 13 F 1938. Member: Salons of Am. Work: Columbus Gal. FA; Newark Mus.; AGAA; MOMA; Art Gal. Toronto [38]

BRAND, Ethel Brand Wise [S] Wash., D.C. [15]

BRAND, Gustave A. [Mur.P] Chicago, IL b. 1863, Parchim, Germany d. 27 My 1944, Chicago. Studied: Germany. Sent to the Columbia Exposition of 1893. Work: murals, theatres and other public bldgs. Chairman: Chicago A. Comm., 1934

BRAND, Virginia (Liebowitz) [C,Dr,S] NYC b. 21 O 1892, NYC. Studied: Frank V. DuMond; James Earl Fraser; Aimee Le P. Voorhees; Victor Raffo; Douglas Hill, Berlin. Member: NYSC; N.Y. Soc. Cer. A. [40]

BRANDEGEE, Robert B. [P,I,C,T] Farmington, CT b. Berlin, CT d. 5 Mr 1922. Studied: Jacqueson de la Chevreuse, in Paris. Member: ANA, 1908; CAFA; Eclectics. Exhibited: Pan-Am. Expo, Buffalo, 1901 (med); Expo Universelle, Paris (med). Work: Hillyer Gal., Smith Col. [21]

BRANDNER, Karl C. [P,E] Riverside, IL b. 17 Ja 1898, Oak Park, IL. Studied: AIC; Chicago Acad. FA; Detroit Sch. A. Member: AFA; Palette and Chisel Cl.; Hoosier Salon; Austin, Oak Park and River Forest AL; Chicago Gal. A.; Soc. Medalists; Chicago APS; Chicago SE. Work: State Mus. FA, Springfield, Ill.; Plymouth H.S., Ill.; Pallette and Chisel Cl., Chicago; State Lib., Springfield [40]

BRANDON, John A. [Li,Des] Sacramento, CA b. 25 N 1870, Franklin, TN. Lithographic designer and sketch artist. [40]

BRANDRETH, Virginia G. Sing Sing, NY [01]

BRANDRIFF, George Kennedy [P] Beverly Hills, CA b. 13 F 1890, Millville, NJ d. 14 Ag 1936. Studied: Borg; J. Wilkinson Smith; Hills. Member: Painters of the West; Laguna Beach AA; Calif. AC; AAPL. Work: murals, Polytechnic H.S., Venice, Calif.; Mt. Vernon Jr. H. S., Los Angeles; UCLA; Los Angeles Mus.; Municipal Coll., Phoenix, Ariz. [33]

BRANDT, Carl L. [P,Mus.Dir] Savannah, GA b. 1831, Holstein, Germany (came to U.S. in 1852) d. 20 Ja 1905, Savannah, GA. Studied: Copenhagen; Hamburg. Exhibited: PAFA; Nat. Acad. Des., 1855. Member: Nat. Acad. Des., 1872. Most of his paintings and art effects were bequeathed to Telfair Acad., Savannah. Position: Dir., Telfair Acad. 1883–1905 [04]

BRANDT, H. George [P] NYC/Sparkhill, NY. Member: GFLA [25]

BRANDT, Henry [P,E] Chicago, IL b. 7 Ap 1862, Germany. Studied: Dorsch, in Dresden; Ufer; Germany. Member: All-Ill. SFA; Hoosier Salon; Ill. Acad. FA; Palette & Chisel Cl. [33]

BRANDT, Rexford [P,T,Des] Corona del Mar, CA b. 12 S 1914, San Diego, CA. Studied: Ray Boynton; Eugen Neuhaus; Perham Nahl; Univ. Calif.; Stanford Univ.; Univ. of Redlands. Member: San Fran. AA; Calif. AC; Laguna Beach AA; Fnd. Western A.; AWCS; Phila. WC Cl.; San Diego FA Gld.; Calif. WC Soc. Exhibited: CGA, 1943; AIC; WFNY, 1939; GGE, 1939; Texas Cent.; San Diego FA Gal., 1939 (prize). Work: Los Angeles Mus. A.; Crocker Gal.; San Diego FA Soc.; murals, San Bernardino & Chemawa H.S; Calif. Community Playhouse, Riverside, Calif. Illustrator: Fortune, Life. Positions: Dir., A. Ctr., Riverside, Calif. (1937–42); Rex Brandt Assoc., Indst. Des. (1946–)[47]

BRANDT, Ruth [P] Newport, RI [19]

BRANN, Esther (E.B. Schorr) [I,W] NYC/Kent Cliffs, NJ b. NYC. Studied: ASL; Cooper Union Women's A.Sch.; NAD; Fontainebleau Sch. FA. Author/Illustrator: "Quebec Sketch Book," "Nannette of the Wooden Shoes," "Lupe Goes to School," "Nicolina," "Yann and His Islan,;" "Bobbie and Donnie were Twins," "Round the World with Esther Braun," "Another Year with Bobbie and Donnie." Illustrator: "Little Pilgrim to Penn's Woods," by Edna Albert; "Shawl with Silver Bells," by Helen Coale Crew; "Children of the Covered Wagon," by Mary Jane Carr [40]

BRANN, Louise [P] Mt. Vernon, NY b. 18 Ag 1906, Mt. Vernon. Studied: A.P. Cole, CUASch; George Bridgman, ASL; St. Hubert, Fountainebleau, France. Member: Westchester A. Gld.; Yonkers AA. Work: Am. & Belgian Fnd., France; Church of the Sacred Heart, Montereau, France; murals, H.S. & Pub. Lib., Mt. Vernon [47]

BRANNAN, Sophie Marston [P,S] San Fransisco, CA b. Mountain View, CA. Studied: Mark Hopkins Inst. A.; Paris. Member: AWCS; Conn. Acad. FA; SPNY; AFA; N.Y. Soc. P. Exhibited: AWCS; Syracuse Mus. FA; AIC; Nebr. AA; PAFA; CGA; Macbeth Gal.; BM; Toronto Mus. FA; NAWA, 1919 (prize); Conn. Acad. FA (prize). Work: NAD; CGA; AIC; Syracuse Mus. FA; PAFA; Mus. FA, Toronto; Nebr. AA; Kansas AA; BM; Vanderpoel Coll.; AWCS; Union Lg. [47]

BRANNER, M. [Car] NYC. Creator: comic strip, "Winnie Winkle" [40]

BRANNIGAN, Gladys Ames [P] Portsmouth, NH b. 1883, Hingham, MA d. 24 A 1944, NYC. Studied: Corcoran A. Sch.; ASL; NAD; H.B. Snell. Member: Allied AA; NYWCC; NYSP; Wash. WCC; North Shore AA. Exhibited: Ariz. Art Exh., 1925 (prize); New Haven PCC, 1928; Greenwich SA; A. Ctr., Ogunquit, Maine. Work: murals, Portsmouth PL, Jr. H.S.; George Washington Univ; LOC; Women's Univ. Cl., NYC; Wesleyan Col., Macon, Ga.; reredos, St. John's Church, Massena, N.Y.; murals, Parker Hall, Keene, N.H.; Municipal Bldg., Dover, N.H.; Univ. Durham, N.H. [40]

BRANSBY, Eric James [P,E] Colorado Springs, CO b. 25 O 1916, Auburn, NY. Studied: Thomas Hart Benton, Fletcher Martin, Kansas City AI; Boardman Robinson, Colorado Springs FA Center. Exhibited: LOC, 1944; Assoc. Am. A., Kansas City AI, 1940; Joslyn Mem., 1940; Oakland A. Gal., 1940; Okla. A. Center, 1945 (one-man.) Work: Nelson Gal., Kansas City, Mo.; Princeton Univ.; Okla. A. Center; murals, schools/theatres, Kansas City, Mo., Colorado Springs, Colo. [47]

BRANSGROVE, Stephen Alfred [P] NYC/Sydney, Australia b. F 1900, Hobart, Tasmania. Studied: George Lambert. Member: ANA; Royal Art Soc., Australia. Exhibited: NAD, 1933 (prize). Work: NGA; Hobart A. Gal., Tasmania [33]

BRANSOME, Edith [P] NYC Member: S.Indp.A. [25]

BRANSON, John Paul [P,I,E] NYC (1976) b. 26 Jy 1885, Wash., D.C. Member: AWCS; SI; SC; NYWCC; Soc. Am. Sporting A. Illustrator: animal magazines; more than 40 books, including "Call of the Wild," "Over Indian and Animal Trails." Position: T., Jackson Hole, Wyo. [47]

BRANSON, Isabel Parke [P] Phila., PA/Coatesville, PA b. 4 S 1886, Coatesville. Studied: Phila. Sch. Des. for Women [15]

BRANSON, Kuhne Beveridge (Mrs. William B.) [S] London, England b. 31 O 1877, Springfield, IL. Studied: William R. O'Donovan; Rodin, in Paris. Exhibited: Paris Expo, 1900 [13]

BRANSON, Lloyd [P] Knoxville, TN d. 12 Je 1925. Studied: NAD. Exhibited: Atlanta Expo, 1885 (med); Appalachian Expo, Knoxville, 1910, (gold). His best-know painting, which took fifteen years to complete, was of the gathering of pioneers at Sycamore Shoals, on the Watauga River, for the march to King's Mountain. [13]

BRANTINGHAM, Grace J. [P] Rockford, IL b. Rockford. Studied: AIC. Position: T., Rockford H.S. [05]

BRANTLY, Benjamin D. [P,T] Little Rock, AR b. Little Rock. Studied: Maryland Inst.; St. Louis Sch. FA. Member: St. Louis AL; NOAA; SSAL; Five AC of Ark. Exhibited: Ark. State Fair, 1923–25 (prizes). Work: ldscp., Little Rock, Scottish Rite Consistory; mural, Baptist Church; portraits, Ark. Supreme Court, Pulaski County Courthouse, Mus. FA [40]

BRASHER, Rex [P] Phoenix, AZ b. 1869 d. 1960. Exhibited: Baltimore, Md., 1933; Kent A. Assn. Ann., 1934; Nat. Geographic Soc. Wash., 1938. Author/Illustrator: "Birds and Trees of North America" [40]

BRASTOFF, Sascha [S,D,I] NYC b. 23 O 1918, Cleveland, OH. Studied: Cleveland Sch. A. Member: Clay Cl., N.Y. Exhibited: Syracuse Mus., 1939; Clay Cl. Gal. Work: Syracuse Mus. [40]

BRASZ, Arnold Franz [P,S,I,E] Oshkosh, WI b. 19 Jy 1888, Polk County, WI. Studied: Minneapolis Sch. FA; Henri. Member: Wis. PS [25]

BRAUGHT, Ross Eugene [P,Li] Woodstock, NY b. 6 Ag 1898, Carlisle, PA. Studied: PAFA; Joseph T. Pearson, Jr. Exhibited: Kansas City AI, 1934, (prize); Midwestern A., 1935, 1936, (prize). Work: PAFA; Beach Mem. Coll., Storrs, Conn.; mural, Music Hall, Kansas City, Mo.; lithographs, Ferargil Gal. Position: T., Cornell Univ. Summer Sch. [40]

BRAUN, Cora Fischer (Mrs.) [P,C,W,L,T] Knoxville, TN b. 27 My 1885, Jordan, MN. Studied: Garber; Hale; Joseph Pearson; Breckenridge; Chase;

Blashfield; Beaux; PAFA. Positions: T., Univ. Nebr., 1918–19, Ohio State Univ., 1919–20, Univ. Tenn. [25]

BRAUN, Hazel Boyer (Mrs. Maurice) [Cr] San Diego, CA b. 1888 d. 22 Mr 1946. Position: art critic, San Diego Tribune

BRAUN, Maurice [P,L,T] Point Loma, CA b. 1 O 1877, Nagy Bittse, Hungary d. 7 N 1941. Studied: E.M. Ward; Maynard, Francis C. Jones: NAD; William M. Chase. Member: SC; Calif. AC; San Diego FAA; Acad. Western P. Exhibited: NAD, 1900 (prize); Panama-Calif. Intl. Expo, San Diego, 1916, (gold); Calif. Ann., San Diego, 1934. Work: Municipal Coll., Phoenix; San Diego FA Gal.; AA, Wichita, Kans.; AA, Bloomington, Ill.; Los Angeles Women's Athletic Club, etc. Position: T., H.S. Adult Education, San Diego [40]

BRAUN, Paul G. [P] Baltimore MD [25]

BRAUNER, Erling B. [P,Edu] East Lansing, MI b. 16 Ap 1906, Ithaca, NY. Studied: Cornell. Position: T., Mich. State Col., East Lansing (1935–) [47]

BRAUNER, Olaf Martinus [P,S,T] Ithaca, NY b. 9 F 1869, Christiana, Norway d. 3 Jy 1947. Studied: Mass. Normal A. Sch.; BMFA Sch.; Benson; Tarbell. Member: Gargoyle Soc.; Central N.Y. AIA; Scandinavian-Am. Artists. Work: altar piece, Church of Our Savior, Chicago; portraits, Kimball Lib., Randolph, Vt.; Cornell Univ. Lib., Col. Mech. Eng., Ithaca; Amherst Col., Amherst, Mass.; sculpture, Walnut Hill Cemetery, Brookline, Mass.; fountain, Seal Harbor, Maine; portraits, Fuirendal, Denmark; Vanderpoel Mem. Gal., Chicago. Position: Prof. FA, Cornell Univ. [40]

BRAUNHOLD, Louis [E] Chicago, IL. Member: Chicago SE [25]

BRAUNSTEIN, Henry [P] Wilmington, DE b. 1838 (came to U.S. from Bavaria in 1846) d. 28 D 1930. He learned the trade of coach painter and later became a landscape painter.

BRAU-ZUZUARREGUI, Mario [E,Car] San Juan, Puerto Rico b. 1871 d. 24 Ag 1941. Position: Dir., Insular Government Mus., San Juan

BRAXTON, William Ernest [P] Brooklyn, NY b. 10 D 1878, Wash., D.C. Studied: John Barnard Whittaker. Member: S.Indp.A.; Salons of Am. [33]

BRAYMER, L.E. [I] Phila., PA b. 2 Je 1901, Chicago, IL. Member: Palette and Chisel Cl.; Phila. AC [33]

BRAZEAU, Wendell Phillips [P,Gr,T] Seattle, WA b. 19 My 1910, Spokane, WA d. 1974. Studied: Univ. Wash. Exhibited: SAM, annually; Northwest Pr.M. Positions: Illus., Boeing Aircraft, 1943–45; Assoc. in A., Univ. Wash., Seattle, Wash., 1945– [47]

BRAZEE, Marion Louise (Mrs. Donald A.) [P] South Acton, MA b. 6 Ap 1914, Barre, VT. Studied: Harriet Lumis. Member: North Shore AA; Copley Soc. Exhibited: Portland SA, 1943, 1944; North Shore AA, 1943, 1944, 1946; Conn. Acad. FA, 1944; Jordan Marsh, 1944; Irvington Pub. Lib., 1943, 1946 [47]

BRAZELTON, William Calvin [I] Evansville, IL b. 10 Je 1909, Quincy, IL. Studied: AIC; Boris Anisfeld; Joseph Binder. Illustrator: "Singing Rails," "Callisto," "Lucretius," pub. Black Cat Press [40]

BRAZINGTON, William Cary [P,I] Bronx, NY b. 9 N 1865, Westfield, IN d. 12 Jy 1914, Indianapolis. Studied: Paris; Simon; Cottet; Bouguereau; Ferrier. Specialty: sanguine portraits. Lived in Ariz., 1912–14. [13]

BRCIN, John David [S,T] Chicago, IL b. 15 Ag 1899, Yugoslavia. Studied: AIC, Albin Polasek; Univ. Chicago; Chicago Acad. FA. Member: NSS; Exhibited: AIC, 1920, 1923, (prize) 1926 (prize); Hoosier Salon, 1929, 1936; Municipal A. Lg., AIC, 1945. Work: bust, Commercial Cl., Gary, Ind.; First Unitarian Church, Omaha, Neb.; sculpture, Joslyn Mem. Bldg., Omaha; mon., Cyrus Hall McCormick, Wash. and Lee Univ.; Witte Mem. Mus., San Antonio, Tex.; Municipal Coll., Chicago [47]

BREARLEY, Harry Chase [I] NYC [13]

BREASTED, James Henry, Jr. [Mus.Dir,T,L] Los Angeles, CA b. 29 S 1908, Chicago, IL. Studied: Princeton Univ.; Heidelberg Univ.; Oxford Univ.; Univ. Chicago; Inst. Advanced Study, Princeton; C.R. Morey; K. Sandford. Member: Archaeological Inst. Am.; CAA. Award: Carnegie Grant, 1939–41. Contributor: College Art Journal. Lectures: Egypt, Greece, Near East. Positions: Asst. Prof., UCLA, 1941–46; Dir., Los Angeles Mus. A., 1946– [47]

BRECHER, Samuel [P,T] NYC b. 4 Jy 1897, Austria. Studied: CUASch; NAD; Charles Hawthorne. Exhibited: WFNY, 1939; GGE, 1939; PAFA, 1936, 1943; NAD, 1924, 1927, 1931, 1936, 1937, 1945, 1946; Carnegie Inst., 1941, 1944; AIC, 1936, 1938; AFA Traveling Exh., 1931, 1944; Walker A. Center, 1943; Dayton AI, 1936; VFMA, 1944; BM, 1944; CM, 1939; SFMA, 1942; ACA Gal., 1935 (one-man); Hudson Walker Gal., 1938, 1940 (one-man); Kraushaar Gal., 1942, 1944 (one-man). Work: MMA; Walker A. Center [47]

BRECK, Bernice [P] Portland, ME b. Portland. Studied: Portland Sch. FA. Member: Portland SA. Position: Registrar, Sch. F.&App. A., Portland [40]

BRECK, G. William [I] b. 1883 d. 15 N 1936, NYC. Studied: Robert Henri. Work: murals, Colgate Univ. Illustrator: "Dere Mable." He worked as an illustrator on the old New York Press. Later he was short-story editor for Brandt and Brandt, New York literary agents.

BRECK, George W. [Mur.P] Flushing, NY b. 1 S 1863, Wash., D.C. d. 22 N 1920. Studied: ASL; Am. Acad., Rome. Member: ASL; Arch. Lg., 1902; N.Y. Municipal AS; Mural P.; Century Assoc.; New York City Art Commission. Exhibited: St. Louis Expo, 1904 (med). Award: Lazarus Scholarship for Mural Painting (Rome, 1896–99). Position: Dir., Am. Acad., Rome, 1904–09. Work: Pub. Lib., Watertown, N.Y.; Univ. Va.; American Church, Rome [19]

BRECK, John Leslie [P] d. 8 M 1898. Member: St. Botolph Cl., Boston [98]

BRECK, Joseph [P,I,Mus.Dir] NYC b. 3 F 1885, Allston, MA d. 3 Ag 1933, Villars sur Ollon, Switzerland. Studied: Harvard; abroad. Member: Assoc. A. Mus. Dir. Exhibited: Minn. State Art Soc., 1916 (gold). He joined the Metropolitan Museum of Art staff in 1909, but between 1914 and 1917 served as director of the Minneapolis Society of Fine Arts. In 1917 he was recalled by the Metropolitan Museum to become curator of the department of decorative arts, and, in January 1932, was made director of "The Cloisters." At the time of his death, he was Assistant Director of the Metropolitan Museum. He had received the award of the Legion of Honor, and was an office of the Swedish Royal Order of the North Star. [21]

BRECK, Robert E(vans) [Por.P] Dolgeville, NY b. 22 N 1907, White Plains, NY. Studied: Harvard Univ.; Yale Sch. FA; ASL; Grand Central A. Sch.; Dean Cornwell. Member: Boston AC; Gloucester SA. Work: Boston A. Cl.; Boston Univ.; Princeton Prep. Sch. [40]

BRECKENRIDGE, Dorothy [Por.P] Houston, TX/Gloucester, MA b. Tampa, Fla. Studied: PAFA; N.Y. Sch. F.&Appl. A.; Hugh H. Breckenridge [40]

BRECKENRIDGE, Hugh H(enry) [P,T] Fort Washington, PA b. 6 O 1870, Leesburg, VA d. 4 N 1937. Studied: PAFA; Bourguereau; Ferrier, Doucet, in Paris. Member: ANA, 1913; NYWCC; Phila. WCC; Conn. Acad. FA; Wash. SA; SSAL; North Shore AA; AFA; Municipal Art Jury of Phila. Exhibited: Atlanta Expo, 1895 (med); Paris Expo, 1900 (prize); Pan-Am. Expo, Buffalo, 1901 (med); S. Wash. A., 1903 (prize), 1927 (med); Phila. AC, 1907 (gold); Wash. WCC, 1908 (prize); Buenos Aires Expo, 1910 (med); P.-P. Expo, San Fran., 1915 (gold); Wash., 1916 (med, prize); PAFA, 1917 (prize), 1919 (gold), 1920 (gold); Locust Cl., 1926 (gold, prize). Work: Jefferson Medical Col., Col. Pharmacy, Col. Physicians, Univ. Pa.; Hist. Soc., Pa. Hospital, Philosophical Soc., City Hall, all in Phila.; Univ. Va.; State House, Hartford; capitol, Harrisburg, Pa; St. Louis Cl.; Phila. AC; University Cl., Indianapolis; SFMA; Los Angeles Mus. A.; Court House, Reading, Pa.; Delgado Mus. A., New Orleans; PAFA. Positions: Instr., PAFA, 1894– ; Dir., Breckenridge Summer Sch. A., Gloucester, Mass. [37]

BRECKONS, St. Clair [P] NYC [15]

BREDEMEIER, Carl [P,C] Buffalo, NY/Holland, NY b. 26 J 1892, Chicago, IL. Studied: Homer Boss; Henry Rankin Poore; Carl Peters. Member: Buffalo SA; The Patteran [33]

BREDIN, C(hristine) S. [P,I] Phila., PA b. Butler, PA. Studied: Cincinnati A. Acad.; Acad. Colarossi, Paris. Member: AI Graphic Arts; Plastic Cl. Exhibited: Atlanta Expo, 1885 (med) [33]

BREDIN, R. Sloan [Por.P,Ldscp.P,T] New Hope, PA b. 9 S 1881, Butler, PA d. 16 Jy 1933, Phila. Studied: Pratt Inst., 1899; PAFA; Eakins, DuMond; Chase; Beckwith. Member: ANA, 1921; All. AA; SC; Intl. Soc. A.&L.; NAC; Rochester AC; Phila. Sketch Cl.; Port. P.; Phila. All.; Phila. AC. Exhibited: NAD, 1914 (prize), 1921 (prize); SC, 1921 (prize), 1923 (prize); Phila. AC, 1922 (prize); AIC, 1922 (prize); P.-P. Expo, San Fran., 1915 (med); Sesqui-Centenn. Expo., Phila., 1926 (med); NAC, 1928 (prize). Work: Minneapolis A. Soc.; SC; Democratic Cl., New York; Phila. AC; N.J. State Mus. [33]

BREEN, Dorothy [Lib] St. Louis, MO b. 9 Jy 1895, Springfield, MO. Studied: Washington Univ., St. Louis; St. Louis Univ.; St Louis Lib. Sch. Member: Am. Lib. Assn.; Mo. Lib. Assn. Position: Chief, A. Dept., St. Louis Pub. Lib., 1929– [47]

BREEN, James T. [P] Boston, MA [01]

BREEN, Katherine [P] NYC. Member: AWCS; NYWCC [25]

BREEN, Marguerite [P] St. Louis, MO. Member: St. Louis AG [25]

BREESE, Eloise Lawrence. See Eresby.

BREEZE, Louisa [P] San Fran., CA [13]

BREGLER, Charles [P,W,S] Phila., PA b. Phila. Studied: PAFA; Thomas Eakins. Contributor: Arts Magazine, 1931 [47]

BREGY, Edith Maurice [P,T] Phila., PA b. Phila. Studied: Phila. Sch. Des. for Women; PAFA; PMSchIA; Moore Inst.; Snell; Beaux; Carlson; Charles Woodbury; Earl Horter; Henry McCarter. Member: F., PAFA. Exhibited: Phila. WC Cl., PAFA; CGA; Woodmere A. Gal. Work: Col. William & Mary; Moore Inst.; John Herron AI, Indianapolis. Positions: Instr., A., Girard Col., Moore Inst. [47]

BREHM, Adam [S] Kansas City, MO b. 15 N 1901, Germany. Studied: Kansas City AI. Member: Kansas City SA [33]

BREHM, George [I,P] NYC b. 30 S 1878, Anderson, IN. Studied: ASL, with Twachtman, DuMond, Bridgman; Ind. Univ. Member: SI; A. Gld.; A.&W. Soc. Illustrator: magazines and advertising [47]

BREHM, Worth [I] New Rochelle, NY/Norwalk, CT b. 8 Ag 1883, Anderson, IN d. N 1928. Studied: John Herron Inst.; AIC; ASL. Member: SI, 1910; SC; GFLA [24]

BREHME, Claire Eichbaum [P,I,L,T,W] Glenside, PA b. 16 My 1886, Berlin, Germany. Studied: Franz von Skarbina; France; Spain. Member: AAPL. Author: "Woman of Two Countries," pub. Gutenberg Publishing Co., 1936. Lectures: Art [47]

BREIDVIK, Mons [E,B,Li,P] NYC b. 15 Ja 1881, Sogn, Norway. Studied: Erik Werenskiold; Hariet Backer. Member: S.Indp.A.; Scandinavian Amer. A. Exhibited: Chicago, 1926 (prize); Phila. Pr. Cl., 1934 (prize). Work: BM; Pub. Lib., Newark, N.J.; NYPL; MMA; BMFA; Royal Palace, National Galleriet, Universitets, all in Oslo; Billedgalleriet, Bergen [40]

BREIMHURST, Dorothy [P] St. Paul, MN. Exhibited: Conn. Acad. FA, 1938; WC Cl., Wash., 1938; Midwestern Ar. Exh., 1938 [40]

BREININ, Raymond [P,T] Chicago, IL b. 30 N 1910, Vitebsk, Russia. Studied: Chicago Acad. FA; Uri Penn; Acad. A., Vitebsk. Exhibited: AIC, 1940 (prize); AV (prize). Work: MMA, MOMA; PMG; AIC; SFMA; Zanesville (Ohio) AI; USPO, Wilmette, Ill., Sect. FA, Fed. Works Agency. Position: A. in residence, Southern Ill. Normal Univ., Carbondale, 1943-46 [47]

BREITMAYER, M.V. [E,P,T] Jackson, MI b. 24 Ap 1889, Jackson Co., MI. Studied: John Wicker; William Chase; Charles Grafly; Hugh Brekenridge; P. Tudor Hart. Member: F., PAFA; AAPL [33]

BREMER, Anne [P] b. San Fran. d. N 1923, San Fran. Studied: Mark Hopkins Inst. A., San Fran.; ASL; La Palette, Académie Moderne, both in Paris. Member: San Fran. AA; Calif. AC. Exhibited: P.-P. Expo, San Fran., 1915 (med); San Fran. AA, 1918 (med), 1922 (prize). Work: YWCA, San Jose; Del Monte A. Gal., Monterey; Bethany Col.; Emmanuel Sisterhood, Pal. FA, both in San Fran.; Mills Col; Oakland A. Gal. [21]

BREMER, Hester [S] Chicago, IL b. 8 Jy 1887, Alsace. Studied: Hudier; Murdach; AIC. Member: Chicago SA. Exhibited: AIC, 1922 (prize) [25]

BREMOND, Jean Louis [E] Paris. Member: Chicago SE [25]

BRENEISER, Babs (Mrs. Elizabeth D[ay]) [C,P,Gr,T] Santa Fe, NM b. 20 Ap 1890, Wash., D.C. Studied: N.Y. Sch. F.&App. A.; Europe; Thatcher; Clark; Ellis. Member: Pac. AA. Exhibited: Mus. N.Mex., Santa Fe. Work: Col. A. Cl. Coll., Santa Maria, Calif. Contributor: Christian Science Monitor. Position: Crafts Dir., Hill & Canyon Sch. A., Santa Fe [47]

BRENEISER, John Day [B,C,I,Li,P] Santa Maria, Calif./Eidolon, NM b. 2 My 1905, Youngstown, OH. Studied: Univ. Oreg. Member: Santa Barbara Assn. Contributor: Christian Science Monitor, Calif. Arts and Architecture. Positions: T., Santa Maria H.S. and Jr. College [40]

BRENEISER, Stanley Grotevent [P,L,W,E,] Santa Fe, NM (1953) b. 10 Ja 1890, Reading, PA. Studied: PMSchIA; PAFA; ASL; N.Y. Sch. F.&Appl. A.; Europe. Exhibited: Col. AC, Santa Maria, Calif.; Faulkner Mem. A. Gal., Santa Barbara, Calif.; Mus. N.Méx., Santa Fe. Work: Col. AC Coll., Blue Mask Cl., both in Santa Maria. Contributor: Christian Science Monitor, state art magazines. Delegate: 6th Intl. Cong. Art, Prague, 1928. Position: Dir., Hill & Canyon Sch. A., Santa Fe [47]

BRENNAN, Alexander Joseph [P] NYC b. 18 My 1881, NYC. Member: S. Indp. A.; Lg. AA [25]

BRENNAN, Alfred Laurens [P,I,W] b. 1853. d. 14 Je 1921, Brooklyn, NY. He made more than 10,000 pen-and-ink drawings which appeared in various publications. He was also a poet and writer of art and literary reviews. [05]

BRENNAN, A.L., Mrs. See Gaul.

BRENNAN, John J. [Metal work,En] Royal Oak, MI b. 6 Ag 1871, Seneca Falls, NY. Member: Phila. SAC. Specialty: copper. Position: Metal patternmaker, Burroughs Adding Machine Co., Detroit [40]

BRENNAN, William A. [P] Chicago, IL. Member: Chicago NJSA [25]

BRENNAN, W. Irvin [B,W,En,S] Pasadena, CA b. 3 S 1891, Lynn, MA. Studied: Henry McCarter; Vesper L. George; Douglas Connah; Howard Smith. Member: Phila. Sketch Cl.; AI Graphic A. [33]

BRENNEMAN, George W. [P,I] NYC/Central Valley, NY b. 1856, New York d. 4 F 1906. Studied: Diez, in Munich. He shared a studio in Munich with Dielman, Chase, Shirlaw, and Duveneck. One of the founders of the Salmagundi Club, he was also a member of the American Watercolor Society of New York. Illustrator: "The First Violin." Specialties: horses in action, animals, landscapes [05]

BRENNEN, Charles [I] Westfield, NJ. Member: SI [33]

BRENNER, Henri [S] NYC. Work: USPO, Aberdeen, Md. WPA artist. [40]

BRENNER, Proctor Knott [P] Louisville, KY, Member: Louisville AL [01]

BRENNER, Sylvia Miriam (Mrs. S.B. Devine) [Por.P] Phila., PA b. 5 Ap 1913, Phila. Studied: PAFA; Univ. Pa. Member: F., PAFA; Phila. Ar. Un. Exhibited: PAFA, 1935; Wanamaker, 1936 [47]

BRENNER, Victor D(avid) [S] b. 12 Je 1871, Shavely, Russia (came to U.S. in 1890) d. 5 Ap 1924. Studied: Louis Oscar Roty. Member: NSS, 1902; Arch. Lg., 1902; NAC. Exhibited: Paris Expo, 1900 (med); Paris Salon, 1900 (prize); Pan-Am. Expo, Buffalo, 1901 (med); St. Louis Expo, 1904 (med); Brussels Expo, 1910 (gold); P.-P. Expo, San Fran., 1915. Work: medals, Sch. A. Lg. New York, 1911; MMA; mem. fountain, Pittsburgh, 1917; Paris Mint; Luxembourg, Paris; Munich Glyptothek; Vienna Numismatic Soc.; Am. Numismatic Soc., New York; BMFA; Phila. Mint; AIC; Minneapolis Inst. Specialty: medals [23]

BRENSON, Theodore [Et,T,L,W,I,P] NYC b. 27 N 1892, Riga, Latvia d. S 1959. Studied: Beaux-Arts, Leningrad; Univ. Moscow; Univ. Riga. Member: SAE; CAA; AFA. Exhibited: SAE; NAD; LOC; AIC; PAFA; MMA; WMAA; Phila. Pr. Cl.; Salon d'Automne; Salon des Indp. Petit Palais; Bibliothèque Nationale; Tate Gal., London; FMA (one-man); Harvard Univ.; Roullier Gal., Chicago; NYPL; Lyman Allyn Mus.; Currier Gal.; Munson-Williams-Proctor Inst. Work: Nat. Mus., Stockholm; Univ. Col., England; LOC; Dumbarton Oaks Fnd.; NYPL; MMA; French Inst. in the U.S.; Carnegie Inst.; Bibliothèque Nationale; mus., Rome, Milan, Florence, Riga. Award: "Officier d'Académie," by the French State. Author/Illustrator: books on European travel, art, education, 1929-34. Contributor: national magazines, U.S. and abroad. Position: Prof. A., College of Wooster, Ohio [47]

BRENT, Adalié Margules [P,T] Baton Rouge, LA b. 27 N 1920, Dallas, TX. Studied: Univ. Tex.; UCLA; Alexander Hogue. Exhibited: Dallas Mus. FA, 1943 (prize); Tex. General Exh., 1942, 1945; Okla. General, 1944; Houston All., 1944; Ney Mus. A., 1941, 1944; UCLA, 1945; Witte Mem. Mus., 1941, 1943, 1945 [47]

BRENT, Marie Louise [S] Paris, France b. United States [17]

BRERETON, Alice Laborde [S] Paris, France b. New Haven, CT [17]

BRESLAU, Leo [P] Brooklyn, NY b. 13 Ja 1909, Brooklyn. Studied: self-taught [33]

BRESSLER, Harry S. [Car,I] West Englewood, NJ b. 7 Ja 1893, Austria. Studied: ASL, with George Bridgman; NAD, with A.L. Kroll. Positions: Car., King Features (1920-28), Dayton Daily News (1929-32), N.Y. Daily Mirror (1934-35); Ed., Bressler Editorial Cartoons, 1935-46 [47]

BRETSNYDER, Arno [P] Chicago, IL b. 13 Jy 1885, Chicago. Studied: Francis A. Acad., Chicago; AIC; John Vanderpoel. Member: Ill. Soc. FA; Vanderpoel A. Assn.; Soc. Sanity in A. Exhibited: AIC, 1939 (med); Galesburg, Ill., 1938 (prize) [47]

BRETT, D(orothy) E. [P] Taos, NM (1976)/San Cristobal, NM b. 1883, London. Studied: Slade Sch., Univ. Col., both in London. Member: Taos Heptagon Group. Work: Mus. N.Mex; Buffalo Mus. Science; portraits of Indians and British celebrities, including D.H. Lawrence [40]

BRETT, Harold M. [P,I] North Chatham, MA b. 13 D 1880, Middleboro,

MA. Studied: Walter Appleton Clark; H. Siddons Mowbray; Howard Pyle. Member: Boston AC [40]

BRETT, Helen Elizabeth. See Babbington, Helen Brett.

BRETT, Ralph Sampson [P,Des] Providence, RI. b. 20 Je 1883, Providence. Studied: MIT. Member: Scenic A. Assn.; Pittsfield A. Lg. Exhibited: Berkshire Mus.; Newport AA; Providence, R.I.; Gloucester, MA. Position: Scenic A., theatrical, operatic productions [47]

BRETZ, Mary [P] Paris. Studied: Gervais; Schommer [13]

BRETZFELDER, Anne [S] St. Louis, MO. b. 15 N 1916, St. Louis. Studied: Simon Moselsio. Exhibited: Toledo MA; St. Louis MA; Soc. Indp. A.; WFNY, 1939. Work: St. Louis MA [40]

BREUER, H(enry) J(oseph) [P,I] Lone Pine, CA b. 16 Ag 1860, Phila. d. 1932, San Fran. Studied: Paris, 1893. Member: San Fran. AA. Exhibited: Alaska-Yukon-Pacific Expo, Seattle, 1909 (med); P.-P. Expo., San Fran., 1915 (gold). Decorator: Rookwood pottery, Cincinnati, 1880–82. Designer: lithographs, 1882–84. Painter: murals, NYC, 1884–88. Artist: San Fran. Chronicle, 1890–92 [21]

BREUER, Theodore Albert [P] Paris b. 1870, Cincinnati. Studied: Karl Marr, in Munich; Cormon, in Paris [04]

BREUL, Harold G. [Des,Car,I,P] North Providence, RI b. 6 My 1889, Providence. Studied: R.I. Sch. Des.; PAFA. Member: Providence AC; Providence WC Cl.; AWCS. Exhibited: AWCS, 1942, 1944, 1945, 1946; Providence AC. Specialty: horses [47]

BREULL, Hugo [Por.P] Providence, RI b. 27 My 1854, Saalfield, Germany d. 5 Ag 1910. Studied: Wilmarth; Chase; O. Seitz, Lindenschmidt, in Germany; Boulanger, Lefebvre, in Paris [08]

BREVOORT, James R(enwick) [Ldscp.P] Yonkers, NY b. 20 Jy 1832, Westchester, Co. NY d. 15 D 1918. Studied: Thomas S. Cummings. Member: ANA, 1861; NA 1863; Yonkers AA; Century Assoc.; Royal Acad., Urbino, Italy. Exhibited: NAD, 1856–90; Boston Athenaeum, 1858. His wife, Marie Bascom, was an artist. Position: T., NAD, 1872–75 [17]

BREWER, Adrian L(ouis) [P,T] Little Rock, AR b. 2 O 1891, St. Paul, MN d. 23 Je 1956. Studied: St. Paul A. Sch.; his father, N.R. Brewer; Alexis Jean Fournier. Member: Chicago SA, 1921; Palette and Chisel Cl., Chicago, 1921; SSAL, 1929. Exhibited: St. Paul Inst., 1917 (med); Northwest Ar. Exh., St. Paul, 1918 (med); Minn. State A. Comm., 1919 (prize); San Antonio AL, 1928 (prize); San Angelo Fair Assn., Tex., 1928 (prize). Work: Lotos Cl., New York; capitol, Little Rock; Municipal A. Gal, Little Rock; Beaumont Reading Cl., Tex.; Women's Forum, Wichita Falls, Tex.; Cowan Coll., Aurora, Ill.; Victoria A. Lg., Tex. [40]

BREWER, Alice Ham (Mrs. F. Layton) [Min.P] Montclair, NJ b. 14 Mr 1872, Chicago. Studied: AIC; ASL; Henry Mosler; W.J. Whittemore; Rhoda Holmes Nicholls. Member: NYWCC [33]

BREWER, Bessie Marsh [Et,Li,I,P,S] NYC b. 1 Je 1883, Toronto d. 29 Ap 1952. Studied: William Chase; Kenneth Hayes Miller; N.Y. Sch. Des. for Women; ASL, with Robert Henri; John Sloan; Joseph Pennell; Mahonri Young. Exhibited: Brooklyn, Mus. E.; N.Y. Sch. Des. for Women, 1924 (prize). Illustrator: national magazines [47]

BREWER, Edward Vincent [P,I] St. Paul, MN b. 12 Ap 1883, St. Paul. Studied: Kenyon Cox; Walter Appleton Clark; Frank V. DuMond; Twachtman; Nicholas R. Brewer. Work: Spokane Trust Co., Wash.; Batavian Nat. Bank, La Crosse, Wis.; Scottish Rite Cathedral, Commercial Club, Minneapolis; Merriam Park Presbyterian Church, St. Paul; courthouse, Capitol, St. Paul; T. Col., St. Cloud; Univ. Minn.; Swedish Inst., Minneapolis. Creator: character "Rastus" for Cream of Wheat Co. [40]

BREWER, Ethellyn. See De Foe, Louis, Mrs.

BREWER, Floyd E. [P,T,L] St. Paul, MN b. 24 Ap 1899, Coin, IA. Studied: Minneapolis Sch. A.; St. Paul Sch. A.; Hans Hofmann, in Munich; Fernand Leger, in Paris; Wassily Kandinsky; Diego Rivera. Member: Minn. AA; Iowa AA; Am. Fed. A. Exhibited: Women's City Club, Minneapolis, 1932 (prize); AFA (prize); 16 paintings, "Uncle Sam's Children," Minneapolis, St. Paul; AIC, 1931–38; AV, 1943; SFMA; Milwaukee AI; Kansas City AI. Work: Globe Bldg., St. Paul; apartment bldg., Mexico City; Walker A. Gal, Minneapolis [47]

BREWER, H.E. [P] Whitestone, NY [15]

BREWER, Harriet E. (Mrs.) [P,Dec] Norwich, CT. Member: Alliance; Decorators Cl.; Soc. Interior Dec.; ASL [33]

BREWER, Nicholas Richard [P,W,L] St. Paul, MN b. 11 Je 1857, Olmstead Co., MN d. 1949. Studied: D.W. Tryon; Charles Noel Flagg; NAD. Member: SC, 1905; NAC; Wash. AC; AIC; Knoxville AL. Exhibited: Minn. State A. Soc., 1912 (prize); St. Paul Inst., 1915 (prize); Springfield (Ill.) State Exh., 1917 (prize); AIC, 1921 (prize); Tex. Wild Flower Exh., San Antonio Mus., 1929 (prize). Work: SC; AIC; St. Paul Inst.; Decatur (Ill.) A. Inst.; Univ. Notre Dame; Macon AA; Hackley Gal., Muskegon, Mich.; Women's Cl., Birmingham; Nat. Gal., Wash., D.C.; Smithsonian Inst.; Witte Mus., San Antonio; South Shore Country Cl., Chicago; Macalester Col., St. Paul; capitol, Providence, R.I.; capitol, Madison, Wis., capitol, Augusta, Maine; capitol, Austin, Tex.; capitol, Little Rock, Ark.; Plymouth Church, Brooklyn, N.Y.; Univ. Minn., Minneapolis; Carnegie Inst.; Univ. Okla.; capitol, Pierre, S.Dak.; capitol, S. Paul, Minn.; Catholic Univ. of America; Univ. Nebr. [40]

BREWSTER, Achsah (Mrs. E.H.) [P] d. 16 F 1945, Almora India. An American, she had gone to India with her husband to study Buddhism.

BREWSTER, Ada Agusta [I,P] NYC b. Kingston, MA. Studied: Samuel Rouse; Lowell Inst., Boston; Virgil Williams, Yelland, both in San Fran. Decorator: of china [01]

BREWSTER, Amanda. See Sewell, R.V.V., Mrs.

BREWSTER, Anna Richards (Mrs. William T.) [P,I] Scarsdale, NY b. 3 Ap 1870, Germantown, PA d. 1952. Studied: Dennis Bunker; H. Siddons Mowbray; NAD, with LaFarge, Chase; Constant, Laurens, in Paris. Member: AWCS; NAWA. Exhibited: NAD, 1889 (prize). Work: Butler Mus.; New Britain MA; Lyman Allyn Mus.; Indianapois MA; Harvard Univ.; Barnard Col. The daughter of marine painter W.T. Richards, she had a studio in London from 1896 to 1905. [47]

BREWSTER, Earl H. [P] Sheldon, IA b. 21 S 1879, Chagrin Falls, OH. Studied: N.Y. Sch. A.; ASL. Work: Hillyer A. Gal., Northampton, Mass. [17]

BREWSTER, Eugene V. [P,W,L] Morristown, NJ b. 7 S 1871, Bayshore, NY. Studied: self-taught. Member: SC; All. AA; Brooklyn SA. Positions: Ed., The Classic Magazine, Motion Picture Magazine [25]

BREWSTER, George T(homas) [S,T,L] Greenwich, CT b. 24 F 1862, Kingston, MA. Studied: Mass. State Normal A. Sch.; Ecole des Beaux-Arts, with Dumont; Mercié, in France. Member: NSS, 1898; Arch. Lg., 1897; NAC; N.Y. Municipal AS; NYSC. Work: Utica, N.Y.; Lib., NYU; Nat. Acad. Des; Hall of Fame, NYC; crowning statues, Indianapolis and State House, Providence; Augusta, Ga.; Athens, Pa.; Danvers, Mass.; Brooklyn Inst. Mus.; Malden, Mass.; Atlanta, Ga.; Hamilton Col.; Allentown, Pa.; Staten Island, N.Y.; Supreme Court, NYC; Peekskill, N.Y. Founder: modeling class, ASL, 1886. Positions: Instr., R.I. Sch. Des. (1892–93), Cooper Union (1900–) [40]

BREWSTER, Isabel (Mrs. Samuel D.) [P] NYC. Member: NAWPS; Women's AC [25]

BREWSTER, Julia [P] Providence, R.I. Member: Providence WCC [10]

BREWSTER, Mela Sedillo [C,P,T,L] Albuquerque, NM b. Socorro, NM. Studied: Raymon Jonson; Hernandez Mariscal; Charles Martin; William Zorach. Member: AL, N.Mex.; Albuquerque AG. Lectures: Spanish Colonial Arts. Position: Instr., A. Dept., Univ. N.Mex. [40]

BREYFOGLE, John Winstanley [P] NYC b. 23 O 1874, Louisville, KY. Studied: PAFA, with William M. Chase, Thomas P. Anschutz. Member: SC; NYWCC; Rochester AC. Exhibited: P.-P. Expo, San Fran., 1915 (med) [19]

BREYMAN, Edna Cranston [P] Portland, OR [13]

BREZEE, Evelyn [P,E] Berkeley, CA b. 27 S 1912, Seattle. Studied: Univ. Calif. Member: San Fran. AA. Exhibited: SFMA, 1936–46; Oakland A. Gal., 1945. Positions: T., A., El Cerrito HS, 1944– ; Instr., Calif. Col. A.&Crafts, Oakland, 1945– [47]

BRICK, Harry [P] Phila., PA b. 23 F 1882, Odessa, Russia. Studied: PAFA [13]

BRICHER, Alfred Thompson [P,Mar.P] New Dorp, NY b. 10 Ap 1837, Portsmouth, NH d. 30 S 1908. Studied: self-taught; Acad. Newburyport (Mass.); in 1851, entered a mercantile house in Boston and studied art in his leisure hours at Lowell Inst., Boston. In 1858 he took up art as a profession and, in 1868, settled in New York. Member: AWCS; BAC; ANA, 1879. Exhibited: Boston Athenaeum; NAD, 1868–90; Brooklyn AA, 1870–86 [08]

BRIDAHAM, Lester Burbank [W,L,P,En] Chicago, IL b. 30 Ag 1899, Denver, CO. Studied: MIT; Harvard Univ.; ASL, with Kenneth Hayes Miller, K. Nicolaides. Member: F., Am. Field Service Fnd., 1931, 1932, in France and Morocco. Exhibited: GRD Gal., New York, 1932; AIC, 1946.

Author: "Gargoyles, Chimeras and the Grotesque in French Gothic Sculpture," 1930. Lectures: Gothic and Modern Art. Positions: Pub. Rel. Counsel, AIC, 1938–42; Instr., U.S. Navy, 1942–45; Secretary, AIC, 1945– [47]

BRIDGE, Evelyn [E,W] NYC b. Chicago, IL. Studied: AIC; Col. de France, Paris; Acad. Colarossi, Paris; AIC. Member: Chicago SE. Exhibited: Salon d'Automne, 1932, 1933; AIC; PAFA; Southern Pr.M. Work: NGA; NYPL; MMA [47]

BRIDGE, Helen (Mrs. Hudson E.) [P] St. Louis, MO. Member: St. Louis AG [25]

BRIDGE, William [P] NYC [13]

BRIDGES, Appleton S. [Patron] Point Loma, CA b. 1848 d. 8 My 1929. Donor of the Fine Arts Gallery building, Balboa Park, San Diego.

BRIDGES, Fidelia [P] Canaan, CT b. 19 My 1834, Salem, MA d. Mr 1924. Studied: W.T. Richards. Member: ANA, 1873; AWCS. Exhibited: PAFA, 1862, 1863, 1865, 1866; NAD, 1863–89 [13]

BRIDGES, Georges [S,Des] Birmingham, AL b. 31 Mr 1899, Chattanooga, TN. Studied: Cincinnati Acad. A.; abroad. Member: SSAL; New Orleans AA. Exhibited: CGA. Work: IBM; Univ. Ala. [47]

BRIDGHAM, Eliza. See Appleton, Everard, Mrs.

BRIDGMAN, F(rederic) A(rthur) [P,En,W] Paris/Eure, France b. 10 N 1847, Tuskegee, AL d. 13 Ja 1928, Rouen. Studied: NAD; Atelier Suisse, Paris, 1866; École des Beaux-Arts, Paris; Gérôme, in Paris. Member: ANA, 1874; NA, 1881; Lotos Cl.; Arch. Lg., 1899; Paris SAP; Am. Ar. in Paris Committee for the Universal Expo, 1889. Exhibited: Paris Salon, 1868, 1877 (med); Paris Expo, 1878 (med), 1889 (med), 1900 (med); Munich, 1891 (gold); Berlin, 1892 (med); Antwerp, 1894 (med); Pan-Am. Expo, Buffalo, 1901 (med); St. Louis Expo, 1904 (med); Mulhouse Mus., France, 1926. Work: CGA; Mus., Brooklyn Inst.; AIC; Acad. A., Leningrad; Liverpool Gal.. Awards: Legion of Honor, 1878; Order of St. Michael of Bavaria. Known for his paintings of scenes from antiquity, especially Egyptian. Painted a lot in Brittany, Algiers, Egypt. Author: in French, "L'Anarchie dans l'Art" ("Anarchy in Art"), his position on Impressionism, "Vers l'Idéal," "Winters in Algeria." Composer/Musician: symphonies, orchestral works; violinist [25]

BRIDGMAN, George Brandt [P,T,W,L] Pelham, NY b. 5 N 1864, Bing, County of Monk, Canada d. 16 D 1943 Studied: Gérôme, Boulanger. Author: "Bridgman's Constructive Anatomy," "Bridgman's Life Drawing," "Bridgman's Book of Hundred Hands; Features and Faces." Lectures: Anatomy, Life Drawing. Positions: Instr., ASL, Grand Central Sch. A. [40]

BRIDGMAN, Lewis Jesse [I] Salem, MA b. 17 N 1857, Lawrence MA. Illustrator: St. Nicholas, other magazines [17]

BRIDWELL, Harry L(oud) [P,Des] Cincinnati, OH b. 13 Ag 1861 d. 13 S 1930. Member: Cincinnati AC. Partially paralyzed for 24 years, he taught himself to use his left hand. Specialty: poster design. Work: decorations, Grand Opera House, Cincinnati [29]

BRIERLY, J. Ernest [P] Chicago, IL. Member: Chicago GFLA [25]

BRIGANTE, Nicholas P. [P] Los Angeles, CA b. 29 Je 1895, Naples, Italy. Studied: ASL, Los Angeles, with Rex Slinkard, Val Costello; Lawrence Murphy; S. McDonald Wright. Member: Calif. WC Soc.; San Diego A. Gld. Exhibited: Los Angeles Fiesta Exh., 1929 (med); Calif. WC Soc. 1931 (prize), 1936 (prize); Calif. State Fair, 1934 (prize); San Diego A. Gld., 1939 (prize); BM, 1924; AIC, 1924; Riverside Mus.; GGE, 1939; San Fran. AA; Los Angeles Mus. A.; Santa Barbara Mus. A., 1942 (one-man); Los Angeles AA, 1946 [47]

BRIGDEN, F.H. [P] Toronto, Ontario. Member OSA [01]

BRIGGS, Annie F. [P] Oakland, CA [09]

BRIGGS, Austin [I] Westport, CT. Member: SI [47]

BRIGGS, Berta N. (Mrs. William H.) [P,L,T,Gr] NYC b. 5 Je 1884, St. Paul, MN d. 1976. Studied: ASL, with Kenyon Cox, George Breck; PIASch; Columbia Univ.; Minneapolis Craft Sch., with Ernest Batchelder; Bertha Lum; Arthur Dow. Member: NAWA; Sch. A. Lg. Exhibited: NAWA, 1927–45; Women's Intl. AC, London, 1931; Pal. Leg. Honor, 1931; Argent Gal., 1932, 1934, 1936 1939, 1943 (one-man); Currier Gal. A., 1943; Whyte Gal., 1944. Work: Wesleyan Col., Macon, Ga. Lectures: History of Painting, Architecture, Romanesque Sculpture. Positions: Trustee/Chm., Medals Com., Sch. A. Lg., 1944–46 [47]

BRIGGS, Caroline deM. [P] NYC. Member: Lg. AA [24]

BRIGGS, Clare A. [I,Car] New Rochelle, NY b. 5 Ag 1875, Reedsburg, WI d. 3 Ja 1930, NYC. Studied: Univ. Nebr. Member: SI. Cartoonist: New York Tribune; New York Herald Tribune, since 1914. Work: syndicated throughout U.S. [27]

BRIGGS, Joseph b. 1873, England d. 28 M 1937. Positions: President: L.C. Tiffany Studios, makers of church decorations and memorials; Trustee, Louis C. Tiffany Fnd.

BRIGGS, Gertrude R(ussell) [P] NYC b. 19 D 1899, Lexington, MA. Studied: BMFA Sch. [33]

BRIGGS, Helen L. [P] Muncie, IN b. 15 F 1912, Sheridan, IN. Studied: John Herron AI; PAFA, Chester Springs, Pa. Member: Hoosier Salon.; Ind. Ar. Cl. Exhibited: Ind. Ar. Cl., 1937 (prize); Hoosier Salon, 1938 (prize); John Herron AI; Ball State AM, Muncie [40]

BRIGGS, Judson Reynolds [P,En,T,L] NYC b. 17 My 1906, Phila., PA. Studied: Charles Schroeder. Exhibited: A. Dir. Cl., 1945 (prize); Palacio de Bellas Artes, Mexico City (prize); PAFA, 1946; MOMA; WFNY, 1939; MMA. Work: Treasury Dept., Wash., D.C.; Carillon Mus., Va.; MOMA; Portland Mus. A.; Athletic Cl., Chicago; Richmond Army Air Base Lib. Contributor: Direction magazine. Position: T., Pr.M., N.Y. Sch. F.&Indst. A. [47]

BRIGGS, Lela (Mrs. Wilbur A.) [P] La Porte City, IA b. 17 Mr 1896, Powersville, IA. Studied: Iowa State T. Col.; AIC; Iowa Univ., with Grant Wood. Exhibited: Iowa State Fair, 1934, 1938, 1939, 1940, 1941; Iowa Rotary Exh., 1945, 1946; Cedar Falls, 1942 (one-man), 1944 (one-man), 1946 (one-man); Waterloo, 1946; Mason City, 1945; Sioux City WC Soc., 1945, 1946. Work: Iowa State T. Col.; Grand View Col., Des Moines [47]

BRIGGS, Lucius A. [Mar.P] b. 1852, Rhode Island d. 8 F 1931, Boston. Work: KWM; Mariners Mus.; Peabody Mus., Salem [*]

BRIGGS, Minnie Louise [I,T,E] Wash., D.C. b. 26 S 1890, Fairmount Manor, MD. Studied: Corcoran Sch. A.; William Mathews; Benson Moore. Member: Wash. SE; Wash. WCC; Min. PS&G Soc.; Wash. Lg. Am. Pen Women. Exhibited: Wash. Lg. Am. Pen Women (prizes); Nat. Lg. Am. Pen Women (prizes). Work: Ten O'Clock Cl.; Wash. Lg. Am. Pen Women; Town Hall Cl., New York; Georgetown Pub. Lib. Illustrator: "Sidney Lanier Oak of Brunswick Georgia." Contributor: author/illus., Flower Grower, American Forestry, The Washingtonian. Lectures: How to Make an Etching. Position: Dir., Briggs Sch. E. [40]

BRIGGS, Richard Delano [P,I,T] Newton Highlands, MA/Nantucket, MA b. 26 Ja 1914, Fairhaven, MA. Studied: Ernest L. Major. Member: Gld. Boston Ar. Exhibited: Jordan Marsh, Boston, 1938 (gold), 1939 (gold); Currier Gal., Manchester, N.H.; NAD; Gld. Boston Ar. Position: T., Mass. Sch. A. [40]

BRIGGS, Warren C. [Ldscp.P] NYC b. 1867 d. 3 Ja 1903. Studied: James M. Hart.

BRIGHAM, Clara Rust (Mrs. W.E.) [P,C] Providence, RI b. 25 Jy 1879, Cleveland, OH. Studied: Blanche Dillaye; William Brigham. Member: Providence AC; Needle and Bobbin Cl.; Handicraft Cl., Providence; AFA. Position: Dir., Indst. Dept., Federal Hill House [33]

BRIGHAM, Gertrude. See Flambeau, Viktor, Mrs.

BRIGHAM, W(alter) Cole [P,C] Shelter Island Heights, NY b. 11 Ja 1870, Baltimore, MD d. 7 Ap 1941. Studied: William M. Chase; Siddons Mowbray; Kenyon Cox; Douglas Volk. Member: ASL. Exhibited: N.Y. Soc. Indp. A., 1901 (med). Work: mem. windows, chapel, Home for the Aged, Brooklyn, N.Y. Designer/Assembler: marine mosaic, art glass [40]

BRIGHAM, William Edgar [C,T,Des] Providence, RI b. 29 Jy 1885, North Attleboro, MA. Studied: R.I. Sch. Des., with Henry Hunt Clark; Denman Ross. Member: Providence AC; R.I. Ship Model Soc.; Boston Soc. A.&Crafts. Exhibited: Boston Soc. A.&Crafts, 1936 (med); Intl. Expo, Paris, 1937 (med); R.I. Fed. Garden Cl., 1939 (med); WMA, 1943; Phila. A. All., 1945; America House, N.Y., 1944. Work: R.I. Sch. Des.; Providence Mus. A. Contributor: Craft Horizons. Lectures: Design, Color [47]

BRIGHAM, William Edgar (Mrs.) [P] Providence, RI. Member: Providence AC [17]

BRIGHT, John Irwin [P] Overbrook, PA b. 1869, Phila., PA. Studied: Gérôme, in Paris. Member: Phila. WCC. Exhibited: Phila. AC, 1901 (prize); AAS, 1902 (med); St. Louis Expo, 1904 (med) [15]

BRIGMAN, Anne W. [Photogr] Long Beach, CA b. 1869, Honolulu d. 1950. Member: Photo. Soc., 1906; Royal Photo. Soc.. Exhibited: 3rd San Fran. Photo. Salon, 1903. Work: IMP; Oakland MA; major photography museums. Her pictorialist work appears in "Camera Work." [30]

BRILL, G(eorge) R(eiter) [I,P] Monument Beach, MA b. 27 Ag 1867,

Allegheny City, PA d. 6 Mr 1918, Fla. Studied: Spring Garden Inst.; PAFA; Cusachs; Boss. Member: Phila. AC; Phila. Sketch Cl.; F., PAFA; Assoc. Ar. Pittsburgh. Exhibited: Pittsburgh AA, 1912 (prize). Author/Illustrator: "Rhymes of the Golden Age," "Andy and Ignoramus," "Paperweight Owl." [17]

BRINDESI, Olympio [S,T] NYC b. 7 F 1897, Abruzzi, Italy. Studied: ASL; BAID; Chester Beach; A.P. Proctor. Member: Arch. Lg.; NSS; Am. Veterans Soc. A. Exhibited: Arch. L, 1927 (prize); NSS; PAFA; AIC; Hispanic Soc.; BMA; Rochester Mem. A. Gal.; BM; WMAA; WFNY, 1939. Work: Lincoln Lib., Shippensburg, Pa. [47]

BRINDLE, Melbourne [Des,I] New Canaan, CT b. 18 N 1904 Melbourne, Australia. Member: SI; A. Dir. Cl. Exhibited: A. Dir. Cl., 1935 (prize), 1938 (prize), 1942 (prize). Illustrator: national magazines [47]

BRINES, John Francis [S] NYC b. 30 Je 1860, Westerly, RI [05]

BRINGHURST, Guido [P] University City, MO [15]

BRINGHURST, Robert P(orter) [S,C,T] University City, MO b. 22 Mr 1855, Jerseyville, IL d. 22 Mr 1925. Studied: St. Louis Sch. FA; Ecole des Beaux-Arts, Paris. Member: St. Louis AG; 2 x 4 Soc. Exhibited: Columbian Expo, Chicago, 1893 (med); Tenn. Centenn., Nashville, 1897 (prize); St. Louis Expo, 1904 (med); St. Louis AG, 1915 (med), 1916 (prize). Work: Indianapolis AA; AIC; St. Louis Mus. [21]

BRINGHURST, Walter [P] St. Louis, MO. Member: St. Louis AG [25]

BRINKERHOFF, N.W. [P] NYC [04]

BRINKERHOFF, R(obert) M(oore) [I] NYC b. 4 My 1880, Toledo, OH. Studied: ASL; Acad. Colarossi, Paris. Member: SI; Dutch Treat Cl. Illustrator: The Saturday Evening Post, Redbook, etc. Author: "Dear Mom," "Little Mary Mixup in Fairyland," pub. Duffield, 1926. Contributor: cartoons, New York World-Telegram. Position: Staff, United Features Syndicate, N.Y. [40]

BRINKLEY, Nell (Mrs. Bruce MacRae) [I] New Rochelle, NY d. 21 O 1944. Studied: self-taught. Member: New Rochelle AA. Position: Affiliated with Hearst publications [40]

BRINKMAN, Otto H. [P] Toledo, OH. Member: Artklan [25]

BRINLEY, Daniel Putnam [P,I,Mur.P] New Canaan, CT b. 8 Mr 1879, Newport, RI d. 1963. Studied: Dwight Sch.; ASL; Florence; Paris. Member: ANA; NAC; NSMP; Silvermine Gld. A.; Arch. Lg.; BAID; Grand Central A. Gal. (founder). Exhibited: Paris Salon, 1906; PAFA, 1908, 1910, 1912; Carnegie Inst., 1916, 1917; NAD; Arch. Lg., 1930 (prize), 1932 (gold); Silvermine Gld. A.; WFNY, 1939. Work: mem., Kansas City, Mo.; murals, Brooklyn Savings Bank; Metropolitan Life Insurance Co. bldg., New York; Daily News bldg., New York; stained glass windows, Fordham Lutheran Church (New York), St. George's Church (Bridgeport, Conn.), St. Mark's Church (New Canaan); USPO, Blakeley, Ga. Illustrator: travel books [47]

BRINTON, Caroline P. (Mrs. Christian Brinton) [P] West Chester, PA b. Pennsylvania. Studied: PAFA; Paris. Member: Plastic Cl.; NAC. Exhibited: PAFA, 1898 (prize) [21]

BRINTON, Christian [Cr,L] West Chester, PA b. 1871 d. 14 Jy 1942. He presented his collection of Russian art to the Phila. Museum of Art.

BRINTON, Sarah W. [G] Phila., PA. Exhibited: Phila. A. All., 1936, 1939 (prize) [40]

BRIOSCHI, Charles [S] St. Paul, MN [17]

BRISAC, Edith Mae [E,Li,En,Des,P,C] Denton, TX b. Walton, NY. Studied: PIASch; Columbia Univ.; Ecole des Beaux-Arts, Paris; Cranbrook Acad. A.; Arthur Young. Member: Tex. FA Assn.; SSAL; NAWPS; NYWCC. Exhibited: West Tex. Exh., 1938 (prize), 1940 (prize), 1944 (prize), 1946 (prize); Dallas Mus. FA, 1941 (prize); Univ. Calif., 1942 (med); LOC, 1944-46; PAFA; BM, 1939; Carnegie Inst., 1944; Laguna Beach AA, 1945; WFNY, 1939; Dallas Pr. Cl., 1938-46; Tex. FA Assn., 1937-46; SSAL, 1939-45; Kansas City AI, 1935-41; Tex. General Exh., 1939-46. Work: Dallas Mus. FA; Cranbrook Acad. A. Lectures: Design, Interior Decoration. Positions: Prof. FA, Ala. Col. for Women (1929-33), Tex. State Col. for Women, Denton (1934- [47]

BRISCOE, Franklin D. [P] Phila., PA b. 1844, Baltimore, MD d. 29 Ag 1903. Studied: Edward Moran, 1860. Specialty: marine scenes

BRISON, Elia S. [I,C] Chicago, IL b. 28 O 1878, South Orange, NJ. Studied: AIC; Holmes Sch. Illus. Member: ASL, Chicago; Chicago A.&Crafts Soc. Specialty: children's books [13]

BRISON, Mary J. [P,C,W,L,T] Athens, OH b. 11 My 1878, Rawdon, Canada. Studied: Dow; Friesz; Twachtman; McFee. Member: College AA; Western AA. Exhibited: All.A.Am. (prize for rug design) [25]

BRISTOL, John Bunyan [P] NYC b. 14 Ap 1826, Hillsdale, NY d. 31 Ag 1909. Studied: self-taught; Henry Ary. Member: ANA, 1861; NA, 1875; A. Fund S. Exhibited: NAD, 1858; Centenn. Expo, Phila., 1876 (med); Paris Expo, 1889 (prize); Pan-Am. Expo, Buffalo, 1901 (med). Work: Peabody Inst., Baltimore [08]

BRISTOL, J. Sherman [P] Martha's Vineyard, MA [19]

BRISTOL, Stone E. [P] Paris b. Phila., PA [09]

BRISTOL, Tanci (Esther Frances) [P,T] Los Angeles, CA b. 22 Je 1915, Madera, CA. Studied: Univ. Southern Calif.; Paul Sample; Dan Lutz; J.D. Prendergast. Member: Calif. WC Soc. Exhibited: Southern Calif. All. A. Festival, 1937 (prize); San Fran. MA; Los Angeles MA; Portland Mus., 1939; Cincinnati Mus., 1939 [40]

BRITSCH, A.G. [P] Toledo, OH. Member: Artklan [25]

BRITSKY, Nicholas [Edu,P,Et] Urbana, IL b. 11 D 1913, Weldirz, Ukraine, Russia. Studied: Yale Univ.; Columbia Univ.; Eugene Savage. Member: CAA. Work: Bell Telephone bldg., Waterloo, Iowa. Contributor: Encyclopaedia Slovanica. Lectures: Peasant Art. Position: Instr., Univ. Ill., Champaign, 1946- [47]

BRITT, Ralph M. [P] Atlanta, GA b. 19 Jy 1895, Winchester, IN. Studied: William Forsyth; Clifton Wheeler; Otto Stark; Olive Rush. Member: Atlanta Studio Cl.; Atlanta Sketch Cl. Exhibited: Hoosier Salon, Chicago, 1927 (prize), 1928 (prize); Atlanta AA, 1927 (prizes); High Mus., Atlanta, 1928 (prize); Ga. State Exh., 1929 (prize). Work: Purdue Memorial Union, Lafayette, Ind. Position: Dir., Britt Sch. A. [40]

BRITTIN, Arna T. [P] Minneapolis, MN [25]

BRITTON, Edgar [P,Li,T,C] Colorado Springs, CO b. 15 Ap 1901, Kearney, NE. Studied: Univ. Iowa; Univ. Kansas; Karl Mattern; Albert Bloch. Member: Ar. U., Chicago; Chicago Soc. Ar. Exhibited: Denver A. Mus., 1943, 1944 (prize), 1945; Pasadena AI, 1946 (prize); Colo. Springs FA Center, 1945, 1946 (prize); Univ. Nebr., 1945. Work: AIC; Denver A. Mus.; Colo. Springs FA Center; Pasadena AI; Univ. Nebr.; USPOs, East Moline, Decatur, Ill.; Dept. Interior bldg., Wash., D.C.; Lectures: Fresco painting. Position: Instr., Colo. Springs FA Center [47]

BRITTON, Harry [P] Toronto, Ontario b. 1879 d. 23 Jy 1958 [21]

BRITTON, James [P,I,En,W] Gloucester, MA b. 20 F 1878, Hartford, CT d. 16 Ap 1936. Studied: C.N. Flagg; A.F. Jaccaci; George de F. Brush; R.B. Brandegee. Member: Eclectics; Soc. Conn. Ar. Exhibited: Farmington, Conn., 1902 (prize). Work: Morgan Mus., Hartford. Position: Staff, Scribner's, 1894. The Conn. Acad. of Fine Arts was founded largely through his efforts. [27]

BRITTON, John K. [S,P] Trenton, NJ [09]

BRITTON, L.N. [I] NYC [19]

BRIXIUS, Dorothy Ann [Des,P] Manitowoc, WI b. 30 Ja 1916, Yankton, SD. Studied: Federal Sch. A.; Layton Sch. A.; Merlin Pollock. Positions: Des., Milwaukee Label & Seal Co., 1941-42; Engineering Dept., Allis Chalmers Mfg. Co., 1942-44; T., Manitowoc Vocational Sch., 1945-46 [47]

BROAD, Harry Andrew [Edu,P,Li,W,L] Ypsilanti, MI b. 17 F 1910, Chicago. Studied: Univ. Chicago; Columbia; Univ. Mich.; Northwestern Univ.; AIC. Member: CAA. Exhibited: AIC, 1932, 1933, 1936, 1937; Laguna Beach AA, 1945; Univ. Chicago, 1932, 1933; Century Gal., Chicago, 1935. Contributor: Design Magazine. Positions: T., Ind. Univ., 1935-37, Mich. State Normal Col., Ypsilanti, 1937- [47]

BROBECK, Charles I. [P] Columbus, OH b. 29 S 1888, Columbus. Studied: Columbus Art Sch.; Detroit Sch. FA. Member: Col. Pen & Pencil C.; Col. Soc. A.&S. [25]

BROCHAUD, Joseph F. [P] San Fran., CA [09]

BROCK, Emma L. [W,I] St. Paul, MN b. Fort Shaw, MT. Studied: Univ. Minn.; Minneapolis Sch. A.; ASL; Bridgman; Robinson; Pennell. Member: Authors Lg. Am.; Minn. AA. Exhibited: Minn. AA; AWCS; Brooklyn SE. Author/Illustrator: "The Umbrella Man," 1945, other children's books [47]

BROCK, Esther [P,T] Richmond, VA. Member: Richmond AC [17]

BROCK, Gustav Frederick [Por.P,Min.P] NYC b. 1881, San Fran. d. 4 F 1945. Studied: Denmark. Specialty: miniatures of royalty and other notables in Europe and U.S.

BROCK, Henrietta M. [P,C] Lincoln, NE. Studied: Vanderpoel; Univ. Nebr.; F.B. Auclih, in Berlin [25]

BROCKDORFF, Herman [Ser,P,T] Valois, NY b. 21 O 1907, Copenhagen, Denmark. Member: A. Lg. Am. Exhibited: Merchant Seamen Exh., 1943 (prize), 1944 (prize), 1945 (prize); LOC, 1945, 1946; NAD, 1946; Phila. Pr. C., 1946; Northwest Pr.M., 1946; New-Age Gal., 1944, 1945, 1946 (one-man) [45]

BROCKENBROUGH, Eleanor [P,C] Lafayette, IN b. Lafayette. Studied: F.F. Fursman; C.W. Hawthorne, H.H. Breckenridge. Member: North Shore AA; Ind. AC; Lafayette AA [25]

BROCKETT, Virginia Mae Eveleth [C,T,W] Madison, WI b. 29 S 1910, Enfield, IL. Studied: W.H. Varnum, Univ. Wis. Member: Wis. Soc. Appl. A. Work: pierced copper signs, Mem. Union Bldg, Univ. Wis. Lectures: History and Technique of Pewter [40]

BROCKHURST, James Baldwin [P,I] Red Band, NJ b. Jersey City. Studied: Chase; ASL; NAD. Member: N.Y. Municipal AS; NSC [13]

BROCKMAN, Ann (Mrs. William McNulty) [P] NYC/Rockport, MA b. 6 N 1899, Alameda, Calif. d. 29 Mr 1943. Studied: Gifford Beal; John Sloan. Instructor: Cape Ann. A. Sch., Rockport, Mass. [40]

BROCKMAN, Paul [P] Seattle, WA [25]

BROCKWAY, James [P] St. Petersburg, FL b. 30 N 1872, Brockway, MI. Studied: G.E. Browne; E. O'Hara; R.M. Pearson. Member: AWCS; Kit Kat AC; Business Men's AC [47]

BROD, Fritzi [P,En,Li,Des] Chicago, IL b. 16 Je 1900, Prague, Czechoslovakia. Studied: Europe. Member: Chicago SA; Chicago AC; Phila. Pr. Cl.; Phila. WCC; Chicago Women's Salon. Exhibited: Chicago SA, 1937 (med), 1939 (med); PAFA, 1934, 1935, 1937, 1938, 1940–45; Detroit Inst. A., 1939; Milwaukee AI, 1939; AIC, 1936–43; Albright A. Gal., 1938; Los Angeles MA, 1945; Dayton AI, 1944; NAD, 1942, 1945, 1946; LOC, 1943–45; TMA, 1939; CMA, 1939; Toronto A. Gal., 1939; Milwaukee AI, 1944; Kansas City AI, 1940. Work: NYPL; Vanderpoel Coll. Author: "200 Motifs and Designs" (1945), "Flowers in Nature and Design" (1946) [47]

BRODERICK, Robert W. [P] Haverhill, MA [15]

BRODEUR, Clarence Arthur [P,T,L] NYC b. 18 O 1905, Westfield, MA. Studied: Harvard; Yale; Ecole des Beaux-Arts, Paris. Exhibited: Poland, 1938; NAD, 1944; All.A.Am., 1942, 1944; Baltimore WC Soc., 1943; Conn. WC Soc., 1945; Am. A. Group, 1943, 1944; Dutchess County AA, 1940–42; New Haven PCC, 1946; Bridgeport A. Lg., 1946. Work: FMA; Yale; New Haven PCC; Vassar Geology Mus. Positions: T., Vassar, 1936–41; Supv., BMA Sch., 1944–45; T., PIASch, Brooklyn, N.Y., 1945– [47]

BRODHEAD, George Hamilton [Ldscp.P] Rochester, NY b. 5 D 1860, Boston, MA. Member: Rochester AC; Rochester Mem. Gal. [40]

BRODHEAD, Quita (Mrs. Truxtun R.) [P,T] Wayne, PA b. 5 Mr 1901, Wilmington, DE. Studied: PAFA; Grande Chaumière, Paris; McCarter; Archipenko. Member: A.All.Am. Exhibited: Wilmington AA, 1941 (prize), 1943 (med); PAFA, 1939–43; Am. Soc. Women P.&S., 1936; Bryn Mawr, Pa., 1944 [47]

BRODIE, Howard Joseph [I] San Fran., CA b. 28 N 1916. Studied: Calif. Sch. FA. Work: Huntington Lib., San Marino, Calif.; San Fran. Chronicle, 1936, 1937. Position: Sporting Staff A., San Francisco Chronicle, Life [40]

BRODNEY, Edward [P] Newton, MA b. 15 Ap 1910, Boston. Studied: Yale; BMFA Sch.; Mass. Sch. A. Work: Mass. State Capitol, Boston; Newton (Mass.) City Hall [47]

BRODOVITCH, Alexey [P] Phila., PA b. 1898, St. Petersburg, Russia. Exhibited: WMAA, 1934; Studio House, Wash., D.C., 1936 [40]

BRODSKY, George [P] b. 15 Ap 1901, Russia (came to U.S. in 1903). Studied: Am. Acad. A., 1921–22; ASL, with Sloan, Robinson, 1923–25. Exhibited: SC; Concord AA; WPA mural in NYC. Was a printer, 1939–65 [*]

BRODSKY, Harry [Li,P,Des,I,T] Phila., PA b. 20 Jy 1908, Newark, NJ. Studied: PMSchIA; Univ. Pa. Member: Artists U., Phila. Pr. Cl. Exhibited: WMAA, 1935; PAFA, 1935; Okla. A. Center, 1942; Phila. Pr. Cl., 1942, 1944–46; LOC, 1945, 1946; CI, 1945, 1946; Barrett Gal., 1946. Position: T., Murrell Dobbins Vocational Sch., Phila. [47]

BRODY, Philip Morton [E,I,L,P,T] Los Angeles, CA b. 22 Ap 1905, New York. Studied: ASL; M. Mower; W. Yarrow; Galileo Chini, in Italy; P. Bornet, in Paris. Exhibited: AIC, 1938; Sarasota AA, 1937; Ferargil Gal., 1938; Mich. State Col., 1939; Los Angeles Mus. A., 1943 [47]

BRODZKY, H(orace) [P,I,E,W] NYC b. 30 Ja 1885, Melbourne, Australia. Studied: Melbourne; London. Member: "The Penguins"; Allied Artists Assoc., London; London Group; Modern AA [25]

BROEDEL, Max [I] Baltimore, MD/Magnetawan, Ontario b. 8 Je 1870, Leipzig, Germany. Studied: Leipzig Acad. FA. Specialty: medical illus. Position: T., Johns Hopkins Medical Sch. [40]

BROEMEL, Carl W. [P,Des,I] White Plains, NY b. 5 S 1891, Cleveland. Studied: Cleveland Sch. A; ASL; Royal Sch. Appl. A., Munich. Member: Cleveland SA; A. Gld., N.Y. Exhibited: CMA, 1920–29 (prizes); AWCS, 1942 (prize), AIC; WFNY, 1939. Work: CMA; BM [47]

BROKAW, Irving [P,W] NYC b. 29 Mr 1871, NYC. d. 19 Mr 1939. Studied: Bouguereau; Ferrier; Académie Julian, Paris; Chase; Field. Member: S.Indp.A; Salons of America. Work: Luxembourg Mus., Paris [38]

BROMBERG, Manuel [P] Colorado Springs, CO. Exhibited: 48 Sts. Comp.; WFNY, 1939. Work: USPOs, Greybull, Wyo., Tahlequah, Okla. WPA artist. [40]

BROMHALL, Winifred [I] NYC. Member: All.A.Am.. Specialties: children's books and bookplates [33]

BROMWELL, (Elisabeth) Henrietta [P,S,T,W] Denver, CO (1929) b. Charleston, IL. Studied: Denver; Europe. Member: Denver AA, 1893. An active suffragette. [25]

BRONESKY, Rudolph [P] Chicago, IL. Exhibited: Chicago Ar. Ann., 1935, 1936; AIC, 1935, 1937, 1938 [40]

BRONESKY, Stephen G.S. [Por.P] Chicago, IL b. 22 Ag 1890, Seney, MI. Member: AIC. Specialty: art glass dec. [40]

BRONSON, Helen [P] Cincinnati, OH b. 10 Mr 1900, Cincinnati. Studied: Cincinnati A. Acad. Member: F., Guggenheim Fnd., 1931; Cincinnati Women's AC. Work: WPA, Ohio [40]

BROOK, Alexander [P] Savannah, GA/Cross River, NY b. 14 Jy 1898, New York. Studied: K.H. Miller. Exhibited: AIC, 1929 (prize); CI, 1930 (prizes), 1939 (prize); PAFA, 1931 (gold); Am. Sect. Intl. Expo, Paris, 1937 (gold); Worcester Mus., 1938 (prize); San Fran. AA, 1938 (med). Work: WMAA; AIC; MMA; Gallery Living Art, N.Y.; Albright A. Gal.; USPO Dept., Wash., D.C. WPA artist. [47]

BROOK, Alexander, Mrs. See Bacon, Peggy.

BROOK, Alexander, Mrs. See Knee, Gina.

BROOKE, C. Gay [P] Baltimore, MD [25]

BROOKE, Lena R. See McNamara.

BROOKE, Richard N(orris) [P,T] Wash., D.C. b. 20 O 1847, Warrenton, Va. d. 25 Ap 1920, Warrenton. Studied: PAFA; Bonnât, Constant, in Paris. Member: S. Wash. A. (Pres.); Wash. SFA. Exhibited: Atlanta Expo, 1895 (med); S. Wash. A., 1901 (prize), 1904 (prize). Work: CGA; Capitol, Wash., D.C.. He served at one time as U.S. Consul at La Rochelle, France. [19]

BROOKER, Nell Danely (Mrs.) [P,C] Urbana, IL b. 1875, Astoria, IL. Studied: AIC; J. Johansen; N.A. Wells; Vanderpoel [09]

BROOKS, Adele R(ichards) [P,T] St. Louis, MO/Kenilworth, IL b. 22 S 1873, Buffalo, KS. Studied: Simon; La Forge; R. Miller; H. Snell; H. Breckenridge; N.Y. Sch. F.&Appl. A.; Pratt Inst.; AIC. Member: St. Louis A. Lg.; St. Louis S.Indp.A. Work: Univ. Ill.; Phillips Acad., Andover, Mass. [40]

BROOKS, A(lden) F(inney) [P,S] Chicago, IL/Fennville, MI b. 3 Ap 1840, West Williamsfield, OH d. ca. 1938. Studied: Edwin White; Carolus-Duran, in Paris. Member: Chicago SA, 1892 (prize); Ill. State Fair, 1895 (prize). Work: Union Cl., Chicago; Pub. Lib., Chicago; Capitol, Springfield, Ill.; Vanderpoel Coll. [38]

BROOKS, Amy [P,I,W] Brookline, MA b. Boston. Studied: BMFA Sch. Author/Illustrator: Dorothy Dainty books, Randy books, "At the Sign of the Three Birches" [21]

BROOKS, Arthur D. [P] Cleveland, OH b. 23 My 1877, Cleveland. Studied: Cornell; Cleveland Sch. A.; H.G. Keller. Exhibited: CMA, 1926 (prize), 1927 (prize), 1928 (prize), 1929 (prize), 1930 (prize), 1931 (prize), 1932 (prize), 1935 (prize), 1936 (prize) [47]

BROOKS, Carol See MacNeil, H.A., Mrs.

BROOKS, Cora [P] Lansdowne, PA/Boothbay Harbor, ME d. 26 Mr 1930. Studied: Phila. Sch. Des. for Women; Daingerfield; Snell. Member: NAC; NAWPS; Plastic Cl.; Phila. All.; Ten Phila. P.; AFA; Delaware County AA. Exhibited: Plastic Cl., 1920 (prize); NAWPS, 1922 (prize). Work: Pa. State Col.; Twentieth Century Cl., Lansdowne. Specialty: highly decorative flower canvases [27]

BROOKS, Erica May [L,P,C,T] NYC b. 9 Jy 1894, London, England. Studied: Myra K. Hughes; N. Garstin; C. Woodbury. Member: NAWA; PBC; Nat. Lg. Am. Pen Women; Royal Dr. Soc., London. Exhibited: Nat. Lg. Am. Pen Women, 1928 (prize), 1938 (prize); NAWA, 1932 (prize), 1939; Wash., D.C., 1928; Barnard Cl., 1932; 8th Street Gal., 1939. Contributor: educational magazines. Position: A. Dir., St. Agnes Sch., Albany [47]

BROOKS, Frances M. [P] Chicago, IL [01]

BROOKS, Grace E. [Min.P] Chestertown, MD [13]

BROOKS, Henry Howard [P] Concord, MA b. Bedford, MA. Studied: W.M. Paxton. Member: Gld. Boston A. [40]

BROOKS, Howard (Grigsby) [Des,C,T,P] NYC b. 21 Mr 1915, Staunton, VA. Studied: W.Va. State Col.; PIASch.; T. Col., Columbia. Exhibited: Solomon Islands A. Show; Textile Des. Comp.; CAM, 1940; CGA, 1940; VMFA, 1944. Work: murals, W.Va. State Col.; U.S. Navy; Am. Red Cross [47]

BROOKS, Isabel [P] Baltmore, MD b. Baltimore. Studied: Hugh Newell; Rhoda Holmes Nicholls; A.P.C. de Haas. Member: Baltimore WCC; North Shore AA. Specialty: watercolors [33]

BROOKS, James [P] NYC b. St. Louis, MO. Studied: B. Robinson; K. Nicolaides; ASL. Member: NIAL, 1973; Artists U.; Mural P. Exhibited: 48 Sts. Comp.; WMAA, 1963 (retrospective); Dallas MFA, 1972. Work: murals, USPO, Little Falls, N.J.; Pub. Lib., Woodside, N.Y.; lithographs, MOMA, WMAA. WPA artist. [40]

BROOKS, Mable H. [P] Austin, TX [25]

BROOKS, Maria [P] NYC b. 1837, Staines, England (came to U.S. in 1883) d. 16 N 1913 (automobile accident). Studied: South Kensington Sch., Royal Acad., both in London. Exhibited: Crystal Palace, London (med); Syracuse, 1898 (med); Pan-Am. Expo, Buffalo, 1901 (prize); Charleston, 1902 (med) [09]

BROOKS, Mary Mason [P] Boston, MA b. 1860, Salem, MA d. 20 S 1915, Jamestown, RI. Studied: Rome; Paris. Exhibited: New York; Boston

BROOKS, Maurice Edmond [S,P,T] Salt Lake City, UT. b. 23 Ja 1908. Studied: Univ. Utah. Exhibited: Utah Sate Fair; Utah A. Center; Utah State Capitol. Work: Church Latter Day Saints, Salt Lake City; Utah State Fair Grounds Admin. Bldg. Position: T., Utah A. Center [40]

BROOKS, Mildred Bryant [E,L] Pasadena, CA b. 21 Jy 1901, Maryville, MO. Studied: Otis AI; Chouinard AI; Univ. Southern Calif.; A. Miller; F.T. Chamberlin. Member: Chicago SE; Calif. SE; Calif. Pr.M.; SAE; Calif. AC; Pasadena SA. Exhibited: Calif. SE, 1932 (prize), 1937 (prize), 1943 (prize), 1946 (prize); Paris Expo, 1937 (med); Calif. Pr.M., 1935 (prize), 1938 (gold); Bookplate Intl., Los Angeles, 1930; Carmelita AI, Pasadena, 1934; Annual Pr.M. Exh., Nashville, Tenn., 1936 (prize); Chicago SE, 1934, 1935 (prize) 1936, 1937 (prize), 1938–45; LOC, 1944, 1945; Intl. Pr.M., 1932–36, 1937 (med), 1938–46; SAE, 1933, 1934 (prize), 1940, 1943, 1946; PAFA, 1933, 1937, 1940, 1944, 1946; NAD, 1935–46; Laguna Beach, 1938, 1945, 1946; Calif. SE, 1931–46; Los Angeles AA, 1937–46; Fnd. Western A., 1933 (prize), 1934–45. Work: NGA; LOC; NYPL; San Diego FA Soc.; Los Angeles Mus A.; Univ. Nebr.; Lyman Allyn Mus.; CMA; Univ. Vt.; Dayton AI; Los Angeles Pub. Lib. [47]

BROOKS, Miriam [P] Wash., D.C. [13]

BROOKS, Nicholas Alden [P] Active in NYC, 1880–1904. Possibly a pseudonym for Robert Fullerton, whose name appears on theatrical memorabilia in Brooks' trompe l'oeil still-life paintings. [*]

BROOKS, Ricard [P,Mur.P] NYC b. 6 Jy 1894, Haverhill, MA. Studied: BMFA Sch.; ASL. Member: NSMP. Work: murals, State Board Edu. Bldg., Harrisburg, Pa., USPO, Richland Center, Wis. [47]

BROOKS, Richard E(dwin) [S] Wash., D.C. b. 1865, Braintree, MA d. 2 My 1919, Boston. Studied: T.H. Bartlett; Acad. Colarossi, Paris, with Aubé, Injalbert. Member: NSS, 1907; NIAL; S. Wash. A. Exhibited: Paris Salon, 1895 (prize), 1899 (med); Paris Expo, 1900 (gold); Pan-Am. Expo, Buffalo, 1901 (gold); medals, P.-P. Expo, San Fran., 1915 (med). Work: Boston; Wash., D.C.; MMA; figures on Capitol, Hartford, Conn. [15]

BROOKS, Ruth W. [Min.P] Manila, Philippine Islands [13]

BROOKS, Ruth Walker [S,T] NYC/Raymond, NH b. 22 My 1909, NYC. Studied: A. Weinman; Mahonri Young; C. Keck; V. Salvatore; C. Hawthorne. Member: NAC; PBC; Am. Women's Assn. Jr. AG; Catherine L. Wolfe AC. Exhibited: Catherine L. Wolfe AC, 1930 (prize), 1935 (prize). Work: Church of the Ascension, Anna Warner Porter Mem. Medal, Am. Women's Soc., all in New York [40]

BROOKS, Thomas Wrighton [P,T,Des] Plattsburg, NY b. 1909, Peterborough, Ontario. Studied: Pratt Inst.; W. Adams. Member: Plattsburg AG. Exhibited: PAFA, 1938; Albany Mus. Hist.&A. Work: Pub. Lib., Plattsburg [40]

BROOME, Isaac [S,C,L,W] Trenton, NJ b. 16 My 1835, Valcartier, Lower Canada d. My 1922. Studied: PAFA. Exhibited: ceramics, Phila. Centenn., 1876 (med); Paris Expo, 1878. Work: Corcoran Mausoleum, Georgetown, D.C. [13]

BROOMHALL, Vincent [C,Des,W,L] East Liverpool, OH b. 3 O 1906, East Liverpool. Studied: CI. Member: Am. Cer. Soc. Contributor: trade publications. Lectures: Ceramic Art and History. Positions: A. Dir., Edwin M. Knowles Co.; Pres./Des., Continental Kilns, Inc. [47]

BROS, Robert [S] NYC. Exhibited: NAD, 1937; NYWCC, 1937; WFNY, 1939 [47]

BROTHER ATHANASIUS [Por.P,P,T] Brooklyn, NY b. 26 My 1893, Richmond, IA. Studied: E.C. Bannister; W. Turney; I.M. Kimball; Catholic Univ. Work: Mt. St. Joseph's Col., Baltimore; Working Boys' Home, Newton Highlands, Mass.; St. Michael's Rectory, Holy Name Rectory, Brooklyn [38]

BROUGH, Walter H. [P] Cleveland, OH b. 2 S 1890, Phila. Studied: Chase; Breckenridge. Member: F., PAFA. Exhibited: CMA, 1922 (prize), 1926 (prize) [33]

BROUGIER, Rudolphe W. [Por.P,Ldscp.P] b. Switzerland d. 11 Mr 1926, Santa Barbara, CA. Studied: France; Germany

BROUN, Aaron [I,C] NYC b. 1 Mr 1895, London. Studied: BAID; N.Y. Sch. Des. Member: Am. Bookplate Soc.; Soc. Poster Friends; All.A.Am. Publisher: "Modern Poster Annual" [25]

BROUWER, Anthony Theophilus, Jr. [P,C] West Hampton, NY [04]

BROUWER, Bernice Annable (Mrs.) [E,T] Baltimore, MD b. 11 F 1891, Grand Rapids, MI. Studied: Columbia; Dr. Tannahill; Charles Martin. Member: EAA; Baltimore Municipal AL [33]

BROWASKI, Edward [P] Newark, NJ [09]

BROWDY, Dorothy R. [P,C,T] NYC b. 20 Mr 1909, Kansas City. Studied: Kansas City T. Col.; AIC; Columbia; Kansas City AI, with T.H. Benton; ASL, with R. Marsh. Member: Kansas City SA; Art T. Gld., N.Y. Exhibited: Univ. Mo., 1926 (med); Kansas City AI, 1934, 1935; Women's City Cl., Kansas City, 1938; Kansas City SA, 1935–38 [47]

BROWN, Abigail K(eyes) (Mrs. Roy H.) [P] Rockford, IL b. 29 Mr 1891, Rockford. Studied: M.E. Reitzel; C. Krafft; W. Owen. Member: Rockford AA; Oak Park, Austin and River Forest AL. Exhibited: Rockford AA, 1926 (prize), 1927 (prize), 1928 (prize). Work: Ill. Acad. FA, Chicago [40]

BROWN, Agnes A. [P] NYC. Exhibited: NAD, 1881–98; BAC [98]

BROWN, Aimee [P] Dayton, OH b. 13 O 1882. Studied: Dayton AI; Cincinnati A. Acad.; Columbia. Member: Dayton AI; Cincinnati Women's AC. Position: T., public schools, Dayton [40]

BROWN, Alfred J. [E,En] Omaha, NE [19]

BROWN, A.K. [P] Boston, MA [01]

BROWN, Alice Van Vechten [P,T,W] Middletown, NJ b. 7 Je 1862, Hanover, NH. Studied: ASL; A. Thayer; W.M. Chase; C.M. Dewey. Member: ASL. Position: T., Wellesley Col. [40]

BROWN, Anna M. [S] Fargo, ND. Exhibited: Midwestern Ar. Ann., 1939; WFNY, 1939 [40]

BROWN, Anne R. (Mrs. C.W.) [P,C] Albany, NY b. 23 Jy 1891, Des Moines, IA. Studied: Drake Univ.; State T. Col., Albany. Member: Albany A. Group. Exhibited: Albany Inst. Hist.&A., 1941–46; Munson-Williams-Proctor Inst., 1944 [47]

BROWN, Annie [P] Phila., PA [05]

BROWN, Arlie [P] Cleveland, OH. Member: Cleveland SA [25]

BROWN, Armantine [P] Mobile, AL [25]

BROWN, Arthur William [I] NYC b. 26 Ja 1881, Hamilton, Ontario.

Studied: ASL; K. Cox; H.S. Mowbray; W. Appleton Clark; DuMond; F.R. Gruger. Member: SI; A.&W. Assn. Illustrator: "The Magnificent Ambersons," "Alice Adams," national magazines. Position: Pres., Soc. Illus., 1945-47 [47]

BROWN, Belmore [P,I,W,L] NYC b. 9 Je 1880, New Brighton, NY. Studied: N.Y. Sch. A.; Académie Julian, Paris. Illustrator: "The Conquest of Mt. McKinley," "Quest of the Golden Valley" [17]

BROWN, Benjamin C(hambers) [Ldscp.P,E] Pasadena, CA b. 14 Jy 1865, Marion AR d. 19 Ja 1942. Studied: Académie Julian, Paris, with Constant, Laurens; St. Louis A. Sch. Member: Calif. Pr.M.; Chicago SE; Pasadena SA; Calif. AC. Exhibited: Lewis and Clark Expo, Portland, Oreg., 1905 (med); Alaska-Yukon-Pacific Expo, Seattle, 1909 (med); P.-P. Expo, San Fran., 1915 (med); Calif. AC, 1916 (prizes), 1918 (prize); P.-P. Expo, San Diego, 1915 (med), 1916 (gold); Sacramento Fair, 1917 (med); Santa Ana, Calif., 1922 (prize), 1923 (prize); Los Angeles Mus. A., 1924 (prize) ; Los Angeles Fed. Women's Cl., 1924 (prize); Calif. State Fair, Sacramento, 1924 (prize), 1925 (prize); Springville, Utah, Comp., 1926 (prize); Los Angeles County Fair, 1926 (prize); Pasadena SA, 1932 (prize); Gardena A. Comp., 1932 (prize). Work: municipal collections, Oakland, Calif., Phoenix, Ariz.; pub. libraries, Pasadena, Boise (Idaho), Helena (Ark.); Calif. State Lib., Sacramento; Los Angeles Mus. A.; Southwest Mus.; Municipal Coll., Los Angeles; CMA; Brit. Mus., London; LOC; Kellogg Lib., Emporia, Kans.; Montclair (N.J.) AM; Witte Mus., San Antonio; MFA, Little Rock, Ark. [40]

BROWN, Bess L. (Mrs. Tracy Brown) [P] Tulsa, OK b. 30 Mr 1891, Washington, KS. Studied: Tulsa Univ. Member: Painters & PM Gld. Exhibited: Tulsa AA (prize) [40]

BROWN, Bolton (Coit) [P,E,L,W,T,Li] Zena, NY b. 27 N 1865, Dresden, NY d. 15 S 1936. Studied: Syracuse Univ. Member: NAC. Work: Nat. A. Cl., N.Y.; Indianapolis AA; Brooklyn Inst. Mus.; Brit. Mus.; BM; MMA; NYPL. Author: "Lithography for Artists," pub. AIC, 1930. A printer and technician, he was associated for many years with George Bellows, whose art he helped to develop. He organized the Dept. of Drawing and Painting at Stanford Univ., and was one of the founders of the Woodstock Art Colony. Positions: T., AIC (1931), NAD; Dir., Summer Sch. Lithography and Etching, Woodstock

BROWN, Brian [I,Des,Car] Wash., D.C. b. 17 N 1911, North Waterford, ME d. 13 N 1958. Illustrator: "Let Them Eat Caviar" (1937); books, magazines, newspaper cartoon features, advertising [47]

BROWN, C. Emerson [P,S,C] Beverly, MA b. 9 Ja 1869, Beverly. Studied: Cowles A. Sch., Boston; W. Adams. Specialties: marines, modeling in wax of natural history groups [13]

BROWN, Caroleen Ackerman (Mrs. Egbert Guernsey Brown) [P] b. NYC d. ca. 1938. Studied: ASL; M.S. Bloodgood. Member: Brooklyn SA [38]

BROWN, Carroll Butler [P] NYC [13]

BROWN, Charles Porter [Mar.P] b. 16 Mr 1855, Salem, MA d. 1930, Providence. Work: Peabody Mus., Salem [*]

BROWN, Charlotte Harding (Mrs. James A.) [P,I] Smithtown, NY b. 31 Ag 1873, Newark, NJ. Studied: Phila. Sch. Des. for Women; PAFA; Drexel Inst., with H. Pyle. Member: Phila. WCC; Plastic Cl. Exhibited: Women's Expo, London, 1900 (med); St. Louis Expo, 1904 (med); P.-P. Expo, San Fran., 1915. Work: LOC. Illustrator: Century [40]

BROWN, D. [P] NYC [13]

BROWN, Don [G,P] Cleveland, OH (1948) b. 1899, Taylor, TX. Studied: AIC; ASL, with B. Robinson, Benton, Miller, Sloan; A. Lhote, in Paris. Exhibited: SSAL, 1939 (prize); La. Ar., Wash. County MFA, 1938; WFNY, 1939. Position: T., Centenary Col. [40]

BROWN, Dorothy Foster [P,W] Worcester, MA b. 9 Jy 1901, Worcester. Studied: Worcester AM Sch. [25]

BROWN, Dorothy Hunter [Por.P,T] Providence, RI b. 11 N 1888 d. 24 Ja 1942. Studied: RISD. Member: Providence AC. Position: T., Mary C. Wheeler Sch., Providence [40]

BROWN, Dorothy Woodbridge [P,C,Des] Milwaukee, Wis. Studied: ASL; Mich. State T. Col. Member: Wis. Ar. Fed.; Wis. Des. Crafters. Exhibited: PAFA, 1938; Wis. Salon A., Madison, 1938; CGA, 1939 [40]

BROWN, Dorothy Woodhead [P,E,T] Malibu, CA (1966) b. 1899, Houston, TX. Studied: Stanford, Univ.; UCLA; H. McFee. Work: UCLA; La Jolla AC; Santa Barbara MA. Position: T., UCLA, 1945 [*]

BROWN, Douglas Edwin [P,T,W,L)] NYC/New Orleans, LA b. 29 S 1904, Coldwater, MI. Studied: M. Lechay; K. Heldner; Leopoldo Mendez, in Mexico. Member: Am. Ar. Cong. Exhibited: Denver M.; MOMA; WFNY, 1939. Position: T., Dillard Univ. [40]

BROWN, E.G. (Mrs.) [P] Brooklyn, NY [25]

BROWN, E. Sheppard [P] NYC [17]

BROWN, Edward Scott (Ted) [Car] Chicago, IL b. 1876, Stillwater, MN d. 28 D 1942, Norwalk, CT. Positions: Editorial Car., New York Herald Tribune, Chicago Daily News [21]

BROWN, Edward T., Jr. [Ser,Des] 25 Jy 1919, Knoxville, TN. Studied: AIC. Member: Oak Ridge AC. Exhibited: Univ. Tenn., 1938; AIC, 1940; Oak Ridge Lib., 1945. Position: A. Dept., Tenn. Eastman Corp., Oak Ridge, 1943-46 [47]

BROWN, Edwin [B,P,T] Rockland, ME/Boothbay Harbor, ME b. 25 Mr 1869, Camden, ME. Studied: H.B. Snell; A.K. Cross. Member: St. Petersburg AC [40]

BROWN, Edwin Blanchard [T,Des,C,P] Alfred, NY b. 27 Je 1909, Providence. Studied: RISD. Member: Boston Color Group; Brown Univ.; UCLA; Eugene Steinhof. Member: Providence WC Soc.; Eastern AA; R.I. Assn. A.T. Exhibited: Dance Intl., 1938; CGA, 1936, 1938; RISD, 1934-46; Brown Univ.; Buffalo Univ.; Providence WC Soc; R.I. AC. Contributor: Design magazine. Positions: T., BMFA Sch., RISD, 1934-46, Buffalo Univ. [47]

BROWN, Eleanor de Laittre, Mrs. See de Laittre.

BROWN, Elmer William [Des,P,Dec,B,Car,I,T] Cleveland, OH b. 30 N 1909, Pittsburgh. Studied: Cleveland Sch. A., with P. Travis; John Huntington Polytechnic Inst. Work: Playhouse Settlement, Cleveland. Costumer: summer operas. Set Designer: Gilpin Players of Cleveland. Position: T., The Playhouse Settlement [40]

BROWN, Elmore [P] Chicago, IL. Member: GFLA [25]

BROWN, Elmore J. [I] Bronxville, NY b. 7 Jy 1899, Buchanan, MI. Studied: AIC. Member: SI; A.&W. Assn. Illustrator: national magazines [47]

BROWN, Emma Elizabeth [I,W] Cambridge, MA b. 18 O 1847, Concord, NH. Author: "Life of Grant" [13]

BROWN, Ethel Crouch (Mrs. J.D.) [T,P,L] Chicago, IL b. 12 Ag 1890, Phila. Studied: AIC, with E. Giesbert; Increase Robinson. Member: Chicago AC; Chicago SA; Chicago Assn. P.&S.; Chicago Women A. Salon. Exhibited: South Side Community A. Center, 1928-46; PAFA, 1933; AIC, 1932; Mich. A. Exh., 1935, 1937. Work: Culver Military Acad. Position: T., Hyde Park A. Center, 1941-46 [47]

BROWN, Ethel Isadore [P] Albany, NY b. 30 N 1871, Boston. Studied: Cowles A. Sch., Boston; Merson, in Paris. Position: T., St. Agnes Sch. [08]

BROWN, Ethel Pennewill [P,I] Frederica, DE b. Wilmington, DE. Studied: Twachtman; H. Pyle. Member: Plastic Cl.; F., PAFA; Wilmington Soc. FA; Phila. All. [25]

BROWN, Ethelbert W. [P] NYC b. 12 D 1870, Camp Verde, AZ. Studied: Ecole des Beaux-Arts, Paris; Whistler, H.G. Dearth, in Paris. Exhibited: Pan-Am. Expo, Buffalo, 1901 (prize) [09]

BROWN, Fanny Wilcox [P,C] NYC b. 10 O 1882, Baltimore. Studied: B. Burroughs. Member: S.Indp.A.; Petrus Styuvesant Cl. Work: YMCA, NYC [25]

BROWN, Florence Bradshaw [P] Provincetown, MA. Exhibited: Provincetown AA, 1934; N.E. Summer Colonies Ann., Springfield MFA, 1934; Am. Soc. Min. P., 1938 [40]

BROWN, Frances. See Townley.

BROWN, Francis Clark [Mur.P,L] Noblesville, IN b. 7 Ag 1908, New Sharon, IA. Studied: C. Wheeler; O. Richey; John Herron Inst. A. Sch. Member: Ind. AC; AAPL. Exhibited: Ind. State Fair, 1934 (prize), 1939 (prize); Richmond P. Exh., 1934 (prize); Anderson AS, 1936 (prize). Work: murals, Hamilton County Courthouse, Pub. Lib., Noblesville [40]

BROWN, Francis F. [Edu,Mus.Dir,P] Muncie, IN b. 19 Ja 1891, Glassboro, NJ. Studied: J.O. Adams; W. Forsyth; John Herron AI; Ball State T. Col., Ohio State Univ. Member: Ind. AC; Hoosier Salon. Exhibited: Richmond AA, 1922 (prize); John Herron AI, 1922 (prize); Hoosier Salon, 1922-45; CMA, 1922-25; PAFA, 1922, 1923. Position: T./Dir. A. Gal., Ball State T. Col., Muncie, 1916-46 [47]

BROWN, Frank A. [P,L] NYC b. 21 Ap 1876, Beverly, MA. Studied: Boston Sch. P.; Académie Julian, Paris. Member: AWCS; Société Internationale

d'Aquarellistes, Paris; Société Coloniale des Artistes Français; SC. Exhibited: NAD, 1926; PAFA; AIC, 1925–30; AWCS, 1926–46; Salon des Artistes Français, Paris, 1924–30. Work: SFMA; Los Angeles Mus. A.; Pasadena AI; Wanamaker Coll.; Luxembourg Mus., Paris; French Nat. Mus., Paris [47]

BROWN, Frank C. [I] Boston, MA [01]

BROWN, George [P] NYC [04]

BROWN, George Bacon [P] Brooklyn, NY/St. Paul, MN b. 9 Ap 1893, Ogdensburg, NY d. Fall, 1923, Mankato, MN. Studied: Chicago AI; St. Paul Inst., with L.W. Zeigler. Member: St. Paul AS [21]

BROWN, George Yeadon [P] Delaware Co., PA [09]

BROWN, Gertrude G. [P] Wash., D.C. b. 9 My 1880, Malden, W.Va. Member: AWCS; Wash. AC [47]

BROWN, G.T. [P] St. Paul, MN [13]

BROWN, Gilbert T. [P] Dayton, OH b. 13 Ag 1869. Member: AFA; Dayton AI [40]

BROWN, Glenn Madison [P,E] Wash., D.C. 28 O 1876, Hartford, CT. Studied: ASL, Wash., D.C.; E.C. Messer; ASL; Académie Julian, Académie Colarossi, Paris; Laurens, Prinet, in Paris. Member: Wash. AC [38]

BROWN, Grace Evelyn [P,W,L,T] Brookline, MA b. 24 N 1873. Studied: Mass. Normal A. Sch.; Joseph De Camp; Albert Munsell. Member: Boston AC; Copley Soc.; Springfield A. Lg.; Brookline A.&Let. Cl.; Boston Salon All. A. Exhibited: PAFA, 1929; Boston AC, 1936–46; Springfield A. Lg., 1941–46; Copley Soc., 1933 (one-man). Contributor: poetry magazines and anthologies [47]

BROWN, (H.) Irene [P,T] Orange, NJ. b. 26 F 1881, Hastings, MI. Studied: William M. Chase; Charles Hawthorne; John Johansen [33]

BROWN, Harold Haven [P,I,T,B] Provincetown, MA b. 6 Je 1869, Malden, MA d. 7 Ap 1932. Studied: Mass. Normal A. Sch.; Ecole des Beaux-Arts, with Gérôme; Académie Julian, Paris, with Laurens. Exhibited: Pan-Am. Expo, Buffalo, 1901 (med). Specialty: art maps and block prints. Positions: Dir., John Herron AI, Indianapolis (1914–21), Provincetown AA [25]

BROWN, Harrison B. [P] (Also known as Henry Box Brown) b. 1831, Portland, ME d. 10 Mr 1915. Studied: began as a sign painter; made survey drawings for John Bartlett in San Fran., 1852. Exhibited: NAD, 1858. Work: Peabody Mus., Salem; Portland MA. Specialty: marine paintings of Casco Bay, Maine

BROWN, Harrison Paul [P,Des,B,C,T] Mt. Clemens, MI b. 29 Ja 1889, Waterloo, IN. Studied: Chicago Acad. FA; George Senseney; Walter M. Clute; Frederick F. Fursman; Saugatuck Summer Sch. P. Member: Ind. Ar. Cl. [40]

BROWN, Henry Box. See Brown, Harrison B.

BROWN, Helen Parrish [P] Stony Brook, NY [21]

BROWN, Horace [P,L] Springfield, VT b. 23 O 1876, Rockford, IL. Studied: John Carlson; John Johansen; W.L. Lathrop; W.L. Metcalf. Member: All. AA; Springfield AL. Exhibited: Springfield (Mass.) AL, 1933 (prize), 1934 (prize); All. AA, 1936 (prize); Conn. Acad. FA, 1937 (prize). Work: PAFA; Municipal Coll.; Oak Park, Ill., Orange, N.J.; Wood Gal., Montpelier; Middlebury Col.; Vanderpoel Gal. [40]

BROWN, (Howard) Scott [Car] Mansfield, OH b. 25 D 1909, Mechanicsburg, OH. Studied: AIC. Exhibited: U.S. Gov. Cartoon Exh., 1943, 1944; Cartoon Exh., English Speaking Union, 1943. Illustrator: Collier's, American, other magazines and newspapers [47]

BROWN, Howard V. [P,L,T] NYC b. 5 Jy 1878, Lexington, KY. Studied: AIC; ASL. Member: SI, 1910 [25]

BROWN, Howard Willis [E] Chicago, IL b. 7 Ag 1905, Fitzgerald, GA. Member: Chicago SE; South Side AA; Chicago Gal. A. Work: NGA [40]

BROWN, Howell C(hambers) [E] Pasadena, CA b. 28 Jy 1880, Little Rock, AR d. 1954. Member: Prairie PM; Chicago SE; Soc. Am. E.; PM Soc. Calif.; AFA. Work: Mus. Hist., Sc.&A., Los Angeles; Calif. State Lib., Sacramento; LOC; Smithsonian Inst. Specialty: Western scenes [40]

BROWN, Irene [P,S,T] South Orange, NJ b. 26 F 1881, Hastings, MI d. 28 Jy 1934, Hyanisport, MA. Studied: Chase; Hawthorne; Johansen. Member: NAWPS [25]

BROWN, James Francis [P] NYC b. 1862, Niagara Falls, NY d. 6 F 1935. Studied: NAD; Collin, Bouguereau, in Paris; Royal Acad., Munich. Member: SC, 1904 [33]

BROWN, John Appleton [P] NYC b. 24 Jy 1844, West Newbury, MA d. 8 Jy 1902. Studied: B.C. Porter; Emile Lambinet, in Paris. Member: ANA; SAA, 1892; NYWCC. Exhibited: NAD, 1875–1900; BMFA; Columbian Expo, Chicago, 1893 (med). Worked in Europe in 1867 and in the 1880s. [01]

BROWN, J. Appleton (Mrs. Agnes A.) [P] NYC. Member: Women's AC [01]

BROWN, J(ohn) G(eorge) [P] b. 11 N 1831, Durham, England d. 8 F 1913, NYC. Studied: William B. Scott, in England; NAD, with Cummings. Member: ANA, 1861; NA, 1863; AWCS; A. Fund S.; SC; Century Assoc. Exhibited: Paris Expo, 1889 (prize); Mechanics' Inst., Boston (medals); Calif., 1894 (med); Pan-Am. Expo, Buffalo, 1901 (med); PAFA; Boston Athenaeum; NAD. Work: CGA; Detroit Mus. A.; MMA; other major mus. He came to the U.S. in 1853, becoming its most popular genre painter of the late 19th century. Specialty: street urchins [13]

BROWN, Joseph [S,T] Princeton, NJ b. 20 Mr 1900, Phila. Studied: Temple Univ.; R. Tait McKenzie. Member: Am. Assn. Univ. Prof.; Am. Fed. T. Exhibited: Montclair A. Mus., 1941 (med), 1942; NAD, 1934, 1935, 1940, 1944 (prize); AIC, 1941; PAFA, 1934–44; Arch. Lg., 1935, 1937. Work: MacCoy Mem., Princeton; Pa. State Col.; Temple Univ. Position: Instr., S., Princeton Univ., 1939– [47]

BROWN, (Joseph) Randolph [P,I] Sharon, MA/Marblehead, MA b. 24 Ja 1861, Port Huron, MI. Studied: Vonnoh; Tomaso Juglaris; abroad. Member: S.Indp.A.; Boston S.Indp.A.; Marblehead AA; Gloucester S.Indp.A. [40]

BROWN, Lillian Cushman (Mrs. Charles Lyman Brown) [P,T,L,W] NYC. Studied: AIC; ASL; Arthur W. Dow. Member: Nat. Edu. Assoc.; Western Drawing and Manual Training Assoc.; College AA; Eastern AA [33]

BROWN, Lillian M. [P] St. Louis, MO. Member: SWA [04]

BROWN, Louise Norton (Mrs. Neal) [P] Lockport, IL b. Lockport. Studied: AIC, with Henry Spread; Chase, in NYC [05]

BROWN, Lucille Rosemary [P,I,T] Venice, CA/Beaumont, CA b. 25 Jy 1905, Hollywood, CA. Studied: UCLA. Member: Calif. WCS; PS; Santa Monica AA. Exhibited: Los Angeles Co. Fair, Pomona, 1929 (prize); Santa Monica AG, 1930 (prize) [40]

BROWN, Lura Thomas [P] Baltimore, MD. Member: Baltimore WCC [25]

BROWN, Lydia M. [P,T,Des] Atlanta, GA b. Watertown, NY. Studied: ASL; DuMond; Hawthorne; Breckenridge; Carlson. Member: New Orleans AA; New Orleans ACC; SSAL [33]

BROWN, M. Lamont [Wood En] South Framingham, MA. Member: Boston SAC [13]

BROWN, Margaretta (Gratz) [P] Provincetown, MA b. St. Louis d. 4 Mr 1932, St. Louis. Studied: E. Ambrose Webster; Woodbury; William Chase. Member: St. Louis AG [33]

BROWN, Mary Johnston (Mrs. DeWitt, Jr.) [P] New Augusta, IN b. 4 F 1918, Indianapolis. Studied: John Herron AI; Butler Univ.; Ind. Univ. Exhibited: Witte Mem. Mus., San Antonio, 1945 (prize); John Herron AI, 1942, 1944 (prize); AIC, 1940, 1943 [47]

BROWN, Mary Page [Min.P] Bryn Mawr, PA [25]

BROWN, Matilda (Mrs. Frederick Van Wyck) [P,S,I,T] Greenwich, CT b. 8 My 1869 d. ca. 1954. Studied: C.M. Dewey; H.S. Bisbing, in Holland; Académie Julian, Paris; Bouguereau; Dupré; La Haye. Member: AWCS; N.Y. Soc. P.; Greenwich AA; All. AA. Exhibited: Columbia Expo, Chicago, 1893 (prize); NAD, 1899 (prize), 1901 (prize); Conn. Acad. FA, 1918 (prize), 1919 (prize); Greenwich SA, 1929 (prize). Work: Mus. City of N.Y.; CGA; Bruce Mus. A., Greenwich. Illustrator: "Recollections of an Old New Yorker," by Frederick Van Wyck, 1932 [47]

BROWN, M(ay) (Morgan) (Mrs. Everett S.) [P] Ann Arbor, MI b. Hartwell, OH. Studied: Univ. MI, with James Donald Prendergast. Member: Ann Arbor AA; Detroit Soc. Women P.; Mich. Acad. Sc.A.&Let. Exhibited: Mich. Acad., 1932 (prize), 1933 (prize), 1943–46; Detroit Inst. A., 1938 (prize); Detroit Inst. A., 1938 (prize); Detroit Soc. Women P., 1933–42, 1943 (prize), 1944–46; NAC, 1928; CGA, 1941; Milwaukee AI, 1946; Ann Arbor AA, 1923–46; Detroit AA, 1929–46 [47]

BROWN, M.R. (Mrs.) [P] Minneapolis, MN [15]

BROWN, Natalie Bayard [P] Newport, RI [19]

BROWN, Olive V.V. [P] Wellesley, MA. Member N.Y. Women's AC; CSB, 1901 [04]

BROWN, Ozni (Mr.) [I] NYC. Member: SI [47]

BROWN, Paul [E,I,Dr,P,L,W] Garden City, NY b. 27 N 1893, Mapleton, MN d. 25 D 1958. Author/Illustrator: "Aintree," "Spills and Thrills," "Hits and Misses," "Crazy Quilt." Illustrator: more than 100 books, including "Hunting Pie," "Fox Hunt Formalities"; Cosmopolitan, Collier's, Harper's Bazaar, Liberty, American Legion, other magazines. Specialty: sports, particularly horses in action [40]

BROWN, Paul F. [I] b. 1871, Concord, NH d. 8 Dec 1944, North Weymouth, MA. Position: Staff A., Boston Herald

BROWN, Pluma [P] NYC. Member: NAWPS. Exhibited: NAWPS, 1935, 1936, 1937 [40]

BROWN, R. Alston [I] NYC b. 4 Je 1878, Xenia, OH. Studied: Chase; DuMond; Mora; Nowottny [25]

BROWN, Ray [I,W] NYC b. 16 Jy 1865, Groton, CT d. 30 Ap 1944. Studied: Worcester Polytechnic Inst. Work: Chicago (1893), and New York newspapers (since 1896). Position: A. Dir., Everybody's Magazine [19]

BROWN, Robert [P,Arch,Des] Winthrop, MA. Member: Boston AC [09]

BROWN, Robert A. (Bob) [P] St. Paul, MN/Lakeland, MN b. 16 S 1895, Berlin, WI. Studied: Robert Henri. Member: Minn. AA; Minn. Ar. U.; Am. A. Cong. Work: White House [40]

BROWN, Robert E. [P] Chicago, IL [04]

BROWN, Robert Franklin (Bo) [I,Car] Jenkintown, PA b. 2 Jy 1906, Phila. Studied: Univ. Pa. Work: English Speaking Union; OWI; A. Dir. Cl.; magazines in the U.S. and England [47]

BROWN, Roy H. [P,I] NYC/Wilton, NH b. 1879, Decatur, IL d. 1956. Studied: ASL; Rafaelli, Ménard, in Paris. Member: NA; AWCS; NAC; SC; Century Assn.; Paris AAA; NYWCC. Exhibited: SC, 1918 (prize), 1925 (prize), 1930 (prize), 1938 (prize); NAD, 1921 (prize), 1926 (prize); Baltimore WCC, 1923 (prize); NAC, 1924 (med,prize); AWCS, 1937 (med), 1938 (med). Work: AIC; Northwestern Univ.; Springfield (Ill.) AA; NAC; Hackley Gal.; MMA; Milwaukee AI; Herron AI; Decatur AI [47]

BROWN, Ruth [P,Des] Richmond, VA. Studied: Boston. Member: Richmond AC [19]

BROWN, Sam [P] Westport, CT. Member: GFLA [25]

BROWN, Samuel Joseph [P,T] Phila. b. 16 Ap 1907, Wilmington, NC. Studied: PMSchIA; T. Col., Univ. Pa. Work: Pa. Mus. A.; Univ. Pa.; Howard Univ.; Lincoln Univ.; Pedagogical Lib., Phila.; PWA Coll. Illustrator: "The Picnic" (textbook). Position: Instr., Bok Vocational Sch. [40]

BROWN, Sonia Gordon [S] NYC/Wellfleet, MA b. 11 Ja 1890, Moscow, Russia. Studied: Europe. Member: N.Y. Soc. Women A.; NAWPS. Work: WMAA; BM [40]

BROWN, Thomas E. [P] Wash., D.C. b. 31 My 1881, Wilmington, N.C. d. 25 Ja 1938. Studied: Corcoran Sch. A.; Fred Wagner; PAFA; W. Lester Stevens; Edgar Nye. Member: Wash. SA; Wash. WCC; SSAL; AFA. Exhibited: Soc. Wash. A., 1928 (prize) [38]

BROWN, Tom [P] San Antonio, TX d. 16 Jy 1917 [15]

BROWN, Walter Francis [P,I] Venice, Italy/Providence, RI b. 10 Ja 1853, Providence d. late 1929, Venice. Studied: Brown Univ; Gérôme, Bonnat, in Paris. Member: Providence AC. Work: Hay Lib., Providence. Illustrator: "A Tramp Abroad," by Mark Twain, "Roger Williams," by Charles Miller. Specialty: scenes of Venice, his adopted home [27]

BROWN, William Alden [P,W,L] Providence, RI b. 15 Mr 1877, Providence. Studied: R.I. Sch. Des.; Lyme, Conn., with Frank DuMond; John F. Carlson; ASL (summer classes), Woodstock, N.Y. Member: Providence AC; Providence WCC; Conn. Acad. FA. Exhibited: Albright A. Gal.; Baltimore WCC; Denver SA; Conn. Acad. FA; Providence AC; New Haven PCC. Contributor: art magazines [47]

BROWN, William Mason [P] Brooklyn, NY b. 1828, Troy, NY d. 6 S 1898. A veteran of the Hudson River school of artists, his first success was as a painter of fruit. [98]

BROWN, W(illiam) Norman [Mus.Cur,L,Edu] Moylan, PA b. 24 Je 1892, Baltimore, MD. Studied: Johns Hopkins Univ. Member: Am. Oriental Soc.; Linguistic Soc. Am.; Am. Philosophical Soc. Author: books on Indian culture, articles to journals of Oriental societies. Lectures: Art of India. Positions: Prof. Sanskrit, Univ. Pa., 1926– ; Cur., Indian Art, PMA, 1930– ; Cur., Oriental Section, Univ. Pa. Mus., 1942– [47]

BROWN, William R., Jr. [P] Boston, MA. Member: Boston AC [09]

BROWNE, Aldis B., II [P] Essex, CT. b. 2 Ag 1907, Wash. D.C. Studied: Westminster Col.; Yale. Exhibited: BAID, 1932–34 (med); Wadsworth Atheneum; 48 Sts. Comp., 1939. Work: murals, U.S. Coast Guard Acad.; USPO, Oneonta, Ala. [47]

BROWNE, Belmore [P,W,I,L] Ross, CA/Seebe, Alberta b. 9 Je 1880, Thompkinsville, NY d. 1953. Studied: N.Y. Sch. A.; Chase; Beckwith; Académie Julian, Paris. Member: Alberta SA; ANA, 1928. Work: NGA; AMNH; Albright A. Gal.; Amherst Col.; Springville Art Assoc. Position: Dir., Santa Barbara Sch. Arts, 1930–34 [47]

BROWNE, Byron (George) [P,Mur.P,Des,S] NYC b. 26 Je 1907 d. 25 D 1961. Studied: NAD. Member: Am. Abstract A.; Am. A. Cong. Exhibited: NAD 1928, 1929; Carnegie Inst., 1946; Audubon A. Gal., 1945; CGA, 1928; PAFA, 1930, 1936, 1946; WMAA, 1935, 1937, 1939, 1946; MOMA, 1939; AID, 1928, 1935, 1946; NYC, 1936–44 (one-man); Kootz Gal., 1946 (one-man). Over 60 one-man shows, 1933–77. Work: murals, WNYC; WFNY, 1939. Specialties: des. stone memorials; abstract murals. His wife, Rosalind Bengelsdorf, also an abstract painter and WPA muralist, became critic in 1947. [47]

BROWNE, Charles Francis [Ldscp.P,T,W,L] Chicago, IL b. 21 My 1859, Natick, MA d. 29 Mr 1920, Waltham, MA. Studied: Boston Mus. Sch., 1882–84; PAFA, with Eakins, 1885–87; Gérôme, 1887–90, Schenck, both in Paris. Member: Chicago SA; Chicago WCC; Chicago Municipal AL. Chicago AG; ANA, 1913. Exhibited: AIC, 1905, 1906 (prize), 1911, 1913 (prize); Panama-Pacific Expo, San Fran., 1915. Positions: T., Chicago, AI; Asst. Art Comm. to Buenos Aires, Santiago, 1910. Brother-in-law of Lorado Taft. [19]

BROWNE, Frances E. [P] Cincinnati, OH. Member: Cincinnati Women's AC [25]

BROWNE, Frederick [P] Bellaire, TX. Exhibited: Ann. Houston Ar. 1939; Houston Mus. FA, 1938 (prize) [40]

BROWNE, George Elmer [P,E,Li] NYC b. 6 My 1871, Gloucester, MA d. 13 Jy 1946. Studied: BMFA Sch.; Lefebrvre, Robert-Fleury, in Paris. Member: ANA, 1919; NA, 1927; SC, 1898; A. Fund S., 1902; Paris AAA, 1912; AWCS, 1915; NAC, 1915; Allied AA, 1915; NYWCC, 1917; Soc. Am. E.; Century C.; Nat. Inst. A.&L.; Lotos Cl.; Aquarellists S.; Am. Soc. PS&G; Brooklyn SE; AAPL; Conn. Acad. FA; Am. FA. Exhibited: Mechanics' Fair, Boston, 1885 (med); Salma. Cl., 1898 (prize), 1901 (prize), 1915 (prize), 1917 (prize), 1919 (prize), 1920 (prize), 1921 (prize), 1927 (prize), 1932 (prize), 1936 (prize); AIC, 1923, (prize); Baltimore WCC, 1926, (prize); NAC, 1928 (prize), 1933 (prize); Allied AA, 1928 (gold), 1934 (gold); NAD, 1934 (prize); AWCS, 1936 (prize); Work: Toledo Mus. A.; NGA; Chicago AI; Montclair Mus., N.J.; Omaha Pub. Lib.; Erie A. Cl., Pa.; Union Lg. Cl., Chicago; Kans. Univ.; Milwaukee AI; Univ. Cl., Milwaukee; French Government; NAD; NYPL; MMA; Los Angeles Mus. A.; NAC; Salma. Cl.; Lotos Cl.; High Mus.; Pub. Lib., Birmingham, Ala.; Mus. Montpellier, France; Hotel de Ville, Cahor's France, 1936. Award: Chevalier of the French Legion of Honor. Director: Browne's Art Class, abroad and Provincetown, Mass. [40]

BROWNE, George Elmer (Mrs.) [P] NYC [25]

BROWNE, Gordon [P] Boston, MA [98]

BROWNE, Harold Putnam [P] Danvers, MA b. 27 Ap 1894, Danvers, MA d. 11 Je 1931, Provincetown. Studied: Caro-Delvaille, Acad. Colarossi; Jean Paul Laurens and Paul Albert Laurens, Académie Julian, Paris; Heymann, in Munich; George Elmer Browne; F. Luis Mora. Member: Paris AAA; Paris AASC; Provincetown AA; College AA; Columbus AL; Beachcombers. Exhibited: Paris Salon. Son of artist George Elmer Browne. [33]

BROWNE, Kate R. St. Louis, MO. Member: SLP [98]

BROWNE, Lewis [I,W,L] Santa Monica, CA b. 24 Je 1897, London. Exhibited: AI Graphic A. 1926 (prize). Author/Illustrator: "Stranger Than Fiction," "Since Calvary," "All Things Are Possible" [40]

BROWNE, Margaret Fitzhugh [P,T,W,L,Cr] Boston, MA b. 7 Je 1884, Boston. Studied: Mass. Normal A. Sch.; BMFA Sch.; Frank Benson; Joseph De Camp; Richard Andrew; Albert H. Munsell. Member: All.A.Am.; NAWA; North Shore AA; Boston AC; Copley Soc.; AAPL; Newport AA. Exhibited: North Shore AA, 1923 (prize); BM, 1928 (prize); CGA, 1924, 1926, 1939 (one-man); 1937; PAFA, 1925, 1931; AIC, 1914; Conn. Acad. FA, 1916–46; Newport AA, 1916–46; All.A.Am.; NAWA; Copley Soc.; Boston AC; North Shore AA, 1924–46. Ogunquit A. Center, 1941 (prize); Soc. for Sanity in Art, Chicago, 1941 (prize). Work: MIT; Boston Univ.; Harvard; Bureau of Standards, Wash., D.C.; Powers Sch., Boston; Springfield AA; Buckley Sch., N.Y.; Master Mariners Assn.;

Driscoll Sch., Brookline, Mass.; High Mus. of Art, Atlanta; Wesleyan Col., Macon, Ga. [47]

BROWNE, Myna Lissner [I] Santa Monica, CA b. 16 Ja 1905, Los Angeles. Studied: Lewis Browne. Illustrator: "Since Calvary," by Lewis Browne. [33]

BROWNE, Syd [E] NYC b. 21 Ag 1907, Brooklyn, NY. Studied: ASL; Eric Pape; DuMond. Member: AWCS; SAE; Southern Pr.M.; SC; Phila. WCC; NYWCC. Exhibited: Paris Expo, 1937; WFNY, 1939; AIC, 1939. Work: LOC [47]

BROWNE, Walter East (Bud) [P,G] Greenville, OH b. 24 Mr 1912, Greenville. Studied: Dayton AI. Member: Greenville AG; Ohio WC Soc.; Ohio Pr. M. Exhibited: Dayton AI; Greenville AG; Ohio WC Soc. Work: Greenville AG [40]

BROWNELL, Franklin P. [P,T] Ottowa, Canada b. 1857, New Bedford, MA. Studied: Bouguereau; Robert-Fleury. Member: RCA; Toronto Soc. A. [01]

BROWNELL, Matilda Auchincloss [P] NYC/Stockbridge, MA b. NYC. Studied: Chase; MacMonnies. Work: Yale; Barnard Col.; N.Y. Bar Assoc.; BMA; Union Col., N.Y. [40]

BROWNELL, Rowena P. [P,Photogr] Providence, RI. Member: Providence AC [25]

BROWNING, Amzie Dee (Mr.) [Des,Mur.P,L,W] Tacoma, WA b. 29 F 1892, Kent, WA. Studied: George Z. Heuston. Member: Tacoma FAC. Work: Wash. State Capitol. Position: Des./En., neon displays, Sharpe Sign Co. [40]

BROWNING, G. Wesley [P] Salt Lake City, UT b. 24 S 1868, Salt Lake City d. 11 O 1951. Studied: Univ. Utah. Member: Assoc. Utah A. Work: Vanderpoel Coll.; State Capitol, Utah. Exhibited: PAFA, 1922; AIC, 1905; Utah State Inst. FA [47]

BROWNING, Victoria Reed [Por.P] Cleveland, OH b. 1 Ag 1914. Studied: Cleveland Sch. of Art; Henry G. Keller. Exhibited: Cleveland Mus. Art, 1936 (prize) [40]

BROWNLIE, Alexander Montclair, NJ d. 24 O 05 [01]

BROWNLOW, Charles Victor [P] Phila., PA b. 28 My 1863, England. Studied: J.W. Whymper [21]

BROWNLOW, William Jackson [I] Shaker Heights, OH b. 22 Ja 1890, Elmira, NY. Studied: Bridgman; Fogarty; Dufner. Member: Cleveland SA; Cleveland Print Cl. [25]

BROWNSCOMBE, Jennie (Augusta) [P] NYC/Palenville, NY b. 1851, Honesdale, PA. d. 5 Ag 1936, Bayside, NY. Studied: L.E. Wilmarth; NAD; ASL; Henry Mosler, in Paris. Member: NAC; NY Mun. AS; NA Women PS. Exhibited: London, RA, 1900. Work: Mus. Pilgrim Hall, Plymouth, Mass.; Newark Mus.; Yale Univ.; Federal Circuit Court, N.Y.; Rutgers Col. Specialty: early American subjects [33]

BROWNSON, Walter C. [P] Chicago, IL [17]

BROWSE, Mabel Elizabeth [P,T] Phila., PA/Grape Island, WV b. 17 My 1875, Grape Island. Studied: PAFA; Phila. Sch. Des. for Women [13]

BROXTON, Margaret K. See Johnston.

BROZIK, Jaroslav [E,Li,P,T] Flint, MI/Cicero, IL b. 29 N 1904, Pizen, Czechoslovakia. Studied: AIC. Exhibited: Intl. Lith. and Wood-Eng. Exh., AIC, 1931; Chicago Artists, 1932 (prize); Detroit AI (gold). Work: lithographs, Flint Inst. A.; Little Gal., Cedar Rapids, Iowa; Cranbrook Fnd., Bloomfield Hills, Mich.; mural, USPO, Howell, Mich. [40]

BRUBAKER, George Randall [P] b. 1908, Kansas d. My 1977. Studied: Univ. Kans.; Grosz, ASL. Member: United Scenic Artists. Exhibited: Prague Int. Exh; Kansas City AI; WFNY, 1939; WPA [*]

BRUBAKER, Jon O. [P,I] Greenport, NY b. 5 O 1875, Dixon, IL. Studied: Bridgman; Académie Julian, Paris. Member: AG. Exhibited: Art Dir. Cl., 1926 (prize); Art Center, 1926 (prize). Specialty: posters [33]

BRUCE, Blanche Canfield [P,L] Terre Haute, IN/Minoqua, WI b. Wells, MN d. 26 Ag 1945. Studied: Charles W. Hawthorne; Susan Ricker Knox; Hayley Lever; AIC. Member: Terre Haute PBC; Hoosier Salon; Ind. AC. Work: Nat. Hist. Mus., Chicago; Ind. State T. Col., Terre Haute [40]

BRUCE, Edward [P] Wash., D.C. b. 1879, Dover Plains, NY d. 26 Ja 1943, Hollywood, FL. Member: ANA, 1935; Nat. Inst. A.&L. Exhibited: Carnegie Inst., Pittsburgh, 1929. Work: Luxembourg Gal., Paris; Phillips Mem. Gal., Wash., D.C.; Honolulu Acad. FA. Position: Chief, Sect. FA, WPA [40]

BRUCE, Helen Kibbey [P] Paris, France b. 1881, Boston, MA [09]

BRUCE, Joseph [P] b. 1839, England d. 8 Je 1909, NYC. Specialty: fruits and flowers

BRUCE, Laura S. [P] Paris b. Lexington, KY. Studied: Courtois; Fournier; Aublet [98]

BRUCE, Marjorie Mackenzie [Des,Cr] Boston, MA/Shelburne, Nova Scotia b. 25 D 1895, Shelburne. Studied: Boston Sch FA&Crafts; C. Howard Walker. Member: Boston SAC. Postion: Des., Folk Handicrafts Gld. [47]

BRUCE, Patrick Henry [P] NYC/Paris, France b. Virginia. Studied: Robert Henri. Member: Paris AAA, Societé Anonyme [10]

BRUCE, Preston (Miss) Louisville, KY. Member: Louisville AL [01]

BRUCE-JOY, Albert [S] Paris, France [05]

BRUCKER, Edmund [P,T] Indianapolis, IN b. 20 N 1912, Cleveland, OH. Studied: Cleveland Sch. A.; Henry Keller; Rolf Stoll; Wayman Adams. Member: Ind. AC; Ind. Soc. Pr.M.; Hoosier Salon. Exhibited: PAFA 1937, 1940, 1944; Carnegie Inst., 1941; AV, 1942; LOC., 1945; NAD, 1943; CMA, 1929-46; Butler AI, 1937-45; John Herron AI, 1939-46; Hoosier Salon, 1939 (prize), 1940 (prize), 1941-46; Milwaukee AI, 1946. Position: Instr., John Herron Sch. A., Indianapolis, 1938-46 [47]

BRUEHLER, Lenor Betterly [P] Cleveland, OH b. 30 Je 1903, Cleveland. Studied: Henry G. Keller; Frederick Gottwald; Julius Mihalik. Member: Cleveland PM. Exhibited: Cleveland Mus. A., 1934, 1935 (prize), 1936. Work: Cleveland Mus. PC [40]

BRUEN, Elizabeth Dorsey [P] Savannah, GA b. 17 Feb 1908, Savannah. Studied: NY Sch. FAA; Paris; Italy. Member: Savannah AL; SSAL [38]

BRUENECH, George Toronto, Ontario. Member: OSA. Exhibited: RCA; AAM [01]

BRUESTLE, Bertram G. [P] New Haven, CT/Lyme, CT b. 24 Ap 1902, NYC. Studied: NAD; Charles C. Curran; Francis Jones. Member: SC; Lyme AA; New Haven PCC. Exhibited: Lyme AA; SC; New Haven PCC. Work: Ames Mem. Gal., New London, Conn. Illustrator: medical journals. Son of G.M. Bruestle. [47]

BRUESTLE, George M. [P,T,Ldscp.P] NYC/Lyme, CT b. 21 D 1871, NYC d. 14 Ag 1939. Studied: ASL; Mowbray; Acad. Colarossi, Paris; Courtois; Aman-Jean, in Paris. Member: ANA, 1927; Lyme AC; SC; Allied AA; Lotos Cl.; NAC; CAFA. Work: Gibbes Mem. Mus., Charlestown, S.C.; Reading Mus.; Cleveland Mus. A.; Dayton Mus. [33]

BRUGGER, Dorothy [Min.P] Dongan Hills, NY. Member: NAWPS; ASMP. Exhibited: ASMP, 1938 [47]

BRUGUIERE, Francis [Photogr,P] b. 1879, San Fran., CA d. 1945, England. Studied: Europe; Frank Eugene. Member: Photogr. Sec. 1905. Exhibited: Albright AG, 1910; Berlin, 1928; Stuttgart, 1929; London, 1949; IMP, 1959. Work: IMP; LOC; Oakland MA; SFMA. Specialties: cut paper; light abstractions. Studio in NYC, 1919. [*]

BRUHL, Adalene Wellborn (Mrs. Charles) [Mus.Cur] Houston, Tex b. 17 O 1904, Houston. Studied: Univ. Houston; British Mus. Position: Cur., Houston Mus. FA, 1937-42 [47]

BRUIN-MALONEY, Louise Burdette (Mrs. Weiger Bruin) [P] Amsterdam, Holland b. Cleveland, OH. Studied: Cleveland Sch. A.; ASL; Maurice Sterne, in Rome. Exhibited: Cleveland A. Center; Cleveland Mus., 1938. Work: Cleveland Mus.; Phillips Mem. Gal., Wash., D.C. [40]

BRUMBACK, Louise Upton (Mrs. Frank F. B.) [P,W,L] Gloucester, MA b. Rochester, NY d. 22 F 1929. Member: NAWPS; NAC; PBC; NYSWP. Work: AA, Omaha, Nebr.; Mem. Gal., Rochester, N.Y.; BM; Newark Mus. [27]

BRUMBAUGH, Roscoe Nickey [Edu,P,L] Hartsville, SC b. 25 S 1918, Columbia City, IN. Studied: DePauw Univ.; Western Reserve Univ.; Butler Univ. Member: CAA. Positions: Asst. Prof./Head, Dept. A., Coker Col., Hartsville, S.C., 1944- [47]

BRUMIDI, Lawrence [Por.P] b. 1862 d. 10 N 1920, Wash., D.C. Studied: Paris. Son of Constina Brumidi who painted "The Progress of Victory," in the dome of the U.S. Capitol. Assisted his father in painting several of the frescoes in the Capitol Rotunda.

BRUMME, Carl Ludwig [S] Brooklyn, NY b. 19 S 1910, Bremerhaven, Germany. Studied: Leo Amino. Exhibited: Massillon Mus. A., 1942-45; Mus. Non-Objective Painting, 1943, 1944; Pinacotheca, 1944, 1945; Dartmouth Col., 1944 [47]

BRUMMER, Beata Mortensson [P] NYC. Member: S.Indp.A. [25]

BRUMMER, Joseph NYC b. 1883, Yugoslavia d. 14 Ap 1947. Studied: Rodin, in Paris. An art dealer, he opened New York gallery in 1914. Award: Chevalier of the French Legion of Honor

BRUNDAGE, Frances I. (Mrs. W.T.) [P] Brooklyn, NY b. 28 Je 1854, Newark, NJ. Studied: her father, Rembrandt Lockwood. [21]

BRUNDAGE, William Tyson [Mar.P,I] Brooklyn, NY b. 14 Ja 1849, NYC d. 6 F 1923. Studied: Shirlaw; ASL. Member: SC; ASL [21]

BRUNER, Louise (Mrs. Raymond A.) [Cr] Cleveland, OH b. 13 Je 1910, Cleveland. Studied: Denison Univ. Contributor: Magazine of Art. Position: Cr., Cleveland News, 1942– [47]

BRUNER, Mary A. [Min.P] Phila., PA [08]

BRUNET, Adèle Laure [P,I,T,Des] Dallas, TX b. Austin, TX. Studied: Univ. Tex.; ASL; AIC; George Bridgman; Henry Rittenberg; Mahonri Young. Member: NAWPS; SSAL; Dallas AA; Tex. FA Soc.; AAPL. Exhibited: Mus. N.Mex., Santa Fe, 1930; Dallas Mus. FA; NAWA; SSAL; Texas FA Assn. Work: murals, Newman Club Hall, Austin; [47]

BRUNETTIN, Afred Joseph [S,C,Des] Cicero, IL b. 28 Ag 1917, Chicago, IL. Studied: Cheuseng; Wallace; AIC; Minneapolis Sch. A.; Carl Milles; Cranbrook Acad. A. Member: F., Cranbrook Acad. Exhibited: AIC, 1940; Detroit AI, 1941; Carnegie Inst., 1939; Minneapolis AI, 1939; Pittsburgh; Milwaukee. Award: Prix de Rome, 1940 [47]

BRUNI, G. L. [P] Brookline, MA. Member: Boston AC [25]

BRUNK, Anne [P] Des Moines, IA/Provincetown, MA b. Harrisonburg, VA. Studied: Henry Hensche. Member: Provincetown AA. Exhibited: Iowa AC, 1932 (prize); Des Moines Women's Cl., 1934 (prize), 1938 (prize) [40]

BRUNN, J.G. [P] St. Louis, MO b. Liverpool, England. Studied: London; Paris. Exhibited: St. Louis Expo, 1898 [98]

BRUNNER, Bruce Christian [Ldscp.P,Dr,L,T] Flushing, NY b. 4 N 1898, NYC. Studied: Cooper Inst. A.&Sc.; Grand Central Sch. Member: Honolulu Prof. AA; Salon Seven A.; Queens County AA; Work: Am. Mus. Nat. Hist. Position: A., AMNH [40]

BRUNNER, F(rederick) Sands [P,I] Phila. PA b. 27 Jy 1886, Boyertown, PA. Studied: PMSchIA; PAFA; Walter H. Everett. Illustrator: national magazines [47]

BRUNNER, Rudolph [P] b. 1860 d. 16 F 1931, NYC. Member: SC. Exhibited: SC

BRUNO, Lucien V. [S] Metuchen, NJ [15]

BRUNQUIST, Hugo [P] Chicago, IL. Member: Chicago NJSA [25]

BRUNS, Edwin John [P,T] Cedar Rapids, IA b. 12 D 1898, Manistee, MI. Studied: AIC; Leon Kroll; George Bellows. Member: Nat. Edu. Assn.; Western AA. Exhibited: AIC, 1924; Cedar Rapids AA; Davenport, Iowa. Work: Cedar Rapids AA; Iowa State Women's Cl. Contributor: Design magazine. Position: Dir. A. Edu., Cedar Rapids, Iowa, 1929–46 [47]

BRUNS, Harry Wynn [P] NYC. Member: GFLA [24]

BRUSETH, Alf [P,T] Seattle, WA b. 10 My 1900, Silvana, WA. Studied: Cornish Sch., Seattle. Member: Wash. Ar. U. [40]

BRUSH, George de Forest [P] NYC/Dublin, NH b. 28 S 1855, Shelbyville, TN d. 24 Ap 1941, Hanover, NH. Studied: NAD, 1871–74; Gérôme, in Paris, to 1880. Member: ANA, 1888; NA, 1908; A. Fund S.; SAA, 1880; Nat. Inst. A.&L.; Am. Acad. A.&L. Exhibited: NAD, 1888 (prize); Columbian Expo, Chicago, 1893 (med); PAFA, 1897 (gold); Paris Expo, 1900 (gold); Pan-Am. Expo, Buffalo, 1901 (gold); St. Louis Expo, 1904 (gold); NAD, 1909 (med). Work: MMA; Corcoran Gal.; Carnegie Inst.; BMFA; National Gal.; PAFA; Worcester Art Mus.; BM; Butler Art Inst., Youngstown, Ohio. Lived in Indian villages, 1882–86; Florence, 1890. Position: T., ASL [49]

BRUSH, Gerome [S] NYC/Southampton, NY [19]

BRUSH, Julia [P] Greenwich, CT [05]

BRUSH, S.A. [P] NYC [19]

BRUSKIN, Kathleen (Spencer) (Mrs. T.R.) [P] Falls Church, VA b. 28 D 1911, Omaha, NE. Studied: PAFA; William C. McNulty; Jon Corbino. Exhibited: CGA, 1945; NAC, 1945; Soc. Wash. A., 1944 [47]

BRUTON, Esther [G,P] Alameda, CA. Exhibited: Calif. Soc. E. Ann., 1932–33; GGE, 1939. Sister of Margaret and Helen. [40]

BRUTON, Helen [G,P] Alameda, CA. Exhibited: Calif. Soc. E. Ann., 1933; GGE, 1939. Work: Univ. Calif.; USPO, Fresno, Calif. WPA artist. Sister of Margaret and Esther. [40]

BRUTON, Margaret [P,Mur.P] Alameda, CA (1948) b. 1894, Brooklyn, NY. Studied: Calif. Sch. FA; ASL. Exhibited: Los Angeles, 1924 (prize); Santa Cruz, 1925 (prize); Oakland, 1934 (prize); San Fran. AA, 1936 (prize); GGE, 1939. Sister of Helen and Esther. [40]

BRUYERE, Louis Y. [P] Toledo, OH. Member: Artklan [25]

BRY, Edith [P,Li] NYC b. 30 N 1898, St. Louis, MO. Studied: Winold Reis; Herman Struck; Europe; ASL; Alexander Archipenko; Charles Locke. Member: Fed. Mod. P.&S.; NAWA. Work: MMA; NYPL; LOC [47]

BRYAN, Henry E. [P] Toledo, OH. Member: Artklan [25]

BRYAN, W(illiam) E(dward) [P,I,T] Dublin, TX (1935) b. 14 S 1876, Iredell, TX. Studied: Duveneck; Renard, in Paris; Laurens, in Paris (1906), in Cincinnati (1901–05); Acad. Colarossi. Member: Phila. WCC. Work: Carnegie Lib., Fort Worth. Specialty: scenes in Tex. and Fla. Position: Instr., Cincinnati AA, 1907–09 [13]

BRYANT, Annie (Nanna) B. Matthews (Mrs.) [P,S] Boston, MA/Waltham, MA b. 1870 d. 28 Je 1933, Waltham. Member: NAWPS; Newport AA; Copley Soc., 1893. Exhibited: New Haven PCC, 1932. She owned a Stradivarius and was an accomplished violinist. [07]

BRYANT, Arthur D. [P] Wash., D.C. [01]

BRYANT, Everett Lloyd [Mur.P] Los Angeles, CA/Wilmer, CA b. 13 N 1864, Galion, OH d. 7 S 1945. Studied: Blanc, in Paris; Herkomer, in London; Anshutz; Chase; Breckenridge. Exhibited: P.-P. Expo, San Fran., 1915 (med). Work: PAFA; St. Paul Inst.; Los Angeles Mus. [49]

BRYANT, Florence L. [P] Chevy Chase, MD. [17]

BRYANT, Harold Edward [P,I] b. 1894, Pickrell, NE d. 1950, Grand Junction, CO. Studied: AIC. Specialty: Western ranch life [*]

BRYANT, Henry G. [I] NYC. Member: SI, 1912 [19]

BRYANT, Lorinda Munson [P,I,W] New York b. 21 Mr 1855, Granville, OH d. 13 D 1933, NY. Studied: Europe. Specialty: books on the history of art and the Bible. Her last book "The Children's Book of Recent Pictures," 1934.

BRYANT, Maribland [Des,B,T] Newport News, VA b. Newport News. Studied: Hans Hofmann; Henry Hensche; Hugo Inden; Rowland Lyon; Blanch Lazzell. Position: Dir./Instr., Bryant Studio of Art, Newport News [40]

BRYANT, Maude Drein (Mrs.) [P] Hendricks, PA b. 11 My 1880, Wilmington. 23 O 1946, Wilmington. Studied: Anshutz; Breckenridge; Chase; PAFA; Acad. Colarossi, Paris. Member: NAWPS; F., PAFA. Work: PAFA [40]

BRYANT, Rebecca L. (Mrs.) [P,L,T] Charlotte, NC b. 13 Je 1903, Parkersburg, IA. Studied: Stanford Univ.; Univ. Iowa; ASL; Fletcher Martin; Cecelia Beaux. Member: Am. Assn. Univ. Women; Wash. A. Cl.; CAA. Exhibited: Mint Mus. A., 1945, 1946. Lectures: Art; Interior Decoration. Positions: T., Grinnell Col., 1941–42, Knox Col., 1942–44, Queens Col., Charlotte, N.C., 1944–46 [47]

BRYANT, Wallace [Por.P] Wash. D.C. b. Boston. Studied: Constant, Laurens, Robert-Fleury, Bouguereau, in Paris [10]

BRYGIDER, Edward [P,Des,I] NYC b. 23 My 1916, NYC. Studied: Kenneth Hayes Miller; ASL. Member: S.Indp.A. Exhibited: S.Indp.A., 1939–41; Mun. A. Exh., 1944; Argent Gal., 1946 (one-man) [47]

BRYHN, Carl F. [P] Chicago, IL. Member: Chicago NJSA [10]

BRYMNER, William [P,T] Montreal, Canada b. Greenock, Scotland. Studied: Bouguereau; Robert-Fleury. Member: RCA [01]

BRYS, Jules [P] Cincinnati, OH [24]

BRYSON, Charles A. [I] NYC. Member: SI [47]

BRYSON, Hope Mercereau [P,L] NYC b. 4 Ja 1887 d. 23 Mr 1944. Studied: Corcoran Sch. A.; Charles Guerin; Morrisset; Edwin Scott, in Paris. Member: Laguna Beach AA; San Diego AG; Calif. WCS [40]

BRYSON, Robert Alexander [P] Wilmington, DE b. 19 S 1906 Marshalltown, DE. Studied: Md. Inst. Member: Wilmington SFA; Wilmington AC. Exhibited: Wilmington Soc. FA, 1934 (prize) [47]

BUBA, Margaret Flinsch [S,I,P,T] Huntington, NY b. 25 Jy 1914, Huntington. Studied: Angelo Jank, Louise Schmidt, in Germany; Abastenia

St. Leger Eberle. Work: Surpreme Court, Wash., D.C.; Goethe Univ.; Am. Mus. Nat. Hist.; "The Forum," "London Illustrated News"[40]

BUBERL, Caspar [S] b. 1834, Bohemia d. 22 Ag 1899, New York. Came to U.S. in 1854. Exhibited: NAD, 1860s, 1870s

BUCCINI, Alberta [P] NYC. Member: S.Indp.A. [25]

BUCH, H.C. [P] Chicago, IL. Member: Chicago NJSA [10]

BUCHAN, Marion [S] Denver, CO. Exhibited: Denver M., 1936; WFNY, 1939 [40]

BUCHANAN, Ella [S] Hollywood, CA b. Preston, Canada. Studied: AIC; Charles J. Mulligan. Member: Chicago SA; Calif. AC; S. Gld., Southern Calif.; Hollywood AA. Exhibited: Calif. Liberty Fair, 1918 (prize); Pomona Fair, 1928 (prize); Calif. AC, 1918 (prize); Ebell Spring Exh., 1934 (prize). Work: Baker Mem., Chicago; Southwest Mus., Los Angeles; Vanderpoel Coll. [47]

BUCHANAN, Laura [P,Des] Dallas, TX b. Waxahachie, TX. Studied: Frank Reaugh. Member: Tex. FA Assn.; SSAL; Dallas AA. Exhibited: SSAL, 1930 (prize) [47]

BUCHANAN, Luvena. See Vysekal, E.A., Mrs.

BUCHBINDER, D.G. [P] Pittsburgh, PA. Member: Pittsburgh AA [10]

BUCHHOLZ, Emmaline (Mrs. T.W.) [T,P,I] Gainesville, FL b. Ormondsville, NC. Studied: Randolph-Macon Col.; PAFA; AIC. Member: Gainesville Assn. FA; Fla. Fed. A. Work: Fla. State Col. for Women; Univ. Fla.; State Lib., Tallahassee. Illustrator: "Growing English." Positions: Teacher/Chm. Board Dir., Pub. Sch., Gainesville [47]

BUCHHOLZ, Fred [P] NYC b. 5 Ag 1901, Springfield, MA Studied: ASL. Member: S.Indp.A.; Creative A. Assoc. Exhibited: S.Indp.A., 1922–42; AWCS, 1946; SFMA, 1946; Lg. Present-Day A., 1943–45; Creative A. Assoc., 1946; Jackson, Miss., 1946; Newhouse Gal., 1934 (one-man); Decorator's Cl., 1938 (one-man). Position: Chm., Creative A. Assoc., 1946 [47]

BUCHHOLZ, Olive Miriam. See Parmelee.

BUCHSBAUM, Elizabeth. See Newhall.

BUCHTA, Anthony [P,Et,T] Chicago, IL. Studied: Chicago Acad. FA; AIC; Charles Schroeder; Leslie F. Thompson. Member: Chicago Gal. Assn.; Chicago P.&S.; Hoosier Salon; Scarab Cl.; Detroit WC Soc.; New Orleans AA. Exhibited: Phila. WCC, 1934; Hoosier Salon, 1935, 1938 (prize), 1940 (prize);Palette & Chisel Cl., Chicago (prize); Chicago Gal. Assn.; Chicago Acad. FA; Little Gal., Cedar Rapids, Iowa [47]

BUCHTERKIRCH, Armin [P,I] Rochester, NY b. 25 N 1859, Corning, NY. Member: Rochester AC. Work: Peabody Mus., Salem [17]

BUCK, Carl [P] Port Washington, NY. Exhibited: Tiffany Fnd.; Grand Central Gal., 1934; NYWCC, 1939 [40]

BUCK, Claude [P,T] Santa Cruz, CA b. 3 Jy 1890, NYC. Studied: NAD; Emil Carlsen; George deForest Brush; Francis Jones; Kenyon Cox; Sch. Met. Mus.; Munich. Member: Carmel AA; Chicago Gal. Assn.; Soc. for Sanity in Art; Santa Cruz A. Lg.; Grand Central AG. Exhibited: Chicago Gal. Assn., 1926 (prize), 1927 (prize), 1928 (prize), 1930 (prize) 1931 (prize); AIC, 1929 (prize); Chicago P.&S., 1932 (med); Pal. Leg. Honor, 1944 (med); Oakland A. Gal., 1945 (med), 1946; Carmel A. Gal.; Santa Cruz A. Gal., 1944–46; Grand Central Gal.; Chicago Gal. Assn. Work: Eastman Mem. Fnd., Laurel, Miss.; Univ. Chicago; Vanderpoel Coll.; Pub. Lib., Santa Cruz. Position: Inst., Studio Sch. A., Chicago [47]

BUCK, Claude, Mrs. See Binner, Leslie.

BUCK, Clifford [P] Toldeo, OH. Member: Artklan [10]

BUCK, Emma G. [P,S,C] Chicago, IL b. 16 F 1888, Chicago. Studied: Charles Mulligan. Member: Chicago AG; Chicago AC; Boston SAC. Work: Wisconsin Perry's Centenn. medal [24]

BUCK, Kirkland C. [P] Baltimore, MD [10]

BUCK, Lawrence [P,Arch] b. 1865, New Orleans d. 17 Ag 1929, Ravinia, IL. Member: Chicago AC; North Shore A. Lg.; Ravinia Sketch Cl.

BUCK, Leslie (Binner) (Mrs. Claude) [P] Santa Cruz, CA b. Chicago, IL. Studied: AIC; Studio Sch., A., Chicago; Claude Buck. Member: Carmel AA; Chicago Gal. Assn.; Soc. for Sanity in Art; Santa Cruz A. Lg. Exhibited: Sanity in Art, Chicago, 1938 (prize); Santa Cruz A. Lg., 1944 (prize); Pal. Leg. Honor, 1944, 1945; Santa Cruz, 1944–46; Carmel AA, 1946; Oakland A. Gal., 1945, 1946;Chicago Gal. Assn.; AIC, 1935, 1937, 1939. Work: Vanderpoel Coll. [47]

BUCK, Richard David [T,Mus.Cons] Cambridge, MA b. 3 F 1903, Middletown, NY. Studied: Harvard Univ. Author: "Technical Studies in the Field of the Fine Arts." Positions: Assoc. in Conservation, FMA, 1937–41; Research F. in Conservation, FMA, 1941– [47]

BUCKHAM, Charles W. [P] NYC. Member: SC [25]

BUCKLER, Charles E. [P] Melrose, MA b. 29 Jy 1869, Bridgetown, Nova Scotia. Studied: Eric Pape; William Robinson. Member: Bay State A. Gld. Exhibited: Vose Gal.; Boston AC [47]

BUCKLEY, Elizabeth [P,T] Chicago, IL b., Chicago. Studied: AIC; Ipswich Summer Sch.; John Vanderpoel [09]

BUCKLEY, Jeannette [P] Chicago, IL [19]

BUCKLEY, John Michael [P,E,T] Pigeon Cove, MA b. 11 D 1891, Boston d. 4 F 1958. Studied: Mass. Normal A. Sch.; Wlbur Hamilton; Ernest L. Major; Aldro T. Hibbard; R. Andrew. Member: Rockport AA; Am. Vet. Soc. A.; North Shore AA; Gloucester SA; Springfield AG. Exhibited: Rockport AA, 1941 (prize); SAE, 1939–41; Whistler Mus. Work: public bldgs. and schools, Boston, Malden, Plymouth, Worcester. Positions: Instr., Boston Univ., Cambridge A. Center [47]

BUCKLIN, Bradley [P] Troy, NY b. 1824, Little Falls, NY d. 24 Ap 1915

BUCKLIN, W(illiam) S(avery) [P] Riverside, CT/Phalanx, NJ b. 2 O 1851, Phalanx d. 3 My 1928. Studied: Mass. Normal A. Sch., Boston; ASL; Rondel. Member: ASL; Greenwich SA; Prof. Lg., New York. Work: Lib., Westminster, Mass., curtain, Philips Chapel, Unitarian Church, Fitchburg, Mass. His career started when he was eleven years old, at which time he sold a painting to the poet E.C. Stedman. [25]

BUCKNER, Melvin D. [P,Des,T] Wash., D.C. b. 28 Mr 1915, Wash., D.C.. Studied: Carnegie Inst.; ASL; George Washington Univ.; Univ. Puerto Rico; Isabel Bishop; Raphael Soyer. Member: Soc. Wash. A.; Wash. A. Gld.; Assoc. A. Pittsburgh. Exhibited: CGA, 1940 (med), 1941; WFNY, 1939; Univ. Puerto Rico, 1945 (med); Assoc. A. Pittsburgh, 1937–39, 1941; Soc. Wash. A., 1941, 1942, 1946; PMG, 1936–46; Hudson Walker Gal.; The Ateneo, San Juan. Postiion: Instr., Univ. Puerto Rico, 1945–46 [47]

BUDD, Charles Jay [P,I] East Orange, NJ b. 14 F 1859, South Schodack, NY d. 25 Ap 1926. Studied: PAFA, with Eakins; ASL. Member: Phila. Sketch Cl.; SC. Specialty: children's books [25]

BUDD, D(enison) M. [I] Chappaqua, NY b. 10 Je 1893, Burlington, IA d. 28 N 1944. Studied: AIC. Member: N.Y. A. Dir. Cl. Specialty: drawings for advertising [40]

BUDD, Katherine Cotheal [P,I,Arch] NYC. Studied: William M. Chase [25]

BUDELL, Ada [P,Et,I,T] Westfield, NJ b. 19 Je 1873, Westfield. Studied: ASL, with Bridgman, DuMond, Pennell. Member: NAWA; AAPL; Westfield AA; Plainfield AA. Exhibited: A. Center of the Oranges, 1927 (prize), 1931 (prize); Westfield AA, 1932 (prize), 1933 (prize), 1935 (prize), 1936 (prize), 1940 (prize); Plainfield AA, 1941 (prize); NAD, 1930; AWCS, 1900, 1916, 1927, 1935, 1945, 1946; Arch. Lg., 1904, 1905; NAWA, 1922–46; Montclair A. Mus.; AAPL; SAE, 1905, 1906; NAC. Illustrator: children's books [47]

BUDELL, (Emily) Hortense [P,T] Westfield, NJ b. 23 Mr 1884, Lyons, France. Studied: John Carlson; Henry B. Snell; George Elmer Browne. Member: All.A.Am.; NAWA; Conn. Acad. FA; AAPL; Westfield AA; Plainfield AA. Exhibited: A. Center of the Oranges, 1926 (prize), 1931 (prize); NAWA, 1926–30, 1931 (prize), 1932–45; Plainfield AA, 1931 (gold,prize); Contemporary Gal., N.J., 1933 (med) 1935 (med), 1936 (med), 1938 (med), 1941 (med); Montclair A. Mus., 1936 (med), 1937 (prize), 1938 (prize); Spring Lake AA, 1939 (med); Irvington A.&Mus. Assn., 1944 (med); NAD, 1927, 1928; All.A.Am., 1927–45; Conn. Acad. FA, 1927, 1928, 1931, 1932, 1936, 1938, 1940, 1941, 1945; Phila. A. Cl., 1925; AAPL, 1939, 1942, 1943, 1944; NAC. Work: Asbury Park Mus. [47]

BUDWORTH, William S(ylvester) [P] Mt. Vernon, NY b. 22 S 1861, Brooklyn, NY d. 6 F 1938. Studied: self-taught. Member: AFA. Exhibited: AAS, 1902 (med), 1903 (med); Atlanta Fair, 1919 (prize), 1920 (prize). Work: Rochester Mus. [38]

BUEHLER, Lytton (Briggs) [P] Provincetown, MA b. Gettysburg, PA. Studied: PAFA [25]

BUEHR, George Frederick [P,L,T,W] Chicago, IL b. 18 Ja 1905, Chicago. Studied: Karl Albert Buehr; AIC. Positions: Lecturer/Teacher, AIC [40]

BUEHR, Karl Albert [P,Et,Li,T] Chicago, IL b. Germany. Studied: AIC;

Académie Julian, Paris, with Collin; London Sch. A. Member: ANA; Chicago Gal. Assn. Exhibited: St. Louis Expo, 1904 (med); Chicago SA, 1914 (med); P.-P. Expo, 1915 (med); Municipal A. Comm., Chicago, 1915 (prize), 1916 (prize); AIC, 1919 (med,prize); Peoria Soc. All. A., 1920 (med); AIC, 1920 (prize), 1922 (prize), 1925 (prize); Municipal A. Lg., Chicago, 1924 (prize), 1933 (prize); Chicago Gal. Assn., 1931 (prize). Work: Vanderpoel Coll.; Univ. Chicago; Northwestern Univ.; Des Moines Hist. Mus. [47]

BUEHR, Mary G. Hess (Mrs. Karl Albert) [P,L,T] Chicago, IL b. Chicago. Studied: AIC; Holland; France. Exhibited: Municipal AL, 1914 (prize); AIC, 1928 (prize). Work: Pub. Lib., Peoria; Civic Loan Coll., Chicago. Docent, AIC, Century of Progress Exh., 1933, 1934 [40]

BUEHR, Walter [P] NYC [25]

BUELL, Alice Standish [E] White Plains, NY/Woodstock, VT b. Oak Park, IL. Studied: Oberlin Col.; ASL; Martin Lewis. Member: SAE; NAWA: PBC. Exhibited: SSAL, 1931 (prize); Southern Pr.M., 1938 (prize); Phila. Pr. Cl., 1939 (prize); SAE, 1931–34, 1943, 1945; PBC, 1945, 1946; LOC, 1944; Carnegie Inst., 1944; WFNY, 1939; AIC, 1938; Calif. Pr.M., 1935; Phila. Pr. Cl., 1931, 1939, 1941; AV, 1942; NAD, 1943, 1946; NAWA, 1941–46; Phila. SE, 1931, 1934, 1937, 1938; Wash. WCC, 1939; Northwest Pr.M., 1935, 1938; SSAL, 1931; Vt. A., 1938–40; Southern Pr.M., 1938. Work: LOC; Univ. Wis.; Montclair A. Mus.; Dartmouth Col. [47]

BUELL, Horace Hervey [P] d. 22 D 1919, NYC. Position: Head, Buell Scenic Co.

BUELL, Marjorie Henderson (Marge) [Car,I] Malvern, PA b. Phila., PA. Author/Illustrator: "Little Lulu," pub. Rand McNally, Co. (1936), "Little Lulu and Her Pals," pub. David McKay Co. (1939). Contributor: articles/illustrations, Saturday Evening Post, Country Gentleman, Ladies' Home Journal, Collier's, other magazines [40]

BUERGERNISS, Carl [Dr,Mur.P,Por.P,T] Westmont, NJ b. 30 D 1877, Phila. Studied: PAFA. Member: F., PAFA; Artists U. Work: mural, Baptist Church, Hainsport, N.J.; "Index of Am. Des."; Office, Fed. A. Proj., Newark, N.J. [40]

BUETTNER-BONAR, H.G. See Bonar, Henry.

BUFANO, Beniamino [S] San Fran., CA b. 14 O 1898, San-Fele, Italy. Studied: NAD; BAID; ASL; Paul Manship; James L. Fraser; Herbert Adams. Exhibited: WMAA, 1917 (prize); ASL, 1914 (prize), 1915 (prize), 1916 (prize). Member: Am. A. Cong.; NSS. Work: MMA; SFMA; Pal. Leg. Honor; San. Fran. Position: A. Commissioner, City of San Fran. [47]

BUFANO, Remo [Des,S,L,W] NYCl b. 12 N 1894. Work: Animal masks and costumes for "Noah," starring Pierre Fresnay; masks for "funnies" of "As Thousands Cheer"; masks and marionettes for Le Gallienne's "Alice in Wonderland"; masks in Gielgud's "Hamlet," and in "Babes in Arms." Oedipus Rex of Stravinsky, marionette stage presentation with Phila. Symphony Orchestra and Stokowski after designs of Robert Edmond Jones; Giant Marionettes, "Hall of Pharmacy," WFNY, 1939. Author: "Be a Puppet Showman," "The Showbook of Remo Bufani," "Pinocchio for the Stage." Lectures: Marionettes and Their Making; Masks and Their Making [40]

BUFF, Conrad [P,Mur.P,Li,I] Los Angeles, CA b. 15 Ja 1886, Speicher, Switzerland d. 1975, Laguna Hills, CA. Studied: Munich; Switzerland. Member: Calif. AC. Exhibited: Calif. State Fair, 1924 (prize); Los Angeles Mus. A. 1925 (prize), 1934 (prize); San Diego FA Soc., 1925 (prize); AIC, 1932 (prize); Santa Paula, Calif., 1944 (prize). Work: Encyclopaedia Britannica Coll.; MMA; NGA; BMFA; AIC; Detroit Inst. A.; Pal. Leg. Honor; CMA; Los Angeles Mus. A.; Los Angeles Pub. Lib.; San Diego FA Soc; Nat. Bank, Phoenix, Ariz.; Edison Co., Los Angeles; Barlow Medical Lib., Los Angeles. Illustrator: "Dancing Cloud, the Navajo Boy," by his wife, Mary Buff, pub. Viking Press, 1937, other children's books [47]

BUFF, Conrad, Mrs. See Marsh, Mary E.

BUFFINGTON, E(liza) [P,I,Li,T,W] Madison, NJ b. 16 N 1883, Springfield, MA d. ca. 1938 Studied: Arthur W. Dow; Denman Ross; Tenchi Hoshino; Nicolai Fechin; Harvey Dunn. Member: NAWPS; Nat. AAI; AAPL; AFA. Author: "Star Dust Fairy" [38]

BUFFINGTON, Ralph Meldrim [Des,Arch,P] Pendergrass, GA b. 7 F 1907, White Sulphur, GA. Studied: Ga. Sch. Tech.; Maurice Guy-Loe, in Paris. Member: SSAL; Assn. Ga. A. Work: Indian Springs State Park, Ga.; des. mem., Gastonia, N.C.; Pub. Lib., Gastonia. Contributor: article, Work of the CCC at Indian Springs State Park, Atlanta Constitution. Positions: Des., Nat. Park Service; Asst. Arch., Suburban Resettlement Adm. [40]

BUFFMIRE, Frank E. [P] Oconomowoc, Wis. Work: USPO, Black River Falls, Wis., Sect. FA Fed. Works Agency [40]

BUFFUM, Clara [C,L,T] Providence, RI 24 Ja 1873, NYC. Studied: F.P. Hathaway; Charles McLeish, in London. Member: Providence AC; N.Y. Gld. Book Workers. Exhibited: San Fran., 1915 (med). Work: bookbindings for church service books, first edition of Chaucer, John Eliot's Bible,, etc. Author: "Brief Dictionary of Musicians' Portraits," pub. Metropolitan Mus. A. (1904), "Hand Bound Books," privately published (1935). Contributor: articles on hand bookbinding, Boston Transcript [40]

BUFFUM, Edith L. [Min.P] Providence, RI. Member: Providence WCC [25]

BUFFUM, Katharine G. [I] b. 2 S 1884, Providence, RI d. Ja 1922. Studied: PAFA. Member: Plastic Cl.; F., PAFA. Illustrator: "Mother Goose in Silhouette," "Silhouettes to Cut in School," "Songs of Schooldays," etc. [21]

BUGBEE, Harold Dow [I,P] Clarendon, TX b. 15 Ag 1900, Lexington, MA d. 1963. Studied: Clarendon Col.; Tex. A.&M. Col; Cumming Sch. A.; W. Herbert Dunton. Member: Amarillo A. Assn. Exhibited: Young Gal., Chicago. Work: murals, Panhandle Plains Hist. Soc. Mus., Canyon, Tex.; Hall of State, Dallas; Amarillo Army Air Field, Tex. Illustrator: Western books [47]

BUGBIRD, Mary Bayne (Mrs. Herbert C.) [P,C] Summit, NJ b. 18 S 1889, Richmond, VA. Studied: ASL, with George Bellows, Kenneth Hayes Miller. Member: NAWA; AAPL; Summit AA; Millburn A. Center. Exhibited: Whitney Studio Cl. (prize); Newark A. Cl., 1940 (prize); NAWPS, 1935–38; WFNY, 1939; Summit AA (one-man); N.J. State Mus., Trenton; Newark Mus.; Montclair A. Mus. [47]

BUGLINO, Joseph [S,C] NYC b. 7 Ag 1878, Palermo, Italy. Studied: Cooper Union [33]

BUHLER, Augustus [Mar.P,Ldscp.P,I] Boston, MA b. 1853, NYC d. 18 Ap 1920, Gloucester, MA. Studied: Académie Julian, Paris, with Constant, Lefebvre, 1888–90; T. Juglaris, in Boston; Worcester, Mass., 1865. Member: Boston AC; SC; BSWCP. Exhibited: Boston, 1909. Work: Cape Ann Hist. Assn.; Farnsworth AM; Peabody Mus., Salem. Illustrator: Youth's Companion, Harper's. Specialty: scenes of Gloucester fishing industry [13]

BUHOLZ, Frances [P,I,T] NYC b. 23 S 1896, Red Wing, MN. Studied: Minneapolis Sch. A. Member: Minn. AA. Exhibited: Minneapolis Inst. A., 1935 (prize); PAFA; AIC; NAD. Illustrator: Woman's Home Companion, "Say It in Spanish." Position: Instr., Minneapolis Sch. A. [47]

BUK See Ulreich, Eduard Buk.

BULENA, Milada L. [Min.P] Chicago, IL. Member: S.Min. P. [25]

BULKLEY, Mary E. [P,C] St. Louis, MO. Member: SWA. Specialties: bookbinding, leather work [10]

BULL, Charles Livingston [I,P,W] Oradell, NJ b. 1874, New York State d. 22 Mr 1932. Studied: Harvey Ellis; M. Louise Stowell; Phila. A. Sch. Exhibited: NAD. Member: Am. Inst. Graphic Arts; NYWCC; SC; S. Mural P.; Arch. Lg.; Ar. Gld.; NAC; SI. Author: "Under the Roof of the Jungle"; stories published in magazines, scientific papers. A painter of birds and animals, naturalist, explorer, and author, his skill as a taxidermist so familiarized him with animal anatomy that his drawings and paintings were unusually accurate. During World War I, he was instrumental in arousing interest in pictorial publicity, his patriotic posters of American eagles being distributed far and wide. He served as taxidermist at Ward's Mus., Rochester, and at the Nat. Mus., Wash., D.C., where he mounted many of the groups, including specimens from the collection of Theodore Roosevelt.

BULL, Johan [I,Por.P,E,Car] Forest Hills, NY b. 22 N 1893. Studied: self-taught. Member: SI; Scandinavian-Am. A.; Am. APL; Car. Gld. Contributor: New Yorker; New York Times; New York Herald Tribune; Independent, etc. Work: U.S. Military Acad. Illustrator: Selma Lagerlof's Diary, pub. Doubleday Doran (1937); Collier's, Woman's Home Companion, Forum, and others [40]

BULL, Ludlow (Seguine) [Mus.Cur,T,W,L] Litchfield, CT b. 10 Ja 1886, NYC d. Jy 1954. Studied: Yale Col.; Harvard Law Sch.; Univ. Chicago. Member: Am. Oriental Soc.; Archaeological Inst. Am.; Egypt, Palestine Exploration Soc.; Soc. Biblical Lit. Co-author: "The Rhind Mathematical Papyrus." Editor: "Publications of the Egyptian Expeditions" (6 vols.), "Publications of the Egyptian Dept., MMA" (6 vols.). Contributor: articles/book reviews, archaeological journals and art magazines. Lectures: Ancient Egypt. Positions: Assoc. Cur., Egyptian Dept., MMA, 1928– ; Prof., Yale, 1936– ; Cur., Yale Egyptian Coll., 1925– [47]

BULL, W.H. [P,I] San Mateo, CA [21]

BULLARD, Marion R. (Mrs.) [P,I,W] Woodstock, NY b. Middletown, NY. Member: NAWPS; Conn. Acad. FA. Exhibited: NAWPS, 1916 (prize),

1923 (prize). Author/Illustrator: "The Sad Garden Toad," "The Somersaulting Rabbit," and others. Position: Ed., Woodstock Sect., The Ulster County News [40]

BULLER, Audrey (Mrs. A.B. Parsons) [P,Des] Little Compton, RI b. 27 N 1902, Montreal. Studied: Kenneth Hayes Miller; Henry Schnakenberg; Randolph Hewton. Member: Am. Soc. PS&G. Exhibited: NAD, 1937 (prize); Pepsi-Cola Comp. (prize); CGA; AIC; PAFA; Carnegie Inst.. Work: MMA; WMAA [47]

BULLER, Cecil [G,P] NYC b. Montreal. Studied: Maurice Denis, in Paris. Exhibited: Nat. Acad., 1938. Work: LOC; NYPL; Nat. Gal., Ottawa [40]

BULLER, Cecil T. [E] Boston, MA [17]

BULLEY, Rachel. See Trump, Mrs.

BULLIET, Clarence Joseph [W,Cr,T] Chicago, IL. b. 16 Mr 1883, Corydon, IN d. 1952. Studied: Ind. Univ. Author: "Apples & Madonnas" (1927), "French Art from David to Matisse" (1941), and others. Contributor: art magazines. Positions: A. Cr., Chicago Evening Post (1924–32), Chicago Daily News (1932–46) [47]

BULLIET, Katherine Adams [P] Chicago, IL b. 1 Ap 1880, New Salisbury, IN d. 21 My 1946. Studied: Sideny Crosier. Member: Wonderland Way AC, New Albany [40]

BULLITT, Marshall (Mrs.) [P] Wash., D.C. Member: Wash. Soc. A. [25]

BULLIVANT, F.J. (Mrs.) [P] St. Louis, MO [25]

BULLOCK, James Cunliffe (Mrs.) [P] Providence, RI. Member: Providence AC [25]

BULLOCK, Jasper N. [P] Columbus, OH. Member: Columbus PPC [24]

BULLOCK, Mary J(ane) M(cLean) (Mrs. Kenneth R.) [P,C,T] Fort Worth, TX b. 10 Ap 1898, Fort Worth. Studied: Tex. Christian Univ.; AIC; Joseph Fleck; Frank Klepper. Member: AAPL; SSAL; Tex. FA Assn.; Fort Worth AA. Exhibited: SSAL, 1936 (prize), 1938 (prize), 1939, 1946 (prize); Tex. FA Assn., 1936, 1937, 1938, 1940; Fort Worth AA, 1946 [47]

BULLOCK, Wynn [Photogr] b. 1902, Chicago d. 1975, California. Studied: Columbia Univ.; W.Va. Univ.; Los Angeles AC Sch., with Edward Kaminski. Exhibited: Los Angeles Co. Mus., 1941; UCLA, 1954; IMP, 1957; MOMA, 1960; San Fran. MA, 1969. Work: MOMA; UCLA; IMP; Yale; other photo. mus. [*]

BULL-TEILMAN, Gunvor (Mrs.) [P,S,I,W,L] NYC b. 14 Mr 1900, Bodoe, Norway. Studied: Grande Chaumière, Académie Julian, Paris; Acad. FA, Leipzig, with A. Lehnert, A. Muller. Member: Am.-Scandinavian Fnd. Exhibited: Albany Inst. Hist.&A., 1935 (prize); Am.-Scandinavia A. Nat. Group, 1936 (prize); Europe, 1922–31; Ferargil Gal., 1943 (one-man); BM; Harvard Univ. Work: murals, Waldorf-Astoria Hotel; U.S. Time Corp., New York. Illustrator: "Sigurd and His Brave Companions," by Undset, 1943. Contributor: articles on art to magazines. Lectures: Art in Occupied Norway [47]

BULMER, Elenore Stuart [T,P] Poughkeepsie, NY b. 10 O 1914, Wappingers Falls, NY. Studied: George Pearse Ennis; Wayman Adams; Syracuse Univ. Member: Dutchess County AA; NYWCC. Position: A. Dir., Commercial Colorgraphic Corp., Poughkeepsie [40]

BUMSTEAD, Ethel Quincy [P] Cambridge, MA b. 22 Je 1873, London. Studied: BMFA Sch.; Abbott Graves; A.W. Bühler. Member: Copley S., 1893 [10]

BUNAND-SEVASTOS, Fanny [P] Paris b. 13 F 1905, France. Studied: Antoine Bourdelle. Member: Salon des Tuileries, Paris [33]

BUNCE, J(ohn) Oscar [S,Arch] Ridgewood, NJ b. Jy 1867, NYC. Studied: NAD; ASL [15]

BUNCE, Louis Demott [P] Portland, OR. Exhibited: Northwest Ar., Seattle AM, 1934 (prize); San Fran. MA, 1935; WFNY, 1939; GGE, 1939; PS. Fed. Bldgs., 1936. Work: USPO, Grant's Pass, Oreg., Sect. FA Fed. Works Agency [40]

BUNCE, W(illiam) Gedney [Mar.P,P] Hartford, CT b. 19 S 1840, Hartford d. 5 N 1916 (hit by automobile). Studied: Cooper Union; William Hart; Achenbach, in Munich; P.J. Clays, in Antwerp; Julius Busch, 1856. Member: ANA, 1902; NA, 1907; Nat. Inst. A.&L.; Lotos Cl. Exhibited: Paris Expo, 1900 (med); Pan-Am. Expo, Buffalo, 1901 (med); Charleston Expo, 1902 (med); St. Louis Expo, 1904 (med); NAD, 1871–75. Work: MMA; NGA; Montclair (N.J.) AM; R.I. Sch. Des. Lived in Europe after 1865, for many years. [15]

BUNCH, Alice [P] St. Louis, MO b. 26 F 1904, Owensboro, KY. Studied: AIC; St. Louis Sch. FA; Joseph Keller-Kuhne, in Munich. Member: Am. Ar. Cong.; St. Louis Ar. Gld. Exhibited: City AM, St. Louis, 1938–39; Mid-West Ar. Ann., AIC, Kansas City, 1938–39; Ar. Gld., St. Louis, 1938–39 [40]

BUNCH, J. Arnold [P] Kansas City, MO [21]

BUND, Clarice [P] NYC [04]

BUNDASZ, Rudolph [P] Cleveland, OH b. 4 Jy 1911, Salank, Hungary. Studied: Cleveland Sch. A. Work: Cleveland Mus.; Cleveland Municipal A. Coll. [40]

BUNDY, Gilbert [I] NYC b. 1911 d. 21 N 1955. Member: SI [47]

BUNDY, John Elwood [Ldscp.P] Richmond, IN b. 1 My 1853, Guilford Co., NC d. 18 Ja 1933. Exhibited: Richmond, 1911 (prize); Herron AI, 1917 (prize). Member: Richmond AA; Chicago Gal. A.; Hoosier Salon. Work: Public Gal., Richmond, Ind.; City AM, St. Louis; Public Art Coll., Vincennes, Ind.; Art Lg., Muncie; AA, Rockford, Ill.; AA, Sioux City, Iowa; AA, Indianapolis. Specialty: woodland scenes, especially beeches. He became head of the art department at Earlham Col., Richmond, Ind., in 1887, resigning in 1895 to devote his time to painting. [33]

BUNGER, Frances [P] Mt. Vernon, NY b. 10 N 1911, NYC. Studied: Arthur W. Woelfle. Member: New Rochelle AA [33]

BUNIN, Alvena Vajda Seckar, Mrs. See Seckar.

BUNKER, Caroline [P] NYC. Member: Copley S., 1892 [09]

BUNKER, Phoebe A. [P] Merrick, NY b. 1863, Brooklyn, NY. Studied: Courtois, in Paris. Exhibited: NAD, 1900 [15]

BUNN, William Edward Lewis [Mur.P,Des,I,P] Fort Madison, IA b. 29 My 1910, Muscatine, IA. Studied: Univ. Iowa; Grant Wood. Member: Chicago AG. Exhibited: Davenport, Iowa, 1941 (prize); 48 Sts. Comp.; NAD, 1937, 1941, 1945; CGA, 1939–41; VMFA, 1942; PAFA, 1941; AIC, 1937, 1942; Kansas City AI, 1938; Davenport A. Mus., 1940, 1941. Work: murals, USPOs, Dubuque, Hamburg (Iowa), Minden (Nebr.), Hickman (Ky.). Positions: Indst. Des., Barnes & Reinecke, Chicago, 1944–45; Manager, Des. Dept., Sheaffer Pen Co., Fort Madison, 1946– [47]

BUNNELL, Charles Ragland [P,T] b. 1897, Kansas City, MO d. 1968, Colorado Springs. Studied: Broadmoor AA, 1922–23; E. Lawson. Exhibited: Carnegie Inst. Position: T., Kansas City AI [*]

BUNNELL, Julia H. [P] NYC [01]

BUNNER, Rudolph F. [P,I] Great Kills, NY. Member: NYWCC; SC, 1890 [10]

BUONGIORNO, Donatus [Mur.P,T] San Fran., CA b. 11 N 1865, Solofra, Italy. Studied: Roil Inst. FA, Naples. Work: Church of St. Leonard of the Franciscan Fathers, Church of the Sacred Heart, Church of St. Peter, all in Boston; Church of St. Michael, Brattleboro, Vt.; Church of the Most Precious Blood, NYC; Church of St. Lazarus, East Boston, Mass., and others [27]

BURBANK, Addison (Buswell) [I,W,P] NYC b. 1 Je 1895, Los Angeles, CA. Studied: Howard Giles; E.J. Bisttram; Harvey Dunn; AIC; Acad. Grande Chaumière, Paris. Member: Cliff Dwellers, Chicago; Ar. Gld.; SI; Fla. Fed. Arts; Miami Art Lg.; Mystic AA. Exhibited: mural, Chicago World's Fair, 1933 (prize). Work: Tulane Univ. Author/Illustrator: "Guatemala Profile," pub. Coward McCann (1939), "The Cedar Deer" (1940). Illustrator: "Wooden Saddles," pub. William Morrow (1940), "The Red Hat" (1941), other Western stories. Contributor: magazines and newspapers [47]

BURBANK, Amy L. [P] Waverly, MA. Member: BAC [05]

BURBANK, E(lbridge) A(yer) [P] Napa, CA b. 10 Ag 1858, Harvard, IL d. 1947, San Fran. Studied: Acad. Des., Chicago; Paul Nauen, in Munich, 1886. Member: Chicago SA. Exhibited: Chicago, 1893 (prize); Atlanta Expo, 1895 (med,prize). Work: Field Mus.; Newberry Lib., Chicago; Smithsonian Inst. Since 1897 he has made portraits of more than 125 types [sic] of North American Indians. [27]

BURBANK, James W. [Mar.P,E,Dr,B] Brooklyn, NY/Narrowsburg, NY b. 22 Ap 1900, New York. Studied: Ernest W. Watson; G.L. Briem; Pratt Inst.; Brooklyn Inst. A.&Sc. [40]

BURBANK, Jessie Lane (Miss) [Des,T,L] Providence, RI b. Medford, MA d. 13 Ap 1937. Studied: Denman Ross; Laurin H. Martin; Henry Hunt Clark. Member: Copley S.; Providence AC; Boston Soc. A.&Crafts; Handicraft Cl., Providence. Position: Head, Dept. Costume, R.I. Sch. Des.

BURBANK, William Edwin [P,T] Manchester, NH b. 6 O 1866, Boston, MA d. F 1922. Studied: Cowles A. Sch.; Laurens, Constant, in Paris. Positions: One of the Directors as well as Instr., Drawing/Painting, Manchester Inst. A. & Sc. [21]

BURCHARD, A(lfred) W(illiam) [P] Falls City, NE b. 10 D 1901, Falls City. Studied: AIC; Leon Kroll [33]

BURCHELL, Nathaniel J. [P,Arch] New Rochelle, NY b. 1868, NYC d. 9 Jy 1934. Studied: William Chase. Position: Instr., ASL

BURCHFIELD, Charles E. [P] Gardenville, NY b. 9 Ap 1893, Ashtabula Harbor, OH d. 1967. Studied: Cleveland Sch. A. Exhibited: Cleveland SA, 1921 (prize); Cleveland Mus. A., 1921 (med); PAFA, 1929 (gold); Carnegie Inst., 1935 (prize). Work: BM; MMA; Cleveland Mus. A.; Albright Gal., Buffalo; Newark Mus.; MOMA; WMAA; Herron AI, Indianapolis; Phillips Mem. Gal., Wash., D.C.; FMA; BMFA; Detroit Inst. A.; R.I. Sch. Des.; Syracuse Mus. A.; Hackley A. Gal., Muskegon, Mich.; Wichita A. Mus.; Nebr. Univ. [47]

BURCHFIELD, Louise H. [Asst.Cur] Cleveland, OH b. 9 Ag 1898, Akron, OH. Studied: Western Reserve Univ. Contributor: museum bulletins. Position: Asst. Cur., Paintings, CMA, 1941– [47]

BURCK, Jacob [Mur.P,Car,Dr,I,Li] Brooklyn, NY b. 10 Ja 1907, Visoky, Poland. Studied: Albert Sterner; Boardman Robinson. Member: Mural P. Work: WMAA. Lectures: What Is to Be Painted? [40]

BURCKHARDT, H.W. [P] Cincinnati, OH. Member: Cincinnati AC [25]

BURD, Clara Miller [P,I,C] Montclair, NJ b. NYC. Studied: New York; Paris. Member: Ar. Gld. Illustrator: "In Memoriam," children's books. Designer: magazine covers [10]

BURDETT, Oliver N. [S] b. 1860, Huntingdon, England (came to U.S. in 1891) d. 5 Ja 1932, Hastings-on-Hudson, NY. He came to this country in 1891. Specialty: carving of stone. Awarded a medal by the Building Trades Congress for his carvings on the New York Life Building. Other buildings which bear examples of his work are the New York Public Library, Grand Central Terminal (group of figures about the clock), Riverside Church in New York, and libraries in Phila., St. Louis, and Detroit

BURDETTE, Dorothy May [P] Independence, KS b. 11 My 1893, Arkansas City, KS. Studied: State Col., Pittsburg, Kans. Member: AAPL. Exhibited: Whistler Mus., Lowell, Mass.; Ogunquit A. Center, 1946 [47]

BURDETTE, Hattie E. [P] Wash., D.C. d. 31 Ja 1955. Studied: Norwood Inst. Member: Wash. AC; Soc. Wash. A.; Wash. WCC; AAPL; Soc. Min. P.S.&G. Work: portraits, Arlington Mansion, Va.; U.S. Capitol, U.S. Navy Dept., Municipal Court Appeals, Wash., D.C., Washington Mem., Alexandria, Va., Washington & Lee Univ., Delaware Col., Theological Sem., Cambridge, Mass., Court House, Raleigh, N.C., Fla. State Col. for Women [47]

BURDICK, Charles J. [P] Richmond Hill, NY [09]

BURDICK, Doris [C,Des,I,L] Malden, MA b. 21 My 1898, Malden. Exhibited: Malden Pub. Lib. Illustrator: Boston Post magazine supplement. Lectures: Silhouettes, Past and Present. Designer: old style silhouettes [47]

BURDICK, H(orace) R(obbins) [Por.P,T,W] Malden, Mass. b. 7 O 1844, East Killingly, CT d. 17 S 1942. Studied: Lowell Inst.; BMFA Sch., with Hollingsworth, Grundmann, William Rimmer. Member: Boston AC. Exhibited: Mechanics Inst., Boston (med). Work: State House, Faneuil Hall, Boston; Memorial Hall, Cambridge; New Bedford Savings Bank; Berkshire Co. Court House; Pittsfield Berkshire Savings Bank; Berkshire Life Insurance Co.; Mass. Supreme Court; City Hall, New London, Conn., MIT. Restorer: oil paintings [40]

BUREAU, Albert G(eorge) [S] Phila., PA b. 21 F 1871, Phila. [13]

BURFORD, Byron Leslie, Jr. [P,G] Jackson, MS b. 12 Jy 1920. Studied: Univ. Iowa. Exhibited: Municipal A. Gal., Jackson, Miss.; 48 Sts. Comp., 1939 [40]

BURG, Copeland Charles [P,T,L,Cr] Chicago, IL b. 18 F 1895, Livingston, MT. Studied: Univ. Wash. Exhibited: Portland (Oreg.) A. Mus., 1939 (prize); PAFA, 1939, 1940 (prize); GGE, 1939; AIC, 1939, 1941 (prize), 1942 (prize), 1943 (prize); San Fran. AA, 1941 (prize), 1942 (prize); Pal. Leg. Honor; Milwaukee AI, 1946 (prize); WMAA, 1945; Carnegie Inst., 1943, 1944; CGA; VMFA; MMA, 1943; Santa Barbara Mus. A., 1945, 1946 (one-man); de Young Mem. Mus., 1945, 1946 (one-man); Chicago Pub. Lib., 1945, 1946 one-man). Work: AIC; PAFA [47]

BURG, Priscilla [P,T] Cazenovia, NY b. 8 My 1916, Sutton, Nebr. Studied: Syracuse Univ.; Univ. Iowa; Emil Ganso; Fletcher Martin. Member: NAWA; Syracuse Assoc. A.; Phila. WCC. Exhibited: Syracuse Assoc. A., 1943 (prize); Cayuga Mus. Hist.&A., 1944 (prize), 1945 (prize); VMFA, 1942; PAFA, 1942; NAWA, 1942–45; Utica A. Exh.; Cortland (N.Y.) State Fair. Work: Radio Station WSYR, Syracuse; Rochester Mem. A. Gal.; Cazenovia Jr. Col; Syracuse Mus. FA. Position: Instr., Cazenovia Jr. Col. [47]

BURGDORFER, René H. [P,T] Kansas City, MO b. 14 My 1908, Paris, France. Studied: Ross E. Braught; John D. Patrick; Kansas City AI. Exhibited: Annual Midwest. Exh., Kansas City AI, 1932 [40]

BURGDORFF, Ferdinand [P,E] Pebble Beach, CA (1962) b. 7 N 1883, Cleveland, OH. Studied: Cleveland Sch. A.; Ménard, in Paris. Member: Carmel AA; Cleveland SA. Exhibited: CGA. Work: SFMA; CMA [47]

BURGER, A.W. [P] Rochester, NY. Member: Rochester AG [25]

BURGESS, Alice Lingow (Mrs. Wilson Harley Warner) [L,Cr,W,I,C] New Haven, CT b. 7 Ja 1880, St. Louis, MO. Studied: N.Y. Sch. A.; A. Shands; William M. Chase; Anton Fabres; Kenneth Hayes Miller; Will Lathrop. Member: Am. W. Assn. Exhibited: New Haven PCC; Brush & Palette Cl.; Yale Univ. A. Gal.; Meriden ACC. Position: Cr., New Haven Register, 1926– . Founder: New Haven A. Gal. [47]

BURGESS, Edward [P] Chicago, IL [13]

BURGESS, Emma Ruth [P] Hyde Park, MA [08]

BURGESS, Gelett Frank [I,W,L] NYC b. 30 Ja 1866, Boston, MA. Member: SI. Author/Illustrator: "Lady Mechante," "The Burgess Nonsense Book," the "Goop" books, etc. [40]

BURGESS, George Henry [P] b. 1831, London d. 1905, Berkeley, CA. Studied: Somerset Sch. of Des., London; came to San Fran., 1849. Member/Founder: San Fran. AI. Work: ACM [*]

BURGESS, Harry George [P] Boston, MA. Member: Boston AC [15]

BURGESS, Henrietta [P,C,W,L,T] Seattle, WA b. 14 My 1897, Auburn, CA. Studied: Wong of Tsing Hua, Peiping, China. Member: Northwest PM; Seattle AI. Specialties: Oriental design, symbolism, textiles [33]

BURGESS, Ida J. [P,C,W] Woodstock, NY b. Chicago, IL d. 1934. Studied: Chase, Shirlaw, in NYC; Merson, in Paris. Member: Chicago SA; N.Y. Women's AC; PBC. Work: Orington Lunt Lib., Northwestern Univ. Exhibited: dec. of Ill. bldg., Columbian Expo, Chicago, 1893 (prize). Specialty: stained-glass windows [33]

BURGESS, Joseph (E.) [I,P,C] NYC b. 28 Mr 1890 d. 16 Ja 1961. Studied: Syracuse Univ.; G. Bridgman, Harvey Dunn, in NYC. Member: Scarab Cl. Positions: Studio Mgr., American Litho. Co., 1928–32; free-lance adv. illus., 1932– [47]

BURGESS, Marguerite (Mrs. Arthur J. Clawson) [P,T,Li,Des] Washington, D.C. b. 14 Ag 1913, Annandale, VA. Studied: Corcoran A. Sch.; PMG Sch. A.; C. Law Watkins. Exhibited: PMG, 1943, 1944; AIC, 1942; NGA, 1941; BMFA, 1941, 1942 (prize); AG Wash., D.C., 1942–44; Am.-British A. Center, 1943; Contemporary A. Gal., 1940; Whyte Gal., 1943 (prize); VMFA, 1939; Oakland A. Gal., 1941. Work: PMG; Carville Hospital, Carville, La.; American Univ.; mural, Whyte Gal., Wash, D.C. [47]

BURGESS, R.T., Mrs. See Rosamund Tudor.

BURGESS, Ruth Payne (Mrs. John W.) [E,Por.P] NYC/Newport, RI b. Montpelier, VT d. 11 Mr 1934. Studied: ASL, with Brush, Cox, Beckwith, Melchers. Member: Hartford A. Acad.; ASL (pres.); AWCS; Allied AA; NAC; PBC; Women's Intl. A.; AFA; MMA; SPNY. Work: Treasury Bldg., Wash., D.C., Pub. Lib., Holyoke, Mass.; Amherst Col.; Potsdam, Berlin, Germany [33]

BURGMANN, William F. [P] Indianapolis, IN [25]

BURGY, Frederick S. [P] NYC. Member: Bronx AG [25]

BURK, Lou [P] Bloomington, IL b. 1845 d. 24 My 1914. Specialty: animal painting. He had painted more than 10,000 pictures of prize-winning horses, cattle and dogs.

BURK, William Emmett, Jr. [S,Des,Arch,T] Santa Fe, NM b. 9 Ap 1909, Louisville, KY. Studied: Cornell; Univ. Southern Calif.; Merrell Gage; Paul Sample; Olaf Brauner; W.E. Fisher; A.A. Fisher. Work: memorials, Univ. Southern Calif., Los Angeles; Pomona, Calif. Specialty: arch. sculpture. Position: T., Univ. N.Mex.; [40]

BURKE, Alfred F. [Edu] b. 1893, Cambridge, MA d. O 31 1936, West Roxbury, MA. Studied: Royal Drawing Soc., London; Acad. Grande Chaumière, Paris; RISD; Harvard; NYU. Position: Dir., A., Cambridge pub. schools

BURKE, Edmund Raymond [P] Bordentown, NJ. Member: F. PAFA [24]

BURKE, Eleanor W. [C,T] Wilwaukee, WI b. 16 F 1899. Studied: Wis. Sch. F&AA; Wis. State Teachers Col. Member: Wilwaukee AI; Wis. Des. Cl. Specialty: weaving [40]

BURKE, Joan [P,I,E,C,T] San Fran., CA b. 2 S 1904, Sydney, Australia. Studied: America; Europe. Member: Calif. SE [25]

BURKE, John W. [W] b. 1847 d. Ap 1916, Jersey City, NJ. Translator: art news from German, French, Spanish, Italian, and Russian journals

BURKE, May Cornelia [P,T,I] NYC b. 30 Ag 1911, Brooklyn, NY. Studied: F.R. Gruger; CCNY; ASL; Grand Central Sch. A.; Phoenix AI. Member: SI. Exhibited: AWCS, 1941; NYWCC, 1941. Illustrator: national magazines. Position: Instr., McLane AI, NYC, 1940–42 [47]

BURKE, Robert E. [P,L,T] Bloomington, IN/Nashville, IN b. 14 S 1884, Winsted, CT. Studied: Pratt Inst. Member: College AA; Brown County (Ind.) AA. Position: Prof. FA, Ind. Univ. [33]

BURKE, Ruth [P] NYC. Member: NAWPS. Exhibited: NAWPS, 1935–38 [40]

BURKE, Selma Hortense [S,T,W,L] NYC b. 1 Ja 1907, Mooresville, NC. Studied: Columbia; Maillol, in Paris; Hans Reiss, in NYC. Exhibited: WFNY, 1939; ACA Gal., 1945; Downtown Gal., 1939; MacMillen Theatre, 1940; Village A. Center, 1941–46; NYU, 1943; BMA; Newark Mus.; Va. State Col.; Albany Inst. Hist.&A.; Hampton Inst.; Atlanta Univ.; Modernage Gal., 1945 (one-man). Work: NYPL; Bethune Col.; T. Col., Winston-Salem, N.C.; Recorder of Deeds Bldg., Wash., D.C.; U.S. Gov. Contributor: magazines, newspapers. Lectures: African Sculpture. Position: Dir., Student's Sch. S., NYC, 1943–46 [47]

BURKE, Stevenson (Mrs.) [Patron] b. 3 Jy 1841, West Springfield, MA d. 3 Ap 1931, Cleveland, OH. Member: trustee of Cleveland School of Art, became its president. The Ellen M. Burke collection of etchings has been established at the School in her honor by Cleveland artists.

BURKE, William Lozier Munro [Hist] Princeton, NJ b. 26 My 1906, Brooklyn, NY d. 25 Mr 1961. Studied: Princeton Univ.; Univ. Hamburg. Member: AM. Assn. Univ. Prof.; CAA; Mediaeval Acad. Am. Contributor: The Art Bulletin. Position: Dir., The Index of Christian Art, 1946– [47]

BURKENROAD, Flora Salinger [P] New Orleans, LA b. 31 Mr 1873, Lafayette, IN. Studied: NAD; Thomas Eakins; Will H. Low; C.Y. Turner. Member: NAWA. Exhibited: NAWA; Delgado Mus. A.; New Orleans ACC[47]

BURKHARD, Henri [P] Fort Lee, NJ b. 17 F 1892, NYC. Studied: ASL; Académie Julian, Acad. Colarossi, Grande Chaumière, all in Paris. Work: WMAA; Pal. Leg. Honor [40]

BURKHARD, Verona Lorraine [P] Buffalo, WY. Exhibited: Pa. Acad. FA Ann., 1936; Denver M. Ann., 1936; NAWPS, 1938; Montclair A. Assn., 1938 (prize). Work: USPOs, Deer Lodge, Mont., Powell, Wyo. WPA artist. [40]

BURKHARDT, Emerson C. [P,T] Columbus, OH b. 30 Ja 1905, Kalida, OH. Studied: Ohio Wesleyan Univ.; NAD; Charles W. Hawthorne. Member: Columbus AL. Exhibited: AIC, 1932, 1933; PAFA, 1932, 1933, 1936; CGA; CM, 1932, 1937, 1938; Butler AI, 1946; WMAA, 1946; Carnegie Inst., 1946; Columbus Gal. FA, 1931–46 [47]

BURKHEIMER, Lena W. (Mrs. Dean Burkheimer) [P] Seattle, WA/Fletcher Bay, WA b. 18 F 1877, Pleasantville, IA. Member: Seattle FAS [25]

BURLEIGH, Sydney Richmond [P,I,C,Arch] Providence, RI b. 7 Jy 1853, Little Compton, RI d. 25 F 1931. Studied: C.Y. Turner, Paul Laurens, Paris. Member: NYWCC; Providence AC, board officer 1886–1931; AWCS; SC; Providence WCC; founder, Art Workers Guild. Exhibited: St. Louis Expo, 1904 (med);Buffalo SA, 1913 (prize). Work: R.I.Sch.Des.; Delgado Mus.; New Orleans [33]

BURLEIGH-CONKLING, Paul [S] Paris, France [04]

BURLIN, Harry Paul [P,Edu] NYC b. 10 S 1886, NYC d. Ap 1969. Studied: England. Member: Am. Soc. PS&G; Salon des Independents, Salon D'Automne, both in Paris. An early member of the Santa Fe School of Western Painting (1913). Exhibited: CI, 1936–46; WFNY, 1939; AIC, 1935–45; MOMA, 1945; WMAA, 1962; Boston Univ. 1964. Work: MOMA; WMAA; BM; Newark Mus.; Encyclopaedia Britannica Coll. Positions: T., Colorado Springs FA Center, 1936, Wash. Univ., St. Louis, 1949–54, Union Col., N.Y., 1954–55 [47]

BURLIN, Natalie Curtis (Mrs.) [P] d. 23 O 1921, Paris. Wife of painter Paul Burlin; sister of portrait painter Constance Curtis.

BURLINGAME, Charles Albert [P,I,T] Nanuet,NY b. 29 Mr 1860, Bridgeport, CT d. 26 N 1930. Studied: Edward Moran; Wm. H. Lippincott; J.B.Whittaker. Member: SC, 1908; Nanuet Soc. Painters. Position: Instr. drawing, 30 yrs. [10]

BURLINGAME, Dennis Meighan [P] Cresco, PA b. 28 Ja 1901, Oneida, NY. Studied: Grant Wood. Work: U.S. Government; mural, USPO, Wildwood, N.J. WPA artist. [40]

BURLINGAME, Ethel R. (Mrs.) [P] Cincinnati, OH. Member: Cincinnati Women's AC [25]

BURLINGAME, Sheila Ellsworth [S,P,T,B] NYC b. Lyons, KS. Studied: AIC; ASL; Grande Chaumière, Paris; Carl Milles Zadkine; John Sloan. Member: St. Louis AG; PBC; Denver AG. Exhibited: St. Louis AG, 1921, 1922, 1926, 1927, 1928 (prizes); Kansas City, 1922 (med); PAFA; NAD; AIC; Buffalo, NY. Work: figures & reliefs, churches, Mo., Ark., Colo., Mont.; woodcuts, St. Louis Post Dispatch, 1923–24. Illustrator: 23 woodcuts, "From the Day's Journey," by Harry Burke, 1924 [47]

BURLINGHAM, Hiram Bristol, RI b. 1867 d. 17 S 1932. Dealer, antique collector. Specialties: 18th century furniture, Early American paintings

BURLIUK, David [P,L,W] Brooklyn, NY b. 22 Je 1882, Kharkov, Russia. Studied: Paris; Moscow; Cormon; Repin; Archipoff. Member: Art societies in Russia, Germany, U.S.; Société Anonyme. Work: Amalgamated Broadcasting Co., N.Y.; PMG; ACA Gal.; museums in Russia, Japan; Phillips Mem. Gal. Lectures: Modern Art [47]

BURNETT, Calvin W. [Des,P,I] Cambridge MA b. 18 Jy 1921, Cambridge, MA. Studied: Mass. Sch. A. Member: Inst. Mod. A., Boston. Exhibited: NAD, 1945, 1946; SFMA, 1946; Jordan Marsh; Inst. Mod. A.; Stuart A. Gal.; Boris Mirski Gal. Illustrator: textbooks. Position: A., Display Advertising Corp., Boston [47]

BURNETT, Caroline C. Paris, France. Member: SBA [01]

BURNETT, Edah Flower [A.Lib] St. Paul, MN b. 4 D 1884, Mandan, ND. Studied: St. Paul Sch.A.; Simmons Col., Boston; Univ. Minn. Member: Am.Lib.Assn.; Minn. Lib. Assn.; Twin City Lib. Cl. Position: Hd., FA Room, St. Paul Pub. Lib., 1917– [47]

BURNETT, Louis A., Mrs. See Moore, Martha E. [47]

BURNETT, Norman F. [S] Baltimore, MD [25]

BURNEY, Mina [Edu] Gunnison, OH b. Jy 8 1891, Rome, GA d. 21 Ap 1958, Rome. Studied: Teacher Col., Columbia Univ. Member: Nat. Edu. Assn.; Colo. Edu. Assn. Position: Instr., Western State Col. of Colo., Gunnison, Colo., 1933– [47]

BURNHAM, Anita Willets [P,W,L,T,Et] Winnetka, IL b. 22 Ag 1880, Brooklyn, NY. Studied: ASL; PAFA; Chase; Freer; Vanderpoel; Du Mond; Cecilia Beaux; John Johansen; Castellucho, in Paris; Lawton Parker; Ralph Pearson. Member: North Shore AA; Chcago SA; Chicago AC. Exhibited: San Diego FA Soc., 1935 (one-man); AIC, 1903, 1905, 1916, (prizes); North Shore AA, 1936 (prize). Work: Pub. Sch., Children's Hospital, Chicago; Beloit Col. Author/Illustrator: "Fourth of July in Old Mexico;" "Around the World on a Penny." Position: Instr., AIC [47]

BURNHAM, Carol-Lou [P,S,I] Winnetka, IL b. 22 F 1908, Chicago. Studied: Fountainbleau Sch., Paris; AIC; Fernand Leger; André Lhote; Paul Baudouin; R. La Montagne St. Hubert. Member: Women's Arch. Cl., Chicago; North Shore AA. Exhibited: AIC, 1923, 1924, 1925, 1927, 1928, 1935, 1938, 1943; Grand Central AG, 1931 (one-man); AIC, 1931 (one-man). Work: fresco mural, Fontainbleau Sch.; Skokie Sch., Winnetka. Illustrator: "Around the World on a Penny," 1933. Lectures: Wood Carving, Travel, Art [47]

BURNHAM, Frederic Lynden [Edu,P,W] Cambridge, MA b. 1872, Taunton, MA d. 23 My 1911, Cambridge, MA. Studied: Mass. Normal A. Sch., Boston; Yale A. Sch. Member: New Haven PCC; Barnard Cl.; Providence; Whittemore Cl., Boston; Conn. State Teachers' Assn.; Council of Supervisors of the Manual Arts; Eastern Art Teachers' Assn. Contributor: articles on manual arts, educational magazines. Positions: T., North Adams, Mass., 1896–1899, New Haven, Conn., 1899–1903, Providence, R.I., 1903–05, summer, Hyannis Mass. Normal Sch.; Agent, Promotion of Manual Arts, Mass., 1906–1911

BURNHAM, L.P. [Des] NYC [09]

BURNHAM, Roger Noble [S,T,L] Los Angeles, CA b. 10 Ag 1876. Hingham, MA. Studied: Harvard Univ.; Caroline Hunt Rimmer. Member: Los Angeles AA; AFA; Calif. AC; P.&S. Cl.; Soc. for Sanity in Art;

Laguna Beach AA; San Diego AA; Los Angeles PSC. Exhibited: Arch.L., 1904; PAFA, 1913; Rome, Paris, Ghent, 1914; Los Angeles Mus. A., 1925-45; SFMA; Long Beach AA; Laguna Beach AA; Hawaii. Work: Boston City Hall; mem., Atlanta, Ga.; Memphis, Tenn,; Honolulu; Chapel Hill, N.C.; Valentino Mem., Hollywood, Calif. Position: Instr., Harvard Univ., 1912-17; Instr. of Sculpture, Otis Art Inst., Los Angeles, 1926-32 [47]

BURNHAM, Wilbur Herbert [Cr,C] Melrose, MA b. 4 F 1887, Boston, MA. Studied: Mass. Sch. Art; Europe; Joseph De Camp; Albert Munsell. Member: AFA; Copley Soc.; Mediaeval Acad. Am.; Stained Glass Assn. Am. (pres.); Boston SAC (Master Craftsman). Work: Riverside Church, NYC; Princeton Univ. Chapel; St. Vincent's Church, Los Angeles; St. Mary's Church, Detroit, Mich.; St. John's Cathedral, Denver; St. Thomas Church, NYC; Westminster Church, Albany; Westminster Church, Buffalo; Leyden Church, Brookline, Mass.; American Church of Paris; Library, Univ. So. Calif., Los Angeles; Rollins College Chapel, Winter Park, Fla.; St. George's School Chapel, R.I.; St. Paul's Sch., Concord, N.H.; St. Paul's Church, San Rafael, Calif.; Union Church, Waban, Mass,; All Saints Episcopal Church, Worcester, Mass.; East Liberty Presbyterian Church, Pittsburgh, Pa.; Cathedral of St. John the Divine, NYC; St. Mary's Cathedral, Peoria, Ill.; Nat. Cathedral, Wash., D.C.; Trinity Cathedral, Cleveland, Ohio. Lectures: Stained Glass [47]

BURNS, Elizabeth M. [P] Yonkers, NY [25]

BURNS, Georgiana [P] Portland, OR [13]

BURNS, J.F. [P] Brooklyn, NY [13]

BURNS, Milton J. [Mar.P,I,E] b. Ja 9 1853, Mt. Gilead, OH d. 27 D 1933, Yonkers, NY (aboard his studio-boat "Sarah"). Studied: W. Bradford, Arctic Expedition, 1869; with J.G. Brown; Paris, ca. 1870s; ASL. Member: SC, 1871 (founder). Exhibited: SC, 1878-86; NAD, 1875-98; Brooklyn AA, 1876-79; Mystic Seaport Mus., 1984 (retrospective). Work: Mystic Seaport Mus.; Mariners Mus. He was a sailor-artist; sailed frequently to the Grand Banks and North Sea, doing illustrations for Harper's, London Graphic, and others. Partnership with Fred Pansing, in Boston, ca. 1896-98. Was a friend of Winslow Homer, Remington, E.A. Abbey, other great illustrators. He lived in Millington, N.J. until 1915; thereafter aboard his boat moored on the Hudson River. [05]

BURNS, Paul Callan [P,T] Collingswood, NJ b. 28 Ap 1910, Pittsburgh, PA. Studied: PMSchIA; PAFA; Europe; Cape Cod Sch. Art. Member: Phila. WCC; Wilmington Soc. FA; SC. Exhibited: NAD, 1936-42 (prize); PAFA, 1934-42; Wilmington Soc. FA. 1939-41; AIC; BM; John Herron AI; Phila. Sketch Cl.; SC; Milch Gal. Montclair A. Mus. (prize); Work: Collingswood Lib.; U.S. Court House, Phila.; Woodrow Wilson H.S. [47]

BURNS, Pearl Robison (Mrs. Pearl Burrows) [Por.P, L,W] Goodwell, OK b. 3 Mr 1903, Shoals, IN d. 1960. Studied: Frank Benson; Edmund Tarbell; BMFA Sch; Harvard. Member: Tex. FA Assoc.; SSAL; Taos AA; PBC. Exhibited: PBC, 1941; Amarillo AA, 1939; Santa Fe Exh., 1936. Work: Courthouse, Dalhart, Tex., Library, La Junta, Colo.; Okla. Hist. Bldg., Okla. City; A&M Col., Goodwell, Okla.; Old Palace of the Governors, Santa Fe, N.Mex. Illustrator: Liberty magazine. Lectures: Influence of Art in Business [47]

BURNS, William John [P] Paterson, NJ b. 16 D 1907, Paterson. Studied: Hayley Lever. Member: AAPL. Exhibited: Montclair Mus., 1938-39; Cincinnati M., 1939; WFNY, 1939 [40]

BURNSIDE, Cameron [P,T] Haverford, PA b. 23 Jy 1887, London, England d. 26 Mr 1952. Studied: Grand Chaumiére, Paris; Réné Ménard, Rupert Bunny, Lucien Simon, in Paris. Member: Société des Artistes Independents; Société Nationale des Beaux Arts. Exhibited: Panama-Pacific Expo. San Fran., 1915 (med); French Colonial Expo., Marseilles, 1922 (gold); PAFA; NAD; RA; Paris Salon; McClees Gal., Phila. Work: French and Japanese Governments. Official painter to Am. Red Cross in France, 1918-19. Award: Officer of the order of Nichan Iftikhar [47]

BURNSIDE, Lucile Hitt (Mrs. Cameron) [P] Washington, D.C. d. 30 S 1927. Member: Wash. AC. Work: French and Japanese Governments [24]

BUROS, Luella (Mrs. Oscar K.) [P,S] Highland Park, NJ b. Canby, MN. Studied: FA Dept., Columbia Univ.; Ohio State Univ. Member: New Brunswick Art Center. Assn. Exhibited: Columbus Gal. FA, 1935 (prize); N.J. State Ann., Montclair AM, 1938; Corcoran Bienn., 1939; Golden Gate Expo, 1939 [40]

BURPEE, William Partridge [P] Rockland, ME b. 13 Ap 1846, Rockland, ME. Studied: William Bradford. Member: Boston AC. Exhibited: St. Louis Expo, 1904 (prize). Work: BAC; Springfield Mus.; Rockland Pub. Lib. [33]

BURR, C.B. (Mrs.) [P] Flint, MI. Member: S. Detroit Women P. [25]

BURR, Edward Everett [P,T,S] Urbana, IL b. 18 Ja 1895, Lebanon, OH. Studied: Leopold Seyffert; Albin Polasek. Member: All-Ill. Soc. FA; Soc. for Sanity in Art. Exhibited: Soc. for Sanity in Art, Chicago, 1938, 1941; AIC, 1926, 1927, 1931, 1933 (prize); Ill. Acad. FA, 1927. Designer: Ark. Centennial half-dollar [47]

BURR, F.C. [P] Monroe, CT [01]

BURR, Frances [P,I] Smithtown Branch, NY b. 24 N 1890, Boston, MA. Studied: ASL; Provincetown Sch. A.; Charles Hawthorne; William M. Chase; Fontainebleau Sch. Member: NSMP; AAPL; NAWA. Exhibited: Ehrich Gal., 1924; Anderson Gal., 1929; Herron AI; Rochester Mem. A. Gal.; Milwaukee AI; Minneapolis Inst. A.; Arch. Lg.; BM; MMA; AIC. Illustrator: magazines, books. Specialties: panels in gesso relief; portrait interiors [47]

BURR, George Brainerd [P] Old Lyme, CT b. Middletown, CT. Studied: Berlin; Munich Acad FA; ASL; Colarossi Acad., Paris. Member: Allied AA; SC; Lyme Art Assn.; Calif. PM. Work: Vanderpoel AA Coll., Chicago [40]

BURR, George Elbert [P,I,E] Phoenix, AZ b. 1859, Cleveland, OH d. N 1939. Studied: AIC; Europe. Member: Chicago SE; Denver AA; Calif. SE; Am. SE; AI Graphic A.; Soc. Française aux Etats Unis; Soc. Am. E.; Calif. P.M. Work: "Harpers;" "Leslie's;" LOC; NYPL; Newark Mus.; City Mus., St. Louis; BM; Cleveland Mus.; MMA; Detroit Inst.; Chicago AI; Denver Art Mus.; Colorado State Univ.; Pub. Lib., Santa Barbara; Carnegie Inst.; Toledo Mus.; Los Angeles Mus.; Calif. State Library; BMFA; Fogg Art Mus., Cambridge, Mass.; Cincinnati Mus.; Fine Arts Gal., San Diego, Calif.; Phoenix Fine Arts Assn.; Berlin; Prints of the Year, 1931; Luxembourg, Paris; Biblioteque Nationale, Paris; Victoria and Albert Mus., British Mus., London. Said to have produced 25,000 etchings [33]

BURR, (Harold) Saxton [Edu,P,W,L] New Haven, CT/Lyme, CT b. 10 Ap 1889, Lowell, MA. Studied: Yale Univ. Member: Lyme AA; New Haven PCC; William Whitmore. Exhibited: Lyme AA. 1926-46; New Haven PCC, 1930-46. Positions: T., Yale Univ. Sch. FA, 1939- , Yale Univ. Sch. Medicine, 1933- [47]

BURRAGE, Barbara [Dr,Li,E,P,T] NYC b. 1 D 1900, Lafayette, IN. Studied: ASL; Hudson Valley AA; Phila. Print Cl.; Phila. SE; Am. A. Cong. Work: Mus. Fine Arts, Moscow; in Fine Prints of the Year, 1935; NYPL; WMAA [40]

BURRAGE, Mildred Giddings [P,T,Des] Wiscasset, ME b. 18 My 1890, Portland, ME. Studied: Grand Chaumiére; Richard Miller, in Paris. Exhibited: PAFA, 1911, 1913, 1928, 1931, 1935; AIC, 1913; BMFA, 1927; Montclair A. Mus., 1932 (one-man); Detroit AI, 1927; Arch.L, 1921; Sweat Mem. Mus., 1934, 1936 (one-man); Ogunquit AA, 1935, 1936; Brick Store Mus., Kennebunk, Maine, 1936-44. Work: murals, Bryn Mawr Science Lib. [47]

BURRELL, Alfred Ray [P,Li,E] San Fran., CA b. 4 Mr 1877, Oakland, CA. Studied: Frank DuMond; William M. Chase Sch. Art; ASL; Mark Hopkins Sch. Art, San Fran. Member: San Fran. AA; Calif. SE. Exhibited: Honolulu Print Makers, 1935 (prize). Work: NYPL; Calif. State Lib.; John Herron AI, Indianapolis, Ind., Honolulu Acad. A. [40]

BURRELL, D.D. [P] Dubuque, IA. Member: Dubuque AA [25]

BURRELL, Louise (Mrs.) [P] Los Angeles, CA b. London, England. Studied: Herkomer. Member: ARMS; Calif. AC [21]

BURRIDGE, Walter W(ilcox) [Ldscp.P,I] Glen Ridge, NJ b. 1857, Brooklyn, NY. Member: Chicago SA; SC, 1908 [13]

BURRILL, E. [P] Lynn, MA [01]

BURR-MILLER, Churchill [S] Lyme, CT b. 3 Ap 1904, Wilkes-Barre, PA. Studied: H. Bouchard; Yale. Member: CAFA; Lyme AA [38]

BURROUGHS, Alan [P] Minneapolis, MN [25]

BURROUGHS, Betty (Mrs. B.B. Woodhouse) [T,S,L] Flushing, NY b. 17 Ag 1899, Norwich, CT. Studied: Kenneth Hayes Miller; ASL; abroad. Member: NSS; ASL; Am. Soc. PS&G. Work: WMAA. Editor: "Vasari's Lives of the Painters," 1946. Position: T., Birch Wathen Sch., NYC [47]

BURROUGHS, Bryson [P,Mus.Cur] NYC b. 8 S 1869, Hyde Park, MA d. 16 N 1934. Studied: ASL; Académie Julian, Paris; Merson, Puvis de Chavannes, in Paris. Member: ANA, 1904; NA, 1930; SAA, 1901; Cincinnati AC. Exhibited: Pan-Am. Expo, Buffalo, 1901 (med); CI, 1903 (med); Worcester, Mass., 1904 (prize); St. Louis Expo, 1904 (med). Work: BM; MMA; AIC; Denver AM; Newark Mus.; CGA; Luxembourg, Paris. Position: Cur. Paintings, MMA, 1909-34 [33]

BURROUGHS, Edith Woodman (Mrs. Bryson) [S] Flushing, NY b. 20 O

1871, Riverdale-on-Hudson, NY d. 6 Ja 1916. Studied: ASL, with Augustus St.-Gaudens; Injalbert, Merson, in Paris. Member: NSS, 1907, ANA, 1913. Exhibited: NAD, 1907 (prize); P.-P. Expo, San Fran., 1915 (med). Bust of John La Farge (at MMA) and "Fountain of Youth" are her best-known works. [15]

BURROUGHS, Edward R. [P,E,L,Des,Gr] Dayton, OH b. 17 Ag 1902, Portsmouth, VA. Studied: Md. Inst.; Elizabeth Shannon; Henry Roben; Charles Walther. Member: AWCS; Ohio WC Soc.; Dayton SE. Exhibited: Md. Inst., 1932 (med); Butler AI, 1941 (med); Dayton, AI, 1943 (med), 1944 (med), 1945 (med) 1946 (med); Ohio WC Soc., 1946 (med); AIC, 1941, 1943; CAA, 1937; MMA, 1944; CM, 1933–38; LOC, 1943–45; AFA Traveling Exh., 1945; PAFA, 1946; Butler AI, 1939–46; Dayton Soc. P., 1936–46. Work: Dayton AI. Lectures: Graphic Arts, Advertising Illustration. Positions: Dean, Sch. Dayton AI, 1938– ; Asst. Prof. A., Univ. Dayton, 1940– [47]

BURROUGHS, Louise (Mrs. Bryson) [Mus.Cur] NYC b. Allentown, PA. Studied: Cedar Crest Col., Allentown; Lib. Sch., NYPL. Contributor: MMA Bulletin, art magazines. Position: Asst. Cur., Paintings, MMA, 1935– [47]

BURROUGHS, Marion L. (Mrs. Alan). See Luce, Molly.

BURROWS, Harold L. [P,E] NYC/Raquette Lake, NY b. 28 N 1889, Salt Lake City, UT. Studied: Young; Henri [25]

BURROWS, Pearl, Mrs. See Burns, Pearl Robison.

BURRUS, James H. [Des,Mus.Cur,P,L,I,W] Rutherford College, NC b. 25 F 1894, Sugar Grove, NC d. 30 Ag 1955. Studied: Duke Univ.; Ringling Sch. A.; Donald Blake; Loran S. Wilford. Exhibited: Mint Mus. A., 1945; Hickory Mus. A., 1943–45. Lectures: Understanding and Appreciation of Art. Position: Cur., Hickory Mus. Art [47]

BURT, Beatrice Milliken [Min.P] New Bedford, MA b. 17 D 1893, New Bedford. Studied: Delecluse, Laforge, in Paris; Lucia F. Fuller, Elsie Dodge Patte, Miss Welch, in New York [21]

BURT, Edith Noonan (Mrs.) [P] Cincinnati, OH [15]

BURT, Frederic [S] Harrison, NY/Provincetown, MA b. 12 F 1876, Onarga, IL. Studied: Bourdelle; Grande Chaumière, Paris [25]

BURT, Louis [P] NYC b. 20 Jy 1900, NYC. Studied: Robert Henri; George Bellows; John Sloan. Exhibited: MacD. Cl., 1916 (prize), 1917 (prize), 1918 (prize), 1919 (prize) [33]

BURT, Margaret James [P] St. Paul, MN [24]

BURT, Mary Theodora [P] Phila., PA b. Phila. Studied: PAFA; Académie Julian, Paris. Member: Plastic Cl., Phila. All. [33]

BURTIS, Mary E(lizabeth) [P] Orange, NJ b. 8 Je 1878, Orange. Studied: Christine Lumsden. Member: S.Indp.A.; Art Center of the Oranges [24]

BURTON, Alfred [P] Phila., PA [98]

BURTON, Arthur Gibbes [P] Newfane, VT b. 11 F 1883, Troy, NY. Studied: Pratt Inst.; ASL. Member: Am. Ar. Prof. Lg.; Southern Vt. Ar. Exhibited: Southern Vt. Ar., Manchester [40]

BURTON, Harriet (B.) (Mrs. Crawford Burton) [S] NYC b. 29 Mr 1893, Cincinnati, OH. Studied: Mario Karbel; Abastina Eberle; Cecil Howard; Alexander Archipenko. Work: Porcupine Cl., Nassau, Bahamas [40]

BURTON, Jack Munson [P,I,L] Cleveland, OH b. 31 D 1917, Cleveland. Studied: Cleveland Sch. A.; Henry G. Keller; Clarence H. Carter. Studied: CMA, 1939 (prize), 1940 (prize), 1942 (prize), 1943 (prize), 1944 (prize), 1945 (prize). Exhibited: CI, 1941; AIC, 1941; Grand Rapids, Mich.; CMA; Butler AI. Work: CMA; WMAA. Contributor: Fortune. Lectures: Illustration [47]

BURTON, Marjorie de Krafft (Mrs.) [P] Winchester, MA b. 8 Jy 1886, Phila., PA. Studied: Elliott Daingerfield; Henry B. Snell; Richard Miller. Member: Winchester AA [33]

BURTON, Netta M. [P,C,T] Chappaqua, NY b. Scott, PA d. 1960. Studied: Columbia Univ. Member: NAWA. Exhibited: NAWA (prize); Mus. Non-Objective Painting, 1946; Ala. WC Soc., 1945; Irvington AA, 1945; Pleasantville AA, 1946 [47]

BURTON, S(amuel) Chatwood [S,P,Et,Li,E,W,I,L] Minneapolis, MN b. 18 F 1881, Manchester, England d. ca. 1955. Studied: Laurens, in Paris; Lanteri, in London. Member: Minneapolis AA; Chicago SE; Calif. Pr.M.; AFA; A. Masters, England. Exhibited: Minn. State Fair, 1917 (prize), 1918 (prize), 1920 (prize); Minneapolis Inst. A., 1921 (prize), 1924 (prize), 1925 (prize), 1926 (prize), 1927 (prize); Arch. Lg.; Grand Rapids, Iowa; New Orleans, La. Work: MMA; Univ. Minn.; AIC; Am. Edu.&Coop. Un., St. Paul; Holy Cross Convent, Merrill, Wis. Author/Illustrator: "Spain Poised," 1937, "Etchings of Spain." Position: Prof. Arch.&FA, Univ. Minn., 1914– [47]

BURWASH, Nathaniel C. [P,En] Cambridge, MA b. 17 Mr 1906, Los Angeles. Studied: ASL, with Grosz, Baylinson; Vaclav Vytlacil; Harwood Steiger. Exhibited: BM, 1939; AIC, 1942; WMAA, 1936; NGA; SFMA, 1946. Work: IBM; Syracuse Mus. FA [47]

BUSA, Peter [P] NYC. Studied: CI; ASL; Hans Hofmann. Exhibited: WFNY, 1939; Walker A. Center; WMAA; Chrysler AM; Parrish AM; AFA; Albright-Knox Gal. (prize); Ford Fnd., 1962 (prize). Positions: T., CUSchA, 1945–54; NYU, 1948–57; Univ. Mich., 1957; Los Angeles State Univ., 1958–59; Southampton Col., 1971. WPA artist. [40]

BUSALACCHI, Gaetano [P] Milwaukee, WI b. 1887 d. 1967. Studied: Fuester, in Florence; Wis. Sch. A., with A. Mueller. Exhibited: Acad. A., Florence [15]

BUSCH, Clarence F(rancis) [P] NYC/York Harbor, ME b. 29 Ag 1887, Phila., PA. Studied: ASL, Académie Julian, Académie de la Grande Chaumière, Académie Colarossi, Paris. Member: SC; Ogunquit AA. Specialties: portraits; figure compositions; murals [40]

BUSCH, Elizabeth W. (Mrs. W.H.) [P,Li,Ser] Dayton, OH b. 6 F 1897, Dayton. Studied: Stout Inst., Menomonie, Wis.; Dayton AI. Member: Ohio WC Soc.; Dayton Soc. P.&S. Exhibited: Butler AI, 1945 (prize); Dayton, Ohio, 1942–44, 1945 (prize), 1946; LOC, 1945; Ohio Pr.M., 1943–46; Tri-State Pr.M., 1944–46; Butler AI, 1944, 1945; Parkersburg (W.Va.) FA Center, 1943–46 [47]

BUSCH, Hans [P] Cleveland, OH. Exhibited: Cleveland MA, 1937 (prize); WC Ann., PAFA, 1935, 1936, 1938; AIC, 1936, 1939 [40]

BUSEBAUM, Richard [P] Cincinnati, OH. Member: Cincinnati AC [15]

BUSENBARK, E.J. [P] Bayside, NY. Member: GFLA [25]

BUSENBENZ-SCOVILLE, V(irginia) [P,E] Salisbury, CT b. 26 Ap 1896, Chicago. Studied: W.J. Reynolds; Ehrlict, in Munich. Member: Chicago AG; Chicago SE; Ar. Gld. Work: screen, Lake Shore Athletic Cl., Chicago; Bibliothèque Nationale, Paris [40]

BUSEY, Norval H. [P] NYC b. 28 D 1845, Christiansburg, VA. Studied: Bouguereau, in Paris. Member: SC [25]

BUSH, Agnes S(elene) [P] Seattle, WA b. Seattle. Studied: Ella S. Bush; Paul Morgan Gustin. Member: Seattle FAS [25]

BUSH, Charles G(reen) [Car] Staten Island, NY b. S 1842, Boston d. 21 My 1909, Camden, SC. Studied: Boston Latin Sch.; Bonnât, in Paris. Illustrator: Harper's. Positions: Car., Am. Press Assn. (1888), New York Herald; Staff, World, from 1897 [08]

BUSH, Ella Shepard [P] Sierra Madre, CA b. N 1863, Galesburg, IL d. ca. 1950. Studied: ASL; J. Alden Weir; Kenyon Cox. Member: Calif. Soc. Min. P.; Pa. Soc. Min. Pa. Exhibited: Seattle Expo, 1909 (prize); Seattle FA Soc., 1920 (prize); Calif. Soc. Min. P., 1922 (prize), 1925 (prize), 1926 (prize), 1929 (prize), 1932 (prize); Ebell Cl., 1924 (prize); Los Angeles Co. Fair, 1928 (prize), 1939 (prize); GGE, 1939. Work: PMA [47]

BUSH, Margaret Fairman (Mrs. J.L.) [Des,C] Chicago, IL b. Chicago. Studied: Chicago Acad. FA. Member: Chicago Women's Arch. Soc.; Houston Sc.&A. Cl. Work: Powhatan Bldg, Avalon Theatre, both in Chicago. Position: Cataloguer, AIC [40]

BUSH, Margaret W. [P] NYC [15]

BUSH, Marian Spore (Mrs. Irving T.) NYC b. Bay City, MI d. 24 F 1946.

BUSH, Vanette Camp [Min.P] Phila., PA [21]

BUSH, William Broughton [P,I] Mobile, AL b. 20 S 1911, Summit, NJ d. ca. 1960. Studied: Univ. Ala.; Anson J. Cross A. Sch.; ASL, with DuMond. Member: Mobile AA; Ala. A. Lg.; Ala. WC Soc. Exhibited: Ala. WC Soc. (prize); Mobile AA, 1944–46; Montgomery Mus. FA, 1946. Illustrator: "Ghosts of Old Mobile," 1946 [47]

BUSH, William H. [Patron] b. 1849 d. 9 Ap 1931, Chicago. He founded the Life Membership Fund at the Art Institute of Chicago, in 1897.

BUSH-BROWN, Henry K(irke) [S] Wash., D.C. b. 21 Ap 1857, Ogdensburg, NY d. 28 F 1935. Studied: NAD; his uncle, Henry K. Brown; Paris, 1886–89; Italy. Member: NSS, 1893; NAC; N.Y. Arch. Lg., 1892; Soc. Wash. A.; Wash. AC; AFA. Exhibited: Columbian Expo, 1893. Work: Mus. N.Mex.; Gettysburg, Pa.; Appellate Court, NYC; Stony Point, N.Y.; Valley Forge, Pa.; Charleston, W.Va.; Union Lg., Phila.;

USPO, Wellsville, N.Y.; MMA; Atlanta Mus.; Nat. Mus., Wash., D.C. Father of Margaret L. and Lydia. [33]

BUSH-BROWN, Lydia (Mrs. Francis Head) NYC b. 5 N 1887, Florence, Italy. Studied: Pratt Inst. Member: Wash. AC. Exhibited: Paris Expo, 1937. Work: silk mural, Board Room, Southern Railway, Wash., D.C. Specialty: silk murals [47]

BUSH-BROWN, Marjorie Conant (Mrs. Harold). See Conant.

BUSH-BROWN, Margaret Lesley (Mrs. H.K.) [Por.P] Wash., D.C. b. 19 My 1857, Phila. d. 16 N 1944, Ambler, PA. Studied: PAFA; Académie Julian, Paris, with Lefebvre, Boulanger. Member: Wash. AC; Soc. Wash. A.; Wash. WCC; F., PAFA. Exhibited: Charleston Expo, 1902 (med); PAFA (prize); Asheville (med). Work: Blue Ridge, N.C.; Nat. Mus., Wash., D.C.; Pub. Lib., Raleigh, N.C.; Am. Philosophical Soc., Phila.; Board Room, Southern Railway, Wash., D.C. [40]

BUSHMILLER, Ernest Paul (Ernie) [Car] NYC b. 23 Ag 1905, NYC. Studied: NAD. Member: SI; Car. Am. Creator: comic strip "Nancy." Position: Car., United Features Syndicate [47]

BUSHNELL, Adelyn [P] Chicago, IL. Member: Cincinnati Women's AC [17]

BUSHNELL, Della O. [P] Aberdeen, WA [24]

BUSONI, Rafaello [I,W,P] NYC b. 1 F 1900, Berlin. Author/Illustrator: "Land & People," "Stanley's Africa" (1945), and others [47]

BUTCHER, Dora Keen (Mrs. D.K.B. Russell) [P] Palm Beach, FL b. 13 F 1905, Ardmore, PA. Studied: Vassar Col.; PAFA; Eliot O'Hara. Member: Phila. WC Cl.; Soc. Four Arts, Palm Beach. Exhibited: Phila. WC Cl., 1945, 1946; Soc. Four Arts [47]

BUTCHER, Gertrude Wiser (Mrs. W.A.) [P,T] South Bend, IN b. 13 My 1898, Jonesboro, IN. Member: AAPL; Hoosier Salon; St. Joseph Valley AL; Ind. Ar. Cl. [40]

BUTENSKY, Jules Leon [S] Pomona, NY b. 13 D 1871, Stolvitch, Russia. Studied: Imperial Acad. FA, Vienna, with Hellmer, Zumbusch; Mercié, Alfred Boucher, in Paris. Work: MMA; First Nat. Bank., Brooklyn, N.Y.; Seward Park, New York; White House; Harvard Law Sch.; Hebrew Inst., Chicago [25]

BUTERA, Joseph [T,P,Li,L] Boston, MA/Hyannis, MA b. 8 My 1905, Sicily. Studied: Child Walker Sch.; John Whorf; Charles Hopkinson; Howard Giles; C.G. Cutler. Member: New England Pr. Soc.; Boston AC; S.Indp.A. Exhibited: PAFA, 1932; WMA, 1938; Inst. Mod. A., Boston, 1937; Worcester AM, 1938; NAD, 1938; CI, 1941; Smith A. Gal., 1941 (prize). Work: White House; BMFA; LOC; Smith A. Gal.; Springfield Pub. Lib. Lecture: Restoration of Paintings [47]

BUTLER, Andrew R. [P,E] NYC/Walpole, NH b. 15 My 1896, Yonkers, NY. Studied: DuMond; Eugene Speicher; F. Luis Mora; Joseph Pennell. Work: prints, Bibliothèque Nationale, Paris; WMAA [40]

BUTLER, Bessie Sandes (Mrs. Sidney H.) [P,C] Los Angeles, CA b. Galesburg, MI. Studied: AIC; Julie Marest, in Paris [09]

BUTLER, Charles Burgess [P] Chicago, IL [15]

BUTLER, C(ourtland) L. [P,Arch] Pittsburgh, PA b. 12 N 1871, Columbus, OH [25]

BUTLER, Edward B(urgess) Chicago, IL b. 16 D 1853, Lewiston, ME d. 20 F 1928, Pasadena, CA. Studied: F.C. Peyraud. Member: Chicago PS; Chicago AG; Chicago Municipal AL; Calif. AC; Palette and Chisel Cl.; Los Angeles AS. Work: Austin, Oak Park and River Forest AL; CMA; St. Louis Mus. A.; Los Angeles Mus. A.; Dallas AM; Vanderpoel Coll. He formed the finest collection of paintings by George Inness in existence, comprising twenty-two canvases, valued at $150,000, which he presented to the Art Institute of Chicago. [24]

BUTLER, Edward Smith [P,C,T] Boston, MA b. 26 J 1848, Cincinnati, OH. Studied: self-taught. Member: Cincinnati AC [10]

BUTLER, George Bernard [P] NYC b. 8 F 1838 d. 4 My 1907, Croton Falls, NY. Studied: Thomas Hicks, in NYC, 1850s; Couture, in Paris. Member: NA, 1873. Exhibited: Paris Expo, 1889 (prize); NAD, 1907 [05]

BUTLER, Helen Sharples (Mrs.) [P] Longport, NJ b. 22 N 1885, West Chester, PA. Studied: Chase; Anshutz. Member: F., PAFA; S.Indp.A.; Plastic Cl. [21]

BUTLER, H.H. [P] Cleveland, OH. Member: Cleveland SA [24]

BUTLER, Herman John [Dec,L] Canandaigua, NY b. 2 My 1882, Bradford, PA. Studied: Frank von der Lancken; Theodore Hanford Pond; Hendrich van Ingen; Sch. F.& Appl. A., Rochester, NY. Exhibited: designs for stained glass, Memorial A. Gal., Rochester (prize). Work: stained glass, Mercersburg Acad., St. Mary's Church (Cincinnati), St. Joseph Church (South Norwalk, Conn.), Princeton Univ. Chapel. Lectures: Stained Glass; Ecclesiastical Decoration; Symbolism [40]

BUTLER, Howard [I] Darien, CT. Member SI [47]

BUTLER, Howard Russell [P] Princeton, NJ b. 3 Mr 1856, New York d. 22 May 1934. Studied: Princeton and Columbia, 1872–82; Dagnan-Bouveret, Roll, Gervex, in Paris; ASL; Frederick E. Church, in Mexico. Member: SAA, 1889; ANA, 1897; NA, 1899; NYWCC; Arch. Lg., 1889; Century Assoc.; Lotos Cl.; NAC; Nat. Inst. AL; ASL; AFA. Founder: AFAS. Exhibited: Paris Salon, 1886 (prize); PAFA, 1888 (med); Paris Expo, 1889 (med), 1900 (med); NAD, 1916 (prize); Chicago Expo, 1893 (med); Atlanta Expo, 1895 (med); Pan-Am. Expo, Buffalo, 1901 (med); St. Louis Expo, 1904 (med); P.-P. Expo., San Fran., 1915 (med). Work: MMA. Painted several eclipses. [33]

BUTLER, James [P] NYC. Member: S.Indp.A. [21]

BUTLER, J.J.P. [P] Giverny, France [17]

BUTLER, John [P] NYC [13]

BUTLER, John (Davidson) [C,T,Gr,P,L] Phila., PA b. 17 Ja 1890, Mauston, WI. Studied: Univ. Wash.; Univ. Pa.; PMSchIA; Alfred Univ. Member: Wash. SA; Wash. WCC; Pa. Gld. Craftsmen; Phila. A. All. Exhibited: portrait, Soc. Wash. A., 1937 (med); figure comp., Soc. Wash. A., 1938 (med). Position: Instr., PMSchIA [47]

BUTLER, Joseph G., Jr. [Patron] b. 1840, Temperance Furnace, PA d. 19 D 1927, Youngstown, OH. A philanthropist, he rose to power and influence in industrial, railroad and financial circles. He erected a $500,000 building for the Butler Art Institute in Youngstown and presented it to the city with an endowment sufficient to maintain it.

BUTLER, Leonard C. [P] Buffalo, NY b. 3 July 1898, London. Member: Calif. WCS; Buffalo SA; The Patteran. Exhibited: WFNY, 1939; GGE, 1939; watercolor, Ar. Western N.Y., Albright Gal., 1938 (prize). Work: Asbury Park (N.J.) Mus. [40]

BUTLER, Mary [P] Phila., PA/Uwchland, PA d. 16 Mr 1946. Studied: Chase; Henri; Redfield; Phila. Sch. Des. for Women; PAFA; Courtois, Prinet, Girardot, in Paris. Member: PAFA; Phila. WCC; Plastic Cl.; Phila. Pr. Cl.; Phila. Contemporary; Phila. A. All.; AFA; Am. APL; Fairmount Park AA. Exhibited: Buffalo SA, 1913 (prize), 1914 (prize); Plastic Cl., 1918 (med), watercolor, 1929 (prize); PAFA, 1925 (prize); Nat. Art Exh., Springville, Utah, 1926 (prize), 1927 (prize); NAWPS (prize). Work: PAFA; State T. Col., West Chester, Pa.; State T. Col., Springfield, Mo.; Springfield (Mo.) AM; Peoria (Ill.) AM; Edmonton (Canada) AM [40]

BUTLER, Philip A. [P] Auburndale, MA [15]

BUTLER, Royal Oertie (Mrs.) [P] NYC b. Nebraska. Studied: Antwerp; Paris; Munich. Specialty: N.Mex. scenery and Indians [17]

BUTLER, Theodore E(arl) [P] NYC b. 1861, Columbus, OH d. 1936, Giverny, France. Studied: ASL, 1883; Académie Julian, Académie Colorossi, Académie Grand Chaumière, all in Paris, 1887. Member: S.Indp.A. Exhibited: Paris Salon, 1888 (prize); Salon d'Automne, 1906; Salon des Indépendants; Turin Intl. Expo, 1911; Armory Show, 1913. He married Monet's stepdaughter, Suzanne Hoschedé, in 1892. [21]

BUTNER, Kathryn Elizabeth (Kitty) [Mur.P,Por.P,S,T] Atlanta, GA b. 20 D 1914, Phila., PA. Studied: Maurice Siegler; Fritz Zimmer. Member: SSAL; Assn. Ga. Ar.; Atlanta Ar. Gld.; Atlanta AA; High Museum AL; Atlanta Studio Cl. Work: Atlanta Women's Cl. [40]

BUTTERWORTH, Rod [Des] NYC b. 27 Jy 1901, Newark, NJ. Member: AIGA; SI; A.&W. Gld.; A. Dir. Cl. Specialty: adv. design [47]

BUTTON, Albert Prentice [P,I] Boston, MA b. 18 N 1872, Lowell, MA. Studied: Boston art schools. Member: NYWCC; Boston SWCP; Providence WCC. Work: Boston AC [33]

BUTTON, Joseph P. [P] b. 1864, Germantown, PA d. 22 D 1931, Phila. Studied: Cauldron Sch. A., London. Exhibited: U.S.; abroad. Specialty: marine paintings

BUTTRAM, Carrie [P] Norman, OK [19]

BUTTRICK, Stedman [P] Concord, MA. Member: Concord AA [25]

BUTTRICK, Sue K(ingsland) (Mrs.) [C,L] Brooklyn, NY b. 21 F 1883, Mt. Vernon, NY. Studied: PIASch; Arthur W. Dow; Maude Robinson. Member: PBC; N.Y. Ceramic Soc. Exhibited: WFNY, 1939; Cornell

Univ.; N.Y. Ceramic Soc., 1921-45; Syracuse Mus. FA, 1930-40; PBC; PIASch; MMA. Specialty: des., original ceramics, original glazes. Lectures: Ceramics [47]

BUTTS, Alfred M. [Arch,E] Jackson Heights, NY b. 13 Ap 1899, Poughkeepsie, NY. Studied: Univ. Pa. Work: MMA [40]

BUTTS, Porter Freeman [Mus.Dir,W,L] Madison, WI b. 23 F 1903, Pana, IL. Studied: Univ. Wis. Member: Madison AA. Member: Madison AA. Author: "Art in Wisconsin: The Art Experience of the Middle West Frontier," 1936. Contributor: art magazines. Lectures: Art in Wisconsin. Positions: Dir., Mem. Un. Gal., Univ. Wis., 1928- ; Exec. Com., Wis. Centenn. A. Program, 1946-48 [47]

BUYCK, Edward P. [P,L] Slingerlands, NY b. 17 Ja 1888, Bruges, Belgium. Studied: Royal Acad., Bruges; Royal Acad., Antwerp; Ecole des Beaux-Arts, Paris; E. van Hove; F. Courtens; Gaston Latouche. Member: Pr. Cl., Albany, NY. Exhibited: Albany Inst. Hist. & A. (one-man). Work: White House; Canajoharie A. Gal.; Lib., Jarvis, N.Y. [40]

BUZBY, Rosella T. [P,I] Phila., PA b. 21 N 1867, Phila. Studied: PAFA. Member: Plastic Cl. [25]

BUZEK, Irene M. [P] Phila., PA b. 8 O 1891, Camden, NJ. Studied: PAFA; Tyler Sch. FA. Member: F., PAFA; AAPL; Woodmere AA. Exhibited: Montclair AA, 1943 (prize); Montclair A. Mus., 1939-45; Sketch Cl., 1940-46; PAFA, 1940-45; DaVinci All., 1941-43; Woodmere A. Gal., 1942-46 [47]

BUZZELLI, Joseph Anthony [P,Li,C,T,L] NYC b. 4 My 1907, Old Forge, PA. Studied: ASL; Univ. Southern Calif.; Columbia Univ.; Thomas Benton; Merill Gage. Exhibited: Riverside Mus., N.Y.; Vendôme Gal., N.Y.; Everhart Mus., Pa.; Butler AI, 1940 (prize); Parkersburg FA Center, 1945 (prize), 1946 (prize); San Diego FA Soc., 1940; AIC, 1942; Denver A. Mus., 1942; LOC, 1944; CI, 1945; Syracuse Mus. FA, 1946. Work: murals, St. Benedict's Church, Holy Cross Church, both in New York. Lectures: Egyptian Art; Greek Art [47]

BYARD, Dorothy Randolph [P,W] Norwalk, CT b. Germantown, PA. Member: Silvermine AG. Author: poems, Poetry Review (London), Ladies Home Journal, etc. [40]

BYBEE, Addison (Mrs.) [P] NYC. Member: Lg. AA [25]

BYE, Arthur Edwin [Mus.Cur,C,P,W,L] Holicong, PA b. 18 D 1885, Phila. Studied: PMSchIA; Princeton Univ.; Académie de la Grande Chaumière, Paris; John Carlson; Charles Rosen. Member: Col. AA; All.A.Am. Contributor: art magazines. Author: "Pots and Pans, or Studies in Still-Life Painting." Lectures: History of Art. Positions: Cur., PMA, 1922-30; Tech. Advisor, Princeton Univ., 1926-46; Restorer, paintings, 1930- [47]

BYE, Ranulph (de Bayeux) [P] Holicong, PA/Falmouth, MA b. 17 Je 1916, Princeton, NJ. Studied: PMSchIA; ASL, with Earl Horter, Henry C. Pitz. Member: Phila. WCC. Exhibited: Boise AA 1943 (prize); Army Art Contest, 1945 (prize); BMA, 1946 (prize); Phila. WCC, 1937-45; AWCS, 1941, 1945; Oakland, AG, 1944; BMA, 1946; Boise AA, 1943, 1944 [47]

BYER, Alexander [P] NYC. Studied: CUSchA, 1928; NAD, 1929. Exhibited: NAD, 1930 (prize); Skidmore Col., 1933; WPA Easel Project, 1934-38; Cincinnati AM; CGA; PAFA; CI. Work: Smith Col. MA [*]

BYER, Samuel [P] Chicago, IL b. 22 F 1885, Warsaw, Poland. Studied: AIC; Chicago Acad. FA. Member: Palette and Chisel Cl.; Chicago NJSA; All-Ill. SFA. Exhibited: Palette and Chisel Cl., 1929 (prize). Work: Our Lady Church, St. Stephen Church, Pub. Lib., all in Chicago [40]

BYERS, Evelyn [P] Houston, TX [24]

BYERS, Maryhelen [P,T] Seattle, WA b. 23 Mr 1902, Seattle. Studied: André Lhote, in Paris. Member: Seattle SFA [33]

BYERS, Ruth Felt [Por.P,I] Council Bluffs, IA b. 17 F 1888, Council Bluffs. Studied: AIC. Member: Omaha AG; Friends of Art. Work: Pub. Lib., Council Bluffs [40]

BYNE, Arthur G. [Mus.Cur,P,Photogr,W,Arch] NYC b. ca. 1884, Phila. d. 16 Jy 1935, Spain (automobile accident). Studied: Univ. Pa.; Rome. Member: N.Y. Arch. Lg. Exhibited: watercolor, P.-P. Expo, San Fran., 1915 (med); Madrid. An authority on Spanish art, he became, in 1914, curator of the Museum of the Hispanic Society of America. Award: Spanish Gran Cruz del Merito Militar [15]

BYRAM, Ralph S(haw) [Ldscp.P,Des] Phila., PA b. 2 Mr 1881. Studied: PMSchIA; C. Philip Weber; John B. Faier. Member: Germantown AL; Phila. Sketch Cl. [40]

BYRD, Mary [S] NYC. Exhibited: PAFA, 1938; NAD, 1938; WFNY, 1939 [40]

BYRNE, Ellen A(lbert) [P] Wash., D.C. b. 4 D 1858, Fort Moultrie, SC. Studied: Corcoran Sch. A.; William M. Chase; Simon, Ménard, in Paris. Member: S. Wash. A. [25]

BYRNE, Robert [Des,P,T,Ser] NYC b. 10 D 1902, Wash., D.C. Studied: George Washington Univ.; Corcoran Sch. A.; Académie de la Grande Chaumière, Paris; Charles Hawthorne. Member: Provincetown AA; Un. Scenic A. Exhibited: Hispano-Am. Expo, 1928 (med); Provincetown AA. Lectures: Medieval Art. Position: Docent, The Cloisters, 1939-42 [47]

BYRNES, Gene [I,Car] Wash., D.C. Creator: comic strip, "Reg'lar Fellers" [40]

BYRNES, S.P. [P] Phila., PA [05]

BYRON-BROWNE, George [P,S] NYC/Lakewood, NJ b. 26 Je 1908, Yonkers, NY. Studied: Karfunkle; Aiken; Zorach. Member: Allied AA; Yonkers AA. Exhibited: NAD, 1928 (prize) [40]

BYRUM, Ruthven Holmes [Edu,P,W,L] Anderson, IN b. 10 Jy 1896, Grand Junction, MI d. ca. 1960. Studied: Ind. Univ.; Académie de la Grande Chaumière, Académie Julian, Paris; Lhote, in Paris; Hans Hofmann, in Munich. Member: AFA; CAA; Ind. AC; Hoosier Salon; Anderson (Ind.) SA; AAPL. Exhibited: John Herron AI, 1943 (prize); Hoosier Salon, 1928-41, 1943-46; Ind. State Fair, 1928 (prize), 1929 (prizes), 1932 (prize), 1933 (prize), 1934 (prize), 1935 (prize), 1936 (prize), 1938 (prize), 1939 (prize); Ind. AC, 1928-38, 1939 (prize), 1940, 1941, 1942 (prize), 1943-46; CGA, 1932; AIC, 1931, 1939; Anderson SA, 1925-46. Work: Swope AG; Richmond (Ind.) AA; Ind. Univ.; murals, schools and churches, Anderson, Ind. Illustrator: "Mr. Noah's ABC Book." Contributor: art magazines. Position: Instr., Anderson Col., Ind., 1936- [47]

BYWATERS, Jerry [Mus.Dir,W,P,L,I,Cr] Dallas, TX (1976) b. 21 My 1906, Paris, TX. Studied: Southern Methodist Univ.; ASL, 1928; Europe. Member: Lone Star Pr.M. Exhibited: Dallas Mus. FA, 1933 (prize), 1937 (prize), 1939 (prize), 1942 (prize); Houston Mus. FA, 1936, 1940 (prize); WFNY, 1939; GGE, 1939; VMFA; AIC; CM; Colorado Springs FA Center; Dallas All. A. Work: Dallas Mus. FA; Tex. State Col. for Women; Trinity Univ.; Southern Methodist Univ.; Princeton Univ. Pr. Cl.; OWI; murals, USPOs, Houston, Farmersville, Trinity, Quannah, all in Tex. Illustrator: "Mustangs"; "Big Spring" (1942). Contributor: Magazine of Art, Southwest Review. Positions: Assoc. Prof. A., Southern Methodist Univ., 1936- ; A. Cr., Dallas News, 1933-39; Dir., Dallas Mus. FA 1943-64 [47]

BYWATERS, Llewellyn [P] Dallas, TX [25]

BYXBE, Lyman [E,T] Estes Park, CO b. 28 F 1887, Pittsfield, IL. Studied: M.M. Levings. Member: Chicago SE. Exhibited: Chicago SE; SAE; Northwest Pr.M.; Intl. Pr.M.; Kansas City AI; LOC; Grand Central A. Gal.; NGA, 1937 (one-man). Work: NGA; LOC [47]

Sketch of Kenyon Cox by an unidentified artist. Private Collection

CABANISS, Lila Marguerite [T,P] Savannah, GA b. Savannah. Studied: Columbia; Syracuse Univ.; ASL; Eliot Clark; Hilda Belcher; Eliot O'Hara; William Chadwick. Member: Wash. WCC; Savannah AC; Assn. Georgia A.; SSAL; AAPL. Exhibited: PAFA, 1926; CGA; SSAL; Assn. Georgia A.; Savannah AC; AAPL. Position: Supv. A., high schools, Savannah [47]

CABANISS, Mary Hope [P,T,W] Savannah, GA b. Savannah. Studied: Eliot Clark; William Chadwick; Hilda Belcher; Clifford Carleton; Adolph Blondheim; Walter Thompson; Mary Alwell. Member: Telfair AA; Southeastern AA. Exhibited: Ga.-Ala. Exh., 1926 (prize). Positions: Supv. A., Jr. high schools, Savannah; Instr., Beauford-Brevard Art Colonies, Beaufort, S.C. [40]

CABLE, Ben [P] Monmouth, IL. Member: Chicago SA [27]

CABOT, Amy W. [P] Boston, MA. Member: NAWPS; Boston Gld. A. [31]

CABOT, Channing [P,Dec] New Haven, CT b. 1868 d. 18 Jy 1932. Studied: Europe. Member: New Haven PCC (pres.). Specialty: screens [25]

CABOT, Edward C. [P] Brookline, MA. Member: AWCS; BAC [01]

CACCIA, Amelio C. [P] Phila., PA. Member: F., PAFA [25]

CADDY, Alice [P] NYC [13]

CADEL, John M. [P,Dr,Li,L,T] Chicago, IL b. 2 O 1905, Fanna, Italy. Studied: Royal Acad., Venice; Royal Acad., Florence; AIC [40]

CADENASSO, Guiseppe [P] San Fran., CA b. 2 Ja 1858, Genoa, Italy d. 11 F 1918. Studied: Arthur F. Mathews; Mark Hopkins Inst. Member: San Fran. AA. Exhibited: Alaska-Yukon-Pacific Expo, Seattle, 1909 (gold); Calif. State Fair (gold). Work: Golden Gate Park Mus. Position: Instr. Mills Col., 1903–1917 [17]

CADMUS, Egbert [P] Old Lyme, CT b. 26 My 1868, Bloomfield, NJ d. 13 Ag 1939. Studied: Charles E. Moss; C.Y. Turner; E.M. Ward; Robert Henri. Member: Phila. Alliance; AWCS (assoc); AFA. Work: Roerich Mus., NYC [38]

CADMUS, Paul [P,Mur,P,E] NYC/Weston, CT b. 17 D 1904. Studied: Joseph Pennell; William Auerbach-Levy; Charles Locke; Jared French; NAD; ASL. Member: SAE; Am. Soc. PS&G; Am. A. Cong.; Phila SE. Exhibited: WMAA, 1934, 1936–38, 1940, 1941, 1945; BM, 1935; AIC, 1935, 1945 (prize); London, 1938; SAE, 1938; GGE, 1939; PAFA, 1941; Carnegie Inst., 1944, 1945; MOMA, 1942, 1943, 1944. Work: MOMA; Sweet Briar Col.; Am. Embassy, Ottawa; Encyclopaedia Britannica Coll.; WMAA; AGAA; Cranbrook Acad. A.; MMA; LOC; AIC; BMA; NYPL; SAM; Milwaukee AI; mural, Parcel Post Bldg., Richmond, Va. [47]

CADORIN, Ettore [S] San Fran., CA b. 1 Mr 1876, Venice, Italy d. 18 Je 1952. Studied: Venice. Member: NSS. Exhibited: GGE, 1939. Work: statues, St. Mark's Square, Venice; Wagner Mem., Venice; Edgewater, N.J.; Statuary Hall, Wash., D.C.; Civic Center, Los Angeles; Court House, Santa Barbara [47]

CADWALADER, Louise [Des,C] Laguna Beach, CA b. Cincinnati. Studied: Cincinnati A. Acad.; ASL; Calif. Sch. FA; Winold Reis; Ralph Johonnot; Rudolph Schaeffer; Judson Starr; Frank Carlson. Member: Laguna Beach AA [40]

CADWALADER-GUILD, Emma Marie (Mrs.) [S] Berlin, Germany [10]

CADY, Gertrude Parmalee (Mrs. Edwin A.) [P] Warren, RI. Member: Providence AC; Providence WCC [27]

CADY, Harrison [P,I,W,E] NYC/Rockport, MA b. 17 Je 1877, Gardner, MA. Member: SI; SAE; AWCS; SC. Exhibited: NAD, 1944, 1945 (prize), 1946; Macbeth Gal. (one-man); Kleeman Gal. (one-man); Currier Gal. (one-man); WFNY, 1939. Work: NYPL; LOC; Univ. Nebr. Author: "Caleb Cottontail," other children's stories. Contributor: Life, Saturday Evening Post, Ladies' Home Journal

CADY, H(enry) [P] 8 Jy 1849, Warren, RI. Studied: NAD; Member: Providence AC [33]

CADY, Walter C. [P] Brookline, MA. Member: Boston AC [10]

CAESAR, Doris (Porter) [S,W] NYC b. 8 N 1893, NYC. Studied: ASL; Archipenko Sch. A. Member: NAWA; NYSWA; Sculp. G. Exhibited: NAD, 1939, 1941, 1942; PAFA, 1937, 1939, 1941, 1945; Fairmount Park, Phila., 1940; WMAA, 1941, 1944; AIC, 1938, 1940, 1942, 1944; WFNY 1939; Montross Gal. (one-man), 1930, 1931; Weyhe Gal., 1933, 1935, 1937; Buchholz Gal., 1943. Author: "Phantom Thoughts," 1933, "Certain Paths," 1935 [47]

CAFARELLI, Michele A. [P] Teaneck, NJ b. 5 Jy 1889, Laurenzana, Italy. Exhibited: MMA, 1942; PAFA, 1932–34; WFNY, 1939; NAD; Newark Mus.; Montclair A. Mus.; WMA; PAFA, 1939. Work: Paterson N.J. Courthouse; Jersey City Pub. Lib. [47]

CAFFIN, Charles Henry [Cr,W,L] NYC b. 4 Je 1854, Miltingbourne, Kent, England (came to U.S. in 1892) d. 14 Ja 1918. Studied: Magdelen College, Oxford. Came to America 1892. Author: "Photography as a Fine Art," "American Masters of Painting," "American Masters of Sculpture," etc. Positions: Art Ed., The Sun, 1901–05; Critic, New York American, until 1918; editorial staff, International Studio

CAGLE, Charles [P] NYC/Arlington, VT b. 21 Jy 1907, Beersheba Springs, TN. Studied: PAFA; Charles Grafly; Hugh H. Breckenridge; Daniel Garber; J.T. Pearson; Francis Speight. Work: Albright Gal.; Richmond (Va.) Mus. FA [40]

CAGLI, Corrado [P,C,Mur,P,Li,I] NYC b. 23 F 1910, Ancona, Italy. Studied: Rome. Member: F., Guggenheim, 1916. Exhibited: Paris Salon, 1937; Carnegie Inst., 1936, 1937, 1939; WMAA, 1946; Europe, 1933–39; Julien Levy Gal., 1940; SFMA, 1916; de Young Mem. Mus., 1942; Wadsworth Atheneum, 1942; Col. Puget Sound, 1943; Lefebre Gal., London, 1944; Hugo Gal., N.Y., 1945; Santa Barbara Mus. A., 1946. Work: mosaics/murals, Italy. Illustrator: art magazines [47]

CAGWIN, Leroy F. [S] Chicago, IL b. Joliet, IL [01]

CAHAN, Samuel George [I] NYC d. 1974. Member: SI [31]

CAHEN, E.T. [P] NYC [10]

CAHILL, Arthur [P,I,T] San Anselmo, CA (1970) b. 15 My 1879, San Fran. Studied: Paris; Calif. Art Sch. Member: Calif. AA; Bohemian Cl. Work: Capitol, Calif.; Crocker A. Gal.; Bohemian Cl., San Fran. Illustrator until 1915, portraiture thereafter. [25]

CAHILL, Helen A. [P] Litchfield, CT [19]

CAHILL, Katharine Kavanaugh [P] Los Angeles, CA/Phoenix, AZ b. Four Oaks, KY. Studied: William V. Cahill; S. Macdonald Wright. Member: Phoenix FAA. Exhibited: Ariz. State Fair, 1926 (prize) [33]

CAHILL, W.H. [P] Boston, MA [01]

CAHILL, William V(incent) [P,T] Chicago, IL b. Syracuse, NY d. Ag 1924. Studied: ASL; Birge Harrison; Howard Pyle. Member: SC; Calif. AC. Exhibited: SC, 1912 (prize), 1913 (prize); Calif. AC, 1917 (prize); Sacramento Expo, 1917 (med), 1918 (med), 1920 (prize), 1921 (prize); Phoenix Exh., 1919 (prize). Work: Mus. Hist. Sc.&A., Los Angeles; Municipal Coll., Phoenix. Position: T., Univ. Kans., 1918–19 [24]

CAHILL, W.V., Mrs. See Kavanaugh, Katherine.

CAHN, Samuel [I] NYC [19]

CAIN, Jo(seph) (Lambert) [P,T,Mur.P,Li] Kingston, RI b. 16 Ap 1904, New Orleans, LA. Studied: Chicago Acad. FA; AIC; ASL; Kenneth Hayes Miller; Kimon Nicolaides. Member: Am. Assn. Univ. Prof.; Contemporary A. Group. Exhibited: PAFA; NAD; AGAA; Fleming Mus.; R.I. Sch. Des; WMAA; Tiffany Exh., 1931 (gold); MOMA. Work: murals, N.Y. State Training Sch., Warwick, N.Y. Position: Dir. FA, R.I. State Col., Kingston [47]

CAIN, Jo, Mrs. See Rachotes.

CAIN, Lillian Joy Martin [P,T,G] Shreveport, LA/Alburquerque, NM b. 27 Ja 1911, Wichita Falls, TX. Studied: Univ. N.Mex. Member: New Orleans A. Assn.; N.Mex. AL; Shreveport AC; AAPL. Exhibited: Delgado Mus., New Orleans; Wichita Mus.; Fort Worth AM; Women's Dept. Cl., Shreveport (one-man) [40]

CAIN, Neville [I,W,P] d. 19 N 1935, Louisville, KY. Studied: Carolus-Duran. Author/Illustrator: "His Fairy Books." Contributor: Louisville Courier-Journal

CAIN, Robert Sterling [Dec,Des] Oakland, CA b. 14 D 1907, Santa Cruz, CA. Studied: Rudolph Schaeffer Sch. Des.; Sch. A.&Crafts, Oakland. Member: East Bay AA, Oakland. Specialty: modern interiors and displays, with Capwell-Sullivan-Furth, Oakland [40]

CAIN, Theron Irving [Edu,P,W] Weymouth, MA b. 16 D 1893, South Braintree, MA. Studied: Mass. Sch. A.; Harvard Univ.; Boston Univ.; Aldro T. Hibbard. Member: Eastern AA; Nat. Edu. Assn.; Am Soc. for Aesthetics. Contributor: Encyclopedia of the Arts, 1946; Journal of Aesthetics & Art Criticism; Am. Journal of Psychology. Position: Instr., Mass. Sch. A., Boston, 1921– [47]

CAIRNS, Hugh [S] Boston, MA. Member: YMCA [15]

CAIT, Caroline E. [P] Cincinnati, OH [19]

CALAHAN, James J. [E] b. 1841 Studied: self-taught. Member: Attic Cl., Newport, R.I. Exhibited: N.Y. Etching Cl. 1883–88, 1892. Work: Parrish AM, Southampton, N.Y. [*]

CALAPAI, Letterio [P,E,En,I,Mur.P,T] NYC b. 29 Mr 1904, Boston, MA. Studied: Charles Hopkinson; H. Giles; Robert Laurent, ASL; Mass Sch. A.; BAID; Ben Shahn, Am. A. Sch. Member: NSMP; Atelier 17 Group; Northwest Pr.M.; Springfield, Mass. AL; Baltimore WCC. Exhibited: PAFA, 1934, 1935; Phila. WCC, 1934–46; AV, 1943; Baltimore WCC, 1944, 1945; AIC, 1936; CM, 1934; Wilmington WC Soc., 1934–46; LOC, 1944, 1945; Northwest Pr.M., 1943–46. Work: LOC; FMA; BM; BMFA; NYPL; mural, 101st Battalion Armory, Brooklyn, N.Y.; MMA. Illustrator: "Tales of Momolu," 1946, "The Mohawk," 1946. Positions: Instr., drawing, Riverside Mus., NYC; Instr., woodcut, Brooklyn Mus. FA Sch. [47]

CALDER, Alexander [S,P,I] Roxbury, CT b. 22 Jy 1898, Phila., PA d. 1976. Studied: Stevens Inst. Tech.; ASL. Exhibited: Pierre Matisse Gal., 1934; Intl. Expo, Paris, 1937; WFNY, 1939; GGE, 1939. Work: MOMA; MMA; Berkshire Mus. A.; Smith Col.; Wadsworth Atheneum; Chicago AC; Mus. Western A., Moscow; Washington Univ.; CAM; PMA. Illustrator: "Fables of Aesop," 1931, "Three Young Rats," 1944. Specialties: mobiles; stabiles. Son of A.S. Calder. [47]

CALDER, Alexander (Milne) [S] Phila. PA b. 23 Ag 1846, Aberdeen, Scotland (came to U.S. in 1886) d. 14 Je 1923. Studied: John Rhind, in Edinburgh; England; J.A. Bailly; Thomas Eakins; PAFA. Work: Fairmount Park, City Hall, Union League Cl., all in Phila.; PAFA; Drexel Inst. [21]

CALDER, A(lexander) Stirling [S,T] NYC/Pittsfield, MA b. 11 Ja 1870, Phila., PA d. 7 Ja 1945. Studied: PAFA; Chapu, Falguière, in Paris. Member: ANA, 1906; NA, 1913; NSS, 1896; AC Phil.; SAA, 1905; N.Y. Municipal AS; Arch. Lg., 1910; Century Assn.; Players'; NIAL; NAC; Por. P.; New SA; Am. PS&Gr. Exhibited: AC Phila., 1893, (gold); Pan-Am. Expo, Buffalo, 1901; St. Louis Expo, 1904 (med); PAFA, 1905, 1932 (prize); Alaska-Yukon-Pacific Expo, 1909 (prize); Sesqui-Centenn. Expo, Phila., 1926 (med); Arch. Lg., 1932 (gold); NAC, 1933, 1935 (prize); N.J. State Exh., 1935. Work: statues, Presbyterian Bldg., Fairmount Park, both in Phila.; Throop Inst., Pasadena, Calif.; Laurel Hill Cemetery, Phila.; Herron AI; Washington Arch., NYC; Iceland; USPO, Wash., D.C.; Smithsonian Inst.; MMA; MOMA; Telfair Acad., Savannah, Ga. WPA artist. Positions: T., National Acad. Des., ASL [40]

CALDER, Clivia [Cer,S,T] Detroit, MI b. 30 My 1909. Studied: Sch. Detroit Soc. AC. Member: Mich. SWPS. Exhibited: Mich. Art Exh., 1937 (prize). Work: ceramic fountains, Women's Lg. Bldg., Ann Arbor; Water Works Bldg., Lansing, Mich. Positions: T., Detroit Soc. AC; Cer. Supv., Mich. A. Proj. [40]

CALDER, Frank H. [P] Dallas, TX [24]

CALDER, James John [P,Mur.P] Detroit, MI b. 29 Mr 1907, Detroit. Studied: Detroit Soc. AC; Samuel Halpert; John Carroll. Exhibited: PAFA, 1938, GGE, 1939; WFNY, 1939; CGA, 1939; WMAA, 1939; Los Angeles Mus. A., 1945; Detroit Inst. A., 1931–45. Work: murals, USPOs, Grand Ledge, St. Clair, Rodgers City, all in Mich. WPA artist. [47]

CALDER, Josephine Ormond (Mrs. John R.) [P] Toledo, OH. Member: NAWPS. Exhibited: Ohio State Fair, 1934, 1935; NAWPS, 1935, 1936, 1937 [40]

CALDER, Mildred Bussing [P,Mur.P] Garden City, NY b. 9 Je 1907, Brooklyn, NY. Studied: Pratt Inst.; PAFA; ASL; Gordon Stevenson; Paul Moschowitz; Ernest Watson. Member: NAC; Alliance. Work: mural, Skytop Lodge, Pa. [40]

CALDER, Nanette L. (Mrs.) [P] Spuyten Duyvil, NY. Member: Lg. AA [24]

CALDER, Norman Day [P] Phila., PA [15]

CALDER, Ralph Milne [P,Arch,Dec] Phila., PA b. 17 Ap 1884, Phila. Studied: PAFA. Work: Hartford Times Bldg., Conn.; Lord and Taylor Bldg., NYC [27]

CALDERWOOD, Ruth V. [P] Newport, MN [13]

CALDWELL, Atha Haydock (Mrs.) [P] Evanston, IL. Member: Chicago SA; Assoc. SWA [04]

CALDWELL, L.H. [I] Phila., PA [21]

CALDWELL, William H. [I,Cr] b. 1837, Rochester d. 1899. Position: Art Ed., New York Daily Graphic

CALEWAERT, Louis H.S. [P,E,S] Chicago, IL b. Detroit, MI. Studied: Wicker; Detroit Sch. FA; Italy; Sicily; France; Belgium. Member: Chicago SE; Calif. SE. Work: TMA [25]

CALFEE, William H. [P,S,Mur.P,T] Wash., D.C. b. 7 F 1909, Wash., D.C. Studied: Paul Landowski, Ecole des Beaux-Arts, in Paris; Carl Milles, Cranbrook Acad. A. Member: Wash. A. Gld. Exhibited: PAFA; MMA. Work: PMG; Cranbrook Acad. A.; Philbrook A. Center; BMA; murals, USPOs, Selbyville (Del.), Phoebus (Va.), Petersburg (Va.), Bel Air (Md.). Position: Chm., Dept. P.&S., American Univ., 1945–46 [47]

CALHOUN, Frederic D. [P] Minneapolis, MN b. 12 Ja 1883, Minneapolis. Studied: ASL; Minneapolis Sch. A. Member: Minneapolis AL; Minneapolis AC [21]

CALIFANO, Eugene [P,E,T] Chicago, IL b. 31 O 1893, NYC. Studied: Capuano; Celentano; Borgoni; Giardiello. Work: Cathedral of Salerno, Italy [24]

CALIFANO, John [P] Chicago, IL b. 5 D 1864, Rome, Italy. Studied: Domenico Morelli, in Rome. Exhibited: Naples, 1880 (gold) [08]

CALIFANO, Michael [Por.P] NYC b. 8 N 1890, Naples, Italy. Studied: Royal Acad. FA, Naples; Antonio Mancini; Paul Vetri. Exhibited: All.A.Am.; Intl. Expo, Tampa, Fla. (med). Work: Columbia; portraits of national and military figures of the U.S. [47]

CALIGA, I(saac) H(enry) [P] Provincetown, MA b. 24 Mr 1857, Auburn, IN. Studied: William Lindenschmidt; Munich. Member: S.Indp.A. Work: N.E. Hist. & Genealogical Soc.; YMCA, Salem, Mass.; N.Y. Chamber of Commerce; Mass. State House; Historical Society, Danvers, Mass. [40]

CALKINS, Loring Gary [Des,E,I] Los Angeles, CA b. 11 Je 1887, Chicago, IL d. Je 1960. Studied: Yale; AIC; Vanderpoel; Duveneck; Freer; Charles Francis Brown. Member: ASL, Chicago; P.&S. Cl., Los Angeles; Soc. Am. Bookplate Des. Work: Yale; Rye Pub. Lib.; Lake Mills (Wis.) Pub. Lib.; Yale Cl., N.Y. Exhibited: AIC, 1902-1920; Laguna Beach Nat. Pr. Exh.; San Gabriel AA; LOC,1944–45; Chicago SE, 1919; Brooklyn SE, 1922–27; NAC, 1926, 1927; Long Beach AA, 1945, 1946; SAE, 1944;

P&S Cl., Los Angeles, 1945–46; Calif. SE, 1945; Los Angeles Mus. A.; Los Angeles County AA. Illustrator: "The Land and Sea Mammals of Middle America and the West Indies," 1904 [47]

CALL, Mary E. [P] Old Lyme, CT b. Algona, IA. Studied: Enneking; Chase; Acad. Colarossi, Paris. Member: Des Femmes Peintures de la France; Calif. AC. Work: Scottish Rites Hall, Los Angeles [19]

CALLAHAN, Caroline [P] Mountain View, CA b. San Fran.. Studied: Collin, in Paris [13]

CALLAHAN, Kenneth L. [Mus.Cur,Cr,P,Mur.P] Seattle, WA b. 30 O 1906, Spokane, WA. Studied: Univ. Wash. Member: Puget Sound Group. Work: SAM; SFMA; MOMA; murals, USPOs, Anacortes, Centralia, both in Wash., Rugby, N.Dak.; Marine Hospital, Seattle. Contributor: art magazines. Positions: Cur., SAM, Seattle, 1932–46; Cr., Seattle Times, 1933–46 [47]

CALLAN, Alice [P] Kansas City, MO [24]

CALLAN, Mary Catherine (Mrs. J.G.) [P,I,T] Lynn, MA b. 16 Ap 1871, Kingston, MO. Studied: F.W. Benson; Edmund C. Tarbell; Joseph de Camp [10]

CALLAWAY, Elizabeth R. Jordan [P,T] La Canada, CA b. 21 Ag 1904, Mexico. Studied: Stanford Univ.; Brackman; Locke; Olinsky; Lewis; ASL; Albright; Mackey; Calif. Sch. FA; Patterson; Chouinard Art Inst. [40]

CALLCOTT, Frank [Edu,P,E,Li,L] NYC b. 28 My 1891, San Marcos, TX. Studied: Southwestern Univ.; Columbia; Bridgman; Nicolaides; ASL. Member: CAFA; SSAL; Southern Pr.M.; Studio Gld., New York; Southwestern AG; AAPL. Exhibited: NAD, 1939; VMFA, 1940; CAFA, 1938–42; SSAL, 1935–42; All.A.Am., 1938, 1940, 1941, 1943; Southern Pr.M., 1936–41, 1939 (prize). Work: MMA; Columbia; Dallas Mus. FA; Southwestern Univ.; Tex. Tech. AI; Tex. State T. Col.; Tex. Senate; Scudder Sch., N.Y.; Lubbock A. Mus.; Grace Methodist Church, N.Y. Author: Spanish textbooks. Lectures: Art of Spain. Positions: T., Columbia, 1920– [47]

CALLENDER, F. Arthur [P] Paris, France b. Boston. Studied: Boulanger, Lefebvre, in Paris. Work: owned by the King of Italy [17]

CALLICOTT, Burton (Harry) [P,T,Mur.P] Memphis, TN b. 28 D 1907, Terre Haute. Studied: Cleveland Sch. A. Member: AFA; AAPL. Exhibited: WFNY, 1939; Tenn. SA, 1939; Black Mountain Col., 1942, 1943; Va. Intermont Col., 1944, 1945; Memphis Acad. FA, 1943–45. Work: murals, Memphis Mus. Nat. Hist. Positions: T., Memphis Acad. A., 1936–46; Dir., Summer Sch., Memphis Acad. A., 1946. [47]

CALMA, Monico C. [P,E,I,W] Anda, Pangasinan, Philippine Islands b. 4 My 1907, Anda, Pangasinan. Studied: Daniel Garber; Joseph T. Pearson, Jr.; George Harding; Roy Nuse; Francis Speight. Member: F., PAFA; Phila. SE; Graphic Sketch Cl., Phila. Work: New Richmond (Ohio) H.S.; etchings, Hattie Strong Fnd., Wash., D.C. Illustrator: Filipino Student Christian Movement, Philadelphia Public Ledger, "Observations of an Art Student" (Philadelphia Evening Bulletin) [47]

CALOENESCO, Aurelia (Mrs. Robert Hallowell) [P] NYC b. Romania. Studied: Beaux-Arts, Bucharest. Work: Luxembourg Mus.; Strasbourg Mus. [40]

CALVERLY, Charles [S] Caldwell, NJ b. 1 N 1833, Albany, NY d. 25 F 1914. Studied: Erastus D. Palmer (was his assistant for 14 yrs.). Member: ANA, 1871; NA, 1872. Work: busts, MMA; NAD [13]

CALVERT, Bertha Winifred [P] Nashville, TN b. 6 D 1885, Nashville. Specialty: ivory miniatures [21]

CALVERT, E. [P] Nashville, TN b. 4 My 1850, York, England. Work: portraits, Mercer Univ., Macon, Ga.; Vanderbilt Univ.; Lake Geneva (Wis.) Assembly Hall; Masonic Grand Lodge, Nashville [21]

CALVERT, Jennie C. (Mrs. Finley H.) [P] Wash., D.C. b. 22 F 1878, Phila., PA d. ca. 1950. Studied: Catherine Carter Critcher; Guy Wiggins. Member: Soc. Wash. A.; SSAL; AAPL; Old Lyme AA; Carolina AA. Exhibited: CGA, 1937, 1939, 1944; Old Lyme AA, 1940, 1942; Gibbes A. Gal., Charleston, S.C., 1941 (one-man). Studio Gld., 1944; Corcoran Gal.; MMA, 1940, 1945 [47]

CALVERT, Peter R. [P] Nashville, TN b. 14 Ap 1855, Leeds, England. Studied: John Sowden. Specialty: ivory miniatures [21]

CALVIN, C.C. Brooklyn, NY [01]

CALVIN, Katherine [P,T] Akron, OH b. 27 1875, Meadville, PA. Studied: Europe; Charles Hawthorne; Henry B. Snell; Hans Hofmann. Member: Ohio WCS; AWCS; NAWA; Akron Women's AL. Exhibited: NAWA, 1938, 1939, 1943, 1944; AWCS, 1938, 1939; Phila. WCC, 1937; Soc. Wash. A., 1929; Akron AI, 1926, 1927 (prize), 1928–36, 1937 (prize), 1938–44, 1945 (prize), 1946 (prize); Butler AI (traveling exh.) 1932–33, 1935–37; Butler AI, 1935, 1940, 1944; Canton AI, 1938 (one-man), 1944 (prize); Columbus A. Gal., 1935. Work: Meadville AI. Position: T., Akron Central H.S. [47]

CAMDEN, Harry Poole Jr., [S] Ithaca, NY b. 10 Mr 1900, Parkersburg, WV d. 29 Jy 1943. Studied: Yale; Am Acad., Rome. Member: NSS; Iroquois Assn. Art Schools Western N.Y. Work: memorials, Cornell; Leaburg Power Plant, Eugene, Oreg.; statues, Fed. Bldg., WFNY, 1939; USPO, Clarks Summit, Pa. WPA artist. Position: T., Cornell [40]

CAME, Kate E. [P] Dorchester, MA b. Boston, MA. Studied: Sandham; Kronberg; Rice. Member: Copley Soc. [10]

CAMERO, Blanche Gonzalez [T,P,E] Phila., PA b. 3 N 1894, NYC. Studied: PMSchIA; PAFA; Earl Horter; Arthur Carles. Member: Phila. WCC; Phila. A. All.; Phila. A. T. Assn.; Nat. Edu. Assn.; Pa. State T. Assn. Exhibited: PAFA, 1931, 1933, 1934, 1937, 1943, 1944; Phila. Pr. Cl., 1934; Phila WCC, annually; Phila. A. T. Exh., 1922–46. Work: Shoemaker Jr. H.S., Phila. Position: T., Overbrook H.S., Phila., 1926– [47]

CAMERON, Edgar S(pier) [Mur.P,L] Chicago, IL b. 26 My 1862, Ottawa d. 5 N 1944. Studied: Chicago AD; ASL; Cabanel, Constant, Laurens, in Paris. Member: Cliff Dwellers. Work: Chicago Hist. Soc.; Chicago Union Lg. Cl.; Supreme Court Lib., Springfield, Ill.; Chicago City Hall; AIC; Genesee Co. Court House, Flint, Mich.; mural, Pub. Lib., Riverside, Ill.; murals, First National Bank, Oklahoma City; Emerson Sch., Gary, Ind. [40]

CAMERON, Elizabeth Wallace [P,T] Pittsburgh, PA b. Woodland, PA Studied: Christian Walter; Ossip Linde; Hugh Breckenridge. Member: Pittsburgh AA; Pittsburgh T. Assoc. [40]

CAMERON, Marie Gelon (Mrs. Edgar S.) [P] Chicago, IL b. Paris. Studied: Moreau de Tours; Cabanel, Laurens, Constant, in Paris; AIC. Work: portraits, Historical Soc., Chicago; First Regiment Armory, Chicago; Cook County Probate Court; Northwestern Univ.; Univ. Notre Dame [40]

CAMERON, (Mrs.) [P] Tacoma, WA. Member: Tacoma FAA [25]

CAMERON, R.C. [P] Wash., D.C. [13]

CAMERON, W(illiam R(oss) [E,B,Li,P] Alameda, CA b. 14 Je 1893, NYC. Studied: F.L. Meye; Xavier Martinez; Nahl; E. Spencer Mackey; Martin Griffin; London; Paris. Member: San Fran. AA; Calif. SE; Thirteen Water Colorists; Oakland AA [40]

CAMERON-MENK, Hazel [P,S,W,L] Sarasota, FL b. 3 N 1888, St. Paul, MN. Studied: Ringling Sch. A.; George Washinton Univ.; Corcoran A. Sch.; Eugene Weiss; Richard Lahey. Member: Wash. AC; NAC; Sarasota AA; Lg. Am Pen Women. Exhibited: S.Indp.A., 1933 (med). Work: Clarendon Lib., Arlington, Va. Contributor: Arlington Chronicle. Position: U.S. Bd. Engineers for Rivers & Harbors, 1917–46 [47]

CAMES, Vina [P] Laramie, WY (1948) b. ca. 1908, Oakland, CA. Studied: Colorado Springs FA Center; Broadmoor Acad.; H.V. Poor; F. Mechau; B. Robinson; L. Barrett. Member: Wyo. A. Assn. Exhibited: 44th Ann. Denver AM, 1938; Chappel House, 1938 (one-man); WFNY, 1939. Work: Univ. Wyo.; Denver AM [40]

CAMFFERMAN, Margaret Gove (Mrs. Peter) [P,L] Langley, WA (1962) b. Rochester, MN. Studied: Minneapolis Sch. FA; N.Y. Sch. Des.; Robert Henri, in N.Y.; André Lhote in Paris. Member: Women Painters Wash. Exhibited: N.Y. Municipal Exh., 1936; Pal. Leg. Honor, 1933; Portland, Oreg. Mus. A., 1929; Spokane AA, 1945; Northwest A., 1932–46; Women Painters Wash., 1932–46, 1942 (prize), 1944 (prize), 1946 (prize); SAM (one-man); Lg. Am. Pen Women, 1946. Work: SAM. Positions: Chm., A. Group, Lg. Am. Pen Women, Seattle, Wash., 1944–46 [47]

CAMFFERMAN, Peter Marienus [P,E,T,W,L] Langley, WA b. 6 F 1890, The Hague, Holland d. 15 N 1957. Studied: Minneapolis Sch. FA; Andre Lhote, in Paris; Vong Slegal; Macdonald-Wright. Member: Puget Sound Group. Exhibited: N.Y. Municipal Exh., 1936; GGE, 1939; MOMA, 1933; SAM, 1932, 1933 (prize) (one-man), 1934, 1935 (prize) 1936 (one-man), 1937 (prize) 1938–40, 1941 (prize), 1942–46; Pal. Leg. Honor, 1933; Portland, Oreg. Mus. A., 1937. Lectures: Modern Art. Positions: T., Helen Bush Sch., Seattle, Wash., Pilgrim Social Center, Seattle, Wash. [47]

CAMILLE, Sister [P,Des,Dr,C,T] Indianapolis, IN/St. Mary-of-the-Woods, IN b. 19 Ja 1901, Vincennes, IN. Studied: Corcoran Sch. A.; AIC;

Chicago Acad. FA; Oskar Gross; Gordon Mess. Member: Ind. Artists Cl. [40]

CAMP, Ellen M. [P] Plainfield, NJ [17]

CAMP, Harold M. [P] Brooklyn, NY. Member: NYWCC. Exhibited: P-P. Expo, 1915, San Fran. (med) [17]

CAMP, Helen B. (Mrs.) [E] Berkeley, CA. Member: Calif. SE [27]

CAMP, Helena L. [P] Milwaukee, WI [17]

CAMP, Robert [P] Ocala, FL. Exhibited: WFNY, 1939 [40]

CAMPANELLA, Vincent Richard [P] NYC. Member: AWCS. Exhibited: WWCS, 1936; WFNY, 1939

CAMPBEL, John [I] NYC [19]

CAMPBELL, A.S. [Photogr] Elizabeth, NJ b. 1839 d. 3 Ag 1912, Arcachon, France. Work: edition of the Bible illustrated entirely with his photographs. A pioneer in art photography in this country.

CAMPBELL, Alice [S,T,L] NYC b. 29 Mr 1908, NYC. Studied: Despiau, Bernard, in Paris; Archipenko; Maurice Sterne. Member: NSS. Exhibited: PAFA, 1938; PS Ann., AIC, 1938; Acad. FA, Honolulu. Position: T., Montclair (N.J.) AM [40]

CAMPBELL, Anne Barraud [Min.P] Wash., D.C./Bremo Bluff, VA b. 13 Ag 1879, Nelson Co., VA d. 24 Mr 1927, NYC. Studied: Alice Beckington; ASL; C.C. Critcher; Corcoran A. Sch.; Bertha E. Perrie. Member: Wash. WCC; Wash. AC [24]

CAMPBELL, Annie [P] Richland, MI. Studied: Arthur W. Dow; Hugo Froehlich; Walter Beck; C. Curry Bohm. Work: Steele H.S., Dayton, Ohio; Circulating Gal., Dayton AI [40]

CAMPBELL, Blendon Reed [P] Meriden, CT/Athol, MA b. 28 Jy 1872, St. Louis, MO. Studied: Constant, Laurens, Whistler, in Paris. Member: SI, 1905; Paris AAA; Arch. Lg., 1911. Work: AIC; Smithsonian Inst.; Wichita AA; Lib., Woodhaven, N.Y.; WMAA; Mus., Bath, England; Brooklyn, Lib.; MMA [47]

CAMPBELL, C. Isabel [P,Mur.P,S] Phila., PA b. Brooklyn NY. Studied: Phila. Sch. Des. for Women; Daniel Garber; Henry B. Snell; Samuel Murray. Member: Plastic Cl.; AFA. Exhibited: Sesqui-Centenn. Expo, Phila., 1926 (med). Work: miniature models, dioramas, Phila. Commercial Mus. [47]

CAMPBELL, Charles [P] Cleveland, OH b. 27 Ag 1905, Dayton, OH. Studied: Cleveland Sch. A. Exhibited: Great Lakes Exh., 1938; Contemporary Am. P. Ann., WMAA, 1938; Mus. Mod. A., Wash., 1938. Work: Cleveland MA; WMAA; USPOs, Angola, Ind., Kenedy, Tex. WPA artist. [40]

CAMPBELL, Cora A. [C,P,T,E] Phila., PA b. 12 D 1873, Phila. Studied: PMSchIA; Charles Hawthorne; W.C. Copeland; Henry Pitz. Member: Phila. Alliance; Plastic Cl.; AFA; Phila. A. T. Assn. Exhibited: Phila. Plastic Cl., 1922, 1941-46; Phila. Alliance, Sketch Cl., 1944-46; Woodmere A. Gal., 1944-46; Cape May, N.J., 1945; Pa. State Col., 1920; PMSchIA, 1922, 1923. Lecturer: Art of Indians of Alaska. Position: Supv. A., Pub. Sch., Phila., 1922-42 [47]

CAMPBELL, E. Elmus [I] Chicago IL. Illustrator: Esquire [40]

CAMPBELL, Edmund S. [P,T,Arch] Charlottesville, VA b. 28 O 1884, Freehold, NJ d. 8 My 1950. Studied: MIT; Ecole Des Beaux-Arts. Member: AWCS. Positions: Prof. A./Cur., Mus. FA, Univ. Va. [47]

CAMPBELL, Edward Morton [P,S,T] St. Louis, MO b. Hannibal, MO. Studied: St. Louis Sch. FA; Lefebvre, Boulanger, Académie Julian, Paris. Member: St. Louis AG; St. Louis Assn. PS; SWA [01]

CAMPBELL, E. Simms [I] White Plains, NY. Member: SI [47]

CAMPBELL, Ethel (Mrs.) [I] White Plains, NY. Member: SI [47]

CAMPBELL, Fannie Soule [P] Berkeley, CA [10]

CAMPBELL, Floy [P,I,W,L,T] Kansas City, MO b. 39 S 1875, Kansas City. Studied: ASL; Garrido, Cottet, Colarossi Acad., all in Paris. Member: Kansas City AS. Work: Jefferson Col., Phila. Author/Illustrator: "Girls in Camp Already" [40]

CAMPBELL, Harriet Dunn (Mrs. W.D.) [P,Des] Columbus, OH b. Columbus. Studied: Columbus A. Sch.; Ohio Univ.; George Bridgman; Arthur W. Dow; Charles Hawthorne; Robert Henri; William Chase; ASL. Member: Columbus AL; Ohio WCS. Exhibited: AWCS, 1934; Boston AC, 1934; Phila. WCC, 1935; AIC, 1935; Columbus AL, 1935, 1927 (prize); Ohio WC Soc.; Little Gal., 1938 (one-man) [47]

CAMPBELL, H(elena) E(astman) Ogden (Mrs.) [Por.P,T,W] NYC b. Eastman, GA. Studied: William Chase; Robert Henri; Lucien Simon. Member: AAPL; NAWA. Exhibited: AAPL; NAD; NAWA; Alliance AA; SSAL; Yonkers AA. Work: Columbia; State T. Col., Upper Montclair, N.J.; Wesleyan Col., Macon, Ga.; Mid-Valley Hospital, Pa.; Mus. City of New York; Hist. Dept., U.S. Navy. Position: T., Barbizon A. Class, N.Y. [47]

CAMPBELL, Heyworth [P,W,L,T] NYC/Oakland, NJ b. 29 Je 1886, Phila., PA. Member: Grolier Cl.; SC; Art Director's Cl.; Advertising Cl. Specialty: adv. art [31]

CAMPBELL, H.M., Jr. (Mrs.) [P] Grosse Point, MI. Member: Soc. Detroit Women P. [25]

CAMPBELL, Hugh Stuart [P] Chicago, IL [15]

CAMPBELL, I(sabella) F. (Mrs. W.T.B.) [P] Los Angeles, CA b. 11 N 1874, Rockford, IL. Studied: AIC; ASL; Joseph de Camp, William Chase; George D. Otis; John H. Vanderpoel; Nicolai Fechin. Member: Calif. AC; Laguna Beach AA; Women Painters of the West. Exhibited: Santa Cruz, Calif., 1938, 1943, 1945, 1946; Oakland A. Gal., 1938, 1945, 1946; Pal. Leg. Honor, 1940, 1942, 1944, 1945; Laguna Beach AA; Soc. for Sanity in Art, 1941. Work: Pilgrim Hall, Hollywood, Calif. [47]

CAMPBELL, Isabella (Gadella?) Graham (Mrs. Henry Munroe) [P] Paris, France. Studied: William Chase; Bourdelle. Member: Detroit SWP [31]

CAMPBELL, Jessie G. [E] St. Paul, MN [17]

CAMPBELL, Jewett [P] Richmond, VA b. 10 Ag 1912, Hoboken, NJ. Studied: Curry; Dubois; Miller, ASL. Exhibited: VMFA, 1941 (prize); NGA, 1942; Acad. Sc.&FA, Richmond, Va., 1942 (prize) [47]

CAMPBELL, Jewett, Mrs. See Begien, Jeanne.

CAMPBELL, John Carden [I,Des,Car,Dec,L] Santa Cruz, CA b. 14 Dec 1914. Studied: ASL, San Fran.; Rudolph Schaffer Sch. Exhibited: San Fran. MA; GGE, 1939. Illustrator: books [40]

CAMPBELL, Marjorie Dunn [Edu,P] Columbus, OH b. 14 S 1910, Columbus, OH. Studied: Ohio State Univ.; T. Col., Columbia; Hans Hofmann; Emil Bisttram; Millard Sheets. Member: Ohio Edu. Assn.; Western AA; Ohio WCS; Columbus AL; Ohio Valley AA. Exhibited: Phila. WCC; Ohio WCS, 1946; CAM, 1944. Positions: T., Univ. Missouri (1942-45), Ohio State Univ., Columbus (1945-) [47]

CAMPBELL, Mary [P] Washington, PA. Member: Cincinatti Women's AC [25]

CAMPBELL, Myrtle Hoffman [P,T] Boulder, CO b. 17 F 1886 Columbus, NE. Studied: AIC; Vanderpoel. Member: Prairie WCS; NAWA; Boulder AL. Exhibited: PAFA, 1933-36; NAWA, 1938-46; WFNY 1939; Denver A. Mus., 1939-40; Joslyn Mem., 1939-43; Kansas City AI, 1935-42; Los Angeles Mus. A. [47]

CAMPBELL, Orland [Por.P] NYC b. 28 N 1890 Chicago, IL d. 1972. Studied: George Washington Univ.; Corcoran A. Sch.; PAFA, with Henry McCarter. Member: Century Assn. Exhibited: CGA, 1923; CAM, 1924; Arch. Lg., 1926. Work: Capitol, Wash., D.C.; Canajoharie Mus.; U.S. Military Acad., West Point; MIT; Univ. Chicago; Rensselaer Polytechnic Inst.; Mus. of City of N.Y. [47]

CAMPBELL, Orson D. [P] b. 1876, Fillmore, UT d. 1933, Provo, UT. Studied: Brigham Young; ASL, with Bridgman, Taylor, DuMond, Cox, 1908-09; Calif. Sch. FA, 1920; AIC, 1922. Positions: T., Brigham Young Univ. (1903-15), Ricks Col. (1915-18), Dixie Col. (1918-20) [*]

CAMPBELL, Pauline [P] Washington, D.C. Member: Wash. WCC [25]

CAMPBELL, Sara Wendell [I,Des] NYC b. St. John, New Brunswick d. 16 Mr 1960. Studied: Pape Sch. A., Boston; Chase Sch. A.; Penfield; Chase; Miller. Member: AG; SI; Audubon A. Exhibited: NAD; SI; AG; Kennedy Gal., NYPL; Art Director's Cl. Illustrator: "Bible Stories"; advertising books & covers, national magazines [47]

CAMPBELL, Thomas [P] Knoxville, TN [13]

CAMPBELL, V. Floyd [I] b. Port Austin, MI d. 21 Ap 1906, Morton, PA. Studied: Detroit Mus. On the art staff of New York paper, for which he went to Cuba to cover the Spanish-American War. In 1899, went to Phila. and worked for papers there. Well known for his drawings of the Roosevelt bears in the Sunday editions of the New York Times.

CAMPBELL, W(illiam) Addison, Jr. [P,T] San Fran., CA b. 18 Je 1914,

NYC. Studied: Calif. Sch. FA, Maurice Sterne. Member: San Fran. AA. Exhibited: San Fran. AA, 1938–46; AFA, 1938–42. Work: Crocker A. Gal.; Chappell House, Denver, Colo. Positions: T., A. C. Center, San Fran. (1938–42), Calif. Col. A.&C., Oakland (1946–) [47]

CAMPRUBI, Leontine (Mrs. L.C. Tintner) [P] NYC/Ames, IA b. 6 Jy 1916, Caldwell, NJ. Studied: ASL; Colorado Springs FA Center; Switzerland. Exhibited: CGA, 1941; Contemporary A. Gal. (one-man); Pinacotheca; Springfield Mus. A., 1944 [47]

CAMPTON, James [P] NYC Exhibited: PS Fed. Bldgs., 1936 [40]

CANADAY, John E. [P,Des,E,L,T,W] Charlottesville, VA b. 1 F 1907, Fort Scott, KS. Studied: Univ. Tex.; Yale. Member: SSAL. Position: T., Univ. Va. [49]

CANADE, Eugene George [P,C,T] NYC b. 22 N 1914, Brooklyn, NY. Studied: Brooklyn Col. Exhibited: Weyhe Gal., 1938; Albright A. Gal.; Contemporary A. Gal.; AAPL, 1940, 1941; Nat. Soldier A. Exh., 1941. Illustrator: "The Second World" (1942), "Time of Year" (1943) [47]

CANADÉ, Vincent [P] NYC b. Albanese, Italy, 1879. Studied: self-taught. Work: PMG; WMAA [40]

CANBY, E. Pontell [P] Woodstock, NY [17]

CANDELL, Victor [P,T,Gr,I] NYC b. 11 My 1903, Budapest, Hungary d. 1977. Studied: Paris; Budapest; NYC. Member: Am. A. Cong.; AAPL; Mural AG. Exhibited: WMA, 1945; Albany Inst. Hist.&A., 1945; Audubon A., 1945; NAD, 1945; Everhart Mus. A., Scranton, Pa., 1944 (one-man); Brooklyn, N.Y., 1946. Work: U.S. Gov.; BMA; Children's Hospital, Schenectady [47]

CANDLER, Eleanor S. [P] Detroit, MI [25]

CANDLER, Marian [P] Detroit, MI. Member: Detroit SWP [25]

CANDLER, Miriam L. [P] Detroit, MI [21]

CANDLIN, Abbie (Mrs.) [P] Long Island City, NY b. 12 Je 1885, Farmington, WI. Studied: Oberlin Col.; John E. Thompson. Exhibited: Denver Art Mus., 1930 [40]

CANE, Alice Norcross [P,T] Louisville, KY/Provincetown, MA b. Louisville. Studied: Charles Hawthorne; James Hopkins; Van Deering Perrine; Jonas Lie; Paris; Vienna; Poland. Member: Louisville AA; Louisville, AC [33]

CANE, Elsie M. [P,T] Brooklyn, NY b. 8 My 1890. Studied: Frederick Boston; Eliot O'Hara [33]

CANE, Florence [P] NYC. Member: NAWPS. Exhibited: Julian Levy Gal., 1938 (one-man); NAWPS, 1938 [40]

CANFIELD, Agnes [Li] Paris, France b. Baltimore. Studied: Collin, in Paris [10]

CANFIELD, Birtley King [S] NYC/Ravenna, OH b. 12 D 1866, Ravenna d. 12 D 1912, Ravenna. Studied: Cleveland; Falguière, in Paris. Member: Arch. Lg., 1898; SC, 1901. Exhibited: Paris Salon, 1896. Specialty: dogs, other animals. He died as the result of having been bitten by a dog. [10]

CANFIELD, Cass, Mrs. See Sage, Jane.

CANFIELD, Flavia (Mrs. James H.) [P] Arlington, VT b. 28 Ja 1844, Wisconsin d. 12 Ag 1930. Studied: Paris. Work: "Around the World at Eighty," written from her own experiences

CANFIELD, Lucetta [P] Newark, NJ [04]

CANFIELD, Richard [Patron] d. 11 D 1914, NYC. His art collection consisted of oils, pastels, drawings, and etchings by Whistler, with whom he was very friendly. He also had a notable collection of Chippendale.

CANFIELD, Ruth [C,T] NYC/Friendship, NY b. 22 Ap 1896, Scio, NY. Studied: C.F. Binns, Alexander Archipenko; A. Couard; NYU. Member: N.Y. Soc. Cer. A.; Am. Ceramic Soc. Work: articles, Boy's Work Hand Book; Pottery; bulletin, Am. Ceramic Soc. Lecturer: National Recreation Assn., Traveling A&C, 1935–36. Position: T., NYU [40]

CANFIELD, William P. [P] Pittsburgh, PA. Member: Pittsburgh AA [15]

CANIFF, Milton A. [Car,I,W,L] New City, NY b. 28 F 1907, Hillsboro, Ohio. Studied: Ohio State Univ.; James R. Hopkins. Member: Car. Soc.; SI; Nat. Press Cl. Exhibited: Detroit AI. Author/Illustrator: "Male Call," 1945, "Pocket Guide to China," 1943. Creator: syndicated feature, "Terry and the Pirates" [47]

CANNARD, Ruth E. (Hintz) [Mus.Cur,Edu,L] Attleboro, MA b. 23 S 1912, Green Bay, WI. Studied: Layton Sch. A. Exhibited: Milwaukee AI; Univ. Wis.; Neville Pub. Mus., Green Bay, Wis. Work: Neville Pub. Mus. Lectures: Early American Silver. Positions: Cur. A., Neville Pub. Mus., 1936–45; Exh. Com., Attleboro Mus. A.&Hist., 1946– [47]

CANNELL, Joseph [P] Lakewood, OH [25]

CANNERT, Jules [P] NYC b. 30 Mr 1890, Paris, France d. 1954. Member: AAPL. Exhibited: Am. Veterans Soc. A., 1943–46; Audubon A., 1944; AAPL, 1945; Ogunquit A. Center, 1946 [47]

CANNON, Beatrice [P,W,T] Chicago, IL b. 6 Jy 1875, Louisville, KY. Studied: AIC [25]

CANNON, Dorothy [P] North Hollywood, CA b. 21 N 1909, Salt Lake City. Studied: UCLA; A. Center Sch., Los Angeles. Member: Calif. WCS. Exhibited: Calif. WCS Traveling Exh., 1941–45 [47]

CANNON, Florence Carch (Mrs.) [S] Salt Lake City, UT [15]

CANNON, Florence V. [P,Gr,E] Camden, NJ b. Camden, NJ. Studied: PMSchIA; PAFA; Charles Grafly; Henry McCarter; Grande Chaumière, Paris. Member: NAWA; Phila. Pr. Cl.; Phila. Alliance; Northwest Pr.M.; AAPL; Springfield AA; Wash. WCC; Southern Pr.M.; Baltimore WCC; Woodmere AA; Marblehead AA; Color Block Pr.M.; Phila. Plastic Cl. Exhibited: Denver A. Mus.; PAFA; Phila. Pr. Cl.; NAWA (prize); Montclair A. Mus.; CGA; AFA; AIC; Laguna Beach AA; Oakland A. Gal.; Northwest Pr.M.; AWCS; Newark Mus.; Southern Pr.M.; Phila. Alliance; Ogunquit AA; Phila. AC; Phila. Sketch Cl. Work: PAFA; Phila. Alliance; Harcum Jr. Col.; Bryn Mawr; PMA; Woodmere A. Gal.; Northwest Pr.M; Southern Pr.M. Positions: Hd., Florence V. Cannon Sch. A., Phila. Pa.; Pres., Am. Color Print Soc., Phila. [47]

CANNON, Jennie Vennerstrom [P,Li] Berkeley, CA b. 31 Ag 1869, Albert Lea, MN. Studied: Hamline Univ.; Stanford Univ.; NAD; Bolton Brown; Chase Sch.; London Sch. A., England. Member: San Fran. AA; Laguna Beach AA; Berkeley Lg. FA; San Fran. Soc. Women A.; Carmel AA; Oakland AA. Exhibited: Nat. Lg. Am. Pen Women, 1934 (prize). Contributor: articles on art to newspapers [47]

CANNON, Marian [P,Des,I] Cambridge, MA/Franklin, NH b. 13 S 1912, Franklin, NH. Member: Boston AC. Exhibited: Grace Horne Gal.; Agassiz Sch., Cambridge, Mass. Illustrator: "The Flight for the Pueblo," "Lazars of the Pueblos," "San Bao" [40]

CANTARELLA, Maria Boveri [P] Bronx, NY b. 26 D 1909, NYC. Studied: CUASch; NYU. Member: NAWA. Exhibited: Studio Gld.; S.Indp.A.; Am. Women's Cl. (prize) [47]

CANTER, Albert M. [P,T] West Orange, NJ b. 1 Je 1892, Norma, NJ. Studied: PMSchIA; PAFA; Grande Chaumière, Paris; Rutgers; N.J. State T. Col.; Joseph T. Pearson. Member: Graphic Sketch C.; AWCS, 1918; Phila WCC, 1917; Montclair A. Mus., 1933, 1936, 1944, 1945; Paris Salon, 1931; Newark Mus., 1939; N.Y. Municipal Gal., 1938, 1939. Work: Phila. Sketch C.; Orange (N.J.) H.S. Position: T., Orange H.S., 1943– [47]

CANTER, Newton Webb [P,Des] Wash., D.C. b. 22 Je 1907, Wash., D.C. Studied: Corcoran Sch. A. Member: A. Union, Wash., D.C. Work: Nat. Coll. FA (Smithsonian); Dept. Agriculture [40]

CANTEY, Maurine [P,Dec,Dr,B] South Pasadena, CA b. 30 Ap 1901, Ft. Worth, TX. Studied: George Luks; Dallas AI. Member: SSAL. Exhibited: SSAL, 1932; Dallas All. A., 1933 (prize). Work: Dallas Mus. FA; mural for asbestos curtains, Auditorium, State Fair Bldg.; dec., Dallas Symphony Orchestra [40]

CANTIENI, Margaret Balzer, Mrs. See Balzer.

CANTINE, Jo (Mrs. J.A.) [P] Woodstock, NY. Exhibited: CI, 1931; WMAA, 1938; Corcoran Bien., 1939 [40]

CANTOR, Robert Lloyd [Edu,Des,D,W,L] Montgomery, WV b. 14 Ag 1919, NYC. Studied: Ohio State Univ.; Rutgers; PIASch; ASL; NYU. Member: Eastern AA; Nat. Edu. Assn.; Am. Vocational Assn.; Am. Indst. AA; Progressive Edu. Assn. Exhibited: U.S. Navy Exh., 1945; U.S. Signal Corps Exh., 1942. Author: "Industrial and Applied Design," 1943, other books on crafts, mechanical drafting. Contributor: education magazines. Lectures: Fine and Applied Arts. Position: T., W.Va. Inst. Tech., Montgomery, 1946– [47]

CANTRALL, Harriet M. [P,Edu] Springfield, IL b. Cantrall, IL. Studied: PIASchIA; Univ. Oreg.; Woodbury, Dow, Townsend. Member: Ill. Edu. Assn.; Nat. Edu. Assn.; Western AA; NAWA; St. Louis AC; Springfield AA. Co-author: "Art in Daily Actvities." Position: A. Supv., Pub. Sch., Springfield, Ill., 1901–40 [47]

CANTRELL, Florence [P] Brooklyn, NY [13]

CANTWELL, James [P] Amber, NY b. 4 Je 1856, Syracuse, NY d. 21 N 1926. Studied: Thomas Moran. Exhibited: Syracuse Mus. FA, 1926. Work: Syracuse Mus. A. [27]

CAPARN, Rhys (Mrs. Johannes Steel) [S] NYC b. 28 Jy 1909, Oneonta Park, NY. Studied: Bryn Mawr Col.; Archipenko Sch. A.; Paris. Member: Fed. Mod. P.&S.; NAWA. Exhibited: WMAA, 1941; PMA, 1940; AV, 1942; NAWA, 1941–46, 1944, 1945 (prizes); Fed. Mod. P.&S., 1940–46; Delphic Studios, 1933, 1935 (one-man); Wildenstein Gal., 1944 (one-man). Position: Pres., Fed. Modern Painters & Sculptors, N.Y., 1943–44 [47]

CAPECCHI, Joseph [S] St. Paul, MN. Award: best medal design, Minn. State Art Commission, 1913 [17]

CAPEHART, Elizabeth Scudder [C,B] Coronado, CA b. 5 Ap 1894, Brooklyn, NY. Studied: Felix Mahony; Katharine Macdonald. Member: San Diego FA Soc. [4]

CAPERS, Harold H(arper) [P,I] Chicago, IL b. 21 Ap 1899, Brooklyn, NY. Studied: F. Tadema; J. Allen St. John; Wellington Reynolds. Member: AG. Specialty: commercial art/adv. [31]

CAPLES, Robert Cole Reno, NV. Exhibited: WFNY, 1939 [40]

CAPLIN, Alfred Gerald (Al Capp) [Car] NYC b. 28 S 1909, New Haven, CT. Studied: PAFA; BMFA Sch.; Des. A. Sch., Boston; Mass. Sch. A. Creator: "L'il Abner," United Features Syndicate [40]

CAPOBIANCO, Louis [I] Brooklyn, NY. Member: SI [47]

CAPOLINO, Gertrude Rowan [P,T] Phila., PA b. 23 Jy 1899, Phila. d. 5 Ja 1946. Studied: Leopold Seyfert; Henry B. Snell; R. Sloan Bredin; Phila Sch. Des. for Women. Member: Phil. Alliance; Plastic Cl.; Phila. WCC; Germantown A. Lg. Exhibited: Phila. Sch. Des. for Women, 1931 (prize); Gimbel's Women's Achievement Exh., 1933; Spring Garden Inst., 1936 (gold). Work: Phila. Sch. Des. Women; PAFA; Spring Garden Inst.; Friend's Central Sch., Overbrook, Pa.; Beach Haven (N.J.) Library; Women's Cent. Cl., Pottstown, Pa.; Penn Charter Sch. Positions: T., Springside Sch., Chesnut Hill; Spring Garden Inst., Phil.; Chestnut Hill A. Center; Cur., Woodmere AG, Phila. [40]

CAPOLINO, John Joseph [Mur.P,E,T] Phila., PA b. 22 F 1896, Phila., PA. Studied: PAFA; abroad. Member: Phil. WCC; DaVinci All. Exhibited: PAFA, 1918 (prize) 1924 (prize); Woodmere A. Gal., 1940 (prize); Sesqui-Centennial Expo, Phila., 1926 (med); Spring Garden Inst., 1936. Work: murals, USMC, Phila.; Jenks Sch., Phila.; Phila. Pub. Lib.; USMC Mus., Quantico, Va.; Municipal Court Bldg., Phila.; Navy Bldg., Wash., D.C.; St. Joseph's Convent, Phila.; USMC Quartermaster's Depot, San Fran.; State Capitol, Del.; Woodmere A. Gal.; Valley Forge Hist. Mus. Painted official portraits of military figures. Desginer: USMC flag. Positions: Dir., Spring Garden Inst., Chestnut Hill A. Center, Phila.; Cur., Woodmere A. Gal., Phila. [47]

CAPON, Charles R. [D,T] Sudbury, MA b. 18 F 1884, Toronto, Ontario d. ca. 1955. Studied: Ontario Soc. Des., Toronto; Eric Pape Sch. A., Boston. Member: AIGA; Boston SAC; Boston Soc. Pr. Illustrator: "A Selection of Bookplates," 1932. Position: Dir., Adv. A., Boston Inst. Advertising [47]

CAPONE, Gaetano [P] NYC b. 17 D 1864, Maiori, Italy (came to U.S. in 1883) d. 5 N 1920. Studied: Palizzi, Morelli, in Naples. Member: SC; Alliance. Award: Knighted, 1896. [19]

CAPP, Al. See Caplin, Alfred Gerald.

CAPPS, Charles Merrick [E,Li,B] Wichita, KS b. 14 S 1898, Jacksonville, IL. Studied: Chicago Acad. FA; PAFA. Member: SAE; Prairie Pr.M.; Calif. Pr.M.; Phila. SE; Chicago SE; Wash. WCC; Kansas City Pr. Cl. Exhibited: Chicago SE 1936, 1937 (prizes); Kansas City AI, 1935, 1937 (prizes); Northwest Pr.M., 1930 (prize); Rocky Mountain Pr.M., 1934, 1937 (prizes); Work: Philbrook A. Center; Swedish Nat. Mus., Stockholm [47]

CAPWELL, Josephine Edwards San Francisco, CA b. New Albany, IN. Studied: San Fran. Sch. Des.; G. Cadanassa, in Paris. Member: San Fran. AA. Exhibited: Mechanics' Inst. Fair [01]

CARABELLI, Joseph [S] b. 1850, Italy d. 19 Ap 1911, Cleveland. Work: statue, Federal Bldg., NYC. Former member, Ohio Legislature.

CARBEE, (Scott) Clifton [Edu,P,T] Boston, MA b. 26 Ap 1860, Concord, VT d. 22 Je 1946. Studied: Hugo Breul, Providence; Bougereau, Ferrier, in Paris; Max Bohm, in Florence. Position: Dir. (and founder), FA Dept., Univ. Vt. Summer School, Burlington, 18 years [33]

CARBONE, Francesco C. [P,Li] Haverhill, MA b. 10 F 1921, Genoa, Italy. Studied: BMFA Sch. Exhibited: LOC, 1945; CGA, 1946; Springfield Mus. A., 1946; Boris Mirski Gal., 1945; Stuart A. Gal., 1944. Position: T., Samuel Adams Sch., Boston [47]

CARBONE, John. See Orb, Ovan.

CARD, Judson [P] d. 5 Je 1933, NYC

CARDAMONE, Cecilia (Cecilia Cardman) [P,Des,L,I,E] Arlington Farms, VA b. 5 Ap 1906, Soveria Mannelli, Italy. Studied: Western State Col.; Univ. Southern Calif.; John Thompson; Francis Hoar; Colo. Univ.; Guiseppe Aprea, Naples, Italy. Member: Nat. Edu. Assn.; Am. Assn. Univ. Women. Exhibited: Springville, Utah, 1935, 1936, 1938; Kansas City AI, 1920, 1933, 1935; Denver A. Mus., 1935–37; Grand Junction, Colo., 1935–41, 1936, 1937, 1940 (prizes); Times-Herald, Wash., D.C., 1942. Illustrator: Am. Medical Journal. Positions: Hd., A. Dept., Grand Junction H.S. & Mesa Col., Grand Junction, Colo., 1933–43 [47]

CARDELL, Frank Hale (Mrs.) [P] NYC b. 1853 d. 27 O 1905, Boston

CARDER, Frederick [Des,S] Corning, NY b. 18 S 1864, Wordsley, England. Studied: Royal Col. A. Member: Arch. Lg.; AFA. Exhibited: Am. Ceramic S., 1934. Position: A. Dir., Corning Glass Works [40]

CARELL, Gosta [S] NYC [19]

CAREW, Berta (Mrs.) [Min.P] Los Angeles, CA b. 12 Mr 1878, Springfield, MA. Studied: Blashfield; Chase; Mowbray; Carlandi, in Rome; Mme. Richard, in Paris. Member: ASMP; Calif. S. Min. P.; Pa. S. Min P.; Phila. Alliance. Exhibited: Calif. S. Min. P., 1932 (prize); Pa. S. Min. P., 1934 (med); Los Angeles County Fair, 1936, 1938 (prizes). Work: Los Angeles Mus. A.; PMA [47]

CAREW, Frank [P] Pine Forge, Pa. Member: SC [25]

CAREY, Alice Inglis (Mrs. Horace W. Blakeslee) [P] Phila., PA b. 8 Ja 1908, Phila. Studied: PAFA; Phila. Sch. Des. for Women. Member: AAPL; Plastic Cl. Exhibited: Plastic Cl., 1934 (gold) [40]

CAREY, Allthea [S] Buffalo, NY. Exhibited: Buffalo Soc. Ar. Ann., 1933; Ar. West N.Y., Albright Gal., 1939 [40]

CAREY, Charles (Christoper) [E,B] Elmhurst, IL b. 29 O 1894, Chicago, IL. Studied: AIC. Exhibited: Phila. Alliance, 1930; NAC, 1930; Phila. Pr. Cl., 1930; Chicago SE, 1931; Cleveland Pr.M., 1931; Calif. Pr.M., 1932; SAE, 1932; LOC, 1944; Mills Col., Calif.; Elmhurst, Ill. Work: Elmhurst Lib. Specialty: bookplates [47]

CAREY, Constance Beddoe [P] Phila., PA b. Birmingham, Eng. Studied: English Sch. Art; ASL. Member: Plastic Cl.; AAPL [40]

CAREY, Edward [Car] b. 1870 d. 10 O 1928, White Plains, N.Y. Positions: Affiliated with Chicago Inter-Ocean, Chicago Daily News, McClure Syndicate (NYC)

CAREY, Evelyn Rumsey [P] Buffalo, NY [01]

CAREY, John N. (Mrs.) [P] Indianapolis, IN Member: Lg. AA [24]

CAREY, Rockwell W. [Li,P] Portland, OR b. 20 N 1882, Salem, OR. Member: Oreg. Gld. P&S; Portland AA. Exhibited: NAD, 1943, 1946; LOC, 1945; Northwest Pr.M., 1943, 1946; J.K. Gill Co., Portland, Oreg., 1945 (one-man); AAPL 1936–39, 1938 (prize). Work: pub. bldgs., Portland, Oreg.; Treasury Dept., Wash., D.C.; USPO, Newburg, Oreg. [47]

CAREY, Rosalie M(acgill) [P] Riderwood, MD b. 8 Je 1898, Baltimore. Studied: C.Y. Turner; H. McCarter; H. Breckenridge; Leon Kroll; Friez; F. Leger; Ozenfant; André Lhote [40]

CARGILL, Anne T. (Mrs. J. Ralston) [P] Columbus, GA. Exhibited: Assn. Ga. A. Ann., 1938; SSAL Ann., Montgomery, Ala., 1938; San Antonio, Tex., 1939 [40]

CARGILL, Jesse Taylor [Car] Cleveland Heights, OH b. 19 Jy 1892, Waco, TX. Studied: Chicago Acad. FA. Position: Ed. Car., Central Press Assn., Cleveland [40]

CARIAN, Varaldo J. [P] Nashville, IN b. 8 F 1891, Renazo, Italy. Studied: NAD; ASL, with DuMond. Member: Springfield AL; Hoosier Salon; Ind. AC; Brown Co. A. Gal. Assn.; F. Tiffany Fnd. Exhibited: Springfield AL, 1923 (prize); Hoosier Salon, 1934 (prize), 1938 (prize); Brown Co. A. Gal., 1943 (prize); Ind. A. Cl., 1945 (prize). Work: Ind. Univ.; Indianapolis Pub. Sch.; State House, Ind.; Glen Park Sch., Gary, Ind.; Tipton (Ind.) AA; Hanover Col., Ind. [47]

CARIATA, Giovanni [S,W] b. 1865, near Rome, Italy (came to U.S. in

1913) d. 22 Je 1917 NYC. Work: bronze medallion presented to General Joffre when he visited America, 1917

CARISS, H.T. Phila., PA b. Phila. Studied: PAFA Member: ACP [01]

CARISS, Marguerite (Mrs. Walter L.) [P] Phila., PA b. 16 Ag 1883, Green Tree, PA. Studied: PMSchIA; Ludwig Faber; A. Margaretta Archambault. Member: Phila. Alliance. Exhibited: CGA; NCFA; PAFA. Work: PAFA; PMA; NCFA [47]

CARL, Katharine Augusta [P,L,W] NYC b. New Orleans, LA d. 7 D 1938. Studied: Laurens. Member: Nat. Soc. French Artists. Work: Nat. Mus., Wash., D.C. [38]

CARLBERG, Magnus Albert P. [C] Gardner, MA b. 11 Ag 1907. Member: Boston SAC [40]

CARLBERG, Wolfgang [P] San Fran., CA. Exhibited: Intl. WC Ann.; AIC, 1936; San Fran. AA, 1939 [40]

CARLBORG, Hugo O.E. [S,T,C] Providence, RI b. 11 O 1892, Minneapolis. Studied: Albert Atkins; Henry Hunt Clark; RISD. Member: Providence AC; Utopian Cl. Work: Strathmore Paper Co.; Canadian National Railways; Western Reserve Col.; Hall of Civil Rights, Lafayette Col.; Fleischmann Gardens; American School for the Deaf, Hartford, Conn.; Burrville (R.I.) Town Hall; tablet, Angeline E. Kirby Memorial Health Center, Wilkes-Barre Pa.; Pub. Lib., C.W. Barrows Mem., Westminster Unitarian Church, all in Providence; Magoun Tablet, Boston, Mass.; Thigpen Tablet, New Orleans; U.S. War Mem., France. Positions: Bronze Art Dept., Gorham Mfg. Co., Providence; T., RISD [40]

CARLE, James [P,E,T] Los Angeles, CA b. 1 Ja 1861, Phila. Studied: self-taught. Member: Artklan; Royal Soc. Etchers, England [25]

CARLES, Arthur B. [P] Phila., PA d. 19 Je 1952. Exhibited: AIC, 1913 (med), 1928 (med, prize); P.-P. Expo., San Fran., 1915 (med); PAFA, 1917 (prize), 1919 (prize), 1930 (gold), 1939 (prize); Phila. AC, 1933 (gold), 1936 (gold). Work: PAFA; PMA; SFMA; AIC [40]

CARLES, Sara [P] Phila., PA [24]

CARLETON, Clifford [P,Dr] NYC/Elizabethtown, NY b. 7 N 1867, Brooklyn, NY d. 16 F 1946. Studied: ASL, with Mowbray. Member: ASL. Illustrator: "Pembroke," by Mary Wilkins, "People We Pass," by Julian Ralph, "Their Wedding Journey," by Howells [40]

CARLETON, H. Elisabeth [P,T] Mt. Carmel, PA [01]

CARLETON, Virginia (Mrs. Horace) [P] NYC b. 1 N 1903, Sewickley, PA. Studied: BMFA Sch.; N.Y. Sch. F.&Appl. A.; George Ennis; C. Dudley. Member: NAWPS. Exhibited: WC Ann. PAFA, 1938; NAWPS, 1938; N.Y. WCS/WCC Ann., 1939; Lawrence AM, Williamstown, Mass. [40]

CARLHART, Genevieve Acee [P] NYC Member: S.Indp.A. [24]

CARLIN, Frances S. [P] East River, CT [19]

CARLIN, James [P,T] Newark, NJ b. 25 Je 1909, Belfast, Northern Ireland. Studied: Belfast Municipal Col., Ireland; Beaumont, in London. Exhibited: AWCS; Phila. WCC; N.J. AA; N.J. A.&Sc. Soc. Exhibited: AWCS, 1940 (prize); Allied AA, 1946 (prize); N.J. Assn. A., 1942, 1943 (prizes); Montclair A. Mus., 1941, 1942 (prizes); Newark AC, 1942 (prize); PAFA, 1940–46; NAD, 1940–46; MMA, 1942; BM, 1943; Denver A. Mus., 1943; N.Y. Hist. Soc., 1945, 1946; Newark Mus., 1943. Position: T., Newark Sch. F.&Indst. A. [47]

CARLING, Henry [P] b. Manchester, England d. 23 N 1932, St. Paul, MN. Studied: largely self-taught. At 11, gave chalk talks on NYC sidewalks; traveled widely; studied art; painted in many countries. Many prominent people sat for his portraits. Specialty: pastels

CARLINO, Charles I. [P] Valley Cottage, NY b. 9 S 1902, NYC. Studied: Ivan Olinsky, NAD; Augustus Dunbier. Member: NYWCC. Work: portrait, Creighton Med. Sch., Omaha, Nebr.; Cabrini Mem. Hospital; St. Francis of Rome Church, N.Y. [40]

CARLISLE, H.I. [Car] Des Moines, IA. Work: Huntington Lib., San Marino, Calif. Position: Car., Des Moines Register [40]

CARLISLE, Henry W. [P,I,T,W] Indianapolis, IN d. 14 D 1945. Studied: ASL. Exhibited: NAD, 1908. Specialty: adv. art [10]

CARLISLE, Mary Helen [Min.P,P] NYC b. Grahamstown, South Africa d. 17 Mr 1925. Studied: Bouguereau, Robert-Fleury, Constant, Académie Julian, all in Paris. Member: NAWPS. Exhibited: NAWPS, 1914 (prize). Specialty: famous gardens of England and U.S. [21]

CARLOCK, George [P] NYC Studied: Matisse. Lived for ten years in France and Italy. [15]

CARLOCK, Pati Stiles [P] White Plains, N.Y. Member: AWCS [47]

CARLOCK, Vernon T. [S,Des] Dayton, OH b. 2 Ag 1912, Evansville, IN. Work: Dayton AI; bas relief, USPO, Worthington, Ohio. WPA artist. [40]

CARLSEN, Dines (Mr.) [P] Falls Village, CT b. 28 Mr 1901, NYC. Studied: his father, Emil Carlsen. Member: ANA; Kent AA. Exhibited: NAD, 1919 (prize), 1923 (prize); CGA, 1923, 1925; Carnegie Inst., 1920–23, 1925, 1930; PAFA, 1917–32; NAD, 1915–46; AIC, 1919, 1925, 1927; CAM, 1919, 1921, 1923, 1926–29; Detroit AI, 1920, 1923–28; Grand Central AG. Work: CGA; John Herron AI; Sweat Mem. Mus. [47]

CARLSEN, Emil [P] NYC b. 19 O 1853, Copenhagen, Denmark (came to U.S. in 1872) d. 2 Ja 1932. Studied: Danish Royal Acad. Member: SAA, 1902; ANA, 1904; NA, 1906; NIAL; NAC; Lotos Cl.; F. PAFA; SC, 1903; Century Assn.; AFA. Exhibited: PAFA, 1912 (gold), 1913 (prize), 1916 (gold); NAD, 1907 (med), 1916 (gold), 1919 (prize); SAA, 1904 (prize), 1905 (prize); SC, 1904 (prize), 1905 (prize); St. Louis Expo, 1904 (gold); CI, 1908 (med); Buenos Aires, 1910 (med); NAC, 1915 (prize); P.-P. Expo, 1915 (med); Sesqui-Centenn. Expo, Phila., 1926 (gold). Work: MMA; RISD; NGA; Brooklyn Inst. Mus.; AIC; Minneapolis Inst.; Herron AI, Indianapolis; WAM; CAM; Engineer's Cl., N.Y.; Lotos Cl.; San Fran. IA; PAFA; CGA; AIC. Jury of Award: Carnegie Inst. International Exh., 1920, 1930 [31]

CARLSEN, Flora Belle (Mrs. Harold) [P,S] NYC b. 7 Mr 1878, Cleveland. Studied: F.C. Jones; DuBois; Solon Borglum; Lentelli. Member: NAWA; PBC. Exhibited: NAD; PBC, 1937 (one-man) [47]

CARLSEN, J.M [P] Hollywood, IL [15]

CARLSEN, John H. [P,E] b. 16 D 1875, Arendal, Norway d. S 1927. Member: Palette and Chisel Cl.; Chicago SA. Exhibited: Palette and Chisel Cl., 1918 (gold) [27]

CARLSON, Charles [P] Brooklyn, NY b. 16 Jy 1866, Eskilstuna, Sweden. Studied: self-taught. Member: Salons of Am.; Scandinavian Am. A. [33]

CARLSON, Charles Joseph [P] San Fran., CA/% Léon Bonnât, Paris, France b. 20 O 1860. Studied: Virgil Williams, in San Fran. Member: San Fran. AA; Bohemian Cl., San Fran. Exhibited: Calif. Sch. Des., San Fran., 1876 (med), 1877 (gold), 1882 (gold); Sacramento State Fair 1884, 1886 (med); Mechanics Fair, 1884, 1890 [08]

CARLSON, Charles X [P,Car,I,W] NYC b. 26 Je 1902, Blackberry, MN. Studied: AIC; NAD; ASL; abroad. Member: Wash. WCC; Ldscp. Cl., Wash. D.C. Exhibited: CGA; PAFA; Univ. Mich.; South America. Work: Bolivian Senate; Pan-Am. Union; Belles Artes, Guatemala; Mack Mem., Ossining, N.Y. Author/Illustrator: books on art mediums & techniques. Contributor: magazine articles on Latin America [47]

CARLSON, Eddy W. [P] NYC [08]

CARLSON, Edward L. [P] Rockford, IL Exhibited: A. Chicago, AIC, 1936, 1938, 1939 [40]

CARLSON, Edward W. [P] Chicago, IL b. 4 My 1883, Chicago. Studied: AIC. Member: Chicago SA; Hoosier Salon; Swedish Am. AA. Exhibited: Hoosier Salon, Chicago, 1928 (prize); Swedish Am. AA, Chicago, 1929 (prize) [33]

CARLSON, George [I] NYC [19]

CARLSON, Gorham [I] Minneapolis, MN [17]

CARLSON, Harry [P] NYC/Brooklyn, NY b. 9 Je 1895, Brooklyn Studied: ASL. Member: Scandinavian Am. A.; Salons of Am. [33]

CARLSON, John F. [P,T] Woodstock, NY b. 5 My 1875, Sweden (came to U.S. in 1884) d. 19 My 1947. Studied: Lucius Hitchcock, ca. 1884; ASL, with DuMond, B. Harrison, 1902–03. Member: ANA, 1911; NA, 1925; NYWCC; AWCS; SC; Wash. WCC; Conn. Acad. FA; PS Gal. Assn.; NAC; F. PAFA. Exhibited: SC, 1912, 1923, 1925 (prizes); Wash. SA (med); P.-P. Expo, 1915 (med); NAD, 1918 (prize), 1923 (prize), 1937 (prize). Work: CGA; TMA; Oberlin Col.; Brooks Mem. Gal., Memphis, Tenn.; Dallas, Tex.; Lincoln, Nebr.; Butler AI; Toledo Cl., Ohio; Fort Worth AA; Randolph Macon Women's Col., Lynchburg, Va.; Baltimore Mus. Art; Montclair (N.J.) Art Mus.; Va. Mus. FA, Richmond; Carnegie Inst. Author: "Elementary Principles of Landscape Painting," 1928. Positions: Dir., ASL Sch., Woodstock, N.Y. (1911–18), Broadmoor AA (1920–21); Founder/Dir., John F. Carlson Sch. Landscape Painting, Woodstock, N.Y. (1922–38) [40]

CARLSON, Margaret Goddard (Mrs. John Carlson) [P] Woodstock, NY b. 6 Ap 1882, Plainfield, NJ. Studied: NAWPS [25]

CARLSON, Margaret Mitchell (Mrs.) [I] Mill Valley, CA b. 25 Mr 1892, Deming, WA. Studied: ASL, with Ella Bush; Pa. Sch. Des.; NAD. Member: West Coast Arts, Laguna Beach, CA [25]

CARLSON, Oscar A. [P,Des,E,En,C] Nashua, NH b. 29 Ja 1895, Glencoe, IL. Studied: AIC; Charles Curtis Allen. Exhibited: Jordan Marsh, Boston; N.H. AA; North Shore AA [47]

CARLSSON, Oscar T. [P,E,C] Brooklyn, NY b. 23 S 1893, Hedemora, Sweden. Studied: WMA Sch.; NAD; ASL; John Sloan; G.L. Nelson; Eugene Fitsch. Exhibited: BM; WMA; Los Angeles Mus.; Germanic Mus., Boston; CAA [47]

CARLSUND, Emma [P] Boston, MA b. 25 O 1861, Sweden. Studied: De Camp, Ernest L. Major, Cowles Art Sch., Boston [13]

CARLTON, Brents [S] San Fran., CA Exhibited: San Fran. AA, 1937 (med). Illustrator: Architectural Forum, 1933 [40]

CARLYLE, Florence [P] NYC [08]

CARMACK, Paul R. [Car] Waban, MA b. 18 D 1895, Madisonville, KY d. 1977. Studied: AIC. Author/Illustrator: "The Diary of Snubs, Our Dog" (4 vols). Illustrator: "Huttee Boy, the Elephant." Lectures: Newspaper Cartoons and Comic Strips. Position: Staff Car., Christian Science Monitor, 1925– [47]

CARMAN, Eva L. [Min.P] NYC. Member: Pa. S. Min. P.; NAWPS [33]

CARMER, Dorothy Ross [C,Bkbind] NYC/Northeast Harbor, ME b. S 1883, Somerville, NJ. Studied: Sch. Appl. Des. for Women, NYC; T. Col., Columbia; Clinton Peters; Fawcett Sch., Newark; Ecole Moderne, Paris. Member: NYSC; Am. Occupational Therapy Assn. Author: article on work for the handicapped [40]

CARMER, Elizabeth Black [I] NYC b. 18 Je 1904, New Orleans. Studied: Newcomb Col., Tulane Univ. Illustrator: "Wildcat Furs to China," 1945, "America Sings," 1942, "Hurricane's Children," 1937 [47]

CARMICHAEL, Ida Barbour [C,L,W,P] Cincinnati, OH b. 1 N 1884, Windham Center, Ontario. Studied: Emory Univ.; A. Acad., Cincinnati; Univ. Cincinnati; Univ. Oreg. Member: Nat. Edu. Assn.; Ohio Edu. Assn; T. Assn.; Ceramic Gld.; Crafters Cl.; Women's A. Cl.; Mus. Assn.; Exhibited: CM, 1938, 1939, 1940, 1943, 1946; Women's A. Cl., Cincinnati, 1931–46; Cincinnati Crafters Cl. Author: "Consumer Education through Art." Lectures: Pottery. Positions: T., Dept. Ceramics, Walnut Hills H.S., Cincinnati, Ohio, 1931–46; Pres., Ceramic Gld., Cincinnati, 1946–

CARMICHAEL, Warree. See LeBron.

CARMODY, Anna T. [P,Li,Dr,T] Providence, RI/Block Island, RI b. Providence. Studied: RISD; ASL; Hugh Breckenridge; Grand Central A. Sch. Position: T., RISD [40]

CARNALL, James Linton [P] Brooklyn, NY. Member: S.Indp.A. [25]

CARNELL, Althea J. [P,I,C] Phila., PA. Member: Plastic Cl. [25]

CARNELLI, Walter Antonius [P,Li,Mur.P,T,M,W,] Wash., D.C. b. 28 F 1905, Graz, Austria. Studied: Graz; Vienna; Paris. Member: Wash. AG; Soc. Wash. A.; Landscape Cl., Wash., D.C. Exhibited: CGA; PMG; BMA; Wash. County Mus. FA, Hagerstown, Md. Work: murals, USPOs, Basset, Va.; Bridgeville, Pa.; St. John's Church, Leitersburg, Md. Position: T., Washington County Mus. FA, Hagerstown, Md. [47]

CARNEVALE, Carmen Richard Mordecai [C,P] Pittsburgh, Pa. b. 6 My 1909, Pittsburgh. Studied: Cleveland Sch. A.; Carnegie Inst.; Sam Rosenberg; William Shugold; Joseph Hugo. Member: Pittsburgh Assoc. Artists. Work: St. Peter's Church, Pittsburgh [40]

CARNEY, Ellen [P] South Minneapolis, MN. Exhibited: Minneapolis Inst. A., 1935 (prize); Midwestern A., Kansas City AI, 1936. Position: T., Minneapolis Sch. A. [40]

CARNOHAN, Harry [P] Colorado Springs, CO. Exhibited: Allied A. Ann., Dallas, 1933, 1935 (prize); Contemporary Am. P. Ann., WMAA, 1934; GGE, 1939 [40]

CAROTHERS, Sarah Pace [E,P] Baltimore, MD b. 15 Ja 1910, Baltimore. Studied: Maryland Inst.; ASL. Exhibited: Southern Pr.M., 1942; Phila. Pr. Cl., 1943; SAE, 1942–44; LOC, 1944; Mint Mus. A., 1946; Laguna Beach AA, 1946; Whyte Gal., 1942, 1943; PMG, 1941; NAD, 1944; BMA, 1941 (prize) 1942–46; Municipal Mus., Baltimore, 1943–45; Contemporary Gal., Baltimore, 1944 (one-man). Work: BMA [47]

CARPENDER, Alice Preble Tucker (Mrs. William) [Mar.P,Min.P,] NYC/East Gloucester, MA b. Boston d. 11 Je 1920. Studied: M.F.H. De Haas; Chase; R. Swain Gifford. Member: NYWCC; NYSP; McDowell Cl.; Women P&S. Specialties: marines, miniature portraits [17]

CARPENTER, A.M. (Miss) [P,Des,E,L,T] Abilene, TX b. 4 Ja 1887, Prairie Home, MO. Studied: D.C. Smith; C.A. Harbert; E.E. Cherry. Member: College AA; Tex. FA Assn.; AAPL; AFA. Work: First Baptist Church, Abilene; Lamar, Travis, Abilene High Schools; Mansfield (La.) Col. [40]

CARPENTER, Bernard V. [P,T] Buffalo, NY/Nantucket, MA b. Foxboro, MA d. 23 Ap 1936. Studied: Mass. Sch. A.; Europe. Member: Buffalo SA. Position: Hd., Dept. Des., Buffalo FA [33]

CARPENTER, Charles E. [P,Arch] Pawtucket, RI b. 1 My 1845 d. 18 D 1923. Member: Providence AC (charter member); F., Am. Inst. Arch., 1875

CARPENTER, Dudley Saltonstall [P,I,T] La Jolla, CA b. 26 F 1880, Nashville, TN. Studied: ASL; Laurens, Constant, Aman-Jean, Académie Julian, all in Paris. Member: Denver AA. Exhibited: Paris Salon, 1911 [21]

CARPENTER, Ellen Maria [P,T] b. 23 N 1836, Killingly, CT d. ca. 1909, Boston. Studied: Thomas Edwards; Lowell Inst., Boston; Europe, 1867, 1873 [*]

CARPENTER, Ethel D.S. (Mrs. C.E.) [I] Fort Washington, PA. Member: F. PAFA [25]

CARPENTER, Eugene J. [P] d. 19 Mr 1922, Pasadena, CA. Member: Minneapolis Soc. FA

CARPENTER, F(letcher) H. [Ldscp.P,T] Rochester, NY/Richland, MI b. 27 Je 1879, Providence. Studied: Ernest Major; Mass. Sch. A. Member: Rochester AD. Exhibited: Rochester Expo, 1925 (gold). Position: T., East H.S., Rochester [40]

CARPENTER, Florence A. [P] Kansas City, MO b. Williamstown, VT. Studied: Miss Hawley; Colarossi Acad., Hortense Richards, Collin, Courtois, all in Paris [04]

CARPENTER, Francis B. [Por.P] NYC b. 6 Ag 1830, Homer, NY d. 23 My 1900. Studied: Sandford Thayer, in Syracuse. Member: NAD; ANA. Exhibited: NAD; Am. Art Union; Brooklyn AA; Wash. AA; Boston Athenaeum. Work: Capitol, Wash., D.C.; New York City Hall. Specialty: portraits. Many noted persons sat for him, including Presidents Fillmore, Lincoln, Tyler and Pierce. [98]

CARPENTER, Fred Green [P,T,C] St. Louis, MO b. Nashville, TN. Studied: St. Louis Sch. FA; Académie Julian, Paris, with Simon, Miller, Laurens, Baschet, Royer. Member: St. Louis AG. Exhibited: P.-P. Expo, 1915 (med); St. Louis AG, 1920, 1925, 1929, 1932, 1945; St. Louis State Fair, 1927, 1940; PAFA, 1912–36; CAM, 1912–44; AI Kansas City; AIC. Work: John Herron AI; CAM; PAFA; St. Louis libraries; USPO, Paris, Ill.; murals, Mo. State Capitol. Positions: T., St. Louis Sch. FA, Washington Univ. [47]

CARPENTER, George M. [I] NYC. Work: Century Magazine [98]

CARPENTER, Hannah T. [P] Providence, RI b. 4 N 1874. Studied: R.I. Sch. Des.; John Goss. Member: Providence AC; Providence WCC; South County AA [40]

CARPENTER, Hattie L. [P] Chicago, IL b. Newark IL. Studied: AIC [98]

CARPENTER, Helen K(nipe) (Mrs. Edward Childs) [I] NYC/New Hartford, CT b. 6 D 1881, Phila. Studied: PAFA, with Chase, Breckenridge, Anshutz [21]

CARPENTER, Horace T. [P,I,Cur] Phila., PA b. 1858, Monroe, MI d. 19 My 1947. Studied: PAFA; PMSchIA; ASL. Member: Lg. AA. Illustrator: novels of F. Marion Crawford. Position: Cur., Independence Hall, Phila. [24]

CARPENTER, J.S. [P] Des Moines, IA [24]

CARPENTER, Kate Holston (Mrs.) [P,I,T] NYC b. 1866, London, England. Studied: NAD; Herkomer Sch., England; Benjamin-Constant, in Paris; Josef Israels, in Holland [08]

CARPENTER, Louise [P] Berkeley, CA [17]

CARPENTER, Margaret [S] NYC [10]

CARPENTER, Marguerite [S] NYC [04]

CARPENTER, Mildred Bailey (Mrs. Fred G.) [P,W,I,T,L,Dec] St. Louis, MO b. St. Louis. Studied: St. Louis Sch. FA; Richard E. Miller. Member: St. Louis AG. Exhibited: St. Louis AG, 1919–40 (prizes); Kansas City AI

(med); AIC; CAM. Work: murals, Christian Orphans Home, St. Louis. Illustrator: children's books. Contributor: Art News. Position: Por.P., Army & Navy hospitals, USO, N.Y. [47]

CARPENTER, N.H. (Mrs.) [P] La Grange, IL [08]

CARPENTER, Newton H. Chicago, IL b. 1853, Olmstead Falls, OH d. 27 My 1918. Member: Am. Mus. Assn.; Mus. Dir. Assn.; AFA. Position: Business Manager, AIC, since 1881

CARPENTER, Rue Winterbotham (Mrs. John Alden) [P,Des] Chicago, IL d. D 1931, NYC. Work: Chicago AC, Casino; Waldorf-Astoria; Elizabeth Arden Bldg. Designer: sets for her husband's modernistic opera, "Skyscrapers," performed at the Metropolitan Opera House and Munich

CARPENTER, Will A. [P] NYC [04]

CARR, Alice Robertson (Mrs. José de Creeft) [S] Santa Barbara, CA b. 3 O 1899, Roanoke, VA. Studied: Stirling Calder; Albin Polasek; Antoine Bourdelle; José de Creeft. Exhibited: Stockbridge A. Exh., 1930 (prize), 1934. Work: Woodland Park, Seattle, Wash. [40]

CARR, Gene [I] Phila., PA b. 7 Ja 1881, NYC. Member: SI. Illustrator: New York World; comic series, "Step Brothers," "Lady Bountiful," "Dooley" [29]

CARR, James Gordon [Des,Arch] Batavia, NY b. 20 F 1907, Batavia. Studied: Jacques Carlu; MIT. Position: Indst. Des., Raymond Loewy [40]

CARR, Lyell [P,I,Des] NYC b. 1857, Chicago, IL d. 17 F 1912. Studied: Ecole des Beaux-Arts, Paris, with Lefebvre, Boulanger. Exhibited: St. Louis Expo, 1904 (med). Work: Thomas Ryan townhouse; Newark Courthouse [10]

CARR, Michael Carmichael [P,En,L,W] NYC/Pomona, NY b. 25 Je 1881, San Fran. d. 1927. Studied: Wilson Steer; Frederick Brown; Gordon Craig; London Univ. Member: S.Indp.A.; Work: Pub. Lib., Bordighiera, Italy [27]

CARR, Myra Musselman [P] Lexington, KY [08]

CARR, Robert Burns [P,Arch] Wash., DC b. 25 Ag 1906, Wash. Studied: N.Y. Sch. F.&Appl. A. Contributor: house designs, House and Garden, House Beautiful, American Home, Better Homes and Gardens. Author/Illustrator: "Les Isles Tuamotu," Country Life, F 1936 [40]

CARR, Samuel S. [P] Brooklyn, NY [01]

CARRE, Jean Louise [P] London, England [01]

CARRENO, Mario [P,I] NYC b. 24 Je 1913, Havana, Cuba. Studied: Cuba; Spain; Académie Julian, Paris. Work: MOMA; Perls Gal.; Musée du Jeu de Paume, Paris; Nat. Mus., Havana; SFMA. Illustrator: House and Garden, Norte, other publications [47]

CARRERE, John Marven [Arch] Boston, MA b. Rio de Janeiro, Brazil d. 1 Mr 1911. Member: Boston Soc. Arch. Work: NYPL; Harvard Trust Co. Bldg. Positions: Arch., McKim, Mead & White.; Instr., Sch. FA, Paris; Founder, Chamberlain & Austin

CARRERE, Robert Maxwell [Mur.P,Arch,Dec,L] NYC/Millbrook, NY b. 30 Ja 1893, NYC. Studied: Univ. Pa. Member: AIA; Arch. Lg.; AAPL. Work: arch., American Church, Florence, Italy; restoration, Castle of Vincigliato, Florence. Author: articles, 18th Century Italian Provincial Furniture. Contributor: House and Garden [40]

CARRET, J.E. [P] NYC. Member: Lg. AA [24]

CARRIGAN, William L. [P] Falls Village, CT b. 21 S 1868, San Fran. d. 27 O 1939. Studied: Emil Carlsen. Member: ANA, 1936; Conn. Acad. FA. Exhibited: Wash. SAA, 1914 (med); P.-P. Expo, 1915 (med); New Haven PCC, 1934 (prize); Stockbridge Exh., 1934 (prize). Work: dec., St. Tiago da Espada, Portugal [38]

CARRINGTON, James Beebee [Art Ed,L] Ridgefied, CT b. Columbus, Ohio d. 14 Jy 1929. Member: SC. Positions: Assoc. Ed., Scribner's Magazine, 1887; Ed., Architecture

CARRINGTON, Omar Raymond [P,I,E] College Park, MD b. 15 O 1904, Phila. Studied: Benson Moore; Hobart Nichols; Univ. Md.; Am. Univ.; Corcoran Sch. A.; PAFA; Hill Sch. A. Member: Soc. Wash. A.; Wash. WCC; Landscape Cl., Wash., D.C.; Wash. AC; Wash. SE; New Haven PPC; AAPL; Phila. All.; Southern Pr.M.; SSAL; F., Tiffany Fnd. Exhibited: Landscape Cl., 1935–42, 1943, 1944 (meds), 1945, 1946; Wash. AC, 1941–43, 1944 (prize); Wash. A., 1935–44, 1945 (prize); SSAL, 1945 (prize); Southern Pr.M., 1942; PAFA, 1945; New Haven PCC, 1936; Wash. WCC, 1936–46; Wash. SE, 1937, 1938, 1941; SSAL, 1945; BMA, 1946. Illustrator: Univ. Md. publications & the Naval Acad. yearbook, 1942. Positions: Asst. Ed., Asst Prof., Univ. Md. Extension Service, 1928–40; Hd., Dept. Publ., Univ. Md., 1940–42; Ed., "Agriculture in the Americas," pub. U.S. Dept. Agriculture, 1942– [47]

CARRIS, Henry T. [P,C] b. 1850, Phila., PA d. 18 S 1903, Phila. Member: Phila. Sketch Cl.; Phila. AC. Specialty: stained glass, architectural dec.

CARROL, Harriet I. [P,T,L] Erie, PA b. 1872, Erie. Studied: Birge Harrison; John Carlson; Hugh Breckenridge; N.Y. Sch. Appl. Des. for Women. Member: Erie AC [33]

CARROLL, John [P] East Chatham, NY b. 14 Ag 1892, Kansas City, KS d. 1959. Studied: Frank Duveneck. Member: Am. Soc. PS&G.; F., Guggenheim Fnd. Exhibited: PAFA, 1922, 1924 (prizes); Pam-Am. Exh., 1924 (prize); AIC, 1927 (med); Calif. Pr. Cl., 1929 (prize); Detroit AI, 1935 (prize); Scarab Cl., 1936 (med). Work: PAFA; Los Angeles Mus. A.; John Herron AI; Joslyn Mem.; Detroit AI; Newark Mus.; TMA; WMAA; Honolulu Acad. A; AGAA [47]

CARROLL, Maude Clifton [S] Pacific Grove, CA. Exhibited: Soc. Wash. A., 1937; PAFA, 1937, 1938 [40]

CARROLL, Orville A. [P,I] New Albany, IN b. 18 F 1912, New Albany. Studied: Fayette Barnum; Isabel Bishop; Louisville AA; ASL, with John Sloan, John Stewart Curry. Member: Louisville AA. Exhibited: Am. Assn. Univ. Women, New Albany; Louisville A. Center. Work: Pub. Lib., Marine Hospital, both in Louisville, Ky.; murals, USPOs, Harrodsburg, Ky., Osceola, Ark., Batesville, Ind. Illustrator: "Louisville, the Gateway City," 1945, "Westward the Course," 1946. Position: Staff A., Louisville Courier-Journal, 1940–46 [47]

CARROLL, Robert Joseph [P] NYC b. 11 O 1904, Syracuse, NY. Studied: Syracuse Univ. Exhibited: Boyer Gal., 1939; Intl. WC, BM; Marie Harriman Gal. Contributor: Harper's, Vogue, McCall's. Position: Artist, CBS, N.Y. [40]

CARROLL, Ruth [I] NYC b. 24 S 1899, Lancaster, NY. Studied: Vassar; ASL, with Cecilia Beaux, Hugh Breckenridge, George Bridgman, Charles Rosen, Frank DuMond, Andrew Dasburg. Member: AG. Exhibited: PAFA, 1921. Work: Newark Mus. Author/Illustrator: children's books. Position: King Features Syndicate, 1936–46 [47]

CARRON, Maude Lilyan [P] Houston, TX. Exhibited: MFA, Houston, 1938, 1939 [40]

CARROTHERS, Grace Neville (Mrs.) [P,E,Li,T] Tulsa, OK. Studied: Bellaire, MI b. Abington, IN. Studied: John Carlson; Anthony Thieme. Exhibited: Phila. Pr. Cl., 1932; Hoosier Salon, 1932; Northwest Pr.M., 1932; Kansas City AI, 1933; N.Y. Municipal Exh., 1937; LOC, 1936; Philbrook A. Center, 1931–38 and 1940 (one-man); Jr. Lg. Gal., Tulsa, Okla. 1932 (one-man). Work: NYPL; Gibbes A. Gal., Charleston, S.C.; NGA; British Mus.; LOC; Royal Ontario Mus., Toronto; Philbrook A. Center. Positions: Instr., Ldscp. Painting, Philbrook A. Center, 1940–46; Hd., Grace Neville Carrothers Sch. Landscape Painting, 1932–46 [47]

CARRUTH, Margaret Ann Scruggs, Mrs. See Scruggs.

CARRUTH, Max [I,W] b. 1898 d. Mr 1943, Camp Truax Army Air Field, Madison, WI. Work: Springfield, Mass. Republican, other newspapers

CARRY, Marion Katherine [P,T,Li] Newport, RI b. 30 Ja 1905, Newport. Studied: John Frazier; RISD; ASL. Member: Newport AA. Exhibited: WFNY, 1939; Providence AC; Newport AA; RISD. Work: RISD. Position: Hd., Sch. A., Newport AA, Newport, R.I., 1945– [47]

CARSEY, Alice [P] Chicago, IL [19]

CARSON, E.C. (Mrs.) [P] Salt Lake City, UT. Member: Soc. Utah Artists [01]

CARSON, E. Francis [P] Boston, MA/Provincetown, MA b. 8 S 1881, Waltham, MA. Studied: Mass. Normal Art Sch.; ASL. Member: Copley Soc.; Providence WCC; Provincetown AA; Boston AC [24]

CARSON, Frank [P,T] Boston, MA b. 8 S 1881, Waltham, MA. Studied: Mass. Normal A. Sch.; Fenway A. Sch.; ASL; Boothbay, Maine, A. Colony. Exhibited: PAFA; BM; Berkley, Mass. Lg. FA; BAC, 1924 (prize); Buffalo FA Acad.; Newport AA; Detroit AI; Provincetwon AA; Gloucester AA; Boston S.Indp.A.; TMA; Providence AC; Providence WCC; BMFA; Wash. AC (one-man); Univ. Washington (one-man). Work: BAC; Berkley Lg. FA; Vanderpoel A. Assn. [47]

CARSON, Jane. See Barron, Amos, Mrs.

CARSON, Ralph M., Mrs. See Bellé.

CARSON, Robert [P,Arch] NYC. Exhibited: Milch Gal., 1940 (one-man) [40]

CARSON, Sol Kent [P,Edu,G] Phila., PA b. 7 Je 1917, Phila. Studied: Barnes Fnd.; Temple Univ. Exhibited: WFNY, 1939; PAFA; Okla. A. Center; Eastern AA, 1939; AAPL; Temple Univ., 1946. Work: Free Lib., Phila. Positions: Mus. consultant, Univ. Pa. Mus., 1945-46; Dir., Dept Visual Edu., Temple Univ. Professional Sch., Phila., 1944- [47]

CARSPECKEN, George Louis [P] Allegheny, PA b. 27 Jy 1884, Pittsburgh, PA d. 15 Jy 1905, Burlington, IA. Studied: Paris. Exhibited: Carnegie Inst.; WAM, 1902 (prize). A self-portrait attracted the attention of Andrew Carnegie, who offered to send George to Paris for two years. An attack of vertigo shortly after his return resulted in his death. [04]

CARSTAIRS, Charles S. [Dealer] London, England/Phila., PA b. 1865, Phila. d. 9 Jy 1928. He maintained a home in Phila. for many years. Position: Ch. Bd., M. Knoedler & Co., Inc., of New York, Paris, and London

CARSTAIRS, J(ames) Stewart [P,S] NYC/Paris, France b. 2 Je 1890, Phila. d. 18 S 1932, NYC. Studied: Académie Julian, Paris. Member: Union Internationale des Beaux-Arts et des Lettres. Exhibited: large screen done in gold leaf and mosaic, NYC, 1929. The greater part of his life was spent abroad, including several years in the Orient. [13]

CARTAINO, G.S. [S] NYC [13]

CARTER, A. Helene [I] NYC b. Toronto, Ontario. Member: GFLA; SI. Illustrator: "Three of Salu," "The Two Little Misogynists" [27]

CARTER, Albert Ross [Edu,P,I] Indianapolis, IN b. 25 Ap 1909, Murphysboro, IL. Studied: Univ. Ill.; Syracuse Univ.; Europe. Exhibited: VMFA; Phila. WCC; CM; Butler AI; Ohio WCS. Position: T., Miami Univ., Oxford, Ohio, 1933-46 [47]

CARTER, Betty M. [P,T,Des] NYC b. NYC Studied: Parsons Sch. Des.; Ennis; Giles. Member: AWCS; NAWA. Exhibited: PAFA, 1932, 1934, 1936; AIC, 1935, 1937, 1940; BM, 1935, 1939; WFNY, 1939; NAWA; AWCS; SSAL; Wash. WCC; Phila. WCC; Conn. Acad. FA; Palm Beach A. Center. Lectures: Painters of the Italian Renaissance. Positions: Asst. Hd., Dept. Adv. Des., 1936-46, Hd. Dept 1946- , Parsons Sch. Des., NYC; T., Painting, French Sch., NYC [47]

CARTER, C.L. [P] Freeport, NY [01]

CARTER, Charles Henry [I] NYC Member: SI [47]

CARTER, Charles M(ilton) [P,T,W] Boston MA b. 9 D 1853, North Brookfield, MA d. 30 My 1929, North Brookfield. Studied: Mass. Normal A. Sch., Boston; Europe. Member: BAC; Denver AC, 1893. Author: "Some European Arts Schools," "Art, Denver Public Schools." Positions: A. Dir., Denver Schools, 1893; State Supv. Drawing, Mass. [29]

CARTER, Clarence Holbrook [P,E,Des] Holicong, PA b. 26 Mr 1904, Portsmouth, OH. Studied: Cleveland Sch. A.; Hans Hofmann. Exhibited: CI; PAFA; CGA; AIC; BM; CMA; VMFA; Detroit AI; TMA; Nebr. AA; W.R. Nelson Gal. A.; Swope Gal. A.; Dallas Mus. FA; GGE, 1939; de Young Mem. Mus.; Pal. Leg. Honor; WMAA; MOMA; MMA; Arch. Lg.; AV; NAC; Albright A. Gal.; Butler AI (one-man); Finley Gal. (one-man); Milwaukee AI (one man). Work: MMA; MOMA; WMAA; BM; FMA; CMA; TMA; Butler AI; Oberlin Col.; W.R. Nelson Gal. A.; Univ. Nebr.; Lehigh Univ. Contributor: art magazines. Positions: T., CI, 1934-44, Chautauqua Inst., NYU, 1943 [47]

CARTER, (Clement) Dean (Jr.) [P] Wash., DC b. 24 Ap 1922, Henderson, NC. Studied: Corcoran A. Sch.; American Univ.; Robert Laurent; Will Hutchins. Exhibited: CGA, 1941 (prize), 1942; Wash. WCC, 1946; Lake Forest, Ill., 1946 (one-man) [47]

CARTER, Dudley C. [S,C,L] Carmel-by-the-Sea, CA/Gibson's Landing, British Columbia. b. 6 My 1892, New Westminster, British Columbia. Studied: Dudley Pratt. Member: Seattle Art Mus.; Carmell AA. Exhibited: Seattle AI, 1931 (prize). Work: Seattle A. Mus.; GGE, 1939; Allocations, WPA [40]

CARTER, Evelyn [P] West Newton, MA [24]

CARTER, Fernando A. [Mus.Dir,P] Syracuse, NY b. 1855, Boston, MA d. 16 Jy 1931. He formed the first All-American collection in the country. Position: Dir., Syracuse Mus. FA, 20 yrs. [27]

CARTER, George W. [P] NYC. Member: SC [21]

CARTER, Gordon Knowles [P,E,T] Webster Groves, MO b. 7 Mr 1902, St. Louis, MO. Studied: F. Tolles Chamberlain; Clarence Hinkle; Laurence Murphy. Member: Calif. WCS; PS; St. Louis AG. Exhibited: Phoenix, Ariz., 1929 (prize); St. Louis AG, 1930 (prize). Work: Ariz. Mus., Phoenix [40]

CARTER, Henry [P] Montreal, Quebec [01]

CARTER, Jesse Benedict [W,L,Ed] b. 16 Je 1872, NYC d. 22 Jy 1917, Bologna, Italy. Studied: Princeton; Berlin; Göttingen; Leipzig. Member: Am. Sch. Classical Studies, Rome, 1907-13; Acad. Rome; Am. Philological Assn.; Am. Archaeological Soc. Author: "The Religious Life of Ancient Rome"

CARTER, Mary Meln (Mrs. James Newman Carter) [Min.P,C] Chadds Ford, PA/Phila., PA b. 16 Ag 1864, Phila. Studied: Carl Weber; C. Faber Fellows. Member: Plastic C.; Phila. Alliance [33]

CARTER, Morris [Mus.Dir] Boston, MA b. 23 O 1877, Woburn, MA. Studied: Harvard. Author: "Isabella Stewart Gardner and Fenway Court," 1925. Position: Dir., Isabella Stewart Gardner Mus., Boston, 1924- [47]

CARTER, Pruett [I] North Hollywood, CA b. 9 F 1891 d. 1 O 1955. Studied: Los Angeles ASL. Member: SE; SC. Illustrator: national magazines. Lectures: Illustration. Position: Dir., Dept. Illus., Chouinard AI, Los Angeles [47]

CARTER, Robert [Car] b. 1873 d. 27 F 1918, Phila. Positions: Staff, Chicago Inter-Ocean, Evening Sun, 1913-16

CARTER, Robert A. [P] Ridgefield, NJ b. 25 Mr 1860, Toronto, Ontario [21]

CARTER, William Sylvester [P,I] Chicago, IL b. 5 My 1909, St. Louis, MO. Studied: AIC; Univ. Ill. Exhibited: CAM, 1940 (prize); Atlanta Univ., 1942 (prize); South Side Comm. A. Center, 1941 (prize); Barnet Aden Gal.; AIC, 1940; McMillen A. Gal, 1940; St. Louis Urban Lg., 1940-46. Position: T., South Side Community A. Center, Chicago [47]

CARTLEDGE, Rachel Hoff [P,T] Phila., PA b. Phila. Studied: PMSchIA; Moore Inst.; Univ. Pa. Member: Plastic C.; Phila. Alliance. Position: T., South Phila. H.S. for Girls [40]

CARTLICH, George L. [P] Kansas City, MO [24]

CARTON, Norman [P,Des,C,G] Phila., PA b. 7 Ja 1908, Russia. Studied: PAFA; Henry McCarter. Exhibited: PAFA 1943-46; WFNY, 1939; CI; PMG; New Sch. Soc. Res.; CGA, 1938. Work: mural, Fleisher Vocational Sch., Phila., Pa. Positions: A. Staff, Phila. Record, 1929-30; Metal Craftsman, Des., Phila. Enameling Works [47]

CARTOTTO, Ercole [G,P,T] NYC/Darien, CT b. 26 Jy 1889, Valle Mosso, Piemonte, Italy d. 3 O 1946. Studied: Bosley; Paxton; Benson; Tarbell; Hale; BMFA Sch. Member: AFA; Soc. of Med. Exhibited: NAD, 1919 (prize); Baltimore WCC, 1924 (prize); Bologna, Italy, 1931 (gold). Work: the Vatican; Johns Hopkins Univ.; Jones Mem. Library, Amherst, Mass.; MMA; San Diego A. Gal.; CMA; Amherst, Col.; Alpha Delta Phi, Amherst, Mass.; Dept. Justice, Wash., D.C.; Phi Gamma Delta Cl., NYC; Pratt Inst.; Columbia; State House, Montpelier, Vt.; Smith College Mus. A.; Springfield (Mass.) Col.; New York Hist. Assn., Ticonderoga, N.Y.; Lowell House, Harvard; Dwight Morrow H.S., Englewood, N.J.; Mansion Mus., Pioneer Mem. State Park, Harrodsburg, Ky. [49]

CARTWRIGHT, Isabel Branson (Mrs.) [Por.P] Phila., PA b. 4 S 1885, Coatesville, PA. Studied: Phila. Sch. Des. for Women; Frank Brangwyn, in London; Daingerfield; Henry B. Snell. Exhibited: Phila. AC, 1906 (gold); PAFA, 1921, 1923 (prize), 1924, 1940; CGA, 1922; NAD, 1922-24, 1927, 1934; AIC, 1930; Buffalo SA, 1920 (prize), 1929, 1932; Phila. Plastic C., 1921 (prize); San Antonio AL, 1928, 1929 (prizes); Ogunquit A. Center, 1934, 1937; Currier A. Gal., 1938-42. Work: Moore Inst. A., Phila. [47]

CARY, Elizabeth Luther [Cr,Art Ed] b. 18 My 1867, Brooklyn NY d. 13 Jy 1936, NYC. Studied: Eleanor C. Bannister; Charles Melville Dewey. Articles and lectures on printmaking and printmakers. Collector: fine prints. Position: Art Ed., New York Times, 1908-36

CARY, Evelyn Rumsey (Mrs. Charles) [P] Buffalo, NY. Member: Buffalo SA, 1914. Exhibited: Charlestown Expo, 1902 [15]

CARY, Julia M. [P] NYC [17]

CARY, Page [P,I,W] Phila., PA b. 29 Ag 1904, Los Angeles, CA. Studied: Ecole des Beaux-Arts, Paris; ASL; CUASch; Mary Baldwin Col., with Ellen Myers; Martinez, Calif. Sch. FA; Cooper Union. Member: Phila. Alliance. Exhibited: PAFA, 1935-45; AIC, 1937-45; AFA Traveling Exh., 1939; NGA; WFNY 1939; WMAA, 1940; MMA, 1914; Butler AI, 1940-42; Friends Sch., Overbrook, Pa., 1940. Author: "Melinda's Hat," 1941. Illustrator: "Yes, Ma'am," 1942 [47]

CARY, William De La Montagne [P,I] b. 1840 d. 7 Ja 1922, Brookline, MA. Work: Gilcrease Col., Tulsa; ACM. His 1861 trip to the Far West provided basis for illustrations from 1866-96, which appeared in Leslie's, Harper's, Scribner's, etc. [*]

CASAD, Walter G. [P] Columbus, OH. Member: Columbus PPC [24]

CASADY, Mrs. Richard R. See Stevenson.

CASARE, O.E. [P] NYC. Position: New York Sun [15]

CASARIN, Alexander [P,S,W] NYC b. Mexico d. 26 My 1907. Studied: Meissonier, in France. Member: circle frequented by Corot, Fortuny, Millet, Diaz, in Paris. Work: bust of McKinley

CASARINI, Athos [P] Brooklyn, NY b. 1884, Bologna, Italy d. Autumn, 1917, Italy (fighting for Italy). He was a follower of Futurism. [15]

CASCIANO, August [P] Providence, RI b. 13 Jy 1910, Providence. Studied: RISD. Exhibited: Art of This Century, 1944; LOC, 1945; GGE, 1939; RISD, 1927 (prize), 1930 (prize), 1940; Brown Univ., 1939

CASE, Andrew W. [P,E] State College, PA b. 19 Jy, 1898, Tipton, IN. Studied: PIASch; Pa. State Col. Member: Scarab C. Exhibited: AWCS, 1935, 1936, 1937; Ind. AC, 1936; Nebr. AA, 1940. Contributor: advertising & liturgical magazines. Position: Instr., Pa. State Col., State College, Pa. [47]

CASE, Elizabeth E. [P,I,T,D] NYC b. 29 S 1867. Studied: Weir; Metcalf; Brush; Low; Chase. Member: C.L. Wolfe AC. Position: Hd., Fashion Dept., Gatchel & Manning [29]

CASEAU, Charles H(enry) [P,Des] NYC b. 2 My 1880, Boston, MA. Studied: BMFA Sch.; Harvard, with Denman Ross; ASL. Position: Indst. Des. & Advertising Illus. [47]

CASELLA, Alfred [P] San Francisco, CA [24]

CASELLAS, Frenando Miranda [S,I] b. 1842, Valencia, Spain (came to the U.S. in 1876) d. 10 My 1925. Member: Juror, World's Fair, Chicago, 1893; NSS; Arch. Lg.; Royal Acad. of San Carlos, Valencia. Work: Tract Soc. Bldg., NYC; N.Y. Hist. Soc. Illustrator: French and American magazines

CASER, Ettore [P,E,Dec] NYC b. 29 D 1880, Venice. Italy d. 26 F 1944. Studied: Acad. Venice; Ettore Tito; M. de Maria. Member: ANA, 1931; Grand Central A. Gal. Exhibited: P.-P. Expo, San Fran., 1915. Work: murals, Engineer's Cl., N.Y.; Winchester, Mass. Pub. Lib.; Savings Bank, Toledo, Ohio [40]

CASEY, Edward F. [Edu,P,L] Brooklyn, NY b. 13 O 1897, Utica, NY. Studied: PIASch; Grand Central Sch. A., with Arthur Woelfle; ASL. Member: Alliance. Exhibited: NAD, 1932; BM, 1934; Alliance, 1939-46. Lectures: Dutch Painting; Italian Art. Positions: Instr. A., Board Edu., NYC, 1922-46, St. Joseph's Col., Brooklyn, N.Y. [47]

CASEY, F. De Sales [I] NYC. Member: SI [31]

CASEY, J(ohn) J(oseph) [I,P] NYC b. 4 My 1878, San Francisco, CA d. 28 Ap 1930. Studied: Tarbell; Benson; Académie Julian, Paris, with Laurens, Lazar, 1910. Illustrator: New York American, New York Evening Journal, magazines [25]

CASEY, Laura Welsh (Mrs. Thomas L.) [P] Wash., D.C. Member: S. Wash. A. [25]

CASH, Bill (William Edmund) [P,I,B,W] Phila., PA b. 8 Ap 1907, Brooklyn, NY. Studied: H.R. Ballinger; Douglas Duer; Henry McCarter; Earl Horter. Member: Phila. Alliance. Exhibited: Howard Pyle Mem. Gal., 1930 (prize); Author: Tiny Tick series. Position: Hd. A. Dept., John C. Winston Co. [40]

CASH, Harold [S] NYC b. 26 S 1895, Chattanooga, TN. Studied: Stanford Univ.; Univ. Va.; N.Y. Sch. F.& Appl. A.; BAID. Member: NSS; SG; Guggenheim F., 1930, 1931. Exhibited: PAFA, 1941-43; WMAA, 1935; MOMA, 1930-34; AIC, 1932-38; BM, 1931; SFMA; MMA [47]

CASHIN, Nora [P] San Fran., CA [13]

CASHWAN, Samuel [S,T] Detroit, MI b. 26 D 1900, Cherkassi, Russia. Studied: Bourdelle; Milles; Maillol; City Col., Detroit; Arch. Lg. Member: Scarab C.; Metropolitan AA, Detroit; WPA; Detroit SAC. Exhibited: nationally, 1920-46. Work: Detroit AI; Vassar; Jackson Mem., Jackson, Mich.; Ypsilanti, Clair, both in Mich. [47]

CASKEY, Julia [B] Seattle, WA b. 22 S 1909, Seattle. Studied: Cornish Sch.; Univ. Wash. Member: SAM; Northwest PM [40]

CASS, Caroline Pickands. See Caswell.

CASS, Katherine Dorn (Kae) (Mrs. Harry B.) [T,P] South Euclid, OH b. 15 My 1901, Cleveland, OH. Studied: Cleveland Sch. A.; Académie Julian, Paris. Member: Cleveland Women's AC; NAWA. Exhibited: CMA, 1926-46; Ohio WC Soc., 1935-46; Women's AC, 1923-46; Cleveland Sch. A., 1940-46. Work: Municipal Coll., Cleveland; CMA. Position: Instr., Cleveland Sch. A. [47]

CASSADY, E. Chase [P] Indianapolis, IN [17]

CASSADY, Edithe Jane [P] Chicago, IL b. 22 Ag 1906, Chicago. Studied: Chicago Acad. FA; AIC; Frederic M. Grant; Ruth Van Sickle Ford; Guy Wiggins. Member: Assn. Chicago PS; Conn. Acad. FA; All-Ill. SFA; South Side AA. Exhibited: Union Lg. Cl., Chicago, 1929 (prize); All-Ill. SFA, 1933 (med). Work: Municipal Coll., Chicago [40]

CASSADY, U.G. [P] Indianapolis, IN [15]

CASSADY-DAVIS, Cornelia (Mrs.) [P] Chicago, IL b. Cincinnati, OH. Studied: Cincinnati Art Acad. Member: Women's Art Cl., Cincinnati [98]

CASSARA, Frank [P,T,Li,S] Detroit, MI b. 13 Mr 1913, Partinico, Italy. Studied: Detroit Sch. A.; Colorado Springs FA Center, with Boardman Robinson; Univ. Mich., with Paul Slusser. Exhibited: AIC, 1939; Detroit Inst. A. Work: Detroit Inst. A.; USPOs, Sandusky, Ohio, East Detroit, Mich. [47]

CASSATT, Mary [P,E] NYC/Paris, France b. 1845, Pittsburgh, PA d. 14 Je 1926, Mesnil-Theribus, Oise, France. Studied: PAFA; Europe. Influenced by Manet, Degas. Exhibited: ANA, 1909. Exhibited: PAFA, 1904 (prize), 1914 (gold). Work: MMA; CGA; Wilstach Gal., Phila.; R.I. Sch. Des.; BMFA; Worcester Mus.; NGA; Detroit Mus.; AIC; Luxembourg, Paris; major mus. worldwide. Award: Chevalier of Legion of Honor of France, 1904 [25]

CASSAVANT, F.J. [I] NYC [19]

CASSEBEER, Walter Henry [Li,Arch] Greece, NY b. 20 N 1884, Rochester, NY. Studied: Columbia Univ. Sch. Arch.-Arts, Paris. Member: Pr. Cl, Rochester. Exhibited: PAFA, 1931 (prize); Third Intl. Li.&Wood En. Exh., Chicago (prize); Mem. Art Gal., Rochester, 1931 (prize); Cleveland Mus., 1931 (prize). Published: Twelve Lithographs of Rochester, 1915 [40]

CASSEDY, Edwin G. [P] Wash., D.C. Exhibited: Min. PS&G Soc. 1937, 1939 [40]

CASSEDY, Morton (Mrs.) (Maud Woodson) [P] Louisville, KY. Member: Louisville AL [01]

CASSELL, Helen Lewis [P] Los Angeles, CA. Member: Calif. AC [25]

CASSELL, John Harmon [Car,I] NYC/Silvermine, CT b. Nebraska City, NE d. ca. 1960. Studied: AIC; Doane Col. Member: SC; Ar. Gld.; SI, 1905. Illustrator: national magazines. Position: Car., Brooklyn Daily Eagle [47]

CASSIDY, I(ra) Diamond Gerald [P,G,I,Mur.P] b. 10 N 1879, Covington, KY (or Cincinnati, OH) d. 12 F 1934, Santa Fe, NM (of poisoning while working on some murals for WPA). Studied: Cincinnati Acad., with Duveneck, 1891; NAD; ASL. Member: Calif. WC Soc.; Santa Fe PS. Exhibited: Pan.-Calif. Expo, San Diego, 1915 (gold,prize); Chicago Gal. Assn., 1928 (prize), 1929 (prizes), 1930 (prize), 1931 (prize), 1932 (prize). Work: San Diego AM; dec., Indian Arts Bldg., San Diego; Hotel Gramatan, Bronxville, N.Y.; Golden (Colo.) H.S.; mural, La Fonda Hotel, Santa Fe; Freer Coll., Wash., D.C.; Mus. FA, Houston; Gary, Ind. H.S.; McPherson, Kans. H.S.; Canton (China) Christian Col.; El Oñate Theatre, Santa Fe; City Mus., Berlin, Germany; Albertina Mus., Vienna; Luxembourg, Louvre, both in Paris; Mus. N.Mex.; NYPL; Southwest Mus. Designer: Parfet Mem. Park, Golden, Colo. One of the founders of the Santa Fe art colony. Known for his paintings of Navajos. [33]

CASSIDY, Laura E. [P] Madisonville, OH. Member: Cinncinati Women's AC; Calif. WCS [31]

CASSIDY, Louise V. [P] Minneapolis, MN [24]

CASTAIGNE, A. [I] NYC. Position: Illus., Century Co., NYC [01]

CASTAING, C(amille) K. (Mr.) [S,Des,C,T] Huntington Beach, CA b. 16 Ag 1899, French Guiana. Studied: CUASch. Member: Soc. Plastic Inst. Exhibited: Anderson Gal., 1931 (prize); Plastics Comp., 1937 (med), 1938 (med), 1939 (med), 1940 (med), 1941 (med); MOMA, 1939 (med); Phila. A. All., 1940 (med) [47]

CASTALDO, Amaylia (Mrs. Amaylia C. Trebilcock) [Por.P] NYC b. 12 Ag 1906, NYC. Studied: ASL; Leon Kroll; Boardman Robinson. Member: Chicago AC [47]

CASTANO, Giovanni [Des,P,T] Needham, MA b. 2 O 1896, Gasperina, Italy. Studied: BMFA Sch., with Philip L. Hale, Leslie P. Thompson; Huger Elliot; F.M. Lamb; Henry James. Member: Boston AC; Cincinnati AC. Exhibited: PAFA, 1918 (prize); Springfield AA, 1926 (prize). Work:

Brockton (Mass.) Pub. Lib.; Springfield AA; murals, First Baptist Church, Covington, Ky.; set design, Cincinnati Opera House, Boston Opera House, and for productions in Town Hall, Peterborough, N.H. Position: T., BMFA Sch. [47]

CASTELLO, Eugene [P,S,W] Phila., PA b. 12 Ja 1851, Phila. d. 3 Mr 1926. Studied: PAFA, with Eakins. Member: SC, 1904; Phila. Pr. Cl.; Phila. ACG; Phila. Chapter AIA, 1871; Intl. Soc. AL; Phila. AC; Wash. AC. Exhibited: AAS, 1904 (med); Phila. A. & Crafts Gld., 1906 (prize); Ghent Expo, 1913 (med). Work: Hist. Soc. Pa.; Univ. Pa. Contributor: "The Studio," London [25]

CASTELLON, Federico [P,E,Li,I] Brooklyn, NY b. 14 S 1914, Almeria Spain. Member: F., Spanish Republic, 1934–36; F., Guggenheim Fnd., 1941; Exhibited: AIC, 1938 (prize); PAFA, 1938, 1939, 1940 (prize), 1941, 1942; Assoc. Am. Ar., 1946 (prize); Weyhe Gal., 1934, 1936–40; AFA Traveling Exh., 1937; AIC, 1937–40; WMAA, 1938–45; Carnegie Inst., 1942. Work: Frank Jewett Mather Coll., Princeton; Univ. Ky.; San Diego Mus. FA; Newark (N.J.) Pub. Lib. Illustrator: "Shenandoah" (1941), "I Went Into the Country" (1941); national magazines [47]

CASTERTON, Eda Nemoede (Mrs. W.J.) [P,Min.P] Evanston, IL b. 14 Ap 1877, Brillion, WI. Studied: Minneapolis Sch. A.; AIC; Chicago Acad. FA; Virginia Reynolds; Lawton S. Parker; Leopold Seiffert. Member: ASMP; Chicago Soc. Min. P. Exhibited: Intl. Art Union, Paris, 1907 (prize), 1908 (prize); P.-P. Expo, 1915 (med); Sesqui-Centennial Expo, Phila., 1926 (med); Evanston Women's Cl., 1942 (prize), 1944 (prize); Paris Salon, 1907; Century of Progress, Chicago, 1933; Grand Central A. Gal., 1934 (one-man); CGA, 1934 (one-man). Work: NGA; BM; Ill. State Mus. [47]

CASTLE, Montague [P] NYC d. 11 Ag 1939. Member: Mural P. [21]

CASTLEDEN, George Frederick [P,I,G] St. Augustine, FL b. 4 D 1869, Canterbury, England d. 23 O 1945. Studied: South Kensington Sch. A., London; T.S. Cooper. Member: New Orleans AL; St. Augustine AA; Brit. Empire Soc.. Exhibited: Imperial Gal., London, 1937; Vose Gal., Boston, 1937 (one-man) [40]

CASTONE, George [P] St. Paul, MN [25]

CASWELL, Caroline Pickands [S] Euclid, OH b. 9 N 1902, Euclid. Studied: Cleveland Sch. A.; BMFA Sch.; H.N. Matzen; Alexander Blazys; Charles Grafly. Exhibited: Cleveland A. & Craftsmen, Cleveland Mus. A., 1931 (prize), 1932 (prize) [40]

CASWELL, Edward C. [I,Dr,L,T,W] NYC b. 12 S 1879, NYC. Studied: Francis C. Jones. Member: Authors Cl. of N.Y. Illustrator: "Old New York," by Edith Wharton, "Coasting Down East," by Ethel Hueston and Edward C. Caswell, the "Patty" books, by Carolyn Wells. Lecturer/Writer: travel and art. Award: decoration of the White Lion, by Gov. of Czechoslovakia. Positions: Illus., Macmillan, Harcourt Brace, Dodd Mead, Clode, Bobbs Merrill Co., Farrar and Rinehart [40]

CATALANO, Guiseppi [E] Chiesannova, Sicily. Member: Chicago SE [24]

CATALANO, Joseph J. [P] Detroit, MI [24]

CATALAW, Guiseppe [S] Detroit, MI. Exhibited: Scarab Cl., Detroit, 1914 (prize) [17]

CATAN-ROSE, Richard [P,T,E,Li,S,L,I] Forest Hills, NY b. 1 O 1905, Rochester, NY. Studied: Royal Acad. FA, Italy; CUASch; Pippo Rizzo; Antonio Quarino; J. Joseph; A. Shulkin. Member: Royal Acad. FA, Italy. Exhibited: All.A.Am., 1939, 1940; Vendôme Gal., 1939, 1940, 1941; Forest Hills, 1944 (one-man), 1945 (one-man), 1946 (one-man); Argent Gal., 1946 (one-man); Europe. Position: A. Dir., Catan-Rose A. Sch., 1945–46 [47]

CATANZARO, Catherine B. [P,Et,Li] Buffalo, NY b. 25 Ag 1921, Buffalo. Studied: Albright A. Sch. Member: Buffalo Pr. Cl. Exhibited: Phila. Pr. Cl., 1943, 1944; Albright A. Gal., 1942, 1946 [47]

CATENARO, Armand [P] Bronx, NY. Exhibited: 48 Sts. Comp. [40]

CATHELL, Edna S. (Mrs. J.E.) [P,S] Richmond, IN b. 1 N 1867, Richmond, IN. Member: Richmond AA; Palette Cl., Richmond [33]

CATLIN, Daniel St. Louis, MO b. 5 S 1837, Litchfield, CT d. 20 Ag 1916. An art collector, he had been a member of the Board of Control of the St. Louis Art Museum for thirty-seven years.

CATOK, Lottie Meyer [P,G] Longmeadow, MA b. Hoboken, NJ. Studied: N.Y. Sch. F.&Appl. A.; Guy Wiggins; W. Lester Stevens. Member: Springfield Ar. Gld; Ar. Union, Western Mass.; Springfield A. Lg. Exhibited: Springfield Ar. Gld., 1932 (prize); Springfield MFFA; Bershire Mus.; Conn. Acad. FA [40]

CATTRON, Vivian Lee (Mrs.) [P,T] Minneapolis, MN b. 1 Mr 1906, Anderson, IN. Studied: Univ. Minn.; Minneapolis Inst. A.; Thurn Sch. A., Gloucester, Mass.; Member: Minn. AA. Exhibited: Minn. State Fair, 1931 (prize), 1932, 1934; Minneapolis Inst. A., 1931, 1932, 1933 (prize), 1934 (prize), 1936; Thurn Gal.; Minneapolis A. Inst., 1939. Work: Mt. Holyoke Col. Illustrator: art magazines. Position: T., A. Dept., Roosevelt HS, Minneapolis [47]

CAULDWELL, John Britton b. 1856, Brooklyn, NY d. 8 Ja 1932. Studied: Columbia Univ. Member: Century Assoc. The director of fine arts on the U.S. Commission to the Paris Expo in 1900, he served on the National Advisory Board for the Buffalo, St. Louis, and San Fran. Expos. Award: Chevalier of the Legion of Honor

CAULDWELL, Leslie Giffen [P,Dec,L,T] Paris, France/Seune et Oise, France b. 18 O 1861, NYC d. 9 Ap 1941. Studied: Académie Julian, Paris, with Boulanger, Lefebvre, Carolus-Duran. Member: N.Y. Arch. Lg., 1894; AAPL (Sec. European Chap.). Exhibited: Intl. Expo, 1900 (gold); "Reconnaissance Française," 1921 (med). Work: PAFA; U.S. Chancellery, Paris; Am. Chamber of Commerce, Paris; Town Hall, Somme; U.S. Embassy, Istanbul; William & Mary Col. [40]

CAVACOS, E(mmanuel A.) [S,P] Paris, France b. 10 F 1885, Cythera, Greece. Studied: Ephraim Keyser; Jules Coutan, V. Peter, in Paris. Member: Baltimore WCC; Assoc. des Anciens Elèves de l'Ecole Nationale des Beaux-Arts de Paris; Inst. Social de l'Enseignement. Exhibited: Paris Salon, 1913 (prize); Intl. Expo Dec. A., Paris, 1925 (med); Intl. Expo, Paris, 1937 (gold). Work: Enoch Pratt Free Lib.; Peabody Inst., Baltimore; Coll. of Queen of Romania; Baltimore MA. Award: "Officier de l'Académie," French Gov., 1927; Cross, Legion of Honor, Paris, 1939 [40]

CAVALLITO, Albino [S] NYC b. 24 F 1905, Cocconato, Italy d. 1966. Studied: Trenton (N.J.) Sch. Indst. A.; BAID; Fontainebleu Sch. FA; José de Creeft. Member: S. Gld. Exhibited: NAD; AIC; WMAA; WFNY, 1939; Dallas Mus. FA; BM; MMA; S. Gld.. Work: AGAA; mural, USPO, Kenovia, W.Va. [47]

CAVALLON, Giorgio [P] NYC b. 3 Mr 1904, Italy. Studied: NAD; C. Hawthorne; Hans Hofmann. Member: F., Tiffany Fnd., 1929; Am. Abstract Ar. Exhibited: Am. Abstract Ar.; Am. Ar. Gal.; Riverside Mus.; WFNY, 1939 [40]

CAVANAGH, J. Albert [P] NYC. Member: SC [21]

CAVANNA, Elise (S.) (Mrs. Merle Armitage) [Li,P,I] Los Angeles, CA b. Ja 1905, Germantown, PA. Studied: PAFA: Arthur Carles; Daniel Garber; Hugh Breckenridge. Exhibited: Ebell Cl., Los Angeles, 1935 (prize); Antheil Gal., Hollywood, 1938 (one-man); WFNY, 1939; 50 Prints of the Year, 1933, 1934, 1935. Work: mural, USPO, Oceanside, CA; Los Angeles Mus. A. Illustrator: "Valdemar," 1938, "Fit for a King," 1939, "Elise," "Have We an American Art?" [47]

CAVE, Edna Selena [B,C] New Hope, PA. b. Phila. Studied: Sch. Indst. A., Phila. Contributor: craft, home decoration, needlcraft articles, Ladies Home Journal, Country Gentlemen, Holland's Magazine, McCalls, Woman's Home Companion. Author: "Craft Work," pub. Century Appleton Co. Specialties: basketry; stenciling; batik; dyeing [40]

CAWEIN, Fred W. [I] b. 1868 d. 19 F 1912, Louisville, KY. Position: Staff A., Louisville Times

CAWEIN, Kathrin [E,En,Li] Pleasantville, NY b. 9 My 1895, New London, CT. Studied: ASL, with George Bridgman, Allen Lewis, Harry Wickey. Member: SAE; Chicago SE; NAWA; Hudson Valley AA; Northwest Pr.; Village A. Center, Inc.; Phila. SE; Westchester AC. Exhibited: SAE, 1936 (prize); Village A. Center, 1944 (prize); Hudson Valley AA, 1944 (prize); NAWA [47]

CAYLOR, Harvey Wallace [P] b. 1867, Noblesville, IN d. 1932, Big Spring, TX. Studied: Indianapolis, with Jacob Cox; sketching scenes as he worked on ranches. Known as a cowboy artist. [*]

CECERE, Ada Rasario [P,T,Des] NYC b. NYC. Studied: ASL; NAD; BAID. Member: NAWA; Soc. Des. Cr. Exhibited: BM, 1936; AWCS, 1928–33; NAWA, 1943, 1946; Arch. Lg., 1928–33; Ferargil Gal., 1928, 1929; Argent Gal., 1930–46; Newport AA, 1944; Dayton AI, 1945; Soc. Des. Cr., 1930. Work: S.S. Pres. Jackson. Contributor: Craft Horizons [47]

CECERE, Gaetano [S,E,L] NYC b. 26 N 1894, NYC. Studied: H.A. MacNeil; BAID; NAD; Am. Acad., Rome; Member: NAD, 1938; NSS. Exhibited: NAD, 1924–46, 1924 (prize); PAFA, 1924–46, 1930 (prize); AIC, 1924–27; WMAA, 1934; MMA, 1935; CAM, 1942–46; Arch.Lg., 1924–33; NSS, 1924–46, 1935 (prize). Work: MMA; Numismatic Mus., NYC; Brookgreen Gardens, S.C.; Norton Gal., West Palm Beach, Fla.; War mem., Clifton, N.J., Plainfield, N.J., Princeton, N.J.; port. monu-

ments, Lincoln Mem. Bridge, Milwaukee, Wis.; State of Tex.; State of Mont. Lectures: Contemporary and Ecclesiastical Sculpture [47]

CEDERQUIST, A(rthur) (E.) [P] Titusville, PA b. 3 Ap 1884, Titusville, PA d. ca. 1955. Studied: William Chase; Robert Henry; Kenneth Hayes Miller. Work: WMAA. Exhibited: Ferargil Gal.; WMA, 1929. [47]

CELENTANO, Daniel Ralph [P,Des] Massapegua, NY b. 21 D 1902, NYC. Studied: Thomas Hart Benton; Parsons Sch. Des.; NAD; Charles Hawthorne; Howard Giles; Ivan Olinsky. Exhibited: BM, 1935; CGA, 1937–39; AIC, 1937–42; Detroit AI, 1937; PAFA, 1936–42; Carnegie Inst., 1937; WMAA; GGE, 1939; CAM; VMFA; Inst. Modern Art, Boston; Walker A. Center, 1939 (one-man). Work: WMAA; murals, Flushing Lib.; P.S. #150, Sunnyside, N.Y.; USPO, Vidalia, Ga.; Grumman Aircraft Corp., Bethpage, N.Y.[47]

CENT, Penny [P] Harrisburg, IL. Exhibited: GGE, 1939 [40]

CERIO, Mabel Norman (Mrs. George) [P] Newport, RI b. Newport. Studied: BMFA Sch. Member: Providence ACI; Newport AA. Exhibited: Providence ACI; Newport AA, 1915 (prize) [40]

CERNY, George [S,P] NYC b. 17 S 1905, Phila., PA. Member: ASL; Clay Cl. [40]

CERUTTI-SIMMONS, Teresa (Mrs. William) [E,En,P,L,W] Roxbury, CT b. Piedmont, Italy. Studied: J. McN. Whistler; Will Simmons. Member: Soc. Am. E. Work: NYPL, 58th St. branch. Author: "The Art of Dancing." Contributor: American Magazine of Art; Connoisseur [40]

CERVANTEZ, Pedro [P] Texico, NM b. 19 My 1915, Wilcox, Ariz. Studied: Eastern N.Mex. Jr. College, Portales; R. Vernon Hunter, Santa Fe. Exhibited: MOMA; WFNY, 1939 [40]

CÉSAR, Rafael [P,S] Wash., D.C. b. 25 My 1906, Mexico City. Studied: NAD; NYU; Corcoran A. Sch.; Phillips A. Sch. Exhibited: Nat. Col. FA (Smithsonian); Studio House [40]

CESARE, O.E. [I] NYC. Contributor: The Evening Post [19]

CESNOLA, Luigi Palma [Mus Dir,W,Arch] NYC b. 29 Je 1832, Rivarolo, Piedmont, Italy (came to U.S. in 1860) d. 20 N 1904. Positions: at Salinos, Cyprus, excavated the first known works of Phoenician art, 1865–66; Dir., MMA, 1878–1904

CHABOT, John T. [P] Los Angeles, CA. Member: Calif. AC [25]

CHABOT, Lucille Gloria [I] Boston, MA/Ogunquit, ME b. 18 Je 1908, Lawrence, MA. Studied: WMA; William Starkweather. Member: Bay State AG. Work: Index Am. Des. [40]

CHACE, Dorothea (Mrs. Peter D.) [P,T] NYC/Nyack, NY b. Buffalo, NY. Studied: Albright A. Gal. Sch.; ASL. Member: NAWA; Woodstock AA. Exhibited: GGE, 1939; MMA, 1942; Carnegie Inst., 1941; CGA, 1937, 1939; AIC, 1938–44; NAWA, 1935 (prize); NAD, 1939, 1940, 1942, 1944; PAFA, 1938; VMFA, 1938, 1940, 1942; Portraits, Inc., 1946; Toledo Mus. A., 1938–40; CM, 1939; Levitt Gal.; Woodstock A. Gal. Position: Instr. A., Bennet Jr. Col., Millbrook, N.Y., 1920–45 [47]

CHADEAYNE, Robert O. [P,T] Columbus, OH/Cornwall, NY b. 13 D 1897, Cornwall. Studied: C.K. Chatterton; George Luks; John Sloan; George Bridgman. Member: Columbus AL. Exhibited: PAFA, 1919 (prize); AIC, 1920 (med); Columbus AL, 1928, 1929, 1932 (prizes). Work: Lambert Coll., PAFA. Columbus Gal. FA. Position: Instr., Columbus A. Sch. [40]

CHADWICK, Arch D. [Des,Dr,L] Ithaca, NY b. 18 My 1871, Ovid, NY. Studied: Ithaca Conservatory of Music and Art. Member: AFA. Scenic artist and designer in theatre and motion pictures. Position: T., Ithaca Col. [40]

CHADWICK, C(harles) W(esley) [En,L] NYC b. 8 F 1861, Red-Hook-on-Hudson, NY. Studied: Frederick Juengling; William Miller; Frank French. Exhibited: Columbian Expo, Chicago, 1893 (med); Pan-Am. Expo, Buffalo, 1901 (med); St. Louis Expo, 1904 (med); P.-P. Expo, San Fran., 1915 (med) [17]

CHADWICK, Grace Willard [P,T] Oklahoma City, OK b. 25 F 1893. Studied: Univ. Okla.; Birger Sandzen; Everett Warner; Hans Hoffman; Anita Delaney. Member: Assn. Okla. A.; Okla. AL [40]

CHADWICK, John Herbert [P] Fort Washington, PA b. England. Studied: South Kensington Mus., London; PAFA. Member: Phila. Sketch Cl. [13]

CHADWICK, William [P] Old Lyme, CT/Black Hall, CT. Member: SC [27]

CHAED, Louise C. [P] NYC [01]

CHAET, Bernard Robert [P] Boston, MA b. 7 Mr 1924, Boston. Studied: BMFA Sch. Exhibited: Los Angeles Mus. A., 1945; ACA Gal., 1945; Inst. Mod. A., Boston, 1943; Boris Mirski Gal., 1946 (one-man) [47]

CHAFFEE, Ada Gilmore [B] Provincetown, MA b. 1883, Kalamazoo, MI d. 1955, Provincetown, MA. Studied: Belfast Sch. A.; AIC, 1903; Robert Henri; Paris, with Ethel Mars, 1913. Member: Provincetown Printers. Exhibited: Provincetown AA; P.-P. Expo, 1915

CHAFFEE, Adeliza B. (Mrs.) [L,W] b. 1856 d. 28 O 1916, Worcester, MA. Studied: Wellesley

CHAFFEE, Everitte S. (Mrs.) [P] Providence, RI. Member: Providence AC [25]

CHAFFEE, Olive Holbert (Mrs. Roy) [P,T] St. Louis, MO/Glendale, CA b. Paducah, KY. Studied: W.A. Knapp; F.H. Woolrych; George Conroy. Member: Nat. Lg. Am. Pen Women; NAC; SSAL; Indp. A., St. Louis. Exhibited: Women's Nat. Expo, St. Louis, 1928 (prize); Nat Lg. Am. Pen Women, 1933 (prize). Work: Christian Col., Columbia, Mo.; Pub. Lib., Jefferson City, Mo. [40]

CHAFFEE, Oliver N(ewberry) [P,T] Provincetown, MA b. 23 Ja 1881, Detroit, MI d. 25 Ap 1944, Asheville, NC (en route to Provincetown). Studied: Chase; Henri; Hawthorne; Miller; Detroit Acad.; lived and studied in Paris many years. Member: S. Indp. A. Exhibited: Detroit AI, 1908; Armory Show, NYC, 1913; Salon d'Automne, Paris, 1913; Provincetown AA; PAFA; S.Indp.A. [24]

CHAFFEE, Roy [P] St. Louis, MO/Glendale, CA b. St. Louis. Studied: Washington Univ., St. Louis. Member: St. Louis WCS. Exhibited: Tricker Gal., NYC, 1938 [40]

CHAFFITZ, Ber [P] NYC. Member: S.Indp.A [21]

CHAIET, Louis Cameron [Por.P] Brooklyn, NY b. 19 Ag 1904, Vulena Guberna, Russia. Studied: NAD; ASL. Member: AL Am. Exhibited: AL Am.; ASL. Position: Staff A., Jewish Examiner, 1945– [47]

CHALE, Ellen Wheeler [P] Paris, France b. Faribault, MN. Studied: Simon; Ernest Laurens, in Paris [17]

CHALFANT, J(efferson) D(avid) [Por.P] Wilmington, DE b. 6 N 1856, PA d. F 1931. Studied: Paris, with Bouguereau, Robert-Fleury, Lefebvre. Specialty: meticulous painting, a facsimile of a one dollar note so perfect, it was confiscated by the government. [29]

CHALFIN, Paul [Mur.P,Arch] Greenwich, CT b. 2 N 1874, NYC. Member: Arch. Lg., 1911 [33]

CHALIAPIN, Boris [I] NYC. Member: SI [47]

CHALLENOR-COAN, Francis [P] NYC b. Orange NJ. Studied: Henry B. Snell; Mrs. E.M. Scott [13]

CHALLISS, Emily [P] Phila., PA [01]

CHALMERS, Audrey (McEvers) [W,I,Car,Des] NYC b. Montreal, Quebec. Studied: Havergill Col., Toronto. Exhibited: NAC, Juvenile Books Exh. Author/Illustrator: "Poppidilly," 1945, "A Kitten's Tale," 1946. Contributor: Child Life magazine, Story Parade [47]

CHALMERS, B(arbara) (Mrs. MacEdwards) [P,Li,L,T] Wash., D.C. b. 12 My 1906, Manchester, NH. Studied: BMFA Sch.; Boston Univ.; Rollins Col.; Univ. Miami; George Elmer Browne; Wayman Adams; George Jo Mess. Member: SSAL. Exhibited: All.A., Winter Park, Fla., 1938, 1939. Calif. SE Traveling Exh., 1944–46; SSAL Traveling Exh., 1944–46; P&S Soc., N.J., 1944; Saranac Lake AL, 1944; Lakeland, Fla., Lectures: Women in Art [47]

CHALMERS, Helen Augusta (Mrs. Stephen) [P] Laguna Beach, CA/Bear Lake, CA b. 29 Mr 1880, NYC. Studied: Henry A. Loop; William J. Whittemore; Irving Wiles. Laguna Beach AA [38]

CHALONER, Walter L. [P] Boston, MA. Member: BAC, 1901 [04]

CHAMALIAN, Lillian [I] NYC b. NYC. Studied: ASL; Parsons Sch. Des. Member: AG. Illustrator: Harper's, New Yorker, Vogue, other magazines [47]

CHAMBELLAN, M(arcel Claude) [S] Paris, France/West Hoboken, NJ b. 26 Je 1886, West Hoboken. Studied: Paris, with Verlet, Greber. [13]

CHAMBELLAN, Rene Paul [S,Arch] NYC b. 15 S 1893, West Hoboken, NJ d. 29 N 1955. Studied: Académie Julian; Solon Borglum. Member: NSS. Work: Pershing Stadium; Russel Sage Fnd. Bldg.; numerous public bldgs., Albany, Ithaca, Buffalo, Chicago; Yale Univ.; Worcester, Mass.;

Cincinnati; Hartford, Conn.; Nashville; decorative arts and crafts, Radio City [47]

CHAMBERLAIN, Arthur B. [P] Rochester, NY/Irondequoit, NY b. 18 Ja 1860, Kitchener, Ontario. Member: Rochester AC [38]

CHAMBERLAIN, Charles F. [P] Dexter, MI [10]

CHAMBERLAIN, Curtis [P] Laguna Beach, CA. Member: Laguna Beach AA [25]

CHAMBERLAIN, Emily Hall [I] NYC b. Shelby, OH d. 28 F 1916. Studied: Pratt Inst.; Paris; London. Member: NAC; Art Workers' Cl., Women. Work: St. Nicholas; Youth Companion. Specialty: drawing children [10]

CHAMBERLAIN, George R. [Edu,I,Car] Ithaca, NY b. 10 O 1865, East Corinth, VT d. 15 Jy 1929. Studied: Cornell Univ.; ASL. Illustrator/Cartoonist, 1896 to 1901. Positions: T., Cornell, 1902, 1906–

CHAMBERLAIN, Glenn [S,P] Des Moines, IA. Exhibited: WC Ann., PAFA, 1938; Intl. WC Ann., AIC, 1939; WFNY, 1939. Work: White House, Wash., D.C. WPA artist. [40]

CHAMBERLAIN, H.R. [P] NYC [15]

CHAMBERLAIN, Jack B. [I] b. 1881 d. 4 Ap 1907, Lakewood, NJ

CHAMBERLAIN, Judith [P] San Fran., CA b. 28 F 1893, San Fran. Studied: Max Weber [21]

CHAMBERLAIN, Katherine P. [E] Los Angeles, CA. Member: Los Angeles Pr.M. [19]

CHAMBERLAIN, Norman Stiles [P,G] Hermosa Beach, CA/Taos, NM b. 7 Mr 1887, Grand Rapids, MI d. 1961, Orange, CA. Studied: Mathias Allen, Grand Rapids; Alson Clark, Calif. Member: West. Muralists; Fnd. West. A. Exhibited: Fnd. Western A., Los Angeles Mus.; CGA, 1937; 48 States Comp. Work: Los Angeles Mus.; USPOs, Huntington Park, Selma, both in Calif. WPA artist. [40]

CHAMBERLAIN, Samuel [E,Li,W,T,L] Marblehead, MA b. 28 O 1895, Cresco, IA d. 1975. Studied: Univ. Wash.; MIT; Royal Col. A., London; Edouard Leon, in Paris. Member: NA; SAE; Am. Acad. A.&Sc.; Chicago SE; ANA, 1939; Northwest PM; Société de La Gravure Originale en Noir, Paris; Guggenheim F., 1926. Exhibited: NAD, annually; Paris Salon, 1925 (med); Boston Tercentenary, 1930 (gold); Soc. Am. E., 1933 (prize). Work: Fine Prints of the Year, 1931; NYPL; LOC; MMA; BMFA; AIC; British Mus.; Victoria and Albert Mus.; Bibliotèque Nationale. Author/Illustrator: "France Will Live Again," 1940; "Fair is Our Land," 1942; "Sketches of Northern Spanish Architecture," 1925; "Domestic Architecture in Rural France," 1928; "Tudor Homes of England," 1929; "Through France with a Sketch Book," 1929; "French Provincial Houses," 1932. Lectures: Technique of Etching, Drypoint, Softground Etching. Position: T., MIT [47]

CHAMBERLIN, Edna Winslow [S] Summit, NJ/Hyannisport, MA b. 2 S 1878, Short Hills, NJ. Studied: Myra Musselman-Carr [17]

CHAMBERLIN, F(rank) Tolles [Mur.P,S,E,T] Pasadena, CA b. 10 Mr 1873, San Fran., CA. Studied: ASL; Dwight W. Tryon, George Bridgman; George de Forest Brush. Member: BAID; Book Workers G.; Calif. AC; Calif. WCS; Calif. Pr.M.; Pasadena SA; Lazarus Scholarship in Mural Painting, Am. Acad. Rome, 1909–1912. Exhibited: Arch. L., 1913, 1914 (prize), 1920; NAD; PAFA; AIC; Pan-P. Expo, 1915; GGE, 1939; Palace Legion Honor, 1929; Pasadena SA, 1924–46; Pasadena AI, 1934 (prize); Fnd. West. A., 1935–40; Calif. AC; Soc. for Sanity in Art, 1940 (prize); Calif. WCS; Scripps Col., Claremont, Calif., 1937. Work: Peabody Inst., Baltimore; New Rochelle Pub. Lib.; Detroit AI; McKinley Jr. H.S., Pasadena; Los Angeles Mus. Lectures: Italian Renaissance Painting. Position: T., A., Jepson Sch. A., Pasadena [47]

CHAMBERLIN, G. Howard [I] NYC [01]

CHAMBERLIN, Helen [I,T] NYC/Jackson Heights, NY b. Grand Rapids, Mich. Studied: AIC; Charles W. Hawthorne. Illustrator: "Princess Hildegarde," "English Fairy Tales," "French Fairy Tales," other books [47]

CHAMBERLIN, Katharine Beecher Stetson. See Stetson.

CHAMBERS, C. Bosseron [P,I,T] NYC b. 13 My 1883, St. Louis, MO. Studied: Berlin Acad., with Louis Schultze; Royal Acad., Vienna, with Alois Hrdliezka. Member: SC; SI; Alliance. Work: St. Ignatius's Church, Chicago; Mo. Historical Soc., St. Louis; Osceola Cl., St. Augustine, Fla. Illustrator: "Quentin Durwood," Sir Walter Scott [40]

CHAMBERS, Charles [I] Chicago, IL [10]

CHAMBERS, Christine F. [P] Phila., PA [24]

CHAMBERS, C(harles) E(dward) [P,I] NYC b. Ottumwa, IA. Studied: AIC; ASL. Member: SI, 1912; SC, 1915; Artists G; Allied AA; SI. Exhibited: SC, 1918 (prize); NAD, 1931 (prize). Work: magazine illustrations and covers; portraits, Steinway Piano Co., etc. [40]

CHAMBERS, Elizabeth Haverstick [Min.P] Beverly, NJ [15]

CHAMBERS, Fanny M(unsell) [I] NYC b. Brooklyn d. 27 Ag 1920. Studied: AIC; ASL. Member: SI 1914. Illustrator: "Saints Progress," by John Galsworthy; covers for Woman's Home Companion, Cosmopolitan [19]

CHAMBERS, Hallie Worthington (Mrs. Kirby L.) [P] Louisville, KY b. 27 O 1881, Louisville. Studied: A. Margaretta Archambault; Hugh Breckenridge. Member: SSAL; Louisville AC. Exhibited: Kentucky State Fair, 1921 (prize) [40]

CHAMBERS, J.K. [P] Boston, MA b. Ireland d. 1916 [08]

CHAMBERS, Jay [E] Lynbrook, NY [19]

CHAMBERS, Mary L. [P] Cincinnati, OH [19]

CHAMBERS, Middleton [P] Belmar, NJ b. Lynchburg, VA. Studied: Richard Miller, in Paris [17]

CHAMBERS, Robert L. [I] NYC. Member: SI [47]

CHAMBERS, Robert W(illiam) [I] NYC b. 26 My 1865, Brooklyn. Studied: Académie Julian, Paris. Member: Nat. Inst. AL; Century Assn. Illustrator: Life; Vogue, other magazines [40]

CHAMBERS, Winifred [P] Victoria, British Columbia [24]

CHAMPANIER, Abram August [P,Des] NYC/Saugerties, NY b. 4 Ja 1899. Studied: Kennth Hayes Miller; F. Luis Mora; George Bridgman. Member: Woodstock AA; SAE. Exhibited: Whitney Studio Cl., 1924–29; Morton Gal., 1928, 1929 (one-man). Work: Highland Park Mus., Dallas, Tex.; Children's Ward, Gouverneur Hospital, N.Y.; Governor Clinton Hotel, N.Y. [47]

CHAMPLAIN, Duane [S] Essex, CT b. 20 Ap 1889, Black Mountain, NC. Studied: A.A. Weinman; I. Konti; A. Stirling Calder; A. MacNeil. Member: NSS. Exhibited: NAD, 1913 (prize); P.-P. Expo, 1915 (med); BAID (prize). Work: Peekskill, N.Y., Jamaica, N.Y.; USPO, Forest City, N.C. [47]

CHAMPLIN, Ada Belle [P] Pasadena, CA b. St. Louis, MO d. ca. 1955. Studied: AIC; ASL; Charles Hawthorne. Member: Calif. AC; Laguna Beach AA; Pasadena SA; Carmel AA. Work: Vanderpoel Coll., Chicago; Montclair A. Mus. [47]

CHAMPLIN, Hallie. See Fenton.

CHAMPLIN, Hattie Elizabeth [P] Chicago, IL b. St. Louis, MO. Studied: AIC. Member: Chicago ASL [01]

CHAMPLIN, John Denison [W] NYC b. 29 Ja 1834, Stonington, CT d. 8 Ja 1915. Studied: Yale. Editor: Standard Dictionary; with Charles C. Perkins, "Cyclopedia of Painters and Paintings." Contributor: numerous encyclopedias

CHAMPNEY, Benjamin [Ldscp.P] Woburn, MA/North Conway, NH b. 20 N 1817, New Ipswich, NH d. 11 D 1907. Studied: lithography, Pendleton Co., Boston; Robert Cooke, with whom he went to Paris, 1841, on the advice of Washington Allston. Member: Boston AC (one of founders). Exhibited: Boston AC; Boston Athenaeum; PAFA; NAD; AM. Art Union; Salons of 1843, 1844. Author: "Sixty Years Memoirs of Art and Artists." Father of James Wells. [08]

CHAMPNEY, James Wells [P,I] NYC b. 16 Jy 1843, Boston, MA d. 1 My 1903, falling down an elevator shaft. Studied: Edouard Frère, 1866; Antwerp Acad., 1868. Member: ANA, 1892; AWCS; BAC; BWC; NAC; Century Assn.; Players; AFAS; MMA. Exhibited: Paris Salon, 1869. Work: Boston MFA; Deerfield Acad. His early work he signed "Champ," but later gave his full name. He established a reputation as a genre painter of rural scenes and especially of country home life. Somewhere about 1880 he practically abandoned oils and water colors to devote his entire energies to pastel. Instr., Smith College; Hartford Soc. Des. Art. [01]

CHAMPNEY, Maria Mitchell [Min.P] NYC. Studied: Europe. Member: SAA. Exhibited: Paris Salon, twice [98]

CHAMPNEY, Marie. See Humphreys.

CHANASE, Dane [Mur.P,P,C,E] NYC b. 21 O 1896, Italy. Studied: George Bridgman; Paul Baudouin; Maurice Denis. Member: Am. Veterans Soc. A.; Brooklyn SA. Exhibited: Paris, 1931 (one-man); Arch.L.; NSMP; Brooklyn SA; Am. Veterans Soc. A.; Intl. Aero. A. Exh., 1937 (prize).

Work: Municipal A. Col., Paris; Los Angeles Mus. A.; Bezalel Nat. Mus., Palestine; BM; murals, Sch. Aviation Trades; Welfare Island Hospital, N.Y. Medal: French Gov., 1930 [47]

CHANDLEE, Ann [P] Baltimore, MD [25]

CHANDLEE, Will H. [P] Washington, D.C. Member: Wash. WCC. Position: Associated with The Reporter [01]

CHANDLER, Anne [P] Walbrook, MD. Member: Baltimore WCC [25]

CHANDLER, Clyde G(litner) (Miss) [S] Chicago, IL b. Evansville, IN. Studied: Lorado Taft; Mass. Normal A. Sch.; AIC. Member: Cordon C.; Tex. FA Assn., Austin, Tex. Work: fountains, Dallas, Tex., Bay City, Mich.; Confederate Mus., Richmond, Va. [17]

CHANDLER, Digby W. [P] Hillside, NY b. 1856 d. 6 D 1928, Hollis, NY. Member: Soc. Brooklyn A. [25]

CHANDLER, George Walter [E] Paris, France b. Milwaukee. Studied: Académie Julian, Paris, with Laurens. Member: Arch. Lg., 1914; Mural P.; S.Indp.A. Work: Victoria and Albert Mus.; LOC [25]

CHANDLER, Helen Clark [P,T] Los Angeles, CA b. 20 Ja 1881, Wellington, KS. Studied: MacMonnies; Birge Harrison; Arthur W. Dow. Member: Calif. WCS; Art T. Assn. Southern Calif.; Pacific AA; Arthur W. Dow Assn. [33]

CHANDLER, Helen M. [C,T] Manchester, NH/Truro, MA b. 15 D 1881, Manchester, NH. Studied: Maud Briggs Knowlton. Member: Manchester Craftworkers G.; Manchester Inst. A.&Sc. Exhibited: Phila. Alliance; Intl. Expo, Paris, 1937. Position: T., Manchester Inst. A.&Sc. [40]

CHANDLER, Izora (Mrs.) [Min.P,I,W] NYC d. O 1906, Kingston, NY. Studied: Col. FA, Syracuse Univ. Member: Committee on Art of the Press Women's Lg. Specialty: dog miniatures [06]

CHANDLER, John William [Mus.Dir] Concord, NH b. 28 S 1910, Concord. Studied: Exeter Sch. A.; Boston; Manchester (N.H.) Inst. A.&Sc.; St. Anselm's Col.; Boston Univ.; Aldro T. Hibbard. Member: N.H. AA; Craft Workers Gl.; Manchester Inst. A.&Sc. Exhibited: Pasadena AI, 1946; N.H. AA, 1941-45; Jordan Marsh, Boston, 1944, 1945. Positions: Instr., 1933-46, Exec. Dir, 1940-46, Manchester Inst.; Acting Dir., Currier Gal. A., 1946– [47]

CHANDLER, Katherine [P] Cleveland, OH. Member: Cleveland Women's AC [25]

CHANDLER, Virginia. See Titcomb.

CHANEY, Lester Joseph [P,Des,I] Chicago, IL b. 19 Ap 1907, Zala, Nagy Kanisza, Hungary. Studied: AIC; C.H. Woodbury; Leon Lundmark. Member: Chicago No-Jury Soc. A. Exhibited: Little Gal., Evanston, Ill., 1932 (prize); Union Lg. Cl., Chicago, 1929. Work: Davenport Pub. Mus. Contributor: illustrated articles, Chicago Evening American, Herald and Examiner [47]

CHANIN, Abraham L. [P] Phila., PA d. ca. 1967. Member: Research F., Maitland Fla., 1937. Exhibited: PAFA Ann., 1934; Wanamaker Regional, 1934; WCC Ann., PAFA, 1936 [40]

CHANLER, Beatrice Ashley (Mrs. W.A.) [S] NYC b. VA d. 19 Je 1946. Studied: George G. Barnard. Work: bas-reliefs, Hotel Vanderbilt, NYC [17]

CHANLER, Robert W. [P] NYC b. 22 F 1872, NYC d. 24 O 1930, Woodstock, NY. Studied: Ecole des Beaux-Arts, Paris. Member: N.Y. Arch. Lg., 1914; Mural P.; S.Indp.A. Work: MMA; Luxembourg Mus., Paris. Descended from Governor Winthrop of Mass., Peter Stuyvesant, last Dutch governor of N.Y., and Robert Livingston, a drafter of the Declaration Independence. [29]

CHANLER, W. Astor [P] NYC [15]

CHANNEL, A. Elizabeth [P,G] Wash., D.C. b. 7 Je 1913, Swarthmore, PA. Studied: N.Y. Sch. FA; Corcoran Sch. A.; Royal Acad., Florence, Italy; Karl Larsson. Member: South County AA, Wickford, R.I. Exhibited: South County AA; Studio Gld., N.Y. [40]

CHANT, Elizabeth A. [P] Minneapolis, MN [13]

CHAPEL, Guy M. [P] Chicago, IL b. 30 Ja 1871, Detroit. Studied: George E. Hopkins. Member: Palette & Chisel Acad. FA, Chicago. Work: Vanderpoel Coll.; Chicago pub. schools [47]

CHAPIN, Archibald B. [I,Car] Kirkwood, MO b. 22 Je 1875, Mt. Vernon, OH [21]

CHAPIN, Charles E. [I] NYC/East Orange, NJ [01]

CHAPIN, Cornelia Van Auken [S,L,G] NYC b. Waterford, CT. Studied: Mateo Hernandez, in Paris. Member: NA; NSS; S. Gld.; All. A. Am.; Arch. Lg.; NAWA; NAC; Salon d'Automne, Paris. Exhibited: NAWA, 1936 (prize); Paris Salon, 1937 (prize); AAPL, 1939 (prize); PBC, 1942-45 (prizes); All.A.Am., 1941-45 (prizes); WFNY, 1939; GGE, 1939; PMA, 1939; PAFA, 1938-46; NAD, 1933-45; Los Angeles Mus. A; SFMA; Montclair A. Mus., 1940-44; WMAA, 1940-42; MMA, 1942. Work: S., Cathedral St. John the Divine, NYC; Rittenhouse Square, Phila.; IBM, Dumbarton Oaks, Wash., D.C. Lectures: Aspects of Modern Sculpture. Positions: Sec., NSS, 1942-44, member of Council, through 1947 [47]

CHAPIN, Francis [P,T,Li] Chicago, IL b. 14 F 1899, Bristolville, OH d. 23 F, 1965. Exhibited: AIC, 1928 (prizes), 1931 (prize), 1935 (prize); Intl. WC Exh., 1929 (prizes); NAD, 1930 (prize); Chicago Gal. Assn., 1939 (prize); 37th Annual Chicago A., 1933 (prize); Chicago SA, 1935 (med); Am. Exh., 1936 (prize); N.W. Harris, 1938 (med); PAFA, 1939 (med). Work: watercolors, AIC; Municipal Gallery, Davenport, Ia.; Municipal Coll., Chicago; PAFA; Brooklyn M.; AGAA. Position: T., AIC [40]

CHAPIN, James (Ormsbee) [P,Li] NYC b. 9 Jy 1887, Orange, NJ. Studied: CUASch.; ASL; Royal Acad. A., Antwerp, Belgium. Member: Am. Soc. PG&S. Exhibited: PAFA, 1938 (med), 1927-37, 1938 (med), 1939-46; AIC, 1928 (med), 1927-46; CGA, 1927-46; CI; WMAA; MOMA; AIC. Work: PMG; PAFA; AIC; Indianapolis AA; Newark Mus.; Amherst Col.; Pa. State Col.; Encyclopaedia Britannica Coll.; Abbott Lab. Coll. Work: Herron Art Inst. Position: T., PAFA [47]

CHAPIN, John R. [P,I] Buffalo, NY b. 2 Ja 1823, Providence d. 1904, Buffalo. Studied: Samuel F.B. Morse. Organized Harper's Art Dept., 1861, superintending it, but left to become field artist during the Civil War. Work: illus. in "Beyond the Mississippi," 1867, "Ten Years a Cowboy," 1888. Illustrator: "Gleason's Pictorial," 1843-45 [08]

CHAPIN, Joseph Hawley [P] NYC/Westport, CT b. 9 N 1869, Hartford d. 22 S 1939. Studied: Charles Noel Flagg. Member: Art Dir. Cl.; SI; Century Assn. Postion: A. Dir., Charles Scribner's Sons [38]

CHAPIN, Hubert [I] NYC [19]

CHAPIN, Lucy Grosvenor [P,T] Syracuse, NY b. Syracuse. Studied: Baschet, Merson, Collin, Prinet, in Paris. Member: Syracuse AA; Nat. Lg. Am. Pen Women. Member: Hiram Gee Fellowship. Work: State Gallery, Augusta, Me.; Dickinson Seminary, Williamsport, Pa. [38]

CHAPIN, Myron Butman [P,E] Ann Arbor, MI b. 12 Je 1887, St. Johns, Newfoundland d. F 1958. Studied: AIC; Univ. Chicago; Vanderpoel; Ralph Fletcher Seymour; Walter Sargent. Exhibited: PAFA, 1928, 1929, 1931, 1934, 1936, 1941, 1942, 1946; AIC, 1928, 1929, 1932, 1943; Detroit Inst. A., 1929-44. Contributor: Christian Science Monitor. Position: T., Col. Arch., Univ., Mich., Ann Arbor, 1924-46 [47]

CHAPIN, Sarah [P] Providence, RI [01]

CHAPLIN, Christine [P] Wash., D.C. [17]

CHAPLIN, Elisabeth [P] Florence, Italy b. Fontainbleau, France. Member: Société Nationale des Beaux-Arts. Exhibited: Minister of Public Instruction, Rome (gold); City of Florence (med). Work: Museo Nationale, Rome; Galerie Moderne, Florence; French Gov.; City of Paris [29]

CHAPLIN, James [P] Seattle, WA [21]

CHAPLIN, Margaret [P] NYC. Member: NAWPS [21]

CHAPLIN, Prescott [E,Li,P,W] Los Angeles, CA b. 10 O 1897, Boston. Studied: George Bellows; William M. Chase; Max Bori. Member: Chicago Gal. A.; Santa Barbara AA; Intl. Print Gld. Work: Los Angeles Pub. Lib.; Scripps Col.; Lehigh Univ. Published: "Mexicans," pub. U. Wash. (1930), 25 woodcuts, pub. Murray&Harris, "To What Green Altar?," pub. Print Guild Intl., "Pershing Square," pub. Murray [40]

CHAPMAN, Carlton T(heodore) [P,I] NYC b. 18 S 1860, New London, OH d. 12 F 1925. Studied: NAD; ASL; Académie Julian, Paris. Member: ANA, 1900; NA, 1914; SAA, 1892; AWCS; A. Fund S.; Century Assoc.; Lotos C.; NAC. Exhibited: Boston, 1892 (med); Columbia Expo, Chicago, 1893 (med); Atlanta Expo, 1895 (med); Pan-Am. Expo, Buffalo, 1901 (med); Charleston Expo, 1902 (med). Work: TMA; Brooklyn Inst. Mus.; City Art Mus., St. Louis. Specialty: marines [24]

CHAPMAN, Charles Shepard [P,Li,L,T] Leonia, NJ b. 2 Je 1879, Morristown, NJ d. 1962. Studied: William Chase; W. Appleton Clark. Member: NA; SC; NAC. Exhibited: NAD, annually, 1917 (prize), 1921 (prize), 1924 (prize); 1938 (prize); SC, 1910 (prize), 1911 (prize), 1917 (prize), 1920 (prize), 1921-25, 1929 (prize); Montclair A. Mus., 1935 (prize), 1936 (med); Paris Expo, 1937; PAFA; LOC; NYPL; Newark Mus.; Ridgewood AA; CGA; CMA; NGA. Work: NGA; MMA; CMA; Amherst Col.;

murals, USPO, Holidays Cove, W.Va.; Methodist Episcopal Church, Leonia, N.J.; Roosevelt Sch., Englewood, N.J.; AMNH; Illustrator: "T. Tembarom," other books. Position: T., ASL [47]

CHAPMAN, Conrad Wise [P] b. 1842 Rome, Italy d. 1910, Virginia. Studied: his father, John Gadsby Chapman. Confederate soldier during Civil War. He and his brother John Linton Chapman were marine painters.

CHAPMAN, C(yrus) Durand [P,I,A,W,T] Wash., D.C. b. 23 S 1856, Irvington, NJ d. 12 Ap 1918. Studied: Wilmarth, J.G. Brown, in N.Y.; Cormon, Constant, in Paris. Member: AAS [21]

CHAPMAN, Dave [Indst.Des.] Chicago, IL b. 30 Ja 1909, Gilman, IL. Studied: Armour Inst. Tech. Member: Soc. Indst. Des.; ADI; 27 Designers. Exhibited: Phila. A. All., 1945, 1946. Position: Hd., Product Design Div., Montgomery Ward&Co., 1934–36 [47]

CHAPMAN, Ernest Zealand [P] NYC b. 1864, Lyttleton, New Zealand. Studied: Jean Paul Laurens, in Paris [06]

CHAPMAN, Esther I.E. McCord [P] Wash., D.C. b. Richardson County NE. Studied: Corcoran Sch. A. Member: Wash. WCC [33]

CHAPMAN, Frederick [I] Mahwah, NJ. Member: SI [47]

CHAPMAN, Frederick A. [Auctioneer] Brooklyn, NY b. 1870, Brooklyn d. 11 D 1933, NY. During his career as auctioneer he had sold $28,000,000 worth of paintings, books and objets d'art. From 1906 to 1930 he was auctioneer for the Anderson Galleries; in 1931 and 1932 he was with the National Gallery.

CHAPMAN, Howard Eugene [D,P,Car] Arlington, VA b. 20 D 1913, Martinsburg, WV. Studied: Corcoran Sch. A.; Richard Lahey; George Washington Univ.; Hobart Nichols; Tiffany Fnd. Member: Ldscp. Cl., Wash. Exhibited: Wash. County Mus. FA, Hagerstown, Md., 1939 (prize); CGA, 1937; Soc. Wash. A., 1936–46; Ldscp. Cl., Wash., 1946. Positions: A. Dir., U.S. Gov.; Visual Information Specialist, Dept. Agriculture, Wash., D.C., 1943-46 [47]

CHAPMAN, Josephine E. [P] Alameda, CA [10]

CHAPMAN, Kenneth M(ilton) [Edu,W,I,L,P] Santa Fe, NM b. 13 Jy 1875, Ligonier, IN. Studied: AIC; ASL. Member: Am. Assn. Advancement of Sc.; Archaeological Inst. Am.; Am. Anthropological Assn.; Soc. Am. Archaeology. Work: Mus. N.Mex., Santa Fe, St. Francis Auditorium. Author/Illustrator: "Pueblo Indian Pottery" (Vol. 1, 1933; Vol. 2, 1936), "The Pottery of Santo Domingo Pueblo," 1936. Contributor: Art and Archaeology, School Arts, other magazines. Positions: Sec./Cur./Asst. Dir., Mus. N.Mex., 1909–29; Sec./Cur./Acting Dir./Dir./Research Assoc., Laboratory of Anthropology, Santa Fe, N.Mex., 1929–; T., Indian Art, Univ. N.Mex., Santa Fe, 1926– [47]

CHAPMAN, M.A. [P] Baltimore, MD. Exhibited: Va. Mus. FA Bienn., 1938; P&S Ann., PAFA, 1939 [40]

CHAPMAN, Minerva (Josephine) [P,Min.P] Palo Alto, CA b. 6 D 1858, Altmar, NY d. 14 Je 1947. Studied: Univ. Chicago, 1875; Mt. Holyoke Col., 1876–78; AIC, with Annie Shaw, John Vanderpoel, 1880–86; Académie Julian, Paris, with J. P. Laurens, Robert-Fleury, 1887–89; Bouguereau; Courtois; Charles Lasar, 1889–97. Member: Intl. Art Union, Paris, 1909–12; Associate, Soc. Nat. des Beaux-Arts, 1905. Exhibited: 124 portrait miniatures and 48 oils, Paris Salon, 1897–1926; AIC, 1898–1928; ASMP, 1908, 1914; SAA, 1900; Pan-Am. Expo, Buffalo, 1901; NAD, 1903; Intl. Art Union, Lodge Art Lg., Am. Women's AA, Am. Art Students Cl., Am. Women's Cl., all in Paris; P.-P. Expo, San Diego, 1915 (gold), 1916 (gold); Royal Acad. London, 1913; Phila. Soc. Min. P., 1919; Calif. Soc. Min. P., 1918–28, 1929 (gold), 1930, 1931 (gold), 1932; Syracuse Mus. FA, 1925; Palo Alto AC, 1919; Adams-Davidson Gal., Wash., D.C., 1917. Work: Luxembourg Mus., Paris; Mt. Holyoke Col. [40]

CHAPMAN, Paul [P] NYC. Exhibited: 48 Sts. Comp. [40]

CHAPMAN, W.E. [P] NYC [21]

CHAPPELL, George S. [P] NYC [19]

CHAPPELL, Warren [I,D,G] NYC b. 9 Jy 1904, Richmond, VA. Studied: Univ. Richmond; ASL; Colorado Springs FA Center, Boardman Robinson, Rudolf Koch; Germany. Author: "The Anatomoy of Lettering," 1935. Illustrator: "Saroyan's Fables" (1941), "Peter and the Wolf" (1940), "Hansel and Gretel" (1944), other books. Contributor: The Dolphin, Virginia Quarterly Review [47]

CHARD, Louise Cable [P] Montclair, NJ. Member: S.Indp.A. [25]

CHARD, Raymond George [P,Des,C] Baltimore, MD b. 14 F 1895, Baltimore. Studied: Md. Inst.; ASL; Harper Pennington. Member: Charcoal C. Exhibited: Baltimore Mus. A.; Md. Inst. Work: State Capitol, Annapolis, Md. [40]

CHARD, Walter G(oodman) [S,C] Cazenovia, NY b. 20 Ap 1880, Buffalo, NY. Studied: Charles Grafly; BMFA Sch.; BAID [29]

CHARLES, Sam [P] Wellesley, MA b. 18 My 1887, Agawam, MA. Studied: self-taught. Member: Inst. Mod. A., Boston. Exhibited: Inst. Mod. A., 1945, 1946; AGAA, 1943; PAFA, 1937, 1941, 1942; Ogunquit AA; Gloucester SA; Provincetown AA; Boston AC; Grace Horne Gal.; Marie Sterner Gal.; WMA; Boston AC [47]

CHARLESON, M(alcolm) D(aniel) [P,I] Chicago, IL b. 4 Ag 1888, Manitoba, Canada. Studied: Chicago AI [25]

CHARLOT, Jean [P,Li,I,T] NYC b. 7 F 1898, Paris, France. Member: ASL. Work: PMG; MMA; Uffizi Gal., Florence, Italy; Mexican Gov.; MOMA; FA Bldg., Iowa City; Parish Church, Peepack, N.J. Work: Fifty Prints of the Year, 1929–30; Fifty Books of the Year, 1935. Illustrator: "Book of Christophor Columbus," by Paul Claudel, "Temple of the Warriors," pub. Carnegie Inst., "Portraits of the Reformation," by Belloc, "The Sun, the Moon and a Rabbit," by Del Rio, "Art from the Mayans to Disney," pub. Sheed and Ward. Position: T., ASL (summers) [40]

CHARLTON, Gene [P,L] Houston, TX b. 13 Ag 1909, Cairo, IL. Studied: McNeil Davidson. Exhibited: Ar. Southeast Tex., Houston MFA, 1938; MFA, Dallas; Corcoran Bienn., 1939 [40]

CHARMAN, (Frederick) Montague [P,Des,L,T,W] Syracuse, NY/Amber, NY b. 6 Ap 1894, London, England. Studied: Sidney Haward, in London. Member: AWCS; A. Worker's Gld., London; Phila. WCC; Assoc. A. Syracuse; Audubon A.; 8 Syracuse Watercolorists. Exhibited: Syracuse Mus. FA, 1929 (prize); Assoc. A. Syracuse, 1935 (prize), 1936 (prize) 1945 (prize); Syracuse Hist. Soc., 1943 (prize); Phila. WCC, annually; AWCS, annually; Phila. A. All.; Baltimore WCC; AIC; Audubon A.; Syracuse Mus. FA; Rochester Mem. A. Gal.; Arnot A. Gal.; Syracuse 8; Albright A. Gal. Work: Springville, Utah A. Soc.; Salt Lake City Municipal Coll. Position: T, Syracuse Univ., 1923– [47]

CHARMAN, Jessie [P,Des,T] Syracuse, NY/Amber, Lake Otisco, NY b. 13 N 1895, Newark. Studied: Phila. Sch. Des. for Women; Sidney Haward, in London. Member: NAWPS; Nat. Lg. Am. Pen Women; Assoc. A. Syracuse; Widener European Fellowship. Exhibited: PAFA; NAWPS, 1932 (prize); Nat. Lg. Am. Pen Women Bien. Exh., Wash., D.C., 1934 (prize); Phila. Sch. Des. for Women, 1934 (med); AA, Syracuse, 1937 (prize). Position: Associated with Syracuse Univ. Col. FA [40]

CHARMAN, Laura B. (Mrs. Albert H.) [S] Magnolia, NJ. Member: F., PAFA [25]

CHARPIOT, Donald [P,T] St. Louis, MO b. 3 Ja 1912, St. Louis. Member: St. Louis A. Gld. Exhibited: CI, 1941; MMA, 1942; Mint Mus. A., 1943; Kansas City AI, 1940, 1942; Joslyn Mem., 1942–46; CAM, 1940-43; St. Louis A. Gld., 1943, 1944; Indp. A., St. Louis, 1940, 1941. Work: Peoples A. Center, St. Louis. Lecturer: African sculpture. Position: T., Peoples A. Center, St. Louis [47]

CHARRY, John [S,T] New Hope, PA b. 24 D 1909, Trenton, NJ. Studied: Sch. Indst. A, Trenton, N.J.; BAID; Inst. Des., Chicago; L. Moholy-Nagy. Exhibited: NAD, 1933; PAFA, 1944; Contemporary Cl., Trenton, N.J., 1946; Phillips Mill, New Hope, 1935, 1936, 1946; Pickett Gal., 1938; Morrisville Historical A. Group, 1939; Princeton Univ.; Delaware River A., 1937; N.J. State Mus. Position: T., N.J. Sch. Indst. A., Trenton, 1933- [47]

CHARTAIN, Alfred [Cr] Chicago, IL b. 7 F 1853, Grenoble, France d. 15 F 1931, Chicago. Position: T., AIC

CHASE, Adelaid Cole (Mrs. W.C.) [Por.P] Boston, MA/Annisquam, MA b. 1869, Boston d. 4 S 1944, Gloucester, MA. Studied: BMFA Sch., with Tarbell; C. Duran, in Paris. Member: ANA, 1906; Copley S., 1898; SAA, 1903; Boston Gld. A. Exhibited: St. Louis Expo, 1904 (med); P.-P. Expo, San Fran., 1915 (med). Work: BMFA. Daughter of J. Foxcroft. [40]

CHASE, Alice Elizabeth [Edu,L] New Haven, CT b. 13 Ap 1906, Ware, MA. Studied: G.H. Edgell; Radcliffe, with P.J. Sachs; Yale, with G.H. Hamilton, Henri Focillon, Sumner Crosby. Member: CAA; Am. Assn. Univ. Women. Lectures: Christmas Story in Art; The Passion in Art. Positions: Docent, 1931–; T., Dept. Edu., 1936–41, Yale, 1942– [47]

CHASE, Althea [P] Pocatello, ID. Studied: AIC; Whistler, Alphonse Mucha, Collin, Merson, in Paris [06]

CHASE, Beulah Dimmick [Mus.Ed] NYC b. 28 F 1901, Birmingham, AL. Studied: Conn. Col. Women; Radcliffe; Univ. Pa.; Columbia; Harvard; NYU. Member: AIGA. Exhibited: Republic of China, 1941 (prize). Positions: Ed. Staff, MMA, 1928– , Hd. Dept., 1941– [47]

CHASE, Clarence M(elville) [P] Boston, MA b. 13 Jy 1871, Auburn, ME. Studied: George B. Gardner; Carl Gordon Cutler. Member: Copley S.; East Gloucester SA; New Indp. S., Boston [33]

CHASE, Edward Leigh [P,W] Woodstock, NY b. 3 Ag 1884, Elkhart, WI d. 20 F 1965. Studied: ASL. Exhibited: Portraits, Inc., 1945. Author/Illustrator: "Intelligent Drawing," 1946 [47]

CHASE, Eliza B. [P] Phila., PA

CHASE, Elizabeth Jane [P] Cambridge, MA [24]

CHASE, Ellen Wheeler [Por.P,T] NYC b. Faribault, MN. Studied: ASL, Buffalo; ASL; BMFA Sch.; Paris. Member: PBC [40]

CHASE, Elsie Rowland (Mrs. Frederick S.) [P,E] Waterbury, CT/Middlebury, CT b. 10 F 1863, Saratoga Springs, NY d. Ap 1937. Studied: Yale. Member: New Haven PCC; NAWPS [38]

CHASE, Emily Chicago, IL b. 1868, London, England. Studied: AIC. Member: ASL, Chicago

CHASE, Francis Dane, Mrs. See Larsh.

CHASE, Frank Swift [P,T] NYC b. 12 Mr 1886, St. Louis d. 27 Jy 1958. Studied: Birge Harrison; F. Luis Mora; John F. Carlson; ASL. Member: All. AA; SC; Springfield (Ill.) AA; Woodstock AA. Exhibited: AIC, 1922 (prize); Newport AA (prize); A. Dir. Cl. (med); CGA; CI; NAD; Woodstock AA; Nantucket AA; SC; Springfield (Ill.) AA; Work: Charleston (S.C.) Mus.; Mechanics Inst., Rochester, N.Y. [47]

CHASE, George H. [Edu,W,L] Cambridge, MA b. 13 Je 1874, Lynn, MA d. 2 F 1952. Studied: Harvard; Am. Sch. Classical Studies, Athens. Member: Archaeological Inst. Am.; Am. Philosophical Soc.; F., Am. Acad. A.&Sc. Author: "The Loeb Collection of Arrentine Pottery," "A History of Sculpture," other books. Contributor: archaeological journals. Lecturer: Ancient art. Positions: T., Harvard 1901-45, Prof. Emeritus, 1945- ; Acting Cur., Classical Dept., BMFA, Boston, 1945- [47]

CHASE, Harry Alonzo [Photogr,L] East Orange, NJ b. 1883 d. 10 N 1935. He exhibited motion and still pictures taken with the British forces in Palestine and with Lawrence in Arabia. His were probably the first motion pictures of Afghanistan, for which he received a fellowship from the Royal Geographic Society of Great Britain.

CHASE, Jessie Kalmbach (Mrs. W.E.) [P,T] Sturgeon Bay, WI b. 22 N 1879, Bailey's Harbor, WI d. 1970. Studied: AIC. Member: Wis. P.&S.; AAPL; Madison AG. Exhibited: Milwaukee AI, 1925 (prize); Madison A. Gld., 1928 (prize); Wis. P.&S., 1914-36. Position: T., Arthur Hill H.S., Saginaw, Mich., 1944-45 [47]

CHASE, Joseph Cummings [Edu,P,Des,W] NYC b. 5 My 1878, Kents Hill, ME d. 15 Ja 1965. Studied: PIASch.; PAFA; Académie Julian, Paris; Jean Paul Laurens. Member: CAA; Eastern AA; AAPL; Audubon A.; NAC. Exhibited: Grunwald Poster Comp., Paris, 1904 (prize); AIGA (prize); PAFA; Paris Salon; Los Angeles Mus. A., 1943 (one-man). Work: U.S. Nat. Mus., Wash., D.C.; Mus. City of N.Y.; portraits, 140 generals, including General Pershing, Marshal Foch. Author/Illustrator: "An Artist Talks about Color," 1930, "Creative Design," 1934, other books. Contributor: national magazines. Lecturer: "The Part Design Plays in Art." Position: T., Hunter Col., NYC [47]

CHASE, Lila Elizabeth [P,T] NYC/Port Williams, Nova Scotia b. 19 Ja 1892, Port Williams. Studied: William M. Chase [17]

CHASE, Marion Monks [P] Carmel, CA b. 14 O 1874, Boston. Studied: BMFA Sch.; George L. Noyes; Henry Hunt Clark; A.H. Atkins; André Lhote, in Paris. Work: FMA; Mus. City of N.Y. [47]

CHASE, Mary M. Pope (Mrs. Timothy) [P,C,T] Aurora, IL b. 23 Mr 1861, Indianapolis. Studied: Frederick W. Freer, AIC; Octman, in N.Y. Member: ASL, Chicago [13]

CHASE, Rebecca [P,T] Milwaukee, WI b. 1878 d. 1965. Studied: R. AIC, with Lorenz; Paris [25]

CHASE, Rhoda C. [P] Woodstock, NY Member: GFLA [27]

CHASE, Richard A. [P] b. 1892, Columbus, KS d. Ja 1985, Columbus, KS. Active, Chicago, 1919-81. Studied: AIC, 1919-25. Exhibited: Chicago Hist. Soc., 1981. Specialty: Chicago street scenes, 1930s. [*]

CHASE, Sidney M. [P] Haverhill, MA b. 19 Je 1877, Haverhill d. 12 Je 1957. Studied: Woodbury; Tarbell; Pyle; Pape. Exhibited: Wilmington Soc. FA, 1932 (prizes). Work: Wilmington Soc. FA [47]

CHASE, Susan Brown (Mrs. V.O.) [P] Wash., D.C. b. St. Louis. Studied: H.B. Snell; C.E. Messer; Bertha Perrie; R.E. James; Chester Springs Summer Sch. Member: Wash. WCC; Soc. Wash. A.; AWCS. Position: Anne Abbott Sch. Fine & Commercial Art, Wash., D.C. [40]

CHASE, Wendell W. [P,E] Newburgh, NY b. 4 Mr 1875, Foxcroft, ME. Studied: George L. Noyes; Hawthorne. Member: Boston WCC [25]

CHASE, William M(erritt) [P,T] NYC b. 1 N 1849, Franklin, IN d. 15 O 1916. Studied: B.F. Hayes; J.O. Eaton; A. Wagner; Piloty. Member: ANA, 1888; NA, 1890; SAA, 1879 (founder); AWCS; Munich Secession; Ten Am. P.; NIAL; AAAL; Por. P.; NAC; Lotos C. Exhibited: Centenn. Expo, Phila, 1876 (med); Paris Salon, 1881 (prize), 1889 (med); Munich, 1883 (prize); Cleveland A. Assoc., 1894 (prize); SAA, 1895 (prize); PAFA, 1895 (gold), 1901 (gold); Paris Expo, 1900 (gold); Pan-Am. Expo, Buffalo, 1901 (gold); Charleston Expo, 1902 (gold); Soc. Wash. A., 1904 (prize); NAD, 1912 (prize); P.-P. Expo, San Fran., 1915 (prize). Work: MMA; CGA; Wilstach Gal., Phila.; Cincinnati Mus.; R.I. Sch. Des.; Providence; BMFA; National Gal., Wash., D.C.; PAFA; Art Assoc., Indianapolis; AIC; Herron AI, Indianapolis; Brooklyn Inst. Mus.; Cincinnati Mus. Major retrospective exhibit at MET and Henry A Gal. (Univ. Wash.), 1983; accompanied by monograph by Ronald Pisano. One of America's great Impressionists and one of its most influential teachers: taught at ASL, 1878-96, 1907-12; privately, at his 10th Street studio, 1878-96; Brooklyn AA, 1887, 1891-95; Chase Sch. A., 1896-1907 [re-named N.Y. Sch. A., in 1898]; AIC, 1897; PAFA, 1896-1909; continued teaching privately in Phila., until 1913; Shinnecock Summer Sch. A., 1891-1902; summer classes in Holland (1903), London (1904), Madrid (1905), Italy (1907, 1910, 1911), Bruges (1912), last summer class, in Venice, 1913 [15]

CHASSAING, Edouard [S] Chicago, IL. Member: Chicago SA; WPA. Exhibited: AIC, 1935 (prize). Work: Medical Group, Univ. Ill.; USPO, Brookfield, Ill. Positions: T., AIC; Suprv., Sculpture Project for Ill. [40]

CHATTERTON, C(larence) K. [Edu,P] Poughkeepsie, NY b. 19 S 1880, Newburgh, NY d. 1973. Studied: Newburgh Acad.; N.Y. Sch..A.; DuMond; Henri; Chase; Mora. Exhibited: Carnegie Inst.; PAFA; CGA; NAD; Dutchess County AA; Wildenstein Gal. (one-man); Macbeth Gal. (one-man). Position: T., Vassar [47]

CHATTIN, Lou-Ellen [P] Towson, MD/Chautauqua, NY b. 16 N 1891, Temple, TX d. 8 O 1937. Studied: J.F. Carlson; DuMond; G. Bridgman; O. Linde; Kathryn C. Cherry; H. Breckenridge. Member: SSAL [38]

CHAVANNES, Puvis De [P,T] Paris, France b. 14 D 1824, Lyons, France d. 24 O 1899. Work: Pantheon, Paris; "The Genius of Enlightenment," Boston Pub. Lib. Teacher of many American artists.

CHAVAU, M [P] NYC [01]

CHAVEZ, Edward Arcenio [P,Li] Woodstock, NY b. 14 Mr 1917, Santa Fe, NM. Studied: Frank Mechau; Boardman Robinson; Peppino Mangravite. Member: NSMP. Exhibited: WFNY, 1939; AIC, 1939, 1940, 1942, 1943, 1946; PAFA, 1942; NAD, 1943; CI, 1942; SFMA, 1940, 1941, 1944, 1945; Los Angeles Mus. A., 1944, 1945. [47]

CHAVEZ, Gilberto [P] NYC. Member: S.Indp.A. [21]

CHAVICCKIOLI, (Dian) William [S] NYC b. 25 Jy 1909, Venice, Italy. Studied: Chester Beach; Walter Hancock. Member: N.J. Art Group. Exhibited: Allied AA, BM, 1933 (prize); Newark AC [40]

CHEESEBOROUGH, Mary Hugger [Min.P] Charleston, SC b. 1823 d. 8 Jy 1902, Saratoga, NY

CHEESEBROW, Nicholas Riley [S,I,C] St. Paul, MN b. 3 My 1894, Minneapolis, MN. Studied: L.W. Zeigler. Exhibited: Minn. State Fair, 1914. [17]

CHEEVER, E.S. [P] Far Rockaway, NY. Member: Women's AC [01]

CHEEVER, Walter L. [Edu,P] Santa Barbara, CA b. 11 Ag 1880, Malden, MA. Studied: BMFA Sch.; Philip L. Hale; Frank W. Benson; Edmund C. Tarbell. Member: Los Angeles PS Cl. Exhibited: San Deigo FAS, 1937 (prize). Positions: T., Santa Barbara State Col., 1931-44, Univ. Calif., Santa Barbara Col., 1944-46 [47]

CHEEVER, William H. [P] Andover, MA. Exhibited: 48 Sts. Comp. [40]

CHEFFETZ, Asa [B,E,En,I] Springfield, MA b. 16 Ag 1897, Buffalo, NY d. 23 Ag 1965. Studied: Philip Hale; Ivan Olinsky; William Auerbach-Levy. Member: PM of Calif.; ANA, 1938; Phila. WCC; Am. Ar. Cong. Exhibited: PAFA, 1928 (gold); Intl. Exh. Prints, AIC, 1929, 1932; Intl. Bookplate Comp., Los Angeles Mus., 1934 (prize); Intl. Exh. Prints, Century of Progress Expo, Chicago, 1934 (prize); Exh. Am. Block P., Phila. Print C., 1934 (prize); Second Intl. Exh. Wood Engraving, Warsaw, Poland, 1936. Work: BMA; Newark Mus.; NYPL; CMA; PAFA; Smithsonian Inst.; AIC; Los Angeles Mus. A.; LOC; Springfield MFA, Springfield (Mass.) Pub. Lib.; Am. Antiquarian Soc., Worcester, Mass.; Washington

County Mus., Hagerstown, Md.; Honolulu Acad. FA; Polish Gov.; Fifty Prints of the Year, 1929, 1934; Contemp. Am. Prints; Fine Prints of the Year, 1935. Illustrator: "An Almanac for Moderns" [47]

CHENEY, Dorothy [P] South Manchester, CT. Member: Hartford AS [25]

CHENEY, Janet D. (Mrs.) [T,P] d. 29 S 1935, Mt. Vernon, NY. Position: A. Dir., NYC high schools

CHENEY, Mary Moulton [P,D,T] Minneapolis, MN b. Minneapolis. Studied: Univ. Minn.; BMFA Sch.; Denman W. Ross; George Elmer Browne. Exhibited: Minn. State Fair, 1917. Position: Dir., Minneapolis Sch.A., 1917–26 [31]

CHENEY, Philip [Li,P,I] Wilmington, VT b. 29 D 1897, Brookline, MA. Studied: Harvard Col.; Am. Sch., Fontainebleau. Member: Phila. WCC. Exhibited: NAD, 1935–41; Los Angeles Mus., 1932, 1934; PAFA; AIGA; Stockholm, Sweden, 1937, 1938; Paris Salon, 1937; AIC, 1937; Oklahoma A. Center, 1939–41; Albright A. Gal., 1940; Grand Rapids A. Gal., 1940; CAM, 1930; CGA, 1941; Springfield (Mass.) Mus. FA. Work: Valentine Mus., Richmond, Va.; Honolulu Acad. A.; Yale; Phila. SE; NYPL; LOC; BMFA. Illustrator: "The Singing Sword" (1930), "Pearls of Fortune" (1931) [47]

CHENEY, Russel [P] Kittery, ME b. 16 O 1881, South Manchester, CT d. 12 Jy 1945. Studied: Yale, 1904; Kenyon Cox; Chase; Woodbury; ASL, 1904–07; Paris, with Laurens, 1907–09. Member: Conn. Acad. FA; Colorado Springs AS; Century Assn. Exhibited: Los Angeles, 1926–27. Work: Morgan Mem. Mus., Hartford, Conn.; SFMA; Newark Mus. Assn.; BMFA; Sweat Mem. AM., Portland, Maine [40]

CHENEY, Sheldon [W,L] Westport, CT b. 29 Je 1886, Berkeley, CA. Studied: Univ. Calif.; Calif. Col. A.&Cr. Member: Authors Lg. Am; F., Union Col. Author: "The Story of Modern Art," 1941, "Men Who Have Walked with God," 1945. Contributor: art magazines. Lectures: Creative Art in America [47]

CHENEY, Warren [S,W,L,Cr,Edu] NYC b. 19 S 1907, Paris, France. Studied: Univ. Calif; Ecole des Beaux-Art, Paris; Hans Hofmann. Member: Am. A. Cong. Exhibited: Marie Sterne Gal., 1936 (one-man); Gumps Gal., San Fran., 1934 (one-man); Dallas Mus. FA, 1934; SFMA, 1936; Weyhe Gal., 1936; PAFA, 1940. Work: SFMA; Teamsters Union, Oakland, Calif.; MMA. Lectures: History of Sculpture. Positions: T., S./Des., Univ. Calif., Los Angeles, 1937–38, Randolph-Macon Women's Col., Lynchburg, Va., 1939–40 [47]

CHENNEY, Stanley James, Jr. [P,I,W,T,Des] Cleveland, OH b. 10 N 1910, Cleveland, OH. Studied: John Carrol Univ.; La. State Univ.; Cleveland Col.; Huntington Polytechnic Inst.; Rolf Stoll; Clarence Carter. Member: Cleveland AC; Kokoon AC. Exhibited: CMA, 1936 (prize); Kokoon AC, 1939; Cleveland AC, 1936, 1937, 1945. Position: T., Univ. Settlement, Cleveland [47]

CHENOWETH, Joseph G. [P] Chicago, IL. Member: GFLA [27]

CHEPOURKOFF, Michael [Des,S,P,C,E] San Fran., CA b. 12 N 1899, Lugansk, Russia. Studied: Imperial Acad., St. Petersburg, Russia; Univ. Calif.; George Luks. Exhibited: San Fran. AA, 1937, 1940 (prize); GGE, 1939. [47]

CHERNER, Norman [Des,Li,P,T] NYC b. 7 Je 1920, NYC. Studied: N.Y. Sch. F.&Appl. A.; Columbia; William V. Viterelli; A.T. Young. Positions: En., Goodyear Aircraft Co., 1943–44; Des., Bureau of Research & Inventions, USNR, 1944–46 [47]

CHERNOFF, Vadim [P,Ser,L,T] NYC b. Russia d. 17 Ap 1954. Studied: St. Petersburg Acad., Russia, with D. Kardovsky; P. Rancon, in Paris; M. Denis; F. Vallotton. Member: NSMP. Exhibited: BM; Sesqui-Centenn. Expo, Phila. Pa.; Dallas Mus. FA; Marie Sterner Gal.; NSMP; Grand Central Gal.; Phila. Alliance (one-man); Ferargil Gal. (one-man). Work: murals, churches in N.Y.; Carbondale, Pa.; Sea Cliff, N.Y.; Seward Park H.S., N.Y. [47]

CHERRY, Denny Winters. See Winters.

CHERRY, Emma Richardson (Mrs.) [P,T,L] Houston, TX (1941) b. 28 F 1859, Aurora, TX. Studied: ASL; Chase; Cox; McCarter; Breckenridge; Zanetti Zilla, in Venice; Merson; André Lhote; Académie Julian. Member: ASL; Denver AA (charter member, 1893); Houston AL; San Antonio AL; helped organize Houston MFA. Exhibited: Western AA, Omaha (gold); SSAL, Birmingham (prize); Nashville (prize); Austin (prize); Mus. FA, Houston; SSAL, Dallas, 1932 (prize). Work: Elisabet Ney Mus., Austin; Soc. Civil Eng. Cl., NYC; San Antonio AL; Houston AM; Denver AM; Vanderpoel AA; Carnegie Pub. Lib., Houston [40]

CHERRY, Herman [P,C,Li,W,T] Woodstock, NY b. 10 Ap 1909, Atlantic City. Studied: Otis AI; SAL. Exhibited: Los Angeles Mus.; PAFA; AIC; NAD; SFMA; Santa Barbara Mus. A.; Woodstock AA; Am. A. Cong., 1940 (prize); Pomona State Fair, 1941 (prize); Oakland A. Gal. 1943 (prize). Work: Chaffey Jr. Col., Ontario, Calif.; PAFA

CHERRY, K(athryn) E. (Mrs.) [P,T] St. Louis, MO/East Gloucester, MA b. Quincy, IL d. 19 N 1931. Studied: St. Louis Art Sch.; N.Y. A. Sch.; Richard Miller; PAFA, with Hugh Breckenridge; abroad. Member: St. Louis AG; Chicago AC; NAWPS; North Shore AA; Rockport AS; PBC; 8 Women P. of Phil.; Atlantic C.; Chicago Galleries Assn.; AFA. Exhibited: St. Louis AL, 1919 (prize); St. Louis AG, 1920 (prize), 1921 (prize), 1922 (prize); Kansas City AI, 1922 (gold); Phila. Artists Week Exh., 1923; NAWPS, 1923, 1927; Chicago Gal. A., 1927 (prize). Work: St. Louis H.S.; Soldan H.S., St. Louis; Principia Acad., St. Louis; So. Eastern Mo. State Teachers College; Laura Davidson Sears Acad. FA, Elgin, Ill.; Pub. Lib. & AC, Quincy, Ill. [29]

CHESKIN, David B. [P] Chicago, IL. Exhibited: 48 Sts. Comp. [40]

CHESKIN, L(ouis) [P,T] Chicago, IL b. 17 F 1907, Russia. Studied: F. Tkatch; Frederic M. Grant. Member: Ill. Acad. FA; Chicago NJSA [33]

CHESNEY, Letitia [P,C,T] Bainbridge Island, WA b. 14 F 1875, Louisville, KY. Studied: Natilia Sawyer Bentz; Paul Sawyer. Member: Seattle AI. Work: Hist. Soc.; Kentucky State House, both in Louisville; Queen Anne Hill Branch Lib., Seattle [40]

CHESNEY, Mary [P,C,T] Bainbridge Island, WA b. 6 Ja 1872, Louisville, KY. Studied: Mary Harbrough. Exhibited: North West Indp. Salon, 1928 (prize) [33]

CHESNO, Jacques R. [P] NYC [24]

CHESSE, Ralph [P,Des,C] Los Angeles, CA b. 6 Ja 1900, New Orleans, LA. Member: Oakland AA; Modern Gal. Group; San Fran. AA. Exhibited: San Fran. AA, 1928 (prize). Work: fresco, Coit Tower, San Fran. [40]

CHESTER, Minnie Edna [P] Newton Center, MA [01]

CHEW, Amos [P] NYC [15]

CHEW, William [P] Baltimore, MD b. O 1902, Baltimore. Studied: Md. Inst.; Charcoal Cl. Member: A. Union. Exhibited: First Int. Am. A., Rockefeller Center, NYC, 1938; Baltimore Md.; Md. Inst. Alumni Exhib. [40]

CHIAPELLA, Edward Emile [P] Hollywood, CA b. 17 Ag 1889, New Orleans, LA d. 1951. Studied: Otis AI; Alexander Warshawsky; Paul Lauritz. Member: PS C, 1943; Santa Paula AA, 1944 (prize); Los Angeles Mus. A., 1945 [47]

CHICHESTER, Cecil [P,Dec,I,T,W] Woodstock, NY b. 8 Ap 1891, NYC. Studied: Maratta; Birge Harrison. Member: Woodstock AA; AG; Adv. C. NYC. Work: White House, Wash., D.C.; Kingston, N.Y. Position: T., Woodstock Sch. Ldscp. P. [40]

CHIDLAW, Paul [P] Cincinnati, OH b. 5 Ap, 1900, Cleves, OH. Studied: Cincinnati A. Acad.; Fontainebleau Sch. FA. Member: Cincinnati Assn. Prof. A. Exhibited: PS Fed. Bldgs., 1936; 48 Sts. Comp.; Cincinnati AM, 1939. Work: Cincinnati Zoological Gardens; Liberty St. USPO, Cincinnati [40]

CHILD, Carroll C. St. Louis, MO b. Middlebury, VT Studied: M. Seymour. Member: SLA [98]

CHILD, Charles [I] Bucks County, PA b. 1902, Montclair, NJ. Member: Phila. ACG; WPA. Exhibited: Am. P. Today Exh., WMA, 1938. Work: mural, USPO, Doylestown, Pa. Illustrator: "A Book of Americans," 1934 [40]

CHILD, Edwin Burrage [P,L] NYC/Dorset, VT b. 29 My 1868, Gouverneur, NY d. 10 Mr 1937, Dorset, VT. Studied: ASL; Amherst Col.; Assistant to John La Farge, glasswork, murals. Member: AFA; Cent. Assn. Exhibited: St. Louis Expo, 1905 (prize). Work: BM; N.Y. Chamber of Commerce; Columbia; CCNY; Mass. State Col., Amherst; Mich. State Col.; Yale; Amherst; Cleveland Chamber of Commerce; Nat. Mus. Art, Wash., D.C. Contributor: illus., Scribner's, other magazines. After 1908, became portrait & landscape painter. [33]

CHILD, Elizabeth Reynolds [P] Phila., PA [01]

CHILD, Jane Bridgham (Mrs. Robert Coleman Child) [P] Wash., D.C. b. NYC. Studied: Julius Rolshoven, in Paris. Member: S. Wash. A.; Wash. WCC. Exhibited: Atlanta Expo, 1895; Wash. WCC, 1901 (prize) [13]

CHILD, Robert Coleman [P] Wash., D.C. b. 1872, Richmond, VA. Studied: Lowell Sch. Des.; MIT; Corcoran Sch. Art. Member: Wash. SFA; Wash. WCC; S. Wash. A. [13]

CHILDERS, Marjorie H(elen) [P] Indianapolis, IN b. 15 D 1902, Aurora, IN. Studied: William Forsyth [24]

CHILDERS, Paul [S] Louisville, KY. Exhibited: WFNY, 1939 [40]

CHILDREY, Merrie [P] Falls Church, VA b. Richmond, VA. Studied: Corcoran Sch. A.; George Washington Univ. Member: Wash. WCC [40]

CHILDS, George Henshaw [S,Mus.Assoc,P,C] NYC b. 20 D 1890, Minneapolis, MN. Studied: Univ. Minn. Member: Am. G. Cr.; Am. Veterans Soc. A. Exhibited: Am. Veterans Soc. A. Work: AMNH; Nat. Hist. Mus., Univ. Minn. Contributor: Natural History magazine. Positions: Scientific A., 1923-38, Asst. Cur., 1938-43, Temp. Chm., Invertebrate Dept., 1943-45, Assoc., Preparation Dept., 1945-46, AMNH [47]

CHILDS, Joseph [I] NYC b. ca. 1869 d. 10 S 1909, Westport, CT

CHILDS, Lillian E. [Min.P] NYC. Studied: AIC; J. Vanderpoel; W.M. Chase; R. Henri. Member: AAPL; AFA [40]

CHILLMAN, Edward [P] Phila., PA b. 1841, Phila. [04]

CHILLMAN, James, Jr. [Mus.Dir,P,Arch,L,T,W] Houston, TX b. 24 D 1891, Phila. Studied: Univ. Pa.; PAFA; Am. Acad., Rome; P.P. Cret; G.W. Dawson. Member: AIA; Am. Assn. Univ. Prof.; F., Univ. Pa., 1913; F., Carl Schurz Fnd., 1936; SSAL; AA Mus.; Tex. FA Assn. Exhibited: Am. Acad., Rome, 1919-22. Work: Houston MFA. Contributor: Encyclopedia of the Arts; articles on architecture, art to American Magazine of Art, other publications. Author: "Memoirs of American Academy in Rome." Lectures: Art and Architecture. Positions: T., The Rice Inst., Houston, 1916-19, 1924- ; Dir., Houston MFA, 1924- [47]

CHILLMAN, Philip Edward [P,T] Phila., PA b. 7 F 1841, Phila. Studied: Carl Weber [13]

CHILTON, William (Brent) [P] Wash., D.C. b. 15 D 1856, Wash., D.C. d. 3 O 1939. Studied: Wash. ASL. Member: S. Wash. A.; Wash. WCC; Wash. AC; AFA [33]

CHIPMAN, C. Dean [Mus.Dir,E] Elgin, IL b. 6 Je 1908, La Porte, IN. Studied: Northwestern; Columbia; Kunstgewerbe Schule, Vienna. Member: Nat. Ed. Assn. Exhibited: Fox Valley AA, Elgin, Ill., annually. Position: T., Monticello Col., Godfrey, Ill., 1935-40; T./Dir. A. Gal., The Elgin Acad. [47]

CHISHOLM, Margaret Sale, Mrs. See Covey.

CHISHOLM, Marie Margaret [P,T] Garnett, SC b. 25 Jy 1900, Garnett, SC. Studied: PAFA; W.W. Thompson; Mary Hope Cabaniss. Member: Carolina AA; FA Lg. of the Carolinas; SSAL. Position: A. Supvr., Lander College, S.C. [40]

CHISLETT, Mabel Clare [S] St. Paul, MN [08]

CHISOLM, Mary B. (Mrs. R.S.) [P] NYC. Member: S.Indp.A.; NAWPS [27]

CHISMAN, William [P] Chicago, IL. Member: Chicago SA [24]

CHISOLM, V.N. [P] Savannah, GA [25]

CHITTENDEN, Alice B(rown) [P,T] San Fran., CA b. 14 O 1860, Brockport, NY. Studied: Calif. Sch. FA, with Virgil Williams. Member: San Fran. AA; San Fran. S. Women A.; AFA. Exhibited: San Fran. Expo of Art and Industries, 1891 (gold); Lewis-Clark Expo, Portland, 1905 (med); Société des Artistes Français, 1908 (med); Alaska-Yukon Pacific Expo, Seattle, 1909 (med); Work: Episcopal Divinity Sch., San Fran.; Calif. Soc. Pioneers; Boalt Law Hall, Univ. Calif. Position: T., Calif Sch. FA, San Fran. [40]

CHITTENDEN, Katherine H. [P] Pelham Manor, NY. Member: New Haven PCC [25]

CHIU, Alfred Kaiming [W,Mus.Cur,T,L] Cambridge, MA b. 11 Mr 1898, Ningpo, China. Studied: Boone Col.; NYPL Sch.; Harvard. Member: Am. Oriental Soc.; Chinese Lib. Assn.; Chinese Mus. Assn. Contributor: library journals, bulletins, art magazines. Positions: Cur., Oriental Coll., Harvard Col. Lib., 1927-30; Research F., Soc. Sciences Research Inst., Academia Sinica, 1930-31; Libr., Harvard-Yenching Inst., Harvard, 1931- ; T., Dept. Far Eastern Languages, Harvard, 1936- [47]

CHIVERS, H(erbert) C(hesley) [P,S,E,A,W] NYC b. Windsor, England. Studied: Luks; Sloan; Robinson; Lever; Young; Preissig; Pennell [29]

CHIZMARK, Stephan (Chizmarik) [P] Detroit, MI b. 25 S 1898, Chertiz, Austria-Hungary. Studied: Detroit Sch. FA, with John P. Wicker. Exhibited: PAFA, 1934-38; AIC, 1939; Grand Rapids A. Gal., 1940, 1941 (prize); NAD, 1942; Great Lakes Exh., 1938, 1939; Detroit AI, 1930-38 (prize), 1939-45 [47]

CHMIELEWSKI, Jan M. [E,P] Phila., PA b. 14 Je 1903, Frankford, PA. Studied: PMSchIA. Exhibited: PMSchIA, 1932 (prize) [32]

CHOATE, Florence [I] NYC [08]

CHOATE, Nat(haniel) [S,C] Phoenixville, PA b. 26 D 1899, Southboro, MA d. 21 Ag 1965. Studied: Harvard; Académie Julian, Grand Chaumière, both in Paris. Member: ANA; NSS; Arch. Lg.; N.Y. Cer. Soc; Century Assn. Exhibited: Arch. Lg., 1939, (med). Work: Brookgreen Gardens, S.C.; Harvard; USPO, Pitman, N.J. [47]

CHODOROW, Eugene [P,Li,Car] Tujunga, CA b. 15 Mr 1910, Ukraine, Russia. Studied: Edu. Alliance, N.Y. Exhibited: ACA Gal., 1940; Glendale Pub. Lib., 1945; Beverly-Fairfax Community Center, 1945. [47]

CHODZINSKI, Kasimir [S] NYC. Member: NSS [13]

CHOINSKA, Marion (Mrs. Walter) [P] Madison, WI b. 19 Jy 1897, Ashland, WI. Member: Madison AA; AFA. Exhibited: Wis. PS., Milwaukee AI, 1937; Fed. A. Center, Laramie, Wyo. (one-man); A. Barn, Salt Lake City (one-man) [40]

CHOUINARD, Nelbert Murphy [P,Des] South Pasadena, CA b. 9 F 1879, Montevideo, MN d. 9 Jy 1969 Studied: A. Dow; E. Batchelder; Pratt Inst., with R. Johannot; Munich, with H. Hoffmann. Member: Calif. AC; Alliance. Position: Dir., Chouinard AI, Los Angeles [40]

CHRIMES, Louise A. (Mrs. W.A.S.) [C] Brookline, MA b. Boston. Studied: Sacker Sch. Decorative Des. Member: Boston SAC; Needle and Bobbin Cl., N.Y.; Copley S. Specialties: needlework, embroidery, lacemaking. Positions: Dir., Craftsmen's G., Craftsmen's G. Sch. of Needlework, Boston [40]

CHRISSINGER, Mary Helen [Edu,P] Hagerstown, MD b. 29 O 1877, Hagerstown, MD. Studied: Kee Mar Col.; Rinehart Sch. S.; Columbia, with A. Heckman, C. Martin. Member: Nat. Edu. Assn.; Eastern AA; Md. State T. Assn. Exhibited: Md. Inst., 1899, 1900 (prizes); Rinehart Sch. S., 1901 (prize); Alliance, 1914, 1915; BMA, 1935, 1937; Wash. County Mus. FA, Hagerstown, Md., 1933-35. Position: Dir. A. Edu., Hagerstown & Wash. Counties, Md., 1939-46 [47]

CHRISTALDI, Angeline A. [P] Phila., PA b. 23 My 1905, Phila. Studied: Univ. Pa.; Tyler Sch. FA, Temple Univ.; PAFA; E. Horter; U. Romano. Member: Phila. WCC; Plastic Cl.; Phila. Alliance; Woodmere AA. Exhibited: PAFA, 1934-36, 1943-45; Woodmere A. Gal.; Plastic Cl.; Phila. WCC; Phila. A. T. Assn.; Montclair A. Mus. [47]

CHRISTENSEN, Carl C.A. [P,Mur.P] b. 1831, Copenhagen, Denmark (came to U.S. in 1857) d. 1912, Ephraim, UT. Work: Brigham Young Univ.; Mormon temples, Utah [*]

CHRISTENSEN, Erwin Ottomar [Mus.Cur,W,L,Ed] Lanham, MD b. 23 Je 1890, St. Louis, MO. Studied: Univ. Ill.; Harvard; AIC. Lectures: History of European Art; History of Architecture. Positions: T., Syracuse Univ., 1934-36, Univ. Pa., 1937-39, Carl Schurz Fnd., 1939-40, American Univ., 1945- ; Cur., Index of Am. Des., NGA, Wash., D.C., 1946- [47]

CHRISTENSEN, Esther M. [I,E,C,W] Cleveland, OH b. 10 My 1895, Milwaukee, WI. Studied: Broom; Aiker; Sinclair. Member: Wis. PS; Cleveland Pr. C. Exhibited: Wis. PS., 1924; Women's Arts and Industries Expo, Grand Central Gal., NYC, 1925 [27]

CHRISTENSEN, Ethel Lenora (Mrs. P.C.) [Min.P,P,G] Wilmington, CA b. 30 S 1896, Santa Barbara, CA. Studied: Sch. A., Santa Barbara State Col.; B. Browne; B. Moore; M. Hebert; C. Peake; D. Carpenter. Exhibited: Calif. Soc. Min. P. Ann., 1938; Santa Barbara A. Exh., 1938, 1939; Ann. Min. P., PAFA, 1939 [40]

CHRISTENSEN, Florence [P] Salt Lake City, UT [15]

CHRISTENSEN, Ingeborg [P,W,L,T] Chicago, IL b. Chicago. Studied: Pauline Palmer; AIC. Member: Chicago AC; Chicago PS; Alumni AIC; Chicago Gal. Assn. Exhibited: AIC, 1925 (prize) [40]

CHRISTENSEN, John Esbern [P,S] Detroit, MI b. 2 Ag 1911, Copenhagen, Denmark. Studied: Dachauer; Mullner; Acad. FA, Vienna. Exhibited: Detroit AI, 1937 (prize). Work: mon., Pinkafeld, Austria [40]

CHRISTENSEN, Ralph A. [P,I,E,W,L,T] Kalamazoo, MI b. 4 Ap 1886, Chicago, IL d. 30 Mr 1961. Studied: Vanderpoel; Ufer; Mucha; AIC. Member: AFA; Calif. AC. Position: Pres., Christensen Industrial Art School, Kalamazoo [31]

CHRISTIAN, Grant Wright [P] Monhegan Island, ME b. 17 Jy 1911, Edinburg, IN. Studied: William Forsyth; Clifton Wheeler; Roy Nuse;

Daniel Garber; Pearson; Speight; Breckenridge; McCarter; Donald Mattison; Hendrik Mayer; Jay Conoway. Member: Indianapolis AA. Exhibited: Hoosier Salon, 1936 (prize). Work: mural, USPOs, Indianapolis, Napanee, both in Ind. WPA artist. [40]

CHRISTIAN, Joane Cromwell. See Cromwell.

CHRISTIANA, Edward L. [P,T] Utica, NY b. 8 My 1912, White Plains, NY. Studied: PIASch; Munson-Williams-Proctor Inst., with William C. Palmer; Utica Sch. A.&Sc. Exhibited: Utica, 1945 (prize); AIC, 1942, 1944; AWCS, 1946; Miss. AA, 1946; Munson-Williams-Proctor Inst., 1938–46; Albany Inst. Hist.&A., 1939, 1942, 1946; Syracuse Mus. FA, 1939. Work: Munson-Williams-Proctor Inst. Position: T., children's classes, Munson-Williams-Proctor Inst. [47]

CHRISTIANSEN, P [P] Brooklyn, NY. Member: S.Indp.A. [24]

CHRISTIE, Mae Allyn. See Schupbach.

CHRISTIE, Ruth Vianco (Mrs. John) [C,Des,P] Rochester, NY/Springwater, NY b. 23 Ag 1897, Rochester. Studied: Rochester Athenaeum & Mechanics Inst. Member: Rochester A. Cl. Exhibited: Rochester Mem. A. Gal.; Rundel Gal., Rochester. Specialty: stained glass murals [40]

CHRISTISON, Muriel Branham [Edu,L] Minneapolis, MN b. 10 O 1911, Minneapolis. Studied: Univ. Minn.; Univ. Paris; Univ. Brussels. Member: Am. Soc. Arch. Hist. Contributor: art and historical publications. Positions: Asst., Dept. FA, Univ. Minn., 1933–36; L., Hd. Dept. Edu., Minneapolis Inst. A., 1936–46 [47]

CHRIST-JANER, Albert William [Mus.Dir,W] Bloomfield Hills, MI b. 13 Je 1910, Appleton, MN d. 1973. Studied: St. Olaf Col.; AIC; Yale Univ.; Harvard Univ. Author: "George Caleb Bingham" (1940), "Boardman Robinson" (1946). Positions: Hd. A. Dept., Stephens Col. (1936–41), Mich. State Col. (1943–45); Dir., Cranbrook Acad. Mus. & Lib. (1946) [47]

CHRISTMAN, Bert [Car] b. 1915, Fort Collins, CO d. 4 F 1942 (while on air patrol over Burma). In 1936, with the Associated Press Feature Service, he developed the air adventures of "Scorchy Smith."

CHRISTMAN, Erwin S. [S] NYC [17]

CHRISTMAS, E.W. [P] San Fran., CA [15]

CHRISTMAS, W.W. [P] Wash., D.C. [01]

CHRISTY, Frank R. [P] Columbus, OH. Member: Columbus PPC [25]

CHRISTY, Howard Chandler [P,Por.P,S,I] NYC b. 10 Ja 1872, Morgan County, OH d. 3 Mr 1952. Studied: NAD; ASL; Chase Sch. A. Member: SI, 1915. Exhibited: Paris Expo, 1900 (med); Pan-Am. Expo, Buffalo, 1901 (prize). Work: Capitol, Columbus, OH; Capitol, White House, State Dept., Pot Office Bldg., all in Wash., D.C.; Rickenbacker A. Mus., Columbus; Bardstown, Ky. Illustrator: leading publishers. He painted portraits of world celebrities during the 1920s. [47]

CHRYSTIE, Margaret H. [P,Li,T] Bryn Mawr, PA b. 23 Jy 1895, Bryn Mawr. Studied: Hugh H. Breckenridge; PAFA; Phila. Sch. Occupational Therapy; Hobson Pittman; Henry McCarter. Member: F., PAFA; Phila. A. All. Exhibited: CGA, 1937; CM, 1941; PAFA, 1931, 1938, 1940–45; Butler AI, 1939, 1941, 1945; Woodmere A. Gal.; Phila AC; DaVinci All.; Bryn Mawr (one-man); Women's Univ. Cl., Phila. Work: PAFA. Position: T., Wayne A. Center, Pa. [47]

CHU, H. Jor [P] NYC b. 2 O 1907, Canton, China. Studied: Michel Jacobs; George Bridgman; Dimitri Romanovsky; China. Member: All. AA; Chinese AC; Am. Ar. Cong. [40]

CHUBB, Charles St. John [P] Columbus, OH. Member: Columbus PPC [25]

CHUBB, Frances Fullerton [Edu,P,En] Tacoma, WA b. 6 O 1913, St. Mary's, ID. Studied: Col. Puget Sound; George Z. Heuston. Member: Tacoma AA; Tacoma A. Gld. Exhibited: Tacoma AA, 1940 (prize), 1941; SAM, 1939, 1941, 1942. Illustrator: "Lumber Industry in Washington," 1939. Position: T., Col. Puget Sound, 1942– [47]

CHUN, David P. [G] San Fran., CA. Exhibited: San. Fran. Mus., 1935; AG, 1939 (one-man) [40]

CHURBUCK, Leander M. [P,I,Car,L,T,W] Brockton, MA b. Wareham, MA. Studied: Copley Soc.; ASL Assoc., Boston. Member: Brockton AL; Marblehead AA. Exhibited: Dallas Expo, 1903 (gold); watercolor, Denver Expo, 1909 (prize). Work: Second Congregational Church, Marblehead; Swedish Lutheran Chuch, Municipal Coll., Paul Revere Lodge A.F. and A.M., Knights of Columbus Hall, all in Brockton [40]

CHURCH, Angelica Schuyler [P,S,T,Li,C] Ossining, NY b. 11 Ap 1878, Briarcliffe, NY. Studied: N.Y. Sch. Appl. Des.; Alphonse Mucha. Member: Ossining Hist. Soc.; French Inst. in U.S. Exhibited: sculpture, Intl. Flower Show, 1921 (prize); N.Y. Municipal A. Soc., 1910; Ossining Hist. Soc. Work: Hall of Records, State Mus., New Orleans, La.; Mark Twain Mem., Hannibal, Mo.; Calvary Church, New York; NYC Police Dept.; Friends Seminary, New York [47]

CHURCH, Charles Freeman [P,I] Chicago, IL. b. 15 O 1874, Gibson City, IL. Studied: AIC. Member: Palette & Chisel Cl.; Chicago SA; Ar. Gld. Work: Vanderpoel Coll. [33]

CHURCH, F(rederic) Edwin [P] NYC/Millneck, NY b. 25 O 1876, Brooklyn, NY d. ca. 1964. Studied: Sch. Arch., Columbia Univ.; Trachtmann; F.V. DuMond. Member: SC; MacD. Cl.; All. AA; N.Y. Arch. Lg.; Lyme AA; AFA. Exhibited: NAD, 1916 (prize) [40]

CHURCH, Frederick E. [Lcscp.P] b. 4 My 1826, Hartford, CT d. 7 Ap 1900, New York. Studied: Benjamin Coe; A.H. Emmons; principal teacher was Thomas Cole, at Catskill, 1844–48. Member: ANA, 1848; NA, 1849. Exhibited: MMA, 1900; Paris Expo, 1867 (med). Work: CGA; Edinburgh Mus.; major U.S. museums

CHURCH, F(rederick) S(tuart) [P,I,E] NYC b. 1 D 1842, Grand Rapids, MI d. 18 F 1923. Studied: Chicago Acad. Des.; L.E. Wilmarth; Walter Shirlaw; NAD. Member: ANA, 1883; NA, 1885; SAA, 1890; AWCS; SI; Lotos Cl.; N.Y. Etching Cl.; SC. Work: NGA; MMA; AM, Montclair, N.J.; Hackley A. Gal., Muskegon, Mich.; St. Louis City AM

CHURCH, Grace [P] Denver, CO [17]

CHURCH, Howard [P,E,Li] East Lansing, MI b. 1 My 1904, South Sioux City, NE. Studied: AIC; Boris Anisfeld; Univ. Chicago; Ohio State Univ.; John Norton; William P. Welsh. Member: CAA. Exhibited: Kansas A. Exh.; Topeka, 1941 (prize), 1942 (prize); Century of Progress, Chicago, 1934; Conn. Acad. FA, 1941, 1942; Dayton AI, 1939; Univ. Nebr., 1945; Northwestern Univ., 1934; Ohio State Univ. Traveling Exh., 1939–40; AIC, 1941; Springfield (Mo.) Mus., 1941; Kansas State A. Traveling Exh., 1940–42; Prairie WC Traveling Exh., 1942, 1943; Midwestern Mus. Assn. Traveling Exh., 1944–45; Sioux City A. Center, 1941; AFA Traveling Exh., 1944; Detroit Inst. A., 1945; Cranbrook Acad. A., 1946; Mulvane A. Mus., 1941, 1942 (one-man); Thayer Mus., 1942 (one-man). Work: murals, Morgan Park Military Acad., Chicago. Positions: Dir., Morgan Park Sch. A., Chicago, 1933–36; Dir., Mulvane A. Mus.; Hd. A. Dept., Washburn Univ., Topeka; Hd. A. Dept., Mich. State Col., East Lansing, 1946– [47]

CHURCH, Mabel [T] Phila., PA. Member: F., PAFA [25]

CHURCHILL, Alfred V(ance) [P,T] Northampton, MA b. 14 Ag 1864, Oberlin, OH. Studied: Académie Julian, Paris. Member: Union Internationale des Beaux-Arts; Col. AA; North Shore AA. Positions: Dir., A. Dept., Iowa Col., 1891–93; Dir. A. Dept., T. Col., Columbia, 1897–1905; T., Johns Hopkins Univ., 1902–03, Univ. Chicago, 1914, 1916, 1917, Smith Col., 1906– ; Dir. Smith Col. Mus. A., 1920– ; Editor, Smith Col. AM Bulletin [31]

CHURCHILL, Francis G(orten) [P,I,E,Arch] New Orleans, LA b. 12 F 1876, New Orleans. Studied: Cincinnati Acad.; Tulane. Member: NOAA; La. Chap. AIA; NAC. Designer: McDermott Memorial Church; Loyola Univ.; Tulane Univ. Stadium; Newcomb College Gymnasium. Author: "Pen Drawings of Old New Orleans" [24]

CHURCHILL, Letha E. [P] Kansas City, MO. Member: Kansas City SA [25]

CHURCHILL, Rose [P] Farmington, CT b. 2 Je 1878, New Britain, CT. Studied: Amy Sacker Sch. Des.; W.M. Chase; Charles Martin; Eliot O'Hara; Guy Wiggins. Member: N.Y. Studio Gld.; NAWA; Conn. WC Soc.; Hartford Soc. Women Painters. Exhibited: NAWA, 1944, 1945, 1946 (prize); Hartford Soc. Women Painters, 1939–43, 1944 (prize), 1945, 1946 (prize); All. AA, 1938, 1941, 1942; Conn. WC Soc., 1938–46; New Haven PCC, 1942, 1944 [47]

CHURCHILL, William W. [P] Boston, MA b. Boston d. 15 F 1926, Wash., D.C. Studied: Bonnât, in Paris. Member: Boston Gld. A.; St. Botolph Cl. Exhibited: Pan-Am. Expo, Buffalo, 1901 (prize); P.-P. Expo, San Fran., 1915 (prize) [25]

CHURCHMAN, E(lla) Mendenhall [P] Manasquan, NJ b. Brooklyn, NY. Studied: PAFA; Tarbell; Benson. Member: F., PAFA; S.Indp.A.; Salons of Am.; AFA; Phila. All. Specialties: portraits and landscapes in oils [33]

CHURCHMAN, Isabelle Schultz [S,C,T] San Diego, CA b. 20 Ap 1896, Baltimore, MD. Studied: T., Col., Columbia Univ.; Md. Inst.; Rinehart Sch. S.; Ephraim Keyser; Maxwell Miller; Herbert Adams. Member: San Diego A. Gld.; La Jolla A. Center. Exhibited: FA Gal., San Diego, 1933 (prize), 1934 (prize); PAFA, 1920–22; San Diego FA Soc., 1930, 1940,

1946; La Jolla A. Center, 1945, 1946. Work: Tuskegee Inst.; Medical Bldg., Baltimore; Goucher Col.; Protestant Episcopal Cathedral, Baltimore. Position: T., Ceramics, Adult Edu., San Diego, 1945–46 [47]

CIAMPAGLIA, Carlo [Mur.P,P,T] Middle Valley, NJ b. 8 Mr 1891, Italy d. 1975. Studied: CUASch; NAD; Am. Acad., Rome. Member: ANA; Alliance. Exhibited: Tex. Centenn. Expo, 1936; WFNY, 1939; NAD. Work: murals, dec., Cranbrook Acad. A.; Slovak Girls Acad., Danville. Pa.; Masonic Temple, Scranton, Pa.; Fairmount Mausoleum, Newark, N.J.; Court House, Sunbury, Pa. Award: Prix de Rome, 1920–23. Contributor: arch. magazines, newspapers, Encyclopaedia Britannica. Position: T., Traphagen Sch. Fashion, NYC [47]

CIANFARINI, Aristide Berto [S,Des,P,T] Providence, RI b. 3 Ag 1895, Italy. Studied: RISD, with A.W. Heintzelman; Italy, with Dazzi, Zanelli, Selva. Member: Providence AC; Arch. Lg.; SC; Audubon A.; Intl. AA, Rome; Utopian Cl., Providence. Exhibited: PAFA; WMAA; WFNY, 1939; Audubon A.; Arch Lg., 1942 (prize); Ogunquit AA; Contemp. Am. A.; Providence AC; Newport AA; RISD. Work: Brown Univ.; Meriden, Conn.; war mem., Northborough, Mass.; Ogden, Utah; statue, Muhlenberg Col., Pa. [47]

CIANI, Victor A. [S] NYC b. Florence, Italy. Studied: G. Mantevende, Rome. Member: Arch. Lg. Award: Cavalier of the Crown of Italy [08]

CIAVARRA, Pietro [S] Phila., PA b. 29 Je 1891, Phila.. Studied: C. Grafly; G. Donato; C.T. Scott; PAFA; PMSchIA; A. Bottiau, in Paris. Member: Phila. Alliance. Work: PAFA; Graphic Sketch Cl. Mus. [40]

CIKOVSKY, Nicolai [P,Li] Wash., D.C. b. 10 D 1894, Pinsk, Poland. Studied: Moscow, with Favorsky, Mashkow; Member: Am. Soc. PS&G. Exhibited: AIC, 1931 (med), 1932 (prize); WMA, 1933 (prize), 1937; Soc. Wash. A., 1938 (med). Work: AIC; PAFA; CAM; WMA; Los Angeles Mus.; W.R. Nelson Gal., Kansas City; lithographs, WMAA, Milwaukee AI; Minn. Univ.; MOMA; PMG; murals, Dept. Interior, Wash., D.C., USPO, Silver Springs, Md. WPA muralist. Positions: T., Col. of Notre Dame, Ind.; CGA [47]

CILFONE, Gianni [P,T] Chicago, IL b. 20 Ja 1908, San Marco, Italy. Studied: Chicago Acad. FA; AIC; W.J. Reynolds; C. Scheffler. Member: Chicago Gal. Assn.; Chicago P.&S.; North Shore AA; SC. Exhibited: AIC, 1928, 1919; Chicago Gal. Assn., 1940, 1941 (prize), 1942, 1943 (prize), 1944, 1945 (prize), 1946; SC, 1943 (prize), 1944 (prize), 1945, 1946; Municipal A. Lg., Chicago, 1946 (prize). Work: Michigan City (Ind.) Lib. Position: T., La Grange, Ind. AL [47]

CIMINO, Harry [En,I,Des,C] Falls Village, Conn. b. 24 Ja 1898, Marion, IN. Studied: AIC; ASL; SI Sch. Illustrator: "Sutter's Gold," "The King's Henchman," "Doubloons," other books [47]

CIMIOTTI, Gustave [P,T] NYC b. 10 N 1875, NYC. Studied: ASL, with Mowbray, Cox, J.A. Weir, R. Blum; Constant, Acad. Julian, Acad. Delacluse, all in Paris. Member: SC. Exhibited: NAD, 1929 (prize). Work: Newark Mus. Position: Dir., Newark Sch. F.&Indst. A. [47]

CINATL, Ludwig John [Des,I,Car,P] Milwaukee, WI b. 20 Ja 1914. Studied: State T. Col., Milwaukee. Exhibited: Milwaukee AI; AIC [40]

CINI, Egisto [B,Cr] Johnston, RI b. 26 F 1891, Florence, Italy. Studied: Ricardo Cini; RISD. Member: Boston SAC. Exhibited: Bologna, Italy, in May 1932 (gold). Work: cover of presentation volumes to Il Duce, Benito Mussolini, His Holiness, the Pope, and the King of Italy [40]

CINI, Guglielmo [C,Des,En] Boston, MA/Dennis, MA b. 3 F 1903, Florence, Italy. Member: Boston SAC. Work: gold, platinum, diamond table for Colleen Moore's Dollhouse, 1936; jewelry, miniature pieces. [40]

CIOBAN, Edward, Mrs. See MacGowan.

CIPOLLINI, B(enedict) R. [S] Somerville, MA b. 12 Ja 1889, Carrara, Italy. Studied: Leio Gangeri; Alessandro Pollina. Work: presentation medal from Boston to General Diaz; Beebe Mem. Lib., Wakefield, Mass.; statues, St. John the Divine; bust of Homer, Univ. Brussels [40]

CIRINO, Antonio [P,C,W,T,L] Providence, RI/Pigeon Cove, MA b. 23 Mr 1889, Serino, Italy. Studied: A.W. Dow; T. Col., Columbia. Member: Eastern AA; R.I. A. T. Assn.; SC; Providence AD; Rockport AA; North Shore AA. Exhibited: NAD; PAFA; CAFA; Ogunquit AA; Rockport AA; North Shore AA; Providence AC, 1930 (prize); Springfield AL, 1920 (prize); SC, 1932 (prize), 1937 (prize), 1944 (prize); Providence AC; RISD. Contributor: art magazines. Position: Hd., Teacher Training, RISD [47]

CITRON, Minna (Wright) [P,Gr,T,L,W] NYC b. 15 O 1896, Newark, NJ. Studied: K.H. Miller; J. Sloan.; Brooklyn Inst. A.&Sc.; N.Y. Sch. Appl. Des.; ASL, with Nicolaides, Miller; Europe. Member: SAE; AFA; A. Lg. Am.; NAWA. Exhibited: CGA; WMAA; ACA Gal., 1946 (one-man); Howard Univ., 1946 (one-man); Delgado Mus., 1946 (one-man); Newark Mus.; CI; PAFA; AIC; N.Y. Sch. Appl. Des., 1926 (prize); SAE, 1942, 1943 (prizes); Newark Pub. Lib., 1975. Work: MMA; WMAA; Norfolk Mus. A.&Sc.; Newark Mus.; CGA; AIC; LOC; NYPL; N.J. Pub. Lib.; murals, USPOs, Newport, Manchester, both in Tenn. Lectures: Genre Painting, Changing Attitudes Toward Art. Positions: T., BM, 1943–46; Paris correspondent, Iconograph magazine, 1946– [47]

CLACK, Clyde Clifton [P,W,I,L,T] Dallas, TX b. 27 N, 1896 d. 24 O 1955. Studied: Southeastern State Col.; Univ. Okla.; Oscar Jacobsson. Member: Western AA; Eastern AA; SSAL; Assoc. A. Inst., Tex.; Dallas AA; Dallas Adv. Lg. Exhibited: SSAL, 1944, 1946; Mus. FA, Houston, 1941, 1942, 1945; Dallas Mus. FA, 1941, 1942, 1944. Author/Illustrator: "Modern Pioneers," 1936, "Practical Drawing Books—Correlated Art Edition," 1930. Contributor: magazines on art education. Positions: Dir., A. Edu., Binney & Smith Co., 1937– ; Assoc. Ed., "The Drawing Teacher," 1945– [47]

CLAGHORN, Joseph C. [E,P] b. 4 S 1869, Phila. Studied: Anshutz; PAFA. Work: LOC; mural, Chamber of Commerce, Orlando, Fla. [40]

CLAIRMONT, Louise Bartley [P] Boston, MA b. 12 Mr 1910, Tahoka, TX. Studied: Col. Indst. A., Denton, Tex.; Sch. FA, Fontainebleau. Member: WPA; Mass. Ar. U. Exhibited: Mass. Ar. U., 1939 [40]

CLANCY, Eliza R. (Mrs. Charles Edwin) [P] Ft. Worth, TX [19]

CLANCY, Joe Wheeler [P,Li,Des,T,L] Birmingham, AL b. 16 Ap 1896, Birmingham. Studied: Ala. Polytechnic Inst. Member: Birmingham AC; Ala. AL; SSAL. Exhibited: CM, 1935–37; Albany Inst. Hist.&A., 1939; VMFA, 1940; WFNY, 1939; SFMA, 1940; Birmingham AC, 1935–46; Ala. AL, 1936–39; SSAL, 1934–38; Mt. Holyoke Col., 1939. Work: Montgomery Mus. FA; Huntingdon Col.; Eastern State T. Col., Charleston, Ill.; Seton Hall, Decatur, Ala. Lectures: Lithography. Position: T., Howard Col., Birmingham [47]

CLAPP, Frederick Mortimer [Mus.Dir,L,Cr,W] NYC b. 26 Jy 1879, NYC. Studied: CCNY; Yale; Univ. Lausanne. Member: Socio dell' Accademia di San Luca, Rome; CAA; Assn. A. Mus. Dir. Author: "Les Dessins de Pontormo," 1914, "Jacopo Carucci, His Life and Works," 1916. Positions: L., Univ. Calif., 1906–14; Hd., Dept. FA, Univ. Pittsburgh, 1926–37; Advisor, 1931–32, Organizing Dir., 1933–35, Dir., 1936– , Frick Collection, NYC [47]

CLAPP, Marcia [S,T] NYC b. 7 D 1907, Hartsville, IN. Studied: John Herron A. Sch.; Butler Univ.; ASL. Member: F. Tiffany Fnd.; Griffith F. Exhibited: NAD, 1931, 1932; John Herron AI, 1931 (prize); Hoosier Salon, 1931, 1932; CM, 1931; PAFA, 1932; Indianapolis, 1934 (one-man) [47]

CLAPP, William Henry [Mus.Dir,P,W,Cr,T,E] Piedmont, CA b. 29 O 1879, Montreal, Quebec. Studied: A. Sch. Montreal AA; Académie Julian, Paris, with Jean Paul Laurens. Member: Assoc., RCA; Montreal AA; AAPL. Exhibited: PAFA; CI; NAD; RCA (prize). Work: Canadian Nat. Gal.; Montreal AA; Oakland A. Gal. Contributor: art criticism, newspapers. Position: Dir., Oakland Art Gal., 1918– [47]

CLAPS, Anthony [P] Buffalo, NY [17]

CLARE, Joseph [Dec,P] b. 1846 (came to NYC in 1871) d. 3 Je 1917, Central Islip, NY. Studied: W. Benson, Theatre Royal, Liverpool. Prepared scenery for plays produced by Lester Wallack.

CLARK, Adele [P,T,L] Richmond, VA. Studied: D.J. Connah; K.H. Miller; Henri; Chase. Work: Richmond Chamber Commerce; Acad. FA, Richmond; Odd Fellows Home, Lynchburg, Va.; WPA, Va. [40]

CLARK, Alfred Houghton [P,I,W,L,T] Kansas City, MO b. 10 D 1868, Lawrence, MA. Studied: Decamp; Tarbell; Benson [17]

CLARK, Allan [S] Santa Fe, NM b. 8 Je 1896, Missoula, MT d. 27 Ap 1950. Studied: AIC; Japanese, Chinese Masters; A. Polasek; ASL, with R. Aitken. Member: NIAL. Exhibited: Univ. Wash. (one-man); Inst. FA, Peking, China; FMA; Wildenstein Gal.; Phila. Alliance; East-West Gal., San Fran.; Mus. N.Mex., Santa Fe; Houston Mus. FA. Work: MMA; Honlulu Acad. A.; WMAA; NYU; Mus. N.Mex. [47]

CLARK, Alson Skinner [P,Li,T,I,Mur.P] Pasadena, CA b. 25 Mr 1876, Chicago, IL d. 22 Mr 1949. Studied: AIC, 1898; Simon, Cottet, Whistler, Mucha, Merson, in Paris, 1900–01; Chase Sch. A., 1898–99. Member: Southern Calif. Pr.M.; Pasadena SA; Calif. WCS; Laguna Beach AC; SC; Grand Central AG. Exhibited: NAD; CI; Salon des Beaux-Arts; CGA; St. Louis Expo, 1904 (med); AIC, 1906 (prize); P.-P. Expo, 1915 (med); Southwest Mus., Los Angeles, 1923 (prize); Los Angeles Mus., 1925 (prize); Pasadena AI, 1930–33 (prizes). Work: Victoria & Albert Mus.,

London; San Diego FA Soc.; AIC; State Lib., Sacramento, Calif; AGAA; NYPL; murals, Cathay Circle Theatre, Los Angeles; First Bank, Pasadena. Position: T., Occidental Col., Eagle Rock, Calif. [47]

CLARK, Arthur Bridgman [B,T,W,Arch,En] Palo Alto, CA b. 11 Ag 1866, Syracuse, NY. Studied: Syracuse Univ.; W. Chase; J. Twachtman; J.M. Whistler. Member: Palo Alto AC; Pacific AA; Calif. A. T. Assn. Work: Arch., Herbert Hoover home, Palo Alto. Author: "Perspective," 1936 (text book). Position: T., Stanford, 1891–31 [40]

CLARK, Arthur E. (Mrs.) [P] St. Paul, MN [15]

CLARK, Arthur F. [P] New Rochelle, NY [06]

CLARK, Arthur T. [P] Boston, MA b. Ja 1864, Boston. Studied: Henry Sandham [01]

CLARK, B. Preston, Jr. [P] Boston, MA [15]

CLARK, (Mabel) Beatrice Smith [Min.P,L] Hollywood, CA b. Phila. Studied: Phila. Sch. Des., with Daingerfield, Sartain, Snell; ASL, with Bridgman; Am. Sch. Min. P. Member: NAWA; Calif. Soc. Min. P.; Calif. AC. Exhibited: ASMP, 1914–21, 1936–39; Pa. Soc. Min. P., 1933; WFNY, 1939; Calif. Soc. Min. P., 1933; CGA; Los Angeles A. Mus., 1922 (prize), 1931, 1932 (prize), 1933–36, 1937 (prize); Calif. AC, 1946 (prize); GGE, 1939; Elizabeth Fisher Gal., 1938–43 [47]

CLARK, Benton H. [I] b. 1895, Coshocton, OH d. 23 My 1964. Studied: A. Woelfle, NAD, 1913; AIC, 1915. Work: murals, Chicago; Columbus; Pony Express Mus., Joplin, Mo. Illustrator: Saturday Evening Post, other magazines. Shared studio with brother Matt in NYC, 1932.

CLARK, C.H. [P,T] Meadville, PA. Studied: Acad. Julian, Acad. Delecluse, both in Paris [21]

CLARK, Charles Cameron [P] NYC [15]

CLARK, Charles E. [I] Phila., PA. Member: F. PAFA [24]

CLARK, Christopher (Lee) [P,T] Tampa, FL b. 21 Je 1903, Quincy, FL. Studied: Univ. Fla.; ASL, with K.H. Miller. Member: Sarasota AL; Fla. Gulf Coast Group; Fla. Fed. A. Exhibited: N.Y. Municipal Exh., 1936; CAA, 1934; Gulf Coast Traveling Exh., 1943, 1944; Fla. Fed. A., 1941 (med), 1942 (prize), 1943; Clearwater Mus. A., 1944; Rheinhardt Gal., 1934. Work: murals, Radio City, NYC. Illustrator: Forbes. Position: T., Ringling Sch. A., Sarasota, Fla. [47]

CLARK, Egbert Norman [I] Columbus, OH b. 15 Ag 1872, Milwaukee, WI [10]

CLARK, Eliot (Candee) [P,W,L,Ed] NYC/Charlottesville, VA b. 27 Mr 1883, NYC d. 1980. Studied: ASL; J. Twachtman; W. Clark. Member: NA; NAC; CAFA; NAD. Exhibited: CGA; CI; PAFA; Albright A. Gal.; CAM; RISD; VMFA; NAC; SC; NAD, 1912 (prize), 1922 (prize); AWCS. Work: NAD; NAC; Dayton AI; Muncie AA; Witte Mem. Mus.; Ft. Worth AA; Wichta Falls, Ft. Worth, San Antonio Women's Clubs. Author: "Alexander Wyant," 1916, "John Twachtman," 1924, "J. Francis Murphy," 1926, "Theodore Robinson." Contributor: Art in America, Scribner's, International Studio, Arts and Decoration. Positions: T., Roerich Mus., Grand Cent. A. Sch. (1931–32), NAC (1943–); Univ. Va. Bd. Governors [47]

CLARK, Elsie Southwick [P] NYC b. Providence, RI [27]

CLARK, Emilia Goldsworthy [P,L,W,T] Los Angeles, CA b. 3 Je 1869, Platteville, WI d. ca. 1955. Studied: AIC; PIASch; Otis AI, Los Angeles; Dow; Forsyth; Snell; Freer; Batchelder; Mannheim; Fursman; Vanderpoel; Townsley. Member: Calif. AC; Women P. of the West. Work: Unitarian Hdqtrs., Boston and Los Angeles [47]

CLARK, Emily J. (Mrs.) [Patron] d. 13 Ag 1929. Member: NAC. Donated the property for the Grand Rapids Art Gal.

CLARK, Elizabeth L. [P] Baltimore, MD. Member: Baltimore WCC [29]

CLARK, Emma E. [I] b. 1883, NYC d. 28 Jy 1930, Whitestone, NY

CLARK, (George) Fletcher [S,I,L] NYC b. 7 N 1899, Waterville, KS. Studied: Univ. Calif.; BAID; Europe. Exhibited: Weyhe Gal.; Julian Levy Gal. Work: Wood Mem. Gal., Montpelier, Vt.; Carmelita Monastery, Santa Clara, Calif. [47]

CLARK, Frank Scott [P] Detroit, MI [24]

CLARK, Franklin B(arber) [P] Wash., D.C./Muskoka Lakes, Ontario b. Brampton, Ontario. Studied: J.W.L. Forster, in Toronto; Bouguereau, in Paris. Work: State House, Annapolis, Md.; Crown Prince of Sweden; Monticello, Charlottesville, Va. [25]

CLARK, Frederick H. [P] Trenton, NJ b. 1862, Trenton d. 5 Mr 1947, Vineyard Haven, MA. Studied: ASL [08]

CLARK, Freeman [P] Holly Springs, MS b. Holly Springs. Studied: ASL; Chase; Wiles. Member: AFA; Nat. A. Soc. Exhibited: NAD, PAFA, CI; Boston AC; Detroit AI; Albright A. Gal.; CAM; SAM; P.-P. Expo, 1915; Men's City Cl., NYC (one-man). Work: Brooks Mem. A. Gal., Memphis; NYPL [47]

CLARK, George R. [Car] NYC Member: SI. Work: Huntington Lib., San Marino, Calif. [47]

CLARK, George M. [P] Buffalo, NY. Member: AWCS [01]

CLARK, Georgia Lawrence [P] Wash., D.C. [17]

CLARK, Grace S. [P] East Orange, NJ [25]

CLARK, Guy Gayler [Des] NYC/Montclair, NJ b. 26 Ag 1882, Brooklyn, NY. Studied: DuMond; W.M. Chase; G. Bellows; Henri; F.L. Mora. Member: Art Dir. C.; East A. Assn. Contributor: articles on design, Printers Ink Monthly. Lectures: Design, Creative Design, Photography. Position: A. Dir., Cooper Union [40]

CLARK, Harriette A. [Min.F] NYC b. 4 Mr 1876, Depere, WI. Studied: Paris, with Laurens, Rovet, Baschet, Mme. Debillemont-Chardon. Work: Pan-Am. Bldg., Wash., D.C. [21]

CLARK, Harrison [P] Tacoma, WA. Member: Tacoma FAA [25]

CLARK, Helen Caroline [Des] Phila., PA b. 12 Jy 1884, Boston, MA. Studied: BMFA Sch.; C.H. Walker; Berkshire Summer Sch.; Katherine Child. Member: Boston SAC. Position: Dir., College Settlement Handicraft Shop, Phila. [40]

CLARK, Henry Hunt [P] Cambridge, MA. Member: Providence AC [27]

CLARK, Herbert Francis [P,I,E] Wash., D.C. b. 18 S 1876, Holyoke, MA. Studied: RISD; Corcoran A. Sch. Member: Wash. SA; Wash. Landscape C. [24]

CLARK, Herbert W., Jr. [S] Bronx, NY [17]

CLARK, Homer [P] Seattle, WA [21]

CLARK, Isaac Carpenter [E,Des] Norfolk, CT b. 25 Ag 1892, Grand Island, NE. Member: Boston SAC; New Haven PCC [47]

CLARK, James Lippitt [S,L] NYC b. 18 N 1883, Providence, RI. Studied: RISD. Member: NSS. Exhibited: NAD, 1930 (prize). Work: Ohio State Univ.; RISD. Author: "Trails of the Hunted," 1929. Contributor: Asia, Natural History, other publications. Position: creator of habitat groups, AMNH. Also an explorer and taxidermist. [47]

CLARK, John [S] NYC [17]

CLARK, Kenneth [Arch,Photogr] New Rochelle, NY d. N 1931, Wash., D.C.. Work: photographs of early Am. Arch., MMA

CLARK, Laurence [Arch,P] Phila., PA b. 25 Mr 1881, Germantown, PA. Studied: Univ. Pa.; Ecole des Beaux-Arts. Member: Phila. Sketch C.; WCC; F. PAFA. Work: Art Mus., Allentown, Pa. [40]

CLARK, Louise Bennet (Mrs.) [Mus.Dir,L] Memphis, TN b. Memphis. Studied: Ward Belmont Sch. A.; Ecole du Pantheon, Paris. Member: AA Mus.; AAPL; SSAL; Memphis AL; Brooks Lg. Position: Asst. Dir., 1932, Managing Dir., 1933–38, Dir., 1938– , Brooks Mem. A. Gal., Memphis [47]

CLARK, Matt [I] Quakerstown, PA b. 1903, Coshocton, OH. Studied: NAD. Member: SI. Illustrator: American, Cosmopolitan, Good Housekeeping. Brother of Benton Clark. [47]

CLARK, Maud J. [P] Buffalo, NY. Member: Buffalo SA [25]

CLARK, Ralph Samuel [P,I] Chicago, IL b. 30 S 1895, Newton, IL. Studied: AIC. Position: Commercial I., Superior Engraving Co., Chicago [40]

CLARK, Roland [E,P,W] NYC/Cutchogue, NY b. 2 Ap 1874, New Rochelle, NY d. Ap 1957, Norwalk, CT. Member: Chicago SE. Author: "Stray Shots," "Roland Clark's Etchings" [40]

CLARK, Rose [P] Buffalo, NY [25]

CLARK, Roy C. [Ldscp.P] Wash., D.C./Pittsfield, MA b. 3 Ap 1889, Sheffield, MA. Studied: E. Nye; I. Wiles; W. Judson. Member: S.Indp.A.; Wash. Ldscp. C.; Wash. SA; Wash. WCC. Exhibited: Wash. SA, 1933 (med); Wash. S.Indp.A., 1935 (prize) [40]

CLARK, Sally (Mrs. James L.) [S] NYC b. 22 F 1883, NYC. Studied: James

L. Clark. Exhibited: Nat. Acad. Work: AMNH; Mus. Comparative Zoology, Cambridge, Mass.; A. Gal. Univ. Nebr. [40]

CLARK, Sarah L. [P,I,T] Phila., PA b. 22 Ag 1869, Phila. d. 16 O 1936. Studied: Chase; Carlson; PAFA. Specialty: pathology, surgical drawings [38]

CLARK, Selden McKinley [P,W,L] Los Angeles, CA b. 18 Ag 1903, Albany, NY. Studied: Lucille Douglas [31]

CLARK, Sheldon P. [P] Cleveland, OH. Member: Cleveland SA [25]

CLARK, Tanner [P] Somerville, NJ. Work: USPO, Newark, N.J. WPA artist. [40]

CLARK, Vera I. See Place.

CLARK, Virginia Keep (Mrs. Marshall) [P,I] Winter Park, FL b. 17 F 1878, New Orleans. Studied: Ind. Sch. A., with W. Forsyth; SAL, with K. Cox, C. Beckwith; H. Pyle; Spain. Member: NAWA. Exhibited: AIC, 1923 (prize); PAFA; CGA; Montross Gal. (one-man); NAWA. Illustrator: "Live Doll Series" [47]

CLARK, Walter [Ldscp.P,S] Bronxville, NY b. 9 Mr 1848, Brooklyn, NY d. 12 Mr 1917. Studied: NAD, 1876; ASL; G. Inness, 1881; J.S. Hartley; MIT; then toured world. Member: ANA, 1898; NA, 1909; SAA, 1898; NYWCC; A. Fund S.; SC, 1901; Ldscp. P.; Century Assn.; NAC. Exhibited: Pan-Am. Expo, Buffalo, 1901 (med); NAD, 1902 (med); St. Louis Expo, 1904 (med). Father of Eliot Clark. [15]

CLARK, Walter Appleton [I] NYC b. 24 Je 1876, Worcester, MA d. 27 D 1906. Studied: H.S. Mowbray; Chase. Member: Players C. Exhibited: Paris Expo, 1900 (med); Pan-Am. Expo, 1901 (med). Illustrator: "Canterbury Tales" (modern version, by Percy Mackaye). Contributor: Scribner's. Position: T., ASL [06]

CLARK, Walter Leighton [P] NYC/Stockbridge, MA b. 9 Ja 1859, Phila. d. 18 D 1935. Studied: PAFA. Member: Century Cl.; India House. He was an engineer for 25 yrs. In 1922 he conceived the idea of a co-operative gallery and, aided by John Singer Sargent and a group of friends, founded the Grand Central Art Galleries. Erected American Pavilion in Venice, in 1928, where artists of the U.S. could be represented at the Biennales. [33]

CLARK, William A. [Patron] NYC d. My 1925. Member: U.S. Senate. His collection valued at several million dollars became the property of the Corcoran Gallery.

CLARK, William Bullock (Mrs.) [P] Baltimore, MD. Member: Baltimore WCC [29]

CLARKE, Carl Dame [I,T,W,L,P] Baltimore, MD b. 26 Ap 1904, Danville, VA. Studied: Yale; Johns Hopkins Sch. Medical A.; Md. Inst.; Am. Intl. Acad. Exhibited: Md. Inst., 1929 (med); Intl. Assn. Medical Mus., Richmond, 1939. Work: Confederate Mem. Mus., Richmond. Author/Illustrator: "Molding and Castings," 1938, "Facial and Body Prosthesis," 1945. Contributor: medical periodicals. Position: Assoc. Prof., Dir., Dept. A. as Applied to Medicine, Univ. Md [47]

CLARKE, Sir Caspar Purdon [Mus.Dir,Medalist] London b. 1846, London d. 29 Mr 1911. Studied: Gaultier's Collegiate School, Sydenham; Beaucourt's Sch., Boulogne, France; Nat. A. Training Sch., South Kensington. Positions: Arch. of the Paris Expo (1878) India Section; Keeper of the South Kensington Mus. art collections (1883); Dir., South Kensington Mus. (1896); Royal Commissioner to Paris Expo (1900), to St. Louis Expo (1904); Dir., MMA, 1905-10

CLARKE, Corneille (Mrs. C. Irvine Clarke) [D,T] Richmond, VA. Studied: Phila. Sch. Des. Position: T., John Marshall H.S., Richmond [24]

CLARKE, Elsie W(hitmore) (Mrs. C. Waterbury Clarke) [Min.P] NYC b. Providence, RI. Studied: Prinet, Dauchez, Mme. Chennevieres, all in Paris [15]

CLARKE, Frederick Benjamin [S] NYC b. 1874, Mystic, CT d. 21 S 1943, Jackson Heights, NY. Studied: Augustus Saint-Gaudens; ASL. Member: BAID; NSS. Work: busts, Fontainebleau Palace (France), Toronto, New York; tablets, New York, Wilkes-Barre, Pa.; plaque, BAID [40]

CLARKE, Gladys Dunham [P] NYC/Weston, CT b. 24 Ag 1899, Southington, CT. Studied: Dickinson; DuMond; Fogarty; Gruger; Lentelli; Calder; Bridgman. Member: NAWPS; Salons of Am. [40]

CLARKE, Grace Olmstead [P] Brooklyn, NY [15]

CLARKE, Harriet [P] Park Ridge, IL. Member: Chicago NJSA [25]

CLARKE, Isaac Edwards [Ed,W] Wash., D.C. b. 1830, Deerfield, MA d. 13 Ja 1907. Studied: Yale. In 1874 he went to Wash., D.C. to help organize the Bureau of Education, his special work being the collection of statistics and the publication of monographs and reports on art and education. For these productions he received a silver medal from the Paris Expo and a gold medal from the St. Louis (1904) Expo.

CLARKE, J.F. Mowbray. See Mowbray-Clarke.

CLARKE, J.W. [P] NYC. Exhibited: AWCS [98]

CLARKE, John L(ewis) [P,S] Culver City, CA/ Glacier Park, MT b. 1881, Highwood, MT d. 1970, Cut Bank, MT. Exhibited: Helena, 1916. Work: AIC; Mont. Hist. Soc.; Mus. Plains Indians. Specialty: Western wildlife. A Blackfoot Indian, who became deaf as a child. [25]

CLARKE, Lillian Gertrude. See MacConnell.

CLARKE, Marjorie Rowland [S] Ruxton, MD b. 10 Ja 1908, Baltimore. Studied: Goucher Col.; Rinehart Sch. S.,; Md. Inst. Exhibited: Md. Inst., 1934 (prize). Work: Univ. Md. Medical Sch. [40]

CLARKE, Mary Dale [photogr] NYC b. 1875, Pittsburgh, PA d. 8 Ag 1936. Specialty: photographs of prominent theatrical and musical figures, including Arturo Toscanini, Walter Hampden, the Barrymores.

CLARKE, Prescott O. [P] Providence, RI. Member: Providence AC [19]

CLARKE, Rene [P] Yonkers, NY. Member: AWCS [47]

CLARKE, Sarah L. [P] Phila., PA. Member: F., PAFA [17]

CLARKE, Thomas B. b. 1849 d. 18 Ja 1931, NYC. An art collector, he began, at the age of twenty, a collection of portraits which displays with unique completeness the history of American painting from its beginning until well into the nineteenth century. Particularly notable are three portraits of Washington painted from life, and the remarkable group of twenty-nine Stuarts, unequalled even in a public collection. He also assembled a very fine collection of Chinese porcelains. For nine years he was president of the New York School of Applied Design. The Clarke prize, given annually at the National Academy of Design, was endowed by him.

CLARKE, Thomas Shields [S,P] Lenox, MA b. 25 Ap 1860, Pittsburgh, PA d. 15 N 1920. Studied: Ecole des Beaux-Arts, Paris; Rome; Florence. Member: NSS, 1893; Arch. Lg., 1898; ANA, 1902; NAC; Century Assoc. Work: PAFA; Supreme Court, New York; Golden Gate Park, San. Fran. [19]

CLARKE, Una C. See Hunt, A.P., Mrs.

CLARKSON, Helen Shelton (Mrs. Banyer Clarkson) [P] NYC [10]

CLARKSON, John D. [P,Des,T,I] Pittsburgh, PA b. 25 Ja 1916, Pittsburgh. Studied: CI. Member: Assoc. A. Pittsburgh; Pittsburgh A. Lg.; Pittsburgh WC Soc. Exhibited: Butler AI, 1946; Assoc. A. Pittsburgh, 1943-46; Pittsburgh A. Lg., 1946; Pittsburgh WC Soc., 1946; CI, 1945, 1946. Position: T., Pittsburgh AI [47]

CLARKSON, Ralph [Por.P,T] Chicago, IL/Oregon, IL b. 3 Ag 1861, Amesbury, MA d. 5 Ap 1942, Orlando, FL. Studied: BMFA Sch.; Académie Julian, Paris, with Lefebvre, Boulanger. Member: ANA, 1910; Chicago SA; Municipal Art Lg., Chicago; NYWCC; Port. Painters: Chicago WCC; Chicago PS; Municipal Art Commission, Chicago; State Art Commission; Chicago AC. Exhibited: AIC, 1919 (prize). Work: AIC. Award: hors concours, P.-P. Expo, San Fran., 1915. Position: AIC [40]

CLASGENS, Frederic [S] Paris, France. Studied: Verlet, Laurens, in Paris [17]

CLASPER, Louise Crosbie [P] Chicago, IL [19]

CLAUS, May Austin (Mrs. W.A.J.) [P] Boston, MA/Provincetown, MA b. 18 Ag 1882, Berlin, NY. Studied: BMFA Sch.; W.A.J. Claus. Member: Pa. Soc. Min. P. [29]

CLAUS, W(illiam) A.J. [Por.P] b. 14 Je 1862, Maintz, Germany. Studied: Grundmann, Boston; Académie Julian, Paris; Henri Quyton, in Belgium. Work: Boston AC; State House, N.E. Conservatory Music, Church of St. Francis de Salesall in Boston; Potsdam Col. Position: Dir., Claus A. Sch. [31]

CLAUSEN, A.R.L. [P] Columbus, OH. Member: Columbus PPC [25]

CLAVERLEY, Charles [S] NYC. Studied: Palmer. Member: NA, 1875; U.S. Public AL, 1897 [01]

CLAWSON, Arthur J., Mrs. See Burgess, Marguerite.

CLAWSON, Charles Howard [P] Richmond, IN. Member: Cincinnati AC [21]

CLAWSON, John Willard [Por.P] b. 1858, Salt Lake City, UT d. 1936, Salt Lake City. Studied: G. Ottinger (a pioneer Utah painter); NAD, 1880-83;

Académie Julian, Paris. Founder/Member: Soc. Utah Ar., ca. 1896. His studio and paintings (in San Fran.) were destroyed by fire, 1906. He moved to Los Angeles, NYC, and then Salt Lake City. [10]

CLAWSON, W.R. [P,T] Cincinnati, OH b. 16 Ja 1885, Eaton, OH d. 1927. Studied: T.C. Lindsey. Member: Cincinnati AC [27]

CLAXTON, Virgie [P] Houston, TX b. 20 Jy 1883, Gatesville, TX. Studied: Emil Bistran; A. Lhote. Member: Mus. FA, Houston; Tex. FA Assoc.; SSAL; Palette and Chisel Cl., San Antonio [40]

CLAXTON, William Rockliff [Des,I,P,Car] Darien, CT b. 13 Jy 1903, NYC. Studied: ASL; Grand Central A. Sch.; John Hopkins A. Sch., San Fran. Member: SI. Positions: A. Dir., Ruthrauff & Ryan, 1942–45, Lambert & Feasley, Inc., NYC, 1945– [47]

CLAY, Alice Hay (Mrs. Randolph) [Min.P] London, England/New Castle, DE b. Chicago. Studied: AIC; Acad. Delecluse, Paris [13]

CLAY, John Cecil [I,C] Mamaroneck, NY b. 2 Ap 1875, Ronceverte, WV d. 24 My 1930. Studied: Mowbray; ASL, Wash., D.C. After his retirement he sold a Button Gwinnet autograph for $51,000, the record price for this signature of one of the Georgia signers of the Declaration of Independence. It was on a document addressed in 1776 to one of Mr. Clay's ancestors. [15]

CLAY, Mary F.R. (Mrs.) [P] Bar Harbor, ME d. 20 My 1939. Member: F., PAFA; NAWPS; North Shore AA; Plastic Cl. Exhibited: NAD, 1923 (prize); AIC, 1925 (prize); PAFA, 1900 (prize) [38]

CLAY, William [Ldscp.P] b. 1861 d. 31 D 1911, New York

CLAYTER, Frederick [P] Pittsburgh, PA. Member: Pittsburgh AA [21]

CLAYTON, Alexander Benjamin [P] Chevy Chase, MD b. 16 Mr 1906, Chevy Chase. Studied: R.S. Meryman; Karl Knaths; Burtis Baker. Member: Wash. SA. Exhibited: Wash. SA, 1938 (prize); 48 Sts. Comp., 1939; Tricker Gal., New York, 1939 (one-man). Work: USPOs, Elkton, Md., St. Marys, W.Va.; Cornell Med. Col. WPA artist. Position: T., Chalet Non Pareil Gal. Sch., Bethesda, Md. [40]

CLEAR, Betty Thompson [S] Alexandria, VA b. 19 D 1913, Clarion, IA. Studied: J. Maxwell Miller; Corcoran Sch. A.; Merrill Gage; Chouinard Sch. A.; William M. Simpson; Rinehart Sch. S. Exhibited: S. Wash. A., CGA, 1937 (med) [40]

CLEAR, Charles Val [Mus.Dir,Ed,Des,C,P,L] Akron, OH b. Albion, IN d. ca. 1967. Studied: John Herron A. Sch.; Ind. Univ.; Corcoran Sch. A.; Fla. Southern Col.; Myra Richards; Seth Velsey; J. Maxwell Miller; Oakley Ritchie; William Forsyth. Member: AFA; Indianapolis AA; John Herron AI; S. Wash. A.; Wash. Ldscp. Cl. Work: Soc. Wash. A.; PMG; John Herron AI; Mt. Ranier Pub. Lib. Positions: Dir., Oreg. Art Centers, 1940, Akron AI, 1945– [47]

CLEARY, Fritz [S,L] Interlaken, NJ b. 26 S 1913, Brooklyn, NY. Studied: NAD; BAID. Member: Clay Cl., N.Y.; Am. Ar. Prof. Lg. Exhibited: Springlake Exh., Am. Ar. Prof. Lg., 1938 (prize), 1939 (prize) [40]

CLEAVER, Alice [P,T] Falls City, NE b. 11 Ap 1878, Racine, Wis. Studied: Vanderpoel; Chase; Beaux; Biloul; Lucien Simon, in Paris. Member: Lincoln AG; Omaha Soc. FA. Exhibited: Omaha Soc. FA, 1922 (prize) [31]

CLEAVER, Clyde Perdue [Tile Des] Lansdale, PA b. 26 D 1903, Unionville, PA. Studied: PMSchIA. Position: Chief des., Franklin Tile Co., Lansdale [40]

CLEAVER, Mildred Day (Mrs. Chester H.) [S] West Deal, NJ b. 7 N 1888, Newark, NJ. Studied: Norton Sch. A.; Genevieve Karr Hamlin. Member: Palm Beach A. Lg.; AAPL. Exhibited: Palm Beach A. Lg., 1944–46 [47]

CLEAVES, Helen E. [P,C] Medford, MA b. 17 S 1878, Rockford, IL. Studied: C.H. Woodbury; E.L. Major; Gustave Rogers. Member: Arts & Crafts Soc., Marblehead. Position: Asst. to Dir., Drawing and Manual Training, Boston Pub. Sch. [10]

CLEAVES, Muriel Mattocks (Mrs. H.) [I,P,T] Staten Island, NY b. Hastings, NE d. Je 1947. Studied: Univ. Mo; AIC, with Birger Sandzen; M.C. Carr; John S. Ankeney. Member: Staten Island AA; Staten Island Inst. A.&Sc. Exhibited: Pueblo, 1922 (prizes); Kansas City AI, 1923 (prize); Honolulu Acad. A., 1924; San Diego FA Soc., 1921; Staten Island AA, 1930–46. Illustrator: "A Child's Book of Verse," 1920, other books. Contributor: children's magazines [47]

CLEELAND, David [P] Redmond, WA [24]

CLEGG, Ernest [Cartog,P,Des,Ill] Bournemouth, England b. 26 D 1876, Birmingham, England. Studied: Birmingham (England) Sch. A. Member: A. Gld. Work: maps, Ticonderoga battlefields (in N.Y. State Hist. Soc. Mus., Ticonderoga), Lindbergh's flights, (pub. John Day Co.), 100 miles around Wash., D.C., commemorating Bi-Centenary of George Washington (for Washington Cathedral), county maps of Great Britain (in "Countryman"); Map of Yacht Races, 1934 [47]

CLELAND, M. Alberta (Miss) [P] Montreal, Quebec [01]

CLELAND, T(homas) M(aitland) [I,L,Des,P,C,W] Danbury, CT b. 18 Ag 1880, Brooklyn, NY d. 9 N 1964. Member: Arch. Lg.; SI; Boston Soc. A.&Crafts; AIGA; SC; Century Cl. Exhibited: Boston Soc. A.&Crafts, 1920 (med); AIGA, 1921 (med), 1940 (med); A. Dir. Cl., 1940. Author/Illustrator: "Harsh Words," 1940. Illustrator: "Jonathan Wild," 1943, other books. Lectures: Book Decoration [47]

CLEMENS, Paul Lewis [P,L] Milwaukee, WI b. 29 O 1911, Superior WI. Studied: Oscar Hagen; Univ. Wis.; AIC. Member: Wis. PS. Exhibited: Wis. Salon A., Madison, 1935 (prize), 1936 (prize); Milwaukee AI, 1936 (prize); AIC; Albright A. Gal; CGA. Work: U.S. War Dept.; Milwaukee AI; Butler AI [40]

CLEMENT, Carl F. [I] NYC [19]

CLEMENT, Catherine [P] Portland, OR [15]

CLEMENT, Edward H(enry) [P,W] Concord, MA b. 19 Ap 1843, Chelsea, MA. Studied: Boston Art Students' Assoc.; New Sch.; Louis Kronberg. Position: Ed. in Chief, Boston Transcript, 1881–1906 [21]

CLEMENT, Helen Barbara [Cr,P,C,Des] Piedmont, CA b. 18 Mr 1912, Berkeley, CA. Studied: Univ. Calif.; Calif. Sch. FA, with Blanch, Labaudt, Stackpole. Exhibited: San Fran. AA, 1940. Work: Coit Tower, San Fran. Position: Cr./A. Ed., Oakland Tribune, 1942–46 [47]

CLEMENT, Joseph M. [I] Chester Springs, PA b. 20 Je 1894, England. Illustrator: Collier's, Red Book, This Week, New York Herald-Tribune [40]

CLEMENT, Walter M. [P] Phila., PA [13]

CLEMENTS, Gabrielle de Veaux [P,E,Dec] Gloucester, MA b. 1858, Phila. Studied: Robert-Fleury, Bouguereau, in Paris. Member: F., PAFA; Chicago SE; North Shore AA; Charleston EC; S. Wash. A.; Wash. WCC. Exhibited: PAFA, 1895 (prize). Work: St. Patrick's Church, Wash., D.C.; St. Paul's Chapel, Baltimore; St. Matthews Church, Sparrow Point, Md.; Trinity Church, Towson, Md.; St. Joseph's Church, Detroit; Speed Mem. Mus., Louisville, Ky.; LOC; Nat. Mus., Wash., D.C. Companion of Ellen Day Hale. [40]

CLEMENTS, George H(enry) [P] NYC b. 1854, Sacramento, CA d. 16 D 1935, Oberlin, LA. Studied: Paris for 15 yrs., after living in New Orleans. Member: NYWCC; Boston SWCP; Boston WCC; SC, 1904. Position: T., Boston (probably BMFA Sch.) [33]

CLEMENTS, Grace [G,P] Los Angeles, CA. Exhibited: WFNY, 1939. Work: Mills Col. [40]

CLEMENTS, Rosalie [P] Hopewell Junction, NY b. 5 Ja 1878, Wash., D.C. Studied: E.F. Andrews; F.L. Mora; T. Fogarty. Member: PBC; S.Indp.A. [33]

CLEMENTS, Ruth Syphard [P,I] Wilmington, DE b. Arlington, VA. Studied: Corcoran Sch.; Drexel Inst., Phila. [13]

CLEMMITT, Mary [P] Baltimore, MD [25]

CLENDENIN, Eve [P] NYC b. 4 My 1900, Baltimore. Studied: Oxford; Sorbonne; Banff Sch. FA, with H.G. Glyde; Eliot O'Hara; Ralph Pierson. Exhibited: Argent Gal., 1945 (one-man); Provincetown AA, 1946; Vose Gal., Boston, 1946; Jacques Seligmann Gal, 1946 [47]

CLEPHANE, Lewis Painter [P] Coral Gables, FL b. 8 F 1869, Wash., D.C. Studied: Birge Harrison; Alexander Robinson, in Holland. Member: S. Wash. A.; Wash. AC; S.Indp.A.; AAPL; Fla. Fed. A.; Blue Dome Fellowship [40]

CLEPHANE, Rosebud [P,T] Coral Gables, FL b. 12 N 1898, Atlanta, GA. Studied: George Washington Univ.; Corcoran Sch. A.; Hawthorne; Adams. Member: Palm Beach A. Lg.; Blue Dome Fellowship, Miami. Exhibited: Fla. Fed. A., 1936 (prize); Lg. Am. Pen Women, 1939; Palm Beach AA, 1940 (prize); Soc. Wash. A.; CGA; Wash. A. Cl.; Adirondacks AA; Four Arts Gal.; Ringling Mus. A.; Miami Beach A. Gal. Work: Children's Home, Miami [47]

CLERE, Hazel [S] NYC b. Syracuse, NY. Studied: Syracuse Univ.; Europe; ASL; Columbia. Work: Nat. Cathedral, Wash., D.C.; churches, Brooklyn, Astoria, Flushing, all in N.Y., Detroit, Mich.; Cardinal Hayes Mem., Monticello, N.Y.; Sheridan Square Bldg., N.Y.; USPOs, Glen Cove, N.Y., Bloomfield, N.J., Everett, Pa. WPA artist. [47]

CLERE, Vera [P,I] NYC/Syracuse, NY b. Syracuse. Studied: Luks; Gruger [25]

CLEVELAND, Margaret [P] Chicago, IL. Member: AG of Authors Lg. [25]

CLEVELAND, Walter G. [P,I] Wash., D.C. [13]

CLEWELL, Charles Walter [C,Des] Canton, OH b. 2 Mr 1876, Canton. Studied: Ohio Northern Univ. Member: Canton AI; Boston SAC; AFA. Exhibited: Paris Salon, 1937 (med); AFA Traveling Exh.; BMA; Newark Mus.; Detroit Inst. A.; Dayton AI; AIC; CM; PAFA. Work: Newark Mus.; Dayton AI. Patinator of bronze. [47]

CLEWS, Henry, Jr. [P,S] NYC b. 1876 d. 29 Jy 1937, Lausanne, Switzerland. Studied: Amherst Col.; Rodin, in Paris. Lived in Europe from 1911 to 1937; his home was near Cannes, France. [17]

CLIFFORD, Chandler R. b. 1858, Boston d. Spring, 1935, New York. He contributed articles on decorating and antiques to the New York Herald Tribune, Saturday Evening Post, and other publications. He served on international juries of several expos, was founder of the American Association of Interior Decorators, and chairman of the Design Registration.

CLIFFORD, John Henry [G] New Bedford, MA/South Dartmouth, MA b. 7 My 1879, New Bedford. Studied: Swain Sch. Des., New Bedford. Member: New Bedford S.Indp.A. Exhibited: Soc. Am. E., 1932, 1934; Intl. Pr. AI Cl., 1934; Currier Gal., Manchester, N.H.; Denver AM [40]

CLIFFORD, Lois Irene [C,T,L] Pittsburgh, PA b. 15 D 1892, Providence, RI. Studied: CI; Penland Inst.; Florence Newcomer. Member: Weaver's Gld., Craftsmen's Gld., A.&Crafts Center, all of Pittsburgh. Exhibited: Contemporary Am. Handwoven Textiles Exh., 1945, 1946; Women's Intl. Inst., N.Y., 1941; Phila. A. All., 1946; Assoc. A. Pittsburgh, 1938–41; St. Louis Weaver's Gld., 1942; Pittsburgh Weaver's Gld.; Pittsburgh Craftsmen's Gld. Lectures: Weaving, Crafts. Position: Occupational Dir., West Pa. Sch. for the Blind, Pittsburgh, 1930– [47]

CLIFFORD, William [Lib] b. 1858 d. 16 Mr 1942, NYC. He was the first MMA librarian and served 49 years, retiring in May 1941.

CLIFTON, Adele R(ollins) (Mrs. Henry) [P,I,E,W,T] Phila., PA/Whitefield, NH b. 27 Jy 1875, Brooklyn, NY. Studied: A.W. Dow; Chase. Member: Plastic Cl.; Phila. All. [33]

CLIME, Winfield Scott [P,E,] Old Lyme, CT b. 7 N 1881, Phila. d. 13 Mr 1958. Studied: Corcoran Sch. A.; ASL; George Washington Univ.; Bridgman; Luks; Pennell; DuMond. Member: SC; All.A.Am.; AAPL; Lyme AA; New Haven PCC; Meriden AA; Soc. Wash. A.; Wash. WCC; Conn. Acad. FA; NAC; Tiffany Fnd.; Brooklyn AA. Exhibited: Conn. Acad. FA (prize); Lyme AA (prize); Palm Beach AA (prize); Ldscp. Cl., Wash. (prize); Lyman Allyn Mus. A. (prize); P.-P. Expo, 1915 (med); Soc. Four Arts, Palm Beach (med); NAD; PAFA; AIC; CGA; New Haven PCC; Meriden AA; Old Lyme AA. Work: Los Angeles Mus. A.; Montclair A. Mus.; Lyman Allyn Mus. A.; Peabody Mus. [47]

CLINEDINST, B(enjamin) West [I,P,T] Pawling, NY b. 14 O 1859, Woodstock, VA d. 12 S 1931. Studied: Cabanel, Bonnât, in Paris; Ecole des Beaux Arts, Paris. Member: ANA, 1894; NA, 1898; SAA, 1891; AWCS; Century Assoc. Exhibited: AWCS, 1900 (prize); Pan-Am. Expo, Buffalo, 1901 (med); Charleston Expo, 1902 (med). Specialties: genre, battle, prominent men [29]

CLINEDINST, M(ay) S(pear) [P,T] Brooklyn, NY. b. 12 Ag 1887, Brooklyn d. ca. 1960. Studied: Cornell; Brooklyn Inst. A.&Sc.; J. Carlson; Stanley Woodward; Anthony Thieme; A. Guptill; J. Koopman; Breen; E. Gruppe; F. Mulhaupt. Member: Gloucester Soc.; NAWA; AAPL; North Shore AA; Brooklyn SA; Ridgewood AA; Catherine Lorillard Wolfe AC. Exhibited: CGA, 1941; AWCS, 1944; All.A.Am., 1937–42; NAWA, 1940, 1941, 1942, 1944, 1946; BM, 1942–45; Brooklyn SA, 1938–41; North Shore AA, 1935–45; Ridgewood AA; Sarasota AA; Ogunquit AA; Wolfe AC [47]

CLINKER, L.C. [P] Cleveland, OH. Member: Cleveland SA [25]

CLIREHUGH, A. La V. [P,I,T] NYC. Studied: NAD [10]

CLISBEE, George H.H.H. [I,W] b. 1895, Chicago d. 5 D 1936, Westport, CT. Studied: Académie Julian, Paris. Illustrator: popular magazines. Position: A. Ed., Cleveland Daily News, 1919–26

CLISE, Jocelyn [En,Li,P] Seattle, WA b. 4 Ag 1923, Seattle. Studied: Univ. Wash.; Cornish Sch., with Amelio Amero. Exhibited: LOC, 1946; Phila. Pr. Cl., 1946; Northwest Pr.M., 1945 [47]

CLIVETTE, Merton [P,S,E,W,L,T] NYC/Stamford, CT b. 11 Je 1868, Wisconsin d. 8 My 1931. Studied: Chase; La Farge; Twachtman; ASL; Rodin, in Paris [29]

CLOETINGH, James H. [P,Des] South Bend, IN b. 3 Jy 1894, Muskegan, MI. Studied: Raymond Weir, in England; Harry Muir Kurtzworth, Emil Jacques, in Belgium. Member: AAPL. Exhibited: Hoosier Salon, 1934, 1939–41; Northern Ind. A., 1940, 1941; Hackley A. Gal., 1943 (one-man); Wawasee A. Gal., 1938–40 [47]

CLOGSTON, Evelyn Belle [P,T] Portland, OR b. 12 Je 1906, Pomona, CA. Studied: Steinhof; Douglas Donaldson; Roscoe Schrader; Edouard Vysekal. Member: AAPL. Exhibited: Oreg. Chap., AAPL, 1932 (prize), 1933 (prize), 1934 (prizes), 1935 (prizes), 1936 (prizes); State Fair, Salem, Oreg., 1934, (prizes), 1936 (prizes); Minn. State Fair, 1937 (prize), 1938 (prize) [40]

CLOPATH, Henriette [P,W,L,T] Tulsa, OK b. Switzerland. Member: Okla. AA. Exhibited: Univ. Okla., 1916 (gold). Lectures: Modern Painting [27]

CLOSE, Dean Purdy [P] Columbus, OH b. 15 Ag 1905, Holmesville, OH. Studied: C.M. DuVall; Ohio State Univ. Member: Columbus A. Lg., Pen & Pencil Cl. Exhibited: Columbus Gal. FA, 1937–39, 1940 (prize), 1941–46; Butler AI [47]

CLOSE, May Lewis [Por.P] Brooklyn, NY b. 18 Ja 1886, Brooklyn. Studied: J.H. Boston [15]

CLOSSON, William B(axter) (Palmer) [P,Wood En] Newton, MA/Magnolia, MA b. 13 O 1848, Thetford, VT d. My 1926. Studied: Lowell Inst., Boston. Member: Boston AC; Copley S.; S. Wash. A.; Wash. AC; Conn. Acad. FA; All. AA; AI Graphic A.; Union Internationale des Beaux-Arts et des Lettres; NAC; Lg. AA. Exhibited: Mass. Charitable Mechanics Assoc. (medals); Paris Salon, 1882 (med); Columbian Expo, Chicago, 1893 (med); Graphic Arts Expo, Vienna (prize); Pan-Am. Expo, Buffalo, 1901 (med); St. Louis Expo, 1904. Work: NGA; BMFA; NYPL; Worcester AM; Springfield (Mass.) Pub. Lib.; CI; Herron AI, Indianapolis; Albright Ar. Gal., Buffalo. Work: NGA; Gallaudet Col.; Nat. Arts Cl., New York [24]

CLOUGH, George L. [Ldscp.P] b. 18 S 1824, Auburn, NY d. 20 F 1901, Auburn. Studied: Charles L. Elliott, 1844–ca. 1849; Europe, 1850. Member: Art Cl., Brooklyn

CLOUGH, Jane B. [S] Kansas City, MO b. 30 Mr 1881, Chicago. Studied: Solon Borglum; Mahonri Young; J.E. and Laura Fraser; Anna V. Hyatt. Member: NSS; Kansas City SA [33]

CLOUGH, Jessie L. [P] Richmond Hill, NY [15]

CLOUGH, Stanley T(homas) [P,Li,I,T] Mentor, OH b. 11 My 1905, Cleveland, OH. Studied: Cleveland Sch. A.; John Huntington Polytechnic Inst. Member: Cleveland P. M. Exhibited: CMA, 1928 (prize), 1929 (prize), 1930 (prize), 1935 (prizes), 1939 (prize). Work: Cleveland Pub. Auditorium [40]

CLOUGH, Thomas [P] Cleveland, OH. Member: Cleveland SA [25]

CLOVER, Philip [Por.P] b. 1842 d. 1905. Formerly of Columbus, Ohio, he painted many portraits of Chicago politicians. His sensational "Fatima" was exhibited all over the country.

CLOVER-BEW, (Mattie) May (Mick) [S,P] San Fran., CA b. 17 Ag 1865, Indianapolis, IN. Studied: Robert Aitken; L.P. Latimer; G. Cadanasso; Karl Bitter. Member: San Fran. Soc. Women A.; Ind. A. Cl. Exhibited: John Herron AI, 1919, 1920, 1921; Ind. State Fair, 1921 [47]

CLUBB, John Scott [Car] Rochester, NY b. 29 Ap 1875, Hall's Corners, NY d. 28 Ja 1934. Studied: Cincinnati A. Acad; ASL. Creator: "Joel Baggs, He Sez, Sez He." Positions: Car., Rochester Herald; Staff, Rochester Times-Union, 1926–

CLUFF, Warren Y. [I] Brooklyn, NY [10]

CLUNIE, Robert [P] Bishop, CA b. 29 Je 1895, Eaglesham, Scotland. Studied: Scotland. Member: Calif. AC; Grand Teton AA. Exhibited: Acad. Western P., 1936 (prize), 1937 (prize); Gardena (Calif.) ann. exh., 1936 (prize); Calif. State Fair, 1938 (prize). Work: Ogden, Utah; Heyburn, Idaho [47]

CLUSMANN, William [P] Chicago, IL b. 1859, North Laporte, IN d. 28 S 1927. Studied: Royal Acad., Munich, with Benczur. Member: Chicago SA; Chicago WCC; Chicago PS; Hoosier Salon; Chicago Gal. Assn. Exhibited: Stuttgart, Germany, 1884 (prize); AIC, 1913 (prize), 1919 (prize) [25]

CLUTE, Beulah Mitchell (Mrs. Walter Marshall) [P,I,L] Berkeley, CA b. 24 Mr 1873, Rushville, IL. Studied: ASL; AI Chicago. Member: Ar. Gld., Chicago; Calif. Book Plate Soc. Specialty: bookplates, illuminated parchments. Position: Des., The Three Redwoods Studio, Berkeley [33]

CLUTE, Carrie (Elisabeth) [P,E,T] NYC/Rhinebeck, NY b. 3 Jy 1890, Schenectady, NY. Studied: Henry B. Snell. Member: AWCS; PBC; NAWPS. Exhibited: NYWCC, 1929 (prize); PBC, 1931 [40]

CLUTE, Walter Marshall [P,I,T,L] Park Ridge, IL b. 9 Ja 1870, Schenectady, NY d. 13 F 1915, North Cucamonga, CA. Studied: ASL; Constant, Prinet, Laurens, in Paris. Member: ASL; Charcoal Cl., Buffalo; Palette & Chisel Cl., Chicago; Chicago SA; Paris AAA; SWA; ASL, Chicago. Exhibited: AIC, 1910 (prize). Positions: T., AIC; Hd., Park Ridge Summer Sch. P. [13]

CLYMER, Edwin Swift [P] Gloucester, MA b. Cincinnati, OH. Studied: PAFA. Member: Phila. Sketch Cl.; Phila. WCC. Work: Mus. A., Reading, Pa. [40]

CLYMER, J(ames) Floyd [P] Provincetown, MA b. 31 Mr 1893, Perkasie, PA. Member: Provincetown AA; Beachcombers' Cl. [40]

COADY, Robert J. [P] NYC b. 1881, NYC d. 6 Ja 1921. Studied: Paris. Member: SC, 1908. Editor: art magazine "The Sail" [19]

COALE, Donald V(incent) [P,T] Greenbelt, MD b. 27 Ap 1906, Baltimore. Studied: John Sloan; Leon Kroll; Henry Boben; Despuglio; Md. Inst.; Fontainebleau Sch. FA. Exhibited: Municipal A. Soc, Baltimore (prize); Evening Sun Sketh Contest, 1928 (prize), 1930 (prize), 1931 (prize); Ldscp., Soc. Wash. Ar., 1939 (med), 1940 (med). Position: Dir., Coale Sch. Art, Baltimore [40]

COALE, Griffith Baily [P] NYC/Stonington, CT b. 21 My 1890, Baltimore. Studied: M. Heymann, in Munich; Richard Miller, Laparra, in Paris; Italy; Spain. Member: Ship Model S., N.Y.; R.I. Ship Model S.; Mural P. Work: Md. Hist. Soc., Johns Hopkins Univ.; N.Y. Athletic Cl.; Lee Higginson & Co.; City Bank Farmers Trust, N.Y.; N.Y. Trust Co.; Dry Dock Savings Inst.; Brooklyn Borough Gas Co.; Columbia; Railroad, Crosley Bldgs.; WFNY, 1939; murals, pub. bldgs., N.Y. [40]

COALE, Walter Irving [P] Hollins Station, MD [13]

COAN, C. Arthur [P,W,L] Nyack, NY b. 16 D 1867, Ottawa, IL. Author: "History of an Appearance," "Southumberland's Yule Tide," "The Fragrant Note Book," "Proportional Form," other books. Lecturer: art, archaeology [29]

COAN, Frances C. [P,I] Nyack, NY b. East Orange, NJ. Studied: H.B. Snell; E.M. Scott; Metropolitan A. Sch. Illustrator: "The Fragrant Note Book," other books. Designer/Painter: stage settings [31]

COAN, Helen E. [B,I,P] Los Angeles, CA b. Byron, NY. Studied: ASL; F. Freer; W.M. Chase. Member: Los Angeles AL; Municipal AL. Exhibited: Alaska-Yukon-Pacific Expo, Seattle, 1909 (meds); San Diego Expo, 1915 (med). Work: Capistrano Mission; Calif. D.A.R. [40]

COAST, Oscar R. [P] Santa Barbara, CA (in Calif. since 1894, although Iowa City was his legal residence) b. 1851, Salem, OR d. 28 F 1931. Studied: Yewell; T. Hickes; Faller; Paris; Rome. Member: SC, 1897; Wash. AC; Santa Barbara AC; AFA. Exhibited: Columbia Expo, 1893. Specialty: desert landscapes [29]

COATE, H.W. [P] NYC b. Ogden, OH. Studied: Delecluse, in Paris [15]

COATES, Edward Hornor b. 1846 d. 23 D 1921, Phila. Member: PAFA

COATES, Hilda. See Altschule.

COATES, Minnie Darlington [P] Phila., PA. Member: F., PAFA [25]

COATES, Palgrave Holmes [P,I,T] San Fran., CA/Manhattan Beach, CA b. 20 Ap 1911. Studied: Chouinard AI, Los Angeles. Exhibited: Los Angeles County Fair, 1935 (prize). Work: Yellowstone Nat. Park; Los Angeles A. Assn.; Los Angeles County Mus.; FA Gal., San Diego [40]

COATES, Robert M. [W,Cr] Bayside, NY b. 6 Ap 1897, New Haven, CT. Studied: Yale. Position: A. Cr., New Yorker [47]

COATS, Claude [Mur.P] Los Angeles, CA b. 17 Ja 1913, San Fran. Studied: M. Sheets; P. Sample; Univ. Southern Calif. Member: Calif. WCS; Delta Phi Delta. Exhibited: Los Angeles Mus. A., 1934 (prize); Nat. Scarab Sketch, 1934 (prize). Work: Univ. Southern Calif. Position: motion picture sketch artist [40]

COATS, Randolph [P,Li] Indianapolis, IN b. 14 S 1891, Richmond, IN. Studied: J.R. Hopkins; Duveneck. Member: Ind. AC; MacDowell Soc.; Beachcombers; Cincinnati Art C. Exhibited: Hoosier Salon, 1924 (prize), 1925 (prize), 1927 (prize), 1928 (prize); Chicago Gal. Assoc., 1928 (prize). Work: Richmond (Ind.) AA; John Herron Art Inst.; A. Assoc., Gary, Ind. [40]

COBB, Arthur Murray (Mrs.) [P] Plainfield, NJ. Member: Women's AC

COBB, Cyrus [S,P,L] Boston, MA b. 6 Ag 1834, Malden, MA d. 29 Ja 1903, Allston, MA. Studied: J.A. Jackson. Member: BAC. Work: Soldiers' Mon., Cambridge Common. He was a musician; also practiced law, Boston 1869-79. His twin brother Darius, with whom he collaborated, was a noted painter. [98]

COBB, Darius [P,W,L] Newton Upper Falls, MA b. 6 Ag 1834, Malden, MA d. 23 Ap 1919. Studied: E.M. Judkins; W. Allston; G. Inness. Work: Nat. D.A.R., Wash., D.C.; Mass. Ancients & Honorables; Capitol, N.H.; Capitol, Mass. He served throughout the Civil War with the 44th Mass. Volunteers. His best-known work was "The Master," a head of Christ, on which he had worked for almost fifty years. Twin of Cyrus, sculptor. Position: A. Cr., The Boston Traveler [17]

COBB, Ethelyn Pratt [P] Buffalo, NY [21]

COBB, Henry Ives [Arch] NYC b. 19 Ag 1859, Brookline, MA d. 27 Mr 1931. Studied: MIT; Harvard. Work: World's Columbian Expo, Chicago, 1892; Fed. Bldg., Chicago; League Island Bldg.; Annapolis; Chicago Opera House; Chicago Athletic C.; Newberry Library; Univ. Chicago. One of first to use steel in the construction of tall buildings.

COBB, Kate McKinley (Mrs.) [P,B,C,T] Athens, GA b. 8 O 1888, Athens. Studied: Ga. State Col. for Women; Univ. Ga. Member: SSAL; Ga. AA; Athens AA; Southern PM Soc. Exhibited: Southern PM Soc., 1937 (prize) (prize) [40]

COBB, Katharine M. (Mrs.) [P] Syracuse, NY b. 5 Ja 1873, Syracuse. Studied: C. Hawthorne; Carlson; Webster. Member: PBC; Assoc. Ar., Syracuse (founder); Orlando AA [40]

COBHAM, Ethel Rundquist [I] NYC b. Minneapolis. Studied: AIC. Member: Gld. Freelance A. Work: covers, Vogue, Vanity Fair, Colliers, Sunset, McCalls, American [47]

COBURN, Alvin Langdon [Photogr] Wales b. 1882, Boston d. 1966. Encouraged to become a photographer by his cousin, F.H. Day, 1898. A pictorialist who late in life became a Vorticist. Member: Photogr. Sec., 1902; Linked Ring, 1903; Royal Photogr. Soc., 1931. Exhibited: Royal Photogr. Soc., London, 1900, 1906, 1957, 1973; NYC studio, 1902. Work: IMP. Illustrator: "London," 1909, "New York," 1910, "Men of Mark," 1913 [*]

COBURN, Frederick William [W,L,Cr] Lowell, MA b. 6 Ag 1870, Nashua, NH d. 14 D 1953. Studied: Harvard; Cornell; ASL, Wash., D.C.; ASL, N.Y. Member: Copley Soc.; Lowell AA; Lowell Hist. Soc.; Merrimack Valley AA. Contributor: art magazines; Dictionary American Biography. Position: Associated with Lowell (Mass.) Hist. Soc., 1936- [47]

COBURN, Julia L. [P] Concord, MA Member: Concord AA [25]

COBURN, Lewis Larned (Mrs.) [Patron] d. 31 My 1932, Chicago. Her private collection included fine examples of the works of Renoir, Monet, Manet, Degas, Cézanne, Gauguin, Van Gogh and Picasso. By her will the AIC received twenty-three French paintings, fifty watercolors and a trust; Fogg Art Mus., Harvard, received ten; Smith Col., nine.

COBURN, Ruth Winoma [Edu] Burlington, VT b. 3 Jy 1904, St. Albans, VT. Studied: Mass. Sch. A.; Univ. Vt.; B. Miller. Member: Eastern AA. Positions: Supv., A. Edu., N.H. and Vt., 1927-45; State Dir., A&Cr., Vt., 1945- [47]

COCHRAN, Allen D. [P] Woodstock, NY b. 23 O 1888, Cincinnati. Studied: K. Cox; B. Harrison. Member: SC [33]

COCHRAN, Barbara [P] Meadville, PA [19]

COCHRAN, Dewees (Mrs. D.C. Helbeck) [C,Des,P,S,T] Norwich, VT b. 12 Apr 1902, Dallas. Studied: PMIASch; Univ. Pa.; PAFA; H. McCarter. Member: Am. Craftsmen's Edu. Council. Exhibited: Marie Sterner Gal., 1931; Phila. Pr. Cl., 1931. Contributor: Craft Horizons. Creator: "Portrait Doll." Positions: Des./Dir./T., Sch. Am. Craftsmen, Hanover, N.H., 1945- [47]

COCHRAN, George Dewar (Dr.) [Ldscp.P] NYC b. 1848 d. 11 N 1935

COCHRAN, Gifford A. [P] North Salem, NJ b. 4 D 1906. Studied: H. Stangl, Munich. Exhibited: WFNY, 1939 [40]

COCHRAN, J.T. [P] Chicago, IL. Member: GFLA [27]

COCHRANE, Constance [P,I] Upper Darby, PA/Monhegan Island, ME b. Pensacola, FL. Studied: E. Daingerfield, H.G. Snell. Member: AWCS; Phila. A. All.; NAWA; Phila. WCC; Wash., WCC; AAPL; Ten Phila. P. Work: Benjamin West Soc., Swarthmore, Pa.; Phila. A. All.; Navy Dept., Wash., D.C.; Allentown (Pa.) Mus.; State T. Col., West Chester, Pa.; Phila. Sch. Des. for Women [47]

COCHRANE, Doris [P] Wash., D.C. [25]

COCHRANE, Grace H.H. [I] Phila., PA b. 15 Je 1881, NYC. Studied: Drexel Inst., Phila.; H. Pyle [06]

COCHRANE, Josephine G. [P] Enfield, CT. Member: Nat. Assn. Women PS.; CAFA. Exhibited: Nat. Assn. Women PS, 1935-37 [40]

COCKCROFT, E. Verian [P,Des.,C] Rockland, NY b. Brooklyn, NY. Member: Am. Cer. Soc. Exhibited: Greenwich Flower Show, 1934 (prize); Fed. Garden Cl. Conn., 1935 (prize). Founder: Cockcroft Arts, Inc. [40]

COCKETT, Marguerite S. [S] Bryn Mawr, PA [17]

COCKING, Gretta [Edu,P] Spearfish, SD b. 11 Ag 1894, Mineral Point, WI. Studied: Univ. Nebr.; Univ. Oreg.; E. Steinhof. Member: Am. Assn. Univ. Women; S.Dak. Edu. Assn. Exhibited: Black Hills T. Col. (one-man); Rapid City AC (one-man); Lead A. Cl. (one-man); Belle Fourche AC, Mitchell, S.Dak. (one-man). Work: Univ. Oreg. Position: Hd. A. Dept., Black Hills T. Col. Spearfish, S.Dak. 1935- [47]

COCKRELL, Dura Brokaw (Mrs. E.R.) [Edu,W,L,P] Winslow Heights, AR b. 16 F 1877, Liscomb, IA. Studied: Drake Univ.; Tex. Christian Univ.; ASL; K.H. Miller; F.L. Mora; R. Henri; W.M. Chase. Exhibited: Women's Forum, 1919 (med); Dallas Mus. FA, 1926. Author: "Introduction to Art," 1930. Position: Hd. A. Dept., Williams Woods Col., Fulton, Mo., 1924-34 [47]

CODMAN, Edwin E. [P] Providence, RI. Member: Providence AC [25]

COE, Charles (Martin) [P] Cleveland Heights, OH b. 10 Jy 1902, Massillon, OH. Studied: H.G. Keller. Member: Cleveland SA. Exhibited: Cleveland A.&Cr., 1932 (prize), 1933 (prize); CMA [40]

COE, Ethel Louise [P,B,I,L,W,T] Evanston, IL b. Chicago d. 22 Mr 1938. Studied: AIC; Hawthorne; Sorolla. Member: Chicago PS; Evanston Univ. G. Exhibited: AIC, 1911 (prize). Work: Sioux City A. Mus.; Vanderpoel Coll.; Municipal A. Coll., Chicago; Kohler (Wis.) Gal. Position: Dir. A. Dept., Sarah Lawrence Col., 1931-38 [38]

COE, Helen A. [P] Newark, NJ [15]

COE, (Matchett) Herring [S] Beaumont, TX b. 22 Jy 1907, Loeb, TX. Studied: Lamar Col.; Cranbrook Acad. A.; C. Milles. Work: portrait busts, panels, statues, mem., Beaumont, Houston, Sabine Pass, New London [47]

COE, Lindsley, Julie [E] NYC [24]

COE, Lloyd [P] Deer Island, New Brunswick b. 23 Ag 1899, Edgartown, MA d. 1977. Studied: NAD; Metropolitan AS; G.P. Ennis [27]

COE, Richard Blauvelt [P,E] Baltimore, MD b. 27 F 1904, Selma, AL. Studied: BMFA Sch. Member: SSAL; Phila. SE; Wash. WCC; NOAA; Birmingham AC; Southern Pr.M. Exhibited: Houston Chamber Commerce, 1936 (prize); NOAA, 1937; SSAL, 1937; BMA. Work: Bar Lib., Birmingham, Ala.; Capitol, Montgomery, Ala. Position: State Dir. Art, WPA [47]

COE, Theodore (Demerest) [P] Tampa, FL b. 13 Ap 1866, Suffern, NY. Studied: NAD; Menard, Paris; Twachtman. Member: BAC. Exhibited: NAD; Phila. AC; SAA; Doll & Richards Gal., Boston 1920-26 (one-man); A. Center, N.Y., 1925-29 (one-man). Specialty: restorer [47]

COEN, Robert [P] Toledo, OH. Member: AWCS [47]

COES, Kent Day [I] Montclair, NJ b. 14 F 1910. Studied: ASL; Grand Central Sch. A. Member: NAC; N.J. WC; S. Soc; Montclair AA. Exhibited: NAC, 1932 (prize), 1934 (prize) [40]

COFFEE, Will [P] Phila., PA [19]

COFFEE, William J. [P] Phila., PA. Member: F., PAFA [25]

COFFEY, Mabel [P,E,W] NYC b. 22 My 1874, NYC d. 22 Mr 1949. Studied: ASL; Chase Sch. A; DuMond; Cox; Henri. Member: Chicago SE. Exhibited: NAD, 1911; S.Indp.A., 1940; NAC [47]

COFFIN, Elizabeth R. [P] Brooklyn, NY b. Brooklyn. Member: Brooklyn A. Gld. Exhibited: NAD, 1892 (prize)

COFFIN, Esther (Mrs.) [P] NYC Member: NYWCC [25]

COFFIN, George Albert [Mar.P] NYC b. 1856 d. 3 F 1922

COFFIN, Isabel C. [P] Summit, NJ b. Portland, ME d. O 1912

COFFIN, J. Edward [Car,W] Manchester, NH b. 1860, Minneapolis d. 19 My 1905. Contributor: newspapers

COFFIN, Robert M. [P] Columbus, OH Exhibited: 48 Sts. Comp. [40]

COFFIN, Robert P(eter) Tristram [B,Dr,I,P,W,T] Brunswick, ME b. 18 Mr 1892, Brunswick d. 1955. Studied: J.J. Lankes; Bowdoin. Author/Illustrator: essays, "A Book of Crowns and Cottages," 1925, "An Attic Room," 1929. Illustrator: "The Forum," "The Bookman," "The American Girl." Jacket designs: "Strange Holiness" (one of his books of poetry, Pulitzer prize, 1935); "John Dawn." End papers: "Lost Paradise." Positions: T. of English, Wells Col., Aurora, N.Y. (1921-26), Bowdoin, (1934-) [40]

COFFIN, Sarah Taber (Mrs. William H.) [P] Chestnut Hill, MA b. 1 Je 1844, Vassalboro, ME d. 16 Jy 1928. Studied: Rimmer; R.S. Gifford; W. Sartain; F. Duveneck; C. Woodbury; C.Y. Turner; R. Turner, in Boston.; ASL. Member: Copley S.; North Shore AA. Work: Moses Brown Sch., Providence

COFFIN, W. Haskell [I,P] NYC b. 1878, Charleston, SC d. 12 My 1941, St. Petersburg, FL. Studied: Corcoran Sch. A.; R. Hinckley; Laurens, in Paris. Member: SI. Exhibited: Cosmos C., Wash., D.C., 1806 (prize) [31]

COFFIN, William A(nderson) [Ldscp.P,W] NYC b. 31 Ja 1855, Allegheny, PA d. 26 O 1925. Studied: Bonnât, in Paris. Member: ANA, 1898; NA, 1912; SAA, 1886; Arch. Lg., 1888; Lotos C.; Soc. des Artistes Français, 1915; Soc. National des Beaux-Arts, 1915; Fraternité des Artistes, 1916; AFAS; Pan-Am. Expo, Buffalo, 1901. Exhibited: NAD, 1886 (prize); Paris Expo, 1889 (med); SAA, 1891 (prize); Phila. AC, 1898 (med); Charleston Expo, 1902 (med); St. Louis Expo, 1904 (med). Work: MMA; Buffalo FA Acad.; Nat. Gal., Wash. D.C.; Municipal A. Gal., Montclair, N.J.; Brooks Mem. A. Gal., Memphis; Yale. Award: Chevalier Legion of Honor, France, 1917 [24]

COFFIN, William Sloane b. 15 Ap 1879, New York d. 16 D 1933, New York. Studied: Yale. He was president of MMA when Michael Friedsam's art collection ($10,000,000) was acquired. Stressed that MMA was an essential part of the city's educational system.

COFFMAN, Page. See Cary.

COGGESHALL, John I. [P] b. 1856, Fall River, MA d. 8 Mr 1927, Lowell, MA. Member: Boston AC. Specialty: marine scenes

COGGESWELL, William [P] Beverly, RI b. 1824 d. 7 Ag 1906, Amityville, NY. He was also a musician.

COGHLAN, Owen [P] Cleveland, OH. Member: SA [25]

COGSWELL, Dorothy McIntosh [Edu,P,L,Li,I] South Hadley, MA b. 13 N 1909, Plymouth, MA. Studied: Yale; Eugene Savage; Richard Miller; Edwin Taylor; Grace Cornell. Member: New Haven PCC; Springfield A. Lg.; CAA; Mediaeval Acad. Am. Exhibited: Eastern States Exh., 1941 (prize); Bridgeport A. Lg., 1937 (prize); Meriden Lg. A.&Cr., 1936 (prize) 1937 (prize); WFNY, 1939; AWCS, 1933, 1934, 1941; Phila. WCC, 1934; New Haven PCC, 1937, 1940-45; Conn. Acad. FA, 1937, 1940-45; Springfield A. Lg., 1940-46; Smith Mus., Springfield (one-man); Albany Inst. Hist.&A., 1941-46. Work: mural, Mt. Holyoke Col.; Squirrel Island (Maine) Lib. Illustrator: "Doctor in Homespun," 1941. Position: T., Mt. Holyoke Col., 1939- [47]

COGSWELL, Ruth McIntosh [Dr,T] New Haven, CT b. 17 Ag 1885, Concord, NH. Studied: Yale; Henry B. Snell. Member: New Haven PCC; New Haven PBC. Position: T., New Haven H.S. [40]

COGSWELL, Theresa [P] Pomona, CA. Member: Calif. AC [25]

COHEE, Marion M. [P,T] Phila., PA b. 11 D 1896, Baltimore. Studied: Univ. Pa.; Temple Univ., with Earl Horter; Arthur B. Carles; Franklin Watkins. Member: Phila. A. T. Assn.; Phila. WCC; Plastic Cl.; Phila. A. All.; Woodmere AA. Exhibited: Phila. A. T. Assn. (prize); Plastic Cl., 1945 (med); PAFA; Phila. A. All.; Sketch Cl.; Woodmere A. Gal. [47]

COHEN, Esther Sima [C,T] NYC b. 29 D 1913, NYC. Studied: ASL, with Sternberg; Alfred Univ., with Harder, Merritt. Member: N.Y. Soc. C.; Eastern AA. Exhibited: Univ. Minn., 1946; America House, 1944-46; WFNY, 1939; NAC; Argent Gal.; Phila. A. All.; Barbizon-Plaza Gal. Lectures: The Art of Ceramics, Crafts as a Hobby. Positions: Dir., Lenox Hill Pottery, 1934-45; Prof., A.&Crafts, Herzliah T. Inst., NYC, 1944-46 [47]

COHEN, Evelyn [P] NYC [21]

COHEN, George Emmanuel [Des,S] b. 15 S 1902, St. John, New Brunswick (came to U.S. in 1922). Studied: St. John A. Sch., 1910. WPA textile designer. Sculptor since 1970. [*]

COHEN, George W. [P] NYC. Member: SC, 1899 [27]

COHEN, H. George [P,Ed,L] Northampton, MA b. 9 S 1913, Worcester,

MA. Studied: WMA Sch.; Herbert Barnett; Kenneth Shopen. Member: Springfield A. Lg.; Worcester Soc. A.&Craftsmen. Exhibited: Springfield A. Lg., 1945 (prize), 1946 (prize); NAD, 1943; AWCS, 1942-44; AIC, 1945; SFMA, 1944; Springfield A. Lg., 1942-46; WMA, 1940, 1941, 1943, 1944, 1946. Lectures: Modern painting. Position: Prof. A., Smith Col., 1946– [47]

COHEN, Harry [P] NYC b. 1891 d. 22 Ag 1921

COHEN, Hy [P,E] NYC b. 13 Je 1901, London, England. Studied: NAD. Member: AWCS; Am. A. Cong. [47]

COHEN, Isabel [P] Charleston, SC. Member: NAWPS; PBC; NAC [27]

COHEN, Katherine M. [S,P] Phila., PA b. 18 Mr 1859, Phila. d. 14 D 1914. Studied: PAFA; ASL, with Augustus Saint Gaudens; Mercié, Puech, in Paris. Member: Plastic Cl. Work: Fairmount Park, Phila. A bronze of Abraham Lincoln is one her best known works. [13]

COHEN, Lewis [Ldscp.P] NYC/Lyme, CT b. 27 Je 1857, London, England d. 4 Ag 1915, NYC. Studied: Dartmouth; Alphonse Legros, Erskine Nicol, in London; Charles Blanc, in Paris (where he lived for twenty years). Member: ANA, 1911; SC, 1904; Lotos Cl. Exhibited: Panama-Pacific Expo, San Fran., 1915 (med) [13]

COHEN, Nessa [S] Newark, NJ b. NYC. Studied: James E. Fraser; Despiau, Charles Malfrey, in Paris. Member: NAWA; S.Indp.A. Exhibited: 9th Olympiad, Amsterdam, Holland, 1928 (med). Work: Am. Mus. Nat. Hist.; Sch. Arch. & All. A., Portland, Oreg.; Stanford Univ. [47]

COHEN-KIRK, Frank. See Kirk.

COHN, Cora M.G. (Mrs. Morris, Jr.) [S] Niagara Falls, NY [25]

COHN, Harold [P,Li,T] Island Heights, NJ b. 27 S 1908, Detroit. Studied: Detroit Soc. A.&Cr., with Samuel Halpert, John Carroll. Exhibited: Friends Mod. A., 1938 (prize) 1940 (prize) 1943 (prize); Detroit Inst. A., 1944; PAFA, 1934; CGA, 1937, 1941; CI, 1941, 1943; VMFA, 1942; Pepsi-Cola, 1945; Los Angeles Mus. A., 1945; Detroit Inst. A., 1933-45. Work: BMFA; Detroit Inst. A. Position: T., Detroit Soc. A.&Cr. [47]

COHN, Max Arthur [P,Ser,W] NYC b. 3 F 1904, London, England. Studied: ASL, with Boardman Robinson, John Sloan; Acad. Colarossi, Paris. Member: A. Lg. Am.; Nat. Serigraph Soc.; BM, 1939; LOC, 1945; MOMA, 1936, 1941, 1942; Corcoran Gal.; Delphic Studios, New York. Author: "Silk Screen Stenciling as a Fine Art," 1942. WPA artist. [47]

COHN, Morris, Jr. (Mrs.) [S] Niagara Falls, NY [24]

COINER, Charles T. [P] Mechanicsville, PA b. 1898, Santa Barbara, CA. Studied: Chicago Acad. FA; AIC; Europe. Member: Phila. All.; A. Dir. Cl. Work: PAFA. Creator: Blue Eagle Des., NRA. Positions: T., Charles Morris Price Sch.; A. Dir., N.W. Ayer and Son, Phila. [40]

COIT, Caroline E. [P] Cleveland Heights, OH [25]

COKER, Walton (Mrs. M.E. Boriss) [P] Birmingham, AL b. 22 Je 1907, Birmingham, AL. Studied: Newcomb Col.; George Bridgman; John Steuart Curry; Harvey Dunn; Arthur Woelfle. Member: Ala. AL; Birmingham AC; SSAL; NAC [40]

COLBERT, F [P] Calera, OK. Member: Lg. AA [24]

COLBORNE, Elizabeth [P] NYC [19]

COLBURN, Eleanor Ruth (Mrs. Joseph Elliott) [P] Chicago, IL b. 1866, Dayton, OH d. 7 My 1939. Studied: AIC. Member: Chicago SA; Chicago WCC. Exhibited: AIC, 1908 (prize). Work: AIC [24]

COLBURN, Francis Peabody [P,E,W,L] Burlington, VT b. 20 O 1909, Fairfax, VT. Studied: Univ. Vt.; ASL, with Raphael Soyer, Harry Sternberg. Member: Fleming Mus. A. Assn.; Springfield (Mass.) A. Lg.; Inst. Mod. A., Boston. Exhibited: Springfield Mus. FA, 1941 (prize); Fed. Women's Cl., Vt., 1933 (prize), 1934 (prize); Pal. Leg. Honor, 1946 (med); WFNY, 1939; Contemporary Am. A., 1939; AIC, 1941; Springfield A. Lg., 1941-43; CGA, 1941; Conn. Acad. FA, 1941; CI, 1941, 1946; Pasadena AI, 1946; WMAA, 1945; Knoedler Gal.; Grace Horne Gal. (one-man); Smith Col. (one-man). Work: Fleming Mus. A.; Bennington Mus.; Okla. Univ. Contributor: critical articles, newspapers. Position: T., Univ. Vt., Burlington [47]

COLBURN, Joseph Elliott (Dr.) [P] Chicago, IL b. 22 S 1853, Massena, NY d. 27 O 1927, Winthrop Harbor, IL. Member: Chicago Soc. Ar.; Business Men's AC; Cliff Dwellers. An eye specialist, he made scientific experiments in the values of color. [17]

COLBY, Charles (Mrs.) [P] NYC [24]

COLBY, Dorothy George. See George.

COLBY, Eugene C. [P,T] Rochester, NY. Member: Rochester AC [27]

COLBY, Frank A. [P] NYC. Member: SC [25]

COLBY, George Ernest [P,I] Chicago, IL b. 29 Mr 1859, Minnesota. Studied: Europe. Exhibited: Springfield, Ill. (med) [13]

COLBY, George Wilbur [P] Malden, MA [24]

COLBY, Homer Wayland [I,E,P,T,Des] Medford, MA b. 30 Ap 1874, North Berwick, ME d. 2 O 1950. Studied: George H. Bartlett. Exhibited: 50 Prints of the Year, 1929; Calif. Pr., 1929; Phila. Pr. Cl., 1932; Brooklyn SE, 1932; Phila. A. All., 1932, 1933. Illustrator: "Ancient Times" (1935), "Story of Newfoundland" (1938), "Classic Myths," by Gayley, "Virgil's Æneid," by Kittredge, other books [47]

COLBY, James W. [P] Waltham, MA b. 1841, Arlington, MA d. 15 O 1909. Author: a work on modern coloring

COLBY, Josephine Wood (Mrs. Franklin G.) [P] Andover, NJ b. 26 Ja 1862, NYC d. 28 D 1930. Studied: ASL; Pratt Inst.; NAD; W. Low; C. Beckwith; W. Sartain; J.W. Alexander; England; France. Member: NYWCC; N.Y. Soc. C.; NAC; SPNY; Women's AC (founder). Work: PAFA; Walker Gal., Liverpool, England; Manchester A. Gal., England [29]

COLDWELL, Ardath [S,P,C] San Fran., CA b. 16 S 1913, Portland, OR. Studied: Calif. Sch. FA; Univ. Calif.; R. Stackpole. Exhibited: San Fran. A. Assn., 1939 (prize); San Fran. MA; State Fair, Sacramento; Calif. WPA [40]

COLE, Alphaeus P. [P,I,T,W] NYC b. 12 Jy 1876, Hoboken, NJ. Studied: Académie Julian, Ecole des Beaux-Arts, both in Paris; Constant, Laurens. Member: NA; ANA, 1930; NYWCC; SC; NAC; AWCS; All.A.Am. Exhibited: Pan-Am. Expo, Buffalo, 1901 (prize); NAC, 1934 (prize), 1937 (prize), 1939 (prize); SC, 1943 (prize); AAPL, 1934 (med); CAFA, 1920 (med); Montclair SA, 1934 (med); Paris Salon, 1900, 1901, 1903; Royal Acad., London, 1904-10; NAD, 1910-19; AWCS. Work: Hist. Soc., Raleigh, Va.; Univ. Va.; Huntington Lib., Oneonta, N.Y.; Akron Univ.; White Plains Court House, N.Y.; Nat. Por. Gal., London; BM; NAD. Co-author: "Timothy Cole, Wood Engraver," 1935. Position: T., Grand Central A. Sch. [47]

COLE, Annie Elizabeth (Mrs. Myron Asa) [P] Wash., D.C. b. 9 D 1880, Providence d. 1 Ap 1932. Studied: Corcoran Sch. A. Member: Wash. WCC [31]

COLE, Bertha Bates [P] New Hope, PA b. 7 N 1904, Wilmington, DE. Studied: PMSchIA; PAFA; Fontainebleau Sch. FA. Specialty: frescoes [40]

COLE, Blanche Dugan (Mrs.) [P] Los Angeles, CA. Member: Calif. AC [25]

COLE, Clarence [P] NYC. Member: GFLA [27]

COLE, Ellis Prentice [P] Chicago, IL b. 14 Je 1862, Monroe, IL. Studied: C. Hecker; Royal Acad., Berlin [06]

COLE, Emily Beckwith [S,T] Hartford, CT b. 2 Ja 1896, New London, CT. Studied: L. Gudebrod. Member: Hartford ACG [25]

COLE, Gail (Shepardson) [P] Los Angeles, CA b. 27 Ap 1914, San Diego. Studied: Calif. Sch. FA; Stanford Univ.; Otis Oldfield; William Gaw; Victor Arnautoff. Member: Calif. WC Soc. Exhibited: AWCS, 1946; Calif. WC Soc., 1943-45; Riverside Mus., 1944; Los Angeles Mus. A., 1945; Biltmore Gal., 1942 (one-man) [47]

COLE, George T(ownsend) [P] Los Angeles, CA b. San Fran. Studied: Lallemand, in Vienna; Bonnât, in Paris [25]

COLE, Gladys [P] Seattle, WA [24]

COLE, Jessie (Duncan) Savage (Mrs. Thomas) [P,Mur.P,C] Yonkers, NY b. 25 My 1858, Pass Christian, MS d. 27 O 1940, Wellesley, MA. Studied: Wyatt Eaton; John La Farge, 1880-85. Assistant to La Farge in stained glass and murals. [21]

COLE, Katharine P. (Mrs.) [S] Tarrytown, NY/Lake Placid, NY b. 8 Ag 1896, Helena, MT. Studied: ASL; Grand Central Sch. A. Member: NAWPS; Hudson Valley AA [40]

COLE, Margaret W(ard) (Mrs. Alphaeus P.) [S] NYC/Lower Montville, NJ b. Haslington, England. Studied: Injalbert, Rollard, both in Paris. Member: All. AA. Work: Akron Univ. Co-author: "Timothy Cole, Wood Engraver" [40]

COLE, Thomas Casilear [P,T] NYC b. 23 Jy 1888, Staatsburgh, NY d. 19 Mr 1976. Studied: BMFA Sch., with Philip Hale, Frank W. Benson; Académie Julian, Paris, with Laurens; Tarbell. Member: Rockport AA; Am. Veterans

Soc. A. Exhibited: NAD; PAFA; BMFA; AIC; Albright A. Gal, 1931; All.A.Am.; Paris Salon, 1923; Knoedler Gal., 1917 (one-man); Ehrich Gal.; Rockport AA, 1930; Ogunquit A. Center, 1945–55; NAC, 1945. Work: Fed. Court, N.Y.; Vt. State Capitol; N.Y. Bar Assn.; Brooklyn Pub. Lib.; Battle Abbey Mus., Richmond, Va.; U.S. Naval Acad.; Newton Theological Seminary; Trinity Col., Hartford; Univ. N.C. [47]

COLE, Timothy [Wood En] Poughkeepsie, NY b. 6 Ap 1852, London, England (came to U.S. in 1857) d. 17 My 1931. Studied: Bond; Chandler. Member: ANA, 1906; NA, 1908; NIAL; Soc. PS&G, London; Gld. Craftsmen, London; AI Graphic A. Exhibited: Columbian Expo, Chicago, 1893 (gold); Paris Expo, 1900 (gold); Pan-Am. Expo, Buffalo, 1901 (gold); St. Louis Expo, 1904 (prize); NAC, 1916 (gold); AAAL, 1927. Work: CI; City AM, St. Louis; AIC; MMA; Boston AM; NGA. A fire in Chicago in 1871 destroyed all of his belongings, and at that time he went to New York. In 1883, he was commissioned by the Century Magazine to travel in Europe for the purpose of making engravings of the old masters; these were among his most notable achievements. [27]

COLE, V(irginia) Thurman [P,T] Shreveport, LA/Provincetown, MA b. Columbus, OH. Studied: George Elmer Browne; Alice Schille; Arthur Woelfle; Columbus A. Sch. Member: Ohio WCS; Columbus AL; Provincetown AA [40]

COLE, Walter [P] NYC. Member: GFLA [27]

COLEBROOK, Alex [P] NYC [04]

COLEGROVE, John W. [Por.P] b. 1863 d. 24 D 1930, Buffalo, NY

COLEMAN, C(harles) C(aryl) [P] Capri, Italy b. 25 Ap 1840, Buffalo, NY d. 5 D 1928. Studied: Buffalo, with W.H. Beard, 1850s; Paris, 1859. Member: Newspaper Ar. Assn.; Order of Loyal Legion; ANA, 1865; Players Cl.; NAC; London AC. Exhibited: Columbian Expo, Chicago, 1893 (med); Pan-Am. Expo, Buffalo, 1901 (med). Work: Buffalo Acad. FA; Detroit Inst.; BM; Seamen's Inst. N.Y.; St. Louis Mus.; Louisville Mus. FA. He returned to Europe after the Civil War, settling in Capri. [29]

COLEMAN, Frederick W. [E] Norwich, CT [17]

COLEMAN, Glenn O. [P,Li] Long Beach, NY b. 18 Jy 1887, Springfield, OH d. 8 My 1932. Studied: Henri; Indst. A. Sch., Indianapolis; N.Y. Sch. A. Member: S.Indp.A.; New Soc. A. Exhibited: Armory Show, 1913; CI, 1928 (prize); AIC, 1930 (prize); MOMA, 1932. Work: Luxembourg Mus.; Newark Mus.; BM; WMAA; NYU; PMG. Specialty: New York street scenes. He was one of the first Independents.

COLEMAN, Herbert [P,I] b. 1883, Goshen, NY d. 22 N 1925, NYC

COLEMAN, Laura Alexander [P,W] Richmond, VA b. 13 F 1914, Boydton, VA. Studied: Sorbonne; Colorado Springs FA Center; Marc Solotareff, in Paris; Bernard Kafiol. Member: AFA; VMFA. Exhibited: VMFA; Colorado Springs FA Center; WFNY, 1939 [40]

COLEMAN, Laurence Vail [W,L] Wash., D.C. b. 19 S 1893, Brooklyn, NY. Studied: CCNY; Yale; Harvard. Member: Brit. Mus. Assn. Exhibited: AA Mus., 1940 (prize); CCNY, 1944 (med). Author: "The Museum in America," 1939, "College and University Museums," 1942, other writings on museums. Contributor: educational magazines, U.S. & Europe. Lectures: Museums, Historic Houses. Position: Dir., AA Mus., 1927– [47]

COLEMAN, Mary Darter. See Darter.

COLEMAN, Phebe R. [P] Bangalore, India. b. 18 O 1890, Salem, MA. Member: NAWPS [27]

COLEMAN, Ralph Pallen [I,P] Jenkintown, PA b. 27 Je 1892, Phila. d. 3 Ap 1968. Studied: PMSchIA. Work: churches in Jenkintown, Lancaster, Pa., Wilmington, Del.; Am.-Swedish Hist. Mus., Phila. Illustrator: U.S., Canadian magazines, "The Narrow Corner," by W. Somerset Maugham, other books

COLEMAN, Vernon Herbert [Edu,P,Des] Hyannis, MA b. 28 Ap 1898, Norwich, CT. Studied: Corcoran Sch. A., with M. Messer, Burtis Baker; Wash. Sch. A., with Will Chandlee. Member: Cape Cod AC. Exhibited: N.Y. Soc. A.&Sc., 1935 (prize), 1936 (prize). Work: mural, Maritime Col., Hyannis; Copley Theatre, Boston. Position: A. Supv., Barnstable (Mass.) Pub. Sch., 1945–46 [47]

COLER, Stella C. (Mrs.) [P] Indianapolis, IN b. 29 Jy 1892, Grand Rapids, MI. Studied: Univ. Mich.; John Herron A. Sch.; ASL; Eliot O'Hara; Jerry Farnsworth. Member: Ind. A. Cl.; Orlando AC. Exhibited: Hoosier Salon, 1940, 1942, 1943, 1944, 1946; John Herron AI; TMA, 1941, 1944; Rollins Col., 1942, 1943, 1944, 1946 [47]

COLES, Ann (Cadwallader) [P] NYC b. 4 Ag 1882, Columbia, SC. Studied: F.L. Mora; Vincent Tack; Harry Sternberg; C.A. Whipple. Member: SSAL. Exhibited: PAFA; AIC; SSAL; Columbia (S.C.) A. Lg. (one-man); Charlotte (N.C.) Women's Cl. Work: Yale Lib.; Parish House, Charlotte, N.C.; Confederate Mus., Richmond, Va. [47]

COLES, J. Ackerman Scotch Plains, NJ b. 1843, Newark d. 16 D 1925. An art collector, surgeon, and philanthropist, he made many gifts of art treasures to the city of Newark.

COLES, Mary Drake [E] NYC b. 6 F 1903, Newark, NJ. Studied: C.W. Hawthorne; A. Lhote. Member: Contemporary A. Gal. [40]

COLES, Roswell Strong [Mus.Dir] Staten Island, NY b. 23 Je 1904, Middletown, CT. Studied: Yale; T. Col., Columbia; Am. Acad., Rome. Member: Am. Assn. Advancement Science; AA Mus.; Classical Soc., Am. Acad., Rome. Positions: Ed., Staten Island Inst. A.&Sc. publications; Cur. (1939–41), Dir. (1941–), Staten Island Inst. A.&Sc. [47]

COLETTI, Joseph Arthur [S,L] Quincy, MA b. 5 N 1898, San Donato, Italy d. 1973. Studied: Harvard; Am. Acad., Rome; John Singer Sargent. Member: Arch. Lg.; NSS; North Shore AA; Mediaeval Acad. Am. Exhibited: Boston Tercentenary FA Exh., 1932 (med); Pal. Leg. Honor, 1929; PAFA, 1929–31; MOMA, 1933; WFNY, 1939; PMA, 1939; MMA, 1942; WMAA, 1940; FMA, 1928 (one-man); Boston Inst. Mod. A., 1940–42; Audubon A., 1946. Work: FMA; Lyman Allyn Mus.; Brookgreen Gardens, S.C.; Gagnon Mem., Quebec; Quincy (Mass.) Pub. Lib.; Widener Lib., Harvard; USPO, Mansfield, Mass. WPA artist. Lectures: Contemporary Sculpture [47]

COLL, Charles J., Jr. [I] Phila., PA. Member: SI [24]

COLL, Francis A. [C,P] Wilmington, DE b. 12 S 1884, Center Port, NY. Studied: Nunn; Horer. Exhibited: Wilmington Soc. FA; Phila. AC; Tricker Gal., 1939. Designer/Maker: hand-carved gold leaf picture frames, ecclesiastical work. Restorer: paintings [47]

COLL, Joseph C(lement) [I] Phila., PA b. 2 Jy 1881, Phila., PA d. 19 O 1921. Member: SI, 1912. He began his career in 1900 on The Chicago American. Illustrator: magazines, stories by A. Conan Doyle, Sax Rohmer [19]

COLLANDER, Helmi (Mrs.) [P] Ashtabula, OH b. Wasa, Finland. Studied: Helsingfors AI, Finland; William Eastman. Member: South County AA, Wickford, R.I. Exhibited: Ohio Valley A., 1945; South County AA, 1945; Swedish Cl., Chicago, 1945 [47]

COLLES, Gertrude [W,P] Morristown, NJ b. 20 Ag 1869, Morristown. Studied: ASL, with George DeForest Brush; Académie Julian, Acad. Delacluse, Laurens, in Paris; Frank Benson; B.R. Fitz. Work: State House, Trenton, NJ [47]

COLLETTE, Maurice [P] NYC. Member: SC [25]

COLLIER, Amy Angell [P,I,T] NYC. ASL [06]

COLLIER, C(harles) Myles [Mar.P,I] NYC/Gloucester, MA b. 1836, Hampton, VA d. 14 S 1908, Gloucester Studied: self-taught. Member: SC, 1897; AAS. Exhibited: Charleston Expo, 1902 (med); SC (prize). He lived in Memphis for many years, and was in the navy during the Civil War. [08]

COLLIER, Estelle E(lizabeth) (Mrs. H.H.) [P,W,Des] South Tacoma, WA b. 1 Ag 1881, Chicago, IL. Studied: F.W. Southworth [40]

COLLIER, J. Howard [Por.P] d. 1900. Exhibited: Boston Athenaeum, 1856; PAFA. Executed crayon portraits in Boston during 1850s. [*]

COLLIER, Nathan Leo (Nate) [Car,W] Leonia, NJ b. 14 N 1883, Orangeville, IL. Studied: Acme Sch. Drawing; Lockwood A. Sch.; J.H. Smith; G.H. Lockwood. Illustrator: "Illiterate Digest," 1927. Co-author/Illustrator: "Breaks," 1932. Contributor: national magazines, newspapers [47]

COLLIN, Benjamin [P] Malverne, NY b. 2 Ja 1896, Copenhagen. Studied: Royal Acad., Copenhagen. Member: Lg. Present-Day A. Exhibited: Royal Acad., Copenhagen, 1919 (prize); Am.-British A. Center; Lg. Present-Day A. Work: Gloria Dei Church, Providence, R.I. [47]

COLLIN, Jennie [P] Wash., D.C. [13]

COLLIN, Jenny Petria [S] San Fran., CA b. Sweden. Studied: Roscoe Mullins, in London. Member: San Fran. AA [19]

COLLINS, Alfred I. [P] NYC. Studied: PAFA [98]

COLLINS, Alfred Quinton [Por.P,I] NYC b. 1862, Boston d. 19 Jy 1903, Cambridge, MA. Studied: Bonnât, in Paris. Member: SAA, 1889; ANA, 1902. Work: MMA; BMFA [01]

COLLINS, Amelia [P] Boston, MA [06]

COLLINS, Arthur G. [P] Boston, MA b. 1866, Boston. Studied: Lefebvre,

Doucet, Robert-Fleury, Roll, Benjamin-Constant, in Paris. Member: BAC [08]

COLLINS, Benjamin Franklin [Adv.Des] Upper Darby, PA b. 5 Mr 1895, Phila. Pa. Studied: PMSchIA. Member: Phila. A. All.; A. Dir. Cl. Position: A. Dir., The Beck Engraving Co., NYC [47]

COLLINS, Corinne Cunningham (Mrs.) [P] Wash., D.C. Member: Wash. WCC [25]

COLLINS, Eileen Henrietta (Mrs. C.H. Hoover) [P] Toledo, OH b. 4 My 1912, Fond du Lac, WI. Studied: R.O. Chadeayne; Mark Russell; Chester Nicodemus; Columbus A. Sch. Member: Columbus AL; Ohio WC Soc. Exhibited: Columbus AL Exh., 1933 (prize). Position: T., TMA [40]

COLLINS, Elizabeth D., Mrs. See Logan.

COLLINS, Fanny P. [S] San Fran., CA [17]

COLLINS, Frank Henry [P,T] NYC b. 1860, Malden, MA d. 8 F 1935, Greenwich, CT. Studied: Sorbonne. In 1899 he became associated with art in the public schools of Queens County, N.Y., and from 1909 to 1930 served as director of drawing in the elementary schools. [29]

COLLINS, Fred L. [I] Columbus, OH/Ancaster, Ontario b. 1 Ja 1876, Prince Edward Island. Studied: Hamilton Art Sch.; S.J. Ireland. Member: Columbus PPC. Position: Manager, A. Dept., Bucher Engraving Co. [31]

COLLINS, Harold Dean [P,I] Frankfort, KY b. 20 S 1908, Lexington, KY. Studied: Chicago Acad. FA; Am. Acad. FA; BMFA Sch.; Herbert Barnett. Member: Louisville AC; Frankfort AC. Exhibited: Louisville AC, 1938. Work: Ky. Hist. Soc. Mus.; Mansion Mus., Harrodsburg, Ky; Court House, Louisville. Illustrator: "Capt. John Fowler," 1942 [47]

COLLINS, John W(alter) [P,I] NYC b. 4 S 1897, Naperville, IL. Studied: Charles W. Hawthorne; Leopold Seyffert; Lucien Simon [40]

COLLINS, Joseph W. [Mar.P,I] b. 8 Ag 1839, Isleboro, ME d. 1904, Brighton, MA. Work: Peabody Mus., Salem. A captain and fisherman, he made illustrations of the fishing industry during 1870s with Henry W. Elliott. [*]

COLLINS, Julia Alice [P] Savannah, GA/Asheville, NC b. Savannah. Studied: Telfair Acad., Savannah; St. Louis Sch. FA. Exhibited: Tri-State Expo, 1921 (prizes), 1923 (prizes) [40]

COLLINS, Kreigh [I] Ada, MI b. 1 Ja 1908, Davenport, IA d. 1974. Studied: Cincinnati A. Acad.; Cleveland A. Sch. Exhibited: Grand Rapids A. Gal., 1930, 1933. Work: mural, East Congregational Church, Grand Rapids. Illustrator: "Marconi" (1943), "Perilous Island" (1942), "World History" (1946), other books [47]

COLLINS, Louise Huntington [P] NYC [01]

COLLINS, Mabel Chislett (Mrs. Frank P.) [S,T] Chicago, IL [10]

COLLINS, Marjorie S. [Min.P] Wilmington, DE. Member: Pa. S. Min. P. [29]

COLLINS, Mary Susan [P,C,T] Saylorsburg, PA b. 1 Je 1880, Bay City, MI. Studied: Arthur W. Dow; AIC; BMFA Sch.; ASL; T. Col., Columbia; Charles Hawthorne. Member: AAPL; AFA. Exhibited: CMA, 1921 (prize), 1922 (prize), 1924 (prize), 1925 (prize), 1929 (prize), 1936 (prize); PAFA, 1925, 1928, 1930, 1932; AFA, 1922, 1924; All.A.Am.; 1925; CMA, 1919-45; Detroit Inst. A., 1926, 1928, 1930, 1931; Great Lakes Exh., 1938, 1939. Work: CMA; Cleveland Municipal Coll. Position: T., East H.S., Cleveland, 1911-45 [47]

COLLINS, Paul E. [Mar.P] Boston, MA. Active, 1882-1925. Work: Peabody Mus., Salem, MA [*]

COLLINS, R.H. [P] St. Paul, MN [13]

COLLINS, Robert C. [I] Rockville Centre, NY. Exhibited: Pan-Am. Expo, Buffalo, 1901 (med) [10]

COLLINS, Roy H. [I] Portland, CT d. 6 Ag 1949. Member: SI [47]

COLLINS, S.O. [P] Wash., D.C. [01]

COLLINS, Sewell [Car] NYC b. 1 S 1876, Denver, CO. Studied: AIC. Author/Illustrator: "Caricatures of the Stage" [10]

COLLINS, Walter [P] b. 26 S 1870, Dayton, OH d. 28 F 1933, Tampa, FL. Studied: Paris; Munich; Berlin. Member: SSAL; Ldscp. Cl., Wash. In 1918, he located in Florida and organized the Tampa Institute of Fine Arts.

COLLINS, Walter [P,Des,T] Birmingham. AL b. 9 My 1891, Baltimore. Studied: Wayman Adams; Louise Cone; Carrie L. Hill. Member: Ala. Al Lg.; Birmingham A. Cl. Exhibited: Civic Center, San Fran.; A. All., Birmingham. Work A. All., Phila. [40]

COLLINSON, Harold F(rank) [E,Li,P,W,L] NYC b. 14 O 1886, Nottingham, England. Studied: Nottingham Col. A. Member: Soc. Gr. A., London; Soc. Woodblock Pr., London; F., Royal Soc. A.; F., Brit. Inst. Dec. Exhibited: LOC, 1943, 1944, 1945; SAE, 1940-44; Am.-Brit. Soc. A., 1941, 1942. Work: LOC; MMA; Nottingham Castle. Contributor: art and arch. magazines. Lectures: Color [47]

COLLISON, Helen F. (Mrs.) [P] Wash., D.C. b. Wash., D.C. Studied: S. Burtis Baker; Richard Meryman; Corcoran Sch. A. Member: Soc. Wash. A.; Lg. Am. Pen Women; Twenty Women P. of Wash. Exhibited: Lg. Am. Penwomen, Wash., D.C. 1938 (prize), 1939 (prize) [40]

COLLISON, Marjory (Mrs. Marjory Collison Schulhoff) [I,P,Li,Des] Pelham, NY b. 17 Ag 1902, Wash., D.C. Studied: PAFA; George Harding; Henry McCarter; A. Carles. Exhibited: SSAL, 1927 (prize); Weyhe Gal.; Gibbes A. Gal., Charleston, S.C. Illustrator: "Penny and the White Horse" (1944), "Sibby Botherbox" (1945), "Water Babies" (1946) [47]

COLLOW, Jean Dee [P] Cincinnati, OH [27]

COLLTER, Estelle E(lizabeth) (Mrs. H.H. Collier) [P,W] Tacoma, Wash. b. 1 Ag 1881, Chicago, IL. Studied: F.W. Southworth. Member: Tacoma FAA. Exhibited: Wash. State Fairs (prizes)[24]

COLLVER, Ethel Blanchard (Mrs.) [P,L] Boston, MA b. Boston. Studied: BMFA Sch.; Tarbell; Benson; Hale; Acad. Colarossi, Naudin, Morisset, Guérin, Lhote, Ozenfant, in Paris; Charles Hawthorne. Member: NAWA; Copley Soc.; Marblehead AA; St. Augustine AA; Greenwich AA; Conn. SA; AAPL. Exhibited: WFNY, 1939; NAWA, 1933 (prize); NAD; CGA; PAFA; Paris Salon [47]

COLMAN, Anne (Mrs. Howell Colman) [P] Kalamazoo, MI b. Parma, MI d. 26 O 1938. Studied: André Lhote; Archipenko. Member: NAWPS [38]

COLMAN, Blanche Emily [P,E,Des] Boston, MA/Somerville, MA. Studied: BMFA Sch.; Am. Acad. Rome; Boston Univ.; Charles Woodbury; Harry Leith-Ross; Alldro T. Hibbard; Henry Hensche. Member: Boston Soc. A.&Crafts; Copley Soc.; NAWA; Wash. WCC; Conn. Acad. FA; North Shore AA; Rockport AA. Exhibited: NAWA, 1936-46; CAFA, 1935, 1946; All.A.Am., 1945; North Shore AA, 1926-46; Doll & Richards Gal., 1941; Copley Soc., 1942; Jordan-Marsh, 1945; Marblehead AA, 1945 [47]

COLMAN, Braley [P] NYC [04]

COLMAN, Charles C. [Des,E,I,W] Cleveland, OH b. 23 Jy 1890, Cleveland. Studied: Cornell; Fenway Sch. A.; Cleveland Sch. A.; John Huntington Polytechnic Inst., Cleveland; Gottwald; Brauner; Bailey; Kubinyi. Member: AIA; Arch. Soc., Ohio. Exhibited: Cleveland Chamber Commerce, 1926 (med), 1935 (med); CMA, 1921 (med) 1922 (med), 1931 (med), 1932). Work: CMA [47]

COLMAN, George Sumner [P] Balboa Beach, CA b. 17 N 1881, Elgin, IL. Studied: AIC. Member: Laguna Beach AA; Los Angeles PS [33]

COLMAN, Roi Clarkson [P] La Jolla, CA b. 27 Ja 1884, Elgin, IL d. ca. 1945. Studied: Académie Julian, Laurens, in Paris; Chicago. Member: Calif. AC; San Diego AG; Laguna Beach AA; Ill. Acad. FA. Exhibited: Tex. Cotton Palace Expo, 1910; Riverside Fair, 1917 (gold); Laguna Beach AA, 1920 (prize), 1922 (prize); Calif. State Fair, 1920 (prize). Work: Pub. Lib., Ajo, Ariz.; Pub. Lib., Waco, Tex.; Santa Monica Women's Cl.; La Jolla Yacht Cl.; Liggett Coll., Tulsa, Okla. [40]

COLMAN, Samuel [P] NYC/Newport, RI b. 4 Mr 1832, Portland, ME d. 27 Mr 1920. Studied: Asher B. Durand, in New York; Europe, in 1860. Member: ANA, 1854; NA, 1862; AWCS (first pres., 1866-71); SAA; N.Y. Etching Cl. (founder), 1877. Exhibited: Boston Athenaeum; Md. Hist. Soc.; PAFA; NAD. Work: Union Lg. Cl.; NYPL; MMA; AIC; RISD. Traveled West in 1870, one year before T. Moran; then went to Spain and North Africa; studied in France and Spain; came back to Calif., mid-1880s. [19]

COLMORGAN, Paul [Des,P,T] Glenview, IL b. 20 Ag 1903, Piqua, OH. Studied: Chicago Acad. FA; Cleveland Sch. A.; AIC. Member: Soc. Typographic A. Exhibited: AIC; Glenview (Ill.) A. Exh. Position: T., Central YMCA Col., Chicago [47]

COLNIK, Cyril [Metalwork] Milwaukee, Wis. b. 20 S 1871, Triebein, Austria. Studied: Franz Roth, in Gratz; Indst. A. Sch., Munich. Member: Wis. Soc. Appl. A.;, Milwaukee AI. Exhibited: Wis. Soc. Appl. A., 1934 (prize). Owner: The Ornamental Iron Shop, Milwaukee [40]

COLOMBANI, Darius [Des] b. 1850, Italy d. 21 Mr 1900, NYC. Notable among his works were the decorations in St. Patrick's Cathedral, NYC.

COLSON, Frank V. [P,I,E,T] Boston, MA b. 24 O 1894, Boston. Studied: BMFA. Member: North Shore AA; Boston SE. Position: Instr., North Shore Summer Sch. A. [29]

COLT, Arthur N. [Por.P,T] Madison, WI b. 1889 d. 1972. Studied: AIC; Paris. Member: Madison AA. Ran summer art colonies at Black River and Devils Lake, Wis. [25]

COLT, Julia (Mrs. Henry V.) [P] Geneseo, NY. Member: NAWPS. Exhibited: Argent Gal., 1938 (one-man); NAWPS, 1937, 1938 [40]

COLT, Martha Cox [Edu,L,P,S] Shiremanstown, PA b. 16 S 1877, Harrisburg, PA. Studied: Kenneth Hayes Miller; Henry B. Snell; Calder Penfield. Member: Harrisburg AA; Plastic Cl., Phila. Exhibited: Harrisburg AA, 1931 (prize); Plastic Cl. Work: PMA; Univ. Pa. Lectures: Portrait Relief During the Middle Ages. Positions: Dir., Central Pa. A. Sch., Harrisburg, 1929–34; State Dir., Mus. Extension Project, FAP, 1935–41 [47]

COLT, Morgan [P,C] New Hope, Pa. b. 11 S 1876, Summit, NJ d. 12 Ap 1926. Studied: Sch. Arch., Columbia; W.L. Lathrop. Member: SC; Boston AC; NYSC; Phila. All. [25]

COLT, Thomas C., Jr. [Mus.Dir] Richmond, VA b. 20 F 1905, Orange, NJ. Studied: Dartmouth; AAMus.; Am. Assn. Mus. Dir. Position: Dir., VMFA, 1935–42, 1945– [47]

COLTMAN, Ora [P,B,T,W] Cleveland, OH b. 3 D 1858, Shelby, OH. Studied: ASL; Académie Julian, Paris; Magadey Schule, Munich. Member: Cleveland SA; Cleveland PM. Work: CMA [40]

COLTON, Gordon W. [P] Brooklyn, NY b. 31 My 1877, Brooklyn, NY. Studied: George Pearse Ennis. Member: AWCS; Brooklyn SA [47]

COLTON, Harriett [C,P,Des,T] Monrovia, CA b. 21 D 1910, Rockford, IL. Studied: UCLA. Member: Calif. WCS; Arthur Wesley Dow Assn. [40]

COLTON, Mary-Russell Ferrell (Mrs. Harold S.) [Mus.Cur,T,P,S,Ser,W] Flagstaff, AZ b. 25 Mr 1889, Louisville, KY. Studied: Daingerfield; Snell; Moore Inst.; Phila. Sch. Des. for Women. Member: NAWA; AAPL; Phila. WCC; AWCS; Wash. WCC. Author: "Indian Art and Folk Lore." Contributor: "Plateau," pub. Mus. Northern Ariz. Position: Cur., Mus. Northern Ariz., Flagstaff, 1928–46 [47]

COLUZZI, Howard [P] Paradox Lake, NY [15]

COLVILLE, L.H., Mrs. See King, G.

COLWELL, Elizabeth [P,E,C,W] Chicago, IL b. 24 My 1881, Bronson, MI. Studied: AIC; B.T. Olsen; B.J.O. Nordfeldt. Member: Chicago SE; N.Y. SE. Exhibited: Rome, Italy, 1911; P.-P. Expo, 1915 (prize); AIGA, 1915; Rouillier A. Gal., 1916 (one-man); Vanderhoogt Gal., 1928 (one-man); LOC, 1945; Riverside Mus. Work: Los Angeles Mus. A.; NCFA; AIC; Univ. Ill. Designer: typeface "Colwell Hand Letter"[47]

COLWELL, Worth [I] NYC. Member: SI [47]

COM, Mo [P,G,T] Brookline, MA b. 18 O 1901, Boston. Studied: BMFA Sch. Exhibited: NA; Nat. A. Cl.; AIC [40]

COMAN, Charlotte B(uell) (Mrs. J.B.) [Ldscp.P] NYC b. 1833, Waterville, NY d. 11 N 1925, Yonkers, NY (92 yrs. old). Studied: James R. Brevoort, N.Y., ca. 1872; Harry Thompson, Emil Vernier, in Paris; Holland. Member: ANA, 1910; NYWCC; NAWPS; SPNY; Art Worker's C. Exhibited: NAD, 1875; Calif. Mid-Winter Expo., San Fran., 1894 (med); NYWAC 1907 (prize), 1911 (prize); SAA, 1905 (prize); S.Wash.A., 1906 (prize); Holland. Work: NGA; MMA [24]

COMANDINI, Peter [Mur.P] b. 1860, Rome d. 11 Je 1935, NYC. Work: murals, LOC, NYPL. At an early age went to S.A., had important role in the development of Buenos Aires

COMB, Voltaire [I] NYC [01]

COMBE, Mary Postell (Mrs.) [P] Fort Worth, TX [24]

COMBES, Lenora Fees [I,P,W] Parma, OH b. 28 Jy 1919, Cleveland. Studied: Cleveland Sch. A. Exhibited: AIC, 1941; CMA, 1940, 1941; Butler AI, 1941. Work: murals, Columbia Broadcasting System, Cleveland; Portage County Cl., Akron. Contributor: children's magazines [47]

COMBES, Willard Wetmore [I,P,T,Car] Cleveland Heights, OH b. 23 D 1901, Cleveland. Studied: Cleveland Sch. A.; Slade Sch., Univ. London. Member: AFA; Cleveland SA. Exhibited: Cleveland MA; Butler AI, Youngstown; Mem. A. Gal., Rochester. Work: Cleveland MA; murals, Citizens Bldg., Cleveland. Positions: Car., Cleveland Free Press; T., Cleveland Sch. A. [40]

COMBS, Frances Hungerford [P] Wash., D.C. Member: WCC. Exhibited: WCC, 1936, 1938, 1939; Min. PS&G Soc., 1937, 1939 [40]

COMER, Sarah Ryel (Mrs.) [C] Newton Center, MA b. 1881, Lowville, NY. Member: Boston SAC; Phila. ACG [40]

COMES, Marcella (Mrs. Randoph Winslow) [P,W] Wash., D.C. b. 3 S 1905 Pittsburgh, PA Studied: Carnegie Inst., with Alexander Kostellow; Giovanni Romagnoli, Europe. Member: Assoc. A. Pittsburgh; SSAL. Exhibited: CGA, 1929; SSAL, traveling exh.; Assoc. A. Pittsburgh, 1929–46, 1929 (prize); Carnegie Inst., 1936 (prize), 1941 (prize); PMG, 1937, 1938, 1944, 1945; Soc. Wash. A., 1938, 1946 (prize); Whyte Gal., 1944. Work: murals, Pittsburgh Pub. Lib.; West Point. Contributor: critical reviews to university publications [47]

COMFORT, Barbara [P] Englewood, NJ. Exhibited: Am. WCS, 1936–37; NYWCC, 1936, 1937, 1939; Am. WCS, 1939 [40]

COMFORT, George Fisk [Mus.Dir,Edu,Cr] Syracuse, NY b. 1834 d. 5 My 1910, Montclair, NJ. Studied: Sch. A., St. Louis. Member: MMA (a founder); Am. Philological Soc. (founder); Syracuse Col. FA (founder); Central N.Y. SA; MFA, Syracuse. Position: Dir., Syracuse Mus. FA

COMFORT, Tom Tyrone [Mur.P] Los Angeles, CA b. 4 N 1909, Port Huron, MI d. 23 Ag 1939. Studied: Walter Barron Currier; Leo Katz. Member: Acad. Western P., Los Angeles. Work: San Diego; White House, Wash., D.C.; Central Lib., Los Angeles [38]

COMINGOR, Ada Marian [P,T] Indianapolis, IN. Studied: ASL, with W.M. Chase, K. Cox [06]

COMINS, Alice R. (Mrs. F.B.) [P] Carmel, CA/Cape Nedick, ME. Member: Concord AA; NAWPS [31]

COMINS, Eben F. [Por.P,W,T] Wash., D.C. b. 19 My 1875, Boston, MA. Studied: BMFA Sch.; Ecole des Beaux-Art, Paris; Harvard; Denman Ross. Member: Boston S.Indp.A.; Copley S.; Wash. AC; AFA. Exhibited: Hartford Exh., 1921 (prize); Soc. Wash. A., 1931 (prize); CGA; PAFA; P.-P. Expo, 1915 (med); WFNY, 1939; Peabody Univ.; Harvard; Nat. Mus., Mexico; South America. Work: Supreme Court; Harvard. [47]

COMITO, Nicholas U. [P,Li] Brooklyn, NY b. 30 S 1906, NYC. Studied: NYU; NAD; Italy. Member: Brooklyn SA. Exhibited: NAD, 1940 (prize), 1941–44; Phila. WCC, 1941; AWCS, 1945; Carnegie Inst., 1943–45; Wash. WCC, 1944; LOC, 1944–46; BM, 1941–43; Wawasee A. Gal., Syracuse, Ind., 1944, 1945 (prizes); Jersey City A. Mus., 1945; Irvington, N.J., 1946. Currier Gal. A., 1941. [47]

COMPERA, Alexis [P] Denver, CO b. 15 Ap 1856, South Bend, IN d. Jy 1906, CA. Studied: Harvey Young; W.H.M. Cox; Benjamin-Constant, in Paris [06]

COMPRIS, Maurice [P] Rockport, MA b. 19 D 1885, Amsterdam, Holland d. 19 O 1939. Studied: Drake; Alebee. Member: North Shore AA; Rockport AA. Exhibited: North Shore AA, 1931 (prize). Work: mural, Mass. State Infirmary, Tewksbury [38]

COMPTON, Carl Benton [P,S,G] Georgetown, TX/South Bend, IN b. 10 D 1905, Estherville, IA. Studied: Notre Dame; Academie de la Grand Chaumière; Academie Colarossi; AIC. Member: Am. Ar. Prof. Lg.; Austin AL; Tex. Fed. A. Exhibited: AIC, 1934, 1935; Denver AM, 1936; Ar. Southeast Tex., Houston MFA, 1938. Position: T., Southwestern Univ. [40]

COMPTON, Caroline Russell [P] Vicksburg, MS b. 10 Ja 1907, Vicksburg, MS. Studied: Sweet Briar; Grand Central A. Sch.; Grant Reynard; Wayman Adams; George Luks; George Pearse Ennis; Virginia McLaws. Member: Miss. AA; SSAL. Exhibited: Annual Exh. Am. A., NYC, 1937, 1938; SSAL, 1930–46; Miss. AA, 1926–46, 1933, 1934 (prizes); Delgado Mus., 1931–37; High Mus. A., 1936; Davenport, Iowa, 1940, 1941; Vicksburg, Jackson, Oxford, Miss. (one-man). Work: Miss. AA

COMPTON, Dorothy Dumesnie [Des,P] Fairfield, AL b. 12 Ag 1917, Edgewater, AL. Studied: AIC. Member: SSAL; Birmingham AC. Exhibited: SSAL, Montgomery, Ala., 1938; San Antonio, Tex., 1939 [40]

COMSTOCK, Anna B(otsford) (Mrs. John H.) [En] Ithaca, NY b. 1 S 1854, Otto, NY d. 24 Ag 1930. Studied: Cooper Union; John F. Davis. Member: Soc. Am. Wood Engravers. Exhibited: Pan-Am. Expo, Buffalo, 1901.Specialty: natural history subjects. Editor: Nature Study Review. Position: T., Cornell, 1899– [15]

COMSTOCK, Enos B(enjamin) [P,I,W] Leonia, NJ b. 24 D 1879 d. 19 Mr 1945. Studied: John Vanderpoel; Frederick W. Freer. Author/Illustrator: children's books. Illustrator: Boys Life, other magazines [40]

COMSTOCK, Francis Adams [Edu,Li] Princeton, NJ b. 26 Mr 1897, South Orange, NJ. Studied: Princeton; England, with F.L. Griggs. Exhibited:

Montclair A. Mus., 1940 (prize). Contributor: Architectural Forum. Illustrator: "English Country Houses." Position: T., Sch. Arch., Princeton [47]

COMSTOCK, Frances Bassett [P,S,I] Leonia, NJ b. 16 O 1881, Elyria, OH. Studied: Gary Melchers; Frederick Freer; John Vanderpoel. Member: NYWCC [31]

COMSTOCK, John [E] Los Angeles, CA [19]

CONACHER, John [I] NYC [13]

CONANT, A(lban) J(asper) [W,Por.P] NYC b. 24 S 1821, Chelsea, VT (came to NYC in 1844, then settled in Troy, NY until 1857) d. 3 F 1915. Studied: self-taught, Madison Univ., Hamilton, N.Y. Member: Western Acad. A., St. Louis, 1857 (founder). Work: MMA; portrait, Philipse Manor, Yonkers. Author: texts on archaeology; "My Aquaintance with Abraham Lincoln" [13]

CONANT, Arthur P. [P] Cincinnati, OH [24]

CONANT, C.W. [P] NYC [01]

CONANT, Homer B. [Mur.P,Dec] Chicago, IL b. 1887, Courtland, NE d. 11 N 1927, NYC. Member: ASL, Chicago. Work: received citations for camouflage work; theatrical art work for the Shuberts. [10]

CONANT, Howard S. [P,Edu,L] Nashotah, WI b. 5 My 1921, Beloit, WI. Studied: Milwaukee State T. Col.; ASL, with Kuniyoshi; Univ. Wis. Member: Milwaukee Men's Sketch Cl.; Wis. P&S Soc. Exhibited: Milwaukee AI, 1943; Layton A. Gal., 1945; NAD, 1946; Wis. State Fair, 1943, 1946 (prizes); Intl. Gal., Wash., D.C. (one-man); Alexandria Publ. Lib. (one-man); Oconomowoc, Wis. Community House (one-man). Position: T., Univ. Wis., Madison, 1946– [47]

CONANT, Lucy Scarborough [P,Edu] Boston, MA b. 1867, Brooklyn, CT d. 2 Ja 1921. Studied: Boston; Paris. Member: Copley S. 1892; Boston WCC; Phila. WCC; Boston SAC. Position: T., Univ. Calif., Berkeley, 1919–20 [19]

CONANT, Marjorie (Mrs. Harold Bush-Brown) [P] Atlanta, GA b. 14 S 1885, Boston, MA. Studied: Hale; Benson; Tarbell. Member: SSAL; Ga. AA. Exhibited: AIC, 1916–20; PAFA, 19189, 1921, 1924; CGA, 1919; Albright A. Gal., 1920; CI, 1921–24; GGE, 1939; SSAL, 1935 (prize); High Mus., 1940, 1944 (prizes); Assoc. Ga. A. Work: IBM; High Mus. A.; Ga. Sch. Tech.; Atlanta Hist. Soc. [47]

CONARD, Elizabeth [P] Maywood, IL [19]

CONARD, Grace Dodge [P,C,T] River Forest, IL b. 10 Ap 1885, Dixon, IL. Studied: AIC. Member: Chicago ASL; Chicago AG. Position: T., AIC [33]

CONAUGHY, Clarence W. [I] Minneapolis, MN [17]

CONDE, J.M. [I] NYC [10]

CONDIT, C(harles) L. (Mrs.) [P,C,T] Austin, TX b. 29 N 1863, Perrysburg, OH. Studied: Maud Mason; R.J. Everett; S.E. Gideon; Walter Rolfe. Member: Tex. FAA; Austin AL; G. Austin A. Specialty: conventional decoration of china [40]

CONDIT, J.L. [P,I,T] Cincinnati, OH. Position: T., Cincinnati A. Acad. [10]

CONDON, Catherine F. [P,T,W] Syracuse, NY b. 30 Ja 1892, PA. Studied: Syracuse Univ. Member: NAWPS; Syracuse AA; Dauber's Cl., Syracuse. Exhibited: NAWPS, 1936, 1937, 1938. Work: Syracuse Lib. Position: T., Syracuse Univ. [40]

CONDON, Grattan [Edu,I,P] NYC b. 10 Je 1887, Eugene, OR. Studied: Los Angeles A. &Des.; Walter Biggs; Lewis Daniel. Member: SC. Illustrator: "They Fly for Victory," 1943, "Brave Ships of World War II," 1944. Position: T., Parsons Sch. Des. [47]

CONDON, Harriet D. [P] South Manchester, CT. Member: Hartford AS [25]

CONE, George W. [P] NYC [10]

CONE, Grace C. (Mrs.) [P] Cincinnati, OH. Member: Cincinnati Women's AC [25]

CONE, Louise (Mrs.) [P,T] Birmingham, AL. Studied: G. Bridgman; W. Adams; G.E. Browne; A.L. Bairnsfather; R.D. Mackenzie. Member: ASL; SSAL; Birmingham AC. Work: Capitol, Montgomery, Ala.; Masonic Grand Lodge, Richmond, Va.; City Hall, Birmingham, Ala. [40]

CONE, Marvin [P,Edu] Cedar Rapids, IA b. 21 O 1891, Cedar Rapids d. 1964. Studied: Coe Col.; AIC; Ecole des Beaux-Arts. Member: Am. Assn. Univ. Prof. Exhibited: PAFA, 1936, 1937, 1941, 1942; CGA, 1937, 1942; AIC, 1938, 1939–45; Chicago Gal. Assn., 1940 (prize); Davenport Municipal A. Gal., 1940 (prize); VMFA, 1940, 1942, 1946; NAD, 1941, 1943–45; WFNY, 1939; CI, 1941, 1943; Colorado Springs FA Center, 1945, 1946; TMA, 1941, 1944; Swope Gal. A., 1942; MMA, 1942; Denver A. Mus., 1940–45; Joslyn Mem., 1943–45, 1945 (prize), 1946 (prize). Work: Cedar Rapids AA; Norton Gal., West Palm Beach, Fla.; Joslyn Mem. [47]

CONE, Miriam [E,B,T] Phila., PA b. 18 Je 1892, Phila. Studied: George J. Hunt. Member: NYSC; Phila. ACG; Phila. PC; Phila. Alliance. Positions: T., Moore Inst., Phila. Sch. Des. [40]

CONELY, William B. [Por.P] Detroit, MI b. 15 D 1830, NYC d. 12 O 1911. Exhibited: NAD, 1882–88 [*]

CONES, Nancy Ford (Mrs.) [P,Photogr] Loveland, OH b. 1870 d. 1962. Specialty: pictorialist photographs [19]

CONEY, Rosamond [P] NYC [19]

CONGDON, Adairene Vose (Mrs. Thomas R.) [P] Campbell, NY b. NYC. Studied: ASL; Paris, with L'Hermitte and Collin; Frank Brangwyn, in London. Member: Paris A. Women's AA; Chicago SE. Work: Petit Palais, Paris; LOC; NYPL [21]

CONGDON, Thomas R(aphael) [P,E,T] b. ca. 1862, Addison, NY d. 15 N 1917. Studied: ASL; Chase; Constant, Collin, Simon, in Paris. Member: SC, 1901; Allied AA; Paris AAA; Chicago SE; NYSE. Exhibited: Paris AA, 1902 (prize). Work: Luxembourg Print Coll.; LOC; NYPL; BAC; Musée du Petit Palais, Paris [17]

CONGDON, William Grosvenor [S] Lakeville, CT b. 15 Ap 1912, Providence, RI. Studied: PAFA; Cape Sch. A.; George Demetrios. Exhibited: PAFA, 1937, 1938; NA, 1938; WFNY, 1939. Work: RISD [40]

CONGERS, Louis [P] NYC. Member: Lg. AA [24]

CONKEY, Samuel [S,Ldscp.P] Brooklyn, NY b. 1830, NYC d. 2 D 1904. Exhibited: NAD, 1967–90. Author: unfinished, "Leaves from an Artist's Sketchbook"

CONKLIN, David Bruce [P] NYC [24]

CONKLIN, Margaret [P] Marquette, MI. Member: S. Detroit Women P. [24]

CONKLING, (David) Paul (Burleigh) [P,S] NYC/Boothbay, ME b. 24 O 1871, NYC d. Mr 1926. Studied: Falguire; MacMonnies [25]

CONKLING, Mabel (Mrs. Paul B.) [P,S] NYC/Boothbay, ME b. 17 N 1871, Boothbay. Studied: A. Saint-Gaudens; F. MacMonnies; A. Injalbert; Collin; Whistler. Member: AAPL; NAWPS. Work: AIC; Plastic C., Phila. Specialty: garden sculpture [40]

CONLEY, Sarah Ward [P,S,I,A,C,W,T] Nashville, TN b. 21 D 1861, Nashville. Studied: Bougueareau, Académie Julian, both in Paris; F.A. Bridgman; Ferrari, in Rome. Member: Nashville AA. Architect: Women's Bldg., Centenn. Expo, Nashville. Work: murals, Battle Creek Sanitarium; London, England; portraits, London and America [40]

CONLEY, William [Por.P] NYC b. ca. 1849 d. 10 Je 1909

CONLON, George [S] Baltimore, MD b. Maryland. Studied: Injalbert, Bartlett, in Paris. Member: Char. C. [25]

CONLON, James H.P. [P,I,Car,T] Branford, CT b. 10 Mr 1894, Meriden, CT. Studied: Conn. ASL; ASL; Chas. N. Flagg. Member: CAFA; Assn. Conn. Ar. [40]

CONLON, J.H.P., Mrs. See Saliske, Helen V. [40]

CONNAH, Douglas John [P,T] NYC b. 20 Ap 1871, NYC d. 23 Ag 1941. Studied: Royal Acad., Weimar; Royal Acad., Düsseldorf; Beaux-Arts; Académie Julian, Paris, with Benjamin-Constant, Laurens. Position: Dir., Am. Sch. Des. [10]

CONNAWAY, Jay Hall [P,T,L] Monhegan Island, ME b. 27 N 1893, Liberty, IN d. 1970. Studied: ASL, with Bridgman, Chase; Académie Julian, Paris, with Laurens; NAD; Ecole des Beaux-Arts. Member: NA; All.A.Am.; SC; NAC; Audubon A.; CAA; Meriden A.&Cr. Assn. Exhibited: CGA, 1932–43; PAFA, 1926–43; NAD, 1924–46, 1926 (prize); NAC, 1928 (prize); AIC, 1928–40; Currier Gal. A., 1934; Toledo Mus. A., 1937; Clearwater, Fla. A. Mus., 1939, 1940; Oberlin Col., 1939; Dayton AI, 1939; John Herron AI, 1911; All.A.Am., 1926, 1945 (prize); Albright Gal., 1928; Macbeth Gal.; Milch Gal.; Grand Central A. Gal., 1928; Vose Gal., Boston. Work: John Herron AI; Sweat Mem. A. Mus.; Canajoharie

A. Mus.; Springville, Utah A. Gal.; Charleston AA. Position: T., Connaway's Monhegan A. Sch., Maine [47]

CONNELL, Edwin D. [P] Clamart, France b. 3 S 1859, NYC. Studied: Paris, with Bouguereau, Robert-Fleury; Julien Dupré. Member: Société Internationale des Beaux-Arts; Paris AAA. Exhibited: Paris Salon, 1899; Orleans Expo, 1905 (med); Toulouse Expo, 1908 (med); P.-P. Expo, 1915 (med). Work: TMA [40]

CONNELL, May K. [P] Phila., PA. Member: F. PAFA [25]

CONNELLY, Eugene L. [P] Pittsburgh, PA. Member: Pittsburgh AA [21]

CONNELLY, George L. [I] Westtown, PA b. 3 Mr 1908, Phila. Studied: PMSchIA; Franz De Merlier, Belgium. Member: Phila. A. Dir. Cl.; Phila. Sketch Cl.; Chester County AA. Exhibited: Phila. A. Dir. Cl. Exh., 1943 (prize); West Chester AA. Illustrator: magazines, journals [47]

CONNELLY, Lillian B. [I] Salt Lake City, UT [15]

CONNELLY, Marc [I] NYC. Member: SI [31]

CONNELY, Pierce Francis [Ldscp.P,S] b. ca. 1840, in the South (raised in England, came to U.S. in 1876; later went to New Zealand). Studied: Paris; Rome. Had sculpture studio in Rome, ca. 1860. [*]

CONNER, Albert Clinton [P] b. 5 S 1848, Fountain City, IN d. 13 Ap 1929, Manhattan Beach, CA. Founder, Calif. AC, Los Angeles. Work: Santa Fe Railroad Co.

CONNER, Grace [P] Willow Springs, PA b. Willow Springs. Studied: Phila.Sch. Des. for Women [08]

CONNER, Jerome [S] Wash., D.C. b. 12 O 1875, Ireland. Studied: self-taught. Member: S. Wash. A. Work: bronze tablet, "Nuns of the Battlefield," Wash., D.C. [29]

CONNER, John Ramsey [P] Doylestown, PA b. 1869, Radnor, PA d. 12 S 1952. Studied: PAFA. Exhibited: P.-P. Expo, 1915 (med); Sesqui-Centenn. Expo, Phila., 1926 (med). Work: PAFA; Des Moines Assn. FA; CGA [47]

CONNER, Paul [P] Long Beach, CA b. 5 S 1881, Richmond, IN. Member: H.L. Richter; A. Clinton Conner. Member: Laguna Beach AA; Long Beach AA; PSC, Los Angeles. Exhibited: Southern Calif. Eisteddfod, 1926; Long Beach AA, 1935 (prizes). Work: Athletic Cl., Los Angeles; Deauville Cl., Santa Monica; Pacific Coast Cl., Ebell Cl., Long Beach; Rockefeller Fnd., London, England [40]

CONNICK, Charles J. [Des,L] Newtonville, MA b. 27 S 1875, Springboro, PA d. 28 D 1945. Member: Mural P.; Boston SAC; NYSC; Century Assn.; Boston Arch. Cl.; Boston AC; Copley S.; Mediaeval Acad. Am.; AFA; Stained Glass Assn. Am.; F., Am. Acad. A.&Sc. Exhibited: AIA, 1920 (med), 1925 (med); P.-P. Expo, San Fran., 1915 (gold); AIC, 1917 (med), 1918 (med), 1919 (med), 1920 (med), 1921 (med). Work: stained glass in churches/chapels, Pittsburgh, San. Fran., NYC, Buffalo, Princeton, Harrisburg, Chicago, Evanston (Ill..), Brookline (Mass.), Boston, Framingham (Mass.), Plymouth (N.H.), Wash., D.C., Baltimore, Detroit, Cincinnati, Cleveland, St. Paul, Minneapolis, Paris (France); AIC. Author: "Adventures in Light and Color," 1937, pub. Random House, series articles, "International Studio," 1923–24 [40]

CONNOR, Charles [P] Fountain City, IN b. Richmond, IN d. 1857. Exhibited: St. Louis Expo, 1904. Known as one of the strongest painters in the Middle West. Specialties: landscapes, still lifes [04]

CONNOR, Clinton B. [P] Manhattan Beach, CA. Member: Calif. AC [25]

CONOVER, Alida [P] NYC. Exhibited: Soc. Wash. Ar., 1937, 1938; VMFA, 1938; GGE, 1939 [40]

CONOVER, Kate [P,T] Detroit, MI. Member: Detroit S. Women P. [25]

CONRAD, Reine Adelaide [P] Chicago, IL b. 1871, St. Louis, MO. Studied: AIC; Acad. Colorossi, Eugéne Farier, in Paris [01]

CONRADI, Joseph [S] b. 1867, Switzerland (came to U.S. in 1887) d. 16 N 1936, Los Angeles. Work: LOC; Los Angeles City Hall; Los Angeles Times Building; various U.S. State Houses

CONRADS, Carl [S] Hartford, CT b. Germany [06]

CONREY, Lee F. [I] NYC b. 11 S 1883, St. Louis, MO. Studied: St. Louis Sch. FA. Member: SI. Illustrator: Cosmopolitan, McClure's, Munsey's [25]

CONROW, Wilford Seymour [P,W,L] NYC/Hendersonville, NC b. 14 Je 1880, South Orange, NJ. Studied: P. Tudor-Hart; Hambridge; Laurens, Morisset, in Paris; N.Y. Sch. FA. Member: All.A.Am.; Brooklyn SA; AAPL; Audubon A.; Century Assn. Exhibited: Paris Salon, 1914; All.A.Am.; CGA, 1927; NAD, 1933; Brooklyn SA, 1920–46; AAPL; High Mus. A., 1927 (one-man); Mint Mus. A., 1933 (one-man); Hickory Mus. A., 1944 (one-man); PAFA, 1927. Work: Brooklyn Polytechnic Inst.; Columbia; Princeton; Yale; Vassar; High Mus. A.; Mint Mus. A.; BM; State House, Trenton, N.J.; Office Postmaster General, Wash., D.C., mural, George Washington Life Ins. Co., Charles Town, W.Va. Coauthor: "Portraits of Washington," 1932. Lectures: The Great Chalice of Antioch [47]

CONROY, George T. [P] NYC. Member: SC [25]

CONSTABLE, S.M. (Miss) [P] Wash., D.C. [13]

CONSTABLE, William George [Mus.Cur,Ed,W,L,Cr] Cambridge, MA b. 27 O 1887, Derby England d. 1976. Studied: Cambridge; Slade Sch., London, with Wilson Steer, Havard Thomas. Member: F., Soc. Antiquaries; A. Workers Gld., London; Am. Acad. A.&Sc. Author: "Flaxman: English Painting 17th & 18th Centuries," and others. Contributor: art magazines, bulletins. Positions: Asst. Dir., Nat. Gal., London; Dir. Inst. A., Univ. London; Slade Prof., Univ. Cambridge; Cur. Paintings, BMFA; L., Yale [47]

CONSTANT, George [P] NYC b. 17 Ap 1892, Greece. Studied: St. Louis Sch. FA; Washington Univ.; AIC; Charles Hawthorne; George Bellows; R.D. Wolcott. Member: Fed. Mod. P.&S. Exhibited: AIC, 1937–42, 1943 (med), 1944, 1945; CI, 1944, 1945; BM, 1937–45; WMAA, 1946; PAFA, 1944, 1945, 1946; VMFA, 1944, 1945; SFMA, 1942. Work: MMA; BM; Dayton AI; State Dept., Wash., D.C.; Detroit Inst. A. [47]

CONSTANTIN, Marie [P] Phila., PA [06]

CONTENT, Daniel [P,I,Car,T] NYC b. 6 F 1902, NYC. Studied: PIASch.; ASL; Harvey Dunn. Member: SI; New Rochelle AA. Illustrator: national magazines [47]

CONTI, Gino Emilio [P,S,C,T] Providence, RI b. 18 Jy 1900, Barga, Italy. Studied: R.I. Sch. Des.; Ecole des Beaux-Arts, Académie Julian, Paris. Exhibited: IBM, 1941 (prize); Artistes Français, Paris, 1925; Arch. Lg., 1929, 1930; NAD, 1929; PAFA, 1929; CAM, 1930; Providence Mus. A.; WMA; CM, 1930; Providence AC; Doll & Richards, Boston; Newport AA. Work: murals, R.I. State Col. [47]

CONTI, Tito [S] b. Florence, Italy (came to U.S. shortly after the Civil War) d. 21 F 1910. Studied: Florence. An ornamental sculptor, he opened a studio in Boston, ca. 1866.

CONTOGURIS, Christ [P,S] Chicago, IL b. 6 Jy 1913, NYC. Studied: Univ. Wis.; Layton A. Sch.; AIC; Gerrit Sinclair; Francis Chapin; Olga Chassaing. Exhibited: AIC, 1944 [47]

CONTOIT, Louis [P] NYC [04]

CONVERSE, Edmund Cogswell [Patron] b. 1849 d. 4 Ap 1921, Pasadena, CA

CONVERSE, H. (Mrs.) [P] Paris, France [19]

CONVERSE, Lily S. [Li,P] NYC b. 14 O 1892, St. Petersburg, Russia. Studied: PAFA; ASL, with Kenneth Hayes Miller; McCarthy. Member: NAWA; AAPL; Am.-Brit. AA; Phila. Pr. Cl.; Phila. A. All. Exhibited: Wilmington Soc. FA, 1940 (prize); Chester Co. (Pa.) AA, 1941 (prize); CGA, 1944, 1945; PAFA, 1945; Phila. Pr. Cl.; NAWA, 1944, 1945; Phila. A. All.; NAD, 1944, 1945; LOC, 1944, 1945; SSAL; San Fran. AA; Laguna Beach AA; NCFA, 1946 (one-man); Sarasota AA, 1945 (one-man); Berkshire Mus. A., 1944 (one-man); England; France. Work: MMA; PMA; BMFA; Detroit Inst. A.; Phila. Pr. Cl.; N.C. State Mus.; NYPL [47]

CONWAY, Frederick E. [P,Edu,L] Webster Groves, MO b. 24 Ag 1900, St. Louis, MO. Studied: Washington Univ.; Académie Julian, Grande Chaumière, Paris. Member: St. Louis AG; Two-by-Four Soc. A., St. Louis. Exhibited: Pepsi-Cola, 1945 (prize); CAM, 1945 (prize); St. Louis AG, 1945 (prize); 48 Sts. Comp., 1941; VMFA, 1946; NAD, 1946; Denver A. Mus., 1946; Kansas City AI, 1945. Work: Pepsi-Cola Coll.; CAM; Springfield (Mo.) A. Mus., mural, USPOs, Jackson, Mo., Purcell, Okla. Position: Instr., Wash. Univ. Sch. A. [47]

CONWAY, John S(everinus) [P,S] Tenafly, NJ b. 21 F 1852, Dayton, OH d. 25 D 1925. Studied: Conrad Diehl; Jules Lefebvre; Boulanger; A. Millet. Member: N.Y. Arch. Lg., 1892; NSS. Work: Chamber of Commerce, Milwaukee [25]

CONWAY, Rebekah Nan B. [P] Phila., PA [19]

CONWAY, William John [P,S] St. Paul, MN b. 26 O 1872, St. Paul. Studied: Acad. Colorossi, Paris, with Collin, Courtois, Prinet. Member: Whistler Cl.; Art Workers' Gld.; Minn. State Art Soc.; Ar. Soc., St. Paul [33]

CONWELL, Averil Courtney (Mrs. L.D.) [P,T] Upper Jay, NY b. 29 Ap 1898, Belvidere, IL. Studied: Dudley Crafts Watson; Carl Krafft; AIC; Chicago Acad. FA; Edmund Giesbert; Jon Corbino. Member: Chicago AC; Assn. Chicago P.&S.; Chicago SA; Austin, Oak Park & River Forest A. Lg.; Chicago Gal. Assn. Exhibited: Chicago Gal. Assn., 1941 (prize); Austin, Oak Park & River Forest A. Lg., 1943 (prize), 1944 (prize), 1945 (prize); CM, 1945; AIC, 1931, 1932, 1935, 1937, 1941, 1944; Findley A. Gal., 1938, 1941 (one-man) [47]

COOCH, Marian Clark (Mrs.) [P] San Fran., CA b. 10 O 1877, Cornwall-on-Hudson. Studied: ASL, Buffalo; Sch. IA, Phila.; Columbia; A.W. Dow; Lucius Hitchcock. Member: Pacific A. Assn.; San Fran. A. Assn. Exhibited: San Fran A. Assn., 1939; Oakland AM; Vera Jones Bright Gal., San Fran. (one-man). Position: Assoc. Prof. A., State Col., San Fran. [40]

COOK, August [Edu,P,En,C,L] Spartanburg, SC b. 15 Mr 1897, Phila., PA. Studied: Harvard; PAFA; Garber; Hale; Carles. Exhibited: Gibbes A. Gal., Charleston, S.C., 1936–41; Mint Mus. A., 1937–46. Position: Prof. A., Converse Col. 1924– [47]

COOK, Blanche Helen McLane (Mrs. Harry C.) [P,T] Yakima, WA b. 1 Jy 1901, Moulton, IA. Studied: Phila. Sch. Des. Member: Yakima Valley AA. Exhibited: Wash. State Fair, 1930 (prize), 1931 (prize); SAM, 1945; Pal. Leg. Honor, 1946; Pacific Northwest A. Exh., Spokane, 1944. Position: Instr., Yakima Valley Jr. Col. [47]

COOK, Charles Bayley [P] NYC [17]

COOK, Charles J. [Dr] Chicago, IL [13]

COOK, Clarence (Chatham) [Cr,W,P] b. 1828, Dorchester, MA d. 1 Je 1900, Fishkill, NY. Studied: Harvard. Editor: "Art and Artists of Our Times" (1888); Studio magazine. He furnished the notes to a translation of Lubke's "History of Art." Position: Art Cr., New York Tribune.

COOK, Daniel [P] Dayton, OH b. 15 My 1872, Cincinnati. Studied: Nicholas Gysis; Cincinnati A. Acad. Member: Munich A. Cl.; Cincinnati AC. Work: Univ. Cincinnati; mural dec., Cincinnati Music Hall [27]

COOK, Edna Rogerson [P] Evanston, IL [19]

COOK, Frances Kerr (Mrs. David C., Jr.) [I] Elgin, IL b. West Union, IA Studied: AIC; Chicago Acad. FA. Member: ASL. Illustrator: "Today's Stories of Yesterday," "The Alabaster Vase," "Red and Gold Stories," other books. Position: Ed. Dir., David C. Cook Publishing Co. [40]

COOK, George E. [P] d. Summer, 1930, Southern Pines, NC. Studied: Arthur E. Pope, in England. Exhibited: England; France; Italy; NYC; Boston. Spent much of his life in Europe.

COOK, Gladys Emerson [I,W,P,E,L] NYC b. 7 N 1899, Haverhill, MA. Studied: Skidmore; Univ. Wis.; ASL, with Anthony Thieme, Yarnall Abbott. Member: SAE; SI. Exhibited: NAD, 1943, 1944, 1945; LOC, 1943, 1944, 1945; NYPL, 1942; NAC; SI, 1945 (one-man). Work: CM; NYPL; MMA. Author/Illustrator: "Hiram and Other Cats," 1941, "American Champions," 1945. Contributor: animal illustrations to newspapers; Carter's Ink cat ads [47]

COOK, Gretchen [T,P,B] Newton Centre, MA b. 29 Jy 1908, Newton Centre. Studied: BMFA Sch.; Aldro Hibbard; Philip L. Hale; Henry Hunt Clark; Leslie Thompson; Frederick Bosley; A.K. Cross; Frederick Allen; Robin Guthrie. Member: Inst. Mod. A., Boston; Boston AC; Copley S.; Boston S.Indp.A.; New Bedford Indp.A. Exhibited: BMFA; Portland, Maine; New Haven and Hartford, Conn. Positions: T., BMFA (1927–), Boston H.S. (1944–) [47]

COOK, Hazelle Grace [P] Milwaukee, WI b. 19 N 1899, Minneapolis, MN. Studied: Anthony Angarola; Cameron Booth. Member: Wis. PS. Exhibited: Kansas City AI, 1928 (prize); Wis. State Fair, 1930 (prize); Milwaukee AI, 1930 (prize) [40]

COOK, Howard Norton [P,Gr,I,Edu,E,B,] Taos, NM b. 16 Jy 1901, Springfield, MA. Studied: ASL, 1919–21; Europe. Member: Prairie PM; Mural P.; SAE; AFA. Exhibited: Phila. PC, 1929 (prize), 1933 (prize); Warsaw, 1933 (prize); Brooklyn SE, 1931 (prize); SAE, 1934 (prize), 1936 (prize); Phila. A. All., 1934 (prize); AIC, 1934, 1935 (prize), 1936–46; Phila. Pr. Cl., 1937 (prize); Arch. Lg., 1937 (gold); 50 Prints of the Year, 1931–35; AV, 1942 (med); WMAA; BM; Calif. WC Soc.; Springfield Mus. FA; Weyhe Gal. (one-man exhibits); Rehn Gal., 1945; Kennedy Gal., 1945. Work: MOMA; MMA; WMAA; murals, Federal bldgs., Springfield (Mass.), Pittsburgh, San Antonio, Corpus Christi; Fogg A. Mus., Harvard; BMA; NYPL; Mattatuck Hist. Soc., Waterbury, Conn.; AIC; Lehigh Univ.; Princeton; Newark Mus.; Pub. Lib., Springfield, Mass.; Hamilton Col.; Bibliothèque Nationale, Paris; Kupferstich Kabinett, Berlin; Brit. Mus.; Victoria & Albert Mus. Author/Illustrator: "Sammi's Army," 1943. Illustrator: Harpers and other magazines, 1922–27. Positions: Guest Prof. A., Univ. Tex. (1942–43), Minneapolis Sch. A. (1945); Instr., Univ. N.Mex, Albuquerque, 1938, 1946 [47]

COOK, I(sabel) Vernon (Mrs. Jerome) [P] NYC b. Brooklyn, NY. Studied: ASL; Chase; Blanche, Simon, in Paris. Member: NAWPS [33]

COOK, Jean Behan (Mrs. S.E.) [P] Waterloo, NY b. Waterloo. Studied: Irving Wiles; Walter Satterlee [10]

COOK, John A. Gloucester. MA b. 14 Mr 1870, Gloucester d. 9 Mr 1936. Studied: DeCamp; E.L. Major; Douglas Volk. Member: Baltimore WCC; Rockport AA; Gloucester SA; North Shore AA; Boston AC; New Haven PCC; AFA [40]

COOK, L.A. [P] St. Louis, MO [25]

COOK, Lauren (Mr.) [I] Provincetown, MA. Member: SI [47]

COOK, Lillian [P] Wash., D.C. [98]

COOK, Mary Elizabeth [S,Li] Columbus, OH b. D 1881, Chillicothe, OH. Studied: Ecole des Beaux-Arts, Acad. Colorossi, Paris; Paul Bartlett. Member: NSS; AFA; Am. Ceramic Soc.; NAC. Exhibited: Intl. PS, Paris, (prize). Work: Ohio State Univ.; pub. bldgs. in Columbus (Ohio), St. Louis, Colorado Springs; Nat. Mus., Wash., D.C. Award: medal, Paris Salon, for war work, 600 life masks and 500 models for reconstruction of faces of American soldiers [47]

COOK, Nelson [Por.P] b. 1817 d. 1892. Exhibited: NAD. Lived in Saratoga Springs, N.Y., 1841–44, 1857–59; Rochester, N.Y., 1852–56 [*]

COOK, Paul Rodda [P] San Antonio, TX b. 17 Ag 1897, Salina, KS. Studied: H.D. Pohl; Birge Harrison; H.D. Murphy. Member: SSAL; San Antonio AL; AAPL. Exhibited: Waco Cotton Palace, 1929 (prize); San Angelo, 1929 (prize); Lockhart State Fair, 1929 (prize); Davis Comp., 1929 (prize); SSAL, 1936 (prize). Work: Vanderpoel Coll.; San Pedro Lib., Groos National Bank, Carnegie Lib., Witte Mus., all in San Antonio [40]

COOK, Peter Geoffrey [P] Kingston, NJ b. 10 Je 1915, NYC. Studied: Princeton; NAD, wiith Gifford Beal, Leon Kroll. Member: Century Assn. Exhibited: NAD, 1940, 1944 (prize), 1945 [47]

COOK, Ruth Rawson [P] Milwaukee, WI [25]

COOK, S.E. (Mrs.) [P] Waterloo, NY b. Waterloo. Studied: Irving Wiles; Walter Satterlee [08]

COOK, Walter William Spencer [Edu,L] NYC b. 7 Ap 1888, Orange, MA d. 1962. Studied: Harvard; Princeton. Member: Hispanic Soc. Am.; F., Mediaeval Acad. Am.; Council, Hispanic Inst., U.S.; N.Y. Hist. Soc.; Archaeological Inst. Am.; Institut d'Estudis Catalans, Barcelona. Contributor: The Art Bulletin, Am. Journal of Archaeology, other publications. Lectures: Spanish Art. Award: Order of Isabela la Catollica. Positions: T., Dir., Inst. FA, NYU; Advisor: PMA, on Spanish Art [47]

COOK, William E(dwards) [Por.P,Mur.P] Paris, France/Independence, IA b. 31 Ag 1881, Independence, Iowa. Studied: AIC; NAD; Laurens, in Paris [17]

COOKE, Abigail W. [P] Providence, RI. Studied: RISD; George W. Whittaker; Sydney R. Burleigh. Member: Providence AC; Providence WCC. Work: Providence AC [21]

COOKE, C. Ernest [Edu,W,Cr,L,P] Bristol, VA b. 3 Je 1900, Owensboro, KY. Studied: Univ. Richmond; Harvard; Oxford; London Univ.; Robert Brackman. Exhibited: Norfolk Mus., 1946; Intermont Exh., 1945, 1946. Lectures: Renaissance Art; Contemporary Art. Position: Hd., Hist. A. Dept., Va. Intermont Col., Bristol, 1940– [47]

COOKE, Charles H. [P] Chicago, IL b. Toledo, OH. Studied: AIC. Member: Palette & Chisel Acad. FA; AAPL; Ill. Acad. FA [40]

COOKE, Charles Montague (Mrs.) d. 8 Ag 1934. Founder: Honolulu Academy of Arts.

COOKE, Donald Ewin [W,I,P,T,B] Phila., PA b. 5 Ag 1916, Phila. Studied: PMSchIA, with Henry C. Pitz. Member: Phila. WCC; Phila. Sketch Cl.; Folio Cl.; AA, Phila. Exhibited: Bookplate Exh., Los Angeles Mus. A., 1936 (prize); PAFA, 1938–40. Illustrator: "The Nutcracker of Nuremberg" (1938), "The Firebird" (1939), "The Sorcerer's Apprentice" (1946); Child Life, Jack & Jill, other magazines. Position: Ed., David McKay Co., 1941– [47]

COOKE, Dorothea [P,I,E] Hollywood, CA b. 10 O 1908, Hollywood. Studied: Chamberlain; Miller; Pruett Carter. Member: Calif. WCS. Exhibited: Ariz. State Fair, 1929 (prize); Calif. State Fair, Pomona, 1929 (prize) [40]

COOKE, Edna (Mrs. E.C. Shoemaker) [I,L,T] Media, PA b. 19 Je 1890,

Phila.. Studied: PAFA, with Breckenridge; McCarter. Member: Phila. A. All. Exhibited: PAFA. Illustrator: "Hans Brinker," "Heidi," "Mother Goose," other children's books. Author: stories/articles for children, national magazines. Lectures: Development of Children's Books [47]

COOKE, Hereward Lester, Jr. [P,I,Art Hist.] Princeton, NJ b. 16 F 1916, Princeton d. 1973. Studied: Oxford; Bridgman; Yale; Wayman Adams. Member: Oxford A. Soc.; Wash. WCC. Exhibited: Beaux-Arts Comp., 1941 (prize); NAD, 1942; WMAA, 1941; PAFA, 1942; NCFA, 1941; CGA, 1946; Sweat Mem. A. Mus., 1946. Illustrator: "British Labour Leaders," 1938 [47]

COOKE, Honoré Guilbeau. See Guilbeau.

COOKE, Jessie Day [P,T] Chicago, IL b. 16 My 1872, Atchison, KS. Studied: AIC; John Vanderpoel; Pauline Dohm; Frederick Freer [38]

COOKE, Mary Melissa [P] Hinsdale, IL b. Chicago, IL. Studied: AIC; Rolshoven, in Paris [01]

COOKE, Regina Tatum [P,W] Taos, NM b. 22 Ag 1902, Corsicana, TX. Studied: Sandzen; Broadmoor A. Acad.; Ward Belmont A. Sch.; Walter Ufer. Member: Taos Ar. Assn.; La Fonda de Taos Gal. Group. Exhibited: Tri-State Expo, Amarillo, Tex., 1931–32 (prizes). Work: Court House, Dalhart, Tex.; Court House, Raton, N.Mex. [40]

COOKMAN, C.E. [P] NYC d. 1915. Member: SC, 1898 [13]

COOK-SMITH, Jean Beman [P,S,I] San Diego, CA b. 26 Mr 1865, NYC. Studied: AIC; Irving R. Wiles; Walter Satterlee; Holland; France; Italy. Member: NAWPS. Work: San Diego Mus. [33]

COOLEY, Blanche Marshall. See Ratcliff, W.B., Mrs.

COOLEY, Dixie (Mrs. John L.) [P,L] Chattanooga, TN b. 25 S 1896, Hartwell, GA. Studied: Gibson-Mercer Acad.; Univ. Chattanooga, with Frank Baisden; Newcomb Col.; ASL, with Brook, Kuniyoshi. Member: Chattanooga AA; SSAL; NAWA; AAPL. Exhibited: Chattanooga AA; IBM; Donald, Tenn. AA; AWCS 1943–45; Audubon A., 1943–45; All.A.Am., 1944, 1945; NAWA; Newhouse Gal.; Am.-Brit. A. Center, 1943 (one-man); Argent Gal., 1945. Work: IBM; Univ. Chattanooga [47]

COOLEY, Ruth Patton [P] Provincetown, MA b. 4 F 1901, Phila, PA. Studied: PAFA, with Daniel Garber; ASL, with Nicolaides. Member: Provincetown AA; Boston AC. Exhibited: PAFA, 1935; Mass. Women's Professional Cl., 1932; Provincetown AA, 1942–45 [47]

COOLIDGE, Bertha [Min.P] NYC b. Ag 1880, Lynn, MA. Studied: BMFA Sch., with Tarbell, Benson; Bourgeois, in Paris; Grueber, in Munich. Member: Société de la Miniature, Paris; Pa. Soc. Min. P. [33]

COOLIDGE, Georgette E. (Mrs. Walter G.) [P] Lyndon, VT b. 17 Mr 1850, Brooklyn, NY d. 16 Ap 1929. Studied: Mrs. A. Van Clef Dodgshun; Roberta Rascovitch. Specialty: watercolors [27]

COOLIDGE, Hazel [P] Lyndon, VT b. 21 S 1882, Chicago, IL. Studied: Virginia Reynolds; William B. Parker; Philip Hale [17]

COOLIDGE, John [P] Los Angeles, CA b. Carbondale, PA. Studied: Lafayette Col.; PAFA; Chase; Cecilia Beaux; T.P. Anshutz; J. Francis Smith. Member: Calif. AC; AAPL; Laguna Beach AA. Exhibited: Santa Cruz AL, 1934 (prize). Work: Los Angeles Mus. A.; U.S. Treasury Dept., Wash., D.C.; U.S. Dept. Commerce, Los Angeles [47]

COOLIDGE, J(ohn) T(empleman), Jr. [P] Readville, MA/Portsmouth, NH b. 28 D 1888, Boston, MA d. 16 N 1945, Boston. Studied: Philip Hale; William James; Europe. Member: Boston AC; BMFA (trustee); Boston Art Commission, for 20 years [33]

COOLIDGE, Mabel L. (Mrs.) [P] Worcester, MA [25]

COOLIDGE, Mary Rosamond [Por.P] Watertown, MA b. 18 My 1884, Watertown. Studied: Mass. Sch. A., with Anson K. Cross, Wilbur Dean Hamilton; BMFA Sch., with Edmund C. Tarbell. Member: Boston AC; NAWA; Copley Soc. Exhibited: Lg. Am. Pen Women, 1946 (prize); CGA, 1915, 1926; AIC, 1909, 1912, 1913; NAD, 1922; PAFA, 1910, 1913, 1918; Jordan Marsh Co.; North Shore AA; Ogunquit A. Center, 1938, 1940; Newport AA, 1940–42; Boston AC. Work: Leverett House, Harvard; First Parish Church, Watertown [47]

COOLIDGE, Mountfort [P] Ogunquit, ME b. 12 Je 1888, Brooklyn, NY. Studied: Henri [27]

COOLIDGE, Richard B. [P] Brooklyn, NY [19]

COOMARASWAMY, Ananda K. [Mus.Cur,W] Needham, MA b. 22 Ag 1877, Colombo, Ceylon d. S 1947. Studied: London Univ. Member: Instituto de Coimbra; Archaeological Survey of India; Bhandarkar Oriental Research Soc.; Royal India Soc.; Indian Soc. Oriental Art. Organized: permanent Indian, Persian, Near Eastern exhibits, BMFA. Positions: Cur., Indian Art, BMFA, 1917; Research F., Indian, Persian, Muhammadan Art, BMFA [47]

COOMBS, D(elbert) D(ana) [P,I,T] Auburn, ME b. 26 Jy 1850, Lisbon Falls, ME d. 1938, Lewiston, ME. Studied: self-taught; Scott Leighton; Harrison Brown. Work: capitol, Maine; Yale; Poland Spring A. Gal.; Bates Col. Apprenticed to a photographer in Portland, Maine; became a sign painter and teacher. Returned to Lewiston after a stint in a Boston engraving company. [17]

COOMER, Mark Allen [P,I,Des] Prospect Heights, IL b. 15 S 1914, Bay City, MI. Studied: Am. Acad. A., with Wilimovsky. Member: Chicago Gal. Assn.; A. Gld., Chicago. Exhibited: AIC; Woodmere A. Gal. (one-man); A. Gld., Chicago. Illustrator: Holiday, 1946 [47]

COON, Howard A. [P] Westerly, RI. Member: Providence AC [24]

COONAVALE, Robert [P] Brooklyn, NY. Member: S.Indp.A. [25]

COONEY, Charles B. [En] Chicago, IL [24]

COONEY, Fanny Y. Cory (Mrs. F.W.) [I] Canyon Ferry, MT b. 17 O 1877, Waukegan, IL. Studied: ASL. Specialty: juvenile subjects [10]

COONSMAN, Nancy [S,Arch,T] St. Louis, MO b. 28 Ag 1888, St. Louis. Studied: Zolnay; Grafly. Member: St. Louis AG. Exhibited: Mo. State Fair (med); St. Louis AG, 1919 (prize), 1920 (prize). Work: Pub. Lib., St. Louis; City Art Mus., St. Louis; Toledo Mus. A.; Mo. War Mem., Cheppy, France [24]

COOPER, A.M. [P] NYC [04]

COOPER, Alice [S] Chicago, IL. Studied: AIC, with Taft [15]

COOPER, Anthony J. [P] Chicago, IL b. 28 F 1907, Chicago. Studied: AIC. Member: Chicago A. Lg. Exhibited: NAD, 1945; CGA, 1943; Chicago Century of Progress, 1934; AIC, 1931–46; Ill. State Mus., 1938. Work: Ill. State Mus., Springfield [47]

COOPER, Astley D.M. [P,I] b. 1865, St. Louis, MO d. 1924, San Jose, CA. Studied: Wash. Univ. Illustrator: Leslie's. Painter: series of Indian portraits, 1877; later, some large nudes for saloons. Moved to San Jose in 1883 where he became an authority on the Old West, which was the subject of his paintings. [*]

COOPER, Barbara Ritchie (Mrs. David M.) [I] Kansas City, MO b. 7 Je 1899. Illustrator: Saturday Evening Post, Cosmopolitan, McCall's, Woman's Home Companion [40]

COOPER, Brother Etienne [S,P,T] Notre Dame, IN b. 11 Jy 1915, Altoona, PA. Studied: Univ. Notre Dame; Catholic Univ. Exhibited: Hoosier Salon, 1943, 1944, 1945 (prize), 1946 (prize); John Herron AI, 1945. Illustrator: "Young Prince Gonzaga," 1944. Position: T., Cathedral H.S., Indianapolis [47]

COOPER, Clarissa L. [P] Brooklyn, NY [13]

COOPER, Colin Campbell [P,W] Santa Barbara, CA b. 1856, Phila. d. 6 N 1937. Studied: PAFA; Académie Julian, Académie Delecluse, Paris. Member: ANA, 1908; NA, 1912; Phila. WCC; AWCS; NAC; SPNY; AFA; San Diego AG; Calif. AC. Exhibited: Atlanta Expo, 1895 (med); AWCS, 1903 (prize); PAFA, 1904 (prize), 1919 (prize); ACP, 1905 (gold); Buenos Aires Expo, 1910 (med); NYWCC, 1911 (prize), 1918 (prize); P.-P. Expo, San Fran., 1915, oil (gold), watercolors (med); San Diego FA Gal., 1930 (prize). Work: Cincinnati Mus.; Dallas (Tex.) AA; City A. Mus., St. Louis; Boston A. Cl.; A. Cl. Phila.; Lotos Cl.; PAFA; French Gov.; Reading Mus.; FA Gal., San Diego. Author: plays produced in community theatre. One of the earliest Taos artists, painting at the Pueblos before 1883.

COOPER, Elizabeth [S] Stamford, CT [24]

COOPER, Elizabeth Ann [P] Seattle, WA b. 1 Mr 1877, Nottingham, England d. 4 S 1936. Studied: Mark Hopkins Inst., San Fran.; Univ. Wash. Member: Group of Twelve, Seattle. Exhibited: Spokane, Wash.; Seattle AM; Pal. Leg. Honor; Univ. Idaho; Oakland A. Gal.; Group of Twelve exhibitions [24]

COOPER, Emma Lampert (Mrs. Colin Campbell Cooper) [P] NYC b. 1860, Nunda NY d. 30 Jy 1920, Pittsfield, NY. Studied: Wells Col.; CUASch; ASL; Agnes Abbatt; William M. Chase; H. Thompson, in Paris; J. Kever, in Holland. Member: Phila. WCC; NYWCC; SPNY; AWCS. Exhibited: Columbian Expo, Chicago, 1893; Atlanta Expo, 1895 (med); AAS, 1902 (gold); St. Louis Expo, 1904 (med); N.Y. Women's AC, 1907 (prize) [19]

COOPER, F.G. [I] Forest Hills, NY. Member: SI, 1910; SC; AI Graphic A. [19]

COOPER, Fern Frances [P,S,T] Topeka, KS b. 22 Ja 1912, Topeka. Studied: Washburn Col.; AIC. Work: Kans. State Col., Manhattan; State T. Col., Emporia, Kans. [40]

COOPER, Florence Alice [P,T] Toledo, OH b. 2 F 1882, Galion, OH. Studied: Arthur Dow; Grace Cornell. Member: Soc. Toledo Women A.; Ohio WCS; Toldeo Fed. A. Soc. Position: Hd., A. Dept., Thomas A. DeVilbiss H.S., Toledo [40]

COOPER, Fred G. [Car,Li,W] NYC b. 29 D 1883, McMinnville, OR d. 1962. Member: SI, 1910; Bohemian Cl.; A. Gld. Illustrator: "The Subway Sun"; Collier's, Life, Liberty. Originator: Cooper Letter. Work: theatre posters for Food Administration. [47]

COOPER, Henry [P,E,Li] Phila., PA b. 6 S 1906, Russia. Studied: PAFA; Henry McCarter; André Lhote, in Paris. Work: PAFA; Phila. Board Ed.; Allentown Mus. [40]

COOPER, Jane Farrow (Mrs. John) [P] Atlanta, GA b. 17 F 1861, Laurens, SC. Studied: Felecie W. Howell; Albert Krebel; Breckenridge; G.E. Browne; Frederick Grant; Will Stephens. Member: Atlanta AA. Exhibited: Atlanta AA, 1923 (prize) [33]

COOPER, (William) Leonard [P] Salinas, CA b. 14 Jy 1899, Salinas. Studied: Col. of the Pacific. Exhibited: Atlanta Univ., 1946 (prize); SFMA, 1944; Oakland A. Gal., 1936, 1937, 1941, 1943, 1944; Santa Cruz A. Lg., 1936, 1937, 1938, 1942. Work: Atlanta Univ. [47]

COOPER, Leone [E,C,P,I,L] Webster Groves, MO b. 30 Mr 1902, St. Louis, MO. Studied: Harris T. Col. Member: SSAL. Exhibited: LOC, 1946; Laguna Beach AA, 1946; William Rockhill Nelson Gal., 1945; Joslyn Mem., 1944, 1945; CAM, 1942-44; St. Louis A. Gld., 1939, 1941, 1946; Springfield A. Mus., 1941, 1944 [47]

COOPER, Margaret Miller (Mrs. Elisha H.) [P] New Britain, CT/Lyme, CT b. 4 Mr 1874, Terryville, CT. Studied: NAD; PAFA, at Chester Springs, Pa.; Henry B. Snell; Guy Wiggins; Dwight Tryon; C. Woodbury; Pratt Inst.; R. Brackman. Member: NAC; NAWPS; AFA; Conn. Acad. FA; New Haven PCC [40]

COOPER, Marie Eleanor [Des] Chicago, IL b. 25 Ag 1910, NYC. Studied: Goodman Sch. Theatre; Edmund Giesbert: Leslie Margolf; Helen Gardner; AIC. Specialty: theatrical design [40]

COOPER, Mario Ruben [I,S,T,L] Port Washington, N.Y. b. 26 N 1905, Mexico City. Studied: Otis AI; Chouinard AI; Grand Central A. Sch.; Columbia; Harvey Dunn; Pruett Carter; Louis Treviso; F. Tolles Chamberlin; Oronzio Maldarelli. Member: SI; N.Y. A. Gld. Illustrator: national magazines [47]

COOPER, Myrtle (Mrs. M.C. Schwarz) [Edu,C,W] Enid, OK b. 10 D 1910, Vanzant, KY. Studied: Western Ky. T. Col.; Univ. Va.; Col. William & Mary; T. Col., Columbia. Author: articles on teaching art for educational journals, magazines. Positions: Supv. Edu., Mecklenburg Co., Va., 1927-31; Supv. A. Edu., Col. William & Mary, 1931-44; Hd. Dept./Prof. A., Phillips Univ., 1944- [47]

COOPER, Olive Ray Long (Mrs.) [Edu,P,Des,L] Natchitoches, LA b. 17 Ap 1896, Winnfield, LA. Studied: Northwestern State Col.; Columbia. Member: New Orleans AA; SSAL; Nat. Edu. Assn. Exhibited: Delgado Mus. A.; SSAL; Nat. Fed. Women's Cl.; Northwestern State Col., Natchitoches. Position: Hd. A. Dept., Northwestern State Col. 1928- [47]

COOPER, Thomas H. [P] Cleveland, OH. Member: Cleveland SA [25]

COOPER, William Brown [Por.P] b. 1811, Smith County, TN d. 1900 Chattanooga. Worked with his brother Washington Bogart Cooper in Memphis, Chattanooga, Knoxville, Natchez, New Orleans. [*]

COOTES, F(rank) Graham [Por.P] NYC b. 6 Ap 1879, Staunton, VA. Studied: Kenneth Hayes Miller; Robert Henri; DuMond; Washington & Lee Univ.; Univ. Va.; Chase A. Sch. Member: SI, 1910. Work: White House, Wash., D.C.; Liberty Mem., Kansas City; Capitol, Wash.; Univ. Va.; Univ. Del. Illustrator: "The Shepherd of the Hills," leading magazines [47]

COOTS, Howard M. [P] Indianpaolis, IN [13]

COOVER, Nell [E,P] Laguna Beach, CA b. Wooster, OH. Studied: Acad. Delecluse, Paris; Delance, Callot, Waltner, in Paris. Member: Laguna Beach AA. Work: Calif. State Bldg., Los Angeles; The Guignol, Paris [40]

COPE, Gordon Nicholson [Por.P,T] San Fran., CA (1973) b. 1906, Salt Lake City. Studied: Le Conte Stewart, A.B. Wright, in Utah, 1916-23; L. Squires, in Ariz., 1923-24; Europe, 1924-28; Académie Julian, Paris, 1928. Exhibited: Paris Salon, 1928. Position: T., Salt Lake City, upon his return from Europe, till 1941 [*]

COPE, Margaretta Porter [P] Phila., PA/Cape May City, NJ b. 17 F 1905, Phila. Studied: Margaretta Archambault; PAFA [29]

COPELAND, Alfred Bryant [Ldscp.P] Boston MA b. 1840 d. 30 Ja 1909. Studied: Royal Acad., Antwerp; Paris; returned to America, 1896. Exhibited: Paris Salon, 1877. Work: Boston Athenaeum. Position: T., Univ. St. Louis [01]

COPELAND, Charles [P,I] Newton Center, MA/Thomaston, ME b. 10 S 1858, Thomaston, ME. Member: Boston AC; Boston SWCP [33]

COPELAND, Eleanor R(ogers) (Mrs. Joseph Frank) [P,T] Drexel Hill, PA b. 24 F 1875, London, England. Studied: PMSchIA; Henry Snell; J.F. Copeland. Member: Phila. WCC; A. T. Assn. Phila. Exhibited: PAFA, 1938 (med). Work: Phila. WCS; Telfair Acad., Savannah, Ga. [40]

COPELAND, Elizabeth E. [P,C] Boston, MA b. Boston. Studied: H. Walker; A. Sacker; D. Ross; London. Member: Boston SAC; Detroit SAC. Exhibited: P.-P. Expo (prize); Boston SAC (prize). Work: Cincinnati Mus.; Detroit IA; BMFA. Specialties: metal work; enameling; silversmith [40]

COPELAND, Ernest (Dr.) [Patron] Milwaukee, WI d. 10 S 1929. Member: Layton Sch. A. (Pres.); Layton A. Gal.; Milwaukee AI. His collection went to the Layton Gal.

COPELAND, Joseph Frank [Dec,C] Drexel Hill, PA b. 21 F 1872, St. Louis. Studied: PMSchIA. Member: Phila. Sketch C.; Phila. Alliance; Phila. Photogr. Soc.; Phila. AG; Phila. WCC. Exhibited: PAFA, 1928 (gold); PMSchIA, 1929 (gold). Work: murals, stained glass, tablets, State Bank and Trust Co., Evanston, Ill.; Durham Park, Phila.; Baptist Temple, Phila. Author: text books on design and color, Intl. Text Book Co. [40]

COPELAND, Lila [P] Woodstock, NY b. 29 Ap 1912, Rochester, NY. Studied: A. Brook; G. Grosz; J. Nichols. Member: ASL. Exhibited: AIC, 1937 (med). Work: Friends of Art, Woodstock, N.Y. [40]

COPELAND, M. Baynon [Por.P] London, England b. El Paso, TX. Studied: Kenyon Cox; Paris, with Ferdinand Humbert, R. Miller; Shannon, in London [29]

COPENHAVER, Laura [C,Dec,Des,L,T] Marion, VA b. 29 Ag 1868, Columbus, TX. Lectures: Mountain Crafts. Position: T., native crafts, Va. Mountain Groups [40]

COPP, Ellen Rankin [S] Chicago, IL b. 1853, Atlanta, IL. Studied: AIC; Fehr Sch., Munich [04]

COPP, Gertrude M. [Cr,T,Des,B,P] Milwaukee, WI b. 26 Mr 1874, Lawrence, MA. Studied: R. Turner; M. Fry; F. Bischoff; N.Y. Sch. F.&Appl. A.; Columbia; BMFA; J. Binder. Member: Boston SAC; Copley S.; Wis. Des.-Cr. Exhibited: Milwaukee AI, 1916 (prize); Boston SAC; AIC. Position: Dir. A., Girls Trade & Tech. H.S., Milwaukee, Wis., 1913- [47]

COPPAGE, Mabel [P] Wilmington, DE. Member: Wilmington SFA [25]

COPPEDGE, Fern Isabel (Mrs.) [P] New Hope, PA. b. Decatur, IL. Studied: Univ. Kans.; ASL; AIC; PAFA; H.B. Snell; J. Carlson; W. Chase. Member: Ten Phila. P.; North Shore AA; Gloucester SA; NAWA; Phila. A. All.; Plastic Cl. Exhibited: NAWA, 1922 (prize), 1933(prize); PAFA; City Hall Mus., St. Joseph, Mo.; Chattanooga Cl., Tenn.; Plastic C., 1924 (prize). Work: Detroit IA; PAFA; Am. Embassy, Rio de Janeiro; Witte Mem. Mus.; Thayer Mus., Kans.; Bryn Mawr, Pa.; Benjamin West Soc., Swarthmore, Pa.; Reading Mus. A.; New Century Cl., Phila.; Western Col., Oxford, Ohio [47]

COPPEDGE, Robert (Mrs.) [P] Topeka, KS [15]

COPPERMAN, (Mildred) Turner [P] Gloucester, MA/Majorca, Spain b. 14 S 1906, NYC. Studied: Cooper Union; L.F. Biloul, in Paris. Member: St. Ives SA, Cornwall, England; Rockport AA; North Shore AA; Gloucester SA; NAWPS [40]

COPPIN, John S(tephens) [P] Detroit, MI b. 13 S 1904, Stratford, Ontario. Studied: Stratford Collegiate Inst., Ontario; John P. Wicker Sch. FA. Member: Detroit Scarab Cl. Exhibited: Detroit IA, 1933 (prize), 1939 (prize), 1946 (prize); Scarab Cl., 1941 (med). 1944 (med), 1946 (med). Work: Capitol, Lansing, Mich.; County Bldg., Detroit, Mich.; Detroit Edison Co.; Rackham Bldg., Detroit; Ann Arbor Lib. [47]

COPPINI, Pompeo Luigi [S,P,L] San Antonio, TX/NYC b. 19 My 1870, Moglia, Italy (came to U.S. in 1896). Studied: Academia di Belle Arti, Florence, Italy; Augusto Rivalta, in Florence. Member: NAC. Exhibited: NAD; NAC. Work: monuments, 75 portrait busts, 16 portrait statues, 3 equestrian statues; Washington Mon., Mexico City. Designer: commemorative half dollar for Tex. Independence Centenn. [47]

COPPOLINO, Joseph [S,Des] St. Albans, NY b. 3 N 1908, NYC. Studied:

CUASch; BAID; NAD; Piccirilli; Lee Lawrie; Gaetano Cecere; Inst. Des., with Dreyfuss, Barnhardt. Exhibited: BAID, 1929 (prize), 1935 (prize); CUASch (prize). Awards: Prix de Rome, 1937, 1938 [47]

CORASICK, William W. [P,T] Drexel Hill, Pa. b. 9 Jy 1907, Phila. Studied: Temple Univ.; Univ. Pa. Member: Phila. A. All.; Phila. A. T. Assn. Exhibited: PAFA, 1936, 1944; NAD, 1943; Phila. A. All. (one-man); Galerie Neuf, 1945 (one-man); Butler AI, 1944; Phila. A. T. Assn., 1944 (prize), 1945 (prize). Position: T., Phila. Pub. Sch. [47]

CORBETT, Bertha L. [P,I] Chicago, IL/Minneapolis, MN b. 8 F 1872, Denver. Studied: D. Volk, in Minneapolis; Drexel Inst., with H. Pyle. Member: ASL, Chicago. Illustrator: children's books [13]

CORBETT, Gail Sherman (Mrs. Harvey Wiley) [S] NYC b. 1871, Syracuse, NY d. 26 Ag 1952. Syracuse, NY. Studied: ASL; Augustus St.-Gaudens; Mowbray; Brush. Member: NSS, 1907; Arch. Lg.; NAWA. Exhibited: P.-P. Expo, 1915 (med); NAWA, 1935 (med). Work: White mem., Syracuse, N.Y.; Municipal Bldg., Springfield, Mass.; Washington mem., Alexandria, Va.; Whitherby mem., Providence, R.I. [47]

CORBETT, Oliver J. [P,Des] Springfield, OH b. 21 Jy 1886, Meridan, IA. Studied: AIC; PMSchIA; J.E. Jenkins. Member: Ozark AA; SSAL. Exhibited: Ozark Empire Fair (prize); Springfield Art Mus. (one-man) (prize); Nelson Gal. A. 1938 (prize); Governor's Mansion, Mo.; Ozark Beach Hotel. Work: 12 murals, St. Louis-San Fran. Railroad Co. [47]

CORBINO, Jon [P,T,S] NYC/Rockport, MA b. 3 Ap 1905, Vittoria, Italy d. 1964. Studied: G. Luks; DuMond; D. Garber; PAFA; ASL. Member: NA; Audubon Soc.; Guggenheim F., 1936–37, 1937–38; WCC; A. Fellowship, N.Y. Exhibited: Kleemann Gal. (one-man); AIC, 1937 (prize), 1944 (prize); BMA, 1938 (prize); NAD, 1938 (prize), 1944 (prize), 1945 (prize); Lotos C., 1939 (prize); New Rochelle, N.Y., 1940 (med); NIAL, 1941 (prize); SC, 1945 (prize). Work: MMA; CI; WMAA; BM; TMA; PAFA; WMA; Montclair A. Mus.; Brooks Mem. A. Gal.; NAD; Butler AI; Muncie Univ.; Amherst Col.; Canajoharie A. Gal.; Brigham Young Univ.; Mt. Holyoke Col.; AGAA. Illustrated: Swift's "Gulliver's Travels," 1945 [47]

CORBRIDGE, Edgar [P] Providence, RI. Member: AWCS [47]

CORCOS, Lucille [P,I,Des,Car] New City, NY b. 21 S 1908, NYC d. 1973. Studied: ASL. Member: Audubon A.; N.Y. S.Indp.A. Exhibited: WMAA, 1936, 1938, 1939, 1941, 1942, 1944; AIC, 1939–44; BM; MMA, 1941, 1942; CI, 1941, 1944; PMG, 1942; Traveling Exh., South America, Great Britain. Work: WMAA; U.S. Gypsum Co.; mural, Waldorf-Astoria, NYC. Illustrator: "Treasury of Gilbert & Sullivan," 1941, "Chichikov's Journey," 1944; magazines [47]

CORDOBA, Matilde De [P] NYC. Exhibited: NYWCC [98]

CORDREY, Earl (Somers) [I] Palm Springs, CA. b. 6 S 1902, Piru, CA. Studied: Chouinard AI; Grand Central Sch. A. Member: SI. Illustrator: Cosmopolitan, Collier's, American, other magazines [47]

CORELL, Florence [P] Lakewood, OH. Member: Cleveland Women's AC [25]

CORL, Frederick [P] Louisville, KY. Member: Louisville AL [01]

CORMACK, Marianne [P] Weymouth, MA [08]

CORMAN, Zoe Carnes [P,S] NYC [25]

CORNE, I. Linda [P] Cambridge, MA [08]

CORNELIUS, Francis duPont [Mus.Conservation,P] NYC b. 19 O 1907, Pittsburgh, PA. Studied: Univ Pa.; Univ. Pittsburgh. Member: CAA; Assn. A. Pittsburgh. Exhibited: Assn. A. Pittsburgh. Author: "Art in America." Position: Research F. in Conservation, 1944–45; F. in Conservation, MMA, NYC, 1945– [47]

CORNELIUS, Marty Lewis (Miss) [P,I] Pittsburgh, PA b. 18 S 1913, Pittsburgh. Studied: CI; R. Marsh; R. Hilton. Exhibited: CGA, 1941 (prize); Butler County (Pa.) Exh. (prize); Pittsburgh AA, 1936–45, 1946 (prize); N.Y. Municipal Exh., 1936; Pal. Leg. Honor, 1946; CI, 1946 [47]

CORNELL, Allela [P] NYC. Exhibited: NYWCC, 1934; GGE, 1939; WC Ann., San Fran. AA (prize) [40]

CORNELL, Grace [P] NYC. Member: NAWPS [25]

CORNER, Thomas C. [Por.P] Baltimore, MD b. 2 F 1865, Baltimore d. 4 S 1938. Studied: K. Cox; J.A. Weir; Benjamin-Constant; Jules Lefebvre. Member: Charcoal C.; Friends of Art, Baltimore; Baltimore Mus. A. Work: mural portraits, Alexander Brown & Co.; Fidelity Trust Co., Baltimore; J.W. Seligman & Co.; Brown, Harriman & Co., N.Y.; other portraits [38]

CORNETT, Myrtle B. [P] Wash., D.C. Member: Soc. Wash. A. [29]

CORNETT, Robert F(rank) [P] Wash., D.C. b. 27 Jy 1867, Lafayette, LA. Studied: George Essig; Corcoran Sch. A. Member: Soc. Wash. A.; Wash. Ldscp. Cl. [33]

CORNFELDT, C.C. [P] Toledo, OH. Member: Artklan [25]

CORNIN, David Edward [I,W] Phila., PA b. 12 Jy 1839, Greenwich, NY. Studied: Europe [10]

CORNIN, Jon (Corka) [P,Car,Des,G] Berkeley, CA b. 24 Mr 1905, NYC. Studied: Grand Central Sch. A.; Phoenix AI; ASL; R. Soyer. Member: AFA; San Fran. AG. Exhibited: Oakland A. Gal., 1939, 1940, 1941, 1945; SFMA, 1938, 1940, 1945; Philbrook A. Center, 1940; Montross Gal., 1936; Denver A. Mus., 1946; Mus. N.Mex., Santa Fe, 1937–39; Kans. State Col.; Kans. galleries. Cartoonist: Saturday Evening Post, New Yorker; newspapers; cartoon anthologies, 1944–46 [47]

CORNISH, John [P] Detroit, MI. Exhibited: Great Lakes Exh., The Patteran, 1938; Intl. WC Ann., AIC, 1939 [40]

CORNISH, (Miss) [P] Charleston, SC [04]

CORNOYER, Paul [P,T] East Gloucester, MA b. 1864, St. Louis, MO d. 17 Je 1923. Studied: Lefebvre; Constant; Louis Blanc. Member: ANA 1909; SC, 1902; Allied AA; NAC. Exhibited: Paris AAA, 1892 (prize); St. Louis Assn. P.&A., 1895 (gold); SC, 1905 (prize), 1906 (prize), 1908 (prize); Phila. AC, 1917. Work: Brooklyn Inst. Mus.; Dallas AA; SAM; Newark AA [21]

CORNWELL, Dean [P,Dec,I,L] NYC b. 5 Mr 1892, Louisville, KY d. 1960. Studied: AIC, with H. Dunn, C. Chapman. Member: NA; NSMP (Pres., 1954); SI (Pres., 1922); Arch. Lg.; NAC; Mural P.; Players C.; Chelsea Arts C., London; London Sketch C.; SC; AAPL; Calif. AC. Exhibited: Wilmington SFA, 1929, 1921 (prize); AIC, 1922; SC, 1927 (prize); Allied Ar. Am., 1939 (prize); Arch. Lg., 1939. Work: murals, Los Angeles Pub. Lib.; Lincoln Memorial, Redlands, Calif.; Detroit Athletic Cl.; USPO, Morganton, N.C.; Davidson County Court House, Nashville; General Motors Bldg.; WFNY, 1939. Illustrator: books, magazines. WPA artist. Position: T., ASL [47]

CORNWELL, Marie [P,T] Ann Arbor, MI b. Ann Arbor. Studied: Harry M. Walcott [24]

CORNWELL, Martha Jackson [S,C,P] Westtown, PA b. 29 Ja 1865, West Chester, PA. Studied: PAFA; Phila. Sch. Des.; ASL; Europe. Exhibited: SAE; PAFA. Work: West Chester, Pa.; AIC [47]

CORNWELL, William Caryl [P] NYC b. 19 Ag 1851, Lyons, NY d. 11 My 1932. Studied: Lefebvre; Boulanger; Académie Julian, Paris. Member: SC; NAC; AFA; Buffalo Soc. A. (Pres.). Creator: a process of illuminative painting which he called "Cornwell Lumino." Position: Cur., Buffalo Acad. FA, 1874–99 [31]

CORR, Mary Jane S. [P] Chevy Chase, MD b. 25 N 1914, Dayton, OH. Studied: Dayton AI, with John King; Corcoran Sch. A., with Richard Lahey, Eugene Weisz. Member: Soc. Wash. A. Exhibited: Dayton AI, 1936–39, 1941, 1943; 1944; Soc. Wash. A., 1937–41, 1943 (med), 1944, 1945; Women P. of Am., 1938 (prize); Butler AI, 1943; Times-Herald A. Fair, 1941 (prize) [47]

CORRELL, Grace Van Norman (Mrs.) [Des,P] Peoria, IL b. 15 N 1912, Peoria. Studied: Bradley Polytechnic Inst., with P.R. McIntosh, Edward Nicholson. Member: Peoria Lg. A. Exhibited: CGA, 1941; Decatur A. Center, 1945; Peoria Lg. A.; Pere Marquette Gal. (one-man). Work: mural, Peoria. Position: Des., Forster Textile Mills, Inc. [47]

CORRELL, Richard [En,Li,P,Des,I] NYC b. 22 O 1904, Springfield, MO. Member: AL Am. Exhibited: WFNY, 1939; PAFA, 1937, 1938; MMA, 1942; Oakland A. Gal., 1938; SFMA, 1941; Northwest Pr.M., 1938–40; Calif. SE, 1938. Work: OWI; LOC [47]

CORSAW, Roger De [C,T] Norman, OK/Alfred, NY b. 27 N 1913. Studied: N.Y. State Col. Cer. Exhibited: Nat. Cer. Exh., Syracuse, N.Y., 1937; Newark Mus.; Cincinnati AM; GGE, 1939. Work: Syracuse MFA. Position: T., Univ. Okla. [40]

CORSER, Charles Farmer [P] St. Paul, MN [19]

CORSO, Sam [Des,S] Forest Hills, NY b. 6 Mr 1888, Montevago, Italy. Studied: CUASch. Member: Un. Scenic A. Exhibited: Grand Central Palace & Mus. of Sc.&Indst., Rockefeller Center; CUASch, 1920, 1921 (prizes). Positions: A. Dir., Paramount Studios (1925–32), West Coast Sound Studio, NYC [47]

CORSON, Alice V(incent) [P] Paris, France b. Phila. d. 1915. Studied: Chase; R.C. Bunny. Member: F. PAFA. Lived in Paris for many years. [13]

CORSON, Charles S(chell) [P] Phila., PA d. 18 Je 1921. Member: Phila. AC. Exhibited: Phila. AC, 1915, 1917 [15]

CORSON, E(mmasita) R(egister) (Mrs. Walter) [P] Bucks County, PA b. 23 N 1880, Milford, DE. Studied: Redfield, Chase, Anshutz, all in Phila. Member: F. PAFA; Phila. WCC [15]

CORSON, Katherine Langdon (Mrs. Walter Heilner Corson) [Ldscp.P,I] Plymouth Meeting, PA b. Rochdale, England d. 12 F 1925. Studied: Emil Carlsen; H.B. Jones; F.C. Jones, in N.Y. Member: NAWPS; F. PAFA; Plastic C. Exhibited: Atlanta Expo, 1895. Work: Hamilton C. [25]

CORT, Howard R. [I] Tenafly, NJ b. 1869 d. 14 N 1946, Rutherford, NJ. Illustrator: drawings of children & animals, New York Herald; The Delineator, other publications

CORTIGLIA, Niccolo [P,T] Wilkes-Barre, PA/Noxen, PA b. 7 Ap 1893, NYC. Studied: John Herron AI; Royal Acad. FA, Florence, Italy, 1920. Exhibited: NAD. Position: T., Cortiglia A. Sch., Wilkes-Barre, Pa. [47]

CORTISSOZ, Royal [S,Cr] NYC Member: NSS. Position: Cr., New York Tribune; attacked the cubists in the famous Armory show, defending traditional painting over modernism. [47]

CORTIZAS, Antonio [S,G] Phila. PA. Exhibited: Germantown AL, 1937 (prize); PAFA 1933, 1934, 1936, 1937, 1938; Wash. Min. PS&G Soc., 1939 [40]

CORTOR, Eldzier [P,Li] Chicago, IL b. 10 Ja 1916, Richmond, VA. Studied: AIC; Inst. Des., Chicago; Columbia. Member: Rosenwald F., 1944, 1945. Exhibited: AIC, 1941–44, 1945 (prize), 1946 (prize); VMFA, 1941; Atlanta Univ., 1943; LOC, 1940; Whyte Gal., 1940; Downtown Gal., 1941; Smith, 1943; Inst. Mod. A., Boston, 1943; BMA, 1944; Albany Inst. Hist.&A., 1945; Minneapolis Inst. A., 1944; Rochester Mem. A. Gal., 1945; CI, 1945; AFA, 1945; Howard Univ., 1945; Milwaukee AI, 1944; Hull House, 1938. Work: Bd. Edu., Chicago; Whyte Gal.; South Side Community A. Center; Howard Univ. [47]

CORTRIGHT, Hazel Packer [P] Phila., PA/Saunderstown, RI. Member: Plastic C. [25]

CORVINUS, Bernard [I] b. 1892, Ozone Park, NY d. 14 D 1945, NYC. Studied: PIASch. Position: A., New York Times

CORWIN, Charles Abel [P,Mur,P,Li] NYC b. 6 Ja 1857, Newburgh, NY d. 1938, Chicago. Studied: Duveneck, in Munich. Member: Chicago SA; SC; Bronx AG. Exhibited: AIC, 1900 (prize); Chicago SA. Work: Piedmont Gal., Berkeley, Calif.; habitat murals, Field Mus., Chicago. Position: T., AIC, 1883 [38]

CORY, F.Y. [P,I] Canyon Ferry, MT [21]

CORY, Florence Elizabeth (Mrs.) [Des] b. Syracuse, NY d. 20 Mr 1902, NYC. Studied: CUASch. She took up designing in 1877, impelled by the sight of ugly carpets. Designer: wallpaper, woolens, silks, carpets. Positions: T., CUASch; Dir./Founder: Sch. Indst. A.&Tech. Des., NYC, 1881–1902

CORY, John Campbell [Car] Newark, NJ [13]

CORY, Kate T. [P,Des,S,W] Prescott, AZ (1957) b. 1861, Waukegan, IL. Studied: CUASch, 1879; ASL, with Cox, Weir. At the suggestion of Louis Akin, she moved to Oraibi in 1905, then to the pueblos at Walpi. In 1912, she moved to Prescott. Member: NAWPS; Ind.p.A. Exhibited: Armory Show, 1913. Work: Smithsonian Inst.; mural, Prescott Pub. Mus.; Univ. Ariz.; Tuzigoot Mus., Clarkdale, Ariz. [47]

CORY, Sarah Morris (Mrs.) [I,W] b. 1855 d. 21 F 1915, NYC

CORYELL, Virginia [P] Phila., PA [06]

CORYN, C.E. [P] Indianapolis, IN [25]

COSENTINO, Oronzo [S] NYC [13]

COSGRAVE, Earle M. [P] b. Santa Catalina Island, CA d. 21 D 1915, Los Angeles. Studied: N.Y. Sch. A.

COSGRAVE, John O'Hara, II [I,P,En,Car] Brooklyn, NY b. 10 O 1908, San Fran. d. 1968. Studied: Univ. Calif.; Calif. Sch. FA; A. Lhote. Exhibited: Paris Salon, 1931–33; AWCS, 1934; PAFA, 1942; AIC, 1941; BM, 1942; AV, 1942; SFMA, 1942; Brooklyn SA, 1939, 1940, 1941 (prize), 1942–46. Illustrator: "Wind, Sand and Stars," 1939, "There Were Two Pirates," 1946, magazine covers [47]

COSGROVE, Alice Ericson (Mrs.) [P] West Concord, NH b. 16 F 1909, Concord, NH. Studied: BMFA Sch. [40]

COSIMINI, Roland F(rancis) [P,I] Winthrop, MA b. 1 My 1898, Paris, France. Studied: R. Andrews; E.L. Major. Specialties: travel posters, book jackets. Illustrator: books [40]

COSNETT, Jennie M. [P] Phila., PA [06]

COSTA, Hector [P,S] NYC b. 6 Mr 1903, Caltanessetta, Italy. Studied: Prior; Hinton; Olinsky; Nicolaides; Ellerhusen. Member: PAFA; F., Tiffany Fnd., 1931; ASL. Exhibited: Italian-Am. Art Exh., 1928 (med) [40]

COSTAGINI, Philippo [P] b. 1839, Italy (came to U.S. ca. 1850) d. 15 Ap 1904, MD. Studied: Brumidi, Wash., D.C. after painting in NYC, Baltimore, Phila. He was appointed to paint the famous fresco frieze in the Capitol Rotunda, the fulfillment of his 25-year ambition to depict the great scenes of American history. He got as far as the Mexican War and the discovery of gold in Calif., when, during the Harrison Administration, Congress neglected to appropriate his $10-per-day salary. He retired to his home to await the appropriation, but it never came.

COSTELLO, Jerry [Cart] Albany, NY b. 25 D 1897, Scranton, PA. Studied: PAFA. Work: Huntington Col., San Marino, Calif. Author: "The Life of Al Smith," cartoon strip pub. New York Evening World. Position: Ed./Car., Gannet newspapers [40]

COSTELLO, Val [P] Los Angeles, CA b. Marion, KS. Member: Calif. AC; Calif. WCS; Laguna Beach AA. Exhibited: Pacific Southwest Expo, (med) [33]

COSTIGAN, Ida [P] Orangeburg, NY [25]

COSTIGAN, John E. [P,E,] Orangeburg, NY b. 29 F 1888, Providence, RI d. 1972. Studied: self-taught. Member: ANA, 1926; NA, 1928; AWCS; NYWCC; SC; All. A. Am.; Am. Soc. Animal PS; NAC; G. Am. P.; Phila. SE; Soc. Am. E. Exhibited: SC, 1920 (prize); 1923 (prizes) 1928 (prize), 1933 (prize), 1936 (prize); AIC, 1922 (prize), 1923 (prize), 1924 (prize), 1927 (med); NAD, 1920 (prize), 1925 (med), 1927 (prizes), 1928 (prize); NAC, 1925 (prize), 1936 (med); Sesqi-Centenn. Expo, 1926 (med); AWCS, 1928 (prize), 1932 (prize), 1933 (prize), 1936 (prize); Grand Central A. Gal., 1928 (prize); Palm Beach AA (prize); Soc. Am. E., 1933 (prize), 1938 (prize); CGA; CI, 1944–1946; PAFA, 1944. Work: AIC; NYPL; Brigham Young Univ.; Rochester Mem. A. Gal.; MMA; AIC; Los Angeles Mus. A.; BM; Montclair A. Mus.; Cranbrook Acad. A.; LOC; murals, USPOs, Girard (Ohio), Rensselaer (Ind.), Stuart (W.Va.); American Artist Series, Scribner's Magazine, March 1937 [47]

COSTIGAN, Thomas [P] NYC [17]

COTE, M.A. Suzor [P] Paris, France [01]

COTHARIN, Kate Leah [P] Brookline, MA b. 27 O 1866, Detroit, MI. Studied: J.M. Dennis. Member: Copley S. Work: Springfield (Mass.) Mus. FA [40]

COTHER, (Dorothy) McVey [P,T] Brooklyn, NY/Chatham, NY b. Crossville, TN. Studied: M.L. Weatherford; Henry B. Snell; Pratt Inst.; Ecole des Beaux-Arts, Fontainebleau. Member: AWCS; NAWPS; L.C. Tiffany Fnd. Exhibited: AWCS, 1926 (prize); NYWCC, 1926 (prize) [40]

COTSWORTH, Staats [I,W] Florence, Italy b. 17 F 1908, Oak Park, IL. Studied: Thornton Oakley. Member: Phila. AC; Phila. WCC; Phila. Sketch Cl.; Phila. All. Illustrator: "The Mild Adventures of an Elderly Person," pub. Barnes, "Deep Water Plays," pub. Macrae-Smith, "Beauty for Ashes," pub. Dorrance [40]

COTTELL, Amelia C. [P,T,Cr] Chicago, IL b. Chicago. Studied: AIC [10]

COTTER, Edward [Ldscp.P] Salem, MA d. N 1917, Ishpeming, MI (hunting accident)

COTTER, Sarah Cecilia. See King, Mrs.

COTTON, John W(esley) [P,E,L] Glendale, CA b. 29 O 1868, Toronto, Ontario d. 1931, Toronto. Studied: E. Marsden Wilson, in London; AI, Chicago; Toronto ASL, 1886. Member: Ontario SA; Chicago SE; Calif. PM; Calif. AC; Calif. WCC; Calif. PS. Exhibited: Chicago SE, 1915 (prize); P.-P. Expo, San Fran., 1915 (prize); Pacific Southwest Expo, Long Beach, 1928 (gold); PS Cl., Los Angeles, 1928 (prize). Work: NYPL; LOC; AIC; Nat. Gal., Ottawa; Toronto AM; State Lib., Sacramento; Oakland Pub. Lib.; Los Angeles AM [31]

COTTON, Leo [P] Los Angeles, CA b. 27 Jy 1880, San Antonio, TX. Studied: R.J. Onderdonk; Holmes Sch. Illustration, St. Louis. Member: Fort Worth P. Cl.; Fort Worth AA; SSAL. Exhibited: Dallas AA, 1920 (gold); West Tex. Fair, San Angelo, 1922 (prize), 1923 (prize), 1924 [27]

COTTON, Lillian (L.C. Impey) [P] NYC b. 17 Ap 1901, Boston d. 1962. Studied: André Lhote Acad., Paris; ASL, with Robert Henri, George

Bellows. Member: NAWA; N.Y. Soc. Women A.; PBC; Société Nationale des Beaux-Arts, Paris. Exhibited: NAWA, 1946 (prize); PAFA, 1930; CGA, 1930; Paris Salon; NAD; N.Y. Soc. Women A.; PBC, 1946 [47]

COTTON, Marietta (Mrs. Leslie) [P] NYC b. New York. Studied: Carolus-Duran, Henner, in Paris. Exhibited: Paris Salon, 1889 (prize). Specialty: portraits [10]

COTTON, William Henry [P] Stockton, NJ b. 22 Jy 1880, Newport, RI. Studied: Cowles A. Sch.; Académie Julian, Paris, with Laurens. Member: ANA; Newport AA. Exhibited: NAD, 1907 (prize); Dallas Mus. FA, 1909 (med); Boston AC, 1916 (prize); PAFA, 1926. Work: murals, theatres in NYC; Easton's Beach, Newport, R.I. Illustrator: New Yorker, 1939; national magazines [47]

COUARD, Alexander P(ernot) [P] Norwalk, CT b. 6 S 1891, New York. Studied: Homer Boss; George Bridgman; DuMond. Member: S.Indp.A.; Brooklyn WCC [27]

COUCH, Frank B. [P] Pierrepont, NY [21]

COUDERT, Amalia Küssner (Mrs. Charles DuPont Coudert) [Min.P] NYC b. 26 Mr 1873, Terre Haute, IN d. Teritet, Montreaux, Switzerland (funeral, 6 Je 1932, Surrey, England). At an early age she became a staff artist at the Tiffany Studios of New York. Later, established on her own, she received portrait commissions from notable persons in New York, Chicago, and European capitals. She painted the Hon. Cecil Rhodes in South Africa, His Majesty King Edward VII of England, and was a resident-guest in the Royal Palace at Moscow during the time required to execute portraits of the Czar, Czarina, Grande-Duchesse Olga and others of the Imperial family. [13]

COUGHLIN, Marietta Ayres (Mrs.) [P] b. 1875 d. 8 Mr 1915, Brooklyn, NY. Studied: Phila. A. Sch.

COUGHLIN, Mildred [E,Li,I,P] NYC b. 16 Jy 1896, Wilkes-Barre, PA. Studied: M. Waltner; Wellesley Col.; Ecole des Beaux-Arts, Paris; ASL. Member: SAE; Chicago SE; Southern Pr.M.; Calif. SE. Exhibited: Paris Exh., 1937 (prize); Pomona, Calif., 1938 (prize); SAE; Chicago SE; Calif. SE; NAD; Phila. Pr.M.; Southern Pr.M.; Europe; major print shows in U.S. Work: LOC; Bibliothèque Nationale, Paris; NYPL; Smithsonian Inst. [47]

COULTAUS, Harry K. [Car] b. 1863 d. 20 Ja 1923, Brooklyn, NY

COULTER, Imogen Adams [P] NYC/Rome, GA b. Rome, GA. Studied: Chase; Collin, Mucha, in Paris. Member: N.Y. A.&Cr.; Paris A. Women's AA [10]

COULTER, Lillian [P] Los Angeles, CA. Member: Calif. AC [29]

COULTER, Mary J. (Mrs.) [P,E,B,L] Santa Barbara, CA b. Newport, KY d. 1966. Studied: Cincinnati A. Acad., with Duveneck, Nowottny, Meakin; AIC; Univ. Chicago; Lionel Walden; Charles Hawthorne; abroad. Member: San Fran. AA; AAMus.; AFA; AAPL; Calif. SE; Calif. AC; NAWA. Exhibited: Lewis & Clark Expo, 1905 (med); P.-P. Expo, 1915 (med); AIC, 1909 (prize); Pal. Leg. Honor (one-man); deYoung Mem. Mus.; Los Angeles Mus. A.; Italy; France; England. Work: MMA; BMFA; AIC; LOC; NGA; Univ. Cl., San Diego; State Lib., Calif.; John Herron AI; Brit. Mus; etchings, Matson Navigation Co.; FMA; NYPL; Cooke Gal., Honolulu [47]

COULTER, William A. [P] Sausalito, CA b. 7 Mr 1849, Glengariff, Ireland (settled in Calif. in 1869) d. 13 Mr 1936. Studied: Vilhelm Melby; F. Musin; J. Jacobsen. Member: San Fran. AA. Exhibited: Yukon Expo, Seattle, 1910 (prize); Sacramento State Fair (prize); San Fran. AA, 1874–90s; Mechanics Inst., 1874–90; Columbia Expo, 1893. In 1934 he held a one-man exhibition in San Francisco, showing 75 pictures painted since his 80th birthday. Specialty: marine paintings. Illustrator: San Francisco Call, 1896–1906 [13]

COUNCE, Harvey [C] b. 19 Ag 1821, Thomaston, ME. Active as a carver of figureheads (1860s–80s), in Thomaston and Rockport, Maine [*]

COUNCELL, Charles Clemmens [P,S] Alexandria, VA b. 9 Ja 1896, Marion, IN. Studied: Eliot O'Hara. Exhibited: Wash. WC Cl., 1936, 1937, 1939; CGA; Nat. Coll. FA (Smithsonian) [40]

COUNSEL, Frederick Alan [P] Altoona, PA b. 8 Ja 1913, Eldorado, PA. Studied: PMSchIA; PAFA; Thornton Oakley; John J. Dull. Member: All Al, Johnstown, Pa.; Blair County (Pa.) A. Lg.; All. A., Pittsburgh; Soc. A.&Sc. Exhibited: Johnstown, Pa., 1938 (prize); Blair County A. Lg., 1942 (prize); Wis. AA, 1944 (prize), 1945 (prize); Army A. Show, Baltimore, 1945 (prize); PAFA, 1934, 1935; Johnstown All. A., 1937, 1938; Phila. A. All., 1938, 1939; New Haven PCC, 1941; Georgetown Gal., 1940 (one-man); No. 10 Gal., 1941, 1942; Soldier Show, Baltimore, 1945; Madison AA, 1944, 1945; Colorado Springs FA Center, 1945; Camp Grant, Ill., 1945. Work: Pub. Lib., Wash., D.C.; murals, airfields in Conn., Wis., Va., Colo. [47]

COUNTRYMAN, Anna R. [P] Rockford, IL b. 1863, Boston. Studied: Boston A. Schools [01]

COUPER, J.S. (Mrs. B. King Couper) [P] Tryon, NC b. 23 F 1867, Augusta, GA. Studied: Chase; Daingerfield; DuMond; Breckenridge; Cox; Lhote, in Pairs. Member: North Shore AA; Columbia (S.C.) AA; Lg. Am. Pen Women; Boston AC; SSAL; NAWPS; NAC. Exhibited: Salon d'Automne, Paris, 1930; Univ. Ga.; Greensboro Col. Work: Sweat Mem. A. Mus.; High Mus. A.; Spartanburg (S.C.) permanent coll.; Currier Gal. A., Manchester, N.H.; BM [47]

COUPER, Richard H(amilton) [P] NYC b. 5 Jy 1886, Norfolk, VA d. 18 Mr 1918. Studied: ASL; Simon, Ménard, in Paris; Rome. Member: Circolo Artistico, Rome. The son of William Couper, the sculptor, he often painted in tempera, becoming so interested in that medium that he started the manufacture of tempera colors. He returned to NYC from Rome in 1915. [17]

COUPER, William [S] NYC b. 20 S 1853, Norfolk, Va. Studied: Thomas Ball; Cooper Inst.; Munich; Florence. Member: NSS; N.Y. Arch. Lg. Exhibited: Pan-Am. Expo, Buffalo, 1901 (med). Work: AM, Montclair, N.J.; statues, Wash., D.C., Jamestown Island (Va)., Rockefeller Inst. (New York), City Park (Trenton, N.J); busts, Am. Mus. Nat. Hist. He lived in Florence for twenty-two years. Retired in 1913. [40]

COURSEN, Louise [P,W] Lewiston, IL b. 26 F 1866, Canton, IL. Studied: AIC; Minneapolis AI. Member: S.Indp.A.; Salons of Am.; Chicago NJSA [29]

COURTNEY, Leo [B,Des,Dr,En] Wichita, KS b. 11 Ag 1890, Hutchinson, KS. Studied: C.A. Seward. Member: Wichita AA; Wichita AG; Prairie PM; Northwest PM; Calif. PM; Kans. State Fed. Art. Exhibited: Kansas City AI, 1928 (med). Work: Smoky Hill Print Cl., Lindsborg, Kans.; Kans. Fed. Women's Cl.; Tulsa Univ.; A. Gld., Topeka [40]

COUSE, E(anger) Irving [P] Taos, NM b. 3 S 1866, Saginaw, MI d. 25 Ap 1936, Albuquerque. Studied: AIC, 1884; NAD; Académie Julian, Paris, with Robert-Fleury, Bouguereau, 1887–90; Ecole des Beaux-Arts, Paris. Moved to Oregon briefly (ca. 1890) but returned to Normandy for ten years. Member: ANA, 1902; NA, 1911; Lotos Cl.; NAC; Taos SA; SPNY; All. AA; AFA. Exhibited: SC, 1890 (prize), 1900 (prize), 1917 (prize); NAD, 1900 (prize), 1902 (prize), 1903 (prize), 1911 (gold), 1912 (prize), 1916 (prize),1921 (prize); Lotos Cl., 1910 (prize); P.-P. Expo, San Fran., 1915 (med); Am. Expo, Buffalo, 1901 (prize); St. Louis Expo, 1904 (medals); Lotos Cl., 1910 (prize); P.-P. Expo, San Fran., 1915 (med); PAFA (prize). Work: NGA; Brooklyn Inst. Mus.; Dallas (Tex.) Mus.; Smith Col.; Lotos Cl.; St. Paul (Minn.) Mus.; Grace Church, Harrisburg, Pa.; Detroit Inst.; Nat. Arts Cl., New York; AM, Montclair, N.J.; Fort Worth (Tex.) Mus.; MMA; Butler AI; Santa Barbara (Calif.) Mus.; TMA; Nashville (Tenn.) Mus.; CMA; Milwaukee AI; capitol, Jefferson City, Mo.; San Diego Mus.; AM, Topeka. Went to Taos in 1902; kept his NYC winter studio until 1927, when he became a permanent Taos resident. Produced about 1,500 paintings of Indian life. [33]

COUSE, William Percy [Des,I,W,L,P,T] Bristol, PA b. 17 D 1898, Farmingdale, NJ. Studied: NYU; ASL; DuMond; Bridgman; Sterne; Speicher; Gruger; Dasburg; Weber; W.H.D. Koerner; Rudolf Scheffler; Hobart Nichols. Member: SC; Asbury Park SFA; Assoc. A., N.J. Exhibited: Montclair A. Mus.; Newark Mus.; N.J. State Mus.; Phila. A. All.; Roerich Mus. A. Illustrator: Harper's, Saturday Evening Post, Country Gentleman, Youth's Companion, St. Nicholas, other publications. Positions: A. Dir., Deal Conservatoire, 1936–41; Supv., Graphic Illus., Kaiser Fleetwings, Inc., Bristol, Pa., 1942– [47]

COUSINS, Clara Lea (Mrs. William Douglass Cousins) [S,P,T,L] New Canton, VA b. 6 Ap 1894, Halifax Co., VA. Studied: Cincinnati A. Acad., with Kate Miller; Corcoran A. Sch., with M.M. Leisenring; PAFA; Grand Central A. Sch., with Ennis, Snell; Cecilia Beaux; Burtis Baker; Clement J. Barnhorne; Georg J. Lober. Member: AAPL; AFA; New Orleans AA; SSAL; Miss. AA. Exhibited: Danville A. Cl.; Richmond Acad. A.&Sc.; Richmond A. Center; Morton Gal.; Buchanan Gal.; SSAL; Witte Mem. Mus.; Miss. AA; Delgado Mus. A.; NGA; Irene Leach A. Gal.; Norfolk, Va. Work: Stratford Col., Danville, Va. Lectures: Garden Sculpture. Position: Dir., Cousins' Sch. Art, Martinsville [47]

COUTTS, Alice (Mrs. Gordon) [P] Piedmont, CA. A contemporary of Grace Hudson, with whose paintings of Indian children hers are often confused. [17]

COUTTS, Gordon [P,T] Piedmont, CA b. 3 O 1880, Aberdeen, Scotland d. 21 F 1937, Palm Springs, CA. Studied: Lefebvre, Robert-Fleury, Dechenaud, in Paris; Académie Julian, Paris; Carl Rossi. Member: Bohe-

mian Cl., San Fran. Exhibited: Alaska-Yukon-Pacific Expo, 1909 (gold); Paris Salon, 1913 (gold); P.-P. Expo, 1915 (med); Sacramento Expo, 1930 (gold); Royal Acad., London. Work CMA; Melbourne A. Gal.; Adelaide Nat. Gal.; Nat. A. Gal., Sydney. He was Government Instr. of Art for ten years at the Art Society of New South Wales, Sydney, Australia. [21]

COUTURIER, Philebert Leon [P] Paris, France b. Macon, GA. Studied: Cabanel, Dagnan-Bouveret, in Paris. Exhibited: Paris, 1881 (med); Paris Expo, 1889 (med) [04]

COVE, John Alfred (Mrs.) [P] Providence, RI. Member: Providence AC [25]

COVELL, Margaret S. [P] Wayne, Pa. [01]

COVERT, John R. [P] NYC b. 1882 d. 1960. Member: Pittsburgh AA [24]

COVEY, Arthur (Sinclair) [P,Mur.P,I,E,Li] Torrington, CT b. 13 Je 1877, Bloomington, IL d. 1960. Studied: Vanderpoel; Karl Marr; Frank Brangwyn; AIC; Royal Acad. A., Munich. Member: N.Y. SE; Chicago SE; SI; NA; Century Cl.; SC; NSMP; Arch. Lg. Exhibited: SC, 1910 (prize), 1911 (prize), 1912 (prize); P.-P. Expo, San Fran., 1915; Arch. Lg., 1925 (med); Fla. Gulf Coast Group, 1946 (prize); AV; NAD; Audubon A.; Fla. Gulf Coast Group. Work: assoc. with Robert Reid, mural panels, FA Bldg., P.-P. Expo, San Fran., 1915; Wichita Pub. lib.; LOC; Norton Hall, Worcester, Mass.; LaGuardia Field, N.Y.; murals, USPOs, Bridgeport, Torrington, both in Conn.; WFNY, 1939. WPA artist. [47]

COVEY, Arthur, Mrs. See Lenski, Lois.

COVEY, Margaret Sale (Mrs. Chisholm) [Por.P] Pelham Manor, NY b. 6 Jy 1909, Englewood, NJ. Studied: Yale; Anne Goldthwaite; Leon Kroll; PAFA Summer Sch., Fontainebleau, France [40]

COVEY, Molly Sale [P,I,T] b. 26 Jy 1880, Dunedin, New Zealand d. Spring 1917. Studied: Brangwyn, in London; Lucien Simon, in Paris. Member: NAWPS. Work: Otago Univ., Dunedin [17]

COVINGTON, Annette [P] Cincinnati, OH b. 14 My 1872, Cincinnati. Studied: ASL; Henry Mosler; William M. Chase; Cincinnati A. Acad.; Pratt Inst.; Arthur W. Dow; Ernest Fennellosa; Japan. Member: Cincinnati Women's AC. Work: Ohio State Univ.; Western Col., Miami Univ., Oxford, Ohio. Author: "Notes of a Baconian," pub. in Cincinnati "Times Star." Discoverer: name of Francis Bacon on first text page of "Shakespeare Plays" in 1623 folio. [40]

COVINGTON, Wickliffe C(ooper) (Mrs. R.W.) [P] Bowling Green, KY b. 2 Jy 1867, Shelby Co., KY d. 1 D 1938. Studied: Kenyon Cox; William M. Chase; ASL. Member: Louisville AA; SSAL; Louisville AC; Miss. State AA; Carmel AA. Work: Louisville AA [38]

COWAN, Cora E. [P] Chicago, IL [10]

COWAN, Elizabeth (Mrs.) [P] Chicago, IL b. 1863, Chicago d. 7 Ja 1932. Studied: Alfred Payne. Painted portraits of prominent Chicagoans. [01]

COWAN, James M. [Patron] d. winter 1930, Aurora, IL. Contributed to the encouragement and advancement of American art, during a period of twenty years, by acquiring between four and five hundred paintings by well-known men. He was an untiring crusader on their behalf.

COWAN, R. Guy [Des,L,S] Fayetteville, NY b. 1 Ag 1884, East Liverpool, OH. Studied: N.Y. State Col. Ceramics; Soc. Des. Craftsmen; Syracuse SA. Exhibited: AIC, pottery, 1917 (prize), applied des., 1924, (med); CMA, 1925 (prize); Exh. Contemporary Ceramics, 1937. Work: BMFA; CMA; Allen Mem. A. Mus., Oberlin, Ohio; Cranbrook Mus. Lectures: Fine Art of Ceramics. Position: A. Dir., Onondaga Pottery Co. [40]

COWAN, Sarah Eakin [P] NYC d. 1958. Member: ASMP; NAWPS; Pa. Soc. Min. P.; PBC. Exhibited: Cragsmoor, 1917; ASMP, 1935 (med); PAFA, 1922, 1935, 1936, 1937; Grand Central A. Gal., 1938; WFNY, 1939 [47]

COWAN, Woodson Messick [Car,L,P] Weston-Westport, CT b. 1 N 1889, Algona, IA d. 1977. Studied: Univ. Iowa; AIC, with Vanderpoel, Dunn. Member: A.&W. Assn.; Westport A. Cl. Contributor: New Yorker, Argosy, other magazines; "Major Hoople" comic, NEA Service. Lectures: Cartooning; Cartoon History. Position: car., newspapers, in Chicago and Wash., D.C., other publications [47]

COWDERY, Corene [P] NYC b. 13 F 1893, Milwaukee, WI. Studied: Henri. Member: Whitney Studio Cl. [25]

COWDERY, Eva D. (Mrs.) [P] Boston, MA. Member: Copley S., 1905 [13]

COWDREY, (Mary) Bartlett [Hist,W,Cr] NYC b. 1910, Passaic, NJ d. 1974. Studied: Rutgers; London Univ. Member: CAA. Author: "National Academy of Design Exhibition Record, 1826–1860," 2 vols., 1944. Co-author: "William Sidney Mount, 1807–1868, An American Painter," 1944. Contributor: art magazines. Positions: Registrar: BM, 1940–42; Cur. Prints, N.Y. Hist. Soc., 1943; Cur. Paintings, Newman Gal., NYC, 1943– [47]

COWELL, Joseph Goss [P,Edu,S,L,W,Des,Arch] Wash., D.C./Wrentham, Mass b. 4 D 1886, Peoria, IL. Studied: DuMond; Tarbell; Benson; Laurens, in Paris; Univ. Ill.; George Washington Univ.; BMFA Sch.; Bradley Polytechnic Inst.; ASL; Bridgman; Chase. Exhibited: Paris Salon, 1920; Arch. Lg., 1923, 1924, 1931; Boston AC, 1922–26; Rockport AC, 1939. Work: murals, churches in Boston, Nashua (N.H.), Whitman (Mass.), Bridgeport (Conn.), NYC, Los Angeles, South Orange (N.J.), Chicago; Pub. Lib., park entrance, Wrentham, Mass.; Capitol, Richmond, Va. Founder: Art Therapy for the Insane. Lectures: Psychopathic Art. Contributor: Mass. State Bulletin on Art Therapy. Position: Dir., Nat. A. Sch., Wash., D.C., 1940–42 [47]

COWELL, William Wilson [Mar.P] Chicago, IL/Nova Scotia. b. 24 Mr 1856, Boston. Studied: PAFA, with E. Moran, J. Faulkner [10]

COWEN, A. Marian [P] Pittsburgh, PA. Member: Pittsburgh AA [29]

COWEN, Lewis [P] NYC [04]

COWEN, Nettie Meyerhuber [C,W,P,T] Mt. Vernon, NY b. 12 Ag 1906, Poughkeepsie, NY. Studied: PIASch; NYU; Hayley Lever. Member: Westchester A.&Crafts Gld.; New Rochelle AA. Exhibited: PIASch, 1924 (med); County A. Center, White Plains, N.Y.; New Rochelle AA; Arch. Lg.; All.A.Am.. Author: "Things Children Can Make," for Herald-Tribune. Position: T., pub. schools, NYC, 1927– [47]

COWEN, Percy Elton [I] Martha's Vineyard, MA b. 13 Mr 1883, New Bedford, MA d. 1923. Studied: Swain Sch. Des.; Pape Sch., Boston; ASL. Illustrator: Rudder, Adventure. Work:Kendall Whaling Mus.; Peabody Mus., Salem, Mass. Had studios in NYC and Martha's Vineyard. [21]

COWHEY, Kenneth [I] NYC. Member: SI [47]

COWIN, Lorilla Rice [P] Minneapolis, MN [24]

COWLES, Cornelia. See Vetter, Mrs.

COWLES, Edith V. [P,I,C,T] b. 17 My 1874, Farmington, CT. Studied: John T. Niemeyer; Bruneau, Laforge, in Paris. Work: St. Michael's Church, Brooklyn, N.Y.; series of twenty-eight drawings for the giotto frescoes, "Life of St. Francis," in the Upper Church at Assisi (Italy), pub. Dutton (New York) and Dent (London). Illustrator: "House of Seven Gables," by Hawthorne; "Old Virgina," by Thomas Nelson Page; "Friendship," by Emerson. Sister of Genevieve, Maud, and Mildred. [33]

COWLES, Frank W. [P,T] Boston, MA. Member: Boston AC [04]

COWLES, Genevieve A(lmeda) [P,I,C,W,L] b. 23 F 1871, Farmington, CT. Studied: Yale, with Niemeyer; Brandegee. Work: mural, Conn. State Prison; Grace Church, NYC; St. Peter's Church, Springfield, Mass.; stained glass windows, Talpioth, Palestine. Illustrator: "The House of Seven Gables," by Hawthorne, "Little Folk Lyrics"; Scribner's, McClure's. Author: "The Prisoners and Their Pictures," McClure's, 1922. Lecturer/Writer: on the prison question; on Palestine. Twin sister of Maud; sister also of Mildred and Edith. [47]

COWLES, Maude Alice [P,I,C] b. 23 F 1871, Farmington, CT d. Summer 1905. Studied: Robert Brandegee; Yale, with Niemeyer. Exhibited: Paris Expo, 1900 (med); Pan-Am. Expo, 1901 (med); St. Louis Expo, 1904 (med). With her twin sister, Genevieve, she executed several important mural decorations, the most recent being the paintings in Christ Church, New Haven. Together they also designed and executed a number of stained glass windows, notably those in the honor room of Grace Church, New York City. Sister also of Edith and Mildred. [04]

COWLES, Mildred Lancaster [P,I,C,W,T] Asolo, Italy b. 24 Ap 1876, Farmington, CT d. 2 Ja 1929, Paris. Studied: Yale A. Sch.; Maurice Sterne; Lucien Simon; Ménard, Paris. Illustrator: Houghton-Mifflin, Scribner's, Putnam, Dodd-Mead. Work: stained glass window, St. Michael's Church, Brooklyn, N.Y. Sister of Maude, Genevieve, and Edith. [27]

COWLES, Russell [P] New Milford, CT (1976) b. 7 O 1887, Algona, IA. Studied: Dartmouth; NAD; ASL; Am. Acad., Rome. Member: Century Assn. Exhibited: AIC, 1925 (med); Denver A. Mus., 1936 (prize); Santa Barbara Mus., 1943 (prize); CGA; PAFA; WMAA; CI. He had forty one-man shows. Work: Denver A. Mus.; Terre Haute Mus. [47]

COX, Abbie Rose [P,Des,T,L] Port Arthur, TX b. 27 O 1906, Houston. Studied: Tex. State Col.; AIC; Chicago Acad. FA. Member: SSAL. Exhibited: SSAL, 1934, 1936, 1938, 1939. Work: Tex. Oil Corp., New York [40]

COX, Albert Scott [P,I,T,W] NYC b. Maine. Studied: Acad. Delecluse, Acad. Julian, both in Paris [10]

COX, Allyn [P,T,L,W,Mur.P] NYC b. 5 Je 1896, NYC. Studied: his father, Kenyon Cox; NAD; ASL; Am. Acad., Rome, 1916; George Bridgman. Member: ANA; NSMP; FA Fed., N.Y.; Mun. AS; AAPL; Arch. Lg. Exhibited: Los Angeles Mus. A., 1926 (med); AAPL, 1945 (med); NAD; Arch. Lg. Work: Princeton Mus.; murals, Clark Mem. Lib., Los Angeles; Univ. Va.; Dumbarton Oaks; S.S. "America" [47]

COX, Charles Brinton [P,S] Phila., PA b. 1864, Phila. Studied: PAFA, with Thomas Eakins; ASL. Member: Paris AAA. Exhibited: AAS, 1902 (med). Specialty: western subjects [08]

COX, Charles Hudson [Ldscp.P,I,T] Waco, TX b. 28 Ja 1829, Liverpool, England d. 7 Ag 1901. Studied: England. Member: Liverpool WC Soc.; Waco A. Lg. (Dir.). Exhibited: Columbian Expo, Chicago, 1893; Dallas, Houston, San Antonio, Tex. He was a cotton broker in Liverpool and continued in the export business at Waco, where he settled. Position: Instr., Summer Chautauqua, Boulder, Colo. Work: Norwich Mus., England [01]

COX, Charles M. [P] Melrose, MA [10]

COX, Clark [Ldscp.P] Dallas, TX b. ca. 1850. He was a theatrical scene painter for nearly sixty years, assisting with the French Opera House, New Orleans, 1903. Began landscape painting ca. 1920. [*]

COX, Doris E. [P,C,B,T] St. Paul, MN b. 4 Ap 1904, Oshkosh, WI. Studied: G. Meuller; A. Heckman. Member: Milwaukee PM. Work: Wis. Printmaker's calendar, 1937, 1938. Position: T., Univ. Minn. [40]

COX, Dorothy E. [P] Harrisburg, PA [25]

COX, Eleanor [S] Wash., D.C. b. 12 Ap 1914, Montrose, CO. Studied: Corcoran Sch. A., with Hans Schuler; Yard Sch. FA, with W.M. Simpson; Temple Univ., with Raphael Sabatini, Boris Blai. Member: Soc. Wash. A. Exhibited: Corcoran Sch. A., 1936 (prize); Lg. Am. Pen Women, 1946 (prize); Soc. Wash. A., 1938–46. Work: Havey Mem., Red Cross Bldg., Wash., D.C. [47]

COX, Eva [P] Kokomo, IN [21]

COX, Frank [P] New Orleans, LA [01]

COX, Gardner [P] Cambridge, MA b. 22 Ja 1906, Holyoke, MA. Studied: ASL; Charles Hawthorne; Harvard; MIT; BMFA Sch. Member: Century Assn. Exhibited: Inst. Mod. A., Boston, 1939, 1945 (prize); CI, 1941; VMFA, 1946; Jordan-Marsh; Soc. Indp. A. Work: Harvard [47]

COX, George J. [P,T,L] NYC. Member: AFA. Position: Chairman, A. Dept., T. Col., Columbia [29]

COX, Helen Morton [P] NYC/Still River, CT b. 22 Mr 1869, New Orleans, LA. Studied: ASL; Bruce Crane; Mrs. R.H. Nicholls [15]

COX, J. Halley [P,Edu] San Jose, CA b. 20 My 1910, Des Moines, IA. Studied: San Jose State Col.; Univ. Calif. Member: San Jose A. Lg.; Pacific AA. Exhibited: Pal. Leg. Honor, 1945 (one-man); San Fran. AA, 1939-45. Position: Chairman, Dept. A. Edu., Cal. Col. A.&Crafts, Oakland, 1946– [47]

COX, John [P] Paris, France. Exhibited: VMFA, 1938; GGE, 1939 [40]

COX, John Rogers [P] Terre Haute, IN b. 24 Mr 1915, Terre Haute. Studied: PAFA; Univ. Pa. Exhibited: AV, 1942 (med); CI, 1941, 1943 (prize), 1944 (prize), 1945, 1946; A. Dir. Cl., 1944 (prize); PAFA, 1944; WMAA, 1943; AIC, 1944, 1945; John Herron AI, 1944; Dallas Mus. FA, 1944; Toledo Mus. A., 1944; Nebr. AA, 1944–46; Pepsi-Cola, 1946; Encyclopaedia Britannica Traveling Exh., 1946. Work: CMA; Encyclopaedia Britannica Coll. [47]

COX, Joseph H. [P,Edu] Iowa City, IA b. 4 My 1915, Indianapolis. Studied: John Herron AI, with Donald Mattison, Eliot O'Hara; Univ. Iowa, with Jean Charlot, Philip Guston. Exhibited: Grand Central Gal.; GGE, 1939;Ind. A. Exh., 1939 (prize); Hoosier Salon, 1940, 1942; CI, 1941; VMFA, 1942; Ind. A. Exh., 1938, 1939; Kansas City AI, 1942; Univ. Iowa. Work: Nat. Hist. Mus., Univ. Iowa; murals, USPOs, Garret, Ind., Alma, Mich. Position: Instr., A., Iowa Univ. [47]

COX, Katherine G. Abbot (Mrs. Allen Howard Cox) [P] Boston, MA b. 1867, Zanesville, OH. Studied: Mowbray; Chase; Merson, Geoffroy, Delance, in Paris. Exhibited: Paris Expo, 1900 (med); Pan-Am. Expo, Buffalo, 1901 (prize) [10]

COX, Kenyon [P,S,I,T,W,L] NYC/Windsor, VT b. 27 O 1856, Warren, OH. Studied: Carolus-Duran, Gérôme, in Paris. Member: ANA, 1900; NA, 1903; Mur. P.; N.Y. Arch. Lg., 1889; Nat. Inst. AL; AAAL; F., PAFA; ASL; Lotos Cl. Exhibited: NAD, 1889 (prize), 1910 (med); Paris Expo, 1889 (medals); PAFA, 1891 (med); Columbian Expo, Chicago, 1893 (med); St. Louis Expo, 1904 (med); N.Y. Arch Lg., 1909 (med). Work: NGA; MMA; Cincinnati Mus.; Bowdoin Col; LOC; Appellate Court, New York; Capitol, Minn.; Capitol, Iowa; Essex County Court House, Newark, N.J.; Luzerne County Court House, Wilkes-Barre, Pa.; Pub. Lib., Winona, Minn.; Federal Bldg., Citizens' Bldg., both in Cleveland; Brooklyn Inst. Mus.; R.I. Sch. Des.; CMA; Oberlin Col.; Capitol, Wis.; Hudson County Court House, Jersey City, N.J.; CI. Author: "Mixed Beasts," "Old Masters and New," "Painters and Sculptors," "The Classic Point of View," "Artist and Public," "Winslow Homer," "Concerning Painters." Father of Allyn Cox and son of Maj. Gen. Cox, governor of Ohio and Secretary of the Interior. [17]

COX, Louise (Howland King) (Mrs. Kenyon Cox) [P] Mount Kisco, NY b. 23 Je 1865, San Fran., CA. Studied: NAD; ASL, with Kenyon Cox. Member: ANA, 1902; SAA, 1893; Mural P., 1919. Exhibited: NAD, 1896 (prize); Paris Expo, 1900 (med); Pan-Am. Expo, Buffalo, 1901 (med); SAA, 1903 (prize); St. Louis Expo, 1904 (med). Work: NGA [40]

COX, Lyda (Morgan) [P,C,T] Seattle, WA/East Cleveland, OH b. 15 My 1881, Depere, WI. Studied: Cullen Yates; Gottwald; Johonnot; Cleveland Sch. A. Member: Seattle FAS; Women's AC, Cleveland; S.Indp.A.; Western Traveling Artists. Exhibited: Seattle FAS, 1923 (prize) [33]

COX, Nancy. See McCormack, Mrs.

COX, Palmer [I] NYC b. 28 Ap 1840, Granby, Canada d. 24 Jy 1924, Granby. Author/Illustrator: "Brownie Clown in Brownie Town," etc. Originator: the "Brownies" [13]

COX, Roland [P] Wabash, IN [24]

COX, W.H.M. [P] Exhibited: Denver, 1883. Painted portraits of well-known Colorado pioneers. Moved to Tex., 1886 [*]

COX, W.H.D., Mrs. See Larter.

COX, Walter B. [Mur.P] NYC b. 25 N 1872, Passcagoula, MS. Studied: Bruce Crane; Robert Blum; Beckwith; Mowbray. Member: N.Y. Kunst Gewerbe Verein. Work: panoramic background for exhibit of terns and seagulls, AMNH; mural, Calvary Church [15]

COX, Walter I. [P] b. 1866, England d. 30 Ap 1930, Alexandria, VA. Work: Supreme Court Bldg., Wash., D.C. Painted portraits of President Harding, Lady Astor, and several European princes.

COX, Warren Earle [C,W,L,Des,G,P] NYC b. 27 Ag 1895, Oak Park, IL. Studied: Emil Carlsen. Member: SC. Exhibited: NAD. Contributor: art magazines. Lectures: Decorations, Craftsmanship. Editor: books on Chinese and Japanese art, theatre and motion pictures. Position: A. Dir., 14th ed., Encyclopaedia Britannica, 1929–39 [47]

COXE, Eliza Middleton [P] Phila., PA b. 1875, Phila. Studied: PAFA [06]

COXE, Mary Bowman [P,T] d. 16 O 1921, Providence, RI. Positions: T., ASL, Buffalo; RISD

COXE, R(eginald) Cleveland [P,E,W,T] Seattle, WA b. 21 Jy 1855, Baltimore, MD (moved to Buffalo at an early age). Studied: Lars Sellstedt; H. Hamilton; NAD, 1876; Bonnât, Gérôme, in Paris, 1879. Member: N.Y. Etching Cl., 1887. Exhibited: NAD, 1886 [24]

COX-McCORMACK, Nancy (Mrs. Charles T. Cushman) [S,Min.P] NYC b. 15 Ag 1885, Nashville, TN. Studied: Victor Holm; Charles Mulligan. Member: Chicago AC. Work: Nashville Mus.; Carmack Mem., Nashville; Univ. Notre Dame; Baker Lib., Dartmouth; Perkins Observatory, Wesleyan Univ., Delaware, Ohio; "H.E. Benito Mussolini," Palazzo Venezia, Rome, (copy at FA Mus., Phila.); Univ. Mich., Ann Arbor; Campedoglio, Rome; Primo de Rivera, Madrid. Awards: Caballero and Cross of Civil Merit, Gov. of Spain, 1927; J. Addams Mem. medal, Hull House, Chicago, 1937 [40]

COY, Anna [P,T] Rockford, IL b. 24 D 1851, Rockford d. 12 Jy 1930. Studied: Chase; Henri; Alexander Robinson. Member: Rockford AA; AAPL. Exhibited: Paris. Work: Rockford Women's Cl. Specialty: Holland paintings [33]

COY, C. Lynn [S,Des,W] Riverside, IL b. 31 O 1889, Chicago. Studied: AIC; A, Polasek; L. Taft. Member: Chicago P.&S.; Chicago AA; Austin, Oak Park & River Forest A. Lg.; LaGrange A. Lg. Exhibited: AIC, 1915, 1917, 1919, 1921. Work: Vanderpoel Coll.; Munroe Mem., Joliet, Ill. [47]

COYE, Lee Brown [P,I,T,C] Syracuse, NY b. 24 Jy 1907, Syracuse. Member: Syracuse Assoc. A. Exhibited: Syracuse Assoc. A., 1936, 1937 (prize) 1938 (prize), 1939–43, 1944 (prize), 1945 (prize), 1946 (prize); GGE, 1939; WMAA, 1939–41; Contemporary A., 1944; Cayuga Mus. Hist.&A., 1941;

Syrause Mus. FA, 1939 (one-man); Skidmore Col., 1940 (one-man); Colgate, 1946 (one-man). Work: Syracuse Mus. FA; MMA; Univ. N.C. Illustrator: "Scylla the Beautiful" (1939), "Sleep No More" (1944). Position: T., Colgate [47]

COYLE, Joseph Edward [P,T] Arlington, MA b. 24 Jy 1903, Wallingford, CT. Studied: BMFA Sch.; Académie Julian, Paris; P.L. Hale. Member: Bay State Ar. Gld. Exhibited: PAFA. Position: T., Arlington H.S. [40]

COYNE, Elizabeth K(itchenman) [P] Phila., PA b. Phila. Studied: Moore Inst. Sch. Des.; Leopold Seyffert; Cecilia Beaux. Member: F.; PAFA; Phila. All.; AFA; Plastic Cl. Exhibited: Plastic Cl., 1931 (prize), 1938 (gold); Moore Inst. Sch. Des., 1934 (prize), 1937 (prize); PAFA 1939 (gold). Work: Lambert Coll., PAFA; Coll. Circulating Picture Cl., Phila. AA [40]

COYNE, Joan Joseph [P,S,C,W] Phila., PA b. 16 Je 1895, Chicago d. 11 O 1930. Studied: G. Mulligan; L. Crunelle; A. Polasek. Member: Chicago SA; S.Indp.A. [29]

COYNE, Will(iam) Valentine [P,I,E] NYC b. 14 F 1895, NYC. Studied: ASL; BAID. Work: NYPL. Illustrator: New York Evening Post, The Bookman [40]

COZE, Paul (Jean) [W,P,I,L,T] Phoenix, AZ b. 29 Jy 1903 d. 1975. Known later as Coze-Dabija. Studied: Lycée Janson de Sailly; Ecole des Arts Decortifs, Paris; F.E. Gonin. Member: Société Nationale des Beaux-Arts; Société des Peintres et Sculpteurs de Chevaux; Société des Artistes Indépendants. Exhibited: Pasadena AI; Los Angeles Mus. A.; Heard Mus. A.; France; Canada. Work: Victoria Mus., Ottawa; Southwest Mus., Los Angeles; Heard Mus., Phoenix. Author: "Quatre Feux," other books. Author/Illustrator: "L'Illustration," "Les Enfants de France." Positions: T., Pasadena AI, 1942–46; Dir., Studio Workshop, Pasadena, 1944–46; Tech. Dir., Twentieth Century Fox Studios; T., Phoenix, 1953 [47]

COZE-DABIJA, (Paul Jean). See Coze.

COZZENS, Evangeline Chapman [P] NYC b. 13 Je 1895, NYC. Exhibited: MMA, 1942; CAA, 1935; BM, 1943; Kraushaar Gal., 1942–46; AWCS, 1932, 1934, 1935. Work: MMA [47]

COZZENS, Frederick S(chiller) [Mar.P,I] Livingston, Staten Island, NY b. 11 O 1846, NYC d. 29 Ag 1928. Studied: Rensselaer Polytech Inst., 1864–67. Exhibited: Mystic Seaport Mus., 1983 (retrospective). Work: Mystic Seaport Mus.; Peabody Mus., Salem, Mass. Illustrator: Harpers, Daily Graphic, other magazines, "Yachts & Yachting" (1887), "Our Navy" (1897). His famous series of lithographs, "American Yachts," was published in 1884. [01]

CRABB, Robert James (Bob) [P] Houston, TX b. 4 Ag 1888, Livermore, KY. Member: SSAL; Houston A. Gal. Exhibited: Houston Mus. FA, 1935 (prize) [40]

CRABBS, Maude Ide (Mrs. Frank W.) [Cr,P,T] Toledo, OH b. 14 Jy 1890, Providence. Studied: PIASch; A.S. Fisher; F.N. Wilcox. Member: Soc. Toledo Women A. Exhibited: Toledo A. Exh., 1917, 1918, 1920, 1921, 1946 (prize). Position: T., Mus. Sch. Des., Toledo [47]

CRAFT, John Richard [Mus.Dir] Hagerstown, MD b. 15 Je 1909, Uniontown, PA. Studied: Yale; ASL; Sorbonne; Am. Sch. Classical Studies, Athens; Johns Hopkins. Member: AA Mus.; AFA. Cataloger: museum exhibitions, 1941–46. Position: Dir., Washington County Mus. FA, Hagerstown, Md., 1940– [47]

CRAFT, Paul [P,T] Amelia, OH b. 3 Mr 1904, Leavittsburg, OH. Studied: Hiram Col., Ohio; Cincinnati A. Acad. Member: Ohio WC Soc.; Cincinnati Indp. A. Exhibited: Smithsonian Inst.; Riverside Mus., 1940, 1941; Cincinnati Mod. A. Soc.; CM; A.B. Closson Gal., 1942, 1944 (one-man); River Road Gal., Louisville, Ky., 1942 (one-man); Dayton; Columbus; Toledo; San Fran.; Butler AI (prize). Work: CM; IBM. Position: T., Cincinnati Pub. Sch., 1943-45 [47]

CRAIG, Anderson [P,T] NYC b. 15 Ap 1904, Iowa City. Studied: Randall Davey. Position: Dir., Experimental School of Art [29]

CRAIG, Anna Belle [P,I] Pittsburgh, PA b. 13 Mr 1878, Pittsburgh. Studied: Pittsburgh Sch. Des.; ASL; Chase; Shirlaw; Henry G. Keller; Martin G. Borgord; Howard Pyle. Member: Pittsburgh AA; Cordova C. of Women P., Pittsburgh. Illustrator: Harper's, St. Nicholas, Metropolitan, children's books [40]

CRAIG, Beatrice Doane [P] NYC [19]

CRAIG, Charles [P] Colorado Springs, CO b. 1 N 1846, Morgan County, OH d. 1931. Studied: self-taught; first Western trip, 1865–69, living with Indians; PAFA, 1872–73; Peter Moran. Exhibited: AWCS; Denver, 1883; Minneapolis Expo, 1886–88; St. Louis, 1889; Omaha, 1894–96. Specialties: cowboys, Indians. Craig was, in 1881, the first major Western artist painting in Taos. Many of his paintings were lost in his studio fire, 1895. [24]

CRAIG, Colin S. [P] Hastings-on-the-Hudson, NY b. ca. 1872 d. 23 D 1914 (leaping from a window in the Fleischman Baths, NYC)

CRAIG, Emmett J(unius) [S,T,L] Kansas City, MO b. 3 Mr 1878, DeWitt, MO. Studied: M. Gage; W. Rosenbauer. Member: Kansas City SA. Exhibited: Kansas City AI, 1925 (med); 1925 (med). Work: Kansas City Pub. Lib.; Kansas City Western Dental Col.; Roosevelt Mem. Home, N.Y.; W.F. Kuhn Mem., Mount Moriah Mausoleum, Kansas City; Wentworth Military Acad., Lexington, Mo. [40]

CRAIG, Frank [I] London, England. Member: SI. Work: Harper's [13]

CRAIG, Margaret [P] Wash., D.C. [01]

CRAIG, Marie Jackson [S] Boston, MA/Memphis, TN b. 4 F 1908, Memphis. Studied: James Lee Mem. Acad. A., Memphis; BMFA Sch.; Fontainebleau Sch. FA; Member: Memphis AA; Memphis AL; SSAL; Fontainebleau AC; NAWPS. Exhibited: SSAL, 1928, 1929; WFNY, 1939. Work: Brooks Mem. A. Gal., Memphis; Montgomery, Ala. MFA [40]

CRAIG, Martin [S] NYC b. 2 N 1906, Paterson, NJ. Studied: self-taught [40]

CRAIG, Netta [P] Wash., D.C. b. Wash., D.C. Studied: W.M. Chase; PAFA. Member: Wash. SA [27]

CRAIG, Ralph Spann [P,Des,T] Indianapolis, IN b. 3 N 1908, Jefferson County, IN. Studied: W. Forsyth; C. Wheeler; P. Hadley; E. Taflinger; G. Bridgman; DuMond; P.A. Laurens, in Paris. Member: Ind. AC. Exhibited: Ind. State Fair, 1928, 1936, 1929 (prizes). Work: Children's Mus., Indianapolis [40]

CRAIG, Robert [P,E,Li,T,C] Indianapolis, IN/Eastport, ME b. Spencer, IN. Studied: Bradley Polytechnic Inst.; W. Forsyth; Columbia; G.P. Ennis. Member: AWCS; SC; Ind. Soc. PM. Exhibited: PAFA; AWCS; LOC, 1944, 1945. Position: Hd. A. Dept., Technical H.S., Indianapolis, 1925–41 [47]

CRAIG, Theodore B. [P] NYC [04]

CRAIG, Thomas B(igelow) [P] Rutherford, NJ b. 14 F 1849, Phila., PA d. summer 1924, Woodland, NY. Studied: self-taught. Member: ANA, 1897; SC, 1902; A.Fund S.; Chicago WCC. Exhibited: PAFA; NAD. Work: PAFA. Specialty: landscapes with cattle [24]

CRAIG, Tom [P,G,C] Los Angeles, CA b. 16 Je 1909. Studied: Pomona Col.; Univ. Southern Calif.; Univ. Calif.; Chouinard AI. Member: Calif. WCC; Phila. WCC; Laguna Beach AA; Bay Region AA; San Fran. AA; Am. Ar. Cong.; San Diego AG. Exhibited: All-Calif. Exh., Los Angeles AA, 1934 (prize); Los Angeles County Fair, 1934 (prize); Calif. AC, 1935 (prize); Los Angeles Ebell A. Patrons Exh., 1935 (prize); Oakland A. Gal., 1935 (prize); Northwest PM, Seattle, 1937 (prize); Calif. State Fair, 1939 (prize); Calif. WCS, 1939. Work: Seattle AM; MMA; Los Angeles Mus.; Los Angeles County Fair Coll. Illustrator: "A Manual of Southern California Botany." Position: T., Occidental Col., Los Angeles [40]

CRAIGHILL, Eleanor R(utherford) [P,T] Williamsburg, VA b. 6 O 1896, Ft. Totten, NY. Studied: Columbia, with R. Brackman, M. Kantor; A. Strauss, in Paris. Member: Richmond Acad. A.; SSAL [40]

CRAM, Allen G(ilbert) [P,I,E] Santa Barbara, CA b. 1 F 1886, Wash., D.C. d. 1947, Ojai, CA. Studied: W. Chase; C.H. Woodbury; Shurtleff. Member: Santa Barbara AL. Exhibited: AA, Newport, 1914 (prize). Work: Court House, Santa Barbara; Hazard Mem., Peace Dale, R.I.; Santa Barbara State Col., Stanford; U.S. Gov. Illustrator: "Old Seaports of the South," "Fifth Avenue," "Greenwich Village" [40]

CRAM, Berniece Banks (Mrs. Hal) [W,Cr,P] Portland, ME/Cape Elizabeth, MA b. 30 N 1903, Scarborough, ME. Studied: Portland Sch. F.&Appl. A., A. Bower; E. O'Hara. Member: Am. Newpaper Gld. Exhibited: Portland, Maine, 1943, 1944, 1945. Contributor: Zontian magazine. Position: A. Cr., Portland Sunday Telegram [47]

CRAM, Bessie (Mrs. T.) [C,Des] Cambridge, MA/Portsmouth, RI b. Middleboro, MA. Studied: BMFA Sch. Member: Boston SAC; Newport AA. Author: articles on leatherwork. Position: T., Sch. Handicrafts, Cambridge, Mass. [40]

CRAM, Dorothea Squire, Mrs. See Squire.

CRAM, E.T. (Mrs.) [P] Williamstown KY. Member: Louisville AL [01]

CRAMER, A.S. [P] Conklin, MI. Member: Chicago NJSA [25]

CRAMER, Elizabeth S. [P] Lake Forest, IL [15]

CRAMER, Florence Ballin [P,G,C] Woodstock, NY b. 13 D 1884, Brooklyn, NY. Studied: ASL, with Burroughs, DuMond, Cox, Brush, Harrison. Member: Woodstock AA. Exhibited: Woodstock AA; Rudolph Gal., 1945 (one-man); Weyhe Gal., 1946. Contributor: International Studio, Phila. newspapers [47]

CRAMER, Howard G. [P] Cleveland, OH. Member: Cleveland SA [25]

CRAMER, Konrad [P,Des,I,L,C,B,Li,T,Photogr,E] Woodstock, NY b. 9 N 1888, Würzburg, Germany. Studied: Acad. FA, Karlsruhe, Germany. Member: Am. Soc. PS&G; Woodstock AA. Exhibited: CGA, 1938, 1939; CI, 1937, 1938; WMAA, 1946; PAFA, 1936; AFA Traveling Exh., 1946; Woodstock AA. Work: MMA; WMAA. Illustrator: "Indian Arts of North America" [47]

CRAMER, S. Mahrea (Mrs. Paul Lehman) [P,E,Des,S,I] Chicago, IL b. 21 1896, Fredonia, OH. Studied: John Herron AI; Otto Stark Acad. FA; AIC; Elmer Forsberg. Member: Assn. Chicago P&S; AWCS; Ohio WCS; Chicago Gal. Assn. Exhibited: AWCS, 1942–44, 1946; Hoosier Salon, 1941–46; Ind. A. Exh., 1943, 1944; Chicago Gal. Assn., 1943, 1945 (one-man) [47]

CRAMOND, Virginia Gruner (Mrs.) [P] Cincinnati, OH. Member: Cincinnati Women's AC [25]

CRAMPTON, Edna [P] Chicago, IL b. Chicago. Studied: AIC, with John C. Johansen [13]

CRAMPTON, R(ollin) McN(eil) [P,S,T] NYC/New Haven, CT/Madison, CT b. 9 Mr 1886, New Haven d. 1970. Studied: Thomas Benton; Yale; ASL. Member: Am. A. Cong. Work: Union League Cl.; House Rep., Wash., D.C. Illustrator: Century Magazine, Harper's, American, Pictorial Review. Position: Supv., mural div., WPA [40]

CRANDALL, Esther [E] Glendale, CA [25]

CRANDALL, Bradshaw [I,Car] NYC/Madison, CT d. 25 Ja 1966, Madison. Member: SI. Work: Saturday Evening Post, Cosmopolitan, 1939 [47]

CRANE, A. Wilbur [P] North Pelham, NY. Member: SC [25]

CRANE, Alan (Horton) [P,Li,I,W] NYC b. 14 N 1901, Brooklyn, NY. Studied: PIASch; Winold Reiss. Member: SC; Phila. WCC; Rockport AA; North Shore AA; Prairie Pr.M. Exhibited: LOC, 1941, 1942, 1943 (prize), 1944, 1945 (prize); SC, 1943 (prize), 1944 (prize); NAD, 1942–44, 1946; CAFA, 1946; MMA, 1942; Rockport AA, 1941 (prize), 1942–44, 1945 (prize), 1946; North Shore AA, 1943–46; Northwest Pr.M., 1942–46; Mint Mus., 1943–46; Laguna Beach AA, 1943–46. Work: LOC; NYPL; CGA; Princeton Pr. C.; CI; Trinity Univ.; Lawrason Brown Mus., Saranac Lake, NY. Author/Illustrator: "Gloucester Joe," 1943, "Nick and Nan in Yucatan," 1945 [47]

CRANE, Alexander [P,Des,T] Cheshire, CT b. 6 Ag 1904, Cataumet, MA. Studied: Harvard; Kaiser Friederich M., Berlin; Prof. Ioni, in Sienna, Italy; Eliot O'Hara. Exhibited: WC Ann., PAFA, 1937; Am. WCS, NYWCC Ann., 1939; Wadsworth Atheneum, Hartford [40]

CRANE, Ann (Mrs. Bruce) [P] Bronxville, NY b. NYC. Studied: Twachtman; Merson, in Paris. Member: NAWPS; Soc. Am. Dec. [40]

CRANE, Bruce [Ldscp.P] Bronxville, NY b. 17 O 1857, NYC d. 29 O 1937. Studied: A.H. Wyant, ca. 1877; ASL; Grez, France, with J.C. Cazin, 1882. Member: ANA, 1897; NA, 1901; SAA, 1881; AWCS; A. Fund S.; SC, 1888; Lotos C.; Union Internationale des Beaux-Arts et des Lettres; NAC. Exhibited: SAA, 1897 (prize); Paris Expo, 1900 (med); NAD, 1901 (med), 1912 (prize), 1919 (prize); Pan-Am. Expo, Buffalo, 1901 (med); Charleston Expo, 1902 (med); St. Louis Expo, 1904 (gold); CI, 1909 (prize); P.-P. Expo, 1915 (med); SC, 1917 (prize), 1933 (prize). Work: MMA; CI; NGA; Brooklyn Inst. Mus.; Montclair Gal., N.J.; Peabody Inst., Baltimore; CGA; Fort Worth Mus.; Hackley A. Gal., Muskegon, Mich.; Syracuse MFA; Mus., Oshkosh, Wis.; Univ. Nebr., Lincoln; FA Cl., Little Rock, Ark. Important tonalist of the Old Lyme colony. [38]

CRANE, Donn P. [E] Chicago, IL b. 1 S 1878, Springfield, MA. Studied: self-taught. Member: Chicago SE [17]

CRANE, Frank [Car,I] NYC b. 1857, Rahway, NJ d. 26 O 1917. Studied: NAD. Illustrator: N.Y. and Phila. newspapers

CRANE, Frederick [P] NYC/Dorset, VT b. 1847, Bloomfield, NJ d. 25 Ja 1915. Member: SC; Municipal A. Soc.; N.Y. Hist. Soc.; Art Committee, City Cl., N.Y. Exhibited: St. Louis Expo, 1904 (med). Specialty: mountain scenery. Position: Pres., Frank Crane Chemical Co., Birmingham, England. [13]

CRANE, Harriet Cross (Mrs. A.R.) [Mus.Dir,L,P,Edu] Norfolk, VA b. 16 Jy 1908, Scranton, PA. Studied: Wellesley Col.; ASL; Brooklyn Inst. A.&Sc.; Umberto Roman; Herbert Barnett. Member: Norfolk A. Corner; AA Mus; CAA. Exhibited: Irene Leach Mem., 1946; Norfolk A. Corner, 1945, 1946. Positions: Asst. Docent, WMA, 1939–41; Research Asst., BM, 1942; Acting Dir., Norfolk (Va.) Mus. A.&Sc., 1945–46 [47]

CRANE, Maria Louisa (Mrs. Robert Treat) [P,T] NYC/Mattapoisett, MA b. 6 O 1882, St. Louis, MO. Studied: K. Cox; DuMond; J.P. Slusser. Member: NAWPS [40]

CRANE, Rebecca Riggs [S] NYC/Hewlett, NY b. 16 My 1875, Turin, Italy. Studied: Sherry E. Fry [17]

CRANE, Roy(ston) (Campbell) [Car,W] Orlando, FL b. 22 N 1901, Abilene, TX. Studied: Hardin-Simmons Univ.; Univ. Tex.; Chicago Acad. FA. Member: SI; Car. C. Work: comic strips, NEA Service, "Wash Tubbs," "Captain Easy," 1924–43; King Features Syndicate, "Buz Sawyer," 1943– [47]

CRANE, Stanley William [P,Des,I] Woodstock, NY b. 14 N 1905, La Porte, IN. Exhibited: Hoosier Salon, 1928 (prize); AIC, 1938; VMFA, 1940; CI, 1941; NAD, 1942, 1944, 1945 (med); PAFA, 1938, 1940–42; Albany Inst. Hist.&A., 1940 (prize), 1945, 1946; MOMA, 1942 (prize). Work: Albany Inst. Hist.& A.; mural, Eastern Airlines, Jacksonville, Fla. Illustrator: national magazines [47]

CRANE, Wilbur [P] NYC/New Rochelle, NY/Lake Hill, NY b. 18 D 1875, NYC. Studied: W.M. Chase; Henri. Member: SC; Arch. Lg.; New Rochelle AS; A. Fellowship [33]

CRANE, William H. [P] Columbus, OH. Member: Columbus PPC [25]

CRANE, Zenas Marshall [Patron] b. 1878, Dalton, MA d. 29 Ap 1936, Boston. Founder, benefactor of the Berkshire Museum, Pittsfield, Mass.

CRANFORD, Kenneth [P] Tompkins Cove, NY. Member: SC [25]

CRANK, James H. [I] Interlaken, NJ. Member: Artists Gld. [31]

CRANMER, Frances [P] Minneapolis, MN. b. 28 Je 1890, Aberdeen, SD. Studied: Chase, in NYC; Benson, in Boston; Castleluccio, in Paris. Member: S.Wash.A.; Minneapolis AL; Attic Cl., Minneapolis. Exhibited: CGA, 1908 (gold); Minn. State Art Soc., 1913 (prize) [15]

CRARY, Amy [P] d. 17 N 1932, Beacon, NY. She was the great-granddaughter of Robert Fulton, inventor of the steamboat.

CRASKE, Leonard [S,Li,L] Boston, MA/East Gloucester, MA b. 1882, London, England d. 29 Ag 1950, Boston. Member: NSS; Boston Soc. S.; Gloucester SA; Copley Soc. Work: Gloucester Fisherman Statue; Peterborough, N.H.; mem., NYC; Amesbury War Mem. [47]

CRATHERN, Helen Goodwin [T,P,L] Detroit, MI/Mason, NH b. 17 Ja 1896, Mason. Studied: WMA Sch.; Wayne Univ.; Columbia; AIC. Member: Soc. Women P.&S., Detroit; Copley Soc.; Mich. Acad. Sc., A.&Let.; Am. Assn. Univ. Women; Mich. Edu. Assn.; Detroit T. Assn. Exhibited: Soc. Women P.&S.; Fitchburg A. Center; Mich. Acad. Sc., A.&Let.; Scarab Cl., Detroit. Contributor: School Arts magazine. Lectures: Community Workshops. Positions: Dir., A. & Skills Corps, Am. Red Cross, Lovell General Hospital, Ft. Devens, Mass., 1944–45; Dir., Coach House Workshop, Mason, N.H., 1940–; Hd., FA Dept., Hutchins Sch., Detroit [47]

CRATZ, Benjimin Arthur [P,Car,I] Toledo, OH/Rockport, MA b. 1 My 1888, Shanesville, OH. Studied: Univ. Mich.; Académie Julian, Paris; George Elmer Browne; Charles Woodbury. Member: Toledo Artklan; Provincetown AA.; Gloucester SA; North Shore AA; Beachcombers Cl.; Springfield Ill. AA; SC; Rockport AA. Exhibited: NAD; BMFA; TMA [47]

CRAVATH, Dorothy Puccinelli (Mrs.) [P,Cr] San Fran., CA b. 19 D 1901, San Antonio, TX. Studied: Calif. Sch. FA, with Gertrude Albright, Spencer Macky. Member: San Fran. Soc. Women A. Exhibited: Pal. Leg. Honor, 1942 (one-man); Gump's Gal., 1942 (one-man); Vera Bright Gal., 1940 (one-man); GGE, 1939; SFMA; San Fran. Soc. Women A., 1932 (prize). Contributor: California Arts and Architecture magazine [47]

CRAVATH, Ruth (Mrs. Wakefield) [S,T] San Fran., CA b. 23 Ja 1902, Chicago. Studied: AIC; Grinnell Col.; Calif. Sch. FA. Member: San Fran. AA; San Fran. Soc. Women A. Exhibited: San Fran. AA, 1924 (prize), 1926, 1927 (prize), 1928, 1930, 1935, 1937; SFMA, 1941; Stockton Mus., 1934; WFNY, 1939; Raymond & Raymond Gal., San Fran.; SAM, 1929; Stockton Mus., 1934; Denver A. Mus., 1933; San Fran. Soc. Women A., 1926–28, 1932, 1934 (prize), 1938–39, 1940 (prize), 1944. Work: SFMA; Stock Exchange, San Fran.; Vallejo, Calif. Lectures: Contemporary Sculpture. Positions: T., Calif. Sch. FA, Sarah Dix Hamlin Sch., San Fran. [47]

CRAVEN, Laura [P] Phila., PA b. 21 Ag 1874, Phila. Studied: Phila.Sch. Des. for Women; E. Daingerfield. Member: Plastic C. [15]

CRAVENS, Julius [I,Des,Cr] d. 4 Jy 1936 (found on a beach near Redwood City, CA). Illustrator: magazines. Positions: Asst. Ed., Vogue; Art Ed., Vanity Fair; Set Designer, NYC; A. Cr., The Argonaut, San Francisco News

CRAVER, Margret [Des,C] NYC b. Pratt, KS. Studied: Univ. Kans.; Baron Erik Fleming, Stockholm, Sweden. Exhibited: GGE, 1939; Phila. A. All., (prize); Currier Gal. A.; Zanesville (Ohio) AI; George Walter Vincent Smith A. Mus.; Springfield, Mass.; Ill. State Mus.; Philbrook A. Center; Decorative A. Cer. Exh., Wichita. Position: Hd. Crafts, Wichita AA Sch., 1935–44; consulting silversmith, Handy and Harman, NYC [47]

CRAWFORD, Annie-Laurie Warmack [Cer,S] NYC/Greenwich, CT b. 17 Ag 1900, Humboldt, TN. Studied: Russell B. Aitken. Exhibited: Traveling Exh., Sweden, Denmark, Norway, 1937; GGE, 1939; Nat. Cer. Exh., Syracuse, N.Y., 1939 [40]

CRAWFORD, Arthur R(oss) [Ldscp.P,C,Dec] Niles, IL b. 29 Jy 1885, Marilla, MI. Studied: Chicago Acad. FA, with W.J. Reynolds, W.P. Henderson. Member: Chicago ASL [33]

CRAWFORD, Barbara (Mrs. B.C. Feinstein) [P,T,Li] Phila., PA b. 16 F 1914, New Castle, PA. Studied: PMSchIA; F. Watkins; E. Horter; H. Pitz; B. Spruance. Member: Phila. A. All.; Phila. Pr. Cl. Exhibited: PAFA, 1937, 1939; AIC, 1937; WFNY, 1939; Phila. Pr. Cl., 1940–46; Phila. A. All., 1939, 1941, 1944–46; PMA, 1945, 1946. Work: PMA; mural, Treasury Dept. Illustrator: "RLS," stories by R.L. Stevenson, 1938. Positions: T., Chestnut Hill Acad., Phila., PMSchIA [47]

CRAWFORD, Brenetta Herrman [P,T] Pasadena, CA b. 27 O 1876, Toledo, OH. Studied: ASL; Albert Benard; Colarossi Acad., Carmen Acad., both in Paris. Member: Por. P; ASMP; NAWPS; N.Y. Min. Soc.; Calif. Soc. Min. P.; NYSWA. Exhibited: NAD; Soc. Am. A.; CAM; Boston AC; CI; Société Nationale des Beaux-Arts, Paris; Monte Carlo Mus. Work: Monte Carlo Mus., Monaco [47]

CRAWFORD, Dorsey Gibbs [P] Dallas, TX [19]

CRAWFORD, Earl [P] Pittsburgh, PA b. 5 Je 1891, Johnstown, PA. Studied: CI; Univ. Pittsburgh; Christian J. Walter. Member: Pittsburgh AA; Golden Triangle A. Exhibited: Golden Triangle A., 1936–46, 1946 (prize); Pittsburgh AA, 1936–46; Butler AI, 1944, 1945; Ind. State T. Col., 1945 (prize), 1946; Parkersburg, W.Va., 1945, 1946. Work: Pa. State Col.; State T. Col., Ind.; State T. Col., Pa. [40]

CRAWFORD, Earl Stetson [P,E] Menton, France b. 6 Je 1877, Phila. Studied: PAFA; Acad. Julian, Acad. Delecluse, Ecole des Beaux-Arts, all in Paris; James McNeil Whistler. Member: Paris AA; SI, 1911; Por. P.; Artists Fund S.; Imperial Three Arts C., London; Soc. des Arts et Lettres; Associè de la Société Nationale des Beaux-Arts; Societaire de la Société Lyonnaise des Beaux-Arts; Société des Graveurs. Work: U.S. Court, San Fran.; Print Coll., Rijks Mus., Amsterdam; Boyman's Mus., Rotterdam; Manchester, Eng.; Christchurch Mus., New Zealand; NYPL. Author: "Gentler Side of Whistler" [47]

CRAWFORD, Edgar A. [P] Rochester, NY. Member: Rochester AC [17]

CRAWFORD, Esther Mabel [P,B] Los Angeles, CA b. 23 Ap 1872, Atlanta, GA. Studied: Whistler; Dow; Beck; Mucha; Cincinnati A. Acad.; Pratt Inst.; South Kensington Sch. Des., London. Member: Calif. AC; Women P. of the West; Laguna Beach AA. Exhibited: San Diego Expo, 1915 (med). Work: British Mus. [40]

CRAWFORD, Isabel [P] Minneapolis, MN [24]

CRAWFORD, Katherine Penn [C] Wash., D.C./Lyons, NY b. 10 F 1865, Clyde, NY. Studied: Madame Oscar I. Bergh, Oslo, Norway. Work: Over mantlepiece of Mt. Vernon, Wakefield Soc. Specialty: Norwegian tapestry weaving [40]

CRAWFORD, Lesley (Buckland) [P,Li] Summit, NJ b. NYC. Studied: Vassar; ASL. Member: NAWA; PBC. Exhibited: NAWA, 1935–38, 1942 (prize); Montclair A. Mus., 1944 (prize); Albany Pr. Cl., 1945 (prize) [47]

CRAWFORD, Ralston [P,T,I,L] NYC b. 25 S 1906, St. Catherines, Ontario. Studied: Otis AI ; PAFA; Barnes Fnd.; Breckenridge Sch.; Columbia; Colarossi Acad. Member: F., Tiffany Fnd., 1931. Exhibited: Wilmington Soc. FA, 1933 (prize); CGA; MMA, 1942 (prize); WMAA; AIC; CM; PMG; Albright A. Gal.; Pal. Leg. Honor; Dallas Mus. FA; Denver A. Mus.; Cornell; Lafayette Col.; Univ. Ind.; WFNY, 1939; GGE, 1939; Rochester Mem. A. Gal.; Santa Barbara Mus. A.; de Young Mem. Mus.; SAM; Portland (Oreg.) Mus. Work: MMA; WMAA; Albright A. Gal.; PMG; Encyclopaedia Britannica Coll.; LOC; Houston Mus. FA; Flint Inst. A. Illustrator: "Stars: Their Facts and Legends," 1940. Contributor: magazines. Lectures: Modern Art [47]

CRAWFORD, Will [I] 1869 Wash., D.C. d. 1944 Scotch Plains, NY. Studied: self-taught. Illustrator: New York World, ca. 1890; later, in NYC, for Life, Collier's, and others. Said to have influenced Charles M. Russell's drawings in 1903. Worked in Hollywood in 1940 as an expert on Indian costumes. [*]

CRAWFORD, William H. (Bill) [Car,I,T] Maplewood, NJ b. 18 Mr 1913, Hammond, IN. Studied: Chicago Acad. FA; Ohio State Univ.; Grande Chaumière, Paris. Exhibited: CMA, 1934 (prize). Illustrator: "Barefoot Boy with Cheek," 1943, "Zebra Derby," 1946. Contributor: national magazines. Position: Sport/Ed. Car., Newark Evening News, 1938– [47]

CRAWLEY, Ida Jolly [P,W,L] Asheville, NC b. 15 N 1867, Pond Creek, TN. Studied: Corcoran A. Sch.; J. Oertell, Germany; Sir Frederic Massi, Paris. Member: Am. Assn. Mus.; AFA. Exhibited: Appalachian Expo, Knoxville (gold); East Tenn. AA (med); Kenilworth Inn Gal. (med); Asheville (med). Work: Univ., Fayetteville, Ark.; Baptist Church, Mansfield, Ohio; City Hall; Crawley Mus. A.&Arch. Position: Founder/Dir., Crawley Mus. Asheville [40]

CRAWSHAW, Luke [Indst.S] Ogden, UT b. 15 O 1856, St. Louis. Studied: AIC, with L. Taft; Académie Julian, Paris [17]

CREAL, J(ames) P(irtle), Jr. [P,E] Anchorage, KY b. 5 1903, Franklin, KY d. 27 S 1933. Studied: J.E. Thompson; Europe. Member: Louisville AA; Denver A. Mus. Exhibited: Speed Mem. Mus., 1927 (prize) [33]

CREANGE, Henry [S] Paris, France b. France. Studied: Rodin; Gérôme; Godefroy. Member: Arch. Lg.; Art-in-Trades C.; Legion of Honor. Exhibited: Indst. art, Arch. Lg. (gold). Specialty: industrial art. U.S. Commissioner to Paris Expo, 1925. Positions: Tech. Adv., Cheney Bros. (NYC), Johnson Bros., potters (England), Brandt & Co., wrought iron (Paris). [30]

CREECY, E.T. (Mrs.) [P] Wash., D.C. [13]

CREEKMORE, Raymond L. [I,Li,E,T] Mamaroneck, NY b. 5 My 1905, Portsmouth, VA. Studied: C.H. Walther; H. Roben; J.M. Miller; H. Schuler; Md. Inst. Member: SI. Exhibited: Md. Inst., 1934 (med); Baltimore Sun, 1936, 1937 (prizes). Author/Illustrator: "Lokoshi," 1946. Position: T., Pratt Inst. [47]

CREIFELDS, Richard [P] NYC b. 26 My 1853, NYC d. 1 My 1939. Studied: NAD; Barth; Wagner; Royal Acad. Munich. Work: St. Andrews Church, NYC; 107th Regiment Armory, NYC; Chamber of Commerce, NYC; Court of Appeals, Albany, N.Y.; Montauk C., Brooklyn [33]

CREIGHTON, Bessy [P,Li,W] Marblehead, MA b. 21 Ap 1884, Lynn, MA. Studied: BMFA Sch. Member: Marblehead AA; Writer's C., Lynn, Mass; Gloucester SA; Inst. Mod. A., Boston; Springfield AL; Boston S.Indp.A. Exhibited: VMFA, 1938; AIC, 1932, 1935; BMFA, 1945; PAFA, 1935; Stuart Gal., Boston; Gloucester SA; Marblehead AA; Springfield AA; Jordan Marsh, Boston. Author/Illustrator: "Adventures of the Wandies," 1926 [47]

CRENIER, Henri [S] Mamaroneck, NY b. 17 D 1873, Paris, France. Studied: Falguiere; Ecole des Beaux-Arts. Member: NSS, 1912; Arch. Lg., 1913. Exhibited: Soc. French Ar., 1897; P.-P. Expo, San Fran., 1915. Work: MMA; City Hall, San Fran.; Fenimore Cooper Mem., Scarsdale, N.Y.; Mt. Vernon Place, Baltimore, Md.; Columbus Mem., Mamaroneck, N.Y.; USPO, Oak Hill, W.Va. WPA artist. [40]

CRESPI, Pachita [P,I,Des,L,W] NYC b. 25 Ag 1900, Costa Rica d. 1971. Studied: N.Y. Sch. F.&Appl. Des.; ASL, with Henri, Luks. Member: NAWA; Pan-Am. Women's Soc.; Lg. Present-Day A. Exhibited: Beaux-Arts, London, 1934 (one-man); Univ. Panama, 1943 (one-man); Nat. Theatre, Costa Rica, 1945 (one-man); Milch Gal., 1931 (one-man); Morton Gal., 1929 (one-man); Pinacotheca, 1942 (one-man); Argent Gal., 1945 (one-man); Nat. Mus., Wash., D.C. (one-man); BMA, 1945 (one-man); Mem. Mus., Memphis, 1943; Four Arts Cl., Palm Beach, 1943; Am.-British A. Center, 1943, 1944; Wildenstein Gal., 1943; NAWA, 1943–46; Lg. Present-Day A., 1945. Work: WMAA; Univ. Ariz. Author/Illustrator: "Manulito of Costa Rica," 1940, "Cabito's Rancho," 1942. Contributor: Horn Book, Holiday [47]

CRESS, George Ayers [P,T] Tallulah Falls, GA b. 7 Ap 1921, Anniston, AL. Studied: Emory Univ.; Univ. Ga. Member: SSAL; Assn. Ga. A.; Southeastern AA; Birmingham AL. Exhibited: Jackson Municipal A. Gal., 1943; Assn. Ga. A., 1940–43; SSAL, 1942, 1943, 1946; Denver AL, 1942; Mint Mus. A., 1942. Work: Emory Univ.; Univ. Ga. Position: T., Judson Col., Marion, Ala., 1945–46 [47]

CRESSEY, Blanche George (Mrs.) [T,W] b. Jacksonville, VT d. 3 S 1930,

Wash., D.C. Studied: Boston. Positions: T., Boston Public Schools; Fashion Ed., Boston Herald (first woman Fashion Ed. sent by an American newspaper to Paris); Chief Des., Ladies Home Journal; Ed., fashion section, New York Herald

CRESSEY, Susan K. [P,T] Milwaukee, WI d. 1942. Studied: AIC; Fafelli, von Salzer; Schade, in N.Y. Exhibited: Wis. PS, 1922 (prize) [29]

CRESSMAN, Wayne E. [P,I,C,T] Phila., PA b. 1883 Chalfont, PA. Studied: PAFA; J. Liberty Tadd; PAFA [10]

CRESSON, Cornelia (Mrs. C.C. Barber) [En,S] NYC b. 15 F 1915, NYC. Studied: G.K. Hamlin; M. Hernandez. Member: A. Lg. Am. Exhibited: All.A.Am., 1938; AIC, 1940; Ellen Phillips Samuel Mem., Phila., Pa., 1940; WMAA, 1940; MMA, 1942; Grand Rapids A. Gal., 1940; Albany Inst. Hist.&A., 1939, 1940 [47]

CRESSON, Margaret French [W,L,S,P] Stockbridge, MA. b. 1889, Concord, MA d. 1973. Member: ANA; NSS; Arch. Lg. Exhibited: NAD, 1921, 1924, 1926, 1927 (prize), 1929, 1936, 1940, 1941, 1943, 1944; PAFA, 1922, 1925, 1927–29, 1937, 1940–42; AIC, 1928, 1929, 1937, 1940; Paris Salon, 1938; WFNY, 1939; CI, 1941; Concord AA, 1923; Phila. A. All., 1927, 1928; WMAA, 1940; Stockbridge A. Exh., 1929 (prize); Soc. Wash. A., 1937 (med); Dublin Hill A. Exh., 1939 (med), 1944 (med). Work: CGA; NYU; Monroe Shrine, Fredericksburg, Va.; Rockefeller Inst.; Mass. State Normal Sch.; Prince Mem., Harvard. Contributor: articles on art and war memorials, New York Times [47]

CRESSWELL, Charles T. [P] Phila., PA. Member: Phila. AC; F. PAFA [21]

CRESSY, Bert [P] Compton, CA. Member: Calif. AC; Los Angeles Mod. AS [25]

CRESSY, Meta [P] Compton, CA. Member: Calif. AC; Los Angeles Mod. AS [25]

CREVELING, Leala [P] NYC b. NYC. Studied: Baschet; Schommer [08]

CREW, Katherin [P] Lawrence, KS [10]

CREW, Mayo [P,I,C,T] Schenectady, NY b. 30 Je 1903, Memphis. Studied: Clara Schneider; Newcomb Sch. A.; ASL. Member: Memphis AA. Exhibited: Memphis Tri-State Fair, (prizes) [33]

CREWS, Monte [I,T] NYC b. 1888, Fayette, MO. d. 5 O 1946. Studied: AIC; ASL. Contributor: Saturday Evening Post, other magazines. Positions: T., Kansas City AI, Pratt Inst., Moore Inst., Phila. [40]

CREWS, Seth Floyd [P,I,Des] El Paso, TX (1948) b. 1885, Mt. Vernon, NY. Studied: AIC. Specialty: produced theatrical posters. Moved to El Paso, 1925. [24]

CRIBBS, George A. [P,L,T] Alliance, OH b. 25 N 1886, Mercer, PA. Studied: R. Field; G. Biddle; Dorothy Dowiatt. Member: Alliance AG. Position: T., Mt. Union Col., Alliance [40]

CRILEY, Theodore [P] Carmel, CA b. 26 Mr 1880, Lawrence, KS. Studied: Ménard, L. Simon, in Paris [24]

CRIMI, Alfredo de Giorgio [P] Bronx, NY b. 1 D 1900, Messina, Italy. Studied: NAD; Beaux-Arts Inst.; Tito Venturini Paperi, Rome. Member: Louis Comfort Tiffany Fnd.; Arch. Lg.; Am. A. Cong.; Mural P. Work: USPO, Wash., D.C.; Rutgers Presbyterian Church; Key West Aquarium [40]

CRISE, Stewart Stroud [P,I] NYC b. 20 Je 1886, Winona, MN. Studied: Miller. Member: ASL; NAC; S.Indp.A.; NYWCC [27]

CRISERA, Joseph John [P,Li] Bronx, NY b. 26 Jy 1907. Studied: Cooper Union; NAD; Grand Central A. Sch.; O'Hara Sch. Painting. Position: Lith., Hopp Litho. Co., N.Y. [40]

CRISLER, Richard (Manning) [P] Chicago, IL/Taos, NM b. 17 My 1908, Dallas. Exhibited: AIC, 1932 (prize). Work: Tex. FA Assn., Austin; Hall of Science, Century Progress Expo, Chicago, 1933 [33]

CRISP, Arthur [P] NYC/Old Lyme, CT b. 26 Ap 1881, Hamilton, Ontario. Studied: ASL. Member: NA; AWCS; NSMP; Arch. Lg.; All.A.Am.; Century Assn.; NAC. Exhibited: Arch. Lg., 1914 (prize), 1920 (prize); P.-P. Expo, 1915 (prize); NAD, 1916 (prize). Work: panels/murals in theatres, hotels, clubs, schools, public buildings in NYC; Newark, N.J.; Elmira, N.Y.; Wilmington, Del.; Ottawa; Toronto; WFNY, 1939. Positions: T., ASL, CUASch, BAID, NAD [47]

CRISP, Mary Ellen (Mrs.) [C,Dec,Des] NYC/Friendship, ME b. 24 D 1896, Nutley, NJ. Studied: Bridgman. Work: Church of Our Lady Of Consolation, Pawtucket, R.I.; St. Aloysius Church, Cleveland, Ohio [40]

CRISS, Francis [P,T] NYC/Spring Valley, NY b. 26 Ap 1901, London, England d. 1973. Studied: PAFA; ASL; J. Matulka. Member: An Am. Group; Am. Soc. PS&G; Am. A. Cong.; F., Guggenheim Fnd., 1934. Exhibited: CGA, 1939; PAFA, 1939, 1941, 1943, 1945; CI, 1944, 1945; WMAA, 1936–38, 1940, 1942; AIC, 1942, 1943; MMA, 1941; South America, 1939; Paris, 1937. Work: NGA; WMAA; PMA; Kansas City AI; La France Inst., Phila. [47]

CRISSEY, Thomas Henry [P,C] New Canaan, CT b. 26 My 1875, Stamford, CT. Studied: Bridgman; W. Florian; E. Dufner [27]

CRIST, Richard Harrison [Mur.P,Por.P,Li] New Hope, PA b. 1 N 1909, Cleveland. Studied: CI; AIC; L. Ritman; B. Anisfeld; D. Siqueiros, in Mexico. Member: Pittsburgh AA. Exhibited: CI; Butler AI; CGA; CM; Pittsburgh AA, 1932 (prize), 1934 (prize), 1938 (prize). Work: Pa. State Col.; Univ. Pa.; Carnegie Lib., Pittsburgh [47]

CRITCHER, Catherine C(arter) [P,T] Wash., D.C. (1947) b. 1868 or 1879, Westmorland County, VA. Studied: Cooper Union; Corcoran Art Sch.; R. Miller; C. Hoffbauer, in Paris. Member: Soc. Wash. A.; Wash. WCC; NAWPS; Provincetown AA; Sail Loft C.; Wash. AC.; Taos AC.; first and only woman member of the Taos SA (1923). Exhibited: Salon des A. Français, 1911; Wash. AC, 1914 (med), 1922; SSAL, 1934; Soc. Wash. A., 1935. Work: Boston AC; NAD; CGA; Witte Mus. Positions: T., Cours Critcher Painting Sch., Paris (founder), Corcoran Sch. A., 1911–17; Dir., Critcher Sch. Painting, 1923 [40]

CRITE, Allan Rohan [P,I,L,W,C] Boston, MA b. 20 1910, Plainfield, NJ. Studied: BMFA Sch.; Mass. Sch. A.; Boston Univ. Member: Boston Soc. Ind. A.; Boston Inst. Mod. A. Exhibited: BMFA Sch., 1935 (prize); CGA; AIC, 1942; WFNY, 1939; CAM (one-man); Univ. Nebr. (one-man); Boston S.Indp.A., 1929–41; Boston Inst. Mod. A., 1943–45; New England Contemporary A., 1930, 1933–46; Grace Horne Gal., 1937–39, 1944 (one-man); Margaret Brown Gal., 1945. Author/Illustrator: religious books and articles [47]

CRITTENDEN, C.D. (Mrs.) [P] Flushing, NY. Member: NAWPS [25]

CRITTENDEN, Ethel Stuart (Mrs.) [P,G,Des] Houston, TX b. 24 Mr 1894, Cincinnati, OH. Studied: Cincinnati A. Acad.; Cincinnati Univ.; McD. Sch.; Wayman Adams. Member: SSAL. Exhibited: Ar. Southeast Tex., Houston MFA, 1938; SSAL, 1938, Montgomery, Ala. Position: Dir., River Oaks Studio A. [40]

CRITTENDEN, Lillian (Mrs. Walter H.) [P] Brooklyn, NY d. 28 My 1919 [17]

CROCE, Isabel M. [Des,Dec] Great Neck, NY b. NYC. Studied: N.Y. Sch. F.&Appl. A. Designer: wallpaper, furniture, china, textiles [40]

CROCKER, A.L. (Mrs.) [P] Minneapolis, MN [24]

CROCKER, Charles Matthew [P] Los Angeles, CA [24]

CROCKER, Kezia [Min.P] Peekskill, NY [08]

CROCKER, Marion E. [P] Brookline, MA b. Boston, MA. Studied: Tarbell; K. Cox; Constant, Laurens, both in Paris; G. Hitchcock, Holland. Member: Copley S., 1888 [33]

CROCKER, Martha [P] Boston, MA b. 3 My 1883, South Yarmouth, MA. Studied: Benson; Tarbell; Cottet; Simon; Hawthorne. Member: NAWPS [40]

CROCKER, W(illiam) H. [P] NYC b. 25 Ag 1856, NYC d. 21 O 1928. Studied: R. Vonnoh; C. Rosen. Member: SC, 1900. Position: Ed., American Architect [27]

CROCKWELL, (Spencer) Douglass [P,I,Des] Glens Falls, NY b. 29 Ap 1904, Columbus, OH d. 1968. Studied: Wash. Univ.; Am. Acad. A., Chicago; St. Louis Sch. FA; F. Carpenter; G. Goetsch; W. Ludwig; O. Berninghaus. Member: F., St. Louis A. Alliance, 1929, 1930. Exhibited: PAFA; AIC; Kansas City AI; CAM; TMA; MOMA; Albany Inst. Hist.&A.; St. Louis G., 1931, 1932 (prizes); A. Dir. C., 1942 (med), 1944 (med), 1945 (med). Work: animated pictures, MOMA; murals, USPOs, White River Junction, Vt., Endicott, N.Y., Macon, Miss. Designer/Illustrator: national magazines. Lectures: "Abstract Animated Moving Pictures" [47]

CROCOV, P.G. [P] Pittsburgh, PA. Member: Pittsburgh AA [21]

CROM, Lillian Hobbes [P] Schwenksville, PA. Member: F., PAFA [24]

CROMARTY, Margaret A. [P] Pensacola, FL b. 7 Ag 1873, Canada. Studied: Scranton Sch. Des. Member: Pensacola AC; Fla. Fed. A. Exhibited: Pensacola Tri-County Fair, 1911 (prize); La Grange, Ind., 1923 (prize) [47]

CROMBIE, Ruth E. [Min.P] Brooklyn, NY [13]

CROMMIE, Michael James [P,I] NYC b. 11 Jy 1889. Member: Allied AA; Salons of Am. [40]

CROMWELL, Joane (Mrs. J.C. Christian) [P] Dana Point, CA b. Lewiston, IL. Studied: AIC; Otis AI; E. Paine; J.W. Smith. Member: Laguna Beach AA. Exhibited: Laguna Beach A. Gal., 1922–46; Los Angeles Mus. A.; Balboa Park A. Gal.; GGE, 1939. Work: murals, Hollywood Park, Calif., 1941; Santa Anita Race Course, Los Angeles, 1939; Millersburgh Military Inst., Ky. [47]

CRON, Nina Nash (Mrs.) [Min.P] Richmond, VA b. 28 1883, Spokane, WA. Studied: E.D. Pattee; M. Welch; A. Fuller. Member: Lg. Am. Pen W.; Phila. Alliance; Pa. Sc. Min. P.; Min. PS&G Soc.; Richmond Acad. FA [40]

CRONBACH, Robert M. [S] Westbury, NY b. 10 F 1908, St. Louis, MO. Studied: St. Louis Sch. FA; PAFA; Europe. Member: S.Gld.; A.Lg.Am.; An Am. Group; PAFA, 1929, 1930. Exhibited: Rosenthal Potteries, 1931 (prize); PMA, 1940; Hudson Walker Gal., 1940 (one-man); FAP, 1940 (prize); S. Gld., 1938, 1939, 1941, 1942; PAFA; WMAA; ACA Gal.; Springfield (Mo.) Mus. A.; MOMA; CAM. Work: CAM; Social Security Bldg., Wash., D.C.; St. Louis Municipal Auditorium; Willerts Park Housing Project, Buffalo, N.Y.; PMA [47]

CRONENWETT, Clare [E] San Fran., CA. Member: Calif. PM [25]

CRONIN, David Edward [I,Por.P,Car] Phila., PA b. 12 Jy 1839, Greenwich, NY d. 9 Je 1925. Studied: A. Conant, in Troy, N.Y.; Europe, late 1850s. Work: N.Y. Hist. Soc. Position: Staff A., Harper's, 1860s. After several careers he illustrated books from 1879–1903; moved to Phila. in 1890. [*]

CRONIN, Marie [P] Bartlett, TX b . Palestine, TX. Studied: L. Simon; C. Castelucho. Member: Tex. FA Assn.; SSAL. Work: San Antonio Cl., Tex.; Bartlett Baptist Church; Tex. State Capitol, Austin [40]

CRONK, Marian (Truby) [P] Denver, CO b. 18 S 1906, Coffeyville, KS. Studied: Broadmoor Art Acad.; Chappell Sch. A. Exhibited: Denver A. Mus., 1935 [40]

CRONYN, George W. [P] Portland, OR [15]

CRONYN, Randolph E. [P] NYC b. 25 F 1901, NYC. Studied: E. Greacen; J. Costigan; G.P. Ennis. Member: SC; NAC; New Rochelle AA [33]

CROOK, A.R. [Mus.Dir] d. 30 My 1930. Studied: British Mus., Jardin des Plantes; Berlin Univ.; Zurich Univ.; Munich Univ. Member: Ill. Acad. FA, founder. Position: In 1907 he was made curator of the Ill. State Mus. Nat. Hist. and remained there until the end of his life.

CROOK, Kenneth E. [P] Boston, MA/Bristol, ME b. 31 Jy 1899. Member: BMFA Sch.; F. Durkee; H. Lund [40]

CROOK, Russell Gerry [Cer] South Lincoln, MA b. 26 Jy 1869, San Fran. Studied: Saint-Gaudens; Twachtman; C. Binns. Member: Boston SAC. Exhibited: Boston Tercentenary, 1930 (gold). Work: Center Harbor, N.H.; Dorchester, MA [40]

CROOK, Susan Lee. See Ingersoll, Susan Crook.

CROOKS, Forrest C. [Des,C,P,I,W] Doylestown, PA b. 1 O 1893, Goshen, IN. Studied: G. Sotter; A. Sparks; CI; ASL. Member: Pa. Gld. Cr.; Assoc. Handweavers. Work: churches in Los Angeles; Pittsburgh. Contributor: Liturgical Arts, national magazines. Designer: looms. Position: cartoon draftsman for Sotter Stained Glass Studio [47]

CROOKS, John Marion [P] Astoria, OR [24]

CROPSEY, Jasper F. [Ldscp.P,Arch] Hastings-on-Hudson, NY b. 18 F 1823, Staten Island, NY d. 22 Je 1900. Studied: NAD; London, 1847–50, 1857–63; Rome. Member: NA, 1851; AWCS; Century C.; Lotos Cl.; Artists' Aid Society; PAFA, F., Soc. Sc. L.&A., London, England. Exhibited: NA. Work: N.Y. Hist. Soc.; BMFA; Peabody Inst. Specialty: autumn scenes. Designed and superintended the Sixth Ave. El stations of NYC. [98]

CROSBY, C. Wellington [P] Hartford, CT. Member: Hartford AS [25]

CROSBY, Gertrude Volz. See Volz.

CROSBY, Katharine V(an) R(ensselaer) (Mrs. John Gregory) [S,T] NYC/Tuxedo Park, NY b. 1 S 1897, Colorado Springs. Studied: Jess M. Lawson. Member: NAWPS; S.Indp.A. [29]

CROSBY, Percy L. [E,Li,P] McLean, VA. Member: SI; SC. Exhibited: Xth Olympic Exh., Los Angeles, 1932 (med). Work: WMAA; British Mus.; Musée Jeu de Paume, Paris; Italian Gov. Originator: cartoon, "Skippy" [40]

CROSBY, Raymond Moreau [I,Li,P] Yarmouthport, MA b. 1876, Grand Rapids, MI d. 13 D 1945, Santa Fe, NM. Member: SI, 1904; Players' C.; Century Assn. [40]

CROSBY, Thomas, Jr. [P] Providence, RI. Member: Providence WCC [25]

CROSIER, S.D. [P] Cincinnati, OH [01]

CROWMAN, Rose [E,S,P,L] Chicago, IL b. Chicago. Studied: PAFA; AIC. Member: Chicago SE. Exhibited: Chicago SE, national etching shows. Work: NGA; AIC. Lectures: Etching [47]

CROSS, Adelyne Schaefer [P,I] East Chicago, IN b. 17 Ja 1905, Columbus, WI. Member: Colt; Moeller. Member: United Am. Ar., Chicago; Am. Ar. Cong.; Soc. Am. E. Exhibited: AIC, 1937, 1938, 1939; WFNY, 1939. Work: Gary and Chicago public schools [40]

CROSS, Amy [P] NYC b. 5 Ap 1865, Milwaukee, WI d. 1939. Studied: Cooper Inst.; R.S. Gifford; W. Sartain; ASL; Hague Acad., with Fritz Jansen, J. Maris, A. Neuhuys; Académie Julian, Paris. Member: NYWCC; AAPL. Exhibited: Hague Acad., 1893 (med); Atlanta Expo, 1895 (med); Charleston Expo, 1902 (med) [40]

CROSS, Anson K(ent) [P,T,W] St. Petersburg, FL/Boothbay Harbor, ME b. 6 D 1862, Lawrence, MA d. 17 Je 1944, FL. Studied: Mass. Normal A. Sch. Member: Boston AC; Copley S.; St. Petersburg AC. Exhibited: Mass. Charitable Mechanics Assn., Boston, 1892 (med); P.-P. Expo, 1915 (med). Author: books on art education. Specialty: vision training method for drawing and painting (patented The Vermeer Finder). Position: Dir., A.K. Cross Art Sch., Boothbay Harbor, St. Petersburg [40]

CROSS, Bernice Francene [P] Wash., D.C. b. 22 Ag 1912, Iowa City. Studied: Wilmington Acad. A.; C.L. Watkins. Studio House, Wash., D.C. Exhibited: Ann. Indp. Exh., Wash., D.C., 1935 (prize). Work: hospitals, Wash., D.C. and Md. [40]

CROSS, Ethel Hendy (Mrs. Roscoe K.) [P] Webster Groves, MO b. 11 Ap 1892, San Fran. Studied: Stanford; PAFA; F. Conway. Member: St. Louis A. Gld. Exhibited: Kansas City AI, 1946 (one-man); CAM, 1939–46 [47]

CROSS, Henry H. [P] b. 23 N 1837, Flemingville, NY d. 2 Ap 1918, Chicago. Studied: Rosa Bonheur, Paris, at age 16.; traveled with Barnum's Circus. In 1862 he painted all of the Sioux Indians who were sentenced to death by Pres. Lincoln for a massacre of white settlers. Work: portraits, King Edward VII, Pres. Grant, Kaiakana (King of Hawaii)

CROSS, Herbert Richard [P,L,T] NYC/Wickford, RI b. 25 Ag 1877, Providence, RI. Member: Providence AC; Providence WCC; South County AA. Position: T., NYU [46]

CROSS, Louise [S,W,Medical I] NYC b. 14 N 1896, Rochester, MN. Studied: Minneapolis Sch. A.; Wellesley; AIC; Cornell Medical Col.; Harriet Hanley; Grande Chaumière. Member: SGI. Exhibited: Minn. Garden C., 1928 (prize); Minneapolis Inst. A., 1928 (prize); PMA, 1935, 1940; WFNY, 1939; MMA, 1942; NSS; WMAA; S. Gld. Traveling Exh., 1940, 1941; Franklin Inst., Phila. Work: Minn. State Capitol; Univ. Minn. Contributor: American Architect, Creative Art, Parnassus, House and Garden, London Studio. Position: T., Westchester County Work Shop [47]

CROSS, Marian Leigh [S] Brookline, MA/Beaver Bay, MN b. 4 Mr 1900, Minneapolis, MN. Studied: C.W. Wells; B. Robinson. Member: NAWPS [40]

CROSS, Robert Nicholson [Por.P,I] b. 1867, Brooklyn, NY d. 6 S 1936, Kew Gardens, NY. Had studio in NYC, from 1921.

CROSS, Sally [Min.P,T] Boston, MA b. Lawrence, MA. Studied: De Camp; Ross Turner. Member: Pa. SMP; NYWCC; ASMP; Gld. Boston A. Exhibited: P.-P. Expo, 1915 (med) [24]

CROSS, Verna M. (Mrs.) [P] Ft. Worth, TX [24]

CROSS, Watson, Jr. [P,T] Los Angeles, CA b. 10 O 1918, Long Beach, CA. Studied: Chouinard AI, with H.L. McFee, R. Lebrun, P. Paradise. Member: Calif. WCS. Exhibited: San Fran. AA, 1946; Los Angeles Mus. A., 1945; Laguna Beach AA, 1945; Calif. WCS, 1941–46; Riverside Mus., 1944–46. Position: T., Chouinard AI, 1944–46 [47]

CROSSER, Hazel F. (Mrs. C.A.) [P,S,C] Des Moines, IA b. 16 S 1894. Studied: A. Dornbush; L. Houser. Member: Am. Ar. Prof. Lg.; Des Moines FA Assn. Exhibited: Iowa A. Salon, 1936 (prize); Kansas City AI, 1936; Iowa A. Exh., 1938 [40]

CROSSMAN, Abner [P] Chicago, IL b. 14 Je 1847, St. Johnsbury, VT d. 2 D 1932. Studied: W. Hart; F.W. Moody, in London. Member: Chicago WCC [31]

CROSSMAN, William H(enry) [P,E] NYC b. 7 Ag 1896, NYC. Studied:

Henri; Lie; Bridgman; Hawthorne. Member: SC; ASL. Work: N.Y. Stock Exchange; Col. William & Mary; Wythe Mus., Williamsburg, Va [40]

CROUCH, Arthur [Car] Saranac Lake, NY b. 21 Jy 1898, Brooklyn, NY. Studied: ASL. Work: cover designs, Collier's, Liberty [40]

CROUCH, Emily H. [P] Providence, RI. Member: Providence WCC [25]

CROUCH, Mary Crete [I,Des] Sacramento, CA b. Virginia City, NV d. 26 D 1931. Member: Kingsley A. Cl.; Calif. Book Plate Soc. Work: Bookplate for the City Library A. Cl.

CROUGHTON, Amy H. [Cr] Rochester, NY b. 2 F 1880, Lowestoft, England d. 10 Ap 1951. Position: A. Cr., Rochester Times-Union, N.Y., 1918-46 [47]

CROUGHTON, G. Hanmer [P] Rochester, NY b. Ap 1843, London, England. Studied: Nat. Sch. A., South Kensington; T.S. Cooper; Antwerp; Paris. Member: Rochester AC. Exhibited: Intl. Expo, London, 1863 (med); Royal Cornwall Polytechnic Exh., 1864 (med); Cotton Centenn. Exh., New Orleans, 1885 (med) [19]

CROW, J. Claude [S] b. 30 N 1912, Stillwell, OK. Studied: Am. A. Sch.; Glintenkamp. Member: A. Lg. Am. Exhibited: WFNY, 1939; Springfield Mus. A., 1938; WMAA, 1939; BM, 1946; ACA Gal., 1939, 1940; New Sch. Soc. Res., 1940; Hudson Walker Gal., 1940; Critic's Choice, 1945. Work: Brooklyn Pub. Lib. [47]

CROW, Louise [P] San Fran., CA/Carmel, CA b. 14 S 1891, Seattle. Studied: P.M. Gustin; W.M. Chase. Member: San Fran. AA. Exhibited: Seattle FAS, 1916 (prize) [17]

CROW, Phil M. (Mrs.) [P] Lima, OH b. Kenton, OH d. D 1942. Studied: G. Luks; J. Noble; E.A.W. Hensche. Member: C.L. Wolfe AC; NAWPS; Columbus AL; Women's AC, Cincinnati; Ohio Born Women P.; Lima A. Study Cl. Exhibited: All. Ar. Am., Buffalo; Cleveland; Columbus, Ohio; Chicago. Work: covers, Literary Digest [40]

CROWDER, Conrad William [S,L,T] Berkeley, CA b. 3 Ap 1915, Hanford, CA. Studied: Riverside Col., Calif; abroad. Member: AFA. Work: mem., Capitol, Madison, Wis.; portrait busts of prominent Army & Navy officers. Position: Dir. S., Va. Sch. Prosthetics, Alexandria, 1947-48 [47]

CROWELL, Margaret [I,P,S] Avondale, PA b. Phila. Member: F., PAFA [25]

CROWELL, Reid Kendrick [P,B] b. 15 S 1911. Studied: O. Travis; C.L. McCann; Ruby Stone; H. Shoupe. Illustrator: Successful Farming, Progressive Farmer, Wilds and Water, Field and Stream, International Journal of Religious Education; covers, Farm and Ranch [40]

CROWLEY, Gray Price (Mrs.) [Min.P] NYC b. 1884, Topeka, KS. Studied: ASL; Shirley Turner. Member: Brooklyn Soc. Min. P. [15]

CROWLEY, Herbert [P,W] Pomona, NY [15]

CROWLEY, Timothy F. [P,Des] Greenwich, CT b. 1874, Providence d. 7 My 1943, Wallum Lake, RI. Specialty: textile design [24]

CROWN, John [P] NYC. Member: GFLA [29]

CROWNFELD, David (Mrs.) [P] Boston, MA [13]

CROWNFIELD, Eleanor F. [P] NYC. Member: Wilmington SFA [25]

CROWNINSHIELD, Frederic [P,I,T,C,W,L] NYC/Stockbridge, MA b. 27 N 1845, Boston d. 13 S 1918, Capri, Italy. Studied: Rowbotham, in London; Benouville, in Rome; Ecole des Beaux-Arts, Cabanel, Couture, all in Paris. Member: Arch. Lg., 1886; Mural P.; ANA, 1905; Copley S.; FA Fed., N.Y.; AIA; Century Assoc. Work: watercolors, BFMA. Author: "Mural Painting," "A Painter's Moods," and other volumes of verse. Specialties: mural decoration; stained glass; easel pictures. Positions: Dir., Am. Acad., Rome, 1909-11; T., BMFA, 1879-85 [17]

CROWINSHIELD, Ralph Gilmore [P] Brooklyn, NY b. 21 S 1908, Providence. Studied: Pratt Inst.; Gustave Cimiotti [40]

CROWTHER, Mollie L. [P] San Angelo, TX [25]

CROWTHER, Robert W. [I] Pitman, NJ b. 20 D 1902, Phila. Studied: PMSchIA; PAFA. Member: Phila. Sketch Cl. Work: Hall of Nations, Asbury Park, N.J.; Univ. Ill., Urbana. Illustrator: Saturday Evening Post, other national magazines [47]

CRUESS, Marie (Mrs.) [P] Berkeley, CA b. 1894, San Fran. Studied: ASL, San Fran.; ASL; H. Hoffman; Paris; Rome. Exhibited: San Fran. S. Women A. (prize); Santa Cruz Ann. (prize) [40]

CRUICE, Alice M. [T] Phila., PA. Member: F., PAFA [25]

CRUIKSHANK, Helen. See Davis, H.C., Mrs.

CRUISE, (Alvyk) Boyd [P] New Orleans, LA b. 20 O 1909, Cains, MS. Studied: New Orleans A. Sch.; PAFA. Member: New Orleans A. Lg. Exhibited: New Orleans A. Sch., 1931 (prize); PAFA 1934 (prize), 1935 (prize); Kennedy & Co., N.Y., 1942; New Orleans A.&Cr. Cl., 1935, 1936; Phila. A. All., 1941; Lieutaud, New Orleans, 1946. Work: La. State Mus. [47]

CRUM, Priscilla [Cur,L] Richmond, VA b. 15 O 1917, Kalamazoo, MI. Studied: Kalamazoo Col.; Western Reserve Univ.; Harvard. Member: AA Mus. Lectures: 19th and 20th Century European and Am. Paintings and Sculpture. Positions: arranged special exhibitions, 25 traveling exhibitions, VMFA, 1943-46; associated with VMFA, 1946- , Kalamazo Inst. A, 1940-43, MMA, 1943-46 [47]

CRUMB, Charles P. [S] Beechwood Park, PA b. 9 F 1874, Bloomfield, MO. Studied: O'Neill; Verlet; Barnard; Taft; Lanteri; Bringhurst; Grafly [33]

CRUMBO, Woodrow Wilson [P,C,T] Colorado (1971) b. 1912, Lexington, OK. Studied: O. Nordmark; H.C. Staples; O.B. Jacobson (who sponsored "Five Kiowas"). Exhibited: 48 Sts. Comp. Work: Mus. North Ariz.; Univ. Okla. Lib.; Philbrook A. Center. Position: Instr., silversmith, Univ. Okla., 1936-37; A. Dir., Bacone (Okla.) Col,, 1936-41; aircraft design, 1941-42; Asst. Dir., El Paso Mus. A., 1952. Crumbo was a Creek-Potawatomi Indian. He conducted a dance group in the early 1930s.[40]

CRUMLING, Wayne K. [P,T] Wrightsville, PA b. 14 D 1896, Hellam Township, PA. Studied: Daniel Garber; PAFA, 1919. Member: York AC [19]

CRUMMER, Mary Worthington [P,C,E,S] Guilford, MD b. Baltimore. Studied: Md. Inst.; Rinehart Sch. S.; Denman Ross; Harvard. Member: Baltimore WCC; Md. Hist. Soc.; AFA. Exhibited: Peabody Inst., 1923 (prize); Md. State Fair, 1928 (prize); BMA, 1939 (prize); Charcoal Cl., 1923 (prize); Baltimore WCC, 1939 (prize) [47]

CRUMP, Kathleen Wheeler. See Wheeler.

CRUMP, Leslie [P,W] Cranford, NJ b. 7 Ja 1894, Saugerties, NY d. 1962. Studied: Académie Julian, Paris; F.L. Mora; C.S. Chapman; ASL. Member: AWCS; Brooklyn WCC. Author: "Conscript 2939," "Directing for Amateur Stage" [47]

CRUMPACKER, Grace Dauchy (Mrs. S.J.) [P] South Bend, IN b. 4 O 1881, Troy, NY. Studied: Univ. Chicago; AIC. Member: Northern Ind. A. Lg. Exhibited: AIC, 1935, 1937; Ind. A. Cl., 1935-44; Midland Acad. A., South Bend, 1935-40; Northern Ind. A. Lg., 1929, 1942-46; Northern Ind. A. Salon, 1944; Ar. Lg. Northern Ind., 1929 (prize). Work: AIC [47]

CRUNELLE, Leonard [S] Chicago, IL b. 8 Jy 1872, Lens, Pas-de-Calais, France d. 10 S 1944. Studied: L. Taft; AIC. Member: Cliff Dwellers Cl.; State A. Commn.; Chicago PS. Exhibited: AIC; statue, Lincoln Park, Chicago; Negro War Mem., Chicago; Lincoln, Lincoln Tomb, Springfield; Abraham Lincoln, Freeport; Lincoln, Dixon, Ill.; flagpole soldier mem., Clinton, Iowa; statue, Wash., D.C. [40]

CSOKA, Stephen [E,P] Brooklyn, NY b. 2 Ja 1897, Gárdony, Hungary. Studied: Budapest Royal Acad. A. Member: ANA; SAE; Audubon A.; Soc. Brooklyn A.; Hungarian E. Assn. Exhibited: Barcelona Intl. Exh., 1929 (med); City of Budapest, 1930 (prize) 1933 (prize); SAE, 1942 (prize), 1945 (prize); LOC, 1944 (prize), 1946 (prize); Soc. Brooklyn A., 1944 (prize); Phila. WCC, 1945 (prize); La Tausca Pearls Comp., 1946 (prize); CGA, 1945; CI, 1943-45; AIC, 1944; Los Angeles Mus. A., 1945; NAD, 1940-45; Contemp. A., 1940, 1943, 1945 (one-man); Minn. State Fair, 1943. Work: CMA; Budapest Mus. A; LOC; British Mus.; Encyclopaedia Britannica Coll. [47]

CSOSZ, John [P,E,I,T] Cleveland, OH b. 2 O 1897, Budapest, Hungary. Studied: Gottwald; Keller; Cleveland Sch. A.; Europe. Member: Cleveland SA. Work: murals in high schools, churches and USPOs in Cleveland. Illustrator: "The Good Ship Mayflower" [47]

CUCUEL, Edward [P] Westerham, Kent, England/Starnberg, Bavaria b. 6 Ag 1879, San Fran. Studied: Constant, Laurens, Gérôme, in Paris; Leo Putz, in Munich. Member: Soc. Nat. des Beaux-Arts, Paris; Isaria and Aussteller-Verbund Munchner Kunstler, Der Ring, Munich. Exhibited: P.-P. Expo, San Fran., 1915 (med). Work: Detroit Art Inst.; Birkenhead Mus., Liverpool; "The Art of Edward Cucuel," by Baron von Ostini, with 100 plates; "Color Plates of Edward Cucuel," pub. E.W. Savory, Pub., Bristol, England; "Masters of Color"; "Elegante Welt," Berlin; "L'Illustration," Paris; "Sketch," London; "Illustrirte Zeitung," Leipzig; Musée Nationale des Artes et Decoration (Louvre); Maison Braun et Cie, Paris [40]

CUDDY, Louise J. [P] Brooklyn, NY

CUE, Harold James [I] Brookline, MA b. 1887 d. 1961. Illustrator: "The

Great Apache Forest," "The Iroquois Scout," other children's Western books [17]

CUGAT, Frances C. [I] NYC [24]

CULBERTSON, J(osephine) M. [P] Carmel, CA b. 4 My 1852, Shanghai, China. Studied: W.M. Chase; A.W. Dow; G.H. Smillie. Member: Carmel AA; Laguna Beach AA. Exhibited: Alaska-Yukon Expo, Seattle, 1909 (prize) [40]

CULBERTSON, Linn [P,T] Des Moines, IA b. 29 S 1890, Princeton, IA. Studied: C.A. Cumming; NAD. Member: AAPL. Exhibited: Des Moines Women's Cl., 1914 (prize), 1922 (gold), 1924 (med), 1928 (med), 1919 (prize). Work: Triangle Cl., Iowa City; Des Moines Women's Cl. [40]

CULBERTSON, Queenie [P,I] Cincinnati b. San Angelo, TX. Studied: Duveneck; W.D. Dodge. Member: Cincinnati Women's AC [40]

CULIN, Alice Mumford [P] b. 30 Ja 1875, Phila. Studied: DeCamp; Carl Newman; Henri. Member: Concord (N.H.) AA, 1925. Exhibited: PAFA, 1906 (prize), 1910 (prize); P.-P. Expo, San Fran., 1915 (med) [33]

CULLEN, Marion Ella (Mrs. Charles Peck Cullen, Jr.) [P] Buffalo, NY b. 4 Je 1901, Evansville, IN. Studied: C. Chichester; Henry Hensche; Albright A Gal. Sch. Member: Buffalo SA; The Patteran [40]

CULLIS, Harriett M. [P] Chicago, IL. Member: Chicago NJSA [25]

CULMER, Henry L.A. [Ldsp.P,I,W,L] Salt Lake City, UT b. 25 Mr 1854, Kent, England (came to U.S. in 1867) d. 10 F 1914. Studied: self-taught; London; A. Lambourne; Julian Rix. He met T. Moran, who influenced his style. Member: Utah A. Assoc.; Soc. Utah Ar.; Utah AI, (Pres., 1899–1902). Exhibited: in Utah (prizes). Work: Utah Capitol; Utah Hist. Soc.; Brigham-Young Univ. A. Center; Culmer Paint and Glass Co. Went to Salt Lake and worked as printer and publisher, 1876–82; at Culmer Paint & Glass Co., 1883–1914. [10]

CULTER, Richard [I] Pelham Manor, NY Member: SI [31]

CULVER, A.P. [P] NYC [15]

CULVER, Byron G. [Des,Dr,T] Rochester, NY b. 26 O 1894, Barre, NY. Studied: C.M. Ulp; von der Lancken; H. Butler; C. Chichester; C.W. Hawthorne; C.H. Woodbury. Member: Iroquois AA; Nat. Gld. A. Ed. Gl. Work: Des., Sch. AA, Mechanics Inst., Rochester [40]

CULVER, Charles [P,Des,C] Bellaire, MI b. 30 My 1908, Chicago Heights. Studied: Wicker A. Sch., Detroit; Cranbrook Acad. A. Member: Scarab Cl. Exhibited: Mich. A., 1932–46, 1935 (prize), 1937 (prize), 1940 (prize), 1941 (prize), 1943 (prize); AIC, 1937–46; CGA; VMFA; MMA; WMAA; Detroit Inst. A., 1935; Friends Mod. Art, 1936 (prize). Work: WMAA; Detroit Inst. A.; New Britain (Conn.) Mus.; Cranbrook Mus.; IBM Coll.; Flint AI; Ann Arbor A. [47]

CULVERHOUSE, Johann Mongles [Ldscp.P] b. Rotterdam, Holland d. NYC. Exhibited: NAD; Am. Art-Union; Boston Athenaeum; PAFA. Worked chiefly in NYC, 1849–91. [*]

CULWELL, Ben(nie) L(ee) [P] Dallas b. 8 S 1918, San Antonio. Studied: Southern Methodist Univ.; Columbia; Colgate Univ.; Cornell. Work: MOMA, 1946; Dallas Mus. FA, 1945 [47]

CUMING, Beatrice [P,E,T] New London, CT b. 25 Mr 1903, Brooklyn, NY d. 1975. Studied: PIASch; France. Member: AWCS; NAWA; Mystic AA; Conn. WC Soc. Exhibited: Hartford, Conn., 1939 (prize), 1941 (prize); Springfield, Mass., 1936 (prize); Bok Fnd. F., 1939 (prize), 1940 (prize); F., MacDowell Colony, N.H., 1936 (prize) 1938 (prize) 1943 (prize), 1944 (prize); CGA, 1937; PAFA, 1932; AIC, 1930, 1942; WMAA, 1938; WFNY, 1939; Syracuse Mus. FA, 1945; Four Arts Cl.; Springfield Mus. FA, 1946; Guy Mayer Gal., 1942 (one-man); Contemporary A., 1946 (one-man); Wadsworth Atheneum, Hartford, Conn., 1939, 1940, 1944; Mystic AA; Lyman Allyn Mus.; Conn. Col. (one-man). Work: Lyman Allyn Mus., New London, Conn.; Syracuse Mus. FA; Lib. Cong. [47]

CUMING, Frederick [P] Brooklyn, NY. Member: Brooklyn SA [29]

CUMMING, Alice McKee (Mrs. Charles A.) [P,S,L,T] Des Moines, IA b. 6 Mr 1890, Stuart, IA. Studied: State Univ. Iowa; Cumming Sch. A. Member: Iowa A. Gld.; Soc. for Sanity in Art; Des Moines A. Forum. Exhibited: Iowa State Fair, 1923 (gold), 1924 (prize); Des Moines Women's Cl., 1925 (prize); AIC, 1942 (med); Soc. for Sanity in Art, Chicago, 1941; Ogunquit AA, 1943–46; Des Moines A. Forum, 1945, 1946. Work: Des Moines Women's Cl.; State Hist. Gal., Des Moines. Position: Cumming Sch. A., Des Moines, 1937– [47]

CUMMING, Charles Atherton [P,Por.P,Mur.P,Ldscp.P,L,T] San Diego, CA b. 31 Mr 1858, Knox County, IL d. ca. 1932. Studied: AIC; Boulanger; Lefebvre; Académie Julian, Paris. Member: Iowa AA; Col. AA of Am.; Cumming Sch. Art (founder/director), Des Moines; Iowa A. Gld. (founder). Work: mural, Polk County Court House; portraits, State Hist. Gal., Free Pub. Lib. (both in Des Moines), State Univ. Iowa (Iowa City); landscapes, Des Moines Women's Cl. Gal., Cedar Rapids Gal. AA. Author: "Classification of the Arts of Expression," "The White Man's Art Defines," "The Psychology of the Symbolic Pictorial Arts," "My Creed." Married to painter Alice McKee. Position: Hd., Dept. Graphic/Plastic A., State Univ., Iowa City [31]

CUMMING, Constance [Min.P] Philadelphia, PA [17]

CUMMING, M.S. [P] NYC [01]

CUMMINGS, Charles A. [P] Des Moines, IA. Member: Boston AC [01]

CUMMINGS, E.E. [P] NYC Member: S.Indp.A. [21]

CUMMINGS, Harold W. [C,L] Belvedere, CA b. 5 Ja 1897, Hampton, IA. Studied: Iowa State Col. Member: Stained Glass Assn. Am. Work: stained glass mem., Presbyterian Church, San Rafael, Calif.; Loyola Univ. chapel, New Orleans; Presidio, San Fran.; Col. of Pacific, Stockton, Calif.; Iowa State Col. Mem. Bldg., Ames. Contributor: Liturgical Arts, Stained Glass, other magazines. Specialty: stained glass [47]

CUMMINGS, M(elvin) Earl [S,T] San Fran., CA b. 13 Ag 1876, Salt Lake City. Studied: Mercié, Noël, in Paris; D. Tilen, in San Fran. Member: Bd. Park Commissioners. Work: "Robert Burns," Golden Gate Park, San Fran. Position: T., San Fran. A. Inst., 1905– [19]

CUMMINGS, Ruth Reed [P] Marcellus, NY b. Mr 1900, Marcellus d. 23 Ja 1973. Self-taught. A painter of primitives, she began painting in 1963 at age 63. Although she said she was "not an artist," she produced hundreds of local nostalgic scenes in a true primitive spirit. Exhibited: Canal Mus., Syracuse, 1972; Everson Mus., Syracuse, 1975 [*]

CUMMINGS, Sarah Rouch [P,Des,Dec] Media, PA b. 8 S 1895, Halifax, PA. Studied: Pa. Sch. Indp. A.; Wayman Adams; M.A. Richardson; M. Molarsky; E. O'Hara. Member: Phila. A. All.; Phila. WCC. Exhibited: Phila. WCC Ann., PAFA, 1935; Newman Gal.; A. All. [40]

CUMMINGS, Willard Warren [P] Skowhegan, ME b. 17 Mr 1915, Old Town, ME. Studied: Académie Julian, Paris; Yale; ASL; Waymann Adams; R. Laurent. Exhibited: Oakland A. Gal., 1940 (prize); AIC, 1941; CGA, 1940; MOMA, 1938–42; Smith Col. Mus. A., 1940 (one-man); Sweat Mem. Mus., 1940; Marie Harriman Gal., 1939. Position: T., Skowhegan Sch. P.&S. [47]

CUNEO, Cyrus Cincinnati [Por.P,I] London, England b. 1878, San Fran., d. 23 Jy 1916. Studied: Paris; Whistler. (Financed his lessons by boxing professionally.) Member: Royal Inst. Oil Painters, 1905–12; Langham Sketching Cl. Exhibited: Royal Acad.; Liverpool. He made a sketching trip through California and the Pacific Northwest, in 1908, for the Illustrated London News. Many of his paintings were destroyed in Liverpool during WWI.

CUNEO, George Humbert [Edu,P] Berwyn, MD b. 11 F 1898, Carlstadt, NJ. Studied: BAID, with Borglum; PAFA, with Garber; Columbia; Univ. Ky.; France. Member: Am. Assn. Univ. Prof.; CAA. Exhibited: Springfield (Mass.) Mus. FA, 1938; Fed. Gal., Newark, N.J., 1940 (one-man); Montclair A. Mus., 1938–41; Newark Mus., 1939, 1940; Princeton, 1939; Newark Univ., 1940; Jersey City Mus. Assn., 1938–40; N.J. State Mus., 1937; CGA, 1946. Positions: Asst. State Dir., FAP N.J., 1936–42; T., Univ. Md., College Park, 1946– [47]

CUNEO, Rinaldo [Mar.P,Landscp.P,T] San Fran. b. 2 Jy 1877, San Fran. d. 29 D 1939. Member: San Fran. AA; Soc. Mural A. Northern Calif. Exhibited: Calif. A.; Gump's Gal., San Fran. (prize); San Fran. AA, 1935 (prize). Work: de Young Mem. Gal.; Walter Coll.; Mus. A., San Fran. [38]

CUNNING, John [P,Li,Des] Brooklyn, NY b. 14 My 1889, Albany, NY. Studied: R. Henri. Exhibited: WMAA, 1933, 1934; PAFA, 1934. Work: WMAA; Albany Inst. Hist. & A.; Labor Bldg. WPA [47]

CUNNING, Shirley [S] St. Louis, MO. Member: St. Louis A. Gld. [10]

CUNNINGHAM, Benjamin Frazier [P,E] San Fran. b. 1904, Colorado d. 1975. Exhibited: Oakland Gal. Ann., 1934. Work: Ukiah, Calif. WPA artist. [40]

CUNNINGHAM, Charles C. [P] Brooklyn, NY b. 1841 d. 15 O 1918

CUNNINGHAM, Charles C. [Mus.Dir,W,L] Hartford, CT b. 7 Mr 1910, Mamaroneck, NY. Studied: Harvard; Univ. London. Member: AFA; Am. Assn. Mus. Dir.; Am. A. Research Council. Contributor: art magazines. Positions: Asst. Cur., BMFA, 1935–41; Dir. Wadsworth Atheneum, Hartford, 1946– [47]

CUNNINGHAM, Corinne. See Collins, Mrs.

CUNNINGHAM, Cornelia [P,I,T] Atlanta, GA b. 2 D 1903, Savannah, GA. Studied: Cooper Union; NAD; Grand Central Art Sch. Member: Atlanta AA; SSAL; Ga. AA; Telfair AA. Specialty: marionettes [31]

CUNNINGHAM, Esther Lowell [P] Manchester, MA [19]

CUNNINGHAM, Fern Frances [P,T,L] Defiance, OH b. 4 Ag 1889, Defiance. Studied: Defiance Col.; Fontainebleau Sch. FA, France; J. Carlson; G.E. Browne; Thieme; Fuche. Member: NAWA; Toledo AA; Miami AA. Exhibited: Argent Gal.; Butler AI; Toledo Mus. A; Greeneville (S.C.) A. Mus.; Studio Gld.; Pa.-Ohio Traveling Exh.; Fla. A. Center; N.Y. Municipal Exh. [47]

CUNNINGHAM, Imogen [Photogr] San Fran., CA b. 1883, Portland, OR d. 1976. Studied: Univ. Wash. Member: Group F/64, 1932-35. Exhibited: Brooklyn MA, 1912; Los Angeles MA, 1932, Cincinnnati MA, 1956; IMP/GEH, 1961; AIC, 1964; Stanford Univ., 1967; Phoenix Col. Lib., 1969. Work: plant forms, nudes, and portraits at Center for Creative Photo., Tucson; AIC; IMP/GEH; MET; MOMA; NOMA; Oakland MA; San Fran. MA; Seattle AM; UCLA; Stanford AM; Smithsonian [*]

CUNNINGHAM, J. Wilton [P] St.Louis, MO b. St. Louis. Studied: St. Louis Sch. FA; Académie Julian, Paris. Member: St. Louis Assoc. P.&S. Exhibited: Paris Salon, 1890 (prize)

CUNNINGHAM, Joan [P,G,I,Car] Rochester, NY b. 19 Ja 1916, Rochester. Studied: ASL; Cane Sch.; T. Benton; J. Charlot; K. McEnery; A. Abels. Exhibited: Rochester Mem. Gal.; FA Center, Colorado Springs; Albright A. Gal. Represented: St. Mary's Church, Jersey City; St. John's Church, Canton, Ohio; USPO, Poteau, Okla. WPA artist. [40]

CUNNINGHAM, Joe [Car,W,L] Phila., PA b. 22 Je 1890, Phila. Member: PPC; Am. Assoc. Car.&Caric. Designer: coat of arms, U.S. Tank Corps. Creator: "Rufus McGoofus" cartoon calendar [31]

CUNNINGHAM, John [C,P,Des,S,T] Carmel, CA b. 5 Ap 1906, New Jersey. Studied: Univ. Calif.; H. Hofmann; B. Bufano; Sch. Fashion A., Munich; André Lhote. Member: Am. A. Cong.; NSS. Exhibited: Cranbrook Mus., 1932, 1933; Carnegie Inst., 1934; Paris Expo, 1937; Greater Tex.&Pan-Am. Expo, 1937; GGE, 1939. Work: Gimbel Bros., N.Y.; Cranbrook Acad. A.; Carnegie Inst. [47]

CUNNINGHAM, John Rex [Arch,P,T] Stillwater, OK b. 30 S 1902, Grank Island, NE. Studied: Doel Reed; Reginald Groomes. Member: Okla. AA; Tulsa AA. Exhibited: Tulsa AA, 1934 (prize). Position: T., Okla. A.&M. Col., Stillwater [40]

CUNNINGHAM, John Wilton [P] b. near St. Louis d. 28 Ag 1903, near San Antonio. Studied: Sch. FA, St. Louis; Académie Julian, Paris. Member: St. Louis Assoc. P.&S. Exhibited: Paris Salon, 1890 (prize)

CUNNINGHAM, Joseph [I] Phila., PA. Illustrator: "The North American" [19]

CUNNINGHAM, Kathleen McE. [P] Rochester, NY. Member: Lg. AA [24]

CUNNINGHAM, Marion [Ser,Li,P,C,Des,W] San Fran., CA b. 29 My 1911, Bend, IN. Studied: Calif. Sch. FA; Stanford Univ.; ASL, with Sternberg, Abel. Member: San Fran. AA; San Fran. Soc. Women A.; Am. Color Print Soc.; Nat. Serigraph Soc. Exhibited: NAD, 1944; Lib. Cong., 1944; Audubon A., 1945; Nat. Serigraph Soc., 1943-46; Northwest Pr.M., 1945, 1946; MOMA, 1944; Ney Mus., Dallas, 1943; San Fran. AA, 1939-44; San Fran. Soc. Women A., 1939-43, 1945; Oakland A. Gal., 1940-42; Stanford Univ., 1946; San Diego FA Soc., 1944; Pal. Leg. Honor, 1945. Work: SFMA; MMA; State Dept., Wash., D.C.; Pal. Leg. Honor; Moscow Mus. A.; San Fran. Housing Authority. Illustrator: "Deny the Day," 1940 [47]

CUNNINGHAM, Mary Ivins [P] Newtown, PA [06]

CUNNINGHAM, Mary Phillips (Mrs. Phelps) [En,T,B] Cleveland Heights, OH b. 7 Jy 1903, Effingham, KS. Studied: Univ. Kans.; J.R. Fraser; Albert Bloch; R. Ketcham; R. Eastwood. Member: Cleveland Pr.M. Exhibited: Univ. Kans., 1927 (prize); CMA, 1931, 1934 (prize) 1937 (prize), 1941-1943, 1945, 1946; Lib. Cong., 1943, 1944; Wichita A Mus., 1934; Phila. Pr. Cl., 1942; Kansas City AI, 1934; John Herron AI, 1945; WMAA, 1937. Work: CMA [47]

CUNNINGHAM, Mildred (Cotnam) (Mrs. O.D.) [P,T] Newton, IA b. 23 Ag 1898, St. Paul, MN. Studied: C.A. Cumming; John Carlson; Grant Wood; C. Macartney; Edith Bell. Member: Iowa AG. Position: A. Supv., Newton Pub. Schools [40]

CUNNINGHAM, Patricia [T,P,S,Des,W,Cr] Carmel, CA b. California. Studied: Univ. Calif; Hans Hofmann; André Lhote. Exhibited: Univ. Calif. Work: Sea View Sch., Monterey, Calif. Positions: A. Cr., Carmel Pine Cone-Cymbal, 1942-46; T., Carmel AI, 1940-46 [47]

CUNNINGHAM, Roger [P] Kansas City, MO [24]

CUNNINGHAM, Theodore Saint-Amant [P,Ldscp.P] St. Gallen, Switzerland b. 5 O 1899, Ennis, TX. Studied: AIC; E.J.F. Timmons; George Bellows. Member: AAPL. Work: Tenn. State Capitol; Women's Cl., Waco, Tex.; collections abroad [47]

CUNNINGHAM, (William) Phelps [Des,En,P,I,L,E,B] Cleveland Heights, OH b. 24 Ag 1903, Humboldt, KS Studied: Univ. Kans.; Guptill; Watson; J.M. Kellogg; R. Eastwood, R. Ketcham. Member: Color Bl. Pr.M.; AIA; Scarab Cl. Exhibited: CMA, 1931-33, 1934 (prize) 1937 (prize) 1939, 1941 (prize); John Herron AI, 1944 (prize); PAFA, 1931-34, 1937; SAE, 1933, 1937; Swedish Nat. Mus., 1938; Wichita AA, 1933, 1934; Woodcut Soc., Kansas City, 1934 (traveling exh.); Phila. Pr. Cl., 1934; Ohio Pr.M., 1933, 1934, 1938, 1939; Kansas City AI, 1932, 1935; WMAA, 1937. Work: CMA; Swedish Nat. Mus.; LOC; Cleveland Pub. Lib.; Herron AI; Cleveland Print C. [47]

CUPIT, Robert [P] Worcester, MA [24]

CUPRIEN, F(rank) W. [Mar.P] Laguna Beach, CA (from 1913) b. Ag 1871, Brooklyn, NY d. 21 Je 1948. Studied: ASL; CUASch; Carl Webber; Munich; Dresden; Leipzig; Italy; Paris. Member: Calif. AC; Laguna Beach AA; Dallas AA; Denver AA; SSAL; New Haven PCC; Los Angeles PSC; AAPL. Exhibited: Berliner Ausstellung (gold); Galveston, Tex., 1913 (med); San Diego Expo, 1915 (med), 1916 (med); Calif. State Fair, 1918 (med), 1920 (prize); Phoenix (Ariz.) State Fair, 1916 (prize); Laguna Beach AA, 1921 (prize); Laguna Beach Mus., 1939-45; Witte Mem. Mus., 1929 (prize); Pacific Southwest Expo, Long Beach (prize). Work: del Vecchio Gal., Leipzig; Chamber of Commerce, Laguna Beach [47]

CUREL-SYLVESTRE, Roger [P] Paris, France b. 1884, Nice, France. Studied: A. Stevens; Noel. Member: Société Royale des Beaux Arts, Brussels; Salons of Am. Work: Milwaukee AI [29]

CURJEL, E. [P] San Fran., CA [17]

CURRAN, Charles C(ourtney) [P,T] NYC/Cragsmoor, Ulster County, NY b. 13 F 1861, Hartford, KY d. 9 N 1942. Studied: Cincinnati Sch. Des.; ASL; NAD; Académie Julian, Paris, with Constant, Lefebvre, Doucet. Member: ANA, 1888; NA, 1904; NYWCC; AWCS; SA, 1888; SC; Lotos Cl.; NAC. Exhibited: NAD, 1888 (prize), 1893 (prize), 1895 (prize), 1919 (prize); Paris Salon, 1890 (prize); Columbian Expo, Chicago, 1893 (med); Atlanta Expo, 1895 (med); Paris Expo, 1900 (med); Pan-Am. Expo, Buffalo, 1901 (med); SAA, 1904 (prize); St. Louis Expo, 1904 (med); S. Wash. A., 1905 (prize); SC, 1933 (prize). Work: NGA; PAFA; Mus. A., Columbus; AA, Richmond, Ind.; TMA; Buffalo FA Acad.; A. Mus., Montclair, N.J.; San Antonio AM; Fort Worth AM; Dallas AA; Witte Mem. Mus.; MMA; Mark Twain Mem., Hartford, Conn.; Vassar; Columbia; Savidge Mem. Lib., Petersborough, N.Y.; Court House, Norwalk, Ohio; Lotos Cl.; Chamber of Commerce, Bar Assoc. Coll., both in NYC. Position: T., NAD [40]

CURRAN, Louis W. [P] NYC [10]

CURRAN, Mary E. [E] Los Angeles, CA [19]

CURRIE, Bessie Bangs [P] Merrian Park, MN [13]

CURRIER, Allen Dale [Des,Edu,L] Sharon, MA b. 21 O 1893, Everett, MA. Studied: Boston Univ.; Harvard; W.T. T. Robinson. Positions: Dir., Swain Sch. Des., New Bedford, Mass., 1930-46; T., Boston Univ. Col. Practical A.&Let., 1946- [47]

CURRIER, Cyrus Bates [P,Des] Los Angeles, CA b. 13 D 1868, Marietta, OH. Studied: Académie Julian, Paris; Alphonse Mucha. Member: SC [47]

CURRIER, E(dward) W(ilson) [P] San Fran., CA b. 11 O 1857, Marietta, OH d. 15 N 1918. Studied: Acad. FA, Chicago; G.L. Clough. Member: San Fran. Acad. FA. Exhibited: Alaska-Yukon Expo, 1909 (medals) [17]

CURRIER, Ernest M. [Silversmith,Des] b. ca. 1867 d. 28 Je 1936, NYC. An authority on early American silver, he formed the firm of Currier and Roby (1900) to make reproductions of antique silver. At the time of his death he was working on a book dealing with the known makers' marks on American silver from Colonial times to 1850. He had one of the largest collections of marks in the U.S.

CURRIER, Everett [P] NYC [25]

CURRIER, George H. [P] Dorchester Centre, MA. Member: Boston AC [25]

CURRIER, J. Frank [P] Roxbury, MA b. 21 N 1843, Boston d. Ja 1909.

Member: BAC. Studied: Acad. FA, Munich. Exhibited: SAA, 1878. Work: Herron A. Gal., Indianapolis; St. Louis Mus. One of the "Duveneck Boys" and a proponent of the "Munich style." [08]

CURRIER, Nathaniel [Li,Publisher] b. 27 Mr 1813, Roxbury, MA d. 20 N 1888, NYC. Studied: Pendleton brothers, in Boston, 1828–33; M.E.D. Brown, in Phila., 1834. He came to NYC in 1834, setting up his own lithography business there in 1835. James M(erritt) Ives became a partner in 1857, after which all prints published by the firm bore the imprint of Currier & Ives. Thousands of views of events, manners, and persons of the U.S., from 1857–1907, bear that imprint. [*]

CURRIER, Richard [Dr,P] NYC b. 1903, Methuen, MA. Studied: Harvard; Slade Sch., Univ. London, with Tonks; Sch. Dec. A., Florence, Italy [40]

CURRIER, Walter Barron [P,E,B,I,W,L,T] Santa Monica, CA b. 3 My 1879, Springfield, MA d. 11 Ja 1934. Studied: Brown; Cornell; Dow; Eben Comins; Kenyon Cox. Member: Calif. AC; Calif. PM; Laguna Beach AA; Santa Monica AA; PS, Los Angeles. Exhibited: Santa Monica AA (prize). Work: Expo Park Gal., Los Angeles; Cecil B. DeMille Home for Girls, Hollywood; Pub. Lib., Santa Monica. Lectures: Art education. Positions: T., Univ. Calif., Berkeley, 1902–05; Dir., Currier Creative A. Sch., Santa Monica (est. 1926) [33]

CURRY, Alison B., Jr. [P] Coral Gables, FL. Work: Dept. Interior Bldg., Dept. Justice Bldg., Wash., D.C. WPA artist. [40]

CURRY, John Steuart [P,Li,S] Madison, Wis. b. 14 N 1897, Dunavant, KS d. 29 Ag 1946. Studied: Kansas City AI, 1916; AIC, 1916–18; Geneva Col., 1918–19; Schoukhaieff, in Paris, 1926–27; Norton Reynolds. Member: ANA, 1937; NA, 1943; ASL. Exhibited: Northwest PM, 1933 (prize); CI, 1933 (prize). Work: WMAA; MMA; Addison Gal. Am. Art, Andover, Mass.; Univ. Nebr., Lincoln; Kans. State Col., Manhattan; murals, Dept. Justice Bldg., Dept. Interior, Wash., D.C. WPA muralist. Famous as one of The Regionalists (along with Thomas Hart Benton and Grant Wood). Position: T., ASL, 1932–36; Univ. Wis., 1936– [40]

CURRY, Noble [P] Columbus, OH [21]

CURT, Edith. See Panke.

CURTIS, Alice Marion [Ldscp.P] Boston, MA b. 1847, Boston d. 1911, Milton, MA. Studied: W.M. Hunt; F. Duveneck; C.H. Woodbury, in Boston; toured Europe, 1885–86. Member: Boston WCC; Copley S., 1893; NYWCC. Exhibited: Boston AC; St. Botolph Cl., Mechanics Fair, J.E. Chase Gal. (1884), all in Boston; NAD. Her studio was in Boston until 1907. [06]

CURTIS, Charles B. [W,Patron] NYC b. 1827, Penn Yan, NY d. 26 Mr 1905. Author: "Catalogue of the Works of Velásquez and Murillo," "Rembrandt's Etchings." In 1901 he gave $10,000 to the MMA for the purchase of works by old masters, and he gave a valuable collection of engravings to the NYPL.

CURTIS, Clarence James [Dec,Des,G] Perrysburg, OH/Ottawa Lake, MI. b. 1 F 1904, New York. Studied: TMA Sch. Work: Rossford Methodist Episcopal Church; Hathaway Sch., Toledo [40]

CURTIS, Constance [P] NYC b. Wash., D.C. Studied: ASL, with W. Chase. Member: All.A.Am.; NAWA; AAPL; A. Workers C. Exhibited: NAC, 1922 (prize); NAWA, 1922 (prize), 1925, 1926, 1929, 1933, 1934, 1935 (prize), 1936–41; AAPL, 1940, 1944 (prize); Paris Salon, 1900; St. Louis World's Fair, 1904; WFNY, 1939; CGA, 1923; PAFA, 1921, 1923, 1924; NAD, 1923, 1927, 1933; Boston AC, 1928, 1932; AIC, 1924, 1925; All.A.Am., 1935–42; Stockbridge AA, 1923–32, 1933 (prize), 1934–38; Carnegie Hall Gal., 1933–41 [47]

CURTIS, Dock (Miss) [Mur.P,Des] NYC b. 1 O 1906, Salt Lake City, UT. Studied: John Koopman; George Pearse Ennis; Frank H. Schwarz. Member: Mural P. Work: dec., Kohler Bldg., Century Progress Exh. (Chicago), Gen. Cigar Bldg., Park Assn. Bldg., WFNY, 1939 [40]

CURTIS, Edmund de Forest [Cer,W,T] Villanova, PA b. 21 Jy 1884, Brooklyn, NY. Member: A. Ceramic S.; Phila. All. Work: MMA. Contributor: articles to Journal and Bulletin, Am. Cer. Soc. Position: T., PMSchIA [40]

CURTIS, Edward S(heriff) [Photog,I] Seattle, WA b. 1868 d. 1952. Exhibited: Morgan Lib., NYC, 1970; Phila. MA, 1972. Work: Morgan Lib.; Phila. MA; Brit. Mus., London; LOC (400 prints); Univ. N.Mex.; UCLA; many others. With the encouragement of T. Roosevelt and J.P. Morgan, he began the monumental task of artistically documenting America's Indian tribes. His famous "The North American Indian" was published in 20 bound volumes and 20 portfolios between 1907 and 1930, each illustrated with photogravures. (A complete set brought $79,200 at Sotheby's in Nov. 1980.) His resources exhausted, Curtis died a poor man. [15]

CURTIS, Edwin [P,T] b. 1885, England (came to U.S. in 1920) d. 23 Ap 1943, Cliffside Park, NJ. Exhibited: All.A.Am.. Position: T., Cliffside, H.S.

CURTIS, Elizabeth [P] NYC/Watertown, CT b. NYC. Studied: Twachtman; Chase. Member: NAWPS [40]

CURTIS, Floyd Edward [P,Gr,W] Cleveland, OH b. 20 O 1894, Cleveland. Studied: John Hammond; Pickering Col. Member: Ohio WC Soc.; Southern Pr.M.; AAPL. Exhibited: NAD, 1944; A. Gal., Toronto, 1939; Los Angeles Mus. A., 1938; Albright A. Gal., 1938, 1940; CMA, 1935, 1936, 1939; Ohio Pr.M., 1940, 1941, 1943, 1944, 1945; TMA, 1939, 1944; CM, 1941, 1942, 1944, 1946; Dayton AI, 1940–45; Ind. Soc. Pr.M., 1944, 1945 [47]

CURTIS, George V(aughan) [P] NYC b. 1859, Southampton, England (came to U.S. ca. 1894) d. 21 Ag 1943, Wash., D.C. Studied: Legros; Constant. Member: S.Indp.A. Exhibited: Société des Artistes Français de Seine et Marne. Work: Musée de Melun; mural, church, Villemomble [24]

CURTIS, George Warrington [S,P] Southampton, NY b. 1869 d. 11 S 1927. Position: Dir., Aeolian Company, NYC

CURTIS, Helen [P,C] Callicoon, NY b. 2 D 1864, Cochecton, NY. Studied: Brush; Freer; Dewey; Paul Grober [25]

CURTIS, I(da) Maynard [P,T] Carmel, CA b. 12 Ja 1860, Lewisburg, PA. Studied: Cornell; ASL; NAC; Hawthorne; Denman Ross; Simon, Maynard, in Paris. Member: NAC; AAPL; Calif. AC; San Diego AC. Exhibited: All.A.Am., 1941–46; NAC, 1928–46; AAPL, 1946; Carmel AC, 1926–46; Calif. AC, 1926–46. Work: Cornell; Mem. Lib., Carmel [47]

CURTIS, Jane Bridgham. See Child, R.C., Mrs.

CURTIS, Leland [P] Carson City, NV (1972) b. 7 Ag 1897, Denver, CO. Member: AAPL; Los Angeles P.&S. Cl. Exhibited: Los Angeles P.&S. Cl, 1924 (med), 1928 (med), 1931 (prize); Calif. State Fair, 1926 (prize), 1934 (prize), 1936 (prize); Los Angeles Mus. A., 1935 (prize), 1937 (prize); Oakland A. Gal., 1944 (prize); NAD, 1945; Toledo Mus. A., 1931; Pal. Leg. Honor, 1946. Work: Artland Cl., Los Angeles; Hollywood Athletic Cl.; City of Los Angeles Coll.; Springville (Utah) AA. Specialty: landscapes of the Sierras, 1920s. Official artist for the U.S. Antarctic Expedition, 1939–41, and the U.S. Navy's Operation Deepfreeze III in the Antarctic, 1957. [47]

CURTIS, Leona (Mrs. Whiteman) [S] Brooklyn, NY b. 26 Ja 1908, Plainfield, NJ. Studied: ASL; Robert Laurent; José de Creeft; Concetta Scarvaglione. Member: N.Y. Soc. Women A.; NAWA. Exhibited: Montclair A. Mus., 1935(med), 1936; NAWA, 1941 (prize); PAFA, 1935; PMA, 1940; NAD, 1942; WFNY, 1939; MMA, 1942; Newark Mus., 1939; Am.-British A. Center, 1941; Bonestell Gal., 1943 [47]

CURTIS, Marian [P] Laguna Beach CA b. 14 F 1912, Los Angeles. Studied: Chouinard Sch. A., Los Angeles. Member: Calif. WC Soc. Exhibited: Los Angeles County Fair, 1938 (prize); San Diego A. Center, 1938 (prize); Calif. State Fair, 1939 (prize); AIC, 1939; PAFA, 1938; GGE, 1939. Work: FA Gal., San Diego [40]

CURTIS, Marjory [S] NYC [17]

CURTIS, Mary Carroll [P] Boston, MA b. 17 D 1896, Wellesely Hills, MA. Studied: Garber; Breckenridge; Carles; Lucien Simon. Member: F., PAFA [25]

CURTIS, Nathaniel Cortlandt [Des,Arch,W,L,T] New Orleans, LA b. 8 F 1881, Smithville, NC. Member: AIA; NOAA. Author: "New Orleans—Its Old Houses, Shops and Public Buildings," "Historical and Decorative Map—Creole City of New Orleans." Position: Affiliated with Tulane [40]

CURTIS, Philip Campbell [P,Mus.Dir] Scottsdale, AZ (1976) b. 1907, Jackson, MI. Studied: Albion Col., 1930; Univ. Mich.; Yale. Member: Royal SA; Member: Phoenix A. Center (founder), 1936–39; Royal SA. Work: Phoenix AM; Ariz. State Univ.; Des Moines A. Center. Known as a "Magic Realist." [*]

CURTIS, Sidney W. [P] NYC. Member: SC [25]

CURTIS, William Fuller [P,I] Brookline, MA/Ashfield, MA b. 25 F 1873, Staten Island, NY. Studied: Julius Rolshoven, Lefebvre, Robert-Fleury, in Paris. Exhibited: S. Wash. A., 1902 (prize); Wash. WCC, 1903 (prize); St. Louis Expo, 1904 (med). Work: Church of St. Michael and All Angels, Geneseo, N.Y.; Cosmos Cl., Wash., D.C. [40]

CURTIS-BROWN, Mary Seymour [P] Lisle, NY b. 28 Jy 1888, Norwalk, CT. Studied: Albert Sterner. Member: NAC [29]

CURTISS, Christine Tuche [P] Jamestown, RI [19]

CUSACK, Helen Woodbury [P] Chicago, IL [06]

CUSHING, Ellen Watson [P,C] Dorchester, MA b. Boston. Studied: George Hitchcock; Dawson Watson. Member: Boston SA; Baltimore Artisans' Cl.; Scituate A.&Cr. [08]

CUSHING, Howard Gardiner [P] NYC b. 1869, Boston d. 26 Ap 1916. Studied: Académie Julian, with Laurens, Constant, Doucet, in Paris. Member: ANA, 1906; SAA, 1905; Port. P.; Arch. Lg., 1914; Mural P. Exhibited: Pan-Am. Expo, Buffalo, 1901 (prize); CI, 1904 (med); PAFA, 1910 (gold); P.-P. Expo, San Fran., 1915 (gold). He did a series of mural paintings for the studios of Mrs. Harry Payne Whitney at Roslyn, N.Y. [15]

CUSHING, Otho [I,Car] b. 1871, For McHenry, MD d. 13 O 1942, New Rochelle, NY. Studied: BMFA Sch.; France. Positions: T., MIT; Staff, Life, for 25 years

CUSHMAN, Alice [P] Phila., PA b. 27 S 1854, Phila. Studied: Ross Turner. Member: Phila. WCC [40]

CUSHMAN, Charles T., Mrs. See Cox-McCormack.

CUSHMAN, Cordelia H. (Mrs. Paul) [S] NYC. Member: NAWPS. Exhibited: NAWPS, 1935-38 [40]

CUSHMAN, Henry [S,C] Los Angeles, CA b. 16 D 1859, London, England. Work: carved ivory cup, Windsor Castle. Specialties: carved wood; stonework [40]

CUSHMAN, Lillian S. See Brown, Lillian.

CUSTER, Bernadine (Mrs. A.E. Sharp) [P,I] NYC b. Bloomington, IL. Studied: AIC. Member: Southern Vt. Ar. Exhibited: AIC; CGA; CM; PAFA; RISD; BM; Phila. WC Cl. Work: Wood Art Gal.; Montpelier, MMA; Detroit Inst. A.; BM; AGAA; murals, Treasury Dept., Wash. D.C.; USPOs, Woodstock, Vt., Summerville, S.C. WPA artist. [47]

CUSTER, E.A. [P] Phila., PA [21]

CUSTIS, Eleanor Parke [P,E,I,Min.P] Wash., D.C. b. Wash., D.C. Studied: Corcoran A. Sch.; Henry B. Snell. Member: AWCS; NAC; Wash. WC Cl.; Soc. Wash. A.; North Shore AA; New Haven PCC; Boston AC; NAWPS; NYWCC; ASMP. Work: New Haven Pub. Lib.; Adams Sch., Wash., D.C. Illustrator: children's books, national magazines [47]

CUSTIS, John Keith, Mrs. See Holt, Naomi.

CUSUMANO, Stefano [P] NYC b. 1912 d. 1975. Exhibited: WFNY, 1939 [40]

CUTCHEON, Frederica Ritter [P] Madison, WI b. 30 N 1904, St. Paul, MN. Studied: BMFA Sch.; Arthur Colt; Univ. Wis.; Académie de la Grande Chaumière, Paris. Member: Madison AA; Madison AG. Work: poster, Wis. Conservation Commission [40]

CUTHBERT, John P. [P] Chicago, IL. Member: Chicago NJSA [25]

CUTHBERT, Virginia (Mrs. Philip C. Elliott) [P,T] Buffalo, NY b. 27 Ag 1908, West Newton, PA. Studied: Syracuse Univ.; CI; Chelsea Polytechnical Inst.; Univ. London; George Luks; Charles W. Hawthorne; Alexander Kostellow; Prinet; Cacain. Member: Pittsburgh AA; The Patteran, Buffalo. Exhibited: CI, 1934 (prize), 1935 (prize), 1937 (prize), 1938-40, 1943-45; Assoc. A. Pittsburgh, 1931-37, 1938 (prize), 1939 (prize), 1940-42; Butler AI, 1938 (one-man), 1940 (prize), 1941; Albright A. Gal., 1941-43, 1944 (prize), 1945, 1946 (prize); Pepsi-Cola, 1946 (prize); VMFA, 1940, 1942, 1946; PAFA, 1935, 1941, 1942, 1944; MMA, 1943; 1944; AIC, 1938-40, 1942, 1943; WMAA, 1946; GGE, 1939; R.I. Sch. Des., 1943; Syracuse Mus. FA, 1939 (one-man); Syracuse Univ., 1944 (one-man); Contemporary A. Gal., 1945 (one-man); Riverside Mus., 1942. Work: Albright A. Gal.; Syracuse Univ.; One Hundred Friends of Pittsburgh Art; mural, Municipal Bldg., Mt. Lebanon, Pa. Position: Instr., Painting, Albright A. Sch., Buffalo, 1944-46 [47]

CUTLER, Carl Gordon [P] Newtonville, MA/South Brooksville, ME b. 3 Ja 1873, Newtonville d. 2 Mr 1945. Studied: BMFA Sch.; Constant, Laurens, in Paris. Member: Copley S. Work: FMA. Father of Charles. [40]

CUTLER, Charles Gordon [S] Newtonville, MA/South Brooksville, ME b. 17 Ja 1914, Newton, MA. Studied: BMFA Sch. Exhibited: PAFA, 1942, 1946; AIC, 1942; Buchholz Gal., 1943; New England S., 1942; RISD, 1938; Fitchburg A. Center, 1946; Grace Horne Gal., Boston (one-man); Vose Gal., Boston (one-man). Work: AGAA; IBM; Fitchburg A. Center. Son of Carl. [47]

CUTLER, Martha Hill [Textile Des,W] NYC/Florence, MA b. 17 O 1874, Florence, MA. Studied: Smith Col.; N.Y. Sch. Appl. Des. for Women; Albert Heckman; Winold Reiss. Member: Keramic Soc.; Des. Gld. of N.Y. Am. Fed. A. Exhibited: Art All. of Am. Textile Competition (prize). Author: articles, Harper's Bazaar, Delineator, other magazines [40]

CUTLER, Merrit [I] South Norwalk, CT. Member: SI [47]

CUTTLER, Charles David [P,T] Columbus, OH/Cleveland Heights, OH b. 8 Ap 1913, Cleveland, OH. Studied: Ohio State Univ.; NYU; J.R. Hopkins; Carolyn Bradley; R. Fanning; abroad. Member: Columbus AL; Ohio WCS. Exhibited: PAFA, 1935; CMA, 1935; Columbus A. Lg., 1936. Position: T., Ohio State Univ. [47]

CUTTS, G. Berthoy [P] NYC. Member: Lg. AA [24]

CZARNOWSKI, Norbert [P,Dec,T] Chicago, IL. b. 9 Ag 1897. Studied: AIC; Chicago Acad. FA; Charles Schroeder; Oscar Gross; FA Acad., Warsaw. Member: Polish Arts Cl. Exhibited: AIC, 1939 (prize). Work: St. Jerome's Church, Cleveland; St. Stanislaus Church, Kankakee, IL [40]

CZERWINSKI, K.G. [P] NYC. Member: Bronx AG [27]

CZURLES, Stanley A. [Edu,P,W,L,Des,E] Kenmore, NY b. 14 S 1908, Elizabeth, NJ. Studied: Syracuse Univ.; Univ. Iowa. Member: Buffalo SA; Nat. Edu. Assn.; Eastern AA. Exhibited: Albright A. Gal., 1931-42; Syracuse Mus. FA; Buffalo Town Cl. (one-man). Contributor: art education magazines. Position: T., State T. Col., Buffalo, 1940- [47]

Frederick Dielman: *A Serious Worker*. From *The Illustrator* (August, 1895)

D

DABELSTEIN, William F. [P] NYC [15]

DABO, Leon [Ldscp.P,Mur.P,W,L] NYC b. 9 Jy 1868, Detroit d. 9 N 1960. Studied: Daniel Vièrge; Pierre Galland; Ecole des Beaux-Arts; Académie Julian, Paris. Member: ANA, 1934; NAC; Sch. A Lg., N.Y.; Brooklyn SA; PS; Mural P.; Three Arts C., Cincinnati. Award: Chevalier Legion of Honor, France. Work: Luxembourg Mus., Paris; MMA; Nat. Gal., Wash., D.C.; Imperial Mus. A., Tokyo; Nat. Gal., Ottawa; Mus. A., Boston; AIC; Herron A. Inst.; A. Mus., St. Louis; Inst. A., Detroit; Toledo Mus. A.; Mus. A., Montclair, N.J.; Poland Springs (Maine) Mus.; Milwaukee AA; Muncie AA; Hackley A. Gal., Muskegon, Mich.; Saginaw, Mich. AA; Arbuckle, Inst., Brooklyn, N.Y.; Mus. A., Baltimore; Mus. A., Newark; Mus. A., Fort Worth; Beloit Col. A. Gal., Beloit, Wis.; Delgado Mus.; Mem. A. Gal., Rochester; Reading (Pa.) Gal.; Mus. A., Minneapolis; Mus. Avignon, France; Montreal AA; Tuskegee Inst., Ala.; Church of St. John, Brooklyn, N.Y.; Flower Mem. Lib., Watertown, N.Y.; Graham Gal., N.Y. [47]

DABO, T(heodore) Scott [P] b. 26 O 1877, New Orleans. Studied: Ecole des Beaux-Arts, Ecole des Arts Decoratifs, both in Paris. Work: Detroit Mus. A. [13]

DABOUR, John [Por.P] NYC b. Smyrna, Turkey (came to Baltimore in 1867) d. 25 Mr 1905. Studied: Paris, 9 yrs. Work: portraits, Gen. Sherman, Gen. Grant, other famous men

DABROWSKI, Adam [Wood Carver,S,C] NYC b. 10 S 1880, Poland. Studied: Polish A. Sch., Warsaw. Member: Alliance. Work: Newark Mus., N.J.; St. Cassimir's Church, Shenandoah, Pa.; Church of the Blessed Sacrament, NYC. Ecclesiastical and other commissions executed in collaboration with architects. Contributor: articles, The International Woodcarver, The Art Digest, New York Times, The Architect. Position: Dir., Sch. Woodcarving, Brooklyn, N.Y. [40]

DACEY, William [P,W,T,L] Princeton, MA b. 10 O 1907, Providence, RI. Studied: R.I. Sch. Des.; Clark Univ. Member: Clark Univ. Scientific Soc. Exhibited: PAFA, 1941; All. A. Am., 1941; Vendôme Gal.; WMA; Fitchburg A. Mus. Author: "Geographic Origins of Art." Position: T., Dunbar Sch., Worcester, Mass. [47]

DA COSTA, John [P] NYC. Exhibited: Paris Salon, 1907 (med) [13]

DACOSTA, Stella May [P] Phila., PA. Exhibited: WC Exh. Pa. Acad. FA, 1936, 1938; Germantown A. Lg., 1937; Intl. WC Exh. AIC, 1937–1939 [40]

DAGGETT, Grace E. [P,C,T,Min.P] New Haven, CT b. 19, Je 1867, New Haven. Studied: Yale; Académie Julian, Paris. Member: New Haven Paint&Clay Cl.; Brush&Palette Cl.; Pa. Soc. Min. P. [47]

DAGGETT, Maud [S] Pasadena, CA b. 10 F 1883, Kansas City, MO. Studied: Lorado Taft; AIC; Paris; Rome. Member: Calif. AC; Pasadena SA. Exhibited: P.-P.Expo, San Diego, 1915 (med). Work: bldgs., Pasadena, Los Angeles; fountain, Occidental Col., Los Angeles [40]

DAGGY, Augustus Smith [P,I] Norwalk, CT b. 1858 d. 16 Je 1942, Stamford, Conn. Studied: PAFA; France. Member: S.Indp.A. Work: Staff, Harper's, Life, Judge [25]

DAGGY, Richard S. [P,E] Norwalk, CT b. 17 F 1892, Chatham, NJ. Studied: Augustus S. Daggy. Member: Sivermine GA [40]

D'AGOSTINO, Vincent [P,E,Li] Los Angeles, CA b. 7 Ap 1898, Chicago. Studied: AIC; Charles Hawthorne; George Bellows. Member: Chicago SA; Am. A. Cong. Exhibited: PAFA, 1931; Newark, N.J., 1930; AIC, 1934, 1935; WFNY, 1939; Whitney Studio, 1929 (one-man); Milwaukee AI; Oshkosh Mus. A.; Univ. Okla.; Mus. FA, Houston, 1934. Work: WMAA; USPO, Gloucester, N.J.; Mount Loretto Inst., Staten Island, N.Y. WPA artist [47]

DAGRADI, Donald [P] Los Angeles, CA. Exhibited: Intl. WC Exh. AIC, 1937, 1938 [40]

DAHL, Francis W. [Car,I] Cambridge, MA b. 21 O 1907, Wollaston, MA d. 1973. Cartoonist: Saturday Evening Post, Boston Herald. Illustrator: The Tails Book [40]

DAHLBERG, Edwin Lennart [I,P] Nyack, NY b. 20 S 1901, Beloit, WI. Studied: AIC. Exhibited: AIC, PAFA. Position: Freelance, 1930– [47]

DAHLER, Warren [P,S,C,Mur.P] Norwalk, CT b. 12 O, 1887, Helena, MT. Studied: NAD; N.Y. Sch. Art; Univ. Chicago; George Grey Barnard. Member: Silvermine Gld. A.; NSMP. Exhibited: NAD, 1920, 1922; Silvermine Gld. A., 1932 (one-man). Work: Capitol, Mo. Position: Dir., Herter Looms, N.Y. [47]

DAHLGREEN, Charles William [P,E,Ldscp.P,T] Oak Park, IL b. 8 S 1864, Chicago d. 1955. Studied: Düsseldorf A. Sch.; AIC; ASL, Chicago. Member: Chicago SE; Oak Park A. Lg.; Brown County (Ind.) A Lg. Exhibited: AIC, 1919 (prize), 1920 (prize), 1928 (prize), 1934 (prize), 1935 (prize); Hoosier Salon, 1925 (prize); P.-P. Expo, San Fran., 1915 (prize); Chicago Gal. A., 1927 (prize), 1928 (prize); PAFA. Work: Lib. Cong; Smithsonian Inst.; Chicago Gal. Assoc.; Intl. Soc. Arts&Letters; Mus. Hist., Science, Art, Los Angeles; Vanderpoel Coll.; NYPL [47]

DAHLGREN, Carl Christian [Ldscp.P,I] Oakland, CA b. 1841, Skelsior, Denmark (came to U.S. in 1872) d. 1920. Studied: Copenhagen Acad. FA, 1867; C. Henreksen. Work: Oakland MA. Illustrator: Californian. First settled in Utah; opened an art sch. in Salt Lake City, 1875; moved to San Fran., 1878. Documented the 1906 earthquake. Brother of Marius. [*]

DAHLGREN, Marius [Ldscp.P,I,Mur.P] b. 1844, Skelsior, Denmark (came to U.S. in 1872) d. 1920, Tucson, AZ. Work: Oakland MA. Active: San Jose, 1873–75; San Fran. 1878. Settled in Tucson, 1905. Brother of Carl. [*]

DAHL-WOLFE, Louise [Photogr] b. 1895. Studied: Calif. Sch. FA, with R. Schaeffer. Work: MOMA; Fashion Inst. Tech.; Harpers Bazaar, 1936–58. Specialties: fashion, portraits

DAILEY, Anne [P,I,T] Denver, CO b. 5 Ap 1872, Denver. Studied: AI, Chicago. Member: Denver AC [15]

DAINGERFIELD, Elliott [P,I,T,W,L] NYC b. 26 Mr 1859, Harper's Ferry, VA (came to N.Y. in 1880) d. 22 O 1932. Studied: G. Inness (whose NYC studio adjoined his), 1880; ASL. Member: ANA, 1902; NA, 1906; NYWCC; SAA, 1903; Lotos Cl.; NAC. Exhibited: Pan-Am. Expo, Buffalo, 1901 (med); NAD, 1902 (prize). Work: MMA; TMA; Nat. Gal., Wash., D.C.; Brooklyn Inst. Mus.; Church of St. Mary, N.Y.; City A. Mus., St. Louis; AIC; Butler A. Inst.; Los Angeles Mus. Author: books on Inness, Ryder, Blakelock. He also painted a number of views of the Grand Canyon in his later years, but is best known for his poetic, mystical landscapes. [31]

DAINGERFIELD, Marjorie (Mrs. J. Louis Lundean) [S,T,L] NYC b. New York d. 1977. Studied: Sch. Am. S.; Grand Central Sch. A.; Borglum Fraser; Amateis. Member: NSS; Audubon A. Exhibited: NAD, since

1920; Arch. Lg., 1945; NSS, 1944, 1945; Mint Mus. A.; Norton A. Gal.; Wildenstein Gal.; Grand Central A. Gal. [47]

DALAND, Katharine Maynadler [I] Waterbury, CT b. 28 Ap 1883, Boston. Studied: Vesper Lincoln George, in Boston. Member: Copley S. Illustrator: "Ballads of the Be-Ba-Boes," "Lyrics of Eliza," other books [24]

DALE, Ben(jamin) (Moran) [I] Long Island, NY b. 15 Mr 1889, Phila. d. 12, Jy 1951. Studied: PMSchIA. Member: SI. Illustrator: Ladies Home Journal, American Home, Philadelphia Inquirer, other publications [47]

DALE, Ellen M. [P] Salem, MA b. 1850, Salem d. 17 Je 1922. Work: Peabody Mus., Salem. Specialty: marine watercolors [*]

DALE, F.C. [P] Minneapolis, MN [17]

DALE, Maud (Mrs. Chester) [Mur.P,W] NYC/Southampton, NY b. Rochester, NY. Studied: J. Beckwith; Mowbray; ASL; Steinlen, in Paris. Member: NAWPS; PBC; Mus. of French Art, N.Y. Award: Chevalier de la Legion d'Honneur, 1931. Author: "Before Manet to Modigliani," "Modigliani," "Picasso." Contributor: articles, L'Intransigeant (Paris), Art News, other publications. Organizer: exhibitions of French art, in New York [40]

DALE, Stanley [P] Cleveland, OH. Member: Cleveland SA [25]

D'ALESSIO, Gregory [Car,L,I,W] NYC b. 25 S 1904, NYC. Studied: ASL. Member: Am. Soc. Magazine Car. Exhibited: MMA, 1942; Los Angeles Mus. A., 1943; OWI. Author: "Welcome Home." Illustrator/Cartoonist, national magazines. Creator: "These Women," syndicated cartoon feature [47]

DALLAM, Elizabeth Forbes [P,T] Phila., PA b. 9 F 1875, Phila. Studied: Anshutz; Breckenridge; McCarter; PAFA [33]

DALLIN, Arthur [Des] b. 1897, France d. 12 Je 1940, Luzancy, France. Designer: stained glass. Son of Cyrus Dallin.

DALLIN, Cyrus E(dwin) [S,T,W] Arlington Heights, MA b. 22 N 1861, Springville, UT d. 14 N 1944. Studied: T.H. Bartlett, in Boston, 1884; Académie Julian, Paris, with Chapu, Dampt, 1888. Member: ANA, 1912; NA, 1930; NSS, 1893; Arch. Lg.; AC Phila., 1895; Boston AC; St. Botolph Cl., 1900; AAAL; Royal Soc. A., London; Boston GA; Boston SS; AFA. Exhibited: Am. A. Assn., N.Y., 1888 (gold); Paris Salon, 1890 (prize), 1909 (med); Columbian Expo, Chicago, 1893 (med); Mass. Charitable Mechanics Assn., 1895 (med); Paris Expo, 1900 (med); Pan-Am. Expo, Buffalo, 1901 (med); St. Louis Expo, 1904 (gold); P.-P. Expo, San Fran., 1915 (gold). Work: Lincoln Park, Chicago; LOC; Salt Lake City; Fairmount Park, Phila.; Syracuse, N.Y.; BMFA; Arlington, Mass.; Washington Univ., St. Louis, Mo.; Cleveland Sch. A.; Plymouth, Mass.; Provincetown, Mass.; Storrow Mem., Lincoln, Mass.; Brookline, Mass. "Appeal to the Great Spirit," at BMFA, is perhaps his most famous Indian sculpture. Father of Arthur Dallin. Positions: T., Drexel Inst. (Phila.), Mass. State Normal A. Sch. [40]

DALRYMPLE, Amy Florence [Ldscp.P] Boston, MA b. Boston. Studied: Mass. Normal A. Sch.; Italy. Member: Boston SAC; Copley S. [33]

DALRYMPLE, Louis [Car] b. 1865, Cambridge, IL d. 27 D 1905, Amityville, NY. He went to New York to study art in 1881. Work: political cartoons, Puck, ca. 1890; newspapers in Chicago, Phila., Pittsburgh

DALRYMPLE, (Helene) Lucille Stevenson (Mrs. Frederic) [Min.P,Por.P] Chicago, IL b. 29 O 1882, Sandusky, OH. Studied: J.F. Smith Acad., Chicago; AIC. Member: Chicago S. Min. P.; Pa. Soc. Min. P.; AAPL; All-Ill. Soc. FA; Municipal A. Lg. Exhibited: Ill. Acad. FA, 1930 (prize), 1932 (prize), 1940 (prize); PAFA, 1941–45; NCFA, 1934, 1944; All-Ill. Soc. FA, 1945, 1946; Grand Central A. Gal.; BM; Los Angeles Mus. A.; AIC; Cordon Gal.; Chicago Gal. Assn.; Carson Pirie Scott Gal. Work: Wabash Univ.; Marietta Univ.; Ill. Univ.; Ill. Acad. FA; Vanderpoel Coll. [47]

DALSEY, Harry [P] Chicago, IL [19]

DALSTROM, Gustaf O(scar) [P,E] Chicago, IL b. 18 Ja 1893, Gothland, Sweden. Studied: AIC; George Bellows; Randall Davey. Member: Chicago SA; Chicago NJSA; Chicago SE. Exhibited: Scan.-Am. Exh., Chicago, 1929 (prize); Chicago SA (gold); Chicago SE, 1934 (prize). Work: MOMA. WPA artist. [40]

DALSTROM, Gustaf, Mrs. See Foy, Frances.

DALTON, Frances L. [P,T] Andover, MA b. 28 D 1906, Amesbury, MA. Studied: BMFA Sch., with Philip Hale. Member: AAPL. Exhibited: Jordan-Marsh, 1944 (med,prize); Springfield Mus. A.; Whistler House; Woodstock A. Gal.; AGAA. Position: T., Pub. Sch., Andover [47]

DALTON, P.H. [P] Chicago, IL. Member: Chicago NJSA [25]

DALTON, Peter [S] NYC b. 26 D 1894, Buffalo, NY. Studied: ASL; BAID; NAD; Robert I. Aitken. Member: ANA; NSS; Audubon A. Exhibited: All.A.Am., 1935 (gold); sculpture, Dance Int., Rockefeller Center, NYC, 1937 (prize); PAFA, 1936, 1941, 1943, 1945; Fairmount Park, Pa.; CI, 1941. Work: USPO, Carthage, Miss. [47]

DALTON, Peter, Mrs. See Chace, Dorothea.

DALTON, William Carlford [Ldscp.P] Columbus, OH b. 28 D 1884, McArthur, OH. Member: Columbus AL; Columbus PPC [25]

DALY, David Raymond [P] NYC b. NYC. Member: All. AA; SC. Exhibited: All. AA Exh., 1937 (prize) [40]

DALY, Matt(hew) A. [P] Cincinnati, OH b. 13 Ja 1860, Cincinnati d. 23 N 1937. Studied: Duveneck; Noble; Lutz. Member: Cincinnati AC; AAPL. Work: Cincinnati A. Mus.; Univ. Cincinnati [38]

DALY, Norman David [P,Edu] Ithaca, NY b. 9 Ag 1911, Pittsburgh, PA. Studied: Univ. Colo.; Ohio State Univ.; NYU. Exhibited: AIC, 1943, 1944; Denver A. Mus., 1943; SFMA, 1939; Columbus Gal. FA, 1940; Assoc. A. Pittsburgh; CI, 1937, 1938, 1940–43; Kleemann Gal., 1944; Assoc. Am. A., 1945; SC, 1945; Brandt Gal., 1945 (one-man). Position: T., Cornell, 1932– [47]

DALY, Rosmond [P] NYC [19]

DALY, Thomas F. [P,T,Li] Chicago, IL b. 5 N 1908, Chicago. Studied: AIC; Georgetown Univ.; Louis Ritman. Exhibited: AIC, 1934–46; Champaign, Ill, 1941; Evanston, Ill., 1940 [47]

DALZIEL, John Sanderson [Wood En] b. 24 D 1839, Edinburgh, Scotland d. 19 Ag 1937, Denver, CO. He came to the U.S. in 1869 and settled in Germantown, Pa. While in school he met Charles Dickens and the two were life-long friends. Later, Dalziel became known for his illustrations of Dickens' works. He also illustrated for Hans Christian Andersen, Punch, and The London Courier. He was particularly well known in America for his studies of birds. Many of his engravings are in American and British museums.

DAM, C(arl) W(ilhelm) [P,E] Aberdeen, WA b. 31 Ag 1883, Stockholm, Sweden. Studied: Edward Berg; Carl Wilhelmson; Philip Monson. Work: City Hall, Stockholm [27]

DAMIANAKES, Cleo [P,E] Shoreham, NY b. Berkeley, CA. Studied: Univ. Calif. Member: Chicago SE. Exhibited: Chicago SE, 1922 (med). Work: AIC; Toronto Mus. [40]

D'AMICO, Victor E. [Edu,W,L,P] Mt. Vernon, NY b. 19 My 1904, NYC. Studied: PIASch; CUASch; Columbia Univ. Member: Com. on A. Edu. Author: "Creative Teaching in Art," 1942. Editor: "Visual Arts in General Education," 1940. Contributor: art/theatre magazines. Lectures: Art education. Work: NYPL. Positions: Hd., FA Dept. Fieldston Sch., N.Y. 1929– ; Dir., Edu. Program & Dir., War Veterans A. Center, MOMA, 1937– [47]

DAMON, Joseph [P] NYC [15]

DAMON, Louise Wheelwright [P,S] Providence, RI/Annisquam, MA b. 29 O 1889, Jamaica Plain, MA. Studied: Pauline MacKay; Philip Hale; Hawthorne; Miller. Member: Providence AC; Newport AA [47]

DAMROSCH, Helen T(herese). See TeeVan, John, Mrs.

DANA, Charles Edmund [P,Arch,T,W] Phila., PA b. 18 Ja 1843, Wilkes-Barre, Pa. d. 1 F 1914. Studied: Royal Acad., Dresden; Royal Acad., Munich; PAFA; E. Luminais, in Paris. Member: Phila. AC; Phila. WCC; NAC; BAC; Fairmount Park AA; F., Soc. Arts, London; Numismatic and Antiquarian Soc., Phila. Exhibited: Phila. AC (gold). Author: "Glimpse of English History," other books. Positions: Trustee, PMSchIA; T., Univ. Pa., until 1904 [10]

DANA, Eugene [Edu,P] Clinton, IA b. 27 Je 1912, Marengo, IL. Studied: Univ. Wis.; Univ. Mich.; Josef Albers. Position: Hd., A. Dept., Drake Univ., 1945–46 [47]

DANA, Gladys Elizabeth [Des,P,T] Lincoln, NE b. 2 D 1896. Studied: Univ. Nebr. Member: Lincoln Ar. Gld.; Nebr. State T. Assn. Exhibited: Nebr. A. Assn.; Joselyn Mem., Omaha; Mid-Western Ar.; Kansas City AI. Position: T., Lincoln H.S. [40]

DANA, John Cotton [Mus.Dir,W] b. 19 Ag 1856, Woodstock, VT d. 21 Jy 1929, NYC. The Newark Museum was his creation. He began it in the Public Library building in 1909. In 1926 the Museum moved to a building of its own, and he continued to direct both institutions. He organized the first library picture collection; he was pioneer in art in industry among

American museum directors, and his showing of modern German decorative art in 1912 was the first museum exhibit of contemporary design in this country. He was active in the campaign to raise the standards of design in American art in industry. Among the exhibitions held in the Newark Museum may be mentioned the New Jersey Clay and Pottery exhibit of 1915, New Jersey textiles, 1916, German applied art, 1922, American leather exhibit, 1926, well-designed manufactured articles costing 5 and 10 cents, 1928, and hardware, wallpaper and metal arts exhibit, 1929. The exhibitions of fine art in 1926, 1928, and 1929, and the purchase of paintings and sculpture which followed them, have had marked influence upon the attitude of museums toward contemporary art. Besides frequent contributions to magazines and newspapers, Dana was the author of "American Art," "The New Museum," "The Gloom of the Museum," "A Plan for a Useful Museum," and many other books. He was the recipient of many honors and more than a score of nationally known research societies claimed him as an active or honorary member.

DANA, Mary Pepperrell [I,P] NYC/Washington, CT b. 25 F 1914, NYC. Studied: ASL; Annot A. Sch., New York. Member: ASL. Illustrator: "Legend of Sleepy Hollow," pub. W.R. Scott (1936), "Hurry Hurry," pub. W.R. Scott (1938) [40]

DANA, W(illiam) P(arsons) W(inchester) [P] London, England b. 18 F 1833, Boston d. 8 Ap 1927. Studied: Ecole des Beaux-Arts, Paris, with Picot, Le Poittevin. Member: ANA, 1862; NA, 1863. Exhibited: Boston Athenaeum, 1857–71; PAFA, 1860s; Paris Expo, 1878 (med), 1889 (med). Lived in Europe from 1870. Work: PAFA. Specialties: marine and figure paintings [25]

DANAHER, Mary Byington [P] Bronxville, NY [13]

DANAHER, May [P,C,T] Little Rock, AR b. La Grange, TN d. 23 Je 1931. Studied: G.E. Browne; Breckenridge. Member: SSAL; Miss. AA; North Shore AA; S.Indp.A.; AFA. Exhibited: Tri-State Fair, Memphis (prizes); Ark. State Fair (prizes). Organizer/Director: Little Rock FA Club. Position: T., Gloucester, Mass. (summers) [29]

DANCE, Elizabeth J(ennings) [P,Des] Richmond, VA b. 5 Mr 1901, Richmond, VA. Studied: N.Y. Sch. F.&Appl. Art; Paris; Italy; Anne Fletcher; O.H. Gieberich. Member: VMFA [40]

DANDO, Susie May (Mrs.) [P,T] Venice, CA b. 6 S 1873, Odell, IL. Studied: W.L. Judson. Member: Calif. AC; Laguna Beach AA; West Coast Arts. Exhibited: Panama-Calif. Expo, San Diego, 1915 [40]

D'ANDREA, Albert Philip [Edu,P,S,En] Brooklyn, NY b. 27 O 1897, Benevento, Italy. Studied: CCNY; Univ. Rome. Member: Brooklyn SA; CAA. Exhibited: CCNY, 1933 (prize) 1946; LOC, 1944 (prize); NAD, 1944; Ney Mus., 1943; Whistler House, 1942; BM, 1941, 1943–45. Work: LOC; CCNY. Designer: medals. Position: T., CCNY, 1940– [47]

D'ANDREA, Italo Eugenio Camerini [P,G] Santa Barbara, CA b. 28 My 1919, Chicago, IL. Studied: Santa Barbara Sch. A.; Chouinard AI; J. Leeper. Member: San Fran. AA. Exhibited: Ariz. Ar., Tucson, 1937; Pal. Leg. Honor; Portland AM, 1939; Santa Monica Lib. A. Gal. [40]

DANEHOWER, Dorothy (Scudder) [P,S,C,L,T] Newark, NJ b. 18 Mr 1880, Princeton, NJ. Studied: Pyle; Grafly. Exhibited: poster, Cleveland Electrical Expo, 1914 (prize) [17]

DANES, Gibson [Edu,L,P,W] Austin, TX b. 13 D 1910, Starbuck, WA. Studied: Univ. Oreg., with M. Mueller; AIC, with Anisfeld; Northwestern Univ.; Yale. Member: CAA. Exhibited: Mo. State Exh., Jefferson City; Univ. Exh., Austin, Tex.; South County AA, Kingston, R.I. Contributor: art magazines, college journals. Position: Prof. A., Univ. Tex., Austin [47]

DANFORTH, Charles Austin [P] Providence, RI b. Boston. Studied: Bouguereau; Munkacsy; Cormon; De Thoren. Member: Boston AC; Providence AC. Exhibited: Boulogne, France (med) [10]

DANFORTH, Margaret [C,T] Gardiner, ME b. Gardiner. Studied: Sears Sch. Bookbinding, Boston; Univ. Va.; Eleanore Van Sweringen. Member: Boston Soc. A.&Crafts. Exhibited: Boston Tercentennial Exh., 1930 (med), CGA, 1935; Boston Soc. A.&Crafts; BMFA; Fayette A. Gal., Boston; Handicraft Cl., Providence. Positions: T., Sears Sch. Bookbinding; Hd., Bookbinding Dept., Handicraft Cl., Providence [47]

DANFORTH, Marie. See Page, Mrs.

DANFORTH, S. Chester [G,C,P,Arch] Park Ridge, IL b. 31 Ag 1896, Ithaca, NY. Studied: AIC; Acad. FA, Chicago. Illustrator: etchings, "Diocese," 1933 [40]

DANIEL, Clarke [P,S] Wash., D.C. b. 12 Ja 1911, Wash., D.C. Studied: André Albertin; Albert Laurens; Alexandre Descatoire. Exhibited: Paris Salon (prize); Paris, 1932 (prize) [40]

DANIEL, Lewis C. [P,I,T,E,Li] NYC b. 23 O 1901, NYC d. 18 Jy 1952. Studied: NAD; ASL; Harry Wickey; MacD., 1935–37. Member: AM. WCC; SAE; Audubon A. Exhibited: PAFA, 1938 (med); Phila. WCC, 1944 (prize); Fifty Prints of the Year, 1927–30; WMAA; SAE; NAD; CI; WFNY, 1939; GGE, 1939. Work: WMAA; PAFA; CUASch; NYPL; Bibliothèque Nationale; LOC; Capehart Coll. Position: T., CUASch [47]

DANIEL, Mell [P] NYC. Member: S.Indp.A. [25]

DANIELL, William Swift [P] Laguna Beach, CA b. 26 Ap 1865, San Fran. Studied: Académie Julian, Académie Delecluse, Académie Vitti, Laurens, in Paris. Member: Calif. AC; Laguna Beach AA; Beach Combers, Provincetown, Mass. [33]

DANIELS, Elmer Harland [S,Des] Pasadena, CA b. 23 O 1905, Owosso, MI. Studied: John Herron AI; BAID. Member: Ind. A. Cl., Hoosier Salon; NSS; Arch. Lg. Exhibited: Hoosier Salon, 1931–37, 1938 (prize), 1939; Ind. A. Cl., 1931–39, 1940 (prize); Chicago, 1931 (prize). Work: Ind. Univ.: Turkey Run State Park; State Lib., Indianapolis; Lincoln Mem., State of Ind.; Ball State T., Col., Muncie [47]

DANIELS, J.B. [P] Cincinnati, OH b. 2 My 1846, NYC. Studied: Lindsay. Member: Cincinnati AC [25]

DANIELS, John K(arl) [S] Minneapolis, MN b. 14 My 1875, Norway. Studied: O'Connor; Okerberg. Member: AIA; Minn. Ar. Assn. Exhibited: St. Louis World's Fair, 1903 (gold). Work: capitol, St. Paul, Minn.; mon., five national cemeteries; flagstaff, City of Minneapolis; Minneapolis Women's Cl.; USPO, Municipal water tower (sculpture), Pioneer Mon., all in Minneapolis [40]

DANIELS, Julia [I] NYC. Member: SI [29]

DANN, Frode Neilsen [P,T,Cr] Los Angeles, CA b. 10 S 1892, Jelstrup, Denmark. Studied: Danish Tech. Trade Sch.; Univ. Copenhagen; Royal Acad., Copenhagen. Member: Calif. WC Soc.; Council All. A., Los Angeles. Exhibited: PAFA, 1938; Santa Barbara Mus. A., 1944; Los Angeles Mus. A.; San Diego FA Soc.; SFMA. Positions: T., Otis AI, Los Angeles, Pasadena SFA [47]

DANNAT, William T. [P] Monte Carlo, Monaco b. 1853, New York d. 12 Mr 1929. Studied: Munich Acad.; Munkacsy; Ecole des Beaux-Arts, Carolus Duran, in Paris. Member: Paris SAP; Nat. Inst. A.&Let.; Intl. Art Jury, 1899. Exhibited: Paris Salon, 1883 (med); Pan-Am. Expo, Buffalo, 1901 (gold). Work: Luxembourg Mus., Paris; MMA; AIC; BMFA. Awards: Order of the Legion of Honor, 1889; Commander, 1901 [27]

DANNER, Sara Kolb (Mrs. W.M.) [P] Santa Barbara, CA b. NYC. Studied: Phila. Sch. Des.; Mass. Normal A. Sch.; Calif. Col. A.&Crafts; G.L. Noyes; Snell. Member: Calif. WCS; Calif. AC; Palo Alto AC; Hoosier Salon; NAWA; Women P. of the West. Exhibited: South Bend A., 1922 (prize); Hoosier Salon, 1928 (prize), 1929–33; Women P. of the West, 1942 (prize), 1943 (prize); NAWA, 1946; NAD; Los Angeles Mus. A., 1942–44; Santa Barbara Mus. A., 1943, 1945 (one-man) [47]

DANOVICH, Francis Edward [P] Detroit, MI b. 25 Ap 1920, Newark, NJ. Studied: Cranbrook Acad. A. Exhibited: watercolor, Mich. Ar. Ann (prize); Cranbrook Acad.; GGE, 1939; WPA Exh., 1938–40. Work: Cranbrook Acad.; McGregor Pub. Lib., Detroit; Univ. Mich., Ann Arbor [40]

DANTE, Giglio Raphael [P,S,] NYC b. 4 S 1916, Rome, Italy. Studied: Acad. Rome. Exhibited: CM, 1945; PAFA, 1934–36; GGE, 1939; Boris Mirski Gal., 1944, 1946 (one-man); Brandt Gal., 1945, 1946 (one-man) Work: Springfield Mus. A.; Savoy Coll., Naples, Italy; Michelangelo Auditorium, Boston [47]

DANTZIG, Meyer [P] Phila., PA Exhibited: AAS, 1902 (prize) [04]

DAPHNIS, Nassos [P] NYC b. 23 Jy 1914, Krokeai, Greece. Member: S.Indp.A. Exhibited: CI, 1946; Contemporary A., 1938 (one-man); Portland (Oreg.) AM; Montclair (N.J.) AM. Work: BMA; Albright A. Gal.; Providence Mus. FA [47]

DAPRICH, Helen [P] Chicago, IL b. 25 O 1879, Belleville, IL. Studied: de la Gandara, in Paris [10]

DARAIO, Innocenzo [P] Los Angeles, CA b. 26 Ap 1903, Potenza, Italy. Studied: Mechanics Inst., NYC. Member: Calif. AC; PS Cl., Los Angeles; AAPL. Exhibited: Los Angeles Mus. A., 1943 (prize), 1944, 1945; Calif. AC, 1946 (prize); Denver A. Mus., 1944; Oakland A. Gal., 1943–46; Santa Cruz A. Lg., 1942–46; San Diego FA Soc., 1944, 1945 [47]

DARBY, Elizabeth [Ldscp.P] d. 31 Mr 1906, Brielle, NJ (burned to death in a fire that destroyed her home)

DARCE, Virginia (Chism) [P,C,W,I,Des,T] Spokane, WA b. 10 D 1910, Portland, OR. Studied: Univ. Oreg.; E. Steinhof. Member: Wash. AA. Exhibited: Portland AM, 1935–38; Palace Legion Honor, 1939; Spokane AM, 1944, 1945; SAM, 1939, 1941, 1945. Work: Oreg. State Col. Mus.; Oregon City Lib. Lectures: "On Ways and Means of Having State Supported Art." Position: W./A., Spokesman-Review, Spokane, 1941–46 [47]

DARGE, Fred [P] Dallas, TX b. 1 Mr 1900, Hamburg, Germany. Studied: AIC. Member: Dallas Ar. Lg. Exhibited: Union Lg. Cl., Chicago, 1928 (prize), 1929 (prize) [40]

DARLING, Dorothy Anne. See Fellnagle, Mrs.

DARLING, George Channing [P] Providence, RI. d. ca. 1939. Member: Providence AC [25]

DARLING, Gilbert [I] NYC. Member: SI [47]

DARLING, Jay Norwood ("J.N. Ding") [Car] Des Moines, IA b. 21 O 1876, Norwood, MI. Member: SI; Century Assn. Cartoonist: Sioux City (Iowa) Journal, 1901–06; Des Moines Register, 1913– ; New York Herald Tribune, 1917– [40]

DARLING, Wilder M. [P] Laren, North Holland b. 1856, Sandusky, OH d. Summer 1933, Toledo, OH. Studied: Académie Julian, Paris, 1875, with Laurens, Benjamin-Constant; Munich; Cincinnati. Exhibited: Paris Salon; Paris Expo, 1900 (med). Work: Mus., Amsterdam; Mus., Brussels; Toledo Mus. A.; mus. throughout the U.S. [17]

DARLINGTON, Mary O'Hara [P] Pittsburgh, PA. Member: Pittsburgh AA [25]

DARNAULT, Florence Malcolm [S,L] NYC b. 24 D 1905, NYC. Studied: ASL; NAD; Europe; Daniel Chester French. Member: PBC. Exhibited: PBC (prize); Verdi Cl., 1936 (prize); Redding Ridge, Conn., 1937 (prize); All.A.Am.; NAC. Work: U.S. Naval Acad.; CCNY; Am. Inst. Engineers; Whitehead Metals Co.; NYU Medical Sch.; Am. Tel. & Tel Co.; Harvard; PBC [47]

DAROUX, Leonora [P] Sacramento, CA b. 14 Je 1886, Sacramento. Studied: Hansen; Lhote, Frieze, in Paris. Member: San Fran. Women's AC. Exhibited: San Fran. Women's AC, 1930 (prize) [40]

D'ARRAGH, Marion [Min.P] Phila., PA [25]

DARRAH, Frank J. [P] Worcester, MA [24]

DARRELL, Margaret (Mrs. Edward F.) [P] NYC. Exhibited: NAWPS, 1935–39 [40]

DARROW, Paul W. [P] Wallingford, PA. Exhibited: Intl. WC Exh., AIC, 1934–39; PAFA WC Ann., 1938 [40]

DARROW, Whitney, Jr. [Car] NYC b. 22 Ag 1909, Princeton, NJ. Studied: Princeton Univ.; ASL; Benton; Nicolaides. Member: Car. Lg.; Am. A. Cong. Author/Illustrator: "You're Sitting on My Eyelashes," 1943. Contributor: New Yorker, Collier's, Saturday Evening Post [47]

DARROW, Whitney, Jr., Mrs. See Parish, Betty.

DART, Edward N. [P] Boston, MA. Studied: NAD; Boston AC [98]

DART, Harry G(rant) [P,I,W] Cleveland, OH b. 3 N 1870, Williamsport, PA d. 16 N 1938. Member: SI [24]

DART, Henry G. [P,I] NYC [01]

DART, Hester Wilson (Mrs. Edward) [Por.P] b. Pekin, IL d. 25 Jy 1913, Ossining, NY. Studied: Paris. She was a descendant of Benjamin West.

DARTER, Mary Sue [P,T] Fort Worth, TX b. 1894, Fort Worth. Studied: Tex. Christian Univ., with Mrs. E.R. Cockrell, until 1915; ASL, with Bridgman, Mora, 1915–16; Woodstock Sch. A., with John Carlson; Edgar Payne, in Los Angeles, ca. 1926. Married artist Harvey B. Coleman, 1925. Positions: T., Midland Col.; Phillips Univ., Okla., 1924–25 [24]

DARTIGUENAVE, Paul [P,C] NYC b. 29 Mr 1862, Pau, France d. 28 Mr 1918. Studied: his father [17]

DAS, Elsie Jensen [Des,G,S] Honolulu, HI b. 1 F 1903. Studied: Portland MA Sch.; Univ. Calif.; Univ. Minn.; Minneapolis Sch. A. Member: Honolulu Pr.M.; Assn. Honolulu Ar. Exhibited: Assn. Honolulu Ar., 1938 (prize); Honolulu Pr.M., 1939 (prize); Univ. Minn.; GGE, 1939. Work: Univ. Minn.; Univ. Tex.; Honolulu Acad. [40]

DASBURG, Andrew Michael [P,T] Taos, NM b. 4 My 1887, Paris, France. Studied: ASL, with Cox, DuMond; Woodstock, with Harrison; Henri, in NYC; Paris, 1908–11. Member: N.Mex. P.; Taos AA; Am. Soc P.S.&G; F., Guggenheim Fnd. Exhibited: Pan-Am. Expo, 1925 (prize), CI, 1927 (prize), 1931 (prize). Work: WMAA; Denver A. Mus.; Los Angeles Mus. A.; Pal. Leg. Honor. Contributor: art magazines. Important as an early modernist influence in Taos. [47]

DASBURG, Grace Mott Johnson (Mrs. Andrew) [P] Yonkers, NY [13]

D'ASCENZO, Myrtle Goodwin (Mrs. Nicola) [P] Germantown, PA/Lanesville, MA b. 31 D 1864, North Tunbridge, VT. Studied: PMSchIA. Member: Phila. WCC; Plastic Cl. [40]

D'ASCENZO, Nicola [C,Mur.P] Germantown, PA/Lanesville, MA b. 25 S 1871, Abruzzi, Italy. Studied: Mariani, Jacovacci, in Rome; PMSchIA. Member: F., PAFA; Phila. All.; Fairmount Park AA; Rockport AA; North Shore AA; Phila. SE; Italian-Am. AA; N.Y. Arch. Lg., 1902; Mural P.; Phila. AC; Phila. A.&Crafts Gld.; NAC; AIA; AFA. Exhibited: Columbian Expo, Chicago, 1893 (prize); T Sq. Cl. (gold); Americanization through Art Exh., Phila., 1916 (prize); N.Y. Arch. Lg., 1925 (gold); PMSchAI (gold). Work: stained glass, St. Thomas Prot. Epis. Church (New York), Washington Mem. Chapel, Valley Forge (Pa.), Chapel at Mercersburg (Pa.), chapel at Princeton Univ., chapel and gallery of Riverside Baptist Church (New York), chapel, Canterbury Sch., New Milford (Conn.), chapel, Muhlenberg Col., Chapel of the Holy Spirit, Nat. Cathedral, Wash., D.C.; murals, Municipal bldgs., Springfield, Mass.; mosaic frieze, Cooper Lib., Camden, N.J. [40]

DASCHBLACH, A.C. [P] Thornburg, PA. Member: Pittsburgh AA [25]

DASHIELL, Margaret May (Mrs.) [P,L,W] Richmond, VA b. New Orleans, LA. Work: Valentine Mus.; Confederate Mus., Richmond; VMFA. Author: "Spanish Moss and English Myrtle," pub. Stratford Co., 1920. Contributor: magazines [40]

DATE, Kotaro [P] St. Louis, MO. Studied: St. Louis Sch. FA. Member: Soc. of Ancients [19]

D'ATTILIO, Anthony [C,P] Yonkers, NY b. 2 Jy 1909, Rodi, Italy. Studied: BAID; DaVinci A. Sch.; Steinhof. Exhibited: Paris Salon, 1937; WFNY, 1939; MMA, 1940. Work: murals, Erie, Pa.; Harrisburg, Pa.; Rochester, Pa.; Oklahoma City [47]

DATUS, Jay [P] Chicago, IL b. 24 Mr 1914, Jackson, MI d. 1974 (in Phoenix?). Studied: Yale; Wayman Adams. Member: Palette & Chisel Acad. FA; A. Gld., Chicago; Founder/Member, Kachina SA, Phoenix, 1948. Exhibited: AIC, 1936, 1937; O'Brien Gal., Chicago, 1940 (oneman). Work: Univ. Wis.; murals, Capitol, Phoenix, Ariz. [47]

DATUS, Jay, Mrs. See Berry, Martha.

DATZ, A. Mark [P,E,S] NYC b. 27 O 1889, Russia. Studied: NAD; CUASch; BAID. Member: Fed. Modern P.&S.; SAE. Work: WMAA; Rochester Mem. A. Gal.; Oshkosh Mus. A.; Los Angeles Mus. A.; NYPL. WPA artist. [47]

DATZ, Abraham [P] NYC. Member: S.Indp.A. [21]

DAUGHERTY, Charles M. [P] Westport, CT. Work: murals, USPOs, Northfield, Vt., Virden, Ill. WPA muralist. [40]

DAUGHERTY, Harry R. [P] NYC [08]

DAUGHERTY, James Henry [P,Li,E,I,L,T] Westport, CT b. 1 Je 1889, Asheville, NC d. 1974. Studied: Corcoran Sch. A.; PAFA; Frank Brangwyn. Member: Silvermine Gld. A. Exhibited: Silvermine Gld. A.; Macbeth Gal. Work: Yale Mus. FA; NYPL; Wilmington Pub. Lib.; murals, Loew's Theatre, Cleveland, OH. Author/Illustrator: "Andy and the Lion," 1938, "Daniel Boone," "Poor Richard," and others. Illustrator: "Abe Lincoln Grows Up," by Carl Sandburg, "John Brown's Body," by Benét, "Knickerbocker's History of New York," by Washington Irving. Contributor: magazines, periodicals. WPA artist. [47]

DAUGHERTY, Nancy Lauriene [P,I,W,L,T] Kittanning, PA b. 21 Je 1890, Kittanning. Studied: Irving Wiles; Douglas Connah; Frank A. Parsons; Simon, Billeau, in Paris. Work: Federal Court, Pittsburgh; Armstrong County Court, Pa. [40]

D'AULAIRE, Edgar Parin [W,I,Li,P] Wilton, CT b. 27 D 1905, Norway (or 30 S 1898, Switzerland). Studied: Europe. Work: portraits, France; frescoes, Norway. Author/Illustrator: children's books. Award: Caldecott Medal, 1940 [47]

DAUTEL, John Daniel [P] South Orange, NJ. Member: S.Indp.A. [25]

DAVENPORT, Brewster [P] Paris, France d. 22 Ja 1927

DAVENPORT, Carson S(utherlin) [P,Gr] Danville, VA b. 14 F 1908,

Danville. Studied: Ennis; W. Adams. Member: AWCS; AAPL; Southern Pr.M. Exhibited: Va. Acad. A.&Sc., 1938. Work: USPOs, Greensboro, Ga., Chatham, Va. WPA artist. [47]

DAVENPORT, E(dith) Fairfax [P,T,L] Zellwood, FL b. 13 Jy 1880, Kansas City, MO. Studied: Ecole des Beaux-Arts, Paris, with Collin, Laurens, Humbert. Member: North Shore AA; SSAL; Fla. Fed. A.; Orlando AA; Mount Dora A. Lg.; AFA. Exhibited: SSAL, 1925 (prize); WWI war poster, King Albert, Belgium (med); Fla. Fed. A. Work: Pub. Lib., Kansas City, Mo.; Pub. Lib., Zellwood; murals, Orlando Chamber of Commerce [47]

DAVENPORT, Ethel (Mrs. Don A.) [C,Des,W] New Hope, PA b. Phila. Studied: PMSchIA; Academia delle Belle Arte, Florence, Italy. Member: Phila. All.; Associated Hand Weavers. Exhibited: Paris Expo, 1938; MMA. Contributor: art and crafts magazines. Specialty: textile design. Position: Co-dir., Independent Gal., New Hope [47]

DAVENPORT, Henry [P,L,T] Paris, France b. 1 Ap 1882, Boston, MA. Studied: Ecole des Beaux-Arts; Dechenaud; Hawthorne; Browne. Member: New Haven PCC; S.Indp.A. Positions: T., Yale A. Sch.; Founder, Clouet Sch., Paris [40]

DAVENPORT, Homer Calvin [Car] Morris Plains, NJ b. 8 Mr 1867, Silverton, OR d. 2 My 1912. Studied: self-taught. Reared on a farm, he was a jockey, railroad fireman, and a clown in a circus. Employed in 1892 by the San Francisco Examiner, he was taken to New York by W.R. Hearst in 1895 and became a member of the staff of the New York Journal (American). He went to Euorpe in 1897, where he met and cartooned many public men, including Gladstone, and sketched the Dreyfus trial. In 1906 he was granted permission by the Sultan of Turkey to export twenty-seven Arabian horses, said to be the only real Arabian horses in America. Author: "Davenport's Cartoons," "The Dollar or the Man?" [10]

DAVENPORT, Jane (Mrs. de Tomasi) [P,S,T] Cold Spring Harbor, NY. b. 11 S 1897, Cambridge, MA. Studied: Stirling Calder; Antoine Bourdelle; Jacques Louchansky; Univ. Chicago; ASL; Grande Chaumière, Paris. Member: ASL; AM. Gld. C. Work: Am. Univ. Union, Paris; Buckley Sch., NYC; CI [47]

DAVENPORT, John Byron [S] Provincetown, MA b. 16 S 1914, Provincetown. Studied: Rollins Col.; Cornell; Brit. Acad., Rome; Ecole des Beaux-Arts, Paris; Cranbrook Acad. Exhibited: Am. Ar. Prof. Lg. Ann., Paris; Tuilleries Salon, Paris, 1938 [40]

DAVENPORT, McHarg [P] Santa Fe, NM b. 22 Mr 1891, NYC d. 12 S 1941. Member: Santa Fe PS. Also a publisher. [40]

DAVEY, Clara [P] Santa Fe, NM [21]

DAVEY, Randall [P,E,Li,Edu] Santa Fe, NM b. 24 My 1887, East Orange, NJ d. 1964. Studied: Cornell; Europe; Robert Henri, 1909. Member: NA, 1938; Nat. Assn. Port. P.; Taos SA; N.Mex. SA. Exhibited: Armory Show, 1913; NAD, 1915 (prize), 1938 (prize), 1939 (prize); Grand Central AA, 1939 (prize). Work: AIC; CGA; WMAA; Montclair A. Mus.; Kansas City AI; CMA; Detroit Inst. A.; U.S. Navy Dept.; USPOs, Vinita, Claremore, Okla.; Will Roger's Shrine, Colorado Springs. WPA muralist. Positions: T., AIC (1920), Kansas City AI (1921–24), Broadmoor AA (1924–31), Univ. N.Mex. (1945–46) [47]

DAVID, Alexander [P,B,Li,L,T] Brooklyn, NY b. 1908, Genoa, Italy. Studied: Bridgman; Romanovsky; ASL; Hunt; Eggers; CCNY; Young; Martin; Columbia. Member: Artists U. Illustrator: New Yorker, other magazines. Lectures: Mexican Art, The Modern Mural Painters and Their Times, The Meaning of Modern Art [40]

DAVID, Don Raymond [Des,P,L] Los Angeles, CA b. 2 My 1906, Springbrook, OR. Studied: Fresno State Col.; A. Center Sch., Los Angeles; Chouinard AI. Member: Calif. WC Soc. All. A., Los Angeles; Laguna Beach AA. Exhibited: SFMA, 1940, 1946; Oakland A. Gal., 1940, 1945; Glendale AA, 1945; Calif. WC Soc., 1945, 1946. Work: IBM. Contributor: travel article, U.S. Camera magazine. Lectures: Advertising art. Position: A. Dir., J.W. Robinson Co., Los Angeles, 1945–46 [47]

DAVID, Lorene [P,T,Li,L] Beaumont, TX b. 31 My 1897, Independence, Mo. Studied: T. Col., Columbia; Charles Martin; Arthur Young; ASL, with Robert Laurent; Eliot O'Hara; G.P. Ennis. Member: NAWA; SSAL; New Orleans AA; Pr.M. Gld.; Southern Pr.M.; Tex. FA Assn.; Nat. Edu. Assn.; Tex. State T. Assn. Exhibited: NAWA, 1936 (prize), 1937–39, 1942, 1943; New Orleans AA, 1939 (prize), 1943 (prize); Southern Pr.M., 1937, 1940 (prize), 1941; Tex. Pr. Exh., 1941 (prize), 1942 (prize); AWCS, 1936–38; CAA, 1936; Oakland A. Gal., 1936; Denver A. Mus., 1936, 1938; PAFA, 1936, 1937; Phila. Pr. Cl., 1942, 1943; Northwest Pr.M., 1942, 1943; MMA, 1943; NAD, 1943; LOC, 1943, 1945; SSAL, 1936–42; Nelson-Atkinson Mus., 1937, 1938, 1941, 1942; Dallas Mus. FA, 1937. Work: Southwestern La. Inst., Lafayette; Dallas Mus. FA; Tex. Tech. Inst.; Southern Methodist Univ.; Mus. N.Mex.; State T. Col., Huntsville, Tex. Position: Supv. A. Edu., Beaumont City Sch, 1944–46 [47]

DAVIDICA, Sister M. [P] Manitowoc, Wis. Member: Lg. AA [24]

DAVIDSON, Bessie [P] NYC [15]

DAVIDSON, Carl Hoth [P,T] Park Ridge, IL b. 2 Je 1881, Gresham, NE. Studied: self-taught; AIC. Member: Chicago Soc. A.; All-Ill. Soc. FA; Chicago NJSA. Work: cartoons, Omaha World Herald [40]

DAVIDSON, Clara D. (Mrs. Simpson) [P,Dr] Norwalk, CT b. 16 Ja 1874, St. Louis, Mo. Studied: ASL; Cooper Union; Emil Blanche; Alphonse Mucha, in Paris. Member: NAWPS; Silvermine GA. Work: Rockford (Ill.) AM [40]

DAVIDSON, Dorothy Mary [Por.P] Wash., D.C. b. Arkansas City, KS. Studied: Corcoran Sch. A. Member: S. Wash. A. [40]

DAVIDSON, Florence A. (Mrs.) [P] NYC b. 30 Ag 1888, Baltimore County, MD. Studied: AIC; ASL; BMFA Sch. Member: NAWPS; PBC; Wolfe AC, New York; New Rochelle AA; Baltimore WCC. Exhibited: Wolfe AC, 1926 (prize), 1927 (prize) [31]

DAVIDSON, George [Mur.P] Shelton, CT b. 10 My 1889, Butka, Russia. Studied: F.C. Jones; Douglas Volk. Member: ANA, 1936; Mural P.; Arch. Lg. Exhibited: Arch. Lg., 1926 (med). Work: Barnard Col.; Buffalo (N.Y.) Savings Bank; Nebr. AA; AGAA; NAD; Sterling Lib., Yale. Position: T., CUASch [47]

DAVIDSON, Harry [P,I,Wood En,Cr] NYC b. 1858, Phila. d. 11 Ag 1924. Studied: Frederick Faust. Member: SC; Soc. Wood En. Exhibited: Paris Expo, 1889 (prize), 1900 (med). He was with the Century Company for twenty-five years. Position: A. Cr., Vogue [24]

DAVIDSON, Jo [S] Lahaska, Pa./France. b. 30 Mr 1883, NYC (or Ap 1884, Moscow, Russia) d. 2 Ja 1952, Tours, France. Studied: Brush; MacNeil. Member: ANA, 1944; NSS. Exhibited: NAD, 1934 (prize). Work: Luxembourg, Paris; Palace of Versailles, France; Musée des Invalides, Paris; Capitol, Wash., D.C.; Pal. Leg. Honor; Univ. Ill.; BMFA; Will Rogers mem., Colorado Springs. Award: Chevalier of the Legion of Honor [47]

DAVIDSON, John [P] Hollywood, CA b. 25 D 1890, NYC [40]

DAVIDSON, John M. [P] Xenia, OH b. 20 Ap 1876, Hamilton, OH. Studied: Chase; DuMond. Member: Cincinnati AC [25]

DAVIDSON, Julian O. [I,Mar.P,W] Nyack, NY b. 1853, Cumberland, MD d. 1893. Studied: Mauritz de Haas. Exhibited: NAD, 1877–94. Work: Dossin Great Lakes Mus., Detroit; FDR Lib., Hyde Park, N.Y. Illustrator: Harper's, 188s. He was a champion sculler, and his studio was at the Nyack Boat Club. [*]

DAVIDSON, Morris [L,T,P,W] Piermont, NY b. 16 D 1898, Rochester, NY. Studied: AIC, with Harry Walcott. Member: Fed. Modern P.&S.; Am. A. Cong. Exhibited: Fed. Modern P.&S., 1945; Mortimer Brandt Gal., 1936–46; Charles Morgan Gal., N.Y., 1939; Contemporary Gal., Rockport, Mass., 1939. Illustrator: Harpers, 1880s. Author: "Understanding Modern Art" (1931), "Painting for Pleasure" (1938). Lecture: Subject Matter and Abstraction in Contemporary Painting. Positions: T., Schenectady Mus. A., 1945–46; Dir., Davidson Sch. Mod. Painting, New York and Provincetown, 1935– [47]

DAVIDSON, Ocyp [P] NYC [08]

DAVIDSON, Ola McNeill [P,L,T] Houston, TX/Brazoria, TX b. Brazoria. Studied: E.R. Cherry; Eva Fowler. Member: SSAL; Tex. Fed. Arts; Houston Mus. FA. Exhibited: SSAL, 1930 (prize) [40]

DAVIDSON, Oscar L. [P] Indianapolis, IN b. 2 Mr 1875, Fithian, IL d. 3 Ja 1922. Member: Ind. Illus. Cl.; S.Indp.A. Specialty: historical ships [21]

DAVIDSON, Robert (Robin W.) [S] Rock City Falls, NY b. 13 My 1904, Indianapolis, IN. Studied: John Herron AI; AIC; Myra R. Richards; Polasek; Iannelli; Amateis; Baillie; Wackerle; Germany. Member: Portfolio Cl., Indianapolis. Exhibited: WMAA, 1944; AIC, 1934; PAFA, 1937; John Herron AI, 1928, 1933, 1939; SFMA, 1928; abroad. Work: John Herron AI; Skidmore Col.; Minneapolis Inst. A.; war mem., Schenectady, N.Y.; Administration Bldg. Saratoga Spa, N.Y. Position: T., Skidmore Col., 1933–46 [47]

DAVIES, Arthur B. [P] NYC b. 26 S 1862, Utica, NY d. 24 O 1928, Northern Italy. Studied: D. Williams, in Utica, at age 15; AIC, with C. Corwin, 1878; ASL, 1887. Member: NYWCC; Am. PS; Mural P. Exhibited: Pan-Am. Expo, Buffalo, 1901 (med); CI, 1913 (prize); CGA, 1916 (gold,prize), 1928. Work: MMA; AIC; Minneapolis Inst. A.; San

Fran. AI; Brooklyn Inst. Mus.; RISD; Butler AI; CGA. His art covered many periods. His media ranged from sculptured wood, ivory, marble, wax, to lithograph and etchings, from water color to oil, from enamel and glass to Gobelin tapestry and rugs of fine weave. He was a mystic thinker, a romantic painter, and a great artist. Although a recluse, he served as president of S.Indp.A. and was active in arranging the famous Armory Show of 1913.

DAVIES, David [P] b. 1876 d. 20 S 1921, Chicago

DAVIES, Gay [Por.P] Omaha, NE. Studied: PAFA; AIC; J. Laurie Wallace. Member: Omaha AG; Omaha Brush & Pencil Cl. Exhibited: Am. Women Painters Exh., Wichita, Kans. (prize); Five States Exh., Joslyn Mem., Omaha, and Blandon Mem., Fort Dodge, Iowa, 1936 (prize). Work: Omaha Univ. [40]

DAVIES, William Teeple [P] Orient, NY [15]

DAVIESS, Maria Thompson [P,C,W,L,T] NYC/Nashville, TN b. 25 N 1872, Harrodsburg, KY d. 3 S 1924, NYC. Studied: Blanche; Mucha; L'hermitte; Delecluse. Member: Nashville AC; Nat. Ar. Cl.; Nashville Centenn. Cl. Author: "The Melting of Molly," "The Tinder Box," "Andrew the Glad," "Over Paradise Ridge," other books [24]

DAVIS, Albert Eggerdon [I,Arch] NYC b. 2 Mr 1866, NYC d. 13 Mr 1929. Studied: Charles I. Berg. Member: Arch. Lg., 1894 [08]

DAVIS, Alice [Edu,P] Iowa City, IA b. 1 AP 1905, Iowa City. Studied: NAD; Chas. W. Hawthorne; S.E. Dickenson; R. Neilson; Richard Miller; Charles A. Cumming. Member: Iowa AG. Exhibited: Kansas City AI; Joslyn Mem. Positions: T., Univ. Iowa, 1929-45, Lindenwood Col., St. Charles, Mo., 1945-46 [47]

DAVIS, Amee (Mrs. Leland) [P] Westfield, NJ. Member: Westfield AA; NAC. Exhibited: Westfield AA, 1939; NAC, 1939 [40]

DAVIS, Arthur F. [P,E] Acton, MA b. 27 Mr 1863, Roxbury, MA. Studied: A.H. Bicknell [17]

DAVIS, Cecil Clark (Mrs.) [P] Marion, MA b. 12 Jy 1877, Chicago. Member: Chicago SA; Chicago AC; NAWPS; Grand Central Gal. Exhibited: Chicago Municipal AL, 1918 (prize); Salon, Rio de Janeiro, 1920 (gold); Phila. AC, 1925 (gold); NAWPS, 1926 (prize); Newport AA, 1932 (prize). Work: Marion A. Center; Tabor Acad. [40]

DAVIS, Charles A. [P] Germantown, PA [01]

DAVIS, Charles F. [P] Boston, MA [01]

DAVIS, Charles H(arold) [Ldscp.P] Mystic CT b. 7 Ja 1856, Amesbury, MA d. 5 Ag 1933. Studied: Otto Grundmann; BMFA Sch.; Académie Julian, Paris, with Boulanger, Lefebvre (lived in France for 10 yrs.). Member: SAA, 1886; ANA, 1901; NA, 1906; Copley S.; Lotos C.; NAC; Mystic SA; AFA. Exhibited: Am. AA, 1886 (gold), 1886 (prize); Paris Salon, 1887, 1889 (prize); Paris Expo, 1889 (med), 1900 (med); AIC, 1890 (prize), 1904 (med); Mass. Charitable Mechanics Assn., 1890 (med); Columbian Expo, Chicago, 1893 (med); Atlanta Expo, 1895 (gold); PAFA, 1901 (prize), 1919 (gold); Pan-Am. Expo, Buffalo, 1901 (med); S. Wash. A., 1902 (prize); St. Louis Expo, 1904 (med); P.-P. Expo, 1915 (gold); NAD, 1917 (prize), 1921 (med); Corcoran Gal., 1919 (med,prize). Work: MMA; CGA; CI; BMFA; WAM; NGA; PAFA; AIC; Hackley A. Gal., Muskegon, Mich.; Minneapolis Inst. A.; CAM; Syracuse MFA; Butler AI; Bruce Art Mus., Greenwich, Conn.; Harrison Coll., Los Angeles [31]

DAVIS, C(harles) H(enry) [Ldscp.P] b. 28 Ag 1845, Cambridge, MA d. 27 D 1921. Member: Wash. WCC; Newport AA. Rear Admiral U.S. Navy. [21]

DAVIS, Charles H. (Mrs.) Montclair, NJ. Member: Woman's AC, BA Students' Assn., 1879 [01]

DAVIS, Charles Percy [P,I,C,T] Clayton, MO b. Iowa City, IA. Studied: Chase; Beckwith; Bouguereau; Ferrier; Robert-Fleury. Member: Boston SAC [31]

DAVIS, Charles Vincent [P,G] Chicago, IL b. 3 N 1912, Evanston, IL. Studied: AIC; George E. Neal. Member: United Am. A. Exhibited: AIC, 1938, 1938. Work: WPA, Chicago; mural, Hall Lib., Chicago [40]

DAVIS, Cornelia Cassady (Mrs.) [P] Cincinnati, OH b. 18 D 1870, Cleves, OH d. 23 D 1920. Studied: Cincinnati A. Acad., with Lutz, Noble, Duveneck. Member: Cincinnati Women's AC. Exhibited: Osborne Comp., NYC, 1906 (prize). Work: Ohio Suffrage Poster, 1912; Westminster Central Hall, London; El Tovar Gal., Grand Canyon, Ariz. [19]

DAVIS, Donna F. [P] San Francisco, CA [19]

DAVIS, Earl R. [P] Providence, RI b. 17 Ja 1886. Member: Providence AC; Providence WCC; S.Indp.A. [33]

DAVIS, Edwin A. [P] NYC d. 28 F 1940(?) [24]

DAVIS, Elizabeth Logan (Mrs. Chester M.) [P,W,T] Rahway, NJ b. 22 Ap 1886, Shelbyville, KY. Studied: AIC; Ivanowski; Ryerson. Member: AAPL. Exhibited: N.J. Women's Cl., 1945 (prize); Rahway Women's Cl. (prize); Southern Vt. A., 1935-41; East Orange AC, 1945; Spring Lake Exh., 1945; Morton Gal., 1946 [47]

DAVIS, Emma Earlenbaugh (Mrs. William J.) [P,I] Bryn Mawr, PA b. 8 S 1891, Altoona, PA. Studied: PAFA; PMSchIA; W. Adams; M. Molarsky; B. Fenton; W. Everett; J.F. Copeland; D. Garber. Phila. A. All. Exhibited: PAFA; Phila. A. All.; Phil. Sketch Cl.; McClees Gal. (one-man); Bryn Mawr A. Center; Bala-Cynwyd Cl. Illustrator: national magazines. Specialty: portraits, including sketches of patients at Valley Forge Hospital, 1945-46 [47]

DAVIS, Emma L. [S] Santa Monica, CA. Exhibited: PAFA, 1938, 1939; WFNY, 1939. Work: USPO, La Plata, Mo. WPA artist. [40]

DAVIS, Faith Howard [P,S,T] Snyder, NY b. 29 Jy 1915, Chicago, IL. Studied: Sarah Lawrence Col.; P. Mangravite; B. Tomlin; K. Roesch; d'Harnoncourt. Member: The Patteran. Exhibited: Albright A. Gal., 1939-46 [47]

DAVIS, Fay Elizabeth [P,G] Indianapolis, IN b. 8 Jy 1916, Indianapolis. Studied: John Herron AI. Member: Ind. AC. Exhibited: Ind. A. Exh., Herron AI, 1938 (prize); GGE, 1939. Work: USPO, Chester, Ill. WPA muralist. [40]

DAVIS, Floyd Macmillan [I] NYC. Member: GFLA; SI. Illustrator: national magazines [47]

DAVIS, Frank L. [P] NYC. Member: Arch. Lg., 1903 [19]

DAVIS, Georgina S. [I,P] NYC b. ca. 1850. Studied: ASL. Member: Boston AC. Was part of "Leslie's" famous railroad tour from NYC to the West Coast in 1877. [98]

DAVIS, Gerald Vivian [P] Summit, NJ b. 8 S 1899, Brooklyn, NY. Studied: Ecole des Beaux-Arts, Académie Julian, both in Paris. Member: Société Nationale des Beaux-Arts, Salon National Independents, both in Paris; N.J. AA; N.J. WCS; SC. Exhibited: London; Copenhagen; Paris Salon, 1929-39; Salon d'Automne, 1930-39; Soc. Gr. A., London, 1938, 1939; NAD, 1941, 1946; AIC, 1928; AWCS, 1941, 1942, 1946; All. A. Am., 1940, 1941; Montclair A. Mus.; Riverside Mus.; Newark Mus.; Princeton; Marquie Gal., 1941 (one-man) [47]

DAVIS, Gladys Rockmore (Mrs. Floyd M.) [P,W] NYC b. 1901, NYC. Studied: AIC, with J. Norton. Exhibited: CGA, 1939 (prize); AIC, 1937 (med); VMFA, 1938 (prize); PAFA, 1938 (prize); NAD, 1944 (prize); Pepsi-Cola, 1946 (prize); Swope A. Gal.; Nebr. AA; NAC; CAM; San Diego FA Soc.; Akron AI; Currier Gal. A. Work: MMA; PAFA; Swope A. Gal.; Nebr. AA; TMA; Butler AI; Encyclopaedia Britannica Coll.; Cranbrook Acad. A. Author/Illustrator: "Pastel Painting," 1943 [47]

DAVIS, Goode Paschall [Por.P] Santa Barbara, CA b. 8 N 1906, Havana, Cuba. Studied: Harvard; Paris; Charles Hawthorne; F. Leger; A. Ozenfant. Exhibited: 460 Park Ave. Gal., 1940; Woodstock, 1933, 1934; Berkshire Mus., 1938 (prize); NAD, 1938 [47]

DAVIS, Hallie [P] Phila., PA [25]

DAVIS, Harry [P] Phila., PA. Member: Pittsburgh AA [25]

DAVIS, Harry Allen, Jr. [P,Li,T] Indianapolis, IN b. 21 My 1914, Hillsboro, IN. Studied: John Herron A. Sch., with D. Mattison, H. Mayer; Am. Acad., Rome, 1938-41. Member: Ind. AA. Exhibited: VMFA, 1937, 1940, 1946; GGE, 1939; Grand Central A. Gal., 1938; Pepsi-Cola, 1946; Exh. Contemporary Am. Drawings, N.Y., 1946; Beloit Col., 1941; John Herron AI, 1938, 1940, 1941, 1944 (prize), 1946 (prize). Work: Hist. Properties, Wash., D.C.; mural, Am. Acad., Rome; French Lick Springs Hotel. Positions: T., Beloit Col, 1940-41, John Herron AI, 1946-47 [47]

DAVIS, Helen C. (Mrs. William B.) [Min.P] Houston, TX b. Elizabeth, NJ. Studied: Chase; La Farge; Ménard, in Paris; Simon; ASL. Member: ASMP; SSAL. Exhibited: Mus. FA, Houston, 1926 (prize), 1934; SSAL, 1930-32 (prize) [47]

DAVIS, Helen Hinds [P] NYC. Member: Boston WCC [01]

DAVIS, Helen S. [S,E] Gloucester, MA b. Phila. Studied: PAFA; ASL; CUASch; Anshutz; Tefft; Brewster; Laurent. Member: Plastic C.; NAWA; North Shore AA; Gloucester SA; Wolfe AC. Exhibited: Wolfe

AC; CUASch. Work: public bldgs., Coral Gables; Daytona Beach; Berkeley, CA [47]

DAVIS, Hubert [P,Et,Li,I,B,W] Milton, PA b. 15 Mr 1902, Milton. Studied: PMSchIA; ASL; Paris. Exhibited: WMAA; PAFA; S.Indp.A.; CI; Phila. Pr. C.; SAE; NAD; Los Angeles Mus. A.; WFNY, 1939; Stockholm, Sweden. Work: WMAA; MMA; PMA; PAFA; Columbus Gal. FA; Newark Pub. Lib.; LOC. Illustrator: "An American Tragedy," 1930. Contributor: national magazines [47]

DAVIS, Irene Ewing (Mrs.) [P] Seattle, WA [25]

DAVIS, James Edward [P,C,Edu] Princeton, NJ b. 4 Je 1901, Clarksburg, WV d. 1974. Studied: Princeton; Andrè Lhote, in Paris. Exhibited: MOMA; 67 Gal., 1945; Ferargil Gal., 1945. Work: MOMA; Mus. Hist. A., Princeton; Daughters of the Confederacy, Clarksburg, W.Va. Specialty: abstract artist. Position: T., Princeton, 1936-42 [47]

DAVIS, Jessie (Freemont) (Snow) [P,S,T] Dallas, TX b. 22 F 1887, Williamson County, TX. Studied: Dallas, with Reaugh, M. Simkins, J. Knott; ASL, with Bridgman, Romanovsky. Member: SSAL; NAWA; Dallas AA. Exhibited: Dallas Mus. FA, 1933 (prize); Oak Cliff Soc. FA, Dallas (prize); NAWA, 1944,; Mus. FA, Houston, 1945; Dallas All. A., 1943, 1944; SSAL, 1940. Work: Dallas Mus. FA; Oak Cliff Gal.; San Angelo Pub. Lib. Position: T., Dallas Pub. Evening Sch. [47]

DAVIS, John Parker [En,Ldscp.P,L,W] Elmhurst, NY b. 17 Mr 1832, Meredith Bridge, NH d. 19 Jy 1910. Studied: Phila. Member: Soc. Am. Wood En. (a founder). Exhibited: Paris Expo, 1889 (med); Pan-Am. Expo, Buffalo, 1901 (med). Came to New York in the 1860s and worked with A.V.S. Anthony on the "Illustrated News." Moved to Schenectady, ca. 1867, and, ca. 1875, settled in New York. Position: associated with Harpers', Scribner's Monthly [10]

DAVIS, John Steeple [P,I] b. 1 F 1844, Parkridge, England d. 6 D 1917, Brooklyn, NY. Studied: Bonnât; Gerôme. Exhibited: Paris Expo, 1900. Work: portrait of Horace Greeley, Tribune Bldg., NYC. Illustrator: "The Standard History of the U.S.," "The Story of the Greater Nations"

DAVIS, Leonard M. [Ldscp.P,L] Los Angeles, CA b. 8 My 1864, Winchendon, MA d. 5 My 1938 (Tarzana, CA?). Studied: ASL, 1884-89; Académie Julian, Paris, with Laurens, Lefebvre, Benjamin-Constant 1889-95; Ecole des Beaux-Arts, 1889-95. Member: AFA; Los Angeles AA; Glendale AA. Exhibited: 127 Alaska paintings, P.-P. Expo, (med). Work: AA Mus.; Seattle, Wash.; Municipal A. Gal., Seattle; Mus. N.Mex., Santa Fe; St. James Palace, London; 23 paintings, Public Archives of Canada; AMNH. Specialties: since 1898, Alaska scenes; Canadian Rockies (over 600), U.S. nat. parks (over 100). Illustrator: "Demond Greed." Lecture: Art in Relation to Human Development [38]

DAVIS, Lew E. [P,T] Scottsdale, AZ (1976) b. 2 N 1910, Jerome, AZ. Studied: NAD, L. Kroll. Member: Am. A. Cong.; Ariz. PS; Tiffany F., 1931. Exhibited: Denver Mus., 1938, 1940 (prizes); Calif. WCS, 1941 (prize); Pasadena AI, 1946; NAD, 1932; WMAA, 1937; AIC, 1937, 1938, 1941; SFMA, 1938-40; VMFA, 1940; CM, 1939; WFNY, 1939; GGE, 1939; Los Angeles Mus. A., 1938; Colarado Springs FA Center, 1938, 1939, 1940 (one-man), 1946; Santa Barbara Mus. A., 1942. Work: Newark Mus.; IBM; Pasadena AI; murals, USPOs, Los Banos (Calif.), Marlow (Okla.), Ft. Huachuca (Ariz). WPA muralist. His wife was sculptor Mathilde Shaefer. Position: Dir., Ariz A. Fnd.; T., Ariz. S. Col. [47]

DAVIS, Marguerite [I] Quincy, MA b. 10 F 1889, Quincy. Studied: Vassar; BMFA Sch.; W. Paxton; P. Hale; H.H. Clark; Eliz. Shippen-Green. Illustrator: "Sugar and Spice," "Trudy and the Tree House," "Magical Melons" [47]

DAVIS, Marshall [I] Jamaica, NY. Member: SI [47]

DAVIS, Martha [C,Des] NYC/Cape Cod, MA b. 12 Jy 1877, Phila. Studied: Sally Stevens; W. Reiss; Univ. Pa. Member: Boston SAC; Phila. ACG; NYSC; Keramic Soc. and Des. Gld. N.Y.. Exhibited: Keramic Soc., 1930 (prie); Nat. Cer. Exh., Syracuse, 1935-39; Intl. Expo, Paris, 1937; WFNY, 1939. Work: Lib. Southwestern Mo. State T. Col., Springfield [40]

DAVIS, Martha Cowles (Mrs. Clarence D.) [P] Ebensburg, PA b. 12 F 1895, Brooklyn, NY. Member: Allied A., Johnstown. Exhibited: Allied A., Johnstown, 1935 (prize), 1936 (prize), 1938 (prize). Work: State Col., State College, Pa. [40]

DAVIS, Mathilde Schaefer. See Schaefer.

DAVIS, Mattie H. [P,T] Rochester, NY. Member: Rochester AC [15]

DAVIS, Myra Louise [C,T] Boston, MA b. Lynn, MA. Studied: Sch. Appl. A., Boston. Member: Boston SAC. Co-author: "The Garden Studio Note Book of Elementary Hand Weaving." Contributor: articles on weaving, Handicrafter. Position: Manager, Woolson House Industries for the Blind, Cambridge, Mass. [40]

DAVIS, Natalie Harlan [I] NYC b. 12 Ja 1898, Phila., PA. Studied: PMSchIA; PAFA. Illustrator: "Four Seasons in Your Garden," by J.C. Wister, "Fragrance in the Garden," by A. Dorrance, "Vines for Every Garden," by D. Jenkins, "The Garden Dictionary" [40]

DAVIS, Ranice W., Mrs. See Birch, Ranice.

DAVIS, Richard [S,L] NYC (1953) b. 7 D 1904, NYC. Studied: De Creeft; J. Flanagan; Ben-Shemuel; Bourdelle. Member: NSS; S. Gld.; S.Indp.A. Exhibited: MOMA; WMAA; AIC; AFA; Ferargil Gal. Work: USPO, Springfield, Ky. [47]

DAVIS, Robert Allen [P,I,Gr,C,T] Tarrytown, NY b. 1 Ja 1912, Chicago. Studied: ASL; Bridgman; Brackman. Member: SI. Exhibited: SI, annually; Hamilton, Ontario, 1946 (one-man). Positions: T., Fashion Acad., NYC, 1940-42, 1945-46, Marymount Col., Tarrytown, NY, 1946- [47]

DAVIS, Ronald Fremont [I,C,T,W] Arlington, MA b. 25 S 1887, Worcester, MA d. 27 Ja 1919, Mt. Vernon, NY. Studied: Mass. Normal A. Sch.; Major; De Camp. Member: Eastern AA; Western Art and Manual Training Assn. Positions: T., Rindge Manual Training School, Cambridge, 1910-11, Utica Vocational Sch., 1911-12; Dir., manual arts, Wilmington, Del. pub. sch., 1912-14; A. Dir., Del. Col. (summer school), 1913-14; Managing Ed., School Arts Magazine, Something-to-do, 1914- [17]

DAVIS, Samuel C. [P] Columbus, OH. Member: Columbus PPC [25]

DAVIS, Samuel P. [I,En] NYC b. 7 Jy 1846, Schenectady, NY. Studied: A.V.S. Anthony; J.P. Davis. Exhibited: Columbian Expo, Chicago, 1893 (med); Pan-Am. Expo, Buffalo, 1901 (med) [13]

DAVIS, Sarah C. [P] Brookline, MA. Member: Copley S., 1893 [10]

DAVIS, Stark [P] Chicago, IL b. 13 My 1885, Boston, MA. Member: Palette and Chisel Cl., Chicago; Chicago PS; Chicago Gal. A.; Grand Central Gal. Exhibited: AIC, 1924 (prize); Chicago Gal. Assn., 1930 (prize) [40]

DAVIS, Stuart [Li,Des,C,W,T,L] NYC b. 7 D 1894, Phila. PA d. 1964. Studied: Robert Henri, 1910-13. Member: Am. Soc. PS&G.; Am. A. Cong.; Un. Am. Ar. Exhibited: Armory Show, 1913; CI, 1944 (prize); PAFA, 1945 (prize); retrospective exh.: Cincinnati AM (1941), Univ. Ind. (1941), MOMA (1945), Boston Inst. (1945). Contemporary A. (1945), Nelson Gal. (1945), Venice Biennale (1952), Walker A. Center (1957), Des Moines A. Center (1957), San Fran. MA (1957), WMAA (1957), PAFA (1964); memorial exh: Nat. Coll. (1965), AIC (1965), WMAA (1965), UCLA (1965), Paris (1966), Berlin (1966), London (1966). Work: WMAA; MOMA; PMG; murals, Radio City Music Hall; WNYC; Ind. Univ.; Los Angeles Mus.; PAFA; Univ. Ky.; Newark Mus.; Minneapolis Inst. A. Contributor: articles, Art Front, Magazine of Art. Positions: T., New Sch. Soc. Res., 1940-50, ASL, 1931-32 [47]

DAVIS, Theodore [Patron] Newport, RI/Miami, FL d. 23 F 1915. He financed several Egyptian explorations and many of the important finds were given to the MMA. He had a notable collection of paintings as well as other objects of art and archæology.

DAVIS, Theodore Russell [I] b. 1840 Boston d. 10 N 1894, Asbury Park, NJ. Studied: Herrick, in Brooklyn, 1850s. Davis was an important illustrator of the Civil War and the Old West for Harper's. He was the first of the artist-correspondents to be sent West after the Civil War, documenting the Plains Indian Wars. He was with Hancock's Indian Expedition in 1867, and with Custer in Nebr. and Colo. Although he did not return West after this major trip, he continued to illustrate western subjects until ca. 1884. [*]

DAVIS, Tulita [P] San Francisco, CA [19]

DAVIS, Virginia [P] Phila., PA. Studied: PAFA; Phila. AC; AIC [98]

DAVIS, Warren [P,E] NYC b. 1865, NYC d. 26 S 1928, Brooklyn, NY. Studied: ASL; Member: SC; Allied AA. Exhibited: SC, 1905 (prize), 1906 (prize), 1916 (prize); SC, 1911 (prize); NAC, 1925 (prize). Work: Milwaukee AI [27]

DAVIS, Wayne Lambert [P,Des,E,I,T] Pelham, NY b. 3 Ja 1904, Oak Park, IL. Studied: Columbia; NYU; ASL, with R.N. McLeod, Pennell. Work: NYPL. Illustrator: Vanity Fair, Fortune, Liberty, other magazines. Position: A. Dir., Grumman Aircraft, 1941-53 [40]

DAVIS, Will Rowland [P,E,B] Jamaica Plain, MA b. 7 Ap 1879, Boston,

MA. Studied: de Camp; Tarbell; Benson. Member: Copley S.; North Shore AA; Rockport AA [33]

DAVIS, William M. [P,T] Mount Sinai, NY b. 23 My 1829, Setauket, NY [17]

DAVIS, William Steeple [P,E,En,B,Photogr,W] Orient, NY b. 7 My 1884, Orient. Member: AAPL; Southern Pr.M.; Photog. Soc. Am. Exhibited: nationally, 1907– . Work: U.S. Naval Acad. Mus.; Toledo Mus. A.; Los Angeles Mus. A.; CMA; Hiram Col., Ohio; LOC; NYPL. Author: "Practical Amateur Photography" [47]

DAVIS, W(illiam) Triplett [P,I] Washington, D.C. b. Wash., D.C. Studied: Corcoran Gal. Sch. A.; Lucien Powell. Member: S. Wash. A. [21]

DAVIS, Willis E. [P] San Francisco, CA d. 11 Mr 1910 (on board the liner "Oceanic"). Member: Bohemian Cl. [10]

DAVISON, Austin L. [I,Des,C,P,T] New Hope, PA b. 14 S 1909, New Hope. Studied: State T. Col., Edinboro, Pa.; D'Ogries Studios, New Hope. Exhibited: NGA; WFNY, 1939; Century of Progress, Chicago; New Hope. Work: Index Am. Des., NGA; Atwater Kent Mus., Phila. Illustrator: "Folk Art of Rural Pennsylvania," 1941. Co-illustrator: "Pennsylvania German Folk Art," 1944. Positions: Tech. I., Naval Research Lab. (Wash., D.C.), John Hopkins Univ. 1943–45 [47]

DAVISON, E.L. [P] Wichita, KS [25]

DAVISON, L(ucien) A(delbert) [P,W,L,T] Brooklyn, NY/Brewerton, NY b. 15 Je 1872, Clay, NY. Studied: Col. FA, Syracuse. Member: S.Indp. A. [33]

DAVISSON, H(omer) G(ordon) [P,E,L,T] Fort Wayne, IN/Somerset, IN b. 14 Ap 1866, Blountsville, IN. Studied: DePauw Univ.; PAFA; Corcoran A. Sch.; ASL; Szbe Sch., Munich. Member: Ind. AC; Hoosier Salon; Brown Co. A. Gal. Assn. Exhibited: Hoosier Salon, 1927 (prize), 1931 (prize); Ind. AC (prize). Work: Ind. Univ.; Emerson Sch., Gary, Ind.; Ft. Wayne A. Mus., Hamilton Cl., Brooklyn; pub. libraries, Marion, Tipton, Peru, all in Ind. Position: T., Ft. Wayne A. Sch. [47]

DAVOL, Joseph B. [Mar.P,T] Ogunquit, ME b. 25 Ag 1864, Chicago, IL d. 15 Je 1923. Studied: Benjamin-Constant, Laurens, in Paris. Member: SC; F., PAFA. Exhibited: P.-P. Expo, San Fran., 1915 (med) [21]

DAVY, James Benjamin [E,S,P] San Fran., CA b. 25 F 1913, San Fran. Studied: Schaeffer Sch. Des. Exhibited: GGE, 1939; San Fran. AA, 1941, 1942, 1945; Oakland A. Gal., 1943, 1944; LOC, 1943 [47]

DAWES, Dexter B. [P,Li] Englewood, NJ b. 15 Je 1872, Englewood. Studied: ASL. Member: New Haven PCC; NAC; Ogunquit AA. Exhibited: Newark AC (prize); Fitzwilliam (N.H.) AA, 1939 (prize); Montclair (N.J.) AM, 1933 (prize) [47]

DAWES, E(dwin) M. [P] Los Angeles, CA b. 21 Ap 1872, Boone, IA. Studied: self-taught. Exhibited: Minn. State Art Soc., 1909 (prize), 1913 (gold), 1914 (prize); St. Paul Inst. A., 1915 (med). Work: State A. Soc., Minn.; Pub. Lib., Owatonna, Minn.; Minneapolis Inst.; Ackerman Gal., Los Angeles [40]

DAWES, Pansy [P,T] Colorado Springs, CO/Woodland Park, CO b. 7 O 1883, Clay Center, Kans. Studied: Sandzen; Emma Church. Member: Prairie WCP. Position: T., Colorado Springs H.S. [40]

DAWES, Ruth Wilcox. See Wilcox.

DAWLEY, Herbert M. [P,S] Chatham, NJ b. 15 Mr 1880, Chillicothe, OH. Studied: ASL, NYC; ASL, Buffalo. Member: Buffalo SA; Chatham AC [40]

DAWSON, Arthur [P,E,W,Cr] Richmond, VA b. Mr 9 1859, Crewe, England (came to U.S. in 1887) d. 27 Ag 1922. Studied: South Kensington Sch.; David Law, William Morris, in London. Member: Artists' Fund Soc.; Lotos Cl.; Authors' Cl., London; Chicago Municipal Art Soc.; Founder/Member, Chicago Soc. Artists. Exhibited: Pan-Am. Expo, Buffalo, 1901 (prize). In 1898 he was in charge of the restoration of paintings at the NYPL and at West Point. [19]

DAWSON, Charles Clarence [I,Des,P,En,W,L] Chicago, IL b. 12 Je 1889, Brunswick GA. Studied: Tuskegee Inst.; ASL; AIC. Exhibited: Chicago A. Lg., 1928 (prize), 1929 (prize); Harmon Fnd., 1929 (prize); American Negro Expo, 1940; AIC, 1919, 1927; Studio Gal., Chicago, 1931; Findlay Gal., 1933. Work: Tuskegee Inst. Author/Illustrator: "ABC's of Great Negroes," 1933. Lectures: The Negro in Art. Position: Administrator, WPA, Chicago, 1936–41 [47]

DAWSON, Eugenie Wireman [I,P] NYC b. Phila. Studied: PAFA; Drexel Inst.; Breckenridge; Pyle; Adams. Illustrator: "Odes of Theocrates," "Children's Story Garden," "Polly Flinders," other books. Contributor: national magazines [47]

DAWSON, George Walter [P,T] West Phila., PA b. 16 Mr 1870, Andover, MA d. 5 F 1938. Studied: Mass. Normal A. Sch.; PAFA. Member: Phila. WCC; Phila. All.; T Sq. Cl.; NYWCC; Chicago WCC; AFA. Specialties: landscapes, flowers. Position: T., Univ. Pa. [38]

DAWSON, John W(ilfred) [P,C] Wickford, RI b. 23 Ag 1888, Chicago, IL. Studied: W. Rice; Arthur Dawson; Académie Julian, Paris. Member: Providence AC; So. County AA [33]

DAWSON, Robert Bennit [P] NYC [06]

DAWSON-WATSON, Dawson. [P,EN,T] San Antonio, TX b. 21 Jy 1864, London, England (came to U.S. in 1893) d. 3 S 1939. Studied: Mark Fisher, in Steyning, England; Carolus-Duran, Chartran, Collin, Aimé Morot, Léon Glaize, in Paris. Member: San Antonio AL; North Shore AA; Tex. FAS. Exhibited: Lewis & Clark Expo, Portland, Oreg., 1905 (med); Sedalia, Mo. (gold,med); Ill. State Fair, 1916 (prizes); State Fair, Austin, Tex., 1926 (prize); Tex. Wildflower Comp. Exh., 1927 (prize), [1928 (hors concours)], 1929 (prizes); Nashville AA, 1927 (prize); SSAL, 1929 (prize), 1931 (prize); Abilene, Tex., 1935 (prize). Work: City AM, St. Louis; Barr Branch Lib., St. Louis; Oakland (Calif.) Mus.; Lib., Houston, Tex.; Springfield (Ill.) AA; St. Louis Club; Lotos Cl.; New Haven PCC; Univ. Tex.; Witte Mem. Mus. He painted in Giverny, 1885–1890; at the urging of C. Beckwith, he went to New England, 1893–97; painted at the Woodstock, N.Y. colony, ca. 1901; and was at the St. Louis Sch. FA, 1904–15, probably as a teacher. Established his studio in San Antonio, ca. 1927. Positions: A. Dir., Mo. Centenn.; A. Dir., St. Louis Industrial Exh., 1920 [38]

DAY, Arthur [P] Niles, OH [01]

DAY, Benjamin Henry, Jr. [I] Summit, NJ b. 1838, NYC. His father was the founder of the New York Sun. Illustrator: "Beyond the Mississippi." He invented (ca. 1879) the labor-saving process of shading illustrations that bears his name, "Benday." Positions: Staff, Harper's, Leslie's, after the Civil War

DAY, Bertha C. See Bates.

DAY, Chon [Car,I] NYC. Work: New Yorker [40]

DAY, Emily Atkins [P] Somerville, MA b. 16 Ag 1903, Malden, MA. Studied: W.R. Davis; P.A. Laurens [32]

DAY, Fred Holland [Photogr,Pub] Southport, ME b. 1864, Norwood, MA d. 1933. Member: Royal Photogr. Soc., 1905. Work: LOC (650 prints); AIC; IMP/GEH; MMA; Royal Photogr. Soc. (exh. in 1973); Bibliothèque Nationale, Paris. From 1893 to 1899, his firm Copeland & Day published some of the most beautiful books ever made in America. Day was the first to promote the poet Keats. He arranged the first exhibition of American pictorial photography, "The New School of American Photography," in London (1900), in which 103 of the 375 photographs were by Day. All his work was lost in his studio fire (1904). An eccentric, Day took to his bed from 1917 until his death in 1933. [*]

DAY, Hallie [P] Findlay, OH. Member: Cincinnati Women's AC [25]

DAY, Helena [P] Swarthmore, PA. Member: Phila. WCC [27]

DAY, Horace Talmage [P,T] Staunton, VA b. 3 Je 1909, Amoy, China. Studied: Tiffany Fnd.; Nicolaides; Miller. Member: ASL; Staten Island AA; Augusta AC; Assn. Ga. Ar. Exhibited: WMAA, 1944, 1945; CI, 1941; Pepsi-Cola, 1943; VMFA, 1942–44; Macbeth Gal., (one-man). Work: VMFA; AGAA; Yale Univ. A. Gal.; Canajoharie A. Gal.; King Col.; mural, USPO, Clinton, Tenn.; "Art in the Armed Forces" (1944). Positions: Dir., Herbert Inst. A., Augusta, Ga., 1936–41; Assoc. Prof. A., Mary Baldwin Col. 1941– . WPA artist. [47]

DAY, Horace T., Mrs. See Nottingham, Elizabeth.

DAY, Howard D., Mrs. See Willson, Martha.

DAY, James Francis [I,P] Lanesboro, MA b. 12 Ag 1863, LeRoy, NY d. 12 Je 1942. Studied: ASL; Ecole des Beaux-Arts, Hébert, Merson, in Paris. Member: SAA, 1891; ANA, 1906; SC, 1888; Pittsfield AL. Exhibited: NAD, 1895 (prize). Work: Montclair (N.J.) AM; Town Hall, Lanesboro [40]

DAY, Katharine Seymour [P,I] NYC b. Hartford, CT. Studied: Chase; Harrison; Woodbury; Simon, Le Beau, Schumacher, in Europe [15]

DAY, Mabel K. [P] Schenectady, NY/Lake Annis, Nova Scotia b. 7 Jy 1884, Yarmouth, Nova Scotia. Studied: Henri; Miller; Snell; H. Boss. Member:

Pittsburgh AA. Exhibited: Pittsburgh AA, 1913 (prize), 1923 (prize), 1927 (prize) [33]

DAY, Martha B. Willson (Mrs. Howard) [Min.P,L] Providence, RI b. 16 Ag 1885, Providence. Studied: R.I. Sch. Des.; Académie Julian, Paris, with Lucia F. Fuller. Member: Providence AC; ASMP; Pa. Soc. Min. P.; Brooklyn Min. S. Exhibited: PAFA, 1932 (prize); ASMP; Pa. Soc. Min. P. Lectures: Miniatures [47]

DAY, Mary Barker [P] Litchfield, CT. Member: New Haven PCC [25]

DAY, Robert James [Car,I,] Rockville Centre, NY b. 25 S 1900, San Bernardino, CA. Studied: Otis AI. Exhibited: car. exhibits, throughout U.S. Author/Illustrator: "All Out for the Sack Race," 1945. Illustrator: "We Shook the Family Tree," 1946. Contributor: New Yorker, Collier's, Saturday Evening Post [47]

DAY, Worden (Miss) [G,P] Alexandria, VA b. 11 Je 1916, Columbus, OH. Studied: Randolph-Macon Women's Col.; ASL; New Sch. Soc. Res.; Sterne; Charlot; Vytlacil; W. Barnet. Member: AAPL; F., VMFA; F., Rosenwald. Exhibited: Va. Intermont Exh., 1944 (prize); VMFA, 1941, 1943 (prize), 1944; Norfolk Mus. A., 1944 (prize); ACA Gal., 1939; Hudson Walker Gal., 1939; Uptown Gal., 1939; LOC, 1945; WMAA, 1941; AV, 1944, 1945; Phila. Pr. Cl., 1944; Northwest Pr.M., 1945; Perls Gal., 1940; SFMA, 1945; PMG, 1943; Butler AI; AIC; MMA. Work: VMFA [47]

DAYTON, F.E. [I] NYC b. Hartford, CT. Member: SI; SC [33]

DAYTON, Helena Smith (Mrs.) [I] NYC. Member: SI [33]

DAYTON, Lillian [P] Los Angeles, CA. Member: Calif. AC [25]

DEACHMAN, Nelly (Mrs. T.W.) [P,W,T] Chicago, IL b. 13 Ag 1895, Prescott, AZ. Studied: Ark. State T. Col.; Peabody Col.; Univ. Chicago; AIC. Member: All-Ill. FA Soc.; AAPL; South Side AA. Exhibited: Wawasee A. Gal., Syracuse, Ind., 1943–45; Ark. Mus. FA, 1942; CAM; Quincy (Ill.) Mus. A. Position: Dir. Exh., All-Ill. Soc. FA, 1942–46 [47]

DEAK-EBNER, Ilona (I.E. Ellinger) [Edu,P] Wash., D.C. b. 12 Je 1913, Budapest, Hungary. Studied: Royal Hungarian Univ. Sch. A.; Royal Swedish A. Acad.; Johns Hopkins; D.M. Robinson; W.F. Albright. Member: Soc. Wash. A. Exhibited: PAFA, 1942; Whyte Gal., 1944 (one-man); Soc. Wash. A.; Am.-British A. Center. Position: T., Trinity Col., Wash. D.C., 1943– [47]

DEAKIN, Edwin [P] b. 1838, Sheffield, England d. 1923, Berkeley, CA. Studied: England; came to Chicago, 1869; settled in San Fran., 1870. Member: Bohemian Cl., friend of S.M. Brookes. Work: Calif. Hist. S.; de Young Mus. Specialty: old Franciscan missions [*]

DEAN, Abner [I] NYC b. 18 Mr 1910, NYC. Studied: NAD; Dartmouth. Member: SI; Nat. Car. S. [47]

DEAN, Edgar W. [P] Columbus, OH. Member: Columbus PPC [25]

DEAN, Edward C. [P] Wash., D.C. Member: Wash. WCC [19]

DEAN, Elizabeth M. (Mrs. Samuel B.) [P] Roxbury, MA b. Cambridge, MA. Studied: Ludovicki, in London; Lazar, in Paris; Duveneck; H.D. Murphy. Member: Copley S., 1896 [25]

DEAN, Eva (Ellen) [P,T,W,E,I] Los Angeles, CA b. 17 S 1871, Storm Lake, IA. Studied: Univ. Akron; AIC; ASL; A.T. Van Lear; Rascovich. Member: Soc. for Sanity in Art; PBC. Exhibited: AWCS, 1938; Calif. WCS; Ariz. Mus. A.; Santa Cruz AL; Calif. Fed. A., 1936 (prize); Oakland A. Gal.; Los Angeles; Women Painters of the West, 1943 (prize); Soc. for Sanity in Art, Los Angeles, Chicago, 1941, San Fran., 1940, 1945; PBC. Author/Illustrator: "In Peanut Land" [47]

DEAN, Gladys Jessie. See Haesler.

DEAN, Grace Rhoades (Mrs.) [E,B,Li,P,T] Toledo, OH b. 15 Ja 1878, Cleveland. Studied: Cleveland Sch. A.; K. Cox; A.W. Dow; Munich. Member: NAWPS; Cleveland Women's AC; Toledo Soc. Women A.; Ohio WCS; Dayton SE. Exhibited: Toledo Mus. A., 1918–30 (prizes), 1934, 1939 (prize); Toledo Fed. A., 1920 (prize), 1924 (prize); Ohio State Fair, 1922 (prize); Ohio Print Salon, 1930. Work: A. Mus., Charleston, S.C. Position: T., Scott H.S., Toledo [40]

DEAN, Helga Haugan [P] Chicago, IL b. Milwaukee. Studied: C.W. Hawthorne; Breckenridge; La Montagne St. Hubert. Member: Assn. Chicago P.&S. Exhibited: North Shore AA, 1926 (prize); Gloucester, Mass., 1926 (prize); Chicago Gal. A., 1926 (prize) [40]

DEAN, Herman E. See Hedean.

DEAN, J(ames) Ernest [P,E,T] Toledo, OH (since 1918) b. 23 F 1871, Smithfield, PA d. Ap 1933. Studied: Twachtman; Beckwith; Chase; McCarter; Hayek; Brockhoff; Groeber, Munich. Member: Toledo Artklan (Pres.) [31]

DEAN, Mallette (Mr.) [P,B,I,En] San Fran., CA b. 9 Mr 1907. Studied: Calif. Sch. FA. Member: San Fran. AA. Exhibited: Ann. Gr., San Fran. AA, 1938 (prize); Ann. Am. Blockprint, Pr. Cl., Phila., 1939 (prize). Work: Coit Tower, San Fran.; San Fran. Mus. A.; de Young Mem. Mus.; NYPL; USPO, Sebastopol, Calif. WPA artist. Illustrator: "The Captivity of the Oatman Girls," by R.B. Stratton, pub. Grabhorn Press (1935), "Solstice and Other Poems," by Robinson Jeffers, pub. Random House (1935), "Lola Montez," by Oscar Lewis (1938), other books [40]

DEAN, Walter Lofthouse [Mar.P] Boston, MA/East Gloucester, MA b. 4 Je 1854, Lowell, MA d. 14 Mr 1912. Studied: Lefebvre; Boulanger; Oudinot. Member: Boston AC; PCC; Copley S., 1906; SC. Exhibited: NAD, 1881–96; Mass. Charitable Mechanics Assn., 1887 (med), 1895 (gold); St. Louis Expo, 1904 (med) [10]

DEAN, Samuel B. (Mrs.) Boston, MA. Member: Copley S., 1896 [04]

DEANE, Keith R. [P] San Fran., CA [13]

DEANE, L(illian) Reubena [Min.F] Los Angeles, CA b. 24 S 1881, Chicago. Studied: AIC; J.W. Reynolds; Virginia Reynolds [33]

DEANE, Lionel [P,I,Arch] Brooklyn, NY b. 9 Jy 1861, Canada. Studied: Rimmer; San Fran. Sch. Des; E. Narjot; V. Williams [25]

DE ANGELO, E. [P] Toledo, OH. Member: Artklan [25]

DEARBORN, Annie F. [P] San Fran., CA [10]

DEARTH, Henry Golden [P] NYC b. 22 Ap 1864, Bristol, RI d. 27 Mr 1918. Studied: Ecole des Beaux-Arts; Hébert, Aimé Morot, in Paris. Member: SAA, 1889; ANA, 1902; NA, 1906; Century Assn.; Lotos C. Exhibited: SAA, 1893 (prize); Paris Expo, 1900 (med); Pan-Am. Expo, 1901 (med); Charleston Expo, 1902 (med). Work: MMA; FAA, Buffalo; NGA; Brooklyn Inst. Mus; Detroit Mus.; AIC; CI [17]

DE BARKOW, Ilona (Baroness) [Des] Los Angeles, CA b. 6 Ap 1894, Budapest, Hungary. Studied: Budapest A. Acad.; Vienna A. Acad.; A. Acad., Ecole Pigier, Ecole Municipal, all in Paris. Award: Honorary Prof., Andhra Research Univ., India. Designer: gowns, costumes [40]

DE BAUN, Etta V. [P] b. 17 My 1902, Kripplebush, NY. Studied: G.E. Browne. Member: AAPL; Ridgewood AA; Provincetown AA. Exhibited: NAD, 1941, 1943, 1944; All. A. Am., 1940–46; N.J. State Mus., 1938–46; N.Y. State Exh., 1940, 1941; N.J. P.&S. Soc., 1945; Ridgewood AA, 1938–46; Provincetown AA, 1945 [47]

DE BECK, Willam Morgan (Billy) [Car,W] NYC/Great Neck, NY b. 16 Ap 1890, Chicago d. 11 N 1942. Studied: Chicago Acad. FA. Member: SI; Authors Lg.; Lotos C.; Dutch Treat Cl. Work: in U.S. and foreign newspapers, "Barney Google and Spark Plug," "Bunky," "Bughouse Fables." Position: Car., King's Features Syndicate [40]

DEBEREINER, George [P,E,C] Cincinnati, OH b. 28 S 1860, Arzberg, Germany d. ca. 1939. Studied: AIC; Holland; Germany. Member: Cincinnati AC. Work: murals, Fifth Third Union Trust Co., Cincinnati; Elk Cl., Indianapolis [33]

DE BEUKELAER, Laura Halliday (Mrs.) [S] Topeka, KS b. 1885, Cincinnati, OH. Studied: Cincinnati A. Acad.; St. Louis Sch. FA. Member: Cincinnati Women's AC. Work: YWCA, Newark; Washburn Col., Topeka, Kans. [24]

DEBLOS, C. Edmund [P] Grosse Pointe, MI. Exhibited: Mich. A. Exh., Detroit Inst. A., 1936 (prize) [38]

DE BOHUS, Irene [P] NYC. Exhibited: Ferargil Gal., 1939 [40]

DEBONNET, M(aurice) G. [P,E,Dec] Bayside, NY b. 14 D 1871, Paris, France d. 12 My 1946. Member: Brooklyn S. Mod. A.; Brooklyn WCC; NYWCC; AWCS; Nassau County AL; AAPL; SC; Allied AA. Exhibited: SC, 1929 (prize), 1931 (prize) [40]

DE BORONDA, Tulita [P] Monterey, CA b. 15 S 1894, Monterey. Studied: Calif. Sch. FA; H.V. Poor. Member: Carmel AA. Work: Pub. Lib.; Oak Grove Sch., Monterey [40]

DE BOUTHILLIER, Guy [P] Cambridge, MA. Member: S.Indp.A. [21]

DEBOUZEK, J.A. [En] Salt Lake City, UT [17]

DE BOW, Constance [P] Newark, NJ [13]

DE BOYEDON, O(scar) H(ugh) [S,C] NYC/Florence, Italy/Paris b. 13 Je

1882, Porto Alegre, Brazil. Studied: Bourdelle, in Paris. Member: Boston SAC [29]

DE BRA, Mabel Mason [P] Columbus, OH b. 24 O 1899, Milledgeville, OH. Studied: Pratt Inst.; Yale; Columbia; H.B. Snell; W.S. Taylor; W. Beck; G.P. Ennis. Member: NYWCC; Wash. WCC; Ohio WCS; Springfield (Mass.) AL; AWCS; NAWPS; Boston AC. Exhibited: Columbus AL, 1929; Baltimore WCC, 1931 (prize); Intl. WC, AIC, 1937, 1938. Work: Ohio State Archaeological Mus. Contributor: Design Magazine [40]

DE BRENNECKE, Nena [S,P] NYC b. 7 My 1888, Argentina. Studied: Univ. London; Henri Matisse; W. Wulff. Exhibited: BM, 1935; Arch. Lg., 1924; Denver A. Mus.; Mus. N.Mex.; London, England, 1914, 1917, 1920; Paris Salon, 1914. Work: Denver AM; Denver Nat. Bank; USPOs, Paulsboro, N.Y., Coraopolis, Pa., Hamlet, N.C., Windsor, Conn. WPA artist. [47]

DE BRUYN, Erich C. [Des,P] El Paso, TX b. 24 Ag 1911, Düsseldorf, Germany. Studied: Carnegie Inst.; Eliot O'Hara. Exhibited: Carlsbad, N.Mex., 1945 (one-man); N.Mex. State Exh., 1945; N.Y. State Exh., 1940, 1941; Syracuse AA, 1940, 1941 [47]

DE CAMBREY, Leonne (Miss) [P,C,W,L,T] Chicago, IL b. 7 1877, Sweden. Studied: A. Jansson; W. Sargent; Vanderpoel. Member: Chicago NJSA; Chicago AA. Author: "Lapland Legends," "A Girl in Sweden." Specialty: color psychology [31]

DE CAMP, Harold Sydney [P,C] Westfield, NJ b. 27 F 1903, Phila. Studied: Molly Hand; L. Crump; A. Budell; H. Budell. Member: AAPL; Westfield AA; Plainfield AA. Exhibited: Newark AC; Newark Mus.; Westfield AA; Plainfield AA; Spring Lake Exh. [47]

DE CAMP, Joseph (Rodefer) [P] Medford, MA/North Haven, ME b. 5 N 1858, Cincinnati, OH d. 11 F 1923, Boca Grande, FL. Studied: Cincinnati Acad., with Duveneck; Royal Acad., Munich. Member: Ten Am. Painters; Nat. Inst. AL; AC Phila.; Por. P.; Boston GA. Exhibited: City Hall, Phila. (prize); PAFA, 1899 (gold), 1912 (prize) 1920 (prize); Paris Expo, 1900; St. Louis Expo, 1904 (gold); CGA, 1909 (prize); AC Phila., 1915 (gold). Work: Wilstach Gal., Phila.; Cincinnati Mus.; BMFA; WMA; PAFA. Studio fires in both Boston and Maine destroyed much of his work. [21]

DE CAMP, Ralph Earll [Ldscp.P,Mur.P,I,Photogr] b. Attica, NY, 1858 d. Chicago, IL, 1936. Studied: Milwaukee, with W.A. Sydaten, ca. 1870; Pa. Sch. A., 1881. Member: Helena Sketch C. (founder, with C.M. Russell), ca. 1890. Work: Mont. Hist. S.; Mont. Cl.; murals, Mont. Capitol (1912, 1927). Lived in Helena, Mont., ca. 1885–1935. A friend of E.S. Paxon. [*]

DECAMP, Rena [P] Cincinnati, OH. Member: Cincinnati Women's AC [24]

DE CARO, Anita [P,G] Paris, France b. 19 O 1909, NYC. Studied: ASL; CUASch. Exhibited: Intl. Exh. E.&En., AIC, 1938 [40]

DE CAUSSE, James Francis, Mrs. See Hamilton, May S.

DE CELLE, Edmond Carl [P,Des,G,I] Mobile, AL b. 26 S 1889, NYC. Studied: London, with A.S. Hartrick; Reginald Savage; Walter Bayes; M. DesLoovre, in Belgium. Member: SSAL; Mobile All. A. Gld.; Gulf AA; New Orleans AA; Un. Scenic A. Am.; Mobile AA. Exhibited: S.Indp.A., 1917; A. All., 1918; Delgado Mus. A., 1921; Salons of Am., 1922; SSAL, 1923; Biloxi City A. Gal., 1930; Montgomery Mus. FA, 1929; Witte Mem. Mus., 1929; Birmingham Pub. Lib., 1929; Telfair Acad., 1931; CGA, 1934; Nat. Exh. Am. A., 1936–38. Work: Brighton Mus. A., England; Montgomery Mus. FA; Dept. Interior, Wash., D.C.; Mobile Pub. Lib.; murals, Huntington Col.; churches and libraries, England [47]

DE CESARE, John [S] NYC. Member: NSS [47]

DECHANT, Miles Boyer [P,Arch,E] Reading, PA b. 10 Ja 1890, Reading. Studied: Univ. Pa.; G.W. Dawson. Member: AIA; Phila. Sketch C. Work: Reading Public Mus. A. Gal. [40]

DE CHELMINSKI, Jan V. [P] NYC b. Warsaw, Poland d. 2 N 1925 (came to U.S. in 1851) Studied: Munich. With Commandant A. Malibran he published "The Army of the Duchy of Warsaw, 1807–15," and also helped prepare other books having to do with Polish military subjects.

DECKER, Alice (Mrs. Davidson Sommers) [S] NYC/Sharon, CT b. 1 S 1901, St. Louis, MO. Studied: Bourdelle, Despiau; Robert Laurent. Member: S. Gld. [40]

DECKER, E. Bennett (Mrs.) [Min.P,I] Wash., D.C. b. 28 F 1869 Wash., D.C. d. 1936. Studied: min. painting, W.H. Whittemore. Member: Wash. AC. Work: microscopic drawings, Smithsonian, National Mus. [33]

DECKER, Harold [P] Orange, NJ. Member: S.Indp.A. [25]

DECKER, John [Por.P,L] Los Angeles, CA b. 1895, San Fran., CA. Studied: Slade Sch., London, with Walter Sickert. Member: Los Angeles AA. Exhibited: Los Angeles Mus. A., 1942–44; AIC; La Tausca Pearls Comp., 1946 (prize); de Young Mem. Mus., 1946 (one-man); VMFA, 1944 (prize). Work: Los Angeles Mus. A. [47]

DECKER, Joseph [P] b. 1853, Württemburg, Germany d. 1 Ap 1924, Brooklyn, NY. Came to the U.S. in 1867 and was apprenticed to a house painter. Later he studied at the schools of the National Academy of Design, and abroad.

DECKER, Richard [I,Car] Riverside, CT. Member: SI. Work: New Yorker, 1939 [47]

DECKER, Robert M. Brooklyn, NY b. 1847, Troy, NY. Studied: R. Swain Gifford. Member: Brooklyn AC; Soc. Brooklyn A. [01]

DE COMPS, Eugene [P] Brooklyn, NY [01]

DE CORA, Angel (Mrs. William H. Dietz) [P,Mur.P,I,T] b. 1871 Dakota County, NE d. 1919, Northampton, MA. Studied: Hampton Inst., VA; Boston. Exhibited: Paris, 1910. Work: murals, Carlisle Indian Sch. Illustrator: "Old Indian Legends", 1901. She was a Winnebago Indian. Position: T., Carlisle Indian Sch. [*]

DE CORDOBA, Mathilde [P,E] NYC b. 1871 NYC d. 1 Jy 1942, Valhalla, NY Studied: ASL, with Whittemore, Cox, Mowbray; Aman-Jean, in Paris. Member: N.Y. Women's AC; MacD. Cl.; NAWPS; Barnard C.; Gr.-Pr. of London; Cercle Intl. des Arts, Paris. Work: Luxembourg Mus.; LOC [25]

DE CORDOVA, Julian [Patron,C] b.1851, NYC d. 23 N 1945, Arlington, MA. Head of the Union Glass Works (Somerville, Mass.) until 1924. He gave his collections to the town of Lincoln, Mass.

DE CORICHE, Mireio [S] Chicago, IL [19]

DE CORINI, M. [P,E,Li,Des] NYC b. 27 O 1902, Clus, Hungary. Studied: B. Robinson; Gordon Stevenson; André Derain. Member: NAWA; Salon des Independents; Salon of Am. Work: City Mus., Budapest [47]

DE COSSY, Edwin [I] Gulfport, FL. Member: SI [47]

DECOTO, Sarah (Horner) [P] Irvington, CA. b. 12 Ag 1863, Irvington, CA. Studied: Henri Morisset, in Paris [25]

DE COUX, Janet [S] Gibsonia, PA. Member: ANA; NSS; Guggenheim F., 1938, 1939. Exhibited: Pittsburgh AA, 1936, 1940. Work: Brookgreen Gardens, S.C. [47]

DE CRANO, Felix F. [P,S] Wallingford, PA. b. France d. 15 S 1908. Studied: Paris; London; Rome; PAFA. Member: Phila. SA; Phila. AC; Phila A. Fund S. [08]

DE CREEFT, José [S,T] NYC b. 27 1884, Guadalajara, Spain. Studied: Académie Julian, Paris; Ecole des Beaux-Arts; Rodin; Landowski. Member: Artistes Français; Salon d'Automne; Société Nationale des Beaux-Arts; Salon de Tuileries; NSS; S. Gld.; Fed. Mod. P.&S. Exhibited: Académie Julian, 1906 (prize); Salon d'Automne; Salon de Tuileries; Salon des Artistes Indépendants; Société Nationale des Beaux-Arts, 1919–28; MMA, 1942 (prize); PAFA, 1945 (prize). Work: MMA; WMAA; MOMA; Wichita Mus. A.; Norton Gal. A.; Univ. Nebr.; BM; IBM; War mem., Sauges, France; two hundred pieces sculpture, Fortaleza, Puerto Pollensa, Majorca; BM. Positions: T., ASL, New Sch. Soc. Res. [47]

DE CREEFT, José, Mrs. See Carr, Alice.

DE CYANERE, Cor. [P] Santa Cruz, CA b. 25 Ja 1877, Java. Studied: Jannen; Guerin. Member: Santa Cruz AL; West Coast Arts [25]

DE DIEGO, Julio [P,Gr,Des,I,C,T] NYC b. 9 My 1900, Madrid, Spain. Studied: Madrid. Exhibited: AIC, 1929–34, 1935 (prize), 1936–43, 1944 (prize), 1945, 1946; Chicago Soc. A., 1938 (gold); Milwaukee AI, 1944; Soc. Advertisers (prize); Polish AS, (prize); major exhibitions in U.S., 1931–46. Work: Walker A. Center; Encyclopaedia Britannica Coll.; IBM; AIC; Milwaukee AI; SFMA; Santa Barbara Mus. A.; MMA; PMG; U.S. State Dept.; Montclair A. Mus. Illustrator: "Rendezvous with Spain" (1946), national magazines [47]

DEEN, Harriet Ogden [P] Staten Island, NY b. 1883, Elmira, NY. Studied: Mrs. E.D. Gardner; Mrs. E.M. Scott [06]

DE ERDELY, Francis [P,E,Gr] Pasadena, CA b. 3 My 1904, Budapest, Hungary d. 1959. Studied: Royal Acad. A., Budapest. Member: Scarab Cl.; Calif. WCS; Pasadena SA; Pasadena AI; Southern Calif. A. T. Assn.; Am. Assn. Univ. Prof. Exhibited: Budapest, 1925 (prize); Detroit AI, 1940–44 (prizes); Scarab Cl., 1942 (med), 1943 (med), 1944 (prize); Pasadena SA, 1946 (prize); PAFA, 1941; AIC, 1942–45; VMFA, 1942;

CGA, 1943; Denver A. Mus., 1945, 1946; San Fran. FAA, 1945, 1946; Pal. Leg. Honor, 1946; Laguna Beach AA, 1945; Los Angeles Mus. A., 1945, 1946; Calif. WCS, 1945, 1946; Pepsi-Cola, 1946; CI, 1946; Detroit Inst. A., 1940-44; Grand Rapids A. Gal., 1942; Los Angeles AA, 1945, 1946. Work: Detroit IA; Los Angeles Mus. A.; de Young Mem. Mus.; Pasadena AI; Denver A. Mus.; Nat. Gal. of Victoria, Melbourne, Australia; abroad. Positions: T., Univ. Southern Calif., Los Angeles, 1945- , Pasadena AI, 1945-46 [47]

DEERING, Roger (L.) [P,L,T] Portland, ME/Kennebunkport, ME b. 2 F 1904, East Waterboro, ME. Studied: Sch. F.&Appl. A., Portland; Anson Cross; G.E. Browne; Aldro Hibbard; Wayman Adams. Member: Portland SA; AAPL. Exhibited: Sweat Mem. Mus., 1926-45; WFNY, 1939; AAPL; Brick Store Mus., Kennebunkport, 1945. Work: Gorham (Maine) State T. Col.; murals, Portland, Scarboro Beach, Sanford, all in Maine [47]

DEFENBACHER, Daniel S. [Mus.Dir,W] Wayzata, MN b. 22 My 1906 Dover, OH. Studied: CI; Ind. Univ. Author: Watercolor—U.S.A." Editor: "American Watercolor and Winslow Homer," 1945, "Jades," 1944. Contributor: Magazine of Art, School Arts. Lectures: Modern Art, Museum Adminstistration. Positions: Asst. to Nat. Dir., FAP, 1936-39; Dir., Walker A. Center, Minneapolis, Minn., 1939- [47]

DE FEO, Charles [P] NYC. Member: AWCS [47]

DE FILIPPIS, August [Ldscp.P] Ridgefield, NJ b. 8 S 1906, Jersey City. Studied: Nicolai Fechin; Sigurd Skou. Member: Kit Kat AC. Exhibited: fifth annual N.J. State Exh., 1935 [40]

DE FILIPPO, Antonio [S] Woodside, NY b. 22 F 1900, Italy. Studied: BAID; Tiffany Fnd.; S., Am. Acad., Rome, 1925. Member: NSS. Work: S., mem., Winthrop Park, Brooklyn; tablet, Bryant H.S, Bronx; mem., Southampton, N.Y.; Princeton Univ. [47]

DE FOE, Ethellyn Brewer (Mrs. Louis) [Min.P] NYC b. NYC. Studied: Whittemore; Mowbray. Member: NAWPS [29]

DE FONDS, A(rdery) V. [I] Kansas City, MO b. 22 My 1858, St. Joseph, MO. Studied: Kansas City AI [24]

DE FOREST, Harriet [P] Riverside, CT b. 19 Je 1909 Milburn, NJ. Studied: Leon Kroll; André Lhote. Member: Greenwich SA [40]

DE FOREST, Julie Morrow (Mrs. Cornelius W.) [P,T] Cincinnati, OH b. NYC. Studied: Wellesley Col.; Columbia; Jonas Lie; Charles Hawthorne; John Carlson. Member: All. A. Am.; NAC; Prof. A. Cincinnati; Cincinnati Mus. Assn.; AAPL. Exhibited: CGA; PAFA; NAD; All. A. Am; NAC; WFNY, 1939; Prof. A. Cincinnati; BM; Kansas City AI; Staten Island Mus. A.; Ohio State Fair; Marie Sterner Gal. (one-man); Milch Gal. (one-man); Farnsworth Mus. (one-man); Jersey City Mus. Assn. (one-man); Loring Andrews Gal., Cincinnati (one-man). Work: Farnsworth Mus.; Wellesley; Am. Fed. Women's C. [47]

DE FOREST, Lockwood [Ldscp.P,Arch,W] Santa Barbara, CA b. 23 Je 1850, NYC d. 3 Ap 1932. Studied: Corrodi, in Rome, 1869; F.E. Church, NYC; traveled widely in Egypt, Syria, Greece, 1875-78. Member: ANA, 1891; NA, 1898; A. Fund S.; Artists Aid S.; Arch. Lg.; N.Y. Soc. C.; Boston SAC; Century Assn.; NAC; AFA; founded Associated Artists with L.C. Tiffany and Mrs. C. Wheeler, 1878. Exhibited: Indian carvings, Colonial Expo, London, 1886 (med); Columbian Expo, Chicago, 1893 (med); St. Louis Expo, 1904 (med). Founded workshops at Ahmedabad, India, in 1881, for the revival of woodcarving. Work: Smith College; Herron AI; Cleveland Mus. A.; MMA; Mus. Brooklyn Inst. A.&Sc.; BMFA; Cleveland Mus. A.; Field Mus. & AI; Mus. A., Baltimore; Lahore Mus., Lahore, India; India Mus., South Kensington, London. Published: "Indian Domestic Architecture," 1885, "Illustrations of Design," 1912 [31]

DE FOREST, Robert Weeks [Mus.Dir,Patron] b. 25 Ap 1848, New York d. 6 My 1931. Member: Am. Fed. Arts; City Art Commission of New York. In 1924, he and Mrs. de Forest gave the American Wing to the Metropolitan Museum of Art. Positions: Dir., Sec., Vice-pres., Pres., MMA, 1913-31; Pres., Russell Sage Fnd.; Chairman, Bd. Dir., Am. Fed. Arts

DE FORREST, Grace Banker [Por.P,P,I,L,T] Grosse Pointe City, MI b 5 D 1897. Studied: J.W. Gies; J.P. Wicker; F.P. Paulus. Member: Detroit S. Women PS; Grosse-Point AC; S.Indp.A., N.Y.; Detroit S.Indp.A.; Chicago AC [40]

DE FRANCESCO, Italo L. [Edu,P,L,W] Kutztown, PA b. 11 N 1901, Rome, Italy d. 1967. Studied: Univ. Pa., NYU. Member: Eastern AA; Nat. Edu. Assn.; Pa. SEA. Exhibited: Reading (Pa.) Mus.; Lehigh A. All. Author: "The Education of Teachers and Supervisors of Art," 1942. Contributor: articles on art education to magazines. Positions: Pres., Eastern Arts Assn., 1946-47; A. Dir., State T. Col., Kutztown [47]

DE FRANCHEVILLE, Andree Lenique (Mrs. Franc B.) [Por.P] NYC b. 1875, Paris, France d. 1 S 1944, Burlington, Vt. Studied: Paris. Became U.S. citizen, with studio in New York City. [21]

DE FRANCISCI, Anthony [S,T] NYC b. 13 Je 1887, Palermo, Italy d. 1964 Studied: CUASch; NAD; ASL; G.T. Brewster; Francis Jones; J.E. Fraser; A.A. Weinman. Member: ANA, 1935; NA, 1937; NSS; Am. Numismatic Soc.; Rockport AA; N.Y. Arch. Lg.; All. AA. Exhibited: Am. Numismatic Soc., 1927 (med), 1937 (med); NSS, 1932 (prize); PAFA, 1936 (med), 1938 (med); NAD, 1939 (med). Work: mem., Union Square, NYC; Am. Numismatic Soc.; MMA; CM; Mus. of French Mint, Paris; All. AA. Designer: U.S. silver dollar; U.S. Veterans' WWII discharge button; Maine Centenn. half dollar. Position: Instr., S., BAID [47]

DEFRASSE, Louise [P] San Fran., CA [10]

DE FUENTES, Ryah Ludins, Mrs. See Ludins.

DE GAVERE, Cornelia [P] Santa Cruz, CA b. 25 Ja 1877, Batavia, Java, of Dutch parents. Studied: Janssen; Guerin. Member: Santa Cruz AL; Bay Region AA; Women P. of the West; Soc. Sanity in A. Exhibited: Santa Cruz Co. Fair, 1937 (prize), 1939 (prize) [40]

DEGEN, Ida Day [S] Mill Valley, CA b. 10 O 1888, San Fran. Studied: Calif. Sch. FA; ASL; Ralph Stackpole; William Zorach. Member: San Fran. AA; NAWA; San Fran. Women Ar.; Marin SA. Exhibited: San Rafael, Calif., 1941 (prize); Oakland A. Gal., 1942 (prize), 1946 (prize); SFMA, 1942 (prize), 1941, 1942, 1943 (prize), 1944, 1945; Conn. Acad. FA, 1942; Denver A. Mus., 1941, 1943, 1945; PAFA, 1942; NAWA, 1942, 1943, 1945, 1946; Pomona, Calif., 1941; Delgado Mus. A., 1942; Oakland A. Gal., 1941, 1942, 1944, 1946; San Fran. Women Ar., 1941-46. Work: Grace Cathedral; deYoung Mem. Mus.; Pal. Leg. Honor, all in San Fran. [47]

DEGENHART, Pearl C. [P,S,T,W] Arcata, CA b. Philipsburg, MN. Studied: Univ. Mont.; Columbia; Univ. Calif; Univ. Oreg.; Univ. N.Mex.; Walter Ufer, in Taos. Exhibited: Univ. Mont., 1919 (prize); San Fran. AA, 1932, 1937, 1940; Contemporary A. Gal., 1939; Denver, Colo., 1938; Humboldt State Col., 1935, 1945. Contributor: School Arts magazine. Position: Instr., A., Arcata (Calif.) H.S., 1928-46 [47]

DE GERENDAY, Laci [S] NYC. Work: USPOs: Tell City, Ind., Aberdeen, S.D. WPA artist. [40]

DE GHIZÉ, Eleanor [P] Cockeysville, MD b. 18 N 1896, NYC. Studied: Md. Inst.; Maurice Denis, in Paris; Leon Kroll; John Sloan. Member: Baltimore AG. Exhibited: BMA, 1939 (med), annually; WFNY, 1939. Work: BMA [47]

DE GOGORZA, Maitland [Des,T,] Northampton, MA b. 1896, Asbury, NJ d. 21 Je 1941. Studied: PIASch. Specialty: commercial art. Positions: T., Pratt Inst.; Asst. Prof. A., Smith Col.

DE GOLIER, K.E. [P] NYC [10]

DE GRAFF, Stanley (Conrad) [G,P,C,T] Detroit, MI b. 21 Jy 1892, Ludington, MI. Studied: Detroit Sch. A.; Robert Godfrey; Walt Speck; Kreigh Collins. Member: Detroit Inst. A. Founders Soc.; Mich. A.; Grand Rapids Friends Am. Art. Exhibited: LOC, 1943-45; Phila. Pr. Cl., 1943, 1944; Laguna Beach A. Lg., 1943, 1944; Mus. FA, Houston, 1942, 1944; Detroit Inst. A., 1934-45; Grand Rapids A. Gal., 1933-45; Hackley A. Gal., 1935-41; Grand Rapids Pub. Lib., 1934 (one-man); A. Center Gal., Grand Rapids, 1940, 1942 (one-man). Work: Detroit Inst. A.; Hackley A. Gal.; Grand Rapids A. Gal. Position: Instr., Printmaking, A. Center Gal. Sch., 1939-43 [47]

DE GRAZIA, Ehore (Ted) [P,I,Li,Mur.P,W] Tucson, AZ b. 1909, Morenci, AZ. Studied: Univ. Ariz.; Rivera, Orozco, in Mexico, ca. 1942. Author: "De Grazia Paints the Yaqui Easter," "De Grazia and His Mountain" [*]

DE GROOT, Adelaide [P] NYC. Exhibited: Valentine Gal., 1937; PAFA, 1939 [40]

DE GROOT, Adriaan M(artin) [Por.P] Woodcliff, NJ b. 10 Ag 1870, Sliedrecht, Holland. Studied: France; Holland; Germany. Member: S.Indp.A.; Salons of Am. Work: Union Lg., Phila.; Roosevelt Savings Bank, Brooklyn, N.Y. [25]

DE GROOT, John [P] Richmond, VA. Exhibited: Soc. Wash. Ar., 1937; WFNY, 1939. Exhibited: USPO, Christiansburg, Va. WPA artist. [40]

DE HAAFF, M. [P] Los Angeles, CA. Member: Calif. AC [25]

DE HAAS, Alice Preble Tucker (Mrs. William Carpender) [Min.P,Mar.P] NYC/East Gloucester, MA b. Boston. Studied: M.F.H. De Haas; Chase; R. Swain Gifford. Member: NYWCC; SPNY; NAWPS; MacD. Cl. Exhibited: NAWPS, 1912 (prize) [19]

DE HAAS, M(auritz) F(rederik) H(endrik) [Mar.P] b. 1832, Rotterdam, Holland (came to NYC in 1859) d. N 1895, NYC. Studied: Rotterdam: The Hague. Exhibited: Boston Athenaeum; NAD; Md. Hist. Soc.; Paris Expo, 1878. He painted naval scenes for Admiral Farragut during the Civil War. Brother of W.F. De Haas. [*]

DE HAAS, William Frederick [Mar.P] b. 1830, Rotterdam, Holland (came to NYC in 1854) d. 16 Jy 1880, Fayal, Azores. Exhibited: NAD, after 1865. Brother of M.F.H. De Haas. [*]

D'HARNONCOURT, Rene [Mus.Cur,L,W] NYC b. 17 My 1901, Vienna, Austria. Studied: Univ. Graz, Austria. Member: Bd. member, AFA; Bd. Dir. member, Inst. Des., Chicago. Author: "Mexicana." Co-author: "Indian Art of the United States," pub. MOMA. Co-author/Illustrator: "The Painted Pig," 1930. Co-editor: "Arts of the South Seas," pub. MOMA. Contributor: Magazine of Art. Position: Cur., MOMA [47]

DE HAVEN, Elizabeth [P] NYC [25]

DE HAVEN, Franklin [Ldscp.P] NYC b. 26 D 1856, Bluffton, IN d. 10 Ja 1934. Studied: George H. Smillie, in New York, 1886. Member: ANA, 1902; NA, 1920; SC, 1899 (Pres., 1926–27); NAC; All. AA. Exhibited: SC, 1900 (prize), 1901 (prize), 1925 (prize); Pan-Am. Expo, Buffalo, 1901 (prize); Charleston Expo, 1903 (med); St. Louis Expo, 1904 (med); NAC, 1921 (med,prize); All. AA, 1930 (gold). Work: Brooklyn Inst. Mus.; NGA; Butler AI. Familiarly known as "Pop" to the members of the Salmagundi Club, he was also a musician and maker of violins. [31]

DE HELLEBRANTH, Bertha [S,P] Ventnor, NJ b. Budapest, Hungary. Studied: Budapest Acad. FA, with Stephen Csoka; Académie Julian, Grande Chaumière, Paris. Member: Hungarian AA; CAA; Assoc. A. N.J.; Audubon A. Exhibited: Budapest, 1932, 1938; AAPL, 1938; Montclair A. Mus., 1941; Audubon A., 1946 (med); Nat. Salon, Budapest, 1928; Stockholm Konsthall, 1928; BM, 1929; NGA, 1935; MMA, 1942; PAFA, 1941, 1942, 1946; AIC, 1944; Springfield (Mass.) A. Mus.; Goucher Col.; Dallas Mus. FA; Marie Sterner Gal. Work: BM; Fordham Univ.; Scranton Univ. [47]

DE HELLEBRANTH, Elena [P,T,Cr,L,W] Ventnor, NJ b. 9 N 1910, Budapest, Hungary. Studied: Acad. FA, Budapest; Grande Chaumière, Paris; Académie Julian, Paris, with Laurent; Stephen Csok. Member: AFA; AAPL; CAA; Hungarian AA. Exhibited: Budapest, 1930, 1936, 1938; Audubon A., 1946; AFA, 1930; WMA, 1936; Springfield A. Mus., 1934; BM, 1933; Silberman Gal., 1937; PAFA, 1940; Grand Rapids A. Gal., 1940; NAD, 1942, 1944; All.A.Am., 1944, 1945; AIC, 1941, 1942; Montclair A. Mus., 1942, 1943; N.J. State Mus., 1942; Marie Sterner Gal., 1932; U.S. Nat. Mus., Wash., D.C., 1935. Work: BM; Scranton Univ.; Hungarian Legation, Wash., D.C. [47]

DEHN, Adolf Arthur [P,Li,I] NYC b. 22 N 1895, Waterville, MN d. 1968. Studied: Minneapolis Sch. A., 1914–17; ASL, 1917–18. Member: ANA; An Am. Group; F.; Guggenheim Fnd.; Am. A. Cong.; Am. Soc. PS&G. Exhibited: Phila. A. All., 1933 (prize), 1936 (prize); AIC, 1943 (prize); Phila. Pr. Cl., 1939 (prize); LOC, 1946 (prize); MMA; MOMA; NYPL; BM; AIC BMFA; CMA; WMAA. Work: MMA; MOMA; WMAA; NYPL; BM; AIC; BMFA; CMA; Minneapolis Inst. A.; CAM; U.S. Navy; Standard Oil Co.; Newark Mus. A.; AGAA; Seattle AM; Milwaukee AI; San Fran. Mus. A.; Nat. Mus., Oslo, Norway; Brit. Mus.; Kupferstich Kabinett, Berlin; The Albertina, Vienna; Honolulu Acad. FA; Fifty Prints of the Year, 1929–36. Author: "Watercolor Painting," 1945. Contributor: illus., Life, 1941 [47]

DEHNER, Dorothy [P,W,Des] Bolton Landing, NY b. 23 D 1913, Cleveland, OH. Studied: UCLA; ASL; Miller; Jan Matulka; B. Robinson. Exhibited: Audubon A., 1945; SFMA, 1944; Albany Inst. Hist.&A.; Butler AI. Contributor: Architectural Forum. Wife of sculptor David Smith [47]

DEHNER, Walt [P,Ldscp.P,T] Whitehouse, OH b. 13 Ag 1898, Buffalo, NY. Studied: ASL; Woodstock; PAFA. Position: Dir. A., Univ. Porto Rico, Rio Piedras [40]

DE HOSPODAR, Stephen [B,P] Los Angeles. b. 3 Ja 1902, Nagy Mihaly, Hungary. Studied: Robert Henri; George Bellows; Charles W. Hawthorne; NAD. Work: Fogg AM; BMFA; Pub. Lib.; Springfield, Mass.; Pub. Lib., Newark N.J.; Syracuse Univ.; NYPL; Dallas Mus. FA; FA Gal., San Diego; San Diego Pub. Lib.; Los Angeles Pub. Lib. UCLA Mus. A. [40]

DEICHLER, J.W. [P] Lancaster, PA [17]

DEIGENDESCH, Herman F(rederick) [P,E,T] Phila., PA/Southampton, PA b. 13 Jy 1858, Phila. d. 9 My 1921. Studied: Munich Acad. Member: Phila. SE. Position: Instr., PMSchIA [19]

DEIKE, Clara L. [P,W,L] Lakewood, OH. Studied: Hans Hofmann, in Munich; Diego Rivera, in Mexico; Cleveland Sch. A.; Europe; F.C. Gottwald; Henry G. Keller; Hugh Breckenridge. Member: Cleveland FA Assn; Cleveland Women's AC. Exhibited: CMA, 1918–21, 1922 (prize), 1923 (prize), 1924, 1925 (prize), 1926 (prize), 1927 (prize), 1928 (prize), 1929–39, 1940 (prize), 1941–46; Halle Bros., Cleveland, 1928 (prize); Great Lakes Exh., 1937; Wash. AC, 1924; Ohio WC Soc.; Dayton AI, 1931; YWCA, Boston, 1943. Work: CMA. Contributor: Design magazine, 1937 [47]

DEINES, E(rnest) Hubert [En,Book Des,G,I] Kansas City, MO b. Mr 1894, Russell, KS d. 1967. Studied: Kansas City AI; Académie Julian, Paris. Member: ANA; SC; Audubon A.; Prairie Pr.M.; Northwest Pr.M.; Woodcut Soc.; Soc. Pr. Connoisseurs; AAPL; AFA. Exhibited: Dallas Mus. FA, 1936; CAM; Phila. Pr. Cl.; Northwest Pr.M.; LOC, 1943 (prize), 1946 (prize); Kansas City Pub. Lib.; Kansas City AI; Kansas City SA; Women's City Cl., Kansas City (one-man); principal mus. in the U.S. and abroad. Work: State Hist. Soc., Mo.; Kans. State Hist. Soc.; Kansas City Pub. Lib.; William Rockhill Nelson Gal. A.; Cleveland Pr.M.; PMA; Vanderpoel Coll.; LOC; Phila. Pr. Cl.; Northwest Pr.M.; Albany Inst. Hist.&A.; Univ. Glasgow, Scotland. Specialty: Book, typographical des. [47]

DEININGER, Ralph [P] NYC. Member: GFLA [25]

DEITCH, Harry [P] Phila., PA. Exhibited: PAFA, 1936, 1938; AIC, 1939 [40]

DE IVANOWSKY, Sigismund [P,I,Arch,W] Westfield, NJ b. 17 Ap 1874, Poland. Studied: Petrograd Acad.; Constant, Laurens, Cormon, in Paris. Member: Petrograd Acad.; SI. Exhibited: Petrograd Acad. (gold); Société des Artistes, Paris, (med). Work: portraits, Persian Colony, Haifa (Palestine), Curtis Inst., Phila. Did series of heroines of stage and fiction for Century Magazine. Illustrator: Ladies' Home Journal [40]

DE JOINER, L(uther) E(vans) [P] Santa Cruz, CA b. 9 O 1886, Sweitzer, KY. Studied: Hopkins AI; F. Currier; A.H. Gilbert; O. De Joiner. Member: AAPL; Soc. for Sanity in Art; Carmel AA; Santa Cruz A. Lg. Exhibited: Sacramento; Santa Cruz; San Fran., Oakland; Los Angeles. Specialty: Calif. landscapes [47]

DE JONG, Betty [P] San Fran., CA b. 1886, Paris, France d. 19 Ja 1917. Studied: Académie Julian, Paris. Member: Salon d'Automne; San Fran. SA. Exhibited: P.-P. Expo, San Fran., 1915 (prize) [15]

DE KAY, Charles b. 25 Jy 1848, Wash., D.C. d. 23 My 1935, NYC. Founder of the National Sculpture Soc., (1892) and the National Arts Club (1899). He invited Stieglitz to organize the first exhibition of the Photo Secession at the NAC in March 1902.

DE KAY, Helena. See Gilder.

DE KLYN, Charles F. [P] Cleveland, OH. Member: Cleveland SA [25]

DE KOSENKO, Stepan [S,Des] NYC b. 1865, Tiflis, Russia d. 24 Je 1932, Brewster, NY. Studied: Ecole des Arts Decoratives, Paris; Munich. Member: SC; NSS; MacD. Cl.; N.Y. Arch. Lg. He came to the U.S. in 1897 on a commission to design the bronze doors of a public building in Philadelphia and remained. He designed the grills, lighting fixtures and bronze doors of the NYPL, Grand Central Terminal, and New York Life Insurance Building in NYC. [33]

DE KRAFFT, Marjorie. See Burton.

DE KRUIF, Henry Gilbert [P,E,Li,W] Los Angeles, CA b. 17 F 1882, Grand Rapids, MI d. 6 Jy 1944. Studied: Gifford Beal; F. Luis Mora; Frederick Richardson; DuMond; Vanderpoel; Ernest Haskel; S. McDonald Wright. Member: Calif. AC; Laguna Beach AA; ASL; Calif. PM; Calif. SE; Calif. WCS; Chicago Soc. E.; Metal Platers, Los Angeles. Exhibited: Los Angeles Co. Fair, 1923 (prize); Southern Calif. PS, Los Angeles Mus., 1925 (prize); Pan-Am. Exh. Paintings, 1926 (prize); Orange Co. Fair, 1926 (prize); Calif. PM, Los Angeles Mus., 1936 (med). Work: Los Angeles Mus.; Los Angeles Pub. Lib.; FA Gal., San Diego; Blanden Mem. A. GAl., Fort Dodge, Ia.; John H. Vanderpoel AA; LOC [40]

DE KRYZANOVSKY, Roman [P] Detroit, MI b. 22 Ja 1885, Balta, Russia. Studied: E. Renard; E. Tournes; P. Gorquet. Member: Scarab Cl., Detroit. Exhibited: Detroit Inst. A., 1915 (prize), 1918 (prize) (prize), 1919 (prize), 1920 (prize), 1921 (prize). Work: Detroit Inst. A.; Detroit Pub. Lib.; State of Mich. Coll. [24]

DE LACY, Eva [P] NYC. Member: S.Indp.A [25]

DE LAGERBERG, Lucy. See Wallace.

DE LA HARPE, Joseph [P] b. ca. 1850, Switzerland d. 11 F 1901, Brooklyn, NY. He came to the U.S. when a boy and settled in Salt Lake City. He made sketches and paintings for Brigham Young, took up the work of scene painting, and painted scenery for forty-seven theatres, twenty-four of which

were in New York and Brooklyn. Among his first patrons was Augustin Daly.

DE LAITTRE, Eleanor (Mrs. Brown) [P,C,Des,I] NYC b. 3 Ap 1911, Minneapolis, MN. Studied: BMFA Sch.; George Luks; John Sloan. Member: Am. Abstract A. Exhibited: Am. Abstract A., 1940–46; GGE, 1939; WFNY, 1939; AIC, 1937–41; Minneapolis Inst. A., 1934–36; Buntman Gal., Chicago, 1938 (one-man); Contemporary A. Gal., 1939 (one-man); Puma A. Gal., 1943 (one-man) [47]

DE LA MOREUX, Dwight [S] b. 1841 d. D 1917, Chicago. He was a veteran of the Civil War.

DE LAMOTTE, Caroline J(ones) (Mrs. Octave John) [P,T] McNary, AZ b. 3 S 1889, Pikesville, MD. Studied: C.Y. Turner; Ephraim Keyser; Charles H. Webb. Exhibited: La. State Fair, Shreveport, 1917 (prizes); Donaldsonville, La., 1917 (prizes). Work: Meth. Epis. Church, Le Compte, La. [29]

DE LAND, Clyde Osmer [I,P,L] Phila., PA b. 27 D 1872, Union City, PA d. 27 Mr 1947. Studied: Drexel Inst., with Howard Pyle. Work: City of Somerville, Mass.; Carpenters' Hall, Phila.; Nat. Mus., Wash., D.C. Illustrator: "The Count's Snuffbox." Illus. Lecture: The Drama of American History [40]

DE LAND, Eugenie [P] Wash., D.C. [01]

DELANEY, Joseph [P] NYC b. 13 S 1904, Knoxville, TN. Studied: ASL, with George Bridgman, Thomas H. Benton, Alexander Brook. Member: Soc.Indp.A.; A.Lg.Am.; F., Rosenwald. Exhibited: Atlanta Univ., 1946 (prize); Village A. Center, 1944 (prize); NAD, 1944, 1945; MMA; BM. Work: Atlanta Univ. [47]

DELANO, Annita [P,Des,L,T] Los Angeles, CA b. 2 O 1894, Hueneme, CA. Studied: UCLA; Barnes Fnd. Member: Calif. WC Soc.; Calif. AC; Archaeological Inst. Southern Calif.; Am. Assn. Univ. Prof. Exhibited: Los Angeles Mus. A., 1925 (prize); MMA, 1942; Calif. WC Soc.; Fnd. Western A.; Riverside Mus. Work: Los Angeles Mus. A.; Am. Lib. Color Slides. Positions: Instr., A., UCLA, 1918– , Otis AI, 1944–46 [47]

DELANO, Elizabeth T. [P] Fairhaven, MA [24]

DELANO, Gerard Curtis [P] Denver, CO (1968) b. 1890, Marion, MA. Studied: New Bedford, Mass.; ASL, with Bridgman; Grand Central Sch. A., with Cornwell, Dunn, N.C. Wyeth. Member: Cowboy Artists Am. Illustrator: Western Story Magazine, 1937. Illustrator in NYC before WWI. Moved to Colo. in 1920, but it was not until 1933 that he settled there permanently. [*]

DELANY, Inez Livingston [P] Phila., PA [19]

DE LAPPE, Phyllis [P,G] Wash., D.C. b. San Fran. Studied: Calif. Sch. FA; ASL; Arnold Blanch. Exhibited: AIC, 1939; WFNY, 1939; Bookshop Gal., Wash., D.C., 1940 (one-man) [40]

DE LAUNAY, Paul [P,S,T,L] Birmingham, AL b. 19 O 1883, Paris. Studied: Laurens; Constant; Gérôme; Bonnât; Frémiet; David. Member: Am. Ar. Prof. Lg. Position: Dir., Acad. FA, Birmingham [40]

DE LAURIER, Thomas G. [P] Hoboken, NJ b. 1872 d. 31 O 1934. An artist on the New York Journal, he had been with the Hearst Publications since 1896. When color printing came into use he became an expert at Benday work, then the only method for making color plates. [15]

DELAVIGNE, Marie [P] New Orleans, LA [19]

DE LAY, Harold S. [P,I] Chicago, IL [10]

DELBOS, C. Edmund [P] Grosse Pointe, MI. Exhibited: Detroit Inst. A., 1936 (prize) [40]

DELBOS, Julius [P,E,L] NYC b. 22 Jy 1879, London, England. Member: AWCS; NYWCC; Soc. Graphic A.; Old Dudley Art Soc., London; AAPL; NAC. Exhibited: NYWCC, 1935 (prize); ANA; NAC; Conn. Acad. FA. Work: Butler AI; Toledo Mus. A.; BM; Yale [47]

DELBRIDGE, Thomas James [P,Des,Et,C,T] NYC/Atlanta, GA b. 16 S 1894, Atlanta. Studied: Hawthorne; Bellows, Henri; NAD; ASL; Grand Central Sch. A.; Georgia Sch. Tech.; Cape Cod Sch. A. Member: All.A.Am.; Nat. All. A.&Indst.; NAC; F., Tiffany Fnd. Exhibited: NAC, 1928 (prize);Southeastern States Exh., (prize); BM; Montclair A. Mus.; CGA; Mus. FA, Houston; Charleston Mus. A.; New Orleans Mus. A.; High Mus. A.; PAFA; AIC. Illustrator: "Practical Book of Tapestries," by George Leland Hunter, pub. Lippincott, 1923 [47]

DEL CASTILLO, (Mary) Virginia (Mrs. Johnston) [P] San Fran. b. 16 Ag 1865, Cuba. Studied: N.Y. Sch. A., with Henri. Work: Capitol lib., Jackson, Miss. [47]

DELE, Coeuillerie Henry [P] Brooklyn, NY [15]

DE LEEUW, Cateau [I,W,P,En,L] Plainfield, NJ b. 22 S 1903, Hamilton, OH. Studied: Metropolitan A. Sch.; ASL; Grande Chaumière, Paris. Member: PBC; Plainfield AA; AAPL. Exhibited: PBC, 1934 (prize); N.J. Gal., 1934 (prize), 1939 (prize);AWCS, 1931; NAWA, 1933, 1934; Montclair A. Mus., 1933, 1934, 1944; New Britain Inst., 1930 (one-man); N.J. Col. for Women, 1938, 1942 (one-man). Author: "The Dutch East Indies and the Philippines," 1943. Illustrator: "Gay Design," 1942; "Linda Marsh," 1943, "Future for Sale, 1946," and others. Contributor: travel and children's magazines. Lectures: Art of Batik; Women in Art; Dutch Masters of the XVII Century 47]

DE LEMOS, Pedro J. [W,I,Et,Des,P,C,L,T] Palo Alto, CA b. 25 My 1882, Austin, NV. Studied: Arthur Mathews; George Bridgman; Arthur Dow; H.S. Fonda; San Fran. Inst. A. Member: Calif. SE; Carmel AA; F., Royal Soc. Art, London. Exhibited: P.-P. Exh., San Fran., 1915 (prize); Calif. State Fair, 1916 (gold). Work: State Lib., Sacramento; City Lib., Monterey. Author: "Applied Art," "Artists Scrap Book," "Block Printing," "Oriental Decorative Designs," other books on design. Positions: Ed., School Arts Magazine; Dir., Stanford Univ. Mus. FA [47]

DE LESLIE, Alexander [P,I,T,W] NYC b. 14 D 1894, Moscow, Russia. Studied: ASL, with Bridgman, Taylor; NAD, with Maynard. Member: GFLA. Illustrator: "How France Built Her Cathedrals," pub. Harpers, "A Childhood in Brittany," pub. Century. Illustrator: Collier's, other magazines. Position: A. Instr., Mechanics Inst., NYC; Acad. Listed as Paul de Leslie in 1925. [47]

DELEVANTE, Sidney [P,T] NYC. Studied: George Luks; Robert Henri; George Bellows. Position: Instr., Cooper Union Sch. A. [40]

DELGADO, O. [P] Porto Rico. Member: S.Indp.A. [24]

D'ELIA, Teresa Ilda [P,S,Gr,I] Greenwich, CT b. 18 N 1918, Greenwich, CT. Studied: ASL; New Sch. Soc. Res..; Simkovitch; Charlot; Picken; Sternberg. Member: Springfield A. Lg. Exhibited: San Fran. AA, 1943 (med); Dougals Aircraft Exh., 1943 (prize); Springfield A. Lg., 1945 (prize), 1946 (prize); PAFA, 1942; AAPL, 1942; SFMA, 1943; Northwest Pr.M.; 1943; Phila. Pr. Cl, 1945; Los Angeles Mus. A., 1945; Springfield A. Lg., 1945, 1946; Greenwich SA, 1945; Pal. Leg. Honor, 1946 [47]

DE LIGNEMARE, Walter [Des,W] b. 1889, France (came to NYC in 1916) d. 11 F 1932, Los Angeles. Studied: Paris. Designer: original sets and costumes for "Abie's Irish Rose." Specialty: stage design

DE LIMON DE ARECIBO, A. (Mrs.) [P] Arecibo, Porto Rico. Member: S.Indp.A. [25]

DELK, Edward Buehler [P] Kansas City, MO [24]

DELLARIPA, Filomena Joan [P,I,T] Phila., PA b. 16 F 1922, Phila. Studied: Moore Inst. A.S.&Indst.; PAFA; Barnes Fnd. Member: Plastic Cl.; Phila. WCC. Exhibited: Graphic Sketch Cl., 1940 (prize); PAFA, 1944, 1945 (one-man); DaVinci All., 1943; Phila. A. All., 1943; Graphic Sketch Cl., 1944. Positions: Instr., A., Graphic Sketch Cl., 1943– ; Illus., Philadelphia Inquirer, 1944– [47]

DELLEANEY, Greta [E] NYC. Member: Calif. PM [25]

DELLENBAUGH, F(rederick) S(amuel) [P,W,Arch] NYC/Cragsmoor, NY b. 13 S 1854, McConnelsville, OH d. 29 Ja 1935. Studied: Académie Julian, Paris, with Carolus-Duran; Munich. Exhibited: Columbian Expo, Chicago, 1893. In 1871 he joined the first exploration through the Grand Canyon and the expedition, lasting three years, furnished the theme for much of his work. He was one of the organizers of the Explorers Club and was a member of the Salmagundi Club (1888), MacDowell Club, Century Association, American Scenic and Historic Preservation Society, Authors Club, and John Burroughs Memorial Association, from which in 1932 he received the Association medal for his book "A Canyon Voyage." Author: "North Americans of Yesterday," "Romance of the Colorado River," "Canyon and Desert," "The Escalante Diary," "John Wesley Powell," and others. Work: FSD Archive, Univ. Ariz. Lib.; Mus. Am. Indian, NYC. Mt. Dellenbaugh was named after him. [13]

DELLENEY, Marie [P] Denton, TX. Exhibited: Golden Jubilee Exh., Dallas, 1938; Midwestern Ar., Kansas City AI, 1938–39; WFNY, 1939. Work: Houston MFA [40]

DELLFANT, Max [Mar.P,S] New Haven, CT b. 1867, Stuttgart, Germany (came to U.S. in 1889) d. 26 Ja 1944. Studied: NAD; Yale, 1901–02; St. Louis, 1903. Member: New Haven PCC. Exhibited: NAD, 1907; New Haven PCC 1916–42. Work: Yale. Became a citizen of the U.S., 1892. He was a sailor, having been at sea from the age of fifteen to the age of twenty-four. [25]

DELMAN, Elias Ben [P] Bronx, NY b. 15 S 1898, Palestine. Studied: Hawthorne; B. Shatz, in Palestine. Member: Artists U. Work: Central Community House, New York; Erasmus Hall, Brooklyn, N.Y.; Brooklyn Col. [40]

DEL MAR, Frances [P,L,W,E] NYC/Greenwich, CT b. Wash., D.C. Studied: Univ. Col., Rolshoven, in London; Sorbonne, Académie Julian, Collin, Robert-Fleury, in Paris. Member: SSAL; PBC; MacD. Cl. Exhibited: Paris Salon; Nat. Soc. Brit. A.; WFNY, 1939; U.S. Work: Bruce Mus., Greenwich, Conn.; Am. Mus. Nat. Hist. Author: "A Year Among the Maoris." Contributor: The International Studio; Asia magazines. Lectures: Polynesian Art [47]

DEL MAR, Dorothy. See Ochtman.

DEL MUE, M(aurice August) [P,Des,T] Forest Knolls, CA b. 24 N 1875, Paris, France. d. 1955. Member: San Fran. AA. Exhibited: P.-P. Expo., San Fran., 1915 (med); Sacramento State Fair, 1934 (prize). Work: Comparative Mus. Art; Golden Gate Park Mus.; Walters Coll., San Fran.; murals, Hamilton Field Air Base. W.P.A. artist. [40]

DE LONGPRE, Paul [P] Los Angeles, CA b. 18 Ap 1855, Lyons, France (came to U.S. in 1890) d. 29 Je 1911. Studied: self-taught. At twelve years of age, he was in Paris painting flowers on fans and at twenty-one his first oil painting was accepted at the Salon. In 1896, he gave his first exhibition in New York, which consisted entirely of floral subjects. In 1899 de Longpré went to California, where the acres of flowers about his home made it one of the conspicuous places near Los Angeles. [10]

DELOOEGNE, Marie [P] New Orleans, LA [15]

DE LORENZO, Fred [S] NYC. Work: USPO, Meyersdale, Pa. WPA artist. [40]

DEL PIATTA, Begni [S] NYC d. 21 D 1939 [25]

DEL PINO, José Moya [Por.P,Mur.P,Ldscp.P,T] San Fran., CA/Ross, CA b. 3 Mr 1891, Cordoba, Spain d. 1959. Studied: Acad. FA, Madrid; Acad. Colarossi, Paris; London. Member: San Fran. AA; Nat. Soc. Mural P.; Fnd. Western A. Exhibited: Granada, Spain, 1910 (med); Madrid, 1912 (med); FA Circle, Barcelona, 1922 (prize); State Ann. Exh., Sacramento, 1933 (prize), 1937 (prize); San Fran. AA, 1935 (prize); GGE, 1939. Work: Art Circle, Barcelona; BM; Pal. Leg. Honor; San Fran. MA; murals, Merchants Exchange Club, Cereal Products Co., both in San Fran.; USPOs, Stockton, Redwood City, both in Calif.; Alpine, Tex. Illustrator: books by Spanish authors. Lectures: "Velásquez." WPA artist. [40]

DEL PRADO, Marina Nuñez [S] La Paz, Bolivia b. La Paz. Studied: FA Acad., La Paz. Member: NAWA. Exhibited: Bolivia, 1930 (med); Venezuela, 1934; Argentina, 1936; Berlin, 1938; Latin-Am. F., Am. Assn. Univ. Women, 1940; NAWA, 1946 (prize); Norfolk Mus. A., 1942 (one-man); Louisville A. Center, 1942; SFMA, 1942; Zanesville (Ohio) AI, 1943; Assoc. Am. A. Work: La Paz; Nat. Mus. FA, Buenos Aires; IBM; many portrait busts of government officials [47]

DELSON, Robert [Des,Edu,P,I,C,W,L] Tallahassee, FL b. 30 D 1909, Chicago, IL. Studied: AIC; Am. Acad A.; W.F. Welsh; O Gross; R.L. Minkus; Hans von Schroetter. Member: Arch. Lg.; Am. Edu. Assn.; Artists Union, Chicago. Exhibited: Arch. Lg., 1938; AIC, 1931–33, 1939. Work: Brookfield (Ill.) Zoo. Illustrator: American Guide series. Positions: Commissioner of Art on Chicago Commission for Century of Progress Expo, 1933; Dir., Fla. Des. Acad., Tallahassee [47]

DE LUCE, Olive S(usanna) [P,T,L] Maryville, MO b. 27 Jy 1894, Owego, NY. Studied: NAD, with Percival De Luce; W. Dow; Columbia; André Lhote, in Paris. Member: AAPL; SSAL; Kansas City Soc. Ar.; Northwestern Mo. Assn. Ar.; Col. AA; Western AA; Col. T. FA of Mo.; AFA. Work: Maryville Art Center. Lectures: Modern French Art. Position: Chm. Dept. F.&Indust. Arts, State T. Col., Maryville [40]

DE LUCE, percival [P,I] NYC b. 26 F 1847, NYC d. 21 F 1914. Studied: Antwerp Acad., with Portaels, in Brussels; Bonnât, in Paris. Member: ANA, 1897; AWCS; SC, 1902; A. Fund S. Exhibited: S.C. Interstate Expo (med). Work: Indianapolis AA [13]

DE LUE, Donald [S] NYC b. 5 O 1900, Boston. Studied: BMFA Sch. Member: ANA; NSS; Nat. Inst. A.&Let.; F., Guggenheim. Exhibited: Arch. Lg., 1942 (prize); NSS, 1942 (prize) 1946 (prize); Nat. Inst. A.&Let., 1945. Work: Court House, Phila., Univ. Pa. WPA artist. [47]

DE LUNA, Francis P. [S] NYC b. 6 O 1891, NYC. Studied: NAD; BAID; CUASch; H. McNeil; J. Gregory. Member: NSS; Arch. Lg. Position: T., Modeling, NYU [47]

DE LUZE, Grace Schuyler [Cer] d. 8 Ag 1924, NYC. Member: Bd. Dir., Art All. Am.

DE MAINE, Harry [P,Des,B] NYC/East Gloucester, MA b. 23 D 1880, Liverpool, England. Studied: Castellucho, in Paris; F.V. Burridge, in London. Member: SC; AWCS; Audubon A.; North Shore AA; NYWCC. Exhibited: SC, 1934 (prize), 1939 (prize); AWCS, 1940 (prize); NAD; Audubon A. [47]

DE MANCE, Henri [P] Clinton Hollow, NY b. 5 O 1871, Hamburg, Germany d. 3 O 1948. Studied: Hamburg AI; Munich, with von Lenbach; Henri. Member: SC; AFA. Exhibited: PAFA, 1925; Salons of Am., 1925; NAD, 1910, 1925, 1934; Boston AC, 1908; All.A.Am., 1936. Work: Schiller Mus., Marbach [47]

DE MAR, John L. [I,Car] Penfield, PA b. 22 S 1865, Phila. d. 5 S 1926. Position: Car., Philadelphia Record, 1903– [25]

DE MARCO, Jean [S,C,En,T] NYC b. 2 My 1898, Paris, France. Studied: Ecole Nationale des Arts Decoratifs, with Antoine Bourdelle, in Paris. Member: S. Gld.,; Arch. Lg. Exhibited: New Rochelle AA, 1940 (med); NSS, 1945 (prize); PAFA, 1938, 1940, 1942–46; AIC, 1938, 1941–43; NAD, 1942, 1944, 1945; WFNY, 1939; Fairmount Park AA, Phila., 1940; MMA, 1942; S. Gld., annually; Marie Sterner Gal., 1936 (one-man); Boyer Gal., 1940 (one-man); Buchholz Gal., 1941, 1943, 1945. Work: Whitemarsh Park, Prospectville, Pa.; War Dept Bldg., Wash. D.C.; USPOs, Weldon, NC., Danville, Pa. WPA artist. Position: Instr., S., Bennett Jr. Col., Milbrook, N.Y. [47]

DE MARE, George [Por.P] Chicago, IL b. 29 Ag 1863, Bagni di Lucca, Italy d. 8 My 1907, Kansas City (killed in a fire). Studied: Ecole des Beaux-Arts, Académie Julian, Paris. Member: Chicago SA; Municipal Art Lg., Chicago. Grandson of the painter G.P.A. Healy. [06]

DEMAREST, Eda Lord (Mrs. Benjamin G.) [S] NYC/Newtown, CT b. 20 Mr 1881, Blue Earth, MN Studied: G. Lober; A. Finta; Lu Duble; Archipenko. Member: NAWPS; AAPL. Exhibited: N.J. State Exh., Montclair AA, 1932 (prize); N.J. Chap., AAPL, Montclair, 1933 (prize). Work: Ina D. Russell Lib., Georgia Col. for Women, Milledgeville; Iowa State Col., Ames [40]

DE MARIS, Walter [P,I] New Rochelle, NY b. 24 Ag 1877, Cedarville, NJ d. 30 Ja 1947. Studied: ASL. Member: AAPL. Work: Saturday Evening Post, other publications [33]

DE MARTELLY, John Stockton [P,I,Car,E,En,Li,T,W] NYC b. 10 S 1903, Phila., PA. Studied: PAFA, with Garber, Spencer, Breckenridge; Florence, Italy; Royal Col. A., England; Carles; Grafly; McCarter; Austin; Malcolm Osborne; Thomas Hart Benton. Member: Am. A. Cong. Exhibited: Midwest A. Annual, 1937 (prize); Phila. Pr. Cl., 1938 (prize), 1939 (prize); Okla. A. Center, 1940 (prize). Work: Victoria & Albert Mus., London. Cartoonist (political)/Illustrator: Democracy Publishing Co. Positions: Instr., Graphic A., Kansas City AI; Mich. State Col., East Lansing (1944) [47]

DE MARTINI, Joseph [P] NYC b. 20 Jy 1896, Mobile, AL. Member: Audubon A.; Am. A. Cong. Exhibited: Pepsi-Cola, 1944 (prize); MOMA, 1941–43; CI, 1941, 1943, 1944, 1946; WMAA, 1934, 1942–45; CGA, 1941, 1943, 1945; CAM, 1938, 1941, 1942, 1946; PAFA, 1940, 1942–45; AIC, 1941, 1942; WFNY, 1939; WMA, 1945; deYoung Mem. Mus., 1941, 1943; PMG, 1942, 1943; Critics Choice, NYC, 1945; VMFA, 1942, 1944, 1946; Colorado Springs FA Center, 1942; BM, 1943; John Herron AI, 1945; Nebr. AA, 1945, 1946. Work: PMG; AGAA; CAM; BMFA; MOMA; MMA; Brooks Mem. Mus., Memphis; Univ. Ariz.; Walker A. Center; Rochester Mem. Mus.; Farnsworth Mus., Wellesley, Mass.; Wichita A. Mus.; New Britain Inst.; Canajoharie A. Gal; State Dept., Wash. D.C.; Pepsi-Cola Coll.; IBM; Nebr. AA; Phillips Mem. Gal., Wash., D.C. [47]

DE MELERO, Elviro M. [P] Havana, Cuba [25]

DE MEO, Victor Anthony [S,Photogr] Yonkers, NY b. 1882, Italy d. 18 My 1947. Studied: Rome Conservatory. He helped J.E. Fraser make death masks of Theodore Roosevelt and Thomas Alva Edison.

DE MERLIER, Franz [P,Mur.P,T,W,L,Li] Marshallton, Pa. b. 28 O 1878, Ghent, Belgium. Studied: Belgium. Member: Wilmington SFA; Chester County AA; Del. Soc. FA. Exhibited: West Chester, Pa., 1937 (prize), 1940 (prize), 1944 (prize) A. Acad., Bruges, Belgium, 1894 (prize); Acad. Ghent, 1895 (prize); Brussels, 1890 (prize); Wilmington SFA, 1935 (prize), 1937 (prize), 1938 (prize); Chester County A. Assn. (prize). Work: West Chester A. Center; Wilmington Soc. FA; West Chester Lib.; Cheney State T. Col.; Reading YMCA. West Allegheny Theatre, Phila.; Lititz (Pa.) Theatre. Contributor: art reviews, magazines. Position: Instr., Bryn Mawr Art Center [47]

DEMETRIOS, George [S,T] Gloucester, MA b. 1 Ap 1896, Greece d. 1974. Studied: Grafly; Antoine Bourdelle. Member: NSS; Boston Soc. Indp. A.; Assoc. Nat. S. Soc. Author: "When I Was a Boy in Greece," pub. Lothrop,

Lee and Shepherd, 1913. Positions: Dir., Demetrios Sch., Boston; Instr., PAFA, Milton (Mass.) Acad. [47]

DE MEYER, Adolf Gayne, Baron (Demeyer Watson) [Photogr] b. 1868, France d. 1946 Los Angeles. Member: Linked Ring, 1903. Exhibited: Linked Ring, beginning 1898; Stieglitz' "291" gallery. Work: MMA; IMP/GEH; NYPL; Bibliothèque Nationale, Paris. De Meyer was prominent in London's pre-WWI society. He promoted the avante-garde, including Diaghliev's "Ballet Russe" and its star, Nijinsky. He photographed for Vogue, Vanity Fair, and Harper's Bazaar, but died in obscurity. [*]

DE MILHAU, Zella [E] Southampton, NY b. NYC. Studied: ASL; M.N. Moran; Arthur Dow; William Chase. Member: NAC; NAWPS; Plastic Cl.; Phila. Pr. Cl.; Chicago SE; Calif. PM; Soc. Am. E.; PBC. Work: NYPL; Nat. Mus., Wash., D.C.; BM [47]

DEMING, Adelaide [Mur.P,Ldscp.P] Litchfield, CT b. 12 D 1864, Litchfield. Studied: ASL; PIASch; Chase; Lathrop; Dow; Snell. Member: AWCS; NAWA; New Haven PCC; Conn. Acad. FA. Exhibited: NYWCC, 1908 (prize); N.Y. Women's AC, 1908 (prize). Work: Litchfield Pub. Lib; Pratt Inst. [47]

DEMING, E(dwin) W(illard) [P,Dec,S] West Redding, CT b. 26 Ag 1860, Ashland, OH d. 15 O 1942. Studied: ASL, early 1880s; Lefebvre, Boulanger, in Paris. Member: Mural P.; NAC. Exhibited: AAS, 1892 (med); St. Louis Expo, 1904 (med); P.-P. Expo, San Fran., 1915 (med). Work: Wis. Hist. Soc.; Madison; MMA; Montclair (N.J.) AM; Nat. Mus., Wash., D.C.; Milwaukee AI; Brooklyn Mus. A.&Sciences; Giles Atherton Coll., Stockbridge, England; Am. Mus. Nat. Hist.; Heye Fnd.; Explorers Cl.; Nat. Arts Cl., all in NYC; John Herron AI; Wis. Tercentennary U.S. stamp. Illustrator: Indian Life series and others by his wife, Therese O. Deming, also articles on life among the Indians in Outing magazine, 1890s [40]

DEMING, Eleanor [P,C] NYC/Putnam, CT b. 2 Ag 1879, Brooklyn, NY. Studied: John W. Alexander; Adams; Mrs. C. Sprague-Smith; C.F. Hamann. Specialties: landscapes, jewelry [13]

DEMING, Elizabeth [P] Litchfield, CT. Member: Lg. AA [24]

DEMING, Mabel Reed [P] San Fran., CA b. 1874, San Fran. [04]

DEMMLER, Fred A. [P] Pittsburgh, PA b. 1888, Allegheny, PA d. Autumn, 1918 (while fighting on the Western Front). Studied: Horatio S. Stevenson; BMFA Sch. Member; Pittsburgh AA; F., PAFA. Exhibited: Pittsburgh AA, 1916 (prize) [17]

DE MOLL, Mary Hitchner (Mrs. Carl) [P,Min.P] Swarthmore, PA b. 7 N 1884, Clayton, NJ. Studied: PAFA, 1912. Member: Pa. S. Min. P. Exhibited: watercolor, Plastic Cl., 1929 (prize) [40]

DEMONET, Inez (Michon) [I,E] Wash., D.C. b. 25 Ap 1897, Wash., D.C. Studied: Corcoran Sch. A.; PMSchIA; Nat. Sch. F.&Appl. A.; Hawthorne; Benson B. Moore. Member: Wash. WCC; Wash. SE; Assn. Medical Illus.; Wash. Soc. FA. Exhibited: Corcoran Sch. A., 1915 (med); Wash. SE, 1935 (prize); Wash. WCC, 1946 (prize); Nat. Mus., Wash., D.C., 1935 (prize); Nat. Inst. Health. Work: Mrs. F.D. Roosevelt Coll.; Smithsonian Inst.; Pub. Lib., Wash., D.C. Specialty: medical illus. Position: Medical Ar., Nat. Inst. Health, 1926–46[47]

DEMUTH, Charles (Henry) [P] Lancaster, PA b. 1883, Lancaster d. 23 O 1935. Studied: Franklin & Marshall Acad.; Drexel Inst., 1901; PMSchIA; Paris, 1904–05; PAFA, with Chase, Anshutz, 1905–08; Acads. Julian, Colarossi, Moderne, all in Paris, 1912–14. Exhibited: Smith Col. Mus. A., 1934; WMAA, 1935, 1937; Cincinnati AM, 1941; Phillips Mem. Gal., 1942; Phila. Mus. A., 1944; Albertina, Vienna, 1949; MOMA, 1949–50 (retrospective); Phila. Sesqui-Centenn. Expo, 1926 (med). Work: MMA; AIC; Fogg A. Mus.; BM; CMA; Rochester Mus.; Barnes Fnd., Merion, Pa.; Phillips Mem. Gal.; Los Angeles Mus. Hist., Science & Art. He worked most of his life under the handicap of poor health. Some critics preferred his watercolors of fruits and flowers, while others considered his best work was done in abstract painting. [33]

DEMUTH, Martin [I,L] South Kent, CT b. 16 Ap 1895, Cardington, OH. Studied: DuMond; Bridgman. Member: SI. Lecturer/Artist: Canadian Pacific around-the-world cruises. Co-author: "Memogram Travel Sketches" [32]

DE MYROSH, Michael [P,I,Dec] NYC b. 24 D 1898, Ukraine. Studied: Acad. FA, Krakow; Sch. Applied Art, Lwow. Member: NYWCC; S.Indp.A. [40]

DE NAGY, Laszlo [P] Hopewell, NJ/Provincetown, MA b. ca. 1906, Hungary (came to U.S. in 1933) d. 15 Je 1944, Trenton, NJ. Exhibited: PAFA, 1938; Am. Salon, New York 1939 (one-man) [40]

DE NARDO, Antonio [P] NYC [15]

DENBY, Edwin Hooper [P,Arch] NYC/Bar Harbor, ME b. 9 F 1873, Phila. Member: AIA; S. Beaux Arts Arch.; N.Y. Arch. Lg.; NAC; McD. Cl.; Diplome S., Groupe American. Exhibited: Paris Salon, 1898, 1899; Osmanieh, 1899. Author: "The Ecole des Beaux-Arts, Its Influence in America," quarterly publication. French Leg. Honor. Specialty: architectural renderings and watercolors of Europe, the Near East, Bar Harbor and Acadia Natl. Park [40]

DE NESTI, Adolfo [S,P,I] Glenolden, PA b. 7 Je 1870, Florence, Italy. Studied: Rivalta; Barabino. Member: Int. Soc. AL [15]

DENGHAUSEN, Alfred L.F. [P,G,Des] West Roxbury, MA b. 4 Je 1906, Boston. Studied: BMFA Sch. Member: Bay State Ar. Gld. Position: Dir., Denghausen Studio [40]

DENGHAUSEN, Franz H. [S,T,] Roslindale, MA b. 8 Ap 1911, Boston. Studied: BMFA Sch., with Charles Grafly; Child-Walker Sch. Des, with Arnold Geissbuhler. Member: Boston AC; Copley Soc.; Inst. Mod A., Boston. Exhibited: PAFA, 1931; NAD, 1931; CM, 1935; WFNY, 1939; Inst. Mod. A., 1943; AGAA; Boston AC; North Shore AA; Rockport AA; Provincetown AA. Position: Instr., S., Cambridge Center Adult Edu. [47]

DENGROVE, Ida L(eibovitz) [P,G,I,T] Interlaken, NJ b. 21 S 1918, Phila. Studied: Phila. Graphic Sketch Cl.; Moore Inst.; Barnes Fnd. Member: Phila. Pr. Cl. Exhibited: LOC, 1943; PAFA, 1937; NGA, 1941; Carlen Gal. (one-man); Phila. Pr. Cl. (one-man); St. Petersburg, Fla.; Phila. A. All.; Norton A. Gal. Position: A. Instr., Phila. Pub. Sch. [47]

DENIS, Leonard [Des] Phila., PA b. Detroit, MI. Studied: PMSchIA; Paul Honore. Member: Phila. Sketch Cl.; Phila. Pr. Cl.; Stagecrafters; All. Français. Exhibited: Detroit Inst. A., 1938; Scarab Cl., 1939; Woodmere A. Gal., 1946; Phila. Sketch Cl., 1945, 1946, 1947 (one-man); A. Gal., Phila., 1946 (one-man) [47]

DENISON, George Henry [Ldscp.P,T] Pittsfield, MA b. 1867, Cheshire, MA d. 19 Jy 1944. Studied: NYC; Wash., D.C. Member: Pittsfield A. Lg.; SC. Position: Hd., A. Dept., Pittsfield pub. sch.

DENISON, Harold (Thomas) [Dr,E,I,P,W] Boston Corners, NY b. 17 S 1887, Richmond, MI d. 17 Jy 1940. Studied: ASL; Chicago Acad. FA. Member: SI; AAPL; Am. A. Group; Phila. SE. Work: Univ. Nebr., Lincoln; Univ. Ill.; M.H. deYoung Mem. Museum, San Fran.; Victoria & Albert Mus., London [40]

DENIVELLE, Paul E. [S] near Lake Tahoe, Calif. b. 1872, France d. early Fall, 1936. In 1915, he went to San Fran. as supervisor of modeling at the P.-P. Expo and was awarded a medal for his work there. He was best known for his invention of imitation travertine.

DENMAN, Herbert [P] NYC b. 1855, Brooklyn, NY d. 3 O 1903, Idylwild, CA. Studied: Carolus-Duran, in Paris; ASL. Member: Soc. AA; Am. FA Soc. Exhibited: Paris Salon 1886 (prize); Paris Expo, 1889 (prize). After returning to America in 1887, he decorated Vanderbilt's house at Dobbs Ferry, the Manhattan Hotel, and the Waldorf-Astoria ballroom. [01]

DENNETT, Mary Ware (Mrs.) [C,W] Astoria, NY b. Worcester, MA. Studied: BMFA Sch.; Dow. Member: Boston SAC; NYSC; PBC. Revived lost art of Guadamaciles. Author: articles in "Handicraft." Specialty: tooled leathers for wall hangings, panels, screens [40]

DENNEY, Irene [P] Phila., PA b. Phila. Studied: E. Horter; H. McCarter; PAFA, 1918. Member: Phila. A. All. Exhibited: Plastic Cl., 1935 (med), 1936 (gold); PAFA, 1936, 1938 (prize), 1945, 1946. Work: PAFA [47]

DENNIS, Charles Warren [P,I] Needham, MA b. 25 F 1898, New Bedford, MA. Studied: Swain Sch. Des.; Fenway Sch. Illus.; BMFA Sch.; Harold Brett; H.E. Smith; F. Bosley. Work: Tufts Col.; Masonic Temple, Boston. Illustrator: covers, Saturday Evening Post [47]

DENNIS, Cherry Velma Nixon (Mrs. T.L.) [G,P] Tulsa, OK/Albuquerque, NM b. Raton, NM. Studied: Univ. Tulsa; Emil Bisttram. Member: Tulsa A. Assn. Exhibited: Tulsa A. Assn., 1935 (prize); Okla. Ar. Exh., 1936 (prize); Midwestern Ar., Kansas City AI, 1939. Work: Okla. A. and M. Col., Stillwater [40]

DENNIS, George B. [I] NYC [01]

DENNIS, J.A. (Mrs.) [P] Tacoma, WA. Member: Tacoma FA Assoc. [25]

DENNIS, Jeannelle Wilson (Mrs. Charles) [P] Evanston, IL d. 20 O 1933. Studied: AIC. Member: Evanston Art Commission; Municipal Art Lg., North Shore Art Lg.

DENNIS, J(ames) M. [P] Detroit, MI b. 26 Ag 1840, Dublin, IN. Studied: Cincinnati; J.O. Eaton, in NYC. Work: Treasury Bldg., Wash., D.C. Had

a studio with Alexander Wyant; was in Indianapolis (1865), NYC (1873), then in the south. Lived in Indianapolis, 1870s–90s, before moving to Detroit. Specialty: pastels [17]

DENNIS, (Burt) Morgan [E,I,W,L] Fort Myers Beach, FL b. 27 F 1892, Boston d. 1960, Key West. Studied: W.H.W. Bicknell; Stanhope Forbes. Member: Authors Lg. Exhibited: Macbeth Gal., NYC. Author/Illustrator: "The Pup Himself" (1944), "The Morgan Dennis Dog Book" (1946). Illustrator: "Pete." Creator: "Black and White Scotties." Contributor: national magazines. Lectures: The Art of Etching; Our Dogs of War. For many years he had a studio in NYC and summered in Falmouth, Mass. [47]

DENNISON, Ethan Allen [Arch,P,C,Des] NYC b. 4 Ap 1881, Summit, NJ. Studied: Ecole des Beaux-Arts. Member: S. Beaux-Arts Arch.; Arch. Lg. Awards: French Legion of Honor, French Diplome Soc. Specialties: architecture; watercolors [40]

DENNISON, Lucy [P] Youngstown, OH b. 5 Ap 1902, Youngstown. Studied: Butler AI; James R. Hopkins; Daniel Garber. Member: Youngstown Soc. Women A.; Mahoning SP [33]

DENNY, Gladys A. [P,C,T] Indianapolis, IN b. 21 S 1898, Portland, IN. Studied: CUASch; PMSchIA; John Herron AI; Univ. Colo.; E. Warwick; J. Boule. Member: NAWA. Exhibited: CUASch, 1925 (prize); Ind. State Fair, 1935, 1936, 1937 (prize), 1938 (prize), 1939 (prize), 1940 (prize), 1946 (prize); Hoosier Salon, 1941–45, 1946 (prize); PAFA, 1937; NAWA, 1942–44; Argent Gal., 1943 (one-man); John Herron AI, 1937–40, 1942, 1944; Ind. State Lib., 1938; Muncie AA, 1940. Position: Instr., FA, Emmerich Manual Training H.S., Indianapolis, 1930–46 [47]

DENNY, Irene [P] Phila., PA [17]

DENNY, Milo B. [P] Saugatuck, MI b. 21 Ap 1887, Waubeek, IA. Studied: AIC; ASL; Cornell Col. Sch. A. [31]

DENSLOW, Dorothea Henrietta [S,T] NYC b. 14 D 1900, NYC d. 1971. Studied: ASL. Member: CAFA. Exhibited: Syracuse Mus. FA, 1938; CAFA, 1914–44; BM, 1936; Springfield, Mass. Mus. FA, 1936; Rochester Mem. A. Gal., 1940; Plainfield AA, 1943; Newark Mus., 1944; Clay C., 1934, 1946; Berkshire Mus. A., 1941; Lyman Allyn Mus., 1939. Work: Mem. Plaque, Beth Moses Hospital, Brooklyn; Brookgreen Gardens, S.C. Position: Dir./Fndr., Clay C. Sculpture Center, NYC, 1928–46 [47]

DENSLOW, Henry Carey [P] Hartford, CT b. 1867, Chicago d. 25 Jy 1944. Studied: ASL. Work: prepared habitat groups for AMNH, Smithsonian Inst., Field Mus., Chicago. Specialty: bird paintings. Position: Cur., Brooklyn Children's Mus.

DENSLOW, William Wallace [I] NYC/Denslow's Island, Bermuda b. 5 My 1856, Phila. Studied: CUASch; NAD. Specialty: children's books, stage extravaganzas [13]

DENT, Dorothy [Des,Dec,P,C,B,T] NYC b. Wash., D.C. Studied: Phila. Sch. Des. for Women; PMSchIA; L. Miller; F. Parsons. Member: NYSC; Alliance. Exhibited: dress des., Com. Pugh, Chicago (prize). Author/Illustrator: "Art as the Persians Saw It," Arts and Decoration [40]

DE ORLOV, Lino S. See Lipinsky.

DE PAUW, Victor [P,E,B,Dr,Li,I] NYC 20 Ja 1902. Studied: Calif. Sch. FA; ASL. Member: ASL. Exhibited: Clayton Gal., 1929, 1935 (one-man); Fifteen Gal., 1942 (one-man); Charles Morgan Gal., NYC, 1938 (one-man), 1939 (one-man). Illustrator: covers, Fortune, New Yorker [47]

DE POLGARY, Geza [Por.P] b. 1862, Hungary (came to America in 1908) d. 26 Ja 1919, Atlantic City. Work: Gov. of Hungary

DE QUELIN, René [P,W] b. 1854, Brittany, France d. 22 Mr 1932, NYC. While living in Japan, ca. 1910, he won the Imperial Gold medal in water color. Positions: Hd. A., Tiffany Studios, for ten years; L., Carnegie Inst.

DERBYSHIRE, Elna [P,C] Waltham, MA/Bar Harbor, ME b. 5 My 1895. Studied: Mass. Sch. A. Exhibited: NYWCC, 1937; Doll & Richards, Boston, 1937. Specialty: flower painting [40]

DERCUM, Elizabeth [P] Phila., PA. Member: F., PAFA [25]

DEREMEAUX, Irma [I] NYC. Member: SI, 1912 [27]

DERGANS, Louis S. [Por.P] Wash., DC b. 4 N 1890, Laibach, Austria d. 27 Je 1930. Studied: Richard S. Meryman; S. Burtis Baker; Calif. School FA. Member: S. Wash. A.; Wash. Ldscp. C.; Wash. AC.; AFA. Position: Asst. Supt., Treasury Dept. [29]

DER GARABEDIAN, Giragos [P,T] Boston, MA/Rockport, MA b. 14 D 1893. Studied: C.C. Allen; A.T. Hibbard; A. Thieme; S. Woodward. Member: Rockport AA; Boston AC. Exhibited: Rockport AA; Boston AC; Jordon Marsh Co. Work: Univ. Theatre, Cambridge; Hawthorne Inn, East Gloucester, Mass. Position: T., South End Art Center, Boston [40]

DER HAGOPIAN, Yenouk [S,P,T] Watertown, MA b. 24 1900, Tiflis, Russia. Exhibited: Pub. Lib., Watertown,; Arch. Cl., Boston [40]

DER HAROOTIAN, Koren [S,P] NYC b. 2 Ap 1909, Ashodovan, Armenia. Studied: WMA Sch. Exhibited: AWCS, 1929, 1931; BM, 1932; Audubon A., 1945; PAFA, 1946; WMAA, 1946; CM, 1945; Kraushaar Gal., 1945 (one-man); WMA, 1931, 1946; Mus. Jamaica, B.W.I, 1930 (one-man), 1935 (one-man), 1937 (one-man), 1940 (one-man), 1942(one-man); Univ. Nebr., 1946; London [47]

DE RIBCOWSKY, Dey [Mar.P] Miami Beach, FL b. 13 O 1880, Rustchuk, Bulgaria. Studied: Paris; Florence; Petrograd. Member: Newport AA; Buenos Aires Soc. FA. Exhibited: Petrograd, 1902 (gold); Uruguay Exh., Montevideo, 1908 (gold); Rio de Janeiro Expo, 1909 (gold); Odessa, 1909 (prize); Moscow, 1910 (prize); Sofia Nat. Gal., 1910 (prize); Southwestern Intl. Fair, El Paso, 1924 (prize). Inventor: the Medium "Reflex." Work: Mus. Alexander III, Petrograd; Tretiacof Gal., Moscow; Odessa Mus.; Uruguay Mus., Montevideo; Buenos Aires Mus.; Nat. Palace, Montevideo; Nat. Palace, Rio de Janeiro; Governor's Palace, Barbados; Manchester, N.H. [40]

DE RIVERA, José [S] NYC b. 18 S 1904, New Orleans, LA. Studied: J.W. Norton. Member: S. Gld. Exhibited: AIC, 1930, 1931; MOMA, 1938–40, 1942; WMAA, 1935–38, 1940, 1941; Harvard, 1941; Yale, 1946; BM, 1938; Willard Gal., 1941; Buchholz Gal., 1942; Mortimer Levitt Gal., 1946; WFNY 1939. Work: mon., El Paso, Texas; Newark Airport [47]

DER NERSESSIAN, Sirarpie [Edu,W,L] Wash., D.C./Paris, France b. 5 S 1896, Constantinople, Turkey. Studied: Sorbonne. Member: Soc. Byzantine Studies; CAA; Mediaeval Acad. Am.; Archaeological Inst. Am.; Am. Assn. Univ. Women. Author: articles/books on Mediaeval & Byzantine art. Positions: T., Wellesley, 1934–37; Dir., Farnsworth Mus., Wellesley, 1937– [47]

DE ROME, John [P] Chicago, IL [10]

DE ROSEN, John Henry [Edu,P] Wash., D.C. b. 25 F1891, Warsaw, Poland. Studied: Univ. Lausanne, Switzerland; Univ. Paris; Univ. Munich; Jan de Rosen; Merson; E. Male; von Tschudi. Member: Polish Inst. A.&Sc.; Legion of Honor, France. Exhibited: WFNY, 1939; abroad. Work: murals, cathedrals in Poland, Vienna, Castelgandolfo; Wash., D.C.; Toledo, Ohio; New Wesley Mem. Hospital, Chicago. Position: T., Catholic Univ. Am. [47]

DEROZAS, Linda [P] Brooklyn, NY [01]

DERRICK, William R(owell) [P,C] NYC b. San Francisco, CA. Studied: Bonnât; Boulanger; Lefebvre. Member: ANA; NAC; CAFA; Lotos C.; Chicago AG; SPNY. Exhibited: CAFA, 1916 (prize). Work: NGA [40]

DERRICKS, Gamaliel F. [P] Phila., PA. Member: AAS [10]

DERUJINSKY, Gleb W. [S,C,P,T] NYC b. 13 Ag 1888, Smolensk, Russia d. 1975. Studied: Univ. & FA Acad., both in Petrograd; France, with Verlet, Injalbert; Russian Acad. Member: ANA, 1933; NSS; Arch. Lg. Exhibited: Petrograd, 1909 (med); Russia, 1916 (med); Sesqui-Centennial Expo, Phila., 1926 (gold); NAD, 1938 (gold); Paris Expo, 1937 (gold); PAFA; MMA; Royal Acad., England; Royal Acad., Belgium; Knoedler Gal., London, 1928 (one-man). Work: MMA; Cranbrook Acad. A.; USPO, Wash., D.C.; San Diego; Toledo; Pittsburgh; Phila. WPA sculptor. [47]

DE SANTIS, Michael [Por.P] b. 1893, Naples, Italy (came to U.S. ca. 1906) d. 14 My 1936, NYC. Studied: Naples Inst. FA, seven years. Work: Columbia; MIT; Union College; Univ. Rochester

DESCH, Frank H. [P] Provincetown, MA b. 19 F 1873, Phila., PA d. 10 1934. Studied: Chase; Hawthorne; Biloul, in Paris. Member: Allied AA; PAFA; SC; Provincetown AA. Exhibited: SC, 1924 (prize); Fla. Fed. A., Miami, 1930 (prize). Work: Butler AI; SC; Bloomington (Ill.) AA [33]

DESCOMBES, Emilie E. [P,T] Boston, MA b. Paris, France d. 1906. Studied: Ross Turner; C.H. Woodbury. Member: Copley S., 1892. Exhibited: Boston WCC (memorial exh.) [06]

DESERENS, Alma [P] Cincinnati, OH. Member: Cincinnati Women's AC [25]

DESHA. See Taksa.

DE SILVER, Carl [Patron] Brooklyn b. 9 Ja 1846, Cincinnati, OH d. 10 Mr 1913. Member: Brooklyn AA, 1896–1913; Brooklyn Inst. A.&Sc. He bequeathed $50,000 for the use of the Institute's Art Museum.

DESJARLAIT, Patrick P. [P] Red Lake, MN. Exhibited: First Nat. Exh. Am. Indian Painters, Philbrook A. Center, 1946 [47]

DESKEY, Donald [Des] NYC b. 23 N 1894, Blue Earth, MN. Studied: Univ. Calif.; Mark Hopkins A. Sch.; AIC; Grande Chaumière. Member: BAID; F., Soc. Indst. Des.; A. Dir. Cl. Exhibited: Paris Expo, 1937 (prize); Pittsburgh Plate Glass Co. (prize); MMA, 1931, 1934, 1940; BM, 1931; Detroit Inst. A.; Chicago World's Fair, 1933; WFNY, 1939; Paris Expo, 1937; Phila. A. All., 1945; Am. Des. Gal., 1929, 1930; MOMA, 1937; N.Y. A. All., 1927–30. Work: des. interiors, Radio City Music Hall. Contributor: articles, London Studio. Position: T., NYU, 1940 [47]

DESMOND, Alice Curtis (Mrs. Thomas) [W,P] Newburgh, NY b. 19 S 1897, Southport, CT. Studied: Parsons Sch. Des.; Hazel Brill Jackson; Jacob Getlar Smith. Member: AWCS; N.Y. Soc. P.; NAWA; Albany Pr. C.; Authors Lg. Am.; PBC; Hudson Highlands AA; Albany A. Group; Hudson Valley AA; Am. Assn. Univ. Women; N.Y. State Hist. Assn. Exhibited: PBC, 1945, 1946; Hudson Highlands AA, 1942–44; Albany Inst. Hist.&A., 1943–45. Author: "The Sea Cats," 1944, "Glamourous Dolly Madison," 1946, other books. Contributor: newspapers, national magazines [47]

DE SOTO, Minnie B. Hall (Mrs. Emilio Dominguez De Soto) [P,S,W,L,T] Denver, CO b. 2 My 1864, Denver. Studied: ASL; AIC; Henry Read. Member: NAC; Denver AC [33]

DESSAR, Louis Paul [P] NYC/Old Lyme, CT b. 22 Ja 1867, Indianapolis d. 14 F 1952. Studied: NAD, NY; Bouguereau; Robert-Fleury; Ecole des Beaux-Arts. Member: SAA, 1898; ANA, 1900; NA, 1906; SC, 1895; Lotos C.; A. Fund S.; Lyme AA. Exhibited: Paris Salon, 1891 (med), 1900 (med); Columbian Expo, Chicago, 1893 (med); Carnegie Inst., 1897; NAD, 1899 (prize), 1900 (prize); Pan-Am. Expo, Buffalo, 1901 (med); Charleston Expo, 1902 (med). Work: NGA; MMA; Montclair AM, N.J.; CAM; Joselyn Mem., Omaha; Lotos Cl.; Lyons, France [47]

DESSAUER, William [Por.P,W] NYC b. 1882 d. 16 D 1943

DESVARREUX-LARPENTEUR, James [P] Paris, France b. 20 O 1847, Baltimore, MD. Studied: Van Marcke; Ecole des Beaux-Arts, Paris. Exhibited: Alaska-Yukon Expo, 1909 (gold). Specialty: landscapes with cattle or sheep [33]

DE TAHY, John [P] NYC [01]

DE TAKACH, Bela [P] NYC [15]

DE TARNOWSKY, Michael [S] NYC [06]

DETHLOFF, Peter H(ans) [P] Los Angeles, CA b. 8 S 1869, Barnsdorf, Germany. Studied: William Gaethe; Christian von Schneidau; Calif. AI. Exhibited: Utah State Fair Assn. (prizes). Work: fresco, St. Mary's Acad. Chapel, Salt Lake City [40]

DE THULSTRUP, Thure (Bror) [I,P] NYC d. 4 Ap 1848, Stockholm, Sweden d. 9 Je 1930. Studied: Paris, 1871 (following service in the French Foreign Legion). Member: Century Cl.; Players Cl.; Am. WCS; SI; John Ericsson Soc. Award: Swedish Knight, Order of Vasa. Exhibited: St. Louis Expo; Pan-Am. Expo, 1901. Specialty: military history. At the age of 27, he came to Canada and then NYC. For some years he was on the staff of the New York Daily Graphic and Leslie's. He was staff artist on Harper's for twenty years, covering the inaugurations of four Presidents and the funeral of General Grant. In his capacity of illustrator he visited most of the countries of Europe and went to Russia in 1888 to sketch the Kaiser of Germany on his visit to the Czar. He later produced some of the best-known paintings of American Colonial life. [29]

DE TOLNAY, Charles [Ed,W] Princeton, NJ b. 27 My 1899, Budapest, Hungary. Studied: Univ. Vienna; Germany. Member: CAA; Atheneum. Member: Inst. Advanced Study, Princeton, 1939– . Exhibited: Institute de France, 1937 (prize). Author: "History and Technique of Old Master Drawings," 1943, "The Sistine Ceiling," 1945, other books. Position: T., Sorbonne, 1934–39 [47]

DE TOMASI, Jane, Mrs. See Davenport.

DE TROBIAND, Regis Denis de Keredern [P,W] b. 1816, Tours, France d. 1897, Bayport, NY. Studied: Col. of Tours, 1834; Poitiers, 1837. Toured U.S. in 1841; in NYC 1847; a U.S. general of volunteers during the Civil War. Assigned by the U.S. Army to Dakota, 1867, Mont., in 1869, Utah & Wyo., in 1871. Work: Post Coll., NYC. Specialties: Western scenes; Indian portraits [*]

DE TURCK, Ethel Ellis (Mrs. A. Eugene Benners) [P] Phila., PA. Member: NAWPS; F., PAFA; Plastic C. [27]

DETWILLER, F(rederick) K(necht) [P,E,Li,I,Arch,T,L,W] NYC/New Harbor, ME b. 31 D 1882, Easton, PA. Studied: Ecole des Beaux-Arts; Instituto di Belle Arti, Florence; Ecole Americane des Beaux-Arts Palais de Fountainebleau; Columbia; ASL. Member: Assoc., NAD, 1939; Paris Am. Students C.; Paris AAA; Brooklyn WCC; AFA; Allied AA; Phila. SE; Artists Fellowship, Inc.; Lotos C.; CAFA; Gld. Am. P.; Phila. Print C.; SC; S.Indp.A.; Soc. Am. E.; Brooklyn PS; Brooklyn Soc. Am. E.; Brooklyn S. Mod. A.; Salons of Am.; Springfield (Mass.) AL; Artists of Carnegie Hall; Carolina AA, Southern PM Soc. Exhibited: Soc. Beaux-Arts Arch., 1910 (med); SC, 1920 (prize); AIC, 1925, 1943; CI, 1944, 1945; AV, 1943; MMA, 1944; Albany Inst. Hist.&A., 1943; PAFA, 1925; Currier Gal., 1940; Butler AI, 1944–46; Bennington Hist. Mus., 1940. Work: LOC; Smithsonian Inst.; NGA; U.S. Nat. Mus.; Mus., City of N.Y.; NYPL; BM; Peabody Mus., Salem; Conn. State Lib.; Farnsworth AM, Wellesley; Vanderpoel AA. Lafayette Col.; Newark Pub. Lib.; Bowdoin Mus. FA; U.S. Naval Mus.; Bibliothèque Nationale, Musséé Carnavalet, both in Paris; Rijks Museum; Bibliotèque Royal de Belgique; Imperial War Mus., British Mus.; Victoria and Albert Mus.; City Mus., Vancouver; Public Archives of Canada, Ottawa. Author: "Prominent Americans of Swiss Origin," 1932, "The Story of a Statue," 1943. Contributor: Print, Connoisseur, art magazines. Lectures: Art in America. Positions: Pres., All.A.Am., 1943–45, SC, 1944–46; Council, SAE, 1939–41, 1945–47 [47]

DE URZAIZ, Elizabeth [P] NYC/Woodstock, NY b. 12 Je 1896, NYC. Member: Woodstock AA. Exhibited: Woodstock Gal., 1939; Newhouse Gal., N.Y. [40]

DEUSCHINSKI, Joe [P] NYC [13]

DEUSS, Otto A. [P] Columbus, OH. Member: Columbus PPC [25]

DEUTSCH, Boris [P,Et,Li] Los Angeles, CA b. 4 Je 1892, Krasnagorka, Lithuania. Studied: Russia; Germany. Member: Calif. WCS; All. A., Los Angeles. Exhibited: San Diego FA Soc., 1930 (prize); Los Angeles Mus. A., 1926, 1929, 1932 (prize), 1941; Oakland A. Gal., 1931, 1939, 1940 (prizes); Pomona Fair, 1938 (prize); Pepsi-Cola, 1946 (prize); Univ. Calif., 1926, 1942; East-West Gal., San Fran., 1929; Calif. AC, 1929; Mills Col., 1929; SAM, 1930; San Diego FA Soc., 1930; Denver A. Mus., 1931; Portland (Oreg.) Mus. A., 1931; Palace Legion Honor, 1931; Dallas Mus. FA, 1932; Jacques Seligmann Gal., 1933; Oakland A. Gal., 1936, 1940; Stockton (Calif.) Mus. A., 1940; Sacramento Mus. A., 1940; Scripps Col., 1946. Work: murals, USPO, Reedley, Calif.; Los Angeles Terminal Annex PO; Palace Legion Honor; Mills Col; Portland (Oreg.) Mus. A.; CI. WPA muralist. [47]

DEUTSCH, Hilda [S,P,T] Spokane, WA b. 1 Je 1911, NYC. Studied: CUASch; ASL. Member: United AM A.; Seattle Ar. Council. Exhibited: ACA Gal., N.Y.; Seattle AM, 1939 (prize); Spokane A. Center. Position: T., Spokane A. Center [40]

DE VAULT, David Sullins [Des,C,P,I] Amsterdam, NY b. 19 D 1876, Bristol, VA. Studied: Baltimore Sch. A.; N.Y. Sch. A.; William M. Chase; Robert Henri; F.V. DuMond; abroad. Work: murals, many U.S. cities [47]

DE VERTI, Adolphe [P] Wash., D.C. [06]

DEVILBISS, I(da) E. [P,I,T] Hampton, VA/Walkersville, MD b. 19 O 1874, Libertytown, MD. Studied: Pratt Inst. [15]

DEVILLE, H. [Et] NYC [15]

DEVINE, Bernard [P] Willard, ME b. 19 O 1884, Portland, ME. Studied: NYC, with G. Bridgman, R. MacCameron; Paris, with Laurens, Lionel Walden. Member: Paris AAA [24]

DEVINE, Bess A. [P] Chicago, IL [15]

DEVINE, Sylvia Brenner, Mrs. See Brenner.

DEVINEY, Jess [P] Toledo, OH. Member: Artklan [25]

DE VINNEY, Laura Laurett [Edu,P,C,E,B] Fredonia, NY b. Howe, IN. Studied: Western State T. Col.; Columbia; Fontainebleau, France. Member: Buffalo SA; The Patteran; Eastern AA; Nat. Edu. Assn. Exhibited: Buffalo SA, 1935 (prize); The Patteran. Contributor: Design Magazine, Everyday Life, other magazines. Position: T., Fredonia State T. Col., 1925–46 [47]

DE VOL, Eugene [P,T] San Diego, CA. Studied: Ulmark; Blomfield; Jonas Lie; Chicago AFA. Member: San Diego AG [27]

DEVOL, Pauline Hamill [P,Des,I,T] Mission Beach, CA b. 7 O 1893, Chicago, IL. Studied: Chicago Acad. FA; Kay-Scott; R. Schaeffer. Member: San Diego AG; Spanish Village Art Group. Position: Dir., San Diego Acad. FA [40]

DE VOLL, F. Usher [P] Providence, RI b. 15 D 1873, Providence d. 13 Mr 1941. Studied: RISD; Chase; Hawthorne; Henri; Mowbray; Laurens, in

Paris. Member: Providence AC; SC; Providence WCC; CAFA; Springfield, Ill. AA; AAPL. Exhibited: P.-P. Expo, San Fran., 1915 (med); Providence AC, 1930 (prize). Work: RISD; St. Johns AC, New Brunswick; Delgado Mus.; Newcomb Col.; Milwaukee AI; Syracuse AM; Hackley A. Gal, Muskegon, Mich.; Vanderpoel AA; Springfield. (Ill.) AA [40]

DE VOS, Florence M(arie) [P] Woodstock, NY b. 13 1892, Cook County, IL. Studied: H. Mattson [29]

DE VREES, John [I] NYC [19]

DE VRIES, Dora (Mrs.) [I,T,L] NYC b. 20 O 1909, Schenectady, NY. Studied: PIASch. Exhibited: Ar. Dir. Cl., N.Y., 1945 (med); Ar. Dir. Cl., Chicago, 1945 (med). Illustrator: national ads, Vogue, Harper's. Position: T., Fashion Illus., ASL, 1945–46 [47]

DEW, Henrietta (Mrs. Edgar H.) [C,T] Catonsville, MD b. 20 D 1894, Winona, MN. Studied: Milwaukee Sch. F.&Appl. A.; Columbia. Member: NYSC; Baltimore Municipal A. Soc. Position: T., Md. Inst., Baltimore, 1922–– [47]

DE WELDON, Felix Weihs [S,P,T,L] Wash., D.C. b. 12 Ap 1907, Vienna, Austria. Studied: Marchetti Col.; Univ. Vienna; Italy; France; England. Member: AFA. Exhibited: Vienna, 1925–28; Paris Salon, 1929, 1930; Cairo, Egypt, 1932, 1933; Royal Acad., London, 1934–37; Montreal Mus. A., 1938; Arch. Lg., 1939. Work: busts, King George V & King George VI, London; Mus. City of Vienna; Nat. Por. Gal., London; Mus., Brisbane, Australia; U.S. Naval Acad.; many por. busts of prominent officials in Scotland, England, U.S. [47]

DE WENTWORTH, Cecile (Marquise) (Mrs.) [Por.P] Peekamose, NY b. NYC d. 28 Ag 1933, Nice, France. Studied: Paris, with Cabanel, Detaille. Exhibited: Tours (gold); Lyons (gold); Turin (gold); Paris Salon, for 30 yrs.; Paris Expo, 1900 (med). Awards: Chevalier Legion of Honor, 1901, one of only two women (the other was Rosa Bonheur) to be so honored for many years; Officer of Public Instruction, France; Order of the Holy Sepulchre, from Pope Leo XIII. Work: MMA; Luxembourg Mus.; Senate Chamber, both in Paris; Vatican Mus.; Catholic Univ.; CGA. She painted many famous persons in Europe, as well as doing portraits of presidents Taft and Theodore Roosevelt. [17]

DEWEY, Alfred J. [I] Pleasantville, NY. Member: SI [25]

DEWEY, Charles H. [P] Boston, MA. Exhibited: Omaha Expo, 1898. [98]

DEWEY, Charles M(elville) [Ldscp.P] NYC b. 16 Jy 1849, Lowville, NY d. 17 Ja 1937. Studied: Carolus-Duran, in Paris. Member: ANA, 1903; NA, 1907; Nat. Inst. AL; Lotos C.; NAC; a good friend of J.S. Sargent, Paris, ca. 1879. Exhibited: Pan-Am. Expo, Buffalo, 1901 (med); St. Louis Expo, 1904 (med). Work: CGA; Buffalo FA Acad.; NGA; PAFA; Brooklyn, Inst. Mus.; Montclair A. Mus., N.J. Minneapolis Inst. A.; MMA [33]

DEWEY, Julia Henshaw (Mrs. C.M.) [P,I] NYC b. Batavia, NY d. 5 N 1928. Studied: C.M. Dewey. Member: NAWPS; NAC [27]

DEWEY, Charles S. [P] Lake Forest, IL b. 10 N 1880, Cadiz, OH. Studied: self-taught. Member: Chicago SA [27]

DEWEY, Francis Henshaw [Mus.Dir] Worcester, MA b. 1856 d. 20 Ap 1933. Positions: Charter VP, 1896–1919, Pres., 1919–33, Worcester AM

DE WILD, Carel F.L. [Mus.Cur] Larchmont, NY b. Holland (came to U.S. in 1911) d. 12 My 1922. Positions: Cur., private collections of Frick, Widener, Morgan

DE WILDE, Victor [P,Et,Des,T] San Francisco, CA b. 4 Ap 1903, Tamise, Belgium. Calif. Col. A.&Cr.; Calif. Sch. FA; Watanabe. Member: San Fran. AA; Calif. SE; Calif. WCS. Exhibited: Am. A. Cong., 1936; GGE, 1939 (prize); Calif. State Fair, 1940 (prize), 1941 (prize); Phila. A. All., 1937; Grand Rapids A. Gal., 1939; CGA, 1940, 1941; Denver A. Mus., 1936; John Herron AI, 1936–43; Detroit Inst. A., 1936; Newark Pub. Lib., 1930; Oakland A. Gal., 1936, 1940 Work: SGMA; Am. A. Cong. [47]

DEWING, Maria Oakey (Mrs. T.W.) [P] NYC b. 27 O 1845, NYC d. F 1928. Studied: Dr. Rimmer; NAD; John La Farge, in NYC; Couture, in Paris. Exhibited: Columbian Expo, Chicago, 1893 (med); Pan-Am. Expo, Buffalo, 1901 (med). Work: Smith College [27]

DEWING, T(homas) W(ilmer) [P] NYC b. 4 My 1851, Boston, MA d. 5 N 1938. Studied: Boulanger; Lefebvre. Member: ANA, 1887; NA, 1888; Ten Am. Painters; Nat. Inst. AL. Exhibited: NAD, 1887 (prize); Paris Expo, 1889 (med); Pan-Am. Expo, Buffalo, 1901 (gold); St. Louis Expo, 1904 (gold); PAFA, 1906 (prize); CI, 1908 (med). Work: NGA; 22 oil paintings, two screens, Freer Coll.; AIC; MMA; CGA; Toledo Mus. A.; FAA; Buffalo; Brooklyn Inst. Mus.; RISD; CAM; Carnegie Inst.; Luxembourg Mus., Paris [38]

DEWING-WOODWARD, (Miss) [P,T] NYC/Shady, NY b. Williamsport, PA. Studied: PAFA; Acad. Julian, Acad. Colarossi, both in Paris. Exhibited: Marseilles Expo, 1903 (silver) [15]

DE WITT, Caroline Pennoyer (Mrs.) [Min.P] Culpeper, VA b. 19 Je 1859, East Greenwich, RI. Studied: Cooper Inst.; F. Rondel, NYC; C.H. Heath, in London [19]

DE WITT, Cornelius Hugh [I,Li,P,L] NYC b. 6 Je 1905, Cassel, Germany. Studied: Germany; France. Exhibited: MMA; Norton A. Gal. Work: murals, Calvert Distilleries. Illustrator: "Regions of America" (series), "History of the U.S. for Young People," other books [47]

DE WITT, Gerard [E] NYC [15]

DE WITT, Jerome Pennington [P,Des,L,T] NYC b. 27 My 1895, Newark, NJ d. 2 Dec 1940. Studied: G.A. Williams; G. Lunger; Pratt Inst., with Prellwitz, Beck, Moschowitz, Paddock. Member: Allied AA; Newark AC; Yonkers AA; SC. Positions: T., Newark Sch. F.&Indst. A., N.J. State T. Col., Montclair, McDowell Sch., NYC [40]

DE WOLFE, Sarah B. [P] San Francisco, CA [10]

DE WOLF, Wallace L. [P,E,W] Chicago, IL b. 24 F 1854, Chicago d. 25 D 1930 Pasadena, CA. Studied: self-taught. Member: AIC; Chicago SA; Municipal AL; Chicago SE; Calif. AC; Calif. PM; Chicago A. Commission; Chicago PS; Los Angeles PS; Pasadena SA; AFA. Work: Springfield Art Assn.; Union L. C., Chicago; South Park Commission; AIC; Vanderpoel AA Coll. He was a benefactor of the AIC, and in 1913 presented the AIC with his collection of rare etchings by Zorn. [29]

DEXTER, E. [I] NYC [19]

DEXTER, Mary L. [P] Milwaukee, WI. Member: S.Indp.A [25]

DEXTER, Wilson [I] NYC b. 1881 d. 6 F 1921 (hit by an "L" train). [19]

DEY, Henry Ellinwood [P,I] Pelham Manor, NY b. 1865, NYC d. 29 O 1942, New Rochelle, NY. Member: Mural P. Illustrator: Life, Puck, Judge. Work: Spanish Chapel, NYC [27]

DEY, Maurice Robert [En,C,P] Cornwall, NY b. 15 My 1900, Ballaigues, Switzerland. Studied: Harry Wickey. Member: Hudson Highlands AA. Exhibited: PAFA, 1936, 1937; Fed. A. Gal., 1938, 1939; NAD, 1941, 1942; Syracuse Mus. FA, 1941; Williams Col., 1940; Hudson Highland AA, 1935–39; Southern Pines, 1946; Pinehurst, N.C., 1946 [47]

DE YONG, Joe [P] Santa Barbara, Calif b. 1894, Webster Grove, MO d. 1975, Los Angeles. A deaf cowboy artist who grew up knowing Will Rogers. He played cowboy parts in Tom Mix movies, and worked in C.M. Russell's studio from 1916–26. Work: murals, USPO, Gatesville, TX. WPA muralist. [40]

DE YONGH, John [Por.P] New Rochelle, NY b. 1856 d. 21 My 1917 (suicide)

DE YOUNG, H(arry) A(nthony) [P,Dr,L,T] Boerne, TX b. 5 Ag 1893, Chicago d. 1956. Studied: AIC, 1917; F. de Forrest Schook; John W. Norton; Univ. Ill., with Edward Lake. Member: Chicago Gal. A.; Chicago PSA; All-Ill. SA; San Antonio AA; Tex. Fed. A. Exhibited: AIC, 1925 (prize); Chicago Gal. Assn., 1927 (prize); San Antonio, Tex., 1929. Work: Witte Mus. Positions: Founder/Dir., de Young Art Sch., San Antonio, de Young Painting Camps [47]

DE ZAYAS, G(eorge) [I] NYC b. 30 N 1895, Mexico City. Studied: Jean Paul Laurens. Member: SI; Artists Gld. Illustrator: Collier's [40]

DE ZORO–DEI CAPPELLER, (Ettore) E. [S] Santa Barbara, CA b. 27 Ja 1894, Cibiana, Italy. Studied: China, Japan; Germany; Italy ; Andhra Univ., India. Member: Los Angeles AA; Calif. AC; Société Academique d'Histoire Intl.; Col. Heraldique de France. Exhibited: Pacific-Intl. Expo, 1935; GGE, 1939; Los Angeles Mus. A.; abroad. Work: San Fran.; Carmel, Calif.; Univ. Southern Calif.; Italy; Ecuador; Bulgaria; Mexico; Wash., D.C.; bronze statue, gift from Am. people to Benito Mussolini; White House [47]

DHONAN, W. [I] NYC [19]

DIAMANT, David S. [Por.P,Ldscp.P] b. 1849 (came to U.S. ca. 1863) d. 19 Jy 1912, NYC. Studied: Ecole des Beaux Arts, Paris. Work: Phila. Cathedral; portrait, Emperor of Germany. Served in the Civil War.

DIAMONDSTEIN, David. See Dobson.

DIANA, Paul [S,Des] NYC b. 22 Jy 1913, NYC. Studied: NYU; NAD; ASL; BAID. Exhibited: Arch. Lg., 1939, 1940; BAID, 1932 (med), 1933 (med). Lectures: Sculpture, Architecture. Positions: T., NYU, 1935; Indst. Des., Everett Worthington, Inc., 1937–40; T., BMFA Sch., 1946– [47]

DIBBLE, George Smith [P,T,Cr] Salt Lake City, UT (1974) b. Laie, Oahu, HI. Studied: ASL, 1929–30; Columbia, 1934–40. Work: Col. of So. Utah; Utah State. Specialty: watercolor (on which he wrote a book). Positions: T., Univ. Utah, 1943 – , colleges in Calif., Wash. [*]

DIBBLE, Thomas (Reilly), Jr. [P] Englewood, NJ b. 19 Ap 1898, Haddonfield, NJ. Studied: V.D. Perrine. Member: Palisade AA; AFA [29]

DIBBLEE, Anita L. [P] Bolina, CA. Exhibited: NAWSP, 1935–38 [40]

DI BENEDETTO, Angelo [P,C] Paterson, NJ b. 19 Je 1913, Paterson. Studied: CUASch; BMFA Sch.; Jacoveloff. Exhibited: Montclair A. Mus., 1938 (prize), 1939; CGA, 1941; Pepsi-Cola, 1942, 1943, 1944, 1946; CI; 1941; PAFA, 1941; AIC, 1940; WMAA, 1941; Univ. Colo., 1945 (oneman). Work: Encyclopaedia Britannica Coll. Illustrated: "Twin Rivers," 1942, "Haitian Folk Lore," 1946 [47]

DI BICCARDI, Adio [S] Marlboro, NH. Exhibited: WFNY, 1939 [40]

DI BONA, Anthony [S,Li] Trudeau, NY b. 11 O 1896, Quincy, MA. Studied: BMFA Sch., 1918–21; Am. Acad., Rome; Paris; London; P.L. Hale; F.W. Allen; R.H. Recchia; C. Grafly; K.P. Thompson; Bela Pratt. Member: Saranac Lake AL; NSS. Exhibited: BMFA Sch., 1918, 1919, 1920 (prizes); PAFA; NAD; WFNY, 1939; MMA; WMAA; BMFA; Albright A. Gal.; North Shore AA; Saranac Lake, N.Y. Work: BMFA Sch.; War Mem., Woburn, Mass.; Trudeau Sanitorium [47]

DICE, David A. [Por.P] York, PA b. 1856 d. 25 Ja 1911 or 1912

DI CICCO, Avito Fabio [S,T,L] North Abington, MA b. 24 N 1913, Dorchester, MA. Studied: BMFA Sch. Exhibited: Fed. A. Gal., Boston [40]

DICK, George [P] Albuquerque, NM (1973) b. 1916, Manitowoc, WI. Studied: Univ. Mich.; Univ. N.Mex., 1951, with K. Adams, R. Davey. Specialties: Western wildlife; cowboy life. Was a ranger in Alaska between studies at Univ. Mich. and Univ. N.Mex. [*]

DICK, Gladys Roosevelt (Mrs. Fairman R.) [P] NYC/Glen Head, NY b. 10 Mr 1889, NYC d. 2 N 1926. Studied: ASL, with Maurice Sterne, George Bridgman. She was a cousin of Pres. T. Roosevelt. [25]

DICK, Samuel M. (Mrs.) [S] Minneapolis, MN [17]

DICKERSON, Grace Leslie [P,S] Ft. Wayne, IN b. 27 Ag 1911, Ft. Wayne. Studied: Ft. Wayne A. Sch.; AIC; G.P. duBois. Member: Ind. AC; Hoosier Salon. Exhibited: Women's Nat. Exh., Cincinnati, Ohio, 1933; Hoosier Salon, 1936, 1938, 1940, 1946; Herron AI, 1938, 1939, 1941, 1944; Ft. Wayne Mus., 1938–46, 1938, 1940, 1944 (prizes); Ind. A., 1939–45. Work: cathedrals, Ft. Wayne, Evansville, South Bend, all in Ind. [47]

DICKERSON, William Judson [P,Li,T] Wichita. KS b. 29 O 1904, El Dorado, KS. Studied: AIC; B. Brown; B.J.O. Nordfeldt. Member: Prairie Pr.M.; Prairie WC Painters; Wichita A. Gld. Exhibited: Kansas City AI, 1930–40, 1931 (med), 1939, 1940 (prizes); AIC, 1931, 1932; PAFA, 1937, 1940; Rockefeller Center, 1936, 1937; LOC, 1943; Pal. Leg. Honor, 1946; Joslyn Mem., 1944–46, 1940 (prize). Position: Dir., Sch. Wichita AA, 1930– [47]

DICKEY, Dan [P,S,T] San Diego, CA b. 17 Mr 1910, NYC. Studied: Carleton Col.; NAD; ASL; Kroll; Covey; Bridgman; Hofmann. Member: San Diego A. Gld. Exhibited: CM, 1936; SFMA, 1938, 1939; Oakland A. Gal., 1937, 1938, 1942; NGA, 1941; San Diego FA Soc., 1937, 1940, 1941; Los Angeles Mus. A., 1938, 1945; San Diego A. Gld., 1940–46; Los Angeles AA, 12941, 1946; AIC, 1935, 1936, 1937. Work: San Diego A. FA Soc.; Otis AI [47]

DICKEY, Robert L(ivingston) [I] Winnetka, IL b. 27 My 1861, Marshall, MI d. 20 O 1944, Cleveland, OH. Studied: J. Francis Smith; AIC. Member: SI. Creator: "Mr. and Mrs. Beans," "Bucky and His Pals," "Why I Draw Dogs," United Features [40]

DICKINSON, Daisy Olivia [S,Cer,P,L] La Crescenta, CA b. 3 Je 1903, Bellingham, WA. Studied: Chouinard AI; Santa Barbara Sch. FA; F. Tolles Chamberlin; S. MacDonald-Wright; F.M. Fletcher. Member: Am. Ceramic Soc., Southern Calif.; All. A., Los Angeles. Exhibited: Los Angeles Mus. A., 1929, 1933, 1939, 1940; Pasadena AI, 1930, 1931; Calif. State Fair, 1930, 1931, 1934. Position: T., Santa Barbara Sch. FA [47]

DICKINSON, Edwin [P,T] NYC b. 11 O 1891, Seneca Falls, NY. Studied: PIASch; ASL, with DuMond; W.M. Chase; Hawthorne. Member: Fed. Mod. P&S Exhibited: Work: BMFA; MOMA; WMAA; PMA; VMFA; Witte Mem. Mus.; Houston Mus. FA; Pasadena AI; Los Angeles Mus. A.; SFMA; Portland Mus. A.; CAM; AIC; TMA; Albright A. Gal.; Rochester Mem. A. Gal.; NAD; S.Indp.A.; abroad. Work: MMA; Albright A. Gal.; Springfield Mus. FA. Position: T., ASL, 1922–23, 1945– [47]

DICKINSON, Ethel [P] Montclair, NJ [06]

DICKINSON, Harlyn Grout [P] NYC b. 24 My 1916, Rochester, NY. Studied: Syracuse Univ.; ASL, with Corbino; State Univ. Iowa, with P. Guston. Exhibited: CI, 1941; Soldier's Show, Wash., D.C., 1942; NAD, 1946; Albright A. Gal., 1938, 1941 (prize) [47]

DICKINSON, Howard Clinton [P] Montclair, NJ [24]

DICKINSON, Mabel E. [P] Worcester, MA [13]

DICKINSON, Marion Louise [P,Edu] Kalamazoo, MI b. 18 Jy 1909, Grand Rapids, MI. Studied: Western Mich. Col. Edu.; Colo. State Col. Edu. Exhibited: Kalamazoo Inst. A., 1935–41, 1942 (prize), 1943–46; Grand Rapids A. Gal., 1946 (prize). Positions: T., Kalamazoo Pub. Sch., 1932–44; Dir., Kalamazoo IA, 1944–46 [47]

DICKINSON, Neville S., Mrs. See Feldman, Hilda.

DICKINSON, Preston [P] NYC b. 1891 NYC d. 1930, Spain. Studied: ASL; Paris, 1910–15. Exhibited: Sesqui-Centennial Expo, Phila., 1926 (med). Work: CMA; BM; Albright Gal.; Fogg Mus.; Omaha; Hartford; PMG [29]

DICKINSON, Ross Edward [P,I,T] La Crescenta, CA b. 29 Ap 1903, Santa Ana, CA. Studied: Chouinard AI; Grand Central Sch. A.; NAD; Santa Barbara Sch. FA; Hawthorne; Costigan; Fletcher; Ennis; Skou; Wright; Chamberlin. Member: Council, All. A. Los Angeles. Exhibited: Los Angeles Mus. A., 1925, 1926, 1928, 1929, 1931–33, 1935, 1945; Calif. State Fair, 1928–40, 1935, 1939 (prizes); Oakland A. Gal., 1937; Santa Cruz A. Lg., 1937. Positions: T., Santa Barbara Sch. FA, A. Center Sch., Los Angeles [47]

DICKINSON, Sidney E. [P] NYC b. 28 N 1890, Wallingford, CT. Studied: Bridgman; Volk; Chase. Member: NAD, 1927; Century C.; Allied AA. Exhibited: NAD, 1917, 1924, 1933, 1938 (prizes); PAFA, 1923 (prize), 1924 (gold), 1931 (prize); CGA, 1924 (prize); Allied AA, 1930, 1937 (prizes); NAC, 1932; NAD, 1982 (retrospective). Work: CGA; AIC; CAM; Mus. FA, Houston; Municipal A., Gal., Davenport, Iowa. Positions: T., ASL, 1920–21, NAD art schools, 1928–30 [47]

DICKENSON, S.T. [P] Lawrence, KS [21]

DICKINSON, William Stirling [P] Chicago, IL. Exhibited: AIC, 1935–37 [40]

DICKMAN, Charles J(ohn) [P,Li] San Francisco, CA b. 14 My 1863, Demmin, Germany d. 24 O 1943. Studied: Laurens, Constant, in Paris, 1896–1901. Member: San Fran. AA. Work: murals, Syndicate Bldg., Oakland; Steamship Co.. San Fran. He came to Calif. in 1893; moved from Monterey to San Fran. ca. 1915. [40]

DICKSON, B.H. [P] Weston, MA. Exhibited: Wash. WCC, 1937, 1939; Am. WCS, 1939; NYWCC, 1939 [40]

DICKSON, Harold Edward [Edu,W] State College, PA b. 18 Jy 1900, Sharon, PA. Studied: Pa. State Col.; Harvard. Member: CAA; Am. Assn. Univ. Prof.; Scarab C. Editor: "Observations on American Art: Selections from the Writings of John Neal (1793–1876)," 1943. Contributor: articles on early American painting, art magazines. Position: T., Pa. State Col., 1923– [47]

DICKSON, Helen [P] Boston, MA./Harrington, ME b. 31 D 1905. Studied: Mass. Sch. A.; George Demetrios; Charles Hopkinson; H.K. Zimmerman. WPA artist. [40]

DICKSON, Mary Estelle [P] Paris, France/St. Louis, MO b. St. Louis. Studied: Robert-Fleury; Lefebvre. Exhibited: Paris Salon, 1896, 1902 (med); Paris Expo, 1900 (med); Pan-Am. Expo, 1901; St. Louis Expo, 1904 (med) [06]

DI CRISPINO, Mary Reina [P] Baltimore, MD b. 20 D 1900, Catania, Sicily. Studied: Md. Inst.; H. Maril. Member: A. Un., Baltimore; Baltimore Municipal A. Soc. Exhibited: Whyte Gal.; NCFA, 1946; CGA, 1945; Peale Mus., 1939–45, 1943, 1945 (prizes); BMA, 1937, 1939–46; BMA Traveling Exh., 1941, 1942; A. Un., Baltimore, 1937; Notre Dame Col., Baltimore, 1944; Contemporary Gal., Baltimore, 1944. Work: Peale Mus.; Baltimore Friends of Art; Mayo Clinic [47]

DIDDEL, Norma L. [Edu,P,Gr] Peru, NE b. 25 Ja 1901, Denver, CO. Studied: Univ. Denver; UCLA; Colo. State; Harvard. Member: Nat. Edu. Assn.; Nebr. Edu. Assn.; Am. Assn. Univ. Women; Am. Assn. Univ. Prof.; Western AA; Lincoln AG. Exhibited: Joslyn Mem., 1931–46; Lincoln A. Gal., 1935–46. Contributor: educational publications. Position: T., Peru State T. Col. [47]

DIDUR, Vladimir [E] NYC b. 1 My 1902, Ukraine. Studied: Dickinson; Kroll; R. Neilson; NAD. Exhibited: SAE, 1937 (prize). Work: LOC [40]

DIEDERICH, (Wilhelm) Hunt [S] NYC/Sands Point, NY b. 3 My 1884, Hungary. Studied: Switzerland; Boston, 1900; ca. 1902 went west to be a cowboy; returned east to study at PAFA with P. Manship; also studied in Paris and Rome. Exhibited: Salon d'Automne, 1924; Salon des Tuileries, Paris; Arch. Lg., 1927 (gold); MOMA, 1938. Specialty: Art Deco figures and animals in iron [40]

DIEDRICKSEN, Theodore [E,Li,Edu] Hamden, CT b. 30 My 1884, New Haven, CT. Studied: Yale, with Weir, Niemeyer, Taylor; Paris, with Baschet, Gervais. Member: New Haven PCC. Position: T., Yale [47]

DIEGGS, Elizabeth H. [P] New Rochelle, NY. Member: Lg. AA [24]

DIEHL, Arthur Vidal [P] Provincetown, MA [19]

DIEHL, Dorothy [P] Milwaukee, WI [24]

DIEHL, Edith [Bkbind,W,L,T] NYC/Brewster, NY b. 21 My 1876, Brewster. Studied: Wellesley; Jena Univ.; D. Cockerell; J. Domont; Sangorski; Sutcliffe. Member: NYSC Alliance; NAC; AIGA; Lyceum C., London. Work: books bound for King George of England, Woodrow Wilson, Gen. Joffre. Author: "Bookbinding, Its Background and Technique," 1946. Positions: T., Sch. Contemporary A. (NYC), NYU [47]

DIELMAN, Ernest B(enham) [P] NYC b. 24 Ap 1893, NYC. Studied: Volk [24]

DIELMAN, Frederick [P,I,C,E,T] Ridgefield, CT b. 25 D 1847, Hanover, Germany (came to U.S. in childhood) d. 15 Ag 1935. Studied: Diez, Royal Acad., Munich. Member: ANA, 1881, NAD, 1883 (Pres., 1900-09; at time of his death the oldest member); AWCS, SAA, 1905; SI, 1910; Mur. P.; Nat. Inst. AL; Century Assn.; SC; FA Fed. of N.Y., 1910-15. Work: two mosaic panels, LOC; Albany Savings Bank; Iowa State Capitol; "Star" office, Wash., D.C. Position: A. Dir., CUASch, 1905-31 [33]

DIEMAN, Clare [S,T] NYC b. Indianapolis, IN. Studied: AIC; Columbia; Ozenfant; Zadkine; Archipenko. Member: NAWA; Phila. A. All.; Phila. Pr. Cl.; Santa Fe P.&S. Exhibited: AIC, 1917; PAFA, 1943, 1945; NAWA, 1945, 1946; Phila. A. All., 1943 (one-man); Santa Fe P.&S., 1930-46. Work: mem., Ind., Iowa, Colo., N.Mex., Pa. Specialty: collaborating with architects on sculpture. Position: T., Shipley Sch. for Girls, Bryn Mawr, Pa., 1934- [47]

DIENES, Sari [S,P,T] NYC b. 8 O 1899, Hungary. Studied: Ozenfant Sch. FA; A. Lhote; Leger; Henry Moore, in London. Exhibited: Mortimer Brandt Gal.; Norlyst Gal.; Vendôme Gal.; New Sch. Soc. Res., 1942 (one-man). Positions: Dir., Ozenfant Sch. FA, 1936-41; T., Parsons Sch. Des. [47]

DIESTEL, George Charles [I,Car,Des] Buffalo, NY b. 13 Mr 1898. Studied: Buffalo Acad. FA. Member: Buffalo SA; Soc. for Sanity in Art. Exhibited: Buffalo SA, 1933, 1934, 1938, 1930 [40]

DIETERICH, Louis P. [Por.P] Baltimore, MD b. 6 Ap 1842, Germany. Member: Charcoal C. [27]

DIETERICH, Waldemar F(ranklin) [P,T] Baltimore, MD b. 10 N 1876, Baltimore. Studied: Md. Inst; ASL, with Mowbray, Cox, Blum; Paris, with Constant, Laurens, L'Hermite. Member: Charcoal C.; ASL. Position: T., Md. Inst. [47]

DIETRICH, Albert M. [P] Pittsburgh, PA. Member: Pittsburgh AA [25]

DIETRICH, Carl J. [P,Arch] Hartford, CT b. 7 D 1865, Coburg, Germany d. 15 N 1914. Studied: Paul Turk, in Coburg; C.N. Flagg, in Hartford; Ross Turner, in Boston [13]

DIETRICH, George Adams [S,Des,P,L,T] Milwaukee, WI. b. 26 Ap 1905, Clark County, IN. Studied: Layton Sch. A.; AIC; C.R. Partridge; Picolli; V. Norman. Member: Wis. P.&S. Exhibited: AIC, 1928, 1930, 1931; PAFA, 1929, 1930; Hoosier Salon, 1927-32 (prizes); Milwaukee AI, 1929 (prize). Work: Layton A. Gal., Milwaukee; mem., City of Milwaukee; USPO, Lake Geneva, Wis. Positions: T., Layton Sch. A., 1929-31, Univ. Mich, 1937-38, Milwaukee Sch. En., 1939-43, U.S. Navy, 1943-46 [47]

DIETRICH, John Franklin [Edu,Cer,P,Des] Las Vegas, NM b. 7 Ag 1909, Wayzata, MN. Studied: State Teachers Col., Superior, Wis.; Univ. Iowa; Univ. Chicago; Ohio State Univ., Member: Western AA. Exhibited: Pittsburgh A.&Cr. Center, 1942; Cedar Falls AA, 1940-45; Iowa State Fair, 1942; Mus. N.Mex., 1946; Mus. N.Mex. Traveling Exh. (ceramics, one-man) 1946. Work: Mus. N.Mex. Positions: T., Iowa State T. Col., 1939-45, N.Mex. State T. Col., 1945-46, N.Mex. Highlands Univ., 1946- [47]

DIETRICH, Louis F. [Por.P] Baltimore, MD. Member: Charcoal C. [15]

DIETRICH, Thomas Mueller (Tom) [P,T] Appleton, WI b. 20 Ja 1912, Appleton. Studied: Univ. Wis. Experimental Col.; Cincinnati A. Acad., with M. Abel; Minneaplis Sch. A., with Krolleman, B. Mitchell. Member: Wis. A. Fed.; Phila. WCC; F., Tiffany Fnd., 1938. Exhibited: AIC, 1938, 1941, 1943, 1946; Madison AA, 1940 (prize); Phila. WCC, 1938, 1940-45; CMA, 1939; Grand Rapids A. Gal., 1940; Kansas City AI, 1940; Audubon A., 1945; All. A. Am., 1945; Wis. P.&S., 1936-42, 1943 (prize), 1944-46; Univ. Wis., 1937-45. Work: AIC; Wis. Union, Univ. Wis.; Rockford AA; Madison AA; Milwaukee Journal Coll.; Milwaukee AI; Lawrence Col.; Appleton Pub. Lib.; U.S. Maritime Comm. mural, S.S. Pres. Van Buren. Position: T., Lawrence Col., 1944- [47]

DIETSCH, C. Percival [S,P] Palm Beach, FL/Old Saybrook, CT b. NYC. Studied: N.Y. Sch. A.; Am. Acad., Rome, 1906-10; W.M. Chase; Beckwith; Attilio Piccirilli. Member: NSS, 1910; Arch. Lg., 1911; Soc. Four A., Palm Beach. Exhibited: PAFA, 1907; Am. Acad., Rome, 1906 (prize); NAD; Fla. Fed. A.; Soc. Four Arts, 1938 (prize); Norton Gal.; P.-P. Expo, 1915 (prize). Work: Peabody Inst., Md.; Rice Inst., Houston; Lighthouse for Blind, NYC; Besso Lib., Rome, Soc. Four Arts; war mem., Deep River, Conn. [47]

DIETZ, Albert Barnett [P] Wilmette, IL [08]

DIETZ, George F. [P] Wilmette, IL [04]

DIETZ, William [P] Cincinnati, OH. Member: Cincinnati AC [04]

DIEUDONNE, Jules A. Wash., D.C. b. Brussels, Belgium. Studied: M.J. Stallaert; J. Portaels; Royal Acad., Munich. Member: Cercle L'Essor, Brussels; Wash. SA [01]

DE FILIPPO, Antonio [S] NYC [27]

DIGGINS, P. Joseph [P] Paris, France [04]

DIGGS, Arthur [Mur.P] Chicago, IL b. 16 N 1888, Columbia, MO. Studied: AIC. Member: Chicago AL; Ill. Acad. FA. Exhibited: Chicago AL, 1929 (prize) [40]

DI GIOLA, Frank [P,I] NYC b. 18 D 1900, Naples, Italy. Studied: CUASch; ASL. Exhibited: AIC, 1942-46; Marie Harriman Gal., 1938 (one-man), 3 other one-man exhibits; WMAA, 1939, 1945; WFNY, 1939; PMG, 1938; AV, 1942; BM, 1945; Milch Gal., 1946. Work: Univ. Ariz.; PMG. Illustrator: "Impressions of Musicians," Theatre Magazine (1923, 1924); satirical illus. and theatrical sketches for newspapers and magazines [47]

DIKE, Phil(ip) (Latimer) [P,Des,T,Car] Los Angeles, CA b. 6 Ap 1906, Redlands, CA. Studied: Chouinard AI, with Chamberlin, Hinkle; ASL, with DuMond, Bridgman, Luks; Am. Acad., Fontainebleau, with St. Hubert. Member: Calif. WCS; Phila. WCC. Exhibited: CI., 1936, 1937; Paris Salon, 1930; AIC, 1935, 1939-41; NAD, 1937, 1938; Phila. WCC, 1928, 1944, 1945; Ferargil Gal., 1938, 1941; Los Angeles Mus. A., 1931 (prize), 1934 (prize), 1945 (prize), 1946; Pasadena AI, 1933 (prize); Calif. State Fair, 1933 (prize); GGE, 1939 (prize); Fnd. Western A., 1946; San Diego FA S.; Pal. Leg. Honor; Biltmore Gal.; Calif. WCS, 1931 (prize). Illustrator: national magazines. Lecture: Design and Color in Animated Motion Pictures. Positions: T., Chouinard AI, 1928, 1929, 1931, 1934, 1945, 1946; Color Consultant, Des., Instr., Walt Disney Studios, 1935-45 [47]

DIKEMAN, Aaron Butler [P] Chicago, IL [04]

DILG, Charles A. [P,W] b. 1845, Nierstein, Germany d. 29 Ap 1904, Chicago. Author: books on Chicago's early history

DILLAWAY, Theodore M. [P,W,T] Narbeth, PA b. 1 N 1874, Somerville, MA. Studied: Mass. Normal A.; Delacluse Acad., Paris. Member: Phila. Art T. Assn.; Phila. A. Alliance; EAA. Author: "American Renaissance," "Picture Appreciation." Position: Dir., Art Edu., Phila. Pub. Sch. [40]

DILLAYE, Blanche [P,I,E] Phila., PA b. 4 S 1851, Syracuse, NY d. 20 D 1931. Studied: PAFA, etching with Stephen Parrish, and painting with Thomas Eakins; Paris, with Garrido. Member: NYWCC; Phila. WCC; Plastic Cl. (a founder); NAWPS; Phila AC. Exhibited: Atlanta Expo, 1895 (med); AAS, 1902 (med); Intl. Expo, Lorient, France, 1903 (med); Conservation Expo, Knoxville, Tenn., 1913 (gold); PAFA, 1883-1927; Phila. AA, 1932 (memorial exh.). Work: WC Art Coll., Univ. Syracuse; Syracuse MFA [29]

DILLE, J.H. [P] Amelia, OH [15]

DILLER, Burgoyne A. [P,Edu] NYC b. 13 Ja 1906, NYC d. 1965. Studied: Michigan State Col.; ASL; Hoffmann. Exhibited: Am. Abstract A., 1937, 1938; Contemporary A. Gal., 1933; Harvard Sch. Des., 1945; Munson-Williams-Proctor Inst., 1946. Work: Syracuse Mus. FA; Yale Mus. FA.

Positions: Hd., WPA murals, NYC, 1935; continued with WPA until 1942 [47]

DILLER, Mary Black [P,I,L,W,T] NYC b. Lancaster, PA. Studied: Carnegie Inst., with Petrovits; PAFA, with McCarter, Garber, Carles; ASL, with DuMond; Metropolitan A. Sch., with Jacobs; P. Hale. Member: Audubon A.; Lancaster County AA; Eastern AA; Tiffany Fnd.; AAPL; Heights AC; Studio C. Exhibited: Lancaster, Pa, 1925 (prize); Studio Cl., 1923 (prize); Ogunquit A. Center, 1940 (prize); Audubon A., 1940, 1941, 1943, 1945; PAFA, 1939–41; Tiffany Fnd.; Newhouse Gal.; Am.-British A. Center; Number 10 Gal.; NYPL (one-man); Reading & Lancaster, Pa. (one-man). Work: Albany Inst. Hist.&A.; Tiffany Fnd. Author: "Drawing for Children," "A Child's Adventures in Drawing." Position: T., Shippen School, Lancaster [47]

DILLON, Frank H. [P] Winnetka, IL/Glen Haven, MI b. 11 O 1886, Evanston, OH. Studied: AIC. Member: Artists G. [33]

DILLON, Henry Patrice [P,Li] Paris, France b. 1851, San Francisco. Studied: Carolus-Duran, Paris. Member: Soc. des Peintres Lithographes; AAA, Paris. Award: Chevalier Legion of Honor, 1896. Exhibited: Paris Salon, 1890, 1892 (med), 1900 (med) [10]

DILLON, Julia (Mrs.) [P] Kingston, NY. Member: NYWCC [17]

DILLON, Mildred Murphy (Mrs. James F.) [P,E,Ser] Phila., PA b. 12 O 1907, Phila. Studied: PMSchIA; PAFA; Barnes Fnd.; Earl Horter. Member: Phila. Pr. Cl.; Phila A. All.; A. Lg. Phila.; Am. Color Pr. Soc. Exhibited: Am. Color Pr. Soc., 1940, 1942–45; PAFA, 1935, 1938; Phila. Pr. Cl., 1938, 1939, 1943–45; Phila. AC, 1933; Woodmere A. Gal., 1946. Work: PMA [47]

DIMAND, Maurice S. [Mus.Cur] NYC b. 2 Ag 1892, Austria. Studied: Univ. Vienna; Strzygowski. Member: Am. Oriental Soc.; The Athenaeum; Research F., Univ. Vienna. Author: "A Handbook of Mohammedan Decorative Arts," 1930, "The Ballard Collection of Oriental Rugs in the Art Museum of St. Louis," 1935. Contributor: Ars Islamica, CAA Bulletin, MMA Bulletin. Position: Cur., MMA, since 1923 [47]

DI MARCO, Jan (Mrs. Rocco) [P,I] Grosse Pointe, MI b. 12 Ag 1905, Chicago, IL. Studied: Cleveland Sch. A.; Wayne Univ.; H.G. Keller; John Huntington Polytech. Member: Detroit Soc. Women Painters; Grosse Pointe AA. Exhibited: Detroit Inst. A., 1940–45; Grosse Pointe AA, 1940–45; PAFA, 1937 [47]

DIMITROFF, Stephen Pope [Mur.P,L] Flint, MI b. 9 My 1910, Bulgaria. Studied: Flint Inst. A; AIC; Diego Rivera. Member: NSMP. Work: Madison House, NYC. Lecturer: Rivera Technique of Fresco [40]

DIMOCK, E. [P] NYC [15]

DIMOCK, Julian A. [I] Peckamose, NY [10]

DIMOND, Jane [P] Bronxville, NY. Exhibited: NYWCC, 1936–37; NAWPS, 1936, 1937, 1938 [40]

D'IMPERIO, Dominic [S] Phila., PA b. 31 Ag 1888, Italy. Studied: Grafly; Leasoly. Member: F., PAFA; Phila. Alliance. Exhibited: Spring Garden Inst., 1916 (med). Work: Church of St. James, Phila.; Graphic Sketch C., Phila. [40]

DI NARDO, Antonio [P] Cleveland, OH. Member: Cleveland SA [25]

DINCKEL, George William [P] Rockport, MA b. 19 Ag 1890, Cincinnati, OH. Studied: A. Acad., Cincinnati, with Duveneck, L.H. Meakin, H. Wessel. Member: Rockport AA; North Shore AA; Marblehead AA. Exhibited: Toledo, Ohio, 1939, (prize), 1946 (prize); Madison Sch., Sandusky, Ohio (prize). Work: Bowling Green State Col. [47]

DI NEGRO, Paul Gwynn [P,Et,C,Des] Key West, FL b. 5 S 1900, Key West. Member: Key West AA. Exhibited: Ringling Sch. A.; Univ. Fla; Univ. Ala.; Key West Fed. Gal. Work: WPA artist for U.S. Naval Station, Key West [47]

DINGLE, Edward Von Siebold [P] Huger, SC. Exhibited: SSAL, 1938; WFNY, 1939 [40]

DINGLEY, H.M., Mrs. See Mudgett, Lucille.

DINI, Mario Victorio [P,I,T] Boston, MA b. 18 D 1916, Boston. Studied: BMFA Sch. Exhibited: Fed. A. Gal., Boston, 1938, 1939 [40]

DINKELBERG, Frederick Philip [Arch] Chicago, IL b. 1861, Lancaster PA d. 10 F 1935. Studied: PAFA. Designer: landmark "Flatiron Building" in NYC, the subject of numerous artists' works

DINNEEN, Alice (Mrs. Allan Gould) [P] Bearsville, NY b. 23 F 1908, NYC. Studied: N.Y. Sch. Appl. Des. for Women; ASL; Nicolaides; Furlong. Exhibited: T.R.A.P. National Traveling Exh., 1935; CMA; WMAA; PAFA; CI. Work: murals, Carville, La.; La Fortaleza, San Juan, Puerto Rico; USPOs, Warrenton, N.C., Corbin, Ky.; Dept. Labor, Wash., D.C. WPA muralist. [47]

DINNING, Robert James [P] Pasadena, CA b. Omaha, NE. Studied: PAFA; ASL; Barnes Fnd.; J. Carlson; Speicher; Dasburg. Member: AAPL; Pasadena FA Center; Pasadena SA. Exhibited: Glendale AA, 1945; Pasadena SA, 1940–46; Pasadena FA Center, 1941–46; Los Angeles Eberle C., 1946 [47]

DINSMORE, E.J. [I] NYC [21]

DIODA, Adolph [S] West Aliquippa, PA b. 10 S 1915, Aliquippa. Studied: Carnegie Inst. Tech.; Cleveland Sch. A.; Barnes Fnd.; J.B. Flannagan. Member: Guggenheim F., 1945; Pittsburgh AA; Soc. S. Pittsburgh. Exhibited: WMAA, 1939; PMA, 1940; CI, 1941; AIC, 1940; PAFA, 1946; AA Pittsburgh, 1941–45 [47]

DIONYSIUS, Dooley [P,I,C,W] Los Angeles, CA b. 17 Je 1907, St. Louis. Studied: St. Louis Sch. FA. Member: Calif. WCS. Author/Illustrator: "The Black Opal," "The Mother Goose Rhymes" [40]

DIRK, Nathaniel [P,T,W,L] NYC 21 D 1895, Brooklyn. Studied: AIC; ASL; Max Weber; K.J. Miller; F. Robinson; Paris, with F. Leger. Member: Audubon A.; Rockport AA; Rockport A. Group. Exhibited: CI, 1930, 1931; AIC, 1932–34, 1936, 1938, 1942; BM, 1935–41; WMAA, 1933–40; CGA, 1934; NCFA, 1941; Audubon A., 1945; MMA, 1941; ASL, 1942, 1944. Work: BM; WMAA. Position: Dir., Contemporary Art Center, 1940 [47]

DIRKS, Gustavus [I] NYC d. 10 Je 1902. Originator: "Bugville Sketches"

DIRKS, Randolph [P] NYC [15]

DIRKS, Rudolph [I] NYC d. 1968. Member: Lg. AA [24]

DIRNFELD, Frederick Arnold [P,Et] NYC b. 1 F 1889, Budapest, Hungary. Studied: NAD; G.M. Ward; C.Y. Turner. Exhibited: Anderson Gal., 1931; SAE, 1932, 1933, 1935, 1939, 1946; NAC 1932, 1933, 1935, 1939, 1946; NAD, 1932, 1933, 1935, 1938, 1942, 1946; Calif. Pr.M., 1934; CMA, 1935 [47]

DISI, Achilles G. [P] Chicago, IL [04]

DISMANT, Marion [I] Washington, PA [21]

DISMUKES, Adolyn Gale (Mrs. George) [P,S,W] Biloxi, MS b. Memphis, TN. Studied: Bethany Col. Exhibited: Nashville, Tenn., 1928 (prize); Biloxi AA, 1929 (prize) [47]

DISMUKES, Mary Ethel [P,L] Biloxi MS. b. Pulaski TN d. 18 F 1952. Studied: Martin Col., Pulaski; ASL, with K. Cox, Loeb, Carleton; Twachtman. Exhibited: Gulf Coast AA, 1927 (gold); Miss. State Fed. Women's Clubs, 1927 (prize); 1931, (gold); State Fair, 1926 (prize); Gulf Coast Fair, Gulfport, 1926 (prize); Gulf Coast AA, 1931 (prize). Work: Pub. Lib., Biloxi, Miss. [47]

DISNEY, Walt(er) E. [Car,Des] Burbank, CA b. 5 D 1901, Chicago d. 1966. Studied: Chicago Acad. FA. Member: Art Workers Gld., London; French Leg. Honor. Awards/Exhibited: "Mickey Mouse" (Acad. Award); "Flowers and Trees," 1932 (Acad. Award), first color cartoon; "Three Little Pigs," 1933 (Acad. Award); "The Tortoise and the Hare" (prize); First Soviet Cinema Festival, USSR (prize); Am. Inst. Cinematography (prize); Second Intl. Cinematographic Art Exh., Venice, Italy, "Funny Little Bunnies," 1934; Third Intl. Cinematographic Art Exh., Venice, "The Band Concert" (prize); Festival Intl. de Cinema, Brussels, 1935 (prize); "Three Orphan Kittens" (Acad. Award); "The Country Cousin," 1937 (Acad. Award); "Snow White and the Seven Dwarfs" (Acad. Award); "Ferdinand the Bull," 1938 (gold). Producer: Mickey Mouse and Silly Symphony cartoons, 1928; full-length animated films, Snow White and the Seven Dwarfs (1938), Pinocchio (1940), Fantasia (1940), Dumbo (1941) [40]

DISSETT, George C. [P] Cleveland, OH. Member: Cleveland SA [25]

DIUGUID, Mary Sampson [P] Lynchburg, VA b. 29 My 1885, Lynchburg. Studied: Grand Central Sch. A.; PAFA; PMSchIA; Henry B. Snell; Ennis. Member: NAC; Wash. WCC; Plastic C. [47]

DI VALENTIN, Louis [P,S] White Plains, NY b. 21 N 1908, Venice, Italy. Studied: Calif. Sch. FA; Corcoran Sch. A.; ASL; Italy. Exhibited: CGA, 1945; Carnegie Inst., 1942–45; NAD, 1942–45; Toledo Mus. A., 1943–45; Springfield Mus. A., 1943–45; Cambridge, Mass., 1944, 1945. Work: Catholic Univ., National Cathedral, St. Matthews Cathedral, all in Wash., D.C. [47]

DIX, Eulabee [Min.P,Dec,L,T,C] NYC b. Greenfield, IL. Studied: St. Louis; NYC; London; Paris. Exhibited: Paris Salon, 1927 (med); ASMP, 1929 (med); Pa. SMP, 1929 (med); PAFA; Royal Acad., London, 1935; Milch Gal., 1928; Grand Central A. Gal., 1929, 1935; Knoedler Gal., London, 1934; Telfair Acad. A.; Mint Mus. A.; Soc. Wash. A., 1938; CGA, 1933 [47]

DIX, Harry [P] NYC. Exhibited: WFNY, 1939. Work: Rochester Mem. A. Gal. [40]

DIX, John Adams [P] b. 1881, NYC d. 1 O 1945, Mt. Kisco, NY. Studied: Ecole des Beaux-Arts, Paris. Exhibited: NYC; other cities.

DIXEY, Ellen Sturgis (Mrs.) [P,I] Boston, MA [08]

DIXON, Francis Stilwell [P] NYC b. 18 S 1879, NYC d. 1967. Studied: ASL, with Henri, Hawthorne. Member: All. AA; CAFA; SC. Work: Morgan Mem., Hartford, Conn. [47]

DIXON, Harry St. John [C] San Fran., CA b. 22 Je 1890, Fresno, CA. Member: Un. Am. Artists, San Fran. Work: San Fran. Stock Exchange; multi-metal plaque, R.H. Hellman, San Fran. Specialty: metal work. Position: T., Artists Co-operative, Inc. [40]

DIXON, John J., Mrs. See Sawtelle.

DIXON, John J.A. [P] Phila., PA b. 14 Ja 1888, Phila. Studied: W.M. Chase. Member: Phila. Alliance; Da Vinci Alliance, Phila. Exhibited: Phila. Sketch C., 1936 [40]

DIXON, Mabel E(astman) [P] Des Moines, IA b. Auburn, IA. Studied: AIC; Columbia; R. Davey; A.W. Dow; Paris, with A. Strauss, Bolonde. Member: Iowa AC; Co-op. A. Iowa. Exhibited: Iowa AC, 1932 (prize); Des Moines Women's C., 1932 (prize); 1934 (prize); All-Iowa Exh., Chicago, 1937. Work: Fountaineblueau Mus., France [40]

DIXON, Maynard [Mur.P] San Francisco, CA b. 24 Ja 1875, Fresno, CA d. 14 N 1946, Tucson, AZ. Studied: self-taught. Member: San Fran. AA; Southwest Soc.; Am. A. Cong.; Western A.; Bay Region AA. Exhibited: San Fran. AA, 1930 (prize); Ebell C., Los Angeles, 1931 (prize), 1933 (prize); Thirteenth Annual Los Angeles Exh., 1932 (prize). Work: dec., dining salons, S.S. Silver State and S.S. Sierra; murals, Mark Hopkins Hotel (San Fran.), Technical H.S. (Oakland, Calif.), Kit Carson Cafe (San Fran.), John C. Fremont H.S., Oakland Theatre; Calif. State Lib.; Ariz. Biltmore, Phoenix; SFMA; Southwest Mus., Los Angeles; BM, 1932; de Young Mus.; Pasadena AI; Mills Col. Gal.; Univ. Idaho; Cook Mus., Honolulu; Brigham Young Univ.; San Diego MA; murals, USPO, Martinez, Calif.; Golden Gate Expo. WPA muralist. [46]

DIXON, Maynard, Mrs. See Hamlin, Edith.

DIXON, Rachel [P] West Bloomfield, NY [19]

DIXWELL, Anna P. [P] b. ca. 1846, Boston d. 1885, Paris, France. Studied: William M. Hunt, in Boston; France, 1876; toured Europe, 1881; Académie Julian, Paris, 1885. Exhibited: J.E. Chase Gal., Boston, 1882, 1884; Williams & Everett Gal., 1882 [*]

DLUGOSZ, Louis Frank [S] Lackawanna, NY b. 21 N 1915, Lackawanna. Studied: Albright A. Gal.; Paris. Member: The Patteran. Exhibited: Albright A. Gal., 1936-38, 1939 (prize) 1940 (prize); The Patteran, 1939; Nierendorf Gal., 1940; Paris A. Exh., 1946 [47]

DMITRIEFF, Nataniel [S] NYC [10]

DOANE, Norman H. [Des,T] Cincinnati, OH/West Baden Spring, IN b. 19 D 1904. Studied: Cincinnati A. Acad. Member: Cincinnati ACI; Ohio WCC; Cincinnati Crafters. Exhibited: Cincinnati A. Ann., 1939; Cincinnati AM; Cleveland Mus.; Herron AI, Indianapolis; Nelson Gal., Kansas City; Butler AI [40]

DOANE, Pelagie (Mrs. P.D. Hoffner) [I,W] NYC b. 11 Ap 1906, Palmyra, NJ. Studied: Sch. Des., Phila. Author/Illustrator: "A Small Child's Bible." Illustrator: "Just Like Me," "Animals Here and There," other books [47]

DOBBERTIN, Otto [S] San Fran., CA [01]

DOBBINS, Helen E. [S] Woodbury, NJ b. 3 Ja 1885, Trenton, NJ. Studied: Grafly [13]

DOBBS, Ella Victoria [Edu,C,W,L] Columbia, MO b. 11 Je 1866, Cedar Rapids, IA d. 13 Ap 1952. Studied: Columbia; Univ. Mo. Member: Nat. Edu. Assn.; Am. Assn. Univ. Women. Author: "Primary Handwork," "Illustrative Handwork," other books. Position: T., Univ. Mo. [47]

DOBKIN, Alexander [P,I,W,L,G,T] NYC b. 1 My 1908, Genoa, Italy d. 1975. Studied: CCNY; Columbia; ASL. Member: A. Lg. Am. Exhibited: AIC; BM; CGA; PAFA; MOMA; CI. Work: U.S. Gov., Wash., D.C.

Illustrator: "Child's Garden of Verses," "Two Years Before the Mast," other books. Contributor: art criticism, New York Times [47]

DOBLER, Maud A. (Mrs. George) [P,T] Rockford, IL b. 3 F 1885, Rockford. Studied: E. Reitzel; C. Krafft; H.A. Oberteuffer. Member: Rockford AA; Austin AL; Oak Park AL; River Forest AL; Ill. Acad. FA; All- Ill. SFA. Exhibited: Rockford AA, 1929 (prize) [40]

DO BOS, Andrew [P,G,Des] San Rafael, CA b. 30 N 1897, Galicia, Poland. Studied: AIC; Chicago Acad. FA; Mizen Acad. FA; F.M. Grant. Member: Oak Park AL; Palette & Chisel Acad. FA; All-Ill. Soc. FA; Marin SA. Work: State Mus., Springfield, Ill.; Amalgamated Lith. Am., Chicago [47]

DOBSON, (David Irving Diamondstein) [P,Des,W,L,Car] Brooklyn, NY b. 14 Ap 1883, Kurentiz, Russia. Studied: AIC; Henri; J. Myers; de Ivanowski; Paris; Düsseldorf. Member: S.Indp.A. Exhibited: S.Indp.A., 1917-1944; Queensboro SA, 1936-38. Cartoons and articles in various publications under "Dobson." [47]

DOBSON, Margaret A. [P] Santa Monica, CA b. 9 N 1888, Baltimore. Studied: Md. Inst.; PAFA; Syracuse Univ.; Fontainebleau Sch. FA; Garber; Beaux; Oakley; Carlsen; Vonnoh; J. Wier; Breckenridge; St. Hubert; P. Baudouin; J. Despujols. Member: Calif. AC; Women P. of the West; Santa Monica AA; Los Angeles AA. Exhibited: Fontainebleau, 1927 (prize); Paris, 1930 (med); Ebell Salon, 1936 (prize); Los Angeles Mus. A; Los Angeles AA. Work: Fontainebleau, Paris; Girl Scouts Bldg., Santa Monica; U.S. Navy; USPO, Kaufman, Tex.; PAFA (Chester Springs, Pa.); Miss. A. Assoc. Coll., Jackson, Miss. WPA muralist. [47]

DOD, Samuel Bayard [P,E,W,Edu] South Orange, NJ b. 1847, Princeton d. 19 Ap 1907. Studied: Princeton, grad. 1856. He was a Presbyterian clergyman until 1869. He became executor of the Stevens estate in Hoboken, and was President of Stevens Institute until his death.

DODD, Jessie Hart [I,P,T,C] Cincinnati, OH b. 18 Ap 1863, Cincinnati d. 16 O 1911. Studied: PAFA; H. Pyle; Drexel Inst., Phila. [13]

DODD, Lamar [P,Edu,L] Athens, GA b. 22 S 1909, Fairburn, GA. Studied: B. Robinson; R. Lahey; Charlot; G. Bridgman; Luks. Member: NYWCC; Southeastern AA; Assn. Ga. A.; Athens AA; SSAL. Exhibited: SSAL, 1931 (prize), 1940 (prize); Ala. A. Lg., 1936 (prize); AIC, 1936 (prize); WFNY, 1939 (prize); IBM (prize); Telfair Acad. A., 1941 (prize); Assn. Ga. A.; NAD; PMA; VMFA; CI; WMAA; NYWCC; AWCS; GGE, 1939; AFA; CAM; BM; Calif. WC Soc.; MMA; Birmingham AC; Syracuse Mus. FA; R.I. Sch. Des. Positions: T., Univ. Ga., Athens, 1938- , Univ. Southern Calif. [47]

DODD, Mark Dixon [P,T] St. Petersburg, FL b. 28 Ja 1888, St. Louis, MO. Studied: Hawthorne; Miller; Johansen; Romanovsky; ASL; St. Louis Sch. FA. Member: St. Petersburg Civic AC; AFA. Exhibited: Tampa AC, 1929 (prize); Miami AC, 1930 (prize). Work: Pub. Lib., Woods Hole, Mass.; State of Fla. Bldg., Century of Progress Expo [40]

DODD, Peggy [P,W,L] Paterson, NJ/Woodstock, NY b. 22 Jy 1900, Paterson, NJ. Studied: Collegiate Inst., Paterson; ASL; Kuniyoski; H. Mattson. Member: AWCS; NAWA; N.J. WCC; Mod. A., N.J.; Montclair AA; Woodstock AA; AAPL. Exhibited: NAWA, 1944 (prize), 1945 (prize); Montclair A. Mus. (prize); PAFA; WMAA; Woodstock AA; AIC; Paterson AA; Newark Mus.; Albany Lib. Position: A. Ed., Paterson Morning Call [47]

DODDS, Robert Elihu [P,T,W,L,C] New Rochelle, NY b. 31 Ag 1903, Guzneh, Turkey. Studied: PIASch; Columbia; S. Fisher; G. Browne; Ennis. Member: SC; New Rochelle AA; Westchester A.&Cr. Gld., 1945. Exhibited: Beaver County, Pa., 1937 (prize), 1938 (prize), 1939 (prize); All. A. Am., 1945 (prize); Westchester A.&Cr. Gld., 1945; AWCS; Phila. WCC; Assoc. A. Pittsburgh; SC; Grumbacher Traveling Exh. Work: State T. Col., Fairmont, W.Va. Author/Illustrator: "Handicrafts as a Hobby." Positions: T., Inst. A, Davis H.S., Mt. Vernon, N.Y., 1930- [47]

DODGE, Arthur B. [P] Los Angeles, CA. Member: Calif. AC; Calif. PM [25]

DODGE, Chester L. [P,Des,I,T] Providence, RI b. 21 My 1880, Salem, ME. Studied: RISD; ASL; DuMond; W.A. Clark. Member: Providence AC; Providence WCC; South County AA. Exhibited: Providence AC. Work: Council Chamber, Washington, R.I. Position: T., RISD, 1919-43 [47]

DODGE, F(rances) Farrand [P,E,L] Easton, MD b. 22 N 1878, Lansing, MI. Studied: Mich. State Univ.; Syracuse Univ.; Cincinnati A. Sch.; ASL; Duveneck; Meakin; Wessel; Pennell; F. Grant. Member: Chicago Gal. Assn.; Chicago P.&S.; Chicago SE; NAWA; Cincinnati Women's AC. Exhibited: Minn. State Fair (prize); PAFA, 1914, 1915; AIC; Cincinnati Inst. FA. Work: Cincinnati Pub. Sch. Coll.; Chicago Pub. Sch. Coll.; Nebr. State Univ. [47]

DODGE, Joseph Jeffers [P,Mus.Cur,Cr,W,L,T] Glens Falls, NY b. 9 Ag 1917, Detroit. Studied: Harvard; Wayne Univ. Exhibited: PAFA, 1945; Detroit Inst. A., 1945; Albany Inst. Hist.&A. 1943, 1944, 1946; Katrina Trask Gal., Saratoga Springs, N.Y., 1943–46; Brandt Gal. Contributor: Art Quarterly. Position: Cur., Hyde Coll., Glens Falls, N.Y., 1941– [47]

DODGE, Mira Reab [P] Wash., D.C. [01]

DODGE, Ozias [P,E] Norwich, CT/Center Harbor, NH b. 14 F 1868, Morristown, VT d. 28 Je 1925. Studied: Yale; ASL; Ecole des Beaux-Arts, Gérome, both in Paris. Member: Chicago SE; New Haven PCC; Calif. PM. Work: Congressional Library, Wash., D.C.; NYPL; AI, Chicago. Position: Dir., Norwich A. Sch., 1897–1910 [24]

DODGE, Richard [P,G,I] Cincinnati, OH b. 18 Ja, 1918, Sacramento, CA. Studied: A. Center Sch., Los Angeles; Cincinnati A. Acad. Exhibited: Oakland (Calif.) A. Gal., 1939. Work: Mills Col. A. Gal., Calif. [40]

DODGE, W(illiam) De Leftwich [Mur.P,I] NYC b. 9 Mr 1867, Liberty, VA d. 25 Mr 1935. Studied: Munich; Gérôme, in Paris. Member: Mur. P. Exhibited: Prize Fund Exh., N.Y., 1886 (gold); Paris Expo, 1889 (med); Columbian Expo, 1893 (med); P.-P. Expo, 1915. Work: dome, Administration Bldg., Columbian Expo, Chicago, 1893; northwest corner pavilion, LOC; 24 paintings for State Capitol, Albany; Acad. Music, Brooklyn; hotels in NYC; T. Col., Cedar Falls, Iowa [33]

DODGE, William Waldo, Jr. [C,Arch,P] Asheville, NC b. 6 F 1895. Studied: MIT. Member: AIA. Specialties: handwrought silver (Dodge silvers); copper work; stained glass; woodcarving [40]

DODSHUN, A. Van Cleef (Mrs.) [P] Chicago, IL b. Jersey City. Studied: G.H. Smillie, in N.Y. Member: Chicago SA [15]

DODSON, Nellie (Plitt) [P] Winston-Salem, NC b. 19 N 1906, Pilot Mountain, NC. Studied: E. Porter; Breckenridge; PAFA. Member: SSAL; N.C. Prof. AA [33]

DODSON, Sarah Paxton Ball (Mrs.) [P] Brighton, England b. 1847, Phila. d. 8 Ag 1906. Studied: Luminais, Lefebvre, Boutet de Vonvel, all in Paris [06]

DODSWORTH, Adah M. [Patron] Englewood, NJ d. 17 N 1932. Fine paintings and objects of American, European, Oriental art were in her collection and frequently loaned for public exhibitions.

DOEDERLEIN, F.W. [P] NYC Member: SC [25]

DOELGER, Frank J. [P] Brooklyn, NY. Member: S.Indp.A. [25]

DOENNECKE, Elena Dorothy [Por.P,Li,T] Davenport, IA b. 4 Je 1910, Davenport. Studied: Ritman; AIC. Position: T., Davenport H.S. [40]

DOEPLER, Carl Emil [P,I] b. 8 Mr 1824 Warsaw, Poland (came to NYC in 1849) d. 20 Ag 1905, Berlin. Illustrator: Harper's, Putnam's 1849–55. Sold two landscapes to Am. Art-Union, 1849, 1850 [*]

DOERFLER, C.D., Mrs. See Anderson, Julia. [40]

DOERING, Paul [P] Laguna Beach, CA [25]

DOERN, Virginia Linise [P,E,I,Des] Milwaukee, WI b. 5 Ap 1913, Milwaukee. Studied: Univ. Wis.; AIC; Philbrick; Forsbeck; Chicago Acad. FA; New Orleans Sch. A.&Cr. Member: Seven Arts Soc., Milwaukee; Chicago SE. Exhibited: Jacksonville (Fla.) FA Mus., 1936 (prize); Wis. Salon A., 1937–38; Kansas City AI, 1939. Position: Illus., Lockheed Aircraft, 1942–44 [47]

DOERR, (James) Edward [P] Portsmouth, OH b. 31 Jy 1909, Portsmouth. Studied: H.G. Keller; Stoll; P. Kalman; Cleveland Sch. A., 1931 [40]

DOGGETT, Allen B. [P,I] Brooklyn, NY b. Groveland, MA d. 2 O 1926. Studied: Boston; Royal Acad. A., Munich, with Carl Marr. Member: Brooklyn SA. Position: T., Eramus Hall H.S., Brooklyn, 30 yrs. [25]

D'OGRIES, Valentine [Stained Glass] New Hope, PA b. Austria. Studied: Carnegie Inst.; Wynd-Young, N.Y. Work: St. Mary's Church, Wayne, Pa.; Grace Church, Newark; St. Thomas the Apostle, Chicago; Trinity Cathedral, Trenton; Corpus Christi, N.Y.; Hatfield Chapel, New Canaan, Conn.; St. Patrick's, Hamilton, Ontario; All Saints, Lakeland, Fla.; St. James, Long Branch, N.J. [40]

DOHANOS, Stevan [I,B,Li,P] Westport, CT b. 18 My 1907. Member: SI; NSMP. Exhibited: Phila. WCC, 1934 (med); Cleveland Pr.M., 1934 (prize). Work: WMAA; Coll. F.D.R., Cleveland Print C.; Forest Service Bldg., Elkins, W.Va.; USPO, West Palm Beach, Fla. WPA muralist. Position: Illus., Charles E. Cooper, Inc. [47]

DOHERTY, Lillian C. (Mrs.) [P] Wash., D.C. Studied: Corcoran Sch. A.; R.H. Nicholls; Hawthorne; Europe. Member: Wash. SA [25]

DOHLGRIN, Josefine [P] Wash., D.C. [08]

DOHME, Emily [P] Baltimore, MD [25]

DOHN, Pauline. See Rudolph, Mrs.

DOHNER, Donald [P] Pittsburgh, PA. Member: Pittsburgh AA [25]

DOHRMANN, Theodore S. [P] Cincinnati, OH [17]

DOI, Isami [P,B,C,En] Kalaheo, Kauai, Hawaii b. 12 My 1903, Ewa, Oahu, HI d. 1965. Studied: Univ. Hawaii, 1921–23; Columbia, 1923–28; A.W. Heckman; J.P. Heins. Member: An Am. Group; Am. A. Cong. Exhibited: Assn. Honolulu Ar., 1938 (prize); Honolulu Acad. FA 1929, 1935, 1939, 1950, 1960, 1966 (memorial); Pal. Leg. Honor, 1932; Univ. Hawaii, 1961 (retrospective). Work: MOMA. WPA artist, in NYC. [40]

DOKE, Sallie George (Fullilove) (Mrs. Fred) [P] Lometa, TX b. Keachie, LA. Studied: Cincinnati Acad.; Chicago Acad. FA. Member: S.Indp.A. Exhibited: Dallas, 1916 (gold) [21]

DOKTOR, Raphael [P] NYC b. 9 Je 1902, Three Rivers, MA. Studied: AIC; Corcoran A. Sch.; ASL. Member: Mural Ar. Gld. Work: Parnassus magazine, 1938. WPA muralist. [40]

DOLAN, Elizabeth Honor [P] Lincoln, NE b. 20 My 1887, Fort Dodge, Iowa. Studied: Fontainebleau Sch. FA; La Montagne; St. Hubert; Paul Baudoin; F. Luis Mora; George Bridgman; Thomas Fogarty. Exhibited: NAC, 1939 (prize); Knoedler Gal., 1924; Joslyn Mem., 1935; AIC; ASL. Work: Cathedral Fourquex, France; Nebr. State Capitol; AMNH; Nat. Hist. Mus., Lincoln, Nebr.; Joslyn Mem., Omaha [47]

DOLBIN, B. F. [P,I,W,Car,Cr] Jackson Heights, NY b. 1 Ag 1883, Vienna, Austria. Exhibited: Intl. Exh., Moscow and Leningrad, 1928 (prize); BM, 1937; Dance Intl., N.Y., 1937; WFNY, 1939; NAC, 1940; Friendship House, N.Y. 1941 (one-man); Am.-Brit. A. Center, 1942, 1944; Tribune A. Center, 1946 (one-man). Work: Mus. City of Vienna; Kunstgewerbe Mus., Moscow; MOMA. Illustrator: books, pub. Europe and U.S. magazines [47]

DOLE, Margaret Fernald (Mrs.) [Por.P,T] Spuyten Duyvil, NY/Nauset Heights, Orleans, MA b. 5 My 1896, Melrose, MA. Studied: Radcliffe; BMFA; P. Hale; C. Woodbury. Member: Providence AC; Phila. A. All.; NAWA. Exhibited: CGA, 1937; PAFA, 1927; NAD; Paris Salon, 1934; All. A. Am.; Ogunquit A. Center; Providence AC; Argent Gal., 1940 (one-man). Position: T., Riverdale (N.Y.) Country School for Girls, 1940 [47]

DOLECHECK, Christine (A.) [P,T] Ellsworth, KS b. 16 D 1894, Dubuque. Studied: W. Griffiths; Sandzen; Wheeler; Hekking; Frazier. Member: Art T. Cl., Youngstown, Ohio. Exhibited: Kans. State Fair, Hutchinson, 1932 (prize) [33]

DOLEJSKA, Frank [P] Houston, TX. Exhibited: Golden Jubilee Exh., Dallas, 1938; MFA, Houston, 1938–39 [40]

DOLEY, Peter [P,T] Gaspee Plateau, RI b. 20 Je 1907, New Haven, CT. Studied: PIASch; Boston Univ.; R.I. Sch. Des.; Cimiotti; C.D. Hubbard. Member: Providence WCC; Providence AC; AAPL; R.I. Art T. Assn. Exhibited: PAFA, 1936; Providence AC, 1935–46; Providence WCC, 1932–46. Work: R. I. State Col.; Nathaniel Greene Sch.; mural, St. Michael's, New Haven. Position: T., Providence Pub. Sch., 1930– [47]

DOLINSKY, Nathan [P,T] NYC/Hunter, NY b. 9 Ag 1890, Russia. Studied: NAD. Member: SC; Arch. Lg.; Mural P. [40]

DOLMITH, Rex [Por.P,Des,L] Wilmington, DE b. 22 Ja 1896, East Canton, Ohio. Studied: AIC; R. Graham; S. Bell; Calif. Sch. A.&Cr. Member: Wilmington SFA. Specialties: portraits; architectural and industrial des. [40]

DOLNYCKA, Marie Sophie [P] Minneapolis, MN [24]

DOLPH, Carey A. [P] Mt. Ranier, MD [13]

DOLPH, John Henry [P] NYC b. 18 Ap 1835, Fort Ann, NY d. 28 S 1903. He began his career by painting portraits in Detroit in 1857; came to N.Y. ca. 1865. Member: ANA, 1877; NA, 1898; Lotos Cl.; SC; Kit-Kat Cl. Exhibited: Pan-Am Expo, Buffalo, 1901 (med). Having studied animal painting under Van Kuyck in Antwerp (paying particular attention to horses), he began to make a reputation in 1875, when he painted a Persian cat. From that time on he made a specialty of cats and dogs. [01]

DOLWICK, William Adelbert [P,I] Lakewood, OH b. 19 F 1909, Lakewood. Studied: Cleveland Sch. A.; Slade Sch., London; Acad. Scandinav, Acad.

Colarossi, both in Paris. Exhibited: Cleveland Mus. A., 1936 (prize). Work: Pub. libraries, Mus. A., both in , Cleveland; Fed. A. Proj. Coll.; murals, USPOs, Hobart, Ind., Gas City, Ind. WPA muralist. [40]

DOMINIQUE, John Augustus [P,E] Los Angeles, CA b. 1 O 1893, Sweden. Studied: Calif. Sch. Des.; Van Sloun Sch. P.; C.C. Cooper. Member: Calif. AC; Glendale AA; Council All. A.; Oreg. SA; Portland (Oreg.) AA. Exhibited: Oreg. State Fair, 1940 (prize), 1941 (prize); Portland A. Mus., 1936; Oakland A. Gal., 1941; Los Angeles Mus. A., 1944 [47]

DOMVILLE, Paul [Edu,Mur.P] Ardmore, PA b. 16 Je 1893, Hamilton, Ontario. Studied: Hamilton Col. Inst.; Hamilton A.&Tech. Sch.; Univ. Pa.; PAFA. Member: Phila. All.; T-Square Cl.; Arch. Lg.; NSMP; Phila. WCC. Exhibited: Univ. Pa., 1920 (med); PAFA, 1923, 1926, 1937, 1938, 1943, 1944; Arch. Lg., 1924, 1928. Work: St. Luke's, Seaman's Church Inst., Mutual Trust Co., City Nat. Bank, all in Phila. Position: T., Moore Inst., Phila, 1938– [47]

DONAGHY, John [P,I] De Land, FL/NYC b. 4 My 1838, Hollidaysburg, PA d. 1931. Studied: Eugene Craig; G. Hertzel; A.L. Dalby; I. Broome; NAD; ASL. Member: Brooklyn AC; Pittsburgh AS. He was a captain for the Union Army and was wounded, captured, and imprisoned at Andersonville Prison, from which he escaped in April 1864. He lived to be 93. [13]

DONAHEY, (James) (Harrison) [Car,C,L] Aurora, OH b. 8 Ap 1875, Westchester, OH. Studied: Cleveland Sch. A. Illustrator: "Sketches in Yucatan" (1930), "Sketches in Alaska" (1935), "Romance of the Great Lakes" (1936). Work: cartoons, in Cleveland newspapers (since 1896) and in numerous public libraries and art museums (Ohio) [47]

DONAHUE, William Howard [P] NYC/Lyme, CT b. 21 D 1891, NYC. Studied: H.R. Poore; E.L. Warner; J. Noble. Member: Brooklyn S. Mod. A.; Lyme Progressives; All.A Am.; Creative A. Assoc.; Lyme AA. Exhibited: CGA, 1924; PAFA, 1925; NAD, 1930; Los Angeles Mus. A., 1924; BM, 1918; Riverside Mus., 1942, 1944, 1946; Am.-British A. Center, 1943; Chappelier Gal., 1944; Lyman Allyn Mus., New London, Conn., 1945 [45]

DONALDSON, Alice Willits [Dec,Indst.Des,P] NYC b. 28 S 1885, Ill. Studied: Cincinnati Acad.; Pa. Mus. Sch. Indst. A.; N.Y. Sch. Display. Member: Nat. AAI; NYWCC; Soc. Des.-Cr. [40]

DONALDSON, Anne D (Mrs.) [P] Wash., D.C. Member: Pittsburgh AA, 1921 [25]

DONALDSON, Douglas [C] Los Angeles, CA b. 24 Ag 1882, Detroit. Studied: E.A. Batchelder; L.H. Martin; J. Winn; R. Schaeffer. Member: Boston SAC; Calif. AC. Exhibited: Boston A.&Cr. Soc., 1916 (med); San Diego Expo, 1915 (gold); AIC, 1916 (prize), 1917 (prize); Southern Calif. Art T. Assn., 1927–28 (prize); Long Beach Expo, 1928 (med). Work: Detroit Inst. A.; Carnegie Inst.; AIC. Specialties: silver; jewelry; enameling. Position: Dir., Donaldson Summer Sch. Color Theory and Design [47]

DONALDSON, Elise [P,Li] La Jolla, CA b. Elkridge, MD. Studied: Bryn Mawr; AIC; L. Kroll; Lhote; abroad. Member: Chicago SA; Chicago AC; NAWA; San Diego A. Gld.; Calif. WC Soc. Exhibited: AIC, 1934 (prize); PAFA; Carnegie Inst.; SFMA; San Fran. AA, 1943; LOC, 1945; Laguna Beach AA, 1945, 1946; Calif. WC Soc., 1944; BM; San Diego FA Soc., 1944 (one-man); La Jolla A. Center. Work: San Diego FA Soc. WPA artist, 1935. [47]

DONALDSON, John [P] Detroit, MI. Member: NIAL [17]

DONALDSON, John A. (Mrs.) [P] Emsworth, PA. Member: Pittsburgh AA [21]

DONATO, Giuseppe [S] Phila., PA b. 14 Mr 1881, Maida, Calabria, Italy d. 1965. Studied: Phila. Indst. A. Sch.; Grafly; J.L. Tadd; PAFA; Ecole des Beaux-Arts, Colarossi Acad., Académie Julian, all in Paris. Member: NSS, 1909; Arch. Lg; Paris AAA; Union Internationale des Beaux-Arts et des Lettres. Exhibited: PAFA, 1900, 1903–05. Work: City Hall, Phila.; PAFA [40]

DONATO, Louis Nicholas [P,Des,T] Jamaica, NY b. 23 O 1913, NYC. Studied: CUASch. Exhibited: WFNY, 1939; PMG, 1940; BM, 1941; PAFA, 1941, 1942, 1946; CI, 1941, 1945; CGA, 1943, 1945; VMFA, 1942, 1946; AFA Traveling Exh., 1943–44; Lilienfeld Gal. (one-man); Am.-British A. Center. Work: PMG [47]

DONDO, Mathurin M. [P,W,L,T] Berkeley, CA b. 8 Mr 1884. Studied: Hawthrone; Henri; Bellows; Schumacher. Member: Berkeley Lg. FA; S.Indp.A. [33]

DONELSON, Earl Tomlinson [P,Li] Trenton, NJ b. 19 Jy 1908, Scranton, PA. Studied: Trenton Sch. Indst. A.; PAFA; J.T. Pearson; Daniel Garber; Breckenridge. Member: AAPL. Exhibited: PAFA, 1927 (prize), 1928 (prize), 1929 (prize), 1930 (prize), 1931–35, 1937, 1938, 1940; N.J. Gal., Newark, 1934 (prize), 1936 (prize), 1937 (prize); AIC, 1932; NAD, 1933; PMA, 1936; VMFA, 1938; BMA, 1932; Soc. FA&Hist., Evansville, Ind., 1932; Hackley Gal. A., 1932; Montclair A. Mus., 1933; Phila. A. All., 1935; Wanamaker Exh., 1935; Newark AC, 1933, 1934, 1936, 1938, 1940; Phila. AC, 1936; N.J. State Mus., 1935, 1937, 1940; N.J. Gal., 1933, 1934, 1936–40. Position: T., N.J. A.&Cr., 1940–42 [47]

DONELSON, Mary Hooper (Mrs. P.T. Jones) [S,P] Old Hickory, TN b. 3 Ja 1906, Hermitage, TN. Studied: Vanderbilt Univ.; AIC; Polasek; Zettler; G.P. duBois. Member: Nashville Studio C. Exhibited: AIC, 1928 (med); Procter&Gamble Comp., 1928 (prize); Public Health Assn., 1929 (prize); PAFA, 1931; NAD, 1938; AIC, 1930; SSAL, 1934; Studio Cl.; Nashville Mus., A., 1945; Ward Belmont Col., 1945. Work: Tenn. State Capitol; Univ. Tenn. [47]

DONIPHAN, Dorsey [P,I,T] Wash., D.C. b. 9 O, 1897, Wash., D.C. Studied: Tarbell; R.S. Meryman; S.B. Baker; A.R. James; Corcoran Sch. A.; BMFA Sch. Member: Soc. Wash. A.; WCC, Wash., D.C. Work: U.S. Navy Dept.; Georgetown Univ. Law Sch.; murals, USPO, Marllinton, W.Va. WPA muralist. [40]

DONLEVY, Alice H(eighes) [P,C,I,L,W] NYC b. 7 Ja 1846, Manchester, England d. 5 Mr 1929, Nice, France. Studied: Sch. Des. for Women, N.Y. Member: Ladies Art Assoc. (one of eight founders); Art Workers C. for Women. Exhibited: tapestry, Columbian Expo, Chicago, 1893 (prize); illumination, Phila. Sketch C. (prize). Author: "Practical Hints on Illumination" [27]

DONLON, Louis J. [P] Hartford, CT. Member: CAFA. Exhibited: Conn. AGA, 1914 (prize) [21]

DONLY, Eva Brook [P] Simcoe, Ontario b. 30 Ap 1867, Simcoe. Studied: F.M. Bellsmith; J.W. Stimson. Member: NYWCC; NAC; Gamut Cl.; NAWPS; Pen and Brush Cl.; Wash. AC; Lyceum Cl., London; Wash. WCC; Brooklyn SA. Exhibited: NAWPS, 1923 (prize); Great Western Fair, London, 1926 (prize), 1927 (prize). Work: Nat. Gal., Ottawa [40]

DONNELL, Carson [P] St. Louis, MO [15]

DONNELLY, John James [S] Yonkers, NY b. 5 O 1899, Amsterdam, NY. Exhibited: WFNY, 1939. Work: Pub. Lib., Mt. Vernon, N.Y.; Yonkers (N.Y.) Mus. [40]

DONNELLY, Mary E. [P] NYC/Lumberville, PA b. 18 Ap 1898, NYC. Studied: Hunter Col.; Columbia. Member: Mod. A., N.J. Exhibited: N.J. Gal., 1939 (prize); Bell System Exh., 1946 (prize); NAD, 1939–41; Montclair A. Mus. [47]

DONNELLY, Thomas [P] Valhalla, NY b. 25 F 1893, Wash., D.C. Studied: Corcoran Sch. A.; ASL; John Sloan; B. Robinson. Member: Am. Soc. PS&G; Artists U.; Am. A. Cong.; Whitney Studio C.; Salons of Am. Exhibited: WMAA, 1931–34, 1936–42, 1944; Carnegie Inst., 1929; AIC, 1929, 1937; CGA, 1930; PAFA, 1940–42; WFNY, 1939. Work: WMAA; Dartmouth; White House, Wash., D.C.; Pub. Lib., Larchmont, N.Y.; Pub. Lib., Ossining, N.Y.; murals, USPOs, Mt. Kisco (N.Y.), Ridgefield Park (N.J.), Attica (N.Y.), Clyde (N.Y.). WPA muralist. [47]

DONNELLY, Thomas H., Mrs. See Kottgen.

DONOGHUE, John [P] NYC. Member: AWCS [01]

DONOGHUE, John [S] b. 1853, Chicago d. 3 Jy 1903, New Haven, CT (his body was found on the shores of Lake Whitney). Studied: Ecole des Beaux-Arts, Paris; Europe. Exhibited: Columbian Expo, Chicago, 1893 (prize). Work: LOC; Appellate Court House, N.Y.. His best known work was "Egyptian Ibis," at Paris Salon, 1886 (prize)

DONOHO, Ruger [Ldscp.P] NYC b. 1857, Church Hill, MS d. 28 J 1916. Studied: ASL; R.S. Gifford, N.Y.; Académie Julian, Lefebvre; Boulanger; Bouguereau; Robert-Fleury, all in Paris, early 1880s. Member: Lotos Cl.; Players Cl. Exhibited: Paris Expo, 1889 (med); Paris Salon, 1890 (prize); SAA, 1892 (prize); Columbian Expo, Chicago, 1893 (med); CI, 1911 (prize); P.-P Expo, San Fran., 1915 (gold). His best known work, "La Marcellerie," is at Brooklyn Inst. Mus. [15]

DONOVAN, Cecil Vincent [Edu,P] Urbana, IL b. 23 Je 1896, Homer, NY. Studied: D. Williams; Syracuse Univ. Exhibited: GGE, 1939. Work: Bloomington AA. Position: T., Univ. Ill., Urbana, 1922–46 [47]

DONOVAN, Ellen [P,B] Phila., PA/Woods Hole, MA b. 24 Ja 1903, Phila. Studied: PMSchIA; Breckenridge. Member: Phila. WCC; Plastic Cl.; Phila. A. All.; AFA. Exhibited: Plastic Cl., 1930 (med); Print Cl., Phila., 1931 (prize) Work: PAFA [47]

DOOLEY, Helen Bertha [Edu,L,P,W,C] Bakersfield, CA b. 27 July 1907, San Jose, CA. Studied: San Jose State Col.; Chouinard AI; Claremont

Col.; M. Sterne; M. Sheets. Member: San Joaquin Valley Supv. Assn. Exhibited: Calif. State Fair; Pal. Leg. Honor; Oakland A. Gal.; PAFA, 1943, 1945; San Jose State Col. (one-man); Claremont Col. (one-man); Carmel AA, 1946. Position: A. Supv., Kern County schools [47]

DOOLEY, Nancy [P] Norman, OK [24]

DOOLEY, Thomas M. [P,G,I] Milwaukee, WI b. 10 Je 1899. Studied: Chicago Commercial A. Sch.; Layton A. Sch.; Milwaukee; Milwaukee State T. Col. Exhibited: Intl. WC Exh., AIC, 1939 [40]

DOOLITTLE, C.E. [P] Toledo, OH. Member: Artklan [25]

DOOLITTLE, Harold L. [E,Li] Pasadena, CA b. 4 My 1883, Pasadena. Studied: Cornell. Member: Pasadena SA; Chicago SE; SAE; Calif. SE; Calif. Pr.M.; Phila. WCC; AFA. Exhibited: Chicago SE, 1938 (prize); Pasadena SA; Chicago SE; SAE; Calif. SE; Calif. Pr.M.; Phila. WCC. Work: Los Angeles Pub. Lib.; NYPL; Calif. State Lib.; San Diego FA Soc.; Brooks Mem. Gal.; LOC; Dayton AI [47]

DOOLITTLE, Warren Ford, Jr. [Edu,P,G] Urbana, IL b. 3 Ap 1911, New Haven, CT. Studied: Yale. Exhibited: AIC, 1944, 1946; Pal. Leg. Honor, 1946; Northwest Pr.M., 1946; Milwaukee AI, 1946; Miss. AA, 1946; Decatur A. Center, 1944–46; Bridgeport A. Lg., 1943. Position: T., Univ. Ill., 1938– [47]

DOONER, Clara [P] Los Angeles, CA. Member: Calif. AC [25]

DOONER, Emilie Zeckwer [C,P] Narberth, PA b. 31 Ag 1877, Phila., PA. Studied: Drexel Inst.; PMSchIA; PAFA; Anshutz; Cecilia Beaux; Simon, in Paris; Maynard. Member: Phila. Pr. Cl.; Phila. A. All.; Pa. Craftsmen Soc. Exhibited: CGA; Paris Salon; PAFA; CM; Syracuse Mus. FA [47]

DOONER, R(ichard) T. [T,I,L,P,Photogr] Narberth, Pa. b. 19 My 1878, Phila. Studied: La Salle Col.; PMSchIA; PAFA; Anshutz; Thouron. Member: Phila. A. Dir. Cl.; Phila. A. All.; Phila. Pr. Cl. Exhibited: Dresden, 1909 (gold); Paris, 1910 (gold); Budapest, 1912 (gold); Royal Photographic Soc. Great Britain, 1923 (gold); Am. Arts and Crafts Assn. (gold). Work: PMA; Free Lib., Phila.; CI. Author: "Modern Portraiture" [47]

DOORHEIN, Jeannettie [Por,P,T] Chicago, IL/Holland, MI b. 27 Jy 1906, Holland, MI. Studied: AIC; Carl Hoeckner. Member: Am. Fed. A.; South Side aA [40]

DORAN, Robert C. [Dec,P,E] NYC b. 13 N 1889, Dallas, TX. Studied: K.H. Miller [21]

DORCY, Dan [P,I,C] Chicago, IL [25]

DORCY, Irene Shurr [P,I,C] Chicago, IL [25]

DORE, Calla Tubbs [P] Auburn, NY b. 21 Ag 1875, Geneva, NY. Studied: Honigman; Gifford, in NYC; Cowles A. Sch. [08]

DORENZ, David [P] NYC b. 1896, Russia. Studied: CUASch; Nat. Acad. Sch. Exhibited: Conn. Acad. FA; Municipal Gal., New York [40]

DORGAN, Thomas Aloysius "Tad" [Car] Great Neck, NY b. 29 Ap 1877 d. 2 My 1929. He originated many expressions in connection with his cartoon characters that are now part of the American vernacular. Position: Staff, New York Evening Journal, from 1905.

DORGELOH, Marguerite Redman (Mrs.) [P] San Fran., CA b. 14 D 1890, Watsonville, CA. Studied: Calif. Sch. FA; San Jose State T. Col. Exhibited: San Fran. AA, 1939. Work: SFMA [40]

DORMONT, Phillip [I] NYC. Member: SI [47]

DORN, Leo F. [B,P,T] Rowayton, CT b. 24 D 1879, Louisville, KY. Member: Silvermine Gld. A.; Darien Gld. Seven Arts; NYSC [32]

DORN, Marion V. [P] San Fran., CA [19]

DORNBUSH, Adrian J. [P,L,T] Wash., D.C. b. 30 Mr 1900. Studied: self-taught. Work: Dubuque AA. Position: Asst. Dir./Artist, WPA [40]

DORNE, Albert [I,L] NYC b. 7 F 1904, NYC. Member: SI; A.&W. Assn.; A. Dir. Cl. Exhibited: SI, 1944 (one-man), 1945; A. Dir. Cl. Illustrator: national magazines. Position: Pres., SI, 1947– [47]

DORR, Roy Linwood (Mrs.) [Cer] NYC/Sunapee, NH b. NYC. Studied: Maude Robinson. Member: N.Y. Soc. Ceramic Art [40]

DORSEY, Stanton Lindsey [P] Wash., D.C. b. 15 Je 1890, Frankfort, KY. Studied: Fisk; Swisher [33]

DORNER, Alexander A. [Hist,W,L] Providence, RI b. 19 Ja 1893, Koenigsberg, Germany. Studied: Univ. Koenigsburg; Berlin Univ. Member: CAA; Archaeological Inst. Am. Author: "Master Bertram" (1937), "The Transformation of Art" (1946), other books. Contributor: art magazines. Positions: T., Hanover Univ., Germany, 1928–36; Dir. Mus. A., R.I. Sch. Des., 1938–41; T., Brown, 1942– [47]

DORSEY, Thomas [P,Des,I] NYC b. 2 F 1920, Onondaga, NY. Studied: Albany Inst. Hist.&A., with H. Stienke. Exhibited: 1st Nat. Exh. Indian Painters, Philbrook A. Center, 1946. Exhibited: Am. Mus. Nat. Hist.; AFA Traveling Exh. Work: Albany Inst. Hist.&A. Contributor: "Indians at Work," pub. Dept. Interior, Wash., D.C. Illustrator: "Masks and Men," pub. Am. Mus. Nat. Hist. Postion: Staff A., Dept. Edu., Mus. Nat. Hist., 1946– [47]

DOSCH, Roswell [P] Hillsdale, OR [13]

DOSCHER, Henry L., Jr. [P] Toledo, OH [24]

DOSKOW, Israel [P,I] NYC b. 30 N 1881, Russia. Studied: PAFA. Member: SC; SI [33]

DOSSERT, Norma Barton (Mrs. F.C.) [Des,C,P] Chazy, NY b. 22 F 1893, Willsboro, NY. Studied: BMFA Sch.; E. O'Hara. Member: AFA. Exhibited: PAFA, 1938, 1939; Albany Inst. Hist.&A., 1940; Plattsburg A. Gld., 1936–42; Saranac A. Gld., 1940 [47]

DOUB, Florence W. [T] b. 1852 d. 19 Ja 1932, Frederic, MD. Member/Founder: Frederick Art Club. Positions: T., Md. Sch. for the Deaf, 1881–1932; Hd. A. Dept., Hood Col.

DOUBLEDAY, F.G. [P] Wash., D.C. [01]

DOUD, Isabel Cohen (Mrs. Gorda Chipman Doud) [P] Charleston, SC b. 12 Ap 1867, Charleston d. 24 O 1945. Studied: Daingerfield, H.S. Rittenberg, in NYC; J. Noel, in Rome; Brit. Acad. A. Member: NAWPS; PBC; NAC; All. AA; SSAL; Carolina AA. Exhibited: S.C. Interstate Expo, 1902 (prize); La. Purchase Expo, St. Louis Mo., 1904 (prize). Work: Gibbes Mem. A. Gal., Charleston [40]

DOUDNA, William L. [Cr] Madison, WI b. 21 F 1905, Dodgeville, WI. Studied: Stevens Point (Wis.) State T. Col.; Univ. Wis. Position: A. Ed., Wis. State Journal, 1934– [47]

DOUGHERTY, Bertha Hurlbut [E,P] Alexandria, VA b. 13 My 1883, Plainfield, NJ. Studied: Fawcett A. Sch.; N.Y. Sch. Des. for Women. Member: Old Lyme AA; SAE. Exhibited: SAE, 1943, 1944; Wash. WCC, annually; Wash. SE, 1945; LOC, 1944; Newport AA; Montclair A. Mus., 1940, 1941; Old Lyme AA; Smithsonian Inst. (one-man); Vassar Col., 1944; Alexandria (Va.) Lib., 1941–45; NYPL, 1944 [47]

DOUGHERTY, Ida. See Marion, J., Mrs.

DOUGHERTY, James [P,E] Brooklyn, NY [15]

DOUGHERTY, Louis R. [S] Stapleton, NY b. 24 D 1874, Phila. Studied: PAFA; Drexel Inst. Member: The Scumblers, Phila. [27]

DOUGHERTY, Parke C(ustis) [P] Paris, France b. 11 Ag 1867, Phila. Studied: Académie Julian, Paris. Member: Phila. AC; Paris AAA; Intl. Soc. AL, Paris. Exhibited: Paris AAA (prize); Intl. Expo, Toulouse, France (prize) [25]

DOUGHERTY, Paul [Mar.P] Carmel, CA b. 6 S 1877, Brooklyn, NY d. 1947, Palm Springs, CA. Studied: Henri, in NYC, ca. 1899; self-taught, in Paris, London, Florence, Venice, Munich, 1900–05. Member: SAA, 1905; ANA, 1906; NA; 1907; NIAL; Lotos Cl.; SC, 1907; AWCS; Century Assoc.; NAC; New Soc. A. Exhibited: CI, 1905 (prize), 1912 (prize); NAD, 1913 (gold), 1915 (prize), 1918 (prize); P.-P. Expo, San Fran., 1915 (gold). Work: CGA; CI; TMA; NGA; Brooklyn Inst. Mus.; AIC; Buffalo FA Acad.; Montclair (N.J.) AM; Mem. A. Gal., Rochester; Hackley Gal., Muskegon, Mich.; City A. Mus., St. Louis; Minneapolis Inst.; Omaha (Nebr.) Mus.; Phillips Mem. Gal.; Nat. Gal. of Canada, Ottawa; Portland (Oreg.) AA; Mus. A., Fort Worth; Pub. Lib., Malden, Mass.; AGAA; William Rockhill Nelson Gal. A., Kansas City, Mo. [47]

DOUGHTEN, Alice B. [P,T] Moorestown, NJ b. 27 Ap 1880, Camden, NJ. Studied: Henry McCarter; Earl Horter; Ralph Pearson; Fred Wagner; Hugh Breckenridge; PAFA. Member: Plastic Cl. Position: T., Des., Phila. Sch. Occupational Therapy [40]

DOUGLAS, Aaron [Mur.P] NYC b. 26 My 1899, Topeka, KS. Studied: Univ. Nebr.; Despiau; Frieze; W. Reiss. Work: Fisk Univ. Lib.; Sherman Hotel, Chicago; NYPL; YMCA, 135th Street Branch, NYC [40]

DOUGLAS, Chester [Des,P,T,I] Lynn, MA b. 6 O 1902, Lynn. Studied: Mass. Sch. A.; J. Sherman. Member: Eastern AA; Marblehead AA; Boston Artist U. Exhibited: AIC; NAD; PAFA; BMFA; WMA; Springfield (Mass.) Mus. A. Work: Reading (Pa.) Mus. A. Position: Instr., Lynn Pub. Sch. [47]

DOUGLAS, Edward Bruce [S] b. 1886, IA d. 6 F 1946, San Fran. Studied:

New York; Paris. Member: NSS; AAPL; Am. Cl. of Paris; SC; Bohemian Cl., San Fran.

DOUGLAS, Eleanor [P] East Aurora, NY. Exhibited: Buffalo Soc. Artists, 1914 (prize) [17]

DOUGLAS, Frederic Huntington [Mus.Cur,L] Denver, CO b. O 1897, Colorado. Studied: Univ. Colo.; PAFA. Co-author: "Indian Art of the United States," 1941. Position: Cur., Dept. Indian Art, Denver A. Mus., 1929– [47]

DOUGLAS, Haldane [P,E] b. 13 Ag 1893, Pittsburgh, PA. Studied: A. Hansen; Lhote, in Paris. Member: Calif. AC; Calif. PS; Laguna Beach AA; Calif. PSC. Exhibited: Salon d'Automne, Paris, 1928 (prize); Los Angeles Mus., 1930 (prize) [33]

DOUGLAS, Harold [P] Farmington, CT. Member: Conn. Acad. FA; SC [29]

DOUGLAS, Harry [Mur.P,I,B,L,W] Los Angeles, CA [33]

DOUGLAS, Helen Atwood, Mrs. See Atwood.

DOUGLAS, Laura Glenn [P,L,T,Dec] Winnsboro, SC b. 26 Ap 1896, Winnsboro. Studied: Col. for Women, Columbia, S.C.; Corcoran Sch. A.; ASL, with Bridgman; NAD, with Hawthorne; Fontainebleau, France; André Lhote, Legèr, in Paris; Hofmann, in Munich; Acad. FA, Florence, Italy. Member: Soc. Am. P. in Paris; Charleston AA; S.C. AA; Wash. A. Gld.; AFA. Exhibited: MMA, 1926 (prize); AIC, 1942 (prize), 1943; PAFA, 1935; WFNY, 1939; Salons of Am., 1935; CGA, 1936; Soc. Wash. A., 1939–46; Wash. A. Gld., 1939–46; Whyte A. Gal., 1939–46; PMG, 1939–43, 1944 (one-man), 1945, 1946; Gibbes Mem. A. Gal., 1935–46; Albany Inst. Hist.&A., 1936; Smithsonian Inst., 1939–45; Caresse Crosby Gal., Wash., D.C.; Rochester Mem. A. Gal.; Fontainebleau Alumni Assn.; Argent Gal.; Bonestell Gal.; Salon d'Automne, Grand Palais, Salon des Tuileries, Paris; Joslyn Mem.; Minneapolis Inst. A.; Milwaukee AI; BMA; CI. Work: PMG; Rochester Mem. A. Gal.; Gibbes A. Gal.; U.S. Treasury Dept., Wash., D.C.; USPO, Camilla, Ga. Position: Instr., YWCA, Wash., D.C., 1945–46 [47]

DOUGLAS, Lester [Des,W,L] Wash., D.C. b. 27 Jy 1893, NYC. Studied: PIASch; ASL; Columbia. Member: AIGA; Am. Hist. Assn.; Soc. Am. Hist.; Newcomen Soc. of England; A. Dir. Cl.; The Typophiles. Exhibited: 50 Books of the Year and the Printing for Commerce Exhibits, AIGA. Author: "Color in Modern Printing," "Modernizing Business Print," "The Battle of the Fifty Books." Contributor: The Printing Art, The American Printer, Nation's Business. Lectures: Typography. Position: Dir. A. & Printing, Chamber of Commerce of the U.S. [47]

DOUGLAS, Lucille Sinclair (Miss) [P,I,E] NYC/Shanghai, China. b. Tuskegee, AL d. 25 S 1935, Andover, MA. Studied: ASL; Lucien Simon, Richard Miller, A. Robinson, in Paris; Italy; Spain; Holland. Member: Société des Artistes Independents, Paris; Chicago SE; Soc. Am. E.; Phila. Pr. Cl.; Calif. SE; Shanghai AA; New Orient Soc.; Inst. Persian Art; India Soc. A.&Let. Exhibited: Brit. Mus., London; Musée Guimet, Paris; etchings of ruins of Angkor (at request of the French Colonial Government), French Colonial Expo, Paris, 1931. Work: MMA; Inst. & Mus. Hist. of Art, Albany; CGA; Mus. FA, Montreal; private coll., U.S., Paris, China. Illustrator: "The Autobiography of a Chinese Dog" and "A Chinese Mirror," by Florence Ayscough, pub. Houghton Mifflin. Lectures: Far East, Angkor. In 1920 she moved to Shanghai where she gained the knowledge of China and the Orient, which is illustrated in her paintings. [31]

DOUGLAS, M. Bruce [Min.P] NYC [04]

DOUGLAS, Walter [P,T] Morristown, NJ b. 14 Ja 1868, Cincinnati, OH. Studied: ASL; NAD; abroad; William Chase. Member: AWCS; SC, 1904; Art Center of the Oranges; Morristown AA. Exhibited: NAD; AWCS; PAFA; AIC; Boston AC; SC. Work: Dallas Mus. FA; SC; New Haven Hist. Soc.; BM; Jersey City Mus. [47]

DOUGLASS. See Crockwell, Spencer.

DOUGLASS, Helen Wright [Des,P,T,L] Akron, OH b. 20 My 1910, Pottsville, PA. Studied: Cleveland Sch. A.; John Huntington Polytechnic Inst., Cleveland; H.G. Keller. Member: Akron Women's A. Lg.; Ohio WC Soc.; ADI. Exhibited: Akron AI, 1930 (prize), 1931–33, 1935, 1944; Canton (Ohio) A. Mus., 1944 (prize); Phila. A. All., 1936, 1937; AIC, 1936, 1939; Wash. WC Cl., 1936–40; AWCS, 1938; NYWCC, 1937, 1938; Phila. WCC, 1936, 1937; Laguna Beach AA, 1938; CM, 1937, 1938; Butler AI, 1938, 1939; Ohio WC Soc., 1935–37; Harrisburg (Pa.) AA, 1935. Lecture: Design in Industry. Position: Indst. Des, B.F. Goodrich Co., 1929–44 [47]

DOUGLASS, R.H. [P] Beverly Hills, CA. Member: Calif. AC [25]

DOUGLASS, Ralph Waddell [Edu,Car,P,Li,I] Albuquerque, NM b. 29 D 1895, St. Louis, MO. Studied: Monmouth Col.; Académie Julian, Paris; AIC; ASL. Member: Wash. WCC; A. Lg., N.Mex. Exhibited: N.Mex. State Fair, 1939 (prize), 1940 (prize); Kans. State Fed A. Traveling Exh., 1941 (prize); Kansas City AI, 1942; Wash. WCC, 1942, 1944–46; CI, 1943; Northwest Pr.M., 1943; Portland SA; New Haven PCC; Mus. N.Mex., 1930–46, 1941 (one-man), 1942–45, 1946 (one-man). Work: Coronado Lib., Univ. N.Mex.; Sch. Oriental Studies, Am. Univ., Cairo. Illustrator: "Baby Jack" (1943), "Dumbee" (1945), "Cocky" (1946), other children's books. Position: Instr., Am. Univ., Cairo, Egypt, 1920–24; Car./Staff A., Chicago Daily News, 1924–29; T., Univ. N.Mex., 1929– [47]

DOULBERRY, Frank R. [P] NYC. Member: GFLA [29]

DOULL, Mary Allison [Min.P,C,T] NYC/Prince Edward Island, Canada b. Prince Edward Island. Studied: C.Y. Turner; NAD; Académie Julian, Paris. Member: PBC; Wolfe Cl.; N.Y. Soc. Ceramic A. [31]

DOUTHAT, Milton [P,L] NYC b. 16 F 1905, Kansas City, MO. Studied: R. Davey; J. Sloan. Member: Am. A. Cong. [40]

DOUX, Mary F. [P] Brooklyn, NY. Exhibited: NYWCC, 1937; NAWPS, 1935–38; Am. WC Soc., 1933, 1934, 1936, 1938 [40]

DOVE, Arthur G. [P] Centerport, NY b. 2 Ag 1880, Canandaigua, NY d. 23 N 1946. Studied: Cornell, 1903; (comm. illus., 1903–07); Paris, 1907–09. Member: Am. Soc. PS&G. Exhibited: Salon d'Automne, Paris, 1908, 1909; Stieglitz' "291" Gal., 1912; retrospectives, Munson-Williams-Proctor Inst., 1947, Cornell, 1954, UCLA, WMAA, Phillips Gal., BMFA; La Jolla A. Center, SFMA, all in the 1950s. Work: Phillips Mem. Gal.; MOMA; An American Place; Univ. Minn.; Smith Col.[40]

DOW, Arthur W(esley) [Ldscp.P,E,T,W,L] NYC/Ipswich, MA b. 1857, Ipswich, MA d. 13 D 1922. Studied: Boulanger, Lefebvre, Doucet, Delance, in Paris. Member: AI Graphic A.; Calif. PM. Exhibited: Paris Expo, 1899 (prize); Pan-Am. Expo, Buffalo, 1901 (med,prize); Boston Mechanics Assoc. (med); P.-P. Expo, San Fran., 1915 (med). Author: "Compositon," "Theory and Practice of Teaching Art," "Constructive Art Teaching," "By Salt Marshes," "Ipswich Prints," "Prints from Wood Blocks." Teacher of Georgia O'Keeffe and Max Weber. Positions: T., Pratt Inst., 1895–1904, T. Col., Columbia, 1904– ; Dir., Summer Art Sch., Ipswich [21]

DOW, George Francis [W] b. 7 Ja 1868, Wakefield, NH d. 5 Je 1936, Topsfield, MA. Member: Walpole Soc.; Am. Antiquarian Soc.; Am. Hist. Assoc.; Mass. Hist. Soc. An antiquarian, he had been director of the Museum of the Society for the Preservation of New England Antiquites (since 1919) and editor of its publications. He organized the Marine Research Society of Salem and the Topsfield Historical Society, and from 1898 to 1918 was secretary of the Essex Institute in Salem, Mass. Author: "The Arts and Crafts in New England, 1704–1775," "The Sailing Ships of New England," other books

DOW, Lelia A. [P,C,T] Madison, WI b. 2 Ap 1864, Cooksville, WI d. 18 F 1930. Studied: AIC; John Vanderpoel; F.W. Fursman. Member: Madison AG; Wis. PS; AFA [29]

DOW, Peter [Photogr] Toledo, OH b. 1822 d. 9 Mr 1919. An authority on photography, he wrote a number of papers on the subject.

DOWD, Gorda C. [P] NYC [24]

DOWDALL, Edward [P,Mur.P] NYC b. 1856, Ireland (came to U.S. as a youth) d. 22 N 1932. Studied: CUASch. Member: S.Indp.A. Exhibited: London and Paris, 1895–1901 (prizes)[25]

DOWDEN, Raymond Baxter [Edu,Des,P,I,Li] NYC b. 25 D 1905, Coal Valley, PA. Studied: CI; Tiffany Fnd.; E. Ashe; C.J. Taylor; A. Kostellow. Member: AA Pittsburgh. Exhibited: Assoc. A. Pittsburgh, 1934 (prize); AIC, 1932, 1935, 1936; WMAA, 1936; CI, 1930–34. Work: murals, Westinghouse Co., Century of Progress Expo, Chicago; Bd. Education, Pittsburgh. Contributor: Carnegie Magazine. Lectures: Creative Art in Children, Eveyone Can Draw. Illustrator: Calendar of the American Spirit, 1946. Position: T., CUASch, 1936–46 [47]

DOWER, Walter H. [Art Ed] b. 1883, Syracuse, NY d. 21 M 1934, Riverside, CT. Studied: Pratt Inst.; NAD. Member: SC; Players Cl.; Art Dir. Cl.; City Cl., all in NYC. Positions: Art Ed., Saturday Evening Post (1915–19), Ladies Home Journal (1919–27), McCall's Magazine (1927–)

DOWIATT, Dorothy [P,E,T] Los Angeles, CA b. Pittsburgh, PA. Studied: Vysekal; E.R. Shrader; H. Hofmann; A. Millier. Member: Calif. AC; Laguna Beach AA; Intl. Bookplate Assn. Exhibited: Ariz. State Fair, 1928 (prizes), 1930 (prizes). Northwest Ar., Seattle, 1929 (prize); Calif. A., Santa Cruz, 1930 (prize); Calif. AC, 1930 (prize), 1932 (prize); Los Angeles Fiesta, 1931 (prize); Los Angeles County Fair, 1931 (prize), 1932 (prize), 1933 (prize); Calif. State Fair, 1934 (prize) [40]

DOWIE, Reta M. [P] Phila., PA [15]

DOWLING, Colista (Mrs. E.H.) [P,I] Portland, OR b. Waverly, KS. Studied: Luks; D. Donaldson; Oreg. State Col.; ASL. Member: Oreg. SA; Portland AA. Exhibited: Oreg. SA, 1935 (prize); Seattle, Spokane, Wash.; Salem, Portland, Oreg. Illustrator: "Six Feet," "Cougar Pass," "The Oregon Girl," other books, stories and poems for children [47]

DOWN, Marion [P] Hartford, CT. Member: Hartford AS [25]

DOWNES, Jerome I.H. [P,A] Waltham, MA. Member: New Haven PCC [27]

DOWNES, J(ohn) I(reland) H(owe) [Ldscp.P] New Haven, CT b. 1861, Derby, CT d. 16 O 1933. Studied: Yale; Ecole de Beaux Arts, Merson, in Paris; J.A. Weir. Member: Fifteen Gal.; Grolier Cl.; New Haven PCC; CAFA; Rockport AA. Work: War Mem. Coll., Nat. Gal., Wash., D.C. Position: Lib., Yale Sch. FA [31]

DOWNES, William Howe [Art Cr] Brookline, MA b. 1855, Derby CT d. 19 F 1941. Member: Boston AC; Gld. Boston A.; AFA. Author: numerous books on art, including biographies of Winslow Homer and John S. Sargent. Position: A. Cr., Boston Transcript, 1883–1922

DOWNEY, Frank [P] Boston, MA [01]

DOWNIE, T.D. [P] Toledo, OH. Member: Artklan [25]

DOWNING, George Elliot [Edu,P] Providence, RI b. 19 Je 1904, Marquette, MI. Studied: Harvard; Univ. Chicago. Member: Col. AA; Providence AC. Positions: T., Univ. Chicago, 1926–30, Brown, 1932– [47]

DOWS, Olin [P,Li,W,L,E] Rhinebeck, NY b. 14 Ag 1904, Irvington-on-Hudson, NY. Studied: Harvard; Yale, with Chatterton, Savage, E.C. Taylor. Member: NSMP; Dutchess Co. AA; Wash. A. Gld. Work: USPO, Rhinebeck, N.Y. WPA artist. [47]

DOYLE, Agnes Ellen [Min.P] Orland, IL. b. 30 Jy 1873, Chicago. Studied: AIC [13]

DOYLE, Alexander [S] Dedham, MA/Squirrel Island, ME b. 28 Ja 1857, Steubenville, OH d. 21 D 1922. Studied: Nicoli; Dupré; Pellicia; Nat. Acads at Carrara and Florence, Italy. Work: marble and bronze statues, many relating to Civil War heroes, in New Orleans, La., Saratoga, N.Y., Cleveland and Steubenville, Ohio, Atlanta, Ga., Montgomery, Ala., Troy N.Y., Frederick, Md., New York City, State Capitol, Indianapolis, state of Mo., state of W.Va., Capitol, Wash., D.C. [21]

DOYLE, Daniel D. [P] Richmond, IN b. 7 Mr 1860, Winchester, IN [25]

DOYLE, Gertrude [P] Phila., PA [08]

DOYLE, James [P] Baltimore, MD [25]

DOYLE, James J. [E] Walbrook, MD [13]

DOYLE, Jerry [Car,T] Melrose Park. Pa. b. 15 N 1898, Phila., PA. Member: Pen & Pencil Cl. Work: Huntington Lib., San Marino, Calif. Author: "According to Doyle," 1943. Position: Car., Philadelphia Record, New York Evening Post [47]

DOYLE, Robert Joseph [P,T] Indianapolis, IN b. 25 Jy 1912, Indianapolis. Studied: R. Sitzman. Member: Ind. Ar. Cl. [40]

DOZIER, Otis [P,Li] Dallas, TX (1976) b. 27 Mr 1904, Forney, TX. Member: Dallas AA. Exhibited: Dallas All. A., 1932 (prize), 1935 (prize), 1937 (prize), 1946 (prize); Denver A. Mus., 1943 (prize); WMAA, 1945; CI, 1946; Pasadena, Calif., 1946. Work: Univ. Nebr.; Dallas Mus. FA; Denver A. Mus.; Newark Mus.; A&M Col., Bryan; Witte Mus.; Mus. FA, Houston; murals, USPOs, Arlington, Giddings, Fredricksburg, Tex. WPA artist. Position: Instr., Colorado Springs FA Center, 1940 [47]

DRABKIN, Stella (Mrs.) [E,P] Phila., PA b. 27 Ja 1906, New York d. 1976. Studied: NAD; Graphic Sketch Cl., Phila., with E. Horter. Member: SAE; Phila. A. All.; Phila. Pr. Cl.; Am. Color Pr. Soc. Exhibited: Am. Color Pr. Soc., 1944 (prize); PAFA; AIC; LOC; Smithsonian Inst.; Springfield Mus. FA; Reading (Pa.) Pub. Mus.; BM; MMA; SFMA; NAD; PMA; Laguna Beach AA; Carlen Gal., Phila., 1938 (one-man), 1939. Work: PMA; NGA; MMA; Phila. A. All. [47]

DRADDY, John G. [S] Bronx, NY b. 1833 d. late 1904. Worked in Cincinnati 1859–60, later in NYC with his brothers Daniel and James. From his studio in Carrara, Italy, he executed many notable church altars, including the Augustin Daly altar and the Coleman Memorial in St. Patrick's Cathedral, NYC.

DRAKE, Ada Brooke [I] Phila., PA [15]

DRAKE, Alexander [Wood En,Art Ed,Patron] NYC b. 1843, Westfield, NJ d. 4 F 1916. Member: Graphic Arts Cl.; Century Cl.; Players Cl.; Grolier Cl.; SC; Authors' Cl.; Arch. Lg., 1886; Caxton Cl., Chicago; Founder/Member: Aldine Cl. In early youth he became an apprentice of William Howland, then a leading wood engraver. From 1881 to 1912 he was director of the Art Department of Century Magazine, of which he was also art editor, and in that capacity the friend and patron of many of the younger artists. He was noted as a collector of brass, samplers, bird-cages, amber, etc. He was also author of a number of poems and short stories. He and his colleague Charles Parsons were perhaps the two most encouraging forces on young illustrators of the "Golden Age of Illustration." [15]

DRAKE, Anna Belle [P] Milwaukee, WI [24]

DRAKE, Bertram Delaney [Ldscp.P] b. 1880 d. 21 Ag 1930, Garrison, NY

DRAKE, Charles [P] Phila., PA. Studied: PAFA [25]

DRAKE, Frank C(ornelius) [I] Brooklyn, NY b. 3 Ag 1868, Palmyra, NY d. 18 F 1922, NYC. Studied: G. Ferrari; A. Will; ASL; CCNY. In 1890 he began his career as a staff artist on The Baltimore American. After working for McClure's Syndicate and The New York Herald, he became, in 1896, art director of The New York Tribune; while there he devised the first method of printing halftones on fast presses and ordinary newsprint paper. He later returned to The Herald, remaining there from 1903 to 1906. In 1908 he joined The World. Author: a history of the Erie Canal [21]

DRAKE, Hilah T. See Wheeler, Clifton, Mrs.

DRAKE, Millicent [P,Des,C] Phila., PA. Member: Plastic Cl. [10]

DRAKE, Ruth H. [P] Milwaukee, WI b. Milwaukee. Studied: Oberteuffer; Holty; A. Hansen; Quirt. Member: Wis. PA; Madison AG. Exhibited: Wis. PS, 1928 (prize); Wis. State Fair, 1929 (prize); Madison AG, 1929 (prize), 1930 (prize). Work: YWCA, Milwaukee [40]

DRAKE, Will H(enry) [P,I] Los Angeles, CA b. 4 Je 1856, New York d. 23 Ja 1926. Studied: Académie Julian, Paris, with Constant, Doucet. member: ANA, 1902; AWCS; NYWCC; SC, 1887; A. Fund. S. Exhibited: Paris Expo, 1889 (prize); SC, 1903 (prize). Illustrator: "Jungle Book." Specialty: animals [25]

DRAKE, William A. [E,Li,P,C,T] Bergenfield, NJ b. 7 N 1891, Toronto, Ontario. Studied: Ontario Col. A. Member: NSMP. Exhibited: Royal Canadian Acad.; LOC; Ontario SA; Laguna Beach AA; Montclair A. Mus. Work: A. Gal. of Toronto; PMA; Montclair A. Mus.; Princeton Pr. Cl.; Nat. Gal. of Canada [47]

DRAPER, Francis [P] Greenwood, MA. Member: Boston AC [10]

DRAPER, Harriette Elza [Min.P] Winchester, MA [15]

DRAPER, William Franklin [P,I] Hyannisport, MA b. 24 D 1912, Hopedale, MA. Studied: Harvard; NAD; ASL; Corbino; Kroll; Zimmerman. Member: SC. Exhibited: NAD, 1934, 1941; AIC, 1941; MMA, 1945; NGA, 1945; CGA, 1943; Inst. Mod. A., Boston, 1940; BMFA, 1942; Nat. Gal., London, 1944. Work: U.S. Navy; U.S. Naval Acad., Annapolis. Author: "The Navy at War," 1943. Illustrator: "5000 Miles to Tokyo" [47]

DRAVNEEK, Henry [I] Scarsdale, NY. Member: SI [47]

DRAYTON, Emily. See Taylor, J. Madison, Mrs.

DRAYTON, G(race) G(ebbie) [Car,I,S] NYC b. 14 O 1877, Phila. d. 31 Ja 1936. Member: F., PAFA; Alliance; SI; Artists Gld. Author/Illustrator: "Fido," "Kitty Puss," other children's books. She created "Toodles and Pussy Pumpkins," "Dimples," and "Pussycat Princess," and illustrated many series in magazines. Her "funny babies" were the mainstay of her tremendous vogue, perhaps the best known being the Campbell Soup Kids. [33]

DREHMANN, Oscar A. [P] Chicago, IL [15]

DREIER, D.A. [P] Brooklyn, NY [15]

DREIER, Dorothea A. [Ldscp.P] d. 14 S 1923, Saranac, NY. Specialty: Dutch peasant scenes

DREIER, Katherine S. [P,L,W] Milford, CT b. 10 S 1877, Brooklyn, NY d. 29 Mr 1952. Studied: W. Shirlaw; Britsch; ASL; PIASch.; abroad. Member: Société Anonyme. Work: BM; Mus. FA Houston; Yale Univ. A. Gal.; John H. Vanderpoel AA, Chicago; Paris; London; Bremen. Translator: "Personal Recollections of Van Gogh," by Elizabeth D. Van Gogh, 1913. Author: "Western Art and the New Era, or An Introduction to Modern Art," pub. Brentano (1923, second ed., 1929), "Shawn: The Dancer," pub. in Germany, England, U.S. (1933); Special Catalog: International Exh. Mod. Art, BM, with Foreword and 104 biographical sketches (1926); Brochures: "Stella" (1923), "Kandinsky" (1923), "The Invisible Line" (1928), "Burliuk" 1944 [47]

DREIFOOS, Byron G(olding) [P,T] Newark, NJ. b. 30 Ja 1890, Phila. Studied: Fawcett Sch. Industrial A.; ASL; Columbia; N.Y. Sch. F.&Applied A.; Académie Julian, Paris. Member: AAPL. Position: Instr., Newark Sch. F.&Industrial A. [33]

DRENNAN, Georgia Bertha [P,I,C] New Orleans, LA b. Lexington, MS. Studied: Newcomb A. Sch.; E. Woodward; G.R. Smith; M.J. Sherer; William Woodward. Member: New Orleans AA [10]

DRENNAN, Vincent Joseph [P] NYC b. 5 Ja 1902, Brooklyn, NY. Studied: NAD; CUASch; Hawthorne Sch., Cape Cod; C. Peters [40]

DREPPERT, C(arl) W(illiam) [E] Lancaster, PA b. 28 F 1892, Lancaster [24]

DRESEL, Louisa [P] Boston, MA [06]

DRESSER, Aileen King [P] NYC. Exhibited: PAFA, 1938; GGE, 1939 [40]

DRESSER, Genevieve Tyler (Mrs. Elliott Lawrence) [P] NYC/Smallwood, NY b. 8 Ag 1856. Member: NAWPS. Exhibited: NAWPS, 1935–38; Argent Gal. (one-man), 1937 [40]

DRESSER, Jane [P] Hartford, CT. Member: Hartford AS [25]

DRESSER, Lawrence Tyler [P] NYC [15]

DRESSER, Louisa [Mus.Cur] Worcester, MA b. 25 O 1907, Worcester. Studied: Vassar; FMA Sch.; Courtauld Inst., Univ. London. Author: "Seventeenth Century Painting in New England" (1935), "Early New England Prntmakers" (1939). Contributor: Art in America, WMA Annual, Antiques magazine. Position: Cur., WMA, 1932–46 [47]

DRESSLER, Bertha, Mrs. See Menzler-Peyton.

DRESSLER, Edward James [P] Chicago, IL b. 1859, Centreville, MI. Studied: San Fran. Sch. Des.; W. Shirlaw; NAD [04]

DRESSLER, Emil [P] NYC [15]

DREW, A(ntoinette) Farnsworth (Mrs.) [P] NYC b. 1866 d. 13 S 1941, Atlanta, GA [08]

DREW, Clement [Mar.P,C,Photogr] b. 27 N 1806, Kingston, MA d. 31 My 1889, Roxbury, MA. Work: Penobscot Mar. Mus.; Mariners Mus.; U.S. Naval Acad. Specialty: New England coastal scenes. He worked in Boston (1827–80s), but opened store as art dealer, painter, and framer in 1846; his son George H. (b. 1833), an artist and photographer, worked with him as of 1863. He joined forces with William Lloyd Garrison in the fight to abolish slavery. [*]

DREW, George W. [P,Ldscp.P] NYC b. 21 D 1875, NYC. Studied: J. Califano; H.P. Smith. Member: Soc. Indp. A. Exhibited: NAD; All.A.Am.; Salons of Am.; Soc.Indp.A.; N.Y. State Fair; Newark Mus.; N.Y. Mus. Sc.&Industry. Work: mural, Travers Island Yacht House, Mt. Vernon, N.Y. [47]

DREW, Lewis [P] Grand Rapids, MI/Saranac Lake, NY b. 1885 d. Je 1915

DREW, William Winter [Patron] Noroton, CT b. 1882 d. Mr 1933. Member: Darien Gld. Seven Arts. He had assembled a representative group of American Art, including works by Inness, Twachtman, Weir, and others.

DREWES, Curt J.H. [P,S] Chicago, IL Exhibited: AIC, 1938. Work: USPO, Carlyle, Rock Falls, both in Ill., WFNY, 1939. WPA artist. [40]

DREWES, Werner [P,T,E,B] Catskill, NY b. 27 Jy 1899, Canig, Germany. Studied: The Bauhaus, Germany; Klee, Kandinsky. Member: Am. Abstract A. Exhibited: MOMA, 1939 (prize); Textile Comp., Mus. of Costume A., 1941 (prize); 50 Best Prints of the Year, 1932, 1944. Work: PMA; Société Anonyme; Bennington Col.; AGAA; BM; Honolulu Acad. A.; SFMA; AIC; Springfield Mus. A.; BMFA; FMA; Newark Pub. Lib.; NYPL; PAFA; Mus., Frankfort, Germany. Position: Instr., Columbia [47]

DREYFOUS, Florence [P] NYC b. NYC. Studied: Henri; Paris [40]

DREYFUS, Isidora C. [Min.P,T] Santa Barbara, CA b. 8 Ag 1896, Santa Barbara. Studied: Delecluse, de Billemont-Chardon, Sonia Routchine, all in Paris [29]

DREYFUSS, Albert [P,W,S] b. 1880, NYC. Studied: G.G. Barnard; Harper; Twachtman; DuMond; Pratt Inst.; ASL. Member: Salons of Am. Work: Arsenal Park Mem., Pittsburgh; Albion, N.Y. Assisted in the studios of R. Hinton Perry, Tonetti, and Victor Ciani on sculpture of public buildings and monuments. Contributor: art criticism/essays, newspapers and magazines [40]

DREYFUSS, Henry [Indst.Des,W,L] NYC/Carmel, NY b. 2 Mr 1904, New York. Work: General Electric Flat Top Refrigerator; Big Ben Alarm Clock; Douglas Airplane; theatrical design; first modern Western Union office; Mercury Train, 20th Century Ltd., etc. Lectures: Industrial Design. Contributor: trade magazines [47]

DRIER, Dorothea A. [P] Riverdale-on-Hudson, NY. Member: S.Indp.A. [21]

DRIESE, Louise K. [P] St. Paul, MN [24]

DRIGGS, Beth [P,I] Indianapolis, IN [10]

DRIGGS, Elsie [P] Lambertvillle, NJ b. 5 Ag 1898, Hartford, CT. Studied: ASL; M. Sterne. Member: Am. Soc. PSG. Exhibited: Rehn Gal.; Am. Soc. PSG; AIC, 1939. Work: Harlem Housing Center, New York; WMAA; Yale; USPO, Rayville, La. WPA artist. [40]

DRISCOLL, Dale Joseph [Des] Hamilton, OH b. 1 O 1906, Hamilton. Studied: Univ. Cincinnati. Designer: plastic and sheet metal products [40]

DRISCOLL, G. Griffin [P,S] NYC b. 26 N 1900, NYC. Studied: Charles Haffner; Hans Hofmann; ASL [40]

DROGKAMP, Charles [P,Des,I,T] Los Angeles, CA b. Chicago. Studied: A. Acad., Chicago; J.F. Smith; Vanderpoel. Member: AAPL; Studio Gld, N.Y.; S.Indp.A.; A. of Carnegie Hall; Calif. AC; P.&S. Cl., Los Angeles; Soc. for Sanity in Art. Exhibited: NAD, 1938–40; All.A.Am., 1937–39; S.Indp.A., 1937; New Rochelle AA, 1939, 1940; Acad. All. A., 1937, 1938; Pal. Leg. Honor, 1945; Los Angeles Mus. A., 1942–46; Soc. for Sanity in Art, 1943–46; P.&S. Cl., Los Angeles, 1943–46; Calif. AC, 1942–46; Ebell Salon, 1943 (one-man), 1945. Position: Dir., Drogkamp Studios Art Instruction [47]

DROGSETH, Eistein Olaf [P] Detroit, MI [21]

DROUCKER, Leon [S] NYC [19]

DROUET, (Bessie) Clarke (Mrs. Henry) [P,S] NYC b. 18 Ja 1879, Portsmouth, NH d. 27 Ag 1940. Studied: P. Hale; G. Bellows. Member: NAWPS. Author: "Station Astral," pub. G.P. Putnam and Sons [40]

DROUGHMAN, Edwin F. [P] Phila., PA. Member: F.,PAFA [24]

DROWN, W(illiam) Staples [Mar.P,Ldscp.P] Providence, RI b. Dorchester, MA d. 24 S 1915. Studied: J. Appleton Clark, in Boston. Member: Providence AC; Providence WCC. Work: Peabody Mus., Salem, Mass. [15]

DRUMMOND, A(rthur) A. [P,I] Toronto, Ontario b. 28 My 1891, Toronto d. ca. 1978. Studied: C.M. Manly. Member: AWCS; Canadian Soc. Graphic A. [29]

DRUMMOND, Charles, Mrs. See Grafly, Dorothy.

DRUMMOND, James F. [P] NYC [01]

DRUMMOND, Nadine [Li,P] Pueblo, CO b. 2 S 1912, Trinidad, CO. Studied: Colo. Col.; Colorado Springs FA Center, with B. Robinson, A. Blanch, A. Dehn. Exhibited: Colo. State Fair, 1945 (prize); SFMA, 1941; Oakland A. Gal., 1940, 1941, 1944; Western A., Denver, 1939–45; Colorado Springs FA Center, 1945; Northwest Pr.M., 1941 [47]

DRURY, Herbert R. [P] Willoughby, OH b. 21 Ag 1873, Cleveland. Studied: Carlson; Hawthorne; DuMond. Member: Cleveland SA; AAPL [33]

DRURY, Hope Curtis (Mrs. William H.) [P] Newport, RI b. 14 Je 1889, Pawtucket, RI. Studied: R.I. Sch. Des. Member: Providence AC; Providence WCC; Newport AA. Exhibited: Providence AC; Newport AA, 1938 [47]

DRURY, John H. [P] Chicago, IL b. 30 Je 1816, Wash., D.C. Studied: Thomas Doughty; Couturier, in Europe, 1856–59. A painter of landscapes, cattle, and figures, he settled in Chicago, ca. 1863–64. [*]

DRURY, William H. [P,E] Newport, RI b. 10 D 1888, Fitchburg, MA. Studied: R.I. Sch. Des.; BMFA Sch.; Tarbell; Woodbury. Member: Providence AC; Providence WCC; Newport AA; SAE; Calif. Pr.M. Exhibited: Newport AA, 1916 (prize). Work: R.I. Sch. Des.; NGA; BM; Calif. State Lib.; Los Angeles Mus. A.; Victoria & Albert Mus., London; St. Georges Sch., Newport [47]

DRYDEN, Helen [Indst.Des,I] NYC b. Baltimore, MD. Studied: PAFA. Member: SI; Artist Gld. Illustrator: magazines, advertising. Designer: automobiles [40]

DRYER, Della Frances [P,T] Birmingham, AL b. Tuskegee, AL. Studied: W.M. CHase; Henri; Luis Mora; Hawthorne; G.E. Browne. Member: SSAL; Ala. AL; Miss. AA; Birmingham AC. Exhibited: Ala. AL Exh., Montgomery Mus., 1933 (prize), 1934 (prize). Work: Montgomery Mus. FA [40]

DRYER, Leona M. [P] Rochester, NY [15]

DRYER, Rufus J. [P] Paris, France [13]

DRYSDALE, Alexander John [P,I] New Orleans, LA b. 2 Mr 1870, Marietta, GA d. 9 F 1934. Studied: Paul Poincy; ASL, with Curran, DuMond. Member: New Orleans AA. Exhibited: New Orleans AA, 1909 (gold). Work: Delgado Mus., New Orleans; La. State Mus.; Supreme Court Bldg., La.; mem.,Florence Nightingale Nursery Home, Bordeaux, France [33]

DUANE, Anne Deas [P] NYC. Member: Lg. AA [24]

DUBE, Mattie (Mrs.) [P] Paris, France b. 27 D 1861, Florence AL. Studied: Bouguereau; Robert-Fleury. Member: Officer of the French Academy, 1900. Exhibited: Paris Salon, 1896 (med); Paris Expo, 1900 (med) [19]

DUBLE, Lu (Mrs.) [S] NYC b. 21 Ja 1896, Oxford, England d. 1970. Studied: A. Archipenko; José de Creeft; Hans Hofmann; C. Scarpitta. Member: ANA; NSS; NAWA; Arch. Lg.; S. Gld.; Audubon A.; Guggenheim F., 1937, 1938; F., Inst. Intl. Edu. Exhibited: PMA, 1940; Carnegie Inst.; Montclair A. Mus., 1941; MMA, 1942; PAFA, 1942–46; WMAA, 1946; NAD, annually; NAWA, annually, 1937 (prize); S. Gld; Audubon A., annually; Marie Sterner Gal., 1938 (one-man); Toledo Mus. A., 1939; Toledo A. Mus., 1939. Positions: T., Bennett Jr. Col., 1924–44, Dalton Sch., NYC, Montclair A. Mus. [47]

DU BOIS, Guy Pène [P] NYC b. 4 Ja 1884, Brooklyn, NY d. 1958. Studied: Chase Sch.; DuMond; Henri. Member: ANA; New Soc. A. Exhibited: Kraushaar Gal., 1944 (one-man); AIC, 1930 (med); NAD, 1936 (prize); CGA, 1937 (med). Work: MMA; WMAA; PMG; Los Angeles Mus. A.; AGAA; Detroit Inst. A.; PAFA; Toledo Mus. A.; Nebr. AA; murals, USPO, Saratoga Springs, N.Y.; FA Gal., San Diego; Milwaukee AI. Position: Ed., Arts and Decoration [47]

DU BOIS, Henri Pène [Cr] NYC b. 1859 d. 20 Jy 1906. Studied: Paris, with Gérôme. Position: Art Ed./music critic, New York American

DU BOIS, Patterson [P] b. 1847, Phila., PA d. 8 Ag 1917, Phila. Studied: PAFA; D.R. Knight; P. Moran. Position: Assayer, Phila. Mint

DU BOIS, Raoul Henri Pène [Des] NYC b. 29 N 1912. Work: Stage sets and costumes for shows, "Ziegfield Follies," etc., WFNY, 1939. Illustrator: Vogue, Theatre Arts [40]

DU BOIS, Yvonne Pène [P] NYC b. 3 Jy 1913, Staten Island, NY. Studied: ASL; Guy Pène du Bois. Exhibited: Kraushaar Gal.; Argent Gal., N.Y.; Arch. Lg.; Bienn., 1939; CGA; GGE [40]

DU BOSE, Charles [Indst.Des,Arch,P] NYC b. 16 Ag 1908, Savannah, GA. Studied: Georgia Sch. Tech.; Univ. Pa.; Fontainebleau Sch. FA. Member: Arch. Lg. [40]

DUBOY, Paul [P] NYC. Member: Arch Lg., 1891 [04]

DU BRAU, Gertrud. See Kogler.

DUBUQUE, Edward W(illiam) [P,T] Providence, RI b. 5 N 1900, Moosup, CT. Studied: Paris, with Heintzelman, Gorguet, Laurens, Boudoüin; Kunstgewerbe Schule, Vienna. Member: Providence AC. Work: Seaman's Bank, NYC; Christ Church, Birmingham, Mich.; St. Joseph's Church, North Grosvenordale, Conn.; St. Stephen's Mission Church, Quinebaug, Conn.; Providence Pub. Lib.; mural panels for Joseph Urban. Specialty: Designs for industrial arts and architectural renderings. Position: T., Providence public schools [40]

DUCASSE, Mabel Lisle (Mrs. C.J.) [P] East Providence, RI b. 3 Mr 1895, La Porte, Colorado. Studied: Walter Isaacs; DuMond; W.S. Taylor; Bridgman; L. Mora; C. Chapman; Yasushi Tanaka; ASL; PIASch; Univ. Wash. Member: R.I. WCC. Exhibited: Seattle FA Soc., 1918, 1919, 1923–25 (prizes) [47]

DUCKETT, Albert [Car,P] Biloxi, MS b. 28 O 1907, Springfield, IL. Studied: Studio Sch. A., Chicago, with J. Norton, J. Chapin; Nat. Acad. A., Chicago; Detroit Soc. A.&Crafts, with Sarkis Sarkisian. Exhibited: Detroit Inst. A., 1943, 1944. Positions: Car., Hearst newspapers, 1926–45; A. Ed., Detroit Times, 1935–46 [47]

DUCKETT, Vernon Francis [P,Arch,Des,T] Wash., D.C. b. 23 Ap 1911, Wash., D.C. Studied: George Wash. Univ.; Catholic Univ.; Fontainebleau Sch. FA; Beaux-Arts Inst. Des. Member: Wash. WCC. Exhibited: Beaux-Arts Inst. Des. (med); Diplome Soc., 1933 (gold), 1934 (med); Illuminating Eng. Soc., 1933 (prize), 1934 (prize); Quarry Tile Comp., 1934 (prize); Rome, 1934, 1935, 1936. Work: design drawings for General Acct. Office, R.I. Ave. Housing Development; "The Hermitage," used in Inauguration decorations, 1937. Position: Arch., War Dept. [40]

DUDENSING, F. Valentine (Bibi) [P] NYC/Paris, France b. F. 1901, San Fran. Studied: R. Miller; L. Wilson. Member: S.Indp.A. [33]

DUDENSING, Richard [E,En] b. Germany (came to U.S. ca. 1857) d. 4 S 1899, NYC

DUDLEY, Carol Reid [P,Textile Des] Short Hills, NJ d. 1 My 1908, Providence, RI. Studied: N.Y. Sch. F.&Appl. Des.; E. O'Hara; G.P. Ennis. Member: AWCS; Studio Cl.; NAWA [47]

DUDLEY, Dorothy [P] NYC b. 23 D 1892, Somerville, MA. Studied: H.B. Snell. Member: NAWPS. Exhibited: NAWPS, 1927 (prize) [40]

DUDLEY, Fanny [C,L] Old Lyme, CT b. Brooklyn, NY. Studied: Evelyn Nordhoff Bindery, N.Y.; Cuzin, Maylander, Noulhac, in Paris. Exhibited: P.-P. Expo, 1915 (gold). Work: St. John's Church by the Sea, Newport, R.I.; J.P. Morgan Lib. Specialties: hand bookbinding, tooling, etc. [47]

DUDLEY, Frank V. [P,L] Chicago, IL/Chesterton, IN b. 1868, Delavan, WI. Studied: AIC. Member: Chicago AC; Chicago AG; Chicago PS; Union Internationale des Beaux Arts et des Lettres, Paris. Exhibited: Chicago Municipal AL, 1907 (prize), 1914 (prize); AIC, 1915 (prize), 1919 (prize), 1921 (prize); Chicago Gal. A., 1927 (prize), 1929 (prize), 1930 (prize); Business Men's AC, 1931 (prize); Hoosier Salon, 1932 (prize), 1937 (prize). Work: AIC; Municipal Coll., Owatonna, Minn.; Cedar Rapids AA; public sch. coll., St. Louis; public sch. coll., Chicago; State Mus., Springfield, Ill [40]

DUDLEY, Katherine [P] Chicago, IL. Work: Municipal Art Comm., Chicago; AIC [17]

DUER, Douglas [P,I] NYC/Wilmington, DE b. 4 O 1887, d. 1964, Huntingdon Valley, PA (where he lived since 1940). Studied: Chase, 1908–09; Pyle, in Wilmington, 1909–17; PAFA. Member: SI [27]

DUER, Henrietta A. [P] Baltimore, MD b. Baltimore. Studied: S.E. Whiteman; Castaign; Girardot. Member: Baltimore Mus. A. [33]

DUESBERG, Otto [P] Brooklyn, NY. Member: S.Indp.A. [24]

DU FAIS, John [Arch] b. 21 D 1855 d. 14 Mr 1935, Miami, FL. Studied: Harvard, 1877; MIT; J. La Farge; Saint-Gaudens. Member: AIA since 1901; member/founder, Architectural Lg. N.Y. Work: with Cass Gilbert, designed the Union Lg. Cl. Bldg., NYC.

DUFF, Walter R. [En,E] NYC [17]

DUFFY, Edmund [Car,I] Baltimore, MD b. 1 Mr 1899, Jersey City, NJ d. 1962. Studied: ASL; Paris. Work: BMA; BM; Princeton Lib.; WMAA; Huntington Coll. Contributor: national magazines. Award: Pulitzer prize, cartoons, 1930–34, 1940. Position: Car., Baltimore Sun [47]

DUFFY, Mary. See Ward.

DUFFY, Richard H. [S] Jamaica, NY b. 22 Ja 1881, NYC. Member: NSS, 1914 [27]

DUFNER, Edward [P,T] Short Hills, NJ b. 5 O 1871, Buffalo, NY d. 1957. Studied: Académie Julian, Paris; Buffalo ASL, with Bridgman; ASL, with Mowbray; Whistler, Laurens, in Paris; Italy. Member: ANA, 1910; ANA, 1929; NYWCC; AWCS; SC, 1908; Paris AAA; Lotos Cl.; NAC; Allied AA; Buffalo SA; Montclair AM. Exhibited: Albright A. Gal., 1893 (prize); Paris Salon, 1899 (prize); Pan-Am. Expo, 1901 (prize); Buffalo SA, 1904 (prize); St. Louis Expo, 1904 (prize); AWCS, 1909 (prize); Peabody Inst., 1921 (prize); PAFA, 1924*(prize); Newport AA, 1935 (prize); NAD; All.A.Am.; N.Y. Soc. P.; Soc. for Sanity in Art; Lotos Cl.; SC; NAC.; Nat. Art Comp., NYC 1925 (gold). Work: Albright A. Gal.; Brooklyn Inst. A.&Sc.; Milwaukee A. Soc.; Seymour (Ind.) AL; Lotos Cl.; NAG; Ft. Worth Mus. A.; Montclair A. Mus.; NAD; Randolph-Macon Women's Col.; Vanderpoel Coll.; Wesleyan Col.; Rochelle Pub. Lib.; Parthenon A. Gal., Nashville, Tenn. Positions: T., ASL of Buffalo, 1903–07, ASL, NYC, 1908–17, Carnegie Inst., 1920 [47]

DUGAN, Irvin [Car,I,P] Huntington, WV b. 8 F 1892, Huntington, WV. Studied: Chicago Acad. FA; Fenway Sch. Illus., Boston; New Sch. Des. Exhibited: WFNY, 1939; GGE, 1939. Work: Huntington Lib., San Marino, Calif.; cartoons/illustrations, Herald-Dispatch, Huntington Advertiser, Herald-Advertiser [47]

DUGGAR, Marie R. (Mrs.) [S] d. 5 My 1922, St. Louis, MO. Work: St. John's Methodist Episcopal Church, Methodist Orphan's Home, both in St. Louis. Specialty: bas-relief portraits of children

DUGMORE, Arthur Radclyffe [I] Newfoundland, NJ b. 25 D 1870, England (came to U.S. in 1899). Studied: Belle Arti, Naples. Specialty: birds. Author: "Bird Homes" [13]

DUGOSH, Ruby Evelyn [Des,P,T] San Antonio, TX b. 8 F 1907, San Antonio. Studied: Texas State Col. for Women, Columbia; C. Martin; H.L. McFee; Hofmann; J.H. Atwell. Member: SSAL; San Antonio AL;

Provincetown AA; Texas FAA. Exhibited: Texas Centennial, Dallas, 1936; Witte Mem. Mus., 1938-39; Mus. FA, Houston, 1938, 1939; Texas State T. Col., 1938 (one-man); Lady of the Lake Col., San Antonio, 1939 (one-man); Southeast Texas A., 1939 (prize); San Antonio A., 1937 (prize). Position: T., Jefferson H.S., San Antonio, Texas [47]

DUHME, H. Richard, Jr. [S] Phila., PA b. 31 My 1914, St. Louis, MO. Studied: PAFA. Exhibited: City AM, St. Louis, 1938; PAFA, 1938-39; Grand Central A. Gal., 1939 [40]

DULAC, Marguerite [P,W] NYC b. 12 S 1918, Wilmette, IL. Studied: Northwestern Univ.; NYU; Paris. Exhibited: AIC, 1924, 1935, 1938; WMAA, 1940; CGA, 1944; Univ. Chicago (prize). Work: murals, Northwestern Univ.; Charles A. Stevens & Co., Chicago [47]

DULIN, James Harvey [P,E] Paris, France/Wilmette, IL b. 24 O 1883, Kansas City, MO. Studied: AIC; Laurens, Naudin, Avy, in Paris [29]

DULIN, Norman M. [Car] Hollywood, CA/Wash., D.C. Position: car., Walt Disney Studios [40]

DULK, Robert [C,J,Des] NYC b. 4 Jy 1863, NYC d. 12 M 1923. Studied: CUASch; NAD; Columbia T. Col. Member: NYSC. His efforts established the first art division in a New York evening high school, the DeWitt Clinton School. Positions: Hd., NY Evening H.S. of Indst. A.; studio workshops, Bar Harbor, Maine, Manchester, Mass., Woodstock, N.Y.

DULL, Christian L(awton) [P,E] Phila., PA/Mortonville, PA. b. 24 My 1902, Phila. Studied: D. Garber; G. Harding; E. Horter; PAFA; NAD; PMSchIA. Member: Soc. Am. E.; Phila. SE; Phila. Print Cl. Exhibited: Graphic Sketch Cl., Phila. (prize); Springville H.S. Nat. Art Exh., Utah, 1931 (prize); Work: PAFA; NYPL [40]

DULL, John J. [P,Arch,B,T] Phila., PA b. 6 D 1859, Phila. Studied: PAFA. Member: T Sq. Cl.; Phila. Sketch Cl. Exhibited: Plastic Cl., 1903 (gold); Phila. WCC, 1934 (gold) [40]

DUMAS, Jack [I] Bainbridge Island, WA (1966) b. 1916, Seattle, WA. Member: Cornish Sch. Allied A.; Seattle Acad. A., with E. Norling. Illustrator: Los Angeles Examiner, 1930s. Specialty: Western wildlife [*]

DUMAS, Jean [Por.P] Chicago, IL/Center Hall, PA b. 1 Ap 1890, Romania. Studied: J.W. Reynolds. Member: AIC; Chicago AC; Romany Cl. Work: Belgrade Mus., Yugoslavia [47]

DUMLER, Martin George [P] Cincinnati, OH b. 22 D 1868, Cincinnati. Studied: E.H. Potthast; M. Rettig; R. Busebaum. Member: SC; Cincinnati AC; Cincinnati Mus. Assn. Exhibited: CM; SC. Work: Xavier Univ.; Cincinnati Cl. [47]

DUMM, Edwina [I] New Canaan, CT. Member: SI [47]

DUMMER, H. Boylston [P,T,I] Rockport, MA b. 19 O 1878, Rowley, MA d. 3 N 1945, Beverley, MA. Studied: E. Pape; G. Noyes; W. Webster; J. Carlson. Member: SC; North Shore AA; Boston S.Indp.A.; Rockport AA. Illustrator: books for Ginn and Co., World Book Co., American Book Co. Specialty: nature illus. [40]

DUMMETT, Laura Dow [P,D,T] Glendora, Chews, NJ b. 17 Ag 1856, Allegheny, PA. Studied: Pittsburgh Sch. Des. for Women; Académie Julian, Académie Desgoffe, both in Paris. Member: Pittsburgh AA [31]

DuMOND, Frank V. [P,I,T] Lyme CT b. 1865, Rochester, NY d. 6 F 1951, NYC. Studied: Boulanger, Lefebvre, Constant, in Paris. Member: SI; Lotos Cl.; Century Assn.; Rochester AC; Yonkers AA; NIAL; NSMP; NAC, NA, 1906; ASL; Players Cl. Exhibited: Paris Salon, 1890 (med); Pan-Am. Expo, 1901 (prize); St. Louis Expo, 1904 (prize); P.-P. Expo, San Fran., 1915 (prize). Work: Pub. Lib., San Fran.; Liberty Tower & Hotel des Artistes, NYC; Lotos Cl.; NAC; Portland (Oreg.) AM; Denver AM; Pub. Gal., Richmond, Ind.; Lake Forest, Ill. Positions: Dir., Dept. FA, Lewis and Clark Expo, Portland, 1905; T., ASL for 59 years (since 1892) [47]

DuMOND, Frederick Melville [P] Paris, France b. 15 Jy 1867, Rochester, NY d. 25 My 1927, Monrovia, CA. Studied: Lefebvre, Cormon, Laurens, Doucet, in Paris. Member: Rochester AC. Exhibited: Paris Salon, 1893; Paris Salon, 1899 (med); P.-P. Expo, San Fran., 1915 (med). Specialty: the desert of the American Southwest. Painted in Southwest, 1909-12. Brother of Frank. [21]

DuMOND, Helen Savier (Mrs. Frank V.) [P,S] NYC/Lyme, CT b. 31 Ag 1872, Portland, OR. Studied: ASL; R. Brandegee; DuMond; Collin, Merson, in Paris. Member: NAC; Art Workers Cl.; Catherine Wolfe AC [40]

DUNBAR, Anna (Glenny) (Mrs. Davis Dunbar) [S] Buffalo, NY b. 28 My 1888, Buffalo. Studied: Bourdelle, in Paris [17]

DUNBAR, Daphne French [Li,Des,P,T,Dec] Boston, MA b. 27 S 1883, Port Colban, Canada. Studied: BMFA Sch.; D. Ross; H. Boss; K.H. Miller; H.E. Field; C. Hawthorne; Roerich; Harvard; Paris. Exhibited: San Diego, Calif., 1941 (prize); Inst. Mod. A., Boston, 1945 (prize). Work: Colorado Springs FA Center; BMFA; AGAA; Los Angeles Mus. A.; Detroit Inst. A.; LOC; four cafeterias, NYC [47]

DUNBAR, E. Helen [Des,Dec] NYC b. 30 Mr 1900, Dayton, IL. Studied: Univ. Chicago; AIC; Columbia; A.W. Dow. Work: Design and color styling for Martex towels, Old Town blankets, Kalzenbach and Warren. [40]

DUNBAR, Frederick A. [S] Holly Oak, DE [13]

DUNBAR, Harold C. [P,T,W] Chatham, MA b. 8 D 1882, Brockton, MA. Studied: E.L. Major; DeCamp; Mass. Sch. Art; E. Tarbell; BMFA Sch.; Acad. Colarossi, Paris. Exhibited: AWCS, 1917. Work: Radcliffe Col.; State House, Montpelier, Vt.; Beuchner Hospital, Youngstown, Ohio; Empire Theatre, NYC; Mus. City N.Y.; Municipal Coll., McPherson, Kans.; Little Theatre, Chatham, Mass. Positions: Ed., The Cape Cod Beacon; Dir., Chatham summer art classes, 1915- [40]

DUNBAR, U(lric) S(tonewall) J(ackson) [S] Wash., D.C. b. 31 Ja 1862 London, Ontario d. My 1927. Studied: F.A.T. Dunbar; Art Sch., Toronto. Member: Wash. AC; U.S. Pub. AL. Exhibited: Columbian Expo, Chicago, 1893 (med); Pan-Am. Expo, Buffalo, 1901 (prize); Atlanta Expo, 1902 (prize); Seattle, Wash., 1906 (prize); St. Louis Expo, 1904 (prize); P.-P. Expo, San Fran., 1915 (prize); Toronto Expo, (prize). Work: Oak Hill Cemetery, U.S. Senate, Hubbard Mem. Hall, Scottish Rite Temple, all in Wash., D.C.; Atlanta, Ga.; Norwich, Conn.; Little Rock, Ark.; Dallas, Tex.; St. Louis, Mo.; Baltimore, Md. [25]

DUNBIER, Augustus William [P,T,L] Omaha, NE b. 1 Ja 1888, Osceola, NE. Studied: Royal Acad., Düsseldorf, Germany; AIC. Member: Omaha SA; SC; S.Indp.A. Exhibited: Northwestern Expo, 1918 (prize); Nebr. Expo, 1922 (prize). Work: Omaha Pub. Lib.; Joslyn Mem.; Governor's Mansion, Lincoln, Nebr. [47]

DUNCAN, Charles Stafford [P,Li] San Fran., CA b. 12 D 1892, Hutchinson, KS. Member: San Fran. AA; Calif. SE. Exhibited: San Fran. AA, 1927 (gold), 1928 (prize); Bohemian C., 1927 (prize); Pacific Southwest Expo, 1928 (gold); Pal. Leg. Honor, 1930 (prize); NAD, 1937 (prize). Work: Emanuel Walter Coll.; Albert M. Bender Coll., SFMA [40]

DUNCAN, Charles W. [I] NYC. Member: S.Indp.A. [25]

DUNCAN, Dorothy [P] Sausalito, CA b. 2 O 1896, Sausalito. Studied: Univ. Calif.; Calif. Sch. FA. Exhibited: San Fran. Soc. Women A., 1931, 1934 (prize), 1935 (prize); San Fran. AA, 1932-34, 1938 (prize); GGE, 1939; CI, 1941; Faulkner Mem. A. Gal., Santa Barbara, 1940; Fnd. Western A., 1941; Colorado Springs FA Center, 1938; Pal. Leg. Hon., 1946; SFMA Traveling Exh., 1940; San Fran. A. Center, 1935 (one-man). Work: SFMA [47]

DUNCAN, Florida (Mrs.) [P] Provincetown, MA b. London, Ontario. Studied: self-taught. Member: NYWCC; Wash. WCC [29]

DUNCAN, Frederick (Alexander) [P,W] NYC b. 11 My 1881, Texarkana, AR. Studied: Bridgman; H.C. Christy [33]

DUNCAN, G.R., Mrs. See Birch, Geraldine.

DUNCAN, Jean [P,T,L] St. Paul, MN b. 26 D 1900, St. Paul. Studied: Vassar; Univ. Minn.; ASL; H. Hofmann; W. Killam; W. O'Hara; G. Bridgman; C. Chatterton; Hawthorne. Member: Montparnasse Cl., St. Paul; Minneapolis AI; Minn. AA; Lg. Am. Pen Women. Exhibited: Minneapolis AI, 1925 (prize), 1918-1945; Montparnasse Cl., St. Paul, 1933-34 (prize); Minneapolis Women's Cl., 1944 (prize); Kansas City AI, 1935 (prize); CGA; Lg. Am. Pen Women, 1938-44; S.Indp.A.; Walker A. Center; Minn. State Fair; St. Paul Pub. Lib.; Univ. Minn. Positions: T., Rockford Col., 1930-31, Northrop Collegiate Sch., Minneapolis, 1931-46 [47]

DUNCAN, Mabel Harrison [P] NYC [01]

DUNCAN, R.G. [E] Pasadena, CA. Member: Calif. PM [25]

DUNCAN, Walter Jack [Car,I,T] NYC b. 1 Ja 1881, Indianapolis d. 11 Ap 1941. Studied: ASL. Member: SC. Work: Official A., A.E.F., 1918. Illustrator: leading magazines. Author: "First Aid to Pictorial Composition" [40]

DUNCAN, W.M. [P] Los Angeles, CA [19]

DUNDAS, Verde Van Voorheees [S,W,L] Chicago, IL b. 31 Ag 1865, Marlin, TX. Studied: L. Taft. Member: Chicago Municipal A. Lg.; Chicago ASL; Western A. Soc.; AAS. Work: Arché Club, Chicago [27]

DUNHAM, Horace C. [P] Auburndale, MA. Member: Copley S., 1893 [10]

DUNK, Walter M. [P,I] NYC b. 7 Jy 1855, Phila. Studied: PAFA. Member: Phila. Sketch Cl.; A. Fund, Phila. [10]

DUNKEL, Eugene B. [P,Des] NYC b. 30 Ap 1890. Studied: Acad. A., Indst. A. Acad., both in Petrograd, Russia. Member: United Scenic Artists U. Work: European museums. Positions: Brooklyn Mus. Theatrical Des.; Affiliated with American Ballet [40]

DUNKELBERGER, Ralph D. [P,I,Des,T] Reading, PA b. 16 Ag 1894, Reading. Studied: PMSchIA; Schearer; Oakley. Member: Phila. Sketch C.; A. Haven Gld., Reading. Exhibited: Phila. Sketch C., 1942; Reading Mus. and A. Gal. Work: Pub. Mus. and A. Gal., Reading; murals, Berks County Hist. Soc. Mus., Reading; Pa. State Col.; Valley Forge, Pa. Illustrator: "Ben Hur." Positions: T., PMSchIA, Wyomissing (Pa.) Inst. FA [47]

DUNLAP, Helena [P] Fullerton, CA b. Los Angeles. Studied: PAFA, 1905; AIC; Lhote, in Paris. Member: San Fran. AA. Exhibited: Panama-Calif. Expo, San Diego, 1915 (gold,med); San Fran. AA, 1919 (med). Work: San Diego FA Gal.; Los Angeles Mus. [40]

DUNLAP, Hope [I] Belmont, MA [13]

DUNLAP, Marjan Lyall [P] Chicago, IL [15]

DUNLAP, Mary Stewart [P] Los Angeles, CA [10]

DUNLAP, William, Mrs. See Sargent, Mary.

DUNLAP, Zoe Fleming [Min.P,W,C] Cincinnati, OH b. Cincinnati d. 26 My 1927. Studied: Cincinnati A. Acad.; Nowottny; Paris. Member: NAC; Cincinnati Women's AC [25]

DUNLOP, Anna Mercer [T,P] Petersburg, VA b. 2 Ag 1883, Petersburg. Studied: ASL; W. Adams; J.M. Whistler; R. Collin, in Paris; Germany; Italy; England. Member: Petersburg A. Lg.; VMFA, Richmond. Exhibited: CI; VMFA, 1938, (one-man). Position: Petersburg Sch. A., 1932– [47]

DUNN, Alan (Cantwell) [Car,I,W,P,Li] NYC b. 11 Ag 1900, Belmar, NJ d. 1974. Studied: NAD; Tiffany Fnd.; Fontainebleau Sch. FA, France; Am. Acad., Rome, 1923–24. Member: NYWCC; Tiffany Fnd.; AWCS; Assoc. Magazine Contributors. Work: Mus. NYC. Author/Illustrator: "Rejection," 1932, "Who's Paying for this Cab?," 1945. Contributor: New Yorker, Architectural Record [47]

DUNN, Alexander Gordon [Lndscp.P] b. 16 D 1815, Glasgow, Scotland (came to U.S. in 1854) d. 2 O 1887 Holton, KS. Lived in Brooklyn, N.Y. until ca. 1885, but most of his paintings were of Scotland. Exhibited: Brooklyn WC Soc., 1870 [*]

DUNN, Bert [P] St. Louis, MO [24]

DUNN, Calvin E. [Des,I] Davenport, IA b. 31 Ag 1915, Georgetown, OH. Studied: Cincinnati A. Acad. Exhibited: WFNY, 1939. Position: Des./Illus., Ramsey Co., Davenport [40]

DUNN, Charles A.R. [P,I] Wash., D.C. b. 9 D 1895, Wash., D.C. Studied: E. Nye; Hawthorne. Member: S. Wash. A.; Wash. WCC; Wash. Ldscp. Cl.; Ten Painters of Wash. Exhibited: S. Wash. A., 1925 (prize). Work: PMG [40]

DUNN, Delphine (Mrs.) [P,T] Boston, MA b. Rushville, IN. Studied: Colo. Col. A. Sch.; Chase A. Sch., N.Y.; AIC; Columbia; PAFA; Fontainebleau Sch. FA; Taft. Position: T., Scott Carbee Sch. A. [40]

DUNN, Edna Marie [P] Kansas City, MO [21]

DUNN, Elizabeth Otis [I] Phila., PA [17]

DUNN, Emelene Abbey [P,S,Arch,Edu] Rochester, NY b. 26 My 1859, Rochester d. 17 F 1929. Studied: Wiles; Lempert; Forbes; Satterlee; Sanderson; Mundy; Powers, Corcos, in Florence; Dube, in Paris. Member: NAC; AAC, 1913. Established N.Y. Normal Art School, 1905. Large group of Oriental pictures and a series of historic Colonial New England, were presented with talks by the artist. Position: Supv., Conn. State Bd. Edu. [27]

DUNN, Frank [P] Cincinnati, OH Member: Cincinnati AC. Position: Affiliated with Strobridge Lith. Co., Cincinnati [01]

DUNN, George Carroll [Des,Dr,I,P] Ozark, AL b. 24 D 1913. Studied: F. Booth; L.T. Phoenix; T. Fogarty; S.W.J. Van Sheck; F. Applebee; Ala. Polytechnic Inst. Member: SSAL; Ala. AL. Work: Ala. Polytechnic Inst. [40]

DUNN, Harvey Hopkins [Des,Dr,Arch] Phila., PA b. 9 Jy 1879, Phila. Studied: Univ. Pa.; PAFA; PMSchIA; Denman Ross; Harvard. Member: Ar. Gld.; AI Graphic A.; Phila. All.; Phila. Sketch Cl.; SI; The Stowaways, N.Y.; AFA. Exhibited: Jewelry Fashion Show, Phila., 1918 (prize); AIA, Phila., 1927 (prize); T-Square Cl., 1927 (prize); Phila. Sketch Cl., 1927 (prize); Doubleday, Page & Co., 1926 (prize); Shakespeare Bookplate Comp., AI Graphic A., 1925 (prize); Lord and Taylor, N.Y., 1926 (prize). Work: trade mark designs, LaFayette Motor Car, Hoover Suction Sweeper, Alexander Bros., GM; PMG bulletin; Am. Optical Co.; Smithsonian Inst.; permanent cover design, "International Studio"; book design, J.D. Rockfeller; cover designs, Journal of Heredity (Wash., D.C.), Literary Digest (N.Y.); book design "Law Triumphant" [40]

DUNN, Harvey T. [I,P,T] Tenafly, NJ b. 8 Mr 1884, Manchester, SD d. 30 O 1952. Studied: Brookings State Col., with A. Caldwell, 1901; AIC, 1902–04; Chadds Ford, with H. Pyle, 1904–06. Member: SI, 1913; SC; A. Gld.; NA, 1945. Work: Dunn Coll. & Archives, S.Dak. State Col. (given by him in 1950); Smithsonian Inst.; national magazines. Had his own illus. studio in Leonia, N.J., 1906. He taught many who became famous illustrators at Grand Central Sch. A., NYC [47]

DUNN, Lena Simons [S] Lansing, MI [19]

DUNN, Louise M. (Mrs.) [P] Cleveland, OH b. O 1875, East Liverpool. Studied: H.G. Keller; Cleveland SA; AFA. Exhibited: CMA, 1923 (prize), 1930 (prize) [40]

DUNN, Marjorie Cline [Min.P,P] Laguna, CA/Sierra Madre, CA b. 7 S 1894, Eldorado, KS. Studied: Los Angeles Sch. A.; E.S. Bush. Member: Calif. Soc. Min. P.; Laguna Beach A. Assn. Exhibited: Los Angeles Mus. A., 1938; Chicago Gal. Assn., 1938; GGE, 1939; CGA, 1939. Work: Los Angeles Mus. A. [40]

DUNN, Montfort [Gal.Dir] St. Paul, MN b. 15 My 1907, St. Paul. Studied: Yale; C. Booth; Ozenfant; Marcoussis. Position: Dir. St. Paul Gal. & Sch. A., 1939–46 [47]

DUNN, Nat [P] Uniontown, PA. Member: Pittsburgh AA [25]

DUNN, Robert [I] NYC. Member: SI [47]

DUNNE, Margaret [E] NYC [24]

DUNNELL, John Henry [Ldscp.P] NYC b. 1813, Millbury, MA d. 25 Ja 1904. Exhibited: NAD, 1847–48. Was a businessman in Coloma, Calif., 1849–51; involved in NYC Republican politics, 1851; returned to Calif., 1857–60; resident of NYC since 1860. [04]

DUNNING, Arthur R. [P] Chicago, IL. Member: Chicago NJSA [25]

DUNNING, Edward Gore [P] Stamford, CT b. 1884 d. 13 Jy 1931

DUNNING, M. Kelso [P] Phila., PA b. Phila. Studied: E. Daingerfield; J. Sartain [01]

DUNNING, Robert Spear [P] Westport Harbor, MA b. 1829, Brunswick, ME d. 12, Ag 1905. Descendant of Earl of Ashburton. As a boy he was employed in the Fall River mill, and later was engaged in coastwise shipping for a few years while studying art. Many of his paintings were exhibited in New York and Boston, and at the NAC, 1850–1880; Am. A Union, 1850.

DUNPHY, Nicholas [E,I] San Fran., CA b. 4 Jy 1891, Seward, NE. Studied: Stanford Univ.; Calif. Sch. FA; R. Harshe; H.V. Poor. Member: SAI; Calif. SE; Northwest Pr.M.; Pr.M. Soc. Calif.; Southern Pr.M.; San Fran. AA. Work: Calif. State Lib., Sacramento; LOC [47]

DUNSMORE, John Ward [P] NYC/Rockaway, NJ b. 29 F 1856, Cincinnati d. 30 S 1945, Dover, NJ. Studied: Cincinnati A. Acad.; Couture, in Paris. Member: ANA; Arch. Lg., 1903; SC, 1903; Boston AC, 1881; AWCS; A. Fund S.; Cincinnati AC; AFA; AAPL. Exhibited: Mass. Charitable Mechanics' Assn., Boston, 1881 (med); SC, 1914 (prize); Grand Lodge of Masons, N.Y., 1934 (prize). Work: Ohio Mechanics' Inst., Cincinnati; Lassell Seminary, Auburndale, Mass.; SC; NAD; Hist. Soc.; Sons of Revolution, N.Y.; Cincinnati A. Mus.; Wagnals Mem. Lib., Lithopolis, Ohio. Positions: Dir., Detroit Mus. A., 1888–90, Detroit Sch. A., 1890–94 [40]

DUNTON, W. Herbert "Buck" [P,Li] Taos, NM b. 28 Ag 1878, Augusta, ME d. 18 Mr 1936. Studied: Cowles A. Sch, Boston; ASL; A.M. Anderson; DeCamp; DuMond; W.L. Taylor; E.L. Blumenschein; L. Gaspard. Member: AFA; SC; Taos SA (founder). Summer studio in Taos, 1912 (became a resident in 1921). Exhibited: Nashville, 1927 (gold); San Antonio, 1928 (prize), 1929 (prize); Pacific Southwest Expo, 1929 (prize). Work: Soc. Appl. A.; Witte Mem. Mus. FA, San Antonio; Mus. N.Mex., Santa Fe; Univ. Cl., Akron, Ohio; Santa Fe Railroad; Mo. State Capitol, Jefferson City. Illustrator: Harpers, Scribner's, other magazines. Specialty: paintings of the West [33]

DUNWOODY, William Hood [Patron] Minneapolis, MN (since 1869) b. near Phila. d. 8 F 1914. Member: Minneapolis Soc. FA. He bequeathed an

endowment fund of $1,000,000 to the Minneapolis Soc. FA, and the residue of his estate, exceeding $2,000,000, to establish the William Hood Dunwoody Industrial Inst., Minneapolis

DUPARQUE, Paul [P] White Plains, NY. Member: S.Indp.A. [25]

DU PEN, Everett George [S,Edu] Kirkland, WA b. 12 Je 1912, San Fran. Studied: Univ. Southern Calif.; Chouinard AI; Yale; Lukens; Sample; Snowden; Fulop. Exhibited: Am. Acad., Rome, 1935–37; NAD, 1943; Kansas City AI, 1942; CAM, 1941, 1942; San Fran. AA, 1943. Position: T., Univ. Wash., Seattle [47]

DUPHINEY, Wilfred I. [P,T,L,I] Johnston, RI b. 16 S 1884, Central Falls, RI. Studied: RISD; W.C. Loring; ASL, Bridgman, G.P. duBois, A.F. Schmitt. Member: Providence AC; Providence WCC. Exhibited: Providence AC, 1932 (prize); PAFA, 1929–33; New Haven, Conn.; Springfield, Mass.; Boston. Work: State of R.I.; R.I. State Col.; City of Providence. Illustrator: "First Lesson in French," 1922, "Rainbow Gold," 1924. Position: T., RISD [47]

DU PONT, Helen A. [Min.P] Johnstown, PA [13]

DUPONT, Kedma [P,E] San Fran., CA b. 7 Ja 1901, Alameda, CA. Studied: Univ. Calif.; Calif. Sch. FA; Grande Chaumière, Académie Julian, both in Paris. Member: San Fran. AA. Exhibited: SFMA; San Fran. AA; Santa Cruz A. Lg.; Oakland A. Gal. [47]

DUPRE, E. [I] Jersey City, NJ [21]

DU PRÉ, Grace Annette [P] NYC b. Spartanburg, SC. Studied: Grand Central Sch. A.; DuMond; H.L. Hildebrandt; K. Anderson. Member: PBC; NAC; AAPL; FA Lg. of the Carolinas; Carolina AA; Spartanburg AC. Exhibited: FA Lg. of the Carolinas, 1934 (prize), 1935–43; Mint Mus. A., 1942 (prize); PBC, 1943 (prize); 1944–45; All.A.Am., 1943; Blue Ridge, N.C., 1942; Gibbes A. Gal., 1939; AAPL, 1944, 1945. Work: Fed. Bldg., Spartanburg; State Capitol, S.C. [47]

DUPRE, L.B. (Mrs.) [P] Sulphur, OK. Member: Okla. AA [25]

DUPREZ, Elizabeth F. Kruseman Van Elten (Mrs.) [P] Paris, France b. New York. Studied: NAD; Courtois; Collin, in Paris. Member: Paris A. Women's AA [25]

DU PUY, Ella M. [P] NYC Exhibited: Nat. Assn. Women PS, 1935–38 [40]

DUQUE, Francis [Por.P] NYC b. 1832, Colombia, South America (came to U.S. ca. 1865) d. 28 Ap 1915. Studied: Paris; Rome. Exhibited: Paris Salon. Popular in his day, his last years were spent in poverty and obscurity.

DUBRAND, Bennett [P] Wash., D.C. b. 5 N 1906, Wash., D.C. Studied: Hawthorne; PAFA; Demetrios. Exhibited: Soc. Wash. A., 1930 (med) [40]

DURAND, E.L. [P] NYC [13]

DURANDO, André [Mur.P,Por.P] Los Angeles, CA b. 1869, Turin, Italy (came to U.S. as young man) d. 31 D 1945. Painted the murals in Boston Opera House and in many churches.

DURAND-RUEL, Joseph [Dealer] Paris, France. d. 30 D 1928. Brother of Paul. Connoiseur of painting; senior member of the famous art firm of Paris and New York founded in 1803. His private collection was considered one of the finest in the world.

DURAND-RUEL, Paul [Dealer] Paris, France b. 1831 d. 5 F 1922. Brother of Joseph. Collector and head of the art firm of Durand-Ruel of Paris and New York. Responsible for bringing the French Impressionists to America. First exhibition in Boston, September 1883, followed by landmark exhibition in New York, April-May 1886, after which Impressionism became the predominant style of painting.

DURCHANEK, Louis W. (Lukvik) [P] Wassaic, NY b. 29 Ag 1902, Vienna, Austria. Studied: New England Sch. A., A. Dallin; WMA Sch., with U. Romano; ASL, with J. Corbino. Member: Dutchess County AA. Exhibited: NAD, 1943–45; Albany Inst. Hist.&A., 1945, 1946; Dutchess County AA, 1945, 1946 [47]

DUREN, Terence Romaine [P,I,L] Shelby, NE b. 9 Jy 1907, Shelby. Studied: AIC; Fontainebleau Sch. FA, France; Vienna. Member: NSMP. Exhibited: AIC, 1927, 1928, (prize); CMA, 1930–32, 1933 (prize), 1934 (prize), 1935, 1936 (prize), 1937–41; Joslyn Mem., 1942, 1943 (prize) 1944–46; Springfield (Mass.) Mus. A., (prize); Pepsi-Cola, 1946 (prize); CI, 1945, 1946; Los Angeles Mus. A, 1945; SFMA; Dallas Mus. FA; New Orleans; Prairie WC Painters, 1944–46. Work: AIC; CMA; CGA; CI; Joslyn Mem.; Butler AI; murals, Pub. Bldgs., Cleveland, Columbus, Ohio. Illustrator: cover drawings, Panoramic Review, World Herald, Omaha, Fortune, other publications [47]

DURFEE, Chiselie [P] Chicago, IL [13]

DURFEE, Hazard [P] Tiverton, RI. Exhibited: 48 Sts. Comp., 1939 [40]

DURFEE, M(ildred) Lucille [Edu] Phoenix, AZ b. 12 D 1908, Mt. Pleasant, MI. Studied: Central Col. Edu, Mt. Pleasant; Am. Acad. A., Chicago; Univ. Calif.; Peabody Col. Member: Nat. Edu. Assn.; Ariz. Edu. Assn. Contributor: School Arts, Everyday Art. Position: T., Phoenix Pub. Sch. [47]

DURGIN, Harriet T. [P] Boston, MA [01]

DURGIN, Lyle [P] Boston, MA. Member: Copley S., 1894 [04]

DURHAM, Charles [Restorer] Watertown, MA b. 1860 d. 1932. Internationally known art expert. Positions: BMFA, 17 yrs.; also worked at Harvard, Yale, and with numerous collectors

DURIEUX, Caroline (Mrs.) [Li,P] Baton Rouge, LA b. 22 Ja 1896, New Orleans. Studied: Newcomb Col., Tulane Univ.; PAFA, H. McCarter; E. Woodward. Member: NAWPS; Am. A. Cong.; New Southern Group; SSAL; New Orleans A.&Cr. Cl.; NOAA, Exhibited: Delgado Mus., 1944 (prize); LOC, 1944 (prize), 1945, 1946 (prize); PAFA, 1944–46; CI, 1944–46; Delgado Mus.; New Orleans A.&Cr. Cl. Work: MOMA; PMA; Delgado Mus.; LOC; Univ. Fla.; Univ. Tulsa. Illustrator: "Gumbo Ya Ya," 1946, "New Orleans Guide," 1939. Positions: T., Newcomb Col., La. State Univ., 1943–46; Dir., WPA Artists, La. [47]

DURIEUX, Pierre [P] New Orleans, LA [24]

DURKEE, Helen Winslow (Mrs. Christopher John Mileham) [Min.P,E] NYC b. NYC. Studied: Bridgman; Mora; Chase; DuMond. Member: Pa. Soc. Min. P.; ASMP; NAWA. Exhibited: Baltimore WCC, 1921 [47]

DURKIN, John [I] NYC b. 1868, in the West d. 12 My 1903. Illustrator: Lumber industry, for "Harper's" during 1880s; tour of the South, 1886. Moved to NYC ca. 1891.

DURLACHER, Ruth G. [P] NYC b. 11 Ja 1912, Springfield, MA. Studied: Corcoran Sch. A., Wash., D.C.; Fontainebleau Sch. FA; Ecole des Beaux-Arts; Yale. Member: Springfield (Mass.) A. Lg.; New Haven Brush & Palette Cl. Exhibited: Springfield A. Lg., 1937 (prize); NAC, 1938; Munson Gal., New Haven, Conn., 1938 (one-man); All.A.Am., 1939. Work: Deaf and Dumb Sch., N.Y. [40]

DURST, David [Edu,P] Iowa City, IA b. 19 Ag 1911, Springfield, MO. Studied: Univ. Iowa; Fletcher Martin; P. Guston. Exhibited: AIC, 1941, 1942; Kansas City AI, 1940. Work: Springfield (Mo.) A. Mus.; Univ. Iowa. Position: T., Univ. Iowa, 1941–42, 1946– [47]

DURWARD, Bernard Isaac [P] b. 1817, Montrose, Scotland d. 1902, Wis. Studied: self-taught. Known in England and Scotland before coming to U.S. in 1845. Specialties: portraits; religious themes [*]

DURY, Loraine Lucille [P,T,L] Green Bay, WI b. Green Bay. Studied: Milwaukee T. Col.; Univ. Minn.; Columbia; L.M. Bedore. Member: Green Bay A. Colony; Am. Assn. Univ. Women. Exhibited: Green Bay A. Colony, annually (1935, prize); Univ. Wis. 1937–44; Northeastern Wis. A., annually; Neville Mus., Green Bay, 1939 (one-man). Work: Roi-Porlier-Tank Cottage Mus., Green Bay. Position: T., Franklin Jr. H.S., Green Bay [47]

DUSHINSKY, Joseph [P] NYC [25]

D'USSEAU, Leon [P,S] Hollywood, CA b. Los Angeles. Exhibited: MMA, 1942; Audubon A., 1945; Pal. Leg. Honor, 1941; Calif. WC Soc., 1946; Los Angeles Mus. A., 1937–40 [47]

DUSTIN, Silas S. [Ldscp.P] Los Angeles, CA b. Richfield, OH. Studied: NAD; W.M. Chase. Member: A. Fund S. Work: Seattle Mus. A.; Berkshire Mus., Pittsfield, Mass. [40]

DUTCH, George Sheldon [Edu,W] Nashville, TN b. 16 Ag, 1891, Chelsea, MA. Studied: Mass. Normal A. Sch.; J. DeCamp. Member: Western AA; Southeastern AA. Author/Illustrator: "Practical Drawing Books," 1925, "Art in American Life and Education," 1941. Position: T., George Peabody Col. for T., Nashville, 1918– [47]

DUTTON, Alice M. [P] NYC [19]

DUVALL, Fanny E(liza) [P,T] Los Angeles, CA b. 8 S 1861, Port Byron, NY d. ca. 1939. Studied: Sartain; ASL; Cooper Union, N.Y.; Olga de Boznanska; La Gandara; Whistler Sch.; F. Auburtin, Paris. Member: Calif. AC; Los Angeles AA; Laguna Beach AA; AFA. Exhibited: Lewis and Clark Centenn. Expo, 1905 (med); Alaska-Yukon-Pacific Expo, 1909 (gold). Work: Jonathan Club, Friday Morning Club, Ruskin Art Club, all in Los Angeles [33]

DU VALL, H.A. [P] Buffalo, NY [19]

DUVALL, R.C. [P] Baltimore, MD [25]

DUVEEN, Charles J. [Dealer] Yonkers, NY b. 1872 Hull, England d. 21 Jy 1940. Under the name of Charles of London, conducted a gallery in NYC which specialized in antique furniture. Brother of Joseph.

DUVEEN, Henry J. [Dealer] NYC b. 1854, Holland d. 15 Ja 1919. Brother of Joseph.

DUVEEN, Joseph (Lord Duveen of Millbank) [Dealer] London, England b. 14 O 1869, Hull, England d. 25 My 1939. Often referred to as the greatest art dealer in history. His clients included Frick, Widener, H.E. Huntington, Kress, Mellon, and J.P. Morgan. He was a benefactor of the National Gallery in London, and donor of the gallery to house the Elgin marbles. "Duveen," by S.N. Behrman, is his biography.

DUVEEN, Louis J. [Dealer] London, England b. 1875 d. 7 Mr 1920. The London representative of the firm of Duveen Brothers, well-known art dealers. Brother of Joseph.

DUVENECK, Elizabeth Boot (Mrs. Frank) [P] b. 1846, Boston d. Mr 1888 (pneumonia). Studied: W.M. Hunt, ca. 1869; Couture, at Villiers-le-Bel, 1876–78; F. Duveneck, in Munich, 1879, and later in Florence. Exhibited: Boston AC and NAD, 1874–86; Doll & Richards Gal., Boston, 1884; Williams & Everett Gal., Boston, 1888 [*]

DUVENECK, Frank [P,S,E,T] Covington, KY b. 1848, Covington d. 2 Ja 1919. (He was born Frank Decker, taking the name Duveneck from his stepfather.) Studied: Diez, in Munich (where he lived for more than ten years). Member: SAA, 1880; ANA, 1905; NA, 1906; Cincinnati AC; NIAL. Exhibited: Soc. Painters-Etchers, London; Columbian Expo, Chicago, 1893 (med); Paris Salon, 1895 (prize); Pan-Am. Expo, Buffalo, 1901 (med); P.-P. Expo, San Fran., 1915 (prize). Work: Cincinnati Mus.; PAFA; Indianapolis AA; mem. statue to his wife, cemetery, Florence, Italy; NGA. A highly influential teacher, he had large group of American students in Munich in the late 1870s, a few of whom became known as "the Duveneck Boys" (in Venice, 1880s, Duveneck having moved his school to Italy in 1879). After the death of his wife, he returned to Cincinnati, devoting himself chiefly to teaching. He bequeathed his collection to the Cincinnati Museum of Art. Position: T., Cincinnati Acad. FA [17]

DUVOISIN, Roger Antoine [I,W,Car] Gladstone, NJ b. 28 Ag 1904, Geneva, Switzerland. Studied: Ecole des Arts Industriels, Ecole des Beaux-Arts, Geneva. Exhibited: 50 Best Books of the Year, AIGA, 1933, 1938, 1939. Author: "They Put Out to Sea," 1944, "The Christmas Whale," 1946, other books. Illustrator: Hudson's "Tales of the Pampas," "Mother Goose," other books, New Yorker covers, national magazines [47]

DWIGGINS, William Addison [Des,I,Typogr] Hingham, MA b. 19 Je 1880, Martinsville, OH. Member: Soc. Printers, Boston; AIGA; Soc. Typogr. A., Chicago; Double Crown C., London; Soc. Calligraphers, Boston. Exhibited: Am. Inst. Graphic A., N.Y., 1929 (gold) [47]

DWIGHT, Antoinette Merwin (Mrs. Timothy) [P] NYC/Pasadena, CA [24]

DWIGHT, Julia S.L. [P] Brookline, MA b. 2 D 1870, Hadley, MA. Studied: Tryon, Tarbell, in Boston; Brush, in NYC [21]

DWIGHT, Mabel [Li,P,Dr] NYC/Pipersville, PA b. 29 Ja 1876, Cincinnati. Studied: Hopkins A. Sch., San Fran.; A. Mathews. Member: Am. A. Cong.; Am. A. Group. Work: MMA; BMFA; CMA; AIC; WMAA; FMA; Detroit Mus.; Brooklyn Mus.; Albright A. Gal.; FA Gal., San Diego; Randolph-Macon Col.; Berlin Mus., Germany; Victoria and Albert Mus., London; Bibliothèque Nationale, Paris [40]

DWYER, Adelaide [P] Wash., D.C./Paris, France b. Wash., D.C. Studied: Mrs. V. von Post Totten; Corcoran A. Sch.; A. Barrett. Member: EAA [33]

DWYER, John [P] NYC [01]

DYCZKOWSKI, Eugene Matthew [P,Des,Car,I,L,T] Grand Island, NY b. 1 My 1899, Phila. Studied: Albright A. Sch.; J. Rummell; A. Lee; E. O'Hara; E. Zimmerman; Buffalo Sch. FA. Member: Buffalo SA; Niagara Falls SA; Rockport AA; The Patteran. Exhibited: Albright A. Gal., 1935–46; Buffalo SA, 1924–33, 1934 (prize), 1935–46; The Patteran, 1946; Albright A. Gal., 1925 (prize); Buffalo Soc. Ar., 1939 (med). Work: Officers Cl., Ft. Niagara, N.Y.; Burgard Vocational H.S. Buffalo, N.Y. [47]

DYE, Clarkson [P] San Fran., CA/Santa Barbara, CA b. 30 Je, 1869, San Fran. Studied: V. Williams; Burridge; Michelson. Work: mural, Cathedral of Los Angeles, Durango, Mexico; Grand Opera House, Waco, Tex. [21]

DYE, Olive Bagg (Mrs.) [P,T] Los Angeles, CA b. 19 Ag 1889, Lincoln NE. Studied: H.H. Bagg; Chicago Acad. FA. Exhibited: Nebr. State Fair, 1930 (prize). Work: mural, church, Schuyler, Nebr.; Nebr. Second Baptist Church, Union Church, both in Lincoln [40]

DYER, Agnes S. (Mrs.) [P] East Orange, NJ b. 14 F 1887, San Antonio. Studied: Onderonk; ASL; A. Dow; J. Carlson [21]

DYER, Briggs [P,Li,T] Minneapolis, MN b. 18 S 1911, Atlanta. Studied: E. Chapin; D. McCosh; Univ. Ga.; Cincinnati AA; AIC. Member: Phila. WCC. Exhibited: MMA; CI; PAFA; DGA; VMFA; SFMA; AIC, 1942 (prize); Denver A. Mus.; Minneapolis Inst. A.; BM; Milwaukee AI. Work: PMG; Univ. Ariz.; Minneapolis Inst. A.; AIC; U.S. Gov. Coll. Contributor: Magazine of Art. Positions: Dir., Rockford AA, 1938–39, Univ. Michigan, 1941; T., Minneapolis Sch. A., 1945– [47]

DYER, Carlos [P,Li] Redondo Beach, CA b. 15 Ja 1917, Springfield, MO. Studied: self-taught. Illustrator: "Stravinsky," "Arnold Schoenberg" both in 1936–37. WPA artist. [40]

DYER, Charles B. [P] Indianapolis, IN b. 4 D 1878, Worthington, IN [17]

DYER, Charles Gifford [P] b. 1851 Chicago d. 26 Ja 1912, Munich, Germany. Edited, with Lincoln, the anti-slavery paper in which Uncle Tom's Cabin was first published. He later devoted himself to painting, selecting chiefly architectural subjects. Work: Mr. J. Pierpont Morgan; a series of thirty paintings showing the ruins of Greece, which was not completed.

DYER, H. Anthony [Ldscp.P,L] Providence, RI b. 28 O 1872, Providence d. 24 Ag 1943. Studied: Holland; France. Member: Providence WCC; Boston SWCP; Newport AA. Work: CGA; Providence AC; RISD. Awards: Commendatore, Crown of Italy; Cavaliere Order of St. Maurice and Lazarus. Positions: L., Brown Univ., RISD [40]

DYER, Harry W. [P,I,Arch,E] NYC/East Stroudsburg, PA b. 16 N 1871, Portland, ME d. 28 Ja 1936. Studied: C.L. Fox; F.W. Benson; R. Turner; Voitz Preissig; ASL; Despradelle; MIT. Member: Arch. Lg.; SC. Exhibited: Beaux-Arts, 1896 [31]

DYER, Lowell [P] St. Ives, Cornwall, England b. 3 D 1856, Brooklyn. Studied: Gérôme [17]

DYER, Nora Ellen (Mrs. A.R.) [C,T,Cer] Cleveland, OH b. 10 S 1871, Medina, OH. Studied: Cleveland Sch. A.; N.Y. State Sch. Ceramics, with C.F. Binns. Member: AFA; Am. Cer. Soc.; Cleveland AA; Women's AA of Cleveland; Cleveland Tech. S. Council. Exhibited: Syracuse Mus. FA; WFNY, 1939; GGE, 1939; European Exh. Am. Cer., 1937; Ohio State Fair; AFA Traveling Exh., 1928, 1929, 1931, 1935, 1937; Am. Cer. Soc., 1932; Nat. All. A.&Indst., 1932; CMA, 1928–33, 1935, 1936, 1938, 1944 (prizes). Work: Cleveland Pub. Lib.; CMA; Syracuse Mus. FA; Duke Univ. Position: T., Cleveland Sch. A., 1923– [47]

DZIEKOUSKA, Kasimir [P] NYC. Member: S.Indp.A. [25]

DYCK, Paul [P,I,W,L] Rimrock, AZ (1976) b. 1917, Chicago. Studied: Munich Acad., with von Skramlik; Paris; Rome; Florence; Prague. He grew up in Calgary, near the Blackfoot Reservation. Work: Phoenix Mus.; Mus. Ariz. Specialty: Western subjects in egg tempera. Author: "Brule: The Sioux People of the Rosebud" [*]

DYE, Charlie [P,I] b. 1906, Canon City, CO d. 1972 (Sedona, AZ?). Studied: AIC; Am. Acad; Dunn, NYC, 1936; raised on ranches working as a cowboy. Member: Cowboy Artists of Am., 1964 (a founder). Contributor: covers and illustrations for many major magazines. [*]

DYER, Herrmann [P,Li,T] Minneapolis, MN b. 29 Ap, 1916, Wichita, KS. Studied: Univ. Chicago; AIC. Exhibited: Minneapolis Inst. A., 1939–42; PAFA, 1941–43; CGA, 1941; SFMA, 1940; CI, 1939, 1941–43; MMA, 1942; Pal. Leg. Honor, 1946; VMFA, 1942, 1944, 1946; PMG, 1942; Denver A. Mus., 1941, 1946; CAM, 1939, 1942, 1943; Rochester Mem. A. Gal., 1939, 1943; Kansas City AI, 1938, 1942; MOMA, 1943; AIC, 1938–45, 1939 (prize), 1943 (prize); PS Ann., 1938. Work: PAFA. Position: T., Minneapolis Sch. A., 1946– [47]

DYER, Nancy A. [P,L] Providence, RI b. 20 O 1903, Providence. Studied: RISD; Paris. Member: Providence WCC; Providence AC; Newport AA. Work: Providence Art Cl.

DYKAAR, Moses W. [S] b. Russia (came to U.S. in 1916) d. 10 Mr 1933, NYC. Studied: Paris. Work: por. busts of prominent Americans, in Capitol and other bldgs., Wash., D.C.

DZIEKONSKAJA, Casimira [P] b. 1851, Poland (came to U.S. in 1896) d. 31 Mr 1934, Warsaw. Studied: Paris. She became known as a portrait painter in NYC, Boston, and Chicago and her work appeared in many American exhibitions. In 1932 she returned to Poland and lived in complete retirement.

Charles S. Reinhart: F. Hopkinson Smith. From *The Illustrator* (1894)

EACOBACCI, Nicholas A. [P] Duluth, MN b. 21 Mr 1891, NYC. Studied: St. Paul AI [17]

EADIE, Riley Daniel [Des,Mur.P,T,L] Auburn, AL/Clayton, GA b. 1 S 1912, Harlem, GA. Studied: F.W. Applebee; Ala. Polytechnic Inst. Member: Ala. AL. Illustrator: "Period Furniture," "Decorating the Home," U.S. Extension Service. Lectures: Modern Art; Crafts. Position: T., Ala. Polytechnic Inst., Auburn [40]

EADY, Millicent [P] NYC. Member: Women PS [17]

EAGAN, Joseph B. [P] Cleveland, OH b. 22 Ap 1906, Cleveland. Studied: Cleveland Sch. A.; Huntington Inst., Cleveland. Work: St. John's Church, Cleveland; BM; Cleveland Pr. Cl. [40]

EAGAN, Thomas J. [P] Conshohocken, PA [04]

EAKINS, Susan MacDowell (Mrs. Thomas) [P] Phila., PA b. 1851, Phila. d. 27 D 1938. Member: Lg. AA. Studied: PAFA, with C. Schussele, 1876–80; T. Eakins, 1880–82. Exhibited: PAFA (prizes), 1973 (retrospective) [24]

EAKINS, Thomas [P,S,T,Photogr] Phila., PA b. 25 Jy 1844 d. 25 Je 1916. Studied: PAFA; Ecole des Beaux-Art, with Gérôme, Bonnât, 1866; visited Spain, 1890, where he admired works by Velásquez; anatomy, Jefferson Medical Col., 1870. Member: ANA, 1902, NAD, 1902. Exhibited: Mass. Mechanics' Assn., Boston (med); Columbian Expo, 1893, Chicago (med); Paris Expo, 1900; St. Louis Expo, 1904 (gold); Pan-Am. Expo, Buffalo, 1901 (gold); PAFA, 1904 (gold); NAD, 1905 (prize); CI, 1907 (prize); AAS, 1907 (gold). Work: Jefferson Medical Col.; Univ. Pa. Roman Catholic Univ.; PAFA; photographs (often studies for his paintings), 1880–1904, at MMA and Phila. MA; sculpture, horses on the Brooklyn Arch, reliefs on the Trenton Monument. Founder: Phila. ASL. Position: began instructing at PAFA in 1873; became chief instructor, 1876 [15]

EAMES, John Heagan [En,E,P] NYC/Boothbay Harbor, ME b. 19 Jy 1900, Lowell, MA. Studied: Harvard; Royal Col. A., London, England; R. Austin; M. Osborne. Member: SAE. Exhibited: Soc. Am. En., 1934; Phila. WCC, 1934, 1936, 1938; AIC, 1938; Venice, Italy, 1940; Royal Acad., London, 1940; PAFA, 1940; SAE, 1940, 1941, 1944; NAD, 1941, 1944–46; AAPL, 1940, 1941; AV, 1942; LOC, 1942, 1945; CI, 1945; East Hampton, N.Y., 1946. Work: LOC [47]

EAMES, Richard, Mrs. See Parish, Betty.

EARHART, John Franklin [Ldscp.P] Cincinnati, OH b. 12 Mr 1853, OH. Member: Cincinnati AC. Exhibited: Cincinnati AC, 1903 (prize) [33]

EARL, F.C. [P] Detroit, MI [10]

EARL, Maud [P] NYC b. England (came to U.S. in 1917) d. 7 Jy 1943. Specialty: dogs

EARLE, Annette [Por.P,Mur.P,S,T] NYC b. 23 Jy 1910, NYC. Studied: ASL; W. Zorach; Bridgman; G. Wiggins; Piccirilli; L. Kroll; NAD; Leonardo da Vinci Art Sch.; Colarossi. Member: AAPL [38]

EARLE, Cornelia [P,T] Columbia, SC b. 25 N 1863, Huntsville, AL. Studied: G.L. Noyes. Member: Columbia AA; SSAL. Exhibited: Columbia AA (prize) [40]

EARLE, Edwin [P,En,T,B,I] Derby Vine, VT b. 9 D 1904, Somerville, MA. Studied: Mass. Sch. A.; ASL; Grand Central Sch. A., with Carter. Member: Vermont A. Gld. Illustrator: "Hopi Kachinas," 1938; cover designs; book jackets; books [47]

EARLE, Elinor [P] Phila., PA b. Phila. Studied: PAFA. Member: Plastic C.; Phila. Alliance. Exhibited: PAFA, 1902 (prize); St. Louis Expo, 1904 (med) [40]

EARLE, George Frederic [P,G,T,L] West Redding, CT/Reno, NV b. 10 N 1913, New Bedford, MA. Studied: RISD; Syracuse Univ.; Swain Sch. Des. Member: Am. A. Prof. Lg.; F., Tiffany Fnd. Exhibited: Allied Ar. Am.; AGAA; Wadsworth Atheneum, 1938 (prize) [40]

EARLE, L(awrence) C(armichael) [Por.P,Mur.P] Grand Rapids, MI b. 11 N 1845, NYC d. 20 N 1921. Studied: Munich; Florence; Rome. Member: ANA, 1897; AWCS; A. Fund. S.; AIC; NYWCC. Work: AIC; murals, Chicago Nat. Bank; one of the muralists for the Columbian Expo, Chicago, 1893 [21]

EARLE, Olive [P,Dr] New Brighton, NY/Jefferson Valley, NY b. 27 D 1888, London. Work: Trade Development Bd., Bermuda; AMNH; Barrett Park Zoo, Staten Island [40]

EARLE, Paul B. [P] NYC. Exhibited: George F. Of Galleries [24]

EARLE, Robert Maxwell [Des,P,C,T] NYC b. 23 My 1918, Syracuse, NY. Studied: Syracuse Univ. Member: Syracuse AA. Exhibited: Syracuse AA; Barbizon Plaza Gal., 1946 (one-man); A. Inst., Buffalo (one-man); N.Y State Exh., Syracuse, 1941. Work: Syracuse Mus. FA. Positions: T., Trinity Sch., NYC; Set Des., Chapel Theatre, Ridgewood, NJ [47]

EARLE, Winthrop [S] NYC b. 1870, Yonkers, NY d. 2 Mr 1902. Studied: Augustus Saint-Gaudens, NYC; Ecole des Beaux-Arts; Rodin; Colarossi. Member: ASL

EARLEY, James Farrington [S] Wash., DC b. 27 S 1856, Birmingham, England. Studied: Royal Acad., London. Member: Wash. Arch. C.; Soc. Wash. A. Exhibited: St. Louis Expo, 1904. Award: Papal medal, Leo XIII. Became an American citizen in 1882. [15]

EARLEY, John Joseph [S] Roslyn, VA. Exhibited: AIA, 1936 (med). Specialty: arch. sculpture [40]

EARLEY, Mary [P] NYC/Woodstock, NY b. 8 Jy 1900, St. Louis, MO. Studied: K.H. Miller; K. Nicolaides; ASL; W.C. Palmer. Member: Woodstock AA. ASL. Exhibited: CI, 1941; Pepsi-Cola, First Annual Gal.; NAD, 1946; Woodstock Gal.; 48 Sts. Comp., 1939. Work: murals, USPO, Delhi, Middleburg, both in N.Y. [47]

EARLEY, Walter [I] Pelham, NY. Member: SI [47]

EARNIST, Florence Reinhold [P] Oakland, CA b. Petaluma, CA. Studied: Calif. Col. A.&Cr.; ASL; J. Sloan; A. Nepole; D. Bartlett. Member: Carmel AA; AAPL; Soc. for Sanity in Art. Exhibited: Oakland A. Gal., 1934–46; Lg. Am. Pen Women 1939 (prize), 1941 (prize); Pal. Leg. Honor, 1935; Soc. for Sanity in Art, 1945; Crocker A. Gal., 1936; AAPL, 1943–45; Carmel A. Gal., 1936–45; Laguna Beach A. Gal., 1930–33; Los Angeles, 1931 (one-man); Long Beach, 1933 (one-man); Oakland, 1934 (one-man), 1936 (one-man), 1943 (one-man) [47]

EASLEY, J. [I] NYC [21]

EAST, Pattie Richardson (Mrs.) [P,E,T] Ft. Worth, TX b. 6 Mr 1894, Hardesty, OK. Studied: AIC; Broadmoor A. Acad.; B. Sandzen; J. Fleck;

J. Arpa ; H.A. de Young. Member: SSAL; Tex. FAA; Allied A., Ft. Worth. Exhibited: SSAL; Tex. FAA; Mus. FA, Houston [47]

EASTER, Charles B. [P] Baltimore, MD [25]

EASTES, W.T. (Mrs.) [P] Nashville, TN [15]

EASTMAN, Charlotte Fuller (Mrs. Guy W.) [Des,P,T] Norwichtown, CT b. Norwich, CT. Studied: Norwich A. Sch.; BMFA Sch.; AIC; ASL; PAFA; W. Adams; H. McCarter; Colarossi. Member: Mystic AA; Norwich AA. Exhibited: Salon d'Automne, 1928; Wash. WCC, 1939, 1940; AWCS, 1939; Mus. A.&Sc., Albany, N.Y., 1945; Mystic AA, 1939–45; Lyman Allyn Mus. A., 1945; Slater Mem. Mus., Norwich, 1939–46; Doll & Richards, Boston, 1939; Univ. Conn., 1939. Work: covers, layouts, des., F.J. Quimby Co., Boston; Univ. Press, Chicago; A.C. McClurg Co., Chicago. Position: Dir., Norwich A. Sch., 1910–43 [47]

EASTMAN, Ruth [I] NYC. Member: SI; Artists G. [31]

EASTMAN, William Joseph [P,T] Cleveland, OH b. 14 F 1881, Cleveland, d. 24 Ag 1950. Studied: Cleveland Sch. A.; Paris. Member: Cleveland Pr. Cl.; Cleveland SA; Cleveland AA. Exhibited: CGA; PAFA; AIC; CMA, 1919 (prize), 1923–25, 1927, 1930, 1936, 1940–42, 1945 (prizes). Position: T., Cleveland Sch. A. [47]

EASTMOND, Elbert Hindley [P,G,T] b. 1876, American Fork, UT d. 1936, Provo, UT. Studied: AIC, 1901; Pratt Inst., 1902; Stanford, with J. Lemos, 1903–04; then traveled through Europe. Position: Hd. Dept., Brigham Young Univ., 1921–36 [*]

EASTON, Frank Lorence [P,L,G,] Denver, CO b. 7 Je 1884, Elmira, NY. Studied: J. Havens; R. Graham; F. Kaufmann; G. Cassedy. Member: Mile High Sketch Cl.; Denver A. Gld.; AAPL. Exhibited: AIC, 1928 (prize); Milwaukee AI, 1928 (prize); Western State Col. Art. Exh., 1939–42, 1939 (prize), 1940 (prize); Denver A. Mus., 1928, 1930, 1937, 1941 [47]

EASTON, Linwood [E] Portland, ME b. 17 My 1892, Portland d. 20 O 1939. Studied: A.E. Moore; A. Bower. Member: Soc. Am. E.; SC; Boston AC; Ogunquit AA; Portland SA; Haylofters; PM Soc. of Calif. Exhibited: Intl. PM, Los Angeles, 1937; SC, 1938 (prize) [40]

EASTON, Spencer G. [P] Rochester, NY. Member: Rochester AC [21]

EASTWOOD, R(aymond) J(ames) [P,Dec,T] Lawrence, KS/Bridgeport, CT b. 25 My 1898, Bridgeport. Studied: ASL, with DuMond; W.S. Kendall; E.C. Taylor. Member: Provincetown AA; Beachcombers. Work: Univ. Kans. Position: T., Univ. Kans., Lawrence [40]

EASTWOOD, Sidney Kingman [P] Pittsburgh, PA/Oswego, NY b. Oswego. Member: Pittsburgh AA [25]

EATON, Ada T. (Mrs. Francis G.) [C] St. Louis, MO/Wequetonsing, MI b. 15 Jy 1871, Louisville, KY. Member: Weavers G. of St. Louis [40]

EATON, Alfred J. [P] Plailly, Oise, France. Member: Paris AAA [25]

EATON, Allen Hendershott [W,T,L] Crestwood, NY b. 10 1878, Union, OR d. 1962. Studied: Univ. Oreg. Member: AFA; AIGA; Lg. New Hampshire A.&Cr. Author: "Handicraft of the Southern Highlands," 1937, "Emigrant Gifts to American Life," 1932, other books; articles on arts & crafts, edu. magazines. Position: A. Dir., Russell Sage Fnd., since 1920 [47]

EATON , C. Harry [P,I] Leonia, NJ b. 13 D 1850 Akron, OH d. 4 Ag 1901. Member: ANA; AWCS. Exhibited: Boston, 1887, (med), 1888 (gold); AWCS, 1898 (prize); Phila. AC, 1900 (gold); Pan-Am. Expo, Buffalo, 1901 (med)[01]

EATON, Charles Warren [Ldscp.P] Bloomfield, NJ (since 1888) b. 22 F 1857, Albany, NY d. 10 S 1937. Studied: NAD; ASL. Member: SC; AWCS; NYWCC (founder, 1890); A. Fund S.; Lotos C. Exhibited: Paris Expo, 1900, 1906 (gold); SC, 1901 (prize); Charleston Expo, 1902 (med); AC Phila., 1903 (gold); NAD, 1904 (gold); St. Louis Expo, 1904 (med); Buenos Aires Expo, 1910 (med); Paris; Antwerp; Brussels; London; Cairo. Work: Cincinnati Mus.; NGA; Brooklyn Inst. A.&.Sc.; Montclair Mus.; Hackley Gal., Muskegon, Mich.; Nashville Mus.; Arnot Gal., Elmira, NY. Specialty: landscapes at evening with pine trees or Dutch poplars; canal scenes. He stopped painting in 1927, but continued to circulate his work to many galleries. [33]

EATON, D. Cady [T,Cr] New Haven, CT b. 1838 d. 11 My 1912. Studied: Yale, 1860; Columbia. Army officer in Civil War. He presented his lectures and over 7,000 lantern slides to MMA. Position: T., Yale, 30 yrs.

EATON, Dorothy [P] NYC/Petersham, MA b. 5 My 1893, East Orange, NJ. Studied: Smith Col.; Columbia; ASL; K.H. Miller. Member: Springfield AL; NAWA; N.Y. Soc. Women A. Exhibited: NAWA, 1941 (prize); CGA, 1930; AIC, 1931; WMA, 1933–35; Acad. All. A., 1934; CI, 1941; NAD, 1940–45 [47]

EATON, Eleanor R. [P] Highland Park, IL [01]

EATON, Elizabeth K. [P] NYC b. Boston, MA [10]

EATON, Hugh McDougal [P,I,C] Brooklyn, NY/Montville, NJ b. 25 J 1865 Brooklyn d. 14 D 1924. Studied: J.B. Whittaker; Beckwith; Cox; Chase. Member: NSC. Specialties: bookplates and illumination; Eaton lead block prints. Positions: A. Ed., American Magazine, Leslie's Weekly [24]

EATON, Louise Herreshoff [P] Providence, R.I./East Gloucester, MA b. Providence. Studied: M.C. Wheeler; Constant; Laurens; Collin. Member: Providence AC; Providence WCC; North Shore AA; Gloucester SA [33]

EATON, Margaret Fernie (Mrs. Hugh M.) [P,I,C] Brooklyn, NY/Montville, NJ b. 22 Ap 1871, Leamington, England. Studied: J.B. Whittaker; ASL, with Cox, Mowbray. Member: NYWCC; ASL [33]

EATON, Marguerite [P] Chicago, IL [15]

EATON, William Bradley [P,Photogr] Salem, MA b. Jy 1836, Salem, MA d. 15 Mr 1896. He worked as a carpenter in Salem; in the photography studio of William Snell; later doing pastel and ink work for Taylor and Preston, in Salem. Work: Peabody Mus., Salem, Mass. [*]

EATON, William S(ylvester) [P,E] Sag Harbor, NY b. 12 D 1861, Waltham, MA. Member: S.Indp.A.; SC; PBC [33]

EBBELS, Victoria [P,T] Denton, TX b. 9 O 1900, Hasbrouck Heights, NJ. Studied: J. Sloan; Luks; Henri; G. Bridgman; F. Van Sloun. Member: Alliance; S.Indp.A. [25]

EBEL, Valentine [P] NYC [01]

EBERBACH, Alice Kinsey (Mrs. Nelson F.) [Des,L,W] Phila., PA b. Phila. Studied: Chase; Lathrop; Henri; Girardot; Courtois; Ingalbert; Univ. Pa. Member: F., PAFA; Phila. Alliance; AFA. Illustrator: "Nature Study for Elementary Schools" [40]

EBERHARD, Robert Georges [Edu,L,C,S,Mus.Cur] New Haven, CT b. 28 Je 1884, Geneva, Switzerland. Studied: Lycée Montaigne, Ecole des Beaux-Arts; PIASch; Yale; MacNeil; Mercie; Carlier; Rodin; Peter. Member: NSS; Société des Artistes Français; New Haven PCC; Kim Tiem, Annam, 1913; Officier Instruction Publique, France, 1929; New Haven Municipal Art Comm.; Clay Cl., NYC. Work: A. Mus., Geneva; Pal. Leg. Honor. Positions: Cur. Sculpture, Yale Gal. FA; Chm., New Haven Municipal A. Comm. [47]

EBERHARDT, Eugenia McCorkle (Mrs. H.C.) [P] Ft. Worth, TX [24]

EBERLE, Abastenia St. Leger [S] NYC/Southport, CT b. 6 Ap 1878, Webster City, IA d. 26 F 1942. Studied: ASL; G.G. Barnard. Member: ANA; NSS. Exhibited: St. Louis Expo, 1904 (med); NAD, 1910 (prize); P.-P. Expo, (med); Garden C. of Am., 1929 (prize); Allied AA, 1930; NSS 1931 (prize). Work: MMA; WMA; Peabody Art. Inst.; Newark Mus.; CI; AIC; Venice, Italy; Twentieth Century C., Buffalo; Brookgreen Gardens, S.C.; Detroit AI; Pacific and Asiatic Fleet; WMAA [40]

EBERLE, Elizabeth [S] Chicago, IL [19]

EBERLE, Merab (Miss) [Cr] Dayton, OH b. Mattoon, IL. Studied: Oxford Col., Ohio. Position: Art Ed., Dayton Journal-Herald, 1927–47 [47]

EBERLEIN, Ernest [Ldscp.P] Summit, NJ d. 28 Ja 1931. His home, "Free Acres," was an artists colony at Berkeley Heights, near Summit. He formerly lived in NYC.

EBERMAN, Edwin [Des,T,P] New Canaan, CT b. 20 1905, Black Mountain, NC. Studied: A. Dir. Cl. Member: A. Dir. Cl. Exhibited: A. Dir. Cl., 1939–46. Author/Illustrator: "Technique of the Picture Story," 1945, "Nantucket Sketch Book," 1946. Contributor: Arts & Decoration, Look. Position: A. Dir., Look, Cowles magazines, 1940s [47]

EBERSOLE, Mabel Helen [P] Keokuk, IA b. Keokuk. Studied: AIC, with Buehr, Norton, Oberteuffer, Anisfeld. Member: SSAL; All.-Ill. Soc. FA. Exhibited: Rockefeller Center, 1936; SSAL, 1930 (prize); Five States Exh., Omaha, Nebr.; Delgado Mus., 1930 (prize) [47]

EBERT, Charles H. [P,I] Old Lyme, CT/Monhegan Island, ME b. 20 Jy 1873, Milwaukee, WI d. 2 O 1959. Studied: Cincinnati A. Acad., 1892–93; ASL; Académie Julian, Paris, 1894–96; Twachtman, in Cos Cob, Conn., ca. 1900. Member: Greenwich SA, 1912 (founder); SC; AWCS; CAFA; Lyme AA; Wis. PS; A. Fellowship; Allied AA. Exhibited: Buenos Aires Expo, 1910 (med); P.-P., San Fran. (med); Milwaukee, 1927 (prize); NAD, 1907–33; Lyme AA, 1914–49; PAFA, 1908–19; CGA, 1916, 1926; CI, 1909–10, 1914; Greenwich SA, 1912,

1928, 1930, 1931; SC, 1914, 1918, 1922; AIC 1920, 1923, 1930; Albright-Knox, 1927; CAFA, 1940–46; AFA, 1964–65; Lyman Allyn Mus., New London, CT, 1979 (retrospective) [47]

EBERT, Mary Roberts (Mrs. Charles H.) [P,C] Old Lyme, CT b. 8 F 1873, Titusville, PA d. 1956. Studied: ASL; Twachtman; G. Hunt, Boston. Member: AWCS; Lyme AA; Greenwich AA; Sarasota AA [47]

EBEY, Marjorie [S] St. Louis, MO. Member: St. Louis AG [10]

EBY, Kerr [Li,E,Dr] Westport, CT/Friendship, ME b. 19 O 1889, Tokyo, Japan d. 18 N 1946, Norwalk, CT. Member: ANA, 1930; NAD, 1934; Soc. Am. E.; Chicago SE; Phila. SE; NIAL. Exhibited: Brooklyn SE, 1931 (prize); Soc. Am. E., 1932 (prize), 1934 (prize). Work: complete collection to 1932, NYPL; Prints of the Year, 1931; Bi-Centenn. portfolio, Life of Washington, 1932, WMA. Eby assisted Hassam with his etchings, and Eby's studio is the subject of an etching by Hassam. [40]

ECHERT, Florence [P,C] St. Augustine, FL/Intervale, NH b. Cincinnati, OH. Studied: Cincinnati AA; ASL; W.M. Chase. Member: Cincinnati Women's AC [33]

ECKBERG, Adrian [C] Roxbury, MA b. 28 Ap 1878, Sweden. Work: Full directions for gilding in Encyclopaedia Britannica. Specialty: restoration of paintings and prints. Position: Cur., pub. schools, Boston [40]

ECKBERG, John E. [Des,C,P] Boston, MA/Silvermine, CO. Studied: H.D. Murphy; C. Schmitt. Member: Boston AC; Boston SAC. Specialty: hand carved, water gilded frames [40]

ECKEL, Juila [P] Wash., DC. Exhibited: Soc. Wash. Ar. Ann., 1936–39 [40]

ECKERSON, Margaret [P] Mt. Vernon, NY b. 25 F 1883, NYC. Studied: Henri [13]

ECKERT, E(velyn) E. [P,L] Mt. Vernon, IL b. 12 Ja 1915, Opdyke, IL. Studied: Univ. Ill. Member: AAPL. Exhibited: WFNY, 1939; S.Indp.A., 1941, 1942; Acad. All. A., 1940; Municipal Auditorium, St. Louis, 1941, 1942; CAM, 1940–42 [47]

ECKERT, Josephine (Mrs. F.O. Saunders) [P] Haverford, PA b. July 18, 1916, Phila., PA. Studied: J. Levi; A. Dehn. Member: AFA. Exhibited: PAFA, 1943, 1944; LOC, 1944; Phila. Pr. Cl., 1943–45 [47]

ECKERT, Katherine Bird [P] Cleveland, OH [25]

ECKFORD, Jessiejo [P,B] Dallas, TX b. 21 N 1895, Dallas, TX. Studied: Aunspaugh A. Sch.; H. Bolton; Reaugh; F.W. Howell. Member: Southern PM Soc.; SSAL; Tex. Soc. FA; Frank Reaugh AC; Woodcut Soc.; Northwest PM. Exhibited: Dallas Women's Forum Exh., 1916 (med); 1919 (gold); San Antonio (prize); SSAL, 1938 (prize). Work: Elisabet Ney Mus., Austin; Witte Mus., San Antonio; North Tex. Agricultural Col., Arlington [40]

ECKHARDT, Edris [S,L,T] Cleveland, OH b. 28 Ja 1906 Cleveland. Studied: Cleveland Sch. A.; A. Blazys; John Huntington Polytechic Inst. Member: Am. Cer. Soc.; N.Y. Soc. Cer. A.; Soc. Des. C. of N.Y. Exhibited: CMA, 1933–37 (prizes), 1943–45; Nat. Cer. Exh., Syracuse Mus. FA, 1933 (prize); 1934–41; Butler AI, 1946 (prize); Paris Expo, 1936; Intl. Cer. Exh., Scandinavian countries, 1939, 1940; WFNY, 1939; GGE, 1939; CAA Traveling Exh., 1933–36; Toledo, Ohio, 1939, 1940; Butler AI, 1946; Wichita AA, 1946; Akron, Ohio, 1937; Phila. AA, 1944. Work: S., Mall, Cleveland; Cleveland Pub. Lib.; CMA; Pub. Lib., Queens; Ohio State Univ.; Phila. A. Alliance. WPA artist. Position: T., Cleveland School Art. [47]

ECKSTEIN, Katherine [S] Chicago, IL b. 29 D 1894, Berlin, Germany. Studied: AIC; Archipenko. Exhibited: Am. PS. Ann., AIC, 1938 [40]

EDDY, Augustus [P] Paris, France b. 1851 d. Summer 1921. Studied: Paris. Lived in Paris, from 1909

EDDY, Henry B. [I,Car] Mamaroneck, NY b. 16 S 1872, NYC d. 29 Jy 1935, Rye, NY. Member: SI, 1914; New Rochelle AA. Illustrator: books. Position: Affiliated with various N.Y. newspapers [33]

EDDY, Henry S(tephens) [P] Westfield, NJ/Nantucket, MA b. 31 D 1878, Rahway, NJ d. 9 Ag 1944, Nantucket. Studied: Volk; Cox; Twachtman; ASL; Mucha; G.E. Browne. Member: SC; Ar. Fellowship; A. Fund S.; Gld. Am. P.; Allied A.; Westfield AA; Am. Assn. Mus.; Lotos C.; Plainfield AA; AAPL. Exhibited: N.J. State Ann. Exh., Montclair AM, 1932; N.J. Gal., Newark, 1936 (prize); Plainfield AA, NJ, 1939 (prize). Work: Milwaukee AI; Reid Mem. Lib., Passaic; Arnot A. Gal., Elmira, Miss Hutchinson's Sch., Memphis; Cranford Pub. Lib., N.J. YMCA, Westfield, N.J.; First Nat. Bank, Plainfield; The Contemporary, Newark; Lotos Cl.; Irving Trust Co., NYC [40]

EDDY, Marvin [P] Louisville, KY b. Hannibal, MO. Studied: Clarence Boyd, Hewett Green, both in Louisville. Member: Louisville AL [01]

EDDY, Ruth R. [P] NYC [19]

EDDY, Sarah J. [P] Bristol Ferry, RI [24]

EDEL, Florence Atherton (Mrs. Alfredo) [P,T] New Rochelle, NY b. 1871, Charleston, SC d. 2 Jy 1944. Studied: Europe

EDEL, Stella C.J. (Mrs. Arthur) [P,B] Provincetown, MA b. 4 Ag 1893, Franklin, MA d. F 1970, Sewickley, PA. Studied: Hawthorne; Bridgman; ASL, with Gruger, 1916–19; many years in Paris with husband, Arthur Edel. Exhibited: Provincetown AA, 1915–20 [*]

EDEN, Harriet [P] Providence, RI b. 23 Mr 1903, Providence. Studied: RISD. Member: Providence AC; Providence WCC; Rockport AA [40]

EDENBOROUGH, Aubrey C. [Des,C] Elmhurst, NY/Stanton Drew, England b. 19 Mr 1887, London. Member: AG of Authors Lg. A. [25]

EDENS, Annette [Edu,P,C,L,G] Bellingham, WA b. 16 Ap 1889, Bellingham. Studied: Univ. Wash.; Ohio Univ.; T. Col., Columbia; Henri; K.H. Miller. Member: Ohio WCS; Women's AC, Cincinnati. Position: T., Univ. Cincinnati, 1928–45 [47]

EDERHEIMER, Richard [Por.P] NYC b. 25 O 1878, Frankfort, Germany. Member: S.Indp.A. [27]

EDGE, F. Gilbert [I] NYC [01]

EDGELL, George Harold [Mus.Dir,Edu,W,L] Newport, NH b. 4 Mr 1887, St. Louis, MO. Studied: Harvard. Member: Boston A. Comm., 1925– ; Chm., Mass. State A. Comm., 1941– ; Trustee, BMFA, 1927– ; F., Am. Acad. A.&Sciences; Archaeological Inst. Am.; Am. Oriental Soc.; CAA. Award: Chevalier of Legion of Honor, 1937. Co-author: "A History of Architecture," 1918. Author: "The American Architecture of Today," 1928, "A History of Sienese Painting," 1932. Positions: Dean of Arch., Harvard, 1922–35; Cur., Paintings, BMFA, 1934–38; Dir., BMFA, 1935– [47]

EDGERLY, Beatrice E. (Mrs. J. Havard Macpherson) [P,Li,I,W] Tucson, AZ b. Wash., D.C. Studied: Corcoran Sch. A.; PAFA; abroad. Member: Phila. A. All.; NAWA; Mystic AA; Author's Gld. Exhibited: PAFA, 1921 (prize); NAWA, 1937 (prize); Tucson FA Assn., 1938 (prize), 1939 (prize); NAD; CGA; Mystic AA. Work: PAFA. Author/Illustrator: "Azarat Cocktail" (1939), "From the Hunter's Bow" (1942). Illustrator: "Peter and Peggy," pub. Macmillan, Ladies' Home Journal, McCall's, Christian Herald, Better Homes and Gardens, other magazines [47]

EDGERLY, Gladys C. [S] Phila., PA. Member: F., PAFA [25]

EDGERLY, Mira. See Korzybska.

EDGERTON, Harold [Photogr] Cambridge, MA b. 1903, Fremont, NE. Studied: Univ. Nebr., 1925; MIT, 1931. Exhibited: IMP/GEH, 1961. Work: IMP/GEH; MIT; Bibilothèque Nationale, Paris. Best known for his pioneering work with high-speed cameras, producing stopped-action sequential images such as the famous "Drop of Milk" (1930s) and "Bullet Through Apple." [*]

EDGERTON, Laura Carter [P] Aiken, SC b. 1868, Charleston, SC. Studied: ASL; Rhoda Holmes Nicholls, in NYC [04]

EDHOLM, C(harlton) L(awrence) [P,W] Dobbs Ferry, NY b. 21 Mr 1879, Omaha, NE. Studied: Ludwig Herterich, in Munich. Member: Hudson Valley AA; Municipal A. Comm., Dobbs Ferry. Work: Community House, Dobbs Ferry. Contributor: Art News, Art Digest [40]

EDIE, Fern Elizabeth [P] Lawrence, KS [17]

EDIE, Stuart Carson [P,Edu] Iowa City, IA b. 10 N 1908, Wichita Falls, TX. Studied: T. Benton; Kansas City AI; ASL. Member: An Am. Group; Woodstock AA; Sawkill PS. Exhibited: MOMA, CI; WMAA; PAFA; NAD; AIC; BM; John Herron AI. Work: WMAA; MMA; BM; Syracuse Mus. FA; Newark Mus.; Univ. Iowa; Univ. Ga.; mural, USPO, Honeoye Falls, N.Y. [47]

EDINGER, Dorothy [P,I] NYC b. 26 Ja 1896, San Fran. Member: GFLA [27]

EDMANDS, Jane L. [Min.P] Cambridge, MA [08]

EDMISTON, Alice R. [P] Lincoln, NE b. Monroe, WI. Studied: AIC; ASL; Paris. Member: Nebr. AA; Lincoln AG. Exhibited: Omaha SFA, 1923 (prize). Work: Vanderpoel AA; Lincoln Pub. Schools [40]

EDMISTON, Henry [P,Car,I,W] Los Angeles, CA b. 21 O 1897, Kansas City, MO. Member: P.&S. Cl., Los Angeles; North Shore AA. Exhibited: Santa Cruz A. Lg., 1944, 1945 (prize); Los Angeles Mus. A., 1945 (prize), 1946 (prize); Denver A. Mus., 1944, 1945; Audubon A.,

1945; Oakland A. Gal., 1944, 1945; North Shore AA, 1943-45; San Gabriel A. Gld., 1944; Glendale AA, 1944, 1945; Fnd. Western A., 1944. Creator: two comic strips. Position: Ed., "Sketch," P.&S. Cl., Los Angeles [47]

EDMOND, Elizabeth [S] Santa Monica, CA b. 29 Ja 1887, Portland, ME d. 22 Je 1918, Pasadena, CA. Studied: Dallin, in Boston; Fraser, in NYC; Paul Bartlett; Injalbert, in Paris. Member: Calif. AC. Exhibited: Panama-Calif. Expo, San Diego, 1915 (gold,med) [17]

EDMONDS, James, Mrs. See Topp, Esther.

EDMONDS, Paul [E] Rangoon, India. Member: Calif. PM [25]

EDMONDSON, George M. [P] Cleveland, OH. Member: Cleveland SA [27]

EDMONDSON, William J. [P] Cleveland Heights, OH b. 1868, Norwalk, OH. Studied: PAFA, with Vonnoh, Chase; Académie Julian, Lefebvre, Aman-Jean, in Paris. Member: Cleveland SA. Exhibited: CMA, 1919 (med,prizes), 1923 (prize); PAFA. Work: Delgado Mus., New Orleans; CMA; Western Reserve Univ.; Soc. for Savings, Municipal Coll., Fed. Reserve Bank, Chamber of Commerce, all in Cleveland; State House, Columbus, Ohio [40]

EDMUNDSON, Carolyn Moorhead (Mrs. Stefan Lazarewicz-Lazarr) [P,I] NYC b. 20 D 1906, Pittsburgh. Studied: CI. Exhibited: PAFA, 1946. Work: portraits, DeBeers Coll. Contributor: covers and articles, national magazines [47]

EDOUARD, Giovani [P] NYC. Member: S.Indp.A. [25]

EDROP, Arthur (Norman) [I,Des,P,W,L,Car] Radnor, PA b. Birmingham, England. Studied: PIASch; Brooklyn Sch. A.; Whittaker. Member: SI; Wayne Art Center. Illustrator: Life, Collier's, Saturday Evening Post, Liberty, other magazines [47]

EDSALL, Mabel Meeker [P,T,Car,L] St. Louis, MO b. Bay City, MI. Studied: ASL; DuMond; Chase; Hawthorne; L. Mora. Member: St. Louis A. Gld.; Pub. Edu. Assn.; Western AA; County A. T. Assn., Mo. Exhibited: PAFA, 1914; Arch. Lg.; NAD; CAM, 1926-40, 1945; St. Louis A. Gld., 1920-46; Assoc. Press Exh., 1944. Work: painting, General Motors Bldg., Century of Progress Expo, Chicago, 1933. Position: T., John Burroughs Sch. Clayton, Mo. [47]

EDSON, Gus [Car] Stamford, CT b. 20 S 1901, Cincinnati, OH. Studied: PIASch; ASL. Member: Car. Soc. Author/Illustrator: "The Gumps," appearing in 329 newspapers. Sports cartoonist for many leading newspapers. [47]

EDSON, Millicent Strange (Mrs.) [C,P,T,L] Clayton, GA b. England. Studied: Royal Col. A., London; Chase; Brangwyn; Dow; K.H. Miller; H. Wilson. Member: Boston SAC; SSAL; Assn. Ga. A.; Atlanta AG. Exhibited: San Fran., 1916 (med); SSAL (prize); Georgia A. Exh., Atlanta (prize); Buffalo, N.Y. (prize); Boston, Mass. (prize); P.-P. Expo, 1915; AIC; Albright A. Gal.; SSAL; High Mus. A. Work: Kyoto Mus., Japan. Specialties: enamels; metalwork; jewelry. Lectures: Enamels. Position: Instr., Edson Sch. A.&Crafts, Clayton [47]

EDSTROM, David [S,W,L,T] Los Angeles, CA b. 27 Mr 1873, Hvetlanda, Sweden d. 12 Ag 1938. Studied: Royal Acad., with Borjison, in Stockholm; Injalbert, in Paris. Member: Los Angeles PS; Southern Calif. Sculptors Cl.; Scandinavian Artists of N.Y.; Calif. PSC. Exhibited: World's Fair, St. Louis, 1904 (med). Work: mon., Ottumwa, Iowa; Masonic Temple, Wash., D.C.; Montreal; Dallas; Lincoln Park, Los Angeles; Iowa State Univ., Iowa City; State of Iowa; Gothenburg Mus., Sweden; Fachrens Gal., Royal Palace, Nat. Mus., all in Stockholm [38]

EDVY, Julius [P,Dec] Cleveland, OH b. 1 Ap 1878, Edve, Hungary. Studied: Royal Hungarian Col. A.; Paris. Work: Cleveland, Ohio. Originator, "Lustrotone" process. WPA artist. [40]

EDWARDS, A.B. [P] Chicago, Il [15]

EDWARDS, A. Elsie [P] Wash., D.C. Member: Wash. WCC [27]

EDWARDS, Edward B. [P,I,D] NYC b. 8 F 1873, Columbia, PA. Studied: Paris; Munich. Member: N.Y. Arch. Lg., 1892.; A. Lg. Graphic A.; SC; Artists Gld. [33]

EDWARDS, Eleanor McGavic (Mrs. Emmett) [P] Woodstock, NY b. 31 O 1906, St. Louis. Studied: Iowa Wesleyan Col.; Stephens Col. Member: Woodstock Ar. Assn. Exhibited: AIC, 1938; BM, 1939; Morton Gal.; Contemporary A. Gal.; Seven Arts Cl.; Woodstock A. Gal.; Bard Col. [47]

EDWARDS, Emily [P,T,B,W] Chicago, IL b. 1888, Ursuline, TX d. 16 F 1980, San Antonio. Studied: R. Clarkson; John Vanderpoel; AIC, with Harry Walcott, 1905-13; Diego Rivera, 1925-26. She lived in Mexico in the 1930s, where she married de Cantabrana. [17]

EDWARDS, Emmet [P] Woodstock, NY b. 11 O 1906, Mt. Pleasant, IA. Studied: Edmund Giesbert; John Norton; AIC. Exhibited: AIC, 1928, 1930, 1935, 1937; CAA Traveling Exh., 1934; BM, 1935; MOMA, 1936, 1937, 1938, 1940 (Traveling Exh.); WFNY, 1939; Mus. Non-Objective Painting, 1942-46; WPA Traveling Exh., 1936-40; Assoc. Am. A., 1936. Work: Zulfer Coll., Chicago; BM; MOMA; Mus. Non-Objective Painting [47]

EDWARDS, Ethel [P] New Orleans, LA. Exhibited: 48 Sts. Comp., 1939 [40]

EDWARDS, Ethel Emett (Mrs. David T.) [P,T] Lynchburg, VA b. Lynchburg. Studied: B. Gutman; Mrs. J.L. Mahood; L. Smith; H. Day; Elliott Clark; Dean Fausett; E. Notting. Member: Lynchburg A. Cl.; VMFA; Lynchburg A. All. Exhibited: MFA, Richmond; Acad. A.&Sciences, Richmond; Whyte Gal., Wash., D.C. Work: Women's Cl., Lynchburg [40]

EDWARDS, George Wharton [P,I,W,Dec] Greenwich, CT b. 14 Mr 1869, Fair Haven, CT d. 18 Ja 1950. Studied: Eugéne Féyen, Cancale, in Paris. Member: ANA, 1930; AWCS; NAC; Nat. Inst. A.&Let.; All.A.Am.; PS Gal. Assn. Exhibited: Boston, 1890 (medals); Pan-Am. Expo, Buffalo, 1901 (med,prize), Charleston Expo, 1902 (med); Barcelona, Spain, 1902 (med); King Albert, 1920 (gold). Work: Hispanic Soc., N.Y.; Houston Mus. FA; Springfield (Mo.) A. Mus.; FMA; High Mus. A.; Luxembourg Mus., Paris; mural, U.S. Military Acad., West Point; Mus. A.&Sciences, Norfolk, Va.; Bruce Mus., Greenwich. Awards: Golden Palms of French Acad., 1921; Knight Chevalier, Legion d'Honneur, France, 1925; Knight Chevalier, Order de la Couronne Belge, 1927; Royal Order of Knight Chevalier (Isabella) from Alfonso XIII, Spain, 1928; Knight Chevalier, Order of the Crown of Italy, 1929. Illustrator: " Sun Dial," "Old English Ballads," "The Last Leaf," other books. Author: "Vanished Towers and Chimes of Flanders," "Vanished Halls and Cathedrals of France," "Marken and its People," books on travel [47]

EDWARDS, Grace Dawson (Mrs. Arthur J.) [P,L] b. 1879, Red Lodge, CA d. 17 D 1943, Montclair, NJ

EDWARDS, H. Arden [P] Los Angeles, CA. Member: Calif. AC [25]

EDWARDS, H(arry) C. [P,I] Brooklyn, NY/Gananoque, Ontario b. 29 N 1868, Phila. d. 9 My 1922. Studied: Adelphi Col., Brooklyn, with J.B. Whittaker; ASL, with Mowbray. Member: SC, 1901; Brooklyn SA. Illustrated: "The Gun Brand," "Blackwater Bayou," other books [25]

EDWARDS, J(oseph) L(ee) [P] Atlanta, GA b. Cuthbert, GA. Member: SSAL; Assn. Ga. A.; Atlanta Studio Cl. [40]

EDWARDS, Kate F(lournoy) [Por.P] Atlanta, GA b. Marshallville, GA. Studied: AIC; Grande Chaumière, Simon, in Paris; Hawthorne; R. Jonson. Member: SSAL; Assn. Ga. A.; Atlanta AA. Exhibited: Southeastern Fair Exh., 1916 (prize); Atlanta AA, 1921 (prize). Work: Capitol, Wash. D.C.; Ga. Sch. Tech.; Mercer Univ.; Wesleyan Col., Macon; Univ. Ga., Athens; churches in Atlanta; Wake Forest Col.; Governor's Palace, Puerto Rico; Court House, Atlanta; High Mus. A.; State of Ga.; Clisby Sch., Macon; Rollins Col.; Orlando (Fla.) A. Gal. [47]

EDWARDS, Maeble. See Perry, M. Claire.

EDWARDS, Mary L. [P] NYC. Member: Pittsburgh AA [21]

EDWARDS, Nancy Bixby [S] Chicago, IL b. 18 F 1882, Evansville, IN. Studied: Pratt Inst. Member: South Side Ar. Exhibited: Hoosier Salon, 1937, 1938, 1939; Am. PS, AIC, 1935, 1937, 1938; Ar. Chicago Vicinity, AIC, 1939; Ceramic Exh., Syracuse, 1938, 1939 [40]

EDWARDS, Robert [P,C,En,I,W,T,L] NYC b. 4 O 1879, Buffalo, NY d. 11 N 1948. Studied: Harvard; Chase A. Sch.; ASL (NYC); ASL (Buffalo); Eric Pape Sch.; Cowles Sch. Member: SI, 1910; Salons of Am. Exhibited: S.Indp.A., 1925. Contributor: national magazines. Illustrator: "Eve's Second Husband," "The Song Book of Robert Edwards." Position: A. Dir., Golden Eagle Press, Mt. Vernon, N.Y. [47]

EDWARDS, W.C. (Mrs.) [P] Rochester, NY [08]

EDWARDSON, Laurence Christie [P] Kensington, CT b. 21 Jy 1904, Waltham, MA. Studied: Hartford A. Sch.; Gifford Beal; E. Duffner; A. Jones; S. Nichols. Member: Conn. AA; Conn. Acad. FA; New Britain A. Lg. Exhibited: Conn. Acad. FA, 1930-45, 1945 (prize), 1946; New Haven PCC, 1941; New Britain Inst., 1942-46 [47]

EGAN, Eloise [P] Westport, CT/St. Paul, France. Studied: G.E. Browne; Luks; W. Adams. Exhibited: Ogunquit A., Center, 1936; Nat. Acad., 1936; Studio Gld., 1936; Durand-Ruel, 1940 (one-man) [40]

EGAN, Harold [P] NYC. Exhibited: 48 Sts. Comp., 1939. Work: USPO, Agriculture Bldg., both in Okolona, Miss. WPA artist. [40]

EGAN, Joseph Byron [I,P,Car,G] Cleveland Heights, OH b. 22 Ap 1906, Cleveland, OH. Studied: Cleveland Sch. A.; Huntington Polytechnic Inst.; Univ. Kans. Exhibited: CMA, 1929 (prize), 1931 (prize), 1932 (prize), 1933 (prize), 1934 (prize), CAA, 1932; CMA, 1929–35; Dayton AI; Butler AI; BM; Ohio State Fair, 1932; AIC, 1934. Work: CMA; Cleveland Municipal Coll.; BM; Cleveland Pr. Cl.; St. James Church, Lakewood, Ohio. Illustrator: "Those Were the Days." WPA artist. [47]

EGAN, L.G. [P] Chicago. IL [04]

EGBERT, Henry [I] b. 1826 d. 12 Mr 1900, Brooklyn, NY. Exhibited: Am. Inst., 1846 (prize). He worked for Harper & Bros. and at eighteen years of age compiled Egbert's Drawing Books, which were published by the firm. In the days of "Boss Tweed," he was cartoonist for a paper called "The Day's Doings."

EGBERT, Lynn (Mrs. Lawrence D.) [E,Des,T] Chevy Chase, MD b. Oakland, CA. Studied: Univ. Calif.; AIC; PAFA; Abbott Sch. A.; abroad. Member: Wash. WCC; Wash. SE. Exhibited: LOC, 1944; Wash. WCC; Wash. Soc. Min. P.&En.; Wash. SE. Position: Instr., Abbott Sch. F.&Comm. A., Wash., D.C., 1941– [47]

EGE, Otto F. [Edu,W,L] Cleveland Heights, OH b. 6 Ap 1888, Reading, PA d. 17 Je 1951. Studied: PMSchIA; NYU; Cleveland Sch. A. Member: Cleveland SA; Nat. Edu. Assn.; Soc. Study of Aesthetics; Western AA; Eastern AA; AIGA. Author/Illustrator: "Pre-Alphabet Days," 1924. Contributor: articles, American Magazine of Art, and others. Position: T., Cleveland Sch. A., 1943– [47]

EGELI, Bjorn P. [P,I] Wash., D.C. b. 15 N 1900, Oslo, Norway. Studied: Meryman; Weisz; Baker. Member: Wash. Ldscp. Cl. Exhibited: CGA, 1932 (prize); S. Wash. A., 1936 (med). Work: Nat. Coll. FA, Smithsonian [40]

EGGELING, Herman [P,I,T] Tuckahoe, NY b. 17 Ag 1884, NYC d. 14 Ja 1932. Studied: ASL, with Bridgman, Sloan. Member: Bronx AG. Illustrator: "Encyclopedia of Foods," by Artemas Ward. Specialty: landscapes [31]

EGGEMEYER, Maude Kaufman [P] NYC b. 9 D 1877, New Castle, IN. Studied: J.E. Bundy; G. Beal; Cincinnati A. Acad.; W. Adams. Member: Chicago Gal. A.; Ind. AC; Richmond Palette Cl.; Cincinnati Women's AC. Exhibited: Hoosier Salon, 1924 (prize), 1927 (prize), 1928 (prize) [40]

EGGENHOFFER, Nick [P,S,I] Cody, WY b. 1897, Gauting, Germany (came to U.S. in 1913). Studied: CUASch. Member: Cowboy Ar. Am.; Nat. Acad. Western Art. Work: Nat. Cowboy Hall of Fame. Author/Illustrator: "Wagons, Mules and Men," 1961. His studio was in West Milford, N.J. from 1925 until the 1960s, when he moved to Cody. A prolific illustrator of the Old West, he is said to have made more than 30,000 Western illustrations. [*]

EGGERS, George William [Edu,Gr,L,W] NYC b. 31 Ja 1883, Dunkirk, NY. Studied: PIASch; H.D. Murphy; B. Harrison; B. Brown. Member: CAA; Nat. Edu. Assn.; Atheneum, N.Y.; Chicago AC; Trustee, Am. Craftsmen's Edu. Council. Exhibited: AIC, 1932 (prize); PAFA, 1928; WMAA, 1933; Milwaukee AI (one-man); Broadmoor Acad., Colorado Springs, 1924; Los Angeles Mus. A., 1924; NYPL, 1941; Denver A. Mus., 1926; Boston AC, 1926; R.I. Sch. Des., 1930; NAC, 1920; WMA, 1928. Work: AIC; R.I. Sch. Des.; Los Angeles Mus. A.; Okla. State Univ.; Honolulu Acad. A.; NYPL; Carl Milles House, Stockholm. Award: Knighthood of North Star (Sweden), 1930. Co-author: "Teaching of Industrial Arts," 1923. Author: "George Bellows," 1931. Contributor: art magazines. Organizer/Commissioner, American Exh. for Sweden, 1930. Lectures: American Mural Painting. Positions: A. Ed., Webster's Dictionary, 1927–35; Dir., AIC, 1916–21, Denver A. Mus., 1921–26, WMA, 1926–30; Chm., Dept. A., CCNY, 1930– [47]

EGGERS, Grace [P] Cincinnati, OH [24]

EGGLESTON, Allegra [P] NYC b. Stillwater, MN. Studied: Charles Lasar; Wyatt Eaton [01]

EGGLESTON, Benjamin [Por.P,Ldscp.P] Brooklyn, NY/West Stockbridge, MA b. 22 Ja 1867, Belvidere, MN d. 15 F 1937. After teaching in Red Wing, Minn. in the early 1880s, he studied at Minneapolis Sch. FA, with Douglas Volk, ca. 1884, and in Paris, 1894–95. Member: Brooklyn WCC; SC, 1903; Brooklyn SA; All. AA; Brooklyn PS; AFA; Scandinavian Am. A.; Pittsfield AL; Brooklyn AC (Pres.), 1903–27. Exhibited: Brooklyn AA, 1881; NAD, 1890–95, 1897–1900. From the 1900s to the 1920s, he summered at the Old Lyme art colony; in the 1930s he spent half his time in West Stockbridge, Mass. Illustrator: Minneapolis Tribune, 1886–87. [33]

EGGLESTON, Edward M. [P,I] Hollis, NY/Twin Lakes, CT b. 22 N 1887, Ashtabula, OH. Studied: J.N. Piersche; A. Fowley; A. Schille; H. Dunn. Member: Artist Gld.; SI [33]

EGGLESTON, George T. [I] Riverside, CT. Member: SI [47]

EGLESON, James D. [P,G] Essex Fells, NJ/Terre Haute, IN b. 12 Mr 1907, Capellon, Quebec. Member: Am. Ar. Cong.; United Am. Ar. Exhibited: WFNY, 1939. Work: murals, Swarthmore Col., USPO, Marysville, OH; Smith Col.; Turner Mem. Bldg., Terre Haute. WPA artist. [40]

EGLINTON, Guy [Cr,Ed] b. 1896, Walsall, England d. 30 Je 1928 (drowned near Fire Island, NY). He was employed in Germany at the outbreak of World War I and was held prisoner until peace was declared. During this period he devoted himself to the study of art, supplemented by later journeyings through France, Italy and Germany. Prominent in New York art circles since 1918, when he came to this country as editor of the American Edition of the International Studio, he was especially interested in the development of contemporary American painting and was among the first of the critics to champion the cause of the non-academic artists.

EHMANN, Fred [P] Cincinnati, OH. Member: Cincinnati AC [25]

EHRENFELS, H.C. (Mrs.) [E] Staten Island, NY [19]

EHRHART, S. [I] Brooklyn, NY [98]

EHRICH, Harold Louis [Dealer,W] b. 9 Ja 1880 d. 28 Mr 1932, Pinehurst, NC. Studied: Yale. With his father (Louis R.) he founded the NYC firm that bears the family name. He specialized in old masters and early American portraits. Co-author: with his brother Walter, "One Hundred Early American Paintings," 1918

EHRICH, Louis R. [W,Dealer] b. 23 Ja 1849, Albany, NY d. 23 O 1911, London. Studied: Yale. He traveled in Europe from 1878 to 1885, studying antique paintings and later opened a gallery in New York. He was prominent in politics and wrote on political economy. Father of Harold and Walter.

EHRICH, Walter Louis [W,Dealer] b. 1879, New York d. 2 F 1936. Studied: Yale; Stanford. Member: Antique and Decorative Art League. After the death of his father (Louis R.), he and his brother Harold Louis continued the family gallery. The most noted of the Ehrich importations was Romney's "Blue Boy." In 1934, he joined Bertram Newhouse in forming the Ehrich-Newhouse Galleries. Co-author: with his brother Harold Louis, "One Hundred Early American Paintings," 1918

EHRICH, William E. [Edu,S] Rochester, NY b. 12 Jy 1897, Koenigsberg, Germany. Studied: State A. Sch., Koenigsberg; Stanislaus Cauer; Erich Schmide-Kestnor; Franz Thryne. Member: The Patteran. Exhibited: Buffalo SA, 1932 (prize), 1934 (prize), 1935 (prize); Albright A. Gal., 1935 (prize), 1938 (prize), 1940 (prize), 1941 (prize), 1945 (prize); Rochester Mem. A. Gal. (prize); Syracuse Mus. FA. Work: Albright A. Gal; Rochester Mem. A. Gal. Positions: Instr., Buffalo AI, Univ. Rochester [47]

EHRMAN, Hyman M. [S] Portland, OR b. 2 F 1884, Russia. Studied: Russia; PAFA. Member: Oreg. SA. Work: portrait reliefs in public buildings, Portland [33]

EICHBAUM, George Calder [P] St. Louis, MO b. 1837, Bowling Green, KY d. Spring 1919. Studied: D.R. Smith. Work: Mo. Hist. Soc.; St. Louis Sch. FA; U.S. District Court, St. Louis; West Point Military Acad.; St. Louis Cl. [17]

EICHBAUM-BREHME, Clare [P,I,L,T,W] 16 My 1886, Berlin, Germany. Studied: Franz Skarbina; France; Spain. Author: "Woman of Two Countries," 1936. Position: T., Abington Friends H.S., Jenkintown [38]

EICHENBERG, Fritz [En,I,T,L] Tuckahoe, NY b. 24 O 1901, Cologne, Germany. Studied: State Acad. Graphic A., Leipzig; H. Steiner-Prag. Member: AIGA; Phila. WCC; Am. Ar. Cong. Exhibited: PAFA, 1940–45; NAD, 1938, 1944–46; LOC, 1943 (prize), 1944 (prize), 1945 (prize), 1946 (prize); CI, 1943–45; AIGA, 1938, 1940, 1944. Work: NYPL; LOC; AIC. Illustrator: "Richard III," "Eugene Onegin," "War and Peace," "Crime and Punishment," "Gulliver's Travels," "Puss in Boots," "Uncle Remus,"other books for leading publishers, including Heritage Press. Contributor: Horn Book, other magazines. Lectures: Experiences of an Illustrator, Wood Engraving—Past & Present. Positions: Instr., New Sch. Soc. Res., MOMA, War Veterans Art Center; Bd. Dir., AIGA, 1943–46 [47]

EICHENHAUER, Henry [P] Brooklyn, NY [24]

EICHLEAY, Harry O. [P] Pittsburgh, PA. Member: Pittsburgh AA [21]

EICHNER, Laurits Christian [metalwork] Bloomfield, NJ b. 7 Mr 1894, Struer, Denmark. Member: NYSC; Boston SAC; Phila. ACG. Exhibited: N.Y. Soc. C., 1938 (prize); Intl. Expo, Paris, 1937 (gold). Work: reproductions, primitive timekeepers, Hayden Planetarium; Franklin Inst., Phila.; Buhl Planetarium. Position: Instr., Craft Students Lg., New York [40]

EICKEMEYER, Rudolf [Photogr,W,I] b. 7 Ag 1862, Yonkers, NY d. 24 Ap 1932, Yonkers. One of the nation's leading photographers, he received nearly one hundred medals (about equally divided between landscape and portrait work), including the medal of the Royal Photographic Society of England, the Viceroy medal of the Calcutta International Exh., special gold medal awarded by the Hamburg Senate, and a gold medal from the St. Louis Exposition. In 1922 the Smithsonian Inst. acquired five of his pictures, and in 1929 obtained one hundred framed pictures, representing all of his medal pictures, and also his medals and diplomas. He was an author and illustrator, belonged to many organizations and served as chairman of the Yonkers Municipal Art Commission, a commissioner of the Yonkers Museum of Science and Art, and president of the Art Association.

EIDE, Palmer [Edu,S,P,C] Sioux Falls, SD b. 5 Jy 1906, Minnehaha Co., SD. Studied: Augustana Coll; AIC; Harvard; Yale. Member: CAA; Am. Oriental Soc. Work: City Hall, Broadcasting Station KSOO, both in Sioux Falls; Trinity Lutheran Church, Rapid City; mural, Univ. S.Dak. Position: T., Augustana Col, 1931– [47]

EIDLITZ, Julia T. [P] NYC. Member: Women's AC [04]

EILERS, Emma [P,C] NYC/Sea Cliff, NY b. NYC. Studied: ASL, with Cox, Chase, Mowbray, Beckwith, DuMond. Member: ASL; N.Y. Women's AC [33]

EILSHEMIUS, L(ouis) M(ichel) [P,I,C,W] NYC b. 4 F 1864, Arlington, NJ d. 29 D 1941. Studied: Geneva; Dresden, with Schenker; ASL, with Cox; R.C. Minor; Van Luppen; Académie Julian, Paris, with Bouguereau, 1886–89. Member: Modern AA; AFA; Salons of Am.; Société Anonyme. Work: PMG; MMA; MOMA; Detroit MA; WMAA; BMFA; Cleveland AM; Mus. N.Mex. A primitive romanticist, he called himself the "Grand Parnassian and Transcendental Eagle of the Arts." He was a prolific artist and an eccentric self-promoter. He stopped painting in 1921, one year after his first one-man show in NYC. [40]

EIMER, Elsa [P] NYC. Member: S.Indp.A. [29]

EINSTEIN, Alice F. [P] NYC. Member: Lg. AA [24]

EIRICHK, Edward C. [P] Ormand, FL b. 1878 d. 28 Ag 1929, Phila. Position: Staff Ar., (Phila.) Evening Bulletin, nearly 25 yrs. [04]

EISELE, C. [P] Salt Lake City, UT. Member: Soc. Utah Ar. [01]

EISENBACH, Dorothy Lizzete [Edu,P] Boulder, CO b. Lafayette, IN. Studied: John Herron A. Sch.; PAFA; Univ. Iowa; P. Guston; W. Forsyth; F.W. Howell. Member: Ind. Soc. PM. Exhibited: Ind. Ar. Exh., 1929 (prize); PAFA, 1934 (prize). Position: Instr., Univ. Colo., Boulder [47]

EISENLOHR, Edward G. [P,Li,L,W] Dallas, TX b. 9 N 1872, Cincinnati, OH d. 1961. Studied: R.J. Onderdonk; F. Reaugh; Acad. Karlsruhe, Germany, with G. Schoenleber; Birge Harrison. Member: SC; Dallas AA; Tex. FA Assn.; SSAL; AFA; AAPL. Exhibited: Dallas AA, 1931 (prize), 1932 (prize); San Antonio A. Lg., 1927 (prize), 1928 (prize); SSAL, 1920 (prize); Tex. Fed. Women's Cl. (prize); CGA, 1917 (prize); NAD, 1920; P.-P. Expo, 1915; Albany Inst. Hist.&A., 1941; WFNY, 1939. Work: Dallas Mus. FA; Elisabet Ney Mus. A.; Delgado Mus. A.; Witte Mem. Mus.; Mus. FA, Abilene; Mus. FA, Houston. Author: several books on the West. Positions: Bd. Trustees, Dallas Mus. FA; MOMA, 1933 [47]

EISENSTADT, Alfred [Photogr] b. 1898, Dirschau, West Prussia. Exhibited: Intl. Center Photography, NYC (retrospective). Work: "Life" Coll.; Royal Photogr. Soc.; many U.S. mus. One of the first modern photojournalists. Worked in Germany from the late 1920s to 1934; staff photographer for "Life" since 1935. [*]

EISENSTAT, Ben [P,Car] Phila., PA b. 4 Je 1915, Phila. Studied: Graphic Sketch Cl.; PAFA; Barnes Fnd. Exhibited: PAFA, 1935, 1936, 1938; Albany Inst. Hist.&A.; MMA, 1942; AIC, 1943; Heerlen, Holland (one-man), 1944. Work: Phila. Graphic Sketch Cl. [47]

EISNER, Anne [P,Li] NYC b. 13 Ap 1911, Newark, NJ. Studied: Holzhauer; Grosz; N.Y. Sch. F.&Appl. A.; ASL. Member: Fed. Mod. P.&S.; NAWA. Exhibited: WFNY, 1939; MOMA; Inst. Mod. A., Boston; AIC; Riverside Mus.; Norlyst Gal., 1944 (one-man) [47]

EISNER, Dorothy (Mrs. McDonald) [P] NYC b. 17 Ja 1906, NYC. Exhibited: B. Robinson; K.H. Miller; ASL. Member: Fed. Mod. P.&S.; NAWA. Exhibited: Dance International, 1936 (prize); CGA, 1938; PAFA, 1935, 1946; VMFA, 1944; WFNY, 1939; AIC; NAWPS, 1939 (prize) [47]

EISNER, William J., Mrs. See Rensie.

EITEL, Cliffe D. [Li,Des,T] Chicago, IL b. 18 Je 1909, Salt Lake City, UT. Studied: H. Ropp; Kepes; J. Binder. Member: Vanguard Pr. Group; Chicago A. Gld. Exhibited: Phila. Pr. Cl., 1946; NAD, 1946; LOC, 1946; Mint Mus., 1946; Laguna Beach AA, 1946; AIC, 1946; Chicago A. Gld., 1945; Cliff Dwellers Cl., Chicago, 1946. Position: Instr., Chicago Professional Sch. A. [47]

EKDAHL, Anne Anderson [E] Chicago, IL b. Elgin, IL. Studied: Chicago Acad. FA; AIC; Hawthorne; Breckenridge; R. Miller. Member: Chicago SE. Work: NGA; Vexsjo, Sweden [47]

ELAND, John Shenton [Por.P,I,E,S] NYC b. 4 Mr 1872, Market Harborough, England d. 7 Ja 1933. Studied: Royal Acad. A. Schools, with Sargent. Member: Pastel Soc. Exhibited: Royal Acad., 1894 (med); Europe; U.S. Work: BM. Specialty: portraits of children [32]

ELARTH, Herschel [Arch,S] Los Angeles, CA b. 15 O 1907, Omaha, NE. Studied: Univ. Ill.; Atelier Defrasse; Madelaine Aublet; Ecole des Beaux-Arts, Paris. Exhibited: Grand Central Gal., 1929 (prize); NYC, 1931 (prize). Work: Sioux City Music Pavilion [40]

ELARTH, Wilhelmina van Ingen (Mrs. Herschel A.) [Edu,W,Cr] Pasadena, CA b. 16 F 1905 Rochester, NY. Studied: Vassar; Johns Hopkins; Am. Sch. Classical Studies, Athens; Radcliffe Col. Member: CAA; Am. Assn. Univ. Prof.; Am. Inst. Archaeology; 1926–28; F., Johns Hopkins, 1926–27; F., Carnegie, 1927–30. Author: "Corpus Vasorum Antiquorum," 1933, "Figurines from Seleucia on the Tigris," 1939. Positions: T., Univ. Mich. (1930–35), Wheaton Col. (1935–46) [47]

ELBERT, Carlos [P] Toledo, OH. Member: Artklan [24]

ELDER, Arthur John [P,E,Des,C,T,B] Westport, CT b. 28 Mr 1874, London. Studied: W. Sickert; T. Roussel; C. Huard; D. Muirhead. Member: Jr. A. Worker's Gld.; Chelsea AC, London. Exhibited: Crystal Palace, 1901 (med); New English AC (prize); Dudley Gal. (prize); Royal Agricultural Hall (prize); San Fran. AA (prize); Baltimore WCC (prize); St. Louis WCC (prize); PAFA; S.Indp.A. Position: Dir., Westport (Conn.) Sch. A., 1926– [47]

ELDER, Inez Staub [P,T,L] Dallas, TX b. 16 Ja 1894, Kosuth, OH. Studied: Art Acad. Cincinnati; New Sch. Design, Boston; ASL; H. Wessel; G. Bridgman; DuMond. Member: Reaugh AC; SSAL; Tex. FAA; Oak Cliff SFA. Exhibited: Tex. Centennial, 1936; Pan-Am. Expo, Dallas, 1937; Tex. All. A., 1928–46; Mus. FA, Houston, 1937–45; SSAL; 1932–34, 1936 (prize); Dallas Mus. FA, 1942 (prize); Tex. State Fair, 1932 (prize), 1933, 1934; Ft. Worth, 1937–45. Work: Dallas Women's Forum, Oak Cliff YMCA, Tex. [47]

ELDER, John Adams [P] Fredericksburg, VA b. 3 F 1833, Fredericksburg d. 24 F 1895. Studied: D. Huntington, in NYC, 1850; E. Leutze, Düsseldorf, 1851. Worked in NYC ca. 1856–59; returned to Fredericksburg to fight for the Confederate Army. Specialties: portraits; landscapes; genre; battle scenes [*]

ELDERKIN, John [W] b. 1841, Setauket, NY d. 23 Ag 1926, Whitefield, NH. Member: Lotos C. (a founder). Author: "Turf and Trotting Horses of America," "Brief History of the Lotos Club"

ELDER, Margaret Dougall [G,T] Boston, MA b. 4 Jy 1914. Studied: Mass. Sch. A.; E.L. Major; R. Andrew; O. Philbrick. Member: Chicago Soc. E.; Soc. Am. E.; Southern Pr.M. Soc. Exhibited: Wash. WCC, 1937; Conn. Acad. FA, 1938; Amherst Lib. (one-man); Milton Lib. (one-man); Waltham Lib. (one-man). Work: Soc. Am. En. Position: T., Mass. Sch. A. [40]

ELDRED, Lemuel D. [Mar.P,E] Fairhaven, MA b. 1848, Fairhaven, MA d. 1921. Studied: spent time in Europe, 1880, 1883. Apparently worked with his friend William Bradford in Fairhaven and NYC. Exhibited: NAD, 1876. Work: Kendall Whaling Mus.; Peabody Mus., Salem; Old Dartmouth Hist. Soc. [*]

ELDREDGE, Emily [P] Hartford, CT [13]

ELDRIDGE, Harold E. [I] NYC. Member: SI [47]

ELDREDGE, Stuart Edson [P,T,Des] Brooklyn, NY/Springfield, VT b. 1 Jy

1902, South Bend, IN. Studied: ASL. Member: NSMP; Am. Des. Group. Exhibited: Hoosier Salon, 1933, 1934; Grand Central Gal., 1935; murals N.Y. Arch. Lg., 1936; murals, Textile Bldg., WFNY, 1939. Position: T., CUASch [40]

ELDRIDGE, Marion [P] NYC. Exhibited: NAWPS, 1935, 1936, 1937, 1938 [40]

ELFENBEIN, Bert [Des,B,T] NYC b. 17 N 1902. Studied: Columbia; H.K. Millikin; abroad. Work: designer of textiles [40]

ELIASOPH, Paula [En,P,I,E,W,T,L] Jamaica, NY b. 26 O 1895, NYC. Studied: PIASch; Columbia; ASL. Member: Fed. Mod. P.&S.; AWCS; ASL; Am. A. Cong.; Queensboro Soc. A.Cr.; NAWPS. Exhibited: Argent Gal., N.Y., 1937; Phila. Soc. E., 1938; Town Hall Cl., N.Y., 1939 (one-man); LOC, 1943; SAE, 1938, 1944; AIC, 1931; BM, 1931; de Young Mem. Mus.; AFA traveling exh. Work: BM; MMA; LOC; Pub. Lib., Wash. D.C.; F.D. Roosevelt Lib.; Hillside Hollis Center, YWHA, Jamaica, N.Y.; MMA; NYPL. Author: complete set of etchings & drypoints of Childe Hassam, 1934; article on Harry Wickey in "Prints," 1935 [47]

ELIOT, Lucy Carter [P] NYC b. 8 My 1913 NYC. Studied: Vassar; ASL, with Bridgman, von Schlegell, Kantor. Exhibited: PAFA, 1946; Finger Lakes Exh., Rochester, N.Y., 1945, 1946; Rochester Mem. A. Gal., 1946 (prize); Vendôme Gal.; Norlyst Gal., 1941, 1942, 1943. Work: Rochester Mem. A. Gal. [47]

ELISCU, Frank [S,L] NYC b. 13 Jy 1912, Brooklyn, NY. Member: Clay C., N.Y. Exhibited: Arch. Lg., 1936. Position: Dir., S. Dept., Master Inst. United Arts, N.Y. [40]

ELLEN, Dorothy Hambly (Mrs. John A.) [P] Wilkinsburg, PA. Member: Pittsburgh AA [25]

ELLENDER, Raphael [P,I] NYC. Member: SI. Exhibited: Phila. WCC, 1938; AIC, 1939; CGA, 1939 [47]

ELLERHUSEN, F(lorence) Cooney (Mrs.) [P] Towaco, NJ b. Canada d. 20 Ap 1950. Studied: AIC; ASL; Luks; W.M. Chase; Vanderpoel. Member: Allied AA; NAWPS; PBC. Exhibited: NAD; All.A.Am.; NAWA; Morristown AA; Baltimore WCC; Newark Mus.; AIC [47]

ELLERHUSEN, Ulric H(enry) [S,P,T] Towaco, NJ b. 7 Ap 1879, Germany (came to US at age 15). Studied: AIC; Lorado Taft; ASL; Karl Bitter. Member: ANA, 1932; NAD, 1934; NSS, 1912; Arch. Lg. 1914; Beaux-Arts Inst., 1916; Allied AA; AFA. Exhibited: St. Louis AL (prize); Arch. Lg, 1929 (med); Allied AA, 1934 (med). Work: Fine Arts Bldg., San Fran.; Yale campus; medal for St. Louis AL; medal for Pa. R.R. service.; Elmswood Park, East Orange, N.J.; F. Douglass Mem. Home, Wash., D.C.; Univ. Pa.; St. Vincent Ferrer Church, N.Y.; Church of St. Gregory, NYC; Univ. Chicago; St. Mary's Col., Notre Dame, Ind.; Christ Church, Cranbrook, Mich.; Church of the Heavenly Rest, NYC; Harrodsburg, Ky.; Century of Progress Expo, Chicago; City Hall, Kansas City, Mo.; State Capitol, Baton Rouge, La.; Oreg. State Capitol, Salem. Specialty: architectural sculpture and monuments. Positions: T., Nat. Acad. Sch. (NYC), Ellerhusen Sch. Painting, Sculpture (Towaco). [47]

ELLERTSON, Homer F. [P,Li] Tryon, NC b. 23 d. 1892, River Falls, WI d. 25 Jy 1935. Studied: Pratt Inst.; Paris, with M. de la Cluse, Naudin, Miller. Member: Scandinavian-American SA; SSAL; AFA. Exhibited: Norse American Centennial, 1925 (med). Work: PMG [33]

ELLERY, Richard V(anderford) [P,S] Marblehead, MA b. 22 O 1909, Salem, MA. Studied: Mass. Sch. A. Member: North Shore AA; Marblehead AA; Merrimack Valley AA. Exhibited: WFNY, 1939. Work: Court House, Salem; Town Hall, Danvers; Little Bldg., Boston; State Teachers Col., Salem [40]

ELLFELDT, Walter Charles [S,C,T,Cer] Kansas City, Mo b. 20 O 1909, Kansas City. Studied: Rosenbauer. Exhibited: Midwestern A, 1933; Mo. State Fair, 1934 (prize). Position: T., ceramics, Kansas City AI [40]

ELLICOTT, Henry J. [S] Wash., D.C. b. 1848, Ellicott, MD d. 11 F 1901. Studied: Wash.; NAD. Work: equestrian statues of Gen. Hancock (Wash., D.C.) and Gen. McClellan (Phila.)

ELLINGER, Carlton D. [P] NYC. Member: AG Authors Lg.; SC [25]

ELLINGER, Ilona E. See Deak-Ebner.

ELLIOT, Bert [P] d. Summer 1931, NYC. Member: NJSA, Chicago. Work: AIC. He spent his early life in Japan.

ELLIOTT, Elizabeth Shippen Green (Mrs. Huger Elliott). See Green, Elizabeth.

ELLIOTT, Frances Gray [P,Dec,C,T] Athens, OH b. 4 S 1900, Liverpool, OH. Studied: Ohio Univ. Member: Ohio WCS; Columbus AL. Exhibited: Ohio State Fair, 1938, 1939. Work: Phila. A. All.; St. Paul's Church, Athens. Illustrator: "General Zoology," by Krecker [47]

ELLIOTT, Hannah [P,Min.P,I,T] Birmingham, AL b. 29 1876, Atlanta, GA. Studied: America; Europe. Exhibited: All Southern Exh., Charleston, S.C., 1921 (prize); SSAL annual, 1933 (prize) [40]

ELLIOT, Henry Wood [I] b. 1846, Cleveland, OH d. 1930's, Lakewood, OH. Official artist to Hayden's U.S. Geological Survey of 1869-71 (W.H. Jackson was the official photographer.) In the 1870's he lived in Alaska and wrote studies on the seals. In 1905 he was instrumental in drawing up a treaty to protect the seals [*]

ELLIOTT, Huger [P] NYC [25]

ELLIOTT, John [P] Newport, RI b. 22 Ap 1858, England d. 26 My 1925, Charleston, S.C. Studied: Paris, Académie Julian, Carolus-Duran; Villegas, Rome. Exhibited: Newport AA, 1917 (prize), 1918 (prize). Work: Boston, Pub. Lib.; Nat. Mus.; MET; Old State House, Boston; Lib. Am. Studs., Rome; Coll. Dowager Queen of Italy; Ethnographical Mus., Athens [24]

ELLIOTT, Martha Beggs [Por.P] Birmingham, AL b. 17 D 1892. Studied: Wayman Adams. Member: Birmingham AC; SSAL; Ala. AL; Nat. AC [40]

ELLIOTT, Philip Clarkson [P,Edu] Buffalo, NY b. 5 D 1903, Minneapolis, MN. Studied: Univ. Minn.; Yale. Member: The Patteran. Exhibited: PAFA; Carnegie Inst., 1943, 1945; Albright A. Gal. Work: Univ. Pittsburgh; Albright A. Gal. Lectures: Techniques of Painting. Position: T., Univ. Pittsburgh, 1934-40; Dir., Albright A. Sch., Buffalo, N.Y., 1944– [47]

ELLIOTT, Philip C., Mrs. See Cuthbert, Virginia.

ELLIOTT, Robert R. [P] Chicago, IL/Manayunk, PA. Member: F., PAFA [25]

ELLIOTT, Ronnie Rose [P,S,Et,Li] NYC b. 16 D 1910, NYC. Studied: NYU; ASL; W. Zorach; A. Brook; Hans Hofmann; F. Luna. Member: ASL; ALA; Am. A. Cong.; United Am. A. Exhibited: AC New Orleans, 1933 (prize); PAFA, 1933, 1934, 1939; Honolulu Acad. A., 1936; GGE, 1939; WFNY 1939; Carnegie Inst., 1941; CGA, 1939; NAD, 1941; Bennington Col., 1943; SFMA, 1945; Western Col., Oxford, Ohio, 1945; Marquie Gal., 1942, 1944 (one-man); Art of this Century, 1943-45; MMA, 1942 [47]

ELLIOTT, Ruth C(ass) [P] Brentwood Heights, CA b. 22 Jy 1891, Los Angeles, CA. Studied: Los Angeles Sch. Art Des.; Otis AI; Univ. Calif., Los Angeles. Member: Calif. AC; Laguna Beach AA; Women Painters of the West; Santa Monica [40]

ELLIS, Betty Corson [P,Dec,T] Fayetteville, NY b. 3 Ja 1917, NYC. Studied: Syracuse Univ. Exhibited: PAFA; Phila. WCC, 1938; Syracuse MFA. Work: Syracuse Univ. [40]

ELLIS, Charles [P] NYC. Member: S.Indp.A. [25]

ELLIS, Clyde Garfield [P,C,T] Los Angeles, CA b. 25 D 1879, Humboldt, KS. Studied: Judson; Chase; Univ. Southern Calif. Member: Pacific AA; PS of Southern Calif. Exhibited: Okla. State Fair, 1921 (prize); Los Angeles Mus. A., 1924 (prize). Position: T., Pub. Sch., Los Angeles [40]

ELLIS, Edmund L(ewis) [P,E,Arch.] NYC b. 30 O 1872, Omaha, NE. Studied: G.B. Post; McKim; Mead; White. Member: Arch. Lg.; Bronx AG; NSS; AIA; AFA. Work: marble, St. James Protestant Episcopal Church, Fordham; interiors, Park Central Hotel, NYC [31]

ELLIS, Fremont F. [Por.P,G,T] Santa Fe, NM b. 2 O 1897, Virginia City, MT. Studied: ASL, 1915. Member: Santa Fe PS; Los Cinco Pintores, 1921-26 (founder). Exhibited: Los A. Mus. A., 1924 (prize). Work: mural, S.S. America [47]

ELLIS, Harriet A. [P] Springfield, MA b. 4 Ap 1886, Springfield. Studied: PIASch; Hawthorne; Johonnot; Beaux; M. Welch; A. Jones. Member: A. Union. Exhibited: PAFA; Jones Library, Amherst, Mass. (one-man); Mus. FA, Springfield; Springfield Pub. Lib.; Springfield AL, AG, A. Union; G.W.V. Smith Mus.; Nat. Hist. Mus.; Academy of Medicine, Springfield [47]

ELLIS, Harvey [P,Arch,C] Rochester, NY b. 1852, Rochester d. 2 Ja 1904, Syracuse. Studied: Edwin White, NAD. Member: NYWCC; Rochester Soc. A.&C (Pres.). Exhibited: NYWCC [04]

ELLIS, Helen E. [S,C] Westport Point, MA b. 23 F 1889, Northboro, MA.

Studied: North Bennett St. Indst. Sch., Boston; Child-Walker Sch. Des., Boston. Member: NAWPS. Exhibited: NAWPS, 1938. Position: Ass. Cur., Whaling Mus., Westport [40]

ELLIS , John [P] Coytesville, NJ [13]

ELLIS, Joseph Bailey [Edu,S,W,L] Pittsburgh, PA b. 24 My 1890, Scituate, MA. Studied: Mass. Sch. A.; BMFA; Ecole National des Beaux-Arts; A. Mumsel; B. Pratt. Member: Soc. S.; AA; Craftsmen's G., Pittsburgh. Exhibited: AIC; Carnegie Inst.; A.&Cr. Ctr., Pittsburgh. Author: Chapter on sculpture in "Enjoyment of the Arts," 1944. Position: T., Carnegie Inst., Pittsburgh, 1920– . [47]

ELLIS, Leigh [I] Position: Illus., New Amsterdam Book Co., NYC [98]

ELLIS, Maude Martin (Mrs.) [P,I] Chicago, IL b. 7 F 1892, Watseka, IL. Studied: J.W. Reynolds [29]

ELLIS, Vernon [P] Hanover, NH b. 5 D 1885, Columbia, PA d. 3 Ag 1944. Studied: W. Chase; Henri; Despujols. Exhibited: Nat. Acad., 1907; Liernur Gal., The Hague, Holland, 1939 [40]

ELLISON, J. Milford [T,P,C,L] San Diego, CA b. 16 S 1909, Sioux City, IA . Studied: Chouinard AI; Am. Acad. A., Chicago; Chicago Acad. FA; San Diego State Col. Member: San Diego A. Gld.; Laguna Beach AA; San Diego T. Assn.; Calif. T. Assn.; Nat. Edu. Assn. Exhibited: AWCS, 1946; San Diego Intl. Expo, 1935; San Diego A. Gld., 1931–46; San Diego FA Soc., 1944–46; A. Center, La Jolla, 1945; Laguna Beach AA, 1946; U.S. Army A.&Cr. Exh., Paris, 1945 (prize). Work: San Diego FA Soc. Lectures: Camouflage; Modern Crafts. Position: T., San Diego City Sch. [47]

ELLISON, Walter W. [P,C,Des] Chicago, IL b. 20 F 1900, Eatonton, GA. Studied: AIC; A. Troy; M. Topchevsky; T.L. Persley; J.A. Pye. Member: United Am. A., Chicago. Exhibited: Chicago NJSA; Navy Pier Exhib., Chicago [40]

ELLSWORTH, Clarence Arthur [I,P] Hollywood, CA b. 23 S 1885, Holdrege d. 1961. Studied: self-taught. Member: Los Angeles AC. Exhibited: Southwest Mus., 1941, 1942, 1944 (all one-man); Charles W. Bowers Mus., Santa Ana, Calif., 1945 (one-man). Work: Southwest Mus., Los Angeles. Illustrator: two books on North American Indians, by Mark Harrington; cover designs and illus. for sports magazines. . Position: Newspaper Artist, Denver Post, Rocky Mountain News; Motion Picture Title Artist, Paramount [47]

ELLSWORTH , Elmer [P] St. Louis, MO. Exhibited: St. Louis Expo, 1898 [98]

ELMENDORF, Stella See Tylor.

ELMER, Rachel Robinson (Mrs. Robert) [P] NYC. Member: NAWPS [21]

ELMORE, Elizabeth [P] NYC [13]

ELMORE, Elizabeth Tinker (Mrs.) [P,E,L] Jersey City, NJ b. 7 Ag 1874, Clinton, Wis. d. 6 Ap 1933. Studied: W.M. Chase; G. deF. Brush; Rome, Italy. Exhibited: Wolfe AC, 1918 (prize), 1919 (prize) [32]

ELMS, Willard F. [P] Chicago, IL. Member: AG Authors Lg.A. [25]

ELSHIN, Jacob (Alexandrovitch) [P,I,T] Seattle, WA b. 30 D 1892 Petrograd, Russia. Studied: Russian Imperial Acad., with Semin; Roussanoff; Andriev; Dimitrieff. Member: Puget Sound Group Northwest Painters; Northwest WCS; Seattle AM; Pacific Coast AA. Exhibited: San Diego FA Soc., 1941; Pal. Leg. Honor, 1946; Denver A. Mus., 1946; SAM, annually; Spokane; Portland, Oreg.; Northwest WCS, 1946 (prize); Pacific Coast AA, 1933 (prize), 1936 (prize); Studio Gal., Northwest Annual, 1945 (prize) 1946 (prize). Work: SAM; Smithsonian Inst., USPO, Renton, Wash.; Univ. P.O., Seattle. WPA muralist. [47]

ELTON, Mary [P] White Plains, NY [25]

ELTONHEAD, Frank [G] Hatboro, PA b. 17 O 1902, Phila. Studied: PMSchIA. Member: A. Dir. Cl., Phila.; SI. Position: A. Dir., Ladies Home Jounal, 1932– [47]

EL VERE. See Simons, Elvera, Mrs.

ELWELL, D. Gérôme [Ldscp.P] Somerville, MA b. 1857 d. 27 D 1912, Naples, Italy

ELWELL, E.S. (Mrs.) [P] Wash., DC [01]

ELWELL, F(rank) Edwin [S] b. 15 Je 1858, Hubbardville, Concord, MA d. 23 Ja 1922, Darien, CT. Studied: D.C. French, in Concord; Falguière; Ecole des Beaux-Arts. Member: NSS; SAA, 1886; Arch. Lg., 1899; NAC; Cincinnati AC. Exhibited: Columbian Expo, Chicago, 1893 (med); AC Phila. 1891 (gold), 1897 (gold); Pan-Am. Expo, Buffalo, 1901 (med). Work: Phila.; Gettysburg, Pa.; Cemetery, Lowell, Mass.; N.Y. Custom House; Orange, N.J.; Nat. Naval Mon., Vicksburg; Old Cathedral, Edam, Holland; Aberdeen Lib. (Scotland); Paris; PAFA; MMA; Amzi Dodd Mem., Mutual Benefit Life, Newark, N.J. He was the adopted son of author Louisa May Alcott, with whom he first studied sculpture. [21]

ELWELL, Jerome D. [Mar. P] b. 1847, Gloucester, MA d. 1912, Naples, Italy [*]

ELWELL, John H. [E,En,Des] Newton, MA/Marblehead, MA b. 10 Mr 1878, Marblehead. Studied: Vesper George; R. Carpenter; Evening Art Sch., Boston. Member: Boston AC. Work: Pub. Lib., Claremont, N.H. Specialty: Ex Libris labels [40]

ELWELL, Robert Farrington [I] Boston, MA b. 1874, near Boston d. 1962, Phoenix, AZ. Studied: self-taught. Illustrator: The National Magazine, Boston. Covered Buffalo Bill Cody's Wild West Show; became Cody's ranch manager in Wyo., 1896–1921. In the 1930s his western illus. appeared in Harper's, Century, and American [98]

ELWELL, Roy A. [Des] Douglaston, NY b. 29 My 1889, Aberdeen, Scotland. Member: Soc. Mem. Designers and Draftsmen. Work: memorials in cemeteries throughout the U.S. Illustrator: Monumental News, Monument and Cemetery Review, Art in Bronze and Stone. Position: Des., Presbrey-Leland Studios, N.Y. [40]

ELWELL, S. Bruce [P,C,W,Arch] Cambridge, MA/Worcester, MA b. 3 O 1886, Cambridge, MA. Studied: Cornell [24]

ELY, Donald H. [P] Indianapolis, IN [15]

ELY, Edward Francis [P] Providence, RI. Member: Providence AC [25]

ELY, Fanny Griswold (Mrs.) [P] NYC b. NYC. Studied: W. Robinson; C. Yates; DuMond. Member: NAC; Allied AA; Buck Hill AA [47]

ELY, Frances Burr. See Burr.

ELY, Frances Campbell [P] Phila., PA. Member: ASMP. Exhibited: PA. SMP, 1938; Min. PS&G Soc. Ann., CGA, 1939 [47]

ELY, John A. (Mrs.) [E] NYC. Member: SAE [47]

ELY, John Carl [S] Seattle, WA b. 1899 d. 4 Ag 1929, Dennis, MA. Position: Affiliated with AMNH

ELY, Letitia Maxwell [P] New Hope, PA. Member: Wash. WCC [25]

ELY, Lydia (Mrs.) [P,W] Milwaukee, WI (came as a child to Milwaukee, 1849) d. 1914. Studied: H.V. Thorne; A. Marquis. Made sketching tours of Old West, Florida, and Europe, 1870–90s. Author: chapter on artists in "History of Milwaukee," 1898. Specialty: watercolors [*]

ELZNER, A.O. [P,Arch] Cincinnati, OH. Member: AIA; Cincinnati AC [08]

EMENS, Homer F. [Ldscp.P] NYC [17]

EMEREE, Berla Ione (Mrs. William Henry) [P,T,C,L] El Paso, TX b. 7 Ag 1899, Wichita, KS. Studied: San Antonio A. Sch.; F.B.A. Linton; José Arpa, in Spain; Xavier Gonzalez, in Mexico; Rolla Taylor. Exhibited: Intl. Mus., El Paso, 1944, 1945; Tex. FAA, 1946; USO Cl., El Paso, 1946. Work: State Mus., Santa Fe, N.Mex.; Ft. Worth Pub. Lib.; Col. of Mines, El Paso. Lectures: Art of Today. Position: Dir., Emeretus, School of Painting, 1924– [47]

EMERSON, Alfred [E] Chicago, IL. Member: AIC [13]

EMERSON, Arthur Webster [P,E,L] Honolulu, HI b. 5 D 1885, Honolulu. Studied: Stanford; ASL; Columbia; J.C. Johansen; Hawthorne; E.A. Webster. Member: Assn. Honolulu A.; ASL. Exhibited: PAFA, 1923; NYWCC, 1920, 1921; AWCS, 1918; NAC; Assn. Honolulu A., 1946; WFNY, 1939; Honolulu A. Soc., 1932 (prize); Honolulu Acad. A., 1935 (prize). Work: Capitol, Honolulu; Honolulu Acad. A. Illustrations. "Pele and Hiiaka," by N.R. Emerson [47]

EMERSON, Belle. See Keith, Mrs.

EMERSON, C(harles) Chase [I,P] Boston, MA d. 1922. Member: SI, 1912; SC; Boston AC [21]

EMERSON, Edith [P,I,L,W,Mus.Cur,T,Dr] Phila., PA b. Oxford, OH. Studied: AIC; PAFA; C. Beaux; E. Carlsen; Violet Oakley; H. McCarter. Member: NSMP; Phila. WCC; CAA; AM. Soc. Bookplate Collectors & Des.; Phila. Alliance; Mural P.; AFA; Plays and Players; Germantown AL. Exhibited: PAFA, 1916–46; CGA, 1924; AIC; NAD; Newport AA, 1941; CAFA, 1938; Arch. Lg.; Woodmere A. Gal., 1940–46; Phila. Pr.

Cl.; Phila. A. All. Work: Plays & Players Theatre; Moorestown Trust Co., N.J.; Temple Keneseth Israel, Phila.; Haverford Prep. Sch., Pa.; Bryn Mawr Col.; Vanderpoel Coll.; Army & Navy triptychs; PAFA. Illustrator: The Century, Christian Science Monitor; "The Song of Roland," 1938; articles in Asia, American Magazine of Art. Positions: T., Agnes Irwin Sch., 1916–27, PMSchIA, 1929–36; Cur. Pro-Tem, Woodmere A. Gal.; Dir., Cogslea Acad. A.&Let., 1940 [47]

EMERSON, Francis C. [I,En] NYC [01]

EMERSON, Louise Harrington (Mrs. Arnold Ronnebeck) [Ldscp.P, Mur.P,Por.P,L] Denver, CO b. 25 Ag 1901, Phila. Studied: K.H. Miller; Bridgman; ASL; Fontainebleau. Member: ASL; Denver AM. Exhibited: Denver AM, 1931, 1934. Work: USPO, Worland, Wyo. WPA muralist. [40]

EMERSON, Sybil (Davis) [P,I,E,W,Des] State College, PA b. Worcester, MA. Studied: Ohio State Univ.; ASL, with Armin Hansen; André Lhote; Academie Falguière. Member: Eastern AA; United Am. A.; Am. A. Cong. Exhibited: AIC, 1935; WMAA, 1939; NGA, 1941; Albany Inst. Hist.&A., 1943; San Fran. AA, 1944; Los Angeles Mus. A., 1945; Butler AI, 1939–41, 1943, 1944, 1946; Parkersburg, W.Va., 1946. Work: American Church, Paris. Author/Illustrator: "Jacques at the Window," 1936, "Pigeon House Inn," 1939. Position: T., Pa. State Col., 1942–46 [47]

EMERSON, W.C. [P] New Preston, CT b. London, England. Member: NYWCC; Westchester AI [40]

EMERTON, James H. [I] Boston, MA b. 1847, Salem, MA d. 5 D 1930. Member: Copley S., 1894. Illustrator: zoological publications. Specialty: American spiders [29]

EMERY, Irene [S] Chicago, IL/Grand Rapids, MI b. 1 F 1900, Grand Rapids. Studied: A. Archipenko; E. Zettler [33]

EMERY, Margaret Rose [P,Gr,C,I,T] Piedmont, CA b. 6 Ap 1907, El Paso, TX. Studied: Hardin Col.; Chicago Acad. FA; Northwestern Univ.; Nebr. Univ.; Emilio Garcia Cahero, in Mexico. Member: San Fran. Soc. Women A. Exhibited: SFMA, 1942, 1943; Audubon A., 1945; WFNY, 1939; Palace FA, Mexico City, 1936, 1937. Work: murals, Tex. Col. Mines; Presidio, San Fran. Positions: A., Nat. Mus., Mexico, 1938, 1939; Medical A., Presbyterian Hosp. Medical Center, NYC, 1944, 1945 [47]

EMERY, Nellie Augusta (Mrs.) [P] Dallas, TX [25]

EMERY, William Henry, Mrs. See Emeree, Berla.

EMIG, Adolph P. Houston, TX. Exhibited: Houston MFA, 1938, 1939 [40]

EMMERICH, Mary. See Ashburton.

EMMET, Edith Leslie [P,Dr,T] NYC/Salisbury, CT b. 17 My 1877. Studied: R. Collin; MacMonnies; B. Burroughs; CUASch. Member: NAWPS; Art Workers Cl. for Women [40]

EMMET, Ellen G. See Rand, Mrs.

EMMET, Jane Erin. See Von Glehn, Mrs.

EMMET, Leslie [P] NYC. Member: NAWPS [24]

EMMET, Lily Cushing [P] NYC. Exhibited: Walker Gal., 1938 (one-man); Nat. A. Cl., 1939. Specialty: flowers [40]

EMMET, Lydia Field [P,I] NYC b. 23 Ja 1886, New Rochelle, NY d. 16 Ag 1952. Studied: Chase, Mowbray, Cox, Reid, all in NYC; Colin, Bouguereau, MacMonnies, Robert-Fleury, all in Paris. Member: ANA, 1909; NA, 1912; Conn. Acad. FA; NAWA; AFA; ASL; NYWCC; Por. P. Exhibited: St. Louis Expo, 1904 (med); NAD, 1907 (prize), 1909 (prize), 1918 (prize); PAFA, 1915 (prize), 1925 (prize); CGA, 1917 (prize); Conn. Acad. FA, 1919 (prize); NAWA, 1921 (prize), 1923 (prize); Stockbridge AA, 1929 (prize), 1931 (prize); Newport AA, 1921 (prize), 1923 (prize); Columbian Expo, Chicago, 1893 (med); Atlanta Expo, 1895 (med); Pan-Am. Expo, Buffalo, 1901 (prize); SAA, 1906 (prize); CI, 1912 (prize) [47]

EMMET, Rosina. See Sherwood, Mrs.

EMMET, Burton [Patron] b. 1872 d. 6 My 1935, Melfa, VA. His desire to stimulate interest in contemporary art was evidenced by the two houses he had filled with paintings by contemporary artists, and by his collection of rare books and prints which contained examples by practically all the master printmakers and illustrators from the fifteenth century to the present day. He was president of the Am. Inst. of Graphic Arts (1924–25) and received the gold medal of the Institute (1927) "for service to the Graphic Arts in America." He was one of the founders and early editors of "Colophon," and held memberships in the SAE, MMA, and MOMA.

EMMONS, Bertha E. [P] Brooklyn, NY [10]

EMMONS, C(hansonetta) S(tanley) (Mrs.) [Min.P,C,Photogr] Newton, MA b. 30 D 1858, Kingfield, ME d. 18 Mr 1937. Studied: Enneking; Alice Beckington; J.G. Brown; W.P. Phelps. Member: Boston SAC; AAPL. Exhibited: Carolina AA, 1926; Boston; Wellesley Col. Mus., 1913. Work: BMFA; Cushing Mem. Gal., Newport, R.I. Her millionaire brothers, F.E. and F.O. Stanley, invented the Stanley Steamer auto and Stanley photographic dry plates. She is best known for her photographs of rural Maine and Charleston, S.C. Mother of Dorothy. [38]

EMMONS, Dorothy Stanley [P,E,I,L,W] Newton, MA b. 14 Je 1891, Roxbury, MA. Studied: Woodbury; G.E. Browne; G.A. Thompson; A.T. Hibbard; G.L. Noyes. Member: AAPL; Copley S. Exhibited: Mass. Fed. Women's Cl., 1933 (prize), 1934 (prize). Work: Mass. Fed. Women's Cl. Author/Illustrator: various magazines. Daughter of Chansonetta. [40]

EMORY, Hopper [I,E] Baltimore, MD/Towson, MD b. 8 My 1881, Baltimore. Member: Baltimore Charcoal Cl. [33]

EMPIE, Hal H. [Car,I,P,S,L] Duncan, AZ b. 26 Mr 1909, Safford, AZ. Exhibited: MOMA; Pepsi-Cola, 1944, 1945; Calif. WC Soc., 1945. Work: Methodist Church, Duncan, Ariz. Illustrator/Cartoonist: Western magazines. Lectures: Cartooning [47]

EMRICH, Harvey [P] Woodstock, NY b. 9 O 1884, Indianapolis, IN. Exhibited: Hoosier Salon, 1933 (prize) [40]

EMVER, Anthony [P] Portland, OR [24]

ENANDER, Ada [P] Chicago, IL [15]

ENDERS, Frank [P] Milwaukee, WI b. Milwaukee. Studied: A. Gable, W.L. Schmidt, in Munich. Exhibited: Omaha Exh., 1898 [98]

ENDICOTT & CO. The largest and best known of several Endicott family lithographic firms; thrived in NYC from 1852 to 1886. Headed by Francis Endicott (b. ca. 1832), the firm did work for Currier & Ives, and employed the well-known Charles Parsons. In 1856 the firm was given an award for lithography by The American Institute. [*]

ENDICOTT, William Crowninshield [Patron] d. 28 N 1936. Member: Incorporator, Soc. for the Preservation of New England Antiquities, which he served from 1910; Trustee, BMFA, 1915; President, Mass. Hist. Soc., to which he bequeathed $100,000.

ENDRES, Louis J. [P] Cincinnati, OH [25]

ENGARD, Robert Oliver [P,Li] Salt Lake City, UT b. 26 Ap 1915, Phila. Studied: Wash. State Col. Member: Calif. WC Soc. Exhibited: Denver A. Mus., 1940, 1941; Okla. A. Center, 1939, 1940; Calif. WC Soc., 1940, 1941, 1945; Riverside Mus., 1946; Oakland A. Gal., 1941; San Fran. AA, 1941; SAM, 1939–41 [47]

ENGEL, George Leslie [P,I,T,C,Dec] Baltimore, MD b. 5 Je 1911, Baltimore. Studied: Md. Inst.; Vocational Sch., Baltimore. Member: A. Un., Baltimore. Exhibited: Md. Inst., 1936 (med); Wash. County Mus. FA, 1934; BMA, 1936, 1937, 1938, 1939 (one-man); 1946; VMFA, 1938; PAFA, 1939; A. Un. Traveling Exh., 1939, 1946; CGA, 1939, 1940; Grand Central A. Gal., 1938, 1939; PAFA, 1939. Work: Md. Inst. Position: Instr., A., Md. Inst., 1935–40; Illus., U.S. Army, 1940–46. [47]

ENGEL, Harry [P,Edu,L,Mus.Cur] Bloomington, IN b. 13 Je 1901, Romania d. 1970. Studied: Notre Dame; Columbia; Maurice Denis, in Paris. Member: Ind. A. Cl. Exhibited: Hoosier Salon, 1931 (prize); Ind. A. Cl., 1931 (prize), 1945 (prize), 1946 (prize); Milwaukee AI, 1946 (prize); PAFA, 1939; AIC, 1940; Detroit Inst. A., 1936; John Herron AI, 1933 (one-man). Work: Ind. Univ. Position: Cur., Ind. Univ. Mus., Bloomington [47]

ENGEL, Michael Martin, Sr. [Por.P,T,W,L,I] NYC b. 22 Ap 1896, Hungary. d. 1969. Studied: CUASch, with Dielman, Cedarstrom; G.W. Harting. Member: Nat. Assn. Pub. Relations Counsel; Audubon A.; A. Gld.; Eastern AA; Lancaster County AA; Phila. All. Exhibited: Mark Twain Centenn. Assn., 1935 (med). Illustrator: "Three Centuries Delaware," children's books. Columnist: Art Digest (1935–37), Western Artist (1936–37). Positions: Dir., Isochromatic Exh. (1936–37), Aqua-Chromatic Exh. (1937–38), Miniature Palette Exh., M. Grumbacher (1938–39) Artists Relations Lecture Bureau [47]

ENGEL, Michael, Jr. [P,G,I] NYC b. 20 Mr 1919, NYC. Studied: A. Katchemakoff; K. Nicolaides; George Picken. Member: ASL. Exhibited: Leonard Clayton Gal., N.Y. Work: Antioch Col. [40]

ENGEL, Richard Drum [P,W] Wash., D.C. b. 25 D 1879, Wash., D.C. Studied: self-taught; France. Member: Soc. Wash. A.; Beachcombers' Cl. [40]

ENGEL, Wilhelmina (Mrs.) [P,T] Madison, WI b. 1 Jy 1871, Middleton, WI. Studied: AIC, with Frederic Fursman; Colt Sch. A. Member: Madison A. Gld. [47]

ENGEL-LEISINGER, Irma (Mrs.) [P] San Fran., CA b. 8 Mr 1908, Badenweiler, Germany. Studied: A. Halleisen, Karl Hofer, in Germany; André Lhote, in France. Member: San Fran. AA; San Fran. Soc. Women A. Exhibited: Karlsruhe, Berlin (prize); San Fran., 1945 (prize); WFNY, 1939; GGE, 1939; A. Critics Show, Cincinnati; SFMA, 1939 (one-man), 1945, 1946; San Fran. AA; San Fran. Soc. Women A. Work: Landes Mus., Karlsruhe [40]

ENGELHARD, Elizabeth [G] Winnetka, IL. Exhibited: AIC, 1937–39 [40]

ENGELS, Charles [P] NYC. Member: S.Indp.A. [25]

ENGLAND, Paul [P,S,W] NYC b. 12 Ja 1918, Hugo, OK. Studied: Carnegie Inst.; ASL, with Grosz, Zorach, de Creeft. Exhibited: ACA Gal., 1945, 1946; Contemporary A. Gal., 1944–46; Riverside Mus., 1946; Galerie Neuf, 1946; Philbrook A. Center, 1943–46 [47]

ENGLANDER, Anna [P] NYC [10]

ENGLE, Amos W. [P] San Fran., CA/NYC. Member: NYWCC [25]

ENGLE, H(arry Leon) [Ldscp.P] Chicago, IL b. Richmond, IN. Studied: AIC. Member: Palette and Chisel Acad. FA; Assn. Chicago PS. Exhibited: Palette and Chisel Acad. FA, 1917 (prize), 1923 (gold). Work: Chicago Art Commission; Long Beach (Calif.) Pub. Lib.; mural, Cook Co. Juvenile Court. Positions: Sec., Chicago Commission for Encouragement of Local Art; Dir., Chicago Gal. Assoc. [40]

ENGLEBERT, Joseph [P] Phila., PA [04]

ENGLER, Arthur [En,Des] Deal Beach, NJ b. 26 Mr 1885. Studied: Francis Clarke. Member: Am. Bookplate Soc.; S.Indp.A. Exhibited: bookplate, Grolier Cl., 1921 (prize) [25]

ENGLEY, Alice D. [P] Paris, France b. Providence, RI. Studied: Acad. Delecluse; E. Ertz. Exhibited: Omaha Exh., 1898 [98]

ENGLISH, Frank F. [P] Point Pleasant, PA b. 4 D 1854, Louisville, KY. Studied: PAFA; England; Holland. Member: Phila. Sketch Cl. Exhibited: AAS, Phila., 1902 (gold) [25]

ENGLISH, Harold M. [P] Los Angeles, CA b. 28 Ap 1890, Omaha, NE. Member: Soc. Salon d'Automne, Paris. Exhibited: Paris Expo, 1937 (gold); Salon d'Automne, 1930–40; Tuileries Salon, Paris, 1931–39; Los Angeles Mus. A., 1941–46. Work: BM [47]

ENGLISH, Mabel Bacon Plimpton (Mrs. J.L.) [P] Hartford, CT/Weekapaug, RI b. 18 F 1861, Hartford. Studied: Chase; D.W. Tryon. Member: Hartford AS; Hartford AC; Conn. Acad. FA; Hartford Arts & Crafts Cl. [40]

ENGLISH, Robert B. (Mrs.) [P] Hartford, CT. Member: Hartford AS [27]

ENNEKING, John J(oseph) [Ldscp.P] Hyde Park, MA b. 4 O 1841, Minster, OH d. 16 N 1916. Studied: Bonnât, Daubigny, in Paris, 1873–76; Lehr, in Munich. Member: Twentieth Century Cl.; Pudding Stone Cl.; Hyde Park Hist. Soc.; Boston AC; Paint and Clay Cl., Boston; Boston Gld. A. Exhibited: Mass. Charitable Mechanics' Assoc., Boston (medals); Paris Expo, 1900 (prize); Pan-Am. Expo, Buffalo, 1901 (med); P.-P. Expo, San Fran., 1915 (gold). Work: Worcester Mus.; BMFA. When the Civil War broke out he enlisted on the Union side and was severly wounded. In 1868 he went to Boston and studied lithography. After spending several years in Europe, he returned to Boston in 1876 and opened a studio there. Father of J. Eliot. [15]

ENNEKING, J(oseph) Eliot [P] Brookline, MA/Rockport, MA b. Hyde Park, MA. Studied: De Camp; Benson; Tarbell. Member: Rockport AA; Copley S.; North Shore AA; New Haven PCC. Son of John J. [40]

ENNIS, Georgia L(eaycroft) (Mrs. G.P.) [P,S] NYC/Eastport, ME b. Wading River, N.Y. Studied: Chase; K.H. Miller [25]

ENNIS, George Pearse [P,C] NYC/Eastport, ME b. St. Louis, MO d. 28 Ag 1936 (result of an automobile accident near Utica, NY). Studied: W.M. Chase; Washington Univ.; Holmes Art Sch., Chicago. Member: SC; All. AA; A. Aid S.; N.Y. Arch. Lg.; NYWCC; Am. WC Soc.; Gld. Am. P.; A. Fund S.; NYSP; Aquarelists; Boston AC; Fla. FA; Founder/Member: Painters and Sculptors Gallery Assoc. (N.Y.). Exhibited: SC, 1922 (prize), 1923 (prize), 1925 (prize); AIC, 1922 (prize); Wilmington WCC, 1931 (prize); PAFA, 1931 (gold); NYWCC, 1932 (prize); AWCS, 1933 (prize). Work: stained glass, Athletic Cl., Church of All Nations, Methodist Episcopal Home (all in NYC), Victory Windows, Chapel, U.S. Military Acad. (West Point); AIC; MMA; Univ. Ark., Fayettville; Ordnance Dept., U.S. Government; stained glass/murals, Unitarian Church, Eastport, Maine; Presbyterian Church, Cornwall, N.Y.; Calvary Methodist Church, Bronx; First Baptist Church, Jamaica, N.Y.; Arts Cl., Wash., D.C. Author: article on watercolor painting, Encyclopaedia Britannica. His works include many stained glass windows and mural paintings, and while he also used pastels, charcoal, and pencil, he was probably best known for his vivid watercolors. He had his own school of painting in New York, with a summer school in Eastport, Maine. [33]

ENNIS, Gladys Atwood (Mrs. George Pearse Ennis) [P] Sedalia, MO. b. Natick MA. Studied: H.B. Snell; G.P. Ennis. Member: AWCS; NAWA; Studio Cl.; Wolfe A. Cl.; NYWCC. Exhibited: Blue Bowl, N.Y. 1939; Smith Gal., Utica, N.Y., 1936 (one-man); Playhouse A. Gal., N.Y., 1938; Attleboro Mus., 1938; Barbizon Gal., N.Y., 1939; NYPL, Columbia Branch, 1939 [47]

ENO, James Lorne [P,T] Columbus, OH b. 17 Jy 1887, Chateuguay, NY d. 12 F 1952. Studied: Whipple Sch. A., Brooklyn, N.Y.; Rene Dubords, in France. Exhibited: NCFA. Work: LOC; Dept. Interior, Wash., D.C. [47]

ENOS, E. Marguerite [P] Troy, NY. Member: S.Indp.A. [25]

ENQUIST, Mary B. [S] Wash., D.C. Member: Wash. WCC [29]

ENRIGHT, Maginel Wright (Mrs.) [I] NYC. Member: SI, 1912 [27]

ENRIGHT, Walter J. [Car] Delray Beach. FL b. 3 Jy 1879, Chicago, IL. Studied: AIC; Armour Inst., Chicago. Member: SI, 1910; Players Cl. Position: Car., Miami Herald [47]

ENSEL, Henry [P] NYC. Exhibited: WFNY, 1939 [40]

ENSER, George [Des,T,L,I,Dec] Tuckahoe, NY b. 16 N 1889, NYC. Studied: Columbia; CUASch; Mechanics Inst. Member: A. in Trades Cl. Work: Ala. State Capitol; Waldorf-Astoria Hotel, NYC. Designer: furniture and interiors. Position: Instr., N.Y. Evening H.S. [47]

ENSER, John F. [P,I,E,T] Lexington, MA b. 17 Jy 1898, Ennis, TX. Studied: AIC; Chicago Acad. FA; H.D. Murphy; J. Arpa. Member: SSAL; San Antonio AL; Boston Gld. Ar.; Tex. FA Assn. Exhibited: SSAL, 1936 (prize). Work: City Hall, Brockton; Cary Lib., Lexington; USPO, Boston. Position: Instr., P., Middlesex Sch., Concord [40]

ENSIGN, Raymond P. [Des,L,T] Newark, NJ/Monterey, MA b. 4 Ag 1883, River Falls, WI. Studied: Pratt Inst.; Ralph Robertson. Member: Western AA; AFA; Fed. Council on Art Ed.; EAA. Exhibited: Cleveland Soc. A., 1921 (med). Positions: Dir., Newark Sch. F.&Indst. A., Berkshire Summer Sch. A. [31]

ENSIGN, William H. [P] Sutherlin, OR [24]

ENSOR, Joseph H. [P] Brockton, MA [19]

ENTERS, Angna [P,I,Gr,S,Car,W] NYC b. 28 Ap 1907, NYC. Studied: U.S.; Europe; Greece; Egypt; Near East. Member: F., Guggenheim Fnd. Exhibited: Newhouse Gal., 1933–45; Warren Gal., London; MMA, 1943; Honolulu Acad. A.; Rochester Mem. A. Gal.; WMA; Minneapolis Inst. A.; Detroit Inst. A.; R.I. Sch. Des.; SFMA; Wadsworth Atheneum; Renaissance Soc., Univ. Chicago; BMA; Bloomington (Ill.) A. Mus.; Los Angeles Mus. A.; Colorado Springs FA Center; Denver A. Mus.; Albany Inst. Hist.&A.; Pasadena AI; Santa Barbara Mus. A.; AGAA; MOMA, 1933, 1944; AIC, 1939–41. Contributor: Hound and Horn Quarterly (1932); Trend Quarterly (1933, 1935) New Theatre (1936), and others. Author/Illustrator: "First Person Plural" (1937), "Love Possessed Juana" (1939), "Silly Girl" (1944). Illustrator: "Best American Short Stories of 1945". Work: MMA; Honolulu Acad. A.; drawings of Greek, Egyptian dynastic, Greco-Roman, Pompeian, Coptic, Persian, Chinese art forms for Guggenheim Fellowship studies; projects for "The Theatre of Angna Enters" [47]

ENTLER, Kathryn Estelle [P,T] Hagerstown, MD b. Virginia. Studied: Los Angeles A. schools; A. Melvill, in London. Exhibited: Wash. County (Md.) Mus. A., 1935, 1937 [40]

ENTRESS, Albert [P] Hartford, CT. Member: Conn. Acad. FA [25]

ENTZ, Marian W. (Mrs. F.S.) [Min.P] NYC b. New York. Studied: H.S. Mowbray; L.F. Fuller; T. Thayer [17]

ENYEART, Mana (Miss) [P] Phila., PA [04]

ENZINGER, Gertrude Cole [P] Milwaukee, WI [24]

EPPENS, William H. [P,Des,E,Li,B] Chicago, IL b. 25 D 1885, Lincoln, NE. Studied: AIC, Chicago Acad. FA; Carl Krafft; Anthony DeYoung; F. Grant. Member: South Side AA; Renaissance Soc. of Univ. Chicago; Chicago P.&S.; All-Ill. Soc. FA; South Side AA; Vanderpoel AA.

Exhibited: AIC, 1924; Chicago P.&S., 1945; All-Ill. Soc. FA, 1927–46; South Side Community A. Center, 1925–46. Work: Vanderpoel Coll.; Univ. Church, Chicago; Chicago Pub. Lib. [47]

EPPENSTEINER, John Joseph [P,I] St. Louis, MO b. 14 F 1893, St. Louis. Studied: St. Louis Sch. FA; Washington Univ. Member: St. Louis A. Gld.; St. Louis Two-by-Four SA. Exhibited: St. Louis A. Gld., 1921, 1923 (prize), 1924 (prize), 1926 (prize), 1928 (prize), 1929 (prize), 1930 (prize), 1932 (prize); Kansas City AI, 1927 (prize), 1928, 1929 (prize), 1931, 1932 (med); St. Louis A.Lg., 1921, 1923, 1928; St. Louis Post-Dispatch, 1929 (prize); Christian Herald, 1929 (prize); A. Dir. Cl., Chicago, 1946; PAFA, 1926, 1927; Toledo Mus. A., 1927; CAM, 1922–24, 1927, 1928, 1931; Missouri-Pacific, 1929 (prize); Midwestern A., 1927 (med), 1929 (med). Illustrator: "Domestic Animal Studies in the Modern Manner," 1930 [47]

EPPING, Franc [S] Lenox, MA b. 27 Je 1910, Providence, RI. Studied: R. Burnham; Otis A. Inst.; M. Miller; Corcoran Sch. A.; Akademie der Bildenden Kunste, Munich; J. Wackerle; B. Bleeker. Member: S. Gld.; Fed. Mod. P.&S. Exhibited: Munich Acad. FA, 1933 (prize); NGA, 1931; PMG, 1932; Soc. Wash. A., 1937; Smithsonian Inst., 1937; NAD, 1938; PAFA, 1938–40; WFNY, 1939; S. Gld., 1939–42; AIC, 1938, 1940, 1941, 1943; WMAA, 1939, 1940; Riverside Mus., 1941; MOMA, 1939–44; MMA, 1942; Ellen Phillips Samuel Mem., 1940; Los Angeles Mus. His. Sc.&A., 1929 (prize). Work: High Mus. A.; Beria Col.; USPOs, Alexander City, Ala., Oakmont, Pa. [47]

EPPINK, Helen B. (Mrs. N.R.) [P,Li,Des,T] Emporia, KS b. 19 Ag 1910, Springfield, OH. Studied: Cleveland Sch. A.; John Huntington Polytechnic Inst. Exhibited: Denver MA, 1939; CMA, 1933 (prize), 1935 (prize); Kansas City AI, 1939 (prize), 1940, 1942; Okla. A. Center, 1940; CMA, 1932–38; Butler AI, 1941. Position: T., Col. of Emporia (Kans.), 1944–46 [47]

EPPINK, Norman R. [P,Li,Des,T,B] Emporia, KS b. 29 Jy 1906, Cleveland, OH. Studied: Cleveland Sch. A.; John Huntington Polytechnic Inst.; Western Reserve Univ.; Henry G. Keller; Frank Wilcox. Member: Am. Assn. Univ. Prof.; Kansas State A. T. Assn.; Kansas Fed. A. Exhibited: CMA, 1927, 1931 (prize), 1932 (prize), 1933 (prize), 1934 (prize), 1935 (prize), 1939, 1942; Kansas City AI, 1938 (prize), 1939–42; Okla. A. Center, 1940; AFA Traveling Exh., 1941; Butler AI, 1941; Topeka, Kans., 1942 (one-man); Wichita, Kans., 1944 (one-man). Work: CMA; Cleveland Municipal Coll.; Mansfield (Ohio) Pub. Lib.; public schools, Lakewood and Winfield, Kans. Position: Instr., Kans. State T. Col., Emporia, 1937– [47]

EPSTEIN, Ernest [I] NYC. Member: SI [47]

EPSTEIN, Jacob [Patron] b. 1864, Lithuania d. 27 D 1945, Palm Beach, FL. Settled in Baltimore, Md., 1881. Trustee: BMA, to which he gave important paintings by old masters.

EPSTEIN, Jacob [S] London, England b. 1880, NYC. Work: Oscar Wilde mon., Père Lachaise, Paris; figures, London Medical Assoc. Bldg. [17]

ERB, Daisy E. [P] Palm Beach, FL/Swannanoa, NC b. Canton, OH. Studied: Md. Col.; Corcoran Sch. A.; Paris; Bruges. Member: NAC; Soc. Four Arts, Palm Beach; Palm Beach Art Lg.; Black Mt. AA; Asheville Ar. Gld.; Lg Am. Pen Women. Exhibited: Asheville A. Gld., 1935 (prize); Nat. Convention Lg. Am. Pen Women, 1935 (prize); Palm Beach AL, 1937 (prize). Work: Women's C., West Palm Beach, Fla. [40]

ERB, George [P] Pittsburgh, PA. Member: Pittsburgh AA [21]

ERBAUGH, Ralph (Waldo) [P] Flint, MI b. 29 Je 1885, Peru, IN. Member: S.Indp.A.; Chicago NJSA [33]

ERDMANN, Charles R. [P] Cincinnati, OH. Member: Cincinnati AC [17]

ERDMANN, R(ichard) Frederick [Por.P] Dedham, MA b. 12 F 1894, Chillicothe, OH. Studied: ASL, with Luks, DuMond; NAD; Curran; Cincinnati A. Acad., with James Hopkins, Duveneck; L.H. Meakin; H. Wessel; P. Jones. Exhibited: Mus. N.Mex., Santa Fe; Myles Standish Gal., Boston; Columbus Gal. FA; Cincinnati A. Acad. [47]

ERESBY, Eloise L. Breese de (Lady Willoughby de Eresby) [S] b. NY. Member: NAD; N.Y. Municipal A. Soc.; NSS [08]

ERESCH, Josie [Li,E,P,W,I,L,B] Beloit, KS b. 13 Ap 1894, Beloit. Studied: N.Y. Sch. F.&App. A.; Fed. Sch. A.; Birger Sandzen; A.E. Cross; Caroline Armington, Paris; Tokyo, with Suigaku Kubota, Chotaro Miyata; Yu Teng-An, Peiping. Member: Kans. Authors C.; Lg. Am. Pen Women; Prairie Pr.M.; Ex Libris Soc., Holland; Ex Libris Soc., Berlin; Woodcut Soc.; Am. Soc. Bookplate Des.; Austrian Ex Libris Soc. Exhibited: Lg. Am. Pen Women, 1937 (prize), 1938 (prize); Kansas City AI; Wichita AA. Work: Pub. Lib., Chanute, Kans.; Pub. Lib., Beloit, Wis. Author/Illustrator: "Elegant Amusement (Flower Arrangement)," 1937, "Come Up and See My Etchings," 1938. Lectures: Process of Making Japanese Woodcuts, Free Brush and Finger Painting, Stencilling. Contributor: Kansas Magazine [47]

ERGANIAN, Sarkis [P] St. Louis, MO [25]

ERICKSON, Arthur Lawrence [En] Highland Park, IL [13]

ERICKSON, C.O. [P] Chicago, IL [17]

ERICKSON, Carl [I] NYC. Member: SI [47]

ERICKSON, Ernest C. [P] Los Angeles, CA. Member: Calif. AC [25]

ERICKSON, Oscar B. [P] Chicago, IL. Member: Brown Co. A. Gal. Assn. Exhibited: Palette and Chisel Acad. FA, 1932 (med); Hoosier Salon, 1936 [40]

ERICSON, David [P] b. 15 Ap 1870, Motala, Sweden. Studied: Chase; Whistler; Prinet. Member: Provincetown AA; Paris AAA. Exhibited: St. Louis Expo, 1904 (med); CI, 1904; Minn. Ar. Expo, St. Paul, 1911 (prize). Work: Duluth AA; La Crosse AA; Commercial C., Duluth [40]

ERICSON, Eric [Car] NYC b. 14 F 1914, East Orange, NJ. Studied: PIASch, with M. Graves; ASL, with W. McNulty, R. Hale. Member: SI; Car. Soc.; Am. Television Soc. Contributor: New Yorker, Collier's, Esquire. Position: Syndicate Car., with King Features [47]

ERICSON, George M(elvin) [I,T] Minneapolis, MN b. 31 Ja 1893, St. Paul, MN. Studied: H. McCarter. Member: F. PAFA [19]

ERICSON, Mauritz A. [S] b. 1836 d. 24 O 1912, Pelham, NY

ERIK-ALT, Lenore (Mrs. Lenore Alt Erickson) [P,Ser,C,T] St. Paul, MN b. 21 Je 1910, Cadillac, MI. Studied: AIC, Boris Anisfeld. Exhibited: AIC, 1941; Walker A. Gal., 1946 (one-man); Twin City Exh., St. Paul, 1942–45; Twin City Exh., Minneapolis, 1945; Detroit Inst. A., 1935, 1938; Paul Theobald's Chicago, 1942 (one-man); Nat. WC Exh., Wash., D.C., 1941. Position: T., Walker A. Center, Minneapolis, 1946; Macalester Col., St. Paul, 1946 [47]

ERIKSEN, John M. [P,I] Milwaukee, WI/Wauwotosa, WI b. 7 N 1884, Silkeborg, Denmark d. 24 Jy 1918, Studied: ASL, Milwaukee; AIC; Royal Acad. FA, Copenhagen. Member: Wis. PS [17]

ERICKSSON, Archie [Des,C,S,T] Oahu, HI b. 2 Ap 1900. Member: Honolulu AA. Exhibited: Honolulu Acad., 1936, 1937, 1939. Work: Ch. Cross Roads, Honolulu. Specialties: Enameling, Cer., Jewelry. Position: T., McKinley H.S., Honolulu [40]

ERLE-SAGHAPHI, Annette [Mur.P,Por.P,S,T] NYC b. 23 Jy 1910, NYC. Studied: ASL; W. Zorach; Bridgman; Guy Wiggins; Piccirrilli; L. Kroll; NAD; Da Vinci A. Sch., N.Y.; Colarossi, in Paris [40]

ERNESTI, Richard [P,T] Seattle, WA (1941) b. 1856, Chemnitz, Germany. Studied: Munich, with Knorr; Chicago Acad. Des., with F. Flinzer. His wife, Ethel, was also a painter. Positions: T., Colo. State T. Col., Pa. State Col., Drake Univ. [*]

ERNST, Ethel M. [P] East Orange, NJ [10]

ERNST, Junes [P] Chicago, IL [19]

ERSEK, Joseph Francis [P,Des,T] Cleveland, OH b. 10 S 1912, Cleveland. Studied: John Huntington Polytech. Inst.; ASL; Grant Wood. Exhibited: CMA, 1938 (prize), 1939, 1940, 1942. Work: Cleveland Metropolitan Housing Bldg.; Sunny Acres Inst., The Dobeckmun Co., both in Cleveland. Position: Indst. Des., General Motors Corp., 1943–45 [47]

ERSKINE, Harold Perry [S] Tryon, NC b. 5 Je 1879, Racine, WI d. 6 Ja 1951. Studied: Williams Col.; Ecole des Beaux-Arts; Colo. Univ. Sch. FA, with Sherry E. Fry. Member: Beaux-Arts Soc.; Century Assn. Exhibited: Dry Dock Savings Bank, 1936 (prize). Work: AMNH. Garden City Golf Cl.; St. Anthony Cl.; Central Presbyterian Church, NYC; Nat. Chi Psi Frat., Ann Arbor; numerous portrait and garden sculptures [47]

ERSTAPHIEVE, C.J. [P] NYC [01]

ERTZ, Bruno [P] Manitowoc, WI b. 1 Mr 1873, Manitowoc. Studied: self-taught. Specialties: birds, insects [29]

ERTZ, Edward (Frederick) [P,E,En,I,L,T,W] Sussex, England. b. 1 Mr 1862, Canfield, IL. Studied: Paris, with Lefebvre, Constant, Delance. Member: Eclectic A. Soc., Rowley Gal., both in London; Royal Soc. British A.; Soc. A., London; Imperial AL; British WCS; Essex AC; Aberdeen AG; Société Intl. d'Aquarellistes, Paris; Société des Cinquante; Union Intl. des Beaux-Arts; Chicago SE; Chicago AG; Calif. SE. Exhibited: Intl. Expo, St. Etienne; Expo, d'Angiers (gold); Intl. Expo, Rouen (prize);

Soc. des Amis des Arts de la Somme, 1899 (med); Ville d'El boeuf, (med); Bristol A.&Cr., England (prize); AAS, Phila., 1902 (med); Festival A.&L., 1927 London, (med). Work: Alexander Palace Mus., London; Pub. Gal., Liverpool; LOC; Calif. State Lib.; NYPL; BMFA; Vanderpoel AA; Wolseley A. Gal., Hove, Sussex; Am. Consulate, London; Public Art Gal., Brighton. Contributor: London Studio, Magazine of Art, London Art Chronicle, other publications [40]

ERTZ, Gordon [P,I,C,T] Chicago, IL b. 19 F 1891, Chicago. Studied: self-taught. Member: Palette and Chisel C. [21]

ERVIN, Gladys Dee [P,T,C,L] Cincinnati, OH b. 4 F 1887, Dayton, KY. Studied: Univ. Cincinnati; Columbia; V. Nowottny; L.H. Meakin. Member: Professional AA; The Crafters; Women's AC; Cincinnati AC. Exhibited: CM; Getz-Brown Gal. (one-man); Women's AC; Professional AA. Positions: T., Hughes H.S.; CM, Cincinnati [47]

ERYTHROPEL, Ilse [P] NYC. Exhibited: NAD, 1938; PAFA, 1939 [40]

ESCHENBACH, Paul [P,I] Cincinnati, OH b. 3 Ja 1867, NYC. Studied: ASL; DuMond, Cincinnati. Member: Cincinnati AC. Exhibited: Cincinnati AC, 1903 (prize) [19]

ESCHERICH, Elsa F. (Mrs.) [P] Pasadena, CA b. 20 Mr, 1888, Davenport, IA. Studied: Vanderpoel; Hawthorne; Walcott. Member: Calif. AC; West Coast Arts, Inc.; Los Angeles AL [33]

ESCHMANN, Jean Charles [C,Bookbinder] East Cleveland, OH. b. 23 Ja 1896, Basel, Switzerland. Studied: Switzerland. Member: Cleveland Mus.; Bookworkers of Am. Exhibited: CMA, 1936 (prize), 1939 (prize); Paris Expo, 1937 (med); GGE, 1939; Intl. Exh. Mod. Bookbinding, N.Y., 1935. Positions: T., Cranbrook Acad. A., 1929–33; Army Medical Lib., 1943– [47]

ESHERICK, Wharton [S,Des,C,Gr,P,B,I] Paoli, PA b. 15 Jy 1887, Phila. d. 1970. Studied: Chase; Beaux; Anshutz. Exhibited: Phila. Print C., 1937 (prize). Work: WMAA [47]

ESHNER, Ann [P] Phila., PA. Exhibited: Wanamaker Regional, Phila., 1934; PAFA, 1934, 1936; ACA Gal., N.Y., 1938; Intl. WC, AIC, 1938 [40]

ESKEY, William A. [E] North Hollywood, CA b. 21 Ag 1891, Sistersville, W.Va. Member: Laguna Beach AA. Work: etchings, Calif. State Lib.; Los Angeles Pub. Lib. [32]

ESKRIDGE, Robert Lee [P,I,Des,L,W] Honolulu, HI b. 22 N 1891, Philipsburg, PA. Studied: Los Angeles Col. FA; AIC; Chicago Acad. FA; A. Lhote; G. Senseney. Exhibited: P.-P. Expo, San Diego, 1915 (med); AIC, 1928 (prize). Work: Ala Moana Park Sports Pavilion. Author/Illustrator: "Manga Reva, The Forgotten Islands," "South Sea Playmates," pub. Bobbs, Merril Co.; "Umi—The Hawaiian Boy Who Became a King," 1937. Position: T., Univ. Hawaii [40]

ESNER, Arthur L. [P,G,T] Newmarket, NH b. 15 My 1902, Russia. Studied: New England Sch. Des.; Mass. Sch. A. Member: Am. Ar. Cong.; Boston S.Indp.A. Exhibited: MFA Springfield, Mass.; Currier Gal., Manchester, N.H. Work: W.R. Nelson Gal., Kansas City; Biro-Bidjan Mus., USSR [40]

ESSIG, George E(merick) [Mar.P,I,E] Atlantic City, NJ b. 2 S 1883, Phila. Studied: PAFA; E. Moran; J. Hamilton. Work: Mariner's Mus.; Phila. Mar. Mus. [25]

ESSINGTON, Edwin [P] Columbus, OH. Member: Columbus PPC [25]

ESTABROOK, Florence C. (Mrs.) [P,T] Wash., D.C. b. Lowell, MA. Studied: BMFA Sch. Member: Lg. Am. Pen and Brush Women [31]

ESTABROOK, Gertrude [P] Chicago, IL [15]

ESTE, Florence [Ldscp.P,En] Paris, France b. 1860, Cincinnati, OH d. 25 Ap 1926, Paris, France. Studied: PAFA; A. Nozai. Member: Phila. WCC; Soc. Nat. des Beaux-Arts. Work: PAFA; Luxembourg Gal. [17]

ESTEY, A. Genevieve (Mrs.) [P] Worcester, MA [24]

ESTHER, Sister (Newport) [Edu,P,L,W,I,S] St. Mary-of-the-Woods, IN b. 17, 1901, Clinton, IN. Studied: AIC; Syracuse Univ.; William Forsyth; Oskar Gross; Frances Foy; St. Mary-of-the-Woods Col. Member: Ind. AC. Exhibited: Hoosier Salon, 1933, 1937 (prize); 1939 (prize), 1940, 1942 (prize); MMA, 1944; Lakeside Press Gal., 1933; John Herron AI, 1938. Illustrator: "A Bible History," 1933. Positions: Founder, Catholic AA, 1936; Founder/Ed., Catholic Art Quarterly, 1937–40; T., St. Mary-of-the-Woods Col., Ind. [47]

ETHERINGTON, C. [P] Far Rockaway, NY [17]

ETNIER, Stephen Morgan [P] NYC/Popham Beach, ME b. 11 S 1903, York, PA. Studied: Yale; PAFA; Rockwell Kent; John Carroll. Work: MMA; BMFA; Vassar; PAFA; PMG; New Britain Mus. A.; Farnsworth Mus. A.; Wadsworth Atheneum [47]

ETS, Marie Hall(Mrs. Harold) [I] NYC b. 16 D 1895, Greenfield, Wis. Studied: N.Y. Sch. F.&Appl. A.; Univ. Chicago; AIC; F.V. Poole. Exhibited: AFA, 1945. Author/Illustrator: "Mister Penny," 1935, "The Story of a Baby," 1939; "In the Forest," 1944 [47]

ETTENBERG, Eugene M. [Des,W,L,T] NYC b. 21 O 1903, Westmount, Quebec. Studied: PIASch; NYU. Member: AIGA. Exhibited: AIGA, 1935–41; Morgan Lib., 1938, 1940; Printers Exh., 1938–41. Work: catalogues, MMA; Bache Coll., N.Y.; WFNY. Author: "Types for Books and Advertising," 1936. Editor: "Advertising and Production Year Book," 1936–40, "News Letter," AIGA, 1935–40. Contributor: American Printer, Publishers Weekly. Lectures: Typography. Position: Typographer, The Gallery Press, NYC, 1945– [47]

ETTING, Emlen [P,Dr] Haverford, PA b. 24 Ag 1905, Phila., PA. Studied: Lhote; Harvard. Member: Phila. Alliance. Exhibited: CI; VMFA; NAD; Audubon A.; PAFA; Midtown Gal. (one-man); CAM (one-man); Butler AI (one-man); Akron AI (one-man); Dayton AI (one-man); Bloomington AA (one-man); Ill. Wesleyan Univ. (one-man). Work: WMAA; PAFA; Atwater Kent Mus. Translator/Illustrator: "Le Cimitiere Matin," by Paul Valéry, 1932. Author/Illustrator: "Drawing the Ballet," 1944. Designer: scenery, costumes, "Joseph and His Brethren," ballet [47]

ETTINGHAUSEN, Richard [Mus.Cur,W,L,Hist] Wash., D.C. b. 5 F 1906, Frankfort, Germany. Studied: Univ. Frankfort; England. Member: Am. Oriental Soc. Editor: Ars Islamica, 1938– , Art Bulletin. Contributor: Ars Islamica; Bulletin of Iranian Inst.; Gazette des Beaux-Arts. Lectures: Persian Miniatures, Art of the Islamic Book. Positions: T., Iranian Inst., N.Y., 1934–37, NYU, 1937–38, Univ. Mich., 1938–44, Freer Gal. AL, 1944– [47]

ETTL, Alex J. [S,Indst.Des] Montclair, NJ b. 12 D 1898, Fort Lee, NJ. Studied: his father; R. Aitken; NAD; Columbia; CCNY. Member: F., NAD; Soc. Am. E. Work: Pennsylvania Bldg., Phila.; East Rutherford, N.J.; Saratoga; Friars Cl., N.Y. [47]

ETTL, John [S] Port Washington, NY/Staatsburg, NY. b. 1 Ag 1872, Budapest, Hungary d. 22 D 1940. Studied: Budapest; Vienna. Work: State Arsenal, N.Y.; East Rutherford, N.J.; Palace of Justice, Berne, Switzerland; Haverstraw; Bergen County Hist. Soc.; Pennsylvania Bldg., Phila. [40]

ETZ, Pearl Potter [P] Wash., D.C. Member: Wash. WCC [25]

EUGENE, Frank [Photogr,Des,Por.P,E,Edu] b.1865, NYC d. 1936, Liepzig, Germany. Family name: Smith (which he dropped). Studied: CCNY; Acad. Graphic Arts, Munich, 1886. Member: Photo Secession. Work: illus., Camera Work, 1904, 1909, 1910, 1916; AIC; MMA; Royal Photogr. Soc. Known as a portrait painter in NYC, ca. 1901; prominent member of the Pictorial Movement. Also known for his art nouveau paintings in Germany. Position: [first] Royal Prof. of Pictorial Photography at the Royal Acad., Munich (1913), having taught there since 1907. [01]

EULBERG, Veronica Appollonia [P] Portland, OR b. 20 Ag 1905, Portland. Studied: Jacques. Member: Oreg. Ar. Soc. [33]

EULER, Edwin [P] Brooklyn, NY/Provincetown, MA [24]

EULER, Reeves [P] Provincetown, MA b. 28 D 1896, De Lamar, NV. Studied: Corcoran Sch.; NAD; Hawthorne. Member: Provincetown AA; Beachcombers C. Exhibited: CGA; NAD; NGA; PMG; Provincetown AA; Univ. Ill.; Univ. Nebr.; Boise, Idaho Gal.; Papermill Playhouse, Short Hills, N.J.; Amherst Col. [47]

EUSTON, Jacob Howard [E,P,C] Chesterton, IN b. 4 O 1892, Lebanon, PA. Studied: Univ. Ill.; Cleveland Sch. A., with A.R. Dyer; AIC; with J. St. John; A. de Sauty. Member: Chicago SE; Northwest PM; Southern PM; AAPL; Chicago Gal. Assn. Exhibited: AIC, 1936; NGA, 1935; Chicago SE, 1935–45; Northwest PM, 1935; Southern PM, 1934–41; Phila. Pr. C., 1933; Chicago Gal. Assn.; Ind. Soc. Print, 1934–46; Hoosier Salon, 1931–40, 1937 (prize). Work: NGA; YWCA, Gary, Ind. [47]

EUWER, Anthony Henderson [I] Bellevue, PA b. 11 F 1877, Allegheny, PA. Studied: ASL. Author/Illustrator: "Rickety Ruins" [13]

EVALENKO, George A. [P] NYC [15]

EVANS, Anne [P] Denver, CO. Member: Denver AC; AFA [29]

EVANS, Blanche Rumsey (Mrs. Jocelyn H. de Grasse Evans) [P] NYC/Bath, NY b. 11 O 1880, Bath. Studied: Archipenko; Tucker. Work: Mem. A. Gld., Rochester [40]

EVANS, De Scott [P,T] b. 1847, IN d. 4 Jy 1898 (aboard the Bourgogne, on his way to paint a ceiling in Paris). Studied: Bouguereau, 1877. Exhibited: NAD; Tenn. Cent. Exh., 1897. Work: T.D. Crocker Coll., Cleveland. Position: Co-dir., Inst., Cleveland Acad. FA

EVANS, Dulah Llan (Mrs. Albert H. Krehbiel) [P,B,Dr,E,Dec,Li] Chicago, IL b. Oskaloosa, IA. Studied: AIC; W.M. Chase; W.A. Clark; ASL; Hawthorne. Member: Chicago AC [40]

EVANS, E.S. (Mrs.) [I] Brooklyn, NY. Member: B.&W. Cl. [01]

EVANS, Edgar Samuel [I,P] b. 1852, East Hamburg, NY d. 9 N 1919, Missoula, MT. Work: murals, Missoula County Court House, Mont. Capitol. Specialties: Indians; pioneers

EVANS, Edith [I,C] NYC b. 1886, Utica d. 27 N 1932. Studied: N.Y. Acad. A.&Des. Later became a well-known occupational therapist.

EVANS, Edwin [P,T] Salt Lake City, UT b. 2 F 1860, Lehl, UT d. 1946, CA. Studied: Univ. Utah, with Ottinger, Weggeland, 1890; Paris, with Laurens, Lefebvre, Benjamin-Constant, 1891–93; BAID, 1917–18. Member: Soc. Utah Ar., 1895 (first Pres.). Work: Brigham Young Univ.; Univ. Utah. Positions: Hd, A. Dept., Univ. Utah, 1898–20; Pres., Utah AI, 1906-16 [27]

EVANS, Elizabeth E. [I,P,G] Willock, PA b. 8 F 1908, Willock. Studied: CI; ASL. Member: Assoc. A., Pittsburgh [40]

EVANS, Elizabeth H. [P,I,C,T] Wash., D.C. b. 13 Mr 1896, Fort Brady, MI. Studied: H.B. Snell; Bredin; Giles. Member: NAWPS; S. Wash. A.; Wash. WCC [27]

EVANS, Ethel [P] Las Vegas, NV b. 1866 d. 22 Ap 1929, NYC. Studied: Paris; Phila. Member: NAWPS; Pen and Brush C., N.Y. Exhibited: WFNY, 1939 [40]

EVANS, Eva Clemence (Mrs.) [P] Providence, RI. Member: Providence AC [25]

EVANS, Fannie [P] Baltimore, MD [13]

EVANS, Francis [Min.P] NYC [25]

EVANS, Frederick, Mrs. See Keyes, Emilie.

EVANS, G. Gerald [P,C,Des] Phila., PA b. Phila. Studied: Phila. art schools. Member: T-Sq. C. Specialty: interiors [10]

EVANS, George [I,Car] NYC. Work: Cosmopolitan, 1939 [40]

EVANS, Grace French [P] Davenport, IA/Woodstock, NY b. Davenport. Studied: H. More; K.H. Miller. Member: AFA; NAWPS; Woodstock AA [33]

EVANS, Grace L. [P] NYC b. 19 F 1877, Pittston, PA. Studied: Drexel Inst.; PAFA; Breckenridge; Anshutz; Chase; Phila. A. All. Exhibited: Warwick Gal.; Kiser Alman Gal., Phila.; Gimbel's, 1934 (prize) [47]

EVANS, Harold E. [P] Cleveland, OH. Member: Cleveland SA [25]

EVANS, Jessie Benton [P,E,T] Scottsdale, AZ b. 24 Mr 1866, Akron, OH. Studied: AIC, 1904; Chase, in Chicago; Zilla, in Venice. Member: Chicago SA; Chicago AC; Phoenix AC; AFA; Salvator Rosa, Naples. Exhibited: Ariz. State Fair, 1913 (prize), 1923 (prize). Work: Municipal Coll., Phoenix; Ariz. C.; College C., Chicago; Vanderpoel AA; AIC Coll.; Akron AI; Ariz. State Fed. [40]

EVANS, Joe [Ldscp.P] b. 29 O 1857, NYC d. 23 Ap 1898. Studied: NAD; ASL; L'Ecole des Beaux- Arts, 1877; Gérôme, 3 yrs. Member: SAA; ASL; FA Soc. Exhibited: SAA

EVANS, John W(illiam) [Wood En] Brooklyn, NY b. 27 Mr 1855. Studied: P.R.B. Pierson. Exhibited: Pan-Am. Expo, Buffalo, 1901 (med); St. Louis Expo, 1904 (med); P.-P. Expo, San Fran., 1915 (med). Work: NYPL; CI; Brooklyn Inst. A.&Sc [40]

EVANS, M.E. [P] NYC [17]

EVANS, Margaret [P,C,L,T] Youngstown, OH b. Youngstown. Studied: ASL, with Birge Harrison, John Carlson; Woodstock; Columbia, with A. Dow; Europe. Position: Dir., Butler AI [31]

EVANS, Rudolph [S] NYC b. 1 F 1878, Wash., D.C. Studied: Corcoran Sch. A.; ASL; Ecole des Beaux-Arts; Académie Julian, Paris; Falguière; Rodin. Member: ANA; NSS; NAD, 1929; Paris AAA; Allied AA; NIAL, 1926. Exhibited: Paris Salon, 1914. Work: U.S. Capitol; Luxembourg Mus.; MMA; CGA; Detroit Inst. A.; Colorado Springs FA Center; NYU; Princeton; Bureau Am. Republics, Wash.; mem., Greenwich, Conn., Green Bay, Wis., Detroit, Nebraska City, Hall of Fame, N.Y.; Capitol, Richmond, Va.; Century of Progress Exh., Chicago [47]

EVANS, Rufus W. [P] Macon, GA [13]

EVANS, S.J. [P] Edgebrook, IL [15]

EVANS, Virginia Bargar [Des,P,T] Moundsville, WV b. Moundsville. Studied: CI; PAFA; Fontainebleau; Tiffany Fnd.; G. Oberteuffer. Member: Wheeling AC; AA Pittsburgh; NAWA. Position: Des., Imperial Glass, Bellaire, Ohio, 1943– [47]

EVANS, Walker [Photogr] b. 1903 St. Louis, MO d. 1975, New Haven, CT. A major photographer, best known for his break from the aesthetics of Stieglitz and Steichen. Work: FMA; LOC; MET; MOMA; Univ. N.Mex.; NOMA; San Fran. MA; Yale; most major collections. His best known illustrations are in Agee's "Let us Now Praise Famous Men," 1941. Positions: FSA photographer, 1930s; worked for Time and Fortune; T., Yale Sch. FA, early 1970s. [*]

EVANS, Wilfrid Muir [P] Hartford, CT [15]

EVANS, William T. [Patron] Glen Ridge, NJ b. 1843, Clough Jordan, Ireland (came to U.S. as a small boy) d. 25 N 1918. He gave collections of paintings to NGA and Montclair Museum.

EVANSON, Lelia L. [P] NYC [24]

EVATT, Harriet (Torrey) (Mrs. William) [P] Worthington, OH b. 24 Je 1895, Knoxville, TN. Studied: Columbus (Ohio) A. Acad; C. Rosen; A. Schille; R. Chadeayne; M. Russel. Member: Columbus A. Lg.; Ohio WC Soc.; Lg. Am. Pen Women. Exhibited: Columbus Gal. FA, 1946 (prize). Author/Illustrator: "The Snow Owl's Secret" (1946), "The Red Canoe" (1940), other books [47]

EVELETH, Lolita [P] Brooklyn, NY [19]

EVERETT, Caroline Mills [Por.P,W] d. 14 Jy 1921, Paris. Author: "The House Opposite," "The Privilege of Pain"

EVERETT, E(dith) M(argaret) Leeson [P,L] Norfolk, NY b. 12 D 1881, London, England. Studied: Sargent, Royal Academicians. Exhibited: Royal Acad., London (prize). Work: stained glass, Farnsfield Church, Nottinghamshire [19]

EVERETT, Edward D. [P] Malden, MA b. 31 Mr 1818, London. Settled in Quincy, Ill. after 1840; Springfield, Ill., during the Civil War; Sing Sing, N.Y., 1865–99; then Roxbury and Malden, Mass. He was the nephew of Edward Everett Hale, the great orator. [01]

EVERETT, Elizabeth Rinehart [P,C,S,L] Seattle, WA b. Toledo, OH. Studied: A. Deming; W. Isaacs; D. Pratt; L. Derbyshire; PIASch; Univ. Wash. Member: SAM; Women P. of Wash.; Seattle Photographic Soc. Exhibited: Western Wash. Fair, 1920 (prize); Women P. of Wash., 1933 (prize); Marshall Field, Chicago, 1946; SAM; Frederick & Nelson, Seattle [47]

EVERETT, Eugenia [S] Ojala, CA b. 27 N 1908, Loveland, CO. Studied: R.N. Burnham; Otis Art Inst.; M. Gage; Chouinard Sch A. Exhibited: Los Angeles Co. Fair, 1931 (prize), 1934 (prize), 1939 (prize); Ebell Cl., 1932 (prize) 1936 (prize), 1938 (prize); Calif. AC, 1932 (prize), 1938 (prize); Southern Calif. Festival FA, 1937 (prize); Los Angeles Mus., 1938 (prize) [40]

EVERETT, Florence [P,T] St. Louis, MO b. Thorold, Ontario. Studied: H.B. Snell; A.W. Dow; F. Fursman. Member: St. Louis Indp. A.; St. Louis AG [40]

EVERETT, George Clowes [Mar.P] Brooklyn, NY b. 1865, Williamsburg, NY d. 16 F 1926. Studied: ASL. Founder: Artists' Colony, Monhegan, Maine [08]

EVERETT, Herbert Edward [S,T] Phila., PA b. Worcester, MA d. 1935. Studied: BFMA Sch.; Académie Julian, Paris; PAFA. Member: Phila. WCC [33]

EVERETT, Joseph A(lma) F(reestone) [P,E,I,T] Salt Lake City, UT b. 7 Ja 1884, Salt Lake City d. Ap 1945. Studied: South Kensington Sch., England, with E.A. Smith, 1906–08; NYC, with Cox; France; Harwood. Exhibited: Utah State Fair (prizes). Work: Utah AI, Salt Lake City; State of Utah [40]

EVERETT, Lena Mills (Mrs. Leo) [P] NYC b. Rhode Island. Studied: Académie Julian, Paris. Specialty: portraits in pastel [04]

EVERETT, Lily (Abbott) [P,W,T] Lorane, GA b. 16 Ag 1889, Macon, GA. Studied: Chase; K.H. Miller. Member: Société des Beaux-Arts et des Lettres, Paris. Exhibited: Ga. State Fair (prizes) [17]

EVERETT, Louise [P,S] Los Angeles, CA b. 9 Ap 1899, Des Moines, IA. Studied: Fursman; Hawthorne; J.B. Wendt; Otis Art Inst.; Fontainebleau Sch. FA; Académie Julian, Paris. Member: Calif. AC; Laguna Beach AA; Women P. of the West. Exhibited: West Coast Arts, 1923 (prize); Laguna Beach AA, 1923 (prize); Pacific Southwest Expo, 1928 (med) [31]

EVERETT, Mary O. (Mrs. H.G.) [P] Los Angeles, CA b. 30 D 1876, Mifflinburg, PA d. 28 Je 1948. Studied: Chase; Hawthorne; F. Furzeman. Member: Calif. AC; Women P. of the West; Laguna Beach AA; AFA. Exhibited: Des Moines Women's Cl., 1909 (prize), 1910 (prize). Work: Ojai A. Center [47]

EVERETT, Raymond [P,S,L,T] Austin, TX b. 10 Ag 1885, Englishtown, NJ. Studied: Drexel Inst., 1906; Harvard, 1909; Pyle; J.L. Lindon; Denman Ross; Académie Julian, Paris; Rome. Member: Tex. FAA; SSAL. Exhibited: SSAL, San Antonio, 1929 (med). Work: Detroit Pub. Lib.; Elisabet Ney Mus., Austin; Univ. Colo. Mus. Positions: T., Univ. Pa.; Univ. Mich.; Univ. Tex., 1917– [40]

EVERETT, Roberta [G] Cranford, NJ b. 2 Je 1911. Studied: Lewis C. Daniel. Exhibited: Nat. Acad., 1938; CAFA, 1938; PAFA, 1938; Denver AM, 1939; WFNY, 1939 [40]

EVERETT, Walter H. [I] Phila., PA [19]

EVERGOOD, Miles [P,T] NYC b. 10 Ja 1871, Melbourne, Australia. Member: SC [27]

EVERGOOD, Philip (Howard Francis) [P,S,T,G,W,L,Des,I] NYC/Barnstable, MA b. 26 O 1901, NYC d. 1973. Studied: Slade Sch., London; Académie Julian, Paris; ASL. Member: An Am. Group; Am. Soc. PS&G; Mural P.; Am. A. Cong.; United Am. Ar. Exhibited: AIC, 1935 (prize), 1946 (prize); AV, 1942 (prize); Pepsi-Cola, 1944 (prize); CI, 1938, 1939, 1945 (prize); La Pintura Contemporanea Norte Americana, 1941; WFNY, 1939; WMA, 1942; Am.-Brit. Goodwill Exh., 1944; Tate Gal., London (loan exh.), 1946. Work: Encyclopaedia Britannica Coll.; Pepsi-Cola Coll.; MMA; MOMA; WMAA; BMFA; Ariz. State Univ.; Denver A. Mus.; BMA; BM; Kalamazoo AI; Nat. Gal., Melbourne; Geelong Gal., Victoria, British Columbia; Los Angeles Mus. A.; FMA; AIC; Richmond Hill (N.Y.) Lib.; USPO, Jackson, Ga.; Kalamazoo Col. Illustrator: Fortune, Time. WPA artist. [47]

EVERHART, Adelaide [P,I] Decatur, GA b. 30 Ja 1865, Charlotte, NC. Studied: Cincinnati A. Acad.; ASL, with Lutz, Noble, Chase, Reid. Member: Atlanta AA; AFA; Assn. Ga. A. Work: Ga. State Capitol; State of Ga.; State of Ala.; Carnegie Lib., Emory Univ.; Ga. Military Acad.; Atlanta Hist. Soc.; De Kalb County (Ga.) court house; Decatur City Hall; Univ. N.C.; Madison County (Ky.) Court House; Eastern T. Col., Ky.; Atlanta Chapter, D.A.R.; portraits, various banks in Ga. and Ky. Illustrator: "Roses of St. Elizabeth," "Gabriel and the Hour Book," "The Young Knight," "Clementina's Highwayman" [47]

EVERINGHAM, Millard [P,E,C,G] Ranchos de Taos, NM b. 8 S 1912, Eagle Village, NY. Studied: Syracuse Univ.; Tiffany Fnd.; Univ. Mexico. Exhibited: Nat. Coll. FA, Smithsonian; GGE, 1939; PAFA, 1940, 1941; Coronado Quatro Centenn., 1940; Mus. N.Mex., 1939, 1940; A. Lg. N.Mex, Albuquerque, 1939, 1945. Work: Syracuse Univ. Coll.; Pal. Leg. Honor; Dallas Mus. FA; Rochester Mem. A. Gal.; mural, Deming, N.Mex [47]

EVERITT, Paulina [P] Independence, MO. Exhibited: PAFA, 1937; Midwest Ar. Ann., Kansas Cty AI, 1937–39; WFNY, 1939 [40]

EVERS, Ivar Eils [P,Arch] New Paltz, NY b. 28 O 1866, Sweden. Studied: Cæsar, in Sweden; De Camp, in Boston; Twachtman, in NYC. Member: S.Indp.A. [25]

EVERTON, Louise Smith [P] Lutherville, MD b. 27 Ag 1920, Birmingham, AL. Studied: ASL, with Marsh, Corbino; Md. Inst., with R.M. Mackall; H. Elliott; K. Fitzpatrick. Member: SSAL; Ala. A. Lg.; Ala. WC Soc.; Birmingham AC. Exhibited: Dixie A. Colony, 1939, 1940, 1941 (prize), 1942, 1944, 1945; Birmingham AC, 1940–44, 1945 (prize); AWCS, 1945; NAC, 1945; Pasadena AI, 1946; BMA, 1944–46; Ala. A. Lg., 1940–42, 1944, 1945; SSAL 1941, 1942 (Traveling Exh.); Miss. AA, 1942; Ala. WC Soc., 1940–42, 1945 [47]

EVETT, Kenneth [P] Colorado Springs, CO. Exhibited: Denver AM, 1936. Work: mural, USPO, Horton, Kans. WPA artist. [40]

EWALD, Louis [P,I,Des,C] Phila., PA b. Bryn Athyn, PA. Studied: Minneapolis Sch. A.; PMSchIA. Member: Phila. All. Work: paintings and interior des., churches in Drexel Hill, Rosemont, Phila., Chester, all in Pa.; Lib., Muhlenberg Col. [47]

EWALD, Marion Butler (Mrs. Lawrence) [P] Harford County, MD b. 22 Je 1910, Meriden, CT d. 22 My 1944. Studied: PAFA. Member: Ar. U., Baltimore; Friends of A., Baltimore. Exhibited: PAFA, 1927 (prize); Baltimore MA; Phillips Mem. Gal., Wash., D.C.; WFNY, 1939. Work: mural, Harford County Courthouse; Municipal A. Soc., Baltimore [40]

EWART, Mary F.R. Clay (Mrs. Alan Campbell Ewart) [P] Winnipeg, Manitoba b. Phila. Studied: Collin, Macmonnies, in Paris; W.M. Chase. Member: Plastic Cl.; F., PAFA; Western Art Assoc., Winnipeg. Exhibited: PAFA, 1900 (prize) [17]

EWELL, Hazel Crow [P,Li] Ravinia, IL b. 18 N 1888, Bird City, KS. Studied: AIC; E. Zorn; G. Oberteuffer. Member: North Shore AL, Evanston; Chicago AC. Exhibited: Evanston Women's Cl., 1932 (prize), 1936 (prize), 1937 (prize); North Shore AL, 1937 (prize) [40]

EWELL, James Cady [P] Evanston, IL [19]

EWELL, Miss [P] Staunton, VA [17]

EWENS, Homer [P] New Rochelle, NY. Member: New Rochelle AA [24]

EWERTZ, Henry [S] Aldan, PA. Exhibited: Nat. Acad., 1933, 1934; PAFA, 1935, 1938, 1939 [40]

EWING, Alice B. [P] Phila., PA. Member: F., PAFA [25]

EWING, Charles [P,I,Arch] Tarrytown, NY [04]

EWING, Charles Kermit [Edu,P,C,Li,T] Pittsburgh, PA b. 27 My 1910, Bentleyville, PA. Studied: CI, with Alexander Kostello; Iowa Univ., with Jean Charlot; Harvard. Member: New Rochelle Ar. Assn.; Assoc. A. Pittsburgh, F., Tiffany Fnd., 1932. Exhibited: Assoc. A. Pittsburgh, 1938, 1939, 1940 (prize), 1941, 1942, 1943 (prize), 1945 (prize), 1946 (prize); Parkersburg, W.Va., 1942 (prize), 1943 (prize); Springfield, Mass., 1941 (prize); NAD, 1938; Butler AI, 1939–43, 1945; CI, 1945, 1946; All. A. Phila., 1941; State T. Col., Indiana, Pa., 1946; Pepsi-Cola, 1946. Work: Pittsburgh Pub. Sch.; State Col., Pa.; Univ. Pittsburgh. Position: T., CI, 1942– [47]

EWING, Edgar [P] Chicago, IL. Exhibited: Intl. WC Exh., AIC, 1934, 1935, 1938; Ar. Chicago Vicinity, AIC, 1934, 1935, 1939; Am. PS Ann., AIC, 1935, 1938 [40]

EYDEN, William Arnold [P,L] Indianapolis, IN b. 25 F 1893, Richmond, IN. Studied: W.A. Eyden, Sr., T.C. Steele, Hawthorne. Member: Bundy Cl.; Hoosier Salon; Marian Co. AC; Richmond AA; Ind. AC; S.Indp.A.; Asheville AA; Indianapolis AA. Exhibited: Hoosier Salon, 1936 (prize), 1941–44, 1945 (prize), 1946 (prize); Richmond, Ind., Exh., 1927 (prize); Richmond AA, 1915–27, 1928 (prize), 1929–44; Wawasee A. Gal., 1944 (prize); Ind. AC, 1945 (prize); PAFA; Indianapolis AC, 1930–46; John Herron AI, 1946. Work: Richmond AA; Ball State T. Col.; Ind. Univ.; public schools in Richmond, Muncie, Anderson, Indianapolis, all in Ind. Lectures: The Rhythm and Pattern of Painting [47]

EYDEN, William T. [Ldscp.P] Richmond, IN b. 1859, Hanover, Germany (came to U.S. in 1866) d. 22 Mr 1919. Founder: Art Assoc. of Richmond

EYRE, Louisa [S] Franklin, NH b. 16 Ja 1872, Newport, RI. Studied: PAFA; ASL; Grafly; Anshutz; St.-Gaudens; Cox. Member: Phila. All.; A.&Crafts Societies of Phila., Boston, New York. Exhibited: Pal. Leg. Honor; NSS; PAFA, 1896–1945. Work: decorative reliefs, Univ. Mus., Phila.; Dennison Bldg., New York; tablet, West Point, N.Y.; mem. tablet, Wash. (D.C.) Cathedral. Designer: Charles E. Dana gold medal [47]

EYRE, Wilson [S,Arch] Phila., PA. Member: T Sq. Cl., 1883; Phila. AC; AIA, 1893. Exhibited: St. Louis Expo, 1904 (med) [08]

EYTINGE, Sol [P,I] Bayonne, NJ b. 1833 d. 25 Mr 1905. On the staff of Harper's Weekly for may years, his pictures of the Southern negro (published during the Civil War) gained him a wide reputation. Illustrator: "Beyond the Mississippi," 1867. He was a warm personal friend of Charles Dickens and fellow illustrator Alfred Waud.

EZEKIEL, Moses (Jacob) (Sir) [S] Rome, Italy b. 28 O 1844, Richmond, VA d. 27 Mr 1917. Studied: Royal Acad. Art, Berlin; Albert Wolf. Member: NSS. Exhibited: Berlin, 1873 (Prize of Rome); Royal Art Assoc., Palermo (med); Urbino (Raphael med); St. Louis Expo, 1904 (med). Work: Fairmount Park, Phila.; Jefferson Monument, Louisville, Ky.; Westminster, London; Lexington, Va. Women's Confederate Mem., Arlington Cemetery; Westmoreland, Va.; Jewish Orphan Asylum, New York; Columbus Mem. Bldg., Chicago; Johnson's Island, Ohio; City of Paris; Cincinnati Mus. Awards: Knighted by King Humbert of Italy; Knighted by the Emperor of Germany; the Cavalier crosses for Merit in Art and Science from the Emperor of Germany and from the Duke of Saxe-Meiningen; the cross of an Officer of the Crown of Italy from King Victor Emmanuel. His studio in Rome, in the ancient structure which formerly sheltered the Baths of Diocletian, was one of the show places of the city. His acquaintance with famous men of his time was wide and among his friends, of some of whom he made busts, were Cardinal Hohenlohe, Liszt, and the Grand Duke of Saxe-Meiningen. [15]

F

A.B. Frost: *Watching the Artist*. Private Collection

FABER, Arthur [P] NYC b. 1 Ja 1898, Phila. Studied: CUASch; NAD; ASL. Member: Am. Ar. Cong.; A. Un., N.Y. Work: WMAA; Pasteur Inst., Paris [40]

FABER, Eugene James [P,Des,C,W,L,T] Milwaukee, WI b. 13 Jy 1910, Milwaukee. Studied: Milwaukee State T. Col.; Gustave Moeller; Arthur Gunther; Robert von Neumann. Member: Wis. P&S Assn.; Western AA. Exhibited: Milwaukee AI, 1933, 1934, 1935 (prize), 1936–41; AIC, 1934, 1936; CGA, 1934, 1939; Univ. Wis., 1935–37; Layton A. Gal., 1934, 1939; S.S. Rotterdam, 1939 (one-man). Work: Wis. and Milwaukee pub. bldgs. Contributor: School Arts; Design. Specialty: redesigning old houses. Positions: Hd. A. Dept., Kilburn Jr. Trade Sch., Milwaukee, Wis., 1935–42; Staff Officer, Combat Engineers, 1944–45; Chief of Military Personnel, Great Lakes Div. Engineers, 1945–46 [47]

FABER, Harman [P,E] Phila., PA b. 1832, Germany (came to U.S. in 1854) d. 10 D 1913. During the Civil War he served as artist on the Surgeon General's staff, U.S. Army. Illustrator: U.S. medical record of the war

FABER, John [P] d. 1906. Member: NYWCC

FABER, Ludwig E. [P,E] Phila., PA b. 21 O 1855, Phila. d. 16 My 1913. Studied: PAFA; Paris, with Constant, Lefebvre, Robert-Fleury; Munich Acad. Member: Phila. Sketch C.; Phila. Soc. Etchers; Paris AAA; Pa. SMP [13]

FABIAN, Lydia Dunham [P] Chicago, IL b. 12 Mr 1867, Charlotte, MI. Studied: ASL; AIC; O. Linde; H. Henshall. Member: Santa Fe SA [33]

FABIEN, Z.H. [P] Paris, France [01]

FABION, John [P,S] Chicago, IL b. 31 O 1905, Vienna, Austria. Studied: AIC, with Boris Anisfeld; Royal Acad., Florence; A. Hanak, Vienna; X. Dunikowski, in Kraków. Exhibited: GGE, 1939; Nat. Mus.; AIC 1933 (prize), 1934, 1936 (prize), 1938, 1939; WPA Exh., AIC, 1938. Work: USPO, Betford, Ind. Positions: T., AIC, 1939; Combat Artist, U.S. Marines, 3 yrs. [47]

FABRI, Ralph [P,E,W,L] NYC b. 23 Ap 1894, Budapest, Hungary d. 1975. Studied: Royal Inst. Tech., Budapest; Royal Acad. FA, Budapest. Member: NA; SAE; SC; CAFA; Audubon A. Exhibited: NAD, 1936–46; SAE, 1935–46; SFMA, 1941–45; Northwest PM, 1941–46; Oakland A. Gal., 1941–46; AIC, 1932, 1935, 1939; PAFA, 1941, 1942; AWCS, 1941; CAFA, 1942–44, 1945 (prize); Phila. WCC, 1942; AV, 1943 (prize); Denver A. Mus., 1944; Phila. Pr. C., 1942–46; Audubon A., 1945; LOC, 1943–46, (prizes); Smithsonian Inst., 1942 (one-man); Honolulu Acad. A., 1943 (one-man); Phila. A. All., 1943, 1944 (one-man). Work: LOC; Honolulu Acad. A.; Vanderpoel Coll. [47]

FABRY, Alois, Jr. [P] NYC. Work: USPOs, Williamsburg, Ky., Upper Sandusky, Ohio. WPA muralist. [40]

FACCI, Domenico (Aurelio) [S,C,T] Brooklyn, NY b. 2 F 1916, Hooversville, PA. Studied: Roerich Acad. A.; Pietro Montana; Louis Slobodkin; W. Zorach. Exhibited: NAD, 1936, 1944. Position: T., Roerich Acad. A., NYC, 1939– [47]

FACKERT, Oscar William [P,I] b. 29 Jy 1891, Jersey City. Studied: Schook; Grant; Gottwald; Bentley. Member: P.&C. C. Exhibited: Northern Ind. Exh., 1923 (prize), 1924 (prize), 1925 (prize); Midwest Exh., Kansas City AI, 1924 [40]

FAGAN, James [Por.P,E] NYC b. 1864, NYC [10]

FAGG, Kenneth S. [I,P,E] Chappaqua, NY b. 29 My 1901, Chicago, IL Studied: Univ. Wis.; AIC; ASL; Pennell; Bridgman; DuMond; Harvey Dunn. Member: SI; AWCS; AG. Exhibited: AWCS, 1942, 1944–46 [47]

FAGGI, Alfeo [S,L] Woodstock, NY b. 11 S 1885, Florence, Italy. Studied: Academia Belle Arti, Florence. Member: Salons Am.; Woodstock AA. Exhibited: AIC, 1942 (prize), 1943; Albright A. Gal., 1941 (one-man); Fairmount Park AA, 1940; WMAA, 1942, 1943; PAFA, 1943; Argent Gal., 1944; Woodstock AA; Little Gal., Woodstock, 1946; Univ. Chicago. Work: AIC; AGAA; WMAA; Mus. N.Mex.; Minneapolis Inst. A.; SAM; Albright A. Gal.; Columbus Mus. A.; PMG; Mich. State Univ.; St. Thomas Church, Chicago; mem., NYC; Wash., D.C.; Chicago, Ill.; Arts Club, Chicago; Wood's Hole, Mass.; Chicago Univ. Mus.; Hutchinson Mem., Graceland, Chicago; Honolulu Acad. A. Position: T., Columbia [47]

FAGIN, Charles F. [P] Macon, GA [13]

FAGNANI, Nina [P] Paris, France [10]

FAHEY, A. Esther Edwards [P] [17]

FAHNESTOCK, Wallace Weir [P] Dorset, VT b. Jan 15, 1877, Harrisburg, PA. Studied: Cleveland Sch. A.; Chase Sch.; ASL. Member: SC; Southern Vt. Artists; CAFA. Work: Boston City C.; Middlebury Col.; Univ. Vt.; Wood A. Gal., Montpelier, Vt. [40]

FAHRENBRUCH, Lottie [P] Wash., D.C. [21]

FAIG, Frances Wiley (Mrs.) [P] Cincinnati, OH. Studied: Duveneck; Grover; Hawthorne. Member: MacD. C. Cincinnati; Cincinnati Women's AC; Cincinnati Soc. Prof. A. Member: Engineering Lib., Univ. Cincinnati [40]

FAILING, Frances E(lizabeth) [P,T] Indianapolis, IN b. Canisteo, NY. Studied: PIASch; Western Reserve; Columbia; Butler Univ.; C. Martin; Hawthorne; Frank Wilcox. Member: Ind. Artists C.; Plymouth (England) AC; NAWA. Exhibited: CM, 1934, 1936, 1937; PAFA, 1936; AIC, 1937; BM, 1937; NAWA, 1936, 1937 (prize), 1938, 1941; CGA, 1937; NYWCC, 1936; Grand Central Palace, 1936; John Herron AI, 1933–35, 1937, 1938, 1940–43; Hoosier Salon, 1934–36, 1941; Ind. A. Cl., 1932–34, 1936; Kansas City AI, 1938; Coulter Gal., Cleveland, 1936; Lieber Gal., Indianapolis, 1936; Dallas Mus. FA, 1938; Mus. FA, Houston, 1939; Baylor Univ., 1938; Ball State A. Gal., Muncie, Ind., 1937; Ind. AA, 1934 (prize); abroad. Position: T., Washington H.S., Indianapolis, 1935– [47]

FAILING, Ida [P] Denver, CO. Member: Denver AA [25]

FAILLE, Carl Arthur [P,E,C,L,T] Clarksville, NY b. 17 F 1884, Detroit, MI. Studied: self-taught. Member: SC; AAPL. Exhibited: Montclair A. Mus.; Albany Inst. Hist.&A.; Union Col.; McClees Gal., Phila. Work: Joslyn Mem.; Detroit Inst. A.; Albany Inst. Hist.&A.; Soc. FA, Omaha. [47]

FAINT, J.B. [P] d. 22 Je 1915, Oil City, PA (suicide)

FAIR, Paul J. [S] Oakland, CA [17]

FAIR, Robert [P] Phila., PA b. 1847, County Mayo, Ireland (came to NYC in 1876) d. My 1907. Exhibited: PAFA

FAIRBANKS, Avard (Tennyson) [S,T] Salt Lake City, UT (1976) b. 2 Mr 1897, Provo, UT. Studied: ASL, with J.E. Fraser; Beaux-Arts, with Injalbert; Yale; Univ. Wash.; Acadmie Colarossi, Grand Chaumière,

both in Paris; Univ. Mich; A.P. Proctor; C.R. Knight. Member: NSS; AFA; Arch. Lg.; Ann Arbor AA; Scarab C.; Circolo degli Artisti of Florence; F., Guggenheim Fnd., 1927. Work: Laie, Oahu, Hawaii; service mem, Oreg. Agriculture Col., Corvallis; U.S. National Bank, Portland, Oreg.; Washburne Gardens, Eugene; mem., Vancouver, Wash.; mem., Salt Lake City; St. Mary's Cathedral, Eugene; Power House, Univ. Oreg.; mem., Fort Lewis, Wash.; Hall of Religion, Century of Progress Expo; Zeder Home, Detroit; Grand Detour, Ill.; mon., Omaha; mem., Utah State Agriculture Col.; WFNY, 1939; mem., Salt Lake City; Brookgreen Gardens, S.C.; Univ. Mich. Positions: T., Univ. Mich. (1927–47), Univ. Utah (1947–) [47]

FAIRBANKS, Charles Mason [P,Cr,W] NYC d. 29 My 1924. Member: SC. Positions: A./Correspondent, New York Times; A. Cr., Town Topics; New York Sun[24]

FARIBANKS, Ella A. [P] Boston, MA [01]

FAIRBANKS, Frances J. (Mrs.) [P] b. 1835 d. 24 F 1913, Paterson, NJ

FAIRBANKS, Frank P. [P,Dec] NYC/Rome, Italy b. 1875, Boston d. 10 Ag 1939. Studied: Tarbell; De Camp; BMFA. Member: Arch. Lg., 1913; Mural P.; F., Am. Acad., Rome, 1909–12. Work: Pub. Lib., St. Paul, Minn.; Univ. Cincinnati; Memorial Apse, Tivoli-on-Hudson; Municipal Bldg., NYC; Scottish Rite Temple, Wash., D.C.; mem. Am. Acad., Rome. Position: T., Sch. FA, Am. Acad, Rome, 1921–32 [38]

FAIRBANKS, John B. [P,T] Salt Lake City, UT b. 27 D, 1855, Payson, UT d. Je 1940. Studied: Paris, with Constant, Lefebvre, Laurens. Member: Paris AAA; Acad. Western Culture. Exhibited: Utah State Fair, 1899 (prize), 1913 (prize), 1918 (prize), 1920 (prizes); Payson H.S. Exh., 1926 (prize). Work: Salt Lake City Temple, Ariz. Temple, St. George Temple, Utah; Latter Day Saints Church, Hall of Religions, Century of Progress Expo, Chicago; San Diego Expo; Hyland Pk. Church, Salt Lake City [40]

FAIRBANKS, John Leo [P,S,Arch,I,L,T,W] Corvallis, OR d. 3 O 1946. Studied: his father, John B.; Académie Julian, Paris, with Laurens, Simon, Bohn, Verlet. Member: AAPL; AFA; Soc. Oreg. A.; Arch. Lg. Work: Mormon Temple, Hawaii; Salt Lake Temple; Oreg. State Col.; State War Mem., Idaho; Mesa, Ariz.; temple, Logan, Utah; Hall of Religion, Century of Progress, Chicago, Ill.; Expo, San Diego. Lectures: Home Building; City Planning. Positions: T., Salt Lake City schools (1904–23), Columbia, Univ. Chicago; Hd. A. Dept., Oreg. State Col., 1923–46 [40]

FAIRBANKS, Mary Lord [E] Cambridge, MA [19]

FAIRCHILD, (Charles) Willard [I] NYC/Washington, CT b. 18 N 1886, Marinette, Wis. Studied: Chicago Acad. FA; ASL. Member: SI; Art. Dir. C.; Players C. [40]

FAIRCHILD, Elizabeth Nelson [P,E] NYC/Rhinebeck, NY b. Yonkers, NY. Studied: G. Bridgman; DuMond; C.W. Holt; May Fairchild. Member: Wolfe AC. Exhibited: All.A.Am., 1945. Illustrator: "True Story of Fala" [47]

FAIRCHILD, Hurlstone [P,I,W] b. 1893, Danville, IL d. 1966, Tucson. Studied: Univ. Ill.; Univ. Mich.; Mo. Sch. Mines. Work: Denver AM; Grand Canyon Nat. Park Coll. Illustrator: "An Artist's Notebook," 1950, "Grand Canyon Sketches and Verse" [*]

FAIRCHILD, Leonard G. [P] Worcester, MA [24]

FAIRCHILD, Lucia. See Fuller.

FAIRCHILD, Mary. See Low, Mrs.

FAIRCHILD, May [Por.P,Min.P] NYC/Rhinebeck, NY b. Boston, MA. Studied: Cowles Art Sch.; ASL, with John F. Carlson, K. Cox, B. Harrison; Colarossi Acad., André Lhote, both in Paris. Member: NAWPS; PBC; ASL; Brooklyn Min. S.; Wolfe AC; Allied AA; Yonkers AA. Work: Northfield School, Mass.; State Normal Sch., Plattsville, Wis. [47]

FAIRCHILD, Willard [I] b. 1887 Marinette, WI d. 4 Ja 1946, NYC. Member: SI. Position: A. Dir., Travel magazine

FAIRFIELD, Clara L. [P] Brooklyn NY [04]

FAIRMAN, James [Ldscp.P,Cr,L,T] NYC b. 1826, Glasgow, Scotland (came to U.S. in 1832) d. 12 Mr 1904. Studied: NAD, 1842; England; France; Italy; Germany, 1871–81. Exhibited: drawings, Am. Inst., 1846. Studio in NYC, 1860s–71. Also a musician. Position: T., Olivel Col., beginning 1880

FAIRMAN, Margaret. See Bush.

FALANGA, Michele (Mr.) [P,T] Brooklyn, NY b. 1870, Naples, Italy (came to U.S. in 1901) d. 1 F 1942. Studied: Rome. Founded and directed the Brooklyn Acad. FA.

FALCO, Henri Louis [P] Brooklyn, NY. Member: S.Indp.A.[25]

FALCONER, John M. [P,E] b. 22 My 1820, Edinburgh, Scotland (came to U.S. in 1861) d. 12 Mr 1903, NYC. Studied: NAD. Traveled extensively in Europe. Member: Am. WCS. Specialties: oil paintings of historic bldgs.; water colors, enamel on porcelain; restoration of paintings

FALER, Phyllis Leanora [Des,Dec] Kansas City, MO b. 25 N 1907, Baldwin, KS. Studied: Kansas City AI. Exhibited: Mo. State Fair, Sedalia, 1929 [40]

FALES, William D. [Des,L,T] Rumford, RI b. 7 Jy 1893, Pawtucket, RI. Studied: H.H. Clark; W.E. Brigham. Member: AC; Utopian C. Lectures: on WEAN, Art of Textiles, 1934. Collaborator: "Cotton Yarn Manufacturing." Position: Hd. Dept. clothing, textiles, RISD [40]

FALK, Anna-Louise (Mrs. Harry R. Rudin) [P] Branford, CT (Hamden, CT, 1985) b. 23 S 1907, Branford, CT. Studied: Yale, with Herman Soderstein; N.Y. Sch. Des., with S.E. Dickinson; D. Connah, in New Haven [33]

FALK, D.W.C. [P] NYC [01]

FALK, Nat [P] NYC [25]

FALKENSTEIN, Claire (Mrs. C. Lindley McCarthy) [P,S,I,T,Des,L] Berkeley, CA b. 22 Jy 1908, North Bend, OR. Studied: Univ. Calif. Member: San Fran. AA; San Fran. Women A.; Arch. Lg.; NSMP. Exhibited: AV, 1942; SFMA, 1935 (prize), 1942 (prize); Oakland A. Gal., 1938 (prize); New Orleans AA, 1941 (prize); AIC, 1945; Palace Legion Honor, 1945, 1946; Riverside Mus., 1940; San Fran. AA; San Fran. Women A., 1934–46. Work: Mills Col, Oakland; Mus. Non-Objective Painting, N.Y. Illustrator: "Salt and Seeds," 1941. Contributor: Magazine of Art [47]

FALL, Frieda Kay [P] Houston, TX. Exhibited: Houston Mus. FA, 1938; NAWPS, 1938 (prize) [40]

FALLER, Hortense Gimbel (Mrs.) [P] Cincinnati, OH/Saranac Lake, NY b. 15 D 1889, Vincennes, IN. Studied: St. Louis Sch. A.; Cincinnati A. Acad. Member: Cincinnati Women's AC; Cincinnati AL [21]

FALLIS, Belle S. [P] Denver, CO [01]

FALLS, Charles Buckles [P,I,Des,B,C,T,S] NYC/Falls Village, CT b. 10 D 1874, Ft. Wayne, IN. Member: SI, 1909; Artists Gld. Exhibited: Phila. WCC, 1918 (prize). Work: General Electric Bldg., Century of Progress Expo, Chicago; Am. Radiator Bldg., NYC; Ford Motor Co. Bldg., San Diego Expo. Designer: sets and costumes for theatres and motion pictures; rugs for Raymond Hood; silks, Stehli Silk Corp.; furniture; linens; posters, U.S. Marines. Illustrator: "ABC Book," "Mother Goose," "Two Medieval Tales," by R.L. Stevenson, "Tom Sawyer," "Huckleberry Finn" [47]

FALLS, D(e) W(itt) C(linton) [P,I] NYC b. 29 S 1864, NYC. Studied: W. Satterlee. Specialties: military subjects; portraits; comic illus. [31]

FALTER, John Philip [I] Phila., PA (1976) b. 28 F 1910, Falls City, ND Studied: Olinsky; M. Young; Bridgman; Wright; ASL; Kansas City AI; Grand Central Sch. A. Member: SI; N.Y. Artists Gld.; NAC; B.&W. Cl. Illustrator: "A Ribbon and A Star," 1946, "The Horse of Another Color," 1946; for M.C. Banning, E. Queen, N. Patterson, P. Wylie, M. de la Roche; magazines of the 1930s; covers, Saturday Evening Post, since 1930 [47]

FANCHER, Louis [I] NYC b. 25 D 1884, Minneapolis, MN d. 2 Mr 1944. Studied: Mowbray; Henri; W.A. Clark; Cox, in Europe. Member: SI, 1911. Work: magazines; film industry [17]

FANCY, Lyman E. [P] Forest Hills, NY [17]

FANGEL, Henry Guy [P,I] NYC. Member: SI, 1913 [25]

FANGEL, Maud Tousey [I,Por.P] NYC/Westport, CT b. Boston. Illustrator: covers, Ladies Home Journal [40]

FANNING, Nettie B. (Mrs. John E.) [P,I,C] Norwich, CT b. 12 Mr 1863, Delhi, India. Studied: Norwich Art Sch.; BMFA Sch. Member: Norwich AA; Copley S., 1895 [10]

FANNING, Ralph [Edu,W,L,P,Arch] Columbus, OH b. 29 N 1889, Riverhead, NY. Studied: Cornell; Univ. Ill. Member: Columbus AL; Ohio WCS; Wash. WCS; AFA. Exhibited: Ohio WCS; Columbus AL. Work: Columbia Univ.; Columbus Gal. FA; Ball State T. Col. Mus. Author: "Survey Outline of Art History." Contributor: American Architect, Architectural Record. Position: T., Ohio State Univ. [47]

FANNING, William Sanders [P,Des,I] Detroit, MI b. 10 My 1887, Detroit. Studied: Detroit Sch. FA, with J.P. Wicker; Univ. Mich.; Acad. Moderne, Paris, with O. Friesz, J. Marchand; F. Paulus; J. Gies. Member: Am. A. Cong.; Detroit A. Union. Exhibited: AIC; Detroit Inst. A.; Detroit Independents [47]

FARBER, Elfie R. (Mrs.) [P,S] Milwaukee, WI b. Milwaukee. Studied: C. Holty; A. Hansen; P. Rotier; Quirt; G. Dietrich. Member: Wis. PS. Exhibited: Milwaukee AI, 1931 (prize), 1932; Wis. Salon A., 1936 [40]

FARBER, Gladys. See Aller.

FARINA, Pasquale [P] NYC b. 2 N 1864, Naples, Italy. Studied: Acad. FA, Naples. Member: Phila. Alliance; F., PAFA; AAPL; Fairmount Park AA; Art Center; MMA; College AA. Exhibited: World's Fair, Chicago, 1893 (med). Work: Atessa, Italy; National Mus., Buenos Aires. Specialty: "Old Masters" work. Positions: T., S., "Aversa", near Naples, 1885-87; drawing, Normal Sch. for Girls, Tucuman, Argentina, 1888-90; Founder/T., art sch., Tucuman [40]

FARIS, Benjamin H. [P] Cincinnati, OH b. 21 Jy 1862 d. 29 Ap 1935. Studied: Cincinnati Acad. Member: Cincinnati AC. Position: A./Car., Commercial Tribune, Cincinnati, 32 yrs. [31]

FARIS, Edgar F. [P,Arch] b. 1881 d. Jy 5 1945 Los Angeles, CA Studied: Kansas City AI. Work: Kansas City; Miami; portrait of President Truman

FARJEON, Elliott Emanuel [Por.P] Pittsburgh, PA b. NYC. Studied: CUASch; ASL; NAD; Bonnât, Bouguereau, Robert-Fleury, Lefebvre, all in Paris. Member: Pittsburgh AA [40]

FARLEY, Charles [P] NYC b. 25 Ja 1892, Bellevue, OH. Studied: Henri; Luks [40]

FARLEY, Frederic H.M.S. [B,Des,Dr,E,L] Baltimore, MD b. 4 Jy 1895, NYC. Studied: Md. Inst.; PAFA; ASL; Slade Sch., London; Grande Chaumière, Académie Julian, both in Paris; Augustus John; B. Boutet de Monvel; Pennel. Member: Friends A., Baltimore; Am. Ar. Prof. Lg. Work: Baltimore Mus.; Friends of Art; Municipal Mus.; Chesapeake C., Baltimore; Md. Natural Hist. Soc.; Johns Hopkins; Cleveland Mus.; MET; British Mus.; LOC; clubs of NYC, San Fran.; Chicago; Minneapolis; England; France; Germany. Illustrator: articles on wild life [40]

FARLEY, Richard Blossom [P,T,B] Eddington, PA b. 24 O 1875, Poultney, VT. Studied: N.J. State Model Sch., Trenton; PAFA; Whistler; Chase; Cecilia Beaux. Member: Phila. Sketch Cl.; Phila. A. All.; PAFA. Exhibited: Phila. AC, 1912 (gold), 1913 (prize); CGA, 1914 (prize); P.-P. Expo, San Fran., 1915 (med); St. Botolph's Cl., Boston; PAFA. Work: National Headquarters, Am. Theosophical Soc., Wheaton, Ill.; Reading Mus. A.; Phila. A. All.; CGA; N.J. State T. Col.; Phila. Univ. C.; PAFA [47]

FARLEY, Robert Corley [P] Miami, FL b. 24 N 1902, Marianna, FL. Studied: D. Fink; H. Hubbell; G.E. Browne. Member: Miami AL [40]

FARLINGER, James S(hackleton) [P] Verona, NJ b. 8 Jy 1881, Buffalo, NY [31]

FARLOW, Harry [Por.P] Newington, CT b. 11 Ap 1882, Chicago, IL. Studied: AIC, with Clarkston; Cincinnati AA, with Duveneck; BMFA Sch., with Tarbell, Benson. Member: SC; Conn. Acad. FA; New Haven PCC; Scottish Soc. A.; MacD. C. Exhibited: NAD; PAFA; CAM; Conn. Acad. FA; New Haven PCC; Royal Canadian Acad.; Royal Scottish Acad.; Acad. Français. Work: Hunter Col.; Lawyers C.; Calumet C.; Princeton C.; Yale C.; NAD; Manufacturer's C., Phila.; Overbrook Col., Phila.; City Hall, Toronto; Trinity Col., Hartford; Neff Col., Phila. [47]

FARMER, Alison. See Wescott.

FARMER, Brigitta Moran (Mrs. Thomas P.) [Min.P] Syracuse, NY b. Lyons, NY. Studied: Syracuse Univ.; Grande Chaumière, Paris. Member: Pa. SMP; NAWPS [40]

FARMER, Edward McNeil [Edu,P,Des,En,L,B,Dec] Palo Alto, CA b. 23 F 1901, Los Angeles. Studied: Stanford; Rudolph Shaeffer Sch. Des.; ASL; G. Bridgman; C. Locke; Jan Matulka. Member: Pacific AA. Exhibited: AIC, 1937-39; Riverside Mus., 1940; NYWCC, 1937-40, 1941; AWCS, 1937, 1938, 1939-42; GGE, 1939; CM, 1938; Sacramento State Fair, 1938-40 (prize); PAFA, 1938-41; Grand Central Gal., 1941. Position: T., Stanford, 1923- [47]

FARMER, Mabel McKibbin (Mrs. Edward) [En,P,T,B] Palo Alto, CA b. 28 Mr 1903, Portland, OR. Studied: Stanford Univ.; ASL, K.H. Miller, G. Bridgman, A. Lewis; W.J. Duncan. Member: Calif. SE. Exhibited: Phila. Pr. C., 1937, 1940-43, 1946; LOC, 1943, 1946; Phila. AC, 1942; AV, 1942; Buffalo Pr. C., 1943; WFNY, 1939; Venice, Calif., 1940; Sweden, 1937; GGE, 1939; Calif. SE, 1938-43, 1945; San Fran. AA, 1939, 1940, 1942, 1946; Laguna Beach, Calif., 1943, 1945; Fnd. Western A., 1938, 1939, 1943, 1945; Northwest PM, 1936, 1938, 1941-43, 1946. Work: CI; SFMA; LOC. Position: T., Palo Alto H.S., 1945-46 [47]

FARNDON, Walter [P] Douglaston, NY b. 13 Mr 1876, Coventry, England. Studied: NAD, with Edgar M. Ward. Member: AWCS; All.A.Am.; ANA, 1928; NAD, 1937; SC; AAPL; NYWCC; NYSP; Artists Fellowship. Exhibited: NAD, annually, 1930 (prize); SC, 1919, (prize), 1926 (prize) 1929 (prize); NAC, 1939 (prize); AWCS, 1925 (prize). Work: BM; NAC; SC [47]

FARNHAM, Jessica Shirley [P,G,T] Citronelle, AL b. New Rochelle, NY. Studied: L. Taft; C. Mulligan; AIC; R. Schaeffer; W.H. Stevens; A. Dow; Courtois. Member: SSAL; Ala. AL; Birmingham AC; Southeastern AA. Work: Florence Normal Sch., Ala.; Montgomery Mus. FA; high schools. Position: T., Woodlawn, H.S., Birmingham, Ala. [40]

FARNHAM, Paul [P,I] Oakland, CA [21]

FARNHAM, Sally James (Mrs. Paulding Farnham) [S] NYC b. Ogdensburg, NY d. 1943. Studied: self-taught, but with criticism from Schrady, Lukeman, F. Roth, and her friend Frederic Remington. Her most famous monument is the equestrian statue of Gen. Bolívar, in NYC. [29]

FARNSWORTH, Ethel N(ewcomb) [P,I] Pasadena, CA b. 17 Ap 1873, Orange, NJ. Studied: Cox; Weir; Chase; DuMond. Member: Minneapolis Soc. FA; Pasadena SA. Exhibited: Minn. Ar. Exh., Minneapolis AI, 1922 (prize) [25]

FARNSWORTH, Jerry [P,T] North Truro, MA b. 31 D 1895, Dalton, GA. Studied: Corcoran A. Sch.; C.W. Hawthorne; Clinton Peters. Member: ANA, 1933; NAD, 1935; Provincetown AA; SC; NAC. Exhibited: NAD (prizes), 1924, 1927, 1933, 1935, 1936 (med), 1938; Grand Central Gal., 1928; Wash. SA, 1924, (prize). Work: Mus. FA, Houston; TMA; PAFA; New Britain Mus.; MMA; Dayton AI; Vanderpoel Coll.; Delgado Mus. A.; WMAA; Cranbrook Acad., Bloomfield, Mich. Positions: T., Univ. Ill., 1942-43; Dir., Farnsworth Sch. A., North Truro, Mass. and Sarasota, Fla. [47]

FARNSWORTH, Jerry, Mrs. See Sawyer, Helen.

FARNSWORTH, Margaret King [P] Boston, MA/Duxbury, MA b. 13 N 1909, Brookline, MA. Studied: BMFA Sch.; ASL. Member: Boston S.Indp.A.; NAWPS; Duxbury AA. Exhibited: Vose Gal., Boston [40]

FARNUM, Herbert Cyrus [P] North Providence, RI b. 19 S 1866, Gloucester, RI. Studied: RISD; Académie Julian, Paris. Member: Providence AC; Providence WCC. Work: RISD [29]

FARNUM, Royal Bailey [Edu,W,L,C] Providence, RI b. 11 Je 1884, Somerville, MA. Studied: Mass. Sch. A.; Cleveland Sch. A.; Brown Univ. Member: F., Royal Soc. A., London; Nat. Edu. Assn.; Eastern AA; Providence AC; AFA; AIA. Author/Illustrator: "Decoration for Rural Schools," 1914; "Fine and Applied Arts," 1914. Position: T., N.Y. State Edu. Dept.; Mass. Sch.; RISD [47]

FARNUM, Suzanne. See Silvercruys.

FARNUNG, Helen M. [P,E,T] NYC b. 31 Mr 1896, Jersey City. Studied: Duveneck; ASL. Member: S.Indp.A.; ASL [25]

FARNY, Henry F. [P] Cincinnati, OH b. 1847, Ribeauville, Alsace (came to Western Pa. in 1853, when his parents fled France as political refugees; moved to Cincinnati, ca. 1859) d. 24 D, 1916. Studied: Düsseldorf; Vienna; Italy; T.B. Read; Munkacsy; Munich, with his friends, Duveneck, Dengler, Twachtman, 1875-76. Member: Cincinnati AC. Exhibited: Paris Expo, 1889 (med); Charleston Expo, 1902 (med); St. Louis Expo, 1904 (med). Work: Amon Carter MA; Cincinnati AM; Univ. Tex., Austin; Taft Mus., Cincinnati. Illustrator: Indian tribal life, Harper's, Century, 1880s [15]

FARR, Bertha M. [P] Wyoming, NY. Member: Rochester AC [25]

FARR, Charles Griffin [P,T] Knoxville, TN b. 30 My 1908, Birmingham AL. Studied: ASL; Paris, with J. Despujols. Exhibited: CGA, 1941; WMAA, 1946; OWI Exh., Paris, 1945. Work: Hist. Section, War Dept., Wash. D.C.; murals, Keesler Field, Miss., Mitchell Field, N.Y. Position: T., Univ. Mich. [47]

FARR, Helen [Li,E,I,P,Dec] NYC/Phillipston, MA b. 24 F 1911. Studied: J. Sloan; B. Robinson. Member: S.Indp.A.; ASL; Hudson Highlands AA; Petersham (Mass.) Handicraft Gld. Work: illus., theater and medical drawings for magazines; sets, costumes for King-Coit Children's Theatre, NYC [40]

FARRAND, Charles [P] NYC. Position: Affiliated with Suffolk Engraving Co. [19]

FARRAR, Frances [Por.P] Chicago, IL b. 26 O 1855, Elmira, NY. Studied: PAFA; AIC [10]

FARRÉ, Henri [P] Chicago, IL b. France d. 6 O 1934. Exhibited: U.S., 1918; Paris Salon; Salon des Artistes Français, 1933 (gold). Award: medal of Legion of Honor, France. He was a pioneer in the painting of war pictures by means of aerial observation. Appointed in WWI by French Gov. to record air fighting from the skies.

FARRELL, A.T. [I] Brooklyn, NY. Member: SI [31]

FARRELL, Katherine Levin (Mrs. Theodore P.) [P,E] Phila., PA b. 15 Mr 1857, Phila. Studied: Phila. Sch. Des. for Women; PAFA; W. Sartain; F. Wagner; H. Breckenridge; PMSchIA; E. Horter. Member: Plastic C.; Phila. Pr. C.; Phila. A. All.; Phila. WCC. Exhibited: PAFA, 1941, 1942; Plastic C., 1922 (med), 1923 (gold), 1939 (med), 1940 (med), 1945 (med); Women's Achievement Comp., Gimbels, Phila., 1933, 1934 (prize); Cape May Exh., 1946. Work: State Col., Cape May; PAFA; Trenton Art Assn.; Pa. State Col. A. Gal. [47]

FARRELL, Ruth Clements [P] NYC. Member: S.Indp.A. [24]

FARRELLY, Regina A. [P,S] NYC b. NYC. Member: S.Indp.A.; Conn. Acad. FA; Southern Pr.M.; ASL [40]

FARRER, Henry [P,E,I] Brooklyn, NY b. 23 Mr 1843, London (came to U.S. in 1861) d. 24 F 1903. Member: N.Y. Etching Cl. (Pres.); AWCS; A. Fund S.; Phila. Soc. E., 1885; F., Royal Soc. Painter-Etchers, London, 1882. Exhibited: NAD, 1867–81; AWCS [01]

FARRINGTON, Katherine [P,W,T] Greenwich, CT b. 3 My 1877, St. Paul, MN. Studied: DeCamp; Mowbray; DuMond; ASL. Member: St. Paul AS; Soc. Conn. Artists [24]

FARRINGTON, Walter (W.F. Moses) [P,T] Los Angeles, CA b. 17 Ap 1874, Sterling, IL. Studied: AIC. Member: P.&S. Cl., Los Angeles. Exhibited: Los Angeles Mus. A.; P.&S. Cl., Los Angeles; Santa Paula, Calif. (prize); Western Acad. P. Author/Illustrator: "Artistic Anatomy" [47]

FARROW, W(illiam) M(acknight) [P,Des,T,W,L,E] Chicago, IL b. 13 Ap 1885, Dayton, OH. Studied: AIC, with Clarkson, Norton, Buehr. Member: Ill. Vocational Assn.; All-Ill. SFA; Chicago AL; Soc. for Sanity in Art. Exhibited: Chicago AL, 1929 (prizes); AIC, 1923, 1929; NAD, 1944; Albright A. Gal., 1944; NYPL, 1924 (one-man). Work: Women's Cl., Western Springs, Ill.; St. Aloysius Church, Calmar, Iowa; St. Joseph's Parish, Bellevue, Iowa; Stewart Community House. Positions: Cur., AIC, 1917–45; Dir., Loop A. Center, Chicago, 1945– [47]

FASANO, Clara [S,T] NYC b. 14 D 1900, Castellaneta, Italy. Studied: Académie Julian, Paris; CUASch; ASL; Adelphi Col., Brooklyn, N.Y. Member: Circolo Artistico Int. di Roma, Italy; NSS; S. Gld.; NAWA. Exhibited: NAWA, 1945 (prize); PAFA, 1940, 1942–46; AIC, 1941, 1942; NAD, 1935, 1939, 1941, 1943; WMAA, 1940, 1946; WFNY, 1939 Fairmount Park AA, 1940; AV, 1941; NAWA, 1945, 1946; Buchholz Gal., 1941, 1943, 1945; S. Gld., 1941, 1942. Work: reliefs, USPO, Middleport, Ohio. WPA artist. Position: T., Dalton Sch., NYC, 1940. [47]

FASNACHT, C.W. [P] Hutchinson, KS [24]

FASSETT, Adaline M. [Por.P] Wash., D.C. d. 4 Ja 1898. She went to Washington in 1875 from Ohio and took up residence there. Her most noted painting is "Electoral College," now in the Capitol; it contains more than one hundred faces, each one of which is a miniature portrait. She also made portraits of President Garfield and many members of the Supreme Court.

FASSETT, Truman E. [P,T] West Falmouth, MA b. 9 My 1885, Elmira, NY. Studied: BMFA Sch.; R. Miller; L. Simon, in Paris. Member: SC; NAC; AFA [40]

FASSITT, Miss [P] Cheyney, PA [06]

FAST, Francis (Redford) [P] Hillsdale, NJ b. 6 D 1889, Pittsburgh, PA. Exhibited: Morgan Gal., New York, 1938; Women's Cl., Maplewood, N.J., 1939; Vose Gal., Boston, 1939, 1942; Boston City Cl., 1939; Montclair A. Mus., 1940; NYU, 1940; Park Ave. Gal., 1941; Westminster Col., 1941; Currier Gal. A., 1943; G.W.V. Smith Mus., Springfield, Mass., 1946; Fitchburg A. Center, 1946; Dayton AI, 1946; Nat. Mus., Wash., D.C., 1946. Work: Montclair A. Mus.; Newark Mus.; Currier Gal.; G.W.V. Smith Mus.; Fitchburg (Mass.) A. Center. Author: "Finger Painting—An Outline of Its Origins of History" [47]

FAUGHT, Elizabeth J(ean) (Mrs. Ray Clinton Faught) [S] Baltimore, MD b. 2 N 1883, Richmond, VA. Studied: Rinehart Sch. Sculpture; Ephraim Keyser; Md. Inst. Member: Baltimore Mus. Art [40]

FAULEY, Albert C. [P,T] Columbus, OH b. 20 My 1858, Fultonham, OH d. 15 D 1919. Studied: Boulanger, Constant, Blanc, in Paris. Member: Lg. Columbus Ar.; Columbus Pen & Pencil Cl. Exhibited: Lg. Columbus Ar., 1919 (prize). Work: portraits, State of Ohio. Position: T., Columbus Art Sch. [17]

FAULEY, Lucy S. (Mrs.) [P] Columbus, OH. Member: S.Indp.A. [21]

FAULKER, Eunice Florence [P] Chicago, IL [04]

FAULKNER, Barry [Mur.P,P,T] Keene, NH b. 12 Jy 1881, Keene d. 1966. Studied: Harvard; Am. Acad., Rome; Abbott H. Thayer. Member: ANA, 1926; NA, 1931; NSMP; NIAL; Century Assn. Exhibited: Arch. Lg., 1914 (med). Work: murals, State House, Concord, N.H., State Capitol, Salem, Oreg.; maps, Cunard Bldg., New York; Eastman Sch. Music, Rochester; dec., Univ. Ill. Lib.; Phillips Acad., Andover, N.H.; Radio City, N.Y.; Archives Bldg., Wash., D.C.; national cemeteries, Thiaucourt and Suresnes, France; Metropolitan Life Ins. Co., Ottawa; Am. Acad., Rome; Bushnell Mem., Hartford, Conn. Position: Instr., NAD [47]

FAULKNER, E.D. (Mrs.) [P] NYC. Member: NAWPS [21]

FAULKNER, Eunice F. [P] NYC [17]

FAULKNER, Herbert W. [C,P,L,W] Washington, CT b. 8 O 1860, Stamford, CT. Studied: ASL, with Beckwith, Mowbray; Collin, in Paris. Member: SC, 1897; Syndicat de la Presse Artistique. Exhibited: Pan-Am. Expo, Buffalo, 1901. Work: Dallas Art Assoc.; City Art Mus., St. Louis, Mo.; Minneapolis Mus.; Herron AI. Author: "Wood Carving as a Hobby," "Designs for Wood Carving," "Decorative Plant Forms" [40]

FAULKNER, Kady B. [P,E,Li,Ser,T] Lincoln, NE b. 23 Je 1901, Syracuse, NY d. 1977. Studied: Syracuse Univ.; ASL; Hans Hofmann; B. Robinson; Henry Varnum Poor; Jeanette Scott; Bridgman; Ernest Thurn; Breckenridge. Member: Nat. Ser. Soc.; Phila. Color Pr. Soc.; NAWA; Prairie Pr.M.; Lincoln A. Gld.; Northwest Pr.M.; Nat. Art Cl. Exhibited: Joslyn Mem., 1940–44, 1945 (prize); Springfield, Mo., 1945, 1946 (prize); NAWA, 1940–43; AWCS, 1944, 1945; Phila. Color Pr. Soc., 1944–46; SFMA, 1945, 1946; Lincoln A. Gld., 1940–46; Denver A. Mus., 1943, 1944. Work: IBM; mural, USPO, Valentine, Nebr.; St. Mary's Episcopal Church, Mitchel, Nebr.; chapel, Union Col., Lincoln. Lectures: Indian Art. Position: T., Univ. Nebr., Lincoln [47]

FAULKNER, Paul W. [P] North Platte, NE b. 2 Ap 1913, North Platte. Studied: Univ. Nebr.; AIC. Exhibited: 48 Sts. Comp., 1939; CGA, 1939; Gov. mural sketches/cartoons to Canada and South America, 1940–41. Work: USPOs, Kewaunee, Wis., Clarion, Iowa. WPA artist. [47]

FAULKNER, R. Lloyd [I,P] St. Paul, MN [19]

FAULKNER, Ray (Nelson) [Edu,W] NYC b. 3 Je 1906, Charlevoix, MI. Studied: Univ. Mich.; Harvard; Univ. Minn. Member: CAA; Eastern AA; Am. Soc. for Aesthetics; Am. Psychological Assn. Exhibited: Sch. Arch., Harvard, 1929 (prize); Minneapolis Inst. A., 1935–37; Ohio WC Soc., 1932. Co-author: "Art Today," 1941. Contributor: articles on college teaching of art, educational journals. Positions: T., Univ. Minn., 1932–39; Columbia, 1939– [47]

FAULKNER, Sarah Mills (Sally) [P,C,S,Des,T,B] Lowell, MA b. 8 My 1909, Lowell. Studied: BMFA Sch.; Army Air Force Photogr. Sch.; P. Hale; F.A. Bosley; L.P. Thompson. Member: Lowell AA; Boston Photogr. Soc.; Merrimack Valley AA. Work: school room figures for Ginn and Co., Century of Progress Expo., Chicago. Position: T., Lowell A. Assn. [47]

FAUNTLEROY, Martha Lorimer [P,T] Richmond, VA b. 2 My 1910, North Yakima, WA. Studied: ASL; Nicolaides; K.H. Miller; William & Mary Col.; T. Pollack; Bridgman. Member: VMFA. Position: Hd., A. Dept., Blackstone Col. [47]

FAURE, Rene B., Mrs. See Greacen, Nan.

FAUSETT, Lynn [P,Ser,Mur.P] Salt Lake City, UT b. 27 F 1894, Price, UT d. 1977. Studied: Brigham Young Univ., 1910–12; Univ. Utah, 1914–16; ASL, 1922–27; France, 1933–36. Member: NSMP. Exhibited: Utah AI; WMAA. Work: murals, City Hall, Price, Utah; Univ. Wyo.; Latter Day Saints Ward Chapel, Farmington, Utah. Older brother of muralist William Dean Fausett. Position: A. Dir., 9th Service Command, U.S. Army, 1943–46 [47]

FAUSETT, (William) Dean [Mur.P,E,Li,S,B] Dorset, VT b. 4 Jy 1913, Price, UT. Studied: Brigham Young Univ.; ASL; BAID; Colorado Springs FA Center; K.H. Miller; Nicolaides; C. Locke; Harry Wicky; B. Robinson. Member: ASL; NSMP; Southern Vt. AA; F., Tiffany Fnd.; F., Guggenheim Fnd. Exhibited: AIC, 1935 (prize), 1943–45; CI, 1941, 1942

(prize), 1943-46; Durand-Ruel Gal., 1943, 1944 (prize); NSMP, 1945 (prize); SC, 1946 (prize); WMAA, 1932, 1940, 1941, 1943-46; CGA, 1941, 1942, 1944, 1945; MMA, 1941; VMFA, 1942, 1944, 1946; NAD, 1944-46; BM, 1935, 1941; Toledo Mus. A., 1939, 1940; Witte Mem. Mus., 1943, 1945; John Herron AI, 1945, 1946; Southern Vt. AA, 1940-43; Univ. Utah, 1940. Work: murals, USPOs, Augusta, Ga., West New York, N.J., Rosenburg, Tex., Grant's Tomb, N.Y., Randolph Field, Tex.; MMA; MOMA; WMAA, TMA; New Britain Mus.; WMA; Bennington Mus. A.; Witte Mem. Mus.; AIC; Univ. Nebr.; Univ. Ariz.; Brigham Young Univ.; Williams Col.; Princeton Univ.; AAAL; Women's Nat. Republican Cl.; U.S. Gov. Coll. WPA artist. Younger brother of artist Lynn Fausett. Position: T., Henry Street Settlement, Arts and Crafts Sch., 1940 [47]

FAUSTINA, James [P,I] Chicago, IL b. 1876, Dyerburgh, TN. Studied: AIC. Member: Chicago ASL [08]

FAVOUR, Frank [P] Minneapolis, MN [13]

FAWCETT, George [Dr,E,I,P] Miami, FL/Ridgefield, CT b. 8 Ap 1877, London d. 4 F 1944. Studied: England. Member: Canadian Soc. P.&E.; Chicago SE. Work: Nat. Gal., Ottawa [40]

FAWCETT, N.M. [P] Cleveland, OH. Member: Cleveland SA [25]

FAWCETT, Robert [I,Car,P,G] Ridgefield, CT b. 26 F 1903, London d. 1967. Studied: Slade Sch., London. Member: SI. Exhibited: Phila. Pr. Cl., 1938; All-Ill. Soc. FA Exh., 1938. Illustrator: "Epitaph," by Dreiser [47]

FAXON, Charles Edward [I] Boston, MA b. 21 Ja 1845, Roxbury, MA d. 6 F 1918. A botanist and, since 1882, assistant director of the Arnold Arboretum, his specialty was the illustration of botanical works. Illustrator: "Silva of North America," by Sargent, "Ferns of North American Garden and Forest," by Eaton [17]

FAXON, John Lyman [P] Boston, MA b. 19 Jy 1851, Quincy, MA. Studied: MIT. Member: BAC; Twentieth Century Cl.; Arch. Lg.; Boston Art Students' Assoc.; Boston Arch. Cl. [98]

FAXON, William Bailey [P] NYC b. 1849, Hartford, CT d. 13 Ag 1941. Studied: J. de la Chevreuse. Member: SAA, 1892; ANA, 1906; AFAS; A. Aid S.; Century Assoc. [40]

FAY, Clark [I] Westport, CT. Member: GFLA [27]

FAY, Ida Hottendorf [P] Norwood, OH [24]

FAY, Jean Bradford [P,I,Car,C,L] San Fran., CA b. 22 Ap 1904, Seattle, WA. Studied: Lyonel Feininger. Member: San Fran. Soc. Women Ar.; Seattle Weavers Gld. Exhibited: tapestry, Calif. State Fair, 1937 (prize); GGE, 1939. Work: Huntington Lib., Pasadena; Seattle Pub. Lib.; Univ. Wash. WPA artist (weaver). [40]

FAY, Nancy [I] Westport, CT. Illustrator: Ladies' Home Journal [27]

FAY, Nellie [P] San Fran., CA b. 11 F 1870, Eureka, CA. Studied: F. Mathews; E. Carlsen. Member: San Fran. SA; Kingsley Art C., Sacramento [21]

FAY, S.B. (Miss) [P] Boston, MA [01]

FAY, Wilbur M. [Des,C,T] Rochester, NH b. 25 Je 1904, Everett, MA. Studied: Wentworth Inst., Boston. Member: Lg. N.H. A.&Crafts; N.H. T. Assn.; N.H. Indst. A. Assn. Specialty: designs in wrought iron. Position: Instr., Spaulding H.S., Rochester [47]

FAYE, Harold [G] NYC. Exhibited: Intl. Lith., Wood Engr., AIC, 1937, 1938; Nat. Acad., 1938 [40]

FAYSASH, Julius F. [P,Des,L,T,I,B] Akron, OH b. 11 Ap 1904, Budapest, Hungary. Studied: Univ. Dubuque; Univ. Akron; Cleveland Sch. A.; W. Adams; H.G. Keller; Sandor Vago. Member: Akron SA; Buffalo SA; AWCS; Ohio WC Soc.; AFA; AAPL. Exhibited: Akron AI, 1923-26, 1927 (prize), 1928-31, 1932 (prize), 1933 (prize), 1934 (prize), 1935, 1936, 1937 (prize), 1938-40, 1941 (prize), 1942, 1943 (prize), 1944 (prize), 1945 (prize), 1946; Tri-City AC, Cleveland, 1939 (prize); Buffalo SA, 1940 (med), 1946 (med); Canton AI, 1940-43, 1944 (prize), 1945, 1946; Cuyahoga Falls (Ohio) AI, 1945 (prize); CM, 1935; Rockport (Mass.) A. Gal., 1930; AWCS, 1940; Buffalo SA, 1940-46; AIC, 1942; Butler AI, 1935-37, 1939, 1941-45; Massillon AI, 1935-37, 1939-45; Ohio WC Soc., 1940, 1942, 1943, 1945, 1946; Little Rock (Ark.) Mus. A., 1937; Mus. N.Mex., Santa Fe, 1938. Work: YWCA, Intl. Inst., Magyar Home, AI, all in Akron; Massillon AI; Shaw Sanatorium, Springfield Lake, Ohio; Cornland (Ill.) Pub. Sch.; Allison-James Sch., Santa Fe, N.Mex. Position: Illus., Firestone Tire & Rubber Co., 1932- [47]

FAZEL, John Winfield [P,En] Topeka, KS b. 15 My 1882, Pleasant Hill, WI. Studied: Washburn Col.; G.M. Stone; J.I. Gilbert. Member: Topeka AG; AFA [40]

FEARING, Kelly [P,E,Edu] Ft. Worth, TX b. 18 O 1918, Fordyce, AR. Studied: La. Polytechnic Inst. Exhibited: Fort Worth AA, 1944, 1945 (prize), 1946; Dallas Pr. Soc., 1945 (prize); San Antonio A. Lg., 1945 (prize); SSAL, 1941-44; Miss. AA, 1942; La. State Exh., 1940-42; Houston Mus. FA, 1944, 1945; New Orleans A. Lg., 1943. Work: Fort Worth AA; La. Polytechnic Inst.; Dallas Mus. FA. Position: T., Tex. Wesleyan Col., 1945– [47]

FECHIN, Nicolai [P] Los Angeles, CA b. 28 N 1881, Kazan, Russia (came to U.S. after the Bolshevik Revolution) d. 1955, Santa Monica. Studied: A. Sch. Kazan, Russia, 1894; Imperial Acad. FA, St. Petersburg, with Repin, 1900-09. Member: Imperial Acad. FA, Petrograd. Exhibited: Imperial Acad. FA, Petrograd, 1908 (prize); Intl. Glass Palace, Munich, 1909 (gold); NAD, 1924 (prize); Exh. Western P., Los Angeles Mus., 1935 (prize); Fnd. Western A., 1936 (med). Work: Imperial Acad. FA, Petrograd; Kuingi Galleries, Petrograd; Mus. Kazan; Albright Art Gal.; AIC. Lived in Taos, 1927-38. [40]

FEDERER, Charles A. [I] Branchville, CT. Member: SI [27]

FEDERICO, Joseph B. [Des,L] Niagara Falls, NY b. 21 Ag 1908, Niagara Falls. Studied: P. James. Member: Intl. Soc. A.&Decoration. Lectures: Industrial Design. Work: des., Dura Company automotive hardware, Stewart Motor Trucks, Dayton refrigerators, Bausch and Lomb spectacle case [40]

FEDEROFF, Frank [P] McDonald, PA b. 9 Je 1909, Russia. Studied: CI; Nat. Acad. Member: Assoc. Ar., Pittsburgh. Exhibited: Assoc. Ar., Pittsburgh, 1939 (prize); Butler AI. Work: Pittsburgh pub. schools [40]

FEELEY, Paul Terence [Mur.P,Por.P,T] NYC b. 27 Jy 1910, Des Moines, IA d. 1966. Studied: C. Beaux. Member: Mural P. Exhibited: BAID, May 1934 (med), June 1934 (med). Work: mural, Lg. Am. Writers, New York. Position: Hd. Plastic Dept., Cooper Union [40]

FEELY, Maurice [P,I] Phila., PA [04]

FEHDMAR, R. [P] Antwerp, Belgium [01]

FEHER, Paul [Des] Cleveland, OH b. 18 Ag 1898, Nagy-Kanizsa, Hungary. Studied: Royal Art Acad., Budapest. Specialty: metalwork. Work: designs for Salon des Artiste Decorateurs, Artiste Français, Salon d'Automne, International Expo at Budapest, Beau Salondes Artiste Decorateurs, Decorative Exh. in Phila., all work exhibited by the Rose Iron Works of Cleveland at the Twelfth Annual Exh. Artists and Craftsmen at CMA. Position: Hd. Des., Rose Iron Works [30]

FEHRER, Oscar [P] Lyme, CT b. 21 Ja 1872, Brooklyn, NY. Studied: NAD; Royal Acad., Munich; Académie Julian, Paris; Univ. Munich. Member: All.A.Am.; SC; NAC; Brooklyn SA; Brooklyn PS; Conn. Acad. FA; Springfield AL. Exhibited: NAD (med). Work: Mem. Gal., Lowell, Mass.; Vanderpoel Coll.; Lyman Allyn Mus. A.; Wadsworth Atheneum; Chapel, Rutgers [47]

FEHRON, William [P] NYC [15]

FEIGIN, Dorothy Lubell (Mrs.) [P,E,Li,T,G] NYC b. 8 Mr 1904, NYC d. 1969. Studied: ASL, with J. Sloan, Luks; W. Locke. Member: Fed. Mod. P.&S.; N.Y. Soc. Women A.; NAWA; Am. Ar. Cong. Exhibited: PAFA, 1940-45; AIC, 1938; Toledo Mus. A.; SFMA, 1938; CI, 1934; LOC, 1944; Wildenstein Gal., 1941-46; NAD, 1946 [47]

FEILD, Robert Durant [Edu,W,L] New Orleans, LA b. 8 S 1893, London, England. Studied: Académie Julian, Paris; Univ. Chicago; Harvard. Member: Am. Assn. Univ. Prof.; Southeastern AA; Soc. Advancement Edu.; Authors Lg. Am. Author: "Courbet and the Naturalistic Movement" (1938), "The Art of Walt Disney" (1942). Positions: T., Harvard (1929-39), Newcomb Mem. Col. (1940–) [47]

FEIN, Sylvia (Mrs. Scheuber) [P] NYC b. 20 N 1919, Milwaukee, WI. Studied: Univ. Wis. Exhibited: Univ. Wis., 1941 (prize), 1942 (prize); AIC, 1943; WMAA, 1944, 1945; Perls Gal., 1946 (one-man); Wustum Mus. A., Racine, 1942. Work: Univ. Wis. Mem. Union [47]

FEINBERG, Alfred [I] NYC [10]

FEININGER, Andreas [Photogr] b. 1906, Paris (came to NYC in 1939). Studied: Bauhaus, Weimar, 1922-25. Exhibited: AMNH; Smithsonian, 1963; Oakland MA, 1970. Work: MMA; MOMA; IMP/GEH; Newark Mus.; Harvard; NOMA; Wellesley Col.; Bibliothèque Nationale, Paris; completed 346 assignments for "Life," 1943-62. Author: 21 books, including "Forms of Nature and Life," 1966. Architect, Germany

(1929–31); worked for Le Corbusier in Paris (1932–33); arch. photogr. in Sweden (1936–39). Son of Lyonel. [*]

FEININGER, Lyonel Charles Adrian [P,G,Car,I] NYC b. 17 Jy 1871, NYC. Studied: Gewerbeschule, Hamburg; Berlin Acad. Exhibited: Dusseldorf, Germany, 1927 (med), 1928 (prize); Los Angeles Mus. A., 1942 (prize); AV, 1942 (prize); WMA, 1943 (prize); murals, WFNY, 1939; CGA, 1941, 1943; CI, 1946; PAFA; Tate Gal., London, 1946; Musée du Jeu de Paume, Paris, 1941; MOMA; BM; Civic Center, San Fran. (one-man); Seattle Mus.; Portland (Oreg.) Mus. Work: MMA; MOMA; WMAA; SFMA; Detroit Inst. A.; Walker A. Center; CAM; Kansas City AI; Fort Worth Mus. A.; San Diego FA Soc.; Encyclopaedia Britannica Coll.; Univ. Gal., Minneapolis; San Diego MA; many other coll. Father of Andreas. Position: Prof., Bauhaus, Dessau [47]

FEININGER, Theodore Lux. See Lux.

FEINSTEIN, Barbara Crawford. See Crawford.

FEISS, Paul [P] Cleveland, OH. Member: Cleveland SA [27]

FEITEL, Arthur Henry [Mus.Dir,P] New Orleans, LA b. 3 Je 1891, New Orleans. Studied: Tulane; Ecole Nationale des Beaux-Arts, Paris. Member: AIA; BAID; La. Arch. Assn. Exhibited: New Orleans AA; New Orleans A.&Cr. Cl. Contributor: Pencil Points. Position: Acting Dir., Delgado Mus. A., 1938–46 [47]

FEITELSON, Alice L.L. [P] NYC. Member: S.Indp.A. [21]

FEITELSON, Lorser [P,T,G] Los Angeles, CA b. 11 F 1898, Savannah, GA. Studied: Bridgman; C. Tefft. Exhibited: San Diego M., 1929 (prize); WMAA, 1937; Los Angeles Mus.; WFNY, 1939. Work: BM; SFMA; Los Angeles Mus. A.; murals, Hooper Ave. Sch., Edison Jr. High Sch., both in Los Angeles. WPA artist. [40]

FEITU, Pierre [S] NYC [13]

FELDMAN, Baruch M. [P,W,T] Uhlerstown, PA b. 4 Mr 1885, Russia. Studied: Anshutz. Member: F., PAFA. Exhibited: Americanization through Art Exh., Phila., 1916 (prize); Phila. Sketch Cl., 1921 (prize) [25]

FELDMAN, Charles [P,W,L] NYC/Rockaway Beach, NY b. 27 Ja 1893, Lublin, Russia. Studied: NAD; Henri; G. Bellows. Member: Salons of Am.; S.Indp.A. [33]

FELDMAN, George (Dr.) [P,Car,I,C,G] NYC b. 13 O 1897, NYC. Studied: ASL; NYU. Member: AWCS. Exhibited: WFNY, 1939; AWCS, 1939–41, 1944–46; BM; Morton Gal., 1939 (one-man); Chautauqua, N.Y., 1945 (one-man) [47]

FELDMAN, Hilda (Mrs. Neville S. Dickinson) [P,T] Maplewood, NJ b. 22 N 1899, Newark, NJ. Studied: Fawcett Sch., Newark; PIASch, with Anna Fisher. Member: AWCS; NAWA; AAPL; Essex WCC; Irvington AA; Eastern AA; Asbury Park Soc. FA. Exhibited: AWCS, 1929, 1930, 1932, 1936, 1938, 1939, 1943–46; NYWCC, 1935, 1939; NAWA, 1930, 1931, 1936–39, 1941–46; Irvington AA; AAPL; Newark AC; Essex WCC; 15 Gal.; Rabin & Krueger Gal.; Newark, N.J. (one-man); Univ. Newark (one-man); Orange Women's Cl.; Maplewood Women's Cl. (one-man). Position: T., Newark Sch. F.&Indst. Arts, 1923– [47]

FELDMAN, Max Marek [Li,T,Arch,Dr,L] NYC b. 27 S 1908, Austria. Studied: Columbia; Sorbonne; NAD. Exhibited: NAD, 1928–34; Arch. Lg.; AWCS; WFNY, 1939. Illustrator: Architectural Forum, Pencil Points. Lectures: Art Appreciation, Appreciation of Prints. Position: T., T. Col., Columbia [47]

FELDMANN, Claire [P] NYC [10]

FELIX, Franz [P,I] Spring Valley, NY b. 18 S 1892, Vienna, Austria. Studied: Vienna; Pochwalski; De Farraris. Work: Dutch Reformed Church, Spring Valley. Illustrator: "Chansons de Bilitis," "Rose of Corinth" [47]

FELKER, Ruth Kate (Mrs. W.D. Thomas) [P] St. Louis, MO b. 16 My 1889, St. Louis. Studied: Sch. A., Washington Univ.; St. Louis Sch. FA; ASL; Soc. Beaux Arts Arch.; Europe. Member: Soc. Ancients of St. Louis; Wash. Univ. Arch. Soc.; St. Louis AG; AAPL. Exhibited: St. Louis AG, 1915 (prize), 1916 (prize), 1917 (prize), 1919 (prize). Work: St. Louis Art Lg. Gal.; Vanderpoel AA [40]

FELL, Olive [P,E,S,Mur.P] near Cody, WY (1949) b. ca. 1900, Big Timber Creek MT. Studied: Wyo. Univ.; AIC; ASL. Work: Buffalo Bill Mus. Specialties: Western scenes and wildlife [*]

FELLGER, Charles J. [P] Phila., PA [04]

FELLIG, Arthur. See Weegee.

FELLNAGEL, Dorothy Darling (Mrs.) [P,Li] Wichita, KS b. 26 Ag 1913, Kansas City, MO. Studied: Clayton; Henri; Staples; E. Sprague; W. Dickerson; B.J.O. Norfeldt; Millard Sheets. Member: Wichita AG. Exhibited: Twentieth Century Cl., Wichita, 1934 [40]

FELLNER, Frank T. [E,Des] Brooklyn,NY b. 14 O 1886, Jersey City, NJ. Studied: ASL, with Bridgman, Nankivell. Member: SAE; SC; Conn. Acad. FA; Phila. Pr. Cl.; Brooklyn SA; Providence WCC. Exhibited: Tex. FA Assn., 1943 (prize); Southern Pr.M., 1940 (prize); SAE, 1939, 1940, 1942–44; MMA, 1942; 100 Prints Exh., 1940, 1942; Am. Color Pr. Soc., 1942, 1944; Phila. Pr. Cl., 1942, 1944; SC, 1944; LOC, 1943, 1944; NAD, 1943; Wash. WCC, 1942; PAFA, 1942; WFNY, 1939; Conn. Acad. FA, 1942, 1944; Northwest Pr.M., 1941–43; Laguna Beach AA, 1943, 1944; San Fran. AA, 1942, 1943; New Haven PCC, 1942; Brooklyn SA, 1943, 1944; Oakland A. Gal., 1943, 1944; Portland SA, 1941, 1943; Newport AA, 1944; Portland SA, 1941, 1943; Newport AA, 1944; Springfield A. Lg., 1941, 1943; Lyman Allyn Mus., 1944; Mint Mus. A., 1944; Bridgeport A. Lg., 1942. Work: Tex. FA Assn.; Harvard [47]

FELLOWES, Frank Wayland [P] b. 1833 d. 16 Je 1900, New Haven, CT

FELLOWS, A.P. [P,E] Upper Darby, PA b. 1864, Selma, AL. Studied: PMSchIA; Drexel Inst.; PAFA; ASL. Member: Phila. SE; Phila. Sketch Cl.; Phila. Pr. Cl. Work: MMA. In 1931 produced print by new discovery called "Dentint." [40]

FELLOWS, Cornelia Faber (Mrs. A.P.) [Por.P] Phila., PA b. Phila. Studied: PAFA; Drexel Inst. Member: F., PAFA; Plastic Cl. [24]

FELLOWS, Lawrence [P] Phila., PA [13]

FELLOWS, William K. [P,T,Arch] Chicago, IL b. 1870, Winona, MN. Studied: Ertz, in Paris. Position: T., Arch., AIC [19]

FELS, C(atherine) P(hillips) [P,C,Ser,Des,T] Burbank, CA b. 29 Ag 1912, Kirksville, MO. Studied: Ball State T. Col., Muncie; Mayville (N.Dak.) State T. Col.; Univ. Calif.; Margaret Peterson. Member: San Fran. Soc. Women A.; New Orleans AA. Exhibited: New Orleans AA, 1943–46; San Fran. AA, 1942–46; San Fran. Soc. Women A., 1943–46; Northwest Pr.M., 1945; Miss. AA, 1945, 1946. Work: SFMA; mural, San Fran. Russian War Relief Headquarters [47]

FELTER, Durand [P] Worcester, MA [24]

FELTON, Major [I] NYC. Member: SI [47]

FENDERSON, Annie M. (Mrs. Mark) [Min.P] NYC b. Spartansburg, PA. Member: NAWPS; Pa. S. Min. P. [31]

FENDERSON, Mark [I,T] NYC b. 1873, Minneapolis, MN d. 6 D 1944, Dobbs Ferry, NY. Studied: Europe. Member: SI, 1913. Position: T., Townsend Harris H.S., 23 years (to 1941) [31]

FENELLE, Stanford [P] Minneapolis, MN b. 1909, Minneapolis. Studied: Minn. Sch. A.; St. Paul Sch. A. Exhibited: Minn. State Fair, 1934 (prize); Minn. IA, 1935 (prize), 1938 (prize); Tex. Centenn. Expo, 1936; Intl. WC Soc., AIC, 1936, 1938; Univ. Colo. Gal., 1937; Mus. Mod. A., Wash., D.C. 1938 [40]

FENELLOSA, Ernest Francisco [Edu,W,Orientalist] b. 18 F 1853, Salem, MA d. 21 S 1908, London, England. Studied: Harvard (grad., 1874). In 1878 went to Univ. Tokyo as Prof. of Political Economy and Philosophy; in 1886 and 1887 he was Imperial Fine Arts Commissioner of Japan, and was afterward appointed Professor of Aesthetics, Manager of the Tokyo Fine Arts Acad. and the Art Dept. of the Imperial Museum at Tokyo. He returned to the U.S. in 1890, and for six years was curator of the Dept. of Oriental Art at the BMFA. He was professor of English literature in the Imperial Normal School, Tokyo, from 1897 to 1900, and was decorated by the Emperor of Japan with the Order of the Rising Sun and the Sacred Mirror. He wrote two volumes of poems, "East and West," and "The Discovery of America," and left mss. of several works on Japanese and Chinese art. Ezra Pound became his literary executor. Interred at the family home, "Kobinato," Spring Hill, Ala.

FENERTY, Agnes Lawson [P] Chicago, IL b. Louisville, KY. Studied: AIC; Univ. Chicago; Chicago Acad. FA; Columbia. Member: South Side Community A. Center; Renaissance Soc., Univ. Chicago; Am. Assn. Sch. Admin.; Chicago A. Edu. Assn.; Western AA. Exhibited: Davenport (Iowa) Municipal A. Gal., 1929 (prize); South Side Community A. Center, 1945. Author/Director: Dialogue in Art Education Series, NBC radio broadcast. Contributor: Design magazine. Position: Supervisor A., Chicago Public Schools [47]

FENETY, F.M. [P] Boston, MA. Exhibited: Poland Springs (Maine) AG [98]

FENIMORE, Ida Estelle [P,T] Phila., PA. Studied: PAFA [25]

FENN, Harry [P,I,E,En] Upper Montclair, NJ b. 14 S 1845, Richmond,

England d. 21 Ap 1911. Member: NYWCC; SI; SC; Am. WC Soc. (founder). Exhibited: Columbian Expo, Chicago, 1893 (med). He came to the U.S. (ca. 1864) ostensibly to see Niagara Falls, but remained for six years. He then went to Italy to study. Shortly after his return to the U.S. he illustrated his first book, Whittier's "Snow Bound," which was soon followed by the "Ballads of New England." These were the first illustrated gift books produced in this country, and they marked an era in the history of book making. In 1870 he made an extended tour of the U.S. to gather material for his landmark book, "Picturesque America." He went to Europe in 1873 to make sketches for "Picturesque Europe" and subsequently spent two winters in the Orient for the last of the trio, "Picturesque Palestine, Sinai and Egypt." The publication of these books won him fame. He returned to the U.S. in 1881.

FENN, W.J. [I] Upper Montclair, NJ [13]

FENNER, Maude Richmond (Mrs. Albert) [P] Providence, RI b. 24 My 1868, Bristol, RI. Studied: Burleigh; Mathewson; RISD. Member: Providence AC; Providence WCC; South County AA [40]

FENNO-GENDROT, Almira T. (Mrs. Felix) [P] Roxbury, MA. Author: "Artists I Have Known," 1923 [01]

FENSKE, Paula [P,C] St. Louis, MO b. St. Louis. Studied: St. Louis Sch. FA; Washington Univ.; K.E. Cherry; H. Snell; S. Skou; E. Thurn. Member: Shikari; NAWA; St. Louis A. Gld. Exhibited: St. Louis A. Gld., 1922, 1924 (prize), 1925 (prize), 1926-28, 1929 (prize), 1932 (prize), 1934-36, 1941; PAFA, 1938; NAWA, 1938, 1939; Kansas City AI, 1927-30, 1932, 1935; CAM, 1925, 1927, 1930. Work: Lindenwood Col., St. Charles, Mo. [47]

FENTON, Beatrice [S] Phila., PA b. 12 Jy 1887, Phila., PA. Studied: PAFA; PMSchIA. Member: Phila. A. All.; NSS; NAWPS. Exhibited: PAFA, 1922 (med), 1942-45; Plastic Cl., 1916 (prize), 1922 (med); Sesqui-Centenn. Expo, Phila., 1926 (med); NAD; AIC; PMA; WFNY, 1939; Phila. A. All., 1946; McClees Gal., 1946; P.-P. Expo, San Fran., 1915 (prize). Work: Phila. Art Cl.; Fairmount Park (fountains), Charles M. Schmitz Mem. Acad. Music, Wister Park, Children's Hospital, Hist. Soc., Univ. Pa., all in Phila.; Danby Park, Wilmington, Del.; Brookgreen Gardens, S.C.; mem. tablets, busts, Phila., Baltimore [47]

FENTON, Hallie Champlin [P,T] Bronxville, NY b. O 1880, St. Louis, MO d. D 1935. Studied: J. Blanche, in Paris. Member: NAWPS [38]

FENTON, John William [P,T] Westport, CT/Conewango Valley, NY b. 6 Jy 1875, Conewango Valley d. 18 N 1939. Studied: N.Y. Sch. F.&Appl. A.; C. Yates; H. Giles. Member: SC; NYWCC; New Rochelle AA; Westport Artist Market. Exhibited: New Rochelle AA, 1923, 1927 (prize); Bridgeport AL, 1933 (prize), 1935. Designer: cover, Literary Digest. Position: T., NYC H.S. [38]

FERAR, Montgomery [Indst.Des] Detroit, MI b. 14 Ap 1909, Boston, MA. Studied: F., MIT, 1933-34; J. Carlu. Member: Soc. Indst. Des.; ADI. Exhibited: Phila. A. All., 1944, 1945; MOMA, 1945; Scarab C.; 1942. Work: MOMA; BM; Walker A. Center, Minneapolis. Positions: Des., General Motors Corp. (1934), Sundberg-Ferar (1935-46) [47]

FERBER, Herbert [P,S,C] NYC b. 30 Ap 1906, NYC. Studied: CCNY; Columbia; BAID. Member: Am. A. Cong.; S. Gld.; Fed. Mod. P.&S. Exhibited: WMAA, 1941-46; MOMA, 1938; MMA, 1942 (prize); PAFA, 1943, 1945; BMFA, 1945; Musée Jeu de Paume. Work: MMA [47]

FERDINAND, John E. [P] Edgewater Heights, NJ b. NYC. Studied: ASL, with W. Sartain [06]

FERG, Frank X. [P] Merchantville, NJ. Studied: PAFA [25]

FERGUSON, Agnes Howell (Mrs.) [P] Dixon, IL b. 6 F 1895, Dixon. Studied: BMFA Sch.; Chicago Acad. FA; J.T. Nolf; G.E. Browne. Member: Rockford AA; Phidian A. Cl., Dixon; All-Ill. Soc. FA. Exhibited: AIC, 1934, 1936; All-Ill. Soc. FA; Frances Shimer Col.; Davenport A. Gal., 1941 [47]

FERGUSON, Alice L.L. (Mrs. H.G. Ferguson) [P] Wash., D.C. b. Wash., D.C. Studied: Corcoran Sch.; Hawthorne; Breckenridge. Member: Wash. WCC; S. Wash. A.; SSAL; NAWPS; AFA [40]

FERGUSON, Bernard LaMarr [P,Des,G] Des Moines, IA b. 9 Mr 1911. Studied: Davenport Municipal A. Gal.; Stone City A. Colony; J. Brozick; J. Frank; B. White; G. Wood. Member: Sioux City A. Center Assn.; Iowa AA. Positions: Des., WPA, Iowa; T., A. Center, Sioux City [40]

FERGUSON, C. Eugene [P] Providence, RI [24]

FERGUSON, Charles A. [P] Minneapolis, MN [13]

FERGUSON, Dorothy, Mrs. See Lawnin.

FERGUSON, Duncan [S,T] University, LA b. 1 Ja 1901, Shanghai, China. Studied: A.H. Atkins; R. Laurent. Member: S.Indp.A.; Salons of Am.; A. Soc. PS&G; New South Group. Work: Newark Mus.; WMAA; Hamilton Easter Field Fnd.; NYC; Bowdoin Col.; La. State Univ.; State Office Bldg., Baton Rouge; La. Polytech. Inst., Ruston; USPO, Leesville, La. WPA artist. Position: T., La. State Univ. [40]

FERGUSON, Duncan, Mrs. See Decker, Alice.

FERGUSON, Edward L. [En] NYC (since 1895) b. 1859, IL d. 3 F 1915. Member: SC

FERGUSON, Edward R., Jr. [P,Li] Lapeer, MI b. 21 Mr 1914, Pueblo, CO. Studied: Flint Inst. A. Exhibited: PAFA, 1941; Phila. A. All., 1940; Okla. A. Center, 1940, 1941; Detroit Inst. A., 1934, 1935, 1937, 1938, 1940, 1941; Flint Inst. A., 1933-42 [47]

FERGUSON, Eleanor M. [S] Hartford, CT b. 30 Je 1876. Studied: C.N. Flagg, Hartford; D.C. French; G.G. Barnard; ASL. Member: CAFA [33]

FERGUSON, Elizabeth F(oote) [I,T] Bay View, MI b. 2 Jy 1884, Omaha, NE. Studied: AIC; PAFA. Member: Omaha AG; Cordon C., Chicago [25]

FERGUSON, Henry A. [P] NYC b. ca 1851, Glens Falls, NY d. 22 Mr 1911. Studied: self-taught. Member: ANA; Century Assn. Exhibited: Century Assn., 1911; NAD. He traveled extensively in Mexico, Italy and Egypt and his pictures showed the architecture and landscape of those countries. [10]

FERGUSON, Henry (Mrs.) [P] Hartford, CT. Member: Hartford AS [25]

FERGUSON, Lillian Prest [P,C] Los Angeles, CA b. 18 Ag 1869, Windsor, Ontario. Studied: Académie Julian, Paris; W. Chase; A. Robinson; Holland; Canada. Member: Laguna Beach AA; Women P. of the West; Calif. State Fair, 1926, 1930; Calif. AC; Soc. for Sanity in Art; Santa Monica AA. Exhibited: Women P. of the West (prize); Los Angeles Mus. A.; Calif. State Fair, 1926, 1930. Work: Vanderpoel Coll.; Pal. Leg. Honor; San Diego FA Soc.; Pasadena AI; Am. Lib. Color Slide, N.Y. [47]

FERGUSON, Mabel B. [P] New Haven, CT. Exhibited: Min. P. Ann., PAFA, 1935, 1936, 1938; New Haven PCC [40]

FERGUSON, Nancy Maybin [P] Phila., PA b. Phila. Studied: Phila. Sch. Des.; PAFA; Daingerfield; Breckenridge; Hawthorne; W. Chase. Member: Phila. A. All.; Provincetown AA. Exhibited: Phila. Sketch C., 1931, 1934 (gold); TMA, 1927, 1936, 1938, 1944; PAFA, 1929 (gold), 1916 (prize), 1945; Gimbel's 1933 (prize); Ar. of Germantown, 1935 (prize); CGA; CI; AIC; Detroit Inst. A.; Reading Mus. A.; Provincetown AA, 1944; Milwaukee AI, 1923; Buffalo FA Acad.; 1924; Columbus FA Gal.; Rochester Mem. A. Gal., 1927; Wilmington Soc. FA, 1928; Univ. Ill., 1939. Work: PAFA; Reading Mus. A.; Phila. Sch. Des.; Phila A. All.; Woodmere A. Gal.; Barnes Coll., Overbrook, Pa. [47]

FERGUSON, Ruth H. (Mrs. Alfred) [P] Greenwich, CT. Member: Greenwich SA [25]

FERGUSON, Thomas Reed, Jr. [Edu,P] Pottsville, PA b. 11 My 1915, Lancaster County, PA. Studied: Pa. State Col.; Univ. Pa.; Harvard; W.W. Dawson. Member: CAA; Honolulu A. Soc.; Lehigh County AA. Exhibited: Lehigh Univ., 1945; Lehigh County AA, 1945. Position: T., Pa. State Col., 1946– [47]

FERGUSON, Van Hood [P] Tallahassee, FL b. 2 Ag 1903, FL. Studied: Emory Univ.; Jacksonville A. Acad.; ASL. Member: Jacksonville FA Assn.; Tallahassee A. Assn. Exhibited: Rockefeller Center, 1937 (prize); Ocala, Fla. (one-man); Acad. All. A., 1943; Am.-British A. Center, 1943; 1945; Tallahasse, Fla., 1940 (prize), 1941. Work: Fed. A. Gal., Fla. [47]

FERGUSON, William Hugh [P,T] Reading, PA b. 8 S 1905, Reading. Studied: PAFA; Paris. Work: Reading Mus.; Pa. Mus. A.; PAFA; Allentown Mus. [40]

FERN, Edward [P] Amelia, OH b. 23 Ja 1909, Milford, OH. Studied: Cincinnati A. Acad. Work: USPO, Pineville, Ky. WPA muralist. [40]

FERNALD, Helen E(lizabeth) [W,L,P,T,Mus.Cur] Toronto, Ontario b. 24 D 1891, Baltimore d. 1964. Studied: Mount Holyoke; ASL; Columbia; Bryn Mawr; Courtauld Inst., Univ. London; G. Bridgman. Member: Am. Oriental Soc.; Soc. Women Geographers; Phila. Plastic C.; Univ. Women's C.; Toronto; Toronto AA. Exhibited: Phila. Plastic C.; Orlando, Fla., 1941; Central Fla. Expo, Orlando, 1939 (prize). Author: "Chinese Paintings," 1922; article on Chinese Sculpture Expo, Burlington House magazine, January, 1936. Positions: Cur., Univ. Pa. Mus. (1921-35), Univ. Toronto (1946–), Royal Ontario Mus., Toronto (1944–) [47]

FERNALD, I.H. [P] Brooklyn, NY [01]

FERNBACH, Agnes B. [E] NYC b. 29 Je 1876, NYC. Studied: CUASch; ASL; N.Y. Sch. Appl. Des., with A. Mucha, E. Haskell. Member: SAE; Phila. SE [47]

FERNE, Hortense [P,E,Li] NYC b. 14 D 1890, NYC. Studied: NAD; T. Col., Columbia; Univ. Pa.; Chase; Hawthorne; Browne; Wagner; Auerbach-Levy; Breckenridge; PMSchIA; ASL. Member: NAWA; AWCS; Phila. SE; SAE; Wash. SA; Wash. WCC; Plastic C.; Springfield (Mass.) AA; North Shore AA. Exhibited: Newman Gal., Phila.; Warwick Gal., Phila.; Milwaukee AI; Currier Gal. A.; Westfield (Mass.) Atheneum; Albany Inst. Hist.&A.; Everhart Mus.; Grosvenor Lib., Buffalo; Utica Pub. Lib.; Westerly (R.I.) Pub. Lib.; Washburn Col.; Mass. State Col.; Hood Col.; Wash. SA, 1940 (prize); Springfield AA, 1939 (prize); Plastic C., 1927, 1932; 1937 (gold). Work: Lenape C., Phila.; portrait of a Cardinal, Rome; Republican Cl., NYC; Graphic Sketch Mus., Phila.; Lincoln Coll., Hartford, Conn. [47]

FERNIE, Margaret. See Hugh Eaton, Mrs.

FERNOW, Bernice Pauahi Andrews (Mrs. B.E., Jr.) [P,T] Clemson, SC b. 17 D 1881, Jersey City. Studied: ASL; Cornell; O.M. Brauner, T. Thayer. Member: ASMP. Exhibited: NAD; NYWCC; ASMP; PAFA; Montclair A. Mus.; WMA; AIC; Wis. P&S; Reinhardt Gal.; CGA; High Mus. A.; Gibbes A. Gal.; Mint Mus. A.; WFNY, 1939; GGE, 1939; Intl. Expo, Rome, Italy. Position: T., Clemson Col. [47]

FERRARI, Dino [W] NYC b. 1900, Italy (came to U.S. in 1915) d. 7 N 1943, Woodstock, NY. Studied: Columbia

FERRARI, Febo [S] Short Beach, CT b. 4 D 1865, Pallanza, Italy. Studied: Royal Acad., Turin. Member: New Haven PCC. Work: figures, Church of St. John the Divine, NYC [47]

FERRELL, Mary Russell. See Colton, Harold, Mrs.

FERREN, John [P,S,Des,Gr,T] Los Angeles, CA b. 17 O 1905, Pendleton, OR d. 1970. Studied: Sorbonne, Paris; Univ. Florence, Italy; Univ. Salamanca, Spain. Exhibited: MOMA, 1937; GGE, 1939; CGA, 1937; PAFA, 1937, 1940, 1945; Pal. Leg. Honor, 1945; Detroit Inst. A., 1946; CAM, 1946; Matisse Gal., 1936–38 (one-man); Willard Gal., 1941; Minneaplis Inst. A., 1936; SFMA, 1937; Putzel Gal., Hollywood, CA, 1936. Work: MOMA; Wadsworth Atheneum; PMA; SFMA. Position: T., BM Ar. Sch., 1946 [47]

FERRER, Vera L. [Min.P] Little Neck, NY b. 13 Ja 1895, NYC. Studied: L.F. Fuller; J.B. Whitaker; NAD. Member: NAWPS [33]

FERRILLO, A. [S] NYC [17]

FERRIS, Bernice Branson (Mrs. Warren W.) [I] Alexandria, VA b. Astoria, IL d. Je 1936. Studied: J.C. Leyendecker; F. Goudy; L. Parker; AIC; Chicago Acad. FA. Member: Lincoln AG; Wash. AC [33]

FERRIS, Edythe (Mrs. Raymond H.) [P,C,En,T,W,I] Phila., PA b. 21 Je 1897, Riverton, NJ. Studied: Phila. Sch. Des. for Women; H.B. Snell. Member: AWCS; Am. Color Pr. Soc.; AAPL; NAWPS. Exhibited: NAD; PAFA; AWCS; Phila. WCC; NAWPS, 1935 (prize). Work: Phila. Sch. Des. for Women Permanent Coll.; St. Luke's Church, Kensington, Phila. Lectures: Color; Design; Crafts. Contributor: School Arts and Crafts, American-German Review. Positions: Dir., Bryn Mawr A. Center, 1938–39; T., Montgomery County Day Sch., Wynnewood, Pa., 1946–[47]

FERRIS, Jean Leon Gerome [P] Phila., PA b. 8 Ag 1863, Phila. d. 18 Mr 1930. Studied: his father, S.J. Ferris and Christian Schuessele, in Phila.; Paris, with Bouguereau, Gérôme. Member: A. Fund S. Phila.; Phila. SE, 1881; Phila. AC, 1890. In 1900 he began his series of paintings on American history; in 1917 a special gallery was built in the Museum of Independence Hall to house a collection of more than 70 of his canvases. Work: Nat. Mus.; N.Y. Hist. Soc. Specialties: historical paintings; Colonial subjects; studies of American ships and vehicles. His uncle was T. Moran.

FERRIS, Mary Danforth [P] NYC [25]

FERRIS, Mary L. [P] Chicago, IL [13]

FERRIS, R. Statira [P] Shanghia, China [19]

FERRIS, Stephen James [Por.P,E,T] Phila., PA b. 25 D 1835, Plattsburg, NY d. 9 Jy 1915. Studied: PAFA, with Schüessele, Sartain, 1846; S.B. Waugh, in Bordentown, N.J. Member: AC Phila.; Phila. Soc. Etchers; Phila. A. Fund S.; Phila. Municipal Lg. Exhibited: Rome, 1876 (prize); N.Y. Etching Cl. He painted more than 2,000 portraits and supplied many of the portraits for Ridpath's Histories. Position: T., Phila. Sch. Des. for Women, 26 years [13]

FERRIS, Warren W(esley) [Des,I] Alexandria, VA b. 22 Je 1890, Rochester, NY. Studied: J. Norton; AIC. Member: Wash. AC. Exhibited: Decorative A. Lg., N.Y., 1923 (prize). Position: des., U.S. Gov. Printing Office [40]

FERRISS, Hugh [I,Arch,Des] NYC b. 12 Jy 1889, St. Louis, MO. Studied: Sch. FA, St. Louis; Washington Univ. Member: AIA; Arch. Lg. Exhibited: Arch. Lg., 1930 (prize). Illustrator: Harpers, Century, Pencil Points, Arts and Decoration. Contributor: article, "Architectural Rendering," Encyclopaedia Britannica, 1929. Positions: T., Columbia (1926), Yale (1923), Univ. Pa. (1928), Wash. Univ. (1928) [40]

FERRITER, Clare [P,T,G] Long Branch, NJ b. Dickinson, ND. Studied: Mass. Sch. A.; Yale; Stanford. Exhibited: Newark AM; Trenton AM; Montclair AM [40]

FERRO, Charles M. [P] Seattle, WA [21]

FERRY, Frances [P,T] Wash., D.C. b. Salt Lake City, UT. Studied: Univ. Wash.; Europe, with Lhote, Ozenfant; Alfred Univ., with K. Nelson. Member: Wash. A. Gld. Exhibited: CGA, 1934; Salon des Tuileries, Paris, 1933; Am.-British A. Center, 1938; Contemp. A. Gal.; Midtown Gal.; Seligmann Gal.; Wash. A. Gld., 1942–46; Wash. SA, 1946; SAM, 1938 (one-man); Henry A. Gal.; Wash. AC; Pub. Lib., Wash., D.C., 1944. Position: T., Univ. Washington, 1940–41 [47]

FERRY, Isabelle H. (Mrs.) [P,T] Easthampton, MA/Boothbay Harbor, ME b. Williamsburg, MA d. ca 1937. Studied: Tryon; Henri; Bouguereau; Boutet de Monvel; Fleury. Member: Springfield, Mass. AL; CAFA; Holyoke AL [33]

FERSTADT, Louis [P,S,I,Des,T,En,L] NYC b. 7 O 1900, Ukraine, Russia. Studied: H.I. Stickroth; K.H. Miller. Member: ASL; Mural P.; Am A. Cong.; Mural Ar. Gld. Exhibited: AIC; BM, 1932 (one-man); ACA Gal., 1935 (one-man); Hudson Walker Gal., 1939 (one-man); WMAA; MMA; MOMA; CI; NAD; PAFA. Work: Walker A. Center; WMAA; Tel-AViv Mus., Palestine; Biro-Bidjan Mus., Russia; murals, Hunter Col.; WNYC; RCA Bldg., NYC; ASL; NYPL; Queens Pub. Lib.; New Rochelle Pub. Lib.; murals, 8th Ave. Subway Station; WFNY, 1939. Illustrator: "Peek-a-Boo," 1931; Chicago Tribune; Fox Features Synd.; comic books. Creator: Collapsible Mural, Revolving Mural, Electro Mural, Motion Mural [47]

FERY, John [P] Morristown, NJ b. ca 1865, Hungary d. 1934, Everett, WA [01]

FESSENDEN, Dewitt Harvey [E,Arch,W] NYC b. 25 S 1884, Waverly, NY [17]

FESSER, Edward [Min.P] Kensico, NY b. 1 N 1863, NYC. Studied: R. Bier [04]

FETSCHER, Charles W. [P,Arch] Richmond Hill, NY. Member: Soc. Deaf A. [29]

FETT, William (Frederick) (Just) [P,T] St. Louis, MO b. 22 S 1918, Ann Arbor, MI. Studied: AIC. Exhibited: WMAA, 1945; AIC, 1944, 1945; CAM, 1945; Art of This Century, 1943; MOMA, 1944; Walker A. Center, 1944; Durlacher Bros., 1943 (one-man), 1946 (one-man); Santa Barbara Mus. A., 1946 (one-man); SAM, 1945 (one-man); Putney Sch., 1945 (one-man). Position: T., Wash. Univ., St. Louis, 1946–47 [47]

FETTWEIS, Leopold [S] Cincinnati, OH. Member: Cincinnati AC [01]

FETZER, Margaret Steenrod [Cer,T] Columbus, OH/Maplewood, OH b. 17 F 1906, Maplewood. Studied: A.E. Baggs, Ohio State Univ. Member: Columbus AL. Exhibited: Columbus Gal. FA, 1934; Robineau Mem. Exh., Syracuse, 1934. Work: coll. Am. ceramics, circulated in Europe, 1937. Specialties: miniatures, gombroon decoration on porcelain. Position: T., Ohio State Univ. [40]

FEUCHTER, Louis [Mar.P,Des] Baltimore, MD b. 10 D 1885, Baltimore d. 11 Ja 1957. Studied: Md. Inst., beginning at age 12; worked for silversmith Samuel Kirk, until 1920. Member: Charcoal C. Work: Mariner's Mus.; Md. Hist. S.; Chesapeake Bay Marine Mus. Specialty: painting Chesapeake Bay craft [15]

FEUDEL, Alma L.M.A. (Mrs. Arthur Feudel) [P,S,T] Chicago, IL b. Leavenworth, KS. Studied: AIC; A. Feudel, NYC. Member: Chicago Municipal AL; AIC [06]

FEUDEL, Arthur [P,I] NYC/Katwyk, Holland b. 27 Mr 1857, Chemnitz, Saxony. Studied: Royal Acads., in Munich and Dresden, with Flinzer, Benczur, Loefftz. Work: Phila. AC [13]

FEURER, Charles F. [C] b. 1861 Brockenheim, Würtemberg, Germany d. 27 Mr 1935, Phila. Studied: PAFA. Member: Phila. A. Alliance; Boston SAC (Master Craftsman); Phila. SAC; N.Y. SAC; Detroit SAC. Exhibited: Boston SAC, 1930 (med). Specialty: trays; was the last exponent of the English craft of japanning

FEURER, Karl [P] Seattle, WA [25]

FEWSMITH, Hazeltine [P] Collingswood, NJ [19]

FFOULKE, Charles Mather [C,W,L] Wash., D.C. b. 1841, Quakertown, PA d. 14 Ap 1909, NYC. Studied: Europe, 1872, 1885 (for 5 yrs.). Member: Nat. Soc. FA (Pres.). Was in the wool business in Phila., 1861–72. Specialty: tapestry. He accumulated one of the largest and most varied collections of tapestries in the world, including the famous Barberini set; he also established, near Florence, a school for repairing tapestries.

FICHTMUELLER, Eleonore [S] Grymes Hills, NY b. 17 D 1904, Stapleton, NY. Studied: E. Epple; B. Bleeker, in Munich [40]

FICKBOHM, Sallie I. [P] NYC. Member: S.Indp.A. [25]

FIDAROFF, Senia [P] NYC. Member: Chicago NJSA [25]

FIELD, Charlotte E. (Mrs.) [Min.P] Brooklyn, NY b. 1838 d. 8 Ap 1920. Member: Brooklyn Soc. Min. P. (Pres.)

FIELD, Edward [P,W] Hartford, CT b. 4 O 1858, Providence. Studied: E.N. Bannister; E.C. Leavitt. Member: CAFA [25]

FIELD, E(dward) Loyal [Ldscp.P,I,E] NYC/Arkville, NY b. 4 Ja 1856, Galesburg, IL d. 22 Mr 1914, NYC. Studied: Académie Julian, Paris; Carolus-Duran. Member: SC, 1899; A. Fund S. Exhibited: SC, 1904 (prize), 1905 (prize) [13]

FIELD, Erastus Salisbury [P] Sunderland, MA b. 19 My 1805, Leverett, MA d. 1900. Studied: self-taught, except for several months with S.F.B. Morse in 1824–25. Married artist Phebe Gilmore, in 1831; lived in Hartford, then Monson and Palmer, Mass.; in NYC, from 1842–48; finally, in Sunderland, where he painted until after 1876. He lived to be 95 yrs. old. Specialties: primitive portraits; mythological and biblical scenes [*]

FIELD, Hamilton Easter [P,E,W,T] Brooklyn, NY/Ogunquit, ME b. 21 Ap 1873, Brooklyn, NY d. 10 Ap 1922, Brooklyn. Studied: Gérôme, Collin, Courtois, Fantin-Latour, Simon, all in Paris. Member: S.Indp.A; Brooklyn SA; Modern AA. Founder: Salons of Am., in 1921, to promote exhibitions open to all artists. Positions: A. Ed., Brooklyn Daily Eagle, The Touchstone, The Arts; Assoc. Ed., Arts and Decoration; Dir., Thurnscoe Sch. A., Ogunquit, Maine, Ardsley Sch. A, Brooklyn [21]

FIELD, Isabel Osbourne (Mrs. Salisbury F.) [P,W] b. 1858 d. 1953, Serena Beach, CA. (formerly the wife of artist Joseph Strong). Author: "This Life I've Loved," 1937 (re: her life in art) [*]

FIELD, J.M. [P] NYC. Member: AG of Authors Lg. A. [25]

FIELD, Laurence B. [P] Colorado Springs, CO. Exhibited: Midwest A. Ann., Kansas City AI, 1935; Colorado Springs FA Center, 1936; WFNY, 1939 [40]

FIELD, Louise Blodgett (Mrs.) [P] Wellesley, MA b. Boston. Studied: R. Turner; F.D. Williams; W.M. Hunt; T. Juglaris; Boston. Member: Boston WCC; Copley S., 1896 [33]

FIELD, M. (Mrs. Herman H.) [P] Chicago, IL b. 14 Ja 1864, Stoughton, MA d. 21 My 1931. Studied: AIC. Member: Chicago SA; Chicago AC. Exhibited: Alaska-Yukon-Pacific Expo, Seattle, 1909 (med); Chicago AC, 1918 (prize) [29]

FIELD, Mary [P] NYC/Bellport, NY b. Phila. Studied: C. Lasar, Callot, Delecluse, all in Paris [15]

FIELD, Sarah Isabella. See Shaw, Mrs.

FIELDING, Mantle [Arch,W] Phila., PA b. 1866, NYC d. 27 Mr 1941. Studied: MIT. Practiced arch. in Phila. Author: lives of several early Am. artists; "Dictionary of American Painters"

FIELDS, Earl T. [P,G,T] Seattle, WA b. 11 Ap 1900, Kuopio, Finland. Studied: Univ. Wash. Member: "Group 12," Seattle; Am. A. Cong. Exhibited: Northwest A. Ann., Seattle AM, 1937 (prize). Work: Seattle AM [40]

FIELDS, Mitchell [S,L] NYC b. 28 S 1901, Belcest, Romania d. 1966. Studied: NAD; BAID. Member: ANA; Am. A. Cong.; Moscow U. of A.; F., Guggenheim Fnd., 1932, 1935. Exhibited: NAD, 1929 (prize); PAFA, 1930 (gold); MOMA; WMAA; BM; MMA. Work: Park of Culture and Rest, Moscow; Mus. Mod. Western A., Moscow; Biro-Bidjan M., USSR; BM; Gorki Literary Mus. [47]

FIENE, Ernest [P,Li,T,E,I] NYC/Southbury, CT b. 2 Nov 1894, Rhineland, Germany d. 1966. Studied: NAD; ASL; BAID. Member: Salons of Am.; Am. Soc. PS&G; Am. A. Cong.; F., Guggenheim Fnd. Exhibited: AIC, 1930–33, 1937 (prize), 1945; CI, 1930–38, 1939 (prize), 1940 (med), 1941 (prize), 1942–45; LOC, 1946 (prize); Corcoran Bienn., 1939 (prize); CGA, 1931-45; PAFA, 1930–45; WMAA, 1930–45. Work: Newark (N.J.) Mus.; BMFA; Harrison Gal., Los Angeles Mus.; Hamilton Easter Field Fnd.; Pal. Leg. Honor; Detroit Inst. A.; FMA; CMA; Mia Coll., Japan; MMA; MOMA; WMAA; BM; CAM; Denver AM; PMG; Swope Gal. A.; NYPL; Columbia; Ohio State Univ.; Dartmouth; murals, USPO, Canton (Mass.), Dept. Interior, Wash., D.C. Illustrator: "Philida & Coridon," 1927, "Phaeton, Son of Apollo," 1929. WPA muralist. Positions: T., ASL (1938–42), Sch. A. Studies, NYC(1945–46), Fashion Inst. (1944–46) [47]

FIENE, Paul [S,P] Woodstock, NY. Member: S. Gld. Exhibited: Bienn. Am. Soc. WC, WMAA, 1934, 1936; WFNY, 1939. Work: USPO, Station O, N.Y. WPA artist. [40]

FIERBAUGH, Margaret [P,Medical I] Cleveland, OH b. Chicago. Studied: Monticello Col.; Univ. Chicago; Chicago Acad. FA; AIC; J.A. Spelman; F.M. Grant; Krehbiel; Giesbert. Member: La Grange (Ill.) A. Lg. Exhibited: AIC, 1936 [47]

FIERO, Emilie L(ouise) [S] NYC b. 1889, Joliet, IL d. 1974. Studied: AIC; abroad; Injalbert; Bartlett; Navelier. Member: NSS; Nat. Assn. Women PS; Art Workers C., N.Y.. Exhibited: NAD; NSS; Arch. Lg.; PAFA. Work: CMA; Eccleston, Md. [47]

FIFE, Mary Elizabeth [P,T] Kansas City, MO b. 26 Ag 1904, Canton, OH. Studied: CI; NAD; CUASch; ASL, with K.H. Miller; Russian Acad., Paris. Member: NAWA. Exhibited: Butler AI, Youngstown, Ohio (prize); AIC; CI; PAFA; WMAA; Pepsi-Cola Exh. Position: T., Kansas City AI, 1946– [47]

FILEMYR, Joseph J. [P] Phila., PA [17]

FILIPPO, A.D. [S] NYC [19]

FILMUS, Tully (Mr.) [Por,P,L,T] Brooklyn, NY b. 29 Ag 1903, Otaki, Russia. Studied: PAFA; NYU; ASL. Member: Am. A. Cong.; Graphic Sketch C.; Audubon A.; A. Lg. Am. Exhibited: Graphic Sketch C., 1925 (prize); WMAA, 1940-46; CGA, 1942; PAFA, 1941–46; AIC, 1941; Denver A. Mus., 1942; CI, 1941–46; Am. A. Cong., 1935–39; Audubon A., 1945; Phila. A. All., 1935. Work: Headquarters, N.Y. Nat. Guard; WMAA; portraits of Army/Navy officials. Position: T., CUASch, 1938– [47]

FILSON, Genevieve W. [P] Houston, TX/Laparte, TX b. 16 Je 1913. Studied: Newcomb Sch. A., New Orleans; Houston MFA. Member: SSAL. Exhibited: Houston Ar. Exh., 1939 (prize). Work: Houston Mus. [40]

FILTZER, Hyman [S] Bronx, NY b. 27 My 1901, Zitomir, Russia d. 1967. Studied: Yale; BAID; G. Borglum; P. Manship. Member: NSS. Exhibited: Nat. Aeronautical Assn., Wash., D.C., 1922 (prize); NAD, 1926, 1936, 1940; PMA, 1940; WFNY, 1939; Arch. Lg., 1938; WMAA, 1940; MMA, 1942; N.Y. Hist. Soc., 1943. Work: S., Pub. Sch., Bronx & Queens, N.Y.; Ft. Wadsworth, N.Y.; Russell Sage Fnd.; U.S. Army Soldier's Trophy; dec., Medical Arts Bldg., Oklahoma City [47]

FINCH, Elinor Gladys [P] Spokane, WA [24]

FINCH, Marjorie [P,Des] NYC b. 28 Mr 1907, West Union, IA. Studied: Coe Col., Cedar Rapids, Iowa; State Univ. Iowa. Exhibited: WFNY, 1939; CGA, 1940, 1941; Delphic Gal., 1937; Dec. C., N.Y., 1941; Julliard Sch., N.Y., 1937 [47]

FINCK, Furman J(oseph) [P,T,E] Saint Johnsbury, VT b. 10 O 1900, Chester, PA. Studied: PAFA; Ecole des Beaux-Arts, Paris. Member: CAFA; Am. A. Cong.; AAPL. Exhibited: NAD, 1943 (prize); WMA, 1945 (prize); nationally. Work: TMA; Lyman Allyn Mus.; Tyler Sch. FA, Temple Univ. Radio talks: Station WIP, Phila. Positions: T., Temple Univ., Oak Lane Sch., Phila. [47]

FINCK, Hazel (Mrs. William C.) [P] Westfield, NJ b. 5 F 1894, New Haven, Conn. Studied: Guy Wiggins; Sigismund Ivanowski. Member: Studio Gld.; NAWA; Irvington A.&Mus. Assn.; Westfield AA; AAPL. Exhibited: N.J. Gal. A., 1937 (prize), 1938 (prize), 1939 (prize) 1941 (prize); Newark AA, 1939 (prize); Irvington A.&Mus. Assn., 1940 (prize), 1943 (prize); Plainfield (N.J.) AA, 1941 (prize), 1942 (prize); NAWA, 1938–45; WFNY, 1939; NAC; Contemporary A. Gal.; Argent Gal.; Studio Gld.; CAFA, 1937–39; Montclair A. Mus., 1938–45; Newark Mus.; N.J. State Mus., Trenton. Work: T., State T. Col., DeKalb, Ill. [47]

FINCKEN, James H(orsey) [E,En,Li,P] Phila., PA b. 9 My 1860, Briston, England d. 23 D 1943. Member: Phila. Sketch C.; Phila. Print C. Exhibited: Print C., 1935 (prize), 1936 (prize). Work: bookplates, NYPL; Oil City, Pa. [40]

FINCKER, James H. [P] Phila., PA [15]

FINDLEY, Ila B. (Mrs. Preston S.) [P] Tuscaloosa, AL b. 18 D 1900, Birmingham, AL. Member: Birmingham AC; Ala. A. Lg. Exhibited: Birmingham AC, 1943 (prize); Birmingham Pub. Lib., 1942 (one-man); Montevallo Col., 1943 (one-man); Mary Buie Mus. FA, Oxford, Miss., 1945 (one-man); Univ. Ala., 1945 (one-man); Ala. A. Lg. [47]

FINE, Perle [P,E,En] NYC b. 1 My 1908, Boston. Studied: H. Hofmann. Member: Am. Abstract A.; Provincetown AA. Exhibited: WMAA; Nierndorf Gal. (one-man); Marion Willard Gal., N.Y. (one-man); Art of This Century; Phila. Pr. C.; Am.-British A. Center. Work: Mus. Non-Objective Painting; prints, MOMA Traveling Exh.; WMAA [47]

FINGADO, Fernando Otto [P] Rosebank, NY [25]

FINGER, Helen [I,T,Li] Fayetteville, AR b. 8 Je 1912, Cincinnati. Studied: R. Braught, Kansas City AI. Illustrator: "Adventures Under Sapphire Skies," "Footloose in the West," (1931–32), other children's books [40]

FINK, Aimee M. [P] NYC. Member: S.Indp.A. [25]

FINK, Bob [P] Elmsford, NY. Member: AWCS [47]

FINK, Denman [P,Des,I,T] Coral Gables, FL b. 29 Ag 1880, Springdale, PA. Studied: Pittsburgh Sch. Des.; BMFA Sch.; ASL; F. Benson; P. Hale; E. Tarbell; G. Bridgman; W.A. Clark. Member: SI; NSMP; SC; Blue Dome Fellowship; Fla. Fed. A. Exhibited: NAD; PAFA; CGA; CAM; AIC; NYWCC; SI; Miami Beach Lib.; Blue Dome Fellowship, Coral Gables, Fla. (one-man). Work: Fed. Court, Miami; USPO, Lake Wales, Fla.; Coral Gables City Hall; Eastern Air Lines ticket office, Miami. Illustrator: "Mace's History of the United States," "The Barrier," "The Post Girl," "Lost Borders." Illustrator: Harpers, Scribner's, Century, Saturday Evening Post. WPA artist. Position: T., Univ. Miami [47]

FINK, Lucille [P,Li] Chicago, IL b. 4 O 1910, Chicago. Studied: AIC. Member: ASL, Chicago [33]

FINK, Robert Richard [Por.P] Terre Haute, IN b. 10 Jy 1909. Studied: W. Adams; Taflinger. Exhibited: Hoosier Salon, 1936 (prize); Ind. State Fair, 1936 (prize). Work: Ind. State T. Col. [40]

FINKELGREEN, David [P] Phila., PA b. 1888 d. 10 Ag 1931. After the usual training in fine arts, he devoted four years to coloring the irises of glass eyes. During WWI, French surgeons sought his assistance in rehabilitating soldiers blinded in battle.

FINKELNBURG, Augusta [P] Kimmswick, MO b. Fountain City, WI. Studied: AIC; Pratt Inst., Brooklyn; Paris; Italy; Holland; England; R. Reid, W. Metcalf, H.B. Snell, H. Adams, Dow. Member: St. Louis AG; St. Louis AL. Exhibited: Mo. State Fair (prizes); St. Louis AL, 1930 (prize), 1933 (prize); St. Louis AG, 1933 (prize). Work: Wash. Univ., St. Louis; State T. Col., Winona, Miss.; Vanderpoel Mem. Gal., Chicago [40]

FINKELSTEIN, Clara S. (Mrs. I.B.) [P,S,Car,I] Wilmington, DE/Arden, DE b. 3 My 1885, Russia. Studied: Wilmington Acad. A.; Hawthorne, N.C. Wyeth. Member: Phila. A. All.; Wilmington Soc. FA; Westchester County AA. Exhibited: Wilmington Acad. FA, 1930 (prize); ACI, Wilmington, 1931 (prize), 1932 (prize), 1933 (prize); Wilmington Soc. FA, 1939; Studio Group, 1939 (one-man). Work: Wilmington Soc. FA [40]

FINKELSTEIN, Maria Hamel [P] Baltimore, MD/Wash., D.C. [25]

FINKLE, Melik [S,C,Des] NYC b. 12 O 1885, Romania. Studied: Cincinnati A. Acad.; Clement Barnhorn. Work: Cincinnati Mus. Assoc.; USPO, Sylvania, Ohio. WPA artist. [47]

FINLAYSON, Donald Lord [Edu] Ithaca, NY b. 20 S 1897, Rye, NH. Studied: Dartmouth; Brown Univ.; Harvard; Princeton. Author: "Michelangelo the Man," 1935. Position: T., Wells Col. (1925–28), Elmira Col. (1938–), Cornell [33]

FINLEY, A. Clemens [P] NYC. Work: USPOs, Brooklyn, Kensington, Station, Buffalo, all in N.Y. WPA artist. [40]

FINLEY, Arthur [I] NYC. Member: SI, 1914 [17]

FINLEY, Charles [P] San Luis Obispo, CA. Member: Calif. AC [17]

FINLEY, Elizabeth R. See Thomas, Mrs.

FINLEY, Ella [P,S,T] Phila., PA b. Phila. Studied: PAFA [10]

FINLEY, Vernon B. [P] Latonia, KY. Member: Cincinnati AC [17]

FINN, James Wall [Mur.P] NYC/Paris, France (1912–13) d. 28 Ag 1913, Giverny, France. Exhibited: Paris Salon, 1896, (prize); Pan-Am. Expo, Buffalo, 1901 (med). Specialty: decorative panels [13]

FINN, Kathleen Macy (Mrs.) [E,Li] Ardsley-on-Hudson, NY b. 1 F 1896. Studied: F.G. Hall, Boston; G. Bridgman; Nankivell; Pennell. Member: SAE; NAWA; Hudson Valley AA; ASL. Exhibited: NWPS; WFNY, 1939 [47]

FINNEGAN, Gladys Louise Brown (Mrs. Frank E.) [Com. A] Great Neck, NY b. 3 My 1903, Minneapolis, MN. Studied: Univ. Minn. Work: Com. Illus., stores in Minneapolis and St. Paul [32]

FINNEY, Clarence J. [P] College Station, TX. Exhibited: Fontainebleau Alumni Exh., 1935; SSAL, 1938; Ar. Southeast Tex. Ann., Houston Mus., 1938 [40]

FINSTERWALD, Corrine (Mrs. Guy Rowe) [P] Hampton, CT b. 5 N 1894, Marion, WI d. 2 Ap 1965, NYC. Studied: R. Kryzanowski; J.P. Wicker; G. Rowe. Member: AFA; Mich. Acad. Sc. A.&L.; Detroit S.Indp.A.; NAWPS. Work: LOC [40]

FINTA, Alexander [S,W,I,L,T] Los Angeles, CA b. 12 Je 1881, Turkeve, Hungary. Studied: Columbia; Europe. Member: P.&S. C. of Southern Calif. Exhibited: P.&S. C., 1941, (prize), 1945 (med); Nat. Mus. FA, Budapest; Bellas Artes Mus., Rio de Janeiro; Numismatic Mus., NYC; MMA; BM; Los Angeles Mus. A.; BM (one-man); NYPL (one-man); Lehigh Univ. (one-man); Lafayette Col. (one-man); Muhlenburg Col. (one-man); Newark Mus. (one-man); Easton Mus. (one-man); Los Angeles Pub. Lib. (one-man); Stendahl A. Gal., Los Angeles (one-man); NAD (one-man). Work: MMA; N.Y. State Gov.; Authors C.; Acad. Medicine; City Health Dept.; Numismatic Soc.; Cleveland Pub. Lib.; mon., Transylvania; Yugoslavia; First Presbyterian Church, NYC; Walt Whitman Mem., Brooklyn; U.S. Gov.; Cathedral, Rio de Janeiro; Nyitra, Maniga, Czechoslovakia; Nat. Mus., Museum of War, Budapest; medal, Hungarian Fed. of Am.; St. Stephen's Church, NYC; Gloucester City, N.J.; Los Angeles Mus. A. Illustrator: books. Author: "Herdboy of Hungary," "Trial by Steel," "Chico." Lectures: Philosophy of Art, Hungarian Folk Art, Art and Religion, Conservative, Modern, and Abstract Art. Position: S., Twentieth Century Fox [47]

FIORATO, Noe [S] NYC [21]

FIORE, Anthony Joseph [S] NYC 10 S 1912, NYC. Studied: NAD. Member: Larchmont AS [33]

FIORE, Rosario Russell [S] Wash., D.C. b. 5 Ja 1908, NYC. Member: Morristown AA. Exhibited: Morristown AA, 1936. Work: U.S. Gov. coll.; portraits, fountains, dioramas, war memorials [40]

FIORENTINO-VALLE, Maude Richmond [P,I,W,T,Cr] Denver, CO/Mt. Morrison, CO. Studied: ASL, with Cox, Chase, Brush, Beckwith; Académie Julian, with Lefebvre, Constant, Beaury-Sorel. Position: Cr., Rocky Mountain News [25]

FIORIGLIO, Michael [P] Phila., PA. Studied: PAFA. Exhibited: PS Ann., PAFA, 1939 [40]

FIREBAUGH, Nettie King (Mrs.) [P] San Francisco, CA b. Oakland, CA [17]

FIRESTONE, I(sadore) L(ouis) [P,I,T] Pittsburgh, PA b. 13 Ap 1894, Austria-Hungary. Studied: CI; N.Y. Evening Sch. of Indp. A.; ASL. Member: Pittsburgh AA [33]

FIRMIN, A(lbert) E(dwin) [S] Dallas, TX b. 6 Mr 1890, Mexia, TX. Studied: Chicago Acad. FA [33]

FIRTH, Karl W. [P,Des,Car] Detroit, MI b. 1 Ja 1911, Kansas City, MO. Studied: Cleveland Sch. A.; H.G. Keller; P. Travis; W. Combes. Member: Scarab C.; A. Dir. Cl., Detroit, Mich. Exhibited: Phila. WCC, PAFA, 1938; Butler AI, 1939 (prize); CMA, 1936–40, 1942 (prize); PAFA, 1938–40; NYWCC, 1940, 1941; AIC, 1941, 1942; Detroit Inst. A., 1941–43, 1945, 1946 [47]

FISCHER, Anton Otto [I] Woodstock, NY b. 23 F 1882, Munich, Germany d. 26 Mr 1962. Studied: A.B. Frost, ca. 1903; Académie Julian, Paris, with Jean Paul Laurens, 1906. Member: SI. Illustrator: Harper's; Saturday Evening Post; books by London, Kipling, Conrad. Work: Kendall Whaling Mus.; Mystic Seaport Mus. Marine painter for the Coast Guard during WW II. [47]

FISCHER, George [Li] Brooklyn, NY b. 1844 d. 6 Mr 1914, Greenwich, CT

FISCHER, H. [P] NYC. Member: S.Indp.A. [25]

FISCHER, Henrietta C. [C,Des,T,Gr,L] Cincinnati, OH b. 26 O 1881,

Cincinnati. Studied: Cincinnati A. Acad.; Columbia; Harvard; A. Dow; D. Ross; R.H. Johonnot. Member: Cincinnati Assn. Pub. Sch. T.; Cincinnati Crafters; Western AA; AFA; Am. Assn. Univ. Women. Exhibited: Ohio PM, 1939, 1940; Saranac Lake AL, 1943; CGA, 1943; Phila. A. All., 1933; Contemporary Crafts Exh., 1933; Cincinnati Women's C., 1916–46; CM, 1936, 1938; Cincinnati Crafters; Ohio State Fair, 1933 [47]

FISCHER, Hulda Rotier [P,Gr,T,] Milwaukee, WI b. 28 Jy 1893, Milwaukee. Studied: Milwaukee Sch. A.; Milwaukee AI; AIC; M. Davidson; A. Hansen; R. von Neumann. Member: Wis. P.&S.; Milwaukee PM. Exhibited: Women Painters of Am., Wichita, Kans., 1938 (prize); Okla. A. Center, 1939–41; Blue Ridge A. Col., N.C., 1941; LOC, 1943–46; John Herron AI, 1946; Miss. AA, 1946; Milwaukee AI, 1935–45, 1946 (prize); Madison AA, 1935–45, 1938 (prize); Kenosha AI 1938; AIC, 1940–43; Wis. State Fair, 1938–44 (prizes); Superior State T. Col., 1946 (one-man); Walrus C., Milwaukee, Wis., 1943 (one-man). Work: LOC. Position: T., Shorewood, Wis. H.S. [47]

FISCHER, Martin (Henry) [P,W,L] Cincinnati, OH b. 10 N 1879, Kiel, Germany. Member: Duveneck Soc. P.; Cincinnati AC; AAPL; AFA. Work: murals, Col. Medicine, Cincinnati. Author: "The Permanent Palette," 1930; technical booklets for AAPL; journals [47]

FISCHER, Mary Ellen Sigsbee (Mrs. Anton O.) [I] Kingston, NY/Shandaken, NY b. 26 F 1876, New Orleans, LA. Studied: Wash. ASL; N.Y. ASL. Member: SI, 1912 [33]

FISH, Gertrude Eloise [S] Roselle Park, NJ b. 28 S 1908, Roselle Park, NJ. Studied: G. Lober; C. Grafly; A. Laessle. Member: F., PAFA; Westfield AA; Clay C. Exhibited: PAFA, 1930 (prize); Exh. by Women Artists, Gimbels, 1932 [40]

FISHBURN, Josephine R. (Mrs.) [P] Mt. Auburn, OH. Member: Cincinnati Women's AC [24]

FISHER, A. Hugh [P,E,W] Hingham Center, MA/London, England b. 8 F 1867, London. Studied: J.P. Laurens; B. Constant; Sir Frank Short. Member: Chicago SE; Calif. PM; Royal Soc. P.&E. Work: Wash., D.C. Pub. Lib.; LOC; British Mus. National Art Gallery of Victoria, London [31]

FISHER, Alleene Lowery (Mrs.) [P,S,Des,T,L] b. 5 N 1901, Oklahoma City, OK. Studied: R.I. Sch. Des. Member: The Crafts Gld. Work: Camp Hanoum, Thetford, Vt.; St. Columba's Church, Detroit; Junior Women's Cl. of General Federation of Women's C.; General Fed. of Women's Cl. Position: Founder/Dir., Crafts Gld. Art Sch. [40]

FISHER, Anna S. [P,T] NYC d. 18 Mr 1942, Cold Brook, NY. Studied: PIASch, 1900. Member: ANA; NA, 1932; AWCS; NYWCC; NAWPS; SPNY; Allied AA; NAC; Louis Comfort Tiffany Fnd. Exhibited: NAWPS, 1919 (prize); NYWCC, 1921 (prize); Baltimore WCC, 1922 (prize); AWCS; NYCC, 1924 (prize); Grand Central Gal., 1930 (prize); NAC, 1932 (prize). Work: NAD; NAC; PIASch; BM; Montclair Mus., N.J. Position: T., PIASch, 41 yrs. [40]

FISHER, Bud [I] NYC b. 3 Ap 1885 [21]

FISHER, Dudley T. [P] Columbus, OH. Member: Columbus PPC [25]

FISHER, Elizabeth [C] Providence, RI/Saunderstown, RI b. 23 N 1910, Melrose, MA. Work: R.I. Sch. Des. Specialty: handwrought gold and silver jewelry [40]

FISHER, Emily Kohler (Mrs. Charles) [P] Germantown, PA/Llanerch, PA. Member: F., PAFA [25]

FISHER, Flavius J. [Por.P] b. 1832, Wytheville, VA d. 9 My 1905, Wash., D.C. Studied: Phila. during 1850s; German Art Inst., Berlin, 1859–60 (first American admitted). Settled in Lynchburg, Va., from ca. 1860 to ca. 1882. His studio was in the CGA, where he painted portraits of prominent people, from 1882–1905.

FISHER, Flavius J. (Mrs.) [P] Wash., D.C. [10]

FISHER, George Harold [P,S,C,W,T] Detroit, MI b. 14 S 1894, Detroit, MI. Studied: Detroit Sch. FA; J. Wicker. Member: Crafts G. Exhibited: Grosse Pointe, Mich, 1934–36 (prizes); Detroit AI, 1919; Los Angeles Mus. A., 1924–26; P.&S. Soc., 1926, 1927; Calif. WCS, 1926; Calif. Mod. A. Workers, Hollywood, 1924; San Diego FA Soc., 1926; Scarab Cl., Detroit, 1936. Work: murals, Westlake Professional Bldg. (Los Angeles), USPO, Chelsea (Mich.), Los Angeles Crematory; portraits, Wayne Univ. Mich. WPA artist. Positions: T., C. Gld. (Detroit), Studios Animated Cartoons [47]

FISHER, George V. [P] NYC. Member: S.Indp.A. [21]

FISHER, Gladys Caldwell [S] Denver CO b. 6 Ap 1907, Loveland, CO. Studied: R. Garrison; J. Thompson; B. Hoyt; C. Kassler; Archipenko; José de Creeft; Antoine Bourdelle; George Hilbert. Exhibited: WFNY, 1939. Work: Denver AM; Denver Court House; CGA; Treasury Dept., Wash., D.C.; mem. to D.H. Lawrence for Frieda Lawrence; USPO, Las Animas, Colo. WPA artist. [40]

FISHER, Hammond E. (Ham Fisher) [Car] NYC b. 1900, Wilkes-Barre, PA. Member: SI. Creator: cartoon strip "Joe Palooka" [47]

FISHER, Harrison [I] NYC b. 27 Jy 1875, Brooklyn d. 19 Ja 1934. Studied: San Fran., with Amedeé Joullin. Member: SI, 1911; Bohemian Cl. Work: Puck, Life; "Beverly of Graustark" (cover), "The Market Place," "Three Men on Wheels." Creator: Harrison Fisher Girl. Position: Illus., San Franciso Call, The Examiner [33]

FISHER, Howard [P] San Antonio, TX. Work: USPO, Liberty, Texas. WPA artist. [40]

FISHER, Howard [Car] Portland, OR b. 12 S 1890, Santa Fe, NM. Studied: Portland AA Sch. Work: Huntington A. Gal., San Marino, Calif.; Princeton Univ. Cartoonist: national magazines and newspapers. Positions: A.Dir., 1934– , Ed. Car., (Portland) Oregon Journal, 1931– [47]

FISHER, Hugh Antoine [Ldscp.P] b. ca. 1850 (Brooklyn, NY?) d. 1916, Alameda, CA. Studied: his father. Moved to San Fran., ca. 1890. His son Harrison became a well-known illustrator.

FISHER, Hugo Melville [P] NYC b. 20 O 1876, Brooklyn, NY. Studied: Whistler; Laurens; Constant. Member: Paris AAA [31]

FISHER, J.W. [P] Paris, France [13]

FISHER, Lillie Fry [P] Terrace Park, OH. Member: Cincinnati Women's AC. Exhibited: Conn. Acad. FA, 1934; Cincinnati Women's AC, 1934; Hoosier Salon, 1933, 1934, 1935 (prize), 1936, 1937, 1940 (prize) [40]

FISHER, Margaret Paine (Mrs. Charles) [Min.P] b. 1874 d. 7 Jy 1946, Mount Holly, NJ. Member: N.Y. Soc. Cr.; Soc. of the Four Arts, Palm Beach, Fla.

FISHER, Mary L. Boston, MA b. Brookline, MA. Studied: BMFA Sch., with Tarbell, DeCamp. Member: BASA, 1886 [01]

FISHER, Orr Cleveland [P,Car] Mount Ayr, IA b. 27 N 1885, Delphos, IA. Studied: Drake Univ.; Cumming Sch. A. Member: Iowa AC. Exhibited: 48 States Comp., 1939. Work: murals, Mt. Ayr, Forest City, Iowa [47]

FISHER, Parker William [C,T] Murphy, NC b. 24 Ap 1880, Harlan IA. Specialty: articles in fine woods [40]

FISHER, Reginald [Mus.Cur,W,L,Edu] Santa Fe, NM b. 19 Ap 1906, Lawton, OK d. 1966. Studied: Univ. N.Mex.; Univ. Southern Calif. Member: AA Mus. Co-author: "Mission Monuments of New Mexico," 1943. Editor: "Sacred Paintings on Skin," 1944. Contributor: museum bulletins & journals. Lectures: Colonial Folk Art of N.Mex. Position: Cur., Mus. N.Mex., 1941– [47]

FISHER, Stowell Le Cain (Mrs. S. LeC. Smith) [P] Ogunquit, ME b. 18 Jy 1906, Wellsville, NY. Studied: K.H. Miller; Lhote; ASL; Paris. Member: ASL; NAWPS; Dutchess County AA. Exhibited: NAWA, 1941, 1942; Portland SA, 1946; N.Y. State Exh., 1941; Hyde Park Lib., 1942; Dutchess County Group, 1941; Five Painters Exh., N.Y., 1942, 1945 [47]

FISHER, Vaudrey [P,C,T] Denver, CO b. 9 Aug 1889 Staffordshire, England. Studied: von Herkomer; Castellucho; Brangwyn [24]

FISHER, William [P,L,T] Teaneck, NJ b. 17 Je 1890, Brooklyn, NY. Studied: PIASch; ASL. Member: SC; CAFA; AAPL; Springfield AL; North Shore AA; Ridgewood AA. Exhibited: NYWCC, 1936, 1937; Asbury Park Soc. FA, 1938 (prize), 1941 (prize); NAD, 1938, 1943, 1945; PAFA, 1936; Pepsi-Cola, 1945 (prize); Springfield AL, 1944 (prize); CAFA, 1944; New Haven PCC, 1944–46; Montclair A. Mus., 1938–46; Ridgewood AA; Currier Gal. A., 1943; All-Jersey Exh., 1939 (prize), 1940 (prize); Newark AC, 1942 (prize). Work: Haddonfield Women's C.; New Haven PCC; Municipal Bldg., Ridgewood, N.J.; Contemporary Women's C., Newark; Presbyterian Church, Garfield, N.J. Position: T., 8th St. A. Sch., NYC [47]

FISHER, William Edgar [Des,Dr] NYC b. 24 O 1872, Wellsville, NY. Studied: Cornell; AIC. Member: A. Bookplate S. (Pres.) Work: bookplates, British Mus.; NYPL; many college libraries in U.S.; "Five Portfolios of Bookplates" [47]

FISHER, (William) Mark [Ldscp.P,P] Hatfield Heath, Essex, England. b. 1841, Boston d. 30 Ap 1923. Studied: Lowell Inst., Boston; Gleyre, Paris. Member: Assoc. Royal Acad., 1911; New English AC; Essex AC. Exhibited: Paris Expo, 1889 (med); Chicago Expo, 1893 (med); Pan-Am. Expo, Buffalo, 1901; St. Louis Expo, 1904 (gold). Work: Detroit Mus. [17]

FISK, Eleanor Hepburn (Mrs. Pliny Fisk) [P] NYC. Member: NAWPS [25]

FISK, Harry T. [I] NYC. Member: GFLA [27]

FISK, Mary Stella [S] Angola, IN. Member: Ind. SS [25]

FISK, Myrtle T. [S] Robbinsdale, MN [24]

FISKE, Charles Albert [P] Greenwich, CT (1865–1915) b. 1836 Alfred, ME d. 13 My 1915. Studied: J.B. Stearns; Dartmouth. Member: Greenwich SA. Exhibited: NAD [01]

FISKE, Gertrude [P] Weston, MA b. 16 Ap 1879, Boston, MA d. 1961. Studied: Tarbell; Benson; Hale; Woodbury. Member: ANA; NA, 1930; Boston Gld. A.; Concord AA; CAFA; New Haven PCC; AFA; State Art Comm. Exhibited: P.-P. Expo, 1915 (med); CAFA, 1918 (prize), 1926 (prize); Wilmington Soc. FA, 1921 (prize); NAD, (prizes) 1922, 1925, 1929, 1931, 1935; NAWA, 1925 (prize); New Haven PPC (prizes) 1925, 1929; Springfield AL, (prizes) 1925, 1931; Ogunquit A. Center, 1932 (prize); Women's Intl. Expo, Detroit, 1929 (prize). Work: PAFA; John Herron AI [47]

FISKEN, Jessie [P,C,T] Seattle, Wash./Winslow, Wash. b. 5 Mr 1860, Row, Scotland. Studied: Glasgow Sch. A. Member: Seattle FAS [25]

FITCH, Benjamin Herbert [P] Phila., PA b. 4 S 1873, Lyons, NY. Studied: self-taught. Member: Rochester AC; Rochester SA [21]

FITCH, Eugene C. [P] NYC. Member: S.Indp.A. [21]

FITCH, Evelyn [P] St. Louis, MO [25]

FITCH, Gladys Kelley [P,T] Lyme, CT b. 29 Ag 1896, NYC. Studied: N.Y. Sch. Appl. Des.; ASL, with Bridgman, Sloan, Henri. Member: AA of N.J.; Conn. WCS; Lyme AA. Exhibited: NGA, 1941; S.Indp.A., 1924–34; Lyme AA, 1940–46; Montclair A. Mus., 1937–40; Conn. WCS, 1942–46; AA of N.J., 1941, 1946. Position: T., Kimberley Sch., Montclair, N.J. [47]

FITCH, John Lee [Ldscp.P] NYC b. 1836, Hartford, CT d. 1895. Studied: Hartford, with J. Busch, G. Wright; Munich, Milan, 1855–59 (returned to Hartford, 1859–66, then settled in NYC; made another trip to Germany in 1871). Member: ANA, 1870; A. Fund S.; Century. Exhibited: NAD, 1860 [*]

FITCH, Walter [P] San Fran. CA. Member: S.Indp.A. [25]

FITE, Frank E., Mrs. See Peck, Anne.

FITE, Harvey [S,L,W,Edu] Saugerties, NY b. 25 D 1903, Pittsburgh, PA d. 1976. Studied: St. Stephen's Col.; Woodstock Sch. Painting; Corrado Vigni, Florence, Italy. Member: Woodstock AA; Dutchess County AA. Exhibited: WMAA, 1945, 1946; Woodstock AA, 1938–45; Dutchess County AA, 1938–40; Upper Hudson Exh., 1946. Lectures: History and Theory of Sculpture During Italian Renaissance; Mayan Civilization; The Art of the Maya. Position: T., Bard Col., 1933– [47]

FITHIAN, Frank Livingston [I,Car] b. 1865, Phila., PA d. 8 Ap 1935, Haddonfield, NJ. Studied: PAFA; N.Y. art schools. Member: Phila. Sketch Cl. Illustrator: Judge (covers), Puck, Saturday Evening Post, Collier's, other magazines

FITLER, William Crothers [P,I] NYC b. 1857, Phila. Studied: PAFA. Member: SC, 1881; NYWCC; Kit-Kat C.; Brooklyn AC; A. Fund S.; N.Y. Municipal AS [10]

FITLER, W.C., Mrs. See Hirst, Claude.

FITSCH, Eugene C(amille) [G,P,T] NYC/Dennis, MA. b. 11 D 1892, Alsace, France. Studied: M. Young; DuMond; Pennell; Albright Art Sch.; ASL; Beaux Arts School of Sculpture. Member: S.Indp.A.; ASL; Alliance; Lyme AA. Designer: stage sets [40]

FITTS, Clara Atwood (Mrs. F.W.) [I] Roxbury, MA/Marlboro, NH b. 6 O 1874, Worcester, MA. Studied: BMFA Sch. Member: Copley S. Work: altar piece, St. John's Church, Roxbury, Mass.; "Vision of St. Francis" Chapel of St. Francis, Marlboro, N.H.; Windham House, NYC. Author/Illustrator: "Jeremy Mouse and His Friends." Illustrator: juvenile books, textbooks [40]

FITZER, Karl H. [P,I] Kansas City, MO b. 4 My 1896, Kansas City. Member: Kansas City SA [33]

FITZGERALD, Beatrice E. (Mrs. John J.) [P] d. My 1944, Detroit, MI. Member: PBC

FITZGERALD, Desmond [Patron] b. 1846, Nassau, B.W.I. d. 22 S 1926. He established and maintained an art museum on his estate in Brookline, Mass.

FITZGERALD, Edmond James [P,E,G,L,Mur.P] Arch Cape, OR b. 19 Ag 1912, Seattle, WA. Studied: Calif. Sch. FA; E.P. Ziegler. Member: NSMP. Exhibited: Am. WCC, 1939; AWCS, 1940, 1946; CGA, 1939, 1940; NAD, 1946; SFMA, 1940; Portland Mus. A., 1941; SAM, 1934; NSMP, 1946 (prize). Work: Nat. Mus., Wash., D.C.; SAM; IBM; Wash. State Col.; murals, USPOs, Ontario (Oreg.), Colville (Wash.), Preston (Idaho); Wash. State; White House, Wash., D.C. Contributor: American Artist. WPA artist. [47]

FITZGERALD, Harrington [Ldscp.P,Mar.P] Phila., PA b. 5 Ap 1847, Phila. d. 16 S 1930, Williamstown, PA. Studied: Fortuny, Gérôme, both in Paris; Phila., with G. Nicholson, J.S. Sargent. Member: Fairmount Park AA; AAS (Pres.); Phila. Sketch C.; Pen and Pencil C., Phila.; Newspaper Artists' Assn.; AAS artist member, Art Jury, Phila., 1908–12. Exhibited: AAS, 1902 (gold); Charleston Expo, 1920 (med); St. Louis Expo (med). Work: Smithsonian Inst.; NGA; Albright A. Gal., Buffalo; Detroit Mus.; Commercial Mus., Phila.; State College, Pa. Position: Bus. Manager and Managing Ed., Philadelphia Item, for 30 yrs. [29]

FITZGERALD, Irene Catharine (Mrs.) [C] Hoboken, NJ b. 20 Je 1895, NYC. Studied: A. Heckman; W. Reiss; Mary Lewis; M. Robinson; H. Reiss. Member: Keramic Soc.; Des. Gld. Specialties: pottery; batik [40]

FITZGERALD, James [P] Monhegan, ME b. 8 Mr 1899, Boston, MA. Member: Calif. WCS. Exhibited: Santa Cruz State Wide Exh., 1930 (prize); 1935 (prize), 1939 (prize) [40]

FITZGERALD, James Herbert [P] Seattle, WA b. 17 Ag 1910. Studied: Univ. Wash.; Art Center Sch., Los Angeles; Kansas City AI, with T.H. Benton; Colorado Springs FA Center, with B. Robinson. Member: Carnegie F., Yale, 1938, 1939. Exhibited: Northwest Ann., Seattle, 1936, 1938; Kansas City, 1937 (prize); CI. Work: Leighton Gal., Kansas City. Position: T., Kansas City AI [40]

FITZGERALD, Jean Banks [C] Charleston, WV b. 3 My 1908, Charleston, WV. Studied: G. Peet; E. Flack; Penland Sch. Handicrafts, N.C. Member: NYSC; Associated C., W.Va. Exhibited: AFA Crafts. Exhib., Intl. Expo, Paris, 1937. Specialties: jewelry; metal work; weaving [40]

FITZGERALD, Laura. See Parsons.

FITZGERALD, Mary M. (Molly) [P,T] Woodmont, CT b. 23 Je, 1889, Shelton, CT. Studied: Charles W. Hawthorne; G. Wiggins; Deane Keller; James G. McManus; Frederick Lester Sexton. Member: Conn. AA; CAFA; New Haven PCC; Brush & Palette Cl. Exhibited: CAFA; New Haven PCC. Position: T., Plainville, Conn. H.S. [47]

FITZGERALD, Pitt Loofbourrow [I,W] Columbus, OH. b. 3 O 1893, Washington Court House, OH. Studied: PAFA; N.C. Wyeth, living in Chadds Ford, 1926. Author/Illustrator: "Trail of the Ragged Fox," "Young Men in Leather," "The Black Spearman," 1930, 1931, 1934. Illustrator: "Little Brother of the Hudson" and "The Carved Sea Chest," by J.A. Braden, pub. Harper's, 1928, 1930 [40]

FITZGIBBON, Geraldine [P] St. Paul, MN [24]

FITZGIBBON, J.L. [P] Kansas City, MO [21]

FITZPATRICK, Daniel Robert [Car] St. Louis, MO b. 5 Mr 1891, Superior, WI. Studied: AIC. Exhibited: PAFA, 1924 (prize); CAM; Assoc. Am. A. Work: Mus. Western A., Moscow; New Zealand Mus. A. Awards: Pulitzer cartoon prize, 1926; Harmon-Survey Prize. Contributor: St. Louis Post-Dispatch; Collier's. Positions: Ed. Car., St. Louis Post-Dispatch, 1913– , Collier's, 1926– [47]

FITZPATRICK, Grace Marie [P,C,T] Brooklyn, NY/Manhasset, NY. b. 25 Jy 1897, Brooklyn. Studied: H. Speakman; B. Eggleston; H.B. Snell. Member: Brooklyn SA; NAWPS [40]

FITZPATRICK, Helena Way [P,T] Phila., PA b. 10 Ag 1889. Studied: Daingerfield; H. Snell; S. Murray; Phila. Sch. Des. for Women. Member: Plastic C.; Lectures: Furniture; The Nativity in Art. Position: Educational Supv., Pa. Mus. A. [40]

FITZPATRICK, John C. [P,I,W] Wash., D.C. b. 10 Ag 1876, Wash., D.C. Studied: ASL. Member: Wash. WCC; Wash. AC [31]

FITZPATRICK, John Kelly [P,I,T] Wetumpka, AL b. 15 Ag 1888, Wetumpka. Studied: AIC; Univ. Ala.; Académie Julian, Paris. Member: SSAL (Dir.); Ala. AL (Pres.); New Orleans AA; Ala. WCS; Birmingham AC; Miss. AA; NAC. Exhibited: SSAL, 1926 (prize); Ala. A., 1927 (prize); Miss. AA, 1937 (gold), 1938 (prize); IBM, 1940 (prize); John Herron AI, 1933; Grumbacher's Exh., 1935; WFNY, 1939; NAC, 1940; Pasadena AI, 1946; Ala. AL, 1932 (prize); Ala. WCS. Work: White House, Wash., D.C.; IBM; Ala. State Mus.; Ala. State Capitol; Univ. Ala.; Ala. Col.; murals, USPOs, Ozark, Phenix City, both in Ala.;

Montgomery Mus. FA; Grand Masonic Lodge of Ala.; Hohemburg Mem. Sch., Wetumpka, Ala. Illustrator: "In and Out of Court," 1942. Positions: Hd., Mus. A. Sch., Montgomery, Ala.; Dir., Dixie Colony, Deatsville, Ala. [47]

FITZPATRICK, L. [P] NYC [04]

FITZ-RANDOLPH, Grace [P,S,T] NYC b. NYC d. 3 Ja 1917. Studied: J.A. Weir; Saint-Gaudens; Constant; Girardot; Puech. Member: ASL; WPS. Exhibited: Atlanta Expo, 1895 [15]

FITZWILLIAMS, Sarah E.R. (Mrs.) [Patron] Chicago, IL b. 1840 d. 31 J 1918. Gave a valuable collection to the Chicago Art Institute.

FJELDE, Paul [S,Edu] Brooklyn, NY b. 12 Ag 1892, Minneapolis, MN. Studied: Minneapolis Sch. A.; ASL; BAID; Royal Acad., Copenhagen; Grande Chaumière, Paris. Member: NSS; Eastern AA; Grand Central A. Gal.; Brooklyn SA; F., Am.-Scandinavian Fnd. Work: monuments, Lier, Oslo, both in Norway; Hillsboro, N.Dak.; Madison, Wis.; St. Paul Hist. Soc.; arch. sculptures, schools and bldgs., Pittsburgh, NYC, Boston, Springfield, Mass, McKeesport, Pa.; N.Y. Mus. Science & Industry; Brookgreen Gardens, S.C. Position: T., PIASch, 1929– [47]

FJELLBOE, Paul [P] Salt Lake City, UT [15]

FLAAD, Barbara Black [Por.P] Providence, RI/Sackville, New Brunswick b. 5 Jy 1903, Sackville. Studied: PAFA; Slade Sch., London; Mount Allison Studio, Sackville. Member: Providence AC. Work: Mount Allison Univ. [40]

FLACK, Arthur W. [P,D,Arch] Rochester, NY b. 1878, San Fran. Studied: Rochester Mechanics' Inst.; Paris; London. Member: Rochester AC; Rochester AL [24]

FLAGG, Charles Noël [Por.P,T,W] Hartford, CT b. 25 D 1848, Brooklyn, NY d. 10 N 1916. Studied: J. de la Chevreuse, in Paris. Member: ANA, 1909; Hartford Municipal AS (Pres.); CAFA (Pres.); International Soc. AL; Art. Com.; Hartford Cl.; SC; Conn. State Commission of Sculpture; Le Cercle Français; Founder/Member, Conn. Lg. Art Students. Exhibited: NAD, 1908 (prize). Work: Hillyer A. Gal., Northampton, Mass.; Wadsworth Atheneaum. His principal portraits were of Mark Twain, Charles Dudley Warner, governors of Conn. Position: Dir., Flagg Evening Sch. Drawing for Men [15]

FLAGG, H. Peabody [P] b. 1859, Somerville, MA. Studied: Carolus-Duran, in Paris. Member: N.Y. Arch. Lg., 1899; Boston AC; SC, 1904. Work: Flower Mem. Lib., Watertown, N.Y. [40]

FLAGG, J(ames) Montgomery [I,P] NYC b. 18 Je 1877, Pelham Manor, NY d. 27 My 1960. Studied: ASL, 1893; Herkomer, in England; V. Marec, in Paris. Member: SI, 1911; Lotos Cl.; Ar. Gld. Illustrator: "City People," "Kitty Cobb," "Boulevards all the Way—Maybe," books of satire; Liberty, Cosmopolitan, other magazines. Collection of drawings published as "The Well-Knowns." Flagg sold his first illustration to St. Nicholas magazine when he was only twelve years old. At fourteen, he began twenty years as a staff member of Life. Best known for his "I Want You" poster of Uncle Sam, 1917 (one of 46 WWI posters), and for his creation, the "Flagg girl." [40]

FLAGG, Jared Bradley [Por.P,W] NYC b. 16 Je 1820, New Haven, CT d. 25 S 1899. Studied: his brother, George W. Flagg (1816–97); Trinity Col. Member: NA, 1850; Yale Art Lib. (founder). He was an Episcopalian priest in Brooklyn, N.Y. (1855–63), but thereafter resumed his career as a portrait and religious painter in New Haven. Author: "Life and Letters of Washington Allston." His brother Henry C. (1811–62) was also a painter. Their father was mayor of New Haven. [98]

FLAGG, Montague [Por.P,T] NYC b. 1842, Hartford, CT d. 24 D 1915. Studied: J. de la Chevreuse, in Paris. Member: SAA, 1883; ANA, 1906; NA, 1910. Exhibited: St. Louis Expo, 1904 (med); NAD, 1909 (prize) [15]

FLAGG, Nellie McCormick (Mrs. James Montgomery Flagg) NYC b. St. Louis, MO d. 20 Ap 1923. She was the model for many of Flagg's paintings.

FLAMBEAU, Viktor (Gertrude R. Brigham) [T,W,L,Cr,P] Gainesville, GA b. Boston. Studied: Mass. State A. Sch.; George Washington Univ.; Anson Cross A. Sch. Member: SSAL; Ga. AA. Exhibited: SSAL; Ga. AA; Cross A. Sch. Work: Cross A. Sch. Coll. Author: "How to Draw and Paint—The New Vision Training Method," 1945, other books on art. Contributor: art magazines. Positions: Dir., Cross A. Sch., Atlanta/Boothbay Harbor (Maine); T., Brenau Col. [47]

FLANAGAN, Albert E. [E,Arch] NYC b. 1886, Newark, NJ. Studied: Columbia Sch. Arch.; E. Leon, in Paris. Member: SAE. Exhibited: LOC, Fifty Prints of the Year, 1933, Fine Prints, 1935, Fine Prints, 1937 [47]

FLANAGAN, Francis [P] Marblehead, MA [25]

FLANAGAN, John F. [S,Medalist] NYC b. 4 Ap 1898, Newark, NJ d. 28 Mr 1952. [Not to be confused with the sculptor John B. Flannagan.] Studied: St. Gaudens; Chapu, Falguiere, in Paris. Member: NIAL; NSS; Am. Numismatic Soc. Exhibited: Paris Salon (med); NAD, 1932 (gold); Paris Expo, 1900 (med); St. Louis Expo, 1904 (med); P.-P. Expo, 1915 (med); Am. Numismatic Soc., 1921 (med); All. AA, 1936 (prize); Pan-Am. Expo, Buffalo, 1901 (med). Work: Musée du Jeu de Paume, Paris; MMA; Newark Mus.; CAM; CI; LOC; statue, Albany, N.Y.; mem., Dept. Agriculture, Wash., D.C.; Free Pub. Lib., Newark; mem., Aetna Life Insurance Bldg., Hartford, Conn.; Sch. AL N.Y.; war medal, town of Marion, Mass.; medal, Garden Cl. Am.; "Medaille de Verdun" (voted by Congress and presented by the Pres. of the U.S. to the City of Verdun); Mus. Ghent, Belgium; Am. Numismatic Soc., N.Y.; AIC. Awards: Chevalier of the Legion of Honor, 1927, Officer, 1934. [47]

FLANAGAN, John Richard [P] NYC. Member: GFLA [27]

FLANDREAUX, Ethel Kerns (Mrs.) [P,W] b. 1895, New York d. 11 Mr 1932, Amityville, NY. Wrote prose and poetry.

FLANIGEN, Jean Nevitt [P,C] Athens, GA b. 7 F 1898, Athens, GA. Studied: Wagner; PAFA, with H. McCarter, Garber, Breckenridge, Pearson. Member: Phila. WCC; SSAL; Assoc. Ga. A.; Southern A.&T. Assn. Exhibited: PAFA, 1926–40, 1943; Wash. WCC; SSAL; Assoc. Ga. A.; BMA. Work: PAFA [47]

FLANNAGAN, John Bernard [S,En] NYC b. 7 Ap 1897, Woburn, MA d. 6 Ja 1942 (suicide). Studied: Minneapolis Inst. Arts, 1914–17. Member: NSS; Am. A. Cong.; F., Guggenheim Fnd. Work: WMAA; MMA; Vassar; Cincinnati Mus.; Pa. Mus.; Soc. A.&Crafts, Detroit; A.&Crafts Cl., New Orleans; Honolulu Acad. A.; Dublin (Ireland) Mus. A. [40]

FLANNERY, Moira [Dec.,L] NYC b. 7 O 1906, Wynnewood, PA. Studied: Breckenridge; PAFA; Univ. Pa. Member: North Shore AA [40]

FLANNERY, Vaughn [P] Darlington, MD b. 6 O 1898 d. 25 D 1955, Phila. Studied: AIC; Chicago Acad. FA. Exhibited: CI; WMAA; PAFA; CGA; AIC; Pal. Leg. Honor. Work: MMA; CI; PMG; BMA; TMA [47]

FLAVELL, Thomas [P] Phila., PA b. 11 Jy 1906, Cynwyd, PA. Studied: Graphic Sketch Cl.; PAFA, with G.T. Gemberling. Member: Woodmere A. Gal.; F., PAFA. Exhibited: PAFA, 1934, 1938, 1944; MMA, 1945, 1946; WMAA, 1934; Germantown A. Lg., 1937; Woodmere A. Gal.; Phila. Sketch Cl.; Cheltenham (Pa.) A. Center. Work: PMA; State Mus., Harrisburg, Pa.; Wilmington Soc. FA; White House, Wash., D.C.; Friends Country Day Sch., Overbrook, Pa.; Woodmere A. Gal. [47]

FLAVELLE, Alan Page [P,T] Portland, OR b. 17 Je 1907, Richmond, VA. Studied: Syracuse Univ.; Lhote. Member: D.C. Ar. U.; Portland (Oreg.) Ar. Cong. Exhibited: Syracuse, 1932; Wash. Soc. Indp. Ar., 1935 (prize); Studio House, Wash., D.C., 1932; CGA; A. Center, Salem, Oreg. Work: murals, Sanitorium, Glendale, Md. WPA artist. [40]

FLAVIN, Eleanor, Mrs. See Platt, E.

FLECK, Helen A. [P] Phila., PA [10]

FLECK, Joseph Amadeus [P,Li,L,Edu,G] Kansas City, MO/Taos, NM (1963) b. 25 Ag 1893, Vienna, Austria. Studied: Royal Acad. FA, Vienna; Sch. Graphic Indst A., Vienna. Member: Taos AA; Chicago Gal. Assn. Exhibited: Phoenix, Ariz., 1928 (prize); Kansas City AI, 1923 (med), 1929 (med), 1934 (prize); AIC, 1927 (prize); CGA, 1935; CI, 1930; PAFA, 1936; AIC, 1924, 1927, 1933, 1936; NAD, 1926, 1929, 1935; GGE, 1939; WFNY, 1939; William Rockhill Nelson Gal. A., 1944 (one-man); Mus. N.Mex., Santa Fe. Work: William Rockhill Nelson Gal. A.; Breckenridge Mus., San Antonio; Mus. FA Houston; Carnegie Mus. FA, Fort Worth; murals, USPOs, Raton, N.Mex., Hugo, Okla.; Univ. Kansas City; Kansas City Pub. Lib.; St. Joseph (Mo.) Art Coll.; Confederate Mus., Richmond, Va. Position: T., Univ. Kansas City, 1943–46 [47]

FLECKENSTEIN, Opal (Mrs. Fred) [P,T,C] Spokane, WA. b. 19 N 1912, Macksville, KS. Studied: Univ. Wash.; Wash. State Col. Exhibited: SAM, 1940–42, 1943 (prize), 1944–46; Denver A. Mus., 1943–46. Position: T., North Idaho Jr. Col., Coeur d'Alene, 1944–46 [47]

FLEISCHMANN, Glen [I] New Rochelle, NY b. 23 F 1909, Manley, NE. Studied: Vogue Sch. A., Chicago. Member: SI [47]

FLEISCHMAN, Robert [P] Baltimore, MD b. 31 Mr 1917, Baltimore. Studied: K. Metzler; H. Despeaux; J. Lambert. Member: Ar. U., Baltimore. Exhibited: Baltimore MA; Md. Inst.; Springfield (Mass.) Mus. [40]

FLEISHER, Lillian Blum (Mrs. M.T.) [P] Jenkintown, PA. Studied: PAFA [25]

FLEISHER, Samuel S. [P] Phila., PA b. 27 N 1871, Phila. Established in

southern section of Phila. a free, non-sectarian art class for poor boys and girls. [06]

FLEMING, Frank [P,Des,I,Dec] Wilton, CT b. 16 Jy 1888, Brooklyn, NY. Studied: ASL. Work: mural, Town Hall, Wilton. Illustrator: national magazines, adv. related to interior dec. [47]

FLEMING, H(enry) Stuart [I,P,S,C] Scarsdale, NY b. 21 Jy 1863, Phila. Studied: Lefebvre, Benjamin-Constant, in Paris. Member: SI, 1901 [31]

FLEMING, Joseph [S] Baltimore, MD [25]

FLEMING, Margot [P] Flemings Island, FL. Member: S.Indp.A. [25]

FLEMING, Thomas [Car] b. 25 F 1853, Phila. d. 4 Mr 1931, Maplewood, NJ. Studied: Phila.; New York. Member: Pa. Soc. A. Center; Soc. Car., N.Y. The most famous of his cartoons was "Senator Tillman's Allegorical Cow." He signed his work "Tom." Positions: Car., New York World, New York Sun, Commercial Advertiser; conducted art syndicate in Newark, 1916-31

FLEMING, Thomas M. [Car] d. 26 O 1918, NYC. Studied: NAD. Work: Newark (N.J.) Evening News

FLEMMING, Amy Dewing [P,T] Mill Valley, CA b. San Fran. Studied: Calif. Sch. FA; San Fran. ASL; A.F. Mathews; Gottardo; Piazzoni; Hans Hofmann. Member: San Fran. AA; San Fran. Soc. Women A. Position: T., San Fran. State T. Col. [40]

FLEMMING, Jean Robinson (Mrs. Ralston) [P] Norfolk, VA b. 22 S 1874, Charleston, SC. Studied: E. Daingerfield; H.B. Snell; J. Carlson; F.S. Chase; Castelluche. Member: Carolina AA; Norfolk SA. Work: S.C. Military Acad., Masonic Lodge, Roper Hospital, S.C. Soc., all in Charleston; Maury H.S., Norfolk; Cavalier Hotel, Virginia Beach [40]

FLERI, Joseph C. [S] NYC b. 20 My 1889, Brooklyn, NY. Member: NSS. Work: church sculpture, Phila., Bethlehem, Northampton, all in Pa., Baltimore, Md. [47]

FLESCH, Richard Adolf [S,P,C] Wash., D.C. b. 17 D 1888, Gera, Germany. Studied: Royal Acad. FA, Dresden; Royal Acad., Munich. Work: exterior sculpture, Col., Erie, Pa.; bust, John Marshall Col., Huntington, W.Va. [40]

FLESSEL, Creig [I,Car] Huntington, NY b. 2 F 1912, Huntington. Studied: Grand Central A. Sch. Member: SI. Exhibited: SI, 1946. Illustrator: Elks Magazine [47]

FLETCHER, Alex T. [P] Greensburg, PA. Exhibited: Assoc. Ar., Pittsburgh, 1934 (prize), 1938 (prize) [40]

FLETCHER, Anne [P,T] Richmond, VA b. 18 Je 1876, Chicago. Studied: Hawthorne; Bridgman; ASL; Simon, Lasar, in Paris. Member: Acad. A., Richmond. Work: Confederate Mus., Governor's Mansion, U.S. District Court, Westmoreland Cl., all in Richmond; Univ. Va., Charlottesville [40]

FLETCHER, Calvin [Edu,P,C,W,L] Logan, UT b. 24 Je 1882, Provo, UT d. 1963. Studied: PIASch; Columbia; AIC; Central Sch. A.&Crafts, London; Colarossi, Biloul, in Paris; R. Stackpole; O. Oldfield; B. Sandzen; Henri, in NYC, 1906-07; Morse, in Chicago. Member: Oakland AA; San Fran. AA; Utah AI; CAA. Exhibited: Utah State Inst. FA (prize); Sunset A. Soc. Kans. (prize); Utah State Fair (prize); San Fran. AA, 1936, 1937; Oakland A. Gal. Work: murals, Latter Day Saints Temple, Logan; Utah State Fair Coll.; Vanderpoel Coll.; Utah State Agriculture Col.; Smoky Hill (Kans.) Art Cl. Position: T., Utah State Agriculture Col., Logan, 1915- [47]

FLETCHER, Charles W. [P] NYC. Member: Soc. Deaf A. (Pres.) [15]

FLETCHER, Clara Irene Thompson (Mrs. Calvin) [P] Logan, UT (1965) b. 1900, Hooper, UT. Studied: her husband, Calvin (1926); summer classes with visiting artists at Utah State Agriculture Col. Exhibited: Utah State Fair; Utah Inst. FA. Work: murals, Logan Lib., Latter Day Saints Temple, Logan [*]

FLETCHER, Elsie Hartley [P,Li,T] Spokane, WA b. 9 Mr 1907, Bloomington, IL. Studied: Wash. State Col.; E.G. Stienhof; W. Adams; L. Bouche; H. Hoffman; Y. Kuniyoshi; G. Picken; ASL. Position: T., Pa. State Col. [40]

FLETCHER, Frank Morley [B,P,L,W] Los Angeles, CA b. 25 Ap 1866, Whiston, Lancashire, England. Studied: A. Cormon, in Paris. Member: Art Workers' Gld & Graver-Printers' Soc., London; Calif. PM. Exhibited: oil, Columbian Expo, Chicago, 1893 (med); prints, Milan Intl., 1906 (med). Work: BMFA; Brit. Mus., Victoria & Albert Mus., London; Galleries in Dresden and Budapest. Author: "Woodblock Printing," "Color Control" [40]

FLETCHER, G(ilbert) [B,I] Towners, NY b. 24 Mr 1882, Mankato, MN. Studied: PAFA. Work: MMA; Newark Mus. A. Illustrator: Ladies' Home Journal [31]

FLETCHER, Godfrey Bocklus [P] Watsonville, CA/Monterrey, CA b. 16 D 1888, Watsonville d. D 1923. Studied: ASL; A. Hansen; Acad. de la Grande Chaumière. Exhibited: San Fran. AA, 1918 (med) 1920 (gold) [24]

FLETCHER, Grace (Mrs.) [P] Venice, Italy. Member: NAWPS [25]

FLETCHER, Mary [P] Baltimore, MD [25]

FLETCHER, S.L. [P] Los Angeles, CA. Member: Calif. AC [25]

FLETCHER, Sidney E. [I] NYC. Member: SI. Active in NYC, 1924-36. Specialty: Western subjects [27]

FLEURY, Albert François [Mur.P,T] Chicago, IL b. 2 F 1848, Havre, France (came to U.S. in 1888). Studied: Lehman; Renouf; Ecole des Beaux-Arts, Paris. Member: Chicago SA; Chicago WCC. Position: Officier d'Instruction Publique, France [25]

FLEXNER, James Thomas [W,L,Cr] NYC b. 13 Ja 1908, NYC. Studied: Columbia; Harvard. Member: CAA; Assn. Am. Historians; Authors Lg. Am.; P.E.N. Cl. Author: "America's Old Masters" (1939), "First Flowers of Our Wilderness" (1947), "The Light of Distant Skies" (1954), "A Short History of American Painting" (1950) [47]

FLIEDNER, Helen [P] Cleveland, OH. Member: Cleveland Women's AC [25]

FLIEGE, Lillian [P,S,C] Laurium, MI b. Michigan. Studied: Pratt Inst.; ASL; Cincinnati A. Acad.; Grand Central A. Sch. Member: PBC. Exhibited: NYWCC, 1939 [40]

FLINT, Alice [P] NYC d. 30 Je 1945. Work: USPOs, Fairfield, Conn., Arabi, La. WPA artist. [40]

FLINT, Alice Morland [Min.P,Por.P] b. 1857, New Brighton, PA d. 23 Mr 1933, Schenectady, NY. Studied: W.M. Chase; Phila.

FLINT, Betty. See Nagelvoort.

FLINT, LeRoy [G] Cleveland, OH b. 29 Ja 1909, Ashtabula, OH. Studied: Cleveland Sch. A. Exhibited: Cleveland Mus., 1936 (prize), 1937 (prize), 1939 (prize). Work: Oxford Sch., Cleveland [40]

FLINT, Ralph [P,L,W] NYC b. 22 Ag 1885, Boston. Studied: Académie Julian, Paris; Italy. Work: altar piece, Providence, R.I.; PMG. Author: "Life and Art of Albert Sterner," "Contemporary American Etching." Coauthor: "America and Alfred Stieglitz." Contributor: Christian Science Monitor, International Studio. Position: Ed., Art News [40]

FLINTOFT, Robert B. [P] White Plains, NY b. 1866, Nottingham, England (came to U.S. in 1872) d. 24 F 1946. Studied: NYC; Munich

FLISHER, Edith E. [P,C,T] Nashville, TN b. 26 S 1890, Cleveland, OH. Studied: PAFA. Member: Nashville AA; Nashville Des. Cl. Work: State Capitol, Nashville; Union Univ., Jackson, Tenn. [40]

FLOCH, Joseph [P,W] NYC b. 5 N 1895, Vienna, Austria d. 1977. Studied: Acad. FA, Vienna. Exhibited: PAFA, 1944 (prize); Paris Salon, 1937 (med); Assoc. Am. A.; WMAA, 1945; Wash. County Mus. FA, 1945; Toledo Mus. A., 1942; CGA, 1945; AIC, 1943; CI, 1943-45. Work: museums in U.S., France, Austria [47]

FLOEGEL, Alfred E. [P] Pleasantville, NY b. 4 S 1894, Leipzig, Germany. Studied: C.C. Curran; F.C. Jones; I.G. Olinsky; NAD; Beaux-Arts Inst. Des.; Am. Acad., Rome [40]

FLOETHE, Richard [I,Ser,W] Middletown, NY b. 6 S 1901, Dortmund, Germany. Studied: Germany. Member: Nat. Serigraph Soc. Work: PMA; MMA; CAM. Illustrator: "Pinocchio" (1946), "Robinson Crusoe" (1945), other books [47]

FLOHERTY, John J., Jr. [I,P] NYC b. 22 F 1907, New York. Studied: Columbia; ASL, with Bridgman; Grand Central Sch. A., with H. Dunn; abroad. Member: SI; SC. Exhibited: Stephens Gal.; Radio City, NYC; Phila. Pr. Cl.; SI; SC. Illustrator: "Where Away" (1945), Collier's, Modern Screen, Motion Picture, New Yorker. Position: Publicity for motion picture companies, including MGM, RKO, United Artists [47]

FLOOD, Mary Emma (Mrs. T.E. Stebbins) [S] Syosset, NY. Exhibited: NAWPS, 1935-38 [40]

FLORANCE, Eustace Lee [P] Dorchester, MA b. Phila. Member: St. Botolph Cl.; Wash. AC [31]

FLORENCE, Sargent (Mrs.) [Mur.P] Marlow, Buckinghamshire, England. Exhibited: series of cartoons, P.-P. Expo, San Fran., 1915 (med) [15]

FLORET, Lydia [P] NYC. Member: NAWPS [25]

FLORIAN, Gordon William [Des,P,T] Bridgeport, CT b. 25 N 1909, Bridgeport. Studied: Grand Central Sch. A.; Yale; G. Wiggins; Thieme. Member: Soc. Indst. Des.; AAPL; A.&W. of Conn. Exhibited: Sterling House, Stratford, Conn. (prize); Phila A. All.; All.A.Am.; New Haven PCC; Munson Gal., New Haven; Bridgeport A. Lg. [47]

FLORIAN, Walter [Por.P,S] NYC b. 1878, NYC d. 1 Ap 1909. Studied: ASL; Académie Julian, Paris; St. Gaudens. Exhibited: St. Louis Expo, 1904 (med); Paris, ca. 1900 (gold); NAD. Member: Paris AAA. Specialty: portraits [08]

FLORIO, S(alvatore) E(rseny) [S] NYC b. 17 D 1895. Studied: MacNeil; Calder. Member: YS; NSS [25]

FLORSHEIM, Richard A. [P,S,E,Li] Highland Park, IL b. 25 O 1916 Chicago. Studied: Univ. Chicago; Bohrod. Member: A. Lg. Chicago. Exhibited: PAFA, 1934, 1935; Los Angeles Mus., 1934; SFMA, 1935; AIC, 1940–43, 1945, 1946 (one-man); No-Jury Soc., 1934; Salon des Refusés, 1935; Century Gal., 1935; Univ. Chicago, 1935; Equity Chicago A., 1935; Toledo Mus. A., 1942; Phila. Pr. Cl., 1946; PMG, 1945; Milwaukee Little Gal., 1935 (one-man); Breckenridge Gal., Chicago, 1935; Quest Gal., Chicago, 1940, 1941; New Sch. Soc. Res., 1944 Chicago. Work: Musée du Jeu de Paume, Paris [47]

FLORY, Arthur L. [W,I,C,Ser,P,Car,G] Yarmouthport, MA b. 14 Ag 1914, Lima, OH d. 1972. Studied: Cape Sch. A., Mass.; PMSchIA; NAD; N.Y. State Col. Ceramics; Henry Hensche; C.M. Harder. Member: Phila. Pr. Cl.; Nat. Serigraph Soc. Exhibited: Mint Mus., Charleston, S.C.; PAFA, 1939; Syracuse Mus. FA, 1940, 1941; Phila. Pr. Cl. Work: U.S. Marine Hospital, Carville, La. Author/Illustrator: children's books [47]

FLOWER, Forrest [P] Wauwatosa, WI. Exhibited: Wis. Salon, 1938 (prize); Great Lakes Exh., Patteran, 1938; AIC, 1938. Work: mural, USPO, Rice Lake, Wis. WPA artist. [40]

FLOWER, Sherwood [P,Arch] Baltimore, MD/Govans, MD b. 3 Ja 1878, Oakwood, Md. [21]

FLOYD, Harry [P] Wash., D.C. b. London, England. Studied: Bouguereau, Robert-Fleury. Member: Wash. SA [01]

FLOYD, Henry [P] Wash., D.C. [04]

FLOYD, Mildred [P] Pittsburgh, PA. Member: Pittsburgh AA [25]

FLYE, Grace Houghton (Mrs.) [P] Sewanee, TN [25]

FLYN, Alexander [P] Grand Rapids, MI b. 5 Ja 1887, Edinburgh, Scotland. Studied: Scotland; England; France [25]

FOBERT, Joseph A. [P] Liberty, NY b. 1880 NYC d. 4 Je 1946.

FOBES, Elizabeth C. [P] NYC. Member: S.Indp.A.[24]

FOERSTER, A.M. [P] Chicago, IL [01]

FOERSTOCK, George M. [P] Baltimore, MD. Member: Baltimore WCC [27]

FOGARTY, Frank [P,I,B,Car,Dec,Des] NYC b. 18 S 1887, NYC. Studied: Henri; J. Peterson. Member: SI. Work: cartoons, "Clarence," "Mr. and Mrs." [40]

FOGARTY, Thomas [I] NYC b. 1873, New York d. 11 Ag 1938. Studied: ASL, Member: SI, 1901; SC, 1908. Illustrator: "The Making of an American," by Riis, "On Fortune's Road," by Will Payne [27]

FOGARTY, Thomas J., Jr. [I] NYC. Member: SI [47]

FOGEL, Reuben W. [P] Chicago, IL [08]

FOGEL, Seymour [P,Li,L] NYC b. 25 Ag 1911, NYC. Studied: NAD; Kroll; Bridgman. Member: Mural Ar. Gld .; NSMP. Exhibited: 48 Sts. Comp., 1940 (prize); Social Security Bldg. Comp., 1941 (prize); AV War Poster (prize); WMAA, 1940, 1941, 1945; CGA, 1939; Arch. Lg.; Nat. Gal., Canada, 1940; MOMA; Springfield Mus. A., 1943, 1946; PAFA, 1940, 1946; Pepsi-Cola, 1946; Iowa Univ., 1946; Mortimer Levitt Gal., 1946 (one-man); WFNY, 1939; Arch. Lg. (med). Work: Edward Bruce Mem. Coll.; Federal Bldg., Safford, Ariz.; Social Security Bldg., Wash., D.C.; USPO, Cambridge, Minn. WPA artist. [47]

FOGG, Margaret Galloway (Mrs.) [P] Chicago, IL. Studied: AIC; BMFA. Member: "The Studio" [10]

FOLAWN, Thomas Jefferson [P] Boulder, CO/Santa Fe, NM b. Youngstown, OH d. 8 Je 1934. Studied: C.S. Niles; Colo. Sch. FA; van Waeyenberge, in Paris; J.M. Waloft, in N.Y. Member: Denver AA; Brush & Pencil C., St. Louis; S.Indp.A.; Boulder AA; AAPL; Boulder AG. Exhibited: Springville (Utah) AA (prize) [33]

FOLDS, Thomas McKey [Edu,P,Des,L,W,Car] Evanston, IL b. 8 Ag 1908, Connellsville, PA. Studied: Yale. Member: AA Northern New England Sch. Exhibited: Traveling Exh., 1940–43; AGAA for AFA, 1942; New England Sch., 1944–45. Positions: T., Phillips Exeter Acad., Northwestern Univ. (1946–)[47]

FOLEY, Cornelia Macintyre (Mrs. Paul, Jr.) [P,G,T] Honolulu, HI b. 31 Ja 1909, Honolulu. Studied: Luquiens; Tonks; M. Tennant; A. Patterson; W. Issacs. Member: Honolulu PM Assoc.; Honolulu A. Soc. Exhibited: Honolulu PM, 1933 (prize), 1934 (prize), 1935 (prize), 1936 (prize); Los Angeles County Fair, 1938 (prize). Work: Univ. Hawaii; Honolulu Acad. A. [40]

FOLGER, Alice Adele [P] Cincinnati., OH. Member: Cincinnati Women's AC [15]

FOLGER, Annie B. [P] Nantucket, MA [24]

FOLGER, Richard T [Des] Floral Park, NY b. 11 S 1898. Specialty: des., cretonnes, printed linen, chintz [40]

FOLGER, Ruth Angell [Edu,W,L,E,Des,C] Troy, NY b. San Antonio, TX d. ca. 1955. Studied: Syracuse Univ.; NYU; N.Y. Sch. F& Appl. A.; Columbia; C. Martin. Member: All. Française; Am. Assn. Univ. Prof.; AFA; N.Y. State T. Assn.; CAA; Nat. Edu. Assn.; Eastern AA; Nantucket Hist. Soc.; N.Y. State Hist. Assn.; Am. Assn. Univ. Women; Pr. C., Albany. Position: T., Russell Sage Col. [47]

FOLINSBEE, John (Fulton) [P,Mur.P,T] New Hope, PA b. 14 Mr 1892, Buffalo. Studied: ASL; B. Harrison; J. Carlson; DuMond; Lie. Member: NA, 1928; NAC; Century Assn.; CAFA. Exhibited: NAD, 1916–18 (prizes), 1921 (prize), 1923 (prize), 1926 (prize), 1941 (prize); AIC, 1918 (prize); PAFA, 1931 (prize); CGA, 1921 (prize); Newport AA, 1917 (prize); NAC, 1922 (prize); SC, 1924 (prize), 1926 (prize), 1930 (prize); Sesqui-Centenn. Expo, Phila. 1926 (med); CI; CAFA, 1919 (prize), 1924 (prize), 1925 (prize); Phila. AC, 1922 (prize); Phila. Sketch C., 1923 (med); SC, 1924 (prize), 1926 (prize), 1930 (prize). Work: Mus. FA, Syracuse, N.Y.; Grand Rapids AA; CGA; NAD; Phila. AC; NAC; murals, USPOs, Freeland, Pa., Burgettstown, Pa.; Paducah Court House, Ky.; RISD; Pub. Mus. A. Gal., Reading, Pa.; Mus. FA, Houston. WPA artist. [47]

FOLLETT, Foster [I] NYC [01]

FOLLRATH, Darwin [P,C,T] Minneapolis, MN b. 16 S 1909, Arlington, MN. Studied: Minneapolis Sch. A.; Univ. Minn.; P. Winchell; G. Mitchell. Member: Minn. AA; Minn. S. Group; Minn. Edu. Assn. Exhibited: Walker Gal., Minneapolis, 1938 (prize); Minn. State Fair, 1931–43, 1934 (prize), 1938 (prize), 1940 (prize), 1943 (prize); Minn. Inst. A., 1936 (prize), 1939 (prize), 1940 (prize), 1942 (prize); Minn. Women's C., 1941 (prize); AIC, 1937, 1938; Portland (Oreg.) Mus. A., 1938, 1939; CI, 1941; Oakland A. Gal., 1944–46; CGA, 1939; SFMA, 1946; Albany Inst. Hist.&A., 1945; Kansas City AI, 1937; Davenport, Iowa, 1940, 1941; Milwaukee AI, 1944; Minneapolis Inst. A., 1931–45; Minneapolis Women's C., 1935–46 [47]

FOLSE, Henrietta Winifred [P,Des,C,T] Oak Ridge, LA b. 17 S 1910, Oak Ridge. Studied: E. Woodward; X. Gonzalez; Newcomb Col. Work: Sophie Newcomb Col. Position: T., Mary Hardin-Baylor Col. [40]

FOLSOM, Ethel F. [P] NYC/Lenox, MA [15]

FOLSOM, Frances [P,T] Buffalo, NY [21]

FOLSOM, George [I] NYC b. 1859 d. 1 Jy 1919. He was one of the first artists to make pen-and-ink newspaper illustrations.

FOLSOM, George W. [P] Lenox, MA [13]

FOLSOM, Janet [P] Wollaston, MA b. 17 Jy 1905, Pittsburgh. Studied: Cleveland Sch. A.; Mass. Sch. A.; BMFA; Iacovleff. Member: Inst. Mod. A., Boston. Exhibited: Portland (Maine) SA, 1944, 1946; NAD, 1945; W.Va. annual, 1946; VMFA, 1946; Jordan Marsh, 1943, 1946; Fitchburg A. Center, 1946; Marblehead AA, 1945; Grace Horne Gal., 1943; Boston City C., 1943–45; Margaret Brown Gal., 1945, 1946; Winchester, Mass., 1946. Work: Dartmouth [47]

FOLSON, E.F. [P] Paris, France [15]

FOLTZ, Josephine Keiffer (Mrs. Charles) [P] Lancaster, PA b. 6 Ja 1880, Lancaster. Studied: J.B. Kieffer; P. Gill. Member: Lancaster County A. Assn. Exhibited: WC Ann., PAFA, 1934; Nat. A. Week, Lancaster, 1938, 1939 [40]

FOLTZ, Lloyd C(hester) [B,E,Li] Wichita, KS b. 24 S 1897, Potawattomie County, KS. Studied: Chicago Acad. FA. Member: Wichita AG; Wichita AA; Prarie PM; Northwest PM; Calif. PM; Chicago SE; Southern PM Soc. Exhibited: Kansas City AI, 1931 (med), 1937 (med); Am. Blockprint Exh., Wichita, 1936. Work: Bethany Col., Lindsborg, Kans.; Thayer Mus.; Kans. Univ., Lawrence; schools, Wichita; A. Gld., Topeka; NGA; prints reproduced in Kansas Magazine (1933, 1936), and in "Prints" [40]

FON, W.W. [P] Phila., PA. Studied: PAFA [24]

FONDA, H.S. [P] Monterey, CA [17]

FONDA, Mina M. See Leonard Ochtman, Mrs.

FONG, Wylog [P] Portland, OR [24]

FONTAINE, Paul. See Mersereau.

FONTAN, Pierre [S] Chicago, IL. Specialty: ivory [15]

FOOTE, Josephine J. [Min.P,P] Mountain Lakes, NJ [24]

FOOTE, Mary (Miss) [Por.P,W] b. 25 N 1872 Guilford, CT d. 28 Ja 1968 West Hartford, CT. Studied: Yale, 1890–91; Vitté Sch., Paris, with Collin; F. MacMonnies, in Paris and Giverney, 1897–01. Member: NAWPS; New Haven PCC. Exhibited: NAD, 1903–20; Madison A. Gal., NYC, 1912; Knoedler's, 1916; CI; AIC. Work: NPG; AIC. She was a close friend of the Samuel Clemenses, Henry James, J.S. Sargent, St. Gaudens; and shared a Paris studio with the Emmet sisters. In 1901 she returned to open her NYC portrait studio. In 1917 she was painting Indians and pueblos in Taos, a guest of Mabel Dodge Luhan. From 1928–1958 she lived in Zurich, joining Jung's circle of scholars. She edited many of Jung's papers, now at Yale. Sargent's picture of her is at Va. Mus. FA. [31]

FOOTE, Mary Hallock (Mrs.) [P,I,En,W] b. 1847, Milton, NY d. 1938, Boston. Studied: CUASch, with W. Rimmer, 1860s; engraving, W.J. Linton; Fordham, with F. Johnson, 1870s. Exhibited: Armory Show, 1913. Illustrator: Harper's, Scribner's, Century; of mining and western life in Colo. and Ind., 1880s. The last 30 years of her life were spent at North Star Mine in Grass Valley, Calif. [*]

FOOTE, Mary Turner (Mrs.) [P] NYC. Exhibited: NAWPS, 1936, 1937, 1938 [40]

FOOTE, Will Howe [Por.P] Old Lyme, CT b. 29 Je 1874, Grand Rapids, MI d. 27 Ja 1965, Sarasota, FL. Studied: AIC; ASL; Académie Julian, Paris, with Cox, Constant, Laurens, Whistler. Member: Lyme AA; Grand Rapids AA; Century C.; ANA, 1910. Exhibited: NAD, 1902 (prize), 1903–46; St. Louis Expo, 1904 (med); P.-P. Expo, 1915 (med); Lyme AA, 1902–24, 1925 (prize), 1926 (prize), 1927 (prize), 1928–31, 1932 (prize), 1933, 1934, 1935 (prize), 1936–42, 1943(prize), 1944–46; Pan-Am Expo, Buffalo, 1901 (prize); PAFA, 1901–15, 1917, 1921, 1922, 1928; CI, 1903–05, 1908, 1914; AIC, 1906, 1910–14, 1918, 1923, 1924, 1926, 1927; CGA, 1907, 1908, 1910, 1927, 1929. Work: Grand Rapids AA; Univ. Nebr., Lincoln [47]

FORBELL, Charles [I,Des] Flushing, NY b. 1886, Brooklyn, NY d. 15 Ap 1946. Studied: PIASch. Member: SC; Artists Gld. [31]

FORBES, Charles F. [P] Paris, France b. Geneva. Exhibited: Paris Expo, 1889 (med) [06]

FORBES, Charles S. [P] NYC [01]

FORBES, E. Armstrong (Mrs.) [P] Penzance, England. Member: Women's AC, N.Y. [01]

FORBES, Edward Waldo [Mus.Dir,Edu,L] Cambridge, MA b. 16 Jy 1873, Wood's Hole, MA d. Mr 1969. Studied: Harvard; New Col., Oxford. Member: Am. Acad. A.&Sc.; AA Mus.; AFA; Archaeological Inst. Am.; Assn. Mus. Dir.; Century Assn. Member: BMFA. Award: Chevalier Legion d'Honneur, 1937. Co-author: "Medieval and Renaissance Paintings," pub. FMA, 1919. Contributor: Art in America. Positions: Dir., BMFA, 1903–, Wadsworth Atheneum, Hartford [47]

FORBES, Edwin C. [I,E,P] b. 1839, NYC d. 6 Mr 1895, Brooklyn, NY. Studied: Arthur F. Tait. Member: London EC, 1877. Exhibited: NAD, 1861–82. Work: Civil War artist-correspondent for "Leslie's." Later, continued to produce etchings and illustrations of the Civil War.

FORBES, Helen (Katharine) [P] Palo Alto, CA b. 3 F 1891, San Fran. Studied: Van Sloun; Hansen; Groeber; Lhote. Member: Mural P.; San Fran. S. Women A.; San Fran. AA; San Fran. A. Center. Exhibited: San Fran. Soc. Women A., 1930 (prize), 1934 (prize); Calif. State Fair, 1934 (prize); GGE, 1939; 48 Sts. Comp. Work: FA Gal., San Diego; Mills Col., Calif.; Fleishacker Zoo Mother House, San Fran.; USPO, Merced, Calif. WPA artist. [40]

FORBES, J. Colin [P] Ithaca, NY [01]

FORBES, Katharine Greeley (Mrs. W. Stuart, Jr.) [Bkbind] Beverly, MA b. 7 Ap 1902, Boston. Studied: M.C. Sears; M. Danforth. Member: Boston SAC; Danforth. Member: Boston SAC; Book in Hand G. Exhibited: Assn. Jr. Lgs. Am., 1929 (prize), 1930 (prize); Jr. Lg. Exh., 1931–32 (prize); Boston Tercentenary Exh. (med) [40]

FORBES, Laura S. [P] NYC. Member: S.Indp.A. [25]

FORBES, L(ionel) C(harles) V(illers) [P,T] Los Angeles, CA b. 8 Ja 1898, Perth, Western Australia. Studied: Van Raalte. Member: Calif. WCS [24]

FORBES-OLIVER, H(arriette) [P,T] Brooklyn, NY b. 24 My 1908, Atlanta. Studied: Newcomb Col.; Tulane Univ.; W. Quirt. Member: Lg. Present-Day A. Exhibited: Finger Lakes Exh., Rochester, N.Y., 1945, 1946; CM, 1945; Mint Mus. A., 1945; BM, 1944–46; Riverside Mus., 1946. Work: J.B. Newmann Gal. [47]

FORBRIGER, C.A. [P] Newport, KY. Member: Cincinnati AC [01]

FORBUSH, William Byron (Mrs.) [P] Swarthmore, PA. Studied: PAFA [25]

FORCE, Clara G. [Min.P] Pasadena, CA b. 30 N 1852, Erie, PA d. 8 Ap 1939. Studied: L.F. Fuller; A. Beckington; T. Thayer; DuMond; Carlson; Hawthorne. Member: Pasadena SA. Work: Art Gal., Erie Public Lib., Women's Cl. [38]

FORD, Edwin Joseph [I,W,Des,P,Car,G] Lacona, IA b. 1 Ag 1914, Milo, IA. Studied: Cumming Sch. A.; Drake Univ.; E.D. Goldmann; W. McCloy; L. Stout; O. Strain. Member: Iowa A. Gld. Exhibited: All-Iowa Exh., Ft. Dodge, 1940 (prize); Sioux City, 1940 (prize); Cedar Rapids, 1941 (prize); Joslyn Mem., 1939 (prize), 1940 (prize), 1941 (prize); NGA, 1942; Iowa State Fair, 1939. Author: "The Dairy," 1938, "Coal Industry," 1938. Illustrator: "The Post Office," 1940 [47]

FORD, Elizabeth Merrill [P,T,L] Chicago, IL/Ganges, MI b. 19 F 1904. Studied: AIC; DePaul Univ., Chicago, IL. Member: South Side A. Assn. Work: Vanderpoel A. Assn.; Ft. Dearborn Sch., Mt. Vernon Sch., vanderpoel Sch., Wash., Lincoln Sch., Erskine College, Chicago. Position: T., Erskine Col. [40]

FORD, Elsie Mae. See Tedford.[40]

FORD, L.W. Neilson (Mrs. W.B.) [P] Baltimore, MD b. Baltimore d. N 1931. Studied: L. Rabillon; H. Newell; B.W. Clinedinst; H. Snell; W. Nickerson; F. Jackson, in Manchester, England; R. Luy, in Vienna; Colarossi Acad., Paris. Member: Baltimore WCC; Plastic C. Exhibited: U.S.; abroad [29]

FORD, (Miss) Lauren [P,E,Li,I] Bethlemen, CT b. 23 Ja 1891, New York. Studied: G. Bridgman; DuMond. Member: Mural P. Work: MMA; CGA; AIC. Author: "A Little Book about God" [40]

FORD, Ruth Van Sickle [P,T] Aurora, IL b. 8 Ag 1897, Aurora. Studied: Chicago Acad. FA; ASL; G. Bellows; G. Wiggins; J. Carlson; Werntz; Grant. Member: Chicago Gal. A.; CAFA; Chicago P&S. Exhibited: AIC, 1931 (prize), annually, since 1924; Chicago Women's Aid, 1932 (prize); CAFA, 1932 (prize), 1934 (prize); NAD, 1933; Chicago Gal. Assn; CAFA, 1932; Grand Central Gal., annually, since 1938. Position: T., Chicago Acad. FA, 1921– [47]

FORD, William B. (Mrs.) [P] Woodbrook Govans P.O., MD. Member: Baltimore WCC [25]

FORD, Winifred [P] Kansas City, MO b. 11 Je 1879, Van Wert, Ohio. Studied: Kansas City AI; Otis AI, Los Angeles. Member: Kansas City A. [40]

FORDHAM, Elwood James [P,T] Venice, CA b. 8 D 1913, Long Beach, CA. Studied: A. Center Sch., Los Angeles; Kansas City AI. Member: Fnd. Western A. Exhibited: PAFA, 1936–40; VMFA, 1940; NAD, 1940; Kansas City AI, 1939; Portland (Oreg.) Mus. A., 1939; Los Angeles Mus. A., 1940, 1941; Portland (Maine) SA, 1946; Pasadena AI, 1946. Position: T., Pasadena AI [47]

FORE, Anna McC. [Des] Middletown, NY [24]

FORESMAN, Alice C(arter) (Mrs.) [T,Min.P] Portland, OR b. 24 Jy 1868, Walwerth County, WI. Studied: Seattle A. Sch.; Am. Sch. Min. P.; L.F. Fuller, M. Welch, E. Dodge. Member: A. T. Assn. Southern Calif.; Calif. Soc. Min. P. Exhibited: Elizabeth Holmes Fisher Gal., 1942 (prize); ASMP; Calif. Soc. Min. P.; CGA; P.-P. Expo, 1915; World's Fairs, Chicago, San Diego, San Fran. Work: Calif. State Bldg., Exposition Park, Los Angeles [47]

FOREST, Katherine [B,C,Des,L,T] Noank, CT b. Brooklyn, NY d. ca. 1955. Studied: Smith Col.; T. Col., Columbia; A. Bement, A. Dow.

Member: Mystic AA. Exhibited: AIC, 1917 (med); Springfield A. Lg., 1934 (prize), 1935 (prize); MMA; Arch. Lg.; Detroit Soc. A.&Cr.; Phila. Soc. A.&Cr.; Mystic AA. Work: Conn. Col.; CI; AIC. Position: T., Acad. A., Memphis, Tenn. [47]

FORINGER, A(lonzo) E(arl) [Mur.P,I] Saddle River, NJ b. 1 F 1878, Kaylor, PA. Studied: H.S. Stevenson, in Pittsburgh; Blashfield, Mowbray, both in N.Y. Member: Mur.P; Arch. Lg., 1911; AFA. Exhibited: Newark poster comp., 1915 (prize). Work: City Hall, Yonkers, N.Y.; Church of Savior, Phila.; County Court House, Mercer, Pa.; House of Rep., Utah State Capitol; Kenosha County Court House, Wis.; bank note designer for European and Canadian banks; Red Cross War poster, "The Greatest Mother in the World"; Home Savings and Loan Co. Bldg., Youngstown, Ohio. Illustrator: Scribner's, other magazines [40]

FORKERT, Otto Maurice [C,Des,L,T] Evanston, IL b. 27 S 1901, Switzerland. Studied: Kunstgewerbe Schule der Stadt Zurich; Chicago Sch. Printing. Exhibited: Lakeside Press Gal. (prize); Architectural Forum, New Magazine Format (prize); The Inland Printer (prize). Responsible for operation and construction of the Gutenberg Workshop of the International Gutenberg Society of Mainz and of the Gutenberg Mus., Century of Progress Expo, Chicago, 1933–34. Contributor: professional Graphic Arts Journals in America and Europe; articles, Standard American Encyclopedia. Lectures: The Lost Art of the Incunabula. Positions: T., AIC, 1929–35; affiliated with The Cuneo Press, Chicago [40]

FORKNER, Edgar [P] Seattle, WA b. Richmond, IN d. 7 Jy 1945. Studied: C. Beckwith; I. Wiles; DuMond; ASL. Member: Chicago Gal. Assn.; Hoosier Salon Patron Assn. Exhibited: Hoosier Salon, 1916 (prize), 1917 (prize), 1932 (prize); Seattle FAS, 1918 (prize), 1923 (prize). Work: AIC [40]

FORMAN, Helen [E] Chicago, IL b. London, England. Studied: AIC; A. Philbrick; R. Peason; C.B. Taylor. Member: Chicago SE. Exhibited: NAC, 1929–31; BM, 1931; Los Angeles Mus. A., 1929–31; Phila. A. All., 1930; Victoria & Albert Mus., London, 1929; Chicago SE, 1929–45; AIC, 1935. Work: Chicago SE; Chicago Pub. Lib. [47]

FORMAN, Henry Chandlee (Dr.) [Edu,W,L,P] Decatur, GA b. 1904, NYC. Studied: Princeton; Univ. Pa.; PAFA. Member: AIA; Atlanta AA; Assn. Ga. A.; Baltimore WCC; CAA. Exhibited: Princeton, 1926 (prize); Univ. Pa. Sch. FA, 1946 (one-man); Pratt Lib. (one-man), Baltimore, 1941; Univ. Club, Baltimore, 1934 (one-man); BMA. Author/Illustrator: "Jamestown and St. Mary's: Buried Cities of Romance," 1938, other books. Positions: T., Haverford Col. (9 yr.), Wesleyan Col., 1941–45, Agnes Scott Col., 1945– [47]

FORMAN, Kerr S(mith) [P,I] El Paso, TX b. 26 O 1889, Jacksonville, IL. Studied: J.D. Patrick; C.A. Wilimovsky. Exhibited: Des Moines Women's C., 1925 (prize), 1927 (prize), 1929 (prize), 1931 (prize); Iowa Art Salon, 1932 (prize). Work: Des Moines Women's Club [40]

FORREST, William O'Fallon [P,I] Phila., PA b. 1897, St. Louis d. 9 My 1947, Bronx. Studied: St. Louis Sch. FA. Exhibited: many western museums

FORSBERG, Elmer A. [P,L,T] Chicago, IL/Covington, MI b. 16 Jy 1883, Gamalakarleby, Finland. Studied: AIC. Member: Cliff Dwellers; Chicago Gal. A.; Chicago PS. Award: Chevalier Cross of the White Rose of Finland. Work: AIC; Municipal Coll., Chicago. Position: T., AIC [40]

FORSTER, Emillie (Mrs.) [P] Wash., D.C. Member: S. Wash. A. [27]

FORSTER, M W. (Miss) [P] Louisville, KY. Member: Louisville AL [01]

FORSYTH, Constance [P,E,Li,T] Austin, TX b. 18 Ag 1903, Indianapolis. Studied: Butler Univ.; John Herron A. Sch.; PAFA; Broadmoor A. Acad.; G. Harding; B. Robinson; W. Lockwood; W. Forsyth; H. McCarter. Member: Ind. AA; Pr.M. Gld.; Ind. Soc. Pr.M. Exhibited: Hoosier Salon, 1928 (prize); John Herron AI, 1936 (prize), 1938 (prize); Dallas Pr. Soc., 1945 (prize); PAFA; Phila. A. All.; SFMA; CM; Phila. Pr. C.; Ind. Pr.M.; WFNY, 1939; NAD; Mus. FA, Houston; Dallas Mus. FA; Tex. FA Assn.; Kansas City AI; LOC; Denver A. Mus.; SAM. Work: John Herron AI; Ball State T. Col.; Manual Training H.S., Indianapolis; State of Ind. Coll.; Scottish Rite Cathedral, Indianapolis. Illustrator: "Lincoln the Hoosier." Positions: T., John Herron AI, 1931–33, Western Col., Ohio, 1939, Univ. Tex., 1940– [47]

FORSYTH, Elizabeth Villeré (Mrs. King L.) [C] New Orleans, LA b. 19 Je 1911, New Orleans. Studied: Sophie Newcomb Col. Exhibited: Regional Jr. League Exh., New Orleans AC, 1937 (prize). Work: Partner, Green Shutter Bookbindery, New Orleans [40]

FORSYTH, William [P,T] Irvington, IN b. 15 O 1854, Hamilton, OH d. 29 Mr 1935, Indianapolis. Studied: Royal Acad., Munich; Loefftz; Benczur; Gysis; Lietzenmeyer. Member: Indianapolis AA; AWCS. Exhibited: Munich, 1885 (med); St. Louis Expo, 1904 (medals); Buenos Aires Expo, 1910 (med); SWA, 1910 (prize); P.-P. Expo, San Fran., 1915 (medals); Richmond, Ind., 1923 (prize); Indianapolis AA, 1924 (prize), 1925 (prize). Work: Indianapolis AA; Pub. Gal., Richmond, Ind.; Brooklyn Mus.; Vanderpoel AA Coll., Chicago [33]

FORSYTHE, J.E. [Mar.P] Chicago, IL (1884–93). Work: Fairport Harbor (Ohio) Marine M. Specialty: Great Lakes ships.

FORSYTHE, (Victor) Clyde [P,S,I,Car,L] Big Bear Lake, CA b. 24 Ag 1885, Orange, CA d. 1962. Studied: L.E.G. Macleod; H. Dunn; H. Giles; E. Bisttram; ASL, with DuMond. 1904. Member: NYSP; SC; Allied A. Am.; Calif. AC; Laguna Beach A. Assn.; Pasadena Soc. A. Exhibited: Painters of the West, 1927 (med). Work: Municipal A. Gal., Phoenix. Creator: poster used in Fifth Victory Liberty Loan, "And They Thought We Couldn't Fight." Shared his Calif. studio with Frank. T. Johnson. [40]

FORT, Evelyn Corlett (Evie) [P,Des,Mur.P,L] Elmhurst, IL b. 18 O 1895, Oak Park, IL. Studied: Church Sch. A., Chicago; AIC; Italy. Member: Chicago SA; North Shore AA; Evanston A. Center. Exhibited: Rome, 1935 (prize); North Shore AA, 1944 (prize), 1945 (prize); AIC, 1942, 1943, 1945, 1946. Work: mural, Evanston, Ill. [47]

FORT, Gladys C(oker) (Mrs. J.C.) [P] Gaffney, SC/Blowing Rock, NC b. 1 Mr 1891, Hartsville, SC. Studied: L. Simon; J.A. Weir; F.L. Mora [27]

FORT, Martha F. See Anderson, Frank H., Mrs.

FORTESS, Karl Eugene [P,G] NYC/Woodstock, NY b. 17 O 1907, Antwerp, Belgium. Studied: AIC; ASL; Woodstock Sch. P. Member: Woodstock A. Assn.; Am. Ar. Cong.; An Am. Group. Exhibited: CI, (prize); F., Guggenheim Fnd., 1946 (prize); Woodstock, N.Y., 1935 (prize); MOMA, 1936; WMAA, 1937–39; PAFA, 1939; WFNY, 1939; GGE, 1939; CGA; Gov. Commission, Alaska, 1939. Work: Univ. Ariz.; Rochester Mem. A. Gal.; Montpelier Mus. [47]

FORTUNA, Ben M. [P,G,T] Detroit, MI b. 22 F 1916, Detroit. Studied: J. Carroll; S. Sarkisian; R. Davis; J.L. Pappas. Exhibited: Mich. State Fair, 1936 (prize); Soc. AC, Detroit, 1937 (prize); Mich. A. Ann., Detroit Inst. A.; Detroit A. Market (one-man) [40]

FORTUNE, E. Charlton (Miss) [P,Dec,Des] Monterey, CA b. 1885, Marin County, CA. Studied: St. John's Wood Sch. A., London; ASL, with Du Mond, Mora, Sterner. Member: Liturgical A. Soc. Exhibited: P.-P. Expo, San Fran., 1915 (med); Panama-Calif. Expo, San Diego, 1915 (med); San Fran. AA, 1916 (prize), 1920 (prize); Société des Artistes Français, Paris, 1924 (med); Calif. State Fair, 1928 (prize), 1929 (prize), 1930 (prize); Liturgical A. Soc., 1937 [40]

FOSBERY, Ernest (George) [P,I,T] Buffalo, NY b. 29 D 1874, Ottawa, Ontario. Studied: F. Brownell, in Ottawa; Cormon, in Paris [13]

FOSDICK, Gertrude Christian (Mrs. J.W.) [P,S] NYC/East Gloucester, MA b. 19 Ap 1862, Middlesex, VA. Studied: Académie Julian, Paris; Bouguereau; Lefebvre. Member: PBC; NAC; Barnard C.; Allied AA. Work: Stacy Mem. and John Henry Twachtman memorial tablet, Gloucester, Mass.; VMFA [40]

FOSDICK, J(ames) William [Mur.P,C,W] NYC b. 13 F 1858, Charlestown, MA. Studied: BMFA Sch.; Académie Julian, Paris, with Boulanger, Lefebvre, Collin. Member: Arch. Lg., 1890; Mural P.; Copley S., 1904; N.Y. Soc. C.; NAC; Lotos C.; North Shore AA. Work: NGA; PAFA; NAC; Lotos C.; St. Louis Mus.; Church St. Joan of Arc, Jackson Heights, N.Y.; St. Johns Church, Montclair, N.J.; Church of Immaculate Conception, Waterbury, Conn. [33]

FOSDICK, Marion Lawrence [Cer,S,T] Alfred, NY b. 31 Jy 1888, Fitchburg, MA. Studied: BMFA; Berlin; C.H. Walker; G. Demetrios; E. Thurn; H. Hofmann. Member: A. Ceramic Sch.; Fitchburg AA; Boston SAC; Am. Fed. A.; N.Y. Soc. Des. C. Exhibited: Boston SAC, 1939 (med); Robineau Memorial Exh., Syracuse Mus. FA, 1932–33 (med, prize). Specialty: pottery. Position: T.; N.Y. State Col. of Ceramics, Alfred. [40]

FOSHKO, Josef [P] Brooklyn, NY. (Listed as Joseph Foschko in 1915.) Exhibited: AIC, 1938; CGA, 1939; PAFA, 1939; GGE, 1939 [40]

FOSMIRE, Cyrus [I] Minneapolis, MN [13]

FOSS, Florence Winslow [S,Edu] South Hadley, MA b. 19 Ag 1882, Dover, NH. Studied: Mt. Holyoke Col.; Wellesley Col.; Univ. Chicago; Radcliffe Col. Member: Am. Assn. Univ. Prof.; CAA; CAFA; Springfield A. Lg.; Deerfield Valley AA; AIC; Sch. Am. Sculpture, N.Y. Exhibited: Springfield AA, 1941 (prize), 1943 (prize); PAFA, 1935–38; NAD, 1937; AIC, 1936, 1941; Soc. Wash. A., 1936 (prize), 1937; CAFA, 1936–46; New Haven PCC, 1940, 1944; Springfield A. Lg., 1937–44; AGAA, 1942;

Amherst Col., 1940; Mt. Holyoke Col., 1936–46; Deerfield Valley AA, 1937–40. Position: T., Mt. Holyoke Col. [47]

FOSS, Harriet Campbell [P] Darien, CT b. Middletown, CT. Studied: J.A. Weir, in N.Y.; A. Stevens, Courtois, both in Paris. Member: AFA [24]

FOSSUM, Sydney Glen [P,T,Car,Ser] Minneapolis, MN b. 18 N 1909, Aberdeen, SD. Studied: Minneapolis Sch. A.; Northern Normal & Indst. Sch.; ASL; with G. Obertueffer, G. Mitchell, E. Kopietz. Member: Un. Am. Ar., Minn.; Am. Ar. Cong.; A. Lg. Am.; Minn. AA; Am. Color Pr. Soc. Exhibited: Minn. State Fair, 1937 (prize), 1938 (prize); Minneapolis Inst. A., 1939 (prize), 1941 (prize), 1932–45; Denver A. Mus., 1942 (prize); PAFA, 1934; AIC, 1934–36, 1939, 1941–43; SAM, 1942 (prize), 1943, 1946; SFMA, 1946; Kansas City AI, 1938, 1939; WFNY, 1939. Work: MOMA; Walker A. Center; Minneapolis Inst. A.; Newark Mus.; Univ. Minn.; SAM; MMA; Mont. Univ. [47]

FOSTER, Alan (Stephens) [I,Car,Des] NYC b. 2 N 1892, Fulton, NY. Member: SI. Illustrator: Saturday Evening Post, Collier's, New Yorker, other publications [47]

FOSTER, Alice [P] Wash., D.C. [25]

FOSTER, Anna. See Thornton.

FOSTER, Anne S. Hobbs (Mrs.) [P] NYC b. Jy 1861, Boston. Studied: Académie Julian, Paris, with Robert-Fleury [04]

FOSTER, Arthur Turner [P,T] Los Angeles, CA b. 1877, Brooklyn, NY. Studied: self-taught. Member: Artland C.; Los Angeles PSC; Calif. WCS [33]

FOSTER, Ben [Ldscp.P,W] NYC/Cornwall, CT b. 31 Jy 1852, North Anson, ME d. 28 Ja 1926. Studied: A.H. Thayer, in N.Y.; Morot, Merson, in Paris. Member: SA, 1897; ANA, 1901; NA, 1904; NYWCC; AWCS; Century Assoc.; Calif. AC; Nat. Inst. AL; Lotos C.; SC; NAC. Exhibited: Columbian Expo, Chicago, 1893 (med); Cleveland, 1895 (prize); Paris Expo, 1900 (med); Pan-Am. Expo, Buffalo, 1901 (med); CI, 1900 (med); SAA, 1901 (prize); St. Louis Expo, 1904 (med); NAD, 1906 (prize), 1909 (gold), 1917 (prize); NAD, 1917 (gold). Work: CGA; TMA; Luxembourg Mus., Paris; NGA; PAFA; Brooklyn Inst. Mus.; Public Gal., Richmond, Ind.; MMA; AIC; CI; Butler A. Inst.; Harrison Gal., Los Angeles Mus.; Montreal A. Assoc.; City A. Mus., St. Louis; Omaha Soc. FA; Grand Rapids A. Assoc.; Albright Gal., Buffalo; Mem. Gal., Rochester [25]

FOSTER, Bertha Knox [P,T] Glendale, CA b. 25 My 1896, Hymer, KS. Studied: Clark; Schaeffer; Wright; Poor. Member: Calif. AC; Pacific AA; Women P. of the West; Southern Calif. A. T. Assn. Position: T., Hoover H.S., Glendale [40]

FOSTER, Betty [P] St. Paul, MN [24]

FOSTER, Betty (Elizabeth Jane) [P,Des,T,L] Indianapolis, IN b. 16 Jy 1910, Columbus, IN. Studied: Ind. Univ.; Herron A. Sch.; AIC; W. Forsyth A. Sch.; Manoir; R.E. Burke; Cambridge. Member: Hoosier Salon; Ind. AC; NAC; Am. Soc. Bookplate Des. & Collectors; Ind. State T. Assn. Exhibited: Ind. AC, 1944 (prize), 1945 (prize); NAC, 1938; Hoosier Salon, 1932, 1933, 1935, 1937, 1939, 1941, 1944; John Herron AI, 1934, 1935, 1938; Ind. AC, 1932-33, 1938–46. Work: bookplates, LOC; Positions: A. Cr., Indianapolis News; T., Emmerich Manual Training H.S., Indianapolis [47]

FOSTER, Charles [P] Farmington, CT b. 4 Jy 1850, North Anson, ME d. 13 Je 1931. Studied: Ecole des Beaux-Arts, Cabanel, de la Chevreuse, all in Paris. Member: CAFA. Position: T., NAD [29]

FOSTER, Elizabeth H(ammond) [P] St. Paul, MN/Otisville, MN b. 5 Mr 1900, St. Paul. Studied: Minneapolis Inst. A.; Lhote, in Paris; H. Hoffman, in Munich. Exhibited: Minn. State Fair (prizes) [29]

FOSTER, Emilie (Mrs.) [P] Wash., D.C. Member: S. Wash. A. [24]

FOSTER, Enid [S] Piedmont, CA b. 28 O 1896, San Fran. Studied: C. Beach. Work: Mausoleum, Oakland, Calif.; mem. pool, Golden Gate Park, San Fran. [40]

FOSTER, Ethel Elizabeth [P] Wash., D.C. b. Wash., D.C. Studied: AIC; T. Col., Columbia; D. Ross; H. Snell; G.P. Ennis. Member: Wash., D.C. AC; Twenty Women Painters of Wash.; AAPL. Position: T., Western H.S., Wash., D.C. [47]

FOSTER, Gerald Sargent [P,I] Westfield, NJ b. 30 S 1900, Westfield. Studied: Princeton; NAD; Am. Acad., Rome; Curran; Jones; Wiles. Member: Princeton Arch. Assn.; Westfield AA; AAPL. Exhibited: AIC, 1930, 1931; WMAA; World's Fair, Chicago; Macbeth Gal., 1940 (one-man). Work: Bulova Sch. Watchmaking; General Accident Insurance Co.; Radio Station WNEW, NYC; USPOs, Freehold, Cranford, Millburn, all in N.J., Poughkeepsie, N.Y. WPA artist. [47]

FOSTER, Grace [P,T] Greenville, TX b. 9 Mr 1879, Wolfe City, TX. Studied: E.J. Hobbs; Z. Webb; F. Reaugh. Member: SSAL [33]

FOSTER, John B. [P] Somerville, MA b. Boston. Studied: Decorative Des., BMFA; A. Dow; T. Juglaris. Member: Boston AC [06]

FOSTER, John M. [P] East Orange, NJ [25]

FOSTER, Kenneth Eagleton [P,Des,L,T] NYC/Peiping, China d. 30 Ag 1964, Santa Fe, NM. Studied: Univ. Chicago; Northwestern Univ.; Chicago Acad. FA; Bourdelle, in Paris; Rabinovitch, in the USSR; Kung Pa King, in Peiping. Work: designs, interior architecture for several high officials, Chinese government, to be placed later in National Gallery of China. Contributor: articles on Chinese theatre, Christian Science Monitor, 1930–35. Lectures: Chinese Art, Chinese Treasure Chest. Positions: A. Dir., Shoemaker Art Looms (Peiping), Weldy Cie (Paris); Dir., Des. Dept., Chicago Acad. FA [40]

FOSTER, Leona A. [P,C] Roxbury, MA b. Boston. Studied: A. Dow; T. Juglaris; BMFA Sch., with H.W. Rice. Member: Copley S., 1893; B.S.A. Crafts [10]

FOSTER, Maxwell [P] Louisville, KY [10]

FOSTER, Norman S. [S] NYC/Port Murray, NJ b. 25 S 1900, Pittsfield, MA. Member: Clay C., N.Y. Work: NAACP, N.Y. [40]

FOSTER, (B.) Norton [P] Keene, NH b. 27 My 1899, Block Island, RI. Studied: R.I. State Col.; Brown Univ.; Columbia; A.K. Cross A. Sch. Member: AAPL; Mid-Vermont A.; N.H. AA. Exhibited: Norlyst Gal., 1944, 1945 (one-man); Upper Montclair (N.J.) Women's C., 1946 (one-man); First Baptist Church A. Gal., Montclair, N.J., 1942, 1944, 1946 (one-man); N.H. AA, 1942, 1944, 1946; Mid-Vermont A., 1946; Keene (N.H.) T. Col., 1946; Anson K. Cross Exh., 1946 [47]

FOSTER, O.L. [P] Lafayette, IN b. 12 My 1878, Ogden, IN. Studied: L.A. Fry; H. Leith-Ross [33]

FOSTER, R. John [P] Newtown, PA b. 23 S 1908, Newtown. Studied: T. Oakley; R. Miller. Member: Phila. WCC; Del. Valley A. [40]

FOSTER, Ralph L. [D,I] Providence, RI b. 20 My 1881, Providence. Studied: RISD; ASL. Member: Providence AC [31]

FOSTER, Robert [I,Des,S,T] NYC b. 11 Je, 1895, State College, PA. Studied: Pa. State Col. Member: SI; A. Dir. C.; Soc. Typophiles; Artists G.; Arch. Lg. Work: WFNY, 1939. Positions: T., Pratt Inst., Brooklyn; Graphic Consultant, N.Y. World's Fair, 1939 [47]

FOSTER, William Frederick [I] Hollywood, CA b. 13 Ag 1883, Cincinnati. Studied: F. Duveneck; Chase; Henri; abroad. Member: SC; ANA, 1929; SI, 1910. Exhibited: NAD, 1926 (prize); SC, 1927 (prize). Illustrator: The Saturday Evening Post, Harper's, Scribner's, magazines in Paris, other publications [47]

FOSTER, Willet S. [P] Riverside, CA b. 11 Mr 1885, Gouverneur, N.Y. d. ca. 1937. Studied: K. Yens; N. Walker Warner. Member: Calif. WCS; Laguna Beach AA; AG of FAS of San Diego; Riverside AA [33]

FOTHERINGHAM, S. Gano [P] Seattle, WA [24]

FOULKE, Hazel M. [P] Phila., PA. Exhibited: PAFA, 1934–36, 1938 [40]

FOULKE, Viola [P,C,T] Aldan-Clifton Heights, PA b. Quakertown, PA. Studied: PMSchIA; Univ. Pa.; Alfred Univ.; G.W. Dawson; E. Horter. Member: Phila. A. All.; Phila. WCC. Exhibited: PAFA, 1937–44; Phila. A. All.; Phila. Plastic C.; PMA; Woodmere A. Gal. [47]

FOURNIER, Alexis Jean [P,W,L,T] East Aurora, NY b. 4 Jy 1865, St. Paul, MN d. 20 Ja 1948. Studied: Académie Julian, Henri Harpignies, both in Paris; D. Volk; Laurens. Member: Cliff Dwellers; Brown Co. AA; Beachcombers' C.; NAC; Chicago Gal. Assn.; Buffalo SA; Ind. AC. Exhibited: Buffalo, 1911 (prize); Minn. Indst. Soc. (gold,med); Hoosier Salon, 1934 (prize); NAD; NAC; CGA; PAFA; AIC; Minneapolis Inst. A.; Muskegon AI; TMA; Buffalo AC; Brown Co. AA; Am. Ar. Prof. Lg. Work: Roycroft Salon, East Aurora, N.Y.; Vanderbilt Univ.; Detroit Inst. A.; St. Paul Lib.; Pa. Hist., Soc.; LOC; Hackley A. Gal.; Minneapolis Lib.; Pub. Sch., Gary Ind.; Women's C., Minneapolis; South Bend, Ind.; Kenwood C., Chicago. [47]

FOURNIER, Marietta [P] Minneapolis, MN [17]

FOUSEK, Frank Daniel [G,P] Cleveland OH b. 8 D 1913, Cleveland. Exhibited: CMA, 1938 (prize), 1939 (prize); AI, Dayton; AIC, 1938; WFNY, 1939. Work: CMA [40]

FOUTS, Herbert E. [P] Indianapolis, IN. Studied: Herron A. Sch. [24]

FOWKES, Phyllis W. [P] Glenside, PA [13]

FOWLER, Alfred [W,Cr] Alexandria, VA b. 1 D 1889, Paola, KS d. ca. 1960. Member: Grolier C., N.Y.; Pr. Collector's C., London; Soc. Pr. Connoisseurs; Woodcut Soc.; Miniature Pr. Soc. Editor: "The Romance of Fine Prints," 1938, "The Print Collector's Quarterly," 1937, "Print Survey" [47]

FOWLER, Arthur Anderson [Por.P,Dr,W] NYC b. 1 Mr 1878 d. 2 S 1934. Because of his portrait sketch of Sir Arthur Rostron, captain of the "Cunarder Berengaria," he was employed as portrait artist of the famous transatlantic Cunard Line. He was also a composer of Negro spirituals.

FOWLER, Beulah [Min.P] Chicago, IL [19]

FOWLER, Carlton C. [P,I] NYC b. 19 Mr 1877, NYC d. 1930. Studied: Académie Julian, Paris; Caro-Delvaille. Member: NAC; SC. Exhibited: Pan-Am. Expo, Buffalo, 1901 (prize). Illustrator: Vogue, Century [29]

FOWLER, Emily [E] Danvers, MA [19]

FOWLER, Eva(ngeline) [P,Li,C] Birmingham, MI b. Kingsville, Ohio d. 5 My 1934. Studied: ASL; PAFA; Delaye, Carl, both in France. Member: Detroit Soc. Women PS; SSAL. Exhibited: Cotton Centennial, New Orleans, 1885 (gold); World's Columbian Expo, Chicago, 1893 (med); SSAL, New Orleans, 1930 (prize). Work: Hillsdale Col., Mich.; Pub. Lib., Serman, Tex. [33]

FOWLER, Frank [Por.P,I,W] Yonkers, NY b. 12 Jy 1852, Brooklyn d. 18 Ag 1910, New Canaan, CT. Studied: Adelphi Acad.; Edwin White, in Florence; Carolus-Duran, Ecole des Beaux-Arts, both in Paris. Member: NA, 1899; SAA, 1882; A. Fund. S.; A. Aid S.; Century Assoc.; Am. FA Soc.; Lotos C. Exhibited: Paris Expo, 1889 (med); Atlanta Expo, 1895 (med); Pan-Am. Expo, Buffalo, 1901 (med); Charleston Expo, 1902 (med). Work: Executive Chamber, Albany. Author: "Portrait and Figure Painting" [10]

FOWLER, Harriet Webster [P] Brooklyn, NY. Member: B.&W. Cl. [01]

FOWLER, Mary Blackford (Mrs. Harold North Fowler) [S,T] Wash., D.C. b. 20 F 1892, Findlay, OH. Studied: Columbia; Corcoran Sch. A.; Oberlin Col.; M. Miller; H. Schuller; G. Demetrios; C. Mose; W.M. Simpson. Member: Soc. Wash. Ar.; North Shore AA. Exhibited: Inst. Mod. A., Boston, 1945; North Shore AA; Soc. Wash. A. Work: Springfield (Mass.) Pub. Lib.; Findlay, Ohio; s. reliefs, Federal Bldg., Newport News, Va. Co-authowith her husband, "The Picture Book of Sculpture," 1929 [47]

FOWLER, Mary D.O. (Mrs. Frank). See Odenheimer.

FOWLER, Morrison B. [P] Kansas City, MO. Member: Kansas City SA [25]

FOWLER, Rhoda G. [P] Norfolk, VA. Member: Norfolk SA [25]

FOX, Cecilia B.B. See Griffith, Mrs.

FOX, Charles Lewis [P] Portland, ME b. 1854, Portland d. 20 Mr 1927. Studied: architecture, with Bonnât and Cabanal, in Paris. Specialty: Indians

FOX, Daniel G(edaliah) [P,I,T] Mattapan, MA [33]

FOX, Fontaine [Car,I] Greenwich, CT. Member: SI. Work: Huntington Lib., San Marino, Calif. Creator: cartoon, "Toonerville Trolley" [47]

FOX, George [P,T] Phila., PA. Studied: PAFA [25]

FOX, Harriott [P] Chicago, IL. Studied: FA Chicago [10]

FOX, Joseph C. [T] Phila., PA. Studied: PAFA [25]

FOX, Margaret M. Taylor (Mrs. George L.) [P,I,E,T] Linden, MD b. 26 Jy 1857, Phila. Studied: P. Moran; T.P. Anshutz. Illustrator: "The Deserted Village," "The Traveller," "English Poems," pub. Lippincott, "Historic Churches of America" [40]

FOX, Milton S. [P,L,W] Cleveland Heights, OH b. 29 Mr 1904, NYC. Studied: Cleveland Sch. A.; Académie Julian, Ecole des Beaux-Arts, both in Paris; Western Reserve Univ. Member: Am. A. Cong. Exhibited: CMA, 1927 (prize), 1928 (prize), 1929–32, 1933 (prize), 1934, 1935. Work: CMA; murals, Cleveland Pub. Auditorium [47]

FOX, Mortimer J. [P] NYC/Peekskill, NY b. 2 O 1874 [29]

FOX, R. Atkinson [P] Phila., PA b. 11 D 1860, Toronto. Studied: Ontario SA, Toronto; J.W. Bridgeman. Member: Phila. AC. Exhibited: Phila. AC, 1898 [01]

FOX, Roy Charles [E,En,P] Horseheads, NY b. 14 Ap 1908, Oneonta, NY. Studied: E. Andersen; Almira Col.; Ill. Wesleyan. Member: Bloomington A. Assn.; Elmira AC. Exhibited: Audubon A., 1942–44; Saranac Lake A. Lg., 1943, 1944; Northwest Pr.M., 1944–46; Wawasee A. Gal., 1944, 1945; Laguna Beach AA, 1944, 1945; Oakland A. Gal., 1944, 1945; SAE, 1944; Phila. Pr. C., 1946; Arnot A. Gal., Elmira, 1936, 1938–46; Elmira Col., 1943 (one-man). Work: Elmira Col. [47]

FOX, Selden [P] NYC [21]

FOX, Virginia Lloyd [P] NYC [17]

FOXLEY, Griffith [I] Parkchester, NY. Member: SI [47]

FOY, Edith C. Gellenbeck [P,L,W] Cincinnati, OH b. 9 O 1893, Cincinnati. Studied: Cincinnati A. Acad., with Weiss, Barnhorn; PAFA, with Garber, Pierson; Wessel; Meakin; Hopkins. Member: Women's AC of Cincinnati; Cincinnati Crafters [47]

FOY, Frances (Mrs. Gustaf Dalstrom) [P] Chicago, IL b. 11 Ap 1890, Chicago. Studied: G. Bellows; AIC. Member: Chicago SE; Chicago SA; Chicago NJSA. Exhibited: Chicago SA, 1929 (gold); AIC, 1929 (prize), 1931 (prize), 1932 (prize). Work: Chestnut St. Postal Station, Chicago; USPOs, East Alton, Gibson City, both in Ill. WPA artist. [40]

FOY, Hans [P] Beechhurst, NY b. 10 My 1894, Brooklyn. Member: Am. A. Cong. [40]

FRACASSINI, Silvio Carl [Edu,P,Des,Cr] Denver, CO b. 4 N 1907, Louisville, CO. Studied: Univ. Denver; AIC; Santa Fe A. Sch.; W. Kuhn; L. Varian; C. Kay-Scott. Member: Denver A. Gld. Exhibited: Univ. Denver, 1931 (prize); Denver A. Mus., 1931 (prize), 1932–34, 1936, 1937, 1939, 1940, 1943 (prize); Denver, 1938 (one-man), 1941 (one-man), 1942 (one-man); Univ. Kans., 1937; Joslyn Mem., 1940. Work: Denver A. Mus.; mural, Southern Hotel, Durango, CO. Position: T., Univ. Denver [47]

FRACK, Mary Alice [P,Gr,L] Phila., PA b. 14 My 1887, Easton, PA. Studied: PAFA; Barnes Fnd. Member: Phila. Pr. Cl. Exhibited: PAFA, 1931; Phila. Pr. Cl., 1938, 1939; Elizabethtown (N.Y.) AA, 1938 (one-man); Bryn Mawr Jr. Col., 1938 (one-man). Work: St. John's Church, Wellington, Kans. [47]

FRACKELTON, Susan Stuart [Cer] b. ca. 1847 d. 14 Ap 1932, Chicago. Member: Nat. Lg. Mineral P. Exhibited: Phila. Centenn. (gold); Columbian Expo, 1893 (gold); Antwerp, 1894 (gold); St. Louis Expo, 1904 (gold); Paris Expo. (invited); AIC (prizes). She was a pioneer woman potter known for her blue and gray ware, and also an important illuminator.

FRACKER, Ruth Miller [P] Los Angeles, CA b. 17 Ja 1904, Chicago. Member: Pasadena SA. Exhibited: Olympic Exh., Los Angeles, 1932 (med); Calif. State Fair, Sacramento, 1932 (prize), 1936 (prize). Work: murals, Children's Ward, Huntington Mem. Hospital, Pasadena [40]

FRAENKEL, Theodore Oscar [P] New Orleans, LA b. 17 Mr 1857, Chicago. Member: NOAA. Exhibited: La. State Art Expo, 1900 (med) [01]

FRAIN, N(ellie) M. (Mrs.) [I,W,P] Chicago, IL b. Furnesville, IN. Studied: AIC; Northwestern Univ.; Univ. Ill. Member: Renaissance Soc., Univ. Chicago. Exhibited: AIC; Century Progress, Chicago. Work: Northwestern Univ. Lib.; Presbyterian Hospital; Univ. Ill. Col. Dentistry. Specialty: medical illus. Illustrator: "Pathology of the Mouth," by Moorehead and Dewey, "Surgical Anatomy," by Eycleschymer, other medical books and publications [47]

FRALEY, Laurence K. [S] Portland, OR b. 17 My 1897, Portland. Studied: H.M. Erhman. Member: AAPL; Oreg. SA [33]

FRAME, Esther Mabel [Metalwork] Waukesha, WI b. 12 Je 1879, Waukesha. Studied: Milwaukee-Downer Col., with E. Upham; Milwaukee State Normal Sch., with F. Kronquist; Layton Sch. A., with C. Partridge; Appl. Arts Summer Sch., Chicago, with E. Worst; Univ. Wis., with W. Varnum; RISD, with A.F. Rose; Berg; Didrich; A. Jones. Member: Wis. Soc. Appl. A.; Milwaukee AI; Wis. Assn. Occupational Therapy; Am. Occupational Therapy Assoc. Exhibited: AIC (prize); Wis. Soc. Appl. A. (prize) [40]

FRAME, Grace Martin [P,Gr,T,L,B] Charleston, WV b. 11 F 1903, Morgantown, WV. Studied: Univ. W.Va.; PAFA; F. Pfeiffer; B. Lazzell; R. Hilton; H. Hofmann. Member: AAPL; Am. Color Pr. Soc.; Southern Pr.M.; All. A., W.Va.; New England Pr. Assn. Exhibited: 50 Best Color Pr., 1933; All. A., W.Va., 1936 (prize), 1942 (prize), 1945 (prize); Oakland A. Gal., 1942; Am. Color Pr. Soc., 1942–44; Wash. WCC, 1940, 1942; AV, 1942; NAD, 1944, 1946; Smithsonian Inst., 1930; AFA Traveling Exh., 1938–40; Southern Pr.M., 1938–40; Intermont Col., 1944–46; Mint Mus., 1946; William & Mary Col., 1938 (one-man); Ohio Univ., 1945 (one-man). Work: Woodcut Soc., Kanawha County, W.Va.; Charleston (W.Va.) Pub. Lib.; Woodcut Soc., Wichita, Kans.. Positions: T., Mason Col. Music & FA, Charleston; Ed. Staff, Dominion News, Morgantown, W.Va. [47]

FRAME, Walter Keith [E,P,Des,Dr,Edu] NYC b. 14 D 1895, Oneida, IL.

Studied: CI; ASL; L.C. Daniel. Member: SAE. Exhibited: NYPL, 1935, 1936, 1938; A. Dir. Cl., 1930 (med). Work: Westchester Inst. FA; WMAA [47]

FRANCE, Eurilda Loomis (Mrs.) [P,I,T] New Haven, CT/Scarboro, ME b. 26 Mr 1865, Pittsburgh d. 15 F 1931. Studied: Académie Julian, Paris; Carolus Duran, Ami Morot, in Paris. Member: Buffalo SA; Phila. A. All.; New Haven PCC; New Haven PPC; AFA [29]

FRANCE, J(esse) L(each) [P,I,T] New Haven, CT/Higgins Beach, ME b. 8 O 1862, Pittsburgh. Studied: Académie Julian, Paris; Carolus Duran, Lefebvre, Constant, in Paris; H.W. Mesdag, in Holland. Member: Buffalo Soc. Ar.; Phila. A. All. [24]

FRANCES, Gene. See McComas, Francis, Mrs.

FRANCIS, A.N. [P] Springfield, MA [24]

FRANCIS, Carl W. [P] Columbus, OH. Member: Columbus PPC [25]

FRANCIS, Helen I. See Hodge, Mrs.

FRANCIS, John F. [P] b. ca. 1808, Phila. d. 15 N 1886, Jeffersonville, PA. Exhibited: A. Fund. S., 1840. Painted in many small towns in Pa. Best known for his traditional fruit still-life painting. [*]

FRANCIS, John Jesse [I,Car,G] Irondequoit, NY b. 12 My 1889. Studied: Cooper Un.; G.T. Brewster. Member: Rochester A. Cl. Exhibited: Rochester Mem. A. Gal. [40]

FRANCIS, Mary [P] Hartford, CT. Member: Hartford AS [25]

FRANCIS, Muriel (Wilkins) [P,C,T,] Fort Worth, TX b. 25 O 1893, Longview, TX. Studied: Shreveport Sch. A.&Des.; Kansas City AI; P. Mercereau; W. Stevens; V.T. Cole. Member: Fort Worth AA; SSAL; AAPL; Fort Worth Ar. Gld.; Shreveport A. Cl. Exhibited: SSAL, Montgomery, Ala., 1938; La. State Fair, Shreveport; Fort Worth, Tex. [47]

FRANCIS, Vida Hunt [I] Phila., PA b. Phila. Illustrator: "Bible of Amiens" (1904), "Cathedrals and Cloisters of France" (1906-10) [15]

FRANCIS, William C. [P,Arch] Ossining, NY b. 21 My 1879, Buffalo, NY. Studied: Buffalo ASL; Columbia Univ. Sch. Arch.; Am. Acad., Rome. Member: Buffalo SA [33]

FRANCIS, William M. [C] Wollaston, MA b. London, England. Studied: King's Col., London. Member: Boston SAC. Specialty: stained glass. Work: stained glass windows, Riverside Church, NYC, Princeton Univ. Chapel, Mercersburg (Pa.) Acad. Chapel, Presbyterian Church, Glens Falls, N.Y., Wellesley Col. Chapel, Cathedral of St. John the Divine, NYC, East Liberty Presbyterian Church, Pittsburgh, Chapel, Colo. Col., Colorado Springs, Am. Mem. Chapel, Belleau Wood, France; designs/drawings, two clerestory windows, The American Church, Paris [40]

FRANCISCO, J(ohn) Bond [P] Los Angeles, CA b. 14 D 1863, Cincinnati, OH d. 1931. Studied: Fechner, in Berlin; Nauen, in Munich; Bouguereau, Robert-Fleury, Courtois, in Paris. Member: Laguna Beach Assoc.; Southern Calif. AC; Los Angeles P.&S. Cl. Settled in Los Angeles in 1887, becoming one of its important early resident artists. [33]

FRANCK, Frederick S. (Dr.) [P,W] NYC b. 12 Ap 1909, Maastricht, Holland. Studied: Belgium; England; U.S. Member: Assoc. A. Pittsburgh. Exhibited: CI, 1942-45, 1946 (prize); PAFA, 1944; Butler AI, 1944; Pal. Leg. Honor, 1946; Contemporary A. Gal., 1942 (one-man); Raymond Gal., San Fran., 1944 (one-man). Work: Univ. Pittsburgh; Latrobe A. Fund. Author: "Modern Dutch Art," pub. CI, 1943 [47]

FRANCKSEN, Jean Eda [Des,Edu] Phila., PA b. 9 My 1914, Phila. Studied: Univ. Pa.; PMSchIA; Barnes Fnd.; B. Spruance; A.B. Carles; S.W. Hayter. Member: Phila. A. All.; Phila. Pr. Cl. Exhibited: PAFA, 1938, 1946; AV, 1943; LOC, 1943, 1944; Phila. A. All.; Everyman's Gal.; Mus. N.Mex., Santa Fe, 1941. Work: LOC. Illustrator: "Fog on the Mountain" (1937), "It's Fun to Listen" (1939), other books. Positions: T., Beaver Col., Jenkintown, Pa. (1938-46), Swarthmore Col., (1944-46) [47]

FRANÇOIS, Alexander [Por.P] Albany, NY b. 1824, Belgium (came to U.S. in 1841) d. 1 Mr 1912. Exhibited: NAD, 1851. Work: Court of Appeals, Albany

FRANDZEN, E(ugene) M. [P,T] Chicago, IL b. 13 Ap 1893, San Diego. Studied: W.J. Reynolds; AIC. Exhibited: AIC, 1917 (prize) [17]

FRANK, Bena Virginia (Mrs. Bena Frank Mayer) [P,T,E,Li,L] NYC b. 31 My 1900, Norfolk, VA. Studied: ASL; CUASch; abroad. Member: N.Y. Soc. Women P.; All.A.Am.; Brooklyn SA; Salons of Am.; United Am. Ar. Exhibited: CUASch, 1916 (med), 1917 (med); SSAL; CI. Work: Hunter Col.; Nassau County (N.Y.) hospitals; Roosevelt H.S., NYC; Brooklyn Pub. Lib.; NYPL; Univ. Maine [47]

FRANK, Charles Lee [P] Wash., D.C. Member: S. Wash. A. [27]

FRANK, Eugene C. [Ldscp.P,Mar.P] Glendale, CA b. 1845, Stuttgart (came to U.S. in 1861) d. 11 Ja 1914. Studied: A.C. Howland; A.H. Wyant; R.C. Minor; G. Maynard; W. Hart; Munich; Carlsruhe, Germany. Member: Societies of Artists in Munich, Carlsruhe, Frieberg; Calif. AC

FRANK, E.H. [P] Minneapolis, MN [24]

FRANK, Gerald A. [P] Chicago, IL b. 22 N 1889, Chicago. Studied: W.J. Reynolds; W. Ufer; Hawthorne; Webster; Nordfeldt. Member: Chicago PS; Chicago Gal. Assn. Exhibited: Chicago Gal. Assn., 1919 (prize), 1931 (prize); AIC, 1921 (prize), 1922 (prize); Municipal A. Lg., Chicago, 1922 (prize), 1930 (prize). Work: AIC; Municipal Coll., Chicago; Pub. Schools, Chicago and Gary, Ind. [40]

FRANK, Helen [P,Des,I] NYC b. 13 Mr 1911, Berkeley, CA. Studied: Calif. Col. A.&Crafts; ASL; G. Wessels; H.A. Wolf; J. Paget-Fredericks; S. Cheney. Exhibited: East-West Gal. (1932), Second Progressive Show (1934), Neighborhood Playhouse (1935, one-man), Gump's (1937), all in San Fran.; SFMA, 1937, 1939, 1942, 1947; Oakland A. Gal., 1938, 1940, 1942; Newport AA, 1944; AIC, 1944; Los Angeles Mus. A., 1945; Crocker A. Gal., 1942 (one-man); Pinacotheca, N.Y., 1943; Santa Barbara Mus. A., 1947; Vancouver (British Columbia) A. Gal., 1947. Work: Crocker A. Gal., Sacramento. Designer: costumes for modern dance. Illustrator: "Mozart," 1946, and a series of music books for children, 1944, 1945 [47]

FRANK, Herman [S] Phila., PA [21]

FRANK, John Nathaniel [Cer,L] Sapulpa, OK b. 31 Ja 1905, Chicago. Studied: M.M. French; C.F. Binns; AIC. Member: Am. Cer. Soc. Exhibited: jewelry, AIC, 1927 (gold). Work: Design/Execution, twin tile fountains, Crippled Children's Hospital, Oklahoma City. Specialty: pottery. Position: Pres., Frankoma Potteries, Sapulpa [40]

FRANK, Kirk C. [P,I] Phila., PA b. 11 My 1889, Zitomar, Russia. Studied: PAFA. Member: Phila. A. All.; S.Indp.A. Work: paintings, Graphic Sketch Cl., Phila. [25]

FRANK, Leo E. [P] NYC [19]

FRANK, W.B.O. [P] Columbus, OH. Member: Columbus PPC [25]

FRANKE, Julius [P,Arch] Munich, Germany b. 1868, NYC. Member: AIA. Exhibited: Munich Art Exh., Deutsches Mus., 1931 [31]

FRANKEL, Max [P] NYC b. 1 N 1909, Austria. Studied: NAD; ASL. Member: United Am. Ar. Exhibited: Springfield (Mass.) Mus. FA; New Sch. Soc. Res.; ACA Gal., New York [40]

FRANKEL, S.W. b. ca. 1876, St. Louis, MO d. 22 O 1935, NYC. Owner/Publisher: Art News, since 1921. Originator/Director: Fine Arts Expo held in November, 1934, at Rockefeller Center, NYC

FRANKENBURG, Arthur [I] NYC. Member: SI [33]

FRANKENSTEIN, Alfred Victor [Cr,W,L,T] San Fran., CA b. 5 O 1906, Chicago. Studied: Univ. Chicago. Member: Am. Soc. for Aesthetics. Contributor: Magazine of Art, Art News, Pacific Art Review, other magazines. Best known for his work on still-life painters, "After the Hunt," 1953. Positions: Cr., San Francisco Chronicle, 1934- ; L., FA, Mills Col., Oakland, 1944- [47]

FRANKENSTEIN, Gustavus [Ldscp.P, Mar.P] b. ca. late 1820s, probably Germany d. before 1902, Cincinnati. The youngest of the Frankenstein family of painters (Eliza, George, Godfrey, John, and Marie were his brothers and sisters.) Except for a brief stay in NYC ca. 1876, he grew up and lived in Cincinnati, undoubtedly the student of his older siblings. [*]

FRANKL, Paul Theodore [Des,C,P,W,Ed,L,Dec] Palos Verdes Estates, CA b. 14 O 1886, Vienna, Austria d. 21 Mr 1958. Studied: Europe. Member: Am. Un. Dec. A.&Crafts. Exhibited: Woodstock AA; Knoedler Gal., 1931 (one-man); Stendahl Gal., Los Angeles, 1944 (one-man). Author: "New Dimensions" (1928), "Form and Reform" (1930), "Machine Made Leisure" (1932), "Space for Living" (1938). Contributor: national dec. and arch. magazines [47]

FRANKL, Walter H. [P] NYC [15]

FRANKLE, Philip [P,I,T] Brooklyn, NY b. 29 Je 1913, NYC d. 8 N 1968. Studied: NYU; Brooklyn Col.; Columbia. Member: A.T. Assn. Exhibited: NGA, 1943-45; Miss. AA, 1946; Mint Mus. A., 1946; NAC, 1946; Nat. Gal., London, 1944; BM, 1941-45; Lincoln Gal., Brooklyn, 1941, 1946. Illustrator: "G.I. Sketch Book" (1944), "Art in the Armed Forces" (1944). Position: T., Abraham H.S., Brooklyn [47]

FRANKLIN, Clinton [P] Wheaton, IL. Member: Chicago NJSA [25]

FRANKLIN, D. Dupont [P] NYC [04]

FRANKLIN, Dwight [P,S] NYC b. 28 Ja 1888, NYC. Member: Am. Assoc. Museums. Work: Am. Mus. Nat. Hist.; Newark Pub. Lib.; MMA; Children's Mus., Brooklyn; Cleveland Mus.; Univ. Ill.; French War Mus.; Mus. City of New York. Specialty: miniature groups, usually of a historical nature [40]

FRANKLIN, Ethel Adams [P] Providence, RI [24]

FRANKLIN, George [P,L] Woodstock, NY b. 19 N 1898, Berlin, Germany. Studied: P. Klee; L. Feininger; F. Itten; A. Wiltz. Member: Woodstock Ar. Assn. Work: Seamen's Church Inst. N.Y. [40]

FRANKLIN, Ione [S,Edu] Commerce, TX b. Texas. Studied: Tex. State Col. for Women; Columbia; ASL; W. Zorach; W. Palmer; R. Laurent; A.S. Baylinson. Member: SSAL; Tex. S. Group. Exhibited: SSAL, 1936 (prize), 1942, 1944, 1946 (prize); Tex. General Exh., 1941 (prize), 1945 (prize); Kansas City AI, 1942. Work: Dallas Mus. FA. Position: T., East Tex. State T. Col., Commerce [47]

FRANKLIN, Jamesine O'Rourke (Mrs.) b. 1894 d. 21 F 1947, NYC. Studied: Parsons Sch. Des., where she taught for 13 years before opening her school at 460 Park Ave. Founder: in 1937, Franklin Sch. Professional Arts

FRANKLIN, Kate Mann [P,C,W,L,T] Flushing, NY/South Bristol, ME b. Flushing d. 2 S 1932. Studied: A.W. Dow; Columbia. Member: NAWPS. Contributor: articles to magazines. Positions: T., Pratt Inst. Kindergarten Training Sch.; Berkeley Inst.; Friends' Sch., Brooklyn; BM; MMA; Cornell [31]

FRANKLIN, Mary [P] Paris, France b. Athens, GA. Studied: Deschamp, Geoffroy, Collin, all in Paris [24]

FRANKS, Elizabeth M. [P,I] NYC b. Brooklyn, NY. Studied: Chase; Shirlaw; Robinson; Eakins. Member: Brooklyn AC; B.&W. Cl. [13]

FRANKS, Jessie Margaret [P] Chicago, IL [01]

FRANQUINET, Eugene [P,L,T] Verdugo City, CA b. 21 F 1875, Brussels, Belgium. Studied: Petit, in Brussels. Member: Laguna Beach AA; Los Angeles PS [33]

FRANTZ, Alice Maurine [I,T] Enid, OK b. 22 Je 1892, Wellington, KS. Studied: AIC; A. Dow; Columbia; A. Robinson. Member: Okla. AA; SSAL; AAPL; Tulsa AA; Pr.M. Gld.; Northwest AA [40]

FRANTZ, (Samuel) Marshall [I,P,L,Por.P] Van Nuys, CA b. 25 D 1890, Kiev, Russia. Studied: W. Everett; PMSchIA. Member: SI. Illustrator: Saturday Evening Post, Cosmopolitan, Harper's Bazaar, Collier's, Liberty, Delineator, other magazines [47]

FRANZEN, August [Por.P] NYC b. 1863, Norrköping, Sweden d. 7 S 1938. Studied: Dagnan-Bouveret, in Paris. Member: SAA, 1894; ANA, 1906; NA, 1920; Century Assn. Exhibited: Columbian Expo, Chicago, 1893 (med); Paris Expo, 1900; Pan-Am. Expo, Buffalo, 1901 (prize); AAS, 1902 (gold); NAD, 1924 (prize). Work: Brooklyn Inst. Mus.; Yale; Nat. Gal., Wash., D.C.; TMA; MMA; Nat. Mus., Stockholm [38]

FRAPRIE, Frank R. [Photogr] Brookline, MA b. 14 Jy 1874, Fall River, MA. Member: Royal Photographic Soc. Great Britain; Boston YMCU Camera Cl.; Boston SAC; N.Y. Camera Cl.; Boston Camera Cl.; Société Française de la Photographie. Exhibited: Royal Photographic Soc. Great Britain (med); Société Française de la Photographie (med). Important pictorialist who won numerous awards at the annual photo salons. Positions: Ed., American Photography, American Annual of Photography [30]

FRASCH, Miriam R. [P] Columbus, OH. Studied: St. Lawrence Univ.; Columbus A. Sch.; Ohio State Univ.. Member: Columbus A. Lg. Exhibited: CGA, 1937; PAFA, 1937; Butler AI; Parkersburg, W.Va.; Columbus A. Lg., 1937 (prize) [47]

FRASER, Emma Bailey (Mrs. Herbert C.) [P] Newton, MA b. 9 Jy 1881, Newton. Exhibited: Vose Gal., Boston, 1938 (one-man); Jordan Marsh Co., Boston [40]

FRASER, James Earle [S] Westport, CT b. 4 N 1876, Winona, MN d. 11 O 1953. Studied: AIC, with R. Bock, 1894; Ecole des Beaux-Arts, Paris, with Falguière; Académie Julian, Académie Colarossi, Paris. Member: Cornish (N.H.) Colony; NIAL; NAC; ANA, 1912; NA, 1917; NSS, 1907; Port. P.; Nat. Commission FA; New Soc. A. Exhibited: NAC, 1929 (prize); Paris AAA, 1898 (prize); Edison Comp., 1906 (med); P.-P. Expo, San Fran., 1915 (gold, sculpture; gold, medals); Vallejo, Calif., 1929 (prizes). Work: medals, MMA; Ghent Mus.; Rome; busts, statues, mem., Wash., D.C.; Jersey City; Montreal; Cleveland; Robert Todd Lincoln sarcophagus, Arlington Nat. Cemetery; FA Acad., Buffalo; Cathedral of St. John the Divine, NYC; City of San Fran.; U.S. Treasury, Wash., D.C.; Bank of Montreal, Winnipeg; WFNY, 1939. Designer: U.S. Victory Medal, Buffalo nickel. He was assistant to St. Gaudens from 1898 to 1902, after which he opened his NYC studio. Position: T., ASL, 1906–11 [47]

FRASER, John Hathaway [P,Li,C,Edu,G] Marietta, OH b. 30 My 1905, Pittsburgh. Studied: ASL; Lafayette Col.; Iowa State Univ.; H. Dunn; Bridgman; Vytlacil. Member: Assoc. A. Pittsburgh. Exhibited: Assoc. A. Pittsburgh, 1938, 1939, 1940 (prize); Parkersburg, W.Va., 1941 (prize), 1942 (prize); 48 Sts. Comp., 1939; NAD, 1938; VMFA, 1939; CI, 1941; Butler AI, 1939. Work: Carroll Col.; mural, Iowa State Univ. Zoology Bldg.; USPO, Littleton, Colo. WPA artist. [47]

FRASER, Juliette May [P,E,I] Honolulu, HI b. 27 Ja 1887, Honolulu. Studied: Wellesley Col.; ASL; Univ. Hawaii; F. Taubes. Member: Assn. Honolulu A.; Honolulu Pr.M.; Calif. WC Soc.; Honolulu A. Soc. Exhibited: CGA, 1941; San Diego FA Soc., 1941; Los Angeles Mus. A., 1941; Honolulu Pr.M., 1940–46; Assoc. Honolulu A. Acad., 1935–46. Work: Honolulu Acad. A.; mural, Lib. of Hawaii; St. Andrew's Cathedral, Honolulu; Hawaii Bldg., San Fran.; Bd. Water Supply Bldg., Honolulu. Illustrator: "Legendes Hawaiiennes" (1932), "Ghost Dog" (1944), other books [47]

FRASER, Laura Gardin (Mrs. James E.) [S] Westport, CT b. 14 S 1889, Chicago, IL d. 13 Ag 1966. Studied: J.E. Fraser; ASL. Member: NSS; NIAL; ANA, 1924; NA, 1931; NAWPS. Exhibited: NAD, 1916 (prize), 1919 (prize), 1924 (gold), 1927 (prize), 1931 (prize); NAWA, 1929 (prize), 1934 (prize); Am. Numismatic Soc., 1926 (gold); Paris. Work: equestrian statue, Baltimore, Md.; Brookgreen Gardens, S.C.; many medals, portraits [47]

FRASER, Malcolm [Mur.P,Por.P,L,I] Orlando, FL b. 19 Ap 1869, Montreal, Quebec d. 12 Je 1949. Studied: Académie Julian, Paris, with Boulanger, Lefebvre, Constant; Ecole des Beaux-Arts, Paris, with Gérôme; C.B. Beckwith; K. Cox; W. Shirlaw; ASL, with Wyatt Eaton. Member: SC, 1897; Orlando AA. Work: Nat. Headquarters, Am. Red Cross, Wash., D.C.; Suffolk County Chap., Am. Red Cross, Islip, N.Y. Illustrator: "Richard Carvel," "Caleb West," national magazines [47]

FRASER, Mary Aldrich (Mrs. Malcolm) [S] Orlando, FL b. 22 F 1884, NYC. Studied: Fraser; W.O. Partridge; G. Lober. Member: Am. Fed. A.; Orlando AA; NAC; Studio Gld.; NAWA. Exhibited: Central Fla. Expo, Orlando, 1937 (prize), 1938 (prize); Argent Gal.; NAC; Studio Gld.; St. Hilda's Gld.; Orlando AA. Work: St. Anne's Convent, Kingston, N.Y.; Nat. Cathedral, Wash., D.C.; Cathedral of St. John the Divine, Church of St. Mary the Virgin, both in NYC; Franciscan Monastery, Port Jefferson, N.Y.; Church of the Good Shepherd, West Springfield, Mass.; St. Luke's Cathedral, Orlando; St. Mary's Church, Baltimore; Cathedral of the Incarnation, Garden City, N.Y.; Holy Cross Monastery, West Park, N.Y.; Emmanuel Church, Champaign, Ill.

FRASER, (Thomas) Douglass [P] Vallejo, CA b. 29 D 1883, Vallejo d. 6 Ag 1955. Studied: Mark Hopkins Inst. A.; Calif. Sch. Des.; ASL; A.F. Mathews; DuMond; Hawthorne. Member: AAPL; Bohemian Cl., San Fran. Exhibited: Calif. State Fair, 1925 (prize); Vallejo Gld. A., 1929 (prize); Bohemian Cl., 1926–46. Work: Bohemian Cl.; George Washington H.S., Vallejo; White House, Wash., D.C.; Mare Island Navy Yard, Golf Cl.; Veterans Mem. Bldg., Vallejo; U.S. Battleship "California"; Lib., Business Men's Cl., Portland, Oreg.; U.S. Submarine S-29; U.S. Cruiser "Chicago"; U.S. Cruiser "San Francisco"; Piedmont (Calif.) H.S. [47]

FRASER, William Lewis [I,W,L] NYC b. 5 N 1841, London, England (came to U.S. in 1856) d. 23 O 1905. Member: Players' Cl.; Grolier Cl.; SC; MMA; Arch. Lg. Position: Management, Century Magazine [01]

FRATZ, Mary E. [P] Phila., PA b. Phila. Studied: R.W. Vonnoh; C. Beaux. Exhibited: PAFA (prize) [01]

FRAZEE, Hazel [P] Chicago, IL. Member: Chicago SA [27]

FRAZER, Harland [P] NYC. Member: St. Louis AG. Exhibited: St. Louis AG, 1921 (prize), 1922 (prize). Illustrator: Saturday Evening Post, Cosmopolitan [40]

FRAZER, John E. [P] Pittsburgh, PA. Member: Pittsburgh AA [21]

FRAZER, Mabel Pearl [Edu,P,L,T] Salt Lake City, UT (1965) b. 28 Ag 1887, West Jordan, UT. Studied: Univ. Utah, with E. Evans, 1914; ASL, with DuMond, 1916–17; BAID, 1919–20; Europe, 1930–32. Member: Am. Assn. Univ. Prof.; Utah A. Council. Exhibited: Utah State Fair (prize); Montross Gal., 1930; San Fran. AA, 1935; Univ. Utah, 1935 (one-man);

Italy. Work: State of Utah; mural, Latter Day Saints Temple, Salt Lake City. Position: T., Univ. Utah, 1920–53 [47]

FRAZER, William Durham [G,Des,Arch] Lexington, KY b. 7 Mr 1909, Lexington. Studied: Univ. Ky. Exhibited: Intl. E. Eng. Ann., AIC, 1937, 1938. Work: Lexington. WPA artist. [40]

FRAZIER, Bernard (Emerson) [Art Dir,S,C,L] Tulsa, OK b. 30 Je 1906, Athol, KS. Studied: Univ. Kans.; Nat. Acad. A.; AIC; Lorado Taft; Fred M. Torrey. Member: NSS; Am. Ceramic Soc.; Scarab Cl.; Kans. State Fed. A. Exhibited: Sweepstake Exh., Kansas City, 1935 (prize), 1939 (prize), 1936 (prize); Kans. State Exh., 1935 (prize), 1936 (prize), 1938 (prize); Syracuse Mus. FA, 1938–41; AV, 1942; SFMA, 1939, 1940; Cranbrook Acad. A., 1946; AIC, 1941; CM, 1941; NAD, 1939, 1941; CGA, 1941; Phila. A. All., 1939, 1941; Mus. N.Mex., Santa Fe, 1942, 1946; Kansas City AI, 1940, 1941, 1943; Springfield Mus. A., 1944; Chicago Gal. Assn., 1939, 1940, 1942, 1943. Work: Univ. Kans.; Baker Univ.; Philbrook A. Center; State Minerals Bldg., Kans.; Ft. Dearborn mem. plaque, Chicago; dioramas, Dyche Mus. Nat. Hist. Lectures: Sculpture; Ceramic Sculpture. Positions: S. in Residence, 1937–38, T., Univ. Kans., 1939–44; A. Dir., Philbrook A. Center, Tulsa, 1944– [47]

FRAZIER, John R(obinson) [P,T] Providence, RI/Provincetown, MA b. 29 Jy 1889, Stonington, CT. Studied: RISD; C.W. Hawthorne. Member: Providence AC. Exhibited: Phila. WCC, 1920 (prize), 1921 (gold); Baltimore WCC, 1922 (prize); AIC, 1923 (prize); Newport AA, 1934 (prize). Work: RISD; AIC; BM. Positions: T., RISD, Summer Sch. Painting, Provincetown [40]

FRAZIER, John R., Mrs. See Stafford, Mary.

FRAZIER, Kenneth [P] Garrison, NY b. 14 Je 1867, Paris, France d. 31 Ag 1949. Studied: Herkimer, in England; Constant, Doucet, Lefebvre, in Paris. Member: SAA, 1893; ANA, 1906; Century Assn. Exhibited: Pan-Am. Expo, 1901 (med) [47]

FRAZIER, S(arah E.) [P,I,T] Kansas City, MO b. 16 Ja 1908, Weatherford, TX. Member: Kansas City SA [33]

FRAZIER, Susan [P] NYC/Garrison, NY b. 25 Ap 1900. Studied: Henri; G. Bellows; A. Tucker; H. Paul, in Paris. Work: BM; WMAA [40]

FRAZIER, Thelma [S] Cleveland, OH. Exhibited: CAM, 1936; Nat. Cer. Ann., Syracuse Mus., 1938 [40]

FRECH, Howard [P] Baltimore, MD. Member: Char. C. [25]

FRECHETTE, M(arie)-M(arguerite) [Min.P,P] Ottawa, Ontario b. 16 Ap 1884, Ottawa. Studied: K. Cox; Hawthorne: Simon, LaForge, in Paris. Member: Union Internationale des Beaux Arts et des Lettres; British Columbian SFA; Calif. S. Min. P. Work: portraits, Château Frontenac, Quebec; Ottawa Carnegie Pub. Lib. [25]

FREDENTHAL, David [P,I,T] NYC b. 28 Ap 1914, Detroit, MI. d. 1958, Rome, Italy. Studied: Cranbrook Acad. A., 1935–38; Colorado Springs FA Center; Wicker Sch. A., Detroit; B. Robinson; Z. Sepeshy. Member: F., Guggenheim Fnd. Exhibited: Detroit Inst. A., 1936 (prize) 1937 (prize); Jackson, Miss., 1942 (prize); Calif. WC Soc., 1940–42, 1943 (prize); AIC, 1936–45, 1946 (prize); Detroit A. Market, 1934, 1935 (prize), 1936–39; Univ. Mich., 1935; Wayne Univ., 1936; Downtown Gal., N.Y., 1937, 1938, 1944, 1946; Olivet Col., 1938, 1939; Mich. State Col., 1938, 1939; Princeton, 1938; Colorado Springs FA Center, 1939; Univ. Mo., 1939; Southern Methodist Univ., 1940; Columbia, 1940; Assoc. Am. A., 1941; Dartmouth, 1942, 1943; Springfield Mus. FA, 1943 (one-man); Flint AI, 1937; CM, 1938; WMAA, 1941–44; BM, 1939, 1943, 1944; GGE, 1939; de Young Mem. Mus., 1939; Newport AA, 1939; WFNY, 1939; CI, 1941–46; AV, 1942; NAD, 1944; 48 Sts. Comp., 1939. Work: frescoes, Detroit Naval Armory; murals, USPOs, Caro, Manistique, both in Mich.; Minneapolis Inst. A.; Cranbrook Acad. A. Illustrator: "Of Men and Battle" (1944), "Tobacco Road" (1940, special edition), "Surprise" (1944); Life, Fortune, other magazines. Positions: War Art Unit, 1943; War A. Correspondent, Life magazine, 1943– [47]

FREDER, Frederick C. [P,Des] NYC b. 4 Jy 1895, Monroe, NY d. 12 N 1954. Studied: NAD; Ecole des Beaux-Arts, Paris; F. Cormon; A. Zarraga; C. Curran; F. Jones; Olinsky; Germany; Italy, Spain. Member: SC. Work: San Diego FA Soc. Position: Animation Dir., U.S. Army Photogr. Center, Long Island City, N.Y., 1942–46 [47]

FREDERICK, Carroll Glenn [Car] Brooklyn, NY b. 21 Jy 1905, Columbia, SC. Studied: NYU; ASL; E. Simms Campbell. Member: Car. Gld. Cartoonist: Saturday Evening Post, New Yorker, New York Journal-American, King Features Syndicate [47]

FREDERICK, Edmund [I] Brooklyn, NY b. 2 Ap 1870, Phila. Studied: PAFA. Member: SI, 1910. Illustrator: books by Elinor Glyn, Robert W. Chambers, Joseph C. Lincoln, and others. Position: Staff, The Morning American, World, both in New York [47]

FREDERICK, Frank F(orrest) [P,C,T,W,L] Trenton, NJ b. 21 O 1866, Methuen, MA. Studied: Mass. Normal A. Sch.; Royal Col. A., London. Position: Dir., Trenton Sch. IA [31]

FREDERICK, George Francis [Cer,Arch] Vineyard Haven, MA b. 15 Ap 1900, Urbana, IL. Studied: P. Cret; Univ. Pa. Member: Boston SAC; Phila.; ACG; AIA; Boston S. Arch. Work: 400-piece tea set, Mem. A. Gal., Rochester. Specialty: pottery. Position: Dreamacre Pottery, Martha's Vineyard [40]

FREDERICK, Millie Bruhl (Mrs. Leopold) [P,S] NYC. b. 28 F 1878, NYC. Studied: W. Frinck. Member: Nat. A. Cl.; N.Y. Sch. Applied Des. for Women. Exhibited: Nat. A. Cl., 1939 [40]

FREDERICKS, Alfred [P] Brooklyn, NY. Member: AWCS [10]

FREDERICKS, Marshall Maynard [S,T] Birmingham, MI b. 31 Ja 1908, Rock Island, IL. Studied: Cleveland Sch. A.; Europe; Carl Milles. Member: Mich. Soc. Sc. A.&L. Exhibited: City of Detroit, 1936 (prize); WFNY, 1939; CMA, 1931 (prize); Detroit Inst. A., 1938 (prize); Dance International Exh., Rockefeller Center, N.Y., 1937 (prize); PAFA; AIC; WMAA; CI; CMA. Work: City of Detroit; Cranbrook Acad. A.; Univ. Mich.; USPOs, River Rouge, Mich., Sandwich, Ill. Position: T., Cranbrook Acad. A., 1933–42 [47]

FREDERICKSON, Frederick Lyder [P,S] NYC b. 18 F 1905, Mandal, Norway. Studied: Oslo Univ., ASL, with Raphael Soyer, Leon Kroll, Laurent. Member: Salons of Am., ASL. Exhibited: PAFA, 1937, 1941; VMFA, 1942; Downtown Playhouse, 1936 (one-man); Hudson Walker Gal., 1937, 1939; Schonemann Gal., 1940; Marie Sterner Gal., 1941; Marquie Gal., 1944; Norway, 1939. Work: PMA, PAFA [47]

FREDERIKSEN, Mary (M.) (Mrs. Walter Ufer) [P,L,T] Taos, NM b. 1 Ja 1869, Copenhagen. Studied: Constant; Laurens; Hofmann; Merson; Whistler. Member: NAWPS; S.Indp.A.; PBC [40]

FREDRICK, W.F. (William Fredrick Fixen) [P] Los Angeles, CA b. Racine, WI. Studied: R. Way Smith; Mrs. C. Erskine. Work: Municipal Art Commission, City Hall, Los Angeles [33]

FREDSALL, Ralph Waldo [P] Wash., D.C. [24]

FREE, Karl R. [P] NYC b. 16 My 1903, Davenport, IA d. 16 F 1947. Studied: Allen Tucker; Joseph Pennell; Boardman Robinson; Kenneth Hayes Miller. Member: Am. Soc. PS&G. Work: WMAA; MOMA; Davenport (Iowa) Municipal Art Gal.; P.O. Dept. Bldg., Wash., D.C.; USPO, Princeton, N.J. Position: Assoc. Cur., WMAA. WPA artist. [40]

FREE, Mary Arnold (Mrs. Robert C.) [P,Li,T] San Antonio, TX b. 6 N 1895, Pleasant Hill, MO. Studied: T. Col., Columbia; Kansas City AI; Snell; Wilomovski; Braught. Member: Nat. Assn. Univ. Women; San Antonio A. Lg.; Nat. Edu. Assn.; Assn. A. T. Tex. Exhibited: Toledo Mus. A., 1934; Witte Mem. Mus., 1935; Kansas City AI; Positions: T., San Anotion Voc.&Tech. Sch., 1935– ; San Antonio Jr. Col., 1945– [47]

FREEBORN, S.M. [S] Florence, Italy [01]

FREEBORNE, Zara Malcolm [Por.P,S] b. 1861, Pennsylvania d. 31 My 1906, Boston. Studied: William Rimmer. Known as a portrait painter during her stay in New York (1880s), she spent fourteen years in Florence (1892–1906) where she was one of the best-known women sculptors. [06]

FREED, Ernest Bradfield [P,T] Rockville, IN b. 20 Jy 1908, Rockville. Studied: C.E. Bradbury; C.V. Donovan; E.E. Nearpass; Univ. Ill.; D. Garber; G. Harding; H.R. Poore; R.C. Nuse; PAFA; Grant Wood; Univ. Iowa. Exhibited: Ind. State Fair, 1936 (prizes), 1937 (prize), 1938 (prize). Work: State T., Col., Kirksville, Mo. [40]

FREED, Maurice [P] Phila., PA. Exhibited: watercolors, PAFA, 1937–39 [40]

FREED, William [P,Mur.P,T] b. 26 Jy 1904, Poland (came to U.S. in 1923). Studied: Edu. All. A. Sch., with Ostrowsky, A. Levy, 1924–28; ASL, with Boas, Lehay, 1929; Hans Hofmann Sch. A., 1937–47. Exhibited: Cape Cod AA, 1959 (prizes). Work: WMAA; Chrysler Mus. A.; Jewish Mus.; Univ. Tex., Dallas. WPA muralist. [*]

FREEDLANDER, Arthur R. [P,T] NYC/Vineyard Haven, MA b. New York d. 24 Je 1940. Studied: Twachtman; Chase; Mowbray; Cormon, in Paris. Member: SC, 1905; Artists Gld.; Brooklyn SA; AWCS; All. AA; CAFA; AAPL. Exhibited: SC, 1915 (prize). Work: H. Vance Swope Mem., Seymour, Ind.; Court Room, Bronx County Bldg., New York. Position: Dir., Martha's Vineyard Sch. A. [40]

FREEDLY, Elizabeth (Mrs. R. Moore Price) [P] New Hope, PA. Member: NAWPS [25]

FREEDMAN, Louise A. [Ser,Li,I,P] NYC b. 6 My 1915, St. Louis, MO. Studied: Vassar; New Sch. Soc. Res.; ASL, with Blanch, Kantor, Sternberg. Member: Nat. Serigraph Soc.; A. Lg. Am.; Am. Color Pr. Soc. Exhibited: Pepsi-Cola, 1944; NAD, 1946; AV, 1942; Nat. Serigraph Soc., 1942–46; CAM, 1945; Kansas City AI; Phila. Pr. Cl., 1945; New Age Gal., 1945, 1946. Work: Am. Assn. Univ. Women; Iowa State Univ.; State Dept., Wash., D.C. [47]

FREEDMAN, Maurice [P] NYC/Dorchester, MA b. 14 N 1904, Boston. Studied: R. Andrew; J. Sharman; Lhote. Work: PAFA [40]

FREEDMAN, Ruth [P] Seattle, WA b. 4 Je 1899, Chicago. Studied: Chicago AFA. Member: Seattle AC. Exhibited: Seattle SFA, 1921 (prize) [27]

FREEDOLIN, Vladimir [P,S,L] b. 1879, Russia d. 4 S 1934, New York. Studied: Univ. St. Petersburg, Russia. He accompanied a Russian Army to Turkey during the early part of World War I as a representative of the government. Once a member of the Czar's Budget Commission, he lost all his property to the Bolsheviki at the time of the revolution and, after spending several years in Turkey, came to New York. He was a naturalized American citizen and lectured on art and philosophy, in addition to painting and sculpting.

FREELAND, Anna C. [P] Worcester, MA [15]

FREELON, Allan Randall [G,P,E,T] Phila., PA b. 2 S 1895, Phila. Studied: PMSchIA; Univ. Pa.; Tyler Sch. FA, Elkins Park, Pa.; E. Horter; H. Breckenridge. Member: Phila. A. T. Assn.; EAA; North Shore AA. Exhibited: Tyler Sch. FA, 1946; Phila. Pr. Cl., 1946; Temple Univ., 1940 (one-man). Work: PMA; Tyler Sch. FA; Vineland (N.J.) Mus.; Lincoln Univ. Positions: T., Phila. Schools, 1936– , PMA, 1940–46; Tech. Adv., Li., Phila. Pr. Cl., 1946– [47]

FREEMAN, A. Albert [Des,W,L] NYC b. 15 N 1905, NYC. Studied: NYU; Univ. State of N.Y. Member: AIGA; Nat. Graphic A. Edu. Assn.; N.Y. C. Printing House Craftsmen [47]

FREEMAN, Alice Imogene [S] Chicago, IL b. 1876. Studied: AIC [04]

FREEMAN, C(harles) H. [P] Brielle, NJ b. 4 S 1859, Camden, NJ d. 29 N 1918. Studied: Duveneck; Lefebvre; Constant [17]

FREEMAN, Clara E. [P] Providence, RI [24]

FREEMAN, Don [P,I,Gr,Li] NYC b. 1908, San Diego, CA d. 1978. Studied: ASL, with John Sloan, A. Wickey. Exhibited: AIC; WMAA; PAFA; CGA; Phila. Pr. Cl., 1936 (prize); Assoc. Am. Ar. Gal., 1940 (one-man). Contributor: New York Times, New York Herald Tribune, theatre magazines [47]

FREEMAN, Dorothy. See Martin, A.T., Mrs.

FREEMAN, Edith Emogene. See Sherman, Mrs.

FREEMAN, Fred [I] Essex, CT. Member: SI [47]

FREEMAN, George [Min.P] Boston, MA d. F 1906, Birmingham, AL (mysteriouly shot)

FREEMAN, Howard Benton [Car] Newark, NJ/Avon, NJ b. 1878, Portland, OR d. 21 Ag 1937. He spent his early years as a professional bicycle racing star. Urged to utilize his natural drawing talent, he went to NYC. Creator: comic strip, "Doc Lee." Position: Car., Newark Evening News, 1912–

FREEMAN, Inez [P] NYC [01]

FREEMAN, Jane [P,T] NYC/Pigeon Cove, MA b. 11 F 1885, Newton, England d. 21 S 1963, Park Ridge, NJ. Studied: ASL, with DuMond, Chase, Henri; Grand Chaumière, Paris; G.E. Browne; F. Fairbanks; Hawthorne; Bredin; CUASch; Andre Lhote. Member: All.A.Am.; Audubon A.; Rockport AA; North Shore AA; Carnegie Hall A. Gal. Exhibited: All.A.Am., 1944 (prize) Audubon A., 1944 (med); Springville (Utah) A. Center, 1933 (med), 1944 (prize); Art and Indst. Exhib., Hotel Astor, NYC, 1928 (prize), 1930 (prize); NAWPS, 1928 (prize). Work: Springville AA [47]

FREEMAN, Lorena E. [P,I,C] Brooklyn, NY [13]

FREEMAN, Lou Blackstone (Miss) [P] d. 2 N 1905, Paris, France. The last years of her life were spent in Paris. Exhibited: Paris Salon

FREEMAN, Margaret (Lial) [I] NYC b. Cornwall-on-Hudson, NY. Studied: Pape; R. Miller; Troy; M.W. Kinney. Illustrator: "The Story of a Wonder Man," by Ring Lardner, pub. Scribner's, "American Folk Tales," "The Provincial Lady in America" [40]

FREEMAN, Marion Delamater. See Wakeman.

FREEMAN, William R. [Por.P] b. ca. 1820, NY d. ca. 1906, St. Louis, MO. Worked in NYC, 1844; in Terre Haute, Ind., 1849; Louisville; St. Louis; Indianapolis, early 1870s; San Fran., 1875; finally returned to St. Louis. [*]

FREER, Charles Lang [Patron] b. 1856, Kingston, NY d. 26 S 1919, NYC. In 1915 he presented his entire art collection to the Smithsonian Inst. and also gave $1,000,000 to house the collection, it being the foundation of today's Freer Gallery of Art. The collection included works by 19th- and 20th-century Americans and is strong in works by Whistler.

FREER, Cora Fredericka [P] Chicago, IL b. Chicago. Studied: AIC; Paris, with Courtois, Merson, Collin. Member: Chicago SA [10]

FREER, Frederick Warren [P,E,T] Chicago, IL b. 16 Je 1849, Chicago d. 7 Mr 1908. Studied: Royal Acad., Munich. Member: AWCS; N.Y. Etching C.; A. Fund S.; Chicago A.; SWA; Chicago AD. NYWCC. Exhibited: Columbian Expo, Chicago, 1893 (med); Pan-Am. Expo, Buffalo, 1901; Charleston Expo, 1903 (med); AIC, 1902 (prize); Chicago AC, 1903 (med); St. Louis Expo, 1904 (med); ANA. Position: T., AIC [08]

FREER, Howard Mortimer [P,Des,T,I] Berlin, CT b. 25 N 1904, Jackson, MI d. 9 Mr 1960. Studied: Chicago Acad. FA; John Huntington Polytechnic Inst. Exhibited: PAFA, 1932–36; AWCS; AIC, 1934–36, 1940–46; AIC, 1934–39, 1941, 1942, 1944, 1946; Detroit Inst. A., 1932–34, 1936 (prize), 1938, 1939 (prize); GGE, 1939; Pal. Leg. Honor; CM, 1934–36, 1938; AIC Traveling Exh., 1941. Work: adv. art, Saturday Evening Post, Fortune, Ladies Home Journal [47]

FREHM, Paul [I] NYC. Member: SI [47]

FREI, Adolph C. [Mur.P] b. 1854, Germany d. 29 A 1935, Landsdowne, PA. Studied: Royal Cadet Sch., Carlsruhe. He spent 57 years painting and restoring ecclesiastical pictures and designing the interior adornment of churches. His works may be found in more than 500 churches in the U.S. and in Europe. One of his large commissions was the painting of 16 murals, known as the "Glories of Pennsylvania," in the Pa. State Bldg., St. Louis Expo

FREI, Emil, Jr. [P] St. Louis, MO [25]

FREIGANG, Paul [C] Jamaica, NY b. 25 Mr 1886, Elsterwerda, Germany. Member: Cer. Soc. N.Y.; N.Y. Craftsmen Soc.; Soc. Des.-Cr. Exhibited: MMA, 1940; Paris Salon, 1937 (gold) [47]

FREILICHER, Hy [S,C,T] Brooklyn, NY b. 13 Ap 1907, Northumberland, PA. Studied: CCNY; BAID. Member: S. Gld. Exhibited: S. Gld., 1939; WFNY, 1939; AFA Traveling Exh.; CI; Inst.; BM; MMA. Position: T., Ft. Hamilton H.S., Brooklyn, N.Y., 1939– [47]

FREITAG, Conrad [Mar.P] b. Germany d. 29 O 1894, Brooklyn, NY. Exhibited: NAD; Brooklyn AA, 1874–83. Work: Mariners Mus.; Mystic Seaport Mus.; Peabody Mus., Salem; Staten Island Hist. Soc. Had a studio in NYC by 1860. [*]

FREITAS, Jon [E,Li] Honolulu, HI. Member: Assn. Honolulu A.; Honolulu PM. Exhibited: Honolulu PM, 1936 [40]

FRELINGHUYSEN, George G(riswald), Jr. [P] NYC/Morristown, NJ b. 25 Jy 1911, Morristown, NJ. Studied: J. Delbos [40]

FRENCH, Alice Helm (Mrs. William M.R.) [P,I,T] Williamstown, MA b. 17 Mr 1864, Lake Forest, IL. Studied: AIC. Work: CAM; Beloit Col.; Doshisa Col., Kyoto, Japan; Vanderpoel Coll.; Colegio International, Guadalajara, Mexico [47]

FRENCH, Allen [P] Concord, MA. Member: Concord AA [25]

FRENCH, Arthur Sheldon [P] Brooklyn, NY [10]

FRENCH, Daniel Chester [S] NYC/Glendale, MA b. 20 Ap 1850, Exeter, NH d. 7 O 1931. Studied: W. Rimmer, in Boston; J.Q. Ward, in NYC; T. Ball, in Florence. Awards: honorary degrees from Dartmouth, Yale, Harvard, Columbia. Established his studio in NYC, 1887. Member: ANA, 1900; NA, 1901; NSS, 1893; SAA, 1882; Arch. Lg., 1890; AIA, 1896; Acad. San Luca, Rome; NAC; Century Assoc.; NIAL; AAAL; Concord AA; Nat. Commission FA, 1910–15; Chevalier, Legion of Honor, 1910; Academie des Beaux-Arts, Paris, 1920. Exhibited: Paris Salon, 1892 (med); Paris Expo, 1900 (med); Arch. Lg., 1912 (med); P.-P. Expo, San F., 1915 (med); NIAL, 1918 (gold). Work: monumental figural sculptures: mem., Boston, Mass.; "The Minute Man," Concord, Mass.; Lincoln, Nebr.; N.Y. Custom House; Worcester, Mass.; Federal Bldg., Cleveland; State Capitol, St. Paul, Minn; Columbia Univ.; Boston, Mass.; MMA; Montclair AM; Saratoga, N.Y.; St. Louis Mus.; Acad. FA, Buffalo; statue of Emerson, Concord, Mass; Brooklyn, N.Y.; "Lincoln," in Lincoln Memorial; CGA; Milton, Mass.; Concord, N.H. [29]

FRENCH, David M. [S] Newburyport, MA b. 1827, Newmarket, NH d. 19 Ap 1910. Studied: P. Stevenson, in Boston. His most important work was a life-size statue of W. L. Garrison in Brown Square, dedicated 4 Jy 1893

FRENCH, Edwin Davis [En] Saranac Lake, NY b. 19 Je 1851, North Attleboro, MA d. 8 D 1906, NYC. Studied: Osborne; W. Sartain. Member: ASL, 1889–91; Am. FA Soc.; Grolier C.; NAC. Illustrator: André's journal. Work: NYPL. Originally an engraver on silver. Specialty: bookplates [06]

FRENCH, Elizabeth D.L. (Mrs.) [Mur.P,S,W,Dec] Kingston, PA /Chase, PA. b. 28 Je 1877, Plymouth, PA d. 8 S 1943. Studied: Chase; Hawthorne. Work: papier-maché figures, Wilkes-Barre Sesqui-Centennial; dec., Grace Church, Kingston (Pa.), Mission Room, St. Stephens Church (Wilkes-Barre, Pa.). Author: plays for children [40]

FRENCH, Frank [Por.P,W,T,I,En] Reeds Ferry, NH b. 22 My 1850, Loudon, NH d. 19 F 1933. Studied: mainly self-taught; H.W. Herrick. Member: ANA, 1923; Soc. Am. Wood En.; SC; A. Fund S. Centenn. Expo, Phila., 1876 (med); Columbian Expo, Chicago, 1893 (med); Pan-Am. Expo, Buffalo, 1901 (med); St. Louis Expo, 1904 (gold). Work: Scribner's magazine. He is said to have been the dean of American wood engravers. [31]

FRENCH, Hazel Blake [C,Des] Sandwich, MA b. 21 Ag 1890, Brockton, MA. Studied: BMFA Sch.; C.H. Walker; H. Elliot; G. Hunt. Member: Boston SAC; Phila. AC Gld. Exhibited: Paris Salon, 1937; Phila. A. All., 1937, 1938, 1940–43, 1945; WMA, 1943; America House, 1944. Specialty: designing and making jewelry [47]

FRENCH, Howard Barclay [P,I] Blairstown, NJ b. 31 Ja 1906, Ft. Thomas, KY. Studied: ASL, with DuMond, Carter. Exhibited: Gov. House, Nassau, Bahamas, 1931 (prize); NAC, 1933 (prize). Work: murals, S.S. America; S.S. African Meteor; U.S. Merchant Marine Acad., King's Pt., N.Y. Illustrator: frontispiece & cover, Yachting; for Peabody Mus., Salem, Mass. [47]

FRENCH, Jared [Mur.P,Dr,E] NYC b. 4 F 1905, Ossining, NY. Studied: Amherst Col.; ASL, with B. Robinson. Member: ASL. Exhibited: Chicago AC; MOMA; CGA; PAFA; WMAA; CI, 1946; AIC; SFMA; NAD. Work: WMAA; Baseball Mus., Cooperstown, N.Y.; BMA; murals, USPOs, Richmond, Va., Plymouth, Pa. WPA muralist. [47]

FRENCH, Jared, Mrs. See Hoening, Margaret.

FRENCH, Myrtle Meritt [Cer,T,W] Chicago, IL/Alfred, NY b. 5 Je 1886, Friendship, NY. Studied: C.F. Binns, Alfred Univ.; AIC; Iannelli; E.J. Wimmer. Member: F., A. Cer. S. Exhibited: Nat. AAI, 1934, (prizes). Author: articles, Journal of the American Ceramic Society, Design, Ceramic Age, The Neighborhood. Positions: T., AIC, Hull House Settlement, Chicago, 1924–37 [40]

FRENCH, Thomas E. [P] Columbus, OH [19]

FRENCH, William Merchant Richardson [Edu,W,L] Chicago, IL b. 1 O 1843 d. 3 Je 1914. Studied: Harvard. Older brother of Daniel French. Position: Dir., AIC (Museum and A. Sch.), since its founding in 1879

FRENZEL, Joseph [I] NYC [01]

FRENZENY, Paul [I] b. ca 1840, France d. 1902, probably London. Work: BMFA; Denver Pub. Lib. Illustrator: "Fifty Years on the Trail," 1889. Best known for his teaming up with another French artist, Jules Tavernier, on a sketching trip through the old West, producing a pictorial record of Western town life, emigrant life, and Indians. Positions: Artist-correspondent, Harper's, 1860–70s, Leslie's, 1880s. [*]

FRERET, Emily M. [P] New Orleans, LA [17]

FRERICHS, William C.A. [Por.P,T] Staten Island, NY b. 1829, Ghent, Belgium (came to U.S. ca 1852) d. 16 Mr 1905. Exhibited: NAD, 1852. Positions: T., Greensboro, SC, 1854–63; Dir. of an art sch. in Newark, N.J., 1869–

FREUND, Arthur [P] NYC. Member: S.Indp.A. [25]

FREUND, Ernest Arthur Paul [P,I] NYC b. 2 Ap 1890, Dolgeville, NY [15]

FREUND, Harry Louis [P,Ed,I] Conway, AR b. 16 S 1905, Clinton, MO. Studied: Mo. Univ., with Ankeney; St. Louis Sch. FA, with Carpenter; Princeton Univ.; Morey; Goetsch; Wuerpel; H. Moriset, in Paris. Member: Ark. WCS; SSAL; Ozark AA; Carnegie F., 1940. Exhibited: St. Louis, 1927 (med); St. Louis AG, 1929 (prize); Ark. WCS, 1938 (prize); Ozark AA, 1939 (prize), 1940–45; Denver A. Mus., 1939; CMA, 1939, 1940; Kansas City AI, 1938–42; SSAL, 1942–45; Ark. A., 1940–46; IBM, 1940; Pepsi-Cola, 1945. Work: Springfield (Mo.) Mus. A.; Little Rock Mus. FA; murals, USPOs Herington, Kans., Windsor, Mo., Idabel, Okla., Pocahontas, Heber Springs, both in Ark., Camp Robinson, Clinton, Mo., Camp Chaffee, Ark. WPA muralist. Positions: A. in residence, Hendrix Col.; T., Little Rock Jr. Col. [47]

FREW, William [P] Pittsburgh, PA. Member: Pittsburgh AA [21]

FREY, Charles D. [I] Chicago, IL b. 1881, Denver, CO. Studied: Denver A. Sch.; G. Mannheim, in Paris [10]

FREY, Erwin F. [S,Edu] Columbus, OH b. 21 Ap 1892, Lima, OH d. 10 Ja 1967. Studied: Lima Col.; Cincinnati AA; ASL; C.J. Barnhorne; J. Fraser; BAID; Académie Julian, Paris, with H. Bouchard, P. Landowski. Member: NSS; Columbus AL. Exhibited: CM, 1918; Paris, 1923; PAFA, 1929; AIC, 1925, 1928; Pal. Leg. Honor, 1929; Arch. Lg., 1925; NAD, 1930; Rockefeller Center, N.Y., 1938; Columbus Gal. FA, 1940 (one-man). Work: mem., Ohio State Univ.; New Rumley, Ohio; Columbus Gal. FA; Fairmont Park, Phila.; mem., Springfield, Ohio; American Soc. Electrical Engineers. Position: T., Ohio State Univ., 1925–46 [47]

FREY, Robert A. [P] Paris, France [01]

FREYMAN, Gertrude [P] Kansas City, MO. Exhibited: Midwest Ar. Ann. Kansas City AI, 1933–39 [40]

FRIBERT, Charles [P] Paris, France b. Sweden. Studied: Royal Acad., Stockholm; Ecole des Beaux-Arts, Falguière, both in Paris. Member: Phila. AC. Work: silver statuette given to King Oscar II [06]

FRICK, Gretchen (Mrs.) [P] Janesville, WI. Member: GFLA [27]

FRICK, Henry Clay [Patron] NYC b. 1849, Westmoreland County, PA d. 2 D 1919. His collection of art treasures was considered to be one of the finest in the U.S., and his home became the museum in NYC bearing his name. Position: Chm., Carnegie Steel

FRIEBERT, Joseph [P,E,B] Milwaukee, WI b. 11 My 1908. Studied: Layton Sch. A.; S. Himmelfarb; R. Schellin; R. von Neumann; H. Thomas. Member: Wis. PS; Milwaukee PM; AG Milwaukee [40]

FRIED, Theodore [P] NYC b. 19 My 1902, Budapest, Hungary. Studied: Europe. Member: Fed. Mod. P.&S. Exhibited: CI, 1943; Albright A. Gal., 1946; NAD, 1944; Fed. Mod. P.&S., 1943–45. Work: Albertina Mus., Vienna; Kunsthalle, Jena, Germany [47]

FRIEDERANG, Maxmilian Franz [P] b. 1857 d. 28 Mr 1929, Brooklyn, NY. His fresco in the grotto of the Church of Our Lady of Lourdes, covering more than 6,000 feet, is said to be the largest painting in the world. One of his frescoes covers the entire dome of St. Joseph's Church at Babylon, N.Y.; others are in the U.S. Supreme Court and the Senate Library. It has been claimed that he discovered the process of fresco painting used by the Renaissance artists

FRIEDLANDER, Isac [En,E] NYC b. 22 Ap 1890, Mitau, Latvia d. 23 Ag 1968. Member: SAE; Chicago SE. Exhibited: CAA, 1931; Weyhe Gal., 1931, 1941; Phila. Pr. Cl., 1930, 1934 (prize), 1940 (prize), 1943 (prize), 1946; Roerich Mus. A., 1932; BM, 1942 (prize), 1943, 1944; LOC, 1943–46; SFMA, 1942; SAM, 1943–46, 1945 (prize); AV, 1942; Kleeman Gal., 1930 (one-man), 1943 (one-man); Stendahl Gal., Los Angeles, 1931; New Sch. Soc. Res., 1933; Phil. Pr. Cl., 1937; Eaton Gal., Montreal, Quebec, 1937; Europe. Work: Galleria Corsini, Rome; museums in Vitebsk, Riga, and Prague; LOC; SAM; Smithsonian Inst. [47]

FRIEDLANDER, Leo [S,P,Arch,L,W] White Plains, NY b. 6 Jy 1890, NYC. Studied: SAL; Ecole des Beaux-Arts, Rome. Member: ANA, 1936; NSS; Arch. Lg.; F., Am. Acad, Rome, 1913–16. Exhibited: NAD, 1918 (prize), 1924 (prize); AIC, 1920; Sesqui-Centenn. Expo, Phila., 1926; Arch Lg., 1933 (med). Work: Wash. Mem. Arch., Valley Forge, 1912; St. Thomas' Church, Frankford, Pa.; Eastman Sch. Music, Rochester; Masonic Temple, Detroit; Nat. Chamber Commerce, Wash., D.C.; Univ. Mich. Mus.; MMA; Cranbrook Church, Mich; Chapel, Berkeley; Goldman Mem., Congregational Cemetery, Queens, N.Y.; Epworth Euclid Methodist Episcopal Church, Cleveland; designed seal for N.Y. Bldg. Congress; marble reliefs, Am. Bank and Trust Co., Phila.; marble metopes, Lee Higginson Bank, NYC; center pediment, NYC Mus., 1929; façades, Jefferson County Court House, Birmingham, Ala., 1929–30; entrance, Genesee Valley Trust Co., 1929–30; Grosse Pointe Church, Mich., 1929–30; exterior reliefs, N.Y. Telephone Co. Bldg., Buffalo; groups, Arlington Mem. Bridge, Wash., D.C., 1930; RCA Bldg., NYC; Century of Progress Expo, Chicago, George Eastman Mem., Rochester; sculptures, Denton, Tex.; Williams Mem., Providence; WFNY, 1939; Oreg. State Capitol, Salem; bas reliefs, Univ. Oreg. Mus. [47]

FRIEDLANDER, Maurice [P,Des,I] Chicago, IL b. 3 My 1899, Blue Island, IL. Studied: AIC; Chicago Acad. FA; Archipenko Sch. A. Member: Chicago SA; Renaissance Soc., Univ. Chicago. Work: mural, Servicemen's Center, Chicago. Exhibited: PAFA, 1946; Univ. Chicago, 1946; AIC, 1944, 1946; Ill. State Mus., 1943; Milwaukee AI, 1944 [47]

FRIEDMAN, Arnold [P,Li,W] Corona, NY b. 23 F 1879, NYC. Studied: Chase; Henri; ASL. Member: Am. Soc. PS&G; Salons of Am. Fed. Mod. P&S. Work: MMA; MOMA; Detroit Inst. A.; Newark Mus.; PMG; murals, USPOs, Orange, Va., Kingstree, S.C., Warrenton, Ga.; Chalfonte-Haddon Hall, Atlantic City. WPA muralist. Contributor: articles, Art Digest, Art in America [47]

FRIEDMAN, Burr Lee. See Singer.

FRIEDMAN, Mark [S,T,C,L] NYC b. 19 D 1905, Brooklyn, NY. Studied: BAID; ASL; Académie Julian, Paris; J. Bouchard; P. Landowski; P. Manship. Member: Soc. des Artistes Français; S. Gld . Exhibited: BAID, 1931 (prize), 1932 (prize); Salon d'Automne, 1931 (prize); Salon de Printemps, Paris, 1930 (prize), 1932 (prize); NAD, 1932, 1933, 1935, 1938; S. Gld., annually ; BM, 1938; Columbia, 1939; N.Y. Municipal A. Exh.; CGA; PAFA; Newark YMHA (one-man); Bonestell Gal., 1944, 1946 (one-man). Work: S., Good Samaritan Hospital, NYC; Columbia; CCNY. Position: T., Herkscher Foundation Class [47]

FRIEDMAN, Martin [P] Brooklyn, NY b. 26 Ap 1896, Budapest. Studied: NAD. Member: Am. Ar. Cong. Exhibited: CGA, 1935, 1939; WFNY, 1939; MMA (AV), 1942; Brownell-Lambertson Gal., N.Y., 1932 (one-man); A. Gal., N.Y., 1942 (one-man); Perls Gal., 1946 (one-man); PAFA, 1939. Work: Univ. Ariz. [47]

FRIEDMAN, Sarah [P] NYC. Member: S.Indp.A [21]

FRIEDSAM, Michael (Colonel) [Patron] b. NYC d. Ap 7 1931, NYC. He was one of America's foremost art collectors. Beginning in 1905, he gathered a collection conservatively valued at $10,000,000. As president of the Altman Foundation, he financed the revival of the College of Fine Arts at NYU, He was active in the MMA, College AA, Arch. Lg, Mus. of French Art, Mus. of NYC, Société des Amis du Louvre, and NAD.

FRIEL, Zenith (Ivy) [P,T] Kansas City, MO b. 22 O 1889, Edwardsville, KS. Studied: A. Murray; I. Summers; R.E. Braught. Member: Kansas City SA [33]

FRIEND, David [P] NYC b. 6 S 1899, Glasgow, Scotland. Studied: France; NYU; W. Farndon. Member: All.A.Am.; AAPL; North Shore AA. Exhibited: All.A.Am., 1939-45; NAD, 1944; North Shore AA, 1944, 1945; AAPL, 1944, 1945; Gld. Hall, Easthampton, 1944, 1945 [47]

FRIES, Charles Arthur [P,I,T] San Diego, CA b. 14 Ag 1854, Hillsboro, OH d. 15 D 1940. Studied: Cincinnati Art Acad. Member: San Diego AG; Laguna Beach AA; La Jolla AC; Calif. AC; San Diego Contemp. A. Exhibited: Seattle FAS, 1911 (med); P.-P. Expo, 1915 (med); San Diego AG, 1932 (prize). Work: San Diego FA Gal. [40]

FRIESEKE, Frederick Carl [P] Paris, France b. 7 Ap 1874, Owosso, MI d. 28 Ag 1939. Studied: AIC; ASL; Paris, with Constant, Laurens, Whistler. Member: ANA, 1912; NA, 1914; Soc. Nat. des Beaux-Arts; Paris AAA; Intl. Soc. AL; NYWCC; Grand Central A. Gal.; Chevalier of the Legion of Honor, France. Exhibited: St. Louis Expo, 1904 (med); Munich, 1904 (gold); CGA, 1908 (prize); PAFA, 1913 (gold); P.-P. Expo, 1915 (prize); AIC, 1916 (med), (prize); Phila. AC, 1920 (gold) (prize), 1922 (prize); CGA, 1935 (prize). Work: Luxembourg Mus.; MMA; AIC; Minneapolis Inst. A.; Telfair Acad., Savannah; Modern Gal., Venice; Mus. of Odessa; Syracuse MFA; CAM,; TMA; New Britain (Conn.) Inst.; Detroit AI; CGA; Cincinnati Mus.; A.&Cr. Gld., New Orleans; Lincoln (Nebr.) Mus.; Cedar Rapids AA; Harrison Gal., Los Angeles Mus. Hist., Sc.&A.; John Herron AI; Springville Utah High Sch. Assn.; Univ. Ill., Urbana; Macbeth Gal., NYC [38]

FRIETSCH, Charlotte G. [P,W,T] NYC/Spotswood, NJ b. 18 Ja 1896, WI. Member: S.Indp.A.; Salons of Am. Exhibited: Allied Am. A. (prize) [29]

FRISCH, Carl Henry [P,Des] b. 1882, England d. 19 My 1934, NYC. He had a valuable collection of typographical art. Position: Bartlett Orr Press, for 36 years

FRISCHKE, Arthur [P] NYC b. 25 Je 1893, NYC. Studied: CUASch; NAD. Member: Bronx AF; AAPL [33]

FRISENBERG, Oldach [P] Chicago, IL [13]

FRISHMUTH, Harriet W(hitney) [S] Phila., PA/Lake Pleasant, NY b. 17 S 1880, Phila. Studied: Paris, with Rodin, Injalbert; New York, with Borglum, H. McNeil. Member: ANA, 1925; NA, 1929; NSS, 1914; NAWPS; Allied AA; N.Y. Municipal AS; AFA; Nat. Inst. Social Sc.; Arch. Lg.; NAC. Exhibited: NAWPS (prize) 1921 (prize), 1924 (med); P.-P. Expo, 1915; NAD, 1922 (gold), 1923 (prize); Allied AA, 1925 (med); Am. Garden C., Phila., 1928 (gold); Grand Central AG, 1928 (prize). Work: MMA; Detroit Inst. A.; Dallas AA; MFA, Houston; John Herron AI; Los Angeles Mus.; Wadsworth Atheneum, Hartford; Mem. A. Gal., Rochester, N.Y.; Currier Gal., Manchester, N.H.; Capitol, Richmond, Va. [47]

FRITON, Ernest T. [P] St. Louis, MO [25]

FRITZ, Eleanor V(irginia) (Mrs. E.B.) [P] Santa Monica, CA/Fort Worth, TX b. 23 N 1885, St. Cloud, MN. Studied: AIC, with J. Vanderpoel; A.W. Dow; H. Hofmann. Member: SSAL; Ft. Worth AA; Allied AC, Ft. Worth; Los Angeles AA. Work: Nash Sch., Ft. Worth. Position: T., Polytechnic H.S., Ft. Worth [40]

FRITZ, Henry Eugene [Edu,W,L,P,B] Sarasota, FL b. 12 O 1875, Lubben, Germany. Studied: CUASch; NAD; Columbia; NYU; Germany; G. Bridgman; R. Blum; G. Maynard; C.Y. Turner; A.W. Dow; BAID; ASL. Member: EAA; Kit Kat C.; New Rochelle AA. Exhibited: New Rochelle AA, 1922. Author: "Art for Gifted Students" pub. American Book Co., "Education of Gifted Children," 1938. Position: T., NYC pub. sch., 1904-40 [47]

FRIZZELL, Ralph Linwood [P,En,B,I] Portland, ME/Chebeague Island, ME b. 13 F 1909, Portland. Work: frieze, Deering H.S., Portland. Illustrator: "The Sacrilege of Alan Kent," pub. Falmouth Book House, 1936 [40]

FROEHLICH, George J. [P] Rochester, NY. Member: Rochester AC [24]

FROELICH, Ava [P,C,T] Richmond Hill, NY b. 1863 d. 12 F 1933, Maplewood, NJ. Position: T., PIASch [04]

FROELICH, Hugo B. [P,I,C,T,W] Bloomfield, NJ b. 26 F 1862, Cincinnati, OH. Studied: A.W. Dow; H.B. Snell; C. Davis. Positions: T., PIASch, 1895-1903, N.Y. Sch. F.&Appl. A., 1912-13, Newark pub. sch., 1913; Ed., Prang Educational Co., 1903-12 [13]

FROELICH, Maren M. [P] San Fran., CA [17]

FROELICH, Paul [Li,E,Dr,P,Edu] New Hope, PA b. 5 S 1897, Phila. d. ca. 1968. Studied: PAFA; Breckenridge; H. McCarter; J. Pearson, Jr.; E. Calsen; D. Garber. Member: Phila. Print C. Work: WMAA; PAFA. Position: T., PMSchIA [40]

FROLA, Joseph R. [P] Latrobe, PA b. 6 D 1904, Irwin, PA. Studied: AL, Pittsburgh; CI. Exhibited: Greensburg AC, 1936-39, 1941-45 (prizes); Pittsburgh AA, 1937 (prize), 1938, 1940, 1942 (prize), 1943-46; Butler AI, 1939-43, 1946; FA Center A., Parkersburg, W.Va., 1941; State T. Col., Ind., Pa., 1944-46; All. A. Johnstown, 1945 [47]

FROLICH, Finn Haakon [S] Los Angeles, CA b. 13 Ag 1868, Norway. Studied: E. Barrias, Ecole des Beaux-Arts, Paris; A. Saint-Gaudens; D.C. French. Member: Southern Calif. S. Gld.; Norse Studio C.; Calif. PS. Exhibited: Paris Expo, 1900 (med); Long Beach Expo, (med). Work: mon., James Hill, Edvard Grieg, Seattle; mon., Jack London, Honolulu; Tower of Legends, Forest Lawn Cemetery, Los Angeles; mon., R. Amundsen, Long Beach, Calif.; mon., Paul Kruger, Johannesburg, South Africa. Positions: Dir., S., Alaska-Yukon-Pacific Expo, 1909; Official S., Pan-Am. Expo, Calif., 1915; Dir., Frolich Sch. S., Hollywood [40]

FROMEN, Agnes Valbourg [S] Chicago, IL b. 27 D 1868, Waldermasvik, Sweden. Studied: AIC, with L. Taft. Member: Swedish Am. AA; Cordon; AIC. Exhibited: Chicago AI, 1912 (prize); Swedish Exh., 1912 (prize); frieze, Ill. State Fair Bldg., 1914 (prizes); Swedish Am. Exh., 1917 (prize), 1919 (prize), 1924 (prize), 1929 (prize). Work: Hyde Park Church, Chicago; fountain, Oxford, Ohio; Forest Lawn Cemetery, Omaha; Museum, Göteborg, Sweden [40]

FROMKES, Maurice [P] NYC b. 19 F 1872, Poland (came to U.S. at the age of 8) d. 17 S 1931, Paris. Studied: NAD, with Ward, Low. Member: ANA, 1927; SC; MacD. C.; Allied AA; AFA. Exhibited: SC, 1908 (prize); Intl. Expo FA, Bordeaux, France, 1927 (prize). Work: Delgado Mus.; Newcomb Cl.; Nat. Mus. Madrid, Spain; Albright Gal.; RISD; PMG; Randolph-Macon Women's Col., Lynchburg, Va.; Vatican [29]

FROMUTH, Charles H(enry) [Mar.P] Finistère, France b. 23 F 1861 d. Jy 1937, Concarneau, France. Studied: PAFA, with T. Eakins. Member: F., PAFA; Assoc. Soc. Nat. des Beaux-Arts; London Pastel Soc.; Soc. des Peintres de Marine; Berlin Secession Soc. Painters. Exhibited: Intl. Expo, Munich, 1897 (gold); Paris Expo, 1900 (med); St. Louis Expo, 1904 (gold); PAFA. Work: Wellington Mus., New Zealand; Christ Church Mus., New Zealand; Mus. Quimper, France; BM; Cincinnati Mus. [33]

FROST, Anna [P,Li,T] Brooklyn, NY b. Brooklyn. Studied: C.W. Hawthorne; G. Senseney; H.B. Snell; H. Breckenridge; B. Brown. Member: Brooklyn WCS; NAWPS; North Shore AA; PBC. Exhibited: PBC, NYC, 1934 (prize) [40]

FROST, A(rthur) B(urdett) [I,P] Pasadena, CA b. 17 Ja 1851, Phila d. 22 Je 1928. Studied: PAFA, with Eakins while also working at engraving and lithography firms at age 15; later in London; largely self-taught. Member:

SI, 1905. Exhibited: Paris Expo, 1900. Illustrator: "Tom Sawyer," "Uncle Remus," "Mr. Dooley." Author/Illustrator: "Golfer's Alphabet," "Stuff and Nonsense." Specialties: humorous drawings, generally of homely farm and country types; animals. His wife was also a painter. Position: Staff, Harper's, 1876; became one of its great illustrators. [27]

FROST, George Albert [P] Cambridge, MA b. 27 D 1843, Boston. Studied: Belgium Royal Acad., with N. De Keyser. Member: Boston AC [06]

FROST, John [P,I] Haverford, PA/Pasadena, CA b. 14 My 1890, Phila. d. 1937. Studied: his father, A.B. Frost; Paris, ca. 1908–16. Exhibited: Southwest Mus., Los Angeles, 1921, 1922 (prize), 1923 (prize); Calif. PS, 1924 (gold) [35]

FROST, John Orne Johnson [Mar.P] b. 1852 Marblehead, MA d. 1952 Marblehead. Began to paint at age 70. Work: Peabody Mus., Salem [*]

FROST, Julius H. [P,S,T] Wash., DC b. 11 Jy 1867, Newark, NJ d. 1934. Studied: self-taught. Member: S.Indp.A.; Salons of America; AFA [31]

FROST, Mabelle G. (Mrs.) [P] Laguna Beach, CA. Member: Laguna Beach AA [25]

FROST, Robert Davey [S,Des] Jackson, MI b. 19 N 1908, Jackson. Studied: Univ. Mich.; AIC. Work: mem., First Congregational Ch., Jackson [40]

FROST, Ruth Sterling [Por.P] NYC/San Trovaso, Venice, Italy. b. 28 Mr 1873, St. Louis, MO. Studied: A.H. Thayer; G. Boldini, in Paris. Member: Societa delle Belle Arte, Florence; A. Prof. Lg., Paris. Specialty: portraits of children [40]

FROUCHTBEN, Bernard [P] NYC b. 20 Mr 1872, Smela, Russia d. 31 Ja 1956. Studied: CUASch; Paris. Exhibited: Un. Am. A., 1940; Acad. All. A., 1942, 1943; S.Indp.A., 1943; ACA Gal., 1943–45; WFNY, 1939; Gal. St. Etienne, 1944; MOMA, 1939; de Young Mem. Mus., 1940; Albright A. Gal., 1940; Marie Harriman Gal., 1942 [47]

FROULA, Joseph [P] Chicago, IL [19]

FRUEH, (Alfred J.) [P,I,C] NYC b. 2 S 1880, Lima, OH. Member: S.Indp.A. [25]

FRUHAUF, Aline [Car,Li] NYC b. 31 Ja 1907. Studied: B. Robinson; K.H. Miller; C. Locke. Member: Am. A. Cong. Work: Lib., Harvard Law Sch.; Butler AI; Law libraries, Yale, Duke. Illustrator: New Yorker, Vanity Fair, Theatre Arts Monthly, Musical America, Creative Art [40]

FRUHURN, G. (Miss) [P] Tacoma, WA. Member: Tacoma FA Assoc. [25]

FRY, Anne Frances [P] Phila., PA [19]

FRY, Eleanora [P] Brooklyn, NY [10]

FRY, Finley [B,Car,Des,E,I,L,Mur.P,Por.P,T,W] Los Angeles, CA b. 19 My 1908. Studied: Univ. Calif.; Hans Hofmann. Exhibited: Los Angeles Mus. Art, P.&S., 1934 (prize). Designer: Bullocks Wilshire Special Luncheon Sets; textiles; stage settings [40]

FRY, Georgia Timken [(Mrs. John H.)] NYC b. 1864, St. Louis, MO d. 8 S 1921, Peking, China. Studied: H. Thompson, A. Morot, Schenck, Cazin, in Paris. Member: Nat. Assoc. Women P.&S.; Soc. N.Y. Artists; Soc. Women Artists. Work: BAC. Specialty: landscapes with sheep [21]

FRY, Guy Edgar [Des,I,Edu] Westtown, PA b. 5 Ag 1903, Milton, PA. Studied: PMSchIA. Member: Phila. Sketch Cl.; Phila. WCC. Exhibited: Phila. WCC, 1934, 1935, 1945; Chester County AA, 1935 (prize). Illustrator: "Christmas Everywhere" (1932), "Victor Herbert Songs for Children" (1943), "Thirteen Ghostly Yarns." Lectures: Advertising art. Positions: Pres., A. Dir. Cl., Phila., 1946–47; Dir., PMSchIA, 1946– [47]

FRY, John H(emming) [P] Greenwich, CT b. 1861, Indiana d. 24 F 1946. Studied: St. Louis Sch. FA; Académie Julian, Paris; Boulanger, Lefebvre, Cormon, in Paris. Member: Union Lg. C.; Paris AAA; A. Fund S.; SC, 1902; SPNY; Wash. AC; AFA. Exhibited: St. Louis Expo, 1898 [33]

FRY, Laura [P] Loveland, OH [25]

FRY, Marshal [P] NYC/Southampton, NY b. 9 Ag 1878, Syracuse, NY. Studied: Chase; Dow; Snell; Whistler, Brangwyn, in London. Member: NAC; SC; All. AA [15]

FRY, M(ary) H(amilton) [C,I] Cambridge, MA b. 18 Ap 1890, Salem, MA. Studied: BMFA Sch. Member: Boston SAC; Copley S. [29]

FRY, Mary L. Finley [P,T,C,Li,Car,W] Phila., PA b. 28 N 1908, San Fran. Studied: Univ. Calif; H. Hofmann. Member: Calif. WC Soc. Exhibited: N.Mex. State Fair, 1944 (prize); Calif. WC Soc., 1939–45; AIC, 1939, 1940; PAFA, 1941, 1946; San Diego FA Soc., 1935, 1940; Audubon A., 1944; SFMA, 1939; Oakland A. Gal., 1940; CAFA, 1939; AWCS, 1944; Los Angeles Mus. A., 1932, 1935, 1940, 1941; Mus. N.Mex., Santa Fe, 1945. Contributor: Hollywood Spectator [47]

FRY, Roger Elliot [P,Cr,Mus.Cur] b. 1866 d. 9 S 1934, London, England. Position: Cur. Paintings, MMA, 1906–08

FRY, Rowena [P,Ser] Chicago, IL b. Athens, AL. Studied: Watkins Inst., Nashville, Tenn.; AIC; Ropp Sch. A. Member: Chicago SA. Exhibited: AIC, 1928, 1930, 1933, 1935, 1936, 1938, 1944 (one-man), 1946; Chicago SA, 1935–46; Chicago Women's Aid, 1936. Work: Abbott Laboratories Coll. Contributor: Block-Print Calendar, 1937–46, pub. Chicago SA [47]

FRY, Sherry E(dmundson) [S] Roxbury, CT b. 29 S 1879, Creston, IA. Studied: AIC, with Taft; MacMonnies, in Paris; Am. Acad., Rome. Member: ANA, 1914; NA, 1931; NSS, 1908; Arch. Lg., 1911. Exhibited: Paris Salon, 1906 (prize), 1908 (med); P.-P. Expo, 1915 (med); NAD, 1917 (gold); AIC, 1921 (prize), 1922 (gold). Work: fountains, Staten Island, N.Y., Toledo Mus. A., Mt. Kisco, N.Y., Worcester, Mass.; Frick House, NYC; statues, Univ. Vt., Oskaloosa, Iowa; Tompkinsville, Conn.; pediment, Clark Mausoleum, Los Angeles [47]

FRY, Waylande, Mrs. See Negueloua, Francisca.

FRY, William H. [S] Cincinnati, OH b. 5 F 1830, Bath, England d. 26 D 1929. Work: carvings on the organ, Cincinnati Music Hall. Specialty: wood carving. Postion: T., Cincinnati Art Acad. [27]

FRYE, Thomas [P] Cincinnati, OH b. 1883, Atlanta, Ga [25]

FRYER, Bryant W. [P] NYC. Member: AG of Authors Lg. A. [25]

FUCHS, Emil [S,E,P,Edu] NYC b. 9 Ag 1866, Vienna, Austria (came to U.S. in 1905) d. 13 Ja 1929. Studied: Imperial Acad. FA, Tilgner, in Vienna; Shaper, in Berlin. Member: NSS; Arch. Lg.; All. AA. Exhibited: Munich, 1896 (gold). Work: MMA; Cleveland Mus.; Numismatic Soc. Mus.; Brit. Mus., Victoria & Albert Mus., London, Walker Art Gal., Liverpool; mem. to Prince Christian Victor, Royal Chapel, Windsor; memorials, Sandringham, Balmoral, Rumsey Cathedral; LOC. Designer: postage stamp and coronation medal for reign of King Edward VII, Hudson-Fulton Commemoration Medal. Positions: T., Royal Acad., in London; Paris; Berlin; Munich; Vienna; Rome [27]

FUCHS, Gustave [P,S] NYC d. 10 N 1905 (suicide)

FUCHS, Helen F. [P] Buffalo, NY [17]

FUCHS, Otto [P,T] b. 1839, Germany (came to U.S. in 1851) d. 13 Mr 1906, Baltimore. Positions: T., CUASch, U.S. Naval Acad.; Dir., Md. Inst. Art & Des., 1883–1906

FUCIGNA, V.A. [P] NYC [04]

FUDJI, Gazo [P] Yonkers, NY b. ca. 1851 d. ca. 1915. Exhibited: Paris Expo, 1900 (med)

FUECHSEL, Herman [P] NYC b. 8 Ag 1833, Brunswick, Germany (came to U.S. in 1858) d. 30 S 1915. Studied: Brander, C.F. Lessing, in Düsseldorf. Member: A. Fund. S. Exhibited: galleries, NYC, Boston, Phila., 1860s; NAD, 1861–1900. Work: Walker AG, Minneapolis [13]

FUERSTENBERG, Paul W. [P] NYC b. 30 S 1875, Düsseldorf, Germany d. 19 Ja 1953. Studied: W. Adams; G.E. Browne; D. Cornwell. Member: All.A.Am. Exhibited: PAFA, 1938; All.A.Am. Work: City Hall, Magdeburg, Germany [47]

FUERTES, Louis Agassiz [Mur.P,I] Ithaca, NY b. 7 F 1874, Ithaca d. 22 Ag 1927, near Unadilla, NY (killed by a train at Porter's Crossing). Studied: Abbott H. Thayer. Work: habitat groups, Am. Mus. Nat. Hist.; murals, Flamingo Hotel, Miami Beach; paintings, N.Y. Zoological Soc.; bird group, State Mus., Albany. Specialty: illus., bird and animal life. Illustrator: Eaton's "Birds of New York," "The Woodpeckers," "Birds of the Rockies," "Burgess's Animal Book for Children," and others. Position: L., Ornithology, Cornell [25]

FUETSCH, Charles [P] NYC [25]

FUGLISTER, Fritz [P] Provincetown, MA b. 1 Ag 1909, NYC. Studied: Corcoran Gal. Sch.; E.A. Webster. Exhibited: Provincetown A. Assn., 1936; WFNY, 1939. Work: mural, Police Station, Falmouth, Mass. [40]

FUHR, C. Clarence [P] Columbus, OH. Member: Columbus PPC [25]

FUHR, Ernest [I] Westport, CT b. 1874, New York d. 12 D 1933. Member: SI; Artists Gld. Exhibited: prominent galleries in the East. Illustrator: leading magazines. Positions: Ar., New York Herald, New York World [31]

FUHRER, Ruth Frieder (Mrs. Eugene) [P] Chicago, IL b. 12 Ap 1903, Toledo. Studied: Principia Col., St. Louis; AIC; K. Cherry; Breckenridge;

A.H. Krehbiel; Acad. Delecluse, Paris. Exhibited: AIC, 1945, 1946. Work: Whitcomb Hotel, St. Joseph, Mich. [47]

FUHRMANN, Otto W. [L,T,W] Elmhurst, NY b. 7 Ap 1889, Germany. Member: Gutenberg-Gesellschaft, Mainz; AI Graphic A. Author: "The 500th Anniversary of the Invention of Printing," pub. Walpole Printing Office, 1937. Position: T., NYU [40]

FUJII, Takuichi [P] Chicago, IL b. 26 S 1892, Hiroshima. Member: Group of Twelve; Seattle Art Mus. [40]

FULDA, E(lisabeth) Rungius [P,S,E] NYC b. 16 Ag 1879, Berlin, Germany. Studied: C. Rungius; A. Gaul; R. Friese. Member: Artists U., N.Y. Work: mural, Public School No. 41, NYC; paintings, Bronx Zoological Park; AMNH; mural, National Zoo, Wash., D.C. Illustrator: "Tales of Nature's Wonderland," by W.T. Hornaday [40]

FULDE, Edward B. [P,T] Neuilly-sur-Seine, France. Studied: J. Bail, F. Bail, in Paris. Member: Paris AAA. Work: Pub. Gal., Doullens, France. Position: Officer of Pub. Instruction, France [19]

FULGHUM, Caroline Mercer [P,I] Goldsborough, NC b. 1873, Goldsborough. Studied: P.A. Bunker; A.B. Wenzell; E. Daingerfield [06]

FULLER, Alfred [P,Li,T] Port Clyde, ME b. 8 Ja 1899, Deerfield, MA. Studied: M. de Gogorza; R.C. Colman; Amherst. Member: Laguna Beach AA; La Jolla AA; SC; All.A.Am.; Southern Pr.M. Exhibited: NAD, 1945, 1946; AWCS, 1939–46; Wash. WCC; All.A.Am.; MMA, 1944; PAFA; Grand Central A. Gal.; New Haven PPC; VMFA; Gloucester SA; Soc. Four A.; Palm Beach, Fla. [47]

FULLER, Andrew Daniel, Jr. [W,P,L,Des] Boston b. 1 N 1903, Wakefield, MA. Studied: Harvard, with Langford, G.P. Winship; Europe; MIT; R. Field; G. Owen. Member: New England Council FA; A. Univ. Mass.; Am. Writers Un. Exhibited: BMFA. Editor/Designer: "Contemporary Paintings of 1932–33," "Modern and Academic Paintings." Contributor: "Massachusetts: Its People and Places," pub. Houghton-Mifflin, 1937. Positions: Scientific Specialist, Boston Pub. Lib., 1926–35; Research Ed., American Guide, 1935–36; Researcher, FA, FMA [47]

FULLER, Arthur D(avenport) [P,I,E] Westport, CT b. 1 S 1889, Exeter, NH. Member: SI [47]

FULLER, Earl Martin [E,P] Kansas City, MO b. 14 Ja 1890, Marion, KS. Exhibited: Kansas City A. (prize); Kansas City AI, 1934; watercolor, Midwestern A., 1935 (prize). Position: Pres., Graphic Art Engraving Co. [40]

FULLER, Elizabeth Douglas [P] NYC b. 3 Mr 1897, Durham, NC. Studied: Bryn Mawr Col.; Bridgman; Mabel R. Welch. Exhibited: WFNY, 1939; ASMP, 1936–42; PAFA Traveling Exh., 1940; BM [47]

FULLER, George [P] b. 17 Ja 1822, Deerfield, MA d. 21 Mr 1884, Brookline, MA. Member: ANA, 1854. Exhibited: Am. Art-Union; Boston Atheneum; NAD. He worked in Boston, 1842–47, in NYC, 1847–59, at the family farm in Deerfield, 1860–75. He resumed exhibiting in Boston and finally met with great success. His sons, Spencer and Henry B. were also artists. [*]

FULLER, Helen [S] Chicago, IL [15]

FULLER, Henry B. [Cr,W] b. 9 Ja 1857, Chicago, IL d. 28 Jy 1929, Chicago. He worked for the Chicago Evening Post but was better known for his novels, "Chevalier of Pensieri-Dani," "The Cliff Dwellers," and "With the Procession." He also wrote a volume of verse, "Lines, Long and Short," and a series of dramatic sketches, "The Puppet-Booths." He was at one time literary critic of the New York Evening Post.

FULLER, Henry B(rown) [P] b. 3 O 1867, Deerfield, MA d. 17 Jy 1934, New Orleans, LA. Studied: Cowles Art Sch., with Bunker; ASL, with Cox, Mowbray; Collin, in Paris. Member: SAA 1902; ANA, 1906; The Cornish (N.H.) Colony. Exhibited: Pan-Am. Expo, Buffalo, 1901 (med); NAD, 1908 (prize); P.-P. Expo, San Fran., 1915 (med). Work: NGA. Son of artist George Fuller. [33]

FULLER, Lucia Fairchild (Mrs. Henry B.) [Min.P] Madison, WI b. 6 D 1872, Boston d. 22 My 1924. Studied: Dennis M. Bunker; Mowbry; Chase. Member: SAA, 1899; ANA, 1906; Am. Soc. Min. P.; Pa. Soc. Min. P.; NYWCC; NAWPS; The Cornish (N.H.) Colony. Exhibited: Paris Expo, 1900 (med); Pan-Am. Expo, Buffalo, 1901 (med); St. Louis Expo, 1904 (gold). Work: MMA. Position: T., Am. Sch. Min. P., NYC, 1914 (founder) [24]

FULLER, Margaret. See Tyng, Mrs.

FULLER, Meta Vaux Warrick (Mrs.) [S,T,L] Framingham, MA b. 9 Je 1877, Phila. Studied: PMSchIA; PAFA; Grafly; P. Lachenmeyer; Rollard; Acad. Colarossi, Paris; Injalbert; Gauqui; Raphael; Collin; Rodin, in Paris. Member: Boston AC. Work: CMA; NYPL; Garfield Sch., Detroit [47]

FULLER, Ralph Briggs [Car] West Boothbay Harbor, ME b. 9 Mr 1890, Michigan [40]

FULLER, Sarah E. [En] Lynbrook, NY b. 1829 d. 14 D 1901. One of the pioneer wood and steel engravers in this country, she did work for Harper's and most of the prominent publishing houses in New York.

FULLER, Susan E.W. (Mrs.) [En,Li,Des] d. 6 Jy 1907. Studied: New York School of Art (later became Cooper Union). After the Civil War, she opened the Washington School of Art—thought to have been the first art school in Washington. Position: Supv., Dr., Wash., D.C. Schools (for 35 years)

FULLER, Spencer [Ldscp.P] Deerfield, MA b. 25 F 1863, Deerfield d. 9 My 1911. Exhibited: Macbeth Gal., 1911. The eldest son of painter George Fuller and largely self-taught, he set high standards for his work; consequently, the number of them is small. Many are of winter scenes.

FULLER, Sue [E,En,P,T,C] NYC b. 11 Ag 1914, Pittsburgh, PA. Studied: CI; T. Col., Columbia. Member: SAE. Exhibited: Pittsburgh Assoc. A., 1941 (prize), 1942 (prize); Northwest Pr.M., 1945, 1946; Phila. Pr. Cl., 1944, 1946; PAFA, 1944–46; NAD, 1944, 1945; LOC, 1944–46; 50 Prints of the Year, 1944; CI, 1944–46; MOMA, 1944, 1945; SAE, 1944–46; Laguna Beach A. Lg.; Butler AI; Assoc. A. Pittsburgh, 1936–44; Newport AA. Work: NYPL; LOC; Harvard Lib.; CI; PMA; BMA; AIC; SAM; MOMA. Contributor: Art Education Today, Design magazine. Position: T., MOMA, 1944–46 [47]

FULLER, Walter B. [P,Arch] NYC b. 3 O 1881, Allston, MA. Studied: NAD [21]

FULLER-LARGENT, Lydia [P,C,L,T] San Fran., CA b. California. Studied: Calif. Sch. FA; R. Schaeffer; R. Johonnot [33]

FULLERTON, Alice V. [P] Laguna Beach, CA. Member: Laguna Beach AA [25]

FULLERTON, Carrie Q. [P] Louisville, KY. Member: Louisville AL [01]

FULLERTON, R.D. [P] Laguna Beach, CA. Member: Laguna Beach AA [25]

FULOP, Karoly [S,P] Los Angeles, CA. Exhibited: Fnd. Western A., 1936; WFNY, 1939 [40]

FULTON, A(gnes) Fraser [P,D,S] Yonkers, NY b. 10 Mr 1898, Yonkers. Studied: Dow; Martin; Bement; Upjohn. Member: Yonkers AA. Position: affiliated with Columbia [29]

FULTON, Antoinette Willner (Mrs. Horace) [B,C,P,T] Wash., D.C./York Beach, ME b. 17 D 1882, Loudoun County, VA. Studied: C. Pellew; Mrs. M.F. Rands; Mrs. J.Rus; C. Saunders; C Woodbury; Corcoran Art Sch. Member: NYSC; Baltimore Handicraft Gld. [40]

FULTON, Cyrus James [P] Eugene, OR b. 26 Je 1873, Pueblo, CO d. 30 Jy 1949. Studied: Portland AA, with A.H. Schroff; H.F. Wentz. Member: AAPL; Portland AA; Soc. Oreg. A. Exhibited: SAM, 1945; Springville (Utah) H.S. Work: Eugene (Oreg.) YMCA; Salem (Oreg.) YMCA; Soc. Oreg. A. [47]

FULTON, Dorothy [P,S,C,T,L] Lititz, PA/Bokeelia, FL b. 23 O 1896, Uniontown, PA. Studied: Garber; Hale; Breckenridge: Bridgman; MacCarter; PAFA; PMSchIA; Univ. Southern Calif.; Univ. Kansas; Univ. Pa. Member: Lancaster County AA. Exhibited: Tampa Art Inst., 1928 (prize); Lancaster (Pa.) AA, 1937–41; Kansas City AI, 1933; PAFA, 1935, 1936–38, 1940, 1945; Ferargil Gal., 1937; Newman Gal., Phila., 1936 (one-man); Mulvane A. Mus., Topeka, Kans., 1930–32; Franklin Marshall Col., 1940. Work: Mulvane A. Mus.; church, Ft. Myers, Fla. Position: T., Linden Hall, Lititz, 1936–46 [47]

FULTON, Dorothy E. [Min.P,Dec] Pasadena, CA b. Waukegan, IL. Studied: Chouinard A. Sch.; A. Clark; E.S. Bush. Member: Calif. S. Min. P.; Pa. S. Min. P. [40]

FULTON, E. Donald [P] Bokeelia, FL. Studied: PAFA [25]

FULTON, Ellen (M.) [W] St. Petersburg, FL b. 15 Je 1887, Scranton, PA. Studied: Wellesley. Member: Lg. Am. Pen Women. Position: Art Ed., St. Petersburg Times, 1944–46 [47]

FULTON, Fitch B. [P] Los Angeles, CA. Member: Calif. WC Soc.; Calif. AC [25]

FULTON, Florence Wellsman [T] Bryn Mawr, PA. Studied: PAFA [25]

FULTON, G.L. [En] Paris, France. Studied: J.J. Champcommunal [06]

FULTON, Lindale K. [P] Buffalo, NY [17]

FULTS, Louise C. [Edu,P,L,W] Huntington, IN b. Huntington. Studied: Nat. Univ., Mexico; Univ. Wis.; PAFA; AIC. Member: Ind. AC; Hoosier Salon. Exhibited: Midland Acad., South Bend (prize); Okla. A. Center, 1943; John Herron AI, 1935–39; Ind. AC; Hoosier Salon; Marshal Field, Chicago; PAFA, 1944–46; Erie Theatre, Ft. Wayne (one-man). Position: T., Huntington Col. [47]

FULWIDER, Edwin L. [P,Li,T] Indianapolis, IN b. 15 Ag 1913, Bloomington, IN. Studied: John Herron A. Sch. Member: Ind. Ar. Cl.; Brown Co., Ind. A. Gal., Assn.; F., John Herron AI. Exhibited: Herron AI, 1936–39, 1940 (prize), 1941, 1942, 1943 (prize), 1944, 1945 (prize), 1946; CM, 1939, 1941; AIC, 1940, 1941; Hoosier Salon, 1936; GGE, 1939. Work: mural, First Methodist Episcopal Church, Bloomington. Position: T., John Herron A. Sch. [47]

FUNG, Paul [P] Seattle, WA. Exhibited: Seattle FA Soc., 1922 (prize) [25]

FUNK, Joseph T. [P,Des,L] Ottumwa, IA b. 18 N 1901, Shenandoah, IA. Studied: Norton; Sax; Iannelli; Oberteuffer. Exhibited: Iowa AC, 1932 (prize); Iowa State Fair, Des Moines, 1933 (prize); Iowa A., 1935 (prize), 1939 (prize); WFNY, 1939. Designer: interior/stage, Armory Coliseum, Ottumwa [40]

FUNK, Wilhelm (Heinrich) [Por.P] NYC b. 14 Ja 1866, Hanover, Germany (came to U.S. in 1885). Studied: ASL; Royal Acad., Munich. Member: NAC [21]

FUNSCH, Edyth Henrietta (Mrs. V.S. Trowbridge) [I,Des,P] St. Louis, MO b. 25 F 1905, St. Louis. Studied: Washington Univ.; Nicholson; Oskar Gross; St. Louis Sch. FA; Am. Acad., Chicago. Member: S.Indp.A., St. Louis. Exhibited: S.Indp.A., 1937, 1938, 1939 (prize), 1940 (prize), 1942, 1944, 1946 (prize); CAM, 1945, 1946; St. Louis Municipal Auditorium, 1937–39. Illustrator: books [47]

FURBUSH, Persis Burnham (Mrs. C. Lincoln) [P] Phila., PA. Studied: PAFA [25]

FUREDI, Lily [P] NYC b. 20 My 1901, Budapest, Hungary. Studied: W.A. Novak, C. Patko, in Budapest. Member: NAWPS. Exhibited: NAWPS, 1931 (med), 1932 (prize). Work: White House, Wash., D.C. [40]

FURLAND, Eleanor M. [P] NYC [25]

FURLONG, Charles Wellington [W,I,L,P,Edu] Cohasset, MA (1962) b. 13 D 1874, Cambridge, MA. Studied: Harvard; AIC; Mass. Normal A. Sch.; Ecole des Beaux-Arts, Paris; Académie Julian, Paris, with Bouguereau, Laurens. Member: SC; Boston AC; F., Royal Geographical Soc., London. Exhibited: Académie Julian, Paris, 1902 (prize); PAFA; NAD; SC; Boston AC; Copley Soc. Work: Dartmouth; Smithsonian Inst.; Stanford; Univ. Oreg. Author/Illustrator: "Gateway to the Sahara" (1909, sec. ed., 1912), tactical field handbooks and maps on Siberia, Russia, Mexico, 1918. Illustrator: for Harper's, Scribner's, other publishers, Bailey's "Cyclopedia of Horticulture." An ethnologist, raconteur, and explorer, he lived in Tierra del Fuego ca. 1908, fought in Morocco, and worked as a cowboy in the West. Position: T., Boston Univ. [47]

FURLONG, Thomas [Mur.P,I,W,L,T] Lebanon, PA/Bolton Landing, NY b. St. Louis, MO. Studied: Washington Univ.; ASL; St. Louis A. Sch.; Lewis Univ., with John Vanderpoel. Work: murals, St. Anthony's Chapel, St. Vincent de Paul Chapel, St. Bridget's Church, all in Brooklyn, N.Y.; St. Mary-of-the-Lake, White Bear, Minn.; panels, Bethlehem Steel Co., Bethlehem, Lebanon, Pa. Position: T., NYU, 1931–41, Hunter Col., 1930–42 [47]

FURLONI, Flavio [S] Barre, VT b. 8 D 1915, Barre. Studied: Acad. A., Genoa; Acad. A., Turin, Italy. Member: Barre A. Assn. Exhibited: Genoa, 1935 (prize), 1936 (prize), 1937 (prize); Grand Central Gal. Work: statues, Genoa, Milan [40]

FURMAN, E.A. [I] NYC [10]

FURNISS, Frank C. [P] Columbus, OH. Member: Columbus PPC [25]

FURNYA, Kinzo [P] Portland, OR [24]

FURRAY, Winifred M. (Mrs.) [Des,C] Oklahoma City, OK b. 30 N 1888, Chillicothe, MO. Studied: AIC; Am. Acad. FA, Chicago; D. Donaldson. Member: SSAL; Assn. Okla. A. Exhibited: Expo Park, Tulsa, 1932 (prize). Position: T., Oklahoma City Univ., 1928–34 [40]

FURRICK, Constant Raphael [P,Des,I,L,T] Avon, CT b. 28 My 1888, Poland. Studied: R. Brandegee; C.N. Flagg. Member: CAFA; Conn. AA [40]

FURSMAN, Frederick F. [P,T,L] Saugatuck, MI b. 15 F 1874, El Paso, IL d. 12 Je 1943. Studied: AIC; Académie Julian, Paris; J.P. Laurens, R. Collin, in Paris. Member: Saugatuck AA; Tavern Cl. Exhibited: AIC, 1911 (prize), 1923 (prize); Chicago SA, 1924 (med). Work: Mus. A., Toledo, OH. Position: T., Summer Sch. P., Saugatuck [40]

FURST, Florence Wilkins (Mrs. F.F. Riner) [P] Freeport, IL b. 27 Ap 1885, Delavan, WI d. 30 D 1955. Studied: Rockford (Ill.) Col.; Oberteufer; Olinsky; V. Oakley; L. Hartrath; M. Reitzell; D. Romanovsk; Amiard, Conrad, in Paris. Member: Chicago AC; Rockford AA; Studio Gld., AAPL; Ill. Acad. FA; NAC; All-Ill. SFA. Exhibited: All-Ill. Exh., Chicago, 1935 (prize); All-Ill. Soc. FA, 1939 (gold); Rockford AA, 1936 (prize); Palm Beach A. Lg., 1939 (prize); Chicago AC; All. A. Am.; Argent Gal.; Dec. Cl., N.Y.; Century Progress, Chicago, 1933; WFNY, 1939; NYPL; AAPL; Springfield (Ill.) Mus. A. Work: State Mus., Springfield (Ill.) [47]

FURST, Harry Robinson [S] Palm Beach, FL b. 29 Mr 1913, Freeport, IL. Studied: A. Fairbanks; Yale. Work: Rockford (Ill.) Col.; Senate Office Bldg., Wash., D.C. [40]

FURTH, Naomi Duckman. See Lorne.

FURYK, Constant [P] Hartford, CT [13]

FUSARI, Louis Joseph [P,I] Hartford, CT b. 1 N 1901, Hartford. Studied: PAFA; J.G. McManus; G. Wiggins; E. Higgins. Member: CAFA; Springfield A. Lg.; Assn. Conn. A. Exhibited: CAFA, 1930–33, 1934 (prize), 1935, 1936 (prize), 1937, 1938; Springfield A. Lg., 1935, 1937 (prize); Lyme AA, 1933, 1934, 1936; New Haven PCC, 1935–37 [47]

FUSSELL, Charles Lewis [P,T] Media, PA b. 25 O 1840, Phila. d. 1909. Studied: PAFA, with P.F. Rothermel. Exhibited: PAFA, 1863. Specialty: landscapes/marines [08]

FYE, Russell Leon [P,Des,Dec] Richmond, IN b. 11 N 1894, Richmond, IN. Studied: George Baker; John L. Bundy. Member: Richmond A. Assn. Exhibited: Morton Gal., Richmond, 1928 (prize); Miami Univ., 1931 (prize); Richmond AA, 1930, 1932, 1936–38, 1941 (prize), 1943 (prize). Work: Richmond-Leland Hotel [47]

FYFE, Gilbert G. [P] Wilkinsburg, PA. Member: Pittsburgh AA [21]

FYFE, John Hamilton [P,T,Car,I,L] Whitehaven, TN b. 10 Ag 1893, Gilby, ND. Studied: AIC; SI Sch., N.Y.; ASL; C.B. Falls; D. Cornwell. Member: Tenn. Edu. Assn.; Nat. Edu. Assn.; Memphis Palette & Brush; Mid-South AA; Southern Group. Exhibited: Mid-South AA; Memphis Palette & Brush; St. Louis A.; Brooks Mem. Gal., Memphis; Univ. Tenn., Knoxville. Work: murals, USPOs, Magnolia, Miss., Camden, Tenn. Illustrator: Collier's, New Yorker, Saturday Evening Post. WPA artist. Positions: T., Whitehaven, Tenn., 1937–46; Supv., A., Shelby County, Tenn., 1939–46 [47]

G

Edmund M. Ashe: *Railroad Invasion*. From *The Illustrator* (1894)

GAAL, Steven [S] NYC [25]

GABA, A. Lester [S,Des,I,Mur.P] NYC b. 24 Je 1907, Centerville, IA. Author: "On Soap Sculpture, pub. Holt and Co., 1935, "Soap Carving," pub. Studio Publications. Lecture: Soap Sculpture [40]

GABAY, Esperanza [P] NYC/Sheffield, MA b. NYC. Studied: K. Cox; W. Shirlaw. Exhibited: NAWPS, 1917 (prize); NAC, 1925 (prize) [40]

GABRIEL, Ada V(orhaus) [P,Li] Brewster, NY. b. 28 Jy 1898, Larchmont, NY. Studied: Barnard Col.; Sch. Des.; E. Gletter, in Munich; E. Ganso. Exhibited: CGA, 1935; PAFA, 1936, 1937; AIC, 1937; WMAA; CAA; Putnam County AA, 1939, 1940; NAD, 1944; Allison Gal., N.Y., 1941, 1944 (one-man); 50 Best Prints of the Year, 1936. Work: NYPL; LOC; Toledo Mus. A. Designer: book jackets [47]

GABRIELE, Gabrielle [P,C,Dec] Stone Harbor, NJ b. 24 D 1906, Phila. Studied: PAFA; D. Garber; Breckenridge. Member: Phila. Plastic Cl. Exhibited: Phila. AC; Phila. Plastic Cl.; Palm Beach A. Lg.; Soc. Four A. [47]

GADBURY, Harry Lee [E,Des,P,I] Dayton, OH b. 5 Je 1890, Greenfield, OH. Studied: Cincinnati A. Acad.; AIC; Buchler; Meekin; Wessel; Duveneck. Member: Dayton SE. Exhibited: NAD; Dayton AI. Founder: Dayton Business Men's Art Cl. [47]

GADE, John [P] Floral Park, NY b. 24 O 1870, Tremont, NY. Studied: self-taught. Member: S.Indp.A.; Salons of Am.; Chicago NJSA [33]

GADO, T.K. [P] NYC. Member: S.Indp.A. [24]

GAENSSLEN, Otto Robert [P,S] Chicago, IL b. 6 Je 1876, Chicago. Studied: A. Chatain; C. Marr; J.P. Laurens. Member: Paris AAA; Chicago SA. Exhibited: Paris Salon, 1906 (prize) [15]

GAER, Fay [S] Wash., D.C. b. London, England. Studied: ASL. Work: Mills Col.; Temple Emmanuel, San Fran. Position: T., Green Acres Sch., Bethesda, Md. [40]

GAERTNER, Carl F(rederick) [P,I,E,T] Willoughby, OH b. 18 Ap 1898, Cleveland. Studied: Cleveland Sch. A.; F.N. Wilcox; H.G. Keller; Western Reserve Univ.. Member: Cleveland SA; SC; Audubon A.; Phila. WCC. Studied: NAD, 1944 (prize); Pepsi-Cola, 1945 (prize); CMA, 1922 (prize). 1923 (prize), 1924 (prize), 1925 (prize), 1926 (prize), 1928 (prize), 1931 (prize), 1941 (prize), 1941 (prize), 1942 (prize), 1943 (prize), 1944 (prize), 1945 (prize), 46 (prize); MMA; WMAA; CI; CGA; VMFA; AIC; PAFA; CAM; Audubon A.; SC; Los Angeles Mus. A.; Critics Show, NYC, 1945; Butler AI; Macbeth Gal., 1945, 1947 (one-man); Colby Jr. Col., 1946 (one-man); Canton AI, 1946 (one-man). Work: WMAA; Ill. State Mus.; Pepsi-Cola Coll.; Midday Cl., Cleveland; Kenyon Col. Positions: T., Cleveland Sch. A., Western Reserve Univ. [47]

GAERTNER, Lillian V. [P,I,E,C] NYC b. 5 Jy 1906, NYC. Studied: J. Hoffmann; F. Schmutzer. Member: Mur.P.; Arch Lg.; AFA. Work: murals, Montmartre Cl., Palm Beach, Fla.; Ziegfeld Theatre, New York; orig. sketch, Ziegfeld Theatre, Vienna Mus., Chicago; Metropolitan Opera Costume Designs, Vienna Museum, Chicago [29]

GAFFNEY, Claribel Honor [S,T] Los Angeles, CA b. 20 S 1901, Carbondale, CO. Studied: R.M. Burnham; H. Swartz; M. Gage. Member: Calif. AC. Exhibited: Nat. Soap Sculpture, 1931 (prize), 1932 (prize), 1934 (prize); Ebell C. Exh.., 1933 (prize); Calif. AC 1934 (prize). Work: Metro-Goldwyn-Mayer Studios [40]

GAFFRON, Horace [I] NYC. Illustrator: Good Housekeeping [40]

GAFILL, John J. (Mrs.) [S] Birmingham, MI [21]

GAG, Wanda [P,I,E] Milford, NJ b. 11 Mr 1893, New Ulm, MN d. 27 Je 1946, NYC. Member: Am. A. Cong.; Lg. Am. Writers. Exhibited: Phila. Lith. Exh., 1930 (prize). Work: MMA; WMAA; Newark Mus.; NYPL; AIC; Wadsworth Atheneum, Hartford; Lehigh Univ.; Mus. FA, Houston; South Kensington Mus., Brit. Mus., London; Bibliothèque Nationale, Paris; Kupferstick Kabinett, Berlin. Illustrator: "The Day of Doom," pub. Spiral Press. Illustrator/Author: "Millions of Cats," "The Funny Thing," "Snippy and Snappy," "Gone Is Gone," and others. Translator/Illustrator: "Tales from Grimm," "Snow White and the Seven Dwarfs" [40]

GAGE, George W(illiam) [P,T] New Rochelle, NY (1962) b. 14 N 1887, Lawrence, MA. Studied: BMFA, with Hale, Benson; PAFA, with W.M. Chase, Pyle. Member: Artists Gld. Exhibited: NAD; BM. Work: Pa. State Col.; Martha Berry Col., Rome, Ga. Illustrator: covers, Saturday Evening Post, other publishers. Positions: T., New York Evening Sch. IA, Traphagen Sch. Fashion, NYC [47]

GAGE, Harry Lawrence [Mur.P,Typographic Des,W,L] Jackson Heights, NY b. 20 N 1887, Battle Creek, MI. Studied: AIC; abroad. Member: AIGA; AFA; Montclair A. Mus., MMA. Exhibited: N.J. State Exh., 1939. Author: "Applied Design for Printers," "Layout and Design in Printing," "Principles of Display." Lectures: Modern Book Design. Positions: T., CI, 1913–19; Sec., Bartlett-Orr Press, 1919–31; Consultant/Vice-pres., Mergenthaler Linotype Co. [47]

GAGE, Henry L. [P] Pittsburgh, PA. Member: Pittsburgh AA [15]

GAGE, Jane [P] La Grange, IL b. Ja 1914, La Grange. Studied: Rockford (Ill.) Col.; Am. Acad., Chicago; Sterba; Gunther; G.E. Browne. Member: NAWA; La Grange A. Lg. Exhibited: All.A.Am., 1942, 1943; Rockford AA, 1946 (prize); AWCS, 1945; NAWA, 1942; AIC, 1941–44; Mississippi Valley A., Springfield, Ill., 1941 [47]

GAGE, Merrell [S,T,L] Santa Monica, CA b. 26 D 1892, Topeka, KS. Studied: ASL; Henri Sch. A.; BAID; Gutzon Borglum. Member: Calif. AC; Calif. PS; Laguna Beach AA; NSS; P.&S. Cl. Exhibited: Kansas City AI, 1921 (gold), 1923 (med); Southwestern Intl. Expo, Long Beach, 1928 (med); Los Angeles Mus. A., 1929 (prize), 1933 (prize); WFNY, 1939; GGE, 1939; MMA; Santa Barbara Mus. A., 1945 (one-man). Work: State of Kansas; Kansas City, Mo.; Jackson County, Mo.; La Folla Pub. Lib.; Calif. State Bldg., Los Angeles; Mulvane Mus., Topeka, Kans.; Edison Bldg., Los Angeles Times Bldg., both in Los Angeles; Am. Numismatic Soc.; Outdoor Theatre, Redlands; Pub. Lib., South Pasadena. Positions: T., UCLA, 1925– , Chouinard Sch. A. [47]

GAGNON, Clarence A. [P,E] Paris, France b. 12 N 1881, Montreal, Quebec. Studied: Art Gal., Montreal; Laurens; Académie Julian, Paris. Member: SC; Royal Canadian Soc. Arts; Arts Cl., Montreal. Exhibited: St. Louis Fair, 1904 (med); Paris Salon, 1906 (med). Work: Nat. Gal., Ottawa; Halifax Mus.; Toronto Art Gal.; Petit-Palais, Paris; South Kensington Mus., London; Dresden Gal.; Venice; Rome; Florence; Hague; Mulhausen [25]

GAHMAN, Floyd [P,T] NYC b. 14 O 1899, Elida, OH. Studied: Hobart Nichols; Valparaiso (Ind.) Univ.; Columbia; H.V. Poor; H. Carnohan. Member: ANA; Audubon A.; SC; All.A.Am.. Exhibited: All.A.Am., 1936–41, 1942 (prize), 1943; SC, 1942 (prize); NAD, 1932–43; WFNY, 1939. Work: Scarsdale Women's Cl. [47]

GAHS, Elsie M. [P,T] Bloomfield, NJ b. 8 Ag 1907, Bloomfield. Studied: R. Gerbino. Exhibited: Newark, 1937 (prize), 1938 (prize); Montclair AM; Newark Mus. [40]

GAILOR, Charlotte [P] Memphis, TN [24]

GAINS, Jacob J. [P,E] Bayonne, NJ b. 4 Ag 1907, Poland. Studied: L. Kroll; C. Curran [40]

GAIRAUD, Paul Eugene [P] Paris, France [10]

GAITHER, David S., Mrs. See Markham, Kyra.

GALE, Alfred [P] Wash., D.C. [13]

GALE, Charles F. [P] Columbus, OH b. 3 Jy 1874, Columbus. Member: Pen and Pencil Cl., Columbus; Col. Lg. A. Exhibited: St. Louis AG, 1914 (prize) [21]

GALE, Edmund W. [Car] Los Angeles, CA. Work: Huntington Lib., San Marino. Position: Car., Los Angeles Examiner [40]

GALE, George (Albert) [Mar.P,B,P,I,E] Barrington, RI b. 16 N 1893, Bristol, RI d. D 1951. Studied: RISD. Member: Providence WCC; Newport AA; Providence AC; South County AA. Work: RISD Mus.; MMA; Nantucket Whaling Mus.; Mariners Cl., New Bedford, Mass.; Kendall Whaling Mus.; Mystic Seaport Mus. Illustrator: Scribner's, Yachting. After 1914 was seaman for American & Hawaiian Steamship Line; later was quartermaster of the Bristol Ferry; worked on the Washington Bridge; finally, worked in boatyard near his home. [40]

GALE, Goddard [P] Oakland, CA [10]

GALE, Harriette Draper [Min.P,Dec,T] Brookline, MA/Hyannis, MA b. 4 Je 1889, Wash., D.C. Studied: BMFA Sch.; W.M. Paxton; P. Hale; ASL; W. Chase; L.F. Fuller; Traphagen Sch. Fashion; G. Cornell. Member: Bay State Ar. Gld. [40]

GALE, Walter Rasin [Edu,P,I,L] Baltimore, MD b. 17 Ja 1878, Kent County, MD d. 22 Mr 1959. Studied: Md. Inst.; Johns Hopkins Univ.; NYU; Univ. Chicago; H.T. Bailey; W. Sargent; H.P. Haney; Charcoal Cl. Sch. A. Member: Baltimore WCC; Sch. A. Lg. Baltimore; Baltimore Mus. A.; Edu. Soc., Eastern Shore Soc., Acad. Sc., Hist. Soc., Pub. Sch. T. Assn., all of Baltimore; Eastern AA; Nat. Edu. Assn.; AAPL. Exhibited: BMA; Baltimore WCC; Md. Inst. Alumni Assn. Position: T., Baltimore City Col., 1905– [47]

GALGIANI, Oscar [P,G] Stockton, CA b. 18 Mr 1903, Stockton. Studied: Calif. Sch. FA. Member: San Fran. A. Assn. Exhibited: Stockton A. Assn., Haggin Mus., Calif., 1937 (prize); Crocker A. Gal., Sacramento, 1939. Work: USPO: San Rafael, Calif. WPA artist. [40]

GALLAGHER, Ella Sheppard (Mrs. William) [P] Braintree, MA b. 11 O 1864, Greenwich, NJ. Member: Copley S., 1894 [10]

GALLAGHER, Genevieve [P,T] Baltimore, MD b. 19 Ja 1899, Baltimore. Studied: H. Roben; Breckenridge; L. Kroll; J. Sloan. Exhibited: Baltimore Municipal Art Soc., 1921 (prize) [33]

GALLAGHER, Michael J. [B,I] Lansdowne, PA b. 1 Ap 1898, Scranton, PA. Studied: T. Oakley; Sch. Industrial A., Phila. Member: Phila. P. Cl. Exhibited: Phila. Pr. Cl., 1936 (prize); WFNY, 1939. Work: BM; NYPL; Phila. Pub. Lib.; State Capitol, Harrisburg, Pa. Illustrator: "The Epic of America," by J.T. Adams, "Mark Twain's America," by Bernard de Voto [40]

GALLAGHER, Sears [P,E,Edu] West Roxbury, MA b. 30 Ap 1869, Boston d. 9 Je 1955. Studied: Juglaris; Laurens, Constant, in Paris; S.P.R. Triscott, in Boston. Member: Chicago SE; AFA; Gld. Boston A.; Boston Soc. WC P.; SAE. Exhibited: AIC, 1922 (med); Calif. Pr.M., 1929 (med); City of Boston Tercentenary, 1930 (med); Jordan Marsh Co., Boston, 1937 (med); Goodspeed's, Boston (monograph), 1920; Boston City Cl., 1915; Doll & Richards Gal., 1915; Kennedy Gal., 1918. Work: BMFA; AIC; Honolulu Acad. A.; LOC; NYPL; Bibliothèque Nationale, Paris. Produced 138 etchings, many of Boston, by 1920. Position: T., Boston Univ. [47]

GALLAGHER, Walter Francis [P,S] Steelton, PA b. 6 Ja 1911, Blair County, PA. Member: Harrisburg A. Assn. Exhibited: Pa. State Mus.; Wash. County A. Gal., Harrisburg; Group Studio, New York [40]

GALLEY, Esther [P] Mt. Pleasant, PA b. 31 My 1896. Studied: Pa. State Col.; H. Pittman. Member: Greensburg A. Cl.; Associated Ar., Pittsburgh. Exhibited: Greensburg A. Cl., 1936 (prize), 1937 (prize) 1938 (prize); PAFA, 1938; GGE, 1939 [40]

GALLATIN, Albert Eugene [P,W] NYC b. 23 Jy 1881, Villa Nova, PA d. 16 Je 1952. Member: Am. Abstract A. Exhibited: Passedoit Gal., New York, 1938; Durand-Ruel Gal., 1947 (one-man). Author: books on art/artists, 1903– . Work: MOMA; PMA; Berkshire Mus. Promoted the American "Concretionists," 1936. Position: Dir., Mus. Living A., NYU, 1927–42 [47]

GALLI, Alfredo [I] NYC [21]

GALLISON, Henry Hammond [Ldscp.P] Cambridge, MA b. 20 My 1850, Boston d. 12 O 1910. Studied: Bonnefoy, in Paris; Boston. Member: Copley S., 1894; Boston AC. Exhibited: Turin Expo, 1897 (prize); Paris Expo, 1900 (prize); St. Louis Expo, 1904 (med) [10]

GALLUP, Jeanie. See Mottet, Mrs.

GALT, Charles F(ranklin) [P] St. Louis, MO b. 1884, St. Louis. Studied: St. Louis Sch. FA; R. Miller. Member: 2 x 4 Soc. Exhibited: St. Louis AG, 1914 (prize), 1917 (prize) [27]

GALVIN, Francys. See O'Connell, George A., Mrs.

GAMBEE, Martin [P,Des,B,L,T] Carmel, CA b. 10 Ap 1905, Newark, NJ. Studied: H. Giles; G. Cimiotti; A. Lhote, in Paris. Member: SC; A. Gld.; Wash. WCC; CAFA; All.A.Am.; New Haven PCC; NYWCC; Carmel (N.Y.) AA; Am. WC Soc. Exhibited: Albany Inst. Hist.&A., 1937 (prize); CAFA, 1937 (prize). Work: Phila. A. All.; Albany Inst. Hist.&A. Position: T., Inst. Allende, San Miguel, Mexico, 1962 [47]

GAMBLE, Edwin [P] Paris, France/Evanston, IL b. 1 O 1876, Chicago, IL. Studied: Académie Julian, Académie Delecluse, Laurens, Delance, in Paris. Member: Paris AAA; Palette & Chisel Cl., Chicago [15]

GAMBLE, James [P] Phila., PA. Studied: PAFA [25]

GAMBLE, John Marshall [P,S] Santa Barbara, CA b. 25 N 1863, Morristown, NJ. Studied: San Fran. Sch. Des.; Académie Julian, Laurens, Constant, in Paris. Member: San Fran. AA; Santa Barbara Community AA; AFA; Fnd. Western A. Exhibited: Alaska-Yukon-Pacific Expo, 1909 (gold). Work: Mus. A., Auckland, New Zealand [47]

GAMBLE, Roy C. [P] Detroit, MI b. 12 Je 1887, Detroit. Studied: Detroit Acad. FA; ASL; Académie Julian, Paris; J. Wicker; Chase; Henri; Laurens. Member: Scarab Cl. Exhibited: Detroit Inst. A., 1911–13, 1914 (prize), 1915–19, 1920 (prize), 1921–25, 1926 (prize), 1927, 1928 (prize), 1929–41, 1942 (prize), 1943, 46; Scarab Cl., Detroit, 1914 (prize), 1920 (gold); Mich. Ar. Exh., 1926 (prize); Paris Salon, 1910, 1911; PAFA, 1920, 1921; CGA, 1921; Mich. Bldg., Exposition of Progress, Chicago. Work: PAFA; Detroit Inst. A.; State Capitol, Lansing, Mich.; Wayne Country circuit courts; Univ. Mich.; Princeton; Detroit Pub. Lib.; murals, Detroit Free Press Bldg. [47]

GAMBRELL, Reuben [P] Belton, SC. Exhibited: 48 Sts. Comp., 1939 [40]

GAMMELL, R(obert) H(ale) Ives [P] Boston, MA b. 7 Ja 1893, Providence, RI. Studied: W. Paxton. Member: Boston Gld. A.; Newport AA; Providence AC; NSMP; N.Y. Soc. P.; All.A.Am. Exhibited: Newport AA, 1936 (prize); All.A.Am., 1941 (prize). Work: Toledo Mus. A.; Women's Cl., Fall River, Mass.; Newark Pub. Lib. Author: "Twilight of Painting," 1946 [47]

GAMMONS, Molly Nye [P] New Bedford, MA. Member: Providence WCC [27]

GANDOLA, P(aul) M(ario) [S,C] Cleveland, OH b. 15 Ag 1889, Besano, Italy. Studied: Milan Acad. FA. Member: Cleveland SA; Cleveland Sculptors Soc. [33]

GANGLE, Martina Marie [P,G] Portland, OR b. 21 D 1906. Studied: Portland AM Sch. Member: Am. Ar. Cong. Exhibited: Portland AM; Seattle AM; WFNY, 1939. Work Portland AM; murals, Rose City Sch., Portland [40]

GANIERE, George Etienne [S,T,] De Land, FL b. 26 Ap 1865, Chicago, IL d. 29 Jy 1935 Hendersonville, NC. Studied: AIC. Member: NSS. Exhibited: AIC, 1909 (prize). Work: Vanderpoel Mem. Coll.; Lincoln Fountain, Chicago; equestrian statue, Fort Wayne, Ind.; Chicago Hist. Soc.; Ill. Hist. Soc.; Grand Army Mem. Hall, Chicago; Highland Park, Starved Rock State Park, Morgan Park, all in Ill.; Milwaukee AI; Omaha Soc. FA; FA Gal., De Land; State of Fla. Among these works are several memorials to Abraham Lincoln. Official sculptor: State of Fla., Century of Progress Expo, Chicago. Positions: T., John B. Stetson Univ. (De Land, Fla.), Rollins Col. [33]

GANINE, Peter [S] Hollywood, CA b. 11 O 1900, Tiflis, Russia. Studied: Corcoran Sch. A.; M. Muller; Russia. Member: Calif. AC; Soc. for Sanity in Art. Exhibited: CGA, 1932 (prize); Calif. AC, 1934 (prize); 1936 (prize); San Diego FA Soc., 1938; Ebell Salon, 1938 (prize), 1939 (prize), 1945; Syracuse Mus. FA, 1940; Los Angeles Mus. A., 1945; GGE,

1939. Work: Syracuse Mus. FA; San Diego FA Soc. Specialty: woodcarving[47]

GANNAM, John [I,P] NYC b. 1907, Lebanon, IL d. 29 Ja 1965, Danbury, CT. Member: SI; ANA. Studied: self-taught; worked for an engraver. Exhibited: AWCS. Position: T., Danbury AA [47]

GANNETT, Mary C. [P] Wash., D.C. [13]

GANNETT, Ruth Chrisman [I] NYC b. 16 D 1896, Santa Ana, CA. Studied: Univ. Calif. Illustrator: "Sweet Land" (1934), "Tortilla Flat" (1935), "Hi-Po the Hippo" (1939), "Miss Hickory" (1946), other books [47]

GANO, Katharine V(allette) [P] Cincinnati, OH b. 31 Ja 1884, Cincinnati. Studied: Cincinnati Art Acad., with Duveneck. Member: Women's AC, Cincinnati [25]

GANSER, Ivan L(aurence) [P,S] Kansas City, MO b. 10 Je 1906, Eugene, OR. Studied: W. Rosenbauer; L. Ney; R. Braught. Member: Kansas City SA. Exhibited: Midwestern Exh., Kansas City AI, 1935 (prizes), 1937 (prize); Kansas City SA, 1936 (prize); Mo. State Fair, 1939 (prize) [40]

GANSO, Emil [P,E,B,Li,Dr,En,L] Woodstock, NY b. 14 Ap 1895, Halberstadt, Germany d. 18 Ap 1941, Iowa City. Member: Soc. Am. E.; F., Guggenheim Fnd. Exhibited: Wichita, Kans. (prize); PAFA, 1938 (med); WFNY, 1939; GGE, 1939. Work: Worcester Art Mus.; Portland Art Assoc.; Los Angeles Mus.; WMAA; MMA; NYPL; Hamilton Easter Field Fnd.; Denver Art Mus.; Cleveland Mus. Art; Mus. FA, Houston; BMFA; Newark Pub. Lib.; Honolulu Acad. Arts; Bibliothèque Nationale, Paris; Fine Prints of the Year, 1931; Print Cl. Cleveland, 1932. Position: Artist in residence, Univ. Iowa [40]

GANTT, James Britton [P,S,T,L] Kansas City, MO b. 1909, Lawrence, KS. Studied: Dallas AI; Kansas City AI. Exhibited: Kansas City AI, 1938, 1939; WFNY, 1939. Work: murals, City Hall, Kansas City [40]

GARBELY, Edward [P,T] Newark, NJ b. 15 Ag 1909, Newark. Studied: A. Baranowski; A.H. Trouck; Newark Sch. F.&Indst.A.; Grabach. Member: P.&S. Soc. N.J.; East Orange A. Center; Irvington A.&Mus. Assn.; A. Center of the Oranges; Am. Ar. Prof. Lg. Exhibited: Montclair Art Mus.; Newark Mus.; N.J. State Mus., Trenton; Newark AC; NAD; Irvington A.&Mus. Assn; WFNY, 1939; Audubon A.; East Orange A. Center. Work: Newark Univ.; Newark City Hall; Rutherford (N.J.) Town Hall; Marlboro State T. Col. [47]

GARBER, Daniel [P,E] Lumberville, PA b. 11 Ap 1880, North Manchester, IN d. 6 Jy 1958. Studied: Cincinnati Art Acad., with Nowottny; PAFA, with Anshutz. Member: ANA, 1910; NA, 1913; NAC; SC, 1909; Phila. PC; Soc. Am. E. Exhibited: NAD, 1909 (prize), 1915 (prize), 1917 (prize), 1927 (prize); ACP, 1910 (prize); CI, 1910 (prize), 1924 (prize); CGA, 1910 (prize), 1912 (med,prize), 1921 (med,prize); AIC, 1911 (prize); Buenos Aires Expo, 1910 (med); PAFA, 1911 (prize), 1918 (prize), 1919 (prize), 1923 (med), 1929 (gold), 1937 (med); P.-P. Expo, San Fran., 1915 (gold); SC, 1916 (prize); Newport AA, 1916 (prize). Work: CGA; Cincinnati Mus.; AIC; City Art Mus., St. Louis; Univ. Mo.; CI; Mus. A.&Science, Los Angeles; Ann Mary Brown Mem., Providence; Nat. Arts Cl.; MMA; St. Paul Inst. Art; PAFA; Detroit Art Inst.; Mem. Hall, Phila.; Locust Cl., Phila.; Albright Gal.; Swarthmore Col.; NGA, Phillips Mem. Gal., both in Wash., D.C.; AA, Topeka, Kans.; Herron AI; Hackley Mus., Muskegon, Mich.; Woodmere A. Gal. Position: T., PAFA [47]

GARBETT, C., Mrs. See Barns, Cornelia.

GARBER, Virginia Wright [P,L,T] Bryn Mawr, PA. Studied: PAFA; PMSchIA; Chase; Constant, in Paris. Member: Plastic Cl. [29]

GARCEAU, Harry J(oseph) [P,C] Muncie, IN b. 11 Jy 1876, Providence d. 14 F 1954. Studied: S. Tolman; F. Mathews; RISD. Member: Hoosier Salon; Ind. AA; Ind. Artists Cl. Exhibited: Hoosier Salon, 1940 (prize); Ind. AA; Ball State T. Col. [47]

GARCIA, Antonio E. [P,T,L] San Diego, TX b. 27 D 1901, Monterrey, Mexico. Studied: AIC; W. Adams; B. Anisfeld. Member: SSAL; South Tex. A. Lg.; Tex. FA Assn.; Corpus Christi A. Gld. Exhibited: SSAL, 1937, 1938, 1939 (prize); poster, Civic Lg., Chicago, 1929 (prize); AIC, 1929 (prize); Kingsville (Tex.) Col. A., 1940 (prize); Corpus Christi Mus., 1939 (prize), 1940 (prize), 1941 (prize); Dallas Mus. FA, 1936; Tex. FA circuit, 1939, 1944-46. Work: Tex. Fed. Women's Cl., Austin; Corpus Christi Mus.; Kingsville A.&Indst. Col. Mus.; frescoes, Sacred Heart Church, Corpus Christi; La Bahia Mission, Goliad, Tex. [47]

GARDE, C.J. [I] Orange, NJ [10]

GARDENER, Hugh (Mrs.) [P] New Rochelle, NY. Member: New Rochelle AA [25]

GARDEN-MACLEOD, L(ouise) E. [P,I,E,L,T] Los Angeles, CA/Redondo Beach, CA b. 25 Ap 1864, London, England. Studied: G. Fiske, Leslie, in London; Eschke, in Berlin; Garrido, Whistler, in Paris. Member: Los Angeles FA Lg. Founder/Director: Los Angeles Sch. Art and Design [19]

GARDIN, Alice Tilton (Mrs.) [P] NYC/Westport, CT b. 18 Ap 1859, Brooklyn, NY. Studied: Paris. Member: NAWPS [40]

GARDIN, Laura. See Fraser.

GARDINER, Eliza Draper [En,P,C,T,B] Providence, RI b. 29 O 1871, Providence d. 14 Ja 1955. Studied: RISD; Europe; C.H. Woodbury; Allen Tucker. Member: Calif. PM; Providence A. Cl.; Providence WCC; Providence Pr. Cl.; AFA; Phila. Pr. Cl.; Am. Color Pr. Soc.; R.I. Art T. Assn.; Phila. Woodcut Soc.; South County AA. Exhibited: Provincetown AA; Paris; LOC, 1944; AIC; PAFA. Work: Bibliothèque Nationale, Paris; Detroit Inst. A.; RISD; Springfield (Mass.) Lib.; Providence AC; Philbrook A. Center. Specialty: color woodblock prints of children [47]

GARDINER, Frederic M(errick) [P,E,W] Contoocook, NH b. 27 Je 1887, Sioux Falls, SD. Studied: E. Leon, in Paris; P.L. Hale. Member: Phila. PC [29]

GARDINER, Sarah D. [P] Bayshore, NY [19]

GARDNER, Adelaide Morris. See Morris.

GARDNER, B(eatrice) Sturtevant [P,W,L,T] Balboa, Canal Zone/Woodstock, NY b. 12 My 1893, Westtown, NY. Studied: Columbia; Ecole des Beaux-Arts, Paris; A. Dow; C. Martin; E. Renard. Member: AAPL; Am. Assn. Univ. Women. Exhibited: Argent Gal, 1937 (one-man); Morton Gal.; Am. A. Week, Balboa (C.Z.), 1941 (prize), 1942 (prize), 1943 (prize), 1944 (prize), 1945 (prize), 1946 (prize); Univ. Panama; Newport AA. Work: mural, St. Luke's Cathedral, Ancon, C.Z. Position: T., Canal Zone Jr. Col., Balboa [47]

GARDNER, Charles Reed [Dr,En,E,B,Li,I,P,W] Phila., PA b. 17 Ag 1901, Phila. Studied: T. Oakley; H. Pullinger. Member: Phila. Print Cl.; Phila. Sketch Cl. Work: Pa. Mus. A.; Pub. Mus., Reading, Pa.; Newark Mus.; N.J. State Mus.; Wilmington Soc. FA; Univ. Pa.; Pa. State Lib.; Independence Hall, Phila.; Baltimore Mus. A. Designer: covers for books and magazines [40]

GARDNER, Clyde A. [S] Chicago, IL [15]

GARDNER, Donald [I] Bronxville, NY. Member: Artists Gld.; SI [33]

GARDNER, E.M. (Mrs.) [P] b. Colchester, CT d. 1915, Pitman, NJ. Specialty: cats

GARDNER, Elizabeth Jeanne. See Bouguereau, William, Mrs.

GARDNER, Elizabeth Randolph (Mrs.) [S] Hampton Bays, NY b. 8 O 1882, Phila. Studied: Académie Julian, Paris; Verlet; Rodin; Ida Matton. Member: NSS; NAC. Work: forty-two carved oak statues, Church of the Annunciation, NYC; St. Bartholomew's Church, New York; Cornell; bas-reliefs of Paderewski (for Steinway Co.) and José Iturbi (for Baldwin Piano Co.), NYC [47]

GARDNER, Eugene D. [En,B] b. 1861, Troy, NY d. 2 S 1937, Altamont, NY. In 1881, he left Albany for New York, where he began his life's work producing wood cuts of many of the famous men of his day for various magazines. Known as the dean of American wood engravers at the time of his death.

GARDNER, Fred [P,E,Des,Arch] Jamesville, NY. b. 16 Ap 1880, Jamesville. Studied: PIASch; ASL, with Sloan. Member: S.Indp.A.; Assoc. A. Syracuse; Syracuse Pr.M. Exhibited: BM, 1935, 1944 (prize); AA Syracuse, 1943 (prize), 1944 (prize), 1946 (prize); Onandaga Hist. Assn., 1943 (prize), 1944 (prize), 1945 (prize); AIC, 1931; Detroit Inst. A., 1923, 1924, 1931; Whitney Studio Cl., 1925; Syracuse Mus. FA, 1924, 1925, 1942-46; Rochester Mem. A. Gal., 1943, 1946; Community A., Utica, N.Y., 1942, 1946; Brooklyn SA, 1933-35; Uptown Gal., 1931-41; Gordon Gal., Detroit, 1931; Vendôme Gal.; Contemporary Gal. Work: BM. Position: Arch., Board of Transportation, NYC [47]

GARDNER, Gertrude G(azelle) [P,T] Flushing, NY b. Fort Dodge, IA. Studied: H.B. Snell; Pratt Inst.; Fontainebleau Sch. FA, France. Member: NAWPS; PBC; Douglaston AA. Exhibited: PBC, 1939 (prize). Position: T., Bayside H.S., N.Y. [40]

GARDNER, G. Ward [P,S] Pitman, NJ b. 19 Ja 1913, New Jersey. Member: Woodbury (N.J.) Sketch Cl. Specialty: animals [40]

GARDNER, Hamlin [I] NYC [21]

GARDNER, Helen [T,L,W] d. 4 Je 1946, Chicago. Author: "Art Through the Ages." Position: T., AIC, for 25 years

GARDNER, Isabella Stewart [Patron] b. 14 Ap 1840, NYC d. 17 Jy 1924, Boston. Exuberant founder of the celebrated Boston museum that bears her name. She bought her first important painting (by Zurbarán) in 1888, acquiring many more masterworks with the help of Bernard Berenson. Her museum, designed to reflect the beauties of the Italian Renaissance, was completed in 1902, and called "Fenway Court." Her motto was "C'est mon plaisir." [*]

GARDNER, J.P. [P] Santa Monica, CA. Member: Calif. AC [25]

GARDNER, Mabel [S] Providence, RI/Matunuck, RI b. 2 Mr 1892, Providence. Studied: RISD; BFMA Sch.; A. Atkins [25]

GARDNER, Maude [P] Brooklyn, NY. Member: Lg. AA [24]

GARDNER, Walter Henry [Edu,P] Phila., PA b. 7 My 1902, Liverpool, England. Studied: PAFA; Temple Univ.; Breckenridge; Carles; Garber. Exhibited: Wanamaker Exh., 1934 (prize); PAFA, 1934–36, 1938, 1939, 1942, 1943; WMAA, 1936; Detroit Inst. A., 1937; CGA, 1937; AIC, 1936; VMFA, 1939; MMA, 1942. Work: murals, USPOs, Phila., Pa., Honesdale, Pa., Bern, Ind.; Municipal Court, Phila.; Pa. Mus.; Wanamaker Gal., Phila. Mus., Allentown, Pa.; Mus., Trenton, N.J. WPA artist. [47]

GARDNER, Willa [P] NYC. Member: Lg. AA [24]

GARDNER-SOPER, James H(amlin) [P,I] Long Beach, NJ b. 17 Jy 1877, Flint, MI. Member: SI, 1910. Exhibited: Paris Expo, 1900 (gold); St. Louis Expo, 1904 (med) [21]

GARESCHE, Marie R. [P,E,W,L] St. Louis, MO/Douglas, MI b. 29 Jy 1864, St. Louis. Studied: J. Machard; H. Mosler. Member: St. Luke AS; AAPL; Indp. A., St. Louis; St. Augustine (Fla.) A. Cl. Author: "Art of the Ages" [40]

GARFIELD, Marjorie Stuart [P,Edu,L,Dec,E,T] Syracuse, NY b. 30 N 1903, Boston. Studied: Syracuse Univ.; H.B. Snell; G.P. Ennis. Member: AWCS; NAWA; Wash. WCC; All. A., Syracuse; Rockport AA; Nat. Lg. Am. Pen Women. Exhibited: Nat. Lg. Am. Pen Women, 1932 (prize), 1936 (prize); All. A., Syracuse, 1937 (prize). Work: Syracuse Mus. FA. Lectures: Interior Decoration. Position: T., Syracuse Univ., 1927– [47]

GARFINKLE, Leonard [P,T] Sunnyside, NY b. 12 O 1898, NYC. Studied: NAD; New Sch. Soc. Res.; Poppenhusen Inst., N.Y. Member: United Am. Am. Ar. Exhibited: WFNY, 1939; ACA Gal. Position: T., Bellevue Hospital [40]

GARLAND, Christine [P] Houston, TX. Exhibited: Houston Mus. FA, 1938, 1939 [40]

GARLAND, George [I] NYC. Member: SI [47]

GARLAND, Leon [P] Chicago, IL b. 24 D 1896, Bobruisk, Russia d. 27 N 1941. Studied: AIC; Hull House Sch. Art, Chicago; Arts and Crafts Prep., Russia; Acad. Moderne, A. Lhote, in Paris; Reimann Schule, Berlin. Member: Chicago Soc. Ar. Work: Chicago; Wash., D.C.; Children's Room, Stanford Park, Chicago. WPA artist. [40]

GARLAND, Sadie Ellis [P] Chicago. IL b. 28 F 1900, Chicago. Studied: AIC; Hull House Sch. Art, Chicago; Acad. Moderne, A. Lhote, in Paris; Berlin [40]

GARNER, Archibald [S] Hollywood, CA b. 21 F 1904, Onida, SD. Studied: R. Stackpole; R. Cravath. Member: Fnd. Western Art. Exhibited: Los Angeles Mus., 1931 (prize), 1934 (prize); Pomona Fair, 1930 (prize), 1933 (prize), 1936 (prize). Work: Los Angeles Mus. Hist. Sc.&Art; Astronomers' Mon., Los Angeles; USPOs, Inglewood, San Diego, Fresno, Los Angeles, all in Calif.; Court House, Fresno; Court House, Los Angeles. WPA artist. Position: Sculpture Des., 20th Century-Fox Studios [40]

GARNER, Charles [P] Phila., PA. Studied: PAFA [25]

GARNER, Charles S., Jr. [I] Solesbury Township, PA b. 1890 d. 4 O 1933

GARNER, Frances Carns [P] Phila., PA [25]

GARNER, Frederick J. [P] Chicago, IL. Member: GFLA [27]

GARNSEY, Clarke Henderson [P,E,C,T,B] Port Orange, FL. b. 22 S 1913, Joliet, IL. Studied: Cleveland Sch. A.; B.E. Ward; Daytona Beach A. Sch., with D.J. Emery; Western Reserve Univ. Member: SSAL; Daytona Beach AL; Fla. Fed. A. Exhibited: SSAL, 1933–46; Fla. Fed. A., 1933–35, 1936 (prize), 1937, 1938; Daytona Beach AL, 1932, (prize), 1935 (prize), 1936 (prize) 1937 (prize). Work: nautical murals, schools of Volusia County, Fla. [47]

GARNSEY, Elmer E(llsworth) [P] NYC b. 24 Ja 1862, Holmdel, NJ d. 26 O 1946, Atlantic City. Studied: CUASch; ASL; G. Maynard; F. Lathrop. Member: Mural P.; Am. Acad., Rome; AIA; 1899; Century Assn.; A. Aid S.; AFA. Exhibited: Columbian Expo, Chicago, 1893 (med); Paris Expo, 1900 (med). Work: general color schemes, LOC; Pub. Lib., Boston; Pub. Lib., St. Louis; Lib. Columbia; Mem. Hall, Yale; Capitol, St. Paul, Minn.; Capitol, Des Moines, Iowa; Capitol, Madison, Wis.; U.S. Custom House, NYC; Richardson Mem. Lib., CAM, St. Louis [40]

GARNSEY, Julian Ellsworth [Mur.P,Des,L,T] Princeton, NJ, b. 25 S 1887, NYC. Studied: S.L. Reckless; Académie Julian, Paris, with Laurens. Member: Arch. L.; Calif. AC; BAID; Century Assn.; Mural P.; AAPL. Exhibited: Calif. WCS; Arch. L.; AIA, 1927 (prize), 1930 (prize). Work: Los Angeles Pub. Lib.; Hotel Del Monte, Calif.; Bank of Hawaii; UCLA; Los Angeles Stock Exchange.; Univ. Southern Calif.; Fine A. Gal., San Diego; Hawaiian Electric Co., Honolulu; Ogden, Utah; Dallas. Positions: T., Princeton, 1942–46; Color Consultant, Board of Design, N.Y. World's Fair, 1939 [47]

GARO, John H. [P] Boston, MA. Member: Boston AC [27]

GARRAT, Arthur [P] NYC [21]

GARRETSON, Albert M. [P,I] Beechurst, NY b. 12 O 1877, Buffalo, NY. Studied: Académie Julian, Paris, with Laurens. Exhibited: SC, 1912 (prize) [32]

GARRETSON, Della [P] Dexter, MI/Ogunquit, ME b. 12 Ap 1860, Logan, OH. Studied: Detroit AM; NAD; ASL. Member: S. Detroit Women P. [29]

GARRETSON, Lillie [P] Dexter, MI. Member: S. Detroit Women P. [25]

GARRETT, Adams Wirt [P,G] Randolph MA. b. 23 Je 1908, Forney, TX. Studied: ASL. Member: NAC; A. Equity of N.J. Exhibited: Montclair MA; Monmouth (N.J.) Mus.; AGAA; SUNY (Alfred); Carnegie Inst., 1941–43; AIC, 1945; Pepsi-Cola, 1945 (prize); 8th Street Gal., NYC (one-man); Phila. A. All.; Tulsa AA; San Fran. MFA. Work: AFA; Fitchburg, Mass. Mus. A.; BMA; Smithsonian. Position: T., SUNY (Alfred, 1972), ASL [47]

GARRETT, Anna [I] Landsowne, PA/Wilmington, DE. Studied: PAFA. Member: Plastic C.; Wilmington SFA [33]

GARRETT, Clara Pfeifer (Mrs. Edmund A.) [S] Beverly Hills, CA b. 26 Jy 1882, Pittsburgh. Studied: St. Louis Sch. FA; Ecole des Beaux-Arts; Mercié, Bourdelle in Paris. Exhibited: La. Purchase Expo, St. Louis, 1904 (med); NSS, 1905; A. Gld., St. Louis, 1915 (prize), 1916 (prize). Work: MET; City of St. Louis; Eugene Field Sch., St. Louis [40]

GARRETT, Edmund H(enry) [P,I,Et,W,L] Cambridge, MA. b. 19 O 1853, Albany, NY d. 2 Ap, 1929, Needham, MA. Studied: Paris, with Laurens, Boulanger, Lefebvre, Leroux. Member: Boston AC; Boston SWCP; Copley S. 1902; Paris AAA; Boston SE. Exhibited: Boston, 1890 (prize). Work: Winchester, Mass. Pub. Lib., Calumet C.; BMFA; Boston Pub. Lib.; Brookside Lib. Great Barrington, Mass.; Conant Mem. Church, Dudley, Mass.; State House, Boston. Illustrator: "Elizabethan Songs," "Victorian Songs," "Puritan Coast," "Pilgrim Shore." He was also a bookplate maker. [27]

GARRETT, John W. (Mrs.) [P] Baltimore, MD [25]

GARRETT, Mary H. [P] Knoxville, TN [13]

GARRETT, Priscilla Longshore [P,L] Scranton, PA b. 29 Mr 1907, Chatham, NJ. Studied: PAFA, with G. Harding; Phila. Sch. Des. for Women; Drexel Inst. Member: Lackawanna County Art Alliance; Chester County AA; Phila. A. All.; AAPL; Plastic C.; Springfield AL. Exhibited: Butler AI, 1939, 1944, 1945; PAFA, 1933; Lackawanna Co. A. All., 1939 (prize); Chester County AA, 1939 (prize); Plastic C., 1940 (prize); Springfield AL; Everhart Mus., Scranton, Pa., 1940, 1945 (one-man). Work: PAFA. Lectures: Contemporary Am. Art [47]

GARRETT, Theresa A. [E] Chicago, IL b. 8 Je 1884. Member: Chicago SE; GFLA [29]

GARRETT, Thomas (Peter) [P,W] b. 16 Je 1891, Autumwa, IA d. N 1917. Studied: K.H. Miller. Position: Ed., American Art Student [17]

GARRIDO, L.R. [P] NYC. Member: Société Nationale des Beaux-Arts, Paris [04]

GARRISON, Eve [P,Dr] Chicago, IL b. Boston, MA. Studied: AIC; Buehr; Oberteuffer; Krehbiel; Sterba; Thurn. Member: AIC; Chicago NJSA; Commission to Advance Am. Art; Around the Palette. Exhibited: Washington SA, CGA, 1933 (prize). Work: Univ. Ill. [40]

GARRISON, J.J. (Mrs.) [P] Detroit, MI. Member: S. Detroit Women P. [25]

GARRISON, Jesse Janes [Edu] Mason, MI b. 5 Ja 1901, Glen Ellyn, IL d. ca.

1957. Studied: Univ. Mich.; Univ. Wis. Member: CAA. Co-author: "Art in the Western World," 1935, 1942. Positions: T., Univ. Wis., 1926–32, Colgate, 1932–39, Mich State Col., 1939 [47]

GARRISON, John L(ouis) [P,I] Columbus, OH b. 14 Je 1867, Cincinnati, OH. Studied: Nowottny; Goltz. Member: Columbus PPC [33]

GARRISON, Minta (or Martha) H. (Mrs. J.T.) [P] Houston, TX b. 5 Ag 1874, Center, TX. Studied: Mrs. E. Cherry. Member: NAWPS; Texas FAA; SSAL. Exhibited: SSAL, Birmingham, 1933 (prize). Specialty: flower paintings [40]

GARRISON, Robert [S,Dec,Des,L,T] NYC b. 30 My 1895, Ft. Dodge, IA. Studied: PAFA; G. Borglum. Member: Arch. L. Exhibited: Okla., 1913 (gold). Work: State Office Bldg. of Colo.; Voorhees Mem.; Post Office (Overseas Mem. Tablet), National Jewish Infirmary, Midland Bldg., all in Denver, Colo.; Mosher Mem., Rochester [40]

GARSTIN, Elizabeth W(illiams) [S] New Haven, CT/Salisbury, CT b. 12 Ja 1897, New Haven. Studied: Eberhard; Yale. Member: New Haven PCC; AFA [40]

GARTH, John [Mur.P,Por.P,Dr,W,L,Cr,T] San Francisco, CA b. 21 D 1894, Chicago, IL d. 1971. Studied: AIC; ASL; London; Paris; S. Kendall; Yale; Vanderpoel; Bridgman; C. Fehr, Berlin; Vienna. Member: Calif. SMP; AAPL; NSMP; Bay Region AA; Prof. Artists Lg., San Fran.; Business Men's AC, San Fran. Exhibited: GGE, 1939; Pal. Leg. Honor, 1939 (med). Work: murals, Univ. Calif.; General Electric Co.; San Fran. Arch. C.; Pacific Marine Contractors; Woodlawn Mem. Park; Fairmount, Somerton, Sir Francis Drake Hotels, all in San Fran.; Miami Univ., Oxford, Ohio; Redding, Calif. Positions: A. Ed., The Argonaut, San Fran.; Dir., his own sch.; T., Robert College, Constantinople, Mid-Pacific Inst., Honolulu [47]

GARVEY, Joseph M. [P,E] NYC b. 28 S 1877. Studied: W.M. Chase [27]

GARVEY, William [Car] b. 1906 d. 22 N 1925, Hackensack, NJ. Illustrator: magazines. Originator: comic strip "Asparagus Tipps"

GARY, Louisa M(acgill) [P] Catonsville, MD b. 19 D 1888, Baltimore. Studied: Md. Inst. Member: Baltimore Friends A. [33]

GASAWAY, John W. [P] Edgewood, PA. Member: Pittsburgh AA [21]

GASBARRO, Nicola [I] San Francisco, CA [21]

GASCH, Herman E. [P] Wash., D.C. Member: S. Wash. A. [27]

GASH, Chester Alan [P] NYC/Stockton, NJ b. 16 My 1906, NYC. Studied: Paris; Lausanne [40]

GASKILL, Marion Hendricks [P] Phila., PA [13]

GASPAR, Miklos [Mur.P,Des] Chicago, IL b. 15 S 1885, Kaba, Hungary d. 30 Je 1946. Studied: K.K. Aladár. Member: All-Ill. SFA; Arch. C. Chicago. Exhibited: Nat. Exh., Budapest, 1920 (prize); Chicago Daily Tribune Comp., 1922 (prize); murals, Century of Progress Exh., Chicago; Chicago Ar. Ann. Exh., AIC, 1924 (prize). Work: murals, Knights of Columbus Bldg., Springfield, Ill.; ceiling paintings, Fisher Bldg., Detroit; Medinah Athletic C.; Union Lg. C.; Forman Bank, Chicago, Ill.; mural, Terra Haute House, Ind. [40]

GASPARD, Jules Maurice [Por.P,I] Chicago, IL b. 1862, Paris, France d. 18 F 1919, NYC. Studied: ASL. At 18 he went to Chicago. Position: A. Cr., Inter Ocean [06]

GASPARD, Leon [P] NYC b. 1882, Vitebsk, Russia (came to NYC in 1916) d. 1964, Taos, NM. Studied: Vitebsk, with Julius Penn; Odessa; Moscow; Académie Julian, Paris, with Toudouze, Bouguereau, 1899. Exhibited: CGA, 1932; Nat. Acad., 1936, 1937, 1938; GGE, 1939. Painted in Siberia, 1908–10; shot down as a WWI pilot for France; settled in Taos, 1918. Work: AIC; Mus. N.Mex. Best known for his bright pallette of loose impressionist scenes. [40]

GASPARO, Oronzo Vito [P,Des,C] NYC b. 16 O 1903, Rutigliano-Prov., Bari, Italy. Studied: Preston Dickinson; NAD. Exhibited: AIC, 1938; MOMO, 1936; PAFA, annually; CGA, 1939; WFNY, 1939; GGE, 1939; WMAA, 1938–41, 1944, 1946; CAM, 1945; CI, 1941, 1945; Tilden & Thurber Gal., Providence, 1928 (one-man); Woodstock, 1929 (one-man); Pinacotheca, 1941 (one-man); Ferargil Gal., 1942 (one-man), 1943 (one-man), 1944 (one-man); Mortimer Levitt Gal., 1945 (one-man); Gal. Neuf, 1946 (one-man). Work: MOMA; MMA; WMAA; Palm Beach AC [47]

GASPARRO, Frank [S,T] Manoa, PA b. 26 Ag 1909, Phila., PA. Studied: PAFA; C. Grafly. Exhibited: PMA, 1940; PAFA, 1946. Work: Harrisburg Mus. A.; Alentown A. Mus.; PMA. Position: T., Fleisher A. Mem., Phila. [47]

GASSER, Henry Martin [P,Des,T] Newark, NJ b. 31 O 1909, Newark, NJ d. 1981. Studied: Newark Sch. F.&Indst. A.; ASL; Brackman; Grabach. Member: AWCS; Phila. WCC; Wash. WCC; N.J. WCC; Baltimore WCC; SC; All.A.Am.; Audubon A.; Miss. AA; N.J. AA; New Haven PCC; SSAL; AAPL; Springfield AL; Asbury Park Soc. FA; Irvington A. & Mus. Assn. Exhibited: CI, 1944, 1945; NAD, 1942–45, 1943 (prize), 1944 (prize); AWCS, 1941–46; Phila. WCC, 1940–46, 1945 (prize); AIC, 1942, 1946; Wash. WCC, 1940–46, 1945 (prize), 1946 (prize); All.A.Am., 1943–45; SFMA, 1944, 1944, 1945; Audubon A., 1945; Albany Inst. Hist.&A., 1943, 1944; Texas Intl. Exh., 1943; Palace Legion Honor, 1946; Denver A. Mus., 1942–44; Miss. AA, 1943–46; Ala. WCS, 1943 (prize), 1944, 1945 (prize), 1946 (prize); Oakland A. Gal., 1941–45, 1943 (prize); Mint Mus. A., 1943, 1944 (prize), 1945, 1946; Smithsonian Inst., 1941 (prize); Santa Barbara, Calif., 1944; Springfield, Mo. Mus. A., 1943 (prize), 1945 (prize); Laguna Beach, Calif., 1943, 1945; Montclair A. Mus., 1939, 1940, 1941 (prize), 1942, 1943 (prize), 1944 (prize), 1945; Springfield, Mass., 1943–45, (prizes); Baltimore WCC, 1943 (prize), 1945 (prize), 1946 (prize); New Haven PCC, 1940–43, 1944 (prize), 1945 (prize), 1946; New Orleans AA, 1944, 1945 (prize), 1946 (prize); High Mus. A., 1946; Guatemala Nat. Fair, 1942; Piedmont, (N.C.) A. Fest, 1945 (prize); State T. Col, Indiana, Pa., 1946; SSAL, 1946 (prize). Work: PMA; New Haven PCC; Newark Mus.; Springfield (Mo.) Mus. A.; Wash. State Col.; Dallas Mus. FA; Irvington A. & Mus. Assn.; Mint Mus. A.; IBM. Contributor: American Artist magazine. Position: Dir., Newark Sch. FA, 1946 [47]

GASSETTE, Grace [P,S] Paris, France b. Chicago. Studied: Mary Cassatt [13]

GASSLANDER, Karl [P,L,W] Chicago, IL b. 3 D 1905, Rockford, IL. Studied: Northwestern Univ.; T. Col., Columbia; C. Martin; A. Heckman; G.J. Cox; A. Storm. Member: Chicago SA. Exhibited: Tex. State Fair, Dallas, 1929; Evanston Women's C., 1939 (prize). Position: A. Cr., Evanston Daily News-Index; T., Evanston Collegiate Inst. [40]

GASSNER, Mordi [P,Des,Dr,I] Sunnyside Gardens, NY b. 27 My 1899, NYC. Member: Guggenheim F., 1929–30, 1930–31. Work: murals, Temple House, Granada Hotel, both in Brooklyn, N.Y.; Long Island Court House; USPO, Great Falls, Mont. WPA artist. Illustrator: Du Pont monthly; RKO Yearbook; Eminent American Illustrators; portfolio, "Six Wild Animals," lithograph pub. Assoc. Am. Artists, 1937 [40]

GAST, August [Li] b. 10 Mr 1819, Belle, Germany (came to U.S. ca. 1848) d. probably St. Louis. Studied: Detmold. With his brother Leopold, he established a lithographic firm which, by 1883, was one of the largest in the West. [*]

GATCH, Lee [P] Lambertville, NJ b. 11 S 1909, Baltimore d. 10 N 1968, Trenton, NJ. Studied: J. Sloan; A. Lhote; Kisling; Metzinger. Exhibited: 48 States Comp.; USPO, Mullins, S.C., 1939. WPA artist. [40]

GATCHELL, Charles [I,P] b. 1883 d. 5 Ap 1933, Paris, France. Studied: ASL, 1907; Paris; Munich. Positions: Reporter/Car., Cleveland Press, New York Evening Journal, other newspapers

GATENBY, John William, Jr. [P,I,T,L,W] Chicago, IL/Marengo, IL b. 16 F 1903, Cicero, IL. Studied: Buck; Elliot; Forsberg; Lyford; Tomaso; Larson. Member: Palette and Chisel C.; Chicago AG; Chicago NJSA; Chicago FAG; Chicago A. Center. Work: Palette and Chisel Acad. FA, Chicago; Marengo Women's C. [40]

GATES, Frank E. [P] NYC. Member: SC [25]

GATES, John Monteith [Indst.Des] Glen Head, NY b. 25 Je 1905, Elyria, OH. Studied: Harvard; Columbia; Member: AIA. Exhibited: Swedish Intl. Comp., 1933 (prize); Steuben Glass Works; Va. MFA, 1938; FA Soc., London, 1935; WFNY, 1939; Paris Salon, 1937. Work: Steuben designs in several U.S. mus. (e.g., Toledo, Chicago, Kansas City). Position: Vice Pres. in charge of des., Steuben Glass Co. [47]

GATES, Laura Bryan (Mrs. Richard H.) [S] b. 1873 d. 4 Je 1943, Yonkers, NY

GATES, Margaret (Casey) (Mrs. Robert F.) [P,T] Vienna, VA b. Wash., D.C. Studied: Corcoran A. Sch.; PMG A. Sch.; Colorado Springs FA Center; C. Law Watkins; H. Varnum Poor. Member: A. Gld. Wash. Exhibited: WMFA; Critics Choice, CM, 1945; Pepsi-Cola, 1946; CGA; PMG; Bignou Gal., 1940; Whyte Gal., 1946 (one-man); Soc. Wash. A., 1945 (prize). Work: PMG; mural, USPO, Mebane, N.C. Position: PMG A. Sch., 1933–46 [47]

GATES, Mary W. [Min.P] Scarsdale, NY [13]

GATES, Miles Standish [P] Chicago, IL. Member: GFLA [27]

GATES, Richard F. [P,G,T] Iowa City, IA b. 20 D 1915, Cedar Rapids, IA. Studied: G. Wood; J. Charlot. Work: USPO, Harlan, Iowa; mural, Physics Bldg., Univ. Iowa. WPA muralist. Position: T., Univ. Iowa [40]

GATES, Robert Franklin [P,T] Vienna, VA b. 6 O 1906, Detroit, MI. Studied: Detroit Sch. A.&Cr.; ASL; PMG A. Sch.; Colorado Springs FA Center; C. Law Watkins; H. Varnum Poor. Member: Wash. A. Gld.; Soc. Wash. A. Exhibited: Soc. Wash. A., 1932 (prize) 1933 (prize), 1936 (prize), 1938 (prize), 1940 (prize); Evening Star Comp., 1940 (prize); Wash. Indp. A., 1935 (prize); Whyte Gal., 1939 (prize); AIC, 1936–41; BM, 1935, 1939; GGE 1939; WFNY, 1939; Wash. A. Gld.; Wash. WCC. Work: PMG; Dumbarton Oaks Coll.; murals, USPOs, Bethesda, Md., Lewisberg, W.Va., Oakland, Md.; PMG; U.S. Gov.; Univ. Fla; Univ. Ind. Position: T., Am. Univ. Summer Sch., Wash., D.C., 1946 [47]

GATES, William D. [C] b. 1853 d. 28 Ja 1935, Crystal Lake, IL. Member: American Ceramic Soc. (founder). Exhibited: St. Louis Expo, 1904 (med); AIA, 1928 (med). Position: Pres., American Terra Cotta and Ceramic Co.

GATEWOOD, Evelyn M(ullaney) (Mrs. J.R.) [P] Dallas, TX b. 31 Ja 1903, Winneshiek County, IA. Studied: C.A. Cumming. Member: Reaugh AC [33]

GATH, Ethel Robertson [P] Wash., D.C. Studied: Flint Inst. A. Sch., with J. Brozik; Corcoran A. Sch., with R. Lahey, E. Weisz, H. Warneke; P. Bacon. Member: Soc. Wash A. Exhibited: Flint AI, 1937 (prize), 1938 (prize), 1939 (prize); Art Fair, Wash., D.C., 1944 (prize), 1945 (prize); Soc. Wash. A., 1943 (med), 1944 (med); Grand Rapids, Mich., 1940; CGA, 1945; VMFA, 1946; Rockefeller Center, 1936; Detroit Inst. A., 1934, 1935, 1937, 1938; Ann Arbor, Mich., 1935; Detroit Scarab Cl., 1936–40; Flint Inst. A., 1933–44; AAPL, 1944, 1945; Min. PS&G, 1944; Pub. Lib., Wash., D.C.; Flint, Mich., 1937 (one-man); Alexandria, Va., 1945 (one-man) [47]

GATHINGER, Minnie [P] Nashville, TN [25]

GATRELL, Marion Thompson [P,Edu] Columbus, OH b. 9 N 1909, Columbus, OH. Studied: Ohio State. Member: Columbus AL; Ohio WCS. Exhibited: Audubon A., 1945; Ohio Valley Exh., 1943–46; Butler AI, 1945; Parkersburg (W.Va.) FA Center, 1942; Toledo Mus. A., 1939–45; Columbus AL, 1937–46. 1939 (prize), 1945 (prize); Ohio State Fair, 1938 (prize), 1939 (prize), 1941 (prize); Ohio Valley Exh., Athens, 1943 (prize). Position: T., Ohio State, 1943– [47]

GATRELL, Robert M. [P,Edu] Columbus, OH b. 18 My 1906, Marietta, OH. Studied: J.R. Hopkins; G.B. Wiser; Ohio State. Member: Ohio WCS; Columbus AL. Exhibited: Ohio State Fair, 1938 (prize), 1939 (prize); Ohio WCS, 1940–46, 1942 (prize), 1943 (prize); Parkersburg FA Center, 1941, 1942 (prize), 1943; VMFA, 1938; AWCS, 1942, 1943; Audubon A., 1945; Oklahoma A. Center, 1941; Columbus AL, 1939–46; Butler AI, 1938–42. Work: Dunbar Mus.; Dayton, Ohio; Denison Univ.; Ohio Northern Univ.; Ohio State Univ. Position: T., Ohio State [47]

GATTER, O(tto) J(ules) [P,I] Phila., PA b. 14 My 1892, Phila. d. 5 Jy 1926. Studied: McCarter; PAFA. Illustrator: Scribner's, Cosmopolitan, Saturday Evening Post; "Arrowsmith," by Sinclair Lewis [25]

GATTUSO, Paul [P] NYC. Exhibited: CGA, 1937; PAFA, 1938, 1939; VMFA, 1938 [40]

GAUG, Margaret Ann [P,Et,I] Mundelein, IL b. 2 O 1909. Member: SAE; Chicago SE; Prairie PM. Exhibited: Chicago SE, 1940 (prize). Work: NGA; Ill. State Lib., Springfield; Art Mus., Belgium. Author: "Buffin," 1935 [47]

GAUGENGIGL, I(gnaz) M(arcel) [P] Boston, MA b. 29 Jy 1855, Passau, Bavaria (came to Boston in 1880) d. 3 Ag 1932. Studied: Acad. Munich. Member: SAA, 1895; ANA, 1906; Copley S.; Boston GA. Exhibited: New Orleans Expo (med); Mass. Charitable Mechanics Assn. (med). Work: RISD; MMA; BMFA. Specialty: in later years, portraits of Harvard professors [31]

GAUGLER, Joseph P. [P] Ridgewood, NJ b. 17 Mr 1896, Paterson, NJ. Studied: ASL; France; W. Adams; G.P. Ennis. Member: Inter-Soc. Color Council; Ridgewood AA. Exhibited: AWCS, 1936, 1937; NYWCC, 1938; Montclair AM, 1936–46; Ridgewood AA, 1935–46. Contributor: American Artist. Position: Pres., Fiatelle, Inc., NYC, 1928–46 [47]

GAUL, Arrah Lee (Mrs. Brennan) [P] Phila., PA. Member: Plastic C.; AWCS; NAWPS [33]

GAUL, C.G. [I] Phila., PA [21]

GAUL, Harvey B. [P] Pittsburgh, PA b. 11 Ap 1881, NYC. Studied: G. Gaul; NAD [21]

GAUL, (William) Gilbert [P,I,T] NYC b. 31 Mr 1855, Jersey City d. 21 D 1919. Studied: NAD, with L.E. Wilmarth; ASL; J.G. Brown, in NYC. Member: ANA, 1879; NA, 1882; SC, 1888. Exhibited: Am. A. Assn., 1882 (prize); Prize Fund, 1886 (gold); Paris Expo, 1889 (med); Columbian Expo, Chicago, 1893 (med); Pan-Am. Expo, Buffalo, 1901 (med); Appalachian Expo, Knoxville, 1910 (gold). Work: Toledo Mus.; Democratic C., NYC. Illustrator: "Battles and Leaders of the Civil War," 1887. Painted on Indian reservations, 1880s. [21]

GAUL, (William) Gilbert (Mrs.) [P] d. 31 D 1921, Orangeburg, SC

GAULEY, Robert D(avid) [P,Dr,T] Winter Park, FL b. 12 Mr 1875, County Monaghan, Ireland (came to U.S. in 1885) d. 31 D 1943. Studied: D.W. Ross; R.W. Benson; E.C. Tarbell; Bouguereau, Ferrier, in Paris. Member: ANA, 1908; NYWCC; AWCS. Exhibited: Paris Expo, 1900 (med); Pan-Am. Expo, Buffalo, 1901; Charleston Expo, 1902; St. Louis Expo, 1904 (med); SC, 1907 (prize), 1912 (prize); NAD, 1908 (prize); Appalachian Expo, 1910, Knoxville, Tenn. (prize); P.-P. Expo, San Fran., 1915 (med). Work: NGA; Capitol, Wash., D.C.; Kolding, Denmark; Watertown (N.Y.) Pub. Lib.; BMFA; Harvard [40]

GAUSTA, H(erbjorn) [P] Minneapolis, MN/Akeley, MN b. 16 Je 1854, Norway. Studied: Royal Acad., Munich. Member: Minneapolis AL [24]

GAVENCKY, Frank J. [P] Chicago, IL b. 10 Je 1888, Chicago, IL. Studied: AIC; Chicago Acad. FA. Member: Palette & Chisel C.; Chicago PS; Bohemian AC; Chicago Gal. Assn. Exhibited: Pasadena AI, 1932 (one-man); AIC, 1930 (prize) (one-man), 1931; Toman Lib., Chicago, 1934 (one-man); Palette & Chisel C., 1925 (med). Work: City of Chicago; Eastern Star Home, Rockford, Ill.; Western Ill. T. Col., McComb, Ill. [47]

GAVIN, Arthur Henry [P,T] Revere, MA b. 2 S 1898, Boston, MA. Studied: Boston Univ., Harvard; New Eng. Sch. Des.; Mass. Sch. A.; Hawes Sch. FA. Member: S.Indp.A, Boston. Position: T., Revere H.S., Mass. [47]

GAVIN, Verona E. (Mrs.) [P] Milwaukee, WI b. 4 Mr 1891, Eau Claire, WI. Studied: F.V. Sinclair, E. Groom. Member: Wis. PS. Exhibited: Milwaukee AI, 1929 (prize) [33]

GAW, Hugh [P] Berkeley, CA [19]

GAW, William A. [P,L,Edu] Berkely, CA b. 26 N 1891, San Fran. Member: San Fran. AA. Exhibited: MOMA, 1933; AIC, 1936; WMAA; Colorado Springs FA Center; de Young Mem. Mus.; Pal. Leg. Honor, 1932 (prize), 1935, 1945, 1946; MMA (AV), 1942; CGA, 1939, 1941; San Diego FA Soc.; SFMA; Mills Col. A. Gal.; CI, 1941; GGE, 1939; WFNY, 1939; CM; Fnd. Western A.; Los Angeles AA, 1934 (prize); San Fran. AA, 1936 (gold), 1937 (prize); Pepsi-Cola, 1946; pub. gal. in Honolulu, Japan, etc. Work: MOMA; SFMA; Pal. Leg. Honor; San Fran. AA; San Diego FA Soc.; Mills Col. A. Gal., Oakland, Calif. Positions: T., Calif. Sch. FA, 1941–45, Mills Col., 1942–46 [47]

GAY, Edward B. [P] Mt. Vernon, NY/Cragsmoor, NY b. 25 Ap 1837, Dublin, Ireland (came to U.S. in 1848) d. 22 Mr 1928. Studied: J.M. Hart, in Albany; Karlsruhe, Germany, with Schirmer, Lessing. Member: ANA, 1869; NA, 1907; NYWCC; A. Fund S.; Lotos C. Exhibited: Am. A. Assn., 1887 (prize); Midwinter Exh., San Fran. (med); New Orleans Expo, 1885 (med); Pan-Am. Expo, 1901 (med); SAA, 1903 (prize); St. Louis Expo, 1904 (med); NAD, 1905 (gold). Work: murals, Mt. Vernon Pub. Lib., F.R. Chambers Lib., Bronxville, N.Y.; paintings, Layton Mus., Milwaukee; MET; Mt. Vernon Pub. Lib.; Minneapolis FA Gal.; NGA; AIC; Montclair AM [27]

GAY, George Howell [P] Bronxville, NY b. 2 Ag 1858, Milwaukee. Studied: P. Brown, H.A. Elkins, in Chicago. Specialties: marines; landscapes [29]

GAY, Lillie H. [P] NYC. Member: S.Indp.A. [21]

GAY, Mary [P,Min.P] Cambridge, MA/Los Angeles, CA b. Oscoda, MI. Studied: Benson; Tarbell; Paris, with Lasar, Ménard, Cottet [08]

GAY, Ruth A. [P,T] Niagara Falls, NY b. 30 N 1911, Ontario. Studied: Syracuse Univ.; ASL; A. Brook; H.V. Poor; C. Cutler. Exhibited: Riverside Mus.; Grand Central A. Gal.; WMA, 1938; Syracuse Mus. FA; Rochester Mem. A. Gal.; Univ. N.Mex.; MacMurray Col. (one-man); Decatur, Ill.; Albright Gal., 1937 (prize), 1938, 1939; Am. Fed. A., 1940. Position: T., MacMurray Col., Jacksonville, Ill., 1938–46 [47]

GAY, Walter [P] Paris, France/Seine-et-Marne, France b. 22 Ja 1856, Hingham, MA d. 14 Jy 1937. Studied: Bonnât. Member: ANA, 1904; AFA; Société Nouvelle; Nat. des Beaux-Arts; Société de la Peinture á

l'Eau; Royal Soc. WC, Brussels; NIAL; Société des Amis du Louvre, Paris; Committee des Amis du Musée de Luxembourg, Paris; Committee des Amis de Versailles; Chevalier Legion of Honor, 1894, Officer, 1906, Commander, 1927. Exhibited: Paris Salon, 1885, 1888 (med); Vienna, 1898 (gold); Antwerp, 1894 (gold); Munich, 1894 (gold); Berlin, 1895, (gold); Budapest, 1895 (gold); Paris Expo, 1900 (med); Pan-Am. Expo, Buffalo, 1901 (med). Work: French Gov., Luxembourg Mus., Paris; BMFA; PAFA; MMA; Mus., Amiens, France; Buffalo; Carnegie Inst.; Pinakothek, Munich; RISD; AIC; Palace of the Elysée, Paris; Detroit Inst. A. Best known for his studies of French interiors [33]

GAY, Winckworth Allan [Ldscp.P] West Hingham, MA b. 18 Ag 1821 d. 23 F 1910. Studied: West Point, with Robert W. Weir, 1838; Troyon, in Paris, 1847. Had studio in Boston, 1850–74; went to Egypt, Japan, and China, 1874–94. Brother of Walter Gay.

GAYLBURD, Joseph [P] Phila., PA [15]

GAYLOR, (Samuel) Wood [P,L] Glenwood Landing, NY b. 7 O 1883, Stamford, CT. Studied: NAD. Member: Salons of Am.; Brooklyn S. Mod. A.; Am. Soc. PS&G; Hamilton Easter Field A. Fnd.; NYC Mus. Art Comm. [40]

GAYLORD, Mary E. [P] Kansas City, MO [19]

GEARHART, Frances H(ammel) [B] Pasadena, CA b. Illinois. Member: Calif. PM; Prairie PM; AFA. Exhibited: Calif. PM, 1933 (prize). Work: Toronto Mus.; RISD; Los Angeles Mus.; Chicago Art Sch.; Smithsonian; LOC; Delgado Mus., New Orleans; State Lib., Sacramento [40]

GEARHART, May [E,T] Pasadena, CA b. Henderson County, IL. Studied: W. Shirlaw; R. Schaeffer; B.C. Brown; A.W. Dow; AIC; San Fran. Sch. FA; Hans Hofmann. Member: SAE; Chicago SE; Calif. Pr.M. Work: Los Angeles Mus. A.; Calif. State Lib., Sacramento; Smithsonian [47]

GEARY, Alice Hildegarde [P,Li,T] Springfield, MA b. 5 N 1897, Springfield. Studied: PIASch; G.P. Ennis; G. Wiggins. Member: Studio Gld., New York; Springfield AG; Boston AC; NAWA; CAFA; AWCS; Wash. WCC; Springfield A. Lg. Exhibited: Springfield A. Lg., 1934 (prize); CAFA, 1934–46; NAWA, 1934–46; AWCS, 1932–46; Wash. WCC, 1935–46; Lyme AA; PAFA; Phila. WCC; AFA Traveling Exh. Position: T., Springfield Pub. Sch., 1921–46 [47]

GEARY, Fred [P,B] Carrollton, MO b. 19 My 1894, Clarence, MO d. ca. 1955. Studied: Jewell Col.; Kansas City AI. Member: Kansas City SA; Woodcut Soc.; Prairie Pr.M.; Southern Pr.M.; SSAL; Exhibited: Rocky Mountain Pr. Cl., 1935 (prize); Philbrook A. Center, 1940 (prize); CAM, 1944 (prize); SSAL, 1945 (prize), 1946 (prize); LOC; Chicago Intl. Pr. Exh., 1936, 1938, 1939; LOC, 1943–46; CI, 1945; AIGA, 1944; NAD, 1936–46; PAFA, 1934; Los Angeles Mus. A., 1935; SFMA, 1941, 1942; Am. Block Pr. Annual, Phila., 1936–46. Work: Navajo Sand paintings/murals, El Navajo Hotel, Gallup, N.Mex.; pictographs, Grand Canyon National Park, Ariz.; Denver A. Mus.; NYPL; Philbrook A. Center; Md. Hist. Soc.; Kansas City Pub. Lib; Tex. Tech. Col.; LOC; Princeton Univ. Illustrator: "Navajo Medicine Man," 1939 [47]

GEBELEIN, George Christian [Silversmith] Wellesley Hills, MA b. 6 N 1878, Bavaria d. 25 Ja 1945. Studied: A. Krass. Member: Boston SAC; Detroit SAC. Exhibited: AIC, 1905 (prize); P.-P. Expo, San Fran., 1915 (med). Work: St. Paul's Church, Dedham; Grace Church, North Church, Salem; St. Mary's Church, Newton; St. James Church, Amesbury; Church of the Epiphany, Winchester; King's Chapel, Boston; Chapel, Phillips Acad, Andover; Grace Church, Providence; Chapel, West Point, N.Y.; Chapel, William and Mary Col.; National Cathedral, Wash., D.C.; sports trophies, Harvard, Yale [40]

GEBERS, Nellie Marae (Mrs. John F.) [P] Lincoln, IA b. 26 O 1901, Iowa. Studied: R. Graham; Grant Wood. Member: Iowa AC; Waterloo AA. Exhibited: Iowa AC, Des Moines, 1934 (prize); Iowa State Fair, 1934 (prize), 1935 (prize); All-Iowa Exh., Chicago, 1937 (prize). Work: Women's Club House, Ames, Iowa [40]

GEBHARDT, C. Keith [Mur.P,S,Des,L,W,I,T] Milwaukee, WI b. 14 Ag 1899, Cheboygan, MI. Studied: Univ. Mich.; AIC. Exhibited: Wis. PS, 1935 (prize). Work: Winnipeg Art Mus.; Milwaukee Pub. Mus. Positions: T., Winnipeg Sch. A., Canada, 1924–29; Artist, Milwaukee Pub. Mus., 1932–46 [47]

GEBHARDT, Harold [S,T,] Burbank, CA b. 21 Ag 1907, Milwaukee, WI. Studied: Layton Sch. A. Member: Wis. PS. Exhibited: Wis. Univ., 1936 (prize); Wis. P.&S., 1937 (prize); Los Angeles Mus. A., 1939–46; Pomona, San Diego, San Fran., all in Calif. Positions: T., Otis AI, Occidental Col. [47]

GEBHARDT, William Edwin [P] Cincinnati, OH b. 4 Mr 1907, Franklin, OH. Studied: J.M. King; J. Weis; H. Wessel; F. Myers; M. Gromaire; O. Friesz; H. de Warroquier; Acad. Scandinave, Paris. Member: Cincinnati Assn. Prof. A.; Contemporary Ar., Cincinnati. Work: portraits, Governors-General, Virgin Islands, for WPA [40]

GEBHART, Paul [Des] Willoughby, OH b. 2 Ja 1890. Studied: H. Keller; H. Matzen; G. Kelly; F.C. Cooper. Member: Cleveland SA [47]

GECK, Francis Joseph [Dec,Des,P,T] Boulder, CO b. 20 D 1900, Detroit, MI. Studied: N.Y. Sch. F.&Appl. A.; Univ. Colo.; Syracuse Univ.; John P. Wicker. Member: Boulder A. Gld.; Boulder AA; Mediaeval Acad. Am.; Bibliographical Soc. Am.; Boulder County Hist. Soc.; AAPL. Exhibited: Kansas City AI, 1933; Boulder A. Gld, 1934–46; Denver A. Mus., 1932, 1933, 1938; S.Indp.A., 1934; Kansas State Col., 1937; Ohio Univ., 1945; Univ. Wyo., 1946; Colo. Women's Col., 1942 (one-man); Univ. Colo., 1941; Colo. State Col., 1942; Syracuse Univ., 1944. Author: "French Interiors and Furniture: The Historical Development" (1932), "Bibliographies of Italian Art," other books. Position: T., Univ. Colo., 1930– [47]

GEDDES, Matthew [P] Verona, NJ b. 10 F 1899, Skive, Denmark. Studied: H. Lever; J. Grabach; Denmark. Member: P.&S. Soc., N.J.; AAPL; Asbury Park Soc. FA; Irvington A.&Mus. Assn. Exhibited: Asbury Park Soc., 1940; Irvington A.&Mus. Assn., 1939; AAPL, 1940; CM, 1940; NAD, 1944; Mint Mus. A., 1945; VMFA, 1946; Montclair A. Mus., 1935–45 [47]

GEDDES, Norman Bel [Des,P,Dr,Arch,W] NYC b. 27 Ap 1893, Adrian, MI d. 1958. Studied: self-taught; Cleveland Sch. A. Member: Players Cl.; Arch. Lg.; Stage Des. Cl.; United Scenic Artists; Dramatists Gld. of Authors Lg. of Am.; Mediaeval Acad. of Am. Work: Ballet Stage for Ruth St. Denis; theatrical productions for The Players Club, Metropolitan and Chicago Opera Companies, "The Miracle" "Jeanne d'Arc," "Hamlet," "Lady Be Good," other productions; medal, MMA. Designer: first streamlined Ocean Liner; first ocean-going streamlined yacht; airplane interiors for Pan-Am; Futurama Bldg., WFNY, 1939; furniture; radio cabinets. Author: "A Project for a Theatrical Presentation of The Divine Comedy of Dante Alighieri," pub. by Theatre Arts, Inc., "Horizons," pub. Little, Brown & Co., "Magic Motorways," pub. Random House. Consultant: to Arch. Commission, Century of Progress Expo, Chicago. Popularizer: streamlining [40]

GEE, John [I,Li,T,W] Sarasota FL/Southbridge, MA b. Southbridge. Studied: V.L. George; T. Oakley; J.A. St. John. Member: Cleveland PC; AIC; AFA; Sarasota AA. Exhibited: CMA, 1929 (prize), 1930 (prize). Work: CMA. Illustrator: "Tumbledown Town," "The Timbertoes," other books. Author/Illustrator: "Bunny Bear," "Poor Little Ugly," other children's books. Positions: Staff, Child Life; Consultant, Highlights for Children [47]

GEE, Yun [P,Des,T,S,I,Li,L] NYC b. 22 F 1906, Canton, China d. 5 Je 1963. Studied: Calif. Sch. A.; Chu; Member: AAPL. Exhibited: PAFA, 1941; BM (one-man). Work: Musée de Jeu de Paume, Paris; Univ. Mo.; altarpiece, St. Peter's Lutheran Church, Bronx, N.Y. Creator: "Lunar Tube" [47]

GEER, Grace Woodbridge [Por.P] Boston, MA b. 25 Jy 1854, Boston d. 26 Je 1938. Studied: Mass. Normal Art Sch.; F.H. Tompkins; Triscott; Tarbell; Vonnoh; Lowell Inst. Member: AG Nat. Am. Pen Women: Copley S., 1900. Work: Intl. Inst. for Girls, Madrid, Spain; New England Historic Genealogical Soc., Boston; Hist. Soc., Greenfied, Mass. [38]

GEERLINGS, Gerald Kenneth [P,I,W] Canaan, CT b. 18 Ap 1897, Milwaukee, WI. Studied: Univ. Pa.; M. Osborne; Royal Col. of Art, London; Paul Cret. Member: Arch. Lg.; Chicago SE; SAE. Exhibited: NAC, 1930 (prize); Century of Progress Expo, 1933, Chicago, (prize); PAFA, 1931 (gold); Royal Acad., London, 1929; Paris Salon, 1937; WFNY, 1939; NAC; NAD; PAFA; BM; AIC. Work: Victoria & Albert Mus., London; LOC. Author/Illustrator: "Color Schemes of Adam Ceilings," 1928; "Wrought Iron in Architecture," 1929, other books, Harper's Magazine, Creative Art, International Studio, other magazines [47]

GEHR, James L. [S,T] Milwaukee, WI b. 8 D 1906, Green Bay, WI. Studied: Layton Sch. A.; Goodyear Tech. Inst.; Taliesin, Spring Green, Wis.; Frank Lloyd Wright. Member: Wis. P.&S.; Seven Arts Soc., Milwaukee. Exhibited: Milwaukee AI, 1938 (prize), 1940 (prize); Howard Univ., 1941; Seven Arts Soc.; Wis. P.&S. Work: Milwaukee Pub. Mus. Specialty: animal sculptures [47]

GEHRING, Louis H. [Des,E,L,P,T] Brooklyn, NY b. 2 Ag 1900, Brooklyn. Studied: NAD; abroad. Member: AAPL. Position: T., St. John's Univ., Brooklyn [40]

GEHRING, Meta S. [P] NYC [13]

GEIGER, Caroline [P] Atlanta, GA [04]

GEIGER, Elizabeth de Chamisso (Mrs.) [S] Poughkeepsie, NY. Member: NSS [47]

GEIGER, H.C. [P] Phila., PA [10]

GEISER, Bernard [P,Dec] Portland, OR b. 28 Mr 1887, Geuda Springs, KS. Studied: PAFA; Univ. Oreg.; Mus. Sch. A., Portland; Andrew Vincent; William Givler. Member: Am. Ar. Prof. Lg.; Oreg. Gld. P.&S.; F., Carnegie. Exhibited: SAM, 1939–45, 1946 (one-man); Portland Mus. A., 1938–45, 1946 (one-man); Butler AI, 1941. Work: St. Thomas Church, Denver; SAM; Lindfield Col., McMinnville, Oreg.; Good Samaritan Hospital, St. Mark's Church, Radio Station KOIN, all in Portland; churches, Gunnison, Colo., Long Beach, Wash.; Vancouver (Wash.) H.S. [47]

GEISLER, Frank E. [Photogr] b. 20 S 1867, Hoboken, NJ d. 1 Ja 1935, Palm Beach, FL. Studied: Paris. Member: Royal Photographic Soc. London; Pictorial Photographers Am.; Professional Photographers Cl., New York. Exhibited: Smithsonian; Chicago; Phila.; salons in many countries; Professional Photographers' Annual exhibitions (prizes for six consecutive years)

GEISMAR, Miriam C. [P] Pittsburgh, PA. Member: Pittsburgh AA [25]

GEISSBUHLER, Arnold [S,T,L] Cambridge, MA b. 9 Ag 1897, De Lemont, Switzerland. Studied: Académie Julian, Grande Chaumière, Paris; Switzerland. Member: S. Gld. Exhibited: CI, 1940; World's Fair, Chicago; Salon d'Automne, Salon des Tuileries, Paris; S. Gld.; WFNY, 1939. Work: A. Mus., Berne, Switzerland; FMA, Farnsworth Mus., Wellesley; mem., Loire, France; USPO, Foxboro, Mass. Positions: Wellesley (1937–46), Child-Walker Sch., Boston [47]

GEISSMAN, Robert [I] NYC. Member: SI [47]

GEIST, Gilbert Allen [P,Arch] d. 12 S 1937, Phila. Position: T., Tex. A&M

GEISZEL, John H. [I,E,B,T,L] Phila., PA b. 31 O 1892, Akron, CO. Studied: Stratton; Copeland; Warwick; Oakley; Harding; Garber; E. O'Hara. Member: Phila. Sketch Cl. Work: murals, Mastbaum Vocational Sch., Phila. [40]

GEIZSEL, Margaret Malpass [Dec,I,T] Phila., PA. Studied: PMSchIA. Illustrator: "King Arthur," Robin Hood," other books, commercial booklets [40]

GELB, Jan (Mrs. Jeannette Gelb Margo) [P,T,Li] NYC b. 18 Jy 1906, NYC. Studied: Yale; Sigurd Skou; Picken; Fitsch; ASL. Member: N.Y. Artists U. Exhibited: Morton Gal.; ACA Gal.; Weyhe Gal., 1944; Delphic Studios, 1940 (one-man); Chinese Gal., 1946 (one-man). Position: T., NYC Pub. Schools [47]

GELERT, J(ohannes Sophus) [S] NYC b. 10 D 1852, Nybel, Schleswig, Denmark (came to U.S. in 1887) d. 4 N 1923. Studied: Royal Acad. FA, Copenhagen. Member: NSS; Arch. Lg.; 1898. Exhibited: Nashville Expo, 1897 (gold); AC Phila., 1899 (gold); Paris Expo, 1900 (prize); Pan-Am. Expo, Buffalo, 1901 (prize); AAS, 1902 (gold). Work: Church of All Souls, NYC; monuments, Chicago; statues, Galena, Ill., Brooklyn Inst. A.&Sciences, Vanderbilt Univ., Nashville, Minneapolis, Bergen County (N.J.) Court House, Battle Creek, Mich.; reliefs, Erenshaw Mem., Cincinnati; museums in Denmark AIC; U.S. Custom House, New York [24]

GELHAAR, E [P] Bethlehem, PA [24]

GELLATLY, John [Patron] b. 1853 d. 8 N 1931, New York. In 1929 the U.S. Government accepted the gift of his art collection, valued at $5 million for the National Gallery. It included about one hundred oil paintings, representing some of the choicest works of Whistler, Sargent, Abbott, Thayer, Twachtman and others, twenty-five watercolors and pastels, many rare pieces of pottery, porcelain, and fine jewelry, and a large number of Gothic sculptures, dating back to the fourteenth and fifteenth centuries, in marble, stone and wood.

GELLENBECK, Ann P. [P] Tacoma, WA b. Shakopee, MN. Work: portrait, Bellarmine Col. Prep. Sch., Tacoma [40]

GELLENBECK, Edith Catherine [P] Clifton, OH b. Cincinnati. Studied: Wessel; Meakin; Hopkins; Weis. Member: Cincinnati Women's AC [27]

GELLER, Todros [En,P,C,T,L,I,Li,E,S] Chicago, IL b. 1 Jy 1889, Vinnitza, Russia. Studied: AIC; L. Seyffert; J. Norton; G. Bellows. Member: Am. A. Cong.; Artists U.; Phila. WCC; Chicago SA; A. Lg., Chicago. Exhibited: LOC, 1943 (prize), 1944 (prize), 1945 (prize); AIGA, 1944 (prize), 1945 (prize); AIC, 1925–46. Work: woodcuts, Buckingham Lib., Chicago; Tel-Aviv Mus., Palestine; Osage Mus., Pawhuska, Okla.; stained glass window, Keneseth Israel Temple, Kansas City; Beth-El Temple, Stamford, Conn; woodcuts, Chicago Pub. Lib., Detroit Pub. Lib., Milwaukee Pub. Lib., Hebrew Union Col.; Jewish Mus., Cincinnati; oil, Temple Beth Israel, St. Louis; Biro-Bidjan Mus., USSR; Anshe Emet Synagogue, Chicago. Illustrator: "Great March," by Marie Lurie, 1928; "The Ghetto," by Louis Wirth, 1929, other books, magazines. Lectures: Jewish Art [47]

GELLERT, Emery [P] 24 Jy 1889, Budapest, Hungary. Studied: Papp; Kriesch; Ignace Udvary; G. Udvary. Member: "Feszek," Hungarian AC. Exhibited: Cleveland Mus., 1925 (prize). Work: The Temple, St. Margaret's Church, both in Cleveland; Greek-Cathedral Church, Detroit [40]

GELLERT, Hugo [Mur.P,Gr,Des,Car,I,Dec,Li,W] NYC b. 3 May 1892, Budapest, Hungary. Studied: NAD. Member: Am. A. Cong.; Mural P.; Am. Soc. PS&G. Exhibited: MOMA, 1931; Pepsi-Cola, 1944, 1945; Pal. Leg. Honor, 1945; Graphic Arts Traveling Exh. Work: Workers' Center, Union Square, NYC; Rockefeller Center, NYC.; MOMA; WMAA; PMA; Princeton Univ.; Birmingham Lib.; Mus. Western A., Moscow, Russia; murals, Center Theatre, NYC; Nat. Maritime Un. Communications Bldg., WFNY. Illustrator: "Aesop Said So," pub. Covici-Friede, 1936, "Century of the Common Man," 1943, other books. Author: "Karl Marx 'Capital' in Lithographs," 1934 [47]

GELLETLY, May Florence [P,Min.P,I,Car,C] Baltimore, MD b. 25 My 1886, Baltimore County, MD d. ca. 1955. Studied: Md. Inst.; ASL; Grand Central Sch. A.; NYU; abroad. Member: Baltimore WCC; Am. Ar. Prof. Lg. Exhibited: Md. Inst., 1905 (med) 1909 (med); Paris Salon, 1932; PAFA, 1938; Wash. Min. PS&G, 1939; Nat. Mus., Wash., D.C., 1946. Author: "Chart of Civilizations," 1936 [47]

GELMAN, Aaron [P] Brooklyn, NY b. 24 N 1899. Studied: K.H. Miller; Luks [40]

GELON, Marie. See Cameron, Edgar, Mrs.

GELSAVAGE, John Zygmund [P,Des,E,I,Li] Detroit, MI b. 26 Mr 1909, Old Forge, PA. Studied: Ind. (Pa.) State T. Col.; ASL; Pittsburgh AI; N.Y.-Phoenix Sch. Des. Member: Mich. Acad. A.&Sc.; Scarab Cl. Exhibited: Cincinnati Acad FA, 1934, 1935; AWCS, 1934; New Haven PCC, 1934, 1935; Anderson Gal., New York; Detroit Inst. A., 1933–36, 1944; J.L. Hudson Gal., 1933, 1934; Scarab Cl., 1943, 1944; Ann Arbor Acad. FA, 1938, 1946 [47]

GELWICKS, D.W. (Mrs.) [P] Oakland, CA [10]

GEMBERLING, Grace Thorp [P] Cynwyd, PA b. 31 Jy 1903, Phila. Studied: PAFA; Breckenridge. Member: Phila. All.; North Shore AA. Exhibited: PAFA, 1930 (prize); NAWPS, 1933 (prize) [40]

GENAUER, Emily [Cr,W,L] NYC b. 19 Jy 1911, NYC. Studied: Hunter Col.; Columbia. Member: N.Y. Newspaper Women's Cl.; N.Y Newspaper Gld. Award: N.Y. Newspaper Women's Cl., 1935. Author: "Labor Sculpture," 1937, "Modern Interiors," 1940. Position: A. Cr., New York World-Telegram, 1932– [47]

GENDELL, Agnes [S] Phila., PA [13]

GENDROT, Felix Albert [P,S] Roxbury, MA b. 28 Ap 1866, Cambridge, MA. Studied: Mass. Normal Art Sch.; Académie Julian, Paris, with Laurens, Constant; Puech; Verlet. Member: Boston AC; Paris AAA; Copley S.; AFA [40]

GENTER, Paul Huntington [Dec,Des,P,S] Denver, CO. Studied: M. Gage; Univ. Calif. Exhibited: Seattle, Wash., 1927 (prize); Santa Barbara Lib., 1930 (prize); San Diego, 1930 (prize); Los Angeles, 1931 (prize); Denver, Colo. Chappell House, 1932 (prize); Kansas City, 1932 (prize); Santa Fe, N.Mex., 1934 (prize). Work: fountains, Beverley Hills, CA; numerous hotels and public buildings, Calif., N.Mex., Kans., Colo., Tex. Position: Pres., Broadmoor Pottery, Denver [40]

GENTH, Lillian [P] NYC b. Phila. d. 1953. Studied: Phila. Sch. Des. for Women, with E. Daingerfield; Whistler, in Paris. Member: ANA, 1908; AFA; NAD; Royal Soc. A., London; Union Internationale des Beaux-Arts et des Lettres, Paris; Assoc. F., PAFA; International Soc. AL; All. AA. Studied: PAFA, 1904 (prize); NAD, 1908 (prize), 1911 (prize); International Expo FA, Buenos Aires, 1910 (med); NAC, 1912 (med); Work: CI; MMA; Phila. AC; Brooklyn Inst. A.&L.; NGA; Engineers Cl., New York; Grand Rapids AA; NAC; Rochester Mem. A. Gal.; Muncie AA; Nashville AA; Dallas AA; Des Moines AA; Detroit Cl.; Cremer Coll., Dortsmund, Germany; Newark Mus.; Mus. Los Angeles [47]

GENTHE, Arnold [I,Photogr] NYC b. 8 Ja 1869, Berlin, Germany d. 9 Ag 1942, Candlewood Lake, CT. Studied: Univ. Berlin and Univ. Jena, 1894. Exhibited: Paris, 1928 (gold). Work: 4,000 prints, N.Y. Hist. Soc.; nega-

tives/autochromes, LOC; IMP/GEH; AIC; MMA; NOMA; Oakland Mus. A.; BMFA; NYPL; Archaeologoical Inst., Rhodes. Illustrator: "Old Chinatown," "The Book of the Dance," "Impressions of Old New Orleans," "Isadora Duncan," other books. Author/Illustrator: "As I Remember" (autobiography). He came to San Fran. as a philologist in 1895; worked there as a portrait photographer until 1911, then moved to NYC. [40]

GENTILE, Edward [Des,P,Dr] Oak Park, IL b. 20 Jy 1890, Chicago. Studied: self-taught; AIC. Member: AIGA; Ill. State Hist. Soc. Exhibited: AIC; Marshall Field Gal.; All-Ill. Soc. FA. Work: cover designs, "Compton's Pictured Encyclopedia," " Our Wonder World"; coats of arms. Speciallty: illuminated manuscripts [47]

GENTILUOMO, Guiseppe [P] Astoria, NY [15]

GENTILZ, Theodore [P,T] San Antonio, TX b. 1819, Paris, France (came to Castroville, Tex. in 1844) d. 1906. Studied: Viollet-le-Duc, in Paris. Work: Dallas Mus. FA; Witte Mus. Best known for his genre paintings of early Tex. life. Positions: T., St. Mary's Col., ca. 1879; Surveyor: in Mexico, 1882 [*]

GENTRY, Carl R(ees) [P,T] Fulton, MO b. 10 Ag 1888, New Florence, MO. Studied: J.S. Ankeney; Fontainebleau Sch. FA. Exhibited: Mo. State Fair, Sedalia, 1923 (prize), 1924 (prize), 1926 (prize) [40]

GENTRY, Helen [Book Des.] NYC b. 21 N 1897, Temecula, CA. Studied: Univ. Calif; apprentice, Grabhorn Press, San Fran. Member: AI Graphic A.; AIGA. Exhibited: AIGA, 1931–46, including 50 Books of the Year exhibits; N.Y. Times Hall, 1945. Co-Author: "Chronology of Books and Printing," pub. Gentry Press, 1933, second edition, Macmillan, 1936. Designer: Holiday House, 1935–44, Gentry Press, Simon & Schuster, Noble & Noble, Random House [47]

GENTZLER, Edwin [P] York, PA [17]

GENUNG, Robert [P] Los Angeles, CA. Member: Calif. AC [25]

GEOGHEGAN, Walter [I] NYC. Member: SI [47]

GEORGE, Dorothy Hills (Mrs. D.H. Colby) [T,P,L,W] East Natick, MA b. 1898, Manchester, NH. Studied: State T. Col., Framingham, MA; Simmons Col., Boston; Univ. Calif. Member: Boston AC. Exhibited: Honolulu Acad. A. (one-man); Boston, Mass. (one-man). Position: Dir., Vesper George Sch. A., Boston, 1934–46 [47]

GEORGE, Elsie [P] Wash., D.C. [10]

GEORGE, H. [S] Newton Center, MA [21]

GEORGE, Margaret [P,S] Denver, CO. Member: Denver AA [19]

GEORGE, Richard F. [S] Brooklyn, NY b. 1865, San Fran., CA d. 28 S 1912. Member: NAC; SC, 1902. Work: mem. tablets, Union Square Hotel, NYC. He made portrait busts of many prominent persons. [10]

GEORGE, Vesper Lincoln [P,T] Boston, MA b. 4 Je 1865, Boston d. 10 My 1934. Studied: Constant, Lefebvre, Doucet, in Paris. Member: Boston AC; Arch. Lg.; Mural P.; North Shore AA. Work: public buildings in various parts of the country. Position: Founder/Dir., Vesper George Sch. A., Boston, 1924–34 [33]

GEORGE, W.C. [P] NYC [01]

GEORGE, Wyn [P] Denver, CO [17]

GEORGES, Nelly [E] Paris, France b. Chicago [10]

GEORGESON, Lloyd W. [P] NYC. Member: S.Indp.A. [24]

GEORGI, Edwin [Des,I] Norwalk, CT b. 14 Ap 1896, NYC. Studied: Princeton. Member: SI; A. Dir. Cl. Exhibited: A. Dir. Cl. (medals,prizes). Illustrator: national magazines [47]

GERALD, Elizabeth Bart [P,Des] NYC b. 8 S 1907, Cleveland, OH. Studied: Cleveland Sch. A.; Europe; Lhote, Hofmann; H. Keller. Exhibited: CMA, 1935 (prize), 1939 (prize), 1941 (prize), 1946 (prize); WMAA, 1942, 1945; CI, 1946. Work: WMAA; CMA. Designer: wallpaper, fabrics [47]

GERARD, Allee (Mrs.) [P] Warsaw, IN b. 9 F 1895, Rochester, IN. Studied: Fort Wayne A. Sch.; Miami A. Sch.; H. Davisson; C. Sheperd. Member: Miami A. Lg.; Northern Ind. A. Exhibited: Hoosier Salon, 1944 (prize), 1945, 1946; Northern Ind. Salon, 1944 (prize); Norton Gal., 1942; John Herron AI, 1943; Fort Wayne A. Mus., 1942, 1943, 1945, 1946 [47]

GERARD, David Charles (Dave) [Car] Crawfordsville, IN b. 18 Je 1909, Crawfordsville. Studied: Wabash Col.; Univ. Ariz. Exhibited: Saturday Evening Post Exh., 1943. Cartoonist: Saturday Evening Post, Judge, Country Gentleman, Collier's, other magazines, Hearst papers, New York World-Telegram [47]

GERARD, Paula [Li,P,T] Chicago, IL. Studied: AIC; abroad. Member: Chicago SA. Exhibited: Phila. Pr. Cl., 1937, 1941; Los Angeles Mus. A., 1937; AIC, 1937, 1946; San Fran. AA, 1938, 1945; Phila. A. All., 1938; NAD, 1945; Denver A. Mus.. 1944; Milwaukee AI, 1946; Layton A. Gal., 1945 (one-man). Position: T., Layton A. Sch., Milwaukee, 1945–46 [47]

GERBINO, Rosario Urbino [P,E,Dr,T] NYC b. 23 N 1900, Sicily, Italy. Studied: NAD; G.W. Maynard; C.L. Hinton; I. Olinsky; Hawthorne. Member: Soc. Sanity in Art; Bergen (N.J.) County A. Gld. Exhibited: Jacques Seligmann Gal. (one-man); Chinese Gal.; Da Vinci All.; Grand Central Gal.; Assoc. Am. A.; Ferargil Gal.; CGA; NAD; PAFA; AIC; All.A.Am.. Work: NAD; Mem. Lib., Georgetown Univ. Position: Associated with Leonardo Da Vinci Art Sch., New York [47]

GERDES, Augustus M. [P] New Canaan, CT. Member: SC [25]

GERE, Nellie Huntington [Ldscp.P,Dec,T,L] Los Angeles, CA b. Norwich, CT. Studied: AIC; Vanderpoel; Freer; PIASch; Ipswich Summer Sch., with Dow. Member: Chicago ASL; A.W. Dow Assn. Author: "Outline on Picture Study in the Elementary School." Position: T., Univ. Calif. [40]

GERHARD, George [Por.P] b. 1830, Hanau, Germany (came to U.S. in 1859) d. 10 N 1902, New York. Studied: Paris. Prominent persons who sat for him included General Grant, Senator Depew, Archbishop Corrigan.

GERHARDT, Emma Josephine [I] Dayton, OH b. 24 O 1894, Dayton. Studied: Dayton AI [32]

GERHARDT, Karl [S] New Orleans, LA b. 7 Ja 1853, Boston. Studied: Paris [15]

GERITZ, Franz [B,Dr,E,I,Li,P,T,W] Los Angeles, CA b. 16 Ap 1895, Hungary d. 27 N 1945. Studied: Nahl; Van Sloun, Martinez. Member: Calif. SE. Exhibited: San Diego FA Gal., 1928 (prize); Pacific Southwest Expo, Long Beach (med); Los Angeles County Fair, Pomona, 1936 (prizes). Work: Calif. State Lib., Los Angeles; Berkeley Pub. Lib.; Oakland Pub. Lib.; San Diego FA Gal.; BM; Los Angeles County Lib.; Contra Costa County Lib.; Palos Verdes Pub. Lib.; Alameda County and City Libraries; Los Angeles AA; LOC; Fifty Prints of the Year, 1927. Illustrator: woodcuts, four vols. of Calif. for nine-vol. set for Powell Pub. Co., "Hills of God," other books. Specialty: color woodblock prints. Position: T., Univ. Calif. Extension Div. [40]

GERLACH, Albert A. [Des,C,P,L] Portland, OR b. 26 O 1884, Chicago. Studied: AIC. Member: AAPL; Oreg. Ceramic Soc.; Oreg. SA; Stained Glass Assn. Am. Work: stained glass, Temple Beth Israel, First Baptist Church, St. Andrew's Church, all in Portland; Elsinore Theatre, Salem; Vert Mem. Bldg., Pendleton, Oreg. [47]

GERLACH, Gustave [S] Weehawken, NJ. Member: NSS [10]

GERMER, George E. [Silversmith] Greenville, NH b. 26 My 1868, Berlin, Germany d. 8 D 1936. Studied: O. Gericke. Member: Boston Soc. A.&Crafts. Exhibited: City of Berlin (med); Boston Soc. A.&Crafts (prize); AIC (prize); Albright A. Gal. (prize). Work: gold baptismal office book, Cathedral of St. John the Divine, NYC; silver chalice, Chapel of Gardner Mus., Boston; silver chalice/offertory plate, Detroit AI; Bishop's staff, St. George's Chapel, Newport.

GERNAND, John [P] Arlington, VA b. 19 O 1913, Wash., D.C. Studied: Univ. Ill.; PMG A. Sch. Member: A. Gld., Wash. Exhibited: Whyte Gal., Wash., D.C., 1944; PMG, 1939 (one-man), 1943; Wash. AC, 1945; Bennington Col., 1945. Position: Staff, PMG, 1938– [47]

GERNHARDT, Henry F. [P,E] Framingham, MA b. 30 Je 1872, Des Moines, IA. Studied: C.N. Flagg. Member: CAFA [31]

GERRER, Robert Gregory [P,T] Shawnee, OK b. 23 Jy 1867, Alsace, France. Studied: Ortiz; Nobile; Gonnella; Galliazzi. Member: AFA; Assn. Okla. A. Work: Vatican; Wightman Mem. Gal., Notre Dame, Ind.; Okla. Hist. Bldg., Oklahoma City; Confederate War Mus., Richmond, Va. Positions: Curator: Wightman Mem. Gal., Notre Dame, St. Gregory's A. Gal. [40]

GERRITTY, John Emmett [P] San Fran., CA. Exhibited: GGE, 1939 [40]

GERRITY, Thomas F. [Patron] b. 1873 d. 15 D 1935, New York. Through his association with M. Knoedler & Co. over a period of forty-six years, he was instrumental in the formation of some of the most important collections in the U.S. Position: Pres., Am. Art Dealers Assoc.

GERRY, Robert (Capt.) [Por.P] b. 1909, Cambridge, MA d. 10 Je 1944

(during an action of the Royal Air Force). Lived in NYC and later in London.

GERRY, Samuel Lancaster [P] b. 10 My 1813, Boston d. 1891. Studied: self-taught. Exhibited: Boston Atheneum; PAFA; NAD; Am. Art Un. Traveled in Europe, late 1830s; set up studio in Boston, 1840. [*]

GERSH, Louis [P,I,Car,S] Ozone Park, NY b. 7 Ja 1901, NYC. Studied: Cooper Un.; Phoenix AI, N.Y.; D. Cornwell; E. Watson. Member: S.Indp.A.. Exhibited: S.Indp.A. [40]

GERSHOY, Eugenie [S,P,C,Gr,T] NYC b. 1 Ja 1903, Krivoi Rog, Russia. Studied: Columbia; ASL; Robinson; Sloan; Miller; Calder. Member: An Am. Group; S. Gld.; San Fran. Assn. Women A.; Am. Soc. PS&G; Am. Ar. Cong. Exhibited: Red Cross Nat. Comp., 1941 (prize); AV, 1942 (prize); WMAA, 1931-46; PAFA, 1940; AIC; Delgado Mus. A., 1941; GGE, 1939; WFNY, 1939; BM; MOMA; Robinson Gal., 1940 (one-man); Raymond & Raymond Gal., San Fran., 1943 (one-man); Gumps Gal., San Fran., 1946 (one-man); Downtown, Weyhe, Midtown, Delphic, ACA, Rehn, Milch, Bonestell, other NYC galleries. Work: Astoria (N.Y.) Pub. Lib.; Biggs Mem. Hospital; WMAA; MMA; AIC. Award: St. Gaudens medal [47]

GERSON, Adele. See Robson.

GERSTENHEIM, Louis [P,T] NYC b. 10 Je 1890, Poland. Studied: NAD; abroad. Member: S.Indp.A.; Salons of Am. [27]

GERSTLE, Miriam Alice [P,I,E] London, England b. 9 Mr 1898, San Fran. Work: mural, Royal Links Hotel, Cromer; Royal Bath Hotel, Bournemouth, both in England [31]

GERSTLE, William Lewis [P,L] San Fran., CA b. 28 Ja 1868, San Fran. Studied: ASL; Calif. Sch. FA; R. Taubes. Member: SFMA (Pres.); AAPL; San Fran. AA. Exhibited: Oakland AA; San Fran. AA. Work: SFMA. Position: Treas., SFMA [47]

GERTH, Ruth [I] San Fran., CA d. 13 Ja 1952. Member: SI [47]

GERVASI, Frank [P] NYC b. 5 O 1895, Palermo, Italy. Studied: N.Y. Sch. Indst. A.; ASL, with DuMond, Bridgman, Henri. Member: SC; All.A.Am.; Brooklyn SA; NAC; Studio Gld. Exhibited: SC, 1945 (prize); All.A.Am., 1942-44, 1945 (prize), 1946; NAD, 1938; Albany Inst. Hist.&A., 1936-46; Brooklyn SA, 1937-46 [47]

GEST, J(oseph) H(enry) [P,Mus.Dir] Cincinnati, OH b. 1859, Cincinnati d. 26 Je 1935. Member: NAC; Cincinnati Municipal AC. Member: Nat. Gal. A. Comm. Positions: Dir., Cincinnati Mus.; Pres., Rookwood Pottery [29]

GEST, Margaret Ralston [P] Phila., PA. b. 27 Jy 1900, Phila. Studied: PMSchIA; PAFA; Breckenridge. Member: Phila. A. All.; Phila. WCC; Plastic Cl.; Contemporary Cl. Exhibited: PAFA, 1928-31, 1932 (gold), 1933-46; Phila. Plastic Cl.; Phila. WCC; Phila. A. All. Work: PAFA; Phila. WCC [47]

GEST, Mary T. [P] Phila., PA. Studied: PAFA [25]

GETCHELL, Edith Loring [E] Worcester, MA b. 25 Ja 1855, Bristol, PA. Studied: Phila. Sch. Des. for Women; PAFA. Work: LOC; NYPL; BMFA; WMA; Smithsonian; Walters Coll., Baltimore [25]

GETTIER, C.R. [I] Baltimore, MD. Member: Charcoal Cl. [29]

GETTIER, G. Wilmer [Ldscp.P] Baltimore, MD b. 23 F 1877, Baltimore. Studied: Baltimore; Munich; S.E. Whitman. Member: Charcoal Cl.; Baltimore All.; FA Cl., Baltimore [33]

GETTY, Francis E. [P] Winchester, MA. Member: SC [21]

GETZ, Arthur [P] NYC. Exhibited: N.J. Ar. Annual, Am. Ar. Prof Lg., 1934; NYWCC, 1934. Work: USPO, Lancaster, N.Y. WPA artist. [40]

GETZ, Arthur, Mrs. See Gibbons, Margarita.

GETZ, John [W] b. 1854 d. 2 Je 1928, New York. Awards: Knight of the Legion of Honor of France; Order of the Crown of Italy. For thirty years he was well known to art dealers and connoisseurs here and abroad. His writings include a handbook for the Garland Collection of Porcelains in the Metropolitan Museum, catalogues, monographs, and magazine articles; he had an important work on Chinese Art in progress at the time he died. In 1900 he had charge of the Decorative Art Exhibit of the U.S. at the Paris Expo, and served on exhibition committees for the National Academy of Design, American Fine Arts Society, and others.

GEYER, Harold C. [E] NYC. Member: SAE [47]

GEYER, Joseph M. [P] Cincinnati, OH b. 12 S 1911, Cincinnati. Studied: Ohio Mechanics Inst.; Bridgman; D. Seldon. Exhibited: Cincinnati Ar. Exh., 1939. Work: murals, Wyoming (Ohio) H.S. WPA artist. [40]

GEYLER, Ida L. [P,Des,C,B,I] Cincinnati, OH b. 17 Dec 1905. Studied: Cincinnati Acad., H.H. Wessel; F. Myers; J.E. Weis; PAFA; L. Kroll; J. Lie; G. Harding; R.C. Nuse. Member: Cincinnati Women's AC; Crafters Co. Work: Univ. Cincinnati [40]

GHARIS, Charles (Mason Tudor) [P] Dallas, TX b. 12 Ap 1910, Dallas. Studied: Reaugh; L. Goff; Mrs. B. Bonner. Member: Reaugh AC; Dallas AA [33]

GHIRARDELLI, Alida [P] San Fran., CA [08]

GHOSN, Assad [Por.P] Richmond, VA b. 20 Mr 1877. Studied: Regio Inst. di Belle Arti, Rome [40]

GIACOMANTONIO, Archimedes Aristedes Michael [S,P,C] Jersey City, NJ b. 17 Ja 1906, Jersey City. Studied: Da Vinci A. Sch.; Acad. FA, Rome; O. Ruotolo; V. Gemito. Member: NSS; AAPL. Exhibited: Montclair AM, 1936 (med). Work: State House, Trenton; Bayview (N.J.) cemetery; mon., Hoboken; M. Mussolini, Rome; Villa Torlonia, Forli; Royal Palace, Rome [47]

GIAMMARTINI, Achille [S] Pittsburgh, PA b. 1861 d. 20 My 1929, Atlanta

GIANTVALLEY, Elinor T. [P,I,E] St. Paul, MN [19]

GIBB, William R. [I] b. 15 Mr 1888, Chicago, IL. Studied: J.F. Smith [10]

GIBBINGS, Robert [En,E] Los Angeles, CA. Member: Calif. PM [24]

GIBBO, Pearl [I,Car,Des] Malone, NY b. 6 Je 1900, Malone. Exhibited: de Young Mus., San Fran, 1939. Work: Index Am. Des., WPA [40]

GIBBONS, Caroline L. [P] Phila., PA. Studied: PAFA [21]

GIBBONS, Margarita (Mrs. Arthur Getz) [P] NYC b. 18 Ag 1906, NYC. Studied: ASL; PIASch; abroad. Member: A. Lg. Am.; NAWA; S.Indp.A. Exhibited: ACA Gal., Norlyst Gal., Newhouse Gal., RoKo Gal., all in NYC; Argent Gal., 1946 (one-man) [47]

GIBBS, George [Dec,I,P,W] Rosemont, PA b. 8 Mr 1870, New Orleans d. 10 O 1942. Studied: CGA Sch.; Wash. ASL. Member: Phila. Alliance; Phila. AC. Author/Illustrator: "American Sea Fights," "Tony's Wife," "The Yellow Dove," more than forty other novels and historical tales [40]

GIBBS, H. Phelan [P] NYC [13]

GIBBS, Howard M., Jr. [P] Boston, MA. Exhibited: PAFA, 1934; WFNY, 1939 [40]

GIBBS, Jo (Mrs. Josephine S.) [Cr,W] NYC b. 20 Ag 1906, Franklin, IN. Studied: Col. Indst. A., Denton, Texas; Sullins Col., Bristol, Va.; AA; Univ. Colo.; Columbia Univ. Author: "IBM: 1936-46," for symposium; "Work for Artists: What? Where? How?," 1947. Contributor: New Yorker. Positions: Ed., Art Digest, 1943- , The Overlook, Woodstock, N.Y., 1931-32 [47]

GIBBS, (Theodore) Harrison [S] Rosemont, PA b. 1908, Phila. d. 28 D 1944, France, WW II. Awards: posthumously, PAFA gold medal, 1945; Prix de Rome, sculpture, 1936. Position: T., Cornell [40]

GIBERSON, Anna [P] NYC b. 2 My 1879, Brooklyn, NY. Studied: N.Y. Sch. A.; Colarossi Acad., Ecole des Beaux-Arts, both in Paris [06]

GIBRAN, Kahlil [P,W] NYC b. 1883 (came to U.S. ca. 1910) d. 1931. A Lebanese artist, mystic, poet, and dramatist, his best-known book is "The Prophet." [15]

GIBSON, Charles Dana [I,P] NYC/Dark Harbor, ME b. 14 S 1867, Roxbury, MA d. 23 D 1944. Studied: ASL; Saint Gaudens; Académie Julian, Paris. Member: Cornish (N.H.) Colony; SI 1902; NIAL; Por. P.; ANA; NA 1932. Exhibited: Pan-Am. Expo, Buffalo, 1901 (med). Author/Illustrator: "Sketches in London," "People of Dickens," "Education of Mr. Pipp" [40]

GIBSON, Cora Purviance [P,T] Phila., PA. b. 6 Ag 1904, Phila. Studied: Breckenridge, PAFA. Member: Plastic C.; North Shore AA. Exhibited: F. PAFA, 1930 (gold); Plastic C., 1931 (gold) [40]

GIBSON, Harry Lee [S] Dallas, TX b. 2 D 1890, Arrington, KS. Studied: R.M. Gage, Washburn Col.; A. Polasek, AIC. Exhibited: ASL, Chicago, 1922 (prize); Milwaukee AI, 1928 (prize). Work: panels, Masonic Temple, Wichita, Kans.; Mulvane Mus., Topeka, Kans.; Charcoal C., Baltimore [40]

GIBSON, Katharine (Mrs. Frank Wicks) [W,T] Cleveland, OH b. 13 S 1893, Indianapolis. Member: AA Mus. Author: "Tell It Again," 1942, "Bow Bells," 1943, "Arrow Fly Home," 1945, other children's books.

Positions: Consultant, Artists and Writers Guild, NYC; T., CMA, 1946–[47]

GIBSON, L.J. [Min.P] NYC [19]

GIBSON, Louise Blinn (Mrs. Thomas L.) [Des,I,Ldscp.P] Cincinnati, OH b. 27 Ag 1900, Glendale, OH. Studied: C.W. Hawthorne; PIASch; Cincinnati A. Acad.; Ecole des Beaux-Arts. Member: NAWPS; Women's Art C., Cincinnati. Author/Illustrator: children's books [47]

GIBSON, Lydia [P,I] Croton-on-Hudson, NY b. 29 D 1891, NYC. Studied: Fraser; Bourdelle; Guerin; Varnum; Poor. Member: S.Indp.A.; Salons of Am. [33]

GIBSON, Mary. See Kremelberg.

GIBSON, Mestre Lydia [P] San Francisco, CA [19]

GICHNER, Joanna. See Kendall.

GIDDENS, Philip H(arris) [E] NYC b. 15 O 1898, Cuthbert, GA. Studied: Ecole Nationale des Beaux-Arts, Paris. Member: Soc. Am. E.; Chicago SE; Arch. Lg. Exhibited: Grand Salon, Paris, 1923; Southern Artists' Exh., Nashville, 1925 (prize). Work: MET; NYPL; BM; LOC; British Mus.; Victoria & Albert Mus.; Contemporary Soc. English Et.; Bibliothèque Nationale, Paris; AIC [40]

GIDDINGS, Albert F. [P,E] Chicago, IL b. 12 F 1883, Brenham, TX. Studied: AIC; F.W. Freer. Member: Chicago ASL; Lg. AA [24]

GIDDINGS, Frank A. [P,E] Hartford, CT b. 3 D 1882, Hartford. Studied: Chase. Member: CAFA [25]

GIDEON, Samuel Edward [P,W,L,T] Austin, TX b. 9 D 1875, Louisville, KY. Studied: R. Turner; MIT; Harvard; Columbia; L'Ecole des Beaux-Arts; Fountainebleau, with Gorguet, Duquesne, Despradelle, Carlu. Member: Tex. FAA; SSAL; AIA; Laguna Beach AA; G. Austin A., Tex. Author: "Historic and Picturesque Austin" (illustrated), articles on landmarks for architectural magazines. Specialty: arch. subjects, including the old Calif. missions [40]

GIDWITZ, Rose (Mrs. J.) [P] Chicago, IL. Exhibited: Ar. Chicago, Vicinity Ann., AIC, 1934, 1935, 1937; All. Ill. Soc. FA, 1937 (one-man) [40]

GIEBERICH, O(scar) H [P,E] NYC b. 25 Mr 1886, NYC. Studied: ASL; C.W. Hawthorne. Work: BM [40]

GIES, Joseph W. [P] Detroit, MI b. Detroit. Studied: Paris, with Bouguereau, Robert-Fleury; Royal Acad. Munich. Member: Scarab C. Work: Detroit Inst. [26]

GIESBERT, Edmund W. [P,W,Des,L,I,T] Chicago, IL b. 1 Je 1893, Neuwied, Germany. Studied: AIC; Acad. FA, Vienna; Paris, with G. Bellows, Lhote; C.W. Hawthorne. Member: Chicago SA. Exhibited: Acad. FA, Vienna, 1927 (prize); AIC, 1929 (med); A. Dir. Cl., 1944 (med); BM. Positions: T., AIC, 1929– , Univ. Chicago, 1928– [47]

GIESE, Augustus F. [P] NYC. Member: S.Indp.A [24]

GIFFARD, Walter Damon [P,T,Des] Kansas City, MO b. 5 D 1909, Honolulu. Studied: PMSchIA; A. Broduitch. Exhibited: Kansas City SA (prize). Position: T., Kansas City AI [40]

GIFFEN, Lilian [W,L,T] Baltimore, MD/Gloucester, MA. b. New Orleans. Member: NAWA; Phila. A. All.; Wash. AC; North Shore AA; Rockport AA; New Orleans AA; SSAL; AAPL; New Orleans A.&Cr. C.; Gloucester SA; AFA; Miss. AA; NAC; Lg. Am. Pen Women. Exhibited: PAFA; Phila. WCC; AWCS; Wash. WCC; SSAL; New Orleans AA; North Shore AA; Ogunquit A. Center; Phila. A. All.; BMA; Wash. AC; NAWA; Baltimore WCC, 1925 (prize); Lg. Am. Pen Women, 1926 (prize) [47]

GIFFORD, Charles B. [Mar.P,Ldscp.P,Li] b. 1830, MA d. probably New Bedford, MA. Active in San Fran., 1860; New Bedford, MA, 1877. Work: Peabody Mus., Salem. His fine landscape views were published by several lithographic firms in the 1860s, including his own, Gray & Gifford, in 1868, 1869, 1872 [*]

GIFFORD, Elizabeth Watt [P,L] Phila., PA b. 23 O 1885, Phila. Studied: M. Gray; W. Hoffsteader; F. Whiting. Member: Phila. Plastic Cl.; S.Indp.A.; Graphic Sketch C. Exhibited: Vendôme Gal.; Morton Gal.; Montclair AM; Ogunquit A. Center [47]

GIFFORD, Frances ("Fannie") Eliot (Mrs. R.S.) [P,I] New Bedford, MA b. 3 S 1844, New Bedford, MA. Studied: her husband, CUASch; S.L. Gerry, Boston. Specialty: birds. Illustrator: Teddy Roosevelt's "Hunting Trips of a Ranchman," 1885. Married R.S. Gifford, 1873. [17]

GIFFORD, Robert Gregory [P,E,I,T,W] NYC/Louisville, KY b. 10 D 1895, West Medford, MA. Studied: BMFA Sch.; Fenway Sch. Illus.; Livingston Pratt's Stage Des. Sch.; N.Y. Sch. Appl. A. Member: Duxbury AA; Rockford AA; Wash. County Assn. FA; W.Va. All. A. Exhibited: BMFA Sch. (prize); Am. Acad., Rome, 1922 (prize); W.Va. All. A. Work: Duxbury Hist. Assn.; Manufacturers C., Phila. Designer: stage sets, bookplates [47]

GIFFORD, Robert Swain [P,I,Et,T] NYC b. 23 D 1840, Island of Naushorn, MA d. 15 Ja 1905. Studied: Albert Van Beest, B. Russell; W. Bradford, New Bedford, late 1850s. Moved to Boston, 1864; then to NYC, 1866. Member: ANA, 1867; N.Y. Etching C.; NA, 1878; SAA, 1877; AWCS; SLP; NAC; Royal Soc. Painters-Etchers, London. Exhibited: NAD, 1863–99; Cent. Expo, Phila., 1876 (gold); Pan-Am. Expo, 1901 (gold); Charleston Expo, 1902 (gold). Illustrator: Picturesque America, 1872; "Harriman Alaska Expedition," 1901. He traveled extensivlvey, painting in Oreg. and Calif. in 1869, and later went to Europe, Algiers and Egypt. Position: T., CUASch., 1866–96 [04]

GIFFORD, Sanford Robinson [P] b. 10 Jy 1823, Greenfield, NY d. 24 Ag 1880, NYC. Studied: NYC, J.R. Smith, ca. 1845; worked in NYC until 1855, then studied in Europe until 1858. Member: NA, 1854; Century; Union Lg. Cl. Exhibited: NAD; Am. Art-Union. Work: Nat. Gal.; CGA; N.Y. Hist. Soc.; MET; AIC; Amon Carter Mus. An important Hudson River school luminist, he was also one of the few artists to fight in the Civil War. In 1870 he traveled with Kensett and Whittredge in the Rockies, and in 1874 sketched along the coast from Calif. to Alaska. [*]

GIGER, Vera M.R. (Mrs. Walter) [P,B,L,T] Zurich, Switzerland b. 12 O 1895. Studied: O. Beck, PIASch; Teachers Col., with J. Martin; ASL, with B. Robinson, J. Sloan. Member: Milwaukee A. Gld. Exhibited: Wis. Salon of Art, Univ. Wis., Madison, 1936 (prize) [40]

GIGLIO, Dante R. [P,S] Boston, MA b. 4 S 1914. Studied: O. Giglio. Member: Ar. U. Work: St. Leonard's Church; Michelangelo Auditorium, Boston. Position: T., South Bay Univ. [40]

GIGUERE, George [I] NYC. Member: New Rochelle AA; GFLA [27]

GIHON, A(lbert) D(akin) [Ldscp.P,T] Paris, France. b. 16 F 1866, Portsmouth, NH. Studied: Eakins; Constant; Laurens; Ecole Des Arts Decoratifs. Member: F., PAFA. Exhibited: Paris AAA, 1900 (prize), 1901 (prize). Work: Luxembourg Mus., Paris [40]

GIHON, Clarence Montfort [P] Paris, France b. 25 O 1871, Phila. d. 1 Ja 1929. Studied: Chase; Cox; Laurens; Constant. Member: Paris AAA. He lived in Paris about 35 years, painting the streets of Paris and the French countryside. [27]

GIKOW, Ruth [P,I,Ser,T,Car] NYC b. 24 D 1913, Russia. Studied: CUASch. Member: United Am. Ar. Exhibited: Weyhe Gal., 1946 (one-man); Nat. Serigraph Gal., 1947 (one-man); Rockefeller Center; GGE, 1939. Work: MMA; MOMA; PMA; murals, Rockefeller Center. WPA muralist. Illustrator: "Crime and Punishment," 1946. Position: T., Am. Ar. Sch. Inc. [47]

GIL, Michele Accolti [S] NYC b. 2 D 1876, Conversano, Italy (came to U.S. in 1903). Studied: Acad. Naples, with Dorsi; Florence, with Rivalta, Zocchi [04]

GILBERT, Arthur Hill [P,T] Monterey, CA b. 10 Je 1894, Chicago. Studied: Northwestern Univ.; Univ. Calif. Member: Carmel AC; ANA, 1930; San Fran. Bohemian C.; Calif. AC; SC; Laguna Beach AA. Exhibited: PAFA; AIC; Laguna Beach AA, 1921; Orange County Exh., 1921 (prize), 1928 (prize); Sacramento State Fair, 1922 (prize); Painters of the West, 1927; Springville, Utah Ann., 1927; NAD, 1929 (prize), 1930 (prizes); Santa Cruz AL, 1945 (prize). Work: Springville Col.; Mission Inn, Riverside, Calif.; Riverside Women's C. [47]

GILBERT, Caroline [P,T] St. Paul, MN b. 12 Ja 1864, Pardeeville, WI. Studied: A. Dow. Member: Montparnasse C. Exhibited: Minn. State Fair, 1920 (prizes), 1935 (prize); Twin City Exh., 1922 (prize) [40]

GILBERT, Cass [Arch] b. 24 N 1859, Zanesville, OH d. 17 My 1934, Brockenhurst, England. Studied: MIT. Member: Chairman, U.S. Council FA; Chevalier, Legion of Honor; AIA; Arch. Lg. (founder); AAAL; NA, 1908, 1926–33. As early as 1899 he was considered one of the best American architects. Father of the modern skyscraper, he designed the 60-story Woolworth Bldg., NYC. At the time of its erection no building of its height (792 feet) had been built, and it became a subject for many artists. He was awarded numerous gold medals both here and abroad for his architecture.

GILBERT, Charles Allan [I,P] NYC b. 9 S 1873 d. 20 Ap 1929. Studied: ASL; Paris, with Constant, Laurens; C.N. Flagg. Member: SI, 1904;

CAFA. Work: camouflaging ships, Liberty Loan Posters (during WWI). Illustrator: "Women of Fiction," "A Message from Mars"; magazines. The choice of art as a career was partly due to his invalidism during his boyhood, when he turned to sketching for recreation. [27]

GILBERT, Dorothy [P] Portland, OH [21]

GILBERT, Grace [C] Englewood, NJ b. 20 My 1872, Toledo. Specialty: hand-dyeing velvets [40]

GILBERT, Isolde Therese [P,Dr] Cambridge, MA/Harrington, ME b. 6 Ap 1907. Studied: Mass. Sch. A.; BMFA Sch. [40]

GILBERT, James I. [P] Topeka, KS. Exhibited: Midwest A. Ann., AI Kansas City, 1935–39; Tex. Centenn. Expo, Dallas, 1936; WFNY, 1939 [40]

GILBERT, John C. [Car] d. 13 Ap 1905, Three Rivers, MI (drowning)

GILBERT, Louise Lewis (Mrs. John) [P,E] Seattle, WA b. 9 Mr 1900, Detroit, MI. Studied: Univ. Wash.; L. Derbyshire; M. Tobey; E. Ziegler. Member: Lg. Am. Pen Women; Women Painters of Wash.; Northwest WCS; Northwest PM; Pacific Coast PS and Writers. Exhibited: Women Painters of Wash., 1937, 1941, 1942, 1944 (prizes); SAM, 1933–46; Portland AM, 1936, 1939; Oakland A. Gal., 1934; PAFA; Northwest WCS, 1943 (prize); Western Wash. Fair, 1946 (prize); Wash., D.C. AC, 1934 (med); Wash. State Fair, Puyallup, 1936 [47]

GILBERTSON, Boris [S] Cornucopia, WI b. 7 My 1907, Evanston, IL. Studied: AIC; Member: Chicago Ar. U. Exhibited: PAFA, 1943, 1944; CGA, 1937; WMAA, 1936; AIC, 1933 (prize), 1943 (prize). Work: USPOs, Fond du Lac, Janesville, both in Wis.; Dept. Interior Bldg., Wash., D.C.; mem., Dubois, Wyo.; Beloit College. WPA artist. [47]

GILBERTSON, Warren Anthony [S] Chicago, IL b. 7 Ag 1910, Watertown, WI. Exhibited: AIC, 1933, 1935, 1938. WPA artist. [40]

GILBREATH, Etta M. [P] Chicago, IL [04]

GILCHRIST, Adelaide [P] Elm Grove, WV [01]

GILCHRIST, Douglas [C,P,T] Lansdowne, PA b. 17 D 1878, Ishpeming, MI. Studied: PAFA. Designer: jewelry, silverware, objects in copper, brass, lead, wood. Position: T., PMSchIA [40]

GILCHRIST, Emma S. [P] Charleston, SC. Member: Carolina AA; SSAL [31]

GILCHRIST, John M., Mrs. See Addison, Agnes.

GILCHRIST, Meda [P] Los Angeles, CA. Member: Calif. AC [25]

GILCHRIST, William Wallace, Jr. [P] Brunswick, ME b. 2 Mr 1879 d. 4 N 1926. Studied: PAFA; Munich; Paris; London. Member: AC Phila.; Phila. WCC; SC; friend of Winslow Homer. Exhibited: P.-P. Expo, 1915; Phila. Sequi-Centenn. (med); Portland, Mass., 1917; Bowdoin Col., 1927; NAD, 1908 (prize); Wash. SA, 1914 (gold); Phila. AC, 1914 (gold). Work: Cincinnati Mus.; Barridoff Gal., Portland, Maine; Bowdoin Col.; Phila. AC [25]

GILDER, Helena de Kay [P] NYC b. 1846 d. 28 My 1916. Studied: CUASch; Dresden. Specialties: flowers; portraits; ideal figures. Widow of Richard Watson Gilder. Granddaughter of Joseph Rodman Drake, the poet, and sister of Charles de Kay, the art writer. It was at her home that the Author's C. had its inception and that the Society of American Artists was founded.

GILDER, Robert F(letcher) [Ldscp.P] Wake Robin, NE b. 6 O 1856, Flushing, NY d. 1940. Studied: A. Will; Univ. C., Omaha; St. Paul Inst.; Amherst; Joselyn Mem., Omaha; Univ. Nebr., Lincoln; and many schools in Nebr. Specialties: Nebr. landscapes; Ariz. desert. Position: noted archaeologist, Univ. Nebr., for 12 yrs. [40]

GILDERSLEEVE, Beatrice (Mrs. C.C.) [P,C] Felton, CA b. 28 Ja 1899, San Fran. Member: San Fran. S. Women A.; Santa Cruz AL [33]

GILE, Selden Connor [P] Belvedere, CA b. 20 Mr 1877, Stow, ME. Studied: P. Nahl; F. Van Sloun; S. Macky; W.H. Clapp. Member: Marin County AA. Exhibited: Santa Cruz, 1929 (prize); Vallejo AG, 1929 (prize); Oakland Ann., 1933 (prize), 1935, 1936. Work: Belvedere Pub. Lib. [40]

GILES, Ellen [P,W] b. 1874 d. 15 Ja 1914, Rome, Italy. Studied: Sch. Des., Phila.; Bryn Mawr

GILES, Evelyn Carter (Mrs. Howard) [P] South Woodstock, VT. Exhibited: Gal. Mod. Masters, Wash., D.C., 1938 (one-man) [40]

GILES, Horace P. [P] Boston, MA [06]

GILES, Howard [P,L] Woodstock, VT b. 10 F 1876, Brooklyn, NY d. 31 O 1955. Studied: ASL; Mowbray; Hambridge; Ross. Member: ANA; NA 1929; A. Fund S.; A. Gld.; AIGA; Century Assn.; Phila. WCC. Exhibited: SC, 1915 (prize); Phila. WCC, 1917 (prize), 1928 (prize); CI, 1921 (prize); AIC, 1918, 1921 (prize); Montclair AA, 1933 (prize); NAD, 1918 (gold); Sesqui-Centenn. Expo, Phila., 1926 (gold); PAFA, 1932 (gold). Work: PAFA; AIC; BM; BMFA; FMA; San Diego FA Soc.; Denver AM; Houston Mus.FA; Wood A. Gal., Montpelier. Vt.; Decatur, Ill. AI; Vanderpoel Coll. Position: Dean Emeritus, FA Dept., Roerich Mus., NYC [47]

GILIEN, Ted [P] NYC. Exhibited: 48 States Comp., 1939 [47]

GILKISON, A.H. (Mrs.) [P] Pittsburgh, PA. Member: Pittsburgh AA [25]

GILL, De Lancey [P] Wash., D.C. Member: S. Wash. A. [27]

GILL, Frederick James [P,T] Phila., PA b. 30 My 1906, Phila. d. 1974. Studied: PMSchIA; Univ. Pa.; C. Woodbury; C. Ricciardi. Member: Phila. A. All.; Phila. WCC; Chester County AA; Phila. Sketch C.; DaVinci A. All.; Am. Ar. Prof. Lg. Exhibited: PAFA, 1937, 1938, 1942, 1945; NAD, 1944–46; Butler AI, 1945, 1946; Chester County AA, 1937, 1938 (prize), 1939 (prize), 1940; Phila. A. T. Exh., 1936–42, 1943 (prize), 1944 (prize), 1945 (prize), 1946; Phila. Sketch C., 1939–43; Woodmere A. Gal., 1940–46; Warwick Gal., Phila., 1939 (one-man); Phila. A. All., 1945 (one-man). Work: Bd. Edu. Bldg., Phila.; Millersville State T. Col. Position: T., Central H.S., Phila., 1930– [47]

GILL, James D. [Dealer] Springfield, MA b. 1850 d. 22 My 1937. He was one of the first dealers to specialize in the works of American artists, and staged an annual exh. of American work for half a century.

GILL, Marquita [P] Boston, MA [01]

GILL, Mary Wright [P] Wash., D.C. [01]

GILL, Paul Ludwig [P,T] Wynnewood, PA b. 14 Mr 1894, NYC d. 30 My 1938. Studied: PAFA; G. Harding; H. McCarter; F. Wagner; D. Garber; Acad. Colarossi, Paris. Member: Phila. WCC; SC; AWCS; NYWCC; Phila. Alliance; Traveling F., AIC, 1926. Exhibited: AIC, 1926 (prize); Sesqui-Centenn. Expo, Phila., 1926 (med); NYWCC, 1927 (prize); Phila. WCC, 1927 (prize); AWCS, 1929 (prize); Mr. and Mrs. Exh., NYC, 1933 (prize). Work: BM; La France Inst., Phila.; Canajoharie AG, N.Y.; Hackley A. Gal., Muskegon, Mich. Positions: T., Moore Inst. and Sch. of Des. for Women, Phila., Syracuse Univ. (summer sch.) [38]

GILL, Rosalie L. (wife of Count De Chalon) b. Elmira, NY d. 27 Ja 1898, Paris. Studied: ASL (at age 12). Exhibited: Paris Expo, 1889; World's Columbian Expo, 1893

GILL, S. Leslie [P] Providence, RI b. 12 My 1908, Valley Falls, RI. Studied: J.R. Frazier, W. Hawthorne. Work: RISD Mus. [33]

GILL, Sue May (Mrs. Paul) [P,S] Wynnewood, PA b. Sabinal, TX. Studied: PAFA (Fellow); Académie Julian, Paris. Member: Phila. A. All.; Ten Phila. P.&S.; NAWA; Phila. Plastic C.; PBC. Exhibited: PAFA, 1922 (prize); NAWA, 1932–33 (prize); Women's Achievement Exh., Phila. 1933 (prize); Phila. Sketch C., 1943 (prize); Phila. Plastic C., 1943 (prize), 1946 (prize); Ogunquit A. Center, 1931 (prize). Specialties: portraits, flowers. Position: T., Syracuse Univ. (summer school) [47]

GILLAM, Frederick Victor [Caric,Car] NYC d. 29 Ja 1920. Member: N.Y. Press; Lotos C. For twenty yrs. he was with "Judge"; also cartoonist on St. Louis Post Dispatch, Denver Times, New York World, New York Globe [10]

GILLAM, W(illiam) C(harles) F(rederick) [E,P,Arch,Des,Dr,I] Burlingame, CA b. 14 O 1867, Brighton, England. Member: Calif. SE. Exhibited: Calif. State Fair, 1930 (prize). Work: State Lib. Print Rooms, Sacramento; St. Paul's Episcopal Church, Burlingame; St. David's Episcopal Church, Pittsburgh; Church of Latter Day Saints, Elmhurst and Oakland; Hambrook House, Sussex, England; Provincial Normal Sch., Victoria; Queen Mary H.S., Vancouver, B.C. [40]

GILLEN, Denver Laredo [I,P] Chicago, IL b. 8 Jy 1914, Vancouver, British Columbia. Studied: Black Mountain Col.; F. Varley; J. Albers. Member: A. Gld. Chicago; Chicago A. Lg. Exhibited: Canadian WC Exh., Toronto, 1937; AIC, 1945, 1946. Contributor: Collier's, Esquire, other publications [47]

GILLESPIE, George [P] Pittsburgh, PA. Member: Pittsburgh AA [21]

GILLESPIE, Jessie (Mrs. J.G. Willing) [Des,I,W,L] NYC b. Brooklyn. Studied: PAFA. Member: NAC; AIGA. Illustrator: "The Bird's Christmas Carol," 1941, "Living with the Family," 1942, "Little Goody Two Shoes," 1944, other books [47]

GILLESPIE, Jimmie Otten (Mrs. Thad R.) [P,Dec,T,L] Cincinnati, OH. Studied: AIC. Member: Ohio WC Soc.; Women's AC, Cincinnati; Am.

A. Prof. Lg. Exhibited: Cincinnati AM, 1939; Women's AC. Position: T., Univ. Cincinnati Evening Col. [40]

GILLESPIE, John [P] McConnellsville, OH b. 15 My 1901, Malta, OH. Studied: Sch. Columbus Gal. FA. Member: Columbus A. Lg.; Ohio WCS. Exhibited: Columbus A. Lg., 1924 (prize) [33]

GILLESPIE, Joseph [S] Chicago, IL b. 1871, Lincoln, IL [04]

GILLESPIE, Ruth Budd [E,B] Phila., PA b. 15 N 1898, Phila. d. 1935. Studied: J. Fincken; PAFA, at Chester Springs [32]

GILLET, John C. [P] NYC [01]

GILLETLY, May A. [P] Baltimore, MD [24]

GILLETTE, Frances W. [Mur.P,Des] La Verne, CA b. 21 F 1880, Humboldt, IA. Studied: Pomona Col. A. Dept. Member: Calif. Mural P. Work: mural panels, Calif.-Pacific Intl. Expo, San Diego. Originator: tin-can flowers for beach homes and roof gardens [40]

GILLETTE, L(ester) A. [P,T] Topeka, KS b. 5 O 1855, Columbus, OH. Studied: Hill; Williams; Chase; Jacobs; Carlson; AIC. Member: Gloucester SA; North Shore AA [40]

GILLETTE, William B. [P,E] b. 1864, Nova Scotia d. 31 Jy 1937, New York. Specialty: marine life

GILLIAM, A.W. [P] Boulder, CO [25]

GILLIAM, Marguerite. See Hubbard.

GILLIS, Richard W. [P] NYC. Member: Baltimore WCC [25]

GILLOOLY, Wilhelmina R. (Mrs. James E.) [Des,P,I] East Providence, RI b. 23 Ag 1895, Providence. Studied: RISD; BMFA; Denman Ross; H.H. Clark. Member: Boston Soc. A. & Cr. Published: "Book of Remembrance." Work: Center Congregational Church, Providence [47]

GILMAN, Benjamin Ives [W,L] b. 19 F 1852, NY d. 18 Mr 1933, Boston. Member: BMFA (Sec. for 32 years); Am. Assoc. Mus. Author: "Manual of Italian Renaissance Sculpture," 1904, "Hope Melodies," "Museum Ideals"

GILMAN, Ben Ferris [P] Phila., PA [01]

GILMAN, Grace Canedy [P] Sodus, MI b. Wauconda, IL. Studied: AIC; H.F. Spread; N.Y. Sch. A.; W.M. Chase [13]

GILMAN, Helen Ethel [Por.P,I,Car] Boston, MA b. 12 Je 1913, Boston. Studied: BMFA Sch.; Harvard. Member: Bay State A. Gld. Exhibited: Intl. Expo, Paris, 1937; MMA; BMFA; FMA; Marshall Field Gal.; AGAA; Wellesley Col.; WFNY, 1939. Work: BMFA; MMA; Franklin Delano Rossevelt Coll., Hyde Park, N.Y. WPA artist. Contributor: New York Times, Fortune [47]

GILMORE, Ada [P,En] Provincetown, MA b. 17 Je 1882, Kalamazoo, MI. Studied: Henri, in N.Y.; AIC; Paris. Work: Municipal A. Commission, Chicago. Specialty: wood engraving [21]

GILMORE, Ethel M. [P,E,T] NYC b. NYC. Studied: Hunter Col.; Columbia; A. Dasburg; C.J. Martin; O. Chaffee; G.E. Browne; A. Hibbard; L. Stevens; H. Snell. Member: NAWA; All.A.Am.; P.&S. Soc., N.J.; Gotham Painters; Wolfe AC. Exhibited: Wolfe AC, 1938, 1939; NAWA, 1938-46; All.A.Am., 1939-45; Audubon A., 1945; P.&S. Soc., N.J., 1945, 1946; WFNY, 1939; Argent Gal., 1938-46; Gotham Painters, 1944-46; High Mus. A., 1943; Currier Gal., 1940 [47]

GILMORE, Marion [P,I,Car,T] Ottumwa, IA b. 7 My 1909. Studied: Sch. FAC, Boston; ASL; Am. Acad., Chicago. Exhibited: 48 Sts. Comp., Corning, Ia. (prize); Ia. State Fair; Ottumwa A. Center; Mem. U., Ames. WPA artist. Position: T., Community A. Center, Ottumwa [40]

GILMORE, O(ctavia) C. [P] Wash., D.C. b. 1 F 1890, Hellensburgh, Scotland. Studied: Noel, in Rome [17]

GILMORE, Priscilla Alden [P] Flushing, NY. Exhibited: Min. PSG; CGA, 1938, 1939; PAFA, 1937; Calif. Soc. Min.P., 1938; WFNY, 1939 [40]

GILPIN, Charles Armour [P] Phila., PA/Gloucester, MA b. 7 O 1867, Cumberland, MD. Studied: PAFA. Member: Phila. A. All. Work: Hundred Friends Pittsburgh Art [40]

GILPIN, Laura [Photogr] Colorado Springs, CO/Santa Fe, NM b. 22 Ap 1891, Colorado Springs d. 1980. Studied: C. White Sch. Photogr. Member: Pictorial Photographers Am.; Royal Photographic Soc., Great Britain. Exhibited: Pictorial Photographers Am., 1929 (prize). Work: Univ. Ariz.; Univ. Kans.; MMA; MOMA; Mus. N.Mex.; NOMA; Oakland MA; Princeton. Specialties: portraits of Navahos, 1930s; southwest landscapes [30]

GILRUTH, May Hardman [P] Chicago, IL b. Jane Lew, WV. Studied: Ohio Wesleyan; AIC. Member: Assn. Chicago P.&S.; Chicago AC; NAWA. Exhibited: AIC, 1934, 1935; Am. WC Soc., 1937; NAWPS, 1938; PAFA, 1939; CGA; VMFA [47]

GILSON, Irene [P] Chicago, IL [25]

GILSON, K. [P] Toledo, OH. Member: Artklan [25]

GILSTRAP, W.H. [P,T] Tacoma, WA b. 24 Ap 1840, Effingham, IL d. 2 Ag 1914. Studied: H.A. Elkins; Kenney; Bigelow; Spread, in Chicago. Position: Cur., Ferry Mus. [13]

GIMENO, Harold [Ldscp.P,Arch] Oklahoma City, OK b. 27 N 1897, NYC. Studied: Harvard; Univ. Okla.; P. Gimeno. Member: Okla. Assn. A. Work: private collections [40]

GIMENO, P(atricio) [P,L,T] Laguna Beach, CA b. 25 D 1865, Arequipa, Peru. Studied: M. Rosas, in Valencia; Spain. Member: Okla. Art Lg. Work: Gov. Palace, Lima, Peru; paintings, Okla. Univ. Lib.; Okla. State Hist. Bldg. Specialty: allegorical paintings. Position: T., Okla. Univ. [40]

GINDELE, Mathias [Por.P,Des] Cincinnati, OH b. 1851 d. 6 S 1930. Member: Cincinnati AC [15]

GINNO, Elizabeth de Gébele [E,Li] Berkeley, CA b. 8 Jy 1911, London. Studied: Mills Col.; Calif. Col. A.&Cr.; J.W. Winkler. Member: Calif. SE. Exhibited: SAE, 1940; Chicago SE, 1940; SFMA, 1940-42, 1945; Williams Col. (one-man); Gumps, San Fran.; Kennedy & Co.; San Fran. SE; de Young Mem. Mus. Work: Mills Col. A. Gal.; de Young Mem. Mus., San Fran. [47]

GINSBURG, A. [P] NYC. Member: PS [27]

GINSBURG, Jacob J. See Gains.

GINTHER, Mary Pemberton [P,W,C,I] Buckingham, PA b. Phila. Studied: PAFA. Member: Phila. All.; Plastic C. Work: Church of Restoration, Phila.; St. John's Church, Suffolk, Va.; Miss. A. Assoc. Author/Illustrator: "Bethanne," "Hilda Series," "The Jade Necklace" [40]

GINTHER, Walter K(arl) [P,E] Winona, MN b. 3 Ap 1894, Winona. Studied: V. Vytlacil; C. Booth; R.F. Lahey; E.D. Albinson. Exhibited: Minn. State Fair, 1924 (prize), 1926 (prize); Minn. State AS, 1923 (prize) [33]

GIONFRIDDA, Joseph M. [P] Hartford, CT b. 14 Ap 1907, Canicattini Bagni, Italy. Studied: J.G. McManus; G. Wiggins. Member: CAFA; Conn. AA; Springfield AL. Exhibited: CAFA, 1932 (prizes), 1934 (prize), 1936 (prize) [40]

GIORDANA, Edward Carl [E,I] Phila., PA b. 8 F 1909, Phila. Member: Phila. Print C. Exhibited: Print C., 1931 (prize), 1936 (prize) [40]

GIRARDIN, Frank J. [Ldscp.P] Redondo Beach, CA b. 6 O 1856, Louisville, KY. Studied: Cincinnati A. Acad., with Noble, Duveneck; Chatain. Member: Los Angeles PS&G; S.Indp.A.; Cincinnati AC; Richmond AA; Los Angeles AL; Artists South Bay. Exhibited: Cincinnati AC, 1903 (prize); Richmond AA, 1912 (prize). Work: Pub. Gal., Richmond, Ind.; Marion A. Lg.; Connersville A. Lg; Queen City Gal., Cincinnati; Cincinnati AC [40]

GIROLAMI, George [S] Brooklyn, NY. Exhibited: WFNY, 1939 [40]

GISCH, William S. [E,En,Li,B,I,P,S] Cleveland, OH b. 8 Jy 1906, Cleveland. Studied: H.G. Keller; P.B. Travis; P. Ulen; W. Sommer; F.N. Wilcox; O. Coltman; S. Vago. Member: Kokoon AC; Cleveland PM; Cleveland ASL; CMA. Exhibited: CMA, 1928 (prize), 1929 (prize), 1930 (prize). Work: Cleveland Print C.; AIC; Kokoon AC; CMA [40]

GIUSTI, George [Des,I] NYC b. 10 O 1908, Milan, Italy. Studied: Milan. Exhibited: A. Dir. C., Phila., 1941 (prize), 1942-45; MOMA, 1941 (prize); A. Headquarters, N.Y., 1945; A-D Gal., N.Y., 1945. Author/Illustrator: "Drawing Figures," 1944. Illustrator: cover design, national magazines. Specialty: adv. design [47]

GIVENS, Keith Sperry. See Sperry.

GIVIENS, Florence May [P] Grafton, MA [24]

GIVLER, William H. [P] Portland, OR b. 17 Mr 1908, Omaha, NE. Studied: Portland Mus. A. Sch.; ASL. Member: Oreg. Gld. P.&S. Exhibited: SAM, 1939 (prize); Portland A. Mus., 1938 (prize), 1939; Topeka, Kans., 1940 (prize); Northwest Pr.M., 1940 (prize), 1941 (prize); WFNY, 1939; PAFA, 1941; NAD, 1940; SFMA, 1940-46; WMA, 1941, 1942. Positions: T., Mus. A. Sch., Portland, 1931-44; Dean 1944- [47]

GJURANOVIC, M. [P] Galveston, TX [24]

GLACKENS, Louis M. [I,Car] NYC b. 4 My 1866, Phila. d. 10 S 1933, Jersey City. Studied: PAFA. Illustrator: "The Log of the Water Wagon," other books; Argosy, Puck, New York American. One of the first artists to do animated cartoons for motion pictures. His brother was artist William J. Glackens.

GLACKENS, William J. [P,I] NYC b. 13 Mr 1870, Phila. d. 22 My 1938. Studied: PAFA; Europe. Member: ANA, 1906; NA, 1933; SI, 1902; SAA, 1905; Am. PS; Port. P.; S.Indp.A.; Los Angeles Modern AS; Paris Groupe PSA. Exhibited: Pan-Am. Expo, Buffalo, 1901 (gold); St. Louis Expo, 1904 (medals); CI, 1905 (prize); P.-P. Expo, San Fran., 1915 (med); PAFA, 1924 (gold); CI, 1929 (prize), 1933 (gold), 1936 (med); Allegheny Garden C., 1936 (prize). Work: Harrison Gal., Los Angeles Mus.; CGA; WMAA; MMA; Minneapolis Inst. A.; Detroit Inst. A.; Chicago AI; Albright A. Gal.; AAGA; Barnes Fnd., Merion, Pa. [38]

GLADDING, Mary [P] Providence, RI. Member: Providence WCC [25]

GLAMAN, Eugenie Fish (Mrs.) [E,P] Chicago, IL b. St. Joseph, MO d. 1956. Studied: AIC; Simon, Cottet, Fremiet, all in Paris; F. Calderon, B. Reviere, both in London. Member: Chicago PS; Chicago Gal. Assn.; Chicago SE; NAC; SAE; CAFA. Exhibited: AIC, 1913 (prize); St. Louis World's Fair, 1904 (med); Tri-State Exh., Indianapolis, 1945 (prize); Toronto, 1928; PAFA, 1908, 1910, 1926, 1928, 1934; CI, 1905; SAE, 1933–46; Northwest Pr.M., 1936–40; Oakland A. Gal., 1936–44; WFNY, 1939; Buffalo Pr. C., 1936, 1938, 1940; LOC, 1943–45; Chicago Gal. Assn. Work: Vanderpoel Coll., Chicago; State Mus., State Lib., both in Springfield, Ill.; NGA; Saddle & Sirloin C., Chicago [47]

GLANNON, Edward John [P,T] Roslyn, NY b. 2 O 1911, Pittsburgh. Studied: ASL, with Miller, Benton; K. Hayes; A. Brook. Exhibited: PAFA, 1941; AIC, 1935. Illustrator: "Guess What's in the Grass," 1945. Position: T., Fieldston Sch., Riverdale, N.Y., 1937–

GLARNER, Fritz [P] NYC b. 20 Jy 1899, Zurich, Switzerland d. 1972. Studied: Royal Inst. FA, Naples. Exhibited: Albright A. Gal., 1931; Am. Abstract A., 1938–44; Gal. St. Etienne, 1940; NYU, 1941; David Porter Gal., Wash., D.C., 1945; Kootz Gal., 1945; Paris; Zurich. Work: Palazzo dela Borsa, Pinacoteca del Instituo di Belle Arti, Naples; Yale [47]

GLASELL, Criss (Christine Albertina Rosner) [P,C,L] Bloomfield, IA b. 8 Jy 1898, Vienna, Austria. Studied: AIC; G. Wood; F. Chapin; Adrian Dornbush. Member: NAWA; Iowa AG; Am. A. Cong. Exhibited: Iowa A. Salon, 1931–34 (prizes), 1938 (prize), 1939 (prize), 1941 (prize); PAFA, 1934; CGA, 1934; Joslyn Mem., 1934; Kansas City AI, 1935, 1936; CM; WFNY, 1939; NAWA, 1945; Argent Gal., 1946; Des Moines (one-man), Mason City (one-man), Cedar Rapids (one-man), Sioux City (one-man), Bloomfield (one-man), all in Iowa. Work: Dubuque AA; USPO, Leon, Iowa. WPA artist. [47]

GLASELL, Don Emil [P,B,E,Li,T] Sioux City, IA b. 16 Ap 1895, Copenhagen, Denmark. Studied: AIC; Copenhagen. Member: AAPL; Am. A. Congress; Co-op A., Iowa. Exhibited: Iowa State Fair, 1932 (prize), 1934 (prize), 1939 (prize). Work: Court House, Cedar Rapids; Pub. Lib., Dubuque, Iowa; Smith Sch., Sioux City. Position: T., Sioux City A. Center (prize) [40]

GLASER, Josephine [P] NYC b. 6 My 1901, NYC. Studied: Savage; ASL, with Peixotto, Bridgman, Curran, DuMond, Gorguet, St. Hubert. Member: Alliance; F., Tiffany Fnd. Work: Georgetown Univ.; Tiffany Fnd., Oyster Bay, N.Y.; Church of Our Lady of Martyrs, Auriesville, N.Y. [40]

GLASGOW, Everett W. [P,I,Car,G] Pittsburgh, PA b. 14 Je 1892, Bakerstown, PA. Studied: CI. Member: Pittsburgh AA; Provincetown AA; North Shore AA. Exhibited: CI; Gloucester SA; Provincetown AA. Position: A. Dir., Pittsburgh Sun-Telegraph [40]

GLASIER, Alice [E] Oakland, CA. Member: Calif. SE [27]

GLASIER, Marshall [P] Madison, WI b. 8 S 1902, Wauwotosa, WI. Studied: Univ. Wis.; ASL; G. Grosz. Exhibited: Milwaukee AI, 1938; Assn. Am. A., 1943 (one-man); Levy Gal., N.Y., 1940. Work: Milwaukee AI [47]

GLASS, Bertha Walker (Mrs.) [Ldscp.P] San Fran., CA b. 28 Ja 1884, Maryville, MO. Studied: Mass. Sch. A.; ASL; Breckenridge Sch. Painting. Member: NAWPS [40]

GLASS, Henry P(eter) [Des,T,W] Chicago, IL b. 24 S 1911, Vienna, Austria. Studied: Tech. Univ., Vienna; Master Sch. Arch., with Theiss. Member: ADI. Work: Furniture, product, commercial interiors displays. Position: T., AIC, 1945– [47]

GLASS, Sarah Kramer [P] East Gloucester, MA b. 7 N 1885, Troy, OH. Studied: B.M. Peyton; ASL; Grand Central Sch. A. Member: NAWPS; North Shore AA; Gloucester SA [31]

GLASSGOLD, Adolph [P,W,T] Brooklyn, NY b. 8 F 1899, Brooklyn [25]

GLASSGOLD, Harry [P,Ser,L,T] Flint, MI b. 30 Je 1908, Frampol, Russia. Studied: N.Y. Sch. F.&Appl. A.; Wayne Univ.; ASL. Member: A. Lg. Am.; Mich. Edu. Assn. Exhibited: PAFA, 1935; Flint Inst. A.; Detroit Inst. A., 1941, 1942 (prize), 1943 (prize), 1944, 1945; AIC, 1941; WMAA, 1941. Work: Flint Inst. A.; Detroit Inst. A. Position: T., Flint Pub. Sch., 1945–46 [47]

GLEASON, (Joe) Duncan [P,W,E,L] Los Angeles, CA. b. 3 Ag 1881, Watsonville, CA d. 9 Mr 1959. Studied: DuMond; Vanderpoel; Renterdahl; Univ. Southern Calif.; Mark Hopkins Inst.; AIC; ASL; San Carlos Acad., Mexico City. Member: Calif. AC; P.&S. Cl.; Soc. for Sanity in A.; Santa Monica AA; Glendale AA; Los Angeles PSC; Long Beach AA; Acad. Western P. Exhibited: NAD, 1923; Arch. Lg., 1921, 1922; Old Lyme, Conn., 1905 (prize); San Diego, 1915–16 (gold); Calif. State Fair, 1931 (prize); Ariz. State Fair, 1932. Work: Franklin Delano Roosevelt Mem., Hyde Park, N.Y.; murals, Hotel Clark, Los Angeles. Author/Illustrator: "Windjammers." Illustrator: "Autobiographies of Admiral Schley and Admiral Dewey." Position: Sketch A., Metro-Goldwyn-Mayer [47]

GLEAVES, William H. [S] Trenton, NJ [13]

GLEESON, Charles K. [E,P] East Haddam, CT b. 5 Mr 1878, St. Louis, MO. Studied: ASL; St. Louis Sch. FA; Grande Chaumière; Renard; Steinlen; Chase; Mora. Member: Chicago SA. Exhibited: AIC; SAE; Chicago SE; WFNY, 1939; St. Louis A. Gld., all from 1914–43, St. Louis A. Gld. 1925, 1927, 1929, 1930 (prizes). Work: CAM; TMA; AIC; NYPL; LOC; John Herron AI; St. Louis Pub. Lib.; Fifty Prints of the Year, 1930 [47]

GLEESON, Charles K., Mrs. See Schulenberg.

GLEESON, J(oseph) M(ichael) [P,S,I,E] Newfoundland, NJ b. 8 F 1861, Dracut, MA. Studied: Paris, with Bouguereau, Dagnan-Bouvert, Robert-Fleury. Member: SC, 1906; Chicago SE; St. Louis Brush and Pencil C. Work: AIC; CAM; TMA; NYPL; LOC. Specialty: animals [17]

GLEITSMANN, Raphael [P,T] Akron, OH b. 11 Je 1910, Dayton, OH. Studied: K. Calvin. Member: Audubon A.; Phila. WCC. Exhibited: Cincinnati AM; Kansas City AI; AIC; VMFA, 1940; PAFA, 1944, 1945 (prize); CI, 1943–45; CAM, 1944, 1946; CM, 1941; SFMA, 1941; Butler AI, 1940–43; Massillon Mus., 1941–45; CGA, 1939; Portland, Oreg. AM, 1939; WFNY, 1939. Work: Newark Mus.; PAFA; Massillon Mus.; Butler AL; U.S. War Dept. [47]

GLENNY, Alice Russell (Mrs. John) [P,S] Buffalo, NY/London, England. b. 1858, Detroit, MI. Studied: Chase; Boulanger. Member: Buffalo SA; ASL, Buffalo; NAWPS. Work: Buffalo Hist. Soc. [27]

GLENNY, Anna [S] Buffalo, NY. Exhibited: Buffalo SA, Albright Gal., 1933, 1934; WMAA, 1934; Ar. Western N.Y., 1935, 1936; Century of Progress, AIC, 1934; Walker Gal., N.Y., 1936 (one-man); AIC, 1937; WFNY, 1939 [40]

GLESSNER, Agnes C. [P] Minneapolis, MN [13]

GLESSNER, John J. [Patron] Chicago, IL b. 1843 d. 20 J 1936. Member: AIC, 1897 (Co-founder); Ferguson Fnd. (which erected sculpture in Chicago). He presented his home, a masterpiece of American architecture by Richardson, to the Chicago chapter of the AIA, as a clubhouse.

GLEYRE, Jessie M. [P] St. Louis, MO [25]

GLICENSTEIN, Enrico [S,C,E] Sunnyside, NY b. 1870, Poland d. 30 D 1942, NYC. Studied: Rodin; Member: S. Gld. Exhibited: PS Ann., AIC, 1935; Jewish Ar. Chicago, AIC, 1934 (prize); Gld. A. Gal., NYC, 1937; Intl. WCC Ann., AIC, 1938; WFNY, 1939 Awards: Prix de Rome, Am. Acad. Rome [40]

GLICKER, Benjamin C. [P] Detroit, MI b. 24 O 1914, Toledo, OH. Studied: Wayne Univ., J. Carroll; Sarkis Sarkisian; S. Cashwan. Exhibited: Detroit Inst. A., 1936 (prize), 1939 (prize); CI, 1941. [47]

GLICKMAN, Maurice [S,W,T,L,P] NYC b. 6 Ja 1906, Jassy, Romania. Studied: ASL; abroad; Edu. Alliance A. Sch. Member: S. Gld.; United Am. Ar.; Am. A. Cong.; F., Guggenheim Fnd., 1934. Exhibited: WMAA, 1937–46; PAFA, 1939–41; PMA, 1940; MOMA, 1935; WFNY, 1939; Morton Gal., 1931 (one-man); Women's C., Univ., 1941 (one-man). Work: Dept. Interior; Binghamton Mus. A.; Howard Univ.; USPOs, Ashburn, Ga., South River, N.J., Northampton, Pa.; bas reliefs; Mus. Western A., Moscow, USSR. WPA muralist. Position: T., Edu. Alliance, NYC, School for Art Studies, NYC, 1945–55 (Founder) [47]

GLIDDEN, Carlton [S] NYC [13]

GLINES, Ellen (Mrs. Walter) [P] Santurce, Puerto Rico b. Hartford, CT d.

24 Ag 1951. Studied: A. Jones; H.B. Snell; Alphaeus Cole. Member: All.A.Am.; NAWA; NAC; S.Indp.A.; Am. Ar. Prof. Lg. Exhibited: All.A.Am.; NAWA, 1938; NAC; AWCS; Municipal Exh., NYC, 1937; Hartford, Conn.; Puerto Rico [47]

GLINSKY, Vincent [S,E,Li,P,T] NYC b. 18 D 1895, Russia d. 1975. Studied: Columbia; BAID. Member: NSS; S. Gld.; Am. A. Cong; F., Guggenheim Fnd., 1935–36. Exhibited: NAD, 1920–24; Arch. Lg., 1926; Salon de Tuileries, Paris; MOMA, 1930; BM, 1930, 1938; MMA, 1942; WMAA; AIC; Contemp. Am. A. Exh., London, 1941; GGE, 1939; WFNY, 1939; PAFA, 1935 (prize), 1936 (gold). Work: S., dec., bronze doors, French Bldg., NYC; USPOs, Hudson, N.Y., Weirton, W.Va., Union City, Pa.; U.S. Navy. WPA artist. [47]

GLINTENKAMP, Hendrik [B,I,Li,P,S,T] NYC/Sparta, NJ b. 10 S 1887, Augusta, NJ d. 19 Mr 1946. Studied: Henri. Member: Am. A. Cong. Work: NYPL; MMA; NYU; Brooklyn Pub. Lib.; Syracuse MFA; Albany Inst. Hist.&A.; N.J. State Mus., Trenton; Newark Pub. Lib.; Montclair Pub. Lib.; Speed Mem. Mus., Louisville; N.C. State A. Col., Raleigh; MFA, State College, Pa.; Easton Sch. Mus., Pa.; Norwalk, Conn.; Manchester (N.H.) Pub. Lib.; Victoria and Albert Mus., London; Biro-Bijan Mus., USSR; six bookplates, MMA; New Rochelle Pub. Lib.; Bridgeport, Conn. Pub. Lib.; Hartford, Conn. Pub. Lib.; Hall of Records, NYC; AA, Richmond, Ind.; Fifty Prints of the Year, 1929, 1930, 1931. Illustrator: "Machine Made Man," by Silas Bent (in woodblock), "The White Gods," by Edward Stucken, "A Wanderer in Woodcuts," by H. Glintenkamp, "Gold Rush Days with Mark Twain," by W.R. Gillis, "Saints of Chaos," by P. Oliver [40]

GLOETZNER, Josephine P. [P,D] Wash., D.C. b. Wash., D.C. Member: Wash. WCC; Soc. Wash. A.; Kunstterinen Verein, Munich. [31]

GLOVER, Bertram [P] Buffalo, NY. Exhibited: Great Lakes Exh., The Patteran, 1938; Ar. Western N.Y. Ann., Albright Gal., 1937 (prize), 1939 [40]

GLOVER, Edwin S. [Li] b. 1845, MI d. 1919, Tacoma, WA. Publisher: lithographic views during Gold Rush Era, 1870s [*]

GLOVER, Frederick W. [P] NYC [06]

GLOVER, Joseph T. [Dec,Des] Mt. Vernon, NY b. 22 N 1906, Mt. Vernon. Studied: Mrs. C.E. Williams, J.B. Moffat. Specialty: rug design. WPA artist. [40]

GLOVER, S. Albertson (Mrs.) [P] NYC [13]

GLUCKMANN, Grigory [P] Los Angeles, CA b. 25 O 1898, Russia. Studied: Ecole des Beaux-Arts, Moscow. Member: Salon d'Automne, Salon National des Beaux-Arts, Salon des Tuileries, Paris. Exhibited: John Levy Gal.; Schneider-Gabriel Gal.; Bignou Gal., N.Y.; Chicago AC; Dalzell Hatfield Gal.; Leicester Gal., Allard Gal., Paris; Paris Salon, 1937 (prize); AIC, 1938 (prize), 1945 (prize). Work: Luxembourg Mus.; Petit Palais, Paris; Musée de la Ville de Havre, France; AIC; San Diego FA Soc.; Encyclopaedia Britannica Coll. Illustrator: "Salvador Rosa," "Nuits Florentines"; L'Illustration [47]

GLUECK, Charles M. [P] New Haven, CT. Member: S.Indp.A. [25]

GLUSHAKOW, Jacob [P] Baltimore, MD b. 23 Jy 1914. Studied: ASL, with Miller, A. Brook, C. Locke. Member: A. Un. Baltimore. Exhibited: NGA, 1942; BMA, 1937–42, 1939 (prize), 1946 (prize); Nat. A. Week Exh., Wash., D.C.; Md. Inst.; YMHA, Baltimore. Work: Baltimore Friends of Art Soc.; BMA; PMG. Position: T., Jewish Edu. Alliance [47]

GNAM, Hugo, Jr. [P,C,Des,Dec,I,T,Arch,W] NYC b. 24 Je 1900, Zurich, Switzerland. Studied: NYC; Switzerland. Member: A. Lg. Am.; Soc. Des.-Cr.; Nat. AAI. Exhibited: BM; Arch. Lg.; Albany Inst. Hist.&A., 1945; Riverside Mus., 1945; Norlyst Gal., 1946 (one-man); WFNY, 1939 (prize). Work: furniture produced with Joseph Urban, MMA; Chrysler Engineering Bldg.; Empire State Bldg. Illustrations: London Studio, Arts and Decoration, New York Times. Position: Assoc., Hugo Gnam and Son, NYC [47]

GODDARD, Florence M. [E] Los Angeles, CA. Member: Calif. PM [25]

GODDARD, George Henry [P,I] b. 1817, Bristol, England (came to U.S. in 1852) d. 1906, Berkeley, CA. Studied: Oxford. Exhibited: flower paintings, London, 1837–44. Artist for lithographers. His large collection of California views was destroyed in the San Fran. fire of 1906. He was also a noted surveyor. Mt. Goddard in the Sierras is named for him. [*]

GODDARD, Margaret. See John Carlson, Mrs.

GODDARD, Ralph (Bartlett) [S] NYC/Madison, CT b. 18 Je 1861, Meadville, PA. d. 25 Ap 1936, Middletown, NY. Studied: NAD; ASL; Académie Julian, Dampt, both in Paris. Member: NSS, 1899; SC. Work: MMA; Detroit Inst.; Hoe Bldg., NYC. Specialties: bronze bas-relief portraits and portrait busts of noted men [33]

GODDARD, Virginia Hargraves Wood (Mrs. Charles Franc) [P,Dr,E,T] Mattituck, NY b. 1873, near St. Louis d. 22 F 1941, Charlottesville, VA. Studied: Chase; Luks; Hawthorne; abroad. Member: NAWPS; Albermarle AA; Nassau AL; Am. Women's A. Specialty: portraits [40]

GODDING, Mary P. [P] Wash., D.C. Member: Wash. WCC [25]

GODFREY, Frank Turner [I] Chicago, IL b. 1873. Grand Rapids, MI. Studied: J.C. Johansen; M.A. Alten. [06]

GODFREY, Robert W. [P,Li,Des] Lowell, MI b. 22 Jy 1910, Jackson, MI. Studied: Am. Acad. A.; ASL, with Bridgman, Lahey; E. Babcock. Member: Friends Am. A.; Kent A. Group. Exhibited: NAD, 1936; Springville, Utah, 1937, 1938; Grand Rapids A. Gal., 1940; Detroit Inst. A., 1939, 1940; Roerich Mus., 1935, 1936; New York; Calif.; S.C. Position: Resident A., Grand Rapids A. Gal. Sch. [47]

GODLEY, Winifred Fay (Mrs.) [P] Davenport, IA. Studied: PAFA [25]

GODWIN, Frances B. [S] Brooklyn, NY. Exhibited: WFNY, 1939 [40]

GODWIN, Frank [P,I,Car,E,Des,C,Dr] New Hope, PA b. 20 O 1889, Wash., D.C. Studied: Corcoran Sch. A.; J.M. Flagg. Member: SC; SI; Dutch Treat Cl. Work: murals, Kings County Hospital, Brooklyn, N.Y.; Riverside Yacht Cl., Greenwich, Conn. Illustrator: magazines, newspapers [47]

GODWIN, Frank, Mrs. See Harbeson, Georgiana.

GODWIN, Karl [P,I,E,T] NYC b. 19 N 1893, Walkerville, Canada. Studied: Hawthorne; Skou. Member: SC; Allied AA [40]

GOE, Lorraine [P] Tacoma, WA. Member: Tacoma FAA [25]

GOEBEL, Louise Erwin [P] Indianapolis, IN [24]

GOEBEL, Paul [Ldscp.P] Yonkers, NY b. 1 Ja 1877, Darmstadt, Germany. Studied: CUASch; NAD, with Ward, Church, Chase, Maynard. Member: Country Sketch Cl. [10]

GOELLER, Charles Louis [Por.P,P,W,T,L] Elizabeth, NJ. b. 10 N 1901, Irvington, NJ d. 6 Mr 1955. Studied: Rensselaer; Cornell; Fontainbleau, France; C. Midjo; A.F. Goerguet; J. Despujols. Exhibited: Salon des Artistes Français, 1927, 1928; Salon d'Automne, 1928; CM, 1933; Municipal Exh., N.Y., 1934; PAFA, 1938; WMAA, 1938; CGA, 1939; VMFA, 1940; Montclair A. Mus., 1938, 1939; Princeton, 1941. Work: MOMA; Newark Mus. Contributor: Art Digest. Position: T., Newark Sch. F.&Indst. A. 1946– [47]

GOELLER-WOOD, Shotwell [C,B,Des,Dr,Mur.P,Por.P,S,T] Sausalito, CA b. 30 Jy 1887, San Fran. Studied: Calif. Sch. FA; Am. Beaux-Arts, Fountainbleau; A. Lhote; La Montagne St. Hubert. Member: San Fran. AA; San Fran. Women A.; Marin SA; Calif. Soc. Mural A. Exhibited: San Fran. Women A., 1935 (prize). Work: Christian Science Monitor Pavilion, Paris Expo; Hospital, Fountainebleau; Sleepy Hollow Golf Cl., San Anselmo, CA [40]

GOESER, August [P] Cincinnati, OH b. 4 My 1858, St. Louis. Member: Cincinnati AC [13]

GOESLE, Sylvan G. [P] NYC [19]

GOETHE, Joseph Alexander [P,En,S,C,W,B] Santa Monica, CA b. 1 Mr 1912, Fort Wayne, IN. Studied: Dayton AI; PMG. Member: Santa Monica A. Gld.; Am. Fed. A.. Exhibited: CM, 1935, 1936; AIC, 1934; NAD, 1943; Hoosier Salon; Chicago S.Indp.A.; A. Cl., Wash.; Centennial Expo, Dallas, Tex.. Author: "Handbook of Commercial Woods," 1938 [47]

GOETSCH, Gustave F. [P,E,Dr,B,T,L] Kirkwood, MO b. 15 Mr 1877, Gaylord, MN. Studied: Koehler; Minneapolis Sch. FA; N.Y. Sch. A., with Chase, Beckwith; Académie Julian, Paris, with Blanche, Julian. Member: St. Louis A. Gld.; Chicago SE; 2x4 Cl., St. Louis, Mo. Exhibited: Minneapolis Inst. A., 1917 (prize); St. Louis A. Gld., 1918, 1920, 1922, 1926, 1928 (prizes); St. Paul Inst., 1917; St. Louis AL, 1918 (prize) 1920 (prize), 1922 (prize), 1926 (gold); Kansas City AI, 1924 (gold), 1927; Mo. State Fair, 1924 (prize); St. Louis AG, 1926 (prize), 1928. Work: Minneapolis Inst. A.; CAM; WMA; LOC; Wash. Univ.; Jefferson Mem.; CAM; Minneapolis Inst. A.; AIC; Mo. State Univ. Position: T., Wash. Univ. [47]

GOETSCH, Gustav F., Mrs. See Weedell.

GOETTING, A.E. [P] Cincinnati, OH. Member: A. Acad. [01]

GOETZ, Esther Becker [P,I] NYC b. 7 Ag 1907, Buffalo, NY. Studied: ASL;

J. Sloan; H. Wickey; Paris. Member: S.Indp.A.; Patteran Soc., Buffalo. Exhibited: PAFA, 1934; AIC, 1935; BM, 1935; WMAA, 1938; Mus. City N.Y., 1944, 1945 (one-man); Albright Gal., 1945 (one-man); Village Indoor Exh., NYC, 1936. Illustrator: "Mr. Nosey," 1945 [47]

GOETZ, George L. [E] Chicago, IL [13]

GOETZ, James Russell [E,En,P] NYC b. 6 Jy 1915, Indianapolis, IN d. ca. 1953. Studied: Westminster Col.; Colgate. Member: Atelier 17 Graphic Group. Exhibited: SAE, 1945; NAD, 1946; LOC, 1946; Assn. Am. A., 1946; SAM, 1946; PAFA, 1946. Author/Illustrator: "The Primordials," 1946 (portfolio of prints) [47]

GOETZ, Oswald H. [Mus.Cur,L,W] Chicago, IL b. 23 N 1896, Hamburg, Germany d. O 1960, NYC. Studied: Univ. Kiel; Univ. Frankfurt; Univ. Munich; R. Kautzsch; H. Wolfflin; P. Frankl. Member: CAA. Author: "The Rembrandt Bible," 1941. Position: Assoc. Cur., Mediaeval & Renaissance A., AIC, 1940– [47]

GOFF, Clifton D. [P] Manhasset, NY Member: S.Indp.A. [25]

GOFF, Henry (Sharp, Jr.) [Car,I] Haddonfield, NJ b. 4 Ag 1905, Haddon Heights, NJ. Studied: PMSchIA. Illustrator: Saturday Evening Post, Country Gentleman, Holiday, other magazines [47]

GOFF, Lloyd Lózes [P,W,Gr,E,Li] Albuquerque, NM b. 29 Mr 1917, Dallas. Studied: ASL; Univ. N.Mex.; Nicolaides; Locke; Sternberg; Miller; P. Cadmus; J. French. Member: ASL. Exhibited: WMAA, 1937, 1938, 1942, 1943; NAD, 1937, 1938; PAFA, 1936, 1938; AIC, 1936–38; WFNY, 1939; San Fran. AA, 1941–43; Mus. N.Mex., Santa Fe, 1940–46; Dallas Mus. FA, 1940, 1946; Levy Gal., 1939 (one-man). Work: LOC; WMAA; MMA; Herbert Mem. Mus., Augusta, Ga.; Dallas Mus. FA; Federal Bldg., Cooper, Tex.; Federal Bldg., Hollis, Okla.; Municipal Bldg., NYC; Southern Methodist Univ., Dallas; U.S. Customs House, NYC. WPA artist. Position: T., Univ. N.Mex., 1943–45 [47]

GOFF, Sudduth [Por.P] NYC b. 6 Ag 1887, Eminence, KY. Studied: Univ. Ky.; Cincinnati A. Acad.; BMFA Sch.; Meakin; Nowottny; Benson; Bosley; Hale. Member: SC; NAC; AAPL; Chicago Gal. Assn.; A. Chicago PS. Exhibited: BMFA Sch., 1915 (prize); Art Colony Exh., Louisville, 1923 (gold); CGA, 1929; AIC, 1934, 1935; Cincinnati A. Acad., 1925; SC, 1945, 1946; NAC, 1946; Assn. Chicago P&S, 1933–43; Chicago Gal. Assn., 1930 (prize) 1931 (prize), 1932–41; Tudor Gal., Chicago (one-man); Brooks Mem. Gal., Memphis; Speed Mem. Mus.; Newton Gal., NYC, 1945. Work: Hist. Soc., Frankfort, Ky.; State Capitol, Ky.; Univ. Ky.; Standard Sanitary Mfg. Co., Pittsburgh; Ky. State Federation Women's C.; Lexington Pub. Lib.; Ky. WCTU, State Hist. Bldg.; Richmond, Ky.; Univ. Tenn.; Vanderpoel AA [47]

GOFFE, Gladys [P] Wilkinsburg, PA. Member: Pittsburgh AA [25]

GOHL, Edward Heinrich [P] Auburn, NY b. 3 N 1862, Harrisburg, PA. Studied: Paris, with Constant, Laurens, Bashet, Schommer. Member: Paris AAA [25]

GOINGS, Martha Henderson (Mrs. Hubert W.) [P,Des,T,] Birmingham, AL b. 12 Mr 1911, Birmingham. Studied: C. Hill; H. Elliot, N.Y. Sch. F.&Appl. A. Member: SSAL; Birmingham AC; Ala. AL. Exhibited: SSAL, 1937 [40]

GOLD, Albert [P] Providence, RI b. 17 F 1906, Raigorod, Russia. Studied: J.R. Frazier; Hawthorne. Work: FMA; RISD [40]

GOLD, Albert [P,Gr,I,T] Phila., PA b. 31 O 1916, Phila. Studied: PMSchIA, with F. Watkins, E. Horter, H.C. Pitz; Graphic Sketch Cl., Phila. Member: Phila. WCC; Phila. Pr. C. Exhibited: PAFA, 1938–42, 1944, 1945,; CGA, 1939; WFNY, 1939; AIC, 1939, 1941–43; CI, 1942, 1943; AV, 1943; Nat. Gal., London, 1944; Musée Galliera, Paris, 1945; Phila. Pr. Cl., 1939 (prize). Award: Prix de Rome, 1942. Work: NYPL; LOC; PMA; Pentagon Bldg., Wash. D.C.; U.S. War Dept., Wash. D.C.; Abbott Laboratories Coll. Illustrator: Salute, Yank (magazines). Positions: Combat A., 1943–45; T., PMSchIA, 1946– [47]

GOLDBECK, W(alter) D(ean) [P,S,E] Little Neck, NY b. 7 O 1882, St. Louis, MO d. O 1925, NYC. Studied: Berlin; London; Chicago; Paris. Exhibited: AIC, 1911 [24]

GOLDBERG, Emily [P] NYC [17]

GOLDBERG, Eric [P] NYC/Montreal, Quebec b. 28 O 1890. Studied: J.P. Laurens; J. Lefebvre; Ecole des Beaux-Arts [40]

GOLDBERG, Rosalind [P,T] Phila., PA b. 18 N 1907, Russia. Studied: Phila. Sch. Des. for Women; Univ. Pa.; Tyler A. Sch.; E. Horter; E. Thurn; A.B. Carles. Member: Phila. A. Alliance. Exhibited: Phila. A. All.; DaVinci All.; LOC; PAFA, 1935, 1939. Position: T., Fitzsimons Jr. H.S., Phila. [47]

GOLDBERG, Rube (Reuben Lucius) [Car,I] NYC b. 4 Jy 1883, San Fran., CA d. 1970. Member: SI. Work: Huntington Lib., San Marino, Calif. Famous for his zany drawings of unnecessarily complex, continuous motion, "cause-and-effect" mechanical contrivances. Cartoonist: New York Evening Mail, 1907–21; syndicated, from 1921. Creator: "Lala Palooza," "Boob McNutt," and others [47]

GOLDE, R.P. [S] NYC b. Germany (came to U.S. in 1884). Studied: Schilling, in Dresden [17]

GOLDEN, Charles O. [P,Li,I,B] Tucson, AZ b. 3 F 1899, Upshur County, WV. Studied: Corcoran Sch. A.; PAFA; J.J. Gould; C.D. Mitchell. Member: Phila. Sketch C.; Wash. WCC; Mystic AA. Exhibited: PAFA; CGA; NAD; AIC; Mystic AA; Tucson FAA, 1938 (prize). Illustrator: "Moby Dick," "The Cruise of the Cachelot"; Saturday Evening Post, Pictorial Review, Etude [47]

GOLDHAMER, Iva [P] Cleveland, OH b. 2 Jy 1917, Cleveland. Studied: Cleveland Sch. A. [40]

GOLDIE, J(ames) Liddell [P] Springfield, MA b. 1892, Dorchester, MA. Member: CAFA; Springfield AL; Art Gld., Tiffany Fnd. [27]

GOLDING, Cecil [P] NYC. Exhibited: NYWCC, 1936; NAWPS, 1935–38 [40]

GOLDMAN, Julia [P,Des,B,C,T,L,] NYC b. Boston. Studied: Mass. T. Training Col.; N.Y. Sch. F.&Appl. A.; T. Col., Columbia; Harvard; Hawthorne; D. Ross; Courtauld Inst. A. of London; H. Woodbury. Member: NYSC; NAWPS; Honolulu Art Soc.; Am. Assn. Univ. Women. Lectures: Symbolism in Oriental Art [47]

GOLDMAN, Robert Douglas [P,T,I] Phila., PA b. 24 Ja 1908, Phila. Studied: PMSchIA; Rutgers; Columbia; ASL; Colorado Springs FA Center, with B. Robinson. Exhibited: Elizabeth, N.J. SA, 1934 (prize); Nat. Army A. Exh., 1945 (prize); PAFA, 1928–31, 1934; Okla. A. Center, 1941; Cheltenham A. Center, Pa., 1940. Work: Elizabeth YMHA; Phila. YMHA. Position: T., Simon Gratz H.S. Phila., 1935– [47]

GOLDSBOROUGH, Nannie Cox (Mrs.) [Por.P] Easton, MD d. N 1923

GOLDSCHMIDT, Margaret [P] NYC [15]

GOLDSMITH, Alice Halleck [I] Brooklyn, NY. Member: B&W C. [01]

GOLDSMITH, M(organ) J(ames) [P] NYC b. 1 Ag 1854, Phila. Studied: R.M. Suertleff; C.G. Naegele. Member: Bronx AG [25]

GOLDSMITH, Wallace [Car] Bedford, MA b. 1873, Cleveland, OH d. 31 Mr 1945. Position: car., several Boston newspapers; Boston Post, since 1920

GOLDSTEIN, Louise Marks (Mrs. Maurice) [P,T] Sherman, TX b. 29 N 1899, Corsicana, TX. Studied: Kidd-Key Col., Tex.; Ward-Belmont Col.; Austin Col., Sherman, Tex.; ASL; G.E. Browne. Member: SSAL; Tex. FAA; Dallas AA. Exhibited: Provincetown AA; Am. Fed. A., 1939; Dallas Mus. FA; Ney Mus. A., Austin, Tex. Work: Austin Col. Position: T., Austin Col. [47]

GOLDSWORTHY, Emelia M. [P,T] Los Angeles, CA b. 3 Je 1869, Platteville, WI. Studied: AIC; Otis AI, Los Angeles; PIASch, with Dow, Forsyth, Snell, Freer, Batchelder, J. Mannheim, Tursman, Vanderpoel. Member: Calif. AC; MacD. C.; AG of Authors Lg. A. Position: Art Dir., Wester States Normal Sch., Kalamazoo, Mich. [25]

GOLDWAITE, Ann [P,E,Li,T] NYC/Montgomery, AL b. 1875, Montgomery d. 29 Ja 1944. Studied: NAD, with Mielatz; Académie Moderne, Paris. Member: NAWPS; NYWCC; Calif. PM; Soc. Am. E.; SPNY. Exhibited: NAWPS, 1915 (prize); P.-P. Expo, San Fran. (med); WFNY, 1939. Work: LOC; MMA; NYPL; AIC; BMA; CMA; Musée du rue Spontini, Paris; BM; Bibliothèque Nationale, Paris; Fine Prints of the Year, 1931, 1932, 1934; MOMA; USPOs, Atmore, Tuskegee, both in Ala. WPA artist. Position: T., ASL [40]

GOLDWATER, Robert [Edu,W,Cr,L] NYC b. 23 N 1907, NYC d. 1973. Studied: Columbia; Harvard; NYU. Member: Guggenhein F., 1944–45. Author: "Primitivism in Modern Painting," 1938, "Artists on Art," 1945. Positions: T., NYC, 1934–39, Queens Col. [47]

GOLINKIN, Joseph Webster [P,Li,I] NYC b. 10 S 1896, Chicago. Studied: AIC; ASL. Member: AWCS; NYWCC. Exhibited: Olympiad, 1932 (med), 1936 (prize); CI; Ferargil Gal. (one-man); NAD; Macbeth Gal. (one-man); AIC; Sporting Gal., NYC (one-man); PAFA; Albright A. Gal.; Mus. NYC; CGA. Work: LOC; Newark Mus.; Mus. NYC; WMAA; Yale Coll. FA. Illustrator: "New York is Like This," 1929, "American Sporting Scene," 1941 [47]

GOLLINGS, Elling William (Bill) [P,E] Sheridan, WY b. 1878, Pierce City,

ID d. 16 Ap 1932. Studied: largely self-taught; briefly at Chicago Acad. FA, ca. 1904. Exhibited: Portland Expo. Work: Wyo. State Capitol; Casper, Colo. A true cowboy-artist who worked on ranches in Nebr., S.Dak., and Wyo. Built a studio-shack in 1909, where he produced scenes of Western life and etchings.

GOLTON, Glenn [P,G] Wichita, KS. Exhibited: Midwest Ar. Ann., Kansas City AI, 1939 (prize), 1933, 1935, 1938; WFNY, 1939 [40]

GOLTZ, Walter [P,T] Woodstock, NY b. 20 Je 1875, Buffalo d. 1956. Exhibited: Sesqui-Centenn. Expo, Phila., 1926 (med); New Haven PCC, 1931 (prize) [33]

GOLZ, Julius, Jr. [P,T] Camden, NJ b. 1878, Camden. Studied: Anschutz; Henri. Position: Dir., Columbus A. Sch., 1910– [17]

GOMBARTS, George K. [L,W,T] NYC b. 3 Je 1877, Hungary. Studied: J. Kopp, Budapest. Member: Municipal AS [25]

GOMEZ, Marco Antonio (Tony) [P] b. 1910, Durango, Mexico (came to Ariz. in 1918) d. 1972, Manhattan Beach, CA. Studied: his father, a Mexican portrait painter; Chouinard, Los Angeles. Specialty: traditional scenes of cowboys and Indians [*]

GONSER, Maude Kershaw [P] Ft. Wayne, IN b. 24 D 1901, Latty, OH. Studied: E. Daingerfield, H.B. Snell, H. Sartain. Member: Hoosier Salon [33]

GONZALES, August D. [I,P] Phila., PA

GONZALES, Boyer [P] Galveston, TX/Woodstock, NY b. 1878, Houston d. 14 F 1934. Studied: ASL; W. Lansil, in Boston; W.J. Whittemore, in NYC; B. Harrison, in Woodstock; Holland; Paris; Florence. Member: NYWCC; SC; NAC; AWCS; Wash. WCC; Miss. AA. Exhibited: Dallas, 1921 (gold), 1924 (gold); SSAL, 1926 (prize). Work: Galveston A. Lg.; Municipal Schools of Galveston; Delgado Mus.; Witte Mus., San Antonio; Vanderpoel AA. Painted with Winslow Homer. [33]

GONZALES, Boyer, Jr. [P,T] Austin, TX/Woodstock, NY b. 11 F 1909, Galveston, TX. Studied: ASL. Member: Woodstock Ar. Assn.; SSAL; A. New So. Group. Exhibited: SSAL, 1939 (prize), 1938 (Montgomery, Ala.), 1939 (San Antonio); Dallas M., 1938; Corcoran Gal., 1939; WFNY, 1939; Golden Gate Expo, 1939; Houston MFA, 1939. Position: T., Univ. Tex. [40]

GONZALES, Carlotta (Mrs. Richard Lahey) [P,S,T] Vienna, VA b. 3 Ap 1910, Wilmington, NC. Studied: PAFA, with Laessle; NAD, with Aitken; ASL, with Laurent, Karfiol; Lahey. Member: S.Indp.A. Exhibited: CGA, 1939; NAD, 1931. Illustrator: "Stars in the Heavens", "U.S.A. and State Seals"; National Geographic. Position: T., Corcoran Sch. A. [47]

GONZALEZ, Juanita [C] b. 20 D 1903, New Orleans, LA d. 10 Jy 1935. Studied: Newcomb A. Sch.; Archipenko. Member: New Orleans ACC. Work: La. State Capitol; La. State Medical Sch. Specialty: pottery. Positions: T., Newcomb Sch. A., ACC

GONZALEZ, Xavier [Mur.P,T] New Orleans, LA/Alpine, TX (living in NYC, 1976)b. 15 F 1898, Almeria, Spain. Studied: AIC, 1921–23; his uncle, José Arpa; San Carlos Acad., Mexico City; Paris; Far East. Exhibited: Los Angeles, 1930 (prize); A.&Cr. Exh., New Orleans, 1937 (prize). Work: War and Peace Auditorium; San Antonio Mus. FA; Dallas Mus. FA; State T. Col.; Alpine, Tex.; USPO, Hammond, La.; Court House, Huntsville, Ala. Positions: T., Newcomb Mem. Col. Sch. A.; Dir. A. Sch., Sul Ros State T. Col., Alpine, Tex. [40]

GOOD, Bernard Stafford [P,I] Wilmington, DE b. 7 Ja 1893, England. Studied: AIC; G. Bellows; N.C. Wyeth. Illustrator: "The Children of the New Forest," "Red Beard of Virginia," "The Splendid Buccaneer," "Two Penniless Princesses"; Scribner's, McCall's, other magazines [40]

GOOD, George White [Des,P,Li] Wilmington, DE/Winchester, VA b. 13 S 1901, Ashtola, PA. Studied: Columbia; Md. Inst.; Charcoal C.; N.Y. Sch. Indst. A. Member: A. Cl., Wilmington, Del. Exhibited: Wilmington A. Cl., 1938 (prize); WFNY, 1939 [40]

GOOD, Leonard [Edu,P,Cr,Mus.Cur,L] Norman, OK b. 25 Je 1907, Chickasha, OK. Studied: Univ. Okla.; ASL, with K. Nicolaides; Univ. Iowa, with J. Charlot. Member: Prairie WC Soc.; Assn. Okla. A.; SSAL; Springfield (Mass.) A. Lg. Exhibited: Univ. Okla., 1927 (prize); Tulsa AA, 1938 (gold), 1939 (prize), 1941 (prize); Assn. Okla. A., 1927–41, 1942 (prize), 1943–46; Municipal Exh., N.Y., 1936, 1937; Philbrook A. Center, 1941–46. Position: T., Univ. Okla., 1930– [47]

GOOD, Minnetta [P,Dec,Li] NYC b. NYC d. 21 My 1946. Studied: F.L. Mora; C. Beaux. Member: NAWPS. Exhibited: NAWPS, 1932 (med), 1933 (prize), 1935 (prize); Phila. All., 1936 (prize). Work: murals, USPO, Dresden, Tenn. WPA artist. [40]

GOODALE, L. [P] Dover, NJ [01]

GOODCHILD, Cecil Wray [B,Des,En,E,P] Glendale, CA b. 19 D 1901, San Luis Obispo, CA. Studied: self-taught. Exhibited: Los Angeles County Fair, Pomona, CA, 1935 (11 prizes), 1936 (prize), 1937 (prize), 1939. Work: Los Angeles Pub. Lib.; Mills Col., Calif.; LOC [40]

GOODELL, Alice [P] St. Paul, MN [24]

GOODELL, William Newport [P,Ser,C,T] Phila., PA b. 16 Ag 1908, Phila. Studied: Univ. Pa.; PAFA. Exhibited: NAD, 1933 (prize); AFA; CGA; VMFA; AIC, GGE, 1939; Woodmere A. Gal.; DaVinci All.; Phila. AC. Position: T., Germantown Friend's Sch., 1936–46 [47]

GOODELMAN, Aaron J. [S,C,I,T,L,E] Bronx, NY b. 1 Ap 1890, Bessarabia, Russia. Studied: CUASch; NAD; Ecole des Beaux-Arts, Paris; BAID; J. Davidson; G. Borglum; J. MacNeil; G.T. Brewster; J. Injalbert. Member: Plastic C.; S.Indp.A.; Am. Ar. Cong.; Un. Am. Ar.; An Am. Group; A. Lg. Am.; S. Gld. Exhibited: CUASch, 1910–13 (med); BAID, 1914–16 (prize); Soc. Beaux-Arts Arch., 1914 (med); 1915 (prize), 1916 (prize); MOMA; WMAA; WFNY, 1939; BM; Carnegie Inst.; PMA; AIC; MMA; S. Gld., annually; An Am. Group; 8th Street Gal., 1933 (oneman); ACA Gal., 1942, 1946 (one-man). Work: Eastern Mus., Russia; Jewish Techological Lib., N.Y.; Lib. Jefferson Sch. Social Science; Project Houses, Wash., D.C.; "Victory Building," Toronto; Classic Theatre; Gabel's Theatre; Sholem Alachem Folks' Inst. Position: T., CCNY [47]

GOODENOW, Earle [P,I,Car] NYC b. 13 Jy 1913, Chicago. Studied: NAD; ASL. Member: Audubon A.; AIC. Exhibited: CGA, 1939; W.Va. Biennial Exh., 1940; CI, 1941; PAFA, 1942; Audubon A., 1945. Illustrator: "Arabian Nights," 1946 [47]

GOODENOW, (Taliaferro) [P,S,W,I] Hollywood, CA b. Kalamazoo, MI. Studied: L. Betts, A. Polasek, A. Mucha. Member: Calif. AC; Nat. Lg. Am. Pen Women. Specialty: carved ivory portraits. Author: "Yours for the Asking" [40]

GOODENOW, Rolf Julian [C] Hollywood, CA b. 23 D 1910, Chicago. Member: Calif. AC; Los Angeles AA. Specialties: goldsmith, silversmith [40]

GOODFRIEND, Arthur [I] NYC. Member: SI [47]

GOODHEART, Anna [P] Wash., D.C. Member: Wash. WCC [25]

GOODHEART, William R. Chicago, IL b. 1880, Germany (came to Chicago ca. 1890) d. 8 Ag 1933, NY. Member: Graphic Arts Assoc. Originator/Producer: first graphic arts expo in U.S.

GOODHUE, Alice Fuller (Mrs.) [Min.P] Buffalo, NY b. 16 Ag 1900, NYC. Studied: G. Bridgman; E.D. Pattee. Member: ASMP; Brooklyn Soc. Min. P.; Pa. Soc. Min. P.; Asbury Park Soc. FA [47]

GOODHUE, Bertram G. [I] NYC [08]

GOODHUE, Harry Wright [C,P,S] b. 1905 d. 12 Ag 1932, Boston. One of the early workers who helped to build up the art of stained glass in the U.S. From age 16, when he designed the Great Chancel window for the Montclair Congregational Church, until his death at 26 he designed many stained glass windows around the U.S.

GOODLOE, Paul (Mrs.) [P] San Fran., CA [10]

GOODMAN, Ann Bedford (Mrs. John S.) [P] Detroit, MI b. 17 O 1896, Ionia, MI. Studied: Halpert; Barker; Staples. Member: Detroit Soc. Women PS [40]

GOODMAN, Ann Taube [P] Bethlehem, PA b. 8 My 1905, Newark, NJ. Studied: W.E. Baum; P. Evergood. Member: WCC; Plastic C.; A. All., Phila. Exhibited: PAFA, 1943, 1944 (med), 1945; Butler AI, 1943–46; CAFA, 1942–45; Montclair A. Mus., 1944; AIC, 1941; Phila. Sketch C., 1939–43; Lehigh Univ.; Muhlenberg Col. Work: Lehigh Univ. [47]

GOODMAN, Arthur Jule [Por.P] Cleveland, OH b. Hartford, CT d. 3 O 1926. He painted many notables, including "Buffalo Bill" Cody, whose portrait was made for King Edward VII, and which now hangs in Buckingham Palace.

GOODMAN, Bertram [P,B,L] NYC b. 21 S 1904, NYC. Studied: H. Wickey, M. Young. Member: Am. Watercolorists [40]

GOODMAN, Ernestine A. [P] Phila., PA. Studied: PAFA [25]

GOODMAN, William Owen [Patron] Chicago, IL b. 1849, Wellsboro, PA d. 22 Mr 1936. Member: AIC; Friends of Am. Art (Founder/First Pres.). With Mrs. Goodman, he gave the Goodman Theatre in Chicago in memory of their only son, who died while serving in World War I.

GOODNOW, Catherine Spencer [Por.P] Greenbush, MA b. 17 Je 1904, Passaic, NJ. Studied: ASL; Bradford (Mass.) Acad.; Smith Col.; BMFA Sch.; J. Sharmon; T. Bengtz. Exhibited: PAFA, 1932; AWCS, 1946; Vose Gal., 1938, 1942, 1944 (one-man); Boston Soc. WC P., 1943; Jordan Marsh, 1945, 1946; North Shore AA, 1945; MIT, 1946 (one-man). Work: many portraits commissioned privately [47]

GOODNOW, Marjorie (Mrs. David F.) [P] Pelham Manor, NY. Exhibited: Argent Gal., NYC, 1938 (one-man); NAWPS, 1935-38 [40]

GOODRICH, Ada Porter [P] Catonsville, MD [25]

GOODRICH, Agatha (Mrs.) [P] NYC [01]

GOODRICH, Alice D.(Mrs.) [S] b. 1881 d. 30 S 1920, Brooklyn, NY. Studied: PIASch. Sister of painter Paul Dougherty.

GOODRICH, Charles H. [P] St. Paul, MN [15]

GOODRICH, E.H. (Mrs.) [P] Laguna Beach, CA. Member: Laguna Beach AA [25]

GOODRICH, Gertrude [P,T,W,L] NYC b. 5 O 1914, NYC. Studied: Nat. Acad.; Da Vinci A. Sch., N.Y. Member: United Am. Ar. Exhibited: ACA Gal.; GGE, 1939; WFNY, 1939; AIC, 1939-45; Santa Barbara, Calif., 1944, 1945; WMAA, 1942, 1946. Work: murals, USPO, Buchanan, Mich.; Social Security Bldg., Wash., D.C. [47]

GOODRICH, Ira B., Jr. [P] Boston, MA [01]

GOODRICH, J(ames) H(arry) [P,T] Nashville, TN b. 29 N 1878, Colon, MI. Studied: Gies, in Detroit; Freer, in Chicago; Harvard. Exhibited: Fogg A. Mus., 1928, 1929, 1932; Columbia T, Col., 1931. Position: T., Fisk Univ., Nashville [40]

GOODRICH, Lloyd [Mus.Cur,W,L] NYC b. 10 Jy 1897, Nutley, NJ. Studied: ASL, with K.H. Miller; NAD. Member: N.Y. Regional Comm., WPA, 1933-34; Ed. Boards, Magazine of Art; Art Bulletin, Art in America; AFA. Author: "Thomas Eakins," 1933, "Henry Schnakenberg," 1934, "Winslow Homer," 1944, "Edward Hopper," 1946, "Thomas Eakins" (2-vol., 1948). Editor: Research in American Art, 1945, "The Arts," 1935-31. Contributor: The Arts, Magazine of Art, Art in America. Positions: Cur., WMAA, 1935-85; Dir., Am. A. Research Council, 1942-

GOODRICH, Matilda Antoinette [P] Brooklyn, NY. Studied: G. Wiegand. Member: NAC; Allied AA; Brooklyn PS [40]

GOODRIDGE, Elinor [P] Cambridge, MA b. 9 D 1886, Cambridge. Studied: BMFA Sch., with U. Romano, P. Jones; H.H. Clark. Member: Springfield A. Lg.; Boston S.Indp.A.; Rockport AA; Gloucester SA. Exhibited: PAFA, 1936; BM, 1937; Univ. Minn., 1937; AWCS, 1936-38; Rockport AA; Gloucester SA. Illustrator: "Children of the Lighthouse," 1924 [47]

GOODRIDGE, Paul E. [P] Providence, RI [24]

GOODSELL, Josephine B. (Mrs.) [P] Norwalk, OH b. 1860, Columbus. Studied: W. Eaton, C.C. Curran, H. Mosler, all in N.Y. [01]

GOODWIN, Alice Hathaway Hapgood (Mrs. Harold) [P,Dec,Des] Wyncote, PA b. 5 N 1893, Hartford. Studied: PAFA; H.H. Breckenridge; E. Carlsen; V. Oakley; H. McCarter. Work: reredos, Episcopal Church, Castleton, Vt. [40]

GOODWIN, Arthur C(lifton) [P,C,W,L,T] b. 12 S 1864, Portsmouth, NH d. 1929. Studied: self-taught. Member: Boston GA; Boston SWCP. Work: Union Club, Boston; St. Botolph C., Boston [27]

GOODWIN, Belle (Mrs.) [P] Chicago, IL [10]

GOODWIN, Caroline Love [P] New Rochelle, NY b. Savannah, GA [04]

GOODWIN, Charles A. (Mrs.) [P] Hartford, CT. Member: Hartford AS [25]

GOODWIN, Clara L. [P] Phila., PA [04]

GOODWIN, Elizabeth Thayer Abbott (Mrs. William B.) [C,Des] Lowell, MA b. 24 My 1887, Lowell. Studied: A.M. Sacker Sch. Des., Boston; Royal Sch. Needlework, Kensington, England. Member: Boston SAC; Lowell AA. Exhibited: Boston SAC (prizes). Specialty: needlework [40]

GOODWIN, Frances [S] Newcastle, IN d. 8 N 1929. Studied: L. Taft, D.C. French. Member: Ind. SS. Exhibited: Chicago World's Fair, 1893. Work: Office of the Governor, Ind.; Ind. State House; Senate Chamber, Wash.,D.C.; Newcastle Pub. Lib.; Henry County Hist. Mus. [25]

GOODWIN, Gilberta Daniels (Mrs.) [P,T] Hackettstown, NJ b. 20 Ag 1890, Burlington, VT. Studied: Yale; ASL; Columbia; J. Weir, E. Taylor, T. Benton. Member: NYWCS; AWCS; AAPL; CAFA; New Haven PCC. Exhibited: PAFA, 1930; Arch. Lg., 1913; AWCS, 1916-45; S.Indp.A., 1931, 1932; Audubon A., 1946; New Haven PCC, 1913-1915; Edgartown, Mass., 1944-46. Positions: T., Bentley Sch., N.Y., Centenary Jr. Col., Hackettstown, 1944- [47]

GOODWIN, Harold [Cr] b. 1858 d. 1931. Studied: Saint-Gaudens, in Paris. Positions: A. Cr., New York Evening Post, Mail and Express and Commercial Advertiser

GOODWIN, Harold [P] NYC. Exhibited: 48 Sts. Comp., 1939 [40]

GOODWIN, Helen A. [P] Albany, NY [01]

GOODWIN, Helen M. [P] New Castle, IN b. New Castle. Studied: Hoffbauer, Mme. La Forge, in Paris; Hawthorne. Member: Ind. AC; Provincetown AA; Am. Women's AA, Paris; Hoosier Salon. Exhibited: Hoosier Salon, 1925 (prize). Work: New Castle Pub. Sch.; Spiceland Acad. Ind.; Pub. Lib., New Castle [40]

GOODWIN, J. Walter [P,E] Seattle, WA b. 14 My 1913, Seattle. Studied: E.P. Ziegler. Work: State Dir. Nat. Youth Admin. [40]

GOODWIN, Jessie S. [P] Hartford, CT [13]

GOODWIN, Lamira [P] Nashville, TN [13]

GOODWIN, Myrtle. See Nicola D'Ascenzo, Mrs.

GOODWIN, Philip R(ussell) [P,I] Mamaroneck, NY b. 16 S 1882, Norwich, CT d. 1935. Studied: RISD; H. Pyle; ASL. Specialties: hunting and fishing scenes; cowboy genre, influenced by C.M. Russel [21]

GOODWIN, Richard LaBarre [P] b. 26 Mr 1840, Albany, NY d. 10 D 1910, Orange, NJ. Studied: his father, Edwin W. [a portrait and miniature painter (1800-45)]; NYC. Exhibited: Lewis & Clark Centenn., Portland, 1905. Work: Stanford; Smithsonian. Worked as itinerant portrait painter for 25 years, in Syracuse, N.Y., Wash., D.C., Chicago; Colorado Springs; Calif.; Portland, Oreg., and then back to Rochester, N.Y. Best known for his still life paintings of game and fish. [*]

GOODYEAR, Clara (Mrs.) NYC b. New Haven, CT. Exhibited: AWCS, BAC, 1898 [01]

GOODYEAR, Grace Rumsey (Mrs. C.W.) [S] Buffalo, NY [17]

GOODYEAR, William H. [Mus.Cur,W,L] Brooklyn NY b. 21 Jy 1846, New Haven, CT d. 19 F 1923. Studied: Germany; Cyprus; C. Friedrichs. An authority on architecture and archaeology. Positions: Cur., MMA, 1881-88, Brooklyn MA, 1899-04; T., Cooper Union, NYC [04]

GOOGERTY, Thomas F. [C,T] Pontiac, IL b. 1865, Pontiac d. 28 Mr 1944. Member: Boston SAC. Exhibited: AIC, 1914-21 (prizes). Author: "Practical Forging and Art Smithing," "Decorative Wrought Iron Work." Position: T., Ill. State Reformatory [40]

GOOKIN, Frederick William [Mus.Cur] b. 1854 d. 18 Ja 1936. Collector of Japanese prints; became international authority on subject. Curator of Buckingham Coll. Japanese prints at AIC, which ranks among the finest in world.

GOOKINS, James Farrington [P,I] b. 30 D 1840, Terre Haute, IN d. 23 My 1904, NYC. Studied: Munich, 1870-73. Illustrator during Civil War, for Harper's; later worked mostly in Chicago, Indianapolis, and Terre Haute as a portrait and landscape painter. He was living in Denver in 1866. [*]

GOOSEY, G. Turland [P] NYC. Member: Salma C. [21]

GOOSSENS, John [P] Chicago, IL/Sioux Narrows, Ontario b. 27 Ag 1887, Norway, MI. Studied: Royal Acad., Antwerp, Belgium; F. Poole; G. Oberteuffer; AIC. Member: Ill. Acad. FA; All-Ill. SFA; North Shore AG; North Shore AL, Winnetka. Exhibited: Aurora, 1927 (prize), 1928 (prize); Springfield, Ill., 1928 (prize). Work: All-Ill. SFA; Stevens Hotel; Amundsen H.S.; Glenola C.; Loyola Community Theatre; Rogers Park, Chicago; Mount St. Mary's Acad., St. Charles, Ill.; St. Joseph's Col., Adrian, Mich.; Little Log Church, Sioux Narrows, Ontario [40]

GORBUTT, John D(etwiler), Jr. [P,S] Topeka, KS b. 20 O 1904, Troy, KS. Studied: V.H. Anderson. Member: Topeka AG. Exhibited: Kans. Free Fair, 1932; Midwestern A., Kansas City AI, 1937. Work: State of Kans. [40]

GORDIGIANI, Eduardo [P] NYC [01]

GORDIGIANI, Michele [P] NYC [01]

GORDON, Bernard [S] Studied: PAFA [25]

GORDON, Elizabeth Stith [P] Baltimore, MD b. 18 Je 1898, Baltimore. Studied: Garber; Breckenridge; Nuse; Pearson. Member: Plastic C.; Phila. Print C.; Baltimore Municipal AS [40]

GORDON, Emeline H. (Mrs. Beirne) [P,T] Walpole, MA/North Hatley, Canada b. 25 Je 1877, Boston. Studied: Tarbell; F. Benson; E. Clark. Member: Savannah AC. Work: Fort George (Fla.) C.; Faulkner Hosp. [40]

GORDON, Emma M. [P] Minneapolis, MN [24]

GORDON, F(rederick) C(harles) [I] Westfield, NJ b. 30 Je 1856, Coburg, Ontario d. 20 Mr 1924. Studied: ASL; Académie Julian, Acad. Colarossi, both in Paris. Member: Westfield AA. Work: Century magazine, under R.W. Gilder. Illustrator/Designer: books, magazines. Position: Mayor, Mountainside, N.J. [21]

GORDON, Grace [P,T] Phila., PA. Studied: PAFA [25]

GORDON, Jessie Fairfield [C] Phila., PA b. 1877, Oswego, NY. Studied: C. Grafly; A. Saint-Guadens; C. Binns. Member: Phila. ACG; Phila. Alliance. Exhibited: Plastic C., Phila., 1922 [40]

GORDON, Leon [Por.P] NYC/Paris, France b. 25 My 1889, Borisov, Russia (came to U.S. in 1904) d. 31 D 1943, Tallahassee, FL. Studied: AIC; ASL; Académie Julian, Paris; Kunst Acad., Vienna; NAD. Member: SC [33]

GORDON, Maurice [I,Car,P,Dec] NYC b. 9 My 1914, Hartford, CT. Studied: N.Y. Sch. F.&Appl. A. Exhibited: Place des Vosges, Paris; Sterner Gal., N.Y., 1938 (one-man); Intl. WC Ann., AIC, 1939 [40]

GORDON, Maxwell [P,Ser] NYC b. 4 S 1910, Chicago. Studied: Cleveland Sch. A; ASL. Member: A. Lg. Am.; Nat. Ser. Soc. Exhibited: Butler AI, 1947 (prize); PAFA, 1945; BM, 1945; Albany Inst. Hist.&A.; Phila. Pr. C., 1936; Springfield Mus. A., 1946; CMA; CGA, 1947. Position: T., Sch. A. Studies, N.Y. [47]

GORDON, Morris [P,I,T] Lincoln, NE b. 17 Jy 1911, Johnstown, PA. Studied: Univ. Nebr.; ASL, with R. Marsh; Provincetown. Member: Lincoln Artists G.; Nebr. AA. Position: T., Univ. Nebr. [40]

GORDON, Robert [P] Brattleboro, VT b. 29 Mr 1854, Brattleboro d. 10 Ja 1904. Studied: CUASch; NAD; ASL; Ecole des Beaux-Arts, with Gérôme. Member: SAA, 1897; A. Fund S.

GORDON, Witold [I,Car] NYC. Exhibited: WFNY, 1939. Illustrator: "Cinderella Married" [40]

GORDON-SQUIER, Donald [P] Boston, MA [25]

GORE, Thomas H. [P,D] Covington, KY b. 1 O 1863, Baltimore d. 1937. Studied: Duveneck. Member: Cincinnati AC [33]

GORELEIGH, Rex [P,I,L,T] Chicago, IL b. 2 S 1902, Penllyn, PA. Studied: AIC, with F. Chapin, 1935; Lhote, in Paris, 1934–35; L. Moll, in NYC and Berlin, 1929–31; X. Barile A. Sch., NYC. Exhibited: BMA, 1939; Negro Expo, Chicago, 1940; S.Indp.A., 1930, 1931, 1934; Assoc. Am. A., 1945; Univ. Chicago, 1944; South Side Community A. Center, 1944. Work: Encyclopaedia Britannica Coll. Lectures: "American Negro Artists." Position: Dir., South Side Community A. Center, Chicago, 1944–46 [47]

GORES, Walter W.J. [Des,C,W,L,T] Ann Arbor, MI b. 23 Ja 1894, Los Angeles. Studied: Stanford Univ.; Ecole du Louvre; Univ. Paris; H.V. Poor, L. Hourticq, F. Benoit. Member: CAA; Ann Arbor AA. Exhibited: French Univ., 1921–24 (prize); Ann Arbor AA, 1930, 1940–44, 1945 (prize), 1946 (prize); Mich. A.&Cr. Exh., 1946. Work: Am. Univ. in Europe, Paris. Author: "Manual of the Visual Arts," 1940 [47]

GORGES, Raymond C.H. [P] Newport, RI b. 1877, Ireland d. 21 F 1943. Member: Newport AA

GORHAM, Sydney [P] NYC/Fern Creek, KY b. 21 N 1870, Plattsburg, NY d. 20 Ja 1947, Louisville, KY. Studied: Ecole des Beaux-Arts, Bonnât, J. Blanc, all in Paris. Exhibited: Paris Salon, 1902 (prize) [10]

GORIANSKY, Lev Vladimir [P,Des,T] Andover, MA b. 11 F 1897, Russia. Studied: MIT; Harvard; Carlu; D. Ross; abroad. Member: Wellesley SA; Gloucester SA; F., Andhra Research Univ., India; Inst. Mod. A., Boston. Exhibited: MIT, 1923 (med), 1925 (med); La Merite Français, Paris, 1938 (prize); Cross of Academic Honor, Intl. Academic Council, Wash., D.C., 1939 (prize); Wellesley Col., 1937–46; S.Indp.A., 1941; Gloucester SA, 1937–40; Milch Gal.; Contemporary A. Gal.; AGAA [47]

GORKY, Arshile [P,G] NYC b. 1904, Turkish Armenia (came to U.S. in 1920) d. 21 Jy 1948, Sherman, CT (hanged himself on a tree). Studied: RISD, 1920; Boston. Member: Mural Ar. Gld. Exhibited: Wanamaker Regional, N.Y., 1934; Gld. A. Gal., N.Y., 1936; "Abstract Painting in America," WMAA, 1937, 1951 (restrospective); MOMA 1962 (retrospective); Venice Biennale, 1962. Work: murals, airports Newark, N.J.; Aviation Expo, NYC, 1939; WMAA. WPA muralist. Positions: T., Grand Central Sch. A. (1926–31), N.Y. Sch. Des.

GORSKI, Belle Silveira (Mrs. W.O.) [P,S,I,C] Chicago, IL b. 21 S 1877, Erie, PA. Studied: J. Vanderpoel; W.M. Chase; F. Richardson [10]

GORSKI, Stanislas [P,W] b. 1854, Poland (came to U.S. in 1902) d. 4 S 1923. Exhibited: Paris, 1884 (prize). His memoirs, written in Polish, were translated into several languages.

GORSON, Aaron Harry [P] NYC b. 2 Jy 1872, Kovno, Lithuania (came to U.S. in 1890) d. 11 O 1933. Studied: PAFA; Académie Julian, Paris, with Constant, Laurens. Member: Pittsburgh AA; Brooklyn AS; Alliance. Exhibited: CI. Work: Coll. Andrew W. Mellon; Coll. Charles M. Schwab; Pa. State Col.; NYU; Newark Mus.; Worcester (Mass.) A. Mus.; Heckscher Park A. Mus., Huntington, N.Y. Specialty: industrial scenes (steel mill ovens glowing in the night) [31]

GORSLINE, Douglas Warner [P,I,Gr,T] Blauvelt, NY b. 24 My 1913, Rochester, NY. Studied: Yale; ASL. Member: ANA; SAE; Great Lakes Exh., The Patteran, 1938; Arden Gal., N.Y., 1939 (one-man); WMAA, 1938; PAFA, 1942 (prize); LOC, 1942 (prize), 1946 (prize); NAD, 1942 (prize), 1944 (prize); CI; PAFA; CGA; AIC; NAD. Work: LOC; Univ. Rochester; New Britain Mus.; Hamilton Col. Illustrator: "Look Homeward Angel," "Compleat Angler," "Little Men," other books [47]

GOSHORN, A.T. [Mus.Dir] Clifton, OH d. 19 F 1902. Director Cincinnati Mus. Assoc. His success in the management of the famous industrial expositions given in Cincinnati (1870s) led to his appointment as Director General of the Centennial Expo at Phila., 1876.

GOSHORN, John T(homas) [P] Pittsburgh, PA b. 16 F 1870, Independence, IA. Studied: AIC; Smith A. Acad. [25]

GOSLIN, Beatrice L. [P] Sioux City, IA b. Ja 1905, Belmond, IA. Studied: Minneapolis Sch. A.; C. Nelson; A. Stillman. Member: Sioux City A. Center Assn. Exhibited: 5 Sts. Ann.; Joslyn Mem., Omaha (prize); Joslyn Mem. (one-man); Ames Col., Iowa [40]

GOSLIN, John [P,S] Cincinnati, OH b. 5 O 1907, Lancaster. Studied: Columbus Sch. A.; Nat. Acad.; A. Acad., Cincinnati; W. Adams. Exhibited: Ohio State Fair, Columbus, 1939 (prize); Butler AI, Youngstown, Ohio, 1939; Cincinnati Ar. Ann., Cincinnati AM, 1938, 1939. Work: Cincinnati AM [40]

GOSS, Alice [P] Chicago, IL [13]

GOSS, Dale [P] Seattle, WA. Exhibited: 48 Sts. Comp., 1939 [40]

GOSS, John [P,G] Walpole, MA b. 19 S 1886, Lewiston, ME d. ca. 1964. Member: Am. WC Soc. Exhibited: Am. WC Soc., 1936–1938. Position: T., RISD [40]

GOSS, Louise H. (Mrs.) [P] Salt Lake City, UT [15]

GOSS, Margaret Taylor [Li,Ser,P,T,C] Chicago, IL b. 1 N 1916, St. Rose, LA. Studied: Chicago T. Col.; AIC. Member: A. Lg. Chicago; South Side Community A. Center, Chicago, 1940–46. Exhibited: Chicago T. Col., 1936 (prize); Atlanta Univ., 1944 (prize); SFMA, 1945; LOC, 1939, 1945; AIC, 1943; Atlanta Univ., 1942–45; Detroit Negro Cong., 1946. Work: Atlanta Univ.; Barnett Aden Gal. [47]

GOSSELIN, Lucien H. [S] Manchester, NH b. 2 Ja 1883. Studied: Verlet; Bouchard; Landowski; Mercie. Member: Société Libre des Artistes Français. Exhibited: French Artists Salon, 1913 (prize) [33]

GOSSETT, Lee Roy [Car,W] b. 1877, Iowa d. 14 Ja 1926, Chicago. Studied: ASL; T. McWhorter; C.A. Cummings; G.R. Bridgman; Henri; W. Morgan. Contributor: Judge, Life, other magazines

GOTCLIFFE, Sid [P] b. 1899, England (came to U.S. in 1920) d. 1969. Studied: largely self-taught. Exhibited: New Sch. Soc. Res., 1938; MMA, 1944; LOC, 1956, 1963; Yale, 1965; BM, 1948–49. Work: Yale; MOMA; Smithsonian. WPA artist of primitive style. [*]

GOTH, (Jessie) Marie [P,T] Indianapolis, IN/Nashville, IN b. Indianapolis. Studied: ASL, with DuMond, Chase, Mora. Member: NAWA; Brown County A. Gal. Assn.; Ind. AC; Hoosier Salon. Exhibited: NAD, 1939 (prize); Hoosier Salon, 1926–29 (prize), 1932 (prize), 1934–42 (prize), 1945 (prize), 1946 (prize); Brown County A. Gal., 1933 (prize); Ind. AC, 1935 (prize), 1939 (prize), 1944 (prize), 1945; Evansville (Ind.) Mus. A.&Hist., 1939 (prize); Fort Wayne AA, 1923 (med); John Herron AI, 1924 (prize); Women's Dept. C., Indianapolis, 1936 (prize). Work: Hanover Col., Ind.; Franklin Col., Ind.; Purdue Univ.; Ind. Univ.; Butler Col., Ind.; John Herron AI; De Pauw Univ. [47]

GOTHARD, William Harry [P,T] Cincinnati, OH b. 4 Mr 1908. Studied: G. Bridgman, H. Wessel, J.E. Weis, F. Myers. Member: New Group of Cincinnati; Cincinnati Soc. Prof. A. Work: murals, Cincinnati Bd. Edu.;

Cincinnati Mus.; Lunken Airport; Cincinnati Pub. Sch. Position: T., Cincinnati AM [40]

GOTHELF, Louis [P,I] Yonkers, NY b. 6 Ap 1901, Russia. Studied: I. Olinsky, G.W. Maynard, NAD; J.W. Reynolds, AIC. Member: Rockford AA; Artklan; United Scenic A., N.Y. Work: Jewish Educational Bldg., Toledo. Position: A. Dir., Orpheum Theatre, Rockford, Ill. [31]

GOTSCHALL, I.W. [P] Toledo, OH. Member: Artklan [25]

GOTTHOLD, Florence W(olf) (Mrs. Frederick) [P,C] NYC/Wilton, CT b. 3 O 1858, Uhrichsville, OH d. 17 Ag 1930, Wilton. Studied: B.R. Fitz; H. Siddons Mowbray; H.G. Dearth. Member: PBC; MacD. C.; Greenwich SA; NAWPS; Silvermine GA; Gld. Book Workers; Wilton SA. Exhibited: Greenwich Soc. Ar. (prize). She exhibited frequently and was well known in N.Y. and Boston art circles. [29]

GOTTHOLD, Rozel [P,S,C,W] New Orleans, LA b. 26 Ja 1886. Inventor: palm baskets [25]

GOTTLIEB, Adolph [P,E] Brooklyn, NY b. 14 Mr 1903, NYC d. 1974. Member: Fed. Mod. P.&S.; Am. A. Cong.; Artists U. Exhibited: Dudensing Comp., 1929 (prize); Brooklyn SA, 1944 (prize); 48 Sts. Comp. (prize). Work: USPO, Yerington, Nev.; Palestine Mus. [47]

GOTTLIEB, Frederick H. [Patron] b. 12 O 1852, Hungary (came to U.S. in 1864) d. 25 Jy 1929 (at sea). Member: Charcoal C. (Pres.); Florestan C.; Friends of A.; BMA; SC (Pres. 1927). He owned a valuable collection of fine violins, as well as a collection of paintings by European and American artists.

GOTTLIEB, Harry [P,Ser,E,Li] NYC b. 25 S 1895, Bucharest, Romania. Studied: Minneapolis Inst. A. Member: N.Y. Ar. U.; Am. Soc. PS&G; Am. A. Cong.; A. Lg. Am.; An Am. Group. Exhibited: F., Guggenheim Fnd., 1932–33; NAD, 1935 (prize); Phila. WCC, 1942 (prize); AIC, 1930 (prize); PAFA, 1934 (gold); CI, CGA; WMAA; other national exh. Work: WMAA; Berkshire Mus.; Univ. Nebr.; Univ. Ariz.; Univ. Ga.; MMA; BM; Newark Mus.; Springfield (Mass.) Mus. A. WPA artist. [47]

GOTTLIEB, Maxim B. [P,Dr,T] Phila., PA b. 5 My 1903. Studied: PAFA; Graphic Sketch C.; Europe. Member: Graphic Sketch C. Work: Graphic Sketch C. Mus.; Allentown (Pa.) Mus. Position: T., Graphic Sketch C., Phila. [40]

GOTTSCHALK, Jules [Des,S] St. Louis, MO b. 14 D 1909, St. Louis. Studied: M. Gottschalk; Washington Univ.; Lausanne, Switzerland. Designer: electrical appliances, furniture, masks, etc. Position: Tech. Advisor, Rural Reconstruction, Newfoundland Commission [40]

GOTTSCHALK, Max [P] St. Louis, MO [25]

GOTTWALD, Frederick Carl [P,T] Cleveland, OH b. 15 Ag 1860 d. 23 Je 1941. Studied: ASL; Royal Acad., Munich. Member: Cleveland SA. Work: Cleveland Mus. Position: T., Cleveland Sch. A. [40]

GOTZSCHE, Kai [P] Elmhurst, NY b. 6 May 1886, Copenhagen, Denmark. Studied: Royal Acad., Copenhagen. Member: Mural P.; Scandinavian-Am. AS. Work: BM. Painted in Taos. [33]

GOUDMAN, Paul L. [Li,P] b. 1873, Amsterdam, Holland (came to U.S. in 1896) d. 26 Mr 1937, NYC. Studied: Amsterdam Acad. A. Member: Poster Ar. Assoc. Am.

GOUDY, Bertha M. Sprinks (Mrs. Frederic W.) [Printer] d. 21 O 1935, Marlboro, NY. Exhibited: Limited Editions Cl., NYC, 1931. Known as America's greatest woman printer. In 1933, she completed setting a special edition of Mary Godwin Shelley's "Frankenstein" by hand in Goethe, a typeface specially designed for the edition. This work consumed seven months during which Mrs. Goudy handled more than a ton of type founded in the Village Press, the workshop on the Goudy estate. She set the type for more than twenty-nine volumes, all by hand and all for de luxe editions.

GOUDY, Frederic W(illiam) [Type Des,Printer,C,W,L] Marlboro, NY b. 8 Mr 1865, Bloomington, IL d. 11 My 1947. Member: Grolier Cl.; AI Graphic A.; Stowaways; The Typophiles; Soc. Typographic A.; Boston Soc. Printers. Exhibited: St. Louis Expo, 1904 (med); AI Graphic A.(gold); AIA, 1923 (gold); Arch. Lg. (gold); School of Journalism, Syracuse Univ., 1936 (med). Author: "The Alphabet," "Elements of Lettering," "Beauty and Design in Printing," "The Story of the Village Type." He established the Village Press in Park Ridge, Ill., in 1903, moved it to NYC, 1906, and to his estate in Marlboro, ca. 1908. He designed more than ninety typefaces, including the one in which this book is set (Goudy Old Style). [40]

GOULD, Alan, Mrs. See Dinneen, Alice.

GOULD, Albert [P,G,I,Car,L] Phila., PA b. 31 O 1916, Phila. Studied: PMSchIA. Member: Am. Fed. A.; Phila. Pr. Cl.; Phila. WCC; Am. Ar. Prof. Lg. Exhibited: Phila. Pr. Cl., 1939 (prize); CGA, 1939; PAFA, 1939; Intl. Lith. Wood En., AIC, 1939; WFNY, 1939 [40]

GOULD, Allan [Des,P] Bearsville, NY b. 17 Je 1908, NYC. Studied: Dartmouth; ASL. Work: USPOs, Roxboro, N.C., Greenville, Ky. Designer: Interiors, Industrial design. WPA artist. [40]

GOULD, Annunziata (Mrs. Kingdon) [P] NYC. Exhibited: NAWPS, 1935–38 [40]

GOULD, Carl Frelinghuysen [P,Arch,L,T] Seattle, WA/Bainbridge Island, WA b. 24 N 1873, NYC. Studied: W. Sartain; Ecole des Beaux Arts; M.V. Laloux. Member: Beaux-Arts Architects; Seattle FA Soc.; AIA; Arch. Lg. Work: Univ. Wash.; Seattle Times Bldg. Position: T., Univ. Wash. [29]

GOULD, Chester [I,Car] NYC. Creator: comic strip, "Dick Tracy" [40]

GOULD, Irving, Mrs. See Kappel, R. Rose.

GOULD, J.J. [I] Phila., PA [19]

GOULD, Janet [S] NYC b. 5 Je 1899, Romania. Studied: A. Finta; C. Neilson. Member: Lg. Present-Day A.; Creative A.; N.Y Ceramic A. Exhibited: Asbury Park AA, 1940 (prize); NAD, 1940, 1942, 1944; CM, 1943; Hartford, Conn., 1942; AIC, 1943; Riverside Mus., 1944; PAFA, 1946; Audubon A., 1945; Irvington Lib., 1946; Wichita A. Center, 1946; Mint Mus. A., 1946 [47]

GOULD, John F. [I] Queens Village, NY. Member: SI [47]

GOULD, Mabel Saxe [Min.P] Phila., PA [04]

GOULD, Northam R(obinson) [Por.P] East Hampton, CT b. Brooklyn, NY. Studied: PIASch; ASL; Cleveland Sch. A. Member: Conn. Soc. P. [33]

GOWELL, Prudentiss (Mrs.) [P] Tacoma, WA. Member: Tacoma FA Assoc. [25]

GOWEN, Elwyn George [B,C,Dec,Des,E,L,P,T] Arlington, MA/Sanford, ME b. 19 Ja 1895, Sanford. Studied: H.H. Clark; D.W. Ross; C.H. Woodbury; P. Hale. Member: Boston SAC; Ogunquit AA; AFA. Positions: T., Woodbury Sch. (Boston), Mus. A. (Attleboro, Mass.) [40]

GRABACH, John R. [P,T] Irvington, NJ b. 1886, Newark, NJ. Studied: ASL. Member: North Shore AA; AFA; Phila. WCC; SC; Irvington A.&Mus. Assn. Exhibited: Los Angeles Mus. A. (prize); AIC, 1924 (prize); PAFA, 1927 (gold); CGA, 1932 (med,prize); CGA, 1931, 1933, 1935, 1941; Montclair A. Mus. Work: AIC; Vanderpoel Art Assoc.; John Herron AI; CGA; IBM; Biro Bidjan State Mus., Russia. Position: T., Newark Sch. F.&Indst. A. [47]

GRABAU, John F. [C,W,L,T] Buffalo, NY b. 4 Ja 1878, Cederburgh, WI. Studied: L.H. Kinder; Albright A. Sch.; Roycroft Shops. Member: Soc. A.&Crafts, Boston; Gld. Book Workers. Exhibited: Pan-Pacific Expo, 1915 (med); Graphic A. Exh., Buffalo, NY, 1930 (med); GGE, 1939; Rockford AA, 1930; Albright A. Gal.; Grosvenor Lib. Author: "The Binding and Care of a Book," 1912, "A Good Book Merits a Good Binding," 1931. Specialty: bookbinding. Work: books, Queen Marie of Romania, Vatican (six vols.), libraries in Europe [47]

GRACE, Louise N. [P] Great Neck, NY. Exhibited: NYWCC, 1936; NAWPS, 1936–38; murals, Rockefeller Center, NYC, 1937 [40]

GRAEBER, John Adams [I] Phila., PA b. 14 F 1871, Phila. Studied: PAFA, with Eakins [13]

GRAEF, Robert A. [P] NYC. Member: GFLA [27]

GRAEF, William [P] Cincinnati, OH [13]

GRAF, Carl C. [P,S,T] Nashville, IN b. 24 S 1890 d. 28 Ja 1947, Indianapolis. Studied: Herron AI; Cincinnati Acad. Member: Ind. AC; Brown County A. Exhibited: Hoosier Salon, 1932 (prize) [40]

GRAF, Gladys H. [P,S,G] Berkeley, CA b. 30 N 1898. Studied: Calif. Sch. FA; Univ. Calif. Member: Ar. U. Exhibited: Seattle FA Assn., 1929 (prize); Oakland A. Gal. Work: mosaic, Schoonover Children's House, Berkeley; Piedmont H.S., Oakland. WPA artist. [40]

GRAFE, C. Paul [P] NYC [13]

GRAFF, W.V. [P] NYC [24]

GRAFLY, Charles [S,T] Phila., PA/Gloucester, MA b. 3 D 1862, Phila. d. 6 My 1929 (result of injuries sustained when hit by an auto in Phila.). Studied: PAFA, with Eakins; Chapu, Dampt, in Paris. Member: NSS, 1893; ANA, 1902; NA, 1905; Arch. Lg., 1902; Phila. AC; NIAL; Munici-

pal Art Jury Phila.; St. Botolph Cl. Exhibited: Paris Salon, 1891 (prize); PAFA, 1892 (prize), 1899 (gold), 1913 (med); Columbian Expo, Chicago, 1893 (med); Atlanta Expo, 1895 (med); Paris Expo, 1900 (gold); Pan-Am. Expo, Buffalo, 1901 (gold); Charleston Expo, 1902 (gold); Buenos Aires Expo, 1910 (prize); Phila. WCC, 1916 (prize); NAD, 1918 (gold); Concord AA, 1922 (prize). Work: Detroit Inst.; St. Louis Mus.; Fairmount Park, Phila.; Custom House, New York; PAFA; San Fran.; CI; mem., Wash., D.C. Specialty: work in bronze. Father of Dorothy. Position: T., BMFA, PAFA [27]

GRAFLY, Dorothy (Mrs. Charles Hawkins Drummond) [W,Cr,L] Phila., PA b. 29 Jy 1896, Paris, France. Studied: Wellesley. Member: Phila. A. All.; Phila. WCC; F., PAFA. Contributor: Magazine of Art, American Artist, Design. Author: one-act plays. Daughter of Charles. Positions: Writer/Critic, Philadelphia North American, 1920–25; A. Ed./Cr., Public Ledger (1925–34), Philadelphia Record (1934–42); Correspondent: Christian Science Monitor (1920–); Cur., Drexel Inst. (1934–45) [47]

GRAFSTROM, Ruth Sigrid [I] NYC b. 26 Ap 1905, Rock Island, IL. Studied: O. Grafstrom; H. Morriset. Member: SI. Illustrator: Vogue, Woman's Home Companion, Delineator, other magazines [40]

GRAFTON, Elbridge Derry [P] b. 17 Ap 1817, Boston d. 20 Je 1900, Cincinnati

GRAFTON, Robert W. [P,Por.P] Michigan City, IN b. 19 D 1876, Chicago d. 17 D 1936. Studied: AIC; Académie Julian, Paris; Holland; England. Member: Chicago PS; Palette & Chisel Cl.; Chicago AC; Chicago Gal. Assn. Exhibited: Richmond AA, 1910 (prize), 1919 (prize); Hoosier Salon (prize). Work: Delgado Mus; New Orleans AA; La Fayette AA; Union Lg. Cl., Chicago; Northwestern Univ.; Purdue; Earlham Col.; Public Art Gal., Richmond, Ind; murals, State House, Springfield, Ill., Kansas Wesleyan Univ.; Tulane; First National Bank, Fort Wayne, Ind.; portraits, State Lib. (Indianapolis), Ind. State Capitol, Mich. State Capitol, Univ. Wis., Dept. Agriculture (Wash., D.C.), Iowa State Col. Agriculture, Paris Embassy, Administration Bldg. (Mundelein); Saddle and Sirloin Cl. He painted portraits of a great many noted men in public and university life. [33]

GRAHAM, Cecilia B(ancroft) [S] Berkeley, CA/Lake Tahoe, CA b. 2 Mr 1905, San Fran. Studied: L. de Jean; O. Thiede; N. D'Antino [29]

GRAHAM, Charles S. [I,P,Li] NYC b. 1852, Rock Island, IL d. 1911. Member: SI. Studied: self-taught. Topographer: Northern Pacific RR survey Mont./Idaho, 1873. Theatrical scenic artist in NYC and Chicago, 1874–77; Western illustrator for Harper's, 1877–92; official artist for Columbian Expo, Chicago, 1893; worked in San Fran., 1893–96, then returned to NYC. [04]

GRAHAM, Elizabeth Sutherland [P,Min.P] Brooklyn, NY b. NYC. Studied: N.Y. Sch. Appl. Des. for Women; M. Despujols; Mme. D. Chardon. Member: NAWPS; Brooklyn S. Min. P.; Pa. S. Min. P. [40]

GRAHAM, Ernest Robert [Arch] Chicago, IL b. 22 Ag 1868, Lowell, MI d. 22 Nov 1936. Studied: Coe Col., Iowa; Notre Dame. He was assistant director of works for the Columbian Expo in 1893, and helped in designing the fine arts bldg. Architect: Shedd Aquarium, Field Mus. of Nat. Hist. He gave to the Field Mus. a large collection of coptic textiles from ancient Egypt; the major part of his $1,570,000 estate endowed the American School of Fine Arts, organized in 1935. It has been said that he participated in the construction of more buildings than any architect since Sir Christopher Wren. Some of the more notable structures are Merchandise Mart, Union Station, Wrigley Bldg. (Chicago), Flatiron Bldg. (NYC), Union Station, General Post Office (Wash., D.C.), Union Terminal, Terminal Tower Bldgs. (Cleveland).

GRAHAM, Harold E. [Des,C] Claremont, CA b. 8 F 1904, El Paso, TX. Studied: Chouinard Art Sch.; K. Huebler, Schule Reimann, in Berlin. Exhibited: Los Angeles County Fair, 1928 (prize), 1933 (prize), 1934 (prize); Festival All. Arts, Los Angeles, 1934 (prize). Work: metal murals, Bullock's Store for Men, Pomona H.S. [40]

GRAHAM, John D. [[P,W]] NYC b. 9 Ja 1891, Kiev, Russia d. 1961. (Born: Ivan G. Dombrowski.) Studied: Imperial Lyceum; Univ. Kiev; J. Sloan. Member: Am. A. Cong. Exhibited: PAFA, 1946. Work: PMG; WMAA; La France Art Inst., Phila.; Galerie La France, Paris; Charkov Mus., Russia. Author: "System and Dialectics of Art," 1937. Contributor: Magazine of Art [47]

GRAHAM, Laura Margaret [Por.P,Ldscp.PP] NYC b. 29 My 1912, Washington, IN. Studied: E.T. Dufner; DuMond; H.B. Snell; Bridgman; ASL; Traphagen Sch. Des.; Rittenberg; Fogarty; E. Pape; Grand Central A. Sch.; M. Schaeffer. Member: All.A.Am.; NAWA; PBC; NAC; Boston AC; Studio Cl.; Ind. Ar. Cl.; A. Workers Cl. for Women; Studio Gld. Exhibited: Studio Cl., 1932 (prize), 1935 (prize), 1937 (prize), 1938 (prize); NAC, 1939 (prize), 1940 (prize), 1942 (prize); All.A.Am., 1943 (prize); NAD, 1932, 1944; PAFA, 1934; WFNY, 1939; John Herron AI; Montclair A. Mus.; CAFA; Ogunquit A. Center; Boston AC; N.Y. Hist. Soc.; PBC [47]

GRAHAM, Margaret Nowell (Mrs. J.L.) [P] Winston-Salem, NC b. Lowell, MA. Studied: BMFA Sch. Member: SSAL; AFA; N.C. Prof. AC [33]

GRAHAM, Payson (Miss) [S,I,W] NYC b. 26 Ap 1878, London, Ontario. Studied: Bourdelle, in Paris; Fraser, Aitken, in NYC. Member: ASL [21]

GRAHAM, Ralph [P] Chicago, IL. Exhibited: AIC, 1936–1938 [40]

GRAHAM, Robert Alexander [P,T] Denver, CO b. 29 Je 1873, Brooklyn, IA d. 19 Ag 1946. Studied: Twachtman; J. De Camp. Member: SC; NYWCC [40]

GRAHAM, William [P] NYC [04]

GRAMATKY, Hardie [I,P,W,] NYC b. 12 Ap 1907, Dallas, TX. Studied: Stanford Univ.; Chouinard AI; Clarence Hinkle; Pruett Carter; F. Tolles Chamberlin; Barse Miller. Member: Phila. WCC; NYWCC; SI; AWCS; Calif. WC Soc. Exhibited: AIC, 1942 (prize); AWCS, 1942 (prize); Calif. WC Soc., 1943 (prize); Los Angeles Mus. A., 1931 (prize), 1934 (prize); Calif. State Fair, 1933 (prize); AIC, 1937–42; WMAA, 1939–41; BM, 1938–40; Southern Calif. Festival All. A., 1934 (prize). Work: AIC; Toledo Mus. A.; BM. Author/Illustrator: "Hercules" (1940), "Loopy" (1941), "Little Toot," other children's books; national magazines [47]

GRAMBS, Blanche [G] NYC. Exhibited: AIC, 1937, 1938; WPA Gal., NYC [40]

GRAMLING, Marta Johnston [P,T] Marietta, GA b. 19 Jy 1912, Marietta. Studied: Frank Wiggins A. Sch.; High Mus. Sch. Member: SSAL; Ga. Assn. Ar.; Atlanta Ar. Assn. Exhibited: Brooks Mem. Gal. Memphis (one-man); Little Rock (Ark.) Mus. FA (one-man); SSAL Ann., Montgomery, Ala., 1938, (one-man). Position: T., St. James' Sch., Marietta [40]

GRANADA, Nina [P,I,Car] NYC b. Janesville, WI. Author: "French Words and Pictures," pub. Viking Press, 1936 [40]

GRANAHAN, David Milton [Mur.P,I] London, KY b. 31 Jy 1909, Litchfield, MN. Studied: G. Mitchell; E. Kopietz; Minneapolis Sch. A.; Europe. Exhibited: watercolor, Minneapolis AI, 1931 (prize), oil, 1932 (prize). Work: murals, Gateway Bldg., Minneapolis; USPO, Hopkins, Rochester, Minn. Illustrator: "101 Best Stories of Minnesota," by M. Potter. WPA artist. Position: Diorama Artist, U.S. Forest Service, London, Ky. [40]

GRANAHAN, David, Mrs. See Wadman, Lolita.

GRANBERY, Henrietta Augusta [Ldscp.P] b. 3 O 1829, Norfolk, VA d. 30 D 1927. Active in NYC during 1860s. Sister of Virginia, and niece of George (1794–1815) [*]

GRANBERY, Virginia [P,T] b. 7 Ag 1831, Norfolk, VA d. 17 D 1921. Specialty: still life. Like her sister Henrietta, was active in NYC during 1860s. Position: T., Packer Inst. [*]

GRANDIN, Elizabeth [P,C] Clinton, NJ b. Hamden, NY. Studied: Henri; Guerin, in Paris. Member: NAWPS; N.Y. Soc. Women A. Exhibited: NAWPS, 1934 (prize) [40]

GRANDSTAFF, Harriet Phillips [I,Car,Des,P,T] Dallas, TX b. 8 Mr 1895, Longview, TX. Studied: Columbia; V. Aunspaugh; F. Reaugh; L.O. Griffith. Member: Frank Reaugh A. Cl. Specialty: commercial design. Position: T., Dallas AI [40]

GRANDY, Julia Selden [P] Baltimore, MD b. 3 Ap 1903, Norfolk, VA. Studied: Grand Central A. Sch.; E. Greacen; L. Bahr; E. O'Hara; R. Johnston. Member: Norfolk Soc. A.; Am. Ar. Prof. Lg.; Lg. Am. Pen Women; Norfolk A. Corner. Exhibited: BMA, 1939–41, 1942 (prize), 1943–45; Norfolk Mus. A.&Sc., 1940 (one-man); Norfolk A. Corner; VMFA, 1944 [47]

GRANDY, Winfred Milton [S] New Haven, CT/Short Beach, CT b. 20 S 1899, Preston, CT. Studied: Burdick; Yale. Exhibited: Univ. Tenn., Knoxville, 1931 (prize); garden figure, Mass. Agriculture/Horticulture Show, 1932 (prize) [40]

GRANER, Luis [P] NYC d. latter part of 1929, Spain. He lived and worked in New Orleans from 1914 to 1922, doing some of his best work. About two hundred of his paintings were owned by those in the area. [25]

GRANGE, Cornelius [Ldscp.P] Elmhurst, IL b. 1895, England (came to U.S. in 1926) d. 18 Ag 1933. Member: West Suburban Ar. Gld. Specialty: watercolors

GRANGER, Caroline Gibbons (Mrs. Percival H.) [P,T] Phila., PA b. 3 Je 1889, Pittsburgh. Studied: Breckenridge; Cecila Beaux; E. Carlsen; PAFA; Kunstschule, Berlin. Member: Phila. All. Illustrator: "Red Man's Luck," by Constance L. Skinner, pub. Coward, McCann. Work: Lotspeich Sch., Cincinnati. Position: L., Irwin Sch., Wynnewood, Pa. [40]

GRANGER, Kathleen Buehr [P] Chicago, IL. Exhibited: Ar. Chicago Vicinity Ann., 1933, 1937, 1938, 1939; Great Lakes Exh., The Patteran, Buffalo, 1938 [40]

GRANT, Ariel [P] NYC [13]

GRANT, Blanche Chloe [P,W,L,I] Taos, NM (since 1920)b. 23 S 1874, Leavenworth, KS d. 1948. Studied: BMFA Sch., with Paxton, Hale; PAFA; ASL. Member: Taos Ar. Assn. Editor: "Kit Carson's Own Story of His Life," 1926. Author: "When Old Trails Were New—The Story of Taos," 1934, other books [40]

GRANT, Catharine Harley [P,Li,T] Phila., PA/Avalon, NJ b. 27 Ja 1897, Pittsburgh d. 27 F 1954. Studied: PAFA; Breckenridge; Vassar; Univ. Pa. Member: NAWA. Exhibited: Pa. State Mus., 1937 (prize); Univ. Pa., 1940 (prize); PAFA, 1921, 1923, 1931–34, 1936, 1937, 1944, 1945 (prize); NAD, 1945; Audubon A., 1945; NAWA, 1945, 1946 (prize); CM, 1937; BMA, 1931; Woodmere Gal. A.; PMA; Phila. AC; Phila. A. All.; Warwick Gal., 1936 (one-man); Philip Ragan Assoc., 1946 (one-man). Work: Friends' Central Sch., Overbrook, Pa.; Pa. Sch. Social Work, Phila.; Univ. Pa. [47]

GRANT, Cecil Vezin [P] Londonderry, VT b. 20 Jy 1880, Jersey City, NJ. Studied: Pingry Sch. Exhibited: Ferargil Gal., 1931; Southern Vt. Ar., Manchester, 1937. Work: Newark Mus. [40]

GRANT, Charles H(enry) [Mar.P] San Fran., CA b. 6 F 1866, Oswego, NY d. ca. 1938. Studied: Dehans; NAD. Member: San Fran. AA; Bohemian Cl., San Fran.; Sequoia Cl., San Fran. Work: Oswego City Hall; Syracuse Mus. A.; Sequoia Cl.; Memorial Mus., San Fran.; Bohemian Cl. Official artist of U.S. Navy on 1925 cruise to Australia. [31]

GRANT, Clement R. [E,P] b. 1849, Freeport (Maine?) d. 1893 Boston. Studied: England, 1867. Exhibited: Paris Salon, 1878; N.Y. Etching Cl., 1889. Established studio in Boston by 1882; moved to NYC. [*]

GRANT, Dorothy Mengis (Mrs. Graves J.) [P] Monroe, LA b. 6 April 1911, Belize, British Honduras. Studied: Newcomb Col.; A. Brewer; M. Hull; V.T. Cole. Member: SSAL; Monroe Sketch Cl. [40]

GRANT, Douglas M. [P,I] Manhasset, NY/Merriewold, NY b. 18 Ap 1894, Oakland, CA. Studied: V. Sloun; Bridgman; DuMond. Member: AAPL; AWCS; NYWCC. Illustrator: "The Tarzan Twins." Positions: T., CUASch, Merriewold Sch. A., PMSchIA [40]

GRANT, Edward Lynam [Des,I,P,T,En] Wilmington, DE b. 13 Ja 1907, Wilmington. Studied: PMSchIA; Wilmington Acad. A. Member: Wilmington AC; AIGA. Exhibited: Wilmington SFA, 1932 (prize); 1934 (prize), 1936, 1937, 1939, 1940; Wilmington A. Cl. Ann., 1939 (prize); Del. A. Center, 1932–35, 1937, 1939–41. Work: Wilmington Soc. FA; mural, Emerson Hotel, Baltimore; Smyrna, Del. Pub. Sch.; Georgetown, Del. Pub. Sch. Position: T., Wilmington Acad. A. [47]

GRANT, Elizabeth (Johnston) [P,L] St. Paul, MN b. 27 Mr 1894, Minneapolis. Studied: Minneapolis Sch. A.; Univ. Minn.; ASL; Parsons Sch. Des. Member: Minneapolis AA. Exhibited: Minneapolis Inst. A., 1937 (prize), 1939, 1940, 1941 (prize), 1942–45; Minn. State Fair, 1938–41, 1942 (prize) 1943–45; Kansas City AI, 1939, 1942; Women Painters Exh., 1943 [47]

GRANT, Frederic M. [P,T] Chicago, IL b. 6 O 1886, Sibley, IA. Studied: Chase; Miller: Vanderpoel, Snell. Exhibited: Chicago AG, 1916 (prize), 1918 (prize); Chicago AC, 1918 (prize); AIC, 1917 (prizes); Palm Beach Art Center, 1935 (prize), 1936 (prize). Work: State Mus., Springfield, Ill.; MMA [40]

GRANT, Gordon (Hope) [Mar.P,E,Li,I,W] NYC b. 7 Je 1875, San Fran., CA d. 1962. Studied: Lambeth & Heatherley A. Sch., London, England. Member: ANA; All.A.Am.; SAE; Chicago SE; AWCS; Phila. WCC; Calif. Pr.M.; SC. Exhibited: SC, 1929 (prize) 1931 (prize); AWCS, 1933 (prize); NAD, 1926 (prize); All.A.Am., 1942 (prize); Chicago SE, 1935 (prize); Paris Salon, 1937 (med); LOC, 1944–46; AIC, 1927, 1933. Work: Kendall Whaling Mus.; Mystic Seaport Mus.; N.Y. Hist. Soc.; MMA; NYPL; Joslyn Mem.; Richmond (Ind.) Mus. A.; Brooks Mem. A. Gal.; Davenport (Iowa) Mus. A.; New Britain Mus. A.; LOC; U.S. Naval Acad., Annapolis; White House, Wash., D.C.; mural, USPO, Kennebunkport, Maine [47]

GRANT, H.R. [P] Boston, MA [06]

GRANT, Helen Peabody (Mrs.) [P] Emporia, VA b. 17 Ap 1861, Keytesville Landing, MO. Studied: AIC; Aman-Jean, Collin, Merson, in Paris. [10]

GRANT, Irene [C] Wauwatosa, WI b. 13 N 1895. Studied: Milwaukee-Downer Col.; Layton Sch. A.; Chicago Sch. Appl. Art; Univ. Wis.; England. Member: Wis. Soc. Appl. Arts. Position: Dir., Occupational Therapy, Muirdale (Wis.) Sanatorium [40]

GRANT, Isaac H. [P] Hartford, CT. Member: CAFA [25]

GRANT, J. Jeffrey [P] Chicago, IL b. 19 Ap 1883, Aberdeen, Scotland d. 20 My 1960. Studied: Aberdeen; Munich. Member: Assn. Chicago P.&S.; Palette & Chisel Acad.; Chicago AC; North Shore AA; Chicago Gal. Assn. Exhibited: Palette & Chisel Acad. FA, 1917 (gold); AIC, 1926 (prize) 1927 (prize); Chicago Gal. Assn., 1930 (prize), 1931 (prize); AIC, 1918, 1919, 1921, 1922 (prize), 1923, 1924 (prize), 1926 (prize), 1927 (prize) (one-man), 1932, 1934 (gold), 1935 (one-man), 1936, 1937 (prize), 1939, 1942, 1944 (one-man); Municipal A. Lg., 1934, 1936 (med, prize); NAD, 1932–35, 1943; CGA, 1930, 1932, 1934; PAFA; Currier Gal., 1936 (one-man). Work: Springfield Mus. A.; Municipal A. Lg., Chicago; Lawrence Col.; Concordia Col. [47]

GRANT, Jane M. [P] Phila., PA [13]

GRANT, Lawrence W. [P] Provincetown, MA b. 10 Je 1886, Cleveland, OH. Studied: Chase; Laurens, Lefebvre, in Paris. Member: SC [33]

GRANT, Louis F. [I] Boston, MA [01]

GRANT, Vernon [I,W,Des] Astoria, NY b. 26 Ap 1902, Coldridge, NE. Studied: Univ. Southern Calif.; AIC. Member: SI; A. Gld. Author: children's books. Illustrator: covers, national magazines [47]

GRANVILLE, Edmond Mario [E] Rocky Point, NY b. 5 Jy 1905, Chicago. Studied: ASL; Grand Central Sch. A.; Master Inst., Roerich Mus. Work: MMA [40]

GRANVILLE-SMITH, W(alter) [P,E] NYC/Bellport, NY b. 26 Ja 1870, South Granville, NY d. 7 D 1938. Studied: W. Satterlee; Beckwith; W. Metcalf; ASL; Europe. Member: ANA, 1908; NA, 1915; AWCS; SC, 1918; SPNY; All. AA; Greenwich SA; NAC; AFA; Grand Central AG. Exhibited: NAD, 1900 (prize), 1908 (gold), 1927 (prize), 1929 (prize), 1933 (prize); Charleston Expo, 1902 (med); AWCS, 1905 (prize), 1916 (prize); CI, 1907 (prize); Buenos Aires Expo, 1910 (prize); SC, 1911 (prize), 1913 (prize), 1918 (prize), 1928 (prize); NAC, 1925 (med,prize), 1936 (prize); Olympic Exh., Amsterdam, 1928 (med). Work: Smithsonian; Butler A. Inst.; Toledo Mus. A.; SC; Nat. A. Cl.; Lotos Cl.; Fencers Cl. of New York; Phila. Art Cl.; Fort Worth Mus. A.; Horace Moses Memorial, Ticonderoga, N.Y.; Curtis Inst. [38]

GRASMUK, Henry [P] Newark, NJ [01]

GRASS, Frank, Mrs. See Patterson, Patty.

GRASSBY, P. [E] Lexington, MA [24]

GRASSBY, Percy [P] Grand Rapids, MI [13]

GRATHWOL, Ray Anthony [P] Cuyahoga Falls, OH b. 17 Jy 1900, Sandusky, OH. Member: Akron SA. Exhibited: Akron, 1940 (prize), 1941 (prize), 1944 (prize), 1945 (prize); Canton AI, 1945 (prize); Parkersburg FA Center, 1945 (prize); WFNY, 1939; CI, 1941, 1943, 1944; Pepsi-Cola, 1946; Springville, Utah, 1941, 1946; Milwaukee, 1946; Butler AI, 1937–46. Work: Massillon Mus.; Ohio Univ.; Akron AI; Pomroy (Ohio) H.S. [47]

GRATWICK, William, Jr. [S] Eggertsville, NY. Exhibited: Albright Art Gal., 1936 (prize), 1937 (prize)[40]

GRAUBARD, Ann Wolfe. See Wolfe.

GRAUER, Natalie Eynon (Mrs. William C.) [P,T] Cleveland, OH/Huntsburg, OH b. Wilmington, DE d. 27 O 1955. Studied: ASL; AIC; Archipenko; Bridgman; L. Seyffert; NAD; E. Fossberg. Member: Old White Art Colony; NAWA. Exhibited: CMA, 1936 (prize); NAWA, 1941 (prize); PAFA; NAD; NAWA; WMAA; AIC; High Mus. A.; VMFA. Work: East H.S., Cleveland; Washington and Lee Univ.; Laird Mem. Coll., Montgomery, W.Va.; Federation Savings & Loan Bank, Cleveland; Western Reserve Univ. Positions: Co-dir., Old White Art Colony; T., Western Reserve Univ., 1935– [47]

GRAUER, William C. [P,I] Cleveland, OH/Huntsburg, OH b. 2 D 1896, Phila. Studied: PMSchIA. Member: Cleveland SA; Old White Art Colony. Exhibited: CMA, 1929 (prize), 1930 (prizes), 1934 (prize), 1936 (prize); PAFA; WMAA; WFNY, 1939; VMFA; CAM; Rochester Mem. A. Gal.; Syracuse Mus. FA. Work: murals, Kansas City (Mo.) City Cl.; Builder's Exchange Bldg., City Cl., Cadillac Lounge, all in Cleveland; Virginia Room, President's Cottage, White Sulphur Springs, W.Va.; Fed.

States Bldg., Century Progress, Chicago; Laird Mem. Coll., Montgomery, W.VA.; CMA. Positions: Co-dir., Old White Art Colony; Cur., Municipal Coll. Cleveland Art; T., Western Reserve Univ., 1935– [47]

GRAUPNER, William [I] Phila., PA. Studied: PAFA [25]

GRAVATT, Sara H(offecker) [P,T] Bluefield, WV b. 31 Ag 1898, Phila. Studied: PAFA; G. Harding; H.B. Snell; J. Pearson; J. Folinsbee. Member: Am. Women's Assn. Work: PAFA [40]

GRAVES, Abbott (Fuller) [P,Dec] Kennebunkport, ME b. 15 Ap 1859, Weymouth, MA d. 15 Jy 1936. Studied: MIT; Cormon, Laurens, Gervais, all in Paris. Member: ANA, 1926; SC, 1909; AAPL; All. AA; NAC; Artists Fund. Exhibited: Expo des Beaux Arts, Paris, 1905 (med); SC, 1933 (prize). Work: Nat. Arts Cl., New York; Portland (Maine) A. Mus. Chiefly known for his decorative work, still life, garden, and figure paintings. Specialty: Colonial doorways [33]

GRAVES, Elizabeth Evans [P,I,C,T] Wash., D.C. b. 13 Mr 1895, Fort Brady, MI. Studied: R.S. Bredin; H.B. Snell; H. Giles. Member: Wash. SA; Wash. WCC; NAWPS; Wash. AC [33]

GRAVES, Etta Merrick [C,W,T] Brookline, MA b. 18 Jy 1882, Boston. Studied: PIASch; Mass. Sch. A. Member: Nat. Lg. Am. Pen Women. Author/Illustrator: books on education [40]

GRAVES, John B. [P] Dormont, PA. Member: Pittsburgh AA [25]

GRAVES, Maitland [P,W,L,T] NYC b. 27 Je 1902, NYC d. ca. 1978. Studied: DuMond; ASL; Grand Central A. Sch.; Brooklyn Polytechnic Inst. Member: NAC; All. AA; ASL. Exhibited: NAC, 1930 (prize), 1932 (prize), 1935 (prize), 1936 (prize); NAD, 1928; Newark Mus., 1934; All. Am. A., 1934, 1935; Arch. Lg., 1936. Work: NAC. Author: The Art of Color & Design," 1941. Contributor: national magazines. Position: T., PIASch [47]

GRAVES, Mary de B(erniere) [Por.P,I] Chapel Hill, NC b. Chapel Hill. Studied: Chase; H. McCarter; Henri; L. Mora. Member: N.C. Prof. AC; AAPL. Exhibited: N.C. Fed. Women's Cl., 1926 (prize), 1929 (prize); Kenilworth Exh., Asheville, N.C., 1927 (silver cup). Work: portraits, N.C. State Capitol, Raleigh; Univ. N.C. Illustrator: New York Evening Post, The World, Tribune, Southern Magazine, The Ruralist, Philadelphia Record, Country Life [40]

GRAVES, Morris [P] Seattle, WA b. 1910, Seattle. Studied: B. Burroughs. Exhibited: Northwest Ann., Seattle Mus., 1933, 1934, 1935; WFNY, 1939. Work: Pal. Leg. Honor [40]

GRAVES, Myrtle E. Benight [P] Hammond, IN b. 30 My 1881. Work: Community House, Frankfort, Ind.; Hoosier Salon; Grand Army of the Republic, Wash., D.C. [40]

GRAY, Abby [P] Cincinnati, OH. Member: Cincinnati Women's AC [25]

GRAY, Archibald R. [P] Great Neck, NY [13]

GRAY, Charles Alden [Por.P] b. 1858 d. 2 N 1933, St. Louis. Among those whose portraits he painted were President McKinley, Eugene Field, and Mark Twain.

GRAY, Frederick G. [P] St. Louis, MO b. St. Louis. Studied: Laurens, in Paris. Exhibited: CI, 1913 (prize); P.-P. Expo, San Fran., 1915 (med). Work: PAFA [17]

GRAY, Harold [P,Car] Baltimore, MD b. 20 Ja 1894, Kankakee, IL d. 9 My 1968, La Jolla, CA. Creator: "Little Orphan Annie" comic strip [40]

GRAY, Harriet Tyny [P] Greenwich, CT b. 26 My 1879, South Orange, NJ. Studied: DuMond; Beaux; Hawthorne; Howell. Member: Greenwich SA; NAWPS; AFA [33]

GRAY, Howard L. [Car] Chicago, IL. Work: Huntington Lib., San Marino, Calif. Position: Staff, Chicago Tribune [40]

GRAY, Kathryn [Min.P,Ldscp.P] NYC b. Jefferson County, KS d. 18 Ja 1931, Kansas City. Studied: ASL; Académie Julian, Paris. Member: AAPL; All. A. New York; AFA. Exhibited: Kansas City, 1917; Paris [29]

GRAY, Leonia Perin (Mrs.) [P] Delhi, OH. Member: Cincinnati Women's AC [25]

GRAY, Lidie E. [P] Pittsburgh. Member: Pittsburgh AA [21]

GRAY, M. May [Por.P,Li,T,W] Eddington, PA b. Phila. Studied: Moore Inst. Des.; PAFA. Member: Phila. A. All.; Phila. Plastic Cl. Work: Allentown (Pa.) Mus.; Franklin Inst.; Rensselaer Polytechnic Inst. [47]

GRAY, Margaret [S] Pensacola, FL. Member: NSS [47]

GRAY, M(arie) Chilton [P] Indianapolis, IN b. 22 N 1888, Phila. Studied: Stark; Forsyth. Member: Ind. Ar. Assoc. [25]

GRAY, Mary [P,Gr,Edu] Pine Orchard, CT. Studied: CI; Columbia; Hetzel; Baity; A.W. Dow. Member: ANA; All. AA; NAC; CAA; Eastern AA; Albany Pr. Cl.; Grand Central A. Gal.; AFA. Exhibited: Grand Central Gal., 1929 (prize). Work: Nat. Arts Cl., New York; Houston Mus. A. Position: T., E. Willard Sch., 1940 [47]

GRAY, Mary Chilton [P,En] Denver, CO b. 22 My 1888, Phila. Studied: John Herron AI. Member: NAWA. Exhibited: NAWA, 1943, 1944; AWCS, 1942; Hoosier Salon, 1931, 1933; New York City, 1942 (one-man); Columbus, Ohio, 1931; Indianapolis, Ind., 1931. Work: murals, Colo. Mus. Nat. Hist. [47]

GRAY, Percy [P] Monterrey, CA b. 3 O 1869, San Fran. Studied: San Fran.; New York. Member: Bohemian Cl.; San Fran. AA. Exhibited: P.-P. Expo, San Fran., 1915 (med) [40]

GRAY, Ralph W. [P,Arch] Boston, MA b. 19 Ja 1880 d. 28 Mr 1944. Studied: Harvard; Ecole des Beaux-Arts, Paris. Member: AWCS; Gld. Boston A.; Boston SWCP; Boston Soc. Arch., AIA. Work: BMFA [40]

GRAY, Sophie de Butts [P] Louisville, KY b. Baltimore, MD. Studied: H. Newell; B.W. Clinedinst; Daingerfield. Member: Louisville A. Lg., Baltimore Decorative Art Soc. Exhibited: Md. Inst. (prize); World's Fair, New Orleans (prize); Louisville A. Lg., 1898 (gold,prize); Nelson County (Ky.) Fair, 1896 (prizes) [01]

GRAY, Una [P] Boston, MA [19]

GRAY, William [P] Pittsburgh, PA. Member: Pittsburgh AA [25]

GRAY, W(illiam) F(rancis) [P,L,T] Phila., PA b. 9 My 1866, Phila. Studied: PMSchIA; PAFA. Member: Phila. AC; Phila. Sketch Cl.; Art T., Assn., Phila. [40]

GRAYDON, Samuel [P] NYC [25]

GRAYSON, Clifford P(revost) [P] Old Lyme, CT b. 14 Jy 1857, Phila. d. 11 N 1951. Studied: PAFA; Ecole des Beaux-Arts, Paris; Eakins; Gérôme, Bonnat. Member: Century Assn.; SC; Lyme AA; Phila. AC. Exhibited: Am. Art Gal., New York, 1886 (prize); PAFA, 1887 (gold); AIC; Paris Salon. Work: CGA; AIC; Art Cl., Phila [47]

GRAZIANI, Adolph [S] Phila., PA [10]

GRAZIANI, Sante [P,T] Cleveland, OH b. 11 Mr 1920, Cleveland. Studied: Cleveland Sch. A.; Yale. Member: NSMP. Exhibited: MMA, 1942; CI, 1941; NAD, 1942; CMA, 1937–41. Work: murals, USPOs, Bluffton (Ohio), Columbus Junction (Iowa); Springfield (Mass.) Mus. FA. WPA artist. Position: T., Yale [47]

GREACEN, Edmund W. [P,T] NYC b. 1877, NYC d. 1949. Studied: Europe; W. Chase; R. Henri; DuMond. Member: NA; AWCS; SC; AAPL; NAC; Lotos C. Exhibited: SC, 1921 (prize); NAC, 1923 (prize), 1935 (prize). Work: Butler AI; NAC; Newark Mus. [47]

GREACEN, Jennie Ruth. See Nickerson.

GREACEN, Nan (Mrs. René B. Faure) [P,T] Scarsdale, NY (living in Ponte Vedra, FL, 1982) b. 6 Mr 1909, Giverny, France. Studied: her father, E. Greacen; A. Woefle; W. Adams; H. Hildebrant; G. Ennis; Grand Central A. Sch. Member: NA, 1962; NAWA; All. A. Am.; Scarsdale AA; NAC; NAWPS. Exhibited: NAD, since 1931; CGA, 1939; All. A. Am.; NAC 1931 (prize), 1933 (prize), 1937 (prize); NAD, 1930 (prize); Montclair A. Mus. Position: T., Grand Central Sch., 1933–43 [47]

GREASON, Donald Carlisle [P,Edu] Winter Park, FL/Colrain, MA b. 14 Jy 1897, Brooklyn, NY. Studied: ASL; Paris. Member: CAA; AFA; Deerfield Valley AA. Exhibited: Inst. Mod. A., Boston, 1939. Positions: T., AGAA, 1933; Res. A., Deerfield Acad., Mass. (1941–46), Rollins Col., Winter Park, Fla. (1946–) [47]

GREASON, William [P] Detroit, MI b. 26 F 1884, St. Mary's, Ontario. Studied: PAFA, with Breckenridge, Chase, Darby; Académie Julian, Paris, with Baschet, Laurens. Member: SC. Exhibited: Scarab C., 1915 (prize), (gold); Palm Beach A. Center, 1934. Work: Detroit AI; Parliament Bldgs., Regina [40]

GREATHEAD, K. (Miss) [P] Norwood, PA. Member: Phila. AA [25]

GREATHOUSE, G.W. (Mrs.) [P] Fort Worth, TX [24]

GREATOREX, Eliza Pratt (Mrs.) [P,E] b. 25 D 1820, Manor Hamilton, Ireland (came to U.S. in 1840) d. 9 F 1897, Paris. Studied: NYC, with W. Wotherspoon, James M. and W. Hart, 1858; Paris, with Lambinet, 1861; Munich. Member: ANA, 1869 (the third woman elected). Exhibited:

Centenn. Exh., Phila., 1876. Work: MMA. Illustrator: "Summer Etchings in Colorado." Active in Colo., 1873. After 1878, she spent much of her time in Europe with her painter-daughters, Kathleen and Eleanor. [*]

GREATOREX, (Elizabeth) Eleanor [P,I] b. 1854 Hoboken, NJ. Studied: with her sister Kate under their mother Eliza; Paris. Specialty: flower paintings, like her sister Kathleen [*]

GREATOREX, Kathleen Honora (Kate) [P,I] Seine-et-Marne, France b. 10 S 1851, Hoboken, NJ. Studied: NAD; Henner, in Paris; Rome; Munich. Member: NAC. Exhibited: Paris Salon, 1886; Paris Expo, 1889; Columbian Expo, Chicago, 1893 (gold); Expos in Phila., Atlanta. Specialty: flower paintings [17]

GREAVES, George Edmund [P] Minneapolis, MN b. 1860 d. 26 My 1926. Member: Minneaplis Inst. A. (a founder). He was one of the first to recommend the halftone for use in magazine illustrating.

GREAVES, Harry E. [Ldscp.P,I] Overbrook, PA b. 17 My 1854, Bryn Mawr, PA d. 31 O 1919, Phila. Studied: E. Moran; T. Eakins. Member: AC Phila.; Phila. Sketch C.; Phila. Soc. Arts & Letters [17]

GREBEL, Alphonse [P] NYC. Member: S.Indp.A. [21]

GREBENAK, Louis Arthur [P] Cleveland, OH b. 9 F 1913, Wasson, IL. Studied: P.B. Travis. Exhibited: Cleveland Mus., 1939 (prize). Work: Cleveland Bd. Ed. [40]

GREBS, Emil [P] Berkeley, CA [17]

GRECO, Daniel [P] New Kensington, PA. Member: Pittsburgh AA [25]

GREELEY, Mary [P,T] b. 13 F 1836, Foxcroft, ME d. 31 D 1924, Foxcroft, ME. Worked in Brooklyn, 1872–85 [*]

GREELEY, Russell [P] Paris b. Chelsea, MA. Studied: Tarbell, Boston [13]

GREEN, Albert V. [P] Phila., PA. Studied: PAFA [25]

GREEN, Alice (Leora) [P,L,T,B] Shawnee, OK b. 27 Ap 1903, Shawnee. Studied: Columbia, with J. Martin. Member: Assn. Okla. A.; Provincetown AA. Exhibited: Annual Mid-Western Exh., Kansas City AI, 1932 [33]

GREEN, Antoinette [S] Brooklyn, NY b. 14 D 1906, Brooklyn. Studied: ASL; N.Y. Clay Cl. [40]

GREEN, Bernard I. [P,Et,T] NYC b. 12 F 1887, Swerzen, Russia d. 8 Ap 1951. Studied: CCNY; NYU; ASL; NAD; Colarossi Acad. Member: All. A. Am.; Rockport AA; Mod. Etchers Group. Exhibited: NAD, 1910 (prize), 1913 (prize); Wash. Heights AA, 1940 (prize); ASL, 1914 (prize); P.-P. Expo, 1915; NAD, 1913–46; WFNY, 1939; All. A. Am., 1934–41; Milch Gal.; Delphic Gal., 1937; Roerich Mus., 1930 (one-man). Work: Oakland A. Gal.; J.B. Speed Mem. Mus. Position: T., Thomas Jefferson H.S., NYC [47]

GREEN, Caroline A. [P] Brooklyn, NY [15]

GREEN, Charles Edwin Lewis [P] Lynn, MA b. 26 Ap 1844, Lynn. Exhibited: Mass. Charitable Mechanics Assn., Boston (med) [10]

GREEN, David (Oliver), Jr. [S,Des,En] Altadena, CA b. 29 Je 1908, Enid, OK. Studied: Am. Acad. A.; Nat. Acad. A., Chicago; Carl Hoeckner; C. Wilimovsky. Member: Pasadena AA. Exhibited: A. Dir. C., 1937, 1938, 1940; Oakland A. Gal., 1941; AIGA, 1937 (prize); AIC, 1936, 1938, 1940, 1941; Chicago NSJA, 1940; Pasadena SA, 1942, 1943; Soc. Typographic A., Chicago, 1937–40, 1946. Work: Pasadena AI. Specialty: typographic layout and design. Illustrator/Designer: "Design: The New Grammar of Advertising," 1940. Position: A. Dir., Mills Novelty Co., Chicago [47]

GREEN, Edith Jackson (Mrs. Erik H.) [P] Providence, RI/North Attleboro, MA b. 22 Mr 1876, Tarrytown, NY. Studied: Twachtman; DeCamp; R. Collin. Member: AFA; Providence AC; Ogunquit AA; So. County AA; AAPL; Studio Gld. N.Y. Work: Providence Plantations C. [40]

GREEN, Edward [P] NYC [19]

GREEN, Elizabeth Shippen (Mrs. Huger Elliott) [I,P] Phila., PA. b. Phila. Studied: PAFA; H. Pyle. Member: AWCS; Phila. WCC; Phila. A. All.; NYWCC. Exhibited: Wash. WCC, 1904 (prize); St. Louis Expo, 1904 (med); PAFA, 1905 (prize); Phila. WCC, 1907; P.-P. Expo, 1915 (med). Work: LOC; RISD; Newcomb Col. A. Gal.; Phila. WCC; Phila. A. All. Illustrator: numerous children's books, 1902–30s; Lamb's "Tales from Shakespeare," 1922. Position: Staff, Harper's, 1902–11 [47]

GREEN, Erik H. (Mrs.) [P] North Attleboro, MA. Member: Providence AC [27]

GREEN, Florence Topping (Mrs. Howard Green) [P,L,W] Long Branch, NJ b. 1882, London, England d. 24 My 1945. Studied: CUASch; R.S. Gifford; J. Carlson. Member: AAPL; PBC; Asbury Pk. SFA. Exhibited: Newark AC, 1934 (med); WFNY, 1939. Work: miniature, White House, Wash., D.C.; Women's Cl., Kans.; Women's Club, Wis.; Women's Club, Atlantic City; Monmouth Mem. Training Sch.; Ariz. State Coll. Author: "Art in the Community," "First Aid in Art." Editor: "Art and the Women of America"; Art Digest [40]

GREEN, Frank G. [P] NYC [01]

GREEN, Frank Russell [P] NYC b. 16 Ap 1856, Chicago d. 20 Ja 1940. Studied: Paris, with Boulanger, Lefebvre, Collin, Courtois. Member: ANA 1897; AWCS; NYWCC; SC, 1887; Lotos C. Exhibited: NAD, 1896 (prize); Paris Salon, 1900; SC, 1903 (prize), 1908 (prize); St. Louis Expo, 1904 (med) [38]

GREEN, Harold Abbott [P] Hartford, CT b. 10 N 1883, Montreal. Studied: Flagg; Brandegee. Member: CAFA. Exhibited: CAFA, 1918 (prize) [33]

GREEN, H(iram) H(arold) [P,I,E] Fort Erie, Ontario. b. 15 N 1865, Paris, NY d. 4 Ag 1930, Buffalo, NY. Studied: Albright A. Acad.; Buffalo; ASL, with Cox, Mowbray, Bridgman. Member: AFA. Exhibited: Albright A. Acad., 1898 (prize). Work: Santa Fe Railroad; Southern Pacific Railroad. Illustrator: U.S. Gov. Liberty Loan Poster; pictorial maps. Specialty: bird's-eye views of Niagara, ca. 1905 [29]

GREEN, James Leahan [P,T] Elsah, IL b. 18 Je 1911, Ware, MA. Studied: Mass. Sch. A.; Univ. Vt., with B. Miller; Otis AI, with P. Clemens. Member: Calif. WCS; Group 15, St. Louis. Exhibited: Calif. WCS, 1937–41; PAFA, 1939–1943, 1944–46 (prizes); AIC, 1939–44; Oakland A. Gal., 1941–46; CAM, 1941–46, 1945 (prize). Position: T., Principia Col., Ill., 1941– [47]

GREEN, Jasper [I] b. 31 Ja 1829, Columbia, PA d. 2 Mr 1910, Phila. Position: Artist-correspondent for "Harper's" during Civil War. Also a wood carver. [*]

GREEN, Lilian Bayliss (Mrs. Albert R.) [Min.P] Boston, MA b. 20 F 1875, Massilon, OH. Studied: H.S. Mowbray; L.F. Fuller [13]

GREEN, Mildred C. [P,T] Buffalo, NY b. Paris, NY. Studied: G. Bridgman; E. Dufner; C. Woodbury; G.E. Browne. Member: Buffalo SA; Buffalo G. Allied A.; The Patteran, Buffalo. Work: mural, Niagara Falls Power Co. Position: T., Albright A. Gal. [40]

GREEN, Rena Maverick (Mrs. Robert B.) [P] San Antonio, TX b. 10 F 1874, Sedalia, MO. Studied: C. Martin; M. Sterne. Member: SSAL; San Antonio AA. Exhibited: SSAL, 1940 (prize). Work: Witte Mem. Mus., San Antonio. Position: Dir., San Antonio A. Sch. [47]

GREEN, Samuel M. [E,En,Li,Edu] Waterville, ME b. 22 My 1909, Oconomowoc, WI. Studied: Harvard; PAFA. Member: SAE; North Shore AA; Phila. PC. Work: FMA; LOC. Position: T., Colby Col. WPA artist. [47]

GREEN, William Bradford [P,L,T] Hartford, CT b. 1 Ag 1871, Binghamton, NY d. 6 Ap 1945. Studied: Chase; Blom; Dow. Member: CAFA; Brooklyn SA; Copley S; SC [40]

GREENAMYER, Leah J. [C,B,E,P,W,L,T] Youngstown, OH b. Ashtabula, OH. Studied: C.B. Austin; G.S. Krispinsky; R. Stoll; J. Lloyd; Butler AI; PAFA; Youngstown Col. Member: Columbus AL; Ohio WCS; Youngstown A. Alliance (Pres.); AAPL; Youngstown Fed. Women's Clubs. Exhibited: Nat. Craft Exh., Phila.; Butler AI; Canfield, Ohio Fair; Massillon, Canton, Cleveland, all in Ohio [47]

GREENAWALT, Frank F. [P] Wash., D.C. Member: S. Wash. A.; Wash. AC; Wash. WCC [33]

GREENBAUM, Delphine Bradt (Mrs. William E.) [P] Iloilo, Philippine Islands. Studied: PAFA [29]

GREENBAUM, Dorothea Schwarcz [S] NYC/Martha's Vineyard, MA b. 17 Je 1893, NYC. Studied: K.H. Miller; N.Y. Sch. F.&Appl. A.; C.W. Hawthorne; J. Lie; R.S. Bredin. Member: Whitney Studio Cl.; S. Gld.; Am. Soc. PSG; Am. Ar. Cong. Exhibited: WFNY, 1939; PAFA, 1941 (med); AIC; WMAA; SFMA; Williams Col., England; IBM, 1941 (prize); Soc. Wash. A., 1941 (prize). Work: WMAA; Lawrence Mus., Williamstown, Mass.; Oberlin Col.; Fitchburg (Mass.) A. Center; Huntington Mus.; Brookgreen Gardens, S.C.; Mus. Moscow, Russia; Puerto Rico [47]

GREENBAUM, Joseph [P] Los Angeles, CA [17]

GREENBERG, A. [P] Newport, KY. Member: Cincinnati AC [19]

GREENBERG, Benjamin [P] Northside, Cincinnati, OH. Member: Cincinnati AC [25]

GREENBERG, Clement [Cr,W] NYC b. 16 Ja 1909, NYC. Studied: ASL; Syracuse Univ. Contributor: Partisan Review; Horizon. Highly influential critic of the 1940s; advocated the formal purity of flatness in modernism. A supporter of Jackson Pollock. Position: A. Cr., The Nation [47]

GREENBERG, Maurice [I] Chicago, IL b. 1893, Milwaukee, WI. Studied: Wisconsin Sch. A.; AIC. Member: Palette and Chisel C. Exhibited: Municipal AL, Chicago 1927 [33]

GREENBERG, Morris [E,W,T] Brooklyn, NY. Studied: B. Harrison; Maynard. Member: Municipal AS; Soc. Am. E.; AFA [40]

GREENBIE, Barry [P] Castine, ME. Exhibited: 48 States Comp., 1939. Work: USPO, Dover-Foxcroft, Maine. WPA artist. [40]

GREENBURG, Samuel [P,T,Dr] Chicago, IL b. 23 Je 1905, Uman, Ukraine, Russia. Studied: Univ. Chicago; A. Lhote. Member: Chicago SA; Chicago T. Un.; A. Lg. Chicago; Chicago NJSA; Around the Palette. Exhibited: PAFA, 1935; LOC, 1943, 1946; WFNY, 1939; AV, 1942; NGA, 1943; CI, 1943; AFA Traveling Exh., 1943–45; AIC, 1931, 1933, 1935, 1936, 194, 1941, 1942 (prize), 1946; Chicago SA, 1936–45; Riverside Mus., 1939, 1941 1945; Ill. State Mus., 1940; Delphic Studios, 1934 (one-man); Chicago Women's Aid, 1939 (one-man); Covenant Cl., 1936 (prize). Work: Mus. Mod. A., Tel Aviv, Palestine. Illustrator: "Art of Today—Chicago, 1933," pub. L.M. Stein Co. Position: T., Tuley H.S., Chicago [47]

GREENE, Albert V(an Nesse) [P,E,B] Phila., PA/Chester Springs, PA. b. 14 D 1887, Jamaica, NY. Studied: Corcoran Gal.; ASL; PAFA; Grande Chaumière. Member: Phila. Sketch C.; Phila. Alliance; Paris AAA; S.Indp.A.; Salons Am. Exhibited: PAFA, 1919 (prize). Work: F. PAFA Coll. [40]

GREENE, Anne Bosworth [P] Boston, MA [13]

GREENE, Balcomb [P,L,W,Ed] Pittsburgh, PA b. 22 My 1904, Niagara Falls, NY. Studied: Syracuse Univ.; Vienna; Columbia; NYU; S. Grabowski, Paris. Member: CAA; Fed. Mod. P.&S.; Am. Abstract A.; Assn. A. Pittsburgh; Am. Soc. Aesthetics; Comm., Cultural Freedom. Exhibited: PAFA; CI; CAM; SFMA; Pal. Leg. Honor; AIC; Am. Abstract A.; Milwaukee AI; Nelson Gal., Kansas City; WMAA, 1938; WFNY, 1939; MOMA, 1939, 1940. Work: MOMA; WMAA; Mus. Non-Objective Painting. Position: T., CI [47]

GREENE, Belle [P] Boston, MA. Member: Copley S., 1893 [10]

GREENE, Beryl Morse [P,I] NYC b. 9 N 1895, Chicago, IL. Studied: Whittemore, F.C. Jones; Bridgman. Member: Alliance [19]

GREENE, Elmer Westley, Jr. [P,T] Boston, MA/Nantucket, MA b. 24 Jy 1907, Boston d. 27 D 1964, New Boston, NH. Studied: Mass. Sch. Art; BMFA Sch.; E.L. Major. Member: Gld. Boston A. Exhibited: CGA, 1936, 1937; NAD, 1935, 1936, 1940; PAFA, 1937; Jordan Marsh Gal., 1932 (prize), 1933 (prize), 1934 (prize), 1935 (prize), 1936 (prize), 1937, 1938, 1939 (prize), 1940–45, 1946 (prize); North Shore AA. Work: Bridgewater Normal Sch.; Mass. State Col.; Sch. Practical Arts, Boston; State T. Col., Framingham, Mass.; Univ. Chicago; Amherst Col. Positions: T., Mass Sch. A. (Boston), Adult Edu. Center (Cambridge) [47]

GREENE, Fred Stewart [P,I,T,W] Belleview, FL b. 23 Je 1876, North Stonington, CT d. 7 My 1946. Studied: RISD; ASL. Member: Ar. C., Clearwater, Fla.; AFA. Exhibited: Fla. Bldg., Century of Progress Expo, Chicago, 1933 (prize). Work: Mem. Lib., Hist. Soc., both in Westerly, R.I.; Cheyenne Pub. Lib.; Civic League, Belleview, Fla.; Women's C., Ocala, Fla.; City Hall, Belleview [47]

GREENE, Gertrude [P,S] NYC b. 24 My 1911, NYC d. 25 N 1956. Studied: DaVinci A. Sch. Member: Am. Abstract A.; Fed. Mod. P.&S. Exhibited: SFMA; Pal. Leg. Honor; BMFA, 1946; William Rockhill Nelson Gal.; Milwaukee AI; Am. FA Gal., NYC; Wildenstein Gal., 1945, 1946; PMA [47]

GREENE, Helen [P] Cincinnati, OH. Member: Cincinnati Women's AC [25]

GREENE, J. Barry [Mur.P,Por.P,Et,I,T,Car] NYC b. 27 Je 1895, NYC d. 5 O 1966. Studied: N.Y. Sch. F.&Appl. D.; ASL; NAD; Grande Chaumière. Member: AAPL; All.A.Am.; Am. Veterans Soc. A.; Am. AC, Paris; F., Guggenheim, 1929. Exhibited: Paris salons, 1919–39; NAD, 1916 (prize), 1917 (prize); CGA; VMFA; All.A.Am., 1942 (prize); Am. Veterans Soc. A.; Howard Young Gal., 1923–25, 1928, 1933, 1935 (all one-man); Newhouse Gal., 1939 (one-man); Grand Central A. Gal., 1945 (one-man). Award: Pulitzer Prize, 1919 [47]

GREENE, Kenneth [P] Guilford, CT b. 9 Ja 1902, Buffalo, NY. Studied: H. Nichols. Exhibited: NA, 1933, 1938; Am. WCS, 1938; Studio Gld., 1938; Allied Ar. Am., 1939 [40]

GREENE, LeRoy E. [P,S,Des,C,T,E] Billings, MT (1969) b. 25 N 1893, Dover, NJ. Studied: R. Shrader; Vysekal; W. Adams; G.E. Browne. Member: AWCS; SC; AFA; AAPL. Exhibited: Municipal Exh., N.Y., 1937, 1938; SAM, 1935–37, 1939, 1941; WFNY, 1939; SC; IBM, 1940; AWCS, 1940; San Fran. AA, 1941; Oakland A. Gal., 1946; Univ. Idaho, 1935; Portland (Oreg.) Mus. A., 1939. Work: IBM; Mont. State Hist. Soc.; Parmley Lib., Billings; Univ. Nebr.; Mont. Pub. Sch. Built his mountain studio at East Rosebud Lake in 1946. Position: T., Billings, 1933–43 [47]

GREENE, Marion Y. (Mrs. G. Holden) [P,Des] Boston, MA b. 12 Je 1888, Somerville, MA. Studied: Radcliffe; A. Acad. Cincinnati. Member: Copley S.; Boston SAC; Boston AC. Exhibited: Boston SAC, 1936 (med). Specialties: decorative des., wall panels, screens, lacquered trays [47]

GREENE, Mary Shepard. See Blumenschein, Mrs.

GREENE, Sarah Morris [P] NYC. Member: NAWPS; Contemporary A. [21]

GREENE, Simon [P,Des,T] NYC b. 20 F 1905, NYC. Studied: NA; CUASch; V. Vytacil; W. Harrison; H. Hofmann. Exhibited: WFNY, 1939; PAFA; AIC [40]

GREENE, Stephen [P,E,I] Bloomington, IN b. 19 S 1917, NYC. Studied: NAD; ASL; Col. William and Mary; State Univ. Iowa. Exhibited: WMAA, 1945, 1946; VMFA, 1946 (prize); Joslyn Mem., 1941 (prize); NAD, 1945, 1946; AIC, 1946; Ohio Univ., 1946 (prize); Univ. Iowa, 1946; Los Angeles Mus. A., 1945; Pal. Leg. Honor, 1946; Milwaukee AI, 1946; Herron AI, 1946 (prize); Butler AI, 1946. Illustrator: Esquire. Position: T., Ind. Univ., 1945–46 [47]

GREENE, Walter L. [I,Arch] Schenectady, NY. Member: Boston AC. Exhibited: BAC, 1898. He was living in Boston, 1901. [15]

GREENER, Charles T(heodore) [P,I,C,T] Faulkton, SD/Rapid City, SD b. 16 Mr 1870, Lancaster, WI. Studied: A.K. Cross; Lopez; CUASch. Work: Capitol, Pierre, S.Dak. [17]

GREENER, George Courbright [C] Boston, MA/Prides Crossing, MA. b. OH. Member: Boston SAC. Work: directed making collection of pottery for Japanese Gov. Specialties: metalwork, pottery. Position: T., North Bennet State Indst. Sch., Boston [40]

GREENFIELD, E.J. Forrest [P,C,W,T] Point Pleasant, NJ b. 24 Je 1866, London, England. Studied: K. Schearer. Member: S.Indp.A. [33]

GREENGARD, B.C. [P] Chicago, IL [19]

GREENING, Harry Cornell [I] Orange, NJ b. 30 My 1876, Titusville, PA. Studied: ASL. Illustrator: comic car., Herald, Judge, other magazines [25]

GREENLAW, Emma V. [P] Newport, RI. Member: Newport AA [25]

GREENLEAF, Helen (Mrs. J.T. Johnson) [P,S,T] Madison, NJ/Center Harbor, NH b. 3 Je 1885, Riverside, IL. Studied: BMFA Sch. Member: CAFA [24]

GREENLEAF, Ida Lynde [P] NYC. Work: Arlington A. Gld. [17]

GREENLEAF, Jacob I. [P] West Somerville, MA b. 2 Mr 1887, Reval, Estonia. Studied: Europe. Member: CAFA; New Haven PCC; North Shore AA; Rockport AA; Copley Soc.; AAPL. Exhibited: NAD, 1943; Mint Mus., 1943, 1944; Portland SA, 1944–46; St. Petersburg AC, 1941; North Shore AA, 1942–46; Copley Soc., 1933, 1934, 1936; New Haven PCC, 1941–46; CAFA, 1945, 1946; Jordan Marsh Gal., 1939 –46 [47]

GREENLEAF, Ray [I] Freeport, NY d. 14 F 1950. Member: SI; SC; AIGA [47]

GREENLEAF, Richard C(ranch) [P] Lawrence, NY b. 15 N 1887, Germany. Studied: Collin, Courtois, Simon, Ménard, all in Paris [29]

GREENLEAF, Viola M. [I] NYC. Member: SI [32]

GREENLEY, Howard [S,Arch,T] Hartford, CT/York Harbor, ME. b. 14 My 1874, Ithaca, NY. Studied: Trinity Col.; Ecole des Beaux-Arts, Paris, Fountainbleau, France. Member: Soc. Beaux-Arts Arch.; Beaux-Arts Inst. Des.; Arch Lg.; Am. Inst. Arch. Exhibited: CAFA, 1937; Wadsworth Atheneum, Hartford [40]

GREENMAN, Frances Cranmer (Mrs.) [Cr,W,P] Minneapolis, MN. b. 28 Je 1890, Aberdeen, SD. Studied: Corcoran Sch. A.; ASL; BMFA Sch.; Grande Chaumière; Chase; DuMond; Henri; F. Benson; Castellucho, in Paris. Member: Soc. Wash. A.; Minn. AA. Exhibited: World's Fair, Chicago, 1933, 1934; CI, PAFA, 1923, 1926, 1935; AIC; NAD; Detroit Inst.

A.; Minn. State Art Comm., 1915 (gold); Minneapolis Inst. A., 1921 (prize), 1922 (prize); Wichita AM. Work: NYU; Ohio State Univ.; Univ. Minn.; Hamline Univ.; Cornell; Lawrence Col.; Aberdeen Pub. Lib.; Nevile Mus., Minneapolis (one-man). Positions: Cr., Minneapolis Sunday Tribune; T., Minneapolis Sch. A., 1941-43 [47]

GREENOUGH, Buhler. See Hardy, Mrs.

GREENOUGH, Charles Pelham III, Mrs. See Sandzen, Margaret.

GREENOUGH, Cornelia [P] Phila., PA [01]

GREENOUGH, Dorothy Garrison [P,T] Providence, RI b. 7 F 1904. Studied: Smith Col.; Carnegie F., 1927; Harvard, with Pope; C.W. Hawthorne. Member: Providence AC. Exhibited: Nat. Jr. Lg. Exh., Minneapolis, 1931 (prize); Jr. Lg. Exh., Providence [40]

GREENOUGH, E.K. [P] Montclair, NJ [25]

GREENOUGH, Richard Saltonstall [S] b. 27 Ap 1819, Jamaica Plain, MA d. 23 Ap 1904, Rome, Italy. Studied: Paris. Among his public monuments are statues of Franklin (1885, in front of Boston City Hall) and Winthrop (Boston). After 1874, he split his studio time between Rome, Boston, and Newport. He was successful with portrait busts in bronze and marble. Brother of the famous sculptor, Horatio [1805-52], whose Florence studio he visited in 1837, and portrait painter John [1801-52].

GREENSTEIN, Benjamin [S] NYC b. 18 Mr 1901, London, England. Studied: Bellows; Henri [19]

GREENWOOD, Cora [P,C] Wellesley Hills, MA/Annisquam, MA b. 11 Jy 1872, Waltham, MA. Studied: D. Ross, A. Mucha. Member: Boston SAC [29]

GREENWOOD, George Arthur [P,S,G,L] Oakland, CA/Watsonville, CA b. 16 Jy 1915. Studied: Univ. Calif.; Mills Col., Calif. Member: Sonora A. Honor Soc.; San Fran. A. Assn.; Mexico City AA. Exhibited: WC Ann., SFMA, 1937; Los Aquas, Calif. A. Gld., 1932 (prize); Sonora A. Gal., 1935 (prize); Sorbonne, 1938 (prize) [40]

GREENWOOD, Grace [Mur.P] NYC/Woodstock, NY b. 15 Ja 1905, Brooklyn, NY. Member: Mur. P. Soc.; Un. Am. Ar.; Am. A. Cong. Work: fresco mural, Mus., Morelia, Michoacan, Mexico; fresco, Mercado Abelardo Rodriguez, Mexico City; mural USPO, Lexington, Tenn. WPA muralist. [40]

GREENWOOD, Joseph H. [P] Worcester, MA b. 8 O 1857, Spencer, MA d. 31 Mr 1927. Studied: R. Swain Gifford. Member: CAFA. Exhibited: CAFA, 1918. Work: WMA; Clark Univ. [25]

GREENWOOD, Laura M. (Mrs. Walter B.) [P,T,L] Phila., PA b. 7 Jy 1897, Phila. Studied: Moore Inst.; La France Sch. A.; Temple Univ.; Barnes Fnd.; E. Horter; Sch. Des. for Women. Member: Phila A. All.; Plastic Cl.; Phila WCC; Woodmere A. Center. Exhibited: PAFA, 1940; Allentown, Pa. (one-man); Phila. A. All.; Contemporary C., Trenton; Phila. Plastic C.; Bryn Mawr, Pa. Work: Seamen's C., Phila. [47]

GREENWOOD, Marion [Mur.P,Li] NYC/Woodstock, NY b. 6 Ap 1909, Brooklyn d. 1970. Studied: ASL; Grande Chaumière. Member: Mur. P.; Am. A. Cong.; Mural P. Gld. Exhibited: MMA; WMAA; BM; Carnegie Inst., 1944 (prize); CGA; Assn. Am. A. (one-man). Work: PAFA; Univ. Ariz.; Encyclopaedia Britannica Coll.; murals, Hotel Taxquenia, Taxco, Mexico; Univ. San Nicola Hidalgo; Civic Center, Mexico City; Community Hall, Camden, N.J.; Red Hook Community Bldg. (for NYC Housing Authority); USPO, Crossville, Tenn. WPA muralist. [47]

GREENWOOD, William Russell [P,E] Lafayette, IN/Colorado Springs, CO b. 25 Je 1906, Oxford, IN. Studied: Sister Rufinia; D. Miller. Member: Lafayette AA; Hoosier Salon; Ind. Acad. Sciences [33]

GREER, Blanche [P,E,I,W,T] Summit, NJ b. 9 Ag 1883, Eldora, IA. Studied: St. Paul Sch. FA; PAFA; Chase; E.F. Comins; Guerin, Naudin, both in Paris. Member: Summit AA. Exhibited: Phila. WCC, 1916 (prize); PAFA; Contemporary N.J. A., 1933 (prize); Montclair A. Mus. Work: PAFA; N.J. Col. for Women; Citizens Com. for Army & Navy, NYC. Author/Illustrator: "Thunder's Tail," 1942. Illustrator: Collier's, Harper's, Scribner's, other magazines [47]

GREER, Dupuy [P] NYC. Member: GFLA [27]

GREER, Jefferson E. [Mur.P,P,S] Bristol, RI b. 1905, Chicago. Studied: Univ. Wis.; Chicago Acad. FA; Layton AI, Milwaukee. Lived on a ranch in Texas, 1925; assisted on murals in El Paso Sch. Mines; assisted G. Borglum at Mt. Rushmore, 1934; WPA muralist, USPO at Prairie du Chien, Wis. [40]

GREGG, A.W. [P] Richmond, IN [13]

GREGG, Frederick James [Cr] NYC b. 1865, Dublin, Ireland d. F 1928. Before coming to the U.S., he took part in the beginnings of the literary renaissance in Ireland.

GREGG, Kenneth, Mrs. See Worden.

GREGG, Kenneth Roger [P,T,G] Richmond, IN b. 18 Je 1913, Richmond. Studied: Ball State T. Col.; Herron AI; G. Wiggins; R. Hirschburg; C. Surendorf; F. Brown. Member: Western A. Assn.; Amateur AC, Muncie; Rendezvous AC, Richmond, Ind. Exhibited: Richmond AA, 1933-39; Muncie AA, 1935-39. Positions: T., Hillsdale Col., Mich. (1939-40), Mich. Pub. Sch. (1941-45), Richmond Sr. H.S. (1946) [47]

GREGG, Lewis C. [Por.P] Atlanta, GA b. 9 O 1880, Atlanta. Studied: ASL; Académie Julian, Paris; Colarossi Acad. Work: Trust Co. of Ga.; Coca-Cola Co., Atlanta; Univ. Ga.; Ga. Sch. Tech.; Emory Univ.; Confederate Mus., Va. [47]

GREGG, Raymond Edward [P] Rushville, IN [24]

GREGORY, Angela [S,P,T,L] New Orleans, LA b. 18 O 1903, New Orleans. Studied: Newcomb Col., Tulane Univ.; N.Y. Sch. F&Appl. A; N.Y. State Sch. Ceramics; C. Keck; Grande Chaumière, Bourdelle, both in Paris. Member: NSS; Le Petit Salon; NOAA; SSAL; NOACC; New South Group. Exhibited: Salon des Tuileries; WFNY, 1939; MMA, 1942; NSS; WMAA, 1940; New Orleans AA (one-man); SSAL, 1930 (prize), 1931 (prize); New Orleans AC, 1933 (one-man); La. State Exh., 1928 (prize). Work: IBM; Delgado Mus. A.; La. State Mus.; Tulane Univ.; Court House, City bldgs., all in New Orleans; Hastings, Nebr.; Newcomb Col.; La. State Capitol; fireplace, Septmonts, France; Silver-Burdett Co., NYC [47]

GREGORY, Anne L. See Ritter.

GREGORY, Dorothy Lake (Mrs. D.G. Moffett) [Li,P,I,T,E] Provincetown, MA b. 20 S 1893, Brooklyn, NY. Studied: Packer Inst.; PIASch; ASL; Robert; C.W. Hawthorne; Henri; Bellows. Exhibited: NAD; MMA; BM; AIC; LOC, 1944, 1946. Work: BMFA; LOC. Illustrator: "Early Candlelight Stories," "Happy Hour Series" [47]

GREGORY, Eliot [P,W] b. 1854, NYC d. 1 Je 1915. Studied: Yale, 1880; Rome; Paris. Member: Legion of Honor, 1911; for writing. Exhibited: Paris Salon, 1899 (gold). Work: Cullom Mem. at West Point. Author: "Idler Papers," in the Evening Post; "The Ways of Men," "Worldly Ways and Byways." A founder of the New Theatre. Position: Dir., Metropolitan Opera Company [03]

GREGORY, Helen Barber [P] Wash., DC. Studied: ASL; Colarosi. Member: Chicago SA [04]

GREGORY, John [S,L] NYC b. 17 My 1879, London, England d. 1958. Studied: Am. Acad., Rome; ASL; Ecole des Beaux-Arts. Member: ANA, 1931; NA, 1934; NSS (Pres.); Arch. Lg; NIAL. Exhibited: Arch. Lg., 1921 (med); AIC, 1921; Concord AA, 1926 (med); PAFA, 1933 (gold). Work: MMA; CGA; Huntington Mausoleum, San Marino, Calif.; Folger Shakespeare Lib., Wash., D.C.; Phila.; Beveridge Mon., Indianapolis [47]

GREGORY, John Worthington [Li,L] Provincetown, MA b. 14 Mr 1903, Brooklyn, NY. Studied: ASL; J. Sloan; Charles Locke; A. Lewis; R. Moffett. Member: Boston AC; Provincetown AA. Exhibited: AIC, 1938; Faulkner Mem. Gal., Santa Barbara, Calif.; Warwick Gal., Phila.; Boston AC; Wheaton Col. Selected as one of best American printmakers by "Prints," 1936 [47]

GREGORY, Katharine V.R. (Mrs. John) [S,T] NYC b. 1 S 1897, Colorado Springs. Studied: Bourdelle; J.M. Lawson; J. Gregory. Member: NAWPS. Exhibited: NAWPS, 1933 (prize) [40]

GREGORY, Lovrien Price (Mrs.) [P] NYC. Member: GFLA [27]

GREGORY, Waylande [S,Des,W,L,C] Bound Brook, NJ b. 13 Je 1905, Baxter Springs, KS d. 1971. Studied: Kans. State T. Col.; Univ. Chicago; Kansas City AI; Lorado Taft. Member: F., Cranbrook Fnd., 1931-32; NSS; Soc. Des.-Craftsmen. Exhibited: Alfred Univ., 1939 (prize); Paris Expo, 1937 (prize); Syracuse Mus. FA, 1933, 1937, 1940 (prizes); Arch. Lg., 1936 (prize); CMA, 1929 (prize), 1931 (prize); AIC, 1933 (prize); Nat. Ceramic Exh., Syracuse, 1939 (prize); Intl. Expo, Paris, 1937 (med). Work: District Bldg., Wash., D.C.; Roosevelt Park, N.J.; Syracuse Mus. FA; Cranbrook Mus.; CMA; General Motors Corp.; Chicago Univ.; Kansas City, Mo.; Dayton AI; WFNY, 1939; USPO, Columbus, Kans. WPA artist. [47]

GREGSON, Marie E(vangeline) [P,Dr] Flushing, NY b. 16 D 1888, NYC. Studied: Twachtman; Cox. Member: NAWPS; Douglaston AL [40]

GREIFFENHAGEN, Maurice [I] NYC. Position: Affiliated with Century magazine [01]

GREITZER, Jack J. [P] Cleveland Heights b. 18 Mr 1910, NYC. Studied:

Cleveland Sch. A. Member: Ohio WCS; Cleveland Pr. M. Exhibited: Soc. Wash. A., 1931 (prize); CMA, 1931–36 (prizes). Work: CMA; PAFA; WMAA; mural, USPOs, Cleveland, Wauseon, both in Ohio; City of Cleveland. WPA muralist. [47]

GREIMS, Mary Hearn (Mrs. Herbert Spencer) [P] Ridgefield, CT b. NYC d. 27 My 1927, NYC. Studied: CUASch; G. Smillie; Phila. Sch. Des. Women; PAFA; C. Waldon; A.H. Wyant. Member: Plastic C.; NAWPS [25]

GRELL, Louis (Frederick) [P,T,I] Chicago, IL b. 31 N 1887, Council Bluffs, IA. Studied: Munich; Hamburg; C.V. Marr; A. Jank. Member: All-Ill. SFA; Cliff Dwellers; Chicago Gal. Assn.; Assn. Chicago P.&S. Exhibited: Municipal A. Lg., Chicago, 1936 (prize). Work: Bank of Detroit; Union Station, St. Louis; Northwestern Military Acad., Geneva, Wis.; Detroit Water Bd. Bldg.; Paramount Theater, Toledo; Chicago Rotary C.; Gateway Theater, Chicago [47]

GRELLERT, Paul J. [P,S,G] Portland, OR b. 7 S 1916, Bredau, Germany. Studied: Portland AM Sch. Work: USPO, East Portland. WPA artist. [40]

GREMKE, Henry Dietrich (Dick) [P,I,Photogr] b. 1860, San Fran. d. 1933, Oakland, CA. Studied: Calif. Sch. Des., with R.D. Yelland. Exhibited: San Fran.; Oakland. Work: murals (now destroyed), Southern Pacific and Santa Fe Railroads. Illustrator: Sunset (March 1901). Specialty: Sierra Nevada landscapes [*]

GREN, Nils [P] San Francisco, CA. Exhibited: GGE, 1939 [40]

GRENET, Edward [P,I,T] Paris, France b. 13 N 1857, San Antonio, TX, to French parents. Studied: Bouguereau, Robert-Fleury, in Paris. Exhibited: London (med); Nantes (med); Rennes (med). Established portrait studio in San Antonio, 1878; also painted some Tex. genre scenes. He settled in Paris, ca. 1884. [15]

GRENHAGEN, Merton [Por.P] b. Orihula, WI. Studied: Chase; Laurens; AIC. Member: Chicago SA; Wis. PS. Work: Univ. Wis.; Wis. Hist. Mus.; Wis. State Capitol; Univ. Ill.; Univ. Mich.; Milwaukee Pub. Lib.; Beloit Col. [40]

GRESS, Edmund G. [P] NYC [24]

GREVE, Cherry [P,L,T,Cr] Cincinnati, OH b. 5 N 1903, Cincinnati. Studied: H.H. Wessel; J. Weis; J. Despujols; H. Breckenridge; H.B. Snell. Member: Crafters Co.; MacD. C. Cincinnati; Three Arts C.; Women's AC, Cincinnati; Archaeological Soc. Position: A. Cr., Cincinnati Times-Star [33]

GREVER, Otto L. [P] NYC. Member: Wash. SA [17]

GREY, Gertrude G. [P] Wash., D.C. [15]

GRIBBEN, Augustine A. (Dr.) [P,W] b. 1866 d. 21 My 1932, Merchantville, NJ. Work: State House, Trenton

GRIBBLE, Harry Wagstaff [I] NYC. Member: SI [31]

GRIBBROEK, Robert [P] Amarillo, TX b. 16 Mr 1906, Rochester, NY. Studied: Rochester Athenaeum; PAFA; E. Bisttram. Member: Rochester AC; Taos AA; Transcendental P. Gr. Exhibited: Santa Fe Mus.; Univ. N.Mex.; Rochester Mem. A. Gal.; GGE, 1939 [40]

GRIDER, Rufus Alexander [P,T] b. 13 Ap 1817, Lititz, PA d. 7 F 1900, Canajoharie, NY. Work: Moravian Archives, Bethlehem, Pa.; N.Y. Hist. Soc. Specialty: floral and landscape watercolors. Position: T., Canajoharie H.S., since 1883

GRIDLEY, Josephine B. (Jo) [P,Des,T] Larchmont, NY b. 10 Mr 1888, Phila. Studied: PAFA; W.M. Chase; D. Garber; H. Breckenridge. Member: AAPL; New Rochelle AA [40]

GRIER, Frances [C] New Castle, NH b. 27 S 1907. Member: Boston SAC. Specialty: jewelry [40]

GRIEST, Mary C. Johnson [P] Phila., PA. Studied: PAFA [24]

GRIEVE, Maurice [P] NYC. Member: Lg. AA [24]

GRIFFEN, (William) Davenport [P,T,Li] Rock Island, IL b. 5 O 1894, Millbrook, NY. Studied: Chicago Acad. FA; AIC; Oberteuffer; J.W. Norton. Exhibited: CI, 1929, 1930, 1933; CGA, 1933; PAFA, 1930, 1932; AIC, 1927, 1928, 1929 (prize), 1930 (prize) 1931–34; WMAA, 1932; Davenport Municipal A. Gal., 1946 (one-man); Chicago Gal. Assn., 1930 (prize), 1931 (prize); Chicago SA, 1931 (med); Chicago A. Exh., 1928; Chicago Women's C., 1929 (prize). Work: AIC; murals, USPOs, Flora, Carmi, both in Ill. WPA muralist. [47]

GRIFFIN, J(ames) M(artin) [P,E,T] Oakland, CA b. 20 F 1850, Cork, Ireland. Studied: J. Brenan, Sch. of Art, Cork. Member: WCS, Ireland [31]

GRIFFIN, Nina Kickbusch (Mrs. Robert C.) [P,S] Chicago, IL b. 13 Ap 1894, Wausau, WI. Studied: AIC; V. Higgins; W. Adams; Thieme; C. Rosen; F. Poole; F. Grant. Member: Chicago AC; Chicago Gal. Assn.; All-Ill. SFA; NAWPS; Allied Ar. Am.; CAFA; Springfield, Mass. Mus. FA. Exhibited: CAFA, 1936; All-Ill. Soc. FA (med). Work: Purdue Univ.; Beloit Col.; Oshkosh Mus. A.; Columbia (Ga.) AC [47]

GRIFFIN, Thomas B. [P] Phila., PA [01]

GRIFFIN, W. Abbott [P] NYC. Member: GFLA [27]

GRIFFIN, Walter [P] Portland, ME b. 1861 d. 18 My 1935. Studied: Collin; Laurens. Member: ANA, 1912; NA, 1922; Allied AA; NYWCC; Paris AA; SC; AWCS. Exhibited: P.-P. Expo, 1915 (med); PAFA, 1924 (gold). Work: Mem. A. Gal., Rochester; Buffalo FA Acad.; Brooklyn AM; Luxembourg Mus., Paris; Imperial Art Inst., Tokyo; Vose Gal., Boston. From 1887 to 1915 he lived chiefly near Nice, France. [33]

GRIFFIN, Wesley A. [P] NYC [25]

GRIFFIN, Worth D. [Edu,P,Li] Pullman, WA b. 15 D 1892, Sheridan, IN. Studied: Okla. Christian Univ.; Univ. Oreg.; John Herron AI; AIC; H. Walcott; G. Bellows; C. Hawthonre; W. Reynolds; C. Wheeler; W. Forsyth. Exhibited: SFMA, 1940, 1942, 1945; Oakland A. Gal., 1939, 1940; SAM, 1939–44. Position: T., Wash. State Col., 1925–46 [45]

GRIFFING, Tracy Arlington [P,S,C] Eastport, NY b. 25 D 1890, Long Island, NY. Member: Boston SAC. Exhibited: P.-P. Expo, 1915 (med). Specialties: jewelry; silversmithing; pottery [40]

GRIFFITH, Armond Harrold [Mus.Dir,L,I,W] b. 1859 d. 23 S 1930, Santa Barbara, CA. He secured the first public funds for support of the Detroit Mus. A. Position: Dir., Detroit Mus. A., 1890–1913

GRIFFITH, Cecilia Beatrice Bickerton Fox (Mrs. Charles F.) [S,C] Phila. b. 6 Ag 1890, Hoylake, Cheshire, England. Studied: C. Grafly; PAFA. Member: Phila. Alliance. Work: Lahore, Pakistan; St. Andrews Hospital, Newfoundland; Franklin Inst., Phila.; Valley Forge Hist. Soc.; Second Presbyterian Church, Phila.; National Cathedral, Wash., D.C.; Sulgrave Manor, England; Buckingham Palace Coll.; Board Edu. Bldg.; Pa. State Capitol, Harrisburg [40]

GRIFFITH, Conway [P] d. 28 Ap 1924, Laguna Beach, CA. Member: Laguna Beach AA. One of the founders of the "Art Colony at the Beach." [24]

GRIFFITH, Don [S,P,G] Denver, CO b. 8 N 1905, Jamestown, NY. Studied: Cleveland Sch. A. Exhibited: Cleveland AC, Cleveland MA, 1929 (prize), 1930 (prize). Position: Pres., Colo. Sch. A., Denver [40]

GRIFFITH, Edward N. [P] Avon Park, FL. Studied: S.Indp.A. [25]

GRIFFITH, Julia S(ulzer) [P] Chicago, IL/Gloucester, MA b. Chicago d. 1945. Studied: AIC; Mulhaupt; Noyes; Breckenridge; F.M. Grant. Member: North Shore AA; Gloucester SA; All-Ill. SFA; Romany C.; North Shore AL, Chicago; Chicago SA; Boston SAC. Exhibited: All-Ill., Chicago (gold). Work: Ill. State Mus., Springfield [40]

GRIFFITH, Lillian Bonita [P] Azusa, CA b. 11 Jy 1889, Phila. Studied: E. Daingerfield; H.B. Snell; PMSchIA; Phila. Sch. Des. Member: Calif. AC. Exhibited: Calif. AC, 1928 [40]

GRIFFITH, Louis Oscar [Ldscp.P,E] Nashville, IN b. 10 O 1875, Greencastle, IN d. 13 N 1956. Studied: St. Louis Sch. FA; AIC; Dallas, with Reaugh, 1896; NAD; Paris. Member: Chicago SE; Brown County AA; Ind. AC; Ind. Soc. PM; Chicago Gal. Assn.; Chicago SPS. Exhibited: Nat. Mus., 1945; LOC, 1943; NAD, 1943; Brown County AA, 1938 (prize); Palette and Chisel Cl., (gold), 1921; Ind. AC; Chicago SE; Ind. PM; P.-P. Expo, 1915 (prize); Hoosier Salon, 1925 (prize), 1938 (prize); San Antonio AL, 1929 (prize). Work: Delgado Mus. A.; Oakland A. Gal.; Ind. Univ.; Lafayette AA; Vanderpoel Coll.; NGA; Witte Mem. Mus.; J.B. Speed Mem. Mus. [47]

GRIFFITH, M.A. [P] New Brighton, NY [13]

GRIFFITH, Marie Osthaus (Mrs.) [P,T] Toledo, OH b. Dülmen, Germany. Studied: E.H. Osthaus. Member: Athena Soc., Toledo [10]

GRIFFITH, Rosa B. [P,T] Terre Haute, IN b. 18 Ap 1867, Merom, IN d. 23 F 1927. Studied: C.A. Cumming; J.F. Smith; A. Dow. Member: Ind. AA; Terre Haute Women's Cl., A. Section. Position: T., Terre Haute Pub. Sch., 30 years [25]

GRIFFITH, Vera Alice [P,T] Anderson, IN b. 2 D 1906, Anderson. Studied: K. Scheffler; D. Mattison; H. Mayer; J. Herron A. Sch. Member: Ind. AC;

Anderson SA. Exhibited: Hoosier Salon, 1936 (prize); Ind. State Fair, 1935 (prizes), 1936 (prizes), 1937 (prizes), 1938 (prize). Position: T., Aurora Pub. Sch., Ind. [40]

GRIFFITH, W(illiam) A(lexander) [P] Laguna Beach, CA b. 19 Ag 1866, Lawrence, KS. Studied: St. Louis Sch. FA; Lefebvre, Constant, in Paris. Member: Laguna Beach AA; Calif. AC. Exhibited: St. Louis, 1889, (gold); Orange County Fair; (prize); Southern Calif. Fair, Riverside, 1928 (prize); Calif. Artists, Santa Cruz, 1929 (prize); Calif. AC, 1934 (prize); Ebell C., Los Angeles, 1936 (prize); Oakland A. Gal., 1936. Work: Mulvane A. Gal., Topeka, Kans.; State Hist. Soc., Topeka; State T. Col., Emporia, Kans.; Thayer Mem. Mus., Lawrence, Kans.; Univ. Cl., San Diego; YMCA, Santa Ana; Univ. Southern Calif.; Women's C., Whittier [40]

GRIFFITHS, Elsa Churchill [Min.P] Seattle, WA [21]

GRIFFITHS, Katherine M. [P] Seattle, WA [24]

GRIFFITHS, W. (Mrs.) [P] Ft. Wayne, IN [13]

GRIGER, Mary J. [P] McMillan, WA [24]

GRIGG, Joanna S. [P] Butte, MT [06]

GRIGGS, Martha E. [P] Wash., D.C. [13]

GRIGGS, Samuel W. [P,Arch] Boston, MA d. 1898 (according to Groce & Wallace). Active in Boston 1848–98 (listed as architect, 1848–52). Exhibited: Boston Athenaeum [01]

GRIGNOLA, John [P] NYC [10]

GRIGOR, Margaret C. [P] Phila., PA. Exhibited: PAFA, 1937–39 [40]

GRIGWARE, Edward T. [P,Mur.P,I,T] Oak Park, IL/Cody, WY b. 3 Ap 1889, Caseville, MI d. 9 Ja 1960. Studied: Chicago Acad. FA, 1911–13. Member: Palette and Chisel C.; Austin, Oak Park and River Forest AL; Chicago PS; Cliff Dwellers. Exhibited: Palette and Chisel C., 1925 (prize), 1928 (gold); Hoosier Salon, 1925 (prize); AIC, 1926 (prize), 1931 (prize); Circle AL, Chicago, 1927 (prize); Austin, Oak Park and River Forest AL, 1928 (prize); Assn. Chicago PS, 1931 (gold); All-Ill. SFA, 1933 (gold). Work: State Mus., Springfield, Ill.; murals: City Hall, Chicago; Kalif. Shrine, Sheridan, Wyo.; Univ. Wyo.; Latter Day Saints Temple, Los Angeles. His wife Blanche Lanaghen (d. 1959) was also an artist. Position: T., (founder) Frontier Sch. of Western A., Cody, 1937 [40]

GRIMES, Frances Taft [S] NYC/Windsor, VT b. 25 Ja 1869, Braceville, OH d. 1963. Studied: PIASch; H. Adams; A. Saint-Gaudens. Member: The Cornish (N.H.) Colony; ANA, 1931; NSS, 1912; NAWPS; AFA. Exhibited: NSS; NAD; Soc. Am. A.; P.-P. Expo, 1915 (med); NAWA, 1916 (prize). Work: TMA; MMA; Hall of Fame, NYU; Grace Church, NYC; Washington Irving H.S., NYC; Wash. Cathedral; Chi Omega Soc.; Town Hall., NYC [47]

GRIMES, Mary Hearn (Mrs. Herbert) [P] NYC [04]

GRIMM, Floyd H. [P] Columbus, OH. Member: Columbus PPC [25]

GRIMMER, Vernon [P] Chicago, IL. Exhibited: Ar. Chicago Vicinity Ann., AIC, 1934, 1935, 1937, 1938 [40]

GRIMSON, Samuel, Mrs. See Hoffman, Malvina.

GRINAGER, Alexander [P,Des] Ossining, NY b. 26 Ja 1865, Albert Lea, MN d. 8 Mr 1949. Studied: P. Clausen; C.W. Knapp; Constant; Laurens; Royal Acad., Copenhagen; Norway; Italy. Member: SC, 1908; Kernow Group, Cornwall, England; All.A.Am.; Minneapolis A. Lg. Exhibited: panels, Mines and Mining Bldg., Century of Progress Expo, Chicago, 1933–34; All.A.Am., annually; SC, 1908–46. Work: P.-Pacific Expo, U.S. Dept. Commerce; N.Y. Central Railroad; Grand Central Palace [47]

GRINNELL, G. Victor [P] Mystic, CT. Member: New Haven PCC; CAFA; Mystic SA [33]

GRINNELL, L.G. (Mrs.) [P] Detroit, MI. Member: S. Detroit Women P. [25]

GRIPON, Paul, Mme. See Sparrow, Louise.

GRIPPE, Peter [S,Gr,P,C] NYC b. 8 Ag 1912, Buffalo, NY. Studied: Albright A. Sch.; Buffalo AI; E. Wilcox; E. Dickenson; W. Ehrich; W. Hayter. Member: Fed. Mod. P.&S.; Am. Abstract A. Exhibited: MMA, 1942; WMAA, 1944, 1945; LOC, 1946; Detroit Inst. A., 1945; PAFA, 1946; Albright A. Gal., 1935–39; Willard Gal., 1942, 1944, 1945 (one-man); Buchholz Gal., 1943 (one-man), 1945; Wildenstein Gal., 1944, 1945; Am. Abstract A., 1946. Work: MOMA; Albright A. Gal.; AGAA [47]

GRISCOM, Lloyd C(arpenter) [P] Syosset, NY b. 1872, Riverton, NJ. Studied: E. Winter; G.P. Ennis. Member: AWCS [47]

GRISEZ, E.A. [P,T,L] La Porte, IN b. 29 Ap 1908, La Porte. Studied: A.C. Winn. Member: Hoosier Salon; Midland Acad. A.; La Porte Co. AC Assn.; NJSA; BPC [40]

GRISWOLD, C(asimir) C(layton) [P] Poughkeepsie, NY b. 1834, Delaware, OH d. 7 Je 1918. Studied: wood engraving, in Cincinnati; painting, in Rome. Moved to NYC ca. 1850. Lived in Rome during 1870s–80s. Member: ANA 1866; NA 1867. Exhibited: NAD, 1857 [17]

GRISWOLD, Celeste Sawtelle [P,I] Great Neck, NY b. 1 O 1869, Salem, OR. Studied: Chase [08]

GRISWOLD, Helen [P] NYC [01]

GRISWOLD, Vermadel [P] Kensington, CT. Exhibited: NA, 1933; CAFA, Hartford, 1937, 1938 [40]

GRISWOLD, Virginia A. [P,Dec] Brooklyn, NY. Studied: ASL; F. Allen; G.E. Browne; W. Longyear; H.P. Browne; A. Guptill; G. Bridgman; Colarossi Acad. Member: Allied Ar. Am.; Brooklyn Soc. Ar.; NYWCC; NAC; PBC. Exhibited: AWCS; All.A.Am.; NAC; NAD; CGA; Adelphi Col.; BM; N.Y. Pan Hellenic Women's Univ. C. [47]

GRIVIEZ, Eugene [P] NYC [01]

GROBEN, W. Ellis [P] Phila., PA. Member: New Century C. [25]

GROCE, George C. [Hist,W,Cr] Wash., D.C. b. 20 S 1899, Waxahachie, TX. Studied: Trinity Univ.; Univ. Tex.; Columbia; abroad. Member: Am. Hist. Assn. Author: "William Samuel Johnson," 1939; Ed., "Early American Portrait Artists." Position: War Dept., 1945– [47]

GROENING, Violet M. [P] Ben Avon, PA. Member: Pittsburgh AA [25]

GROENKE, Sherman Austin [P,I,Car,G] Racine, WI b. 15 N 1914. Studied: Layton Sch. A., Milwaukee. Exhibited: All States Cathedral, Milwaukee; Wis. PS Ann., Milwaukee AI, 1938 (prize). Work: Wilwaukee AI [40]

GROETZINGER, Earl [P] Chilton, WI [24]

GROETZINGER, Emil (Mrs.) [P] Chilton, WI [15]

GROFE, Lloyd Nelson [I,C] Boyertown, PA b. 10 Jy 1900, Bechtelsville, Berks County, PA. Studied: T. Oakley; G. Harding. Member: Phila. Sketch C. Illustrator: "The Wolf's Head and the Queen," pub. Scribner's, 1931; Good Housekeeping, other national magazines. Designer: marionettes of carved wood [40]

GROFF, June Gertrude [P,Des] Phila., PA b. 26 Je 1903, North Lawrence, OH. Studied: PAFA; H. McCarter. Member: Phila. A. All. Exhibited: WFNY, 1939; PAFA, 1936–45; AWCS, 1935, 1936, 1939, 1940; CGA, 1941; PAFA, annually; Phila. A. All.; Carlen Gal. Work: Barnes Fnd.; PAFA; Pa. State Col.; fabric des., Harper's Bazaar, Hattie Carnegie; Clare Potter [47]

GROHE, Glenn Ernest [I,Des,P,L] Westport, CT b. 13 N 1912, Chicago, IL d. 15 Ap 1956. Studied: Am. Acad., Chicago; Chicago Acad. FA; AIC. Member: SI; Westport A. Group. Illustrator: Saturday Evening Post, Cosmopolitan [47]

GROLL, Albert L(orey) [P] NYC b. 8 D 1866, NYC. Studied: Royal Acad. Antwerp, ca. 1894–95; Royal Acad. Munich, with Gysis, Loeffetz, 1899. Member: ANA, 1906; NA, 1910; NYWCC; AWCS; A. Fund S.; SC, 1900; Lotos C.; NAC; Allied AA; SPNY. Exhibited: SC, 1903 (prize), 1904 (prize); St. Louis Expo, 1904 (med); PAFA, 1906 (med); NAD, 1912 (gold); P.-P. Expo, 1915 (prize); NAC, 1939 (prize). Work: CGA; Brooklyn Inst. Mus.; NGA; Montclair A. Mus.; MMA; Minneapolis Inst. A.; Lotos C.; Ft. Worth Mus.; BMFA; CAM; NAC; CI; NYPL. Specialty: Ariz. and N.Mex. desert landscapes [47]

GRONHOLDT, A. [P] NYC. Member: S.Indp.A. [25]

GROOM, Emily (Parker) [P,T] Milwaukee, WI b. 17 Mr 1876, Wayland, MA d. 1975. Studied: AIC; BMFA Sch.; J. Vanderpoel; B. Harrison; F. Benson; Brangwyn. Member: Phila. WCC; AWCS; Wis. P.&S; NYWCC; NAWPS. Exhibited: Milwaukee AI, 1918 (prize), 1920 (prize), 1925 (prize), 1926 (prize), 1931 (prize), 1946 (prize); St. Paul Inst., 1917 (gold); Wis. Art, 1928 (prize), 1931 (prize); St. Louis, 1926 (prize); PAFA; AIC; Oshkosh; Beloit; Racine; Fond du Lac; Green Bay, 1946. Work: St. Paul Inst. A.; Wilwaukee AI; Vanderpoel AA Coll. Position: T., Milwaukee-Downer Col. & Layton Sch. A. [47]

GROOM, Mary B. [P] NYC [25]

GROOM, Sarah H. (Mrs. Thomas) [C] Brookline, MA b. 14 Mr 1879,

Boston, MA. Member: Boston SAC. Exhibited: Tercentenary Exh., Horticultural S., Boston, 1930. Specialty: pottery [40]

GROOME, Esther M. [P,E,T] Carlisle, PA/East Gloucester, MA b. York County d. 28 N 1929, Phila. Studied: PAFA; Fuchs; Castaigne; W.M. Chase; Henri; C. Beaux. Member: Phila. Alliance; North Shore AA. Position: T., State Normal Sch., West Chester, Pa. [27]

GROOMS, Jessie Roberts [Edu,P] Cincinnati, OH b. 7 D 1891, Sidney, OH. Studied: Ohio Univ.; T. Col., Columbia; A.W. Dow; C. Martin. Member: Ohio WCS; Cincinnati Prof. A.; Women's AC, Cincinnati. Exhibited: Ohio WCS; Cincinnati Prof. A.; Women's AC, Cincinnati. Position: T., Univ. Cincinnati [47]

GROOMS, Reginald Leslie [Edu,Li,L,T,P] Cincinnati, OH b. 16 N 1900, Cincinnati. Studied: A. Acad. Cincinnati; Académie Julian, Paris; Pages; Royer; Laurens. Member: Scarab C.; Cincinnati Prof. A.; Cincinnati AC (Pres.); Ohio WCS; Cincinnati MacD. S. Exhibited: CM, 1923–44; Butler AI, 1936–45; PAFA, 1935, 1936; GGE, 1939; WFNY, 1939; AIC, 1936, 1937; Kearney Gal., Milwaukee, 1946. Work: Univ. Cincinnati. Illustrator: Design. Position: T., Univ. Cincinnati, 1925–46 [47]

GROPPER, William [P,Li,Car,I] Croton-on-Hudson, NY b. 3 D 1897, NYC d. ca. 1978. Studied: NAD, 1913–14; Ferrer Sch., 1912–13; N.Y. Sch. F.&Appl. A., 1915–18; Henri; Bellows; Giles. Member: An Am. Group; Guggenheim F., 1937; Audubon A.; Am. Newspaper Gld. Exhibited: CGA; PAFA; VMFA; AIC; CI; WMAA; NAD; WFNY, 1939; LOC, 1915 (prize); Los Angeles Mus. A. 1945. Work: MMA; MOMA; WMAA; Mus. Western A., Moscow; Wadsworth Atheneum; PMG; Newark Mus.; CAM; Walker A. Center; Univ. Ariz.; PAFA; FMA; AIC; Encyclopaedia Britannica Coll.; murals, USPO, Freeport, N.Y.; Northwestern Station, Detroit, Mich.; Interior Bldg., Wash., D.C.; Schenley Corp. Author: "The Golden Land," 1927. Illustrator: "Lidice," 1942, "The Crime of Imprisonment," 1945. WPA muralist and painter of social comment. Positions: Staff Car., The Post, Morning Freiheit, 1924–; Ed. Bd., New Masses, 1936– [47]

GROSBECK, Dan Sayre [P,I] San Fran., CA [21]

GROSE, Harriet Estella (Mrs.) [P] Wash., D.C. b. 1863 d. 5 O 1914, Brooklyn, NY. Widow of painter D.T. Grose.

GROSE, Helen M(ason) (Mrs. Howard B.) [I] Kingston, RI b. 8 O 1880, Providence. Studied: F. Benson; W. Foote; C. Wyeth; E.S.G. Elliot. Member: Providence AC. Illustrator: "The House of the Seven Gables," "Rebecca of Sunnybrook Farm," "Anna Karenina," "Lorna Doone," pub. Jacobs and Co. Specialty: pencil drawings of old houses [40]

GROSHNER, F.M. [P] Napoleon, OH [24]

GROSS, Albert R. [P] Baltimore, MD. Member: Charcoal C. [24]

GROSS, Chaim [S,T,I] NYC b. 17 Mr 1904, Kolomea, Austria. Studied: ASL; BAID; Edu. All. A. Sch. Member: Am. Ar. Cong. S. Gld.; An Am. Group. Exhibited: WFNY, 1939; S. Gld, 1938–40, 1942; WMAA, biennially; CI, 1938, 1940; PAFA, 1943, 1945; BM, 1940; AIC, 1938–42; MOMA, 1940; Detroit Inst. A., 1946; CAM, 1946; FAP, 1936 (prize); AV, 1942 (prize); Paris Salon, 1937 (med). Work: USPOs, Wash., D.C., Irvin., Pa.; Queen's Col., N.Y.; Fed. Trade Bldg., Wash., D.C.; MMA; WMAA; Newark Mus.; MOMA; AGAA. Illustrator: childrens' stories by N. Gross. Contributor: article, Magazine of Art. Positions: T., BM Sch. A.&Edu., Laboratory Sch. Indst. Des. (NYC), All. A. Sch. (NYC) [47]

GROSS, Earl [P,L] NYC b. Pittsburgh, PA. Studied: Carnegie Inst. Member: AWCS; All-Ill. Soc. FA; NYWCC. Exhibited: PAFA, 1937; Wash. WCC, 1939; AIC, 1940; Am. WCS; NYWCC, 1939; Assn. Am. Ar. Gal. [47]

GROSS, Emilie M. [P] St. Louis, MO b. Wubenthal, Austria. Studied: St. Louis Sch. FA. Member: St. Louis AG. Exhibited: St. Louis Expo, 1898 [25]

GROSS, Harold [P] NYC [24]

GROSS, Juliet White (Mrs. John Lewis) [P,T,E] Phila., PA/Sellersville, PA b. Phila. Studied: Phila. Sch. Des. for Women; PAFA; E. Leon, in Paris. Member: Phila. Print C.; Phila. Alliance. Exhibited: PAFA, 1919 (prize), 1920 (prize). Plastic C., 1925 (gold); Paris Salon, 1926. Position: T., Ogontz School, Rydal, Pa. [40]

GROSS, Milt [I,Car] NYC b. 4 Mr 1895, NYC. Creator: "Nize Baby," "Gross Exaggerations." Position: Car., King Features Syndicate [40]

GROSS, Oskar [P] Chicago, IL b. 1871, Vienna, Austria. Studied: Imperial Royal Acad. FA, Vienna; Munich; Paris. Member: Chicago PS; Cliff Dwellers; AC Chicago; Palette and Chisel Acad. FA; Chicago Gal. Assn. Exhibited: AIC, 1928 (prize); Assn. Chicago PS, 1930 (gold); Chicago Gal. Assn., 1930 (prize). Work: Chicago Municipal Commission; Municipal Gallery, Vienna; Univ. Chicago; Chicago AIA; Northwest Univ.; Am. Conservatory of Music [40]

GROSS, P(eter) A(lfred) [Ldscp.P,Mar.P] Paris, France. b. 21 Ja 1849, Allentown, PA d. 24 Ja 1914, Chicago. Studied: Paris, with Yon, Petitjean. Member: Office Pub. Instruction, Paris; French Acad. Exhibited: Paris Expo, 1889; Crystal Palace Intl. Expo, London (med); Union Française (gold). Lived in France from 1874–1914. His will provided for the founding of an art mus. at Allentown, and an art school at Muhlenburg Col. [13]

GROSS, Sidney [P] NYC b. 9 F 1921, NYC. Studied: ASL. Exhibited: NAD, 1940; WMAA, 1945; Albright A. Gal., 1946; CI, 1946. Work: WMAA [47]

GROSS, Sydney [P,I,W,T] Phila., PA b. 9 Ja 1897, Phila. Studied: A. Pope. Member: Phila. Sketch C. Author: "A Short Outline of European Painting." Position: T., Olney H.S., Phila. [40]

GROSSE, Garnet Davy (Mrs. L.S.) [P] Scottsdale, AZ b. 23 Ja 1895, Genda, KS. Studied: W. Paxton; P.W. Nahl; F. Meyer, in Berlin; R. du Quillan, in Paris; Berlin; Calif. Col. A.&C.; ASL; NAD; Univ. Southern Calif.; W. Judson; Xavier Maritinez; C. Chapman; N.C. Wyeth. Member: All.A.Am.; AFA; Am. A. Cong.; Phoenix FA Assn.; Phoenix Art Center; Scottsdale SA; AAPL; Charcoal C.; Am. Ar. Cong. Exhibited: Calif. State Fair, 1911 (prize); Ariz. State Fair, 1919 (prize); Ariz. State Contest, 1918 (prize); Ariz. Mus. A., 1930 (med), 1938 (med); Ariz. Brick and Tile Co., 1922 (prize); Woman's Home Companion, 1922 (prize); Gen. Fed. Women's Cl., 1930 (prize), 1931; Gen. Fed. Women's Cl., Denver, 1931 (prize), 1934 (med). Scottsdale SA, 1937 (prize); AAPL, 1942 (prize), 1944 (prize); SC; Painters of Far West, 1924; Biltmore Salon, Los Angeles, 1924; Sesqui-Centenn. Expo, Phila., 1926; PAFA, 1941; Nat. A. Week, 1922–36; AAPL, 1936–45; Laguna Beach AA, 1939; Phoenix FAA, annually; P&S, 1940; Ariz. Mus. A., 1938; Townsend's Gal., Flagstaff, 1946. Work: Ariz. Mus. A.; Scottsdale Women's C.; Williams Field, Ariz.; Tempe Col., Ariz.; Hotel, Catalina Island, Calif.; YWCA, Phoenix; Friday Morning Cl., Los Angeles; Temple Music and Art, Tucson; Rockfeller Center, NYC. Author: Year Book, Scottsdale A. Colony [47]

GROSSE, Joseph L. [P,Des,T,L] NYC. Studied: R. Henri; G. Bellows; W. Adams. Position: T., City H.S., NYC [40]

GROSSMAN, Edwin Booth [P] NYC b. 9 Ap 1887, Boston, MA. Studied: W.M. Chase; R. Miller. Member: S.Indp.A. [33]

GROSSMAN, Elia S. Mandel [P,L,G] NYC b. 8 Ja 1898, Kobryn, Russia. Studied: Edu. All. A. Sch.; CCNY; ASL; CUASch.; W. Starkweather; R. Ligeron, in Paris. Member: SAE. Exhibited: NAC, 1938, 1939; Grand Central A. Gal., 1939, 1940; Md. AI, 1939; LOC, 1944 (prize); NAD; SAE; Milch Gal. (one-man). Work: British Mus.; Jewish Theological Seminary, NYC; Tel-Aviv Mus., Palestine; BMFA; LOC; MMA; FMA; BM; Md. Inst.; N.Y. Hist. Soc.; NYPL; Los Angeles Mus. A. Author: "An Etcher's Intimate Album," 1938 [47]

GROSSMAN, Isidore [S,C,T] NYC b. 23 F 1908, NYC. Member: A. Lg. Am.; United Am. Ar. Exhibited: CI, 1939; PAFA, 1939–46; WFNY, 1939; New Sch. Soc. Res., 1939, 1940; Municipal A. Gal., 1940; Fairmount Park, Pa., 1940; WPA Gal., NYC [47]

GROSSMAN, Joseph B. [P] Phila., PA. b. 1889, Latvia. Studied: PAFA. Exhibited: PAFA, 1935; WMAA, 1934; AIC, 1938; PMA, 1933, 1935; Phila. AC, 1940. Work: Pa. State Col.; Free Lib., Graphic Sketch C.; Pa. Mus. A.; Mus., Allentown, Pa.; White House, Wash., D.C. [47]

GROSSMAN, Milton H. [S] Buffalo, NY b. 2 Mr 1908, British Columbia. Member: Buffalo SA. Exhibited: Albright A. Gal., Buffalo; Buffalo SA, 1934 (prize). Work: Warner Bros. Theatre, Buffalo [40]

GROSSMAN, Roy [P] Los Angeles, CA. Member: Calif. AC [25]

GROSSMAN, Edwin Booth [P] Fishkill, NY/Ogunquit, ME b. 9 Ap 1887, Boston, MA. Studied: Paris; W. Chase; R. Henri. Exhibited: Société des Artistes Français, Paris, 1910; NAD, 1914, 1915, 1920, 1927, 1929; AIC, 1914, 1915, 1927, 1928); P.-P. Expo, 1915; CI, 1931–45; CGA, 1931; PAFA, 1915, 1916, 1930, 1933; CAM; Sweat Mem. Mus., 1939; Montross Gal.; Salons of Am.; WMAA; New Art Circle (one-man); Marie Harriman Gal., 1941 (one-man); Lilienfeld Gal., 1945 (one-man) [47]

GROSSPIETSCH, Catherine [Des,P,G] Milwaukee, WI b. 17 Ag 1917. Studied: Layton Sch. A., Milwaukee. Exhibited: Layton A. Gal.; Wis. Salon A., Madison, 1938; Milwaukee AI, 1939. Work: Layton A. Gal. [40]

GROSVENOR, L.P. [P] Boston, MA [06]

GROSVENOR, Thelma Cudlipp (Mrs. Charles S. Whitman) [P,I,S] NYC b. 14 O 1892, Richmond, VA. Studied: ASL; St. John's Wood Sch.; Royal Acad. Sch., London; K.H. Miller. Member: NYSWA; NAWPS.

Exhibited: PAFA; CGA; Toledo Mus. A.; AIC; WMAA; Newport AA; NAD; VMFA; RISD; CAA Traveling Exh.; NAWPS, 1936 (prize). Lectures: "Pre-Columbian Sculpture." Illustrator: Saturday Evening Post, Harper's, Century, Vanity Fair, Town and Country [47]

GROSZ, Franz [P,Des] NYC b. 7 O 1909, NYC. Studied: ASL, with B. Robinson; NAD, with Kroll, Anderson. Exhibited: NAD; CGA; PAFA; Currier Gal.; WFNY, 1939; GGE, 1939; CI; AFA Traveling Exh. [47]

GROSZ, George [P,I,T,W] Douglaston, NY b. 26 Jy 1893, Berlin, Germany d. 6 Jy 1959. Studied: Dresden Acad., with R. Muller; Kunstgewerbe Mus., Berlin, with Sterl, Orlik; Paris. Member: Am. Soc. PS&G; F., Guggenheim Fnd., 1937, 1938. Exhibited: CI, 1945 (prize); CGA; PAFA; WMAA; Amsterdam, Holland, 1928 (med); Düsseldorf, Germany, 1928 (med). Work: AIC; WMAA; MMA; MOMA; Detroit Inst. A.; Los Angeles Mus. Hist. Sc.&A.; Minneapolis Inst. A.; Springfield Mass. Mus. FA; Harvard; Wichita AM. Illustrator: O. Henry short stories, pub. Limited Editions C., 1935. Author: "Interregnum" (60 drawings), 1936, "A Little Yes and a Big No," 1946, more than forty books in Germany, France, England, and Russia [47]

GROTELL, Maija [C,T] Bloomfield, MI b. 19 Ag 1899, Helsingfors, Finland d. 1973. Studied: Sch. A.&C., Ateneum, Helsingfors, Finland; A.W. Finch; C.F. Binns. Member: Soc. Des.-Cr.; N.Y. Soc. Cer. A.; Am. G. of C. Exhibited: Syracuse Mus. FA, 1931-35, 1936 (prize), 1937-41; Chicago World's Fair, 1933; WFNY, 1939; GGE, 1939; Contemp. Am. Cer. Intl. Traveling Exh., 1937; MMA, 1940; Portland A. Mus., 1942; W.R. Nelson Gal. A., 1945; AIC, 1946; Am. Cer. Soc., Cleveland, 1922 (prize); Cer. Exh., 1933, 1934, 1936 (prize); Intl. Expo, Paris, 1937 (med); Barcelona, Spain, 1929 (prize); Paris Salon, 1937 (prize). Work: ceramics, MMA; AIC; Detroit Inst. A.; Springfield, Mo. Mus. A.; Cranbrook Mus.; IBM Coll.; Museum at Helsingfors. Positions: T., Henry St. Crafts Sch., NYC (1929-38), Rutgers Univ.(1937-38), Cranbrook Acad. A. (1938-) [47]

GROTENRATH, Ruth (Mrs. R.G. Lichtner) [P,I,Gr,C,B] Milwaukee, WI b. 17 Mr 1912, Milwaukee, WI. Studied: State T. Col., Milwaukee. Member: Wis. PS. Exhibited: 48 Sts. Comp., 1939; CGA, 1939; AIC, 1936 (prize), 1942, 1944 (prize); GGE, 1939; MMA (AV), 1942; SFMA, 1946; Milwaukee AI, 1934 (prize), 1937 (one-man), 1940 (prize), 1944 (prize); Wustum Mus., Racine, Wis.; Wis. Salon, 1937 (prize); Layton A. Gal.; State Hist. Soc.; Wis. State Fair, Madison Un.; Renaissance Soc., Chicago; Madison AI, 1935 (prize). Work: Madison Un.; Milwaukee AI; IBM Coll.; Wis. State T. Col.; murals, USPOs, Hart, Mich., Hudson, Wis. WPA muralist. [47]

GROTH, John August [P,I,G,Car,W,T,L] NYC b. 26 F 1908, Chicago, IL. Studied: AIC; ASL; T. Geller; A. Blanch; Grosz. Member: SAE; Am. Newspaper Gld.; SI; ANA; AWCS Exhibited: nationally; F.A R Gal., NYC; Dayton AI, 1936; NA, 1937; WMAA; CGA, 1939; WFNY, 1939. Contributor: Vogue, Esquire, Collier's, other publications. Lectures: War Art. Positions: A. Dir., Esquire, 1933-37, Parade Publ., 1941-44; War Correspondent, Chicago Sun, 1944; Am. Legion Mag., 1945; Artist-Correspondent in Vietnam, 1967; T., ASL [47]

GROTHJEAN, Francesca C.R. [P] NYC/Portland, OR b. 12 Ap 1871, Hamburg, Germany. Studied: Paris, with G. Courtois, P. Puvis de Chavannes, G. Callot, M. Fritel, J. Blanc, L.A. Girard [06]

GROTZ, Albert [P,T] Buffalo, NY b. 28 D 1907, Buffalo. Member: The Patteran Soc. Exhibited: Ar. Western N.Y. Ann., Albright Gal., Buffalo, 1938, 1939; Great Lakes Exhib., The Patteran, Buffalo, 1938, 1939. Position: T., Albright Gal. [40]

GROUT, H.L. [I] NYC [21]

GROVER, Allen, Mrs. See Beard, Beatrice.

GROVER, Oliver Dennett [P] Chicago, IL b. 29 1861, Earlville, IL d. 14 F 1927. Studied: F. Duveneck, in Munich; Paris, with Boulanger, Lefebvre, Laurens; AIC. Member: ANA, 1913; Chicago PS; SC; AIC; Por. P.; NAC; Cliff Dwellers, Chicago; Arts and Industries; Chicago Gal. A.; Chicago AC. Exhibited: Chicago SA, 1892 (prize); St. Louis Expo, 1904 (medals); FA Bldg., Chicago 1906 (prize), 1914 (prize); Municipal Art Lg. Chicago, 1910 (prize); AIC, 1913 (prize), 1918 (gold); P.-P. Expo, San Fran., 1915 (med). Work: Pub. Lib., Branford, Conn.; Chicago Pub. Lib.; Union Lg. C., Chicago; AIC; St. Louis AM; Detroit AI; Cincinnati AM [25]

GROVES, Dorothy Lyon (Mrs.) [P] New Haven, CT b. Coudersport, PA. Studied: J. Carlson; H. Leith-Ross; G.P. Ennis; H.B. Snell. Member: New Haven PCC; New Haven BPC; AAPL; Springfield AL [40]

GROVES, Hannah Cutler (Mrs.) [Por.P,E,T] Haddonfield, NJ b. 30 D 1868, Camden, NJ d. 18 Mr 1952. Studied: Phila. Sch. Des.; Temple Univ.; W.M. Chase; Fred Wagner. Member: AFA; Phila. WCC; Phila. A. All.; Cape May A. Lg.; N.J. A. Lg.; Plastic C.; Cape May AA.; N.J. Hist. Soc. Exhibited: PAFA; Phila. Min. Soc.; Phila. A. All.; Cape May A. Lg.; Phila. WCC; Newark; Trenton, Montclair; Southern Expo, Montgomery, Ala. (prize); Calif. Soc. Min. P., 1944 (prize); N.J. Fed. Women's C. (prize). Work: Haddonfield Hist. Soc.; portraits and miniatures of notable persons [47]

GROWER, William Frederick (Mrs.) [Patron] d. 3 My 1930, Chicago. Since the World's Fair, 1893, she had been prominently identified with art movements in Chicago. She was the most active supporter of the Municipal Art League. Sixty-two women's clubs became interested in the study of art,as a result of the "gallery tours" she originated.

GROZELIER, Sara Peters (Mrs. Leopold) [Min.P] b. 21 My 1821, Andover, MA d. 1907, Boston. Exhibited: Boston Atheneum. Lived in Boston 1866; 1877-83. Married Leopold (a portrait painter and lithographer, 1830-65) in 1855. [*]

GRUB, Henry [P,S,I,Arch] Great Neck, NY b. 10 D 1884, Baltimore. Studied: Maynard; Ward; Bridgman. Member: Lg. AA; S.Indp.A.; Salons of America [24]

GRUBB, Elizabeth C. [P] Phila., PA [06]

GRUBB, Ethel McAllister [P] San Fran., CA. b. 18 F 1890, San Fran. Studied: San Fran. AI; ASL. Member: San Fran. AA [25]

GRUBE, Vara [P,T] Seattle, WA/Maltby, WA b. 9 Ja 1903, Seattle. Member: Women A. of Wash.; SAM; Northwest PM. Exhibited: Wash. State Fair, Puyallup, 1935 (prize), 1936 (prize) [40]

GRUBER, Shirley Edith. See Moskowitz.

GRUELLE, Justin C. [P,I] NYC b. 1 Jy 1889, Indianapolis. Studied: his father, R.B. Gruelle; John Herron AI; ASL. Exhibited: Richmond, Ind. [17]

GRUELLE, R(ichard) B(uckner) [Ldscp.P] Norwalk, CT, IN b. 22 F 1851, Cynthana, KY d. 8 N 1914, Indianapolis. Studied: self-taught. Member: SWA; The Hoosier Group. Work: Indianapolis Pub. Lib.; Herron AI; Richmond (Ind.) Pub. Gal. Author: "Notes— Critical and Biographical, Collection of William T. Walters, Baltimore" [13]

GRUENBERG, Ruth [P] Phila., PA [24]

GRUENEWALD, Otto A.C. [Mur.P] Providence, RI b. 1868 d. 4 My 1946, Brunswick, ME

GRUENFELD, Caspar Laehne [S] Los Angeles, CA b. 29 D 1872, Holzminden, Germany. Studied: J. Gelert; AIC. Member: Calif. AC. Exhibited: P.-P. Expo, San Diego, 1915 (med). Work: statues, Administration Bldg., Univ. Southern Calif., Los Angeles; portrait busts [40]

GRUENHAGEN, Leon Lorado Merton [P] Paris, France b. Oshkosh, WI. Studied: Paris, with Laurens, L.S. Parker. Member: Paris AAA [10]

GRUGER, Frederick R. [I] NYC b. 1871 d. 21 Mr 1953. Member: GFLA [27]

GRUMIEAUX, Emile J(aques) [P,T] Chicago, IL/Palos Park, IL b. 17 My 1897, Hainaut, Belgium. Studied: AIC. Member: Chicago SA; The Ten. Exhibited: Chicago SA, 1931 (prize); Ill. Acad. FA, 1932 (prize). Work: State Mus., Springfield, Ill.; Northwestern Univ.; Southern Ill. State Normal Sch. [40]

GRUMIEAUX, Louis P. [P] Palos Park, IL b. 16 Ap 1872, Charleroi, Belgium. Studied: AIC; Bourlard, in Belgium. Exhibited: Am. PS. Ann., AIC, 1935; Ar. Chicago, Vicinity, AIC, 1936, 1938, 1939 [40]

GRUNDMANN, (Emil) Otto [P,T] b. 4 O 1844, Meissen, Germany d. 27 Ag 1890, Dresden, Germany. Studied: J. Hubner, in Dresden; Holland; Antwerp; Paris. It was Grundmann who must be credited with giving the "Boston School" of painters its most distinctive characteristic—the old Dutch tradition of observing and rendering the most subtle aspects of color. At the urging of F.D. Millet he took over the painting dept. of the BMFA Sch. shortly after its founding in 1876. He insisted upon "systematic memory training" and careful study of composition, light and color. Many of his students became well-known, including seven members of "The Ten": F. Benson, Tarbell, Hassam, T. Dewing, R. Reid, W. Metcalf, E. Simmons. The BMFA School's Grundmann Building was named for him. [*]

GRUNER, Virginia [P] Cincinnati, OH [13]

GRUNVALD, Samuel [P] NYC (1977) b. 1893, Hungary. Exhibited: Am. WCC Ann., 1934, 1937, 1938; NYWCC Ann., 1936, 1937; AWCS, 1932-42; BM, 1942. Work: Jewish Mus. WPA artist. [40]

GRUPPE, C(harles) P(aul) [P] NYC/East Gloucester, MA b. 3 S 1860, Picton, Ontario d. 30 S 1940, Rockport, MA. Studied: Holland; chiefly

self-taught. Member: NYWCC; AWCS; AC Phila.; SC, 1893; NAC; Rochester AC; AFA; Pulchre Studio, The Hague. Exhibited: Rouen, (gold); Exh. Paris et Province (gold); Phila. AC (gold); St. Louis Expo, 1904 (med); Appalachian Expo, Knoxville, 1910 (med); AIC, 1917 (prize). Work: BM; Detroit AI; NGA; Reading, Pa. Mus.; Butler AI; National Art C., NYC; Mem. Gal., Rochester, N.Y.; CAM; Md. Inst.; Museum, London, Ontario; Nat. Gal., Ottawa; Lib., Rouen, France; Queen of Holland Coll.; Joslyn Mem., Omaha; Dayton AI; Parthenon, Nashville [40]

GRUPPE, Emile Albert [P,T] East Gloucester, MA b. 23 N 1896, Rochester, NY. Studied: ASL; NAD; J.F. Carlson; R. Miller; G. Bridgman; C. Chapman; abroad. Member: SC; North Shore AA; Gloucester AA; Rockport AA; All.A.Am.; CAFA; Audubon A.; Northern Vt. A.; New Haven PCC. Exhibited: NAD, 1916-1938; All.A.Am., 1934-46, 1944 (prize); AIC, 1920; Audubon A., 1944, 1945; North Shore AA, 1922-38, 1939 (prize), 1940-46, CAFA, 1913-45; Rockport AA, 1925-46; New Haven PCC, 1933, 1935 (prize), 1936, 1937, 1938 (prize), 1939 (prize), 1940 (prize), 1941-46; SC, 1916-40, 1941 (prize), 1942-45; Springville, Utah, 1928 (prize), 1946 (prize); Bridgeport AA, 1940 (prize); Ogunquit A. Center, 1941 (prize); Jordan Marsh, 1943 (prize); Meriden, Conn. A.&Cr., 1939 (prize), 1946 (prize); Guilford, Conn., 1939 (prize). Work: Los Angeles Mus. A.; San Antonio Mus.; Univ. Idaho; Webber Col.; Smith Col.; New Haven PCC; de Cordova Mus., Lincoln, Mass.; White House, Wash., D.C.; Silberman Col., Montreal; Mechanics Inst., Rochester, N.Y.; Greenbrier Col., Lewisburg, W.Va.; Gruppe Summer Sch., Gloucester [47]

GRUPPE, Karl H(einrich) [S] NYC b. 18 Mr 1893, Rochester, NY. Studied: Karl Bitter; Royal Acad., Antwerp, Belgium; ASL. Member: NSS; Assn. Nat. Acad., 1939. Exhibited: P.-P. Expo, San Fran.; NSS, 1923; NAD, 1926 (prize), 1928, 1929, 1945; WMAA, 1940; WFNY, 1939; Arch. Lg., 1920 (prize). Work: Adelphi Col., Brooklyn; Curtis Inst. Music, Phila.; Henry Hudson mem., Spuyten Duyvil Hill, NYC; Numismatic Soc., NYC; City C., NYC; Princeton Charter C.; mem., Clinton, N.C. Position: Chief S., Dept. Parks, NYC, 1934-37 [47]

GRUPPE, Virginia Helena [P] NYC/Rockport, MA b. 21 O 1907, Leyden, Holland. Studied: P. Gruppe. Member: Rochester AC; Rockport AA. Exhibited: Am. WCS; AI, Dayton, Ohio; CGA. Work: Lib., AI, Dayton [40]

GRUPPE, Virginia Helena [P] NYC/Rockport, MA b. 21 O 1907, Leyden, Holland. Studied: C.P. Gruppe. Member: Rochester AC; North Shore AA; Gloucester Soc. A.; Rockport AA. Exhibited: Am. WCS; AI, Dayton, Ohio; CGA; Lib., Dayton AI [40]

GUACCERO, I. Vincent [Edu,Des,Gr,C,P,S] Baton Rouge, LA b. Italy. Studied: T. Col., Columbia. Member: Eastern AA; Soc. for Advancement of Edu.; Am. Assn. Univ. Prof. Position: T., La. State Univ. [47]

GUALTIERI, Joseph Peter [P,T] Norwich, CT b. 25 D 1916, Royalton, IN. Studied: Norwich A. Sch.; AIC. Member: Mystic AA; Norwich AA. Exhibited: NAD, 1945; CGA, 1941; SFMA, 1941, 1942; PAFA, 1942; Audubon A., 1945; AIC, 1940, 1941 (med,prize), 1942, 1943; Lyman Allyn Mus. A., 1944, 1945. Position: T., Norwich A. Sch. [47]

GUARD, Shirley R. [Des] NYC [10]

GUARINA, Salvatore Anthony [P,E] NYC b. 16 My 1883, Girgenti, Sicily. Studied: Whittaker; Blum. Member: SC; Wash. AC; Brooklyn SE; Chevalier of the Crown, Italy. Work: Modern Art Gal., Palermo, Sicily [25]

GUCK, Edna [S,P] NYC b. 17 Mr 1904, NYC. Studied: ASL; Paris. Exhibited: MMA; WFNY, 1939; CGA; Newark Mus.; AMNH; Salon D'Automne, Paris; Bonestell Gal.; Newman Gal., 1935; N.Y. Soc. Women A., 1935, 1936, 1939; Fed. A. Gal., 1938 [47]

GUDEBROD, Charles A. [P,S] NYC [possibly the same person as Louis; 1904 annual lists both at same NYC address]. Exhibited: Charleston Expo, 1902 (med) [04]

GUDEBROD, Louis A(lbert) [S] Meriden, CT b. 20 S 1872, Middletown, CT. Studied: Yale; ASL, with M. Lawrence; A. Saint-Gaudens; Dampt, in Paris. Member: NSS, 1902; Arch. Lg. 1902; CAFA; New Haven PCC; Lyme AA. Exhibited: Charleston Expo, 1902 (med); P.-P. Expo, (gold). Work: Andersonville Prison Mon. for N.Y. State, Andersonville, Ga.; Mayflower tablet, State Capitol, Hartford; Bristol Pub. Lib.; Meriden Pub. Lib.; South Coventry, Conn.; State Office Bldgs., NYC, Buffalo [40]

GUÉ, D(avid) J. [P] Brooklyn, NY b. 17 Ja 1836, Farmington, New York d. 1 My 1917. Studied: self-taught. Member: SC, 1903. Moved to Iowa, 1852; became a lawyer in Fort Dodge, then a pharmacist. Not until he was past 50 did he become an artist. Best known for his portraits of Grant, Lincoln and Beecher. Also painted landscapes and marines. [15]

GUENTHER, Felix [Patron] Cleveland,, OH b. 1843, Germany (came to Cleveland in 1854) d. 11 Ap 1928. Founder and President of Guenther's Gal., Cleveland, Ohio. Active in art circles for 60 yrs.

GUENTHER, Lambert [I] NYC. Member: SC [27]

GUENTHER, Sue Cory (Mrs. Rundolph) [P] NYC b. 7 Ja 1875, Waukegan, IL d. ca. 1955. Studied: AIC; PIASch; G.E. Browne; W. Adams; J. Freeman; Grand Central Sch. Member: NAC; All.A.Am.; PBC; Studio Gld. Exhibited: All.A.Am.; Studio Gld. [47]

GUERAZZI, Lucie Honiss [P] Chicago, IL [04]

GUERIN, Joseph [P] NYC b. 6 F 1889, Ennis Clare, Ireland. Studied: J. Lie; J. Sargent. Member: AWCS; All.A.Am.; SC; NYWCC [47]

GUERIN, Jules [Mur.P,I] NYC b. 18 N 1866, St. Louis, MO d. 13 Je 1946, Neptune, NJ. Studied: Paris, with Constant, Laurens. Member: ANA, 1916; NA, 1931; Arch. Lg. 1911; AIA; Société des Beaux-Arts; Art Commission Assoc., NYC; AAPL; Century C. Exhibited: Chicago (med); Paris Expo, 1900; Pan-Am. Expo, 1904; Phila. WCC, 1913 (prize); P.-P. Expo, 1915 (gold). Work: Lincoln Mem.; Pennsylvania Station; Fed. Reserve Bank, San Fran.; Ill. Merchant's Trust Co., Chicago; Kansas City, Mo.; Union Trust Co. and Terminal Bldg., Cleveland; Capitol, Baton Rouge, La.; Merchandise Mart, Chicago. Illustrator: "The Near East," "Egypt and Its Monuments," "The Chateaux of the Loire" [40]

GUERNSEY, Eleanor Louise [S,T] Fargo, ND b. 9 Mr 1878, Terre Haute, IN. Studied: AIC. Member: Chicago ASL; Ind. SS; Northwestern AA. Exhibited: AIC, 1909, (prize). Position: T., Recreation Training Sch., Chicago, 1921-25 [25]

GUEST, George [S] Groton, MA b. 3 Ap 1864, Buckinghamshire, England. Studied: E.W. Borroughs; Norwich Acad.; B.L. Pratt, in Boston. Position: Assistant, B.L. Pratt, 20 yrs. [19]

GUEYDAN, Marie [P] Paris, France [13]

GUGGENHEIMER, Richard Henry [P,T,W,L] Briarcliff Manor, NY b. 2 Ap 1906, NYC d. 1977. Studied: Johns Hopkins; Sorbonne, Paris; Grande Chaumière, Paris; P. le Doux; Morriset; Coubine. Member: Am. Soc. for Aesthetics. Exhibited: CGA; PAFA; NAD; WMAA; AFA; Van Diemen (one-man); Lilienfeld (one-man); Macbeth (one-man); Seligmann Gal. (one-man); Paris. Work: Cone Coll., Baltimore; Lewisohn Coll., NYC. Author: "Sight and Insight, A Prediction of New Perceptions in Art," 1945. Position: T., Briarcliff Jr. Col. [47]

GUGLER, Frida [P] NYC b. Milwaukee, WI. Studied: AIC; Paris; W. Chase; Munich; Italy. Member: NYWCC. Work: Vanderpoel Coll.; Milwaukee AI [47]

GUIGLIA, Nadja F. [P] NYC. Exhibited: NAWPS, 1935-38 [40]

GUGLIELMI, Louis O. [P] NYC b. 9 Ap 1906, Cairo, Egypt (came to NYC in 1914) d. 3 S 1956, Amagansett, NY. Studied: NAD. Member: Am. A. Cong. Exhibited: CI, 1943-46; AIC, 1938, 1943 (prize); CGA; CAM; PAFA, 1935; Walker A. Center; Pal. Leg. Honor; MOMA; WMAA, 1936-46; La. State Univ., 1953 (retrospective). Work: MMA; MOMA; WMAA; Walker A. Center; Newark Mus.; AIC; Santa Barbara Mus. A.; Downtown Gal., NYC. Illustrator: Fortune, 1946. WPA muralist. [47]

GUIGNARD, Caroline [P] Columbia, SC b. 1 F 1869, Aiken County, SC. Studied: R. Henri; K.H. Miller; W.M. Chase; A. Springs; Italy. Member: SSAL; AFA; Studio G.; Columbia AA; Carolina AA [40]

GUIGNON, Henri [P] NYC [19]

GUILBEAU, (Cooke) Honoré [Li] Cleveland, OH/Peninsula, OH b. 11 F 1907, Baton Rouge, LA. Member: Cleveland PM. Exhibited: AIC, 1931 (prize); SSAL, 1932; CMA, 1936 (prize). Work: AIC [40]

GUILD, E. Cadwalader (Mrs.) [S] Berlin, Germany. Exhibited: St. Louis Expo, 1904, (med) [06]

GUILD, Eleanor R. [P] Merchantville, NJ. Studied: PAFA [25]

GUILD, Frank S. [P] Phila., PA. Member: Phila. AC; Phila. Sketch C. [29]

GUILD, Lurelle Van Arsdale (Mr.) [Indst.Des,I] Noroton, CT b. 19 Ag 1898, NYC. Studied: Bridgman; Syracuse Univ. Member: SI; Artists G.; A. Dir. Cl.; Advisory Bd., CUASch. Exhibited: A. Dir. Cl., 1924 (prize). Illustrator: House and Garden, other publications [40]

GUILLAUME, Louis Mathieu Didier [P] b. 1816 Nantes (came to NYC in 1855) d. 13 Ap 1892, Wash., D.C. Studied: Paris, with Delaroche, Lacour.

Settled in Richmond, Va., ca. 1857–72; in Wash., D.C., 1880. Work: Valentine Mus., Richmond; Univ. Tex., Austin; Norton AG, Shreveport [*]

GUILLOT, Ann (Mrs.) [P,C] Dallas, TX b. 18 My 1875, KY. Studied: D. Garber; W.S. Robinson; M. Mason. Member: Highland Park AA; Reaugh AC; Tex. FA Assn.; SSAL; Art Dept., Dallas Women's Forum. Exhibited: Annual Exh. Tex. Ar., Dallas Women's Forum, 1922 (prize); Annual All. A. Exh., Dallas Public Art Gal., 1929 (prize). Work: Dallas Women's Forum. Specialty: stained glass [40]

GUIMARD, Adeline Oppenheim (Mrs. Hector) [P] Paris, France/NYC b. 1O 1872, NYC. Studied: ASL, with Beckwith; Paris, with H. Levy, A. Maignan, J. Bail. Exhibited: Paris Salon, 1900 [10]

GUINNESS, Benjamin (Mrs.) [P] Brooklyn, NY. Member: NAWPS [25]

GUINZBURG, Frederic V(ictor) [S,C,L,T] Chappaqua, NY b. 18 Je 1897, NYC. Studied: V.D. Brenner; Grazzeri, in Rome. Member: NSS; Westchester AC Gld.; Chappaqua AC Gld. Exhibited: Sesqui-Centenn. Expo, 1926 (med); Concord AA, 1924 (prize); Women's Intl. Aeronautical Assn., 1937 (prize); Westchester Garden Show, Greenwich, Conn. (prize). Work: mem., Rye, N.Y.; Pleasantville, N.Y. Position: T., Westchester County A. Center [47]

GUINZBURG, Ruth Levy [G,P,T] Chappaqua, NY b. 25 My 1898, NYC. Studied: ASL; Columbia; F. Leger, in Paris. Member: NSS; Westchester AC Gld. Exhibited: Delphic Studios, NYC; Grand Central A. Gal., NYC [40]

GUION, George [P] NYC [01]

GUION, Molly [Por.P] New Rochelle, NY b. 23 S 1910, New Rochelle. Studied: A. Woelfle; I. Olinsky; G. Bridgman; D. Romanovsky. Member: NAWPS; New Rochelle AA. Exhibited: New Rochelle AA, 1936 (prize) [40]

GUIPON, Leon [I,P,W] NYC b. 1872, France (came to NYC ca. 1903) d. 14 Je 1910. Studied: Paris; ASL; N.Y. Sch. A. Author/Illustrator: "Monsieur Cronky, Last of the Crocabiches," pub. Century magazine [10]

GUISLAIN, J.M. [P,W] Brussels, Belgium b. 27 Mr 1882 Louvain, Belgium. Member: AWCS [27]

GULDBERG, Christian A(ugust) [P,Arch] Montclair, NJ b. 13 Ap 1879, Madagascar. Member: N.Y. Arch. C.; Montclair AA [33]

GULLBURG, Bertha I. [P] NYC [19]

GULLEDGE, Josephine [P] Wash., D.C. Member: Wash. WCC [24]

GULLIVER, Mary [P,T] Eustis, FL b. 9 S 1860, Norwich, CT. Studied: BMFA Sch.; Grundmann; Niemeyer; Vonnoh; Crowninshield; Whistler; Collin; Delance; Callot; Lazar; Prinet; Delecluse; Colarossi Acad.; England; Holland; Italy; Spain; Germany. Member: Copley S., 1883 [40]

GUMAER, Alfred H. [P] Phila., PA [10]

GUMMO, Blanchard (Stanley) [P,Edu,Gr,W,B,Dr] Lock Haven, PA b. 3 F 1906, Lock Haven. Studied: Yale; H. Pittman; A. Brook. Exhibited: AIC, 1935, 1936; CM, 1935–39, 1940; Soc. Wash. A., 1934 (prize), 1937; CGA, 1939; PAFA, 1936, 1937, 1940, 1944; CAFA, 1935, 1936, 1938–40; All.A.Am., 1936–38; Springfield AL, 1937, 1938, 1940, 1941, 1943, 1945; New Haven PCC, 1939; Butler AI, 1938–41, 1943–45; Indiana (Pa.) Exh., 1944–46; Ohio Valley Exh., Athens, Ohio, 1946; Pepsi-Cola, 1945; Harrisburg AA, 1936 (prize), 1939 (prize), 1941 (prize). Work: PAFA. Position: T., Bucknell Univ., Lewisburg, Pa., 1931–46 [47]

GUNCHEL, Will H. [P] Toledo, OH. Member: Artklan [25]

GUNDERSON, Stanley H. [E] Los Angeles, CA b. 14 Ap 1898 Sioux City, IA [32]

GUNDLACH, Helen Fuchs (Mrs. Emanuel G.) [P,C,S,L] Ebenezer, NY b. 9 F 1890, Buffalo d. Je 1959. Studied: Syracuse Univ.; PMSchIA; Albright A. Sch.; J. Carlson; C. Rosen; W. Everette. Member: Buffalo SA; Lg. Am. Pen Women. Exhibited: Buffalo SA, 1923 (prize). Designer: Zonta Club pin [47]

GUNDLACH, Max E.H. [P,I,C] Chicago, IL b. 1863, Breslau, Germany. Studied: AIC. Member: Palette and Chisel C. [10]

GUNN, Archie [Min.P,Por.P,I,E,T] NYC/Rockaway, NY b. 11 O 1863, Taunton, Somersetshire, England (came to NYC in 1888) d. 16 Ja 1930. Studied: his father, Archibald Gunn; P. Calderon, in London; Tettenham Col., Staffordshire; Calderon A. Acad., London. At seventeen he painted a portrait of Lord Beaconsfield that was given to Queen Victoria. Illustrator: New York World; "Truth." Best known for his designs for magazine covers. [29]

GUNN, Edwin H. [P,E] NYC b. 1876 d. 10 O 1940. Studied: CUSchA; NAD. Member: SC; NYWCC; Yonkers AA; Allied AA. Exhibited: NAD, 1895 (med); New Rochelle AA (prize); WFNY, 1939; SC, 1932 (prize); Allied Ar. Am., 1933, 1934; NYWCC, 1936, 1937; Am. WC Soc., N.Y., 1939. Work: Wesleyan Col., Macon, Ga.; Mus. of NYC [40]

GUNN, Maurice G. [P] Chicago, IL. Exhibited: ASL, Chicago, 1908 (prize) [13]

GUNTER, Charlotte G. Frietsch [P,T,L,W] Spotswood, NJ b. 18 Ja 1896, Wis. Member: Alliance; S.Indp.A.; Salons of Am. Exhibited: Alliance (prize) [33]

GUNTHROP, Doris [P,S,E,T] Phila., PA b. 17 O 1894, Chicago. Studied: Phila. Sch. Des. for Women; AIC [25]

GUNTRUM, Emilie Ida [P] Elizabeth, NJ b. Brooklyn, NY. Studied: N.Y. Sch. Appl. Des. for Women; ASL; NAD; C. Hawthorne; G. Luks; G. Bridgman; H. Hofmann. Member: AAPL; Elizabeth SA; Provincetown AA. Exhibited: PAFA, 1938; AWCS, 1939; NYSWA, 1939; Montclair A. Mus.; WFNY, 1939; Newark Mus.; Montross Gal.; Contemp. A. Gal. [47]

GUPTILL, Arthur L(eighton) [W,T,I,P,L,Des,Arch] Brooklyn, NY b. 19 Mr 1891, Gorham, ME d. 28 F 1956. Studied: PIASch; MIT; abroad. Member: AIA. Author: "Sketching as a Hobby," 1936, "Pen Drawing," 1937, "Norman Rockwell, Illustrator," 1946, other books on art. Editor: "Masks," 1945, "Animal Drawing and Painting," 1946, "Painter's Question and Answer Book," 1946, "Art Instruction," other books. Co-founder: American Artist magazine, Guptill Publications, Inc. Author: "Guptill's Corner," in Pencil Points magazine. Specialty: design of ornamental detail for wrought iron, leaded glass, carved wood and stone [47]

GURNEE, Marie Belle [P] Brooklyn, NY d. 5 O 1915

GURNEY, Wilson [I] Brooklyn, NY d. F 1929. Member: SI [27]

GURR, Lena (Mrs. L.G. Biel) [P,Li,Ser,T] Brooklyn, NY b. 27 O 1897, Brooklyn. Studied: Brooklyn Training Sch. T.; Edu. All.; ASL; J. Sloan; M. Sterne; Paris. Member: A. Lg. Am.; NAWA; NYSWA; Brooklyn SA; Audubon A.; Am. A. Cong. Exhibited: NAWA, 1937 (prize); Brooklyn SA, 1941, 1943 (prize), 1944–46; Whitney Studio C., 1936–38; CGA, 1928; PAFA, 1938; WFNY, 1939; AV, 1942; Critics Choice, N.Y., 1945; NAD, 1944–46; CI, 1945; VMFA, 1946; BM, 1936; ACA Gal., 1935(one-man), 1939 (one-man), 1945 (one-man). Work: Biro-Bidjan Mus., Russia; LOC. Position: T., N.Y. pub. sch. [47]

GURREY, Hartley Fletcher (Mrs. Richard B.) [Li,P,Des] Honolulu, HI b. 9 Mr 1907, Bloomington, IL. Studied: Wash. State Col.; Univ. Oreg.; ASL; E. Steinhof; W. Adams; L. Bouche. Member: New England Pr.M.; Southern Pr.M.; Honolulu Pr.M. Exhibited: AIC; CM; PAFA; SFMA; Sydney, Australia; Portland (Oreg.) Mus. A.; Northwest Pr.M.; Honolulu Acad. A.; Women Painters Exh., Wichita, Kans. Work: Honolulu Acad. A. [47]

GUSSOW, Bernard [P,Li,T] NYC b. 2 Ja 1881, Russia. Studied: CCNY; ASL; NAD; Ecole des Beaux-Arts, Paris; Bonnât. Member: Am. A. Cong.; A. Lg. Am. Exhibited: Intl. Armory Show, 1912; Luxembourg Mus., Paris, 1919; AIC, 1930–32; NGA, 1938; LOC, 1944–46; CI, 1944; WMAA, 1930–36; Municipal Exh., Rockefeller Center, 1937; WFNY, 1939. Work: WMAA; Newark Mus.; Barnes Fnd.; MOMA; Los Angeles Mus. A.; U.S. Marine Hospital, La.; USPO, East Rochester, N.Y. WPA artist. Position: T., Newark Sch. F.&Indst. A., 1912– [47]

GUSTAFSON, Frank G. [S] Chicago, IL/Oden, MI b. 8 N 1863, Sweden. Studied: AIC [17]

GUSTIN, Paul Morgan [P,Dec,E] Seattle, WA b. 1886, Fort Vancouver, WA. Member: Grand Central AG. Work: Univ. Wash.; Wash. State Col. [40]

GUSTON, Philip [P,T,W,I] St. Louis, MO b. 27 Je 1912, Montreal. Studied: Otis AI. Member: Nat. Soc. Mur. P.; Mur. A. Gld.; Am. Ar. Cong. Exhibited: WFNY, 1939 (prize); MOMA, 1940 (prize); CI, 1941–44, 1945 (prize); VMFA, 1946 (med); Midtown Gal., 1945 (one-man); BMFA, 1946; PAFA, 1944, 1945; CGA, 1943, 1944;; WMAA, 1938–45; AIC, 1942–45; AFA, 1942; Arch. Lg., 1940; Critics Choice, Armory Show, N.Y., 1945; 48 Sts. Comp., 1939. Work: Univ. Michoacan, Mexico; Los Angeles Sanitorium, Duarte, Calif.; WPA Bldg., WFNY, 1939; CAM; Wash. Univ.; VMFA; Ill. Wesleyan Univ.; Univ. Iowa; Queensbridge Housing Project, N.Y.; USPO, Commerce, Ga.; Forestry Bldg., Laconia, N.H.; Social Security Bldg., Wash., D.C.; President Lines, S.S. Monroe, Van Buren, Jackson; WPA artist. Positions: T., Univ. Iowa (1941–45), Wash. Univ., St. Louis (1945–) [47]

GUTE, Herbert Jacob [P,L,Edu] New Haven, CT b. 10 Ag 1908, Jeffersonville, NY d. 1977. Studied: Yale; abroad. Member: Audubon A.; AWCS; SC; Phila. WCC. Exhibited: AWCS, 1940 (prize), 1942 (prize); Wash. WCC, 1943 (prize); Audubon A.; Phila. WCC. Work: Yale; Dept. Interior; Submarine Base, New London, Conn. Illustrator: "Rise of American Democracy," 1942, other books. Contributor: American Artist. Position: T., Yale [47]

GUTEKUNST, Frederick [P,Photogr] b. 1831 d. 1917, Phila. Work: pastel port., Univ. Pa.; photographs, PAFA; FMA; NPG; IMP. Prominent Phila. portrait photographer; ran his gallery from 1856–1917. Reportedly had the largest collection of celebrity cabinet card portraits. [*]

GUTEMAN, Ernest [S] NYC. Exhibited: WFNY, 1939 [40]

GUTHERSON, F. Gerome [P] Pittsburgh, PA. Member: Pittsburgh AA [25]

GUTHERZ, Carl [Mur.P] Wash., D.C. b. 28 Ja 1844, Schoeftland, Switzerland (brought to U.S. by parents in 1851) d. 7 F 1907. Studied: Ecole des Beaux-Arts, with Pils; Boulanger, Lefebvre, in Paris; Simonetti, in Rome. Exhibited: Centenn. Expo, Phila., 1876 (med); Paris Expo, 1889 (med); Nat. Jury Awards, Chicago, 1893; St. Louis Expo, 1904. Work: ceiling dec., Representatives Reading Room, LOC. Position: Affiliated with CAM [06]

GUTMAN, Elizabeth [P] Pikesville, MD b. Baltimore. Studied: Breckenridge; H.B. Snell; S.E. Whiteman. Member: Baltimore WCC [31]

GUTMANN, Bernhard [P,E,T] New Canaan, CT b. 26 S 1869, Hamburg, Germany (came to NYC in 1885) d. 23 Ja 1936, NYC. Studied: Düsseldorf, Karlsruhe, both in Germany; Paris; NYC. Member: Allied AA; SC; Silvermine Gld. A. (Pres.); Darien G. Seven A. Work: Alfred Univ., N.Y. [33]

GUTMANN, Bessie Pease [I] NYC [13]

GUTMANN, John [Edu,P,Gr,Photogr] San Fran., CA b. 28 My 1905, Breslau, Germany. Studied: State Acad. A.&Cr., Breslau; State Acad., Berlin; O. Mueller. Member: Am. Assn. Univ. Prof. Exhibited: SFMA, 1935, 1939, 1942; de Young Mem. Mus., 1938; abroad. Work: San Diego FA Soc.; MOMA; Mills Col., Oakland, Calif.; Mus. Breslau. Illustrator: New Revue (Berlin, 1929, 1930), Life, Time, Asia, other national magazines. Position: T., San Fran. State Col., 1938– [47]

GUTSCHE, Paul [P] Edmond, OK. Member: Okla. AA [25]

GUTSELL, Ida Squier [P] Ithaca, NY [08]

GUTTRIDGE, Eleanor N. (Mrs. G.H.) [P,E] Berkeley, CA b. 2 N 1901, Poughkeepsie, NY. Studied: C.K. Chatterton; H.T. Lewis; H. Snell; R. Jackson; R. Boynton. Member: San Fran. A. Center [40]

GUY, Amy L. [P] NYC [01]

GUY, James M. [P] East Hampton, CT b. 11 F 1909, Middletown, CT. Studied: Hartford A. Sch. Member: Am. Ar. Cong. Exhibited: Bover Gal., N.Y. (one-man); Am. Ar. Cong.; WFNY, 1939; WMAA, 1940. Work: Meriden, Conn. Pub. Sch.; Wadsworth Atheneum, Hartford [40]

GUY, Seymour Joseph [P] NYC b. 16 Ja 1824, Greenwich, England (came to NYC in 1854) d. 10 D 1910. Studied: Buttersworth, Ambrosini Jerome, in England. Member: ANA, 1862; NA, 1865; Century; A. Fund. S. Exhibited: Paris Expo, 1900 (med); Pan-Am. Expo, Buffalo, 1901 (med); St. Louis Expo, 1904 (gold); Boston Athenaeum; Md. Hist. Soc. Specialties: children's portraits; genre scenes [10]

GUYER, Irving [P] NYC. Exhibited: WFNY, 1939 [40]

GUYSI, Alice Viola [P] Birmingham, MI b. Cincinnati d. ca. 1940. Studied: H. Thompson; Acad. Colarossi, Paris. Member: Founders Soc. Detroit Inst. A.; Detroit SAC; Detroit Soc. Women P.; Am. Fed. A. Position: T., Pub. Sch., Detroit, 1903–34 [40]

GUYSI, Jeanette [P,C] Birmingham, MI b. Cincinnati d. 23 Mr 1940. Studied: Acad. Colarossi, Paris. Member: Detroit Mus. A. Founders Soc. [40]

GWATHMEY, Robert [P,Ser,T] NYC b. 24 Ja 1903, Richmond, VA. Studied: N.C. State Col.; Md. Inst.; PAFA. Member: An Am. Group; A. Lg. Am.; Nat. Ser. Soc. Exhibited: PAFA, 1929 (prize), 1930 (prize); 48 Sts. Comp., 1939 (prize); ACA Gal., 1939 (prize); PM Artist as Reporter, 1940 (prize); San Diego FA Soc., 1941 (prize); Rosenwald F., 1944 (prize); Am. Acad. A.&Let., 1946 (prize); WMAA, 1939–45; CGA, 1945; VMFA, 1942, 1944; AIC, 1941–45; PAFA, 1941–45; CI, 1941, 1942 (prize), 1943–45; Pepsi-Cola, 1944, 1945, 1946 (prize); WFNY, 1939; GGE, 1939; AV Exh., London. Work: BMFA; CI; PAFA; Telfair Acad.; VMFA; Encyclopaedia Britannica Coll.; IBM; U.S. State Dept.; San Diego FA Soc.; Albright A. Gal.; NYPL; LOC; PMA; Flint Mus. A.; Grand Rapids Mus. A.; USPO, Eutaw, Ala. WPA artist. Position: T., CUASch, 1942–46 [47]

GWOZDECKI, Gustaw [P] NYC b. Warsaw, Poland. Studied: Ecole des Beaux-Arts, Paris. Member: Soc. Intl. des Beaux-Arts; Salon d'Automne, Paris. Work: coll. Warsaw, Poland and Cracow. Position: Dir., Acad. FA, Paris 1913– (founder) [19]

GYBERSON, Indiana (Miss) [P] Chicago, IL. Member: Chicago PS; Chicago Gal. A.; AFA [31]

GYER, E.H., Jr. [I,P] b. 15 O 1900, Tacoma, WA. Studied: G.Z. Heuston. Member: Tacoma FAA. Exhibited: Tacoma FAA, 1922 (prize) [33]

GYRA, Francis Joseph, Jr. [P,I,T,L] Newport, RI b. 23 F 1914, Newport. Studied: RISD; Parsons Sch. Des.; Europe; N.Y. Sch. F.&Appl. A., Paris. Member: Newport AA; Providence WCC; Phila WCC; AAPL. Exhibited: Newport AA, 1938 (prize); AIC, 1937, 1939; Phila. WCC; AFA Traveling Exh., 1940; Wash. AC (one-man); Sweat Mem. Mus.; Robert Vose Gal., Boston; Sch. F.&Appl. A., Paris, 1935, 1936 (Italian research). Work: Providence A. Mus. Illustrator: "Letters of Father Page" [47]

Edward Payne: *I Always Put Soul Into My Work.* From *The Illustrator* (June, 1895)

HAAG, Charles [S] Winnetka, IL b. 1867, Norrkoping, Sweden d. 19 S 1933. Studied: Junghaenel Ziegler; Injalbert. Exhibited: Swedish Am. Exh. (med). Work: MMA; Johnstown, Pa.; series figures/groups in wood ("the spirits from the woods"); series stones ("stoneworld") [33]

HAAPANEN, John N(ichols) [P,T] Boothbay Harbor, ME b. 13 O 1891, Niantic, CT. Studied: E.L. Major; W.F. Brown; A.K. Cross. Member: Boston AC; Copley S. Work: Tufts; Dean Acad., Franklin, Mass. [40]

HAAS, Fridolin [P] NYC. Member: AG of Authors Lg. A. [25]

HAAS, Helen [S] NYC. Exhibited: WFNY, 1939 [40]

HAAS, M.F.H. (or W.F.) See De Haas.

HAAS, Paul Thomas [P,T] Cleveland, OH b. 5 Mr 1909, Cleveland. Studied: Cleveland Sch. A.; John Huntington Polytechnic Inst.; H. Keller. Exhibited: CI, 1941; AV, 1942; CMA, 1936–39 (prize), 1940, 1941, 1942 (prize), 1944–46; Butler AI, 1940–42. Work: CMA; Cleveland Municipal Coll.; WPA, Cleveland. WPA artist. Position: T., Cudell A.&Cr. Center, Cleveland, 1946– [47]

HAAS, Runi L. [P] Buffalo, NY [17]

HABBEN, Joseph E. [P,I] Anderson, IN b. 25 Mr 1895, Britt, Iowa. Member: ASL [29]

HABERER, C. Winston [E] Louisville, KY b. 1 Ap 1905, Louisville. Studied: AIC; Am. Acad. A., Chicago. Member: SSAL; Southern PM Soc.; Chicago SE. Work: Nat. Coll. FA; Mass. State Col., Amherst; Ky. Hist. Soc., Frankfort; Denver A. Mus. [40]

HABERKONE, Adelaide D. [P] NYC/Grosse Pointe Park, MI. Member: Lg. AA [24]

HABERMAAS, Edward W. [C] Cincinnati, OH. Specialty: wood carving [19]

HABERSTROH, Albert [P] Boston, MA. Member: Boston AC; Copley S., 1879 [13]

HACK, Gwendolyn Dunlevy Kelley (Mrs. Charles Wesley) [Min.P] NYC b. 10 N 1877, Columbus, OH. Studied: Mme. Debillemont, Mme. Gallet, Acad. Julian, Acad. Colarossi, all in Paris. Award: decorated by Queen Margherita of Italy for Min.P. [24]

HACKETT, Grace E(dith) [C,Des,T,W,P,L] West Roxbury, MA/Cutler, ME b. Boston. Studied: Mass. Sch. A.; BMFA Sch.; England; France. Member: Boston Soc. A.&Cr.; Copley S.; AWCS; AAPL; Pub. Sch. A. Lg.; NYWCC; EAA; Prof. Women's C.; Boston AC. Exhibited: AAPL (prize); Boston Soc. A.&Cr. (prize); AWCS; WMA; Copley S.; Boston AC. Position: T., Boston Pub. Sch., 1909–44 [47]

HACKETT, Malcolm [P] Chicago, IL b. 1903, Duluth, MN. Studied: AIC. Exhibited: AIC, 1935, 1936–38, 1939 (prize); Great Lakes Exh., The Patteran, 1938; MOMA, Wash., D.C., 1938; 48 Sts. Comp., 1939. Work: Skokie Sch., Winnetka; Lincoln Sch., Oak Park, Ill. WPA artist. [40]

HACKETT, Nelson G. [P] Fayette, MO [13]

HADAWAY, Julia Peck [P] Boston, MA [01]

HADDEN, Ellen [Des,Dec] Pacific Grove, CA b. Ireland. Studied: R.H. Johonnot. Exhibited: Golden Gate Expo, 1939 [40]

HADDON, Rawson W. [P] NYC [19]

HADER, Berta Hoerner [Min.P,I,W] Nyack, NY. Studied: Calif. Sch. Des. Author/Illustrator: "Farmer in the Dell," "Ugly Duckling," "Little Red Hen," "Wee Willie Winkie," other children's books, 1930s [40]

HADER, Elmer Stanley [Por.P,I,W,L] Nyack, NY b. 7 S 1889 d. 1973. Studied: Calif. Sch. Des.; Académie Julian, Paris, with Flameng. Work: San Fran. Inst. A.; Bohemian C., San Fran. Author/Illustrator: "Picture Book of Mother Goose," "Two Funny Clowns," "Whiffy McMann," other children's books of the 1930s [40]

HADLEY, George [P] b. 1876, England d. 7 Ja 1922, Brooklyn, NY. Position: Sign P., Keith's Theatre

HADLEY, Mary Hamilton [P] New Haven, CT. Member: New Haven PCC [25]

HADLEY, Paul [P,Des] Mooresville, IN b. Indianapolis. Studied: PMSchIA. Work: design for Indiana flag, accepted 1917. Position: Cur., John Herron A. Inst. [40]

HAEFEKER, William A. [P] Harvey, IL [10]

HAENEL, William M. [P,I,L,T] Chicago, IL b. 26 Ap 1885, Chicago. Studied: Chicago Acad. FA; AIC; L. Putz, in Munich. Member: Arts C. Chicago; MOMA. Exhibited: AIC, 1928 [40]

HAENIGSEN, Harry [I] NYC. Member: SI [47]

HAESELER, Alice P.S. [P] Phila., PA. Studied: PAFA [25]

HAESELER, Lillie Lipman (Mrs. Albert S.) [P] Phila., PA b. Phila. Studied: PAFA. Member: Plastic C. [13]

HAESLER, Gladys Jessie (Mrs. Paul) [P,Dr] Montauk, NY b. Grand Rapids, MI. Studied: AIC; ASL; R. Henri; H. Lever; W. Adams. Member: NAC; NAWPS; Allied AA [40]

HAFEN, John [Ldscp.P] Springville, UT b. 22 Mr 1856 Scherzingen, Switzerland (came to Utah in 1862) d. 3 Je 1910. Studied: Provo, Utah; self-taught, beginning at age 8; PIASch, with J. Fairbanks, L. Pratt; Académie Julian, Paris, with Constant, Lefebvre, 1890. Work: Mormon Temple, Salt Lake City [10]

HAFFNER, F.J. [I] Denver, CO. Member: Denver AA [25]

HAFFNER, J.J. [P] Cambridge, MA. Member: Boston SWCP [29]

HAFNER, Charles Andrew [S,P,T] NYC b. 28 O 1888, Omaha, NE. Studied: BMFA Sch.; ASL; BAID; Tarbell; P. Hale; S. Borglum; F.W. Benson; J.E. Fraser; McCartan. Member: NSS. Exhibited: First Mun. A. Exh., NYC, 1934 (prize). Work: theatre sculpture, NYC; Numismatic Mus.; Engineers C., NYC; NYU; Chatauqua, N.Y.; Rockefeller Center; Paramount Theatre. Position: T., N.Y. Evening Sch. Indst. A. [47]

HAFTEL, Charles [P] NYC. Member: GFLA [27]

HAGAMAN, Carol A. (Mrs. Ralph C. Miller, Jr.) [C,B,Des] Bryn Mawr, PA b. 20 N 1914, Mt. Vernon, OH. Studied: Ohio State Univ. Member: CMA. Exhibited: CMA, 1935 (prize), 1937 (prize), 1939 (prize). Work: CMA [40]

HAGAMAN, James H. [P] NYC b. Je 1866, Rochester, NY. Studied: Paris, with Benjamin-Constant, Lefebvre, Laurens, Gérôme [06]

HAGAR, Helen C. [Dec,Des] Salem, MA b. 8 S 1896, Peabody, MA. Studied: V. George; D. Connah. Specialty: restoration [40]

HAGEN, Louise [P,L,T] NYC b. 16 Mr 1888, Chicago. Studied: Henri. Member: NAWPS [29]

HAGEN, Lucy T. (Mrs. Winston) [P] Wash., CT [15]

HAGENDORN, Max [P,Des,T] Sharon, MA b. Stuttgart, Germany. Studied: Royal Acad. F.&Indst. A., Stuttgart. Exhibited: St. Louis Expo, 1904 (med). Work: BMFA [40]

HAGENHOFER, John Daniel [P,I,Des,Car] Boston, MA b. 6 D 1913, Chicago. Studied: AIC; Chicago Acad. FA. Member: Boston Ar. U. Exhibited: Ar. U. Exh., Boston. WPA artist. [40]

HAGER, Luther George [I] Seattle, WA b. 19 Mr 1885, Terre Haute, IN. Studied: ASL. Position: Car., Seattle Post-Intelligencer, since 1905 [13]

HAGERMAN, Worthington E. [P] Paris, France b. 1878, Carmel, IN. Studied: AIC; Laurens, L. Parker, in Paris. Member: Paris AAA [08]

HAGERT, Charles H. [P] Phila., PA b. Phila. Studied: Spring Garden Inst.; Drexel Inst.; PAFA. Exhibited: AAS, 1902, 1903 (med) [08]

HAGERT, Henry S. [Des] Dingman's Ferry, PA b. 3 My 1895. Member: Phila. A. All.; Phila. ACG; Soc. Des.-Craftsmen. Work: Bryn Mawr Nat. Bank; Acorn C., Phila.; Lutheran Church, Phila.; Science Lib., Bryn Mawr Col. [40]

HAGGIN, Ben Ali [P,Por.P,Des] Tuxedo Park, NY b. 1882 d. 2 S 1951. Member: ANA, 1912. Specialties: portraits; stage design [47]

HAGIUDA, Shinyo [P] NYC. Member: S.Indp.A. [25]

HAGUE, J. Russell [P] Columbus, OH. Member: Columbus PPC [25]

HAGUE, Maurice S(tewart) [Ldscp.P] Columbus, OH b. 12 My 1862, Richmond, OH. Member: S.Indp.A.; AAPL; Soc. for Sanity in A. Work: Columbus Gal. FA [40]

HAGUE, Morton [S] Chicago, IL/Long Beach, IN b. 2 Mr 1894, Brooklyn, NY. Studied: Wilcoxson; Fromen. Member: Chicago AA [40]

HAGUE, Raoul [S] NYC b. 1904, Armenia. Studied: ASL; BAID. Exhibited: PAFA, 1934; WFNY, 1939 [40]

HAHN, Harold Maxwell [E,En,P] Shaker Heights, OH b. 25 My 1920, Oakland, CA. Studied: Col. Wooster; Cleveland Sch. A.; Western Reserve Univ.; Case Sch. Appl. Sc.; La. State Univ. Member: Cleveland Pr. C. Exhibited: Oakland A. Gal., 1942; AV, 1942; LOC, 1944 (prize), 1946 (prize); NAD, 1944; SAE, 1944; CI, 1944; John Herron AI, 1946; CMA, 1940-46, 1942 (prize) 1946 (prize); Ohio PM, 1942, 1945; Tri-State Exh., Indianapolis, 1945. Work: CMA; LOC [47]

HAHN, Nancy Coonsman (Mrs.) [S,T,L] Winnetka, IL b. 28 Ag 1892, St. Louis, MO. Studied: Wash. Univ.; St. Louis Sch. FA; Zolnay; C. Grafly; Eberle. Member: St. Louis A. Gld.; North Shore AA; North Shore AL. Exhibited: St. Louis Sch. FA (med); Kansas City AI (med); PAFA, 1916, 1918, 1920-24; Arch. Lg., 1916, 1918; NAD, 1916, 1918; P.-P. Expo, 1915; Albright A. Gal.; CGA; AIC, 1916-18, 1920, 1922, 1924, 1944, 1946; Kansas City AI, 1921, 1922; St. Louis A. Gld., 1915-26 (medi); Mo. State Exh., 1923-25; Okla. State Exh., 1924, 1925. Work: S., CAM; CMA; mem., St. Louis, Mo.; Culver, Ind.; Memphis, Tenn.; New London, Mo.; Chicago, Ill.; Clayton, Mo.; Mo. State Mem., to the French Gov.; Barrington, Ill.; Burlington, Wis.; Argentina [47]

HAHN, William [P] b. 1829, Saxony, Germany (came to NYC ca. 1870) d. 1887, Dresden, Germany. Studied: Dresden Acad., with J. Huebner; Düsseldorf. Exhibited: NAD, San Fran. AA; Graphics Sketching C., San Fran.; MMA, 1939. Work: de Young Mus.; Oakland AM; Yonkers Mus.; Pal. Leg. Honor. Specialty: Calif. genre of the 1870s-80s. Had studio in San Fran. [*]

HAIG, M(abel) G(eorge) (Mrs.) [P,L] Whittier, CA b. Blue Earth, MN. Studied: W.L. Judson, H. Dunlap; A. Hills; M.O. Sheets; E. Colburn. Member: Laguna Beach AA; Calif. WCS; Whittier AA [40]

HAIGH, Eliza Voorhis [P] Winsted, CT b. 12 1865, Brooklyn, NY. Studied: ASL; Paris. Member: CAFA [29]

HAIGHT, Charles V. (Mrs.) [P] Cincinnati, OH. Member: Cincinnati Women's AC [25]

HAILMAN, Johanna K. Woodwell (Mrs. James D.) [P] Pittsburgh, PA b. 1871. Member: AFA; NAWPS; Pittsburgh AA. Exhibited: Pittsburgh AA, 1911 (prize); P.-P. Expo, San Fran. (med). Work: CI [40]

HAINES, B(owen) Aylesworth [P,I] Hilton, NY b. 21 D 1858, Canada. Studied: F. Smith; L. Cooper. Member: Rochester AC [31]

HAINES, Charles Richard [Mur.P,I,Des] Minneapolis, MN/Marion, IA b. 29 D 1906, Marion. Studied: Minneapolis Sch. A. Member: Minn. AA. Work: USPOs, Wichita, Kans., Cresco, Iowa, Hastings, Minn., Shelton, Wash.; Auditorium, Willmar; Fort Snelling, Minn. WPA muralist. [40]

HAINES, Fred S. [E] Thornhill, Ontario. Member: Chicago SE; Calif. PM [31]

HAINES, Marie Bruner [Por.P,Mur.P,B,C,W] College Station, TX b. 16 N 1884, Cincinnati, OH. Studied: Cincinnati A. Acad.; AIC, with L. Wilson; NAD, with F.C. Jones, D. Volk; ASL, with DuMond, Romanovsky. Exhibited: SSAL, annually, 1930 (prize), 1937 (prize); Mus. N.Mex., Santa Fe; Highland Park, Calif.; Dallas; Corpus Christi AL, 1943-45. Work: Mus. N.Mex.; Tex. A.&M. Col.; Iowa State Col. [47]

HAINES, Mary L. [P] West Chester, PA [01]

HAINES, Marie S. [P] Atlanta, GA [19]

HAINES, Richard [P] Marion, IA b. IA. Studied: Minneapolis Sch. A.; Beaux-Arts, Fontainebleau; John Norton. Work: USPOs, Cresco, Iowa, Wichita, Kans., Hastings, Minn. WPA muralist. [40]

HAITE, George C. [P] NYC [08]

HAKE, Otto Eugene [P,T,Gr,I] Chicago, IL b. 17 D 1876, Ulm, Germany. Studied: AIC; Morisset; Acad. Colarossi, Paris; Debschitz, in Munich. Member: Assn. Chicago A.&S.; Chicago Gal. Assn.; Palette & Chisel Acad.; AIC. Exhibited: Municipal A. Lg., Chicago, 1927 (prize); Chicago Gal. Assn., 1946; AIC, 1928-30; All-Ill. Soc., 1946; Palette & Chisel Acad., 1935 (med). Work: murals, Lake Shore C.; Mus. Sc.&Indst., Chicago; Pub. Lib., Wheaton, Ill.; Ill. State Mus.; Lincoln Sch., Evanston, Ill.; Blackhawk Mus., Rock Island; Champaign, Ill. Position: T., Palette and Chisel Acad., FA, Chicago [47]

HALBERG, Charles Edward [Mar.P] Austin IL b. 15 Ja 1855 Gothenburg, Sweden. Member: Chicago SA; Swedish-Am. AS. Exhibited: AIC, 1914 (prize). Work: Stockholm Mus.; Gothenburg Mus. [33]

HALBERSTADT, Ernst [Mur.P,Des] Cambridge, MA b. 26 Ag 1910, Budingen, Germany. Exhibited: Krausharr Gal., 1946 (one-man). Work: New Britain, Conn. Mus. FA; FMA; murals, State Bd. of Housing, Mass.; Fortress Monroe, Va.; USPO, Chicopee Falls, Mass.; U.S. Coast Artillery Bd., Va. Illustrator: "I Heard Them Sing," 1946. WPA muralist. [47]

HALE, Dorothea [P] NYC/Nantucket, MA b. 9 My 1884, Easthampton, MA. Member: Whitney Studio C. [27]

HALE, Ellen Day [P,E,W] Baltimore, MD/Rockport, MA b. 11 F 1855 d. 10 F 1940. Studied: Boston, with W. Rimmer, 1872, W.M. Hunt, Helen Knowlton, 1870s; (teaching classes for Rimmer, 1878); Acad. Colarossi, with Collin, Courtois, 1882; Carolus-Duran; Académie Julian, Paris, with Robert-Fleury, Bouguereau, Henner. Member: Boston AC; Charleston (S.C.) EC; S. Wash. A.; Wash. WCC; Chicago SE; North Shore AA. Exhibited: Centenn. Exh., Phila., 1876; Boston AC, 1878, 1884, 1886, 1890, 1894; PAFA, 1883, 1889, 1891, 1894, 1898, 1927, 1934; CGA, 1905 (prize), 1907, 1924, 1926, 1935; AIC, 1897, 1899, 1908; NAD, 1884; S. Wash. A., 1902, 1905; 1909-12; Paris Salon, 1885; New Orleans Expo, 1885-86; St. Botolph C., Boston, 1886; Williams & Everett Gal., Boston, 1888; Columbian Expo, Chicago, 1893; Wash. WCC, 1909; Mechanics Bldg., Expo, Boston, 1911; Worcester, MA, 1915; etchings, Goodspeed's Bookshop, Boston, 1922, 1924; Rockport AA, 1930; North Shore AA, 1935, 1940; J.B. Speed Mus., 1935; WMAA, 1976; R. York Gal., N.Y., 1981. Work: Yale; Iowa State Univ.; MIT; U.S. Capitol; AIC; LOC; Nat. Mus. Am. A.; Columbus (Ga.) MA; Nat. Mus. Women's Art; Boston Athenaeum. Daughter of the famous orator, Edward Everett Hale; sister of Philip, whom she helped teach. Was fluent in five languages; wrote several pamphlets on European masters. [38]

HALE, Frank Gardner [C] Marblehead, MA b. 13 N 1876, Norwich, CT d. 19 S 1945, Salem, MA. Studied: Norwich A. Sch.; BMFA Sch.; Guild of Handicraft, Chipping Campden, England.; F. Partridge, in London. Member: Boston SAC; Detroit SAC; Copley S.; Marblehead Cr. G. Exhibited: Norwich Acad., 1924 (med); P.-P. Expo, 1915 (med); Boston SAC, 1915 (med); AIC, 1917 (med). Work: enamels, J.B. Speed Mus., FA Gal., San Diego, Calif. Specialties: hand-wrought jewelry, enamels [40]

HALE, Gardner [Mur.P] NYC/Paris, France b. 1 F 1894, Chicago d. 28 1931, Santa Maria, Calif. (in an automobile accident). Studied: Harvard; ASL; Carlandi, in Rome; Maurice Denis, in Paris. Member: Arch. Lg.; Mural P.; AFA; Salons of Am.; S.Indp.A. Work: Director's Room, Ill. Merchants Bank, Chicago; Souverain Moulin, France. One of America's foremost young painters of murals and frescoes. His decorations are to be found in many prominent homes. [29]

HALE, Girard [P] Paris, France b. NYC. Studied: Laurens, in Paris. [15]

HALE, James (Mrs.) [P] Meadville, PA [19]

HALE, Lilian Westcott(Mrs. Philip L.) [P,Dr] Dedham, MA b. 7 D 1881, Hartford, CT d. 1963. Studied: BMFA Sch.; Hartford A. Sch.; Tarbell; Hale; Chase; E. Stevens. Member: CAFA; Gld. Boston A.; ANA; NA, 1931; Grand Central A. Gal. Exhibited: NAD, 1924 (prize), 1927 (prize); Concord AA, 1925 (prize); North Shore AA, 1941 (prize); Contemp. A. New England, 1945 (prize); Buenos Aires Expo, 1910 (med); P.-P. Expo, San Fran., 1915 (gold); Phila. AC, 1919 (gold); AIC, 1919 (gold); PAFA, 1923 (gold). Work: PAFA; PMG; CGA; Phila. AC; MMA; Concord AA; BMFA; Denver AM [47]

HALE, (Mary Powell) Helme (Mrs. William) [P,S,T] Gloucester, MA b. 12 Ap 1862, Kingston, RI. Studied: ASL; RISD; Chase; Saint-Gaudens; Duveneck; Knowlton. Member: North Shore AA; AAPL; AFA [33]

HALE, Philip L(eslie) [P,T,W] Dedham, MA b. 21 My 1865, Boston. Studied: early training under his sister, Ellen Day Hale; J.A. Weir, in NYC; BMFA Sch.; ASL; Académie Julian, Ecole des Beaux-Arts, both in Paris. Member: ANA, 1917; Phila. AC; St. Botolph C.; Boston GA; San Fran. AC; F.; PAFA; Eclectics; Port. P; Intl. Art Jury, San Fran. Expo, 1915; NAC. Exhibited: Pan-Am. Expo, Buffalo, 1901; St. Louis Expo, 1904 (med); Buenos Aires Expo, 1910; AIC, 1914 (med); P.-P. Expo, San Fran., 1915 (prize); NAD, 1916 (prize); Phila. WCC, 1916 (prize); PAFA, 1919 (prize). Work: PAFA; Mus. Montevideo, Uruguay; CGA; Phila. AC. Author: biographical sketches of painters, Jan Vermeer. Son of Rev. Edward Everett Hale. Positions: A. Cr., Boston Herald, Boston Evening Transcript; T., BMFA Sch. (for thirty yrs.), PAFA [29]

HALE, Robert [P,E,W,L,T] St. Paul, MN b. 26 F 1876, Chicago, IL. Work: Royal Palace, Rome [21]

HALE, Susan [P,W,T] Boston, MA/Matunuck, RI b. 1834 d. 17 S 1910. Studied: England, France, Germany, 1871–72. Specialty: watercolors. An important teacher of women during the 1870s, including her niece Ellen Day Hale. Author: "A Family Flight Through Spain," 1883, "Instructions in Painting," 1885

HALE, Van Barkaloo [P] Paris, France [15]

HALE, Virginia [P] Chicago, IL [17]

HALE, Walter [I,E,W] NYC b. 4 Ag 1869, Chicago, IL d. 4 D 1917. Studied: Minneapolis Sch. FA. Member: SI, 1912. Illustrator: "A Motor Car Divorce," "Motor Journeys," "On The Trail of Stevenson," "We Discover The Old Dominion," "We Discover the Empire State"; Harper's. Also an actor. [17]

HALEY, Helen Mary [P] Minneapolis, MN b. 18 F 1916, Minneapolis. Studied: St. Paul Sch. A.; Cameron Booth; Vaclav Vytlacil; A. Abels. Member: Minn. AA. Exhibited: Kansas City AI, 1938 (prize), 1939; AIC, 1938, 1942; Davenport Inst. A., 1940; SFMA, 1941–43; Contemp. A. Gal., 1942; Minn. State Fair, 1938, 1939, 1942, 1943; Minneapolis Inst. A., 1939, 1940, 1942; Walker A. Center, 1938; St. Paul Gal. A., 1941–46 [47]

HALEY, John Charles [Mur.P,Por.P,C,Edu] Richmond, CA b. 21 S 1905, Minneapolis. Studied: Minneapolis Sch. A.; Sch. Mosaics, Ravenna; C. Booth; H. Hofmann, in Munich; Lhote, in Paris. Member: San Fran. AA; Calif. WCS. Exhibited: AIC, 1940; San Fran. AA, 1935, 1936 (prize) 1937, 1938, 1939 (prize) 1940–43, 1944 (prize), 1945, 1946. Work: City Hall, Minneapolis; SFMA; Mills Col., Oakland, fresco, Gov. Island, Alameda, Calif.; church windows, St. Paul, Duluth, Benson, Rochester, all in Minn. Specialty: stained glass. Position: T., Univ. Calif., 1930– [47]

HALEY, (Robert) Duane [P,S] Bridgeport, CT b. 6 Ja 1892, Lambertville, NJ d. 25 Je 1959, Trumbull, CT. Studied: K.H. Miller; G. Bridgman; R. Tolman; J.C. Johansen [29]

HALEY, Sally (Mrs. S.H. Russo) [P,T] Waterbury, CT b. 29 Je 1908. Studied: Yale; T. Col., Columbia. Member: Hartford Soc. Women P. Exhibited: CGA; ASMP, 1944–46; Wadsworth Atheneum, 1944–46; Mattatuck Hist. Soc.; Waterbury, 1945 (prize), 1946 (prize); Hartford, 1935 (one-man); Zanesville, Ohio, 1944 (one-man); Waterbury, 1942–44 (one-man); Bridgeport, 1939–46. Work: USPO, McConnellsville, Ohio. WPA muralist. [47]

HALL, Alice V. [P] Fort Wayne, IN [19]

HALL, Arnold [I] Brooklyn, NY/Binghamton, NY b. 21 Mr 1901, Binghamton. Studied: G. Bridgman; C.C. Curran; F.C. Jones. Illustrator: "The Swiss Family Robinson," "Brackie, the Fool," "Jataka Tales Out of Old India" [40]

HALL, Arthur William [E,P] Santa Fe, NM b. 30 O 1889 Bowie, TX. Studied: AIC. Member: SAE; Southern PM; Chicago SE; Calif. PM; Prairie PM; Chicago Gal. Assn. Exhibited: Kansas City AI, 1929 (prize), 1932 (prize), 1933 (prize); Calif. PM, 1930 (prize); SAE (prize). Work: Smithsonian Inst.; LOC; Calif. State Lib.; Bibliothèque Nationale, Paris [47]

HALL, Caroline Minturn [Ldscp.P] Paris, France/Plainfield, NJ b. 23 Ag 1874, South Portsmouth, RI. Studied: W.S. Kendall, NYC; Paris, with Delance, Callot, Delecluse, Thaulow, Collin, Courtois, Simon, Prinet, R. Ménard. Member: Paris Women's AAA [13]

HALL, Doris (Mrs. Kalman Kubinyi) [C,P,E,B] Lakewood, OH b. 5 F 1907, Lakewood, OH. Studied: Cleveland Sch. A.; R. Stoll; H.G. Keller; C.W. Hawthorne. Member: Ten Thirty Gal. Group; Cleveland PM; Cleveland Artists U.; Am. A. Cong. Exhibited: A. Un., Springfield, Mass., 1938; AIC, 1938, 1939; WMAA, 1937; Boise Mus. A., 1944; Ten Thirty Gal., Cleveland, 1945; CMA, 1929–45, 1946 (prize) [47]

HALL, Douglas [P,S,G] Flossmoor, IL b. 4 N 1885, Ann Arbor, MI. Studied: AIC. Member: Am. Cer. Soc. Work: Flossmoor Community Church; Pr. Am. College Soc. Pr. Collectors. Position: Pres., Dougall Ceramic Studios [40]

HALL, Edith Allen (Mrs.) [Des] NYC b. Boston, MA. Studied: Mass. Sch. A.; R. Johonnot. Member: Alliance; Boston SAC. Exhibited: Expo, Applied Arts, AIC, 1918 (med). Specialty: textile des. [40]

HALL, Edith Emma Dorothea [P,T] Westfield, NJ b. 10 O 1883. Studied: Ivanowski; G.E. Browne; J. Carlson; J. Allen; R. Atwood. Member: Westfield AA; Plainfield AA; Milburn AA. Exhibited: Raritan Valley AA, 1942 (prize); Plainfield AA, 1943 (prize); Newark, 1938 (prize); Montclair Mus.; NAC; N.J. Gals., Newark [47]

HALL, Edward Hagaman [Antiquarian] b. 3 N 1858, Auburn, NY d. 4 My 1936, Laramie, WY. Member: Am. Scenic and Hist. Preservation Soc.; Municipal Art Comm., N.Y. He was widely known for the preservation of outstanding scenic and historic monuments; discovered the hitherto unknown value of a large collection of paintings in the City Hall; designed the historical medal to commemorate the consolidation of Greater New York, 1898. His wife was a craftswoman (d. 6 Ag 1929).

HALL, Florence S(locum) [P,T] Chicago, IL/Denver, CO b. Grand Rapids, MI. Studied: AIC; Johansen. Member: Chicago ASL [24]

HALL, Frances Cushing [Des,W] NYC b. 19 N 1892, Somerville, MA. Studied: Radcliffe; CI; New Sch. Soc. Res. Member: Nat. AAI. Exhibited: Modern Packing Exh., 1933, prize for 100 best packages. Contributor: articles, Good Furniture and Decoration, Textile World, other publications [40]

HALL, Frances Devereux Jones (Mrs.) [S,C,Dec,T] Gwynedd, PA b. New Orleans d. Autumn 1941. Studied: H. Sophie Newcomb Col., New Orleans; H. McCarter; H. Pyle; C. Grafly; Skeaping, in London. Position: T., Springside Sch., Phila. [40]

HALL, Frederick G(arrison) [P,E] Boston, MA/Gloucester, MA b. 22 Ap 1879, Baltimore, MD d. 15 O 1946. Studied: W. Paxton; H. Royer. Member: ANA, 1938; Soc. Am. E.; Boston AG; North Shore AA; Chicago SE; AFA. Exhibited: Brooklyn SE, 1922 (prize); Chicago SE, 1926 (prize); Phila. Print C., 1926 (prize); Sesqui-Centenn. Expo, Phila., 1926 (med); PAFA, 1927 (gold). Work: CMA; Print Dept., LOC; AIC; BMFA; Bibliothèque Nationale, Paris; Uffizi Gal., Florence [40]

HALL, George F. [P,Arch] Providence, RI b. Providence. Member: Providence AC [31]

HALL, George Henry [P] NYC b. 21 S 1825, Boston, MA (or Manchester, NH) d. 17 F 1913. Studied: Düsseldorf; Paris; Rome, 1849. Member: ANA, 1853; NA, 1868; Century Assn. Exhibited: Royal Acad., British Inst., Suffolk Street Gal., all in London, 1858–74; NAD, 1862–1900. Work: MMA. Traveled to Europe and North Africa, 1860–95. Specialty: North African and Italian peasant life. [13]

HALL, Helen Jameson (Mrs. Arnold) [P,I] Brooklyn, NY/Binghamton, NY b. 30 S 1902, Summit, NJ. Studied: G. Bridgman; L. Simon; C.W. Hawthorne. Member: Tiffany Fnd. Illustrator: "Anything and Everything," "A Child's Thought of God," "Little Otis" [33]

HALL, Isabel Hawxhurst [C,Des,P,I] NYC b. NYC. Studied: PIASch.; ASL; N.Y. Sch. Appl. Des. for Women; DuMond. Member: NYSC. Work: stained glass window in churches; Catholic Church, Tuxedo, N.Y. Illustrator: "Rubaiyat of Omar Khayam" [47]

HALL, James [P,I,T,W] North Scituate, MA b. 20 D 1869, Boston d. 14 F 1917. Studied: Mass. Normal A. Sch., Boston; ASL; Académie Julian, Paris. Member: Boston SAC. Author: "With Pen and Ink." Positions: T.,

Springfield, Mass., Public Sch., 1896–1902, Ethical Culture Sch., NYC, 1903–11 [15]

HALL, John Belmar [I] NYC [19]

HALL, Katherine [P] NYC. Member: Lg. Am. A. [24]

HALL, Kleber [P] West Somerville, MA [15]

HALL, Leola [P] Berkeley, CA [10]

HALL, Mabel B. [P] Phila., PA. Member: AWCS. Exhibited: AWCS, 1934, 1936, 1938; PAFA, 1935, 1937 [47]

HALL, Margaret [P] Wilmette, IL. Member: Chicago WCC [27]

HALL, Nathaniel Conkling, Jr. [C,En] Annapolis, MD b. 8 D 1901, Old Lyme, CT. Specialties: copper craft wares; lead garden accessories [40]

HALL, Norma Bassett (Mrs.) [P,En,Ser,B,T] Santa Fe, NM b. 21 My 1890, Halsey, OR. Studied: Portland AA; Sch.; AIC; London. Member: Calif. PM; Prairie PM; Southern PM; Am. Color Pr. Soc.; Nat. Serigraphic Soc.; Chicago Gal. Assn. Exhibited: Southern PM, 1938 (prize); Kans. State Fed. A., 1937. Work: Brooklyn Pub. Lib.; Smithsonian Inst.; Honolulu Acad. A.; Calif. State Lib.; Univ. Tulsa; Wichita AA; Univ. Wichita; Currier Gal. A. [47]

HALL, Norman Philip [I] Chicago, IL b. 21 F 1885, Chicago. Studied: AIC, with Vanderpoel, Richardson, Clute, Johansen. Member: ASL, Chicago; Artists G. [32]

HALL, Parker L. [P,S,C] Carmel, CA b. 15 S 1898, Denver. Studied: Calif. Sch. FA. Member: San Fran. AA; Bohemian C. Exhibited: Pal. Leg. Honor, 1931 (prize). Work: Coit Tower, San Fran.; LOC [40]

HALL, Richard [P] NYC [08]

HALL, Susan [S] NYC. Member: NAWPS [29]

HALL, Thomas [P,T] Oak Park, IL b. 23 Ap 1883, Sweden. Studied: AIC; Freer; Wolcott; Reynolds; Zoir. Member: SI; AAPL; Chicago SA; Chicago Gal. Assn.; Scandinavian-Am. A., NYC. Exhibited: Swedish-Am. Soc., 1920, 1923, 1924 (prize), 1925 (prize), 1937 (prize). Work: Vanderpoel Coll.; Frances Shimer Coll., Mt. Carroll, Ill. [47]

HALL, T(homas) Victor [P,I] NYC/Peekskill, NY b. 30 My 1879, Rising Sun, IN. Studied: Nowottny; Meakin; Duveneck; Art Acad., Cincinnati. Member: SC; Kit-Kat C.; Cincinnati AC; A. Fellowship [33]

HALL, W.W. [P] New Orleans, LA/Phila., PA. Member: Lg. AA [24]

HALL, William S(tanley) [P,I,W,C] NYC b. 30 N 1889, NYC. Studied: Grand Central A. Sch.; G. Ennis; Henry de Laussucq. Member: AI Graphic A. Specialty: heraldic des. Author: "The Spirit of America," 1930, "The Red Indian," 1931, pub. The Studio, London. Contributor: Studio, other magazines [47]

HALLADAY, Allan Wells [Dr,I,L] Rumford, RI b. 2 Jy 1906. Studied: RISD; ASL. Member: Providence AC. Position: Illus., Providence Journal [40]

HALLADAY, Milton Rawson [Car] Rumford, RI b. 16 D 1874, East Dover, VT. Studied: Mass. A. Sch., with W. Bartlett. Member: Providence AC; Providence WCC. Position: Car., Providence Journal [47]

HALLAM, J.C. [P] Washington, PA. Member: Pittsburgh AA [25]

HALLBERG, Ben [P] Chicago, IL [15]

HALLBERG, Charles Edward [Mar.P] Austin, IL b. 15 Ja 1855, Gothenburg, Sweden. Member: Chicago SA; Swedish-Am. AS [19]

HALLE, Ilse [P,Des] NYC b. 25 N 1915, NYC. Studied: PIASch; Phoenix AI, NYC. Member: Studio Gld.; NYWCC. Exhibited: NYWCC ann., 1940; Studio Gl., 1940 [40]

HALLER, Alfred J. [P] Pittsburgh, PA. Member: Pittsburgh AA [24]

HALLETT, Florence (Mrs. Hendricks A.) [P] Boston, MA d. after 1927. Exhibited: Poland Springs AG (Maine), 1909; Boston AC, 1905–08 [08]

HALLETT, Hendricks A. [P,Mar.P] Boston, MA b. 1847, Charlestown, MA d. 17 Mr 1921. Studied: Antwerp; Paris. Member: Boston AC; Boston SWCP. Exhibited: Mass. Charitable Mechanics Assn., 1892 (med); Boston AC, 1877–1909; J. Eastman Chase Gal., Boston, 1886; Jordan Marsh Gal., 1896–97. Many of his seascapes are of Boston Harbor and Mt. Desert, Maine. [19]

HALLIDAY, Hughitt [P] Berlin, Germany [15]

HALLIDAY, Laura. See De Beukelaer, Mrs.

HALLIDAY, (Mary) Hughitt [P] Santa Monica, CA b. 31 O 1866, Cairo, IL. Studied: W.M. Chase; C. Lasar; Académie Carmen; Académie Colarossi. Member: Calif. AC; Chicago Gal. A.; AFA [33]

HALLMAN, Henry Theodore [P,I,Car] Souderton, PA b. 17 S 1904, Milford Square, PA. Studied: Phila. Sch. Indst. A. Member: Lehigh AA. Exhibited: PAFA. Work: Lutheran Church, Souderton [40]

HALLOCK, Ruth M(ary) [P,I,B] NYC/Gloucester, MA b. Erie, PA d. 17 My 1945. Studied: AIC; ASL. Member: North Shore AA; PBC. Exhibited: PBC, 1932 (prize), 1933 (prize). Illustrator: books for Ginn, Rand McNally, other publishers [40]

HALLOWELL, Elizabeth. See Saunders, Mrs.

HALLOWELL, George H(awley) [P,I,C,Arch] Arlington, Heights, MA b. 5 D 1871, Boston d. 26 Mr 1926. Studied: Benson; Tarbell; architecture, with Rotch, H.L. Warren. Member: Boston SWCP; WCP; Aquarellists; NYWCC. Exhibited: NYCWCC, 1904 (prize); St. Louis Expo, 1904 (gold); P.-P. Expo, San Fran., 1915 (gold) [25]

HALLOWELL, Harriet [Min.P] Paris, France b. Boston, MA [15]

HALLOWELL, May. See Loud, Mrs.

HALLOWELL, Robert [P,E] New Brighton, NY b. 12 Mr 1886, Denver, CO d. 27 Ja 1939. Work: BM; PMG; Lewisohn Coll., N.Y.; Baltimore Mus.; Marbella Gal., NYC. Position: Asst. Dir., WPA, 1935–36 [38]

HALLOWELL, Robert, Mrs. See Caloenesco, Aurelia.

HALLSTHAMMAR, Carl [S,T] Chicago, IL b. 24 Je 1897, Westeras, Sweden. Studied: A. Zorn. Member: Chicago Gal. Assn.; Chicago SA; All-Ill. SGA; Swedish AA. Exhibited: AIC, 1928 (prize), 1937 (gold); Swedish C. of Chicago, 1925 (prize) 1927 (prize); Swedish A., 1929 (prize), 1931 (prize). Work: General Motors Bldg., Century of Progress Expo; AIC; State Mus., Springfield, Ill.; Los Angeles Mus. A.; Dayton AI. Author: book on figure carving. Position: T., Hallsthammar Acad. Wood Sculpture [40]

HALPERT, A. [I] NYC. Member: SI [47]

HALPERT, Edith Gregor (Mrs. Samuel) [Dealer] NYC. Studied: ASL. Founder of Downtown Gal., 1926. Promoted Marin, Dove, Weber, Demuth, Sheeler, O'Keeffe, Kuniyoshi, Davis; held first exh. for W. Harnett, 1939; first exh. for Shahn, 1930; forty-one black artists, 1941. Gallery retrospective exh. at U. Conn. Mus. A., 1968 [*]

HALPERT, S(amuel) [P] Detroit, MI/Ogunquit, ME b. 25 D 1884, Russia (came to U.S. as a child) d. 5 Ap 1930. Studied: NAD; L'Ecole des Beaux Arts, Paris; European cities. Member: New SA; S.Indp.A., Detroit; Sociétare Salon d'Automne, Paris. Exhibited: Paris Salon, 1903. Work: PAFA; Newark Mus. Assn.; Cleveland Mus.; SFMA; Harrison Gal., Los Angeles Mus.; PMG; Detroit Inst. A. Position: T., Art School of the Society of A.&C. [29]

HALPIN, Warren T. [P,W] Brooklyn, NY b. 24 N 1908, NYC. Studied: NA; Grand Central A. Sch., NYC; St. John's Wood A. Sch., London.; C. Schmit. Exhibited: Sporting Gal., NYC. Specialty: horses [40]

HALSALL, William F(ormby) [Mar.P] Provincetown, MA b. 21 Mr 1841, Kirkdale, England d. N 1919. Studied: Boston, with W.E. Norton, 1860, (after a 7-yr. stint as a sailor); Lowell Inst., Boston, ca. 1862–70. Member: Boston AC. Work: Mariners Mus.; Peabody Mus., Salem; U.S. Naval Acad. [17]

HALSETH, Edna Scofield [S] San Diego, CA. Member: Calif. AC [25]

HALSEY, William Melton [P,T,L] Charleston, SC b. 13 Mr 1915, Charleston, SC. Studied: Univ. S.C.; BMFA Sch., with A. Jacovleff, K. Zerbe. Member: SSAL; BMFA Sch., 1939–41. Exhibited: Gibbes A. Gal., Charleston, 1936, 1937, 1938; AIC, 1939, 1941–43; PAFA, 1943; Mint Mus., 1944–46 (prizes); Pasadena AI, 1946; Chicago AC, 1943; Miss. AA, 1946; SSAL, 1942 (prize) Savannah AC; Telfair Acad., 1943; Univ. Ga., 1944 (one-man); Agnes Scott Col., 1944 (one-man); Oshkosh Pub. Mus., 1940 (one-man); Norfolk Mus. A.&Sc., 1940 (one-man); Berkshire Mus., 1939 (one-man). Work: Telfair Acad.; Gibbes A. Gal.; Univ. Ga.; Berkshire Mus., Pittsfield, Mass. Positions: T., BMFA Sch., 1938–39, Telfair Acad., 1942–43; Gibbes A. Gal., Charleston, 1945–46 [47]

HALSMAN, Philippe [Photogr] b. 1906, Riga, Latvia d. 1979, NYC. Studied: Tech. Univ. Dresden; Sorbonne; self-taught in photography. Member: Am. Soc. Magazine Photogr. (first Pres.) Exhibited: Intl. Center Photography, NYC (retrospective) 1979; MMA; MOMA; NOMA; LOC. Illustrator: "Jump Book," 1959, "Sight & Insight," 1972; the greatest

number of covers (101) for Life. Best known for his portraits of Einstein, Dali, Marilyn Monroe. [*]

HALSTED, Helen H. [P] NYC [10]

HALTOM, (Minnie) Hollis [P,T] San Antonio, TX b. Belton, TX. Studied: R. Taylor; J. Arpa, in Spain; MMA Sch., NYC; X. Gonzales. Member: San Antonio AL; Tex. FA Assoc.; Palette & Chisel C.; Am. Ar. Prof. Lg.; SSAL. Exhibited: Austin Women's C., 1937 (prize) [40]

HALVERSON, Josephine Jesik (Mrs.) [P] Chicago, IL b. 19 Mr 1890, Chicago, IL. Studied: C. Krafft; J. Spelman; J. Nolf; Oak Park AL; River Forest AL. Member: Austin AL; Oak Park AL; River Forest AL; All.-Ill. SFA; Technic Arts L.; Northwest AL [40]

HALVORSEN, Ruth Elise [Edu,P] Portland, OR b. Cama, WA. Studied: Portland Mus. A. Sch.; PIASCh; Univ. Oreg.; Columbia; W. Beck, Charles Martin; Jean Charlot. Member: AAPL; Portland A. Soc.; CAA; Oreg. A.&S. Gld. Exhibited: SFMA, 1939; Wash., D.C., 1938; Portland AM, 1939; Oakland A. Gal. Position: T., Portland Pub. Sch. [47]

HAM, Alice [P] NYC [01]

HAMACHI, Seimatsu [P] NYC [21]

HAMAKER, Ray Parker (Mrs. John Irvin) [P,L] Lynchburg, VA b. 22 Je 1890, Madison, MO. Studied: H. B. Snell; E. Clark; P. Kalman, Munich. Member: Lynchburg AC; Lynchburg Civic AL; Va. A. Alliance [40]

HAMANN, Carl F. [S,T,C] NYC d. 8 N 1927. Member: NSS 1893. Position: T., jewelry and silversmithing, PIASch, 1904-27 [17]

HAMBIDGE, Jay [I,P,W,L] NYC b. 13 Ja 1867, Simcoe, Canada d. 20 Ja 1924. Studied: ASL; Chase, late 1890s. Member: Graphic AC of Toronto. Illustrator: New York Herald; Century. Best known for promoting his theory of "dynamic symmetry," based on his extensive studies of classical Greek art & architecture and mathematical formulas. [24]

HAMBLETON, Roy S. [P] Chicago, IL [15]

HAMBLIN, William Osborne [T] Jersey City, NJ b. 1866, New Bedford, MA d. 5 Ap 1929. Studied: BMFA Sch. Positions: T., Jersey City Pub. Sch. (over 20 yrs.), R.I., Mass. Pub. Sch.

HAMBLY, Edgar [E] NYC. Member: Chicago SE [27]

HAMILL, Lafayette C. [S,Des,C,L] Worcester, MA b. 5 N 1873, Prince Edward Island, Canada. Studied: I. Kirchmayer. Member: Boston SAC. Work: R.I. Supreme Court Bldg.; churches, public bldgs., throughout New England [40]

HAMILL, Virginia [Des,Dec,W,L] Stamford, CT b. Chicago, IL. Studied: N.Y. Sch. F.& Appl. A.; Europe. Member: Arch. Lg.; Fashion Group. Work: designs for Congoleum, Scranton Lace Co., Cannon Mills. Specialty: indst. des. [40]

HAMILTON, Agnes [P] Ft. Wayne, IN/Phila., PA. Studied: PAFA [25]

HAMILTON, Blanche [P] West Barrington, RI b. 23 S 1880, Wash., DC. Studied: W.M. Chase; AIC. Member: S.Indp.A. [40]

HAMILTON, Clara Laughlin (Mrs. N.C.) [P,T] Kokomo, IN b. 8 Ap 1872, Belle Center, OH. Studied: Gottwald; Coats; Forsyth. Member: Ind. AC; Kokomo AA; North Shore A. of Evanston. Work: Kokomo Pub. Lib., Country Cl.; Women's Dept. C. [40]

HAMILTON, D.A. [P] South Portland, ME [24]

HAMILTON, David Osborne [E,P,W] Grosse Pointe Farms, MI b. 19 Je 1893, Detroit, MI d. ca. 1955. Studied: Detroit Univ. Sch.; Yale; ASL. Member: SAE. Exhibited: WFNY, 1939; Detroit Inst. A., 1933-36; NAD; Grosse Pointe AA, 1938-46; Michigan Acad. A.&Sc., 1944-46. Also a poet and novelist. [47]

HAMILTON, Edgar Scudder [P] Stamford, CT b. 31 Jy 1869, San Antonio, TX d. 3 Je 1903, Sulllivan County, NY. Studied: ASL, with G. Forest Brush; W.L. Metcalf; Académie Julian, Paris, with Constant, Laurens; Ecole des Beaux-Arts, with Gérôme [01]

HAMILTON, Edward W.D. [P,I,Dec] Boston, MA. Studied: Ecole des Beaux-Arts. Member: BAC; Arch. Lg., 1899. Exhibited: Boston (prize); Atlanta Expo, 1895, (med) [01]

HAMILTON, Ethel Heaven (Mrs.) [P,Li,T] NYC/Pittsfield, MA b. 14 Jy 1871, Mexico d. 1 Je 1936. Studied: Chase; MacMonnies; Colarossi Sch.; Corcoran A. Sch.; J. Rolschoven, in Florence, Italy. Member: Pittsfield AL; NYWCC; Wolfe AC; Nat. Leg. Am. Pen Women. Exhibited: Nat. Lg. Am. Pen Women, 1930 [33]

HAMILTON, Fred A. [I] Chicago, IL [19]

HAMILTON, Genevieve Bartlett [S,Des,Cer] Altadena, CA b. St. Louis, MO. Studied: M. Hopkins, Univ. Calif.; Chouinard AI; CUASch, with Brewster; Archipenko; M. Hamilton. Exhibited: GGE, 1939; Allied Arch. Am., 1924 (prize); Robineau Mem. Exh., Syracuse Mus., 1934; Riviera Gal., Hollywood, 1937 Work: Friday Morning C., Los Angeles; pottery and sculpture owned by Metro-Goldwyn-Mayer, Fox and others, used in producing films; Kunstindustri Mus., Copenhagen; MFA, Syracuse, N.Y.; Northwestern Univ. Position: Des., May and Vieve Hamilton Pottery [40]

HAMILTON, George (Theodore) [I,T,W,L] Detroit, MI b. 25 F 1882, Detroit, MI. Studied: PMSchIA; D. Ross. Member: Detroit SAC; Detroit FAS; Alliance. Position: Dir., Detroit Sch. Des., since 1911 [21]

HAMILTON, Grant E. [I,T] Huntington, NY b. 16 Ag 1862, Youngstown, OH. Position: Art Ed., N.Y. Graphic, Judge, Leslie's Weekly [13]

HAMILTON, Hamilton [P] Norwalk, CT b. 1847, Oxford, England (came to U.S. as a child) d. 4 Ja 1928. Studied: J. Ruskin; self-taught. Member: ANA, 1886; NA, 1889; AWCS; Silvermine, Conn. colony of artists (founder). Work: FA Acad., Buffalo, NY. Specialties: genre; landscapes [27]

HAMILTON, Helen [P] Norwalk, CT. Member: NAWPS [27]

HAMILTON, Hildegard Hume [P,W] Ft. Lauderdale, FL b. 11 S 1906, Syracuse, NY. Studied: Académie Julian, Ecole des Beaux-Arts, both in Paris; ASL; John Herron AI; Cincinnati A. Acad.; Syracuse Univ.; Harvey and Proctor Sch., England; Grande Chaumière. Member: NAC; PBC; Wash AC; Lg. Am. Pen Women; Boston AC; Louisville AA; MacD. C.; SSAL. Exhibited: NAC; Ainsley Gal. (one-man); Vendôme Gal.; Syracuse Mus. FA; Univ. Ky.; Univ. Ga.; Ogunquit A. Center, 1944; S.Indp.A., 1944; Barbizon A. Gal., 1945; abroad; Am. Salon (one-man); Decorators C. Gal., N.Y., 1939. Work: Wesleyan Col., Ga.; Hall of Art, N.Y.; Evergreen Sch., Plainfield, N.J.; Va. Military Inst., Lexington; Darwin's House, London, England; Am. Church of Paris; Univ. Ga.; Hanover Col., Ind. Author: "Human Bits" [47]

HAMILTON, James [P,I,T] b. 1 O 1819 near Belfast, Ireland (came to Phila. in 1834) d. 10 Mr 1878, San Fran. Exhibited: A. Fund S., Phila., 1840; galleries in NYC, Phila., Boston, Baltimore, Wash., D.C. Work: BMFA; MET; Brooklyn Mus.; Oakland AM. Illustrator: Kanes "Arctic Explorations," 1855, Fremont's "Memoirs." He sold of 109 of his paintings at auction in Phila., 1875, then traveled around the world. He taught Thomas Moran. [Note: There were two James Hamiltons active in Phila. ca. 1850s; the other was an engraver.] [*]

HAMILTON, J(ames) Whitelaw [P] Helensburgh, Scotland b. 26 N 1860, Glasgow, Scotland. Studied: Dagnan-Bouveret; A. Morot. Member: RSA; RSS of Painters in Water Color; Chevalier of the Order of the Crown of Italy; Scottish Artists' Benevolent Assn.; Royal Glasgow Inst. FA. Exhibited: Intl. Expo, Munich, 1905 (gold). Work: The Corp. of Glasgow; Scottish Modern Arts Assn., Edinburgh; CAM; Albright A. Gal., Buffalo; CI; Royal Pinakothek, Munich [25]

HAMILTON, Jessie [P] Ft. Wayne, Ind. Studied: PAFA [25]

HAMILTON, John McLure [Por.P,I] Mandeville, Jamaica b. 31 Ja 1853, Phila., PA d. 10 S 1936. Studied: PAFA; Royal Acad., Antwerp; Ecole des Beaux-Arts, Paris. Member: Kingston AC; Phila. WCC; AFA; Royal Soc. Por. P.; Pastel Soc.; Senefelder C., London. Exhibited: Paris Salon, 1892; Pan-Am. Expo, Buffalo, 1901 (gold); St. Louis Expo, 1904 (gold); P.-P. Expo, San Fran., 1915 (prize); PAFA, 1918 (gold). Work: PAFA; CI; Luxembourg Mus., Paris; Nat. Gal., Tate Gal., both in London. Author: "Men I Have Painted." Lived abroad for 58 yrs., first in London and later in Jamaica, but made frequent visits to the U.S. [33]

HAMILTON, Marjorie Lang (Mrs. H.H.) [P,T] Plymouth, MA b. 4 My 1908, Barnet, VT. Studied: BMFA Sch.; H. Hofmann. Exhibited: Plymouth, 1937 (one-man). Work: Athenaeum, St. Johnsbury, Vt. [40]

HAMILTON, Mary W. [Min.P] Grosse Pointe, MI. Member: Detroit S. Women P. [31]

HAMILTON, May Stuart (Diane) (Mrs. James Francis de Causse) [S,Des,Cer] Altadena, CA b. St. Louis, MO. Studied: Mark Hopkins Univ.; Calif.; Otis AI; Columbia; ASL; Am. Sch. Sculpture, N.Y.; Académie Julian, Paris with Landowski; D. Gelin, Fontainebleau Sch. FA; research, mus. and potteries in France, Italy, Spain, England, U.S. Exhibited: Exhibited: GGE, 1939; Allied Arch. Am., 1924 (prize); Robineau Mem. Exh., Syracuse Mus., 1934; Riviera Gal., Hollywood, 1937 Work: Friday Morning C., Los Angeles; pottery and sculpture owned by Metro-Goldwyn-Mayer, Fox and others, used in producing films; Kun-

stindustri Mus., Copenhagen; MFA, Syracuse, N.Y.; Northwestern Univ. [Her exhibits and prizes are identical to those of her partner-sister, Genevieve.][40]

HAMILTON, Leah Rinne [P,T,Des] San Fran. CA b. Finland. Studied: Univ. Calif.; abroad. Member: San Fran. AA; San Fran. Fed. A.; San Fran. Soc. Women A. Exhibited: CI, 1941; AIC, 1939, 1943; CGA; SFMA; Los Angeles, Calif.; GGE, 1939; San Fran. AA, 1939-42 (prizes); San Fran. Women A., 1936-45 (prizes). Position: T., Dominican Col., San Rafael, Calif., 1930-42 [47]

HAMILTON, Norah [E,Li,I,T] Hadlyme, CT b. Ft. Wayne, IN, 1873. Studied: Cox, in NYC; Whistler, in Paris. Member: Chicago SE [32]

HAMILTON, Robert [P,T] NYC/Pittsfield, MA b. County Down, Ireland. Studied: London; Paris. Member: SC; Kit Kat C.; Pittsfield AL; Lime Rock A. Exh.; Gloucester SSA; North Shore AA. Work: Everhart Mus., Scranton, Pa. [40]

HAMILTON, Wilbur Dean [P,I,C] Kingston, MA b. 1864, Somerfield, OH. Studied: Ecole des Beaux-Arts. Member: Copley S. 1903; Boston GA; St. Botolph C. Exhibited: Boston (prize); Atlanta Expo, 1895 (med); P.-P. Expo, San Fran., 1915, (gold). Work: RISD; BMFA; Boston Univ.; Am. Univ.; John Wesley Mem. Room, Lincoln Col., Oxford, England. Position: T., Mass. Sch. Art, Boston [40]

HAMLIN, Edith A. (Mrs. Maynard Dixon) [Mur.P,Des,Dec,T,L] Tucson, AZ b. 23 Je 1902, Oakland, CA. Studied: Calif. Sch. FA; Maynard Dixon. Member: San Fran. AA; Am. A. Cong. Exhibited: San Fran. AA, annually; SFMA, 1924-37; San Diego FA Soc., 1927-29; Dayton AI, 1942, 1943; Delphic Studios, 1929, 1930; A. Center, N.Y., 1930; Biltmore Gal., Los Angeles, 1940-46; Gumps, San Fran., 1945, 1946; Dallas Mus. FA, 1932; de Young Men. Mus.; Stendahl Gal., Los Angeles, 1923. Work: SFMA; San Diego FA Soc.; USPO, Tracy, Calif.; Coit Mem. Tower, San Fran. WPA muralist.

HAMLIN, Genevieve Karr [S,T,L,W] NYC b. 1 Je 1896, NYC. Studied: Vassar; Eberle, Henry Dropsy, André Lhote in Paris. Member: S. Gld.; NAWA; Fifteen Gal.; F.; Cranbrook Acad. A. Exhibited: PAFA, 1923-38; NAD, 1923-38; AIC, 1926; AFA Traveling Exh., 1943; PMG; Outdoor Sculpture Exh., 1938-40; WFNY, 1939; Rehn Gal., 1931 (one-man); Fifteen Gal., 1936-38 (one-man). Work: Joslyn Mem., Omaha; medals for Am. A. Dealer's Assn.; Antique and Decorative A. Lg.; Tsing Hua Col., Peking. Position: T., Newark Sch. F.&Indst. A., 1926-43 [47]

HAMLIN, Marston [P] Lynbrook, NY. Exhibited: WFNY, 1939 [40]

HAMLIN, Talbot Faulkner [Arch,W,L,Cr,P] NYC b. 16 Je 1889, NYC. Studied: Amherst; Columbia. Member: AIA; N.Y. Hist. Soc. Exhibited: Contemporary A., 1941; NYWCC, 1936. Work: Col. New Rochelle, N.Y.; Charity Tower, Royal Oak, Mich.; Ginling Col., Nanking, China Author: articles on architecture, Encyclopaedia Britannica (14th ed.), Pencil Points magazine. Positions: Ed. Bd., Magazine of Art, 1943- ,T., Columbia Sch. Arch. [47]

HAMM, Beth Creevey (Mrs.) [P] NYC b. 5 Ap 1885, Brooklyn, NY d. 21 N 1958. Studied: Smith Col.; N.Y. Sch. F.&Appl. A.; ASL; Chase; Bredin; Weber; Henri. Member: NAWA, pres., 1944-46; PBC. Exhibited: NAWA, 1942-46, 1945 (prize); All. A. Am., 1943; AWCS, 1943-45; Conn. WCS, 1944; Nantucket AA, 1945 (prize); Denver A. Mus., 1945 (one-man); PBC, 1945 (prize). Work: Denver A. Mus. [47]

HAMMANN, C.F. [S,T] NYC. Member: NSS [13]

HAMMARGREN, F(rederick) E. [S] Los Angeles, CA. b. 7 Ap 1892, Orebro, Sweden. Studied: A. Sch., Gothenburg, Sweden; Bourdelle, in Paris. Member: NSS. Exhibited: CAFA, 1927 (prize); Montclair AM, 1932 (prize); AAPL, 1934 (prize). Work: Morton Mem. Bldg., Phila.; BM; Newark Mus.; Orebro, Sweden. Specialties: figures; fountains; small sculptures [27]

HAMMARSTOM, H. [P] San Fran., CA [17]

HAMMELL, Elizabeth Lansdell (Mrs. Will) [P] Red Bank, NJ b. 28 N 1889, Brooklyn, NY. Studied: G. Bridgman; E.C. Taylor. Exhibited: PAFA, 1930 (prize). Work: flower covers, illus., Woman's Home Companion, 1929-33 [40]

HAMMELL, George M. [P] Cincinnati, OH [17]

HAMMELL, George M. (Mrs.) [P] Cincinnati, OH. Member: Cincinnati Women's AC [25]

HAMMELL, Will [P,I] Red Bank, NJ b. 14 Ag 1888, Trenton, NJ. Studied: R.S. Bredin; G. Bridgman; H. McBride; F.W. Taylor; T. Fogarty; W.M. Chase; DuMond. Member: SI [40]

HAMMER, John [P] NYC. Member: GLFA [29]

HAMMER, Oscar F. [P] Leechburg, PA. Member: Pittsburgh AA [25]

HAMMER, Trygve [S,C,Des,T] Douglaston, NY b. 6 S 1878, Arendal, Norway d. 28 Je 1947, Kearny, NJ. Studied: Skeibrok; MacNeil; Calder; S. Borglum. Member: NSS; NYSC; Douglaston AL; Scandinavian-Am. A. Work: mem., Tenafly, N.J.; Crescent Athletic C.; BM; Zion Lutheran Church, Brooklyn; Newark Mus.; tablet, Stevens Inst., Hoboken; Scofield Mem. Lib. NYC; mem., Cold Spring Harbor, N.Y.; reredos, Zion Episcopal Church, Douglaston, N.Y.; tablet, Franciscan Monastery, Wash., D.C.; Princeton; gate posts, Wianno, Mass. and Grosse Pointe, Mich.; Brookgreen Gardens, S.C.; designs for book jackets, Am.-Scandinavian Foundation, NYC. Specialties: modeling; woodcarving [40]

HAMMERSLOUGH, Ruth H(elprin) [P] Paris, France b. 3 S 1883, Wash., D.C. Studied: Chase [21]

HAMMERSMITH, Paul [P,E] Milwaukee, WI b. 17 Mr 1857, Naperville, IL d. 11 N 1937. Studied: self-taught. Member: Milwaukee AS; Calif. SE; Chicago SE; Wis. PS. Exhibited: St. Paul Inst., 1916 (med), 1918 (med). Work: NYPL; Newark Pub. Lib.; AIC; Milwaukee AI [38]

HAMMERSTROM, H. [P] San Fran., CA [10]

HAMMILL, Helen A. (Mrs.) [P] River Forest, IL [15]

HAMMITT, Clawson S(hakespeare) [P,T] Wilmington, DE b. 7 N 1857, Wilmington d. 28 Jy 1927. Studied: PAFA, with Eakins; W.M. Chase, NYC; Académie Julian, Paris, with Lefebvre, Constant. Member: AAS; Phila. Sketch C. Work: U.S. Capitol; State House, Dover, Del.; State Col., Newark, Del.; portraits, Battleship Delaware [27]

HAMMON, James [I] Position: Illus., Public Ledger, Phila., Pa. [19]

HAMMON, Walter E. [S] Seattle, WA [21]

HAMMOND, Arthur J. [P] Rockport, MA b. 3 Ap 1875, Vernon, CT. Studied: Pape; C. Woodbury; G.L. Noyes. Member: North Shore AA; CAFA. Exhibited: CAFA, 1919. Work: Lynn Pub. Lib.; Women's C., Roswell, N.Mex. [40]

HAMMOND, Arthur H.K. [P] Boston, MA. Member: AWCS [47]

HAMMOND, Edith [P,S,T] Chicago, IL b. Omaha, NE. Studied: Fursman; Polasek; Vanderpoel; Clute; Mulligan; AIC. Member: AIC; Chicago ASL. Work: civic art coll., Chicago Municipal Pier. Position: T., Summer Sch. of Painting, Saugatuck, Mich. [27]

HAMMOND, Elizabeth [P] Detroit, MI b. 22 Ja 1891, Evanston, IL. Studied: self-taught [17]

HAMMOND, George F. [P] Zanesville, OH b. 25 N 1855, Boston, MA. Studied: Mass. Normal A. Sch.; W.M. Chase; W.L. Sonntag; W.F. Lansil. Member: Cleveland SA [29]

HAMMOND, H.H. (Mrs.) [P] San Antonio, TX. Member: San Antonio AL [25]

HAMMOND, Helen Todd [P] Boston, MA [19]

HAMMOND, Idea [P] Evanston, IL [13]

HAMMOND, Jane Nye [S] Providence, RI b. 3 Mr 1857, NYC d. 23 O 1901. Studied: BMFA Sch.; Paris with Injalbert, Bartlett. Member: Bd. of Sculpture, Worlds's Fair in Chicago. Exhibited: Pan-Am. Expo, Buffalo, 1901. Specialty: portrait busts. Called the "leading woman sculptor in R.I." [01]

HAMMOND, Mildred Welsh [S] Kansas City, MO. Exhibited: Midwest A. Ann. Kansas City AI, 1933 (gold), 1934, 1935, 1938, 1939 (prize); WFNY, 1939 [40]

HAMMOND, Natalie Hays [P,I,W] NYC b. 6 Ja 1905, Lakewood, NJ. Studied: Soudekine. Member: AFA; NAWA; Royal Soc. Min. P., Sculptors and Gravers; Guilford Soc. of England; NAC; Wash. AC; Boston AC. Exhibited: PAFA; BM; French & Co. (one-man); CGA (one-man); Rochester Mem. A. Gal. (one-man); Arch. Lg. (one-man); Marie Sterner Gal. (one-man); Phila. A. All. (one-man); La Palette (one-man), Paris; Grieves Gal., London (one-man); Springfield (Mass.) Mus. FA. Author/Illustrator: "Elizabeth of England," 1936 [47]

HAMMOND, Ruth Evelyn (Mrs. Edward S.) [P] Brunswick, ME b. 19 Mr 1894, West Haven, CT. Studied: Mt. Holyoke; D. Ricci, in Rome, Italy. Member: Portland SA; Rockport AA; North Shore AA; Copley S., Boston; NAWA; St. Augustine AC. Exhibited: PAFA, 1943; All.A.Am., 1944; NAWA, 1943-45; Sweat Mem. Mus., 1942-45; North Shore AA; Rockport AA, annually; St. Augustine AC; Soc. Four A., 1942, 1943;

New Haven PCC, 1943; Walker A. Gal., Brunswick, Maine; Deerfield Acad., 1946; Mt. Holyoke Col. Mus. [47]

HAMOND, Richard Henry [P] Cincinnati, OH b. 2 Ag 1854, Cincinnati. Studied: Noble; Weber; Duveneck. Member: Cincinnati AC; Poster A. Assn. Am. Exhibited: Cincinnati AC, 1873 (med), 1877 (gold) [21]

HANA, John S. [P] Peoria, IL [19]

HANNAH, William M. [P] b. 10 F 1855, Brooklyn, NY d. 7 Ja 1927, Providence. Studied: CUASch; NAD; British Mus. Member: Concord AA

HANATSCHEK, Bertha (Mrs.) [P] b. 1874 (came to U.S. in 1903) d. 11 Mr 1932, NYC. Studied: Nat. Acad., Austria

HANATSCEK, H. [P] NYC/Metuchen, NJ b. 19 1873, Zuaim Moraira. Studied: Griepenkeri; Eisenmenger; Vienna; Munich [29]

HANCKEL, Mary Bull [P] NYC [13]

HANCOCK, Adelaide D. [P] Chicago, IL b. Boston. Studied: Chicago AFA; E.N. Casterson [29]

HANCOCK, Betsy [P] Chicago, IL. Studied: AIC. Exhibited: Great Lakes Exh., The Patteran, 1938; PS Ann., AIC, 1937, 1938, 1939 [40]

HANCOCK, James Carl [Et,Des,Dr] Little Rock, AR b. 10 My 1898, Springville, TN. Studied: self-taught. Member: SSAL; Southern PM Soc.; Miss. AA. Work: Women's C.; Pub. Lib., New Orleans; Pub. Lib., Monroe, La.; Municipal A. Gal., Jackson, Miss.; Cossit Lib., Memphis; Pub. Libraries, Ft. Smith, Little Rock, both in Ark., Beaumont, Tex., Lake Charles, La.; Tulane Univ.; La. State Univ. Author/Illustrator: "New Orleans" [47]

HANCOCK, Joseph Lane [Ldscp.P] Chicago, IL b. 12 Ap 1864, Chicago. Studied: AIC [21]

HANCOCK, Louise Barker [P] NYC [15]

HANCOCK, Walker (Kirtland) [S,T] Gloucester, MA b. 28 Je 1901, St. Louis, MO. Studied: Holm; E.H. Wuerpel; Grafly; Wash. Univ.; Univ. Wis.; PAFA; Am. Acad., Rome. Member: NSS; Arch. Lg.; North Shore AA; NIAL; Phila. AC; Nat. Acad., 1938. Exhibited: PAFA, 1930-42, 1921 (prize), 1925 (gold); NAD, 1930-42, 1935 (prize); Arch. Lg.; WFNY, 1939; North Shore AA, 1930-42. Awards: Prix de Rome, 1925, 1928. Work: S., PAFA; John Herron AI; CGA; CAM; Brookgreen Gardens, S.C.; Parrish A. Mus., Southampton, N.Y.; Girard Col.; City Hall, Kansas City; Kansas City War. Mem.; St. Louis Soldier's Mem. Bldg.; NYU; USMC medal; U.S. Air Mail Flyers Med.; Army & Navy Air Med.; Medalist Soc.; mem. fountain, St. Louis. Position: T., PAFA, 1929– [47]

HAND, Jo Hale [Por.P] Alhambra, CA b. 26 Je 1901, Chicago. Studied: Seyffert; AIC. Member: Calif. AC [40]

HAND, Molly Williams [T,P,E,En,W,L,B,Dr] Roselle, NJ b. 29 Ap 1892, Keene, NH d. 3 S 1951. Studied: PAFA; ASL; NYU; Columbia; D. Garber; J.T. Pearson; H. Breckenridge; A. Carles; G. Luks; R. Henri; J. Sloan; P. Hale; F. von der Lancken; A. Heckman; G. Bridgman. Member: NAWA; AAPL; Elizabeth (N.J.) SA; Art Council, State of N.J.; ASL; Westfield AA. Exhibited: NAWA; Intl. Women A., London, England, 1931; Toronto, Canada, 1937; Montclair A. Mus.; BM; Newark Mus.; Elizabeth, 1928 (prize), 1940 (prize); Art Week, Newark, 1932 (prize); N.J. Women's Cl., 1943 (prize), 1946 (prize). Work: Newark Mus.; Elizabeth Pub. Lib. Position: T., Pub. Sch. No. 13, Elizabeth [47]

HANDFORTH, Thomas (Schofield) [Li,P,I,W,E,L] Wilmington, DE b. 16 S 1897, Tacoma, WA d. 20 O 1948. Studied: Univ. Wash.; NAD; ASL; Ecole des Beaux-Arts; Grande Chaumière; Hawthorne; M. Young. Member: Guggenheim F., 1930; SAE; Chicago SE; Calif. SE; Baltimore WCC. Exhibited: WMAA, 1933, 1934, 1936; NAD, 1943, 1944; TMA, 1946; Brooklyn SE, 1926-29, 1927 (prize); SAE, 1930-36; Chicago SE, 1931-40, 1937 (prize); Phila. SE, 1932-38; Baltimore WCC, 1932-42; Calif. SE, 1941; Northwest PM, 1934 (prize), 1935-37; Paris; Boston S.Indp.A., 1937 (prize); Phila. Pr. C. Award: Caldecott Medal, 1939. Work: MMA; LOC; NYPL; FMA; Honolulu Acad. A.; SAM; PMA; CI; AIC; Bibliothèque Nationale, Fogg Mus.; Baltimore Mus.; Seattle Pub. Lib.; Los Angeles Mus.; Joslyn Mem., Omaha; Hackley Gal., Muskegon, Mich.; Minneapolis Inst. A.; "Fine Prints of the Year," 1926–34. Illustrator: "The Art of Terpsichore," by Luigi Albertiere. Contributor: Forum, Asia, other publications [47]

HANDLEY, Hester Merwin [Mur.P,I] NYC b. 26 Ja 1902. Studied: A. Polasek; N. Fechin; H. Giles. Work: stage sets, Town Hall; Withers Pub. Lib., Bloomington, IL [40]

HANDY, Ray D. [I] Duluth, MN b. 21 Ag 1877, Minneapolis. Position: Car., Duluth News-Tribune [21]

HANEMANN, J. Theodore [P] NYC [15]

HANEY, Irene W. [P,T] Pittsburgh, PA b. 3 F 1890, Pittsburgh. Studied: C. Walter. Member: Pittsburgh AA; Teachers AC [33]

HANEY, James Parton [P,T,W,L] NYC b. 16 Ap 1869, NYC d. 3 Mr 1923. Studied: Columbia; CCNY; ASL, with Bell, DuMond, Mucha, Woodbury. Member: SC; N.Y. Municipal AS; MacD. C.; Sch. Crafts C.; Sch. AL; Nat. Edu. Assn.; Council Supervisors Manual A. Nat. Soc. Promotion Indst. Edu.; Intl. Fed. Art Teaching; Nat. Assn. Decorative Arts and Industries, 1918–19; Eastern AA; Art-in-Trades C. Positions: T./Dir., Pub. Schools of N.Y., 1896–09; T., NYU Summer Sch., since 1907 [21]

HANKES, Louis C. [P,Des] Chicago, IL/Marblehead, MA b. 1882, St. Cloud, MN d. 30 S 1943, Chicago. Studied: AIC [17]

HANKINS, Cornelius [P] Nashville, TN b. 1864, Guntown, MS (settled in Nashville ca. 1900) d. 12 My 1946. Studied: W.M. Chase, N.Y. Sch. FA; Europe. Work: portraits, in public bldgs. [25]

HANKS, Emily Grace [W,I,L,S,Por.P] Brooklyn, NY b. NYC. Studied: Henri; J. Sloan; L. Simon. Exhibited: BM, 1927, 1931, 1935. Author: five illus. articles, "How to Draw the Head," Art Instruction Magazine, 1937. Lecture: How to Draw Heads. Positions: Des., tapestries, Herter Looms; T., PIASch; Newark Sch. F.&Indst. A. [47]

HANLEY, Francis Joseph [Edu,L,P] South Bend, IN b. 6 Ap 1913, Providence. Studied: RISD; Brown Univ.; Fordham Univ. Member: AAPL; Northern Ind. A.; Providence WCC; South County AA. Exhibited: Hoosier Salon, 1939, 1940 (prize), 1941, 1942; Northern Ind. A., 1939–41, 1946; Wightman Gal., Notre Dame, Ind. Work: Univ. Notre Dame; St. Remuald Chapel, Matunuck, R.I. Contributor: Providence Journal. Position: T., Univ. Notre Dame, 1937–46 [47]

HANLEY, Harriet Clark [S] Minneapolis, MN b. St. Louis, MO. Work: Fergus Fall, Minn. [33]

HANLEY, Meredith [P] Chicago, IL. Member: GFLA; Chicago AC [29]

HANLEY, Sarah E. [P] NYC/Oyster Bay, NY b. Ireland d. 11 F 1958. Studied: Tiffany Fnd., Oyster Bay. Member: Am. Assn. Women PS; Studio Gld., N.Y. Exhibited: NAWPS, 1935, 1936, 1937, 1938; Am. Anderson Gal., N.Y., 1928, 1930, 1931; Tricker, Ga., 1937. Work: Swarthmore Col.; St. Raymond's Convent, N.Y. [40]

HANLIN, Corna Searcy [P] Chicago, IL. Member: Chicago NJSA [25]

HANLON, Louis Wilfred James (Lou) [I] Richmond Hill, NY b. 12 O 1882 d. ca. 1955. Studied: PAFA; Drexel Inst.; PMSchIA. Member: SI. Position: Staff, N.Y. Daily Mirror [47]

HANNA, Theodore [P] Caldwell, NJ. Member: GFLA [27]

HANNA, Thomas King [P,I] Chester, CT b. 10 Ap 1872 d. 18 Mr 1951. Studied: Yale; ASL; Cox; Volk; I. Wiles; C.S. Rheinhart; J. Carlson. Member: AAPL; CAFA; Lyme AA; SC. Exhibited: AWCS; CAFA, 1937–45; Palm Beach A. Center, 1936; Clearwater A. Mus., 1936, 1943 (prize), 1945; Fla. Gulf Coast Group, 1944, 1945; Montclair A. Mus., 1914–26, 1931, 1935, SC, 1914–45; New Haven PCC, 1940-42; Soc. for Sanity in A., 1941; Lyme AA, 1943 –45. Work: Nat. A. Gal., Sydney, Australia. Illustrator: Harper's, Scribner's, American, Liberty, Woman's Home Companion, Saturday Evening Post, Life, to 1930 [47]

HANNA, William M. [P] Concord, MA b. 10 F 1855, Brooklyn, NY. Studied: CUASch; NAD; British Mus. Member: Concord AA [27]

HANNAFORD, Alice S. Ide (Mrs. Foster) [S] Winnetka, IL/White Bear, MN b. 28 Ag 1888, Baltimore. Studied: J.E. Fraser; ASL. Work: BM [40]

HANNAH, Muriel [P,G,I] NYC b. England. Studied: BMFA Sch.; ASL; P. Hale; W. James; Henri. Member: NSMP. Exhibited: WFNY, 1939; NSMP, 1940; Chicago AC, 1931 (one-man); BMA (one-man); A. Gal., Santa Barbara, (one-man). Illustrator: "People of Poros," 1942; national magazines [47]

HANNELL, H(azel Johnson) [P] Chesterton, IN b. 31 D 1895, La Grange, IL. Studied: Church Sch. A.; AIC [40]

HANNELL, V.M.S. [P,S] Chesterton, IN b. 22 Ja 1896, Negaunee, MI. Studied: AIC; Acad. FA, Obo, Finland. Member: Chicago SA. Exhibited: AIC, 1934 (prize). Work: St. Joseph's Church, Woods Hole, Mass.; Women's Athletic C., Chicago [40]

HANNELL, Vinol [P] Chicago, IL. Member: Chicago NJSA [25]

HANNIFORD, M. [P] Toledo, OH. Member: Artklan [25]

HANNON, Olga Ross (Mrs.) [B,T] Bozeman, MT b. 15 S 1890. Positions: Art Ed., Mont. Edu. Assn. magazine; T., Mont. State Col. [40]

HANNY, William F. [Car] Phila. PA. Work: Huntington, Lib. San Marino, Calif. [40]

HANSCOM, Trude (Mrs.) [E,P] Arcadia, CA b. 6 D 1898, Oil City, PA. Studied: Syracuse Univ.; Univ. Calif.; Univ. Southern Calif.; Otis AI. Member: SAE; Calif. SE; Calif. AC; Women Painters of the West. Exhibited: GGE, 1939; SAE, 1942, 1946; Laguna Beach AA, 1946 (prize); Springville, Utah; Los Angeles Mus. A., 1943 (prize); Calif. AC, 1943 (prize); Ebell C., Los Angeles, 1945 (prize); Los Angeles Pub. Lib., 1946 (prize). Work: LOC; SAE [47]

HANSEL, Caroline [P] Hartford, CT. Member: Hartford AS [25]

HANSELL, Ingeborg [P] Bronxville, NY. Member: S.Indp.A. [25]

HANSEN, Armin Carl [P,Et,T] Monterey, CA b. 25 O 1886, San Fran. d. 1957. Studied: his father, Henry W.; Mathews; Royal Acad., Stuttgart, Germany, with Grethe, 1906–08. Member: ANA, 1926; San Fran. AA; Calif. SE; SC; Allied AA; Wis. PS; Société Royale des Beaux-Arts, Brussels. Exhibited: P.-P. Expo, 1915 (med); Intl. Expo, 1910; San Fran. AA (med), 1918 (prize), 1919 (gold); NAD, 1920; Los Angeles Mus., 1923 (prize); Intl. PM, Los Angeles, 1924 (prize); Painters of the West, 1925 (gold); Print C. Phila., 1927 (prize); Santa Cruz AL, 1930 (prize), 1936; Olympic Exh., Los Angeles, 1932. Work: CMA; Kansas City AI; LOC; Newark Mus.; Los Angeles Mus. A.; de Young Mem. Mus.; NYPL; NAD [47]

HANSEN, Armin O. [P,T] Milwaukee, WI b. 1893 d. 1976. Studied: Fursman, AIC; NAD, with A. Mueller, G. Oberteuffer; Munich; Paris [*]

HANSEN, Bertha J. [S] NYC. Member: NSS [47]

HANSEN, Demont B. [P] Indianapolis, IN. Exhibited: 48 Sts. Comp., 1939 [40]

HANSEN, Douglas Reid [Edu,P,W,L] Columbia, MO b. 15 Jy 1900, Jersey City. Studied: NAD; Corcoran Sch. A.; Broadmoor A. Acad.; abroad; C. Hawthorne; Douglas Volk; Fontainebleau Sch. FA; State Kunstgewerbe Schule, Vienna. Member: CAA, Bd. Dir., 1942–48. Exhibited: TMA, 1937; Kansas City AI, 1939; CAM, 1945, 1946. Position: T., Univ. Mo. [47]

HANSEN, Einer [P] Chicago, IL. Member: Chicago SA [24]

HANSEN, Ejnar [P,Li,S,T] Pasadena CA b. 9 Ja 1884, Copenhagen, Denmark. Studied: Royal Acad. FA, Copenhagen. Member: Calif. WSC; Calif. AC; Pasadena SA; Council All. A.; Am. A. Cong.; Scandinavian-Am. A. Soc. Exhibited: AIC, 1918; Western Fnd., A., 1934 (prize), 1935; Sacramento (prize); Pomona, 1936 (prize); Pasadena, 1937 (prize), 1939 (prize); Los Angeles; Oakland, 1937 (prize); WFNY, 1939; GGE, 1939; CGA, 1943; CM, 1945; AIC, 1945, 1946; Los Angeles Mus. A., 1927 (prize) 1945 (prize); City of Los Angeles, 1945 (med); San Diego FA Soc., 1941 (prize); Los Angeles AC, 1941 (prize); Calif. WCC, 1944 (prize); NAD, 1946; Pasadena AI, 1943 (prize). Work: Los Angeles Mus. A.; San Diego FA Soc.; Pasadena AI; Pomona, Calif., Municipal Coll.; Santa Paula, Calif., Mus. Coll.; NYPL; USPO, Lovelock, Nev. WPA artist. Positions: T., Los Angeles County AI; Pasadena AI [47]

HANSEN, Frances Frakes [Edu,P,Des,C] Denver, CO b. 3 D 1915, Harrisburg, MO. Studied: Univ. Denver, with J.E. Thompson; AIC; Colo. State Col. Member: Denver A. Gld. Exhibited: Denver A. Mus., 1945; Denver A. Gld., 1944, 1945. Positions: T., Univ. Denver, 1942–46, Colo. Women's Col. [47]

HANSEN, Hans Peter [P,T] NYC b. 4 O 1881, Denmark. Member: Kunstgewerbe Verein. Exhibited: Arch. Lg. 1915 (prize). Position: T., ASL [25]

HANSEN, Herman Wendleborg [P,E] b. 1854, Dithmarschen, German (came to NYC ca. 1877) d. 1924, Oakland, CA. Studied: Simmonsen, in Hamburg, 1870; England, 1876; AIC, ca. 1881. Work: Denver AM; Eastman Mem. Fnd.; Miss. Best known for his Western genre scenes made during trips to Tex., N.Mex., Ariz, Mexico. His "Pony Express," 1900, was widely reproduced. Father of the Calif. etcher, Armin. [*]

HANSEN, James L. [S] Los Angeles, CA. Exhibited: 48 Sts. Comp., 1939. Work: USPO, Court House, both in Los Angeles. WPA artist. [40]

HANSEN, Oscar J.W. [S] b. 1892, Norway (came to U.S. in 1910) d. 1962, Charlottesville, VA. Member: Port Arthur Col., Texas; Evanston Acad., Ill.; Northwestern. Work: Smithsonian; colossal figures, Hoover Dam, Boulder Dam, 1935 [*]

HANSON, Arthur C. [P] Minneapolis, MN [24]

HANSON, B.K. [P] Wash., D.C. [04]

HANSON, Berta M. [P,I,T] Phila., PA b. 9 D 1876, Belmont County OH. Studied: H. Helmick, in Wash.; Ecole des Beaux-Arts, Paris. Member: S. Wash. A. [13]

HANSON, Floy Katherine [P] NYC. Member: Lg. AA [24]

HANSON, Henry T(hurland) [P,I] NYC/Milford, CT b. 12 Ag 1888, Chicago, IL. Studied: DuMond; Bridgman; Snell; J. Carlson [27]

HANSON, Maude [P] Woodstock, NY. Member: NYWCC; Art Dir. C. [29]

HANSON, Oscar [P] Chicago, IL. Member: AG of Authors Lg. A. [25]

HANWELL, T. [P] Crafton, PA. Member: Pittsburgh AA [25]

HAPGOOD, Alice. See Goodwin.

HAPGOOD, Dorothy Alden [P] West Hartford, CT b. 31 O 1892, Hartford, CT. Studied: H. Breckenridge; C.H. Woodbury. Member: CAFA; North Shore AA; Springfield AL; Hartford S. Women P. [40]

HAPGOOD, Theodore B. [Des] Watertown, MA b. 28 Ag 1871, Boston, MA d. 2 Jy 1838. Studied: BMFA Sch. Member: Soc. Printers; AI Graphic A.; Grolier C.; Boston SAC. Work: Western Reserve Acad. Bldg., Hudson, Ohio; Clark Univ.; Jamaica Plain (Mass.) Tuesday C.; General Alliance, Unitarian Bldg., Boston; Lakeside Press Bldg., Chicago [38]

HAPPERSBERGER, Paula [P] Avondale, OH. Member: Cincinnati Women's AC [19]

HAPPERSBURGER, Frank [S] San Fran., CA b. 21 O 1859, CA. Studied: Munich, with Knable, Eberle. Member: San Fran. AA [08]

HARARI, Hananiah [P] NYC b. 29 Ag 1912, Rochester, NY. Studied: Syracuse Univ.; Fontainebleau; Paris, with Leger, Lhote, Gromaire. Member: A. Lg. Am.; CAFA; Nat. Ser. Soc.; Audubon A.; Am. Abstract A. Exhibited: MOMA, 1941, 1943; WMAA, 1942–44; AV, 1942; Univ. Ariz.; MMA, 1943; NAD, 1941 (prize), 1942; CM, 1940; CAFA, 1941, 1942; AIC, 1940, 1943; PAFA, 1946; NGA, 1945; Finger Lakes Exh., Rochester, 1941, 1943–46; Audubon A., 1945 (prize). Work: WMAA; Univ. Ariz.; PMA; MOMA; Albright A. Gal.; SFMA; Rochester Mem. A. Gal.; State Univ. Iowa [47]

HARBAUGH, Marjorie Warvelle (Mrs.) [S] Hudson, OH b. 28 Jy 1897, Chicago. Studied: Milwaukee-Downer Col.; Univ. Wis.; M. Frame; W. Varnum; F. Aust. Member: Wis. Soc. Appl. A. Exhibited: Massillon Mus. A., 1945; Milwaukee AI. Work: Oriental Consistory Lib., Chicago; Univ. Wis. [47]

HARBESON, Georgiana Brown (Mrs. Frank Godwin) [P,I,C,Des,W,L,T] New Hope, PA b. 13 My 1894, New Haven, CT. Studied: PAFA; Moore Inst.; N.Y. Sch. Des.; NYU; PMSchIA; B. Breckenridge; J.T. Pearson, Jr.; D. Garber; V. Oakley. Member: NAWA; N.Y. Soc. Craftsmen; Phila. WCC; PBC; Needle and Bobbin C., NYC. Exhibited: PAFA, 1915 (prize), 1916 (prize); N.Y. Women's Expo. A.&Indst., 1929 (prize); N.Y. A. All., 1927 (prize); NAWPS, 1926 (prize); Art Alliance Am., 1929 (prize); Powell House Exh., 1935 (prize), 1937 (prize). Work: Honolulu Acad. A. Author: "American Needlework," 1938 [47]

HARCOFF, Lyla Marshall [P,T,Dec] Santa Barbara, CA b. Lafayette, IN. Studied: Purdue; AIC; Paris. Member: Hoosier Salon. Exhibited: Santa Barbara Mus. A., 1944 (prize); San Fran., 1944; San Diego; Los Angeles; Chicago [47]

HARCOURT, George E. [I] Detroit, MI b. 23 My 1897, Detroit. Studied: J. Wicker. Member: Scarab C.; Art Founders Soc. [33]

HARCOURT, Millicent Gifford [P,T] Larchmont, NY b. 17 N 1889, Jersey City. Studied: PAFA; C. Hawthorne; D. Garber; H. Breckenridge; G. Oberteuffer. Work: M.W. Kellogg Co., Chemical Show, Grand Central Palace [40]

HARDCASTLE, Corinne B. [P,T] Germantown, PA b. Chicago d. 20 Ap 1941. Studied: Moore Inst., Phila.; Europe. Exhibited: PAFA; Phila. AL. Position: T., Germantown H.S., 25 yrs.

HARDENBERGH, Elizabeth R(utgers) [P,C] NYC b. New Brunswick, NJ. Studied: H.B. Snell; Mrs. E.M. Scott. Member: NAWPS; NYWCC; Allied AA; SPNY [40]

HARDENBERGH, Gerard Rutgers [I] Bay Head, NJ b. 1855 d. 19 Ag 1915. Specialty: bird life

HARDER, Charles M(abry) [Cr,Des,T] Alfred, NY b. 23 N 1899, Birmingham, AL d. S 1959. Studied: AIC; Alfred Univ.; C.F. Binns; H. Hofmann. E. Thurn; State Col. Cer. Member: Am. Cer. Assn. Exhibited: Syracuse Mus. FA, 1932 (prize), 1935 (prize) 1937 (prize), 1938, 1939 (prize); MMA, 1930; Paris Expo, 1937 (gold); Boston SAC, 1935 (prize). Positions: T., State Col. Cer., Alfred (Univ.) Sch. Pottery, 1928–40 [47]

HARDER, Nicholas [P] Chicago, IL [10]

HARDIE, Robert Gordon [P] NYC/Brattleboro, VT b. 29 Mr 1854, Brattleboro. d. 10 Ja 1904. Studied: CUASch; NAD; ASL [04]

HARDIN, Adlai S. [P,S] Darien, CT b. 23 S 1901, Minneapolis. Studied: AIC; Princeton. Exhibited: NA, 1938; PS Ann., PAFA, 1939; Arch. Lg., 1941 (prize); NAD, 1945 (med). Work: PAFA; IBM Coll. [47]

HARDIN, Ernest R. [Des,Dec,P,B] Austin, TX b. 13 S 1902, Granger, TX. Studied: G.E. Browne; W. Adams; AIC. Member: SSAL [40]

HARDING, Anne Seamon (Mrs. Nelson) [Por.P] b. 1887, Charlottesville, VA d. 15 Ap 1936, NYC. Studied: R. Henri; K.H. Miller

HARDING, Blanche Lillibridge (Mrs.) [B,C,Des,L] Jamestown, ND/Dickinson, ND b. 8 Ag 1909. Exhibited: Syracuse Art Exh., 1934. Work: Univ. N.Dak. Author: "Lets Make Puppets" (pamphlet), "Game Boards and Puzzles" (bulletin) [40]

HARDING, Charlotte. See Brown, James A., Mrs.

HARDING, Chester [P] New Orleans/Vineyard Haven, MA b. 31 D 1866, Enterprise, MS d. 1937. Studied: M.E. Browne; Delecluse; Paris. Member: SSAL; Ala. AL; NOAA [33]

HARDING, Constance [Des,P] Frederick, MD/Woodstock, NY b. 26 Ap 1890, Frederick. Studied: N.Y. Sch. F.&Appl. A.; G. Bridgman; W. Reiss; W. Goltz; ASL; PMSchIA; NAD; N.Y. Evening Sch. Indst. Art; D. Romanovsky; research work, AMNH. Member: Am. Ar. Prof. Lg. Exhibited: CGA, 1937; Wash. County Mus. FA, Hagerstown, Md., 1937, 1938, 1939; designs, textiles, stage costumes [40]

HARDING, Dorothy Sturgis (Mrs. Lester W.) [Des,Dr,W] Portsmouth, NH b. 28 1891, Boston. Studied: BMFA Sch. Member: Am. Soc. Bookplate Collectors & Designers; Boston SAC. Exhibited: Phila. Pr. Cl.; Jr. Lg. Gal., Boston; Boston Tercentenary, 1930 (med). Work: bookplates, MMA, Am. Antiquarian Soc. (Worcester, Mass.), Phila. Pr. C., Boston Soc. A.&Cr., British Mus. (London); bookplate for Mrs. Franklin D. Roosevelt. Author: article, "Contemporary Bookplates," Am. Magazine of Art, 1932 [47]

HARDING, George [P,Mur.P,Dec,I] Wynnewood, PA b. Phila. d. 1959, Wynnewood. Studied: PAFA; H. Pyle; abroad. Member: NA. Exhibited: CI; CGA; PAFA, 1939 (prize). Work: USPO, Administration Bldg., Wash., D.C.; USPO, Municipal Court Parkway, U.S. Customs House, First Nat., Corn Exchange Banks, all in Phila.; WFNY, 1939. Positions: Official Artist AEF, 1918–19; T., PAFA [47]

HARDING, Goldie Powell (Mrs.) [P,T,L] San Marino, CA b. 11 Ja 1892, San Leandro, CA. Studied: Univ. Calif.; Calif Sch. FA; Columbia. Member: Calif. AC; Calif. WSC; Los Angeles AA; Women Painters of the West; Council All. A. Exhibited: Oakland A. Gal., 1932–40; SFMA, 1927, 1928; Los Angeles Mus.; San Diego FA Soc., 1937; Riverside Mus., 1946; GGE, 1939; Los Angeles AA, 1946; Calif. AC, 1936–38, 1940; Santa Cruz, Calif., 1928 [47]

HARDING, Grace M. [P] Wash., D.C. [25]

HARDING, J. Horace [Patron] b. 1863, Phila. d. 4 Ja 1929, NYC. Member: Am. Fed. Arts. He was a patron of art and collector of rare paintings.

HARDING, Nelson [I,Car] Brooklyn, NY b. 1876, Brooklyn, NY d. 30 D 1944, NYC. Studied: ASL; Chase Sch. FA. Award: Pulitzer art award, 1926, 1927. Position: Staff, Brooklyn Eagle, 25 yrs. [19]

HARDMAN, Charles [P] Augusta, GA. Work: USPO, Beach Branch, Miami, Fla. WPA artist. [40]

HARDRICK, John W. [P,T] Indianapolis, IN b. 21 S 1891, Indianapolis. Studied: W. Forsyth; O. Stark. Member: Ind. AA. Exhibited: Ind. State Exh., 1933 (prize). Work: Fletcher Savings and Trust Co., YMCA, both in Indianapolis; Wilberforce Univ.; John Herron AI; Tuskegee, Ala. [40]

HARDWICK, Alice R. (Mrs. Melbourne H.) [P,W,T] Annisquam, MA. b. Chicago. Studied: DuMond; B. Harrison; ASL; Holland; Belgium. Member: Springfield AL; North Shore AA; Copley S.; AFA [33]

HARDWICK, John W. [P] Indianapolis, IN [24]

HARDWICK, Lily Norling [Por.P,L] Seattle, WA b. Ellensburg, WA. Studied: Chicago AFA. Member: Women A. Wash. Lectures: Painting Among the Indians (a Seattle AM lecture) [40]

HARDWICK, Melbourne H. [P] Belmont, MA. b. 29 S 1857, Digby, Nova Scotia d. 25 D 1916. Studied: Boston; Europe. Member: SC 1907; Boston SWCP; Boston AC; CAFA [15]

HARDY, Anna Eliza [P] South Orrington, ME b. 26 Ja 1839, Bangor, ME d. 15 D 1934. Studied: G. Jeanin, in Paris; A.H. Thayer, in Dublin, N.H. Exhibited: NAD, 1876–77. Specialty: flowers. Daughter of Jeremiah Hardy (1800–88). [25]

HARDY, Beulah Greenough (Mrs.) [P,Min.P] Phila., PA b. Providence. Studied: Paris, with Collin, Merson, Courtois, V. Reynolds; Sir C. Holroyd, in London. Member: Soc. Miniaturists, London; Plastic C.; Phila. Alliance; Phila. PC; AFA [33]

HARDY, Charles [P,I] Westport, CT b. 29 My 1888, England d. 12 Ag 1935, Utica, NY. Studied: E.P. Kinsella. Member: Artists Gld.; SI [33]

HARDY, Horace W. [P,I,Li] Phila., PA d. ca. 1955. Studied: PAFA. Member: SI [47]

HARDY, Howard C. [I,P] NYC. Member: SI. Exhibited: 48 Sts. Comp., 1939 [47]

HARDY, Walter Manly [P,I] Brewer, ME b. 9 F 1877, Brewer d. 17 S 1933, East Holden, ME. Studied: Bangor, Maine, with Mary Merrill, Helen Smith, Lucy Kimball, ca. 1897; ASL, with Blum, Cox, Brush, Clark, Bridgman; C. Lasar, in Paris. Opened NYC studio, 1902. Related to Jeremiah Hardy (1800–88), Anna E., and Mary Ann (1809–87), all painters. His sister Fannie H. Eckstrom (1865–1946) was a noted Maine author. He maintained a well-known orchard in East Holden. [21]

HARE, Channing (Weir) [Por.P] Ogunquit, ME b. 20 Ap 1899, NYC. Studied: ASL; R. Henri; G. Bellows; W. Zorach. Member: Soc. Four A., Palm Beach, Fla. Exhibited: Soc. Four A., 1942 (prize), 1943 (prize), 1944 (prize); WMA, 1935; BMA, 1936; John Herron AI, 1943. Work: Va. Hist. Soc. [47]

HARE, Elizabeth Sage [P] Huntington, NY. Member: CAFA [25]

HARE, J. Knowles [I,E] NYC b. 19 Ja 1884, Montclair, NJ d. 27 F 1947. Member: SI. Illustrator: magazines, cover designs. Portraits in drypoint. [40]

HARE, Jeannette R. [S] NYC/Ogunquit, ME b. 24 Ag 1898, Belgium. Studied: C.C. Rumsey; A.S. Calder; H. Frischmuth. Member: NAWPS [33]

HARE, Michael Meredith [Des,Arch] NYC b. 17 Ja 1909 d. 30 Ag 1968, Smithtown, NY. Studied: Groton Sch.; Yale; Columbia; Paris. Member: Municipal Art Soc., N.Y.; MOMA. Work: des., Nordic Theatre, Marquette, Mich. [40]

HARE, Richard Clark [P] Brooklyn, NY/Lake Ozonia, NY b. 23 Ag 1906, Brooklyn. Studied: G. Bridgman; R. Lahey; E. Penfield; ASL; Pratt Inst. Member: Brooklyn SA; Brooklyn PS; NYWCC; AWCS [40]

HARER, Frederick W. [P,S,C] Uhlerstown, PA b. 15 N 1879, Blossburg, PA d. 27 Ap 1949. Studied: PMSchIA; PAFA; Chase; Anschutz. Exhibited: NAD, 1942–45, 1945; PAFA, 1916, 1939–43, 1944 (med), 1945; PMA, 1940; Baltimore WCC, 1921 (prize). Work: PAFA; Reading (Pa.) Mus. A. [47]

HARGENS, Charles (W., Jr.) [I] Carversville, PA b. 30 Ag 1893, Hot Springs, SD. Studied: PAFA; Breckenridge; Garber; McCarter; Chase; Carlson; Beaux. Member: SI; Phila. Sketch C. Illustrator: Western stories, history books for leading publishers, national magazines. Position: T., PAFA [47]

HARGER, Jessie C. (Mrs.) [Min.P] New Haven, CT [15]

HARGRAVE, Ronald [P] Peoria, IL. Studied: AIC [15]

HARHBERGER, Florence E. Smith (Mrs.) [P,I,T] Syracuse, NY b. 19 N 1863, Cortland County, NY. Studied: ASL; CUASch, with Brush, J.A. Weir, Shirlaw, F. Freer. Member: Utica Art C.; Utica Sketch C. [29]

HARITONOFF, Nicholas B. [Por.P] NYC b. 1880, Russia (came to U.S. after Russian Revolution) d. 30 S 1944. Studied: Imperial Acad., St. Petersburg, Russia; France; Germany.

HARKAVY, Minna R. [S] NYC b. 13 N 1895, Estonia. Studied: Hunter Col.; Paris, with Bourdelle. Member: An Am. Group; NAWA; S. Gld.;

Am. Soc. PS&G; NYSWA; Soc. Am. S.; Collaborative Group PS&Arch.; Boston AC; Am. A. Cong.; Salon de Tuileries, Paris. Exhibited: AIC; CI; PAFA; WMAA; MMA; Albright A. Gal.; SFMA; Munson-Williams-Proctor Inst.; NAWA (prizes). Work: USPO, Winchester, Mass.; MOMA; Mus. Western A., Moscow; Biro-Bidjan Museum, USSR [47]

HARKER, George A. [S,L] St. Louis, MO b. St. Louis. Studied: St. Louis Sch. FA. Member: St Louis A. Gld. Exhibited: St. Louis Expo, 1898 [98]

HARKER, Katherine Van Dyke [B] Mill Valley, CA b. 11 Ap 1872, San Fran. Studied: Mucha; Castelucho; Matthews; Fletcher. Member: San Fran. AA; San Fran. Soc. Women A. [32]

HARLAN, G(race) Paul [P,T] Omaha, NE b. 32 My 1908, Seattle. Studied: AIC; Chicago Acad. FA; J. Norton. Member: Omaha AG. [33]

HARLAN, H(arold) C(offman) [P,I,E] Dayton, OH b. 5 Ap 1892, Dayton. Studied: M. Seiffert; C. Howell. Member: AIA; Dayton SE; Ohio State A. of Arch.; Allied Arch. and Engineers S. Specialties: book illustrating; mural dec. of bldgs. [40]

HARLAND, Mary [P,Min.P] Santa Monica, CA b. 8 O 1863, Yorkshire, England. Studied: London; Dresden; Paris. Member: Calif. Soc. Min. P. Exhibited: Pan-P. Expo, San Fran., 1915 (med) [33]

HARLES, Victor Joseph [P,T] Clayton, MO b. 22 F 1894, St. Louis, MO. Studied: St. Louis Sch. FA. Member: St. Louis AL [27]

HARLEY, Charles R(ichard) [S] New Hope, PA b. 25 Mr 1864, Phila. Studied: Spring Garden Inst.; PAFA; Académie Julian, Paris; St. Gaudens; Florence Acad. FA. Member: NSS; Boston SAC. Exhibited: Pan-Am. Expo, Buffalo, 1901 [25]

HARLEY, John J. [P] Dorchester, MA [06]

HARLOS, Stella [P,T] Milwaukee, WI b. 6 Ag 1901, Milwaukee d. 1978. Studied: Layton Sch. A.; G.V. Sinclair; W. Owens, Jr. Member: Wis. Soc. AC. Exhibited: Milwaukee AI, 1924 (prize) [33]

HARLOW, Arthur [P] Salem, MA [13]

HARLOW, H(arry) M(errick) S(utton) [P,B,Dr,C,Dec,Des,L,T] Portsmouth, NH b. 19 Jy 1882, Haverhill, MA. Studied: Eric Pape Sch. A. Member: AAPL. Work: Trinity Church, Haverhill, Mass.; St. Augustine & St. Martin Mission Church, Boston; Chapel of the Soc. of the Divine Compassion, NYC; Christ Church, Masonic Home, Portsmouth, N.H.; Haverhill Hist. Soc.; bookplates, Los Angeles Mus. A. Lectures: "Colonial—Doorways, Houses, Ships" [47]

HARLOW, Robert Elsing, Jr. [Ser,C,W] Brooklyn, NY b. 20 Mr 1914, Phila. Studied: Univ. Pa.; PAFA; Columbia. Member: Phila. Ar. U.; Springfield (Mass.) AL. Exhibited: CGA, 12937; VMFA, 1938; NAD, 1941, 1942; CI, 1942; MMA (AV), 1942; Albany Inst. Hist.&A., 1941-43; Hartford Atheneum, 1941-43; CAFA, 1940-42. Work: Albany Inst. Hist.&A.; Dumbarton Oaks Coll. [47]

HARMAN, Fred, Jr. [I,P,Car] Pagosa Springs, CO (1974) b. 1902 (OH? MO?). Member: SI; Cowboy A. Am. Creator: cartoon strip "Red Ryder," 1935-60 [47]

HARMER, Alexander F. [P,I] b. 1856, Newark, NJ d. Ja 1925, Santa Barbara, CA. Studied: PAFA, with Eakins, Anshutz, ca. 1874. Work: Los Angeles Mus. A.; Univ. Tex., Austin. Illustrator: of Indians for Harper's, 1883; "Snake Dance of the Moquis," 1880s

HARMER, T(homas) C. [Ldscp.P] Tacoma, WA b. 29 Ap 1865, Hastings, England. Studied: L.H. Meakin; Duveneck. Member: Tacoma AS; Seattle FA Soc. [27]

HARMES, Adrienne Etesse [P] Sarasota, FL b. 29 Je 1904, Ridgewood, NJ. Studied: V. Perard; Hawthorne. Member: Sarasota A. Assn. Exhibited: Wis. State Fair, 1929 (prize); Minn. State Fair, 1931 (prize). Work: Shorewood H.S., Milwaukee [40]

HARMON, Evelyn Shaylor [S,P,Min.P] Gloucester, MA b. 26 Ag 1871, Portland, ME. Studied: BMFA Sch.; E.A. Bourdelle, in Paris. Member: North Shore A. Cl.; Boston A. Cl.; Gloucester Soc. Ar.; Copley Soc.; Pa. Soc. Min. P. Exhibited: Vose Gal., Boston (one-man); PAFA [40]

HARMON, Elizabeth Charles [P,I,E] Mossy Creek, VA b. 9 Ja 1876, Wash., D.C. [17]

HARMON, Edith Boynton [P,S] Highland Park, IL. Exhibited: Chicago A. Exh., AIC, 1936 (prize) [40]

HARMON, Adelaide Heinitah [P] Nashville, TN b. 6 My 1897, Spartanburg, SC. Studied: Lee Acad., Memphis. Exhibited: WC Ann., PAFA, 1937, 1938 [40]

HARMES, Elmer Esmond [P,Dr,T] Sarasota, FL b. 30 Je 1902, Milwaukee d. 1951. Studied: G. Oberteuffer; A. Carles; H. McCarter; G. Moeller. Member: Wis. PS; Minn. AA; Sarasota A. Assn. Exhibited: PAFA, 1924 (prize); Wis. PS, 1928 (prize); Milwaukee AI, 1929 (med,prize), 1931 (prize); Wis. State Fair, 1929 (prize), 1930 (prize); Twin City A. Exh., Minneapolis, 1929 (prize), 1933 (prize), 1934 (prizes). Work: Milwaukee AI; Univ. Minn. Position: T., Ringling Sch. A. [40]

HARMON, Harriet (Mrs.) [I,P] Atlanta, GA b. 20 Je 1891, Springfield, OH. Studied: N.Y. Sch. F.&Appl. A.; Univ. Tenn. Member: SSAL; Assn. Ga. A.; Atlanta AA. Position: A., Ruralist Press, Atlanta [40]

HARMON, Lily [P,Li] NYC b. 19 N 1913, New Haven, CT. Studied: Yale; ASL; Paris. Member: NAWA; A. Lg. Am. Exhibited: CI, 1943-45; PAFA, 1944; WMAA, 1945; AIC, 1946; Los Angeles Mus. A., 1945. Work: Encyclopaedia Britannica Coll. Illustrator: "Pride and Prejudice," 1945 [47]

HARMON, Luella Shaylor (Mrs. Harry True) [Min.P] Portland, ME [19]

HARMS, Alfred [P] San Fran., CA [17]

HARMSTONE, John H(erbert) [Indst.Des,S] Attleboro, MA b. 17 S 1873, Sheffield, England. Studied: Royal Col. A., London. Member: Boston Soc. A.&Crafts; Utopian Cl., Providence. Exhibited: Attleboro, Mass., annually. Work: Genealogical Soc., Boston; Brackett Sch., Arlington, Mass.; Sweet Pub. Lib., Attleboro. Positions: Des., Gorham & Co., Tiffany & Co., International Silver Co.; Partner, Charles Thomas & Son, Inc. (enameled gold and silverware), Attleboro, 1922– [47]

HARN, W.F. (Mrs.) [P] Oklahoma City, OK. Member: Okla. AA [25]

HARNEY, Paul E. [P] St. Louis, MO/Alton, IL b. 21 O 1850, New Orleans. Studied: Royal Acad., Munich. Member: St. Louis AG [15]

HARNLY, Perkins [P,T] NYC b. 14 O 1901, Ogallala, NE. Studied: N.Y. Sch. Interior Dec. Exhibited: WMAA, 1936; Levy Gal., N.Y. Acad. All. A. WPA artist. Position: T., YMHA, New York [40]

HARO, Julio [Des,C,P,Dec] Flint, MI b. 28 O 1898, Mexico City. Studied: Carl Bergmans; Mexico. Member: AFA; Flint Inst. A. Work: dec., "SS Manhattan," "SS Washington"; Univ. Detroit; Pontiac Motor Co. (Pontiac motor car instrument panel, 1937). Specialty: tile dec. Position: A., General Motors Corp. [47]

HARPER, Edith Walters [P] Cincinnati, OH b. Dayton. Studied: Duveneck. Member: Cincinnati Women's AC [27]

HARPER, E(dwin) L(aurence) [Car,Des,P] NYC b. 27 Ap 1883, Alexandria, VA. Studied: Md. Inst.; NAD; ASL; Columbia; Paris. Cartoonist: King Features newspapers [47]

HARPER, F.R. [Por.P] Glencoe, IL b. 3 Ja 1876, Rock Island, IL. Studied: AIC; Chase; Henri. Member: Chicago PS; Chicago Gal. Assn. Work: Northwestern Univ.; Lawrence Col., Appleton, Wis.; Chicago Bar Assoc. Position: T., Evanston Acad. FA [40]

HARPER, Frank Robert [I,Des] Grand Rapids, MI b. 19 Ag 1908, Grand Rapids. Studied: AIC; Kendall A. Sch., Grand Rapids. Illustrator: "Forgetful Bear, 1942, "Unhappy Rabbit," 1943. Positions: Staff, Detroit Free Press, 1935; Des., General Motors Corp., 1944-45 [47]

HARPER, George C(oburn) [E,En] Northville, MI b. 23 O 1887, Leetonia, OH d. 31 Jy 1962, Santa Barbara, CA. Studied: Cleveland Sch. A.; ASL; M. Fuller. Exhibited: Detroit IA, 1930 (prize); Chicago SE, 1928-30; Brooklyn SE, 1928, 1930; NAC, 1930; Bibliothèque Nationale, Paris, 1928; Calif. Pr.M., 1929, 1930; NAD, 1936; LOC, 1945; Sweden, 1937, 1938. Work: Detroit IA; Akron AI; Los Angeles Mus. A.; Bibliothèque Nationale [47]

HARPER, Lillie Hyde [C,S] NYC b. 25 Je 1881, NYC d. 22 S 1941. Studied: Inwood Pottery; Grand Central A. Sch.; ASL; Fontainebleau, Ecole des Beaux-Arts, Paris. Member: NYSC; NAC; Keramic Soc; Des. Gld., N.Y. Exhibited: Wolfe AC, New York, 1930 (prize). Specialty: pottery. Work: baptismal font, St. Stephen's Church, Fort Yukon, Alaska [40]

HARPER, Lois [P] NYC. Member: S.Indp.A. [24]

HARPER, Margaret [P] NYC/Lenoir, NC [25]

HARPER, Marian Dunlap [Min.P] Glencoe, IL. Studied: AIC; Paris. Member: Chicago SA; Chicago Soc. Min. P.; Chicago AG [33]

HARPER, Nina [P] New Orleans, LA [15]

HARPER, Sophie Louise [Des,Por.P] Bronx, NY b. 6 N 1893. Studied: F. Erlich; F. Southard; W. Starkweather; G. Petit; T. Furlong. Designer: textiles [40]

HARPER, William A. [P] Chicago, IL b. 1873, near Cayuga, Canada d. 27 Mr 1910, Mexico City. Studied: AIC, 1895–1901. Member: Chicago SA. Exhibited: AIC, 1905 (prize), 1908 (prize). Active in Paris, 1903–05, 1907–08, with O. Tanner. Position: T., Pub. Sch., Houston [13]

HARPER, William St. John [P,E,T] NYC b. 8 S 1851, Rhinebeck, NY d. 2 N 1910. Studied: NAD; Bonnât, Munkacsy, in Paris. Member: ANA, 1892; A. Aid Soc.; N.Y. Etching Cl. Exhibited: NAD, 1885 (prize); Pan-Am. Expo, Buffalo, 1901 (prize). Positions: Head/T., ASL; T., NAD; CUASch; Sch. A.&Crafts; Emma Willard Art Sch. (Troy, N.Y.), Summer Sch. Painting (Northport, N.Y.); A. Dir., New York Daily Graphic, 1878 [10]

HARRINGTON, Esther [P] Yonkers, NY [24]

HARRINGTON, G.W. (Mrs.) [P] Louisville, KY. Member: Louisville AL [01]

HARRINGTON, George [Ldscp.P] b. 1833 d. 11 Jy 1911, Springfield, MA. Exhibited: NAD, 1885; PAFA; Boston A. Cl. In his youth he gave up a profitable business to study art.

HARRINGTON, Joseph [P] b. 1841 d. 1900. Active in San Fran., ca. 1870s, painting mining scenes. Work: SFMA [*]

HARRIS, Albert L. [P] Wash., D.C. [25]

HARRIS, Alexandrina Robertson [Min.P] Hollis, NY b. 11 Jy 1886, Aberdeen, Scotland. Studied: Adelphi Art Sch., with Whitaker; ASL; Am. Sch. Min. P.; Fontainebleau Sch. FA, Paris, with Despujols. Member: Am. Soc. Min. P.; Brooklyn WCC; Municipal A. Com.; NAWA; Brooklyn Soc. Min. P.; Pa. Soc. Min. P.; Brooklyn SA; AWCS. Exhibited: Brooklyn Soc. Min. P., 1935 (prize); Baltimore WCC, 1922 (prize); NAWA, 1922 (prize), 1935 (prize), 1944 (med); Calif. Soc. Min. P., 1941 (prize); CGA, 1940; PAFA, 1920–45; BM, 1936; Century of Progress, Chicago, 1933; High Mus. A., 1944; Royal Soc. Min. P., London, 1924; WFNY, 1939; MMA, 1944. Work: PMA; CGA [47]

HARRIS, Alice Fogg (Mrs.) [C] Cambridge, MA b. 10 Je 1868, South Berwick, ME. Studied: Mrs. P. Brooke; M. Hill. Member: Textile Weavers Gld., Boston. Exhibited: weaving, Boston SAC, 1929 (gold star). Specialty: weaving [40]

HARRIS, Ben Jorj [I,Car] New Rochelle, NY b. 24 O 1904, Albany, GA d. 19 D 1957. Member: New Rochelle AA. Illustrator: "Riding the Air" (1943), "The Adventures of Tommy Teaberry" (1945), national magazines, covers [47]

HARRIS, C. Hartman K. [P] Devon, PA d. 11 Ag 1909, near Boston (drowned in the Charles River). A young painter, he studied and exhibited at PAFA. [08]

HARRIS, C.N. [P] Phila., PA [13]

HARRIS, Caroline Estelle [P,I,Car,T] Raleigh, NC/Junction City, Arkansas, LA b. 26 S 1908, Junction City. Studied: Newcomb Col., AIC. Member: SSAL. Exhibited: New Orleans A. Assn. Ann., Delgado Mus., 1929 (prize); N.C. Women's Cl. Traveling Exh. Position: T., St. Mary's Jr. Col., Raleigh [40]

HARRIS, Caroline R. [P] Villa Nova, PA [15]

HARRIS, Charles Gordon [P] Lincoln, RI b. 17 O 1891, Providence, RI. Studied: RISD; C. Farnum; S. Tolman; G.A. Hays. Member: Providence AC; Providence WCC; South County AA. Exhibited: Providence AC; Providence WCC; South County AA [47]

HARRIS, Charles S. [P] NYC [01]

HARRIS, Caryl [P] NYC b. 31 Mr 1884, Walton, NY. Studied: Yale; ASL. Member: S.Indp.A.; MacD. Cl. Exhibited: S.Indp.A., 1939; Vendôme Gal., 1939; All.A.Am., 1939, 1941; Oakland A. Gal., 1940, 1944; Town Hall Cl., 1945; Blue Bowl, N.Y., 1939 (one-man); MacD. Cl., 1939 [47]

HARRIS, Charles X. [P,C] Richmond, VA b. 1856, Foxcroft, ME. Studied: Cabanel, in Paris. Work: Memorial Hall, Phila.; portraits, Manor Hall, Yonkers; Mercantile Lib.; Lambs' Cl., New York; Univ. Va.; Va. Hist. Soc.; stained glass window, Doylestown, Pa.; Percé, Quebec. Worked in stained glass. [31]

HARRIS, Daniel Albert [P] NYC b. 22 D 1914, NYC. Studied: NYU; Master Inst. United Arts, New York; NAD; W. Reiss [40]

HARRIS, Edith Maud [P] Wash., D.C. [17]

HARRIS, Florence E. [P] Wash., D.C. [13]

HARRIS, George A. [P,Gr,Mus.Cur,Des,T,S,Li] Sausalito, CA b. 24 Ja 1913, San Fran. Studied: Calif. Sch. FA. Member: Art Center San Fran.; Am. A. Cong.; San Fran. AA. Exhibited: San Fran. AA, 1935 (prize), 1944; San Fran., 1944–45 (prize); AIC, 1937; NAD, 1943; CGA, 1943; LOC, 1945; Buffalo Pr. Cl., 1943; CI, 1945; Colorado Springs FA Center, 1945. Work: SMA; San Fran. AA; Coit Tower, San Fran.; mural, USPO, Woodland, Calif. WPA artist. Positions: T., Stanford Univ., 1944–46; SFMA, 1944–46 [47]

HARRIS, George E(dgerly) [P,E] Winchester Center, CT b. 22 O 1898, Milford Hundred, DE d. ca. 1938. Studied: NAD; C.C. Curran; C.X. Harris; Académie Julian, Paris. Member: Mural P.; SC. Work: portraits, Phillipse Manor Hall, Yonkers, N.Y. [38]

HARRIS, Georgia Maverick [P] San Antonio, TX b. 20 O 1889, San Antonio. Studied: H.L. McFee; H.A. DeYoung. Member: SSAL. Exhibited: San Antonio A. Lg, 1938 (prize); Tex. FA Assn., Austin, 1937, 1938; SSAL, Montgomery, Ala., 1938; San Antonio, 1939. Position: Staff, Witte Mus. [40]

HARRIS, Greta [P] Pasadena, CA [19]

HARRIS, John Rolla [Des,C] NYC b. 24 S 1888, Cincinnati, OH. Studied: PIASch; Ecole des Beaux-Arts; Ware; Hornbostle; Hirons. Exhibited: Nat. Toy Fair, 1944, 1945. Designer/Constructer, mechanical toys, articles for interior decoration [47]

HARRIS, John Taylor [P,E,Car,I,T] Phila., PA b. 7 D 1908, Phila. Studied: PMSchIA. Exhibited: PAFA, 1934; Cheyney State Col., 1945; Morgan State Col., 1945. Position: Art T., Wharton Settlement, Phila., 1940 [47]

HARRIS, Julian Hoke [S,C,T] Atlanta, GA b. 22 Ag 1906, Carrollton, GA. Studied: Ga. Sch. Tech.; PAFA. Member: Studio Cl., Atlanta; Assn. Ga. Ar.; SSAL; Atlanta A. Assn. Exhibited: SSAL, San Antonio, Tex., 1939 (prize); Am. A. Ann., Rockefeller Center, New York, 1937, 1938; WFNY, 1939. Work: Coca-Cola Co., Capitol Hill, Morris Plan Bank, Ga. Sch. Tech., all in Atlanta; Ga. State Prison; Water Works Bldg., Augusta, Ga.; County Court House, Kingston, N.C. Position: T., Ga. Tech. [40]

HARRIS, Louis [P,T] NYC b. 7 N 1902, St. Louis, MO. Studied: ASL; K.H. Miller; M. Weber. Member: Fed. Mod. P.&S. [47]

HARRIS, Margie Coleman [P,S,T,E,W,L,C] Johnstown, PA b. 30 Mr 1891, Wash., D.C. d. ca. 1968. Studied: CI; Univ. Pittsburgh. Member: Eastern AA; Nat. Edu. Assn.; Assoc. A. Pittsburgh; All. A., Johnstown; Cambria County AA. Exhibited: Ebensburg, 1932–41; Ebensburg Fair, 1935 (prize); All. A. Johnstown, 1933 (prize), 1934 (prize), 1935 (prize), 1936 (prize), 1937 (prize), 1938–46; Garden Cl., 1938–45 (prizes); Indiana, Pa., 1944–46; Assoc. A. Pittsburgh, 1924–46. Work: Cambria Lib.; All. A. Johnstown. Positions: T., Pa. State Col., 1919–38; Pres., All. A. Johnstown, 1933–46 [47]

HARRIS, M(arian) D. (Mrs. Robert M. Barton) [P,T] Wilmington, DE b. 22 Ap 1904, Phila. Studied: PAFA; Breckenridge; Wayman Adams. Member: AWCS; Plastic Cl.; Wilmington Soc. FA; AAPL. Exhibited: Wilmington Soc. FA, 1930 (prize); PAFA; NAD; AIC; AWCS, 1946; Rochester Mem. A. Gal.; TMA; Wilmington Soc. FA, annually; Phila. AC; Phila. Plastic Cl.; WFNY, 1939; Harrisburg Mus. A. Work: Albright A. Gal.; Phila. A. All.; Wilmington YWCA [47]

HARRIS, Mary Aubin [P] Portsmouth, NH b. 1864, San Fran. Studied: Chase; Wiles [10]

HARRIS, Reginald G., Mrs. See Davenport, Jane.

HARRIS, Robert George [I,L] Westport, CT (1976) b. 9 S 1911, Kansas City, MO. Studied: Kansas City AI, with Crews; Grand Central Sch. A., with H. Dunn; ASL, with Bridgman. Member: SI; Westport A. Group. Exhibited: SI; A. Dir. Cl., 1943–46; New Rochelle AA; Westport A. Group. Illustrator: Western pulps, Saturday Evening Post, other magazines [47]

HARRIS, Saide (Mrs.) [P] Rochester, NY [08]

HARRIS, Sam H. [P] Los Angeles, CA. Member: Calif. AC [25]

HARRIS, Sarah L. [P] Pittsburgh, PA. Member: Pittsburgh AA [25]

HARRIS, William Laurel [Mur.P,P] NYC/Lake George, NY b. 18 F 1870, NYC d. 3 Jy 1924. Studied: T.W. Dewing; Gérôme, Galland, Lefebvre, Doucet, all in Paris. Member: Mural P.; Arch. Lg., 1898; NAC; N.Y. Municipal AS; A. Aid Soc.; MacD. Cl.; Fine Arts Fed., N.Y. Work: Catholic Univ.; St. Mary's, Lake George; Paulist Church, New York; tapestry back to the Cardinal's Throne, St. Patrick's Cathedral, NYC;

Corpus Christi Chapel, New York; St. Nicholas of the Children, Passaic, NJ; Catholic Club, NYC; LOC. Positions: Dir., Art Center; Contrib. Ed., Good Furniture Magazine. [24]

HARRISON, C(atherine) N(orris) (Mrs. Charles Leland) [P,I] Phila., PA b. Phila. Studied: PAFA. Member: Plastic Cl.; PMSchIA; Phila. Sch Des. for Women (Dir.)[15]

HARRISON, Dorothy [P,T] NYC b. NYC. Studied: Columbia; J.R. Koopman; D. Rosenthal; A. Young; C.J. Martin. Member: NAWA; Brooklyn SA. Exhibited: BM, 1935; AWCS, 1933–40; Dec. Cl., 1940; High Mus. A., 1944; NAWA; Brooklyn SA; Argent Gal., 1939 (one-man). Position: T., Pub. Sch. 174, Brooklyn [47]

HARRISON, Edith (Mrs. Julius S.) [P,Des,T] Jacksonville, FL b. 3 Ag 1879, Florida. Studied: CUASch; H. Lever; R. Moffett. Member: Fla. Fed. A.; A. Soc. Jacksonville; SSAL; Provincetown A. Assn. Exhibited: Rockefeller Center, NYC; Fed. A. Gal., Fla.; Provincetown A. Assn. Work: Tampa AI [40]

HARRISON, Gabriel [Ldscp.P,W,] b. 25 Mr 1818, Phila., PA d. 15 D 1902, Brooklyn, NY. Exhibited: Crystal Palace, London (prize); WFNY, 1939 (prize). He was one of the first in this country to produce daguerrotypes. He was also an actor, and in 1838 joined the National Theatre Co., in New York. In 1851 he organized the Acad. of Arts in Brooklyn, and in 1863 opened the Park Theatre in that city. His father, Charles P. [1783–1854] and grandfather, William, Sr. [d. 1803] were well-known engravers.

HARRISON, Grace Earle [P] Chicago, IL b. New York [04]

HARRISON, Helen [P] Bridgeport, CT. Member: New Haven PCC [25]

HARRISON, Henry [Por.P] b. Nottingham, England (came to US. ca. 1866) d. summer, 1923, Jersey City, NJ. He painted portraits of former President Wilson and other well-known public men.

HARRISON, (Lovell) Birge [P,I,T,W] Woodstock, NY b. 28 O 1854, Phila. d. 12 My 1929. Studied: PAFA; Carolus-Duran, Cabanel, in Paris, 1875. Member: ANA, 1902; NA, 1910; SAA, 1882; NIAL; Century Assoc.; NAC; MacD. Cl. NYWCC; All. AA; SC; Ends of the Earth Cl.; Rochester AC. Exhibited: Paris Expo, 1889 (med); Columbian Expo, Chicago, 1893 (med); Pan-Am. Expo, Buffalo, 1901 (med); Soc. Wash. A., 1904 (prize); St. Louis Expo, 1904 (med); AAS Phila., 1907 (gold); Dallas, Tex., 1912 (med). Award: Hors Concours, Paris Salon. Work: Wilstach Gal., Phila.; PAFA; Detroit Inst. A.; museums, Quimper, Marseilles, both in France; TMA; CGA; City A. Mus. St. Louis; St. Paul Inst.; Omaha Mus. FA; Municipal Coll., Spartanburg, S.C., Oakland, Calif.; Lincoln (Nebr.) A. Assoc.; Herron Art Inst.; Brooks Mem. Art Gal., Memphis; Atlanta A. Assoc.; Calif. Cl., Los Angeles; NAC; Butler Art Inst.; Lawrence (Kans.) Art Mus.; Dallas Art Assoc.; Richmond (Ind.) Art Assoc.; Calumet Cl., New York; Chicago Cl.; Luxembourg, Paris. Founder: Woodstock Art Colony, ASL Summer School. Author: "Landscape Painting." Brother of Alexander and Butler. [27]

HARRISON, Robert Rice [Edu,P] Richmond, VA b. 5 My 1908, Detroit, MI. Studied: AIC; Wayne Univ.; NYU; State Univ. Iowa; H. Gardner; Goldwater; Weinberger; Panofsky. Position: T., William & Mary, 1945– [47]

HARRISON, (Thomas) Alexander [P] Paris, France/Woodstock, NY b. 17 Ja 1853, Phila. d. 13 O 1930. Studied: PAFA; Ecole des Beaux-Arts, Bastien-Lepage, Gérôme, in Paris. Member: SAA, 1885; ANA, 1898; NA, 1901; AC Phila.; Paris SAC; Century Assoc.; Phila. WCC; Cercle d'Union Artistique; Soc. Nat. des Beaux-Arts; Royal Inst. of Painters in Oil Colours, London; Soc. Secessionists, Berlin and Munich; NIAL. Exhibited: Paris Salon, 1885 (prize); PAFA, 1887 (med), 1894 (gold); Paris Expo, 1889 (gold); Munich Salon, 1891 (med); Brussels, 1892 (med); Ghent, 1892 (med); Vienna (med); Berlin (med). Awards: Chevalier of Legion of Honor (1889), Officer (1901), Officer of Public Instruction, by French Gov. Work: Luxembourg Mus., Paris; PAFA; St. Louis Mus.; CGA; Quimper Mus., France; AIC; Royal Gal., Dresden; Wilstach Gal., Phila.; MMA; St. Paul Inst. [29]

HARRISS, Belle C. (Mrs. Richard T.) [S] NYC b. Brenham, TX. Member: All. AA; SSAL; Keramic Soc. Work: BM [40]

HARRITON, Abraham [P,T] Long Island City, NY b. 16 F 1893, Bucharest, Romania. Studied: NAD; Brush; Carlson; Cox; Maynard; D. Volk; C.F. Mielatz. Member: Am. A. Cong.; An Am. Group; Audubon A.; A. Lg. Am. Exhibited: CI; PFA; CGA; MMA; CAM; WMAA; AIC; BM; ACA Gal., 1946 (one-man); NAD (prize); WFNY, 1939; 48 Sts. Comp., 1939. Work: Tilden H.S., Bryant H.S., both in New York; Biro-Bidjan Mus., USSR; WMAA; Oakland A. Gal.; State T. Col., Indiana, Pa; Queens Col.; Fordham Univ.; USPO, Louisville, Ga. [47]

HARRITON, David M. [Des.,C,P,S,L] NYC b. 1 Ap 1895, Romania. Studied: NAD; ASL. Member: Soc. Designer-Craftsmen. Exhibited: Paris Expo, 1937 (med); Soc. Designer-Craftsmen, annually. Work: glass ceiling, Clark Mem., Vincennes, Ind.; Worcester War Memorial; Federal Reserve Bldg., Wash., D.C.; U.S. Bureau Shipping, New York. Lectures: Carved Glass [47]

HARROD, Warren K. [P] Worcester, MA [24]

HARSANYI, Charles [P,Dr] Jackson Heights, NY b. 21 N 1905, Tapolcza, Hungary d. 1973. Studied: Royal Acad. FA, Budapest; A. Benkhard. Member: All.A.Am.; CAFA; Audubon A.; SC; Brooklyn PS; Am. Ar. Cong.; S.Indp.A.. Exhibited: All. AA, 1937 (prize); CGA, 1935, 1941; VMFA, 1942, 1946; PAFA, 1933–35, 1942; AIC, 1941–44; CM, 1941; WFNY, 1939; NAD, 1933, 1934, 1936, 1938, 1940–45; All.A.Am., 1935–45; BM, 1934; Denver A. Mus., 1937–39; Wash. County Mus. FA, 1937–46; BMA, 1939; SC, 1945 (prize), 1946; CAFA, 1942, 1943, 1945 (prize); Audubon A., 1945; Mint Mus. A., 1946. Work: MMA; U.S. Gov. [47]

HARSHBERGER, Florence E. (Mrs.) [P,I,T] Syracuse, NY b. 19 N 1863, Freetown, NY. Studied: ASL; CUASch, with Brush, J.A. Weir, Shirlaw, F. Freer. Member: Utica Art Cl.; Utica Sketch Cl. [15]

HARSHE, Robert Bartholow [P,E,W,Mus.Dir] Chicago, IL b. 26 My 1879, Salisbury, MO. Studied: AIC; ASL; Cent. Sch. A.&Crafts, London; Acad. Colarossi, Paris. Member: Calif. SE; Soc. Am. E.; Palette and Chisel Acad. FA; Chicago SE; Cliff Dwellers; The Arts; Renaissance Soc., Univ. Chicago; Bd. Dir.; Am.-Hungarian Acad. A.; Intl. Assn. Mus. Officials; Assn. Art Mus. Dir. Awards: Chevalier Legion of Honor (France), 1925; Knight of Royal Order of the North Star, 1929. Work: Luxembourg Mus., Paris; BM; Los Angeles Mus. Author: "Reader's Guide to Modern Art," "Prints and Their Makers." Positions: Dir., Oakland (Calif.) Mus., 1915–16, AIC, 1921– ; Supt., Dept. FA, P.-P. Expo, San Fran., 1915; Asst. Dir., Dept. FA, CI, 1916–20; Am. Com. to Intl. Cong. Art Ed., Paris; Adv. Council, Artistic Relations Sec., Lg. of Nations, Intl. Inst. Intellectual Cooperation, 1927; Adv. Com., Louis Comfort Tiffany Fnd., 1931–34; Exec. Com., Olympic Games Intl. FA Comp., 1932; Exec. Dir., Century of Progress FA Exh., 1933–34 [38]

HART, Alice L. [Min.P] Boston, MA [10]

HART, Bernard [C,W] Malden, MA b. 5 Ap 1876, Sweden. Work: AGAA; BMFA; Marine Mus., Boston. Specialty: building/repairing ship models [40]

HART, Charles Henry [W] b. 1847, Phila. d. 29 Jy 1918, NYC. Member: Dir., PAFA, 1882–1902; committee chairman, Retrospective Am. Art, Chicago Expo, 1893; Am. Hist. Assoc.; Essex Inst.; Phila. Soc. Et. Author: "Frauds in Historical Portraiture," "Life of Houdon," "Portraits of Washington," "Sully's Diary," other books.

HART, Echo [P] NYC [10]

HART, Edna F. [I] Bronx, NY [13]

HART, Edythe B. [P] NYC b. New York. Studied: Humbert, in Paris [15]

HART, Ernest Huntley [P,G,I,Car] North Haven, CT b. 2 O 1910, NYC. Studied: ASL. Member: Assn. Conn Ar.; Assoc. Am. Ar. Exhibited: Yale Gal. FA; PAFA; Assoc. Am. Ar. Gal., New York. Illustrator: "Pigeon City," 1930. WPA artist. [40]

HART, (George Overbury) ("Pop") [P,E,Li] Coytesville, NJ b. 10 My 1868, Cairo, IL d. 9 S 1933 N.Y. Studied: self-taught. Member: AWCS; NYWCC; Soc. Am. E.; Salons of Am.; S.Indp.A.; Brooklyn Soc. E. Exhibited: Brooklyn SE, 1923–24 (prize); Palisade Art Assoc., Englewood, N.J., 1924 (prize); Sesqui-Centenn. Expo, Phila., 1926 (med); NYWCC, 1929 (prize); NAD, 1932 (prize). Work: NYPL; MMA; Brooklyn Mus.; Smithsonian Inst.; Newark Mus.; Chicago AI; Harrison Gal., Los Angeles Mus. A.; Cincinnati Mus.; Mem. Gal., Rochester, N.Y.; CMA; South Kensington Mus., London; British Mus., London. He was a creative genius and philosopher, and in his wanderings he traveled and sketched in Iceland, Egypt, South Sea Islands, South America, Mexico and the West Indies. In June 1933 Mrs. John D. Rockefeller, Jr., presented to MOMA a portrait bust of "Pop" Hart by Reuben Nakian. Specialties: watercolors; etchings [32]

HART, Harriet Louise [P] Elizabeth, NJ [13]

HART, James M. [P] Brooklyn, NY b. 10 My 1828, Kilmarnock, Scotland (came to U.S. in 1831) d. 24 O 1901. His children, Robert, Mary T., and Letitia were artists, as was his wife, Marie. Studied: his brother, William Hart; Munich; Schirmer, in Düsseldorf. Member: NAD; ANA, 1857; NA, 1859. Exhibited: Centenn. Expo, 1876 (med); Mechanics Inst., Boston (gold); Paris Expo, 1889 (med); CGA. An auction of his paintings was held

at the Fifth Ave. Art Gal., 1902, and 146 canvases were sold for a total of $20,287. [01]

HART, John Francis [Car,En,B] Phila., PA b. 30 My 1868, Phila. Member: AFA; AAPL. Exhibited: Biltmore Hotel, Palm Beach, Fla. (one-man); San Juan, Puerto Rico; Port-au-Prince, Haiti. Illustrator: Boston Globe, Philadelphia Record, others. Puzzle Car.: Bell Syndicate, N.Y. [47]

HART, Joseph H. [P] NYC b. 1858 d. 21 Jy 1916. Specialty: stage scenery. He made all the scenery for the Bijou Theatre, NYC.

HART, Lantz W. [P,T] Eugene, OR d. 26 My 1941. Work: USPO, Snohomish, Wash. WPA artist. [40]

HART, Leon [P] NYC. Member: S.Indp.A. [24]

HART, Letitia B(onnet) [P] NYC/Lakeville, CT b. 20 Ap 1867, NYC. Studied: his father, J.M. Hart; NAD, with E.M. Ward. Exhibited: NAD, 1898 (prize). Work: Va. Col., Roanoke [33]

HART, Marie T. Gorsuch (Mrs. James M.) [P,Edu] b. 1829 d. 19 S 1921, Lakeville, CT. Mother of Robert G., Mary T., and Letita B. Member: Bd. Ed., Brooklyn

HART, Mary E. [P] NYC d. 30 N 1899. Exhibited: NAD; Boston AC. Specialty: watercolors of violets [98]

HART, Mary Theresa [P,I] Brooklyn, NY/Lakeville, CT b. 7 Ja 1872, Brooklyn. Studied: his father, J.M. Hart; NAD, with E.M. Ward. Exhibited: NAD, 1901 (prize). Work: Engineers' C., N.Y. Illustrator: "Wee Winkler and Wideawake," Life, Judge [17]

HART, Robert Gorsuch [P] d. 4 O 1906, Mexico, where he had lived for two years. He was son of J.M. Hart. [Note: Groce & Wallace list him as William G.]

HART, Tod [P] Minneapolis, MN [24]

HART, William M. [Ldscp.P] b. 31 Mr 1823, Paisley, Scotland (came to U.S. with his brother James M. and family in 1831) d. 17 Je 1894, Mt. Vernon, NY. Studied: self-taught (was painting portraits by age 18). Opened studio in NYC; later moved to Brooklyn. Member: Brooklyn Acad. Des. (first Pres., 1865); NA, 1858; AWCS (founder). Exhibited: NYC; Phila.; Wash., D.C.; Baltimore; Boston. Work: MMA; many museums [*]

HART, William H(oward) [P] NYC b. 1863, Fishkill-on-Hudson, NY. Studied: ASL; J.A. Weir; Boulanger, Lefebvre, in Paris. Member: Century C.; AFA; The Cornish (N.H.) Colony [33]

HARTE-JOHNSON, Robert [P] Paris, France [01]

HARTELL, John (Anthony) [P,Des,T] Ithaca, NY b. 30 Ja 1902, Brooklyn, NY. Studied: Cornell; Royal Acad. FA, Stockholm. Exhibited: Mod. A. Festival, Boston, 1945; CAM, 1945; Critic's Choice, Cincinnati, 1945; CI, 1945, 1946; WMAA, 1945; Univ. Nebr., 1946; Cornell; Kleeman Gal., 1937 (one-man); Kraushaar Gal., 1943, 1945; Syracuse Mus. FA, 1945. Contributor: Art News. Position: T., Cornell, 1930– [47]

HARTER, Tom J. [Edu,Des,P,I] Tempe, AZ b. 8 O 1905, Naperville, IL. Studied: Ariz. State Col.; Univ. Oreg.; ASL; Grand Central A. Sch. Member: Calif. WC Soc.; Ariz. Edu. Assn.; Nat. Edu. Assn.; Am. Assn. Univ. Prof. Exhibited: Ariz. PS Ann., Phoenix, 1938; Am. WC Soc.; NYWCC Ann., 1939; BM, 1935; AWCS, 1937, 1938; Mus. N.Mex., Santa Fe; Southwest A., 1941–46; Calif. WC Soc., 1945; Ariz. State Fair, 1941. Work: Ariz. State Col. Illustrator: "Game in the Desert," 1939, "Hunting in the Southwest," 1946. Position: T., Ariz. State Col., 1937–46 [47]

HARTGEN, Vincent Andrew [P,T,Des,Mus.Cur] Orono, ME b. 10 Ja 1914, Reading, PA. Studied: Univ. Pa. Member: CAA; Catholic AA. Exhibited: BAID, 1935 (prize); NGA, 1945 (prize); BMA; Md. Inst., 1945; Reading A. Mus., 1944; Women's Univ. C., Phila., 1944. Work: Phoenixville, Pa. Positions: T., Univ. Pa. (1941–42), Univ. Maine (1946–)[47]

HARTING, G(eorge) W. [I] NYC b. 11 D 1877, Little Falls, MN. Studied: Henri; Chase; Mora; Miller; Koehler. Member: SI; SC; Pictorial Photog. Am.; Dutch Treat C.; Pittsburgh Photo Salon. Exhibited: Photo Salons, U.S., Japan. Illustrator: Vogue, other magazines [40]

HARTL, Leon [P] NYC. Exhibited: Wanamaker Regional, N.Y., 1934; Valentine Gal. N.Y., 1936; Brummer Gal., N.Y., 1938; Contemp. Am. Ann., WMAA, 1938; MOMA, 1938; PS, PAFA, 1939 [40]

HARTLEY, Elaine [Por.P] Wash., D.C./Manassas, VA b. 25 Ja 1909. Studied: E. Weisz; R. Meryman; R. Lahey [40]

HARTLEY, Florence [P] NYC [24]

HARTLEY, Harrison Smith [Des,P,Car,I,L] St. Joseph, MO b. 9 N 1888, Savannah, MO. Studied: Kansas City AI; Chicago Acad. FA; AIC. Member: AAPL. Exhibited: WFNY, 1939; Nelson Gal., 1943; Joslyn Mem., 1945, 1946; St. Joseph A. Lg., 1940–44, 1946 [47]

HARTLEY, Joan [S,T] NYC b. 26 Ja 1892, Utica, NY. Studied: J.E. Fraser; R. Aitken; E. Tefft. Member: NAWPS. Exhibited: NAWPS, 1926 (med); 1929 (prize). Work: Brookgreen Gardens, S.C. [40]

HARTLEY, Jonathan Scott [S] NYC b. 23 S 1845, Albany d. 6 D 1912. Studied: England; Paris; Rome. (His aptitude as a stone worker attracted the attention of Erastus D. Palmer, one of the early American sculptors.) Member: NAD; SAA; NSS; Arch. Lg.; SC. (He was a founding member of the SC, in 1871; this "bohemian" group held their first regular meetings at Hartley's sculpture studio, where they critiqued each other's works and then lunged into boxing matches.) Exhibited: Royal Acad., 1869 (med); Pan-Am. Expo, Buffalo, 1901 (med); NA, 1891. He married George Inness' daughter. [10]

HARTLEY, Joseph [S] NYC b. 19 My 1842, Albany. Member: SC [21]

HARTLEY, Marsden [P,Dr,Li,L,T,W] Ellsworth, ME b. 4 Ja 1877, Lewiston, ME d. 2 S 1843. Studied: Cleveland Sch. A.; NAD, 1900; Nina Waldeck; DuMond; Cox; Luis Mora; Francis Jones; Chase Sch., ca. 1898. Exhibited: Stieglitz' gal. "291," 1909; Blue Rider Group, Munich; Autumn Salon, Berlin; Armory Show, 1913; Max Liebermann, Berlin, 1914; Dresden; Breslau; Provincetown, 1916; Ogunquit, Me., 1917; Bermuda, 1918; N.Mex., 1919–20; auction of his paintings by Anderson Galleries, NYC, 1921, permitted his return to Europe; Gal. Briant-Robert, Paris, 1924–26; Herron Sch. A., 1946 (one-man); Univ. Minn., 1953; Roswell (N.Mex.) Mus., 1958–59; AFA Traveling Exh. 1960–62. Work: PMG; WMAA; Barnes Fnd., Phila.; Columbus Gal. FA; Mus. N.Mex.; CMA. Lived in Provence (1926–28), N.H. (1930), Cape Cod (1931), Mexico and Berlin (1932–33), Maine (1934–35), Nova Scotia (1936), finally, in Maine (1937). [40]

HARTLEY, Rachel [P,I,L,T] Southampton, NY b. 4 Ja 1884, NYC. Studied: ASL. Member: ASL; NAC; PBC; Wash. AC; AFA. Work: Mus. Georgetown, British Guiana [33]

HARTLEY, Thomas R. [P] Pittsburgh, PA. Member: Pittsburgh AA [25]

HARTMAN, Bertram [P] NYC b. 18 Ap 1882, Junction City, KS d. ca. 1960. Studied: AIC; Royal Acad., Munich; Paris. Member: Mural P.; Am. Soc. PS&G; AWCS. Exhibited: P.-P. Expo, 1915; CI, 1933; AIC, 1926–34; PAFA; CGA; WMAA, annually; MMA; BM; Grand Central Palace; South America, 1940. Work: MMA; WMAA; BM; Randolph-Macon Col. for Women; USPO, Dayton, Tenn. WPA artist. [47]

HARTMAN, Daisy. See Osnis, Mrs.

HARTMAN, Hazel [Des,P,T] Fresno, CA b. 1900, CA. Studied: D. Rosenthal; C.J. Martin; G.J. Cox; A. Heckman; H. Hofmann. Position: T., State Col., Fresno [40]

HARTMAN, Reber S. [P] Phila., PA [25]

HARTMAN, Rosella [P,G] Woodstock, NY b. 1894. Member: Am. Pr.M.; F., Guggenheim Fnd. Work: WMAA; Baltimore Mus. A.; A. Mus., St. Louis [40]

HARTMAN, Sterling Reber [P,T] Phila., PA b. 24 F 1901, Bloomsburg, PA. Studied: PAFA; Tiffany Fnd.; Am. Acad., Rome; Acad. Grand Chaumiere, Paris. Member: Am. Ar. Prof. Lg. Exhibited: PAFA, 1924 (prize), 1925 (gold,prize); Tiffany Fnd. Sch., 1927 (prize); Germantown Acad., 1939 (one-man). Work: Phila. Bd. Edu.; Lutheran Church, Williamsport, Pa.; Merchants Bank, Pittsburgh [40]

HARTMAN, Sydney K. [P,I,T,E] NYC b. 2 Ag 1863, Germany d. 1929. Studied: Laurens, Constant in Paris [21]

HARTMANN, Georg Theo [I,E,P] NYC b. 1 N 1894, Hoboken, NJ d. 1976. Studied: NAC; H. Boss. Member: Audubon A. Exhibited: 48 Sts. Comp., 1939; PAFA, 1945; NAC, 1945; Audubon A., 1945. Illustrator: "Yu Lan" (1945), "This is My Life" (1942), George Washington's "Rules of Civility" (1942), other books [47]

HARTMANN, Sadakichi [Cr,P,L,W] Andover, NH/Banning, CA b. 8 N 1869 d. 29 N 1944, St. Petersburg. Studied: J.W. Stimson. Author: "Shakespeare in Art," "The Whistler Book," "Japanese Art," "Composition in Portraiture," "A History of American Art" (1901); articles for Stieglitz' "Camera Work." Specialty: pastels. He was an art expert, and believed that the outstanding American characteristic was an "accuracy of looking at things" with a "freshness of view." [47]

HARTNETT, Eva Valker (Mrs.) [Edu,C] Minot, ND b.10 D 1895, Wahpeton, ND. Studied: Univ. Minn.; Univ. Oreg. Member: NIAL. Co-

Author: "Handbook to Picture Study," 1928. Position: T., State T. Col., Minot, N.Dak. [47]

HARTRATH, Lucie [P,T] Chicago, IL b. Boston. Studied: Rixens, Courtois, Collin, in Paris; A. Jauk, in Munich. Member: Chicago PS; Cordon C.; Chicago AC; K. Verein, in Munich; NAWPS; Brown County AA, Ind. Exhibited: AIC, 1911 (prize), 1912 (prize), 1915 (prize), 1916 (prize); Municipal A. Lg. (prize); Hoosier Salon, 1925 (prize), 1927 (prize), 1928 (prize), 1929 (prize), 1930 (prize), 1931 (prize), 1935 (prize), 1937 (prize), 1939 (prize), 1940 (prize); Assn. Chicago PS, 1939 (gold). Work: Governor's Mansion, Springfield, Ill.; Municipal A. Lg., Public Sch. A. Soc., both in Chicago; Public Sch., Gary, Ind.; Pub. Lib., Bedford, Ind. [40]

HARTSHORNE, Howard Morton [P] Paris, France/NYC b. NYC. Studied: Constant, Laurens, in Paris. Exhibited: Paris Salon, 1911 (med) [17]

HARTSHORNE, Lois. See Wilde.

HARTSON, Walter C. [Ldscp.P] Wassaic, NY b. 27 O 1866, Wyoming, IA. Member: Dutchess County AA; Chicago Soc. Ar.; SC; Kit Kat C.; NYWCC; Allied Ar. Am. Exhibited: Atlanta Expo, 1895 (med,prize); NAD, 1898 (prize); Am. A. Soc., Phila., 1902 (gold), 1904 (prize) [40]

HARTWELL, Arthur Lewis [C] Gardner, MA b. 13 My 1882. Member: Boston SAC. Specialty: silversmith [40]

HARTWELL, Edith [P] NYC. Member: S.Indp.A. [27]

HARTWELL, (George) Kenneth [Li,En,C,P,I] NYC b. 6 Je 1891, Fitchburg, MA d. 11 D 1949. Studied: ASL; DuMond; K.H. Miller; W. Leigh. Member: Un. Scenic A. Exhibited: LOC, 1944–46; Laguna Beach AA, 1945, 1946; CI, 1945. Work: BM; PMA; Toronto Mus. FA. Illustrator: Theatre Arts [47]

HARTWELL, Marjorie [P] Hartford, CT [21]

HARTWELL, Nina Rosabel [Min.P,P] Paris, France b. Salt Lake City, UT. Studied: Académie Julian, Paris; Collin, Garrido, in Paris [15]

HARTWICH, Herman [P] Munich, Germany (since 1896)b. 8 Jy 1853, NYC. Studied: Diez; Loefftz; Munich. Exhibited: Paris Salon, 1892 (prize), 1901 (med); Paris Expo, 1900 (med); Berlin, 1902 (gold); St. Louis Expo, 1904 (med); Munich, 1905 (med); Salzburg, 1907 (gold). Work: museums, Leipzig, Germany; Cleveland [17]

HARTWIG, Cleo [S,T] NYC b. 20 O 1911, Webberville, MI. Studied: Western Mich. Col.; AIC; Intl. Sch. A.; J. de Creeft. Member: NAWA; Audubon A.; N.Y. Soc. Ceramic A.; S. Gld.; N.Y. Soc. Women A.; Clay C. Exhibited: Detroit Inst. A., 1943 (prize); NAWA, 1945 (prize), 1946; N.Y. Soc. Ceramic A., 1945 (prize); Audubon A., 1945; CAFA, 1946; NAD, 1938, 1941–45; AV, 1942; PAFA, 1945, 1946; Nebr. AA, 1946; Newark Mus., 1944; NSS, 1946; AIC, 1942; Detroit Inst. A., 1942–45; N.Y. Soc. Women A., 1946; N.Y. Soc. Ceramic A., 1945; Clay C., 1939. Work: Newark Mus.; Detroit Inst. A. Positions: T., Cooper Union, 1945–46, Montclair Mus. A. Sch., 1945– , Lenox Sch., Ecole Française, N.Y. [47]

HARVEY, Charles Y. [S] b. 1869 d. 27 Ja 1912, N.Y. Studied: A. Saint-Gaudens; Am. Acad., Rome. Work: Shaw Memorial, Boston; Sherman Monument, N.Y., 1907. At the time of his death, he was at work on a fountain for a Connecticut town.

HARVEY, Eli [S,P,C,I] Alhambra, CA b. 23 S 1860, Ogden, OH. Studied: Cincinnati A. Acad., with Leutz, Noble, Rebisso; Académie Julian, Paris, with Lefebvre, Constant, Doucet, Delecluse Acad., Paris, with Delance, Callot; Jardin des Plantes, with Fremiet. Member: Arch. Lg.; Societé Nationale des Beaux-Arts, Paris. Exhibited: Paris-Province Expo, 1900 (gold); Paris AAA, 1900 (prize); Pan-Am. Expo, Buffalo, 1901 (med); St. Louis Expo, 1904 (med); P.-P. Expo, San Fran., 1915 (med); Paris Salon, 1894. Work: MMA; Lion House, N.Y. Zoo; Eaton Mausoleum, N.Y. Zoological Soc.; Am. Numismatic Soc.; Eagles, Victory Arch, N.Y.; Elk for BPOE; Brown Bear Mascot for Brown Univ.; Los Angeles Mus.; Brookgreen Gardens, S.C.; Cranbrook Mus., Bloomfield Hills, Mich.; City Mus. St. Louis; Newark Mus.; Cincinnati Mus.; AMNH. Specialty: animal sculpture. His wife, Grace, was a photographer [d. 16 Ja 1924, NYC] [40]

HARVEY, George [P] b. ca. 1835 d. after 1920, Burlington, IA. Studied: his uncle, George Harvey (1800–1878); T. Hicks, in NYC, ca. 1869. Specialties: views along the Miss. River; portraits of Mo. governors

HARVEY, George W(ainwright) [P,E] Annisquam, MA b. 13 Ja 1855, Gloucester, MA. Studied: Holland [21]

HARVEY, Harold LeRoy [P,Des,Photogr] NYC b. 7 Jy 1899, Baltimore. Studied: PAFA; Turner; McCarter; Despujols; Baudouin; M. Denis. Member: Charcoal C., Baltimore; Paris AAA; Royal Photogr. Soc. [40]

HARVEY, Laura Cornell (Mrs. Stewart) [Mur.P,Por.P] Libertville, IL b. 27 D 1906, NYC. Studied: Hunter Col.; NAD; ASL; Robinson; R. Davey; E. Lawson. Exhibited: Mus. N.Mex., Santa Fe, 1930–44; Univ. N.Mex., 1944; Contemporary A. Gal., 1944; Lake Forest (Ill.) Acad., 1946. Work: Century of Progress Expo, Union Station, Monroe Bldg., all in Chicago [47]

HARVEY, Paul [P] NYC b. Chicago. Studied: AIC; BMFA Sch. Member: Boston AC; Calif. AC. Work: Boston AC [33]

HARVEY, Robert [P] NYC/Plattsburg, NY b. 12 My 1868, Dublin, Ireland. Studied: G. Smillie. Member: AAPL; S.Indp.A.; Salons of Am. [33]

HARVEY, Sara Edith [Edu,L] Deland, FL b. Rome, GA. Studied: Shorter Col., Rome; Peabody Col.; Columbia; C. Martin. Member: AFA; Southeastern AA. Position: T., J.B. Stetson Univ., Fla. 1835– [47]

HARVEY, V G. (Miss) [P] NYC. Member: Lg. AA [24]

HARVEY, W. Craig [P,Des] Plainfield, NJ b. 31 Ja 1882, New Brunswick, NJ. Studied: J.F. Carlson. Member: Plainfield AA; Westfield AA; Asbury Park Soc. FA [40]

HARWOOD, Burt S. [P] Paris, France b. 1897, Iowa d. ca. 1924, Taos, N.Mex. Studied: Laurens, Collin, Constant, in Paris. Work: Univ. N.Mex. Namesake of the Harwood Foundation (Taos), established by wife Lucy, 1923. [15]

HARWOOD, Elizabeth [P] Paris, France b. U.S. Studied: Collin, in Paris [13]

HARWOOD, H.T. [P] Salt Lake City, UT [15]

HARWOOD, J(ames) Taylor [P,E,T] Salt Lake City, UT b. 1860, Lehi, UT d. 1940. Studied: Salt Lake City, with Weegeland, Lambourne; San Fran. Acad. FA, with V. Williams, 1885; Académie Julian, Paris with Laurens, Lefebvre, Bonnât, Constant. (He was the first Utah artist to study at the Académie Julian.) Work: State Col. Utah; Univ. Utah [40]

HARWOOD, Sabra B. [S] Boston, MA b. 18 Ja 1895, Brookline, MA. Studied: B. Pratt; C. Grafly. Member: Copley S. [33]

HASBROUCK, Du Bois Fenelon [Ldscp.P] Stamford, NY b. 1860, Pine Hill, NY. Work: NGA [17]

HASBROUCK, Elsa [S] NYC [17]

HASELTINE, Charles Field [P,Art Dealer] Phila., PA b. 29 Jy 1840 d. 5 D 1915. Studied: Univ. Pa. Member: Phila. Sketch Cl.; Phila. AC; Union Lg. Cl. Exhibited: AAS, 1907 (gold). Established his gallery in Phila., 1868; visited Europe 52 times. Brother of James H. and William S. [10]

HASELTINE, Elisabeth. See Hibbard.

HASELTINE, Herbert [S] NYC b. 10 Ap 1877, Rome, Italy d. 8 Ja 1962, Paris. Studied: Royal Acad., Munich; Académie Julian, Paris; Aime Morot. Member: NIAL; Burlington FAC, London; NA; NSS; NIAL. Exhibited: NAD, 1934 (prize). Work: Field Mus., Chicago; Racquet Cl.; Knickerbocker Cl.; Mus. Hispanic Soc. Am., MMA, WMAA, Mus. NIAL, all in New York; BM; AGAA; NGA; VMFA; RISD; Tate Gal., London; Luxembourg Mus., Paris; Imperial War Mus., Cavalry Cl., London; Jamnagar, Nawanagar, India. Award: Legion d'Honneur, by French Gov. [47]

HASELTINE, James Henry [S] b. 2 N 1833, Phila. d. 9 N 1907, Rome, Italy. Studied: J.A. Bailly, in Phila.; France and Italy, ca. 1857–61. Exhibited: PAFA, 1855. After the Civil War, he spent most of his life in Rome. Brother of Charles F. and William S. [*]

HASELTINE, William Stanley [Ldscp.P] b. 11 Je 1835, Phila. d. 3 F 1900, Rome, Italy. Studied: Weber; Düsseldorf; Rome. Member: NA, 1861; Century Assoc. In 1856 he traveled down the Rhine on a sketching tour with Bierstadt, Whittredge, and Leutze. Brother of Charles F. and James H. Like James, he settled in Rome after the Civil War.

HASELTON, Helen A. [P] Chicago, IL [15]

HASHIMOTO, Michi (Mrs.) [P,I] Los Angeles, CA b. 10 Jy 1890, Japan. Studied: Univ. Calif. Member: Calif. WCS; A.W. Dow [33]

HASKELL, Ernest [I,P,Li,E,W] New Milford, CT b. 30 Jy 1876, Woodstock, CT d. 1 N 1925, Phippsburg, ME (automobile accident). Studied: Paris. Member: Chicago SE. Exhibited: etching, P.-P. Expo, San Fran., 1915 (med). Illustrator: New York American [25]

HASKELL, Frederick T. [P] d. S 1935, Chicago. Member: AIC. He left about forty paintings to the AIC.

HASKELL, Ida C. [Por.P] NYC/Brookhaven, NY b. 1861, Calif. d. 28 S

1932. Studied: AIC; PAFA; ASL; Paris. Exhibited: Paris, U.S. Work: Univ. Club Madison, Wis. Position: T., PIASch [31]

HASKELL, William Homer [P] Elizabeth, NJ/Merrimac, MA b. 19 Ap 1875, Merrimac d. 15 D 1952. Studied: BMFA Sch., with Tarbell, Benson; Académie Julian, Paris, with Benjamin-Constant, Laurens [13]

HASKELL, William Lincoln [P] Chicago, IL [01]

HASKEY, George [P,S] Watertown, NY b. 24 O 1903, Windber, PA. Studied: Pittsburgh AI; CI; Emile Walters; Samuel Rosenberg; Hobart Nichols. Member: F., Tiffany Fnd.; Assoc. Ar., Pittsburgh; All. Ar. Johnstown. Exhibited: All. Ar. Johnstown, 1933, 1934 (prize), 1935 (prize), 1936, 1937, 1938 (prize), 1939–43; Grand Central Gal.; All. A. Pittsburgh; A. Lg., North Kensington, Pa., 1940 (prize); Tiffany Fnd., 1935, 1936; CI, 1937–44; Munson-Williams-Proctor Inst., 1946. Work: Latrobe (Pa.) H.S. [47]

HASLER, William N. [P,E] Caldwell, NY b. 9 My 1865, Wash., D.C. Member: SC, 1908 [29]

HASSAM, Childe [P,E,Li] NYC b. 17 O 1859, Boston, MA d. 27 Ag 1935, East Hampton, NY. Studied: Boston AC, 1878; Gaugengigl, in Boston, 1879; Académie Julian, Paris, with Boulanger, Lefebvre, Doucet, 1886–89. Member: ANA, 1902; NA, 1906; AWCS; NYWCC; Boston AC; Ten Am. P.; Munich Secession; Soc. Nat. des Beaux-Arts; NIAL; AAAL. Exhibited: Paris Expo, 1889 (med), 1901 (med); watercolor, AC Phila., 1892 (gold), 1915 (gold); Columbian Expo, Chicago, 1893 (gold); Cleveland Art Assoc., 1893 (prize); SAA, 1895 (prize), 1905 (prize), 1906 (prize); Boston AC, 1896 (prize); CI, 1898 (med), 1905 (med); PAFA, 1899 (gold), 1906 (prize), 1910 (gold), 1920 (gold), etching, 1931 (gold); Pan-Am. Expo, Buffalo, 1901 (gold); St. Louis Expo, 1904 (gold); Worcester, 1906 (prize); CGA, 1910 (prize), 1912 (gold,prize); AWCS, 1912 (prize), 1919 (prize); NAD, 1918 (prize), 1924 (prize), 1926 (prize); Phila. WCC, 1919 (prize); Sesqui-Centenn. Expo., Phila., 1926 (gold). Work: MMA; Club House, Easthampton, N.Y.; CGA; Cincinnati Mus.; CI; Toledo Mus. A.; FA Acad., Buffalo; RISD; Worcester Art Mus.; NGA; PAFA; Indianapolis Art Assoc.; Detroit Inst. A.; AIC; Minneapolis Inst. A.; Brooklyn Inst. Mus.; Art Mus., St. Louis; Los Angeles Mus.; Smith Col.; AGAA; all paintings in his estate left to AAAL. Internationally recognized as one of the great American painters, he was one of the foremost exponents of American impressionism. [33]

HASSELLBUSCH, Louis [P,Por.P] Phila., PA b. 8 N 1863, Phila. d. ca. 1938. Studied: PAFA; Académie Julian, Paris, with Constant, Lefebvre; Royal Acad., Munich. Member: Phila. Sketch Cl. Work: portraits, libraries/museums [38]

HASSELMAN, Anna [Mus.Cur,P,T,L] Indianapolis, IN b. 12 Ja 1872, Indianapolis. Studied: AIC; ASL; Columbia; Chase; Hawthorne; O'Hara; Forsyth. Member: Ind. Print Cl.; Ind. AC; Indianapolis AA; AWCS. Exhibited: AWCS; Ind. A., annually. Work: watercolor, John Herron AI. Positions: T., John Herron AI, 1925–35; Cur., John Herron AI, 1930– [47]

HASSELMAN, Jan [P] Brooklyn, NY [24]

HASSELRIIS, Malthe M. (Mr.) [Min.P,I,Des] Forest Hills, NY b. 16 Ja 1888, Skive, Denmark. Member: Am. Soc. Min. P.; Brooklyn Soc. Min. P.; Grand Central AG. Exhibited: Brooklyn Mus., 1934 (prize). Illustrator: Ladies' Home Journal, McCall's, Woman's Home Companion, stories of Pearl Buck, Harriet Welles [47]

HAST, Etta [P] Louisville, KY. Member: Louisville AL [01]

HASTE, L.B. [I] San Fran., CA [21]

HASTINGS, Constance S. [P,Des] NYC b. 6 Ap 1911. Studied: Grand Central Sch.; ASL; Am. Sch. Des., N.Y. Member: Rockport AA. Exhibited: ASL; All. AA [40]

HASTINGS, Helen M. [Ldscp.P] Phila., PA b.. Rochester, NY. Studied: PAFA. Member: Plastic Cl. [13]

HASTINGS, Marion Keith [P,T] Los Angeles, CA b. 25 Ja 1894, Geneva, NY. Studied: A.H. Platt; D.J. Connah; A.H. Hibbard; E.P. Ziegler; E. Forker. Member: Women Painters of the West; Nat. Lg. Am. Pen Women; Beverly Hills A. Assn. Exhibited: Yakima, Wash., 1929 (prize), 1930 (prize), 1932 (prize), 1933 (prize); Nat. Lg. Am. Pen Women, 1932 (prize) [40]

HASTINGS, Matthew [Por.P,Car] b. 1834 d. 1919. Worked in Mo. Also painted Indian scenes. [*]

HASTINGS, T. Mitchell [P] Phila., PA. Exhibited: Warwick Gal., Phila., 1938; Studio Gl., N.Y., 1938 [40]

HASTINGS, Thomas [Arch] b. 1860, NYC d. 22 O 1929, Mineola, NY. Studied: Columbia; Ecole des Beaux-Arts, 1884. Member: BAID (Pres.); AIA (Pres.); Arch. Lg. (Pres.); Fed. Arts Commission (founder). Formed partnership of Carrere & Hastings; designed NYPL, Metropolitan Opera House, numerous important bldgs. [*]

HASTINGS, Thomas Wood (Mrs.) [P] Yonkers, NY [25]

HASTINGS, William Granville [S,Cer] b. ca. 1868, England (came to U.S. in 1891) d. 13 Je 1902, Mt. Vernon, NY. Studied: London; Paris. Work: mon., Pawtucket, R.I., Orange, N.J., Cincinnati

HASWELL, Ernest Bruce [S,L,W,T] Cincinnati, OH b. 25 Jy 1889, Hardinsburg, KY. Studied: Cincinnati A. Acad.; Acadamie Royale des Beaux Arts, Brussels; Barnhorn; Meakin; Dubois. Member: Cincinnati AC; Cincinnati Assn. Prof. A. Exhibited: Acadamie Royale des Beaux Arts, 1912 (prize); Cincinnati MacDowell Soc., 1939 (med); NSS. Work: Brookgreen Gardens, S.C.; CM; mem., Springfield, Ill.; Univ. Cincinnati; Miami Univ; Princeton Univ.; Hebrew Union Col.; Spinoza House, The Hague; Times Star Bldg., Cincinnati; St. Coleman's Church, Cleveland; war memorials, Bond Hill (Ohio), Avondale (Ohio) Sch.; University Sch.; Greensville, Ohio; Louisville, Ky.; State Office Bldg., Columbus, Ohio; mem., Ivorydale, Ohio; Cincinnati MacDowell Soc.. Author: "Carving as an Aid to Rehabilitation," 1946. Contributor: International Studio. Position: T., Univ. Cincinnati [47]

HASWELL, Leona Halderman (Mrs. Ernest Bruce) [P,Des,C,T] Cincinnati, OH b. Hagerstown, Ind. Studied: Cincinnati Art Acad.; W. Stevens. Member: Women's AC Cincinnati; Hoosier Salon; Ohio WC Soc.; Cincinnati MacD. Soc.; Crafters Co., Cincinnati [40]

HATCH, Emily Nichols [P,B,L,T,W,Por.P] NYC/Tarrytown, NY b. 2 Ag 1871, Newport, RI d. 26 D 1959. Studied: J.W. Stimson; E. Ullman; Shirlaw; Chase; Hawthorne; W. Edwards. Member: MacD. Cl.; SPNY; Hudson Valley AA; Westchester Gld. A.; NAWA; PBC. Exhibited: Hudson Valley AA, 1941 (prize), 1946 (prize); N.Y. Women's AC, 1912 (prize); CI, 1913, 1914; NAD, 1913, 1915, 1916, 1932; NAWA, annually; BM; CAM; All.A.Am., 1935, 1936; N.Y. Soc. Painters; AWCS; CGA, 1914; Union Lg. Cl., 1915; St. Louis AM, 1915; Montclair AM, 1924; Baltimore Mus. A., 1925; PBC, 1931 (prize) 1934 (prize), 1960 (memorial); Univ. Va., 1974 (retrospective). Work: Richmond (Ind.) AM; Nat. Mus., Wash., D.C. She made frequent trips to Europe; had studio in Paris, 1926–27. Position: Dir., Tarrytown Art Center, 1940 [47]

HATCH, Lorenzo James [I,P,En] Bronxville, NY b. 16 Jy 1857, Hartford, NY d. 1 F 1914. Studied: Wash., D.C. ASL; N.Y. Sch. A. Member: N.Y. Municipal A. Soc.; Century Assoc.; SC, 1902 [13]

HATFIELD, Dalzell [P,E,L] Los Angeles, CA. b. 23 Ag 1893, Pittsburgh. Studied: self-taught. Member: Calif. AC. Exhibited: Ebell Cl., Los Angeles, 1932 (prize). Owner: Dalzell Hatfield Galleries [40]

HATFIELD, Eunice Camille (Mrs. John C. Smith) [Por.P] Poughkeepsie, NY b. 6 Je 1911, Mamaroneck, NY. Studied: Syracuse Univ.; J. Sloan; ASL. Member: Dutchess County AA; Chatham AC; Hudson Valley A. Assn. [40]

HATFIELD, Joseph Henry [P] Canton, MA b. 21 Je 1863, near Kingston, Ontario d. 12 Ja 1928. Studied: Constant, Doucet, Lefebvre, in Paris. Exhibited: Mass. Charitable Mechanics' Assoc., Boston, 1892 (med); NAD, 1896 (prize). Work: Boston AC [27]

HATFIELD, Karl L(eroy) [P,E] El Paso, TX/Santa Fe, NM b. 19 F 1886, Jacksonville, IL. Studied: J. Montgomery; C. Kay-Scott. Member: SSAL; El Paso AG [33]

HATFIELD, Nina [C,Mur.P] Hoboken, NJ b. Jersey City. Studied: G. Cornell; A. Heckman; M. Fry; M. Robinson; W. Reiss; P. Mijer. Member: Keramic Soc. Des. Gld.; NYSC. Exhibited: Keramic Soc. Exh., Mus. Nat. Hist., 1925; Intl. Expo, Paris, 1937. Contributor: Keramic Studio [40]

HATFIELD, Thomas F. [P] Hoboken, NJ d. O 1925. Position: City Librarian, Hoboken

HATHAWAY, George M. [Mar.P] b. ca. 1852 d. 1903. Work: Kendall Whaling Mus.; Mariners' Mus.; Peabody Mus., Salem; Portland (Maine) Mus. A. New England painter of coastal scenes. [*]

HATHAWAY, John W. [G,C] Phila., PA. Exhibited: Phila. A. All., 1937. Work: windows, Murphy Chapel, Beaver Col. (Jenkintown, Pa.), Holy Trinity Church (Bowie, Md.). Specialty: stained glass [40]

HATHAWAY, Josephine Ames (Mrs. E.P.) [C,Des] Wash., D.C. b. 31 Ag 1886, Williamsport, PA. Studied: H.T. Smith. Member: Boston SAC. Author: booklets on basketry. Designer: national magazines [40]

HATHAWAY, Lovering [P] Dedham, MA b. 8 N 1898, New Bedford, MA d. 16 My 1949. Studied: BMFA Sch.; H.W. Rice. Member: Gld. Boston A.;

Boston Soc. WC Painters. Exhibited: PAFA, 1935; BMFA; Gld. Boston A. [47]

HATHERELL, W. [I] London, England [21]

HATLEY, Olga [P] Fort Smith, AR [17]

HATLO, Jimmy [I] Carmel, CA d. 30 N 1963. Member: SI [47]

HATTON, Clara Anna [Edu,C,Gr,P,E] Fort Collins, CO b. 19 O 1901, Bunker Hill, KS. Studied: Univ. Kans.; Royal Col. A., London; Cranbrook Acad. A.; J. Frazier; A. Bloch; A. Hibbard; R. Austin; R. Eastwood; A. Thayer; Cent. Sch. A.&Crafts, London. Member: MacD. Cl.; Cleveland PM. Exhibited: SAE; Syracuse Mus. FA; Cranbrook Acad. A., 1945; Denver, 1946; Tulsa, Okla., 1946; Amarillo, Tex., 1945; Lawrence, Kans., 1945. Work: Smithsonian Inst.; Cranbrook Mus. Position: T., Colo. A.&M. Col., 1936–46 [47]

HATTORF, Alvin, Mrs. See King, Helen.

HATTORF, Alvin F(rederick) [P] Richmond, VA b. 13 My 1899, Newport News, Va. Studied: John Marshall; G.W. James; H. Hensche; PAFA. Member: Richmond Acad. A.; SC. Exhibited: VMFA, 1938–40, 1941 (one-man), 1942, 1944; Butler AI, 1942, 1946; Richmond Acad. A.&Sciences, 1936–40 [47]

HAUBISEN, Christopher [Por.P] St. Louis, MO b. 1830 d. F 1913

HAUBRICH, Edward [P] Indianapolis, IN [13]

HAUCKE, Frederick [P,Des,T,L] Hamilton, NY b. 7 D 1908, Kimberley, South Africa. Studied: NYU; Yale. Exhibited: Morgan Gal., N.Y. Work: WMAA; CAM. Position: T., Colgate [47]

HAUENSTEIN, Eugenia [P] Buffalo, NY [21]

HAUENSTEIN, Oskar [Mur.P] NYC b. 15 Ja 1883, Vienna, Austria. Studied: Laske, Axentowicz, in Vienna. Work: Olney Inn, Wash., D.C.; murals, Industrial Arts Sch., Providence, R.I., "S.S. Leviathan"; Court House, Elizabeth N.J.; Pub. Sch. No. 72, NYC [40]

HAUGHTON, Marie L. [P] Phila., PA [04]

HAUGSETH, Andrew John [P,I,Dec,T] Hollywood, IL b. 30 My 1884, Norway. Studied: Hawthorne; R. Clarkson; G. Bellows; AIC. Illustrator: "God's Drum," "Manito Masks" [40]

HAUKANESS, Lars [P] Chicago, IL b. 1865. Norway. Studied: Werenskjold [04]

HAUKINS, Cornelius [P] Nashville, TN [24]

HAUN, Robert Charles [P,Dec,Des,I,Mur.P,T] Edgewood, RI b. 31 D 1903, Boston. Studied: Mass. Sch. A.; J.G. Cowell; R. Andrew. Work: murals, Providence-Biltmore Hotel, churches and pub. bldgs. throughout New England. Positions: T., Mass. Sch. A., Boston; A. Advisor, Boston Store, Providence [47]

HAUPERS, Clement (Bernard) [P,En,S,L,T,Li,E] St. Paul, MN/Rutledge, MN b. 1 Mr 1900, St. Paul. Studied: Minneapolis Sch. A.; Lhote, Bourdelle, Jacovleff, Acad. Colarossi, Acad. Grande Chaumière, all in Paris; C.S. Wells; V. Vytlacil; R. Hale; W. Shukhaeff. Member: Minn. AA; Ar. Un. Minn. Exhibited: Minn. State Fair, 1920 (prize), 1925 (prize), 1926 (prize), 1939; Minneapolis Inst. A., 1928 (prize); AIC; WFNY, 1939; Milwaukee AI; Walker A. Center. Work: BM; NYPL; PMA; Minneapolis Inst. A.; San Diego Soc. FA; Dallas Mus. FA; Fifty Prints of the Year, 1930–31. WPA Dir./Artist. Positions: Supt., FA Dept., Minn. State Fair, 1930–41; T., St. Paul Sch. A., 1931–36, St. Paul A. Center, 1945– [47]

HAUPT, Charlotte [S,T] Cincinnati, OH b. 2 N 1898, Pittsburgh, PA. Studied: Univ. Cincinnati; Cincinnati A. Acad., with C. Burnhorn; Europe. Member: Cincinnati Prof. AA. Exhibited: CM, annually, 1944 (one-man); Pittsburgh Garden Center, 1934; Ephraim, Wis., 1945. Work: CM [47]

HAUPT, Erik Guide [Por.P] South Egremont, MA b. 7 Ag 1891, Cassel, Germany. Studied: Bavarian Acad., Munich, with von Marr; Académie Julian, Paris, with Laurens; R. Miller; Md. Inst. Exhibited: Peabody Inst., Baltimore; BMA; CGA; PAFA; NAD. Work: Johns Hopkins Univ. & Hospital; Shepard-Pratt Hospital, Baltimore; Court House, Wilmington, Del.; Vassar Hospital, Poughkeepsie, N.Y. [47]

HAUPT, Theodore G. [P,I] NYC b. 11 O 1902, St. Paul, MN. Studied: Minneapolis Sch. A.; Lhote, in Paris. Member: Am. A. Cong.; N.Y. Artists Un. Exhibited: WMAA, 1937, 1938; WFNY, 1939; Minn. State Fair, 1927 (prize). Work: Mus. City of New York [47]

HAUPT, Winifred Hope [Por.P,I,T] Natchitoches, LA b. 28 Je 1891, Bijou Hills, SD. Studied: W.S. Taylor; W.O. Beck; M. Hermann; E. Watson; La. State Normal Col.; Columbia; PIASch. Member: SSAL. Exhibited: La. State Fair, 1923 (prize), 1924 (prize). Illustrator: "Natchitoches," 1936. Position: T., La. State Normal Col., Natchitoches [40]

HAUPTLE, Frederick W. [P] Phila., PA [19]

HAUSCHKA, Carola Spaeth [Por.P,T,L,W,Dr] Princeton, NJ b. 29 Ap 1883, Phila. d. 23 D 1948. Studied: PAFA; Anson Kent Cross; Hilton Leech; Graphic Sketch Cl., Phila. Member: AAPL; Phila. WCC; Phila. Plastic Cl. Exhibited: Newark Graphic Exh., 1942 (prize); PAFA; Gld. Hall, East Hampton, N.Y.; AGAA; Copley Gal., Boston; Present Day Cl., Princeton. Work: 50 portraits of Nobel prize winners in physics for "College Physics," pub. McGraw-Hill; portrait of Einstein, Fortune, 1936. Specialty: portraits of children. Position: T., Anson Kent Cross Sch. A., Boothbay Harbor, Maine, 1929–46 [47]

HAUSDORFER, Richard B. [P] Indianapolis, IN [17]

HAUSEMAN, George [P] NYC [21]

HAUSENBUILLER, C.E. (Mrs.) [P] St. Joseph, MO [24]

HAUSER, Alonzo [S,T,P] St. Paul, MN b. 30 Ja 1909, La Crosse, WI. Studied: Layton Sch. A.; Univ. Wis.; ASL, with William Zorach; apprentice, Greenwich Workshops, N.Y. Member: An Am. Group; S. Gld.; Minn. AA; Minn. S. Gld. Exhibited: Wis. Salon A., Madison; WMAA, 1936, 1939; Wis. P.&S., 1940 (prize), 1941 (prize), 1942 (prize); IBM, 1941 (prize); Minn. Regional S., 1946 (prize); BM; WFNY, 1939; S. Gld.; ACA Gal., 1936 (one-man); Layton A. Gal., 1941; Walker A. Center, 1946; St. Paul Gal. A., 1946. Work: Greendale, Wis.; IBM; Wustum Mus. A., Racine, Wis.; Milwaukee AI; Walker A. Center; reliefs, USPO, Park Rapids, Minn. WPA artist. Positions: T., Layton Sch. A., 1940–42, Carleton Col., 1944–45; Hd., A. Dept., Macalester Col., St. Paul, 1945– [47]

HAUSER, John [P,T] Clifton, OH b. 1858 (or 1859), Cincinnati d. 6 O 1913. Studied: Cincinnati AA, ca. 1872; McMicken A. Sch., with T. Noble, 1873; Royal Acad., Munich, with Gysis, 1880; Düsseldorf; Paris. Work: Smithsonian. Specialty: Amerindians. In 1901, he was "adopted" as a Sioux and named "Straight White Shield."

HAUSER, Joseph S. [P] NYC. Exhibited: watercolors, AIC, 1934, 1935, 1936, 1938; PAFA, 1938 [40]

HAUSER, Josephine [P] NYC [21]

HAUSHALTER, George M. [P] New Hope, PA/Wiscasset, ME b. 9 Ja 1862, Portland, ME. Studied: Académie Julian, Paris; Ecole des Beaux-Arts. Member: AWCS; Rochester AC. Work: dec., churches, Rochester (N.Y.), Boston [40]

HAUSMANN, George E. [P] NYC/Leonia, NJ b. St. Louis, MO. Studied: Chase; R. Miller; Académie Julian, Paris, with Laurens. Member: Artists Gld. Work: mural, The Fleishman Co. [33]

HAUTEVILLE, Paul D. [P] Paris, France b. Newport, RI [15]

HAVELKA, George R. [P] Brooklyn, NY [06]

HAVEMEYER, Helen Mitchell [Ldscp.P,Dec] Falls Village, CT b. 21 Jy 1900, Yonkers, NY. Member: NAWPS [40]

HAVEMEYER, Henry O. (Mrs.) [Patroness] NYC b. 1855 NYC d. 6 Ja 1929. As a child she was a lover of paintings and as a young girl saved money until able to purchase a $100 picture by Degas, the first of his works to enter America. Her collection of about two hundred paintings, one of the finest in the U.S., had a value of several million dollars in 1929. It includes works of Rembrandt, Corot, Hals, Goya, Rubens, Manet, and numerous other masters, along with many fine pieces of porcelain and pottery. She willed the collection to the Metropolitan Museum of Art, and it is now known as the H.O. Havemeyer Collection, in memory of her husband. She was an early supporter of Mary Cassatt.

HAVENS, Belle. See H.M. Walcott, Mrs.

HAVENS, James Dexter [Wood En,B,I,P] Fairport, NY b. 13 Ja 1900, Rochester, NY d. 1960. Studied: Univ. Rochester; Rochester Inst. Tech.; T. Fogarty; T. Kinney; C.H. Woodbury. Member: Color Block Pr.M.; Southern Pr.M. Soc.; Woodcut Soc.; Rochester AC; Rochester Pr. Cl.; Am. Color Pr. Soc.; AAPL. Exhibited: Univ. Rochester, 1939 (prize); Rochester Pr. Cl. (annually), 1936 (prize), 1939 (prize); AWCS, 1938, 1941; Denver A. Mus., 1935, 1936, 1938; PAFA, 1941; Los Angeles Mus. A., 1934–36, 1938; Audubon A., 1945; NAD, 1942; Phila. Pr. Cl., 1934–43, 1946; LOC, 1943, 1944; Rochester AC, annually; Rochester Mem. A. Gal; Albright A. Gal. Work: Rochester Mem. A. Gal.; William

Smith Col., Geneva, N.Y.; Arnot A. Gal.; Rochester Inst. Tech.; Arlington (Mass.) Pub. Lib.; LOC; Rochester Pr. Cl. [47]

HAVRE, C. [P] Minneapolis, MN [17]

HAWEIS, Stephen [P,C,E,W] NYC b. London, England. Studied: Mucha, E. Carrier, in Paris. Member: Arch. Lg.; Faculty of Arts, London. Work: mural, War Mem. Chapel of St. Francis Xavier, Nassau; Stone Ridge Church, New York; painted windows, St. Anselm's Church, Bronx, N.Y.; paintings, Detroit Inst., Toledo Mus. A.; etchings, Nat. Gal. Sydney, Australia. Author: "The Book about the Sea Gardens, Nassau," "Egyptian Cove" [25]

HAWES, Charles M. [I] Bronxville, NY. Member: SI [47]

HAWES, Stephen [P] NYC [15]

HAWK, Kenneth C. [P] Muncie, IN [17]

HAWKES, McDougall b. 29 Jy 1862, New York d. 30 S 1929. Studied: France; Germany; Columbia. Member: MMA; AMNH; Société de l'Historie de l'art Française. Awards: Commander of the Legion of Honor (French); Order of Crown (Romanian); Order of Cambodia (French); Order of Morocco. Founder: Museum of French Art and French Institute in the U.S.

HAWKINS, Arthur, Jr. [Des] NYC b. 9 Ap 1903, Cumberland, MD. Studied: Univ. Va.; ASL, with Nicolaides, K.H. Miller. Member: A. Dir. Cl.; SI; Nat. Soc. A. Dir. Exhibited: AIGA, 1932, 1937, book jacket/advertising des., 1946 (prizes); Direct Mail Advertising Assn., 1944 (prize), 1945 (prize); A. Dir. Cl., 1946 (prize) [47]

HAWKINS, Basil G. [G,P] Flint, MI b. 18 Ja 1903, Vincennes, IN. Studied: J. Brozik. Member: Flint Ar. Group. Exhibited: watercolor, Flint Inst. A., 1938 (prize), 1939. WPA artist. [40]

HAWKINS, Benjamin F(ranklin) [S] Ossining, NY b. 17 Je 1896, St. Louis, MO. Studied: V. Holm; L. Lentelli; L. Lawrie. Member: NSS. Exhibited: Arch. Lg., 1933 (prize), 1937 (prize). Work: Univ. Mich.; U.S. Military Acad., West Point; USPOs, sculpture, Hyannis, Mass., metal grilles, Albany N.Y.; fountains, Brookgreen Gardens, S.C., Day Nursery, Colorado Springs; figures, Fed. Bldg., St. Louis, Little Rock (Ark.) H.S.; entrances, City Bank-Farmers' Trust, New York; War Mem., Milwaukee. WPA artist. [47]

HAWKINS, Edward Mack Curtis [P] Newburgh, NY b. 24 N 1877, NYC. Studied: Whistler; Monet, Cazin; Beardsley. Member: Charcoal Cl., Baltimore, Binghamton SAC; Buffalo Soc. A.&Crafts; Binghamton AA; Hudson Highlands AA. Exhibited: Liège, Belgium 1899–1902 (med); Turin, Italy, (med). Awards: Order of the Crown of Belgium; Iron Crown, Romania. Work: owned by Queen of Romania, King of Serbia, King Leopold of Belgium [47]

HAWKINS, G(race) Milner (Mrs.) [P,L] Palos Verdes Estates, CA b. 20 O 1869, Bloomington, WI. Studied: H.S. Mowbray; Kenyon Cox; Twachtman. Member: NAC; Springfield (Ill.) AC; Chicago A. Cl.; Madison (Wis.) A. Gld.; Laguna Beach A. Assn.; Long Beach A. Assn. Exhibited: Midland Empire Fair, Billings, Mont., 1925 (prize), 1932 (prize); Inter-Mountain Fair, Bozeman, Mont., 1929 (prize). Work: Ney Gallery, Hartford, Conn.; Tucson, Ariz.; Springfield (Ill.) A. Gal.; Mont. State Col., Bozeman [40]

HAWKINS, Josph Walter [P] Passaic, NJ b. 11 Ap 1877, Passaic d. 2 My 1953, Clifton, NJ. Studied: Laurens, in Paris [17]

HAWKINS, May Palmer (Mrs. Edward M.C.) [P,T] Newburgh, NY b. 14 F 1879, London, England. Studied: Cadmus; B. Meyers; E.M.C. Hawkins; I. Ward; J.E. Stouffer. Member: AFA; Hudson Highlands AA; Binghamton SAC [40]

HAWKINS, Rush C. [Patron,W] New York b. 1831, Pomfret, VT d. 24 O 1920 (struck by an automobile). Member: Legion of Honor, France. Founder: in memory of his wife, The Annmary Brown Memorial, Providence; the building contained his private collection. Position: Am. Commissioner FA, Paris Expo

HAWKS, Rachel M(arshall) (Mrs. Arthur W.) [S,T] Ruxton, MD b. 20 Mr 1879, Port Deposit, MD. Studied: Md. Inst.; Rinehart Sch. Sculpture, with E. Keyser, C. Pike. Member: Baltimore Friends of A. Exhibited: Fed. Garden Clubs Md. (med); Grand Central A. Gal.; Houston, Tex.; Biltmore Forest, N.C., 1938. Work: Md. Casualty Co., Memorial Hospital (fountain), City Hall, all in Baltimore; Hockiday Sch., Dallas; U.S. Naval Acad.; garden of Ambassador Bingham, Louisville, Ky. [47]

HAWLEY, Benjamin [P] Phila., PA. Studied: PAFA. Member: AC Phila. [25]

HAWLEY, Carl T. [P,I,L,T] Montrose, PA b. 4 Ap 1873, Montrose. Studied: Syracuse Univ.; ASL; Acad. Julian, Acad. Colarossi, both in Paris. Member: EAA; CAFA; Assoc. A. Syracuse; Iroquois AA. Exhibited: Sesqui-Centenn. Expo, Phila., 1926 (med). Work: Court House, Pulaski, N.Y.; Syracuse Mus. A.; Rochester (N.Y.) Athenaeum & Mechanics Inst. Illustrator: "History in Rhymes and Jingles," "Tanglewood Tales." Position: T., Syracuse Univ. [40]

HAWLEY, Gene [P,Des] NYC/Heart Lake, PA b. 3 O 1910, Wash., D.C. Studied: Syracuse Univ.; Acad. Delacluse, Acad. Moderne, both in Paris. Work: mural, Central H.S., Wash., D.C.; District of Columbia Pub. Lib. Position: A. Dir., Architectural Record [40]

HAWLEY, Hughson [P,Des] Brighton, England. b. 1850, England d. 11 My 1936. He maintained a studio in New York for more than fifty years, specializing in painting cathedral interiors.

HAWLEY, James J. [S] b. 1871 d. 11 D 1899, New York

HAWLEY, Margaret Foote [Min.P] NYC b. 12 Je 1880, Guilford, CT d. 19 D 1963. Studied: Corcoran A. Sch.; Howard Helmick; Acad. Colarossi, Paris. Member: ASMP; Pa. Soc. Min. P.; Brooklyn Soc. Min. P.; Boston Gld. A.; New Haven PCC; AFA; Concord AA; Wash. AC. Exhibited: PAFA, 1918 (med), 1920 (med); Baltimore WCC, 1926 (prize); Sesqui-Centenn. Expo, Phila., 1926 (med); Brooklyn Soc. Min. P., 1931 (med); NAWPS, 1931 (med). Work: MMA; BM; Concord AA. Sister of Mary Foote. [47]

HAWLEY, T. DeR. [P] NYC[06]

HAWLEY, Theodosia [P] NYC. Member: NAWPS; Concord AA [29]

HAWLEY, Wilhelmina D. [P] Risgoord, Holland. Member: NYWCC; N.Y. Women's AC [08]

HAWORTH, Edith E. [P] NYC. Member: S.Indp.A. [21]

HAWTHORNE, Charles W(ebster) [P,T] NYC/Provincetown, MA b. 8 Ja 1872, ME d. 29 N 1930. Studied: NAD; ASL; Shinnecock, with Chase. Member: ANA; NA; SC; NAC; Lotos C; A.Fund S.; Players; Société Nat. des Beaux-Arts, Paris; AWCS; Port. P.; NIAL; Century Assn. Exhibited: SC, (prize), 1904 (prizes); NAD, 1904 (prize), 1906 (prize), 1911 (prize), 1914 (gold), 1915 (gold,prize), 1924 (prize), 1926 (prize); CI, 1908 (prize), 1925 (prize); Buenos Aires Expo, 1910 (med); P.-P. Expo, San Fran., 1915 (med); PAFA, 1915 (gold), 1923 (prize), AIC, 1917 (med), 1923 (med,prize); Concord AA, 1922 (prize), 1925 (med); Phila. Expo, 1923 (med,prize); CGA, 1923 (prize), 1926 (prize); Sesqui-Centenn. Expo, Phila., 1926 (gold); Newport (R.I.) AA, 1928 (prize). Work: MMA; CGA; Syracuse Mus. FA; RISD; Worcester Mus.; Buffalo FA Acad.; Detroit Inst.; City A. Mus., St. Louis; Chicago AI; Peabody Inst., Baltimore; Herron A. Inst.; Boston Mus. A.; Engineer's C., N.Y.; Houston Mus. FA; TMA; Cincinnati Mus.; High Mus., Atlanta; Hackley A. Mus., Muskegon, Mich.; Dayton A. Inst., Ohio; New Britain Inst., Conn.; Mus. A., Fort Worth, Tex.; Union League, Chicago; NAD; NAC; Lotos C.; Forbes & Wallace Dept. Store, Springfield, Mass.; Town Hall, Provincetown, Mass.; Denver A. Mus.; Univ. Ill., Champaign; CI; Mulvane Mus., Washburn Col., Topeka, Kans.; Brooklyn Mus. Important Impressionist. Founder: Cape Cod Sch. A. [29]

HAWTHORNE, Edith G. [P,S,C,W,T] San Francisco, CA b. 29 Ag 1874, Copenhagen, Denmark. Studied: Chase. Member: Laguna Beach AA [33]

HAWTHORNE, Marion Campbell (Mrs. Charles W.) [P] NYC/Provincetown, MA. b. 1870, Joliet, IL d. 16 Ap 1945, NYC. Studied: AIC; Chase; Simon, Cottet, in Paris. Member: NAWPL; PBC; Grand Central A. Gal. [40]

HAY, Alice. See Clay, Mrs.

HAY, Eleanor [P] La Mesa, CA. Member: Calif. AC. Specialty: Impressionist scenes in France, 1890s; Maine [25]

HAY, Genevieve Lee (Mrs.) [S,T] NYC b. 12 S 1881, Cleveland d. 7 Ap 1918, Flemington, NJ. Studied: Cooper Union; Henri; ASL. Member: MacD. C. [17]

HAY, Gertrude [S] NYC. Work: Macbeth Gal., NYC [13]

HAY, Stuart [P] NYC b. 22 F 1889, Sewickly, PA. Member: GFLA; AFA [29]

HAYAKAWA, Miki (Miss) [P,S] New Monterey, CA b. Hokkaido, Japan. Studied: Berkeley Sch. AC; Calif. Sch. FA. Member: Calif. Sch. FA Assn. Exhibited: Calif. Sch. FA, 1924 (prize); Monterey State Fair, 1937 (prize); Monterey County Fair, 1937; GGE, 1939 [40]

HAYDEN, Charles H. [P,Patron] Belmont, MA b. 4 Ag 1856, Plymouth, MA d. 4 Ag 1901. Studied: BMFA; Boulanger; Lefebvre; Collin; Paris.

Member: Boston WCC. Exhibited: Paris Expo, 1889 (prize), 1900 (med); Boston, 1895 (prize); Atlanta Expo, 1895 (med). He left $50,000 to the BMFA. [01]

HAYDEN, Edward Parker [Ldscp.P] Haydenville, MA d. 7 F 1922 [01]

HAYDEN, Ella Frances [Ldscp.P] Providence/Pomfret, CT b. 21 Mr 1860, Boston. Studied: NAD; Delecluse Sch., Paris; Nat. A. Sch., Munich; Cowles A. Sch., Boston. Member: Providence AC; Providence WCC [33]

HAYDEN, Florentine H. [P] Waterbury, CT. Member: S.Indp.A. [25]

HAYDEN, Harriet Winslow (Mrs.) [P,T] Denver, CO b. 20 Jy 1840, Franklin, MA d. 29 1906. Studied: Rockford Seminary; Dearborn Seminary. Member: Le Brun C., Denver (founder); Denver AC. Specialty: flower paintings in oil and watercolor [06]

HAYDEN, Hayden C. [P] NYC. Member: GFLA [27]

HAYDEN, Palmer Cole [P] NYC b. 1890, Widewater, VA d. 1973. Specialty: rural and urban aspects of the Black experience. WPA artist. [*]

HAYDEN, Sara S. [P,L,T] Chicago, IL b. Chicago. Studied: AIC; Collin, Merson, Lasar, in Paris; Chase; Duveneck. Member: Chicago SA [31]

HAYDOCK, May S. [P,C,T] Alfred, NY b. Phila. Studied: PAFA; Phila. Sch. Des.; London; Paris. Member: Plastic C.; Phila. WCC; Baltimore WCC; Boston Soc. A.&Cr. Position: T., Alfred Univ. [10]

HAYES, Bartlett H., Jr. [P,T] Andover, MA b. 5 Ag 1904. Positions: T., Phillips Acad.; Cur. AGAA [40]

HAYES, Chester C. [P] Highlands, NJ/Etaples, France. Member: NYWCC [21]

HAYES, G. Mark [Mur.P,Dec,B] Ipswich, MA b. 19 Jy 1907, Ipswich. Studied: Des. A. Sch., Boston. Member: North Shore AA; Gloucester SA. Work: Sacred Heart Church, Ipswich; St. Mary's Church, Boston; restaurants, Waltham, Mass., Providence; theatres, Springfield and Roxbury, Mass. [40]

HAYES, J.M. Kinney [P] Columbus, OH. Member: Columbus PPC [25]

HAYES, Katharine W(illiams) (Mrs. James A.) [P,I,T] Wallingford, PA b. 5 Ap 1889, Wash., D.C. Studied: E. Nardi, in Rome; R. Logan; P. Hale; W. James; F. Bosley. Member: CAFA. Illustrator: "Pirates and Pigeons" [40]

HAYES, Lee [P,E] Butte, MO b. 13 O 1854, Platteville, WI. Studied: self-taught [25]

HAYES, Louisa [P,S,C] Buffalo, NY/Ridgeway, Ontario b. 15 Ja 1881, Buffalo. Studied: Buffalo Albright A. Sch.; R. Reid. Member: Buffalo SA; Buffalo GAA [25]

HAYES, Thomas [P,Dec,C,L] San Francisco, CA b. 8 My 1910, Houston. Studied: Pratt Inst., Brooklyn; R. Boynton; R. Stackpole. Member: San Fran. A. Assn.; San Fran. Ar. U.; Am. Ar. Cong. Exhibited: SFMA; Los Angeles Mus. A. Work: SFMA; San Fran. Boys' C. [40]

HAYES-MILLER, Kenneth. See Miller.

HAYMAKER, Susan I. [P] Pittsburgh, PA. Member: Pittsburgh AA [24]

HAYN, Walter [P] Brooklyn, NY/Provincetown, MA [24]

HAYNES, Caroline Coventry [P] Highlands, NJ b. New York. Studied: ASL; Paris, with A. Stevens, Courtois. Member: NYWCC; NAWPS [25]

HAYNES, Elsie Haddon [Ldscp.P] Denver, CO b. Isle of Wight, England. Member: Ar. Gld. Colo. Illustrator: talks on England and the Colorado Rockies [40]

HAYNES, Frank Jay [Ldscp.Photogr] b. 1853 d. 1921. Work: Haynes Mus., Bozeman, Mont. Best known as the official photographer of Yellowstone Nat. Park. Like Edweard Muybridge and Carleton Watkins before him, his majestic western landscapes were popular with tourists and were often used by artists in their paintings. [*]

HAYNES, Perry [P,T,L] Center Ossipee, NH b. 22 Ja 1870, Lynn, MA. Studied: Eric Pape Sch. A.; G.L. Noyes. Work: private collections [40]

HAYS, Austin [S] NYC/New Hampshire b. 1869, NYC d. 24 Jy 1915, White Mountains. Studied: Mercié, Peuch, both in Paris. Member: SC; Arch. Lg. Exhibited: Petit Salon; NAD. Son of William J. Hays, A.N.A.; brother of William J. Hays, Ldscp. P. [13]

HAYS, Barton S. [Por.P] b. 5 Ap 1826, Greenville, OH d. 14 Mr 1914, Minneapolis. Position: T., McLean's Female Seminary, Indianapolis. Painting portraits in Ind., ca. 1850s–82; moved to Minneapolis in 1882. [*]

HAYS, George A. [Ldscp.P] Providence, R.I. b. 23 N 1854, Greenville, NH. Studied: self-taught. Member: Providence AC; Copley S., 1892; S.Indp.A.; Providence WCC. Specialty: landscapes with cattle [33]

HAYS, Gertrude V. [P,Min.P] Akron, OH. Exhibited: Min. P. Ann., PAFA, 1937–39 [40]

HAYS, William Jacob, Sr. [P] NYC b. 8 Ag 1830, NYC d. 13 Mr 1875. Studied: J.R. Smith. Member: ANA, 1853. Exhibited: NAD, 1850–57. Work: CGA; Amon Carter Mus.; Denver AM; NYPL; St. Louis Am; Wash Univ. Best known for his views of the upper Missouri, 1860. Later traveled to England, Nova Scotia, Adirondacks. Father of William, Jr. [*]

HAYS, William J(acob), Jr. [P] Millbrook, NY b. 1 Jy 1872, Catskill, NY. d. 30 S 1934. Studied: NAD; Académie Julian, Paris; Colarossi Acad., Paris. Member: ANA, 1909; SC, 1900; AFA. Exhibited: SC, 1912 (prize) [33]

HAYTHE, Ethel Campbell (Mrs. John G.) [P] Lynchburg, VA b. 15 O 1888. Studied: H.B. Snell; E. Browne; H.H. Breckenridge. Member: NAWPS [40]

HAYWARD, Alfred [P] Phila., PA b. Camden, NJ d. 26 Jy 1939. Studied: PAFA. Member: Phila. WCC; Phila. Sketch C.; Phila. AC; NYWCC. Exhibited: Phila. WCC, 1919 (gold) [33]

HAYWARD, Beatrice Burt (Mrs. Caleb Anthony) [Min.P] New Bedford, MA b. 17 D 1893, New Bedford. Studied: Delecluse, Mme. La Farge, both in Paris; L.F. Fuller, E.D. Pattee, M. Welch, all in N.Y. [40]

HAYWARD, F. Harold [P,I,S,T] Mt. Clemens, MI b. 30 Je 1867, Romeo, MI. Studied: Whistler, Laurens, Constant, all in Paris [15]

HAYWARD, Gerald Sinclair [Min.P] NYC b. 1845 d. Mr 1926. Painted miniatures of many royal personages in England, Russia, Germany and of many notables in this country.

HAYWARD, Lucy [P] Boston, MA [10]

HAYWARD, Mildred (Mrs. John) [P,W] NYC/Centerville, MA b. 23 Ja 1889, Chicago. Studied: H.T. Leggetti; D. Ochtman. Member: Greenwich A. Soc.; Nat. A. Soc.; Studio Gld., N.Y. Exhibited: Studio Gld., 1938; NAC, 1939. Work: Dayton, Ohio, AI [40]

HAYWOOD, (Mary) Carolyn [P] Phila., PA b. 3 Ja 1898, Phila. Studied: PAFA; V. Oakley; E.S.G. Elliott; H. Breckenridge. Member: Phila. WCC. Work: PAFA; Manayunk Nat. Bank, Northeastern Title and Trust Co., Holmesburg Trust Co., all in Phila.; offices of Hooker-Electro-Chemical Co., Lincoln Bldg., N.Y. Illustrator: (and cover designs) Doubleday, Doran Co.; Curtis Publishing Co. Author/Illustrator: "'B' is for Betsy," "Two and Two are Four" [40]

HAZ, Nicholas [P,I,T] Los Angeles, CA b. 18 Ja 1883, Zolyom, Hungary. Studied: F. von Stuck, P.A. de Laszlo. Member: Calif. AC. Work: Mus. Hildesheim [17]

HAZARD, Arthur Merton [P] Hollywood, CA b. 20 O 1872, Bridgewater, MA d. 26 Jy 1930. Studied: DeCamp; Duveneck; Prinet, Henri Blanc, both in Paris. Member: St. Botolph C.; Copley S.; Calif. AC; SC; Painters of the West. Exhibited: Mass. Charitable Mechanics' Assn., 1892 (med). Work: Red Cross Mus., Wash., D.C.; Nat. Mus., Wash., D.C.; Temple Israel, Boston; Houses of Parliament, Canada. Specialty: war pictures [29]

HAZARD, Grace [P] Kirkwood, MO. Member: St. Louis AG [10]

HAZELL, Frank [P,I,Des] NYC b. 7 Je 1883, Hamilton, Ontario d. ca. 1957. Studied: ASL. Member: AWCS; Ar. Fund Soc.; GFLA. Position: T., Grand Central Sch. A. [40]

HAZELTINE, Florence [P,T] St. Louis, MO b. 28 ap 1889, Jamestown, NY. Studied: Pratt Inst.; Fursman; Watson; Garber; Lever; H. Snell; B.C. White. Member: St. Louis AG; NAWPS. Exhibited: St. Louis AG, 1924 (prize) [40]

HAZELTINE, Herbert [S] NYC [15]

HAZELTON, I(saac) B(rewster) [P,I] Nutley, NJ/Isle au Haut, ME b. 30 D 1875, Boston d. 27 Ja 1943. Studied: Tarbell; Benson; De Camp; W.F. Brown. Member: AG. Work: MIT [40]

HAZELTON, J.B. [I] NYC [19]

HAZELTON, Mary Brewster [P,T] Wellesley Hills, MA b. Milton, MA. Studied: Tarbell. Member: Copley S.; Boston GA; Concord AA; CAFA. Exhibited: NAD, 1896 (prize); BMFA, 1899 (prize); Pan-Am. Expo, Buffalo, 1901 (prize); P.-P. Expo, San Fran., 1915 (med); Newport AA, 1916 (prize). Work: Wellesley Hills Church [40]

HAZELWOOD, Ella [P] Pittsburgh, PA. Member: Pittsburgh AA [25]

HAZEN, Bessie E(lla) [P,T] Los Angeles, CA b. 1861, Waterford, New Brunswick d. 11 Mr 1946. Studied: Columbia; Univ. Calif. Member: Calif. AC; Calif. WCS; Women P. of the West; Calif. A. Teachers. Exhibited: Ariz. State Fair, 1916, (prize), 1917 (prize), 1919 (prize); Art T. Assn., Los Angeles, 1924 (prize); West Coast Arts, 1926 (gold); Ebell C., 1931 (prize), 1932 (prize). Work: Springfield (Mass.) Pub. Lib.; Sacramento (Calif.) Pub. Lib.; Los Angeles Pub. Lib.; Expo Park Mus.; Los Angeles Pub. Sch.; Vanderpoel Coll., Chicago; Dixie Col., St. George, Utah; Honolulu Acad. A. Position: T., Univ. Calif. Extension, Los Angeles [40]

HAZEN, (Fannie) Wilhelmina (Mrs. B.F. Ledford) [P,S] Los Angeles, CA/Los Gatos, CA b. 27 Ag 1877, Murphy's Gulch, CA. Studied: Hopkins Inst., San Fran., Académie Moderne, Paris [40]

HAZEN, Grace [C] Rocky Neck, MA b. 12 N 1874, Cincinnati d. 3 Mr 1940. Studied: Chase Sch. A., N.Y.; Pratt Inst. Member: NAC; Boston SAC. Specialty: jewelry and metal work (gold, silver, platinum) [38]

HAZENPLUG, Frank [C,T] Chicago, IL. Member: SWA [10]

HAZLEHURST, Mary S.L.(Mrs. George Purves) [P,L] Baltimore, MD/Shepherdscote, ME b. 7 Jy 1878, Conshohocken, PA. Studied: PAFA; Chase; C. Beaux; H.H. Breckenridge; H. McCarter [40]

HAZLETT, Lawrence [Des,T] Chicago, IL b. 10 F 1911, St Louis. Studied: AIC; E.S. Campbell. Position: T., South Side Settlement House, Chicago [40]

HAZLEWOOD, Phoebe W(eeks) (Mrs.) [P] Sackett Harbor, NY b. 12 D 1885, Ellendale, ND. Studied: S. Hayden. Member: St. Petersburg AC. Specialties: glass painting, silhouette cutting [31]

HAZZARD, Sara [Min.P] Jamestown, NY/Lakewood-on-Chautauqua, NY b. Jamestown. Studied: ASL; Chase; Am. Sch. Min. P. Member: Pa. Soc. Min. P.; NAWPS [40]

HEAD, Cecil F. [P] Indianapolis, IN b. 1 Jy 1906, Lebanon, IN. Studied: W. Forsyth; C. Wheeler; F.E. Schoonover; John Herron AI. Member: Ind. Ar. C. Exhibited: John Herron AI, 1933 (prize), 1937 (prize); Hoosier Salon, 1934 (prize), 1937 (prize); WFNY, 1939 [40]

HEAD, Francis, Mrs. See Bush-Brown, Lydia.

HEADE, Martin Johnson [P] b. 11 Ag 1819, Lumberville, PA d. 4 S 1904, St. Augustine, FL. Studied: T. Hicks; Italy; France; England, ca. 1837–40. Work: MMA; BMFA; other major museums. Active in St. Louis, 1852; Chicago, 1853–54; Brazil, 1863–64; Nicaragua, 1866; Colombia; Puerto Rico; Jamaica, 1870; British Columbia; Calif.; Fla.; NYC, early 1880s. Best known for his paintings of tropical birds and flowers and his Eastern salt marsh landscapes. Also painted portraits in the East. Known as a naturalist and poet. Important "luminist" painter.

HEALD, Sarah Thorp [P] Hubert, MN [15]

HEALY, Aaron Augustus [Patron] Cold Spring Harbor, NY b. 26 Je 1850, Brooklyn d. 28 S 1921. Member: Brooklyn Inst. A.&Sc. (Pres., 25 yrs.); Municipal A. Comm.; Brooklyn Acad. Music; NA; Century Gal.; Rembrandt Gal.; Hamilton Gal. Honored by the king of Italy for his aid to Italian immigrants.

HEALY, Arthur K.D. [P,Arch,L] Middlebury, VT b. 15 O 1902, NYC. Studied: E. O'Hara; Princeton; Fontainebleau Sch. FA. Member: AWCS; NYWCC; Phila. WCC. Exhibited: AWCS, 1936 (prize); Stockbridge AA, 1936 (prize), 1937 (prize), 1938 (prize) [40]

HEALY, Frank D. [P,I,C] St. Louis, MO b. 1862, St. Louis. Studied: St. Louis Sch. FA; Hastings. Member: Daubers' C.; St. Louis Arch. C. [10]

HEALY, George Peter Alexander [Por.P] b. 15 Jy 1813, Boston d. 24 Je 1894, Chicago. Studied: France, with Gros. Work: NPG; BMFA; NAD; Essex Inst.; Minn. Hist. Soc.; Chicago Hist. Soc. He and W.M. Hunt were the most successful portrait painters of the mid-19th century. He was patronized by the royal families of England and France in the 1830s and 1840s. From 1844 to 1867 he worked in Wash., D.C. and in major cities of the East and South, settling in Chicago, 1854–67. He then returned to Rome and Paris, traveling extensively on commissions. Returned to Chicago in 1892. [*]

HEALY, Laura [P] Nice, France b. Chicago. Studied: G. Thurner [06]

HEALY, Marion Maxon (Mrs. Rufus Alan) [E,Por.P] Cincinnati, OH b. 5 O 1890, Mobile, AL. Studied: H.H. Wessel; J. Weis; D. Garber; E.T. Hurley; H. Wickey; Cincinnati A. Acad.; PAFA; ASL. Member: Cincinnati Women's AC; Crafters Cl.; Cincinnati Mus. Assn.; Ala. AL [40]

HEANEY, Charles Edward [E,B,P] Portland, OR (1950) b. 22 Ag 1897, Oconto Falls, WI. Studied: Portland MA Sch.; Univ. Oreg.; H. Heinie, in Milwaukee. Member: Northwest PM. Exhibited: Northwest PM, 1929 (prize), 1930 (prize), 1931 (prize), 1932 (prize), 1936 (prize); WFNY, 1939. Work: Seattle AM; Bucknell Univ.; Western Wash. Col. [40]

HEAP, Jane [P] Chicago, IL [13]

HEARD, Edith V.R. (Mrs.) [P] Pittsburgh, PA Member: Pittsburgh AA [24]

HEARN, Alfred [P] Minneapolis, MN [19]

HEARN, George Arnold [Patron] NYC b. 7 D 1835 d. 1 D 1913. He gave MMA a collection of paintings, the majority by living American artists, and $250,000 for the increase of the American collection.

HEARN, Mary H. See Herbert Greims, Mrs.

HEARTT, Harold [P] Paris, France [10]

HEASLIT, William (John) [E,P,I,Li] Rahway, NJ b. 16 My 1898. Studied: NAD; ASL. Member: SI; NYAG. Exhibited: First Intl. Aeronautical Art Exh., Los Angeles, 1937 (prize). Work: Franklin Inst., Phila.; Heinz & Co., Pittsburgh; "Fine Prints of the Year", 1936. Illustrator: Saturday Evening Post, Collier's [40]

HEATH, Alice [P] NYC. Member: NAWPS [21]

HEATH, Arch B. [I,W] NYC b. 1891, Brooklyn, NY d. 6 Ja 1945. Positions: Staff Car., Assoc. Newspapers Syndicate; A. Ed., Tichenor publications; also a film director

HEATH, Edda Maxwell [P,L,T] Carmel, CA b. Brooklyn, NY. Studied: Pratt Inst.; Chase. Member: Brooklyn SA; Nanuet PS; Yonkers AA; Carmel AA; AAPL; AFA. Work: State Col. Idaho [40]

HEATH, Ella [P,I,T] Baldwin, KS/Santa Fe, NM b. Rockford, IL. Studied: Taft; Beckwith; Vanderpoel [25]

HEATH, Grace Comstock [P] Milwaukee, WI/Lakewood, WS b. 18 F 1897, Ithaca, MI. Studied: I. Christensen, Chicago; Sister Stanisia, Mount Mary Col., Milwaukee. Member: Seven Arts Soc. of Wis. Work: Mount Mary Col. [33]

HEATH, Howard P. [P,B,Dec,I] Norwalk, CT b. 2 O 1879, Boulder, CO. Studied: AIC; ASL; Nankivell. Member: NYWCC; Westport A. Market; Silvermine Gld. Work: Ferguson Lib., Stamford, Conn.; Town Hall, Westport, Conn.; Hurlbut Sch., Weston, Conn. [40]

HEATH, Lillian Josephine Dake (Mrs.) [P,C] Santa Cruz, CA b. 2 Ag 1864, Milwaukee. Studied: Heath; Yard; Latimer; Bier. Member: Santa Cruz AL [25]

HEATON, (Augustus) G(oodyear) [P] West Palm Beach, FL b. 28 Ap 1844, Phila. d. 13 S 1930, Wash., D.C. Studied: PAFA; Ecole des Beaux-Arts, with Cabanel [his obituary claims he was the first American to enter the school]; Bonnât, 1879; Moore Inst. for Women. Member: Phila. Sketch C.; S.Indp.A.; SC, 1908. Exhibited: Columbian Expo, Chicago, 1893 (med); PAFA, 1863; Paris Salon. Work: Wash., D.C. (engraving on fifty-cent postage stamp, Columbian Expo, and engraving on ten-cent postage stamp, Omaha Expo); Union Lg. C., Phila.; War Col., State Dept., Navy Dept., all in Wash., D.C.; Del. State House; N.Y. Hist. Soc.; Tulane Univ.; Cornell. Author: "The Heart of David," "Fancies and Thoughts in Verse," "Mint Marks," "New National Anthem" [29]

HEATON, Charles M., Jr. [Min.P,Por.P] b. 17 D 1840, South Bend, IN d. 19 Ag 1921, Tacoma Park, D.C. Work: South Bend Hist. Mus. Also a realtor. [*]

HEATON, Clement [C,Des] West Nyack, NY b. 1861, Watford, England d. 27 Ja 1940. Studied: Burlison, Grylls, both in London. Member: Société des Beaux-Arts; NYSC; AFA. Work: Huguenot Church, Pelham Manor, N.Y.; Grace Church, Colorado Springs; Blessed Sacrament, NYC; Trinity Cathedral, Cleveland; CMA; Chapel Col. T., Wash. Cathedral, Wash., D.C.; Kent Sch. Chapel, Kent, Conn.; First Baptist Church, Montclair, N.J.; Christ Church, Detroit; Congregational Church, Glenridge, Montclair, N.J.; St. Paul's Church, Yonkers, N.Y.; various important coll., Europe. Specialties: stained glass, mosaics [40]

HEATON, Maurice [C] West Nyack, NY b. 2 Ap 1900, Neuchatel, Switzerland. Member: NYSC; Phila. ACC; Arch. Lg.; Soc. Des. & Crafts Boston SAC. Work: Rockefeller Center, N.Y.; Polygraphic A. Cl.; Court Rooms, Bay County Bldg. Contributor: art and architecture magazines. Specialty: illuminated glass murals [40]

HEAVEN, Ethel R. See Hamilton, Mrs.

HEBALD, Milton Elting [S,T] NYC b. 24 My 1917, NYC. Studied: ASL; BAID. Member: An Am. Group; S. Gld.; Am. Ar. Cong.; United Am.

Ar. Exhibited: ACA Gal. 1937 (one-man); BM, WMAA; MOMA; WFNY, 1939; GGE, 1939. Position: T., Am. Ar. Sch., N.Y. [40]

HEBER, Carl Augustus [S] NYC b. 15 Ap 1875, Stuttgart, Germany d. 1956. Studied: AIC; Taft, in Chicago, 1899; Académie Julian, Paris; Ecole des Beaux-Arts, Paris. Member: NSS; Grand Central AG. Exhibited: St. Louis Expo, 1904 (med); P.-P. Expo, San Fran, 1915 (med). Work: St. Louis Mus. FA; Champlain Mem., Crown Point, N.Y.; Champlain statue, Plattsburg, N.Y.; Schiller Mon., Rochester, N.Y.; statue Benjamin Franklin, Princeton; statue "Valor," NYC; Everett Mem., Goshen, N.Y.; Soldiers and Sailors Mon., Geneva, Ill.; World War Mem., Wausau, Wis.; BMFA; Batavia, N.Y.; Manhattan Bridge, NYC; St. Ann Church, Phila.; USPO, Phila.; Univ. Mus., Phila.; Tompkins Mem., New City, N.Y. [40]

HEBER, Charles G. [S] NYC [10]

HEBER, Claudia. See Smith, Marcella.

HEBERER, Charles [P] St. Louis, MO b. St. Louis. Studied: St. Louis Sch. FA; Lefebvre, Constant, Vuillefroy, in Paris [10]

HEBERT, Marian [P,E,B,T] Santa Barbara, CA b. 5 Je 1899, Spencer, IA. Studied: F.M. Fletcher; E. Borein; C. Boone; Santa Barbara Sch. A.; Santa Barbara T. Col. Member: SAE; Santa Barbara AA. Exhibited: SAE, 1938 (prize). Work: Univ. Nebr., Lincoln; Veterans Mem. Bldg, Carpinteria, Calif.; LOC. Position: T., Evening H.S., Santa Barbara [40]

HECHT, Victor D(avid) [P] b. 15 My 1873, Paris, France. Studied: ASL; Lefebvre, Robert-Fleury, in Paris. Member: Port. P. [33]

HECHT, Zoltan [Mur.P] Brooklyn, NY b. 24 Je 1890, Nagy Varad, Hungary d. 1968. Studied: Cleveland Sch. A. Member: Am. A. Cong.; United Am. Ar. Work: Syracuse Mus. FA; Newark, N.J. Airport; Brooklyn Col.; Brooklyn Pub. Lib. WPA artist. [40]

HECHTER, Charles [P,G] Chicago, IL b. 24 My 1886, Romania. Studied: Minneapolis Sch. FA. Member: United Am. Ar., Chicago. Exhibited: Chicago; N.J. Soc. Ar.; Navy Pier, Chicago. Also a Restorer. [40]

HECKER, Frank J. [Patron] Detroit, MI d. 26 Je 1927. He owned an art collection, including works by Whistler.

HECKLINGER, Guy Edwards [P] Baltimore, MD [25]

HECKMAN, Albert William [P,E,Li,Des,L] NYC/Woodstock, NY b. 29 S 1893, Meadville, PA d. 1971. Studied: Leipzig Inst. Graphic A.; Columbia. Member: Woodstock AA. Exhibited: Phila. Print C., 1929 (prize). Work: WMAA; AGAA; Springfield (Mo.) A. Mus.; LOC; Honolulu Acad. A. Author: "Paintings of Many Lands and Ages." Position: T., Hunter Col. [40]

HEDEAN, (Herman E. Dean) [P,Com.A] Ivortyon, CT (1985) b. 31 My 1904, Foxboro, MA. Studied: BMFA Sch.; New Sch. Des., Boston, with A. Gorky, A. Thieme, ca. 1924–26. Member: Essex (Conn.) Art Assoc. Exhibited: Galerie Centro, Gallarate, Italy; Am. P. Exh., Centre International de Paris; Toronto FA Gal.; Venable/Neslage Gal., Wash., D.C.; IBM Gal., Poughkeepsie, N.Y.; Stamford Mus., Munson Gal. (New Haven), Bruce Mus. (Greenwich), Stoneledge Gal. (Noank), Greene Art Gal. (Guilford), Old Lyme Art Works, all in Conn. Work: Finch Col. Mus., NYC; private coll. in Canada, Europe, U.S. Designer: adv., American Tobacco Co., P. Lorillard, others. Specialty: abstract painting [*]

HEDGES, Margaret Ricker (Mrs. Donald A.) [C,B] New Hope, PA b. 14 My 1906, Cadillac, MI. Studied: Univ. Mich. Member: Am. Gld. Craftsmen. Specialty: batik [40]

HEDGES, Robert Danforth [Mar.P] Brooklyn, NY b. 26 D 1878, Chicago. Studied: AIC; Chicago Manual Training Sch. Member: Brooklyn SA; AAPL; SC [40]

HEDIAN, Helena [P] Baltimore, MD. Member: Baltimore WCC [29]

HEEBNER, Ann. See McDonald, Mrs.

HEERMAN, Norbert [P,W,L] Woodstock, NY b. 10 My 1891, Frankfort, Germany. Studied: Reynolds, in Chicago; Robert-Fleury, in Paris; Corinth, in Berlin; Duveneck, in Cincinnati; Member: Woodstock A. Assn. Work: Evanston Sch., Cincinnati; Cincinnati A. Mus. Coll.; Farnsworth Mus., Wellesley Col. Author: "Frank Duveneck"; Duveneck Catalogue, WMAA, 1938 [40]

HEFFERMAN, William L. [P] Springvale, ME [15]

HEGARTY, Anna Agnes [Des,P,T] Indianapolis, IN b. 20 Ap 1906, Indianapolis. Studied: W. Forsyth; C. Wheeler; O. Richey; John Herron Art Inst. Exhibited: Ind. State Fair, 1932 (prize). Work: U.S. Treasury Dept.; St. Vincent's Gld. Lib., Indianapolis. Designer: liturgical vestments, church goods [40]

HEIDEL, Edith Ogden (Mrs.) [S,W] Wash., D.C. b. St. Paul, MN. Studied: Saint-Gaudens. Member: Wash. AC [31]

HEIDRICK, Madeleine [P] Peoria, IL. Exhibited: 48 Sts. Comp., 1939 [40]

HEIFFEL, Eugene [P] NYC. Member: S.Indp.A. [25]

HEIKKA, Earle Erik [S,P] b. 1910, Belt, MT d. 1941, Great Falls, MT. Studied: self-taught, although he knew C.M. Russell. Exhibited: Worlds Fair, Chicago, 1932. Specialty: Western genre [*]

HEIL, Charles Emile [P,E,I,T] Jamaica Plain, MA b. 28 F 1870, Boston. Studied: Boston; Paris. Member: Boston WCC; Boston SWCP; Chicago SE; Calif. PM; SAE; AFA. Exhibited: P.-P. Expo, San Fran., 1915 (gold); Jordan Marsh Co., Boston, 1938 (med). Work: Worcester (Mass.) A. Mus.; Malden (Mass.) Pub. Lib.; NYPL; Concord AA; AIC; CMA; Milwaukee AI; Cincinnati Mus.; Calif. State Lib.; Los Angeles Mus.; LOC; Yale; Lawrence Col., Appleton, Wis.; Univ. Nebr.; Honolulu Acad. A.; State Gal., Munich; Bibliothèque Nationale, Paris [40]

HEIL, Elizabeth [P,C] Seattle, WA b. 3 Ag 1877, Columbus, OH. Studied: Cincinnati A. Acad., with C. Lord, T.S. Noble [15]

HEILPRIN, Gertrude [P] Wash., D.C. [24]

HEIMERDINGER, H. [P] Girard, OH. Member: Artklan [25]

HEINE, F.W. [P,T] Milwaukee WI b. 1845, Leipzig, Germany (came to U.S. in 1885) d. 27 Ag 1921. Studied: Germany. Founder: Heine Art School of Milwaukee [17]

HEINEMANN, Ernst [En] Fort Wadsworth, NY b. 10 F 1848, Brunswick, Germany (came to U.S. in 1872) d. 11 My 1912, Staten Island, NY. Studied: A. Closs; Brendeamoure; ASL. Member: SC. Exhibited: Pan-Am. Expo, Buffalo, 1901 (med). Specialty: wood engraving [10]

HEINIGKE, Otto [P,I,C,W] Bay Ridge, NY b. 1851, Brooklyn, NY d. 1 Jy 1915. Member: Mural P. Designed and manufactured all the stained glass in the LOC; many windows in Manhattan churches. Specialty: stained glass [13]

HEINRICH, Christian [S] Brooklyn, NY. Work: USPO, Rockwood, Tenn. WPA artist. [40]

HEINRICH, Edith Clara [P] Chicago, IL [04]

HEINRICH, Roy Frederic [I] NYC b. 6 Ap 1881, Goshen, IN d. 1943. Studied: Conn. Lg. A. Students, with C.N. Flagg, Brandegree. Member: SI; A. Directors C. Exhibited: WFNY, 1939; advertising illustration, 1925 (prize). Work: General Electric; Guardian Trust Co., Detroit. Illustrator: historical, National Life Insurance, Vt. [40]

HEINRICI, Gertrud [P] Columbia, MO [15]

HEINTZ, Marion [P,C] Buffalo, NY b. 16 Ag 1900. Studied: Buffalo Sch. FA. Member: Allied AG [33]

HEINTZELMAN, Arthur William [E,Mus.Cur,W,L,P,T] Marblehead, MA b. 22 N 1890, Newark, NJ d. 4 Ap 1965, Rockport, MA. Studied: RISD; Holland; France; Belgium; Spain; England; Scotland. Member: ANA; NA; Phila. SE; SC; AFA; MMA; Paris AAA; Marblehead A. Assn.; Am. Assn. Mus. Dir.; Royal Soc. A., London; Société Nationale des Beaux-Arts, Société de la Gravure Originale en Noir, both in Paris; Am. Nat. Com. En.; SAE; Chicago SE; Calif. Pr.M. Exhibited: AIC, 1920–22 (prizes); Brooklyn SE, 1920 (prize), 1924 (prize); Calif. PM, 1934 (gold); Intl. Expo, Paris, 1937 (gold); Chicago SE, 1919 (prize), 1920 (med), 1925 (prize); SAE, 1920 (prize), 1924 (prize); Calif. SE, 1921 (prize); Phila. SE, 1924 (prize); Phila. Pr. C., 1925 (prize); Soc. for Sanity in Art, 1939 (prize); AAPL, 1929 (prize), 1945 (prize); Southern Pr.M., 1940 (prize); Northwest Pr. M., 1941 (prize); New England Women's C., 1940 (prize), 1945 (prize); LOC, 1945 (prize); Wichita AA, 1946 (prize); Montclair A. Mus, 1939 (prize); NAD, annually since 1933; Paris; Milan; Rome; Geneva; Lausanne; London, 1925–35; nationally since 1917. Work: MMA; BMFA; Boston Pub. Lib.; British Mus.; Victoria & Albert Mus.; Musée du Luxembourg; Bibliothèque Nationale; AIC; NYPL; LOC; CGA; Honolulu Acad A.; TMA; Milwaukee AI; Los Angeles Mus. A.; Detroit Inst. A.; RISD; Newark Pub. Lib.; Cincinnati Mus.; FMA; AAGA; Fine Prints of the Year, 1923–39; Fifty Prints of the Year, 1934. Author: "More Books," Boston Pub. Lib.; exh. catalogs, art periodicals, special articles on graphic artists. [Books, articles, pamphlets on Heintzelman: Am. Etchers Series; Crafton Coll.; John Taylor Arms, in Print Collectors Quarterly (Feb., 1937); complete catalog by British Mus.] [47]

HEINZ, Charles L(loyd) [P] Provincetown, MA b. 8 Ja 1885, Shelbyville, IL d. ca. 1955. Studied: St. Louis Sch. FA; Chicago Acad. FA; R.M. Root; Miller; Hawthorne, at Cape Cod Sch. A.; Harrison. Member: SC;

Provincetown AA. Exhibited: NAC, 1946; PAFA, 1930, 1932; CI, 1941, 1943–45; CGA, 1931, 1935, 1937, 1939, 1943; AIC, 1928, 1937, 1938, 1942; NAD, 1929–32, 1937, 1938, 1941; MMA, 1941; AGAA, 1939; SC, annually, 1939 (prize); Provincetown AA, annually. Work: Springfield Mus. A.; Fitchburg Mus. A. [47]

HEINZE, Adolph [P] Downers Grove, IL b. 5 F 1887, Chicago. Studied: Buehr; Grant; Chase; Snell. Member: Chicago PS; Chicago Gal. A.; All-Ill. SFA. Exhibited: Municipal AL, 1927 (prize); Chicago Gal. A., 1927 (prize) [40]

HEINZMANN, O.J., Mrs. See Jameson, Samilla.

HEISS, Jesse S.C. [P,I,En] Berlin, NJ b. 7 Ag 1859, Phila. Studied: painting, H. Simon; designing, M.R. Longacre. Specialty: wood engraving [13]

HEISSER, Margarethe E. [P] Minneapolis, MN b. 1871, Minneapolis. Studied: ASL; Castelluchi, in Paris; Madrid. Member: Women's A. Assn., Paris [10]

HEITER, Michael M. [P,I] Scarsdale, NY b. 15 S 1883, NYC. Studied: W.L. Taylor; O. Rouland; M.H. Bancroft; Skou. Member: Bronx AG; S.Indp.A. [33]

HEITKAMP, Charles P. [P] Brooklyn, NY b. 1852, Brooklyn d. 15 O 1933. After he retired from business his work was shown to the public, his first exhibition of paintings being held when he was seventy-six years old.

HEITKAMP, Irving R. [P,T] Brooklyn, NY b. ca. 1892 d. 26 Ja 1917. Studied: PIASch; Sch. Nat. delle Belle Arte, Rome. Positions: T., PIASch, Columbia [15]

HEITLAND, Wilmot Emerton [P,I,T] NYC b. 5 Jy 1893, Superior, WI. Studied: ASL; Paris; PAFA; Garber; Beaux; Biggs. Member: NYWCC; Aquarellists; Darien Gld. Seven Arts; AWCS; Phila. WCC; Audubon A.; SI; A. Gld. Exhibited: PAFA, 1913 (prize); A. Dir. C., 1921 (med); Phila. WCC, 1922 (gold), 1924 (prize); Baltimore WCC, 1925 (prize); AWCS, 1930 (prize), 1936 (prize); AIC, 1924 (med); Phila. A. Week, 1925 (gold); Rehn Gal.; Arden Gal.; Macbeth Gal.; Marie Sterner Gal.; Hudson Walker Gal.; O'Brien Gal., Chicago; Findlay Gal., Chicago. Illustrator: "Ambling Through Arcadia"; Century, Collier's, New Yorker, Harpers Bazaar. Positions: T., ASL, PAFA [47]

HEITMAN, W.F. [P] Indianapolis, IN [13]

HEITMANN, Charles G. [P,I,C] Brooklyn, NY [10]

HEITMULLER, Louis [P,T] Pittsburgh, PA b. 24 My 1863, Klein Palubin, Poland. Studied: Royal Acad. FA, Düsseldorf; Munich; Geneva. Member: Pittsburgh AA [25]

HEITMULLER, Marian R(oeder) [P] Wash., D.C. b. 22 D 1894, Wash., D.C. Studied: H. Helmick [21]

HEKKING, William M. [P,E,W,L,T] Hollywood, CA/Monhegan Island, ME b. 10 Mr 1885, Chelsea, WI. Studied: Syracuse Univ.; Laurens; R. Miller; ASL; Académie Julian, Paris. Member: SC. Exhibited: Kansas City AI, 1922 (gold); Columbus SA, 1924 (prize); Wilmington SA, 1926 (prize); Buffalo SA, 1931 (prize). Work: Albright A. Gal.; Franklin Sch.; Nichols Sch., Buffalo. Position: Cur., Contemp. A., Los Angeles Mus. A., 1937, 1938; Dir., Div. A., 1938, 1939; Chmn., Comm. Southern Calif., GGE, 1939; Chmn, S. Div., WFNY, 1939 [40]

HELBECK, Dewees Cochran, Mrs. See Cochran.

HELBIG, Margaret A. (Mrs.) [P,Dr,Des,Li,T] Lynchburg, VA b. 8 N 1884, Leesville, VA. Studied: J. Carlson; H.B. Snell; R. Miller; E. Dufner; A. Thieme; Manoir. Member: Boston AC; Va. Mus. A. Work: Randolph-Macon Women's Col. [40]

HELBLING, Albert F. [Por.P] Phila., PA b. 6 Ag 1863, Phila. Studied: PAFA, with Schussele [06]

HELCK, C. Peter [I,P,E] NYC. Member: AWCS; SI; Phila. WCC; SC; All.A.Am.; A. Gld. Exhibited: PAFA, 1936 (prize); A. Dir. C., 1937 (med); All.A.Am., 1938 (med); Phila. Pr. Cl., 1938 (prize), 1939 (prize); Exh., Kansas, 1938 (prize). Illustrator: American, Woman's Home Companion, Cosmopolitan, Saturday Evening Post [47]

HELD, Alma M. [P,T] Waterloo, IA b. Le Mars, IA. Studied: State Univ. Iowa; NAD; Hawthorne; Cummings; Dickinson. Member: Waterloo AA; Cedar Falls AA; NAWPS; Iowa AG. Exhibited: Joslyn Mem., 1934; Kansas City AI, 1935; Little Gal., Cedar Rapids; Mem. Un., Iowa City; Davenport Municipal A. Gal.; Des Moines Pub. Lib.; Iowa State Fair and Expo, 1925 (med), 1926 (gold) [47]

HELD, Jack [I] NYC. Position: Illus., Leslie-Judge Publishing Co. [15]

HELD, John, Jr. [I,S,W] Westport, CT/Palm Beach, FL b. 10 Ja 1889 d. 2 Mr 1958, Belmar, NJ. Studied: M.M. Young. Author/Illustrator: "Women Are Necessary," 1932, "The Flesh is Weak," 1932, "The Works of John Held, Jr.," 1932, other books. Famous illustrator for New Yorker. His comic and idiosyncratic style represented the Flapper generation of the 1920s. He sold his first illustration to Life at age 15; moved to NYC, 1912. By the 1910s his work was in numerous magazines. His name is often associated with F. Scott Fitzgerald. Positions: T., Harvard, Univ. Ga. [40]

HELDER, Zama Vanessa (Mrs. Helder Paterson) [P,Li,T,Des] Los Angeles, CA b. 30 My 1904, Lynden, WA. Studied: Univ. Wash.; ASL, with R. Brackman; G. Picken; DuMond. Member: AWCS; NAWA; Women P. of the West; Calif. FWS; NYWCC; Women A. Wash.; Pacific Coast P.S.&Writers. Exhibited: NAWA, 1936–46; AWCS, 1936, 1937, 1939, 1943–46; Calif. WCS, 1940, 1941, 1942, 1945, 1946; Oakland A. Gal., 1938, 1940, 1941; Denver A. Mus., 1938, 1940; MOMA, 1943; BM, 1941; MMA, 1942; WMAA, 1945; Macbeth Gal.; SAM, 1936 (prize), 1937–38, 1940, 1941; San Diego FA Soc., 1941; SFMA, 1936, 1937; Portland (Oreg.) A. Mus., 1936; Pacific Coast P.&S., 1936 (prize), 1939 (prize); Women P. of Wash., 1936, 1937 (prize), 1938; Women P. of the West, 1945, 1946 (prize). Work: SAM; Newark Mus.; High Mus. A.; IBM; AAAL [47]

HELDNER, Knute [P] New Orleans, LA. Member: SSAL. Exhibited: Century Progress, AIC, 1934; Am. Fed. A.; SSAL, San Antonio, Tex., 1939 [40]

HELENE, Sister [C,S,P,Gr,T,W] Adrian, MI b. Alameda, CA. Studied: St. Joseph Col.; AIC; Cranbrook Acad.; abroad. Member: AAPL; Catholic AA; Stained Glass Assn. Am.; A. Comm., Assn. Am. Col. Exhibited: Inst. Mod. A., Boston, 1944; Detroit Inst. A., 1939, 1942, 1945; Catholic AA, 1938–42. Work: medal, Christian Culture; churches. Specialty: stained glass. Position: Dir., Studio Angelico, Adrian, Mich., 1935– [47]

HELFOND, Riva (Mrs. Barrett) [Li,Ser,P] Atlantic Highlands, NJ b. 8 Mr 1910, NYC. Studied: ASL, with Kuniyoshi. Member: Nat. Ser. Soc.; A. Lg. Am. Exhibited: MOMA, 1942 (prize); NAD, 1945, 1946; PAFA, 1944; SFMA, 1944; CI, 1942; LOC, 1943–46; Montclair Mus., 1944 (prize). Work: MMA; MOMA; Los Angeles Mus. A.; Cornell; Princeton; CI; Cincinnati MA; Springfield MA; LOC; BM. WPA artist. Position: T., NYU [47]

HELGUERA, Leon [I] NYC. Member: SI [47]

HELIKER, John Edward [P] Yonkers, NY b. 17 Ja 1909, Yonkers, NY. Studied: ASL; Kimon Nicolaides; K.H. Miller; B. Robinson; T.H. Benton. Exhibited: CGA, 1941 (prize), 1943, 1945; WMAA, 1941–46; CI, 1943–45; TMA, 1942, 1943, 1945; VMFA, 1942; AIC, 1937, 1938, 1942, 1943, 1945; MMA, 1942; WMAA, 1945; PAFA, 1944, 1946; CAM, 1946; CMA, 1946; Pepsi-Cola, 1946 (prize); Hudson Walker Gal., 1938, 1941 (one-man); Kraushaar Gal., 1945 (one-man). Work: CGA; WMAA; New Britain Mus.; Telfair Acad.; Walker A. Center; Univ. Nebr.; FMA; AGAA; SFMA; SAM; Denver AM; BM [47]

HELLAWELL, John [En] Brooklyn, NY b. 1837, Yorkshire, England d. 6 Mr 1919. Illustrator: Harper's Weekly, Leslie's, Scribner's Monthly. Specialty: wood engraving

HELLER, Bessie Peirce [Mur.P,Des,I] Culver City, CA b. 25 Je 1896, St. Paul, MN. Studied: St. Paul Inst. Sch. A.; Fontainebleau Sch. FA, with M. Saint-Hubert. Exhibited: BAID, 1931 (med). Position: A. Dept., MGM Studios, 1945 [47]

HELLER, Eugenie M. [P,C] NYC. Studied: J.A. Weir, NYC; Paris, with Aman-Jean, Grasset, Rodin, Whistler. Exhibited: Phila. AA., 1903 (med) [40]

HELLER, Helen West (Mrs.) [P,C,En] NYC b. 1870, Rushville, IL d. 19 N 1955. Exhibited: BM, 1929–32; WMAA, 1935; Am. A. Cong., 1936; NAD, 1942–46; LOC, 1943, 1944 (prize), 1945; AFA Traveling Exh., 1943–45; Lowell Mass. AA, 1944. Work: LOC; BM; Chicago Municipal Coll.; Lindsborg AG, Kans.; Ill. State AG, Springfield, Grosvenor Lib., Buffalo; Berkshire Mus., Pittsfield, Mass.; Newark Pub. Lib.; NYPL. Author: "Migratory Urge" (text cut in wood) [47]

HELLER, Maxwell L. [T,P,W,L] NYC b. 17 Mr 1881 NYC d. 16 My 1963, Hollis, NJ. Studied: CCNY; NYU; Parson's Sch. Des.; H. Giles; Albert Thayer; S. Schulman; N.Y. Sch. F.&Appl. A.; Rockport A. Sch. Member: Rockport AA; Am. Veterans Soc. A.; S.Indp.A.; Bronx A. Gld. Exhibited: NAD, 1938; AFA, 1932, 1938; All.A.Am.; Rockport AA; Am. Veterans Soc. A.; S.Indp.A.; Bronx A. Gld. Author: "New Standard Letterer," "How to Letter," other books. Position: T., Seward Park H.S., NYC, 1935–40 [47]

HELLER, Robert [Indst.Des] NYC b. 10 F 1906, NYC. Studied: Princeton [40]

HELLMAN, Bertha Louise (Liza) [P,C,Des,Dr,T] Houston, TX b. 30 Ja 1900, La Grange, TX. Studied: Rice Inst.; PAFA; Vytlacil; Lhote. Exhibited: SSAL, 1925 (prize); San Antonio, 1929 (med); Houston Mus., FA, 1934. Work: PAFA; Southern Sch. FA, Houston; mural, USPO, Houston; Tex. Jr. Lg. WPA muralist. Position: T., Southern Sch. FA, Houston [47]

HELM, John F., Jr. [Edu,Gr,P,E] Manhattan, KS b. 16 S 1900, Syracuse, NY d. 1972. Studied: Syracuse Univ.; Charman; Sandzen. Member: Prairie WC Painters; Prairie Pr.M.; CAA; Baltimore WCS; Dir., Kans. State Fed. Art. Exhibited: Kansas City AI, 1937 (prize). Work: Kans. State Col.; Bethany Col.; Calif. State Lib.; Tulsa AA; Salina (Kans.) AA; Kans. State Fed. Women's Cl. Position: T., Kans. State Col., 1924– [47]

HELM, Katherine [P] Elizabethtown, KY b. Louisville, KY. Studied: ASL; W. Chase [01]

HELME, J(ames) Burn [Arch,T] State College, PA/Smiths Falls, Ontario b. 29 My 1897, Smiths Falls. Studied: Harvard, with A. Pope; C.W. Jefferys, Univ. Toronto, with C.W. Jefferys, with Despujols, G. Balande, A. Strauss. Member: College AA; AIA. Exhibited: Fontainebleau Sch. FA, 1927 (prize). Position: T., Pa. State Col. [40]

HELMICH, J. Gustav [Por.P] Baltimore, MD b. 1864, Germany d. 20 Mr 1936. Studied: Europe. Also a restorer; did work for Nat. Gal.

HELMICK, Alice. See Hemmick. [She is listed as Helmick in the 1913 edition.]

HELMICK, Howard [P,E,I] Wash., D.C. b. 1845, Zanesville, OH d. 28 Ap 1907. Studied: Cabanel; Ecole des Beaux-Arts, Paris. Member: Royal Soc. Brit. A.; Royal Soc. P.-Etchers. Position: T., Georgetown, Univ. [06]

HELMOLD, Adele M. Von [P] Phila., PA b. Phila. Studied: PAFA [06]

HELMUTH, Jessie L. [S,P] Chicago, IL b. 20 Jy 1892, Chicago. Studied: Mulligan; Crunelle; Polasek; C. Schroeder [21]

HELOK, C. P(eter) [P,I,E] Yonkers, NY b. 17 Je 1893, NYC. Studied: W. de Leftwich Dodge; F. Brangwyn. Member: SC; AWCS [33]

HELSTROM, Bessie [P] Chicago, IL [13]

HELWIG, Albert M(ettee) [Des,Dec,Dr,I] Baltimore, MD b. 27 S 1891, Baltimore. Studied: C.Y. Turner; O. Fuchs; H.B. Snell; Md. Inst. Sch. A. Member: Charcoal C. [40]

HELWIG, Arthur Louis [T,Gr,P,Li] Cincinnati, OH b. 22 Ap 1899, Cincinnati d. 1976. Studied: Cincinnati A. Acad.; Académie Julian, Paris; Marchand; H.H. Wessel; J.E. Weis. Member: AAPL; Cincinnati AC; Cincinnati Crafters; Cincinnati MacD. S.; Cincinnati Prof. A.; Am. Watercolorists. Exhibited: Dayton AI, 1934 (prize), 1945; Rockefeller Center, 1937, AIC, 1938; SFMA, 1937–39; WFNY, 1939; CM, 1935–42; Butler AI, 1939; TMA, 1944–46; Women's City C., Cincinnati, 1937 (prize); Denver A. Mus., 1935 (prize); Cincinnati Garden C., 1945 (prize). Work: Denver A. Mus.; Cincinnati Women's C.; murals, churches in Covington, Ky.; Norwood, Ohio; indst. mural, Cincinnati Milling Machine Co.; Univ. Cincinnati; Newport, Ky.; Cincinnati Water Works. Position: T., Cincinnati A. Acad., 1930–46 [47]

HEMBERGER, Armin B(ismarck) [I,E,L] Hamden, CT b. 1 Ap 1896, Scranton, PA. Studied: Md. Inst.; M. Brodel. Member: New Haven PCC [32]

HEMENWAY, Alice Spaulding (Mrs.) [Por.P,S,T,L,W] Tampa, FL b. 9 Ap 1866, Dedham, MA. Studied: Mass. Sch. A.; RISD; Ecole des Beaux-Arts. Member: Tampa Civic AC; AFA; Fla. Fed. A.; Tampa AI; SSAL; AFA; Fed. Intl. des Arts Appliques a l'Industrie, Paris. Exhibited: Paris Salon; RISD; Tampa AI; Tampa Civic AC; Boston AC (one-man); Mass. Sch. A. (med); A. Luncheon Cl., Tampa, 1937 (prize). Work: Tampa AI; Hillsboro Masonic Lodge, Children's Home, YWCA, Pub. Sch., all in Tampa.; Boston AC; John Hay Lib.; RISD; Mass. Sch. A. [47]

HEMENWAY, Louise Jordan (Mrs. Frank S.) [P,C] Tampa, FL b. 24 My 1893, Birmingham, AL. Studied: Newcomb Col., Tulane Univ.; ASL; Grand Central A. Sch.; Grande Chaumière; W. Woodward; E.A. Webster; H. Balink; W. Stevens. Member: SSAL; New Orleans A.&Cr.; Ala. AL; Alexandria AL. Exhibited: Natchitoches A. Col., 1922 (prize); Tampa AI; Montgomery Mus. A., 1944 (prize); SSAL, 1932 (prize); Shreveport Mus. A., 1939 (prize); NAC, 1945. Work: Tampa AI. Specialty: jewelry [47]

HEMING, Arthur [I,P,W] Toronto, Ontario b. 17 Ja 1870, Paris, Ontario d. 1940, Hamilton, Ontario. Studied: Hamilton A. Sch., 1886; DuMond; Brangwyn. Member: SI; Ontario AS; Royal Canadian Acad.; Canadian C. (founder). While a student he was told he was colorblind, a mistake not uncovered for 30 yrs. As a result, he painted mostly in black and white. After he discovered the error, his work took on more brilliant hues. He traveled extensively, illustrating the wilderness of the Canadian West. Went by dog sled over 1,000 miles with the Royal Mounties, 1,200 miles by snowshoe, and 3,300 by canoe. He summered at the Old Lyme Colony. Author: "Spirit Lake," pub. MacMillan, 1907, "Drama of the Forests," 1921, "The Living Forest," 1925. Illustrator: Saturday Evening Post, Collier's, Scribner's, Harper's, Scientific American [40]

HEMINGWAY, (Grace) Hall [P,W,L,T] River Forest, IL b. 15 Je 1872, Chicago, IL. Studied: AIC; L. Kroll; L.L. Stacey; C. Krafft; K. Buehr; P. Grimm. Member: AAPL; Chicago SA; Soc. for Sanity in A.; Chicago Municipal AL; All-Ill. Soc. FA; Austin, Oak Park, River Forest AL; All-Mich. SFA. Exhibited: State of Ill., 1940 (prize); Fed. Women's C., Chicago, 1935 (prize). Work: 19th Century C., Oak Park; Congregational Church, Oak Park; Hepsibah Home, Oak Park; Taiku Hospital, China; Merom Inst., Ind. [47]

HEMMICK, Alice Barney (Mrs. Christian) [P] Wash., D.C. b. Cincinnati, OH. Studied: Carolus-Duran; Whistler. Member: S. Wash. A.; Wash. WCC; Wash. SFA. Work: CGA; French Gov. [19]

HEMMINGS, Robert [P] Paris, France. b. Boston. Studied: Lefebvre; Robert-Fleury [15]

HEMPSTEAD, Joseph L(eslie) [Por.P,E] Chicago, IL b. 3 F 1884, Brooklyn, NY. Member: Chicago AC. Work: Ill. State Hist. Lib.; LOC; Chicago Hist. Soc. Specialty: portraits of U.S. presidents [40]

HENCKE, Albert [P,I] Manasquam, NJ b. 1865 d. 13 F 1936, Asbury Park, NJ [24]

HENDERSON, A. Elizabeth [Min.P] NYC b. 25 O 1873, Ashland, KY. Studied: ASL; N.Y. Sch. A.; Cincinnati Acad. Member: NAWPS [24]

HENDERSON, Dorothy [Des,P,T] Haddonfield, NJ b. 24 My 1912, Swarthmore, PA. Studied: Syracuse Univ.; PAFA; E. O'Hara. Member: Phila. Plastic C.; Soc. Four A., Palm Beach, Fla.; Phila. WCC. Exhibited: PAFA, 1941, 1944, 1945; Phila. WCC, 1944–46; Nat. A. Week, Haddonfield, 1930–46; Montclair A. Mus., 1945; Soc. Four A., 1942, 1944; Woodmere A. Gal., 1945, 1946; PAFA, 1942–45; Phila. Plastic C., 1940–46; Haddonfield A., 1941–46 [47]

HENDERSON, Ernest M. [I,T,Car,Li,L] Birmingham, AL b. 3 N 1905, Greenville, SC. Studied: Southern Union Col.; Chicago Acad. FA. Member: SSAL; Birmingham AC. Work: LOC; Birmingham Pub. Lib.; Presbyterian Church, Birmingham. Positions: Illus., Register-Tribune Syndicate; Ed., Birmingham News; T., Birmingham Southern Col.; Dir. Southern Sch. A. [47]

HENDERSON, Evelyn [P,B] Mill Valley, CA. b. Cape Ann, MA. Studied: Guerin; Le Beau. Member: Intl. Soc. AL [40]

HENDERSON, Harry V.K. [P,A] NYC b. 6 Mr 1883, Poughkeepsie, NY. Studied: PIASch. Member: AWCS; Arch. Lg.; AIA; Soc. Beaux-Arts Arch.; NYWCC [33]

HENDERSON, Jeanie H. Reid (Mrs.) [P] b. 1835 d. 15 S 1921, London

HENDERSON, John R. [S,P,B] Member: Denver AC (charter mem.). Work: Denver AM. Active in Denver, 1893–98. [*]

HENDERSON, Leslie (Mr.) [P,E,T,Des] Phila., PA b. 20 N 1895, Phila. Studied: PMSchIA; J.F. Copeland; J.R. Sinnock; J.H. Fincken. Member: Phila. Sketch C.; Woodmere A. Gal.; Phila. A. T. Assn.; Phila. WCC. Exhibited: Phila. WCC, 1933; Phila. Pr. C., 1935; Newman Gal., 1939; Phila. Sketch C., 1945; Woodmere A. Gal., 1946. Work: church, Merchantville, N.J. [47]

HENDERSON, Philip L. [P,T,L] Mt. Vernon, IA b. 6 Ap 1911, Youngston, OH. Studied: L. Ritman; E. Giesbert; R. Chapin; B. Anisfield; J. Wicker; C. Wilimovsky, AIC; Detroit Sch. SAC. Position: T., Cornell [40]

HENDERSON, William Penhallow [Arch,Mur.P,T] Chicago, IL/Santa Fe, NM b. 1877, Medford, MA d. 15 O 1943. Studied: Mass. Normal A. Sch.; BMFA Sch., with Tarbell; Europe, 1901–03. Member: Cliff Dwellers, Chicago; Denver AA; Mus. N.Mex. Work: AIC; Denver A. Assn. He collaborated with with his wife, the poet Alice Corbin, on children's books, 1911. Position: T., Chicago Acad. FA [40]

HENDRICKS, Bessie [P] Indianapolis, IN b. 1867, Indianapolis d. 2 Jy 1929. Studied: T.C. Steele; J.O. Adams; John Herron A. Sch. [24]

HENDRICKS, Edith F. [P] Holden, MA [24]

HENDRICKS, Emma Stockman (Mrs. H.G.) [P,L,T] San Antonio, TX b. 1 S 1869, Solan County, CA. Studied: Campion; E. Haywood; O. Miller; G. Cassidy; J. Arpa; E. Lawson; NAD; Santa Fe Sch. A.; Broadmoor Acad., Colorado Springs. Member: Amarillo AA (founder); Hist. Art Soc.,

Canyon, Tex.; San Antonio AL; SSAL; Tex. FAA; AFA; S.Indp.A.. Exhibited: Tri-State Fair, 1932 (prize); Cotton Palace Expo, Waco, Tex., 1927 (prize); Mus. Tech. Tex., 1935. Work: Amarillo Lib.; Hist. Soc., Canyon, Tex. [40]

HENDRICKS, R. [P] Indianapolis, IN [01]

HENDRICKSEN, Ralph [P] Chicago, IL. Exhibited: AIC, 1934, 1935 (prize), 1938, 1939. Work: USPO, Monroe, MI. WPA muralist. [40]

HENDRICKSON, David [I,E] Palo Alto, CA b. 4 F 1896, St. Paul, MN. Studied: St. Paul Inst. A.; Ecole des Beaux-Arts; Grand Central A. Sch.; Calif. Sch. FA; ASL; G. Bridgman; D. Cornwell; H. Dunn. Member: SAE; Artists Gld.; Phillips Mill AA; SI. Exhibited: Sesqui-Centenn. Expo, Phila., 1926; Brooklyn SE, 1926, 1928; SAE, 1932; SI, 1937, 1942; A. Dir. C., 1924, 1926, 1927, 1929, 1932, 1943. Illustrator: "Speaking for Myself," 1943, "Jacoby's Corners," 1940; other publications [47]

HENDRIE, Marion G. [P] Denver, CO [25]

HENIUS, L(illian) G(race) (Mrs.) [P] Pittsburgh, PA b. 6 Ag 1879 d. 29 Mr 1925. Studied: H. Keller; C.W. Hawthorne; G. Sotter. Member: Pittsburgh AA; S.Indp.A. [24]

HENKE, Bernard [P,I] Pasadena, CA b. 25 Ap 1888, Cologne, Germany. Studied: G. Rose. Member: Calif. AC [33]

HENKEL, A. Vandalaine [P] St. Louis, MO [19]

HENKEL, August [Ser,P,Car] NYC b. 31 Jy 1880, Phila., PA. Studied: PAFA; Chase; T. Anschutz. Member: A. Lg. Am.; Nat. Ser. Soc. Work: MMA; LOC [47]

HENKORA, Leo A(ugusta) [P,B,Li,L,T] Minneapolis, MN b. 10 Ag 1893, A. Angarola; C. Booth. Member: S.Indp.A.; Nat. AA; AAPL; AFA. Exhibited: Minn. State Fair, 1924 (prize), 1928 (prize); PAFA, 1929; Minn. Lith. A., 1930. Work: Court House, Bismarck, N.Dak. [40]

HENN, Rudolph [S] NYC. Work: USPO, Loudonville, OH. WPA artist. [40]

HENNEGAN, Paul M. [P] Cincinnati, OH [15]

HENNEMAN, Valentin [Por.P,S,E,L,T] Bangor, ME/Boothbay Harbor ME b. 7 Jy 1861, Oost-Camp, Belgium d. 23 My 1930. Studied: Belgium; Germany; Italy; France. Work: Belgian Gov.; Mus. of Bruges; City Hall, Bruges; City Hall, Oost-Camp. Three hundred portraits of noted Belgians. Known as the "Snow Sculptor." Position: T., Bangor Soc. A. [29]

HENNERS, H.H. [P] Los Angeles, CA. Member: Calif. AC [25]

HENNESSEY, Mary Erkenbrack [S,G] Seattle, WA b. Seattle, WA. Studied: Archipenko. Exhibited: Northwest PM. Ann., Seattle AM, 1937. Work: YMCA, Seattle [40]

HENNESSY, William J(ohn) [P,I] Rudgwick, Sussex, England b. 1839, Thomastown, County Kilkenny, Ireland (came to U.S. in 1849) d. 26 1917. Studied: NAD, 1856. Member: ANA, 1861; NA, 1863; AWCS. Returned to England, 1870; France, 1875; settling in England, 1893. Specialty: illustrations for poetry books [17]

HENNING, Albin [I] b. 1886, Oberdorla, Germany (or St. Paul, MN) d. 1943, Woodstock (NY/CT?). Studied: AIC; Grand Central Sch. A., with H. Dunn. Illustrator: Saturday Evening Post, Western pulps. Best known for his WWI illustrated stories. [*]

HENNING, Henrietta Hunt [P,G] Phila., PA/Old Lyme, CT b. 31 My 1893, Louisville, KY. Studied: PAFA; H. Breckenridge; R. Brackman. Member: F., PAFA; Phila. A. All.; Phila. Pr. C.; Louisville AA. Work: PAFA [40]

HENNING, Ludwig H. [P] Johnstown, PA. Member: Pittsburgh AA. Position: Valley Engraving Co. [25]

HENNING, William Edwin [P,I,Car,Mur.P,W] Cedar Rapids, IA b. 14 My 1911, Cedar Rapids. Studied: A. Dornbush. Exhibited: Iowa State Fair, 1934 (prize); Iowa Exh., Chicago, 1937 (med). Work: Cedar Rapids AA; mural, USPO, Manchester, Iowa. WPA muralist. [40]

HENNINGER, Joseph Morgan [P,I,Car] b. 15 My 1906. Studied: Herron AI; NA; L. Simon, in Paris; W. Forsyth; I. Olinsky. Member: F., Ecole des Beaux-Arts. Exhibited: Hoosier Salon (prize). Work: Muncie Mus. FA, Ind. Positions: Car., Indianapolis Post; Staff, Indianapolis News [40]

HENNINGS, E(rnest) Martin [P] Taos, NM b. 5 F 1886, Pennsgrove, NJ d. 1956. Studied: PAFA; AIC; Munich Acad., with W. Thor, A. Junk, 1914.

Member: AIC; Taos SA, 1921; Chicago PS; Chicago Gal. A.; Chicago Cliff Dwellers. Exhibited: Palette and Chisel C., 1916 (gold); AIC, 1916 (prize); PAFA, 1925 (prize); NAD, 1926 (prize); Paris Salon, 1927; Tex. Wild Flower Comp., 1929 (prize); Acad. Western P., Los Angeles, 1938 (prize). Work: Los Angeles Mus. A.; Chicago Municipal Coll.; Temple Coll., PAFA; Houston MFA; State Coll., Springfield, Ill.; Vanderpoel AA; mural, USPO, Van Buren, Ark. WPA muralist. [40]

HENOCH, Hanley [P] NYC [21]

HENOCH, S. Stella [P] NYC. Exhibited: WC Ann., PAFA, 1936; Am. WCS, 1936, 1937; NAWPS, 1936–38 [40]

HENRI, Robert [P] NYC b. 24 Je 1865, Cincinnati, OH d. 12 Jy 1929. Studied: PAFA, 1886–88; Académie Julian, Paris, with Bouguereau, Robert-Fleury, 1888-91; Ecole des Beaux-Arts; Spain; Italy. Member: SAA, 1903; ANA, 1904; NA, 1906; NIAL; Port. P.; NAC; Am. PS; Taos SA; Los Angeles Modern A. Soc.; Indp. A.; Boston AC; New Soc. A. Exhibited: Pan-Am. Expo, Buffalo, 1901 (med); St. Louis Expo, 1904 (med); AIC, 1905 (prize); AC Phila. 1909 (gold); Buenos Aires Expo, 1910 (med); PAFA, 1914 (med); P.-P. Expo., San Fran., 1915 (med); Wilmington SFA, 1920 (prize). Work: Luxembourg Gal., Paris; AIC; CI; Galley of Spartanburg, S.C.; Dallas AA; Columbus Gal. FA; New Orleans AA; Brooklyn Inst. Mus.; PAFA; Carolina AA; Kansas City AI; San Fran. Inst. A.; MMA; NAC; Minneapolis Inst. A.; Buffalo FAA; Oberlin Col. Gal.; Santa Fe Mus. A.&Arch.; Memphis Mus.; Cincinnati Mus.; Detroit Inst.; TMA; Milwaukee AI; Telfair Acad.; CGA; CAM, St. Louis; Los Angeles Mus. A.; Wilmington SFA; Butler AI; Newark Mus.; Decatur AI; Canajoharie A. Gal; Rochester Mus.; Montclair AM; San Diego Mus.; Des Moines AA. Outspoken leader of "The Eight," later called the "Ashcan Group." Positions: highly influential teacher at ASL; Valtin Sch.; Ferrar Sch.; Chase Sch.; and his own Henri Sch., all in NYC [27]

HENRI, Robert, Mrs. See Organ, Marjorie.

HENRICH, Jean. See Mackay.

HENRY, Alice [P] Pittsburgh, PA. Member: Pittsburgh AA; S.Indp.A. [25]

HENRY, Charles Trumbo [Mur.P,Gr,T,L,De,Dr] NYC b. 17 F 1902, Niagara Falls, NY. Studied: Northeast Mo. State T. Col.; ASL,; Benton; Robinson; Grosz. Member: F., Tiffany Fnd., 1929. Exhibited: WMAA, 1937, 1943; PAFA, 1934, 1937; NAD, 1940, 1942; Carnegie Inst., 1940; AFA Traveling Exh., 1940, 1941; BM, 1937, 1939, 1943; San Diego FA Soc., 1940; MMA (AV), 1942; AWCS, 1941; CGA, 1934, 1937; Kansas City AI, 1937; High Mus. A., 1939 (one-man); Univ. Ga., 1939 (one-man); Northeast Mo. State T. Col. (one-man). WPA muralist. [47]

HENRY, Coah (Miss) [P,T] Kansas City, MO b. 14 Ag 1878, Hamilton, MO. Studied: Kansas City AI; Chicago Acad. FA; N.Y. Sch. F.&Appl. A.; Colo. Univ.; H.B. Snell; E. O'Hara; F.S. Chase. Member: AAPL; Kansas City SA; NAWPS. Exhibited: NAWA; AIC; NYWCC; Wash. AIC; Chappel House, Denver; Kansas City AI. Work: Newark Mus. Position: T., Central HS., Kansas City, 1910–46 [47]

HENRY, E(dward) L(amson) [P,I] NYC/Cragsmoor, NY b. 12 Ja 1841, Charleston, SC d. 11 My 1919, Ellenville, NY. Studied: PAFA; F. Weber, in Phila., 1858; W.M. Oddi, in NYC, 1855; Paris, with Suisse, Gleyre, Courbet, 1860. Member: ANA, 1867; NA, 1869; AWCS; A. Fund S.; Century Assn. Exhibited: NAD, 1861–1900; London, 1875–79; Paris, 1878; Paris Expo, 1889; New Orleans Expo, 1885 (med); Columbian Expo, Chicago, 1893 (med); Pan-Am. Expo, Buffalo, 1901 (med); Charleston Expo, 1902 (med); St. Louis Expo, 1904 (med). Work: Westerly, R.I.; Albany Hist. Soc.; CGA; MMA; San Fran. Specialty: historical rural genre scenes. He was in Europe during the early 1860s, 1871, 1875 and 1881. An early member of the Cragsmoor Colony. [17]

HENRY, Howard Forrest [P] Havertown, PA b. 15 O 1901, Nashville, TN. Member: Phila. WCC. Exhibited: PAFA, 1934, 1935, 1944; CGA, 1944; SSAL; Butler AI, 1941; Tenn. State Exh., 1931 (prize); SSAL, 1933 (prize) [47]

HENRY, J. [I] NYC [21]

HENRY, Jesse P. [E] St. Louis, MO. Member: SAE [47]

HENRY, Natalie S(mith) [P,Gr,Mur.P] Chicago, IL b. 4 Ja 1907, Malvern, AR. Studied: AIC; Ropp Sch. A., Chicago. Member: Chicago SA. Exhibited: AIC, 1935–38, 1941, 1944; Chicago SA, 1944–46. Work: mural, USPO, Springdale, Ark. WPA muralist. [47]

HENRY, Ouidabon [P,T] Connersville, IN/Bay View, MI b. 10 F 1907, Connersville, IN. Studied: C. Hawthorne; G. Bridgman; W. Forsyth; I. Olinsky; John Herron AI. Member: Hoosier Salon; Mich. AA; NAC. Exhibited: John Herron AI, 1934 [40]

HENRY, Philip S. Asheville, NC d. 10 Ap 1933. Member/Pres.: Asheville AA and Mus. His home, "Zealandia," became the Asheville AA and Museum in 1921.

HENRY, Rebecca [G] Houston, TX. Exhibited: SSAL, 1933; Houston MFA, 1939 [40]

HENRY, Sarah [P] West Chester, PA. Member: S.Indp.A. [25]

HENRY, W. Frank (Mrs.) [P] Germantown, PA [15]

HENSCHE, Ada. See Rayner.

HENSCHE, Henry [P,T,L] Provincetown, MA. Studied: AIC; NAD; ASL; BAID; Hawthorne; Bellows. Member: SC; Provincetown AA; Grand Central AG. Exhibited: NAD, 1930 (prize); PAFA; CGA; CI; AIC; Provincetown AA; Mint Mus. A.; Jordan Marsh, Boston. Position: Dir., T., Cape Cod Sch. A. [47]

HENSHAW, Anne Bigelow [P,C] Newport, RI b. Providence, RI. Studied: W.C. Loring; H.H. Clark. Member: Providence AC; Newport AA; Boston SAC [40]

HENSHAW, Glenn Cooper [P] Baltimore, MD b. 1885 d. 5 Ap 1946. Studied: Ecole des Beaux-Arts; Académie Julian, Paris. Exhibited: CGA; AIC; Herron AI; BM, (one-man); AGAA, (one-man); Santa Fe Mus., (one-man); Md. Inst. (one-man) [40]

HENSHAW, Gorham [P] Providence, RI. Member: Providence AC [21]

HENSHAW, Julia. See Dewey, C.M., Mrs.

HENSHAW, Olive Roberts [P] NYC [24]

HENTSCHEL, Alza. See Stratton.

HENTSCHEL, William E(rnst) [Des,C,P,E,T] Burlington, KY b. 15 Je 1892, NYC. Studied: Cincinnati A. Acad.; ASL; Columbia. Member: Cincinnati Assn. Prof. A. Exhibited: Syracuse Mus. FA; Norton Gal., Palm Beach, 1944 (one-man); Taft Mus., 1945 (one-man); CM. Work: IBM; Smithsonian Inst.; MMA; CM. Positions: Des., Rookwood Pottery; T., Cincinnati A. Acad. [47]

HENWOOD, Frederick D. [P] Boston, MA. Studied: P.W. Steer, in London; Paris, with Bouguereau, Lefebvre, C. Duran, Boldini. Member: BAC [01]

HENWOOD, Mary R. [Min.P] Germantown, PA [25]

HEPBURN, Cornelia. See Cushman, Paul, Mrs.

HEPPENSTALL, George M.P. [P] Pittsburgh, PA. Member: Pittsburgh AA [25]

HEPPES, J.Albert [P,I] La Grange, IL [10]

HERANCOURT, Oscar (Mrs.) [P] Louisville, KY. Member: Louisville, AL [01]

HERBERT, Donna M. (Mrs.) [P] St. Paul, MN [13]

HERBERT, Eleanor [P] NYC b. 17 My 1878, NYC. Studied: ASL. Member: ASL [10]

HERBERT, Francis E. (Mr.) [P] Columbus, OH d. My 1918. Member: Pen and Pencil C., Columbus. His portrait of William McKinley was his best known work. [17]

HERBERT, James Drummond [P,S,I] NYC b. 26 D 1896, NYC d. 3 Mr 1970. Studied: Henri; K.H. Miller; Columbia; ASL; Académie Julian, Paris. Member: A. Dir. C.; NSS; SI. Exhibited: NAD; PAFA; AIC; Arch. Lg.; A. Dir. C. Position: T., RISD, 1947–52 [47]

HERBERT, V(irginia) (B.) [P] Cairo, IL b. 7 S 1912, Cairo, IL. Studied: AIC; BFA, with B. Anisfeld. Exhibited: AIC, 1941; AFA Traveling Exh., 1941–43; MMA (AV), 1943; Miss. AA, 1946 (prize); All-Ill. Exh., 1940; CAM, 1942, 1944; Atkins Mus., 1945; Ohio Valley Exh., 1945; Carbondale, Ill., 1944 (one-man); Cairo, 1945 (one-man). Work: Marine Hospital, Lexington, Ky. [47]

HERBERT, W.L. [P] Phila., PA. Exhibited: AAS, 1902 [04]

HERBST, Frank C. [I] Newark, NJ. Member: SI [31]

HERDLE, Frederick A. [P] Rochester, NY [10]

HERDLE, George Linton [Mus.Dir,P,C] Rochester, NY b. 27 Ag 1868 d. 29 S 1922. Studied: Holland; Paris. Member: Rochester AC; Rochester Municipal A. Com.; Assn. A. Mus. Dir. Position: Dir., Art Gal., Rochester Univ. [21]

HERFORD, Oliver [I] NYC b. 1863, Sheffield, England d. 5 Jy 1935. Studied: Europe. Author/Illustrator: books of light verse. Illustrator: Ladies' Home Journal. Known also as a versifier and playwright. [31]

HERGENRODER, Emilie [P] Baltimore, MD d. 25 Ja 1925. Member: Lg. AA [24]

HERGESHEIMER, Ella Sophonisba [P,E,B,T] Nashville, TN/Reading, PA b. Allentown, PA d. 24 Je 1943. Studied: PAFA; C. Beaux; Chase; H. Breckenridge; R. Pearson; Prinet; Mucha. Member: NAC; AFA; Phila. PC; Nashville Studio C.; SSAL; Tenn. SA; Wash. WCC; AAPL; Southern PM Soc.; CAFA; New Orleans AA; Color Block PM. Exhibited: Appalachian Expo, Knoxville, 1910 (gold), 1925 (prize); Tenn. State Exh., 1924 (prizes); Tenn. State Fair, 1926 (prizes), 1933 (prizes). Work: U.S. Capitol, Wash., D.C.; Naval Acad., Annapolis; Vanderbilt Univ.; Tenn. State Capitol; McKendry Church; Mus. A., Nashville; Presbyterian Church, Chattanooga; Reading MA; Allentown MA; Agnes Scott Col., Ga.; State T. Col., Ky.; Southern Methodist Univ.; Bennett Col., Rio de Janeiro [40]

HERING, Elsie Ward (Mrs. Henry) [S] NYC b. 29 Ag 1872, Fayette, MO d. Ja 1923. Studied: Denver; Saint-Gaudens. Member: Denver AC; Cornish, N.H. Colony. Exhibited: Charleston Expo, 1902 (med); St. Louis Expo, 1904 (med). Work: Chapel of Our Saviour, Denver; WCTU fountain, St. Louis Mus. She completed the Baker Mem. at Mt. Kisco, begun by Saint-Gaudens a short time before his death.[21]

HERING, Emil [I,P] Ridgewood, NJ b. 1872, Staten Island, NY d. O 1917. [17]

HERING, Harry [P,E] NYC b. 12 Ja 1887, NYC d. 13 Ap 1967. Studied: self-taught. Member: NYWCC; Allied AA; AAPL; Salons of Am. Exhibited: Long Island AL, 1933 (gold); All. A. Am., 1939 (prize); Mineola Fair (prize); PAFA; NAD; CI; WMAA; AIC; Detroit Inst. A.; CGA; CMA; WMA; BM; Rehn Gal., 1926 (one-man), 1928 (one-man), 1937 (one-man), 1939 (one-man); Milch Gal., 1941 (one-man), 1944 Fontainebleau Sch. FA [47]

HERING, Henry [S] NYC b. 15 F 1874, NYC d. 15 Ja 1949. Studied: CUASch; ASL; Ecole des Beaux-Arts; Colarossi Acad.; Saint-Gaudens. Member: ANA, 1933; NA, 1937; Arch. Lg. 1910; NSS, 1913; AFA; Pres., A. Comm. Assn., NYC, 1944–45. Exhibited: P.-P. Expo, San Fran., 1915 (meds). Work: mem., Yale; Marquette, Gary, both in Ind.; Ind. State War Mem.; Field Mus. Nat. Hist.; Fed. Res. Bank Bldgs., Kansas City; Dallas; Pittsburgh; Cleveland; statues, Indianapolis; Church of the Messiah, NYC; Pylons, Mich. Ave. Bridge, Chicago; Severance Hall, Cleveland; Indst. A. Bldg., Chicago; Paris; Conn. Wesleyan; Williams; Princeton; St. Georges Church; 1st Street Armory; Chicago Opera; Court House, Clarksburg, W.Va.; Ridgewood, N.J.; bridge, Cleveland [47]

HERKOMER, Herman Gustave [P] Auburn, CA b. 1862, Cleveland, OH d. 4 N 1935, Sacramento, CA. Studied: Boulanger; Lefebvre. Exhibited: Paris Salon, 1888; P.-P. Expo, San Fran., 1915. Lived in London for 31 yrs. then returned to U.S. [17]

HERL, C.E. [I] NYC. Position: Affiliated with Truth magazine [98]

HERLIN, Emil [P,Cartogr] b. 1905, Brooklyn. d. 6 Ja 1943, Mineola, NY. Studied: ASL. Author/Illustrator: War Atlas—A Handbook of Maps and Facts. Position: Cartogr., New York Times

HERMAN, Brenetta [P] NYC [01]

HERMAN, Harold [P] NYC. Exhibited: Am. WCC, 1936, 1937; Morton Gal., NY, 1938 [40]

HERMAN, Lenore [I] NYC b. 15 My 1901, Russia. Studied: A. Astrowski. Member: GFLA [27]

HERMAN, Leonora Owsley [P,E,W] Merion, PA b. 2 Jy 1888. Studied: Simon; Académie Julian, Grande Chaumière, both in Paris; ASL; PAFA; Ménard; Helleu; Leon, in Paris. Member: AAPL; Phila. A. All. Exhibited: PAFA; AIC; BMA; CGA. Author: "Rather Personal." Work: private mural commissions [47]

HERMAN, Vic [Car,L] Kew Garden Hills, NY b. 12 My 1919, Fall River, MA. Member: Am. Soc. Magazine Car. Author/Illustrator: "Winnie the Wac," 1945; also syndicated as a daily cartoon. Contributor: cartoons, national magazines in U.S., Canada, England, Austria [47]

HERMANN, Max [P,E,T] Brooklyn, NY b. 16 Jy 1879, Dresden, Germany. Studied: PIASch; Royal Acad. FA, Munich. Member: SC. Work: drawing, BM. Position: T., PIASch [40]

HERMANT, Leon [S] Chicago, IL b. 1866, France d. 14 D 1936. Studied: Paris. Member: French Div., Century of Progress Expo, 1932. Work: Mem.

to Pasteur, Grant Park, Chicago. A few days before his death he received a WPA contract for a fountain in Indianapolis.

HERNDL, Maris [P] Milwaukee, WI d. 14 My 1912. Exhibited: Chicago World's Fair, 1893 (med); St. Louis World's Fair, 1904 (medals). Specialty: stained glass windows

HERNDON, Lawrence [P] NYC b. 25 D 1883, Carey, OH. Studied: AIC. Member: GFLA [27]

HEROLD, Don [Car,W,Des] NYC b. 9 Jy 1889, Bloomfield, IN. Studied: Ind. Univ.; AIC. Author/Illustrator: "Doing Europe and Vice Versa," 1931. Contributor: national magazines [47]

HERON, Edith Harvey [P,T,C] San Jose, CA b. 2 Ja 1895, San Jose. Studied: Stanford; Calif. Sch. FA; A.L. Solon, in England; Calif. Col. A.&Cr. Member: NAWA; Pacific A. Assn. Exhibited: NAWA, 1937, 1938; Lg. Am. Pen Women, 1937 (prize), 1938 (prize), 1939 (prize); Soc. for Sanity in A., 1939 (med); South Side AA, 1942 (prize) [47]

HERPOLSHEIMER, A. [P] Toledo, OH. Member: Artklan [25]

HERPST, Martha (Jane) [Por.P] Titusville, PA b. 4 N 1911, Titusville. Studied: PAFA; W. Adams; E. Greacen; H. Dunn. Member: NAC; S.Indp.A. Exhibited: NAC, 1933–41; Butler AI, 1938, 1943; Titusville Women's C., 1934, 1935; Benson Mem. Lib., Titusville, 1946 [47]

HERR, Laetitia Neff. See Malone, John E., Mrs.

HERR, Margaret [P] NYC. Member: NAWPS [21]

HERRERA, Velino (Ma-Pe-Wi) [P] Santa Fe, NM b. 1902, Zia Pueblo, NM d. 1973. Studied: Santa Fe, with E. Hewett. Work: Amon Carter Mus.; AMNH; CGA; Denver AM; Mus. N.Mex.; U.S. Dept. Interior. Stopped painting in 1950 after an automobile accident. Position: T., Albuquerque Indian Sch., 1936 [40]

HERRESHOFF, Louise C. [P] NYC [04]

HERRICK, Edward B. [P] NYC. Exhibited: Arch. Lg., 1913 (prize) [15]

HERRICK, Ethel [P] Phila., PA [13]

HERRICK, Henry W. [P,I,En,T] Manchester, NH b. 23 Ag 1824, Hopkinton, NH d. 1906. Studied: NAD, ca. 1844. Illustrator: "Beyond the Mississippi," 1867. Author: "Water Color Painting," 1880. Work: Manchester Hist. Assn.; Currier Gal. Best known for his engravings after F.O.C. Darley [06]

HERRICK, Hugh M. [P] Los Angeles, CA b. 8 My 1890, Rocky Ford, CO. Studied: W. Forsyth; E. Shrader. Member: Calif. AC [33]

HERRICK, Margaret Cox [P,Port.P] Piedmont, CA b. 24 Je 1865, San Fran. Studied: Carlsen; R. Yates; A. Mathews; M.C. Richardson; ASL; San Fran.; Europe. Member: San Fran. AA; AFA. Work: YWCA, Oakland, Calif.; Piedmont Community Church; portrait, Pres. Hoover, hung in Convention Hall, Kansas City; Veteran's Home, Livermore, Calif. Specialty: portraits, flowers, still life [33]

HERRICK, Pru (Prudence C.) [I,T,P] NYC b. 14 My 1897, Kodaikanal, India. Studied: Mt. Holyoke Col.; PIASch; C. Hawthorne. Member: AWCS. Exhibited: Mt. Holyoke Col.; Am. WCS, 1933, 1934, 1936, 1938; Am. WCC, 1939. Illustrator: "Holly Berry Family," 1939; textbooks. Position: T., PIASch [47]

HERRIN, M.H. [P,W] Arlington, VA b. 1 N 1897, Moss Point, MS. Studied: PIASch; N.F. Riley. Member: AAPL. Exhibited: Rockefeller Center, Brentano's, Canadian Pacific Railway, all in NYC. Work: Ballard Mem. Sch., Bradenton, Fla.; Mod. Indst. Bank, NYC; heraldry, numerous societies [47]

HERRING, Elsie T. [Min.P] Phila., PA. Studied: PAFA [13]

HERRING, Frank Stanley [Por.P] NYC/ Milledgeville, GA b. 20 Mr 1894, Pen Argyl, PA. Studied: C. Hawthorne; G. Bridgman; Bartlett; G. Tyler; Forsburg; Grell; Stickroth; Paul. Work: Ga. State Col. for Women, Milledgeville; High Mus. A., Atlanta; Mecklenburg Court House, Charlotte, N.C. Position: T., Grand Central Sch. A. [40]

HERRING, James Vernon [W,Edu,L,C,P] Wash., D.C. b. 7 Ja 1887, Clio, SC. Studied: Howard Acad.; Crouse Col. FA; Syracuse Univ.; Harvard; Columbia. Member: CAA; AFA; AA Mus.; Am. Assn. Univ. Prof.; Friends of A., Wash. Position: T., Howard Univ., 1921– [47]

HERRING, M. [S] Windsor, VT. Position: Saint-Gaudens Studios [08]

HERRINGTON, Florence E. [P] Lawrence, KS [10]

HERRMANN, E. Adele [P,T] Highland Park, NJ b. 15 Ag 1895, North Plainfield, NJ. Studied: T. Col, Columbia; ASL. Member: New Brunswick AA; Gotham Painters; AAPL. Exhibited: CGA; Smithsonian Inst.; PAFA; All.A.Am.; N.J. State Mus.; Montclair A. Mus. [47]

HERRMANN, Fernande Luise [P,T] San Fran., CA b. San Fran. Studied: H.V. Poor; Kempter, in Germany; Paris, with Biloul, Vignal; Park, in England. Member: Pacific AA. Position: T., Lowell H.S., San Fran. [40]

HERRMANN, Frank Simon [P] NYC/Elberon, NJ b. 22 Ja 1866, NYC d. 1942. Studied: CCNY, 1883–88; Royal Acad., Munich, 1892–93; Ecole des Beaux-Arts, Paris, with Bouguereau, Ferrier, 1894–95. Exhibited: Munich, Paris, Venice, during 1890s; Babcock Gal., 1927; WMAA, 1927; Salons of Am., 1929, 1934; J.B. Neumann Gal., 1932, 1935, 1936, 1944 (memorial); Albright AG, Buffalo, 1932; Smith Col. MA, 1932; WFNY, 1939; Newark MA, 1939; Stendahl AG, Los Angeles, 1944; Seattle MA, 1945; de Young MA, 1945. Herrmann studied and lived in Paris and Munich, traveling widely from 1891–1919. With his close friend Paul Klee he was an early member of the "Neue Sezessiona" group in Munich, 1914. Beginning as a highly refined academic realist under Bouguereau, his Munich years saw him turn to lyric abstraction in the post-Impressionist vein. Returning to the U.S. after WWI, he had his first one-man show at Babcock Gal., NYC, at the age of 61. For the rest of his life he was represented by J.B. Neumann's Contempora Art Circle, NYC. He was also a life-long friend of Stieglitz, with whom he traveled to Paris, Munich, and Katwyk (Holland), 1890s. He was a prolific artist, producing thousands of works, but many were lost in the two World Wars. He avoided publicity and spent his last years painting around his mansion in Elberon, N.J. [40]

HERRMANN, Julia [P] Brooklyn, NY [19]

HERRON, Jason (Miss) [S,W,L] Los Angeles, CA b. 11 S 1900, Denver, Studied: Stanford; Los Angeles County AI; Merrell Gage; F. Tolles Chamberlin; Univ. Southern Calif.; Colarossi Acad., Paris; Otis AI. Exhibited: Pal. Leg. Honor, 1929; NAD, 1944, 1945; CGA, 1944; Medalic A. Soc., 1938; AIC; Los Angeles Mus. A., 1925, 1928–32, 1937, 1940, 1943; Calif. AC, 1926–35, 1938, 1943, 1944, 1945 (prize); Greek Theatre, Los Angeles, 1945; San Diego FA Soc.; Los Angeles County Fair, 1934 (prize); Los Angeles AA; (med); Soc. for Sanity in A., 1945 (prize); Ebell C., Los Angeles, 1935 (prize), 1939 (prize). Work: Los Angeles Mus. A.; Browning Mus., London, England. WPA artist. [47]

HERSCH, Lee [P,Li] NYC b. 5 S 1896, Cleveland, OH. Studied: H. Keller; Cleveland Sch. of Art; K. Cox; D. Volk; NAD. Work: Pal. Leg. Honor [40]

HERSCHEL, S. Frances (Mrs. Arthur H.) [P] Montclair, NJ b. Boston, MA d. 11 Mr 1937. Studied: H.B. Snell; J.L. Boyd; Corcoran A. Sch. Member: Wash. WCC [33]

HERSHEY, Samuel Franklin [Des,P,T,L,C] Rockport, MA b. 10 Ag 1904, Peru, IN. Studied: MIT; PAFA; BMFA Sch.; P. Hale; Hibbard; Stevens. Member: Rockport AA; New Haven PCC; North Shore AA. Exhibited: CGA; NAD; PAFA; Rockport AA; North Shore AA; New Haven PCC, 1932 (prize); Hoosier Salon, 1933 (prize), 1938 (prize); Boston; Springfield, Mass.; Hartford, Conn. Positions: T., Harvard, 1937–42, RISD, 1946– [47]

HERSHFIELD, Harry [I] NYC. Member: SI. Position: Illus., New York Journal [31]

HERTER, Adele (Mrs. Albert) [Por.P] Hampton, NY b. 27 F 1869, NYC d. 1 O 1946. Studied: Courtois. Member: NAWPS. Work: Lib. Med. Col., Univ. Pa.; Mannes Music Sch., NYC; Emma Willard Sch., Troy, N.Y.; Soc. Four A., Palm Beach [40]

HERTER, Albert [Mur.P,Por.P,C,I] East Hampton, NY b. 2 Mr 1871, NYC d. 15 F 1950. Studied: ASL, with Beckwith; Paris, with Laurens, Cormon. Member: NA; AWCS; Century Assn.; SAA, 1894; NYWCC; Mural P.; Arch. Lg., 1901. Exhibited: AWCS, 1899 (prize); Paris Salon, 1890 (prize); Atlanta Expo, 1895 (med); PAFA, 1897 (prize); Nashville Expo, 1897; Paris Expo, 1900 (med); Pan-Am. Expo, 1901. Work: MMA; Brooklyn Inst. Mus.; theatre murals, San Fran. [47]

HERTER, Christine (Mrs. Sargeant Kendall) [P] Hot Springs, VA b. 25 Ag 1890, Irvington, NY. Studied: S. Kendall. Member: NYWCC; New Haven PCC; NAWPS; Newport AA. Exhibited: NAD, 1916 (prize); Newport AA, 1915 (prize); NAWPS, 1922 (prize); Palm Beach A. Center, 1934. Work: Episcopal Church, Hot Springs [40]

HERTER, Everit A. [P] Killed in action in France in the summer of 1918, working as a camouflage artist. Son of Albert and Adele.

HERTHEL, Alice [P] St. Louis, MO b. St. Louis. Studied: St. Louis Sch. FA; Paris, with Simon, Anglada-Camarasa. Member: SI; Louis AG [33]

HERTS, Henry B. [Arch,P,S,C] NYC b. 23 Ja 1871, NYC. Studied: W.R.

Ware, Columbia; Paris, with Deglane, Puvis de Chavannes. Member: Arch. Lg., 1899; Soc. des Arch. Française; SCUA 1893 [08]

HERVEY, Hanna. See Rion.

HERVEY, (Robert) Morris [Li,P,I] Phila., PA b. 10 Jy 1913, Wheeling, WV. Studied: PAFA; Univ. Pa. Work: Barnes Fnd.; PAFA. Exhibited: MMA (AV), 1942; PAFA, 1940, 1941; LOC, 1944, 1946; Phila. Pr. C., 1941, 1942; SAM, 1942; Okla. A. Center, 1940, 1941 [47]

HERZBERG, Robert A. [P,I,E,T] NYC b. 22 My 1886, Germany. Studied: Vanderpoel; H.M. Walcott; A. Mucha; K. Cox; AIC; ASL; Sorolla; Henri. Member: Scarab C., Detroit, Mich. Exhibited: Newton Gal., 1945, 1946; NAC. Work: City Hall, Detroit; USPO, Detroit [47]

HERZEL, Paul [S,P] Brooklyn, NY b. 28 Ag 1876, Germany. Studied: St. Louis Sch. FA; BAID. Member: NSS; AFA. Exhibited: 1915 (prize); NAD, 1915 (prize); Garden C. Am., 1929 (prize) [40]

HERZFELD, Emy [P] NYC b. 27 Ja 1890, NYC. Studied: U. Romano; W. Palmer. Member: ASL. Exhibited: ASL; Rheinhardt Gal., Montross Gal., both in NYC. Work: Gal. Ridgefield, N.J. [40]

HERZOG, F. Benedict [P,Photogr] NYC b. NYC d. 21 Ap 1912. Studied: Columbia; F. Rondel; ASL. Member: NAC; Camera C.; N.Y. Municipal AS. He devised a method of illustrating by photographing groups of models in classical poses. [10]

HERZOG, George [P] NYC b. 19 O 1851, Munich, Germany. Member: Phila. AC. Exhibited: Centenn. Expo, Phila., 1876 (med) [06]

HERZOG, Hermann [P] Phila., PA b. 16 N 1831, Bremen, Germany (came to Phila. in 1869) d. 6 F 1932, West Phila. Studied: Düsseldorf Acad., with Schirmer, Lessing, Achenbach, Gude, 1849; Berlin, 1867-68. Exhibited: Paris Salon, 1863 (prize). Work: NYPL; Mem. Hall, Phila.; Cincinnati AM; Reading M.; Goth, Hanover, and Mulhouse museums, all in Germany. Queen Victoria, the Grand Duke Alexander of Russia and other members of royalty were among his patrons. Several months prior to his death at the age of one hundred, he held a joint exhibition with his son, Lewis Herzog. [10]

HERZOG, Lewis [I,P] Scarsdale, NY b. 15 O 1868, Phila. Studied: London, Rome; Berlin; Düsseldorf; Munich; Venice. Member: AC Phila.; NAC; SC; AFA. Exhibited: Munich (gold); Berlin; St. Louis Expo, 1904 (med). Son of Hermann. [33]

HERZOG, Max [P] Chicago, IL [15]

HESKETH [S] NYC b. Maine. Studied: J. Flannagan. Exhibited: Detroit Inst. A., 1946; CAM, 1946; PMA, 1940; CI, 1941; AIC, 1942, 1943; PAFA, 1943; MMA, 1943; De Motte Gal.; Egan Gal.; J.B. Neumann; Gal.; SFMA, 1943 (one-man); SAM, 1943 (one-man); Ferargil Gal., 1942 (one-man), 1943 (one-man), 1945 (one-man); Cosmopolitan C., Phila., PA, 1946 (one-man) [47]

HESS, Alexander [P,E] NYC b. 17 Ag 1892, Bath, NY [21]

HESS, Emma Kipling. See Ingersoll, D.W., Mrs.

HESS, Julian Christian [P] b. 1877, Germany (came to U.S. ca. 1900) d. 17 F 1935, NYC. Noted for his newspaper portraits of many of the best known personalities of the world.

HESS, Mary G. See Buehr, Karl A., Mrs.

HESS, Sara (M.) [P] San Diego, CA (1962) b. 25 F 1880, Troy Grove, IL. Studied: Académie Julian, Paris; R. Miller, H. Hubbell; Ossip Linde; AIC. Member: NAWA; San Diego A. Gld.; Laguna Beach AA; SPNY; La Jolla AC; Wolfe AC. Exhibited: Am. Women A., Paris (prize); NAWA; Laguna Beach AA; San Diego FA Soc.; Ridgewood AA (prize). Work: Oshkosh Mus. A.; Vanderpoel Coll.; Gary (Ind.) Mem. Gal., Gary; Ridgwood, N.J. Women's C. [47]

HESSE, Henry Melton [P,Li,T] Glendale, CA b. 30 1908, Greeley, CO. Studied: P. Sample; M. Sheets; Univ. Southern Calif. Member: Calif. WCS; Laguna Beach AA; Western Fnd. A. Exhibited: Ebell Annual Exh., Los Angeles, 1934 (prize) [40]

HESSELTINE, Francis S. [P,L] b. 1833 d. Mr 1916, Boston. Also lawyer, traveler, orator, poet, Civil War veteran.

HESTHAL, William [Mur.P,Li,E,Dr] San Fran., CA. b. 24 Ag 1908, San Fran. Studied: Calif. Sch. FA. Member: San Fran. AA; Soc. Western A.; Calif. PM, 1936-37; Calif. SE. Exhibited: GGE, 1939; WFNY, 1939; San Fran. AA, 1935 (prize). Work: fresco, Coit Tower, Calif. Sch. FA; Bender Coll., SFMA [40]

HETHCOCK, Edith E. [S] NYC [19]

HETHERINGTON, Alfred H. [P] NYC/Monhegan Island, ME b. 13 Je 1868, Grand Rapids, MI. Studied: AIC [31]

HETZEL, Lila B. (Mrs.) [P] Somerset, PA. Member: Pittsburgh AA [25]

HEUERMANN, Magda [Min.P,P,W,L,T] Oak Park, IL/Palisades Park, MI 10 S 1868, Galesburg, IL d. ca 1964, Marshall, MO. Studied: AIC; F.H.C. Sammons; Akademie der feinen Künst, Munich, with von Lenbach, Roth, Max Doerner, Duerr. Member: Chicago SA; Chicago AC; NAC; Chicago NJSA; Chicago S. Min. P.; Chicago Women's C.; AAPL. Exhibited: Phila., 1935 (med,prize); New Orleans (prize); Columbian Expo, Chicago, 1893 (prize); PAFA, 1935 (prize). Work: Carnegie Lib., Joliet, Ill.; Univ. Iowa; Beloit Col.; Vanderpoel Coll.; Winfield Scott Schley Sch., Chicago; Carnegie Lib., Nashville; Springfield, Ill. Acad. FA; Victoria & Albert Mus., London; many portrait miniatures [47]

HEUGH, James [I] Phila., PA. Studied: PAFA [40]

HEUSCHE, Henry [P] Provincetown, MA [24]

HEUSTIS, Edna F. See Simpson, Mrs.

HEUSTIS, Louise Lyons [Por.P,P,I] NYC b. 2 N 1878, Mobile, AL. Studied: ASL; Académie Julian, Paris; W. Chase; F. MacMonnies. Member: NAWA; Newport AA; Workers' C. for Women. Exhibited: NAD; CGA; PAFA; CI; Cleveland; New Orleans; Birmingham; Brown & Bigelow Nat. Comp., 1925 (prize); Newport AA, 1921 (prize), 1927 (prize), 1928 (prize); Nashville AA, 1926 (prize); Birmingham, Ala, 1928 (prize); NAWPS, 1931 (prize). Work: War Dept., Wash., D.C.; Yale; Montgomery (Ala.) Mus. FA; Mobile Mus., Ala. [47]

HEUSTON, Frank Zell [P,G] NYC b. 14 D 1880, Lacrosse, WI. Studied: NA; ASL; Columbia. Member: SC. Exhibited: 1938, 1939, Columbia; Nat. Acad.; SC [40]

HEUSTON, George Franklin [P,G,T] NYC b. 24 Ag 1906, South Bend, WA. Studied: NA; ASL; Columbia; Cape Sch., Provincetown, Mass. Member: SC. Exhibited: SC, 1938 (prize); Montross Gal.; Ferargil Gal. Position: T., Traphagen Sch. [40]

HEUSY, Charles W. [P] Etna, PA. Member: Pittsburgh AA [25]

HEWES, Horace G. [P] Boston, MA/Ogunquit, ME b. Boston. Studied: Lowell Inst.; Richardson. Work: Portland Mus. FA [25]

HEWETT, Ainslie [E] Louisville, KY [19]

HEWIT, Mabel A. [Li,C] Cleveland, OH b. 27 Ja 1903, Conneaut, OH. Studied: B. Lazzell; Ohio State Univ.; Columbia; Cleveland Sch. A. Member: Cleveland PM. Exhibited: PAFA, 1933, 1936; Am. Block Print Exh., 1934, 1935; Intl. PM, 1935; Wash. WCC, 1934; CMA, 1936-46 (prizes); Ohio PM, 1936-46; Tri-State Pr. Exh., 1945, 1946. Work: CMA [47]

HEWITT, Donald [I] Astoria, NY. Member: SI [47]

HEWITT, Dudley Fergusson Barbour (Miss) [Por.P,T] Marietta, GA b. 1 Jy 1913, Marietta. Studied: C.F. Naegele. Work: Wash. and Lee Univ. Position: T., Inst. of the South, Memphis [40]

HEWITT, Edward S. [P] NYC. Work: F. Keppel Co. [25]

HEWITT, Edwin H. [P,Arch] Excelsior, MN b. 26 Mr 1874, Red Wing, MN. Studied: Paris Ecole des Beaux-Arts, with Pascal. Member: F., AIA; Minneapolis SGA. Exhibited: Minn. State A. Soc., 1914 (prize) [33]

HEWITT, Eleanor Gurnee [Patron] d. 27 N 1924. Founder: Cooper Union Museum of Decorative Arts

HEWITT, Sarah Cooper [Patron] NYC b. 1859 d. 16 O 1930. The granddaughter of Peter Cooper who founded Cooper Union, her life work was the foundation and development of the Museum of Fine Arts of Cooper Union, of which she was director. Her time and fortune was devoted to searching the world for additions to its resources. It embraces one of the finest collection of textiles in existence. She was awarded honorary degrees by the French Gov. and NYU for her contribution to the arts.

HEWLETT, Arthur T. [Mur.P] Brooklyn, NY [17]

HEWLETT, C. Russell [Ed] Pittsburgh, PA b. 30 O 1872, Brooklyn, NY d. 11 N 1913. Studied: Columbia; Japan; Paris. Member: Pres., Pittsburgh A. Soc.; Bd. Dir., Am. Fed. A. Position: T., CI, 1908–

HEWLETT, J(ames) Monroe [Mur.P,Arch] Lawrence, NY b. 1 Ag 1868, Lawrence d. 18 O 1941. Studied: Columbia; McKim; Mead; White; P.V. Gailland, in Paris. Member: ANA; NA, 1931; AIA; Mural P.; Arch. Lg; AFA. Work: Carnegie Tech. Sch., Pittsburgh; Cornell Theatre, Ithaca; Columbia C., Bank of New York, Trust Co., all in NYC; Newark Bank,

Essex Bank, both in Newark; Bronx County Bldg.; Soldiers and Sailors monuments, in Phila., Albany, Brooklyn. Position: Dir., Am. Acad., Rome, 1932-35 [40]

HEWLETT, Joseph M. [Mur.P] Brooklyn, NY [15]

HEWLINGS, Drew Walgrave [P,I,Car] Denver, CO b. 23 Jy 1915, Denver. Studied: Denver A. Col. WPA artist. [40]

HEWTON, Otto [P] Rochester, NY. Member: Rochester AC [25]

HEYD, Conrad [Min.P,Por.P] b. 1837, Germany (came to NYC ca. 1860) d. 1912, Milwaukee. Considered by his contemporaries the foremost artist in Wis. [*]

HEYDT, Edna [Mur.P,Des,I] NYC b. 17 O 1903, Union City, NY. Studied: N.Y. Sch. Appl. Des. for Women; T. Furlong; K. Nicolaides; W. Pogany. Member: NAWPS. Work: murals, Wilbraham (Mass.) Acad. [40]

HEYER, H(erman) [P,I,E,C] Douglaston, NY/Deer Park, NY b. 31 Jy 1876, Germany [21]

HEYER, William B. [P,I,E] Brooklyn, NY b. 25 N 1896, NYC d. 6 Ag 1973. Studied: Auerbach-Levy; ASL, with Bridgman, 1916-18; E. Fitsch, 1928; Italy, late 1920s. Member: SAE; Chicago SE. Exhibited: etchings, NYC, Italy, Canadian Natl. Exh., Toronto (1929) [32]

HEYERDAHL, Ruth Lovold [P] Chicago, IL b. 17 Ag 1894, Arendal, Norway. Studied: CI; AIC; G. Kielland, Norway; Royal A. Sch., Oslo, Norway [40]

HEYLER, Mary P. Ginther (Mrs.) [P,I,C,W] Buckingham, PA. b. Phila. Studied: PAFA. Member: Plastic C. Work: stained glass windows, Church of the Restoration, Phila.; St. John's Church, Suffolk, Va. [31]

HEYSER, Orwin [P] Toledo, OH. Member: Artklan [25]

HEYSINGER, Ernest W. [P,T] Phila., PA b. 1872, Phila. Studied: G.R. Bonfield; PAFA. Member: Phila. Sketch C. [13]

HEYSINGER, Evelyn L. [P] Phila., PA b. Phila. [04]

HEYWARD, Katherine Bayard [Des,C,T,L] Columbia, SC b. Lexington, VA. Studied: Columbia; A.W. Dow; W. Reiss; E. Cadorin; N.Y. Sch. F.&Appl. A.; N.Y. Sch. Appl. Des. for Women. Member: SSAL; AFA; Southeastern AA; Columbia AA; Carolina AA; Wash. AC; PBC; Am. Coll. Soc. Print Collectors. Position: T., Univ. S.C. [40]

HEYWOOD, Mona [P] Seattle, WA [21]

HIATT, Aletha M. [P] Hinsdale, IL. Member: Chicago NJSA [25]

HIATT, Maurine. See Roberts, Arthur, Mrs.

HIBBARD, A(ldro) T(hompson) [P] Rockport, MA b. 25 Ag 1886, Falmouth, MA d. 1972. Studied: Mass. Normal A. Sch.; BMFA Sch.; E.L. De Camp; Tarbell. Member: Gld. Boston A.; North Shore AA; SC; ANA; NA, 1933; CAFA; New Haven PCC; Rockport AA. Exhibited: CGA, 1935, 1937, 1939; PAFA, annually to 1936, 1923 (gold), 1928 (prize) 1931 (prize); AIC, 1921 (prize), 1926-32; NAD, annually, 1922 (prize), 1928 (prize), 1931 (prize); Duxbury, 1920 (prize); North Shore AA, 1930 (prize); New Haven PCC, 1933 (prize), 1941 (prize); Palm Beach A. Center, 1936; CAFA, 1937 (prize); Jordan Marsh Co., Boston, 1938 (prize); Springfield AL, 1931 (prize); GGE, 1939 (prize); IBM, 1940 (prize); All.A.Am., 1943 (prize), 1946 (prize); SC, 1944 (prize). Work: MMA; BMFA; Portland (Maine) A. Mus.; AGAA; Currier Gal. A.; Rochester Atheneum; San Diego FA Soc.; IBM; NAD; Phillips Acad. Coll. Founding member of the Rockport Colony, he taught summer classes at his studio at Bearskin Neck, 1920-50; also painted in E. Jamaica, Vt. The Rockport AA is housed in his old studio. A professional baseball player. [47]

HIBBARD, Elisabeth Haseltine (Mrs. Frederick C.) [S,L,T] Chicago, IL b. 25 S 1894, Portland, OR. Studied: Portland A. Sch.; Univ. Chicago; AIC; Grande Chaumière; Polasek; Bourdelle; Navellier; de Creeft; Mestrovic. Member: NAWA; Chicago Gal. Assn.; Women's A. Salon, Chicago; Renaissance Soc., Univ. Chicago. Exhibited: NAWA, 1937 (prize), 1938-39, 1946; AIC, 1924-32, 1935-40, 1943, 1944; PAFA, 1928, 1929, 1936, 1942; BM, 1930; Paris Salon, 1927; Chicago Gal. Assn., 1927-28, 1929 (prize), 1930 (prize), 1931, 1932 (prize), 1934; Chicago Arch. L., 1929; Ill. Acad. FA, 1931; Women's A. Salon, Chicago, 1943-45; Dayton AI, 1930; Albany Inst. Hist.&A., 1939; Portland A. Mus., 1925, 1930; Studio Mus., Bellingham, Wash., 1936 (one-man); Evanston A. Center, 1939 (one-man); Univ. Chicago, 1940 (one-man); St. Catherine's Col., St. Paul, 1946 (one-man). Work: S., Ill. State Mus., Springfield; Vanderpoel Coll.; Univ. Chicago; Norton Mem. Hall, Chautauqua, N.Y.; Jackson Park, Chicago. Position: T., Univ. Chicago, 1943- [47]

HIBBARD, Frederick Cleveland [S] Chicago, IL b. 15 Je 1881, Canton, MO. Studied: Culver-Stockton Col.; Univ. Mo.; Ill. Inst. Tech.; AIC; L. Taft; J. Vanderpoel; Armour Inst., Chicago. Member: Chicago Municipal AL; AIC. Exhibited: AIC, 1903, 1904, 1908, 1911-13, 1916, 1918, 1919, 1924, 1933-35, 1939, 1940, 1943; Chicago Gal. Assn., 1932; Century of Progress, 1933, 1934; P.-P. Expo, 1915; Phila. A. All., 1924; BMA, 1923; PAFA, 1904; NSS, 1923; Kansas City AI, 1924 (gold); Cliff Dwellers, 1940 (one-man); Studio Mus., Bellingham, Wash., 1936 Work: Vanderpoel Coll.; Northwestern Univ.; Loyola Univ.; Univ. Chicago; Ill. Inst. Tech.; Wabash Col.; Univ. Ohio; Butler AI; Canton, Ill. Pub. Lib.; Louisville, Ky. Pub. Lib.; State Dept., Jackson, Miss.; Hannibal, Mo.; Winchester, Va.; Shiloh National Park, Tenn.; Vicksburg, Miss.; Lincoln Park, Chicago; Youngstown, Ohio; Ft. Wayne, Ind.; Pittsburgh; McConnelsville, Ohio; Bowling Green, Mo.; Grant Park, Chicago; Nevada, Mo.; Frankfort, Ky.; Carrollton, Ill.; Armour Inst., Chicago [47]

HIBBARD, George [P,W] Buffalo, NY b. 1858 d. 3 Jy 1928. Exhibited: NAD. He published several books and was a contributor to magazines; also was a lawyer, as well as librarian of Grosvenor Lib., Buffalo.

HIBBARD, Mary P. [P] NYC. Exhibited: Studio G., 1936; NAWPS, 1935-38 [40]

HIBBEN, Helene [S] Indianapolis, IN b. 18 N 1882, Indianapolis. Studied: Herron AI, with W. Forsyth; AIC, with L. Taft; ASL, with J.E. Frazer. Member: NYSC; Indianapolis AA [33]

HIBBEN, Thomas [E,Arch] NYC b. 22 O 1893, Indianapolis. Studied: W. Forsyth; R. Locke; Stark; Jaussley; Cret [29]

HIBEL, Edna [P,C] Brookline, MA b. 13 Ja 1917, Boston, MA. Studied: BMFA Sch.; Jacovleff, C. Zerbe. Exhibited: PAFA, 1936-38, 1941, 1943; AIC, 1942, 1943; AWCS, 1946; Vose Gal., 1940-44; Smith Gal., 1944-46; Inst. Mod. A., 1943; Shaw Gal., 1945, all in Boston. Work: BMFA; Norton Gal., West Palm Beach. She became successful in promoting her collectible plates and opened galleries in Palm Beach and NYC [47]

HICKEN, Philip Burnham [P,Ser,T] Cummington, MA b. 27 Je 1910, Lynn, MA. Studied: Mass. Sch. A.; S. Henry. Member: Nat. Ser. Soc.; Am. Ar. Cong.; Ar. Un. Western Mass. Exhibited: LOC, 1944, 1946; NGA, 1945; Nat. Ser. Soc., 1940-46; Wichita, Kans., 1946; Pittsfield AL, 1942; Mint Mus. A., 1946; Kansas City USO, 1944; 9th Service Command Exh., Calif., 1945; Black Mountain (N.C.) AC, 1943 (prize); Springfield (Mass.) Soldier A., 1944 (prize); New England Soldier A., 1944 (prize); San Fran., Calif., 1945 (prize); ACA Gal., NYC. Work: MMA; PMA; U.S. State Dept., Wash., D.C.; Springfield Mus. A.; Berkshire Mus.; Univ. Iowa; Am. Assn. Univ. Women; Princeton Pr. C.; Northfield (Mass.) Seminary; mural, Ft. Warren, Boston, Mass. WPA artist. Position: T., Cummington Sch., 1940 [47]

HICKEY, Isabel [P] Phila., PA b. 25 O 1872, Phila. Studied: Chase; Pyle; Italy; PAFA; France; Spain. Member: Print C.; AFA; AAPL; Phila. Alliance; Plastic C.; Phila. A. T. Assn. Position: T., Phila. Pub. Schools [31]

HICKEY, Rose Van Vranken [S,E,Li] Altadena, CA b. 15 My 1917, Passaic, NJ. Studied: Pomona Col.; ASL; Univ. Iowa; G. Bridgman; W. Zorach; R. Laurent. Member: Pasadena SA; Laguna Beach AA. Exhibited: CGA, 1943; Elisabet Ney Mus., 1943; SAM, 1943; Denver A. Mus., 1943; SFMA, 1943; Okla. A. Center, 1942; Oakland A. Gal., 1944-46 (prizes); Nat. Mus. Week, Los Angeles, 1945, NYC, 1941; Pasadena SA, 1944-46; Los Angeles Mus. A., 1944 (prize); Laguna Beach AA, 1945, 1946; San Diego FA Soc., 1945; Pasadena AI, 1943, 1945 (prize), 1946 [47]

HICKEY, Willard [P] Phila., PA [04]

HICKMAN, Harriet [P] Cincinnati, OH. Member: Cincinnati Women's AC [25]

HICKMAN, Harry L. [P] Arnold, PA. Member: Pittsburgh AA [21]

HICKOK, Conde Wilson [P] Berwyn, IL b. Batavia, IL. Studied: AIC; C.P. Browne. Member: Chicago SA; Chicago AC; Hoosier Salon. Work: Danville, Ill.; Chicago Col. Cl. [33]

HICKOX, Ann Lenhard [P,T] Weekapaug, RI b. 26 Je 1893, Phoenixville, PA. Studied: Chester Springs School Indst. A.; PAFA; F. Wagner. Member: Eastern AA [33]

HICKS, Ami Mali [C,W,L,P] Scotch Plains, NJ b. 3 Ja 1876, Brooklyn, NY d. ca. 1955. Studied: W. Chase; R. Henri; C. Chaplin; Berlin; Paris. Member: PBC; Member: Nat. Soc. Craftsmen; AWCS. Work: Bowdoin Col. Designer: costumes. Author: "Craft of Handmade Rugs," "Color in Action" (1937), "Everyday Art" [47]

HICKS, Anna S. [I] Kenneth Square, PA [15]

HICKS, Elizabeth [P] Tolland, CT b. F 1886, NYC. Studied: Henri; W.

Chase; LaFarge; K. Cox. Member: NAC; NAWA; NYWCC; Art Worker's C. for Women; Studio Gld. Exhibited: NAD, 1927; All.A.Am.; Palm Beach A. Center. Work: Univ. Conn. [47]

HICKS, Herbert [P,I] Arlington, VA b. 26 Je 1894, Columbus, OH. Studied: Messer; Brooks; Wagner; Garber; Harding; Corcoran Sch. A.; Chester Springs Sch. Member: Wash. WCC; Wash. Ldscp. C. Exhibited: Arlington County Exh., 1934 (prize). Illustrator: Pan-Am. Bulletin; U.S. Gov. [40]

HICKS, Morley [P] Milwaukee, WI b. 16 Mr 1877, Picton, Ontario d. 1959. Studied: G. Moeller; G. Oberteuffer; Milwaukee ASL. Member: Wis. PS. Exhibited: Milwaukee AI, 1931 (prize) [40]

HICKS, Philip Trueman [Por.P] Boston, MA b. 19 My 1906, Boston. Studied: S. Carbee. Member: Boston AC. Exhibited: Springville, Utah, 1934; Boston AC; Jordan Marsh Gal., 1933 (prize), 1934 (prize), 1937 (prize). Work: Navy Dept. Position: T., Carbee Sch. A., Boston [47]

HICKS, Thomas [P,T] b. 18 O 1823, Newtown, PA d. 8 O 1890, Trenton Falls, NY. Studied: his cousin, Edward Hicks [1780–1849], 1836; PAFA; NAD; London; Florence; Rome; Paris, with T. Couture, 1845–49. Work: portraits of prominent Americans, including Lincoln. Work: N.Y. Hist. Soc. [*]

HICKS, William [G,P,S] Brooklyn, NY b. 24 Ag 1895, Brooklyn, NY. Studied: H. LeRoy. Exhibited: AIC, 1938; SAE; Fed. A. Gal., N.Y. WPA artist. [40]

HICKSON, Richard G. [P] Phila., PA. Studied: PAFA, 1938. Work: PAFA [40]

HIDALGO, Felix Resurrection [P] Paris, France b. Manila, Phillipines d. Ap 1915. Studied: Ecole des Beaux-Arts de Manila, Madrid. Exhibited: Madrid Expo, 1884 (med); Paris Expo, 1889 (med); Columbian Expo, Chicago, 1893 (med); St. Louis Expo, 1904 (prize); Salon of Paris Soc. des Artistes Français (prize); Barcelona Expo (prize). Work: Museo Ultramarino, Madrid; MFA, Valladolid; Ayrntamiento de Manila [10]

HIESTER, Mary Baer (Mrs. Isaac) [P] Reading, PA. Studied: PAFA [25]

HIGDON, Helen [P,L] Birmingham, AL b. Decatur, AL. Studied: Tarbell; R. Meryman; B. Baker; C. Critcher; M. Leisenring; F.E. Browne. Member: SSAL; Birmingmam AC; Ala. AA. Exhibited: Birmingham, 1926 (prize); Ala. State Fair, 1928 (prize), 1930 (prize); Birmingham AC, 1936 [40]

HIGGINS, Aldus C. [P] Worcester, MA [25]

HIGGINS, Cardwell S. [I,Des,P] NYC b. 7 Jy 1902, East Orange, NY. Studied: NAD; ASL. Member: Bloomfield AL. Work: mural, U.S. Army Air Base, Richmond, Va. Illustrator: national magazines; for corporations [47]

HIGGINS, Eugene [P,E] NYC/Lyme, CT b. F 1874, Kansas City, MO d. 18 F 1958. Studied: Académie Julian, Ecole des Beaux-Arts, both in Paris. Member: NA, 1928; NYWCC; SAE; NAC; AWCS; SC; AFA; Lyme SA. Exhibited: CI; PAFA; AIC, 1929 (med); Grand Central Gal., 1930 (prize); NAD, 1931 (prize) 1937 (prize); NAC, 1933 (prize); SC, 1932 (prize); NYWCC, 1937 (prize); Am. WCS, 1937 (med). Work: Milwaukee AI; Los Angeles Mus. A.; William and Mary Col.; WMAA; MMA; British Mus.; NYPL; Brooklyn Lib.; Wash. Lib.; CAM, St. Louis; Bibliothèque Nationale, Paris; WC; AIC; USPOs, Beaver Falls, Pa., Shawano, Wis.; 25 monotypes, Catholic Lib., Hartford, Conn. "Ashcan School" painter of slums. [47]

HIGGINS, Joseph T. [E] Rockport, MA b. 22 S 1878, Milford, MA. Studied: R. Beal. Member: Rockport AA; New Haven PCC; Southern PM Soc.; New Orleans AA [40]

HIGGINS, Victor [P] Taos, NM b. 28 1884, Shelbyville, IN d. 23 Ag 1949. Studied: Chicago Acad. FA; AIC; Grande Chaumière; Robert Henri. Member: NA; Taos SA; Cliff Dwellers. Exhibited: CGA; Chicago SA, 1917 (med); PAFA; CI; Palette & Chisel C., 1914 (prize); Chicago Municipal AL, 1915 (med); NAD, 1918 (prize), 1927 (prize), 1932 (prize); Municipal Art Lg., 1915 (prize); AIC, 1915 (prize), 1916 (prize), 1917 (med), 1928 (med), 1932 (gold); abroad. Work: Terre Haute AA; Santa Fe Railroad; Union Lg. C.; Des Moines Assn. FA; Los Angeles Mus. A. Position: T., Chicago Acad. FA, 1940 [47]

HIGGINS, Violet Moore [P] Riverdale, NY. Member: GFLA [27]

HIGH, Joseph Madison (Mrs.) [Patron] b. 30 N 1862, Atlanta, GA d. 21 Mr 1932, Atlanta. In 1926 she gave her house in Atlanta as a home for the Atlanta Art Assn. This became the High Mus. of Art. She was a vice-president and a director of the association and the museum.

HILDEBRAND, Gustave [S,P,T] Detroit, MI b. 19 Ja 1897, Chicago. Studied: AIC; E. Bistram. Member: Scarab C. Work: Highland Park, Mich.; Naval Armory, Detroit; Union Dorm., Ann Arbor [40]

HILDEBRANDT, Cornelia Ellis (Mrs.) [P,L,Min.P] New Canaan, CT b. Eau Claire, WI. Studied: AIC; Paris; A. Koopman; V. Reynolds. Member: ASMP; Pa. Soc. Min. P. Exhibited: ASMP, 1941 (med); NAWA, 1946 (med); Pa. Soc. Min.P. Work: CGA. Lectures: The History and Development of the Portrait Miniature [47]

HILDEBRANDT, Howard Logan [Por.P,T] NYC b. 1 N 1872, Allegheny, PA d. 11 N 1958. Studied: NAD; Académie Julian, Ecole des Beaux-Arts, Constant, Laurens, all in Paris. Member: All.A.Am. Member: Lotos C.; ANA; NA, 1932; SC, 1899; NYWCC; AWCS; Pittsburgh AA; S.Indp.A.; AFA. Exhibited: All.A.Am. (med); AWCS, 1906 (prize); Artists of Pittsburgh, 1911 (prize); SC, 1931 (prize); NAC, 1934 (med); CGA, 1935; WFNY, 1930; NAD; Silvermine Gld. A. Work: John Herron AI; Butler AI; Lotos C. Position: T., NAD, NYC, 1944–46 [47]

HILDEBRANDT, William Albert, Jr. [P,S,T] Sharon Hills, PA b. 1 O 1917, Phila., PA. Studied: Tyler Sch. FA; Temple Univ.; PMSchIA; F. Watkins. Member: Phila. A. T. Assn.; Pa. State Edu. Assn.; Nat. Edu. Assn. Exhibited: PAFA, 1941; Temple Univ., 1946 (one-man); Woodmere Gal., 1943–46; Ragan Gal., 1946. Illustrator: "Sculpture, Inside and Out," 1939. Positions: T., Upper Darby, Pa., Jr. H.S., 1944– , Tyler Sch. A., 1944– [47]

HILDER, Howard [Mur.P] Coconut Grove, FL/Muscongus, ME b. 28 S 1866 d. 30 Je 1935. Studied: Paris, with Bouguereau, Ferrier, Dagnan-Bouveret, De la Gandara, Jacque; Holland, with De Bock, J. Israels. Member: Arch. Lg. Greater Miami; St. Lucas Soc., Amsterdam; Newport AA; Fla. Soc. A.&Sc. (founder); Miami AL; Blue Dome Fellowship. Exhibited: NAD, 1906 (med); Palm Beach, 1935 (prize). Work: St. Stephens Church, Coconut Grove, Fla.; Women's C., Miami; YWCA, Miami; Rollins College, Winter Park, Fla. [33]

HILDRETH, Susan W. [P] Cambridge, MA b. Cambridge, MA d. ca. 1938. Studied: R. Turner; A.H. Thayer. Member: Boston AC [38]

HILER, Hilaire [Mur.P,Dec,Des,W] NYC b. 16 Jy 1898, St. Paul, MN d. 19 Ja 1966, Paris. Studied: self-taught. Author: "From Nudity to Raiment, An Introduction to the Study of Costume," 1929, "Notes on the Technique of Painting," 1934 [40]

HILGENDORF, Fred C. [P] Milwaukee, WI b. 28 D 1888, Milwaukee, WI. Studied: Milwaukee Sch. FAA; Milwaukee ASL. Member: Wis. PS; Wis. Soc. Appl. Arts [33]

HILL, Abby Williams (Mrs. Frank R.) [Ldscp.P] Tacoma, WA b. 25 S 1861, Grinnell, IA. Studied: W. Chase; ASL; AIC, with H.F. Spread; H. Hesse, in Germany. Member: Laguna Beach AA; Boston AC. Exhibited: Alaska-Yukon-Pacific Expo, 1909 (gold); World Columbian Expo, 1893; Jamestown Expo; Lewis & Clark Expo. Specialties: national park scenery; Indians [40]

HILL, Alice Stewart [P,I] b. ca. 1850, Beaver Dam, WI d. ca. 1921. Studied: Wis.; CUASch; NAD; Chicago. Work: Pioneer's Mus., Colo. Illustrator: "Her Garden," "Procession of Flowers in Colorado" Specialty: flowers. Active in Colo., 1875–80. [*]

HILL, Anna Wyers (Mrs.) [Des] b. Holland d. 2 Ag 1935, Cleveland, OH. Studied: Hague Acad.; Berlin; metal work, London, one yr. Exhibited: AIC, 1923 (med); CMA (13 awards); London (prizes). Member: Cleveland Women's Art C.

HILL, Arthur Turnbull [P] NYC/East Hampton, NY b. 26 Ap 1868, NYC d. 24 N 1929. Studied: chiefly self-taught; Brooklyn Inst. Art Sch.; G. Inness. Member: A. Fund S.; Brooklyn AC; NAC; SC. Work: Mus. Brooklyn Inst.; NGA; NAC. During WWI he was a marine camofleur. [29]

HILL, Carrie L. [P,T] Birmingham, AL b. Bibb County, AL. Studied: Wash., D.C. AL; Blanc-Garin; Brussells; Daingerfield; G.E. Brown. Member: NAWPS; SSAL; Birmingham AC; Miss. AA. Exhibited: Miss. AA., 1925 (gold); Nashville AA, 1926 (prize); SSAL, 1933 (prize); Ala. AL, 1933 (prize). Work: Birmingham Pub. Lib.; Univ. Ala., Birmingham; MFA, Montgomery [40]

HILL, Clara P. [S] Wash., D.C. b. Massachusetts d. 7 Jy 1935. Studied: Saint-Gaudens; Académie Julian, Paris, with Puech; Colarossi Acad., Paris, with Injalbert; Brussels, with Blanc-Garin; ASL, Wash., D.C. Member: S. Wash. A.; AFA; Wash. SMP, Sculptors & Gr. Exhibited: Seattle Expo, 1909 (gold); Nat. Lg. Am. Pen Women, 1935 (prize). Work: Trinity Col.; CGA; Army Med. Mus., Wash., D.C.; Women's Medical Col., Phila. [33]

HILL, David Wyers [P] Boston, MA. Exhibited: PAFA, 1938; WFNY, 1939 [40]

HILL, Edith L. (Mrs. George P.) [P,S] Wash., D.C. b. 13 Ag 1884, Ridgewood, NJ. Studied: Nat. Acad.; Corcoran Gal. Sch.; Hill Sch. A., Wash., D.C. Member: Wash. Soc. PS&G. Exhibited: Wash. Soc. PS&G; CGA, 1937; Officers' C., Governor's Island, N.Y. [40]

HILL, Edward Rufus [Ldscp.P] b. 1852 d. 1908 (CA?). Active in Calif., 1880s. [*]

HILL, Evelyn Corthell [Ldscp.P] Laramie, WY (1948) b. 4 My 1886, Laramie. Studied: Univ. Wyo.; Wellesley; PAFA, with Garber; AIC; ASL, J. Sloan; Broadmoor Acad., with B. Robinson; T. Benton. Member: Am. Ar. Cong.; Wyo. AA; Rocky Mountain A. Exhibited: Chicago, 1928. Position: T., Univ. Wyo. [40]

HILL, George Snow [P] St. Petersburg, FL b. 13 N 1898, Munising, MI d. 3 F 1969. Studied: Mercersburg (Pa.) Acad.; Lehigh Univ.; Syracuse Univ. Member: St. Petersburg AC; Clearwater AC; SSAL; Gulf Coast Group; Fla. Fed. A. Exhibited: PAFA, 1932; WFNY, 1939; Gulf Coast Group Traveling Exh., 1945, 1946; Clearwater Mus., 1945 (prize), 1946; St. Petersburg AC, 1932, 1935 (prize), 1946; Salon des Artistes Français, 1925; Olympic Exh., Los Angeles Mus. A., 1932; Fla. Fed. A., 1933. Work: Athens Mus. (Univ. Ga.); Clearwater Municipal Auditorium; Gulfport Municipal Auditorium; USPOs, Perry, Madison, Milton, all in Fla.; Tampa Airport; St. Petersburg City Hall; U.S. Coast Guard Station, St. Petersburg; Speed Mem. Mus.; Syracuse Mus. FA. WPA muralist. [47]

HILL, Gertrude [P] Yonkers, NY. Member: Yonkers AA [25]

HILL, Herbert Wilbur [P,C] Roxbury, MA b. 16 Mr 1868, Brooklyn, NY. Studied: F.T. Lent; Daingerfield; H.B. Jacobs; Lowell Sch. Des.; MIT; Cowles Art Sch., Boston [06]

HILL, Homer [I] d. ca. 1968, Livingston, NJ. Member: SI [47]

HILL, James Jerome II [P,I,W] St. Paul, MN/Del Monte, CA b. 2 Mr 1905, St. Paul, MN. Studied: L.W. Hill. Exhibited: New Haven PCC, 1922 (gold), 1923 (gold). Work: St. Paul Acad. [40]

HILL, Jessie F. [S] Hollywood, CA. Member: Calif. AC [27]

HILL, John Henry [P,E] b. 1839, West Nyack, NY d. 1922. Studied: his father, John William [1812-79]. Exhibited: NYC; Phila., late 1850s. Work: NYPL. Author/Illustrator: "An Artist's Memorial," with etchings after his father's paintings (1888), "Sketches from Nature." Specialty: Eastern landscapes. Major still life artist of the 1860s. [*]

HILL, Julia Faulkner (Mrs. Albert F.) [S] Cambridge, MA/Surry, ME b. 21 Jy 1888, Keene, NH. Studied: Santa Barbara Sch. A.; George Demetrios. Member: NAWPS; Copley S.; Boston AC; AFA; Boston S.Indp.A. [40]

HILL, Louis W. [P] St. Paul, MN [25]

HILL, Mabel B(etsy) [I] NYC b. 7 My 1877, Cambridge, MA. Member: Artists Gld. Illustrator: "Bolenius," "Barnes," "The Children's Method," other children's books [33]

HILL, Margaret E. [C,T] Billerica, MA b. 8 F 1867. Studied: Mass. Sch. Art. Member: Weavers Gld., Boston [40]

HILL, (Pauline) Polly Knipp (Mrs. George S.) [En,E,Li,P,I] St. Petersburg, FL/Urbana, IL b. 2 Ap 1900, Ithaca, NY. Studied: Univ. Ill.; Jeannette Scott; Carl Hawley; Syracuse Univ; G. Hess. Member: Phila. SE; St. Petersburg AC; Fla. Fed. Art; Southern PM Soc.; Northwest Pr.M.; Gulf Coast Group; SSAL; Chicago SE. Exhibited: NAD, 1927, 1929, 1935, 1940, 1944, 1946; Brooklyn SE, 1930 (prize); Fla. Fed. A., 1932 (prize), 1933 (prize), 1944 (prize); Gulf Coast Group, 1945, 1946 (prize); Clearwater Mus.; St. Petersburg AC; Smithsonian Inst., 1937 (one-man); Ferargil Gal., 1927 (one-man), 1930 (one-man); Hanna Gal., Detroit; Newhouse Gal.; Syracuse Mus. FA; Speed Mem. Mus.; Brooks Mem. A. Gal.; Dayton AI; Holman Print Shop, Boston; SAE, 1929 (prize), 1930-44; SSAL, 1943 (prize); Phila. Pr. C., 1930-41, 1942 (prize). Work: LOC; Syracuse Mus. FA; Speed Mem. Mus.; "Contemporary Am. Prints," 1931; "Fine Prints of the Year," 1930-33; Syracuse MFA; Speed Mus. Illustrator: "Woodpile Poems," by B.S. Foley [47]

HILL, Pearl L. (Mrs. G.E. Worthington) [P,I,Car] New Rochelle, NY b. 11 D 1884, Lock Haven, PA. Studied: PMSchIA; PAFA. Member: New Rochelle AA. Exhibited: New Rochelle Pub. Lib.; Women's C. Work: New Rochelle Women's C.; posters, Nat. Biscuit Co., 1924-28 [40]

HILL, R(obert) Jerome [P,I,C,Min.P,T,Mus.Cur] Dallas, TX b. 1878, Austin, TX. Studied: Univ. Tex., with J. Downie; ASL, with Twachtman, W.A. Clark, Bridgman, Blum, Christy; Kunz-Meyer, in Dallas. Member: Dallas AA; Reaugh AC; SSAL; Dallas Public AG. Exhibited: Dallas Allied A. (prize). Work: State T. Col., Nacogdoches, Tex.; Confederate Mus., Austin. Position: Cur., Dallas Public AG [40]

HILL, Robert John [Des,P,I,Car] Cranston, RI b. 31 Jy 1891, Meriden, CT. Member: Providence AC; Providence WCC; Utopian C.; South County AA. Work: ceremonial mace, Brown Univ.; Intl. Auto Race trophy; Bennet balloon race trophy; Meriden war memorial bronze doors, Notre Dame Church, Southbridge, Mass.; U.S. Naval efficiency trophy, etc. Positions: Chief Des., bronze and plastics, Gorham Co.; Dir., R.I. Lg. A.&Cr. [40]

HILL, Roswell Stone [P,T] Syracuse, NY b. 17 Ap 1861, Lawrence, KS. Studied: ASL; Paris, with Gérôme, Bouguereau, Ferrier. Member: Paris AAA; SC, 1901. Position: T., Col. FA, Syracuse [08]

HILL, S(ara) B. [E,Des] NYC b. Danbury, CT. Studied: A. Mucha. Member: Am. Bookplate Soc.; Soc. Bookplate Collectors and Des. Work: MMA; Grolier C., NYC; LOC; Harvard Lib.; Vassar; CI; British Mus., Nat. Gallery, Guild Hall, all in London. Specialty: bookplates [40]

HILL, Thomas [P] San Fran., CA b. 11 S 1829, Birmingham, England (came to Taunton, MA, in 1841) d. 1 Jy 1908, Raymond, CA. Studied: PAFA, with Rothermel, 1853; Paris, with P. Meyerheim, 1866; but principally self-taught. Member: Boston AC; San Fran. AA. Exhibited: Art Union, San Fran., 1865 (prize); Centenn. Expo, Phila., 1876 (med); PAFA, 1884 (med); in all he received 31 awards. Work: Denver AM; Calif. Capitol; Los Angeles Mus. A.; Worcester MA; Univ. Kans. MA; Oakland MA. Illustrator: 19 illus. in Muir's "Picturesque California," 1888. He worked as a carriage painter, 1840s; worked in San Fran., 1861-66; in Boston, 1867-71; back in San Fran., 1871-1908, often traveling to New England in late 1870s-early 1880s. He helped V. Williams found San Fran. Sch. Des., 1874; commissioned by Muir to paint in Alaska, 1887. Best known for his majestic landscapes of Calif., especially Yosemite. [08]

HILL, W.E. [Car] NYC. Position: Staff, Herald Tribune [27]

HILLARD, William H. [P] Baltimore, MD d. Ap 1905, Wash., D.C. Among his best-known pictures were "The Flight Above the Clouds," which sold for ten thousand dollars; a portrait of President Garfield; and the tomb of John Howard Payne (author of "Home, Sweet Home")

HILLBLOM, Henrik [P,Des] Wallingford, CT/Lyme, CT. b. 3 Ap 1863, Sweden. Studied: Lefebvre; Constant. Member: SC; CAFA. Exhibited: Minneapolis AI, 1936 (prize); Meriden AA, 1936 (prize). Work: MMA. Position: silver des., Wallace Mfg. Co., since 1899 [40]

HILLBLOM, Ralph [P] Woodstock, NY [17]

HILLER, Lejaren à [I,Photogr] NYC b. 3 Jy 1880, Milwaukee. Studied: AIC; Paris. Member: SI, 1910; A. Dir. C. Illustrator: magazines; adv. [47]

HILLERS, John K. [Photogr] b. 1843, Germany d. 1925. Work: Boston Pub. Lib.; Denver AM; LOC; IMP/GEH; NYPL; Mus. N.Mex. Best known as Powell's photographer for his 1872 Grand Canyon expedition. He continued to work for the U.S. Geological Survey until 1919. Mt. Hillers, in Utah, is named for him. [*]

HILLERY, Arthur M. [P] West Hartford, CT [24]

HILLES, Carrie P. [Min.P] Phila., PA [25]

HILLES, Florence Bayard (Mrs. W.S.) [C] Wilmington, DE b. 17 1865, Wilmington. Studied: Baron von Rydingsvard; Bertha Campbell, in London. Member: Boston SAC [40]

HILLIARD, Clyde Stafford (Mrs.) [Ldscp.P] Belmont, MA b. 25 S 1900, Boston, MA d. 18 Je 1937. Studied: S. Carbee; J. Hilliard; R. Andrew; A. Spear. Member: Boston AC; Copley S.; NAC; Women's City C., Boston. Position: Art Ed., Arts and Artists magazine, Boston [38]

HILLIARD, F. John [P,E] Boston, MA b. 1 F 1886, Burlington, VT. Studied: Pape; G.L. Noyes; C. Emerson; H. Brett; S. Carbee; R. Andrew. Member: Boston AC; NAC; Copley S. Work: Boston Univ.; Boston Col. [40]

HILLIARD, William Henry [P] b. 1863, Auburn, NY d. Ap 1905, Wash., D.C. Exhibited: NAD, 1876-88; Royal Acad., London, 1880. Best known as a New England landscape and marine painter. After study in NYC he went West, continued study in England and France. Later settled in Boston. [*]

HILLMAN, Anna G. [P] Brooklyn, NY [06]

HILLS, A(nna) A(lthea) [P,L,T] Laguna Beach, CA b. Ravenna, OH d. Je 1930. Studied: AIC; CUASch; Académie Julian, Paris. Member: Calif. AC; Laguna Beach AA (Pres.); Wash. WCC. Exhibited: Panama-Calif. Expo, San Diego, 1915 (med); Calif. State Fair, 1919 (med); Laguna Beach AA, 1922 (prize), 1923 (prize); Orange County Fair, 1925 (prize) [29]

HILLS, David [P] Phila., PA. Member: Phila. AA [17]

HILLS, Dorothy [P,I] Evanston, IL [19]

HILLS, Laura Coombs [P,Min.P] Newburyport, MA 7 S 1859, Newburyport d. 1952. Studied: Cowles A. Sch., Boston; ASL; Helen M. Knowlton. Member: ASMP; SAA, 1897; ANA, 1906; Boston WCC; Copley S., 1892; Boston GA; Pa. SMP; AFA. Exhibited: P.-P. Expo, 1915 (prize); PAFA, 1916 (prize), 1920 (prize); ASMP, 1928 (prize); Paris Expo, 1900 (prize); S. Wash. A., 1901 (prize); Pan-Am. Expo, Buffalo, 1901 (med); Charleston Expo, 1902 (med); St. Louis Expo, 1904 (gold). Work: MMA. Specialties: miniatures and flowers in pastel [47]

HILLS, Metta V. (Mrs. Elijah C.) [P] NYC b. 1 Ap 1873, Orleans, NY. Studied: J. Gerrity; R. Boynton; Lhote; H. Hofmann. Member: San Fran. S. Women A. [40]

HILLS, Ralph Wash., D.C. [01]

HILTON, J. Ten E. [P] Albany, NY. Exhibited: 48 Sts. Comp., 1939 [40]

HILTON, Ned [Car,Dr] NYC. Member: Car. Gld. Contributor: Saturday Evening Post, Collier's, New Yorker [40]

HILTON, Roy [I,P,T] Pittsburgh, PA b. 24 F 1891, Boston. Studied: Pape Sch. A.; Fenway Sch., Boston; C. Woodbury. Exhibited: Pittsburgh AA, 1932 (prize). Work: USPOs, Westfield, N.J., Rockymount, Va. WPA muralist. Position: T., CI [47]

HIMLER, Mary Martha [Por.P,B,I,L,T] Latrobe, PA b. Greensburg, PA. Studied: T. Col., Indiana, Pa.; Univ. Pittsburgh; CI; L. Winslow; E. Ashe; F. Bicknell; N. MacGilvary; A. Kostellow. Member: Pittsburgh AA; Greensburg AC. Exhibited: Pittsburgh AA, 1925-33, 1934 (prize), 1935-46; Butler AI, 1937, 1943, 1945, 1946; All. A. Johnstown, 1946 (prize); Greensburg AC 1934, 1935 (prize) 1936 (prize) 1937 (prize) 1938 (prize), 1939 (prize), 1940-42, 1943 (prize), 1944, 1945, 1946 (prize); Ebensburg Fair, 1939 (prize); Indiana, Pa. State T. Col., 1943-46. Position: T., Latrobe Pub. Sch. [47]

HIMMEL, Kalman Edward [P] Chicago, IL b. 13 O 1903, Chicago. Studied: AIC. Exhibited: AIC, 1934, 1938, 1940-1942, 1944, 1946 (prize); Miss. Valley A.; Ill. State Mus., 1940; Milwaukee AI, 1946. WPA artist. [47]

HIMMELBERGER, Ralph [P] Irvington, NJ b. 24 My 1887, Reading, PA. Member: AAPL; Essex County WCS; P.&S. Soc. N.J. Exhibited: NAD, 1944, 1945; Audubon A., 1945; All.A.Am., 1943, 1945; AWCS; P.&S. Soc., 1945 (prize), 1946; Montclair A. Mus., 1940, 1942, 1944, 1945; Newark AC, 1945, 1946 (prize); Art Center of the Oranges, 1939-45, 1946, (prize); Newark Sch. F.&Indst. A. (one-man); Irvington A.&Mus. Assn., 1945 (prize); Plainfield AA, 1946 (prize); Union, N.J. AA, 1945 (prize) [47]

HIMMELFARB, Samuel [P,Des] Winfield, IL b. 4 Jy 1904, Latvia. Studied: Wis. Sch. FA; Univ. Wis.; NAD; ASL; Hawthorne; R. Robinson; G. Moeller, at Milwaukee State T. Col. Member: Wis. PS; Am. A. Cong. Exhibited: AIC; Milwaukee AI, 1932 (one-man), 1937 (prize); Wis. State Fair, 1930 (prize). Work: Milwaukee AI [47]

HIMMELSBACH, Francesca (Mrs. J.F.) [P] Phila., PA [04]

HIMMELSBACH, Paula. See Balano, Mrs.

HINCHMAN, John H. [P] Woodmont, CT. Member: S.Indp.A. [21]

HINCHMAN, John Herbert [P,T] New Hope, PA b. 4 Ap 12884, Detroit, MI. Studied: Wicker; Detroit Sch. FA; Hawthorne; Kendall; Carlson; Lhote; Académie Julian. Member: Am. AS, Paris; Calif. AC; San Diego AG; Laguna Beach AA; AAPL. Work: Detroit Inst. A. Contributor: Detroit Saturday Night and South Coast News [40]

HINCHMAN, Margaretta S. [P,Li,C,I] Phila., PA/Washington, CT b. Phila. d. 23 Jy 1955. Studied: H. Pyle; K. Cox; C. Grafly; PAFA. Member: Phila. WCC; Wash. WCC; AFA; A. & Crafts Gld., Phila.; Phila. A. All.; AAPL, AAMus.; Arch. L.; La Musée des Arts Decoratifs; NAWA; NSMP; Phila. Plastic C.; Phila. Pr. C. Exhibited: AIC; NAD; NAWA; Arch. L.; CGA; Phila. Pr. C.; Carlen Gal.; PAFA, 1935 (prize), 1943 (prize); Phila. Plastic C., 1927 (prize) 1945 (prize); Gimbel's, 1933 (prize); Wilmington SFA, 1935 (prize). Work: murals, Sweet Briar Mansion, Fairmount Park; PAFA. Illustrator: "Early Letters of Nantucket," etc. Position: V. Pres., Women's Comm., PMA, Phila. [47]

HINCHY, Theresa [G] Buffalo, NY. Exhibited: Albright Gal., 1937 (prize); Ar. Western N.Y., 1939 [40]

HINCKLEY, Lawrence Bradford [P,L] Fillmore, CA b. 29 N 1900, Fillmore. Studied: Otis AI. Member: Calif. WCS; Calif. AC. Exhibited: GGE 1939; San Diego FA Soc., 1941; Calif. WCS; Los Angeles Mus. A. Lectures: "Adventuring in Art." Position: Dir., The Artist's Barn, Fillmore, 1936- . [47]

HINCKLEY, Robert [Por.P] Wash., D.C. b. 3 Ap 1853, Boston, MA d. 1 Je 1941, Rehoboth Beach, DE. Studied: Paris, with Carolus-Duran, Bonnât, Ecole des Beaux-Arts. Work: West Point; Annapolis. Position: T., Corcoran A. Sch. [08]

HIND, James F. [P] Morristown, NJ. Member: AWCS [01]

HINDS, Donald [P] New Rochelle, NY b. 14 O 1883. Studied: PMSchIA. Member: Gloucester SA; New Rochelle AA; Westchester AG. Work: American Flying C. [40]

HINE, Lewis Wickes [Photogr] b. 1879, Oshkosh, WI d. 1940. Studied: Frank Manny; Univ. Chicago, ca. 1898; Columbia; NYU, 1905; self-taught as photographer. Best known as the first to use photography for social reform. Series on Ellis Island immigrants made in 1905. Series for the Nat. Child Labor Committee, made mostly from 1908-16, the strongest being those of children living in slums and working in mines. Empathy for his work is reflected in the subject matter of some of the "Ashcan School" of painters. [*]

HINES, Jack [I] NYC. Member: SI [25]

HINES, Jefferson L. [S] Chicago, IL [17]

HINEY, Elsie I. [P] Phila., PA. Member: S.Indp.A. [25]

HINKELMAN, Edna Webb (Mrs. Edward) [P,I,T] Wynantskill, NY/Navesink, NJ b. 12 F 1892, Cohoes, NY. Studied: C.L. Hinton; Emil Carlsen. Member: Troy SAC. Position: anatomical illus., Albany Hospital and Medical Col. [33]

HINKLE, Clarence K. [P,T] Santa Barbara, CA b. 19 Je 1880, Auburn, CA d. 20 Jy 1960. Studied: PAFA, with Anshutz, 1906; W. Chase; Académie Julian, Paris, with Laurens. Member: Calif. AC; FA Soc. San Diego; Laguna Beach AA. Exhibited: Calif. C., San Fran., 1914; Pasadena, 1929 (prize); CI, 1944, 1945; Santa Barbara Mus. A., 1944 (one-man); Calif. AC, 1944 (prize); Oakland A. Gal., 1937 (prize), 1945 (med); Los Angeles Mus. A., 1921 (prize), 1925 (gold), 1945 (prize). Work: Los Angeles Mus. A.; Santa Barbara Mus. A.; de Young Mem. Mus.; Crocker A. Gal., Encyclopaedia Britannica Coll. San Diego Gal. FA; Montpelier Mus., Vt. Position: T., Chouinard Sch. A.; Santa Barbara Sch. A. [47]

HINKLE, Lucile Bernice [P,T] Fullerton, CA b. 2 Jy 1895, Kansas City. Studied: Univ. Calif.; Stanford. Member: Calif. AC. Exhibited: Southern Calif. Art T. Assn., Los Angeles, 1930 (prize). Position: T., Fullerton Jr. Col. [40]

HINKLE, Lucille A. Foote (Mrs. William H.) [Min.P] Cincinnati, OH b. 10 Ja 1853, Cincinnati. Studied: C. Chaplin, in Paris; D. Volk; W. Chase [08]

HINMAN, Leana McLennan [P] Chicago, IL b. Chicago. Studied: Holland. Member: Palette C., Chicago [04]

HINRICHSEN, Helen Johnson [P] Davenport, IA b. Springfield, IL. Studied: AIC; G. Wood. Member: Tri-City AC. Exhibited: Iowa A. Salon, 1933 (prize), 1934 (prize). Work: Davenport Centenn. mural, First Nat. Bank Bldg.; Masonic Temple, Cherokee, Iowa. Position: T., Davenport A. Gal. [40]

HINSDALE, Mabel F. (Mrs.) [P] Cincinnati, OH. Member: Cincinnati Women's AC [25]

HINSHAW, Arthur Glenn [P] Paris, France/Anderson, IN [06]

HINTERMEISTER, H(enry) [P,I] Brooklyn, NY b. 10 Je 1897, NYC. Studied: W. Taylor; O.W. Beck; A. Fisher. Member: NYWCC; AWCS; NAC [40]

HINTERMEISTER, John Henry [Por.P] Brooklyn, NY b. 1870, Switzerland (came to U.S. in 1892) d. Feb. 10, 1945. Member: SC; Brooklyn SA; AAPL

HINTON, Charles Louis [P,S,I] Bronxville, NY b. 18 O 1869, Ithaca, NY d. 1950. Studied: NAD, W.H. Low; Paris, with Gérôme, Bouguereau. Member: ANA 1916; NSS; Century C.; NA 1941. Work: Court House, Second Nat. Bank, Wilkes-Barre, Pa. Illustrator: "Emmy Lou," "Under the Trees," "Child of Nature," other children's books. Position: Dean, NAD Sch. [47]

HINTON, Clio. See Bracken, William B., Mrs.

HINTON, Erwald Stuart [S] Chicago, IL b. 3 Ja 1866, NYC [10]

HINTON, Howard (Mrs.) [S] b. 1834 d. 19 D 1921, NYC. Studied: L. Thompson

HINTON, Lewis J. [Arch-S] b. 1845, London (came to U.S. in 1869) d. 5 D 1831, NYC. Work: stone work, Cornell; the "Million-dollar staircase", State Capitol, Albany; stone work, pulpit, Cathedral St. John, Jacksonville, Fla.

HIPKISS, Edwin James [Mus.Cur,W,L] Waltham, MA b. 7 S 1885, Buffalo, NY d. ca. 1955. Studied: abroad. Author: "18th Century American Arts," 1941, "Philip L. Spalding Collection of Early American Silver," 1943. Contributor: The White Pine Monographs, The American Collector, other art publications. Position: Cur., BMFA [47]

HIRAM, B.D. [P] NYC [04]

HIRAMOTO, Masaji [P,S] Paris, France b. 8 D 1888, Fukui, Japan. Studied: PAFA; Columbia. Member: S.Indp.A.; Japanese AS; Salons of Am.; Salon D'Automne; Société Nationale Des Beaux-Arts. Work: Columbia [33]

HIRONAKA, U. [P] Indianapolis, IN [17]

HIROTA, Susumu [P] Rockport, MA b. 18 D 1898, Kochi, Japan. Member: Rockport AA, 1941; New Haven PCC, 1946; Gloucester SA. Exhibited: AIC, 1936, 1940, 1941; CGA, 1939, 1941; WFNY, 1939; PAFA, 1941, 1942; Inst. Mod. A., Boston; Bowdoin Col.; Univ. Utah; RISD; Toledo Mus. A.; Univ. Nebr. Work: BMFA [47]

HIRSCH, Joseph [P,E,Li] NYC b. 25 Ap 1910, Phila. PA. Studied: PMSchIA; Luks; H. Hensche. Member: Guggenheim F., 1942–43, 1943–44; A.Lg.Am.; An Am. Group; Woolley F., Paris, 1935–36. Exhibited: PAFA, 1934 (prize); Prix de Rome Comp., 1935; WFNY, 1939 (prize); LOC, 1944 (prize); NAD, 1934 (prize). Work: WMAA; MOMA; PMA; BMFA; CGA; AGAA; LOC; Univ. Ariz.; Encyclopaedia Britannica Coll.; IBM; murals, Amalgamated Clothing Workers Bldg., Phila.; Phila. Municipal Court Bldg.; documentary paintings for U.S. Gov. Illustrator: "Mother Goose," 1946. Position: T., Phila. Ar. Union, 1940 [40]

HIRSCH, Jules [Dec,P,I,Cart] NYC b. 18 N 1907, Waterbury, CT. Studied: CUASch; W. Van Ingen. Member: S.Indp.A. Exhibited: N.Y. Bldg. Cong., NYC, 1932 (gold); Grand Central A. Gal. [40]

HIRSCH, Stefan [T,P,Li,L] Annandale-on-Hudson, NY b. 2 Ja 1899, Nuremburg, Germany d. 30 S 1964, NYC. Studied: Europe; H.E. Field. Member: NSMP; Am. Soc. P.S.& G.; Brooklyn SA; Am. A. Cong.; Audubon A.; Assn. Am. Col. Prof. Exhibited: S.Indp.A., 1919, 1920; Salons of Am., 1921–30; CI; CGA; PAFA; WMAA; AIC; WFNY, 1939; Manchester, Vt., 1935–39. Work: WMAA; Newark Mus.; WMA; PMG; Harrison Gal., Los Angeles; Dartmouth Col.; Milwaukee AI; SAM; MMA; murals, Lenox Hill Assn.; U.S. Court House, Aiken, S.C.; USPO, Booneville, Miss. WPA muralist. Position: T., Bennington Col., 1940; T., Bard Col, Annandale, N.Y., 1942– . [47]

HIRSCHBERG, Alice Kerr-Nelson (Mrs. Carl) [P,I] NYC b. 12 F 1856, England (came to NYC in 1884). Studied: Heatherley Acad., London; Colarossi Acad., Paris [15]

HIRSCHBERG, Carl [P,I] Kent, CT b. 8 Mr 1854, Germany d. 2 Je 1923, Danbury, CT. Studied: ASL; Ecole des Beaux-Arts, with Cabanel, Lefebvre. Member: Salma. Cl. (founder). Specialty: figure painting of genre [21]

HIRSCHFIELD, Harry [I] NYC. Member: SI [47]

HIRSCHI, Lillian M. [S] Wichita Falls, TX b. 18 F 1907, Wichita Falls. Studied: J. Camus. Member: Int. Women PS; AAPL. Exhibited: Salon Des Artistes Francais, 1934; S. Wash. A., 1935 [40]

HIRSH, Alice [P] NYC. Member: NAWPS; CAFA [31]

HIRSIG, Alma M. See Bliss, Mrs.

HIRST, Claude Raguet (Mrs. W.C. Fitler) [P] NYC b. 1855, Cincinnati, OH d. 1942. Studied: Cincinnati Art Acad., with Noble; A.D. Abbatt; G. Smillie; C. Curran. Member: NAWPS; NYWCC. Exhibited: Syracuse, N.Y., 1897, 1898 (prize); NAWPS, 1922, 1927. Work: Boston AC; Phila. AC [40]

HIRT, Joseph [P] NYC [25]

HISSEL, A.W. [P] Chicago, IL. Member: Chicago NSJA [25]

HITCHCOCK, Cecil. See Jay.

HITCHCOCK, Charlotte E. (Mrs. A.W.) [C] Southbridge, MA b. 3 Ja 1874, Northampton, MA. Studied: N.Y. Sch. Appl. Des. for Women; AIC; Hartford A. Sch. Member: NYSC. Specialty: batik [40]

HITCHCOCK, David Howard [Ldscp.P,S,I] Honolulu, HI b. 15 My 1861, Hilo, HI. Studied: V. Williams; Paris, with Bouguereau, Ferrier. Member: SC, 1904; Honolulu AS (Pres.) [40]

HITCHCOCK, George [P,I] Paris b. 29 S 1850, Providence, RI d. 2 Ag 1913, Island of Maarken, Holland. Studied: London; Paris, with Boulanger, Lefebvre; Düsseldorf; Mesdag, Holland. Member: Munich Secession; Paris S.A.P; ANA, 1909; Vienna. Exhibited: Paris Salon, 1887; Am. A. Assn. NYC, 1887 (gold); Paris Expo, 1889 (gold); Columbia Expo, Chicago, 1893 (med); Berlin, 1896 (med); Dresden, 1897 (med); Vienna, 1898 (med); Munich, 1900 (med). Acad. Award: Order of Franz Josef. Work: Dresden Gal.; McCullough Gal., London; Municipal Gal., Alkmaar, Holland; AIC; RISD; Albright A. Gal., Buffalo; CAM; Herron AI; AI Minneapolis. His winters were usually spent in France and his summers in Holland. He was noted for pictures of Dutch tulip fields and for religious subjects with Dutch models. [10]

HITCHCOCK, Helen Marshall [P,T] West Hartford, CT b. 17 My 1902. Studied: Smith Col.; Yale. Member: Elmira AC. Illustrator: "Lucy Perhaps," Alfred M. Hitchcock, 1935. Position: T., Elmira Col. [40]

HITCHCOCK, Henry-Russell [Hist,Cr,Edu] Middletown, CT b. 3 Je 1903, Boston, MA. Studied: Harvard. Member: Carnegie Traveling F., 1928–29; Guggenheim F., 1945–46. Author: "Frank Lloyd Wright," 1928, "In the Nature of Materials, the Buildings of Frank Lloyd Wright," 1942, other books on art and arch. Positions: T., Vassar, 1927–40, Weslayan, 1940– , MIT, 1946– [47]

HITCHCOCK, Lucius Wolcott [P] New Rochelle, NY/Southport, ME. b. 2 D 1868, West Williamsfield, OH d. 18 Je 1942. ASL; Lefebvre; Constant; Laurens; Colarossi Acad. Member: SI 1904; SC 1907; New Rochelle AA. Exhibited: Paris, 1900 (med); Pan-Am. Expo, Buffalo, 1901; St. Louis Expo, 1904 (meds) [40]

HITCHCOCK, Mary D. [P] NYC. Member: S.Indp.A. [21]

HITCHCOCK, Ripley [Cr,W] b. 1857, Fitchburg, MA d. 4 My 1918, NYC. Member: NIAL; Am. Hist. Assn.; Century C.; Author's C.; Harvard C.; MacDowell C. Positions: Writer, New York Tribune, Appleton & Co.. Harper & Brothers

HITCHENS, Joseph [P] b. 1838, England d. 1893, Pueblo, CO. Work: Colo. State Mus.; Mus. N.Mex. A popular Pueblo landscape and genre painter of the 1880s. [*]

HITCHNER, Mary R. [P] Phila., PA. Studied: PAFA [24]

HITE, Marcia S. (Mrs. Allen) [P] Louisville, KY b. 25 N 1876, Louisville. Studied: A. Center, Louisville. Member: AFA; SSAL; N.E. Soc. Contemporary A.; Louisville AA; Louisville AC. Exhibited: Speed Mem. Mus., 1929 (prize); SSAL, New Orleans, 1930 (prize). Work: Mem. A. Gal., Rochester, N.Y. [40]

HITTELL, Charles J. [P] San Fran., CA b. 4 Ag 1861, San Fran. d. 1938, Pacific Grove, CA. Studied: Univ. Calif., Berkeley, 1879–81; San Fran. Sch. Des., 1881–83; Royal Acad., Munich, 1884–92; Académie Julian, Paris, 1892–93. Work: drawings, Univ. Calif., Berkeley; San Fran. Pub. Lib.; paintings, AMNH. Specialty: Western life [17]

HITTLE, Margaret A. [P,I,E,L,T] Chicago, IL b. 19 Ap 1886, Victor, IA. Studied: AIC; Chicago ASL. Member: Chicago SA. Work: frieze, Bennett Mus., Garrett Biblical Inst., Evanston, Ill. [24]

HITZ, H.A. [P] Milwaukee, WI. Member: Wis. PS [25]

HIX, John M. [Car] Hollywood, CA b. 1908, Huntsville, AL d. 6 Je 1944. Contributor: cartoons, Washington Herald, McClure syndicate, movie shorts

HOAGLAND, Mary Adams (Mrs.) [P] Chicago, IL b. Chicago. Studied: AIC; Paris; Rome [10]

HOA-LeBLANC, Marie de (listed in 1908 as Emilie M.) [P,C,I,T] New Orleans, LA b. 23 N 1874, New Orleans d. 24 N 1941. Studied: Newcomb Col., Tulane; Loyola; Harvard; AIC; Paris. Member: New Orleans AA; Nat. Edu. Assn.; Am. Vocational Assn.; La. State T. Assn. Exhibited: New Orleans AA (med); St. Louis World's Fair (med); Delgado Mus., annually. Work: Delgado Mus. Position: T., New Orleans Pub. Sch. [40]

HOAR, Frances [P,T] Boulder, CO b. 12 Ap 1898, Phila. Studied: W. Forsyth; F. Howell; PMSchIA. Member: Boulder AG; Prospectors. Exhibited: watercolors, Denver Mus., 1928 (prize), 1929 (prize), 1931 (prize), 1933 (prize). Position: T., Univ. Colo. [40]

HOARD, Margaret [S,Des] Mt. Vernon, NY b. 1880, IA d. 30 O 1944. Studied: ASL. Member: L'Union Internationale des Beaux-Arts et des Lettres, Paris, 1914; ASL; NAWPS. Exhibited: P.-P. Expo, San Fran., 1915 (prize). Work: MMA. Specialty: wallpaper design [40]

HOBAN, Frank J. [P,Des] Chicago, IL b. Cincinnati, OH. Member: Palette and Chisel Cl. [31]

HOBART, Clark [E,P] San Fran., CA b. Illinois. Studied: Mark Hopkins Inst. A., San Fran.; ASL, with Bridgman, R. Blum; Paris. Member: San

Fran. SA; Calif. SE. Exhibited: monotype, P.-P. Expo, San Fran., 1915 (med); San Fran. AA, 1918 (prize), 1921 (gold), 1922 (gold). Work: Gate Mus.; Palace FA, San Fran.; Oakland Mus. Position: Ed., Burr-McIntosh Monthly, 1903–10 [25]

HOBART, Gladys Marie [F,T] San Fran., CA b. 28 Ag 1892, Santa Cruz, CA. Studied: J.C. Johansen. Member: San Fran. AA [33]

HOBART, Helen F. [P] NYC. Member: S.Indp.A. [25]

HOBART, Mabel Deming [P] NYC [06]

HOBBS, Anne S. See Foster, Mrs.

HOBBS, George L. [P] Phila., PA b. 18 F 1846, Phila. Studied: PAFA; Bouguereau, Robert-Fleury, in Paris. Also a restorer. [21]

HOBBS, Louis. See Allen.

HOBBS, Morris Henry [E,En] New Orleans, LA b. 1 Ja 1892, Rockford, IL. Studied: E. Dean; C. Keith; R.F. Seymour. Member: SAE; Chicago SE; Cleveland Pr.M.; Toledo Pr. Cl.; NAC; Evanston A. Center; All. Ill. Soc. FA; North Shore Art Lg. Exhibited: Evanston A. Center, 1930 (prize); Toledo Mus., 1930 (prize), 1931 (prize), 1936 (prize); SSAL, 1941 (prize). Work: represented in "Fine Prints of the Year," 1930, "Contemporary American Etchings," 1931 [47]

HOBBY, Carl Frederick [P,T] San Fran., CA b. 10 Mr 1886, Iowa City. Studied: ASL; Cumming Sch. A., Des Moines. Work: Ft. Monmouth, Va. WPA artist. Position: T., Art Center, San Fran. [40]

HOBDY, Ann F. [P] NYC. Exhibited: NAWPS, 1935–39 [40]

HOBSON, Ella Howe (Mrs. George H.) [C] Brookline, MA. Member: Boston SAC. Exhibited: Tercentenary Exh., Boston, 1930 (med). Specialty: pottery [40]

HOBSON-KRAUS, Katherine Thayer (Mrs.) [S] Paris, France b. Denver, CO. Studied: W. Sintenis [15]

HOCHGESANG, Rebekah Culin [P] Phila., PA [01]

HOCKADAY, Hugh [P,I] b. 1892, Little Rock, AR d. 1968, Lakeside, MT. Studied: St. Louis Sch. FA, with Berninghaus, Goetsch, Carpenter, Wuerple; Commercial Art of St. Louis, with D.C. Nicholson. Work: Mont. Hist. Soc. Began painting landscapes and portraits in late 1950s. [*]

HOCKER, Trew [P,T] NYC b. 17 Je 1913, Sedalia, MO. Studied: Univ. Mo.; St. Louis Sch. FA; Thomas Hart Benton; K. Hudson. Exhibited: NGA, 1945; Kansas City AI, 1938, 1939; Mo. State Fair, 1935 (prize), 1937 (prize), Ark. PS Exh., Little Rock, 1939 (prize); WFNY, 1939; GGE, 1939. Work: WPA mural, USPO, St. Louis. [47]

HOCRI, Ichiro E. [P] NYC [15]

HODGSON, Sylvester Phelps [Por.P] b. 1830 d. 1906 (Boston?). Exhibited: Boston Athenaeum, 1858–73; NAD, 1964–68. Active in Salem (1855), Boston (1856) [*]

HODGE, Helen (Mrs.) [P] Topeka, Kans. Studied: Corcoran Sch. A.; G.M. Stone; G. Hopkins. Member: Topeka AG; Laguna Beach AA; AAPL; AFA; Kans. Fed. A. Exhibited: Kans. Free Fair (prizes). Work: Mulvane Art Mus., Women's Cl., Children's Lib., High School, all in Topeka; Women's Cl., high schools, all in Wichita [40]

HODGE, Lydia Herrick [S] Portland, OR. Studied: A. Fairbanks; H. Camden; Univ. Oreg.; Univ. Calif.; Calif. Sch. FA; Archipenko; Paris. Member: NAWPS [40]

HODGE, Margaret M(agill) [P] Wash., D.C. b. Wash., D.C. Studied: Corcoran Sch. A. Member: Wash. WCC [25]

HODGES, Alice [P] Boston, MA [08]

HODGES, George S(chuyler) [P] Pontiac, MI b. 3 Mr 1864, Pontiac. Studied: Ecole des Beaux-Arts, with Gérôme, in Paris [17]

HODGES, Marjorie [P] Los Angeles, CA [19]

HODGIN, Marston Dean [P,L,T] Oxford, OH b. 3 D 1903, Cambridge, OH. Studied: E.F. Brown; R.L. Coats; J.R. Hopkins; Hawthorne; Earlham Col.; Ind. Univ.; Univ. Chicago; R.E. Burke; T.C. Steele; W. Sargent. Member: Richmond (Ind.) AA; Oxford AC. Exhibited: Ind. Exh., 1924–25 (prizes); Richmond (Ind.) AA, 1925 (prize), 1927 (prize), 1928 (prize), 1933 (prize), 1936 (prize), 1941 (prize); Butler AI, 1940. Work: Earlham Col.; Miami Univ., Oxford, Ohio; Richmond (Ind.) AA. Position: T., Miami Univ., 1927– [47]

HODGKINS, A.W. [F] Wash., D.C. Member: Soc. Wash. A. [27]

HODGKINS, Samuel [P] Wash., D.C. Member: Wash. SA [17]

HODGSKIN, Helen [P] Brooklyn, NY. Member: S.Indp.A. [25]

HODGSON, Christman William [P] b. 1830 d. 12 F 1914, Grand Rapids, MI

HODGSON, Daphne [I] NYC. Member: SI [47]

HOE, Mabel Kent (Mrs. C.R.J.) [P,S] Cranford, NJ b. 27 Ja 1880, Cranford. Studied: ASL; Archipenko; A. Lee; Bridgman; Miller; Nicolaides. Member: NAWA; Asbury Park Soc. FA. Exhibited: NAWA, 1936 (prize); Montclair A. Mus.; AAPL; Asbury Park, Spring Lake, Newark, all in N.J. [47]

HOEBER, Arthur [Ldscp.P,I,P,W,L,Cr] Nutley, NJ b. 23 Jy 1854, NYC d. 29 Ap 1915. Studied: ASL, with Beckwith; Ecole des Beaux-Arts, Gérôme, in Paris. Exhibited: Pan-Am. Expo, Buffalo, 1901 (prize); Paris Salon, 1882–85. Member: ANA, 1909; SC, 1900; Lotos Cl. Position: Art Cr., (New York) Globe [10]

HOEBER, Paul B. [P] NYC [24]

HOECKNER, Carl [P,Gr,T,B,Des,Li] NYC b. 19 D 1883, Munich, Germany. Studied: Hamburg; Cologne. Member: Am. A. Cong.; Chicago SA; "Cor Ardens." Exhibited: AIC, 1922 (prize), 1923 (prize); NAD, 1942, 1943. Work: murals, U.S. Grant H.S. (Portland, Oreg.), Coonley School (Downers Grove, Ill.). Position: T., AIC, 1929–43 [47]

HOEFLICH, Sherman Clark [I,P,Des] Phila., PA b. 1 Mr 1913, Phila. Studied: PAFA; PMSchIA, with H. Pitz. Exhibited: Phila. A. Dir. Cl., 1941. Illustrator: "Little Toad," 1938, "Bright Heritage," 1939, "Seven Go to Eastcroft," 1939 [47]

HOEGGER, Augustus [P] b. 1846, Switzerland (came to U.S. as a youth) d. 2 Ja 1908, Phila. (from injuries received while trying to save his paintings from a fire in his studio)

HOEHN, Edward W. [P] Chicago, IL b. Davenport, IA. Studied: Paris; Munich [04]

HOEHN, Werner [B,Dr,E,Li,P] New Orleans, LA b. 30 S 1882, New Orleans, LA. Studied: A. Lohr; Mexico. Exhibited: watercolor, Delgado Mus., 1934 (prize), NOAA, 1935 (prize). Work: Southwestern Univ.; Peters H.S., New Orleans [40]

HOELSCHER, May B. [P] Aurora, IL b. 4 My 1884, Aurora. Studied: B. Sandzen; Hans Hofmann; AIC. Member: Chicago SA. Work: East Aurora H.S.; Bardwell Sch., Aurora; Women's Univ. Cl., Chicago [40]

HOELZEL, Elise [P] Kansas City, MO. Member: Kansas City SA [25]

HOELZER, Virginia Ida [P,T] Bloomfield, NJ/Bernardsville, NJ b. NYC. Studied: Bridgman; AIC; Yale; PMSchIA. Member: ASL. Work: bookplate, Friends of the Bloomfield Public Library; portrait, Mt. Hermon (Mass.) Sch. Position: T., Summer Art Sch., Bernardsville [40]

HOEN, August [Li] b. ca. 1825, Germany (came to U.S. ca. 1840s). He took over his uncle's lithographic firm in Baltimore (1848). A. Hoen & Co. was still active in Baltimore and Richmond in 1943; his brothers, Ernest and Henry worked with him. [*]

HOEN, Elizabeth [P] Santa Rosa, CA [19]

HOENER, Berta [Min.P] San Fran., CA [19]

HOENING, Margaret (Mrs. Jared French) [P,E] NYC. Studied: Smith Col., ASL, with A. Lewis, H. Wickey, C. Locke, W. von Schlegell. Exhibited: SAE, 1934–36; NAD, 1935; AIC, 1936. Work: LOC [47]

HOERGER, D. Adelbert [Des,C,L,T,P] Laurelton, NY b. 21 Ap 1899, Phila., PA. Studied: Temple Univ.; NYU; S. Yellin; V. Van Lossberg; R. Bertelli. Member: Arch. Lg.; Art in Trades Cl., N.Y.; Soc. Des.-Craftsmen; AFA; Mun. AS, N.Y. Exhibited: WFNY, 1939. Work: U.S. Naval Acad.; Yale; fountain, Phila.; Dept. Justice Bldg., Wash., D.C.; gates, Cathedral of St. John the Divine, NYC; East Liberty Presbyterian Church, Pittsburgh; Christian Science Pub. Co., Boston. Lectures: Metalwork; Wrought Iron. Position: Des., Roman Bronze Corp. Corona, N.Y. [47]

HOERMAN, Carl [P,E,C,Arch] Saugatuck, MI/Riverside, CA b. 13 Ap 1885, Babenhausen, Bavaria. Member: Chicago Gal. Assn.; Saugatuck AA; Assn. Chicago PS; Riverside A. Assn. Exhibited: AIC, 1927 (prize); Ill. Assn. FA, Springfield, 1928 (prize). Work: State Mus., Springfield, Ill.; mural, Paw Paw, Mich. H.S.; pub. schools in Gary, Ind., Holland, Mich., LaGrange, Ill.; Univ. Ill. [40]

HOERTZ, Frederick J. [Mar.P,Li] Atlanta, GA (1959) b. Brooklyn, NY. Studied: his father; Brooklyn Inst.; ASL; PIASch; Albright Inst., Buffalo; NY Sch. A. Position: Lithographic artist with Pansing, ca. 1910 [*]

HOFF, Charlotte Mina [P,L] Akron, OH b. Akron. Studied: Cleveland Sch. A.; N.Y. Sch. A.; Chase; Mora; Bredin; Miller; Henri; J. Sloan; W. Kuhn; F. Parsons. Member: Ohio WC Soc.; Ohio-born Women P.; Cleveland Women's AC; Women's A. Lg., Akron; AFA; Three Arts Cl., N.Y.; Ohio Fed. Women's Cl. Exhibited: Ohio Fed. Women's Cl., 1941 (prize); Athens, Ohio, 1944; Three Arts Cl., 1927; Montross Gal., 1940–42; Akron AI, 1923 (prize), 1924 (prize), 1925–37, 1938 (one-man), 1939–41; Butler AI, 1945; Columbus, Ohio, 1934; Babcock Gal., 1926. Work: MMA; City Cl., Akron; Stark County School [47]

HOFF, Guy [P,I] NYC b. 1 My 1889, Rochester, NY. Studied: Wilcox; Dumond. Exhibited: Albright Art Gal., 1916 [29]

HOFF, Syd(ney) ("Hoff") [Car] Miami Beach, FL b. 4 S 1912, NYC. Studied: NAD. Member: Authors Gld. Author/Illustrator: "Danny and the Dinosaur," 1958, "Grizzwold," 1963, other books. Cartoonist: King Syndicate, 1957– ; New Yorker, Collier's, Life, Saturday Evening Post; Hearst newspapers [40]

HOFFBAUER, Charles [P] Paris, France b. 28 Je 1875, Paris. Studied: G. Moreau; F. Flameng; Cormon, in Paris. Member: juries, Ecole Nationale des Beaux-Arts, Société des Artistes Français, Exposition Internationale (1937), all of Paris; Société des Artistes anciens combattants; Société des Artistes Français. Exhibited: Paris Salon, 1898 (prize), 1899 (prize); Paris Expo, 1900 (med). Awards: Bourse de Voyage, 1902; Prix Rosa Bonheur, 1902; Prix National du Salon, 1906; Bonaparte-Prix de L'Institut de France, 1929; Knight of the Legion of Honor; distinguished service gold medal, City of Richmond, Va. Work: CI; Mem. Hall., Phila.; mural, Mem. Hall, Richmond, Va., House Rep., Jefferson City, Mo.; Nat. Gal., Sydney, Australia; Mus. Rouen, Castle of Montbazon; Town Hall, Arras; Musée de la Guerre, Vincennes; Musée de Saint Quentin; Luxembourg Mus.; Mus. City of Paris; Mus. Leg. of Honor, Paris. [40]

HOFFHINE, Helen G. [P] NYC. Member: GFLA [27]

HOFFLER, Othmar [P] Chicago, IL. Studied: M.B. Cox; U. Wilcox; H.R. Poore; K. Buehr; Schroeder; F. De Forest Schook; Castellucho; Morisset; Naudin; Albright Art Gal. Sch. FA; AIC; Acad. Colarossi, Acad. Grande Chaumière, both in Paris. Member: Chicago Gal. Assn.; Assn. Chicago PS; Palette and Chisel Acad. FA; Ill. Acad. FA; Hoosier Salon; Brown County Art Gal. Assn.; De Paul Univ. A. Lg. Exhibited: Palette and Chisel Acad. FA (gold); Albright Art Gal. (prize); AIC, 1933 (prize), 1939 (prize). Work: City of Chicago Coll.; Palette and Chisel Acad. FA; Municipal Art Lg., Chicago; Ill. State Mus.; Purdue Univ.; Saddle & Sirloin Cl., Chicago; Iowa State Col. [40]

HOFFMAN, Belle [Ldscp.P,I] NYC b. 28 Ap 1889, Garretsville, OH. Studied: H. Snell; Cleveland Sch. A.; ASL. Member: NAWPS; Cleveland Women's AC. Exhibited: Cleveland Mus., 1923 (prize) [40]

HOFFMAN, Bernt Anker [P] North Minneapolis, MN b. 21 My 1875, Norway. Studied: Minneapolis Sch. A. Exhibited: Minneapolis Inst. FA, 1922 (prize) [24]

HOFFMAN, Frank B. [I,P,S] b. 28 Ag 1888, Circleville, OH d. 1958, Taos, NM. Studied: J.W. Reynolds, ca. 1910–15; L. Gaspard. Exhibited: AIC; Harwood Gal., Taos. One of New Mexico's most successful illustrators, his Western subjects appeared in national magazines in the late 1920s. [47]

HOFFMAN, Frank V. [Mur.P,Des] Chicago, IL b. 20 F 1902, NYC. Studied: Otis AI; AIC; Univ. Southern Calif. Member: Hoosier Salon; Soc. Sanity in Art. Exhibited: Hoosier Salon, 1939 (prize); AIC, 1938–46; S.Indp.A., 1937–42. Work: murals, Baptist Church (Chicago), St. Anthony's Church (Panama), Oil Men's Cl., Chicago; Univ. Wis.; Century of Progress Expo [47]

HOFFMAN, Grace LeGrand [P,T] New Rochelle, NY b. 11 N 1890, Syracuse, NY. Studied: Fontainebleau Sch. FA; A. Dow; W. Sargent; J.P. Haney; Columbia; Despujols, A. Strauss, G. Ballande, Gorguet, Billeul, Ouvré, in France. Member: New Rochelle AA [40]

HOFFMAN, Gustave Adolph [P,Por.P,Dr,E,L] Rockville, CT b. 28 Ja 1869, Cottbus, Brandenburg, Germany d. 30 Ag 1945. Studied: NAD; Royal Acad. FA, Munich. Work: etchings, Nat. Gal., Berlin; Royal Gal., Munich; Nat. Gal., Leipzig; Art Gal., Frankfort; Brit. Mus., London; Lenox Lib., NYC; portraits, State Capitol, Supreme Court, Hartford Hospital, Dime Savings Bank (all in Hartford), Superior Court, Rockville [40]

HOFFMAN, Harry L(eslie) [P] Old Lyme, CT b. 16 Mr 1874, Cressona, PA d. 6 Mr 1966. Studied: ASL, with DuMond; Yale, with J.F. Weir; Académie Julian, Paris, with Laurens, 1903. Member: ANA, 1930; SC, 1908; MacD. Cl.; A. Aid S.; NYWCC; NAC; AWCS; Baltimore WC Soc.; New Haven PCC; Lyme AA. Exhibited: P.-P. Expo, San Fran., 1915 (gold); Lyme AA, 1924 (prize); ldscp., New Haven PCC, 1925 (prize); Paris AAA, 1903. Work: Memphis, Tenn.; Milwaukee AI; AIC; Boston City Cl.; NGA; Oshkosh Pub. Mus.; NAC. At his death one of the oldest American Impressionists, he lived in Old Lyme more than 60 years. [47]

HOFFMAN, Harry Zee [P,Gr,Car,I] Baltimore, MD b. 5 D 1908, Baltimore. Studied: Univ. Md.; Md. Inst.; R. Brackman; A. Hibbard; B. Meyers. Member: Baltimore WC Soc.; Baltimore A. Un. Exhibited: Baltimore Evening Sun, 1934 (prize), 1935 (prize), 1940 (prize), 1942 (prize), 1945; PAFA, 1941; Baltimore WC Soc., 1939, 1940, 1942; Albany Inst. Hist.&A., 1945; Audubon A., 1945; Laguna Beach AA, 1945; Irvington A.&Mus. Assn.., 1946; Md. Inst., 1934, 1936; Municipal Mus., Baltimore, 1941–45; A. Un., 1946; BMA, 1936, 1937, 1939, 1940–46 [47]

HOFFMAN, Irwin D. [P,Li,E] NYC b. 8 Mr 1901, Boston. Studied: BMFA Sch. Member: SAE. Exhibited: GGE, 1939; SAE (prize); WMAA; New Sch. Soc. Res.; BM; PAFA; Los Angeles Mus. A.; Valentine Mus.; Honolulu Acad. A.; Dayton AI; Phila. SE; SAE; Assoc. Am. A., 1940 (one-man). Work: Kansas City AI; mural, Colo. Sch. Mines (in Golden), Gold Operators, Inc., New York; "Fine Prints of the Year," 1934. Position: Artist/Correspondent: Abbott Laboratories [47]

HOFFMAN, Malvina Cornell (Mrs. Samuel Grimson) [S] NYC b. 15 Je 1887, NYC d. 10 Jy 1966. Studied: Rodin, in Paris; G. Borglum; H. Adams; J.W. Alexander. Member: ANA, 1925; NA, 1931; NSS; Arch. Lg.; Nat. Inst. Soc. Sciences; Three Arts' Cl., N.Y.; Alliance; P&S Gal. A.; Am. Women's Assn.; NAWA. Exhibited: Paris Exh., 1911 (prize); NAD, 1917 (prize), 1921 (prize), 1924 (gold); "Russian Dancers" Exh., Paris, 1911 (prize); P.-P. Expo, San Fran., 1915 (prize); PAFA, 1920 (gold); NAWPS, 1925 (gold); Concord AA, 1925 (prize); Stockkbridge, 1931 (prize). Awards: Palmes Academiques, France, 1920; Royal Order of St. Sava, III, Yugoslavia, 1921. Work: Mus. A., Stockholm; Harvard War Mem., Cambridge, Mass.; Queen's Hall, London; Acad. Rome: memorials, Greenville (Miss.), St. Marks Sch. (Southbridge, Mass.), Groton, Mass.; Frick Coll.; Bush House, London; 101 full-length figures, Field Mus., Chicago; Luxembourg Mus., Paris; MMA; BM; stone pulpit, Church of the Heavenly Rest, New York; CI; Univ. Pittsburgh; CGA; AMNH; Detroit Inst. A.; CMA; USPO, Mahanoy City, Pa. Author: "Heads and Tales" (autobiography), 1936, "Sculpture Inside and Out" (1939) [47]

HOFFMAN, Nathan [P] Long Branch, NJ [25]

HOFFMAN, Polly (Mrs. Luther) [P,Dec,L,T] Wichita Falls, TX b. 8 F 1890, Bryan, TX. Studied: PIASch; H.B. Snell; A. Brunet; X. Gonzalez; T. Col.; Columbia; W. Stevens; H.V. Poor. Member: SSAL; Tex. FA Assn. Exhibited: Tex.-Okla. Fair, 1925 (prize), 1926 (prize), 1927 (prize); Tex. Art Colony, 1929 (prize); Tex. General Exh., 1946 (prize); SSAL, 1940; Tex. FA Assn., 1946. Work: Jr. Col., First Methodist Church, First Christian Church, pub. schools, all in Wichita Falls [47]

HOFFMAN, Richard Peter [P,Des] Allentown, PA b. 10 Ja 1911, Allentown. Studied: N.Y. Sch. F.&Appl. A. Member: Lehigh A. Alliance [40]

HOFFMAN, Ruth Erb (Mrs. Burton A.) [P,S] Buffalo, NY/Fort Erie, Ontario b. 13 Ap 1902, Buffalo. Studied: Wellesley Col.; Child-Walker Sch. FA&Crafts; A. Lee; A. Abbot; E. Dickinson. Member: The Patteran. Exhibited: Albright A. Gal., 1934–38, 1939 (prize), 1940 (prize), 1941–45, 1946 (prize); CI, 1941, 1943, 1944; MMA, 1942; AIC, 1943; Riverside Mus., 1939, 1942; AFA Traveling Exh., 1939. Work: busts, Northwestern Univ. Hall of Fame [47]

HOFFMAN, Seth [P,E,T,L] NYC b. 8 S 1895, Phila. Studied: PAFA; Ecole des Beaux-Arts, Paris; P. Hale; E. Carlsen; D. Garber; C. Grafly; H. McCarter. Exhibited: Pepsi-Cola, 1945; NAD, 1940; Macbeth Gal. (one-man); Grand Central (one-man); Milch Gal., N.Y. (one-man); Casson Gal., Boston; O'Brien Gal., Chicago; Tilden & Thurber Gal., Provid ce; Milwaukee AI; Detroit Inst. A.; Grand Rapids A. Gal.; Westchester Center, White Plains, N.Y. Specialty: monotypes. Position: Instr. A., Intl. Ladies' Garment Workers' Union, NYC [47]

HOFFMAN, Spencer Augustus [Des,P,G] Scranton, PA b. 26 F 1902, Wayne County, PA. Studied: Faucett Sch., Newark, NJ; ASL. Exhibited: Everhart Mus., Scranton. Work: window, United Brethren Church, Island of Borneo [40]

HOFFMAN, Wilmer [S] Ruxton, MD b. 1 Ag 1889, Catonsville, MD d. 21 My 1954. Studied: Grafly; A. Laessle; PAFA. Exhibited: WFNY, 1939 [40]

HOFFMAN, Arnold [Por.P,T,L,Li] NYC b. 22 N 1886, Odessa, Russia d. 21 Ag 1966. Studied: Ostromensky, in Russia; Munich. Member: AWCS; All.A.Am.; Audubon A.; Staten Island Inst. A.&Sciences; Am. Ar. Cong. Exhibited: All.A.Am., 1939 (med), 1944 (prize); AWCS; NAD; Audubon A.; ACA Gal.; Freedom House, N.Y.; NAC; Montross Gal. Work: Post-Graduate Hospital, N.Y.; Jersey City Prep. Sch.; museums,

Odessa, Warsaw, Moscow; Univ. Palestine. Position: T., Acad. Allied Arts, N.Y. [47]

HOFFMANN, Arnold, Jr. [P,Des,I,En] NYC b. 16 Ja 1915, NYC. Studied: NAD, with I. Olinsky, L. Kroll. Member: All.A.Am. Exhibited: AWCS, 1940–42, 1944, 1945; All.A.Am., 1940–42, 1944, 1945; Audubon A., 1945 [47]

HOFFMANN, Maximilian A. [S,P] Chicago, IL b. 6 F 1888, Trier, Germany d. 1 Jy 1922. Studied: Milwaukee ASL; Royal Acad., Munich. Member: Chicago SA; Soc. Western Sculptors [21]

HOFFMANN, Murray [P,Mur.P] Active: 1900–ca. 1945. Studied: Harvard. Exhibited: Woodstock AA; MMA; galleries, NYC, France. Work: murals made with Soudekeine, NYC; sets for ballets [*]

HOFMAN, H(ans) O. [P,I] b. 20 Ag 1893, Saxony, Germany. Member: S.Indp.A. Illustrator: New Yorker, Chicagoan, The Nomad, Plain Talk [33]

HOFFMASTER, Maud Miller (Mrs. H.C.) [P,Por.P,I,E,B,L,T,W] Traverse City, MI b. 29 D 1886, Manistee, MI. Studied: J. Carlson; E. Timmins; G. Bal, in Paris. Member: AFA; AAPL. Work: etchings, Olivet Col., Olivet & Ryerson Lib., both in Grand Rapids; block prints, Highland Park Soc. A., Dallas; Traverse-City State Bank, High School; Traffic Cl., Chicago; portraits, Munson (Mich.) Hospital, (Ypsilanti) State Hospital [47]

HOFFMEISTER, E.C. [P] Chicago, IL. Member: Chicago NJSA [25]

HOFFNER, Pelagie, Mrs. See Doane.

HOFMANN, Hans [P,T] NYC/Provincetown, MA b. 21 Mr 1880, Weissenburg, Germany d. 1966. Studied: Munich, with W. Schwartz. Exhibited: Berlin, 1910; San Fran., 1931; Delgado Mus., 1940; Chicago AC, 1944; Paris, 1949; Univ. Ill., 1950 (prize); Contemporary AS, 1952 (prize); Baltimore Mus. A., 1954; NYC gal., 1959 (retrospective); Venice Biennale, 1960; Nuremberg, other German cities, 1960; M. de Poche, Paris, 1961. Work: museums, U.S., Germany. Called by critic Clement Greenberg "the most important teacher of our time" (The Nation, 1945), his own paintings were not widely recognized until the 1960s. Worked in Paris (1904–14), and opened his own school in Munich (1915). Taught in the Bavarian Alps, Italy, and France, as well as summer classes at the Univ. Calif. (1930–31) and ASL (1932–33). Opened Hans Hofmann School of Fine Art in NYC (1933) and Provincetown (1934). Most of the young painters who were to become abstract expressionists were his students, notably Clifford Still and Jackson Pollack. After 1955 his own work changed from "action painting" to geometric abstraction. [40]

HOFMEIER, Miriam McKinnie [P,Li] Edwardsville, IL b. 25 My 1906, Evanston, IL. Studied: Minneapolis Sch. FA; Kansas City AI; A. Angarola. Member: NAWPS; St. Louis AG; AFA; Am. A. Cong. Exhibited: St. Louis AG, 1929 (prize), 1930 (prize), 1931 (prize), 1933 (prize); Midwestern Exh., Kansas City AI, 1932 (med), 1933 (prize); St. Louis Post Dispatch Exh., 1933 (prize); St. Louis, 1933 (prize); NAWPS, 1935 (prize), 1937 (prize), 1939 (prize). Work: murals, Edwardsville (Ill.) Pub. Lib., USPOs, Marshall, Forest Park, both in Ill. WPA artist. [40]

HOFSTEN, H. von [P,I] Winnetka, IL b. 20 Je 1865, Sweden. Studied: Royal Acad., Stockholm [13]

HOFSTETTER, Mary M. [Ldscp.P] Phila., PA/Hammonton, NJ b. 4 Ja 1913, Phila. Studied: W.A. Hofstetter. Member: Phila A. All.; Phila. WCC; Germantown Art Lg.; Plastic Cl. Work: Hallahan Catholic Girls H.S., Phila. [40]

HOFSTETTER, William Alfred [P,Des,T] Phila., PA b. 15 Jy 1884, Phila. Studied: Drexel Inst.; PAFA. Member: Phila. WCC; Phila. Alliance; Germantown AL [40]

HOFTRUP, J.S. [P] Chicago, IL [15]

HOFTRUP, (Julius) Lars [P,T] Pine City, NY b. 21 Ja 1874, Kjevlinge, Sweden d. 10 Ap 1954. Studied: self-taught. Member: AWCS; Phila. WCC; Iraqua A. T. Assn.; Brooklyn Soc. Modern A.; Scandinavian-Am. A. Exhibited: AIC, 1944; BM; CMA; Hobart Col.; Arnot Gal.; Richmond Hill H.S., Brooklyn, N.Y.; mural, Ziegler Mem. Church, Iowa; PMG; Cedar Rapids Mus.; Davenport Municipal Gal., Muscatine Art Assn., both in Iowa; Phillips Mem. Gal., Wash., D.C. [47]

HOGAN, Inez [P] Wash., D.C. [27]

HOGAN, Jean (Virginia M.) [P,G,T] Hartford, CT b. Hartford. Studied: Pembroke Col.; J.G. McManus; A.E. Jones. Member: CAFA; New Haven PCC; Springfield A. Lg.; Hartford Soc. Women P. Exhibited: NAD; New Haven PCC; Ogunquit A. Center; Brown Univ.; Morton Gal., N.Y., 1945 (one-man); WFNY, 1939; Hartford Soc. Women P.; Ethel Walker Sch., Simsbury, Conn.; Springfield A. Lg., 1938 (prize), 1942 (prize); CAFA, 1943 (prize). Work: Mt. St. Joseph Col., Hartford [47]

HOGAN, Thomas [I,Li] b. ca. 1839, Ireland d. after 1900 (NYC?). His illustrations first appeared in "Beyond the Mississippi" (1867), but he is best known for his 30-year partnership in illustration with F.H. Schell. Much of their work appeared in Harper's. [*]

HOGG, Fred, Jr. [P] West Phila., PA. Work: USPO, Vandergrift, Pa. WPA artist. [40]

HOGG, Isobel [S] Kingston, NY [19]

HOGNER, Nils [B,E,I,L,Mur.P,Por.P,T] NYC (1962) b. 22 Jy 1893, Whiteville, MA. Studied: Boston Sch. Painting; BMFA Sch.; Rhodes Acad., Copenhagen; L. Gaspard; I. Nyberg. Member: AAPL; Arch. Lg.; NSMP; SC; Silvermine Gld.; Studio Gld.; Litchfield A. Cl.; Ar. Color Proof Associates. Exhibited: Mus. Northern Ariz., 1930 (prize); (Albuquerque) N.Mex. A. Lg., 1933 (prize); Albany Inst. Hist.&A.; Wadsworth Atheneum, Hartford; Riverside Mus.; Whistler House, Lowell, Mass.; Okla. A. Center; Sartor A. Gal., Dallas (one-man); Silvermine, Conn. (one-man); Mus. N.Mex., Santa Fe (one-man). Work: pub. schools, Oklahoma City; Okla. A. Center; Hickory Mus., N.C.; Whistler House, Lowell, Mass.; St. Louis Pub. Lib.; murals, Floyd Bennett Field, N.Y.; Naval YMCA, Brooklyn, N.Y.; Halloran General Hospital. Illustrator: "Farm Animals," 1945, other children's books [47]

HOGUE, Alexandre [P,Li,W,T,Dr] Tulsa, OK (1976) b. 22 F 1898, Memphis, MO. Studied: F. Reaugh; Minneapolis AI. Member: Lone Star Printmakers. Member: Southwestern AA; Audubon A.; Lone Star Printmakers. Exhibited: All. A., Dallas, 1930 (prize), 1931 (prize), 1932 (prize), 1933 (prize); SSAL, 1932 (prize); Dallas Pr. Soc., 1937 (prize); Paris Salon, 1938; CI, 1938, 1939, 1946; WFNY, 1939; GGE, 1939; Tate Gal., London, 1946; MOMA; AIC; WMAA; CGA. Work: Philbrook A. Center, Tulsa; Gilcrease Fnd.; Musée du Jeu de Paume, Paris; Dallas Mus. FA; IBM; Encyclopaedia Britannica Coll.; LOC; Houston Mus. FA; Corpus Christi A. Fnd.; murals, USPOs, Houston, Graham (both in Tex.), Dallas City Hall (in collaboration with Jerry Bywaters); Tex. State Col. for Women; Univ. Okla. Illustrator: "The Flavor of Texas," by J. Frank Dobie, other books. Cartoonist: editorial, Dallas Times-Herald. Contributor: art magazines/newspapers. Positions: T., Tex. State Col. for Women, Denton, Tex. and Taos, N.Mex.; Hockaday Sch. for Girls, Dallas (1940); Univ. Tulsa, 1945– [47]

HOGUE, Herbert Glenn [Edu,C] Ellensburg, WA b. 21 O 1891, Ellensburg. Studied: Wash. State Col. Position: T., Central Wash. Col. Edu., Ellensburg, 1935–46 [47]

HOGUE, Kate L. [P] Youngstown, OH. Exhibited: Ohio State Fair, 1934, 1935; Nat. Assn. Women PS, 1935–39 [40]

HOHENBERG, Marguerite (Mrs.) [P,Des,C,L] Chicago, IL b. 16 Ag 1883, Vienna, Austria. Studied: Univ. Chicago; Chicago Acad. FA. Member: Am. Inst. Dec. Exhibited: AIC, 1941, 1943, 1946; Mus. Non-Objective Painting, 1941–46; Roullier Gal., Chicago, 1937 (one-man). Work: Mus. Non-Objective Painting [47]

HOHENSTEINER, John [P,Des] Brooklyn, NY b. 15 D 1901 Württemberg, Germany. Studied: M.H. Schwenski; A. Bauer; A. Bjorn [40]

HOHL, F.C.P. [P] Cambridge, MA. Member: Boston AC [25]

HOHLEN, May Marjorie [P,T] Burlington, IA b. 5 May 1896, Burlington. Studied: Univ. Colo.; Columbia; E. Thurn; C.J. Martin. Member: Western AA; AFA; Friends of Art, Davenport, Iowa. Exhibited: Iowa A. Salon, 1937 (prize), 1938 (prize), 1946 (prize); Mississippi Valley Fair, Davenport, 1946 (prize); Iowa Fed. Women's Cl., 1944 (prize); Swedish-Am. Exh., Chicago, 1940, 1941; Davenport Municipal A. Gal., 1941–45, 1946 (one-man); Iowa WC Exh., 1945, 1946; Nat. Am. A., Rockefeller Center, 1938; Women P. Am.; Wichita, Kansas, 1938, 1939. Position: T., Burlington pub. schools, 1922– [47]

HOHMANN, Hans [S] Yonkers, NY b. 24 Ap 1911, Klein Steinheim am Main, Germany. Studied: K. Huber; R. Koch [40]

HOHN, Victor S. [P] St. Louis, MO. Position: affiliated with Washington University, St. Louis [25]

HOHNER, John F. [P,G,S] Cincinnati, OH b. Cincinnati. Studied: Cincinnati A. Acad. Award: Prix de Rome, 1921. Exhibited: St. Paul's Church, Cincinnati; Taft Auditorium, Columbus, Ohio [40]

HOHNHORST, Harry [I] NYC. Member: SI [47]

HOHNHORST, Will [P] Cleveland, OH. Member: Cleveland SA [29]

HOKANSEN, Alna [P] Cambridge, MA [19]

HOKE, K.B. [P] Toledo, OH. Member: Artklan [25]

HOKE, Martha [P] St. Louis, MO [13]

HOKE, Robert A. [I,P] Wash., D.C. b. 24 Ap 1910, Hanover, PA. Studied: San Jose (Calif.) State Col.; Corcoran Sch. A. Position: A., Washington Star, 1938– [47]

HOKEAH, Jack [P] Anadarko, OK (1967) b. 1902, western Okla. Studied: Anadarko FA Cl.; Univ. Okla., 1926. Exhibited: Prague Expo, 1928; NYC. Work: Denver AM; Joslyn AM; Mus. N.Mex. One of the "Five Kiowas" about whom books were written in 1929 and 1950, he became an actor in NYC (1930s). [*]

HOKINSON, Helen E(lna) [I] NYC b. 29 Je 1893, Mendota, IL d. 1 N 1949 (airplane crash over Nat. Airport, Wash., D.C.). Member: NAC. Covers and illustrations for the New Yorker; illustrations for the Woman's Home Companion, other magazines. Creator: the "Hokinson girls." [40]

HOLBERG, Ludvig O. [P,I] Milwaukee, WI b. 27 Ag 1870, Trondjhem, Norway. Studied: Acad. Colarossi Acad., Acad. Julian, both in Paris. Illustrator: "The Heart of the Geisha" [15]

HOLBERG, Richard A. [P,I] Rockport, MA b. 11 Mr 1889, Milwaukee, WI d. 1942. Studied: A. Mueller; L. Wilson; E.A. Webster; ASL, New York; ASL, Milwaukee. Member: SC; Wis. PS; Rockport AA; North Shore AA; Artists G.; Boston AC; AWCS. Exhibited: Wis. PS, 1920, 1922. Illustrator: children's books [40]

HOLBERG, Ruth Langland (Mrs.) [P,I,W] Rockport, MA b. 2 F 1891, Milwaukee, WI. Studied: A. Mueller; F.F. Fursman; E.A. Webster. Member: AWCS; NAWPS; Rockport AA; North Shore AA. Exhibited: Nat. Lg. Am. Pen Women, 1930 (prize). Author: "Mitty and Mr. Syrup," "Mitty on Mr. Syrup's Farm," "Hester and Timothy," "Pioneers" [47]

HOLBERTON, Wakeman [P] b. 1 S 1839, NYC d. 4 Ja 1898. Specialty: He was a sportsman who painted game and fish.

HOLBROOK, Anna Stanley [P] Chester, PA [08]

HOLBROOK, Emeline M. [P] NYC [06]

HOLBROOK, Hollis Howard [Edu,P,Des,Mur.P,I,L] Gainesville, FL b. 7 F 1909, Natick, MA. Studied: Mass. Sch. A.; Boston Univ.; Yale. Member: SSAL; Fla. Fed. A.; Fla. Edu. Assn. Exhibited: John-Esther A. Gal., Andover, Mass.; 48 States Comp. Work: murals, USPOs, Natick (Mass.), Haleyville (Ala.), Jeanerette (La.). WPA muralist. Positions: T., Univ. Fla., 1938–46; L., 1941–44 [47]

HOLBROOK, Vivian Nicholas [P,T,L] Gainesville, FL b. 31 1913, Mt. Vernon, NY. Studied: Yale. Member: SSAL; Soc. Four A.; Fla. Fed. A. Exhibited: SSAL, 1944; Fla. Fed. A., 1942, 1943, 1945; Soc. Four A. Positions: T., Colby Jr. Col., 1936–38, Univ. Fla. [47]

HOLCOMB, Mabel Crawford [C,Des,T] Isle La Motte, VT b. 1 N 1902, NYC. Studied: ASL; Greenleaf. Work: Tapestry Mus., Chazy, N.Y. Contributor: articles in Ladies' Home Journal. Specialty: weaving household linen and rugs [40]

HOLCOMBE, Fred M. [P] Associated with AIC. [17]

HOLDEN, Cora Millet [Por.P,Mur.P,T] Cleveland, OH b. 5 F 1895, Alexandria, VA d. ca. 1938. Studied: Mass. Sch. of Art; Cleveland Sch. Art. Member: Cleveland AA. Work: murals, mem., Goodyear Hall, Akron, Ohio; Federal Reserve Bank; Allentown Mem. Medical Library; Pearl St. Bank of the Cleveland Trust Co., Admin. Bldg., Bd. Edu., Sorosis C., all in Cleveland. Position: T., Cleveland Sch. A. [38]

HOLDEN, James Albert [Mur.P] Oakland, CA b. England. Studied: J.H. Partington; R.L. Partington. Member: Bay Region AA. Exhibited: Bay Region AA; Soc. for Sanity in Art; Sacramento, 1910 (gold); Oakland A. Gal., 1934 (prize). Work: murals USPO, Turlock, Calif. WPA muralist. Position: A. Dir., Pacific Railway Adv. Co., San Fran. [47]

HOLDEN, Lephe Kingsley (Mrs.) [Edu,P,W] Westport, CT b. 1 My 1884, Hadley, MA. Studied: PIASch; ASL; G. Wiggins; G.E. Browne; de Caviedes; Merida; D. Tryon; A.V. Tack; J.G. McManus; D. Ross; Harvard. Member: NAWA; Silvermine Gld. A.; Conn. Water Colorist; Eastern AA; Conn. AA; Springfield AL; EAA; Nat. Assn. for Art Ed.; Old Lyme AA; Studio Gl. Exhibited: NAWA, 1936–38, 1940–46; AWCS, 1936–43; All.A.Am., 1940–43; AFA Traveling Exh.; Old Lyme AA, 1938–46; Avery Mus. A.; Argent Gal. (one-man); N.Y. Studio Gld. (one-man); WC Exh.; Essex, Conn., 1938 (prize) Bridgeport AL, 1937. Position: T., Pub. Sch., Westport, Conn., 1927–46 [47]

HOLDEN, Luella M. Stewart (Mrs. Hendrick S.) [P] Syracuse, NY d. 15 My 1931. Studied: A. Thayer; W.M. Chase; Paris, with Collin, Courtois. One of the original sponsors of Syracuse MFA. Position: T., Syracuse Univ., from 1889 [06]

HOLDEN, R(aymond) J. [I] North Sterling, CT b. 2 My 1901, Wrentham, MA. Studied: RISD. Member: AIGA. Exhibited: AIGA, 1935, 1942; Jones Lib., Amherst, Mass., 1939 (one-man), 1941 (one-man); Boston Pub. Lib., 1941 (one-man); Providence Pub. Lib., 1941 (one-man); State Lib., Hartford, Conn., 1942 (one-man). Illustrator: "Flowering of New England," 1941, "Poems of Whittier," 1945, other books [47]

HOLDENSEN, Peter [P,C] Roslindale, MA [10]

HOLDREDGE, Ransom Gillet [P] b. 1836, NY (or England) d. 1899, Alameda County, CA. Studied: San Fran., 1850s; Europe, ca. 1874. Work: Oakland MA. He won acclaim in San Fran. during the 1880s for his Barbizon style landscapes, but it was said his abilities declined in the 1890s due to alcoholism. [*]

HOLDSWORTH, Watson [P] Graniteville, RI. Member: Providence WCC [29]

HOLGATE, E.J. [P] Tarrytown, NY [01]

HOLLAND, F(rancis) Raymond [P] NYC/Darien, CT b. 10 Ja 1886, Pittsburgh, PA d. 20 Ap 1934. Studied: Princeton; Europe; ASL. Member: S.Indp.A.; Silvermine Group; Conn. SA; Pittsburgh AA. Exhibited: Pittsburgh AA, 1916 (prize). Work: Tate Gal., London [33]

HOLLAND, Janice [P,I] Wash., D.C. b. 23 My 1913, Wash., D.C. d. S 1962. Studied: Corcoran Sch. A.; PIASch; E. O'Hara. Member: Wash. WCC. Exhibited: PAFA, 1933; Wash. WCC, 1935–37; PMG, 1935, 1936; Nat. Mus., Wash., D.C., 1935, 1936; CGA, 1935 (one-man); Wash., D.C. Pub. Lib., 1946 (one-man). Illustrator: "Our Country's Story," 1945, other books [47]

HOLLAND, Marie [P] Indianapolis, IN [13]

HOLLAND, R(obert) A. [P,T] Kansas City, MO b. 6 My 1868, Edgarton, MO. Studied: Cincinnati A. Acad., with Duveneck. Member: Kansas City AS; Assoc., Art Mus. Dir. Positions: Dir., CAM; Dir., Kansas City AI [31]

HOLLAND, W.J. [P] Pittsburgh, PA. Member: Pittsburgh, AA [25]

HOLLANDER, Clifford, Mrs. See Wingate, Arline.

HOLLERITH, Lucia Beverly [P] Wash., D.C./Mathews, VA b. 1 Jy 1891, Wash., D.C. Studied: PMG Sch.; Corcoran Sch. A.; C. Burnside; H. Snell; K. Knaths; Mrs. Sleeth. Member: NAWA; SSAL; Soc. Wash. A.; Wash. AC; Wash. SFA; Laguna Beach AA. Exhibited: NAD; SSAL; Springfield AL [47]

HOLLEY, Robert Maurice [I,Car,Des] Kew Gardens, NY b. 7 Jy 1913, Stigler, OK. Studied: ASL; G.P. Ennis; G.B. Bridgman; K. Nicolaides; H. Sternberg; R. Marsh. Position: Car., "Esquire," 1937–39 [40]

HOLLIDAY, Rebecca Francis [S] Hingham, MA b. Boston. Studied: A. Lee.; F.W. Allen; D. Gelin; BMFA Sch.; Ecole des Beaux-Arts, at Fontainbleau. Position: Dir., Hingham Jr. A. Center [40]

HOLLINGSWORTH, Alice Claire [I] Indianapolis, IN b. 12 F 1907, Indianapolis. Studied: Herron A. Sch.; Circle A. Acad. [31]

HOLLINGSWORTH, William R., Jr. [P] Jackson, MS d. 1 Ag 1944. Exhibited: Am. PS. Ann., 1935; WC Ann., 1937; AIC; 48 States Comp., 1939 [40]

HOLLISTER, Antoinette B. [S] Richmond, VA/Greenwich, CT b. 19 Ag 1873, Chicago, IL. Studied: AIC; Paris, with Injalbert, Rodin. Member: Chicago SA. Exhibited: Pan-P. Expo, San Fran., 1915; AIC, 1919 (prize) [40]

HOLLISTER, Emily H. [P] NYC b. 18 Ap 1908, Mt. Gilead, OH. Studied: Ohio State Univ.; ASL. Member: NAC. Exhibited: NAC, 1939 [40]

HOLLISTER, Laura S. [P] Cincinnati, OH [08]

HOLLMAN, Charles E. [P] Columbus, OH. Member: Columbus PPC [25]

HOLLOWAY, Charles [P,C,Car,Mur.P] Chicago, IL b. 14 Je 1859, Phila., PA d. 27 Ja 1941. Member: Mural P. Exhibited: Paris Expo, 1900 (gold). Work: Mural dec., college theatres, Chicago; Studebaker Admin. Bldg., Southbend, Ind.; Court House, Ft. Wayne, Ind.; USPO, Milwaukee; State Capitol, Pierre, S.Dak.; stained glass: Keeley Inst., Dwight, Ill.; Northwestern Univ.; sketches and cartoons owned by the French Gov. [17]

HOLLOWAY, Edward Stratton [Ldscp.P] Phila., PA b. Ashland, NY d. 3 N 1939. Studied: PAFA. Exhibited: St. Louis Expo, 1904. Author: "American Furniture and Decoration," and similar books [38]

HOLLOWAY, Ida H(olterhoff) (Mrs. George C.) [P,Des,T] Cincinnati, OH b. Cincinnati. Studied: Cincinnati A. Acad.; F. Duveneck; H.B. Snell; Europe. Member: Cincinnati Women's AC; Cincinnati MacD. C.; The Crafters Co.; Three Arts C.; Ohio WCS; Cincinnati Assn. Prof. Ar. [40]

HOLLROCK, George L. [P] NYC. Member: GFLA [29]

HOLLY, W.A. [P] Richmond, IN [10]

HOLLYER, Samuel [En] NYC b. 1826, London d. 29 D 1919. Studied: Finden (who did much of the engraving for J.M.W. Turner.) Author/Illustrator: a book of engravings of old NYC, 1904; several books of engraved portraits

HOLM, Florence French (Mrs. Victor S.) [C] St. Louis, MO b. 4 Ag 1897, St. Louis. Studied: O. Jones; A. Vorhees; Univ. Wis. Member: Art Center, N.Y. Exhibited: Crafts Exh., St. Louis AG, 1930 (prize); Midwest Exh., Kansas City AI, 1932 (med). Specialty: Ceramics. Position: T., Wash. Univ., St. Louis [40]

HOLM, Milton W. [P] Rochester, NY b. 29 O 1903, Rochester. Studied: E. Siebert. Member: All.A Am.; Rochester AC. Exhibited: NAD, 1935, 1937, 1938, 1940, 1942–44; All.A.Am., 1938–44; CM, 1945; Currier Gal. A., 1940; Syracuse Mus. FA, 1941; Phila. A. All., 1940; Rochester Mem. A. Gal., 1924–46; Rundel Gal., Rochester, NY, 1938–46. Work: Univ. Rochester; NAD [47]

HOLM, Victor S. [S,T] St. Louis, MO b. 6 D 1876, Copenhagen, Denmark (came to U.S. in 1890) d. 11 N 1935. Studied: AIC, with Lorado Taft; Philip Martiny, in NYC. Member: NSS, 1913; St. Louis AG; St. Louis AL; Two-by-Four S. of St. Louis; Municipal Art Comm.; St. Louis Arch. C.; Ethical Culture S.; Société Française. Exhibited: Mo. State Fair, 1913 (med); St. Louis AG, 1914 (prize), 1916 (prize), 1917 (prize); P.-P. Expo, 1915; St. Louis AL, 1922 (prize); Midwestern Ar., Kansas City, 1926 (med). Work: mem., State Univ. Lib., Rolla, Mo.; CAM, St. Louis; Mo. State mon. at Vicksburg; mon., Carrollton, Ill.; mon. Bellefontaine, St. Louis; St. Louis Pub. Lib.; St. Pius' Church, St. Louis; mon., New Orleans; Wash. Univ. War Mem., St. Louis; fountain, Le Claire, Ill.; fountain, Forest Park, St. Louis; mem., CAM; mon., Maplewood, Mo., mem., WMHA, St. Louis; medal for Two-by-Four Soc., St. Louis; mem., Granite City, Ill.; mem., Mercantile Trust Co., St. Louis; mem., Mo. State Capitol Bldg., Jefferson City; medal for Am. S. Mech. Eng. for Aviation; Masonic Temple, Continental Life Insurance Bldg. St. Louis; medal for Mo. Botanical Gardens. Position: T., Washington Univ. Sch. FA, since 1909 [33]

HOLMAN, Abigail [P,T] Denver, CO. Member: Denver AA. Position: Dir., Denver FA Acad. [27]

HOLMAN, Frank [P] Paris, France b. 15 Ja 1865, Attleboro, MA d. 23 Ja 1930, Paris. Studied: Cabanel; Carolus-Duran; Ecole des Beaux-Arts. Exhibited: Paris Expo, 1900. He resided in Paris (where he was one of the deans of the American colony) for more than forty-five years. [10]

HOLMAN, Louis A. [P] Boston, MA. Director of the well-known Boston bookshop, Goodspeed's. He published a series of monographs on European printmakers (Dürer, Rembrandt) and American etchers (Hornby, Gallagher, Benson); held exhibitions for many American etchers, the best being during the 1920s. [13]

HOLMAN, William [I,Cart] Chicago, IL. Creator: comic strip "Smoky Stover." Position: Associated with Chicago Tribune [40]

HOLMBOE, Henrik B. [P] Cleveland, OH. Member: Cleveland SA [27]

HOLME, John Francis (Frank) [I,C,T,Eng,W] Chicago, IL b. 29 Je 1868 d. 27 Jy 1904, Denver, CO. Member: Palette and Chisel C., Chicago. Work: Huntington Lib., San Marino, Calif.; Ariz. Hist. S.; 400 illus. and etchings in Univ. Ariz. Lib. In 1898, organized the Holme Sch. of Illus., Chicago. He established the Bandar Log Press, 1893. [04]

HOLME, Lucy D. [P] Phila., PA b. Salem Co., NJ. Studied: PAFA; Paris. Member: Plastic C. [15]

HOLMES, Elisha S. [P] Waxpool, VA [24]

HOLMES, Ellen A. [P,T] Chicago, IL b. Columbus, NY. Studied: AIC, with H.F. Spread; A.C. Shaw [17]

HOLMES, Ethel G(reenough) (Mrs. Massey) [P] Kansas City, MO/Nahant, MA b. 30 My 1879, Boston, MA. Member: S.Indp.A. [25]

HOLMES, F. Mason [P] Tacoma, WA. Member: Tacoma FAA [25]

HOLMES, Frank Graham [Cer,Des] Trenton, NJ b. 2 Ap 1878, Pawtucket, RI. Studied: RISD; Farnum; R. Henri. Member: SC; Art-in-Trades C.; Arch. Lg; Comm. to report on Intl. Exh. Mod. & Indust. A., Paris, 1925. Exhibited: Am. Inst. Arch., Wash., D.C., 1927 (med); Alfred Univ., 1928 (med). Work: Ceramic Mus., Sevres, France. Position: Des., Lenox Pottery, Trenton [40]

HOLMES, (Frank) Graham (Jr.) [P,Mur.P] Trenton, NJ b. 22 Je 1908, Trenton. Studied: PAFA, 1931; W. Adams. Exhibited: PAFA, 1929; NAD, 1929, 1933; Albright A. Gal., 1929; SC. Work: mural, Trenton Country C. [47]

HOLMES, Gerald A. [P] NYC [15]

HOLMES, Harriet Morton (Mrs. J. Garnett) [E,En,B,I,P] Phoenix, AZ b. Portland, ME. Member: Calif. PM; Northwest PM. Exhibited: Ariz. State Fair, 1931 (prize); 1932 (prize) [32]

HOLMES, Kate Osgood (Mrs. William Henry) [P] Wash., D.C. d. 9 Ap 1925. Member: Wash. WCC [19]

HOLMES, Margaret D. Irish (Mrs.) [P,I,L,T] Webster Groves, MO b. Blenheim, Canada d. 8 F 1939. Studied: St. Louis Sch. FA; Univ. Nebr. Member: Twentieth Century AC; St. Louis A. All.; St. Louis S.Indp.A.; AFA. Exhibited: State Fair, St. Louis, 1912 (prize), (med). Work: Mo. Botanical Gardens, St. Louis. Illustrator: botanical books [38]

HOLMES, Marjorie Daingerfield [S,T] NYC/Blowing Rock, NC b. NYC. Studied: Daingerfield, S. Borglum; M. Young; E. Amateis; J.E. Fraser; Lober. Member: NAC. Work: Sch. Tropical Medicine, San Juan, Puerto Rico; bronze, Rollins College, Winter Park, Fla.; Canada House, London; Church St. Mary the Virgin, N.Y. [40]

HOLMES, Mary Adams (Mrs. O'Malley) [P,T] Reisterstown, MD/Greeley, IA b. 8 My 1910, Aberdeen, SD. Studied: Acad. Colarossi; D. Coale; A. Brooke. Exhibited: Iowa A. Salon, State Fair; Greenbelt A. Center, Md. Position: T., Hannah Moore Acad., Reisterstown [40]

HOLMES, Ralph (William) [P,T] Los Angeles, CA b. 1 O 1876, La Grange, IL. Studied: Northwestern Univ.; AIC; Europe. Member: P.&S. C.; Los Angeles AC; Acad. Western P., Calif; Calif. AC; Laguna Beach AA; Am. A. Cong. Exhibited: Pittsburgh AA, 1915 (med); PSC., Los Angeles, 1926 (med). Position: T., Otis AI, Los Angeles [47]

HOLMES, Rhoda. See Nicholls, Mrs.

HOLMES, Stuart [S] Hollywood, CA b. 10 Mr 1884. Work: USPOs, Bell, Claremont, Oceanside, all in Calif. WPA artist. Specialty: portraits in wood [40]

HOLMES, Sue [P] East Nashville, TN [15]

HOLMES, Victor [P] St. Louis, MO. Position: Associated with Washington Univ. Sch. FA, St. Louis [13]

HOLMES, William Henry [P,W,Mus.Dir] Wash., D.C. b. 1 D 1846, Cadiz, OH d. 20 Ap 1933, Royal Oak, MI. Studied: T. Kauffmann, in Wash., D.C. Member: Wash. WCC (Pres.); S. Wash. A.; Wash. Ldscp. C.; AFA. Exhibited: Wash. WCC, 1900 (prize), 1902 (prize). Work: CGA; NGA. Positions: A. Ed., "Art and Archaeology"; Field A., U.S. Geological Survey, with Hayden (1872), in Colo. (1874), N.Mex. and Ariz. (1875); Cur., Univ. Chicago, 1898–1906; Cur., 1906, Dir., 1920–32, NGA [31]

HOLMGREN, R. John [I,P] NYC b. 27 N 1897, St. Paul, MN d. 12 Jy 1963. Studied: Bridgman; Woodbury. Member: SI. Illustrator: Cosmopolitan, American, Collier's [47]

HOLMSTROM, Henry [P] Minneapolis, MN. Exhibited: Minn. State Fair, 1934; PS Fed. Bldgs., 1936. Work: USPO, Marshall, Minn. WPA muralist. [40]

HOLMWOOD, Loren C. [P] Los Angeles, CA b. Seattle, WA. Member: GFLA [27]

HOLOW, E.J. [P] Bethlehem, PA [24]

HOLSCHUH, George Frederick [S,T,L] Lansdowne, PA b. 19 N 1902, Germany. Studied: PAFA, 1933, 1935; Germany. Member: Phila. Alliance; AFA; Phila. Sketch C. Work: Brookgreen Gardens, S.C.; Suddeutsche Mus., Germany; Finance Bldg., Harrisburg, Pa. [40]

HOLSING, Hans C.C. [Des] Jackson Heights, NY b. 27 Jy 1893, Bremen, Germany. Studied: F.H. Ehmke; Munich. Member: Nat. AAI; Soc. Mem. Draftsmen and Des. [40]

HOLSLAG, Edward J. [P,Dec] Aurora, IL b. 1870, Buffalo, NY d. 10 D 1925, DeKalb, IL. Studied: NAD; J. La Farge. Member: Mural P.; Chicago SA; Palette and Chisel C. Work: murals, LOC; many hotels [24]

HOLSMAN, Elizabeth Tuttle [P,S] Chicago, IL/Lauderdale Lakes, WI b. 25 S 1873, Brownville, NE. Studied: AIC. Member: Chicago SA; Chicago

AC; Chicago Gal. A. Exhibited: St. Paul Inst., 1916. Work: Omaha Soc. FA; Tarkio Col., Tarkio, Mo.; Univ. Nebr., Lincoln; Univ. Nebr. Law Sch.; U.S. Destroyer "The McCormick" [40]

HOLT, Anna B. [P] NYC [01]

HOLT, Dorothy Morgianna (Mrs. Manuel) [P] Newport, RI b. 6 S 1909, Providence, RI. Studied: RISD. Member: Providence WCS. Exhibited: PAFA, 1936, 1937, 1938, 1939, 1940, 1941, 1943, 1946; Ferargil Gal., 1939; AIC, 1938-41, 1944; AIC Traveling Exh., 1939-40, 1940-41; San Diego FA Soc., 1941; MMA, 1942, 1943; TMA, 1944; CI, 1941-43; Soc. Four A., 1941; WMA; AGAA; Pepsi-Cola, 1946; Stuart Gal., Boston, 1946; Portland (Maine) Mus. A., 1946; RISD, 1940-46; Armour Gal., Providence, 1936, 1939, 1941, 1946; Newport AA, 1941, 1943-45; Tilden Thurber Gal., 1941; Brown Univ., 1941; Providence AC, 1937, 1939-46. Work: RISD; Bristol(R.I.) Yacht C.; Bristol Mfg. C. Position: T., RISD [47]

HOLT, Geoffrey [P] Minneapolis, MN [17]

HOLT, Henry, Jr. [P,Arch.] Fairholt, Burlington, VT b. 18 Jy 1889, New Rochelle, NY d. 2 S 1941, Boston, MA. Studied: Harvard; Columbia. Work: BMFA; BM [40]

HOLT, Julia Samuel Travis [P,T] Hampton VA b. 5 My 1897. Studied: State T. Col., Farmville, VA; William & Mary; J. Farnsworth. Member: Norfolk A. Corner; NAWA; SSAL; Nat. Edu. Assn. Exhibited: VMFA, 1942; NAWA, 1943, 1944, 1945; Norfolk A. Corner, 1939-41; Argent Gal., 1943 (one-man); Butler AI, 1945; Norfolk Mus. A.&Sc., 1944 (one-man); SSAL, 1944-46; Mariner's Mus., Newport News, Va., 1945 (prize) [47]

HOLT, Maud S. (Mrs. Winfield Scott) [P,I,Por.P,Ldscp.P,C,W,Des] Little Rock, AR b. 1 N 1866, Carbondale, IL. Studied: Grande Chaumière, Paris; H. Thompson; H. Anthony Dyer; G.E. Browne; P. Tudor; G. Hart. Member: Little Rock FA Cl. Exhibited: St. Louis Fair, 1890 (prize). Work: Medical Sch., State House, public schools, FA Gal., Boys Club, all in Little Rock; Arcola (Ill.) Pub. Lib.; Capitol, Nashville, Tenn.; Court House, Maryville, Tenn.; Alamo Mus., San Antonio; Helena Pub. Lib.; Fort Smith Pub. Lib. [47]

HOLT, Naomi (Mrs. John Keith Custis) [Por.P] Chevy Chase, MD b. 27 1911, Wash., D.C. Studied: San Diego Acad. FA; Corcoran Sch. A.; PAFA. Member: Wash. AC. Exhibited: Wash. AC; Ill. State Soc.; Waukegan, Ill. AC; Corcoran Sch. A., 1934 (prize). Award: St.-Gaudens & Alexander medal, 1930[47]

HOLT, Percy William [P,Des,T,W] Galveston, TX/Woodstock, NY b. Mobile, AL. Studied: B. Harrison; J.F. Carlson; C. Rosen; A. Dasburg; F.S. Chase; R. Henri; W. Goltz. Exhibited: Cotton Expo, Galveston; Women's Forum, Dallas (gold). Position: T., Univ. Buffalo [40]

HOLT, Winifred [S] NYC b. NYC. Studied: Trentanove; A. St.-Gaudens; Italy [15]

HOLTERHOFF, Ida. See Holloway, Mrs.

HOLTON, Grace [P,Des,C,W,L,B,T] New Brunswick, NJ. b. Springfield, MA. Studied: PIASch; Columbia; NYU; ASL. Member: Am. Assn. Univ. Women; EAA; NYSC; Coll. AA. Exhibited: AAPL, 1944 (prize); Greenwich SA; Phila. A. All.; Phila. Plastic C.; Montclair A. Mus.; New Brunswick A. Center; Atlantic City AA; Kresge Gal., Newark; N.Y. Soc. Craftsmen. Author: "College Instruction in Art," 1933. Positions: T., N.J. Col. for Women, Rutgers Univ. (1928-47), Conn. T. Col. Summer Sch., Yale (1940) [40]

HOLTON, Leonard T. [I,W] NYC b. 6 S 1900, Phila. Member: SI; Phila. AG [47]

HOLTY, Carl Robert [P,T,L] NYC b. 21 Je 1900, Freiburg, Germany d. 1973. Studied: Marquette Univ.; NAD; Hans Hofmann, in Munich. Member: Audubon A; Am. Abstract A. Exhibited: CI, 1946; WMAA, 1944, 1945; Kootz Gal., 1945; New Art Circle, 1944; Nierendorf Gal., 1938; Audubon A., 1945; AIC, 1936; WFNY, 1939. Work: Milwaukee AI [47]

HOLTZMAN, Irving [P] NYC b. 16 F 1897, Russia. Studied: CUASch; NA. Exhibited: Allied A. Am.; Vendôme Gal., NYC [40]

HOLYOKE, Thomas G. [P] St. Paul, MN [17]

HOLZER, J.A. [Mur.P,S] NYC b. 30 O 1858, Berne, Switzerland. Studied: Paris, with Fournier, Bernard. Member: Arch. Lg., 1894; S.Indp.A. Exhibited: Columbian Expo, Chicago, 1893. Work: Princeton; mosaic windows, Troy, N.Y. [21]

HOLZHAUER, Emil Eugen [P,Des,L,S,T] Macon, GA b. 21 Ja 1887, Schwabish Gmund, Germany. Studied: Henri; H. Boss; Germany. Member: SSAL; Am. Soc. PS & G; Am. Ar. Cong. Exhibited: AIC, 1927-35, 1930 (prize), 1941; Century of Progress, 1933, 1934; PAFA, 1928-32; CGA, 1930, 1934; CI, 1930; BM, 1920, 1933; Albight A. Gal., 1930, 1931; WMAA, 1933, 1934; BMA, 1933; N.C. A. Exh., 1942 (prize); SSAL, 1946 (prize). Work: Albany Inst. Hist.&A.; Univ. Ga.; AIC; Newark Mus.; WMAA; Oberlin Col.; Rochester Mem. A. Gal.; Syracuse Mus., FA; Denver A. Mus.; AA, Los Angeles. Lectures: Henri and His Group. Positions: T., Bennett Jr. Col., Millbrook, N.Y. (1940), Wesleyan Col., Macon Ga. (1942-46) [47]

HOMANS, Nannie [Min.P] NYC [10]

HOMER, Eleazer B. [P] Providence, RI. Member: Providence AC [27]

HOMER, Ruth Wellington [P] Providence, RI. Member: Providence AC [27]

HOMER, Winslow [P,I] Prout's Neck, Scarboro, ME b. 24 F 1836, Boston d. 29 S 1910. Member: NA, 1865; AWCS, 1876; Century Assn.; NIAL. Exhibited: CI, 1896 (prize); PAFA, 1896 (gold), 1902 (gold); Paris Expo, 1900; Pan-Am. Expo, 1901, Buffalo (gold); Charleston Expo, 1902 (gold); St. Louis Expo, 1904 (gold). One of the greatest American artists. At nineteen he began working for lithographer J.H. Bufford, in Boston. Two years later took up illustrating for Ballou's and Harper's. In 1859 he came to NYC and studied for a short time at NAD and with Frederick Rondel. Harper's sent him to make war pictures in 1861, and his "Prisoners from the Front," exhibited at the Academy of Design in 1866, attracted much attention. After the war he painted many pictures of negro life and a visit to the Adirondacks inspired his camping scenes with mountain guides. He then traveled in England (1881-1882) and France (1866-67). He is best known, however, for his pictures of the Maine coast, where, from 1882, he lived the life of a recluse at Scarboro, the fisher folk serving as his models. A number of his works were included in the Thomas B. Clarke sale in NYC, 1899, among them "The Lookout—All's Well" ($3,200), now at the BMFA; "Life Line," bought by G.W. Elkins (for $4,500) and "Eight Bells," which brought the highest price ($4,700). The MMA owns his "Northeaster," "Searchlight—Santiago de Cuba," and "The Gulf Stream." After 1873 Homer painted chiefly in watercolor, most of his subjects being scenes in the Bermudas, Florida, Bahamas, Adirondacks, and Quebec, where he visited frequently. [The authoritative biography is Lloyd Goodrich's "Winslow Homer"; catalogue raisonné in preparation. The complete illustrations are discussed in Philip Beam's "Winslow Homer's Magazine Engravings" (1979)]. [10]

HOMSEY, Samuel Eldon [Arch,P,L] Wilmington, DE B. 29 Ag 1904, Boston, MA. Studied: MIT. Member: Wilmington SFA, 1936. Exhibited: Associated Am. A. Gal., NYC, 1940; Del. A. Center; Wilmington Soc. FA, 1936 (prize), 1938 (prize). Contributor: arch. magazines [40]

HONDIUS, Gerrit [P] NYC/Provincetown, MA b. 4 Jy 1891, Kampen, Holland d. 22 Jy 1970 Studied: ASL, with Max Weber, A. Dasburg; Royal Acad., The Hague. Member: An Am. Group. Exhibited: WFNY, 1939; GGE, 1939; Rockefeller Center; MOMA; Graham Gal.; 55 one-man exh. in U.S. & Europe. Work: WMAA; SFMA; Provincial Mus., Kampen, Holland; Reading Pub. Mus. and A. Gal., Pa.; Newark MA; Norfolk Mus. [47]

HONG, Anna Helga. See Rutt.

HONIG, George H. [Por.P,S] Evansville, IN b. 1881, Rockport, IN. Studied: NAD; H.A. MacNeil. Member: Evansville SGA and Hist. Exhibited: NAD, 1914 (med), 1915 (med). Work: war mem., Salina, Kans.; Soldiers' and Sailors' Coliseum, Evansville, Ind.; park, Denver, Colo.; Court House, Bowling Green, Ky.; A. Lincoln Trail Markers, Grand View, Ind.; Transylvania Co., Henderson, Ky.; Transylvania Univ., Lexington, Ky.; Univ. N.C., Chapel Hill; Fine Arts S., Evansville; war memorials, Elks House, Princeton, N.J.; Mt. Vernon, Ind.; Eagles Home, Anderson and Richmond, Ind.; Masonic Temple, Evansville; Court House, Bloomington, Ill.; Court House, Evansville, Ind.; Joliet, Ill.; fountain, Shelbyville, Ind.; mem., Evansville; war mem., Evansville, Connerton, Ind.; Rescue Mission, Evansville [40]

HONORE, Paul [P,B,Dec,En,I,L,T,W] Royal Oak, MI b. 30 My 1885, Crawford County, PA. Studied: Brangwyn; Wicker; PAFA. Member: Scarab C.; Mural P. Exhibited: Mus. Art Fnd. Soc., Detroit AI, 1917 (prize); Detroit AI, 1917 (prize); Scarab C. (prize). Work: Dept. Arch., Univ. Mich.; County Courthouse, Midland, Mich.; Student Church, East Lansing, Mich.; Pub. Lib., Dearborn, Mich.; Player's C., Detroit; Mich. Bldg., Century of Progress Expo; Detroit AI. Illustrator: "The Winged Horse Anthology," "Tales Worth Telling" [40]

HOOD, B. Vallette [P] Phila., PA [04]

HOOD, Ethel Painter [S] NYC b. 9 Ap 1906, Baltimore, MD. Studied: I. Olinsky; G. Bridgman; ASL; R. Kramer; W. Simpson; Md. Inst.; Académie Julian, Paris, with Laurens. Member: NSS; NAWA. Exhibited: Soc. Wash. A., 1939 (prize), 1940-41, 1946; WMAA, 1940; PAFA, 1937; NAD, 1940, 1944, 1945; NAWA, 1944-46; BMA, 1933, 1934, 1936, 1939,

1940, 1943–46; Karl Freund A. Gal., 1939 (one-man); Decorator's C., 1945 (one-man). Work: NBC Bldg., Rockefeller Center; Radio City; French Bldg., NYC [47]

HOOD, G.H. [I] NYC. Position: Affiliated with F.A. Stokes Co. [13]

HOOD, George Washington [P,I] Weehawken, NJ b. 2 S 1869, Greenwich Village, NYC d. 1 Ja 1949. Studied: PIASch; NAD; ASL. Illustrator: "Chinese Fairy Book," "Spanish Fairy Book"; many children's stories; covers, calendars, drawings, paintings for advertising [47]

HOOD, Gertrude H. [P] Phila., PA [08]

HOOD, M.S. [P] NYC [04]

HOOD, (Thomas) Richard, Jr. [E,Li,Des,W,L] Phila., PA b. 13 Jy 1910, Phila. Studied: Univ. Pa. Member: Phila. Pr. C.; Phila. Sketch C. Exhibited: AIC, 1936, 1937; LOC, 1945; PAFA, 1937; SAE, 1937; New Haven PCC, 1937; Phila. A. All., 1937, 1939; WFNY, 1939; MOMA, 1936; Palace FA, Mexico City, 1942; Phila. Pr. C., 1937, 1939; Times-Herald Exh., Wash., D.C., 1945 (prize); Soldier A. Exh., NGA, 1945 (prize). Work: Phila. Pub. Lib.; PMA; LOC; Dept. of Banking, Harrisburg, Pa. Illustrator/Editor: "The Poe Book," 1935, "American Authors," 1934. WPA artist. [47]

HOOKER, Evelyn [P] Cincinnati, OH. Member: Cincinnati Women's AC [25]

HOOKER, Margaret Huntington [I] Rochester, NY b. 10 Je 1869, Rochester. Studied: ASL; Met. Sch., NYC; Paris; London. Position: Staff, New York Tribune, 1897 [15]

HOOKHAM, Eleanor, Mrs. See King.

HOON, Ivan [P] Cleveland, OH b. 18 Mr, 1890, East Palestine, OH. Studied: Pittsburgh AI; S. Vago; F. Wilcox; C. Broemel. Work: Carnegie Hall, Cleveland; Capitol Bldg., Wash., D.C. WPA artist. [40]

HOOPER, Annie Blakeslee (Mrs.) [P,I,C] Spuyten Duyvil, NY b. CA. Studied: San Fran. A. Sch.; ASL; D.M. Dewey. Member: NYWCC [31]

HOOPER, Charles [P] Warsaw, NY [17]

HOOPER, Elizabeth [P,E,C,Des,T,W,L] Baltimore, MD b. 6 O 1901, Baltimore. Studied: H.B. Dillehunt; E.J. Pierce; R.C. Wood; M. Phillips. Member: Baltimore WCC; Sch. AL, Baltimore. Exhibited: Md. Fed. Women's C., 1937 (prize). Author: "Dolls the World Over," 1936–37, "Royal Dolls," 1938 [4C]

HOOPER, Grace [P,S,T] Boston, MA b. N 1850, Boston. Studied: C. Dallin, Boston; Injalbert, in Paris [13]

HOOPER, Katherine. See Prescott.

HOOPER, Katharine Amory [P,Des] Dedham, MA b. 21 O 1892, Boston, MA. Studied: BMFA Sch.; ASL; K. Nicolaides; G. Hamilton. Member: Boston S.Indp.A.; ASL. Exhibited: Morton Gal., N.Y., 1938, 1939, 1940 [40]

HOOPER, Laura B. [P] Baltimore, MD. Member: Baltimore WCC [29]

HOOPER, Rosa [P,Min.P] NYC b. 19 Jy 1876, San Fran., CA. Studied: San Fran. A. Sch.; San Fran. AL; O. Eckhardt, in Dresden; Mme. Debillemont, in Paris. Member: Calif. S. Min. P. Exhibited: Alaska-Yukon-Pacific Expo, Seattle, 1909 (prize); P.-P. Expo, San Diego, 1915 (gold,med); Calif. S. Min. P., Los Angeles, 1929 (prize). Work: CGA [40]

HOOPER, Will Phillip [P,I,W] Forest Hills, NY b. Biddeford, ME d. 24 Ja 1938. Studied: B. Fitz; ASL; Mass. Normal A. Sch., Boston. Member: NYWCC; SC. Contributor: Frank Norris' stories of the West, 1903 [38]

HOOPES, Elizabeth Geary [P,Des,T] NYC b. 20 O 1908, Sewickley, PA. Studied: N.Y. Sch. F.&Appl. A. Member: NYWCC. Exhibited: Stockbridge AA, 1935 (prize); Arch. Lg., 1936 (prize). Work: CUASch [40]

HOOPES, Henrietta [Por.P,E] Wash., D.C. b. 23 F 1904, Wilmington, DE. Studied: Paris, with Lhote, L. Marcoussis; Corcoran Sch.. Member: A. Gld. Wash. Exhibited: AIC, 1941; Paris Salon, 1934 (prize); Delaware A. Center, 1939 (prize), 1940 (prize); Riviera C., Calif., 1936 (prize); Wilmington SFA, 1939 (prize). Work: Knoedler Gal.; IBM; Delaware A. Center; PMG [47]

HOOPLE, William Clifford [I] Syracuse, NY b. 20 O 1893, Brooklyn, NY. Member: SI; Artists G. [40]

HOOTON, P.R. [P] Wash., D.C. [19]

HOOVEN, Charles Edward [P] Chicago, IL [10]

HOOVEN, Herbert Nelson [P,T,W] Solebury, PA b. 31 Ja 1898, Hazleton, PA. Studied: PAFA; BAID; PMSchIA. Member: Salons of Am.; S.Indp.A.; AAPL; Springfield AL. Work: Hazleton Pub. Lib.; Church St. Louis, Waterloo, Canada; Valparaiso Univ. Lib.; Civic C., Hazleton; A. Gal, Lehigh Univ.; Univ. Mich; Valparaiso Civic C.; Col. FA, Univ. Mo.; Cornell Univ.; San Joaquin Mus., Stockton, Calif.; Edwin Chubb Lib., Ohio Univ.; Mus. Peiping, China. Author/Illustrator: "Rig Veda," "Pencilled Hands," by Henry Harrison, "The Laughing One," 1937 [40]

HOOVER, Bessie. See Wessel.

HOOVER, Charles [P,I] Wash., D.C. b. 8 Ap 1897, Wash., D.C. Studied: H. Breckenridge. Member: Wash. Ldscp. C., Wash. AC; S. Wash. A. Position: Staff, Washington Evening Star [33]

HOOVER, Curdis S., Mrs. See Collins, Eileen.

HOOVER, Ellison [Li,Car] NYC b. 10 Ag 1888, Cleveland, OH d. 17 Mr 1955. Studied: Cleveland Sch. A.; ASL; Gottwald; Bridgman. Exhibited: Mint Mus. A., 1945, 1946; NAD, 1944, 1946; Buck Hill Falls., Pa. AA, 1945; Wash. WCC, 1931, 1944; Northwest Pr.M., 1944; SAE; Grand Central Gal., 1945 (one-man); LOC, 1946 (prize); Laguna Beach AA, 1946 (prize). Work: LOC; Huntington Mus.; CI; CMA. Position: Car., N.Y. Herald-Tribune syndicated cartoon, "Mr. & Mrs." [47]

HOOVER, Marie Louise Rochon (Mrs.) [Por.P,I] Wash., D.C. b. 12 O 1898, Wash., D.C. d. 1976. Studied: H. Breckenridge. Member: Wash. AC; S. Wash. A. [33]

HOPE, John William [S] Flushing, NY b. 28 Jy 1889, Sydney, Australia. Studied: Sydney Tech. Col.; BAID; Am. Art Training Center, Paris. Member: NSS; Nassau County AL; Am. Assn. Mus. Work: African Hall, South Asiatic Hall, etc., AMNH; Bear Mountain, N.Y.; mem., Meadsville, Pa. Position: T., Art Inst., Nassau County, N.Y. [40]

HOPE, Leona [P,T] Madison, WI. b. 26 Ja 1873, Meadville, PA. Studied: PIASch; RISD [15]

HOPE, Thelma Paddock (Mrs. Fred) [P,B,Dec,L] Beverly Hills/Corona Del Mar, CA b. 6 N 1898, LaPort, IN. Studied: Otis AI; AIC; J.F. Smith; J. Norton; A. Sterba; L. Seyfert. Member: Calif. AC. Exhibited: Santa Cruz, 1921 (prize); Southwest Mus., 1923; Riverside, Calif., 1926 (prize); Pomona, 1929. Position: Sketch A./P., MGM studios [40]

HOPE, Thomas H. [P] Devon, CT b. England (came to U.S. while still a young man) d. 8 Ja 1926. Studied: PAFA. Also a musician.

HOPKIN, Robert [Mar.P] Detroit, MI b. 3 Ja 1832, Glasgow, Scotland (came to Detroit, 1843) d. 21 Mr 1909. Member: Detroit AA; Detroit WCS; SWA. Work: 6 paintings, Cotton Exchange, New Orleans; many drop curtains for Chicago, Denver, Toronto [08]

HOPKINS, Anna Mary [P,Min.P] Lansdowne, PA. Exhibited: Min. P. Ann., PAFA, 1934, 1935, 1938 [40]

HOPKINS, C(harles) B(enjamin) [P,I,W,T] Marysville, CA b. 23 O 1882, Toledo, OH. Studied: Polytechnic Sch., Toledo. Member: Artklan. Illustrator: "A Dog's Life," by Tige. Author/Illustrator: "Comic History of Our Boys in France" [40]

HOPKINS, C(harles) E(dwin) [P,W] Cincinnati, OH b. 19 D 1886, Cincinnati, OH. Studied: Duveneck; Meakin; Nowottny; Barnhorn. Member: Cincinnati AC [25]

HOPKINS, Edna Boies (Mrs. James R.) [B,T] Paris, France b. 1872, Hudson, MI d. 1937, OH. Studied: PIASch, with Dow, 1899. Member: Société du Salon d'Automne; Société Internationale des Graveurs en Couleurs; Société des Artistes Decorateurs; Société Nationale des Beaux-Arts, Paris. Exhibited: P.-P. Expo, San Fran., 1915 (med). Work: LOC; Walker A. Gal., Liverpool; National Mus., Stockholm; Kunst Gewerke Mus., Berlin; Bibliothèque d'Art et Archaeologie, Paris; Cincinnati A. Mus.; Detroit IA. Married artist James R. Hopkins, 1904. [32]

HOPKINS, Elinor F. [P] Hot Springs, VA b. 1 D 1901, Hot Springs. Studied: N.Y. Sch. F.&Appl. A.; Md. Inst.; Acad. Delacluse, Paris. Member: NAWPS. Exhibited: NAWPS, 1933 (med) [40]

HOPKINS, George E(dward) [P,T] Raleigh, NC b. 30 Jy 1855, Covington, KY. Studied: Munich Acad., with Gabl, Hockl; Florence; Venice [15]

HOPKINS, James Frederick [P,T] Monterey, CA b. 26 F 1869, Newton, MA d. 11 N 1931. Studied: Mass. Normal A. Sch., 1889. Positions: T., PIASch, 1889–96; public schools of Boston; Dir., Sch. of A.&Des.; Md. Inst.; Dir., Art Edu., Mass.

HOPKINS, James R. [Edu,P] Mechanicsburg, OH b. 17 My 1877, Irwin, OH. Studied: Columbus A. Sch.; A. Acad. Cincinnati; Paris, France. Member: ANA; Assn. Société Nationale des Beaux-Arts; SC. Exhibited:

P.-P. Expo, 1915 (gold); CI; CGA; PAFA; NAD, 1920 (prize); AIC, 1916 (prize); Salon Société Nationale des Beaux-Arts. Positions: T., A. Acad. Cincinnati (1914–44), Ohio State Univ. (1944–) [47]

HOPKINS, Marie A. [P] Savannah, GA [25]

HOPKINS, Mark, Jr. [S] Williamstown, MA b. 9 F 1851, Williamston d. 22 Je 1935, Pau, France. Studied: F. MacMonnies. Member: Société des Artistes Français; Union Internationale des Beaux Arts [31]

HOPKINS, Ruth Joy (Mrs.) [P,E] Casper, WY b. 17 Ag 1891, Fremont, NE. Studied: Colorado Springs FA Center; B. Robinson; W. Nash; Broadmoor A. Acad. Member: NAWPS; Casper A. Gld.; Wyo. AA. Work: Wyo. State Capitol. Exhibited: Denver A. Gal., 1935; N.Y. Municipal Exh., 1937; NAWA, 1936, 1937; Denver A. Mus., 1935 (one-man); Univ. Wyo. (one-man); Rock Springs, Wyo., 1935, 1936 [47]

HOPKINSON, Charles [P] Boston, MA/Manchester, MA b. 27 Jy 1869, Cambridge, MA d. 16 O 1962. Studied: Harvard; J. Twachtman; K. Cox; D. Ross; C. Cutler; ASL; Académie Julian; Aman-Jean. Member: Phila. WCC; NIAL; AAAL; ANA; NA, 1929; Am. Acad. A.&Sc.; SAA, 1898; AWCS; Port. P.; Concord AA. Exhibited: Pan-Am. Expo, 1901 (med); St. Louis Exp, 1904 (med); Pan-P. Expo, 1915 (med); Sesqui-Centennial Expo, Phila., 1926 (med); AIC, 1926 (med); NAD, 1943 (prize); Worcester Mus., 1902 (prize), 1905 (prize); PAFA, 1915 (gold). Work: Harvard; Va.; Colo.; Pa.; Yale; Columbia; Brown Univ.; Dartmouth; Bryn Mawr; Oberlin; Union; Vassar; St. Mark's; Exeter; Andover; MMA; BMFA; BM; WMA; AGAA; FMA; White House, Wash., D.C.; Radcliffe; Smith; Wellesley; T. Col., N.Y.; Bar Assns., N.Y.; Buffalo; Nat. Coll. FA, Smithsonian; RISD; Cleveland MA; AIC [47]

HOPP, George [P] NYC. Member: GFLA [24]

HOPPE, Leslie F. [Des] Chicago, IL b. 1889, Jerseyville, IL. Studied: Chicago AFA; AIC. Member: Palette and Chisel C. [29]

HOPPER, Edward [P,E,W] NYC b. 22 Jy 1882, Nyack, NY d. 15 My 1967. Studied: Correspondence Sch. A., NYC, 1899–1900; N.Y. Sch. A., with A. Keller, DuMond, Henri, W.M. Chase, K.H. Miller, 1900–06. (He traveled to Paris, London, Holland, Berlin, 1906–07; back in Paris, 1909, Madrid, 1910.) Member: NIAL, 1945, 1954 (gold); rejected membership in NA, 1932. Exhibited: Armory Show, 1913; MacDowell C., 1912–18, 1966 (med); S.Indp.A., first exh., 1917; Chicago SE, 1918–24; Penguin C., NYC, 1919; Whitney Studio C., 1920–27; NAC, 1920, 1923; Ontario AG, 1920; Brooklyn SE, 1920–25; Los Angeles MA, 1921–23; NAD, 1921–23; AAAL, 1922; PAFA, 1923–25, 1935 (gold); BM, 1923, 1925; CMA, 1923–28; Corcoran, 1923, 1928, 1937 (gold); Rehn Gal., NYC, (1st successful gal. exh.) 1924, 1928; NYPL, 1925; Alliance, 1925; Macbeth Gal., 1925; Downtown Gal., 1927, 1928; Boston AC, 1926; Cincinnati AM, 1926, 1928; Fogg AM, 1928; Wadsworth Athenaeum, 1928; PMG, 1928; Detroit AI, 1928; Albright AG, Buffalo, 1928; CI, 1928; Pan-Am. Expo, Baltimore, 1931; MOMA, 1933 (retrospective); WMAA, 1932–60s (with major retrospectives in 1950, also traveling to BMFA and Detroit AI, and in 1964 to Detroit AI, St. Louis AM and AIC); Venice Biennale, 1954; RISD, 1954; Currier Gal., 1954; Butler AI, 1954; Phila. MA, 1962 (with catalogue raisonné); WMA, 1962; Ariz. A. Gal., 1963 (retrospective); São Paulo Bienal, 1967; WMAA Traveling Exh., including Detroit IA, Milwaukee Art Center, SAM, Ga. MA, BMFA (1979–80, retrospective). Work: all of the above and many others.

HOPPER, Floyd D. [P,Li,B] Indianapolis, IN b. 1 N 1909, Martin County, IN. Studied: John Herron A. Sch.; PAFA; E. O'Hara; W. Forsyth; C. Wheeler; F.E. Schoonover; F. Harding; F. Speight. Member: Ind. AC; Phila. WCC; Ind. Soc. Pr.M.; Indianapolis AA; AAPL. Exhibited: AIC; CM; PAFA; Kansas City AI; Grand Rapids A. Gal.; Southern Pr.M.; Hoosier Salon, 1936 (prize), 1942 (prize); Ind. AC; Ind. Soc. Pr.M.; Kansas City AI (prize); Ind. State Fair, 1937 (prize), 1938 (prize), 1939 (prize); Lith. Exh., Oklahoma City (prize); Ind. A. (prize), 1935. Work: Fort Wayne A. Mus.; Oklahoma City; Ball State T. Col. [47]

HOPPER, Josephine N. (Mrs. Edward) [P] NYC/South Truro, MA b. NYC d. 6 Mr 1968. Studied: R. Henri; K.H. Miller. Exhibited: CGA, 1943; PAFA, 1938; GGE, 1939; AIC, 1943; BM; Weyhe Gal., 1944; Rehn Gal., 1946; WFNY, 1939 [47]

HOPPER, Justine [G] Kansas City, MO. Exhibited: Midwest Ar. Ann., Kansas City AI, 1934, 1935, 1938, 1939 [40]

HOPPIN, Helen I. [P] Provincetown, MA [24]

HOPPIN, Howard [P] Providence, RI. Member: Providence AC [29]

HOPPIN, Tracy [P] New Hope, PA. Member: SC [25]

HOPSON, William Fowler [E,En,I,Des] New Haven, CT/Wells, VT b. 30 Ag 1849, Watertown, CT d. 13 F 1935. Studied: L. Sanford, in New Haven; J.D. Felter, A. Will, both in NYC. Member: Grolier C., NYC; Rowfant C.; New Haven PCC; AFA; Odd Volume C., Boston; Trumbull AC, New Haven; Bibliophile Soc., Boston; Calif. Bookplate Soc. Exhibited: England; France; Italy; Spain. Work: AIC; NYPL; LOC; MMA; Harvard; Yale; others. Specialty: bookplates. Last of the Conn. Sch. of hand engravers; did a series of two thousand five hundred blocks engraved for an edition of Webster's Unabridged Dictionary, ca. 1890s. [32]

HORCHERT, Joseph A. [S] St. Louis, MO b. 4 My 1874, Hechingen, Germany. Studied: Staedel AI, Frankfort AM; Royal Acad., Munich. Member: St. Louis AL; St. Louis AG. Work: fountain, St. Louis (prize); figures, Berlin; Sacrament Church, St. Louis.; mem. College of Pharmacy, St. Louis; Preparatory Seminary, St. Louis; mem., Westminster Col., Fulton, Mo.; portraits, Lindenwood Col., St. Charles, Mo. [40]

HORD, Donal [S] San Diego, CA b. 26 F 1902, Prentice, WI d. 30 Je 1966. Studied: Santa Barbara Sch. A., 1917; Univ. Mexico, 1928–29; PAFA; BAIC. Member: NSS; Guggenheim F., 1945; NA, 1951. Exhibited: MOMA, 1942; MMA (AV), 1942; Am.-Brit. Exh., 1944; Los Angeles, 1931 (prize); So. Calif. A., 1931 (prize); San Diego Expo, 1935 (med), 1936 (med); AAAL, 1942 (prize). Work: San Diego FA Soc.; SFMA; fountain, Balboa Park, San Diego; bas-reliefs, Coronado, Linda Vista, Calif. [47]

HORDYK, Gerard [P,I] NYC b. 12 S 1899, The Hague, Holland. Studied: Holland. Exhibited: BM, 1935, 1941; AIC, 1939, 1943, 1944; PAFA, 1940; CI, 1945; Contemporary A. Gal., 1935, 1940, 1944 (all one-man); Wildenstein Gal., 1943 (one-man); Whyte Gal., Wash., D.C., 1942 (one-man); Vigeveno Gal., Los A., 1944 (one-man). Illustrator: "The Picture Story Book of Holland," 1946 [47]

HORE, Ethel. See Townsend.

HORI, Ichiro E. [P] NYC b. 13 Ap 1879, Izumo, Japan [27]

HORLE, Edith Louisa [E,En,P,T,C,B] Syracuse, NY b. Syracuse. Studied: Syracuse Univ.; PMSchIA; Breckenridge; B. Buck; S. Yama. Member: Sch. Art Lg. of Syracuse; Syracuse AA; Syracuse Pr.M.; Syracuse Print C.; Daubers C.; New Orleans AA; Prof. Women's Lg., Syracuse; Southern Pr.M. Exhibited: Southern Pr.M., 1936–43; LOC, 1943, 1945; NAD; Phila. Pr.C., 1934–46; Phila. A. All.; Northwest Pr.M., 1933–37; Woodcut Soc., Kansas City, 1933, 1936; New Orleans AA; Wichita AA; Buffalo Pr.C., 1945; Auburn Exh., N.Y., 1945; Albany Pr. C., 1945; Finger Lakes Exh., Rochester, 1938–46; Syracuse AA, 1933–46; Daubers of Syracuse, 1936–46; Rochester Mem. A. Gal., 1945 (prize); Syracuse Pr.C., 1946 (prize). Work: Rochester Mem. A. Gal.; Woodcut Soc., Kansas City, Mo.; Syracuse Univ. Position: T., Onondaga Valley Acad., Syracuse [47]

HORN, Axel [Des,P] Riverdale, NY b. 11 Ja 1913, NYC. Studied: Newark Sch. FA; ASL; T. Benton; C. Locke; D. Sequieros. Member: A. Lg. Am. Exhibited: CGA; Arch. L.; WFNY, 1939; ACA Gal.; Chicago Mus. SC. Work: murals, Bellevue Hospital, NYC; Nurses Home, Welfare Island, N.Y.; USPOs, Whitehall, N,Y., Yellow Springs, Ohio. WPA artist. Position: T., The Displayers, N.Y., 1943– [47]

HORN, Milton [S,P,W,L,T,Dr] Olivet, MI b. 1 S 1901, Ukraine, Russia. Studied: Educational All., N.Y.; BAID; H. Kitson. Member: S. Gld.; Mich. Acad. A.&Sc.; Am. A. Cong. Exhibited: PAFA, 1936; WFNY, 1939; BM, 1930; MMA (AV), 1942; N.Y. Municipal Exh., 1937; S. Gld., 1938–43; Am. A. Cong., 1939; CAA Traveling Exh.; VMFA; BM, 1932 (one-man); Gld. A. Gal., 1936 (one-man); Wayne Univ., 1940 (one-man); Wustum Mus., 1942 (one-man); Kalamazoo Inst. A., 1944 (one-man); 1945 (one-man). Work: Savoy-Plaza, NYC; S., Brookgreen Gardens, S.C.; Olivet Col., Mich.; USPOs, Swarthmore, Pa., Whitinsville, Mass., Iron River, Mich.; mon., Olivet Col. WPA artist. Position: S. in residence, Olivet Col. 1939– [47]

HORN, Robert F. [P] Indianapolis, IN

HORNADAY, J.K. [P] Kansas City, MO [24]

HORNBY, Lester George [P,E,Li,I,W,L,T] Rockport, MA b. 27 Mr 1882, Lowell, MA d. 17 D 1956. Studied: RISD; Pape Sch., Boston; Acad. Julian, Acad. Colarossi, Acad. Delaclause, Acad. de la Grande Chaumière (with Steinlen), Sorbonne, all in Paris, 1906–10. Member: Paris AAA (Dir., 1902–08); Boston AC; Gld. Boston A.; Boston WCC; Brooklyn SE; Chicago SE; Calif. SE; New York SE; Gloucester SA; Painter-Gravers of Am.; Providence AC; Providence WCC; Rockport AA; SC; Soc. Amis de l'Eau-Forte, Paris. Exhibited: Paris Salon, Soc. A. Français, 1907–13, 1937 (med); Dresden Intl. Exh., 1908; Doll & Richards Gal., Boston, 1909, 1913–16, 1930; Boston Pub. Lib., 1910; Irving & Casson, Boston, 1914; Roulliei AG, Chicago, 1910, 1916; Kennedy Gal., NYC, 1914, 1919; Grace Horne Gal., Boston, 1919; Goodspeed's, Boston, 1919–24; Venice Intl. Exh. 1920; Lotos C., 1919; Anderson Gal., NYC, 1922; Swedish Intl. Exh. 1922; Fine Art Soc. London, 1920; Aix-les-Bains Exh., France, 1920s; Boston City C., 1922; CGA, 1923; Detroit Inst. A., 1911, 1914, 1920; Vose

Gal., Boston, 1928; RISD, 1931; Boston AC, 1937; Speed Mus., Louisville, 1937; WMA, 1940; San Diego FA Gal., 1941; LOC, 1944 (one-man); BMFA, 1945 (one-man); Cape Ann Hist. S., 1957; Bancroft Lib., Worcester, 1964; N.Y. Hist. Soc., 1983; R. York Gal., NYC, 1984; Assd. Am. Artists, NYC, 1984; Lowell AA, 1984; Rockport AA, 1985. Work: AGAA; Boston Pub. Lib.; Boston Athenaeum; CI; AIC; Detroit IA; LOC; MMA; N.Y. Hist. Soc.; NYPL; Phila. MA; Newark Pub. Lib.; RISD; Yale; Rockport AA; San Diego MA; Speed Mus., many more in U.S. and Europe. One of the founders of the "Rockport School," he named the popular fish shack of Rockport, "Motif #1." Also produced an important series of etchings documenting WWI. [47]

HORNE, Grace R. [Dealer] Boston, MA b. Watertown, MA d. 14 F 1934. Position: Dir., Grace Horne Gal. in Boston; Promoted many well-known Boston artists.

HORNE, Laura Trevitte [P,T,Dec,Dr] NYC b. 30 Je 1891, Dalton, GA Studied: NAD; G. Maynard; F. Jones; G. Bridgman; L. Kroll; V.D. Perrine. Member: AAPL; Allied Ar. Am. Exhibited: NAD; All.A.Am.; SSAL; AAPL; Montclair A. Mus.; Columbia; Anderson Gal.; Babcock Gal.; Atlanta AA. Work: ceramic coll., Chinese Embassy, Wash., D.C. [47]

HORNE, Muriel L(orraine) [P,S,I] Newark, NJ b. 25 Ja 1904. Studied: PIASch [24]

HORNER, Blanche A. (Mrs. Edward R. Rowley) [P,Dec,G] Provincetown, MA b. 23 Je 1915, Alexandria, VA. Studied: V. Diserens, in Switzerland; R. Miller; J. Farnsworth; C.C. Critcher. Member: Provincetown AA; Soc. Wash. Ar. Exhibited: Soc. Wash. Ar., CGA, 1936–39; Provincetown AA [40]

HORNER, Hannah Mee [P] Upper Darby, PA b. Phila. Studied: Phila. Sch. Des. Women. Member: Phila. Alliance. Specialty: restoring paintings [25]

HORNUNG, Clarence P. [Des,W] Hempstead, NY b. 12 Je 1899, NYC. Studied: CCNY; Columbia; CUASch. Member: AIGA; ADI. Author: "Hand Book of Designs and Devices," 1932, "Lettering from A to Z," 1946, "Handbook of Early American Advertising Art," 1946, others [47]

HOROWITZ, Frank [P,W,L,T,Dr] NYC b. 5 Jy 1889, Odessa, Russia. Studied: PAFA; PMSchIA. Member: A. Lg. Am.; Lg. Present-Day A.; Am. A. Cong.; Artists U. Exhibited: BM; PAFA; BM; AIC; Harvard Univ.; NAD; AFA Traveling Exh., 1942, 1943–44; Montross Gal., 1933 (one-man); Ehrich Gal., 1932 (one-man); Milch Gal., 1931 (one-man); Pal. Leg. Honor, 1932 (one-man); Tricker Gal., N.Y., 1938. Work: Roerich Mus.; PAFA; BM; Riverside Mus.; Pal. Leg. Honor; Mus. Western A., Moscow; Odessa Mus., Russia; Biro-Bidjan Mus., Russia; Tel-Aviv Mus., Palestine [47]

HORSFALL, Carolyn S(arah) [P,C] Hartford, CT/Boothbay Harbor, ME b. 3 Jy 1901, Hartford, CT. Studied: A. Fisher; H.B. Snell; G.P. Ennis. Member: Springfield A. Lg.; NAWPS; AWCS; NYWCC [33]

HORSFALL, Emil [P] NYC b. Lyons, IA. Studied: J.H. Stich, in Clinton, Iowa; L.C. Lutz, in Cincinnati; Munich; Paris [01]

HORSFALL, R(obert) Bruce [I,P,W] Wash., D.C. b. 21 O 1869, Clinton, IA d. 1948 (Fairport, NY?) Studied: Cincinnati A. Acad., with L.C. Lutz, T.S. Noble, 1886–89; N. Gysis, Munich Bavaria Konig Acad.; Colarossi Acad., Paris. Member: Wash. Ldscp. C. Exhibited: World Columbian Expo, Chicago, 1893. Work: N.Y. Zoological Soc.; Univ. Minn.; Ill. Mus.; Nat. Zoo Park, Grand Rapids,; Nat. Mus. Illustrator: Century and St. Nicholas, 1899–21, thirty nature books. Author: "Bird and Animal Paintings." Contributor: articles, illus., many publications; scientific drawings, Princeton, 1904–14, AMNH, 1898–99, Nat. Coll. FA. Specialty: bird illus. Positions: T., Princeton, Am. Nature Assn., Wash. [40]

HORSTMEIER, Albert [P] Boston, MA. Member: Boston AC [06]

HORTER, Earle [I,E] Phila., PA d. 29 Mr 1940. Member: SI, 1910. Exhibited: P.-P. Expo, San Fran., 1915 (med); AIC, 1932 Etch. show (prize); Nat. Exh. Prints, Phila. Pr. C., 1933 (prize), 1938 (prize). Specialty: etchings of urban scenes [40]

HORTER, Emil [P] NYC [10]

HORTER, Frederick Formes [S] Weehawken, NJ b. 1 N 1869, Tremont, NY. Studied: CUASch. Exhibited: NYU (prize) [10]

HORTON, Charles Orson [P,B,E,L,T] Oakland, CA b. 8 D 1896, Hayward, CA. Studied: A. Hansen; Calif. Sch. FA; Calif. Sch. AC. Member: Carmel AA; Bay Region AA. Exhibited: Oakland A. Gal., 1933, 1934, 1935; Bay Region AA, San Fran., 1935 (prize); Oakland WC Ann., 1938 (prize). Work: St. John's Church, Oakland [40]

HORTON, Clyde E. [P] Cleveland, OH. Member: Cleveland SA [27]

HORTON, Dorothy E. (Mrs. T.J. Stewart) [P] Erie, PA b. 14 O 1898, Poplar Bluff, MO. Studied: St. Louis Sch. FA; PAFA; S.R. Knox. Exhibited: Erie AC, 1928 (prize) [33]

HORTON, Elizabeth S(umner) [P] Brookline, MA b. 27 Je 1902, Boston. Studied: P. Hale; A. James; W. James; F. Bosley; M. Morrisset, in Paris. Member: NAWPS. Exhibited: Jr. Lg, Boston, 1928 (prize) [40]

HORTON, Harriet H. [Por.P,Min.P] St. Paul, MN d. Summer, 1922. Work: portraits, Minn. Hist. Soc.

HORTON, Herbert R.F. [P] Paris, France [10]

HORTON, Ruth Durland [P,Dec,Des,L] Middletown, NY b. 5 Mr 1894, Johnson, NY. Studied: ASL; N.Y. Sch. F.&Appl. A.; Woodstock Sch. Landscape P.; J. Lie; W. Reiss; M. Sarg. Member: Keramic Soc., Des. Gld.; F., MacD. Colony; Hudson Highlands AA. Exhibited: Currier Gal., A., N.H., 1937; MacD. C., N.Y., 1939; Hudson Park Lib., N.Y., 1939; Ann. Textile Des. Comp., 1919 (prize), 1922 (prize) [40]

HORTON, William S(amuel) [P] Paris, France b. 16 N 1865, Grand Rapids, MI. Studied: ASL; NAD; Académie Julian, Paris, with Constant. Member: NYWCC; AFA; Société Moderne, Soc. Internationale, Salon d'Automne, all in Paris. Exhibited: Intl. Expo, Nantes, 1904 (gold); Orleans, 1905 (med). Work: Bradford Mus., England; Luxembourg Mus.; Nat. Mus., Wash., D.C.; BM; Bootles Mus., Liverpool, England; Nat. Mus, Stockholm; Musée du Jeu de Paume, Musée Carnavalet, both in Paris [40]

HORVATH, Ferdinand Huszti [I,W,Car,P] Hollywood, CA b. 28 Ag 1891, Budapest, Hungary. Illustrator: "Fiddler's Green"; "The King of the Golden River"; "Red Caboose"; other books; national magazines. Position: Lanyi and Horvath Ceramic Studios, Hollywood [47]

HORWITZ, Louise McMahan [P,Des] St. Louis, MO b. 8 Jy 1903, Pauls Valley, OK. Studied: Kidd Key Col., Sherman, Texas; Wash. Univ. Member: NAWA. Exhibited: CI, 1941; A.Dir.C., 1941; NAWA, 1943, 1944; CAM, 1945; Kansas City AI, 1945 [47]

HOSFORD, H(arry) Lindley [E] St. Paul, MN/Lyme, CT b. Terre Haute, IN. Studied: Chase; DuMond; Beckwith; Maynard; F.C. Jones. Member: Chicago SE. Exhibited: Minneapolis M., 1935 (prize), 1938 (prize). Work: NYPL; Minneapolis Inst. A., LOC; U.S. Nat. Mus. [40]

HOSHALL, Earl Slade [P] Brooklyn, NY b. 17 N 1909, Baltimore, MD. Studied: Md. Inst.; ASL; NA. Member: United Am. A. Exhibited: Springfield MFA, Mass.; Intl. WC Ann., AIC; WFNY 39 [40]

HOSKING, Arthur N. [I,Et,P] Wayne, PA b. 5 Ap 1874, Liberty, MD. Studied: AIC [13]

HOSKINS, Gayle Porter [P,I,Des,T] Wilmington, DE b. 20 Jy 1887, Brazil, IN. Studied: AIC, with Vanderpoel, 1904; H. Pyle. Exhibited: Wilmington Soc. FA, (prize), 1916–46. Illustrator: "Kazan," "Me, Smith," "Bill and Jim" series; magazines; adv. Specialty: historical military subjects. Position: T., Wilmington Acad. A. [47]

HOSKINS, Margaret Morris (Mrs. Ray) [P] New Haven, CT b. 10 D 1886, Williamstown, MA d. ca. 1955. Studied: Bryn Mawr Col.; Yale. Member: NAWA; New Haven PCC; A. & Cr. Assn., Meriden, Conn. Exhibited: NAWA, 1941, 1942, 1944–46; Am.-British A. Ctr., 1942–45; New Haven PCC, 1942–46; A. & Cr. Assn., 1946 [47]

HOSKINS, Minna [P] Chicago, IL [17]

HOSKINS, Winfield Scott [P,I] NYC b. 19 O 1905, Los Angeles, CA. Member: AWCS; Audubon A.; Calif. WCS; SI. Exhibited: AWCS, 1940–46; Audubon A., 1945; BM, 1943; Calif. WCS, 1937, 1938, 1940, 1942 1944; MMA, 1942; PAFA, 1940; WMAA, 1945; San Diego FA Soc., 1938 (prize); Los Angeles M. Hist. Sc.&A., 1938 (prize); NYWCC, 1937. Work: New Haven PCC; Ill. State Mus.; AAAL. Illustrator: "Golden Book of Fairy Tales," 1942, "The Fertile Land," 1943, "The Burma Road," 1946; national magazines [47]

HOSMER, Florence Armes [P,T,C,Des] Sudbury, MA b. Woodstock, CT. Studied: Mass. Sch. A.; BMFA Sch., with DeCamp, A.K. Cross; C. Woodbury. Member: Copley S., Boston; Cambridge AA. Exhibited: Copley Soc.; Boston A. Gld.; BMFA; Cambridge AA, 1945; Mass. Women's C., 1946; Boston AC. Work: Essex Inst. Salem, Mass. [47]

HOSMER, Harriet [S,W] Cambridge, MA b. 9 O 1830, Watertown, MA d. 21 F 1908. Studied: Stevenson, in Boston; anatomy, Medical Col., St. Louis; J. Gibson, in Rome, 1852. Work: St. Louis Pub. Lib. She on an international reputation after 1860 as the leading woman sculptor; also noted for her prose and poetry. [08]

HOSMER, Madeline Flint [Des,C,T,L] Decatur, GA b. 16 Ja 1890, St. Louis,

MO. Studied: St. Louis Sch. FA, Wash. Univ.; Mason Sch. Des., N.Y. Member: SSAL; Atlanta AA; Atlanta A. Gld. Position: T., Univ. Ga. [40]

HOSTATER, Robert B. [P] Paris, France [25]

HOSTERMAN, Naomi S. (Mrs. R.C.) [Por.P,I] Charleston, WV b. 13 Ja 1903, Elkhart, IN. Studied: Herron AI; Scott Carbee Sch., Boston; Ind. Univ.; CM Sch.; W. Forsyth; F. Stark; R. Grooms; C. Barnhorn; B. Keyes. Member: Hoosier Salon; Ind. AA; All.A. W.Va.; Ind. AC. Exhibited: Hoosier Salon; All.A., W.Va., 1938 (prize), 1942 (prize), 1946 (prize). Work: First Presbyterian Church, Baptist Temple, Charleston, W.Va.; Kanawha County, W.Va. Illustrator: "Greenbrier Pioneers and their Homes," 1942 [47]

HOSTETLER, Rena A. [P] Winnetka, IL. Exhibited: Hoosier Salon, 1937, 1940 (prize) [40]

HOTSFORD, Harry Lindley [Et] b. 1877, Terre Haute, IN d. 5 S 1945, New Haven, CT. Studied: NAD; N.Y. Sch. A. Work: LOC; Minneapolis Inst. A.; other print coll.

HOTT, Nell Inez [I] NYC. Member: SI [25]

HOTTENDORF, Ida Louise [P] Cincinnati, OH [19]

HOTTINGER, William A. [I,Mur.P] Glen Ellyn, IL b. 11 O 1890, Phila. Studied: C. von Marr. Work: St. Isidor's Church, Cloverdale, Ill.; St. Petronille's Church, Glen Ellyn; St. Malachy's Church, Chicago. Position: A. Dir., U.S. Printing and Lith. Co. [40]

HOTVEDT, C(larence) A(rnold) [P,D,Des] Ft. Worth, TX b. 16 Ap 1900, Eau Claire, WI. Studied: AIC. Member: Wichita AG; Prairie PM; Calif. PM; Allied A. of Ft. Worth. Position: A., Stafford-Lowdon Lith. Co. [40]

HOUGH, Edward Beach, 3rd [S,C] Haddonfield, NJ b. 12 Je 1914, Haddonfield, NJ. Studied: W.T. Boogar, Jr.; O.P. Hough. Member: A.C. Gl., Phila.; Boston SAC. Exhibited: PAFA, 1936, 1938. Work: A. C. Gl., Phila.; Courier-Post Newspapers, Camden, NJ [40]

HOUGH, Ruth Beverly [P] Council Bluffs, IA b. 22 Ja 1899, Crescent, IA. Studied: Mrs. J. Gamble; M.F. Earle; Stanford Univ. [33]

HOUGH, Walter, Dr. [P,W,L] Wash., DC b. 23 Ap 1859, Morgantown, WV d. 19 S 1935. Studied: E.F. Andrews; W.H. Holmes. Member: Wash. WCC; AFA [33]

HOUGHTON, Merrit Dana [P,Dr,Photogr,T] b. 1846, Otsego, MI d. 1918, Seattle, WA. Settled in Laramie, Wyo., 1875; then in Saratoga. Work: Amon Carter Mus.; Wyo. State AG [*]

HOUGHTON, Sara Gannett [P] Leicester, MA [13]

HOULAHAN, Kathleen [P] Seattle, WA b. 31 Ja 1887, Manitoba, Canada. Studied: R. Henri; K.H. Miller; C. Hawthorne. Member: Pacific Coast PS & W [40]

HOULISTON, William James, Jr. [P] Houston, TX. Exhibited: Ar. S.E. Tex. Ann., Houston MFA, 1938; Golden Jubilee, Dallas MFA, 1938; SSAL, 1936, 1938, 1939; Ann. Houston MFA, 1938, 1939 [40]

HOUNSELL, C.L. (Mrs.) [P] Glendale, CA. Member: Calif. AC [25]

HOURDEBAIGHT, Lucie [P] NYC b. 24 O 1901, Bourdeaux, France. Studied: J. Sloan; S. Davis; A. Lhote; D. Rivera. Member: NYSWA [40]

HOUSE, Howard Elmer [P] Portland, OR b. 5 F 1877, Manhattan, KS. Studied: AIC; Chicago Acad. FA. Member: AAPL [40]

HOUSE, James (Charles), Jr. [S,T] Springfield, PA b. 19 Ja 1902, Benton Harbor, MI. Studied: Univ. Mich.; PAFA; Univ. Pa. Exhibited: PAFA, 1939, 1940, 1942, 1945, 1946; Dallas Mus. FA, 1936; BM, 1932; WMAA, 1934, 1936; PMA, 1933, 1940; CI, 1941; N.Y. Municipal Exh., 1936; MMA (AV), 1942; MOMA, 1942; Detroit Inst. A., 1932, 1935, 1938–40; Kansas City AI, 1935. Work: S., WMAA. Author: "Fifty Drawings," 1930. Position: T., Univ. Pa., 1936– [47]

HOUSER, Allan (C.) [P,S,G] Los Angeles, CA b. 30 Je 1915, Apache, OK. Studied: Indian A. Sch., Santa Fe, with D. Dunn, O. Nordmark. Exhibited: O'Hara Exh., Goose Rocks Beach, Maine, 1937; WFNY, 1939. Work: murals, Dulce, N.Mex.; Ft. Sill Indian Sch., Okla.; Southwestern Mus., Los Angeles; Mus. N.Mex.; Philbrook A. Center; Ariz. State Capitol. Chiricahua Apache painter whose parents were imiprisoned at Fort Sill along with his great-uncle, Geronimo. His bold paintings of Indian dancers and Indian life made him the leading Apache artist. Living in Santa Fe, N.Mex., 1975. WPA muralist. [47]

HOUSER, Lowell [I,B,P,T] Des Moines, IA b. Chicago, IL, 1903. Studied: AIC. Work: WPA murals, USPOs, Ames, Iowa, Piggot, Ark. Position: T., ASt. [sic] Workshop, Iowa [40]

HOUSH, Carter [I] NYC b. 1887 d. 14 My 1928, Custer, SD. Member: SI; GFLA

HOUSTON, Caroline A. [P] Ridgewood, NJ b. 1871, Brooklyn. Studied: F.V. DuMond, NYC; Paris, with Collin and Trasset [06]

HOUSTON, Frances C. (Mrs. William C.) [P,C] Windsor, VT b. 14 Ja 1867, Hudson, MI d. 1906. Studied: Lefebvre, Boulanger, in Paris. Member: Boston WCC; Boston SAC; NYWCC [06]

HOUSTON, Grace [P,T] Indiana, PA. Studied: Ohio State Univ.; Columbia; N.Y. Sch. Appl. Des.; CI; Provincetown art colony; Woodstock art colony. Member: Pittsburgh AA. Positions: T., Pa. State T. Col. (Indiana, Pa.), McKeesport, Pa., Pittsburgh, Pa. [40]

HOUSTON, Helene [P] Paris, France b. Los Angeles. Studied: AIC [13]

HOUSTON, Nora [P,G,T] Richmond, VA. Studied: K.H. Miller; B.P. Vonnoh; R. Henri; W.M. Chase; Paris, with Simon, Blanche, Menard, Cottet. Member: SSAL. Exhibited: WMAA, 1937; GGE, 1939; VMFA, 1940 [40]

HOUSTON, Russell A. [S] Kensington, MD b. 28 S 1914, Morgantown, WV. Studied: Corcoran Sch. A.; Univ. Hawaii; R. Laurant. Member: S. Wash. A. Exhibited: PAFA, 1946; CGA, 1940 (prize), 1941 (prize), 1942 (one-man); Morgantown, W.Va., 1938 (one-man); S. Wash. A., 1939–44, 1940 (prize), 1941 (prize), 1943 (prize); Assn. Fed. Arch., 1939, 1942, 1946; Nat. Mus., 1940; Honolulu Acad. A., 1945 (one-man). Work: WFNY, 1939; Am. Legion Med.; s. panel, Officer's Cl., Wash., D.C.; mem., War Dept., 1946 [47]

HOVANNES, John [S,T] NYC b. 31 D 1900, Smyrna d. 1973. Studied: RISD; BAID. Member: Guggenheim F., 1940; S. Gld.; Audubon A.; Westchester A.&Cr. Gld. Exhibited: PAFA, 1937, 1942, 1943, 1945, 1946; AIC, 1935, 1942, 1943; MMA (AV), 1942; NAD, 1943; Riverside Mus., 1943; WMAA, 1942–46; Nebr. AA, 1945; WFNY, 1939; S. Gld., annually; Robinson Gal., 1941 (one-man); Wings for Victory Comp., 1942 (prize). Work: Newark Mus. Positions: T., CUASch (1945–46), ASL (1945–46) [47]

HOVELL, Joseph [S,T] NYC b. 28 O 1897, Kiev, Russia. Studied: Russian Imperial A. Sch., Odessa; CUASch, with G. Brewster; R. Aitken; NAD. Member: United Am. A.; S.Indp.A. Exhibited: Bronx A. Gld., 1927; Central Synagogue Community House, NYC, 1928, 1933; NAD, 1929, 1931; BM, 1930; Carnegie Hall A. Gal., 1934, 1935; All.A.Am., 1935; Grand Central Palace, 1937; Am. Veterans SA, 1944; Audubon A., 1935. Work: N.Y. Mus. Sc. & Industry; Carnegie Hall; Yeshiva Col.; White House, Wash., D.C.; 12th Regiment Armory, NYC; Bucharest, Romania; Lewisohn Stadium, NYC [47]

HOVENDEN, Helen Corson (Mrs. Thomas) [P] Plymouth Meeting, PA b. 1846 d. 6 O 1935, Phila. Studied: Phila. Sch. Des; PAFA; Paris. Member: Plastic C. [13]

HOVENDEN, Martha Maulsby [S] Plymouth Meeting, PA b. 8 My 1884, Plymouth Meeting d. 27 F 1941, Phila. Studied: PAFA; C. Grafly; H.A. MacNeil. Member: Plastic C.; Wash. AC. Work: Wash. Mem. Chapel, Valley Forge, Pa. [40]

HOVENDEN, Thomas [P] b. 1840, Dunmanway, Ireland (came to NYC in 1836) d. 1895, Plymouth Meeting, PA. Studied: Cork Sch. Des., Ireland; NAD; Paris, with Cabanel. Member: NA, 1882. Exhibited: Columbian Expo, Chicago, 1893 [*]

HOVER, Lillian Sooy (Mrs. John I.) [P,T] Linlithgo, NY b. 19 S 1889, Colorado Springs. Studied: E.E. Evans; W. Sartain; C.C. Curran; F.C. Jones; C.W. Hawthorne. Member: Allied AA. Work: portraits, Lima Col., Ohio; First Nat. Bank, Hudson, N.Y. [40]

HOVEY-KING, Rita [P,S,G,L] New Orleans, LA/Lake Saranac, NY b. 6 Mr 1911, Charleston, SC. Studied: Newcomb Col.; PAFA; ASL; W. Adams. Member: SSAL; New Orleans AA; NAWPS. Exhibited: Montross Gal., N.Y., 1936; SSAL, Montgomery, Ala., 1938 [40]

HOVSEPIAN, Leon [P,Gr,L,T] Worcester, MA b. 20 N 1915, Bloomsburg, PA. Studied: WMA; Yale. Exhibited: AIC, 1941; WMA, 1945; NGA; CGA; MMA; PAFA; Albright A. Ga.; Milwaukee AI; Fitchburg A. Center; RISD. Work: Fitchburg A. Center; PBA; murals, Ft. Warren, Mass.; Sheraton Hotel, Worcester, Mass. Position: T., WMA Sch. [47]

HOW, Beatrice [P] Paris, France [25]

HOW, Kenneth (Gayoso) [P] NYC b. 8 Je 1883, Wantaugh, NY. Studied: Jane Peterson; H.B. Snell. Member: NYWCC; Arch. Lg.; SC; AWCS;

NAC; All.A.Am.; AAPL AFA. Exhibited: SC, 1936 (prize), 1938 (prize); AWCS, 1937 (prize); All.A.Am., 1940 (prize). Work: Inn, Shawnee-on-Delaware, Pa.; Hotel Gramatan, Bronxville, N.Y. [47]

HOWARD, B.K. [P,T] New Ashford, MA b. 30 S 1872, Ft. Collins, CO. Studied: BMFA Sch., with Tarbell, C.H. Davis [15]

HOWARD, Cecil (de Blaquiere) [S] NYC b. 2 Ap 1888, Niagara Falls, Canada d. 1956. Studied: Académie Julian, Paris; ASL, Buffalo, N.Y. Member: NSS; NIAL; Société Nationale des Beaux-Arts; Salon d'Automne; Salon des Tuileries. Exhibited: WMAA, 1934; WFNY, 1939; Paris Salon, 1937 (prize); PAFA, 1934, 1944 (med). Work: WMAA; BM; Albright A. Gal. [47]

HOWARD, Charles [P,T] Castle Camps, Cambridgeshire, England. b. 2 Ja 1899, Montclair, NJ. Studied: Univ. Calif. Member: San Fran. AA. Exhibited: San Fran. AA, annually; AIC, 1943, 1945; Critic's Choice, Cincinnati, 1945; MOMA, 1942; SFMA 1940 (prize), 1942 (prize); MMA (AV), 1942 (prize); Pal. Leg. Honor, 1946, (prize); Pasadena AI, 1946 (prize). Position: T., Calif. Sch. FA, San Fran., 1945 [47]

HOWARD, Clara F(rances) [Min.P,T] Poughkeepsie, NY b. Poughkeepsie d. ca. 1938. Studied: NAD; ASL, with Brush, Chase. Member: NAWPS; ASMP [33]

HOWARD, Edith Lucile (Mrs. Herbert Allen Roberts) [P,T,L,I] Moorestown, NJ b. 28 My 1885, Bellows Falls, VT. Studied: Phila. Sch. Des. for Women; E. Daingerfield; H. Snell. Member: NAWA; AWCS; AAPL; Phila. A. All.; Phila. WCC; Wilmington SFA; NYWCC; Am. Women's Assn.; Plastic C.; Lyceum C., London. Exhibited: Plastic C., 1915 (prize), 1917 (gold); Am. Women's Assn., 1933 (prize); PAFA; Albright A. Gal.; CGA; NAD; AIC; Phila. AC; AWCS; Phila. WCC; Baltimore WCC; AFA; NAWA; Phila. A. All.; Phila. Plastic C.; Wilmington SFA. Work: Wilmington SFA; Swarthmore Col.; Moore Inst.; Am. Women's Assn.; New Century C., Lansdowne, Pa. [47]

HOWARD, Eloise [En,B,P] Milton, NY b. 8 My 1889, Pine Valley, OR. Studied: Portland (Oreg.) AA; ASL; NAD. Exhibited: Third Intl. Exh. Lith. and Wood En., Chicago; NAWPS, 1932 (prize) [40]

HOWARD, Florence [P] NYC d. 10 Ja 1914, Colorado Springs. In 1908, she left her home in search of health.

HOWARD, Harold C. [P] Chicago, IL. Member: Chicago NJSA [25]

HOWARD, Henry Mowbray [Mar.P] Paris, France b. 1 Je 1873, Wash., D.C. Studied: F. Cormon, in Paris. Member: Paris AAA [10]

HOWARD, H(ugh) H(untington) [P] Cleveland, OH b. 28 Jy 1860, Cherry Valley, OH d. 25 Jy 1927. Member: Cleveland SA [25]

HOWARD, Jane B. See Berlandina.

HOWARD, John L(angley) [P] Mill Valley, CA b. 5 F 1902, Montclair, NJ. Studied: Univ. Calif.; Calif. Sch. A.&Cr.; ASL, with K.H. Miller. Member: Am. A. Cong.; San Fran. AA; Marin SA. Exhibited: San Fran. AA, 1934 (prize), 1937 (prize); CGA, 1943; CI, 1941; GGE, 1939; AIC, 1945; Pal. Leg. Honor, 1945, 1946 [47]

HOWARD, Josephine (Mrs.) [P] Paris, France b. Louisville, KY. Studied: Académie Julian, Paris [01]

HOWARD, Katharine Lane [I,W] b. NYC(?) d. 5 Jy 1929, Cincinnati, Author/Illustrator: "The Little God," a child's book of verse adopted for use in English schools. As a girl in England, she did much of the hand-coloring of Audubon's "Birds of America." Also a poet.

HOWARD, Len R. [C] Kent, CT b. 2 Ag 1891, London, England. Studied: PIASch; ASL; W. Aikman, London. Member: Meriden A.&Cr.; N.Y. Soc. Cr.; Arch. Lg.; AAPL; Lime Rock AA; Kent AA. Work: stained glass in churches and schools, Torrington; New Milford, Brookfield Center, Canaan, all in Conn.; Memphis, Tenn.; Augusta, Ga.; Santa Maria, Calif.; Ann Arbor, Mich.; church, Stuyvesant Square, NYC; Edison Bldg., Brooklyn. Specialty: stained glass [47]

HOWARD, Lizzie [P] Rochester, NY b. 14 O 1852, Rochester, NY. Member: Rochester AC [25]

HOWARD, Loretta (Mrs. Howell) [P] NYC b. 1 N 1904, Chicago, IL. Studied: Bennett Sch. Milbrook, N.Y.; Henri. Member: NAWA; AAPL. Exhibited: WMAA, 1936; AIC; WFNY, 1939; NAWPS, 1937, 1938 (prize) [47]

HOWARD, Marion [Dec,Des,P] North Conway, NH b. 1883, Roxbury, MA. Studied: BMFA Sch.; W.M. Chase; E. Barnard. Work: City Cl., Boston [40]

HOWARD, Marion [P] NYC b. 22 Mr 1886, Phila. Studied: ASL, with DuMond, Chase, Mora, Bridgman. Member: Lg. Am. Pen Women. Work: Madison Square Boys C., NYC. Exhibited: All.A.Am., 1945 [47]

HOWARD, Mary R. Bradbury (Mrs. J.G.) [P] Berkeley, CA b. 22 D 1864, Cambridge, MA. Studied: ASL; Delecluse Acad. Member: N.Y. Women's AC [13]

HOWARD, O(scar) F(rederick) [I] Westport, CT b. 1888 d. 7 Ja 1942. Studied: ASL. Member: GFLA. Cartoonist: "Metropolitan Movies"; New York World [27]

HOWARD, Robert Boardman [P,S,C,T] San Fran., CA b. 20 S 1896, NYC. Studied: Calif. Sch. A.&Cr., 1915–16; ASL, 1916–17; A. Pope, K.H. Miller; P.W. Nahl; W. Ryder; Z. Martinez, 1919–22. Member: San Fran. AA.; Calif. Soc. Mural A. Exhibited: CGA, 1937; CI, 1941; AIC, 1944; Pal. Leg. Honor, 1946; WFNY, 1939; GGE, 1939; Oakland A. Gal., 1937; San Fran. AA, 1923 (med), 1924 (prize), 1941 (prize), 1943 (prize), 1944 (prize). Work: SFMA; Mills Col.; murals des., Yosemite Nat. Park, 1929–36, San Fran. Stock Exchange Bldg.; Oakland MA; Univ. Calif., Santa Cruz. Positions: T., Calif. Sch. FA (1944–46), Mills Col., Oakland, Calif (1945) [47]

HOWARD, Robert B., Mrs. See Kent, Adaline.

HOWARD, Sallie [P] Tuskegee, AL [01]

HOWARD, Stephen Colgate [P] St. James, NY b. 20 Jy 1912, Flushing, NY. Studied: NAD; G. Wiggins [40]

HOWARD, Wallace E. [P,L] Chicago, IL b. 2 D 1882, Shawneetown, MO. Member: Ridge AA; All-Ill. SFA. Exhibited: Howard Studio, Chicago, 1939; All-Ill. SFA; AIC [40]

HOWARTH, F.M. [I] Germantown, PA b. 1865 d. 22 S 1908. Work: Life; Puck; Judge. Position: Illus., a Chicago syndicate

HOWE, Allen [P] Brewster, MA [01]

HOWE, Arthur Virgil [Ldscp.P] d. Mr 1925, Troy, NY

HOWE, George [I] NYC. Member: SI [25]

HOWE, Gertrude Herrick [I] Hastings-on-Hudson, NY b. 6 Ag 1902, Canajoharie, NY. Studied: Mt. Holyoke Col.; PIASch; C. Hawthorne. Exhibited: AIGA; Studio Gld. Illustrator: books for leading publishers [47]

HOWE, J. Raymond [P] Alhambra, CA b. 7 D 1879, Chicago. Studied: AIC; Otis AI, Los Angeles [27]

HOWE, J. Theodore [Mar.P] NYC b. 1870, Boston, MA. Studied: NAD. Member: NYWCC; SC, 1897 [13]

HOWE, Jonas Holland [P] b. 1821, Petersham, MA d. 1898, probably MN. Studied: Boston, with Caroline Negus. Work: Hennepin Hist. S. Moved to Minn. before 1860. Cousin of George Fuller. [*]

HOWE, Katharine (L.) M(allett) [P,I,Des,T] NYC b. Norwich, CT d. 23 S 1957. Studied: Norwich Acad. A. Sch.; BMFA Sch.; ASL; P. Hale; H.H. Clark; G. Bridgman; J. Bindrum. Member: NAWA; Mystic AA. Exhibited: AWCS, 1943; Mystic AA, 1943–45; NAWA, 1944–46; Argent Gal., 1942, 1944–46. Author/Illustrator: children's books. Position: A., Des., Norcross Pub. Co., NYC, 1930– [47]

HOWE, Samuel [Mur.P] NYC [13]

HOWE, Susan Rosalind [P] Hammond, IN b. 28 My 1873, Manchester, IN. Member: Hoosier Salon; Hammond PS Lg.; Ind. Ar. C.; Soc. for Sanity in A. Exhibited: Lake County Fair, Ind., 1936 (prize), 1938 (prize), 1939 (prize) [40]

HOWE, Wallis E. [P] Providence, RI. Member: Providence AC [21]

HOWE, William H(enry) [Ldscp.P] Bronxville, NY b. 1846, Ravenna, OH d. 15 Mr 1929. Studied: Royal Acad., Düsseldorf, Germany; O. de Thoren, Vuillefroy, in Paris. Member: ANA, 1894; NA, 1897; SAA, 1899; NIAL; SC, 1891; A. Fund S. Exhibited: New Orleans, ca. 1895 (med); New Orleans Expo, 1885; Paris Salon, 1886, 1888 (prize); Paris Expo, 1889 (med); PAFA, 1890 (gold); Crystal Palace, London, 1890 (gold); Boston, 1890 (gold); Columbian Expo, Chicago, 1893 (med); Calif. Midwinter Expo, 1894 (gold); Atlanta Expo, 1895 (gold); Pan-Am. Expo, Buffalo, 1901 (med). Award: Chevalier Legion of Honor. Work: St. Louis Mus.; CI; Detroit Mus.; CMA; NGA; Grand Rapids AA [27]

HOWELL, Catherine M. [P,E,Li] New Orleans, LA b. 26 Ag 1892, East Feliciana Parish, LA. Studied: AIC; ASL. Member: New Orleans AG. Exhibited: New Orleans AG, Delgado Mus., 1934 (prize). Work: painting, White House, Wash., D.C.; the Cabildo, New Orleans [40]

HOWELL, Charles [I] NYC [19]

HOWELL, Claude Flynn [P] Wilmington, NC b. 17 Mr 1915, Wilmington, NC. Studied: J. Corbino, B. Karfiol; C. Rosen. Member: SSAL. Exhibited: WFNY, 1939; FWA Comp., Wash., D.C., 1940 (prize); Mint Mus. A., 1941, 1942–43, 1945, 1946; IBM, 1940 (prize); Pasadena AI, 1946; SSAL, 1946; N.C. State A. Soc., 1939 (prize), 1940–46; Raleigh, Greensboro, Charlotte, Wilmington, Greenville, all in N.C. (one-man shows) [47]

HOWELL, Felicie (Mrs. George W. Mixter) [P,T] NYC/Rockport, MA b. 8 S 1897 d. 1968. Studied: Corcoran A. Sch., with E.C. Messer; Phila. Sch. Des. for Women; H.B. Snell. Member: ANA, 1922; Phila. WCC; Concord AA; PS Gal., Assn.; NYWCC; Wash. WCC; AWCS; NAC. Exhibited: NAWPS, 1916 (prize); Concord AA, 1919; S. Wash. A., 1921 (med), 1922 (med); NAD, 1921 (prize); Wash. WCC, 1921 (med); AIC, 1921 (prize); State Fair, Aurora, Ill., 1922; Intl. WCC Exh., AIC, 1927 (prize). Work: CGA; NGA; Am. Legion Bldg., Gloucester, Mass.; John Herron AI; Telfair Acad., Savannah; MMA; NAC; Mus. City of N.Y.; Mystic Seaport Mus. Her husband was a yachtsman, and many of her watercolors were made while cruising the New England coast aboard their schooner "Teragram," including a 1937 series of the America's Cup races. In her early years her work was largely of interiors. Position: T., N.Y. Sch. Appl. A.&Painting, 1933 [47]

HOWELL, Helen [P,T] Cincinnati, OH. Studied: Cincinnati A. Acad.; ASL. Member: Women's C. Cincinnati; Cincinnati MacD. Soc. Position: T., College Prep Sch. for Girls, Cincinnati [40]

HOWELL, Josephine C. [P] NYC Member: S.Indp.A. [21]

HOWELL, Lucien b. Virginia. Studied: Fitz, in London; NGA; E. Moran; PAFA. Member: S. Wash. A. Exhibited: Omaha Expo, 1898 [98]

HOWELLS, Alice I(mogen) [P,B] NYC/Provincetown, MA b. Pittsburgh, d. ca. 1938. Studied: ACL; R. Henri; W. Chase; C.W. Hawthorne. Member: Wolfe AC; Provincetown AA. Exhibited: P.-P. Expo, San Fran., 1915 (med) [38]

HOWELLS, Gertrude Whitman [C] Las Cruces, NM b. 15 D 1865, Cambridge, MA d. ca. 1938. Studied: M. Mathieson, in Copenhagen. Member: Shuttlecraft Gld. Work: CMA [38]

HOWELLS, Ilka [P] Flushing, NY d. F 1942, Short Hills, NJ. Studied: Twachtman. She married Edward Dufner. [01]

HOWELLS, J.M. [P] NYC [15]

HOWELLS, Mildred [P,I] NYC b. 26 S 1872, Cambridge, MA. Studied: D.M. Bunker; A.H. Thayer [13]

HOWELLS, William Dean [W,Cr] b. 1 Mr 1837, Martin's Ferry, OH d. 10 My 1919. Member: AAL (Pres.); NIAL, 1915 (gold). Author: numerous novels, including "The Rise of Silas Lapham"; poems; plays; essays. Impressions of his life in Venice as U.S. Consul, 1861–65, are in "Venetian Life," 1866. He was well acquainted with artists of his day. Positions: Ed., Atlantic Monthly, 1866; Chief Cr., Harper's, 1886–92

HOWES, Alfred Loomis [Mur.P,Des,I] Clarksburg, WV b. 18 Ap 1906, Danbury, CT. Studied: NAD; Springfield Col. Exhibited: N.J. Gal.; Argent Gal. (one-man); Milwaukee AI (one-man). Work: John Lester Recording Laboratories; All Souls Church, Brooklyn, N.Y. Illustrator: "The Four Bremen Town Musicians" [47]

HOWES, Edith M.W. [P] Phila., PA [19]

HOWES, Edward Townsend [P,Et] Stamford, CT [10]

HOWITT, John Newton [I,P,L,T] White Plains, NY b. 7 My 1885, d. 24 Ja 1958. Studied: ASL; DuMond; W.A. Clark; H. Reuterdahl. Member: SC; Westchester ACG (Pres.). Exhibited: Westchester ACG, 1945 (prize). Illustrator: cover des., national magazines; adv. posters [47]

HOWLAND, Alfred Cornelius [P] NYC/Williamstown, MA b. 12 F 1838, Walpole, NH d. 17 Mr 1909, Pasadena, CA. Studied: Walpole Acad., with a Boston engraver; NYC; Royal Acad., Albert Flamm, both in Düsseldorf; Emile Lambinet, in Paris. Member: NAD, 1874; NA, 1882; A. Fund S., 1873; Century Assn. Work: Layton A. Gal., Milwaukee; Yale [08]

HOWLAND, Allen S. [Min.P] Boston, MA [15]

HOWLAND, Anna Goodhart (Mrs.) [P,T] Wash., D.C. b. Atchison, KS. Studied: Corcoran A. Sch. Member: Arts C. Wash.; Wash. WCC [40]

HOWLAND, Edith [S] Catskill-on-Hudson, NY b. Auburn, NY d. 8 S 1949. Studied: G. Michel; Saint-Gaudens; D.C. French. Member: NSS; NAWA. Exhibited: Paris Salon, 1913 [47]

HOWLAND, Elizabeth H. [P] Chicago, IL/Provincetown, MA. Member: NAWPS [27]

HOWLAND, Garth [Edu,P] Bethlehem, PA b. 25 Jy 1887, Charles City, IA d. 20 Ap 1950. Studied: Univ. N.Dak.; Harvard; Sorbonne, Paris; W.E. Baum; J. Guy; A. Finta. Member: CAA; Am. Veterans Soc. A. Exhibited: Am. Veterans Soc. A., 1940, 1941, 1946; Lehigh A. All., annually. Author: "Transactions of the Moravian Historical Society," "Pennsylvania History—John V. Haidt," other books. Position: T., Lehigh Univ., Pa., 1927– [47]

HOWLAND, George [P] Paris, France b. 12 F 1865, NYC d. 13 S 1928, France. Studied: Yale; Paris, with Benjamin-Constant, Laurens, Collin. Award: Chevalier Legion of Honor. Exhibited: Paris Salon, 1914, 1921 (med) [27]

HOWLAND, Georgiana [Ldscp.P] NYC. Studied: N.Y. Sch. A. Member: A. Workers C. for Women [08]

HOWLAND, Isabella [P] Woodstock, NY b. 3 O 1895, Brookline, MA. Member: Am. Soc. PS&G. Work: WMAA [40]

HOWLAND, John Dare [P] b. 1843, Zanesville, OH d. 1914, Denver. Studied: Paris, with Dumaresq, ca. 1862; again in Europe, 1872. Member: Denver AC, 1886 (founder). Work: Amon Carter Mus.; Colo. Hist S.; Denver AM. Position: Artist-correspondent, Harper's and Leslie's for the 1860s Indian Wars [*]

HOWLETT, Carolyn Syrluga [P,Gr,C,Des,W,L,T] Chicago, IL B. 13 Ja 1914, Berwyn, IL. Studied: AIC; Univ. Chicago; H. Gardner; F. Chapin; M. Artingstall. Member: Chicago SA; Western AA; Chicago A. Edu. Assn. Exhibited: AIC, 1932 (prize), 1945, 1946; Chicago Hist. Soc., 1942; Chicago SA, 1945. Author/Illustrator: articles on basketry. Position: T., AIC, 1937– [47]

HOWORTH, (Emma) Louis [P,B,T] Montgomery, AL b. Kosciusko, MS. Studied: Belhaven Col.; Huntingdon Col.; George Wash. Univ.; Columbia; Dixie A. Colony; Colo. State Col. Edu. Member: Miss. AA; Ala. AL; SSAL. Exhibited: Miss. State Fair, Jackson, 1925; Miss. State Col., 1936 (med); Dixie A. Colony Exh., Montgomery MFA, 1939 (prize). Work: Montgomery Mus. FA; Art Gal., Leila Cantwell, Seton Hall, all in Decatur, Ala.; Cary Art C., Belhaven Col.; Miss. Fed. Women's C. Bldg., Jackson [40]

HOXIE, E.E. [P] Boston, MA. Member: Boston AC [25]

HOXIE, George Richmond [Des,T,W] Oxford, OH b. 16 S 1907, Brookfield, NY. Studied: Montague Charman; Syracuse Univ. Member: Ohio WCS; AAPL; Cincinnati AC. Positions: T., Miami Univ. (Oxford, Ohio), Univ. Cincinnati [40]

HOXIE, Vinnie Ream (Mrs. Richard L.) [S] Wash., D.C. b. 25 S 1847, Madison, WI d. 21 N 1914. Studied: C. Mills, Wash., D.C., age 15. She was working on a statue of Pres. Lincoln when he was assassinated, and when Congress made an appropriation for a marble statue of Lincoln, she won the $30,000 prize. She then went to Paris and studied with Bonnât, and also to Rome where she studied with Majoli. While abroad she modeled Cardinal Antonelli and Liszt. Beside the Lincoln statue, which is in the rotunda of the Capitol, she did the figure of Admiral Farragut, which is also in Wash., D.C. She was the first woman to sculpt for the U.S. Gov., but gave up sculpture in 1878 when she married, becoming a popular Wash., D.C. hostess. [13]

HOYER, Ernest T.H. [P] Chicago, IL. Exhibited: Theobald Gal., Chicago, 1937; AIC, 1938. WPA artist. [40]

HOYER, Frans [P] Brooklyn, NY b. Dordracht, Netherlands. Studied: BM Sch.; Holland; Switzerland; Brackman; Brook; Picken; H.E.O. Campbell. Member: AAPL. Exhibited: Holland House Corp. of Netherlands, 1945; Little Gal., 1945 (one-man); Brooklyn SA, 1943; NYPL, Columbia branch, 1945; All.A.Am., 1946; AAPL, 1946 [47]

HOYLE, A(nnie) E(lizabeth) [P,I,T] Chevy Chase, MD b. 29 Ap 1851, Charlestown, WV d. 7 My 1931. Studied: Rouzee; Uhl; G.H. Story, in NYC; H. Mosler, in Paris; Académie Julian, Paris. Member: Wash. AC; AFA. Illustrator: "Forest Trees of Pacific Slope" and "Forest Trees of Rocky Mountains," by G.B. Sudworth, "Native American Forage Plants," by A.W. Sampson [31]

HOYLE, Ethel G. [Dec,C] NYC b. 5 D 1883, Norwood, MA. Studied: A.M. Sacker. Member: A. Gld. Specialty: bookplates [25]

HOYT, Alice P. [P] NYC [15]

HOYT, Andrew J. [P] Phila., PA b. 1847 d. N 1919. Associated with PAFA.

HOYT, Edith [Ldsp.P,I] Wash., D.C. b. 10 Ap 1894, West Point, NY. Studied: Corcoran Sch. A.; France; C. Woodbury; H.B. Snell. Member: Wash. WCC; Soc. Wash. A. Exhibited: BM, 1930; PAFA, 1931; AWCS, 1930, 1945; CGA, 1936; Joslyn Mem., 1937; Soc. Wash. A., 1916, 1917,

1922-43, 1946; Wash. WCC, annually; Hartford Atheneum, 1937. Work: Quebec Provincial Mus.; Quebec Hist. Mus.; Château Frontenac; Canadian Nat. Railways; Canadian steamships; Little Rock AA; Manoir Richelieu, Canada [47]

HOYT, Fred Kitson [Des,P,E,B] Pittsburgh, PA b. 31 Ja 1910, Mancelona, MI. Studied: CI; F., Tiffany Fnd. Member: Pittsburgh AA [40]

HOYT, Henry E. [P] NYC b. ca. 1833 d. 30 D 1906, Germantown, PA. Work: theatre curtains in NYC, best known being the curtain in the Metropolitan Opera House

HOYT, Henry M. [P] NYC b. 1887, Rosemont, PA d. 25 Ag 1920. Studied: PAFA; BMFA, with Tarbell, Benson; Europe. Work: photographic section of the Aviation Corps, WWI [19]

HOYT, Hettie J. [P,S,Des,I,W] Stamford, CT b. Harvard, IL. Studied: C. Von Marr; F.W. Heine; F. Grant. Member: AAPL. Work: D.A.R. Continental Hall, Wash., D.C.; Women's C., Col. Women's C., both in Milwaukee [40]

HOYT, Margaret (Howard Yeaton) [P,E,Dr] Lexington, VA/Gloucester, MA b. 1 Jy 1885, Baltimore d. 26 S 1943. Studied: G. deV. Clements; R. Bernstein; W. Meyerowitz; G. Demetrios. Member: Gloucester SA; North Shore AA; SSAL; VMFA; Wash. WCC [40]

HOYT, Mary Huntoon [P,E,L,En,T] Topeka, KS/ Paris, France b. 29 N 1896, Topeka. Studied: J. Pennell; Henri. Exhibited: Fifty Prints of the Year, 1928-29; dry point portrait, Salma (Kans.) AA. Position: T., Washburn Col., Kans. [31]

HOYT, Vivian Church (Mrs. W.J.) [P,W,L,Des,Dr,T] Oak Park, IL b. 28 N 1880, Walworth, WI. Studied: AIC; M. Baker; L. Millet; F. Richardson; J. Johansen; F. Freer. Member: Lg. Am. Pen Women; NIAL; Chicago NJSA; Chicago AL. Exhibited: Lg. Am. Pen Women, 1941 (prize), 1943 (prize); Oak Park A. Lg., 1944 (prize); AIC, 1932, 1935, 1938, 1941; Mandel's C. Bureau, 1938 (one-man); Kenosha A. Mus., 1940. Work: Raster Sch., Chicago; altarpiece, Erie Chapel. First painter of relativity landscapes. [47]

HOYT, Whitney Ford [P,Des] NYC b. 7 Jy 1910, Rochester, NY. Studied: Ecole des Beaux-Arts, Fontainebleau Sch. FA; C. Liausu, in Paris; G. Parker; F. Trautman; C. Peters. Member: All.A.Am.; CAFA; A. Fellowship, Inc; SC. Work: Springfield Mass., MFA; Rochester Mem. A. Gal. [47]

HRDY, Olinka (Miss) [Mur.P,Des] Los Angeles, CA. Studied: Univ. Okla.; Roerich Acad. A. Member: Assn. Okla. A. Work: murals, FA Bldg., Univ. Okla.; Riverside Studio, Convention Hall, both in Tulsa; Los Angeles Mus. Position: Associated with Acoustical Eng. Co., Los Angeles [40]

HRUSKA, George [Por.P] Chicago, IL b. 3 D 1892, Chicago. Studied: J.H. Vanderpoel; AIC; Munich. Member: Hamilton Park AC. Exhibited: Tuskegee Inst., Ala., 1914 (prize); Hall of Sc., Century of Progress, 1933 (prize). Work: Neighborhood Women's C., Chicago; Tuskegee Inst. [40]

HSIAO, Sidney C.T., Mrs. See Karawina, Ericka.

HUBACEK, William [P] San Fran., CA [17]

HUBBARD, Alice Cooper [S] Chicago, IL [15]

HUBBARD, Bess Bigham (Mrs. Chester A.) [Li,S] Lubbock, TX b. 18 F 1896, Ft. Worth. Studied: Chicago Acad. FA; with Stevens, Robinson, Gonzalez, Dozier, Britten, Zorach. Member: SSAL; Tex. S. Group; Tex. FA Assn. Exhibited: Audubon A., 1945; Laguna Beach AA, 1943; Ney Mus., 1943; Dallas Mus. FA; Northwest Pr.M.; SSAL; Tex. FA Assn.; P.&S. of Southwest; Sch. Am. Research Mus., Santa Fe, N.Mex.; Mus. FA, Houston; Univ. Tex., 1944, 1945; Witte Mem. Mus. Work: Colorado Springs FA Center; Dallas Mus. FA; Tex. FA Assn.; Ney Mus. [47]

HUBBARD, C(harles) D(aniel) [P,I,T] Guilford, CT b. 14 Jy 1876, Newark, NJ d. 18 S 1951. Studied: Yale; ASL; Kenyon Cox; John H. Niemeyer. Member: New Haven PCC. Exhibited: Ogunquit A. Center, 1946; New Haven PCC, 1937 (prize); 1945. Work: Hagaman Mem. Lib., East Haven, Conn. Author/Illustrator: "Old Guilford." Position: T., New Haven Commercial H.S. [47]

HUBBARD, Florence Tuttle [P,T] Long Island City, NY/Woodstock, NY b. 3 Jy 1892, Hartford. Studied: PIASch; Columbia; H. Lever; C. Rosen; Charles Martin; Elsie Ruffini; Albert Heckman. Member: NAWA; Woodstock AA. Exhibited: NAWA; Woodstock AA [47]

HUBBARD, Frank L. [P] NYC [24]

HUBBARD, Frank McKinney "Kin" [I] Indianapolis, IN b. O 1868, Bellefontaine, OH. Position: Caric., "News," since 1891 [21]

HUBBARD, Helen [C,T] Minneapolis, MN b. Darlington, WI. Studied: Downer Col. Member: Wis. Soc. Appl. A. Exhibited: Milwaukee AI, 1933 (prize) [40]

HUBBARD, L.M.B. [P] New Haven, CT [01]

HUBBARD, Marguerite (M. Gilliam) [P,T] Boulder, CO b. Boulder. Studied: Worcester A. Mus. Sch.; PAFA; ASL; Paris. Member: Boulder AG. Exhibited: Kansas City AI, 1925 (med). Position: T., Boulder County Sch. [40]

HUBBARD, Mary W(ilson) [P] NYC b. Ap 1871, Springfield, MA. Studied: ASL; Constant, in Paris. Member: NAWPS; NYWCC [40]

HUBBARD, Platt [P,E,Arch] Old Lyme, CT b. 2 N 1889, Columbus, OH d. 7 My 1946. Studied: Henri. Member: Lyme AA [40]

HUBBARD, Sidnee. See Neale, Russel, Mrs.

HUBBARD, Walter W(hiteley) [P,I,W,L,T] Phila., PA b. 15 Ap 1893, Phila. Studied: G. Scott, in Paris; M.L. Blumenthal; W.H. Everett. Member: Am. Assn. Car.&Caric. Editor/Publisher: "The American Art Student," "Commerical Artists." Position: Assoc. Ed., Cartoons Magazine [27]

HUBBARD, Whitney Myron [P,T] Greenport, NY b. 18 Je 1875, Middletown, CT. Studied: Wesleyan Univ.; ASL; DuMond. Member: CAFA; New Haven PCC; Brooklyln WCC. Exhibited: CAFA, 1924 (prize); NAD; FAPF; AWCS; Wash. WCC; BM; New Haven PCC; AIC; AFA; Montclair A. Mus. (one-man); Cornell (one-man); Wesleyan Univ. (one-man); St. Petersburg AC (one-man); Scranton Mus. (one-man); Utica Pub. Lib. (one-man); High Mus. A. (one-man); Binghamton Mus. (one-man). Work: Cahoon Mem. Lib., H.S., Southold, N.Y.; H.S., Greenport, N.Y. Position: T., Suffolk Conservatory of Music and Arts, Riverhead, N.Y. [47]

HUBBELL, Charles E. [Mur.P] NYC [15]

HUBBELL, Henry Salem [P,T] Miami, FL b. 25 D 1870, Paola, KS d. 9 Ja 1949. Studied: AIC; Paris, with Laurens, Constant, Collin, 1898; Acad. Carmen, with Whistler, 1901. Member: ANA, 1906; SC, 1905; Allied AA; Fla. SA (Pres., 1931).Exhibited: Paris Salon, 1901 (prize), 1904 (med), 1906, 1908; WMA, 1905 (prize); AIC, 1910 (med); Miami Pub. Lib., 1950 (memorial); Lowe AM, 1975 (retrospective). Work: Luxembourg Mus., Paris; Lille Mus.; Vanderpoel Coll.; Wilstach Coll., Phila.; Union Lg. C., Phila.; Grand Rapids AA; Dept. Interior, Wash., D.C. Hubbell was one of only several students of whom Whistler thought highly. He worked at Giverny (1909) and was a friend of Monet and MacMonnies. Had a studio in NYC (1911), then Silvermine (1912-16). Later in life, painted portraits, including one of Franklin Delano Roosevelt. Positions: T., CI (1918-21), Univ. Miami (1925- ; one of founders) [47]

HUBBELL, Katherine [S] NYC [21]

HUBBELL, Rose Strong (Mrs. Henry S.) [P] Paris, France. Studied: AIC [10]

HUBER, Helen Ruth [W,L,P,Cr] Gary, IN b. 19 Mr 1902, East Chicago, IN. Studied: Chicago Acad. FA; Univ. Chicago; Northwestern Univ.; G. Bolande, R. Chase. Member: Western AA; Chicago A. Edu.; Ind. Artists C.; Hoosier Salon. Exhibited: Northern Ind. A., 1946; Gary, Ind., 1945; East Chicago, Ind., 1945. Positions: T., Pub. Sch. Gary, Ind.; A. Cr., Gary Post-Tribune [47]

HUBER, Leo [P] Long Island, NY/Schoharie, NY b. 1886, Switzerland. Studied: ASL; J. Sloan, C.M. Prior. Member: Allied AA; S.Indp.A.; Salons Am.; Long Island SA; Queens Allied AC. Work: Mus. Newark (N.J.); Mus. FA, Houston [40]

HUBERT, August [S] Chicago, IL [15]

HUBERT-ROBERT, Marius [P,I] NYC/Paris, France b. 22 Je 1885, Paris. Studied: Ecole des Beaux-Arts, Paris; L.H. Robert. Member: Salon des Artistes Français, Salon des Indépendants, Salon d'Automne, all in Paris. Exhibited: BM, 1924; Calif. Sch. FA; Salons in Paris, Buenos Aires, Rio de Janeiro, Nice, Cannes; U.S. (many one-man exh.). Work: CGA; Albright A. Gal.; Pal. Leg. Honor; SAM; museums in Montreal and Vancouver; Luxembourg, Musée de la Guerre; Musée des Invalides, all in France; Mansion House, London. Illustrator: Limited Edition books; national, foreign magazines [47]

HUCKEL, Christiana [P] NYC [19]

HUDDELL, William Henry [Por.P] b. 1847, Wytheville, VA d. 1892, probably Austin, TX. Studied: his cousin, Flavius Fisher, Lynchburg, Va., 1865; NAD, 1875; ASL, with Wilmarth; Munich, 1884-85. (His studio was in Austin by 1876.)Work: Dallas Mus. FA; Tex. State Capitol; portraits, past governors of Tex., 1884 [*]

HUDGINS, Mary Margaret [Por.P,T] Wash., D.C. b. 19 O 1903, Mobile, AL. Studied: Corcoran Sch. A. Member: Wash. S.Indp.A. Work: Columbus Univ., Wash., D.C. [40]

HUDNUT, Alexander M. [P] NYC/Allenhurst, NJ b. Princeton, NJ. Member: SC; Century Assn.; Lotos C.; NYWCC; Grolier C. [29]

HUDNUT, Joseph [P] Charlottesville, VA. Member: SC. Associated with McIntire Sch. FA, Univ. Va. [27]

HUDSON, Anna Hope [P] London, England b. NYC. Studied: Aman-Jean, Carrière, in Paris [10]

HUDSON, Charles Bradford [P,W] Pacific Grove, CA b. 27 Ja 1865, Ontario, Canada d. 27 Je 1938. Studied: Brush; Chase; Bouguereau, in Paris. Exhibited: Expo, Bergen, Norway, 1898 (med); Paris Expo, 1900 (med). Work: BMFA; Calif. Acad. Sc., San Fran.; Presidio of Monterey, Calif.; Royal Gal., Sweden; Dominion Gal., New Zealand; private coll. Author: "The Crimson Conquest," "The Royal Outlaw"; magazine articles [38]

HUDSON, Charles W(illiam) [P] Boston, MA/Thornton, NH b. 21 Ag 1871, Boston d. 12 Je 1943. Studied: BMFA Sch. Work: FMA; Boston City C.; Middlesex Sch., Concord, Mass.; Beloit Col., Wis. [40]

HUDSON, Edith F(razier) (Mrs. C.E.) [P] Dallas, TX b. Centralia, IL. Member: Reaugh AC; Highland Park Soc. Arts; SSAL; AAPL. Exhibited: Ann. Allied A. Exh., Dallas Pub. A. Gal., 1929 (prize) [33]

HUDSON, Elmer F(orrest) [Mar.P] Monhegan Island, ME b. 14 Ag 1862, Boston d. 1932. Member: Boston AC; Copley S., 1895; SC [33]

HUDSON, Eric [Mar.P] NYC/Monhegan Island, ME b. Boston d. 22 D 1932, Rockport, MA. Studied: Member: ANA; North Shore AA; SC; NAC (life); Allied AA; Rockport AA. Exhibited: Sesqui-Centenn. Expo, Phila, 1926 (med); North Shore AA, 1929 (prize); NAD, 1931 (prize) [31]

HUDSON, Grace Carpenter (Mrs. John W.) [P,I,T] Ukiah, CA b. 21 F 1865, Potter Valley, CA d. 1937. Studied: Mark Hopkins Inst., San Fran.; Virgil Williams. Exhibited: Mark Hopkins Inst. (med); San Fran. Industrial Expo; Columbian Expo, Chicago, 1893 (prize). Specialty: Indian children. (She also painted Hawaiian children, in 1901.) She made two long European tours with her husband, who was an ethnologist for the Field Mus. [10]

HUDSON, Henrietta (Mrs.) [I,W,T] Bolton Landing-on-Lake George, NY b. 9 My 1862, Hudson City, NJ. Member: NAC. Illustrator: "The Blue Veil," "Roses Red" [33]

HUDSON, John Bradley [Mar.P] Boston, MA b. 1832, Portland, ME d. 1903, Weston, MA. Studied: C.O. Cole, in Portland. Exhibited: Boston Athenaeum. Work: BMFA; Colby Col. Active in Portland, late 1850s–late 1890s. [01]

HUDSON, Kenneth Eugene [Edu,P] St. Louis, MO. b. 28 D 1903, Xenia, OH. Studied: Ohio Wesleyan Univ.; Royale, Brussels, Belgium; Yale; Fontainebleau Sch. FA, France. Exhibited: Belgian-Am. Edu. Fnd., 1935. Work: Univ. Oreg.; Municipal Bldg., Columbia, Mo. Positions: T., Univ. Oreg., 1927–29, Univ. Mo., 1928–38; Dean, Sch. FA, Wash. Univ., St. Louis, 1938– [47]

HUDSON, Kenton Warne [P,Des,Gr] Drexel Hill, PA b. 8 My 1911, Phila. Studied: Phila. Graphic Sketch C.; PMSchIA; E. Horter. Member: Phila. A. All.; Phila. WCC. Exhibited: PAFA, 1942–45; Phila. A. All., 1945 (one-man); Phila. WCC, 1943–45; Phila Pr. C., 1936–39 [47]

HUDSON, Mabel Ruth [P] NYC. Exhibited: NAWPS, 1935–39 [40]

HUDSON, Ralph M. [Edu,Des,P,W,L,I] Columbus, MS b. 18 D 1907, Fields, OH. Studied: Ohio State Univ. Member: AAPL; Ark. WC Soc.; Ark. Edu. Assn.; Am. Assn. Univ. Prof. Exhibited: Morehead, Ky., 1931–32, 1933–36; Hendrix Col., 1940–41 (one-man); Univ. Ark.; Little Rock Mus. FA; Ky. A.T. Traveling Exh., 1931–36; Ark. WC Soc., 1937–40; Grumbacher's Exh., 1938. Work: Mus. FA, Little Rock, Ark.; Univ. Ark. Contributor: Design magazine; Arkansas Historical Quarterly. Positions: T., Morehead (Ky.) State T. Col., 1931–32, 1933–36, Univ. Ark., 1936–46, Miss. State Col. for Women, 1946– [47]

HUDSPETH, Robert Norman [Min.P,C,S,L,T] Concord, MA b. 2 Jy 1862, Caledonia, Ontario. Studied: Académie Julian, Paris; Bouguereau; Ferrier; Baschet; Schommer. Member: Boston SAC; Gloucester SA. Exhibited: Paris Salon, 1933 (prize) [40]

HUDSPETH, Rosalie (Mrs. Robert N.) [Min.P] Concord, MA b. 19 Je 1882, Brooklyn, NY. Studied: Yale; G. Bridgman; ASL; Acad. Delacluse, Paris [40]

HUEBNER, Richard Harris [C,Des,T] Wheeling, WV b. 8 Je 1911, Wheeling. Studied: Alfred Univ., with C.F. Binns; Ohio State Univ., with A.E. Baggs. Exhibited: Columbus Gal. FA, 1934 (prize); Intl. Expo, Paris, 1937 (gold). Work: Intl. Expo. Arts & Techniques in Modern Life, Paris. Position: T., Byrd H.S., Shreveport, La. [40]

HUEBSCH, Daniel A. [P] Cleveland, OH. Member: Cleveland SA [25]

HUELSE, Carl [P] Phila., PA [25]

HUESTIS, Joseph W. [P] Brooklyn, NY. Member: S.Indp.A. [25]

HUEY, Florence Greene (Mrs. J. Wistar) [Min.P] Ruxton, MD b. 13 Ag 1872, Phila. d. 31 My 1961. Studied: PAFA; DeCamp; Beaux; G. Clements; Thouron. Member: Pa. Soc. Min. P. Exhibited: Baltimore WCC, 1927 (prize); Pa. Soc. Min. P.; ASMP; Chicago World's Fair [47]

HUF, Karl (Philip) [P,I] Phila., PA b. 28 S 1887, Phila. d. 1937. Studied: PAFA; Chase; Breckenridge; Anshutz; Weir; McCarter. Illustrator: Ladies Home Journal, newspapers, magazines. Position: Asst. A. Dir., F. Wallis Armstrong Co., Phila. [33]

HUFF, William Gordon [S] Berkeley, CA b. 3 F 1903, Fresno, CA. Exhibited: Oakland A. Gal., 1937 (prize). Work: Civil War Mon., Bennington, Vt.; Professor Fay Mem., Tufts Col., Mass.; Francis Marion Smith Mem., Oakland Calif.; Chief Solano Mon., Solano County, Calif.; Berkshire Mon. (Revolutionary War), Walloomsac Heights, N.Y. [40]

HUFFINGTON, John C. [Mar.P,I,T] Darien, CT b. 5 F 1864, Brooklyn, NY d. 3 My 1929 (on his houseboat in Five Mile River). Studied: self-taught; through early association with artists in his father's art store, he became adept at painting. Member: NYWCC; CAFA. Exhibited: NAD, while still a schoolboy; NYWCC. At height of career he became blind, but ca. 1925 his vision was restored and he resumed painting. [27]

HUGER, Emily H(amilton) [P,C,L,T] Lafayette, LA b. 11 Ja 1881, New Orleans d. 21 F 1946. Studied: E. Woodward; Chase; H. Breckenridge; Newcomb A. Sch. Member: NOAA; EAA; SSAL; AFA. Position: T., Southwestern La. Inst. [40]

HUGER, Katherine M. [P] NYC b. Charleston, SC. Member: NYWCC; Women's AC. Exhibited: New Orleans Centenn. (prize) [01]

HUGGER, Gustave [P] Cleveland, OH [08]

HUGGINS, Estelle Huntington [P] Leesburg, OH b. 28 Ag 1867, Brown County, OH. Studied: Columbus A. Sch.; ASL; Member: Am. Ar. Prof. Lg. Exhibited: Columbus, Ohio (one-man); Leesburg, Ohio (one-man) [40]

HUGHES, Alan [I] Roslyn Heights, NY. Member: SI [47]

HUGHES, D(aisy) Marguerite [P,T,Li] Los Angeles, CA/Provincetown, MA b. Los Angeles. Studied: Univ. Calif.; ASL; G.E. Browne; G. Birdgman; L.E.G. Macleod; R. Schaeffer. Member: Calif. AC; Calif. WCS; All.A.Am.; NAWA; Calif. WC Soc.; A. T. Assn. Southern Calif.; Provincetown AA. Exhibited: NAD; CGA; NAWA; All.A.Am.; Los Angeles Mus. A.; Babcock Gal. (one-man); Montross Gal., 1939 (one-man). Position: T., Pub. Sch., Los Angeles [47]

HUGHES, Ethel Parrot (Mrs. J.T.) [P] Kingston, NC [24]

HUGHES, George [Por.P] Paris, France b. 1863, Albany d. 7 Mr 1932, Albany. Studied: Paris, with Bonnât, Laurens, seven yrs. Opened studio in N.Y.; later established himself in his native city. Work: portraits, state bldgs. in Albany [13]

HUGHES, George E. [I,P] Winscott, NY. Member: SI. Exhibited: PAFA, 1937, 1938; AIC, 1939 [47]

HUGHES, M.A. (Mrs.) [P] Salt Lake City, UT [15]

HUGHES, Margaret M. [P] NYC. Member: Bronx AG [27]

HUGHES, Phillipa [P] Paducah, KY. Exhibited: Am. WC Soc., 1933, 1934; NAWPS, 1935–39 [40]

HUGHES, Roy V. [P,I] Pittsburgh, PA b. 14 F 1879, Elmira, NY. Studied: ASL, with DuMond. Member: Assn. A. Pittsburgh. Work: One Hundred Friends of Pittsburgh Art [33]

HUGHES-MARTIN, Agnes (Mrs.) [P,I] Boston, MA b. 11 D 1898, Claremorris, Ireland d. 18 F 1930. Studied: H.G.R. Martin. Member: Boston S.Indp.A. [29]

HUGHS, Mildred [S] Houston, TX. Exhibited: All-Tex. Ann., MFA, Houston, 1940 (prize) [40]

HUGHS, Tincie [P] San Angelo, TX b. San Angelo. Studied: R. Bassett; X.

Gonzales; H.K. Kendall. Member: Tex. FA Assn.; SSAL; San Angelo AC. Exhibited: SSAL, 1938; Studio Gld., N.Y. Work: mural, Ch. of Christ, County Court House, San Angelo [40]

HUGO, Ian [E] NYC. Member: SAE [47]

HUGO, Joseph [P] Pittsburgh, PA. Member: Pittsburgh AA [25]

HUGO, Leopold [Photogr] b. 1860s, Prussia d. 1933 La Jolla, CA. Work: Amon Carter Mus.; Monterey MA. Specialty: trees and seascapes at Monterey. His studio was at La Jolla by 1913. [*]

HUGY, Alice Elizabeth [P] St. Paul, MN [24]

HULBERT, Charles Allen [P,I,S] South Egremont, MA b. Mackinac Island, MI d. 21 S 1939. Studied: PAFA; MMA A. Sch.; Artist-Artisan Inst., N.Y. Member: SC; Brooklyn PS; Pittsfield (Mass.) AL. Work: Pub. Lib., Erie, Pa.; portrait, Capitol, Albany, N.Y. [40]

HULBERT, Katherine Allmond (Mrs. Charles A.) [I] South Egremont, MA b. Sacramento Valley, CA. Studied: San Fran. Sch. Des.; NAD; J.W. Stimson. Member: NAWPS; Brooklyn PS; Pittsfield (Mass.) AL. Work: Lib., Girls H.S. Brooklyn [40]

HULETT, Charles Willard [P,T,Car,I,Des] Hollywood, CA b. 25 Jy 1903, Fairmount, IN. Studied: Otis AI, Los Angeles; T. Lukits; C. Von Schneidau; R. Holmes; Will Foster. Member: P.&S. C. Los Angeles; Calif. AC; San Fernando Valley AC. Exhibited: San Fernando Valley AC, 1946 (prize); Palos Verdes Gal.; Clearwater A. Mus.; Raymond & Raymond Gal.; Santa Paula, Calif.; Los Angeles Mus. A.; Ebell Salon, Stendahl Gal.; State Bldg., Expo Park, all in Los Angeles; Pasadena Pub. Lib.; San Gabriel Ar. Gld. Illustrator: "They Call It California" [47]

HULL, A.G. [I,Mur.P] NYC. Work: 3 WPA murals, Norwalk (Conn.) H.S. [19]

HULL, Lester Theodore [Ldscp.P,E,S,B,T] Chicago, IL b. 23 My 1888, Chicago. Studied: AIC; D. Ericson; Lorado Taft; W. Sargent. Member: Topeka PM; Chicago NJSA [40]

HULL, Marie Atkinson (Mrs. Emmett J.) [P,T] Jackson, MS b. Summit, MS. Studied: PAFA; ASL; Broadmoor A. Acad.; J. Carlson; R. Reid; R. Vonnoh; G.E. Browne. Member: SSAL; NOAA; Miss. AA; Wash. WCC; AWCS; NAWA. Exhibited: SSAL, 1926 (prize), 1929 (prize), 1931 (prize); San Antonio, Tex., 1929 (prize); Springville, Utah (prize); Miss. AA, annually, 1920 (gold); New Orleans ACC, 1932 (prize); New Orleans AA, 1932 (prize), 1935 (prize); AFA Traveling Exh., 1929–40; AIC, 1928, 1938; WFNY, 1939; GGE, 1939; PAFA; AWCS; SSAL, annually; CM; Davenport Mus. A.; NAWA; BMA; Wichita Mus. A.; BM. Work: Witte Mem. Mus.; Springville (Utah) Mus.; Miss. AA; Municipal A. Gal., Miss. State Capitol, Governor's Mansion, all in Jackson; Hinds County Court House, Port Gibson (Miss.) Pub. Lib.; Miss. State Col.; Univ. Miss.; Tex. State T. Col.; Meredith Col., N.C.; Blue Mountain Col.; Belhaven Col., Miss.; Southwestern Tex. Normal Sch.; Young Univ., Provo, Utah; State Fed. C. Bldg., Miss.; Public Coll., Abilene, Tex. [47]

HULL, Nellie Evangel [P,T] Chicago, IL b. Chicago. Studied: AIC; Lhote, in Paris; H.V. Poor. Exhibited: Ar. Chicago Vicinity Ann., AIC, 1939; Colorado Springs FA Center [40]

HULME, James Sanford [P,I] NYC b. 25 N 1900. Studied: AIC. Member: Brooklyn SA; FA Gld. Am.; Hudson Valley AA; Chappaqua A.&Cr. Gld. Work: Grange C., Bangall, N.Y.; Wesleyan Col., Macon, Ga.; Knaben-Vokschule, Gustrow, Macklenburg, Germany. Illustrator: "Robbers' Roost," by Zane Grey, 1933 [40]

HULME, W.O. [P] Wash., D.C. [19]

HULSE, Marion Jordan Gilmore [P,S,Des,I] Minneapolis, MN b. Ottumwa, IA. Studied: BMFA Sch.; ASL; Univ. Ky.; Am. Acad. A. Exhibited: Iowa State Fair; Ottumwa A. Center; Iowa State Col. Work: USPOs, Corning, Corydon, both in Iowa. WPA artist. [47]

HULSE, Robert Harley [T,P,Des,L] Minneapolis, MN b. 1 Ap 1915, Malcom, IA. Studied: Grinnell Col.; Minneapolis Sch. A.; Univ. Ariz.; Univ. Minn. Exhibited: Minn. State Fair, 1937; Iowa State Fair, 1938, 1939; Minn. Inst. A., 1943–45; Univ. Minn. (one-man). Position: T., Univ. Minn. [47]

HULT, Harry [I] NYC. Member: SI [47]

HULTBERG, Charles [P] New Orleans, LA [17]

HULTEEN, Rubert J. [C] Hartford, CT/Old Saybrook, CT b. 17 Ja 1916, Brockton, MA. Studied: C.K. Nelson; M. Fosdick; C. Harder. Specialty: ceramics [40]

HUMANN, O. Victor [P,T] Worcester, MA/Ipswich, MA. Studied: AIC; ASL; Columbia. Member: CAFA; Worcester Gld. A&Cr. Work: Worcester A. Mus. [40]

HUMBER, Yvonne Twining [P,T] Seattle, WA b. 7 D 1907, NYC. Studied: NAD; Tiffany Fnd.; C. Hawthorne. Member: Women Painters, Wash.; Lg. Am. Pen Women. Exhibited: Women Painters, Wash., 1945 (prize); Lg. Am. Pen Women, 1946 (prize); Pal. Leg. Honor, 1946; NAD, 1935; WFNY, 1939; SAM, 1944, 1945 (prize); Inst. Mod. A., Boston, 1939, 1941; Spokane, Wash., 1945, 1946; Stockbridge, Mass., 1934–37 (prize); Macy Gal., 1933-36; Contemporary A. Gal., 1940; PMG, 1937; Three AC, 1929 (one-man), 1930 (one-man), 1931 (one-man). Work: SAM [47]

HUMES, Ralph Hamilton [S] Coconut Grove, FL b. 25 D 1902, Phila. Studied: PAFA; Laessle; C. Grafly. Member: NSS; CAFA; New Haven PCC; Soc. Wash. A.; Blue Dome F. Exhibited: PAFA, 1929, 1930 (prize), 1931–34; NAD, 1932 (prize), 1933, 1935, 1937 (prize), 1940, 1945; New Haven PCC, 1932 (prize), 1933, 1934, 1936 (prize), 1939; Soc. Wash. A., 1932 (prize), 1937 (prize); CAFA, 1934, 1936 (prize), 1937, 1939, 1941 (med); Fla. Fed. A., 1938 (prize). Work: Brookgreen Gardens, S.C.; fountain, Coral Gables, Fla.; PAFA, Chester Springs, Pa. [47]

HUMPHREY, David W. [P,C,G] Noroton, CT b. 28 F 1872, Elkhorn, WI. Studied: AIC; Académie Julian, Paris. Member: Silvermine Gld. A.; Darien Gld. Seven A. Exhibited: NAD; AIC; Stamford Mus. A.; Rockefeller Center, N.Y. Work: Newark (N.J.) Mus.; Cove Sch., Stamford, Conn.; Royal Sch., Darien, Conn. [40]

HUMPHREY, Elizabeth B. [P,I] NYC (after 1867) b. before 1850, Hopedale, MA. Studied: CUASch; W. Whittredge. Illustrator: "Beyond the Mississippi" [*]

HUMPHREY, Florence (Mrs.) [P] Chicago, IL [01]

HUMPHREY, Francis S. [P] NYC [17]

HUMPHREY, Don [P] Hartland, WI. Exhibited: 48 Sts. Comp., 1939 (prize); Wis. Salon A., 1938. Work: USPO, St. Paul, Minn. [40]

HUMPHREY, Fred P. [P] Minneapolis, MN [24]

HUMPHREY, Mabel [I] NYC [01]

HUMPHREY, Maud (Mrs. B. De Forest Bogart) [I] NYC b. Rochester, NY. Studied: ASL; Académie Julian, Paris, with Dupré. Member: Women's AC. Exhibited: AWCS, 1898 [01]

HUMPHREY, Walter Beach [I,P,T] New Rochelle, NY b. 22 N 1892, Elkhorn, WI. Studied: Dartmouth; ASL, with DuMond. Member: New Rochelle AA. Exhibited: New Rochelle AA, 1922–46. Work: Dartmouth; New Hampton Sch. Positions: T., Albert Leonard H.S., New Rochelle, 1941– , Phoenix A. Inst., N.Y. [47]

HUMPHREYS, Albert [P,S] NYC b. Cincinnati. Studied: Gérôme, Robert-Fleury, A. Harrison, in Paris. Member: Paris Sketch C.; Intl. Soc. P., Paris. Exhibited: Paris AAA (prize). Work: Detroit Inst. A.; Boston Pub. Lib.; NGA; Children's fountain, South Manchester, Conn. [21]

HUMPHREYS, Beatrice Jackson [P] Paris, France b. 25 D 1905, London. Studied: G.E. Browne. Member: Allied AA [40]

HUMPHREYS, David [P] Paris, France b. 22 Jy 1901, Morristown, NJ. Studied: G.E. Browne. Member: SC; Allied AA; Societé Nationale des Beaux-Arts, Paris [40]

HUMPHREYS, Malcolm [P] Concarneau, France b. 7 N 1894, Morristown, NJ. Studied: J.H. Carlson; C.W. Hawthorne; G.E. Browne. Member: SC; Allied AA; AFA; Palm Beach AL; Grand Central Gal. Assn.; AAPL. Exhibited: NAD, 1929 (prize); Allied AA, 1929 (prize); Paris Salon 1931 (prize). Work: NAD; FA Center, Little Rock, Ark. [40]

HUMPHREYS, Maria Champney (Mrs. John Sanford) [Min.P] Deerfield, MA/NYC b. 18 S 1876, Deerfield, MA d. 1 D 1906, New Rochelle, NY. Studied: Chicago AI; Mme. Noemie Schmitt, V. Reynolds. Member: Women's AC, N.Y. Exhibited: Paris Salon, 1900. Work: throughout U.S. Daughter of J. Wells Champney. [06]

HUMPHREYS, Sallie Thomson [Des,P,L,T,Dec,C] Delaware, OH b. Delaware, OH. Studied: Ohio Wesleyan Univ.; ASL; AIC; FMA; Colarossi Acad., Paris; E. O'Hara; F. Wilcox; C. Gaertner. Member: AFA; Am. Assn. Univ. Prof.; Wash. WCC; Ohio WC Soc.; Wash. AC; Cincinnati Women's AC; Alliance; College AA. Exhibited: NGA (one-man); CM (one-man); CGA, 1946; Ohio WC Soc. Traveling Exh., 1941, 1942, 1943, 1945, 1946; Cincinnati Women's AC, 1941–46; Butler AI, 1942, 1944, 1945. Specialty: textile design. Position: T., Ohio Wesleyan Univ., Delaware, Ohio, 1906– [47]

HUMPHREYS-JOHNSTONE, John. See Johnston, John.

HUMPHRIES (OR HUMPHRISS), Charles Harry [S] NYC b. 1867, England. Member: NSS, 1908; S.Indp.A. Exhibited: N.Y. Acad. Des.; PAFA (prize); P.-P. Expo, 1915. Specialty: Indians [33]

HUNDLEIGH, William T. [P] Georgetown, KY b. 1848, Central, KY d. S 1916. Studied: Cincinnati A. Acad.

HUNEKER, Clio Hinton. See Bracken, Mrs.

HUNIPAL, Frank R. [P] Oak Park, IL. Member: Chicago NJSA [25]

HUNLEY, K(atharine) J(ones) [P,L,T,C,I] Redlands, CA b. 12 S 1883, Beacon, IA. Studied: AIC; Colo. State Col.; Chicago Acad. FA; Batcheor Sch. A., Pasadena, Calif. Member: Calif. AC; Laguna Beach AA. Exhibited: Southwest Mus., Los Angeles; Calif. AC; Los Angeles Lib. Traveling Exh. Work: Redlands Univ.; Contemporary C., Redlands. Specialty: book jacket des. [47]

HUNNER, Isabella S(tevens) [P] Baltimore, MD/Pasadena, MD b. 12 N 1903, Baltimore. Member: Baltimore Mus. A.; Soc. Baltimore Indp. A.; S.Indp.A. [33]

HUNT, A.W. [P] St. Paul, MN [19]

HUNT, Charles D. [Ldscp.P] Brooklyn, NY b. 1840, Detroit d. 25 S 1914. Studied: Wyant, Kensett, in NYC. Member: B.&W. Cl. Exhibited: NAD; Brooklyn AC [01]

HUNT, Clyde du Vernet [S] NYC b. 1862, Glasgow, Scotland (came to U.S. before 1898) d. 1 F 1941, Wash., D.C. Work: CGA; MMA [01]

HUNT, Dorothy H.W. (Mrs. S. Foster) [P] Providence, RI. Exhibited: NAWPS, 1935–38 [40]

HUNT, E. Aubrey [P] Sussex, England b. 7 F 1855, Weymouth, MA d. 22 N 1922, Hastings, England. Studied: Paris, with Gérôme. Member: English AC, London. Work: Leeds Gal. A.; Leicester Gal. A., England [21]

HUNT, Emma Gates (Mrs. George J.) [C] Boston, MA/Belmont, Nova Scotia b. 26 N 1871, Londonderry, Nova Scotia. Studied: G.J. Hunt. Member: Boston SAC; Phila. ACG; NYSC. Specialty: jewelry [40]

HUNT, Esther [P,S] NYC b. 30 Ag 1885, NE. Studied: W. Chase. Member: Laguna Beach AA. Exhibited: P.-P. Expo, San Diego, 1915 (gold) [33]

HUNT, F. Marcia [P] Cincinnati, OH. Member: SWA. [01]

HUNT, Helen Dunlap [Min.P] Phila., PA [04]

HUNT, Helen Zerbe [I] NYC/Massillon, OH b. 8 D 1905, Massillon. Studied: Smith Col.; Cleveland Sch. A. Specialties: illus., geology, paleontology, zoology. Position: Scientific Illus., Dept. Mammalogy, AMNH [40]

HUNT, James M.W. [G,P] b. 1855, Detroit, MI d. 16 S 1935, East Orange, NJ. Exhibited: Phila. Centenn., 1876 (prize)

HUNT, Leigh (Dr.) [E,T,L] Flushing, NY b. 19 My 1858, Galena, IL d. 1937. Studied: H. Farrer. Member: A. Fund S.; SAE; Haden EC; Arti et Amicitae, Holland; B.&W. Cl.; NAC [38]

HUNT, Lynn Bogue [I,P] NYC d. 12 O 1960, Mineola, NY. Member: SI; Phila. Sketch C.; Alliance. Illustrator: Saturday Evening Post; Collier's [47]

HUNT, M(abelle) Alcott (Mrs.) [P,B,T] Savannah, GA b. 1 S 1898, NYC. Studied: Savannah Sch. A.; Adelphi Inst., Brooklyn, with Whittaker, Holland. Member: Savannah AC [33]

HUNT, Margaret L. [P,T] Buffalo, NY b. 14 Ja 1914, Buffalo. Studied: Univ. Buffalo; Buffalo Sch. FA; Buffalo AI. Member: The Patteran. Exhibited: Albright A. Gal., 1937; Town C., Buffalo. Position: T., Bd. Edu., Buffalo [40]

HUNT, Mary Isabel [P,I,Min.P] Chicago, IL b. New London, NY. Studied: NYC, with Reaser; Chicago; Acad. Julian, Acad. Delecluse, both in Paris. Member: Pa. Soc. Min. P. [10]

HUNT, P.C. [P] Brookline, MA. Member: Boston AC [29]

HUNT, Rachel McMasters Miller (Mrs. Roy Arthur) [C,Des,L,W] Pittsburgh, PA b. 30 Je 1892. Studied: with E. Bakewell; T.T. Cobdon-Sanderson, in London. Member: Pittsburgh AA; Gld. Bookworkers, N.Y. Specialty: bookbinding [40]

HUNT, Rosamond Pier (Mrs. William Morris) [P] Milton, MA b. 8 D 1916, Milton. Studied: Child Walker Sch., Boston; E. O'Hara; L.B. Smith. Member: boston AC; NAWPS. Exhibited: NAWPS; Am. WC Soc.; NYWCC, 1939 [40]

HUNT, Sybil G. [P] Indianapolis, IN [19]

HUNT, Thomas [P] NYC. Member: NYWCC [25]

HUNT, Thomas L. [P] Laguna Beach, CA [25]

HUNT, Una Clarke (Mrs. Arthur P.) [P,I] Pasconaway, NH b. 6 Ja 1876, Cincinnati. Studied: BMFA Sch.; D.W. Ross. Member: Wash. WCC. Work: reredos, St. Michael's Church, Geneseo, N.Y. [33]

HUNT, Will Harvey [Mur.P,Des,Dr] Indianapolis, IN b. 13 Je 1910, Indianapolis. Studied: W. Forsyth; D.M. Mattison; H.M. Mayer; John Herron A. Sch. Member: Ind. AC. Exhibited: Hoosier Salon, 1935, (prize); John Herron A. Sch., 1935 (prize); Block Gal., Indianapolis, 1936 (prize). Work: Northwestern Univ. Coll., Chicago; ceiling dec., James Whitcomb Riley Hospital for Children, Indianapolis. Position: A., Display Depart., H.P. Wasson and Co. [40]

HUNT, William Morris [P,Mur.P,Por.P] Boston, MA b. 31 Mr 1824, Brattleboro, VT d. 8 N 1879, Isle of Shoals, NH (drowned; probably a suicide). Studied: Harvard; Düsseldorf; T. Couture, in Paris, 1847–53; Barbizon, with Millet, 1853–55. Exhibited: BMFA, 1979 (retrospective). Hunt was Boston's leading portrait painter from 1850–70. More than any other artist he was responsible for spreading the influence of Millet and the French Barbizon school in the U.S. He was also an important teacher, conducting classes in Boston by 1868, largely attended by women whose careers he firmly championed. He influenced many artists, including Winslow Homer. His teaching philosophy is captured in Helen Knowlton's volumes "Talks on Art" (1875, 1883) and her "Life of William M. Hunt," 1899. Although his murals for the Albany State Capitol (commissioned 1878) received acclaim, funding was vetoed, leaving Hunt depressed and, perhaps, leading him to suicide. [*]

HUNTER, David Charles [P,S,T] Chicago IL b. 1865, England d. 29 Jy 1926. Studied: AIC; J. Gelert. Member: Palette & Chisel C.; Chicago Arch. C. Position: Northwestern Terra Cotta Co., Chicago [25]

HUNTER, Edward [P] Pittsburgh, PA. Member: Pittsburgh AA [25]

HUNTER, Evangeline Deming [Min.P] Phila., PA [25]

HUNTER, F. Leo [P] Ossining, NY [24]

HUNTER, Frances Tipton [I] Phila., PA b. 1 S 1896, Howard, PA d. ca. 1958. Studied: PMSchIA; PAFA; T. Oakley. Member: SI; Ar. Gld. Illustrator: "The Frances Tipton Hunder Picture Book," all major magazines, covers for Collier's, Country Home [47]

HUNTER, H. Chadwick [P] Wash., D.C. Member: Wash. WCC [13]

HUNTER, Ida Clark (Mrs.) [P,S] Paris, France [10]

HUNTER, Isabel [P,T] Alameda, CA b. San Fran. Studied: A. Mathews, E. Carlsen; Joullin; San Fran. A. Inst.; ASL. Member: San Fran. AA; San Fran. Soc. Women A. [33]

HUNTER, J. Young [P] NYC [24]

HUNTER, (James) Graham [Car,W,I] West Orange, NJ b. 2 F 1901, La Grange, IL. Studied: Landon Sch. Car., Cleveland; AIC; Federal Sch., Minneapolis. Work: car. originals, for Collier's—at Art. Cl., Univ. Ga., for Rotarians—at Belmar (N.J.) Fishing C., for Saturday Evening Post—at Minneapolis Golf C.; syndicated "Jolly Jingles" series, McClure Syndicate. Cartoonist: Saturday Evening Post, Country Gentleman; creator, "Sycamore Center" series, in Southern Agriculturist, "Brainy Bill," in Boys' Life, "Tubby," in Rural Progress, "Biceps Brothers," in Motor, "Isn't It the Truth!," in Progressive Grocer [47]

HUNTER, L(illian) W(oolsey) [P,I] Cleveland, OH b. Sandusky, OH. Studied: Cleveland Sch. A.; H.B. Snell; M. Walter [25]

HUNTER, Lizbeth C(lifton) [P] Redding Ridge, CT b. 29 N 1868, Gilroy, CA. Studied: H.B. Snell. Member: AWCS [47]

HUNTER, Mary M. [P] NYC [17]

HUNTER, Russell Vernon [P,Des,T,W,Mus.Dir] Santa Fe, NM b. 26 Mr 1900, Hallsville, IL d. 1955. Studied: Millikan Univ.; Denver Acad. A.; AIC; S. MacDonald-Wright. Member: Santa Fe P.&S. Exhibited: VMFA, 1946 (prize); Parkersburg (W.Va.) A. Center, 1946 (prize); BM, 1927, 1931; Pal. Leg. Honor, 1933; AIC, 1925; CGA, 1939; Tex. State Fair, 1933; WFNY, 1939; Pan-Am. Expo, 1937; Denver A. Mus., 1936; AFA Traveling Exh., 1942–43, 1943–45; Colorado Springs FA Center, 1941–45; Los Angeles Mus. A., 1927; P.&S. Southern Calif., 1925, 1926, 1928, 1934; Mus. N.Mex., 1922–1945, 1955 (retrospective); Univ. N.Mex., 1940; Dallas Mus. FA; Denver A. Mus.; Univ. Colo. Work: DeBaca County Court House, Ft. Sumner, N.Mex.; Amarillo (Tex.) Broadcasting Station; Central Baptist Church, Clovis N.Mex. Positions: N.Mex. State Dir.,

1935-42; Reg. Dir., USO, 1943-48; Dir., Dallas MFA 1948-52; Dir., Roswell Mus., N.Mex., 1952 [47]

HUNTER, Sara Katherine [Min.P] NYC [15]

HUNTER, Warren [P] Bandera, TX. Work: USPO, Alice, Tex. WPA artist. [40]

HUNTINGTON, Adelaide [P,I] Richmond, IN [10]

HUNTINGTON, Alonzo St. George [P,I] Versailles, France/Chicago, IL b. 2 Je 1968, Fort Leavenworth, KS d. 3 Ag 1941, Chicago. Studied: Robert-Fleury, Bouguereau, in Paris. Member: Paris AAA [13]

HUNTINGTON, Anna V. Hyatt (Mrs. Archer M.) [S] Bethel, CT b. 10 Mr 1876, Cambridge, MA d. 1973. Studied: ASL; H. MacNeil, G. Borglum, in New York; H.H. Kitson, in Boston. Member: Hispanic Soc. Am. (trustee); Brookgreen Gardens, S.C. (Bd. member); Copley S., 1901; ANA, 1916; NA; NSS; AFA; Inst. A.& L.; Am. Acad. A.&L.; Spanish Acad., San Fernando. Awards: Chevalier Legion of Honor, 1922; Citizen of Blois, 1922; Grand Cross Alfonso XII, 1929. Exhibited: Paris Salon, 1910 (prize); P.-P. Expo, San Fran., 1915 (med); French Gov., 1915 (prize); Plastic C., 1916 (gold); Phila., 1917 (gold); NAD, 1920 (med), 1922 (med), 1928 (prize); Am. Acad. A.&L. 1930 (med); San Diego, Calif., 1933 (prize); PAFA, 1937 (gold). Work: lions erected at Dayton, Ohio; NYC; Newport News, Va.; Gloucester, Mass.; San Fran.; Blois, France; Cathedral of St. John the Divine, NYC; San Diego; Seville, Spain; Buenos Aires; New Orleans; Austin, Tex.; Cambridge, Mass.; Brookgreen Gardens, S.C.; Carnegie Mus.; CMA; Luxembourg, France; Edinburgh Mus. Specialty: animals. Worked with her sister Harriet Hyatt Mayer. [47]

HUNTINGTON, Clara [S] Los Gatos, CA b. 2 F 1878, Oneonta, NY. Studied: A. Dazzi; Rome. Member: NAWPS. Work: Huntington Lib. and A. Gal., San Marino, Calif.; Berkeley Women's C. Specialty: bas-reliefs [33]

HUNTINGTON, Daniel [Por.P] NYC b. 14 O 1816, NYC d. 18 Ap 1906. Studied: Yale, with S.F.B. Morse; NYU; Inman; went to Florence, 1839. Member: Nat. Acad., 1840; MMA (Vice-Pres. from its founding, in 1870, until 1903). Exhibited: NAD, 1838, 1850; Phila. Centenn. Expo, 1876; retrospective organized by William C. Bryant and friends, 1850; Phila. Centenn. Expo, 1876; Univ. Expo, Paris; Century, 1908 (memorial). Lived in Rome, 1842-45; NYC, 1845-50; London, 1851-58; then back to NYC, where he was president of NAD, 1862-69 and 1871-91, longer than anyone else in that office. Of his 1,200 known works, 1,000 are portraits.

HUNTINGTON, D(aniel) R(iggs) [P,Arch] Seattle, WA b. 24 D 1871, Newark, NJ. Member: Pac. NE Acad. of Arts; Wash. Chap. AIA. Work: Firlands Hospital Group, Univ. Bridge Piers, Seattle; rose garden, Woodland Park, fountain and Harding Memorial in collaboration with Alice Carr [40]

HUNTINGTON, Elizabeth Hamilton Thayer (Mrs. Raymond Edwards) [P] Wellesley Hills, MA b. 9 O 1878, South Braintree, MA. Studied: Mass. Sch. A.; Thayer Acad.; E.L. Major; V. George. Member: Wellesley SA; Gld. Boston A. Exhibited: AWCS; Fifteen Gal., N.Y. (one-man); Newport AA; BMFA; Doll & Richards (one-man); Gld. Boston A. (one-man); Concord A.; Children's A. Center [47]

HUNTINGTON, F.R. [P] Columbus, OH. Member: Columbus PCC [25]

HUNTINGTON, Henry Edwards [Patron] Phila., PA b. Oneonta, NY d. 23 My 1927. A member of the railroad magnate family, he was considered one of the foremost art and book collectors. During the latter part of his life he devoted his time almost exclusively to his collection at San Marino, Calif., which, by terms of trust, became public property at the time of his death. This is conceded to be the finest private collection of British art in the world. He left a trust fund of $8,000,000 to be used exclusively for research in American and English history.

HUNTINGTON, John W.P. [P] Rockport, MA/Damariscotta, ME. Exhibited: Am. WC Soc. Ann., 1934; Am. P. Today, Worcester Mus., 1938; GGE, 1939 [40]

HUNTINGTON, Margaret Wendell [P] NYC b. 1867 d. 18 Ap 1958. Member: NAWPS; N.Y. Soc. Women Ar. Exhibited: NAWPS, 1927 (prize), 1931 (prize). Work: PAFA [40]

HUNTLEY, Samantha Littlefield (Mrs.) [P] Kinderhook, NY b. Watervliet, NY. Studied: ASL, with Twachtman, Mowbray; Ecole des Beaux-Arts, with Cuyer; Normal Sch. of Des., Paris, with Grasset; Académie Julian, Paris, with Lefebvre, Robert-Fleury. Member: AFA; AAPL. Work: War Dept., Wash., D.C.; State Hist. Lib., Court House, both in Madison, Wis.; Archbishop's House, St. Louis; Capitol, Historical and Art Society, both in Albany, N.Y.; Emma Willard Sch. Coll., Troy, N.Y.; Schofield Barracks, Honolulu; Smithsonian Inst.; Vanderpoel Mem. A. Assn., Chicago; City of Mt. Vernon, N.Y.; Payn Fnd., Chatham, N.Y.; Davie Mem. Lib., Kinderhook, N.Y.; Chemist's C., N.Y. [40]

HUNTLEY, Victoria Ebbels Hutson [Pr.M,,Li,P,Dr,E,T,L] Fern Park, FL b. 9 O 1900, Hasbrouck Heights, NJ. Studied: N.Y. Sch. Appl. Des.; ASL; BAID; J. Sloan; M. Weber; W.C. Palmer; K.H. Miller; Martin. Member: ANA; NSMP; An Am. Group; Am. Soc. PS. Exhibited: AIC, 1930 (prize); Phila. Pr. C., 1933 (prize); LOC, 1945 (prize); Assoc. Am. A., 1946; Grant Am. Acad. A.&L., 1947 (prize); NAD; WMAA; Phila. A. All.; CI; WFNY, 1939; NYPL; Albany Inst. Hist.&A.; PAFA; abroad; Weyhe Mem. Mus, 1935 (one-man); Kennedy Gal., 1942 (one-man); 48 Sts. Comp. Work: MMA; AIC; BMFA; FMA; CMA; WMAA; LOC; Houston Mus. FA; PAFA; NYPL; Newark Pub. Lib.; Phila. Pr. C.; Univ. Glasgow; Italian Gov.; USPOs, Springville, N.Y., Greenwich, Conn.; Mus. Calif.; Newark Mus.; Fifty Prints of the Year, 1931-32. Author/Illustrator: "Portraits of Plants and Places," 1946. Positions: T., Rollins Col., Winter Park, Fla., 1946-47, Birch-Wathen Sch., N.Y. [47]

HUNTOON, Mary (Mrs. Erwin W. Seeman) [P,S,T,E,En,L,Li,Pr.M] Topeka, KS b. 29 N 1896, Topeka. Studied: Washburn Univ.; ASL, with Henri, Pennell; G. Bridgman; France. Member: Prairie Pr.M.; Prairie WC P.; Topeka PM. Exhibited: Women P., Wichita, 1936 (prize); Brooklyn SA, 1930; Salon d'Automne, Paris, 1929; N.Y. Mun. Exh., 1936; Women P. Am., 1936-38; WMAA, 1942; Am. Graphic Exh., Stockholm, 1937; Kansas City AI, 1932, 1935, 1937, 1941; Joslyn Mem. Mus.: Salina (Kans.) AA; Fed. Women's C., Kans.; Topeka Pub. Lib.; Topeka State House; "Fifty Prints of the Year," 1928, 1929; A. Gld., Mulvane Mus., Topeka; U.S. Gov.. WPA artist. Position: T., Washburn Col., Topeka, 1940 [47]

HURD, Angela (M.) [P] Escondido, CA b. 18 Jy 1898, Stafford, England. Studied: England; Florence, Italy; C.L. Watkins; K. Knaths; Sartoni, C. Pisa, in Florence, Italy. Member: Soc. Wash. A. Exhibited: VMFA, 1938; Nat. Exh. S.&Cr., Wash., D.C., 1940; Soc. Wash. A., 1930-44; PMG, 1932-43; Wash. A. Lg. Traveling Exh., 1933, 1934; Greater Wash. Indp. A., 1935; Phila. A. All., 1940; Whyte Gal., 1944-46 [47]

HURD, Eleanor H(ammond) [P] Baltimore, MD b. Kalamazoo, MI. Studied: C. Hawthorne; H. Breckenridge; C. Woodbury. Member: Baltimore WCC; Baltimore Mus. A. [40]

HURD, L. Fred [P] NYC b. Brooklyn NY. Studied: Member: SC, 1893 [04]

HURD, Peter [P,Li,I,W] San Patricio, NM (living in Roswell, NM, 1984) b. 22 F 1904, Roswell, NM. Studied: PAFA; N.C. Wyeth. Member: NA; Phila. Pr. C.; Wilmington Soc. FA; Chester County AA. Exhibited: AIC, 1937 (prize); Wilmington Soc. FA, 1930 (prize), 1941 (prize), 1945 (prize); PAFA, 1945 (med); Phila. Print C., 1937 (prize). Work: USPOs, Big Spring, Dallas, both in Tex., Alamogordo, N.Mex.; La Quinta Municipal A. Gal., Albuquerque, N.Mex.; AIC; W.R. Nelson Gal.; Herron AI; MMA; BM; Nat. Gal., Edinburgh, Scotland; Wilmington (Del.) Soc. FA; Rochester (N.Y.) Mem. A. Gal. Illustrator "The Last of the Mohicans," 1926, "Great Stories of the Sea and Ships," 1933, "Habit of Empire," 1938, other books. Married to painter Henriette Wyeth. Position: War Correspondent, Life, 1942-45 [47]

HURD, Peter, Mrs. See Wyeth, Henriette.

HURFORD, Miriam Story [I] Chicago, IL b. 23 N 1894, Rome, NY. Studied: AIC; Syracuse Univ.; Sch. FA, Albright A. Gal., Buffalo. Member: Artists Gld.; AIC. Illustrator: children's books [40]

HURLBUT, Gertrude (Mrs.) [Por.P,Min.P,E] NYC b. Germany d. 30 N 1909, Geneva, Switzerland. Work: Reform C.

HURLBUT, Irving E. [P] New Haven, CT. Member: New Haven PCC [24]

HURLBURT, Mary Allis [P] Brooklyn, NY [01]

HURLEY, Edward Timothy [E,P,Des,C,Dec] Cincinnati, OH b. 10 O 1869, Cincinnati d. 29 N 1950. Studied: Cincinnati A. Acad.; Walter Beck; F. Duveneck. Member: Cincinnati SE; SAE; Ohio Pr.M.; The Crafters, Cincinnati; Cincinnati AC; Duveneck Soc. PS. Exhibited: La. Purchase Exh. (med); AIC, 1921 (prize); St. Louis World's Fair, 1904 (gold); Columbus, 1921 (prize); CI; NAD; AIC; Herron AI; CM. Work: LOC; NGA; NYPL; CM; BM; Richmond, Ind.; Detroit Inst. A.; Paris; London; A. Assn. Indianapolis; TMA; St. Xavier Univ.; Cincinnati C.; Newman C.; Univ. Cincinnati Y.M.C.A., Western Hills H.S., all in Cincinnati; National Gal. Ireland, Dublin; CMA. Author/Illustrator: "Familiar Scenes," 1937, "Memories," 1943, eight books on Cincinnati. Designer: metal art objects. Creator: Hurley Bronzes. Painted landscapes for Rookwood Pottery Co. [47]

HURLEY, Irene Bishop (Mrs. Edward T.) [Min.P] Cincinnati, OH b. 5 D 1881, Colorado Springs, CO d. 3 Ap 1925. Studied: ASL, with K. Cox; M.

Fry; F. Barnum; Cincinnati A. Acad. Member: Cincinnati Women's AC; NAWPS; NYWCC [24]

HURRY, Lucy Washington (Mrs.) [P,C] Hempstead, NY b. Hagerstown, MD. Studied: ASL, with K. Cox; M. Fry; F. Barnum. Member: NYWCC; NAWPS; AWCS; AL Nassau County [40]

HURST, Clara Scott (Mrs.) [P,I,T] Kirwin, KS b. 27 D 1889, Kirwin. Studied: K.L. Perkins; G.M. Stone; B. Sandzen. Exhibited: State Fair, Topeka, Kans., 1927 (prizes); State Fair, Topeka, 1926 (prizes); Hutchinson, Kans., 1927 (prizes). Illustrator: "The Adventures of Dickie Bear," 1937 [40]

HURST, Earl Oliver [I,W,Des,Car,T,L] Douglaston, NY/Cape Island, Newagen, ME b. 19 Ag 1895, Buffalo, NY. Studied: Albright A. Sch.; Cleveland Sch. A.; John Huntington Inst.; France. Member: SI. Work: Soc. I., N.Y. Ilustrator: Collier's [47]

HURST, L(ou) E. [P,I,C] Avon, OH b. 30 O 1883, Avon. Studied: Cleveland Sch. A; F.C. Gottwald; H.G. Keller. Specialty: botanical illus. [21]

HURST, Mary E. [P] Brooklyn, NY. Studied: W.M. Chase; H. Mosler. Member: B.&W. Cl. [01]

HURST, Sue Richards [P] St. Louis, MO b. Quincy, IL. Studied: St. Louis Sch. FA. Exhibited: St. Louis Expo, 1898 [98]

HURTT, Arthur R. [P,I,Mur.P] Los Angeles, CA b. 31 O 1861, Wisconsin. Studied: D. Volk; I. Wiles; ASL; France. Member: Calif. AC; Minn. AL; Oakland AL. Exhibited: Pan-Calif. Expo, San Diego, 1915 (med). Work: State Bldg., Exposition Park, Los Angeles. Specialties: stage scenery, murals [33]

HUSE, Marion (Mrs. Barstow) [P,T,Li,Ser] North Pownal, VT b. 1 D 1896, Lynn, MA. Studied: New Sch. Des., Boston; CI; Charles Hawthorne; D.J. Connah; H.S. Hubbell; C.W. Hawthorne. Member: Southern Vt. A.; Albany A. Group; Springfield A. Lg.; CAFA; Nat. Ser. Soc.; Am. Color Pr. Soc. Exhibited: Springfield A. Lg., 1925 (prize), 1936 (prize), 1941 (prize); CAFA, 1933 (prize); Albany Inst. Hist.&A., 1938 (prize), 1944 (prize). Work: Lawrence Mus. A., Williamstown, Mass.; Wood Gal. A., Montpelier, Vt.; Bennington Mus. Hist.&A.; Albany Inst. Hist.&A.; BMFA. Positions: Dir., Springfield A. Sch.; T., Albany Inst. Hist.&A. [47]

HUSHEER, John [P] Jersey City, NJ. Member: Lg. AA [24]

HUSSA, Theodore F(rederick), Jr. [P] Manchester Center, VT b. 31 Jy 1909, East Orange, NJ. Studied: PAFA (Country Sch., Chester Springs). Member: AAPL; Southern Vt. AA. Exhibited: Montclair A. Mus., 1936 (prize). Work: Newark Airport, N.J.; Sussex-Avenue Armory, Newark; Wood Art Gal., Montpelier, Vt.; AGAA [40]

HUSSAR, Laci [Photogr,I,Mur.P] Shokan, NY b. 1903, Hungary (came to NYC in 1921) d. 1977. Exhibited: Catskill Center Photog., Woodstock, N.Y., 1982. Work: sets, Metropolitan Opera; murals, Barnum&Bailey Circus, with Willy Pogany in NYC; photos of NYC and the Catskills [*]

HUSSEY, Mabel De (Mrs.) [P] Paris, France [10]

HUSTEAD, Elvera C. (Mrs. James E. Simons) [Car,Dec,Des,T,W] San Fran., CA b. Omaha, NE. Studied: AIC; Los Angeles AI; Federal Sch. Minneapolis. Work: magazine articles and caricatures. Co-author: "Colorology." Position: T., Pacific Col. Chromatics [40]

HUSTED, Mary Irving [C,Dec,Des,P,B,I,L,T] Boston, MA b. Brooklyn, NY. Studied: D.W. Tryon; W.M. Chase; J.W. Boston; Smith Col.; Columbia. Member: Boston SAC. Author/Illustrator: "Cunning-Cunning and His Merry Comrades," magazine articles. Position: Dir., Sch. Handicraft and Occupational Therapy [40]

HUSTED-ANDERSEN, Adda [Des,T,C] NYC b. Denmark. Studied: Thyra Vieth's Sch., Technical State Sch., both in Copenhagen; Badishe Kunstgewerbe Schule, Pforzheim, Germany; Jean Dunand, in Paris. Member: N.Y. Soc. Cr.; Soc. Des.-Cr. Exhibited: Gold & Silversmith Gld., Copenhagen (med). Position: T., Cr. Students' Lg., N.Y.; Am. Women's Assn., N.Y. Specialty: jewelry [47]

HUSTON, C. Aubrey [P] Phila., PA b. 1857, Phila. Studied: PAFA. Member: Phila. Sketch C. [04]

HUSTON, William [P] Cranford, NJ [01]

HUTAF, August W(illiam) [P,I] Woodcliff-on-Hudson, NJ b. 25 F 1879, Hoboken, NJ d. 28 O 1942. Studied: W.D. Streetor. Member: Am. Numismatic Soc.; SI. Author: poster, "The Spirit of the Fighting Tanks," Fifth Liberty Loan. Specialties: posters; book covers; decorations [40]

HUTCHENS, Frank Townsend [Por.P,Ldscp.P,L] Norwalk, CT/Taos, NM b. 1869, Canandaigua, NY d. 6 F 1937, Palm Beach, FL. Studied: ASL, with Wiles, DuMond, Mowbray, de Forest Brush; Studied: Académie Julian, Paris, with Constant, Laurens; Acad. Colarossi, Paris; A. St.-Gaudens. Member: NAC; Allied AA; Paris AAA; SC; AWCS; AFA; St. Petersburg AC; Silvermine Ar. Gld.; Taos Soc. Ar.; New Orleans Art Assoc. Work: Carnegie Lib., Sioux Falls, S.Dak.; Mus., West Point, N.Y.; Erie (Pa.) Art Cl.; Herron AI; Toledo Mus. A.; Capitol, Albany; Sioux Falls Art Assoc.; Art Gal., Rochester, N.Y.; Syracuse Mus. FA; High Mus. A.; Milwaukee AI; Capitol, Concord, N.H.; Warren (Pa.) AA; Delgado Mus.; Capitol, Tallahassee, FL [33]

HUTCHINS, Charles Bowman [P,W,L] Boulder, CO b. 3 O 1889, Seattle, WA. Studied: Horsefall; Graham. Member: Boulder AA; AMNH. Work: pub. schools, Denver, Detroit, Milwaukee, Chicago. Specialty: birds. Author: "Whiff o' the West" [40]

HUTCHINS, Frederic Loudon [P,I,A] Boulder, CO b. 11 Mr 1896, Seattle, WA. Studied: Graham, Colo. Univ. Atelier; Univ. Pa.; Fontainebleau Sch. FA, France [33]

HUTCHINS, John E(ddy) [P,C] Palisades, NY b. 4 Mr 1891, Wyoming, PA [25]

HUTCHINS, Maude Phelps McVeigh (Mrs.) [S,W] Chicago, IL b. NYC. Studied: Yale. Member: Chicago AC. Exhibited: Cosmopolitan Cl., N.Y. (one-man); Grand Central A. Gal.; Univ. Chicago; Univ. Wis.; CAM; Wildenstein Gal.; Chicago Women's Cl.; SFMA; Toledo Mus. A.; Eleanor Smith Gal., St. Louis, Mo.; Quest A. Gal., Chicago; Roullier Gal., Chicago, 1942-45; New Haven PCC; BM; NAWA; Chicago World's Fair; Women A. Salon, Chicago; Evanston A. Center; Chicago No-Jury Soc.; AIC; Am. FA Soc. Co-author: "Diagrammatics," 1932. Contributor: New Yorker, Kenyon Review, other magazines [47]

HUTCHINS, Will [P,W,L,T] Wash., D.C./Herricks, ME b. 11 Je 1878, Westchester, CT. Studied: Yale; Laurens, in Paris. Position: T., American Univ. [31]

HUTCHINSON, Allen [S] NYC b. 8 Ja 1855, Handford, Stotre on Trent, Staffordshire, England. Studied: J. Dalou. Work: Bishop Mus., Honolulu; Nat. Art Gal., Sydney, Australia; Honolulu Acad. A.; Stevenson Soc. Am., Saranac Lake, N.Y.; Auckland Art Mus., New Zealand. Specialty: Hawaiian types, figures and busts of Hawaiian notables. [29]

HUTCHINSON, Charles L. [Patron] b. 1854, Lynn, MA d. 7 O 1924, Chicago. Member: AIC; AFA; AIA; Municipal Art Lg. President and one of the founders of AIC; one of the organizers of the American Federation of Arts (president, three years); director/chairman of the fine arts committee of World's Columbian Expo, Chicago, 1893.

HUTCHINSON, Charles L. (Mrs.) d. 29 Mr 1936, Chicago. Founded the collection of costumes at AIC. Wife of the president of AIC, she gave the collection of paintings he left her to the Institute.

HUTCHINSON, Mary E(lizabeth) [P,T,L] Atlanta, GA b. 11 Jy 1906, Melrose, MA d. 1970. Studied: Agnes Scott Col.; NAD; Europe. Member: NAWA; N.Y. Soc. Women A.; Lg. Present-Day A.; S.Indp.A.; Am. A. Cong. Exhibited: WFNY, 1939; AIC; N.Y. Municipal Exh.; AFA Traveling Exh.; High Mus. A., 1933, 1940 (one-man); Midtown Gal., 1934, 1938 (one-man); Phila. A. All.; Riverside Mus.; BM; Am.-British A. Center; Contemporary A. Gal.; ACA Gal.; Chappellier Gal.; Ferargil Gal. Work: High Mus. A.; Saratoga (Calif.) Mus.; Syracuse Univ. WPA artist. Position: T., High Mus. A. Sch., 1946– [47]

HUTCHISON, D.C. [I] NYC b. 19 Ag 1869, Arbroath, Scotland d. 1954. Studied: Laurens, in Paris. Illustrator: "The Lonesome Trail," "Flying U Ranch," "With Kit Carson in the Rockies," other Western books [23]

HUTCHISON, David [Mur.P,P] Nashville, TN b. 23 Ag 1883, Canada. Work: murals, USPOs, Jessup (Ga.), New Rochelle (N.Y.), Ingleside Hotel, Jessup; Baldwin Law Bldg., Cleveland; Capitol, N.Y. WPA artist. [40]

HUTCHISON, Ellen Wales (Mrs.) [P] New Haven, CT b. 12 Je 1868, East Hartford, CT d. 1937. Studied: C.E. Porter; G. Thompson; G. Wiggins; M. Jacobs. Member: CAFA; New Haven PCC; New Haven BPC [38]

HUTCHISON, F(rederick) W. [P,T] NYC b. 1871, Montreal, Quebec d. 1 My 1953. Studied: Laurens, Benjamin-Constant. Member: ANA; NA, 1935; NAC; SC. Exhibited: SC, 1935 (prize); Nat. Acad. Ann., 1938 (prize). Work: Art Gal., Toronto; Quebec Nat. Gal. [40]

HUTCHISON, Joseph Shields [Mus.Dir,S,P,T] Charlotte, NC/Vinalhaven, ME b. 15 O 1912, Mt. Pleasant, Pa. Studied: Ohio State Univ.; Western Reserve Univ.; J. Hopkins; E. Frey. Member: Pen & Brush Cl; Columbus (Ohio) A. Lg.; Am. Assn. Univ. Prof. Exhibited: Columbus Art

Lg., 1937 (prize); Ohio State Fair, 1937 (prize); Ohio Wesleyan, 1938, 1939; Columbus Gal. FA, 1938, 1939. Work: mon., Worthington, Ohio; Ohio Wesleyan. Positions: T., Ohio State Univ., 1935-37, Ohio Wesleyan Univ., 1937-40; Dir., Mint Mus. A., Charlotte, N.C., 1946- [47]

HUTSON, Charles Woodward [P,W,T] New Orleans, LA b. 23 S 1840, McPhersonville, SC d. 27 My 1936. Studied: E. Hutson. Member: New Orleans ACC; Southern SAL; NOAA; Gulf Coast AA. Exhibited: NOACC, 1925 (prize). He began painting at age 70. [33]

HUTSON, Ethel [P,I,T,Des,C,W,L] New Orleans, LA b. 19 Ap 1872, Baton Rouge, LA. Studied: Univ. Miss.; A.&M. Col., Tex.; NAD; CUASch; ASL; PIASch.; Newcomb Col; F.C. Jones; G. Maynard; L. Mora; Mrs. J.P. McAuley; H.C. Christy; M.G. Sheerer; G.R. Smith; A.W. Dow; E. Woodward. Member: New Orleans AA; New Orleans A.&Crafts Cl.; Miss. AA; SSAL. Exhibited: SSAL, 1929, 1931, 1933-35, 1937, 1943, 1945; Miss. AA; New Orleans AA, 1904-45; New Orleans A.&Crafts Cl., 1922-46. Work: Mus. FA, Montgomery, Ala.; Bellhaven Col., Municipal Cl. House, both in Jackson, Miss.; Miss. AA. Contributor: articles, American Magazine of Art, Garden Magazine, other magazines [47]

HUTSON, Victoria. See Huntley.

HUTT, Henry [I] NYC b. 18 D 1875, Chicago [19]

HUTTBUG, Charles E. [P] Biloxi, MS b. 16 My 1874, Sweden. Studied: Talmadge, Oslen, in England. Member: Gulf Coast AA. Exhibited: Gulf Coast AA, 1927 (gold) [33]

HUTTIO, E.W. [P] Pittsburgh, PA. Member: Pittsburgh AA [25]

HUTTON, Amy S. [P] NYC. Member: Lg. AA [24]

HUTTON, Dorothy Wackerman (Mrs.) [E,Li,P,Des,T] Phila., PA b. 9 F 1898, Cleveland, OH. Studied: Minneapolis Sch. A.; Univ. Minn.; Paris; M.M. Cheney; R. Lahey; A. Angarola; E. Horter; Vytlacil; Lhote. Member: Phila. A. All.; Phila. Plastic Cl., Phila. Pr. Cl.; Phila. WCC. Exhibited: Phila. Plastic Cl., 1943 (prize), 1944 (prize), 1945 (prize); CGA, 1936; PAFA, 1937; Phila. A. All., 1946; SAE, 1946; CI, 1945, 1946; Phila. Pr. Cl., 1944, 1945; Am. Color Pr. Soc., 1946; LOC, 1944-46; Woodmere A. Gal., 1946 [47]

HUTTON, Hugh McMillen [Car,I,L,E] Phila., PA b. 11 D 1897, Lincoln, NE d. 1976. Studied: Univ. Minn. Member: Phila. Sketch Cl.; Bryn Mawr A. Center; Phila. A. All.; The Players. Exhibited: LOC, 1946; PMA, 1946; Phila. Sketch Cl., 1945; Phila. A. All., 1945, 1946. Position: Car., editorial, Philadelphia Inquirer [47]

HUTTON, William Rich [P,Dr] b. 1826, Wash., D.C. d. 1901, Montgomery County, MD. Work: Huntington Lib., San Marino, Calif. From 1847 to 1852 he drew views of Los Angeles and Monterey. [*]

HUTTY, Alfred (Heber) [E,Li,P] Charleston, SC/Woodstock, NY b. 15 S 1877, Grand Haven, MI d. 28 Je 1954. Studied: St. Louis Sch. FA; ASL, with Chase, B. Harrison. Member: British Soc. Graphic A., London; SAE; Chicago SE; Calif. Pr.M.; Prairie Pr.M.; Southern Pr.M.; All.A.Am.; NAC; AWCS; SC; Soc. Wash. A.; Wash. WC Cl.; North Shore AA; Rockport AA; Woodstock AA. Exhibited: Chicago SE, 1924 (med,prize); Kansas City AI, 1922 (prize); Detroit Inst. A., 1923 (gold), 1925 (prize), 1926 (prize); Mich. AI, 1923 (med); SC, 1924 (prize); Scarab Cl., 1921 (prize); New Haven PCC, 1925 (prize); Palm Beach A. Center, 1935 (prize); Detroit, 1938 (prize); NAD; AWCS; Phila. WCC; SAE; Prairie Pr.M.; Calif. Pr.M.; British Soc. Graphic A.; Wash. WCC; SC; CMA; Baltimore WCC. Work: AIC; Detroit Inst. A.; LOC; CMA; NYPL; Los Angeles Mus. A.; Municipal Gal., Phoenix, Ariz.; Nat. Mus.; Calif. State Lib.; Univ. Mich.; Colo. State Lib.; Bibliothèque Nationale, Paris; Herron AI; Gibbes A. Gal.; MMA; British Mus., London; Princeton Univ.; Harvard Medical Sch.; Lg. of Nations, Geneva; Pasteur Inst.; A. Gal. Toronto; Honolulu Acad. A.; Ill. State Col.; FMA; Boston Pub. Lib.; Ashmolean Mus., Oxford, England; Fine Prints of the Year (annually); "Alfred Hutty" (American Etchers Series, vol. 2). Illustrator: "How to Make Etchings," 1932 [47]

HUXFORD, Marie. See Luce, Mrs.

HUYCK, Laura Talmage (Mrs.) [P] Albany, NY. Exhibited: NAWPS, 1935-38 [40]

HUYN, Paul [S] NYC. Exhibited: WFNY, 1939 [40]

HYATH, Winfred S. [P] Bryn Athyn, PA [21]

HYATT, Anna Vaughan. See Huntington.

HYATT, Audella (Mrs. Alpheus) [Ldscp.P] Princeton, NJ b. 1839 d. 10 N 1932. Assisted her husband, a Harvard paleontologist, by painting sketches and diagrams for his books and lectures.

HYATT, Harriet Randolph. See Mayor, Mrs.

HYATT, W.S. [P] Phila., PA [13]

HYDE, Alice Earle (Mrs. Clarence R.) [P,I] Waterbury, CT b. 1876, Brooklyn, NY d. 17 Ja 1943. Specialty: wild flowers

HYDE, Emily Griffin [Ldscp.P] Spiceland, IN b. 1859, Indiana d. 13 S 1919. Exhibited: Cincinnati Art Acad; Europe. [17]

HYDE, Hallie Champlin (Mrs. Edward B.). See Fenton, Mrs.

HYDE, Helen [P,E] Chicago, IL b. 6 Ap 1868, Lima, NY d. 13 My 1919, Pasadena, CA. Studied: E. Carlsen; Collin, in Paris; Skerbina, in Berlin; Tomonobu, in Tokyo. Member: San Fran. AA; Chicago SE; Calif. SE; Société de la Gravure Originale en Couleur, Paris. Exhibited: Alaska-Yukon Expo, 1909 (gold); Paris Salon, 1913 (prize); P.-P. Expo, San Fran., 1915 (med). Work: LOC; NYPL; San Fran. Mus.; Newark Mus.; Boston Mus.; Toronto Mus. Specialty: Japanese and Mexican subjects in colored wood blocks and etching [17]

HYDE, John [E,En] b. 1846, England (came to U.S. in 1882) d. 9 Mr 1927, NYC. Specialty: steel engravings

HYDE, Laura [P] Paris, France [15]

HYDE, Marie A.H. (Mrs.) [P,S,Por.P,Cr,I,W] Hollywood, CA b. 12 O 1882, Sidney, OH. Studied: NAD; ASL; Cleveland Sch. A.; William Chase; Frank Parsons. Exhibited: Cleveland Sch. A., 1905 (prize); Los Angeles Mus. Hist., Science & Art; Santa Fe Mus.; Ebell Cl., Los Angeles, 1940. Work: MMA; Southwest Mus., Los Angeles; Mus. N.Mex., Santa Fe. Position: Illus., tech. handbooks, Lockheed-Connors-Joyce, 1943-46 [47]

HYDE, Mary Elizabeth [P] Clifton, OH. Member: Cincinnati AC [24]

HYDE, Pascal (Mrs. Della Mae) [P,Mur.P,Dec] Wash., D.C. b. Oakland, MD. Studied: Nat. Park Col., Forest Glen, Md.; ASL; Henri; Bellows; Mora; Hawthorne; NAD; Bridgman; Miller. Member: Salons of Am.; ASL; Wash. AC; Brooklyn Soc. Mod. A.; Gloucester SA; Rockport AA. Exhibited: Md. State Fair (prize); Wash. Landscape Cl. (prize). Work: Senate Office Bldg., State Dept., Dept. Interior Bldg., all in Wash., D.C.; murals, Balboa Park, San Diego; Railways Hotel, Alaska. Position: Supv., A., Nat. Parks, Dept. Interior, 1935-44 [47]

HYDE, Raymond Newton [Ldscp.P] Douglaston, NY b. 1863, Boston. Studied: Couture, in Paris [06]

HYDE, Russell Taber [P,E,L,T] Waltham, MA b. 14 Jy 1886, Waltham, MA. Studied: Laurens; Baschet; Richer. Member: Pittsburgh AA. Position: T., CI [40]

HYDE, Violet Buel [P] NYC [04]

HYDE, W.D. [I] NYC. Position: Illus., Harper's [98]

HYDE, William H(enry) [Por.P] NYC b. 29 Ja 1858, New York d. 7 F 1943, Albany. Studied: Boulanger, Lefebvre, Doucet, A. Harrison, in Paris. Member: ANA, 1900; SAA, 1893; Century Assoc.; Cornish (N.H.) Colony. Exhibited: Paris Expo, 1900 (prize); Pan-Am. Expo, Buffalo, 1901 (med); P.-P. Expo, San Fran., 1915 (prize) [40]

HYDEMAN, Sid L. [I,W] NYC/Lake Candlewood, Danbury, CT b. 10 Mr 1895, Lancaster, PA. Studied: Bridgman; D. Cornwell. Member: SI; Chelsea Arts Cl., London. Position: Art Ed., Hearst's International Cosmopolitan, Harpers Bazaar [32]

HYETT, Will J. [P] Allison Park, PA b. 10 Ja 1876, Cheltenham, England. Studied: Sir A. East. Member: Pittsburgh AA; Pittsburgh Arch. Cl. Exhibited: P.-P. Expo, San Fran., 1915 (med); Pittsburgh AA, 1917 (prize) [40]

HYKES, Ethel Johnt. See Johnt.

HYMAN, Moses [E] NYC b. 14 D 1870, NYC. Studied: CUASch; NAD; ASL. Exhibited: NAC; SAE; NAD; Phila. Pr. Cl.; 100 Prints of the Year, 1942; Venice, Italy, 1940. Work: LOC; NYPL [47]

HYND, Frederic Stuart [P,Mur.P,L,T] Granby, CT b. 11 F 1905, Cleveland, OH. Studied: ASL, with Guy Pène DuBois, John Sloan, Nicolaides. Member: CAFA; New Haven PCC, 1935, 1936 (prize), 1937-39, 1940 (prize), 1941-46; CAFA, 1935-42, 1943 (prize), 1944-46; CI, 1936. Work: Wadsworth Atheneum, Hartford; mural, State Savings Bank, Hartford. Position: Dir., Hartford A. Sch., 1933-46 [47]

HYNEMAN, Herman N. [P] NYC b. 27 Jy 1859, Phila., PA d. 23 D 1907. Studied: Bonnât, in Paris. Member: Phila. AC; SC, 1897. Exhibited: AAS, 1902 (med) [06]

HYNEMAN, Juliet J. [P] NYC Exhibited: NAD, 1898; N.Y. State Fair, 1898 [98]

HYNES, Edith [Dec,L,Ldscp.P,T,W] Los Angeles, CA b. Quincy, IL. Studied: N.Y. Sch. Indst. A.; Europe; Orient. Member: Calif. AC; Women Painters of the West; San Diego FAS. Positions: T., Univ. Calif. (Extension Div.), Manual Arts Evening H.S., Los Angeles [47]

HYNES, Mary Helen [C,Dec,L,T,W] Washington, GA b. 13 F 1894. Studied: BMFA Sch.; G.J. Hunt; J. Mullen; J. Reynolds; N.Y. Sch. Interior Dec. Member: Washington (Ga.) Women's Cl.; SSAL. Author: "Practical Stagecraft," pub. Walter Baker Co., Boston. Position: T., Sch. Allied A., Washington, Ga. [40]

HYSLER, Minnie [P] Paris, France [01]

HYSLOP, Alfred John [P,Mur.P,T] Northfield, MN b. 10 Ap 1898, Castle-Douglas, Scotland. Studied: Edinburgh Col. A.; Royal Col. A., London; G.W. Browne, in Scotland. Member: Midwestern Col. A. Conference; Minn. AA; Am. Col. Soc. Pr. Coll. Exhibited: Western AA, 1935; Minn. AA, annually; Walker A. Center, 1946; Kansas City AI; Univ. Minn.; Hanley Gal., Minneapolis. Work: murals, Buckham Mem. Lib., Faribault, Minn. Position: T., Carleton Col., Northfield [47]

A.B. Frost: *Preparing for a Day on the Water*. Private Collection

IAMS, J(ohn) Howard [P] Harrisburg, PA b. 10 Ap 1897, Washington County, PA. Studied: CI; ASL. Member: SSAL; Pittsburgh AA; Miss. AA. Exhibited: S. Wash. A., 1928 (prize); SSAL, 1928 (prize), 1931 (prize); Miss. AA, 1930 (med), 1933 (gold), 1934 (med). Work: Birmingham (Ala.) Pub. Lib.; Bennet Lib., Weston, W.Va.; White House [40]

IANNACCONE, Piero [P] Phila., PA. Studied: PAFA, 1936. Exhibited: PAFA, 1938 (prize) [40]

IANNELLI, Alfonso [S,Des,C,L,P,T] Park Ridge, IL b. 17 F 1888, Andretta, Italy. Studied: Newark Tech. Sch.; ASL; W. St. John Harper; G. Brigdman; G. Borglum. Member: Cliff Dwellers; ADI. Exhibited: AIC, 1921, 1925 (one-man); Minneapolis, 1926. Work: S., Midway, Adler Planetarium, Chicago; Winnebago County Court House, Oshkosh, Wis.; Woodbury County Court House, Sioux City, Iowa; Bronson Park, Kalamazoo, Mich.; St. Francis Xavier Sch., Wilmette, Ill.; H.S. and church, Racine, Wis.; AIC; Goodyear Bldg., Century of Progress Expo, Chicago [47]

IARICCI, A(rduino) [P] NYC b. 2 My 1888, Italy. Studied: self-taught. Member: S.Indp.A.; Salons of Am.; Bronx AG [29]

IBLING, Miriam [P,Des,G,T] Minneapolis, MN/Stillwater, MN b. 17 F 1895, Parkersburg, IA. Studied: Minneapolis AI Sch.; E. Kinzinger. Member: Minn. AA; United Am. Ar. Exhibited: Intl. WC Ann., AIC, 1936; Minneapolis AI, 1939; Minneapolis Women's C., 1936 (prize). Work: State Sch. Dependent Children, Owatonna, Minn. Position: T., Walker A. Center, Minneapolis [40]

ICART, Louis [P,E,I] NYC b. 1888, France d. 1950, France. Illustrator: Collete's "L'ingenue Libertine," Goethe's "Faust." Best known for his large color etchings of glamourous women and sleek dogs in elegant settings. [24]

ICKES, Paul A. [I,P] Rye, NY b. 2 Ap 1895, Laclede, MO. Studied: DuMond; G. Bridgman; N. Fechin; H. Leith-Ross. Member: SI. Illustrator: juvenile books and magazines [40]

IDE, Alice Steele. See Hannaford, Foster, Mrs.

IHLEFELD, Henry [P] Mt. Vernon, NY b. 1859, Germany (came to U.S. as a child) d. 4 Ap 1932. Studied: CUASch; NAD; Paris. Member: Lotos C.; SC. Positions: Des., Tiffany & Co., American Lith. Co. [06]

IHRIG, Clara Louise [P,S,T] Pittsburgh, PA b. 31 O 1893, Pittsburgh. Studied: Sparks; Zeller; Sotter; CI. Member: Pittsburgh AA. Illustrator: McCall's, other publications [40]

ILGEN, R.L. [I] Chicago, IL [19]

ILIFF, Cynthia [G] Ambler, PA. Exhibited: WC Ann., PAFA, 1936, 1937; E.&En. Ann. AIC, 1936, 1938; Phila. Pr. C. Ann., 1938 [40]

ILIGAN, Ralph W. [I,Por.P] Elmhurst, NY b. 1894 d. 1960 [47]

ILLAVA, Karl [S] Bronxville, NY/Oak Bluffs, MA. Studied: G. Borglum; R. Henri; Columbia. Member: NSS; Arch. L. Work: war mem., NYC; war mem., Gloversville, N.Y.; mem., Joint Disease Hospital, NYC; Vets mem., Whitestone, N.Y. [40]

ILLIAN, George (John) [I,P,T] NYC (since 1916) b. 29 N 1894, Milwaukee, WI. d. 18 Je 1932. Studied: Milwaukee AI; AIC; ASL; Royal Acad. Munich. Member: SI; Players; Artists G.; SC. Position: T., school for disabled veterans [31]

ILSEY, Frederick J(ulian) [P] Portland, ME/Rockport, MA b. 6 Mr 1855. Studied: self-taught. Member: Portland SA; SC; Rockport AA; AAPL; Hayloft C.; AFA [33]

ILYIN, Peter [P] San Fran., CA b. 19 Je 1887, Kazan, Russia. Studied: Imperial Acad. A., St. Petersburg; C.G. Pashovsky. Member: Soc. for Sanity in A. Exhibited: Imperial A. Exh., Tokyo, 1921, 1922; City of Paris, San Fran., 1924; Palace Legion Honor, San Fran.; AIC, 1939 (med); murals, GGE, 1939 [40]

IMFELD, Fred M. [P] d. 5 S 1927, Cincinnati, OH

IMHOF, Joseph A. [P,Li,T] Taos, NM b. 1871, Brooklyn, NY d. 1955. Studied: self-taught lith. for Currier & Ives; apprenticed to artists in Europe, 1891. Work: Amon Carer Mus.; Mus. N.Mex. Active in Albuquerque, 1907–12; settled in Taos (1929) and set up the first lithographic press there, making prints of Indian artifacts. [*]

IMLACH, William Bertram [P] NYC. Member: SC; CAFA [25]

IMLER, Edgar [P,E,En] NYC b. 31 Ja 1896, Clairsville, PA. Studied: Franklin & Marshall Col.; AIC; PAFA; ASL. Member: SAE; Am. Veteran's Soc. A. Exhibited: nationally; LOC; CI; AIC; MMA; Am. Vet. Soc. Ar. Ann., 1939. Work: LOC; NYPL; MMA. Specialty: wood engraving [47]

IMMACULATA, Sister M. [P] Notre Dame, IN. Member: St. Mary's Col. [15]

IMMEL, Paul [P,Des,C,T,I] Seattle, WA b. 30 O 1896, Helena, MT. Studied: Ball Sch. Des., Minneapolis, MN; Otis AI; M. Tobey; A. Amero. Member: Puget Sound Group of Northwest Painters; Northwest WCS. Exhibited: SAM, 1936–46; Northwest WCS, 1939–46; SAM, 1941 (one-man); Studio Gal., Seattle, Wash., 1944 (one-man); Elfstrom Gal., Salem, Oreg., 1946 (one-man); Graves Gal., San Fran., Calif. (one-man). Work: SAM. Position: T., Burnley Sch. A., Seattle, Wash., 1946 [47]

IMMERMAN, David [P] Bronx, NY b. 22 Mr 1911, Brooklyn, NY. Studied: G. Bridgman; ASL; L. Kroll; K. Anderson; C. Curran; NAD. Member: F., Tiffany Fnd. Work: Court of General Sessions, NYC; Nat. Democratic C., NYC; Bill Robinson Theatre, Richmond, Va. [40]

IMPERATO, Edmund, Mrs. See Milsk, Mark.

IMPEY, Lillian Cotton. See Cotton.

IMREY, Ferenc [P,G,Des] Wash., D.C. b. 6 Jy 1885. Studied: Royal Acad. A., Budapest; Beaux A., Paris. Member: Ar., S. C., Los Angeles; Mandzan Gyoska. Exhibited: murals, GGE, 1939. Work: Municipal M., Tokyo. Position: T., Gonzaga Col., Wash., D.C. [40]

IMRIE, Herbert David [E] Berkeley, CA b. Napa, CA. Studied: G. Piazzoni. Member: Calif. SE [40]

INDEN, Hugo [Des,I,Car,P,T] Wash., D.C. b. 5 Mr 1901, Germany. Studied: Sch. Applied A., Düsseldorf, Germany; Munich A. Sch., with C. Bagerlein. Member: Wash. AC; Wash. Ldscp. C. Exhibited: Wash. WCC, Corcoran Gal. A., 1939; ash. AC, 1939. Position: T., Abbot Sch. FA, Wash., D.C. [40]

INGALLS, C.T. (Mrs.) [P] Oklahoma, City, OK. Member: Okla. AA [25]

INGALLS, Eileen Brodie [P] Cleveland, OH b. 8 O 1903, East Orange, NJ. Studied: Western Reserve Univ.; Cleveland Sch. A.; R. Soyer; C. Carter; H. Keller. Member: NAWA; Cleveland AA. Exhibited: VMFA, 1942; CM, 1942; All.A.Am., 1942; NAWA, 1942, 1943; Butler AI, 1939-43; CMA, 1932-40, 1941 (prize); 1942, 1943 (prize), 1944 (prize), 1945-46, Traveling Exh., 1941-46; Detroit AI, 1943; Ruth Coulter Gal., Cleveland (one-man), 1940; Cleveland Sch. A., 1943 (one-man); Cleveland Col., 1944 (one-man); Ten Thirty Gal., 1945, 1946 [47]

INGALLS, Frank [S] Chicago, IL [15]

INGEBORG, Hansell (Mrs.) [Des] Malverne, NY [25]

INGELS, Frank Lee [S,Arch,C] Los Angeles, CA b. 2 Ja 1866, Tamora, NE. Studied: L. Taft; AIC. Exhibited: AIC, 1915. Work: Agricultural Sch., Goodwell, Okla.; Forest Lawn Cem., Los Angeles; Calvary Cem., Chicago [40]

INGELS, Kathleen Beverley (Robinson) (Mrs. Frank L.) [S] Los Angeles, CA b. 31 D 1882, Aurora, Ontario, Canada. Studied: L. Taft. Exhibited: 1913, (prize); Los Angeles Mus., 1922 (med). Work: mem., AIC; mem., Univ. Ill. [40]

INGERLE, Rudolph F. [P] Highland Park, IL b. 14 Ap 1879, Vienna, Austria. Studied: AIC. Member: Assn. Chicago P.&S.; Palette & Chisel Acad.; Municipal A. Lg.; Cliff Dwellers; Bohemian AC; North Shore AA. Exhibited: NAD; CGA; PAFA; CAM; Mint Mus. A.; Hickory Mus.; Springville AA; AIC, 1927 (prize); Springfield Mus. A.; CI; World's Fair, Chicago; Bohemian AC, 1916 (gold); Ill. A. (med); Palette & Chisel C., 1921 (prize); Chicago SA, 1922 (prize); Chicago P.&S., 1926 (gold), 1936; All-Ill. Acad. FA, 1934 (gold); Municipal A. L., 1922 (prize), 1923 (prize), 1929 (gold); Women's A., Evanston, Ill., 1931, (prize), 1932; 1934, Schaffer Prize; 1946, Barnes prize. Work: City of Chicago Col.; AIC; Eastman Mem. Fnd.; Gary Col.; Springville (Utah) AA; mural, Highland Park, Ill. Lib.; Arché C.; Municipal AL [47]

INGERSOLL, Anna Warren [P] Phila., PA b. 30 S 1887, Phila. Studied: PAFA. Exhibited: PAFA, 1938 (gold). Work: PAFA [40]

INGERSOLL, Emma Kipling Hess (Mrs. D.W.) [Min.P,T] Chestertown, MD b. 18 Ja 1878, Chicago, IL. Studied: AIC. Member: Pa. SMP; SWA; Chicago SA. Exhibited: St. Louis Expo, 1904 (med); Pa. SMP, 1933 (prize). Work: Position: Carnegie Lib., Evanston, Ill. [40]

INGERSOLL, Susan Crook (Mrs. W. King) [Por.P,T] Wilmington, DE b. 27 O 1908, Columbus, GA. Studied: Converse Col.; PAFA. Member: West Chester AA; PAFA. Position: T., Friends Sch. [40]

INGERSOLL, W(yllys) King [I,P] Wilmington, DE b. 6 Ag 1909. Studied: PAFA. Member: Phila. Alliance; PAFA, 1934 [40]

INGHAM-SMITH, Elizabeth (Mrs. Francis S.) [P,C] North Shirley, MA b. Easton, PA. Studied: PAFA; H.B. Snell; Whistler, Paris; Jameson, London. Member: Phila. WCC; NYWCC; Wash. WCC [33]

INGLE, Eliza [E,Des,C] Baltimore, MD b. 27 Ap 1885, Baltimore. Studied: Bryn Mawr; G. de V. Clements; M.E. Haydock; E.V. Sweringen. Member: Boston SAC; Rockport AA; Baltimore WCC. Specialty: bookbinding; marble book papers; illuminations [47]

INGLES, Eric Ingeson [C,Des,T] Center Sandwich, NH b. 27 Je 1896, Norrkoping, Sweden. Studied: G.A. Wennerstrom; Lenning scholarship for textile studies in foreign countries, 1918. Member: Worcester ACG; Lg. N.H. A.&C. Position: T., WMA Sch. [40]

INGLIS, Antoinette Clark (Mrs. Alexander) [P,I] Annisquam, MA b. 31 O 1880, Cortland, NY. Studied: ASL. Member: AAPL; North Shore A.; Gloucester AS; NYSP; Boston AC. Exhibited: Ogunquit A. Center, 1937-39; North Shore AA; Soc. for Sanity in A.; Contemp. A. of New England; NYSP; Sheldon Swope A. Gal., Terre Haute, Ind. [47]

INGLIS, John J. [P,L,T] Rochester, NY b. 26 Ag 1867, Dublin, Ireland d. 2 S 1946. Studied: Dublin Acad.; Ecole des Beaux-Arts, with Gèrome; Colarossi Acad., with Courtois, Collin; Acad. Schs., London. Member: Royal Hibernian Acad. Arts, Dublin; Rochester AC. Rochester Expo, 1925 (gold); Rochester AC, 1931 (prize) [40]

INGLIS, Wm. T. [P] NYC [01]

INGOLD, J.T. [P] Chicago, IL. Member: GFLA [27]

INGRAHAM, Ellen M. [Min.P,Por.P,T] b. 12 Ag 1832, New Haven, CT d. 2 Je 1917, Indianapolis. Studied: New Haven; NYC. Position: T., Indianapolis, where she lived after 1865. [*]

INGRAHAM, F.T. [P] New Hyde Park, NY [06]

INGRAHAM, George Hunt [E,Arch] East Cleveland, OH b. 17 Mr 1870, New Bedford, MA. Studied: MIT [27]

INGRAHAM, Katherine Ely (Mrs. M.H.) [E] Madison, WI b. 1 Je 1900, Minneapolis, MN d. 1982. Studied: Univ. Wis.; ASL; J. Pennell. Member: Madison AG; Wis. PS. Exhibited: Madison AA, 1944 (prize), 1946 (prize); SAE, 1943, 1945; LOC, 1943; Brooklyn SE, 1926, 1927; Wis. Salon A., 1941, 1943, 1945; Univ. C., Madison, 1938, 1940; Madison A. Gl., 1937, 1938. Work: LOC [47]

INGRAHAM, Natalie (Mrs.) [S] Paris, France b. NYC. Studied: M. de Marcilly [10]

INGRES, Maurice [P] NYC [15]

INMAN, F. Tempest [P] NYC. Member: GFLA [27]

INMAN, John O'Brien [P] b. 10 Je 1828, NYC d. 28 My 1896, Fordham, NY. Studied: his father, Henry (1801-1846). Member: ANA, 1865. Exhibited: NAD. Worked in Paris and Rome, 1866-78. Work: N.Y. Hist. S. Specialty: portraits and genre [*]

INNESS, George [P] NYC/Montclair, NJ b. 1 My 1825, Newburgh, NY d. 3 Ag 1894, Bridge of Alan, Scotland (while visiting). Studied: largely self-taught, but was apprenticed to a NYC map engraver, 1841; briefly with R. Gignoux, Brooklyn, 1846. Member: NA, 1853. Exhibited: NAD, regularly since 1844; Am. Art-Union, 1845. Work: MMA; 20 paintings, AIC; most major museums. Worked in London, Rome, 1847; Paris, 1859; France and Italy, 1870-74. One of America's greatest landscape painters, his works were compared with those of Corot and Rouseau. A spiritualist, Inness accepted the doctrines of Swedenborg and after 1878 his landscapes increasingly reflected an independent and poetic style. [*]

INNESS, George, Jr. [P,I,W] Montclair, NJ/Cragsmoor, NY. b. 4 Ja 1853, Paris d. 27 Jy 1926, Cragsmoor. Studied: his father, in Rome, 1870-74; briefly with Bonnât, in Paris, 1875. Member: ANA, 1893; NA, 1899; SAA, 1880; Boston AC; SC, 1876; A. Fund S.; Lotos C. Exhibited: Paris Salon, 1899 (gold); Pan-Am. Expo, Buffalo, 1901 (med); AAS, 1902 (gold). Work: MMA; Montclair AM; BMFA. Illustrator: Scribner's, Century. He had a studio in Paris from 1895 to 1899. In 1917 he wrote about the life and works of his father. Best known as an animal and ldscp. painter. [25]

INSLEY, Albert B. [P,T] Nanuet, NY b. 1 Ap 1842, Orange, NJ d. 21 O 1937. Member: Nanuet PS [27]

INUKAI, Kyohei [P] NYC. Exhibited: NAD, 1926 [40]

INVERARITY, Robert Bruce [P,T,L,Li,Gr,W,Des,B,E] Seattle, WA b. 7 Jy 1909, Seattle, WA. Studied: K. Yamagishi; M. Tobey. Member: F., Royal SA; Calif. WCS; Northwest PM; Pacific Coast PSA. Exhibited: Brooklyn SE, 1931; Chicago SE, 1930; Nat. Gal., Canada, 1933; WFNY, 1939; Calif. WCS, 1942, 1943; Northwest A., 1928, 1929, 1934; SAM, 1935; Oakland A. Gal., 1941; Edward Weston Gal., Carmel, Calif., 1929 (one-man); Workship Gal., San Fran., 1929 (one-man); Santa Barbara AL, 1930 (one-man); El Paso Gal., Palm Springs, Calif., 1930 (one-man); Hudson Bay Co., Vancouver, B.C., 1931 (one-man); Vancouver A. Gal., 1932 (one-man); Gumps, San Fran., 1935 (one-man). Work: U.S. Naval Col.; U.S. Naval Air Station, Seattle, Wash.; Univ. Wash.; Wash. State Mus., Seattle, Wash.; S.S. Northsea. Author/Illustrator: "Blockprinting and Stencilling," 1930; "The Rainbow Book," 1931; "A Manual of Puppetry." Illustrator: Natural History Magazine, 1942. WPA Artist. [47]

INVERARITY, Wallace Duncan [Des,Dec,B] Seattle, WA b. 26 N 1904, Seattle, WA. Studied: W.F. Blinn; A.G. Snider. Member: Northwest PM [40]

INVERNIZZI, Prosper [P] NYC. Member: S.Indp.A. [27]

IOANOWITS, Paul [P] NYC b. 16 Je 1859, Versecz, Hungary. Studied: L. Ch. Müller, Vienna. Exhibited: Vienna, 1898 (gold); Berlin, 1900 (gold); Paris Expo, 1900 [06]

IONS, Willoughby [P] Fairfax Station, VA. Exhibited: WFNY, 1939 [40]

IORIO, Adrian J. [I,De,T,W,L] Randolph, MA b. 13 My 1879 NYC d. 15 My 1957. Studied: ASL; L. Kronberg; W.A.J. Clauss. Member: Biological Photog. Assn. Author: serial "Making the Book," in the Graphic Arts. Illustrator: scientific books. Position: T., Boston, Univ. [47]

IOUKAI, Kyahei [P] NYC [21]

IPCAR, Dahlov (Mrs.) [P,I,Li] Robinhood, ME b. 12 N 1917, Windsor, VT. Studied: Oberlin Col. Exhibited: CGA, 1939, 1943; PAFA, 1940, 1942; CI, 1941, 1943; MMA (AV), 1942; Pepsi-Cola, 1944; MOMA; Detroit Inst. A., 1943; Bignou Gal., 1940 (one-man); Passedoit Gal., 1943 (one-man); Phila. A. All., 1944 (one-man); ACA Gal., 1946 (one-man); 48

States Comp., 1939. Work: murals, USPOs, La Follette (Tenn.), Yukon (Okla.). Illustrator: "Little Fisherman," 1945. WPA artist. [47]

IPER, Van D. [P] NYC [01]

IPSEN, Ernest L. [Por.P] South Dartmouth, MA b. 5 S 1869, Malden, MA d. 2 N 1951. Studied: BMFA Sch.; Copenhagen Royal Acad. Member: AWCS; SC; Century Assn.; ANA; NA, 1924; NAC. Exhibited: NAD, 1921, (prize), 1929 (prize); PAFA, 1937 (prize). Work: AIC; MIT; Butler AI; Barnard Col.; NAD; Century Assn.; Harvard Med. Sch.; U.S. Supreme Court Bldg.; Johns Hopkins Univ.; Princeton; U.S. Military Acad., West Point; Amherst Col.; Un. Lg. C.; Boston State House; Trenton State House; Hotchkiss Sch., Lakeville, Conn.; New Bedford City Hall; Butler AI; Court of Appeals, NYC; Carnegie Endowment for Intl. Peace; Columbia; Harvard C., NYC; Princeton C., NYC; Court of Appeals, Albany; AT&T; Prudential Ins. Co., Newark; N.Y., Board of Trade and Transportation; Union Theological Seminary; Delaware and Hudson R.R.; Rutgers Col.; CCNY; Equitable Life Assurance Soc., NYC; West Point; Randolph-Macon Col.; Court of Appeals, Trenton; Phillips Exeter Acad.; St. Marks in The Bowrie; Church, Chicago Univ.; Collegiate Church, NYC; Union Col., Schenectady; So. Dartmouth Pub. Lib.; Pembroke Col., R.I. [47]

IRANYI, Ella [E] Chicago, IL [24]

IREDELL, Russel [Por.P,I,Et,S,Des] Laguna Beach, CA b. 28 F 1889 d. 1959. Studied: H. McCarer; C. Beaux; D. Garber; C. Grafly; Cresson traveling Schol., 1911. Member: Laguna Beach AA. Exhibited: Laguna Beach AA, 1943–46; Los Angeles (one-man); Pasadena (one-man); La Jolla (one-man); Coronado (one-man); Santa Ana (one-man); Huntington Beach, Calif. (one-man). Work: portrait commissions. Illustrator: Good Housekeeping; Woman's Home Companion; covers, Collier's; Delineator: Town and Country [47]

IRELAND, Beryl [Min.P] Hollywood, CA b. Melbourne, Australia. Studied: Westminster Sch. of A., London. Member: Calif. SMP; Women P. of West. Exhibited: Royal SMP, London, 1938; Nat. Exh. Miniatures, Los Angeles Mus., 1935 (prize). Work: Nat. Gal., Sydney; Los Angeles Mus. [40]

IRELAND, Harry C. [P] Cambridge, MA. Member: Boston AC [13]

IRELAND, Leroy [P] NYC b. 24 D 1889, Phila., PA d. ca. 1970. Studied: PAFA, with. W.M. Chase; Garber; E. Carlsen, NYC. Member: SC; F., PAFA; A. Fund. S. Work: "God of the Snake Dance," Dallas AA; San Antonio Mus. Specialty: still life [40]

IRELAND, Meta S. (Mrs.) [P] NYC [15]

IRELAND, Sarah [P] Baltimore, MD [24]

IRELAND, William Addison ("Billy") [Car,I] Columbus, OH b. 8 Ja 1880, Chillicothe, Ohio d. 29 My 1935. Member: Columbus PPS. His page, "The Passing Show," was a feature of the Columbus Sunday Dispatch for years, and his signature was invariably the Shamrock. [33]

IRISH, Margaret Holmes [P] Webster Groves, MO b. Blenheim, Canada. Studied: St. Louis Sch. FA. Member: Alliance; Twentieth Century C., St. Louis; AFA. Exhibited: State Fair, St. Louis, 1912 (prize) [33]

IRVIN, Sister Mary Francis [P,T,En,S] Greensburg, PA b. 4 O 1914, Canton, OH. Studied: Seton Hill Col.; Carnegie Inst. Member: Pittsburgh AA; Greensburg AC; CAA; Catholic AA. Exhibited: LOC, 1944; Pittsburgh AA, 1943–46, 1945 (prize); CI, 1944; Greensburgh AC, 1944 (prize), 1945. Work: Carnegie Inst.; St. Charles Borromeo Church, Twin Rocks. Pa. Position: T., Seton Hill Col., Greensburg [47]

IRVIN, Melita McCormack (Mrs. William A.S.) [S] Chicago, IL b. Port Hope, Ontario. Studied: G. Hruska; A. Keeney. Member: Women A. Salon, Chicago; South Side AA; Chicago No-Jury SA; Renaissance Soc., Univ. Chicago. Exhibited: Women A. Salon, Chicago, 1940–45; South Side AA, 1943–45; Chicago No-Jury Soc., 1933–45; Ill. State Mus., 1945 [47]

IRVIN, Rea [P,I,Car] Newtown, CT b. 26 Ag 1881, San Fran. d. 1972. Studied: Mark Hopkins AI. Position: Illus./A. Ed., New Yorker, 21 yrs. [47]

IRVIN, Virginia Hendrickson (Mrs.) [Min.P] Ann Arbor, MI b. 9 O 1904, Chicago. Studied: AIC; E.D. Pattee. Member: ASMP; Pa. SMP; Mich. Acad. Sc., A.&Let.; Detroit Soc. Women P.&S. Exhibited: ASMP, 1932, 1935, 1938, 1940, 1943, 1944 (prize), 1945; MMA (AV), 1942; Calif. S. Min. P., 1936, 1938, 1941, 1942; Smithsonian Inst., 1943, 1945; Detroit Soc. Women P.&S., 1945, 1946; Ann Arbor A. Exh. [47]

IRVINE, Charles [P] NYC. Member: AG of Authors Lg. A. [25]

IRVINE, Jack [Des] Mt. Vernon, NY b. 24 Mr 1904, Nelson, British Columbia. Studied: NYU. Designer: packages, labels, window displays [40]

IRVINE, M. Bell [P,T] Norfolk, VA. Studied: PAFA. Member: Norfolk SA. Position: T., Pub. Sch., Norfolk [27]

IRVINE, Sadie A.E. [B,C] New Orleans, LA b. 21 Jy 1886, New Orleans. Studied: Newcomb A. Sch.; ASL. Member: SSAL; NOAA. Exhibited: SSAL, Ann., Dallas, 1926 (prize); NOAA Ann., Delgado Mus. A., 1930 (prize), 1933 (prize). Position: T., Newcomb Pottery Sch., New Orleans [40]

IRVINE, Wilson Henry [Ldscp.P] Lyme, CT b. 28 F 1869, Byron, IL d. 21 Ag 1936. Studied: AIC; mostly self-taught. Member: ANA, 1926; Lyme AA; Chicago SA; Chicago WCC; Cliff Dwellers; Palette and Chisel C., Chicago; SC; Allied AA; NAC. Exhibited: AIC, 1912 (prize), 1915 (prize), 1916 (prize), 1917 (prize); P.-P. Expo, San Fran., 1915 (prize); Chicago SA, 1916 (med); Palette and Chisel C., 1916 (med); CAFA, 1929 (prize); his experimental "aqua-prints," Roullier G., Chicago, 1920s; jewel-like "prismatic paintings" first exhibited at Grand Central AG, 1930; Lyme AA, 1934 (prize). Work: AIC; Municipal AL, 1911; Sears Mem. Mus., Elgin, Ill.; NAC; Rockford AA, Ill.; Phoenix AM; Benton MA; Lyme Hist. S.; Friends Am. Art; Union League C. [33]

IRVING, Anna Duer [Por.P] NYC b. 14 Ap 1873, Madison, WI d. 11 N 1957, Bronx, NY. Studied: Oldfield Sch., Baltimore; Henri; G. Bellows; C. Hawthorne; A.W. Dow; Johansen. Member: New Haven PCC; PBC; NAWA. Exhibited: NAWA, annually; PBC, 1933 (prize), 1934 (prize), 1937 (prize), 1938 (prize); New Haven PCC, 1929 (prize). Work: Oldfield Sch. Lib. [47]

IRVING, Jay [Car] NYC b. 3 O 1900. Member: SI. Position: Comic Ar., Collier's Weekly, NYC [40]

IRWIN, Edwin [P] Cincinnati, OH [01]

IRWIN, Mary Brooks (Mrs. Lee F.) [P,Min.P] b. 22 O 1840, Mobile, AL d. 11 Ag 1919. Amateur painter of flowers, Negro life and miniatures. [*]

IRWIN, William Hyde [P,Des,E,W,Car] San Fran., CA b. 14 O 1903, San Fran. Studied: Stanford; Calif. Col. A.&Cr.; Univ. Calif.; H. Hofmann; H. Marchand; Colarossi Acad.; Acad. Moderne. Member: San Fran. AA; Carmel AA; Santa Cruz AL. Exhibited: Chicago SE, 1930; NAC, 1930; San Fran. AA, 1930, 1932, 1935, 1938, 1939, 1946; Pal. Leg. Honor, 1934; Oakland A. Gal. 1930, 1932, 1934, 1935, 1938; Santa Cruz A. Lg., 1930, 1932–38, 1941; Calif. WCS, 1938; Calif. State Fair, 1935–37, 1939; Santa Cruz Fair, 1937, 1938 (prize), 1941; Calif. Statewide Exh., Santa Cruz, 1934. Work: Old Customs House, Monterey [47]

ISAACS, Amy [P] St. Louis, MO. Member: St. Louis AG [25]

ISAACS, Betty Lewis (Mrs. Julius) [S,Dec,Des,I,P,L,T] NYC b. 2 S 1894, Hobart, Tasmania d. 1971. Studied: CUASch; ASL; Alfred Univ.; Vienna, Kunstgewerbe Schule, with Wimmer, E. Zweybruck; M. Werten, in Warsaw, Poland. Member: Nat. AAI; N.Y. Soc. Cer. A. Exhibited: Audubon A., 1945; N.Y. Soc. Cer. A., 1944, 1945; Phila. All. [47]

ISAACS, Elizabeth F. [P] Vincennes, IN [10]

ISAACS, Jessie [P] NYC [10]

ISAACS, Walter F. [Edu,P,W,L] Seattle, WA b. 15 Jy 1886, Gillespie, IL. Studied: Millikin Univ.; ASL; AIC; Columbia; Paris. Member: Am. Assn. Univ. Prof.; Pacific AA. Exhibited: CI, 1946; Northwest A., annually, 1929 (prize). Work: SAM. Contributor: Magazine of Art. Position: T., Univ. Wash., Seattle [47]

ISAACSON, J.H. [P] Toledo, OH. Member: Artklan [25]

ISABELL, Ella Louise [C,Dec,Des] Brookline, MA b. 29 Jy 1861, Syracuse, NY. Studied: G. Leykanf; M. Frey. Member: Boston SAC. Specialty: china decoration [40]

ISELIN, Lewis [S] NYC b. 22 Je 1913, New Rochelle, NY. Studied: Harvard; ASL, with M. Young. Member: Century Assn. Exhibited: NAD, 1939 (prize), 1943; PAFA, 1941; MMA (AV), 1942; WFNY, 1939 [47]

ISENBURGER, Eric [P] NYC b. 17 My 1902, Frankfort, Germany. Exhibited: CI, 1943–45; PAFA, 1943–45; CGA, 1943, 1945; AIC, 1942, 1945; WMAA, 1944; CAM, 1945; NAD, 1942, 1945 (prize); Indianapolis, 1946; CMA, 1946; Knoedler Gal., 1941 (one-man), 1943 (one-man), 1945 (one-man), 1947 (one-man); de Young Mem. Mus. 1945 (one-man); BMA, 1943 (one-man); Springfield (Mass.) Mus., 1945 (one-man); Colorado Springs FA Center, 1945 (one-man); Herron AI, 1946; McClees Gal., Phila., 1942 (one-man). Work: MOMA; PAFA; Herron AI; IBM; Encyclopaedia Britannica Coll. [47]

ISERMANN, Haino [S] Chicago, IL b. 1830 d. 5 Ja 1900

ISHAM, Norman M. [P] Providence, RI. Member: Providence AC [19]

ISHAM, Samuel [P,W,Cr] NYC b. 12 My 1855, NYC d. 12 Je 1914, East Hampton, NY. Studied: Yale; Académie Julian, Paris, with J. de la Chevreuse, Boulanger, Lefebvre. Member: Cornish (N.H.) Colony; SAA, 1891; NAD; NA; NYWCC; Arch. Lg.; NIAL; SC; Century Assn. Exhibited: Buffalo Expo, Art Jury, 1901; St. Louis Expo, 1904 (med). Author: "A History of American Paintings" [13]

ISIDOR, Joseph S. [Patron] NYC b. 1860 d. 14 F 1941. Donated his collection of American paintings to Newark Mus.

ISKANTOR [P] NYC b. 5 Ja 1906, Russia. Studied: self-taught. Member: S.Indp.A.; Contemp. A. [40]

ISNOGLE, Walter H. [P] Middletown, IN [17]

ISRAEL, Nathan [P] NYC b. 21 D 1895, Brooklyn, NY. Studied: M. Weber; K.H. Miller; B. Robinson. Member: ASL; S.Indp.A. [24]

IUNGERICH, Helene [P] NYC. Studied: PAFA [19]

IVANOFF, Eugene [P] San Fran., CA. Exhibited: GGE, 1939; San Fran. AA, SFMA, 1935 (med) [40]

IVANOWSKI, Sigismund de [Por.P,I] Mountainside, NJ b. 17 Ap 1875, Odessa, Russia (came to U.S. in 1903) d. 12 Ap 1944, Westmoreland, NH. Studied: Europe. Member: SI; NAC. Specialty: actresses in character parts [13]

IVERD, Eugene [P,I] Erie, PA b. 31 Ja 1893, St. Paul, MN d. ca. 1938. Studied: St. Paul Inst. A.; PAFA. Work: cover designs and illustrations for Saturday Evening Post, American Magazine, other publications. Specialty: children [38]

IVES, Chauncey Bradley [S] Rome, Italy b. 14 D 1810, Hamden, CT d. 2 Ag 1894. Studied: under a woodcarver, New Haven; Boston. Had studio in NYC ca. 1840–44; Florence, 1844–51; Rome, 1851–94. Work: U.S. Capitol; Conn. Capitol. Specialty: portrait busts [*]

IVES, Elsie (Mrs. Percy Ives) [P] d. 11 D 1915, Detroit, MI

IVES, Halsey Cooley [P,Mus.Dir] Redcroft, St. Louis, MO b. 27 O 1847, Montour Falls, NY d. 6 May 1911, London. Studied: A. Piatowsky. Member: St. Louis A. Gld.; AIA; SWA; NSS; NAC. In 1875 he became an instructor at Washington Univ., St. Louis, and through his efforts the St. Louis Sch. of Fine Arts was established. In 1881, at the establishment of the Museum of Fine Arts, he became its director. He was in charge of the Dept. of Fine Arts at the World's Fair in Chicago, 1893, and the A. Purchase Expo, St. Louis, 1904 [10]

IVES, Neil McDowell [P] 27 N 1890 d. 12 S 1946, Kingston, NY. Studied: AIC; St. Louis Sch. FA, Wash. Univ.; Woodstock. Member/Director: Woodstock AA [40]

IVES, Percy [Por.P,T] Detroit, MI b. 5 Je, 1864, Detroit. 14 F 1928. Studied: L.T. Ives; Paris, with Bouguereau, Gèrôme, Lefebvre, Robert-Fleury, Constant, Boulanger. Member: Scarab C. Exhibited: Pan-Am. Expo, Buffalo, 1901. Work: portraits of Grover Cleveland, Walt Whitman [27]

IVEY, Elizabeth Hall (Mrs. A. Lynn) [P,L] Bon Air, VA b. Thomson, GA. Studied: S.I. Habersham; H.H. Osgood; G.W. James, Jr.; A. Fletcher. Member: Richmond Acad. A.; Arts C. Wash.; VMFA [40]

IVINNEY, Faith E. [P] Westwood, NJ [24]

IVINS, Florence W. (Mrs. W.M., Jr.) [P,En] NYC. Member: NAWPS [27]

IVINS, William M., Jr. [Mus.Cur] Woodbury, CT b. 13 Ja 1881, NYC d. 14 Je 1961, White Plains, NY. Author: "How Prints Look," 1943. Position: Cur. of Prints, MMA, 1916–46 [47]

IVONE, Arthur [S] Cincinnati, OH b. 29 My 1894, Naples, Italy. Studied: A. D'Orsi, in Naples; E. Ferrari, in Rome; C.J. Barnhorn, at Cincinnati A. Acad.; Mossuti, in Naples. Member: Cincinnati AA; Cincinnati Assn. Prof. A. Exhibited: Columbus Mem. Comp., Syracuse, N.Y. Work: S., Ohio State War Mem.; Springfield (Ohio) Mus.; mem., Indianapolis; Mt. Wash. Park, Cincinnati; State Archives Bldg., Montgomery, Ala.; panels, Birmingham, Ala.; State House, Columbus, Ohio; Symmes Mem., North Bend, Ohio; Stephen Foster Mem., Indianapolis [47]

IVORY, P.V.E. [I] Harriman, NY. Studied: H. Pyle. Member: SC; SI [31]

IVY, Gregory Dowler [T,P,Li] Greensboro, NC b. 7 My 1904, Clarksburg, MO. Studied: Central Mo. State T. Col.; St. Louis Sch. FA, Wash. Univ.; Columbia. Exhibited: AIC, 1939–42; BM, 1938–42; MMA (AV), 1943; Kansas City AI. Author/Illustrator: "An Approach to Design" (monograph). Positions: T., State T. Col., Indiana, Pa. (1932–35), Women's Col., Univ. N.C., 1935– [47]

IWERSEN, Marguerite (Mrs. Emilio) [C,T] Tuckahoe, NY b. 25 Jy 1897, Brooklyn, NY. Studied: M. Lewis; A. Voorhees. Member: N.Y. Sch. Cer. A.; NYSC [40]

IZOR, Estelle Peele [P,W] Indianapolis, IN. Studied: Forsyth; Steel; Freer; Vanderpoel; Chicago; Chase; Herter; H.D. Murphy. Member: Ind. AC [21]

J

Dawson-Watson: My Studio. Field & Sky. From The Illustrator (1893)

JABAL, Dhula Jehan Satyakama [P,T,Dec,L] NYC b. 20 F 1898, Dalcour, LA. Exhibited: Charpentier Gal., Paris; Petit Matin Gal., Tunis; Cairo Mus., Egypt. Work: St. Mary's Convent, N.Y.; Municipal Opera, Rio de Janeiro. Founder: Hindu-Egyptian Inst. P., N.Y. [40]

JABLECKI, Kasnia Boleslaw (Mr.) [Mur.P] Pawtucket, RI b. 24 Ag 1907, Providence. Studied: RISD. Designer: posters, Leroy Theatre. Position: T., Pawtucket Evening Sch. [40]

JABLONSKI, Joseph S. [Edu,E,P,C,Mus.Dir] Huntington, WV b. 9 F 1898, Poland. Studied: Harvard; F. von der Lancken; F. Wagner; A. Pope. Exhibited: Rochester Mem. A. Gal., 1928 (prize); PAFA, 1926, 1927; Rockport AA, 1926; Rochester AC, 1925–28; All. A., W.Va., 1931, 1932, 1945; Marshall Col., 1933 (one-man). Work: Rochester Athenaeum & Mechanics Inst.; Marshall Col.; Harvard Univ. Position: T., Marshall Col., 1929– [47]

JACCACI, August Florian [Mur.P,W] b. 28 Ja 1856, Fontainebleau, France (came to U.S. in early 1880s) d. 22 Jy 1930, Chateau Neuf-de-Grasse, France. Work: murals, Capitol, St. Paul, Minn. Author: "On the Trail of Don Quixote" (in English and French). He planned a monumental work, "Noteworthy Pictures in American Private Collections," to be issued in many portfolio volumes. The first volume appeared, but work was halted by WWI. After the war he gave up art for philanthropic causes. Positions: A. Dir., McClure's, Scribner's

JACK, Ella [Edu,P] Stillwater, OK b. Hiawatha, KS. Studied: Chouinard AI; Otis AI; AIC; Univ. Chicago; Claremont Col.; M. Sheets; E. Vysekal. Member: Okla. AA; NAWA. Exhibited: Okla. State Fair (prize); High Mus. A., 1944; NAWA, 1939–46; Okla. AA, 1929–46; Kansas City AI; Women P. of Am., 1939; Stillwater, Okla. (one-man). Work: Kansas City AI; Mayo Clinic Lib. Position: T., Okla. A.&M. Col. [47]

JACKLEY, F. Dano [P,G,Arch] Baltimore MD b. 22 Ja 1900, Frankton, IN. Studied: Herron AI, Indianapolis; PAFA; J.W. Smith. Member: Am. Ar. Prof. Lg.; Southern Pr. M.; Baltimore WCC; Assn. Am. Inst. Arch. Exhibited: WC Ann., Baltimore MA, 1939; Md. Inst.; Southern Pr.M. [40]

JACKMAN, Oscar F. [I] Richmond Hill, NY. Member: SI [13]

JACKMAN, Reva [P,Gr,I,Des] Skokie, IL b. Wichita, KS. Studied: AIC; Académie Julian, Paris; W. Reynolds; P. Carter. Exhibited: Paris Salon, 1937; Jacques Seligmann Gal., Paris, 1927; Am. Lib., Paris, 1930; All-Ill. Soc. FA, 1936, 1937; Municipal A. Lg., 1929, 1938; AIC, 1936, 1937; Evanston Women's C., 1937–42, 1944. Work: Pub. Lib., Bd. Ed., Pub. Sch., all in Chicago; Holy Trinity Church, Skokie, Ill.; USPOs, Attica, Ind.; Bushnell, Ill. Specialty: textile design. WPA artist. [47]

JACKMAN, Reva [P,B,I,Des] Niles Center, IL b. 16 Ja 1892, Wichita, KS. Studied: AIC; W. Reynolds; Lhote; F.M. Armington, in Paris. Member: United Am. Ar. Work: Bd. Edu., John Marshall, Calumet H.S., pub. schs., Pub. Lib., all in Chicago; USPOs, Attica, Ind., Bushnell, Ill.; Holy Trinity Church, Niles Center; Hawthorne Sch., Libertyville, Ill. WPA artist. [40]

JACKMAN, Theodore [P] Laguna Beach, CA. Member: Laguna Beach AA [25]

JACKMAN, Theodore (Mrs.) [P] Laguna Beach, CA. Member: Laguna Beach AA [25]

JACKSON, Annie Hulburt [Min.P] Brookline, MA b. 19 Ag 1877, Minneapolis d. ca. 1960. Studied: Pape; Murphy; Woodbury; Hawthorne; O'Hara. Member: ASMP; Copley S.; Pa. Soc. Min. P.; Boston Gld. A. Exhibited: Pa. S. Min. P., 1925 (med); Sesqui-Centenn. Expo, Phila., 1926 (gold); Baltimore, 1926 (prize); Boston Tercentenary, 1930 (med); Los Angeles, 1935 (prize). Work: BM; PMA [47]

JACKSON, C.D. [P] New Orleans, LA [17]

JACKSON, Charles Akerman [Por.P] Jamaica Plain, MA b. 13 Ag 1857, Jamaica Plain. Work: Providence City Hall; Oberlin Col.; Brown Univ. [17]

JACKSON, Chevalier [I,W,L,T] Schwenkville, PA b. 4 N 1865, Pittsburgh. Studied: A.Bryan Wall. Member: Pittsburgh AA [25]

JACKSON, Dennis Emerson [P,W] Cincinnati, OH b. 3 S 1878, Ridgeport, IN. Studied: Ind. Univ.; self-taught. Member: Am. Physicians AA; Cincinnati AC. Exhibited: Cincinnati AC; Univ. Cincinnati [47]

JACKSON, Elbert McGran [I] NYC. Member: GFLA. Illustrator: Saturday Evening Post [24]

JACKSON, Ethel A. [P] East Orange, NJ [19]

JACKSON, Everett Gee [P,I,Li,T] San Diego, CA (1976) b. 8 O 1900, Mexia, TX. Studied: Tex. A.&M. Col., AIC, 1921–23; San Diego State Col.; Univ. Southern Calif. Member: San Diego FA Soc.; Western A. (founder); Laguna Beach AA. Exhibited: San Fran., 1928 (prize); Laguna Beach AA, 1934 (prize); Los Angeles Mus. A., 1934 (prize); Houston Mus. FA; San Diego FA Soc.; Pal. Leg. Honor, 1946. Work: Houston Mus. FA; San Diego FA Soc.; Los Angeles Mus. A.; "Int'l Studio," 1927. Illustrator: "Paul Bunyan," 1945, "Ramona," 1960. Position: T., San Diego State Col., 1930–63 [47]

JACKSON, F.W. [P] Phila., PA [06]

JACKSON, Frank H(enry) [P] Aberdeen, MA/Etaples, Pas-de-Calais, France b. 21 S 1864, England. Member: Copley S.; Soc. Odd Brushes; Boston AC; Boston SWCP [19]

JACKSON, Frederick Ellis [P] Providence, RI. Member: Providence AC [17]

JACKSON, Gordena Parker (Mrs.) [P,G,C,Des] Berkeley, CA b. 3 Ja 1900, Pleasanton, CA. Studied: Calif. Sch. A.–Cr. Exhibited: Albany Inst. Hist.&A., 1941, 1943, 1945; NAD, 1942, 1943; Okla. A. Center, 1940; San Fran. AA, 1932, 1937–39, 1941; Oakland A. Gal., 1933, 1937, 1941, 1942; Tex. FA Assn., 1943; Laguna Beach AA, 1944; Calif State Fair, 1941; Santa Cruz A. Lg., 1932, 1933, 1935, 1937, 1943; Mills Col., 1933 (one-man); Stanford Univ., 1939 (one-man); Gelber-Lilienthal Gal., San Fran., 1932 (one-man), 1940 (one-man) [47]

JACKSON, H.B. [P] Monroe, MI. Member: Artklan [25]

JACKSON, Hazel Brill [S,En,B] Newburgh, NY b. 15 D 1894, Phila. Studied: BMFA Sch.; B. Pratt, A. Zanelli, in Rome; C. Grafly. Member: NAWA; Gld. Boston A.; NSS; Albany Pr. C.; PBC; L.C. Tiffany Fnd.; Grand Central AG. Exhibited: Nat. Acad., Rome, 1927–29, 1930 (med); NAD, 1944, 1945 (prize); Nat. Acad., Firenze, Italy, 1927–30; Grand Central A. Gal.; Gld. Boston A. Work: Concord A. Mus.; Montpelier (Vt.) A. Mus.; Hotchkiss Sch., Lakeville, Conn.; Andover Theological Seminary; mem. tablet, Turin, Italy; portrait of Mussolini's favorite horse, "Ned," Palazzo Torlonia, Rome [47]

JACKSON, H(oward) M(erritt) [P] Carmel, CA b. 10 Je 1906, San Bernar-

dino, CA. Studied: Calif. Sch. FA. Member: San Fran. A. Center. Exhibited: San Fran. AA Ann. Exh., 1931 (prize) [40]

JACKSON, John Edwin [Mur.P,Des,I] NYC b. 7 N 1875, Nashville, TN d. ca. 1950. Studied: NAD; ASL. Member: SC. Exhibited: Nashville AC, 1920 (prize). Work: NYPL; N.Y. State T. Col., Albany; Nat. City Bank, N.Y.; County Court House, NYC; Nashville AC. Illustrator: Harper's; Scribner's; Doubleday, Doran [47]

JACKSON, John LeRoy [P,L,T] Atlanta, GA b. 5 My 1905. Studied: I. Olinsky; C. Martin; B.E. Shute; Columbia. Member: SSAL; Atlanta AA; Ga. ATA. Exhibited: SSAL. 1939 (prize). Work: murals, public schools, Atlanta [40]

JACKSON, John P. [P] Chicago, IL [13]

JACKSON, Joseph (Francis Ambrose) [Li,W,L] Phila. b. 20 My 1867, Phila. Studied: C.U. Boizard; PAFA; Spring Garden Inst., Phila. Member: AIA. Work: lithographs of modern Phila., 1927-28, Free Lib., Phila.; Hist. Soc. Pa. Author: "Lithography in Philadelphia," "Early Philadelphia Architects and Engineers." Editor: "Pennsylvania Architect" [40]

JACKSON, Lee [P,G] NYC b. 2 F 1909, NYC. Studied: ASL; W. McNulty; G. Luks; J. Sloan. Member: F., Guggenheim Fnd., 1941. Exhibited: PAFA, 1937; NAD, 1938, 1942, 1944, 1945; GGE, 1939; CI, 1941, 1943; WMAA, 1941, 1943-1946; CGA, 1941, 1943, 1945; AIC, 1942, 1946; CAM, 1945; Los Angeles Mus. A., 1945; Soc. Four A., 1942; Butler AI, 1946; Babcock Gal., 1941 (one-man), 1943 (one-man); Nat. Gal., Canada, 1940 (one-man); A. Gal. of Toronto, 1940 (one-man); Montreal AA., 1940 (one-man); Inst. Mod. A., Boston, 1945 (one-man). Work: MMA; CGA; Nebr. AA; Los Angeles Mus. A.; St. Bonaventure Col., N.Y.; Walker A. Center [47]

JACKSON, Leslie (Miss) [P,E] Wash., D.C. b. 1866, Rochester, MN d. 19 Ja 1958. Studied: E.C. Messer; C. Hawthorne; H. Snell; ASL. Member: Wash. WCC; NYWCC; AWCS; Soc. Wash. A.; AFA; Wash. SE. Exhibited: Wash. WCC, 1905 (prize); New Haven PCC, 1924 (prize). Work: Smithsonian Inst.; Speed Mem. Mus. [47]

JACKSON, Louise W. [P] Cambridge, MA. Member: Copley S., 1900 [10]

JACKSON, Mabel C. [P] St. Paul, MN [13]

JACKSON, Martin J(acob) [P] Los Angeles, CA b. 12 Ap 1871, Newburgh, NY. Studied: CUASch; NAD, with E.M. Ward; Comelli, in London; Paris; Brussels; Antwerp. Member: Los Angeles AL. Exhibited: Alaska-Yukon-Pacific Expo, Seattle, 1909 (medals); 10th Olympiad, Los Angeles, 1932 (med). Designer: costumes. Illuminator. [40]

JACKSON, May Howard (Mrs.) [S] Wash., D.C. b. 12 My 1877, Phila. d. Jy 1931. Studied: PAFA. Member: S.Indp.A. Exhibited: Harmon sculpture, 1928. Work: St. Thomas' Church, Phila.; Dunbar H.S., Howard Univ. [31]

JACKSON, Nathalie L'Hommedieu [Min.P] Orange, NJ. Exhibited: PAFA, 1934, 1935, 1937, 1938; Calif. Soc. Min. P. Ann., Los Angeles, 1938 [40]

JACKSON, Robert Fuller [P,Arch,Des,T] Brookline, MA b. 22 Jy 1875, Minneapolis. Studied: Harvard. Member: Copley S. [40]

JACKSON, Robert Macauley [P] Washington, CT [25]

JACKSON, Roy [P] Earlington Heights, WA b. 1892, WA. Studied: abroad. Member: Seattle FA Soc. [24]

JACKSON, Virgil Vernon [P,C,I] Columbus, OH b. 17 S 1909, Peoria, OH. Studied: A. Schille; M. Russell; C. Nicodemus; R.O. Chadeayne. Member: Columbus AL. Work: Auditorium, Marysville, Ohio. WPA artist. Position: Staff, Columbus Citizen [40]

JACKSON, Will F. [P,Cur] Sacramento, CA b. 1851 d. 9 Ja 1936. Position: Cur., Crocker A. Gal., Sacramento, since its opening in 1884. [17]

JACKSON, William H. [P] Boston, MA b. 13 Ag 1833, Watertown, MA. Studied: Enneking, Juglaris, Sandham, Rimmer, all in Boston. Member: Boston AC. Exhibited: Phila.; Boston; London. Specialty: religious subjects [13]

JACKSON, William Henry [Photogr,P,W] NYC b. 1843, Keesville, NY d. 30 Je 1942. Work: 20,000 prints and 30,000 negatives, LOC; 7,000 negatives, Colo. Hist. Soc.; 2,000 negatives of Indians, Bur. of Ethnology; IMP; Yale; major museums. Perhaps the best known of the landscape photographers of the Old West. He was official photographer for Hayden's U.S. Geological Surveys, and his photos helped influence Congress to establish Yellowstone Nat. Park. He was a prolific artist and traveled widely. He also painted in watercolor.

JACOB, F.W. [P] Norwood, OH. Member: Cincinnati AC [21]

JACOBI, Eli [P,E,I,Car,B] NYC b. 1 My 1898, Russia. Member: United Am. Ar. Illustrator: Nation, Saturday Review, Living Age. Specialty: block printer. WPA artist. [40]

JACOBI, Lotte [Photogr] Deering, NH (1984) b. 1896, Germany (came to NYC in 1935). Studied: Bavarian Acad. Photogr.; Univ. Munich; her father. Exhibited: Royal Photogr. Salon, Tokyo, 1931 (med). A well-known portrait photographer she was active in Berlin 1927-35; fled Nazi Germany, opening studio in NYC. Best known portraits are of Einstein, E. Roosevelt, R. Frost, Steichen, Stieglitz, and Strand. Also known for her "photogenics," cameraless abstract light prints. [*]

JACOBI, Rudolf [P,T] Gloucester, MA b. 11 D 1889, Thuringia, Germany. Studied: Royal Acad., Berlin. Exhibited: CI; AIC; PAFA; CAM; SFMA; abroad. Work: MMA; Springfield (Mass.) Mus. A.; Germanic Mus., Cambridge, Mass.; CAM. Position: T., Annot A. Sch., N.Y. [47]

JACOBI, Ruth [P] NYC. Member: Lg. of AA [24]

JACOBS, Elmer [Typographic Des,I,P,L] Chicago, IL b. 9 My 1901, Streator, IL. Studied: Moholy-Nagy; Schroeder; G. Kepes. Member: Soc. Typographic A.; A. Gld., Chicago; Palette and Chisel Acad. FA; 27 Chicago Designers; Soc. for Sanity in A. Exhibited: AIGA, 1937-39 (prizes); Soc. Typographic A., 1935-39 (prizes), 1945 (prize); A. Gld., Chicago, 1941 (prize). Illustrator: "Anthology of the Flame," "Qwert Yuiop," other books [47]

JACOBS, Frank [P] Seattle, WA [24]

JACOBS, Harry W. [P,T] Buffalo, NY [21]

JACOBS, Hobart B. [P,L,T] Greenwich, CT b. 1851 d. 8 Ag 1935. Member: Greenwich SA. Position: T., Greenwich Pub. Sch. [25]

JACOBS, Isabel M. [P,T] Phila., PA b. Phila. Studied: Pa. Mus. Sch. Indst. Art; F.A. Parsons; E. Horter; F. Watkins. Member: Phila. A. All. [40]

JACOBS, Leonebel [Por.P] NYC b. Tacoma, WA. Studied: Brush; Hawthorne. Member: AWCS; PBC; NAWA; NYWCC; Municipal A. Com., N.Y. Work: portraits of Mrs. Calvin Coolidge, Mr. Herbert Hoover, Gutzon Borglum. Author: "Portraits of Thirty Authors" [47]

JACOBS, Lillyan Estelle [Des,P,C] Des Moines, IA b. 15 My 1915, Des Moines. Studied: L. Houser; A. Dornbush; E. Giesbert. Exhibited: Iowa A. Salon, 1932 (prize), 1933 (prize), 1934 (prize), 1935 (prize), 1939 (prize); WFNY, 1939. Work: Hotel Franklin, Des Moines; Iowa State Col., Ames. WPA artist. [40]

JACOBS, Michel [Por.P,S,W,L,T] Rumson, NJ b. 10 S 1877, Montreal d. 4 F 1958. Studied: NAD; Ecole des Beaux-Arts, Paris; Berlin; Laurens, in Paris; NAD, with E.M. Ward. Member: SC; S.Indp.A.; A. Fellowship; A. Gld.; F.R.S.A. Exhibited: NAD; All.A.Am.; Gloucester SA; Paris Salon; Montreal Mus. A.; Wash. SA; Dallas A. Soc. Work: NGA; Capitol, Wash. D.C.; State Dept., Wash. D.C.; 26 portraits, Baron de Hirsch Inst., Montreal. Author: "Portrait Painting," 1946, "The Art of Color," other books [47]

JACOBS, William [P,C,B] Chicago, IL b. 31 Jy 1897. Studied: AIC; Herman Sachs, in Europe. Member: United Am. Ar. Exhibited: AIC, 1927 (prize). Work: Chicago Women's Aid, Dental Arts Bldg. Illustrator: blockprints, Survey Graphic magazine, 1934 [40]

JACOBS, William L. [I] NYC b. 1869, Cleveland, OH d. 8 Ap 1917, in his NYC studio. Studied: Paris: Acad. Julian; Acad. Colarossi, both in Paris. Member: SI. Contributor: Century, Scribner's, Life, other publications [15]

JACOBSEN, Antonio Nicolo Gaspara [Mar.P] Hoboken, NJ b. 2 N 1850, Copenhagen (came to NYC in 1871) d. 2 F 1921. Studied: Royal Acad., Copenhagen. Work: every major marine art coll. in U.S. & Europe; the largest coll. (250) being at Mariner's Mus.; Peabody Mus.; Salem; Mystic Seaport Mus.; N.Y. Hist. Soc.; Fall River Mar. Mus.; La. State Mus. America's most prolific marine artist, he painted about 6,000 portraits of steamships that came into NYC harbor between 1876-1919 (over 3,000 listed in catalogue raisonné, Smith Gal., NYC 1984). [*]

JACOBSEN, Ethel, Mrs. See Plummer.

JACOBSEN, Emmanuel [P,T] Chicago, IL b. Chicago. Studied: AIC; Northwestern Univ. Member: Chicago SA. Exhibited: WIC, 1934, 1935, 1939, 1940, 1946. WPA artist. [47]

JACOBSEN, Oscar [P] Minneapolis, MN [13]

JACOBSON, Oscar B(rousse) [P,W,L,T] Norman, OK (1962) b. 16 My 1882, Westervik, Sweden (came to U.S., 1890). Studied: Bethany Col.; Yale; Paris, B. Sandzen; Weir; A. Thompson; Niemeyer. Member: CAA;

AFA; SSAL; Assn. Okla. A. Exhibited: WFNY, 1939; Colorado Springs FA Center; Albuquerque, N.Mex., 1940; CGA; Dallas Mus. FA; Mus. FA of Houston; Univ. Wis.; Univ. Kansas; Syracuse Univ.; Cornell; Okla. A. Center; Grinnell Col.; Wichita A. Mus.; Philbrook A. Center; IBM, 1940 (prize); GGE, 1939 (prize); Kansas City AI 1931 (prize). Work: McPherson A. Gal, Kansas; Bethany Col. A. Gal.; State Capitol, Okla. City, Okla.; Broadmoor A. Acad.; Univ. Okla.; Okla. A. Lg. WPA advisor. Sponsor of the "Five Kiowas." Position: T., Univ. Okla., 1914–45 [47]

JACOBSSON, Edward Gustave [P,T] Canaan, NY b. 29 Jy 1907, NYC. Studied: NAD; ASL; Grand Central A. Sch.; AIC; Olinsky; Charlot; Skou; B. Robinson. Member: CAFA; Springfield AL; North Shore AA; Mid-Vermont A.; Ogunquit A. Center; Berkshire A. Center. Exhibited: PAFA; Palace Legion Honor, 1946; Mint Mus., 1945, 1946; George Walter Vincent Smith Gal., 1945, 1946; Springfield Mus. FA, 1945; Morgan Mem., 1945, 1946; Phila. Sketch C., 1945, 1946; Jersey City Mus., 1945; Berkshire Mus.; Swedish C., Chicago, 1946 (prize); CAFA, 1946 (prize); North Shore AA, 1946 (prize) [47]

JACOBSSON, Sten W. John [P,S,Mur.P,T,C] Detroit, MI b. 28 Mr 1899, Stockholm, Sweden. Studied: Carl Milles; Germany; France; Tekniska Skolan, Stockholm. Exhibited: Detroit 1936 (prize). Work: murals, First Swedish Baptist Church, N.Y.; First Lutheran Church, Arlington, N.J.; S., USPO, Forest Hills, N.Y. WPA artist. Position: T., Wayne Univ. [47]

JACOBY, Graziella [P] Chicago, IL [15]

JACOBY, Hazel Bertha [Ldscp.P,Des,I,B,Li] Toledo, OH b. 20 Ja 1908, Toledo. Studied: Toledo Univ.; Cleveand Sch. A.; AIC; Grand Cent. A. Sch.; Abramofsky; G.R. Dean. Member: Palette C.; Toledo Women A.; Ohio WCS. Exhibited: Butler AI, 1939–41, 1943; LOC; Toledo Mus. A., 1941 (one-man), 1944 (one-man) (prize): Mexico, 1946 [47]

JACOBY, Helen Eaton [P,I] Indianapolis, IN b. Indianapolis. Studied: O. Stark, Indianapolis; PIASch. [27]

JACOBY, Minnie R. [P] West Phila., PA [06]

JACOVELLI, Ettore [P] NYC [10]

JACQUES, Emil [P,T,C] Notre Dame, IN b. 17 Jy 1874, Moorslede, Belgium d. 17 Ag 1937, Bellaire, MI. Studied: Institut Superieur des Beaux-Arts de Belgique, Antwerp. Member: Chicago Gal. A.; Hoosier Salon; Ind. Artists C.; Am. Artists Prof. Lg. Exhibited: Hoosier Salon, 1936 (prize). Work: Wightman A. Gal., Univ. Notre Dame; St. Mary's Cathedral. Established Art Dept., Columbia Univ., Portland, Oreg. Position: Dir., Sch. FA, Univ. Notre Dame, since 1929 [33]

JAECKEL, Gertrude [P] NYC. Exhibited: 48 States Comp., 1939 [40]

JAEDIKER, Max [Et] NYC. Member: SAE [47]

JAEDIKER, Theodore [P] NYC. Member: GFLA [21]

JAEGER, Arthur S. [P] Detroit, MI. Exhibited: Scarab C., Detroit, 1914 (prize) [24]

JAEGER, Charles H. [P] NYC [24]

JAEGER, George [P] St. Louis, MO [25]

JAEGERS, Albert [S] Suffern, NY b. 29 Mr 1868, Elberfeld, Germany d. 22 Jy 1925. Member: NSS, 1899; Arch. Lg., 1898; NIAL. Work: statue, Wash., D.C.; mon., Germantown, Pa.; Customs House, NYC [24]

JAEGERS, Augustine [S] Jackson Heights, NY b. 31 Mr 1878, Barmen, Germany. Studied: ASL; Ecole des Beaux-Arts, with Mercié. Member: NSS, 1909. Exhibited: Arch. Lg., 1909 (prize). Work: S., San Fran. Expo, 1915; mem., NYC; panels, Customs House, Phila.; State Col. Lib., State Col., Pa.; USPO, McDonald, Pa. WPA artist. [47]

JAGO, Ernest T. [P] NYC [25]

JAKOBB, Christian Arpad [Des,S,T,W] Bayside, NY b. 12 D 1880, Hungary. Studied: Royal A. Sch., Budapest. Member: Jewelry Des. G.; Soc. Des. Crafts.; Intl. Soc. Arts and Dec. [40]

JALANIVICH, Manuel [C,S,T] San Fran., CA b. 24 Je 1897, Biloxi, MI. Studied: L. Volkmar; E. Dismukes. Exhibited: Oakland A. Gal., 1937 [40]

JAMAR, S. Corinne [Min.P,P] Elktown, MD b. 7 N 1873, Elkton. Studied: Wilson Col.; Chambersburg, Pa.; AIC; Drexel Inst. Tech.; Md. Inst. Exhibited: SSAL, Charleston, 1921 (prize); Memphis, 1922 (prize); Atlanta C. of C., 1925 (prize); Md. Fed. Women's C., Baltimore, 1936 (prize) [40]

JAMBOR, Louis [P,Et,I,Mur.P] NYC b. 1 Ag 1884, Nagyvárad, Hungary d. ca. 1955. Studied: Royal Acad. A., Budapest; Germany. Member: All.A.Am.; Fla. WCS; AWCS; SC. Exhibited: NAD, 1929–31, 1933, 1944; AWCS, 1942, 1943, 1945; PAFA, 1941; All.A.Am., 1941; 1944 (prize); Grand Central A. Gal., 1945. Work: murals, Atlantic City Auditorium; churches, Buffalo, N.Y., Middletown, Conn. [47]

JAMES, Alexander [P] Dublin, NH b. 1890, Cambridge, MA d. 26 F 1946. Studied: A.H. Thayer; F.W. Benson. Member: Century Assn; AGAA. Work: AGAA; BMFA; Fogg Art Mus.; MET [40]

JAMES, Alfred Everett [P,S,Et,Des,T,C] Auburn, AL b. 17 Ap 1908, Edgewood, RI. Studied: RISD; Thurn Sch. Mod. A.; H. Hofmann. Member: Scarab C.; Ala. A. Lg.; Nat. Edu. Assn. Exhibited: Montgomery Mus. FA, 1940–43, 1945 (prize). Work: Providence Pub. Lib. Position: T., Ala. Polytechnic Inst., 1937–46 [47]

JAMES, Alice Archer Sewall (Mrs. John H.) [P,I] Urbana, OH b. 23 Ag 1870, Glendale, OH. Studied: Glasgow (Scotland) Sch. A.; H. Helmick, Wash., D.C. Exhibited: CGA; Wash. WCC, 1902 (prize). Illustrator: Harper's [17]

JAMES, Arthur E. [I] NYC. Member: SI [25]

JAMES, Austin [S] Pasadena, CA/Pebble Beach, CA b. 12 Mr 1885, Phila. Studied: Calif. Sch. FA; Bufano; Stackpole; Mora. Member: Carmel AA; Los Angeles PS; Pasadena AI; Calif. AC [33]

JAMES, Bess B. (Mrs. H.M.) [P] Monroe, LA b. 12 Ja 1897, Big Spring, TX. Studied: Las Vegas Univ.; A.L. Armstrong; A. Brewer; Southwest Tex. Col.; M. Hull; R. Henderson; V.T. Cole. Member: SSAL; Miss. AA; New Orleans AA; Palm Beach A. Cr. Exhibited: Chicago AC, 1943; SSAL, 1936, 1938, 1940, 1941; Miss. AA, 1937, 1939, 1942 (prize); Lubbock, Tex., 1938 (prize). Work: YWCA, Monroe; Ouachita Parish Jr. Col, Monroe, La. [47]

JAMES, E. [S] NYC [15]

JAMES, Esther M(orse) [Min.P] Brookline, MA b. 15 O 1885, Brookline, MA. Studied: Hale; Benson [21]

JAMES, Eva Gertrude (Mrs.) [P,S,C,T] Brazil, IN b. 18 Jy 1871, Moran Co., IN. Studied: Ind. Univ.; St. John's Acad.; R.E. Burke. Member: Hoosier Salon; Ind. AC. Exhibited: Hoosier Salon; Ind. State Fair, Brazil, Ind. (prize). Work: Oddfellows Hall, Eminence, Ind. [47]

JAMES, Evalyn Gertrude [P,C,T,W] Brazil, IN b. 22 My 1898, Chicago, IL Studied: Herron AI; Earlham Col.; Ind. Univ. Member: Hoosier Salon; Ind. AC; Western AA. Exhibited: Herron AI; Hoosier Salon, annually; Swope A. Gal.; Purdue Univ.; Terre Haute, Brazil, Ind.; Ind. State Fair (prize). Position: T., Dir. Studio Sch. FA, Brazil, Ind. [47]

JAMES, Faustina. See Kelly, John H., Mrs.

JAMES, Frederick [P] NYC b. 1845 d. Ag 1907, Peru, Quebec. Studied: PAFA; Paris, with Gérôme. Exhibited: NAD [06]

JAMES, G. Watson, Jr. [P,T,W] Richmond, VA/Salisbury, VT b. 15 Mr 1887, Richmond, VA. Member: Soc. Wash. A.; Southern Vt. Ar.; Acad. FA&Sc., Richmond; VMFA; Southern Vt. Ar. Work: VMFA. Position: T., Kewaydin Camps [40]

JAMES, H. Francis [P,T] Emporia, KS. Studied: J.P. Laurens, in Paris. Member: Chicago WCC; Prairie WCC. Exhibited: SSAL. Positions: T., Ill. State Normal Sch., Kans. State T. Col. [40]

JAMES, Henry C. (Mrs.) [P] St. Paul, MN [15]

JAMES, John Wells [P] NYC/Solebury, PA b. 22 F 1873, Brooklyn, NY. Studied: J. Knox. Member: SC; All. AA; Brooklyn PS; Rockport AS. Exhibited: SC (prize) [40]

JAMES, Rebecca Salsbury (Mrs. William H.) [P] b. 1891, London, England d. 1968, Taos, NM. Formerly Mrs. Paul Strand. Studied: self-taught. Exhibited: Stieglitz' Am. Place, 1932; annually, with Painters of the Southwest. Work: Mus. N.Mex.; Denver AM. Specialty: floral reverse paintings on glass [*]

JAMES, Roy Harrison [Car,I] St. Louis, MO b. 10 My 1889, Zalma, MO. Member: St. Louis AG [31]

JAMES, Roy Walter [P,S,T,W,L] Los Angeles, CA b. 24 S 1896, Gardena, CA. Studied: self-taught. Member: Calif. AC; Laguna Beach AA; Long Beach AA. Exhibited: Oakland A. Gal.; Palace Legion Honor; Los Angeles Mus. A.; Laguna Beach AA, 1942 (prize); 1945 (prize), 1946 (prize). Work: Covina (Calif.) Pub. Lib. Author: poetry in ten anthologies, including "California Poets." [47]

JAMES, Sandra [P] NYC. Member: AWS [47]

JAMES, T.M. (Mrs.) [S] Kansas City, MO [17]

JAMES, Victor [S] NYC [15]

JAMES, Will [P,I,E,W] Billings, MT b. 6 Je 1892, St. Nazaire de Acton, Quebec d. 3 S 1942, Los Angeles. Born Ernest Dufault, he came to Montana ca. 1911, using the alias of Will James. He died an alcoholic on his 12,000-acre ranch. Author/Illustrator: "The Drifting Cowboy," "Cowboys, North and South," "Smoky," "Lone Cowboy" (the last two having been made into movies), and many other books in the 1930s about cowboy life. [40]

JAMES, William [P,T] Cambridge, MA b. 17 Je 1882, Cambridge, MA d. 1961. Studied: Harvard; BMFA Sch.; Benson; Tarbell. Exhibited: P.-P. Expo, San Fran., 1915 (med); PAFA, 1925 (gold); Newport AA, 1930 (prize). Work: Gardner Mus., Boston; Providence A. Mus.; RISD. Position: T., BMFA Sch., 1913–26. Nephew of novelist Henry James. R.H.I. Gammell asserts that it was James' administration of the BMFA Sch. that lead to its decline and fall after 1929. [47]

JAMESON, Arthur E(dward) [I] NYC b. 26 Mr 1872, England. Studied: ASL. Member: SI [33]

JAMESON, Donald (Cleve) [B,Des,P] Chicago, IL b. 10 Ja 1901, Weeping Water, NE. Studied: Univ. Nebr. Sch. FA; AIC. Member: AFA [40]

JAMESON, John William [E,Des,I,Eng] Wheaton, IL b. 25 Mr 1882, Chicago d. 24 Je 1939. Studied: G.M. Melville; E.R. von Mauser; AIC. Member: Am. Soc. Bookplate Coll. and Des.; Calif. Bookplate Soc. Work: Heraldic Dept., Newberry Lib., Chicago; Dartmouth; Col. Wm. and Mary; Am. Antiquarian Soc.; Deane Mem. Coll.; LOC; "1935 Yearbook, American Society of Plate Collectors and Designers." Specialty: heraldic engraver and artist for Genealogical and Hist. Lib. and Soc. [38]

JAMESON, Lillian E. [P] Ten Hills, MD [25]

JAMESON, Minor Story [P] Chevy Chase, MD b. 26 Ag 1873, NYC. Studied: C. Yates; J.F. Carlson. Member: S. Wash. A.; Wash. AC; Wash. Landscape C. Exhibited: NAD; CGA; NGA; Md. Inst.; WMA; Ogunquit A. Center; S. Wash. A., 1924 (med), 1936 (prize); Landscape C., 1938 (med); Fed. Women's C., Wash., D.C., 1936 (prize) [47]

JAMESON, Rebecca [P] Chicago, IL [04]

JAMESON, Samilla Love (Mrs. O.J. Heinzmann) [S,P,I,C,Des,L,T] Princes Bay, NY b. 22 Ap 1881, Indianapolis, IN. Studied: AIC; Detroit FAA; CI; A. De Lug, Vienna. Member: SI AA; Kit Kat AC. Work: T. Payne Mem. tablet, NYC; Henry Hudson Tablet, Amsterdam, Holland [40]

JAMIESON, Agnes D. [P] Portland, OR [15]

JAMIESON, Bernice (Evelyn) [En,P,Des,C,Mus,Asst.Cur,T,B] Cranston, RI b. 18 Ap 1898, Providence, RI. Studied: RISD; Harvard; Brown; BAID; Steinhof; Thurn; Hibbard. Member: AM Mus.; Soc. Des.-Craftsmen; CAA; Providence AC; Providence WCC. Exhibited: AIC, 1935, 1939, 1940; Intl. Exh. Pr.M., Los Angeles, Calif., 1934–37; NAD; textile exh., Greensboro, N.C., 1944; Boston AC; Wash. WCC, 1936, 1938; Providence A.; Phila. Pr. C.; Phila. A. All., 1935, 1937, 1938; BM, 1933; Southern Pr.M., 1938, 1939; Wichita AA, 1936; Studio Gld., 1938; MMA, 1942; Providence Mus. A.; Pencil Points Comp., 1927 (prize). Positions: T., RISD, 1940; Cur., N.J. State Mus., Trenton, 1944–46 [47]

JAMIESON, Malcolm McGregor, Jr. [P,I] NYC [04]

JAMIESON, Mitchell [P,G,Mur.P] Linden, VA b. 27 O 1915, Kensington, MD. Studied: Abbott Sch. A.; Corcoran Sch. A.; Sokol; Nordmark. Member: Wash. A. Gld.; Wash. Ldscp. C.; Guggenheim F., 1946; AAAL. Exhibited: CGA, 1937, 1939, 1943, 1945; Soc. Wash. A., 1941 (prize); Anderson Mural Comp., Wash., 1941 (prize); AIC, 1938; PAFA, 1943, 1944; Wash. A. Gld., 1944–46; A. Fair, Wash., D.C., 1945; Soc. Wash. A., 1941 (prize); WCC, 1938, 1939; 48 States Comp., 1939. Work: White House, Wash., D.C.; Interior Bldg., Wash., D.C.; USPOs, Upper Marlboro, Laurel (both in Md.), Willard (Ohio). WPA muralist. [47]

JAMIESON, Percy D.V. [P] Chicago, IL [15]

JAMISON, Celia (Mrs. Clifford H. Sankey) [P,T] Denton, TX b. 17 Ja 1920, Prosper, TX. Studied: Tex. State Col. for Women; Univ. Iowa; P. Guston. Member: Tex. FAA; Tex. T. Assn. Exhibited: Weyhe Fal., 1945; Ft. Worth AA; Mus. FA Houston, 1945, 1946; Kansas City AI, 1942; Dallas Mus. FA; San Antonio, Tex.. Work: Univ. Iowa; Ft. Worth AA. Position: T., Tex. State Col. for Women, 1945–46 [47]

JANASZAK, Helen (Mrs. George Magnuson) [P] Chicago, IL b. 1 Ja 1909, Kalamazoo, MI. Studied: AIC; Am. Acad. Art, Chicago; G.E. Browne. Member: All-Ill. SGA. Exhibited: Kalamazoo Inst. of A., 1936 (prize) [40]

JANES, Elizabeth (Betty) [E,Mur.P,Por.P] Seminole, OK b. 21 My 1908, Shawnee, OK. Studied: J.S. Ankeney; Fontainebleau; J. Despujols; Achille Ouvre; La Montagne St. Hubert. Member: Westchester ACG. Exhibited: Nat. Lg. Am. Pen Women, Chicago 1933 (prize). Work: La Maison Française, Baton Rouge, La. [40]

JANES, Walter [I] NYC [15]

JANIN, Louise [D] NYC [25]

JANNELLI, Vincent [Por.P,Mur.P] Newark, NJ b. 29 Ag 1882, Andretta, Italy. Studied: NAD; Royal Inst. FA, Naples; Columbia; Rutgers. Member: Un. Scenic A. of Am.; AAPL. Exhibited: PAFA, 1935, 1936, 1938, 1939; CGA, 1967; NAD, 1936, 1940, 1941; VMFA, 1940; PBA, 1939; Newark AC, 1931–43; Contemporary Gal., Newark, 1936, 1937; Montclair A. Mus., 1932–42; Kresge Exh., Newark, 1934 (prize), 1935–37, 1938 (prize), 1939–41. Position: T., Newark Sch. F.&Indst. A., 1922–46 [47]

JANNI, Pino [P] NYC b. 13 Ja 1899, Venice, Italy. Studied: Royal Acad. FA, Venice [40]

JANOUSEK, Louis [P] Yankton, SD [17]

JANOWSKY, Bela [S,Mur.P] NYC b. 12 Ap 1900, Budapest, Hungary. Studied: PAFA; A. Howell; C. Grafly, A. Blazys. Member: All.A.Am. Work: Queens Univ., Kingston, Ontario; Treasury Dept., Wash., D.C.; mural USPO, Cooperstown, N.Y.; tablet, Mem. Bldg., Queens, N.Y. WPA artist. [47]

JANOWSKY, Bela, Mrs. See Bell, Clara Louise.

JANSEN, Richard H. [P,Mur.P] Milwaukee, WI. Exhibited: Intl. WC, AIC, 1934, 1936, 1938; Wis. Salon, 1938; Great Lakes Exh., The Patteran, Buffalo, 1938; WFNY, 1939. Work: USPOs, Lincolnton, N.C., Reedsburg, Wis. WPA muralist. [40]

JANSON, Andrew R. [Mus.Cur,P,I,C,L,Des,T] Marianna, FL b. 18 N 1900, NYC. Studied: Syracuse Univ.; N.Y. Sch. F.&Appl. A.; Columbia; ASL; Luks; Jeanette Scott; G. Bridgman; BAID; H.E. Fritz; M. Wilkes; Univ. Southern Calif. Member: Nat. Speleological Soc.; Miami AL; ASL. Exhibited: MMA; Syracuse Mus. FA; Los Angeles Mus. A.; Iowa State Col.; Santa Fe; San Jose; AMNH, 1936 (med). Work: Iowa State Col., Ames; murals, State Office, Tallahassee, Fla.; bird life groups, AMNH; Fla. State Mus.; Pub. Lib., Staten Island, N.Y. Illustrator: "Atlas of Animal Anatomy," "North American Fresh Water Fishes"; scientific publications; covers, Natural History. Position: A., Fla. State Mus., 1940–42; Mus. Cur., Fla. State Park Service, 1944–46; tech. adv. to motion picture industry [47]

JANSON, Dorothy Plymouth [P,I,C] Marianna, FL b. Jersey City, NJ. Studied: Iowa State Col; Univ. Fla.; H.C. Plymouth. Exhibited: Ft. Lauderdale, Fla., 1931; Mus. N.Mex., Santa Fe, 1929, 1931; Pomona, Calif., 1932; Miami, 1930; Univ. Fla., 1941, 1942; Fla. Park Service, 1946; Southern Fla. Flower Exh., 1931. Work: Fla. Park Service, Tallahassee; Pasadena Pub. Lib., Calif.; Los Angeles Mus. A.; U.S. Nat. Parks, Dept. Interior.; Univ. N.Mex. Illustrator: National Boy Scout Handbook; "Atlas of Anatomy of Domestic Animals"; etc. [47]

JANSON, H(orst) W(oldemar) [Edu,W,Cr,L,Mus.Cur] St. Louis, MO b. 4 O 1913, Leningrad, Russia. Studied: Harvard; Germany. Member: CAA. Awards: C.W. Holtzer F., Harvard, 1935–36, 1937–38 (prizes). Contributor: Magazine of Art. Positions: T., Harvard (1936–37), Iowa State Univ. (1938–41), Wash. Univ., St. Louis (1945–) [47]

JANSSON, Alfred [P] Chicago, IL b. Vermland, Sweden, 1863 (came to U.S. in 1889) d. 5 S 1931. Studied: Stockholm; Christiania; Paris. Member: Palette and Chisel C.; Chicago AC; Chicago SA; Chicago AG; Swedish Am. A.; A. Lg. of Chicago. Exhibited: Swedish Am. A., 1911 (prize), 1913 (prize), 1915 (prize); AIC, 1912 (prize), 1914 (prize). Work: ACI; Swedish Bldg., Columbian Expo, 1893 [29]

JANSSON, Arthur A(ugust) [P,Des,Dec] Pearl River, NY b. 1 Ag 1890, White Mills, PA. Studied: W.R. Leigh; W.M. Chase; Bridgman. Work: cover des., Natural History; African landscapes made for AMNH on British East African Expedition, 1926–27 [40]

JANVIER, Catherine Ann Drinker (Mrs.Thomas A.) [I] NYC b. Phila. Studied: PAFA; ASL [17]

JAQUES, Bertha E. (Mrs. W.K.) [E,L,W] Chicago, IL b. Covington, OH. Studied: AIC. Member: Chicago SE; Calif. SE; Calif. PM. Exhibited: P.-P. Expo, San Fran., 1915 (med); AIC (med). Work: AIC; NYPL; LOC; St. Paul Inst. A. [40]

JAQUES, F(rancis) L(ee) [P] NYC b. 28 S 1887, Geneseo, IL. Studied: C.C. Rosenkranz. Work: dome, AMNH, NYC. Illustrator: "Florida Bird Life," "Oceanic Birds of South America," "Field Book of Birds of Panama Canal Zone." Position: Staff, AMNH [40]

JAQUISH, Orin W. [P] NYC b. 1886 d. 8 S 1931, Greenwood, CT. Member: GFLA [27]

JARDET, Florence [P] New Orleans, LA [15]

JARRELL, Adah [P] Phila., PA. Studied: PAFA [17]

JARRETT, Charles D. [P] Los Angeles, CA. Member: Calif. AC [25]

JARVIS, Mary E. [P,T] Phila., PA. Studied: PAFA [25]

JARVIS, W. Frederick [P,C,T] Dallas, TX. Studied: ASL; Munich, with I. Mueller; S. Martin; C. Bullette; A. Schille. Member: SSAL; S.Indp.A. Exhibited: Tri-State Fair, 1926 (gold). Position: T., Merdick FA Sch., Dallas, 1922. Also an art potter. [33]

JAY, Cecil (Mrs. George Hitchcock) [P,Min.P] NYC. Member: NYWCC. Exhibited: Pan-P. Expo, San Fran., 1915 (med) [21]

JAYNE, De Witt Whistler [I,P,E,B] Wheaton, IL b. 18 S 1911, Boston, MA. Studied: PMSchIA; Wheaton Col.; Univ. Chicago; A. Lewis; Oakley, J. Dull. Member: A. Dir. Cl., Chicago; Chicago A. Gld.; CAA. Work: Wheaton Col.; Pikeville Col., Pikeville, Ky. Illustrator: "Deep Water Days," 1929, "The Rudder." Position: T., Wheaton Col., 1936-46; A. Dir., Scripture Press, Chicago, 1946 [47]

JEANFIL, Henri (Jacques) [P,S,E,L] Buffalo, NY b. 8 Je 1909, Tonawanda, NY. Studied: D. Campagna; Richardson; K. Green; F. Bach. Member: Buffalo SA; Boston AC; PAFA; NSS. Work: Buffalo Sch. FA. Position: T., Buffalo Social Welfare classes [40]

JEFFERSON, Joseph IV [P,Ldscp.P] Buzzard's Bay, MA b. 20 F 1829, Phila. d. 23 Ap 1905, Palm Beach, FL. An actor-painter like his father and grandfather before him, he made his stage debut at age 4 and for the rest of his life was one of America's most popular actors. Best known for his role as Rip van Winkle. Member: NAC. Exhibited: PAFA, 1868; NAD, 1890; Wash., D.C., 1899 (one-man) [04]

JEFFERSON, Orville [P] Kokomo, IN [24]

JEFFERY, Charles Bartley [C,T] Cleveland, OH b. 6 Jy 1910, Paducah, KY. Studied: Cleveland Sch. A.; Western Reserve Univ.; J. Mihalik. Member: Western AA; Ohio Edu. Assn.; Cleveland FAA. Exhibited: Syracuse Mus. FA, 1937, 1940; Phila. A. All., 1945; CMA, 1932-46, 1942, 1943, 1944, 1945 (prizes); Paris Salon, 1937 (prize); Cleveland Mus. A., 1932, 1933, 1939. Positions: T., CMA (1935-46), Cleveland Sch. A. (1944-46), Shaker Heights Sch., Cleveland (1946) [47]

JEFFERYS, Charles William [P,I] NYC b. 1869, Rochester, England d. 8 O 1951 [04]

JEFFREYS, Lee [P,W,L,T] Utica, NY/Barneveld, NY b. 24 Ja 1901, NYC. Studied: ASL; Académie Julian, Paris. Member: NAC; Grand Central Gal.; Soc. Am. A. in Paris; Utica ASL [33]

JEFFRIES, L(ulu) R(ita) (Mrs. H.P.) [P,I,W,T] Sussex Corners, New Brunswick b. Nova Scotia. Studied: P. Moschowitz; Pratt Inst. Member: Newport AA [29]

JEGART, Rudolph [S] Chicago, IL. Exhibited: Wis. Salon A., 1938; Ar. Chicago, Vicinity Ann., AIC, 1939. Position: Associated with AIC [40]

JEHN (or JEHU), John M. (Mrs.) [P] NYC [10]

JEHU (or JEHN), John M. [S] NYC. Work: S., Cincinnati Mus. [17]

JELINEK, Frances [P] Milwaukee, WI [24]

JELINEK, Hans [En,I,T] NYC. b. 21 Ag 1910, Vienna, Austria. Studied: Wiener Kunstgewerbe Schule; Univ. Vienna. Member: Northwest Pr.M.; A. Lg. Am. Exhibited: NAD, 1942-46; PAFA, 1941, 1942; SFMA, 1943-46; SAM, 1943-45; Albany Inst. Hist.&A.; Laguna Beach AA; Denver A. Mus.; Santa Barbara Mus. A., 1944; CI, 1945; Oakland A. Gal., 1943, 1944; Calif. SE, 1943; VMFA; Mint Mus.; AV, 1943 (prize); LOC, 1945 (prize). Work: NYPL; VMFA; Munson-Williams-Proctor Inst.; LOC. Position: T., New School for Social Research, NYC 47]

JEMNE, Elsa Laubach (Mrs.) [Mur.P,Des,Dec,I] St. Paul, MN b. St. Paul. Studied: V. Oakley; C. Beaux; D. Garber; E. Carlsen; J. Pearson; PAFA, 1914, 1915. Member: Minn. AA. Exhibited: St. Paul Inst., 1911 (med), 1916 (gold); Minn. State Fair, 1921 (gold), 1932 (prize). Work: Stearns County Court House, St. Cloud, Minn.; Leamy Home, Phila.; Nurses Home, Northern States Power Co. Bldg., Women's City C., all in St. Paul; Community House, Brandon, Minn.; USPOs, Ely, Minn., Ladysmith, Wis.; fresco, Armory, Minneapolis. WPA artist. [40]

JENCKS, Eleanor [P] Baltimore, MD [25]

JENKINS, Alfred W. [Patron] Vichy, France. b. 17 Jy 1862, Mystic, CT d. Fall 1932. Member: Brooklyn Inst. A.&Sc. (trustee). He gave many works of art to the Brooklyn Inst. Mus. and the Brooklyn Botanic Garden.

JENKINS, Burris, Jr. [I] NYC b. 1897 d. 25 F 1966, Hallandale, FL. Member: SI [47]

JENKINS, Clayton Evans [B,I,Arch,T,Des] Germantown, PA b. 20 Jy 1898. Studied: Univ. Pa. Exhibited: Phila. Pr. C., 1929 (prize). Work: NYPL. Illustrator: "Sons of Seven Cities," by R.S. Holland, "Deep Water Days," by O.G. Swan. Position: des., arch. woodwork, Erik Jansson, Inc. [40]

JENKINS, F. Lynn [S] NYC [24]

JENKINS, George Washington Allston [P] b. 1816 d. 1907. Exhibited: NAD, 1842-65. Best known for his "Headless Horseman of Sleepy Hollow," at Sleepy Hollow Restorations, Tarrytown, N.Y. [*]

JENKINS, Haley Dodge [P] Wash., D.C. [01]

JENKINS, H(annah) T(empest) (Mrs.) [P,W,L,T] Claremont, CA b. Phila. d. 27 S 1927. Studied: Spring Garden Inst., Sch. of Indst. A.; PAFA; Paris, with Robert-Fleury, Constant; Seiho, in Kyoto, Japan. Member: Plastic C.; Southern Calif. AC; Laguna Beach AA. Exhibited: Alaska-Yukon-Pacific Expo, Seattle, 1909. Work: Pomona Col. Position: T., Pomona Col., Claremont [33]

JENKINS, Harry [P] Chicago, IL. Member: GFLA [27]

JENKINS, John Eliot [P,L,T] Houston, TX b. 1868, Onaga, KS. Studied: Constant; Lefebvre; Monet. Work: portraits, State Capitol, Richmond, Va.; Tex. Capitol; Lib., Univ. Tex., Austin; landscapes, Pub. Libs. in Waco, Tex., Tulsa, Okla.; Topeka, Kans.; Springfield, Mo. [40]

JENKINS, Leonard Seweryn [P,G,I,Car] NYC b. 4 Ja 1905, Poznań, Poland. Studied: ASL; T. Benton; J. Sloan; A. Lewis; F. Du Mond. Exhibited: Roerich Mus.; Arch L., 1936; Textile Des. Exh. with Mus. Costume A., Radio City, 1941; Mun. Gal., Charleston, W.Va., 1942; NAD, 1942; Brooklyn Mus.; ASL. Work: BM; Children's Lib., Brooklyn [47]

JENKINS, Martha E. (Mrs.) [P] Chicago, IL b. Charleston, IL d. F 1923. Studied: Boston; Chicago; Duveneck. Member: Chicago AC; Wash. AC. For many years she acted as the Illinois representative for "The American Art Annual." [21]

JENKINS, Mattie M(aude) [Min.P,I,C] Whitman, MA b. 30 Jy 1867, South Abington, MA. Studied: H. Cook; E.B. Colver; C.W. Reed [40]

JENKINS, W. Irving [Patron] b. 1850 d. 12 My 1916, Clinton, MA. A collector of steel engravings and the owner of one of the most valuable collections in the U.S.

JENKINS, Will [P] Boston, MA [08]

JENKS, Col. Albert [Por.P] b. 1824, N.Y. d. 22 Jy 1901, Los Angeles

JENKS, Dea S. [P] Denver, CO [01]

JENKS, Jo (Miss) [S,T] Morristown, NJ b. 30 D 1903. Studied: A.B. Schmuel. Work: WMAA. Position: T., Mt. Kemble Sch., Morristown, NJ [40]

JENKS, Phoebe A. Pickering Hoyt (Mrs. Lewis E.) [P] NYC b. 28 Jy 1847, Portsmouth, NH d. 20 Ja 1907. Studied: B.C. Porter; D.T. Kendrick, Boston. Specialty: portraits of women and children [06]

JENNETT, Norman Ethre [I,Car,P,W] Cedar Grove, NJ b. 10 Mr 1877, Bentonville, Township, NC. Studied: NAD; Chase Sch. A. Exhibited: NAD, 1945; West Essex AA, 1941; Montclair A. Mus. Work: NYU; Mutual Life Insurance Co. Illustrator: "Editor in Politics," 1941, "Tar Heel Editor," 1939. Position: Macfadden Publ., 1922-39 [47]

JENNEWEIN, Carl Paul [S,P] Larchmont, NY b. 2 D 1890, Stuttgart, Germany d. 1978. Studied: ASL; Am. Acad., Rome; C. Peters. Member: NIAL; AIA; NSS; Century; F., Am. Acad. Rome, 1916-22; Audubon A.; FA Comm., NYC; Arch. Lg. Beaux-Arts Inst. Arch. Exhibited: Arch. Lg., 1912 (prize), 1927 (med); AIC, 1921; NAD, 1942 (med); PAFA, 1932 (gold), 1939 ((med); Fairmount Park AA, 1926 (prize); Concord AA, 1926 (med). Work: S., MMA, BMA; BM; CGA; CM; Detroit Inst. A.; Finance Bldg., Harrisburg, Pa.; Herron AI; Dept. Justice Bldg., Wash. D.C.; Mus. FA Houston; Hartford Atheneum; Newark Mus.; PAFA; Brookgreen Gardens, S.C.; PMA; Eastman Sch. Music, Rochester, N.Y.; mem., Wash., D.C.; Providence, R.I.; Worcester,

Mass.; Boston, Mass.; fountain, Wash., D.C.; Ravenna, Italy; Phila. Mus. A.; Ft. Wayne, Ind.; Metropolitan Opera House; Kingston, N.Y.; mem. fountain, Plymouth, Mass.; Mt. Pleasant, N.Y.; Arlington Mem. Bridge, Wash., D.C.; Tours, France; Harvard; John Herron A. Sch.; Elks C., Brooklyn; Harrisburg, Pa., Rockefeller Center; Mellon Inst., Pittsburgh; WFNY, 1939 [47]

JENNEY, Edgar W(hitfield) [P,Li] Nantucket, MA b. 11 D 1869, New Bedford, MA. Studied: Major; Paris, with Laurens, Emmanuel, Cavaille Coll. Member: Mural P.; Arch. Lg.; AFA; AWCS; Phila. WCC; Boston Soc. WCP. Work: Wis. State Capitol; Union Central Life Ins. Co., Cincinnati; Senate Chamber and House of Commons, Ottawa, Ontario; Hibernia Bank, New Orleans; Standard Oil Bldg., NYC; Equitable Ins. Bldg., NYC; Palmer House, Chicago. [40]

JENNINGS, Dorothy (Mrs.) [P,S] St. Louis, MO b. 19 N 1894, St. Louis. Studied: N. Hahn; V. Holm; G. Goetsch; W. Ludwig; F. Conway; E. Wuerpel. Member: St. Louis AL; St. Louis Indp. A. Exhibited: St. Louis A. Gld., 1928 [40]

JENNINGS, Edward I.R. [P] Charleston, SC [25]

JENNINGS, Ellen [S,T] Columbus, OH b. 27 Jy 1912, Massillon, OH. Studied: Columbus A. Sch.; R. Nicodemus; A. Schille; R.O. Chadeayne; M. Russell. Member: Columbus AL. Exhibited: Columbus A. Gal., 1939 (prize). Work: Columbus A. Gal.; Columbus Pub. Lib. [40]

JENNINGS, Francis A. [P,T,S] Phila., PA b. 27 F 1910, Wilmington, DE. Studied: Wilmington Acad. A.; Graphic Sketch C., Phila. Member: Wilmington AC. Exhibited: PAFA, 1939, 1942, 1943; Wilmington Acad. A., 1935–37, 1939–43; Wilmington Soc. FA; Wilmington AC. Work: mural, Delaware Inst. Sch. for Boys; Ferris Sch., Delaware. WPA artist. Position: T., Ferris Sch. [47]

JENNINGS, Harry G. [P] Cincinnati, OH b. 25 Ag 1878, Cincinnati, OH. Studied: Cincinnati A. Acad. Member: Men's A.C., Cincinnati. Exhibited: Cincinnati AM, 1937, 1939; Dayton, Ohio AI [40]

JENNINGS, Louise B. (Mrs H.S.) [P] Baltimore, MD b. 6 N 1870, Tecumseh, MI. Studied: W.M. Chase; H. Breckenridge; D. Morgan; Bryant; PAFA. Member: Baltimore WCC; Baltimore S.Indp.A.; Laguna Beach AA. [40]

JENNINGS, Martin J. [P] Floral Park, NY b. 3 Mr 1888, Scranton, PA. Studied: ASL; A. Mucha. Member: Eastern AA; Springfield AL; S.Indp.A. Exhibited: WC Ann., PAFA, 1938, 1939; Am. WCS-NYWCC, 1939; Intl. WC Ann., AIC, 1939. Work: Our Lady of Victory, Floral Park. Specialty: illumination of testimonials. Position: T., Boys High Sch., Brooklyn [40]

JENNINGS, Rixford [P] Buffalo, NY b. 26 F 1906, Troy, NY. Studied: Buffalo Sch. FA; Buffalo AI. Member: AWCS; Goose Rocks Beach, Maine AA; Buffalo Pr. C.; Phila. WCC. Position: T., summer session, Univ. Buffalo [47]

JENNINGS, Wilmer Angier [Des,G,P] Providence, RI b. 13 N 1910, Atlanta, GA. Studied: RISD. Exhibited: Intl. B. Pr. Ann., AIC, 1939; Baltimore Mus., WFNY, 1939. WPA muralist. [40]

JENNY, Charles O. [S] Phila., PA [21]

JENS See Yens.

JENS, Karl [P] Cambridge, MA b. 11 Ja 1868, Altona, Germany. Studied: Benjamin-Constant, Laurens, in Paris [06]

JENSEN, Dorothy Dolph [P,E,T] Seattle, WA b. 26 Jy 1895, Forest Grove, OR. Studied: S. Bell; Mus. Art Sch.; Laurens, in Paris. Member: Women P. Wash.; Nat. Lg. Am. Pen Women; Northwest PM; Pacific Coast PS and Writers. Exhibited: Women P. Wash., SAM, 1934 (prize), 1937 (prize). Work: Women's C., Corvallis, Oreg.; SAM [40]

JENSEN, Georg [C] b. 27 S 1870 d. 2 O 1935, Copenhagen, Denmark. Member: Paris Salon. Exhibited: museums worldwide. Work: Louvre; Luxembourg; Stockholm; Berlin; Copenhagen Mus.; Cologne Mus.; Musée d'Art, Geneva; Mus. Folkwang; The Hague; Detroit Inst. A.; Newark Mus.; Brooklyn Mus.; MMA. Specialty: hand-wrought silver. The Georg Jensen Handmade Silver Studios are still operating in NYC.

JENSEN, George [Ldscp.P,Des,T] Toledo, OH b. 9 Ag 1878, Clinton, OH. Studied: AIC; J. Carlson; G.E. Browne; J. Kabrial; W. Darling. Member: Scandinavian AS; Toledo AC. Exhibited: Toledo Mus. A., 1927 (prize), 1930 (prize), 1931 (prize), 1943 (prize); Scandinavian-Am. A., 1932–36; Ft. Wayne A. Sch. Position: T., Toledo Mus. A. [47]

JENSEN, Harold C. [E,I,B] Evanston, IL b. 24 S 1900, Racine, WI. Studied: AIC; Tyler; Schmidt. Member: Palette and Chisel Acad. FA. Work: Northwestern Univ.; Alumni Assn., Univ. Wis. Illustrator: "My Animal Book," "Circus Cut-out Book" [40]

JENSEN, H(olger) W. [P] Dixon, IL B. 6 Ja 1880, Denmark. Studied: AIC; Chicago Acad. FA. Member: Chicago PS; Austin, Oak Park, River Forest AL; Palette and Chisel Acad. FA; Chicago Gal. Assn.; Ill. Acad. FA; All-Ill. SFA. Exhibited: Austin, Oak Park, River Forest, 1929 (med); Chicago Gal. Assn., 1930 (med); Palette and Chisel Acad. FA, 1934 (gold) [40]

JENSEN, John Paul [E,Eng] Chicago, IL b. 31 My 1904. Studied: A. Philbrick; J. Norton; AIC. Member: Chicago SE. Work: prints dept., AIC; LOC. Position: Nuart Engraving Co., Chicago [40]

JENSEN, Martha [P] Seattle, WA [24]

JENSEN, (Peter) Thorvald [E] Chicago, IL/Green Lake, WI b. 17 Mr 1895, Odense, Denmark. Studied: AIC [32]

JENSEN, Thomas M. [Por.P] Bay Ridge, NY b. 1831, Apenrade, Denmark (came to U.S. in 1870) d. 6 Mr 1916. Studied: Royal Acad., Denmark. Work: portraits of judges, now in Kings County Court House

JENSSEN, Haakon A. [P] San Fran., CA b. 10 D 1883, Kristiania, Norway. Member: San Fran. AA [27]

JENTTER, Charles [P] Jersey City, NJ. Member: S.Indp.A. [21]

JEPPERSON, Samuel Hans [P] Provo, UT b. ca. 1854, Copenhagen, Denmark (came to Salt Lake City in 1857) d. 1931. Studied: self-taught, although he sketched with J. Hafen. He Produced more than 1,000 paintings, largely about the history of Utah. He also worked as a house painter. [15]

JEPSON, George [P,T] b. 1844, Leeds, England (came to U.S. as young man) d. My 1917. Position: T., Mass. Normal Sch.; Boston Evening A. Sch.

JEPSON, Paul [I] Bronxville, NY. Member: SI [47]

JEPSON, W.R., Mrs. See Wiles, Gladys.

JEROME, Elizabeth Gilbert (Mrs. Benjamin) [P,Min.P] New Haven, CT b. 18 D 1824, New Haven, CT d. 22 Ap 1910. Member: Julius Busch, in Hartford, ca. 1851; NAD; E. Leutze; Springly Inst. Exhibited: NAD, 1866–75; PAFA, 1869. Began miniature painting in 1904. [*]

JEROME, Mildred [S,Mur.P] Bethel, PA. Exhibited: PS Ann., AIC, 1938. Work: USPOs, New Milford, Conn., Turtle Creek, Pa. WPA muralist. [40]

JERREMS, Leonore Smith (Mrs. Arthur W.) [P] Barrington, IL. Exhibited: Intl. WC AIC, 1934, 1935; Ar. Chicago, Vicinity, Ann., AIC, 1934, 1935, 1938 [40]

JERRY, Cherry Barr [Li,P] Racine, WI b. 19 F 1909, Denver, CO. Studied: Nat. Sch. F.&App.A., Wash., D.C. Member: Wis. P.&S. Exhibited: Albany Inst. Hist.&A.; Phila. Pr.C.; SFMA; Wis. P.&S.; Wis. Un.; Detroit Inst. A.; Racine Painters; Wis. Graphics [47]

JERRY, Sylvester [Mus.Dir,Lith,P] Racine, WI b. 20 S 1904, Woodville, WI. Studied: Layton Sch. A.; ASL. Exhibited: LOC, 1946; Detroit Inst. A., 1945; AIC, 1946. Position: Dir., Wustum Mus. FA, Racine, WI, 1941–70. Directed WPA Art Project in Kalamazoo, 1930s [47]

JESSEN, Agnes Cecelia [P,Des,B,C,T] Milwaukee, WI b. 24 My 1908, Milwaukee. Studied: F. Moeller; Milwaukee State T. Col. Member: Wis. PS; Milwaukee PM; Wis. Fed. Arts. Exhibited: Wis. State Fair, 1931 (prize); Milwaukee AI, 1935 (prize). Illustrator: Wis. Artists Calendar, 1935–37 [40]

JESSUP, Josephine [Min.P,P,I] Rowaton, CT b. 1858, NYC d. 29 Ag 1933, Norwalk, CT. Studied: W. Eaton. Member: NAWPS; ASMP [21]

JESTER, Ralph [Des,S,T,L] Hollywood, CA b. 1 Jy 1901. Studied: Yale; Am. Acad. Fountainebleau; H. Bouchard, in Paris. Author/Illustrator: American Architect; American Magazine of Art; New York American. Lectures: Art of the Motion Picture. Positions: Des., motion pictures; Costume/A. Dir. for Cecil B. DeMille, Paramount Prod., Inc. [40]

JEWELL, Bess Devine [P] Chicago, IL. Member: GFLA [27]

JEWELL, Foster [P] Grand Rapids, MI b. 21 Jy 1893, Grand Rapids. Member: M.J. Alten [29]

JEWELL, K. Austin [Des,I,P,Car] Evanston, IL b. 6 S 1902, Chicago, IL. Studied: AIC; Chicago Acad. FA. Illustrator: Chicago Tribune; Chicago Daily News; Saturday Evening Post; New York Herald-Tribune (1927–32). Position: A. Dir., Chicago Herald American [47]

JEWELL, William MacIntyre [P,T] Cambridge, MA b. 9 D 1904, Lawrence, MA. Studied: Harvard. Member: Boston WCS; Gld. Boston A. Exhibited: BMFA; Addison Gal., Andover; Sweat Mem. Mus., Portland, Maine. Work: Fogg Mus., Cambridge. Positions: T., Vesper George Sch., Boston, Boston Univ. [40]

JEWELL, Wynn R. (Mrs.) [P] Oklahoma City, OK [17]

JEWETT, Arthur E. [P] Cincinnati, OH b. 31 Jy 1873, Newtown, OH. Studied: Cincinnati A. Acad. with T.S. Noble [08]

JEWETT, Eleanor (Mrs. Godfrey Lundberg) [W,Cr,L] Winnetka, IL b. 9 F 1892, Chicago. Studied: Univ. Ill.; Univ. Wis. Member: Lg. Am. Pen Women. Author: "From the Top of My Column," "In the Wind's Whistle." Position: A. Cr., Chicago Tribune, 1917– [47]

JEWETT, Maude Sherwood (Mrs. Edward H.) [S] Easthampton, NY b. 6 Je 1873, Englewood, NJ. Studied: ASL. Member: NAWPS; AAPL. Work: Cleveland Mus.; War Mem., Easthampton [40]

JEX, Garnet W. [P,I] Arlington, VA b. 19 O 1895, Kent, OH. Studied: Corcoran Sch. A.; George Washington Univ.; PAFA. Member: S. Wash. A.; Wash. Ldscp. C.; Wash. AC. Exhibited: CGA, 1936; CM, 1926; Md. Inst., 1925–29; SSAL, 1921–46; S. Wash. A., 1937 (med); Ldscp. C., 1941 (med); Wash. AC, 1939. Work: Nat. Zoological Park, Wash., D.C.; murals, Smithsonian Inst.; George Washington Univ. Lib.; Tex. Centenn., Dallas, 1936–37. Positions: Staff A., U.S. Pub. Health Service; Illus., Nature magazine, 1926– [47]

JICHA, Joseph W. [P] Cleveland, OH. Exhibited: Butler AI, Youngstown, OH, 1939 (prize); PAFA, 1938; Intl. WC Ann., AIC, 1936, 1937, 1939; Great Lakes Exhb., The Patteran, Buffalo, 1938; WFNY, 1939 [40]

JIRAK, Ivan [P] Pittsburgh, PA b. 5 N 1893, Allegheny, PA. Studied: C. Walter. Member: Pittsburgh AA. Exhibited: Pittsburgh AA, 1922 (prize). (listed in 1924 as Joan Jirak.) [33]

JIROUCH, Frank Louis [S,P,E,L,C,T] Cleveland Heights, OH. b. 3 Mr 1878, Cleveland. Studied: Matzen; Ludikie; Grafly; Garber; Pearson; Landowski; Bouchard; Cleveland Sch. A.; PAFA; Académie Julian, Paris. Member: NSS; Cleveland SA. Exhibited: PAFA (prize); CMA (prize); Paris Salon; Los Angeles Mus. A.; CAM; Arch. Lg.; PMA. Work: CMA; Cleveland FA Gardens; mem. tablet, Havana, Cuba; plaque, Bird Sanctuary, Cleveland; mem., Indianapolis; USPO, Cleveland, Ohio; Union Nat. Bank; United Saving and Trust Bank; Cleveland Ball Park; Columbus, Ohio [47]

JIVOTOVSKY, Sergey Vasilevitch [P,Dealer] NYC b. 1869, Kiev, Russia (came to U.S. in 1922) d. 10 Ap 1936. Studied: Imperial Acad. A., St. Petersburg. Dealer in artistic shawls and other hand-painted articles of wear in NYC. Position: T., Ksenin Inst., for 24 yrs.

JOANSSON, Ruth [P,T] Chicago, IL b. 13 F 1912, Chicago. Studied: AIC; C. Pougialis. Member: Swedish Am. AA. Exhibited: PS Ann., AIC, 1938; Ar. Chicago Vicinity Ann., AIC, 1939; Swedish C., Chicago, 1939. Work: Northwestern Univ.; Taylorville Training Sch., Ill. Position: T., St. Chrysostom's Church, Chicago [40]

JOB, Alice E. [P,W] NYC b. Alton, IL. Studied: Lefebvre, Constant, Puvis de Chevannes, all in Paris. Member: NAWPS; Nat. Lg. Am. Pen Women [33]

JOB, Herbert K. [I] West Haven, CT [13]

JOCHIM, Arthur [P] Jersey City, NJ. Member: S.Indp.A. [25]

JOCHIMSEN, Marion [Por.P] NYC b. 4 Jy 1904, Juneau, AK. Studied: Calif. Sch. Des.; F. Van Sloan. Member: AWCS; AAPL. Exhibited: AWCS, 1936–45; NAWA, 1941; N.J. State Mus., Trenton, 1937; Albany Inst. Hist.&A., 1938; Newhouse Gal., 1935 (one-man) [47]

JOCOVELLI, Ettore [P] NYC [08]

JOFF, Edward Ernany Mathew [S,T,L] San Fran., CA b. 16 Je 1900, St. Petersburg, Russia. Studied: Ivanoff, Cebulkin, in Russia; D. Ginsbourg, in Paris. Member: Am. Fed. A.; Studio Gld.; San Fran. AA; Chicago NJ Soc. Ar. Exhibited: Chicago NJ Soc. Ar.; Studio Gld. [40]

JOFFE, Bertha [Des] NYC b. 11 O 1912, Leningrad, Russia. Studied: N.Y. Sch. Appl. Des. for Women; CCNY; Columbia; NYU; ASL; Zorach; W. Reiss; Malderelli. Exhibited: Provincetown AA, 1940; AV, 1942; Intl. Textile Exh., 1944; des., Art in Business Exh., 1942. Her textile designs used in leading hotels. Specialty: textile design [47]

JOFFE, Mark S. [P,I,Car,T] NYC b. 28 Mr 1864, Dvinsk, Russia d. 27 Je 1941. Studied: Imperial A. Acad., Petrograd. Member: Am. Ar. Cong.; S.Indp.A. Exhibited: Acad. Allied Ar.; Am. Ar. Cong. Work: Jewish C., N.Y.; Jewish Theological Seminary, N.Y.; LOC [40]

JOHANN, Helen L. [G,T] Milwaukee, WI b. 30 My 1901, West Depere, WI. Studied: Milwaukee State T. Col.; Columbia. Exhibited: Milwaukee AI, 1936 (prize), 1940 (prize), 1945 (prize); Oakland A. Gal., 1942, 1943; PAFA, 1941, 1942; MMA (AV), 1942; LOC, 1942–46; Milwaukee AI, 1936–1945; NAD, 1946; Wis. Salon, 1943. Work: LOC [47]

JOHANSEN, Anders D. [P,I] Brooklyn, NY/Chatham, NY b. Denmark. Studied: Fisher; W. Beck; W.S. Taylor; M. Herrmann; Pratt Inst. Member: Scandinavian-Am. A.; Tiffany Fnd.; AWCS; Brooklyn PS. Exhibited: Pratt Art Alumni European Fellowship, 1924. Work: Vanderpoel AA, Chicago; Yale [40]

JOHANSEN, John C., Mrs. See MacLane, Jean.

JOHANSEN, John C(hristen) [Por.P] NYC/Stockbridge, MA b. 25 N 1876, Copenhagen, Denmark d. ca. 1964, NYC. Studied: AIC; Duveneck; Académie Julian, Paris. Member: ANA, 1911; NA, 1915; Por. P.; NAC; Century; Inst. Arts & Letters; MacD. C.; AFA. Exhibited: AIC, 1903 (prize), 1911 (med), 1928 (gold); Arts C., Chicago, 1903 (prize); Chicago SA, 1904 (med); St. Louis Expo, 1904 (med); Buenos Aires Expo, 1910 (gold); NAD, 1911 (gold); CI, 1912 (prize); Newport AA, 1915 (prize); P.-P. Expo, San Fran., 1915 (gold); Sesqui-Centenn. Expo, Phila., 1926 (med); Stockbridge AA, 1929 (prize); NAC, 1932 (prize). Work: Nat. Gal., Santiago, Chile; PAFA; AIC; Public Gal., Richmond, Ind.; Mus., Dallas, Tex.; Conservative C., Glasgow; A. Mus., Syracuse, N.Y.; Union Lg., Chicago; Porteus C., Des Moines; Arché C., Chicago; University C., Chicago; Gal. Vincennes, Ind.; State Normal Sch., Terre Haute; Herron AI, Indianapolis; Masonic Temple, NYC; Wis. Univ.; Yale; Clark Univ.; CGA; NGA; AIC; Wells Col., Aurora, N.Y.; MMA; Wadsworth Atheneum, Hartford; Univ. Pa.; CI [47]

JOHANSEN, Margaret McLane [P] NYC. Member: NAC. Exhibited: Stockbridge AA, 1934 (prize) [40]

JOHANSON, Edward W. [P] San Fran., CA. Exhibited: San Fran. AA, 1937; WFNY, 1939 [40]

JOHN, Carolyn A. [P] Moorestown, NJ. Exhibited: WC Ann., PAFA, 1934, 1936, 1938 (med); NYWCC, 1937 [40]

JOHN, Grace Spaulding (Mrs.) [P,W,L] Houston, TX/NYC b. 10 F 1890, Battle Creek, MI d. 1972. Studied: St. Louis Sch. FA; AIC; NAD; Hawthorne; Garber; F. Weber. Member: SSAL; NAWPS. Exhibited: Tiffany F., 1924; PAFA, 1923; Pal. Leg. Honor, 1933; World's Fair, Chicago, 1933; Mus. FA, Houston, 1936 (one-man); Oakland A. Gal., 1935 (one-man); Los Angeles Mus. A., 1935 (one-man); Highland Park Mus., Dallas, 1928; Town Hall, N.Y. Work: Houston Pub. Lib.; Hist. Bldg., Austin; Okla. Hist. Soc.; Mus. FA, Houston; Huntsville (Tex.) Lib.; murals, City Hall, Sidney Lanier Sch., both in Houston [47]

JOHN, Margaret Sawyer (Mrs. Robert N.) [P,C,T] Corvallis, OR b. Marion County, IL. Studied: AIC; Lindenwood Col., St. Charles, Mo.; Univ. Mo. Member: Oreg. SA; Portland and Oreg. Chapters AAPL [40]

JOHNS, Clarence M. [P] Pittsburgh, PA. Member: Pittsburgh Ar. Assn. [40]

JOHNS, Craig [P] Dayton, KY [15]

JOHNS, Ivor G. [P] Cleveland, OH. Member: Cleveland SA [27]

JOHNSON, Addison [P] Minneapolis, MN [24]

JOHNSON, Adelaide (Mrs.) [S] Wash., D.C. b. 1847, Plymouth, IL d. 10 N 1955 (age 108). Studied: J. Monteverde, F. Altini, in Rome. Work: MMA; Chicago Hist. Soc.; monuments to Lucretia Mott, Elizabeth Cady Stanton, Susan B. Anthony, Capitol, Wash., D.C.; port. bust of Susan B. Anthony reproduced on Susan B. Anthony memorial stamp, 1936 [40]

JOHNSON, Albert [Des] NYC. Designer: costumes/stage sets, "Frontier Frolics," Texas Expo, 1936; "As Thousands Cheer," "Band Wagon," "Criminal Code," "Jumbo," "Leave it to Me," Aquacade, WFNY, 1939; sets, Radio City Music Hall [40]

JOHNSON, Alexander L.P., Mrs. See Mix, Elena.

JOHNSON, Annetta [S] Flint, OH [01]

JOHNSON, Arthur A(loysius) [I,D,L,T] Joliet, IL b. 29 Je 1898, Joliet. Work: posters, Chicago Rapid Transit Co., Chicago North and South Shore Railroads [31]

JOHNSON, Arthur Clark [P,T,E] Hampton, NH b. 5 S 1897, Hyde Park, MA. Studied: Tarbell; Meryman; Hale; Bosley; E.L. Major; F.W. Brown. Member: Springfield AA. Work: Ill. State Lib.; Farnsworth Mus.; Springfield AA [47]

JOHNSON, Avery F. [P,I,E] Denville, NJ b. 3 Ap 1906, Wheaton, IL. Studied: Wheaton Col.; AIC. Member: N.J. WCC. Exhibited: 48 Sts. Comp., 1939 (prize); PAFA; AIC; AWCS; NAD; GGE, 1939; Kansas City AI. Work: Newark Mus.; Montclair A. Mus.; murals, USPOs, Bordentown, N.J., Marseilles, Ill., Liberty, Ind., Lake Village, Ark., North Bergen, N.J., Catonsville, Md. WPA artist. Illustrator: "Mouseknees," 1939 [47]

JOHNSON, B.D. [P] Phila., PA [21]

JOHNSON, (B.) Pauline [P,T] Yakima, WA b. Everett, WA. Studied: Univ. Wash.; Columbia. Member: Western AA; Colo. AA. Exhibited: WC, Ann., Seattle AM, 1937 (prize). Position: T., Colo. State Col. Edu. [40]

JOHNSON, Belle [P] NYC [25]

JOHNSON, Burt W. [S,T] Flushing, NY/Claremont, CA b. 25 Ap 1890, Flint, OH d. 27 Mr 1927, Claremont. Studied: Louis Saint Gaudens, J.E. Fraser, Robert Aitken, George Bridgman. Member: Laguna Beach AA; Arch Lg. Work: FA Bldg., Los Angeles [25]

JOHNSON, C. Everett [P,I,W,L] Altadena, CA b. 7 D 1866, Gilroy, CA. Studied: AIC; R. Miller, in Paris. Member: Cliff Dwellers, Chicago AC. Work: Adv. Illus., Quaker Oats Co., others [31]

JOHNSON, Carol (Mr.) [I] NYC. Member: SI [47]

JOHNSON, Caroline R. [P] San Fran., CA [17]

JOHNSON, Carrie Rixford [P] San Fran., CA [13]

JOHNSON, Catherine C. [P] Seattle, WA [24]

JOHNSON, Cecil A. [S] NYC [17]

JOHNSON, Charles M. [P] Brooklyn, NY. Member: S.Indp.A. [25]

JOHNSON, Clarence R. [P] Lahaska, PA b. 11 S 1894, Maxtown, OH. Studied: Columbus A. Sch.; PAFA; E. Carlson; C. Beaux; E. Blashfield; P. Hale; Paris. Exhibited: NAD, 1925 (prize); Sesqui-Centenn. Expo, Phila., 1926 (med); AIC, 1926 (prize) [40]

JOHNSON, Clifton [I] Hadley, MA b. 25 Ja 1865, Hadley. Illustrator: "Natural History of Selbourne," "Window in Thrums," "Lorna Doone" [17]

JOHNSON, Content [Por.P] Beverly Hills, CA b. Bloomington, IL d. 9 N 1949. Studied: CUASch; ASL; N.Y. Sch. A.; Académie Julian, Paris; Chase; Cox; DuMond; Weir. Member: PBC; N.Y. Soc. P. Exhibited: Pal. Leg. Honor, 1945 (prize); NAD; All.A.Am.; N.Y. Soc. P.; PAFA; PBC; Los Angeles Mus. A.; Ebell C., Los Angeles; Soc. for Sanity in A.; Calif. AC; Phila. AC; Fisher Gal., Los Angeles (one-man); Beverly Hills Women's C. (one-man); AIC; Rome. Work: Princeton; Pub. Lib., Elizabeth, N.J. [47]

JOHNSON, Cordelia [P] Omaha, NE b. 11 Jy 1871, Omaha. Studied: J.L. Wallace. Member: Omaha A. Gld. [33]

JOHNSON, David [Ldscp.P] Walden, N.Y. b. 10 My 1827, NY d. 30 Ja 1908. Studied: self-taught; few lessons with Jasper F. Cropsey. Member: NAD; A. Fund. S. Exhibited: Centenn. Expo, Phila., 1876 (med); Mass. Charitable Mechanics Assn., Boston, 1878 (med); he never visited Europe, but did exhibit "Housatonic River" at Paris Salon, 1877. Based in NYC, he made numerous sketching trips throughout New England. He was one of the last survivors of the Hudson River School of landscape painters. [08]

JOHNSON, Doris Miller (Mrs. Gardiner) [P,T,Dr] Berkeley, CA b. 8 D 1909, Oakland, CA. Studied: Univ. Calif.; Calif. Col. A&Cr. Member: San Fran. Women A.; San Fran. AA. Exhibited: Colorado Springs FA Center (prize); San Fran. Women A., 1935 (prize), 1938 (prize); San Fran. AA, 1940 (prize); AIC, 1934, 1935; Oakland A. Gal.; San Fran. Women A.; San Fran. A. Lg.; Santa Cruz A. Lg., 1938; Sacramento State Fair, 1939; GGE, 1939; SFMA Traveling Exh., 1938-42; Univ. Tex., 1941; Fnd. Western A., 1940; Portland (Oreg.) A. Mus., 1936; St. Paul A. Mus., 1936; Berkeley Women's City C., 1936 (one-man); SFMA, 1938 (one-man); Crocker A. Gal., 1939 (one-man); Hotel Senator, Sacramento, Calif., 1937 (one-man); Delta Delta Delta Nat. exh., 1936 (one-man). Position: Pres., San Fran. Women A., 1946-48 [47]

JOHNSON, Dorothy May [P,T] Chicago, IL b. 1 F 1912, Chicago. Studied: Univ. Chicago; AIC. Member: ASL, Chicago. Exhibited: AIC, 1937 (prize), 1938, 1939. Position: T., Herzl Jr. Col. [40]

JOHNSON, Eastman [P] NYC b. 29 Jy 1824, Lowell, ME d. 5 Ap 1906. Studied: worked at Bufford's lithography firm in Boston at age 16; Düsseldorf; Rome; Paris; at the Hague (where for four years he was known as the "American Rembrandt"). Member: NAD, 1860; SAA, 1881; Century Assn. Exhibited: Paris Expo, 1889 (med), 1900 (med); Pan-Am. Expo, Buffalo, 1901 (gold); St. Louis Expo, 1904 (gold). He worked at crayon portraiture in Augusta, Maine, Newport, R.I., and Wash., D.C., from 1841-49. After being in Europe, he worked in Wis., 1856-57; settled in NYC, 1859. He painted his best rural genre in Nantucket, during 1870s. After the 1880s, he primarily painted portraits (with great success). His collection was sold at auction (American Art Gal., NYC), in 1907. [06]

JOHNSON, Edward (Arthur) [P,Des,I,W,Car,Ser] Chicago, IL b. 18 D 1911, Chicago. Studied: CAFA; AIC. Member: Chicago Gld. Freelance A. Exhibited: Gld. Freelance A., 1943 (prize); Nat. Army Arts Exh., CGA, 1945 (prize); NGA, 1945; Swedish-Am. Annuals, 1940 (prize), 1941; Swedish C., 1946; AIC, 1938, 1945; Evanston Women's C., 1938; High Mus. A., 1945. Work: Nat. Mus., Vexio, Sweden. Illustrator: color cartoons, Esquire, other magazines. Position: U.S. Army, 1944-46 [47]

JOHNSON, Edwin Boyd [Por.P,Mur.P,Li,C,S,Des] Nashville, TN b. 4 N 1904, Watertown, TN. Studied: Kunstgewerbe Schule, Vienna, Austria; Ecole de Fresque, Paris; NAD; R.L.M. Hubert; L. Ritman; J. Norton; B. Anisfeld; G. Oberteuffer. Member: Chicago SA. Exhibited: Chicago, 1930 (prize), 1940 (prize); Lathrop European Fellowship, 1939; BM, 1935; CM, 1939; PAFA, 1939; AIC, 1931, 1932, 1934-38, 1941. Work: USPOs, Melrose Park, Ill., Dickson, Tenn., Tuscola, Ill.; Univ. Ill.; U.S. Gov. WPA artist. [47]

JOHNSON, Edyth A.B. [Min.P] b. 26 Ja 1880, Portsmouth, NH. Studied: Twachtman; A. Beckington; C. Beckwith. Member: Plastic C.; Print C.; Fairmount Park AA [33]

JOHNSON, Elena Mix (Mrs. Alexander L.P.) [P] Wash., D.C. b. 19 Ag 1889, Nogales, AZ. Studied: PAFA; Garber; H. McCarter; J.T. Pearson; C. Grafly; G.A. Bringas, at Nat. Acad. of Mex. Member: AFA; AAPL [31]

JOHNSON, F. [P] Bradford, MA. Member: Boston AC [29]

JOHNSON, Floyd E. [Des,Arch] Charlottesville, VA b. 9 Je 1909, Charlottesville. Studied: McIntyre Sch. FA, Univ. Va. Member: SSAL; Albemarle A. Lg.; Am. Inst. Arch. Exhibited: Va. MFA, 1938 (prize); WC Ann., PAFA, 1937; SSAL, Montgomery, Ala., 1938; Va. MFA. Work: Va. MFA [40]

JOHNSON, Francis Norton [P] Paris, France b. 1878, Boston d. 21 N 1931, Paris. Studied: Laurens, in Paris. Member: Paris AAA (25 years). In 1919 he invented a device for registering the human voice on motion picture films. [24]

JOHNSON, Frank Edgar (Mrs.) [P] Yonkers, NY [24]

JOHNSON, Frank Edward [P,W,L] Marianao, Cuba/Norwich CT b. 6 Jy 1873, Norwich d. 19 S 1934. Studied: Laurens, Constant, in Paris. Member: Wash. WCC [33]

JOHNSON, Frank Tenney [P,I] Alhambra, CA b. 26 Je 1874, Big Grove, IA d. 1 Ja 1939. Studied: Milwaukee, with F. Heine, 1888; R. Lorenz, 1889; ASL, with Henri, Chase, Mora, K.H. Miller, 1902. Member: ANA; NAD; SC; NAC; Allied AA; AWCS; NYWCC; Laguna Beach AA; Calif. AC; P. of the West; Highland Park SA, Dallas; Fnd. Western A.; San Gabriel AG. Exhibited: Wis. PS, 1919 (prize); SC, 1923 (prize); Tex. Wild Flower Comp., 1929 (prize); Allied AA, 1929 (med); P. of the West, 1930 (med); Ebell C., Los Angeles, 1933 (prize). Work: NGA; NAC; Dallas AA; Highland Park Soc. A., Dallas; Fort Worth Mus. A.; Women's C., Fort Worth; Municipal A. Gal., Phoenix; New Grand Hotel, Billings, Mont.; Paramount Theatre, NYC; curtain murals, Carthay Circle Theatre, Los Angeles; Chicago Athletic C.; Amherst Col.; Royal Palace, Copenhagen; Ball State T. Col.; Dunedin Mus., New Zealand. A successful illustrator of Zane Grey books, he was later best known for his western scenes under moonlight and stars. [38]

JOHNSON, George H. Ben [P,Car,I] Richmond, VA b. 1 Mr 1888, Richmond. Studied: Hampton Inst.; Columbia; Landon Sch., Cleveland. Member: Craig House A. Center. Richmond, Va. Exhibited: Cross Assn.; Boothbay Harbor, Maine, 1936 (prize), 1937 (prize); VMFA, 1945 (prize); Imperial Gal., London; VMFA, 1945; WMAA; Dillard Univ., New Orleans, 1939-41; Tanner Gal., Chicago, 1940; Atlanta Univ., 1942-46. Work: Valentine Mus. A.; Speed Mem. Mus.; Va. Union Univ.; Am. Lib. Color Slides; Va. State Col.; VMFA; Second Baptist Church, Trinity Baptist Church, both in Richmond [47]

JOHNSON, G(race) M(ott) [S,P,W] Pleasantville, NY b. 28 Jy 1882, NYC. Studied: ASL; G. Borglum. Member: NAWA; Am. A. Cong. Exhibited: NAWA, 1927 (med), 1917 (prize), 1935 (prize), 1936 (prize). Work: WMAA; Brookgreen Gardens, S.C.; NYPL; Pub. Lib., Pleasantville, N.Y. [47]

JOHNSON, Harold LeRoy [B,Dr,Por.P,Ldscp.P] Kansas City, MO b. 22 Ag 1909, Kansas City. Studied: A. Bloch; C. Mattern; R. Ketcham; Univ. Kans. Member: McD. C. Work: portrait drawings, The Kansas City Star; 24 woodcuts, Univ. Kans. Yearbook; Nelson Gal. A., Kansas City [40]

JOHNSON, Harrison Wall [P] Minneapolis MN [24]

JOHNSON, Harry L. [Min.P] Swarthmore, PA. Member: Pa. S. Min. P.; Am. S. Min. P. [40]

JOHNSON, Hazel [P] Chicago, IL [24]

JOHNSON, Helen Lossing (Mrs. Frank Edgar) [P] Yonkers, NY b. 31 My 1865, Poughkeepsie, NY d. 4 Ja 1946. Studied: NAD; C.M. Dewey. Member: Yonkers AA. Author/Illustrator: "Tally-Ho," "A Spaniel of New Plymouth," "Love of Earth" [40]

JOHNSON, Helen Sewell. See Morley, Helen.

JOHNSON, Herbert [I,Car] Huntingdon Valley, PA b. 30 O 1878, Sutton, NE d. 4 D 1946, Phila. Member: SI; Phila. AC; Phila Sketch C.; Phila. Alliance; Ar. Gld. Positions: Associated with Denver Republican, Kansas City Journal, Philadelphia North American; Staff Car., Saturday Evening Post, since 1912 [40]

JOHNSON, Howard C. [P] Cedar Rapids, IA b. 28 Ap 1913, Griswold, IA. Member: Coop. A. Iowa. Exhibited: Iowa State Fair, 1934 (prize), 1936 (prize); Cornell, 1938 (prize). Work: Agricultural Bldg., Iowa State Fair, Des Moines. Position: T., Ottumwa, Iowa, A. Center [40]

JOHNSON, Irene Charlesworth (Mrs. Edwin Lee) [S] Nashville, TN b. 27 S 1888, Gering, NE. Studied: Zolnay. Member: SSAL; Studio C., Nashville. Exhibited: All Southern Exh., 1921 (prize); SSAL, 1925 (prize). Work: Nashville Mus. A. [47]

JOHNSON, John Grover [Patron] Phila., PA b. 1841, Phila. d. 14 Ap 1917. His collection of old masters included nearly 1800 pictures, and filled to overflowing his old house on South Broad Street. He was a Trustee of the Metropolitan Museum.

JOHNSON, J.T., Mrs. See Greenleaf, Helen.

JOHNSON, J. Theodore [P,S,T] San Jose, CA b. 7 N 1902, Oregon, IL. Studied: AIC; Lhote, A. Maillol, in Paris; L.G. Seyffert; L. Kroll. Exhibited: AIC, 1928 (gold), 1929-30, 1931 (prize); Swedish C., Chicago, 1929 (prize); Chicago Gal. Assn., 1929 (prize); F., Guggenheim Fnd., 1919; Minneapolis Inst. A., 1938-42 1943 (prize), 1944 (prize); Minn. State Fair, 1944 (prize); CGA, 1928, 1930, 1937; CI, 1929, 1930; PAFA, 1929, 1937; AIC, 1928-30, 1932, 1940; NAD, 1936; GGE, 1939; Toronto, Canada, 1940; Nat Gal., Canada, 1940; Montreal AA, 1941; BM, 1932; SFMA, 1946; Minn. State Fair, 1942-44; WMAA. Work: AIC; TMA; Vanderpoel Col.; Minneapolis Inst. A.; Univ. Chicago; Field Mus.; murals, Garden City, N.Y.; Oak Park, Ill.; Morgan Park, Ill.; Western Ill. State T. Col. WPA aritst. Positions: T., Minneapolis Sch. A., 1938-45, San Jose State Col., 1945- [47]

JOHNSON, Jeanne Payne (Mrs. Louis C.) [Min.P] Stony Brook, NY b. 14 Ap 1887, Danville, OH d. 11 O 1958. Studied: ASL; Mme. La Forge, R. Miller, L. Simon; Paris. Member: Brooklyn Soc. Min. P.; Pa. Soc. Min. P. [47]

JOHNSON, Jessamine Inglee (Mrs.) [P,T] Connersville, IN b. 2 D 1874, Delphi, IN. Studied: Herron A. Inst. Member: Ind. AC. Exhibited: Hoosier Salon, Chicago, 1929 (prize) [33]

JOHNSON, Joseph [P] NYC. Member: GFLA [27]

JOHNSON, Joseph Hoffman [Por.P] b. 1821, NYC d. 1890. Exhibited: Am. Inst., 1847. Active in NYC early 1840s-1890. Brother of David. [*]

JOHNSON, M. Martin [Des,I] Burbank, CA b. 4 D 1904, Rockford, IL. Member: Soc. Typographic A.; Chicago A. Gld. Exhibited: Soc. Typographic A., 1938 (prize), 1940 (prize), 1944 (prize); A. Dir. C., 1939 (prize); Chicago A. Gld., 1945 (prize); AIGA, 1937, 1938, 1940; AIC, 1940; Chicago A. Gld., 1945 [47]

JOHNSON, Malvin Gray [P] NYC b. 28 Ja 1896, Greensboro, NC. Studied: F.C. Jones; NAD. Member: S.Indp.A.; Salons of Am. Exhibited: Harmon Fnd., Intl. House, N.Y., 1929 (prize). Work: Musical Art Forum, Orange, N.J. [33]

JOHNSON, Mamie (C. Irwin) [P] Tescott, KS b. 1 D 1879, Saline County, KS. Member: Salina AA [3]

JOHNSON, Margaret [P,I] Mt. Vernon, NY b. 5 Ap 1860, Boston. Studied: CUASch; ASL. Author/Illustrator: "Procession of the Zodiac," "A Bunch of Keys," other books [24]

JOHNSON, Marie Runkle [P] Pasadena, CA b. 21 D 1861, Flemington, NJ. Studied: Collin, Girardot, Courtois, Prinet, in Paris; Chase, in NYC. Member: Calif. AC. Exhibited: Pan.-Calif. Expo, San Diego, 1915 (med) [29]

JOHNSON, Marjorie Remy [S,T] b. 1894 d. 22 Jy 1925, Indianapolis. Studied: M.R. Richards; A. Polasek. Position: Hd., Art Dept., Tudor Hall, Indianapolis

JOHNSON, Marshall [Mar.P] Boston, MA b. 13 My 1850, Boston d. 21 Mr 1921. Studied: Lowell Inst.; Boston AC; W.E. Norton; Holland; France; England. Member: Boston AC; Copley S., 1900. Work: Peabody Mus., Salem. At 18, he was a sailor aboard the "Sunbeam," bound for South America. The ship burned at sea, but he was rescued. [17]

JOHNSON, Mary Craven (Mrs. Theodore W(oolsey) [P,Por.P] Annapolis, MD b. 4 Jy 1874, Phila. Studied: Henri; Pyle; Hawthorne; Clinedinst; Phila. Sch. Des. for Women. Member: Baltimore WCS; Wilmington SFA. Work: portrait, U.S. Naval Acad. [40]

JOHNSON, Mary Rolfe (Mrs.) [P] St. Petersburg, VA b. 25 D 1881, Virginia. Work: Mus. Am. History, Valley Forge, Pa. [40]

JOHNSON, Merle DeVore [I] NYC b. 24 N 1874, Oregon City, OR d. 2 S 1935. Member: Artists Gld. An authority on Mark Twain and Frederic Remington. [31]

JOHNSON, Minnie Wolaver [P,T] Dallas, TX b. Diana, TN. Studied: Reaugh; Bridgman; L. Douglas; ASL. Member: Dallas AA; F. Reaugh AC, Dallas. Work: murals, Tex. high schools. WPA artist. [40]

JOHNSON, Neola [P,S,I,T] Gary, IN/Lindstrom, MN b. Chicago. Studied: A. Angarola; C. Booth. Member: Gary PPC [29]

JOHNSON, Newbern (Mrs.) [C,T] Crossnore, NC b. 8 S 1894, Crossnore. Studied: E.F. Worst; C. Miller. Specialties: Hand weaving, hooked rugs, metal work. Position: T., Crossnore Sch. [40]

JOHNSON, P. [S] Cambridge, MA [19]

JOHNSON, P.D. [P] NYC. Member: GFLA [27]

JOHNSON, Ralph Cross [Patron] d. 10 Jy 1923, Bath, ME. Donor of a valuable collection of paintings to the National Gallery of Art.

JOHNSON, Reginald [Ldscp.P] Los Angeles, CA b. 10 Jy 1905, NYC. Studied: F.T. Chamberlin; P. Carter; Chouinard Sch. Art. Member: Calif. WCS; Laguna Beach AA. Exhibited: Laguna Beach AA, 1936 (prize) [40]

JOHNSON, Reuben Le Grand [Ldscp.P] Riverdale, MD b. 1850, Alexandria, VA d. 17 Je 1918. Studied: France; Spain; Morocco. Member: Wash. SA

JOHNSON, Robert Ward [I,P] NYC d. 12 D 1953. Member: SI [47]

JOHNSON, Samuel Frost [P] b. 9 N 1835. Studied: NAD; Milwaukee; Düsseldorf, Antwerp, Paris, 1859. He had a studio in London. Positions: T., Fordham, MMA, 1870s [*]

JOHNSON, Sargent Claude [S,Gr,C,P] San Fran., CA b. 7 O 1889, Boston. Studied: Calif. Sch. FA; Beniamino Bufano; Ralph Stackpole. Member: San Fran. AA. Exhibited: San Fran. AA, 1935 (med); Leg. of Honor, 1925 (gold), 1927 (prize), 1929 (med), 1931 (prize), 1933 (prize). Work: SFMA; San Diego FA Soc.; GGE, 1939; George Washington H.S., San Fran.; tile, Aquatic Park, San Fran.; statues, Sunnydale (Calif.) Housing Project [47]

JOHNSON, Susan Wall [P] Minneapolis, MN [24]

JOHNSON, Thomas [Wood En,I] NYC b. London, England. Studied: F. Williams. Member: Soc. Am. Wood En. Exhibited: Columbian Expo, Chicago, 1893 (med); Pan-Am. Expo, Buffalo, 1901 (med) [10]

JOHNSON, Tom Loftin [Mur.P,P,Des,L,T] Bedford, NY b. 5 O 1900, Denver, CO. Studied: E. Winter; Yale; L. Simon; Ecole des Beaux-Arts, Paris. Member: Mural P. Exhibited: CI, 1941 (prize); Arch. Lg.; CGA; CI. Work: Palmer House Hotel, Chicago; George Washington H.S., NYC; theatre curtain, Miss Beard's Sch., Orange, N.J.; des. dome, Louisville (Ky.) War Memorial; Denver A. Mus.; murals, U.S. Military Acad. (West Point), Headquarters Bldg., Governors Island (N.Y.), Radio Station WOR (NYC), Ritz-Tower Hotel (NYC). Position: T., Rollins Col., Winter Park, Fla. [47]

JOHNSON, W.J. [P] Uniontown, PA. Member: Pittsburgh AA [25]

JOHNSON, W. Parke [S,P] NYC. Member: GFLA [27]

JOHNSON, Willard Charles [P,Des,Dec] Chicago, IL/Clarkia, Idaho b. 2 D

1902, Minneapolis. Studied: AIC. Exhibited: Intl. WC Ann., AIC, 1939 [40]

JOHNSON, William H. [P,B,T] NYC b. 18 Mr 1901, Florence, SC d. 1970. Studied: NAD, with Hawthorne, 1921–26. Member: Un. Am. Ar. Work: Nat. Mus., Stockholm; Nat. Coll. Lived in Paris, Denmark, and Norway, 1926–38. Important Black painter; used expressionist style in his religious, prison, war, and farm scenes of Blacks. Positions: T., Harlem A. Center, NYC; associated with WPA, 1939–43 [40]

JOHNSON, William Martin [I]. Member: Phila. AC. Position: Illus., Ladies' Home Journal [01]

JOHNSON, Wynne [P] Wash., D.C. [27]

JOHNSON-HERTER, Robert [P] Paris, France. Exhibited: Société des Beaux-Arts, Paris, 1898 [98]

JOHNSTON, Addison [Car] Jackson, TN b. 12 F 1894, Memphis. Studied: P. Saunders. Work: Huntington Lib., San Marino, Calif. Author: "The Peregrinations of Miss Prints," 1928. Position: Car., The Jackson Sun [40]

JOHNSTON, Bertha G(ill) (Mrs. James I.) [P,C] Pittsburgh, PA/Chautauqua, NY b. 30 Ag 1870, Pittsburgh. Studied: ASL; K. Cox; R.H. Nichols; G. Sotter; Hawthorne. Member: Pittsburgh AA [25]

JOHNSTON, Danny Sundberg (Mrs.) [C,T] Oakland, CA b. 19 O 1905, Oslo, Norway. Studied: Univ. Minn.; AIC. Exhibited: metalwork, Seattle AM, 1936 (prize) [40]

JOHNSTON, Frances Benjamin [Photogr] Wash., D.C. b. 1864, Grafton, WV d. 1952. Studied: Académie Julian, Paris, 1883–85; photogr., with T.W. Smillie, in Wash., D.C. Member: Wash. AC; Phila. Alliance; AFA. Exhibited: Pan-Am. Expo, 1901 (gold), La. Purchase Expo (gold), Paris Expo, 1901 (gold); pictorial survey of Fredericksburg, Va., LOC. Work: MOMA; LOC. Author: "What a Woman Can Do With a Camera." Opened her Wash., D.C. studio in 1880. Known as the first woman press photographer. Later, concentrated on architectural photographic documentation of the historic South. [30]

JOHNSTON, Frederic [P,T,Arch] Riverside, CA b. 8 Je 1890, Chicago, IL. Studied: M. Sheets; G. Brandriff; Univ. Calif; Claremont Col. Member: Calif. WC Soc.; San Diego FA Gld.; Laguna Beach AA; FA Gld., Riverside, Calif. Exhibited: Riverside (N.Y.) Mus., 1939, 1941; Oakland A. Gal., 1939, 1941, 1942; San Diego FA Soc., 1938–41, 1943, 1946; Los Angeles Mus. A., 1937, 1938, 1940, 1941, 1943, 1944; Laguna Beach AA, 1936–46. Position: T., Riverside (Calif.) Col, 1946–47 [47]

JOHNSTON, Henry Mortimer [Patron,Photogr] b. 1831 d. 11 N 1920, Hackettstown, NJ

JOHNSTON, John Humphreys [P] Paris, France b. 2 N 1857, New York d. 7 Ap 1941, Cannes, France. Studied: J. La Farge; Lefebvre, Doucet, in Paris. Member: Assoc., Soc. Nat. des Beaux-Arts, Paris; Assoc., Intl. Soc. PS&G, London; Paris SAP; Century Assoc. Exhibited: PAFA, 1896 (gold); Paris Expo, 1900 (med); Munich, 1901 (gold); Pan-Am. Expo, Buffalo, 1901 (med); St. Louis Expo, 1904 (med). Award: Chevalier of the Legion of Honor, 1901. Work: CI; Luxembourg Mus., Paris [17]

JOHNSTON, Julia [P] NYC [06]

JOHNSTON, Margaret Isabelle [P,Min.P] Hollywood, CA b. 22 N 1884, Chicago, IL. Studied: AIC; Los Angeles FA Acad.; Otis AI. Member: Calif. AC; Women P. of the West; Calif. Soc. Min. P.; AAPL; Soc. for Sanity in A.; Pa. Soc. Min. P.; East Los Angeles AA. Exhibited: Pal. Leg. Honor, 1942 (med), 1945 (med); Los Angeles Mus. A., 1944 (prize); Women P. of the West, 1943 (prize), 1946 (prize); Los Angeles Pub. Lib.; 1946 (prize); Fisher Gal., 1942 (prize); Calif. Soc. Min. P., 1944 (med); PAFA, 1944, 1945; Smithsonian, 1944, 1945. Work: illus. map, Hollywood USO [47]

JOHNSTON, Margaret Kalb Broxton (Margot) [S] Deerfield, MA b. 9 F 1909, Shrewsbury, Shropshire, England. Studied: E.E. Foster; C.C. Mose; J.M. Miller; R.W. Johnson. Member: Wash. AL; Creative AC, Arlington County, Va. Exhibited: New Haven PCC, 1933; Soc. Wash. Ar., 1933, 1937, 1938 [40]

JOHNSTON, Mary G. [P] Pewee Valley, KY b. 16 N 1872, Evansville, IN. Studied: Hawthorne; R. Miller; C. Hopkins. Member: Provincetown AA; Louisville AA [40]

JOHNSTON, Mary Virginia del Castillo. See Del Castillo, Virginia.

JOHNSTON, Randolph [S,T,L,W] Deerfield, MA b. 23 F 1904, Toronto, Ontario. Studied: Central Tech. Sch., Toronto; Univ. Toronto; Ontario Col. Art; Cent. Sch. A.&Crafts, London; Royal Canadian Acad. Member: Clay Cl.; Audubon A.; Western Mass. Ar. Un. Exhibited: Springfield (Mass.) A. Lg., 1937 (prize), 1938; Royal Canadian Acad., 1925, 1926; Nat. Gal., Ottawa, 1927; S.Indp.A., 1942; AV, 1942; Audubon A., 1945; Clay Cl., 1944 (one-man), 1945; Pittsfield A. Lg., 1936; George Walter Vincent Smith A. Gal., 1945 (one-man). Work: mem. tablets, Toronto, Montreal; reliefs, Smith Col.; mem. panels, Eagle Brook Sch.; St. John's Church, Northampton, Mass.; Queen's Univ., Kingston, Ontario. Author/Illustrator: "The Country Craft Book," pub. Farrar and Rinehart, 1937. Illustrator: "The Golden Fleece of California," by Edgar Lee Masters, pub. Farrar and Rinehart, 1936. Lectures: Direct casting, bronze. Position: T., Smith Col, 1940– [47]

JOHNSTON, Reuben Le Grande [Ldscp.P] Wash., D.C. b. 27 Jy 1850, Alexandria, VA. Member: Soc. Wash. Ar. Specialty: landscapes with animals [17]

JOHNSTON, Robert E. [I] Leonia, NJ b. 14 S 1885, Toronto, Ontario d. 29 N 1933. Studied: Harvey Dunn; Walter Sickert, in London. Member: SI; SC; Arts & Letters Cl., Toronto [33]

JOHNSTON, Ruth [P,I,W,L,T] Baltimore, MD b. 26 Ap 1864, Sparta, GA. Studied: Cox; Beckwith; Blum. Member: Baltimore WCC; ASL. Illustrator: magazines/children's calendars [40]

JOHNSTON, S.H., Mrs. See Aitken, Irene.

JOHNSTON, Sarah J.F. [Dr,T] b. 1850, Boston d. 1925, Dorchester, MA. Studied: her father, David Claypool Johnston (1798–1865); her brother, Thomas (1836–69); W.M. Hunt. Exhibited: Boston AC, 1882–97; Williams & Everett Gal., Boston, 1888. Specialty: charcoal drawings of genre scenes, often with children, for which she was critically acclaimed as one of Boston's best artists. [*]

JOHNSTON, Scott [P,S,I] Chicago, IL b. 5 D 1903, Sac City, IA. Studied: AIC; A. Iannelli [33]

JOHNSTON, William M. [Ldscp.P,Por.P] Brooklyn, NY b. 1821, NYC d. 30 Ap 1907. Active: NYC, 1849; Boston, 1856; then returned to Brooklyn

JOHNSTON, William M.P. [S] Johnstown, PA [19]

JOHNSTON, Winant [P,S,A,W] Wash., D.C. b. 2 Jy 1890. Studied: Grafly [25]

JOHNSTONE, B. Kenneth [Edu] Pittsburgh, PA b. 20 Ja 1907, Chicago, IL. Studied: Univ. Ill.; Yale; Am. Acad., Rome. Member: AIA. Exhibited: Rome, Italy, 1929 (prize). Positions: T., Pa. State Col., 1933–45; Dir., Col. FA, CI, 1945– [47]

JOHNSTONE, Ralph Wilbur [Des,P,T,C,L] Chicago, IL b. 26 Jy 1911, Cicero, IL. Studied: AIC; Emil Zettler; Francis Chapin; M. Artingstall; ASL of AIC; Industrial Des. All., Chicago. Exhibited: ASCA Advertising Exh., Chicago, 1946 (prize); Kansas City AI, 1936; AIC, 1935–38; 1940; 1942; 1945; 1946; Chicago A. Dir. Cl., 1946. Position: T., AIC [47]

JOHNSTONE, Will B. [I,Car] NYC d. 6 F 1944, West Palm Beach, Fla. Member: SI. Position: Car., New York World-Telegram [31]

JOHNT, Ethel (Mrs. W.E. Hykes) [P,T,Des,C] Buffalo, NY b. 22 O 1904, Hamburg, NY. Studied: L. Kroll; C. Anderson; A. Covey; Buffalo Sch. FA; NAD. Member: The Patteran. Exhibited: Albright A. Gal., 1938, 1939 (prize), 1943 (prize); AFA Traveling Exh., 1941–42; CI, 1941; Great Lakes Exh., The Patteran, 1938. Work: Albright A. Gal. [47]

JOHONNOT, Ralph H. [P,T,Des] Los Gatos, CA d. N 1940 [17]

JOHST, Paul Spener [P] NYC. Member: S.Indp.A. [21]

JOINER, Harvey [P] Prather, IN b. 8 Ap 1852, Charlestown, IN d. 30 My 1932, Louisville, KY. Studied: self-taught. Member: Louisville Artists Lg. Specialty, Ky. beechwoods. At 16, he began sketching Blacks on the Mississippi River boats. Commissioned to do portraits of the first five governors of Ind. [31]

JOLLY, Wade Lytton [P] Phila., PA b. 10 O 1909, Phila. Studied: Breckenridge; E. Horter; PAFA. Member: Phila. Print Cl.; Phila. A. All. Position: T., Sch. Cultural A., Jenkintown, Pa. [40]

JONAS, LeRoy F. [P,Mur.P,Des,T] Wausau, WI b. 18 Ap 1897, Wausau d. 1981. Studied: AIC; Schook; Seyffert; Wilimovsky; Norton; Lundmark. Member: AFA. Exhibited: Milwaukee AI, 1924 (prize). Work: murals, City Hall, High School, both in Wausau [40]

JONAS, Louis Paul [S] New Rochelle, NY b. 17 Jy 1894, Budapest, Hungary. Studied: C.E. Akeley. Member: New Rochelle AA; Arch. Lg; Am. Assn. Mus.; Mus. Assn. Great Britain. Work: Indian Elephant group, AMNH; group in bronze, City of Denver; mem. fountain, Humane Soc., New Rochelle [40]

JONES, A. Howard [P] Chicago, IL [10]

JONES, Adaline W. [P] Brooklyn, NY [10]

JONES, Albertus E(ugene) [P,T] South Windsor, CT b. 31 O 1882, South Windsor d. 1 Mr 1957. Studied: Charles Noel Flagg; Conn. Lg. A. Students. Member: CAFA; Conn. WC Soc.; New Haven PCC. Exhibited: CAFA, 1912 (prize) 1927 (prize), 1930 (prize), 1932 (prize), 1944 (prize); Conn. WC Soc. 1939 (prize), 1941 (prize), 1943 (prize), 1944 (prize); Bridgeport A. Lg., 1944 (prize); New Haven PCC, 1945 (prize); Wadsworth Atheneum, Hartford, 1939 (prize). Position: T., Randall Sch., Hartford [47]

JONES, Alfred [En,Por.P] Yonkers, NY b. 7 Ap 1891, Liverpool, England (came to U.S. in 1834) d. 28 Ap 1900. Studied: apprentice, banknote company in Albany and NYC; Europe. Member: NA, 1851; AWCS; Artists' Fund Soc. Work: portraits, Grolier Cl. Specialty: vignette portrait engravings. Among his best-known works are "The Image Breaker," after Leutze, and many after A.B. Durand and other painters. He engraved a number of U.S. postage stamps, including the two cent, thirty cent, $4 and $5 of the Columbian series. [98]

JONES, Allan Dudley, Jr. [P,Mur.P,Li,Des,T] Newport News, VA b. 25 F 1915. Studied: Univ. Pa.; PAFA; Arthur Carles. Member: SSAL. Exhibited: Norfolk Mus. A., 1944, 1945 (prize); PAFA, 1938, 1939 (prize); Grand Central Gal. VMFA, 1939–41, 1945. Award: Prix de Rome, 1939. Work: murals, USPO, Athens, Pa.; S.S. President Monroe. Lectures: Art and Industry. Position: T., PAFA [47]

JONES, Amy (Mrs. D. Blair) [P,I,Li,L,G,T] Mount Kisco, NY b. 4 Ap 1899, Buffalo, NY. Studied: PIASch; Cecil Chichester, Peppino Mangravite, Anthony di Bona; W. Adams; Giesbert; H. Hensche; Buffalo SA. Member: The Patteran; Saranac Lake A. Lg.; NAWA. Exhibited: Baltimore, WCC, 1941; Saranac A. Lg. 1938 (prize), 1939 (prize), 1940 (prize), 1941 (prize), 1942 (prize); Adirondack, A. Gal., 1938 (prize);; AIC, 1938, 1939; NAD, 1940, 1943, 1945; PAFA, 1936, 1938, 1940, 1942–44; AWCS, 1940–42, 1944–46; NAWA, 1941–43, 1945, 1946; Northwest Pr. M., 1943; Laguna Beach AA, 1943; New Haven PCC, 1943; AFA Traveling Exh., 1942, 1943; Portraits, Inc. Traveling Exh., 1942, 1943; Mississippi AA, 1944; Balitmore WCC, 1941; Albright A. Gal., 1940, 1941, 1943; Mid-Vt. A., 1943; Soc. Wash. A., 1944; Butler AI, 1944; NAC, 1946. Work: Wharton Sch. Hollywood (Fla.) Hospital; Marine Hospital, Carville, La.; murals, USPOs, Winsted, Conn., Painted Post, N.Y., Schenectady, N.Y. Illustrator: "Child's Garden of Verses," 1946. WPA artist. [47]

JONES, Annie Weaver [P,I] Chicago, IL. Studied: AIC; ASL; Lasar, Collin, Merson, in Paris. Member Chicago SA; SWA [15]

JONES, Aristine M.P. [Min.P] Seattle, WA [24]

JONES, Arthur E.W. [P] Milwaukee, WI [15]

JONES, (Arthur) Sidney (H.) [P] Red Bank, NJ b. 22 Ja 1875, Montreal, Quebec. Studied: ASL. Member: NAC; SC. Exhibited: NAD; PAFA; SC; NAC [47]

JONES, Bayard [I] Merrick, NY b. 9 O 1869, Rome, GA. Studied: Laurens, Constant, in Paris. Member: SI, 1903 [24]

JONES, Carmita de Solens [P] Phila., PA [25]

JONES, Catherine (Mrs. Bollam) [W,Cr] Portland, OR b. 20 Mr 1899, Madison, MN. Studied: Oreg. State Col. Position: A. Cr., Portland Oregonian, 1934– [47]

JONES, Catherine Forbes [P] NYC. Member: NAWPS. Exhibited: Nat. Acad. Ann., 1938; NAWPS, 1938; CGA, 1939 [40]

JONES, Clifford Edgar [Mur.P,I,T] Woodmont, CT b. 17 Je 1915, Greentown, IN. Studied: D. Mattison; H. Mayer; John Herron AI; Am. Acad., Rome; Univ. Iowa; J. Charlot. Member: A. Assn., Kokomo, Ind. Exhibited: Ind. A., 1941; Hoosier Salon, 1941; All-Iowa Exh., 1940; New Haven PCC, 1946; Ind. State Fair, 1936, 1940, 1941. Award: Prix de Rome, 1937. Work: St. John's Church, Bridgeport, Conn. Position: T., Univ. Iowa [47]

JONES, C(ora) Ellis (Mrs.) [Ldscp.P] Birmingham, AL b. 14 My 1875, Aurora, IL d. 18 Ag 1932. Studied: Roderick Mackenzie; George Elmer Browne. Member: Birmingham AC; SSAL; Gloucester SA; AFA; Ala. A. Lg. Work: Lib., Brimingham Southern Col.; Ala. A. Lg. [31]

JONES, Dorothy B. [P] NYC/South Windsor, CT b. 27 Ap 1908. Member: CAFA. Exhibited: Springield AL, 1926 (prize); CAFA, 1929 (prize), 1930 (prize), 1931 (prize) [39]

JONES, E.A. [P] Birmingham, AL [15]

JONES, E. Russell (Mrs.) [P] Phila., PA. Studied: PAFA [25]

JONES, Elberta Mohler [P,Por.P,I,T] Hollywood, CA b. 16 Mr 1896, Kansas City, MO. Studied: AIC; Otis A. Inst.; Chouinard AI. Member: Calif. AC; Women P. of the West. Exhibited: portrait, Intl. Aeronautical Exh., 1937 (prize); oil, Ebell Cl., 1939 (prize); Los Angeles Mus. A. Work: Los Angeles Conservatory Music; Birmingham Hospital; Los Angeles Athletic Cl. Illustrator: Chicago Journal, Chicago Herald-Examiner. Position: T., Holmby Col., Los Angeles [47]

JONES, Elizabeth D. [P] Baltimore, MD [25]

JONES, Elizabeth Ivins [I,P,T] Cincinnati, OH [10]

JONES, Elizabeth Orton [E,I] Highland Park, IL b. 25 Je 1910, Highland Park. Studied: AIC, Univ. Chicago; Ecole des Beaux-Arts, Fontainebleau, France. Member: Chicago SE. Exhibited: Chicago Soc. E., 1939 (prize). Work: Smithsonian; Highland Park Hospital. Author/Illustrator: "Ragman of Paris," pub. Oxford Univ. Press, "David," pub. Macmillan, 1937. Illustrator: "Brownies—Hush!," "The Scarlet Oak," "Told Under the Magic Umbrella" [40]

JONES, Elizabeth Sparhawk. See Sparhawk-Jones.

JONES, Elsie (Brown) [P] Evanston, IL b. 11 Je 1903, Evanston. Studied: Northwestern Univ.; AIC; F. Chapin; A. Philbrick; E.A. Rupprecht. Member: Chicago SA; Women A. Salon; ACL, Chicago. Exhibited: CGA, 1941; MMA, 1942; PAFA, 1942; NAD, 1942; AIC, 1938–44; Women's Cl., Evanston, 1936 (prize), 1939 (prize); North Shore A. Lg., 1937 (prize) [47]

JONES, Emrys Wynn, Mrs. See Seldon, Reeda.

JONES, Ernest E. [P,T] Brooklyn, NY/Rochester, NY b. 27 July 1885, Penn Yan, NY. Studied: F. von der Lancken; O. Beck [24]

JONES, Esther [P] Dallas, TX [24]

JONES, Eugene Arthur [E,P] NYC b. Brooklyn, NY. Studied: J.H. Boston; F.J. Boston. Member: SC; Brooklyn SA; Southern Pr.M.; Allied AA; SC. Exhibited: SC; Brooklyn SA; Southern Pr.M. Work: Newark Mus.; Ft. Worth Mus.; LOC; N.Y. Hist. Soc. [47]

JONES, Florence M. [P] Delavan, WI [15]

JONES, Francis C(oates) [P,T] NYC b. 25 Jy 1857, Baltimore, MD d. 27 My 1932. Studied: Ecole des Beaux-Arts, Paris, with Boulanger, Lefebvre. Member: ANA, 1885; NA, 1894; SAA, 1882; AWCS; Arch. Lg., 1888; Mural P.; NIAL; NAC; A. Aid S.; Century Assooc.; SI; Lotos Cl.; SC; AFA; trustee, MMA, 1917–30. Exhibited: NAD, 1885 (prize), 1913 (med); Pan-Am. Expo, Buffalo, 1901 (med); SAA, 1904 (prize); St. Louis Expo, 1904 (med); P.-P. Expo, San Fran., 1915 (med) [31]

JONES, Frances Devereux. See Hall.

JONES, Gertrude Fish. See Savage, Trudi.

JONES, Grace Church ("Jonzi") [P,Des,Dec,T] Denver, CO b. Westfalls, NY. Studied: Acad. Colarossi, Acad. de la Grande Chaumière, both in Paris; ASL. Member: Denver A. Exhibited: Kans. SA; Oakland A. Gal.; Denver A. Mus.; Paris Salon. Work: Denver A. Mus.; Morey Jr. H.S., Denver [47]

JONES, H.C. (Mrs.) [P] Baltimore, MD. Member: Baltimore WCC [27]

JONES, Harry Donald [Mur.P,P] San Fran., CA b. 13 Ag 1906, Vincennes, IN. Studied: Cumming Sch. A.; Child-Walker Sch. Des.; Mexico; Iowa Univ.; BMFA Sch.; Harvard. Exhibited: Carson Pirie Scott Co., Chicago (prize); Des Moines, 1930 (prizes), 1932 (prize); Iowa State Fair, 1932 (prize), 1933 (prize); All-Iowa Exh., Chicago, 1937 (prize); AIC, 1935, 1936; PAFA, 1936–38; Rockefeller Center, 1937; William Rockhill Nelson Gal., 1937; Kansas City AI. Work: Des Moines Women's Cl.; Iowa State T. Col.; Des Moines Pub. Lib.; Cedar Rapids Court Room (in collaboration); asst. on murals, Ames Col.; Eli Lilly & Co., Indianapolis. Positions: Iowa State Supv., Index Am. Des., 1937–39; Dir., Iowa Art Program, 1939–41 [47]

JONES, Haydon [E] Boston, MA. Work: Doll & Richards, Boston [24]

JONES, Henrietta Ord [P] St. Louis, MO. Member: SWA. Position: associated with St. Louis Sch. FA [10]

JONES, Henry Bozeman [P,Mur.P,Por.P, Gr,W,T,L,B] Phila., PA b. 11 Mr 1887, Phila. Studied: Chase; C. Beaux; Breckenridge; T. Anshutz; Univ. Pa.; PAFA. Exhibited: Detroit, Mich., 1939 (prize); Intl. House, 1929 (prize); Warwick Gal., Phila., 1931–33; NYPL, 1933; Phila. Pr. Cl., 1933–44; ACA Gal., 1939; Wharton Gal., 1945, 1946; Carlen Gal., 1944; Phila. A. All., 1945, 1946. Work: U.S. Steel Co., Gary, Ind.;

Phila. Pr. Cl.; Warwick Gal.; pub. sch., Wash., D.C.; Douglas Sch., Wilmington, Del.; Settlement houses, Phila./NYC/Chicago; murals, Ancient Mystic Order Rosae Crucis (AMORC) Temple, Phila.; mem., Douglas Hospital, Phila.; schools, Phila.; Lincoln Univ., Pa.; portraits, St. Thomas Church, Phila. Lectures: Negro Artists of Today [47]

JONES, Herschel V. [Patron] b. 1861 d. 24 My 1928, Minneapolis. Publisher and owner of the Minneapolis Journal, he assembled one of the most notable small collections in the country. He donated prints valued at more than $700,000 to the Minneapolis AI, of which he was a trustee for fourteen years.

JONES, H(ugh) Bolton [Ldscp.P,C] NYC b. 20 O 1848, Baltimore, MD d. 24 S 1927. Studied: France; Md. Inst.; H. Robbins. Member: ANA, 1881; NA, 1883; SAA, 1881; AWCS; NIAL; NAC; A. Fund S.; Century Assoc.; SC; N.Y. Soc. P. Exhibited: Paris Expo, 1889 (med), 1900 (med); Columbian Expo, Chicago, 1893 (med); SAA, 1902 (prizes); St. Louis Expo, 1904 (gold); P.-P. Expo, San Fran., 1915 (med). Work: MMA; CGA; PAFA; Brooklyn Inst. Mus. [25]

JONES, Hugh G. [P,Arch,C] Brooklyn, NY b. 1872, Randolph, WI. Specialty: watercolors [06]

JONES, Isabelle [P] Champaign, IL [19]

JONES, Jacquelyn Judith [S] West Palm Beach, FL/Marion, IN b. 5 Je 1913, Blaine, IN. Studied: Chicago Sch. Sculpture; John Herron AI; R. Davidson. Member: Ind. AA; Hoosier Salon. Exhibited: Intl. Soap Sculpture, N.Y., 1932 (prize), 1933 (prize); Ind. State Fair, 1933 (prize), 1934 (prize). Work: Haines Mem., Portland; bust, Wabash Valley Trust Bank, Wabash, Ind.; Hiland Country Cl., Indianapolis; Marion (Ind.) Col. [40]

JONES, James Pope [P,S,Car,T,L] Richmond, VA b. 23 F 1890, Crewe, VA. Studied: self-taught. Exhibited: Anderson Gal. A., Richmond, 1931 (prize); Richmond Acad. Sc.&FA, 1930 (prize), 1938 (prize); VMFA, 1938 (prize), 1943 (prize); WFNY, 1939; VMFA, 1938, 1939, 1945, 1946; Richmond Acad. Sc.&FA, 1930, 1938. Work: VMFA; Richmond Acad. Sc.&FA; mural, Labor Temple, Richmond [47]

JONES, Jessie Barrows [P,Des] Cleveland, OH/Daytona, FL b. 15 Mr 1865, Cleveland d. 12 S 1944. Studied: Twachtman; Chase; Hitchcock. Member: Cleveland AA; AFA; Dayton AL. Designer: bookplates [40]

JONES, John L. [I] NYC. Member: SI [47]

JONES, Joseph Cranston b. 1909 d. 11 Ag 1930, Augusta, GA. A silhouette artist, he was confined to a wheelchair from the time he was two years old. He was considered a genius and his pictures were well known among silhouette collectors.

JONES, Joseph John (Joe) [P,Por.P,Mur.P,Li,T] Morristown, NJ b. 7 Ap 1909, St. Louis, MO. Studied: self-taught. Member: John Reed Cl.; F., Guggenheim Fnd., 1937. Exhibited: PAFA (med); NAD, 1946 (prize); WMAA, 1935, 1946; CI, 1937, 1947; CGA; GGE, 1939; WFNY, 1939, 1939; Colorado Springs FA Center; Kansas City AI; CAM; Detroit Inst. A.; Dayton AI; St. Louis AG, 1933 (prize); City Art Mus., St. Louis, 1932 (prize); 48 Sts. Comp., 1939 (winner). Awards: Baldwin prize, 1931; Spaeth prize, 1932. Work: PAFA; WMAA; MMA; WMA; CMA; CAM; Walker A. Center; Encyclopaedia Britannica Coll.; LOC; Nebr. Univ.; U.S. Army; Standard Oil Co.; Pa. State Col.; murals, USPOs, Seneca (Kans.), Magnolia (Ark.), Anthony (Kans.), Charleston (Mo.), others POs, KMOX Radio Station (St. Louis). WPA artist. [47]

JONES, L. Lova [P,I] Brandon, SD b. 27 S 1880, Sioux Falls, SD. Studied: ASL; AIC; Pyle; Duveneck; Melchers; Parker; Vanderpoel [25]

JONES, Laura R(ose) [P] Dallas, TX b. Memphis, TN. Studied: ASL; Aunspaugh Art Sch., Dallas; J.I. Knott; F. Reaugh. Member: Dallas ASL [25]

JONES, Leon Foster [P,E,Dr,T] Port Jefferson, NY b. 18 O 1871, Manchester, NH d. 4 Ja 1940. Studied: Cowles Art Sch., Boston, with Major, De Camp. Member: SC; A. Fund. S. Exhibited: P.-P. Expo, San Fran., 1915 (med). Work: BMFA; Port Jefferson Free Lib. Position: T., Stony Brook Prep. Sch. [40]

JONES, Lois Mailou [P,I,Des,T] Wash., D.C. b. 3 N 1906, Boston. Studied: Designers Art Sch.; Boston Normal A. Sch.; BMFA Sch.; T. Col.; Columbia; Howard Univ.; Paris; P. Hale; J. Adler; J. Berges. Member: AWCS; Wash. A. Gld.; Vineyard Haven (Mass.) Art Gld.; Am. Ar. Cong.; S.Indp.A., France. Exhibited: Harmon Exh.; 1931; BMFA Sch., 1926 (S); Nat. Mus., Wash., D.C., 1940 (prize); CGA, 1941 (prize); Atlanta Univ., 1942 (prize); Paris Salon, 1938, 1939; Galerie de Paris, 1938; Galerie Charpentier, 1938; PAFA, 1934–36, 1938, 1939; CAA Traveling Exh., 1934; Harmon Fnd., 1930, 1931; Tex. Centenn., 1936; BMA, 1939, 1940, 1944; Inst. Mod. A., Boston, 1943; Am.-British A. Center, 1944; NAD, 1942, 1944; AWCS, 1942, 1944, 1946; Albany Inst. Hist.&A., 1945; Vose Gal., 1939 (one-man); Howard Univ., 1937 (one-man); Barnett Aden Gal., 1946; PMG, 1941, 1942, 1944, 1945; Wash. A. Gld, 1939–43, 1945; Whyte Gal., 1941–44; Soc. Wash. A., 1938–43, 1945, 1946; Wash. WCC, 1931–36, 1939–46. Work: W.Va. State Col; Howard Univ.; Atlanta Univ.; NYPL (135th Street Branch); PMG; H.S. Practical A., Boston; Palais National, Haiti; Rosewald Fnd.; Barnett Aden Gal. Illustrator: "The Picture Poetry Book," by Gertrude McBrown, "Negro Folk Tales," by Helen Whiting. Position: T., Howard Univ., 1930–46 [47]

JONES, Louis E(dward) [P] Woodstock, NY b. 7 Mr 1878, Rushville, PA. Studied: PAFA; B. Harrison; J.F. Carlson. Member: SC; AFA [33]

JONES, Margaret Atwater (Mrs. Gilbert N.) [P,C,Des,T,Dr] Andover, MA b. 20 N 1864, Westfield, MA d. ca. 1955. Studied: Smith Col.; Académie Julian, Paris; Bouguereau, Fleury; A. Sacker; D. Tryon; A. Klumpke; A.W. Dow; L.H. Martin. Member: Boston SAC; Wellesley AA. Exhibited: Whistler House, Lowell, Mass.; Farnsworth Mus.; Boston Soc. A.&Crafts; watercolors, extensively in U.S. Lectures: Early American Crafts [47]

JONES, Marguerite Casanges [P] Indianapolis, IN [17]

JONES, Marguerite M(ignon) [P,I] Chicago, IL b. 12 D 1898, Chicago. Studied: Chicago AFA. Member: GFLA. Illustrator: "The Brownie Twins in Pancake Town," by E.B. Neffies [29]

JONES, Martha M(iles) [P,C,T,Min.P] La Jolla, CA b. 28 Ap 1870, Denison, IA d. 8 Ag 1945. Studied: Vanderpoel; Paris. Member: San Diego AG; La Jolla AC; Calif. S. Min. P. [40]

JONES, Mary Bacon (Mrs.) [P,B,C,T] Provincetown, MA b. 21 My 1868, Hampstead, NH d. 28 Ap 1924, Nice, France. Studied: Marie Blanchard, in Nice; Mass. Normal Art Sch.; C.H. Woodbury. Member: NYSC; Copley S., 1899. Exhibited: Provincetown AA, 1915, 1916 [19]

JONES, Mary Elizabeth [P] Scranton, PA/Nantucket, MA b. 14 S 1905, Scranton, PA. Studied: PAFA; PMSchIA; E. Horter. Member: Phila. Alliance; Phila. Pr. Cl.; Graphic Sketch Cl. Work: Drew Univ.; Knox Sch., Cooperstown, N.Y. Position: T., PAFA [40]

JONES, Mary Klauder (Mrs. Thomas B.) [S] Bala, PA. Studied: PAFA [24]

JONES, Nancy (Mrs. George P. Love) [P,T] West Barrington, RI b. 7 My 1887, Providence. Studied: RISD; Fontainebleau Sch. FA; C. Hawthorne; H. Leith-Ross. Studied: BMA; PAFA; Providence AC; RISD; BMFA; Boston AC; Grace Horne Gal. Work: RISD. Position: T., RISD, 1912–46 [47]

JONES, Nell Choate [P] Brooklyn, NY b. Hawkinsville, GA. Studied: Adelphi Acad.; F.J. Boston; J. Carlson; R. Johonnot; Gorguet. Member: Brooklyn Soc. PS; NAWA; Brooklyn SA; SSAL; Boston AC; Lg. Am. Pen Women. Exhibited: WFNY, 1939; NAD; All.A.Am.; Women's Engineering Cl.; Adelphi Col.; Columbia; Argent Gal.; BM; Brooklyn Col.; PIASch. Work: High Mus. A.; Ft. Worth Mus. [47]

JONES, P.T., Mrs. See Donelson, Mary Hooper.

JONES, Paul [Por.P] Cincinnati, OH b. 9 Je 1860, Harrodsburg, KY. Studied: Académie Julian, Paris; Flameng, Courtois, Laurens, in Paris. Member: Cincinnati AC; Duveneck S.; Cincinnati MacD. Cl. Author: "Marco Polo II." Librettist: grand opera, "Paoletta" [40]

JONES, Paul Rowland [Des,Dr,Por.P,T] Indianapolis, IN b. 28 Je 1909, Columbus, OH. Studied: W. Forsyth; E. Taflinger; DuMond; Bridgman. Member: Ind. Ar. Cl. Exhibited: Ind. State Fair, 1927–1937 (prizes). Work: Pub. Lib., West Indianapolis Branch; Pub. schools/Lib., Indianapolis [40]

JONES, Pauline Sawtelle (Mrs.) [P] Old Greenwich, CT b. 1853, Old Town, ME d. 9 N 1943. Studied: Boston; Phila. Work: portraits, state governors, Capitol, Maine [24]

JONES, Prescott M.M. [P,E,T,Dr] Boston, MA b. 27 F 1904, Haverhill, MA. Studied: W.B. Hazelton; Tufts Col.; Vesper George Sch. A. Member: North Shore AA; Gloucester SA; Rockport AA; Merrimack Valley AA; Springfield AL; Boston S.Indp.A.; F., Tiffany Fnd., 1934. Exhibited: Soldiers & Sailors Exh., Boston, 1942 (prize); PAFA, 1936–38; AIC, 1935, 1937, 1938, 1940, 1941; WFNY, 1939; Phila. Pr. Cl., 1935, 1936; Phila. A. All., 1935, 1937; Calif. WC Soc., 1941; AGAA, 1938–41; Grace Horne Gal., 1930–40; Milch Gal., 1941. Work: Haverhill (Mass.) H.S.; BMFA; U.S. Dept. Interior, Wash., D.C.; City of Boston Coll.; Fitchburg A. Center; IBM Coll.; City of Haverhill Coll. Position: Dir., Studio Workshop [47]

JONES, Rachel Rand [P] New Haven, CT b. 17 Ap 1905, New Haven.

Studied: Yale, with Taylor, Savage. Exhibited: New Haven PCC, 1926 (prize) [33]

JONES, Rebecca [P] Paris, France b. Eaton, GA. Studied: Acad. Delecluse, Paris [04]

JONES, Robert Edmond [Des] NYC b. 12 D 1887, Milton, NH d. 1954. Studied: Harvard. Member: Am. Acad. A.&L. Exhibited: Yale, 1925 (prize); AIA, Williamsburg, Va., 1936 (med). Work: drawings, AIC, Victoria and Albert Mus., London. Author: "Drawings for the Theatre," pub. Theatre Arts Publishing Co., 1924. Co-author: with Kenneth Macgowan, "Continental Stagecraft," pub. Harcourt Brace, 1924. Designer: stage sets, Othello (1926), Green Pastures (1930), Night Over Taos (1932), other plays; color films, La Cucaracha, Becky Sharp, other films. His designs for The Man Who Married a Dumb Wife, in 1915, began a new trend in American set design—emphasizing integration of a set with all aspects of its play. He was connected with all of O'Neill's early plays, some of which he also directed. [40]

JONES, Rose F. [P] Chicago, IL [10]

JONES, Ruth Gertrude [P,T] Schenectady, NY b. 29 My 1906. Studied: H. Keller; G.P. Ennis; Cleveland Sch. A. Member: NAWPS. Work: Lib., Eastport, Maine. Position: T., McKinley Sch., Schenectady [40]

JONES, Seth C. [T,P,I] Rochester, NY/Linden, NY b. 15 Jy 1853, Rochester d. ca. 1932. Studied: W.H. Holmes; T. Moran. Member: Rochester AC; Picture Painters Cl.; Municipal Art Commission; Chicago AG [29]

JONES, Sidney [P] NYC/Pittsfield, MA b. 22 Ja 1875, Montreal, Quebec. Studied: C.H. Allis; M. Roebuck; ASL. Member: SC; NAC [40]

JONES, Sidney, Mrs. See Scribner, Elizabeth.

JONES, Susan Alice [P,Des,I,C] Phila., PA b. 12 D 1897, Phila. Studied: PAFA; Moore Inst.; Phila. Sch. Des. for Women. Exhibited: PAFA, 1935 (gold); Phila. AC. Position: A. Dept., Phila. Signal Depot, 1941– [47]

JONES, Thomas Benedict [P,S,Li] Baltimore, MD b. 6 D 1893, Phila. Studied: PAFA. Exhibited: CGA; PAFA; NAD; abroad [47]

JONES, Thomas Hudson [S] Mechanicsville, PA b. 24 Jy 1892, Buffalo, NY. Member: ANA, 1932; Century Assn. Award: Prix de Rome, 1919–22. Work: Hall of Fame, NYU; medal, Columbia; mem. reliefs, Holyoke, Mass.; St. Matthew's Church, Wash., D.C.; Mechanics Inst., NYC; Am. Acad., Rome; Pub. Lib., Houston, Tex.; war mem., Port Chester, N.Y.; U.S. Treasury Dept., Wash., D.C.; sculpture, Tomb of the Unknown Soldier, Arlington, Va.; portrait figure, Rochester (N.Y.) park; relief, Birmingham, Ala; portrait, Trinity Col., Hartford, Conn.; Yellow Fever Medal, U.S. Treasury; mem., Burlington, Wis. [47]

JONES, Vernon H. [P] Lebanon, OH [15]

JONES, Villa [P] Brooklyn, NY [08]

JONES, W. Barham (Mrs.) [P] Norfolk, VA. Member: Norfolk SA [25]

JONES, Wendell Cooley [P] Woodstock, NY b. 25 O 1899, Galena, KS. Studied: ASL. Exhibited: GGE, 1939; Walker Gal.; CGA. Work: murals, USPOs, Granville, Ohio, Johnson City, Tenn. WPA artist. [40]

JONES, Wilfred J. [P,I] NYC/Hackensack, NJ b. 20 Ja 1888, Phila. [19]

JONGERS, Alphonse [Por.P] Montreal, Quebec (NYC, 1900–24) b. 17 N 1872, France (came to U.S. in 1897) d. 2 O 1945. Studied: Ecole des Beaux-arts, with Delaunay, G. Moreau; Spain, 2 yrs. Member: SAA, 1905; ANA 1906; Lotos C. Exhibited: St. Louis Expo, 1904; Paris Salon, 1909 (med). Work: NGA; MMA [33]

JONSON, J(on) M(agnus) [S] Frankfort, IN b. 18 D 1893, Upham, ND d. 1947. Studied: A. Polasek; Lorado Taft; AIC; BAID. Member: Hoosier Salon; Ind. AA; AAPL. Exhibited: Hoosier Salon, 1931 (prize), 1932 (prize), 1935 (prize), 1940 (prize); Ind. AA, 1937 (prize), 1942 (prize). Work: Intl. House, Chicago; pub. park fountain, Frankfort, Ind.; State Col., Fargo, N.Dak. Position: T., Cranbrook Acad. A. [47]

JONSON, Raymond [P,Edu] Santa Fe, NM (1976) b. 18 Jy 1891, Chariton, IA. Studied: Portland (Ore.) A. Sch., 1909–10; Chicago Acad. FA, with B.J.O. Nordfeldt; AIC. Member: Am. Fnd. Transcendental P. Exhibited: Swedish C. (prize), Chicago, 1921; N.Mex. State Fair, 1940 (prize), 1941 (prize), 1945 (prize); AIC, 1913–15, 1917–23; Minneapolis Inst. A.; CAM; Milwaukee AI; CM, Critics Choice, 1945; Roerich Mus.; Mus. N.Mex., several times (one-man). Work: Mus. N.Mex.; Univ. N.Mex.; Gilcrease Fnd., Tulsa; Vanderpoel Coll.; Eastern N.Mex. Col.; Miss. AA; Houston MFA. Position: T., Univ. N.Mex., 1934–54 [47]

JOOR, Harriet [P] Morgan Park, IL [10]

JOPLING, Frederic Waistel [P,S,I,E] Buffalo, NY b. 23 Ap, 1860, London, England. Studied: Shirlaw; Sartain; Penfold; Hoboken AC; ASL; Chase. Exhibited: etching, Wembley, (med). Work: Nat. Gal., Ottowa, Canada [25]

JOR, Chu H. [P] NYC b. 2 O 1907, Canton, China. Studied: M. Jacobs; G. Bridgman; D. Romanovsky; China. Member: Allied AA; Chinese AC [38]

JORDAN, Anna E. [C] Boston, MA/Chesham, NH b. 2 Ja 1883, Cochranville, PA. Member: Boston SAC; Weavers Gld., Boston; N.H. Home Industries S. Specialty: weaving [40]

JORDAN, Annie P. [Min.P] Woodbury, NJ [10]

JORDAN, David W(ilson) [Ldscp.P] NYC b. 2 Je 1859, Harrisburg, PA. Studied: PAFA, with Schüssele, Eakins. Member: Phila. Sketch C. [33]

JORDAN, Elizabeth R. See Callaway.

JORDAN, F(redd) E(lmer) [S,C] Detroit, MI b. 25 N 1884, Bedford, IN. Exhibited: Hoosier Salon, Chicago, 1928 [33]

JORDAN, Helen Adelia [Dr,I,P,T] Los Angeles, CA b. 4 Mr 1903, Haywards, CA. Studied: J.F. Smith; J.E. McBurney; T. Lukits. Member: Calif. AC. Work: San Diego Expo; Southwest Mus., Los Angeles [40]

JORDAN, J(ames) B(lount) [P,I] Narberth, PA b. 20 Ap 1904, Nashville, TN. Studied: C. Cagle. Member: SSAL; Studio, C., Nashville. Exhibited: Tenn. State Fair, Nashville, 1930 (prize), 1931 (prize). Illustrator: "Sally Goes to Court" [40]

JORDAN, L.B., Mrs. See Schwinn, Barbara.

JORDAN, Lena E. (Mrs.) [P] Springfield, MA d. ca. 1950. Member: Am. WCS; Springfield A. Lg.; AAPL; AWCS; Springfield AG. Exhibited: Stockbridge AA, 1934 (prize), 1936 (prize) [47]

JORDAN, Mildred C. [Min.P] New Haven, CT b. Portland, ME. Studied: Yale. Member: New Haven PCC [21]

JORGENSEN, Christian [Ldscp.P] Yosemite, CA b. 1860, Oslo, Norway d. 1935, Piedmont, CA. Founder, with G. Sterling, of the artist colony at Carmel, Calif. Work: Yosemite Nat. Park [17]

JORGENSEN, Jorgen [P,S,E] Maplewood, NJ b. 6 D 1871, Denmark. Member: AAPL; S.Indp.A.; Newark Outdoor Sketch C. Work: etchings, Newark Mus. [47]

JORGULESCO, Jonel [I] NYC. Member: SI [47]

JORNS, Byron Charles [P,I] Madison, WI b. 28 S 1898, Portage, WI d. 7 Jy 1958, Mt. Horeb, WI. Studied: Univ. Wis.; AIC; Chapin; Rupprecht; Wilkowski. Member: Madison AA. Exhibited: Madison AA, 1941 (prize), 1942 (prize), 1945 (prize), 1946 (prize); AIC, 1941 (prize), 1942 (prize), 1943 (prize); State T. Col., Indiana, Pa.; MMA, 1941. Work: Madison AA; Madison Pub. Lib. [47]

JOSEPH, Joan A(delyn) [P,S,C,W] Chicago, IL/Green Lake, WI b. 16 Je 1895, Chicago. Studied: G. Mulligan, L. Crunelle; A. Polasek. Member: Chicago SA; S.Indp.A. [27]

JOSEPHI, I(saac) A. [Ldscp.P,Min.P] NYC b. NYC. Studied: ASL; Bonnât, Paris. Member: AS Min.P.; AWCS; Royal Soc. Min. P., London; Lotos C. Exhibited: Paris Expo, 1900; Charleston Expo, 1902 (prize) [40]

JOSEPHS, Lemuel B.C. [P] NYC [06]

JOSEPHS, Samuel [P] NYC. Member: GFLA [27]

JOSEPHS, Walter W. [P] Phila., PA b. 11 F 1887, Phila. Studied: PAFA; D. Garber. Member: Phila. AC [31]

JOSIMOVICH, George [P,Des,Li,C] Chicago, IL b. 2 My 1894, Mitroviga, Yugoslavia. Studied: AIC; G. Bellows. Member: Chicago SA. Exhibited: CI, 1929; TMA, 1930; AIC, 1934, 1936, 1939, 1941, 1942, 1944; Univ. Chicago, 1943 (one-man). Work: Mattoon, Ill., H.S. [47]

JOSLYN, Adele [P,T] Buffalo, NY [21]

JOSLYN, Florence Brown [P,I] Oklahoma City, OK b. MI. Studied: AIC; ASL; Chicago Acad. FA; J. Carlson; B. Harrison. Member: Okla. AA; SSAL. Exhibited: Okla. AA; Muskogee State Fair, 1939; Tri-State Fair, Amarillo, Tex.; SSAL; Midwest AA; Spokane, Wash.; Edmond Normal Col., Okla.; Chicago Acad. FA; Delgado Mus. A.; Intl. Bookplate Exh., Los Angeles [47]

JOSSET, Raoul (Jean) [S] NYC b. 9 D 1900, Tours, France d. 1957. Studied: Bourdelle, Injalbert. Member: NSS. Exhibited: Paris Salon, 1922 (med), 1923 (med). Work: memorials, France, Vincennes, Ind.; Marquette Park,

Chicago; USPO, Chicago; Century of Progress, Chicago; Centenn. Expo, Dallas, 1936; Palmolive, Chicago; Carbide-Carbon, Chicago; Elm St. Bldgs., Chicago [47]

JOUET, Belinda Hearn [Min.P] d. 7 O 1935, Roselle, NJ

JOULLIN, Amédée [P] San Fran., CA b. 13 Je 1862, San Fran. d. 3 F 1917. Studied: San Fran. A. Sch.; Ecole des Beaux-Arts; Académie Julian, Paris, with Bouguereau, Robert-Fleury. Member: Bohemian C.; Paris AAA; French Acad. 1901; Officer of Pub. Instruction, France, 1905. Exhibited: NAD, 1901; St. Louis Expo, 1904 (prize). Specialty: Indians [15]

JOULLIN, Lucille (Mrs. Amédée) [P,Ldscp.P] San Fran., CA b. 6 Ag 1876, Geneseo, IL d. 5 Je 1924. Studied: Vanderpoel; Freer; R. Clarkson, AIC; A. Mathews, San Fran. AA. Work: Bohemian C., San Fran. Specialties: Indians; landscapes. Position: T., Mills Col., 1919 [24]

JOURNEAY, Helen [S] Odenton, MD b. 1 D 1893, Piermont, NY. Studied: M. Young; J.M. Miller, Md. Inst. European schol., 1925. Member: NAWPS; Municipal A. Soc., Baltimore. Exhibited: Baltimore Mus. A., 1935 (prize); Municipal A. Soc., 1936 (prize). Work: Brookgreen Gardens, S.C.; bust, Johns Hopkins; medal, Municipal A. Soc., Baltimore. Position: T., Md. Inst. [40]

JOUVENAL, Jacques [Por.S] Wash., D.C. b. 18 Mr 1829, Pinache, Germany (came to NYC in 1853) d. 8 Mr 1905. Studied: Stuttgart. Work: bust, Aaron Burr, Capitol, Wash., D.C.; finishing the capitals of the columns of the Capitol, Wash., D.C., 1855–61 [*]

JOY, Robert [P] Houston, TX. Exhibited: SSAL, 1938; Ar. Southeast Tex. Ann., Houston MFA, 1938, 1939 [40]

JOY, Sue [P] Nashville, TN b. 23 Ja 1903. Studied: Sophie Newcomb Coll.; AIC; Paris, with F. Leger, J. Marchand. Member: SSAL; Studio C., Nashville; Tenn. SA. Exhibited: SSAL, 1930 (prize) [40]

JOYNER, Arista Arnold [P,L,W] Arlington TX b. 1911, Kansas City, MO. Studied: Gulf Park (Miss.) Col.; Univ. S.Dak.; J.D. Patrick; W. Rosenbauer; M.L. Rounds; R. Braught, Kansas City AI [40]

JOYNER, Howard Warren [P,L,Des,Dr,T] Arlington, TX b. 12 Jy 1900, Chicago, IL. Studied: Kansas City AI; Univ. Mo.; Univ. Calif.; Univ. Iowa; Ecole des Beaux-Arts, Paris; R. Davey; L. Henkora; K. Hudson; J. Despujols; H. Hofmann; R. Braught; Harvard, 1933. Member: Ft. Worth AA; Assn. A. Instr. Exhibited: Rockefeller Center, NY, 1936; Detroit Inst. A., 1931; Kansas City AI, 1934; Joslyn Mem., 1936; Tex. General Exh., 1941, 1942; Ft. Worth, Tex., 1941–43. Position: T., North Tex. Agriculture Col. [47]

JUDD, Neale M. [S] Wash., D.C.. Member: Wash. WCC [27]

JUDELL, Anna [P] Chicago, IL. Member: Chicago NJSA [25]

JUDSON, Alice [P] NYC/Beacon, NY b. Beacon, NY d. 4 Ap 1948. Studied: ASL, with J.H. Twachtman. Member: All.A.Am.; North Shore AA; Dutchess County AA; Putnam County AA; Hudson Highlands AA; Pittsburgh AA; Gloucester SA; Fifteen Gal. Exhibited: CI; PAFA; Phila. WCC; All.A.Am., 1936–45; North Shore AA, 1921–45; Springville AA, 1946; Pittsburgh AA, 1932 (prize); Hudson Highlands AA, 1935 (prize). Work: Hudson Highlands AA; Wesleyan Col., Macon, Ga.; Mattewan State Hospital, Beacon; Pittsburgh Friends of A.; Pub. Sch. coll., Pittsburgh [47]

JUDSON, Almira [P] San Fran., CA/Los Gatos, CA b. Milwaukee, WI. Studied: Women's Acad., Munich; Colarossi, Garrido, in Paris; Henri. Member: San Fran. S. Women A. [33]

JUDSON, C. Chapel [P] Berkeley, CA [17]

JUDSON, Jane Berry [P] Castile, NYC. Member: Rochester AC [25]

JUDSON, Minnie Lee (Mrs.) [Ldscp.P] Stratford, CT b. 20 O 1865, Milford, CT d. 1938. Studied: Yale. Member: CAFA; New Haven PCC; AFA [38]

JUDSON, Oliver B. [P] Phila., PA. Studied: PAFA [25]

JUDSON, Sylvia Shaw [S,C] Lake Forest, IL b. 30 Je 1897, Chicago, IL. Studied: AIC; Grande Chaumière, with Bourdelle; Polasek. Member: Chicago AC; NSS. Exhibited: World's Fair, Chicago; GGE, 1939; WFNY, 1939; Chicago AC; AIC, 1926, 1929 (prize) 1935; WMAA; MOMA; MMA; PMA; Arden Gal., 1940. Work: Kosciusko Park, Milwaukee; Brookgreen Gardens, S.C.; Dayton AI; Chicago Hist. S. Lecture: "Sculpture Suitable for Gardens" [47]

JUDSON, William L(ees) [P,T] Los Angeles, CA b. 1 Ap, 1842, Manchester, England (came to U.S. in 1852) d. N 1928. Studied: his father, John R.; J.B. Irving, in NYC; Boulanger, Lefebvre, in Paris. Member: Calif. AC; Laguna Beach AA; Artland C. Exhibited: Colonial and Indian Exh., London 1886 (med); Southwest Mus., 1921 (prize). Author: "Kuhleborn," "Building of a Picture." Position: T., Univ. Southern Calif., 1896–1920 [27]

JUERGENS, Alfred [P] Oak Park, IL b. 5 Ag 1866 d. ca. 1934. Studied: Chicago AD; Munich Royal Acad., with Gysis, Diez. Member: Chicago SA; Munich AA; AA of Germany; S. Intl. des Beaux-Arts. Exhibited: Madrid (med); Munich (med); AIC, 1914 (prize), 1923 (prize); Pan-P. Expo, San Fran., 1915 (med). Work: St. Paul's Church, Chicago; Cliff Dwellers C., Chicago; Municipal Gal. AI, Chicago, 1913; Union Lg. C., Chicago; Clark Gal., Grand Rapids, Mich.; Women's City C., Chicago; Oak Park C. [33]

JUERGENS, Charles [P] Chicago, IL b. 29 Jy 1875, Cincinnati, OH. Studied: self-taught. Member: SWA; Pen and Pencil C., Columbus [15]

JULES, Mervin [P,Gr,I,L,T] Northampton, MA b. 21 Mr 1912, Baltimore. Studied: Baltimore City Col.; Md. Inst.; ASL, with Benton. Member: Am Am. Group; A.Lg. Am.; Audubon A.; Am. Ar. Cong.; United Am. Ar. Exhibited: WFNY, 1939; GGE, 1939; WMAA, 1938, 1940–46; AIC, 1938–41; CI, 1941, 1944, 1945; PAFA, 1939, 1941; VMFA, 1946; LOC, 1940, 1945, 1946; BMA, 1937–41, 1943, 1944, 1946; BMA, 1936 (prize), 1939 (prize), 1940 (prize), 1941 (prize); MOMA, 1941 (prize); LOC, 1945 (prize); BM. Work: MOMA; MMA; BMA; BM; AIC; PMA; BMFA; LOC; Portland (Oreg.) Mus. A.; PMG; Walker A. Center; Ill. State Mus.; Encyclopaedia Britannica Coll. Positions: T., MOMA (1943–46), Smith Col. (1946–47) [47]

JULEY, Peter A. [Photogr] b. 1862, Germany d. 13 Ja 1937, NYC. Started in U.S., 1884, as a portrait photographer. He reproduced paintings in their original colors. Positions: Staff photographer, Harper's, 1902; founder of the firm of Peter A. Juley & Son, which photographed more than 100,000 works of art.

JULIAN, Marvin [P,T] Watertown, MA b. 23 Jy 1894, Armenia. Studied: ASL; Académie Julian. Member: Boston AC. Exhibited: Boston AC; Ann. Exhib.; Jordan Marsh Co., Boston; Downtown Gal., NYC. Work: ports., Naval Acad., Annapolis. Position: T., South End House, Boston [40]

JULIAN, Paul Hull [P,B,L,T] Santa Barbara, CA b. 25 Je 1914, IL. Studied: L.T. Murphy, M. Sheets; Choinard AI; B. Brown; E. Julian; C. Paine. Exhibited: Santa Cruz AL, 1936; Calif. State Fair, 1936; Oakland A. Gal., 1936 [40]

JULIUS, Oscar H. [P] NYC/Eastport, ME b. 26 Jy 1886, Boston, MA. Studied: BMFA Sch.; NAD; PAFA. Member: AWCS; SC; Allied AA; A. Fund S.; A. Fellowship; Brooklyn PS. Exhibited: AWCS 1934 (prize). Specialty: des./builder, stained glass windows [40]

JULIUS, Victor [P] Red Bank, NJ/Manasquan, NJ b. 26 Jy 1882, Boston, MA. Studied: NAD; ASL. Member: NYWCC; SC; A. Fellowship; Allied AA [33]

JUNCO, Pio [I] NYC. Member: SI [47]

JUNG, A. Jac [P,E] NYC [15]

JUNG, C(harles) Jac(ob) [P,E] West Hoboken, NJ b. 21 D 1880, Rodenbach, Bavaria. Studied: E. Ward; C.Y. Turner; NAD. Member: Chicago SE; Brooklyn SE [19]

JUNG, Max [P] Chicago, IL [10]

JUNGE, Carl Stephen [Des,P,C,I] Oak Park, IL b. 5 Je 1880, Stockton, CA. Studied: Hopkins AI; Partington Sch. Illus., San Fran.; Sch. of Art, London; Académie Julian, Paris. Member: Chicago W. Gld.; Austin, Oak Park & River Forest A. Lg.; Hoosier Salon. Exhibited: Am. Bookplate Soc., 1916 (prize), 1917 (prize), 1921 (prize), 1922 (prize), 1925 (prize); The Bookplate Assn., 1926 (prize), 1931 (prize), 1936 (prize); AIC; CI; NAC; Toledo Mus. A.; Los A. Mus. A., etc. Work: LOC; British Mus.; Columbia; MMA; BMFA; Toledo Mus. A.; Vanderpoel Coll. Illustrator: "Bookplates," "Ex Libris" [47]

JUNGERICH, Helene [P] NYC. Member: Societé Anonyme [24]

JUNGQUIST, Neva Gertrude [I,Des] d. 17 Mr 1930, Kingston, NY

JUNGWIRTH, Irene Gayas [P,T] East Lansing, MI b. 23 D 1913, McKee's Rocks, PA. Studied: Detroit A. & Crafts Sch.; Marygrove Col.; Wayne Univ.; E. Yaeger; J. De Martelly. Exhibited: VMFA, 1946; Mint Mus. A., 1946; Detroit Inst. A., 1944–46; Kalamazoo Inst. A., 1941; Scarab C., Detroit, 1935, 1937–39; Mich. State Col., 1944; Marygrove Col., Mich. [47]

JUNGWIRTH, Leonard D. [S,T,C,G] East Lansing, MI b. 18 O 1903,

Detroit, MI d. Ag 1964. Studied Univ. Detroit; Wayne Univ.; Germany. Exhibited: Detroit Inst. A., 1935 (prize), 1940, 1941, 1943, 1945. Work: Detroit Inst. A.; Kalamazoo Inst. A.; Richard Mem., Detroit; Grosse Pointe, MI; reliefs, Mich. State Col.; MacGregor Lib., Highland Park. Lectures: Sculpture Techniques Positions: T., Wayne Univ., 1936-40, Mich. State Col., 1940-47 [47]

JUNKER, Leo Helmholz [P,E] Pelham, NY b. 31 O 1882, Chicago, IL. Studied: AIC; PAFA. Exhibited: WFNY, 1939. Work: Fitkin Mem., Yale Medical Group; Hartford (Conn.) Retreat; Caleb Heathcote Trust and Co., Scarsdale, N.Y.; Tompkin Mem., New Haven, Conn. Work: State Armory, New Rochelle, N.Y. [40]

JUNKIN, Marion Montague (Mrs.) [P,S,E,T] Nashville, TN b. 23 AG 1905, Chunju, Korea d. 1977. Studied: Wash. Lee Univ.; ASL; R. Johnson; Luks; G. Bridgman; E. McCarten. Exhibited: AIC, 1939; PAFA, 1933, 1938; CGA, 1935, 1937; VMFA, 1942, 1944, 1946 (prize); CI; WMAA; WFNY, 1939; IBM (prize); Pepsi-Cola, 1946; Butler AI, 1946 (prize); Tenn. Ann. Exh. Work: VMFA; IBM. Positions: T., Vanderbilt Univ. (1941-46), William & Mary Col.

JURECKA, Cyril [S,T] Claremont, CA b. 3 Jy 1884, Prikazy, Moravia, Czechoslovakia d. ca. 1960. Studied: Acad. FA, Prague. Member: AFA; Calif. AC. Lived in Chicago, 1915. Position: T., Pomona Col., Claremont [47]

JURGENSEN, Louis O. [P,T] St. Paul, MN b. 1863, Schleswig, Germany. Studied: Académie Julian, Paris; Lefebvre, Boulanger, Benjamin-Constant, in Paris. Member: St. Louis AG; St. Paul AG [08]

JUSKO, Jeno. See Juszko.

JUSTICE, Martin [I,P] Hollywood, CA. Member: SI 1911 [33]

JUSTUS, Roy B. [I,Car] Minneapolis, MN b. 16 My 1901, Avon, SD. Studied: Morningside Col., Sioux City, Iowa. Member: Nat. Press C., Wash., D.C. Positions: Ed. Car., Sioux City Journal & Tribune (1927-43), Star-Journal, Minneapolis (1944-) [47]

JUSZKO, Jeno [S] NYC b. 26 N 1880, Hungary d. 5 Ja 1954. Member: NSS; All.A.Am.; AAPL; SC. Exhibited: All.A.Am., 1935 (prize), 1940 (prize). Work: mon., Santa Fe, N.Mex.; statue, Newark Mus.; busts, Grant's Tomb (NYC), Brooklyn Botanical Gardens [47]

Edward Cucuel: *A Nouveau (a first-year student at Gérôme's Atelier).* From W.C. Morrow's *Bohemian Paris of Today*, 1899

K

KAAN, Emma [P] Buffalo, NY [13]

KABOTIE, Fred [P,Des,I,T,W] Oraibi, AZ b. 20 F 1900, Shungopavy, AZ. Studied: Santa Fe Indian Sch., 1913–24; O. Nordmark. Member: F., Guggenheim Fnd., 1945–46. Exhibited: GGE, 1939; MOMA, 1941; Philbrook A. Center, 1946; Inter-Tribal Ceremonials, Gallup, N.Mex., 1946. Work: Mus. N.Mex.; Mus. Am. Indian, NYC; murals, Indian Tower, Grand Canyon, Ariz.; Indian A.&Crafts Bd. Illustrator: "Tatay's Tales," 1925, "Five Little Katchinas," 1929, "Swift Eagle of the Rio Grande," 1929. Influential Hopi painter of the 1920s, 1930s; painted little after 1959. Position: T., Hopi H.S. Oraibi, 1937– [47]

KACHINSKY, Alexander [Pr.M,P,Des,T,B,Li,E] White Plains, NY b. 17 O 1888, Kharkov, Russia d. 22 Ja 1958. Studied: FA Acad., Leningrad; Acad. Benson, Paris; M. Denis. Member: Westchester A.&Crafts Gld. Exhibited: CGA, 1939, 1941; AIC, 1939; SAE, 1937; Phila. SE, 1937; Okla. A. Center, 1931; Intl. Exh. Mod. A., Geneva, Switzerland; New Hudson River Group, 1938; Yonkers AA, 1945; Albany Pr. Cl., 1945; NAC, 1936, 1939. Work: prints, LOC; stage sets, Diaghilev's Russian ballet, Spain/France; des., interior of the Rolls Royce Autombile Agency in New York, and the office of the Art All. Am. [47]

KADISH, Reuben [Mur.P,Li] San Fran., CA b. 29 Ja 1913, Chicago, IL. Studied: Stickney Sch. A., Pasadena, Calif. Member: Am. A. Cong. Work: fresco murals (in collaboration with P. Goldstein), Mus., Univ. Michoacán, Mexico; Lib., Los Angeles Sanitorium, Duarte, Calif.; fresco mural, San Fran. State T. Col. [40]

KAELIN, Charles S(alis) [P] Rockport, MA b. 19 D 1858, Cincinnati d. 28 Mr 1929. Studied: Cincinnati Art Sch.; ASL. Member: Cincinnati AC; Phila. AC; Rockport AA; North Shore AA. Exhibited: P.-P. Expo, San Fran., 1915 (med). Work: Cincinnati Mus.; Queen City Cl.; Cincinnati Univ. Cl. [27]

KAEP, Louis J. [P] Chicago, IL b. 19 Mr 1903, Dubuque, IA. Studied: Poole; Reynolds; Schook. Member: Palette and Chisel Acad. FA; AI Graphic A.; Ill. Acad FA; All-Ill. SFA; Iowa AC; Chicago Gld. Free Lance Ar. Work: Dubuque AA [40]

KAESELAU, Charles Anton [P,Li,T] Provincetown, MA b. 26 Je 1889, Stockholm, Sweden. Studied: Kensington Sch. A., London, England; AIC; Hawthorne; Sorrolla. Member: Am. A. Cong.; Provincetown AA; Boston WC Soc.; AAPL; Scandinavian-Am. Fnd. Exhibited: U.S. Work: PMG; Newark Mus.; Dept. Agriculture, Phillips Mem. Gal., both in Wash., D.C.; murals, USPOs, Concord, Mass., Lebanon, N.H.; Zachau Gal., Uddevalla, Sweden; Provincetown Art Mus. WPA artist. [47]

KAESER, William Frederick [P,Des,T] Indianapolis, IN b. 31 O 1908, Durlach, Germany. Studied: John Herron AI; Ind. Univ.; W. Forsyth; C. Wheeler; F. Piccirilli; F. Schoonover; Leonardo Da Vinci Art Sch. Member: Ind. AA; Ind. A Cl.; Hoosier Salon; Irvington A., ASL, both in Indianpolis. Exhibited: CGA, 1937; CM, 1935, 1937; CI, 1941; PAFA, 1935, 1937; Hoosier Salon, 1936 (prize), 1937–39, 1940 (prize), 1941–46; Ind. A., 1936–46; WFNY, 1939; Culver Military Acad., 1939 (prize). Work: Culver Military Acad.; mural, USPO, Pendleton, Ind. WPA artist. Position: Dir., ASL, Indianapolis [47]

KAESER, William Vogt [G,Arch] Madison, WI b. 18 Jy 1906, Greenville, IL. Studied: Univ. Ill.; MIT; Cranbrook Acad. A. Exhibited: Owens, Ill., 1939 (prize); Marshall Field, Chicago, 1938; Union Gal., Univ. Wis. [40]

KAGANN, Theo [S] NYC [21]

KAGANOVE, Joshua [P,T] Chicago, IL b. 22 Ag 1892, Kiev, Russia. Exhibited: MMA, 1942; Springfield Mus. A.; AIC, 1936, 1937, 1939. Position: T., AIC, 1940 [47]

KAGEN, Boris Timiochino [S] NYC b. 23 Mr 1908, St. Petersburg, Russia. Studied: I. Kravtchenco, in Russia; I. Keith, in Germany. Member: S.Indp.A.. Exhibited: Contemporary A., N.Y.; AIC, 1937, 1938; S.Indp.A. Work: Springfield (Mass.) Art Mus. [40]

KAGY, Sheffield (Harold) [P,Gr,Cr,T,B] Wash., D.C. b. 22 O 1907, Cleveland, OH. Studied: Cleveland Sch. A.; John Huntington Polytechnic Inst., Cleveland; H. Keller; P. Travis; O. Nordmark; Corcoran Sch. A., with E. Weisz; B. Baker. Member: A. Gld., Wash.; Soc. Wash. A.; Landscape Cl., Wash., D.C.; Wash. Pr.M.; Cleveland PM; Southern PM Soc.; Wash. AC. Exhibited: White Sulphur Springs, W.Va., 1936 (prize); CMA, 1933 (prize), 1935 (prize); AIC, 1934; WMAA; PAFA; PMG; AFA; Nat. Mus., Wash., D.C.; CGA; Palm Beach A. Center; Norfolk Mus. A.; WFNY, 1939; GGE, 1939; murals, Christian Church (Cleveland), USPOs, Walterboro (S.C.), Luray (Va.); map, Presidential Yacht "Williamsburg"; relief cut, CMA; Norfolk Mus. A.&Sciences; Women's City Cl., Wash., D.C. WPA artist [47]

KAHAN, Sol B. [S] NYC b. 23 D 1887, Zitomir City, Russia. Studied: ASL, with Laurent. Member: ASL. Exhibited: NAD; WMAA; CAA; BM; Arch. Lg. [47]

KAHILL, Joseph B. [Por.P] Portland, ME b. 15 My 1882, Alexandria, Egypt d. 29 Je 1957. Studied: C.L. Fox; Richard Miller, Collin, Prinet, in Paris. Member: Portland SA. Exhibited: Portland Mus. A., 1943 (one-man). Work: Portland Mus. A.; Walker A. Gal.; Capitol, Augusta, Maine; County & Fed. Court House, Portland; Bowdoin Col.; Univ. Maine; Colby Col.; Bates Col.; Sweat Mem. Mus. [47]

KAHILL, Victor [S] Phila., PA. Studied: Grafly; PAFA [25]

KAHLE, Herman [P] Bridgehampton, NY. Member: Lg. AA [24]

KAHLE, Julie (Mrs.) [Min.P] NYC. Member: NAWPS; Am. S. Min. P.; Pa. Soc. Min. P. Work: MMA [33]

KAHLER, Carl [P] NYC b. 1855, Linz, Austria. Member: S.Indp.A. Exhibited: Berlin, 1880; Dresden; Vienna; Munich; Phila., 1921. Had studio in NYC, 1891; again, 1921–24 [24]

KAHLER, John [P] Meadville, PA [19]

KAHLES, C.W. [I] Queens, NY [21]

KAHLICH, Karl Hermann [S,P,I,Car] Milwaukee, WI b. 6 Je 1890, Loeban, Saxony, Germany. Studied: R. Hoch; B. Jonas; H. Jonas; Dresden, Germany. Member: Seven Ar. Soc., Milwaukee; Wis. Ar. Fed. Exhibited: Wis. PS Exh.; Seven Ar. Soc. Exh. Work: relief, Kelling, Breslau, Germany; sculpture, Parklawn Fed. Housing Project, Wis. [40]

KAHN, Ely Jacques [T,Arch,P,Des,L] NYC b. 1 Je 1884, NYC. Studied: Columbia; Ecole des Beaux-Arts, Paris. Member: AIA; Arch. Lg.; Municipal A. Soc. (Pres.). Exhibited: Paris Salon, 1910 (prize); Bonestell Gal., 1946 (one-man). Author: "Design in Art & Industry," 1936, "Contemporary Architecture." Position: Chm. Bd., BAID [47]

KAHN, Helen Beling. See Beling.

KAHN, Isaac [P,S] Cincinnati, OH b. 16 Ag 1882, Cincinnati. Studied: Duveneck. Member: Cincinnati AC; Ceramic Soc. [33]

KAHN, Judith Pesmen [P,I] Chicago, IL b. 21 N 1920, Kansas City, MO. Studied: AIC. Exhibited: CI 1941; SFMA, 1941; PAFA, 1942; AIC, 1942. Illustrator: Esquire, Coronet. Position: A., Esquire, Inc., 1944–46 [47]

KAHN, Julia S. [P] NYC b. 6 F 1875, Cincinnati, OH. Studied: D. Romanovsky; Duveneck. Member: NAWPS [40]

KAHN, Max [G,S,P,Li,T] Chicago, IL b. 15 Mr 1903, Russia. Studied: AIC; Despiau; Bourdelle; Paris. Exhibited: AIC, 1939; PAFA, 1939; WFNY, 1939. Work: Univ. Ind. Position: T., AIC [40]

KAHN, Otto H(ermann) [Patron] NYC b. 21 F 1867, Mannheim, Germany (came to U.S. in 1893) d. 29 Mr 1934. One of the world's most famous financiers, philanthopists, and patrons of the arts (especially of music and the stage), he was the presiding genius of the Metropolitan Opera in New York, serving as its president and chairman of the board (to 1931). He was a pioneer among American collectors. In his New York home, the atmosphere of the Florentine Renaissance was most apparent. In addition to the Italian gallery, paintings, tapestries, sculptures in bronze and marble, all of rare worth, a fine group of Byzantine gold enamels were to be found. In 1918 he was made Commander of the Legion of Honor of France; other decorations came from Spain, Italy, Belgium, and Japan. He was a director of the American Federation of Arts, treasurer of the American Shakespeare Foundation, and served numerous organizations covering a wide range of interests outside of business.

KAIGHN, M.M. [P] Phila., PA [01]

KAINEN, Jacob [Mus.Cur,E,Li,P,T,L,W] Wash., D.C. b. 7 D 1909, Waterbury, CT. Studied: ASL; PIASch.; NYU; George Washington Univ.; N.Y. Sch. Industrial A.; Nicolaides; F.L. Allen. Member: Am. Ar. Cong.; United Am. A.; Soc. Wash. A.; Wash. A. Gld.; Landscape Cl., Wash.; Wash. SE. Exhibited: ACA Gal.; Phila. Pr. Cl.; Springfield (Mass.) AM; AIC; Albright A. Gal.; PMG, 1942–45; Oakland A. Cal., 1944; Springfield Mus.; LOC, 1944; BMA, 1944; CGA, 1942–45; Nat. Mus., 1945, (retrospective) 1976. Work: MMA; BM; Brooklyn Pub. Lib.; Queen's Col.; PMG; Biggs Mem. Hospital, Ithaca, N.Y.; N.Y. State Merchant Marine Acad.; East Tex. State T. Col. A social realist of the 1930s who explored color lithography, he later turned to working in abstracts. Position: Cur., Graphic A., U.S. Nat. Mus., 1942–70 [47]

KAINZ, Luise [E,En,S,T,C] NYC b. 3 My 1902, NYC. Studied: ASL; Hunter Col.; T. Col., Columbia; Munich Acad. F.&Appl. A. Member: ASL; Westchester ACG; Carmel AA. Exhibited: Weyhe Gal.; NAC; Brooklyn SE; Dudensing Gal. Positions: T., H.S. Art and Music, N.Y., Bay Ridge H.S., Brooklyn [47]

KAINZ, Martin [P,Li,T,Dr] Carmel, NY b. 7 My 1899, Dachau, Germany. Studied: Munich Acad. FA. Member: Westchester ACG; Carmel AA. Exhibited: Weyhe Gal. (one-man); Dudensing Gal. (one-man); Lilienfeld Gal. (one-man); Reading Mus. A. (one-man); Carl Schurz Fnd. (one-man) [47]

KAISER, August [P,I,E] NYC b. 2 O 1889, Krumbach, Bavaria, Germany. Studied: Sloan; Randall. Member: Gld. AA; Attic Cl., Minneapolis [25]

KAISER, Charles [I] Bronxville, NY b. 2 Ja 1893, Buffalo, NY. Studied: H.G. Kellar. Member: SI; Artists Gld. [47]

KAISER, Estelle Elizabeth [C,T] Chula Vista, CA b. 4 F 1905, Pittsburgh. Studied: CI. Member: Boston SAC; Spanish Village Art Center; Los Surenos Art Center, San Diego; F., Tiffany Fnd., 1927. Specialty: jewelry [40]

KAJIWARA, Takuma [P] NYC b. 15 N 1876, Japan d. Mr 1960. Member: St. Louis A. Gld.; 2 x 4 Soc., St. Louis; AAPL; All.A.Am.; Audubon A.; Exhibited: St. Louis A. Gld., 1922 (prize); Kansas City AI, 1926 (med); All.A.Am., 1945 (prize); NAD, 1922, 1943; PAFA, 1924, 1926, 1928–30; 1932; CAM, 1930; AFA Traveling Exh., 1928–29; Toledo Mus. A.,, 1928; Detroit Inst. A., 1929; Kansas City AI, 1926, 1928. Work: Washington Univ.; St. Louis Univ.; Stony Brook (N.Y.) Sch.; Hunter Col. [47]

KALB, Dorothy B. [P] Wash., D.C. [25]

KALBHEN, Lydia [P] NYC Member: Chicago NJSA [25]

KALDENBERG, F(rederick) R(obert) [S,C] NYC b. 7 Je 1855, NYC d. O 1923. Studied: self-taught. Member: NAC, 1901; NSS, 1893; Arch. Lg., 1898; N.Y. Soc. C. Exhibited: Am. Inst., New York, 1869 (med); Cincinnati, 1884 (gold). Specialty, ivory carving [21]

KALER, Gladys Ricker (Mrs.) [Dec,Des,C,I,P,T] Weston, MA b. 30 D 1889, Waltham, MA. Studied: Boston Normal A. Sch.; Boston Univ. RISD. Member: Boston Soc. A.&Crafts; Lexington A.&Crafts; Wellesley SA; Boston Textile Gld.; Boston Weavers' Gld. Exhibited: Jordan Marsh, Boston; Farnsworth Mus.; handcrafts exhibits in Boston, Wellesley, Waltham, Lexington, Weston, Worcester, all in Mass. [47]

KALISH, Max [S,T] Great Neck, NY/Cleveland, OH b. 1 Mr 1891, Poland d. 18 Mr 1945, NYC. Studied: Matzen; Adams; Calder; Injalbert; Konti. Member: ANA, 1933; NSS; Allied Ar. Am. Exhibited: CMA, 1924 (prize), 1925 (prize); Grand Central A. Gal., 1929 (prize). Work: NGA; CMA; Newark (N.J.) Mus.; Mus. Art, Amherst Col.; Art Gal., Canajoharie, N.Y. [40]

KALKHOFF, Fred [P] NYC [24]

KALKREUTH, G. [P] NYC [17]

KALLEM, Henry [P] NYC. Studied: NAD, 1933; Hans Hofmann Sch., 1946. Exhibited: PAFA, 1936; WFNY, 1939; N.Y. Realists, ACA Gal., 1939; NAD; BM; Casein S., 1959. Work: CGA; Newark (N.J.) Mus.; Chrysler Mus.; Colby Col.; Matatuck Mus.; Univ. Mass.; Lehigh Univ. WPA artist, 1934–39. [40]

KALLEM, Morris J. [P] NYC [25]

KALLMAN, Kermah [S] NYC b. 11 Ap 1903, Sweden. Studied: A. Goodelman; S. Berman. Member: Audubon A.; N.Y. Soc. Women A.; Contemporary A.; A. Lg. Am.; Lg. Present-Day A.; N.Y. Soc. Ceramic A. Exhibited: Am.-British A. Center; Riverside Mus.; NAD; ACA Gal.; Bonestell Gal.; Peikin Gal.; Chappelier Gal.; Norlyst Gal.; NAC; Argent Gal. [47]

KALLOS, Arpad [P] b. 9 S 1882, Hungary. Studied: E. Ballo; J. Benczur. Member: Soc. Hungarian A.; Cleveland SA. Exhibited: nudes, Hungarian Nat. Exh., 1916 (prize), 1917 (prize). Work: Hungarian Andrassy Mus., Budapest; former Hapsburg Dynasty of Austria-Hungary [33]

KALMENOFF, Matthew [P,I,L,T] NYC b. 11 F 1905, NYC. Studied: DuMond; Bridgman. Member: NAC; Allied AA. Exhibited: NAC, 1931 (prize). Position: T., Bronx House [40]

KALTENBACH, Lucile [P,I,W] Chicago, IL b. Durban, South Africa. Studied: AIC; J. Norton; A. St. John; Lhote, in Paris. Member: ASL, Chicago. Exhibited: ASL, Chicago, 1927 (prize); AIC, 1928 (prize). Specialty: watercolors [33]

KALTWASSER, George A. [S] Brooklyn, NY b. 1849 d. 3 Ag 1917. Specialty: woodcarving

KAMEN, Samuel [P,Des,Li] Brooklyn, NY b. 15 Je 1911, Brooklyn. Studied: ASL; NAD; Bridgman; DuMond; ASL. Member: AWCS. Exhibited: AWCS, 1942, 1944–46; All.A.Am., 1943, 1944; NAD; Brooklyn SE, 1943, 1945. Specialty: design of ceramics, rugs, furniture [47]

KAMENSKY, Theodore [S] Clearwater, FL b. 1836, St. Petersburg, Russia (came to U.S. in 1872). Studied: St. Petersburg Acad. FA. Member: St. Petersburg Acad. FA. Exhibited: London Intl. Expo (med); Vienna Expo (med). Work: statue, reliefs, Capitol, Topeka, Kans.; St. Petersburg Acad. [17]

KAMENY, Aaron [P,G,T] Baltimore, MD b. 1 Ja 1908, Siedlce, Poland. Studied: Nat. Acad.; ASL. Member: Am. Ar. Cong.; Municipal A. Soc., Baltimore; Ar. Un., Baltimore. Exhibited: Baltimore Mus. A.; Springfield (Mass.) AM. Work Baltimore Mus. A.; Howard Univ. A. Gal.; Municipal A. Soc., Baltimore. Position: T., Kernan Hospital Crippled Children, Hillsdale, Md. [40]

KAMINSKI, Edward B. [P,Des,T] West Los Angeles, CA b. 9 O 1895, Milwaukee. Studied: Milwaukee AI; Terlikowski, in Paris. Exhibited: Ransom Gal., Paris; Los Angeles Mus. Hist., Science & A. Work: Luxembourg Mus., Paris; FA Gal., San Diego [40]

KAMINSKY, Dora Deborah [Ser,P,Des,C,I,W] NYC b. 10 Ag 1909, NYC. Studied: Paris; Stuttgart; Munich; Vienna; ASL. Member: Nat. Serigraph Soc. Exhibited: Norlyst Gal., 1943; Nat. Serigraph Soc., 1947 (one-man). Work: MMA; Albany Inst. Hist.&A. [47]

KAMP, Louis M. [P] Buffalo, NY b. 1867 d. 1959. Studied: Woodstock, N.Y., with J.F. Carlson. Exhibited: Buffalo Soc. A., 1914 (prize) [15]

KAMPF, Melissa Q. (Mrs.) [P,T] Norfolk, VA/South New Berlin, NY b. 1 My 1867, Phila. Studied: Chase; Poore; C. Duran. Member: S.Indp.A.; Norfolk SA. Exhibited: Norfolk SA, 1922 (gold) [33]

KAMROWSKI, Gerome [P,S] NYC b. 29 Ja 1914, Warren, MN. Studied: St. Paul Sch. A.; ASL; Hans Hofmann Sch. FA. Member: Am. Abstract

Ar.; F., Guggenheim, Fnd., 1938, 1939. Exhibited: GGE, 1939; AIC, 1945, 1946; WMAA, 1946; Albright A. Gal., 1946. Work: PMG [47]

KAMYS, Walter [P,T] Montague, MA b. 8 Je 1917, Chicago, IL. Studied: AIC; H. Ropp; F. Chapin; L. Ritman; Anisfeld. Award: Prix de Rome, 1942. Exhibited: Ohio Valley Exh., 1946; Portland SA, 1946; AIC, 1943; Springfield Mus. A., 1946. Position: T., Putney (Vt.) Sch., 1945–46 [47]

KANE, Francis T. [P,E,Des] Wilmington, DE. b. 29 S 1919, Wilmington. Studied: Wilmington Acad. A.; ASL. Exhibited: PAFA, 1941; VMFA, 1939, 1940; Valentine Mus., 1940, 1941; Wilmington Soc. FA, 1938–41; Wilmington AC, 1940, 1941; Del. A. Center, 1945 (one-man). Work: mural, YMCA, Wilmington [47]

KANE, John [P] b. 19 Ag 1860, West Calder, Scotland (came to U.S. in 1879) d. 10 Ag 1934, Pittsburgh, PA. Studied: self-taught. Exhibited: CI, 1928 (first public recognition), 1934. At the first memorial exhibit of his painting in 1935, he was hailed as "America's Rousseau" and heralded as one of America's greatest primitive painters. Work: CI. His important work began in 1910 (although the 140 paintings of his career are difficult to date).

KANE, Kathleen [P] Minneapolis, MN [25]

KANE, Margaret Brassler [S] Brooklyn, NY b. 25 My 1909, East Orange, NJ. Studied: Syracuse Univ.; ASL; J. Hovannes. Member: S. Gld.; NAWA. Exhibited: NAWA, 1942 (prize); Montclair AA, 1943 (prize); Arch. Lg., 1944 (prize); Brooklyn SA, 1946 (prize); ACA Gal., 1944 (prize); MMA, 1942; PMA, 1940; BM, 1938, 1942, 1946; Riverside Mus., 1943; WMAA, 1938–40, 1945; Montclair A. Mus.; 1943, 1945; S. Gld., 1938–42, 1944; Arch. Lg., 1944; NAD, 1941; PAFA, 1942, 1945, 1946; AIC, 1941; AFA Traveling Exh., 1939–40; NSS, 1938, 1940; WFNY, 1939; Robinson Gal., 1939–40; NAWA, 1942–46; Lyman Allyn Mus., 1939; Lawrence A. Mus., 1938; Audubon A., 1945; Jacques Seligmann Gal.; Argent Gal.; ACA Gal.; Vendôme Gal.; Clay Cl.; Municipal A. Gal., 1936–46. Work: U.S. Maritime Coll. Contributor: American Artist [47]

KANE, Robert William [P,Li] NYC b. 17 Ag 1910, NYC. Studied: Grand Central A. Sch.; E. Pape. Member: SC. Work: AMNH. Positions: Staff A., AMNH, 1931–42; A./Draftsman, East Africa Project, 1942–44; U.S. Navy, 1945–46 [47]

KANE, Theodora [P,Car,I,T] Wash., D.C. b. 8 Ap 1906, Boston. Studied: N.Y. Sch. F.&Appl. A.; Corcoran Sch. A.; Lahey; St. Martins and Westminster Art Sch., London. Member: Soc. Wash. A., Wash. AC; Va. Acad. Sc.&FA. Exhibited: CGA, 1939; Nat. Mus., Wash., D.C.; Smithsonian Inst.; Wash. AC; Whyte Gal.; Va. Acad. Sc.&FA, 1940 (one-man); No. 10 Gal., N.Y., 1941 (one-man). Illustrator: book jackets. Cartoonist: Saturday Evening Post, The Graphic. Position: Dir., Georgetown Gal. [47]

KANELLOS, Charlotte Markham (Mrs.) [P,Mur.P,T] Manitowoc, WI b. 1892, Manitowoc d. 27 Jy 1937. Studied: AIC. With her husband, she helped produce the Delphic Festival in Greece in 1927, and the Greek government commissioned them to organize and direct the ancient classic outdoor theaters of Greece. Known for her murals and watercolors, she also designed stage settings for many theaters in the U.S. and Greece. Positions: T., AIC, Milwaukee Downer Col.; Dir., Art Sch., Milwaukee AI

KANELOUS, George [P] Brooklyn, NY. Exhibited: PAFA, 1935, 1938; 48 Sts. Comp., 1939 [40]

KANGOONY, Gregory [P,Mur.P] San Fran., CA b. 18 Ja 1895, Tokat, Sivas, Armenia. Studied: Fr. Jesuit A. Sch., Tokat. Work: murals, monastery, Tokat; St. Joseph's Church, San Jose, CA [40]

KANN, Frederick I. [P,Des,T,S] Hollywood, CA b. 25 My (1886 or 1894), Gablonz, Czechoslovakia. Studied: Art Acad., Prague; Art Acad. Munich. Member: Am. Abstract A.; Council All. A.; AAPL; Abstraction Creation, Paris. Exhibited: Midwest Ar. Exh., Kansas City, 1937 (prize). Work: posters, Chemin de Fer d'Etat Français; Musée d'Ethnographie du Trocadero, Paris. Contributor: French magazines. Positions: T., Kansas City AI, Chouinard A. I.; Dir., Kann Inst. A. [47]

KANN, Theresa H. [P] NYC. Member: Lg. AA [24]

KANNE, Benjamin S. [P,Por.P] Chicago, IL b. 23 Je 1897, Odessa, Russia. Studied: AIC; Académie Julian, Paris; R. Pougheon, R. Jaudon, in Paris. Member: Assn. Chicago PS. Exhibited: Chicago Gal. Assn., 1936 (prize), 1939 (prize); AIC, 1935–37, 1938 (prize), 1939–41 [47]

KANNO, Gertrude Boyle (Mrs.) [S] San Fran., CA b. 1876, San Fran. d. 14 Ag 1937. Her marriage in 1907 to Takeshi Kanno, Japanese poet-philosopher, created widespread interest. Work: portrait busts of Joaquim Miller, Edwin Markham, Christy Mathewson

KANOVITCH, A. [P] NYC [15]

KANTACK, Walter W. [C,Des] St. Albans, NY b. 28 Jy 1889, Meriden, CT d. 20 Ja 1953, Lake Charles, LA. Studied: F. Caldwell; PIASch; Europe. Member: Arch. Lg.; The Art in Trades Cl.; Am. Inst. Dec. Exhibited: AIA, Wash., D.C., 1934 (prize). Work: lighting fixtures, furniture, Irving Trust Co., NYC; Jocelyn Mem., Omaha, Nebr. Contributor: articles on arch./dec., leading magazines. Position: Des., Sterling Bronze Co., NYC [40]

KANTOR, Joseph [P] Stone Ridge, NY b. 10 Ag 1904, Russia. Studied: ASL; Educational All. Member: Salons of Am. [33]

KANTOR, Leonard [I] NYC. Member: SI [47]

KANTOR, Martha Rythor [P,T] New City, NY b. 12 F 1896, Boston. Studied: BMFA Sch.; Acad. de la Grande Chaumière, Ecole Moderne, both in Paris. Member: NYSWA [40]

KANTOR, Morris [P,T] New City, NY b. 15 Ap 1896, Minsk, Russia (came to NYC in 1906) d. 1974. Studied: Indp. Sch. A., with H. Boss, 1916. Member: S.Indp.A.; Am. Soc. PSG; Fed. Modern P.&S. Exhibited: AIC, 1929, 1930, 1931 (med,prize), 1932–45; CGA, 1939 (prize), 1945; PAFA, 1929–39, 1940 (med), 1941–46; CI, 1931, 1932, 1934, 1936, 1938, 1940–45. Work: WMAA; MMA; MOMA; AIC; PAFA; Detroit Inst. A.; PMG; Denver A. Mus.; Univ. Nebr.; Univ. Ariz.; Newark Mus.; Wilmington Soc. FA [47]

KAPLAN, Joseph [P,Des,E] NYC b. O 1900, Minsk, Russia. Studied: NAD. Member: A. Lg. Am. Exhibited: CI, 1941; PAFA, 1945, 1946; Pepsi-Cola, 1944; AV, 1942; NAC, 1946; Am. A. Cong. Work: Mus. Western A., Biro Bidjan Mus., Russia; MMA [47]

KAPLAN, Nat [G,S,Arch,L] Gallup, NM/Taos, NM b. 5 Jy 1912, NYC. Studied: C. Sheppard; V. McNeil; W. Crumbo. Exhibited: Mus. N.Mex., Santa Fe; N.Mex. A. Lg., Albuquerque. Work: Harwood Fnd., Taos; Mus. N.Mex. Position: Dir., Gallup A. Center [40]

KAPLAN, Samuel [P] NYC b. 1890, Kishineff, Russia (came to U.S. as a child) [17]

KAPLAN, Ysabel De Witte [Min.P,I] Cincinnati, OH b. Cincinnati. Studied: Cincinnati Art Acad.; ASL. Member: Cincinnati Women's AC. Specialty: bookplates [10]

KAPOUSOUZ, Vasileos [S,P,T] Scituate, MA b. 25 Ja 1912, Mytelene, Greece. Studied: Monastery Aghion Orros, Mt. Athos, Greece; BMFA Sch; Mass. Normal A. Sch.; G. Eliott, in Antwerp. Member: Copley Soc. Exhibited: Doll & Richards, Boston. Position: T., South Boston Sch. A. [40]

KAPPEL, Philip [E,Li,I,W,L,P] New Milford, CT b. 10 F 1901, Hartford, CT. Studied: PIASch; Philip Little. Member: North Shore AA; Chicago SE; SAE; CAFA; SC; Marblehead AA; MacD. Cl. N.Y.; Cleveland PM; Phila. SE; Wash. WCC; Authors' Cl. N.Y. Exhibited: Palm Beach AA, 1935 (prize); Brooklyn SE, 1926 (prize); Marblehead AA, 1926 (prize); NAD, 1928–46; WFNY, 1939; New Haven PCC; CAFA; Kent AA; Meriden A.&Crafts Soc.; prints, U.S./abroad; retrospective of marine prints, Wesleyan Univ., 1979. Work: "Fine Arts Prints of the Year," 1926, 1927; Bibliothèque Nationale, Paris; NYPL; CMA; High Mus. A.; mem., Hartford, Conn.; LOC; Montclair A. Mus.; BM; Peabody Mus.; MMA; CGA; Nat. Mus., Wash., D.C.; Wesleyan Univ.; Toledo Mus. A.; CI; CGA. Illustrator: "American Etchers Series," vol. 4 (1929), "Yankee Ballads" (1930), "Last Cruise of the Shanghai" (1925), "Lord Timothy Dexter" (1925). Position: T., with H.B. Snell, Boothbay (Maine) Studios, 1923–24 [47]

KAPPEL, R. Rose (Mrs. Irving Gould) [P,Des,I,E,T,Dec,L,W] Jackson Heights, NY b. 23 S 1908, Hartford, CT. Studied: PIASch; NYU; Harvard; Fordham; Washington Univ.; N.Y. Sch. F.&Appl. A. Member: Rockport AA; NAWA. Exhibited: NAWA, 1929–46; PAFA, 1939, 1940; BMFA, 1940; Newark Mus., 1937; NYWCC, 1939–41; NAD, 1943, 1945; LOC, 1943, 1944. Work: LOC; BMFA; Gloucester AA; murals, Culture & Health Sch., Brooklyn, NY; Assoc. Am. Ar. Position: T., Dept. for Handicapped Boys & Girls, NYC, 1940–46 [47]

KAPPES, Karl [P,T] Toledo, OH b. 28 My 1861, Zanesville, OH d. 17 N 1943. Studied: W.M. Chase; Constant; C. Marr. Member: Scarab Cl., Detroit. Work: Zanesville AI [40]

KAPUSTIN, Razel [P,Mur.P,Li,T,L] Phila., PA b. 26 D 1908, Ladizhen, Russia. Studied: Barnes Fnd.; D.A. Siqueiros. Member: Phila. A. All. Exhibited: Albany Inst. Hist.&A., 1943–45; LOC, 1944–46; PAFA, 1944, 1945; Los Angeles Mus. A., 1945; AV, 1945; Albany Pr. Cl., 1945; Oakland A. Gal., 1943–45; Butler AI, 1943, 1944; Mint Mus. A., 1943;

Phila. A. All., 1943; PMA, 1946; Phila. Pr. Cl., 1944–46. Work: mural, Frederick Douglass Sch., Phila. [47]

KARAGHEUSIAN, Charles A., Mrs. See Tavshanjian.

KARASICK, Mary K. (Mrs. Samuel) [C,Por.P,L,T] Mt. Vernon, NY/Kent, CT b. 18 My 1888, Minsk, Russia. Studied: NAD; Detroit FA Acad.; G. de Forest Brush; S. Nichols. Member: NAWPS; Gloucester SA; AAPL; New Rochelle A. Assn.; Kent A. Assn.; Westchester AC Gld. [40]

KARASZ, Ilonka [Des,I,P,T] Brewster, NY b. 13 Jy 1896, Budapest, Hungary. Studied: Royal Sch. A.&Crafts, Budapest [40]

KARAWINA, Erica (Mrs. Sidney C.T. Hsiao) [P,Des,S,Li] Boston, MA b. 25 Ja 1904, Wittenberg, Germany. Studied: France; C.J. Connick; F.W. Allen. Exhibited: Boston AC; S.Indp.A., Boston; PAFA; Rockefeller Center, NYC, 1937; WFNY, 1939; Okla. A. Center; Grand Rapids A. Gal., 1940; Grace Horne Gal., Boston (one-man); Univ. N.H., Durham, 1937; Lancaster (Pa.) AC, 1937; Wadsworth Atheneum, 1938; Tex. State Col., 1939. Work: AGAA; Los Angeles Mus. A.; Biro-Bidjan Mus., Russia; MOMA; Les Archives International de la Danse, Paris; MMA; BMFA; WMA; stained glass churches in San Fran., Denver, Chicago, Cincinnati, NYC, Paris; Colo. Springs FA Center [47]

KARFIOL, Bernard [P] Irvington-on-Hudson, NY/Ogunquit, ME b. 1886, Budapest, Hungary d. 16 Ag 1952. Studied: NAD, 1900; Académie Julian, Paris. Member: Am. Soc. PS&G. Exhibited: P.-P. Expo, 1925 (prize); CI, 1927 (prize); VMFA, 1942 (prize); CGA, 1928 (gold); Paris Salon, 1904; Salon D'Automne, 1905; Armory Show, NYC, 1913; Brummer Gal., 1923, 1925, 1927; Downtown Gal., annually. Work: MMA; PMG; Detroit Inst. A.; WMAA; MOMA; CGA; Los Angeles Mus. A.; BMA; Pal. Leg. Honor; AGAA; CI; BM; Wichita A. Mus.; Newark Mus.; Lyman Allyn Mus.; VMFA; Dartmouth; Hamilton Easter Field Fnd., Brooklyn, N.Y.; Ft. Dodge Fed. A.; Encyclopaedia Britannica Coll. His style reflected the strong influences of Picasso and Cézanne. [47]

KARFUNKLE, David [P,Mur.P,T] NYC b. 10 Je 1880, Austria. Studied: NAD; F. Jones; E. Ward; Royal Acad., Munich; Bourdelle, in Paris. Exhibited: CI; PAFA; AIC; NAD; Boston AC; abroad. Work: Newark Mus.; CMA; murals, Grace Church, Jamaica, N.Y.; Municipal Court, NYC [47]

KARFUNKLE, O. [P] NYC [19]

KARGERE, Raymond [P] Woodstock, NY b. 19 S 1899, Paris, France. Studied: France; M. Gromaire. Exhibited: French Salon, 1940; NAD, 1946; Albany Inst. Hist.&A., 1943, 1944, 1946 [47]

KARL, Mabel Fairfax (Smith) (Mrs.) [S,E,B,C,Dr] San Diego, CA/Sweeny, TX b. 27 Je 1901, Glendale, OR. Studied: L. Lentelli; J. Pennell; Bridgman; DuMond; A. Dawson. Member: ASL; A.G. Members of FA Soc., San Diego; AFA. Exhibited: FA Ga., San Diego, 1931 (prize), 1932 (prize), 1933 (prize), 1934 (prize), 1935 (prize), 1938 (prize); Mus. FA, Houston, 1932 (prize), 1934 (prize), 1935 (prize); GGE, 1939. Work: FA Gal., San Diego; Wilson Memorial H.S., San Diego; Mus. FA, Houston [40]

KARL, Walter C. [P] Akron, OH. Member: Cleveland SA [27]

KARLIN, Eugene [P,G,I,Car] Woodside, NY/Chicago, IL b. 15 D 1918, Kenosha, WI. Studied: Hull House, Chicago; Harrison Comercial A. Sch., Chicago; ASL; Colorado Springs FA Center; Prof. Sch. A., Chicago. Member: Young Am. Ar.; Cart. Gld., Chicago. Exhibited: AIC; PAFA, 1939; CGA, 1939 [40]

KAROLY, Andrew B. [Mur.I,P,E,Dec] NYC b. 5 My 1895, Varanno, Hungary. Studied: Univ. A.&Arch., Budapest; Acad. A., Munich; Académie Julian, Paris. Member: Budapest AC; Royal Acad. A., Budapest; Mural PL Gld., N.Y.; Soc. Mural P., N.Y. Exhibited: WFNY, 1939. Work: Nat. Mus., Budapest; A. Mus. Helsinki, Finland; murals, Bellevue Hospital, St. Clement Church, Pennsylvania Hotel, all in NYC; Thomspson Aircraft Products Co., Hotel Cleveland, both in Cleveland; Worcester (Mass.) Acad.; Mod. Gal., Munich [47]

KAROW, Annie (Mrs. Edward) [P] Savannah, GA. Member: SSAL [27]

KARP, Leon [P] Phila., PA/Buckingham Valley, PA d. 2 Ag 1951. Exhibited: PAFA, 1939 (med); GGE, 1939; WFNY, 1939 [40]

KARPICK, John J. [P,Des,L] NYC b. 24 Ag 1883, Posen, Germany d. 15 Ja 1960. Studied: ASL; Buffalo, N.Y.; De Paul Univ.; E. Duffner; U. Wilcox; L. Hitchcock. Member: AAPL; Bronx A. Gld.; Audubon A.; Yonkers AA. Exhibited: NAD, 1942; Okla. A. Center, 1940-42; AWCS, 1931; All.A.Am., 1941; Miss. AA, 1946; Audubon A., 1942-45; AAPL, 1944, 1945; Yonkers AA, 1934, 1944; Woodmere A. Gal., 1944–46; Bronx A. Gld., 1931, 1946; Vendôme A. Gal., 1941; Contemporary A. Gal., 1942 [47]

KARRAS, Spiros John [Ldscp.P] Pasadena, CA b. 25 D 1897, Kollerion Ellis, Greece. Studied: Thomopoulos Art Sch., Athens.; H.J. Karras; J.L. Sangster. Member: Calif. AC [33]

KARSAY, Joseph L. [P] d. 6 D 1936, NYC

KARST, John [Wood En] De Bruce, NY b. 1836, Bingen, Germany (brought to U.S. as a baby) d. summer, 1922. The earliest book illustrated by him is dated 1855. He was an authority on porcelains, prints and first editions of books.

KASBARIAN, Yeghia [P,S] Belmont, MA b. 6 Jy 1896, Armenia. Studied: BMFA Sch.; Académie Julian, Paris. Work: panel, Armenian church, Watertown, Mass. [40]

KASE, Paul G. [C,P] Reading, PA b. 4 N 1895, Reading. Studied: H. Breckenridge; E. Carlsen; J. Pierson; PAFA. Member: Reading Arch. S. Work: painting, Reading Mus.&A. Gal.; glass, Clarendon Congregational Church, Boston.; Riverside Baptist Church, NYC; St. Florian Church, Detroit, Mich. Position: Chief Des., Kase Stained Glass Studios, Reading [40]

KASEBIER, Gertrude Stanton (Mrs. Eduard) [Photogr] NYC b. 1852, Des Moines, IA d. 13 O 1934. Studied: PIASch, 1888; with a photography chemist, Germany, 1897. Member: Phila. Salon (Jury), 1899; Linked Ring (first woman elected) 1900; Photo-Secession (founder-member), 1902—ousted 1910; founder (with C. White, A.L. Coburn) of Pictorial Photographers of Am., 1916. Exhibited: N.Y. Camera C., 1898; Photo-Secession; Phila. Salon, 1898; "New Sch. of Am. Photogr." at Royal Photogr. S., London, 1900; Albright AG Intl. Expo, 1910; Brooklyn IA 1929. Work: AIC; IMP; LOC; MMA; MOMA; Mus. N.Mex.; NOMA; Princeton; Royal Photogr. S. Opened Paris studio, 1894. One of the leading pioneers of pictorial photography, she is best known for her mother-and-child scenes, and portraits of Rodin and Stieglitz. Her work excelled among the photographers working in a "painterly" style.

KASSEL, Morris [P] NYC. Member: S.Indp.A. [25]

KASSLER, (Marguerite) Bennett [S] Taxco, Mexico. b. 22 O 1900, Tacoma, WA. Studied: Whitworth Col.; AIC; Paris, with Bourdelle; Hilbert; Despiau. Exhibited: Princeton. Work: Denver A. Mus.; murals, USPOs, East Stroudsburg, Mifflinburg, both in Pa. [40]

KASSLER, C.M. [P] Denver, CO [25]

KASSLER, Charles, II [B,Des,Mur.P,T] Los Angeles, CA b. 9 S 1897. Exhibited: Los Angeles Mus. A., 1936 (prize). Work: frescos, Los Angeles Pub. Lib.; Fullerton (Calif.) District Jr. Col.; USPO, Beverley Hills, Calif.; Denver AM; Los Angeles Mus. A.; Santa Barbara AM. WPA muralist. Position: T., Calif. Grad. Sch. Des., Pasadena [40]

KAT, William [P,E] NYC b. 27 Ap 1891, Holland. Studied: Sch. van Kunstnyverheid, Holland. Member: AWCS. Work: Oberlin Col. [33]

KATADA, Seisuro [P] San Francisco, CA [19]

KATCHADOURIAN, Sarkis [P] NYC b. 1889, Iran d. 3 Mr 1947. Studied: Reggio Inst. de Belle Arti, Rome; Ecole des Arts Decoratifs, Paris; Munich. Exhibited: MOMA; MMA. Specialty: restorations. Recreated the Persian frescoes dating from the period of Shah Abbas the Great; in 1937, worked for 4 yrs. in recreating the almost lost 5th- and 6th-century frescoes in temple caves in India and Ceylon.

KATCHAMAKOFF, Atanas [P,S,C] Palm Springs, CA b. 18 Ja 1898, Leskovetz, Bulgaria. Studied: FAA, Sofia, Bulgaria. Exhibited: FAA, Sofia, 1919 (prize), 1920 (prize); International S. Exh., Venice, Italy, 1921 (prize); Calif. State Fair, 1929 (prize); A.All.Am., 1931 (prize); Los Angeles Exh., 1932 (prize). Work: City of Leskovetz, Bulgaria; fountain, Sofia; S., Deutsche Bank, Berlin [40]

KATES, Herbert S. [P,Et,I,W] New Rochelle, NY b. 12 Ja 1894, NYC. Studied: ASL, with G. Bridgman; PIASch; CCNY; F. Dielman. Member: New Rochelle AA; SI. Exhibited: NAD; NAC; Inst. A.&Sc., Kingston, Jamaica; New Rochelle Pub. Lib., 1932-46. Work: Inst. A. & Sc., Kingston, Jamaica. Author/Illustrator: "Great Moments in the Life of Washington," 1932, "Minute Stores of Famous Explorers," 1935. Illustrator: "New York," by Fleming and Kates. Contributor: Harper's, Arts & Decoration [47]

KATO, Kay [Cart,P,T] Boston, MA b. 11 D 1916, Budapest, Hungary. Studied: A. Acad., Budapest; PAFA: W. Aba-Novak; J. Vaszary; S. Szonyi. Member: Am. Soc. Magazine Cart. Exhibited: cart., Wartime Conservation, Am. FA S. Gal., 1943; Anti-Axis War Bond Exh., Treas-

ury Dept., 1942; OWI Exh. on Absenteeism, 1943; "Cartoonist Looks at War," Boston Pub. Lib., 1945 (one-man); Vose Gal., 1945 (one-man); PAFA, 1941. Work: portrait, New England Tel. & Tel. Co., Boston. Contributor: national magazines; "Best Cartoons of the Year," 1943. Position: T., Cambridge Center, 1945–46 [47]

KATO, Kentaro [P] NYC/Fukuoka, Japan b. 15 N 1889, Japan d. 18 Ag 1926, NYC. Studied: H. Read. Exhibited: NAD, 1920 (prize) [25]

KATOAKA, Genjiro [P,I] Tokyo, Japan. b. 1867, Arita, Japan. Studied: J.H. Twachtman, NYC. Member: NYWCC; SC 1889. Exhibited: SC, 1905 (prize) [25]

KATZ, Alexander (Sándor) Raymond [Mur.P,Gr] Chicago, IL b. 21 Ap 1895, Kassa, Hungary d. 1974. Studied: AIC; Chicago Acad. A. Member: Chicago SA; Around-the-Palette; Ill. SA. Exhibited: AIC, 1930, 1934–37, 1939, 1940, 1944; PAFA, 1934; BM, 1934; CGA, 1939; Miss. AA, 1944 (prize); Feragril Gal., 1940; CM, 1940; CI, 1941; GGE, 1939; Los Angeles Mus. A., 1945; SFMA, 1945; NAD, 1944, 1945; Albany Inst. Hist.&A., 1945; Chicago Room, 1946 (one-man); Milwaukee AI, 1941, 1942, 1944; Evanston Mus. FA, 1937 (one-man); Univ. Ark., 1941 (one-man); Springfield Mus. (one-man); Century of Progress, Chicago, 1934 (prize); Evanston AA, 1944 (prize). Work: murals, Elizabeth YMHA; USPO, Madison, Ill.; Downtown Temple, Chicago; stained glass, Anshe Emet Temple, Vaughan Army Hospital, Ner Tamid Temple, Chicago; Century of Progress Expo; Auditorium Hotel, Will Rogers Theatre, both in Chicago; North Shore Temple, Glencoe, Ill.; St. Joseph, Mich. WPA muralist. Author: "Black on White," 1933, "The Ten Commandments," 1946 [47]

KATZ, Ethel (Mrs. Abraham S.) [P,G,T,Li] NYC b. 12 Jy 1900, Boston, MA. Studied: BMFA Sch.; Mass. Normal A. Sch.; ASL; R. Davey; H. Giles; S. Halpert; New Sch., Boston; Broadmoor Acad., Colo. Member: NYSWA; NAWA; Am. A. Cong. Exhibited: BM, 1935; CAA Traveling Exh.; WFNY, 1939; NAWA Traveling Exh., 1942, 1943; High Mus. A., 1944; NAWA, 1939–46, 1939 (prize); NYSWA, 1937–46; Am. A. Cong., NYC, 1939. Work: Riverside Mus. Position: T., ASL, 1943– [47]

KATZ, Hilda [P,Gr] Bronx, NY b. 2 Je 1909, Bronx, NY. Studied: New Sch. Soc. Res.; A. Covey, NAD. Member: AAPL; Audubon A.; NAWA; CAFA. Exhibited: CGA, 1937; Phila. WCC, 1937–39, 1941–44; NYWCC, 1936, 1937; All.A.Am., 1938–43; Audubon A., 1944, 1945; Christmas-in-our-Time Exh., 1943; Albany Pr. C., 1945; America-in-the-War Exh. (26 mus.), 1943; Albany Inst. Hist.&A., 1941, 1945; NAWA, 1936–1946, 1945 (prize); Denver A. Mus., 1940; WFNY, 1939; SAE, 1942; NAD, 1933–35 (prize), 1942, 1946; Mint Mus. A., 1946; Laguna Beach AA, 1946; CAFA, 1941, 1942, 1945, 1946; MMA, 1942; Intl. Expo, Women's A.&Indst.; Intl. Women's C., England, 1946; Venice, Italy, 1940. Work: LOC; BMA; FMA [47]

KATZ, Hyman William [E,P] NYC b. 20 Ja 1899, Poland. Studied: Auerbach-Levy; Miller; NAD [40]

KATZ, Leo [Mur.P,Por.P,Min.P,Dr,L,Li,T,W] Hampton, VA b. 30 D 1887, Roznau, Czechoslovakia. Studied: Vienna Acad.; Munich Acad.; Mexico; South America. Exhibited: Ehrich Gal.; Seligmann Gal.; Montross Gal.; Puma Gal.; CMA; Los Angeles Mus. A.; San Diego FA Soc.; BM; Long Beach AA, 1938 (prize); LOC, 1946 (prize). Work: MMA; BM; NYPL; LOC; Albertina Mus., Vienna; murals, Frank Wiggins Trade Sch., Los Angeles; abroad; Century of Progress Expo, Chicago. Author/Illustrator: "Understanding Modern Art," 1936 (3 vols), chapters to "Encyclopedia of Social Sciences," "Encyclopedia of Photography," 1942, "Miniature Camera Work," 1938, "Magazine of Art." Position: T., Brooklyn Col., 1943–46; CUASch, 1938–46; T., Chouinard A. Sch., A. Center Sch., Los Angeles, 1940; T., Chm., Hampton Inst., Va. [47]

KATZENELLENBOGEN, Adolf Edmund Max [Edu,L,W] Poughkeepsie, NY b. 19 Ag 1901, Frankfurt, Germany d. 30 S 1964. Studied: Freiburg; Leipzig; Munich; Frankfurt Univ.; Univ. Hamburg. Member: CAA. Author: "Allegories of the Virtues and Vices in Mediaeval Art," 1939. Lectures: Mediaeval Art. Position: T., Vassar Col, 1940–43 [47]

KATZENSTEIN, Elizabeth. See Kaye, Mrs.

KATZENSTEIN, Irving [P,T] Hartford, CT b. 13 Je 1902, Hartford. Studied: Hartford A. Sch.; PAFA; Arthur Carles. Member: CAFA; Conn. WCS. Exhibited: PAFA, 1928, 1939, 1941; CAFA, 1930–45; Conn. WCS, 1937–45, 1937 (prize), 1939 (prize), 1942 (prize), 1944 (prize), 1945 (prize); Kraushaar Gal.; Mortimer Levitt Gal.; Wadsworth Atheneum, Hartford, 1938 (prize) [47]

KATZIEFF, Julius D. [P,E] Boston, MA/Rockport, MA b. 16 O 1892, Lithuania. Studied: BMFA Sch.; PAFA [25]

KAUBA, Carl [S] b. 1865, Austria d. 1922, Vienna. Studied: Austria, with C. Waschmann, S. Schwartz. Though not an American, Kauba traveled widely through the West, ca. 1895. In Vienna he cast bronzes of Indians from 1895–1912 for a receptive American market. [*]

KAUFER, Waldo Glover [E,Dr,P] Providence, RI b. 1 D 1906 Providence RI. Studied: J.R. Frazier; C. Hawthorne; S. Davis; RISD. Member: Providence AC [40]

KAUFFMAN, (Camille) Andrene [P,S,T,B] Chicago, IL b. 19 Ap 1905, Chicago, IL. Studied: AIC; Univ. Chicago; G. Oberteuffer; L. Kroll; André Lhote; AIC, 1926. Member: Chicago SA; Am. Assn. Univ. Prof.; Chicago NJSA; Am. A. Cong.; Un. Am. A. Exhibited: AIC, annually; WMAA, 1934; BM, 1934; Chicago SA, 1926–46. Work: WPA murals/ sculpture, USPO, Ida Grove, Iowa; medal, Rockford, Ill. Col.; Hirsch H.S.; Burbank Sch. Chicago; Lincoln Sch., Evanston, Ill.; Lowell Sch., Oak Park, Ill. WPA muralist. Positions: T., AIC (1926–), Rockford (Ill.) Col. (1943–) [47]

KAUFFMAN, G. Francis [I] Chicago, IL [21]

KAUFFMANN, Robert C. [I,Por.P] Flushing, NY b. Chicago, IL. Studied: AIC; Metropolitan A. Sch., NYC. Member: GFLA. Illustrator: covers, Saturday Evening Post, adv. posters [40]

KAUFFMANN, Samuel Hay [Patron] Wash., D.C. b. 30 Ap 1829, Wayne Co., OH d. 15 Mr 1906. President of Corcoran Gal. A. Authority on equestrian statues in America. Newspaper publisher in Ohio during the fifties; part owner of the Washington Evening Star at time of death.

KAUFMAN, Edwin [E,T] Sunnyside, NY b. 6 D 1906, Cleveland, OH d. 22 Jy 1939. Studied: H.G. Keller; H. Hofmann; H. De Waroquier; Munich; Paris; Agnes Gund Schol., 1929. Member: Cleveland PM; Cleveland Pr. C. Exhibited: Cleveland SA., 1929 (prize); lith., Cleveland Mus. A., 1931 (prize). Work: etching, Cleveland Mus. A. Illustrator: Chinese poems, "There are Numberless Steps" [38]

KAUFMAN, Enit [Por.P] NYC b. 28 F 1897, Rossitz, Czechoslovakia d. 17 Ja 1961. Studied: Europe; A. Hanak. Exhibited: Vienna, Austria, 1924; Gallery Tedesco, Paris, 1937; Columbia, 1930; NGA, 1944; BMA, 1945; Albany Inst. Hist. & A., 1945; de Young Mem. Mus., 1945; SAM, 1945; Univ. Ariz., 1946; Wichita, Kans., 1946; Gibbes A. Gal., 1946; Springfield A. Mus., 1946; Dayton AI. Work: N.Y. Hist. Soc. Co-author: "American Portraits," 1946 [47]

KAUFMAN, Gerald L. [En] NYC [19]

KAUFMAN, Joe [I] NYC b. 21 My 1911, Bridgeport, CT. Studied: Laboratory Sch. Indst. Des.; H. Bayer. Exhibited: A. Dir. C., 1943, 1944, 1945; SI, 1945. Illustrator: Collier's, Look. Work: MOMA [47]

KAUFMAN, John François [P,S,E] b. 31 O 1870, Uznach, Switzerland. Studied: Gérôme; Ecole Nationale des Beaux-Arts, Paris. Exhibited: Paris Salon, 1927. Work: War Dept., Wash., D.C.; Monumental Church, Richmond, Va.; bust, Poughkeepsie, N.Y. [33]

KAUFMAN, Maude [P] Richmond, IN [06]

KAUFMANN, Arthur [P,T] NYC b. 7 Jy 1888, Muehlheim, Germany. Studied: Europe. Exhibited: Marie Sterner Gal. (one-man); Stendahl A. Gal., Los Angeles (one-man); Ministry of Edu., Rio de Janeiro (one-man). Contributor: Fortune [47]

KAUFMANN, Ferdinand [P] Pasadena, CA b. 17 O 1864, Oberhausen, Germany. Studied: Paris, with Laurens, Constant, Bouguereau. Member: Paris AAA; Pittsburgh AA; North Shore AA; Laguna Beach AA. Exhibited: Pasadena AI, 1929 (prize); Calif. State Fair, Sacramento, 1935, 1939 (prize). Work: Municipal A. Gal., Davenport, Iowa [40]

KAULA, Lee Lufkin (Mrs. W.J.) [P] Boston, MA/New Ipswich, NH b. Erie, PA. Studied: C.M. Dewey, in NYC; Aman-Jean, in Paris. Member: NAWPS. Exhibited: CAFA, 1925 [40]

KAULA, William J(urian) [Ldscp.P] Boston, MA/New Ipswich, NH b. 1871, Boston. Studied: Mass. Normal A. Sch.; Cowles A. Sch.; Collin, in Paris. Member: Boston AC; NYWCC; Paris AA; Boston AA; Boston WCC; Boston GA; Boston SWCP; AWCS. Exhibited: P.-P. Expo, 1915 (med); Buffalo SA, 1924; CAFA, 1924 [47]

KAUMEYER, George F. [P] Chicago, IL [13]

KAUTZY, Theodore [P] NYC d. 1953. Member: AWCS. Exhibited: AWCS, 1933, 1936, 1937, 1938, 1939; NYWCC, 1934, 1936, 1937; Argent Gal., NYC, 1938 [47]

KAVANAOUGH, Brideen T. [P] Notre Dame, IN [17]

KAVANAUGH, Katherine (Mrs. William V. Cahill) [P] Chicago, IL b. 5

My 1890, Falmouth, KY. Studied: William V. Cahill. Member: Calif. AC; Laguna Beach AA [25]

KAVANAUGH, Marion. See Wachtel, Elmer, Mrs.

KAWA, Florence Kathryn [P,T,Des] Baton Rouge, LA b. 24 F 1912, Weyerhauser, WI. Studied: Milwaukee State T. Col.,; La. State Univ.; H. Thomas; R. von Neumann; C. Albrizio. Exhibited: Polish-Am. Exh., Milwaukee, Wis., 1940; NGA 1941; Jackson, Miss., 1942, 1943 (prize); MOMA, 1946; Wis. Salon A., 1938–40, 1944, 1945; Wis. State Fair, 1939 (prize), 1940; Wis. P.&S., 1933–40; Wis. A. & Cr., 1938, 1939; La. A. Comm., 1945 (prize); Milwaukee AI, 1938 (prize); Wis. Salon, 1939 (prize); Milwaukee City C., 1940 (prize); PBA, 1941 (prize). Work: New Roads Pub. Lib. Position: T., La. State Univ., 1942–46 [47]

KAWACHI, J(oseph) B(unzo) [I,C] NYC. b. 26 Je 1885, Toyoaka Tujima, Japan. Studied: Japan. Member: S.Indp.A. [24]

KAWAMURA, Gozo [S] NYC b. 15 Ag 1886, Japan. Studied: Ecole des Beaux-Arts, Paris; MacMonnies; Granville-Smith; T. Hastings; A. Proctor. Member: NSS; Am. Numismatic S. Work: Lithopolis, Ohio; American Jersey Cattle C.; Japanese Imperial Family; ideal type of cow and bull for Holstein-Friesian Assn. of America (to be placed in every college of agriculture in the U.S.) [47]

KAY, Gertrude Alice [P,I,Car] Alliance, OH b. Alliance, OH. Studied: H. Pyle. Member: NYWCC; Wash. WCC; Studio Gld. Exhibited: Wash. WCC, 1937, 1938; NYWCC, 1936, 1937; WC Ann., AIC, 1937; AWCS-NYWCC, 1939 [40]

KAYE, Elizabeth Gutman [P] Pikesville, MD b. 5 S 1887, Baltimore, MD. Studied: Md. Inst.; Whiteman; Breckenridge; Snell. Member: Friends of A., Baltimore [31]

KAYE, J. Graham [I] NYC. Member: SI [47]

KAYE, Joseph [P] Pittsburgh, PA. Member: Pittsburgh AA [25]

KAYN, Hilde B. [P] NYC b. 1903, Vienna, Austria d. 29 Ag 1950, Toledo, OH. Studied: ASL; G. Luks; G. Bridgman. Member: ANA; AWCS. Exhibited: NAWA, 1935–38; PAFA, 1938; CI, 1941; All.A.Am. (med); AWCS-NYWCC, 1939. Work: Toledo Mus. A.; Butler AI [47]

KAY-SCOTT, Cyril [P] NYC b. 3 Ja 1879, Richmond, VA. Studied: Colarossi Acad., Paris, with R. Fleury, Bonnât, Moreau, Quelvee. Work: Denver AM; murals, France, Algeria, Tunisia; portraits, eminent persons in Europe and America [40]

KAYSER, Louise Darmstaedter [P,I] San Jose, CA b. 26 Ap 1899, Mannheim, Germany. Studied: Europe. Exhibited: de Young Mem. Mus., 1942 (one-man); Oakland A. Gal., 1943; San Jose State Col., 1946; Munich Acad., 1922 (prize); State of Baden, 1928 (prize). Work: Mannheim; Karlsruhe; Baden-Baden A. Gal., Germany [47]

KAYSER, Stephen S. [Edu,W,L] San Jose, CA b. 23 D 1900, Karlsruhe, Germany. Studied: Classical State Sch., Karlsruhe; Univ. Heidelberg. Member: CAA. Contributor: Pacific Art Review. Positions: T., Univ. Calif., Berkeley (1941–44), San Jose Col. (1945–)[47]

KAZ, Nathaniel [S,C] NYC b. 9 Mr 1917, NYC. Studied: ASL, with G. Bridgman. Member: S. Gld. Exhibited: AIC, 1937–39; PMA, 1940; Univ. Gal., Lincoln, Nebr., 1945; Riverside Mus., 1943; WMAA, 1938, 1942–45; BM; Downtown Gal., N.Y., 1939; WFNY, 1939; Detroit Inst. A., 1929 (prize); AV, 1943 (prize). Work: BM; USPO, Hamburg, Pa. Position: T., ASL, 1946– [47]

KAZUKAWA, Suji [P] Chicago, IL. Member: Chicago NJSA [25]

KEAHBONE, George Campbell [P] Taos, NM. Exhibited: First Nat. Exh. Am. Indian Painters, Philbrook A. Center, 1946 [47]

KEALING, Ruth Elizabeth [P] Indianapolis, IN b. 23 Ja 1890, Indianapolis. Studied: E. Sitzman; A.R. Hadley. Exhibited: Ind. State Fair, 1931 (prize) [33]

KEALLY, Francis [Arch,Des,W] NYC/Darien, CT b. 3 D 1889. Studied: CI; Univ. Pa. Member: BAID; Arch. Lg.; Am. Inst. Arch. Exhibited: First Nat. Comp., Harrodsbrug, Ky. (prize); in collaboration with Trowbridge, Livingston, Oregon State Capitol (prize). Contributor: articles, American Architect, New York Times [40]

KEAN, Edmund A. (Reverend) [P,L] NYC b. 1893, Brooklyn d. 12 D 1927. Member: Soc. of St. Hilda (founder; organized to create interest in ecclesiastical art, on which he was an authority.)

KEANE, Frank M. [P] Coral Gables, FL b. 6 Je 1876, San Francisco, CA. Studied: San Fran. AA. Exhibited: Calif. State Fair, 1932 (prize). Work: Steinway Hall, N.Y. [40]

KEANE, Theodore J. [P] Chicago, IL b. 1880, San Francisco. Studied: Calif. Sch. Des.; AIC. Member: Palette and Chisel C.; Chicago SA; Cliff Dwellers; NAC; Attic C. of Minneapolis. Position: Dir., Keane's Art Sch., Toledo, Ohio [33]

KEARFOTT, Robert Ryland [I,Por.P,S] Mamaroneck, NY b. 12 D 1890, Martinsville, VA. Studied: Univ. Virginia; ASL; Bridgman; Miller; Hawthorne; Castelucho. Member: SC; A. Gld.; Studio Gld. Work: advertising illus., nat. magazines; cover des., Collier's. [47]

KEASBEY, Henry T(urner) [P] NYC/Marblehead, MA b. 23 S 1882, Phila. Studied: Herkimer; Brangwyn; Swan; Talmage. Member: North Shore AA [33]

KEASBY, William P. [I] East Cranford, NJ [19]

KEAST, Susette Schultz (Mrs. M.R. Morton Keast) [P] Phila., PA/Lumberville, PA b. Phila. d. 5 S 1932. Studied: Breckenridge; Anshutz; Chase; McCarter; F. Wagner; Phila. Sch. Design for Women; PAFA, 1912. Member: NAWPS; Phila. Alliance; Plastic C., Phila. Print C.; North Shore AA; Ten Phila. P. Exhibited: PAFA, 1932 (prize); Plastic C., 1922 (prize), 1926 (prize), 1928 (gold); NAWPS, 1929. Work: PAFA; F. PAFA; Phila. Sch. Arts for Women; Pa. State Col.; Franklin & Marshall Col.; Chattanooga Men's C. [31]

KEAST, William R. Morton [P,Arch] Phila., PA [19]

KEATING, Mary Aubrey (Mrs. Peter M.) [P,W,T] San Antonio, TX b. 25 S 1898, San Antonio d. 1953. Studied: self-taught; Notre Dame Col., Baltimore. Member: NAWA; SSAL; Tex. FA Soc. Exhibited: AWCS; PAFA; Painters of the Southwest; CM; AFA; one-man traveling exh., 1945; Ney Mus. A.; numerous one-man exh. in U.S.; Witte Mus., 1939; Argent Gal (one-man), 1939; NAWA, 1937 (prize), 1940 (prize); SSAL, 1946 (prize). Work: Gunter Hotel, Pub. Lib., Aviation Cadet Center, Hospital, USO, all in San Antonio. Author/Illustrator: "San Antonio," 1938. Position: T., Witte Mus., San Antonio [47]

KECK, Charles [S] NYC b. 9 S 1875, NYC d. 23 Ap 1951. Studied: NAD; ASL; AM. Acad. Rome; P. Martiny; A. St.-Gaudens; Greece; Florence; Paris. Member: NA, 1928; Arch. Lg., 1909; Numismatic S.; AFA; NSS; NAC; Century Assn. Exhibited: NAD; NAC; Arch. Lg., 1926 (prize); Century Assn.; State of N.Y., 1940 (prize). Work: Brookgreen Garden, S.C.; Hall of Fame, NYU; Hall of Fame, Richmond, Va.; busts, Charlottesville, Va.; Tuskeegee, Ala.; Buenos Aires; Robert Col., Constantinople; Irvington, N.J.; Inst. A. & Sc., Brooklyn, N.Y.; Binghamton, N.Y.; Springfield, Ohio; Ticonderoga, N.Y.; Yale C., NYC; Harrisonburg, Va.; Montclair, N.J.; Columbia; Forrest Hills, Stadium, N.Y.; Scranton, Pa.; Pittsburgh; Kansas City, Mo.; Lynchburg, Va.; Gold Dollar, San Francsico Expo.; State Edu. Bldg., Albany, N.Y.; Bridge, Pittsburgh; Pittsburgh City Hall; war mem., East Orange, N.J.; Duke Univ.; Nelson-Atkins Mus., Jackson County Court House, Kansas City; Bronx Co. Bldg.; Toronto, Canada; Times Square, NYC [47]

KECK, Josephine F(rancis) (Mrs.) [P] Santa Cruz, CA b. 12 F 1860, St. Mary's, PA. Studied: M. Brown; F.L. Heath; L.T. Latimer. Member: Santa Cruz AL [25]

KEEFE, Dan [I] NYC. Member: SI [47]

KEEFER, Elizabeth E. [E,T] Austin, TX b. 4 N 1899, Houston, TX. Studied: AIC; J. Pennell. Member: ASL of Chicago; ASL; PBC; Chicago SE. Work: 29 prints, Southwest Mus., Los Angeles; 18 prints, Mus. N.Mex.; NGA [40]

KEELER, Burton, Mrs. See Southwick, K.

KEELER, Charles B(utler) [Et,P,Des] Cedar Rapids, IA b. 2 Ap 1882, Cedar Rapids. Studied: Harvard; AIC; B.E. Jacques; Johansen. Member: Chicago SE; Calif. PM; New Haven PCC. Exhibited: Chicago SE, 1934 (med); Pasadena Pr.M.; Brooklyn Pr.C.; New Haven PCC; Smithsonian Inst.; Fifty Prints of the Year, 1927; Fine Prints of the Year, London, 1929; Los Angeles (one-man); San Fran. (one-man); St. Paul, Minn., 1915 (one-man) (med); Morocco; Spain. Work: St. Paul Mus.; LOC; Smithsonian Inst.; Los Angeles Mus. A.; AIGA; Pub. Lib., Cedar Rapids, Iowa; NGA [47]

KEELER, Grace (Mrs. John M.) [P] Baltimore, MD. Member: Baltimore WCC [29]

KEELER, Harold Emerson [B,Dr,En,Li,P,L] Denver, CO b. 9 O 1905, Denver. Studied: AIC. Member: Denver AG. Work: 3 lith., 1 woodblock, Denver A. Mus.; blockprint, State Hist. Mus. Colo.; SAM [40]

KEELER, Julia Annette [P,T] Deerfield, KS b. 4 N 1895, Garden City, KS. Studied: R. Reid; R. Davey; E. Lawson; Kans. Univ.; PIASch; Broadmoor

A. Acad. Exhibited: Iowa Artists C., Des Moines, 1934. Position: T., Callanan Jr. H.S. [40]

KEELER, Katherine Southwick (Mrs. R. Burton) [I,Car,P] Scarsdale, NY b. Buxton, ME. Studied: Chicago Acad. FA; AIC; PAFA; Cresson Traveling Schol., PAFA, 1911, 1913. Member: Scarsdale AA. Author/Illustrator: "Children's Zoo," 1942; "Dog Days," 1944; "Apple Rush," 1944; "Spring Comes to Meadow Brook Farm," 1946; other children's books [47]

KEELER, Louis Bertrand Rolston [P] Bethel, CT b. 9 N 1882, NYC. Studied: NAD. Exhibited: NAD; PAFA; Phila. WCC; AWCS; Conn. WCS [47]

KEELER, R. Burton [P,T,Des] Scarsdale, NY b. 5 Ap 1886, Phila., PA. Studied: PMSchIA; PAFA; Cresson Traveling Schol., PAFA, 1911, 1912. Member: Scarsdale AA. Exhibited: PAFA, 1912 (prize); NAC; WFNY 1939; Scarsdale AA. Position: T., Adult Sch., Scarsdale [47]

KEELEY, Lester (Mrs.) [P] Brooklyn, NY. Member: S.Indp.A. [25]

KEENAN, Armide Elizabeth [C] New Orleans, LA/Biloxi, MS b. 1 D 1910, New Orleans. Studied: Sophie Newcomb Col. Exhibited: book binding, NOACC, 1937 (prize). Specialty: hand book binding [40]

KEENAN, John S. [P] NYC [19]

KEENAN, Mary Winifred [S] Phila., PA [17]

KEENAN, Peter [Mur.P,Por.P,T,W,L] New Hope, PA b. 20 Ag 1896, Belfast, Ireland. Studied: Royal Hibernian Acad., Ireland; Slade Sch., London Univ.; Beaux-Arts, Paris. Member: New Hope Independents. Work: mural, Cardiff Univ. of Prince of Wales; Eifel Tower, London; Australian Gov.; French Gov.; British Gov.; Canadian Gov.; Midtown Gal., NYC. Position: Ed., New Hope Magazine of Art [40]

KEENER, Anna Elizabeth (Mrs. Wilton) [P,C,T,B] Portales, NM b. 16 O 1895, Flaglor, CO. Studied: Bethany Col.; AIC; Kansas City AI; Colo. State T. Col.; Univ. N.Mex.; B. Sandzen; R. Davey; others. Member: SSAL; AFA; Am. Assn. Univ. Prof.; Am. Assn. Univ. Women; Western AA; Nat. Edu. Assn.; New Mexico Edu. Assn. Exhibited: Mus. N.Mex.; Kansas City AI (med). Work: San Fran. Pub. Lib.; Vanderpoel Coll.; Sul Ross State T. Col.; McKinley County Court House, Gallup, N.Mex.; Bethany Col., Okla. Univ.; Lindsborg AC, Kans.; Texas Hist. S., Canyon, Texas. Author: "Spontaneity in Design." Position: T., Eastern New Mexico Col., 1942– . [47]

KEENEY, Anna [S] Chicago, IL b. Falls City, OR. Studied: A. Fairbanks; H.P. Camden; R. Stockpole; AIC; Calif. Sch. FA. Member: San Fran. S. Women A. Work: First National Bank, Condon, Oreg.; Univ. Oreg.; fountain, Stone Sch., Chicago [40]

KEEP, Helen Elizabeth [P] Detroit, MI b. 10 D 1868, Troy. Studied: AIC; MIT. Member: Detroit S. Women PS. Illustrator: "Shakespeare's England," William Winter [40]

KEEP, Peter (Miss) [S] Maplewood, MO b. 19 D 1909. Studied: St. Louis Sch. FA. Member: Am. Ar. Cong. Exhibited: City AM, St. Louis; St. Louis AG; WFNY, 1939. Position: T., St. Louis YMHA [40]

KEEP, Virginia. See Clark, Marshall, Mrs.

KEFFER, Frances [P,T] San Diego, CA b. 6 Ja 1881, Des Moines, IA d. 1954. Studied: PIASch; W. Robinson; Brangwyn; O. Linde. Member: San Diego A. Gld.; Laguna Beach AA; La Jolla A. Center; NAWPS; Wolfe AC; Ridgewood (N.J.) AA; A. Center of the Oranges. Exhibited: NAD; NAWA; CAFA; Newport AA; San Diego AG; Des Moines Women's C., 1912 (prize) [47]

KEGG, George W. [Cart,I,P,S,T] San Francisco, CA b. 27 O 1884, Wilmot, SD. Studied: R.L. Partington; P. Nahl; F. Meyers. Member: Calif. AA. Illustrator: West Winds, Coll. of Calif. Writers Stories; producer of "Marionettes." [40]

KEHM, Bimel [S,Des,W] New Canaan, CT b. 4 F 1907, Dayton, OH. Studied: Univ. Ill.; Académie Julian; Yale; BAID. Member: Arch. Lg. Exhibited: Arch. Lg.; NAD; All.A.Am. Work: USPO, Struthers, Ohio. Contributor: House & Garden, arch. magazines. WPA artist. [47]

KEHRER, F.A. [I] Columbus, OH. Member: Pen and Pencil C., Columbus [25]

KEILA, Louis [S] NYC [17]

KEISTER, Roy C. [P,I,E] Chicago, IL b. 2 Ja 1886, Germantown, OH. Studied: Wellington; Reynolds; Sterba; Clute; Shrader. Member: Palette and Chisel C. [33]

KEITH, Belle Emerson (Mrs.) [P,C] Rockford, IL b. 27 Ja 1865, Rockford. Studied: Carl Marr, in Munich [10]

KEITH, Dora Wheeler (Mrs. Boudinot) [P] NYC/Tannersville, NY b. 12 Mr 1856, Jamiaca, NY d. 27 D 1940 Studied: ASL; W. Chase; Académie Julian. Member: ANA, 1906; SAA, 1886. Exhibited: Prang Prize, 1885, 1886; Pan-Am. Expo, 1901; Columbian Expo, Chicago, 1893 (med). Work: portraits, BM; Boston Pub. Lib.; ceiling, Capitol, Albany, N.Y. [40]

KEITH, Elisha Boudinot [Ldscp.P] b. 1892 d. Winter, 1918, Tours, France, during WWI. Son of Dora Keith.

KEITH, Lawrence Augustus Haltom [Mur.P,Arch.C,L] Asheville, NC/Little Switzerland, NC b. 24 N 1892, Wilmington, NC. Studied: PIASch; D. Garber; PAFA. Member: Southern Arts S. Exhibited: Asheville AG, 1934. Position: A. Dir., Asheville A. Sch. [40]

KEITH, Susan Bacon [P] New Haven, CT/Holderness, NH b. 12 N 1889, NYC. Studied: B. Kendall; E. O'Hara. Member: Studio G.; So. County AA; Wickford, R.I. Exhibited: Studio G., 1938, 1940 [40]

KEITH, W. Castle [P] Syracuse, NY [10]

KEITH, Warren [P] NYC [21]

KEITH, William [P,En] San Fran., CA b. 21 N 1839, Aberdeenshire, Scotland (came to NYC in 1851) d. 13 Ap 1911, Berkeley, CA. Active as an engraver for Harper's until 1859 when he went to Calif., where he took up landscape painting. Made scenes for Northern Pacific Railroad; then studied in Munich from 1869–71, 1893. Studio in Boston with W. Hahn, 1871–72; returned to Calif., 1872; in New Orleans, 1880s. Deeply influenced by George Inness, who stayed at his studio in 1890. Exhibited: Pan-Am. Expo, Buffalo, 1901 (med). Work: CGA; AIC; San Fran. Inst. A.; Los Angeles Mus. A.; BM; Amon Carter Mus., many private gal. [10]

KELEMEN, Pál [W,H,L] Norfolk, CT b. 24 Ap 1894, Budapest, Hungary. Studied: Univ. Budapest; Munich; Paris. Member: F., Royal Anthropological Inst.; Societé des Americanistes, Paris. Author: "Battlefield of the Gods: Aspects of History, Exploration, and Travel of Mexico," 1937; "Medieval American Art, A Survey of pre-Columbian Art," 2 vols. [47]

KELLAYE, Blanche [P] Phila., PA. Member: Chicago WCC [15]

KELLEHER, Maude E. [S] Brooklyn, NY [17]

KELLER, Arthur I(gnatius) [I,P] NYC/Cragsmoor, NY b. 4 Jy 1866, NYC d. 1 D 1924, Riverdale, NY. Studied: NAD, with Wilmarth, Ward, 1883; Loefftz, in Munich, 1886–90. Member: AWCS; NYWCC; AI Graphic A.; NAC; SI, 1901; SC, 1900; GFLA; Lg. of AA. Exhibited: AC Phila. 1899 (gold); Paris Expo, 1900 (med); Pan-Am. Expo, Buffalo, 1901 (med); AWCS, 1902 (prize); St. Louis Expo, 1904 (prize); SC, 1914 (prize); P.-P. Expo, San Fran., 1915 (gold). Work: Munich Acad. Illustrator: "The Virginian," "The Right Way," Irving's "Legend of Sleepy Hollow," other books [24]

KELLER, Charles [P] NYC. Exhibited: Intl. WC Ann., AIC, 1939; 48 Sts. Comp., 1939; Young Am. Ar. Assn., Uptown Gal., 1940 [40]

KELLER, Charles Frederick [P] b. 18 Ag 1852, Milwaukee, WI d. 10 Jy 1928, Franklin Square, N.Y. Studied: Royal Acad. FA, Munich. Member: Am. Artists C., Munich (first Pres.) Exhibited: Munich; Paris; NYC

KELLER, Clyde Leon [P,T] Portland, OR b. 22 F 1872, Salem, OR. Studied: E.W. Christmas, in London; Bridges, in Munich; Knowles, in Boston. Member: S. Oreg. A.; Palette C. Work: Liberty Theatre; BPOE, Portland; Portland Press C.; Pub. Gal., Norway; landscapes, owned by Herbert Hoover and Franklin Delano Roosevelt [40]

KELLER, Deane [P,T] Hamden, CT b. 14 D 1901, New Haven. Studied: E.C. Taylor; E.F. Savage; Yale. Member: Mural P.; New Haven PCC; SC; F., Am. Acad., Rome. Exhibited: Grand Central A. Gal., 1926 (prize); New Haven PCC, 1926 (prize); 1934, 1936 (prize). Work: "Fascism," Italian Gov.; Yale; Masonic Temple, New Haven; Bishop Mus., Honolulu; Civilian Aid S., Boston; Yale Med. Sch.; City Hall, New Haven; Nat. Acad. Position: T., Yale [40]

KELLER, Edgar [P] NYC. Member: Phila. AC [25]

KELLER, Edgar Martin [P,S,I,E,T,Por.P,Ldscp.P] Hollywood, CA b. 12 S 1868, Crescent City, CA d. 10 Ja 1932. Studied: AIC. Member: Calif. AC. Work: tablets, Douglas Mem. Bridge, Klamath River; Downer Summit Bridge, Calif. State Highway. Illustrator: "Daddy Long Legs Fun Songs," "Yama Yama Land" [31]

KELLER, George [P] Hartford, CT. Member: CAFA [25]

KELLER, George Antone [S] Davenport, IA b. 3 Ja 1908, Davenport, IA. Studied: self-taught. Exhibited: Davenport Tri-City Exh., 1935 (prize); All-Iowa Exh., 1937 (gold); Kansas City AI, 1938 (prize). Work: Univ. Iowa [40]

KELLER, Henry George [P,Et,Li,T] Cleveland, OH b. 3 Ap 1870, Cleveland, OH d. 3 Ag 1949. Studied: Cleveland Sch. A.; Cincinnati A. Sch.; Bergman, Düsseldorf; Baische, Karlsruhe; Zügel, in Munich. Member: S. Cleveland A.; ANA, 1939. Exhibited: NAD; CI; AIC, 1929 (prize); CMA; PAFA; South America; Munich, 1902 (med); Cleveland Mus. A., 1919, 1922; Witte Mem. Mus., 1928 (prize). Work: AIC; CMA; MMA; BM; WMAA; BMFA; EMG; Oberlin Mus.; AGAA. Position: T., Cleveland Sch. A. [47]

KELLER, Joan Theresa [S] Miami, FL b. 30 N 1916, Cleveland, OH. Studied: M. Cramer; E. Burtis. Exhibited: S., Studio Gld., Miami, 1938 (prize); Fla. Bldg., WFNY, 1939. Work: Nat. Youth Cong. [40]

KELLER, John G. [P] Columbus, OH. Member: Columbus PPC [25]

KELLER, Marie De Ford [P,T] Baltimore, MD b. Germany. Studied: Shirlaw; Chase; Munich, with Dürr, Lenbach [25]

KELLEY, Albert Sumter [P,T,W] Jacksonville, FL b. 12 Ja 1909, Slocomb, AL. Studied: Ringling A. Sch.; ASL; Emory Univ.; G. Ennis. Exhibited: AWCS; NYWCC; Municipal A. Gal., NYC; Tallahassee Women's C., Fla. Work: murals, children's ward, Lincoln Hospital, N.Y. Position: Exh. Dir., Jacksonville A. Center [40]

KELLEY, Arlanna [P] Hartford, CT [19]

KELLEY, Gwendolyn Dunlevy [P] NYC b. Columbus, OH. Studied: Chicago; St. Louis; Paris; Rome [01]

KELLEY, Hannah Rusk [P] Phila., PA [01]

KELLEY, J. Redding [P] NYC. Exhibited: NAD, 1898; Phila. AC, 1898 [98]

KELLEY, May McClure (Mrs. William Fitch) [P,S] Wash., D.C./Rockville Pike, MD. Studied: Cincinnati A. Sch.; H. Vos; C. Hawthorne; B. Putnam; G.J. Zolnay; J. Davidson; A. Bourdelle. Member: Wash. AC; S. Wash. A. Work: bas-relief, Grace Coolidge, White House; Women's Universal Alliance, Wash., D.C. [40]

KELLEY, Sue E. [P,Des,C] Berkeley, CA b. CA. Studied: Martinez; Otis; Schrader; Hansen. Member: Calif. AA; Women P. of the West; Riverside AA. Work: Pub. Lib., Redondo [40]

KELLNER, Charles H(arry) [P] Chicago, IL b. 13 S 1890, Kasa, Czechoslovakia. Studied: W. Reynolds; V. Higgins; H. Lachman; P. Bonnard. Member: Chicago SA; N.Y. SA; Ill. Acad. FA; All-Ill. SFA; Chicago Palette and Chisel C.; Springfield AA; AAPL. Exhibited: murals, Ill. Bldgs., WFNY, 1939; GGE, 1939; Bellevue, France (prize); All-Ill., 1937. Work: U.S. Gov.; Univ. Ill., Champaign; Vanderpoel AA [40]

KELLOGG, Alfred Galpin [Por,P,T] Boston, MA b. 1888, Brookline, MA d. 22 Ap 1935. Studied: Paris, with Bashet, Royal. Member: Concord AA. Exhibited: Salon des Artistes Français, Paris. Position: T., Fessenden Sch. (West Newton, Mass.), Groton Sch. [25]

KELLOGG, Anna P. [P] Chicago, IL b. Chicago. Studied: AIC; Mrs. A.V.C. Dodgshun [08]

KELLOGG, Edmund P(hilo) [P,L,T] Chicago, IL b. 11 S 1879, Chicago. Studied: Freer; Duveneck; Chase; A. Herter; AIC. Member: Chicago AC; Chicago Arch. C. Work: St. Paul Inst.; Chicago Athletic Assn.; Indianapolis Athletic C.; Metro. Theatre, Boston; murals, Church of the Sacred Heart, Rochester, N.Y. Position: T., Chicago Acad. FA [40]

KELLOGG, Elizabeth R. [Des,W,L,T] Cincinnati, OH b. Cincinnati, OH. Member: Crafters Co. Specialty: metalwork. Position: Librarian, Cincinnati Mus. Assn., 1909–29 [40]

KELLOGG, Harriet B. [P] Elizabeth, NJ [01]

KELLOGG, Herbert Steele (Mrs.) [P] NYC [01]

KELLOGG, Janet Reid [P] Walton, CT b. 19 Ja 1894, Merrill, WI. Studied: AIC; Milwaukee-Downer Col.; Grande Chaumière, Paris; G.P. Ennis; G.E. Browne. Member: AWCS; All.A.Am. Exhibited: NAD, 1930 (prize); Milwaukee AI, 1929 (prize) [47]

KELLOGG, Jean [P] Wash. D.C. b. 16 Jy 1910, Berkeley, CA. Studied: ASL; Yale; CGA; PMG Sch.; P. Dougherty. Member: Carmel AA. Exhibited: Ferargil Gal., 1938 [40]

KELLOGG, Joseph Mitchell [Arch,P,T] Lawrence, KS/Laguna Beach, CA b. 26 S 1885, Emporia, KS. Studied: Univ. Kans.; Cornell. Member: AIA. Position: T., Univ. Kans. [40]

KELLOGG, Katherine L. [P] Brooklyn, NY [10]

KELLOGG, Martin [P] Hartford, CT. Exhibited: CAFA, 1936, (prize) [40]

KELLY, Annie D. [Ldscp.P] Wash., D.C. d. 3 Jy 1933. Member: Wash. WCC; S. Wash. A.; Wash AC [31]

KELLY, Clay [P] Chicago, IL b. 11 Je 1874, Jeffersonville, IN. Studied: NA. Member: Hoosier Salon. Exhibited: Hoosier Salon, 1938 [40]

KELLY, Edna [S] Long Beach, CA b. 23 Jy 1890, Bolivar, NY. Studied: Cincinnati A. Acad., E. Buchanan. Member: Calif. AC; Long Beach AA; Laguna Beach AC. Exhibited: Pomona-Los Angeles County Fair, 1927 (prize); P.-P. Expo, Long Beach, 1928 [40]

KELLY, Faustina James (Mrs. John H.) [E,P] Chicago, IL b. 1876, Dyersburg, TN. Studied: AIC; Chicago A. Acad.; Chase, in NYC. Member: Chicago ASL [13]

KELLY, Grace Veronica [P,I,W,T] Cleveland, OH b. 31 Ja 1884, Cleveland. Studied: H.G. Keller. Exhibited: CMA, 1924 (prize), 1925 (prize); Cleveland A.&Cr., 1930. Work: City of Cleveland; CMA. Position: A. Cr., Cleveland Plain Dealer [40]

KELLY, Hannah R. [Min.P] Phila., PA b. Paisley, Canada. Studied: Ontario Sch. A., Toronto; Paris, with Courtois, Girardot, Blanc [15]

KELLY, Herbert [P] NYC [10]

KELLY, J. Redding [P,L,T] NYC/Bass Rocks, MA b. NYC d. 8 D 1939. Studied: NAD. Member: Allied AA; SC; Ar. Fellowship, Inc. (Pres.) Work: "Abraham Lincoln," Encyclopaedia Britannica; Columbia; CCNY; 71st Regiment Armory. Position: T., Brooklyn Col., NYC [38]

KELLY, James Anthony [I] NYC. Member: SI [47]

KELLY, James E(dward) [S,I,P] NYC b. 30 Jy 1855, NYC d. 25 My 1933. Studied: NAD; ASL (a founder); T. Robinson; C. Hirschberg. Work: battle mon.; equestraian Gen. Sherman, Col. Roosevelt; Battlefield of Gettysburg; Columbia; relief, Edison with first phonograph. Illustrator: Harper's; etc, until 1881. [31]

KELLY, John Melville [E] Honolulu, Hawaii b. 2 N 1879, Oakland, CA. Studied: F.V. Sloan; E.S. Mackey. Member: Chicago SE; Calif. SE; Honolulu PM; Prairie PM. Exhibited: International PM, Los Angeles, 1934; Calif. PM, 1936; Honolulu PM, 1936 (prize), 1938 (prize); Calif. SE, 1937 (prize). Work: Fogg Mus.; NYPL; L.J. Rosenwald Coll.; NGA [40]

KELLY, John S. [P] Cleveland, OH. Member: Cleveland SA [27]

KELLY, Julia [P] Great Neck, NY. Member: S.Indp.A. [25]

KELLY, J. Wallace [S] Phila., PA. Exhibited: WMAA, 1934, 1936; WFNY, 1929. Work: Samuel Mem., Fairmount Park, Phila. [40]

KELLY, Leon [Mur.P,Dr,E] Phila. ,PA b. O 1901, Phila. Studied: PAFA; A.B. Carles. Work: WMAA; La France AI, Phila.; PAFA [40]

KELLY, Louise (Mrs. Edward P.) [P,L] Minneapolis, MN/Provincetown, MA b. Waukon, IA. Studied: AIC; PAFA; G.E. Browne; L. Richmond, London; France; Italy. Member: AFA; NAWPS; Chicago Gal. A.; Provincetown AA; Minneapolis SGA; Nat. Lg. Am. Pen. W. Exhibited: Nat. Lg. Am. Pen W., Chicago, 1933 (prize); Wash., 1934 (prize) [40]

KELLY, Loucile Jerome [P,T] San Angelo, TX b. 29 Ja 1913, San Angelo, TX. Studied: Newcomb Col., New Orleans; Ross Col., Alpine, Texas. Member: Tex. FAA; SSAL; San Angelo AC. Exhibited: All Texas. Ann., Houston MFA, 1940 (prize); SSAL, San Antonio, 1939 [40]

KELLY, Marie [P] Barrington, NJ [15]

KELLY, Paul Gregory [I,Car,G,T] Burlington, VT/Bomoseen, VT b. 9 Ja, 1908, Rutland, VT. Studied: ASL; New Sch. Des.; N.Y. Sch. F. Appl. A.; Forum Sch. A., N.Y. Member: Vt. AG. Illustrator: Saturday Evening Post, 1935, 1936; Judge, 1937. Position: T., Burlington Community A. Center [40]

KELLY, S.W. [P] Wash., D.C. [25]

KELMAN, Benjamin [P,Des,T] Chicago, IL b. 2 Ap 1887, Jassy, Romania. Studied: PAFA; AIC; Phila. Sch. F.&Appl. A.; NAD. Member: Palette, Chisel C., Chicago; Chicago Gal. Assn. Exhibited: A. Chicago, Vicinity, AIC, 1939 (prize); NA, 1919 (prize); GGE, 1939; WFNY, 1939. Work: AIC; Graphic Sketch C., Phila.; port., Metropolitan Opera, NYC [40]

KELPE, Karl [P,Mur.P] Chicago, IL. Exhibited: A. Chicago, Vicinity Ann.,

AIC, 1935, 1936; Fed. A. Prog. Exh., AIC, 1938; 48 States Comp., 1939. Work: USPO, Carthage, IL. WPA muralist. [40]

KELSEY, Muriel Chamberlain [S,P] Dobbs Ferry, NY b. Milford, NH. Studied: Univ. N.H.; D. Denslow. Member: Clay C. Sculpture Center. Exhibited: CAFA; PAFA; Newark Mus., 1943; Clay C., 1935–46 Work: Brookgreen Gardens, S.C. [47]

KELSEY, Richmond Irwin [B,Dec,L,P,T] Los Angeles, CA b. 3 My 1905, San Diego, CA. Studied: B. Browne; F. M. Fletcher; C. Paine ; A. Simmons; Otis AI; Santa Barbara Sch. of A. Member: San Diego FAS; Calif. PM. Exhibited: San Diego Expo, 1935 (med); WC Exh., Calif. State Fair, Sacramento, 1937. Work: San Diego FA Gal.; Smithsonian; murals, Rotary C., Santa Barbara. Position: Super., San Diego County Exh., Calif. Intl. Expo, 1935; Lay-out man, Disney Studios [40]

KELSO, Helen May [P,T] Syracuse, NY b. 6 D 1890. Studied: D. Craig ; AIC; Cleveland Sch. A.; Syracuse Univ.; Valparaiso Univ. Member: Syracuse AA; Daubers C., Syracuse; AFA; EAA. Exhibited: Syracuse Mus. FA, 1936, 1937 (prize). Position: T., H.S., East Syracuse [40]

KELSO, Ruth Cromble [P] Brooklyn, NY [15]

KEMBLE, E(dward) W(indsor) [I,Car,W] NYC b. 18 Ja 1861 d. 19 S 1933, Ridgefield, CT. Studied: self-taught. Illustrator: "Uncle Tom's Cabin," "Huckleberry Finn." Author: "Kemble's Coons," "Thompson St. Poker Club." Illustrator: Life, ca. 1883. Specialty: negro subjects [31]

KEMENY, John [P] Cleveland, OH. Member: Cleveland SA [27]

KEMEYS, Edward [S] Wash., D.C. b. 31 Ja 1843, Savannah, GA d. 11 My 1907. Studied: mostly self-taught, but did study Bayre's methods, Paris, 1877–78. Work: the "Still Hunt," Central Park, NYC; the "Wolves," Farimount Park, Phila. and the "Lions" in front of the AIC. A collection of fifty small bronzes is at the NGA. The first American sculptor to specialize in Western animals. He hunted buffalo with the Indians inside a wolf skin. [06]

KEMEYS, Laura S. (Mrs.) [S] Wash., D.C. b. Cumberland County, NJ. Studied: AIC, with E. Kemeys, L. Taft. Member: Wash. SA [15]

KEMP, Oliver [P,I,W] Detroit, MI/Bowerbank, ME b. 13 My 1887, Trenton, NJ d. 24 Ag 1934. Studied: H. Pyle; Chase; Gèrôme; Whistler; Abbey; Sargent. Member: Wilmington SA. Work: Gen. Charles P. Summerall; murals, "Ancient Mayans," New Mayan Theatre, Bay City, Mich.; Post Tavern, Battle Creek. Illustrator: text and covers, Scribner's, Harper's, Century, Colliers, Saturday Evening Post [33]

KEMPER, A.L. [S] Baltimore, MD [25]

KEMPER, John Garner [Edu,P,Des,L,W,Gr] Kalamazoo, MI b. 3 Je 1909, Muncie, IN. Studied: Ohio State Univ.; Chicago Acad.; Columbia. Member: CAA. Exhibited: Kalamazoo IA, 1943 (prize), 1944–46, 1946 (one-man); Detroit Inst. A., 1944; Western Mich. A., 1946; Butler AI, 1946; Professional Exh. Advertising A., Minneapolis, Minn, 1941 (prize). Work: murals, Avalon C., Cleveland. Position: T., Western Mich. Col., 1942– [47]

KEMPER, Ruby Webb [Por.P,I,En] Montclair, NJ. Studied: F. Duveneck; L.H. Meakin; T. Noble; Cinncinnati A. Acad.; H.L. Fry; W. Fry. Member: Cincinnati Women's AC [40]

KEMPF, F.P.T. [P] Chicago, IL [25]

KEMPF, Thomas M. [P] Chicago, IL [25]

KEMPF, Tud [S,T,L,W] Chicago, IL b. 22 O 1886, Jasper, IN. Member: Hoosier Salon; Chicago NJSA. Contributor: article in Popular Mechanics, Home Crafts, others. Specialty: woodcarving [40]

KEMPSON, Julie Hart (Mrs.) [P] Trenton, NJ b. 1835, Pittsfield, MA d. 13 Ag 1913. In mid 1850s came to NYC, with her two brothers, James and William Hart, both well-known painters, and her first husband, Mr. Beers. As Julie Hart Beers she exhibited landscapes at NAD, 1867; Boston Athenaeum, 1867–68

KEMPTON, Elizabeth A. [P,T] Washington, CT [17]

KEMPTON, Elmira [P,T] Richmond, IN b. Richomd, IN. Studied: Cincinnati A. Acad.; W. Adams; E. O'Hara; A. Krehbiel; J.R. Hopkins; H. Wessel; C. Barnhorn. Member: NAWA; Cincinnati Women's AC; Ind. AC; Richmond Palette C.; Hoosier Salon; WAA. Exhibited: NAWA, 1944–46; Argent Gal., 1944 (one-man); Ind. AC, 1944, 1946; Richmond AA, 1944–46; Hoosier Salon, 1943. Work: Richmond AA; Earlham Col. Position: Earlham Col., Ind., 1937– [47]

KEMPTON, Martha Greta (Mrs. A.M. McNamara) [P,T] NYC b. 22 Mr 1903, Vienna, Austria. Studied: NAD; ASL; Rauchinger; Willonce, Vienna. Member: Acad. Allied A. Exhibited: Grand Central Gal.; NAD; New Orleans, La. Work: Fleming Mus.; NAD; Lib., Univ. Vt. [47]

KENAH, Richard Hay [P,Mur.P,T] Vienna, VA b. 3 F 1907, New Brighton, PA. Studied: Antioch Col.; AIC. Member: Pittsburgh AA; Wash AG. Exhibited: CI, 1937 (prize); Pittsburgh AA, 1937 (prize); Beaver Co. Exh., Beaver, Pa., 1937 (prize); 48 States Comp., 1939 (prize); AIC; Wash. AG. Work: 100 Friends of A., Pittsburgh; PBA; murals, USPOs, Louisburg (N.C.), Bridgeport (Ohio), Bluefield (Va.); Westmoreland Homesteads, Pittsburgh, Pa. WPA muralist. [47]

KENDAL, H.H. [P] Boston, MA. Member: Boston AC [29]

KENDAL, Minerva [P] Wash., D.C.. Member: S. Wash. A. [25]

KENDALL, Beatrice [P,C,T,Dec] NYC b. 14 Ja 1902, NYC. Studied: Yale; Univ. London; W.S. Kendall. Member: Winchester F., Yale, 1922; NSMP; SAE; AFA. Exhibited: NAD; New Haven PCC; Ogunquit A. Center; CAFA; Newport AA; Brooklyn Botanical Gardens (one-man); Studio Gld. (one-man); Children's Center, NYC (one-man); New Haven PCC, 1926 (prize). Work: Lawrenceville, N.J.; Arnold Arboretum, Boston; Quinnipiac C., New Haven; New Haven Lawn C.; Lyman Allyn Mus. [47]

KENDALL, C.H. [I,En] NYC [01]

KENDALL, Elisabeth [P,S,I] New Haven, CT b. 22 S 1896, Gerrish Island, ME. Studied: Yale [25]

KENDALL, Joanna Gichner (Mrs.) [S,C] Baltimore, MD b. 25 My 1899, Baltimore. Studied: PAFA, with Grafly; Md. Inst. [25]

KENDALL, Kate [P] Cleveland, OH [01]

KENDALL, Louise L. [P] Providence, RI [01]

KENDALL, Margaret (Stickney) (Mrs.) [Min.P] Simsbury, CT b. 29 N 1871, Staten Island, NY. Studied: J.A. Weir; J. Rolshoven. Member: ASMP; New Haven PCC. Exhibited: St. Louis Expo, 1904 (med) [33]

KENDALL, Marie B(oening) (Mrs.) [P,L,T] Long Beach, CA b. 16 Ag 1885, Mt. Morris, NY. Studied: Los Angeles Col. FA; W. Chase; J. Mannheim. Member: Long Beach AA; NAWPS; Women P. of West. Exhibited: Southwest Expo, Long Beach (prize); Long Beach AA, 1936 (prize). Work: Ebell C., Long Beach, Calif.; T. Col., Mt. Pleasant, Mich.; Hollywood Riviera Clubhouse, Redondo, Calif.; Women's C., Riverside, Calif.; Women's C., Beaumont, Calif.; Los Angeles section, Chamber of Commerce, Chicago [40]

KENDALL, (William) Sergeant [P,S] Hots Springs, VA b. 20 Ja 1869, Spuyten Duyvil, NY d. 1938. Studied: ASL; Eakins, in Phila.; Académie Julian, Ecole des Beaux-Arts, Merson, all in Paris. Member: SAA, 1898; ANA, 1901; NA, 1905; NIAL; NYWCC; Century A.; Newport AA. Exhibited: Paris Salon, 1891; Columbian Expo, Chicago, 1893 (med); PAFA, 1894 (prize); Tenn. Centenn. Expo, Nashville, 1897; WMA, 1900 (prize), 1901; Paris Expo, 1900 (prize); CI, 1900 (med); Pan-Am. Expo, Buffalo, 1901(med) (prize); SAA, 1901 (prize), 1903 (prize); St. Louis Expo, 1904 (gold); NAD, 1908, 1927 (med); AIC, 1908 (prize), 1910 (gold), 1918 (prize); P.-P. Expo, San Fran., 1915 (gold,med); Miss. AA, 1926 (gold); Palm Beach A. Center, 1934 (prize). Work: PAFA; MMA; NGA; CGA; Detroit Inst. A.; RISD; Albright A. Gal., Buffalo; Col. Physicians and Surgeons, NYC; Peabody Inst., Johns Hopkins Univ.; Williams Col.; U.S. War Col., Newport, R.I.; St. Paul's Sch., Concord, N.H.; Yale. Position: Dean, Sch. FA, Yale, 1913–22 [38]

KENDE, Geza [P] Hollywood, CA b. 5 Ja 1889, Budapest, Hungary. Studied: Nat. Acad. A., Budapest; Italy; France. Member: Calif. AC; P.&S. C.; Soc. for Sanity in Art; AAPL. Exhibited: Los Angeles Mus. A.; P.&S. C., 1945 (med); Santa Cruz AL; Albright A. Gal.; Soc for Sanity in Art, Los Angeles, 1943 (prize), 1944 (prize), 1945 (prize); AAPL, 1945 (prize); Oakland A. Gal., 1946 (med) [47]

KENDRICK, Charles [I] Brooklyn, NY d. 16 Je 1914. Position: Staff, Leslie's

KENDRICK, E.A. [P] Odell County, NY [24]

KENNARD, Joseph Spencer, Jr. [P] Paris, France. Member: Phila. AC [17]

KENNE, K. [S,P] Eagle Harbor, MI b. Port Huron, MI. Studied: S. Cashwan; S. Jacobsen; A. Armstrong. Exhibited: Detroit Inst. A.; WFNY, 1939 [40]

KENNEDY, Andrew Dwight [P] Cleveland, OH. Member: Cleveland SA [27]

KENNEDY, Clarence [Edu,Photogr] Northampton, MA b. 4 S 1892. Studied: Univ. Pa.; Harvard; Am. Sch. Classical Studies, Athens. Member: Guggenheim F., 1930; F. CAA, 1931; Norton F., 1920. Illustrator/Editor:

"Studies in the History & Criticism of Sculpture," vols. 1–7, 1927; "Sculpture of the Dreyfuss Collection," 1930. Specialty: photographing the sculpture he wrote about. Position: T., Smith Col., Mass., 1924 [47]

KENNEDY, Dawn S. [P,L,T] Montevallo, AL b. Crawfordsville, IN. Studied: PIASch; Columbia. Member: SSAL; Southeastern AA; Ala. AL; Ala. WCS; Birmingham AC; Nat. Edu. Assn.; Col. AA. Exhibited: Birmingham AC; Ala. WCS; Ala. AL. Contributor: Design magazine (Guest Ed., D 1945). Position: T., Ala. Col., 1934– [47]

KENNEDY, Doris [P] Edmond, OK [24]

KENNEDY, Edward Guthrie [Patron,Dealer,W] NYC b. 1849, Garvagh, Ireland (came to Boston in 1867) d. 8 O 1932. A close friend of Whistler, he compiled the monumental illus. catalogue of Whistler's etchings during his term as president of the Grolier C., in 1910. In 1928, he presented a bust of the artist to NYU. He gave a group of cloissonés and Japanese priest robes to MMA (1929). Position: Hd., Kennedy & Co., 1877–1916

KENNEDY, Edward L. [P] Buffalo, NY [17]

KENNEDY, Ginevra [Min.P] NYC [10]

KENNEDY, (John) William [Ldscp.P,Por.P,T,L] Champaign, IL b. 17 Ag 1903, Cincinnati, OH. Studied: Cincinnati A. Acad.; CI; H.H. Wessel; J.E. Weis; N. MacGilvary; E. Asche. Member: Beachcombers' C.; Provincetown AA. Exhibited: CGA, 1937; PAFA, 1937–39; Toledo Mus. A., 1937; CM, 1936, 1937; VMFA, 1938; GGE, 1939; AFA Traveling Exh.; Soc. Four A., Palm Beach, Fla.; Milwaukee AI, 1944; Decatur A. Center, 1943, 1944 (prize), 1945; Chicago Gal. Assn., 1942 (prize). Work: Wash. Sch.; Withrow H.S., Cincinnati. Position: T., Univ. Ill., 1926–46 [47]

KENNEDY, Lawrence [P] Hinsdale, IL b. 31 O 1880, Pittsburgh, PA. Studied: AIC. Member: Chicago SA; Cliff Dwellers [33]

KENNEDY, Leta M. [C,Des,L,E,B,T,Dr] Portland, OR b. 4 Jy 1895, Pendleton, OR. Studied: Portland Mus. A. Sch.; T. Col., Columbia; H. Rosse; H. Hofmann; Moholy-Nagy. Member: Portland AA; Oreg. Cer. Studio; Portland AG. Exhibited: Phila. A. All., 1939; Oreg. Cer. Studio, 1946; Northwest Pr.M., 1938 (prize), 1939; Portland Mus. A.; Seattle AM, 1938 (prize) Position: T., Mus. A. Sch., Portland [47]

KENNEDY, Martha [P,Des,T] Roswell, NM b. 3 S 1883, Roswell, NM. Studied: K. Cherry; W.K. Titze; A. Hills. Exhibited: N.Mex. Mus.; Roswell Mus.; Melrose Fed. A. Center, N.Mex.; Pacific Expo, Long Beach, Calif., 1928 (prize). Position: Dir., Melrose A. Center, N.Mex. [40]

KENNEDY, Owen W. [P] Boylston, MA b. 26 My 1891, Wash., D.C.. Studied: WMA A. Sch., Mass. Member: Business Men's AC, Boston [31]

KENNEDY, Ruth Edwards [S,T] Dunstable, MA b. 12 Ja 1910, Antrim, NH. Studied: R.A. Porter; C.E. Dallin; Mass. Sch. A. Member: Lowell AA. Work: war mem., Dunstable [40]

KENNEDY, Sam(uel) J(ames) [P] Chicago, IL/Laguna Beach, Calif. b. 7 Je 1877, Mt. Pleasant, MI. Studied: H. Martin. Member: Chicago SA. Work: Mt. Pleasant Pub. Gal.; Lib., Mich. Agricultural Col. [25]

KENNEDY, William [P] Champaign, IL. Exhibited: VMFA, 1938; PAFA, 1939 [40]

KENNEL, Louis [P,Dr,I,Dec,Des,L,T] Dumont, NJ/Hainesville, NJ b. 7 My 1886, North Bergen, NJ. Studied: G. Bridgman; W.H. Lippincott; G. Melrose; E. Gros. Member: Un. Scenic AA. Work: Center Theater, NYC; scenic display, Electric Utility Bldg., WFNY, 1939. Position: Des., stage scenery [40]

KENNICOTT, R.H. [P] Los Angeles, CA b. 3 Mr 1892, Luverne, MN. Member: Calif. AC; FAS, San Diego; Calif. WCS; Laguna Beach AA [40]

KENNON, Raymond Kenneth [P,C,Des,Arch] Springfield, MO b. 28 F 1903, Dunnegan, MO. Member: Ozark AA (Pres.). Exhibited: Philbrook A. Center; CAM; William Nelson Gal.; Little Rock A. Mus.; Springfield A. Mus., 1936 (prize), 1939 (prize), 1940 (prize), 1941 (prize), 1943 (prize); Mo. State Fair, 1940 (prize). Work: Springfield A. Mus. Position: T./Founder: Ozark A.&Cr. Center, Springfield, Mo. [47]

KENNY, John A. [I] NYC. Member: SI [47]

KENSETT, John Frederick [Ldscp.P,En] b. 22 Mr 1816, Cheshire, CT d. 14 D 1872, NYC. Studied: engraving, with his father, Thomas [1786–1829], his uncle, Alfred Daggett [1799–1872], in New Haven; Europe, 1840–47. Member: NA, 1849. One of the leading landscape painters of the Hudson River Sch., he painted extensively throughout New England. In Colo., 1866. [*]

KENT, Ada Howe [P] Carmel Highlands, CA b. 1858, Rochester, NY d. 29 Je 1942, Rochester. Studied: Brush; Abbott; Thayer; Whistler, in Paris. Member: AWCS. He gathered together a large coll. of Japanese prints. [27]

KENT, Adaline (Mrs. Robert B. Howard) [S,P] San Fran., CA b. 7 Ag 1900, Kentfield, CA. Studied: Vassar; Calif. Sch. FA; Grande Chaumière, R. Sheldon, A. Bourdelle, all in Paris; R. Stackpole. Member: San Fran. AA. Exhibited: WFNY, 1939; San Fran. AA, 1935–46; Palace Legion Honor, 1946; SFMA, 1937 (prize); West Coast Ceramic Exh., 1945 (prize); GGE, 1939; Los Angeles Mus. A. Work: Stanford Univ.; Mills Col.; SFMA [47]

KENT, Dorothy [P] Tarrytown, NY [21]

KENT, Dorothy C(urtis) [P] Springfield, PA b. 12 Ja 1892, Pittsburgh, PA. Studied: L. Raditz. Member: Phila. Alliance [25]

KENT, F.M. Rich [P] Brooklyn, NY [10]

KENT, Frances Adams [S] Bronxville, NY. Studied: S. Borglum; M. Young. Work: CMA; war mem., New Canaan, Conn.; war mem., New Rochelle, N.Y. [25]

KENT, Frank Ward [P,Gr,I,T] Syracuse, NY b. 16 F 1912, Salt Lake City, UT d. 1977. Studied: Univ. Utah; ASL; Syracuse Univ. Member: Am. Assn. Univ. Prof.; Utah A. Colony; Syracuse AA; Syracuse Pr.M. Exhibited: SFMA, 1934; Springville, Utah, 1934–40; Univ. Utah, 1935 (prize), 1936, 1939, 1940; All-Ill. Exh., 1940, 1942; Peoria AL, 1940–43; Syracuse AA, 1945, 1946; Kansas City AI, 1904; Decatur, Ill., 1942; Heyburn, Idaho, 1934 (prize). Work: Univ. Utah; Heyburn, Idaho; Bradley Polytechnic Inst., Ill. Position: T., Syracuse, Univ. [47]

KENT, Margaret Louise [Des,T] Topeka, KS b. 14 S 1913, Clovis, NM. Studied: Washburn Col., Topeka. Exhibited: Kans. Free Fair, Topeka; Mulvane AM, Topeka; Univ. Colo. A. Gal., 1938. WPA artist. Position: T., Community A. Center, Topeka [40]

KENT, Norman [I,T,L,B,En,P,W] NYC b. 24 O 1903, Pittsburgh, PA d. 1972. Studied: Rochester Inst. Tech.; ASL; A. Lewis; L. Hoftrup; Clifford Ulp. Member: ANA; SC; Prairie Pr.M.; Phila. WCC; Print C., Rochester. Exhibited: CGA, 1940; Venice, Italy, 1940; NAD, 1944, 1945; PAFA, 1945; NAD, 1930–46; Milwaukee AI (one-man); Am. A. Gal., Rochester (one-man); Albright A. Gal., Buffalo (one-man); Univ. Rochester, 1929 (prize); Phila. Pr. C., 1941 (prize). Work: Rochester Mem. A. Gal.; Rochester Inst. Tech.; CMA; BMA; Syracuse Mus. FA; Milwaukee AI; NYPL; LOC; CI; Nat. Gal., Canada; Rochester Pub. Lib.; Hobart Col.; William Smith Col. Author/Co-editor: "Drawings by American Artists," 1946. Specialty: wood engraving. Positions: T., Hobart Col.; William Smith Col.; Managing Ed., American Artist, 1943 [47]

KENT, Rockwell [En,Li,P,Mur,P,I,W,L,B] Au Sable Forks, NY b. 21 Je 1882, Tarrytown Heights, NY d. 1971. Studied: Columbia; Chase, 1897–1900; Henri; A. Thayer; K.H. Miller. Member: A. Lg. Am. (Pres.); Am. Ar. Cong.; Un. Am. Ar. Work: MMA; AIC; BM; CGA; PMG; murals, USPO, Fed. Bldg.; WMAA; large coll. of prints, etchings. Author/Illustrator: "Wilderness" (1920), "Voyaging" (1924), "N by E" (1930), "Salamina" (1935), "It's Me O Lord" (autobiography, 1955). Illustrator: "Candide," "Moby Dick," "Canterbury Tales," "Venus and Adonis," "Beowulf," "Leaves of Grass," works of Shakespeare. WPA artist. Kent's communist affiliations were well-known. He won the Lenin Peace Prize, 1967. [47]

KENYON, Henry R. [P] Ipswich, MA d. 16 Ja 1926. Member: Providence AC; North Shore AA. Work: RISD

KENYON, Norman [P,I,Des] Chappaqua, NY. b. 7 Ja 1901, Holyoke, MA. Studied: PIASch. Member: SI; AG. Exhibited: NAD, 1932, 1933; A. Dir. C., 1929, 1930, 1935. Work: Army Air Corps; U.S. Maritime Comm.; Wartime Shipping Admin. Illustrator: Cosmopolitan, Collier's [47]

KENYON, Zula [P] Chicago, IL. Studied: AIC [08]

KEPLINGER, Lona Miller [P] Bethesda, MD. Member: S. Wash. A.; Wash. WCC. Specialty: flower painting [40]

KEPPLER, George [S] Providence, RI b. 22 Ja 1856, Germany. Studied: Baden; Berlin [24]

KER, Balfour [I] NYC [19]

KER, Marie Sigsbee. See Fischer, A.O., Mrs.

KER, William B. [I] NYC [08]

KERBY, Kate (Mrs. Philip H.) [Cr] d. 19 My 1936, Severna Park, MD. Contributor: newpapers and magazines in this country and abroad. Author: "A Chinese Garden," critical essays on Oriental Art, approved by the NAC as the most beautiful book of the year.

KERFOOT, Margaret [P,T] Meadville, PA b. 4 Jy 1901, Winona, MN. Studied: Hamline Univ.; AIC; N.Y. Sch. FA, Paris; Univ. Iowa, with G. Wood; Harvard. Member: Western AA; Minn. AA. Exhibited: Kansas City AI, 1937; AIC, 1936; Minn. State Fair, 1934–41; Minn. Inst. A., 1935–41; North Shore AA, 1936 (prize). Positions: T., Carleton Col. (1937–45), Allegheny Col. (1945–46) [47]

KERIGAN, Ambrose, Jr., Mrs. See Post, Mildred.

KERKAM, Earl [P] NYC b. 7 O 1890, Wash., D.C. d. Ja 1965. Work: Pa. Mus. A. [40]

KERLIN, Laura L. [P] Wash., DC (living in Chester, PA, 1908) [13]

KERN, Josephine M. [S] Chicago, IL [21]

KERNAN, Joseph F. [P,I,T] NYC b. 13 S 1878, Brookline, MA. Studied: E. Pape. Member: AG. Specialty: nat. advertising and mag. covers [40]

KERNODLE, Ruth [P] Lawrence, KS [17]

KERNS, Fannie M. [P,T] San Marino, CA b. CA. Studied: A.W. Dow; S.M. Wright; L. Katz; Columbia. Member: Pacific AA; Calif. ATA; Pasadena FAC; San Gabriel AG. Position: T., Pasadena Sch., Calif.; A. Center, Los Angeles [40]

KERNS, Maude I(rvine) (Mrs.) [P,T,Des,B] Eugene, OR b. 1 Ag 1876, Portland, OR. Studied: Univ. Oreg.; Columbia; Acad. Moderne, Paris; W. Dow; R. Johonnot; Chase; E.A. Taylor; H. Hofmann. Member: AAPL; Oreg. SA; Calif. WCS; Kansas City Pr. C. Exhibited: NGA; Mus. Non-Obective Painting, 1941–46; Denver A. Mus.; Oreg. Gld. P.&S.; Calif. WCS; SAM, 1946 (one-man); Studio Gld., NYC, 1939; Alaska-Yukon Expo, Seattle, Wash. Work: Murray Oriental Mus., Eugene.; SAM; Mus. Non-Obective Painting, NYC. Position: T., Univ. Oreg., 1921–46 [47]

KERR, Blanche Weyburn (Mrs.) [P,Dec,T] Oak Park, IL b. 18 Jy 1872, Rockford, IL. Studied: AIC. Member: Oak Park, River Forest AL; All Ill. SFA; Soc. Sanity in A.; Chicago AC. Exhibited: Soc. Sanity in A.; Chicago AC. Work: Vanderpoel Mem. Gal. Position: T., Home C. Studio [40]

KERR, Bobbie Gladys [P,G,Dec] Wash., DC b. 24 Ag 1910, Pittsburgh, PA. Studied: Critcher Sch., Wash., D.C.; Cincinnati A. Acad.; Corcoran Gal. Sch. Exhibited: PMG; CGA, 1937, 1939; Georgetown, Gal., Was., D.C. (one-man) [40]

KERR, Chester (Mrs.) [P] NYC. Member: S.Indp.A. [25]

KERR, Edward T. [Por.P] NYC b. 1862 d. 10 Ap 1907 (suicide)

KERR, George F. [I] Bronxville, NY. Member: SI, 1913. Position: N.Y. Journal [47]

KERR, Irene Waite [P,L,T] Oklahoma City, OK b. 11 Ja 1873, Pauls Valley, OK. Studied: Walcott; Clarkson; Chase; J. Fraser; DuMond; F.L. Mora. Member: Okla. AA. Exhibited: Okla. State Fair (prizes) [24]

KERR, James Wilfrid [P,Et,L,W,G] Waldwick, NJ b. 7 Ag 1897, NYC. Studied: NY Sch. F.&App. A.; H. Giles; M. Maroger; Camille Egas. Member: EAA; WAA; Ridgewood AA; N.J. S. P.&S.; Am. Veterans SA. Exhibited: NAD, 1944, 1945 (prize); All.A.Am., 1944, 1945; Am. Veterans SA, 1944, 1945; VMFA, 1946; Ridgewood AA, 1940–46; N.J. P.&S., 1945, 1946; Plainfield AA, 1946. Co-Illustrator: "Historic Design for Modern Use," 1939. Contributor: School Arts mag. Position: Mgr., Fairbairn Publishers [47]

KERR, Mary S(eymour) [Por.P] Whitney Point, NY b. 28 Jy 1888, Norwalk, CT. Studied: A. Sterner [25]

KERR, Robert Scott [P] Chicago, IL. Member: Chicago NJSA [25]

KERRICK, Arthur T. [P] Minneapolis, MN. Exhibited: Twin City Ann., Minneapolis Inst. A., 1938; WS Ann., PAFA, 1930; Intl. WC Ann., AIC, 1938; Midwest A. Ann., Kansas City AI, 1939 [40]

KERTESZ, André [Photogr] NYC (1985) b. 1894, Budapest (came to Paris in 1925; to NYC ca. 1936). Exhibited: Julian Levy Gal., NYC, 1937; AIC, 1946; Long Island Univ., 1962; Bibliothèque Nationale, Paris, 1963; MOMA, 1964; Photogr. G., London, 1972; MMA, 1985. Work: Detroit IA; MMA; MOMA; NOMA; WMA; most major mus. Became free-lance photographer in Paris, 1925; contract with Condé Nast pub., 1949–62. Like Cartier-Bresson, an important photographer of the "decisive moment" and formal invention. Well known in Paris, it was not until the late 1970s that his work began to be widely recognized in U.S. He was shot in the heart during the war in Hungary, 1914. Book: "Andre Kertesz, Sixty Years of Photography," 1972 [*]

KERWIN, Mary Catherine [Min.P] Los Angeles, CA b. 12 N 1902, MI. Studied: E.S. Bush. Member: Calif. SMP; Women P. West. Work: Calif. SMP, Los Angeles Mus. A. [40]

KERZESKE, Ralph [P] Pittsburgh, PA. Member: Pittsburgh AA [17]

KESKULLA, Carolyn Windeler [Et,Li,P,T] Dunellen, NJ b. 20 Ja 1912, Farmingdale, NJ. Studied: ASL; PIASch; NYU. Exhibited: SFMA, 1942, 1943; Okla. Lith. Exh., 1942; Phila. Pr. C., 1943; Tex. FAC, 1943; LOC, 1943; Newark Mus., 1940, 1941; Montclair A. Mus., 1939, 1940, 1946; CMA, 1942, 1943, 1945; Butler AI, 1943; Ohio Pr.M., 1941–43; Parkersburg, W.Va., 1942–45 [47]

KESLER, Clara E(lise) [P,I] Minneapolis, MN b. 23 Jy 1910, Minneapolis, MN. Studied: Y. Kuniyoshi; C. Wells; R.L. Turner. Member: ASL; Artist Un. N.Y. Exhibited: 17th Ann. Exh. of Minneapolis, St. Paul Artists, Minneapolis Inst. A., 1932 (prize) [40]

KESSEL, Therese Woodleaf [P,T,C] NYC/Bearsville, NY b. 13 F 1883, Brooklyn, NY. Studied: Vassar Col.; Columbia. Member: NAWA. Exhibited: NAWA, 1938–44, 1946; NYWCC, 1940; AWCS, 1940; Woodstock AA, 1941; Buck Hill Falls, N.Y., 1945. Position: T., George Washington H.S., NYC, 1929–46 [47]

KESTER, Lenard [P] Los Angeles, CA b. 10 My 1913, NYC. Studied: CUASch. Exhibited: AIC, 1945, 1946; San Diego FA S., 1941; CI, 1946; SFMA, 1946; Los Angeles Mus. A., 1941, 1942, 1943 (prize), 1944–46; Oakland A. Gal., 1943 (prize), 1944 (prize), 1945, 1946; de Young Mem. Mus., 1946 (one-man); NAD, 1947; PAFA, 1947 [47]

KESZTHELYI, Alexander Samuel [Por.P,E,T] Los Angeles, CA b. 23 Mr 1874, Sambor, Poland. Studied: Acad. FA, Vienna; Acad. FA, Munich; Herterich, in Munich; Leefler. Member: Los Angeles AA; Calif. AA. Exhibited: San Diego FA Soc.; Blanchard Hall, Los Angeles (one-man); Los Angeles Mus. A.; Coronado, Glendale, both in Calif.; Intl. Exh., Budapest, 1903 (prize); Vienna, 1903 (prize); Winnipeg, Canada, 1909 (gold,med). Work: CA; State Capitol, Winnipeg; Superior Court, Los Angeles; Paramount Pictures, Hollywood; County of Maramares, Hungary [47]

KETCHAM, Austin [P,Dec,T] Kansas City, MO b. 29 O 1898, Richmond Hill, NY. Studied: AIC; Lewis Inst.; B.E. Perrie; J.W. Norton; R. Davey. Member: Kansas City SA. Exhibited: Mo.-Kans.-Okla. Exh., 1923 (prize); Kansas City SA, 1930 (prize). Work: Pembroke Country Day Sch.; Chamber of Commerce, Kansas City; Belmont Christian Church, Kansas City. Position: T., Kansas City AI [40]

KETCHAM, Howard [L,T,W,Des] NYC/Ridgefield, CT b. 4 S 1902, NYC. Member: Scarab C. Exhibited: Am. Management Assn., 1937 (prize) (for packaging). Work: color schemes, Flying Clipper ships, Pan-Am Airways. Contributor: articles on color, Harper's; Reader's Digest, 1937. Specialty: color engineering. Position: Dir., Colorcode Corp. [40]

KETCHAM, Merrill [P] Indianapolis, IN [13]

KETCHAM, Rosemary [Des,C,L,T] Lawrence, KS b. Springfield, OH d. 17 Jy 1940. Studied: A. Dow; Columbia; D. Ross; Harvard; N.Y. Sch. Des. for Women; PIASch; F. Brangwyn; Westminster Tech. Inst., London. Member: AFA; Col. AA; S. of Med.; Kans. State Fed. A.; AAPL; Western AA. Exhibited: Midwestern Artists' Exh., Kansas City, Mo., 1922. Contributor: articles, Design, Everyday Art. Position: T., Univ. Kans. [40]

KETCHAM, Roy A. [P] Chicago, IL. Member: Hoosier Salon. Exhibited: Hoosier Salon, 1937 (prize) [40]

KETCHAM, Susan M. [P] NYC/Ogunquit, ME b. Indianapolis, IN. Studied: ASL, with Chase, Bell; AIC. Member: NAWPS. Exhibited: N.Y. Women's AC, 1908 (prize). Work: Herron AI, Indianapolis [29]

KETCHAM, Elizabeth B. [P] NYC [06]

KETO, Henry [P] Cleveland, OH b. 24 Jy 1917. Studied: Cleveland Sch. A. Exhibited: Cleveland M.; Butler AI, Youngstown, Ohio [40]

KETTEN, Maurice [I,P,Cart] NYC b. 2 Mr 1875, Florence, Italy. Studied: Ecole des Beaux-Arts, Paris, with Cabanel, Delaunay, Moreau. Member: SI. Illustrator: "Can You Beat It," "Such is Life," "The Day of Rest." Contributor: daily cartoons, World-Telegram [47]

KETTERER, Gustave [P,C,Dec,Des] Phila., PA b. 20 My 1870, Germany. Studied: PAFA. Member: T. Sq. C.; AIA. Work: Int. dec., Detroit Mus.

A.; Indianapolis Lib.; Hartford County Court House; murals of Keneseth of Israel Temple; dec., Persion Bldg., Sesqui.-Centenn.; interior, Heinz Auditorium, Pittsburgh; Chapel, Episcopal Divinity Sch., Phila.; Hershey (Pa.) Auditorium; dec., new Fed. Reserve Bank, Wash., D.C.; dec., "Tower of Learning", Univ. Pittsburgh; Dept. Bldg., Justice Bldg.; Bureau of Arch., Wash., D.C. [40]

KEUHNE, Max [P] NYC b. 7 N 1880, NYC. Studied: K.H. Miller; Chase; Henri [21]

KEUPING, Victor L. [I,E,B] Dayton, OH b. 12 S 1903, Dayton. Studied: Dayton AI; Sauer; Blau; N. King. Member: Dayton SE; Dayton A. Center. Illustrator: "White Smoke Over the Vatican," 1943. Position: A. Dir., Pflaum Publ., Inc., Dayton, 1943– [47]

KEVORKIAN, Mihran H. [Min.P] Phila., PA [10]

KEY, John Ross [P,I] Boston, MA b.16 Jy 1832, Hagerstown, MD d. 24 Mr 1920 Baltimore. Studied: Munich; Paris. Member: S. Wash. A.; Boston AC. Exhibited: NAD; PAFA; Boston Athenaeum; Centennial Expo, Phila., 1876 (med). Work: CGA. Grandson of the author of "The Star Spangled Banner." [17]

KEY, Mabel [P,T] Chicago, IL b. 1874, Paris, France d. 6 Jy 1926. Member: Chicago AC. Exhibited: St. Paul Inst., 1915, 1916 (med); Milwaukee AI, 1917; Wis. PS, 1919 (med); Chicago SA, AIC, 1923 (prize). Position: T., AIC [25]

KEY, Rae (Mrs. Edmund, Jr.) [P,S] Marshall, TX b. Marshall. Studied: self-taught. Member: SSAL [33]

KEY, Theodore [I,Cart,W] NYC b. 25 Ag 1912, Fresno, CA. Studied: Univ. Calif., Col. A. Member: Cart. Gl. Contributor: New Yorker, Collier's, Saturday Evening Post [40]

KEYES, Alicia M. [P] Concord, MA. Member: Concord AA [25]

KEYES, Bernard M. [P,L,T] Waltham, MA b. 27 Ag 1898, Boston, MA d. 1973. Studied: BMFA Sch. Member: ANA, 1938; Boston AG. Exhibited: CGA, 1937 (prize); NAD, 1938 (prize). Work: Emerson Col., Boston; Holy Cross Col., Worcester, Mass. Position: T., Scott Carbee Sch. A., Boston, 1938– [47]

KEYES, George S. [P] Concord, MA. Member: Concord AA [25]

KEYES, Grace B. [P] Concord, MA. Member: Concord AA [25]

KEY-OBERG, Ellen Burke [S,T] NYC b. 11 Ap, 1905 Marion, AL. Studied: CUASch. Member: AL Am.; Lg. Present-Day A.; N.Y. S. Ceramic A.; NYSWA; Audubon A. Exhibited: MMA (AV), 1942; PAFA, 1942; All.A.Am., 1941; NAD, 1943; Audubon A., 1943–45; AL Am.; Lg. Present-Day A.; N.Y. S Ceramic A.; NYSWA, all annually; Howard Univ., Wash., D.C.; Studio Gl., 1938 (prize); Russell Sage Fnd., N.Y. Position: T., Chapin Sch., N.Y., 1940; MOMA, War Veterans Center, NYC [47]

KEYS, Harry J. [I] Columbus, OH. Member: Pen and Pencil C., Columbus [25]

KEYSER, Ephraim [S,T] Baltimore, MD b. 6 O 1850, Baltimore d. 26 Ja 1937. Studied: Royal Acad., Munich; Royal Acad., Berlin. Member: NSS, 1907. Exhibited: Munich Acad. (med); New Orleans Expo, 1885 (med). Work: Annapolis, Md.; mem. to Chester Arthur, Rural Cemetery, Albany, N.Y.; "Psyche," CMA; bust, Johns Hopkins. Award: Meyerbeer scholarship to Rome, for "Psyche." Positions: T., Rhinehart Sch. Sculpture (Baltimore), Md. Inst. Sch. of Art [33]

KEYSER, Ernest Wise [S] Atlantic Beach, FL b. 10 D 1876, Baltimore, MD d. 25 S 1959, Rome, Italy. Studied: Md. Inst.; ASL; Académie Julian, Paris; St.-Gaudens. Member: NSS 1902; Paris AAA; Arch. Lg., 1908. Exhibited: N.Y. S. Arch., 1923 (gold). Work: mem., Baltimore; statue, Annapolis; mem., Ottawa, Ontario; fountain, Newark A. Mus.; mem., Troy, Ohio [47]

KEYSER, James M.B. [Des] Mt. Airy, PA b. 6 N 1902. Studied: S. Yellin; J.J. Dull, PMSchIA. Member: Phila. Sketch C.; Phila. WCC. Work: gates, Princeton; gates, St. Michael's Chapel, Torresdale, Pa.; bronze light, Keating Hall, Fordham Univ.; Swarthmore Col. [40]

KIBBEE, Edward E. [P,Des,Ldscp.P] Maywood, IL b. 13 O 1897, Buffalo, NY. Studied: AIC. Member: Maywood AC; Austin, Oak Park and River Forest AL; All-Ill. Soc. FA. Exhibited: Maywood AC, 1932–36 (prizes); Cook County Fair, 1935 (prize). Work: Soc. Sc.&Indst., Chicago; Bds. Edu., Maywood, Arlington Heights, Melrose Park, Sycamore, Barrington and Chicago; stage sets, Ravinia Opera Co., Chicago Civic Opera Co.; Granada Theatre; South Bend, Ind.; Century of Progress Expo, Chicago [40]

KIBBEY, Helen C. [P] Marshfield Hills, MA. b. NYC [06]

KIBBEY, Ilah Marian [P,E,T] Kansas City, MO b. 23 F 1883, Geneva, OH d. 10 Ag 1958. Studied: N.Y. Sch. F.&Appl. A.; AIC; H. Breckenridge; E. O'Hara; C. Wilimovsky; H.B. Snell; L. Stevens; Kansas City AI. Member: NAWPS; Prairie WCC; Kansas City SA. Exhibited: Kansas City AI, 1921 (prize), 1923 (prize), 1933 (prize); Midwestern AA, 1927 (med); Gld. A., 1932 (prize); Kansas City SA, 1935 (prize); Midland Theatre, Kansas City, 1928 (prize); Missouri State Fair, 1928 (prize). Work: Mo. State Bldg, Sedalia; Northwest Normal Sch., Maryville, Mo.; Vanderpoel Coll.; LOC; Midland Theatre; Public Lib., Argentine [47]

KIDD, Hari Matthew [P,G] El Paso, TX b. 18 Mr 1899. Studied: PAFA. Work: Mus. A., Phila.; Allentown (Pa.) Mus.; La France AM, Frankford, Phila. [40]

KIDD, Steven R. [I,T] NYC (1966)b. 1911, Chicago. Studied: AIC; ASL, with Bridgman, ca. 1930; Grand Central A. Sch., with H. Dunn, ca. 1930–40. Member: SI. Work: Pentagon. Positions: Official Army artist in World War II; T., Newark Sch. FA, ASL [*]

KIDD, Velma E. See Logan.

KIDDER, Ben L. [I] NYC. Member: SI [25]

KIDDER, Frank Howard [P] New Canaan, CT b. 16 S 1886, Litchfield, CT. Studied: K.H. Miller; D. Wortman [21]

KIEFER, Edwin H. [P] Paris, France b. 1860, Port Huron, MI. Studied: Constant, Laurens, Cazin, in Paris [01]

KIEFER, Sam P. [P] Columbus, OH. Member: Pen & Pencil C., Columbus [25]

KIEFNER, C.H. [P] Houston, TX. Exhibited: Houston Ar. Ann., Houston MFA, 1938, 1939; SSAL, San Antonio, 1939 [40]

KIEHL, Christine [S] Alma, MO b. 1885, MO. Studied: Zolnay, in St. Louis [13]

KIER, Sadle [P] Beaver Falls, PA. Member: Pittsburgh AA [21]

KIESLER, Frederick John [Des,Li,Arch,L] NYC b. 22 S 1892, Austria d. 1966. Studied: Art Acad., Vienna. Exhibited: City of Buffalo, 1935 (prize). Work: Juilliard Sch. Music; Metropolitan Opera Co. Author: "Contemporary Art." Contributor: articles, Architectural Record. Specialties: scenic and interior design; furniture construction. Position: Dir., Scenic Des., Juilliard Sch. Music, NYC [47]

KIHN, Alfred C. [E,En] NYC b. 1868, NYC d. 12 Ag 1936. Studied: ASL. During his early years, he devoted himself to etching. Painted portraits of Karl Marx, Edward Bellamy and Susan B. Anthony. With his brother he founded a steel engraving firm in 1880, specializing in bank note engraving, which occupied the rest of his active career.

KIHN, W(illiam) Langdon [P,I] Hadlyme, CT b. 5 S 1898, Brooklyn, NY d. 12 D 1957. Studied: ASL, 1916–17; H. Boss; W. Reiss. Member: SC. Exhibited: Mus. N.Mex., 1921; AMNH, 1952. Work: Litchfield (Conn.) Mus.; Ohio State Univ.; Seattle FA Soc.; Univ. Okla.; Montreal Gal. A.; Nat. Gal., Ottawa; Seattle FA Soc.; Provincial Mus. British Columbia; Montreal Gal. A.; McGill Univ., Montreal; Royal Ontario Mus.; Mus. Winnipeg; A. Center, Vancouver. He traveled widely throughout the U.S. painting Indians from 35 tribes. A prolific painter, his works were illustrated in a major series for National Geographic, beginning 1937. Position: T., Wiggins-Kihn A. Sch., Essex, Conn., 1953 [47]

KILBERT, Robert P. [P,T] Chicago, IL/Bridgman, MI. Studied: AIC; Chicago Acad. FA; Paris; Munich. Member: PCC; AAPL; All-Ill. SFA; Chicago Municipal AL; AIC. Exhibited: Chicago AI, 1900 (gold); All-Ill. SFA, 1930 (prize), 1935 (gold), 1937 (prize); Soc. for Sanity in A., 1939 (prize). Work: Los Angeles AI; Mich. Normal Sch.; Jennings Seminary, Aurora. Position: Dir., Treasure Hill Acad. [40]

KILBOURN, Samuel van Dusen [P] NYC. Exhibited: WC Ann., PAFA, 1936, 1938; Am. WC Soc., N.Y. WCC, 1939 [40]

KILENYI, Julio [S] NYC b. 21 F 1885, Arad, Hungary d. 29 Ja 1959. Studied: Royal A. Sch., Budapest. Member: NSS; Arch. Lg.; Am. Numismatic Soc.; All.A.Am.; Audubon A. Exhibited: 10th Olympiad A. Exh., Los Angeles, 1932 (prize); All.A.Am., 1930 (prize), 1937 (prize); NAD; PAFA; Albright A. Gal. Work: MMA; N.Y. Hist. Soc.; Numismatic Mus.; CMA; Newark Mus.; Roosevelt Lib., Hyde Park, N.Y.; Masonic Mus., St. Louis. Specialty: medalist. Medal designs: distinguished service medal of U.S. Navy Dept.; Lindbergh medal of St. Louis; Benjamin Franklin medal for 200th anniversary; medal for 150th anniversary, Battle of Lexington; medal for 150th anniversary, Battle of Bunker Hill; medal of

the 10th Olympiad; George Washington Bridge dedication medal; Around the World Flight plaque; commem. medal, WFNY [47]

KILGORE, Charles P. [P] Chicago, IL Exhibited: AIC, 1935 (prize), 1933-39 [40]

KILHAM, Jane Houston [P] Boston, MA/Tamworth, NH b. 22 F 1870, Modesto, CA d. 19 F 1930, Boston. Studied: E. Carlsen; R. Collin; P. Serusier. Member: North Shore AA; Gloucester SA; Boston S.Indp.A. (Pres.). Exhibited: Boston AC, 1925 (prize) [29]

KILHAM, Teresa [Des] Boston, MA b. 25 Ag 1908, Boston. Studied: J. Hoffman; Kunstgewerbe Schule, Vienna; Paris; Berlin. Specialty: des. of wallpaper, textiles [40]

KILHAM, Walter H. [P,Arch,W] Boston, MA b. 30 Ag 1868, Beverly, MA d. 11 S 1948. Studied: MIT. Member: AIA; Rockport AA; Business Men's AC, Boston (Pres.). Exhibited: Copley S.; Rockport AA; Jordan Marsh Co. Author: "Mexican Architecture of the Vice-Regal Period," 1927, "Boston After Bulfinch," 1946 [47]

KILIANI, Otto J.T. (Mrs.) [P] NYC. Member: Women's AC [01]

KILLAM, Walter Milton (Walt) [G,P,T] Noank, CT (California, 1979)b. 18 Je 1907, Providence d. 1979. Studied: RISD; J. Frazier; F. Sisson. Member: Mystic AA; South County AA, Wakefield, R.I.; Noank Watercolorists. Exhibited: Wadsworth Atheneum, Hartford, 1938 (prize); AIC, 1933-46; WMAA, 1942-45; PAFA, 1944, CI, 1945, 1946; LOC, 1945; Canada; Hawaii; Mexico. Work: Lyman Allyn Mus., New London, Conn.; Millbrook (N.Y.) Sch.; College AA. Illustrator: "Parnassus." Position: T., Noank Summer Sch. [47]

KILPATRICK, Aaron (Edward) [P] Eagle Rock, CA b. 7 Ap 1872, St. Thomas, Canada. Studied: W. Wendt. Member: Calif. AC; P. of the West; Laguna Beach AA. Exhibited: Panama-Calif. Expo, San Diego, 1915 (meds). Work: Los Angeles Athletic C. [40]

KILPATRICK, Ada Aurilla [P,C] San Fran., CA b. Petersburg, NE d. 1951. Studied: Univ. Utah; Calif. Sch. FA; Hartwell Sch. Des.; T. Polos; V. De Wilde. Member: NAWA; AAPL; Calif. WCC. Exhibited: San Fran. AA, 1940, 1945; NAWA, 1943-45; Calif. WCC, 1942-45; Riverside Mus., 1943, 1944; Oakland A. Gal., 1940; Paul Elder Gal., San Fran., 1942, 1943 (one-man); SFMA, 1944 [47]

KILPATRICK, D. Reid Minor [Min.P] Paris, France [10]

KILPATRICK, DeReid Gallatin [P,S] Uniontown, PA/Ogunquit, ME b. 21 S 1884, Uniontown. Studied: Paris, with L. Simon, R. Prinex, E. Menard, A. Bourdelle, R. Collin. Work: statue, Lincoln Highway at Waterford (Pa.), Connellsville (Pa.); Methodist Episcopal Church, Greensburg, Pa.; Court House, Uniontown [40]

KILPATRICK, Ellen Perkins [P,C] Baltimore, MD b. 16 F 1877, Baltimore d. 21 Mr 1951. Studied: Bryn Mawr Col.; E. Whiteman; T. Anschutz; C.H. Woodbury. Member: Ogunquit AA; Baltimore WCC; Municipal A. Soc., Baltimore; AAPL; Handicraft C., Baltimore; Friends of Art; AFA; SSAL. Exhibited: BMA [47]

KILPATRICK, Mary (Grace) [P] Baltimore, MD b. 28 Ja 1879, Baltimore. Studied: Bryn Mawr Col.; Md. Inst.; C. Woodbury, B. Karfiol. Member: AAPL; Baltimore WCC; Ogunquit AA; Municipal A. Soc., Baltimore; Friends of Art; SSAL. Exhibited: BMA, 1939, 1940, 1941; Ogunquit A. Center, 1940-45; Md. Inst. [47]

KILROY, J. C(osgrove) [P] Pittsburgh, PA b. 1890, Pittsburgh. Studied: CI [24]

KILVERT, Benjamin Sayre Cory [P,I] NYC b. 1881, Hamilton, Canada (came to U.S. in 1900) d. 29 Mr 1946. Studied: ASL, with G. Bridgman. Exhibited: Osborne Litho. Co. (prize); Life Publishing Co. (prize); WC Ann., PAFA, 1936, 1938; Am. WCC, 1936, 1937, 1938; NYWCC, 1939. Illustrator: children's books. Positions: Staff A., Collier's, New York World [40]

KIMBALL, Alonzo M(yron) [P,I] Cleveland, OH b. 14 Ag 1874, Green Bay, WI d. 27 Ag 1923, Evanston, IL. Studied: ASL; Académie Julian, Paris; Lefebvre; Whistler; Courtois. Member: SI, 1911 [21]

KIMBALL, Charles Frederick [Ldscp.P,E] Portland, ME b. O 1835, Monmouth, ME d. 28 Ja 1907. Studied: briefly under Charles O. Cole, 1857. Member: Portland SA (founder). Work: Portland MA. Received acclaim for his etchings by 1881. [*]

KIMBALL, Charlotte Stuart [P,T] Baltimore, MD b. 8 My 1889, Baltimore. Studied: Md. Inst.; ASL. Member: Friends of A., Baltimore. Exhibited: Friends of A., Baltimore; PMG, 1939. Position: T., Greenwood Sch., Ruxton, Md. [40]

KIMBALL, E. Wyatt [P] d. 9 F 1927, Cambridge, MA. Work: State House, Concord, N.H.

KIMBALL, Fiske [Mus.Dir,Hist,W] Phila., PA b. 8 D 1888, Newton, MA d. 15 Ag 1955, Munich, Germany. Studied: Harvard; Univ. Mich. Member: AIA; Royal Inst. British Arch.; AA Mus. Author: "Mr. Samuel McIntire, Carver, the Architect of Salem," 1940, "The Creation of the Rococo," 1943, other books. Positions: T., Univ. Va. (1919-23), NYU (1923-25); Dir., Pa. MA, Phila., 1925 [47]

KIMBALL, H.M. [P] Glen Ridge, NJ [21]

KIMBALL, Harriet Stockton [Ldscp.P,Por.P] Buffalo, NY/East Aurora, NY b. 30 Ag 1877, Westfield, NY. Studied: G.W. Bridgman, D.W. Tryon, A. Webster, C.W. Hawthorne, R. Clark; Smith College; Albright A. Sch., Buffalo. Member: Buffalo SA; NAWPS. Exhibited: Buffalo SA, 1934 (prize) [40]

KIMBALL, Helen [P] West Phila., PA [06]

KIMBALL, Isabel Moore [S] Elgin, IL b. Wentworth, IA. Studied: PIASch.; Herbert Adams. Member: NAWA; Brooklyn SA; Soc. Medalists; Fifteenth Gal. Work: Edmundson A. Fnd., Des Moines, Iowa; fountains, mem., mon., Central Park, Winona, Minn.; Vassar; Iowa Hist. Soc.; Essex, Conn.; Burnt Hills, N.Y.; Kalamazoo, Mich.; Brooklyn Botanical Gardens; Riceville, Iowa; war mem., Mountainville, N.Y.; mon., Highland Park, Ill. [47]

KIMBALL, Katharine [Dr,E,I] London, England b. 17 Ap 1866, NH. Studied: NAD; W.J. Wittemore; Sir F. Short. Member: Royal Soc. P.&E., London. Exhibited: P.-P. Expo, San Fran., 1915 (med). Work: NYPL; Pa. MA, Phila.; BMFA; Oakland Pub. Mus.; LOC; British Mus., Victoria & Albert Mus., both in London; Bibliothèque d'Art et d'Archeologie, Paris; Briston Gal. & Mus., Melbourne, Australia [40]

KIMBALL, Maulsby, Jr. [P,T] Phila., PA/East Aurora, NY b. 20 My 1904. Member: SC; Phila. All. [33]

KIMBALL, Maxwell [S] Glen Ridge, NJ. Exhibited: N.J. State Exh., Montclair AA, 1938 (med); WFNY, 1939 [40]

KIMBALL, Yeffe [P] NYC. Exhibited: First Nat. Exh. Am. Indian P., Philbrook A. Center, 1946 [47]

KIMBEL, Richard M. [P] NYC/Banff, Alberta (living in Warren, Mass., 1919) b. 1865, NYC d. 14 N 1942, NYC. Member: Allied AA; SC; N.Y. Soc. P.; NAC. Exhibited: SC, 1930 (prize). Work: PAFA [33]

KIMBERLY, Cara Draper (Mrs. Samuel A.) [P] Wash., D.C. b. 19 Jy 1976, St. Louis, MO. Studied: Washington Univ.; BMFA; Chicago A. Acad.; St. Louis Sch. FA; Corcoran Gal. A. Sch.; Hawthorne; Vanderpoel; Messer. Member: Wash. A. Lg.; Soc. Wash. A.; Wash. WCC; Wash. AC. Exhibited: AIC; BMFA; Boston WCC; CGA; PMG; Wash. WCC; CAM; Soc. Wash. Ar., 1936-1938. Work: interiors, White House, Arlington House, Dumbarton House, Mt. Vernon [47]

KIMBROUGH, Frank Richmond [P,I] England (also lived in RI) b. Tennessee d. D 1902. Studied: Herkomer Sch., Bushey, England, 1898. Illustrator: book covers, London

KIMMEL, Lu (Mr.) [P,I,T] Brooklyn, NY b. Brooklyn d. 1973, Queens, NY. Studied: P. Carter, Luks; Pratt Inst. Member: SI. Exhibited: Nat. Red Cross poster comp., 1933 (prize); Am. Legion poster comp., 1934 (prize). Work: Am. Red Cross Headquarters. Illustrator: Scribner's, Saturday Evening Post. Specialty: Western subjects. Positions: T., Commercial Illus. Sch. (N.Y.), Hunter Col. [40]

KINAIS, Rudolph [P] NYC. Member: Bronx AG [27]

KINDER, Maria List [P,E,Li,S,Dec] Boston, MA b. 10 Mr 1902, Boston. Studied: Scott Carbee Sch. A.; BMFA Sch.; ASL; A. Hibbard; C. Nordstrom. Member: Gloucester A. Soc.; Boston AC; North Shore AA. Exhibited: North Shore AA; Gloucester SA; Boston AC. Work: Boston; NYC [47]

KINDER, Milton Robert [Des,C,G] Cincinnati, OH b. 21 My 1907, WV. Studied: Cincinnati AA; Meyers; Wies; H. Wessell. Member: Cincinnati Men's AC [40]

KINDLEBERGER, D. [P] Wash., D.C. [04]

KINDLER, Alice Riddle. See Riddle.

KINDLUND, Anna Belle Wing (Mrs. Alois Trnka) [P] White Plains, NY b. 18 F 1876, Buffalo, NY. Studied: W. Hitchcock, in Buffalo; G. Bridgman, in N.Y. Member: Buffalo Soc. A.; N.Y. Soc. C. Exhibited: Pan-Am. Expo, Buffalo, 1901 (prize); St. Louis Expo, 1904 (med); P.-P. Expo, San Fran., 1915 (med) [24]

KINERT, Reed C. [I,Car] Richmond, IN b. 31 Ag 1912, Richmond. Exhibited: Richmond AA, 1937; Lieber Gal., Indianapolis. Position: Illus., United Aircraft Corp. Am., Beechcraft Aircraft [40]

KING, Albert F. [P] Pittsburgh, PA b. 6 D 1854, Pittsburgh. Studied: self-taught. Member: Pittsburgh AA; Pittsburgh AS. Work: Homeopathic Hospital, Duquesne C., both in Pittsburgh [33]

KING, C. [P] Spring Valley, NY [04]

KING, Charles B. [P,E] Detroit, MI b. 2 F 1869, Angel Island, CA. Studied: Paris, with Laurens; London, with Brangwyn. Member: Soc. de la Gravure Originale en Couleur, Paris; Chicago SE. Work: NYPL; LOC [21]

KING, Clement [P] Walkerville, Ontario. Member: SC [25]

KING, Clinton (Blair) [P] Chicago, IL b. 3 O 1901, Fort Worth, TX. Studied: Princeton; C.W. Hawthorne; R. Reid; R. Davey. Member: Phila. WCC; Fort Worth A. Gld. Exhibited: Fort Worth A. Gld., 1938 (prize); AIC, 1929, 1944 (prize), 1942-46; NAD, 1945; PAFA, 1932, 1944; CGA, 1941; TMA, 1929; Springfield Mus. A., 1944, 1945; CI, 1946. Work: Mus. N.Mex., Santa Fe; Texas Fed. Women's C. Bldg., Austin [47]

KING, Daisy Blanche [Mur.P,S] NYC b. 8 S 1875, Wash., D.C. Studied: Corcoran Sch. A., with E.F. Andrew; BMFA Sch., with B. Pratt; H.J. Ellicott; U.S.J. Dunbar. Exhibited: Corcoran Sch. A. (prize); Arch. L.; NAD; S.Indp.A. Work: St. Paul's Church, Stockbridge, Mass.; Gurley Mem. Church, Wash., D.C. [47]

KING, David H., Jr. [Patron] b. 1849 d. 20 Ap 1916, NYC. His first collection sold in 1896 for $273,000, and a second in 1905 (seventy works chiefly English, French and Dutch) for $201,035.

KING, E. Stanton [P] Minneapolis, MN [25]

KING, Edith Lawrence [P] Belmont, MA [15]

KING, Edward [P] Pelham Manor, NY. Member: S.Indp.A. [25]

KING, Eleanor (Mrs. Salley Hookham) [P,I,W,L,T] Elmhurst, IL/Pensacola, FL b. 5 Ap 1909, Marlow, OK. Studied: Oklahoma City Col. Member: Pensacola AC; Gulf Coast AA; Fla. Fed. A.; Tallahassee AC; SSAL. Exhibited: West Palm Beach A. Center, 1935; Montross Gal., 1939 (one-man), 1940, 1941 (one-man), 1942; Gulf Coast AA, 1929 (prize); SSAL, 1934; Fed. A. Gal., Pensacola, 1940 (one-man); Milton A. Center, 1940; Women's C., Pensacola, 1946; Pensacola AC, 1928 (prize), 1946. Work: Talahassee Women's C.; Pensacola AC; Capital City Bank, Tallahassee; Fla. Capitol Bldg.; Senate Chamber and Supreme Court of Fla.; Pensacola Beach Corp.; C.P.O. C., Naval Air Station, Pensacola. Illustrator: "Old Pensacola Landmarks," 1932 [47]

KING, Elizabeth A. (Bessie) [P] Atlanta, GA b. 14 Ag 1855. Studied: Candler Sch. A., Detroit. Member: Atlanta AA. Work: Detroit Mus. A. [40]

KING, Emma B. [P] Indianapolis, IN b. 1858, Indianapolis d. 17 Jy 1933. Studied: ASL, Cox, Beckwith, Chase, in New York; Boulanger, Lefebvre, Carolus-Duran, Edwin Scott, in Paris. Member: Ind. AC; Soc. Women P.&S. Am.; Nat. Lg. Am. Pen Women; Ind. Poetry Soc. She was also a poet, and many of her poems were published; her most valued prize in poetry was won in an international contest held under the American section of the Poetry Society of Great Britain. [31]

KING, Fanny Mahon (Mrs. Thomas Gadsen) [P] Charleston, SC b. 14 Je 1865. Studied: W.P. Silva; F.S. Chase; H. Leith-Ross; E. Gruppe; I. Summers; A. Hutty; G.H. Hilder. Member: SSAL; Carolina AS; Sketch C., Charleston. Exhibited: All-Southern Exh., Gibbes Mem. A. Gal. Charleston, 1921 (prize). Work: Charleston Mus.; Nashville Mus. A.; High Mus. A. [40]

KING, Francis Scott [En,P,I] Newark, NJ b. 24 Mr 1850, Auburn, ME. Studied: J.W. Orr, A. Will, in New York. Member: Soc. Am. Wood En. (founder). Exhibited: Paris Expo, 1889 (med); Columbian Expo, Chicago, 1893 (med); Pan-Am. Expo, Buffalo, 1901 (med) [15]

KING, Frank O. [Car] Kissimmee, FL b. 9 Ap 1883, Cashton, WI d. 24 Je 1969. Studied: Chicago Acad. FA. Member: SI. Author: "Skeezix and Uncle Walt," "Gasoline Alley," daily strip and Sunday page, News Syndicate [47]

KING, Frederic Leonard [Mar.P,I,W,T,L] Rockport, MA b. 31 Ag 1879, NYC d. 2 F 1947. Studied: PIASch, ASL; NAD; Bridgman; Mora; DuMond; Cox. Member: SC; North Shore AA; Rockport AA; Copley S. Exhibited: SC; Dayton AI; BMFA; Boston AC; Copley S.; North Shore AA; Rockport AA. Work: Shawnut Bank, Boston; Boston Pub. Lib.; Tewksbury (Mass.) Hospital. Lectures: Development of Ships [47]

KING, George Clinton [P] Rochester, NY b. 14 Ag 1854, Scipio, NY. Studied: I.M. Wiles. Member: Rochester AC; Rochester SA [13]

KING, Gertrude (Mrs. L.H. Colville) [P,C,T] Mendham, NJ b. Newark, NJ. Studied: R.H. Johonnot; I.W. Stroud. Member: NAWPS [33]

KING, Gillis [P] West Caldwell, NJ b. 8 F 1904, Dewville, TX. Studied: S.E. Gideon; M. Jacobs; G. Bridgman. Member: Texas FAA; SSAL. Work: Austin AL; San Angelo AL; Tom Green County Court House, San Angelo, TX [40]

KING, Gwyneth [P] Princeton, NJ b. 1 F 1910, Wales [40]

KING, Hamilton [I,P,E] East Hampton, NY b. 21 D 1871, Lewiston, ME d. 7 Ja 1952. Studied: Académie Julian, Paris. Member: SI, 1915 [47]

KING, Harriott L. [Min.P] Baltimore, MD [10]

KING, Harry (Mrs.) [C,Des,L] Batesville, AR b. 20 S 1895, Powhatan, AR. Studied: Ark. Col.; CM Sch. A.; Newcomb Col., Tulane Univ. Exhibited: Eastern States Expo, 1940; Memphis Mus. A.; Ridgefield House, Chicago, 1941, 1946; Women's City C., Ft. Worth, Tex., 1942; Philbrook A. Center, 1940; Women's City C., Little Rock, Ark.; Brooks Mem. A. Gal.; Dallas, Texas; Springfield, Ill.; New Orleans. Work: featured in Life, 1940, Nat. Geographic, 1946; McCall's, 1941; La Revnue des Fermieres magazine, 1942 [47]

KING, Helen A. (Mrs. Alvin Hattorf) [Ldscp.P,T] Richmond, VA b. 12 F 1904. Studied: AIC; C. Hawthorne; R. Miller; W. Adams; R. Brackman; A. Brook; G. Bridgman; H. Hensche; ASL. Member: Hoosier Salon; NAWPS. Exhibited: Hoosier Salon, 1929 (prize), 1932 (prize). Position: T., Thomas Jefferson H.S., Richmond [40]

KING, Horace [Ed,Des,P,L] Granville, OH b. 27 Ap 1906, Pittsfield, OH. Studied: Ohio State Univ.; Ill. Inst. Tech.; F. Payant; J.R. Hopkins; R. Fanning; H.G. Spencer. Member: AFA; CAA; Ohio Valley Regional A. Conference. Work: Inst. mural, A.H. Heisey & Co., Newark, OH. Position: T., Denison, Univ. [47]

KING, James S. [E,P] Upper Montclair, NJ b. 26 D 1852, NYC d. spring, 1925. Studied: ASL; NAD; Ecole des Beaux-Arts, with Gèrôme, Bonnât, ca. 1881. Member: SC, 1884; Allied AA. His etchings are included in J.R.W. Hitchcock's three books on etching, 1880s. [24]

KING, Jane Spear [P] Chicago, IL b. 24 Mr 1906, La Grange, IL. Studied: AIC. Exhibited: AIC, 1929, 1935, 1936, 1939. Work: Ryerson Coll., Chicago; Chicago Hist. S. [47]

KING, John M. [P,T] Dayton, OH b. 1 Jy 1897, Richmond, IN. Studied: Earlham Col.; Cincinnati A. Acad.; H.H. Wessel. Member: Richmond Palette C.; SC; Dayton S. P.&S. Exhibited: Chicago, 1926-29 (prize); Hoosier Salon, 1923 (prize). Work: Purdue Univ.; Administration Bldg., Oxford, Ohio; National Cash Register Co., Dayton; Municipal Bldg., Dayton; Miami Univ.; Butler College. Position: T., Dayton AI, 1927-46 [47]

KING, Joseph B. [I] NYC. Member: SI [47]

KING, Katherine M. [P] Chicago, IL b. Russellville, AR. Studied: AIC. Member: Chicago ASL [08]

KING, Louise H. See Cox, Kenyon, Mrs.

KING, M.E. (Miss) [P] Danville, VA [17]

KING, Mabel DeBra [P,Gr,W] Columbus, OH b. 24 O 1895, Milledgeville, OH d. 20 Jy 1950. Studied: Ohio State Univ.; PIASch; Columbia; Yale. Member: AWCS; Columbus AL. Exhibited: Baltimore WCC, 1931 (prize); AWCS, 1930-40; Phila. WCC, 1932-38; BM, 1937; NYWCC, 1928-32; Wash. WCC, 1929-32; NAWA, 1929-36; Boston AC, 1935, 1936; Newport AA, 1935; Ohio WCS, 1936; Columbus AL, 1928-45, 1928 (prize), 1943 (prize); Wash. AC, 1931; Pa. State Col., 1932; Springfield, Mass. AL, 1935. Work: Columbus Gal. FA; mural, Ohio Archaeo. Mus., Ohio State Univ. Contributor: Harper's, Design [47]

KING, Marion P(ermelia) [S] Ashtabula, OH b. 7 O 1894, Ashtabula, OH Studied: PAFA, with Grafly; Cleveland Sch. A. [40]

KING, Mary A. [P] Chicago, IL [13]

KING, Mary Elizabeth (Mrs. Archibald) [Min.P] Wash., D.C. b. 19 Ja 1899, Springfield, MO. Studied: Corcoran Sch. A.; Académie Julian; Chelsea A. Sch., London; Savini, Florence. Member: Ass. Ga. A.; Wash. Min.PS and G; Pa. SMP [40]

KING, Mary Louise [Des,C,B] Lakewood, OH b. 28 S 1907, Lakewood, OH d. 8 O 1939. Studied: J. Mihalik; Cleveland Sch. A. Member: Cleveland PM; Cleveland AA. Exhibited: CMA, 1930 (prize), 1933 (prize), 1934,

1937 (prize). Work: costumes, summer operas, Cleveland, 1931–32; scenery, Akron Light Opera Lg., 1936; Peer Gynt, 1937; print coll., CMA [38]

KING, M(innie) (Clark) (Mrs. William) [P] San Antonio, TX/ Camp Arpa, Waring, TX b. 16 Ag 1877, Caldwell, TX. Studied: Chase; Bishop; McArdie; Onderdonk; Arpa. Member: San Antonio AL; San Antonio AG. Exhibited: Bishop Art Levee (gold); Intl. Fair (gold). Work: City National Bank; City Federation C. House; City Auditorium; Guaranty State Bank, San Antonio [25]

KING, Oliver D. [P] Columbus, OH. Member: Columbus PPC [25]

KING, Paul [P] NYC b. 9 F 1867, Buffalo, NY d. 27 N 1947. Studied: ASL, Buffalo; ASL, Mowbray; PAFA. Member: SC; NAC; AAPL; All.A.Am.; ANA; NA, 1933; A. Fund S.; A. Fellowship; Inter. S. AL; AFA. Exhibited: PAFA, 1908–35, 1918 (prize); NAD, 1907–45, 1923 (prize); CGA; CI; AIC; Phila. AC, 1911 (prize), 1913 (gold); Ferargil Gal.; Grand Central A. Gal.; Lake Placid C., N.Y. 1926–46; Town Hall C., NYC, 1946; SC, 1906 (prize), 1928 (prize); P.-Pacific Expo, 1915 (prize); NAC, 1937 (prize). Work: Engineers C., NYC; Phila. AC; Reading Mus.; Butler AI; Smithsonian Inst.; Rogers Mem. Lib., Laurel, Miss.; Cabilido A. Gal., New Orleans,; Albright A. Gal.; Mus. FA, Houston; Suffolk Mus., N.Y.; New Parthenon, Nashville, Tenn.; Buffalo Athletic C.; Quinnipiack C., New Haven, Conn.; NGA [47]

KING, Ralph Thrall [Patron] Cleveland, OH d. 12 Mr 1926. Member: CMA; Am. Fed. Arts; CMA (Pres.)

KING, Roy E. [S] Honolulu, HI b. 22 N 1903, Richmond, VA. Studied: BAID; Bridgman; Lawrie; Jennewein; U.H. Ellerhusen. Member: NSS. Work: S., busts, CCNY; USPOs, Bloomsburg, Pa., West Point, N.Y. WPA sculptor. [47]

KING, Ruth [I] NYC/Bartley, NJ b. Chicago, IL. Studied: AIC. Member: AIC. Illustrator: "Allison's Girl," "Anne at Large," "Side-Saddle Ranch," "Stars Rising," "Swift Flies the Falcon" [40]

KING, Sarah Cecilia Cotter (Mrs. W.A.) [S,P] Ironton, OH b. 30 O 1874, Tipperary, Ireland. Studied: Cincinati A. Acad., with Sharp, Nowottny, Rebisso. Member: SWA [15]

KING, Virginia Morris (Mrs. Sylvan) [S] Norfolk, VA b. 16 O 1899, Norfolk. Studied: S. Borglum; H. Frishmuth; Yale. Member: Norfolk SA; S. Wash. A.; Wash. AC; SSAL. Exhibited: Norfolk SA, 1921 (prize), 1926 (prize) [27]

KING, Will [Por.P,G] b. 26 Je 1905, Kurtin, TX d. 11 Ap 1936, Milwaukee, WI. Member: Seven Arts S., Milwaukee. Work: State Supreme Court, Wis.

KING, W(illiam) B. [P,I] Paterson, NJ b. 4 Jy 1880, Paterson, NJ d. 4 S 1927. Studied: Mowbray; Cox; Brush; DuMond. Member: SC; SI; GFLA [27]

KING, William C., Mrs. See Peacock, Jean.

KING, William J., Jr. [I,Cart] NYC b. 25 D 1909, Seattle, WA. Studied: ASL. Illustrator: Esquire; Collier's [40]

KING, Wyncie (Mr.) [I] Bryn Mawr, PA b. 21 S 1884, Covington, GA. Member: Artists G. Illustrator: Sat. Eve. Post; many newspapers [40]

KINGAN, R.W. James [Mar.P] Meriden, CT b. 1877, NYC d. 31 D 1935. Member: North Shore AA, Gloucester. Exhibited: North Shore AA

KINGAN, Samuel Latta [P,W] Tuscson/Oracle, AZ b. 8 N 1869, Pittsburgh. Member: NAC. Exhibited: Montross Gal., NYC, 1937; Allied A., NYC. Author: "Nature of Landscape," 1920 [40]

KINGMAN, (Doug) [P] San Fran., CA b. 1 Ap 1911, Oakland, CA. Studied: Long Non Sch., Hong Kong; Fox-Morgan Sch., Oakland. Member: San Fran. AA; Bay Region AA; Calif. WCS. Exhibited: WC exh., San Fran. AA, 1936 (prize); Oakland A. Gal., 1937 (prize); SFMA, 1936, 1937, 1939; Portland Am. 1937; MOMA, MOMA, Wash., D.C., 1938. Work: MOMA, NYC; SFMA; Mills Col., Oakland. Position: T., Sacramento A. Center. [40]

KINGMAN, Eugene [Mus.Dir,P,Li] Omaha, NE b. 10 N 1909, Providence, RI d. 1975. Studied: Yale. Member: AA Mus.; Audubon A.; Providence AC; New Haven PCC; Providence WCC; Prairie Pr.M. Exhibited: NAD, 1937–42; AV, 1942; San Fran. AA, 1937–39; Kansas City AI, 1940; Colorado Springs FA Center, 1940, 1942; Okla. A., 1940 (prize); Dallas Pr. S., 1943; Providence AC, 1927–40, 1929 (prize); Delgado Mus., 1940 (prize). Work: LOC; Philbrook A. Center; Crompton Richmond Co., N.Y.; USPOs, Hyattesville, Md., Kemmerer, Wyo., East Providence, R.I. Mus., Glacier Nat. Park, Mont.; Colonial Expo, Paris, 1931; Fogg AM; National Geographic Magazine, March, 1937; Journal of Geology, March, 1937; Hayden Planetarium. WPA muralist. Positions: T., RISD, 1936–39; Dir., Philbrook A. Center, 1939–42; Asst. Dir., Joslyn Mem., Omaha, Nebr., 1946– [47]

KINGSBURY, Alison Mason (Mrs. Morris Bishop) [P,Dec] Ithaca, NY b. 11 Ja 1898, Durham, NH. Studied: F. Du Mond; P. Baudouin; A. Janiot; E. Winter. Member: NAWPS; Greenwich SA. Exhibited: NAWPS, 1939 (prize). Work: War Mem., Cornell Univ. Illustrator: "Love Rimes of Petrarch," trans. by Morris Bishop [40]

KINGSBURY, Edna A. [P] Indianapolis, IN b. 5 My 1888, Xenia, OH. Studied: J. Herron AI; J.O. Adams; O. Stark; W. Forsyth. Member: Indiana A. All.; S.Indp.A.; Boston AC; Ind. AC. Exhibited: S.Indp.A.; Hoosier Salon; Boston AC; Indianapolis, 1942–44 [47]

KINGSBURY, Edward R(eynolds) [P] Cambridge, MA/Ogunquit, ME b. Boston d. 1 My 1940. Studied: Mass. Normal A. Sch.; Mus. Sch. FA, Boston; Paris. Member: SC; Ogunquit AA [40]

KINGSBURY, Margaretta Mason [P,I] Greenwich, CT [24]

KINGSBURY, Mildred Coburn (Mrs. Lester L.) [C,L] Baltimore, MD b. Titusville, PA. Studied: H.B. Paist; Md. Inst.; T.H. Pond. Member: Baltimore Handicraft C.; Ceramic S. of Baltimore; Occupational Therapy S.; Chm. FA third dist. Md. Fed. Women's C. Contributor: articles and lectures on Colonial Furniture, Glass, Silver. Position: Baltimore Mus. A. [40]

KINGSLEY, Chester S. [P] NYC [15]

KINGSLEY, Elbridge [P,T,En] Hadley, MA b. 17 S 1841, Carthage, OH d. 28 Ag 1918, Brooklyn, NY. Studied: CUASch. Member: Ruskin AC, Calif.; Kingsley AC, Calif.; Soc. Am. Wood Engravers, NYC. Exhibited: Paris Expo, 1889 (gold); Columbian Expo, Chicago, 1893 (med); Mid-Winter Expo, Calif., 1894 (gold). Work: Dwight Art Bldg., Mt. Holyoke Col., Mass.; Print Dept., NYPL. Specialty: wood-engraving. He started a school of engraving in 1880. [17]

KINGSLEY, Norman W(illiam) [S,Por.P,Engr] Warren Point, NJ b. 26 O 1829, Stockholm, NY. Member: Lotos C. Exhibited: NAD, 1859–80. He was a dentist in Elmira and Troy before moving to NYC, 1852. [13]

KINIRY, Dorcas Evangeline Campbell (Mrs. Ralph) [C,Dr,Por.P,S,T] Claremont, NH. b. 19 S 1887, Ft. Covington, NY. Studied: Annetta St. Gaudens; PIASchIA. Exhibited: Member: NAWPS [40]

KINKEAD, Charles Edwin [P] New Haven, CT. Member: SC [25]

KINKEAD, Robert C. [P] Louisville, KY. Member: Louisville AL [01]

KINKER, H.E. [P] Toledo, OH. Member: Artklan [25]

KINNEY, Belle (Mrs. Lee Scholz) [S] Boiceville, NY. Work: Court House, Nashville, Tenn. WPA sculptor. [40]

KINNEY, Margaret West (Mrs. Troy) [P,E,T,W] Falls Village, CT b. 11 Je 1872, Peoria, IL. Studied: ASL; Académie Julian, Paris, with Robert-Fleury, Collin, Merson, Lefebvre. Member: SI, 1912. Work: etchings of the Great Chalice of Antioch, art libs. Co-author: "The Dance, Its Place in Art and Life" [430]

KINNEY, Troy [E,L,W] Falls Village, CT b. 1 D 1871, Kansas City, MO d. 29 Ja 1938. Studied: Yale; AIC. Member: ANA, 1933; Chicago SE; SAE; Phila. PC. Work: AIC; Cleveland Mus. A.; Brooklyn Mus.; NYPL; LOC; Yale; Bishop Mus., Honolulu; Bibliothèque Nationale, Paris. Co-author: "The Dance, Its Place in Art and Life," "The Etchings of Troy Kinney," pub. Doubleday, 1929, "Troy Kinney" (Vol. IX, Am. Et.). Contributor: articles, Magazine of Art, Century [38]

KINNICUTT, W.H. [P] Cleveland, OH. Member: Cleveland SA [27]

KINSELLA, J. [P] Toledo, OH. Member: Artklan [25]

KINSELLA, James [P] NYC/Marblehead, MA b. 14 D 1857, NYC d. 5 Ja 1923. Studied: NAD; Ecole des Beaux-Arts, Paris. Member: A. Aid S.; NAC. Exhibited: AAS, 1903. Work: Newark Tech. Sch. Mus. [21]

KINSELLA, Katherine [P] Paris, France b. Brooklyn, NY. Studied: Whistler, Lasar, in Paris. Member: N.Y. Women's AC [10]

KINSEY, Alberta [P] Wilmington, OH. Member: Cincinnati Women's AC [21]

KINSEY, Helen F(airchild) [P,Des,I,L,T] Phila., PA b. 12 Ag 1877, Phila. Studied: H. Thouron; W.M. Chase; C. Beaux; T.P. Anshutz; H.H. Breckenridge; C. Grafly; Dr. J.P. Haney; A.W. Dow. Member: Phila. Alliance; AFA; S. Med.; Phila. Mus. A. Illustrator: "Nature Study" by L.W. Wilson, "Home and School Sewing," by Patton, "Practical System for

Drafting," by Blakeley & Patton; for technical articles; bookplate, Phila. Normal Sch. [40]

KINSMAN-WATERS, Ray [P,Dec,C,T] Columbus, OH/Sugar Grove, OH b. 21 Jy 1887, Columbus. Studied: Columbus A. Sch.; A. Schille. Member: NYWCC; Columbus AL; Ohio WCC; AWCS. Exhibited: Columbus AL, 1923-25 (prizes), 1937 (prize). Work: Columbus Gal. FA. Position: T., Columbus Gal. FA [40]

KINZINGER, Alice Fish [P,E,S,C] Waco, TX b. 6 N 1899, Grand Rapids. Studied: Univ. Mich.; AIC; H. Hofmann; Baylor Univ. Member: Tex. FAA. Exhibited: Minneapolis Inst. A.; Grand Rapids AL; West Tex. Exh., Ft. Worth. Position: T., Baylor Univ., Waco, Tex., 1935-46 [47]

KINZINGER, Edmund Daniel [P,Li,T,S] Waco, TX b. 31 D 1888, Pforzheim, Germany. Studied: Univ. Iowa; Ecole Moderne, Paris; Germany. Member: A. Assn. Univ. Prof.; SSAL; Texas FAA. Exhibited: AIC, 1935, 1938; Bloomsbury Gal., London, England, 1933; Rouillier Gal., Chicago, 1935; Texas Centenn., 1938; WFNY, 1939; GGE, 1939; Paris; Houston MFA, 1938 (prize); Women's C., Beaumont, Tex., 1939 (prize); Dallas MFA, 1938. Position: T., Baylor Univ., Waco, Tex. [47]

KIP, W. Redding [P] NYC [04]

KIPP, Orval [P,Gr,T] Indiana, PA b. 21 My 1904, Hyndman, PA. Studied: J.B. Stetson Univ.; CI; Columbia; Univ. Pittsburgh. Member: Nat. Edu. Assn.; Eastern AA; Am. Assn. Univ. Prof.; Pittsburgh AA; Golden Triangle A., Pittsburgh; All. A. Johnstown; CAA. Exhibited: Provincetown AA, 1936-44; All.A.Am., 1938; All. A. Johnstown, 1931-46, 1932-44 (prizes); Pittsburgh AA, 1932-46; AFA Traveling Exh., 1940; Ind. AA, 1943-46, 1946 (prize). Illustrator/Des.: "Indiana Through the Camera's Eye," 1941. Position: T., State T. Col., Ind., Pa., 1936- [47]

KIRAFLY, Verona A(rnold) [Por.P] Pittsburgh, PA b. 1 O 1893, d. 1 S 1946. Studied: Chase; ASL. Member: F. Tiffany Fnd.; Pittsburgh AA. Exhibited: Pittsburgh AA, 1922 (prize) [33]

KIRBEY, Lena Rue [P,C] Independence, MO b. 28 S 1900, Grain Valley, MO. Studied: Hawthorne; Frazier. Exhibited: Kans.-Mo.-Okla. Exh., 1923 [25]

KIRBY, C. Valentine [C,W,L,T] Harrisburg, PA b. 19 Jy 1875, Canajoharie, NY. Studied: ASL; Chase Sch. A., NYC; Europe. Member: Eastern AA; Western AA; Phila. Alliance; Phila. Sketch C; Am. Indust., 1920; Comm. Intl. A. Cong., Prague, 1928, Vienna, 1932; A. Comm., Nat. Cong. of Parents and Teachers; Fed. Council on A. Edu. Lectures: Carnegie Inst.; Univ. Pittsburgh; Pa. State Col.; Am. Rep. and Speaker, Intl. A. Cong., Dresden, 1912. Author: "The Business of Teaching and Supervising the Arts." Positions: T., Manual Training H.S., Denver, Colo., 1900-10; Dir./A. Instr., Buffalo, 1911, 1912, Pittsburgh 1912-20; State Dir., A. Edu., Pa., since 1920 [31]

KIRBY, Helen (Mrs. Walter B.) [P] New Canaan, CT. Exhibited: NAWPS, 1936, 1937, 1938 [40]

KIRBY, Rollin [Cart,W] NYC/Weston, CT b. 4 S 1875, Galva, IL. Studied: J. Twachtman; J.M. Whistler. Work: LOC; Huntington Lib., San Marino, Calif.; NYPL; Lib. MET. Author: "Highlights," pub. W.F. Payson, 1930; articles in Century, Life, New York World. Illustrator: Scribner's, Century, Collier's, Harper's. Position: Cart., New York Post [40]

KIRBY, Thomas Ellis [Dealer,Cr] Haverford, PA b. 1847 d. 16 Ja 1924. As a youth he entered the auction business in Phila. In 1883 became associated with the Am. Art Assn. Auctioneers, of which he was director for 40 yrs. During this time some of the most famous collections in the U.S. were sold by the Assn.

KIRCHBAUM, Joseph [Dr] b. ca. 1831, Germany (came to Nauvoo, IL ca. 1846) d. 1926, Nauvoo, IL [*]

KIRCHMAYER, John [C] Cambridge, MA b. 31 Mr 1860, Oberammergau (came to U.S. ca. 1880) d. 29 N 1930. Studied: G. Lang. Member: Boston SAC (founder); Boston Arch. C.; Boston S. Sculptors. Exhibited: Am. Inst. Arch., 1924 (med). Work: Church of Blessed Sacrament, Boston; St. Catherine's Church, Somerville, others in Greater Boston area; Christ Church, Cranbrook, Mich., 1927 Specialty: wood carving

KIRCHNER, Eva Lucille (Eo) (Mrs.) [S,Des,T,L] Denver, CO b. 25 S 1901, Rich Hill, MO. Studied: Denver A. Acad.; Denver Univ.; Univ. Chicago; Columbia; Univ. Southern Calif.; G.C. Fisher; E. Licari; A. Polasek. Member: Denver A. Gl.; Atelier, Denver. Work: USPO, City & County Bldg., Denver; Garden S., St. Anne's Orphanage, Denver. Position: T., Denver Univ., 1944-46 [47]

KIRCHNER, Helen Isabel Ottilie [P] NYC [01]

KIRISHJIAN, Vahe [P] Brooklyn, NY. Work: P.O. Dept., Lib., Wash., D.C. WPA muralist [40]

KIRK, Arthur Nevill [Min.P,C,T,Des] Birmingham, MI b. Lewes Sussex, England. Studied: Central Sch. A.&C., London, England. Member: Royal SMP, London. Exhibited: Royal Acad., South Kensington Mus., London; British Empire Exh., London; Royal SMP, London; Denver A. Mus.; Arch. Lg.; Springfield Mus. A.; Detroit Inst. A.; Paris Exh. of Dec. Art, 1925 (gold). Work: Victoria & Albert Mus., London; Wichita A. Mus.; Cranbrook Acad. A.; Nat. Cathedral, Wash., D.C.; St. Paul's Cathedral, Detroit; Church of Heavenly Rest, NYC. Specialty: des., making ecclesiastical silver. Position: T., Wayne Univ., Detroit [47]

KIRK, Dorothy [C,Dec,Des,Ldscp.P,T,I] Norman, OK b. 15 Ja 1900, Inez, KY. Studied: Univ. Okla.; N.Y. Sch. F.&Appl. Des.; Grande Chaumière; O.B. Jacobson. Member: Tulsa AA; Kansas City AI, 1932 (gold). Position: T., Univ. Okla., 1925-47 [47]

KIRK, Elizabeth [P] Waterbury, CT b. 25 F 1866, Waterbury. Studied: Waterbury A. Sch.; F.L. Sexton; P. Elliot; L.E. York. Member: New Haven PCC; Springfield AL; MOMA [40]

KIRK, Francis C. (Miss) [P] Hollywood, CA. Member: Calif. AC [25]

KIRK, Frank C. [P,S] NYC b. 11 My 1889, Zitomir, Russia d. 1963. Studied: PAFA, with H. Breckenridge; D. Garber; C. Beaux; P. Hale; Russia. Member: Phila. Alliance; Grand Central A. Gal.; Brooklyn SA; Brooklyn PS; AAPL; ANA; CAFA; S. Wash. A.; Boston AC; All.A.Am.; Wash. AC; North Shore AA; Copley S., Boston; Am. A. Cong.; Springfield AL. Exhibited: CAFA, 1934 (prize), 1939 (prize); Ogunquit A. Center, 1935 (prize); All.A.Am., 1943 (prize), 1945; Springfield AL, 1943 (prize); Grand Central A. Gal., 1930. Work: Mus. Western A., Moscow; State Mus., Trenton, N.J.; Binghamton Mus. A.; Cayuga Mus. Hist.&A.; PMA; Biro-Bidjan Mus., Russia; Graphic Soc. C., Phila.; Minneapolis Inst. A.; theatre, Mahanoy City, Pa.; theatres, Phila.; theatres, Reading, Phoenixville, Pa. [47]

KIRK, Lydia C. [P] Wash., D.C. [25]

KIRK, Maria L(ouise) [P,I] Phila., PA b. Phila.. Studied: PAFA. Exhibited: PAFA, 1894 (prize). Illustrator: Macdonald's "The Princess and the Goblin," "Hiawatha," "The Secret Garden," by Mrs. Burnett [13]

KIRK, Mary Wallace [E] Tuscumbia, AL b. Tuscumbia, AL. Studied: L. Lewis; L. Douglas; H. Smith; H. Sternberg. Member: SSAL; Ala. AL; So. Pr.M. Soc. Work: Carnegie Lib., Agnes Scott Col., Decatur, Ga.; MFA, Montgomery, Ala. [40]

KIRKBRIDE, E(arle) R(osslyn) [P,I] b. 11 Mr 1891, Pittsburgh d. 15 Ag 1968. Studied: Vanderpoel; Buehr; Clarkson. Member: Cliff Dwellers; Palette and Chisel C. Illustrator: "Sunny Sam" "Myself and Fellow Asses," by Thos. Temple Hoyne; stories for Redbook [33]

KIRKBRIDE, Vernon Thomas [E] Chicago, IL. Member: Chicago SE [27]

KIRKBRIDE, Vernon (Mrs.) [P,I,E] Chicago, IL b. 12 S 1894, Evanston, IL. Studied: R. Clarkson,; C. Hawthorne; W.J. Reynolds. Member: Chicago SE; Cordon C. Illustrator: "Sunny Sam." Specialty: paintings & etchings of children [27]

KIRKGAARD, L. Maria [Por.P,Min.P] Altadena, CA b. San Jose, CA. Studied: F.T. Chamberlin; L. Murphy; E.S. Bush. M.K. Wachtel; A. Clark. Member: Calif. SMP. Work: Los Angeles MA [47]

KIRKHAM, Charlotte Burt (Mrs.) [P,T] Springfield, MA b. East Saginaw, MI. Studied: D. Volk; B. Baker; Lefebvre, Paris. Member: Wash. SA; Springfield AL [33]

KIRKHAM, Ralph W. [S] Wash., D.C. [06]

KIRKHUM, R.N. (Mrs.) [P] Wash. D.C. Member: S. Wash. A. [24]

KIRKLAND, F(orrest) [P] Dallas, TX b. 24 N 1892, Mist, AR d. 1942. Studied: E.G. Eisenlohr; Battle Creek Sch. Appl. A. Member: Dallas AA; SSAL. Exhibited: Dallas Pub. A. Gal., 1931 (prize); SSAL, 1932 (prize) [40]

KIRKLAND, Vance H. [P,L,T] Denver, CO b. 3 N 1904, Convoy, OH. Studied: H.G. Keller; F.N. Wilcox; Cleveland Sch. A. Member: Denver AG. Exhibited: Midwest A. Ann., Kansas City AI, 1938 (prize). Work: Denver AM; USPO, Eureka, Kans. WPA artist. Position: T., Extension Div., Univ. Colo. [40]

KIRPAL, Elsa. See Peterson.

KIRKPATRICK, A.B. (Mrs.) [P] Boston, MA [01]

KIRKPATRICK, Donald M(orris) [E,Arch,T] Bryn Mawr, PA b. 17 Mr

1887, Easton, PA. Studied: E. Léon, Paris. Member: Phila. SE; AIA; Phila. PC; Societé des Artists Francaise. Exhibited: Paris Salon, 1930, 1931 [40]

KIRKPATRICK, Frank Le Brun [P] Phila., PA b. 1853, Phila. d. 11 N 1917. Studied: Munich [06]

KIRKPATRICK, Harriet (Mrs.) [P,C,T,Ser] Columbus, OH Studied: Columbus A. Sch.; Hawthorne; Carlson; Thurn; Hofmann. Member: Ohio WCS; Columbus AL. Exhibited: AWCS; NYWCC; Phila. A. All., 1944; Athens Univ., 1943 (one-man); Columbus AL, 1922 (prize), 1931 (prize), 1936 (prize). Position: T., Columbus Sch. for Girls [47]

KIRKPATRICK, Marion Powers. See Powers.

KIRKPATRICK, W(illiam) A(rber-Brown) [I,P] Waldoboro, ME/Friendship, ME b. 7 N 1880, England. Studied: Laurens, Paris; London. Member: Boston AC [40]

KIRKUP, Mary A. [P,W,L] Larchmont, NY b. Fort Atkinson, IA. Studied: ASL; Lasar, Paris. Member: New Rochelle AA. Exhibited: New Rochelle AA, 1926 (prize); Wolfe AC, NYC, 1927 (prize) [40]

KIRLEY, Rollin [I] NYC. Position: The World, NYC [19]

KIRMSE, Marguerite [E,I,P,S] NYC/Bridgewater, CT b. 14 D 1885, Bournemouth, England d. 12 d 1954. Studied: F. Calderon. Member: Phila. PC. Illustrator: "Bob, Son of Battle," by Ollivant; "Thy Servant a Dog," by Rudyard Kipling; leading magazines; etchings of dogs [40]

KIRSCH, Agatha B. [P,G,T] Seattle, WA b. 9 My 1879, Creston, IA. Studied: Univ. Wash.; Seattle A. Sch. Member: Women P. of Wash. Exhibited: Women P. of Wash.; Seattle AM. WPA artist. [40]

KIRSCH, (Frederick) Dwight, Jr. [P,E,W,L,Des,I,T] Lincoln, NE b. 28 Ja 1899, Pawnee County, NE. Studied: Univ. Nebr.; ASL; Parsons Sch. Des.; B. Robinson; N.Y. Sch. F.&Appl. A. Member: Lincoln A. Gld.; Nebr. AA; Am. Assn. Univ. Prof.; Lincoln Camera C. Exhibited: AIC, 1944; Joslyn Mem., annually; Colorado Springs FA Center, 1946; Lincoln AG, annually; Midwestern A., Kansas City, 1935. Work: Nebr. AA; Wichita A. Mus.; PMA; Univ. Nebr.; schools, Lincoln. Illustrator: "My Very First Music Lessons," pub. Schirmer, "The Prairie State Capitol," pub. Miller and Paine, "Little Songs for Little Players," pub. Carl Fischer. Contributor: articles, American Annual of Photography. Position: T., Univ. Nebr., 1935- [47]

KIRSHNER, Raphael [Por.P] b. 1876, Vienna, Austria (came to U.S. from London in 1915) d. 2 Ag 1917, NYC. Creator: the "Kirschner Girl"

KIRSTEIN, Lincoln Edward [Cr,W,L] NYC b. 4 My 1907, Rochester, NY. Studied: Harvard. Author: "American Mural Painters," 1932; "Gaston Lachaise," 1935; "American Battle Painting," 1944; "Cartier-Bresson," 1946 (MOMA); "Dance, A Short History," 1934; "Blast at Ballet," 1938; "Ballet Alphabet," 1939; "Pedro Figari," 1946. Contributor: reviews, articles, art and nat. magazines. Position: Advisor, MOMA, 1941-43 [47]

KIRSTEN, Richard Charles [Des,P] Seattle, WA b. 16 Ap 1920, Chicago, IL. Studied: AIC; Univ. Wash. Member: AFA; AAPL; Tech. Engineers & Arch. Assn. Exhibited: SAM, 1943 (one-man), 1945. Position: Specialist A., U.S. Navy. 1944-46 [47]

KIRTLAND, Elizabeth S(cribner) [P,E] Riverdale, NY b. 16 Mr, 1876, NYC. Studied: Chase; Beckwith; Rondel; ASL; Paris. Member: NAC; Yonkers AA [25]

KISELEWSKI, Joseph [S] NYC b. 16 F 1901, Browerville, MN. Studied: Minneapolis Sch. A.; NAD; BAID; Am. Acad., Rome; Académie Julian, Paris; L. Lawrie; P. Landowski; H. Bouchard. Member: ANA, 1936; NA; NSS; Arch. Lg. Exhibited: NAD, 1937 (gold); Beaux-Arts, Paris, 1925-26 (prizes). Award: Prix de Rome, 1926-29. Work: mon., Milwaukee; S. groups/mon., Bronx County Court House, N.Y.; U.S. War Dept., Commerce Bldg., both in Wash., D.C.; Vincennes, Ind.; Fargo, N.Dak.; Tarrytown, N.Y.; Metropolitan Life Ins. Co.; Rosary Col., River Forest, Ill.; John Wesley Methodist Episcopal Church, Winston-Salem, N.C.; Lyman Allyn Mus.; Soc. Medalists; Brookgreen Gardens, S.C.; Occidental Col., Calif.; Bryn Mawr Col.; church, Browerville, Minn.; WFNY, 1939 [47]

KISER, Virginia Lee [P,E] Columbus, OH b. 12 D 1884, Roanoke County, VA. Studied: W.M. Chase; F. DuMond; F.L. Mora; J. Pennell; N.Y. Sch. FA; ASL; Grande Chaumière. Work: CI; etchings, MMA; NYPL; etchings, BM; VMFA; Valentine Mus., Richmond, Va.; Civic AL, Women's C., both in Lynchburg, Va.; Houston MFA [40]

KISH, Maurice [P] Brooklyn, NY b. 19 F 1898, Dvinsk, Russia. Member: All.A.Am.; Brooklyn SA; CAFA. Exhibited: NAD, 1932-34, 1938, 1940-45; CGA, 1935, 1937, 1939; PAFA, 1938, 1942, 1942, 1946; VMFA, 1942; AFA traveling exh., 1938, 1939; CI, 1941; WFNY 1939; All.A.Am., 1933-46, 1945 (prize); CAFA, 1942, 1945 (prize), 1946; Brooklyn SA; Ogunquit A. Center; Macbeth Gal.; Findlay Gal.; ACA Gal.; Am.-British A. Center; Edu. All.; BM; Phila. A. All. [47]

KISSACK, R.A. [P] NYC b. 4 Mr 1878, St. Louis, MO. Studied: St. Louis Sch. FA; Paris. Member: St. Louis AG. Exhibited: St. Louis Sch. of FA (gold); St. Louis AG (prize). Work: dec., Mo. State Capitol, portraits, NYU [40]

KISSEL, Eleonora [Por.P,Ldscp.P,E] NYC/Taos, NM b. 23 O 1891, Morristown, NJ d. 1966. Studied: ASL, abroad. Member: Taos Heptagon; NAWA; Taos AA. Exhibited: CGA. Work: Mus. N.Mex.; Harwood Fnd. [47]

KISSEL, Irene [E,T] Cleveland, OH b. 30 D 1904, Hungary. Studied: Cleveland Sch. A.; Western Reserve Univ. Member: Cleveland PM; Am. A. Cong.; Print C. of Cleveland. Exhibited: Ohio PM, 1931 (prize); CMA, 1933 (prize); Cleveland PM, 1936. Work: CMA; "Fifty Prints of the Year," 1932-33 [40]

KITCHEN, Annie Louise [P,C] Toledo, OH b. 31 O 1871, Springton, PA. Studied: Toledo Sch. Des.; Alfred Univ.; AIC; Columbia; Germany; C. Binns; M. Fosdick; M. French; E. Chassan. Member: A. Ceramic S.; Toledo S. Craftsmen; Ohio WCS; Toledo Women A.; Toledo Crafts C. Exhibited: Cleveland, 1931 (prizes); TMA, 1934 (prize), 1936 (prize), 1937 (prize), 1938 (prize); Syracuse Mus. FA [47]

KITSON, Anne Meredith (Mrs. Samuel J.) [S] b. 1855, Waltham, MA d. 25 Mr 1937, NYC. Since the death of her husband in 1904, she completed many of his unfinished sculptures.

KITSON, Henry H. [S] Lee, MA b. 9 Ap 1863, Huddersfield, England d. 26 Je 1947, Tyringham, MA. Studied: Bonnaissieux; Ecole des Beaux Arts, Paris. Member: Copley S.; Boston SAC; Boston AC; NSS; NAC. Exhibited: Mass. Charitable Mech. Assn. (gold); Am. AA, N.Y., 1886 (gold); Paris Expo, 1889 (med), 1900 (med); Columbian Expo, Chicago 1893 (med). Work: statue, Plymouth, Mass.; mon., Watertown, Mass.; statues of Minutemen, Lexington, Framingham; statue, Salem; mem., mon., Boston; BMFA; fountain, statue, Providence, R.I.; Drexel Chapel, Phila.; mem., Newark, N.J.; mem., Inst. Musical Art, NYC; statues, Newburgh, N.Y.; statue, Minute Man, Cedar Rapids, Iowa; busts, NGA; statue, Paducah, Ky.; statues, Columbus, Miss.; Vicksburg, Miss.; busts, Nat. Gal., London; busts, Newark AM; Temple of Music, Pittsfield, Mass.; Harvard [40]

KITSON, Samuel James [S] Boston, MA b. 1 Ja 1884, Huddersfield, England (came to U.S. in 1878) d. 9 N 1906, NYC. Studied: St. Lukes Acad., Rome; Italy, with Todesti, Jocomeli. Member: BAC. Work: sculptor for the interior of W.K. Vanderbilt's house, NYC; mon., Arlington, Va.; Monument Arch, Hartford, CT; State House, Boston [06]

KITSON, Theo Alice Ruggles (Mrs. H.H.) [Des,S] Framingham, MA b. 1876, Brookline, MA d. 29 O 1932. Studied: H.H. Kitson, in Boston; Dagnan-Bouveret, in Paris. Member: Copley S.; NSS. Exhibited: Paris Salon, 1890 (said to have been the first American woman to recieve honorable mention); Mass. Charitable Mech. Assn. (meds); Columbian Expo, Chicago; St. Louis Expo, 1904 (med). Work: Framingham, Mass.; group for Ill.; Newburyport, Mass.; Goshen, N.Y.; Walden, N.Y.; Vicksburg, Miss.; Minneapolis, Minn.; Pasadena, Calif.; Providence, R.I.; Little Falls, R.I.; Ashburnham, Mass.; North Andover, Mass.; Topsfield, Mass.; war mon., Schenectady, N.Y.; Lynn, Mass.; WWI mem., Dorchester, Mass; Brookline, Mass.; Francestown, N.H.; equestrian statue, Pub. Gardens, Boston; mem. statue, Cambridge, Mass.; Galesburg, Ill.; Detroit AI [31]

KITT, Emma [Edu,P,Dr,T] Ames, IA b. 16 O 1885, Melbourne, SD d. ca. 1955. Studied: AIC; N.Y. Sch. F.&Appl. A.; Chicago Acad. A.; R. Johonnet; G. Wood. Member: AAPL. Exhibited: Kansas City AI, 1935; Joslyn mem., 1934, 1939, 1942, 1944; Iowa A. Salon, 1933, 1934 (prize), 1935 (prize), 1936, 1938; Iowa WC Exh., Sioux City, 1945. Work: Iowa Fed. Women's C. Position: T., Iowa State Col., 1940- [47]

KITT, Katherine F(lorence) [P,I,T] Tucson, AZ b. 9 O 1876, Chico, CA. Studied: R. Miller; H. Horrisot. Member: Cincinnati Women's AC; NAC. Position: T., Univ. Ariz., since 1925 [40]

KITTREDGE, Kraemer [Ldscp.P] Cincinnati, OH/Wisconsin Dells, WI b. 15 Ag 1905, Clinton, MA. Studied: Mass. Sch. A.; Vesper George Sch. Des.; AIC. Member: Cincinnati Assn. Prof. A. Position: T., Cincinnati A. Acad. [40]

KITTREDGE, Robert [S] Flagstaff, AZ. Exhibited: Ariz. P.&S. Fed. A. Center, Phoenix, 1938. Work: USPOs, Flagstaff, Springerville, both in Ariz. WPA sculptor. [40]

KITTS, Jasmine de Lancey (Mrs. L.T.) [P,Dec,Des] San Fran., CA b. 9 O 1869, Knoxville, TN. Studied: Minn. Sch. FA; Calif. Sch. FA. Member: San Fran. S. Women A. [40]

KIZER, Charlotte. See Bitz.

KJELDSEN, Lana [P] NYC b. Copenhagen, Denmark. Studied: Henri; ASL; M. Young [27]

KLACKNER, Christian [Dealer,Pub] NYC b. 1850, New York d. 4 Jy 1916. While still a boy entered the employ of M. Knoedler & Company; remained with the firm for twenty years. In 1883 he started in business for himself, publishing many popular prints and mezzotints in color and maintaining a photogravure plant. He was a member of the Print Sellers' Assoc. of London.

KLACKNER, John [Dealer,Pub] b. 1848 d. 20 N 1916 (suddenly, at Pennsylvania Station). Associated with Klackner & Company for many years, he succeeded his brother Christian as head of the firm, in 1915.

KLAGES, Frank H(enry) [P,I,T] Phila., PA b. 24 Jy 1892, Phila. Studied: PAFA; E. Carlsen; C. Beaux; P. Hale. Exhibited: PAFA, 1914 (prize) [25]

KLAGSTAD, Arnold Ness [P] Minneapolis, MN b. 14 Jy 1898, Marinette, WI. Studied: Minneapolis Sch. FA; Fontainebleau Sch. A.; J. Despujols. Member: Minneapolis AA. Exhibited: Minn. State Fair, 1932 (prize), 1933 (prize), 1934 (prize). Work: Univ. Minn. [40]

KLAGSTAD, August [P] Minneapolis, MN b. 14 Ag 1866, Bingen, Norway. Studied: Chicago Acad. A.; AIC, with W.J. Reynolds; Minneapolis Sch. FA. Member: Minn. AA. Exhibited: Minneapolis Inst., 1915 (prize); Minn. State Fair. Work: St. Olaf Col., Northfield, Minn.; Stout Inst., Menomonie, Wis.; Univ. Minn.; Minneapolis Pub. Lib.; Vanderpoel Coll.; Temple, Eau Claire, Wis. [47]

KLAPKA, Jerome J. [P,I] Berwyn, IL b. 19 N 1888, Czechoslovakia. Studied: AIC; W.F. Reynolds. Member: Chicago Gal. Assn.; Chicago Gld. Free Lance Ar. [40]

KLAR, Mary Shepard (Mrs. W.H.) [P] Buffalo, NY/Westfield, MA b. 2 F 1882, Westfield. Studied: Pratt Inst. [17]

KLAR, Walter Hughes [Edu,W,P,L] Springfield, MA b. 20 Mr 1882, Westfield, MA. Studied: Mass. Sch. A.; NAD. Member: Eastern AA; Springfield A. Lg.; Nat. Edu. Assn. Exhibited: Pittsburgh AA, 1919–1926; Springfield A. Lg.; Buffalo, N.Y.; Greenfield, Mass. Co-author: "Appreciation of Pictures," 1930, "Theory and Practice of Art Education," 1933. Position: T., Pub. Sch., Springfield, Mass., 1934– [47]

KLASSEN, John P. [P,S,C,T] Blufton, OH b. 8 Ap 1888, Ukraine, Russia. Studied: Ohio State Univ.; Germany. Member: Columbus A. Lg. Exhibited: Columbus Gal. FA, 1939–46, 1945 (prize); Syracuse Mus. FA, 1939. Lectures: Mennonite Art. Position: T., Bluffton Col., Ohio, 1924–46 [47]

KLASSTORNER, Samuel [S,T] Chicago. IL b. 25 N 1895, Russia. Studied: AIC. Member: Chicago PS; Chicago SA. Exhibited: Englewood Women's C., AIC, 1921 (prize), 1923 (prize); Chicago Soc. A., 1916 (med) [40]

KLAUBER, Alice [P,Cur] San Diego, CA b. 19 My 1871, San Diego. Studied: Chase; Henri. Member: San Diego FA Soc.; Los Angeles WCC. Exhibited: San Diego Gal. FA, 1927 (prize). Work: des., finish and furnishings, "Persimmon Room," San Diego Expo, 1915, Men's Smoking Lounge, San Diego Expo, 1936–37, living rooms, Community Center, Balboa Park; YWCA, San Diego; Wednesday C. House, San Diego; San Diego Gal. FA; Santa Fe (N.Mex.) Mus. Positions: Chairman A. Dept., San Diego Expo, 1915–16; Hon. Cur., Oriental Dept., San Diego FA Gal. [40]

KLAUDER, Charles Z. [P] Phila., PA Studied: PAFA. Related to Elfrieda. [25]

KLAUDER, Elfrieda [S] Phila., PA. Studied: PAFA. Related to Charles Z. [25]

KLAUDER, Mary. See Jones, Thomas B., Mrs.

KLAW, Alonzo [P] Carmel, NY b. 15 Ap 1885, Louisville, KY. Studied: N.Y. Sch. A.; ASL. Member: SC; AWCS; NYWCC [40]

KLEBE, Elfreda D. [P,T] New Haven, CT/Guilford Lakes, CT b. 5 Jy 1884, New Haven. Studied: Bicknell; Wiggins. Member: New Haven PBC; CAFA [33]

KLEBOE, Bernhardt [P] Chicago, IL. Member: GFLA [27]

KLEEN, Tyra [P] NYC [17]

KLEIBER, Hans [P,E] Dayton, WY b. 24 Ag 1887, Cologne, Germany (came to Wyoming in 1906) d. 1967. Studied: self-taught. Member: Calif. PM. Exhibited: Calif. PM, 1931 (med). Work: LOC; Wyo. State AG; Univ. Wyo.; Calif. State Lib. [40]

KLEIMINGER, A.F. [P] Chicago, IL/Nonquitt, MA b. 4 D 1865, Chicago. Studied: H. Martin. Member: Chicago SA; S.Indp.A.; New Bedford SA [33]

KLEIN, Benjamin [P,I,E] NYC b. 4 S 1898, Austria-Hungary. Studied: NAD; Europe; M. Kinney; T. Kinney. Exhibited: Eberhard Faber Comp. for Dr., 1927 (prize). Illustrator: magazines [40]

KLEIN, Frank Anthony [S,C,I,W] Brooklyn, NY b. 23 Je 1890, Trier, Germany. Studied: Van de Velde, Municipal Art Sch., in Trier; Art Sch., Cologne, with Grasseger; Bosse, Sch. FA, Düsseldorf; Sobry, in Brussels. Member: Brooklyn SA; All.A.Am. Exhibited: Arch. Lg.; NSS; WMAA; BM; PAFA; N.Y. Hist. Soc. Work: Court St., Brooklyn, N.Y.; St. Nicolas Cemetery, Passaic, N.J.; St. Catherine of Siena Church, N.Y.; Brooklyn Tech. H.S.; Richmond Hill, N.Y.; St. Stephens Church, Arlington, N.J.; Our Lady of Angels Church, Brooklyn, N.Y.; War Veterans' Organization. Contributor: articles/illus., to newspapers, magazines [47]

KLEIN, Henry [P] Chicago, IL [13]

KLEIN, I(sidore) [Car,E,P] Long Island City, NY b. 12 O 1897, Newark, NJ. Studied: NAD; ASL. Member: Screen Car. Gld. Exhibited: NAD, 1922–1930, 1942, 1946; BM; NAC; AIC. Illustrator: cartoon books. Contributor: New Yorker, Colliers, Saturday Evening Post, Life. Did animated cartoons for motion pictures, 1935– [47]

KLEIN, J. Alan. See Alan.

KLEIN, Jeanette [S] Kansas City, MO. Exhibited: Midwest Ar. Ann., Kansas City AI, 1933 (med), 1935, 1937, 1938 [40]

KLEIN, Lillie V. O'Ryan [P] Portland, OR [15]

KLEIN, Mabel S. [P] Newark, NJ [17]

KLEIN, Medard P. [P,G] Chicago, IL b. 6 Ja 1905, Appleton, WI. Exhibited: Mus. Non-Objective P., annually; AIC; Joslyn Mem.; SFMA; Everhart Mus.; Oakland A. Gal.; Albany Inst. Hist.&A.; NAD; LOC; Wichita AA; Phila. Pr. C.; Northwest Pr.M.; Laguna Beach AA; Little Gal., Springfield, Mass.; AGAA; Olivet Col.; Univ. Wash.; Theobold Gal., Chicago (one-man); St. Louis A. Center (one-man); Univ. Minn. (one-man); Springfield AA (one-man); Lawrence Col. (one-man); Chicago Pub. Lib. (one-man); Snowden Gal., Chicago (one-man) [47]

KLEIN, Michael [P] Kingston, NY. Exhibited: CGA, 1935; PAFA, 1936; WFNY, 1939 [40]

KLEIN, Nathan [P] Brooklyn, NY [25]

KLEIN, William [P] NYC [01]

KLEINBARDT, Ernest [P,L,Arch,Dec] Mt. Vernon, NY b. 24 S 1874, Łódz, Poland d. 8 Ja 1962. Studied: Acads., Berlin, Munich, Germany. Member: Munich A. Soc.; Am. A. Soc. Exhibited: Acad., Berlin, 1906 (med); Leipzig, 1906 (med); Breslau, 1907 (med); Hanover, 1907 (med); Nurenburg, 1909 (med). Work: St. Mary's Church; St. Mark's Church, Brooklyn; St. Lazarus Church, Newark, N.J. [47]

KLEINERT, Hermine E. [P] Woodstock, NY b. 1880, NYC d. 26 Jy 1943, Woodstock. Studied: ASL. Member: Woodstock AA [40]

KLEINHOLZ, Frank [P,T,L] NYC b. 17 F 1901, Brooklyn, NY. Studied: Fordham Univ.; Am. A. Sch.; A. Kobkin; Y. Kuniyoshi; S. Wilson. Member: An Am. Group; A. Lg. Am. Exhibited: AV, 1942 (prize); CI, 1941, 1943–46; PAFA, 1942, 1944, 1945; VMFA, 1942, 1944; WMAA, 1943, 1945; AIC, 1943; Pepsi-Cola, 1944; Univ. Nebr., 1944; State Univ. Iowa, 1944–46; CGA, 1945; Albright A. Gal., 1946; CAM, 1945; Springfield Mus. A., 1945; MMA (AV), 1942; PMG, 1943 (one-man); Whyte Gal., 1944 (one-man); Assn. Am. A., 1942, 1944, 1945 (one-man); An Am. Group 1944, 1945; BM, 1944; A. Lg. Am., 1944, 1945. Work: MMA; PMG; Encyclopaedia Britannica Coll. Position: T., Jefferson Sch., N.Y. (1944–46), BM Sch. A. (1946) [47]

KLEISER, Lorentz [C,P,L,Des] NYC b. 26 My 1879, Elgin, IL. Studied: Europe. Member: AIA; AID. Exhibited: AIC, 1921 (med). Work: Newark Mus.; Cranbrook Acad. A.; Mo. State Capitol; Nebr. State Capitol; State House, Jefferson City, Mo. Specialty: tapestries [47]

KLEIST, Addie L. (Mrs.) [P] Whitefish Bay, WI [24]

KLEITSCH, Joseph [P,L,T] Laguna Beach, CA b. 1885, Banad. Studied: Chicago; Budapest; Munich; Paris. Member: Chicago PS; Palette and Chisel C.; Chicago SA; Laguna Beach AA. Exhibited: Palette and Chisel

C. (gold); P.&S. C. (med); State Fair, Sacramento, Calif. (prize); Laguna Beach AA (prizes); Arché C., Chicago (prize) [33]

KLEITSCH, Joseph (Mrs.) [P,S,E,T] Laguna Beach, CA. Member: AIC; Laguna Beach AA; Soc. for Sanity in A. [40]

KLEMM, Germany (Miss) [B,C,Des,E,T] Eugene, OR b. 10 F 1900. Studied: A.H. Schroff; Univ. Oreg.; H.N. Rhodes; Univ. Wash.; C.J. Martin; S.B. Tannahill, Columbia; A. Cirino; RISD; F.M. Robitaille, E. Drescher, in Providence. Member: Northwest PM. Work: RISD [40]

KLEMPNER, Ernest S. [P,E,Dr,I,L] Evanston, IL b. Vienna, Austria. Studied: Vienna Acad., with L'Allemand. Member: AFA. Exhibited: Chicago Municipal AL; Ar. Chicago Exh., 1930 (prize); Calif. SE, 1936 (prize); Evanston Women's C., 1936 (prize). Work: City of Vienna; Chicago Hist. Soc.; Seabury-Western Theological Seminary; Charles Deering Lib., SAE House, Church Lib., all at Northwestern; Saddle & Sirloin C.; Passavant Mem. Hospital, Chicago [40]

KLEP, Rolf [I] New Rochelle, NY b. 6 F 1904, Portland, OR. Studied: Univ. Oreg. Member: SI. Author/Illustrator: "Album of the Great," 1937. Illustrator: "The Children's Shakespeare," 1938, "Beowulf," 1941; national magazines; technical marine and aeronautical magazines [47]

KLEPPER, Frank Earl [P,Ldscp.P,E,C,T] Dallas TX b. 3 My 1890, Plano, TX d. ca. 1955. Studied: AIC; H. Lachman, in Paris. Member: Ark. State AA; SSAL; Dallas AA; Tex. FAA. Exhibited: SSAL, 1930 (prize), 1932 (med); Oakcliff FA Soc., Dallas, 1935 (prize); All. A., Dallas, 1936 (prize); Tex. State A., 1916 (prize), 1920 (gold), 1922 (prize), 1928 (prize), 1929 (prize); San Antonio; New Orleans; Tex. FA Assn. Work: Dallas Mus. FA; Ark. State AA; West Tex. AA; Fed. Bldg., McKinney, Tex.; Prairie View State Normal Sch., Tex. Specialties: landscapes, negro subjects [47]

KLEPPER, Max Francis [I,P] NYC b. 1 Mr 1861, Zeitz, Germany (came to Toledo in 1876) d. 5 My 1907, Brooklyn. Studied: ASL; Royal Acad., Munich, 1887–89. Illustrator: magazines. Specialty: horses [06]

KLEPSER, Harold [I] b. 1893 d. 26 N 1933, New York

KLETT, Walter Charles [I,P,Des,L] NYC b. 28 Ap 1897, St. Louis d. D 1966. Studied: St. Louis Sch. FA; Wash. Univ. Member: SI; A. Gld.; A.&W. Assn.; Lotos C. Exhibited: PAFA; CAM; Kansas City AI. Illustrator: Collier's, Arts and Decoration, Harper's Bazaar, Cosmopolitan, other magazines [47]

KLEY, Alfred J. [C,P,Li] Hollywood, CA b. 24 Je 1895, Chicago d. 26 Je 1957, Los Angeles. Studied: AIC; Wilimovsky; Schroeder; D. Palumbo. Member: Calif. WCC. Exhibited: Okla. A. Center, 1941; Los Angeles Mus. A., 1940, 1942, 1945; Riverside Mus., 1946; Calif. WCC, 1942, 1944 [47]

KLINE, Edith L. B(ollinger) (Mrs.) [P,T,G] Darby, PA b. 8 N 1903, Phila. Studied: PMSchIA; Moore Inst.; Univ. Pa.; PAFA; Ecole des Beaux-Arts; E. Horer; J. Lear. Member: Phila. A. All.; Phila. WCC; Phila. A. T. Assn.; Eastern AA; AAPL. Exhibited: NAC, 1941 (prize); Phila. A. T. Assn., 1944 (prize); PAFA, 1939; Ecole des Beaux-Arts; Arch. Lg.; Phila. A. All.; Phila. Sketch C.; Woodmere A. Gal.; Phila. WCC; Women's Univ. C., Phila. (one-man); Reading Mus. A. (one-man). Position: T., Sulzberger Jr. H.S., Phila. [47]

KLINE, Franz [P] b. 1910, Wilkes-Barre, PA d. 1962, NYC. Studied: Boston Univ., 1931–35; London, 1937–38. Work: WMAA; MOMA; PMG. Important abstract expressionist, whose form matured in the 1950s; best known for his large black and white paintings. Position: T., Black Mountain Col., 1952 [*]

KLINE, George T. [L,T,Medical I] St. Louis, MO b. 22 Ag 1874, Baltimore d. 24 My 1956. Studied: S.E. Whiteman. Member: St. Louis AL. Illustrator: scientific articles. Positions: Medical Illus., Wis. Univ. Medical Sch., Mo. Univ., St. Louis Medical Sch., Washington Univ. (St. Louis, Mo.) [47]

KLINE, Hibberd Van Buren [I,E,P,T] Syracuse, NY b. Auriesville, NY. Studied: Syracuse Univ.; ASL. Member: SC; AFA; AAPL; Syracuse AA; Phila. SE. Contributor: national magazines. Position: T., Syracuse Univ. [47]

KLINE, William F(air) [Mur.P,I,C] NYC b. 3 My 1870, Columbia, SC d. 30 Jy 1931. Studied: NAD, with Low, Ward; J La Farge, in N.Y.; Académie Julian, Paris, with Bouguereau, Constant; Colarossi Acad., Paris; Ferrier, in Paris. Member: ANA, 1901; Mural P.; NYWCC, 1918; AWCS, 1919; AFA. Exhibited: Pan-Am. Expo, Buffalo, 1901 (med); NAD, 1901 (prize), 1903 (prize); St. Louis Expo, 1904 (prize). Work: mem. window, Second Presbyterian Church, Chicago [29]

KLING, Bertha [S,L] Phila., PA b. 8 Ag 1910, Phila. Studied: BMFA Sch.; Fontainebleau Sch. FA, France; PAFA; RISD. Member: Phila. A. All. Exhibited: Boston, 1933; R.I. Chronicle, 1936 (prize); PAFA, 1940 (prize); WFNY, 1939; PAFA, 1935, 1936, 1938, 1943; NSS, 1935, 1938, 1940, 1942; Phila. A. All., 1935–45; Newport AA, 1938, 1939, 1940; Providence AC, 1935–39, 1941. Work: St. Peter's Col., N.Y. [47]

KLING, Wendell [I] Bronxville, NY. Member: SI [47]

KLINGBEIL, Otto H. [P] Columbus, OH. Member: Columbus PPC [25]

KLINK, Ethel H. See Myers.

KLINKER, Orpha [E,P,I] Los Angeles, CA b. Fairfield, IA d. 1964. Studied: UCLA; Académie Julian, Paris; W. Foster; M. Brooks; E. Payne; John Hubbard Rich; Acad. Colarossi, Paris. Member: SAE; Calif. SE; Calif. AC; Women P. of the West; Am. Soc. Heraldry; Los Angeles AA; Nat. Soc. Sc.&A., Mexico. Exhibited: Univ. Panama (med); Los Angeles Mus. A., 1935 (prize); MMA (AV), 1943; Grand Central A. Gal., 1940; NAD, 1943, 1944, 1946; PAFA, 1939; WMAA, 1944; GGE, 1939; Mexico City, 1944; LOC, 1944; Laguna Beach AA, 1943–46; Denver A. Mus., 1945; Los Angeles Mus. A. annually; Pal. Leg. Honor; Soc. for Sanity in Art, 1943–45; Calif. SE, 1939–45; Ebell C., Los Angeles; Oakland A. Gal., 1940–46. Award: Croix de Commandeur, Belgium. Work: City Hall, Polytechnic H.S., both in Los Angeles; Los Angeles AA. Illustrator: "The City That Grew," "Enchanted Pueblo," other books [47]

KLINKERFUES, Fulton [S] St. Paul, MN [17]

KLIPPART, Josephine [P] Columbus, OH b. 1848, Osnaburg, OH d. 24 N 1936. Studied: Columbus AA. Member: Columbus AL; Ohio Water Color Society (founder); Columbus A. Gal. (patron). Exhibited: Columbus AL [13]

KLITGAARD, Georgina (Mrs. Kaj) [P,E] Bearsville, NY b. 3 Jy 1893, Spuyten Duyvil, NY. Studied: Barnard Col.; NAD. Member: Audubon A.; Am. Soc. PS&G. Exhibited: PAFA, annually, 1930 (gold); Pan-Am. Expo. 1931 (prize); Guggenheim F., 1933; CI, 1928 (prize), 1929–46; San Fran. AA, 1932 (prize); CGA, 1928–46; VMFA, annually; other U.S. mus. Work: MMA; WMAA; Newark Mus.; Dayton AI; New Britain AI; BM; Wood Gal. A., Montpelier, Vt.; USPOs, Poughkeepsie, N.Y., Goshen, N.Y., Pelham, Ga.; Chicago AI; TMA. WPA muralist. [47]

KLOHS, Kate K. (Mrs. S.F.) [P] Palos Park, IL b. 7 Je 1872, IL. Studied: AIC [13]

KLONIS, Bernard [P,T] NYC b. 1 F 1906, Naugatuck, CT d. 21 Je 1957. Studied: ASL; Homer Boss. Exhibited: PAFA; AIC, 1942–46; BM; WMAA; TMA. Work: MMA; Univ. Ariz. Positions: T., ASL, Parsons Sch. Des. [47]

KLONIS, Stewart [P,T,L] Astoria, NY b. 24 D 1901, Naugatuck, CT. Studied: ASL; H. Boss. Member: A. Aid Comm., 1932–36. Work: IBM Coll. Position: T., Queens Col., N.Y., 1940–45 [47]

KLOPPER, Zan(will) D(avid) [P,I] Chicago, IL b. 20 O 1870, Russia. Studied: Académie Julian, Paris, with Repin, Laurens. Work: St. Mary's of the Woods. Specialty: anatomical and surgical drawings. He was a physician. [25]

KLOSS, Gene [E,P] Berkeley, CA b. 27 Jy 1903, Oakland. Studied: Univ. Calif., 1924; Calif. Sch. FA, 1924–25. Member: SAE; Chicago SE; Phila. WCC; Prairie Pr.M.; Calif. SE; N.Mex. A. Lg. Exhibited: PAFA, 1936 (med); Calif. SE, 1934 (prize), 1940 (prize), 1941 (prize), 1944 (prize); Oakland A. Gal., 1939 (prize); Chicago SE, 1940 (prize); Tucson FA Assn., 1941 (prize); Phila. Pr. C., 1944 (prize); LOC, 1946 (prize); NAD; SAE; Prairie Pr.M.; CI, 1943–45; WFNY, 1939; GGE, 1939; U.S. Exh., Paris, 1939; Sweden, 1937; Italy, 1938; Mus. N.Mex., Santa Fe; SFMA; San Diego FA Soc.; Denver A. Mus. Work: CI; Smithsonian Inst.; LOC; NYPL; PAFA; AIC; SFMA; Honolulu Acad. A.; Dallas Mus. FA; Mus. N.Mex., Santa Fe; Okla. Univ.; Tex. Tech. Inst.; Prairie Pr.M.; "100 Prints of the Year," 1936–38 [47]

KLOSTER, Paula Rebecca [Edu,P,S] Tempe, AZ b. 16 S 1902, Hatton, ND. Studied: Univ. N.Dak.; Stanford Univ.; Chouinard AI; ASL; Univ. Southern Calif.; D. Lutz; F. McIntosh; Carlow Merida, in Mexico City. Member: CAA; Pacific AA; Ariz. AA; Ariz. Edu. Assn.; Nat. Edu. Assn.; Am Ar. Prof. Lg. Exhibited: Phoenix FA Assn., 1929 (prize), 1930 (prize), 1931 (prize); Ariz. A. Gld. Work: Adams Hotel, Phoenix. Position: T., Ariz. State Col., 1927– [47]

KLOTS, Alfred Partridge [P] Wash., D.C. [25]

KLOTZ, L. Edmund [P] Gloucester, MA [25]

KLOUS, Rose M. (Mrs. Isidore P.) [P,E] NYC/East Gloucester, MA b. 28 My 1889, Petrograd, Russia. Studied: ASL; Grand Central Sch. A.; Académie Julian, Paris. Member: Société Anonyme; Gloucester SA; S.Indp.A. [40]

KLUCKEN, Gerard A. [Por.P] NYC b. 1851, Genoa, Italy (came to Boston; then NYC) d. 10 D 1912

KLUG, Helen M. [P] Wash., D.C. Exhibited: Wash. WCC, 1937–39 [40]

KLUMKBE, Anna Elisabeth [P,L,T,W] San Fran., CA b. San Fran. Studied: R. Bonheur, Robert-Fleury, Lefebvre, Académie Julian, all in Paris. Member: Hon. Cor. Société des Artistes Français; Chevalier de la Legion d'Honeur, promoted to Officer, 1936, France; AFA; San Fran. AA. Exhibited: Paris Salon, 1885 (prize); Versailles, 1886 (med); PAFA, 1889 (gold); St. Louis Expo, 1904 (med). Work: PAFA; MMA; French Gov.; Pal. Leg. Honor; Smithsonian Inst. Author: "Rosa Bonheur, sa vie son oeuvre" [40]

KLUTH, Robert C. [Mar.P,Ldscp.P] Brooklyn, NY b. 1854, Germany (came to U.S. in 1861) d. 23 S 1921. Studied: U.S.; Germany; Norway. Member: Brooklyn Soc. Ar. (founder). Many of his paintings were purchased by Andrew Carnegie for public libraries. [08]

KLUTTS, Ethel Lindsay [P] d. spring 1935. Member: Ala. A. Lg.; Birmingham AC; Ala. Assoc. A. T.; SSAL. Specialty: flowers

KNABEL, June M. [Mur.P] Chicago, IL b. 1 N 1907, Saginaw, MI. Studied: AIC. Exhibited: AIC, 1931 (prize). Work: Mich. Acad. A., Saginaw; ceiling, Chicago Daily News; Chicago Bd. Trade; hist. map, Loyola Univ.; maps, Notre Dame Univ. [40]

KNAP, J(oseph) D(ay) [P,I,E] NYC b. 7 Je 1875, Scotdale, PA. Studied: J.H. Holden [29]

KNAPP, Corwin. See Linison.

KNAPP, C.W. [Ldscp.P] Phila., PA b. 1823, Phila. d. 15 My 1900. Exhibited: NAD, 1859–61

KNAPP, Frank De Villo [I,Des,P] Buffalo, NY b. 28 Ap 1896, Jamestown, NY. Studied: Buffalo Sch. FA; PAFA; Cornell; C.L. Holmes. Exhibited: Albright A. Gal., 1935–39, 1943; Chautauqua County SA, 1941, 1942; Great Lakes Traveling Exh., 1938, 1939. Illustrator: publications of Curtiss-Wright Research Lab., Cornell Aeronautical Lab. Specialty: indst. illus. [47]

KNAPP, George Kasson [Por.P,W,En] b. 1833 d. 9 My 1910, Syracuse, NY. He was for a time a bank note engraver and, later, a portrait painter. Among his sitters were Daniel L. Dickinson and Gen. G.W. Leavenworth. He also wrote about the history of middle New York.

KNAPP, Grace Le Duc (Mrs. C.C.) [P,I] Pasadena, CA b. 28 Ja 1874, Minnesota. Studied: ASL; Corcoran A. Sch. Member: Wash. WCC [33]

KNAPP, Leon [P,T] NYC b. 1902, Pochep, USSR (came to NYC in 1926) d. 13 Jy 1970. Studied: Moscow Acad. A. with L. Pasternak. WPA artist. [*]

KNAPP, Martha Severance (Mrs. Lyman E.) [P,T] b. 1827, Middlebury, VT d. 1928, Portland, OR. Work: Alaska Hist. Lib. Amateur painter in Sitka and Wrangell, Alaska (beginning 1889), when her husband was appointed Governor there. [*]

KNAPP, Walter Howard [I,Des,P,G] Northport, NY b. 2 N 1907, Cleveland. Studied: Oberlin Col.; Cleveland Sch. A.; H. Keller. Member: SI. Exhibited: CMA, 1932–34; Argent Gal., 1940 (one-man); SI, 1940, 1941. Work: CMA. Specialty: book illustrations [47]

KNAPP, Willi [P,S,E] Milwaukee, WI b. 4 Ap 1901, Hofeld, Germany d. 1974. Studied: AIC. Member: Wis. PS. Exhibited: Wis. State Exh., 1929 (prize), 1930 (prize); Milwaukee AI, 1930 (prize); Wis. Appl. AA, 1931 (prize); Milwaukee AI, 1932 (med), 1933 (prize). Work: State T. Col., Milwaukee. Did sculpture in Saarbrücken, Germany, commissioned by Adolf Hitler. [40]

KNATHS, (Otto) Karl [P,T,B] Provincetown, MA b. 21 O 1891, Eau Claire, WI d. 9 Mr 1971. Studied: AIC, 1912–16; Milwaukee AI. Member: NA, 1968; Am. Abstract Ar., 1936. Exhibited: AIC, 1928 (med); Boston Tercentenary FA, 1930 (med). Work: PMG; Gal. Living Art, NYU; MMA; MOMA; AIC; PAFA; Detroit IA; WMAA [40]

KNAUBER, Alma Jordan [P,Des,I,E,W,L] Cincinnati, OH b. 24 Ag 1893, Cincinnati. Studied: Ohio State Univ.; Cincinnati A. Acad.; Univ. Cincinnati; C. Hawthorne; G. Beal; F. Duveneck; L.H. Meakin; C.J. Barnhorn; Hopkins; E. Bisttram; France; England. Member: Professional A., Cincinnati; Columbus A. Lg.; Am. Assn. Univ. Prof.; Cincinnati Women's AC; Cincinnati Assn. Prof. A. Exhibited: Columbus, Ohio, 1926 (prize), 1945 (one-man); Cincinnati, 1941 (prize), 1945 (one-man); Professiona A., 1945 (one-man); Women's AC, 1946 (one-man). Work: Western Col. for Women, Oxford, Ohio; Rothenberg Sch., Cincinnati; Ohio State Univ. Author/Illustrator: art examiners test manuals. Position: T., Univ. Cincinnati [47]

KNAUFFT, Ernest [I,T,W,L] NYC b. 9 MY 1864, Summit, NJ d. 21 Ap 1942, Brooklyn. Studied: ASL. Position: T., Purdue Univ. [15]

KNECHT, Fern (Elizabeth) Edie (Mrs.) [P] Little Rock, AR/Taxco, Mexico b. Du Bois, NE. Studied: ASL; J. Carlson; C. Hawthorne; St. Louis Sch. FA. Exhibited: St. Louis AG, 1925 (prize). Work: Little Rock A. Gal.; murals, Pub. Lib., Women's City C., both in Little Rock [40]

KNECHT, Karl Kae [Car,I,W,L] Evansville, IN b. 4 D 1883, Iroquois, SD. Studied: AIC. Member: Am. Car. Assn.; Evansville Soc. FA. Exhibited: Evansville, 1934 (prize). Work: Hoosier Salon; Evansville Mus. A.; Huntington Lib., San Marino, Calif.; Press C. Bldg., San Fran. Author/Illustrator: "Surprise Puzzle Drawing Book," other books. Contributor: Billboard, Variety. Position: Columnist–Car., Evansville Courier [47]

KNEE, Gina (Mrs. Alexander Brook) [P] Savannah, GA b. 31 O 1898, Marietta, OH. Studied: briefly with W. Lockwood, in Taos. Member: Calif. WCC; N.Mex. SA. Exhibited: Calif. WCC, 1938 (prize); N.Mex. State Fair, 1939 (prize); AIC, 1940–46; BM, 1945; Pal. Leg. Honor, 1943; Los Angeles Mus. A., 1941–44; Hatfield Gal., Los Angeles, 1942 (one-man); Santa Barbara Mus. A., 1943 (one-man); Pal. Leg. Honor, 1943(one-man); Willard Gal., 1941 (one-man), 1943 (one-man). Work: Denver A. Mus.; PMG; Santa Barbara Mus. A.; Buffalo FA Acad.; Mus. N.Mex.; Denver AM [47]

KNEELAND, Eleanor [P] Brooklyn, NY [15]

KNEELAND, Roy C. [P] Rochester, NY [19]

KNEELAND, Stillman F. [P] Brooklyn, NY [01]

KNERR, Harold Hering [P] Primos, PA. Member: Phila. AC [27]

KNICKERBOCKER, Irving S. ("Knick") [Cart] d. 26 Ja 1930, Cleveland, OH. Position: staff artist, Newspaper Enterprise Assn.

KNIFFIN, H(erbert) R(eynolds) [P,T] New Brunswick, NJ. Studied: CUASch; Columbia; Paris; Munich. Author: "Elements of Art Appreciation," "Fine Arts and Education," "Masks." Positions: T., Pope Pius Art and Indst. Sch. (1906–07), Greenwich Handicraft Sch. (1908), Univ. Pittsburgh (1912–17), Ethical Culture Sch., Fieldstone Prof. A. Acad. (1918–30), N.J. Col. for Women, Rutgers, Grand Central Sch. A. [31]

KNIGHT, Augusta [P,C,D,T] Omaha, NE b. Augusta, IL d. ca. 1938. Studied: St. Louis Sch. FA; ASL; PIASch; AIC; C. Hawthorne. Member: Omaha AG. Exhibited: St. Paul Inst., 1916; Nebr. Ar., 1922 (prize); Midwestern A., Kansas City AI, 1924. Position: T., Univ. Omaha [33]

KNIGHT, Bertram G. [P,I] NYC. Member: GFLA [27]

KNIGHT, Charles Robert [P,S,Li,I,W,L] NYC b. 21 O 1874, Brooklyn, NY d. 15 Ap 1953. Studied: ASL; G.deF. Brush; F.V. DuMond; Brooklyn Polytechnic Inst. Work: AMNH; Field Mus., Chicago; Los Angeles; Wash., D.C.; Princeton; Hayden Planetarium. Author/Illustrator: "Before the Dawn of History," 1935, "Life Through the Ages," 1946. Contributor: article "Prehistoric Life," Natiional Geographic Magazine, 1940. Specialty: animals and birds, modern and fossil. WPA muralist. [47]

KNIGHT, Clayton [I,Mur.P,W,L] NYC b. 30 Mr 1891, Rochester, NY. Studied: Von der Lancken; R. Henri; G. Bellows. Member: SI. Work: Aviation murals, Gotham Hotel, NYC. Illustrator: "Pilot's Luck," "Non Stop Stowaway." [40]

KNIGHT, D(aniel) Ridgway [P] Poissy, Seine-et-Oise/Rolleboise-par-Bonnières, France b. 15 Mr 1839, Phila. d. 9 Mr 1924, France. Studied: PAFA; Ecole des Beaux-Arts, with Gleyre, Meissonier, in Paris, 1872. Member: Paris SAP. Exhibited: Paris Salon, 1884, 1888 (med); Munich, 1888 (gold); Paris Expo, 1889 (med); Legion of Honor, 1889; Columbian Expo, 1893 (med); Antwerp Expo, 1894 (med). Awards: Officer of the Legion of Honor, France; Knight of St. Michael of Bavaria. Work: PAFA; Brooklyn Inst. Mus. [24]

KNIGHT, Frederic (Charles) [P,L,T,Dr] Woodstock, NY b. 29 O 1898, Phila., PA. Studied: PMSchIA; self-taught. Member: An Am. Group; Woodstock AA; Am. Assn. Univ. Prof.; Am. S. PS&G; Am. Ar. Cong. Exhibited: CI, 1941, 1943–45; CGA, 1935, 1943, 1945; WMAA, 1940; AIC, 1944; NAD, 1945; PAFA, 1938; WFNY, 1939; GGE, 1939; Babcock Gal.; Woodstock AA, 1931 (prize). Work: Dartmouth Col.; WMAA; Univ. Ariz.; IBM; Woodstock AA; murals, USPO, Johnson City, N.Y. WPA artist. Positions: T., Newcomb Sch. A., Tulane Univ. (1943–46), Columbia (1946) [47]

KNIGHT, Katherine Sturges [I] Roslyn, NY. Member: SI [33]

KNIGHT, Lois Atwood [I,Des] b. 1869, Utica, MI d. 1 Je 1899

KNIGHT, L(ouis) Aston [Ldscp.P] Paris/Beaumont le Roger Eure, France b.

3 Ag 1873, Paris, France (of Am. parents). Studied: Paris, with Lefebvre, Robert-Fleury, and his father, D.R. Knight. Member: Rochester AC. Exhibited: Paris Expo, 1900 (med); Paris Salon, 1901, 1905 (gold); Rheims Expo, 1903 (gold); Lyons Expo, 1904 (gold); Nantes Exh., 1904 (gold); Geneva Exh., 1904 (gold), AAS, 1906 (gold), 1907 (gold). Work: Luxembourg Mus.; Musée des Colonies; Paris; Nimes; Evreux; Toledo Mus. A.; Newark Mus.; Marion AC; Delgado Mus.; Omaha S. of Liberal Arts [40]

KNIPE, E(milie) Benson (Mrs. Alden A.) [I] NYC b. 12 Je 1870, Phila. Studied: PMSchIA, H. Pyle. Author/Illustrator: "The Red Magic Book" [13]

KNIPE, Helen. See Carpenter, Mrs.

KNOBBS, Harry R. [E,P] Pueblo, CO b. 30 Ap 1902, McCook, NE. Studied: Pueblo Acad. FA; Cape Cod Sch. A.; S. Colo. Jr. Col.; C. Hawthorne; R. Miller. Member: Southern Pr.M.; Provincetown AA. Exhibited: SAE, 1938; WFNY, 1939; Buffalo Pr. C., 1940; Southern Pr.M., 1936–42; Denver A. Mus.; Kansas City AI; Provincetown AA; Mus. N.Mex.; S. Liberal A., Omaha, Nebr. [47]

KNOBLOCH, Isabelle S. (Mrs.) [C,Des,P,S] NYC/Orient, NY b. 19 My 1879, Brooklyn. Studied: N. Hatfield; S.F. Stevens; A. Heckman; W. Reiss; M. Fry; R.M. Pearson. Member: Keramic S. & Des. G. [40]

KNOCH, Leland McIntyre [P,B,Cart] Pittsburgh, PA b. 24 Mr 1901, Pittsburgh. Studied: CI; B. Robinson; G. Biddle; Colorado Springs FA Center Sch. Member: Am. A. Cong.; Pittsburgh AA; Allegheny AL. Exhibited: Pittsburgh AA, 1936 [40]

KNOEDLER, Edmond L. [Dealer] b. 1862, NYC d. 6 Mr 1933, Hyeres, France. He was one of 3 sons of Michael Knoedler, who founded the house of Knoedler, 1848. Remained in assn. with his brothers, 1882–96 then became a private print dealer, specializing in Whistler, Meryon, M. Bone

KNOEDLER, Roland F. [Dealer] Paris (since 1928) b. 1856, NYC d. 3 O 1932. Known for many years as Dean of the Art World in America. Associated with the firm of M. Knoedler & Co. for more than fifty years. He took an active part in forming the outstanding collections in America. Received many honors from the French Gov.; was made Commander of the Legion of Honor.

KNOLLENBERG, Bernhard, Mrs. See Tarleton, Mary.

KNOOP, Guitou (Miss) [S] NYC. Member: NSS [47]

KNOPF, Alfred A. [P] NYC [24]

KNOPF, Nellie A(ugusta) [P,E,L] Lansing, MI b. Chicago, IL. Studied: AIC; C. Woodbury; Vanderpoel; Freer; J.F. Carlson; B. Sandzen. Member: AWCS. Exhibited: AIC, 1920–22, 1925–27, 1929, 1930, 1937; CGA, 1929, 1935; PAFA, 1925, 1927, 1929; NAD, 1926; CAM; AWCS; Baltimore WCC; Detroit Inst. A., 1942, 1943; Toledo Mus. A.; Ill. Acad. FA; Ind. AC; All.A.Am.; Phila. AC; Phila. WCC; John Herron AI; CAFA; AFA; Broadmoor A. Acad., Colorado Springs (prize). Work: Lafayette, Ind. AA; MacMurray Col., Jacksonville, Ill.; John H. Vanderpoel AA. Position: T., MacMurray Col. [47]

KNOTT, Arthur Harold [P] Morro Bay, CA b. 22 My 1883, Toronto, Canada. Studied: B. Harrison; G. Bridgman; H.D. Murphy; PIASch. [29]

KNOTT, Franklin Price [Photogr.,Min.P] b. 1854 d. 6 Ag 1930, Santa Barbara, CA. He was widely known for his miniatures and autochrome pictures which appeared in travel magazines. In 1927, he returned from a tour of 40,000 miles through the Orient as an explorer for the Nat. Geo. Society, bringing back several hundred natural-color photographs of scenes and persons never before photographed. Outstanding in his collection was a photograph of the Maharajah of Kashmir wearing an emerald two and one-half inches in diameter, the first natural color picture of the brilliant royal court of Kashmir ever made. Rare scenes in Japan, China, Island of Bali and Dutch East Indies were also obtained.

KNOTT, Gene [Car,I] St. Louis, MO b. 1883 d. 5 Je 1937. Creator: "Penny Ante" cartoons

KNOTT, John F. [Car] Dallas, TX. Exhibited: Huntington Lib., San Marino, Calif. [40]

KNOWLES, Elizabeth A. McG(illvray) (Mrs.) [P,T] NYC b. 8 Ja 1866, Ottawa, Canada d. 4 O 1928, Riverton, NH. Studied: F.M.G. Knowles. Member: Royal Canadian Acad., 1908; NAWPS; Wash. WCC; Pa. SMP; Brooklyn SMP. Exhibited: Toronto, annually. Work: Canadian Nat. Gal.; Ontario Gov. Coll. [27]

KNOWLES, F. McGillvray [P,I,W,L,T] NYC (since 1915) b. 22 My 1860, Syracuse d. 9 Ap 1932, Toronto. Studied: U.S.; England; France; Canada. Member: R.C.A.; Allied AA; Brooklyn SMP. Exhibited: Pan-Am. Expo, Buffalo, 1901; La. Purchase Expo, 1904 (med); Pan-P. Expo, San Fran., 1915 (med). Work: Nat. Gals., Ottawa, Toronto, Winnipeg, Edmonton, Regina; AIC [31]

KNOWLES, Florence M. [P] NYC [01]

KNOWLES, Joe [I] b. 1869 d. 22 O 1942. Specialty: wildlife

KNOWLES, Wilhelmina [P] Washington, CT [15]

KNOWLTON, Annie D. [P] Rochester, NY. Member: Rochester AC [25]

KNOWLTON, Daniel (Mrs.) [P] Buffalo, NY [21]

KNOWLTON, Helen Mary [P,T,W] Needham, MA b. 16 Ag 1832, Littleton, MA. Studied: W.M. Hunt; F. Duveneck. Member: Copley S., 1896. Work: por., W.M. Hunt, WMA. Author: "Life of William M. Hunt," and "Hunt's Talks on Art." She was Hunt's principal student, and directed his class beginning in 1871. Traveled to Europe with Ellen Day Hale, 1882. Many of her works, like those of Hunt and Rimmer, were lost in the Boston Fire of 1872. [13]

KNOWLTON, Mary F. [P] NYC [10]

KNOWLTON, Maud Briggs (Mrs.) [Mus.Dir,C,P,Gr,B,E,Des] Concord, NH/Monhegan Island, ME b. Mr 1870, Penacook, NH d. 15 Jy 1956. Studied: R.H. Nicholls; A. Williams; T. Christiansen. Member: Am. Assn. Mus.; N.H. Ar.; N.H. Lg. A.&Cr. Exhibited: NYWCC; Boston AC; Manchester Inst. A.&Sc., Manchester, N.H.; N.H. SA. Work: Manchester Inst. A.&Sc. Positions: Dir., Currier Gal. A., Manchester, 1929–46; Pres., A. Dept., Manchester Inst. A.&Sc. [47]

KNOX, Clara Thomson (Mrs.) [P] Quincy, IL b. 30 Mr 1882, Andover, MA. Studied: Smith Col.; Boston A. Sch.; D. Tryon; P. Hale. Member: New Haven Brush & Palette C.; New Haven PCC; CAFA; North Shore AA. Exhibited: Palm Beach, Fla., 1932; New Haven PCC, 1928–46; CAFA, 1930–46; North Shore AA, 1937–46; Quincy AC, 1943 [47]

KNOX, Edward [P] Tom's River, NJ. Member: S.Indp.A. [25]

KNOX, Grace M. [P] Schenectady, NY d. D 1944. Exhibited: Am. WCS, 1933, 1934, 1936; NAWPS, 1935, 1936, 1937, 1938; WC Exh., Albany Inst. Hist. A., 1938; WC ann., PAFA, 1938 [40]

KNOX, Helen Estelle [P,L] Springfield, MA b. Suffield, CT. Studied: Hartford A. Sch.; W.L. Stevens; H. Stein; E.F. Marsden; D.W. Tryon, Smith Col. Member: AWCS; AAPL; Springfield AL; Boston AC. Exhibited: AWCS, 1931–33, 1936, 1938–46; WFNY, 1939; Am. Lib. Color Slides, 1941; Phila. WCC, 1934; Wash. WCC, 1940; Amherst Col., 1935; Mt. Holyoke Col., 1936; Am.-British A. Center, 1941; New England Women A., 1934; Boston AC, 1933–39; New Haven PCC, 1934, 1940, 1941, 1945; Westfield Atheneum, 1932; G.W.V. Smith Mus., 1933; Springfield Mus., 1938; Ogunquit AA, 1939–41; Springfield AL, 1931–39, 1941, 1943–46; Phillips Acad., Andover, Mass., 1931; Stockbridge AA, 1931–38, 1931 (prize) [47]

KNOX, James [P] Brooklyn, NY b. Ap 1866, Glasgow, Scotland. Member: NYWCC; Allied AA; AWCS; SC; Brooklyn PS. Work: "First Attack of the Tanks," Nat. Mus. [40]

KNOX, Jean [P] Phila., PA [25]

KNOX, Susan Ricker [P] NYC/Ogunquit, ME (1959) b. Portsmouth NH. Studied: Drexel Inst.; CUASch; H. Pyle; D. Volk; C. Grayson; Europe. Member: AAPL; Chicago AG. Assn.; North Shore AC; Ogunquit AA; N.H. AA. Exhibited: St. Louis, Mo., 1929 (prize); Mus. Northern Ariz., 1932 (prize), 1935 (prize); Ogunquit AA, 1931 (prize), 1946 (prize); North Shore AA, 1935 (prize); All.A.Am., 1938, 1940; AIC; PAFA; CGA, 1929 (one-man); San Diego FAS, 1929 (one-man); Currier Gal., 1932; State Mus., Springfield, Ill.; Kansas City AI, 1933; FA Gal., Phoenix, Ariz., 1934; Brooks Mem. A. Gal., 1933, 1943; Palacio de Bellas Artes, Mexico, 1934; AMNH; WFNY, 1939; CAFA, 1927 (prize); Springfield, Mass. AL, 1927 (prize). Work: Cornell; Mt. Vernon, Iowa; Wesleyan Col., Macon, Ga.; Brooks Mem. A. Gal.; Kansas City Bd. of Trade. Specialty: children [47]

KNUDSON, Helen Eliza [P] Springfield, IL b. Farmingdale, IL. Member: AFA; WAA; Ill. Acad. FA; Springfield AA. Work: Ill. State Mus.; Springfield AA [40]

KNUEBEL, John [P,T] Position: T., Technical H.S., Buffalo, N.Y. [21]

KNUTESEN, Edwin B. [P,T] Milwaukee/Nashotah, WI b. 26 My 1901, La Crosse, WI. Studied: Milwaukee State T. Col; PAFA. Exhibited: Wis. State Fair, Madison, 1938, 1939. WPA artist. [40]

KNUTESON, Oscar [P] Laguna Beach, CA. Member: Laguna Beach AA [31]

KOBAK, Evelyn [S] Exhibited: NYSWA, 1935, 1936, 1939 [40]

KOBBE, Gustave [W] b. 1857, NYC d. 27 Jy 1918 (killed by a hydroplane while sailing near Bayshore, NY). Founder, Lotos Magazine, 1909. Author: "Wagner's Life and Works," "Famous Actors and Actresses and their Homes," "Loves of the Great Composers"; articles on music drama, and art subjects. Position: A. Cr., New York Herald

KOBBE, Helen Metcalfe [P] New Rochelle, NY [13]

KOBBE, Herman [P] Nassau, NY. Member: Baltimore, WCC [27]

KOBBE, Marie Olga [P] NYC/Stockbridge, MA b. 1 Je 1870, New Brighton, NY. Member: NYWCC; NAWPS. Specialty: pastel portraits [40]

KOBER, Leo [Por.P,I,W] b. 1878 d. 17 S 1931, NYC. Work: series of portraits of U.S. presidents, widely reprinted and used in educational work, 1924. Illustrator: newspapers and periodicals in U.S. and Europe.

KOBMAN, Clara H. [P] Norwood, OH/Cincinnati, OH. Member: Cincinnati Women's AC [29]

KOCH, Arthur P. [P,T] Wallingford, CT/Greenwood, Lake, NY b. 14 O 1904, Brooklyn, NY. Studied: PIASch; ASL; Yale. Member: New Haven PCC; Sch. AL, N.Y. Exhibited: New Haven PCC. Position: T., Choate Sch. [40]

KOCH, Berthe Couch [P,C,L,Ser,W,T,B,Dr] Omaha, NE/Gloucester, MA b. 1 O 1899, Columbus, OH d. 1975. Studied: Ohio State Univ.; G. Beal; L. Kroll; A. Archipenko; J. Hopkins; Rockport AA. Member: CAA; Midwestern Col. A. Conference; AFA; F., Ohio State Univ., 1928, 1929. Exhibited: Syracuse Mus. FA, 1941; Passedoit Gal., NYC, 1940. Work: IBM Coll.; Passedoit Gal.; Ohio State Univ.; Syracuse Mus. FA. Position: monographs, "The Apparent Weight of Colors," "Creative Landscape Painting." Position: T., Univ. Omaha, 1933 [47]

KOCH, Charles Louis Phillip [P] Chicago, IL b. 16 Jy 1863, Tell City, MD. Studied: McMicken Sch. Des., Cincinnati; ASL, with Mowbray, Shirlaw; Paris, with Bouguereau, Ferrier; Belle Arti, Florence, Italy. Member: Chicago NJSA [25]

KOCH, Edna [P] Brooklyn, NY. Member: S.Indp.A. [25]

KOCH, George [P,I] Mystic, CT [10]

KOCH, Helen C. [P,Des,T,W] Cincinnati, OH b. 2 Mr 1892, Cincinnati. Studied: Univ. Cincinnati; Cincinnati A. Acad.; H. Snell; L.H. Meakin; J. Hopkins. Member: Ohio WCS; Women's AC, Cincinnati; Crafters; AAPL. Exhibited: Ohio WCS, 1941; CM, 1945 (prize). Contributor: School Arts magazine. Position: T., East Vocational H.S., Cincinnati, 1940-46 [47]

KOCH, John [P,T] NYC b. 18 Ag 1909, Toledo, OH. Studied: Ecole de Paris, France. Exhibited: CI, 1939-46; WMAA, 1938; CGA; PAFA; AIC; Valentine Gal., NYC, 1935, 1939, 1941 1943, 1946; Kraushaar Gal.; Wash., D.C. (one-man); Detroit, Mich. (one-man); Phila. (one-man); Kansas City AI (one-man). Work: BM; Boston Inst. Mod. A.; William Rockhill Nelson Gal.; Newark Mus.; Springfield Mus. A.; Canajoharie A. Gal. Position: T., ASL [47]

KOCH, Lizette J. [P,Des,T] River Edge, NJ b. 25 Ag 1909, NYC. Studied: PIASch. Member: Nat. AAI; NAWPS. Exhibited: Nat. AAI, 1935; Montclair AM, 1945; pencil sketching, Eberhard Faber, Brooklyn, 1925 (prize). Illustrator: books, cover des., for Motor Boating, Home Building, other magazines, newspapers. Position: Associated with Pollak & Sons Publ. Co., NYC [47]

KOCH, Peter [P,I,L,T] Chicago, IL b. 25 D 1900 St. Marys, OH. Studied: Duveneck; Hopkins; J. Norton. Member: Ill. SFA; Minn. AI [29]

KOCH, Richard [P] New Orleans, LA [17]

KOCH(MEISTER), Samuel [P] Brooklyn, NY b. 13 N 1887, Warsaw, Poland. Member: AL Am. Exhibited: BMA, 1940; CGA, 1943; Univ. Ariz.; MMA, 1943; Kelekian Gal., 1942; CAM, 1945; Pal. Leg. Honor, 1945; BM, 1941-44; R.I. Mus. A., 1944; Albright A. Gal., 1941; MOMA, 1941; Ferargil Gal., 1943; WFNY, 1939; Hudson Walker Gal., 1940; ACA Gal.; Contemporary A. Gal., 1942 (one-man); Bignou Gal., 1944 (one-man); Niveau Gal., 1946 (one-man). Work: Univ. Ariz.; R.I. Mus. A. [47]

KOCH, Theo. John [Dr,Ldscp.P] Columbus, IN b. 24 Ag 1881, Düsseldorf, Germany. Studied: self-taught. Member: Hoosier Salon; Ind. SA [40]

KOCH, William [I] Saulsbury, MD. Member: Charcoal C. [25]

KOCSIS, Ann [P,Des] Forest Hills, NY b. NYC. Studied: Pittsburgh AI; NAD. Member: NAC; PBC; AAPL; Pittsburgh AA. Exhibited: CI, 1940-46; Montross Gal., 1939 (one-man), 1941 (one-man); Morton, Vendome, Contemporary Gal. (one-man); All.A.Am. (one-man); AAPL, 1945 (one-man) [47]

KOECHL, Paul [P,T] NYC b. 27 Jy 1880, Brooklyn, NY. Studied: H. Boss. Member: S.Indp.A. [29]

KOEHL, Edward H. [P] Minneapolis, MN [13]

KOEHLER, Alvin [P] Phila., PA. Member: AWCS [47]

KOEHLER, Paul R. [Ldscp.P] b. ca. 1875, NYC d. Jy 1909, Colorado Springs. Studied: self-taught. Obliged to do commercial work, but found time to execute a few landscapes in pastel which gave promise.

KOEHLER, Robert [P,I,Li] Minneapolis, MN b. 28 N 1850, Hamburg, Germany (came to U.S. in 1853) d. 24 Ap 1917. Studied: NAD; ASL; Munich Acad., with Loefftz, Defregger. Member: Munich Et. S.; ASWA; Minneapolis AL; Minneapolis A. Comm.; Minn. State AS (Pres.). Exhibited: Munich Acad. (medals); Paris Expo, 1889; Minneapolis AL, 1914 (prize). Work: PAFA. Position: Dir., Minneapolis Sch. FA [10]

KOEHLER, Sylvester R. [Mus.Cur,W,L] b. 1837, Leipzig, Germany (came to U.S. in 1849) d. 15 S 1900, Littleton, NH. Positions: Cur. Prints, BMFA; Hon. Cur. Prints, Smithsonian; Ed., American Art Review

KOEHLER, Theodore C. [P] Southbend, IN [25]

KOEN, Irma René [P,W,L] Rock Island, IL b. Rock Island. Studied: C.F. Brown; Lathrop; Snell; abroad. Member: Chicago PS; Ill. Acad. FA; A.-Ill. SA; Chicago AC. Work: Toledo Mus.; PAFA; Peoria AA; Davenport Municipal Gal.; Chicago Collection for Encouragement of Local Art; Ill. State Mus. [40]

KOENIG, Elsa [P,I] Phila., PA b. 24 Mr 1880, Phila. Studied: Phila. Sch Des. Women, with W. Daingerfield, H.B. Snell; PAFA [10]

KOENIG, Ferdinand [P] Milwaukee, WI. Member: Wis. PS [27]

KOENIGER, Walter [P] NYC/Woodstock, NY b. 6 My 1881, Germany. Studied: Duecker; von Gebhard. Member: SC. Work: TMA. Article: "Koeniger, Painter of Snow," in International Studio, Je 1925 [33]

KOEPF, Werner [P,C,Des] Derby, CT b. 21 S 1909, Neckarsulm, Germany. Studied: Kunstgewerbe Schule, Bremen, Germany; ASL, with Morris Kantor. Exhibited: S.Indp.A., 1935-37; Contemporary A. Gal., 1938 (one-man); PAFA, 1938, 1939, 1941; Montclair A Mus., 1940; AIC, 1941, 1942; Springfield Mus. A. Work: Landschulheim, Bremen [47]

KOEPNICK, Robert Charles [S,T] Dayton, OH b. 8 Jy 1807, Dayton, OH. Studied: Dayton AI; Cranbrook Acad. A.; C. Milles. Member: Dayton S. P.&S. Exhibited: PAFA, 1936-38, 1940; NAD, 1938-40, 1940 (prize), 1941 (prize); Dance Intl., 1937; CAA, 1931 (prize); AIC, 1937; Syracuse Mus. FA, 1938; Nat. Catholic Welfare Comp., 1942 (prize); NGA, 1945 (prize); CM, 1935-37, 1939, 1940; Dayton Soc. P.&S., 1937-45. Work: S., County Court House, St. Paul's Church, Parker Sch., Dayton, Ohio. Position: T., Sch. Dayton AI, 1936-41, 1946- [47]

KOERNER, Daniel [P,T,I] NYC b. 1910, NYC d. 5 F 1977. Studied: ASL; Edu. Alliance. Member: WPA Artists, Inc. (pres.) Exhibited: ACA Gal., NYC; WFNY, 1939; Am. Ar. Cong. Work: MMA; Brooklyn Col.; Queens Col. [*]

KOERNER, W(illiam) H(enry) D(ethlef) [I] Interlaken NJ b. 19 N 1878, Lun, Germany d. 11 Ag 1938. Studied: AIC; F. Smith A. Acad.; ASL, with Bridgman, 1905-07; H. Pyle, in Wilmington, 1907-11; F. Breckenridge. Member: SC; Wilmington SFA; Asbury Park SFA. Exhibited: Wilmington SFA, 1915 (prize), 1935 (prize). Important western illustrator, well known by the 1920s for his work in Saturday Evening Post and other magazines and books. [38]

KOESTER, Alexander [P] NYC [15]

KOFFMAN, Nathan [P] Phila., PA b. 28 S 1910, Phila. PA. Studied: PAFA; PMSchIA. Exhibited: PAFA; PMSchIA [40]

KOGAN, Belle [Indst.Des] NYC b. 26 Je 1902, Russia. Studied: PIASch; NYU; ASL; RISD; B. Robinson; W. Reis; Kuntsgewerbe Schule, Pforzheim, Baden, Germany. Member: ADI. Exhibited: Phila. A. All., 1946 (one-man); ADI, 1942 (med). Work: des., Fed. Glass Co.; Bakelite Corp.; Reed & Barton; Quaker Silver Co.; Red Wing Pottery; Warren Telechron Co.; Ebeling and Reuss; Samson United Corp.; Nat. Brush Co.; Kirk & Son. Contributor: trade publications [47]

KOGLER, Gertrud Du Brau [P,I,C,T] Cumberland, MD b. 1 Je 1889, Germany. Studied: Md. Inst., Baltimore; Royal Acad., Liepsig, Germany. Member: S.Indp.A. Work: murals, Masonic Temple, Cumberland; City Hall Rotunda, Cumberland [40]

KOHLER, Charlotte Schroeder (Mrs. Walter J.) [P] Kohler, WI b. Kenosha, WI d. 2 F 1947. Studied: A. Dow; A. Froelich; H. Bain: H. Adams; PIASch. Member: Wis. PS; AFA; Wis. AA; Seven Arts S. [10]

KOHLER, Eleanor [P] Tujunga, CA. Member: Calif. AC [25]

KOHLER, Melvin Otto [Mus.Dir,P,Gr,T] Tacoma, WA b. 7 D 1911, Saskatchewan, Canada. Studied: Univ. Wash.; Columbia; Calif. Sch. FA; M. Sterne; A. Ozenfant. Member: Western Assn. A. Mus. Dir.; Pacific AA; Tacoma AA. Position: T., Col. Puget Sound, Tacoma, 1934-41 [47]

KOHLER, Otto [P] Washington's Crossing, NJ [15]

KOHLER, Rose [S,P] NYC b. 21 Mr 1873, Chicago, IL d. 4 O 1947. Studied: Cincinnati A. Acad.; ASL; Duveneck; Zorach; Lober; Hawthorne; C. Barnhorn; V. Brenner. Member: AAPL; Cincinnati Women's AC; Studio G., NYC. Exhibited: PAFA, Cincinnati, NYC, all annually; Chicago. Work: Temple Emanu-El, NYC; Temple Beth-El, Detroit; Hebrew Union Col., Cincinnati; Louisville Temple [47]

KOHLHEPP, Dorothy (Mrs. Norman) [P] Louisville, KY b. Boston, MA. Studied: Mass. Sch. A.; NOAC; Grande Chaumière, Académie Julian, André Lhote, all in Paris. Member: Salon des Tuileries Assn.; Mod. Eng. & Am. Painters, France; Louisville A. Center Assn.; Gal. de Paris. Exhibited: Salon des Tuileries, Paris; VMFA; New Orleans; Louisville, 1932-45 1946 (prize); Louisville AC, 1937 (one-man), 1940 (one-man), 1944 (prize), 1945 (one-man) (prize); Kentucky A., 1946 (prize); Southern Ind., 1946 (prize); Speed Mem. Mus., 1938 (one-man); Univ. Louisville, 1944 (one-man); Anchorage, Ky., 1945 (one-man). Position: Officer/Bd., A. Center Sch. & Assn., Louisville, 1940-47 [47]

KOHLHEPP, Norman [P] Louisville, KY. Exhibited: Jr. Lg. Exh., Speed Mem. Mus., 1938 [40]

KOHLHOFF, Alma Reed (Mrs.) [P,I,Car,T] Attleboro, MA b. 11 Mr 1905, St. Johnsbury, VT. Studied: RISD; Brown Univ.; J. Frazier. Member: Providence WCC. Exhibited: Providence AC, 1939, 1940; Attleboro Mass. Work: murals, Finberg Sch., Lincoln Sch., Attleboro [40]

KOHLMANN, Rena Tucker. See Magee.

KOHLMEIER, Helen Louise [Por.P] Los Angeles, CA. Studied: F. Freer; W. Chase; J.H. Rich; E. Vysekel; M. Russell. Member: Calif. AC; Women P. of the West; Los Angeles AA [44]

KOHN, Irma [Ldscp.P] Chicago, IL/Boothbay Harbor, ME b. Rock Island, IL. Studied: AIC; C.F. Brown; H.B. Snell; H.L. Lathrop; abroad. Member: NYWCC; Chicago SA; Chicago PS; Chicago ASL. Work: Toledo Mus.; PAFA [25]

KOHUS, Frank [S] Cincinnati, OH. Member: NSS [21]

KOIRANSKY, Alesander [P] Seattle, WA b. 21 F 1884, Moscow, Russia. Studied: V. Seroff [33]

KOLDE, Frederick William [Des,C,P] Cincinnati, OH b. 7 Jy 1870, Breslau, Germany d. ca. 1958. Studied: Cincinnati A. Acad.; V. Nowottny; F. Duveneck; Breslau. Member: Cincinnati Crafters; Cincinnati Men's C.; Ohio WCS. Exhibited: CM; Taft Mus. A.; Ohio WCS; Phila. WCC. Work: jewelry, Fox Bros., Whitehouse Bros., Cincinnati, Ohio; chalices, St. Peter's Cathedral, Cincinnati; St. William's Church, Cincinnati [47]

KOLKER, Florence R. [Min.P] Chicago, IL [15]

KOLLER, E. Leonard [Des,L,W,T] Scranton, PA b. 8 D 1877, Hanover, PA. Studied: Pyle; Morse; Willett. Member: AFA. Work: mon., Hanover; mem. windows, Pittsburgh, Phila. Author: all vols. on art used by Intl. Corres. Sch. Position: T., Intl. Corres. Sch., Scranton [40]

KOLLIKER, William A. [Des,I] Norwalk, CT b. 12 O 1905, Bern, Switzerland. Studied: Md. Inst.; NAD; Grand Central A. Sch.; H. Dunn. Member: Westport AA. Illustrator: Pix magazine. Position: Illus./A. Dir., American Weekly, NYC [47]

KOLLOCK, Mary [Ldscp.P] NYC b. 20 O 1832, Norfolk, VA d. 12 Ja 1911. Studied: PAFA, with Robert Wylie; J.B. Bristol; A.H. Wyant, in NYC; Académie Julian, Académie Delecluse, both in Paris. Exhibited: PAFA, 1864; NAD, 1866-87 [06]

KOLSKI, Gan [Li,P,I,T] NYC b. 4 Ap 1899, Poland d. 18 Ap 1932 (jumped to his death from George Washington Bridge, in protest against unemployment. Studied: Skoczylas; Mrozewski. Exhibited: NAD, 1922 (med), 1923 (med); on exh. at the time of his death. Work: Fifty Prints of the Year, 1930, 1931 [31]

KOMARNITSKY, R.S., Mrs. See Olshanska, Stephanie.

KOMISAROW, Don [I] NYC. Member: SI [47]

KONERSMAN, Robert [P] Cleveland Heights, OH [25]

KONI, Nicolaus [S,P,C,T] NYC b. 6 My 1911, Transylvania. Studied: Europe. Member: NSS; Arch. Lg. Exhibited: abroad; U.S. Work: BM; Rockford, Ill. Mus.; mon. in Europe [47]

KONRATY, Lola [P,S] Pittsford, NY b. 24 F 1900, Riga, Russia. Studied: abroad; Serge Soudeikine; W. Ehrich. Exhibited: Albright Gal., Buffalo, 1938, 1939; Syracuse MFA; Rochester Mem. A. Gal., 1935-46. Work: Rochester Mem. A. Gal. [47]

KONTI, Isidore [S] Yonkers, NY b. 9 Jy 1862, Vienna, Austria (came to U.S. in 1890) d. 11 Ja 1938. Studied: Imperial Acad., Vienna, with Helmer, Kundmann. Member: ANA, 1908; NA, 1909; NAC; Yonkers AA; NSS, 1897; Arch. Lg., 1901; SC, 1904; Allied AA; AFA. Exhibited: St. Louis Expo, 1904 (gold). Work: MMA; Detroit AI; Italian Gov.; Wash., D.C.; Minneapolis Inst.; Peabody Inst., Baltimore; Nat. Mus. A., Wash., D.C.; Court House, Cleveland; fountains, New Orelans; Trinity Church, NYC; mem., St. John's Cathedral, NYC; mem. WWI, Yonkers; St. Louis Mus.; CGA; Newark Mus.; Lincoln Mem., Yonkers; McKinley Mem., Phila.; fountain figure, Plaza, NYC [38]

KOOPMAN, Augustus [P,Et] Montparnasse, Paris/NYC b. 2 Ja 1869, Charlotte, NC d. 31 Ja 1914, Etaples, France. Studied: PAFA; Ecole des Beaux-Arts, with Bouguereau, Robert-Fleury. Exhibited: Paris AAA, 1898 (prize), 1899 (prize), Paris Expo, 1900 (meds); Pan-Am. Expo, 1901 (med); St. Louis Expo, 1904 (med); Appalachian Expo, Knoxville, 1911 (med). Work: des, U.S. Govt. Pavilion, Paris Expo, 1900; Cosmos C., Wash.; St. Louis Mus.; Phila. AC; Brooklyn Inst. Mus.; Detroit Mus.; Congressional Lib., Wash.; NYPL [13]

KOOPMAN, John R. [P,T] Denville, NJ b. 5 Je 1881, Falmouth, MI d. 16 S 1949. Studied: Chase; Henri; Miller; Wiles. Member: AWCS; SC; NYWCC. Exhibited: Detroit Inst. A., 1924 (prize); Mich. State Fair, 1924 (prize); NYWCC, 1929 (prize). Positions: T., Brooklyn Inst. A.&Sc., Montclair A. Mus. A. Sch., N.Y. Sch. F.&Appl. A. [47]

KOOTZ, Samuel M. [W,Cr,Des] NYC b. 23 Ag 1898, Portsmouth, VA. Studied: Univ. Va. Author: "Modern American Painters," 1930, "New Frontiers in American Painting," 1943, "Puzzle in Paint," 1943. Contributor: N.Y. Times, Creative Arts. Specialty: industrial and textile design [47]

KOPCAK, Adolph J. [E,Li] NYC b. 6 Jy 1895, Milan, Italy. Studied: E. Fitch. Member: ASL. Specialty: drypoints [32]

KOPENHAVER, Josephine Young [P,T] Los Angeles, CA b. 9 Je 1908, Seattle, WA. Studied: Univ. Calif.; Univ. Southern Calif.; Chouinard AI; M. Sheets; P. Sample; D. Lutz; J. Chapin; C.J. Bulliet; W. Ryder; H. Wolf; E. Neuhaus. Member: Calif. WCS; Calif. AC; Audubon A.; Am. Ar. Cong.; Am. Ar. Prof. Lg. Exhibited: Audubon A., 1945; Traveling Exh., Calif. WCS, 1938-46, 1944 (prize); Riverside Mus., 1944, 1946; Los Angeles Mus. A.; San Diego FA Soc.; Oakland A. Gal.; Santa Cruz AL; Fnd. Western A.; Los Angeles AA; GGE, 1939; Women P. of the West, 1940 (prize). Position: T., Experimental Jr. H.S., Los Angeles [47]

KOPIETZ, Edmund Martin [P,I,L,Des,T] Minneapolis, MN b. 9 Ap 1900, Everest, KS. Studied: Wichita Univ.; AIC; NAD; Norton; Forsberg; Kroll; Seyffert. Member: Western AA; Minn. AA; Prairie PM; Nat. All. for Art Ed.; Twin City Artists. Exhibited: Minneapolis AI, 1936 (prize), 1937 (prize), 1944 (prize), 1945 (prize); Kansas City AI, 1935 (prize); Twin City A., 1929 (prize). Work: Minneapolis AI; Wichita Mus. A.; McPherson, Kansas, Municipal Coll.; Wichita AA; Nokomis Sch., Minneapolis. Positions: T., AIC, 1922-28; Dir., Minneapolis Sch. A., 1929- [47]

KOPLOWITZ, Benjamin (Ben Kopel) [I,Des,C,Mar.P,Car] Baltimore, MD b. 1 Ap 1893, NYC d. ca. 1958. Studied: NAD; CUASch; Md. Inst.; Johns Hopkins Med. Sch.; M. Brodel; C. Hinton; A.Q. Ward. Exhibited: Pratt Free Lib., Baltimore. Work: Baltimore City Health Dept.; Municipal Bldg., Baltimore. Specialty: surgical illus. Position: Illus., Baltimore City Health Dept. [47]

KOPMAN, Benjamin [P,Li,E,I,S,W] Far Rockaway, NY b. 25 D 1887, Vitebsk, Russia (came to U.S., 1903) d. 3 D 1965, Teaneck, NJ. Studied: NAD. Member: Am. Group; Am. A. Cong. Work: MOMA; WMAA; BM; PAFA; PMG [40]

KOPMAN, Katherine [P,C,T,I] New Orleans, LA b. New Orleans. Studied: A. Molinary; E. Woodward; D. MacKnight. Member: La. Art T. Assn.; NOAA [06]

KOPY, Adolph J. [E,I,P,Li] NYC b. Milan, Italy. Member: ASL. Specialties: drypoints, pen and ink, scratchboard [40]

KORACH, Dean [P] Brooklyn, NY. Member: S.Indp.A. [24]

KORBEL, Mario J. [S,L] NYC b. 23 Mr 1882, Osik, Czechoslovakia d. 1954. Studied: Berlin; Munich; Paris. Member: NSS; ANA, 1937; Arch. Lg.; Chicago SA. Exhibited: AIC, 1910 (prize); Grand Central Gal., 1920 (prize). Work: CMA; Univ. Havana; AIC; WMAA; Vatican, Rome; MMA; mon., Denver, Colo.; med., Czech Republic [47]

KORDA, Augustine [P] Buffalo, NY b. 17 Je 1894, Buffalo. Studied: J.E. Thompson; Buffalo FA Acad. [25]

KORDER, Walter O.R. [P] Hartford, CT [24]

KORMENDI, André [P,G,W] NYC b. 19 N 1905, Budapest, Hungary. Studied: Budapest Acad. FA. Member: KUT, Budapest. Exhibited: Morgan Gal., NYC, 1938 (one-man); Intl. Lith., AIC, 1938. Work: MMA [40]

KORMENDI, Elisabeth (Mrs. Eugene) [P,C] South Bend, IN b. Budapest, Hungary. Studied: Europe. Member: Budapest SFA. Exhibited: Milwaukee AI, 1940 (one-man), 1945 (one-man); Renaissance S., Univ. Chicago, 1941; Oak Park AL, 1941; Herron AI, 1943; Norton Gal., 1944; Nurnburg, Germany; Venice, Italy; Barcelona, Spain; Budapest, Hungary. Position: T., St. Mary's Col., South Bend, Ind., 1946 [47]

KORMENDI, Eugene (Jeno) [S,T] South Bend, IN b. 12 O 1889, Budapest Hungary d. 14 Ag 1959, Wash., D.C. Studied: Budapest B. Acad.; Paris. Member: SFA, Budapest; S. Four A., Palm Beach, Fla.; Audubon A. Exhibited: Soc. Four A., 1945 (prize); Hoosier Salon, 1946 (prize); Barcelona Intl. Expo (med); Milwaukee AI, 1940 (one-man), 1945 (one-man); Norton Gal., 1944; Renaissance S., Univ. Chicago, 1941; Oak Park AL, 1941; Herron AI, 1943; Audubon A., 1946; AIC, 1946; abroad, Work: Heeres Mus., Vienna; Budapest Mus.; mem., monu., Valparaiso, Ind.; Univ. Notre Dame; Mt. Mary Col., Milwaukee; Boys Town, Nebr.; abroad. Position: T., Univ. Notre Dame, 1941– [47]

KORN, Elizabeth P. [P,T,L] Hoboken, NJ b. 4 Ag 1900, Germany. Studied: Europe; E. Orlick. Member: AAPL. Exhibited: NAD, 1942, 1943; AWCS, 1942, 1943; Newark Mus., 1943; Montclair A. Mus., 1943–45; Drew Univ., Madison, N.J., 1945; Theo. Kohn Gal., 1945. Illustrator: "Skippy's Family," 1945; "At Home With Children," 1943; "Portraits of Famous Physicists," 1942. Position: T., Drew Univ., Madison, N.J. [47]

KORNHAUSER, David E. [P] Phila., PA. Studied: PAFA. Member: Pittsburgh AA; Graphic Sketch C. Work: PAFA [25]

KORNHAUSER, Mary Parker [P] Phila., PA. Studied: PAFA [21]

KORONSKI, André Marc Noel [I,C] Phila., PA b. 25 D 1879, Geneva, Switzerland. Studied: A.J. Morse; Drexel Inst. Specialty: bookplates, jewelry, metal work [10]

KORTHEUER, Francis Dayrell [P,E,T] NYC b. 25 Jy 1906, NYC. Studied: Bridgman; Du Mond; Hawthorne; Carroll; Stevenson; Romanovsky. Member: NAC; ASL. Exhibited: NAC, 1931 (prize). Work: Merchants Assn., Woolworth Bldg., NYC [33]

KORTUM, Elmer F. [P] Chicago, IL. Member: Chicago NJSA [25]

KORYBUT, Kasimir (Kovahlsky) [P,Des,W,L] Los Angeles, CA b. 25 Ap 1878. Studied: Acad. Modérne; Acad. Grand Chaumière, Paris. Member: Calif. AC; PS C., Los Angeles. Exhibited: Oakland A. Gal.; Temple A. & Music, Tucson, Ariz. Work: panel, E. End Union, Cambridge, Mass.; curtain, Symphony Hall, Boston [40]

KORYBUT, Wanda (Mrs. Kovahlsky) [P,I,Car,C] Los Angeles, CA b. 5 Ap 1907, Short Hills, NJ. Studied: Yale; Grand Central A. Sch. Member: NAWPS. Exhibited: NAWPS. 1935–39. Work: Newark AM. Illustrator: "The Flying Horse," 1928 [40]

KORZYBSKA, Mira Edgerly [P,W,L] Chicago, IL b. 16 Ja 1879, Aurora, IL. Member: Arts C., Chicago. Work: MMA; AIC; Calif. Palace Legion of Honor; portraits, England and America; port., Mus. Nat. Bella Artes, Buenos Aires [40]

KOSA, Emil Jean, Jr. [Mur.P,Por.P] Los Angeles, CA b. 28 N 1903, Paris, France d. 4 N 1968. Studied: Acad. FA, Prague, with Thille; Calif. AI; Ecole des Beaux-Arts, Paris; Kupka; Laurens. Member: AWCS; Audubon A.; Calif. WCS; NYWCC; San Diego AG; PS Cl., Los Angeles; Calif. AC. Exhibited: NAD, 1942–46; PAFA 1938–46; CGA, 1941, 1943; AWCS, 1936–46, 1938 (prize), 1939 (prize); AIC, 1941–46; CI, 1941, 1943, 1944; VMFA, 1940, 1946; MMA, 1942; Denver A. Mus., 1938–45; TMA, 1946; Colorado Springs FA Center, 1941–45; Los Angeles Mus. A., 1926–46; P.-P. Expo, 1928 (med); Baltimore WCC, 1939 (prize); San Diego AG, 1937 (prize), 1942 (prize); Fnd. Western A., 1942 (prize), 1945 (prize); Oakland A. Gal., 1938 (prize), 1942 (prize); Calif. State Fair, 1934 (prize), 1938 (prize), 1939 (prize); Calif. AC, 1937 (prize), 1938 (prize); Los Angeles Col. Fair, 1931 (prize); Ariz. State Fair, 1932; Santa Cruz AL, 1932 (prize), 1938 (prize); San Diego Gal. FA, 1933, 1936 (prize), 1937 (prize); Santa Paula Ann., 1939 (prize); Ebell C., 1939 (prize). Work: NAD; Calif. State Lib.; Springfield (Mass.) Mus.; Cranbrook Acad. A.; Wash. State Col.; Chaffey Jr. Col.; Santa Barbara Mus. A.; Los Angeles Mus. A.; Am. WCS; Santa Paula, Calif.; A. Dept., 20th Century Fox Film Co. [47]

KOSAK, Con [P] McKees Rocks, PA. Member: Pittsburgh AA [25]

KOSAKOFF, David [P,S,G] NYC b. 11 Ag 1917, NYC. Studied: CUASch; CCNY; Des. Lab. Member: United Am. A.; Am. Ar. Cong. Exhibited: BAID, (prize); ACA Gal.; 48 Sts. Comp. [40]

KOSICKI, Catherine Watha (Mrs.) [P,L,T] Detroit, MI b. 12 My 1890. Studied: F. Moritz, Latvia; Kozlof A. Sch., Kiev, Russia. Exhibited: Mich. State Fair, 1928 (prize), (med); Posnan, Poland Exh., 1929 (prize); Govt. of Poland, 1931 (med). Work: Detroit Engineering S. [40]

KOST, Frederick W. [Ldscp.P] Brookhaven, NY b. 15 My 1861, NYC d. 23 F 1923. Studied: NAD, with W. Macy. Member: SAA, 1889; ANA, 1900; NA, 1906; A. Fund S.; Lotos C.; Century C. Exhibited: Paris Expo, 1900; Pan-Am. Expo, Buffalo, 1901 (med); St. Louis Expo, 1904 (med). Work: PAFA; Brooklyn Inst. Mus.; Montclair, N.J. MA [21]

KOSTELLOW, Alexander J. [P,L,T] Pittsburgh, PA b. 25 D 1897, Persia d. 31 Ag 1954. Studied: V. Vytlacil; A. Angarola; ASL; NAD. Member: Kansas City SA; Pittsburgh AA. Exhibited: Pittsburgh AA, 1933 (prize); CI, 1933 (prize). Work: USPOs, Jeanette, Somerset, both in PA. WPA artist. Position: T., Carnegie Inst. [40]

KOSTER, Harry [E] Brooklyn, NY b. 16 Mr 1893, Bad Axe, MI. Studied: B. Sanders [32]

KOTILAINEN, Hans [P,S,G] West Allis, WI b. 25 Jy 1913, Finland d. 15 D 1944 (in the Army). Studied: Layton Sch. A., Milwaukee. Member: Milwaukee Pr.M.; Wis. PS. Exhibited: Wis. Salon A., Madison, 1938; AIC, 1938; WFNY, 1939. Work: Wilwaukee AI [40]

KOTIN, Albert [P,Li,T] NYC b. 7 Ag 1907, NYC. Studied: ASL; NAD; BAID; C. Hawthorne; Grand Chaumière, Acad. Colarossi, both in Paris. Member: Am. A. Cong. Exhibited: An. Am. Group, 1938; Syracuse MFA. Work: Syracuse MFA; Brooklyn Pub. Lib.; Newark Bd. Edu.; U.S. Marine Hospital; murals, USPOs, Arlington, N.J., Ada, Ohio; NYU. WPA muralist. [47]

KOTOKU, Shiehei Y. [P] Los Angeles, CA Member: Calif. AC [25]

KOTTGEN, Eve (Mrs. Thomas H. Donnelly) [P] Valhalla, NY b. 18 Je 1903, London, England. Studied: ASL; G.P. DuBois; B. Robinson. Member: ASL; Salons of Am.; Un. Am. A.; Am. A. Cong.; N.Y. Ar. U. Exhibited: AIC, 1934, 1935, 1938; PAFA 1932–41; VMFA, 1938; WFNY, 1939; MMA, 1944; Wanamaker Exh., 1934; ACA Gal., 1936–38; WMAA, 1945; BM, 1945; Contemporary A., 1933, 1936–38, 1945 [47]

KOTTING, Maris [P] Detroit, MI. Member: Detroit S. Women P. [27]

KOTZ, Daniel [Ldscp.P] Park Ridge, NJ b. 21 Mr 1848, South Bend, IN d. 17 S 1933. Studied: H.F. Spread. Member: SC; Nanuet P.; Am. Ar. Prof. Lg.; Beachcombers' C., Providence [31]

KOTZ, Mary Whittlesey (Mrs. Daniel) [P] Park Ridge, NJ b. 1858, Ravenna, OH d. 23 Ap 1947, Wentworth, NH. Specialty: flowers [25]

KOTZIAN, Ernest [Des,C] Boston, MA b. 20 My 1908, Munich, Germany. Studied: Harvard; Germany. Member: Stained Glass Assn. Am. Exhibited: All.A.Am., 1943; Inst. Mod. Art, Boston, 1944; PAFA, 1946; Jordan Marsh, 1946. Position: des., stained glass, W.H. Burnham, Boston, 1938– [47]

KOULISH, Meyer [P] Bronx, NY. Member: S.Indp.A. [25]

KOURY, Leon [S] Greenville, MI. Exhibited: WFNY, 1939 [40]

KOVNER, Saul. See Saul.

KOWNATZKI, Alice A. [P] NYC [13]

KOWNATZKI, Hans [P,S] Peconic, NY b. 26 N Königsberg, Germany d. ca. 1947. Studied: Neide; Knorr; Koner; Lefebvre. Exhibited: Soc. Wash. Ar., 1929 (prize). Work: portraits, 1935, 40 [40]

KOZLOW, Sigmund [P] Woodside, NY b. 7 D 1913, NYC. Studied: NAD; Ecole des Beaux-Arts, Paris; Leon Kroll; Maxwell Starr. Member: F., Tiffany Fnd., 1936; Contemporary A., NYC; Un. Am. A. Exhibited: AIC, 1936; CGA, 1943; CI, 1943–45; PAFA, 1936, 1937; VMFA, 1938; NAD, 1934, 1945 (prize); Detroit Inst. A., 1945; Albright A. Gal., 1946; BM, 1943; GGE, 1939; State T. Col., Indiana, Pa., 1945, 1946; Munson-Williams-Proctor Inst., 1946 (prize). Work: Munson-Williams-Proctor Inst., Utica [47]

KRAEMER, Alfred Achille [P] NYC b. 5 N 1906. Studied: R. Lahey; J. Matulka; ASL. Exhibited: Midtown Gal., 1937 (one-man); PAFA, 1938; AIC, 1938; CGA, 1939; CM; BM; Denver A. Mus. [47]

KRAEMER, Eric, Mrs. See Andrus, Zoray.

KRAFFT, Carl R. [P] Oak Park, IL b. 23 Ag 1884, Reading, OH. Studied: AIC; Chicago FA Acad.; E.E. Savage; L. Kroll. Member: Chicago PS; Cliff Dwellers; All-Ill. SFA; Allied AA; Austin, Oak Park and River Forest Art Lg.; Chicago Gal. A.; Ill. Acad. FA; Grand Central AG. Exhibited: AIC, 1915 (prize), 1920 (med), 1925 (med,prizes); Municipal Art Lg., 1916 (prize); Chicago AG, 1916 (prize); Ar. Gld., 1917 (prize); Ill. Ar. Expo., 1920 (med); Chicago SA, 1921 (med); Central States Exh., Aurora, 1922 (med); Allied AA, 1926 (med); Chicago Gal. A., 1926 (prize), 1927 (prize), 1929 (prize), 1930 (prize); Oak Park AL, 1930 (prize). Work: Municipal Ar. Lg., Chicago; Peoria Soc. Allied Arts; Englewood Women's Cl.; Los Angeles Mus.; Aurora (Ill.) Art Lg.; Arché Cl., Chicago; South Shore Country Cl., Chicago; Wichita Falls, Tex.; Lincoln Sch., River Forest, Ill.; Univ. Ill.; Ill. State Mus.; murals, First National Bank, York H.S., both in Elmhurst, Ill.; Richmond, Ind. Art Assoc.; Howe Sch., Austin; Faulkner Sch., Chicago; Holmes Sch., Oak Park Cl.; First Methodist Church, Nineteenth Century Women's Cl., Municipal Bldg., Pub. Lib., all in Oak Park; Blackburn Col., Carlinville, Ill.; Pub. Sch., Kenilworth; Glen Oak Country Cl., Glen Ellyn; St. Olaf Col., Minn.; Ryerson Coll., AIC [40]

KRAFFT, Elton [P] Chicago, IL. Exhibited: Hoosier Salon, 1940 (prize); AIC, 1937 [40]

KRAFT, Allison A. (Mr.) [Des] Cleveland, OH b. 17 Mr 1900, Cleveland. Studied: Cleveland Sch. A.; J. Huntington Polytech. Inst. Member: Cleveland SA. Exhibited: Cleveland Mus. A., 1921 (prize), 1929 (prize), 1930 (prize), 1931. Work: tablets on Maine mem., Havana, Cuba; trophies, air races; chalices, churches. Position: affiliated with Ruth Coulter Gal., Cleveland [40]

KRAMER, Edward Adam [Ldscp.P] Bronx, NY/Bloomingdale, Essex, NY b. 8 O 1866, NYC d. 28 D 1941. Studied: J.W. Stimson; W.V. Diez, in Munich; Académie Julian, Paris. Work: Newark (N.J.) Mus. [40]

KRAMER, Erwin [P] Milwaukee, WI. Member: Wis. PS [25]

KRAMER, Peter [P,Li] b. 24 Jy 1823, Zweibrucken, Germany (came to U.S. in 1848) d. 30 Jy 1907, Brooklyn, NY. Worked for P.S. Duval, lithographers, in Phila., ca. 1848–57, then the Rosenthal lithographers. Set up his own business in Stuttgart, in 1858, but was exiled because of his caricature of the king. Returned to U.S. and set up his studio in NYC. Both his son and grandson, namesakes, were artists. [*]

KRAMER, Reuben Robert [S,T] Baltimore, MD b. 9 O 1909, Baltimore. Studied: Rinehart Sch. S.,; Am. Acad., Rome; London; Paris. Exhibited: Am. Acad., Rome, 1934 (prize); Douglas Homes Comp., Baltimore, 1940 (prize); Nat. A. Week, Baltimore, 1941 (prize); BMA, 1939 (one-man), 1940, 1941–46; PMA, 1940; Md. Inst., 1936 (one-man). Work: City Col., Baltimore; IBM Coll; woodcarvings, USPO, St. Albans, W.Va.; relief, St. Mary's Seminary, Alexandria, Va. Position: T., Baltimore A. Center [47]

KRANS, Olaf [P] b. Olaf Olson, 2 N 1838, Selja, Sweden (came to Bishop Hill, IL, in 1850) d. Ja 1916, Altoona, IL. Primitive portrait and genre painter who changed his name after serving in the Civil War. A decorative painter, he worked in Galesburg and Galva, Ill., in the late 1860s, continuing his folk art into the 1900s. [*]

KRANSZ, Sigmund [P] Chicago, IL. Member: Chicago NJSA [25]

KRASA, Edward Jan [I] Chicago, IL b. 27 Ap 1877, Chicago. Studied: AIC. Member: Palette and Chisel Cl. [10]

KRASNER, Lee (Mrs. Jackson Pollock) [P] b. 1908. Studied: CUASch and NAD, 1926–32; Hans Hofmann, 1937–40. Exhibited: Am. Abstract A., beginning 1940; WMAA, 1973. WPA artist, 1934–43. Best known as an abstract expressionist in the 1940s, she turned to biomorphic shapes in 1950s. [*]

KRASNOW, Peter [P] Los Angeles, CA. Member: Calif. AC [25]

KRATINA, George [S] NYC. Studied: Yale; Am. Acad., Rome. Exhibited: Nat. Acad., 1936. Award: Prix de Rome, 1938

KRATINA, Jos(eph) M. [S,T] Brooklyn, NY/Mt. Tremper, NY b. 26 F 1872, Prague, Czechoslovakia. Studied: L'Ecole des Beaux-Arts, Acad. Julian, both in Paris. Member: Alliance; Brooklyn SA [40]

KRATOCHVIL, Stephen [P] Cleveland, OH b. 8 Je 1876, Czechoslovakia. Studied: P.A. Laurens; J.P. Laurens; H. Royer, in Paris. Member: Cleveland SA [33]

KRATZ, H(arriett) Frances [P,T] Phila., PA b. 25 Ap 1893, Phila. Studied: Daingerfield; Snell; Everett; Seyffert [21]

KRATZ, Laura [P] Monticello, IL [13]

KRATZ, Philip W. [P] NYC [25]

KRAUS, Adolph F. [S] b. 5 Ag 1850, Zeulenroda, Germany (came to U.S. in 1881) d. 7 N 1901, Danvers (Mass.) Insane Hospital. Award: Grand Prize of Rome. Work: "Theodore Parker" and "Crispus Attucks" monuments; winged figure of "Victory" for the towers of Machinery Hall, Columbian Expo, Chicago, 1893

KRAUS, Bertha (Mrs.) [P] NYC [19]

KRAUS, Romuald [S,T] Cincinnati, OH b. 7 F 1891, Itzkany, Austria d. 19 D 1954. Studied: BAID; Langer, in Düsseldorf; Kleimsch, in Berlin; Wackerle, in Munich. Exhibited: GGE, 1939 (prize); MMA, 1938; CM, 1946; PAFA, 1935, 1936. Work: Court Houses, Newark (N.J.), Covington (Ky.); Howard Univ.; Evander Childs H.S., Bronx, N.Y.; USPOs, Ridgewood (N.J.), Williamstown, (N.Y.); CM. WPA artist. Positions: T., A. Center, Louisville (Ky.), Cincinnati Mus. [47]

KRAUSE, Erik Hans [Des,W,I] Rochester, NY b. 27 Je 1899, Halla a Saale, Germany. Studied: Acad. Graphic A., Leipzig; Univ. Leipzig; Acad. Appl. A., Dresden. Member: AIGA; Rochester AC. Exhibited: AWCS, 1927; BM, 1928; Great Lakes Exh., The Patteran, 1938; Mem. A. Gal., Rochester. Illustrator: "The Murders in the Rue Morgue," 1946, "Lysistrata," 1946. Contributor: American Printer [47]

KRAUSE, Glen Adolph [P,Des,T] Chicago, IL b. 10 S 1914, Chicago. Studied: AIC; Univ. Chicago; B. Anisfeld. Exhibited: AIC, 1935–39, 1940 (prize), 1941 (prize), 1942–45; CGA, 1942; S.Indp.A., 1940. Positions: T., AIC, 1938–42; Naval Air Corps, 1943–45 [47]

KRAUSE, Lisbeth B. [Min.P,I] New Haven, CT b. Königsberg, Germany. Studied: A. Meyer, in Berlin; A. Sch., Königsberg, with Profs. Feist and Rodemeier. Member: NAWPS. Work: Deutsches Hygiene Mus., Dresden. Illustrator: "Textbook of Anatomy," by Rauber-Kopsch, "Cystoscopy," by W. Stockel; "Kystoscopische Technik," by Eugen Joseph, "Atlas der Blutkrankheiten," by A. Pappenheim, other books. Specialty: drawings/paintings for scientific books [40]

KRAUSHAAR, Charles W. [Dealer] b. 1854, New York d. 6 Ja 1917, NYC. He started in the art business in 1872, and founded his own firm in 1886. The first dealer to exhibit the modern Dutch painters, he introduced the work of Zuloaga to the American public. He was also interested in some of the 19th-century French painters, including Fantin Latour and Henri Le Sidaner.

KRAUSHAAR, John F. [Dealer] Hartsdale, NY b. 1871 d. 12 D 1946. The younger brother of Charles, who started their New York gallery. American artists were encouraged and works by French artists were also shown. The Gallery was continued by his daughter Antoinette and his son Charles.

KRAUSZ, Sigmund [P,W] Chicago, IL b. 14 My 1857, Tolna, Hungary. Studied: Vienna; Munich. Member: All-Ill. SA; Business Men's AC; Numismatic Soc., Vienna [27]

KRAUT, Irving [P] Chicago, IL [15]

KRAUTH, Charles Philip [P] Pine Knot, San Bernardino County, CA b. 20 N 1893, Pittsburgh. Studied: Breckenridge; Shrader; Vysecal; DuMond; Bridgman; Von Slaken. Member: Laguna Beach AA; Riverside AA; Bear Valley AC. Position: T., Polytechnic H.S., Riverside, Calif. [40]

KRAWIEC, Harriet B. (Mrs. Walter) [P] Chicago, IL b. 14 O 1894, Chicago. Studied: K. Buehr; C.W. Hawthorne; A. Oberteuffer. Member: Chicago Gal. A.; Assn. Chicago PS. Exhibited: Ill. Acad. FA, 1931 (prize); Polish AC, 1932 (prize); Chicago Gal. A., 1936 (prize); AIC, 1937 (prize). Work: Ill. State Mus., Springfield; Municipal Art Lg., Chicago [40]

KRAWIEC, Walter [P,I,Car] Chicago, IL b. 24 S 1889, Poland. Studied: A. Sterba; R. Clarkson; W.M. Clute. Member: Assn. Chicago PS; Cliff Dwellers; Chicago Gal. Assn. Work: City of Chicago; schools, Michigan City, Ind. Illustrator: "First Cardinal of the West," by P.R. Martin, 1934. Cartoonist: Polish Daily News [40]

KRAYKOVIC, Michel Alfred [Des,W] Rankin, PA b. 17 O 1902, Rankin. Studied: Wash. D.C. Sch. A.; CI. Member: Assoc. Ar. Pittsburgh. Exhibited: Carnegie Gal. [40]

KREDEL, Fritz [I,P] NYC b. 2 F 1900. Studied: Europe; R. Koch; V. Hammer. Exhibited: Paris Salon, 1937 (med). Illustrator: "Grimm's Fairy Tales" (1931), "Decameron" (1940), "Soldiers of the American Army" (1942), "Anderson's Fairy Tales" (1943), "The Three Cornered Hat" (1945), "Pinafore," (1946), "Plato" (1944), pub. Limited Edition, other books [47]

KREEFTING, John [P] NYC. Exhibited: WFNY, 1939 [40]

KREGARMAN, Josephine (Mrs. S.L.) [P] b. 1910, San Angelo, TX d. 21 Ap 1944, New Rochelle, NY. Studied: NYC. Member: New Rochelle AA (Pres.)

KREHBIEL, Albert, Mrs. See Evans, Dulah.

KREHBIEL, Albert H. [Mur.P,T,P] Park Ridge, IL b. 1875, Chicago d. 29 Je 1945, Evanston, IL. Studied: AIC; F. Richardson; Laurens, in Paris. Member: Chicago PS; Chicago WCC; Cliff Dwellers; Mural P. Work: murals, Supreme Court, Springfield, Ill. Positions: T., AIC, Armour Inst., Chicago [40]

KREHM, William P. [P] Los Angeles, CA b. 2 F 1901, Kansas City, KS. Studied: D. Bartlett; W.T. McDermitt; J. Swinnerton. Member: Soc. for Sanity in Art; Calif. AC; P.&S. Cl. Exhibited: GGE, 1939; Ariz. State Fair, 1941; Pal. Leg. Honor, 1945; Los Angeles Mus. A., 1944; Calif. AC, 1944; P.&S. Cl., 1944 (prize), 1945 [47]

KREIGHOFF, W(illiam) G(eorge) [Por.P,Ldscp.P] Phila., PA b. 31 Ag 1875, Phila d. 20 Ap 1930, Ardmore, PA. Studied: Chase; Meakin; Sharp. Member: Phila. Alliance; Phila. Soc. AA. Work: portraits, Phila. Law Assoc., State Col., Tex., Walt Whitman Hotel, Camden, N.J. Painted portraits of notable people, including Charles A. Lindbergh, Eva Le Gallienne, Walt Whitman. Work: A. Staff, Philadelphia Public Ledger, for 15 years [29]

KREINDLER, Doris Barsky [P,E,T,Li,Dr] Brooklyn, NY b. 12 Ag 1901, Passaic, NJ d. 1974. Studied: N.Y. Sch. Appl. Des. for Women; NAD; ASL; H. Hofmann; I. Olinsky; C. Hinton; B. Eggelston; E. Carlsen; J. Margolies; A.R. Harris. Member: Brooklyn SA; NAWA; Brooklyn PS; Studio Gld.; Am. Ar. Cong.; Am. Ar. Prof. Lg. Exhibited: BM, annually; PAFA, 1932-44; Montross Gal.; NAWA [47]

KREIS, Henry [S,T] Essex, CT b. 27 Jy 1899, Essen, Germany d. Ja 1963. Studied: State Sch. Appl. A., Munich, with J. Wackerle; BAID; P. Manship. Member: NSS; Arch. Lg.; CAFA; Conn. State Sculpture Comm. Exhibited: bas relief, NSS, 1936 (prize); New Rochelle AA, 1939 (gold); national comp., sculpture, Bronx (N.Y.) Post Office (winner); CAFA, 1937-46; Arch. Lg., 1938, 1939; PAFA, 1936-41, 1942 (med), 1943-46; WMAA, 1937-46; NAD, 1942-45; AIC, 1936-43; CI, 1938. Work: MMA; WMAA; PAFA; Intl. Magazine Bldg., N.Y.; War Dept. Bldg., Soc. Security Bldg., Dept. Justice Bldg., all in Wash., D.C.; Court House, Erie, Pa.; Educational Bldg., Harrisburg, Pa.; USPO, Bronx, N.Y.; medals, Conn. Tercentenary (1935), WFNY (1939), NSS; U.S. coins, Conn. Tercentenary half-dollar, Bridgeport Centennial half-dollar, Ark. Centennial half-dollar (1936); marble group, Housing Project, Stamford, Conn. WPA artist. Contributor: Magazine of Art, 1938. Position: T., Hartford Art Sch. [47]

KREISEL, Alexander [P,G,S] Brooklyn, NY b. 20 My 1901, Russia d. 2 Je 1953. Studied: CUASch; Grand Central A. Sch.; ASL. Member: United Am. Ar. Exhibited: Lincoln H.S. Gal., Brooklyn, 1937; Montross Gal, 1939. Positions: Dir., Kew Gardens Art Center; T., Hyde Park Sch., Brooklyn [40]

KRELSCHMANN, Fredolin [Glass En] d. 13 Ag 1898, Long Island, NY. Awards: decorations, Austria and Bavaria; Knight of the Legion of Honor, France. Work: Royal Mus., Berlin; Luxembourg Mus., Paris; South Kensington Mus., London; MMA. Position: affiliated with Tiffany glass works. During his lifetime, a ten-inch piece of his work commanded fifteen hundred dollars.

KREMELBERG, Mary A. (Mrs. Frederick Gibson) [P] Baltimore, MD d. 10 Ja 1946. Studied: PAFA. Member: NAWPS; Baltimore WCC [33]

KREMP, Laura Amelia (Mrs. L. Dixon Miller) [P] Reading, PA b. Wilmington, DE. Member: Plastic Cl.; Reading Sketch Cl. [40]

KREMP, Marie Ada [Por.P,E,T,I,L] NYC b. 9 Je 1901, Reading, PA. Studied: CMA Sch.; PAFA; Garber; Breckenridge; McCarter. Member: Provincetown AA; Gloucester Soc. Ar.; Rockport AA; Catholic A. Gld. Exhibited: Alonzo Gal., N.Y. (one-man); H.C.J. Acad., Sharon Hill, Pa. (prize); PAFA, 1944; Rockport AA, 1946; Gloucester AA, 1946; Barbizon Plaza, N.Y.; Ogunquit A. Center, annually. Work: Reading Pub. Mus. and Art Gal.; West Phila. H.S. [47]

KRESS, Frederick B. [P] San Fran., CA [19]

KRESS, George Henry [Indst.Des] Vestal, NY b. 19 Ja 1912, NYC. Studied: PIASch. Member: ADI. Position: Des., IBM, Endicott, N.Y., 1943– [47]

KRESSY, Edmund F. [P] Cleveland, OH [25]

KRETSCHMAN, Edward A. [S,T] Phila., PA b. 27 Ag 1849, Germany (came to U.S. in 1856). Studied: J.A. Bailey; George Starkey. Exhibited: Am. Inst., 1875 (prize) [10]

KRETZINGER, Clara Josephine [P] Dublin, Ireland b. Chicago. Studied: AIC; Chicago AFA; Lefebvre, Robert-Fleury, Laurens, Congdon, R. Miller, in Paris. Member: Chicago AC. Exhibited: Paris Salon (prize). Work: Beloit Art Mus. [40]

KREUTZBERG, Marguerite G. [P] Bethlehem, PA b. 14 S 1880, Elgin, IL. Studied: W.P. Henderson. Member: Chicago AC. Exhibited: AIC, 1923. Work: Chicago public schools; mural, Lake Bluff (Ill.) Pub. Sch. [40]

KREWITT, Marie E. [I,Des] Phila., PA b. 10 D 1902, Phila. Studied: Phila. Sc. Des. for Women. Member: Phila. Ar. Un. Specialty: fashion illus. [40]

KRICK, Perna [S] Baltimore, MD b. 18 Ag 1909. Studied: Dayton AI; Rinehart Sch. S., Baltimore. Exhibited: Women's Lg. Comp., Baltimore, 1931 (med); Arch. Lg., 1938 (prize); Am. Auto. Assn. Comp., Wash., D.C., 1939 (prize); PAFA, 1934, 1937, 1938; Baltimore AM. Work: WPA sculpture, USPO, Pcomoke City, Md. [40]

KRIDER, Alden [P,E] Newton, KS b. 17 D 1908, Newton. Studied: K.H. Miller; J.S. Curry; J.F. Helm, Jr. [33]

KRIENSKY, Morris E. [P,I,S,Gr,Des] NYC/Malden, MA b. 27 Jy 1917, Glasgow, Scotland. Studied: Prof. Des. Sch.; BMFA Sch.; A.O. Le Brect. Member: AWCS. Exhibited: AWCS, 1946; Dept. Interior, Wash., D.C. (one-man); White House, Wash., D.C.; Malden (Mass.) Pub. Lib.; G.W.V. Smith A. Gal.; Ind. Univ.; Currier A. Gal.; AIC; Hackley A. Gal.; Wilmington Soc. FA; Dartmouth Col.; M. Knoedler & Co. Work: M. Knoedler & Co. [47]

KRIZE, Emillie Mary [P,I] Suffolk, VA b. 6 Ag 1918, Luzerne, PA. Studied: Md. Inst.; PAFA; Johns Hopkins Univ.; Maroger. Member: Norfolk A. Corner. Exhibited: Md. Inst., 1941 (med); BMA, 1941 (one-man), 1942; Norfolk Mus. A.&Sc., 1941, 1946; Women's Cl., Suffolk, Va., 1943. Work: State House, Annapolis, Md. Specialty: medical illus. Positions: Illus., Norfolk Navy Yard, 1942-46; Medical Illus., Portsmouth (Va.) Naval Hospital, 1946– [47]

KROHMER, Joseph A. [P] Chicago, IL [10]

KROLL, Elise M. [P,I] Chicago, IL [19]

KROLL, Leon [Li,Por.P,Mur.P,Ldscp.P,Cr,T] NYC b. 6 D 1884, NYC d. 5 O 1974. Studied: ASL, with Twachtman, 1899; NAD; Académie Julian, Paris, with Laurens. Member: NA, 1927; NAC; New Soc. A.; Phila. AC; Am. Soc. PS&G (Pres.); Boston AC; NIAL (Vice-pres., 1943). Exhibited: SC, 1914 (prize); P.-P. Expo, San Fran., 1915 (med); AIC, 1919 (prizes), 1924 (gold,prize); Wilmington SFA, 1921 (prize); NAD, 1921 (prize), 1922 (prize), 1932 (prize), 1935 (prize); CI, 1925 (prize), 1936 (prize); PAFA, 1927 (gold), 1930 (gold); Newport, R.I., 1929 (prize); NAC, 1930 (prize); Indianapolis, 1930 (prize); Pan-Am. Exh., Baltimore Mus., 1931 (prize); Boston AC, 1932 (med); Intl. Expo, Paris, 1937 (med); Armory Show, NYC, 1913. Work: MMA; WMAA; AIC; MOMA; CGA; SFMA; CI; Dayton AI; Columbus Gal. FA; CMA; Detroit Inst. A.; Minneapolis Inst. A.; Denver A. Mus.; San Diego FA Soc.; Clearwater (Fla.) Mus.; Norton Gal.; Los Angeles Mus. A.; PAFA; Univ. Nebr.; Wilmington Soc. FA; murals, Justice Bldg., Wash., D.C.; war mem., Worcester, Mass.; St. Louis Mus.; John Herron AI; Univ. Ill., Urbana; Des Moines AA; Municipal Univ. of Omaha. Positions: T., Md. Inst. A. (1919-23, 1929), AIC (1924-25), PAFA (1929-30) [47]

KROLLMANN, Gustav Wilhelm [P,Mur.P,Por.P,T,L] Minneapolis, MN b. 31 Jy 1888, Vienna, Austria. Studied: Acad. FA, Vienna. Member: Minneapolis Soc. FA. Exhibited: Minneapolis Inst. A. Work: murals, Univ. Minn.; portraits, private collections. Position: T., Minneapolis Sch. A., 1931– [47]

KROMER, Carol Adelaide [P] Los Angeles, CA b. 30 Ap 1892, Elgin, IL. Member: Women P. of the West [40]

KROMER, E.A. [I] NYC [21]

KRONBERG, Louis [P,Por.P,T] NYC b. 20 D 1872, Boston d. 1965. Studied: BMFA Sch.; ASL; Académie Julian, Paris, with Benjamin-Constant, Laurens, Collin. Member: ANA, 1935; NA; SC; Boston AC; Salon des Beaux-Arts, Paris; Boston Gld. A.; Copley S.; AWCS; NYWCC; Boston SWCP. Exhibited: P.-P. Expo, San Fran., 1915 (med); SC, 1919 (prize); Intl. Expo, Paris, 1937 (med). Work: MMA; BMFA; Isabelle Stewart Gardner Mus.; Joslyn Mem.; PAFA; Herron AI; Butler AI; Albright Art Gal.; San Diego FA Gal.; Luxembourg Mus., Paris [47]

KRONDORF, William F. [P] Lansing, NJ [19]

KRONENGOLD, Adolph [Des,I] Crestwood, NY b. 14 N 1900, New Orleans, LA. Studied: PAFA; ASL; Grande Chaumière, Paris; Garber;

Spencer; Bridgman; Luks. Exhibited: Mus. City of N.Y.; A. Dir. Cl.; SI; SSAL; New Yorker (magazine) Traveling Exh. Illustrator: New Yorker (covers), other magazines [47]

KRONENGOLD, Naomi [C,T,L] Crestwood, NY b. 16 Je 1904, Bradford, PA. Studied: PIASch; NYU. Exhibited: County Center, White Plains, N.Y. (prizes); WFNY, 1939; America House, N.Y. Positions: T., public schools/art centers, 1930–40; A. Dept., Scholastic magazine, 1942– [47]

KRONQUIST, E.F. [P] Milwaukee, WI [15]

KROTH, Richard [P,C,T,L] Spring Valley, NY/NYC b. 10 S 1902, Frankfort-am-Main, Germany. Studied: NAD; CUASch; AIC; W.E.B. Starkweather; N. Remisoff. Member: Staten Island AA. Exhibited: Staten Island Inst. A.&Sciences; NYWCC, 1934, 1937, 1938; Bryn Mawr A. Center; CUASch (med); CAA; PAFA, 1932; S.Indp.A.; Wanamaker Exh., 1934; New York, 1935, (one-man) 1944 (one-man) 1946 (one-man) [47]

KRUCKEMEYER, Edward H. [P] Cincinnati, OH. Member: Cincinnati AC [15]

KRUEGER, Jewel E. [P] Milwaukee, WI d. 1936. Studied: Layton Sch. A.; Mabel Kay; Dudley C. Watson [24]

KRUELL, Gustav [Wood En] East Orange, NJ b. 1843, Düsseldorf, Germany d. 3 Ja 1907, San Luis Obispo, CA. Studied: R. Brendeamour, in Düsseldorf. Organizer/Member: Am. Wood Engravers Soc., 1881. Exhibited: Paris Expo, 1889 (prize); Columbian Expo, Chicago, 1893 (med); Pan-Am. Expo, Buffalo, 1901 (med); St. Louis Expo, 1904 (gold). His portraits included those of Darwin, William Lloyd Garrison, Lincoln (1890s); some of his portraits were later published under the title of "A Portfolio of National Portraits." [06]

KRUETZFELDT, Pauline Wulf [P,I] Fort Plain, NY b. Holstein, Germany. Studied: E. Dufner; ASL, with Bridgman, Ben Foster. Member: AAPL. Exhibited: Horticultural Soc. N.Y., 1930 (prize); NGA; CI, 1943; Albany Inst. Hist.&A., 1946; Munson-Williams-Proctor Inst., 1946. Work: Amsterdam (N.Y.) City Hospital; Canajoharie A. Gal.; triptychs, U.S. Navy, U.S. Coast Guard. Illustrator: American Home, Better Homes & Gardens, Woman's Home Companion, 1936, Country Gentleman, 1937, other magazines [47]

KRUGER, Henry, Jr. [P] NYC. Exhibited: Scarab Cl., Detroit, 1914 (prize) [17]

KRULLAARS, William John [P] Chicago, IL b. 27 Jy 1878, Rotterdam, Holland. Studied: Rotterdam Acad. FA; AIC. Member: Chicago SA; All-Ill. SFA; South Side AA. Exhibited: Chicago SA, annually; AIC, 1935, 1946 [47]

KRUPKA, Joza [S] NYC [19]

KRUPP, Louis [P,T,L] Pensacola, FL b. 26 N 1888, Bavaria. Studied: AIC; ASL. Member: Pensacola A. Cl. Position: T., Pensacola A. Center [40]

KRUSE, Alexander Zerdin [E,Li,P,W,Cr,L,T] NYC b. 9 F 1890, NYC. Studied: Edu. All.; NAD; ASL; McBride; Carlson; Sloan; Luks; Henri. Exhibited: AIC; "50 Prints of the Year"; Phila. SE; Fine Prints of the Year; Los Angeles Mus. A.; Intl. Exh.; SAE; WMAA; NAD; Grand Central A. GAl.; BM; Dudensing Gal.; Findlay Gal. Work: MMA; MOMA; BM; NYPL; LOC; Britih Mus., Victoria & Albert Mus., both in London; Nat. Gal., Ottawa, Ontario; PMA; AGAA; State Mus., Biro-Bidjan, Russia; Mus. Mod. A., Moscow, Russia; Bibliothèque Nationale, Paris; Univ. Ariz.; Berry (Ga.) Col.; Mus. City of N.Y.; Cleveland Mus. Positions: Columnist, Art Digest; Cr., Brooklyn (N.Y.) Eagle, 1938–46 [47]

KRUSEMAN VAN ELTON, ELizabeth. See Duprez, Mrs.

KRUSEMAN VAN ELTON, Hendrik-Dirk [Ldscp.P,E] Paris, France b. 1829, Alkmaar, Holland (came to U.S. in 1865) d. 12 Jy 1904. Studied: C. Lieste, in Alkmaar. Member: NA, 1883; Acad. Amsterdam; Acad. Rotterdam; AWCS; N.Y. Etching Cl.; A. Aid S.; Soc. P.-Etchers, London, 1881. Exhibited: Amsterdam Intl. Expo, 1860 (gold); NAD, 1866–1900. Work: BMFA; an etching included in "Works of American Etchers," by S.R. Koehler, 1880. Award: Chevalier, Order of the Lion, Holland. In 1905, two hundred of his paintings were auctioned at Am. Art Gld., N.Y., bringing in $9,335 for the A. Aid S. [04]

KRUSEN, William Morrison [S] Phila., PA. Exhibited: WFNY, 1939. Work: USPO, Clyde, Ohio. WPA artist. [40]

KRUSH, Joseph [P] Camden, NJ. Exhibited: watercolors, PAFA, 1937, 1938; AIC, 1939 [40]

KRUSOE, William Attila [P,Mur.P,Des] Cleveland, OH b. 25 Ap 1898, Hungary. Studied: Cleveland Sch. A.; Detroit A. Lg.; Huntington Polytech Inst., Cleveland; Budapest Hungarian Royal AI. Member: Cleveland MA. Exhibited: Cleveland MA, 1939 (prize); Butler AI. Work: mural, Lincoln H.S., Cleveland [40]

KRYSHER, Elizabeth [P,I] Chicago, IL [06]

KRYZANOVSKY, Roman [P] Detroit, MI b. 22 Ja 1885, Balta, Russia d. 31 Jy 1929. Studied: E. Renard; E. Tournes; P. Gorguet. Member: Detroit Art Colony; Scarab Cl., Detroit (a founder). Exhibited: Detroit Inst. A., 1915 (prize), 1918 (prize), 1919 (prize), 1920 (prize), 1921 (prize). Work: Detroit Inst. A.; State of Mich. Coll.; Detroit Pub. Lib.; Kijev (Russia) City Mus. A leader in the Detroit Art Colony. [27]

KRYZANOVSKY, Sari [P] Detroit, MI b. Lexington, KY. Studied: R. Kryzanovsky. Exhibited: watercolor, Detroit Inst. A., 1925 (prize) [29]

KUBINYI, Kálmán (Mátyas Béla) [P,C,I,L,Li,B,En,E,T] Lakewood, OH b. 29 Jy 1906, Cleveland. Studied: Cleveland Sch. A.; A.V. Kubinyi, in Munich; R. Stoll; H.G. Keller. Member: Cleveland Ar. Un.; Am. A. Cong. Exhibited: CMA, relief cut, 1930 (prize), etching, 1931 (prize), portrait/landscape 1932 (prizes), 1933 (prize), 1934 (prize), 1936 (prize), 1938 (prize), 1941 (prize); Am. A. Cong., 1936; Phila. Pr. Cl., 1942; AIC, 1938, 1939; Springfield Mus., 1938; WFNY, 1939; CMA, 1925–46; WMAA, 1937; Boise (Idaho) Mus., 1944; 1030 Gal., Cleveland, 1945. Work: CMA; Cleveland Municipal A. Coll.; mural, South H.S., Cleveland; represented, Print-a-Month editions, Cleveland Printmakers, 1932–37. Illustrator: "The Goldsmith of Florence" (1929), "Sokar and the Crocodile" (1928). Contributor: Magazine of Art. Author: intaglio processes, "Dictionary of the Arts." WPA artist. Positions: T., John Huntington Polytechnic Inst., Cleveland Sch. A., Y.W.C.A., CMA [47]

KUBINYI, Kálmán, Mrs. See Hall, Doris.

KUBLANOV, Boris [P,T] Coney Island, NY b. 2 S 1894, South Russia. Studied: Kostandi. Member: Alliance; Union of South Russian Artists in Odessa [25]

KUCERA, John [P] Phila., PA b. 1911, Pittsburgh. Studied: PAFA; Charles-Watkins Sch., Phila. Exhibited: murals for elevators comp., Gimbel's, 1937 (prize) [40]

KUCHARYSON, Paul [E,En,C,Des,I,S] Kansas City, MO b. 2 Jy 1914, Utica, NY. Studied: John Huntington Inst. A. Member: Soc. FA, Cleveland; Ar. Un. Exhibited: WFNY, 1939; CMA (prize); Dayton AI (prize); Oakland, Calif. (prize). Positions: A., Inter-Collegiate Press, Kansas City (1946–), Harter Pub. Co. [47]

KUCK, Martha D. [P] San Fran., CA [13]

KUEHN, Edmund Karl [P,S] Columbus, OH b. 18 Ag 1916, Columbus. Studied: A. Schille; R.O. Chadeayne; N. Tuttle; Columbus Art Sch. Member: Columbus AL [40]

KUEHNE, Max [E,P] NYC b. 7 N 1880, NYC. Studied: K.H. Miller. Member: SAE; Phila. SE. Exhibited: Intl. Exh., CI, 1926 (prize). Work: WMAA; Los Angeles Mus. A.; Detroit Inst. A.; Hispanic Soc. [47]

KUEHNS, Carl [P,S] b. 1854, Magdeburg, Germany (came to Milwaukee in 1880) d. 17 My 1947, Milwaukee. In 1884, he formed the Milwaukee Ornamental Carving Co., with O.H. Papke.

KUEMMEL, Cornelia A. [P,S,T] Glasgow, MO b. Glasgow, MO d. ca. 1938. Studied: St. Louis Sch. FA, with J. Fry, E. Wuerpel. Member: St. Louis AG [33]

KUGHLER, (William) Francis Vandeveer [P,Por.P,Li,T,L] NYC/Kingsbridge, NY b. 20 S 1901, NYC. Studied: NAD. Member: SC; NAC. Exhibited: SC, 1944 (prize); F., Tiffany Fnd., 1925; NAD; PAFA; NAC. Work: portrait, Hudson River Mus.; War Correspondents Mem., Associated Press, 1946 [47]

KUGHLER, Francis, Mrs. See Livingston, Charlotte.

KUHLMAN, Isabel [P] Toledo, OH b. 7 O 1888. Studied: Toledo Mus. Sch. Des.; AIC; NAD; N.Y. Sch. F.&Appl. A.; Columbia; Master Inst. United Arts, N.Y. Work: Master Inst. United Arts [40]

KUHLMAN, Walter Egel [P,T] St. Paul, MN b. 16 N 1918, St. Paul. Studied: St. Paul Sch. A. Member: Minn. Ar. Assn. Exhibited: landscape, State Fair, Minn., 1939 (prize); WFNY, 1939; Minneapolis IA; Little Gal., Univ. Minn. Work: PMG. Position: T., St. Paul Sch. A. [40]

KUHLMANN, Edward [P] Oshkosh, WI d. 1973. Studied: AIC; PAFA; Lutheran Seminary, Columbus, Ohio [24]

KUHLMANN, G. Edward [Ldscp.P,W,P,L] Oil City, PA b. 26 S 1882, Woodville, OH. Studied: Capital Univ., Columbus, Ohio; AIC; L. Blake;

PAFA; abroad. Work: Pub. Mus., Oshkosh, Wis. Author: "Watch Yourself Go By," "Cross Examined," and others. Specialty: altar paintings [47]

KUHN, Charles [Car] Indianpolis, IN. Work: Huntington Lib., San Marino, Calif. [40]

KUHN, Harry P(hilip) [P,C] Paterson, NJ/Wheelerville, PA b. 27 N 1862, Zurich, Switzerland. Exhibited: La. Purchase Expo, St. Louis,, 1904 (gold) [33]

KUHN, Robert J. [P] Richmond Hill, NY [25]

KUHN, Walt [P,Car] NYC b. 27 O 1880, NYC d. 13 Jy 1949. Studied: Acad. Colarossi, Paris, 1901; Munich Acad; Holland; Italy; Spain. Exhibited: Harriman Gal., 1930–41; Durand-Ruel Gal., 1943–45; retrospective, Cincinnati AM, 1960. Work: AGAA; Pal. Leg. Honor; AIC; Columbus (Ohio) Gal. FA; Denver A. Mus.; Detroit Inst. A.; Dublin (Ireland) Mus.; Los Angeles Mus. A.; MOMA; W.R. Nelson Gal.; NYPL; PMG; Univ. Nebr.; Wichita A. Mus.; WMAA. Author: "The Story of the Armory Show," 1938. Author/Producer: motion picture, "Walt Kuhn's Adventures in Art," 1939. He was a cartoonist for Life, Judge, and Puck (in NYC) until 1910, when he began painting. In 1913, he and A.B. Davies organized the landmark Armory Show in NYC. [47]

KUHNE, Hedvig (Harriett B.) [P,C,S,T] Hart, MI/Crystal Lake, RI b. 8 Ap 1891, Berlin, Germany. Studied: AIC; Chicago Acad. FA; Archipenko. Member: AAPL. Exhibited: Detroit IA; MMA, 1942; AIC, 1938, 1942 (prize). Work: Hackley public schools, Muskegon, Mich.; Hart (Mich.) H.S. [47]

KULL, Leo J. [P] Chicago, IL [19]

KUMM, Marguerite Elizabeth [E,P,Mur.P,Des] Falls Church, VA b. Redwood Falls, MN. Studied: Harvard; Minneapolis Sch. A.; Corcoran Sch. A.; Cameron Booth; Richard Lahey; Anthony Angarola. Member: SAE; Southern Pr.M. Exhibited: SAE, 1938–42, 1943 (prize), 1944, 1945; decorative des., New York, 1926 (prize), Boston, 1929 (prize); WFNY, 1939; San Fran. AA, 1939; Northwest Pr.M., 1939; Albright A. Gal., 1940, 1943; Southern Pr.M., 1940–42; Phila. Pr. Cl., 1942; NAD, 1942, 1944; AFA Traveling Exh., 1943–44; Mint Mus., 1943, 1944; LOC, 1943–46; Venice, Italy, 1940; AV, 1942; Valentine Mus., 1939, 1941, 1945; Kansas City AI, 1940; VMFA, 1943, 1945; Kansas City AI, 1940; VMFA, 1943, 1945; Wash. SE, 1939, 1945; PMG, 1939; Wash. WCC, 1940–42; Wash. Min. Soc., 1940–45. Work: LOC; BMFA; Valentine Mus.; VMFA; Oreg. State Col.; SAE; murals, Lowry Hill Children's Clinic, Minneapolis; cover, House Beautiful, 1930. Contributor, Antiques magazine [47]

KUMME, Walter (Herman) [P,T] NYC b. 16 D 1895, Phila. Studied: PAFA. Member: T. Square Cl.; Wilmington Soc. FA. [33]

KUMMER, Erwin George [P] Chicago, IL b. 9 O 1900, Chicago. Studied: Chicago Acad. FA; AIC; E.J.F. Timmons. Member: Palette & Chisel Acad.; All-Ill. Soc. FA; Assn. Chicago P.&S.; North Shore AA. Exhibited: AIC, 1945; Neville Pub. Mus., Green Bay, Wis., 1941, 1944; Assn. Chicago P.&S., 1946; Palette & Chisel Acad., 1941–46; All-Ill. Soc. FA, 1942–46; North Shore AA, 1940–46; Evanston Women's Cl., 1944. Work: Neville Pub. Mus. [47]

KUMMER, Frederic Arnold [P] New Rochelle, NY b. 5 Ag 1873, Baltimore, MD. Studied: Md. Acad. A.&Design [06]

KUNER, Albert [En] b. 10 O 1819, Lindau, Germany (came to San Fran. in 1848) d. 23 Ja 1906, San Fran. [*]

KUNIYOSHI, Katherine Schmidt [P] Brooklyn, NY/Ogunquit, ME b. 15 Ag 1898, Xenia, OH. Studied: K.H. Miller. Member: S.Indp.A. [31]

KUNIYOSHI, Yasuo [P,Li,T] NYC/Woodstock, NY b. 1 S 1893, Okayama, Japan (came to U.S. in 1906) d. 14 My 1953, NYC. Studied: Los Angeles Sch. A.&Des., 1908–10; Indp. A. Sch., 1914–16; NAD, 1912; ASL, with K.H. Miller, 1916–20. Member: F., Guggenheim Fnd., 1935; An Am. Group; Am. Ar. Cong.; Am. Soc. PS&G; Woodstock AA. Exhibited: Los Angeles Mus. A., 1934 (prize); GGE, 1939 (prize); CI, 1939 (prize), 1944 (prize); PAFA, 1934 (gold), 1944 (prize); Chicago, 1945 (med); La Tausca Pearls Exh., 1947; WMAA, 1948 (retrospective); Venice Biennale, 1952 (retrospective); Tokyo Mus. Mod. A., 1954; Boston Univ., 1961. Work: MMA; MOMA; CI; WMAA; BM; Newark Mus.; Albright A. Gal.; Columbus Gal. FA; VMFA; Univ. Nebr.; AGAA; Univ. Ariz.; Santa Barbara Mus. A.; Portland A. Mus.; PMG; Encyclopaedia Britannica Coll.; Detroit Inst. A.; Cranbrook Acad. A.; AIC; BMA. Positions: T., ASL (1933), New Sch. Soc. Res. (1936) [47]

KUNSCHIK, Marta [P] Indianapolis, IN [13]

KUNZ, J.E. [P] Cincinnati, OH [25]

KUNZE, E(dward) [P,C,T] Jersey City, NJ b. 8 O 1848, Waldenburg, Germany. Studied: Kongl, Danisch Academi Art, Copenhagen. Member: S.Indp.A. [25]

KUNZIE, Doris (Mrs. Roswell Weidner) [P,G] Phila., PA b. 17 Jy 1910, NYC. Studied: Grand Central Sch. A.; PAFA; Barnes Fnd. Exhibited: PAFA, 1938; Phila. Sketch Cl.; Phila. A. Cl. [40]

KUPFERMAN, Lawrence [E,P,T,L] Dorchester, MA b. 25 Mr 1909, Boston. Studied: BMFA Sch.; Mass. Sch. A. Member: ANA; SAE; Phila. WCC. Exhibited: AV, 1942 (prize); San Fran. AA, 1938 (prize); SAE, 1937, 1939 (prize), 1940, 1941, 1943, 1944; CI, 1941; PAFA, 1938, 1940–45; WMAA, 1938, 1940–42, 1945, 1946; AIC, 1938; BM, 1943, 1945; SFMA, 1938, 1939, 1941–44, 1946; WFNY, 1939; MOMA, 1943; Inst. Mod. A., Boston, 1943; Mortimer Brandt Gal., 1946 (one-man); Phila. A. All., 1946; Boris Mirski Gal., Boston, 1944–46. Work: Mills Col.; LOC; MMA; CI; BMFA; IBM Coll.; BMA; SFMA; FMA; Harvard; WMA; Boston Pub. Lib.; AGAA. Position: T., Mass. Sch. A., 1941– [47]

KUPFERMAN, Murray [C,Ldscp.P,T,L] Brooklyn, NY b. 10 Mr 1897, Brooklyn. Studied: PIASch; NAD; BAID. Member: Art T. Gld. Exhibited: America House; George Jensen; Arch. Lg.; NAD; G-R-D Gal.; Marie Harriman Gal.; Ferargil Gal.; BM; AMNH; Midtown Gal.; NAD. Work: NAD; NYWCC; Arch. Lg.; BM. Positions: T., Alexander Hamilton H.S. (Brooklyn), DeWitt Clinton H.S. (NYC) [47]

KURFISS, Alex [P] Kansas City, MO [24]

KURTZ, Benjamin T(urner) [S,W,L,T] Baltimore, MD b. 2 Ja 1899, Baltimore. Studied: PAFA; Grafly; Albert Laessle. Member: Phila. A. All.; Archaeological Inst. Am.; NSS; Arch. Lg.; Baltimore Mus. A. Exhibited: Arch. Lg., 1926 (prize); AIC, 1926 (prize); Sesqui-Centennial Expo, Phila., 1926 (med); Concord AA, 1926 (prize). Work: Ft. Worth (Tex.) Pub. Lib.; Curtis Inst. Mus., Phila.; Camden (Maine) Pub. Lib.; BMA; NGA; Peale Mus., Radio Station WBAL, Hochild-Kohn Dept. Store, all in Baltimore; fountain, Norton Gal., West Palm Beach, Fla. Position: T., Notre Dame Col., Baltimore [47]

KURTZ, Charles M. [Mus.Dir,W] b. 1855, Newcastle, PA d. 21 Mr 1909. Studied: Washington and Jefferson Col.; NAD. For nine years he was editor of "National Academy Notes," giving illustrations and notes of the pictures in the Spring Exhibition of the National Academy of Design. In 1891 he became assistant chief of the Department of Fine Arts of the World's Columbian Expo at Chicago, at the close of which he became art director of the St. Louis Expo. From 1894 to 1899 he visited the art centers of the U.S. and Europe in the interests of that Exposition. Made assistant chief of the Department of Art of the Louisiana Purchase Expo in 1901, he directed the installation of the paintings in the U.S. section, for which he was awarded a gold medal. For services in the interest of Bulgarian art, he was made Officer of the Order of Merit, by Prince Ferdinand. He became director of the Buffalo Fine Arts Academy, Albright Art Gallery, Buffalo, in January 1905, which position he held at the time of his death.

KURTZ, Julia Wilder [P,T] Buffalo, NY b. Harrodsburg, KY. Studied: Sch. FA, Buffalo; R.E. Miller; C.W. Hawthorne. Member: Gld. Allied A., Buffalo; Buffalo SA; AFA; AAPL [19]

KURTZ, Wilbur G. [P,Mur.P,I,W] Atlanta, GA b. 28 F 1882, Oakland, IL. Studied: De Pauw Univ.; AIC; G.E. Browne. Member: Atlanta Hist. Soc.; Atlanta AA. Exhibited: Atlanta AA, 1916 (prize), 1932 (prize). Work: Atlanta Women's Cl., Clark Howell Sch., Fed. Reserve Bank, First Nat. Bank, Hist. Soc., Atlanta Chamber of Commerce, 10th Street Public Sch., Governor's mansion (mural), First Fed. Savings & Loan (mural), Piedmont Driving Cl., Capitol Homes Housing Project (auditorium), all in Atlanta; Chattanooga Pub. Lib.; murals, Nat. Bank, Abbeville, S.C.; Macon (Ga.) Auditorium. Contributor: articles/illus., Atlanta Constitution, Atlanta Journal. Technical Director/Historian: film, "Gone With the Wind," Selznick Intl. Pictures, Inc. [47]

KURTZ, William [Photogr,P] Far Rockaway, NY b. 1833, Germany (came to U.S. before 1861) d. 5 D 1904. Exhibited: Centennial Expo., Phila., 1876 (prize); NAD, 1865–82. Early in his career he worked on crayon portraits but soon became, like Gutekunst, one of the most popular portrait photographers of the 19th century. He produced thousands of portraits of prominent people at his Madison Square studio and, in 1892, was the first to perfect a color halftone printing process—the results of which were evident in his exhibition at the N.Y. Soc. Amateur Photographers in 1894. [04]

KURTZWORTH, H(arry) M(uir) [Indst.Des,W,L,T,Dr] Los Angeles, CA b. 12 Ag 1887, Detroit, MI. Studied: Detroit Mus. Sch. Art, with Paulus, Gies; Detroit Acad. FA, with Wicker; Columbia, with Dow; PMSchIA; J. Melchers; Europe; Andhra. Research Univ., India. Member: Fourth Intl. Art Cong., Dresden, 1912; Calif. AC; Western Assoc. Art Mus. Dir.; AIA. Exhibited: Kansas City AI, 1923; France, 1939 (med). Awards:

Commander Cross, Grand Prix Humanitaire, Belgium, 1939. Author: "Genius, Talent or Mediocrity," 1924, "Motion Picture Handbook," 1946, other books. Contributor: World Book Encyclopedia, 1945–46. Designer: Xth Olympiad Diploma, 1932. Positions: T., Chicago Acad. FA, 1920–21, 1926–30; A. Dept., Los Angeles Mus. A., 1930–32; Dir., Kansas City AI (1921–25), Mich. AI (1920–26), Los Angeles AA (1932–37), Woodbury Col. A. Acad., Los Angeles (1946–) [47]

KURZ, Gertrude Alice [C,Des] St. Louis, MO b. St. Louis d. 14 N 1951. Studied: Washington Univ.; C.T. Baker; E. Prentis; E. Diehl; C.E. Pellew; H.H. Clark; Bussinger. Member: Boston Soc. A.&Crafts; St. Louis A. Center; SSAL. Exhibited: Witte Mem. Mus., 1939 (prize); SSAL, 1941 (prize); Boston Soc. A.&Crafts, 1930; Nat. All. A.&Indst. Traveling Exh., Am. Craftwork, 1933; AFA Traveling Exh., 1937; Phila. A. All., 1937; CAM, 1945; William Rockhill Nelson Gal., 1945; Intl. Expo, Paris, 1937. Work: hand-bound books, St. Louis Town Cl., Twentieth Century Art Cl., New Jewish Hospital Sch. Nursing, all in St. Louis. Specialties: bookbinding; leatherwork [47]

KURZ, Louis [Li,Mur.P] Chicago, IL b. 1834, Austria (came to U.S. in 1848) d. 21 Mr 1921. After serving in the Civil War, he founded the Chicago Lithographic Co. (1863–71) and the American Oleograph Co., in Milwaukee (1870s). In 1878 he joined with Alexander Allison to form Kurz & Allison (active until 1899), best known for chromolithographs of the Civil War. He was also one of the founders of the AIC and was a personal friend of Lincoln. Illustrator: "Chicago Illustrated," 1866

KUSANOBU, Murray [P] Newark, NJ b. 30 Ja 1907, Montreal, Quebec. Studied: Columbia; ASL, with W. Zorach, W. Von Schlegell. Member: Ar. of Today. Exhibited: Montclair A. Mus.; Riverside Mus.; N.J. Gal., Newark; WFNY, 1939; Newark Mus., 1945; Rabin & Kreuger Gal.; Ar. of Today; ACA Gal. Work: Newark Mus. [47]

KUSCHE, Carlton J(ules) [P,I] Oshkosh, WI b. 15 Ag 1873, Oshkosh d. 1943. Studied: AIC; W. Wendt; French; Dressler. Made sketches as he delivered the U.S. mail. [25]

KUSHER, Florence Taylor. See Sherman.

KUSSNER, Amalia. See Coudert, Mrs. [08]

KUTCHER, Ben [Des,I] Hollywood, CA b. 15 Ag 1895, Kiev, Russia. Studied: PAFA. Exhibited: Bookplate Assn. Intl., Los Angeles Mus., 1927 (prize). Illustrator: "A House of Pomegranates" (by Oscar Wilde, pub. Dodd Mead), "Venus and Adonis" (by Shakespeare), "Lalla Rookh" (by Thomas Moore, pub. Dial Press), "Story of the Theatre" (by Burleigh, pub. Harper), "School and the Theatre" (by Ommanney, pub. Harper), other books; Asia, Century. Position: A. Dir., Edward Everett Horton's Theatres in Los Angeles, 1927, Hollywood, 1928 [40]

KUTCHIN, Lucius Brown [Mur.P,Por.P,W] Columbus, OH/Santa Fe, NM b. 11 O 1904, Columbus d. 11 N 1936. Studied: PAFA; Woodstock; Gloucester; Santa Fe; Europe. Member: Columbus A. Lg. Exhibited: Columbus A. Lg. Ann. (prize). Work: mural, Columbus H.S. [38]

KUTKA, Anne (Mrs. David McCosh) [Li,P,Dr] Eugene, OR b. Danbury CT. Studied: ASL, with Nicolaides, K.H. Miller, E. Fitsch. Member: ASL. Exhibited: PAFA, 1932, 1934; AIC, 1935; WFNY, 1939; Denver A. Mus., 1938; Okla. A. Center, 1940; AV, 1943; Am. Red Cross Traveling Exh., 1942; G-R-D Gal., 1931; SAM, 1936–39, 1941, 1945; Portland (Oreg.) A. Mus., 1935, 1937–39, 1946; Northwest Pr.M., 1940; Contemporary A., 1938; Univ. Oreg., 1944 [47]

L

Edward Cucuel: *The Last Moments of an Unfinished Picture (en route to the Salon for judgment).* From W.C. Morrow's *Bohemian Paris of Today*, 1899

LABAUDT, Lucien Adolph [P,L,T] San Fran., CA b. 14 My 1880, Paris, France, d. 13 D 1943 (in a plane crash in India where he had gone to paint war scenes for Life magazine). Studied: self-taught. Member: San Fran. AA; San Fran. A. Center; Fnd. Western A.; Am. A. Cong. Exhibited: San Fran., 1927 (prize); First Ann. Calif. Painters' Comp., Gump's, San Fran., 1933 (prize); San Fran. AA, 1937 (prize); GGE, 1939. Work: Family C., San Fran.; Paramount Theatre, Oakland; Coit Mem. Tower, San Fran.; San Fran. Mus.; murals, Beach Chalet, Library, Washington School, Court House, all in San Fran.; USPO, Los Angeles. WPA artist. Position: Dir., Calif. Sch. Des. [40]

LA BOITEAUX, Mary Mitchell Hinchman (Mrs. Isaac) [P] Bryn Mawr, PA d. 18 Mr 1946. Exhibited: Phila. Plastic C., 1934 (med); WC Ann., PAFA, 1934 (prize), 1935, 1936; NAWPS, 1937, 1938 [40]

LABORDE, C.A.B. (Miss) [S] Paris, France b. New Haven, CT. Studied: Laporte-Blairsy [13]

LABOUISSE, Frederick T. [Arch,E] Bar Harbor, ME b. 1908 d. 4 O 1936. Studied: Yale

LABOURIER, J.E. [P] NYC/Nantes, France [08]

LA BRUCE, F(lora) M(cDonald) (Mrs.) [P,C,W,T] Charleston, SC/Edneyville, NC b. NYC. Studied: Cooper Inst.; J. McNevins. Member: Carolina AA; Sketch C.; SSAL [33]

LABUNSKA, Dorothea [S] NYC b. 10 My 1910, Brookline, MA. Studied: PAFA, with C. Grafly; BMFA Sch., with F.W. Allen, W. Hancock; Kunstgewerbeschule, Munich, with H. Wadere. Member: NAWPS; N.Y. S.Indp.A. [40]

LACEY, Bertha [P,L] Perrysville, IN b. 6 My 1878, Perrysville d. 25 N 1943. Studied: F. Duveneck, G. Bellows, J. Vanderpoel; Cechi, Italy. Member: Wabash River Sketch C. Exhibited: Hoosier Salon, 1927 (prize). Work: Covington (Ind.) Lib.; Clinton (Ind.) Lib.; Newport (Ind.) Lib.; Court House, Fountain County, Ind. [40]

LACEY, Jessie P. [P] Evanston, IL. Member: Chicago SA [27]

LACEY, Margaret Schaff [P] NYC/Falls Village, CT b. 25 D 1903, NYC. Studied: H. Giles; ASL; Grand Central A. Sch. Member: NAWPS. Work: FMA [40]

LA CHAISE, Eugene A. [P] Paris, France b. New York d. Spring 1925, Paris. Member: Paris SAP. During World War I, he was made a Chevalier of the Legion of Honor and, later, an Officier [24]

LACHAISE, Gaston [S] NYC/Georgetown, ME b. 19 Mr 1882 (came to Boston in 1906) d. 19 O 1935, NYC. Studied: Bernard Palissy; Gabriel Jules Thomas; Ecole des Beaux-Arts. Work: Nat. Coast Guard Mem., Arlington Nat. Cemetery; American Telephone and Telegraph Bldg., N.Y.; CMA; Newark Mus.; Pa. Mus.; Morgan Mem. Mus., Hartford, Conn.; PMG; Smith Col. A. Mus.; WMAA; Rockefeller Center, N.Y.; Century of Progress Expo, Chicago; many private coll.; one-ton figure "The Mountain" exhibited at MOMA. Author: "Gaston Lachaise." Best known for his stylized monumental female nudes, dating from 1918 to the 1930s. [33]

LA CHANCE, Georges [Mur.P,Por.P] Nashville, IN b. 13 O 1888, Utica, NY. Studied: St. Louis A. Sch. Member: Brown County A. Gal. Assn.; Hoosier Salon. Exhibited: Hoosier Salon, 1937 (prize), 1939 (prize), 1942 (prize), 1945 (prize); Chicago, 1940 (prize), 1941 (prize); Brown County AA, 1941 (prize); Swope Gal.; Marshall Field Gal.; Findlay Gal. Work: Ind. Univ.; De Pauw Univ.; Vincennes (Ind.) Jr. H.S.; Old Territorial Hall, County Court House, both in Vincennes; Toledo Scale Auditorium; Nashville House (Ind.); Bloomington (Ind.) Limestone Co.; Fremont Nat. Bank, Ohio; Lamson Bros. Co., Toledo [47]

LACHE, Albert R. [T,P] South Orange, NJ d. 7 F 1910. Studied: PAFA; NAD; Munich. Member: SC. Positions: T., Chautauqua Summer Sch.; T., Fawcett Drawing Sch., Newark, N.J. (for 7 years), Dir., since 1905

LACHENMEYER, Paul N. [S] Phila., PA. Exhibited: ACP, 1898 (gold) [13]

LACHER, Gisella Loeffler (Mrs.) [P] Kirkwood, MO b. 24 S 1900, Vienna, Austria. Studied: M. McCall, H. Breckenridge. Member: St. Louis AG; Alliance; Boston SAC. Exhibited: Ar. Gld., 1919 (prize), 1920 (prize), 1927 (prize), 1928 (prize); Kansas City A. Inst., 1923 (prize). Work: public sch., St. Louis [40]

LACHMAN, Harry [P] b. 29 Je 1886, La Salle, IL. Member: Société Inter. Des Artistes et Sculpteurs; Société Paris Moderne; Chevalier of the Legion of Honor, France. Work: Delgado Mus. A.; Musée du Luxembourg; Musée du Petit Palais, Paris; AIC; Memphis A. Women's C. [33]

LACY, Lucile Land [T,P,Li,C] Temple, TX b. 18 Ag 1901, Temple. Studied: Mary Hardin-Baylor Col.; Columbia; N.Y. Sch. Interior Dec. Member: SSAL; Assn. A. Instr. Tex.; Pr.M. Gld.; Tex. FA Assn. Exhibited: NAD, 1942; Provincetown AA, 1940; Tex. General Exh., 1940-43; Pr.M. Gld., 1941-45; Tex. FA Assn., 1939-43; SSAL, 1938-43. Positions: A. Dir., Mary Hardin-Baylor Col., Belton, Tex.; Occupational Therapist, Old Farms Convalescent Hospital, Avon [47]

LADANYI, Emory [P,B] NYC b. 8 N 1902, Hungary. Studied: J. Szekely. Member: Am. Ar. Cong. [40]

LADD, Anna Coleman (Mrs. Maynard) [S,L,T,W] Beverly Farms, MA b. 15 Jy 1878, Bryn Mawr, PA d. 3 Je 1939. Studied: Paris; Rome; Rodin; C. Grafly. Member: NSS; Boston Gld. A.; Copley S.; San Diego AA. Exhibited: P.-P. Expo, San Fran., 1915 (prize). Award: Chevalier Legion of Honor, France. Work: bronzes, RISD; Gardner Mus.; fountain, Public Gardens, Boston; memorials, Hamilton, Beverly Farms, Manchester Lib., Widener Lib., Harvard, Brookline, all in Mass.; Grand Rapids, Mich.; South Bend, Ind.; Blanden Mem. A. Gal., Fort Dodge, Iowa; Brookgreen Gardens, S.C.; Farnese Coll., Borghese Coll., both in Rome. Founder: ARC, studio of Portrait Masks, France, 1917-19. Author: "Hieronymus Rides," "The Candid Adventurer" [38]

LADD, Laura D. Stroud (Mrs. Westray) [P] Phila., PA b. 1 Jy 1863, Phila. d. 21 My 1943. Studied: Phila. Sch. Des. for Women; PAFA. Member: Plastic C.; Phila. WCC; Alliance; NAWPS; North Shore AA. Exhibited: PAFA, 1937, 1938. Work: PAFA [40]

LADD, Peter (Wallis Hall Sturtevant) [Por.P,I] Hasbrouck Heights, NJ b. 22 Ap 1897, Greenfield, MA. Studied: W.R. Winter. Illustrator: "Old Times in the Colonies," "Days of the Leaders," "Weedon's Modern Encyclopaedia," other books [47]

LADENDORF, Frank H. [I] NYC [01]

LA DRIERE, L.L. [P] Chicago, IL. Member: AG of Authors Lg. A. [25]

LAESSLE, Albert [S,T] Miami, FL b. 28 Mr 1877, Phila. d. 1954. Studied: Spring Garden Inst., Phila.; Drexel Inst.; PAFA; M. Bequine, in Paris. Member: ANA; NA; NSS; NIAL; Am. Soc. PS&G. Exhibited: PAFA, 1902 (prize), 1904-07, 1915 (prize), 1918 (gold), 1923 (gold), 1928; Buenos Aires, 1910 (med); P.-P. Expo, 1915 (gold); Americanization Through

Art, Phila., 1916 (prize); AIC, 1920 (prize); Sesqui-Centenn. Expo, Phila., 1926 (gold); Phila. A. Alliance, 1928 (prize). Work: Univ. C., Phila.; PAFA; MMA; CI; Peabody Inst.; Pal. Leg. Honor; Reading Mus. A.; bronzes, Rittenhouse Sq., Phila.; Zoological Gardens, Phila.; Johnson Sq., Camden, N.J.; Brookgreen Gardens, S.C.; mem., Logan Sq., Phila.; Widener Mem.; Soc. Medalists; Sesqui-Centenn. Expo; Concord AA; Univ. Pa.; MMA; Phila. AC; Rittenhouse Sq.; Pal. Leg. Honor. Position: T., PAFA Country Sch., Chester Springs, Pa., 1919-39 [47]

LAESSLE, Margaret Smoot (Mrs. Albert M.) [S] Greensboro, AL b. 29 Ag 1907, Lakeport, CA. Studied: PAFA; C. Grafly; A. Laessle. Exhibited: PAFA, 1930 (prize), 1931 (prize); Gimbel's Women's Achievement Contest, Phila., 1932 (gold). Work: Univ. Fla., Gainesville [40]

LAESSLE, Paul [P] Phila., PA b. 21 D 1908, Germantown, PA. Studied: PMSchIA; PAFA. Exhibited: PAFA, 1935 (prize). Work: PAFA [40]

LAFAIR, Samuel [P] Phila., PA Studied: PAFA [25]

LA FARGE, Bancel [P,C] Mt. Carmel, CT d. 14 Ag 1938. Member: Mural P.; NYWCC; Century Assn.; Paris AAA; NIAL; New Haven PCC; AFA. Work: Church of Blessed Sacrament, Providence, R.I.; St. Charles Col., Catonsville, Md. [31]

LA FARGE, John [P,C,W,Cr,T,L] NYC b. 31 Mr 1835, NYC d. 14 N 1910, Providence, RI. Studied: with maternal grandfather, a miniaturist; Europe, in Couture's studio; Louvre, studying drawings by old masters; Holland; Belgium; England; Newport, with W.M. Hunt (after entering law and giving it up). Member: ANA; NA; SAA; NSMP; AIA; NIAL; Am. Acad. A.; Century Assn. Exhibited: French Expo, 1889 (Legion of Honor); Pan-Am. Expo, Buffalo, 1901 (gold); St. Louis, 1904 (med); Arch. Lg., 1909 (med). At first he painted chiefly landscapes, then figures and still life; in 1866, he made drawings for Riverside Magazine. His first opportunity to do important decorative work came in 1876, when H.H. Richardson, the architect of Trinity Church, Boston, asked him to take complete charge of the interior of that church. This was the first real mural painting in America and marks an epoch in art. His other works of this type include the decorations of St. Thomas' Church, N.Y. (begun in 1877 and destroyed by fire in 1905); the panels in the Church of the Incarnation, and his masterpiece, the end wall above the altar in the Church of the Ascension, N.Y., which were painted in 1885. Other mural decorations by him are in the Church of the Paulist Fathers, N.Y.; the Court House, Baltimore; and the Capitol at St. Paul. In the early 1870s he became interested in the practical problems of glass making and gradually evolved the method of glass overlays (plating) and the use of opalescent glass, now generally known as American stained glass. He had designed the windows for Trinity Church before his experiments with this new method, which he used first in orders for private houses. One of his most important windows, undertaken in 1878, is the so-called Battle Window in Memorial Hall at Harvard; others are the Watson Memorial in Trinity Church, Buffalo, and the Church of the Ascension, N.Y. Later came a series of jewel-like flower panels for private houses, such as those for Cornelius Vanderbilt, Henry Marquand and William C. Whitney. His last work of this type, "The Peacock," was purchased by WMA. In all, he made several thousand windows, some monumental and others only small notes in the decorative scheme. Lecturer: "Considerations on Painting," MMA; "The Higher Life in Art," AIC [10]

LA FARGE, Mabel Hooper (Mrs. Bancel) [P,W] Mt. Carmel, CT b. 26 Je 1875, Cambridge, MA d. 28 S 1944. Studied: J. La Farge. Member: New Haven PCC. Exhibited: New Haven PCC, 1927 (prize). Contributor: "A Niece's Memories," in "Letters to a Niece," by Henry Adams; article, "John La Farge, the Artist," in Commonweal [40]

LA FARGE, Margaret Mason Perry (Mrs. John) [P] Newport, RI d. spring 1925. Mother of C. Grant La Farge, arch., and Bancel La Farge, painter.

LA FARGE, Oliver H.P. [P] NYC b. 1867 d. 29 My 1936. Studied: with father, John La Farge; Columbia. Member: Century Assn. He followed a business career on the West Coast and in N.Y. He retired on January 1, 1931, and at that time held the first exhibition of his pictures, at Ferargil Galleries. Most of them were pastel landscapes and covered a period of thirty years.

LA FARGE, Thomas (Sergeant) [Mur.P,C] Mt. Carmel, CT b. 5 S 1904, Paris d. Mr 1943 (while commander of the Coast Guard cutter "Natsek"; reported missing; age 38). Studied: E. Savage. Member: Arch. Lg.; Century Assn.; Mural P. Work: St. Andrews Church, Southampton; St. Matthew's Cathedral, Wash., D.C.; USPO, New London, Conn.; Trinity Chapel, Wash.; Seminary, St. Paul. Specialties: stained glass; mosaics. WPA artist. [40]

LA FAVOR, Will [S] Pittsburgh, PA b. Frankfort, NY. Studied: AIC, with L. Taft; H.A. MacNeil. Member: ASL, Chicago; Pittsburgh AA [17]

LAFFERTY, Blanche C. (Mrs. Charles E.) [C,T] Milwaukee b. 6 My 1896. Studied: Milwaukee-Downer Col. Member: Wis. Soc. Appl. A. Position: Dir., Occupational Therapy, Milwaukee Protestant Home for the Aged [40]

LA FONTAINE, Charles [P] Paris, France b. New Orleans. Studied: Paris, with Lefebvre [06]

LAGANA, Filippo [S] Darien, CT b. 27 Ap 1896, Italy. Studied: BAID. Member: NSS; Silvermine Gld. A.; Darien Gld. Seven Arts. Work: PMA [47]

LA GATTA, John [I,P] Port Washington, NY/Woodstock, NY b. 26 My 1894, Naples, Italy d. 1976. Studied: Sch. F.&Appl. A., N.Y.; H. Giles; K.H. Miller. Member: SI. Illustrator: Saturday Evening Post, Cosmopolitan, Ladies Home Journal, other magazines [40]

LAGERCRANTZ, Ava de [Min.P] NYC b. Sweden. Studied: Paris, with Lefebvre, Constant, Robert-Fleury [17]

LAHEE, Arnold Warburton [P] Glen Ridge, NJ b. 7 My 1888, Hingham, MA. Member: Am. Ar. Prof. Lg.; Bloomfield A. Lg. Exhibited: Montclair AM; N.J. Gal., Newark; Glen Ridge Women's C. [40]

LAHEY, Marguerite Dupuz [C,Des] Brooklyn, NY/Paris, France b. 22 Ja 1890 d. O 1958, Paris. Studied: Paris. Exhibited: Morgan Library, N.Y.; Arch. Lg. Work: Morgan Lib., N.Y. Specialties: bookbinding, tooling, illuminated manuscripts. Position: Staff, Morgan Lib. [40]

LAHEY, Richard (Francis) [P,L,T,E] Vienna, VA b. 23 Je 1893, Jersey City, NJ. Studied: ASL, with Henri, Bridgman. Member: Soc. Wash. A.; Wash. A. Gld.; S.Indp.A.; Am. Soc. PS&G; Salons of Am. Exhibited: AIC, 1925 (prize), 1945; PAFA, 1929 (gold), 1940-46; Soc. Wash. A., 1940 (med), 1944 (med), 1946 (med); VMFA, 1942-46, 1943 (one-man); CGA, 1935-45; CI, 1943, 1944; WFNY, 1939; GGE, 1939; CMA. Work: PAFA; BM; Detroit Inst. A.; WMAA; AGAA; TMA; CGA; BMA; MOMA; LOC; NYPL; Newark Pub. Lib.; Elk's C., Wash., D.C.; USPO, Brownsville, Pa; MMA. WPA artist. Positions: T., ASL (1923-25), Corcoran Sch. A. (1935-), Goucher Col. (1935-), George Washington Univ. (1940-) [47]

LAHEY, Richard, Mrs. See Gonzales, Carlotta.

LAHM, Renée D. (Mrs.) [P,Li] NYC/Stamford, CT b. 13 Je 1897 d. 3 My 1945, Tucson, AZ. Studied: C. Hawthorne; G.P. Du Bois; Kreiner, in Germany. Member: ASL; Am. Ar. Cong.; NAWPS. Work: Mus. NYC [40]

LAHR, Florence G. (Mrs. Walter L.) [P,T] Chicago, IL b. 26 F 1898, Medaryville, IN. Studied: Eggers; C. Kelly; Fredericks. Member: South Side AA, Chicago. Exhibited: Southern Ind. A., Evansville, 1936 (prize). Position: T., Calumet H.S., Chicago [40]

LAHR, Leanna [P] NYC/Ogunquit, ME b. 6 O 1903, Quincy, IL. Studied: North Vayana; Grand Central Sch. A.; Univ. Ill. Exhibited: Nat. Exh., Palm Beach Art Center, 1934 (prize), 1935 (prize) [40]

LAHR, R(obert) W. [I,T] Evansville, IN b. 18 F 1890, Evansville. Studied: AIC. Member: ASL, Chicago [25]

LAIDLAW, Jennie L. (Mrs.) [P] NYC b. 28 S 1861, Milwaukee. Studied: G. Belin, C. Ulahr, in Munich; DuMond. Member: NAWPS; NAC [33]

LAING, Laura Pauline [P] Kansas City, MO b. 1873, Toronto. Studied: Nulich; Lykouf; Thormacher. Member: Tiffany Art Class; Elkins Class. Exhibited: Omaha Expo, 1898. Specialty: water-color dec of china [98]

LAING, William D. [P] NYC. Member: GFLA [27]

LAISNER, George Alois Ferdinand [P,G,S,C,L,T] Pullman, WA b. 5 My 1914, Czechoslovakia. Studied: AIC; Univ. Chicago; Chapin; Polasek; Anisfeld. Member: Northwest AA; ASL, Chicago; Wash. Creative AA. Exhibited: Puyallup, Wash., 1939 (prize); SAM, 1940-42, 1943 (prize), 1944 (prize), 1945; SFMA, 1939, 1941, 1943 (prize), 1944; AIC, 1937, 1940, 1946; LOC, 1943; Northwest Pr.M., 1938-45; GGE, 1939; San Fran. AA, 1940-44; Oakland A. Gal., 1940-45; Wash. State Col. Work: SAM; SFMA; Northwest Pr.M. Position: T., State Col. Wash., Pullman [47]

LAITY, Warren Randolph [T,Photogr] New Brunswick, NJ b. 14 Jy 1890, Boston d. 14 S 1936. Studied: Rutgers; Oberlin. Position: T., N.J. Col. for Women, 1923-

LAKE, Edward John [P,S,T,L] Champaign, IL b. 5 My 1870, Dalkeith, Scotland d. 1 Jy 1940. Studied: H. Adams; F. Brangwyn; Laurens, in Paris.

Member: Western AA; Coll. AA. Author: "Birds and Animals." Position: T., Univ. Ill. [40]

LAKE, Ethel M. [Des] Farmington, ME b. 29 Je 1891, Farmington. Studied: Ringling Sch. A.; A.M. Sacker; A.K. Cross. Member: Boston SAC; AFA [40]

LAKE, L. Wiltsie [P] Brooklyn, NY [25]

LAKEY, Emily Jane (Mrs. Charles) [P] b. 22 Je 1837, Quincy, NY d. 24 O 1896, Cranford, NJ. Studied: France, 1877–78. Exhibited: NAD, 1873. Specialty: genre [*]

L'ALLEMAND, Gordon Lynn [B,I,Por.P,Mur.P,W] Los Angeles, CA b. 2 Ap 1903, Bowling Green, KY. Studied: J.F. Smith. Member: Calif. AC. Exhibited: Nat. PS Exh., Los Angeles Mus., 1931 (prize). Work: "Modern American Blockprints," 1931–32. Author/Illustrator: "Pageantry on the Mesa." Illustrator: "Horns of Gur" [40]

LALLIER, Victor [Por.P] Dallas, TX b. 22 Ap 1912, Fort Worth, TX. Studied: Southern Meth. Univ. Work: First Presbyterian Church, Dallas; Southern Methodist Univ., Dallas; Western States Life Insurance Co., Dallas [40]

LALONDE, J(oseph) W(ilfrid) [P,S] St. Paul, MN b. 19 Mr 1897, Minneapolis. Studied: G. Goetsch; F.L. Mora; DuMond; Stanislas Stickgold. Exhibited: Minn. State AS, 1923 (prize). Work: St. Louis Church, St. Paul, Minn.; St. Adelbert's Church, St. Paul [40]

LAMADE, Erich [P,S,C] Portland, OR b. 6 Mr 1894, Braunschweig, Germany. Studied: Herron AI; Portland AM Sch.; ASL; Grand Central Sch. A. Exhibited: Portland AM; 48 Sts. Comp. Work: USPO, Grants Pass, Oreg.; Portland AM; Seattle Marine Hospital. WPA artist. [40]

LAMAN, Thomas [P,S] Portland, OR b. 23 S 1904, Walla Walla, WA. Studied: Portland AA; Calif. Sch. FA. Member: San Fran. AA. Work: USPO, Whittier, Calif; Oreg. State Col.; Children's Home, San Fran.; Timberline Lodge Gov. Camp, Mt. Hood Nat. Forest, Oreg. WPA artist. [40]

LAMAR, Julian [Por.P] NYC b. 14 O 1893, Augusta, GA. Studied: Corcoran Sch. A.; PAFA; Florence, with Chase; Munich, with Marr; U.S. Military Acad. Member: NAC; Newport AA; SC. Work: AMNH; U.S. Military Acad., West Point; Barnard Col.; Princeton; Princeton C., N.Y.; Am. Col. Surgeons, Chicago; U.S. Supreme Court; Capitol, Montgomery, Ala.; Trinity Col., Hartford, Conn.; Roosevelt Lib., Hyde Park, N.Y.; British Embassy, Wash., D.C.; Zoological Gardens, NYC; Univ. Ala.; Calvary Church, N.Y.; Conn. State Col. [47]

LA MARRE, John H. [P,G,S] Somerville, MA b. 13 F 1913. Studied: S.J. Guernsey. Member: Provincetown AA. Exhibited: WFNY, 1939. Specialty: dioramas [40]

LAMASURE, Edwin, Jr. [P] Wash., D.C. [10]

LAMB, Adrian [P] Cresskill, NJ b. 22 Mr 1901, NYC. Studied: DuMond; Bridgman; Browne. Member: SC; Allied Ar. Am. Exhibited: Jr. Ar. Exh., NAC, 1927 (prize), 1928 (prize). Work: Columbia; Univ. Nebr.; N.Y. Evening Post Bldg.; Union Col., Schenectady, N.Y. [40]

LAMB, Aimee [P] Milton, MA b. 1893, Boston. Studied: W. James; C. Beaux; C.H. Woodbury; G. Demetrios. Exhibited: Inst. Mod. A., Boston, 1939 [40]

LAMB, Alberté Spratt. See Spratt.

LAMB, Charles R(ollinson) [P,C,Arch] Cresskill, NJ b. NYC Studied: ASL. Member: Mural P.; N.Y. Municipal AS; NAC; Arch. Lg.; Ar. Fellowship; Sch. Art Lg.; AAPL; Soc. Ar.&Sc.; NYSC. Specialties: religious, historical and municipal art in stained glass and mosaic. Son of Joseph. [40]

LAMB, Ella Condie (Mrs. Charles R.) [P,I,C] Cresskill, NJ b. 1862, NYC d. 23 Ja 1936. Studied: N.Y., with W.M. Chase, C.Y. Turner; England, with H. Herkomer; Paris, with Collins, Courtois. Member: Mural P.; NAC. Exhibited: NAD, 1889 (prize); Columbian Expo, Chicago, 1893 (prize); Atlanta Expo, 1895 (med); Pan-Am. Expo, Buffalo, 1901 (prize). Work: NAC; Sage Chapel, Cornell; Flower Lib., Watertown, N.Y.; Lakewood Mem. Chapel, Minneapolis; St. Mary's Church, Wayne, Pa.; St. John's Church, Detroit; Christ Church, Springfield, Ill. Specialties: mural decorations; stained glass; portraits [33]

LAMB, F. Mortimer [P,T] Stoughton, MA b. 5 My 1861, Middleboro, MA d. 24 Je 1936. Studied: Mass. Normal Art Sch.; BMFA Sch.; Académie Julian, Paris. Member: NYWCC; AWCS; Wash. WCC; New Haven PCC; Boston SWCP; Boston AC. Exhibited: 20th Century Expo, Boston 1900 (gold); P.-P. Expo, San Fran, 1915 (med). Work: City Hall, Brockton, Mass.; Universalist Church, Stoughton, Mass.; Chicatabut Cl., Stoughton, Mass.; Christian Science Students' Lib., Brookline, Mass.; Boston Univ.; First Baptist Church, Montclair, N.J. [33]

LAMB, F(rederick) S(tymetz) [Mur.P,C,W,L] NYC/Berkeley, CA b. 24 Je 1863, NYC d. 9 Jy 1928, Berkeley. Studied: ASL, with W. Sartain, Beckwith; Paris, with Lefebvre, Boulanger. Member: Arch. Lg.; Mural P.; N.Y. Municipal AS; NAC; Am. Scenic & Hist. Preservation Soc.; N.Y. Soc. C.; Arch. Lg. Am.; Berkeley Lg. FA. Exhibited: Columbian Expo, Chicago, 1893 (prize); Atlanta Expo, 1895 (gold); Paris Expo, 1900 (gold). Work: Plymouth Church, Brooklyn; Church of the Messiah, N.Y.; Brooklyn pub. sch. His chef-d'oeuvre is "Religion Enthroned" (1899), at BM. Son of Joseph. [27]

LAMB, Joseph [Des,C] b. 1833, England (came to U.S. as young man) d. 13 D 1898. Founder of J.&R. Lamb Studios (1857) which is today the oldest existing stained-glass manufacturer in the U.S. During the late 19th century it was famous for its stained-glass windows, mosaics, and murals. Joseph's sons, Charles and Frederick, took over the business in the 1880s. Specialty: ecclesiastical and memorial work

LAMB, K. Brainard [P] Toledo, OH [10]

LAMB, Katharine Stymets (Mrs.) [Des,P,C,I,T,L] Cresskill, NJ b. 3 Je 1895, Alpine, NJ. Studied: Columbia; NAD; ASL; CUASch; A.W. Dow. Member: NSMP; NAC; Soc. Des.-Cr.; Mural P. Work: Newark Mus.; Camp LeJeune, N.C.; U.S. Naval Hospital Chapel, Chelsea, Mass.; Charlotte Mem. Hospital, N.C.; First Baptist Church, Richmond, Va.; All Souls Chapel, Morris, N.Y.; Tuskegee Inst.; Ferncliff Mausoleum, N.Y.; mosaic murals, churches in Wash. D.C.; Brooklyn, N.Y.; St. Paul's Church, Fairfield, Conn.; Christ Lutheran Church, NYC; Alpine, N.J.; Christ Episcopal Church, Hackensack, N.J.; St. Mark's Church, Syracuse, N.Y.; Ga. Sch. of Tech., Atlanta; Dellenbaugh Mem. Rose Window, Holy Name Chapel, Cragsmoor, N.Y.; St. Andrews Church, Walden, N.Y. Specialties: stained glass; mosaics [47]

LAMB, Rose [Por.P,T] Boston. MA b. 1842. Studied: Boston, with W.M. Hunt, H. Knowlton, ca. 1876; possibly in Paris on her trips there in 1881 and 1890. Exhibited: Mechanics Fair, Boston, 1878 (med.). Edited and published, with Annie A. Fields, the letters of poet Celia Thaxter, 1895. Specialty: children. A highly regarded student of Hunt who stopped painting ca. 1900 due to illness. Position: assisted G. Bartlett at S. Boston Sch. A., 1884. [*]

LAMB, Tom [Des,P,I,L,W] NYC b. 18 S 1896, NYC. Studied: G. Bridgman. Member: SI. Author: "The Tale of Bingo," 1927, "Kiddyland Story Balloons," "Jolly Kid Alphabet," "Runaway Rhymes." Illustrator: "Kiddyland Movie," Good Housekeeping, 1921–25. Work: Congoleum-Nairn Co.; Lebanon Paper Co.; P.F. Volland Co. Specialty: industrial des. [40]

LAMB, William F. [P] Flushing, NY [13]

LAMBDEN, Herman [Ldscp.P] New Rochelle, NY b. 4 Ja 1859, New Rochelle d. 4 My 1935. Studied: Rondel; Hartman; Yates. Member: New Rochelle AA; SC; Huguenot and Historical Assn. Exhibited: NAD; throughout the east [33]

LAMBDIN, George Cochran [P] b. 1830, Pittsburgh, PA d. 28 Ja 1896, Phila. Studied: his father, James Reid Lambdin (1807–1889); Munich and Paris, 1855; Rome, 1870. Member: NA, 1868. Exhibited: PAFA, annually, beginning 1848; his famous "The Dead Wife," at Paris Expo, 1867. Work: Md. Hist. Soc.; St. Johnsbury Athenaeum, Vt.; BMFA. Specialties: flowers, especially roses; children's portraits; sentimental genre [*]

LAMBDIN, J. Harrison [P] b. ca. 1841, probably Phila. Exhibited: PAFA, 1859–62. Work: Pa. Hist. Soc. Brother of George. [*]

LAMBDIN, Robert Lynn [P,I] Westport, CT (1966) b. 7 O 1886, Dighton, KS. Studied: Denver Sch. A., with H. Read; Kansas City AI, with C.A. Wilimovsky. Member: Westport AA. Work: USPO, Bridgeport, Conn.; Bridgeport Brass Co.; Pub. Sch., Westport, Conn. Illustrator: juvenile books, national magazines (often western subjects) [47]

LAMBDIN, Victor R. [I,Car] Denver, CO. Member: Denver AC Car. Position: Associated with Denver Republican [01]

LAMBERT, George E., Jr. [Des,I,T] Lynnfield Centre, MA b. 3 Ja 1889, Boston. Studied: Pape Sch. A. Member: Ar.&Des. Assn. New England. Work: BMFA. Illustrator: Open Road, Outdoors, Child Life. Position: Dean, Com. A., Scott Carbee Sch. A., Boston [47]

LAMBERT, Gertrude A. [P] NYC b. 10 A 1885, Bethlehem, PA. Studied: Phila. Sch. Des. for Women; PAFA. Exhibited: PAFA, 1912–13 (prize), 1915 (prize); P.-P. Expo, San Fran., 1915 (med). Work: PAFA [40]

LAMBERT, Henry A. [P] Richmond Hill, NY. Member: Brooklyn SA [27]

LAMBERT, Jack Lincoln [Car,I,S,P,L] Chicago, IL b. 24 Ag 1892, NYC. Studied: NAD; ASL; Soc. Beaux-Arts Arch. Exhibited: PAFA; Chicago Hist. Soc., 1945; BMA (one-man). Work: Baltimore Stadium Trophy; Emerson Mem., Baltimore. Positions: Car., Baltimore Sun, Chicago Sun [47]

LAMBERT, John [Por.P] Jenkintown, PA b. 10 Mr 1861, Phila. d. 29 D 1907. Studied: PAFA; ASL; Paris, with Merson. Member: ACP [06]

LAMBERT, Nora Sarony [P] Clinton County, NY b. 24 F 1891, England. Studied: G. de F. Brush; K. Miller; G. Breck; F. Jones [31]

LAMBOURNE, Alfred [Ldscp.P,I] Salt Lake City, UT b. 1850, England (came to St. Louis in 1860; Salt Lake City, 1866) d. 1926. Studied: Deseret Acad., with Ottinger; largely self-taught. Work: murals, Latter Day Saints Temple; Salt Lake theatre scenery. Prominent Utah artist of the 1880s, he traveled with the photographer C.R. Savage and painted throughout the Western states. [01]

LAMEY, Richard [P] Phila., PA. Member: Phila AA [25]

LAMMERS, Herman C. [P,I,Des] Chicago, IL b. 2 N 1867, Cincinnati. Member: Palette and Chisel C., Chicago [10]

LA MOND, Stella Lodge [Des,L,P,B,T] Dallas, TX b. 30 S 1893, Morganfield, KY. Studied: Peabody Col.; Columbia; Cranbrook Acad. A.; A. Hogue; G.S. Dutch, A. Young; C. Martin; S. Tannahill. Member: AFA; Am. Assn. Univ. Prof.; Pr.M. Gld.; Dallas AA; Dallas Dr. Soc.; Nat. Assn. Art Edu.; Dallas AL. Exhibited: San Antonio Pr. Soc., 1944 (prize); Intl. Textile Exh., Greensboro, N.C., 1944, 1945 (prize); NAD, 1942; Dallas Mus. FA, annually; Tex. Gen. Exh., annually; Dallas All. A. Work: Evansville (Ind.) A. Mus.; Dallas Mus. FA; Southern Methodist Univ.; Tex. Tech. Col.; Corpus Christi (Tex.) Mus.; Mus. A., Greensboro, N.C. Position: T., Southern Methodist, 1936–45 [47]

LAMONT, Frances Kent (Mrs.) [S] NYC d. 1975. Studied: S. Borglum; M. Young. Member: NSS. Work: CMA; mem., New Canaan, Conn.; New Rochelle, N.Y. [47]

LA MONTAGUE (or LA MONTAGNE), Walter E. [P] b. 1839 d. 30 Je 1915, Detroit (killed by an automobile). Active in Buffalo, 1856–58; in Detroit by 1867.

LA MORE, Chet Harmon [P,G,T,L] Buffalo, NY b. 30 Jy 1908, Dane County, WI. Studied: A.N. Colt, at Colt Sch. A., Madison, Wis.; Univ. Wis.; Columbia. Member: Nat. Ser. Soc.; Am. Ar. Cong.; Un. Am. Ar. Exhibited: Intl. Exh. Lith., Wood En., AIC, 1937; NAD, 1938; WMAA, 1942–43, 1945–46; PAFA, 1939, 1940, 1945; WFNY, 1939; AIC, 1938; MOMA, 1937 (prize) 1943–45; Pal. Leg. Honor, 1945; Albright A. Gal., 1943–45; ACA Gal., 1941 (one-man), 1942 (one-man); Perls Gal., 1944 (one-man); Albright A. Gal., 1943 (one-man); AFA Traveling Exh., 1941 (one-man), 1943–44 (one-man). Positions: T., Albright A. Sch., Buffalo, N.Y., Univ. Buffalo (1942–) [47]

LA MOTTE, Bernard [I] NYC. Member: SI [47]

LAMPE, Edith [Des,Por.P,T] Phila., PA b. 3 Mr 1912, PA. Studied: H.B. Snell; R.S. Bredin; P. Gill; L. Howard; A. Meltzer; G. Harding. Member: Alumni Phila. Sch. Des. for Women. Work: Moore Inst. A., Sc.&Indst., Phila. Position: T., Harcum Jr. Col., Bryn Mawr, Pa. [40]

LAMPERT, Emma. See Cooper, C.C., Mrs.

LAMPKIN, R(ichard) H(enry) [P] Cincinnati, OH b. 11 Je 1866, Georgetown, KY. Studied: H.D. Fulhart; Cincinnati A. Acad. [31]

LANBENDER, Ruth E(lizabeth) [P] Malvern, OH b. 6 Jy 1864, Malvern. Studied: E. Knauft; A. Fleury; L. Kroll. Member: Chicago NJSA; Austin, Oak Park and River Forest Art Lg. [25]

LANCASTER, Elizabeth Greig (Mrs.) [P,I,Car,T] Manhasset, NY b. 13 Ag 1889, Denver. Studied: AIC. Member: S.Indp.A.; Douglaston A. Lg. Exhibited: Douglaston A. Lg.; Acad. Allied A.; S.Indp.A. [40]

LANCE, Elizabeth [P] Kingston, PA. Member: S.Indp.A. [25]

LANDACRE, Paul Hambleton [En,I] Los Angeles, CA b. 9 Jy 1893, Columbus, OH d. 1963. Studied: Ohio State Univ. Member: ANA; Calif. SE; San Diego SFA; Am. A. Group, N.Y.; Southern PM Soc. Exhibited: Phila. Pr. C., 1933 (prize), 1936 (prize); Northwest Pr.M., 1944 (prize); LOC, 1943 (prize), 1946 (prize); Assn. Am. A., 1946 (prize); Calif. SE, 1932 (prize), 1938 (prize); Los Angeles Print Group, 1933 (prize); San Diego FA, 1934 (prize); Phila Alliance, 1936 (prize). Work: LOC; NYPL; MOMA; BMFA; PMA; Rochester Mem. A. Gal.; Mills Col.; Honolulu Acad. A.; SFMA; Columbus (Ohio) Pub. Lib.; SAM; Los Angeles Pub. Lib.; Univ. Calif; Pomona Col.; Los Angeles City Col.; Springfield (Mass.) Lib.; Hackley A. Gal.; San Diego FA Soc.; "Fifty Prints of the Year," 1930–33; San Diego Mus. Author: "California Hills and Other Wood Engravings." Illustrator: "Tales of Soldiers and Civilians," "Immortal Village," other books. Contributor: American Artist. Specialty: wood engraving [47]

LANDAKER, H.C. [P] Chicago, IL Member: Chicago NJSA [25]

LANDEAU, Sandor L. [P] Paris, France b. 1864, Hungary. Studied: Paris, with Laurens, Constant. Member: Paris AAA. Exhibited: Paris AAA (prize); Pan-Am. Expo, Buffalo, 1901 (prize); Paris Salon, 1905 (prize), 1907 (med) [29]

LANDECK, Armin [E,En,Li,T,L] Litchfield, CT b. 4 Je 1905, Crandon, WI. Studied: Columbia. Member: NA; SAE; ANA. Exhibited: LOC, 1943 (prize), 1944 (prize), 1945 (prize); SAE, 1932 (prize), 1936 (prize); AIC, 1942 (prize); PAFA, 1938 (med); Exh. Graphic Arts, 1932 (prize). Work: MMA; AIC; NYPL; TMA; Newark Mus.; Nebr. State Mus.; LOC; Swedish Nat. Mus., Stockholm; Kaiser-Friedrich Mus., Berlin [47]

LANDEFELD, Frederick C. [P] Erie, PA [25]

LANDER, Benjamin [E] b. 1842. Member: The Scratcher's C., Brooklyn. Exhibited: N.Y. Et. C., 1882–88; Parrish AM, 1984. Work: Parrish AM. Specialty: sentimental genre [*]

LANDER, Louisa [S] Wash., D.C. b. 1 S 1826, Salem, MA d. 14 N 1923. Studied: Rome, with Crawford, ca. 1855 [13]

LANDERS, Bertha [P,E,Li] Dallas, TX b. 18 F 1911, Winnsboro, TX. Studied: Sul Ross State T. Col.; ASL; Colorado Springs FA Center. Member: Dallas AA; Tex. FA Assn.; Dallas Pr. Soc. Exhibited: Dallas All. A., 1935–46; Tex. General Exh., 1936–45; Denver A. Mus., 1941–44; Oakland A. Gal., 1935–42; NAD, 1943, 1944, NGA, 1942 (one-man); Laguna Beach AA, 1943–45; Corpus Christi, Tex., 1945; Southern Pr.M., 1940–42; Okla. A. Center, 1941–44. Work: LOC; Dallas Mus. FA; Univ. Tex.; Southern Methodist Univ. [47]

LANDIS, Marguerite A. [P] Seattle, WA [24]

LANDON, Edward A. [Ser,W,P,L] NYC b. 13 Mr 1911, Hartford, CT. Studied: Hartford A. Sch.; ASL; Mexico. Member: Springfield A. Lg.; Phila. Pr. C.; Am. Color Pr. Soc.; Nat. Ser. Soc.; Am. A. Cong.; Artist U. of Western Mass. Exhibited: Springfield A. Lg., 1933 (prize), 1934 (prize), 1945 (prize); Northwest Pr.M., 1944 (prize), 1946 (prize); nationally in print exh., since 1941. Work: Springfield Mus. FA; Smith Col.; PMA; Cornell; Wesleyan Univ.; AGAA; SFMA; CI; LOC; U.S. State Dept.; Albright A. Gal.; PAFA; Honolulu Acad. A.; Berkshire Mus.; SAM; Mt. Holyoke Col.; Fla. State Col.; MMA; Phila. Pr. C.; Am. Assn. Univ. Women; Berkeley Bd. Edu.; Trade Sch., Springfield, Mass. Author/Illustrator: "Picture Framing." Editor: Serigraph Quarterly [47]

LANDRUM, Mabel [P] Chicago, IL [17]

LANDT, Theodore Lins [P,C,Dec] Douglas Manor, NY b. 10 F 1885, NYC. Studied: PIASch; ASL. Member: S.Indp.A. [25]

LANDY, Art [P,Li,T,C] Bellflower, CA b. 18 My 1904, Newark, NJ. Studied: Faucett A. Sch., Newark, N.J.; Otis AI. Member: Calif. WCC; Calif. AC; Los Angeles P.&S. Cl.; Laguna Beach AA; Whittier (Calif.) AA; Northwest Pr.M. Exhibited: Calif. WCC, 1941–43, 1945, 1946; Northwest Pr.M., 1943, 1944; Laguna Beach AA, 1943–45; Calif. AC, 1941–46; Los Angeles Mus. A., 1943–45; Los A. P.&S. Cl., 1942, 1943, 1944 (prize), 1945 (prize), 1946; Whittier AA, 1942, 1942 (prize), 1943 (prize), 1944, 1945 (prize), 1946 [47]

LANDY, Harold A., Mrs. See Walker, Mary E.

LANE, Betty (Mrs. Noxon) [P] Niagara-on-the-Lake, Ontario b. 30 S 1907, Wash., D.C. Studied: Corcoran Sch. A.; Mass. Sch. A.; Lhote, in Paris. Work: PMG; MMA [47]

LANE, Edith [P] Dubuque, IA. Member: Dubuque AA [25]

LANE, Emma [P] Cleveland, OH [10]

LANE, Francis Ranson [P] Wash., D.C. Member: Wash. WCC [01]

LANE, Gardiner M. Boston, MA b. 1 My 1859, Cambridge, MA d. 3 O 1914. Studied: Harvard. Member: Am. Sch. Classical Studies, Athens; Boston Soc. Archaeological Inst. Am.; BMFA

LANE, Harry [P] NYC b. 26 D 1891, NYC. Studied: Europe. Member: Nat. A. Soc.; S.Indp.A.; Un. Am. A. Exhibited: Rockefeller Forum, 1935; PAFA, 1933, 1940; Dallas Mus. FA, 1936; WFNY, 1939; TMA, 1932, 1940. Work: MMA; WMA; Standard Oil Co., N.J.; USPO, Port Washington, N.Y. WPA artist. [47]

LANE, J.H. (Mrs.) [P] Chickasha, OK. Member: Okla. AA [25]

LANE, John [Publisher] London, England d. 2 F 1925. Publisher of International Studio. In 1896 he founded the American branch of the business.

LANE, Joseph [P] Chicago, IL b. 4 Mr 1900, Austin, TX. Studied: F.M. Grant; L. Van Pappelendam; AIC. Exhibited: Chicago Artist Exh., AIC, 1935 (prize). Work: mural dec., Chicago Theatre; Picwick Restaurant, Betty Hall, Inc., both in Chicago [40]

LANE, Katharine Ward [S] Boston, MA/Manchester, MA b. 22 F 1899, Boston. Studied: BMFA Sch.; C. Grafly; A.H. Huntington; B. Putnam. Member: NAWA; NSS; Arch. Lg.; CAFA; PBC; Gld. Boston A.; North Shore AA; ANA; NA; Boston SS; Grand Central AG; AAPL; Boston AC; Mass. State Art. Comm. Exhibited: Sesqui-Centenn. Expo, Phila, 1926 (med); PAFA, 1927 (gold), 1940, 1942–44; NAWPS, 1928 (gold), 1931 (prize); Boston Tercentenary Exh., 1930 (prize); NAD, 1931 (prize); 1932 (prize), 1941, 1944, 1946; NAWA, 1933, 1944, 1946 (prize); Arch. Lg., 1942, 1944; AIC, 1926–28; Inst. Mod. A., Boston, 1943; Paris Salon, 1928 (prize); North Shore AA, 1929 (prize); Grand Central Gal., 1929 (prize). Work: BMFA; Reading Mus. A.; PAFA; Brookgreen Gardens, S.C.; BMA; carvings, Inst. Biology, Harvard; motion picture "From Clay to Bronze," BMFA, 1930; Lotta Fountain, Boston [47]

LANE, Lina M. [P] Brooklyn, NY [19]

LANE, Marian U. M. [Bookbinder,I,T,Min.P] Wash., D.C. b. Great Gransden, Huntingdonshire, England. Studied: Sangorski; Sutcliffe; Clifford. Member: Wash. WCC; Wash. AC; Boston SAC; Min. PS&G Soc. Exhibited: SI, 1927 (prize), 1938 (prize), 1940 (prize); Wash. WCC, annually. Work: books presented to Queen Elizabeth of Belgium, Colonel Charles A. Lindbergh, the Emperor of Japan; Washington Cathedral; greeting presented to Mrs. Calvin Coolidge; Pub. Lib., Leeds, England; CGA, 1939 [47]

LANE, Martella Cone (Mrs.) [P] Fortuna, Humboldt County, CA [25]

LANE, Mary B. (Mrs.) [P] East Savannah, GA. Member: AWCS [47]

LANE, Mary Comer [P] Savannah, GA. Member: Baltimore WCC; SSAL [29]

LANE, Melvin [P] NYC [19]

LANE, Susan Minot [P,T] Cambridge, MA b. 1832 d. 1893. Studied: W.M. Hunt, in Boston. Work: BMFA; Bostonian S. Author: "Old Boston Houses," 1881–82 (portfolio). Specialty: genre. Regarded by Hunt as one of his most promising students, she rarely exhibited and led a quiet life. [*]

LANE, Thomas Henry [Min.P,Por.P] Elizabeth, NJ b. 24 F 1815, Phila. d. 27 S 1900. Studied: E. Leutze, in Washington. Position: Staff, Broadway Journal. He was also a poet and an intimate friend of Edgar Allen Poe.

LANE, Willie Baze [P,L,T] Chickasha, OK b. 16 Mr 1896. Studied: Santa Fe, with Nordfeldt. Member: Okla. AA; Chickasha AL; Okla. City AL; Okla. Traveling Exhibitors. Work: First Christian Church, First Baptist Church, both in Chickasha [31]

LANFAIR, Harold Edward [Des,I,P] Los Angeles, CA b. 3 My 1898, Portland, OR. Studied: Los Angeles Sch. A.&Des.; Nicholas Haz Sch.; Otis AI; John Huntington Sch., Cleveland; R. Moffett. Exhibited: CMA, 1932 (prize), AIC, 1932, 1933, 1934, 1940; SFMA, 1941. Work: CMA. Positions. Des./Illus., Columbia, Twentieth Century Fox, Universal, Goldwyn, other motion picture companies [47]

LANFAIR, Harriet (Keese) [Li,B] Los Angeles, CA b. 12 F 1900, Pasadena. Studied: Otis AI, with J.F. Smith; UCLA, with N. Haz, Exhibited: Los Angeles Print Group, 1933 (prize) [40]

LANG, Annie Traquair [P,T] NYC b. 8 S 1885, Phila. d. 8 N 1918. Studied: W. Sartain; E. Daingerfield; W.B. Snell, W.M. Chase; C. Beaux. Member: NAC. Exhibited: P.-P. Expo, San Fran., 1915 (med). Work: Minneapolis Mus.; Herron A. Inst. [17]

LANG, Alfred Ernest [Ldscp.P] Rye, NH b. 26 Jy 1879, Rice County, KS. Studied: MIT; H. Rice. Member: Gloucester SA; Merrimack Valley AA [40]

LANG, Charles Michael Angelo [P,S,I] NYC b. 26 Ag 1860, Albany, NY d. 15 Mr 1934, Saratoga County, NY. Studied: NYC; Venice; London; France; Munich; J. Benzur; Prof. Lofftz. Member: SC. Exhibited: Cornell. Work: City of Albany; Capitol, Court House, Masonic Temple, all in Albany; Troy, N.Y.; Manhattan C., NYC. Position: Dir., Emma Willard Sch. A., Troy [33]

LANG, Florence Osgood Rand (Mrs. Henry) [P,Patron] Montclair, NJ b. 1862 d. 5 F 1943. Member: Montclair AA; NAC; Wash. AC; Province-town AA; NAWPS. Gave Evans collection of American paintings to Montclair A. Mus.; contributed toward Westfield (N.J.) Athenaeum; gave art museum to Scripps Col., Claremont, Calif. [25]

LANG, Henrietta Dean [P,T] Detroit, MI [21]

LANG, Louis [Por.P,Min.P] b. 29 Mr 1814, Württemberg, Germany (came to Phila. in 1838) d. 6 My 1893, NYC. Studied: Paris, 1834. After several years in Italy, settled in NYC, 1847 where he was well-known. [*]

LANG, Will, Mrs. See Sibley, Marguerite.

LANGDON, Gordon [P] San Fran., CA. Exhibited: WC Ann., San Fran. A. Assn., SFMA, 1937–39 [40]

LANGDON, Helen Haven [P] NYC b. 5 N 1870, NYC. Studied: H.B. Snell [06]

LANGDON, Katherine. See Corson, W..H., Mrs.

LANGE, Dorothea [Photogr] b. 1895, Hoboken, NJ d. 1965. Studied: NYC, with A. Genthe; Columbia, with C. White, 1917–18. Work: Oakland MA holds 50,000 prints and negatives; IMP; LOC; NYPL; MOMA; most major museums. In 1919 she opened a portrait studio in San Fran., but is best known for her empathic documentation of the nation's poor during the Depression, taken for the Farm Security Administration. Her best known image is "Migrant Mother, Nipomo, Calif.," 1936. Illustrator: P. Taylor's "An American Exodus," 1939. She was a prolific photographer for Life during the 1950s. [*]

LANGE, Erna [P,T] Phoenix AZ b. 19 O 1896, Elizabeth, NJ. Studied: ASL; NAD; CUASch; AcadémieJulian, Grande Chaumière, Colarossi, all in Paris; C. Beaux; F. Olivier. Member: AAPL; Société Nationale des Beaux-Arts, Paris; NAWPS; Elizabeth SA [47]

LANGE, Frederic, Mrs. See Condit, Louise.

LANGE, Katharine Gruenner (Mrs. Oscar J.) [S] Shaker Heights, OH b. 26 N 1903, Cleveland. Studied: Smith Col., Cleveland Sch. A.; A. Blazys. Member: Cleveland AA. Exhibited: CMA, 1936 (prize), 1939 (prize), 1940–42 (prizes), 1945 (prize), 1946 (prize); Arch. Lg., 1938; WFNY, 1939; CAM, 1935–46; WMAA, 1940; MMA (AV), 1942. Work: CMA [47]

LANGENBAHN, August A. [S] Buffalo, NY b. 28 Ag 1831, Germany (came to U.S. in 1852; settled in Buffalo, ca. 1885) d. 7 Je 1907. Member: Buffalo Hist. Soc.; Buffalo Soc. Ar. Work: Buffalo Hist. Soc.; Buffalo Pub. Lib.; museums in Buffalo

LANGENBACH, Clara Emma [P,T] Buffalo, NY b. 28 Ja 1871, Sebringsville, Ontario. Studied: Albright A. Sch.; PIASch; ASL; Carlson; Goltz; H. Leith-Ross; Chase; Fosbery. Member: North Shore AA; Lg. Am. Pen Women; Soc. for Sanity in A. Exhibited: All. Am. Am., 1925, 1935; North Shore AA, 1928, 1930–45; Lg. Am. Pen Women, 1929–35, 1936 (prize), 1937–41, 1942 (prize), 1943–46. Boston AC, 1934; CAM, 1943; Buffalo SA, 1906–1935. Work: Lackawanna Pub. Lib., Buffalo, N.Y.; pub. sch., Bronx, N.Y.; pub. sch., Buffalo [47]

LANGENBECK, Elizabeth (Mrs. MacCubbin) [P] Wash., D.C. b. 18 S 1907, Wash., D.C. Studied: Concoran Sch. A.; Perry ; G.P. Ennis. Member: Wash. AL; Nat. S.Indp.A., Wash. [33]

LANGENBERG, Gustave C. [P] NYC b. 1859, Düsseldorf, Germany d. 27 N 1915. Studied: Paris; Holland; Germany. Work: battle scenes during the Boer War, museums in Europe; Netherlands Gov.; portraits of Pres. Wilson, others [10]

LANGFORD, Ruth Betty [P,G,T] Enterprise, TX b. Sherman, TX. Studied: Harding Col.; Univ. Iowa; F. Martin; E. Ganso; P. Guston. Exhibited: Ney Mus. A., 1943; Kansas City AI, 1942; Ark. State Exh., 1942 (prize), 1946. Work: Hendrix Col., Ark. Position: T., Harding Col., Searcy, Ark., 1942–46 [47]

LANGHAM, Emily [P] Houston, TX b. 22 Ap 1895, Shepherd, TX. Studied: Newcomb Col. Sch. A.; N.Y Sch. F.&Appl. A.; J. Arpa. Member: SSAL; Tex. FA Assn. [33]

LANGHORNE, Katherine. See Adams, Benjamin, Mrs.

LANGHORNE, Rieta B. (Miss) [P] NYC/Lynchburg, VA [25]

LANGLEY, Amelia [P] NYC [04]

LANGLEY, Elizabeth [P,E] Phila., PA b. 20 My 1907, Chicago. Studied: ASL; A. Carles; H. Breckenridge [31]

LANGLEY, Lise [P,E] Phila., PA/Harvey Cedars, Ocean County, NJ b. 20

My 1907, Chicago. Studied: A. Carles; H. Breckenridge; ASL. Exhibited: Sketch C.; Graphic Sketch C., Phila., 1932 [40]

LANGLEY, Sarah (Mrs. Earl Mendenhall) [P,S,I,W,T] Phila., PA/Eagles Mere Park, PA b. 12 Jy 1885, Texas. Studied: PAFA. Work: PAFA [40]

LANGS, Mary Metcalf [S] Niagara Falla, NY b. 12 Mr 1887, Burford, Ontario. Studied: Paris, with Bourdelle, Despiau, Gimond. Member: The Patteran. Exhibited: Albright A. Gal., 1931–37, 1938 (prize), 1939, 1940, 1941 (prize), 1942–44, 1945 (prize), 1946; Salon de Printemps, Paris, 1929, 1931, 1932; Salon d'Automne, Paris, 1933; NAD, 1931; PAFA, 1937, 1938; WFNY, 1939 [47]

LANGSDORF, Clara M. [P] Cincinnati, OH. Member: Cincinnati Women's AC [27]

LANGSDORF, Martyl Schweig. See Martyl.

LANGSETH-CHRISTENSEN, Lillian [P,Des] NYC b. NYC. Studied: Vienna Kunstgewerbe Schule; Vienna Acad. A.; ASL. Member: Arch. Lg. Exhibited: AIC, 1926; MMA, 1926–36. Work: Essex House, N.Y.; Maritime Exchange Bldg.; Bankers Trust Co.; numerous hotels and theatres in NYC. Specialty: textile design [47]

LANGTON, Berenice Frances (Mrs.) [S] NYC b. 2 S 1878, Erie County, PA d. 1959. Studied: A. Saint-Gaudens; A. Rodin. Member: PBC. Exhibited: N.Y., 1915 (prize); Stockbridge, Mass., 1939 (prize); MMA (AV), 1942; PAFA; Walters Gal., Baltimore; NAD; Berkshire Mus.; Salon des Beaux-Arts, Salon des Tuileries, Paris [47]

LANGTRY, Mary [P] NYC. Member: NYWCC; NAWPS [29]

LANGWIG, Augustus [P] Jersey City, NJ. Member: Lg. AA [24]

LANGZETTEL, George H(enry) [P] New Haven, CT b. 3 Ap 1864, Springfield, MA. Studied: Yale. Member: New Haven PCC [40]

LANHAM, Emily [P] Houston, TX b. 22 Ap 1895, Shepherd, TX. Studied: Newcomb Col.; N.Y. Sch. F.&Appl. A.; J. Arpa. Member: SSAL; Tex. FAA. Exhibited: Houston Mus. FA, 1935 (prize). Position: T., Houston Mus. FA [40]

LANIER, Fanita (Mrs. Alex Acheson) [Des,E,P] Gallup, NM/Lindenlure Lake, Rogersville, MO b. 15 Ag 1903, Miami, FL. Studied: ASL; Tex. State Col. for Women, Denton; Ecole des Beaux-Arts, Paris. Work: maps, Federal Bldg., Tex. Centenn. Expo, 1936; El Rancho Hotel, Gallup, N.Mex. Specialty: design and execution of pictorial maps [40]

LANING, Edward [P,T] Kansas City, MO (living in NYC, 1976) b. 26 Ap 1906, Petersburg, IL. Studied: AIC, 1923–24; Univ. Chicago, 1925–27; ASL, with M. Weber, B. Robinson, J. Sloan, K.H. Miller, 1927–30. Member: Mural P.; Am. Soc. PS&G; An Am. Group. Exhibited: AIC, 1945 (prize); CI, 1945; VMFA, 1944, 1945; Pepsi-Cola, 1945. Work: MMA; WMAA; NYPL; Richmond Prof. Inst.; Admin. Bldg., Ellis Island, N.Y.; Hudson Gld., N.Y.; murals, USPOs, Rockingham, N.C., Bowling Green, Ky. WPA muralist. Author: "The Sketch Books of Reginald Marsh," "Perspective for Artists." Positions: ASL (1932–33, 1945–50, 1952), Kansas City AI [47]

LANKES, Gene (Porter) [I] NYC/Pequot Lake, MA b. 6 O 1894, Louisa, KY. Member: Bronx AG [27]

LANKES, Julius J. [En,I,T,W,B] Hilton Village, VA b. 31 Ag 1884, Buffalo, NY d. 1960, Durham, NC. Studied: ASL, Buffalo; BMFA Sch.; Mary B.W. Coxe; Ernest Fosbery; Philip Hale; W.M. Paxton. Member: Calif. PM; AAPL; Prairie PM; ANA. Exhibited: CGA (one-man); CI (one-man); Albright A. Gal. (one-man); BMA (one-man); Rochester Mem. A. Gal. (one-man); Richmond Acad. FA (one-man). Work: LOC; MOMA; British Mus., London; BM; BMA; Newark Pub. Lib.; Bibliothèque Nationale, Paris; Boston Pub. Lib.; NYPL. Author: "A Woodcut Manual," "Virginia Woodcuts." Illustrator: "New Hampshire," "West Running Brook," by Robert Frost, "Homes of the Freed," "Marbacka," "John Henry" [47]

LANKESTER, Edwin [P,W,L,T] Pittsburgh, PA b 20 O 1858, Sutton, Surrey, England. Studied: E.A. Penley. Member: Pittsburgh AA. Exhibited: Pittsburgh AA, 1885 (med). Work: Gov. House, Calcutta, India [25]

LANOE, J. Jicquel [P] Hollywood, CA. Member: Calif. AC [27]

LANPHER, Helen F. [S] Baton Rouge, LA b. 29 Ag 1904, Superior, WI. Studied: Univ. Wash.; Chouinard Sch. A.; A. Archipenko. Member: Chicago Soc. Ar. Exhibited: Ar. Chicago Vicinity Ann., AIC, 1937, 1938; Chicago Soc. Ar., 1938; WFNY, 1939 [40]

LANSIL, Walter F(ranklin) [P] Boston, MA b. 30 Mr 1846, Bangor, ME. Studied: Bangor, with J.P. Hardy; Académie Julian, Paris. Member: Bangor AA, 1876; Boston AC, 1877. Exhibited: NAD, 1878–92. Work: Boston AC [21]

LANSING, Richard H. [P] Rochester, NY. Member: Rochester AC [25]

LANTHIER, Louis A. [Dealer] NYC b. 1840, Montreal d. 2 F 1910. Opened "The Old Curiosity Shop" in NYC; was an authority on old pictures, porcelains, furniture, silverware, antique jewelry, armor, precious stones, the dress and customs of different periods of history.

LANTZ, Alfred D. [S] NYC. Member: NSS [25]

LANTZ, Michael [S] New Rochelle, NY b. 6 Ap 1908, New Rochelle. Studied: NAD; BAID; L. Lawrie. Exhibited: BAID, 1926 (prize), 1927 (prize), 1929 (prize), 1930 (prize), 1931 (prize); PAFA, 1935, 1939, 1941, 1945; Phila. A. All., 1946; Arch. Lg., 1946. Work: Fed. Trade Bldg., Wash., D.C.; Thunderbolt Trophy, Republic Aviation. WPA artist. [47]

LANTZ, Paul [Mur.P,Por.P] Santa Fe, NM b. 14 F 1908, Montana. Studied: ASL; Kansas City AI. Member: Col. AA; Rio Grande Painters. Work: U.S. Gov.; La Fonda, Santa Fe; La Quinta, Albuquerque [40]

LAPORTE, Paul M. [Edu,G,P,L] Olivet, MI b. 22 N 1904, Munich, Germany. Studied: Munich, with Max Doerner; Univ. Munich. Member: CAA. Exhibited: MOMA, 1942; CAFA, 1940–45; Grand Rapids, Mich., 1946. Author: "Johann Michael Fischer," 1934. Contributor: Apollo, College Art Journal, other publications. Positions: T., Ethel Walker Sch., 1940–45, Olivet Col., 1945– [47]

LAPPE, Alexander H. [P] Pittsburgh, PA b. Pittsburgh. Studied: C. Walter, at Chester Springs Sch. Member: Pittsburgh AA; 100 Friends Pittsburgh A. [24]

LA PRADE, Malcolm [P] NYC [19]

LA RIAR, Lawrence [Cart] Hollywood, CA b. 25 D 1908. Studied: N.Y. Sch. F.&Appl. A. Work: N.Y. Sch. F.&Appl. A. Contributor to Collier's, Saturday Evening Post, Judge, Life, Country Gentleman, Cinema Arts, American Magazine; New York American. Position: Cart., Walt Disney Studios [47]

LARIMER, Harry E. [Cart] Fort Wayne, IN. Work: Huntington, Lib., San Marino, Calif. [40]

LARKIN, Alice [P] NYC b. NYC. Studied: ASL. with K. Cox, F.V. DuMond; Paris, with Aman-Jean, Collin; Dupré. [15]

LARKIN, Katherine B.S. (Mrs. Adrian H.) [P] NYC. Member: NAWPS. Exhibited: Argent Gal., 1936 (one-man); NAWPS, 1937, 1938 [40]

LARNED, Charles W. [P,T] West Point, NY b. 9 Mr 1850, NYC d. 18 Je 1911, Dansville, NY. Studied: West Point, with R. Weir. Member: Arch. Lg., 1892. Contributor: magazines on drawing and design. Position: T., Dean, West Point [10]

LARNED, Marguerite Y. [P] NYC. Member: NAWPS. Exhibited: NAWPS, 1935, 1936, 1937, 1938 [40]

LARNED, Walter Cranston [W,L] Chicago, IL b. 1850, Chicago d. 19 Je 1914, Winnetka. Studied: Harvard. Author: "Arnaud's Masterpiece," "A Romance of the Pyrenees," "Churches and Castles of Mediaeval France," "Rembrandt," "A Romance of Holland." Also a lawyer. Position: Art Ed., Chicago Daily News

LAROCQUE, Eleanor Theodora [P] NYC [17]

LARSEN, Andreas R. [P] Minneapolis, MN [24]

LARSEN, B(ent) F(ranklin) [P,T] Provo, UT b. 10 My 1882, Monroe, UT. Studied: Brigham Young Univ.; Univ. Chicago; Univ. Utah; AIC, 1922; Paris, with H. Royer; P.A. Laurens; Académie Julian, 1924–25; André Lhote, 1929–30; Acad. Colarossi; Acad. de la Grand Chaumière. Member: French S.Indp.A.; AWCS; Assn. Utah A. Exhibited: Paris Salon, 1930, 1931; French S.Indp.A., 1931; AWCS; Assn. Utah A., 1938–46; Utah State Inst. FA, 1920–46; Springville AA, 1912–46; Miss. State Exh., 1930 (prize); Heyburn, Idaho Exh., 1935 (prize). Work: Springville, AA; State Capitol Bldg., Salt Lake City; Utah State Fair Col.; Weber Col. Coll; Dixie Col. Coll. Position: T., Brigham Young Univ., 1931–53

LARSEN, (Charles) Peter [C,Des,P,E] York, PA b. 7 Mr 1892, Phila., PA. Studied: W. Chase; D. Garber; R. Pearson, Jr. Member: Chicago SE; NYSC. Work: AIC. Position: T., Leonardo Da Vinci A. Sch., NYC; N.Y. Unit of Index of Am. Des. [40]

LARSEN, John R. [P] Oak Park, IL. Member: Chicago NJSA [25]

LARSEN, Mae Sybil [P,I] Chicago, IL b. Chicago d. 18 F 1953. Studied:

AIC; J. Sloan; R. Davey; B. Anisfeld; E. Zettler. Member: Renaissance S., Univ. Chicago; Swedish-Am. AA; Chicago NJSA. Exhibited: AIC; Mus. N.Mex.; Swedish-Am. AA; the Cordon Gal., Chicago; S.Indp.A.. Illustrator: "Art of Today, Chicago, 1933," by J.Z. Jacobson [47]

LARSEN, Wilhelm R. [S] Minneapolis, MN [19]

LARSH, Theodora (Mrs. Francis Dane Chase) [Min.P,S,L] NYC b. Crawfordsville, IN d. 29 O 1955. Studied: Oberlin Col.; AIC; ASL; Johanson; Luks; Beaux; Vanderpoel; Bridgman; Hawthorne; Mme. La Forge, Paris. Member: Carnegie Hall A.; Crawfordsville AL. Exhibited: PAFA; ASMP; AWCS; CGA; AIC; AFA Traveling Exh.; Pa. SMP; NAWA; Brooklyn SMP; Indianapolis AI; Hollins Col.; Paris; Hoosier Salon, 1920 (prize), 1926 (prize); Crawfordsville AC (prize) [47]

LARSON, Frank E. [I] Woodstock, NY. Member: SI [47]

LARSON, Fred T. [P,B,E] Chicago, IL b. 19 Ap 1868, Chicago, IL. Studied: AIC. Member: Palette and Chisel Acad. FA. Exhibited: Palette and Chisel Acad. of FA, 1930 (prize). Specialty: woodcuts and color block prints [40]

LARSON, George W. [E] St. Paul, MN [15]

LARSSON, Marjorie Flack [P] NYC [25]

LARSSON, Martha Sofia [S] Detroit, MI b. 20 Ag 1887, Sweden. Studied: C. Milles; A. Sch., Stockholm. Exhibited: Detroit, Mich, 1936 (prize). Position: Cranbrook Acad. A. [40]

LARTER, Josenia Elizabeth (Mrs. W.H.D. Cox) [P,I,E,T] Newark, NJ b. 6 Ap 1898, Newark, NJ. Studied: Gruger; Rosen; Henri; Du Mond; Bridgman; Pennell; I.W. Stroud; Van Sloun; C.S. Chapman. Member: AFA. Specialty: figure composition [29]

LARTER, Robert E. [P] Topeka, KS. Work: WPA mural, USPO, Phila.; Southwark, Pa. WPA muralist. [40]

LA SALLE, Charles Louis [I] NYC b. 1894, Greenwood, MA d. 1958, Scottsdale, AZ. Studied: Fenway A. Sch., Boston; H. Dunn, in NYC. Member: SI. Specialty: Western subjects. Successful illustrator of the 1920s–30s, he changed his name from "Lasell" to "La Salle" after 1931 because so many people were mispronouncing his name. Moved to Scottsdale, Ariz., 1954. [47]

LASANSKY, Maurico [P,G] Iowa City, IA b. 12 O 1914, Buenos Aires, Argentina. Studied: Superior Sch. FA, Buenos Aires, 1933. Member: F., Guggenheim Fnd., 1943, 1945. Exhibited: PMA, 1945 (prize), 1946 (prize); SAM, 1944 (prize); NYPL; LOC, 1945 (prize); Denver A. Mus., 1946 (prize). Position: T., State Univ. Iowa, 1945– [47]

LASAR, Charles A.C. [P,T] Paris, France b. 1856, Johnstown, PA d. 1936, Neuilly (Paris). Studied: Beaux-Arts, Paris, with Gérôme. Affectionately known as "Shorty," he was an influential teacher, attracting many women students to his studio in the Montparnasse section of Paris. He also taught at Salisbruy, England, 1900. Among his students were Minerva Chapman, Cecilia Beaux, and Violet Oakley. [10]

LASSELL, Charles. See La Salle.

LASCARI, Hilda Kristina (Mrs. Salvatore) [S] b. Sweden 18 D 1885 (came to U.S., 1916) d. 7 Mr 1937, NYC. Studied: Stockholm, Greece; Southern Europe. Member: ANA. Exhibited: NAD, 1926 (gold), 1936 (gold); NAWPS, 1927 (prize); PAFA, 1934 (prize). Work: PAFA; Amherst Col. A. Gal.

LASCARI, Salvatore [Mur.P,Por.P,L] Lodi, NJ b. 3 My 1884, Sicily. Studied: NAD; Member: NA; Am. Acad., Rome, F.A.A.R.; Arch. L.; ANA 1934; Mural P. Exhibited: NAD, 1927 (prize). Work: Currier Gal., A., Manchester, N.H.; Welch Medical Lib., Balt., Md.; staircase, "Historic Landmarks of NYC." [47]

LASH, Lee [P,Des] New Rochelle, NY. Member: New Rochelle AA [27]

LASKER, Joseph L. [P,I,Car] Brooklyn, NY b. 26 Je 1919, Brooklyn. Studied: CUASch. Exhibited: St. Louis City AM; 48 States Comp., 1939 [40]

LASKOSKI, Pearl [P] Des Moines, IA b. 12 Ja 1886, Hardin County IA. Member: NAWA. Exhibited: Argent Gal., 1941 (one-man); NAWA, 1941–46; MOMA, 1941; Stuart Gal., Boston, 1944; Des Moines Lib., 1941 (one-man); Des Moines FAA, 1941 (one-man), 1943 (one-man); Sioux City, Iowa, 1941 (one-man); Iowa State Univ., 1942; Cornell Col.; Mt. Vernon, Iowa, 1942; State Col., Ames, Iowa, 1942 [47]

LASKY, Bessie (Mrs. Jesse L.) [P,W] Beverly Hills, CA b. 30 Ap 1890, Boston, MA. Studied: F.W. Howell. Member: NAWPS; North Shore AA; New Haven PCC; AFA; Women P. of West. Work: Newark Mus. Author: "And I Shall Make Music," "Songs of the Twilight." [40]

LASSAW, Ibram [S,T] NYC b. 4 My 1913, Alexandria, Egypt (came to U.S. ca. 1921). Studied: BAID; CCNY; D. Denslow; McCartan, Member: A. Abstract A., (fndr.); Clay C., NYC. Exhibited: WMAA, 1936, 1946; Am. Abstract A., 1938–46; Art of the Century, 1944; Mus. Living A., 1942. Work: WMAA, Springfield, Mass. MFA; WNYC, NYC; Newark Mus. Position: T., Contemporary A. Ctr., NYC [47]

LASSONDE, Omer Thomas [P,L] Manchester, NH/Boscawen, NH b. 9 Ag 1903, Concord, NH. Studied: Manchester Inst. A. & Sc.; PAFA; Barnes Fnd.; H. Breckenridge; Europe. Member: Gloucester SA; Springfield AL; Boston S.Indp.A.; Ogunquit A. Ctr.; Palm Beach A. Ctr.; Société des Artistes Français, Paris. Exhibited: Paris Salon, 1934; WFNY 1939; WMA, 1935; AGAA; Babcock Gal., 1931 (one-man); Doll & Richards; Gal., Boston; Grace Horne Gal.; Brooks Mem. A. Gal.; NOAC; Contemporary AC. Work: PAFA; N.H. Historical Soc.; Samoa; Nashville, Tenn. WPA artist. [47]

LASZLO, George [P,E,L] NYC b. 12 Mr 1891, Hungary. Studied: ASL; E. Feiks, Budapest. Member: Am. A. Cong. Work: portraits in many coll., U.S., Europe. Lecturer: WMAA; MOMA; others [47]

LATHAM, Barbara (Mrs. Howard Cook) [P,I,E,W] Taos, NM (1976) b. 6 Je 1896, Walpole, MA. Studied: Norwich, Conn. A. Sch.; ASL, with A. Dasburg, C. Rosen.; PIASch. Exhibited: AIC; WMAA; BM; NAD; Phila. A. All.; LOC, Weyhe Gal. (one-man); Witte Mem. Mus. (one-man); Slater Mem. Mus. (one-man); Dallas Mus. FA (one-man); Phila. Pr.C., 1937. Work: Mus. N.Mex.; Phila. MA; Dallas MFA. Illustrator: "The Silver Dollar," "Hurdy-Gurdy Holiday," other juvenile books [47]

LATHAM, O'Neill [I] NYC. Position: staff, Collier's Weekly [98]

LATHE, Nama Aurelia [C,P,T] Mt. Vernon, IA b. 1 Mr 1881, Lyndon, IL. Studied: Knox Col.; De Pauw Univ.; AIC; Univ. Chicago; Harvard Univ.; T. Col., Columbia. Member: Am. Assn. Univ. Women; Am. Assn. Univ. Prof.; Iowa Artists C.; Coll. AA. Exhibited: WFNY, 1930; Iowa State Fair, 1933, 1940, 1941; All-Iowa Exh., 1938. Position: T., Cornell Col., Iowa, 1922– [47]

LATHROP, Clara W. [P] Northampton, MA. Member: N.Y. Women's AC [01]

LATHROP, Dorothy Pulis [P,I,En] Albany, NY b. Albany, NY. Studied: A.W. Dow; H. McCarter; F.L. Mora; PAFA. Member: NAWPS. Illustrator: "Down-Adown-Derry" by Walter de la Mare; "Tales from the Enchanted Isle," by Ethel May Gate; "Hitty," by Rachel Field; "Stars Tonight," by Sara Teasdale; "The Snow Image," by Nathanial Hawthorne; "Fierce Face," by Dhan Gopal Mukerji; "The Little Mermaid," Hans C. Andersen. Author/Illustrator: "The Fairy Circus," "The Little White Goat," "The Lost Merry-Go-Round," "The Snail Who Ran," "Who Goes There?," "Bouncing Betsey," "Hide and Go Seek" [40]

LATHROP, Elinor (Louise) [P,S] West Hartford, CT/Old Lyme, CT b. 26 S 1899, Hartford, CT. Studied: P. Hale; R.F. Logan; Mora; Calder; A. Jones. Member: Hartford AS [25]

LATHROP, Francis [P,Dec] Woodcliffe Lake, NJ b. 22 Je 1849, Pacific Ocean d. 18 O 1909. Studied: Dresden; Jones, in London. Exhibited: Phila., 1889 (gold) (med); Pan-Am. Expo, Buffalo 1901 (med). Member: SAA, 1877; ANA, 1906; Mural P.; N.Y. Municipal AS; Arch., Lg. 1899; Century Assn.; NIAL [10]

LATHROP, Gertrude K. [S] Albany, NY 24 D 1896, Albany. Studied: S. Borglum; C. Grafly. Member: NSS; NAWA; ANA, 1933. Exhibited: NAD, 1928 (prize), 1931 (prize), 1936 (prize); AIC, 1924; NAWPS, 1930 (prize). Work: Houston Pub. Lib.; Albany Pub. Lib.; N.Y. State T. Col.; War mem., Memorial Grove, Albany, N.Y; Smithsonian Inst.; commemorative half dollar, Albany, 1936; New Rochelle, NY, 1937 [47]

LATHROP, Ida Pulis (Mrs. Cyrus Clark) [P] Albany, NY b. 27 O 1859 d. 7 S 1937. Studied: self-taught. Member: NAWPS. Exhibited: Albany Inst. Hist.& A., 1937; CGA. Work: Prendergast AG, Jamestown, N.Y.; NAD [38]

LATHROP, W(illiam) L(angson) [P] New Hope, PA b. 29 Mr 1859, Warren, IL d. S 1938. Member: ANA, 1902; NA, 1907; NYWCC; Rochester AC. Exhibited: AWCS, 1896; Phila. AC (gold); SAA, 1899 (prize); Pan-Am. Expo, Buffalo 1901 (med); CI, 1903 (prize); Worcester, 1904 (prize); P.-P. Expo, 1915 (gold,med). Work: MMA; Minneapolis Mus.; Nat. Mus. A.; CI; Hackley Gal., Muskegon, MI; William & Mary Col., Richmond, Va. [38]

LATIMER, Glenna Montague [Mur.P,Por.P] Norfolk, VA b. 10 My 1898, Newport News, VA. Studied: PAFA; D. Garber; H. Breckenridge; A.B. Carles; H. McCarter. Member: NAWA; Norfolk A. Corner. Exhibited: CGA, 1939; PAFA, 1923; TMA; VMFA, 1940 (prize); WFNY, 1939.

Work: Norfolk Mus. FA; VMFA; Senate Chamber, Richmond, Va.; murals, Court House, Norfolk, Va; William & Mary Col.; Newport News Women's C.; Court House, Seaboard Citizens Nat. Bank, both in Norfolk. Illustrator: children's books [47]

LATIMER, Lorenzo Palmer [P,T] San Francisco, CA b. 1857, Gold Hill, CA d. 1941 (Berkeley, CA?). Studied: San Fran. Sch. Des. Specialty: watercolor. Positions: T., Nev., 1921; Mark Hopkins AI; Univ. Calif., Berkeley [17]

LATTARD, N.A.L. [S] NYC [15]

LATZKE, Caroline [P] Brooklyn, NY [10]

LAUB, Albert F. [Edu,P] Buffalo, NY b. 28 My 1870, Buffalo d. 7 Mr 1921. Position: Dir., Buffalo FAS

LAUBER, Joseph [Mur.P,E,D,Dr,L,T] NYC b. 31 Ag 1855, Meschede, Germany (came to U.S. in 1864). Studied: C. Muller; W. Shirlaw; W. Chase; J. La Farge. Member: NSMP; SC; A. Fellowship; Mural P.; Arch. Lg., 1889. Exhibited: SC, annually (prizes); Columbian Expo, Chicago, 1893; Atlanta, 1895 (gold); Midwinter Fair, Calif. (med); A. Fellowship (prizes). Work: Old Centre Church, New Haven, Conn.; Church of the Ascension, NYC; Appellate Court, NYC; Trinity Church, Lancaster, Pa.; Euclid Ave. Baptist Church, Cleveland; House of Representatives, Wash., D.C. Position: T., Columbia Univ. [47]

LAUDERDALE, Ursula (Mrs. Edward) [P,L,T] Dallas, TX b. ca. 1880, Moberly, MO. Studied: ASL, with Henri, W. DeVol, M. Braun, M. Jacobs; Reaugh. Member: Dallas AA; Fort Worth AA; Dallas Women's Forum; SSAL; AFA. Work: stained glass, City Temple, Dallas. Position: T., Trinity Univ., Waxahachie [33]

LAUER, Sister Jane Catherine [P,E,T] Toledo, OH. b. G.M. Baker; F. Allen; D. Rosenthal; S.B. Tannahill; C. Martin; J.E. Dean. Member: Ohio WCS; S. Toledo Women A. Exhibited: Toledo Fed. A. Soc., 1931, 1934, 1935. Position: T., Mary Manse Col.; Ursuline Convent, Toledo [40]

LAUF, Leonard F. [P] Columbus, OH. Member: Columbus PPC [25]

LAUFER, Berthold [Mus.Cur] b. 1874, Cologne, Germany (came to U.S. in 1898) d. Fall 1934. Member: Oriental Art societies. Author: books on the symbolism of jade and early pottery figures. He was a scholar of Chinese art, Asiatic history and ethnology. Due to his efforts the Field Mus. possesses a jade collection that is regarded as the most important such collection outside China. Positions: Cur., Field Mus., since 1915; Hon. Cur., Chinese Antiquities, AIC

LAUFMAN, Sidney [P,T,Dr] Woodstock, NY b. 29 O 1891, Cleveland, OH. Studied: AIC; ASL. Member: NA; ANA, 1939. Exhibited: AIC, 1932 (prize), 1941 (med); CI, 1934 (prize); NAD, 1937 (med); Pepsi-Cola, 1946. Work: MMA; WMAA; MOMA; AIC; CMA; Toledo Mus. A.; W. Rockhill Nelson Gal., Kansas City, Mo.; John Herron AI; Minneapolis AI; Univ. Oreg. (one-man). T., ASL [47]

LAUGHLIN, Alice D(enniston) [Mur.P,C,En,Des] NYC b. 19 O 1895, Pittsburgh, PA d. 30 Jy 1952. Studied: ASL; Basile Shoukaeff, in Paris. Member: Mural A. Gld.; Stained Glass Assn. Am.; N.Y. S. Craftsmen. Exhibited: Weyhe Gal., 1928 (one-man); Rochester Mem. A. Gal., 1929, 1935 (one-man); Palette Française, Paris, 1929; Marie Sterner Gal., 1932, 1936; Gillespie Gal., Pittsburgh, Pa., 1936; Park Ave. Gal., 1940 (prize); Grace Horne Gal.; Dallas Mus. FA, 1940; VMFA, 1940; St. Paul Gal. A., 1941; Denver A. Mus., 1941; Joslyn Mem., 1941; Vose Gal., 1944. Work: French Gov.; NYPL; Rochester Mem. A. Gal.; Masters Sch., Dobbs Ferry; Chapel, Brighton, Mass.; windows, Whale Key Chapel, Bahama Islands; PMG. Illustrator: engravings, "Lincoln," by Emile Ludwig, 1930, "We'll to the Woods No More," by Edouard Dujardin [47]

LAUGHLIN, Clarence John [Photogr] b. 1905, Lake Charles, LA. Exhibited: Delgado Mus. A., 1936; Julian Levy Gal., NYC, 1940; PMA, 1946, 1973; PMG, 1949; Milwaukee Mus., 1965. Work: Univ. Louisville holds 17,000 negatives and 17,000 prints; LOC; FMA; MMA; MOMA; NOMA; PMA; PMG. Illustrator: "New Orleans and Its Living Past," 1941, "Ghosts Along the Mississippi," 1948, J. Williams monograph, 1973. A prolific romantic-mystic photographer; also a poet. [*]

LAUGHLIN, T.I. [P] NYC. Exhibited: 48 State Comp., 1939. Work: USPO mural, De Funiak Springs, Fla. WPA artist. [40]

LAUGHNER, L.M. [P] Ligonier, PA. Member: Pittsbugh AA [21]

LAUNE, Paul Sidney [P,I] Rhinebeck, NY b. 5 My 1899, Milford, NE. Studied: Chicago AFA. Exhibited: Midwestern Exh., 1924 (med); Kansas City AI [47]

LAURENCE, Jacob Armstead [P] Brooklyn, NY b. 7 S 1917, Atlantic City, NJ. Studied: Am. A. Sch., with R. Refregier. Member: A. Lg. Am; Guggenheim, F., 1946; Rosenwald F., 1940–42. Exhibited: AV, 1942 (prize). Work: PMG; MMA; WMA; MOMA; Univ. Ariz.; Portland, Oreg. Mus. A. [47]

LAURENCE, Sidney. See Lawrence.

LAURENCE, Sturgis [P] Cincinnati, OH. Member: Assoc., SWA [04]

LAURENT, Robert [S,T] Brooklyn, NY b. 29 Je 1890 Concarneau, France d. 1970. Studied: British Acad., Rome, Italy; Paris, with H.E. Field, Frank Burty; M. Sterne. Member: Audubon A; NSS; Salons of Am.; S. Gld.; Am. S. PS&G; Modern Ar. Am.; Brooklyn S. Mod. A.; H.E. Field Art Fnd. Exhibited: WMAA; BM, 1942 (prize); PAFA; AIC, 1924 (med), 1938 (prize); MMA; WFNY, 1939; Daniel Gal. (one-man); Bourgeois Gal. (one-man); Valentine Gal. (one-man); A.&Cr. C., New Orleans (one-man); Vassar Col. (one-man); CGA (one-man); John Herron AI (one-man), 1943 (prize), 1944 (prize), 1945 (prize); Ind. Univ.; Hoosier Salon, 1945 (prize), 1946 (prize); Audubon A., 1945 (prize). Work: WMAA; BM; AIC; Newark Mus.; Vassar; Barnes Fnd.; Brookgreen Gardens; H.E. Field Fnd.; Fairmount Park, Phila., Pa.; Radio City Music Hall; Fed. Trade Bldg., Wash., D.C.; MMA; IBM Coll.; Norton Gal. A.; MOMA; Ind. Univ. mural, USPO, Garfield N.J. Positions: T., Ind. Univ., 1942–46, ASL; Dir., Ogunquit Sch. P.&S., Maine [47]

LAURIE, Lee [S] New Haven, CT. Member: NSS 1908 [15]

LAURIE-WALLACE, John [P,T] Omaha, NE b. 29 Jy 1863, Garvagh, Ireland. Studied: PAFA; T. Eakins. Member: Omaha AG; Chicago SA. Work: Joslyn. Mem.; Lincoln A. Gal. [47]

LAURITZ, Paul [P,Ldscp.P,E] Los Angeles, CA (1976) b. 18 Ap 1889, Larvik, Norway d. 1975. Studied: self-taught. Member: SC; Calif. AC; Calif. A.&S. C.; Los Angeles PS; Western Acad.. Exhibited: CI; AIC; BM; PAFA; CGA; SFMA; Calif. State Expo, 1920 (prize), 1922 (prize), 1923 (prize), 1924 (prize), 1926 (prize), 1934 (prize), 1939 (prize), 1940 (prize); San Diego FA Soc., 1928 (prize); Long Beach, Calif. 1928 (prize); Pasadena AI, 1928 (prize); Santa Cruz, 1929 (prize); Pomona State Expo, 1930 (prize); Palos Verdes, 1931 (prize); Springville, Utah, 1932 (prize), 1933 (prize); Clearwater, Calif., 1935 (prize); Los Angeles Ebell C., 1936 (prize), 1943 (prize); Acad. Western P., 1936 (prize); Los Angeles Mus. A., 1940 (prize), 1943 (prize); Calif. AC, 1940 (prize), 1946 (prize); Santa Paula, 1942 (prize); Pal. Leg. Honor, 1942 (prize), 1945 (prize); Oakland A. Gal., 1943 (med), 1944(med); GGE, 1939 (prize). Work: Joslyn MA; San Diego AG; Vanderpoel Coll.; Univ. Chicago [47]

LAUSSUCQ, Henri (Henry L.) [P,T,Des,I,L] Pittsburgh, PA b. 24 D 1882, Bordeaux, France. Studied: Univ. Paris; Ecole des Beaux-Arts, Paris; Grand Central A. Sch. Member: SC; AWCS; Brooklyn SA; Pittsburgh WCS; NYWCC. Exhibited: AWCS, annually; Argent Gal., NYC, 1937 (one-man); SC, 1938 (one-man); Am. WCS, NYWCC, 1939 (prize). Position: T., Pittsburgh AI [47]

LAUTENSLAGER, Lena [P] Wash., D.C. [13]

LAUTER, Flora [P,Li,C] Indianapolis, IN b. NYC. Studied: N.Y. Sch. A.; Herron A. Sch.; Henri; Sloan. Member: Ind. AC; Ind. A. All.; Women's Intl. AC, London; Salons of Am.; Buffalo S.Indp.A.; S.Indp.A.; Indp. A. of Chicago; Hoosier Salon; Indianapolis AG; Alliance; Gloucester SA; AAPL. Exhibited: AIC; Hoosier Salon, 1926, 1940; Herron AI; Ind. A., 1943; Ind. AC, 1938 (prize). Work: Christamore Settlement House, Indianapolis [47]

LAUTERER, Arch [Des,T] Oakland, CA b. 4 Ag 1904, Chagrin Falls, OH d. ca. 1958. Member: Nat. Theatre Conference. Exhibited: Arch. Lg., 1933; Intl. Theatre Exh., 1934; Intl. Dance Exh., 1939; BM, 1939; MOMA, 1944, 1946. Contributor: theatre and art magazines. Specialty: theatrical design. Positions: T., Sarah Lawrence Col., Bronxville, N.Y., 1943–44, Mills Col., Oakland, Calif., 1946– [47]

LAUTZ, William [S] Buffalo, NY b. 20 Ap 1838, Unstadt, Germany (came to U.S. in 1854) d. 24 Je 1915. New York. Work: Buffalo Hist. S. Bldg. Also a Shakespearean actor.

LAUX, August [P,Ldscp.P] Brooklyn, NY b. 1853, Bavaria (came to U.S. in 1863) d. 21 Jy 1921. Studied: NAD. Specialties: still-life, landscapes, fresco [01]

LAVALLE, John [P,I] NYC b. 24 Je 1896, Nahant, MA. Studied: Harvard; BMFA Sch.; Académie Julian, Paris; P. Hale; J.F. Auburtin, in Paris; L. Thompson. Member: Gld. Boston A.; Boston S. WC Painters; Copley S.; Rockport A.; North Shore AA; Grand Central A. Gal.; NAD; St. Botolph C. Exhibited: CGA; NAD; PAFA; AIC; CI; Albright A. Gal.; Milwaukee AI; CM, 1940; BMFA; Newport AA; Baltimore SCC; Boston Soc. WC Painters, 1927-42; Rockport AA, 1927–42. Work: BM; BMFA

U.S. Army Air Forces Coll.; British Air Ministry; Harvard; St. Paul's Sch., Concord N.H.; Columbia Univ. C.; Harvard C.; Mass. State Coll. Illustrator: "Mediterranean Sweep," 1944, "Bay Window Ballads," by David McCord, 1935 [47]

LA VALLEY, J(onas) J(oseph) [P] Springfield, MA b. Ag 1858, Rouses Point, NY d. 9 Ag 1930. Member: Springfield AL; CAFA. Work: City of Springfield; Springfield AM; Mass. Agricultural Col. [29]

LAVARON, Leonide C. [P,C,W] Chicago, IL b. 1866, NYC d. 5 Ag 1931. Exhibited: throughout the U.S. Specialties: metallurgy, monotypes, jewelry. She recovered a "lost Egyptian art," the producing of an irridescent surface on copper, which she perfected after many years of study. She fashioned metal to give it the colorings of its imbedded jewels. [27]

LAVENDER, Eugenie E. Aubanel (Mrs. Charles) [P] b. 1817, France (came to Waco, TX in 1851) d. 1898, Corpus Christi, TX. Studied: Paris, with Delaroche, Scheffer. Work: cathedral, Corpus Christi. Specialty: religious subjects [*]

LAVERTY, Elizabeth Stevens (Mrs. Maris A.) [P] Merion, PA b. Scranton, PA. Studied: PMSchIA; St. Botolph A. Sch.; F.E. Copeland. Member: Phila. WCC; Phila. A. All. Exhibited: AWCS, 1934; Wash. WCC, 1934; Phila. WCC, 1933; Phila. A. All., 1934–36, 1938, 1943; Haverford Col.; Bryn Mawr A. Center [47]

LAW, H.V. [P] Oakland, CA [17]

LAW, Margaret Moffett [P,E,Li,L,T] Spartanburg, SC b. Spartanburg d. ca. 1958. Studied: Converse Col.; ASL; PAFA; Henri; Chase; Martin; Mora; Hawthorne; Lhote. Member: Baltimore WCC; AAPL; Am. Color Pr. S.; SSAL; FA Lg. of the Carolinas; Carolina AL. Exhibited: Southern Pr.M., 1937; Okla. A. Center, 1939, 1941; Baltimore WCC, 1940; Mint Mus., 1940, 1943, 1945; Buffalo Pr. Cl., 1940; Boston AC, 1941; SAM, 1942, 1943; Oakland A. Gal., 1942, 1943; PAFA, 1942; Am. Color A. Gal., 1942, 1946; Austin FAA, 1942; CAFA, 1942, 1944; Phila. A. All., 1942; Phila. Pr. C., 1944; Laguna Beach AA, 1944; Albany Inst. Hist.&A., 1946. Work: PMG; BMA; Phila. Pr. C.; Mint Mus.; High Mus.; Converse Col.; S.C. Sch. for Blind & Deaf, Cedar Spring; Kennedy Lib.; AC, Spartanburg, S.C.; Clifton H.S., Baltimore; prints, Coll., Baltimore Friends Art. Position: T., City H.S., Spartanburg [47]

LAW, Pauline (Elizabeth) [P] NYC b. 22 F 1908, Wilmington, DE. Studied: ASL; Grand Central A. Sch.; Carlson; Snell; Hibbard. Member: NAWA; PBC; AAPL; Studio Gld.; Rockport AA. Exhibited: All.A.Am., 1937, 1941; NAWA, 1940–43, 1945, 1946; Rockport AA, 1941, 1943, 1945; Lowell AA, 1945; CAFA; Rochester Mem. A. Gal.; Binghamton Mus. A.; PBC, 1946 (prize); Argent Gal.; A. of Carnegie Hall; Women's Engineering C. [47]

LAWFORD, Charles [P] Member: Attic C. Minneapolis; Minneapolis AL. Exhibited: Minneapolis Inst., 1915 (prize); St. Paul Inst., 1917 (med); Minn. State Art Comm., 1917 (gold) [29]

LAWGOW, Rose [P,I,C] Seattle, WA b. 20 Ja 1901, Portland, OR. Member: Seattle FAS [31]

LAWLER, C. Genevieve [C] Sappington, MO b. New Orleans. Studied: E. Woodward; A. Rose; F. Meyers; W. Varnum; T. Millovitch; P. Valenti, Italy. Member: St. Louis AG; A. Ceramic S. Specialties: metal work, pottery, textiles. Position: Dir., Workbench, St. Louis [40]

LAWLESS, Carl [P] Mystic, CT b. 20 F 1894, IL. Studied: PAFA; Chicago Acad. FA; New Haven PCC; Mystic AA. Exhibited: PAFA, 1922 (prize); NAD, 1923 (prize), 1927 (prize); CAFA, 1925, 1931 (prize); Grand Central Gal., 1929; New Haven PCC, 1930 (prize). Work: PAFA; Carlisle, Pa. Mus.; New Haven Pub. Lib.; Conn. State Col., Storrs [40]

LAWLOR, George W(arren) [P] Brooklyn, NY b. 21 O 1878, Chelsea, MA. Studied: Académie Julian, Colarossi Acad., Ecole des Beaux-Arts, all in Paris. Member: Boston AC [29]

LAWMAN, Jasper Holman [Ldscp.P,Por.P] Pittsburgh, PA b. 1825, Cleveland (or Xenia), OH d. 1 Ap 1906. Studied: Couture, in Paris, 1859–60. Exhibited: London; NYC. Well-known portrait painter of prominent families in Western Pa., 1850s–1893

LAWNIN, Dorothy Ferguson (Mrs.) [P,E] St. Louis, MO b. 9 D 1896, Alton, IL. Studied: C. Hawthorne. Exhibited: St. Louis AG, 1928 (prize) [40]

LAWRENCE, Charles Arthur [I,T] Lynn, MA b. 12 F 1865, Ashburnham, MA. Studied: Mass. Normal A. Sch.; Eric Pape Sch., Boston [15]

LAWRENCE, Edna W. [P,T] Providence, RI/Richmond, NY b. 27 N 1898, Concord, NY. Studied: RISD; A. Hibbard. Member: Providence AC; Providence WCC; South County AA; R.I. Inst. of A.&Sc. Position: T., RISD [40]

LAWRENCE, Harry Zachary [P] Dallas, TX. b. 1 Ja 1905, Chicago, IL. Studied: F. Klepper; A. Cross; Lhote; O. Friez. Member: Dallas AL; Dallas Print and Draw. Coll. S.; Dallas MFA. Exhibited: Dallas All. A., Dallas MFA [40]

LAWRENCE, Helen Christopher (Mrs. Frank R.) [P,Des,T] Darien, CT b. Red Oak, IA. Studied: ASL; Grand Central Sch. A.; Mafori-Savini Acad., Florence; M. Weber. Member: NAWPS; AWCS; Silvermine Gld. A.; Darien Gld. Seven Arts; Honolulu SA; Westport A. [40]

LAWRENCE, H(elen) H(umphreys) (Mrs.) [Por.P,S] NYC b. 14 O 1878, Dayton, OH d. ca. 1950. Studied: Univ. Minn.; Minneapolis Sch. FA; Grand Central A. Sch.; J. Lie; A. Woefle; M. Mason; H. Rittenberg; D. Volk; E. Greacen; G. Lober; J. Freeman. Member: NAC; PBC; AAPL; NAWPS; AFA. Exhibited: NAC, 1933–46; PBC, 1935–46; AAPL, 1944–46; Evanston, Ill., 1940 (one-man); Minneapolis, Minn., 1940 (one-man). Work: Univ. Miss.; Faribault Mem. House, Minn.; PBC; Univ. Oreg.; D.A.R. Mem., Mendota, Minn. [47]

LAWRENCE, Jacob [P] b. 1917, Atlantic City, NJ. Studied: Col. AA, NYC, with C. Alston, H. Bannarn, 1932–37; WPA classes, Harlem; Am.A.Sch., NYC, with Refregier, 1937–39. Important negro painter of the Black experience in America, known for his Harlem, War and Civil Rights themes. WPA artist, 1938–41. [*]

LAWRENCE, Jean Mitchell (Mrs.) [P] Minneapolis, MN [17]

LAWRENCE, Josephine [Por.P,Min.P] Birmingham, AL b. 29 S 1905, Sumter, SC. Studied: W. Adams; Grand Central Sch. of A.; N.Y. Sch. F.&App.A.; A.L. Bairnsfather. Member: SSAL; Alabama AL [40]

LAWRENCE, Kathleen [P] Ft. Worth, TX. Exhibited: SSAL, San Antonio, 1939; GGE, 1939 [40]

LAWRENCE, Marion [Edu,Hist,L,W] NYC b. 25 Ag 1901, Longport, NJ. Studied: Bryn Mawr Col.; Radcliffe; Am. Acad. Rome; Inst. for Advanced Study, Princeton. Member: CAA; Archaeological Inst. Am.; Mediaeval Acad. Am.; Carnegie F., 1926–27; F., Inst. for Advacnced Study, 1941–42. Author: "The Sarcophagi of Ravenna," 1945. Position: T., Barnard Col., 1929– . [47]

LAWRENCE, Mary. See Tonnetti, Mrs.

LAWRENCE, Mary Stickney [S] NYC [17]

LAWRENCE, Ruth (Mrs. James C.) [T,W,L,S,C] Minneapolis, MN b. 9 Je 1890, Clarksfield, OH. Studied: Ohio State Univ.; Akron Univ.; Univ. Minn.; Italy. Member: CAA; Western AA; Am. Mus. Dir. Assn.; S. Gld.; Am. S. Aesthetics. Work: Univ. Minn.; Walker A. Ctr. Position: T., Univ. Minn., 1934–40

LAWRENCE, Sydney M. [P,I] Anchorage, AK b. 14 O 1865, Brooklyn, NY d. 1940 (Anchorage, AK?) Member: SC. Exhibited: Salon des A. Français, 1894 (prize). Painted Indians and Alaska landscapes. Lived in Cornwall, England, 1901 [29]

LAWRENCE, T. Cromwell [I] Brooklyn, NY b. Leicester, England (came to NYC in 1900) d. 11 D 1905. Studied and worked in Europe till 1900

LAWRENCE, William Hurd [I,P] Richmond, NY b. 2 Mr 1866, Keene, NH d. 3 Mr 1938. Studied: F.P. Vinton; W.L. Taylor; H. Adams. Member: AAPL. Illustrator: leading magazines, 1897–1918 [38]

LAWRENCE-WETHERILL, Maria [P,E] NYC/Palm Beach, FL b. 11 D 1892, Phila., PA. Studied: C. Peters; Paris, with Guillomet, Bashet, Pagess. Member: NAWPS; NAC; Phila. Print C.; PBC; AAPL [33]

LAWRIE, Alexander [P] b. 25 F 1828, NYC d. 15 F 1917, Lafayette, IN. Studied: NAD; Düsseldorf, with E. Leutze; Picot, Paris; Florence. Member: ANA, 1868. Worked in Phila. before serving in the Civil War. Went to Europe again in 1865, but from 1866–76 had his studio in NYC. In 1896 he was living in Chalmers, Ind. but from 1902–17 he lived at the Soldiers' Home in Lafayette. From 1905–17 he painted the portraits of Civil War generals which were to hang in the Ind. State House and West Point.

LAWRIE, Anne [C,Des] NYC b. 16 D 1904, Rutherford, NJ. Studied: NY Sch. App. Des.; Yale; N.Y. State Coll. Ceramics, Alfred Univ. Member: New Haven PCC; NAC. Exhibited: WFNY, 1939 [40]

LAWRIE, Archer [S] NYC b. 2 N 1902, Rutherford, NJ. Studied: Yale; PAFA. Member: L. Lawrie; A. Laessle. Member: NAC. Exhibited: PS Ann., PAFA, 1939; Montclair MA, N.J.; Arch. Lg. [40]

LAWRIE, Lee [S] Easton, MD b. 16 O 1877, Rixford, Germany (came to U.S. as an infant) d. Ja 1963. Member: NSS; NAD; NIAL; Century C.;

ANA 1928, NA 1932; AIA; Nat. Comm. FA, 1933–37. Exhibited: Arch. L., 1931 (med); AIC, 1921 (gold), 1927 (gold). Work: Church of St. Vincent Ferrer, NYC; reredos, St. Thomas Church, NYC; Harkness Mem. Tower, Yale; Nat. Acad. Sc., Wash., D.C.; Neb. State Capitol; MMA; Los Angeles Pub. Lib.; Bok Carillon Tower, Fla.; Goodhue Mem., NYC; Cornell; City Hall, St. Paul, Minn.; RCA Bldg., NYC; Peace mem., Gettysburg, Pa.; "Atlas," Rockefeller Ctr., NYC; La. State Capitol; Edu. Bldg., bridge, Harrisburg, Pa. Specialty: best known for his Art Deco architectural sculpture. Position: T., Harvard, 1910–12; Yale, 1908–18; consultant on S., Century of Progress Expo, 1933; consultant to Bd. of Des., WFNY, 1939 [47]

LAWRIE, Mary B. [Min.P] NYC [17]

LAWSER, Mary Louise [S] Phila., PA. Member: "The Phila. Ten," 1938. Exhibited: PS Ann., PAFA, 1935, 1939; "The Ten," 1938. [40]

LAWSON, Adelaide J. [P] Long Island, NY b. 9 Je 1889, NYC. Studied: ASL; K.H. Miller. Member: S.Indp.A.; Salons of Am.; NYSWA [40]

LAWSON, Ernest [P,T] NYC b. 22 Mr 1873, San Fran., CA d. 18 D 1939, Miami Beach (suicide by drowning). Studied: Santa Clara A. Acad., Mexico, 1889, ASL; Cos Cob, Conn., with Twachtman, J.A. Weir, 1891; Académie Julian, Paris, with Laurens, Constant, 1893. Member: ANA, 1908, NA, 1917 (although it was his rejection in 1905 and that of his friends Luks, Glackens, and Shinn in 1906 that led to the first exh. of "the Eight" at Macbeth Gal., 1908); NIAL; NAD; Am. S. PS&G; Century Assn. Exhibited: Armory Show, 1913; St. Louis Expo, 1904 (med); PAFA, 1907 (med), 1920 (gold); AAS, 1907 (gold); NAD, 1908 (prize), 1916 (prize), 1917 (prize), 1921 (prize), 1928 (prize), 1930 (med), 1934 (prize); NAC 1933 (prize), 1934 (prize); SC, 1936 (prize); Pan-P. Exh., San Fran., 1915 (gold); Pittsburgh Intl. Expo, 1921 (prize). Work: NGA; Montclair AM; MMA; WMAA; BM; CAM, St. Louis; CGA; Los Angeles Mus.; WMMA; AIC; SFMA; CI; Butler I.; Youngstown, Ohio. He was in France, 1893–95, again in 1903–04; studio in Wash. Heights, NYC, 1898; in NYC, 1906; Spain, 1916; NYC, 1920. He worked in a bold bright heavy impasto in a style unique among the Impressionists. Positions: T., Kansas City AI, 1926, Broadmoor Acad., Colorado Springs, 1927–28 [38]

LAWSON, H. Raymond [P] Cincinnati, OH. Member: Cincinnati AC [24]

LAWSON, Jess M. See Lawson-Peacey.

LAWSON, John Donald (Mrs.) [S] Saugatuck, CT. Member: NAWPS [27]

LAWSON, Katharine S(tewart) (Mrs.) [S] Saugatuck, CT/Westport, CT b. 9 My 1885, Indianapolis, IN. Studied: L. Taft; H.A. MacNeil. Member: NAWPS; Ind. SS. Exhibited: NAD, 1921 (prize) [33]

LAWSON, Leonore Condé [P,E,L] Hammond, IN b. 27 My 1899, Batavia, IL. Studied: M.M. Wetmore; C.E. Bradbury; F.F. Fursman; E. Rupprecht; C.W. Dahlgreen; L.R. Ritman. Member: Hoosier Salon; South Side AA, Chicago; Ind. S. PM; Hammond AA. Exhibited: WFNY, 1939; Hammond A. Exh., 1939 (prize) [40]

LAWSON, Louise [S] Cincinnati, OH d. 4 Ap 1900

LAWSON, Margaret [S] NYC [17]

LAWSON, Robert [I,E,W] Westport, CT b. 4 O 1892, NYC d. 26 My 1957. Studied: N.Y. Sch. F.&Appl. A., with H. Giles, R.S. Bredin, 1911–13. Member: SAE. Exhibited: SAE, 1931 (prize); Am. Lib. Assn., 1941 (med), 1945 (med). Author/Illustrator: "Ben and Me," 1939, "Rabbit Hill," 1944, "Mr. Wilmer," 1945, other children's books. Illustrator: "Ferdinand," by Munro Leaf [47]

LAWSON-PEACEY, Jess M. [S] NYC b. 18 F 1885, Edinburgh, Scotland. Member: Brit. Inst.; Assn. Royal Col. A., London; Alliance; NSS; NAWPS. Exhibited: NAD, 1918 (prize); PAFA, 1919 (gold) [33]

LAWTON, Alice [C,W,L] Boston, MA b. Boston. Studied: Boston Univ.; Sorbonne, Ecole des Beaux-Arts, Ecole du Louvre, all in Paris; Univ. Lausanne, Switzerland; Paul Revere Pottery Sch.; Child-Walker Sch. FA. Member: Boston SAC; Authors Lg. Am.; Boston Authors C.; PBC; AFA. Exhibited: Grace Horne Gal.; Children's A. Center; Women's City C., Boston. Author: "Goose Towne Tales." Contributor: articles, articles. Position: Art. Ed., Boston Post, 1928– [47]

LAWTON, Almira C. [P] NYC [01]

LAWTON, Harry C. (Mrs.) [S] St. Paul, MN [17]

LAWYER, Jean [Cer] Los Angeles, CA b. 11 My 1909, Spokane, WA. Studied: A. Katchamakoff; A. Archipenko; M. Hamilton. [40]

LAX, David [P,S] NYC b. 16 My 1910, NYC. Studied: Fieldston Sch., NYC; Ethical Culture Sch.; V. Frisch; A. Archipenko. Member: Grand Central Gal.; Tallahasse AA. Exhibited: War Dept., Wash., D.C.; Galerie Borghese, Paris, 1945; Grand Central Gal., 1940, 1944 (one-man); Mus. Sc.&Indst., Radio City, NYC, 1945 (one-man); Union Col., 1945 (one-man); Filene's, Boston, 1945 (one-man); Westfield Atheneum, 1945 (one-man); Providence Sch. Des., 1945 (one-man); High Mus. A., 1945 (one-man); Clearwater A. Mus., 1945 (one-man); Zanesville AI, 1945 (one-man); Springfield A. Mus., 1945 (one-man); Mus. N.Mex., 1946; de Young Mem. Mus., 1946; Crocker A. Gal., 1946; Portland A. Mus., 1946; SAM, 1946; CI, 1940; Grand Central Gal., 1939–46; Arden Gal., 1941; CGA, 1943; Phila. A. All., 1939; Joslyn Mem., 1941. Work: War Dept., Wash., D.C.; Clearwater A. Mus.; Grand Central Gal.; Phila. A. All.; Paris, France; s. frieze, Brill Bldg., NYC. Illustrator: "A Series of Paintings of the Transportation Corps, U.S. Army, in the Battle of Europe," 1945. Contributor: Yank magazine, newspapers, art periodicals [47]

LAY, Charles Downing [P,W,E,Arch] Stratford, CT b. 3 S 1877, Newburgh, NY d. 15 F 1956. Studied: Columbia; ASL; Harvard. Member: ANA; F., Am. S. Landscape Arch.; AIC; NAC. Work: MMA; BM; PMG; WMAA. Author: "Freedom of the City," 1926, "Garden Book for Autumn and Winter" [47]

LAYBOURN-JENSEN, (Lars Peter) [P,S] Roselle Park, NJ b. 3 Jy 1883, Copenhagen, Denmark. Studied: Danish Acad. Member: S.Indp.A. [25]

LAYMAN, Elizabeth [P] Cincinnati, OH. Member: Cincinnati Women's AC [25]

LAYMAN, Walter [P,I,T] Cincinnati, OH b. 22 My 1871, Covington, KY. Studied: Cincinnati Art Acad.; ASL; Paris. Member: Cincinnati AC; Paris AAA [15]

LAYING, George W. [P] Pittsburgh, PA. Member: Pittsburgh AA [25]

LAZAER, Lewis [P] Cincinnati, OH. Exhibited: Am. Ar. Ann., 1934; Cincinnati A. Ann., 1939; Cincinnati Mus. [40]

LAZARD, Alice A. [P] Highland Park, IL b. 1 N 1893, New Orleans. Studied: Newcomb Col.; Tulane Univ.; AIC; F. Chapin; R. Davey; A. Archipenko. Member: North Shore AA; Evanston A. Mart. Exhibited: PAFA, 1925–29; AIC, 1920, 1922, 1925, 1936, 1939; Am. Lib. Color Slides, 1942; Springfield A. Mus., 1928; Evanston, Ill., 1944, 1945. Work: Vanderpoel Coll. [47]

LAZAREWICZ-LAZARR, Stefan, Mrs. See Edmundson, Carolyn.

LAZARUS, Isabelle. See Miller.

LAZARUS, Joseph Lippman (Jay Ell) [Car] NYC b. 23 O 1908, NYC. Studied: N.Y. Sch. F.&Appl. A.; ASL. Cartoonist: Saturday Evening Post, Colliers, Liberty, American Magazine, Passing Show (London) [47]

LAZARUS, M(innie) Rachel [P,C,T] Miami, FL b. 4 D 1872, Baltimore, MD d. 27 O 1932. Studied: Dewing Woodward; Académie Julian; Louis DesChamps. Member: Blue Dome Fellowship; Baltimore WCC; Handicraft C., Baltimore. Exhibited: Fla. Fed. A., 1928 (prize). Illustrator: Univ. Miami [31]

LAZZARI, Pietro [P,L,I,Et,S] Wash., D.C. b. 15 My 1898, Rome, Italy. Studied: Ornamental Sch. Rome. Member: NSMP; AG Wash.; Mural AG; United Scenic Ar. Am. Exhibited: MMA, 1942; WMAA, 1943; AIC, 1943; NAD, 1944, 1945; Contemporary A. Gal., 1938; Whyte Gal., 1943; Crosby Gal., 1945; Paris, France, 1945; Montclair, N.H. AM.; Ornamental Sch., Rome (prize). Work: PMG; murals, Jasper, Fla.; Brevard, N.C.; murals, USPO, Sanford, N.C. Specialty: developed "Fresco Mosaic." WPA muralist. [47]

LAZZARINI, Aldo [P,I,Car] Flushing, NY/Port Washington, NY b. 1 Ja 1898, Bergamo, Italy. Studied: Acad. Carrara; Scuola Libera, Rome. Member: Arch. Lg.; Nat. S. Mur. P. Exhibited: NA; Arch. Lg.; Carrara, 1920 (gold). Work: murals, USPO, Orville, Ohio; Guggenhiem Dental Clinic, NYC; Univ. Chicago. WPA muralist. [40]

LAZZELL, Blanche [P,B] Morgantown, WV b. 10 O 1878, Maidsville, WV d. 1 Je 1956. Studied: W.Va. Univ.; ASL; Paris, with C. Guerin, Leger, Lhote, Gleizes; Chase; Schumacher. Member: NYSWA; Am. Color Pr. S.; Provincetown AA; N.E. S. Contemp. A.; Wolfe AC; NAWPS; Provincetown Printers; Societé Anonyme. Exhibited: NYWWA, 1925–46; Provincetown AA, 1916–46; WFNY, 1939; Am. Color Pr. S., 1946; San Fran. AA, 1946; LOC, 1946; Phila. Pr. C., 1946. Work: Detroit Inst. A.; RISD; PMA; Pub. Lib., Charlestown, W.Va.; W.Va. Univ. Lib.; mural, Court House, Morgantown, W.Va.; Skidmore Col.; State Normal Sch., Potsdam, N.Y. [47]

LEA, Anna W. See Merritt.

LEA, Bertha. See Low, Mrs.

LEA, Frances Trumbull [P] Paris France. Sister of Anna. [13]

LEA, Tom [P,I,W,Mur.P] El Paso, TX b. 11 Jy 1907, El Paso. Studied: AIC, 1924–26; J. Norton, in Chicago, 1926–33; murals, in Italy, 1930. Exhibited: All-Tex. Ann., MFA, Houston, 1940 (prize); 48 Sts. Comp. Work: murals, South Park Comm. Bldg. (Chicago), Court House (El Paso); Branigan Mem. Lib., Las Cruces, N.Mex.; Lib., N.Mex. Col. A.&M.; State of Tex. Bldg., Dallas, 1936; USPOs, Pleasant Hill (Mo.), Odessa (Tex.), Seymour (Tex.); P.O. Dept. Bldg., Wash., D.C.; First Baptist Church, El Paso. Work: Dallas MFA; El Paso MA; Mus. N.Mex. Author/Illustrator: "A Grizzly from the Coral Sea," 1944, "Peleliu Landing," 1945. Illustrator: Saturday Evening Post, 1939, "Apache Gold and Yaqui Silver," by J. Frank Dobie, pub. Little, Brown, 1939. WWII artist-correspondent for Life. WPA artist. [47]

LEACH, Alice Frye (Mrs. James Edward) [P] Brookline, MA b. 1857, Boston d. 1 Ap 1943. Studied: BMFA Sch. A member and one of the founders of the Copley Society, Boston.

LEACH, Bernard (Howell) [P,E,C,L,W,T] Llandaff, Cardiff, Wales. b. 5 Ja 1887, Hong Kong, China. Studied: Slade Sch., London; F. Brangwyn. Member: Chicago SE [21]

LEACH, Ethel P(ennewill) B(rown) (Mrs.) [P,Por.P,B] Frederica, DE/Rehoboth Beach, DE b. Wilmington, DE. Studied: ASL; PAFA; C. Guerin; Breckenridge; Twachtman; Pyle. Member: Wilmington Soc. FA; A. All., Pr. Cl., Plastic Cl., all of Phila.; AFA. Exhibited: Wilmington Soc. FA (prize); Phila. Plastic Cl., 1944 (prize); Phila. A. All., 1944; N.J. State Mus., Trenton, 1945. Work: Miss. AA; Wilmington Soc. FA; portraits, State House, Dover, Del.; Dickinson Col.; Washington Col., Chestertown, Md.; Court House, Bellefonte, Pa. Illustrator: "Catching Up with the Circus," by Gertrude Crownfield, "Once Upon a Time in Delaware," by Katharine Pyle [47]

LEACH, Louis Lawrence [S] Taunton, MA b. 4 My 1885, Taunton d. 10 F 1957. Studied: Mass. Sch. A.; C. Dallin. Work: mon., mem., bas-reliefs, Taunton; Mass. State House; Garden City, N.Y.; Brighton, Mass.; Sioux City, Iowa [47]

LEACHE, Jeanette Landon [P,Por.P] Wash., D.C./Middleburg, VA b. 4 D 1911, Phila. Studied: Phila. Sch. Indst. A.; PAFA; Corcoran Gal. Sch. Exhibited: portrait, Phila. Jr. Lg. (prize). Work: Allocations, WPA, Wash., D.C. WPA artist. Position: T., Temple Center, Wash. A. Sect. [40]

LEAF, (Wilbur) Munro [I,Car,W] Phila., PA b. 4 D 1905 d. 21 D 1976. Author: "Noodle" (1937), "The Story of Ferdinand" (1936), "Wee Gillis" (1938), other children's books. Author/Illustrator: "Watchbirds—a Picture Book of Behavior," 1939 [40]

LEAKE, Gerald [P] NYC b. 26 N 1885, London, England d. 1975. Member: ANA, 1937; NAC; SI. Exhibited: SC, 1923 (prize), 1926 (prize), 1927 (prize); NAD, 1934 (prize), 1937 (med); All.A.Am., 1929 (gold). Work: NAC [47]

LEAKE, Marybelle [P] Richmond Hill, NY [25]

LEALE, Marion [P,Por.P] NYC b. NYC. Studied: ASL; L.F. Fuller. Member: Nat. Lg. Am. PW; Baltimore WCC. Exhibited: Nat. Lg. Am. PW, 1933 (prize), portrait, 1938 (prize) [40]

LEAMING, Charlotte [P,L,T] Colorado Springs, CO b. 16 Ja 1878, Chicago. Studied: AIC; F.D. Murphy; F. Freer; Chase; Duveneck; Herter. Member: Colorado Springs FA Center; Palm Beach A. Center; Ogunquit A. Assn.; Denver A. Soc. Illustrator: books. Specialty: animals. Positions: T., AIC (1899–05), Oak Park schools (1905–06), Chicago Acad. FA (1909–10), Colorado Springs Acad. FA (1911–), Colo. Col., Colorado Springs[40]

LEAR, George [En,P,B] Phila., PA b. 14 Mr 1879, Doylestown, PA d. 5 My 1956. Studied: Yale; PAFA; W.J. Server; R. McLellan; J. Pardi. Member: PAFA; CAFA; New Haven PCC; Phila. A. All.; Phila. Pr. Cl.; Business Men's AC, Phila.; Art Lg., Germantown; Southern Pr.M. Soc.; Am. Ar. Prof. Lg. Exhibited: All. A., Johnstown, 1945 (prize); PAFA, 1927, 1930, 1943, 1944, 1945; NAD, 1944–46; CI, 1944, 1946; LOC, 1943, 1944, 1946; CGA; Phila. Sketch Cl.; Phila. Pr. Cl., 1929–46; Phila. A. All., 1939, 1940; Wash. Soc. Min. P., 1942–46; CAFA, 1937–46; New Haven PCC, 1936–46; Oakland A. Gal., 1938–46 [47]

LEAR, John B., Jr. [P] Phila., PA. Exhibited: PAFA, 1934, 1936, 1938, 1939 [40]

LEARNED, Arthur G(arfield) [Dec,Dr,E,P,W] NYC/Stamford, CT b. 10 Ag 1872, Chelsea, MA. Studied: Munich; Vienna; Laurens, Steinlen, in Paris. Member: NAC. Work: NYPL; Brooklyn Inst. Mus.; LOC; Univ. Pa.; Brooklyn Museum Quarterly, 1930; E.A. Poe portraits in Japanese textbooks; Braille pictures, Am. Red Cross. Illustrator: two volumes on Poe, pub. in Paris. Specialty: portraits, decorations [40]

LEARNED, Harry [Ldscp.P] Itinerant landscape painter active in Denver, 1874–96. One of the founders of Denver AC, 1893. Work: Denver AM; Amon Carter Mus.; Colo. Hist. Soc.; Greeley Opera House, Denver [*]

LEARY, Daniel F. [P] Monaca, PA. Member: Pittsburgh AA [25]

LEASON, Jean Isabel [P,Mus.Cur] Stapleton, Staten Island, NY b. 18 O 1918, Sydney, Australia. Studied: Melbourne Sch. Painting. Member: Staten Island Inst. A.&Sc. Exhibited: All.A.Am., 1944, 1945; Staten Island Inst. A.&Sc., 1943–46. Position: A. Cur., Staten Island Inst. A.&Sc., 1945, 1946 [47]

LEASON, Percy [I] Stapleton, Staten Island, NY. Member: SI [47]

LEATHERMAN, Ruth Anne [P] Hinsdale, IL b. 28 Ag 1900, Muskegon, MI. Studied: AIC; L. Kroll; J. Norton; K. Buehr [33]

LEATHERS, Florence A. (Mrs.) [P] Louisville, KY. Member: Louisville AL [01]

LEAVITT, Agnes [Ldscp.P] San Fran., CA b. 1859, Boston. Studied: Enneking, Hardwick, Sandham, in Boston; Spread, in Chicago. Exhibited: watercolor, Boston AC (prize) [25]

LEAVITT, D(avid) F(ranklin) [I,Dec] St. Louis, MO b. 28 Ag 1897, St. Louis. Studied: Paris. Exhibited: St. Louis A. Gld., 1927 (prize) [33]

LEAVITT, Edward C. [P] Providence, RI d. 20 N 1904. Exhibited: NAD, 1877–86. Specialty: still life

LEAVITT, Emma F. See Randall.

LEAVITT, F.S. [P] Boston, MA [01]

LEAVITT, Joel J. [P] NYC b. 29 Ap 1875, Russia. Studied: Repin; Imperial Acad. Art, Petrograd. Member: People's Art Gld; S.Indp.A.. Work: Wilna (Russia) Mus.; Petrograd Mus.; Toronto Mus. [19]

LEAVITT, Robert [I,Car] NYC. Work: Cosmopolitan, 1939 [40]

LEAVITT, W.H. [P] Newport, RI [04]

LEAYCRAFT, Georgia [P] NYC [24]

LEAYCRAFT, Julia Searing [P,T,W] Woodstock, NY b. N 1885, Saugerties, NY. Studied: Vassar; ASL. Member: NAWA; Woodstock AA. Exhibited: NAWA, 1944–46; Albany Inst. Hist.&A., 1942–44; CAFA, 1937 [47]

LEBDUSKA, Lawrence H. [P] NYC b. S 1894, Baltimore, MD. Studied: Leipzig; Fleider; Shneider, Swoboda. Member: Audubon A. Exhibited: WMAA, 1937, 1938; Valentine Gal., N.Y., 1939 (one-man); Leipzig Intl. A. Expo, 1912 (prize); Kleeman Gal.; Contemporary A. Gal.; Ferargil Gal.; Brandemeyer Gal., Buffalo. Work: MOMA; WMAA; Newark Mus.; Albright A. Gal.; Univ. Ariz. [47]

LEBER, Roberta N. [Cer,C,T] West Nyack, NY b. New Jersey. Studied: C.F. Binns. Member: NYSC; N.Y. Soc. Ceramic A.; Soc. Des. Craftsmen. Specialty: ceramics. Positions: Associated with Craft Students League; New York Art Workshop [40]

LE BLANC, Emilie de Hoa [P,I,T] New Orleans, LA b. 17 Je 1870, New Orleans. Studied: AIC; D.W. Ross; Lhote, Colarossi, Grande Chaumière, in Paris. Member: NOAA; Am. Ar. Prof. Lg. Exhibited: NOAA, 1912 (med); A.&Crafts Cl., 1930 (prize). Position: T., McDonough H.S., Orleans Parish, La. [40]

LE BLANC, Marie de Hoa [P,T,I] New Orleans, La. b. 23 N 1874, New Orleans. Studied: AIC; D.W. Ross; M. Heyman, in Munich; Lhote, Colarossi, Grande Chaumière, in Paris. Member: NOACC; NOAA. Exhibited: NOAA, 1914 (gold). Work: Delgado Mus. A. [40]

LEBOIT, Joseph [P,Gr,Wood En] NYC b. 23 N 1907, New York. Studied: CCNY; ASL, with T. Benton. Member: A. Lg. Am. Exhibited: AIC, 1937, 1938; ACA Gal., 1946 (one-man). WPA artist. Position: Staff A., PM newspaper, 1943– [47]

LE BOUTILLIER, George [P] Ridgefield, CT. Member: S.Indp.A. [25]

LE BOUTILLIER, Isabel G. (Mrs. George) [P] Ridgefield, CT. Member: NAWPS [21]

LE BRON, Warree Carmichael (Mrs. Adolphe) [P] Montezuma, GA b. 23 Ja 1910, Elba, AL. Studied: Huntingdon Col.; Sullins Col.; ASL; Ecole des Beaux-Arts, France; J.K. Fitzpatrick; Fontainebleau Sch. FA. Member: SSAL; Ala. A. Lg.; Ala. WC Soc.; Ga. AA; Birmingham AC; Miss. AA. Exhibited: Ala. A. Lg.; Ala. WC Soc.; Birmingham AC; Dixie A.

Colony. Work: Montgomery Mus. FA; Ala. Col.; Ala. War Mem. Mus.; Seton Hall, Decatur, Ala. Position: T., Dixie A. Colony [47]

LE BRUN, Frederico, "Rico" [Des,P,T,S] Los Angeles, CA b. 10 D 1900, Naples, Italy d. 1964, Malibu, CA. Studied: Naples AFA, 1918–22. Member: F., Guggenheim Fnd., 1936, 1937. Exhibited: Los Angeles Mus. A., 1967 (retrospective). Work: Syracuse Mus. FA. He designed stained glass in Naples (1922–24), and in Springfield, Ill. (1924) before settling in NYC as a commercial artist. Moved to Calif. in 1938. Position: T., Chouinard AI [40]

LECHAY, James [P,T] Iowa City, IA b. Jy 1907, NYC. Studied: Univ. Ill.; M. Lechay. Member: Am. Ar. Cong. Exhibited: Another Place, 1936 (one-man), Ar. Gal., 1938 (one-man), both in NYC; GGE, 1939; WFNY, 1939; PAFA, 1940, 1942 (prize), 1944–46; Pepsi-Cola, 1945 (prize); AIC, 1941 (med), 1942–45; VMFA, 1940, 1944; BM, 1941, 1944; MMA, 1941, 1943; CGA, 1943, 1945; PMG, 1942; WMAA, 1942, 1944, 1946; CI, 1943–45; Herron AI, 1945; CAM, 1945; WMA, 1945; Springfield Mus. A., 1945; State Univ. Iowa, 1945, 1946; Colorado Springs FA Center, 1946. Work: AIC; PAFA; Univ. Ariz.; State Univ. Iowa; BM; Brooklyn Pub. Lib.; Roosevelt H.S., Childs H.S., both in NYC. Position: T., State Univ. Iowa [47]

LECHAY, Myron [P] New Orleans, LA b. 24 Ag 1898, Kiev, Russia. Studied: Nat. Acad. Member: Am. Ar. Cong. Exhibited: Ar. Gal., N.Y., 1940 (one-man); WFNY, 1939. WPA artist. [40]

LECKIE, Wilhelmine Sloan [Mur.P,P] Columbus, OH/Big Sandy, WY b. 12 N 1904, Jackson, OH. Studied: Cincinnati Art Acad.; PAFA Country Sch., Chester Springs; NAD. Member: Columbus AL. Work: murals, Va. Hotel, restaurants, Children's Hospital, all in Columbus [40]

LECKWER, Emilie [P] Phila., PA [13]

LE CLAIR, Charles (George) [P,T,L] Pittsburgh, PA b. 23 My 1914, Columbia, MO. Studied: Univ. Wis.; Columbia; C. Booth. Exhibited: Wis. Salon A., 1935, 1936 (prize), 1938–40, 1942; Madison AA, 1940 (prize); Milwaukee Journal, 1942 (prize); Albright A. Gal, 1944 (prize), 1945, 1946; CI, 1941, 1943–45; AIC, 1944, 1945; VMFA, 1944; Wis. P.&S., 1936, 1937. Work: Milwaukee Journal Coll.; Albright A. Gal.; Wis. Union; Madison (Wis.) Pub. Sch.; Tuscaloosa (Ala.) Pub. Sch.; Ala. Col. for Women. Positions: T., Univ. Ala., 1935–42, Albion Col., 1942–43, Albright A. Sch., 1943–46, Pa. Col. for Women, 1946– [47]

LEDBETTER, Alice McGehee (Mrs.) [P] Montgomery, AL b. Montgomery. Studied: N.Y. Sch. F.&Appl. A.; J.K. Fitzpatrick: Breckenridge. Member: SSAL; Ala. AL. Exhibited: Ala. AL Exh., 1933 (prize). Work: Montgomery Mus. FA [40]

LEDERER, Charles [I,Car] Chicago, IL b. 31 D 1856, Lowell, MA d. 13 D 1925. Cartoonist: Leslie's Weekly, Harper's Weekly, Chicago publications, New York Herald, New York World [13]

LEDERER, Edna Theresa [P] Cleveland, OH b. 12 S 1909, Cleveland. Studied: Cleveland Sch. A.; ASL; S. Vago; R. Brackman; John Huntington Polytechnic Inst. Exhibited: CMA, 1932 (prize), 1933, 1936 (prize), 1938, 1945; Butler AI; Ohio State Fair, 1936 [47]

LEDERER, Estelle MacGill [P,S,L,T] NYC b. 7 Ap 1892, Cleveland, OH. Studied: ASL [40]

LEDERER, Lucy (Christine Kemmerer) (Mrs. Eugene H.) [P,L,Dr,Des] State College, PA b. Milton, PA Studied: PIASch; Pa. State Col.; ASL; Pittman; Miller; Marsh. Member: NAWPS; Phila. A. All.; Plastic Cl., Phila. Exhibited: CGA, 1935; CAFA, 1936; CM, 1936; NAWA, 1938; Bucknell Univ., 1937; Reading Mus., 1938; PAFA, 1938; AIC, 1937; VMFA, 1940; Pa. State Col., 1938, 1942. Work: Pa. State Col.; Presbyterian Church, State College, Pa. [47]

LEDFORD, B.F., Mrs. See Hazen, Wilhelmina.

LEDGERWOOD, Ella Ray (Mrs. H.O.) [P,T,Dr,E] Fort Worth, TX b. Dublin, TX d. 27 Mr 1951. Studied: Tex. Christian Univ.; N.Y. Sch. A.; Irving Wiles; K.H. Miller. Member: Fort Worth AA; Allied AC; Fort Worth Art Comm.; Art Edu. Assn. Exhibited: Fort Worth Mus. A., annually; Grand Central Gal.; Three A. Cl. Position: T., Arlington Heights H.S., Fort Worth [47]

LE DUC, Alice Sumner [P,I,C] Minneapolis, MN/Hastings, MN b. Hastings [29]

LE DUC, A(rthur Conrad) [P] Haddonfield, NJ b. 23 Mr 1892, Wash., D.C. Studied: Corcoran Sch. A.; Acad. Julian, Acad. Colarossi, both in Paris. Member: S.Indp.A.; Salon d'Automne; Soc. Modern Arts [33]

LE DUC, Grace [P] Wash., D.C. Member: Soc. Wash. A. [13]

LEE, Alexander W. [P] Greenwich, NJ b. 9 Ag 1907, Trenton, NJ. Studied: Trenton Sch. Indst. A.; Corcoran Sch. A.; E. Horter; J. Giezel; W. Grauer. Member: Wash. WCC; Landscape Cl., Wash. Exhibited: PAFA, 1943; Wash. WCC, 1942, 1943; Landscape Cl., 1942–46 [47]

LEE, Arthur [S,T,L] NYC b. 4 My 1881, Trondhjem, Norway d. 14 My 1961, Newtown, CT. Studied: K. Cox; ASL; Paris; London; Italy. Member: F. Guggenheim, Fnd., 1930. Exhibited: PAFA, 1924 (gold); San Fran., 1916 (gold); Phila. Alliance, 1930 (prize); NAD, 1937 (med). Work: Cooper Union; MMA; Valentine Mus., Richmond, Va.; BM; WMAA; USPO Dept., Wash., D.C. WPA artist. Position: T., ASL [40]

LEE, Bertha Stringer (Mrs. L. Eugene) [P] San Fran., CA b. 6 D 1873, San Fran. d. 19 Mr 1937. Studied: W. Keith; J. Mathews; abroad. Member: Nat. Lg. Am. Pen Women; San Fran. Art Assoc.; Calif. AC; A.&Crafts Cl. Exhibited: Chicago Expo, 1893 (prize); Seattle Expo, 1909 (prize); San Fran., Art Assoc. (prize); Sacramento State Fair. Work: Del Monte Art Gal.; Golden Gate Park Mus., San Fran. [33]

LEE, Bertina B. [P] Trenton, NJ [10]

LEE, C. Brinckerhoff [P,En,I,Car] West Mystic, CT b. 1 Jy 1908, NYC. Studied: PIASch; Grand Central Sch. A.; Brooklyn Inst. A.&Sc.; W. Biggs; H. Dunn; H. Stein; L. Hechenbleickner; R. Brackman. Member: Brooklyn Acad. A.; Conn. WC Soc.; Mystic AA. Exhibited: CAFA, 1939 (prize); AWCS, 1939; Wadsworth Atheneum, 1939–41; Lyman Allyn Mus., 1942, 1943, 1946; Mystic AA [47]

LEE, Cora [P] Pittsburgh, PA. Member: Pittsburgh AA [25]

LEE, Doris (Emrick) [P,G,I,L] Woodstock, NY b. 1 F 1905, Aledo, IL. Studied: Rockford Col.; Kansas City AI, with E. Lawson; San Fran. Sch. FA, with A. Blanch; A. Angarola; Lhote, in Paris, 1927–29; Calif. Sch. FA. Member: An Am. Group; Am. Soc. PS&G; Am. A. Cong. Exhibited: AIC, 1935 (gold); PAFA (prize); American Painters Today, Worcester (Mass.) Mus., 1938 (prize). Work: MMA; AIC; RISD; PMG; mural, USPO, Wash., D.C. WPA artist. [47]

LEE, Elizabeth (Mrs. Allan McKissack) [P] Boston, MA/Falmouth, MA b. 21 Ag 1906, Boston. Studied: Hawthorne. Member: Provincetown AA [33]

LEE, Elmina Bennett [Ldscp.P] b. 1821, Westmoreland, NH d. 1908 (Boston?). Studied: W.M. Hunt. Exhibited: Boston, 1840–60 [*]

LEE, George [P] b. 1857, Brookline, MA d. 25 My 1932, Boston. Studied: England. Member: Boston Art Cl.; St. Botolph Cl.

LEE, Geo(rge) D. [P,T] Louisville, KY b. 1 D 1859, St. Louis, MO d. 4 Mr 1939. Member: AFA; Louisville AA; SSAL [31]

LEE, Henry Charles [Ldscp.P,W,L] Cornwalll, NY b. 3 My 1864, NYC d. 19 Jy 1930, Paris. Studied: J. Israels; G. Holston. Member: Lotos Cl.; SC; Paris Groupe PSA; SI. Work: Bohemian Cl., San Fran. Position: Art advisor, Officers' Cl., West Point, N.Y. He was also an archaeologist. [29]

LEE, Henry Jay [P] Croton-on-Hudson, NY. Member: AWCS. Exhibited: PAFA, 1935, 1936; AWCS, 1936, 1937, 1939; NYWCC, 1936, 1937 [47]

LEE, Homer [P,En] NYC b. 18 My 1856, Mansfield, OH d. 26 Ja 1923. Studied: his father, John Lee; R.C. Minor: R. Mackintosh, in Toronto; Europe. Member: Lotos Cl., 1895; SC, 1895; A. Fund Soc. Exhibited: Vienna, 1873 (prize); State of Ohio, 1887 (med); Paris Expo, 1900 (prize); Charleston Expo, 1902 (med). Founder: Homer Lee Banknote Co., New York [21]

LEE, Jim [P,Mur.P] Detroit, MI b. 24 N 1914, Canton, China. Studied: A.&Crafts Sch. Detroit. Member: Scarab Cl. Exhibited: Detroit Inst., 1935 (prize), 1938 (prize); Kansas City AI; Toledo Mus.; AIC, 1938; PAFA, 1938, 1939. Work: murals, Ford Sch., Highland Park, Rochester H.S., all in Mich. [40]

LEE, Josephine W(att). See Radue.

LEE, Laura [C,P] Stoneham, MA b. 17 Mr 1867, Charlestown, MA. Studied: BMFA Sch.; Académie Julian, Paris. Member: Copley S.; Boston SAC. Work: Pub. Lib., Chelsea, Mass. [40]

LEE, Lawrence, Mrs. See Taintor, Musier.

LEE, Leslie W. [Por.P,P,E,I] La Jolla, CA b. 26 Mr 1871, Manchester, England. Studied: NAD; ASL; Académie Julian, Paris; Constant, Laurens, in Paris; Twachtman. Member: Grand Central A. Gal.; NAC; La Jolla A. Center; San Diego A. Gld.; Contemporary P.&S. Soc.; San Diego. Work: CAM; San Diego FA Soc.; San Diego Mus. of Man; San Diego Pub. Lib.; Smith Col.; mural, Encinitas Clinic, Calif. [47]

LEE, Lowell Merritt [P,S,B,T] Milwaukee, WI/Grand Marais, MI b. 3 Mr

1905, Oscoda, MI. Studied: Cleveland Sch. A.; Western Reserve Univ. Member: Cleveland PM; Milwaukee PM; Wis. PS. Exhibited: Cleveland Mus. A., 1934 (prize). Work: Cleveland Mus. A.; Milwaukee AI. Position: T., Milwaukee State T. Col [40]

LEE, Manning de Villeneuve [Por.P,Mar.P,P,I] Ambler, PA b. 15 Mr 1894, Summerville, SC. Studied: PAFA, with Breckenridge, D. Garber, P. Hale, Pearson, Harding. Member: SSAL; Phila A. All. Exhibited: PAFA, 1922 (prize); 1923 (prize). Work: portrait, U.S. Mint, Phila.; marine paintings, U.S. Naval Acad., Annapolis. Illustrator: "The Blue Fairy Book," "The Red Fairy Book" (by Andrew Lang, pub. Macrae-Smith), "Historic Ships," "Historic Railroads," "Historic Airships" (by Rupert Sargent Holland, pub. Macrae-Smith), "When You Grow Up to Vote" (by Eleanor Roosevelt), Liberty, MacLeans (Toronto), other national magazines [47]

LEE, Mattie Crawley (Mrs.) [Ldscp.P,Por.P] Asheville, NC b. 1856, Pine Bluff, Ark. Member: Calif. AC; Miami AC. Exhibited: Atlanta Expo, 1895 (2 golds) [25]

LEE, Musier (Mrs. Lawrence) [P] Riverdale, NY b. 6 Mr 1909, NYC. Studied: ASL. Member: A. Lg. Am. Exhibited: ACA Gal., 1943–46; VMFA, 1942, 1943; Univ. Va., 1936–40; Va. State Exh., 1935, 1939; Boston, Mass., 1938 [47]

LEE, Percy Myron [P] Whitestone, NY b. 1 Ap 1903, Tacoma, WA. Studied: H. Mouiset; E. Renard. Member: AWCS [33]

LEE, Ralph L. [E] Dayton, OH b. 4 S 1891, Springfield, OH. Member: Dayton SE [31]

LEE, Robert Edmond [P,I,L,T] NYC b. 22 Jy 1899, San Fran. Studied: Henri; Larson; Gallen. Member: Artists Gld.; Swedish Acad. Exhibited: Swedish Nat. Acad., 1925 (prize). Work: Canadian Pacific; Chase National Bank; General Motors; American Express Co. Illustrator: Ladies' Home Journal. [33]

LEE, Rosa [Patron] d. 28 Ap 1936, Memphis. A charter member of the Memphis Art Assoc., organized in 1914 to promote art through education and maintain an art school. She loaned a house and grounds for its establishment, and this, with additional property, was given to the city; it became the James Lee Memorial Academy of Arts, named for her father.

LEE, Russell W. [P,Photogr] Woodstock, NY b. 21 Jy 1903, Ottawa, IL. Studied: John Sloan; Arnold Blanch. Member: Woodstock AA; AFA. Work: photographs, BMFA, Univ. Ariz., LOC. Best known for his documentary photographs made in the midwest, beginning 1936, for the FSA. [40]

LEE, Ruth Hudson [P,T] Syracuse, NY b. 9 Je 1885, Ellisburg, NY. Studied: Syracuse Univ.; Hawthorne; Adams; Ennis; O'Hara; P. Gill; W. Adams, H. Giles. Member: AWCS; Wash. WCC; NAWA; Assoc. A. Syracuse; Eight Syracuse Watercolorists. Exhibited: Phila. WCC; AWCS; NAWA; Baltimore WCC; Springfield A. Lg.; Argent Gal.; Rochester Mem. A. Gal.; Munson-Williams-Proctor Inst.; Assoc. A. Syracuse; Binghamton A. Gal. (one-man); Albany Inst. Hist.&A.; Everhart Gal.; Auburn A. Mus.; Charleston, W.Va.; East Aurora, N.Y.; Syracuse Mus. FA. Position: T., Syracuse Univ., 1921– [47]

LEE, Selma [E,P] Scarsdale, NY [33]

LEE, Thomas A. [P] Ardsley-on-Hudson, NY. Member: S.Indp.A. [25]

LEE, Vivian E. See Cattron.

LEE-ROBBINS, Lucy [P] Paris, France b. New York. Exhibited: Paris Salon, 1887 (prize) [15]

LEECH, Dorothy Sherman [P,Des,Mur.P] Sarasota, FL b. 28 D 1913, Pittsburgh. Studied: CI; Ringling A. Sch.. Member: Sarasota AA; Fla. Gulf Coast Group; Fla. Fed. A.; Guild Hall A. Assn., East Hampton, N.Y.; 4 A. Cl., Palm Beach. Exhibited: oil, Ringling Mus., 1938 (prize); watercolor, Ringling Mus., 1939 (prize); WFNY, 1939; Fla. Fed. A. (prize); Fla. Gulf Coast Group (prize); Albright A. Gal.; Clearwater Mus. A.; Radio City, N.Y., 1938. Work: mural, Lido Casino, Sarasota; des., Ringling Bros. circus. Position: Des., Sherman Reynolds Studio, Sarasota [47]

LEECH, Hilton [P,Mur.P,T] Sarasota, FL b. 13 O 1906, Bridgeport, CT. Studied: Grand Central Sch. A.; ASL; G.P. Ennis. Member: SSAL; AWCS; Phila. WCC; Fla. Fed. A. Exhibited: AWCS, 1930 (prize); NYWCC, 1930 (prize); Fla. Fed. Art., 1932 (prize), 1933 (prize), 1934 (prize); Dallas Mus. FA, 1944 (prize); Albright A. Gal., 1944 (prize); Clearwater Mus., 1946 (prize); Palm Beach AC, 1942 (prize); Pasadena AI, 1936; WFNY, 1939; Phila. WCC; AIC; Southeastern AA; Gulf Coast Group. Work: Guild Hall, East Hampton, N.Y.; murals, Court House, Chattanooga, Tenn.; USPO, Bay Minette, Ala. WPA artist. Positions: T., Ringling Sch. A. (Sarasota), Amagansett A. Sch. (N.Y.) [47]

LEEDY, J. Harvey [P] Youngstown, OH b. 24 N 1869, Bryan, OH. Member: Am. Ar. Prof. Lg. Exhibited: Butler AI, 1938, 1939 (one-man) [40]

LEEDY, Laura A. (Mrs. Edwin C.) [P,E,L] St. Paul, MN b. 26 O 1881, Bloomington, IL. Studied: Minneapolis Sch. A.; Cikovsky; Nordfeldt; A. Angarola; G.E. Browne. Member: St. Paul ASL; Montparnasse Cl., St. Paul. Exhibited: Minn. State Fair, 1925 (prize), 1928 (prize), 1935; Minneapolis AI, 1933 (prize); Phila. Pr. Cl., 1945 [47]

LEEPA, Harvey [G,Des,I,Car,L] NYC b. 29 Mr 1890, Russia. Studied: Ecole des Beaux-Arts, Académie Julian, both in Paris; J. Muncis, in Riga, Latvia. Member: Am. Ar. Assn., Paris. Exhibited: Southitt Gal., N.Y. Work: motion picture sets, Hollywood, 1927, 1931 [40]

LEEPER, John Porter [P,I,Mur.P,T] Hollywood, CA b. 23 Ap 1909, Dandridge, TN. Studied: Otis AI. Member: Calif. WC Soc.; Council All. A.; Ariz. PS; Ariz. Ar. Gld. Exhibited: Calif. WC Soc., 1944–46; Los Angeles Mus. A., 1944, 1945; Calif. WC Soc. Traveling Exh., 1946; Ariz. PS, Phoenix, 1938. Work: mural, Ariz. State T. Col.; IBM Coll. Positions: Illus., Paramount Studios, 1942–46; T., Phoenix A. Center [47]

LEEPER, Vera B(eatrice) [P,Mur.P,C,Des,L,T] Los Angeles, CA b. 13 Mr 1899, Denver. Studied: Denver Univ.; BMFA Sch., with Eben S. Comins; NYU; Pars. Member: Hudson River Valley P.; NSMP; Hudson Valley AA; Chappaqua A. Gld. Exhibited: Art Center of the Oranges, 1927 (prize); Wolfe A. Cl., 1920 (prize), 1922 (prize); NYWCC, 1926 (prize); Kansas City AI, 1934; Brown Robertson Comp., N.Y., 1928 (prize); NAD, 1929 (prize); Paris Salon; MMA; NSMP; Grand Central Gal.; Hudson Valley AA; Chappaqua A. Gld. Work: Denver A. Mus.; murals, public schools (N.Y./N.J.), Roger Sherman Restaurant (New Haven, Conn.), theatres (New London/Derby, both in Conn.), Morene Products Co., NYC. Position: T., Yorktown Women's Cl. Camp [47]

LEES, Harry Hanson [I] Flushing, NY d. ca. 1960. Member: SI [47]

LEE-SMITH, Hughie [P,Mur.P,Li,T] Ferndale, MI b. 20 S 1915, Eustis, FL. Studied: John Huntington Polytechnic Inst.; Detroit Soc. A.&Crafts Sch.; Cleveland Sch. A.; H.G. Keller; C. Gaertner. Exhibited: CMA, 1938 (prize), 1939 (prize), 1940 (prize); Atlanta Univ., 1943 (prize); Okla. A. Center, 1939; Denver A. Mus., 1939; Grand Rapids A. Gal., 1940; Atlanta Univ., 1942–45; Dayton AI, 1939, 1940; CMA, 1938–40; Snowden Gal., Chicago, 1945 (one-man); South Side Community A. Center, Chicago, 1945. Work: South Side Community A. Center; Atlanta Univ.; murals, U.S. Navy Great Lakes Training Center. Position: T., Claflin Univ. [47]

LEESON, E(dith) M(argaret). See Everett, Mrs.

LEETE, Clara [P] St. Louis, MO. Member: St. Louis AG [25]

LEEWITZ, George J., Mrs. See Bevin, Alice.

LEFEVRE, Lawrence E. [P] Chazy, NY b. 9 D 1904, Plattsburgh, NY d. 6 Ag 1960. Studied: Plattsburgh State T. Col.; E. O'Hara. Member: Plattsburgh AG. Exhibited: PAFA, 1938; AWCS, 1940, 1941; Wash. WCC, 1942; Plattsburgh AG, 1934–40; O'Hara Gal., 1937, 1939–43, 1945; Saranac Lake AL, 1938, 1940, 1941 (prize); Albany Inst. Hist. & A., 1939; Elizabethtown, NY, 1938 (prize); CGA, 1942 (prize). Work: CAM; O'Hara WC Sch. Gal. [47]

LE FEVRE, Robert [P] Wash., D.C. [13]

LEFFERTS, Winifred E(arl) (Mrs. Carleton Macy) [P,I,Des] NYC/Blandford, MA b. 9 O 1903, Newtonville, MA. Studied: PIASch; NAD; Tiffany Fnd. Member: AWCS; NYWCC; NAWPS; NAC; Tiffany Fnd.; Allied AA; All.A.Am. Exhibited: NAC, 1931 (prize), 1933 (prize), mural, 1936 (prize) [47]

LEFFINGWELL, Lucia Dodge [Por.P] NYC/McKinley, ME b. 1879, Oakland, CA d. 12 O 1944, Montclair, NJ. Studied: Twachtman; Cox; Tack; Hawthorne; Menard; Simone. Member: ASL; North Shore AA; Gloucester SA [47]

LEFRANC, Margaret (Mrs. Schoonover) [P,Des,I] Santa Fe (living in Miami, 1962) b. 15 Mr 1907, Brooklyn, NY. Studied: NYU; Paris, with Schoukaieff; Bourdelle, Lhote. Exhibited: PAFA; WFNY, 1930; N.Mex. SA; S.Indp.A.; Salon des Tuileries, Salon d'Automne; Salon des Artistes Français, all in Paris. Illustrator: "Maria, the Potter of San Ildefonso," 1948, "Indians of the Four Corners," 1952 [47]

LEGGE, Russell Holcomb [I,Mur.P] Detroit, MI b. 1832 Perryton, OH d. 9 S 1941. Member: Scarab C., Detroit (Pres.). Specialties: pen-and-ink drawings of theatrical personages; murals in theatres

LEGGETT, Lucille (Mrs.) [P] Santa Fe, NM b. 1896, TN. Studied: El Paso, Tex.. Specialties: Western bldgs.; desert. Work: Mus. N.Mex. [*]

LEGGETT, Theodore H. [P] NYC [01]

LEHMAN, Harold [Mur.P,Por.P,Li,Des,Dr,S] NYC b. 2 O 1913, NYC. Studied: Otis AI; Fettelson; Siqueros. Member: Un. Am. Ar.; Mural P.; AL Am.; Woodstock AA. Exhibited: WFNY, 1939; WMAA, 1940; MOMA, 1943; NAD, 1943; Woodstock AA, 1942–45; NGA, 1943; Los Angeles Mus. A., 1933 (prize); Municipal A. Gal., NYC, 1937 (prize). Work: Newark Mus.; MOMA; murals, Rikers Island, NYC; USPO, Renovo, Pa.; State of Calif. Contributor: Art Front [47]

LEHMAN, Irving G. [P,Des,En,T] Brooklyn, NY b. 1 Ja 1900, Russia. Studied: CUASch; NAD. Member: Am. Ar. Cong. Exhibited: PAFA; AIC; NAD; S.Indp.A.; BM; SAM, 1930–46. Work: Vanderpoel Coll. WPA artist. [47]

LEHMAN, Louise Brasell (Mrs. John) [P] Memphis, TN b. 15 O 1901, Orwood, MS. Studied: Miss. State Col. for Women; George Wash. Univ.; Corcoran Sch. A.; Columbia; Oberteuffer; M. Mason. Member: SSAL; New Orleans AA; Palette & Brush C. Exhibited: Audubon A., 1945; VMFA, 1946; Whistler Mus. SSAL; NOAA; Palette & Brush C. Work: Montgomery Mus. FA. Position: Dir., Nat A. Week, Tenn., 1944– [47]

LEHMAN, Paul, Mrs. See Cramer, S. Mahrea.

LEHMER, Caroline [P] Cincinnati, OH d. 31 O 1933. Member: Cincinnati Women's AC; various WCC. Specialty: watercolor (for which she won some awards) [25]

LEHNER, Marion Ebert (Mrs. O.P.) [P,C,Des,Dec] Green Bay, WI b. 25 N 1902 Milwaukee, WI. Studied: E.E. Ulbricht, M.K. Mueller; G. Moeller; G. Oberteuffer; B. Robinson. Member: Wis. S. Appl. A.; Wis. Fed. Ar. Exhibited: Wis. S. Appl. A., 1929 (prize) [40]

LEHR, Adam [P,C] Cleveland, OH b. 1 N 1853, Cleveland. Studied: ASL [08]

LEHR, Anton A. [P] Roxbury, MA [06]

LEHRE, Florence Wieben (Mrs.) [Cr] Oakland, CA b. 1899, Oakland d. 22 S 1931. Positions: Staff, Oakland Tribune Art Digest; Asst. Dir., Oakland A. Gal.

LEICH, Chester [E,T,L,P] Arlington, VA b. 31 Ja 1889, Evansville, IN. Studied: H. Lesker, in Munich; W. Oesterle, in Berlin; G. Giacometti, in Florence; Siebelist, in Hamburg; Columbia. Member: SAE; Chicago SE; Ind. S. Pr.M.; Phila SE; AAPL. Exhibited: SAE, annually; Chicago SE, annually; Ind. S. Pr.M., 1934, 1936, 1938; WFNY, 1939; Nat. Mus., Stockholm, Sweden, 1937; NAD; Paris Salon, 1937; Montclair A. Mus., 1932 (med), 1933–37, 1938 (med), 1939–46; Paris Salon, 1937 (prize); Tucson FAA, 1938 (prize); AAPL, 1932 (med), 1938 (med). Work: LOC, NGA; Newark Pub. Lib.; Mus. N.Mex.; Evansville, Ind. Pub. Mus.; Swope A. Gal.; Coll. Fine Art, Wash., D.C.; SAE; NAD; Central H.S., Evansville, Ind. [47]

LEICHTAG, Lillian Helen [P] NYC b. 17 Jy 1904, Hungary. Studied: NAD; C. Hinton; L. Kroll; A. Covey. Exhibited: CGA, 1939; Beaux-Arts, 1931, 1936, 1938; 48 States Comp., 1939. Work: NYPL; murals Army Postal Terminal, Long Island City, N.Y.; Gouverneur Hospital, N.Y.; Ft. Hamilton, N.Y. [47]

LEIDY, Carter (Mrs.) [Patron,P] Easthampton, NY d. 8 Mr 1933 (her car skidded over an embankment into a stream and she was drowned). Member: NAWPS. Exhibited: NAWA; Ogunquit A. Center, 1932 (prize); Easthampton (prize)

LEIENDECKER, Paul H. [P] Columbus, OH. Member: Columbus PPC [25]

LEIF, Florence (Mrs. Peers) [P] Cranton, RI b. 17 Mr 1913, NYC. Studied: RISD; J.R. Frazier. Member: Provincetown AA. Work: Providence AC; IBM Coll. CI, 1941; Nat. Exh. Am. Art, 1938; WMA; Newport AA; RISD; Provincetown AA [45]

LEIFTUCHTER, F.B. [Mur.P] NYC [15]

LEIGH, A.W. [I] NYC [01]

LEIGH, Esther L. [P] NYC [13]

LEIGH, Hazel [P] Milwaukee, WI [19]

LEIGH, Howard [P,Li] Chicago, IL/Spieceland, IN b. 9 Ag 1896, Cecilia, KY. Studied: P. Mauron; J.A. Seaford. Exhibited: Paris Salon, 1927; Hoosier Salon, 1931 (prize). Work: Musée de la Guerre, Paris; NYPL; Boston Pub. Lib.; Henry County Hist. S., New Castle, Ind.; Dayton AI; John Herron AI [40]

LEIGH, William R., Mrs. See Traphagen, Ethel.

LEIGH, W(illiam) R(obinson) [P,W,I,L,S,T] NYC b. 23 S 1866, Berkeley County, W.Va. d. 11 Mr 1955. Studied: Md. Inst., with H. Newell, 1880–83; Munich Acad., with Raupp, 1883–84; Gysis, 1885–86; Lofftz, 1887; Lindenscmid, 1891–92. Member: All.A.Am.; SC; Author's Lg. Exhibited: Babcock Gal. (one-man); Grand Central A. Gal. (one-man), 1939, 1941, 1944; Gumps Gal., San Fran., 1944 (one-man); Royal Acad., Munich (med); Appalachian Expo, Knoxville, Tenn., 1911 (med). Work: Phillips Mus., Bartlesville, Okla.; African Hall, AMNH; Munich; Wash. & Lee Univ.; Nayasset C., Springfield, Mass.; Huntington MFA, Huntington, N.Y.; 534 oils and 344 charcoals in Gilcrease Inst. Author/Illustrator: "Frontiers of Enchantment," 1938. Contributor: Scribner's, Natural History, Collier's [47]

LEIGHTON, Elizabeth B. [P] New Haven, CT. Exhibited: Phila. WCC, 1938; Am. WCS-NYWCC, 1939 [40]

LEIGHTON, Kathryn W. (Mrs.) [P] Los Angeles, CA b. 17 Mr 1876, Plainfield, NH d. 1952. Studied: Boston Normal A. Sch. Member: Calif. AC; West Coast Arts; Los Angeles AA. Exhibited: Calif. AC, 1936 (prize); Ebell C., Los Angeles, 1937 (prize). Work: Los Angeles Mus. A.; Northwestern Univ.; Gary, Ill. H.S.; Univ. Southern Calif. Specialty: portraits of Mont. Blackfeet Indians [47]

LEIGHTON, Nicholas Winfield Scott [P] Boston d. 18 Ja 1898, MacLean Insane Asylum. He was an animal painter and it was only by raising and trading horses that he was able to pursue his studies. Among his important works are "Three Veterans," "The Smugglers," and "In the Stable."

LEIMDORF, Adele [P] NYC [15]

LEINDORFER-LUBZER, Adele (Mrs.) [P] Livingston, NJ b. 22 Je 1876, Austria. Studied: Robert-Fleury, in Paris. Member: S.Indp.A.

LEINROTH, Robert G. [P] Phila., PA. Studied: PAFA [25]

LEISENRING, L. Morris [P,Arch] Wash., D.C. b. 29 O 1875, Lutherville, MD. Studied: Md. Inst.; Drexel Inst.; PAFA; Univ. Pa.; Duquesne, in Paris; Am. Acad., Rome. Member: Wash. AC; Wash. WCC; Wash. Chapter AIA; Bd. Examiners and Registrars of Archs., Wash., D.C. [40]

LEISENRING, Mathilde Mueden (Mrs. L.M.) [Por.P,T] Wash., D.C. b. Wash., D.C. Studied: ASL; ASL, Wash., D.C.; Paris, with Laurens, Constant, Henner. Member: S. Wash. A.; Wash. WCC; Wash. AC. Exhibited: S. Wash. A., 1903 (prize); Wash. WCC, 1903 (prize); Appalachian Expo, Knoxville, Tenn., 1910. Position: T., CGA [40]

LEITH, Jessie [P] NYC [06]

LEITH-ROSS, Harry [P,I,T] New Hope, PA b. 27 Ja 1886, Mauritius. Studied: NAD; ASL; Académie Julian; England; C.Y. Turner; B. Harrison; J. Carlson; Laurens; S. Forbes. Member: SC; CAFA; New Haven PCC; AWCS; Phila. WCC; Audubon A. ANA; NA, 1936; North Shore AA; NYWCC. Exhibited: NAD, 1915–42, 1944, 1945, 1927 (prize); PAFA, 1916, 1922–29, 1933, 1936, 1938, 1940–46, 1946 (prize); CGA, 1919, 1921, 1933, 1935, 1937, 1939, 1941, 1943, 1945; CI, 1943–45; AIC, 1914, 1916, 1920–27; AWCS, 1936, 1938–46, 1937 (prize) 1941 (prize); MMA (AV) 1942; 48 States Comp.; CAFA, 1921 (prize), 1943 (prize); SC, 1915 (prize), 1938 (prize), 1944 (prize), 1946 (prize). Work: PAFA; mural, USPO, Masontown, Pa. Position: T., Adult Sch. Edu., Bound Brook, N.J. [47]

LEITNER, Leander [P,B,T] NYC/Wilmington, DE b. 30 Ap 1873, Delphos, OH. Studied: ASL; J.B. Whittaker; H. Prellwitz; J. Boston; F.V. DuMond. Member: AAPL; Salon All. A., Boston; Wilmington FAS. Illustrator: Wash. Anthology, with Wash. U.S. Bicentennial Comm. Position: T., Raymond Riordon Sch., Highland, N.Y. [40]

LELAND, Clara Walsh (Mrs. D.R.) [P] Lincoln, NE b. Lockport, NY. Studied: PAFA; Whistler Sch., Paris; W. Chase; C. Beaux. Member: Nebr. AA; Lincoln AG. [40]

LELAND, Elizabeth [S] Brookline, MA/North Andover, MA b. 6 Ap 1905, Brookline, MA. Studied: G. Demetrios; Landowski; Académie Julian; Fontainebleau Sch. FA; Ecole des Beaux Arts. Member: Salon of Allied A.; Merrimack Valley AA. Exhibited: Jr. Lg. Regional Exh., New Haven Hist. S., 1935 (prize); Nat. Jr. Lg. Exh., San Fran. Mus., 1935 (prize) [40]

LELAND, Francis I. [Patron] NYC d. 28 Mr 1916. Member: MET (trustee). He gave $1,000,000 in 1912, the largest gift ever made by any one during his lifetime.

LELLA, Carl [Mur.P] Colonia, NJ b. 4 F 1899, Bari, Italy. Studied: B. Faulkner; A.V. Tack. Member: Arch. L; Mural P. Work: murals, Farmers Nat. Bank, Reading, Pa. [47]

LEMBKE, Halford [S] Seattle, WA b. 2 O 1889, Topeka, KS. Studied: F.

Tadama. Exhibited: Cleveland AA, 1919 (prize); Annual Exh. of Northwest A., Seattle AI, 1932 (prize), 1933 (prize). Work: wood-sculpture, SAM; AIC [40]

LE MESSURIER, Ernest [Car] b. 1894, d. 27 O 1932, Montreal, Canada. Work: cartoons of prominent financiers, politicians, sportsmen and others, featured in Canadian and New York newspapers.

LEMING, Charlotte [P] Chicago, IL [04]

LEMLY, Bessie Cary [B,T] Jackson, MS b. 4 Je 1871, Jackson. Studied: ASL; P.J. Lemos; E.A. Webster; M.M. Mason. Member: Miss. AA; Art Study C.; SSAL; AFA. Work: Miss. AA; Cary AC Coll. [40]

LEMMON, G.N. [P] Marietta, GA. Member: Pittsburgh AA [21]

LEMMON, Thetis [P,C,T] Denton, TX b. 30 Ja 1907, Dallas, TX. Member: Denton AL. Exhibited: Midwest A. Ann., Kansas City AI, 1937, 1938; Dallas MFA; Ney M., Austin, Tex.; Denton AL, 1936 (prize), 1937 (prize), 1938 (prize), 1939 (prize). Position: T., Tex. State Col. for Women [40]

LEMON, Frank [S] East Point, GA b. 10 N 1867, Wash., D.C. Studied: Corcoran Sch. A. Member: Arch. Lg., 1902. Exhibited: Pan-Am. Expo, Buffalo, 1901 (prize) [17]

LEMON, Joseph A. [I] NYC [01]

LEMOS, Frank B. [P,I,C,T] Palo Alto, CA b. 14 Jy 1877, Austin, Nevada [25]

LEMOS, Pedro J. [P,E,B,I,T,L,W] Palo Alto, CA b. 25 My 1882. Studied: M. Benton; A. Dow; San Fran. Inst. A. Member: Calif. SE; Carmel AA; Palo Alto AC. Exhibited: P.-P. Expo, San Fran., 1915; Calif. State Fair, 1916 (gold). Work: Calif. State Lib., Sacramento. Author: "Applied Art," "Color Cement Handicraft," "The Bird in Art," "The Tree in Art," "Principles of Beauty in Design," "Plant Form in Design," "Indian Decorative Designs," "Oriental Decorative Design," "Old World Decorative Design," "Modern Art Portfolios," "Indian Arts." Positions: Ed., School Arts Magazine; Dir., Mus. FA, Stanford [33]

LENDERS, Emil W. [P,S] Phila., PA b. Germany d. 5 Ap 1934, Oklahoma City. Specialties: wild life; the buffalo [15]

L'ENGLE, Lucy (B.) [P,G] Truro, MA b. 28 S 1889, NYC. Studied: ASL; Paris. Member: NYSWA; St. Augustine AC; Provincetown AA. Exhibited: NYSWA; Provincetown; St. Augustine AC; Palm Beach Fla. [47]

L'ENGLE, William Johnson, Jr. [P] Truro, MA b. 22 Ap 1884, Jacksonville, FL d. 24 N 1957. Studied: Yale; Ecole des Beaux-Arts, Paris; ASL, with G. Bridgman; R. Miller; J.P. Laurens; Collin; L. Biloul. Member: Provincetown AA; St. Augustine AC. Exhibited: CGA; PAFA; WFNY, 1939; Provincetown AA; St. Augustine AC; Norton Gal. [47]

LENHARD, Josef [P] NYC [25]

LENHARDT, Walmsley [P] Laguna Beach, CA. Member: Laguna Beach AA [25]

LENIQUE, Andree [P] NYC [15]

LENNEY, Annie (Mrs. William Shannon) [P,L,T] West Caldwell, NJ b. 26 My 1910, Potsdam, NY. Studied: Col. St. Elizabeth, N.J.; Grand Central A. Sch.; ASL; NYU; H. Lever. Member: AAPL; Newark AC; Irvington A. & Mus. Assn. Exhibited: PAFA, 1939; NYWCC, 1940; Albany Inst. Hist. & A., 1943; AWCS, 1943–46; Audubon A., 1945; Montclair A. Mus., 1941–43, 1945; Princeton Univ., 1941; Upper Montclair Women's C., 1946; Irvington Lib., 1940 (prize), 1946; Newark AC, 1940 (prize); Kresge Exh., 1940 (prize). Work: Contemporary C., Newark, N.J. [47]

LENSCH, Frances [P] Glenside, PA [19]

LENSKI, Lois (Mrs. Arthur Covey) [I,W,P] Torrington, CT b. 14 O 1893, Springfield, OH. Studied: Ohio State Univ.; ASL; Westminster Sch. A., London; K.H. Miller; W. Bayes, in London. Member: PBC; Authors Lg. Work: murals, Lord And Taylor's, NYC. Author/Illustrator: "Blueberry Corners," 1940, "The Little Farm," 1942, "Strawberry Girl," 1945, "Blue Ridge Billy," 1946, other children's books [47]

LENSON, Michael [Mur.P,L] Nutley, NJ b. 21 F 1903, Russia d. 1971. Studied: NAD; Univ. London; Ecole des Beaux-Arts, Paris. Member: N.J. AA; Mural P.; Collab. Group PS and Arch. Exhibited: CGA, 1938; PAFA, 1939; CI, 1943; Newark Mus., 1944–46; Riverside Mus., 1944–46. Work: Newark Mus.; Essex Mountain Sanatorium; Newark City Hall; Mt. Hope, W.Va.; Electronic Corp., N.Y.; Verona, N.J.; H.S., Newark, N.J. Position: Dir., Newark Sch. F.&Indst. A., 1944–45, 1945–46 [47]

LENSSEN, Heidi (Ruth) [P,I,W,T] NYC b. 23 Ag 1909, Franfurt, Germany. Studied: Europe. Member: Audubon A. Exhibited: WFNY, 1939; Audubon A. 1944, 1945; Mod. A. Studio, N.Y., 1945; Jordan Gal., 1937 (one-man); Schoneman Gal., 1940 (one-man); Am. Sch. Des., 1940 (one-man); Baden, Germany, 1929 (prize), 1931 (prize). Work: European mus. and gal. Author/Illustrator: "Art and Anatomy," 1944, 1946 [47]

LENT, Margarete (Mrs. Hunter P. Mulford) [P,T] Wash., D.C. b. Wash., D.C. Studied: Corcoran Sch. A.; N.Y. Sch. F.&Appl. A.; Hawthorne; Snell; Ennis. Member: AWCS; NAWPS; W. Wash. A.; Wash. WCC; Wash. AC; NYWCC. Exhibited: NYWCC, 1928 (prize), 1929 (prize), 1930 (prize) [40]

LENTELLI, Leo [P,S] NYC b. 29 O 1879, Bologna, Italy d. 1 Ja 1962, Rome. Member: ANA, 1928; NSS, 1907; Arch. Lg. 1909. Exhibited: Arch. Lg., 1911 (prize), 1913 (prize), 1921 (prize), 1922 (gold); San Fran. AA, 1916. Work: S., Cathedral St. John the Divine, NYC; San Fran. Pub. Lib.; Straus Bank Bldg., NYC, Chicago; Corning Free Acad., N.Y.; Steinway Bldg., Rockefeller Center; equestrian statue, Charlottesville, Va.; Mission Branch Lib., San Fran.; St. Louis Orpheum Theatre; playfield, Pelham, N.Y.; Pan-Pac. Expo, San Fran.; 16th Bridge, Pittsburgh; Wash., D.C. [47]

LENTINE, James [P] Chicago, IL. Exhibited: AIC, 1935, 1938, 1939 [40]

LENZ, Alfred (David) [S] Flushing, NY b. 20 My 1872, Fond du Lac, WI d. 26 F 1926, Havana, Cuba. Studied: self-taught. Member: NSS; Art Workers C. Work: MMA; CMA; Newark Mus. Specialty: silver [25]

LENZ, Norbert [P,Des,I] Cleveland, OH b. 2 Mr 1900, Norwalk, OH. Studied: Cleveland Sch. A.; Huntington Polytechnic Inst. Member: Cleveland SA. Exhibited: PAFA, 1930–39; AIC, 1936; Butler AI, 1943, 1944; CMA, 1930–44; Ohio WC Exh., 1945 [47]

LENZ, Oscar [S] b. 1874, Providence, RI d. 25 Je 1912. Studied: RISD, at age 12; ASL, with Saint-Gaudens, age 17; later, with Saulierre, in Paris. Work: Charleston, S.C.; bridge, Buffalo; Pennsylvania Station, NYC; Columbian Expo, Chicago, 1893

LENZI, Alfred [S] Berwyn, IL b. 19 Ja 1906, Italy. Studied: A. Polasek, in Chicago; L. Andreotti, in Italy. Exhibited: AIC, 1937, 1938 (med); Ill. SFA, 1934 (gold); Chicago SA, 1937 (gold) [40]

LEONARD, B(eatrice) (Mrs. Arduino Laricci) [P] NYC b. 11 Jy 1889, Marion, IN. Studied: Chicago Acad. FA. Member: Hoosier Salon; Bronx AG; S.Indp.A. [31]

LEONARD, George H(enry) [Ldscp.P,W] Northampton, MA b. 3 My 1869, Boston. Studied: Paris, with Gérôme, Bouguereau, Aman-Jean. Member: Paris AAA; Boston AC; AFA. Work: Boston AC Coll. [40]

LEONARD, Helen [I] b. 1885, San Fran., CA d. 21 Ap 1908, Wilmington, DE. Studied: F. Brangwyn, in London; H. Pyle

LEONARD, J.D. [Mur.P,Arch,I,E,Indst.Des] NYC b. 20 Ag 1903, Chicago. Studied: NAD; Grand Central Sch. A.; C.K. Hinkle; Lawlor; F.N. Leonard. Member: Am. Ar. Prof. Lg.; Ridgewood AA. Exhibited: Phoenix FAA, 1929 (prize), 1930 (prize); Palace Legion of Honor, San Fran., 1930 (prize), 1933 (prize); Santa Cruz, 1931 (prize); Ridgewood AA, 1935 (prize); Montclair AM, 1937 (med), 1938 (prize). Work: Laguna Beach Sch., Laguna Beach [40]

LEONARD, Jean Y. [P] Baltimore, MD [25]

LEONARD, Lank [I,Cart] NYC. Creator: comic strip "Mickey Finn" [40]

LEONARD, William J(ackson) [P] Accord, MA b. 23 F 1869, Hinsdale, NH. Studied: Paris, with Laurens, Constant [25]

LEONARD-SORENSEN, Clara B. [P] Indianapolis, IN [15]

LEONETTI, Carlo [P] NYC b. 9 Ja 1899, Naples, Italy. Studied: G. Bridgman; F.V. DuMond; F.L. Mora; R. Henri; G. Bellows; K.H. Miller [40]

LEONHARDT, Olive [P,I,G] New Orleans, LA b. 16 Ag 1895, Jackson, MI. Studied: Newcomb A. Sch., Tulane Univ.; N.Y. Sch. F.&Appl. A.; ASL. Exhibited: NOACC; Morgan Gal., 1939 (one-man). Illustrator: "New Orleans Drawn and Quartered," 1938 [47]

LEOPOLD, William [I] Brooklyn, NY b. 1867 d. 15 N 1911. He had served in the Spanish-American War.

LEPPER, Robert Lewis [P,Des,T] Pittsburgh, PA b. 10 S 1906, Aspinwall, PA. Studied: CI; Harvard. Member: Pittsburgh AA; Abstract Gr. Pittsburgh; Am. Soc. for Aesthetics. Work: murals, USPOs, Caldwell, Ohio, Grayling, Mich.; W.Va. Univ. Exhibited: AIC, 1936; CI, 1941; Pittsburgh AA; 48 Sts. Comp., 1939; Butler AI. Contributor: Architectural Forum [47]

LEPPERT, Rudolph E. [I] Mamaroneck, NY b. 20 D 1872, NYC. Studied: G. deF. Brush; B. deGrimm. Member: SC; AFA [47]

LE PRINCE, S.E. [P] NYC [01]

LE PROVOST, E.G. [P] Pittsburgh, PA. Member: Pittsburgh AA [25]

LERCH, Charles A. [P] Union Hill, NJ [15]

LERCH, Helen Adele [S] Chicago, IL [17]

LERMAN, Leo [W,L,T] NYC b. NYC. Author: "Leonardo da Vinci; Artist and Scientist," 1946; "Michelangelo; A Renaissance Profile," 1942 [47]

LERMONT, Charlotte Kudlich (Mrs. Bas) [Ldscp.P] NYC b. NYC. Member: NAWPS; PBC. Exhibited: NAWPS, 1933; PBC, 1935, 1937 (prize) [40]

LE ROY, Anita [P,I] Phila., PA b. Nashua, NH. Studied: PAFA; Whistler, Paris. Member: Plastic C. [10]

LESAAR, Charles M. [P] Oakland, CA b. S 1884, Belgium. Studied: Royal Acad., Antwerp; Acad. Düsseldorf; H. Luyten; J. Israels, Belgium. Exhibited: Oakland AG. Work: Chicago Press C.; Sacred Heart Col., San Fran.; City Hall, Ghent, Belgium [40]

LESCAZE, William [Arch,Des] NYC b. 27 Mr 1896, Geneva, Switzerland. Studied: K. Moser; Ecole Polytechnique Federale, Zurich. Member: AIA; Munic. AS, NYC. Work: Wilbur Lib., Brooklyn Mus. Contributor: Architectural Forum. Specialty: industrial and arch. des. [40]

LESEURE, M. [P] New Rochelle, NY [01]

LESLEY, Ellen [Por.P,I] Chambersburg, PA b. Phila. Studied: PAFA; ASL, with Cox, Mowbray; Académie Julian, with Constant, Laurens [10]

LESLEY, Florence Carroll [S] Chambersburg, PA b. Phila. Studied: ASL, Saint Gaudens; Académie Julian with Puech, Verlet [10]

LESLIE, Jean G(orman) (Mrs. Grant) [P] Santa Monica, CA b. 18 Ag 1888, Omaha, NE. Studied: A. Rothery; V. Vytlacil; Minn. Sch. A. Exhibited: Minn. State Fair, 1918 [33]

LESPINASSE, Herbert [P,I,En] Paris, France b. 13 Je 1884, Stamford, CT. Studied: Ecole des Beaux-Arts, etc., Paris. Member: Societé Nationale des Beaux-Arts; Societaire du Salon d'Automne. Work: 10 engravings, French Govt. [19]

LESSER, Elizabeth M. [P,I,C] NYC b. Warren, PA. Studied: W. Shirlaw; Colarossi Acad., Paris. Member: AAS; Chicago ASL. Exhibited: AAS, 1903 (med) [06]

LESSHAFFT, Franz [P] Phila., PA b. 8 Mr 1862, Berlin, Germany. Studied: PAFA; Royal Acad. FA, Berlin, with A.V. Werner, Thumann, Meyerheim. Member: Phila. Sketch C.; S.Indp.A.; Phila. AC; Art Teachers Assn. Exhibited: Berlin; AAS, 1902 [33]

LESTER, C.F. [I] NYC [19]

LESTER, Howard [Des,Photogr.] NYC b. 23 Mr 1904, Richland, NY. Member: Alliance. Exhibited: National Textile Competition, 1931 (prize). Specialty: textile design [40]

LESTER, Leonard [P,I] NYC/Pasadena, CA b. 4 F 1876, Penrith, England. Studied: AIC; NAD; ASL; Munich; Dresden [08]

LESTER, William H(arold) [I,E,W] Los Angeles, CA/Wolf, WY b. 23 Jy 1885, Valparaiso, Chili. Studied: AIC. Member: Chicago SE; Brooklyn SE [21]

LESTER, William Lewis [P,G,T] Austin, TX b. 20 Ag 1910, Graham, TX. Studied: A. Hogue; T. Stell. Member: Dallas MFA. Exhibited: Rockefeller Center, 1935; Tex. Centenn., 1936; Pan-Am. Expo, 1937; WFNY, 1939; GGE, 1939; PAFA, 1940, 1941; BM, 1941; San Diego FAS, 1941; AIC, 1941, 1942; VMFA, 1946; Colorado Springs FA Center, 1946; Dallas, Tex., (prizes) 1940, 1941, 1942; Witte Mem. Mus., 1941 (prize); Tex. Pr. Ann., 1941 (prize); Tex. General, 1945 (prize); Dallas Co. Allied Arts Exh., 1931 (prize). Work: Dallas MFA; Tex. Tech. Col. Position: T., Univ. Tex. [47]

LESTER, William R. [Cr] Phila., PA b. 1855 d. 22 Ja 1920. Positions: Ed., book reviews, Philadelphia North American; Ed., drama, Philadelphia Record

LE SUEUR, Mac [P,L,T,S] Minneapolis, MN b. 13 D 1908, San Antonio, TX. Studied: Minneapolis Sch. A. Member: Minnesota AA; Un. Am. Ar., Minn. Exhibited: Pal. Leg. Honor; AIC; WMAA; Critics Show, 1944; WFNY, 1939; Minn. State Fair, 1936 (prize), 1939 (prize); Minneapolis Inst. A.; Walker A. Center (one-man) Position: Dir., Walker A. Sch., Minneapolis [47]

LESVIOS, Alkie [P] Lynn, MA b. 6 Ag 1882, Athens, Greece. Studied: Polytech Sch., Athens. Member: Boston Ar. Un.; Lynn AC. Exhibited: BMFA [40]

LETAIYO, Chief [S,L] NYC/Hopewell, NJ b. 7 S 1906, Ouray, CO. Studied: ASL; BAID; Ecole des Beaux-Arts, Paris; J. Conradi. Member: Am. Ar. Prof. L.; 4 Artists C., NYC. Exhibited: NA, 1938; Am. Salon of A., NYC. Position: Dir., Am. Salon A. [40]

LETCHER, Blanche [P] Berkeley, CA [13]

LETHBRIDGE, Rodney [P,T] Woodhaven, NY/Port Ewen, NY b. 26 D 1891, Catskill, NY. Studied: H.E. Field; NYU. Member: Salons of Am. Position: T., NYC H.S. [40]

LEUSCH, Franziska A(ugusta) [P,C,T] Glenside, PA. b. Phila., PA. Studied: F. Wagner; F. Allen [24]

LEVER, (Richard) Hayley [P,E,L,T] Mt. Vernon, NY b. 28 S 1876, Adelaide, Australia d. 6 D 1958. Studied: Prince Alfred Cl., Adlelaide; ASL; Paris; London. Member: Am. P.&En.; NAC; CAFA; Royal British A., London; ANA, 1925; NA, 1933; Royal Inst. Oil P., London; Royal West of England Acad.; Contemporary; New SA. Exhibited: Macbeth; Rehn; Ferargil; Daniels; French and Co., Clayton, & others; NAD, 1914 (prize), 1936 (prize), 1938 (prize); NAC, 1914 (med), 1915 (med), 1916 (gold), 1922 (prize), 1940 (prize); P.-P. Expo, 1915 (gold); PAFA, 1917 (gold), 1926 (gold); Phila. WCC, 1918 (prize); Montclair AA, 1930 (med); New Rochelle AA, 1941 (med); Newark AC, 1936 (prize); Westchester A.& Cr., 1945 (prize); Sesqui-Centenn. Expo, Phila., 1926 (med). Work: PAFA; MMA; BM; Montclair AM; BMA; CGA; White House, Wash., D.C.; Ft. Worth Mus. A.; Dallas Mus. FA; Los Angeles Mus. A.; Telfair Acad.; Detroit Inst. A.; Des Moines A. Mus.; Univ. Nebr.; PMG; Duquesne C., Pittsburgh; NAC; Adelaide A. Mus.; Sydney, Australia AM; WMAA; Syracuse MFA; CAM; Memphis A. Mus.; Springville (Utah) AA; Perth Amboy Pub. Lib.; Little Rock AM; Salt Lake City Univ. Mus.; Lincoln Univ., Nebr. [47]

LEVERING, Albert [I] NYC b. 1869, Hope, IN d. 12 Ap 1929. Studied: Munich. Member: SI, 1912; Dutch Treat C. Illustrator: Collier's, Life, Judge, Cosmopolitan; New York Tribune, Minneapolis Times, Chicago Tribune, New York American. He practiced architecture in San Antonio, Tex., for several years, abandoning it to become a newspaper artist. Positions: Staff, Puck, Harper's [24]

LEVETT, Joel J. [P] NYC [17]

LEVEY, Aaron [En] NYC [19]

LEVEY, Jeffrey King [P,T] NYC/MacDowell Colony, Peterborough, NH b. 25 S 1908, NYC. Studied: D. Karfunkle; I. Olinsky; B. Robinson; D. Garber [40]

LEVI, Julian Clarence [P,Arch,E] NYC b. 8 D 1874, NYC. Studied: W.R. Ware, at Columbia; Scellier de Gisors, Ecole des Beaux-Arts, Paris. Member: BAID; AFA; NSS; NSMP; Arch. Lg.; AIA; Arch. Institutes in Brazil, Chile, Mexico, Uruguay; French Inst. Am.; Société Architectes Diplomés par le Gouvernement Français; SBAA; S. Beaux-Arts Arch.; Chevalier, Legion Honor, 1921. Exhibited: Paris Salon, 1904, 1905, 1937 (prize); Santiago, Chile, 1923 (gold); Turin, Italy, 1926; Boston AC, 1905; BM, 1933; Sch. A. Lg. Traveling Exh., 1936–37; NYWCC; AIC; Arch. Lg., 1905–46, 1933, (med), 1941 (one-man); Pan-Am. Expo, 1923 (med); Société des Architectes Diplomés, (med) 1927. Work: mem., Norfolk, Conn.; church, Norfolk; Co-Operative Apts., NYC; Paris Expo, 1937; Columbia Univ.; WMAA [47]

LEVI, Julian (E.) [P,T,Li] NYC b. 20 Je 1900, NYC. Studied: PAFA; France. Member: F., PAFA; An Am. Group; Am. A. Cong. Exhibited: Salon d'Automne, Paris, 1919 (prize), 1920, 1921; PAFA, 1928, 1930, 1939–46; CI, 1940, 1941, 1943–45; WMAA, 1936–45; AIC, 1938, 1940–45; CGA, 1941, 1943, 1945; VMFA, 1942, 1944, 1946 (prize); Herron AI, 1945; CAM, 1941, 1946; WMA, 1942, 1945; de Young Mem. Mus., 1940, 1943; Los Angeles Mus. A., 1945; Palace Legion Honor, 1945; BM, 1943; Dallas Mus. FA, 1945; NAD, 1944-46; Univ. Iowa, 1945; RISD, 1940; CM, 1934; TMA, 1941; Albright A. Gal., 1046; PAFA; Pepsi-Cola, 1945 (prize); NAD, 1945 (prize); AIC, 1942 (prize) 1943 (prize). Work: MOMA; MMA; WMAA; Springfield, Mass. Mus.; Albright A. Gal.; AIC; TMA; New Britain AI; PAFA; Newark Mus.; Univ. Nebr.; Univ. Ariz.; Cranbrook Acad. A.; Encyclopaedia Britannica Coll.; Walker A. Center; U.S. State Dept.; La France Inst., Phila. Contributor: Magazine of Art. Position: T., ASL [47]

LEVICK, Milnes [P,E,W,Li,B] NYC b. 1887. Member: Un. Am. A. Exhibited: AIC; SAE; CAA; Wichita AA; Albany Pr. C.; United Seamen's Service Exh., 1943. Author/Illustrator: "This is the Master Race," 1945. Contributor: national magazines [47]

LEVICK, Richard [E,P] b. 1864, Phila. d. 23 D 1917, London, England. Studied: Munich; Paris; Florence; U.S.

LEVIN, Alexander [P] Los Angeles, CA. Exhibited: 48 Sts. Comp., 1939. Work: USPO, Jasper, Tex. WPA muralist. [40]

LEVIN, Alexander B. [P,I] Chester Springs, PA b. 19 F 1906, Russia. Studied: PAFA, with D. Garber, Pearson, G. Harding. Exhibited: PAFA, 1927 (prize), 1929 (prize); Wash. SA, 1930 (med) [33]

LEVIN, Herman [P] Hartford, CT [19]

LEVINE, David Phillip [P,Des,Gr] Los Angeles, CA b. 13 D 1910, South Pasadena, CA. Studied: Univ. Southern Calif.; A. Center Sch., Los Angeles; Barse Miller; S. Reckless. Member: Am. Ar. Cong.; Calif. WCS; Council All. A., Los Angeles. Exhibited: Calif. WCS, 1936–42; Portland A. Mus., 1939; San Diego FAS, 1941; Riverside Mus., 1940; Denver AM, 1941; Colorado Springs FA Center, 1941; CI, 1941; Los Angeles County Fair, Pomona, 1938 (prize); Dallas MFA; CGA. Work: Los Angeles County Fair Coll. [Not to be confused with David Levine (NA, 1971) [P,I] b. 1926, active after 1953.] [47]

LEVINE, Gilbert [I] Los Angeles, CA. Member: SI [47]

LEVINE, H. Gilbert [P] Chicago, IL. Member: GFLA [27]

LEVINE, Jack [P] NYC b. 3 Ja 1915, Boston, MA. Studied: BMFA Sch., with H. Zimmerman; D. Ross. Member: Artists U. Mass.; F., Guggenheim Fnd., 1945. Exhibited: AV, 1943 (prize); CI, AIC; WMAA. Work: MMA; MOMA; AGA; Univ. Nebr.; Portland, Oreg. A. Mus.; Walker A. Center; Univ. Ariz.; FMA; Hirschorn M. WPA artist, 1935. [47]

LEVINE, Morris L. [Des,C] NYC b. 6 Jy 1896. Member: S. Des.-Craftsmen; NYSC. Exhibited: Intl. Expo, Paris, 1937 (med). Specialty: metal craft [40]

LEVINE, Saul [P,S] Wash., D.C. b. 11 Je 1915, NYC. Studied: Syracuse Univ.; Yale; Corcoran A. Sch., with H. Warneke. Member: United Am. Ar. Exhibited: PAFA, 1946; Pepsi-Cola, 1944; WMAA, 1943; AIC, 1943 (prize); WFNY, 1939; CI, 1940; VMFA, 1946; A. Gld. Wash., 1945; S. Wash. A., 1946; NA, 1938; 48 Sts. Comp., 1939. Work: BM; murals, USPOs, Ipswich, South Hadley, both in Mass. WPA artist. [47]

LEVINGS, Mark M. [E,En,B,Arch,L] McCook, NE b. 19 F 1881, Canton, IL. Studied: Pennell, AIC; Ecole des Beaux-Arts, Paris. Exhibited: Mid-Western A. Exh., Kansas City, 1927. Work: Soc. of Liberal Arts, Omaha, Nebr.; Los Angeles Mus. [40]

LEVINSKI, E. [P] Coolbaugh, PA [04]

LEVINSON, Abraham F. [P] Jamaica, NY/Rockport, MA b. 1 Ag 1883 d. 21 Jy 1946 NYC. Studied: R. Henri; M. Weber. Member: Am. A. Cong. Work: PMG [40]

LEVINSON, Horace, Mrs. See Wells, Alma.

LEVINSON, Ruth [P] Chicago, IL. Member: Chicago NJSA [25]

LEVIT, Herschel [P,Li,I] Phila., PA b. 29 My 1912, Shenandoah, PA. Studied: PAFA; Barnes Fnd. Member: Phila. A. All.; Phila. Pr. C.; Mod. Etchers Group. Exhibited: PAFA, 1934–36; AIC, 1934, 1938; Okla. A. Center, 1940; Phila. Pr. C., 1946; LOC, 1946; ACA, Phila., 1938 (one-man); Phila. A. All., 1938, 1944–46; Springfield A. Mus., 1938; New Sch. Social Research, 1938; All.A.Am., 1945, 1946. Work: Free Lib., Dept. Edu., Phila.; Univ. Pa. Mus.; Rowan Sch., Phila.; Mexican Navy Dept., Mexico City; Deeds Bldg., Wash., D.C.; USPOs, Lewisville, Ohio, Jenkintown, Pa. Illustrator: RCA record covers, Boy's Life, Salute. WPA artist. [47]

LEVITT, Alfred (H.) [P,L,Li] NYC b. 15 Ag 1894, Starodub, Russia; H. Hofmann. Exhibited: Babcock Gal., 1945 (one-man), 1946 (one-man); ACA Gal.; Wildenstein Gal.; Butler AI; Manchester (N.H.) Community Center; BM [47]

LEVITT, Joel J. [P,E] NYC b. 1 F 1875, Kiev, Russia d. 28 Mr 1937. Studied: Odessa Art Sch.; Acad. Design, Petrograd; Ilia Repin. Member: SC; North Shore AA; Allied AA; AAPL. Exhibited: Sesqui-Centenn., Phila., 1926 (med). Work: Petrograd Mus., Wilna Mus., Russia; Nat. Gal., Ottawa; Mus. Broadmoor A. Acad., Colorado Springs [33]

LEVITZ, Ebbitt A. [P] South Ozone, NY/New Haven, CT b. 17 S 1897, New Haven, CT. Studied: S. Kendall; Yale. Member: Queensboro AA; S.Indp.A. [29]

LEVONE, Albert Jean [I] Phila., PA b. 25 O 1895, Russia. Studied: T. Oakley; J.R. Sinnock. Illustrator: The Designer, Century [33]

LEVOW, Irving [E,Mur.P,Por.P,Ldscp.P] Highland Mills, NY b. 31 Ja 1902, Irkutsk, Russia. Studied: H. Wickey; ASL. Member: Hudson Highlands AA; N.Y. S.Indp.A.; Artists U., N.Y. [40]

LEVY, Alexander Oscar [P,I,Gr,Des] Buffalo, NY b. 26 My 1881, Bonn, Germany d. 1947. Studied: Cincinnati A. Acad.; N.Y. Sch. FA; Duveneck; Chase; Linde; Henri. Member: Buffalo SA; Soc. for Sanity in A.; SC. Exhibited: CM; PAFA, annually; Albright A. Gal., 1925–46; Rundel Gal., Rochester, N.Y., annually; Buffalo SA (prizes), 1922, 1923, 1924, 1935, 1937, 1938. Work: CM; Denver A. Mus.; AIC; Peabody Inst., Baltimore; Detroit Inst. A.; TMA; Temple Beth El, Buffalo; St. Mary's Church, Batavia, N.Y.; Temple Beth El, Niagara Falls, N.Y.; BM [47]

LEVY, Beatrice S. [E,En,P,B,Dr,L,T] Chicago, IL b. 3 Ap 1892, Chicago, IL d. 1974. Studied: AIC; C. Hawthorne; V. Preissig. Member: Chicago SA; Chicago SE; Chicago AC; Renaissance Soc., Univ. Chicago. Exhibited: P.-P. Expo, San Fran., 1915 (prize); AIC, 1917, 1919, 1922, 1923 (prize), 1928, 1929, 1930 (prize), 1931–40, 1942–46; CI, 1929; PAFA, 1923, 1924, 1929, 1931; NAD, 1945, 1946; SAE, 1938, 1940, 1944, 1945; Chicago SE, 1914–19, 1922–31, 1935–45; LOC, 1945, 1946; Fifty Prints of the Year, 1932, 1933; Springfield Acad., 1928 (prize); Chicago SA, 1928 (med). Work: AIC; Chicago Municipal Coll.; Bibliothèque Nationale, Paris; AIC; Los Angeles Mus. A.; LOC; Smithsonian Inst.; Vanderpoel Coll.; Corona Mundi Coll., NYC [47]

LEVY, Edgar [P] Brooklyn, NY b. 26 S 1907. Studied: ASL. Member: Un. Am. Ar.; Am. Ar. Cong. [40]

LEVY, Florence N. [W] NYC b. 13 Ag 1870, NYC d. 1947. Author: "Art in New York" (6 editions), "Art Education in the City of New York," articles on art in industry and education. Positions: Founder/Ed., "American Art Annual," 1898–1917; Staff, MMA, 1908–17; Manager, A. Alliance Am., 1917–20; Dir., BMA, 1922–26; Supv., Fed. Council on A. Edu., 1934–38; Dir., A. Edu. Council, 1938–45; Sec., Sch. A. Lg., NYC, 1909–45; Bd. Trustees, AFA, 1909–42 [47]

LEVY, Henry L. [P] Chicago, IL b. 6 O 1868. Studied: Lefebvre; Constant; Mosler. Member: Palette and Chisel Acad. FA [40]

LEVY, Herbert A. [P] NYC b. NYC. Studied: Gérôme, in Paris. Member: SC, 1892; A. Fund S. [01]

LEVY, Hilda P. (Mrs. Herman) [P,T] Hamden, CT b. 11 Ag 1907, Syracuse, NY. Studied: Syracuse Univ.; O'Hara. Member: New Haven PCC; Conn. WCS. Exhibited: All.A.Am., 1940, 1943; AWCS, 1945; Conn. WCS, 1938–46; North Haven Gal., 1944, 1945; New Haven PCC, 1935–46 [47]

LEVY, Philip [P] Los Angeles, CA. Member: Calif. AC [25]

LEVY, William Auerbach [P,E,T] NYC b. 14 F 1889, Russia. Studied: NAD; Académie Julian, Paris, with Laurens. Member: ANA, 1926; SC; Chicago SE. Exhibited: Chicago SE, 1914 (prize), 1918 (prize); P.-P. Expo, 1915 (med); NAD, 1921 (prize), 1925 (prize); Calif. PM, 1923 (med); SC, 1923 (prize), 1925 (prize); PAFA, 1924 (prize). Work: WMA; NYPL; CI; Detroit Inst. A. Position: T., NAD, NYC; Edu. Alliance, NYC [27]

LEVYNE, Sidney Alfred [P] Baltimore, MD b. 6 Ag 1903, Brooklyn, NY. Studied: D. Coale. Exhibited: Baltimore MA, 1937 (med), 1938; PMG; Greenbelt, Md. (one-man) [40]

LEWANDOWSKI, Edmund D. [P,Des,Dec,B,T] Milwaukee, WI b. 3 Jy 1914, Milwaukee. Studied: Layton Sch. A. Member: Wis. PS; Polish-Am. A.; Chicago FA Cl.; Calif. WCS; Wis. Fed. A. Exhibited: AIC, 1938–45; CI, 1940–46; CGA, 1939, 1940; PAFA, 1940, 1942, 1944; BM, 1939–42; Wis. PS, 1938–42; Wis. Salon, 1939, 1940; Layton A. Gal., 1938 (one-man); MOMA, 1943; Milwaukee AI, 1938 (prize), 1940 (med); Wis. State Fair, 1939 (prize); Univ. Wis., 1939 (prize); WFNY, 1939 (prize); Wis. WC, 1946 (prize); 48 Sts. Comp. (prize). Work: MOMA; Univ. Wis.; Milwaukee AI; Layton A. Gal.; BMFA; Grand Rapids AI; AGAA; U.S. Treasury Dept.; Shell Oil Co.; U.S. Maritime Comm.; Milwaukee Real Estate Bd.; USPO, Hamilton, Ill.; Gov. Collections, Warsaw, Krakow, both in Poland. Contributor: articles, New York Times, New Rebublic, Nation; Chicago Tribune; Milwaukee Journal. Positions: T., Layton Sch. A., Milwaukee (1946), Forest Home Ave. Social Center [47]

LEWENBERG, N. [P] NYC [10]

LEWIS, Ada [P] Beards, KY. Member: Louisville AL [01]

LEWIS, Alice L. [P,Des,T] Pittsfield, MA b. 1873, Providence. Studied: Collin, in Paris; D. Donaldson; J.L. Tadd; RISD; E. Zweybruck, in Vienna; M. Werten, in Poland. Member: Boston SAC; Pittsfield AL; Intl. A. Group, NYC; Providence Handicraft C.; Mass. A. T. Assn. Work: murals, May C. Wheeler Sch., Providence; Women's Union, Fall River, Mass. Position: T., Berkshire Sch. Crippled Children, Pittsfield [47]

LEWIS, Alonzo Victor [P,S] Seattle, WA b. 1886 d. 7 N 1946 [25]

LEWIS, Archie Henry [P] Minneapolis, MN [24]

LEWIS, Allen [E,En,I,Des,W,L,T,P] Basking Ridge, NJ b. 7 Ap 1873, Mobile, AL d. 1957. Studied: Buffalo ASL; Ecole des Beaux-Arts, Paris; Bridgman; Gérôme. Member: SAE; Am. Soc. Typophiles; NA, 1935; Chicago SE; AI Graphic A.; Stowaways; Calif. PM; AFA. Exhibited: Buffalo SE, 1915 (prize); AIC, 1915 (prize); NAD, 1928 (prize); St. Louis Expo, 1903 (med); Sesqui-Centenn. Expo, Phila., 1926; Chicago SE, 1915 (prize); P.-P. Expo, 1915 (gold); Brooklyn SE, 1917 (prize); NAC, 1928 (prize); 50 Books of the Year, 1933; 50 Prints of the Year, 1926, 1929, 1932; 100 Prints of the Year, 1936. Work: NYPL; MMA; BM; CMA; Detroit Inst. A.; British Mus., London; Oakland A. Gal.; LOC; Newark Pub. Lib.; Columbia; AIC; Herron AI; Univ. Rochester; Univ. Calif.; Michigan City, Ind. Pub. Lib.; Hotchkiss Sch., Conn.; Yale; Princeton; Bibliotheque Nat.; Univ. Nebr.; Providence Lib. Author/Illustrator: Bookplate Annual. Illustrator: "Short Stories," by Walt Whitman, "Journeys to Bagdad," by Charles Brooks, "Paul Bunyon," "Jesus Christ in Flanders," by Honoré de Balzac, "Hepatica Hawks," by Rachel Field [47]

LEWIS, Bertram [P] Brooklyn, NY. Member: S.Indp.A. [25]

LEWIS, Cyril Arthur [P,Des,L] East Williston, NY b. 24 Jy 1903, Birmingham, England. Studied: Birmingham Col. A. & Crafts, England. Member: SC; All.A.Am.; Audubon A.; Brooklyn SA; Nassau County AL. Exhibited: AWCS; All.A.Am., 1943 (med); Audubon A.; SC; Brooklyn SA [47]

LEWIS, Edmonia [S] Rome, Italy (1898) b. 1843 (or 1845), Greenbush, NY. Studied: self-taught; briefly under E.A. Brackett, in Boston, 1865. Member: White Marmorean Flock, Rome, 1867 (expatriate Am. Women S.). Exhibited: Soldiers Relief Fair, Boston, 1865; Phila. Centenn. Exh., 1876. Prominent Negro-Indian sculptress working in neoclassical tradition. Settled in Rome, 1867 [*]

LEWIS, Edmund Darch [Mar.P,Ldscp.P] Phila., PA b. 17 O 1835, Phila. d. 12 Ag 1910. Studied: Phila., with P. Weber, 5 yrs. Exhibited: PAFA, 1854; NAD; Boston Athenaeum. Best known for his watercolor marines. Also a noted furniture and china collector. [*]

LEWIS, Edwin S. [P] Boyce, VA. Work: USPOs, Berryville, Petersburg, both in Va. WPA artist. [40]

LEWIS, Elizabeth (Mrs. M.H.) [P,Des] Victorville, CA b. 30 Ap 1908, Capitol View, MD. Award: House Beautiful Cover Des., 1931 (prize), 1933 (prize) [40]

LEWIS, Elizabeth H. [P,C,L,T] NYC/St. Peter's Rectory, Peekskill, NY b. Peekskill, NY. Member: S.Indp.A. [25]

LEWIS, Eva Oak Park, IL b. Bloomingdale, IL. Studied: H.F. Spread, AIC [01]

LEWIS, F.C. [P] Toledo, OH. Member: Artklan [25]

LEWIS, George Albert [P] d. 23 D 1915, Phila.

LEWIS, (Harry) Emerson [P,Et,L,I,T] Corte Madera, CA b. 28 F 1892, Hutchinson, KS. Studied: Northwestern Univ.; AIC; Sorbonne, Paris; Alton; E.H. Lewis; A. Robinson; Milan; Florence; Rome. Member: AAPL; Western AA; Soc. Sanity A.; Bay Region AA; Santa Cruz AL; Oakland AA; Springville A.; Palette and Chisel C.; San Fran AL. Exhibited: Delgado Mus. A.; NOAA; Pal. Leg. Honor; Calif. State Fair, 1938 (prize); Grand Rapids AG; Kansas Fed. A.; Los Angeles Mus. A.; Springville AA; Palette & Chisel C.; Oakland AG; Santa Cruz AA; Los Angeles AA, 1931 (prize); Bay Region AA, 1939 (prize); GGE, 1939 (prize); Am. P.&S., Los Angeles, 1931, (prize). Work: Grand Rapids Mus. Coll.; Hotel Roosevelt, Hollywood; El Dorado Hotel, Hollywood. Position: T., natural camouflage, U.S. Army, WWI [47]

LEWIS, Helen V(aughan) [Min.P] Hudson, NY b. Mr 1879(?). Studied: Cox; Du Mond; Beckington. Member: Pa. SMP [33]

LEWIS, Henry [P] b. 12 Ja 1819, Scarborough, England (came to Boston, 1829, settled in St. Louis, 1836) d. 16 S 1904, Düsseldorf, Germany. Best known for his 1846-48 sketching trip along the Mississippi which resulted in his 4,000 ft. panorama painted in Cincinnati, 1848-49. As U.S. Consul, he brought the panorama to London and Europe, settling in Düsseldorf. He was general art manager for the great Crystal Palace Exh. Had 78 illus. in "Illustrierte Mississippithal," 1854. He sent many landscapes and still lifes back to the U.S. for sale.

LEWIS, Herbert Taylor [P,T,L] Oak Park, IL/Richards Landing, Ontario. b. 30 D 1893, Chicago. Studied: AIC; Académie Julian, Paris. Chicago Acad. FA; Chicago Univ. Exhibited: AIC; Calif. SE, 1933 (prize). Work: Rockford Col., Ill. Positions: T., Rockford Col., 1924-27; A. Dir., Maine Township H.S., Jr. Col., Des Plaines, IL [40]

LEWIS, Jeannette Maxfield (Mrs. H.C.) [E,En,P] Fresno, CA b. 19 Ap 1896, Oakland, CA. Studied: Calif. Sch. FA; W. Reiss; H. Hofmann; G. Piazzoni; A. Hansen. Member: SAE; Calif. SE; AFA; NAWA; San Fran. S. Woman A.; Oakland AL; AAPL; Pacific AA; Fresno AA; Santa Cruz AL; Carmel AA; Northwest PM; So. PM. Exhibited: NAD, 1932, 1934-36, 1944; SAE, 1932, 1934, 1935, 1939; Venice, Italy, 1940, 1941, 1944, 1945; NAWA, 1933, 1934, 1936, 1945; Los Angeles Mus. A., 1934, 1935, 1937; Wash. WCC, 1934; AIC, 1936; GGE, 1939; Southern PM, 1943; MMA, 1942; LOC, 1945, 1946; Calif. SE, 1934-46; Northwest Pr.M., 1934-44; New Haven PCC, 1934, 1937; WFNY, 1939; Crocker A. Gal., 1946 (one-man); Gumps A. Gal. (one-man); San Diego FA Soc., 1934 (one-man); Calif. State Lib., 1939 (one-man); Rouze Gal., Fresno, Calif., 1946 (one-man); Santa Cruz AL, 1930 (prize); Calif. SE, 1934 (prize), 1946 (prize). Work: NYPL; SAE; Calif. SE [47]

LEWIS, Jennie [G] San Diego, CA b. San Diego, CA. Studied: Col. AC, Oakland; Calif. Sch. FA, San Fran.; Chase Summer Sch., Carmel. Exhibited: SFMA, 1939 [40]

LEWIS, Jessica [P,T] Camden, ME b. 1859, Bangor, ME d. 12 Je 1947, NYC. Studied: Boston art schs.; F. Tompkins; D. MacKnight; H.J. Carter. Work: All Souls Unitarian Church., N.Y. [10]

LEWIS, John Frederick [Patron] Phila., PA b. 10 S 1860, Phila. d. 24 D 1932. Member: PAFA (Pres.); Hist. Soc. Pa.; Art Jury of Phila.; Am. Acad. Mus.; Mercantile Lib.; Am. Fed. Arts; Archaeological S. Pa.; Numismatic and Antiquarian S. He owned one of the world's finest collections of illuminations from medieval manuscripts, and a notable collection of rare books. Also a lawyer.

LEWIS, John Smith [P] Dinard, France [10]

LEWIS, Josephine M(iles) [P] NYC/Scituate, MA b. New Haven, CT. Studied: J.F. Weir; J.H. Niemeyer; Yale; R. MacMonnies, Aman-Jean, in Paris. Member: NAWPS; New Haven PCC; Allied AA. Exhibited: NAD, 1916 (prize); New Haven PCC, 1923 (prize), 1933, 1939 (prize) [40]

LEWIS, L. Howell [P,S] b. 1853 d. 23 My 1935

LEWIS, Lalla Walker [P,En,I,B,T] Greenwood, MI b. 14 N 1912, Greenwood, MS. Studied: Miss. State Col. for Women. Member: SSAL; Miss. AA; Southeastern AA. Exhibited: Laguna Beach AA, 1945; LOC, 1944; CI, 1944; Phila. Pr. C., 1946; SSAL, 1935 (prize); Minneapolis Inst. A., 1936 (prize). Work: Miss. State Col. for Women; Delgado Mus.; Belhaven Col. & Municipal Gal., Jackson, Miss.; Newcomb Col., Tulane; mural, Greenwood, Miss. Pub. Lib. Illustrator: Progressive Farmer. Position: T., Delta A. Center, Greenville, Miss. [47]

LEWIS, Laura Blocker [P] New Orleans/Fort Russell, Marja, TX b. 14 Je 1915, Manila, Phillipines. Studied: New Orleans ACC; X. Gonzalez. Exhibited: Witte M., San Antonio, Tex.; West Tex. A. Exh., Ft. Worth. Work: mural, USPO, Eunice, La. WPA artist. [40]

LEWIS, Laura C. (Mrs.) [P] Phila., PA b. 21 Ag 1874, Phila. Studied: Phila. Sch. Des. for Women; PAFA; E. Daingerfield; W.L. Lathrop; W.M. Chase. Member: Plastic C. Work: portrait in Lib. Coll. Acad. Natural Sc., Phila. [33]

LEWIS, Louise G. [P] Atlanta, GA [24]

LEWIS, Margaret Sarah [T,Ldscp.P,G,Des,D,L,B] York, PA b. 8 F 1907, York, PA. Studied: Md. Inst.; Columbia; M. Sheets; C.H. Martin; J. Chapin; C. Walthers. Member: Eastern AA; Nat. Edu. Assn.; Pa. Council A. Edu.; York AC. Exhibited: LOC, 1943, 1944, 1946; AFA Traveling Exh., 1943; PAFA, 1945; Md. Inst. (one-man); Martin Lib., York; York AC, 1931-46; Pa. A. T. Assn. Exh.; Pa. State Col., 1935-37; Hagerstown, Md., 1935. Positions: T., York Jr. Col. 1943- , York City Sch. District, 1929- [47]

LEWIS, Martin [P,E] NYC b. 1881, Castlemain, Australia (came to San Fran. in 1900, then settled in NYC) d. 20 F 1962. Studied: J. Ashton A. Sch., Sydney, Australia. Member: SAE; Chicago SE; AWCS. Exhibited: LOC; SAE, 1926 (prize), 1940 (prize); Chicago SE, 1929 (prize); Phila. Pr. C., 1930 (prize), 1931 (prize); Southern Calif. PM, 1929 (prize); Boston AC, 1929 (prize); NYWCC, 1929 (prize); WFNY, 1939; AV; AWCS, 1929 (prize); Kennedy Gal., NYC, 1973 (retrospective). Work: BMFA; MMA; CMA; WMAA; AGAA; AIC; LOC; NYPL; Nat. Mus., Stockholm, Sweden; Univ. Glasgow, Scotland; Chicago SE; Cleveland Pr. C.; SAE; Prints of the Year, 1932. He made about 145 etchings/drypoints, beginning in 1915, many of which were urban night scenes. Position: T., ASL [47]

LEWIS, Monty [P,Des,L,T] Coronado, CA b. 6 S 1907, Cardiff, Wales. Studied: ASL, with K.H. Miller, K. Nicolaides; Europe. Member: NSMP; San Diego AG; F., Tiffany Fnd., 1928; F., Guggenheim, 1930; Mural AG;

Exhibited: MOMA, 1932, 1939, 1942; WMAA, 1933; AGAA, 1932; AIC, 1936; PAFA, 1937; Newark Mus., 1940; CGA, 1943; San Diego FA Soc., 1942-45; NYC; San Fran.; La Jolla, Calif.; Baltimore; St. Louis. Work: San Diego FA Soc.; frescoes, N.Y. Sch. Women's Garment Trades. Position: T., Coronado Sch. FA, Calif. [47]

LEWIS, Phillips F(risbie) [P] Oakland, CA b. 26 Ag 1892, Oakland d. 24 F 1930. Studied: Calif. Sch. of A.&C.; A.C. Hansen. Member: San Fran. AA; Oakland AL; San Fran. Galerie Beaux Arts; AFA. Exhibited: Palace of Fine Arts, San Fran., 1922; Berkeley Lg. FA, 1924; Springville, Utah, 1926; Ariz. State Fair, Phoenix, 1927 (prize). Work: Oakland Pub. A. Gal. [29]

LEWIS, Ralph Mansfield [Des,C,P] Manchester, NH b. 1 S 1911, Hingham, MA. Studied: Manchester Inst. A.&Sc.; Harvard. Member: Ar. Un., Manchester. WPA artist. [40]

LEWIS, Ross A. [Car] Milwaukee, WI b. 9 N 1902, Metamora, MI. Studied: Milwaukee State T. Col.; Wis. Sch. A.; Layton Sch. A.; ASL; G. Oberteuffer; G. Sinclair; B. Robinson; W. Duncan. Exhibited: AIC; Wilwaukee AI; Kalamazoo AI; Wustum Mus. FA; New Orleans; Los Angeles; Sacramento, Calif. Work: Huntington A. Gal., Los Angeles; Milwaukee AI; Univ. Minn.; Univ. Mo.; Kent Col.; Boston Univ.; Peabody Inst.; Columbia; Northwestern Univ. Award: Pulitzer Prize, 1936. Position: Car., Milwaukee Journal, 1933- [47]

LEWIS, Ruth [P] Mt. Vernon, NY b. 6 O 1905, NYC. Studied: ASL; R. Soyer; M. Soyer; F. Criss; S. Laufman. Member: NAWA; Audubon A.; NYSWA. Exhibited: Everhart Mus., 1944; NAWA, 19445; NYSWA, 1946; Audubon A., 1944; Am.-British A. Center, 1945; Norlyst Gal. Work: Everhart Mus., Scranton, Pa. [47]

LEWIS, St. John [P] b. 1866, France d. 21 Ag 1915, NYC. At age of 12 one of his paintings was hung in the Acad. of Art, London. He painted the scenery for many of the Brady and Frohman productions.

LEWIS, Tom E. [P] Kailua, HI b. 22 F 1909, Los Angeles, CA. Member: San Fran. AA. Exhibited: Los Angeles Co. Fair, 1931 (prize); San Diego FA Gal., 1932 (prize); Ebell patrons, Los Angeles, 1934 (prize); So. Calif. A., Santa Cruz, 1934; Calif. WCS, 1934 (prize), 1936 (prize); San Diego AG, 1934 (prize); Oakland A. Exh., 1935 (prize), 1937 (prize); Ebell Salon, Los Angeles Mus., 1935 (prize), 1936 (prize); San Fran. AA, 1939 (prize). Work: Los Angeles Mus.; SFMA; Calif. Palace of the Legion of Honor [40]

LEWIS, Toma [S] NYC [15]

LEWISOHN, Irene [Patron] d. 4 Ap 1944, NYC. One of founders in 1915 of the Neighborhood Playhouse; co-dir., 1928-44; pres., Costume Inst., 1937-44, now part of MET. Friedsam Medal in Indus. A. awarded posthumously, 1945.

LEWISOHN, Raphael [P] NYC [10]

LEWITIN, Isaac Moise [P] NYC. Member: Lg. AA [24]

LEY, Mary Helen [P,Des,I,T] Fort Wayne, IN/NYC b. Ap 1888, Leadville, CO. Studied: AIC, with D.C. Watson, A. Sterba; NYU; Columbia. Member: Ft. Wayne Art Sch. and Mus. Author: "Trees," art textbook, 1937. Position: T., South Side H.S., Ft. Wayne [40]

LEYDEN See Van Leyden, Ernst.

LEYENDECKER, Frank Xavier [I] New Rochelle, NY b. 19 Ja 1877, Montabour, Germany (brother of Joseph, came to Chicago, 1882) d. 19 Ap 1924 (possibly of drug overdose). Studied: Paris, with Laurens, Constant. Member: SI. Illustrator: covers for leading magazines [27]

LEYENDECKER, J(oseph) C(hristian) [I,P] New Rochelle, NY b. 23 Mr 1874, Montabour, Germany (came to Chicago in 1882) d. 26 Jy 1951. Studied: AIC; Académie Julian, Paris, with Bouguereau, Laurens, Constant; Acad. Colarossi, 1896-98. Member: SC. Award: poster-cover, Century, 1896 (prize). The most successful illustrator of his era, he is best known for his ads for the "Arrow Collar Man," which created a sensation and brought him a fortune (which he spent freely through the 1930s and died poor). He created 321 covers for the Saturday Evening Post, beginning 1899. [40]

LIBBEY, Edward Drummond [Patron] Toledo, OH b. 1854, Chelsea, MA d. 13 N 1925. Made many gifts to the Toledo Mus., including $1,000,000 a few months before his death. By the terms of his will the Museum receives bequests amounting to $4,850,000. Position: Pres., Toledo Mus. Art

LIBBY, Elsa [E] Wells, ME b. 30 D 1909, Jackson, MS. Studied: Otis AI; AIC. Specialty: textile design [40]

LIBBY, Francis Orville [P,C,Photogr] Portland, ME b. 7 Ag 1883, Portland, ME. Studied: Princeton. Member: SC; Portland SA; North Shore AA; Boston SAC; SC; Hayloftyers, Portland; Royal Photogr. S., Great Britain; London Salon. Exhibited: PAFA; Pa. SMP; ASMP; BM; AIC; Baltimore WCC; Portland SA; Boston AC; Ogunquit A. Center; North Shore AA; SC [47]

LIBBY, William Charles [Li,P,T] Pittsburgh, PA b. 6 F 1919, Pittsburgh. Studied: CI. Exhibited: LOC, 1945; Laguna Beach AA, 1945, 1946; John Herron AI, 1946; CI, 1945; Pittsburgh AA, 1940-46, 1945 (prize). Position: T., CI [47]

LIBERTE, Lewis Jean [P,T] NYC b. 20 Mr 1896, NYC d. 24 Ag 1965. Studied: CUASch; ASL; BAID; A. Crisp; D. Karfunkle. Member: Am. A. Cong. Exhibited: GGE, 1939; PAFA, 1945; Nebr. AA, 1944-46; CI, 1943-46; CGA, 1945 (prize); AIC, 1944; MOMA, 1943; WMAA, 1944, 1945; WMFA, 1942, 1944, 1946; Clearwater A. Mus., 1943-45; BM, 1945; Walker A. Center, 1943; Critics Choice, N.Y., 1945. Work: WMAA; MMA; Telfair Acad.; Nebr. AA; St. Bonaventure Col., N.Y; Walker A. Center; Univ. Ariz.; Univ. Ga. Positions: T., Dorothy Paris Workshop (NYC), ASL (1946), Great Neck AA (1946) [47]

LIBERTON, Evelyn Heysinger (Mrs.) [P] Phila., PA [10]

LICHNOVSKY, Jennie M. [P,S] Omaha, NE b. Everest, KS. Studied: J.L. Wallace. Member: Omaha AG [40]

LICHTEN, Frances M. [P,I,E] Phila., PA b. Bellefonte, PA d. 29 Mr 1961. Member: Phila. WCC; Phila. Pr. C. [33]

LICHTNAUER, J(oseph) Mortimer [Mur.P,S] Westport, CT b. 11 My 1876, NYC. Studied: ASL; Julian Acad., Paris; Mowbray; Merson; Laurens, Paris; Italy. Member: NSMP; Arch. L.; Silvermine G. A.; SC; A. Fellowship; AAPL; Mural P.; AFA; Westport A. Market. Exhibited: NSMP, annually; NAD, 1945; SC; Silvermine Gl. A.; Argent Gal., 1946 (oneman); Arch. L., 1903 (med), 1905 (med); Paris Salon, 1937 (med). Work: Smithsonian Inst.; MMA; BM; AAAL; triptychs, U.S. Army; Wallach Theatre; Shubert Theatre; Adelphi Theatre, NYC [47]

LICHTENFELD, Donald [P] NYC b. 30 S 1891, London, England [17]

LICHTENSTEIN, Gertrude W. [P] Kansas City, MO [17]

LICHTENSTEIN, Marie E. [P] NYC [15]

LICHTIN, Rosa (Mrs. Aaron) [P] Phila., PA/Wildwood, NJ b. 31 D 1898, Russia. Studied: PAFA. Member: Graphic Sketch C. Work: portrait, North Phila. Zionists [33]

LICHTNER, F. Schomer [P,G,Des,I,Li,B] Milwaukee, WI b. 18 Mr 1905, Peoria, IL. Studied: State T. Col., Milwaukee; AIC; ASL; Univ. Wis.; G. Moeller; B. Robinson; O. Hagen. Exhibited: Wis. State Fair, 1930 (prize); Wis. A. Exh., 1932 (prize), 1937 (prize); Wis. PM, 1937 (prize); Wis. Ar. Fed. (prize); Wis. PS, 1939; AIC, 1914; Wis. Hist. S., 1945; Milwaukee City C., 1945; Milwaukee AI, 1945 (prize), 1946 (prize). Work: murals, USPOs, Sheboygan, Wis., Hamtramck, Mich., Hodgenville, Ky. WPA artist. [47]

LICHTNER, Ruth G. See Grotenrath.

LICHTY, George Maurice [Car] Evanston, IL b. 16 My 1905, Chicago, IL. Studied: AIC; Univ. Mich. Work: Huntington, Lib., San Marino, Calif. Positions: Car., Chicago Daily Times and United Features Syndicate [40]

LICINI, Frank [P] Phila., PA. Studied: PAFA [25]

LIDDELL, Alberta B. (Mrs. Fred R.) [P,T] La Porte, IN b. 3 N 1887, La Porte, IN. Studied: W. Adams; M.M. Hoffmaster; C.C. Bohm; F.L. Allen, Boothbay Harbor, Maine. Member: Northern Ind. A.; La Porte FAA; Northern Ind., A. Salon; Hoosier Salon. Exhibited: Hammond, Ind., 1946 (prize) [47]

LIDDELL, Katherine (Forbes) [P] Provincetown, MA b. Montgomery, AL. Studied: E.A. Webster. Member: Provincetown AA; NYSWA [33]

IDOV, Arthur Herschel [P,Des,G,I] Patterson, NJ b. 24 Je 1917, Chicago, IL. Studied: Univ. Chicago; E. Armin. Member: Un. Am. Ar. Exhibited: AIC, 1939-44; Milwaukee AI, 1945; Fed. A. Project Exh., 1938; Hyde Park Gal., Chicago; 48 Sts. Comp. Illustrator: Fortune [47]

LIE, Jonas [Ldsc.P] NYC b. 29 Ap 1880, Oslo, Norway (came to NYC in 1893) d. 11 Ja 1940. Studied: NAD; CUASch; ASL. Member: ANA, 1912; NA, 1925; NAD (Pres.), 1934-39; PMA, 1934; NAC; Century C.; AFA; Boston AC; Three AC; Studio C.; Lotos C.; Municipal A. Comm.; Municipal AS; NIAL; Art Comm. Assoc. Exhibited: St. Louis Expo, 1904 (med); NAD, 1914 (prize), 1927 (prize), 1936 (med), 1937 (prize); P.-P. Expo, San Fran., 1915 (med); Newport, R.I., 1916 (prize); Art Week, Phila., 1925 (gold); Chicago Norske Klub, 1925 (prize), 1927 (prize); H.S. AA, Springville, Utah, 1927 (prize); NAC, 1929 (prize); Amsterdam, 1928

(prize); PAFA, 1935 (med). Work: CI; MMA; Detroit Inst. A.; AIC; Luxembourg Mus., Paris; Peabody Inst.; Rochester Mem. Gal.; Dallas AA; Lafayette AA; BMFA; CMA; Brooklyn Inst. A.&.Sc.; Albright A. Gal.; Telfair Acad.; CGA; Norwegian Legation, Wash., D.C.; Cedar Rapids AA; Elmira AA; Canajoharie Lib., N.Y.; Saranac Lake Lib., N.Y.; RISD; Plainfield City Hall, N.J.; Lotos C.; NAC; Engineers C.; WMAA; Norske C., Chicago; Springville H.S. AA,; Iowa State Univ.; St. Louis Merchants C.; AGAA; Franklin Delano Roosevelt Coll.; Crown Prince Olav of Norway Coll.; Minneapolis Inst. A. Coll.; series on the Panama Canal, West Point, 1929 [38]

LIEBERMAN, Frances Beatrice [P] Palo Alto, CA b. 22 Ja 1911, San Francisco. Studied: Calif. Sch. FA. Member: San Fran. Women A.; San Fran. AA [40]

LIEBERMAN, Frank Joseph [B,Des,Dr,I,S] NYC b. 4 My 1910, Atlanta, GA. Illustrator: covers., Vanity Fair, Vogue [40]

LIEBES, Dorothy Wright (Mrs. Relman Morin) [Des,C,L,W,T] San Fran., CA b. 14 O 1899, Santa Rosa, CA d. 1972. Studied: Calif. Sch. FA; Univ. Calif.; Columbia. Member: San Fran. AA; San Fran. SWA; Art Center, San Fran.; MOMA; Friends of Far Eastern Art; S. Des.-Craftsmen; Am. Inst. Arch. Exhibited: SFMA (one-man); BM (one-man); CAM; AIC; Walker A. Center; MOMA; MMA; Lord & Taylor, NYC (prize); Nieman-Marcus, Dallas, Tex. (prize); AID (prize); ADI (prize); Plastic Assn. (prize); Am. Inst. Arch., 1938, Hollywood; Intl. Expo, Paris, 1937. Work: hotel, Yosemite, Calif.; hotel, San Fran.; Honolulu Acad. A.; Ft. Worth MA; WFNY, 1939; Yerba Buena C.; San Fran. Bldg., GGE, 1939. Author: Decorative Arts Catalog, GGE, 1939. Contributor: House Beautiful, Vogue, California Arts and Architecture; Plastics, other publications. Specialty: textile designs. Position: A.Dir., Arts & Skills Corps, Wash., D.C, 1943-46 [47]

LIEBMAN, Aline Meyer (Mrs. Charles J.) [P] NYC b. Los Angeles, CA. Studied: Barnard Col.; Columbia; H. Mosler; S. Hirsch; M. Fromkes. Exhibited: Walker A. Gal., 1936 (one-man); SFMA, 1937 (one-man); Bennington Col., 1937 (one-man); Portland A. Mus., 1939; Kelekian Gal., 1942 (one-man); Weyhe Gal., 1943 (one-man); Art of this Century, 1943; Salons of Am., 1929, 1930, 1932, 1934, 1935. Work: San Fran. MA [47]

LIEBNER, O.F. [P] Cleveland, OH. Member: Cleveland SA [27]

LIEBSCHER, Gustave [P] Brooklyn, NY [06]

LIEDLOFF, James E. [Des,S,T] NYC b. 10 S 1905, WI. Studied: C. Wells, at Minneapolis Sch. A.; L. Lentelli, ASL. Illustrator: covers, Esquire, 1936; illus., McCall's, 1934, Dupont Acele Corp., 1935. Position: T., Craft Students Lg., NYC [40]

LIEFTUCHTER, Felix B. [P] Cincinnati, OH b. 29 O 1883, Cincinnati. Studied: Munich, with Duveneck, F. von Stuck. Work: Apse dec., St. Agnes' Church, Cleveland, Ohio; murals, Cathedral of the Magdalene, Salt Lake City [17]

LIELLO, John [P] NYC. Member: S.Indp.A. [24]

LIETZ, Mattie [P,T] Dixon, IL b. 21 Jy 1893, Peoria, IL. Studied: Butler Col., Irvington, Ind.; AIC; F. Grant; G.E. Browne; J.T. Nolf; A. Hansen; Oberteufer. Member: Chicago Gal. Assn.; P.&S. Assn.; La Grange AL; All-Illinois FAA. Exhibited: NAD; AIC; Hoosier Salon, 1935 (prize); Chicago Gal. Assn.; P.&S. Assn., Chicago; All-Ill. FAA, 1946 (prize); Burpee A. Gal., Rockford, Ill. Work: Tipton Ind., Lib.; Norton A. Gal., West Palm Beach, Fla. [47]

LIFVENDAHL, Robert [P] Chicago, IL. Exhibited: PS Ann., 1937; WC Ann., 1938; Ar. Chicago, Vicinity, 1938; AIC; NA, 1938; WC Ann., PAFA, 1938; GGE, 1939 (prize); Chicago, 1937 (prize). [40]

LIGGETT, Henry T. [P] NYC. Member: NAC. Exhibited: Studio G., NYC, 1938. Work: Port. Met. Opera, NYC [40]

LIGGET, Jane Stewart [S,P,T] Merion, PA b. 4 S 1893, Atlantic City, NJ. Studied: PAFA, B. Fenton; Paris. Member: NAWA; AAPL; Phila. A. All.; AFA; F., PAFA. Exhibited: Woodmere A. Gal., 1941-45; PAFA, 1941-46; All A. Am., 1943; Phila. A. All., 1942-46; NAWA, 1942. Position: T., Valley Forge Gen. Hospital, Phoenixville, Pa., 1944-45 [47]

LIGGETT, John, Jr. [P] Pittsburgh, PA. Member: Pittsburgh AA [21]

LIGHT, Ruth [Des,Dr,P] Brooklyn, NY. Studied: CUASch; W. Reiss. Work: Ben Uri S., London; Wizo Center, Tel-Aviv, Palestine. Contributor: article, London Studio [40]

LIGHTON, Gertrude G. [P] Kansas City, MO [25]

LILLIE, Ella Fillmore (Mrs. Charles D.) [Li,P,C] Danby, VT b. 3 O 1887, Minneapolis, MN. Studied: Minneapolis Sch. FA; AIC; NY Sch. FA; Cincinnati A. Sch.; R. Koehler; K.H. MIller; A. Webster; W. Fry; A. Gunther. Member: Ind. S. PM; Hoosier Salon; Calif. PM; Springfield AL; Albany Pr. C.; Northwest PM. Exhibited: AIC, 1935, 1936, 1940; CGA, 1935, 1940; PAFA, 1936; Minneapolis Inst. A., 1936; SFMA, 1937; Herron AI, 1946; Albright A. Gal., 1940, 1943; SAM, 1939, 1940; CAFA, 1941, 1944; Okla. A. Center, 1939-41; Oakland A. Gal., 1941; CI, 1945; LOC, 1944-46; NAD, 1942, 1946; Mid-Vermont A.; Hoosier Salon, 1939-46, 1940 (prize), 1945 (prize), 1946 (prize); Calif. PM; Southern PM, 1938 (prize); Northwest PM, 1940 (prize); Springfield, Mo., 1941 (prize), 1942 (prize); LOC, 1945 (prize). Work: Fleming Mus., Burlington, Vt.; BMFA; LOC; Dayton AI; Calif. State Lib.; SAM [47]

LILLIE, John [Ldscp.P] Dorset, VT b. 23 Mr 1867, Dorset, VT. Studied: self-taught, primitive painter. Work: MMA; Concord A. Center, Concord, Mass.; Canajoharie A. Gal., N.Y.; Wood Mem. Gal., Montpelier, Vt.; State Normal Sch., Castleton, Vt. [40]

LILLY, J.J. [P] Toledo, OH. Member: Artklan [25]

LILLY, Joseph, Mrs. See Lowengrund, Margaret.

LILLYWHITE, Raphael [P,T] b. 1891, Woodruff, AZ d. 1958, Evanston, WY. Studied: Univ. UT; Gonzales; Tigera, Sonora, Mexico. Specialty: traditional Western ranch scenes in Colo. and Wyo. Work: Colo. Mus. Nat. Hist. [*]

LIMARZI, Joseph [P] NYC b. 15 S 1907. Studied: AIC. Work: mural, USPO, Wapakoneta, Ohio; Western Reserve Univ. WPA artist. [40]

LIMBACH, Russell T. [Li,P,W,L,T,Car,I] Middletown, CT b. 9 N 1904, Massillon, OH. Studied: Cleveland Sch. A. Exhibited: CMA, 1926-29 (prizes), 1931 (prize), 1934 (prize), 1935 (prize); Phila. PM, 1928 (med); LOC, 1946 (prize); Calif. PM, 1928 (med); AIC, 1931. Work: CMA; AIC; BM; MMA; NYPL; WMAA; LOC; Yale; Wesleyan Univ.; SFMA; Herron AI; Glasgow Univ.; Lyman Allyn Mus.; Massillon Mus.; Hunter Col.; Univ. Wis.; Los Angeles Mus. Author/Illustrator: "American Trees," 1942, "But Once a Year," Am. A. Group, 1941. Position: T., Wesleyan, Middletown, CT [47]

LIMBORG, Thomas [P] St. Paul, MN [24]

LIMERICK, J(ames) Arthur [S,P,C,L,T] Roland Park, MD b. 19 Jy 1870, Phila. d. 21 N 1931. Studied: PAFA, with Grafly, Anshutz, Boyle, Thouron; Ecole des Beaux-Arts, Paris; Switzerland. Member: Baltimore Friends Art; Baltimore WCC; Phila. Sketch C.; Charcoal C.; Handicrafts C. Exhibited: Md. Inst., 1921 (gold); City of Baltimore, (med). Work: caster of statues by P.W. Bartlett, Waterbury (Conn.), Calumet (Mich.), Phila.; Harvard; Phila. Custom House; Mem. Hall, Phila. Well known internationally as a bronze caster. [29]

LIMOURO, Raphael [P] NYC [13]

LINCOLN, Agnes Harrison [P,T] Mystic, CT b. 5 Mr 1870, Minneapolis, MN d. ca. 1955. Studied: ASL; BMFA Sch.; J.A. Weir; E. Tarbell. Member: Mystic AA. Exhibited: PAFA; CGA; AIC; Milwaukee AI, 1928 (prize); Minn. Inst. A., 1929 (prize), 1931 (prize). Position: T., Kemper Hall, Kenosha, Wis., 1931-39, 1944- [47]

LINCOLN, F. Foster [I] Woonsocket, RI. Member: SI, 1910 [31]

LIND, Edward G. [P] Kansas City, KS b. 6 N 1884, Kansas City. Studied: self-taught. Member: Kansas City SA; Kansas City AI. Work: Benton Chapter, D.A.R. [33]

LIND, Frank C. [P] Columbus, OH. Member: Columbus PPC [25]

LINDBERG, Arthur H. [P,I] Lynbrook, NY b. 29 S 1895, Worcester, MA. Studied: W. Beck; Pratt Inst.; ASL, with F. DuMond, G. Bridgman; Grand Central Sch., with H. Dunn, D. Cornwell. Member: Nassau Co., AL [40]

LINDBERG, T(horsten H.F.) [P,T,I,W,Des] Milwaukee, WI b. 13 Ja 1878, Stockholm, Sweden. Studied: Sch. Arch. and Appl. Arts, Stockholm. Member: AAPL. Exhibited: Milwaukee AI, 1935, 1937 (one-man); Swedish-Am. Exh., 1939. Work: Milwaukee Pub. Mus.; Milwaukee City Park; Milwaukee Courthouse. WPA supervisor. [47]

LINDBORG, Alice Whitten (Mrs.) [P] Newtown, Square, PA b. 18 Ja 1912, Wilmington, DE. Studied: Smith Col.; PAFA; A. Carles. Member: Wilmington SFA; Wilmington AC. Exhibited: Wilmington SFA, annually; Wilmington AC, annually, 1936 (prize), 1937 (prize); PAFA, 1939-43; Friends Central Sch. Gal., 1940-45. Work: PAFA [47]

LINDBORG, Carl [P,T] Newtown Square, PA b. 27 N 1903, Phila., PA. Studied: PMSchIA; PAFA; Académie Julian, Paris; Lhote. Member: Delaware County AA; Exhibited: CGA, 1931; PAFA; WMAA; Friends Central Sch. Gal., annually; F. PAFA; PMA; Phila. AC, 1937 (med). Work: PAFA; Friends Central Sch. Gal.; Allentown Mus. [47]

LINDBORG, Ingeborg A. See Andreasen-Lindborg.

LINDE, Ossip L. [P] Westport, CT b. Chicago. Studied: AIC; Laurens, Paris. Member: Allied AA; SC; SPNY. Exhibited: Paris Salon, 1907 (prize), 1910 (med). Work: Oakland Mus. [40]

LINDEM, C.J. [P] Minneapolis, MN [17]

LINDEN, Carl T. [P] Bensenville, IL. Exhibited: Ar. Chicago, Vicinity, Ann., AIC, 1934–39 [40]

LINDEN, Frank L. [P] Chicago, IL [01]

LINDENMUTH, Arlington N. [P] Allentown, PA b. 16 N 1867, Hamburg, Pa. Studied: self-taught. Member: SC [27]

LINDENMUTH, R.L. [P] Allentown, PA. Member: SC [25]

LINDENMUTH, Tod [P,G,B] St. Augustine, FL/Rockport, MA b. 4 My 1885, Allentown, PA d. 6 N 1976. Studied: Chase Sch. A.; R. Henri; A. Webster; G.E. Brown; W.H.W. Bicknell. Member: St. Augustine AC; Rockport AA; Provincetown AA. Exhibited: PAFA (prize). Work: Newark Mus.; Pa. State Col.; Allentown Mus. FA; Bibliothèque Nationale, Paris; Springfield Mus. A.; Kansas City AI; Mus. FA, Houston; NYPL; Los Angeles Mus. A.; TMA; Rochester Mem. Gal.; PAFA; 50 Color Prints of the Year, 1932–33 [47]

LINDENMUTH, Tod, Mrs. See Warren, Elizabeth.

LINDENTHALER, Charles J. [P] Union Hill, NJ [24]

LINDER, C. Bennett [P] NYC b. 6 Ap 1886, Helsingfors, Finland. Member: SC [29]

LINDER, Henry [S] Brooklyn, NY b. 26 S 1854, Brooklyn d. 7 Ja 1910. Studied: Prof. Knabl. Member: NSS; NSC; Albrcht Dürer Verein. Exhibited: St. Louis Expo, 1904 (med); NSS, Am. Fine Arts Bldg., 1910 (memorial exh.) [10]

LINDER, S.B. [P] Chicago IL. Work: port., J.H. Vanderpoel, AIC [19]

LINDERMAN, Winnifred [Min.P] Whitehall, MI b. 1868, Grand Rapids, MI. Studied: AIC, with H.F. Spread; ASL [06]

LINDHEIM, Ray [P] NYC b. 1884, NYC d. 24 Jy 1910. Studied: ASL, with F.V. DuMond [10]

LINDIN, Carl (Olof Eric) [P] Woodstock, NY b. 15 Je 1869, Sweden d. 7 N 1942. Studied: Paris, with Laurens, Constant, Aman-Jean. Member: Am. Ar. Prof. Lg.; Woodstock AA. Exhibited: Swedish C., Chicago, 1919 (prize), 1925–28 (prizes). Work: Hull House, Chicago; Brooks Mem. A. Gal., Memphis, Tenn.; Vanderpoel AA, Chicago [40]

LINDING, Herman M(agnuson) [P,S,C] Ossining, NY/NYC b. 1 Je 1880, Sweden. Studied: Callmander; C. Wilhelmson; Acad. Colarossi, Paris. Member: S.Indp.A.; Whitney Studio C.; Alliance [25]

LINDING, Lillian (Mrs. H.M.) [Li,P] Ossining, NY b. NYC. Studied: CUASch; NAD, with E. Carlsen. Member: NAWPS; Whitney Studio C.; S.Indp.A. Work: WMAA [40]

LINDNER, Norman [P] Rochester, NY. Member: Rochester AC [27]

LINDNER, Richard [P,I,T] NYC b. 1901, Hamburg, Germany (fled to Paris in 1933, then to NYC in 1941) d. 1978. Studied: Nuremburg Sch. FA, 1922; Munich Acad., 1924. Work: MOMA; Dallas MA. Illustrator: Vogue, 1941–50. Abstract figure painter known for his hard-edged bright colors and austere characters. Position: T., PIASch, 1951–65 [*]

LINDNEUX, Robert Ottokar [P] Denver, CO b. 11 D 1871, NYC d. 1970. Studied: Düsseldorf, with Vautier; Ecole des Beaux Arts, with Munkascsy; Munich Acad., with F. Stuck. Member: Royal SA, London; State Hist. S., Colo. Active in Mont. and Colo. after his return from Europe, 1893. Established studio in Denver, 1908. Was a friend of C.R. Russell and Buffalo Bill. Work: Amon Carter Mus.; Buffalo Bill Mem. Mus.; Colo. State Hist. Mus.; Northwestern Univ.; Univ. Okla; F. Philips Mus., Bartlesville, Okla.; Denver [47]

LINDNIG, Lillian [P,Li] Ossining, NY [33]

LINDQUIST, Harold S. [P,T] NYC/Greensboro, CT b. 29 Ap 1887, NYC. Studied: Dielman; H. Meyer [40]

LINDSAY, Henry A. [P] NYC. Member: SC [21]

LINDSAY, Ruth A(ndrews) (Mrs. Harry W.) [Por.P,T] Pasadena, CA b. 23 N 1888, Ada, OH. Studied: ASL; PAFA; NAD; Royal Acad., Brussels. Member: Pasadena SA (Pres.). Exhibited: Los Angeles Mus. A.; Pasadena AI; Stanford Univ.; Laguna Beach AA; San Diego FAS; Pasadena SA, 1938 (prize) [47]

LINDSAY, Thomas C. [P] Cincinnati, OH [06]

LINDSLEY, Emily Earle [P,T] Larchmont, NY b. 25 F 1858, New Rochelle, NY d. 18 O 1944. Studied: W.M. Chase; J.A. Weir; R.H. Nicholls; Ferrari, in Italy. Member: NAWPS; New Rochelle AA; S.Indp.A. Work: N.Y. Hist. S. [40]

LINDSLEY, Julia I.C. [P] New Haven, CT. Member: New Haven PCC [19]

LINDSTROM, August [S] NYC [01]

LINDSTROM, Carl E. [P] Worcester, MA [24]

LINES, C(harles) M(orse) [P] Cleveland Heights, OH/Rockport, MA b. 15 D 1862, Angola, IN. Member: Cleveland SA; Cleveland Pr.C.; AFA [29]

LINES, M.M. (Mrs.) [P] Detroit, MI. Member: Detroit SWP [27]

LINES, Nellie Day [P] Chicago, IL [01]

LINGAN, Violetta D.P. [P,S,T] Brooklyn, NY b. NYC d. ca. 1938. Studied: Cox; Twachtman; ASL; D.C. French; Chase; Ennis. Member: AWCS; Gloucester SA [38]

LINGEN, Penelope [S,Min.P] Houston, TX. Member: SSAL [27]

LINK, B. Lillian [S] Boston, MA/Truro, MA b. NYC. Studied: Mrs. Sprague-Smith; G.G. Barnard; H. Adams. Exhibited: Arch. Lg., 1907 (prize); NYWAC, 1912 (prize) [40]

LINK, Carl [P,I,T,C,Des] NYC/Kings Beach, CA b. 13 Ag 1887, Munich, Germany. Studied: Royal Acad., Munich; Royal Acad., Dresden; Kunstgewerbe Mus., Berlin. Member: Palm Beach AL. Exhibited: AWCS, 1946; Intl. Dance Exh., 1938; Palm Beach AL, 1941 (prize), 1942; Royal Acad., Munich, 1913 (prize). Work: stage designs; portraits of leading actors, Oberammergau Passion Players, 1922, 1930 (syndicated); private colls., NYC, London, Innsbruck, Munich, Port. Ct. House, Cincinnati. Position: T., N.Y. Evening Sch. Indst. A. [47]

LINN, Louis C. [P] Phila., PA. Associated with PAFA. [24]

LINN, Orson [P] San Fran., CA. Exhibited: 48 States Comp. [40]

LINNELL, Harry A. [I] NYC b. 20 N 1873, Attleboro, MA. Studied: F.V. DuMond, C. Beckwith, Wm. M. Chase; F.L. Mora [08]

LINS, John [P] Chicago, IL. Member: Chicago NJSA [25]

LINS, Theodora. See Landt.

LINSLY, Wilford [Ldscp.P] d. 4 Ag 1898, NYC. Studied: Sheffield Sc. Sch., Yale Member: Yale C.

LINSON, Corwin Knapp [P,W,I] Atlantic Highlands, NJ b. 25 F 1864, Brooklyn, NY. Studied: Gèrôme, Ecole des Beaux Arts; Académie Julian, Laurens. Member: SC; All.A.Am. Exhibited: NAD; PAFA; All.A.Am.; NYWCC; Montclair A. Mus.; Newark AC. Work: Court House Freehold, N.J.; Williams Col.; N.Y. Military Acad.; Richmond, Va.; Hon. Paul M. Pearson Coll., Ex-Gov. Virgin Islands' Baptist Temple, Brooklyn; Presb. Church, Rumson, N.J. Illustrator: "I.N.R.I.," Rosegger; "The Lost Word," by Dr. Watson; "Modern Athens," by George Horton. Author/Illustrator: articles in Scribner's, Century, Cosmopolitan; House Beautiful, etc. [47]

LINTNER, William (or M.) Campbell [S] Albany, NY [01]

LINTON, Frank Benton Ashley [P] Phila., PA/Herford, PA b. 26 F 1871, Phila. d. 13 N 1943. Studied: T. Eakins; Paris, with Gèrôme, Bouguereau, Benjamin-Constant, Bonnât, Laurens. Member: Intl. Union des Beaux-Arts et des Lettres; Phila. AC. Exhibited: Paris Salon, 1927 (med). Work: Johns Hopkins; Girard Col. Phila.; Hahnemann Col., Phila.; Col. Physicians, Phila.; Baldwin Locomotive Works, Phila.; French Govt.; State Bldg., Dover, Del.; Temple Univ., Phila. [40]

LINTON, Jay Roland (Mrs.) [S,T] NYC b. NYC. Studied: Brooklyn Acad.; R. Laurent; J. de Creeft. Member: NAWA; N.Y. S. Cer. A.; Audubon A.; Brooklyn SA; NYSWA. Exhibited: NAWA, 1942–46; NYSWA, 1944–46; Brooklyn SA, 1942–46; Audubon A., 1944, 1945; N.Y. S. Cer. A., 1944–46; Am. British A. Center, 1942, 1943; Vendôme; Bonestell; Norlyst Gal., BM; Riverside Mus. Long Is. A. Fest., 1946 (prize). Position: T., Halloran General Hospital, N.Y. [47]

LINTON, William James [En,W] New Haven, CT b. 1812, London (came to New Haven, 1867) d. 29 D 1897, at his home "Appledore," New Haven, where he lived in seclusion for 30 yrs., although his home was a rendezvous for artists and literateurs. He owned an engraving firm in New Haven. Also author of about 50 books including "The Plain of Freedom," 1854, "Claribel and Other Poems," "The English Republic," "Some Practical Hints on Wood Engraving," 1879, "Life of Thomas Paine," 1879, "A Manual of Wood Engraving," 1884; "Poems and Translations," 1889 and "The Masters

of Wood Engraving," which sold for $100 in 1890. Specialty: wood engraving

LINTOTT, E(dward) Barnard [P,W,T,L,Dr] Ridgewood, NJ b. 11 D 1875, London, England d. 12 Mr 1951. Studied: Ecole des Beaux-Arts; Académie Julian; Sorbonne.; J.P. Laurens; Benjamin-Constant; M.E. Cuyer. Member: Nat. Port. S.; Art C., London, England; Intl. S., London. Exhibited: Knoedler (one-man); Reinhardt (one-man); Marie Sterner (one-man); MacBeth Gal. (one-man). Work: BMFA; Hackley AG; AGAA; Louvre Mus.; Musée du Jeu de Paume; British Mus.; Victoria & Albert Mus.; Imperial War Mus., London; Musée de Ghent, Belgium; BM; Haggin Mem. Gal., Stockton, Calif.; NGA; Contemporary Art S.; Aberdeen, Scotland; New South Wales, Australia; Prince Paul of Servias, Nat. Gal. Author: "The Art of Water Color Painting," 1920 [47]

LION, Henry [S,P] Los Angeles, CA b. 11 Ag 1900, Fresno, CA d. 1966. Studied: Otis AI; S. MacDonald-Wright. Member: Calf. AC; Los Angeles AA; SWA (founder). Exhibited: P&S S.; GGE, 1939; Los Angeles Mus. A., 1937 (one-man), 1945 (one-man); Otis AI, 1923 (prize), 1940 (prize), 1941 (prize); Nat S. Comp., 1923 (prize); Pacific Southwest Expo, 1928 (prize); Los Angeles County Fair, 1922 (prize), 1923 (prize), 1933 (prize), 1934 (prize), 1939 (prize); Ebell Salon, 1937 (prize), 1942 (prize); Calif. AC, 1938 (prize). Work: figures, Los Angeles City Hall; Ebell C., Los Angeles; Fed. Bldg., Los Angeles; fountain, De Anza Mem., Los Angeles. WPA sculptor. [47]

LIPINSKY, Lino S. [Et,En,P] NYC b. 14 Ja 1908, Rome, Italy. Studied: British Acad. A.; Royal Acad. A., Rome; S. Lipinsky. Member: SAE; Chicago SE; Audubon A. Exhibited: Los Angeles Mus. A., 1927, 1928, 1932; AIC, 1934; Chicago SE, 1941 (prize); SAE, 1942 (prize), 1943, 1945; Grand Central A. Gal., 1942; LOC, 1942 (prize), 1943; NAD, 1943-46; CMA, 1943; Detroit Inst. A., 1943 (prize); Albany Inst. Hist. & A., 1945; Vose Gal., 1941 (one-man); Symphony Hall, Boston, 1941; Jr. Lg., Boston, 1942; St. Paul G., 1945; Knoedler Gal., 1945; abroad: Paris Salon, 1937 (med); Budapest, 1936 (med); Rome, 1931 (med). Work: Severance Music Hall, Cleveland; St. Patrick's Cathedral, NYC; Boston Symphony Hall; NYPL; LOC; Detroit Inst. A.; Cranbrook Acad. A.; MMA. Many portraits of prominent persons. Co-author: "Anatomy for Artists," 1931 [47]

LIPMAN, Jean [W] Cannondale, CT b. 31 Ag 1909, NYC. Studied: Wellesley; NYU. Author: "American Primitive Painting," 1942. Editor: "Richard Jennys, New England Portrait Painter," 1941, "Art in America," 1938-46 [47]

LIPMAN, Michael [I] St. Louis, MO. Member: 2x4 Soc. [19]

LIPPERT, Leon [P] Newport, KY b. Bavaria d. ca. 1950. Studied: Cincinnati A. Acad., with Duveneck, Nowottny; abroad. Member: Cincinnati AC. Exhibited: Cincinnati AC. Work: St. Xavier Church, Holy Sacrament Church, Cincinnati; Sacred Heart Church, Bellevue, Ky.; Military Order, Loyal Legion of U.S. [40]

LIPPINCOTT, Fanchon Warden [C] Norristown, PA b. St. Louis, MO. Studied: N.Y. Sch. Des. Member: Phila. ACG. Specialty: design, weaving of linens [40]

LIPPINCOTT, J. Gordon [Des,W,L] Scarsdale, NY b. 28 Mr 1909, White Plains, NY. Studied: Swarthmore Col.; Columbia. Member: ADI; Indst. Des.; Arch. Lg. Position: Ed., Interiors magazine [47]

LIPPINCOTT, Margarette [P,T] Phila., PA b. 1862 d. S 1910. Studied: PAFA;; ASL. Member: NYWCC; Phila. WCC. Exhibited: PAFA, 1897 (prize) [10]

LIPPINCOTT, William H(enry) [P,E,I,T] NYC b. 6 D 1849, Phila., PA d. 16 Mr 1920. Studied: PAFA; Bonnât, Paris. Member: ANA 1885; NA 1897; AWCS; NY Etching C., 1888; Century Assn. Exhibited: Pan-Am. Expo, Buffalo, 1901; St. Louis Expo, 1904 (med). Work: NYPL; Parrish M.; scenery for "La Bohème," "Salambo." After 8 yrs. study in Paris opened studio in Portland, Maine; then NYC where he taught at NAD for 3 yrs. Illustrator: Century [19]

LIPTON, Seymour [S,T] NYC b. 6 N 1903, NYC. Studied: CCNY; Columbia; but mostly self-taught. Member: S. Gld.; A. Lg. Am. Exhibited: PAFA, 1946; WMAA, 1946; S.Gld., 1942-44; A. Lg. Am., 1944, 1945; Buchholz Gal., 1943, 1945; SFMA, 1944; ACA G., 1938 (one-man); Galerie St. Etienne, 1943 (one-man); Puma Gal., 1944, 1945; Am.-British A. Center, 1943, 1944. Work: MOMA; WMAA; Temple Beth El, Gary, Ind.; Milwaukee Performing A. Center; IBM. Positions: T., CUASch (1945-46), New Sch. Soc. Res. (1940-65) [47]

LISHINSKY, A. [P] Brooklyn NY. Exhibited: 48 States Comp. [40]

LISLE, Mable [P] Seattle, WA. Member: Seattle FAS [21]

LISLE, W.H. [P,I] NYC [08]

LISSIM, Simon [Des,P,I,L,T] NYC b. 24 O 1900, Kiev, Russia. Studied: Naumeko Sch., Kiev, Russia; Sorbonne, Louvre Sch., both in Paris. Member: Salon d'Automne, Artistes Decorateurs, both in Paris; CAA; Theatre Lib. Assn. Am. Exhibited: Paris Salon, 1925 (med); Intl. Exh., Barcelona, 1928 (med); internationally and nationally. Work: Musée du Jeu de Paume, Musée des Arts Decoratifs, both in Paris; Victoria & Albert Mus.; Stratford-on-Avon Mus.; Albertina Mus.; Bibliothèque Nationale; Russian A. Mus., Prague; City of Riga; BM; CAC; French Inst. in the U.S. Mus.; porcelain dec. design for Sevres, France. Illustrator: books and articles. Positions: Dir., A. Edu. Project, NYPL, 1942- ; T., Lycée Français, NYC, 1943- , CCNY, 1944-45 [47]

LISTER, William H. [P,I,C] Phila., PA b. 5 N 1866, Phila. Studied: H. Pyle. Member: Sketch C. [10]

LIT, D. Ellis [P] Jenkintown, PA. Studied: PAFA [25]

LITCHFIELD, Donald [I] Seattle, WA b. 30 S 1897, London, England. Studied: ASL; Bridgman; Duffner. Member: Northwest Ar. Group; Puget Sound Group. Exhibited: PAFA. Position: Staff, Seattle Post Intelligencer [40]

LITCHFIELD, G.H. [P] NYC [19]

LITCHFIELD, J. Homer [P] NYC. Member: NYWCC [21]

LITTLE, Arthur [I] NYC. Member: CI 1912; AI Graphic A.; SC [33]

LITTELL, William Doughty [En] Brooklyn, NY b. NYC 1849 d. 5 S 1911. Specialty: wood engraving

LITTLE, A.P. [P] St. Louis, MO b. St. Louis. Studied: St. Louis Sch. FA; P. Cornoyer. Exhibited: St. Louis Expo, 1898 [98]

LITTLE, A. Platte [P] French Village, IL [08]

LITTLE, Edith Tadd (Mrs.) [P,S,Des,Arch,W,L,T] Winter Park, FL b. 27 Je 1882, Phila., PA. Studied: PAFA; Chase; Beaux; Grafly. Member: St. Petersburg AC; Orlando AA; Chm. FA, Fla. Fed. Women's C. Contributor: Florida newspapers [40]

LITTLE, Florence E. [P] Pittsburgh, PA. Member: Pittsburgh AA [17]

LITTLE, Gertrude L. [Min.P] Los Angeles, CA b. Minneapolis, MN. Studied: ASL; E.S. Bush; S. Macdonald-Wright; Seattle AS; Sch. Am. SMP; Chase. Member: Calif. SMP. Exhibited: PAFA, 1924-26; AIC, 1927; Phila. Sesqui-Centenn. Expo, 1926; Century Progress, Chicago 1933; Calif. Pacific Intl. Expo, 1935; GGE, 1939; CGA; Los Angeles Mus. A., 1925; Seattle FAS, 1921 (prize); Calif. SMP, 1923 (prize), 1924 (prize), 1925 (prize), 1928 (prize); San Diego FAS, 1926 (prize); Pacific Southwest Expo, 1926 (prize); Los Angeles County Fair, 1928 (prize) [47]

LITTLE, H.B. [P] Concord, MA. Member: Boston AC [27]

LITTLE, Ida D. [P] NYC b. 1873, Chicago, IL. Studied: NAD; Wm. Chase [06]

LITTLE, James [P] Boston, MA [01]

LITTLE, Joe [I] Scarsdale, NY. Member: SI [47]

LITTLE, J(ohn) Wesley [Ldscp.P] Picture Rocks, PA b. 24 Ag 1867, Forksville, PA d. Fall, 1923. Studied: NAD; Leonard Ochtman. Member: Wash. WCC; Phila. WCC; Phila. Sketch C.; Chicago WCC. Exhibited: AAS, Phila., 1902 (med). Work: murals, Franklin Bldg., Williamsport, Pa. [21]

LITTLE, Nat(haniel Stanton) [I] Phila., PA b. 18 F 1893, Helena, MT. Studied: ASL; PAFA. Member: Phila. Sketch; S. Mystic A. Exhibited: Phila. WCC, 1923 (prize); F. PAFA, 1925 (gold), 1929 (prize); Phila. Sketch C., 1927 (med) [40]

LITTLE, Pauline Graff (Mrs. Donald Ozmun) [Mur.P,Dec] Mt. Prospect, IL b. 20 Mr 1902, Evanston, IL. Studied: Northwestern Univ.; AIC; L. Seyffert; L. Kroll; J. Norton; Lhote, Paris; H. Hofmann, Munich. Member: AC of Chicago; Town and Country AC, Chicago. Exhibited: AIC, 1935-46 [47]

LITTLE, Philip [P,E] Salem, MA b. 6 S 1857, Swampscott, MA d. 31 Mr 1942. Studied: BMFA Sch. Member: Boston GA; Chicago SE; Portland, Maine, AA; SAE; NAC; Minneapolis AI. Exhibited: AIC, 1912; Pan-P. Expo, 1915 (med). Work: PAFA; CAM; Minneapolis FAS; Bowdoin Col.; Portland (Maine) SA; Nashville, AA; Milwaukee AA; Dubuque AA; Essex Inst., Salem; RISD; BMFA; LOC; Minneapolis AI; NYPL; Bibliothèque Nationale, Paris. Position: Cur., Essex Inst., Salem [40]

LITTLE, Tacey M(ay Bates) (Mrs. Frank) [E] South Orange, NJ/Provincetown, MA b. 24 My 1879, Whitehall, IL. Studied: F. DuMond; ASL; W.P.

Robbins; Century Sch. A.&Cr., London. Member: Provincetown AA; A. Center of the Oranges [40]

LITTLEFIELD, Edgar [C,T] Columbus, OH b. 27 Jy 1905, Nashville, TN. Studied: A.E. Baggs. Member: Columbus AL; Am. Ceramic S. Exhibited: Syracuse MA, 1934 (prize), 1935 (prize), 1938 (prize); Columbus AL, 1936 (prize), 1937 (prize); traveling exh., Am. Ceramics, Norway, Sweden, Denmark, 1937. Work: Syracuse Mus. FA; Columbus Gal. FA. Contributor: article, "Glaze" in Design. Position: T., Ohio State Univ. [40]

LITTLEFIELD, William Horace [P,Li,I] Falmouth, MA b. 28 O 1902, Roxbury, MA. Studied: Harvard. Exhibited: New England S. Contemporary A., 1929; Boston Indp. A., 1931, 1935; PAFA, 1930-34; WMA, 1930, 1933, 1935, 1938; Harvard S. Contemporary A., 1930, 1931; MOMA, 1932, 1934; WMAA, 1932; CMA, 1935; CAA, 1935; Inst. Mod. A., Boston, 1929; Gld. A. Gal., 1936; one-man exhibits: Ferargil Gal., 1930; Weyhe Gal., 1930; Becker Gal., 1930; Chicago AC, 1930; Albright AG, 1931; BMA, 1931; BMFA, 1936; Grace Horne Gal., 1938; Smith Col., 1940; Milwaukee AI, 1940; Currier Gal. A., 1940; Wadsworth Atheneum, 1940; Nelson Gal., 1941; Denver A. Mus., 1941; Dallas Mus. FA, 1941; Dayton AI, 1942; Palace Legion Honor, 1942; Haggin Gal., Stockton, Calif., 1942; Wustum Mus. FA, 1942; Oshkosh Mus., 1942; Amherst Col., 1945; Paris. Work: BMFA; FMA; WMA; Smith Col.; Vassar Col.; Albright A. Gal.; Lockwood Mem. Lib., Univ. Buffalo; William Rockhill Nelson Gal.; MOMA; Kansas City AI; Addison Gal. Am. Art [47]

LITTLEJOHN, C(ynthia Pugh) [P] New Orleans, LA b. Assumption Parish, LA. Studied: W. Woodward; A.A. Dow; Newcomb Col., Tulane. Member: NAC; SSAL; Am. S. Bookplate Collectors & Des. [33]

LITTLEJOHN, Hugh Warwick [Dr,Mur.P,Por.P,Min.P] Oakland, Calif. b. 28 F 1892, NYC d. 1938. Studied: J.E. Gerrity. Member: San Fran. AA; San Fran. A. Center [38]

LITTLEJOHN, Margaret Martin [P,T] Fort Worth, TX b. 12 D 1885, Jefferson, TX. Studied: W. Paxton; R. Pratt; A.K. Cross; BMFA Sch.; W.M. Chase; J. Carlson; E. Speicher. Member: Ft. Worth AA; Allied A., Ft. Worth; Tex. AG. Work: children's hospital and public schools, Ft. Worth [40]

LITTLETON, B.F. [P] Columbus, OH. Member: Columbus PPC [24]

LITWAK, Israel [P,C] Brooklyn, NY b. 10 Ja 1867, Odessa, Russia. Exhibited: BM, 1937, 1939, 1940. Work: BM [40]

LITZINGER, Dorothea M. (Mrs. John W. Thompson) [P,E] NYC b. 20 Ja 1889, Cambria County, PA d. 4 Ja 1925. Studied: NAD; SPNY. Member: CAFA; New Haven PCC; Alliance. Illustrator: "Country Life in America." Specialty: flowers [24]

LIVEZEY, Will(iam) E. [P,S,I] Chicago, IL b. 12 Ap 1867, Unionville, MO. Illustrator: "The Days of Long Ago," by W.E. Comstock [21]

LIVINGSTON, Charlotte (Mrs. Francis Kughler) [P] NYC b. NYC. Studied: NAD; ASL. Member: Bronx AG; S.I. Inst. A.&SC; Yonkers AA; AAPL; Ixia S. [40]

LIVINGSTON, Robert Crawford [P,T,I,Car,L] Eliot, ME b. 16 O 1910, Boston, MA. Studied: BMFA Sch. Member: Newport AA; Rockport AA; Boston AC; Ogunquit AA. Exhibited: PAFA, 1939-42; AIC; SAM; Sweat Mem. M., Portland, Maine; Symphony Hall, Boston. Work: Harris Mus., Belfast, Ireland; mural, USPO, Plymouth, N.H. WPA artist. [47]

LIVINGSTON, Sidnee [P] NYC b. 7 d 1909, NYC. Studied: NYU; NAD. Member: Lincoln AG; Woodmere A. Gal.; Lg. Present-Day A. Exhibited: PAFA, 1941; Butler AI, 1943; Nebr. AA, 1945; Kansas City AI; Lincoln AG; Phila. Sketch C.; Woodmere A. Gal.; Parkersburg, W.Va. FA Center; Denver AM; Argent Gal., 1944 (one-man) [47]

LIVINGSTONE, R.H. [P] Chicago, IL [15]

LIVIO, (Tito) Macrini [P] Chicago, IL b. 12 My 1899, Lucca, Italy. Studied: A. Campriani [25]

LIZA See Hellman, Bertha Louise.

LLANUZA, Pedro [P] Chicago, IL. Member: Chicago, NJSA [25]

LLOYD, Benjamin F. [P] NYC [06]

LLOYD, Bertha Elizabeth [Des,Bkbind] Detroit, MI b. 13 My 1869, Albany, NY. Studied: A.W. Dow; F. Foote. Member: Detroit SAC; Soc. Medalists; AFA. Work: books for the Diocese of Mich., Mont., Ky.; Univ. Mich.; Twentieth Century C., Detroit; St. John's Church, Detroit; lace, St. Paul's Church, Flint, Mich.; calendar heads for St. Paul's Cathedral, Detroit. Specialties: leatherwork; lacemaking; embroidery [40]

LLOYD, Caroline A. [S] Montparnasse, Paris, France b. 7 Mr 1875, d. 30 D 1945. Exhibited: WFNY, 1939 [40]

LLOYD, Ethel Spencer [Des,C] Detroit, MI b. 25 Ja 1875, Albany, NY. Studied: J.H. Winn; G.E. Germer. Member: Boston SAC; Detroit SAC; S. Medalists; AFA. Work: crosses for Bishop of Mont.; Bishop coadjutor, Mont.; Bishop of Ky.; Bishop of Erie; Bishop of Wyo., Bishop of Western N.Y.; Univ. Mich.; Twentieth Century C., Detroit; Diocese of Mich.; Diocese of Mont.; St. John's Church, Detroit; bookplates, Stevens Mem. Lib., Detroit; St. James' Church, Birmingham, Mich. Specialties: jewelry; silversmithing; embroidery. Related to Bertha E. Lloyd. Position: cataloguer, Children's Mus., Detroit [40]

LLOYD, Frank Edward [P,T] d. 29 Mr 1945. Studied: PAFA; Albright A. Sch. Position: T., Norton Sch. A., West Palm Beach

LLOYD, Helen Sharpless [P,L] Phila., PA/Harvey Cedars, NJ b. 5 F 1903. Studied: PAFA; Smith Col.; Acad. Scandinave, Paris. Member: Phila. A. All.; Plastic C. Exhibited: Smith Col. C., NYC; Phila. A. All.; PAFA. Work: PAFA [40]

LLOYD, Lucile [Mur.P,Dec] Los Angeles, CA b. 20 Ag 1894, Cincinnati, OH. Studied: R. Fairbanks; E. Savage. Member: Calif. AC; Women P., West. Work: murals, Church of St. Mary, Hollywood; Calif. State Bldg., Los Angeles [40]

LLOYD, Mary Lowell [P] Phila., PA. Studied: PAFA. Member: Acorn C. [25]

LLOYD, Mary Wingate (Mrs. Horatio Gates) [P] Haverford, PA b. 3 Je 1868, NYC. Studied: Chase; C. Beaux; Mowbray. Member: Plastic C. [24]

LLOYD, Sara A. Worden (Mrs. Hinton S.) [P] Hamilton, NY b. Xenia, OH. Studied: R. Swain, Gifford, Volk, Chase, in NYC. Work: portraits, Mt. Holyoke Col.; Colgate Univ.; Theological Seminary, Xenia, Ohio [21]

LOAS, Anna J. [P] Secane, PA [06]

LOBEL, Paul A. [C,Dec,Des,S] NYC b. 4 Mr 1899, Romania. Studied: B. Robinson. Member: N.Y. Soc. Des.-Craftsmen. Exhibited: Intl. Expo, Paris, 1937 (meds). Work: Hupmobile Co., Hartford, Conn.; Barbizon Plaza, & St. Moritz Hotels, NYC. Contributor: magazines. Positions: Des. Consult., Intl. Silver Co. and Regal Art Glass Co. [40]

LOBER, Georg John [S,L,T] NYC b. Chicago, IL d. 14 D 1961. Studied: NAD; BAID; Columbia Col.; Calder; Borglum; Longman. Member: ANA, 1932; NA, 1935; Arch. Lg.; NSS; CAFA; NAC; SC; Allied AA; Am. Numismatic S.; Grand Central A. Gal.; Lotos C. Exhibited: NAD; PAFA; All.A.Am.; NAC; Montclair A. Mus., 1934 (med); Century C.; Seligmann Gal.; Ferargil Gal.; Arch. Lg., 1911 (prize); AIC, 1918, 1920; CAFA, 1924 (prize); A. Center of the Oranges, N.J., 1926 (prize); Grand Central A. Gal., 1931 (prize); Allied AA, 1932 (prize); NAD, 1935 (med). Work: MMA; BM; Smithsonian Inst.; Musée des Medailles, Paris; Nat. Mus., Copenhagen, Denmark; mem., Niagara Falls., N.Y.; Port Chester, N.Y.; Aquia, Va.; CGA; Montclair Mus.; Numismatic Mus., NYC; Norfolk, Va.; State of Ill.; NYC Armory; Wesleyan Col., Middletown; church, Plainfield, N.J.; church, Pawtucket, R.I.; mem., Central Park, NYC; Golden Gate Mus., San Fran.; Univ. Mich., Ann Arbor; cemetery, Lewiston, N.Y.; NAC; mem., Battery Park, NYC. mem., Hartford, Conn.; Odense Mus., Denmark; chapel, Belgium; Masonic Order, NYC; Fed. Garden C. of Am.; medal, AWCS; WFNY, 1939. Position: T., Grand Central Sch. A., NYC [47]

LOBINGIER, Elizabeth Miller (Mrs. John L.) [P,W,T] Winchester, MA b. 17 Ap 1889, Washington, D.C. Studied: Univ. Chicago; Chicago Acad. FA; AIC; Univ. N.Mex.; A.T. Hibbard; L. Hornby; W. Sargent; A. Churchill; W.B. Hazelton; H.H. Breckenridge; C. Nordstrom; Member: Copley S.; Ga. AA; SSAL; Rockport AA; North Shore AA; Gloucester SA; Ogunquit A. Center; Winchester AA; Boston AC. Exhibited: Assn. Ga. Ar., 1935-46; SSAL, 1937-46; Copley S., 1935-46; Boston AC, 1935-42; North Shore AA, 1943-46; Ogunquit A. Center, 1945; Winchester AA, 1934-46; Jordan Marsh Exh., 1943, 1945; High Mus. A., 1942 (prize); Mint Mus. A., 1945 (prize). Work: Mint Mus. Author: "Ship East-Ship West," 1937; "How Children Learn to Draw," (with Walter Sargent) Ginn & Co., 1916. Position: T., Winchester Studio Gld., Mass., 1935- [47]

LOCHER, Robert E(vans) [Arch,Dec,Des,Mur.P,T,W] Staten Island, NY b. 10 N 1888, Lancaster, PA. Work: Hotel Nacional, Havana; WMAA; Am. Women's Assn. Illustrator: "The Blind Bow Boy," "The White Robe"; des., book jackets. Author/Illustrator: articles, Interior Architecture and Decoration; Vogue; House and Garden; Vanity Fair. Positions: Indst. Des., Lunt Silversmiths, Sargent Hardware, Imperial Paper & Color Corp. [47]

LOCHMAN, Anna Cordelia [E,P] Chicago, IL b. 14 Ag 1909, Springfield, IL. Studied: AIC. Member: Am. Ar. Prof. Lg.; Am Fed. A. [40]

LOCHOW, Curt F. [P] Seattle, WA [21]

LOCHRIE, Elizabeth Davey [P,S,Des,I,L,Car] Butte, MT (1976) b. 1 Jy 1890, Deer Lodge, MT. Studied: PIASch; Stanford; W. Reiss, 1943–44; D. Puccinelli; N. Brewer. Member: AAPL; Northwest Assn. A. Exhibited: AAA, 1939–45; WFNY, 1939; Baltimore A., 1945; Northwest AA, 1944–46; Rhodes Gal., Tacoma, 1940; Findlay Gal., 1945; Mont. AA; Mont. Col., Bozeman. Work: murals, USPOs, Burley, Idaho, Dillon, Mont., St. Anthony, Idaho; State Hospital, Galen, Mont.; BM Coll. WPA artist. Specialty: Indian portraits (1930s) [47]

LOCKARD, Robert Ivan [P,E,T] Lubbock, TX b. 18 S 1905, Norton, KS. Studied: J.F. Helm, Jr. Member: S.Indp.A.; Prairie WCP. Exhibited: Kansas City AI, 1932 (med). Position: T., Tex. Tech. Col. [40]

LOCKE, Alexander S. [Mur.P] Brooklyn, NY b. 14 F 1860, NYC. Studied: J. La Farge. Member: Arch. Lg., 1894; Mural P.; NAC [33]

LOCKE, Alice G. [P,T] Flushing, NY/Gloucester, MA b. 18 S 1883, Lexington, MA. Studied: H.B. Snell. Member: NAWPS; Gloucester AA; Brooklyn SA; North Shore AA [31]

LOCKE, Caroline T. (Mrs. Jesse) [P] Hackensack, NJ. Member: N.Y. Women's AC [13]

LOCKE, Charles [P,T,Li,E,Dr,] Garrison, NY b. 31 Ag 1899, Cincinnati, OH. Studied: J. Pennell; H.H. Wessel; J.E. Weis. Member: ANA; SAE; Am. PM; Am. Soc. PS&G. Work: MMA; CM; British Mus., London. Illustrator: "Tale of a Tub," by Swift, pub. Columbia Univ. Press. Position: T., ASL [47]

LOCKE, Edwin A. [Mar.P] Salem, MA (1925) b. 1851. Work: Peabody Mus., Salem. He was also a sailor. [*]

LOCKE, Lucie H(arris) (Mrs. David Roger) [P,T] Corpus Christi, TX b. 22 F 1904, Valdosta, GA. Studied: Newcomb Col.; Tulane; San Antonio A. Sch.; C. Rosen; X. Gonzales; O. Travis. Member: SSAL; NOAA; AFA; Corpus Christi A. Fund.; Lg. Am. Pen Women; South Tex. AL; Tex. FAA; AAPL. Exhibited: Corpus Christi A. Fnd., 1946 (prize); Caller Times Nat. Exh., 1945; Lg. Am. Pen Women, 1946; San Antonio, Tex., 1933–35, 1940; South Tex. AL, 1935–46; NOAA, 1933–43, 1954; SSAL, 1931, 1932, 1935, 1936–40, 1942–45; Tex.-Okla. General Exh., 1941; Tex. General Exh., 1944, 1945; Witte Mem. Mus., 1935 (one-man). Work: Montgomery (Ala.) MFA; Corpus Christi Jr. Col.; Corpus Christi A. Fnd. Position: Chm., Corpus Christi A. Fnd., 1944–46 [47]

LOCKE, Walter Ronald [E,P] Tarpon Springs, FL b 13 F 1883, Winchester, MA. Studied: A. Hutty; L. Kronberg. Exhibited: Ferargil Gal.; LOC; SAE; AAA; Phila. A. All.; Palm Beach, Fla., 1942 (prize); Fla. Fed. A., 1943 (prize), 1944 (prize); Gulf Coast Group, 1946 (prize). Work: Lib., Atlanta; Binghamton (Ga.) MFA; Valentine Mus.; Honolulu Acad. A.; Mint Mus. A.; Yale; Wesleyan Univ.; Iowa State Col.; Berea Col.; William Nelson Gal.; Fleming Mus.; Cornell; Skidmore Col.; Syracuse MFA; Brooklyn Col.; Grace Hospital, Detroit. [47]

LOCKHART, Glada Trenchard (Mrs.) [P] Calumet City, IL b. 25 S 1892, Boone, IA. Studied: Grant; Mrs. A. Oberteuffer; Alworthy; AIC. Member: Hoosier Salon; All-Ill. AS; S. for Sanity in A.; PS Lg., Hammond, Ind., 1939 (prize) [40]

LOCKINGTON, Walter Percy [P,W,Arch] Phila., PA b. 5 Ag 1857, Chertsey, England (came to U.S. in 1885) d. 20 Jy 1905. Studied: Oxford.

LOCKMAN, De Witt M. [Por.P] NYC. Member: NA; All.A.Am.; A. Comm. Assn., NYC; AFA; NIAL; AAPL; ANA, 1917; NA, 1921; A. Fund A.; Por. P.; Sch. A. Lg. Exhibited: P.-P. Expo, 1915 (med); PAFA, 1918 (prize); NAD, 1922 (prize); N.Y. Hist. S., 1933 (gold); All.A.Am, 1936 (gold). Work: PAFA; NAD; MMA; N.Y. Hist. S.; Yale; Supreme Court, Cincinnati, Ohio; West Point, N.Y.; Armory, N.Y.; Ft. Ticonderoga Mus., N.Y.; Union C. [47]

LOCKWOOD, Clinton Benedict [P] Crestwood, NY b. 23 1907, NYC. Studied: G. Luks; G.P. Ennis. Member: AWCS; NYWCC. Work: PAFA [47]

LOCKWOOD, (John) Ward [P,Li,L,T] Austin, TX b. 22 S 1894, Atchison, KS d. 6 Jy 1963. Studied: Univ. Kans., 1912–14; PAFA, 1914–16; Acad. Ransom, Paris. Member: NWMP; Am. S. PS&G; Mural P. Exhibited: AIC, 1931 (prize); SFMA, 1932 (prize); Denver A. Mus., 1932; Kansas City AI, 1937; Salon d'Automne, Paris, 1922; CGA; PAFA; Colorado Springs FA Center; Mus. N.Mex., Lone Star PM; Tex. General Exh. Work: WMAA; PAFA; Denver A. Mus.; Pal. Leg. Honor; PMG; AGAA; Iowa State Col.; Dallas MFA; Baker Univ., Wichita, Kans.; murals, Taos (N.Mex.) Court House; Colorado Springs FA Center; Fed. Court Room, Lexington, Ky.; USPOs, Wichita, Kans., Wash., D.C., Edinburg, Tex., Hamilton, Tex. A "regionalist," he was also a follower of Dasburg and Marin. Had more than 45 one-man exhibits. His later work became abstract. Positions: T., Univ. Tex., Austin, 1938–49, Univ. Calif., Berkeley, 1949–61 [47]

LOCKWOOD, Mary M. [P] Wash., D.C. [19]

LOCKWOOD, Wilton [P] Orleans, MA b. 12 S 1862, Wilton, CT d. 20 Mr 1914, Bookline, MA. Studied: J. La Farge; Paris; Munich; went to NYC, 1880. Member: ANA 1906, NA 1912; SAA 1898; Copley S. 1898; Century Assn. Exhibited: CI, 1897; PAFA, 1898 (gold); Paris Expo, 1900 (med); Pan-Am. Expo, Buffalo, 1901 (med); St. Louis Expo, 1904 (med). Work: BMFA; PAFA; MMA; CGA; WMA [13]

LODBERG, Agnes C.L. [P,S,C,W,T] Newport, RI b. 8 Ap 1875, Denmark (came to U.S. in 1906) Studied: Royal Acad. FA, Copenhagen. Member: Scandinavian Am. S., NYC. Work: Am. Numismatic S.; King of Denmark; Univ. Lib., Morgantown, W.Va. [19]

LODWICK, Agnes [P,T] St. Louis, MO b. Bergen Point, NJ. Studied: St. Louis Sch. FA; F.S. Chase; Delecluse, in Paris. Member: Western AA; St. Louis AG; St. Louis Alliance [40]

LOEB, Dorothy [P,G] South Orleans, MA b. 1887, Germany. Studied: AIC; F. Leger; L. Marconissa, in Paris. Exhibited: Am. P. Today, WMA, 1938; Contemp. New England P., Inst. Mod. A., Boston, 1939 [40]

LOEB, Ella [P] Chicago, IL [13]

LOEB, Louis [P,I,T] NYC b. 7 N 1866, Cleveland, OH d. 12 Jy 1909, Canterbury, NH. Studied: Gérôme, in Paris. Member: SAA 1900; ANA 1901; NA, 1906; Arch. Lg., 1902; SI. Exhibited: S. Wash. A., 1906 (prize); Paris Salon, 1895, 1897 (med); Pan-Am. Expo, Buffalo, 1901 (med); Hallgarten prize, NAD, 1902 (prize); SAA, 1903 (prize), 1905 (prize); St. Louis Expo, 1904 (med). Work: MMA [08]

LOEB, Sidney [S] Chicago, IL. Exhibited: AIC, 1935–38; WFNY, 1939. Work: USPO, Royal Oak, Mich. WPA artist. [40]

LOEBL, Florence Weinberg [P,W] NYC b. 13 N 1894, NYC. Studied: K.H. Miller. Member: S.Indp.A. [25]

LOEDERER, Richard A. [E,P,Des,T,I,W,Car,B] NYC b. 26 Mr 1894, Vienna, Austria. Studied: Prof. Klinger, Berlin; Acad. FA, Vienna; Schule Reimann, Berlin; W. Reiss. Exhibited: Acad. FA, Vienna; Pan-Am. Union, Wash., D.C., 1942; Am. Commons, NYC, 1944. Work: Blue Ribbon Restaurant, NYC; Stoll's Tavern, Troy, N.Y.; hotel, St. George's, Bermuda; Nat. Canadian Expo, Toronto. Author/Illustrator: "Voodoo Fire in Haiti," 1935, "Immortal Men of Music," 1940. Illustrator: "One Lives to Tell the Tale," by E. Gilligen, New Yorker, London Studios, Creative Art. Position: T., N.Y. Drafting Inst. [47]

LOEFFLER, Gisella. See Lacher.

LOEFFLER, Moritz [C,T] b. Germany d. 6 O 1935, Bloomfield, NJ. Positions: T., PIASch (for 38 yrs.), Newark Sch. F.&Indst. Arts (for 28 yrs.)

LOERCHER, Elsie A. [S] NYC. Exhibited: NAWPS, 1935–38 [40]

LOESER, Charles A. [Patron,Cr] Florence, Italy b. 1864 d. 15 Mr 1928. Studied: Harvard, 1886. Italian critic & consultant for BM and European museums.

LOESER, Elizabeth H. [Min.P] Lansdowne, PA b. Pottsville, PA. Studied: PAFA; ASL, with W. Sartain [08]

LOEWENGUTH, Frederick M. [P,C] Rochester, NY b. 18 Ap 1887, Rochester, NY. Studied: London; Paris. Member: Rochester AC [33]

LOEWENHEIM, S. Frederick [I] New Rochelle, NY b. 1870, Berlin, Germany (came to U.S. in 1874) d. 14 N 1929. Studied: Kunst-Schule, Berlin; AIC. Member: SI, 1911; SC, 1911; GFLA; New Rochelle AA; AFA; Advertiser's C., NYC. Designer: covers, The Country Gentleman, Woman's Home Companion. Illustrator: magazines

LOEWY, George (Mrs.) [S] NYC [24]

LOFGREN, Charles [I] NYC. Member: SI [47]

LOFGREN, N.P. [P] Minneapolis, MN [13]

LOFTING, Hugh [I,W,L] NYC b. 14 Ja 1886, Maidenhead, England (settled in U.S. in 1912) d. 1947. Author/Illustrator: "Story of Doctor Doolittle," "The Voyages of Doctor Doolittle" (1922, Newberry Medal), other Dr. Doolittle books, "The Story of Mrs. Tubbs," "Porridge Poetry" (1924),

"Noisy Noah," "Gub Gub's Book" (1932), other books. Was a civil engineer; practiced as such till 1912. [33]

LOGAN, Charlotte E. [Des] NYC b. 31 Ja 1900, Mansfield, OH. Studied: Rochester Atheneum; Mechanics Inst. Member: Nat. AAI. Position: Dir., Charlotte Logan Studio [40]

LOGAN, Clarice George [P,Des,B,I,T] Milwaukee, WI b. 18 Je 1909, Maysville, NY. Studied: G. Moeller; A. Gunther; H. Thomas; R. Von Neumann; Milwaukee State T. Col. Member: Wis. PS; Milwaukee PM; Wis. Artists Fed. Exhibited: Milwaukee PM, 1936 (prize); Wis. PS, 1936. Work: Milwaukee AI; County Court House, Milwaukee; Indst. Home for Girls, Milwaukee; City Hall, Milwaukee [40]

LOGAN, Elizabeth D(ulaney) (Mrs. E.D.L. Collins) [P,E,Car,G] NYC b. 26 O 1914, Bowling Green, KY. Studied: Antioch Col.; Ohio State Univ.; C. Holty; A. Refregier; H. Hofmann; Louisville A. Center; Am. Ar. Sch., N.Y. Exhibited: 48 Sts. Comp. Work: USPO, Akron, NY. Illustrator: trade magazines [47]

LOGAN, Frank G. [Patron] b. 1852, Cayuga County, NY d. 18 Jy 1937, Chicago. A supporter of the AIC, he founded the Logan Art Institute Medal and Prizes in 1916, which amounted to over $76,000. Honorary president of the Art Institute; founded the chair of anthropology and the Logan Archaeological Museum at Beloit College; was a patron of Chicago Civic Opera, and one to the builders of Orchestra Hall. In 1934, the French Government awarded him the Cross of the Legion of Honor in recognition of his contributions to art and science.

LOGAN, Frederick M. [P,En,L,Des,B,T,W] Milwaukee, WI b. 18, Jy 1909, Racine, WI. Studied: Milwaukee State T. Col.; AIC; Columbia; H. Gardner; A. Young; E.H. Swift; G. Moeller; A. Gunther; H. Thomas; R. Von Neumann; V. D'Amico; A. Heckman. Member: Wis. PS; Wis. Edu. Assn.; Am. Fed. T.; Wis. Ar. Fed. Exhibited: Great Lakes Exh., 1938; Univ. Wis. Salon; Wis. PS (prize); AIC; Wis. State Fair; Milwaukee AI, 1933 (prize). Position: T., Steuben Jr. H.S. (Milwaukee), Milwaukee State T. Col. [47]

LOGAN, Herschel C. [En,Des,I,W,B] Salina, KS b. 19 Ap 1901, Magnolia, MO. Studied: Chicago Acad. FA; Fed. Schools, Inc. Member: Prairie PM; Calif. PM; Salina AA; Wichita AG. Exhibited: Prairie PM; Calif. PM; Kansas City AI, 1926 (prize), 1927 (med), 1930 (prize), 1934 (prize), 1937 (prize); Rocky Mountain PM, 1934 (prize); Kans. Fed. A., 1935 (prize), 1938 (prize); Friends of A., 1935 (prize); WFNY, 1939 (prize); Kans. State Fair, Topeka, 1929–38; Intl. PM Exh., Los Angeles, 1934; Wichita, 1935 (prize), 1938 (prize). Work: LOC; Univ. Kans.; Denver AM; NYPL; Mass. State Col.; Century A. Coll., NYC; Lindbergh Coll., St. Louis; Pub. Schs., Winfield, Kans.; pub. and parochial schools, Salina. Author/Illustrator: "Hand Cannon to Automatic," 1944. Illustrator: "Other Days," 1928 [47]

LOGAN, Marjorie Sybilla [Edu,L,Des,T] Milwaukee, WI b. Meadville, PA. Studied: Wellesley; Univ. Chicago; Harvard; AIC; C. Hawthorne; G. Cornell; Church Sch. A. Member: Carnegie F.; AFA; CAA; Am. Assn. Univ. Women; Western AA; Midwestern Col. A. Conference; College S. of Pr. Collectors; The Cordon, Chicago. Exhibited: Milwaukee AI; The Cordon, Chicago; Milwaukee Col. C.; AIC. Position: T., Milwaukee-Downer Col., 1921– [47]

LOGAN, Maurice [P,I] Oakland, CA b. 1886 d. 1977. Exhibited: A. Center, San Fran., 1935; AIC, 1936; GGE, 1939 [40]

LOGAN, Robert Fulton [P,E,L,T] New London, CT b. 25 Mr 1899, Manitoba, Canada. Studied: AIC; BMFA Sch.; P.L. Hale; E. Tarbell; F. Benson; Noyes. Member: SAE; Chicago SE; Mystic AA; CAFA; CAA; Salon Nationale, Paris; Soc. Intl. Gravure Originale en Noir. Exhibited: PAFA, 1916–28; CGA, 1916–22; Chicago SE, 1921, 1922 (med), 1923–30, 1939 (med); SAE, annually, Paris Salon, 1921–30; CAFA, annually; Mystic AA, annually; MMA, 1921 (med). Work: Luxembourg Mus., Paris; Yale; MMA; AIC; BMFA; NGA; British Mus., London; Bibliothèque Nationale, Paris; Lyman Allyn Mus.; Avery Mem., Hartford, Conn.; Am. Embassy, Paris; LOC; NYPL; Morgan Mus., Hartford; Conn. State Lib.; Ann Arbor A. Mus.; BM; Fitzwilliam Mus., Cambridge, England; Musée de Blerancourt, France; Mus. Saint Denis, France. Position: T., Conn. Col., New London, 1934– [47]

LOGAN, Robert Henry [P] Waltham, MA b. 1875 d. 9 Ja 1942. Studied: BMFA Sch.; Paris

LOGAN, Samantha Louisville, KY. Member: Louisville AL [01]

LOGAN, Velma Kidd (Mrs. Marshall) [P,B,Dr,C] Birmingham, AL b. 12 N 1912, Birmingham. Studied: E. Woodward, Newcomb Col. Member: SSAL [40]

LOGASA, Charles [P] NYC b. 14 Jy 1883, Davenport, IA d. 23 F 1936. Studied: J.L. Wallace, Corcoran Sch.; J.P. Laurens; H. Royer. Member: S.Indp.A. (Dir.); Salons of Am. Exhibited: Contemp. A. Gal., NYC [33]

LOGES, Herbert [I] NYC. Member: SI [47]

LOGGIE, Helen A. [E,P,Dr] Bellingham, WA b. Bellingham, WA d. 1976. Studied: Smith Col.; ASL; G. Bellows; M. Young; J.T. Arms; E. Haskell; G. Luks; G. Bridgman. Member: SAE; Southern PM; Calif. SE; Northwest PM; Audubon A. Exhibited: NAD, 1934–46; SAE, 1930–44; Chicago World's Fair, 1934; WFNY, 1939; PAFA, 1938, 1940, 1941, 1943, 1944; Phila. Pr. C., 1936, 1938–42; Denver A. Mus., 1939, 1940, 1944; SAM, 1939 (one-man), 1940–44, 1946; Calif. SE, 1938–44; Southern PM, 1939–42; Albany Inst. Hist.&A., 1941, 1943, 1945; Albany Pr. C., 1945; San Fran. AA, 1931; SFMA, 1940; CI, 1941; WMAA, 1942; MMA (AV), 1942; LOC, 1931, 1940–42, 1943 (prize); Audubon A., 1945; Kleemann Gal., 1938 (one-man); Western Wash. Col. Edu., 1942 (one-man); Smithsonian, 1944 (one-man); Northwest PM, 1939 (prize). Work: Univ. Nebr.; LOC; MFA, Houston; SAM; Western Wash. Col. Edu.; Nat. Mus., Stockholm; Glasgow Univ.; Contemp. A. Soc., England [47]

LOHANSEN, Edna May S. [P] Chicago, IL [10]

LOHERTY, Curtis [P] Paris, France b. U.S. Studied: Paris, with Benjamin-Constant, Laurens [06]

LOHMANN, Albert C. [P] Meriden, CT [13]

LOHMANN, Erika [P,C,T] NYC b. 21 Jy 1900, Hamburg, Germany. Studied: W. Reis. Member: NAWPS; AUDAC. Work: St. George Hotel, Brooklyn; Univ. Place Hotel, NYC [33]

LOHMANN, F.D. [P] Cincinnati, OH. Member: Cincinnati AC [27]

LOHMULLER, Joseph [Modeler] NYC [10]

LOHR, Alfred [P] Worcester, MA. Member: S.Indp.A. [25]

LOHR, Kathryn Lavinia [P,C] Johnstown, PA b. 17 Ag 1912, Johnstown. Studied: Johnstown AI; W. Kipp; R. Pearson. Member: NAWA; AAPL; Pittsburgh AA; All. A. Johnstown. Exhibited: S.Indp.A., 1941, 1942; NAWA, 1946; Ind. Col., 1944–46; Cambria County Fair, 1937–41, 1937 (prize); Pittsburgh AA; All. A. Johnstown, 1938–39, 1940 (prize), 1941–45; FA C., Johnstown, 1938 [40]

LOHRMANN, Ernest [S] Meriden, CT. Work: USPO, Coudersport, Pa. WPA artist. [47]

LOHSE, Willis R. [Des,I] NYC b. 30 Ja 1890, Dresden, Germany. Member: SI; AWCS. Specialty: design of jackets and end papers. Illustrator: children's books [47]

LOKKE, Marie. See Mathiesen, Mrs.

LOMASNEY, Ethel M. [P] Minneapolis, MN[25]

LOMBARD, Warren P(limpton) [E] Ann Arbor, MI/Monhegan, ME b. 29 My 1855, West Newton, MA d. 13 Jy 1939. Member: Ann Arbor AA; AFA [38]

LOMBARDO, Emilio Vincent [P,E] Dorchester, MA b. 9 S 1890, Italy. Studied: San Fran. Inst. A. [27]

LOMBARDO, Josef Vincent [Edu,W,P,S,L] Jamaica, NY b. 11 N 1908, NYC. Studied: CUASch; Royal Acad. FA, Florence; NYU; Columbia; Univ. Florence. Member: AFA; CAA; Nat. Edu. Assn.; Am. Assn. Univ. Prof.; Inst. Int. Edu. Author: "Attilio Piccirilli, Life of an American Sculptor," 1944. Position: T., Queens Col., 1938–42 [47]

LO MEDICO, Thomas (G.) [S] NYC b. 11 Jy 1904. Studied: BAID. Member: NSS. Exhibited: Metropolitan Life Insurance Co. Comp., 1938 (prize); AV, 1942 (prize); NSS, 1946 (prize); WMAA; MMA; PAFA; NAD, 1933. Work: USPO, Wilmington, N.C.; USPO, Crooksville, Ohio [47]

LONDERBACK, Walt [I] Edgewater, NJ [19]

LONDON, Frank (Marsden) [P,C] NYC b. 9 My 1876, Pittsboro, NC d. 10 Mr 1945. Studied: A. Dow; W. Chase; K. Cox. Exhibited: International Exh., Bordeaux, France, 1927 (prize). Specialty: design stained glass [40]

LONDON, Leonard [I,Des] Wash., D.C. b. 13 Jy 1902, NYC. Studied: G. Bridgman; C. Phillips. Member: SI; A. Dir. C.; Lotos C. Exhibited: A. Dir. C., 1934 (prize); Chicago Chamber of Commerce Poster Exh., 1934 (prize). Work: U.S. Tires Posters, 1933–34 [47]

LONDONER, A(my) [P] NYC b. 12 Ap 1878, Lexington, MO. Studied: R. Henri; J. Sloan. Member: ASL; S.Indp.A. [27]

LONERGAN, John [Li,Ser,P,C,W,T] NYC b. 15 Ja 1897, Troy, NY d. 1969. Studied: Ecole des Beaux-Arts, Paris; ASL; P. Vignon. Member: An Am. Group. Exhibited: WMAA, 1941; Assn. Am. A., 1941, 1942; ACA Gal., 1938-40 (one-man); Ferargil Gal., 1943 (one-man). Work: Tucson (Ariz.) Mus.; Phillips Acad., Andover, Mass.; MMA; Princeton Univ. Author: "Techniques and Materials of Gouache Painting," 1939. Position: T., Friends Seminary, NYC; Greenwich House, NYC [47]

LONE WOLF, (Schultz, Hart M.) [P,I,S] b. 1882, Blackfoot Reservation, MT d. ca.1965 (Tucson?). Studied: encouraged early by T. Moran; Los Angeles ASL; Chicago, 1914-15. Work: Univ. Nebr.; Santa Fe Railroad. An Indian-cowboy, he illustrated many of his father's [James W. Schultz] books on Indian life. His style was similar to Russell's and Remington's, and he signed his works with a wolf's face.

LONG, Adelaid Husted (Mrs. George T.) [P,T,W] White Plains, NY b. N.Y. Studied: ASL; J. Twachtman; E. Knaufft; G.T. Collins; Anglade in Paris. Member: NAC [40]

LONG, Betty [P] Cleveland, OH [25]

LONG, Birch Burdette [P,I,Arch] NYC b. 1878 d. 1 My 1927. Member: SC. Work: William Penn Hotel, Pittsburgh; N.Y. Bldg., San Fran. Expo. Position: Cur., Arch. League [08]

LONG, Charles Raymond [I,Car,Dec,C] Chicago, IL b. 17 Ja 1909, Fort Scott, KS. Studied: Am. Acad. A., Chicago. Exhibited: Fed. A. Project Exh., AIC, 1938 [40]

LONG, Dorothy [P] Brooklyn, NY [19]

LONG, Ellis B(arcroft) [P,S] Baltimore, MD b. 30 O 1874, Baltimore. Studied: A. Castaigne, E.S. Whiteman, in Baltimore; Cox, Mowbray, Saint-Gaudens, D.C. French, in NYC. Member: Char. C. [24]

LONG, Eulah Biggers [P] Ft. Worth, TX [24]

LONG, (Fannie) Louella [P,Des,G] Rock Island, IL b. 1 S 1898, St. Paul, MN. Studied: Minneapolis Sch. A.; AIC; V. Bobritzski; I. Karasz. Member: Alumnae Assn., AIC. Exhibited: Ldscp., Tri-City Ar., Davenport Municipal A. Gal., 1929 (prize); Springfield, Mass., MA; Corcoran Gal., Wash., D.C.; Fed. A. Project Exh., AIC, 1938; Ar. Chicago Vicinity, AIC, 1939. Work: Allocations, WPA artist. Specialty: textile design [40]

LONG, Frank Weathers [P,En,S] Berea, KY b. 7 My 1906, Knoxville, TN. Studied: AIC; PAFA; Académie Julian, Paris. Exhibited: WFNY, 1939; GGE, 1939; AFA, traveling exh.; IBM traveling exh. to S. America; Speed Mem. Mus., 1940 (one-man); Berea Col., 1938-40 (one-man); Ashland (Ky.) AA, 1939 (one-man). Work: IMB Coll.; Berea Col. Coll.; murals, Univ. Ky.; Davidson (N.C.) Col.; USPO, Berea, Morehead, Louisville, Ky.; Drumright, Okla.; Crawfordsville, Ind.; Hagerstown, Md.; WPA artist. Author/Illustrator: "Herakles: The Twelve Labors," 1931. Illustrator: "Wood Engravings and Text" [47]

LONG, Marion Lee [Ldscp.P] Louisville, KY b. 1 S 1898, Louisville. Studied: Parsons Sch. Des.; Louisville Sch. A.; Hawthorne; Archipenko; Barnum; N.Y. Sch. F. App. A. Member: Louisville A. Center; Louisville AC; SSAL; AFA; Louisville AA. Exhibited: WFNY, 1939; SSAL, 1937, 1939, 1940; Louisville AC, 1936-41, 1944-46; Louisville A. Center, 1937-45; John Herron AI, 1937 [47]

LONG, R(obert) D(ickson) [P,I,L,Car] Carnegie, PA b. 18 Je 1884, Pittsburgh. Member: Assn. A. Pittsburgh. Exhibited: PAFA, 1931; CM, 1931; Assn. A. Pittsburgh, annually; CI. Work: Pittsburgh; Carnegie, Forest Hills, Latrobe H.S., all in Pa. [47]

LONG, Stanley M. [P,I,T] b. 1892, Oakland, CA d. 1972, San Carlos, CA. Studied: Calif. Inst. FA; Mark Hopkins IA, San Fran.; Académie Julian, Paris. Work: Shasta City (Calif.) Mus. Illustrator: "Black Military Experience in American West." Specialty: western ranch life [*]

LONGACRE, Breta [P] NYC. Member: NAWPS [21]

LONGACRE, Lydia E. [Min.P] NYC b. 1 S 1870, NYC d. 19 Je 1951. Studied: ASL, with Chase, Mowbray; Paris, with Whister. Member: ASMP. Exhibited: Pa. Soc. Min. P., 1939 (med) [47]

LONGACRE, Margaret Gruen (Mrs. J.J., IV) [W,L,G,T] Cincinnati, OH b. 21 N 1910, Cincinnati d. 1976. Studied: Univ. Cincinnati; Cincinnati A. Acad.; E.T. Hurley. Member: New Orleans AA; Springfield A. Lg.; Ohio Pr.M.; New England Pr. Assn.; Am. Color Pr. Soc.; Crafters, Woman's AC, Cincinnati; Mus. Assn., Cincinnati; A. Circle, Cincinnati; Pr. Soc., Cincinnati. Exhibited: LOC, 1942 (prize); Print of the Year, Mass., 1942; CM, 1944 (prize); CMA, 1941 (prize); NAD, 1941, 1942, 1944; Ohio Pr.M., 1938-46; Northwest Pr.M., 1941, 1942; Phila. Pr. C., 1941, 1942, 1944-46; Boston S.Indp.A., 1941; CAFA, 1941-43, 1945; Springfield A. Lg., 1941-46; Oakland A. Gal., 1941, 1945; PAFA, 1941; SAE, 1942-45; New England Pr. Assn., 1941; San Fran. AA, 1942, 1943; CGA, 1942-46; New Haven Paint&Clay C., 1942, 1944; Am. Color Pr. Soc., 1942-44; Denver A. Mus., 1942-44; MMA, 1942, 1943; Texas FA Assn., 1943, 1944; LOC, 1943-46; Laguna Beach AA, 1942-44; Mint Mus. A., 1943-46; New Orleans AA, 1944-46; CM, 1944-46; Audubon A., 1945; SFMA, 1941; Baltimore Gal., 1942, 1946 [47]

LONGFELLOW, Ernest Wadsworth [Ldscp.P] NYC/Magnolia, MA b. 23 N 1845, Cambridge d. 23 N 1921, Boston. Studied: Paris, with Hébert, Bonnât, Couture. Member: Century Assn. Work: BMFA. Son of the poet Henry Wadsworth Longfellow. [19]

LONGFELLOW, Mary King [P] Portland, ME. Member: Boston WCC [29]

LONGFELLOW, William Pitt Preble [Ldscp.P,Arch,W,Dec] b. 25 O 1836, Portland, ME d. 3 Ag 1913, East Gloucester, MA. Studied: Harvard, 1855. Early instructor at the BMFA Sch. after 1876. Nephew of the poet Henry Wadsworth Longfellow. [*]

LONGMAN, John B. [P,I,T] Nashville, TN b. 1860, Toronto. Studied: Paris, with Gérôme, Boulanger, Lefebvre; Royal A. Acad., Munich. Member: Nashville A.C. [06]

LONGMAN, Mary Evelyn Beatrice (Mrs. Nathaniel Horton Batchelder) [S] Windsor, CT b. 21 N 1874, Winchester, OH. Studied: Olivet Col.; AIC, with L. Taft; D.C. French. Member: AFA; CAFA; NAC; Am. Numismatic Soc.; NSS, 1906; ANA, 1909; NA, 1919. Exhibited: St. Louis Expo, 1904 (med); Pan-Pacific Expo, 1915 (prize); NAD, 1918 (prize), 1923 (prize), 1924 (gold), 1926 (prize); AIC, 1918 (med), 1920 (gold); PAFA, 1921 (gold);CAFA, 1925 (prize). Work: U.S. Naval Acad., Annapolis, Md.; Wellesley Col.; War Mem., Naugatuck, Hartford, Windsor, Conn.; Union Station, Denver, Colo.; USPO, Hartford; Fed. Bldg, Hartford; Harvard; MMA; AIC; Toledo Mus. A.; CAM; CM; CMA; Wadsworth Atheneum; Pub. Lib., Paterson, N.J.; mon., Des Moines, Iowa; Am. Telephone and Telegraph Bldg., NYC; All Souls' Church, NYC; Deutches Mus., Munich; Herron A. Inst., Indianapolis; memorials: Denver; Colorado Springs, Colo.; Hampton Inst., Va.; Salt Lake City; Mexico City; Tuskegee Inst., Va.; Penn Sch., S.C.; Avon, Conn.; Titusville, Pa. [47]

LONGSTRETH, Edward [Dr] b. 22 Je 1839, Hatboro, PA d. 24 F, 1905, Phila. Known for his drawings of the Baldwin locomotives where he worked, 1857-70 [*]

LONGSTRETH, Margaret [P] NYC [17]

LONGWORTH, B.W., Mrs. [P] Paris, France [10]

LONGYEAR, Ida [P] La Crescenta, CA. Member: S. Detroit Women P. [27]

LONGYEAR, William Llowyn [Des,T] Manhasset, NY b. 17 Je 1899, Kingston, NY. Studied: ASL; Columbia; Pratt Inst. Member: EAA; A. Directors C. Work: Mus. Science, Industry, N.Y.; Fortune Magazine. Author/Illustrator: "Garden Pools." Position: T., Pratt Inst., Brooklyn [40]

LOOMIS, Andrew [P,Dr,I] Pasadena, CA b. 15 Je 1892, Syracuse, NY. Studied: DuMond; G. Bridgman; L. Seyffert; J. Carlson. Member: Chicago Freelance Gal.; SI. Exhibited: Harvard Awards for advertising; U.S. Shipping Board (prize); Nat. Outdoor Adv. Contest (prize) (prize). Illustrator: McCall's Pictorial Review [40]

LOOMIS, Chester [P,I] Englewood, NJ b. 18 O 1852, near Syracuse, NY d. 1924. Studied: Paris, with H. Thompson, Bonnât. Member: SAA; ANA; N.Y. Arch. Lg.; A. Fund S.; Mural P. Exhibited: Mass. Charitable Mechanics' Assn., 1890 (gold); N.Y. Arch. Lg., 1904 (prize). Work: Herron A. Inst., Indianapolis; Cornell; Englewood Pub. Lib. [24]

LOOMIS, D. Jean [P] Wash., D.C. [13]

LOOMIS, Helen [P,C,T] NYC/Woodland Park, CO b. Andover, MA d. 5 Je 1920, NYC. Studied: Paris, with A. Mucha; ASL, with G. Noyes, L.P. Thompson. Member: NAWPS [19]

LOOMIS, Kenneth Bradley [Edu,P,Gr,Mus.Cur,Des] Bloomington, IL b. 25 Ag 1900, Steubenville, OH. Studied: AIC; NAD; ASL; BAID; Univ. Toledo; Univ. Iowa; C.W. Hawthorne; V. Vytlacil; A. Crisp; I. Olinsky. Member: NSMP; Westchester County His. Soc.; Mural P. Exhibited: BAID, 1933 (med); Butler AI, 1943, 1944, 1945 (prize); Toledo Mus. A., 1944, 1945 (med); Ill. A. Exh., 1945 (prize); Arch. Lg., 1930-32; NSMP, 1936; AIC, 1945; Kansas City AI, 1941; Milwaukee AI, 1946; Century of Progress Expo, Chicago. Work: Ill. Wesleyan Univ.; Univ. Toledo; WPA artist. [47]

LOOMIS, Lillian (Anderson) [Des,P,L] Poughkeepsie, NY b. 29 Jy 1908, Peitaiho, North China. Studied: Mass. Sch. A., Boston; A.B. Tufts; M. Huse; G. Wiggins; E. O'Hara. Member: Dutchess County A.; NAWA. Exhibited: NAWA, 1942; Dutchess County AA, 1942 (one-man); Fifteen Gal., 1941; AWCS, 1942; Morton Gal., 1941; Vendôme Gal., 1941; Hud-

son Highlands Exh., Newburgh, N.Y.. Work: IBM Country C., Poughkeepsie [47]

LOOMIS, Lyman A. [P] Peoria, IL [19]

LOOMIS, Manchus C. [P] Chicago b. Fairview, PA. Studied: San Fran. Sch. Des., with V. Williams; AIC, with Vanderpoel, Grover, Boutwood. Member: Palette and Chisel C. [33]

LOOMIS, Richard N. [I] Flushing, NY. Member: SI [47]

LOOMIS, (William) Andrew [I,Des,P,W,T,L] North Hollywood, CA b. 15 Je 1892, Syracuse, NY. Studied: ASL; AIC; G.Bridgman; F. DuMond; G. Obertueffer. Member: Chicago Freelance A. Gld.; SI; AFA. Author/Illustrator: "Fun with A Pencil," 1939, "Figure Drawing for All It's Worth," 1943. Contributor: national magazines [47]

LOOP, Edith [Por.P] Laguna Beach, CA. Member: Laguna Beach AA. Daughter of Henry and Jeannette. [25]

LOOP, Henry Augustus [Por.P] b. 9 S 1831, Hillsdale, NY d. 20 O 1895, Lake George, NY. Studied: Henry P. Gray; Paris, with Couture, 1856; Italy. Member: NA, 1861 [*]

LOOP, Jeannette Shepperd Harrison (Mrs. Henry) [Por.P] Saratoga, NY b. 5 Mr 1840, New Haven, CT d. 17 Ap 1909. Studied: New Haven, with Louis Bail, W. Hotchkiss, G. Durrie; NYC, with Henry Loop, 1863; Rome, Paris, Venice, 1867–68. Member: ANA, 1873. Exhibited: NAD. Specialty: children [08]

LOOP, Leota Williams [P,T] Nashville, IN b. 26 O 1893, Fountain City, IN. Studied: O. Rush; W. Forsythe; R.L. Coats. Member: Ind. AC; Hoosier Salon; Am. Ar. Prof. Lg.; Brown Co. Art Gal. Assn. Exhibited: Hoosier Salon, 1939 (prize). Work: Tipton Library; Milwaukee Children's Home; Women's Department C., Kokomo, Ind.; Governor's Mansion, Indianapolis; Mem. Bldg., Purdue Univ.; Pub. Lib., Marion, Kokomo, Ind. [40]

LOOS, Anna J. [P] Secane, PA [04]

LOOSE, Jessie [P] Bronxville, NY. Member: Lg. AA [24]

LOPER, Edward L. [P] Wilmington, DE b. 7 Ap 1906, Wilmington. Exhibited: Wilmington SA, 1939 (prize); PMA, 1944 (prize); PAFA, 1945 (prize); Whyte Gal.; N.J. State Mus., 1945; Albany Inst., 1945; SFMA, 1945. Work: Wilmington SA; PMA; PAFA [47]

LOPEZ, Carlos [P,T] Ann Arbor, MI b. 24 My 1908, Havana, Cuba d. 6 Ja 1953. Studied: AIC; Detroit A. Acad; G. Rich. Member: SC, Detroit; Ann Arbor AA. Exhibited: Detroit Mich., 1938–45 (prizes); SC, 1938 (gold); Detroit Inst. A., 1934, 1935, 1936 (prize), 1937–45; Friends Mod. A., 1937 (prize); CGA, 1937–45; PAFA, 1938, 1939; AIC, 1937–46; WFNY, 1939; GGE, 1939; CI, 1945; WMAA, 1945; Detroit, 1936 (one-man), 1938 (one-man), 1941 (one-man), 1945 (one-man). Work: Detroit Inst. A.; WMAA; Abott Lab. Coll.; Standard Oil Coll.; murals, Recorder of Deeds Bldg., Wash., D.C.; USPO, Dwight, Ill.; Plymouth, Paw-Paw, Birmingham, Mich.; WPA artist. Position: T., Univ. Michigan, Meinzinger Foundation A. Sch., Detroit [47]

LOPEZ, Charles Albert [S] NYC b. 19 O 1869, Matamoras, Mexico d. 18 My 1906. Studied: NYC, with J.Q.A. Ward; Falguière, Ecole des Beaux-Arts, both in Paris. Member: Soc. Am. Artists; ANA, 1906; Nat. S. Soc.; Arch. Lg. Exhibited: Sun Dial Competition, N.Y. 1898 (prize); Flag Staff Competition, N.Y., 1898 (prize); Charleston Expo, 1902 (med); St. Louis Fair (gold); Pan-Am. Expo (prize); Fairmount Park, Phila. (prize) [06]

LOPEZ-REY, Jose [Edu,W,L] Northampton, MA b. 14 My 1905, Madrid, Spain. Studied: Univ. Madrid; Univ. Florence; Univ. Vienna. Member: CAA. Author: "Antonio el Pollaiuolo y el fin del 'Quatrocento,'" 1935, "Realismo e impresionismo en las artes figurativas españolas del siglo XIX," 1937. Contributor: Gazette des Beaux-Arts; Archivo Español de Arte. Positions: T., Univ. Madrid (1932–39), Smith Col. (1940–44), NYU (1944–) [47]

LO PINTO, Ferdinand [P,Des,I] NYC b. 4 Ja 1906, NYC. Studied: NAD. Member: Un. Am. A. Exhibited: CI, 1941; CGA, 1941; Springfield Mus., 1943; WFNY, 1939; AFA, 1941; BM, 1939; de Young Mem. Mus., 1938; Contemporary A. Gal.; Valentine Gal.; Yonkers Mus., 1938; G.W.V. Smith Gal., 1940; New Sch. Social Research, 1939; Vendome Gal., 1939. Work: U.S. Gov. Coll. Illustrator: "Guide to Alaska" [47]

LOPP, Harry Leonard [P,I,L] Somers, MT (1966) b. 1888, Highmore, SD. Studied: Union Col., Lincoln, Nebr., with P.J. Rennings; Univ. Wash., with Updyke; R. Gissing. Staff artist in Glacier Natl. Park for Great Northern Railroad, 1936–41 [*]

LOPP, Lilia Anne [I,T] Cincinnati, OH b. 14 D 1891 [24]

LORAN, Erle [P,W,T,Li] Berkeley, CA b. 3 O 1905, Minneapolis. Studied: Univ. Minn.; Minneapolis Sch. A.; C. Booth. Member: San Fran. A. Assn. Exhibited: Chaloner Paris, 1926 (prize); Minn. A. Soc., 1924 (prize); Minneapolis Inst. A., 1925 (prize), 1931 (prize); Minn. State Fair, 1924 (prize), 1925 (prize), 1926 (prize), 1934 (prize), 1935 (prize), 1945 (prize), 1946 (prize); PAFA, 1940 (prize), 1945 (prize); Chicago AC, 1943 (prize); SFMA, 1936–41, 1942 (prize), 1944 (prize), 1945, 1946; MOMA Traveling Exh., 1933; Rockefeller Center, N.Y., 1935; Colorado Springs FA Center, 1938; WMAA, 1937, 1941, 1944; AIC, 1933, 1938, 1939, 1941, 1943, 1944, 1946; TMA, 1943; Palace Legion Honor, 1945, 1946; Oakland A. Gal., 1936–46; Calif. WCC, 1941–46; Kraushaar Gal., 1931 (one-man); A. Gal., N.Y., 1938 (one-man); Milwaukee AI (one-man); St. Paul Gal. A. (one-man). Work: SFMA; Denver A. Mus.; Univ. Minn.; U.S.Treasury Dept., Wash., D.C. Author: "Cézanne's Composition," 1943, "The Arts," 1930, "An Artist Goes to Italy," "The Arts." Contributor: American Magazine of Art. Position: T., Univ. Calif., Berkeley, 1943– [47]

LORCH, Emil Detroit, MI b. 1870, Detroit. Studied: Detroit Mus. A. Sch.; MIT. Exhibited: Omaha Expo, 1898 [98]

LORD, Austin Willard [P,Arch] b. 1860, Rolling Stone, MN d. 19 Ja 1922, Silvermine, CT. Studied: MIT; Minneapolis. Member: Salma. Cl. Work: Isthmian Canal Commission. Position: Dir., Am. Sch., Rome, 1894–1896. T., Columbia, 1912–15 [21]

LORD, Betty [Com.Des,I] West Medford, MA b. Sommerville, MA. Studied: Mass. Sch. A.; Berkshire Summer Sch. A.; Syracuse Univ. [32]

LORD, Caroline A. [P,T] Cincinnati, OH b. 10 Mr 1860, Cincinnati d. 1928. Studied: Cincinnati A. Acad.; ASL; Académie Julian, Paris. Member: Cincinnati Women's AC. Exhibited: Columbian Expo, Chicago, 1893 (med); Buffalo FA Soc., 1925 (prize). Work: Cincinnati Mus. Position: T., Cincinnati Art Acad. [29]

LORD, E. E. [Des] NYC [10]

LORD, Evelyn Rumsey [P] Buffalo, NY/Youngstown, NY b. Buffalo. Studied: Buffalo A. Sch.; C.W. Hawthorne; C. Woodbury. Member: Buffalo SA; The Patteran. Exhibited: Buffalo, 1916 (prize), 1925 (prize); Ar. Western N.Y. Exh., Albright A. Gal., Buffalo, 1937 (prize) [40]

LORD, Harriet [P] NYC/Nantucket, MA b. 7 My 1879 d. 24 Jy 1958. Studied: J. De Camp; F.W. Benson; E. Tarbell; W.L. Lathrop. Member: NAWPS; Allied AA; North Shore AA [40]

LORD, Louise [P] Orange, NJ [08]

LORD-WOOD, E. Russell [S] Folcroft, PA. Studied: PAFA [25]

LORE, J. M. [P] College Point, NY [24]

LORENSEN, Carl [S] Chicago, IL b. 1864, Klakring, Denmark d. 17 Ja 1916. Studied: Copenhagen Acad., with Kroyer. Exhibited: AIC; Columbian Expo, 1893

LORENZ, Louis F.A. [I] NYC [01]

LORENZ, Richard [P,I] Milwaukee, WI b. 9 F 1858, Weimar, Germany (came to Milwaukee in 1886) d. 3 Ag 1915. Studied: Brendel, Steuss, Leunig, Thedy, 1874–86. Member: SWA; Deutsche AA. Exhibited: Weimar, 1884 (prize); Berlin; Munich; Osborne prize, 1905; Milwaukee A. Center, 1966 (retrospective). Said to have been a Texas Ranger ca. 1887–90. Teacher of Frank T. Johnson. Position: T., Milwaukee Sch. A., 1890 [13]

LORENZANI, Arthur E. [S] Staten Island, NY b. 12 F 1886, Carrara, Italy. Studied: Royal Acad., Carrara. Member: Arch. Lg.; Staten Island Inst. A.&Sc.; NSS. Exhibited: Parma, Italy, 1907 (prize); NAD; PAFA; BMA; CM; Albright A. Gal. Work: Gal. Mod. A., Carrara, Italy; Brookgreen Gardens, S.C. [47]

LORENZINI, Eldora Pauline [P,Des,I,T,Dec,B,C] Louisville, CO b. 28 Mr 1910, Weldona, CO. Studied: Colorado Springs FA Center; Colo. State Col.; Yale; Robinson; Biddle; Burlin; Poor; E. Stinchfield; C. House, in Denver; G. Baker; P. Mangravite. Member: Colorado Springs FA Ctr.; Denver A. Gld. Exhibited: Colorado Springs FA Ctr., 1936 (prize), 1939 (one-man). Work: NGA; Big Bend Sch., Greeley, Colo.; Colorado Springs FA Bldg.; USPOs, Hebron, Nebr., Colorado Springs; USPO Bldg., Wash., D.C. WPA artist. Associated with Taylor Mus., Colorado Springs [47]

LORING, Augustus P., Jr. (Mrs.) [Bkbind,C] Boston, MA/Prides Crossing, MA b. 2 My 1889, Jamaica Plain, MA. Studied: M.C. Sears. Member: Boston SAC; Book-in-Hand Gld.; Gld. Bookworkers, N.Y. Position: Asst. Lib., Club of Odd Volumes, Boston. Specialty: marbling [40]

LORIMER, Amy (McClellan) (Mrs. Fred D.) [P,T] Detroit, MI b. 11 N

1893, Toronto d. ca. 1950. Studied: Collegiate Inst., Winnipeg, Canada; Detroit Soc. A. & Crafts; S. Halpert; J. Carroll. Member: Detroit Soc. Women P. & S. Exhibited: Detroit Soc. A., 1936 (prize); Detroit Soc. Women P. & S., 1938; WFNY, 1939; PAFA; AIC, 1940; Grand Rapids, Mich., 1940; Detroit Inst. A., annually; Mich. State Fair, 1930 (prize), 1935 (prize); Detroit Inst. Arts, 1936 (prize). Position: T., Central Y.W.C.A., Detroit [47]

LORING, Charles Greely [Mus. Dir] Beverly, MA b. 22 Jy 1828, Boston d. 18 Ag 1902. Studied: Harvard. He accompanied Prof. Louis Agassiz on an exploration of the shores of Lake Superior, and later traveled to Europe. He also served in the Union Army. In October, 1872, he undertook the installation of the Way Egyptian Coll. for BMFA; appointed curator 1876. Was executive head 26 years

LORING, Francis William [Ldscp.P] b. 1838, Boston d. 1905, Meran, Austria. Work: BMFA [*]

LORING, Nellie A. [C,T] Norwich, CT b. 2 D 1884, Norwich. Studied: BMFA Sch.; N.Y. State Sch. Clayworking & Ceramics. Member: Boston SAC. Specialties: jewelry; metalwork. Position: T., Norwich Art Sch. [40]

LORING, R. F. [I] NYC. Illustrator: "Leslie's" [98]

LORING, Rosamond B. [Des,C,Mus.Cur,W] Boston, MA b. 2 My 1889, Boston. Author: "Marbled Papers," 1933; "Decorative Book Papers," 1942. Contributor: Merrymount Press; Anthoensen Press; Limited Editions C. Positions: Cur. Exh., Peabody Mus., Salem, Mass.; Asst. Lib., The Club of Odd Volumes, Boston [47]

LORING, William Cushing [P,T,W] Newton Center, MA b. 10 Ag 1879, Newton Center. Studied: NYC; Boston; London; Haarlem; Paris. Member: Prov. AC. Work: Brown Univ.; R.I. State House; RISD; Harvard [40]

LORNE, Naomi (formerly Naomi Duckman Furth) [P,W,Dec,L] Brooklyn, NY b. 26 Je 1902, NYC. Studied: A.G. Schulman; A.T. Hibbard; G. Bridgman; F.J. Waugh; CCNY; ASL. Member: S.Indp.A.; Audubon A.; NAWA; AAPL; Georgetown Gal., Wash., D.C. Exhibited: Audubon A., 1944 (prize); S.Indp.A.; Georgetown Gal., Wash., D.C.; Vendôme Gal., 1940 (one-man); Everhart Mus.; BM; Arch. Lg.; NAC; Am.-British A. Center; NAD; Norlyst Gal.; Bronx Mus.; Newhouse Gal.; Argent Gal. Work: Staten Island Hospital; General Steel Co.; American Cyanamid Co. [47]

LORRAINE, Alma Royer (Mrs.) [Por.P] Seattle, WA b. 28 My 1858, Randolph, OH. Studied: AIC; Paris, with Bouguereau; Rome, with Molinari; Alexander Harrison. Exhibited: Alaska–Yukon–Pacific Expo, Seattle, 1909 (med). Work: West Chester Seminary. Specialty: animals [47]

LORRAINE, Helen Louise [Med.I,L] Richmond, VA b. 23 Je 1892, Webster Grove, MO. Studied: Richmond Sch. A.; Johns Hopkins Medical Sch.; N. Houston; A. Clark; M. Brodel. Member: Acad. Sc.&FA, U.S.; Assn. Medical I. Exhibited: Richmond, Va. (Hist. of Medical Illustration); Southern Surgical Assn.; AMA Exh.; Medical Soc. Va.; Exh. by Modern Medicine, of medical illus. Work: Col. Physicians, Phila. Illustrator: medical, operative, surgical publications. Position: St. Elizabeth's Hospital, Richmond, Va. [47]

LOS, Naum Michel [S,T,L] NYC b. 19 O 1882, Novomoskovsk, Russia. Studied: Royal Acad. FA, Berlin; Royal Acad. FA, Brussels; Univ. Lausanne, Switzerland; Paris. Member: French Inst. in the U.S.; NYC; NSS; Amatori e Cultori di Belle Artí in Rome. Exhibited: GGE, 1939; NAD; NSS; PAFA. Work: French Inst. in the U.S.; portrait busts in U.S. and abroad; Kings Col., Cambridge, England; Giarre, Sicily. Position: T., Naum Los Sch. A., NYC [47]

LOSERE, F. Westervelt [P] Boonton, NJ [13]

LOSEY, Luther Curtis, Mrs. See Morgan, Blanche.

LOSS, Bernice Segaloff (Mrs. Louis) [P,T] Ardmore, PA b. 1 Ag 1914, New Haven. Studied: Yale. Exhibited: Merwin Gal., New Haven, Conn.; Westville Lib., New Haven; New Haven PCC, 1937. Work: Nye Council House, Wash., D.C. Position: T., J.K. Nye, Council House, Wash., D.C. [47]

LOTAVE, Carl G. [P,I,T] Lindsborg, KS b. 29 F 1872, Jonkoping, Sweden (came to Kans. in 1897) d. 27 D 1924, his NYC studio. Studied: Sweden, with Zorn, A. Bergh; Acad. Julian, Acad. Colarossi, both in Paris. Work: Mus. N.Mex.; Pioners Mus., Colorado Springs; murals: N.Mex. State House; Archaeological Mus., Santa Fe. Illustrator: "Mountain Sunshine"; "Gazette" magazines. Specialty: painter of the American Indian for the Bureau of Ethnology [01]

LOTHROP, C.B., Mrs. [P] Grosse Pointe, MI [24]

LOTHROP, Gertrude Fay [P,I,W] NYC/Shelter Island, NY b. 19 N 1889, Springfield, MA. Studied: L. Gaspard; Monte [25]

LOTHROP, Isabella (G. B.) [P,C,W] Detroit, MI/Leamington, Ontario b. 4 My 1858, Detroit. Studied: PAFA; Eakins; Chase; DuMond; Reiss; Marr. Member: NAC; Detroit SAC; Detroit Women P. [27]

LOTHROP, Stanley B. [P,L,T] Newton, MA b. Newton d. 14 My 1944, Mexico. Studied: Harvard. Lecturer: Am. Acad., Rome. Positions: Dir., Tiffany Fnd. (Oyster Bay, N.Y.), Colorado Springs FA Center

LOTHROP, Susan [Min.P] Cambridge, MA. Member: Copley S., 1900 [13]

LOTTERHOS, Edith [Cer,P] Crystal Springs, MS b. Crystal Springs. Studied: Newcomb Col., with E. Woodward; Mrs. M. Hall. Member: Miss. AA; NOAA; Arts&Crafts C., New Orleans; SAL. Exhibited: Miss. State Fair, Jackson, 1916 (prize), 1928 (prize), 1931 (prize), 1932 (prize); Crystal Springs Fair (prize). Work: Art Gal., Belhaven Col., Jackson, Miss. [40]

LOTTERHOS, Helen Jay [Dr,P,T] Jackson, MS b. 9 N 1905, McComb, MS. Studied: AIC. Member: Miss. AA; SSAL. Exhibited: Ann. Exh. Miss. AA, Municipal A. Gal., Jackson, 1934 (prize); Miss. Fed. Women's C. Exh., Hattiesburg, 1933 (prize); Miss. State Fair, 1936 (prize). Work: Municipal A. Gal., Jackson [40]

LOTZ, Matilda [P] Paris, France b. 29 N 1861, Franklin, TN. Studied: San Fran. A. Sch., with V. Williams; Van Marcke; Paris, with F. Barrias. Specialty: animals [13]

LOUD, Marion V. [P,W,L,T] Detroit, MI/Mackinac Island, MI b. 6 O 1880, Medford, MA. Studied: D. Ross; Munich, with M. Heymann; E. O'Hara. Member: Detroit Soc. A. & Crafts. Exhibited: Detroit Fed. Women's Clubs, Indp. Exh., 1924 (prize); Mackinac Hist. Fair, 1934 (prize). Work: Children's Mus., Detroit. Illustrator: "A Picnic on a Pyramid." Position: T., Liggett Sch., Detroit; SAC [40]

LOUD, May Hallowell (Mrs. Joseph Prince) [Por.P,T] West Medford, MA b. 22 Ap 1860, West Medford d. 16 F 1916, Boston. Studied: BMFA Sch. with O. Grundman; Académie Julian, Paris; Deschamps, in Paris. Member: Boston WCC; Copley S.; Boston SAC. Specialty: children in pastel [21]

LOUDEN, Adelaide Boldon (Mrs. Norman) [I,W,L] Quakertown, PA b. Phila. Studied: Mount Holyoke Col.; PAFA; H. McCarter. Exhibited: PAFA, 1921, 1936; Phila. A. All., 1921. Author/Illustrator: "Historic Costumes," 1936. Illustrator: "Arabian Nights," 1920; advertising in national magazines [47]

LOUDEN, Norman P [Des,I,Ldscp.P,L,T] Quakertown, PA b. 2 S 1895, Quakertown. Studied: PAFA, with H. McCarter. Exhibited: PAFA; Phila. A. All., 1921. Collaborator: "Historic Costumes." Position: T., Mary Lyon Jr. Col., Swarthmore, Pa. [47]

LOUDEN, Orren R. [P,W,L,T] San Diego, CA b. 24 Ap 1903, Trenton, IL. Studied: George Washington Univ.; Corcoran Sch. A.; ASL; Provincetown Sch. A.; DuMond; Bridgman; Tucker; Benton; K. Nicolaides; J.S. Curry. Member: Springfield AA; A. Council, San Diego. Exhibited: Progressive A., N.Y.; Am. Salon, N.Y.; Springfield AA; Georgetown Gal., Wash., D.C.; Ferguson Gal., La Jolla, Calif.; Village Sch. A. Gal., San Diego; Springfield (Ill.) MA. Contributor: National Geographic, American Motorist magazines. Position: Dir., Village Sch. A., San Diego [47]

LOUDENSCHLAGER, N. [P] Toledo, OH. Member: Artklan [25]

LOUDERBACK, Walt S. [P,I] NYC b. 1887, Valparaiso, IN d. 15 O 1941, Socorro, N.Mex. Studied: AIC. Member: SC; Phila. WCC; NYWCC. Exhibited: Hoosier Salon, 1933 (prize), 1940 (prize); Am. WCC, 1939 (med). Work: Mus. des Beaux-Arts, Monte Carlo; Municipal Gal., Davenport, Iowa; Univ. Mich. [40]

LOUGHBOROUGH, Margaret McLelland [P] Wash., D.C. b. Montgomery County, MD. Studied: Andrews; Chase; Simpson. Member: Wash. SA. Work: State House, Phoenix, Ariz.; Georgetown Children's House, Wash., D.C. [40]

LOUGHEED, Robert Elmer [P,I] Santa Fe, NM (1976) b. 1910, Massie, Ontario. Studied: Ontario Col. A.; Ecole des Beaux-Arts, Montreal; NYC, with DuMond, Cornwell, 1935. Member: Cowboy A. Am.; Nat. Assoc. Western A. Work: Cowboy Hall of Fame; Montreal AA. Illustrator: "Mustang"; many magazines. Creator: Mobil's "Pegasus." Designer: U.S. wildlife stamp, 1970 [*]

LOUGHERY, William [P] Phila., PA b. 24 S 1900, Phila. Member: Chester County AA [40]

LOUGHRAN, William Stoddard [P,L] Bound Brook, NJ/Califon, NJ b. 12 Jy 1902, Atlantic City, NJ. Studied: ASL. Member: Mod. Ar. N.J.; Plainfield A. Assn. Exhibited: N.J. Am. Ar. Cong., 1937 (prize); NA, 1937;

WFNY, 1939; Mod. Ar. N.J. Exh., Montclair Mus.; Ar. Gal., N.Y.; Trenton Mus. [40]

LOVE, C.W. [P] NYC. Member: GFLA [27]

LOVE, George Paterson [P,I,T] West Barrington, RI b. 28 Mr 1887, Providence. Studied: RISD; BMFA Sch.; E. Tarbell; F. Benson. Member: Copley S.; Providence WCC. Exhibited: NAD, 1941; Currier Gal. A., 1942, 1943; Providence AC; Boston AC; BMFA; RISD; Attleboro (Mass.) Lib. Work: Masonic Temple, Providence [47]

LOVE, George P., Mrs. See Jones, Nancy.

LOVEGROVE, Stanley D. [P,I,E] Phila., PA b. 19 F 1881, East Orange, NJ. Studied: PAFA, with T. Anshutz. Member: Phila. Sketch C.; Phila. Alliance; Phila. WCC; Phila. Print C. [33]

LOVELAND, John Winthrop [P] Wash., D.C./Nantucket, MA b. 1 O 1866, West Pittston, PA. Studied: Swain Sch. A., New Bedford, Mass. Member: Soc. Wash. Ar. Exhibited: Swain Sch., 1921 (prize). Work: Nat. Coll. FA. Specialty: ship models [40]

LOVELL, Caroline C. [P] NYC [10]

LOVELL, K(atharine) (Adams) [P] Brooklyn, NY b. NYC. Studied: PIASch.; Hawthorne; Carlson; Pierson; W.M. Chase. Member: NAWPS; PBC; Brooklyn SA; Studio Gld., N.Y. Exhibited: NAD; NAWA; Brooklyn SA; BM; Ogunquit A. Center; Gloucester SA; PBC. [47]

LOVELL, Tom [I] Westport, CT (1976) b. 5 F 1909, NYC. Studied: Syracuse Univ. Member: SI; Nat. Assoc. Western A. Exhibited: SI. Work: Headquarters, U.S. Marine Corps; New Britain Mus.; Nat. Cowboy Hall Fame; Va. Military Inst. Illustrator: national magazines. Specialties: historical; western [47]

LOVEMAN, Hilda [W] NYC b. 19 N 1915, Chattanooga, TN. Studied: Barnard Col., Columbia. Position: A. Ed., Newsweek [47]

LOVEN, Frank W. [P,I] Jersey City, NJ b. 2 O 1868, Jersey City. Studied: B. Harrison; DuMond; J. Carlson. Work: Hoboken Pub. Lib. [40]

LOVERIDGE, Clinton [P] Brooklyn, NY [01]

LOVET-LORSKI, Boris [S] NYC b. 25 D 1894, Lithuania d. 1973. Studied: Europe. Member: ANA; NSS; Salons of Paris. Exhibited: one-man exh. nationally. Work: Luxembourg Mus., Petit Palais, Bibliothèque Nationale, all in Paris; British Mus., London; MMA; Dumbarton Oaks; San Diego FA Soc.; Los Angeles Mus.; A.; SAM; SFMA; City Hall, Decatur, Ill.; Boston Univ.; Columbia; busts of 1929 Am. Embassy members in Rome; royal families, Italy, Greece; St. Jean, South of France [47]

LOVETT, Alice M. [I] Brooklyn, NY. Member: B.&W. Cl. [01]

LOVETT, Caroline Lewis [P] Phila., PA b. 21 Ja 1901, Screven County, GA. Studied: St. Louis Sch. FA; Wash. Univ.; PAFA; Barnes Fnd., Merion, Pa. Exhibited: PAFA, 1938, 1939; Free Pub. Lib., Phila. [40]

LOVETT, Esther Parker (Mrs. Sidney) [Por.P] New Haven, CT/Holderness, NH b. 3 N 1887, Winchester, MA. Studied: P. Hale; D. Keller. Member: New Haven PCC [40]

LOVEWELL, Rominer [Mar.P,E] b. 4 S 1853, Gardner, MA d. 26 N 1932, Everett, MA. Studied: Richardson's A., Boston, 1872–73; W.A. Titcombe, 1874. Exhibited: N.Y. Etching C., 1882, 1884–86; Boston Etching C.; Columbian Expo, Chicago, 1893; Phila., 1883–84; Mystic Seaport, 1981… traveled to Mariners' Mus. (retrospective); Peabody Mus., Salem. Painter of Boston waterfront, 1875–25. Also a machinist, living in Chelsea, Mass., until 1924. [*]

LOVEY, Allen [Car] d. 11 Mr 1907, Reno, NV

LOVICK, Annie Pescud (Mrs. H.J.) [P] Raleigh, NC b. 5 Ag 1882, Raleigh. Studied: Hilderbrandt; Mora; Williams; Brackman; R.H. Moore; E.W. Greacen; A.P. Cole; G. Raynard; N. Greacen. Member: N.C. State A. Soc.; Studio Gld., N.Y. Exhibited: Mint. Mus.; Min. P.&S., Wash., D.C.; CGA; N.C. State Fair; Grand Central Gal., N.Y.; Finlay Gal., N.Y. [47]

LOVINS, Henry [P,Des,C,W,L,T] Hollywood, CA b. 12 Mr 1883, NYC. Studied: CCNY; N.Y. Sch. F.& Appl. A.; J. Mannheim; W. Keith; Henri; E.L. Hewett. Member: AFA; Calif. AC; Council All. A., Hollywood; Los Angeles PS; Intl. Ar. C.; Laguna Beach AA; Los Angeles AA; Authors and Artists C.; SI. Exhibited: Los Angeles AC; Los Angeles AA; P.-P. Expo, 1915; GGE, 1939; Denver AA; Denver A. Mus.; Laguna Beach AA; Calif. AC. Work: Southwest Mus., Los Angeles; San Diego FA Soc.; Mus. N.Mex., Santa Fe; Whitely Park Country C.; San Diego Mus.; Sea Breeze Beach C., Santa Monica; P.-P. Housing Expo; Beaux-Arts Ball, Los Angeles; Fox Theatre, Hollywood; Fox Theatre, Los Angeles; Fox Theatre, Beverly Hills; Grauman's Egyptian Theatre, Hollywood. Position: Dir., Hollywood A. Center Sch. [47]

LOW, Bertha Lea (Mrs.) [P,T] Flushing, NY b. 4 D 1848, Phila. Studied: PAFA, with Anshutz, C. Beaux, Chase [21]

LOW, Lawrence Gordon [P,I,Car,T] Brockton, MA b. 21 O 1912, Denver. Studied: B. Keyes; E. Greene, Jr.; E. Sargent. Member: Brockton A. Lg. Exhibited: Brockton Pub. Lib. Gal. [40]

LOW, Mary Fairchild (Mrs. Will H.) [P] Bronxville, NY b. 11 Ag 1858, New Haven d. 23 My 1946. Studied: St. Louis Sch. FA; Carolus-Duran, in Paris; Académie Julian, Paris. Member: SAA, 1896; ANA, 1906; Intl. Women's AC, London; Assn. Soc. Nat. des Beaux-Arts. Exhibited: Columbian Expo, Chicago, 1893 (med); Paris Expo, 1900 (med); Pan-Am. Expo, Buffalo, 1901 (med); Dresden, 1902 (gold); SAA, 1902 (prize); Normandy Expo, Rouen, 1903 (gold); Marseilles, 1905 (gold); St. Brieux, France, 1906 (gold). Work: Mus. Rouen, France; Union Lg. C., Chicago; City A. Mus., St. Louis; Mus. Vernon, Normandy; Mus. Les Andelys, Normandy; AIC [40]

LOW, Minnie [P] Green Cove Springs, FL b. 1876, Hyattsville, MD. Studied: Wash., with H. Helmick [04]

LOW, Sanford Ballad Dole [P,I,B,Dec,Des,T,L] New Britain, CT/Martha's Vineyard, MA b. 21 S 1905, Honolulu d. 6 O 1964, Southington, CT. Studied: P. Hale; P. Carter; H.H. Clark; L. Thompson; F. Bosley. Member: NYWCC; New Britain AL; Assn. Conn. A.; AWCS; SC; Springfield A. Lg.; CAFA. Exhibited: New Britain A. Lg., 1931 (prize), 1932 (prize); Springfield AL, 1933 (prize); New Haven PCC, 1937 (prize); WFNY, 1939. Work: Avery Mem., Hartford, Conn.; Mus. FA, Springfield, Mass.; New Haven PCC; Hotel N.Y.; Hotel 2400, Wash., D.C.; Hotel Taft, Hew Haven; Hotel Barnum, Bridgeport; Hotel Burritt, New Britain, Conn.; Hotel Berwick, Rutland, Vt.; New Crown Hotel, Providence; City of New Britain. Positions: T., Loomis Sch. (Windsor, Conn.), New Britain A. Lg. [47]

LOW, Will H(icok) [P,I,T,C,L,Mur.P,L,W] Bronxville, NY b. 31 My 1853, Albany, NY d. 27 N 1932. Studied: Ecole des Beaux-Arts, Paris, with Gérôme, Carolus-Duran, 1873–77. Member: SC, 1871 (founder); ANA; NA; SAA; Mural P.; Arch. Lg.; Century Assn.; NIAL; Intl. Jury of Awards, St. Louis Expo, 1904. Exhibited: Paris Expo, 1889 (med); Columbian Expo, Chicago, 1893 (med); Lotos C. Fnd.; NAD, 1895 (prize); Pan-Am. Expo, Buffalo, 1901 (med). Work: AIC; NGA; MMA; Essex County Court House, Newark, N.J.; Luzerne County Court House, Wilkes-Barre, Pa.; Federal Bldg., Cleveland; St. Paul's Protestant Episcopal Church, Albany; A. Mus., Montclair, N.J.; State Edu. Bldg., Albany; Legislative Lib., N.Y. State Captol; Columbia. Author: "A Chronicle of Friendships," "A Painter's Progress." Lecturer: Scammon lectures, AIC [31]

LOWDON, Elsie Motz (Mrs.) [Min.P] NYC b. Waco, TX. Studied: ASL; Am. Sch. Min. P. Member: NAWPS; SSAL. Exhibited: Los Angeles Mus., 1927 (prize) [33]

LOWE, Alice Leszinska. See Ferguson, H.G., Mrs.

LOWE, Mary Elizabeth [P] Nashville, TN [25]

LOWE, Peter [P,G,Dec] San Fran., CA b. 4 Jy 1913, Los Angeles. Exhibited: San Fran. Mus. A., 1939; GGE, Expo, 1939; Oakland A. Gal. [40]

LOWELL, Edith Allen [P,W] NYC/Greenfield, MA b. Greenfield. Studied: A. Saint-Gaudens; G.A. Renouard [21]

LOWELL, Frederick E. [Ldscp.P] Concord, MA b. 1873, Boston d. 25 Ap 1933. Member: Concord AA; Boston AC; Tavern C. Exhibited: various galleries [25]

LOWELL, Lemuel L. [P] Watertown, NY d. 12 J 1914. Also a musician.

LOWELL, M(ilton) H. [P] New Rochelle, NY b. 6 My 1848, Lamberton, NY d. 3 Ap 1927. Studied: Boston, with R.M. Yardley; largely self-taught. Member: New Rochelle AA. Specialties: New England landscape; art calendar subjects. Son of Orson. [25]

LOWELL, Nat [Dr,E,L,T] NYC b. 3 N 1880, Riga, Latvia. Studied: ASL; C. Beckwith; S. Mowbray. Work: MMA; Newark (N.J.) Mus.; NYPL; Lenox Lib., N.Y.; Yale Gal. FA; Binghamton Mus., N.Y.; Univ. Calif., Los Angeles. Contributor: New York Times. Positions: T., Hunter Col., New Sch. Soc. Res., both in NYC [40]

LOWELL, Orson (Byron) [I,P,Des,Car,W,T] New Rochelle, NY/Stockbridge, MA b. 22 D 1871, Wyoming, Iowa d. 1956. Studied: AIC, with Vanderpoel, O.D. Grover. Member: SI, 1901; Ar. Gld.; New Rochelle AA; Stockbridge AA; Iowa Artists and Authors C. Work: Cincinnati Mus.; La Crosse (Wis.) AA; Md. Inst; Mechanics' Inst., Rochester; Vanderpoel AA, Chicago. Illustrator: books; national magazines [47]

LOWENGRUND, Margaret (Mrs. Joseph Lilly) [E,Li,P] Woodstock, NY b. 24 Ag 1902, Phila. d. N 1957. Studied: J. Pennell; A.S. Hartrick; Lhote. Member: Am. A. Cong.; Artists U.; An Am. Group. Work: Fifty Prints of the Year, 1930–33; Fine Prints of the Year, 1936; "America 1936," pub. American Artists Cong.; British Mus. [40]

LOWENSTEIN, Loretta [P] Wash., D.C. [13]

LOWES, Sadie H. [P] Chicago, IL b. 7 My 1870, Indiana. Studied: C. Buck. Member: Hoosier Salon; All-Ill. SFA; Ill. Acad. FA [33]

LOWNDES, Anna [P] Phila., PA Studied: Phila. Sch. Des.; Acad. Delecluse, Paris [06]

LOWREY, (Alice) Rosalie [Por.P] Dayton, OH b. 27 F 1893, Dayton. Studied: Dayton AI; PAFA; C. Beaux. Member: NAWA; Ohio WCC; Dayton Soc. P. Exhibited: NAWA, 1934–44; Ohio WCC, 1932; Ohio Women P.; Dayton AI Traveling Exh. Work: Hist. Mus., Springfield, Ohio; Dayton AI [47]

LOWRIE, Agnes Potter [P,L] Cincinnati, OH b. 31 O 1892, London, England. Studied: Univ. Chicago; N.Y. Sch. F.&Appl. A.; Minneapolis Sch. FA; AIC; Hawthorne; Breckenridge. Member: Chicago AC; Cincinnati Assn. Prof. A.; Cincinnati Women's AC. Exhibited: AIC, 1929 (prize); Chicago Women's Aid, 1932 (prize); CM, 1945 (prize). Work: Chicago Municipal Coll.; FMA [47]

LOWRY, Ethelwyn [S] St. Paul, MN [17]

LOWRY, Everett E. [Car] Chicago, IL b. 1870 d. 5 O 1936. Positions: a Chicago newspaper cartoonist, from 1893; Pres., Lowry Cartoon Corp.

LOWRY, Lydia P. Hess [P] Chicago, IL b. Newago, MI. Studied: Paris, with Lasar, Delance, Laugée, Dupré; AIC [01]

LOWRY, Willis Gentry [Des,C,S] High Point, NC b. 8 Mr 1908, Whiteville, NC. Studied: Phila. Sch. F.&Indst. A.; PAFA, at Chester Springs. Member: Phila. A.All. Exhibited: Phila. A. All.; PS Ann., PAFA, 1938, 1939; WFNY, 1939; GGE, 1939. Specialty: glass. Position: Des., Logan Porter Mirror Co. [40]

LOXLEY, Benjamin Rhees, Mrs. See Younglove, Ruth Ann.

LOZOWICK, Louis [Li,P,Des,W,I,L,T] South Orange, NJ b. 10 D 1892, Ludvinovka, Russia (came to NYC in 1906) d. 1973. Studied: Kiev A. Sch., 1904–05; NAD, with Kroll, 1912–15; Ohio State Univ. Member: An Am. Group; Audubon A.; A. Lg. Am.; Am. Soc. PS&G; Am. A. Cong. Exhibited: AIC, 1929 (prize); Phila. A. All.; 1930 (prize); CMA, 1930 (prize); Cleveland Print C., 1931 (prize); BM, 1926; Steinway Hall, 1926; MOMA, 1943; WMAA, 1933, 1941; CI, 1930; CGA, 1932; WFNY, 1939; MMA (AV), 1942; Pepsi-Cola, 1946; New Art Circle, 1926; Weyhe Gal., 1929, 1931, 1933, 1935; Grand Central A. Gal., 1930; Stendahl Gal., Los Angeles, 1932; Courvoisier Gal., San Fran., 1932; Downtown Gal., 1929, 1930, 1931; An Am. Group, 1938–41; PAFA, 1929; NAD, 1935. Work: WMAA; MOMA; MMA; NYPL; CMA; LOC; PMA; CM; BMFA; Honolulu Acad. A.; Mus. FA, Houston; Los Angeles AA; CI; Syracuse Mus. FA; Rochester Mem. A. Gal.; Newark Mus.; Victoria & Albert Mus., London; Mus. Western A., Moscow; USPO, NYC; Fifty Prints of the Year, 1929–32. Author: "Modern Russian Art," 1925. Co-author: "Voices of October," 1930. Co-editor: "America Today." Illustrator: Nation, Theatre Arts Monthly, Travel Magazine; Herald Tribune. WPA artist. [47]

LUBAN, Boris [P,T,L] NYC b. 25 Jy 1881, Moscow. Studied: Royal Acad., Antwerp, Belgium; Royal Acad., Berlin; Leisticow, Berlin. Exhibited: WFNY, 1939. Work: Harvard; Mitchell Field Airport; Columbia; CCNY; Erasmus Hall H.S., Brooklyn; Tilden H.S.; Manual Training H.S.; portraits of prominent persons [47]

LUBIN, Morris A. [C,W,L] Boston, MA b. 25 D 1888. Member: Boston AC. Exhibited: Boston Ar. U.; Universal Sch. Handicrafts, RKO Bldg., N.Y. [40]

LUBOVSKY, Maxim H. [P] Bronx, NY [15]

LUCAS, Albert P(ike) [P,S] NYC b. 1862, Jersey City, NJ d. 2 My 1945. Studied: Paris, with Hébert, Boulanger, Dagnan-Bouveret, Courtois. Member: NA, 1927; Soc. Nat. des Beaux-Arts, Paris; NAC; Lotos C.; Allied AA (Pres.); SC; NSS; FA Fed. N.Y.; SPNY (Pres.); Paris Expo, 1900 (prize); Pan-Am. Expo, Buffalo, 1901 (med), 1928 (med); Allied AA, 1931 (prize), 1937 (prize). Work: MMA; FA Gal. San Diego; Milwaukee AI; Jersey City Mus. [40]

LUCAS, E.B. [P] Baltimore. MD [21]

LUCAS, Essie Leone Leavey (Mrs.) [P] b. 1872 d. 17 Ja 1932, Oconomowac, WI. Formerly lived in Lexington, Ky. Specialty: famous racing horses

LUCAS, J. Carrell [Min.P] Baltimore, MD. Member: Charcoal C. [27]

LUCAS, Jean (Williams) [P,T,L] NYC b. Hagerstown, MD. Studied: Phila. Sch. Des for Women, with Henri, Daingerfield; Columbia, with Dow; Whittemore. Member: NAWA; Pa. Soc. Min. P.; AFA; Am. Assn. Mus. Exhibited: P.-P. Expo, 1915 (prize); NAWA, 1937; Pa. Soc. Min. P.; Argent Gal., 1942 (one-man) [47]

LUCE, C. [Des] NYC [10]

LUCE, Cal [P] Cleveland, OH Member: Cleveland SA [27]

LUCE, J.E., Jr. [P] Glen Ellyn, IL. Member: Chicago NJSA [25]

LUCE, Laura H. (Mrs.) [Ldscp.P,T,L] Titusville, PA b. 19 Je 1845, Salem, NY. Studied: N.Y., with A.H. Wyant, C.B. Coman, H.B. Snell. Member: NAWPS [33]

LUCE, Leonard E. [P,I] Cleveland, OH b. 27 S 1893, Ashtabula, OH. Studied: Gottwald; Keller; DuMond. Member: Cleveland SA [33]

LUCE, Lois [I] Bloomfield Hills, MI b. 22 My 1906, Waterloo, IA. Studied: J.P. Wicker. Illustrator: Packard Motor Car Co. [40]

LUCE, Marie Huxford (Mrs.) [P] Florence, Italy/Skaneateles, NY b. Skaneateles. Studied: Holland, with J.S.H. Keever; Boston, with Mr. and Mrs. C.H. Woodbury. Member: NYWCC; AFA [29]

LUCE, Molly (Mrs. Alan Burroughs) [P] Little Compton, RI b. 18 D 1896, Pittsburg. Studied: Wheaton Col.; ASL, with K.H. Miller. Member: ASL, N.Y.; Boston AC. Exhibited: CGA, 1939, 1943, 1945; PAFA, 1938–43; CI, 1939, 1943, 1945; NAD, 1943, 1945; WMAA, 1938, 1940, 1943–45; AIC, 1930–32; GGE, 1939. Work: MMA; WMAA [47]

LUCHTEMEYER, Edward A. [P,Li,Des,I] Webster Groves, MO b. 19 N 1887, St. Louis, MO. Studied: self-taught. Member: St. Louis AL; St. Louis AG; Soc. for Sanity in A.; A. Gld., St. Louis; 2x4 Soc., St. Louis; Am. A. All. Exhibited: Soc. for Sanity in A.; Oakland, Calif.; Kansas City, Mo.; Chicago; Springfield, Ill.; Little Rock, Ark. Work: all branches of the St. Louis Pub. Lib.; St. Louis A. Lg.; Ninth and Olive Streets, St. Louis. Position: A. Director, Skinner and Kennedy Stationery Co., St. Louis [47]

LUCIONI, Louis J. [P] West Hoboken, NJ [25]

LUCIONI, Luigi [P,E] Union City, NJ b. 4 N 1900, Malnate, Italy. Studied: CUA Sch.; NAD. Member: ANA; Southern Vt. Ar.; SAE. Exhibited: Tiffany Fnd., N.Y., 1928 (med); Allied Ar. Am., N.Y., 1929 (med); CI, 1936 (prize), 1939 (prize); CGA, 1939 (prize), 1941 (prize); LOC, 1946 (prize); NAD; PAFA; AIC; TMA; Herron AIC. Work: MMA; WMAA; CI; PAFA; LOC; TMA; Denver A. Mus.; SAM; BM; Victoria & Albert Mus., London; High Mus., Atlanta, Ga.; FMA; Hamilton Col.; MMA; AGAA; Nebr. State Capitol, Lincoln; Kansas City Mus.; RISD; Lib., Canajoharie, N.Y.; Dartmouth; Lawrence AM, Williamstown, Mass. [47]

LUCIUS, Florence G. [P,S] NYC. Member: NAWPS [21]

LUCKEY, B.M. [P] NYC d. N 1916 (suicide)

LUDBROOK, Alberta [P] NYC [15]

LUDEKENS, Fred [I,Des,T] NYC (Belvedere, CA, 1976) b. 13 My 1900, Hueneme, CA. Studied: briefly with O. Shepard; mostly self-taught. Member: SI. Exhibited: Art Dir. C., 1931 (prize), 1935 (prize), 1936 (prize); Intl. Gal., N.Y. Illustrator: "Ghost Town," "The Ranch Book," "Smoky the Crow." Contributor: Saturday Evening Post, national magazines. Position: T., Famous Artists Sch., Westport, Conn. (co-founder) [47]

LUDINGTON, Katharine [P] NYC b. 1869, NYC. Studied: R. Brandegee; M. Flagg; DuMond [13]

LUDINS, Eugene (David) [P] Woodstock, NY b. 23 Mr 1904, Mariupol, Russia. Studied: ASL; K.H. Miller; A. Tucker. Member: An Am. Group; Woodstock AA; Am. Soc. PS&G. Exhibited: Woodstock, N.Y., 1938 (prize); CI; PAFA; AIC; VMFA; WMAA; MOMA; Pepsi-Cola. Work: WMAA [47]

LUDINS, Ryah (Miss) [Mur.P,Por.P,I,W,Des,L,Li,T,E,Enr] NYC. Studied: Lhote, in Paris; W.S. Hayter; C.J. Martin; Columbia; K.H. Miller; ASL. Member: NSMP; Mural P.; Am. A. Cong. Exhibited: CGA, 1936; NSMP, 1939; AIC, 1944; SAE, 1945; MOMA; WMAA; Arch. Lg.; Downtown Gal.; Willard Gal.; Pal. Leg. Honor. Work: CMA; TMA; AIGA; NYPL; Newark Pub. Lib.; murals, Bellevue Hospital, N.Y.; USPOs, Nazareth, Pa., Cortland, N.Y.; State Mus., Michoacan, Mexico; "Fifty Prints of the Year," 1931. Author/Illustrator: "The Wonder Rock," 1932 [47]

LUDLOW, J.L. [P] Cincinnati, OH [01]

LUDOVICI, Alice E. [Por.P,Min.P] Pasadena, CA b. 7 N 1872, Dresden,

Germany. Studied: New York, with J. Ludovici; Europe. Member: AFA; Calif. S. Min. P. Exhibited: Alaska-Yukon-Pacific Expo, Seattle, 1909 (med); Calif. S. Min. P., 1914 (gold); Pan.-Calif. Expo, San Diego, 1915 (gold). Specialties: portraits in pastel, miniatures on ivory [40]

LUDOVICI, Julius [P,T] NYC b. Germany (came to NYC ca. 1870). Exhibited: NAD, 1879–80. Work: Mystic Seaport Mus. Father of Alice. [04]

LUDWIG, Alexis [P] Leonia, NJ b. 1861, Vienna, Austria [06]

LUDWIG, Amalia [P] East Orange, NJ b. 4 N 1889, Columbus, OH. Studied: Columbus A. Sch.; ASL. Exhibited: ACA Gal., N.Y.; Springfield, Mass., MFA; Newark Mus.; WFNY, 1939; Co-Op Gal., Newark (one-man) [40]

LUEBKERT, Alma [P] NYC [24]

LUELOFF, Marjorie Kaltenback (Mrs.) [P,Des,L] Grafton, WI b. 26 Je 1906, Kenosha, WI. Studied: AIC; Univ. Wis.; H. Ropp; J. Carroll. Member: Detroit Ar. Market; Wis. P.&S. Soc. Exhibited: Detroit Inst. A., 1935, 1937, 1939; Milwaukee AI, 1932, 1940, 1945, 1946; Madison A. Salon, 1936–38. Work: Kenosha (Wis.) Country C. [47]

LUFFMAN, Charles E. [P,T] South Orange, NJ b. 24 Mr 1909, London, England. Studied: Newark Sch. A.; ASL; New Sch. Soc. Res.; Grabach; McNulty; Picken; Kuniyoshi. Exhibited: AWCS, 1942, 1944, 1946; Phila. WCC, 1941; N.J. State Exh., 1938–40; Kresge A. Gal., 1939, 1941. Position: T., New Sch. Soc. Res., NYC [47]

LUFKIN, Lee. See Kaula, Mrs.

LUGANO, Ines Somenzini (Mrs. G.) [Min.P] New Orleans, LA b. Verretto, Italy. Studied: Acad. FA, Pavia, Italy; R. Borgognoni. Member: Pa. Soc. Min. P.; NOAA; New Orleans A.&Cr. C.; SSAL. Exhibited: Milan, Italy, 1930 (med); Calif. Soc. Min. P., 1935 (prize); New Orleans AA, 1939 (prize); SI, 1940; ASMP, 1940; Century of Progress, Chicago, 1933; Pa. Soc. Min. P.; NOAA; Mus. FA, Houston; Italy [47]

LUINI, Costanzo [C,S] Elmhurst, NY b. 31 Ag 1886, Milan, Italy. Studied: Aitken; MacCartan. Member: Arch. Lg.; AFA; Boston SAC; AL of Nassau County. Work: Soc. des Femmes de France à N.Y.; U.S. Naval Acad. [40]

LUISI, Nicholas [P] Brooklyn, NY b. 1894, Brooklyn d. 1977. Studied: NAD. Member: S.Indp.A. Work: MMA. Specialties: landscapes along the Hudson River; Monhegan Island, Maine. WPA artist. [25]

LUITWEALER, Lillian [P] Rochester, NY. Member: Rochester AC [19]

LUKE, Kathryn Logan [Min.P] Cincinnati, OH. Position: Associated with Cincinnati A. Acad. [15]

LUKEMAN, (Henry) Augustus [S] NYC/Stockbridge, MA b. 28 Ja 1872, Richmond, VA d. 3 Ap 1935. Studied: N.Y., with L. Thompson, D.C. French; Ecole des Beaux-Arts, Paris, with Falguière. Member: ANA; Arch. Lg.; NSS; NAC. Exhibited: St. Louis Expo, 1904 (med). Work: Adams, Mass.; Dayton, Ohio; Appellate Court, N.Y.; Royal Bank Bldg., Montreal [33]

LUKENS, Glen [C] Los Angeles, CA b. 15 Ja 1890. Member: Soc. Des.-Craftsmen; ATA of Southern Calif. Exhibited: Robineau Mem. Exh., Syracuse, 1936 (prize). Work: FA Gal., San Diego. Illustrator: Design. Position: T., Univ. Southern Calif. [38]

LUKITS, Theodore N. [P,I,T] Los Angeles, CA. Studied: AIC; St. Louis Sch. FA; Barnes Med. Col., St. Louis. Member: L'Institute Litteraire et Artistique de Fr., Paris; AAPL; A. Fellowship; Am. Inst. FA Soc., Calif; Laguna Beach AA; Riverside (Calif.) AA; Los Angeles AA; Calif. AC; Soc. for Sanity in Art. Exhibited: AIC, 1913 (prize), 1919 (prize), 1926 (prize), 1927 (prize), 1929 (gold); Los Angeles Mus. A., 1937 (prize); P.&S. of Los Angeles, 1942 (med); Ateneo Nacional de Sc.&A., Mexico (prize); F., Academia Hispano Americana, Cadiz; Brand Mem., 1913 (prize); Intl. Ar. Lg. (prize); L'Inst. Lit. et Artistique de Fr., 1939 (gold). Work: Pittsburgh Press Assn.; Edgewater Beach C., Santa Monica; Jonathan C., Los Angeles; Santa Barbara. Positions: Dir., Lukits Acad. FA, Los Angeles; A.R.U., Vizianagaram, India (1938) [47]

LUKS, George (Benjamin) [P,T] NYC b. 13 Ag 1867, Williamsport, PA d. 29 O 1933. Studied: PAFA, Düsseldorf, Paris, London, all 1885–95. Member: Por. P.; Am. PS; NYWCC; Boston AC. Exhibited: Corcoran, 1916 (prize); NYWCC, 1916 (prize); PAFA, 1918 (gold); AIC, 1920 (med) 1926 (med); Locust C., Phila., 1927 (gold). Work: MMA; Delgado Mus., New Orleans; Milwaukee A. Inst.; Detroit AI; CMA; Harrison Gal., Los Angeles; PMG; NYPL; Barnes Mus., Phila.; Neco Allen Hotel, Pottsville, Pa.; large coll. at Munson-Williams-Proctor Inst., Ithaca, N.Y. Creator: comic strip, The Yellow Kid, in New York World. Along with R. Henri, an outspoken member of "The Eight" who exhibited at Macbeth Gal., NYC, 1908. An influential teacher at ASL—not for his methods but for his powerful personality. Known as a hard drinker, his works were imbued with gusto as he captured slum life in NYC. Positions: Staff A., Philadelphia Press, Philadelphia Bulletin; War Correspondent in Cuba [31]

LUM, Bertha Boynton (Mrs.) [B,P,I,E,W] Peking, China b. 1879, Iowa d. 1954, Genoa, Italy. Studied: AIC; F. Holme; A. Weston. Member: Boston SAC; Calif. SE; Asiatic Soc. of Japan; Calif. PM. Exhibited: P.-P. Expo, San Fran., 1915 (med); Detroit Inst. A.; NYPL; Minneapolis Inst. A.; British Mus., London; Los Angeles Mus. A., 1920; Stendahl Gal., Los Angeles, 1926; Calif. PM Soc. Author/Illustrator: "Gods, Goblins and Ghosts," 1922. Specialty: Oriental-syle color woodblock prints en gaufrage. Although she made her home in Pasadena, Calif., she made many extended trips to the Orient. [40]

LUMIS, Harriet Randall (Mrs. Fred W.) [P,T] Springfield, MA b. 29 My 1870, Salem, CT d. 6 Ap 1953. Studied: Springfield, with M. Hubbard, J. Hall, Willis Adams, 1883; N.Y. Summer Sch., Cos Cob, Conn., with L. Ochtman; Gloucester, with Breckenridge; E.P. Hayden. Member: CAFA; Springfield A. Lg., 1919 (founder); Phila. A. All.; NAWA, 1921; Boston AC. Exhibited: New Haven PCC, 1932 (prize); NAD; PAFA; CAFA, 1925 (prize); Providence AC; Buffalo SA; J. Rand Mus., Westfield, Mass. (one-man). Work: Springfield A. Mus.; Paseo H.S., Kansas City; Middlesex Hospital, Middletown, Conn. Impressionist active in Conn., 1870–92, and periodically, 1892–53. [47]

LUMLEY, Arthur [I,P] NYC b. 1837, Dublin, Ireland (came to NYC ca. 1857) d. 27 S 1912, Mt. Vernon, NY. Studied: NAD. He was the first artist sent to the army of the Potomac by Leslie's. Position: Associated with illustrated papers, U.S. and Europe [06]

LUMPKINS, William Thomas, Jr. [Des,P,C,S,T] Santa Fe, NM b. 8 Ap 1909, Marlow, OK. Studied: Univ. N.Mex.; Colo. State Col.; UCLA; Tex. Christian Univ. Member: Am. Ar. Cong.; Transcendental P. Group, Santa Fe. Exhibited: Pal. Leg. Honor, 1934; Southwest Annual, 1934–40, 1946; Chappell House, Denver, 1938; WFNY, 1939; Paris Salon; Memphis, Tenn., 1945; Mus. N.Mex., Santa Fe, 1938, 1939; Denver A. Mus. Author/Illustrator: "Modern Pueblo Homes." Position: T., summers, N.Mex. Normal Univ. [47]

LUMSDON, Christine Marie Voss (Mrs. John W.) [Por.P,T] NYC b. Brooklyn, NY d. 8 Ap 1937. Studied: Paris, with Carolus Duran; Childe Hassam; Irving Wiles. Member: Brooklyn Mus.; NAD; NYWCC; Salons of Am.; Carnegie A. Gal.; NAWPS; AFA. Exhibited: Paris Salon, 1904 (prize); PAFA; AIC; Omaha Expo; NAD; CGA. Work: "Ideal Head of Christ" [38]

LUND, Belle Jenks [P] Hammond, IN/Williams Bay, WI b. 22 Ag 1879, Alexandria, SD. Studied: F.F. Fursman; E.A. Rupprecht; E. Cameron; J. Norton; AIC. Member: South Side AA, Chicago; Seven A. Soc., Milwaukee [40]

LUND, Charlotte [P] NYC [19]

LUND, Harold Marrat [P,T] Brooklyn, NY/Provincetown, MA b. 28 Mr 1904, NYC. Studied: C. Hawthorne; R. Miller. Member: SC; Brooklyn PS; Scandinavian Am. A. Positions: T., Child-Walker Sch. Des., Vesper George Sch. A., Boston [40]

LUND, P.F. [P] Brooklyn, NY [01]

LUNDAHL, Frank A. [Ldscp.P] Montclair, NJ b. 11 N 1858, Rock Island, IL. Studied: J.R. Robertson [08]

LUNDBERG, A.F. [Scenic P] Columbus, OH. Member: Pen & Pencil C., Columbus [27]

LUNDBERG, Godfrey, Mrs.. See Jewett, Eleanor.

LUNDBORG, Florence [Por.P,I] NYC b. ca. 1880, San Fran. d. 18 Ja 1949. Studied: Mark Hopkins Inst.; Paris; Italy. Member: San Fran. AA; NAWA. Exhibited: San Fran. AA (gold); P.-P. Expo (med). Work: Wadleigh H.S., N.Y.; Curtis H.S., Staten Island, N.Y.; MMA. Illustrator: "Rubaiyat of Omar Khayyam," "Yosemite Legends," "Honey Bee," other books [47]

LUNDEAN, J. Louis, Mrs. See Daingerfield, Marjorie.

LUNDEAN, Louis [I,P,W,L,T] NYC b. 29 Mr 1896, Newcastle, WY. Studied: Univ. Omaha; Mo. Univ.; B. Robinson; N. Los; G. Luks. Exhibited: CCA; WMAA; Colony Cl., Phila.; Westchester AA; Hudson Valley AA. Work: St. Luke's Hospital, NYC; public schools, Scarsdale, N.Y.; Grasslands Hospital, N.Y.; N.Y. State Police Headquarters, Albany/Hawthorne, N.Y. Illustrator: "Golden Hoofs," "Stories Boys Like Best," other books. Contributor: Town & Country, Sportsman, Outdoor Life [47]

LUNDGREN, Eric (B.E.K.) [P,G,I,T] West Palm Beach, FL b. 5 My 1906, Linkoping, Sweden. Studied: N.Y. Sch. Des.; ASL; AIC. Member: Palm Beach A. Lg. Exhibited: PAFA, 1937; Phila. A. All., 1939; AIC, 1938; Marshall Field Gal., 1937, 1938 (one-man). Contributor: Esquire, Coronet, Professional Art Quarterly. Position: T., Norton Gal A., West Palm Beach [47]

LUNDGREN, Martin [Mur.P] Chicago, IL b. 1871, Sweden. Studied: AIC; L. Betts. Member: Palette and Chisel Cl.; Chicago NJSA [33]

LUNDIN, Emelia A. (Mrs.) [P] Seattle, WA b. 16 Ja 1884, Stockholm, Sweden. Studied: P. Gustin; F. Tadema. Member: Seattle FA Soc. [29]

LUNDMARK, Leon [P] Chicago, IL b. 1875, Sweden. Studied: Zillén; Swenson; Baugh. Exhibited: Swedish Art Exh., Chicago, 1923 (prize) [25]

LUNDQUIST, Einar [P] Rockford, IL b. 4 Ag 1901 Shovde, Sweden. Studied: S. Garber; AIC. Member: Am. Ar. Prof. Lg.; Swedish-Am. AA. Exhibited: watercolor, Swedish-Am. AA, Chicago, 1929 (prize), Swedish Cl., Chicago, 1929 (prize) [40]

LUNEAU, Omer Joachim [P,L,T] Concord, NH b. 22 Ag 1909, Canada. Studied: Newark Sch. F.&Indst. A.; L. Blake. Member: N.H. AA; Audubon A.; AAPL. Exhibited: All.A.Am.; Audubon A.; Argent Gal., 1945 (one-man); Currier Gal. A. (one-man); Dartmouth; Carpenter Gal., Manchester, N.Y. [47]

LUNG, Rowena Clement (Mrs. Gordon Dee Alcorn) [P,E,T] Aberdeen, WA/Vashon Island, WA b. 27 Mr 1905, Tacoma. Studied: Parshall; Herter; Cooper; Armstrong; Cadorin; Fletcher; C.O. Borg. Member: FAC, Tacoma; Tacoma Civic AA; Tacoma Studio Gld.; Women A. of Wash.; S.Indp.A.; Chicago NJSA. Exhibited: Nat. Mus., Smithsonian, 1938 (one-man); Del. A. Center, Wilmington, 1939; Campbell Mem. AM, Spokane, 1939; Wash. State Col., 1945, 1946. Work: Col. Puget Sound; Pub. Lib., Lowell Sch., both in Tacoma; State Mus., Seattle; Capitol, Boise, Idaho; Chamber Commerce, Lewiston, Idaho. Specialty: Nez Perce Indians, Idaho. Position: T., Grays Harbor Jr. Col., Aberdeen, Wash. [47]

LUNGERICH, Helene [P] Phila., PA [17]

LUNGREN, Fernand [P,I] Santa Barbara, CA b. 13 N 1859, Hagerstown, MD d. 9 N 1932. Studied: Cincinnati; NYC; PAFA, with Eakins, 1878; NYC; Paris, 1890-92. Member: Santa Barbara A. Lg.; AFA. Founder: Santa Barbara A. Sch. Specialties: Indians; southwest desert scenes. Illustrator: Harper's, Scribner's, Century (all in the 1890s); "The Mountains," "The Pass" (both novels by S.E. White) [31]

LUPFER, E.A. [P] Columbus, OH. Member: Columbus PPC [25]

LUPPRIAN, Hildegaard [I,W,Des] NYC b. 25 O 1897, Staten Island. Studied: Phila. Sch. Indst. A. Author/Illustrator: "Lullabyland," "Honeyland," "Ducky Drake." Illustrator: "Lolly-Pop," "Read Aloud Stories," "Little Black Sambo," other children's books [40]

LUQUIENS, Elizabeth Koll (Mrs. Frederick B.) [P] New Haven, CT b. 19 Ja 1878, Salem, OR. Studied: A.G. Thompson; Delecluse, Mucha, in Paris. Member: New Haven PCC [40]

LUQUIENS, Huc-Mazelet [E,P,T] Honolulu, HI b. 30 Je 1881, Auburndale, MA d. 9 My 1961. Studied: Yale; Ecole des Beaux-Arts, Paris; J.F. Weir; J.H. Niemeyer; Bonnât, Merson, in Paris. Member: Chicago SE; CAFA; New Haven PCC; Calif. SE; Honolulu A. Soc.; Honolulu Pr.M.; Prairie Pr.M. Exhibited: New Haven PCC, 1925 (prize), 1934 (prize); Calif. SE, 1922 (prize), 1938 (prize); Chicago SE; Prairie Pr.M.; SAE; Honolulu Pr.M., 1933 (prize), 1939 (prize). Work: NYPL; NGA; Yale; Honolulu Acad. A. Author: "Hawaiian Art," pub. Bishop Mus., Honolulu. Position: T., Univ. Hawaii, Honolulu, 1924-46 [47]

LURIA, Corinna [P] New Orleans, LA [17]

LURID, Corsnua M. [sic] [P] New Orleans, LA. (Note: address is the same as that for Corinna Luria, above.) [15]

LUSH, Vivian R. (Mrs. V.L. Piccirilli) [S] Bronx, NY b. 3 Ag 1911, NYC. Studied: Leonardo da Vinci A. Sch.; NAD; ASL; A. Piccirilli; C. Keck; R. Aitken; R. Laurent. Member: NAWA; Clay Cl. Exhibited: NAWA (prize). Work: with Robert Garrison, Riverside Church, NYC; with Attilio Piccirilli, panels, International & Italian Bldgs., Rockefeller Center; figure, Port Richmond H.S.; Unity Hospital, Brooklyn; Monroe, Roosevelt H.S., both in Bronx [47]

LUSK, George [Mur.P,Por.P,T,L] Wilmette, IL b. 28 Mr 1902, Chicago, IL. Studied: AIC; NYU; Nat. Acad.; Prague; Dresden; Lhote, in Paris; Univ. Chicago. Member: Chicago SA. Exhibited: Chicago, 1934 (prize). Work: murals, Village Hall, Wilmette; Chicago Acad. FA. WPA artist. [40]

LUSK, Marie Koupal (Mrs. Charles D.) [P] Wilmette, IL b. 12 F 1862, Bohemia. Studied: NAD; ASL; Colorossi Acad., Paris; Chicago [15]

LUSK, Mildred E. [P] Worcester, MA [17]

LUST, Dora C. [P,T] NYC b. Riga, Latvia. Studied: Lhote, in Paris; Northwestern Univ.; Hawthorne; Kroll; L. Seyffert. Member: NAWPS. Exhibited: NAWA, 1934 (prize). Work: PAFA [47]

LUSTIG, Sally [P] NYC b. Romania. Studied: Acad. Munich; Nat. Acad. Exhibited: Argent Gal., 1936 (one-man); NAWPS, 1935-38 [40]

LUSTY, Isabel [P] NYC [15]

LUTHARDT, William (Mrs.) [P] Chicago, IL. Member: Chicago WCC [17]

LUTHER, Jessie [C,P,L,T,W] Providence, RI/Westport Point, MA b. 3 N 1860, Providence. Studied: S.R. Burleigh; M.C. Wheeler; A. Weeks; P. Bartlett; R. Collin; B. Cram; C. Buffum; RISD. Member: Providence AC; Providence Handicraft Cl.; Boston SAC (Master Craftsman); Providence WCC; RISD; Am. Occupational Therapy Assn. [40]

LUTHER, Mabel Willcox [C] Providence, RI b. 9 S 1874, East Providence. Studied: L.H. Martin; RISD. Member: Boston SAC; Phila. ACG; N.Y. Studio Cl. Specialty: jewelry [40]

LUTZ, Dan [P,T] Los Angeles, CA b. 7 Jy 1906, Decatur, IL. Studied: AIC; Univ. Southern Calif.; B. Anisfeld. Member: Calif. WC Soc.; AWCS; Phila. WCC. Exhibited: San Diego FA Soc., 1937 (prize) NAD, 1941 (prize); Calif. WC Soc., 1936 (prize), 1938 (prize), 1942 (prize); Los Angeles Mus. A., 1942 (prize) PAFA, 1945; Caller-Times, Corpus Christi, Tex., 1945 (prize); VMFA, 1940, (prize), 1946 (prize); Santa Cruz A. Lg., 1931 (prize), 1933 (prize), 1937 (prize); Oakland Exh., 1937 (prize). Work: Wood Gal., Montpelier, Vt.; Vanderpoel Gal., Chicago; PMG; Los Angeles Mus. A.; Encyclopaedia Britannica Coll.; San Diego FA Soc.; Santa Barbara A. Mus.; Pasadena AI. Positions: T., Univ. Southern Calif. (1940), Chouinard AI (1945-46) [47]

LUTZ, Edwin George [I,W] Dumont, NJ b. 26 Ag 1868, Phila. Studied: PAFA; PMSchIA; Académie Julian, Paris; H.F. Stratton; T. Eakins. Contributor: Life, New York World. Author/Illustrator: "Practical Drawing," "Practical Graphic Figures," Practical Engraving and Etching," "Animated Cartoons," (pub. Scribner's), "Animal Drawing in Outline" (pub. Dodd, Mead), other books [40]

LUTZ, John C. [P] Cincinnati, OH b. 27 Jy 1908, Hickory, NC. Studied: Cincinnati A. Acad. Member: Creative Negro Ar. Work: Stowe Sch., Cincinnati [40]

LUTZ, Josephine (Mrs. J.L. Rollins) [P,Mur.P,Li,T] Stillwater, MN b. 21 Jy 1896, Sherburne, MN. Studied: Cornell Col., Mt. Vernon, Iowa; Univ. Minn.; Corcoran Sch. A.; Minneapolis Sch. A.; H. Hofmann; C. Booth; E. Kinsinger. Member: Minn. Assn. A.. Exhibited: Nelson Gal., Kansas City, 1935 (prize), 1936 (prize), 1939 (prize); Minneapolis AI, annually, Twin City Exh. (prize); AWCS, 1936, 1946; All.A.Am., 1946; Newport AA, 1946; Sacramento, Calif., 1941; Minn. State Fair, annually; Oakland A. Gal. Work: Univ. Minn.; Virginia (Minn.) Lib.; Owatonna (Minn.) Lib.; Crosby-Tronton (Minn.) H.S.; mural, University H.S., Minneapolis. Positions: T., Univ. Minn.; Assoc. Dir., Stillwater A. Colony [47]

LUX, Eugene J. [Des,L] NYC/South Norwalk, CT b. 1900, Hungary. Studied: Intl. Expo, Paris, 1937 (prize). Specialty: commercial des. [40]

LUX, Gladys Marie [P,E,Ser,C,B,T] Lincoln, NE b. Chapman, NE. Studied: Univ. Nebr.; AIC. Member: Lincoln A. Gld.; Nebr. A. T. Asssn.; Nebr. AA. Exhibited: Rockefeller Center, N.Y., 1936-38; WFNY, 1939; AIC, 1936; Women's Nat. Exh., Wichita, Kans., 1936-38; LOC, 1944; Kansas City AI, 1934-38; Denver A. Mus., annually; Joslyn Mem.; Lincoln A. Gld, annually; Nebr. AA, annually. Work: Doane Col.; Kearney (Nebr.) Pub. Sch.; YWCA, Nebr. Wesleyan Univ. Position: T., Nebr. Wesleyan Univ. [47]

LUX, Gwen [S,L,T,Des,W] Detroit, MI b. 17 N 1908, Chicago. Studied: Detroit SAC; Md. Inst.; BMFA Sch.; I. Meštrović, in Zagreb, Yugoslavia. Member: Am. A. Cong.; F. Guggenheim Fnd., 1933. Exhibited: Detroit Inst. A., 1943, 1944 (prize) 1945 (prize); WMAA, 1934; PAFA, 1935; Am. A. 1946 (one-man). Work: fountains, Detroit Inst. A.; Trustees System Service Bldg., McGraw-Hill Bldg., both in Chicago; Music Hall, Radio City, NYC. Contributor: articles, Creative Art, Parnassus, Art Digest. Position: T., Detroit Soc. A.&Crafts, 1944-46 [47]

LUX, Theodore (T.L. Feininger) [P,W,I,T] NYC b. 11 Je 1910, Berlin, Germany. Exhibited: Bauhaus, Weimar, Dessau, Germany. Exhibited: CI,

1932, 1933, 1935, 1936, 1938, 1946; AIC, 1938, 1940; MOMA, 1943; abroad [47]

LYFORD, George (Mrs.) (Cherry Greve) [Por.P,L,W] Cincinnati, OH b. 5 N 1903, Cincinnati. Studied: H.H. Wessel; J. Weis; Cincinnati Art Acad.; Breckenridge; Despujols; Ecole des Beaux-Arts, Fontainebleau, France; H.B. Snell; A. Pope. Member: Cincinnati Women's AC; Three Arts; MacD. Soc.; Archaeological Inst. Am.; Cincinnati Assn. Prof. Ar.; Crafters. Position: A. Cr., Cincinnati Times Star [40]

LYFORD, Philip [Dr,I,Por.P,T] Hinsdale, IL b. 20 Ag 1887, Worcester, MA. Studied: P. Hale; F. Benson; E.C. Tarbell. Illustrator: Saturday Evening Post, Collier's, Redbook, American Magazine, Liberty, other magazines [40]

LYKE, Virginia Ryder [Dec] Malden, MA b. 10 Ap 1909, Malden. Studied: A.M. Sacker. Studied: Vesper-George Sch., Boston; Boston Univ. Member: Boston Soc. AC; Eastern A. Assn. Specialty: jewelry. Position: T., Malden public schools [40]

LYMAN, Harry [P] b. 1856 d. 23 Ap 1933, Chicago. Specialty: race horses

LYMAN, Joseph [P,I] Wallingford, CT b. 17 Jy 1843, Ravenna, OH. Studied: J.H. Dolph; S. Colman, in NYC. Member: ANA, 1886; Century Assoc. Exhibited: St. Louis Expo, 1904 (med); NAD, 1874–1900 [13]

LYMAN, Mary Elizabeth [P] Middlefield, CT b. 2 D 1850, Middlefield. Studied: Yale; Bail; J.H. Niemeyer. Member: New Haven PCC [29]

LYMAN, Sylvester S. [Ldscp.P,Por.P] b. 24 S 1813, Easthampton, MA d. 23 Ag 1890 (Hartford, CT?). Studied: Hewins; E. White. Still active in Hartford in the 1870s. [*]

LYNCH, Anna [P,Min.P,Por.P] Elgin, IL b. Elgin. Studied: AIC; Bouguereau, Simon, Cottet, Debillemont, in Paris. Member: Chicago PS; Pa. S. Min. P.; Chicago City Commissison for Public Art; Paris A. Women's AA; Chicago AC; Chicago S. Min. P.; Cordon Cl.; Chicago Gal. A.; Lg. Am. Pen Women; De Paul A. Lg. Exhibited: Chicago AC (prize); P.-P. Expo, San Fran., 1915 (med); AIC (prize); Chicago Art Inst. Alumni (prize); Arché Cl. (prize); Chicago Gal. Art (prizes); Springfield, Ill., 1927 (prizes); Soc. Sanity in A., 1939 (med). Work: portraits, Court House, Memorial Hall (both in Chicago), Archibald Church Medical Lib., Northwestern Univ.; miniature, University Gld., Evanston, Ill.; paintings, City Commission, Chicago [40]

LYNCH, John [P,I] Brooklyn, NY. Member: AWCS; SI [47]

LYNCH, Lorena Babbitt (Mrs.) [P,Des,G] Bloomfield, NJ b. Laurens, NY. Studied: N.Y. Sch. F.&Applied A.; Oneonta Normal Sch., N.Y. Member: Am. Ar. Prof. Lg.; Art Center of the Oranges; Bloomfield A. Lg. Exhibited: A. Center of the Oranges, 1939 (prize); Bloomfield A. Lg. Exh., Nat. A. Week, 1939 (prize); Bloomfield Women's Cl., 1940 (one-man); Montclair AM, Newark Mus. [40]

LYNCH, Virginia [P,W,L,T, Cr] NYC/Lime Rock, CT b. NYC. Studied: J. Schledorn; ASL; China; Japan. Member: NAC; Lime Rock AA. Exhibited: watercolor, C.L. Wolfe AC, 1922 (prize). Positions: A. Cr., Herald-Tribune, Waterbury Republican [40]

LYND, J. Norman [I] Lynbrook, NY b. 15 N 1878, Northwood, OH. Member: SI, 1913; Artist Gld. [33]

LYNDALL, Isabel [Min.P] Phila., PA [15]

LYNE, Esther [P] Henderson, KY. Exhibited: Soc. Wash. Ar., Corcoran Gal., 1933, 1934, 1940 [40]

LYNES, George Platt [Photogr] NYC b. 1907 d. 1955. Studied: self-taught. Work: AIC; IMP; MMA; MOMA; NYPL. Best known for his portraits of Hollywood stars, ballet dancers, writers, and male nudes. Tchelitchev created many of his backgrounds. Brother of the critic, Russell Lynes. [*]

LYNN, Charles [P] Augusta, GA. Exhibited: 48 Sts. Comp [40]

LYNN, James, Jr. [Mar.P] Port Huron, MI b. 5 Mr 1855, Canada (came to Port Huron, Mich. as a young man) d. 1924. Work: Mariner's Mus. Also a sailor and shipbuilder. [*]

LYNN, Katherine Evans (Mrs.) [P] Nantucket, MA b. 13 My 1875, Phila. d. 18 S 1930, Montreux, Switzerland. Studied: Pa. Sch. IA; ASL; Acad. Colarossi, Constant, Mme. Richard, all in Paris. Member: NAWPS; Phila. Alliance; Wash. WCC; Wash. AC [29]

LYNN-JENKINS, Frank [S] NYC b. 1870, Torquay, England d. 1 S 1927. Studied: Lambeth Sch. Modeling, Royal Acad. Art, both in London. Exhibited: Paris Expo, 1900 (med). Work MMA

LYON, Alfred B. [S] Indianapolis, IN. Member: Ind. SS [25]

LYON, Harriette A. (Mrs.) [C] Phila., PA/Kennebunk, ME b. Canton, OH. Studied: ASL; RISD. Member: Phila. ACG; Phila. Alliance; Boston SAC. Specialty: jewelry [40]

LYON, Hayes [P,Mur.P] Santa Fe, NM b. 10 F 1909, Athol, KS. Studied: Univ. Colo.; Univ. Denver; A. Dasburg; J. Bakos. Member: Denver Ar. Gld. Exhibited: Denver A. Mus., 1937, 1939 (prize), 1940, 1941; FAP, 1941 (prize); Nat. Exh. Am. A., N.Y., 1938; PAFA, 1938; AIC, 1938; WFNY, 1939; NGA, 1941; Colorado Springs FA Center, 1940, 1941, 1946; Joslyn Mem., 1936, 1940; Kansas City AI, 1942. Work: Denver A. Mus.; murals, Ft. Lupton (Colo.) H.S. [47]

LYON, Jeannette Agnew (Mrs. William T.) [Ldscp.P] Cleveland, OH b. 3 D 1862, Pittsburgh. Studied: R.C. Minor; Mesdag, at The Hague; Constant, in Paris. Member: Cleveland Women's AC; North Shore AA [33]

LYON, Nicholas [P] Houston, TX. Studied: Houston Mus. FA, 1938. Work: USPO, Conroe, Tex. WPA artist. [40]

LYON, Richard [I] Westport, CT. Member: SI [47]

LYON, Rowland [P,T,B,Car,Ldscp.P] Wash., D.C. b. 16 Jy 1904, Wash., D.C. Studied: Corcoran Sch. A.; George Washington Univ.; Hawthorne. Member: Wash. AC; Soc. Wash. A.; Wash. WCC; Landscape Cl., Wash.; Wash. SE. Exhibited: S.Indp.A., Wash., D.C., 1933 (prize), 1935 (prize); Fed. Women's Cl., 1934; Wash. Landscape Cl., 1935, 1936, 1937 (prize), 1938–46; Times Herald A. Fair, Wash., D.C., 1944 (prize); Metropolitan State A. Contest, 1944 (prize); Soc. Wash. A., 1930–34, 1935 (med), 1936–46; Wash. WCC, 1942–46; Wash. SE, 1943–46. WPA artist. [47]

LYONS, Matthew [P] Bridgeport, CT. Exhibited: 48 Sts. Comp. [40]

Alice Morlan: *Friendly Criticism*. From *The Illustrator* (1895)

M

MAAS, George [Des,P,I,T] Topeka, KS b. 17 Mr 1910, Kansas City, MO. Studied: T. Benton. Positions: Kansas City Star, 1935–37; T., A Center, Topeka [40]

MAAS, Raymond [P] Milwaukee, WI. Member: Wis. PS [27]

MAASEN, Margaret (Ms. Baesemann) [P] Chippewa Falls, WI b. 24 O 1907, Milwaukee, WI. Studied: Layton Sch. A. Member: Wis. PS; Wis. A. Fed. Exhibited: AIC, 1930, 1934; Layton Sch. A.; Wis. PS; Madison Salon; Wis. State Fair; Mt. Mary Col., Milwaukee [47]

MABIE, George Harold [Cart] Palisades Park, NJ b. 23 N 1892, Leonia, NJ. Studied: NAD. Contributor: cartoons, American; Collier's; Sat. Even. Post; New York Am.; Elks Mag.; Parents' Mag.; Boy's Life; This Week Mag. [40]

MABIE, Helen [P] NYC. Member: NAWPS. Exhibited: NAWPS, 1935–38 [40]

MABIE, Lester W. [P] Fort Lee, NJ [13]

MACADAM, Freda Churchwell [Dec,Des,P] Wilmington, DE b. 8 N 1907, Chester PA. Studied: PMSchIA; Fontainebleau Sch. FA; G. Beland; C. le Meunier; W.C. Grauer; N. Grauer; H.E. Winter. Member: Phila. Alliance; Wilmington SFA; Am. Ar. Prof. Lg. Exhibited: WFNY, 1939; Wilmington SFA, 1934, 1935. Work: Adelphia Hotel, Phila.; CI; YMCA, Wilmington, Del. [40]

MACALISTER, Paul (Ritter) [Des,W,I,L,Dec,Arch] NYC. b. 15 O 1901, Camden, NY. Studied: PAFA; PMSchIA; Yale; PIASch; Ecole des Beaux-Arts. Member: AIC; Soc. Des. Craftsmen. Exhibited: Beaux Arts, 1925; Permanent Exh. Dec. Arts and Crafts, 1933–35 (med). Work: interiors, leading industrial companies; Rockefeller Center Author/Illustrator: "Plan-a-Room." Contributor: Times; Tribune; Arts and Decoration; etc. Position: Dir., The Permanent Exhibition of Decorative Arts and Crafts, Inc. [47]

MACCARTNEY, Catherine (Naomi) [P,T] Iowa City, IA b. Des Moines, IA. Studied: C.A. Cumming; R. Miller; H.H. Clark; W. Adams; G.P. Ennis; Colarossi Acad., Paris. Member: Iowa AG; L.C. Tiffany fnd. Exhibited: Des Moines Women's C., 1912 (prize), 1914 (prize); Iowa State Fair, 1916 (gold), 1921 (gold). Work: F.L. Owen Coll., Des Moines, Iowa; Univ. Iowa, Iowa City. Position: T., Univ. Iowa [40]

MACAULEY, Charles Raymond [Car,I] Montclair, NJ (1906) d. 24 N 1934. Studied: self-taught. Position: Staff, New York World. [33]

MACAULEY, Ellen [P] Jamestown, RI b. Portsmouth, NH. Studied: PAFA; E. Laurent, Paris [24]

MACBETH, Robert Walker [Dealer] b. 1884, Brooklyn, NY d. 1 Ag 1940, Orange, NJ. Studied: Columbia. The Macbeth Gallery, founded by his father in 1892, was influential in the formation of important private and public coll. of early and contemporary American art.

MACBETH, William [Dealer] NYC b. 1851, Ireland (came to U.S., 1871) d. 10 Ag 1917, Southampton, NY. Macbeth Gal. (founded 1892) was one of the principal dealers promoting American painters. In 1908 he launched "The Eight," later known as the "Ashcan Group." He was a dealer with rare vision: many of the artists he represented are highly sought after today. The Macbeth Gal. papers are in the Archives of Am. A.

MACCARTAN, Edward [P] Paris, France [10]

MACCAMERON, Robert Lea [P] NYC b. 14 Ja 1866 d. 29 D 1912, NYC. Studied: Paris, with Gérôme, Collin. Member: ANA 1910; Paris SAP; Intl. Soc. PS&G; Port. P. Exhibited: Paris Salon, 1914, 1908 (med); Legion of Honor, 1912. Work: CGA; Wilstach Gal., Phila.; MMA [10]

MACCHESNEY, Clara T(aggart) [P,W] NYC/Tannersville, NY. b.1860, Brownsville, CA d. 6 Ag 1928, London. Studied: San Fran. Sch. of Des., with V. Williams; Gotham A. Sch, New York, with Mowbray, Beckman; Paris, with Giradot, Courtois, Colarossi Acad. Member: AWCS; NAWPS; NAC; SPNY; Barnard C.; Lyceum C., London. Exhibited: Columbian Expo, Chicago, 1893 (med); NAD, 1894 (prize), 1901 (prize); Pan-Am. Expo, Buffalo, 1901 (med); St. Louis Expo, 1904 (med); Paris Salon. Work: BAC; Sacramento, Calif.; NAC; Emigrant Savings Bank, NYC; Union Lg. C., Chicago; NGA; Altoona Lib.; Aldine C., NYC; Erie AC [27]

MACCONNELL, Lillian G. Clarke (Mrs.) [T,C,J,Dec] Melrose, MA/Hampton Beach, NH b. Boston, MA. Studied: BMFA Sch.; Mass. Sch. A. Member: Boston SAC (master craftsman); N.H. Lg. AC. Specialty: cut silhouettes [40]

MACCORD, Charles William [P] Bridgeport, CT/Stockbridge, MA b. 3 F 1852, Alleghany City, PA d. 7 Ja 1923. Member: SC, 1897; Lg. Am. A.; Thumb Tack C., Bridgeport (Pres., 1903–04); Lotos C. Work: Bridgeport Pub. Lib.; Sea Side C., Bridgeport [21]

MACCORD, Mary N(icholena) [P] NYC b. Bridgeport, CT. Member: NAC; NAWPS; AWCS; CAFA; NYWCC; New Haven PCC; NYSP; Wash. WCC; Allied AA; AFA. Exhibited: Baltimore WCC, 1923 (prize); NAWPS, 1931 (prize). Work: NAC [40]

MACCORMICK, Evelyn [P] Monterey, CA [17]

MACCOY, Guy [P,Ser,L] NYC b. 7 O 1904, Valleys Falls, KS. Studied: Kansas City AI; ASL; Broadmoor A. Acad.; T. Benton; E. Lawson; J. Matulka; A.J. Kostellow. Exhibited: Kansas City AI 1937, 1938; Laguna Beach AA, 1943 (prize); AIGA, 1944 (prize); CMA, 1946 (prize). Work: Encyc. Brit. Coll.; NYPY; Toledo Mus. A; Santa Barbara A. Mus.; Parkersburg FA Center; Univ. Iowa; Univ. Calif., Los Angeles; Pepperdine Col.; SFMA; CI; LOC; MMA; Newark Mus.; PMA; Honolulu Acad. A.; Univ. Minn.; Philbrook A. Center; Univ. Okla.; Okla A.&M: Col.; mural, BM; mural, Brooklyn Indst. H.S. for Girls. Contributor: Lithographers Journal [47]

MACCUBBIN, Elizabeth. See Langenbeck.

MACCUISTON, Jacques (Jax) (Miss) [S] Hollywood, CA b. 19 O 1906, Texarkana, TX. Studied: F.H. Frolich; G.D. Otis; R. Aitken; R. Laurent; W. Zorach; ASL. Exhibited: Dallas Pub. A. Gal., 1933 [40]

MACCALLUM, Bertha A. [P] Baltimore, MD [25]

MACDERMOTT, Stewart Sinclair [P,Et] NYC b. 14 Jy 1889. Studied: ASL; BAID; Fontainebleau Sch. FA. Exhibited: CGA; PAFA; AIC; Salon d'Automne, Paris; NAD; CI; Springfield AL, 1931 (prize). Work: MMA [47]

MACDOMEL, Edward [S] Paris, France [10]

MACDONALD, Arthur N. [En] East Orange, NJ b. 31 Mr 1866, Attleboro, MA. Member: Am. Bookplate S., 1919. Exhibited: Am. Bookplate S., 1919 (prize) [25]

MACDONALD, Donald [P] Boston, MA. Member: BAC [21]

MacDONALD, F(rank) E. [P,I] Kansas City, MO b. 8 F 1896, Kansas City. Studied: R. Thomas; G.V. Millett; J.D. Patrick. Member: Kansas City AG [33]

MacDONALD, Geneva A.C. [P,C,T,Gr] Boston, MA b. 28 Ag 1902, Natick, MA. Studied: Mass. Sch. A.; BMFA Sch.; R.M. Pearson; Des. Workshop, N.Y.; Harvard Univ.; E. Thurn; U. Romano. Member: S.Indp.A., Boston; Copley S.; NAWA; Inst. Mod. A., Boston; Gloucester SA; Ar. Un., Boston. Exhibited: Jordan Marsh Gal., 1945, 1946; Inst. Mod. A., Boston; NAD; NAWA; Stuart Gal., Boston [47]

MacDONALD, Harold L. [P,S,I,T] Purcellville, VA b. 13 My 1861, Manitowac, WI. Studied: Paris with Boulanger, Lefebvre. Member: S. Wash. A. [21]

MacDONALD, James Wilson Alexander [S,P,W] Yonkers, NY b. 25 Ag 1824, Steubenville, OH d. 14 Ag 1908. Studied: St. Louis, with A. Waugh, 1845. Gave up publishing business in 1854 to sculpt. Became successful portrait sculptor in NYC after Civil War. Work: bust of Senator Benton, 1854, said to be the first marble cut west of the Mississippi. Work: Appellate Court, NYC; NYC Law Lib.; "Halleck," Central Park, NYC; "Washington Irving," Prospect Park, Brooklyn [08]

MacDONALD, John A. [Min.P] NYC b. NYC. Studied: NAD; Cormon, in Paris. Member: ASMP; SC 1888 [01]

MacDONALD, Katharine Heilner [B,T] Burlingame, CA b. 30 N 1882, Brooklyn, NY. Studied: PIASch; Fed. A. Sch., Minneapolis; A. Dow. Member: FA Soc., San Diego. Work: San Deigo FA Soc.; Fed. A. Sch., Minneapolis [47]

MacDONALD, Pirie [Photogr] b. 1867, Chicago d. 22 Ap 1942, NYC. Studied: Forshew Studio, NYC, 1883. Opened studio in NYC, 1900; photographed 70,000 notables in soft-focus style, including dealer Sir Joseph Duveen. Work: N.Y. Hist. S. [*]

MacDONALD-WRIGHT, Stanton [P,W,L,T] Santa Monica, CA b. 8 Jy 1890, Charlottesville, VA d. 1973. Studied: ASL, Los Angeles, ca. 1906; Sorbonne, Acad. Colarossi (briefly), Acad. Julian, Acad. Grande Chaumière, Ecole des Beaux-Arts, all in Paris, 1907. Exhibited: with Morgan Russell, mounted major exhibits in Paris and Munich, 1913; Armory Show, 1913; NYC, 1914, 1917, 1919, 1950; Los Angeles MA, 1956 (retrospective); Nat. Coll., 1967 (retrospective). Work: Detroit Inst. A.; PMA; Grand Rapids A. Gal.; Los Angeles Mus. A.; San Diego FA Soc.; Denver A. Mus.; murals, Pub. Lib., City Hall, H.S., all in Santa Monica; MOMA; WMAA; Santa Barbara MA. Author: "Color: Theory and Chart," privately printed. Co-author: with his brother, Willard H. Wright, "Modern Art, Its Tendencies and Meaning," 1914, "The Future of Painting." With M. Russell he invented "Synchronism," a style in which form was generated by color, 1913. Position: T., UCLA [47]

MacDONALL, Angus (Peter) [P,I] Westport, CT b. 7 Ap 1876, St. Louis. d. 18 D 1927. Studied: St. Louis Sch. FA. Member: SI; GFLA; Chicago WCC; Author's Lg.; Palette and Chisel C. [27]

MacDOUGALL, Dugald [P] Madison, NJ [24]

MacDOUGALL, John A. [Min.P,T] Nantucket, MA b. 1843, NYC. Studied: NAD; Cormon, in Paris. Member: ASMP. Exhibited: Charlestown Expo, 1902 (med) [24]

MacDOUGALL, Robert Bruce [P,Mar.P,Ldscp.P] NYC d. 20 S 1931, Long Beach, NY. Studied: CUASch; NAD. Member: SC. Positions: T., Brooklyn C., CCNY [27]

MacDOWELL, Edward [S] NYC [15]

MacDOWELL, Elizabeth [P] Phila., PA [01]

MacDOWELL, Susan Hannah. See Eakins.

MacEDWARDS, Barbara. See Chalmers.

MacEWEN, Walter [P] Paris, France b. 13 F 1860, Chicago d. 20 Mr 1943. (Lived in Europe for many years; was part of the Am. colony at Egmond, Holland [1880s] with G. Hitchcock and G. Melchers.) Studied: Paris, with Cormon, Robert-Fleury. Member: ANA, 1903; Century C.; Paris SAP; NIAL; PAFA. Awards: Chevalier Legion of Honor (1896), Officer (1908); Order of St. Michael, Bavaria; Order of Leopold II, Belgium, 1909. Exhibited: Paris Salon, 1886; Paris Expo, 1889 (med) 1900 (med); Berlin, 1891 (gold); Columbian Expo, Chicago, 1893 (med); Antwerp, 1894 (med); Munich, 1897 (med), 1901 (med); Vienna, 1902 (med); PAFA, 1902 (prize); AIC, 1902 (prize); St. Louis Expo, 1904 (med); Liège, 1905 (med); P.-P. Expo, San Fran., 1915; NAD, 1919 (prize). Work: Luxembourg Mus., Paris; LOC; CGA; Indianapolis AA; AIC; PAFA; Telfair Mus., Savannah; Honolulu Mus.; Musée Liège, Belgium; Musée Budapest; Musée Ghent; Los Angeles; CMA; Musée de Magdebourg, Prussia; Richmond (Va.) A. Mus. Specialty: printer's etching [40]

MacFARLAN, Christina [P] Ardmore, PA b. Phila. Studied: Chase; Breckenridge [27]

MacFARLAND, Barbara [P] Peru, VT b. 23 S 1895, Santa Barbara, CA. Studied: E. O'Hara; D. Ricci, Rome. Member: NAWPS. Work: Corcoran Sch. A. Illustrator: "The Bitter Tea of General Yen," by Grace Zaring Stone, 1930 [40]

MacFARLANE, Scott B. (Mrs.) [I] Washington, D.C. b. 23 S 1895, Santa Barbara, CA. Studied: D. Ricci, Rome; A. Musgrave [29]

MacGILLIVARY, M.C. [P] Minneapolis, MN [15]

MacGILVARY, Norwood [P,T] Pittsburgh, PA b. 14 N 1874, Bangkok, Siam d. ca. 1950. Studied: Davidson Col.; Mark Hopkins Inst.; M. Barlow; J.P. Laurens. Member: AWCS; SC; Pittsburgh AA; Pittsburgh A. Comm.; Pittsburgh Arch. C. Exhibited: Pan-P. Expo, 1915 (med); Pittsburgh AA, 1928 (med). Work: NGA. Position: T., CI, 1921– [47]

MacGINNIS, Henry Ryan [P,T] Fairlee, VT b. Martinsville, IN. Studied: Royal Acad., Munich, Germany; Adams; Steele; Forsythe; Paris, with Collin, Courtois. Member: AAPL; All. A. Am.; Audubon A.; SC; Hoosier Salon; S.Indp.A. Exhibited: Munich Royal Acad.; AIC; Omaha Exp; PAFA; Intl. Exh., Munich; NAD; Richmond, Ind., 1929 (prize); Hoosier Salon, 1930 (prize). Work: State House, Masonic Temple, Trenton, N.J.; Lehigh Univ.; Customs House, N.Y.; Rutgers Univ. murals Ewing Cem. Assn., Trenton, N.J.; St. Thomas Church, Woodhaven, N.Y. [47]

MacGOWAN, Clara (Mrs. Edward Cioban) [P,C,Gr,L,W,T] Evanston, IL b. 15 S 1895, Montreal, Canada. Studied: Univ. Washington; Paris, with Lhote, Leger. Member: Chicago SA; Women's Salon, Chicago; Chicago AC; CAA; Nat. Edu. Assn.; Soc. Typographic A.; Am. Soc. for Aesthetics; Chicago NJSA; WAA. Exhibited: AIC; Chicago AC; Chicago SA, 1934; Findlay Gal.; Rouillier Gal., 1944; Marshall Field, Chicago, 1945; Soc. Typographic A.; North Shore A. Exh., Evanston, 1934 (prize). Published: with J.A. James, "Chicago, A History in Block-Print." Contributor: articles, "School Arts," "Design." Position: T., Northwestern Univ., Evanston [47]

MacGREGOR, Donald [P] Pemberton, NJ b. Phila. Studied: PAFA, with Chase. Member: Phila. Sketch C. Exhibited: AAS, 1902 (med) [27]

MacGREGOR, J. Duncan, Jr. [P] Brookville, NY b. 10 S 1907, Elberon, NJ. Studied: E. Savage; S. Dickinson; W.L. Stevens; Yale [40]

MacGREGOR, Nina (Mrs.) [P] Montclair, NJ

MacGREGOR, Sara Newlin (Mrs. Donald) [Min.P,I] Princeton, NJ b. Pa. Studied: W.M. Chase; B. Gilman; C. Beaux; H. Thouron; PAFA. Member: Plastic C. Exhibited: AAS, 1902 (med) [33]

MACHAN, Knowles [I] NYC. Worked with Will Bradley [13]

MACHANIC, Ethel [P,S] Wash., D.C. b. 23 S 1908, Burlington, VT. Studied: BMFA Sch. Member: A. Lg. Am; Am. A. Cong.; Artists Union. Exhibited: San Fran. AA, 1938; Springfield Mus. A., 1938; Assn. Am. A., 1943; A. Lg. Am., 1943; MOMA Traveling Exh.; BAC; Northern Vt. A., 1935; Jordan Marsh Co. Exh., 1936 [47]

MacHARG, Katherine [Des,P,S,T] Duluth, MN b. 5 O 1908, Biwabik, MN. Studied: PIASch.; PAFA; Univ. Ariz.; Duluth State T. Col. Member: Minn. S. Group; AFA. Exhibited: Chester Springs Traveling Exh.; Minn. State Fair, 1940; Duluth Arrowhead Exh. Contributor: School Arts. Position: T., Duluth A. Center [47]

MACHEFERT, Adrien Claude [P,G,I,Car] Glendale, CA b. 29 N 1881, San Jose, CA. Studied: Mark Hopkins Sch. A., San Fran. Member: Am. Ar. Cong. Exhibited: WFNY, 1939 [40]

MACHIN, Grace Keeler (Mrs.) [P,W] Brooklyn, NY b. 1841, Ohio d. 16 Ag 1917. Served in the Art Department, St. Louis Expo, 1914.

MacINTOSH, Jennie B. (Mrs.) [P,T] d. 5 D 1925, Indianapolis, IN. Member: Logansport AA, 1911. Position: T., Logansport Pub. Schools, since 1902

MacINTOSH, Marian T. [P] Princeton, NJ b. ca. 1871, Belfast, Ireland d. 2 O 1936, New England. Studied: H. Knirr; H.B. Snell; Bryn Mawr. Member: Phila. Alliance; Plastic C.; NAWPS. Exhibited: AIC, 1919 (prize); NAD; CM; PAFA; Plastic C., 1922 (gold); NAWA, 1927 (prize). [33]

MacINTOSH, William W. [S] Phila., PA b. West Phila. Studied: PAFA,

with Eakins, Shüssele, Poore, Chase; C. Beaux; C. Piton. Specialty: making medals [17]

MacINTYRE, Dorothy Morrison [E] Phila., PA b. 8 Je 1909, Phila. Studied: PMSchIA; R. Horter. Member: SAE; Phila. A. Lg.; Southern PM; Phila. Color Pr. S. Exhibited: LOC, 1943, 1944, 1946; NAD, 1943, 1936; Oakland A. Gal., 1941, 1942; PAFA, 1941, 1943; Southern PM, 1940, 1942; Phila. Pr. C., 1937, 1940, 1941, 1943, 1944; SAE, 1940, 1942, 1944, 1946. Work: PMA [47]

MacINTYRE, Emilie (Mrs. Charles S.) [P] Seattle, WA b. Black Forest, Germany. Studied: Univ. Wash.; L. Murphy; L. Derbyshire; J. Butler; P. Camfferman; M. Tobey. Member: Northwest PM. Exhibited: Northwest A. Ann, SAM, 1939; Wichita AM, 1939 [40]

MacIVER, Ian Tennant Morrison [Ldscp.P,Arch,P] NYC b. 22 My 1912, Aberdeen, Scotland. Member: NYWCC [40]

MacIVER, Loreen (Miss) [P,I] NYC b. 2 F 1909, NYC. Studied: ASL. Member: Un. Am. Ar. Exhibited: MOMA, 1936–46; WMAA, 1944, 1945; CGA; CAM; PAFA; East River Gal., 1938; MOMA; CGA; GGE, 1939. Work: MMA; MOMA; Newark Mus.; Detroit Inst. A.; SFMA; AGAA. Illustrator: Fortune, Town and Country [47]

MACK, Frank [Mur.P,Por.P] Atlanta, GA b. Chicago, IL. Studied: AIC; J. Vanderpoel; L. Betts; R. Clarkson. Member: Atlanta AA; Assn. Ga. A.; SSAL; AAPL; Studio C. Atlanta. Exhibited: Atlanta AA; Assn. Ga. A.; SSAL [47]

MACK, Harry Francis [I,Por.P,E] Baton Rouge, LA b. 4 My 1907, Gloversville, NY. Studied: NAD; N.Y. Sch. Appl. Des.; I. Olinsky; I. Wier; M. Sterne; W. Auerbach-Levy; L. Kroll. Member: Southern PM S.; SC. Exhibited: La. State A. Comm., 1942 (one-man), 1946. Work: U.S. War Dept., Wash., D.C. [47]

MACK, Warren B(ryan) [En,T,B] State Col., PA b. 18 Ja 1896, Flicksville, PA. Studied: Lafayette Col.; Pa. State Col.; Mass. State Col.; Johns Hopkins Univ. Member: Woodcut S.; ANA; SAE. Exhibited: Appalachian Mus., Mt. Airy, Ga., 1940 (prize); LOC, 1943 (prize), 1946 (prize); NAD, 1940–46; PAFA, 1944, 1945; AIC, 1937, 1939; MMA, 1942; Wichita AA, 1931–34, 1949; Northwest PM, 1933, 1939, 1943; Phila. Pr. C., 1936, 1946; Southern PM, 1936–40; AFA traveling exh., 1940, 1943; WFNY, 1939; Venice Italy, 1940; Am.-British Goodwill Exh., 1943–44; Vanguard Press, 1940, 1941; Nat. Comm. on Engraving, 1941; Calif. PM, 1934; Laguna Beach AA, 1945; Newport AA, 1945; Albany Inst. Hist.&A., 1945. Work: BMA; NYPL; FMA; Harvard; LOC; Glasgow Univ., Scotland; SAM. Position: T., Pa. State Col., 1937– [47]

MACKALL, (Robert) McGill [P,C,T] Baltimore, MD b. 15 Ap 1889, Baltimore, MD. Studied: Md. Inst.; ASL; Julian Acad., Paris, with J.P. Laurens; R. Miller; Royal Acad., Munich. Member: NSMP; A. Gld.; Arch. Lg.; Municipal A. Comm., Baltimore; NSS. Exhibited: CGA; CMA; NAD; WFNY, 1939; Paris Salon; NYWCC; Arch. Lg.; BMA. Work: Constitution Hall, Wash., D.C.; City Hall, Johns Hopkins Hospital, Court House, Md. War Mem. Bldg., Municipal Mus., many churches, all in Baltimore; St. John's Col., Annapolis; Univ. Ga.; 2nd Nat. Bank, Towson, Md.; glass, Ral Parr Mausoleum, Pikesville, Md.; churches, Luray, Va., Frederick, Md., West River, Md.; Wilson Hotel, New Brunswick, N.J.; DAR Hall, Wash., D.C.; Logan Theatre, Phila.; State House, St. Mary's City, Md. Position: T., Md. Inst. [47]

MacKAY, Edwin Murray [Por.P] Detroit, MI/Silvermine, CT. b. 1869, Detroit d. 28 F 1926. Studied: NYC; Paris; other cities of Europe; Laurens; Blanche; K. Cox. Member: Scarab C.; Conn. Soc. A. Work: Mich. State Cap. Bldg.; Mich. Supreme Court, Lansing; NYPL; several European gals. [25]

MacKAY, Jean V. (Mrs. Henry) [S,T,L,En] Buffalo, NY b. 19 S 1909, Halifax, N.S., Canada. Studied: Antioch Col.; AIC; Buffalo AI; Acad. Ozenfant, Paris; Univ. Vienna. Member: Buffalo Pr. C.; The Patteran; Buffalo SA. Exhibited: PAFA, 1942; Butler AI, 1941; SAM, 1942; SFMA, 1942; Denver A. Mus., 1942; Albright A. Gal., 1936–46. Work: Chautauqua County Jail, N.Y. Position: T., Buffalo AI, 1937–43, 1944–46 [47]

MacKAY, William A(ndrew) [Mur.P,I] Coytesville, NJ b. 10 Jy 1878, Phila. d. Ag 1939. Studied: Paris, with Constant, Laurens; Am. Acad., Rome; R. Reid, in NYC. Member: SI, 1910; Mural P.; Arch. Lg., 1911; Players C.; Beaux-Art S.; Paris AAA. Work: murals, Senate Reading Room, LOC; House of Representatives, St. Paul, Minn.; Supreme Court Room, Essex County Court House, Newark, N.J.; Castle Gould, Port Washington, N.Y.; dec., Knickerbocker C., 42nd St. Bldg., NYC; Merchants Trust Co., Chicago; St. Georges Church, Roosevelt Mem., NYC; State Office Bldg., Albany; Kings County Hospital, N.Y.; Civic Theatre, Chicago, Chicago Opera House; La. State Capitol [38]

MACKE, Harry J. [Des,C] Newport, KY b. 26 Ag 1890. Studied: F. Duveneck; C. Barnhorn; L.H. Meakin. Position: A. Dir./Tile Colorist, Cambridge Tile Co. [40]

MacKENZIE, Florence Bryant (Mrs. Frank J.) [P] San Fran., CA b. 4 O 1890, Boston, MA. Studied: Corcoran Sch. A., Wash., D.C.; Nat. Sch. F. App. A., Wash., D.C.; Phila. Sch. Des. for Women. Member: AC, Wash., D.C.; Soc. Sanity in A. (San Fran.). Exhibited: Smithsonian; CGA; AC, Wash., D.C. Work: private portraits. Position: A., U.S. Forestry Service [40]

MacKENZIE, Frank J. [P] Wash., D.C./Mayo, MD b. 27 Jy 1867, London, England d. D 1939. Studied: Académie Julian; London. Member: AC, Wash., D.C.; AMNH. Work: habitat groups, AMNH; Los Angeles Mus. Hist. Sc. & A.; Nat. Hist. Mus., Springfield, Mass.; N.J. State Mus., Trenton; many paintings and dioramas, U.S. Gov. [38]

MacKENZIE, J.B. [P] Phila., PA. Member: Phila. AA [25]

MacKENZIE, Janet [P,T] Detroit, MI [21]

MacKENZIE, Roderick D. [P,S,I,E,W,L,T] Mobile, AL b. 30 Ap 1865, London, England. Studied: BMFA Sch.; Paris, with Constant, Laurens, Jules Lefebvre, Chapu; Ecole Nat. des Beaux-Arts, Paris. Member: Royal SA, London; AFA. Exhibited: India (med). Work: Calcutta Mus.; Fort, Delhi, India; Birmingham, Ala.; State Capitol, Montgomery [40]

MACKEY, (E.) Spencer [Edu,P,L,S] San Fran., CA b. 16 N 1880, Auckland, New Zealand d. 5 My 1958. Studied: Académie Julian; Melbourne, Australia, B. Hall; J.P. Laurens; Lhote. Member: SFAA; San Fran. A. Comm.; Bohemian C. Exhibited: P.-P. Expo, 1915; GGE, 1939; SFAA, annually; Bohemian C., annually; SFMA; de Young Mem. Mus.; Pal. Leg. Honor. Positions: Dean, Faculty, Calif. Sch. FA, 1940; Pres. Calif. Col. A.&Cr., Oakland, 1944– [47]

MACKEY, William Enro [P,Gr] Phila., PA b. 17 F 1919, Phila. Studied: Graphic Sketch C., Phila.; PAFA. Member: F., PAFA. Exhibited: Ragan Gal., 1942; Phila. A. All., 1946; Phila. Graphic Sketch C., 1942; Gimbel A. Gal., 1938; PAFA, 1939 [47]

MacKILLOP, William [P] NYC b. Phila., PA. Studied: St. Louis Sch. FA; J.P. Laurens, E. Laurent, in Paris. Member: Allied AA; SC. Exhibited: P.-P. Expo, San Fran., 1915 (med) [33]

MacKINNON, Archibald Angus [Et,I] d. 5 N 1918, East Orange, NJ. Studied: ASL; Ecole des Beaux Arts, Antwerp. Member: SC

MacKINNON, Ella Cecelia [I,P,E,C] Paris, France/Wellesley, MA b. 9 Ap 1887, St. Catherine, Onatario. Studied: ASL, Buffalo; Dow; Leon. Member: Buffalo G. Allied A.; Société des Aquafortistes Français. Exhibited: Artistes Français, Paris Salon, 1929. Work: etchings, NYPL; Wellesley Col. AM, Mass. [31]

MacKINNON, Mary (Mrs. Frederick Johnson) [P,I] NYC/Saratoga Springs, NY b. 23 Mr 1890, NYC. Member: SI; Artists G. Work: port., fashion work, Harper's Bazaar; advertising, Lux, McCallum Hosiery [32]

MacKINSTRY, Elizabeth (Conkling) [S,I,T] Buffalo, NY b. 31 Mr 1879, Scranton, PA. Studied: A. Dow; PIASch; Gérôme, Paris [17]

MacKNIGHT, Dodge [P] Sandwich, MA b. 1 O 1860, Providence, RI d. 1950. Studied: Cormon, in Paris. Work: FMA; Gardner Mus.; BM; large coll. watercolors at BMFA; RISD. During the 1920s, Vose Gal. in Boston sold out every exh.. of his watercolors. [40]

MacKNIGHT, Nino (Mrs. Wilbur Jordan Smith) [I,W] Los Angeles, CA b. 5 Ap 1908, Syndey, Australia. Studied: ASL, with G.P. du Bois; Australia, with N. Tindall. Illlustrator: "Little Amish Schoolhouse," 1939; "Along the Erie Towpath," 1940; "Sing for Your Supper," 1941; other juvenile books [47]

MACKUBIN, Florence [Por.P,Min.P] Baltimore, MD b. 1866, Florence, Italy d. 7 F 1918. Studied: Galea, in Nice; Herterich, in Munich; J. Rolshoven, in Florence, Paris; L. Deschamps, in Paris. Exhibited: Tenn. Expo, 1897, (med). Work: Md. State House, Annapolis; Baltimore C.; Univ. Va.; Walters Gal., Baltimore; Johns Hopkins Univ. [17]

MACKUBIN, Kate [P] Baltimore, MD [25]

MACKWITZ, William [En] St. Louis, MO b. 1831, Germany (came to St. Louis in 1856) d. 6 Ag 1919. Established engraving firm in St. Louis, 1856–1916. Work: Mo. Hist. Soc. Specialty: wood engraving [*]

MACKY, Constance L. [P] San Fran., CA [25]

MacLANE, Jean (Mrs. John C. Johansen) [Por.P] NYC b. 14 S 1878, Chicago, IL d. 1964. Studied: AIC; F. Duveneck; J. Vanderpoel. Member: ANA, 1912; NA 1926; Port. P.; NAC; AAAL; AWCS; NYWCC; AIAL.

Exhibited: St. Louis Expo, 1904 (med); NAD, 1912 (prize), 1913 (prize), 1923 (prize), 1928 (prize), 1935 (prize); PAFA 1914 (prize), 1936 (prize); P.-P. Expo, 1915 (med); AIC, 1924 (med,prize); Stockbridge AA, 1933 (prize), 1936 (prize); Intl. Lg., Paris, 1907 (prize), 1908 (prize); N.Y. Women's AC, 1907 (prize), 1908 (prize); Grand Central A. Gal., 1929 (prize). Work: TMA; AIC; Syracuse MFA; San Antonio Mus.; NGA [47]

MacLAUGHLIN, Donald Shaw [E,P] NYC b. 1876, Canada d. 1938. Studied: Boston; Paris; Girome, in Italy. Member: ANA 1935; SAE. Exhibited: SAE, 1932 (prize). Work: AIC; Kennedy Gal. [38]

MacLEAN, Christina [P] Ft. Worth, TX

MacLEAN, J. Arthur [W,Mus.Cur,L] Toledo, OH. Author: "Modern Japanese Prints," 1936, "East Indian Sculpture," 1940, "Ancient Chinese Bronzes," 1941, "Northern Asiatic Art," 1942. Contributor: Parnassus, Magazine of Art. Position: Cur., TMA [47]

MacLEAN, Marion [Min.P] Paris, France b. NYC. Studied: Mme. Debillemont-Chardon, in Paris [10]

MacLEAN, William Lacy [P,S,W,T] b. 1860, New Phila., OH d. 4 Je 1940, Takoma Park, MD. Studied: PAFA. Member: FAS, East Tenn. (founder; Pres.) Positions: Staff, Lexington (Ky.) Herald; T., PAFA

MacLEARY, Bonnie [S] NYC b. San Antonio, TX. Studied: N.Y. Sch. A.; Académie Julian, Paris; ASL; DuMond; J.E. Fraser; G. Derujinsky. Member: NSS; All.A.Am.; SSAL; AAPL; ANA 1930; NAWPS. Exhibited: NAD; NAC; NAWA, 1928 (prize), 1929 (prize); PAFA; SSAL; Arch. Lg.; All.A.Am. Work: MMA; Brooklyn Children's Mus.; Wesleyan Col., Macon, Ga.; Baylor Univ.; Witte Mem. Mus.; CGA; monuments, Univ. Puerto Rico; San Juan, Puerto Rico; San Antonio, Tex.; Rio Piedras, Puerto Rico; mem., Brooklyn [47]

MacLEISH, Norman [P,G] Glencoe, IL b. 29 Ag 1890, Glencoe, IL. Studied: AIC; P. Vignal, Paris. Member: Chicago SA. Exhibited: AIC, 1938 (med), 1939; WFNY, 1939; GGE, 1939. Work: Detroit IA. WPA supervisor, Chicago. [40]

MacLELLAN, Charles Archibald [P] Wilmington, DE b. 22 Je 1887, Trenton, Ontario. Studied: AIC. Member: Wilmington SFA. Exhibited: PAFA, 1944; Pasadena AI, 1946 (prize); Wilmington SFA, 1936-46, 1942 (prize). Work: Wilmington SFA [47]

MacLENNAN, Eunice C(ashion) [P,Li,T] Santa Barbara, CA b. 28 Ap 1890, St. Louis, MO. Studied: Wash. Univ., St. Louis; PIASch; AIC; Académie Julian; Grande Chaumière; Sylvester; Johonnot; Carpenter, Paris, with Laurens, Prinet; St. Louis Mus. FA. Member: Santa Barbara AA; Santa Barbara PM S.; Calif WCS; NAWPS. Exhibited: NAWA, 1931-41, 1935 (prize); PAFA, 1939; Women's Intl. Exh., Montreal, Canada, 1937; Los Angeles PM, 1938; Santa Barbara Mus. A., 1943, 1944 (one-man); Illsley Gal., Los Angeles, 1937 (one-man); Calif. State Fair, 1932 (prize), 1933 (prize); Sacramento, Calif., 1930 (prize), 1931 (prize); Santa Cruz, 1936 (prize). Work: Santa Barbara Branch of Univ. Calif.; Santa Barbara Pub. Lib. [47]

MacLEOD, Alexander Samuel [L,P] Honolulu, HI b. 12 Ap 1888, Orwell, P.E.I., Canada. Studied: McGill Univ.; Calif. Sch. Des.; F. Van Sloun. Member: Honolulu PM; Assn. Honolulu A.; Calif. SE; Northwest PM. Exhibited: NAD, 1917-41; N.Y. WCC, 1917; BM, 1935; Nat. A. Gal., New South Wales, 1942; PAFA, 1930; MMA, 1942; AIC, 1931-35; Palace Legion Honor, 1933; CI, 1941; SFAA; Phila. Pr. C.; Vancouver A. Gal.; Honolulu PM, 1933 (prize), 1934 (prize), 1935 (prize) 1942 (prize); 1943 (prize), 1945 (prize); Los A. AA; Calif. SE, 1930 (prize); Northwest PM, 1934 (prize); Assn. Honolulu A., 1935 (gold), 1941-44 (prizes); Phila. Pr. C. Work: Honolulu Acad. A.; SAM; LOC; NGA; Newark Pub. Lib.; Smithsonian Inst.; Univ. Hawaii; Honolulu PM, 1935 gift print. Author/Illustrator: "The Spirit of Hawaii—Before and After Pearl Harbor," 1943. Illustrator: London Studio magazine; U.S. Army Forces, 1944-45 [47]

MacLEOD, John [P] Fort Lee, NJ. Member: S.Indp.A. [25]

MacLEOD, Robert James [P] Brooklyn, NY b. 24 Ag 1888, NYC. Studied: B.M. Peyton; F. Howell [25]

MACLIN, Elizabeth (Mrs.) [P,T] Richmond, VA. Member: Richmond AC [19]

MacMILLAN, Henry Jay [P,Dec,Des] Wilmington, NC/Wrightsville Beach, NC b. 13 Ja 1908, Wilmington, NC. Studied: J. Smith; ASL, with Y. Kuniyoshi, G. Bridgman, A. Woelfle; N.Y. Sch. F.&App.A. Member: N.C. Prof. Artists C. Work: Sperry Corp. R.C.A. Bldg. NYC; Coq Rouge Rest., NYC. Position: Dir., Wilmington MA Sch. [40]

MacMILLAN, Mary [P] Chicago, IL. Member: Chicago SA [15]

MacMONNIES, Frederick W(illiam) [S,P] NYC/Eure, France b. 28 S 1863, Brooklyn, NY d. 22 Mr 1937 NYC. Studied: NAD; ASL; A. Saint-Gaudens (apprenticed at age 16); Paris, with Falguiere, Ecole des Beaux-Arts, 1883, Mercié. Member: SAA 1891; ANA 1901; NA 1906; NAC; the Cornish (NH) Colony; Arch. Lg. 1892; NIAL; Chevalier Legion of Honor; Chevalier Order of St. Michael of Bavaria. Exhibited: Paris Salon, 1889, 1891 (med), 1900 (prize), 1901, 1902, 1904 (med); Columbian Expo, Chicago, 1893 (med); Antwerp, 1894 (gold); Phila. AC, 1895 (med); Atlanta Expo, 1895 (med); Munich (med); Boston AC (prize); Pan-Am. Expo, Buffalo (gold); Olympic Exh., Los Angeles, 1932 (prize). Work: Brooklyn, N.Y.; MMA; Luxembourg, Paris; West Point; Boston Pub. Lib.; LOC; statue, Wash., D.C.; Denver; Buffalo FA Acad.; fountain, statues, NYC; Princeton, N.J.; Hall of Fame, NYC; Lindbergh Medal for S. of Medalist; largest project was the famous WWI Marne Monument, Meaux. Important international sculptor. His highly controversial sculpture "Bacchante and Infant Faun" was rejected from public display in Boston, owing to its subject. Position: T., Whistler's Acad. Carmen, Paris, 1898 [33]

MacMONNIES, Mary Fairchild. See Low, W.H., Mrs.

MacMORRIS, Daniel [Dec,Des,C] NYC b. 1 Ap 1893, Sedalia, MO. Studied: Pennell; L. Gaspard; Gorguet; Despujols. Member: Mural P.; Artists of Carnegie Hall. Work: murals, W. Rockhill Nelson Gal., Kansas City, Mo.; State Office Bldg., Columbus, Ohio [40]

MacMULLEN, Nellie C. [P] Wash., D.C. [04]

MacMURRAY, M. [S] Cleveland, OH [19]

MacNAB, John S. [P,T] NYC b. 9 D 1853, Paisley, Scotland. Studied: Glasgow, with R. Greenlees, Glasgow Sch. A. Member: Art in Trades C. [13]

MacNAUGHTON, Mary Hunter [P,I,C] Palestine, TX [33]

MacNEAL, Frederic S. [P] Boston, MA [01]

MacNEIL, Carol Brooks (Mrs. H.A.) [S] Queens, NY/Towners, NY b. 15 Ja 1871, Chicago d. 22 Je 1944. Studied: L. Taft, AIC; Paris, with MacMonnies, Injalbert. Exhibited: Member: NSS, 1907; NAWPS. Exhibited: Paris Expo, 1900 (prize); St. Louis Expo, 1904 (med). Specialty: children's sculpture [40]

MacNEIL, H(ermon) A(tkins) [S] Queens, NY b. 27 F 1866, Everett, MA d. 1947. Studied: Mass. Normal A. Sch., Boston; Paris, with Chapu, at Académie Julian; Falguiere, at Ecole des Beaux-Arts. Member: NSS, 1897; ANA, 1905; NA, 1906; SAA, 1901; Arch. Lg., 1902; Century A.; Munic. AS; Nat. Acad. AL; AFA; NAC. Exhibited: Columbian Expo, Chicago, 1893 (med); Atlanta Expo, 1895 (med); Paris Expo, 1900 (med); Pan-Am. Expo, Buffalo, 1901 (gold); Charleston Expo, 1902 (gold); St. Louis Expo, 1904 (gold); Jewish Settlement in Am. (med); P.-P. Expo, San Fran., 1915 (gold); Arch. Lg., 1917 (med). Award: Prix de Rome. Work: statues, mem., monu., friezes, MMA; CGA; City Park, Portland, Oreg.; Columbus, Ohio; Albany, N.Y.; State Capitol, Hartford, Conn.; AIC; Montclair A. Mus.; Northwestern Univ.; Cornell Univ.; Wash. Arch, NYC; Mo. State Capitol; Flushing, N.Y.; Waterbury, Conn.; Seattle, Wash.; U.S. Supreme Court Bldg., Wash., D.C.; NYU; Whitinsville, Mass.; Northfield Univ., Mass.; New Parkway, Phila.; mem., Chicago; Charleston, S.C.; Vincennes, Ind.; des., Pan-Am. medal of award; Arch. Lg. medal of honor; U.S.. Gov. quarter dollar [47]

MacNICHOL, Joyce [P] NYC. Exhibited: Argent Gal., 1940 (one-man). Specialty: animals [40]

MacNICOL, Roy Vincent [P] NYC. Studied: Univ. Ill. Exhibited: AIC; NA; Newhouse Gal., 1927, 1940 [40]

MacNUTT, Glenn Gordon [P,Des] Dorchester, MA b. 21 Ja 1906, London, Ontario. Studied: Mass. Sch. A.; BMFA Sch. Member: AWCS; Boston S. WC Painters; Phila. WCC; Boston AG. Exhibited: MMA, 1941, 1942; AWCS, 1942-46; Phila. WCC, 1937, 1942-45; AIC, 1939, 1941, 1942; BM, 1941; CM, 1945; Boston S. WC Painters, 1940-46; Boston AG, 1941-46; New England A., 1941-46; AIC, 1939; PAFA, 1937; Jordan Marsh, 1942 (prize). Work: New Britain AI; Wheaton Col.; Rockland (Maine) Mus. A. [47]

MacNUTT, J. Scott [Por.P] St. Louis, MO b. 11 Ja 1885, Ft. D.A. Russell, WY. Studied: Harvard; MIT; BMFA Sch.; C.H. Woodbury. Member: St. Louis AG; St. Louis Representative, Woodbury Training Sch. in Appl. Observation, Boston, Mass. Exhibited: CAM, annually [47]

MACOMBER, Allison R. [S,Des,T] Taunton, MA b. 5 Jy 1916, Taunton. Studied: Mass. Sch. A.; C.E. Dallin; R. Porter; PAFA. Member: Boston Soc. S. Exhibited: PAFA, 1938, 1939; Boston Soc. S.; Jordan Marsh Gal.; Lyme AA, 1946. Work: mem., busts, Reany Mem. Lib., St. Johnsville,

N.Y.; State T. Col., Lowell, Mass.; Univ. Miss. Position: T., Attleboro Trade Sch., Mass. [47]

MACOMBER, Eva M. (Mrs.) [P] Boston, MA. Member: Copley S. 1895 [04]

MACOMBER, Mary L. [P] Boston, MA/NYC b. 21 Ag 1861, Fall River, MA d. 6 F 1916. Studied: BMFA Sch., with Dunning, Duveneck, 1883. Member: Copley S. 1884; Boston AG. Exhibited: Mass. Charitable Mech. Assn., Boston, 1895 (med); Atlanta Expo, 1895 (med); NAD, 1897 (prize); CI, 1901 (prize). Work: BMFA; Fall River (Mass.) Pub. Lib. [15]

MACOMBER, Stephen [P,L,T] Westerly, RI. Member: Providence AC; Mystic SA; Utopian C. Position: T., RISD [40]

MACOMBER, William Kaluna [P] Minneapolis, MN [24]

MacPHEARSON, M. (Mrs.) [P] Chicago, IL. Member: Chicago SA [19]

MacPHEE, James F. [Car] d. 3 Ja 1936, Springfield, MA. Position: Car./Newswriter, Springfield Union

MacPHERSON, Frances L. [P] Germantown, PA [06]

MacPHERSON, J. Howard [P] Wash., D.C. [19]

MacPHERSON, John Havard [P] Pike County, PA b. 25 F 1894, Phila. Studied: PAFA. Member: Phila. Sketch C.; Mystic AA [40]

MacPHERSON, J. Havard, Mrs. See Edgerly, Beatrice.

MacPHERSON, Marie (Mrs.) [P] Chicago, IL. Member: Chicago SA

MacPHERSON, Orison [I] New Rochelle, NY. Member: SI [47]

MacRAE, Bruce, Mrs. See Brinkley, Nell.

MacRAE, Elmer L(ivingston) [P] NYC/Cos Cob, CT b. 16 Jy 1875, NYC d. 2 Ap 1953. Studied: ASL; Twachtman; Beckwith; Blum; Mowbray. Member: NYWCC; Am. PS; Greenwich SA (Pres.); Am. Pastels (founder); AAPS (founder), sponsors of the 1913 Armory Show. Exhibited: Holley House, 1908-10; Madison AG, NYC, 1910; Armory Show, 1913; Milch Gal., NYC (retrospective), 1959; Greenwich SA, 1929 (prize). Work: Mystic Seaport Mus. Impressionist; settled in Cos Cob, 1896; lived at Holley House. [33]

MacRAE, Emma Fordyce (Mrs. Homer Swift) [P] NYC/Gloucester, MA b. 27 Ap 1887, Vienna, Austria. Studied: ASL, with R. Reid, Mora, Blumenshein; N.Y. Sch. A., with K.H. Miller. Member: ANA, 1930; MacD. C.; North Shore AA; Gloucester SA; PBC; NAWA; All.A.Am.; NSMP; AFA; Grand Central A. Gal.; Boston AC. Exhibited: CI, 1930; AIC, 1930, CGA, 1935, 1937; PAFA 1934-36; Pepsi-Cola, 1945; Joslyn Mem.; Houston MFA; de Young Mem. Mus.; SAM; Colorado Springs FA Center; Newport AA; NAD; All.A.Am.; Boston AC, 1937; MMA; BM; Currier G.; PMA; Montclair MA; Syracuse MFA; Parrish AM; R. York Gal., NYC, 1983; NAWPS, 1924, 1927, 1928 (prize), 1934 (prize); NAWA, 1945 (prize); NAC, 1930 (med); Allied AA, 1932, 1942 (prize); PBC, 1946 (prize); NAC, 1930 (med). Work: NAD; Wesleyan Col.; Cosmopolitan C. [47]

MacREADY, William H. [E,P] Woodstock, NY b. 11 Ag 1898, Newark, NJ d. 19 D 1956. Studied: ASL, Woodstock, with C. Rosen. Painted during the 1920s, turned to etching (self-taught) during the 1930s-40s [*]

MACRUM, George H. [P,T] NYC. Studied: ASL. Member: Allied AA; Phila. AC. Exhibited: Appalachian Expo, Knoxville, Tenn., 1911 (gold); SC, 1914 (prize); P.-P. Expo, San Fran., 1915 (med). Work: PAFA; Canadian Nat. Gal., Toronto [40]

MACSOUD, Nicolas S. [P,T,E] NYC b. 7 Mr 1884, Zahle, Syria. Studied: NAD. Member: SC; Brooklyn SMP; Brooklyn PS. Exhibited: Soc. Four A., Palm Beach, 1940 (prize). Work: BM; hotel, hospital, both in Asbury Park, N.J.; Pocono Manor Inn, Pa. [47]

MACTARIAN, Ludwig [P] NYC. Exhibited: PS Fed. Bldgs., 1936; PAFA, 1938. Work: Agriculture Bldg., USPO, Dardanelle, Ark. WPA artist. [40]

MacVEAGH, Louise Thoron [P,I] NYC/Dublin, NH b. Lenox, MA. Studied: L. Bakst. Member: NAWPS. Work: murals, Three Arts C., NYC; Holderness Sch., Plymouth, N.H. Illustrator: "The Great Fables," pub. Dial Press, "How You Began," pub. Coward McCann [40]

MACY, Carleton, Mrs. See Lefferts, Winifred.

MACY, Harriet P. [P,T] Des Moines, IA b. 21 Je 1883, Des Moines. Studied: Drake Univ.; Cumming Sch. A.; ASL; PAFA; RISD. Member: Des Moines Assn. A. Edu.; Iowa AG (Pres.). Exhibited: NYWCC, 1919, 1921, 1923; AFA Traveling Exh., 1922, 1924; Joslyn Mem., 1927, 1930, 1934; Univ. Iowa, 1930-33; Iowa State Col., 1938; Des Moines A. Center, 1939, 1940, 1943, 1945; Des Moines Women's C., 1915 (prize) 1923 (prize), 1924 (gold), 1927 (gold), 1937 (prize); Iowa Fed. Women's C., 1934 (prize). Work: Fort Dodge (Iowa) AA. Position: T., East H.S., Des Moines [47]

MACY, William Starbuck [P] Santa Barbara, CA b. 1853, New Bedford, MA d. 29 Jy 1945 (age 92, although Fielding says d. 1916.) Studied: NAD; Munich

MADAN, Fred [I] Irvington-on-Hudson, NY b. 10 F 1885, Brooklyn. Studied: H. Dunn. Member: SI [47]

MADDIGAN, Isabelle Maeder (Mrs. John P.) [Por.P] Buffalo, NY/Waverly Beach, Ontario b. 7 F 1880, Buffalo. Studied: E. Kaau; F.J. Bach. Member: Buffalo SA. Exhibited: Buffalo SA, 1935 (prize) [40]

MADEIRA, Clara N. (Mrs.) [P] Phila., PA b. Phila. d. 7 F 1929. Studied: PAFA; Paris, with Simon, Cottet. Member: Phila. WCC; Phila. Alliance; Plastic C.; Wash., WCC; St. Louis WCC; Chicago WCC [27]

MADSEN, Otto [P,I] Kansas City, MO b. 30 Ap 1882, Germany. Studied: Wilimovsky; Berninghaus; Tolson; I. Summers. Member: St. Louis PBC; Kansas City SA. Work: First Italian Baptist Church, St. Louis; Calif. State Bldg., Transportation Bldg., Panama-Pacific Expo, San Fran., 1915 [29]

MADURO, Jose N. [P] Arecibo, Puerto Rico. Work: USPO, Mayaguez, Puerto Rico. WPA artist. [40]

MAENE, Edward [S] Phila., PA b. 1852 d. 4 D 1931. Studied: Paris; Belgium. Work: Memorial Chapel, Valley Forge; many churches in Phila.

MAERCKLEIN, Marion C. [P] Hartford, CT. Member: Hartford AS [25]

MAESCH, F(erdinand) [P] Yonkers, NY b. 21 Je 1865, Nuhlhausen, Germany. Studied: Paris, with Bouguereau, Ferrier; Germany. Work: Surrogate Court, Kings Co., N.Y. [40]

MAGAFAN, Ethel [Mur.P] Woodstock, N.Y. b. 10 O 1916 (or 10 Ag 1915), Chicago. Studied: Colorado Springs FA Center; F. Mechau; B. Robinson; P. Mangravite. Exhibited: CI, 1941, 1943-45; PAFA, 1939, 1941, 1942; MMA (AV), 1942; NAD, 1940, 1942, 1943; CGA, 1939; Denver A. Mus., 1938-40, 1942, 1943; Los Angeles Mus. A., 1945; SFMA, 1945; Santa Barbara Mus. A., 1944, 1945; WFNY, 1939; Kansas City AI, 1940; Colorado Springs FA Center, 1937-40, 1945. Work: Denver A. Mus.; Senate Chamber, Wash., D.C.; Recorder of Deeds Bldg., Wash., D.C.; Social Security Bldg., Wash., D.C.; USPOs, Auburn (Nebr.), Wynne (Ark.), Madill (Okla.), South Denver Branch. WPA artist. [47]

MAGAFAN, Jennie [P,Mur.P,Li] Woodstock, NY b. 10 O 1916 (or 10 Ag 1915) d. ca. 1950. Studied: Colo. Springs FA Center; F. Mechau; B. Robinson; P. Mangravite. Member: Colorado Springs FA Center. Exhibited: 48 Sts. Comp. (winner); Denver Colo., 1933 (prize); PAFA, 1942; CI, 1941; SFMA, 1941, 1944, 1946; Colorado Springs FA Center, 1938, 1940, 1941, 1945; NAD, 1943-45; MMA, 1942; NGA, 1942; Los Angeles Mus. A., 1945; Denver A. Mus., 1934, 1935, 1938-42; Inst. Mod. A., Boston, 1941; AIC, 1941, 1942; MOMA, 1942; Kansas City AI, 1940, 1942. Award: Peixotto Mem. Prize for mural, 1942. Work: Newark Mus.; Colorado Springs FA Center; White House, Wash., D.C.; Grand Rapids A. Gal.; murals, H.S., Denver; Social Security Bldg., Wash., D.C.; Beverly Hills (Calif.) Hotel; USPOs, Glenwood Springs (Colo.; in collaboration with Edward Chavez), Albion (Nebr.), Anson (Tex.), Helper (Utah). WPA muralist. [47]

MAGEE, James C. [P] Phila., PA b. 1846, Brooklyn, NY d. 15 Ja 1924. Studied: PAFA; N.Y., with Chase; Paris, with Henri. Member: S.Indp.A.; AAS; Concord AA. Exhibited: AAS, 1902 (med), 1907 (gold). Work: Johnson Coll., Phila.; Lord Richmond Coll., London [24]

MAGEE, Regina [P] Phila., PA [15]

MAGEE, Rena Tucker Kohlman (Mrs. Franklin) [P,S,T,W] NYC b. 29 N 1880, Indianapolis. Studied: ASL; J. DeCamp; C.H. Woodbury; H.S. Mowbray; G.G. Barnard. Member: NSS. Work: Columbia C.; Children's Mus., Indianapolis. Contributor: International Studio, Country Life [47]

MAGER, (Charles A.) Gus [P,Car,Dr,I,W] South Orange, NJ b. 21 O 1878, Newark, NJ. Member: Salons of America; Am.Soc. PS&G; Modern A. of N.J. Work: WMAA; A.; Hamilton Easter Field Art Fnd., N.Y.; Newark Mus. A., N.J. Contributor: Outdoor Life; Hawkshaw the Detective; United Features Syndicate [40]

MAGIE, Gertrude [P,E] NYC b. 1 O 1862, Trenton, NJ. Studied: Chase; Hawthorne; Martin; Morriset; Guerin; Bridgman; E. Leon. Member: Wash. AC; NAC; A. & Archaeology of Am.; Assn. Professionelle des

Graveurs à l'eau forte, Paris. Work: MMA; NYPL; Mus. Historic Art, Princeton [40]

MAGILL, Beatrice [P] Swathmore, PA [01]

MAGNER, Adelaide [P] Winona, MN [15]

MAGNER, Helen E. [P] New Castle, IN [25]

MAGNO, Pastor [S] Chicago, IL [17]

MAGNUSON, George, Mrs. See Janaszak, Helen.

MAGNUSSEN, Erik [C,Des,S,P,L,W] Hollywood, CA b. 14 My 1884, Copenhagen. Studied: S. Sinding. Work: The Mus. Industrial Art, Copenhagen. Contributor: American and European magazines. Specialties: jewelry; hollowware; flatware [40]

MAGNUSSON, Kristjan H. [P] Winchester, MA b. 6 Mr 1903, Isafjord, Iceland d. My 1937, Isafjord. Studied: J. Sharman. Work: Worcester A. Mus., Worcester, Mass. [33]

MAGONIGLE, Edith M. (Mrs. H. Van Buren) [P,S] NYC b. 11 My 1877, Brooklyn, NY. Member: NAWPS; Mural P. Work: Administration Bldg., Essex County Park Commission, Newark, N.J.; The Playhouse, Wilmington, Del. [40]

MAGONIGLE, H. Van Buren [Arch,P,S,W] NYC b. 17 O 1867, Bergen Heights, N.J d. 29 Ag 1935. Member: ANA; F., AIA; Arch. Lg.; Alumni Am. Acad., Rome; NSS; AFA; Soc. Beaux-Arts; N.Y. Chapter AIA; Am. APL. Exhibited: Arch. Lg., 1889 (gold); Rotch Traveling Scholarship, 1894; N.Y. Chapter AIA, 1930 (med). Work: McKinley Nat. Memorial, Canton, Ohio; National Maine Monument, NYC; Firemen's Memorial, NYC; Liberty Memorial, Kansas City, Mo.; Arsenal Technical Sch., Indianapolis; Liberty Memorial; Colossal Eagles, World War Veterans Memorial, New Britain, Conn. Author: "The Nature, Practice and History of Art," "The Renaissance" [33]

MAGRATH, Edmund [Por.P] East Orange, NJ b. 22 O 1885, Spencer, MA. Studied: Ecole des Beaux-Arts, France; RISD; Paris, with Despujols. Member: SC; Am. Ar. Prof. Lg.; A. Center of the Oranges (Pres.). Exhibited: Nat. Exh. Am. A., Rockefeller Center, N.Y., 1936; Montclair AM; Newark AM; Argent Gal., N.Y. Work: Bell Telephone Co., Newark, N.J.; Am. Surety Co., N.Y.; N.Y. Bd. Trade; S.B. Penick Co., N.Y.; City Hall, East Orange, N.J.; Lib. Clifford Scott H.S., East Orange, N.J.; Washington Gal., Chestertown, Md.; Civic Lg., Somerville, N.J. [47]

MAGRATH, William [P] New Brighton, NY b. 20 Mr 1838, Cork, Ireland (came to NYC, 1855). Member: ANA, 1873; NA, 1876; AWCS. Work: MET. Specialty: Irish genre. Had studio in NYC 1868–79; in England 1879–83; in Wash., D.C. 1883–89; returned to NYC 1889; in England 1915 [17]

MAGUIRE, Edith [P] Monterey, CA [25]

MAGUIRE, Mary M. [Por.P,Min.P] b. Connecticut? d. 1910, Baltimore, MD. Exhibited: NAD, 1849; PAFA, 1867. Active in Hartford, Conn., 1840s; in Baltimore since 1867. [*]

MAHAFFIE, Isabel Cooper (Mrs. Charles D.) [I,Car,W,Des,P] Wash., D.C. b. 22 Ag 1892, Tacoma, WA. Studied: ASL; A. Bement. Exhibited: Wash. WCC, 1939. Work: Encyclopaedia Britannica; watercolor, N.Y. Zoological Soc. [40]

MAHER, Elizabeth B. [P] Kenilworth, IL [19]

MAHIER, Edith [P,L,T] Norman, OK/Baton Rouge, LA b. 14 D 1892, Baton Rouge. Studied: E. Woodward; Newcomb Memorial Col. Sch. A.; N.Y. Sch. F&Appl. A.; G. Bridgman; W. Stevens. Member: SSAL; Newcomb Col Alumni Assn.; Assn. Okla. Artists. Exhibited: Newcomb Col. Sch. A. Gal., 1917 (med) [33]

MAHIER, Lois [S] Baton Rouge, LA. Exhibited: WFNY, 1939 [40]

MAHLER, R(ebecca) [Por.P,T] NYC b. 16 Ja 1877, NYC. Studied: N.Y. Sch. A.; W.M. Chase. Member: AAPL. Exhibited: PAFA; CGA; NAD; Audubon A.; BM; Am.-British A. Center. Work: H.S., New Rochelle, N.Y. [47]

MAHON, Josephine [P] Caldwell, NJ b. 31 O 1881, Caldwell. Studied: C.W. Hawthorne; R. Hayley Lever; N.Y. Sch. F.&Appl. A.; Pratt Inst.; Columbia. Member: AAPL; C.L Wolfe AC; NAWPS [40]

MAHONEY, James Owen [Mur.P,E] Ithaca, NY b. 16 O 1907, Dallas. Studied: Southern Methodist Univ.; Yale; Am. Acad., Rome. Member: NSMP. Exhibited: PAFA, 1942; Grand Central A. Gal., 1935; Mace Gal., Dallas, 1946; Arch. Lg., 1936, 1938. Award: Prix de Rome, 1932.

Work: Hall of State, Tex. Centenn., Dallas, 1936; Fed. Bldg., Communications Bldg., WFNY, 1939; Yale. Position: T., Cornell Univ. [47]

MAHONEY, John H. [S] Indianapolis, IN Member: Ind. Soc. S. [25]

MAHONY, Felix [P,I,L,T] Wash., D.C. b. NYC d. 27 S 1939. Studied: Paris, with Steinlen; Corcoran Sch. A., Wash., D.C.; N.Y. Sch. F&Appl. A. Member: Wash. AC; Beachcombers; Provincetown AA; S. Wash. A. Position: Dir., Nat. Sch. F.&Appl. A., Wash., D.C. [38]

MAHOOD, Annie W. R. [P] Pittsburgh, PA. Member: Pittsburgh AA [25]

MAIER-KRIEG, Eugene [S] Los Angeles, CA. Work: Statue of Modjeska, City Park, Santa Ana, Calif. [40]

MAINE, Henry C. [P] Rochester, NY. Member: Rochester AC [25]

MAININI, Trovatore [C] Quincy, MA b. 9 JY 1893, Barre, VT. Member: Boston SAC. Specialty: stained glass. Position: C.J. Connick, Inc., Boston [40]

MAIRS, Clara Gardner [E,P,T] St. Paul, MN b. 5 Ja 1879, Hastings, MN. Studied: PAFA; Grande Chaumière, Paris; Académie Julian, Paris; D. Garber; Lhote; Bourdelle. Member: Minn. AA. Exhibited: Minn. State Fair, 1931 (prize); Minn. Inst., 1931 (prize), 1936 (prize); SAE; NAD; Phila. Pr. C.; WFNY; Walker A. Center; St. Paul A. Gal.; Sweden, 1937. Work: PMA; Minn. Inst. A.; San Diego FA Soc.; Dallas Mus. FA; Fine Prints of the Year, 1932 [47]

MAISON, Mary [P] Manhattan Beach, CA b. 1886, Bethlehem, PA. Member: Calif. AC. Exhibited: Santa Barbara A. Lg. (one-man); Tuscon A. Lg., Ariz. (one-man); Phila. A. All. (one-man) [40]

MAJOR, Alfred Sarony [Engr] Freeport, NY d. 23 Jy 1929. Work: Columbian Expo stamps, U.S. Gov.; bank notes. Specialty: stamps; securities for American Bank Note Co., since 1880. Expert in engraving bank notes.

MAJOR, Charlotte Ruth [P,T,C] Milwaukee, WI b. 1 Ap 1893, Sarnia, Ontario. Member: Wis. Painters and Sculptors; Wis. Soc. Appl. A. Exhibited: Wis. Soc. Appl. A., 1930 (prize); Wis. PS, 1936 (prize). Work: State Teachers Col., Milwaukee. Specialties: weaving; metalwork; pottery. Position: T., State Teachers Col., Milwaukee. [40]

MAJOR, Ernest [P,T] Boston, MA b. 1864, Wash., D.C. Studied: ASL; Paris, with Boulanger, Lefebvre. Member: Boston AC; Boston GA. Exhibited: P.-P. Expo, San Fran., 1915 (med); PAFA, 1917 (prize). Position: T., Mass. Sch. A., Boston [33]

MAJORS, Robert J. [P,Des,E,Li] Ontario, CA b. 23 My 1913, Ottumwa, IA. Studied: L. Murphy; M. Sheets; P. Dike; S. Macdonald-Wright; H.M. Luquiens. Exhibited: Honolulu Acad. A., 1936 (prize). Work: Coll. Honolulu A. Soc.; Honolulu Printmakers. Position: Des., Walt Disney Studios, Hollywood [40]

MAKIELSKI, Bronislaw Alexander [P,L,T] Charlottesville, VA b. 13 Ag 1901, South Bend, IN. Studied: AIC; L.A. Makielski. Member: Scarab C. Exhibited: Hoosier Salon; Detroit Inst. A., 1926–45. Work: Church of the Holy Comforter, Charlottesville, Va.; Lincoln Sch., Ypsilanti, Mich.; Royal Oak H.S., Mich.; Mich State Col.; McDonald Sch., Dearborn, Mich.; Univ. Mich., Ann Arbor [47]

MAKIELSKI, Leon A. [Por.P,T] Detroit, MI b. 17 My 1885, Morris Run, PA. Studied: AIC; Académie Julian, Grande Chaumière, both in Paris; L. Simon; R. Menard; H. Martin. Member: Scarab C., Detroit. Exhibited: Detroit IA, 1917 (prize), 1919 (prize), 1921 (prize), 1923 (prize), 1925 (prize); Mich. State Fair, 1925 (prize); Scarab C., 1929 (prize); AIC, 1908 (prize); U.S.; abroad. Work: Univ. Mich.; McDonald Sch., Dearborn, Mich.; Lincoln Sch., Ypsilanti, Mich.; Fordson H.S., Dearborn; Angel Sch., Ann Arbor, Mich. Position: T., Community Center, Detroit [47]

MAKIELSKI, Stanislaw John [P,Arch,T] Charlottesville, VA b. 6 O 1893, South Bend, IN. Studied: Univ. Notre Dame; Univ. Va.; F. Kimball. Member: Am. Inst. Arch. Position: T., Univ. Va. [40]

MAKINO, K. [P] NYC [10]

MALCOLM, O. C. [I] NYC. Position: Affiliated with New York Tribune [01]

MALCOLM, Thalia Wescott (Mrs. Donald) [P] NYC/Domaine de Malbosquet, Vence A.M., France b. 10 S 1888, NYC. Studied: R. Davey; A. André. Member: MMA; NYWCC; S.Indp.A.; Alliance; French Inst. in U.S.; Am. Assn. Mus.; AAPL. Exhibited: Durand Ruel, N.Y.; Wildenstein's, London. Work: Luxembourg Jeu de Paume, Paris; Musée Orn, Gard, France [40]

MALDARELLI, Lawrence [S] NYC. Member: NSS [27]

MALDARELLI, Oronzio [S] NYC/Townshend, VT b. 1892, Naples, Italy d.

1963. Studied: NAD; Cooper Union; Beaux Arts Inst. of Des. Member: Sculptors Gld.; Am. Ar. Cong. Exhibited: Fairmount Park AA, Phila., 1933. Work: Chittenden Memorial, Binghamton; St. George's Chapel, Moheqau, N.Y.; Municipal Bldg., Plainfield, N.J.; City Art Mus., St. Louis, Mo.; Federal Post Office Bldg., Wash., D.C.; USPO, Orange, Mass., Sect. FA, Fed. Works Agency. Designer: Chas. Peck Warren, Egleston medals. Position: T., Columbia [40]

MALDURA, Cesare C. [Arch,Des] NYC b. 1853 Rome d. Jy 1907. Known for his discoveries of the statues of gladiators of Nero's time, which he found in Italian ruins. Position: with the firm of McKim, Mead&White

MALICOAT, Philip Cecil [P] Provincetown, MA b. 9 D 1908, Indianapolis. Studied: John Herron A. Sch.; Hawthorne; Hensche; Dickinson. Member: Provincetown AA. Exhibited: PAFA, 1933; CGA, 1935, 1937, 1939; NAD, 1936, 1938–40; AIC, 1941; Phila. WCC, 1931, 1935; Inst. Mod. A., Boston, 1939; Provincetown AA, 1931–45 [47]

MALINSKI, John [P] Saginaw, MI. Member: Chicago NJSA [25]

MALLARD, Louise [I,Caric] Biloxi, MS b. 22 Mr 1900, New Orleans. Studied: H.A. Nolan; J.C. Parker. Exhibited: Miss. State Fair, Jackson [40]

MALLET, Roma [S,C,T] Hawthorne, CA b. 21 My 1905, Bingham, UT. Studied: A. Archipenko; R. Schaeffer; Chouinard A. Inst. Member: Am. A. Cong. Exhibited: Calif. PS, Los Angeles Mus., 1936 (prize). Co-producer: Karl-Roma Ceramics, Hawthorne, Calif. Positions: T., Westlake Sch. for Girls; Holmby Col., West Los Angeles, 1936–38 [40]

MALLISON, Euphame C(lason) [P,C,T] University, VA b. 30 Ap 1895, Baltimore. Studied: G. De Preydour. Member: SSAL; Baltimore WCC. Work: Pa. State Col. [33]

MALLON, Fred [P] Phila., PA [06]

MALLON, Grace Elizabeth [P,I] North Hollywood, CA b. 1 N 1911, Elizabeth, NJ. Studied: Newark Sch. F.&Indst. A.; Otis AI; Chouinard AI; R. Holmes; M.Sheets; P. Paradise. Member: Calif. WCC; Calif. AC; Laguna Beach AA; San Diego AA; San Fernando Valley AC. Exhibited: Los Angeles Pub. Lib., 1939 (prize); San Fernando Valley AC, 1945 (prize); Southern Calif. AC, 1946 (prize); Riverside Mus., 1944; GGE, 1939; de Young Mem. Mus., 1937; Santa Paula, Calif, 1935–45; Calif. WCC, 1941–45; Calif. AC, 1939, 1940, 1941 (prize), 1942–46; Laguna Beach AA, 1939–46. Work: Calif. State Lib. Illustrator: "First Foods of America," 1936, "Near Side and Far," 1937, others. Position: Art Dept., Universal Studios, 1941– [47]

MALLONEE, Miss Jo [P,C] Stratton, ME b. 4 S, 1892, Stockton, NY. Studied: G. Bridgman. Member: ASL [25]

MALLY, George W. [E] Chicago, IL [19]

MALM, Gustav N. [P,I,C,W] Lindsborg, KS b. 20 Ja 1869, Svarttorp, Sweden. Studied: Sweden. Member: Smoky Hill Art Cl. Author/Illustrator: "Charlie Johnson" [29]

MALM, Leo [Woodcarver,T] Concord, NH b. 4 My 1878, Orebro, Sweden. Studied: A. Van Stry; L. Lang; J. Kirchmayer. Member: Manchester Inst. A.&Sc.; Manchester A.&Crafts; Concord AC; N.H. Lg. A.&Crafts. Work: Mass. State House. WPA artist. Position: T., Manchester Inst. A.&Sciences [40]

MALMAR, Ruth May [Mur.P] Montclair, NJ/New Marlboro, MA b. 28 My 1891. Studied: E. Bisttram; P. Gill; R. Randall; C. Lemonnier; A. Strauss; Fonatinbleau; S. Rembski; Grand Central Sch. A. Member: AAPL; Art Center of the Oranges [40]

MALMQUIST, Olof Carl [S] San Fran., CA. Member: NSS [47]

MALONE, Blondelle [P] Wash., D.C. Member: NAWPS; AFA [29]

MALONE, Laetitia Neff Herr (Mrs. John E.) [P,I] Lancaster, PA b. 30 My 1881, Lancaster. Studied: PAFA, with Chase, Mora, Beaux, Anshutz, McCarter. Member: Phila. Alliance [25]

MALONE, May. See Kelley, William F., Mrs.

MALONE, Robert James [E,Caric] St. James, NY b. 14 Mr 1892, Birmingham, AL. Contributor: New York Times, Cosmopolitan, International Book Review, Review of Reviews, The London Graphic, King Features Syndicate [40]

MALONE, Rosamund [P] NYC [15]

MALONEY, Louise B. [P] Cleveland Heights, OH [25]

MALVERN, Corinne [I] NYC b. Newark, NJ d. O 1956, Norwalk, CT. Studied: ASL; T.N. Lukits. Member: SI. Exhibited: NYPL, 1941 (prize), 1944 (prize). Award: Jr. Literary Gld. Selection, 1944–46. Illustrator: "Valiant Minstrel," "First Woman Doctor," other books [47]

MALY, Václav [P] NYC [10]

MAMIGONIAN, Vahan [P] NYC b. 4 Ag 1902, Jaffa, Palestine. Studied: NAD. Member: AWCS [40]

MAN, Gertrude [P] Minneapolis, MN [17]

MANAR, Maurine [S] Kansas City, MO. Exhibited: Midwest A. Exh., Kansas City AI, 1937 (prize) [40]

MANATT, William Whitney [S] Berkeley, CA b. 2 Mr 1875, Granville, OH. Studied: ASL, with Saint Gaudens [17]

MANBERT, Barton [P,E] Glendale, CA/Balboa Island, CA b. Jamestown, NY. Studied: Bridgman; L. Hitchcock; Reynolds. Member: Calif. AC; Glendale AA. Exhibited: San Diego Expo, 1915 (med) [33]

MANCA, Albino [S,C,T] NYC b. 1 Ja 1898, Tertenia, Sardinia, Italy. Studied: Acad. FA, Rome, with Ferrari, Zannelli. Member: AAPL; All.A.Am.. Exhibited: Acad. FA, Rome, 1926 (prize); Roman Exh., 1928 (prize); WFNY, 1939; Rome, Italy, 1937 (prize); Montclair A. Mus., 1941 (prize); AAPL, 1941 (prize); All.A.Am., 1943 (prize); Newark Mus., 1941; MMA, 1942; Italian Salon, Rockefeller Center, N.Y., 1940 (one-man). Work: Mod. A. Gal., Littoria, Italy; Rocca delle Comminate, Italy; mon., Cagliari, Sardinia; USPO, Lyons, Ga. [47]

MANCHESTER, Arthur Williams, Mrs. See Waite, Emily.

MANDEL, Howard [P,Mur.P,S,I] Bayside, NY b. 24 F 1917, Bayside. Studied: PIASch. Member: Clay Cl.; Woodstock AA; F., Tiffany Fnd., 1939. Exhibited: AWCS, 1937–40; NYWCC, 1937–40; Toledo Mus. A., 1941; Utah State Inst. FA, 1941; Clay Cl., 1940–46; PMA, 1940–42; Woodstock AA, 1946; Vendôme Gal., 1942. Work: Lexington, Ky.; Marine Hospital, Ft. Stanton, N.Mex.; mural, Arthur Studios, N.Y. Illustrator: national magazines [47]

MANDELMAN, Beatrice [Li,Ser,P,T] Taos, NM (1976) b. 31 D 1912, Newark, NJ. Studied: ASL; Newark Sch. F.&Indst. A.; G. Picken. Member: Nat. Serigraph Soc. Exhibited: AIC; PAFA; Phila. A. All.; WMAA; CGA; CI; BMFA; MOMA; MMA; BMA; SFMA; SAM; Mus. N.Mex., Santa Fe (one-man); ACA Gal. (one-man); Hudson Walker Gal. Positions: Graphic Dir., WPA, NYC; T., Taos Valley A. Sch. 1959 [47]

MANDEVILLE, Cornelius R. [P,T] Chicago, IL b. 8 Ap 1881, Philo IL. Studied: Ecole des Beaux-Arts, Bonnât, both in Paris. Member: Palette and Chisel Cl. Position: T., Chicago Acad. FA [10]

MANDL, A(dolph) [P] NYC b. 13 Jy 1894, Munich. Studied: PAFA; D. Garber; L. Ireland [25]

MANGELSDORF, Hans [S,P,Mur.P,C] New Orleans, LA b. 22 N 1903, Leipzig, Germany. Studied: M. Klinger; F. Klee; K. Rupflin; J. Hofmann; Germany; Vienna. Member: A. Assn New Orleans; SSAL; Am. Ar. Cong. Exhibited: WFNY, 1939; Delgado Mus., 1939 (one-man). Work: murals, Rabouin Trade Sch., New Orleans; USPO, Opp, Ala. WPA artist. [40]

MANGRAVITE, Joseph G. [P] NYC. Member S.Indp.A. [24]

MANGRAVITE, Peppino [Li,Mur.P,P,W,L,T,Dr] NYC/Westport, NY b. 28 June 1896, Lipari, Italy. Studied: CUASch; ASL; Italy. Member: Am. Soc. PS&G; Salons of Am.; F., Guggenheim Fnd., 1932, 1935. Exhibited: Sesqui-Centenn. Expo, Phila., 1926 (gold); AIC, 1942 (med,prize); GGE, 1939 (prizes); Woodmere A. Gal., 1943 (prize); PAFA, 1946 (med); CGA, annually; AIC; WMAA; Toledo Mus. A.; CM; CI; Nebr. AA. Work: CGA; PMG; WMAA; AIC; PAFA; Denver A. Mus.; Pal. Leg. Honor; CM; Encyclopaedia Britannica Coll.; Governor's Mansion, Virgin Islands; murals, USPOs, Hempstead (N.Y.), Atlantic City (N.J.), Jackson Heights, (N.Y.); Toledo Mus. A. Contributor: articles, The Arts, Progressive Education; American Magazine of Art, other magazines. WPA artist. Positions: T., ASL (1940–41), AIC (1940–42), CUASch, Columbia (1945–) [47]

MANGTRY, Mary [P] NYC d. 27 N 1936, New York. Studied: PIASch, 1902. Exhibited: PAFA; various watercolor societies of New York. Position: T., PIASch, to 1912

MANIEVICH, Abraham [P] Bronx, NY b. 25 N 1883, Russia (came to U.S. in 1921) d. 30 Je 1942. Studied: Government Art Sch., Kiev; Art Acad., Munich. Exhibited: FA Gal., Montreal, 1937; Everhart Mus., Scranton, Pa., 1937; Mellon Gal., Toronto, 1938. Work: Luxembourg Mus., Paris; Horvatt Gal., Geneva; Imperial Acad. Art, Petrograd; Folk Mus., Tre-

tiakov Gal., both in Moscow; Government Mus., Tereschenko Mus., both in Kiev; Mus. Odessa; Kuindzi Mus., Leningrad; A. Gal., Toronto; BM [40]

MANIGAULT, E(dward) Middleton [P] NYC/Colebrook, NH b. 14 Je 1887, London Ontario d. 4 S 1922, San Fran. Studied: K.H. Miller. During WWI he served with the expeditionary force of Canada as an ambulance driver. [21]

MANIKOWSKI, Boles. See von Manikowski.

MANKOWSKI, Bruno [S,P,C] Whippany, NJ b. 30 O 1902, Berlin, Germany. Studied: BAID; Municipal A. Sch., Berlin. Member: NSS; Arch. S.&Carvers; Studio Gld. Exhibited: N.J. State Exh., 1945 (prize); Studio Gld.; NAD, 1940–42; MMA, 1942; NSS, 1939–42, 1946; Montclair A. Mus., 1940–42, 1945; CGA, 1935, 1939; Philbrook A. Center, 1945; VMFA; WFNY, 1939. Award: N.Y. Bldg. Congress, 1937, Cert. of Craftsmanship. Work: USPO, Chesterfield, S.C.; Dept. Agriculture, Post Office Dept., both in Wash., D.C. WPA artist. [47]

MANLEY, Thomas R. [P,E,Li] Upper Montclair, NJ b. 29 N 1853, Buffalo, NY d. 13 My 1938. Member: AWCS; NAC; NYWCC. Exhibited: etchings, St. Louis Expo, 1904 (med). Work: Montclair AA; Yale Cl., NYC [47]

MANN, Edith Marian [P] Phila., PA. Studied: PAFA, ca. 1916 [25]

MANN, Edwin C. [P] Columbus, OH. Member: Columbus PPC [25]

MANN, Emily P. [P] Boston, MA [01]

MANN, Forest Emerson [P,C] Grand Rapids, MI b. 6 Mr 1879, Portland, ME. Studied: Pratt Inst., Brooklyn, N.Y. Member: NSC. Position: Dir., Forest Craft Gld. [13]

MANN, Harrington [Por.P] London, England b. 1865, Glasgow, Scotland d. 28 F 1937, NYC. Studied: London; Paris; Rome. Work: BM; museums in England and Europe. He spent much of his time in the U.S., and for many years he had a studio in New York. Specialty: portraits of children. He painted several members of the royal family.

MANN, Helen [P] Chicago, IL b. Amboy, IL. Member: Chicago SA; Chicago NJSA [40]

MANN, Helen. See Van Cleve.

MANN, Jack [P] NYC [25]

MANN, Joseph Merrill [P] Boston, MA. Studied: J.F. Waldo [06]

MANN, Parker [P] Princeton, NJ/Arkville, NY b. 6 Jy 1852, Rochester, NY d. 15 D 1918. Studied: Ecole des Beaux-Arts, Paris, with Cabanel. Member: SC, 1898; Soc. Wash. A.; Wash. WCC [17]

MANN, Russell O. [P,C,T] Boulder, CO b. 4 O 1910, Boulder. Studied: Univ. Colo. Member: Boulder Ar. Gld. Exhibited: Midwest Ar. Ann., Kansas City AI; Chappell House, Denver; Boulder A. Gal. [40]

MANN, Virginia [P] Nampa, ID. Member: Cincinnati Women's AC [17]

MANNEN, Paul William [P,L,T] Chickasha, OK b. 22 Je 1906, Topeka, KS. Studied: Univ. Kans.; Ohio State Univ.; A. Bloch; R.J. Eastwood; K. Mattern. Member: MacD. Cl. Exhibited: Kansas City AI, 1931–34, 1935, 1936, 1937 (prize), 1939, 1940, 1941, 1942; Joslyn Mem., 1934; Columbus Gal. FA, 1938. Work: Student Union, Univ. Kans.; Kans. coll. Fed. Art Proj.; Thayer A. Mus.; Carnegie Pub. Lib.; Pub. Sch., both in Lawrence, Kans. Lectures: Mexican A.&Crafts. Position: T., Okla. Col. for Women, Chickasha [47]

MANNHEIM, Jean [P] Pasadena, CA b. 18 N 1863, Kreuznach, Germany. Studied: Ecole Delecluse; Colarossi; London Sch. Art. Member: Pasadena AC. Exhibited: Seattle Expo, 1909 (gold); San Diego Expo, 1915, (gold,med). Work: Denver Mus. [40]

MANNING, H. Rosalie [P] New Dorp, Staten Island, NY [25]

MANNING, Reg(inald West) [Car,W,Des] Phoenix, AZ b. 8 Ap 1905, Kansas City, MO. Member: Ariz. Press Cl.; The Cartoonists Soc., N.Y. Work: Huntington Lib., San Marino, Calif.; San Fran. Press Club. Author/Illustrator: "Cartoon Guide of Arizona" (1938), "What Kinda Cactus Izzat?" (1941), "California" (pub. J.J. Augustin, 1938, 1939). Positions: Car., Arizona Republic (1926–); Ed. Car., Republic & Gazette Syndicate, Phoenix (1934–) [47]

MANNING, Virginia [S] Chicago, IL b. 4 N 1907, NYC. Member: NAWPS [40]

MANNING, Wray [P] Port Washington, NY [15]

MANOIR, Irving K. [P,C,Des,Mur.P,E,W,L] Corona del Mar, CA b. 28 Ap 1891, Chicago. Studied: AIC; PAFA; H. Hofmann. Member: Laguna Beach AA. Exhibited: J.B. Speed Mem. Mus., 1931 (prize); Laguna Beach AA, 1925 (prize). Exhibited: Century of Progress, Chicago, 1933, 1934; CGA; PAFA; AIC; CI; Minneapolis State Fair; Milwaukee AI (oneman); Pasadena AI (one-man). Work: Milwaukee AI; AIC; mural, Vincennes (Ind.) H.S. [47]

MANON, Estelle Ream (Mrs. Armstrong) [P] Nutley, NJ b. 11 My 1884, Lincoln, IL. Studied: W.M. Chase; Hawthorne; H.B. Snell. Member: St. Joseph A. Lg.; NAWPS [27]

MANOR, Florence [S] San Fran., CA b. 29 O 1881, Santa Cruz, CA. Exhibited: Alaska-Yukon-Pacific Expo, 1909 (gold) [15]

MANOR, Irving (K.) [P,S,E,Li,B,L,T,W] Corona Del Mar, CA b. 28 Ap 1891, Chicago. Studied: H.M. Wollcot; AIC; Chicago Acad. FA; H. Hofmann. Member: Laguna Beach AA. Exhibited: Speed Mem. Mus., Louisville, Ky. (prize). Work: Speed Mem. Mus.; Milwaukee AI; Brooks Mem. Art Mus., Memphis; AIC. Position: Dir., Manor Studios, Corona Del Mar [40]

MANSFIELD, Blanche McManus (Mrs. Francis Miltoun) [I,P,W] Paris, France b. 2 F 1870, East Feliciana, LA. Studied: Paris. Author: "The American Woman Abroad," "Our French Cousins." Illustrator: books, periodicals [31]

MANSFIELD, James Carroll [I,Car,P,W,Hist] NYC b. 4 Ja 1896, Baltimore. Studied: Md. Inst.; N.Y. Sch. F.&Appl. A.; ASL; Bridgman; DuMond; Henri. Member: Gld. Freelance A.; Authors Lg. Am. Exhibited: Md. Hist. Soc., 1944 (one-man). Work: Enoch Pratt Lib., Baltimore; BMA; Md. Hist. Soc.; N.Y. Hist. Soc. Author/Illustrator: "Highlights of History," 1925, newspaper educational feature, syndicated U.S./abroad [47]

MANSFIELD, Louise B(uckingham) [P,I] Brooklyn, NY b. Le Roy, NY. Studied: ASL; Hawthorne. Member: Brooklyn SA; ASL. Illustrator: House and Garden [40]

MANSFIELD, Richard Harvey (Dick) [Car,L,T] Cheverly, MD b. 5 F 1888, Wash., D.C. Studied: Corcoran A. Sch.; Evans Sch. Cartooning, Cleveland. Exhibited: Chicago Tribune Nat. Comp. for Cartoonists (prize). Lectures: Chalk talks. Creator: "Those Were the Happy Days" (Sunday Star, 1926–), "Who Remembers" (Washington Star). Position: Car., Wash., D.C. Evening Star [47]

MANSHIP, Paul [S,L,T,W,] NYC b. 25 D 1885, St. Paul, MN d. 31 Ja 1966. Studied: St. Paul Sch. FA; PAFA, with Grafly, 1906; Am. Acad., Rome, 1909–12. Member: ANA, 1914; NA, 1916; NSS, 1912–42 (pres., 1939–42); AIAL, 1918; Century Assoc.; F., Am. Acad. A.&Sciences; Nat. A. Cl.; Cornish (N.H.) Colony; Inst. France, 1946; Argentine Acad. FA, 1943. Exhibited: NAD, 1913 (prize), 1917 (prize); Paris Salon, 1937 (prize); NSS, 1943 (prize); PAFA, 1914 (gold); P.-P. Expo, San Fran., 1915 (gold); AIA, 1921 (gold); Am. Numismatic Soc., 1924 (med); Phila. AA, 1925 (gold); Sesqui-Centennial Expo, Phila., 1926 (gold); 54 bronze statues, CGA, 1937; Smithsonian, 1958 (retrospective). Award: Chevalier, Legion d'Honneur, 1929. Work: MMA; fountain, Fairmount Park, Phila.; Detroit Inst. A.; City Art Mus., St. Louis; Pratt Inst., Brooklyn; Minneapolis Inst. A.; CMA; TMA; Luxembourg, Paris; CGA; fountain group, Cochran Mem. Park. St. Paul, Minn.; Ft. Wayne, Ind.; Am. Acad., Rome; war mem., Am. Cemetery, Thiaucourt, France; mausoleum, Père Lachaise Cemetery, Paris; Brookgreen Gardens, S.C.; mem. gateway, Zoological Park, N.Y.; fountain/sphere, Phillips Acad., Andover, Mass; Woodrow Wilson Mem., League of Nations, Geneva; Norton A.; Univ. Fla.; war mem., Detroit Athletic Cl.; portrait busts, U.S. Senate, John Herron AI, AIC, De Pauw Univ.; USPO Dept. Bldg., Wash., D.C. Widely known for "Prometheus Fountain," Rockefeller Center, NYC (1933). Contributor: Encyclopaedia Britannica, "The History of Sculpture," "Decorative Sculpture." WPA artist. [47]

MANSON, Harold [P] Calverton, NY. Member: S.Indp.A. [21]

MANTELL, Ann [P] NYC [25]

MANUEL, Boccini [P,S,Dr] Paris, France/Rye, NY b. 10 S 1890, Pieve di Teco, Italy. Studied: A. Favory; A. Derain. Member: ASL; S.Indp.A.; Salons of Am.; Salon d'art Français Indp., Paris; Chicago NJSA [40]

MANUEL, Dorothy Holt. See Holt.

MANUEL, Margaret [E,T] Lake Grove, NY b. Hawick, Scotland. Studied: E. Haskell; N.Y. Sch. Appl. Des. for Women. Member: SAE; PBC; AAPL; NAWPS; AFA. Work: AIC; Nat. Mus., Wash., D.C.; Corona Mundi, Intl. Art Center, NYC; Vanderbilt permanent coll., Beverly Hills, Chicago; Bibliothèque Nationale, Paris; Univ. Nebr., Lincoln [40]

MANUILOV, Giorgi [P,Mur.P] Newark, NJ b. 14 O 1897, Rostov-on-Don.

Studied: Popov A. Sch.; Moscow A. Acad., both in Russia. Exhibited: Nat. Acad., 1938; CGA, 1939; WFNY, 1939. WPA artist. [40]

MANY, Alexis B. [P,T] Wash., D.C. b. 10 Ag 1879, Indianapolis d. 27 D 1937. Member: Soc. Wash. A. Exhibited: Soc. Wash. A., 1921 (med,prize); Calif. AC, 1921 (prize) [38]

MANYARD, Adolph Best [P] NYC. Member: GFLA [21]

MANZI, Angelo [P] Phila., PA [06]

MA-PE-WI See Herrera.

MAPEL, Ida Bigler [P] Paris, France [10]

MAPLES, Anna B.C. [P] Port Chester, NY [04]

MAPLESDEN, Gwendoline E. See Bond.

MAQUARRE, D. [P] Brooklyn, NY. Member: S.Indp.A. [21]

MARAFFI, Luigi [S,C] Phila., PA b. 4 D 1891, Aversa, Italy. Studied: PAFA; Grafly. Member: Graphic Sketch C., Phila. Exhibited: PAFA (prizes). Work: Drexel Bank, Phila. [33]

MARAGLIOTTI, Vincent [P] NYC [13]

MARANS, Moissaye (Mr.) [S,T] Brooklyn, NY b. 11 O 1902, Kisinau, Russia d. 1977. Studied: CUASch; NAD; PAFA; Cincinnati Acad. FA; BAID. Member: NSS. Exhibited: CUASch (prize); NAD (prize); BAID (prize); PAFA, (prizes) 1941, 1942, 1946; All.A.Am., 1935, 1937; Los Angeles Mus. A., 1938; CGA, 1939; WFNY, 1939; FMAA, 1940; PMA, 1940; NSS, 1937–46; BM, 1942–44; NAC, 1945; Dance Intl., Rockefeller Center, 1937. Work: Brooklyn Botanical Gardens; CCNY; USPO, Boyertown, Pa.; Chagrin Falls, Ohio; Court of Peace, WFNY. WPA artist. [47]

MARATTA, Hardesty Gillmore (Mr.) [P,I,T] Chicago, IL b. 22 Ag 1864, Chicago d. O 1924. Studied: AIC; European gals. Exhibited: Nashville, Expo, 1897. Specialty: water colors [10]

MARBLE, John Nelson [P] NYC b. 11 Ap 1855, Woodstock, VT d. 1 Ap 1918, Woodstock. Studied: Académie Julian; Italy. Member: SC 1877. Work: Groton Sch., Groton, Mass.; Univ. Cl., NYC; N.H. Historical S., Concord, N.H. [17]

MARCH, Carl [P] Chicago, IL [15]

MARCH, Emma [P,T,C] Chicago, IL b. Jacksonville, IL. Studied: AIC; A.W. Dow, NYC [08]

MARCHAND, John Norval [P,I,S] NYC b. 1875, Leavenworth, KS d. 1921, Westport, CT. Member: SI. Studied: Harwood A. Sch., St. Paul, Minn.; Munich Acad., 1897–99. A friend of C.M. Russell he was staff artist for N.Y. World, beginning 1895; later illus. 35 books such as "Girl of the Golden West" and "Arizona: A Romance of The Great Southwest," despite his brief career. [10]

MARCHAND, Paul [Mar.P] Mt. Vernon, WA b. 31 Ag 1870, Bar Harbor, ME. Studied: W.M. Hunt; C. Bennett [29]

MARCHBANKS, Hal [P] NYC [24]

MARCIUS-SIMONS, Pinckney [P] b. 1867, NYC d. 17 Jy 1909, Bayreuth, Bavaria. He began painting at twelve years of age. Chiefly self-taught, haunting the studios of artists and studying architecture, perspective, and anatomy. First known for his genre pictures; his success was attained in his ideal works, culminating in the poetic rendering of the "Nibelungen Ring," a series of elaborate pictures, wherein he tried to orchestrate his pictures as a musician scores.

MARCOUX, George E. [Cart] Naugatuck, CT b. 1896, Waterbury, CT d. 14 Ap 1946. Contributor: cartoons, Waterbury Sunday American

MARCUS, Edwin [Cart] NYC. Work: Huntington, Lib., San Marino, Calif. Position: Staff, New York Times [40]

MARCUS, Elli [Por.Photogr] NYC b. 1899, Germany (moved to Paris, 1933, to NYC, 1941) d. 1977. Famous 1920s–30s portrait and fashion photographer in Berlin; continued portraits of famous personalities in NYC, 1941–56. Later became a graphologist. Work: Nat. Port. Gal.; Princeton; Illus. in U.S. Camera, 1940's–50s [*]

MARCUS, Nathan [I,Car,P] Chicago, IL b. 7 Ja 1914, Chicago. Studied: T. Geller; R. Katz. Member: United Am. A., Chicago. Work: Ill. WPA artist. [40]

MARCUS, Peter [P,E,W] NYC/Stonington, CT b. 23 D 1889, NYC d. 8 Je 1934. Studied: Ecole des Beaux-Arts, Ecole des Beaux-Arts Decoratifs, Paris; C.H. Davis; H.W. Ranger. Member: Arch. Lg.; CAFA; Lotos C.; SC; New Haven PCC; SAE; AAPL; NAWPS. Exhibited: CAFA, 1918 (prize). Author/Illustrator: "New York, the Nation's Metropolis" [33]

MARCUS, Zola (Carl) [P,T] Huntington, NY b. 13 Je 1915, Brooklyn, NY. Studied: Cornell; NAD; ASL; Cummington (Mass.) Sch. A.; E. Fiene; R. Williams. Exhibited: Dayton AI, 1942 (med); Acad. All. A., 1939; Contemporary A. Gal., 1940; S.Indp.A., 1940, 1942; Adelphi Col., 1941; Nassau Lg. A., 1939; Number 10 Gal., 1941, 1942 (one-man); Ohio WCS, 1942, 1943; Cummington, Mass., 1941. Work: Cummington Sch. A.; Ft. Dix, N.J. Illustrator: "White Christmas Yarn," 1942, "From This Hill," 1941 [47]

MARGE. See Buell, Marjorie.

MARGESON, Gilbert Tucker [Mar.P] Rockport, MA b. Nova Scotia. Dean of the Rockport colony, he opened its first studio in 1873. [01]

MARGO, Boris [P,E,T,L] NYC b. 7 N 1902, Wolotschisk, Russia. Studied: Leningrad; Moscow; Odessa. Exhibited: CM, 1939; MMA, 1942; SFMA Traveling Exh., 1944; Critics Choice, Cincinnati, 1945; WMAA, 1946; NAD, 1946; LOC, 1944, 1946; Armory Show, NYC, 1945; Roerich Mus., 1932 (one-man); Am. Univ., Wash., D.C., 1946; Norlyst Gal., 1942; Brandt Gal., 1946. Work: MMA; BM; AGAA; MOMA; Mus. Mod. A., Odessa, Russia [47]

MARGO, Jeannette. See Gelb, Jan.

MARGOLIES, S.L. [E,P,T,W,L] Brooklyn, NY b. 10 Mr 1897, NYC. Studied: CUASch; NAD; V. Perard. Member: SAE; Am. PM, Am. Veterans SA; New Group Am. A. Cong. Exhibited: WFNY, 1939; Mineola N.Y. State Fair, 1935 (prize); Queensboro S. Allied Arts and Crafts, 1936, (prizes), 1937 (prize). Work: SAE, NYC; LOC; various embassies, fed. bldgs., Wash., D.C. [40]

MARGOLIS, David [P,S] NYC (1977) b. 3 S 1911, Voloshisk, USSR. Studied: Ecole des Beaux-Arts, Montreal, 1929; NAD, 1931; ASL, 1934. Exhibited: Brooklyn Col., 1969; NYU, 1972. Work: WWII posters; WPA murals, Tilden H. Sch., Brooklyn. [*]

MARGOLIS, Nathan [E,Li,P,Des,T] Phila., PA b. 26 Ja 1908, Phila. Studied: Univ. Pa.; Harvard; Tyler Sch. FA, Temple Univ.; Barnes Fnd. Member: Nat. Edu. Assn.; CAFA; Da Vinci All. Exhibited: AIC, 1935; LOC, 1942, 1945; Cleveland PM, 1937; CAFA, 1945, 1946; PAFA, 1936, 1937; Woodmere A. Gal.; A. All., Pr. C., Sketch C., AC, all of Phila. Work: Graphic Sketch C. Positions: T., Graphic Sketch C.; Phila. Sr. H.S. [47]

MARGON, Lester [Des,W] NYC b. 26 Ja 1892, NYC. Studied: NYU; CUASch; New Sch. Social Research; PIASch; Columbia; BAID; Mechanics Inst. Member: S. Des.-Craftsmen; S. Furniture Des. Exhibited: BAID, 1924 (med), 1925 (med); Mechanics Inst., NYC, 1920 (prize). Author/Illustrator: series of drawings & commentary, "Little-Known Furniture Treasures of the Old and the New Worlds," "Furniture of Scandinavia." Specialty: furniture [47]

MARGOULIES, Berta (Mrs. B.M. O'Hare) [S,T] NYC b. 7 S 1907, Lowitz, Poland. Studied: Hunter Col.; ASL; Paris, at Académie Julian, Ecole des Beaux-Arts. Member: NAWA; An Am. Group; S. Gld; F., Garnder Fnd., 1929; F., Guggenheim, 1946. Exhibited: Arch. Lg., 1936; AAAL, 1944; WMAA; CGA; N.J. State Mus.; PAFA; CI; Springfield MFA; ACA Gal.; "Women Artists of Am., 1907–64," Newark Mus., 1965; WFNY, 1939. Work: WMAA; busts, CCNY; Wash., D.C.; Monticello, Ark.; USPO, Canton, N.Y. WPA sculptor. (Living in Flanders, N.J., 1977) [47]

MARGULES, De Hirsh [P,W] NYC b. 7 Ag 1899, Jasse, Romania d. 3 F 1965. Studied: M. Lechay. Member: Am. Ar. Cong. Work: Biro-Bidjan Mus., Russia; MOMA; BMFA; BM; Univ. Ariz.; U.S. State Dept.; Bezalel Sch. Coll., Palestine. Author: "Figure in Pompeii," essay on Gertrude Stein, Panorama mag., 1933 [47]

MARGULIES, James [P] NYC [17]

MARGULIES, Joseph [P,E,Li,T,L] NYC b. 7 Jy 1896, Vienna, Austria. Studied: NAD; ASL; J. Pennell; Ecole des Beaux-Arts, Paris; M. Waltner, in Vienna. Member: AWCS; SAE; Chicago SE; North Shore AA; Louis Comfort Tiffany G.; Gloucester AA; F., Tiffany, 1920. Exhibited: Smithsonian; Pan-Am. Bldg., Wash., D.C.; Stendahl Gal., Los Angeles; Midtown, Milch, Grand Central, Ferargil, Ainsley, Assn. Am. A. Gal., all in NYC)all one-man); NAD, (prize) Work: MMA; BM; SFMA; BMA; N.Y. State Capitol; N.Y. Theological Seminary; Queens Col.; Brooklyn Jewish Hosp.; Yale Univ. Lib.; LOC; NYPL; Fed. Court, Brooklyn, N.Y.; Willkie Mem. Bdg., N.Y.; CCNY; Clinton H.S.; Unity C., Brooklyn; Ethical Culture Sch., NYC; Brooklyn Ethical Culture S.; Iowa State Col.; Smithsonian. Illustrator: "Art of Aquatint," "Understanding Prints." Position: T., CCNY [47]

MARGULIES, Pauline [S] NYC b. 1 S 1895, NYC. Studied: A. Eberle; G.W. Brewster; Fraser [21]

MARI, Valerie de [Et] Paris, France b. 1886, NYC [15]

MARIANETTI, Louise E. [P] Providence, RI b. 16 Mr 1916, Providence. Studied: RISD; ASL; R. Brackman; W.C. Palmer. Member: AWCS; Audubon A.; South County AA; Contemporary A., R.I. Exhibited: NAD; AWCS; Ferargil Gal.; Newhouse Gal.; CM; R.I. Mus. A.; Newport AA; Contemporary A., R.I.; Providence AC; South County AA [47]

MARIE-TERESA, (Sister) [P,T] St. Paul, MN b. 27 Ap 1877, Stillwater, MN. Studied: N.Y. Sch. A.; ASL; PAFA; Henri; Florence; Munich. Member: St. Paul AS. Exhibited: St. Paul Inst., 1916 (prize), 1918 (med); Minn. State Art, 1919 (prize); Minn AA, 1920 (med); Minn. State Fair, 1922 (prize); Minn. State Art S., 1923 (prize) [33]

MARIINSKY, Harry [S,P,Des,I] Rowayton, CT b. 9 My 1909, London, England. Studied: RISD; PIASch. Exhibited: AIC, 1944; MOMA, 1943; Madison Square Garden, N.Y., 1946 (one-man); R.I. Mus. A., 1940–42; Montross Gal., 1941; Am.-British A. Center, 1943–45; A. Dir. C., 1945 (prize). Illustrator: "Mexico in Your Pocket," 1938, "Judy at the Zoo," 1945, other books; national magazines [47]

MARIL, Herman [P,T,Dr] Baltimore, MD b. 13 O 1908, Baltimore. Studied: Baltimore Polytechnic Inst.; Md. Inst. Member: CAA; Baltimore AG; Wash. AG; Baltimore A. Un.; Am. A. Cong. Exhibited: CGA, 1939, 1941, 1943, 1945; PAFA, 1935, 1938, 1939, 1943; VMFA, 1940, 1942, 1944, 1946; Macbeth Gal.; CI, 1943–45; AIC; WMAA; Pasadena AI; Palace Legion Honor; WFNY, 1939; GGE, 1939; BMA, annually; White House and Labor Dept. Bldg., Wash., D.C.; Peale Mus.; Jr. H.S., Baltimore; Cummington Sch., Mass.; Cummington Sch., Mass.; MMA; Encyclopaedia Britannica Coll.; BMA; PMG; Howard Univ.; USPOs, Alta Vista, Va., West Scranton, Pa. WPA muralist. Positions: T., Univ. Md.; Cummington Sch. [47]

MARIL, Lee (Luise H. Marill) [I,W,P,Ser] NYC b. 28 Jy 1895, Harburg, Germany. Studied: Kunstgewerbe Schule, Hamburg; Acad. Graphic A., Leipzig. Exhibited: WFNY, 1939; NAC; Freedom House, N.Y. Author/Illustrator: "Four Airplanes," 1942; "Mary and the Spinners," 1946, other children's books [47]

MARIN, John [P,E] Cliffside, NJ/Addison, ME b. 23 d 1870, Rutherford, NJ d. 1 O 1953. Studied: PAFA, with Anshutz, W.M. Chase, 1899–01; ASL, with DuMond, 1902–03; Académie Julian, Paris, briefly, 1905. Exhibited: Salon des Indépendants, 1909; Salon d'Automne, 1909–10; Stieglitz' "291" Gal., NYC, 1909, 1910, 1911, 1913 (which launched him before the American public); Armory Show, 1913; MOMA, 1936 (retrospective); Boston Inst. Contemp. A. (retrospective); PMG (retrospective); Walker A. Center, 1947 (retrospective); de Young Mus. (retrospective); Santa Barbara MA (retrospective); Los Angeles MA, 1949 (retrospective); Munson-Williams-Proctor Inst., 1951 (retrospective); Houston MFA, 1953 (retrospective); NIAL, 1954 (retrospective); Mem. Exh. to 9 U.S. museums and to London, 1955–56; Dallas MFA, 1962. Work: MMA; BM; San Fran. MA; PMG; Los Angeles MA; MOMA; Fogg MA; Amon Carter MA; Mus. N.Mex; AIC; Denver AM; most major mus. Marin quit his architectural practice shortly after opening his office in 1893 to pursue painting. A proficient etcher, he made 103 plates, in Paris, 1905–10; after encouragement from Stieglitz focused upon watercolor as his chosen medium. His original bold and fluid style earned him a place as one of America's greatest early modernists. [47]

MARINKO, George J. [P,Li,T] Waterbury, CT b. 18 Je 1908, Derby, CT. Studied: L.E. York; Yale; Waterbury A. Sch. Member: CAFA; New Haven PCC. Exhibited: Waterbury, Conn., 1935 (prize), 1937 (prize); New Haven PCC, 1937 (prize). Work: City Hall Map, Waterbury. Wadsworth Atheneum, Hartford. Position: T., Waterbury A. Sch. [40]

MARINO-MERLO, Joseph [P,E,L] Auburn, AL b. 22 Jy 1906, Atlanta, GA d. 1 Ag 1956. Studied: Howard Col., Birmingham, AL. Member: SSAL; Southeastern AA; CAA; Atlanta AC; Assn. Ga. A.; Providence WCC; Miss. AA; Ala. AL; Ala. WCS; Birmingham AC; Scarab C. Exhibited: AWCS, 1937, 1938; NYWCC, 1938; Contemp. A., 1943, 1945; Wash. WCC, 1944; Mint Mus. A., 1944, 1945; Miss. AA, 1946; Ala. WCS, 1941 (prize), 1942–46; SSAL, 1937 (prize), 1940, 1943, 1945, 1946; NOAA, 1937, 1941; Ala. AL, 1940–45, 1942 (prize); Birmingham AC, 1938–44, 1943 (prize); Providence WCC, 1944; Albany Inst. Hist. &A., 1938; Studio Gld., 1945; Ala. State Fair, 1939 (prize), 1941 (prize), 1944 (prize). Work: FAP; Montgomery Mus. FA; Ala. Col.; Ala. Polytechnic Inst.; Birmingham Bd. Edu. Position: T., Ala. Polytechnic Inst. [47]

MARION, Ida Dougherty (Mrs. J.) [P,I,C] Leonia, NJ b. 6 F 1878, Fairport, NY. Studied: Cox; Pyle; Tarbell. Work: St. John's Cathedral, Wilwaukee, Wis.; Methodist Episcopal Church, NYC [13]

MARION, Markham [P] Syracuse, NY [15]

MARIS, Alyse Tyson (Mrs. William R.) [P,S,C] Cleveland, OH b. 2 Ag 1895, Brooklyn, NY. Studied: N.Y. Sch. F.&Appl. A.; Wilmington A. Acad., Del.; Ohio State Univ. Member: San Fran. SWA; Columbus AL. Exhibited: Columbus AL, 1939 (prize) [40]

MARJOT, Ernst b. 1827, France (came to U.S., 1848) d. 24 Ag 1898, San Fran. Work: private collections, U.S. and Mexico

MARK, Bendor [P] Brooklyn NY b. 5 Je 1912, NYC. Studied: CUASCh. Exhibited: BM, 1933, 1943–45; Springfield Mus., 1937; WFNY, 1939; AIC, 1940; AFA Traveling Exh., 1940, 1941; Pepsi-Cola, 1945; Tex. FAA, 1943 [47]

MARK, Louis [P] NYC/Budapest, Hungary b. 25 Ag 1867 Hungary (came to U.S. in 1910) d. 18 Mr 1942, NYC. Studied: Bouguereau, in Paris. Member: NAC. Work: Royal Mus., Budapest; BM; Albright A. Gal. [29]

MARKELL, Isabella Banks [E,P] NYC b. 27 D 1896, Superior, WI. Studied: Md. Inst.; PAFA; Ecole des Beaux-Arts. Member: NAWA (Pres., 1946–48); SAE; PBC; Phila. Pr. C.; SSAL. Exhibited: Newark Mus.; Northwest PM; Phila. Pr. C.; BMA; Birmingham A. Mus.; High Mus. A.; All.A.Am.; N.Y. Hist. Soc.; AWCS; SAE; Mus. City of N.Y.; Du Motte Gal., 1943; Argent Gal., 1945; LOC; Pal. Leg. Honor; Laguna Beach AA; New Haven PCC [47]

MARKER, Thomas Morrison [P,B,Ldscp.P] Cleveland, OH b. 23 My 1901, Wayne, MI. Studied: Cleveland Sch. A. Member: Cleveland PM. Exhibited: CMA, 1929 (prize), 1932 (prize). Work: Cleveland Pr. C. Coll., CMA; assisted W. Sommer on mural, Cleveland Pub. Lib., 1934 [40]

MARKESON, E.P. [P] Columbus, OH. Member: Columbus PPC [25]

MARKHAM, Charles C. [P] Brooklyn, NY b. 1837 d. 1907. Exhibited: NAD, 1859. Specialties: genre, still-life [*]

MARKHAM, Charlotte (Hobbs) [P,T] Manitowoc, WI b. 22 Ja 1892, Manitowoc, WI. Studied: AIC. Member: Wis. PS [25]

MARKHAM, Joy Pratt (Mrs. P.) [P] Fayetteville, AR [24]

MARKHAM, Kyra (Mrs. David S. Gaither) [P,E,Li,C,Dec,Dr,I] Halifax, VT b. 18 Ag 1891, Chicago, IL. Studied: AIC; ASL, with A. Abels. Member: AAPL; NAWA. Exhibited: NAD, 1937, 1938, 1945, 1946; PAFA, 1935; NAWPS, 1931; Phila. Pr. C., 1935 (prize). Work: Smithsonian; LOC; NYPL; MMA; WMAA [47]

MARKHAM, Marion [P,T] NYC b. Syracuse, NY. Studied: Chase; Syracuse Univ. Member: NAWPS; Whitney Studio C. Work: Syracuse MFA [27]

MARKLE, Alvan, Jr. [P] Hazleton, PA b. 28 Jy 1889, Hazleton. Studied: H.N. Hooven. Member: Phila. AC; Grand Central GA [33]

MARKOE, Francis Hartman [P,W,L,T] NYC b. 11 Je 1884, NYC. Studied: A. Weir. Member: Mural P.; Arch. Lg. [33]

MARKOE, S. Bendelari [P] Brighton, MA [08]

MARKOW, Jack [P,Cart,Li,Des,I] NYC (1977) b. 23 Ja 1905, London, England. Studied: ASL; B. Robinson; R. Lahey; W.J. Duncan. Member: Am. A. Cong.; An Am. Group; Soc. Magazine Cart.; Provincetown AA. Exhibited: WMAA; PAFA; AIC; Phila. Sketch C.; Phila. Pr. C.; Princeton Pr. C.; WFNY, 1939; NAD; ACA Gal., 1937 (one-man); CGA. Work: MMA; Univ. Ga.; CCNY; Hunter Col.; Brooklyn Pub. Lib.; Brooklyn Col.; Queensboro Pub. Lib. Contributor: cartoons, New Yorker, Collier's, Life, other magazines [47]

MARKS, Charles E. [P] Phila., PA. Studied: PAFA, Traveling F., 1938. Exhibited: PAFA, 1939 [40]

MARKS, Isaac [P,S] Harvey, IL b. 17 Jy 1859, Lithuania. Exhibited: AIC. Specialty: biblical figures [40]

MARKS, Montague [P] NYC [17]

MARKS, Stella Lewis (Mrs. Montague) [Min.P] Hertfordshire, England b. 27 N 1892, Melbourne, Australia. Member: ASMP; RMS, London; NAWPS. Work: Nat. Gal., Victoria, Melbourne, Australia; English royal Family [47]

MARKS, William [I] Calumet, MI d. 7 S 1906. Position: Staff, Leslie's where he was a friend of T. Nast

MARLATT, H. Irving [Ldscp.P,Por.P] Mt. Vernon, NY b. ca. 1860s, Wood-

hull, NY d. 10 O 1929. Member: SC; NAC; Cleveland AC. Work: Pub. Lib., Mt. Vernon. Illustrator: covers, Literary Digest [13]

MARLCHAMM, Charlotte [P] Chicago, IL. Member: Chicago WCC. Position: Associated with AIC [19]

MARLETT, Wilson [P] Rochester, NY [08]

MARLETTO, Carlos Joseph [Des,G,T] Dayton, OH b. 16 D 1909, Sicily, Italy. Studied: Cincinnati A. Acad.; Univ. Cincinnati; Wittenberg Col., Ohio. Member: Cincinnati A. Cl. Exhibited: Ohio PM S.; WFNY, 1939. Position: Des., Stanley Manufacturing Co. [40]

MARLIN, Hilda. See van Stockum.

MARLOW, Henry [S] New Rochelle, NY b. 1838, Liverpool, England (came to U.S. ca. 1881) d. 28 D 1911. Lived in Vt.; then Tuckahoe, N.J., until 1906.

MARLOW, Lucy Drake (Mrs. George A.) [P] Tucson, AZ/Erie, PA b. Erie. Studied: ASL; CI; PAFA; G.E. Browne; E. Speicher; E. Blumenschein; B. Romagnoli, in Italy. Member: Pittsburgh AA; Hoosier Salon; Erie (Pa.) AC; Tucson FAA. Exhibited: Hoosier Salon; Pittsburgh AA; CI; A. Center, Phoenix; Ariz. Expo, 1928 (prize), 1931 (prize), 1932 (prize); Erie AC, 1939 (prize). Work: Univ. Ariz., Tucson; Pittsburgh Bd. Ed. [40]

MARMANIK, Frank J. [P] NYC [10]

MARMET, Leon [P] Grand Rapids, MI [13]

MARPLE, Charles F. [P] Phila., PA [13]

MARPLE, Mary [P] Norristown, PA [06]

MARPLE, William L. [P] b. 1827 d. 1910 Active in Calif. Work: Oakland AM; Calif. State Lib. [*]

MARQUIS, Tomlinson, Mrs. See Tomlinson, Dorothea.

MARR, Carl. See von Marr.

MARR, Owen K. [Mar.P] b. 10 Ag 1861, Georgetown, ME d. 1 D 1933, Bath, ME. Work: Bath Marine Mus. A sailor as a young man; house and sign painter; also prolific marine painter. [*]

MARR, Thomas [I] Boston, MA [08]

MARRINER, William F. [I] NYC [01]

MARRON, Eugenie Marie [Mur.P,Por.P,S,T] NYC b. 22 N 1901, Jersey City, NJ. Studied: Columbia; A. Archipenko; R. Belling; F. Leger; C. Martin. Member: NAWA. Exhibited: Montross Gal. (one-man); Charles Morgan Gal. (one-man); Lilienfeld Gal. (one-man); Montclair A. Mus. (one-man), 1944 (prize); AAPL, 1944 (prize); Montclair AA, 1944 (prize) [47]

MARS, Ethel [P,G,I,B] Vence, France b. 19 S 1876, Springfield, IL d. after Mr 1956. Studied: L.H. Meakin, at Cincinnati AA, 1892–97; NYC, ca. 1900. Member: Société, Salon d'Automne, Paris. Exhibited: Salon d'Automne, Paris, 1907–13; Provincetown AA, 1915–19. Work: Coll. French Gov. [40]

MARS, Irma Bratton (Mrs. Reginald) [P,I,T] Des Plaines, IL b. 27 Ag 1901, Newton, IA. Studied: C.A. Cumming. Member: Iowa AG; Chicago Gal. A. [40]

MARS, Reginald Degge [P,I,En] Des Plaines, IL b. 1 S 1901, Petersburg, IL. Studied: C.A. Cumming. Member: Brush and Pencil C., Des Plaines, Ill. Exhibited: Iowa State Exh., Des Moines, 1924 (prize) [40]

MARSCHALL, Frederick [Mur.P] Great Kills, NY. Member: A. Fellowship [27]

MARSCHALL, Nicola [Por.P,T] Louisville, KY b. 16 Mr 1829, Germany d. 24 F 1917. Studied: Munich and Italy, 1857–59. Settled in New Orleans (1849), then settled in Mobile, Ala. Designer: Confederate flag and uniform. [*]

MARSCHNER, Arthur A. [P,E,I] Detroit, MI b. 11 Ap 1884, Detroit. Studied: J.P. Wicker. Member: Scarab Cl.; The Bohemians. Work: Scarab Cl. Illustrator: Detroit News [40]

MARSDEN, Edith Frances [P,T] Springfield, MA b. Utica, NY. Studied: N.Y. Sch. F.&Appl A.; H. Leith-Ross; B. Harrison; H.R. Poore; G.P. Ennis; A. Freelander. Member: AWCS; NAWA; AAPL; Springfield A. Lg.; Springfield A. Gld.; NYWCC. Exhibited: Springfield A. Gld., 1934 (prize). Position: T., H.S. of Commerce, Springfield [47]

MARSDEN, Ruth Gladys [P,T] Springfield, MA b. Pittsfield, MA. Studied: N.Y. Sch. F.&Appl. A.; Grand Central Art Sch.; G.P. Ennis. Exhibited: Ar. Gld., Springfield, 1932 (prize), 1934 (prize); watercolor, Stockbridge AA, 1933 (prize) [40]

MARSH, Alice Randall (Mrs. Fred D.) [Min.P] Sakonnet Point, RI b. Coldwater, MI. Studied: AIC; Merson, Collin, Whistler, MacMonnies, all in Paris. Member: Am. Soc. Min. P. Mother of Reginald. [25]

MARSH, Anne Steele (Mrs. James R.) [P,T,C,B,Des,Dr] Essex Fells, NJ b. 7 S 1901, Nutley, NJ. Studied: CUASch. Member: N.Y. Soc. Women A.; Assoc. A. N.J.; Ar. of Today, N.J.; Am. A. Cong.; Southern Pr.M. Soc.; N.J. WC Soc.; Modern Ar. N.J. Exhibited: Phil. Pr. Cl., 1935 (prize); MMA, 1943; NAD, 1942, 1946; AIC, 1935, 1939; WFNY, 1939; AWCS Traveling Exh., 1934; BM, 1935, 1939; SAE, 1937; Newark Mus., 1938–41, 1943; PAFA, 1940; Venice, Italy, 1940; Riverside Mus., 1941, 1943–45. Work: Phila. Pr. Cl.; Newark Pub. Lib.; MMA; Collectors Am. A. Position: T., Buxton Sch., Short Hills, N.J., 1938–45 [47]

MARSH, Charles H(oward) [P,E,T,L] San Diego, CA b. 8 Ap 1885, Magnolia, IA. Studied: W.V. Cahill; G. Rose; C. Hinckle; Gorguet, Despujol, in Paris; Stickney Mem. Sch. of Pasadena. Member: Calif. AC; Laguna Beach AA; Calif. WCS. Exhibited: Southern Calif. Fair Exh., Riverside, 1920 (prize). Work: Lib., Univ. Fla., Gainesville [40]

MARSH, Fred Dana [Mur.P] Ormond Beach, FL b. 6 Ap 1872, Chicago d. 20 D 1961, Daytona Beach. Studied: AIC. Member: SAA, 1902; ANA, 1906; Arch. Lg., 1902; Mural P., 1904; New Rochelle AA; AFA. Exhibited: Paris Expo, 1900 (med); Pan-Am. Expo, Buffalo, 1900 (med); St. Louis Expo, 1904 (med). Work: Rochester Mem. A. Gal.; decorations, Hotel McAlpin, NYC; Un. Engineering Soc. Bldg., Mus. Safety, both in NYC; Detroit Country Cl.; Automobile Cl. of Am.; pictorial maps, SS "Malolo", SS "Berkshire"; private collections. Father of Reginald. [47]

MARSH, Harold D(ickson) [P,Arch] Portland, OR b. 1 F 1889, Portland. Studied: MIT. Member: AAPL; Oreg. APL; AIA. Exhibited: Oreg. State Fair, 1931; Portland Mus. A., 1933 (prize). Work: Pub. Lib., La Grande; City Water Works Bureau, Portland; Oreg. State Art Mus. Assn., Salem [40]

MARSH, Florence (Mrs. Harold Dickson Marsh) [P] Portland, OR b. Minneapolis, MN d. D 1936. Studied: Univ. Oreg. Member: AAPL; Portland Sch. AL (Dir.); Oreg. SA; Portland AA; Portland Art Class; Park and Garden SS (Pres.); Nat. Art Week (Nat. Chairman). Exhibited: Oreg. SA, 1930 (prize) [38]

MARSH, J.E. [P] Muncie, IN [13]

MARSH, Jean [P,Min.P,L] Mason City, IA b. 10 O 1910, Salem, SD. Studied: Univ. Chicago; AIC, 1913; ASL; Minneapolis Inst. A. Exhibited: S.Dak. State Fair, 1932 (prize); PAFA, 1938, 1939; Nat. Women's Show, Kans., 1939; Baltimore Min. P., 1939; Syracuse Mus. FA, 1939; Univ. Pittsburgh, 1939; Herron AI, 1940; Okla. Col. for Women, 1940; Brooks Mem. A. Gal., 1940; Gibbes Mem. A. Gal., 1940; VMFA, 1940; Smithsonian Inst., 1940; Grand Central A. Gal., 1941 [47]

MARSH, Lucile Patterson [I,Gr] NYC b. 21 O 1890, Rapid City, SD. Studied: AIC. Member: GFLA. Work: advertising, for Ivory Soap, Jello, Pet Milk, and others. Illustrator: Saturday Evening Post, other national magazines; Gates "School Reader" [47]

MARSH, Mary E. (Mrs. Conrad Buff) [P,W] Eagle Rock, CA b. Cincinnati. Studied: B. Sandzen; Chicago Acad. FA; Cincinnati Art Acad. Member: Calif. AC; Laguna Beach Art Assoc. [33]

MARSH, Norman [P,Car] Chicago, IL. Creator: comic strip "Dan Dunn" [40]

MARSH, Reginald [P,E,T,I,Car,Mur.P] NYC b. 14 Mr 1898, Paris, France d. 30 Jy 1954, Dorset, VT. Studied: Yale; periodically, ASL, with Sloan, K.H. Miller, Luks; learned egg tempera and emulsion technique from Jacques Maroger, 1940–46. Member: NA; NIAL; SAE; Mur.P; Am. Soc. PS&G. Exhibited: CGA, 1945 (prize); SC, 1945 (prize); AIC, 1931 (prize); Phila., 1940 (med); NAD, 1937 (prize); Whitney Studio Cl., 1924, 1928; most nat. exhibs of cotemporary American artists since 1931; 16 one-man shows at Rehn Gal., NYC; retrospective, WMAA, 1955. Work: MMA; WMAA; AGAA; Univ. Nebr.; Springfield (Mass.) Mus.; PAFA; AIC; Wadsworth Atheneum; BMFA; murals, "Sorting the Mail," "Transfer of Mail from Liner to Tugboat," USPO Dept. Bldg., Wash., D.C.; U.S. Customs House, N.Y.; Wood Gal., Montpelier, Vt.; AM, Wichita, Kans.; Brookline Mus. Author: "Anatomy of Artists" (1945), "Round and Round Horse" (1943). Contributor: Magazine of Art. Son of Fred D. and Alice R. Marsh, he was a lifelong free-lance illustrator for the New Yorker, Esquire, and many other national magazines. Best known for his scenes of vaudeville, night clubs, burlesque, and New York City. After his divorce from sculptress Betty Burroughs in 1933, he married painter Felicia Meyer, in 1934. [47]

MARSH, Sam [I] NYC. Member: SI [47]

MARSH, Susan R. [P] Muncie, IN [25]

MARSHALL, Charles H. (Mrs.) [S] NYC [10]

MARSHALL, Clark S. [P] Hurlock, MD [13]

MARSHALL, Edward N. [P] Boston, MA [01]

MARSHALL, Frank H(oward) [P] Carmel, CA b. 6 Ja 1866, England. Studied: ASL; Chase Sch., New York; Académie Julian, Paris, with Laurens; Madrid; London. Member: SC, 1910; AFA [40]

MARSHALL, Frank W(arren) [Ldscp.P,C,T,I] Providence, RI b. 24 S 1866, Providence d. 5 My 1930. Studied: RISD; Académie Julian, Paris. Member: Providence AC; Providence WCC. Known as "dean" of Rhode Island newspaper illustrators. [29]

MARSHALL, Frederic [P] Woodridge, NJ. Member: Mural P.; Arch. Lg., 1894 [01]

MARSHALL, Isabelle C. [P] NYC [10]

MARSHALL, (James) Duard [P,Mur.P,Li,Ser] Colorado Springs, CO b. 29 S 1914, Springfield, MO. Studied: Kansas City AI; Colorado Springs FA Center; B. Robinson; Univ. Ark.; T.H. Benton; M.W. Hammond; S. DeMartelly; W. Rosenbauer. Member: Ozark Ar. Assn. Exhibited: Kansas City AI, 1938, 1940 (prize); Ark. WC Soc., 1940 (prize); LOC, 1945 (prize); CI, 1945; Phila. Pr. Cl., 1940, 1945, 1946; NAD, 1946; LOC, 1945, 1946; Jackson, Miss., 1946; SFMA, 1938; Oakland A. Gal., 1939; Denver A. Mus., 1939, 1940, 1945, 1946; Mus. N.Mex., Santa Fe, 1943 (one-man); Philbrook A. Center, 1943 (one-man); Okla. A. Center, 1943 (one-man). Work: Univ. Ark.; LOC; mural, Neosho (Mo.) Pub. Lib. [47]

MARSHALL, MacLean [S] Rome, GA b. 2 My 1912, NYC. Studied: ASL; Univ. Va.; Child-Walker Sch. Des.; Yale; G. Bridgman; Nicolaides; G. Demetrios. Member: NAC; North Shore AA; Gloucester SA. Exhibited: Telfair Acad. A., Savannah, Ga., (prize); Nat. A. Cl., 1939 (prize). Work: Telfair Acad. A. [47]

MARSHALL, Margaret Jane [P,C,I,W,L,T] Glenside, PA b. 29 Jy 1895, Phila. Studied: PAFA. Member: Phila. Plastic. Contributor: historical magazines. Illustrator: "Children of the Alps" [47]

MARSHALL, Mary E. (Mrs.) [P] Phila., PA b. Plainfield, PA. Studied: Dow; W. Sargent; Breckenridge; PMSchIA; PAFA. Member: Phila. Alliance; Plastic Cl.; Phila. ATA; NAWPS. Work: Gettysburg Col.; State T. Col., Shippensburg, Pa.; Willim Penn H.S., Phila. Position: T., PMSchIA [47]

MARSHALL, May Chiswell [Por.P] Alexandria, VA b. 30 Ap 1874, Markham, VA. Studied: Chase Sch. A., with Chase; Univ. Va.; Corcoran Sch. A.; Webster; Critcher. Member: Wash. AC; Soc. Wash. A.; Columbia AA; Studio Gld. N.Y. Exhibited: San Antonio, Tex. (one-man); Colorado Springs FA Center; Studio Gld., N.Y.; Wash. AC; Gibbes Mem. A. Gal.; Alexandrian Pub. Lib., 1946; Boyer Gal., Phila.; Delgado Mus. A. Position: T., Univ. S.C. [47]

MARSHALL, Rachel. See Arthur L. Hawks, Mrs. [33]

MARSHALL, William C. [Ldscp.P] NYC/Ocean Bluff, MA. d. 7 Mr 1929

MARSHALL, William Edgar [En,Por.P] NYC b. 30 Je 1837, NYC. Studied: Cyrus Durand, in NYC, 1856; Couture, in Paris, 1863–65. Painted portraits of prominent Americans at his NYC studio (from 1866). Best known for his widely distributed engraving of Lincoln (original oil at Yale), and his heroic ideal engraving of Christ, 1870s (original oil widely exhibited).

MARSTON, Richard [P] NYC b. 1842, England (came to U.S. in 1867) d. 16 F 1917. Designer: sets for many of the largest theatrical productions of Richard Mansfield and David Belasco. Son of actor/director Henry Marston.

MARTEN, Christine Walters [P] Jackson Heights, NY/Woodstock, NY b. 15 Ag 1896. Studied: A. Brook; H.L. McFee; I. Olinsky; Y. Kuniyoshi. Member: NAWPS [40]

MARTIN, Alice Ethel [P,T] Phila., PA. Studied: PAFA [25]

MARTIN, Ann [P] Chicago, IL [19]

MARTIN, Basil E(dwin) [P,Des,C] Fairfax, VA b. 23 Ap 1903, Chelmsford, England. Studied: Central Sch. A.; Chelsea Sch. A., London; G. Harcourt; W. Dyson; Adams; Marston. Member: NYWCC; AWCS. Exhibited: AWCS, 1930–36; WFNY, 1939. Work: High Mus. A.; dioramas, U.S. Forest Service; Morristown (N.J.) Hist. Mus.; Dept. Interior, Wash., D.C.; models, AMNH; Univ. Vt. Position: in charge exhibits, U.S. Forest Service, 1936– [47]

MARTIN, Caroline Louise [P] San Fran., CA b. 15 N 1903, San Fran. Studied: Calif. Sch. FA, with M. Sterne. Member: San Fran. AA; San Fran. Women A.; NAWPS. Exhibited: San Fran. Women A., 1935, 1936 (prize), 1937–44, 1945 (prize); WFNY, 1939; San Fran. AA, 1935–37, 1940, 1943–46; Bay Region AA, 1945, 1946; Pal. Leg. Honor, 1945. Work: SFMA [47]

MARTIN, Charles [Por.P,Ldscp.P] London, England b. 1820 d. 5 Ap 1906. Exhibited: NAD, 1851. Active in Charlestown, S.C. (1846–48), Bristol, R.I. (1851) [*]

MARTIN, Charles E. [Car,I,Des,P] NYC b. 12 Ja 1910, Chelsea, MA. Member: Soc. Magazine Car. Illustrator: New Yorker, Collier's, Saturday Evening Post, Harper's, Life [47]

MARTIN, Charles J. [E] NYC [19]

MARTIN, Christine [P] Forest Hills Gardens, NY b. 15 Ag 1895, NYC. Studied: Columbia; ASL, with H. McFee; J. Sloan; J. Smith. Member: Woodstock AA; NAWA. Exhibited: PAFA, 1935; NAWA, 1935–46; Weyhe Gal., 1945, 1946; Woodstock AA, annually; Rudolph Gal., 1943–45 [47]

MARTIN, David Stone [P,D,Mur.P,T,] Knoxville, TN b. 13 Je 1913, Chicago, IL. Studied: AIC. Exhibited: 48 Sts. Comp, 1939 (prize); Fed. A. Gal., Norris, Tenn. Work: USPO, Lenoir, Tenn.; mural, Elgin (Ill.) State Hospital. Position: T., Univ. Tenn. [47]

MARTIN, Dorothy Freeman (Mrs. A.T.) [P] NYC. Member: NAWPS [27]

MARTIN, Easoin J. [P] NYC. Member: S.Indp.A. [25]

MARTIN, Edna M. [E,B,P,T] Seekonk, MA b. 1 Mr 1896, Seekonk. Studied: RISD. Member: Providence WCC; Providence AC. Work: RISD Gal. Position: T., Lincoln Sch., Providence [40]

MARTIN, Fletcher [P,Li,Mur.P,B,T] NYC/Guanajuato, Mexico (1976) b. 29 Ap 1904, Palisade, CO. Studied: Stickney Mem. Sch. A. Member: Calif. WC Soc.; Am. Artists Cong.; Fnd. of Western Art. Exhibited: Los Angeles Mus. A., 1935 (prize), 1939 (prize), 1944; FAP, 1937 (prize); 48 Sts. Comp., 1939 (prize); VMFA, 1941; PAFA, 1941, 1942; CI, 1942–44; AIC, 1941–42; MOMA, 1942; NAD, 1943. Work: MOMA; MMA; Cranbrook Acad. A.; W.R. Nelson Gal.; Los Angeles Mus. A.; LOC; Denver A. Mus.; Mus. FA, Houston; SFMA; frescoes, North Hollywood (Calif.) H.S.; murals, Fed. Bldg., San Pedro, Calif.; USPOs, La Mesa (Tex.), Kellogg (Idaho). Specialty: Western subjects. Illustrator: "Tales of the Gold Rush" (1944), "Mutiny on the Bounty" (1946), both pub. Limited Editions. WPA artist. Positions: T., Los Angeles A. Center Sch. (1938–39), Univ. Iowa (1940–41), ASL (1948–49); War A./Correspondent, Life (1943–44) [47]

MARTIN, Floyd Thornton [P] Glenville, CT. Work: USPO, Wadsworth, Ohio. WPA artist. [40]

MARTIN, Francis Thomas Beckett [P,Dr,L] Omaha, NE b. 29 N 1904, Omaha. Studied: Univ. Nebr.; G. Barker; J.L. Wallace. Member: AAPL; Lincon A. Gld.; Omaha AG. Exhibited: Rockefeller Center, NYC, 1938; Kansas City AI; Omaha A. Gld.; Joslyn Mem., Iowa-Nebr., 1933–37. Work: City of Fremont, Nebr.; Chamber Commerce, Omaha; Joslyn Mem. [47]

MARTIN, Frederick C. [P] NYC. Member: Mural P.; SC, 1900 [06]

MARTIN, Gail Wycoff (Mr.) [P,Li,T] Falmouth, IN b. 19 Ap 1913, Tacoma, WA. Studied: John Herron A. Sch.; State Univ. Iowa; F. Martin; P. Guston; E. Ganso. Exhibited: St. Louis A. Gld., 1943 (prize); AIC, 1936, 1939; CI, 1942, 1943; VMFA, 1942; Denver A. Mus., 1941, 1944; PAFA, 1942; GGE, 1939; MMA, 1943; Kansas City AI, 1941–43. Work: mural, USPO, Danville, Ind. WPA artist. [47]

MARTIN, (George) Keith [Por.P,T,L] Kansas City, MO b. 22 Ja 1910, Perth Amboy, NJ. Studied: Emile de la Montagne, in Antwerp; France; W. Adams. Member: SC; Plainfield AA; Westfield AA; Calif. AC; Los Angeles AA. Exhibited: Plainfield Exh., Kresge Gal., Newark, 1934 (prize), 1936 (prize). Work: portraits, Swarthmore Col. (for the Benjamin West Soc.); Rollins Col., Winter Park, Fla. Position: Dir., Kansas City AI [40]

MARTIN, Grace S. [P] Phila., PA. Studied: PAFA [10]

MARTIN, Homer Dodge [Ldscp.P,I] St. Paul, MN b. 28 O 1836, Albany, NY d. 12 F 1897. Studied: J.M. Hart; (encouraged by sculptor E.D. Palmer, mid-1850s). Member: NA, 1874. Work: CMA; MMA; Century

Assoc.; Nat. Gal., Wash., D.C. Often referred to as the first American Impressionist he was, like Inness, an important and innovative landscape painter. He began painting in the tradition of the "Hudson River School," but two trips to Europe (1876; 1881–86 in Normandy) greatly changed his style so that it was closer to the styles of Corot, Rousseau, and Daubigny. He had a studio in NYC (1862–92), and then moved to St. Paul. Despite his progressive blindness, he produced some of his best work up to the time of his death. [*]

MARTIN, J.H. [P] Denver, CO [04]

MARTIN, J(ohn) B(reckenridge) [Ldscp.P,W] Dallas, TX b. 29 Ap 1857, near London, KY d. ca. 1938. Studied: self-taught. Member: Dallas AA. Raised in the Appalahians, he did not see a town until he was 17; then became a cowboy in Texas (Sherman, 1876; Fort Worth, 1881; Dallas, 1888). His work was admired by T.H. Benton. [33]

MARTIN, Keith Morrow [P] Lincoln, NE b. 27 Ja 1911, Lincoln, NE. Studied: Univ. Nebr.; AIC. Exhibited: Wadsworth Atheneum, 1935; AIC, 1936; VMFA, 1946; Nebr. AA, 1943; Southern Vt. A., 1937; Lincoln A. Gld.; Julien Levy Gal., 1936, 1937; Kuh Gal., Chicago, 1937; Vendôme Gal., Paris, 1945; Batsford Gal., London, 1945 [47]

MARTIN, Kirk [P,B] Yucca Valley, CA (1975). Like his brother, Fletcher, he was trained as a printer as a boy. Specialty: horses [*]

MARTIN, Laurin H. [C] Lowell, MA b. 30 My 1875, Lowell, MA. Studied: J. De Camp; A. Fisher; A. Gaskin; Birmingham (England) Sch. A.; Cowles Art Sch., Boston. Member: Boston SAC; Phila. ACG; N.Y. Soc. Craftsmen. Exhibited: South Kensington, London, 1899 (med). Work: shield, Women's Eastern Golf Assoc. Specialties: metalwork; enamelwork. Position: T., Mass. Sch. Art [40]

MARTIN, Lester W. [P] d. 1 Je 1934, Ridgewood, NJ

MARTIN, Margaret [P] Minneapolis, MN. Work: USPO, St. James, Minn. WPA artist. Position: Associated with Minn. Sch. A. [40]

MARTIN, Marshall B., Mrs. [P] Providence, RI. Member: Providence WCC [29]

MARTIN, Marvin B. [S,T] Champaign, IL b. 28 Jy 1907, Fort Worth, TX. Studied: Kansas City AI. Member: AAPL; Denver A. Gld.; AFA. Exhibited: Denver AM, 1933, 1935 (one-man), 1936, 1938, 1939 (prize), 1940, 1941, 1944 (one-man); Mo. State Fair, 1927 (prize), 1932 (prize), 1933; Kansas City AI, 1933, 1935, 1938, 1939; CM, 1935; Univ. Colo. 1937 (one-man); Arch. Lg., 1938; WFNY, 1939; Univ. Ill. Faculty Exh., 1945, 1946; Univ. Ill. Traveling Exh., 1945. Work: Univ. Wyo.; Kent Sch. for Girls, Fairmount Cemetery, Guldman Mem., Nat. Home for Jewish Children, Colo. Hist. Soc., Kirkland Sch. A., Rosehill Cemetery, Police Bldg., all in Denver; H.S. and Art Mus., both in Boulder; mon., U.S. Dept. Interior, Ignacio, Colo.; Univ. Colo. Positions: T., Denver Univ. (1935–38), Univ. Ill. (1944–) [47]

MARTIN, Mildred Smith [P] Phila., PA b. 12 My 1900. Studied: PAFA; Paris. Exhibited: watercolor, Gimbel's, Phila., 1933 (prize) [40]

MARTIN, Paul [P,I] Ossining, NY b. 6 Je 1883, NYC [27]

MARTIN, Robert [Min.P] Ridgefield, NJ. Exhibited: BM, 1933; WFNY, 1939 [40]

MARTIN, Robert (Joseph) [P] NYC/East Gloucester, MA b. 6 Ja 1888, NYC. Studied: Henri. Member: Calif. AC [19]

MARTIN, Sue Pettey (Mrs. Richard) [Por.P,P,B,L,T] Tulsa, OK b. 12 D 1896, Bonham, TX. Studied: Univ. Tulsa; AIC; E. Bisttram; W. Adams; C. Kay-Scott; A.M. Robinson; A. Woelfle; R. Brackman. Member: Assn. Okla. A.; P.&Pr.M. Gld.; Prairie PM; Southwestern AA. Exhibited: Tulsa AA, 1934 (prize), 1935 (prize), 1936 (prize); Okla. A. Center, 1940–44, 1945 (prize); Assn. Okla. A., 1945 (prize), 1946 (prize); Ruskin AC, 1945 (prize); CGA; Kansas City AI; Denver A. Mus.; AIC. Work: Univ. Tulsa; Philbrook A. Center. Position: T., Philbrook A. Center [47]

MARTIN, Walter [P] Newark, NJ [25]

MARTIN, Wayne [C,P,T] Wayne, PA/Quakertown, PA b. 16 Jy 1905, California, PA. Studied: M. Parcell; CI. Member: EAA. Work: lamp, Church of St. Francis, Rutherfordton, N.C.; Phila. Art Alliance [40]

MARTINELLI, Ezio [P,Gr,L] Phila., PA b. 27 N 1913, West Hoboken, NJ. Studied: NAD; Barnes Fnd.; Tiffany Fnd.; Italy. Exhibited: Elgin Acad. FA, 1941 (prize); Phila Pr. Cl., 1944 (prize); Newark Mus., 1943; Art of this Century, 1942, 1943; San Fran. AA, 1942; PAFA, 1940, 1944; San Diego FA Soc., 1941; Denver A. Mus., 1941; AIC, 1941; ACA Gal., 1939; Ragan Gal., Phila., 1943; Willard Gal., 1946 (one-man). Work: PMA; AIC; Elgin Acad. FA [47]

MARTINET, Marjorie D. [P,T,W] Baltimore, MD b. 3 N 1886, Baltimore. Studied: Md. Inst.; Rinehart Sch. S.; PAFA; C. Beaux; W. Chase. Member: BMA; Phila. A. All.; NAWA; AFA. Exhibited: Peabody Inst.; PAFA (prize); Phila. Plastic Cl.; Phila. AC; BMA, 1930 (one-man); Newman Gal., Phila., 1936; McClees Gal., Phila., 1946. Position: Dir., Martinet Sch. A., Baltimore [47]

MARTINEZ, Alfredo Ramos [P] b. 1873 d. 8 N 1946, Los Angeles. Work: Mount Carmel Church, Montecito, Calif.; fresco, Scripps Col., Claremont, Calif; stained glass windows, paintings, St. John's Church, Los Angeles. Established Mexico's free outdoor art schools.

MARTINEZ, Julian [P,C] San Ildefonso Pueblo, Santa Fe, NM b. 1879 San Ildefonso Pueblo d. 6 Mr 1943. Studied: self-taught. Exhibited: watercolors/pottery, Inter-Tribal Arts Exh.; blackware pottery, with his wife, Marie, fairs in Santa Fe and Gallup, N.Mex. (prizes); U.S. museums. Work: Amon Carter Mus.; Denver Mus. A.; Mus. N.Mex.; Mus. Am. Indian; paintings representing ceremonies and symbols of Pueblo Indians, U.S. Indian Sch., Santa Fe. Decorator: pottery made by Marie Montinez. His black-on-black decorative ceramic method (perfected ca. 1919) brought extensive tourist business to the Pueblo. The decorating was continued by his son Tony (Popovi Da) after Julian died (an alcoholic). [40]

MARTINEZ, Marie Montoya (Mrs. Julian) [C] San Ildefonso Pueblo, Santa Fe, NM (1976) b. 1881. Studied: self-taught. Exhibited: pottery made with her husband, Julian, Inter-Tribal Arts Exh., Century of Progress Expo, Chicago (1934), GGE (1939), U.S. museums. (All exhibitions were hugely successful.) A full-blooded Tewa Indian, she was known as "The Potter of San Ildefonso." She gave demonstrations at the Mus. N.Mex., and taught pottery making to girls in her pueblo. [40]

MARTINEZ, Xavier (Tizoc Martinez y Orozco) [P,E,I,L,W,T] Piedmont, CA b. 7 F 1869, Guadalajara, Mexico d. 1943, Carmel, CA. Studied: Mark Hopkins Inst., San Fran., with A. Mathews, 1895; Ecole des Beaux-Arts, with Gérôme, Carrière, 1897–01. Member: San Fran. Sketch Cl.; Bohemian Cl.; San Fran. AA. Exhibited: San Fran. AA, 1895 (gold); Paris Expo, 1900 (prize); P.-P. Expo, San Fran., 1915 (gold,prize); Oakland Mus. A., 1974 (retrospective). Work: de Young Mem. Mus.; Oakland A. Gal.; Art Mus., Guadalajara. Illustrator: "El Zarco," pub. W.W. Norton. One of San Francisco's famous bohemians, he lost all his work in the 1906 fire. Position: T., Calif. Sch. A.&Cr., 1908–43 [40]

MARTINI, H(erbert) E. [P,I,E,W,L] Bronx, NY b. 8 Ja 1888, Brooklyn, NY. Studied: DuMond; Munich Royal Acad, with A. Jank, M. Doerner. Member: AAPL. Work: panels, Chamber Commerce Host House, WFNY, 1939. Illustrator: "Golden Treasury Readers," "French Reader." Author: "Color." Position: Dir., Martini Artists Color lab. [40]

MARTIN-NICHOLS, Pegus (Peggy) [P] Los Angeles, CA b. Atchison, KS. Studied: Chase; C. Beaux; Vanderpoel. Member: Calif. AC [31]

MARTINO, Antonio Pietro [P] Phila., PA b. 13 Ap 1902, Phila. Studied: PMSchIA. Member: NA; AWCS; Phila. WCC; DaVinci Alliance; Assoc. Nat. Acad.; 1938. Exhibited: Phila. Sketch Cl., 1925 (prize), 1926 (med); PMSchIA Alumni Assn., 1939 (med); Phila. AC, 1925 (prize); Sesqui-Centennial Expo, Phila., 1926 (med); NAD, 1926 (prize), 1927 (prize), 1937 (prize); Wanamaker Regional Exh., 1935 (prize); PAFA, 1938 (med). Work: Reading (Pa.) Mus.; PAFA; Wanamaker Gal., Phila. [47]

MARTINO, Frank [P,T] Phila. PA d. 9 S 1941. Studied: PMSchIA. Position: T., PMSchIA

MARTINO, Giovanni [P] Penn Wynne, PA b. 1 My 1908, Phila. Studied: Spring Garden Inst.; La France AI; Phila. Sketch Cl. Member: NA; Phila. WCC. Exhibited: Phila. A. All., 1934 (prize); VMFA, 1940 (prize); DaVinci All., 1939 (gold), 1940 (prize), 1944 (prize); NAD, 1941 (prize), 1942 (prize); Woodmere A. Gal., 1945 (prize); PAFA, 1942 (prize); Sweat Mem. Mus., 1946 (prize); State T. Col., Pa., 1946 (prize); Pepsi-Cola, 1946 (prize); CGA; WMAA; AIC; GGE, 1939; CI. Work: Phila. A. All. [47]

MARTINO, Michel [S] Norris Cove, CT b. 22 F 1889, Alvignano, Casserta, Italy. Studied: L. Lawrie; H. Kitson; F., Yale, abroad. Work: Strong Sch., New Haven; mem. tablet, While Plains (N.Y.) H.S.; commemorative medal, Am. Pub. Health Soc.; flag staff, Brooklyn, N.Y.; Spanish war mem., New Haven; pediment, St. Anne Church, Hartford [33]

MARTINSEN, Mona [S] Paris, France b. New York [08]

MARTINY, Philip [S] Bayside, NY b. 10 May 1858, Strasbourg, Alsace (then France) (came to U.S. ca. 1876) d. 26 Je 1927, NYC. Studied: France, with François and Eugene Dock; Saint-Gaudens. Member: ANA, 1902; SAA, 1891; Arch. Lg. Work: doors, St. Bartholomew's Church, NYC; McKinley Mon., Springfield, Mass; Soldiers and Sailors Mon., Jersey City; portrait statue, Paterson, N.J.; sculpture, Hall of Records, NYC; groups, Chamber of Commerce, NYC; World War Mon., Greenwich Village, NYC; sculpture dec., Columbian Expo, Chicago (1893), Pan-Am. Expo, Buffalo (1901), St. Louis World's Fair (1904); marble carvings in balustrade, LOC [25]

MARTYL, (Suzanne Schweig) [P,Li,Mur.P] Chicago, IL b. 16 Mr 1918, St. Louis, MO. Studied: Washington Univ.; Colorado Springs FA Center, with A. Blanch; B. Robinson; Hawthorne; A. Schweig. Member: Am. Ar. Cong.; A. Lg. Am.; Renaissance Soc., Univ. Chicago. Exhibited: Kansas City AI, 1939, 1940 (prize); CAM, 1941 (prize), 1942, 1943 (prize), 1944, 1946; AIC, 1944, 1945 (prize), 1946; Los Angeles Mus. A., 1945 (prize); CI, 1940-45; PAFA, 1944; VMFA, 1946; CGA, 1941; WMAA, 1945, 1946; Milwaukee AI, 1946; St. Louis City AM, 1929 (prize), 1930 (prize); 48 Sts. Comp., 1939; WFNY, 1939. Work: Recorder of Deeds Bldg., Wash., D.C.; PAFA; Univ. Ariz.; CAM; murals, USPOs, Russell, Kans., Sainte Genevieve, Mo. Illustrator: "How to Paint a Gouache," 1946. WPA artist. [47]

MARUGG, Theodore Jacob [Mur.P,Por.P] Evanston, IL b. 17 S 1909, Chicago. Studied: R. Weisenborn; Chicago Acad. FA. Member: Chicago NJSA [40]

MARUSIS, Athan [P] Seattle, WA b. 25 D 1889, Athens, Greece. Studied: Manos; P.M. Gustin; Y. Tanaka. Member: Seattle FA Soc. [25]

MARVIN, F.H. [P] Provincetown, MA b. NYC. Work: TMA [24]

MARWEDE, Richard L. [P] NYC b. 5 F 1884, NYC. Studied: ASL. Member: Alliance [31]

MARYAN, Hazel Sinaiko [P,S,T] Chicago, IL b. 15 My 1905, Madison, WI. Studied: Univ. Wis.; AIC; E. Chassaing; A. Polasek; E. Simone. Exhibited: AIC, 1932-44; Wis. Salon, 1932-45; Chicago No-Jury Exh., 1933, 1934. Position: T., Von Steuben H.S., Chicago [47]

MARY LAUREEN, (Sister) [P,Des,L,T] Woodstock, IL/Holy Cross, IN b. 16 Je 1893, Fort Wayne, IN. Studied: Univ. Chicago; AIC; Univ. Calif.; Notre Dame Univ. Member: Hoosier Salon. Exhibited: still life, Hoosier Salon, 1937 (prize). Position: T., St. Mary's Sch., Woodstock, Ill. [40]

MARZOLO, Leo Aurelio [P] Warrenville, IL b. 22 F 1887, Martinez, CA. Studied: Chicago Gal. Assn.; Assn. P.&S.; Palette & Chisel Acad. A. Exhibited: Palette & Chisel Acad. A., 1941 (med). Work: State Mus., Springfield, Ill. Position: Restorer of paintings, AIC, 1928– [47]

MASE, Carolyn C. [P] St. George, Staten Island, NY b. Mattawan (Beacon), NY. Studied: J.H. Twachtman. Member: CAFA; NAWPS; Wash. WCC; Staten Island A. Assn.; New Orleans A. Assn. Exhibited: Wash. WCC, 1937, 1938; CAFA, 1938. Position: T., Staten Island Inst. A.&Science [40]

MASKI, J. [P] Chicago, IL [19]

MASLEY, Alexander Simeon [P,E,B,Des,Li,T,En] Austin, TX b. 6 D 1903, Akeley, MN. Studied: Minneapolis Sch. A.; Univ. Minn.; Columbia; Central Sch., London; H. Hofmann Sch., Munich; Des. Laboratory, N.Y.; C. Booth; W.P. Robins, in England. Member: Tex. FA Assn.; Minn. AA.; Prairie PM. Exhibited: Minn. State Fair, 1927 (prize), 1939 (prize); Twin City, 1927 (prize), 1928 (prize) 1930 (prize), 1931 (prize), 1932 (prize); Women's Cl., Minneapolis, 1939 (prize); San Fran. A. Assn., 1939; AIC, 1941; Pepsi-Cola, 1944; WFNY, 1939; SFMA, 1939, 1941; Tex. General Exh., 1944–46; Minneapolis Inst. A., 1928–41. Work: Univ. Minn.; Minneapolis Inst. A.; San Fran. AA. Positions: T., Minneapolis Sch. A., Univ. Tex. [47]

MASON, Alice F. (Mrs. Michael L.) [P,E,L,Li] Chicago, IL b. 16 Ja 1895, Chicago, IL. Studied: Northwestern Univ.; AIC. Member: Chicago SA; The Cordon; Women's Salon; NAWA; Chicago AC. Exhibited: MMA (AV), 1942; PAFA, 1938, 1939; CGA, 1941; Wichita AA, 1937-39; AIC, 1937-40, 1946 [47]

MASON, Alice Trumbull [P,E] NYC b. 16 N 1904, Litchfield, CT d. 1971. Studied: British Acad., Rome; NA; A. Gorky, NY. Member: Am. Abstract A.; Fed. Mod. P.&S. Exhibited: AIC, 1937-39; WMAA, 1938; PAFA, 1939; Phila. Pr. C., 1946 (prize). Work: PMA; Mus. Non-Obective Painting; Berkshire Mus. A. [47]

MASON, C.D. [S] b. 1830 France (came to U.S. in 1860) d. 1 Jy 1915, Mineola, NY. Work: Vanderbilt mansion; Soldiers and Sailors Monument and the Angels of Art at the entrance to Greenwood Cemetery; Garden City Cathedral; Phila. Expo; Chicago Expo

MASON, Doris Belle Eaton (Mrs. Edward F.) [S,L,T,P] Iowa City, IA b. 29 Je 1896, Green River, WY. Studied: Univ. Idaho; Univ. Iowa; Univ. So. Calif. Exhibited: PAFA, 1941, 1942; Munic. A. Exh., N.Y., 1936, 1937; Iowa Univ., 1938 (one-man); Joslyn Mem., 1943, 1944; Denver A. Mus.; Davenport Mus. Gal., 1938 (one-man); Iowa State Fair, 1937 (prize), 1938 (prize) [47]

MASON, Georgine [P] Des Moines, IA. WPA artist. [40]

MASON, John [P,D] Phila., PA b. 1868, NYC. Studied: Académie Julian, with Laurens, Constant. Member: Alliance. Exhibited: Paris Expo, 1889 (med). Work: Harmonic C., NYC; NYC Armory; Wanamaker's; Gueting's Shoe Store; Louis Mark Shoe Store, Inc.; Blum Store; and Dalsimer Shoe Store, Phila. [29]

MASON, John [P] Saybrook, CT [15]

MASON, Josephine [P] Paris, France b. Wash., D.C. [01]

MASON, Kathleen [P] Germantown, PA [24]

MASON, Mary (Stuard) Townsend (Mrs. William Clarke) [P] Phila., PA/Monhegan Island, ME b. 21 Mr 1886, Zanesville, OH. Studied: Md. Inst.; PAFA, with Chase, Breckenridge. Member: Phila. A. All.; Phila. WCC; SSAL; F., PAFA. Exhibited: CGA, 1925-44; NAD; AIC; CI; Albright A. Gal.; PAFA, 1909 (med), 1920-45, 1922 (prize), 1933 (gold), 1939 (prize); Phila. Sketch C., 1929 (gold); CAM; SSAL, 1934 (prize); Phila. AC, 1930 (gold); Woodmere A. Gal.; Phila. Exh. Am. Painting, 1933 (prize); Germantown AG, 1939 (prize). Work: PAFA; Albright A. Gal. [47]

MASON, Mary S. Winfield [S] b. Jackson, TN d. 26 O 1934 Elmsford, NY

MASON, Maud M. [P,C,T,L] NYC b. 18 Mr 1867, Russelville, KY d. 28 Ag 1956. Studied: A. Dow; H. Snell; W. Chase; Brangwyn, in London. Member: ANA; AWCS; NAC; PBC; All.A.Am.; N.Y. S. Cer. A.; NAWPS; Boston SAC (Master Craftsman). Exhibited: P.-P. Expo, 1915 (gold); NAC, 1920 (med); NAWPS, 1922 (prize); NAC, 1937 (prize. [47]

MASON, Michael L. (Mike) [P,Li] Chicago, IL b. 23 Ap 1895, Rossville, IL. Studied: Northwestern Univ.; F.F. Fursman; A.H. Krehbiel; E. Rupprecht. Member: Chicago SA. Exhibited: PAFA, 1938, 1940; GGE, 1939; AIC, 1936, 1938-40, 1943; All-Ill. SFA, 1937, 1938 [47]

MASON, Olive [P] St. Paul, MN. Exhibited: Minneapolis AI, 1937 (prize), 1938 (prize) [40]

MASON, Robert Lindsay [I,P,W] Knoxville, TN b. 5 Je 1874, Knoxville, TN. Studied: H. Pyle. Member: Knoxville AL (Dir.); Wilmington FA Soc. Exhibited: Southern Appalachian Expo (med). Illustrator: Harper's. Author: "Lure of the Great Smokies"; short stories and articles on life in the Great Smoky Mts. [31]

MASON, Roy Martell [P] Batavia NY b. 15 Mr 1886, Gilbert Mills, NY d. 1972. Studied: self-taught. Member: NA; AWCS; SC; All.A.Am.; Audubon A.; Phila. WCC; Buffalo SA; ANA, 1930; Rochester AC; NYWCC; New Haven PCC. Exhibited: Rochester AS, 1928, 1931 (prize); SC, 1930 (prize), 1931 (prize); NAD, 1930 (prize); Rochester Mem. A. Gal., 1931 (prize); AWCS, 1931 (prize); AIC, 1941 (prize); Phila., 1940 (med); Albright A. Gal., 1941 (prize), 1943 (prize); Audubon A., 1945 (prize); Buffalo SA, 1928 (prize). Work: Reading Mus. A.; AIC; Currier Gal. A.; Ill. State Mus.; Univ. Iowa [47]

MASON, William Albert [P,T] Phila., PA b. 25 D 1855, Cambridge, MA d. 23 D 1923. Studied: PAFA. Member: Phila. AC. Position: Dir. Art Edu., Phila. Public Schs. [24]

MASSA, Frederick [P,S,T] NYC b. 9 S 1909, NYC. Studied: Yale Sch. FA; O. Ruotolo. Work: WPA murals, Brooklyn Pub. Lib., St. Giles Hospital (Brooklyn), USPO, Ticonderoga, N.Y. [40]

MASSAGUER, Conrado [Car,I,L] Jackson Heights, NY b. 3 Mr 1889. Member: SI; Dutch Treat C. Work: Lyceum C.; Old Ponce de León House, Havana. Illustrator: Collier's, American Magazine, Literary Digest, New Yorker, Life. Author: collection of caricatures [40]

MASSEE, Clarissa D(avenport) [S,T] Williston, ND. Studied: Paris, with Injalbert, Bourdelle [15]

MASSIE, Julia M. [P] Bains, LA b. 27 N 1875, MS. Member: NOAA. Exhibited: NOAA (gold) [27]

MASSIE, Martha Willis [Ldscp.P] Lynchburg, VA b. 31 O 1894, Three Springs, VA. Studied: H.B. Snell; E. Clark. Member: SSAL. Exhibited: SSAL, 1937 (prize). Work: Robert E. Lee H.S., Lynchburg [40]

MASSON, Margaret [P,Des] NYC b. Peterboro, Ontario. Studied: V. George. Member: N.H. AA; Merrimac Valley AA. Exhibited: House Beautiful Cover Comp. (prize). Illustrator: covers, Better Homes and Gardens, American Home. Work: murals, Concord (N.H.) Lib., Nashua (N.H.) Lib. [38]

MASSON, Raymond [S] Boston, MA [01]

MASSONI, R. [S] NYC [13]

MAST, Gerald [P,T] Providence, RI b. 28 Jy 1908, Topeka, IN d. 1971. Studied: John Herron AI; Detroit Sch. A. & Crafts; J. Carroll. Member: Providence AC. Exhibited: Ind. AC, 1932 (prize); Detroit Inst. A., 1938 (prize), 1943 (prize); Great Lakes Exh., 1938; Albright A. Gal.; R.I. Ar. Work: murals, Franklin settlement, Detroit. Position: T., RISD [47]

MAST, Josephine [P] Brooklyn, NY/Rockport, MA b. NYC. Studied: G.E.Browne; H.B. Snell; H. Lever; A. Fisher. Member: NYWCC; NAWPS; NAC. Exhibited: L.I. Fed. of Women's C., 1935 (prize) [40]

MAST, Karl F., Mrs. See Sinclair, Ellen.

MAST, S.P. [P] Kokomo, IN [24]

MASTBAUM, Jules E. [Patron] Phila., PA d. 7 D 1926. He presented a collection of 200 Rodin bronzes and money for a museum (plans by architects J. Breber, P. Cret) to the city of Phila.

MASTELLER, John R. [P] Chicago, IL b. 10 Jy 1913, Bird Island, MN. Studied: AIC; E. Giesbert; L. Ritman. Exhibited: AIC, 1937, 1938; Am. A. Group, NYC, 1937, 1938. WPA artist. [40]

MASTERS, A. Gerturde [P,T] Haverford, PA. Studied: PAFA. Position: T., Haverford Sch. [25]

MASTERS, Frank B. [I] Brooklyn, NY b. 25 S 1873, Watertown, MA. Studied: C.H. Woodbury; H. Pyle. Member: SI, 1907 [32]

MASTERSON, James W. [I,P,S,W] Miles City, MT (1970) b. 1894, Hoard, WI. Studied: AIC; Chicago Acad. FA; San Jose A. Sch. Author/Illustrator: "It Happened in Montana." Position: T., Custer County Jr. Col. [*]

MASTON, R. Thomas [P] Rochester, NY b. Greenfield, IN. Studied: E.E. Siebert. Member: Rochester AC; Genesseeans [25]

MASTRO-VALERIO, Alessandro [E,P] Ann Arbor, MI b. Italy. Studied: Salvator Rosa Acad., Naples. Member: Chicago SE; SAE; Ann Arbor AA. Exhibited: Chicago SE, 1935 (prize), 1936 (prize), 1937 (prize); SAE, 1935. Work: Fine Prints of the Year, 1935, 1936; NYPL; LOC; Smithsonian. Position: T., Univ. Mich. [40]

MASTROVITO, Ottavia [P] NYC. Exhibited: 48 States Comp., 1939 [40]

MASUROVSKY, Disraeli S. [P] b. the Bronx, NY, 1927 d. 26 Ap 1947, Sarasota, FL. Studied: ASL; Parsons Sch. Des.; MOMA. Illustrator: New Yorker, Saturday Review of Literature, The Nation

MATCHEREK, Karl A. [P] Pittsburgh, PA. Member: Pittsburgh AA [21]

MATHER, Frank Jewett, Jr. [Mus.Dir,Edu,W,L] Princeton, NJ b. 6 Jy 1868, Deep River, CT d. 11 N 1953. Studied: Williams Col.; Johns Hopkins; Univ. Berlin; Ecole des Hautes Etudes, Paris. Member: NIAL; AAAL. Author: "Venetian Painters," 1936, "Western European Painting of the Renaissance," 1939; numerous books on art and artists. Position: T., Princeton, 1910–33; Mus.Cur, Princeton 1922–46 [47]

MATHER, Margrethe [Photogr] b. 1885 d. 1952. Best known for her association with Edward Weston, with whom she worked for 10 yrs. in a similar pictorial style, 1912–20s. Her work is rare. Exhibited: de Young MA, 1931 (after which she stopped photographing). Work: IMP; Univ. Ariz.; Univ. N.Mex.; MOMA; NOMA; SFMA [*]

MATHER, Winifred Holt (Mrs. Rufus G.) [S,Por.S] b. NYC d. 14 Je 1945, Pittsfield, MA. Studied: U.S.; Europe. Noted for her services to the blind throughout the world.

MATHES, Henry A. [P] NYC [24]

MATHESON, Johanna [P] Seattle, WA. Exhibited: Seattle SFA, 1922 [25]

MATHEWS, A.A. [P] Rochester, NY. Member: Rochester AC [17]

MATHEWS, Arthur F(rank) [P,T,C] San Fran., CA b. 1 O 1860, Markesan, WI d. 1945. Studied: arch. with his father; Académie Julian, Paris, with Boulanger, Lefebvre, ca. 1885–89; Holland. Member: Phila. AC. Exhibited: AIA, 1925 (gold). Work: Oakland AM; murals, Oakland Lib.; Calif. State Capitol Bldg.; Univ. Calif. Lib.; Lib., Stanford Univ.; Masonic Temple, San Fran.; MMA; Curran Theatre, San Fran. With his wife, Lucia, popularized the "California Decorative Style" of the Arts & Crafts Movement, through their magazine, "Philopolis" and their gal., "Furniture Shop," from 1906. Positions: T./Dir., Calif. Sch. Des., 1889–1906 [40]

MATHEWS, F(erdinand) Schuyler [I,L,Ldscp.P,W] Cambridge, MA/Plymouth, NH b. 30 My 1854, New Brighton, NY d. 20 Ag 1938. Studied: CUASch; Italy. Author/Illustrator: "Familiar Trees," "Fieldbook of American Wild Flowers," "Fieldbook of Wild Birds and Their Music." Specialties: landscape in water color; illumination. Position: Botanical A., Gray Herbarium, Harvard [38]

MATHEWS, John Eddy [Dr,P] Chicago, IL b. 7 Ap 1912, Chicago, IL. Studied: K. Buehr; Louis Ritman; E.A. Forsberg; R.V.S. Ford. Member: Oak Park AL[40]

MATHEWS, Lucia Kleinhans (Mrs. Arthur F.) [P,I,C] San Fran., CA b. 29 Ag 1882, San Fran. Studied: A.F. Mathews; Whistler. Exhibited: P.-P. Expo, San Fran., 1915 (med). Specialties: theatre dec.; furniture. [See entry for her husband Arthur.] [31]

MATHEWS, William T. [Por.P] Wash., D.C. b. 7 My 1821, Bristol, England (came to Rochester, Ohio, ca. 1833) d. 11 Ja 1905. Active in Ohio, 1840s; studio in NYC, 1850 to late 60s; then in Wash., D.C., where he painted Lincoln, Garfield, Harrison, McKinley. His address was the Corcoran Bldg., where he may have taught. He died in poverty and obscurity. [04]

MATHEWSON, Frank C(onvers) [P] Providence, RI/Wakefield, RI b. 12 My 1862, Barrington, RI d. 24 D 1941. Studied: Laurens; Nat. Sch. Decorative Art, Paris. Member: NYWCC; Providence AC; Providence WCC; AWCS; South County AS; North Shore AA. Exhibited: Providence, 1903 (prize); Providence AC, 1930 (prize). Work: RISD; Univ. C., Providence; BAC; South County AA, Wickford, R.I. [40]

MATHEWSON, Lucy Stickney [P] Wash., DC. Member: Wash. WCC [21]

MATHEY, Paul [E] Paris, France [24]

MATHIESEN, Marie Lokke (Mrs. Finn) [Ldscp.P] Chicago, IL b. 9 Ja 1877, Christiania, Norway. Studied: Christiania; Dresden. Member: Chicago SA [21]

MATHIEU, Hubert Jean [P,S,E,I,L,W] NYC/Westport, CT b. 4 Ja 1897, Brookings, SD. Studied: H. Dunn; H. Raleigh. Illustrator: mags., newspapers, advertising [40]

MATHUS, Henry [P,C] Cranston, RI b. 19 Ap 1870, Boston,MA. Studied: RISD. Member: Providence AC [33]

MATRANGA, Paul [P] Baltimore, MD [25]

MATSCHAT, Cecile Hulse (Mrs.) [P] Croton Falls, NY. Exhibited: NAWPS, 1935–38 [40]

MATSEN, Ida M. [P] Seattle, WA [24]

MATSON, A. Nathalie [Des] Brooklyn, NY [10]

MATSON, Greta [P] Norfolk, VA b. 7 Je 1915, Claremont, VA. Studied: Grand Central Sch. A. Member: NAWA; PBC; SSAL. Exhibited: AIC, 1942, 1943, 1946; CI, 1941, 1944, 1945; Pepsi-Cola, 1945; Albany Inst. Hist.&A., 1940, 1945; Butler AI, 1943–45; VMFA, 1939, 1941–46; NAD, 1941, 1943 (prize), 1944, 1945; SSAL, 1945 (prize), 1946 (prize); Va. Ar., 1943 (prize) 1945 (prize); NAWA, 1943 (prize); State T. Col., Pa., 1945 (prize); Norfolk Mus. A., 1943 (prize). Work: VMFA; Norfolk Mus. A.; State T. Col., Indiana, Pa.; New Britain AI; Texas Tech. Col. [47]

MATSUBARA, Takeji [P] Phila., PA. Position: Associated with PAFA [25]

MATTEI, Antonio (Tony) [P,T,C,I,Li,L] Ogunquit, ME b. 9 Ja 1900, NYC. Studied: CUASch; NAD; ASL. Member: AAPL; Ogunquit AA; Artists U. Exhibited: 4 one-man exh., N.Y.; GGE, 1939; PAFA, 1941–43; CI, 1941; CGA, 1935, 1939; Springfield Mus. A.; VMFA; Albright A. Gal.; NYU; Butler AI; MOMA; Detroit Inst. A.; Minn. Inst. A., etc. Work: NYU; Albright A. Gal.; MOMA; Minn. Inst. A.; Detroit Inst. A.; Navy Base, Portsmouth, N.H.; head of 6-month expedition of 12 artists, painting scenes in Alaska for the Dept. of Interior, 1937. Lectures: Totem Carving in Alaska [47]

MATTEI, Clarence [P] Paris, France b. California. Studied: Laurens, in Paris [10]

MATTEI, Virgilio P. [P,Dec,I] Ponce, Puerto Rico b. 30 Je 1898, Puerto Rico. Exhibited: Exh., Ponce, 1919 (prize). Work: mural, Masonic Mausoleum, Ponce [40]

MATTEOSSIAN, Z.N. [P] NYC [13]

MATTERN, Alice [P] b. 1909, NYC d. 19 Ag 1945. Studied: NYC. Exhibited: Mus. Non-Objective Painting, 1946

MATTERN, Karl [P,L,T] Lawrence, KS b. 22 Mr 1892, Durkheim, Germany d. 18 Ja 1969, Des Moines, IA. Studied: AIC; G. Bellows. Member: Kansas A.T. Assn. Exhibited: AIC, 1925, 1927, 1928, 1931, 1934, 1936, 1937, 1939, 1940, 1942–44, 1946; BM, 1937, 1939, 1945; PAFA, 1929–31, 1933–35, 1939, 1940; WMAA, 1944; Colorado Springs FA Center, 1935–38, 1941, 1945, 1946; CAM, 1944, 1945; Kansas City SA, 1934 (prize); Kansas City AI, 1928 (prize), 1932 (med), 1934 (prize); GGE, 1939 (prize). Work: BM; IBM Coll.; Nebr. AA; Wichita Mus. A.; Denver AM; Baker Univ., Baldwin City, Kans. Position: T., Univ. Kans., 1941– [47]

MATTESON, Barlow V(an) V(oorhis) [Li,I,P] NYC/Saugerties, NY [33]

MATTHAEI, Beatrice E. [E,P,T] Houston, TX b. Arlington Heights, MA. Studied: N.Y. Sch. FA; ASL; PAFA; Univ. Calif. Member: Houston MFA; Houston A. Gal.; AFA. Exhibited: Houston MFA, 1935 [40]

MATTHEW, John Britton [P,T,L] Sacramento, CA b. 16 S 1896, Berkeley, CA. Studied: Univ. Calif.; AIC; H. Hofmann; L. Kroll; H. McFee. Exhibited: Calif. State Fair; Crocker A. Gal.; Laguna Beach AA. Work: murals, Ft. Ord, Calif. Position: T., Sacramento Col., 1926–46 [47]

MATTHEWS, A.G. [P] Etaples, Pas-de-Calais, France [10]

MATTHEWS, A(nna) Lou [S,P,T,L] Green Bay, WI/Big Suamico, WI b. Chicago, IL. Studied: AIC, with Taft, Vanderpoel; Chicago A. Acad.; Paris, with Simon, M. Bohm, Garrido; Ecole des Beaux-Arts, Paris; Brangwyn, in London. Member: A. Chicago PS. Exhibited: Minn. State Art Comm., 1913, 1914 (prize); AIC, 1921 (prize), 1929 (prize); Mun. AL, Chicago, 1932 (prize). Work: St. Paul Inst. A.; Juvenile Court Room, Walter Scott Sch. (murals), Rosenwald Coll.; Mun. AL Coll., City of Chicago Coll., all in Chicago; Assembly Hall, Jr. Col., Harvey, Ill.; murals, Lib., West High; Neville Pub. Mus., Green Bay, Wis. Position: T., Vocational Sch., Green Bay [40]

MATTHEWS, Elizabeth St. John (Mrs.) [S] NYC b. 25 Ja 1876, Phila. d. 27 Ap 1911. Studied: L. Tadd, in Phila.; L. Gerardet, in Paris; O.L. Warner, in NYC. Member: Intl. Jury Awards, St. Louis Expo, 1904. Work: bust of President Taft [06]

MATTHEWS, Lester Nathan [S,P,C,Des,Gr] Los Angeles, CA b. 8 Ag 1911, Pittsburgh. Studied: Calif. Col. A. & Crafts; S. Johnson; M.B. Young; W. Ryder; Calif. Sch. FA. Member: San Fran. AA; Ar. Un., San Fran. Exhibited: AIC; Oakland A. Gal.; SFMA, 1939 (prize); GGE, 1939; Sacramento A. Center. Work: S., Stockton (Calif.) Jr. Col.; Salina (Calif.) Jr. Col.; Ft. Ord, Calif.; Sacramento A. Center [47]

MATTHEWS, Lou (Mrs. Anna Bedore) [P,T] Lake Geneva, WI b. 26 Je 1882, Chicago. Studied: AIC, with L. Taft; Grande Chaumière, Paris, with T. Simon; London Sch. A., with F. Brangwyn. Member: Chicago P.&S.; Green Bay A. Colony. Exhibited: PAFA, 1930; AIC, 1926 (prize), 1930 (prize), 1933 (prize), 1944; Green Bay A. Colony; South Side Community A. Center, 1925 (prize). Work: Rosenwald Coll.; Mun. AL, Chicago; Green Bay A. Mus., Neville Pub. Mus., West High Lib., all in Green Bay, Wis; Chicago Mun. Coll. Position: Supv. A., Pub. Sch., Indianapolis [47]

MATTHEWS, Nanna B. [P] Boston, MA. Studied: A.E. Klumpke, in Boston; Bouguereau; Académie Julian; H. Bourée, in Paris [04]

MATTHEWS, William F. [P] Brooklyn, NY b. 1878, St. Louis, MO. Studied: St. Louis Sch. FA. Member: St. Louis AG; 2 x 4 S.; Soc. of Ancients; Brooklyn SA; Kit-Kat C.; PS; Arch. Lg. Exhibited: St. Louis AG, 1914 (prize), 1915 (prize) [33]

MATTHEWSON, F.C. [P] Providence, RI. Member: AWCS. Exhibited: AWCS, 1898 [98]

MATTHIAS, Martha [P,I,C,T] Los Angeles, CA b. 1 S 1903, Los Angeles, CA. Studied: Univ. Calif., Los Angeles. Member: Calif. WCS [33]

MATTINGLY, M.L. [P] Wash., D.C. Member: Wash. WCC [01]

MATTIO, Christy [Des,Arch] Cleveland, OH b. 22 F 1903, Conneaut, OH. Studied: Cleveland Sch. A. Member: AFA; Arch. Lg. of West. Exhibited: Cleveland A. Exh., 1932 (prize). Work: des./redecorating Cleveland City Hall [40]

MATTISON, Donald M. [P,T] Indianapolis, IN b. 24 Ap 1905, Beloit, WI d. 1975. Studied: E.F. Savage; Yale; Am. Acad., Rome. Member: Mural P.; N.C. Prof. A.; Grand Central AG; Ind. AC. Award: Prix de Rome, 1928. Exhibited: Indianapolis AA, 1935 (prize). Work: Yale Mus. of the Sch. FA; mural, Albert H. French Co., NYC; Cities Service Bldg., NYC; WPA mural, USPO, Tripton, Union City, both in Ind. Position: Dir., Herron A. Sch. [40]

MATTOCKS, Muriel. See Cleaves.

MATTOX, Charles Porter [E,Li,Mur.P,T,W] NYC b. 21 Jy 1910, Bronson, KS. Studied: B. Sandzen; E. Bisttram; J.D. Patrick; J. de Martelley. Exhibited: Kans. State Exh., 1928 (prize); Mid Western Exh., Kansas City, 1930. Position: Tech. Supv., College AA, WPA [40]

MATTSON, Henry E(lis) [P] Woodstock NY b. 7 Ag 1887, Gothenburg, Sweden d. 1971. Studied: WMA. Member: Woodstock AA; F., Guggenheim, 1935. Exhibited: AIC, 1931 (prize); WMA, 1933 (prize); CGA, 1935 (prize), 1943 (prize); CI, 1935 (prize); Ft. Dodge Mus., 1940 (prize); PAFA, 1945 (med); SC, 1946 (med). Work: MMA; WMAA; CI; CAM; CGA; Wichita AM; WMA; BM; CMA; Toledo Mus. A.; CM; Santa Barbara Mus. A.; Kansas City AI; Detroit Inst. A.; Ft. Dodge Mus. A.; murals, USPO, Portland, Maine; PMG; Mun. AG, Davenport, Iowa; White House, Wash., D.C.; Newark Mus. WPA artist. [47]

MATULKA, F. [P] NYC [17]

MATULKA, Jan [P] NYC b. 7 N 1890, Prague, Czechoslovakia d. 1972. Studied: NAD; G.W. Maynard; Paris, 1917 (NAD scholarship) Exhibited: CI, 1944; WMAA, 1944; ACA Gal., 1944. Work: WMAA; NYPL; PAFA; SFMA; Detroit Inst. A.; Cincinnati Mus. Working on representational cubism, 1930s. Lived in Paris, 1951–55. Position: T., ASL, 1940s [47]

MATZAL, L(eopold) C(harles) [P,T,L] Newark, NJ b. 13 Ag 1890, Vienna, Austria. Studied: Austria. Member: SC; Artists U. Exhibited: A. Center, Orange, N.J., 1927 (prize); Newark, 1934 (med). Work: State House, Trenton, N.J.; Hoboken City Hall; Hoboken Pub. Lib.; Jersey City Hall; murals, Jersey City Lib.; mural Branch Brook Sch., Newark. Position: T., Newark Sch. F.&Indst. Art [40]

MATZEN, Herman N. [S,T] Cleveland, OH b. 15 Jy 1861, Loit Kjerkeby, Denmark (came to Detroit as a boy) d. 22 Ap 1938. Studied: Munich and Berlin Academies FA, 1896. Member: NSS; NAC; Cleveland SA. Exhibited: Berlin Expo, 1895 (med), 1896 (med); Lincoln Mem. Comp., Milwaukee, 1933 (prize). Work: monuments, Detroit; Akron County Court House; Cleveland Court House; Lake County Court House; Cleveland Pub. Square; Harvard; Western Reserve Univ.; colossal groups, War and Peace, Indianapolis. Position: T., Cleveland Sch. A. [38]

MATZINGER, Philip F(rederick) [P] Pasadena, CA b. 1860, Tiffin OH d. 18 Je 1942. Studied: J. Vanderpoel, AIC [40]

MATZKE, Albert [P,I] NYC b. 8 Ag 1882, Indianapolis, IN. Studied: ASL, with DuMond, G. Bridgman [25]

MATZKES, F.W. [P] Pittsburgh, PA. Member: Pittsburgh AA [25]

MATZKIN, Meyer [Mur.P,Por.P] Roxbury, MA b. 25 N 1880, Russia. Studied: self-taught [40]

MAUCH, Carl [P,I] Chicago, IL b. 7 Ja 1854, Stuttgart, Germany d. 18 Je 1913 (he had become despondent because he was losing his sight). Studied: Stuttgart Acad., with Noeher, Rustige, Piloty, C. Buehr. Member: Palette and Chisel C., Chicago (Pres.) [10]

MAUCH, F.A. [P] Pittsburgh, PA. Member: Pittsburgh AA [21]

MAUCH, Max [S] Chicago, IL b. 6 F 1864, Vienna, Austria (came to U.S. in 1891) d. 13 F 1905. Studied: Vienna Acad. A., with C. Kündmann. Member: Chicago Municipal Art Society (founder); Chicago Arch. C.; Chicago SA [04]

MAULL, Margaret Howell [I] Phila., PA b. 22 Je 1897, Whitford, PA. Studied: PAFA; H. McCarter. Member: Phila. AG [33]

MAUNSBACH, George Eric [Por.P,S,W,L,T,Dr,E,Li] NYC b. 5 Ja 1890, Helsingborg, Sweden. Studied: Stockholm Acad., with A. Zorn; Royal Acad., with Sargent; BMFA Sch., with Pape; Landis, France; Carson, in England. Member: AAPL; Scandinavian-Am. A. Exhibited: BM; AIC; NAD; PAFA; Paris Salon; Newport AA. Work: Columbia; Marywood Col., Scranton, Pa.; World Works Coll., Wash. D.C.; Am. Soc. Composers, Authors & Publ., NYC; Lincoln and Benjamin Franklin Hotels, NYC; Court House, Easton, Pa.; Ft. Dix, N.J.; Symphony Hall, Detroit; LOC; Cavalry Armory, Brooklyn; Ft. Jay; Ft. Slocum; Camp Upton; Lawrence Univ.; Supreme Court, Louisville, N.Y.; Swedish-Am. Hospital, Rockford, Ill.; Supreme Court, Schenectady; U.S. Court of Appeals, Albany; Supreme Court, Elizabethtown, N.Y.; Wilbraham Acad.; Browning Fnd., NYC; Belgium Bureau, NYC; Inst. Music, Tulsa, Okla.; Snug Harbor, N.Y.; Mus., Venice, Italy; Berlin, Germany; Engineers C., Stockholm, Sweden; Governor's Island, N.Y. [47]

MAUNSBACH, Olin C. [P] NYC. Member: S.Indp.A. [24]

MAURER, Alfred H(enry) [P] NYC b. 21 Ap 1868, NYC d. 4 Ag 1932 (discouraged because of ill health, he took his life only a couple of weeks

after the death of his centenarian father, Louis). Studied: NAD, with Ward, 1884; Académie Julian, Paris, 1897. Member: Paris AAA; Paris SAP. (He lived in Paris, 1897–1914.) Exhibited: SC, 1900 (prize); CI, 1901 (prize); Worcester, 1901 (prize); Pan-Am. Expo, Buffalo, 1901 (med); St. Louis, 1904 (med); Liège Expo, 1905 (med); Intl. Expo, Munich, 1905; Paris Salon (prize); Stieglitz' "291" Gal., NYC, 1909; Armory Show, 1913; Forum Exh. Mod. Am. P., 1916; S.Indp.A., 1917–32; Nat. Coll., 1973 (retrospective). Work: Mem. Hall Mus., Phila.; PMG; Barnes Coll., Phila.; Hirschhorn Mus.; Univ. Minn. The first American painter to abruptly drop the traditional Impressionist style (1905–07) and quickly adapt to Fauvism. [31]

MAURER, Charles G. [P] Phila., PA b. Lorraine, France (1844) (came to U.S. in 1849) d. 26 My 1931. Studied: PAFA, 1858. Work: portraits of prominent Philadelphians

MAURER, Louis [P] NYC b. 21 F 1832, Biebrich, Germany (came to U.S. in 1851) d. 19 Jy 1932. Studied: at age 52, with W. Chase, 1884 Worked in lithography firm of T.W. Strong, 1852; Currier & Ives, 1852–60; Major & Knapp, ca. 1861; then headed Maurer & Heppenheimer, 1872–84. After retiring in 1884, painted until his death at over 100 yrs. Exhibited: Old Print Shop, NYC, 1931 (at 99). Father of Alfred H. [31]

MAURER, Sascha A. [Des,P] NYC b. 18 Ap 1897, Munich, Germany d. 16 Mr 1961. Studied: Sch. Appl. A., Acad. FA, both in Munich, Germany. Member: AG; SI; Audubon A.; Rockport AA; AAPL. Exhibited: Argent Gal., 1945 (one-man); Audubon A., 1945, 1946; Rockport AA, 1945; All.A.Am., 1941, 1942; AWCS, 1939–46; A. Dir. Exh., Rockefeller Center, 1936, 1937, 1938 [47]

MAURONER, Fabio [E] Venice, Italy b. 22 Jy 1884, Tisano, Italy. Studied: E.M. Lynge. Member: Chicago SE; Calif. PM. Work: NYPL; AIC [29]

MAURY, Cornelia Field [P] St. Louis, MO b. New Orleans, LA. Studied: St. Louis Sch. FA; Académie Julian, Paris. Member: St. Louis AG; S.Indp.A., St. Louis; SSAL; Southern PM Soc.; Chicago SE. Exhibited: Portland Expo, 1905 (med); Kansas City AI, 1923; St. Louis AL, 1926 (prize), 1927; 1931 (prize); S.Indp.A., 1931 (prize); Mo. State Fair, 1932 (prize). Work: CAM; St Louis Pub. Lib; NGA [40]

MAURY, Louisa M. [P] NYC [01]

MAUST, Adele Van Gunten (Mrs. R.W.) [Min.P] NYC. Studied: PAFA [08]

MAUST, Henry [P] Chicago, IL. Member: GFLA [27]

MAUZEY, Merritt [Li,P,I,W] Dallas, TX b. 16 N 1898, Clifton, TX d. 1975. Member: Guggenheim F., 1946; Dallas Pr. S.; Tex. FAA; Dallas AA; AAPL; CAFA; Tex. A. T. Assn. Exhibited: WFNY, 1939; WMAA, 1939; MMA; NAD, 1939–46; PAFA, 1939–46; CAFA, 1939–44; AIC, 1939; Dallas Mus. FA (prize); Dallas All. A. (prize); Tex. FAA (prize). Work: AIC; CGA; LOC; PMA; PAFA; MMA; Witte Mem. Mus.; Elisabet Ney Mus.; Houston MFA; Fondren Lib., Dallas; Dallas Mus. FA. Author/Illustrator: "Texas Ranch Boy" (1955). Contributor: "The Artist in America," "Prize Prints of the 20th Century" [47]

MAVERICK, Lucy Madison [P] San Antonio, TX [24]

MAWICKE, Tran [I,P] Bronxville, NY. Member: SI; AWCS [47]

MAXEY, (H.) Holderread [P] NYC b. 4 d 1907, Des Moines, IA. Studied: S. Halpert; J.P. Wicker. Member: Detroit S.Indp.A. [33]

MAXEY, Katherine [P] Wheaton, IL [15]

MAXFIELD, J.E. [P] Ridgefield, NJ. Member: SC 1890 [04]

MAXON, Edith (Mrs. Paul G. Swars) [S,Des,W] NYC b. 28 Je 1883, Ft. Davis, TX. Studied: Milwaukee AI; Westchester County Center; Vienna. Specialty: designing toys and display materials [40]

MAXWELL, Coralee DeLong [S] Cleveland, OH b. 13 S 1878, Ohio. Studied: H. Matzen; Cleveland Sch. A. Member: NSS. Exhibited: CMA, 1926; Bernards Gal., NYC, 1928 (prize). Work: fountain, Newark, N.J. [40]

MAXWELL, Guida B. [P] Phila., PA b. Phila. Studied: F. Wagner; M. Walter. Member: Phila. Alliance; Lyceum C., London [29]

MAXWELL, H.J. [P] Columbus, OH. Member: Columbus PPC [25]

MAXWELL, John Alan [I,Li,L] NYC b. 7 Mr 1904, Roanoke, VA. Studied: Corcoran Sch. A.; ASL; Bridgman; DuMond; Luks; Pennell. Member: SI. Illustrator: "Hang My Wreath," 1941, "If Judgment Comes," 1944, "The Selected Works of Washington Irving," 1946, other books. Contributor: New Yorker; Golden Book, Life, American [47]

MAY, Beulah [S,W,I] Santa Ana, CA b. 24 Je 1883, Hiawatha, KS. Studied: AIC; PAFA; L. Taft; F. Mulligan; C. Grafly; W. Chase. Member: Calif. AC; Ebell Soc., Santa Ana; Laguna Beach AA; Santa Ana AG. Exhibited: Southern Calif. Exh.; Calif. AC; Calif. Fed. Women's C.; Santa Ana AG. Author/Illustrator: "Buccaneer's Gold," 1935 (won book prize, All. A. Fest., Los Angeles). Co-author: "Cuentes de California," 1937; book of paintings of Evelyn Nunn Miller [47]

MAY, Charles C. [P,Arch] NYC b. 8 Jy 1883, Lee, MA. Member: AIA [27]

MAY, Florence (Lister) Land (Mrs.) [P] NYC b. Caddo Parish, LA. Studied: self-taught. Work: San Fran. Inst. A. [15]

MAY, M. Stannard [P] Providence, RI [24]

MAY, Margaret S. [P] Paterson, NJ [19]

MAY, Thomas [Cart] Detroit, MI b. 30 Je 1860, Detroit d. 2 D 1927. Work: His masterpiece of pencraft was a sketch entitled "Forgotten," 1907, reproduced internationally for charity appeals. Position: Staff, Detroit Journal, since 1892 [21]

MAYBEE, Eli D. [P] Paris, France [15]

MAYBELLE, Claude S. [Car] NYC b. 1872, Portland, OR. Studied: San Fran. Sch. Des. Position: Affiliated with Brooklyn Eagle [08]

MAYER, A.E. [P] NYC. Member: S.Indp.A. [25]

MAYER, Bela [P] NYC/Port Wash., N.Y. b. 5 Ag 1888, Hungary. Studied: C.Y. Turner; Olinsky; Ward. Member: SC; Gld. Am. P.; Allied AA [33]

MAYER, Bena. See Frank.

MAYER, Casper [S] Astoria, NY b. 24 D 1871, Bavaria d. 12 Ag 1931. Studied: J.Q.A. Ward; CUASch; NAD. Member: Cong. A.&Sc. Exhibited: St. Louis Expo, 1904 (med). Work: Albany State Mus.; Explorers C.; AMNH. Specialty: life-size casts of American Indians, particularly tribes native and contiguous to N.Y. State. Position: Anthro. A., AMNH [29]

MAYER, Constant [P] Paris, France b. 3 O 1829, Besançon France (came to NYC in 1857) d. 12 My 1911, Paris (became a U.S. citizen but spent his last 16 yrs. in Paris). Member: Chevalier, Legion of Honor; Paris Salon (hors concours); ANA, 1866; AS Français [08]

MAYER, Edward A(lbert) [P] Chicago, IL b. 8 Ja 1889, Columbus, OH [24]

MAYER, Francis Blackwell [P] b. 27 D 1827, Baltimore, MD d. 28 Jy 1899, Annapolis. Studied: Baltimore, with A.J. Miller; Paris, with Gleyre, Brion. Author: "With Pen & Pencil on the Frontier," 1850s. Specialties: Colonial subjects; Plains Indians. Active in Paris, 1864–70; Baltimore and Annapolis, 1870–99 [*]

MAYER, Fred. A. [I,Des,Car] NYC b. 4 Ap 1904, Ober-Ingelheim, Germany. Studied: Berlin A. Col., with L. Bernhard. Illustrator: "Nana," 1936, "Sonnets from the Portuguese," 1938, "Merchant Adventurers"; Forum, St. Nicholas; McCall's; New York Times, Herald Tribune, Brooklyn Eagle; Metro-Goldwyn-Mayer and United Artists film companies [47]

MAYER, Grace M. [Mus.Cur] NYC b. NYC. Arranged many exh., including "Currier and Ives and the N.Y. Scene," 1938; "Philip Hone's N.Y.," 1940; "N.Y. between Two Wars," 1944; "Charles Dana Gibson's N.Y.," 1950; many others. Position: Cur., N.Y. Iconography, Mus. City of N.Y., 1931– [47]

MAYER, Henrik Martin [Por.P,Mur.P,I,T,Li] Essex, CT b. 24 D 1908, Nashua, NH. Studied: Manchester Inst. A.&Sc.; Yale.; Maud Briggs Knowlton. Member: Ind. AC; Phila. WCC; Audubon A.; S.Indp.A.; Mural P. Exhibited: NAD, 1938 (prize), 1941 (prize), 1943–45; Springfield AL, 1940 (prize); CAFA, 1941 (prize); Herron AI, 1937 (prize), 1942 (prize), 1943 (prize), 1945 (prize); Hoosier Salon, 1935 (prize); AIC, 1937; Toledo Mus. A., 1938, 1945; GGE, 1939; CGA, 1940, 1943, 1946; PAFA, 1941, 1942, 1944, 1945; CI, 1938, 1939, 1945; Toronto Mus., 1940; Montreal Mus., 1940; CAM, 1939, 1940; CM, 1941; Butler AI, 1945; Herron AI, 1934–46. Work: Ind. Univ.; Ind. State T. Col.; Herron AI; murals, Women's Cosmopolitan C., N.Y.; U.S. Marine Hospital, Louisville, Ky.; WPA murals, USPOs, Lafayette, Aurora, both in Ind. Positions: T., Herron AI, 1933–46; Dir., Hartford A. Sch., Wadsworth Atheneum, 1946 [47]

MAYER, Henry ("Hy") [I,E] b. 18 Jy 1868 d. 21 Ap 1953, Grossinger, NY. Author/Illustrator: "Autobiography of a Monkey," "Fantasies in Ha-Ha," "A Trip to Toyland," "Adventures of a Japanese Doll," "Hy Mayer Puck Album," "In Laughland" [31]

MAYER, Jane Smith (Mrs.) [B,P,T,W] Salina, KS b. 24 Ag 1883, Lincoln Co., KS. Studied: B. Sandzen. Member: Salina AA [32]

MAYER, Jessie Hull [P] Indianapolis, IN b. 28 Jy 1910, New Haven, CT. Studied: Yale. Work: WPA murals, USPO, Culver, Jasper, both in Ind. [40]

MAYER, Jules [P] NYC b. 3 Ag 1911, Baltimore, MD. Studied: L. Kroll; G. Beal. Member: N.Y. Artists U. Work: murals, Hotel New Yorker [40]

MAYER, Louis [P,S] Hopewell Junction, NY b. 26 N 1869, Milwaukee. Studied: M. Thedy, in Weimar; P. Hoecker, in Munich; Paris, with Constant, Laurens. Member: All.A.Am.; Wis. PS. Exhibited: P.-P. Expo, 1915 (med); St. Paul AI, 1915 (med); AIC, 1919; Milwaukee AI, 1922; NAD; PAFA; Copley S.; AIC; Milwaukee AI. Work: McKinley Birthplace Mem.; Hist. S. Iowa; Hist. S., Wis.; Milwaukee AI; Burlington, Iowa Pub. Lib.; Nat. Mus., Wash., D.C.; Rand Sch. of Social Sc., NYC; American Labor; S.S. "Milwaukee"; Intl. Inst. of China, Shanghai [47]

MAYER, Milton [P] NYC. Member: S.Indp.A.; New Rochelle, AA [25]

MAYER, Peter Bela [P,Des] Port Wash., N.Y. b. 5 Ag 1888, Loeche, Hungary. Studied: NAD; C.Y. Turner. Member: SC; AAPL; All.A.Am. Exhibited: CGA, 1937; Nat. Acad., 1938; SC, 1938; All.A.Am., 1939; PAFA [47]

MAYER, Ralph [W,P,L,T] NYC b. 11 Ag 1895, NYC. Studied: Renssaelaer Polytechnic Inst.; ASL. Member: Am. Ar. Cong. Author: "The Artists Handbook of Materials and Techniques," 1941 [47]

MAYER, William G. [P] Pittsburgh, PA. Member: Pittsburgh AA [21]

MAYERSON, John H. [P] Phila., PA [10]

MAYFIELD, R(obert) B(ledsoe) [P,E] New Orleans, LA b. 1 Ja 1869, Carlinville, IL d. Winter, 1936. Studied: St. Louis Sch. FA; Académie Julian, with Lefebvre, Constant. Exhibited: NOAA (gold). Work: Delgado Mus., New Orleans. Position: Asst. Ed., New Orleans Times-Picayune [33]

MAYHEW, Nell Brooker [Ldscp.P,E] Los Angeles, CA b. Astoria, IL. Studied: Univ. Ill., with N.A. Wells; J. Johansen, at AIC. Member: Laguna Beach AA. Exhibited: Alaska-Yukon-Pacific Expo, Seattle, 1909 (med). Work: State Lib., Sacramento; Oreg. State Mus., Salem; mural, Mayo Clinic, Rochester, Minn.; mural, Mem. Lib., Ashton, Ill. [40]

MAYNARD, George W(illoughby) [P] NYC b. 5 Mr 1843, Wash., D.C. d. 5 Ap 1923. Studied: NAD, NYC; Royal Acad, Antwerp. Member: ANA, 1881; NAD, 1885; SAA, 1880; AWCS; A. Aid S.; SC; Century A. Exhibited: PAFA, 1884 (gold); Am. AA, NYC, 1888 (med); AWCS, 1889 (prize); Columbian Expo, Chicago, 1893 (med); SAA, 1897 (prize); Pan-Am. Expo, Buffalo, 1901. Work: St. John's Church, Jamaica Plain, Mass.; Bijou Theatre, Boston; Metropolitan Opera House; Appellate Court House, NYC; panels, LOC; Essex County Court House, Newark; Boston Pub. Lib.; Columbia Lib.; MMA; PAFA; NGA; NAD [21]

MAYNARD, Guy [P] Grez-sur-Loing, Seine-et-Marne, France b. Chicago, IL. Studied: AIC; Paris [04]

MAYNARD, Harold B. [P,Et] b. 1866, Brooklyn, NY d. 12 N 1941, Brooklyn

MAYNARD, Harold Milton [P] NYC [15]

MAYNARD, Richard Field [P,S,W,I] Old Greenwich, CT b. 23 Ap 1875, Chicago. Studied: Cornell; Harvard; ASL; N.Y. Sch. A.; W. Chase; I. Wiles; J. De Camp; Blum. Member: N.Y. Soc. Painters; All.A.Am.; Authors Lg. Am.; AWCS; NYWCC; MacD. C. Exhibited: NYWCC; NAD; AWCS; NAC; Phila. WCC; CGA; AIC. Author/Illustrator: short stories, for Scribner's and others [47]

MAYO, Reba (Harkey) (Mrs. W.P.) [P,I,Car,T] Prestonsburg, KY b. 9 My 1895, Bryant's Mill, TX. Studied: Southwest Tex. State T. Col.; Oklahoma Univ. Member: AWCS; SSAL; Louisville A. Center. Exhibited: SSAL, annually; Kentucky & Southern Ind. Exh., annually; Ky. Fed. Women's C. (prize) [47]

MAYOR, Alpheus Hyatt [Mus.Cur,W,L] NYC b. 28 Je 1901, Annisquam, MA. Studied: Princeton Univ.; Oxford Univ.. Member: Grolier C. Author: "Life in America," 1939, "The Bibiena Family," 1945. Position: Cur. Prints, MMA, 1932– [47]

MAYOR, Harriet Hyatt Randolph (Mrs.) [P,S,T] Princeton, NJ/Annisquam, MA b. 25 Ap 1868, Salem, MA. Studied: H.H. Kitson, D. Bunker, in Boston. Member: AAPL; NAC. Worked with sister Anna Hyatt Huntington. Work: Princeton Univ.; CI; Woods Hole, Mass.; Gloucester, Mass.; Annapolis, Md.; Newport News, Va.; Brookgreen Gardens, S.C.; S. Experimental Psychologists, Cornell Univ. [40]

MAYS, Paul (Kirtland) [Des,I,Mur.P] Carmel, CA b. 4 O 1887, Cheswick PA d. 30 Je 1961. Studied: ASL, 1907–10; Hawthorne, 1911; Newlyn Sch.,

London, 1923–24; Acad. Colarossi, Acad. Grand Chumière, both in Paris; W.M. Chase; J. Johansen; A. Robinson; E. Proctor; H. Harvey; H. Keller. Member: NSMP; Carmel AA. Exhibited: CGA; WMAA, 1938; Palace Legion Honor, 1938; Carmel AA, 1923, 1942, 1946; Stendahl Gal., Los Angeles, Calif. Work: murals, White House, Wash., D.C., USPO, Norristown, Pa; Univ. Pa.; Bryn Athyn Lib.; Oberlin Col. Illustrator: Benjamin Franklin's "Autobiography," pub., Salvat, Barcelona, Spain [47]

MAZESKI, Walter Adolph [P,Des,I,Car,Gr,L,T] Elmwood Park, IL b. 28 Jy 1909, Globe, AZ. Studied: AIC; C. Schroeder; F. Chapin; C. Wilimovsky; L. Cheskin. Member: Am. A. Assn.; Ill. SA; Polish AC. Exhibited: Chicago World's Fair, 1933; AIC, 1937–46; Polish AC, 1929–33 (prizes), 1934, 1935, 1936 (prize), 1937 (prize), 1938, 1939, 1940 (prize), 1941, 1942 (prize), 1943–45; Milwaukee AI, 1940, 1942 (prize). Work: Polish Nat. All. Archives & Mus.; Kosciuszko Fnd.; scenery and properties for Polish Day, 1934 [47]

MAZIERES, Marquise de Traysseix [P] NYC. Member: S.Indp.A. [24]

MAZIO, Gertrude Greenblatt [P,Des,T] Columbia, MO b. 26 N 1915, Phila. Studied: Graphic Sketch C., Phila.; Sch. Des. for Women, Phila. Exhibited: PAFA; Phila. A. All.; St. Louis A. Center (one-man); Sch. Des. for Women, 1938 (prize). Work: Phila. A. All. Position: T., Recreation Comm., Columbia, Mo. [40]

MAZUR, Wladyslaw [S] Cincinnati, OH b. 3 My 1874, Jaslo, Poland. Studied: Acad. FA, Vienna. Member: Salon d'Automne, 1904. Exhibited: P.-P. Expo, 1915 (med) [21]

MAZZANOVICH, L(awrence) [Ldscp.P] Tryon, NC b. 19 D 1872, CA. Studied: AIC; ASL. Member: SC, 1905; NAC, 1913; AFA. Work: Hackley Gal., Muskegon, Mich.; AIC [33]

MAZZEO, Natale [P] Bloomfield, NJ [24]

McADAMS, Gladys Wilson [Por.P,T] Lexington, KY b. Cynthiana, Ky. Studied: Univ. Ky.; ASL; AIC; W. Adams; G. Bellows; E. Ashe; A.V. Tack; E. Speicher; H.B. Snell. Member: Louisville AC; Louisville AA; SSAL. Exhibited: Pencil and Brush Cl., Lexington (Ky.); SSAL, 1934, 1935, 1936 (prize), 1937–43; Soc. Wash. A., 1936 (med); NAD, 1936; CM; N.Y. Municipal Exh., 1936, 1937; AIC; TMA; Montross Gal., 1939. Position: T., Pub. Sch., Lexington, Ky. [47]

McAFEE, Ila (Mrs. Elmer Turner) [P,I,Des,Mur.P] Taos, NM b. 21 O 1900, Gunnison, CO. Studied: Western State Col., Gunnison; ASL; NAD. Member: Taos AA. Exhibited: Denver AM, 1936; 48 Sts. Comp., 1939. Work: murals, USPOs, Cordel (Okla.), Edmond (Okla.), Gunnison (Colo.), Clifton (Tex.); Denver AM; Mus. N.Mex.; Baylor Univ.; Koshare Mus., Colo. Specialty: horses and other animals. WPA artist. [47]

McALISTER, R.F. [I] Columbus, OH. Member: Pen and Pencil Cl., Columbus [24]

McALLISTER, Abel Franklin [P,Des,C] Chicago, IL b. 9 S 1906, Herington, KS. Studied: E. Giesbert; Univ. Chicago. Member: Renaissance Soc., Univ. Chicago; Am. Ar. Prof. Lg. Exhibited: Union Lg. Cl., Chicago, 1929 [40]

McALLISTER, E.P. [P] San Fran., CA [17]

McALLISTER, Ethel Louise [P,T,I] Wash., D.C. b. 7 Ap 1898, Providence, RI. Studied: Brooke; Tarbell; Critcher; B. Perrie [21]

McALLISTER, V. Jane [P,Des,T,L] Ypsilanti, MI/Delaware, OH b. 10 O 1912, Portsmouth, OH. Studied: PIASch; Ohio State Univ.; Guy Pène DuBois. Member: Ohio WC Soc.; Ark. WC Soc.; Columbus (Ohio) A. Lg.; Am. Assn Univ. Prof. Exhibited: Philbrook A. Center, 1941 (one-man); Univ. Ark.; Henderson Col., Conway, Ark.; Detroit Inst. A., 1945; Ohio Valley A. Exh., 1943, 1944; Ohio WC Soc., 1946; Ann Arbor A., 1944–46; Ark. WC Soc., 1941, 1942. Work: Univ. Ark.; Liberty Church, Delaware, Ohio. Lecture: Mexican Colonial Architecture. Position: T., Mich. State Normal Col., Ypsilanti, 1942– [47]

McARDLE, Harry Arthur [P,T] b. 9 Je 1836, Belfast, Ireland (came to US. 1847 [1851?]) d. 16 F 1908, San Antonio, TX. Studied: Belfast, with Sauveur; Md. Inst., with D.A. Woodward. Active in Richmond, Va. in the 1860s; settled in Independence, Tex. after the Civil War; taught at Baylor Female Col. An historical and military painter, he died in financial straits. Nineteen years after his death the state of Texas finally paid his heirs $25,000 for his major paintings, "Dawn" and "Battle." [*]

McARDLE, Jay [I] NYC. Member: SI [47]

McARTHUR, Betty [P] Columbus, MS. Member: SSAL. Living in Tuskegee, Ala., 1904. [27]

McARTHUR, Carolyn [P,Gr,T] NYC b. Newton, KS. Studied: Univ.

Chicago; AIC; ASL; F. Chapin; L. Ritman; W. Barnet. Exhibited: Phila. WCC, 1938; PAFA, 1938; Oakland A. Gal., 1938; LOC, 1944; CI, 1944; AIC, 1939; Gallery House, Chicago, 1939; Contemporary A. Gal., 1944; Am.-British A. Center, 1944, 1945; Norlyst Gal., 1945. Position: T., Child Education Fnd., NYC, 1944-46 [47]

McARTHUR, Leon [P] Montgomery County, PA [04]

McAULEY, John K. [I] NYC b. 1865, Morristown, PA. Studied: NAD; Académie Julian, Paris [01]

McAULEY, Mary E. [P] Pittsburgh, PA. Member: Pittsburgh AA [21]

McAULIFFE, James J. [P] b. 1848, St. John's, Newfoundland d. 22 Ag 1921, Medford, MA. Studied: Boston A. Sch. Work: Roman Catholic Cathedral, St. John's; Parlin Library, Everett, Mass. Specialties: religious and marine subjects

McAULIFFE, T.J. [S] Worcester, MA [17]

McAUSLAN, Helen [P,Li] Westfield, NJ b. Providence, RI. Studied: ASL. Member: An Am. Group. Work: lithograph, NYPL [40]

McBEY, James [P,E] Phila., PA b. 23 D 1883, Newburgh, Aberdeenshire, Scotland d. 1 D 1959, Tangier, Morocco. Studied: self-taught. Work: large coll. etchings/watercolors, Boston Pub. Lib.; British Mus., London; Imperial War Mus.; Egypt; Palestine; Syria. Official artist with the Egyptian Expeditionary Force, 1917. Best known for his etchings of Venice and Egypt. [47]

McBRIDE, Clifford [Car] Altadena, CA b. 26 JA 1901, Minneapolis, MN. Illustrator: Cosmopolitan, 1937. Creator: "Napoleon and Uncle Elby," syndicated in nat./intl. newspapers daily and Sunday by Lafave Newspapers Features, Cleveland (since 1932). Newspaper drawings and work for Life published as book by Castle Press, 1932. [40]

McBRIDE, E(dward J.) [Car] NYC/Great Neck, NY b. 10 Mr 1889, St. Louis, MO. Studied: Berdanier; St. Louis SFA. Member: Am. A. Car.&Caric.; St. Louis Sketch Cl. Exhibited: book cover, World's Fair, St. Louis, 1904 (prize). Work: LOC. Position: A. Manager, New York Tribune Syndicate [40]

McBRIDE, Eva Ackley (Mrs. James H.) [P,E] b. 27 D 1861, Wisconsin. Studied: H.J. Breuer; W.M. Chase. Member: Calif. AC; Pasadena SA; La Jolla AC [33]

McBRIDE, Henry [I,Cr,W] NYC/West Chester, PA b. 1867, West Chester d. 1962 (age 95). Studied: Artists & Artisans Inst., NYC, with J.W. Stimson, 1889. Author: "Matisse," "Some French Moderns." Positions: Dir./Founder, Edu. Alliance, NYC (1900); Dir., Trenton Sch. Indst. A., 1901; A. Cr., New York Sun (1912-50), Dial, 1920- ; Ed., Creative Art (1930-32), Art News (1950-55). Early champion of Modernism and Stieglitz' group, he was also the first to rediscover Thomas Eakins (1913). His recognition of artistic talent was prophetic. [See "Essays and Criticisms of H. McBride," by D.C. Rich, 1975.] [47]

McBRIDE, Walter Henry [Mus.Dir,T,C,B,Des,E,L,P] Fort Wayne, IN b. 20 Ap 1905, Waterloo, IN. Studied: Harvard; Ind. Univ.; Herron A. Sch.; D. Ross. Member: Midwest Mus. Dir.; Am. Assoc. Mus. Dir.; Northeast Ind. T. Assn.; Ind. Soc. Pr.M. Positions: T., Herron A. Sch. (1929); Dir. Fort Wayne A. Sch. & Mus., 1933-46 [47]

McBROOM, Louise G. [P] Des Moines, IA. Exhibited: Tex. Centennial Expo, Dallas, 1936; WFNY, 1939 [40]

McBRYDE, Ellen D. [P] Wash., D.C. [25]

McBURNEY, James Edwin [P,Mur.P,I,L,T] Chicago, IL b. 22 N 1868, Lore City, OH. Studied: PIASch.; C.H. Davis; Twachtman; H. Pyle; A.W. Dow; Paris. Member: All-Ill. SFA; South Side A.; Cliff Dwellers. Exhibited: P. P. Expo, San Diego, 1915 (med); Chicago Gal. Assn. Work: Parkside Sch., Wentworth Sch., Tilden Tech. Sch., Scott Sch., all in Chicago; murals, Univ. Mich. (Ann Arbor), Century of Progress Expo, Palmer Park Field House (Chicago); panels, Woodlawn Nat. Bank (Chicago), Fed. Bank & Trust Co., Dubuque, Iowa, State Agricultural Expo Bldg., Los Angeles;Pasco((Wash.) Bank; Cheney, Wash.; Southern Calif. Counties' Commission, San Diego. Positions: T., A.E.F. University, Beaune, France (1919); A. Dir., Chicago Park District [47]

McCABE, Junius D. [P] Corapolis, PA. Member: Pittsburgh AA [25]

McCAGG, Edith [P] Newport, RI [19]

McCAGUE, Lydia Scott [P,Des,L,T] Omaha, NE b. 30 N 1870, Omaha. Studied: Wellesley Col; T. Kimball, in Omaha; AIC, with W. Sargent. Member: Nebr. ATA. Work: window des., Central United Presbyterian Church, Omaha. Position: T., Tech. H.S., Omaha [40]

McCAHILL, Agnes McGuire (Mrs. Daniel William) [S,P] NYC b. New York. Studied: H. Adams; Saint-Gaudens. Member: ASL; N.Y. Women's AC [13]

McCAHILL, Mary C. [S] NYC [01]

McCAIG, Flora T. (Mrs.) [P] La Canada, CA/Flintridge, CA b. Royalton, NY. Studied: PAFA; B.F. Ferris; G.W. Waters; C. Beckwith. Work: Women's Un., Kindergarten Training Sch., both in Buffalo [31]

McCALL, Eva Struthers [Min.P] Phila., PA [15]

McCALL, Mary A. [P] St. Louis, MO [10]

McCALL, Virginia Armitage [P,I,W,L,Gr] Haverford, PA b. 25 F 1908, Phila. Studied: PAFA. Member: Phila. Pr. Cl.; Phila. All. Exhibited: Phila. AC, 1934 (prize), 1935 (prize), 1940 (med); PAFA, 1932 (prize); AIC, 1934 (prize); Chicago AC, 1934 (prize); PMA; Butler AI; Detroit Inst. A.; CAM; CGA; Albright A. Gal.; WMAA; VMFA; Paris Salon; Century of Progress, Chicago; GGE, 1939. Work: PAFA; PMA; WMAA; Univ. Pa. Specialty: medical illus. Position: Med. Illus., Valley Forge General Hospital, Phoenixville, Pa. [47]

McCALL, William Sherwood [P] Jacksonville, FL. Work: USPO, Montevallo, Ala. WPA artist. [40]

McCALLUM, R(obert) H(eather) [P,I] Detroit, MI b. 28 Ag 1902, Rochester, NY. Studied: L. Birch. Member: Scarab Cl. [31]

McCAN, J(ames) Ferdinand [P] Boerne, TX b. 25 S 1869, Tralee, County Kerry, Ireland. Studied: Kensington Art Sch., London. Member: Soc. Tex. A. [25]

McCANDLISH, Edward G. [I,Car,W] Portsmouth, NH b. 1887, Piedmont, WV d. 6 D 1946, North Brookfield, MA. Studied: Md. Agricultural Col.; PAFA. Author/illustrator, 21 children's books. Positions: with The Free Press, 1922-32; Illus./Car., Washington Post

McCANN, Minna (Mrs.) [S] New Orleans, LA [24]

McCANNA, Clare [I] NYC. Member: SI [47]

McCARTAN, Edward [S] NYC b. 16 Ag 1879, Albany, NY d. 1947. Studied: PIASch; ASL; Ecole des Beaux-Arts, Paris; H. Adams; G.G. Barnard; H. McNeil. Member: ANA; NA, 1925; NSS, 1912; AIA; NIAL; AAAL; Arch. Lg.; BAID; Concord AA. Exhibited: PAFA, 1916 (gold), 1931 (prize); All.A.Am., 1923 (med), 1931, 1933 (gold); NAD, 1912 (prize); Arch. Lg., 1923 (prize); Concord AA, 1925 (gold); Grand Central Gal., 1931 (prize). Work: MMA; FMA; CAM; Brookgreen Gardens, S.C.; Eugene Field Mem., Chicago; clock on Grand Central Bldg., NYC; Dept. Labor Bldg., Wash., D.C.; Albright Gal.; PAFA; John HerronAI [47]

McCARTER, Henry [P,I,Dec,L,T] Phila., PA b. 5 Jy 1866, Norristown, PA d. 20 N 1942. Studied: P. de Chavannes, Bonnât, A. Harrison, T. Lautrec, M. Roll, M. Rixens, in Paris; PAFA, with Eakins. Exhibited: Pan-Am. Expo, Buffalo, 1901 (med); St. Louis Expo, 1904 (med); Phila. WCC, 1906 (prize); P.-P. Expo, San Fran., 1915 (2 golds); PAFA, 1930 (prize), 1939 (med); Phila. AC, 1935 (gold), 1936 (gold). Work: Pa. Mus. A.; PAFA. Illustrator: R.W. Gilder's poems; Scribner's, Century, Harper's, Collier's. Position: T., PAFA [40]

McCARTHY, Claire Lindley. See Falkenstein.

McCARTHY, Clarence J. [I,P] Woodstock, NY b. 21 My 1887, Rochester, NY d. O 1953. Studied: ASL; Henri; F.L. Mora; F.R. Gruger. Member: SI. Illustrator: Saturday Evening Post, Collier's, Cosmopolitan, other magazines [47]

McCARTHY, Dan [Car] NYC d. 16 F 1905. One of his most famous cartoons was the dollar mark in the tail of the Tammany Tiger. His best work was his series of cartoons for "The World" during the Strong mayoralty campaign.

McCARTHY, Elizabeth White [P,Min.P] Phila., PA Exhibited: PAFA, 1937 (med), 1938 [40]

McCARTHY, Helen K. [P] NYC/Boothbay Harbor, ME b. Poland, OH d. 1 N 1927. Studied: Phila. Sch. Des.; Daingerfield; Snell. Member: Plastic Cl.; NAWPS; SPNY. Exhibited: Plastic Cl., 1914 (gold); PAFA, 1918 (prize); NAWPS, 1919 (prize), 1926 (prize) [27]

McCARTHY, John O'Toole [P,Des] Wash., D.C. b. 1843, Ireland (came to U.S. in 1863) d. 25 Jy 1923, Wash., D.C. An expert penman, he made memorials and other official papers so perfectly that they often passed as steel engravings.

McCARTNEY, Edith (Mrs. Edward Sprague Tobey) [Por.P] Wash., D.C. b. 18 Mr 1897, Boston. Studied: New Sch. Des., Boston; H.D. Murphy; D.J. Connah, in Boston. Member: Wash. WCC. Exhibited: Wash. WCC,

1922–39, 1940 (prize), 1941–46; AWCS, 1939; A. Center, Wash., D.C., 1924 (one-man); Wash. AC, 1932, 1940; Ferargil Gal.; Vose Gal.; Wash. A. Lg.; Women's City Cl., Wash., D.C. Work: YWCA, Wash., D.C. [47]

McCAUSLAND, Elizabeth [W,T,Cr,L] NYC b. 16 Ap 1899, Wichita, KS d. 14 My 1965. Studied: Smith Col. Member: A. Lg. Am.; F., Guggenheim Fnd., 1943. Author: "Changing New York" (1939), "Käthe Kollwitz" (portfolio with essay, 1941), "Picasso" (brochure, 1944), "Life and Work of Edward Lamson Henry, N.A., 1841–1919" (1946); "George Inness, 1825–1894" (1946). Arranged many museum exhibits. Selected photographs to illustrate "Poems of the Midwest" (1946). Editor: "Work for Artists: What? Where? How?" and author of section "The Use of Art in America," 1947. Positions: T., New Sch. Soc. Res., NYC (1946–), Sarah Lawrence Col. (1942–44); Writer, Springfield (Mass.) Republican, 1923– [47]

McCAY, Winsor Zenic [Car] NYC b. Spring Lake, MI d. 26 Jy 1934. Position: Car., New York American [27]

McCLAIN, F.M. [P] Cincinnati, OH. Member: SWA. Position: associated with A. Acad., Cincinnati [10]

McCLAIN, Helen Charleton [P,Por.P] Toronto, Ontario b. 25 My 1887, Toronto. Studied: N.Y. Sch. F.&Appl.A. Member: NAWPS; NYSC. Exhibited: NAC (prize); NAWPS, 1918 (prize), 1931 (prize) [40]

McCLAIRE, G(erald) A(rmstrong) [P,I] Seattle, WA b. 16 S 1897, Seattle [25]

McCLEAN, Avis L. (Mrs. Alexander) [P] NYC. Exhibited: All.A.Am., 1934; NAWPS, 1935–38 [40]

McCLEAN, Clara [P,Por.P] Cleveland, OH b. 24 Je 1889, Washington, IA. Studied: Cleveland Sch. Art; ASL; Corcoran Sch. Art. Member: Cleveland Women's AC. Exhibited: CMA, 1922 (prize), 1924 (prize), 1925 (prize), 1926 (prize), 1927 (prize), 1928 (prize) [33]

McCLEAN, Roberta Fisk [P,I,L] Russellville, KY b. 22 O 1882, Russellville. Studied: Chase; Mora; Dow. Member: S.Indp.A. Exhibited: Tri-State Fair, Memphis, 1920 (prize); Kentuckiana Exh., Louisville, 1936 (prize). Contributor: articles/illus., newspapers [40]

McCLEARY, Bee L. (Mrs.) [P] Pittsburgh, PA. Member: Pittsburgh AA [21]

McCLEARY, Nelson [P,I,Car,Des,L] Paris, France b. 11 Je 1888, Medicine Lodge, KS. Studied: Slade Sch., London; Académie Julian, Paris; P. Vignal, in Paris; E.A. Huppert. Member: British WC Soc.; Soc. des Ar. Français; Sindacato Fascista de Belle Arti di Roma. Award: Mo. State Medal, 1936. Work: Victoria and Albert Mus., London; Mus. Carnavelet, Paris; Nat. Gal. Mod. A., Rome; Nelson Gal., Kansas City [40]

McCLEES, Douglas [P] Brooklyn, NY [06]

McCLELLAN, John Ward [Li] Cambridge, NY b. 20 My 1908, London, England. Studied: H.H. Clark; H.L. McFee. Member: Woodstock Ar. Assn.; Print Cl., Albany [40]

McCLELLAN, Mary [P,I] Phila., PA b. 12 Jy 1860, Phila. d. 21 F 1929. Studied: PAFA; Acad. Delecluse, Paris. Member: Plastic Cl.; Phila. Alliance. Exhibited: Plastic Cl., 1919 (gold) [27]

McCLELLAND, Rachel P. [P] Pittsburgh, PA. Member: Pittsburgh AA [25]

McCLINTOCK, Lucy [P] Meadville, PA [19]

McCLOSKEY, A.B. (Mrs.) [P] San Fran., CA [04]

McCLOSKEY, (John) Robert (Balfour Dangerfield) [P,Mur.P,I,Car,G,W] Hamilton, OH b. 15 S 1914, Ohio. Studied: Nat. Acad. Exhibited: Kleeman Gal., N.Y.; Grand Central Gal. Award: Prix de Rome, 1939. Work: bas relief, Municipal Bldg., Hamilton. Author/Illustrator: "Lentil" (1940), "Make Way for Ducklings," "Homer Price," "Blueberries for Sal," other children's books. Illustrator: "Henry Reid, Inc.," other books [40]

McCLOSKEY, Martha Linwood [Des,P,Ldscp.P,W] East Palestine, OH b. 10 Ja 1899, Rogers, OH. Studied: Butler AI; Wooster Col.; Cambridge Univ., England. Member: Mahoning SA; NAWPS; Ohio WCS; Ohio Born Women P.; Youngstown WSC. Exhibited: Butler AI, 1928 (prize), 1929 (prize), 1943 (prize), 1946 (prize); Parkersburg, W.Va., 1945 (prize); Mahoning SA, 1945 (prize). Work: Butler AI [47]

McCLOSKEY, William J. [P] Phila., PA. Exhibited: AAS, 1902 (prize) [04]

McCLOY, William Ashby [P] Des Moines, IA. Exhibited: PAFA, 1936, 1938; AIC, 1938; Kansas City AI, 1939 [40]

McCLUNG, Florence (White) [P,Li,Ldscp.P,C,L,T] Dallas, TX (1964) b. 12 Jy 1896, St. Louis. Studied: Southern Methodist Univ.; A. Dehn; A. Hogue; Reaugh; O. Travis; C. McCann, at Cincinnati AI; Simkins, in NYC; T. Stell. Member: SSAL; NAWA; Dallas AA; Pr.M. Gld., Tex.; Dallas Pr. Soc.; Reaugh AC; Dallas AL. Exhibited: Tex. State Fair, 1933 (prizes); Tex. Federation Exh., Dallas, 1932 (prize); Dallas All., 1942 (prize), 1943 (prize), 1944 (prize), 1946 (prize); Pepsi-Cola, 1942 (prize); PAFA, 1937; NAWA, 1937–44, 1945 (prize), 1946; Kansas City AI; Dallas Mus. FA, 1936; WFNY, 1939; Pan-Am Expo, Dallas, 1937; Tex.-Okla. General Exh., 1941, 1942; SSAL; circuit, Tex. FA Assn.; SFMA, 1942–44; NAD, 1943, 1944, 1946; MMA, 1943; LOC, 1943, 1944; one-man exhibits, Tex., La., Ala., London (England), all in 1946. Work: MMA; Dallas Mus. FA; Mint Mus. A.; High Mus. A.; Delgado Mus.; Birmingham (Ala.) Lib.; Univ. Kans.; Univ. Tex.; Trinity Univ., Waxahachie, Tex. Lectures: Batiks. Position: T., Trinity Univ., 1929–41 [47]

McCLURE, Caroline S(umner) (Mrs. G.G.) [S] Carmel, CA b. St. Louis, MO. Studied: L. Taft; H. MacNeil. Member: NAC. Work: figure of Victory, dome of Mo. bldg., St. Louis Expo, 1904 [40]

McCLURE, Frederick A. [P] Worcester, MA [24]

McCLURE, Henrietta Adams (Mrs. Charles A.) [P,I,Car,T] Wayne, PA d. 27 Mr 1946, Bryn Mawr, PA. Studied: Drexel Inst.; Phila. Sch. Des. for Women. Member: Phila. A. All.; NYWCC. Exhibited: Phila. A. All; Univ. Cl., Phila. (one-man). Position: T., Wayne A. Center [40]

McCLURE, Maud [S] Oregon, IL b. 4 O 1884, Mt. Morris, IL. Studied: AIC; L. Taft. Member: Chicago AC [27]

McCLYMONT, John I. [Por.P,Ldscp.P] b. 1858, Manchester, England (came to Colorado Springs ca. 1900) d. 1934 (Colorado Springs?). Studied: Edinburgh SA, 1876–79; RSA, 1879–83. Work: Colorado Springs FA Center; Colo. State Capitol; Vassar [*]

McCOLL, Mary A. [P,Ldscp.P,C,W,T] St. Louis, MO/Kimmswick, MO b. Forrest, Ontario. Studied: Cornoyer; Courtois; J. Carlson; Breckenridge; H. Hoffman, in Munich. Member: St. Louis AG; St. Louis A. Lg.; Western AA. Exhibited: St. Louis A. Gld., 1916 (prize), 1917 (prize), 1918 (prize); Black and White Comp., Chicago, 1929 (prize). Work: Town Cl., St. Louis [40]

McCOLLUM, James Herman [P,Des,I,Car] Des Moines, IA b. 1 Ap 1904, Missouri. Studied: Am. Acad. A., Chicago. WPA artist. Position: T., WPA, Iowa [40]

McCOMAS, Francis John [P,Ldscp.P,Mur.P] Pebble Beach, CA b. 1 O 1874, Fingal, Tasmania (came to U.S. in 1898) d. 28 D 1938. Studied: Sydney (Australia) Tech. Col. Member: (jury) P.-P. Expo, 1915; Phila. WCC; AWCS. Exhibited: Phila. WCC, 1918 (gold), 1921 (prize); AWCS, 1921 (prize); Armory Show, 1913. Work: murals, Del Monte Lodge (Pebble Beach), Del Monte (Calif.) Hotel; MMA; Park Mus., San Fran.; Portland Art Soc. Best known for his desert landscapes. [38]

McCOMAS, Gene Frances (Mrs. Francis) [P] Pebble Beach, CA b. San Fran. Studied: Berkeley Sch. A. Cl. Member: Carmel A. Assn. Exhibited: Roullier Gal., Chicago (one-man); San Fran. A. Assn.; Carmel A. Assn.; GGE, 1939. Work: Mills Col.

McCOMB, Marie Louise [P] Winter Park, FL b. Louisville, KY. Studied: PAFA; D. Garber; H. McCarter. Exhibited: PAFA; NYWCC; Morse Gal. A., Women's Cl., both in Winter Park; Research Gal., Maitland, Fla., 1946 (one-man) [47]

McCOMBS, James William [Des,C] New Hope, Pa. b. 16 Ag 1898. Designer: furniture [40]

McCOMMON, Frances V. (Mrs.) [P] Pittsburgh, PA. Member: Pittsburgh AA [25]

McCONAHA, Lawrence [P,Ldscp.P] Richmond, Ind. b. 8 Ag 1894, Centerville, IN. Studied: G.H. Baker; G. Wiggins. Member: Palette Cl., Richmond; Indianapolis AA; SC; Hoosier Salon; Springfield A. Lg.; CAFA; Wash. WCC; Ind. A. Cl.; AAPL; Richmond AA (Pres.). Exhibited: Earlham Col., 1927 (prize); Hoosier Salon, 1929 (prize), 1930 (prize), 1931 (prize); Richmond AA, 1929 (prizes), 1930 (prize), 1931 (prize), 1933 (prize), 1934 (prize), 1936 (prize); Ind. State Fair, 1938 (prize), 1939 (prize); John Herron AI, 1929 (prize), 1932 (prize), 1934 (prize), 1936 (prize), 1937 (prize); CAFA, 1931 (prize), 1933 (prize)Work: Richmond AA; Pub. Lib., Tipton, Ind. [47]

McCONKEY, William Victor [C] Berea, KY b. 18 Ap 1905, Copen, WV. Member: Craftsmen's Gld. Berea Col. Position: Des., Berea Col. Furniture Shop [40]

McCONNELL, Annette [P] New Orleans, LA [01]

McCONNELL, Emlen [I] Haddonfield, NJ b. 2 Ag 1872, Phila. Studied: PAFA, with Chase, Pyle [25]

McCONNELL, Genevieve K(napp) (Mrs. Guthrie) [P,I,W] St. Louis, MO/Easton, MD b. 18 Mr 1876, St. Louis. Studied: St. Louis Sch. FA. Member: Plastic Cl.; St. Louis AG. Author/Illustrator: "The Seeing Eye," children's stories in magazines [29]

McCONNELL, George [Mar.P] Portland, ME b. 1852, Steubenville, OH d. 1929. Studied: NYC; Phila.; Paris. Seacoast painter who settled in Portland, 1883. [*]

McCONNELL, James Houston [Li,Ser,P] East Lansing, MI/Chicago, IL b. 19 O 1914, Chicago. Studied: Denison Univ.; State Univ., Iowa; G. Wood; J. Charlot; F. Martin; E. Ganso. Member: Nat. Serigraph Soc.; Am. Color Pr. Soc. Exhibited: Am. Color Pr. Soc., 1942 (prize); CAM, 1942 (prize); Springfield (Mo.) Mus. A., 1942 (prize); Zanesville, Ohio, 1945 (prize); Kansas City AI, 1941, 1942; Northwest Pr.M., 1942–46; WMAA, 1941; Un. Seaman's Service Traveling Exh., 1943, 1944; NAD, 1946; LOC, 1946; Laguna Beach AA, 1946. Work: Denison Univ.; State Univ., Iowa; CAM. Position: T., Mich. State Col., 1945– [47]

McCONOMY, Nancy [P,C,I,T] Phila., PA/New Hope, PA b. 30 Jy 1903, Phila. Studied: Oakley; Herbert; Pullinger. Member: Phila. Pr. Cl. [33]

McCOOL, Daisy D. [Dec,Des,E,Mur.P,L,T] Oklahoma City, OK b. 30 Je 1901. Studied: AIC; Kriehbiel; J.P. Lacey; N.Y. Sch. F.&Appl. A.; N.Y. Sch. Ceramics; Columbia; Woodstock Sch. Des. Member: Okla AA. Work: murals, Skirvin Hotel, Huckins Hotel, both in Oklahoma City. Position: Dir., McCool Studio A. [40]

McCOOL, Ira W. [E] Astoria, NY b. 21 D 1886, Salem, NE. Studied: AIC. Member: Phila. SE [32]

McCORD, Elizabeth S. [I] NYC. Member: Black and White Cl. [01]

McCORD, Esther I.E. [P] Wash., D.C. b. Richardson County, NE. Studied: J.H. Moser, in Wash., D.C. [13]

McCORD, George Herbert [Ldscp.P,Mar.P] Brooklyn, NY b. 1 Ag 1848, NYC d. 6 Ap 1909. Studied: M. Morse. Member: ANA, 1880; AWCS; Brooklyn AC; SC, 1884; A. Fund Soc.; Lincoln Cl.; Lotos Cl. Exhibited: New Orleans Expo, 1885 (med); Mechanics Inst., Boston (med); St. Louis Expo, 1904 (med) [08]

McCORD, Mary Nicholena [P] Bridgeport, CT [06]

McCORD, Peter B. [I,Caric] Newark, NJ b. ca. 1868, St. Louis, MO d. 9 N 1908. Author/Illustrator: "The Wolf." Position: Staff, Newark Evening News, since 1900

McCORD, William A. [P,I,C] Cincinnati, OH. b. Cincinnati d. 8 N 1918. Studied: self-taught. Member: Cincinnati AC [17]

McCORMACK, Nancy Mal Cox (Mrs.) [S] Chicago, IL b. 15 Ag 1885, Nashville, TN. Studied: V. Holm, in St. Louis; C. Mulligan, in Chicago. Member: SW Sc.; Cordon Cl.; Nashville Art Assoc. Work: Nashville Mus.; Carmack Mem., Nashville; Woodruff Mem., First National Bank, both in Joliet, Ill.; panels, Trinity Church, Chicago [25]

McCORMICK, Amy Irwin (Mrs. Robert R.) [P,Por.P] Chicago, IL/Wheaton, IL b. 15 Ap 1880, Fort Riley, KS d. 14 Ag 1939. Studied: Clark; Henderson; Parker. Member: Chicago Gal. A.; Chicago AC. Work: Pub. Schools, Chicago; portraits, Surgeon General's Lib. (Wash., D.C.), Passavant Mem. Hospital, Chicago [38]

McCORMICK, Donald [Arch,E,L] Tulsa, OK b. 20 Ag 1898, Wilkes-Barre, PA. Studied: Cornell Univ. Member: AIA; Southwestern A. Assn. Exhibited: Tulsa AA, 1931 (prize) [40]

McCORMICK, Howard [P,Mur.P,I,Wood En] Leonia, NJ/NYC b. 19 Ag 1875, Indiana d. 13 O 1943. Studied: Indianpolis Sch. A.; N.Y. Sch. A., with W.M. Chase, Forsyth; Académie Julian, Paris, with Laurens. Member: ANA; SC, 1907; Stowaways. Work: Hopi, Apache and Navajo habitat group, AMNH; John Herron AI; murals/habitat group, State Mus., Trenton, NJ; murals, Mus. Sc.&Indst. (N.Y.), Lib., Mayo Clinic, Rochester, Minn.; wood engravings, various magazines [40]

McCORMICK, Katharine Hood [Ldscp.P,P,Gr] Phila., PA b. 17 S 1882, Phila. d. 23 Mr 1960. Studied: PAFA, with H. McCarter, F. Wagner, R. Pearson. Member: Am. Color Pr. Soc.; Phila. Plastic Cl.; AAPL; Phila. Alliance. Exhibited: Phila. Sketch Cl., 1923 (prize); Plastic Cl., 1936 (med); NAD, 1930; PAFA, 1940; Phila. Pr. Cl.; Phila. A. All.; Am. Color Pr. Soc. [47]

McCORMICK, M. Evelyn [P] Monterey, CA. Exhibited: P.-P. Expo, San Fran., 1915 (med) [15]

McCORMICK, Robert James [P] Ventura, CA b. 16 S 1911, Havre, MT. Studied: Yale. Exhibited: SFMA. Work: Yale [40]

McCOSH, David (John) [P,Mur.P,Li,T,Dr] Eugene, OR b. 11 Jy 1903, Cedar Rapids, IA. Studied: Coe Col.; AIC; ASL. Member: Am. Assn. Univ. Prof.; F., Tiffany Fnd., 1930. Exhibited: Chicago Ar. Exh., 1929 (prize); Seattle AM, 1936 (prize); CI, 1936; CM; Univ. Nebr., 1936, 1938; PAFA, 1937; AIC, 1929–38; BM, 1937; GGE, 1939; WFNY, 1939; Denver A. Mus., 1940; Okla. A. Center, 1940; Colorado Springs FA Center, 1935–38, 1945; Portland A. Mus. Work: Cedar Rapids AA; Portland A. Mus.; SAM; WMAA; IBM Coll.; murals, Century of Progress Expo (Chicago), USPOs, Kelso (Wash.), Beresford (N.Dak.), Dept. Interior (Wash., D.C.). WPA artist. Position: T., Univ. Oreg., 1934– [47]

McCOSH, David, Mrs. See Kutka, Anne.

McCOUCH, Gordon Mallet [P,E,I] Phila., PA/Porto-di-Rongo, Ticinio, Switzerland b. 24 S 1885, Phila. d. 1962, Switzerland. Studied: Chestnut Hill Acad.; Pyle Sch. A., 1903; Royal Acad., Munich, with H. von Zugel. Member: Phila. All.; Soc. Swiss P&S. Exhibited: CGA; CI; Toronto, Ontario; Paris Salon; A. Center, N.Y.; Phila. All.; Delgado Mus. A.; Ferargil Gal.; Montross Gal. [47]

McCOUN, Alice Louise Troxell (Mrs.) [E,I,Por.P,Dr,T] Omaha, NE b. 3 O 1888. Studied: J.L. Wallace; AIC; Nebr. Univ.; R. Pearson; Columbia; Fed. Sch., Minneapolis. Author/Illustrator: children's verses [40]

McCOY, George A. [P] NYC. Member: Lg. AA [24]

McCOY, John W., II [P,Des,T] Chadds Ford, PA b. 11 My 1910, Pinole, CA. Studied: Cornell; Am. Sch., Fontainebleau, France; N.C. Wyeth; L. Medgyes, in Paris. Member: Chester County AA; ANA; AWCS; Phila. WCC; Wilmington Soc. FA. Exhibited: Del. A. Center, 1940 (prize), 1941 (prize); WFNY, 1939; CI, 1941, 1946; PAFA, 1940, 1946; BM, 1945; AIC, 1944; Pepsi-Cola, 1945; NYC, 1941 (one-man), 1945 (one-man), 1946 (one-man); Boston, 1940; Utica, N.Y., 1942; Manchester, N.H., 1945; Wilmington, Del., 1940. Positions: Dir., Wilmington, Del., Soc. FA, 1945–46; T., PAFA, 1946 [47]

McCOY, Joseph [P] Minneapolis, MN [15]

McCOY, Julia [P] McKeesport, PA. Member: Pittsburgh AA [21]

McCOY, Lawrence [P] Worcester, MA b. 17 Ap 1888, Lakeland, MN. Studied: WMA Sch.; J. Farnsworth; R. Brackman. Member: AAPL; Am. Veterans Soc.; North Shore AA; Provincetown AA; Springfield A. Lg.; Copley Soc.; CAFA. Exhibited: NAD, 1945; All.A.Am., 1944, 1945; CAFA, 1945, 1946; WMA, 1944, 1946; Newport AA, 1944, 1945; North Shore AA, 1944, 1945; Am. Veterans Soc. A., 1944, 1945; Springfield A. Lg., 1944, 1945; Jordan Marsh, 1944, 1945; Inst. Mod. A., Boston, 1945; Portland Soc. A., 1945; New Haven PCC, 1945; Ogunquit A. Center, 1945; Provincetown AA, 1945; Copley Soc., 1945 [47]

McCOY, Raymond A. [Des] St. Albans, NY b. 15 S 1893, Brooklyn, NY. Member: A. Fellowship; SC; Lotos Cl. [40]

McCOY, Samuel Duff [I] Hinsdale, IL b. 17 Ap 1882, Burlington, IA. Studied: AIC. Member: Art Cl., Princeton Univ. [08]

McCRACKEN, Carolyn B. (Mrs.) [P] Chicago, IL b. 22 O 1876, Oneida, IL. Member: All-Ill. Soc. FA; South Side AA; Chicago NJSA; Soc. Sanity in Art. Exhibited: Alaska-Yukon Expo, Seattle, 1909 (med). Work: Carnegie Lib., Sunnyside, Wash. [40]

McCRACKEN, J.H. [I] NYC [19]

McCRACKEN, Susanne Suba. See Suba.

McCRADY, John [Li,P,Dr,T] New Orleans, LA b. 5 S 1911, Canton, MS. Studied: Univ. Pa.; New Orleans Art Sch.; ASL. Member: F., Guggenheim Fnd., 1939; SSAL; NOAA; NOACC; New Southern Group. Exhibited: NOAA, 1935 (prize); NOACC, 1939 (prize); La. A. Commission, 1939 (prize). Work: City Art Mus., St. Louis, Mo.; High Mus. A.; USPO, Amory, Miss. Commissioned to do painting, Life, 1939. WPA artist. [40]

McCRAIG, Flora Thomas (Mrs.) [P] Beverley, WV b. Royalton, NY d. 28 Mr 1933, Flintridge, CA. Studied: PAFA. Work: Women's Un., Kindergarten Training Sch., both in Buffalo, N.Y. [01]

McCREA, S(amuel) Harkness [Ldscp.P] Darien, CT b. 15 Mr 1867, Palatine, Cook County, IL. Studied: San Fran.; Chicago; NYC; Paris; Munich. Member: SC [40]

McCREADY, Thomas, Mrs. See Tudor, Tasha.

McCREARY, Carolin (Mrs. G.W.) [P,W,T] Pittsburgh, PA b. 26 O 1907, Oil City, PA. Studied: CI, with A. Kostellow, L. Gabor, H. Hofmann. Member: Assoc. A. Pittsburgh; Authors Cl., Pittsburgh. Exhibited: Pittsburgh AA, 1935 (prize), 1937 (prize); CI, 1935 (prize), 1937 (prize),

1943–45; Pittsburgh Garden Cl., 1942 (prize), 1943 (prize); Butler AI, 1945 (prize); CGA, 1937, 1939; MMA, 1942; AIC, 1943; CM (Critic's Choice), 1945; TMA, 1944; Assoc. A. Pittsburgh, 1935–46. Contributor: Liberty, 1946 [47]

McCREARY, Harrison B. [P] NYC. Member: GFLA [27]

McCREER, Samuel H. [P] Paris, France b. 1867, near Chicago. Exhibited: AIC, 1898 [98]

McCREERY, Franc Root [Por.P,I,T] Buffalo, NY b. Dodge City, KS d. 31 O 1957. Studied: Buffalo Sch. FA; AIC; Students Sch. A., Denver. Member: Buffalo SA; Buffalo Gld. All. A.; Lg. Am. Pen Women. Exhibited: Lg. Am. Pen Women, 1932 (prize), 1935 (prize); Buffalo SA, 1934 (prizes). Work: Buffalo Gld. All. Al.; Lg. Am. Pen Women. Positions: T., Buffalo Sch. FA, State T., Col, Univ. Buffalo [47]

McCREERY, Frances [P] Pittsburgh, PA. Member: Pittsburgh AA [21]

McCREERY, James Lindsay [S] Brooklyn, NY. Exhibited: BM, 1934; 48 Sts. Comp., 1939. Work: USPO, Monett, Mo. WPA artist. [40]

McCULLOUGH, Edward L. [Car] b. 1901 d. 21 My 1928, Bayonne, NJ. Originator: several widely syndicated comic strips; best known were "Embarrassing Moments" and "Folks in Our Town"

McCULLOUGH, Lucerne (or Suzanne?) (Mrs. C.E. Robert) [Des,P,I,Car] NYC b. 6 Dec 1916, Abilene, TX. Studied: Newcomb Col.; ASL; NOACC. Member: A. Gld. Exhibited: Direct Mail Advertising Assn., 1941 (prize), 1942 (prize), 1944 (prize), 1945 (prize); A. Dir. Cl., 1944 (med), 1945, 1946; La. State Exh., 1938; Newcomb Col., 1939. Work: MOMA; murals, USPOs, Booneville (N.Y.), Thomaston (Conn.). WPA artist. Creator: advertising for Vogue, Harper's Bazaar, Town & Country, other magazines [47]

McCULLOUGH, Maxie Thomas (Mrs. Alice M.) [P,Des,T,B,W] Laguna Beach, CA b. 9 N 1874, Forrest City, AR. Studied: Cincinnati A. Acad; Académie Julian, Paris; Nowottony; Meakin; Duveneck; Renard; La Farge; Debillemont-Chardon, in Paris. Member: Dallas AA; Miss. AA; Highland Park Soc. FA, Dallas; SSAL; AFA; Tex. FA Assn.; AAPL; Ark. WC Soc.; Harding Col. AC. Exhibited: Miss. State Fair, 1910 (prize); Tex. State Fair (prize); N.C. State Fair, 1931 (prize). Work: Little Rock (Ark.) Mus. FA. Co-author: "Flower Painting on Porcelain," pub. Keramic Pub. Co. Founder/Director: A. Sch. for Children, Dallas, 1933 [47]

McCULLOUGH, Minnie [P] NYC. Member: S.Indp.A. [25]

McCULLOUGH, William A. [P] Brooklyn, NY [06]

McCURDY, Caroline Gardiner [P] NYC/St. George's, Bermuda. Studied: Norwich Acad.; Paris. Member: NAWPS; S.Indp.A. [27]

McCUTCHEON, John T(inney) [Caric,W] Chicago, IL b. 6 My 1870, South Raub, IN. Studied: Purdue Univ., with E. Knaufft. Member: SI, 1911; AIC. Award: cartoon, Pulitzer prize, 1931. Author: "Stories of Filipino Warfare," "Bird Center Cartoons," "In Africa." Position: Staff, Chicago Tribune (since 1903), and correspondent, during Spanish War and WWI [47]

McDADE, Ira [P] Pittsburgh, PA. Member: Pittsburgh AA [24]

McDAVID, Mittie Owen (Mrs. E.R.) [P,W] Birmingham, AL b. Birmingham, AL. Studied: W. Parish; M. Hanby; C. Hill. Member: SSAL; Art Div., L. Am. Pen Women; Ala. AL; Birmingham AC. Author: books and feature stories, leading Sunday newspapers [40]

McDERMITT, William Thomas [Ldscp.P,B,T] Los Angeles/Pomona, CA b. 2 Mr 1884, Percy, IL. Studied: Pomona Col.; PIASch; ASL; J.W. Smith; Europe [40]

McDERMOTT, Cecilia [P] Dallas, TX [24]

McDERMOTT, Charles R., Mrs. [P] Norfolk, VA. Member: Norfolk SA [25]

McDERMOTT, Elizabeth [P] Cincinnati, OH. Member: Cincinnati Woman's AC [19]

McDERMOTT, William Luther [S,P,C,L,T,Des] Fredericksburg, VA b. 21 F 1906, New Eagle, PA. Studied: CI; Univ. Pittsburgh; Herron AI; J. Ellis; J.P. Thorley; F. Nyquist. Member: Pittsburgh S. S.; Pittsburgh AA; AAPL; Am. Assn. Univ. Prof. Exhibited: Pittsburgh AA, 1932–37; Pittsburgh S. S., 1934–37; VMFA. Work: SS. Peter and Paul Church, St. Joseph Church, St. Joseph A. Sch., De Paul Inst., all in Pittsburgh; Providence Normal Sch., Pa.; Mary Wash. Col., Fredericksburg, Va. Position: T., Mary Washington Col., Fredericksburg, Va., 1941–46; Dir., Mus. Extension Project, WPA [47]

McDONALD, Ann Heebner (Mrs.) [P] Swarthmore, PA b. Phila. Studied: PAFA; H.H. Breckenridge; Whistler Sch., Paris. Member: NAWPS; Phila. Alliance; Plastic C. Work: PAFA [40]

McDONALD, Dorothy Eisner See Eisner.

McDONALD, Edward M. [P] Columbus, OH. Member: Columbus PPC [25]

McDONALD, G.L. [Des,I,P,Dr] Park Ridge, IL b. 10 S 1896. Studied: J. Norton. Member: Chicago SA [40]

McDONALD, M. Lydia [Min.P] Savannah, MO [13]

McDONALD, Marjorie [P] Buffalo, NY [17]

McDONALD, Mason [P] NYC [25]

McDONALD, Michael A. [Dealer] NYC b. 1877 d. 8 D 1942. As a young man was associated with Keppel & Co., later with A.H. Harlow. In 1935 founded his own firm. Helped to form many well-known print collections by old masters.

McDONALD, William P(urcell) [P] Cincinnati, OH b. 18 S 1863, Cincinnati. Studied: Cincinnati A. Acad., with Duveneck. Member: Cincinnati AC; Duveneck S. PS. Position: staff, Rookwood Pottery, since 1882 [31]

McDONNELL, John [P] Oak Park, IL b. 15 O 1880, Chicopee, MA. Studied: Reynolds; Schook; Clute. Member: Palette and Chisel C.; Austin, Oak Park, River Forest AL; All-Ill. Acad. FA. Position: T., Black River A. Sch., Sheboygan, Wis. [33]

McDONNELL, Margaret [P] Warsaw, NY [17]

McDONOUGH, James Vernon [Edu,L,C] Milledgeville, GA b. 5 My 1905, Pittsburgh, PA. Studied: Princeton Univ.; Univ. Pittsburgh; Harvard. Member: Am. Assn. Univ. Prof. Exhibited: Minn. S. Group, 1944. Positions: T., Northwestern Univ. (1938–39), Carleton Col. (1939–45), Ga. State Col. for Women (since 1945) [47]

McDOUGALL, Margaret L. [P] Highland Park, IL [13]

McDOUGALL, Walter H. [I] Glenn Ridge, NJ [01]

McDOWELL, Dorothea [T,C,P] Wilmington, NC b. 13 My 1898, Merrill, WI. Studied: Am. Univ., Wash., D.C.; Corcoran Sch. A.; N.C. State Col.; Wilmington Acad. A.; Chester Springs Summer Sch.; G.W. Jex. Member: N.S. State AS. Exhibited: Wilmington Fair, 1935 (prize); S.Indp.A., Wash., D.C., 1935; Wash. AL, 1933; Potomac Landscape Cl., 1933–37; Delaware A., 1936–38; N.C. Fed. Women's C., Traveling Exh., 1945–46; Wilmington A., 1945. Position: Dir./A. Cr., Camp Betty Hastings, Winston-Salem, N.C. [47]

McDOWELL, Edward [P] NYC [01]

McDUFFIE, Jane See Thurston.

McELROY, Jane [P] San Francisco, CA [13]

McELROY, Wilbur Joseph [P,B] Norwalk, CT b. 19 Ag 1903, London, England. Illustrator: "Motor Boats," 1937. Work: W.R. Nelson Gal., Kansas City, Mo. [40]

McENERNY, Daniel H. [P] Chicago, IL [10]

McENERY, Kathleen [P] Detroit, MI [15]

McENTEE, Dorothy Layng [T,P,I,B] Brooklyn, NY b. 21 S 1902, Brooklyn, NY. Studied: PIASch; PAFA. Member: AWCS; Brooklyn SA; Phila. WCC; Print C. of Phila. Work: BM. Illustrator: "Knuckles Down," 1943, "No School Friday," 1945. Positions: Bd. Edu., NYC; T., Prospect H.S., Brooklyn (1924), Girls' Commercial H.S., Brooklyn [47]

McENTEE, Jervis [Ldscp.P] Rondout, NY b. 14 Jy 1828, Rondout d. 27 Ja 1891. Studied: F.E. Church, NYC. Member: NAD, 1861; important member of "Hudson River Sch." Work: CGA; Peabody Inst. [*]

McEVOY, Harry N. [Por.P] b. 1828, Birmingham, England (came to Hamilton, Ontario, then NYC, then Indianapolis, 1860) d. 21 Ap 1914, Detroit, MI

McEVOY, Myrtle L. [P,Dec,T,L] NYC b. Dubuque, IA. Studied: Acad. Colarossi, Paris; NA; ASL; Am. Acad. FA, Chicago; Kansas City AI; W. Goltz. Exhibited: Allied A. Am.; Studio Gld., N.Y. [40]

McEWEN, Alexandrine [I,C,W,D] Johnson, AZ b. Mottingham, England. Member: Detroit SAC; Boston SAC [27]

McEWEN, Katherine [P] Dragoon, AZ b. 19 Jy 1875, Mottingham, England. Studied: Chase; Miller; Wicker; Woodbury. Member: Mural. P. Work:

water colors, Detroit Inst. A.; frescoes, Christ Church; A. & Crafts Bldg., Sch. for Boys, Cranbrook Mich. (lived in Detroit for many years) [40]

McFADDEN, Florence Glyn-Wells [P,En] San Antonio, TX b. London, England. Studied: Armitage; Calif. Sch. Des.; Arpa. Member: San Antonio AG; San Fran. Palette and Chisel C.; San Fran. AL Specialty: wood engraving. [33]

McFADDEN, Rae Raethel [P] Minneapolis, MN [24]

McFADDEN, Sarah Yocum See Boyle.

McFALL, Jay Vaughn [I] b. 1878, Sandusky, OH, 1878 d. 5 D 1912, Detroit. Studied: ASL. Illustrator: Saturday Evening Post. First worked in Detroit; then NYC (7 yrs.); then Chicago.

McFARLAND, Eugene James [P,T] Delaware, OH b. 10 S 1908, St. Louis, MO d. 21 O 1955. Studied: Univ. Kans.; Univ. Southern Calif.; Ohio State Univ.; Mexico; A. Bloch; K. Mattern; R. Eastwood. Member: CAA; Ohio WCS; Columbus AL; Okla. AA; Enid AL. Exhibited: Denver AM, 1938–40; Okla. A., 1938–41; Tulsa Fives States Exh., 1938, 1940; Kansas City AI, 1936–38, 1940, 1942; Butler AI, 1943, 1944, 1946; Parkersburg FAC, 1943–45; Ohio Valley A., 1943–45; Columbus AL, 1943–46; St. Joseph A. Week, 1937 (prize); Okla. A. Exh., 1939 (prize); Okla. State Fair, 1939 (prize). Work: Phillips Univ.; San Miguel, Mexico; Okla. Hist. Bldg. Positions: Dir., Wichita AM; T., Phillips Univ. (1938–42), Ohio Wesleyan Univ. (since 1942) [47]

McFEE, Henry Lee [P,L,T] Claremont, CA b. 14 Ap 1886, St. Louis, MO d. 19 Mr 1953. Studied: ASL. Member: NIAL; Am. S. PS&G; Woodstock AA. Exhibited: Paris Salon, 1937 (med); VMFA, 1938 (med,prize); Pepsi-Cola, 1946 (prize); CI, 1923 (prize), 1930 (prize); CGA, 1928 (prize); AIC, 1929 (prize); PAFA, 1937 (gold); nationally, 1916–46. Work: MMA; CGA; PAFA; CAM; CM; CMA; Dayton AI; Springfield Mus. A.; Columbus Gal. FA; Kansas City AI; BM; WMAA; Los Angeles County Fair Coll.; PMG; Albright A. Gal.; Detroit AI; Ann Arbor AA. Position: T., Scripps Col., Claremont, Calif. [47]

McGAIG, Flora Thomas (Mrs.) [P,C,T] Chicago, IL b. NY State. Studied: PAFA; self-taught. Member: Buffalo SA [15]

McGANN, Grace Farwell [P] Chicago, IL [17]

McGARVEY, Sara Marie [P,T] Phila., PA. Studied: PAFA [25]

McGAVOCK, Bessie Dawson (Mrs. F.F.) [Ldscp.P] Columbia, TN b. 14 O 1889. Studied: Randolph-Macon Women's Col.; ASL, with G. Bellows. Member: Nashville Studio C.; SSAL. Exhibited: Tenn. State Fair, 1938 (prize). Work: Montgomery MFA [40]

McGAW, D.E., Mrs. [Min.P] Atlanta, GA [04]

McGEE, Will T. [P] Ft. Worth, TX [24]

McGEHEE, Alice [P,C] Montgomery, AL b. Montgomery. Studied: Fitzpatrick, NH Sch. F.&App.A. Member: SSAL; Ala. AL [31]

McGEHEE, Helen M(ahood) (Mrs. W.G.) [P] Jackson, MS b. 12 S 1892, Lynchburg, VA. Studied: S.L. Mahood; J.V. Worsham; B. Gutmann; H.B. Snell. Member: A. Study C., Jackson, Miss.; Miss. AA; Lynchburg AC; SSAL. Exhibited: Miss. AA (gold); Mun. A. Gal., Jackson, 1932 (gold) [40]

McGILL, Eloise Polk [P] San Antonio, TX. Member: San Antonio AL; SSAL [27]

McGILL, Leona Leti [P,I] Ft. Worth, Texas b. 25 My 1892. Studied: AIC. Member: ASL of AIC; SSAL; Allied A. Ft. Worth. Illustrator: "Research Design in Nature," by J.G. Wilkins, 1926. Position: T., Dallas AI [40]

McGILLIVRAY, F(lorence) H(elena) [P] Ottawa, Canada/Whitby, Ontario b. 1864, Whitby. Studied: Paris, with Simon, Ménard. Member: Intl. A. Union, Paris; NAWPS; Ontario SA. Work: Canadian Gov. [33]

McGILVERY, Francis E. [P] Wash., D.C. Exhibited: 48 States Comp., 1939 [40]

McGINN, Forest A. [P] NYC. Member: GFLA [27]

McGINNIS, Henry R. [P] Muncie, IN b. Morgan Co., Ind. Member: T.C. Steele; J.O. Adams; W. Forsyth [01]

McGINNIS, Mabel [P] East Hampton, NY [01]

McGLASHAN, Helen Caird [P,T] Paterson, NJ b. 3 Je 1893, Paterson. Studied: Columbia; R.M. Pearson; H.L. McFee. Member: Eastern AA; Ridgewood AA; Paterson AA. Exhibited: Montclair AM, 1939, 1940; Ridgwood AA, 1942–46; Vendôme Gal., 1940–42; S.Indp.A., 1941, 1942; Paterson AA, 1946. Position: T., Pub. Sch., Paterson, 1927–46 [47]

McGLYNN, Thomas A. [P] San Fran., CA/Pebble Beach, CA. Member: Carmel AA; Santa Cruz AL; Soc. for Sanity in A. Exhibited: Calif. State-wide Exh., Santa Cruz, 1937, 1938. Position: T., San Fran. Sch. Dept. [40]

McGOWAN, Ruth [P] Wash., D.C. [08]

McGRATH, Anthony A. [B,E,P,L,Des,I] NYC b. 7 Ap 1888, Worcester, MA. Studied: St. Paul, Minn. Sch. A.; J. Huntington Polytech. Inst.; L.W. Siegler. Member: Calif. SE; New Haven PCC. Exhibited: AV, 1942; NAD, 1936; AIC, 1930; NAC, 1930; Cleveland Pr. C., 1931; Calif. SE, 1930–33; New Haven PCC, 1933–36; Beaux-Arts Gal., London, 1930; Brooklyn SE, 1930–35; Fifty Prints of the Year, 1933. Illustrator: Columbia, Franciscan (magazines); for the Salvation Publ. Co. Specialties: religious and historical subjects [47]

McGRATH, Beatrice (Willard) [S] New Haven, CT b. 28 N 1896, Dodge City, KS. Studied: Cleveland Sch. A.; H.N. Matzen. Member: Cleveland SS. Exhibited: Garden C. Comp., Cleveland, Ohio, 1925 [40]

McGRATH, Jeannette [P,T] Phila., PA. Studied: PAFA [25]

McGRATH, John [P,G] Baltimore, MD b. 9 N 1885, Ireland. Studied: Md. Inst.; Charcoal C. A. Sch., Baltimore; Acad. Julian, Acad. Colarossi, both in Paris; Slade Sch., London. Member: Baltimore WCC; Charcoal C. (Pres.); Baltimore E. Soc. Exhibited: Baltimore WCC, 1939; Los Angeles PM. Work: Adler Coll., Baltimore [40]

McGRATH, Lenore K. [Min.P] Seattle, WS [10]

McGRATH, Sallie T(omlin) [P] NYC b. Galena, IL. Studied: C. Lumsdon. Member: Salons of Am. [29]

McGRAW, Edgar [I] Richmond Hill, NY. Illustrator: nat. mags. [40]

McGRAW, Hazel Fulton [Et,Li,P,C] Ballinger, TX b. 22 S 1897, Sherman, TX. Studied: Hardin Simmons Univ.; F. Klepper; M. Mauzey; H. de Young. Member: AAPL; Tex. PM Gld. Exhibited: W.R. Nelson Gal. A., 1942 (prize); Ft. Worth AA, 1941, 1942 (prize), 1943 (prize), 1944–45; Abilene, Tex. Mus. A., 1944 (prize); LOC, 1945; Laguna Beach AA, 1945; Am. Monotype S., 1941; Okla.-Tex. General Exh., 1941; Tex. General Exh., 1942–44 [47]

McGRAW, T.A., Jr., Mrs. [P] Detroit, MI [21]

McGUIRE, Agnes. See D.W. McCahill, Mrs.

McGUIRE, Frederick B. [Mus.Dir] Wash., D.C. b. Wash., D.C. d. 11 D 1915. Position: Dir., Corcoran, since 1900 (trustee since 1882)

McGUIRE, William J. [P] Paterson, NJ. Member: S.Indp.A. [24]

McGURK, Jonce [Dealer] NYC b. Cleveland, OH d. 10 Ja 1947. Personal representative of Percy Rockefeller; art advisor to Andrew Mellon; appraised Ringling Bros. art collection at Sarasota, Fla.

McGUSTY, H(enry) A(lexander) [P,S,I,W] Enterprise, MS b. 31 Ja 1871, Dublin, Ireland. Studied: B. Constant; Delecluse; Cavalier [25]

McHENCK, Andrew [S] NYC [17]

McHUGH, Arline B. [P,I] Rye, NY b. 9 Mr 1891, Owensboro, KY. Studied: H.R. Ballinger; A.W. Salisbury; G. De Witt. Member: New Rochelle AA; Westchester Inst. FA [40]

McHUGH, Irene (Mrs.) [P] Tacoma, WA [24]

McHUGH, James Slater [P] NYC [24]

McHUGH, John Paul [P,E] New Canaan, CT b. 7 F 1895, Holyoke, MA. Studied: DuMond; Bridgman; Dodge. Member: NAC; New Rochelle AA; Silvermine Gld. [33]

McILHENNEY, C. Morgan [P,E] Shrub Oak, NY b. 1858, Phila., PA. Studied: Phila. Member: AWCS; NYWCC; N.Y. Etching C.; A. Fund S. Exhibited: AWCS, 1892 (prize); NAD, 1893 (prize); Columbian Expo, Chicago, 1893 (med); Paris Expo, 1900; Pan-Am. Expo, Buffalo, 1901; ANA [04]

McILHENNEY, John D. [Edu,Patron] Phila., PA d. 23 N 1925. Member: A. Alliance, Phila. (Dir.); Fairmount Park AA (trustee)

McILRATH, Vira. See Scheibner.

McILVAIN, Dorothy S. [B,P,Des,T] Seattle, WA b. 27 Je 1901, Mansfield, OH. Studied: Univ. Wash.; Columbia. Member: AFA; Northwest PM. Position: T., Women's Col., Univ. N.C. [40]

McILVAIN, Duff [P,G,I,Car] Wichita, KS b. 29 Ag 1918, Wichita, KS. Studied: Wichita AA Sch. Member: Wichita AG; Wichita AA; Kans. Fed.

A. (Pres.). Exhibited: Miss. AA, Jackson, Miss.; Sterling Sch. Gal., Ill. [40]

McILVAINE, Edith Van R. [P] East Libety, PA [13]

McILWRAITH, William Forsythe [P,E,I] b. 1867, Gault, Ontario d. 1940 Fishkill, NY. Studied: ASL. Specialty: scenes along rivers of the Pacific Northwest. Active in Portland, Oreg., after 1923. [*]

McINTEE, William H. [P] b. 1857, Almont, MI d. 12 N 1917, Detroit. Studied: Bouguereau, in Paris

McINTIRE, Katharine [P] NYC b. Richmond, VA. Studied: ASL, with K.H. Miller; N.Y. Sch. F.&Appl. A.; Guerin, at Ecole Moderne; Lhote, in Paris. Member: NAWPS [40]

McINTOSH, Joe M. [S,P] NYC b. 30 O 1905, Indianapolis, IN. Studied: Clay C., NYC; BAID; NAD; ASL; A. Sch., John Herron AI; Fontainebleau Sch. FA. Work: Hiram Col., Hiram, Ohio [40]

McINTOSH, Pleasant Ray (Mr.) [P,T] Peoria, IL b. 4 O 1897, New Salisbury, IN. Studied: AIC; Univ. Chicago; Bradley Polytechnic Inst.; Tiffany Fnd. Member: Am. Ass. Univ. Prof.; Midwest A. Conference; Western AA. Exhibited: Biarritz, France, 1946 (one-man); Paris, France, 1946 (one-man); Peoria, 1927, 1929 (med), 1932 (med), 1933, 1944, 1945; Columbus AL, 1925 (prize); Hoosier Salon, 1927 (prize). Positions: T., Bradley Polytechinc Inst. (1926–45), U.S. Army Univ., Biarritz, France (1946) [47]

McINTYRE, Florence M. [T,P] Memphis, TN b. 7 Ag 1878, Memphis. Studied: AIC; W. Chase; A.M. Archambault; L. Taft. Member: NAWA; Memphis AA. Position: Dir., Memphis AA Free A. Sch. [47]

McINTYRE, Grace H. [P] NYC [17]

McINTYRE, Oliver Franklyn [Por.P,Car,I,E,L] Coral Gables, FL b. 21 Jy 1901, Dayton, OH. Studied: Chicago Acad. FA; Am. Acad. A., Chicago; R. Miller; D. Fink; J. Katzieff; C.W. Hawthorne; H.L. Timmins; J.R. Frazier; RISD, with D. Cornwell. Member: Provincetown AA; Blue Dome F.; Fla. Soc. PE. Exhibited: Miami Beach Pub. Lib.; Provincetown AA; Miami AI, 1935 (prize); Palm Beach A. Center, 1936 (prize). Work: Northwestern Univ. Illustrator: magazines. Position: A. Dir., Miami Daily News [47]

McIVER, Loren (Mrs. Lloyd Frankenberg) [P] NYC (1982). Exhibited: "Fantastic, Dada & Surrealist Art," MOMA, 1936; WMAA, 1953. Work: MOMA; Los Angeles MA; WMAA; Hirschhorn Mus.; WPA [*]

McIVER, Portia Ragland (Mrs.) [P] Dallas, TX [24]

McKAIN, Bruce [P] Provincetown, MA b. 22 Je 1900, IN. Studied: Herron AI; C.W. Hawthorne. Member: Provincetown AA. Exhibited: NA, 1938; Provincetown AA, 1934, 1936, 1939; WFNY, 1939 [40]

McKAY, Francis [S] NYC. Exhibited: WFNY, 1939 [40]

McKAY, Helen C. [P] Pittsburgh, PA. Member: Pittsburgh AA [21]

McKAY, Pauline [P] Boston, MA [13]

McKAY, Walter Hood [Des,P] Briarcliff Manor, NY b. 4 F 1897, Columbus Grove, OH. Studied: AIC; ASL; Meyer-Both. Exhibited: Barbizon Plaza Hotel, NYC, 1934 (one-man); Tricker Gal., NYC, 1939. Specialty: commercial art [40]

McKEAGE, Edna P. [P] Chicago, IL. Member: Chicago NJSA [25]

McKEAN, Hugh Ferguson [P,T,L] Winter Park, FL b. 28 Jy 1908, Beaver Falls, PA. Studied: Rollins Col.; Williams Col.; ASL; PAFA; Bridgman; Garber; A. Strauss; Boland, at Fontainebleau Sch. FA. Member: SSAL; Fla. Fed. A. Exhibited: Fla. Fed. A., 1931 (prize). Work: TMA; Univ. Va. Position: T., Rollins Col., Winter Park, Fla. [47]

McKEE, Alice. See Cumming.

McKEE, Clare Alva (Mrs.) [P] Waukegan, IL b. 15 Jy 1895, Benton Harbor, MI. Studied: AIC. Member: Chicago NJSA. Exhibited: Lake County AL, Waukegan. Work: Vanderpoel AA; Pierce Sch., Chicago [40]

McKEE, Donald [Car] NYC b. 1 Mr 1883, Indianapolis, IN. Studied: N.Y. Sch. A. Illustrator: Life, Judge, Saturday Evening Post, Collier's [40]

McKEE, John Dukes [I] Chicago, IL b. 4 D 1899, Kokomo, IN. Studied: E. Forsberg. Exhibited: Hoosier Salon, 1925 (prize), 1926 (prize) [33]

McKEE, Katherine Louise [P,Gr,S,Des,C,T] East Cleveland, OH b. 27 Ag 1905, Cleveland. Studied: Columbia; Cleveland Sch. A.; J. Huntington; J. Binder. Member: NAWA; Women's AC, Cleveland. Exhibited: NAWA, 1931–33, 1944; Am. FA Gal., NYC, 1931 (prize); Pal. Leg. Honor, 1940; WFNY, 1939; Weatherspoon Gal., N.C., 1944; CMA, 1929, 1932, 1933, 1934 (prize), 1935, 1936, 1937 (prize), 1938, 1939 (prize), 1940, 1941 (prize), 1943–46; A. Center, N.Y., 1930; Cleveland Col., 1936; CM, 1941; Butler AI, 1939, 1943, 1945, 1946; Kearney Mem. Exh., Milwaukee, 1946; Wichita AA, 1946; Ohio Valley Exh., 1946. Work: CMA; Cleveland Mun. A. Coll. Position: T., Andrews Sch., Willoughby, Ohio [47]

McKEE, Virginia [P] NYC [19]

McKELL, James C. [I] Phila., PA [21]

McKELLAR, Archibald [S] Bridgeport, CT b. 23 O 1844, Paisley, Scotland d. 4 Jy 1901. Work: Wilmington, Del. His best known piece, "Defence of the Flag," has been copied nearly 1,000 times. Position: Dir., Monumental Bronze Co. of N.Y., in Bridgeport

McKELVEY, Ralph Huntington [Mus.Dir,P,W,T,Cr] Clearwater, FL b. 7 D 1877, Sandusky, OH. Studied: Ohio State Univ.; Stanford; Oberlin Col. Member: Palm Beach AL; Manatee County AL; Fla. Fed. A. Exhibited: Studio Gld., NYC, 1939; Fla. Fed. A., 1938–46; Gulf Coast Group, 1940–46. Work: Rollins Col.; Ohio State Normal Col.; Oberlin Col.; Bradenton, Fla., Chamber of Commerce. Position: Dir. Clearwater AM, 1943–46; Pres., Fla. Fed. A., 1945–46; Dir./T., Clearwater Mus. Sch. A., 1943–46 [47]

McKENZIE, R(obert) Tait [S,W,L] Phila., PA b. 26 My 1867, Almonte, Ontario d. 29 Ap 1938. Member: Phila. Sketch C.; Century A.; Phila. AC; AFA. Exhibited: St. Louis Expo, 1904 (med); Sweden, 1912 (med); P.-P. Expo, San Fran., 1915. Work: Fitz William Mus., Cambridge, England; Ashmolean Mus., Oxford, England; MMA; Canadian Nat. Gal., Ottawa; mem. statue, Montreal A. Gal.; mem. statue, Canadian War Mus., Ottawa; Univ. Ga.; Brown Univ.; Univ. Pa.; Newark Mus.; medals, Franklin Inst., Phila.; Univ. Buffalo; Achilles C., London; ICAA; Guischan, Scotland; fountain, Athletic Park, Phila.; statues, Univ. Pa., 1919; St. Paul's Sch.; mem., Cambridge, England; statue, Parliament Bldgs., Ottawa; Princeton, N.J.; St. Louis A. Mus.; mem., Edinburgh, Scotland; Greenwich, England. Specialty: athletes. Position: Dir., Phys. Ed., Univ. Pa., to 1931. [31]

McKENZIE, Vinnorma Shaw [P,Li,T] Port Huron, MI b. 27 S 1890, Downs, KS d. 18 Jy 1952. Studied: Chicago Acad. FA; Yale; Kendall; Fursman; AIC. Member: Detroit SWPS; NAWA; Port Huron AA; AAPL. Exhibited: Detroit SWPS, 1944 (prize) [47]

McKERNAN, Frank [P,I] Ridley Park, PA b. 19 S 1861, Phila. d. 23 D 1934. Studied: PAFA; H. Pyle. Member: Phila. Sketch C. [33]

McKEWEN, Anne [P,T] Baltimore, MD [27]

McKEY, Edward M. [P] d. Summer, 1918 (while in command of a rolling canteen, Italy). A lieutenant in the American Army.

McKILLOP, William [P] Paris, France b. Phila. Studied: St. Louis Sch. FA; Paris, with J.P. Laurens, E. Laurent [10]

McKIM, Charles Follen [Arch] NYC/St. James, NY b. 24 Ag 1847, Chester County, PA d. 14 S 1909. Studied: Harvard; Columbia; U. Pa.; Ecole des Beaux-Arts, with Daumet. Member: Assoc., AIA, 1875, Fellow, 1877, Pres., 1902–03; NAD, Assoc., 1905, Academician, 1907; Am. Acad., Rome (Pres.); NSMP (hon.); NSS; Arch. Lg., 1889; S. Beaux-Arts Arch. (charter). Exhibited: Paris Expo, 1900 (gold); King Edward of England, 1903 (gold); AIA, 1909 (gold). Work: Boston Pub. Lib.; R.I. State House; Madison Square Garden, NYC; Columbia Univ. Lib.; Brooklyn Inst. A. Mus.; Univeristy C.; Century C.; J.P. Morgan Lib.; Pennsylvania Station; Agriculture Bldg., Columbian Expo, Chicago, 1893. In 1877 joined W.R. Mead and in 1879, Stanford White, forming McKim, Mead and White.

McKIM, Musa [P] NYC. Exhibited: 48 States Comp., 1939. Work: USPO, Waverly, N.Y. WPA artist. [40]

McKIM, William Wind [Li,P,T,I,Car] Independence, MA b. 13 My 1916, Independence. Studied: Kansas City AI; Benton; de Martelly; animal anatomy, J.F. Frazier. Exhibited: WFNY, 1939; Kansas City AI, 1938 (prize), 1939, 1940 (prize), 1941; N.Y. State Fair, 1938 (prize). Position: T., Kansas City AI, 1945–46 [47]

McKINNEY, E(arl) B(raddoc) [Arch,E] NYC/Upper Montclair, NJ b. Ap 1881, Marietta, OH d. 20 O 1935. Studied: Chase; Henri. Member: Beaux Arts S.; Arch. Lg. Work: Little Theatre, CI; Univ. Nebr., Lincoln [32]

McKINNEY, Gerald T. [P,I] Youngsville, PA b. 26 F 1900, Garland, PA. Studied: E.M. Ashe; C.J. Taylor; H.S. Hubbell; N. MacGilvary. Member: Pittsburgh AA [33]

McKINNEY, Katie Cable (Mrs.) [P,T] Bolivar, MO b. 28 Jy 1903, Shendandoah, IA. Studied: J.L. Wallace. Member: Omaha AG; Bolivar AG.

Exhibited: Sioux City Inter-State Fair, 1918–19 (prizes). Work: Southwest Baptist Col., Bolivar; Pub. Lib., Bolivar [40]

McKINNEY, Roland Joseph [Edu,Mus.Dir,W,L,P] NYC b. 4 N 1898, Niagara Falls, NY. Studied: Niagara Univ.; abroad. Work: Presbyterian Church, Davenport, Iowa. Author: "Thomas Eakins," 1942; "English and American Painting," Grolier Encyclopedia, 1946. Positions: Dir., Davenport Mun. A. Gal. (1925–27), High Mus. A., Atlanta, Ga. (1928–29), BMA (1929–38), Am. Section Painting, GGE (1939), Los Angeles Mus. A. (1939–46), Pepsi-Cola A. Competitions (from 1946) [47]

McKINNIE, Miriam. See Hofmeier.

McKINNON, Murdock [P] Westville, NJ. Member: Lg. AA [24]

McKINSTRY, Elizabeth [S] Buffalo, NY [21]

McKINSTRY, Grace E. [Por.P,S,T] NYC b. Fredonia, NY d. 26 N 1936, Minneapolis. Studied: ASL; AIC; Acad. Julian, Acad. Colarossi, R. Collin, all in Paris; Spain; Holland. Member: AAPL; NAC; Lg. APW. Work: St. Paul, Minn.; Univ. Minn.; Lake Erie Col., Painesville, Ohio; Carleton Col., Minn.; Shattuck Sch., Faribault, Minn.; Army and Navy C., Wash., D.C.; Women's C., Minneapolis; Beloit Col.; Pomona Col.; Cornell Univ.; Lincoln Mem. Univ., Russell Sage Col., Troy, N.Y.[33]

McKNIGHT, Eliza [P] NYC/Old Lyme, CT. Exhibited: Argent Gal., NYC, 1938 (one-man); NAWPS, 1935–38 [40]

McKNIGHT, J.R., Mrs. [P] Oklahoma City, OK. Member: Okla. AA [25]

McKNIGHT, Robert Johnson [S,Des,L] Springfield, OH b. 26 F 1905, Bayside, NY. Studied: Yale; Bouchard, in Paris; C. Milles; Am. Acad., Rome; C. Keck. Member: Springfield AA; Grand Central Gal. Award: Prix de Rome, 1932. Exhibited: PMA; CI; Grand Central A. Gal.; Robinson Gal., N.Y.; Brooks Mem. A. Gal., Memphis; Springfield AA. Work: S., Brookgreen Gardens, S.C. Positions: Dir., Memphis Acad. A., 1937–41; T., Southwestern Univ., Memphis, 1941–45 [47]

McLAIN, Helen [P] NYC [17]

McLAIN, Mary [Mur.P,Min.P] NYC. Exhibited: ASMP, 1935, 1937; NAWPS, 1935–38 [40]

McLANE, Iris [P] Chicago, IL [15]

McLANE, Jean (Mrs. John C. Johansen) [Por.P] NYC b. 14 S 1878, Chicago. Studied: AIC; Duveneck. Member: ANA, 1912; Port. P. Exhibited: St. Louis Expo, 1904 (med); Intl. Lg., Paris, 1907 (prize), 1908 (prize); N.Y. Women's AC, 1907 (prize), 1908 (prize); NAD, 1912 (prize), 1913 (prize); PAFA, 1914 (prize); P.-P. Expo, San Fran., 1915. Work: Mus. A., Toledo; AIC; Syracuse AM; San Antonio Mus.; NGA [24]

McLANE, Laura Vernon [P] NYC [15]

McLARTY, William James (Jack) [P,T,Li] Portland, OR b. 24 Ap 1919, Seattle. Studied: Mus. A. Sch., Portland, Oreg.; Am. A. Sch., N.Y.; A. Refregier; J. Solman. Member: Oreg. Gld. P.&S. Exhibited: Northwest PM, 1943, 1944, 1945; SFMA, 1945; Pasadena AI, 1946; Indianapolis Pr. Exh., 1946; All-Oreg. A., 1942, 1944, 1946; Portland Mus. 1945 (one-man). Work: murals, Schs., Portland. Position: T., Portland A. Mus. [47]

McLAUGHLIN, Charles J. [P,D,Dec] Covington, KY b. 6 Je 1888, Covington. Studied: Cincinnati A. Acad.; Duveneck; Ecole des Beaux-Arts; Fontainebleau Sch. FA; arch., in France, Belgium, Italy and Greece. Member: Cincinnati AC; MacD. C. of Cincinnati; Cincinnati Arch. Lg. Positions: Des., Rookwood Potteries, 1913–20; T., Col. of Texas, College Station, 1926–28 [40]

McLAUGHLIN, James Moore [P] Wash., D.C. b. 4 Ja 1909, Louisville, KY. Studied: Phillips Mem. Gal. Sch. Exhibited: Whyte Gal., Wash., D.C., 1939; PMG, 1939. Work: PMG [40]

McLAUGHLIN, M.B. [P] Cleveland OH. Member: Cleveland SA [27]

McLAUGHLIN, M. Louise [P,E,C] Cincinnati, OH b. 29 S 1847, Cincinnati d. 17 Ja 1939. Studied: Farny; Duveneck. Member: Cincinnati Women's AC. Exhibited: Paris Expo., 1889 (med); Intl. Expo, Paris, 1900; Pan-Am. Expo, Buffalo, 1901. Work: Cincinnati Mus.; Phila. Mus.; BMFA. Specialty: ceramics [38]

McLAWS, Virginia R(andall) [P] Sweet Briar, VA b. 29 Ag 1872, Augusta, GA. Studied: Charcoal C. Sch., Baltimore; N.Y. Sch. F.&Appl. A.; H. Caro-Delvaille, in Paris; PAFA; ASL. Member: Ga. AA; SSAL; AFA. Position: Dir. Art, Sweet Briar Col. [40]

McLEAN, Donald J., Mrs. See Porter, Doris.

McLEAN, Grace (Mrs.) [P,T] Pasadena, CA b. 21 F 1885, Jasper County, IA. Studied: J. Vanderpoel; H. Walcott; L. Murphy; AIC. Member: Am. Ar. Cong.; Pasadena Acad. FA. Exhibited: Western A. Fnd., Los Angeles, 1934 (prize). Position: T., Stickney A. Sch. [40]

McLEAN, Howard White [P,I] NYC b. 25 O 1879, Virginia [17]

McLEAN, James A(ugustus) [P,T] Raleigh, NC b. 2 My 1904, Lincolnton, NC. Studied: D. Garber; J. Pearson; C. Garner; PAFA. Member: SSAL; N.C. State AS; N.C. Prof. AA [33]

McLEAN, Ruth S. [Min.P] Larchmont, NY. Exhibited: Brooklyn SMP, 1932, 1934; Pa. SMP, 1934, 1935; NAWPS, 1937, 1938 [40]

McLEAN, W.D. [P] Revere, MA [01]

McLEAN, Wilma Christine [C,T] Hempstead, NY b. 23 S 1909, Hempstead, NY. Studied: C.F. Binns, at Alfred Univ. Member: EAA; AL, Nassau County. Position: T., Hempstead H.S.; Hofstra Col. [40]

McLEARY, Bonnie [S] NYC b. 2 Ja 1890, San Antonio, TX. Studied: Mora; Fraser. Member: Allied AA; NAWPS [24]

McLEARY, Kindred [P,Des,T] Pittsburgh, PA/Confluence, PA b. 3 D 1901, Weimar, TX. Studied: Univ. Tex.; Fontainebleau Sch. FA; J. Carlo, in Rome. Member: Pittsburgh AA. Exhibited: Pittsburgh AA, 1938, 1939. Work: WPA murals, USPO, Madison Sq. Postal Station, NYC; U.S. Court, Pittsburgh. Position: T., CI [40]

McLELLAN, Ralph [P,T,B] NYC b. 27 Ag 1884, San Marcos, TX. Studied: BMFA Sch.; ASL; Hale; Benson; Mora; E. Tarbell. Member: Boston Mus. AA; Tex. FAA; Phila. Alliance; SSAL; Phila. WCS. Exhibited: CAFA, 1917 (prize); NAD, 1919 (prize); SSAL, 1928 (prize), 1930 (prize), 1934 (prize). Work: Reading Mus., Pa.; T. Col., San Marcos, Tex.; Sam Houston State T. Col., Huntsville, Tex.; Furness Jr. H.S., Phila. Position: T., PMSchIA [47]

McLENNAN-HINMAN, T. (Mrs.) [P,T] NYC b. Chicago, IL. Studied: Holland, Germany; France [04]

McLENDON, Louise [P] Ft. Worth, TX [17]

McLENEGAN, Harry Richardson [P,C,T] Milwaukee, WI b. 11 Jy 1899, Milwaukee. Studied: E.M. Church; M. Key; D.C. Watson; G. Sinclair; C. Partridge. Member: Wis. PS [33]

McLENNAN, Eunice [P] Santa Barbara, CA. Exhibited: Calif. State-wide exh., Santa Cruz, 1936 [38]

McLEOD, L.E.G. (Mrs.) [P] Los Angeles, CA. Member: Calif. AC [25]

McLEOD, Ronald [I] Bronxville, NY. Member: SI [47]

McLOUGHLIN, Evelyn W. (Mrs.) [P] Maplewood, NJ. Member: Lg. AA [24]

McLOUGHLIN, Gregory [P] Wash., D.C. b. Santa Monica, CA. Studied: E. Speicher; G.T. Cole; R.V. Sewell. Work: Pub. Lib., Westport, Conn. [40]

McMAHON, A. Philip [W,L,T] NYC b. 14 Ag 1890, Warren, OH d. ca. 1950. Studied: Harvard. Member: Am. Inst. Archaeology; CAA; Mediaeval Acad. Am.; Mod. Lang. Assn. Author: "Art of Enjoying Art," 1938, "Preface to an American Philosphy of Art," 1945, other books. Contributor: The Arts, other magazines. Position: T., NYU, 1928– [47]

McMAHON, Jo L.G. [P] NYC [19]

McMAHON, Molly [Por.P] NYC. b. 17 D 1908, NYC. Studied: K. Nicolaides; ASL; A. Woefle; Grand Central A. Sch.; T. Webb; K. Inukai; T. Filmus [40]

McMANN, G.C. [P] Toledo, OH. Member: Artklan [24]

McMANUS, Blanche. See Mansfield, F.M., Mrs.

McMANUS, George [I,Car] NYC d. O 1954. Member: SI [31]

McMANUS, James Goodwin [P,T] Hartford, CT/Lyme, CT b. 5 F 1882, Hartford d. 15 S 1958, Old Lyme, CT. Studied: C.N. Flagg; R.B. Brandegee; W.G. Bunce; M. Flagg; W. Griffin. Member: CAFA (Pres.); Hartford Mun. AS; SC; Springfield AL; Lyme AA; New Haven PCC; Hartford Salmagundians (Pres.); Conn. AA. Exhibited: New Haven PCC, 1928 (prize); CAFA, 1922 (prize), 1923 (prize), 1928 (prize), 1929 (prize), 1930 (prize), 1933 (prize). Work: State Capitol, Hartford; Dauntless C., Essex, Conn.; Beach Mem. Coll., Storrs, Conn. Positions: T., Conn. ASL, Hartford Pub. H.S. [40]

McMEEN, Irene [P] NYC/Milford, NJ b. 13 MY 1896, Pittsburgh. Studied: ASL; Lhote, in Paris. Member: FA Gld., N.Y. Exhibited: FA Bldg., N.Y; Contemp. A., N.Y. [40]

McMEIN, Neysa (Mrs. John G. Baragwanath) [P,Des,L,I] NYC/Port Wash., NY b. 25 Ja 1890, Quincy, IL d. ca. 1950. Studied: AIC; ASL. Member: SI; Ar. Gld. Exhibited: AIC (prize); NYC. Illustrator: covers, Saturday Evening Post [47]

McMILLAN, Emily D. [P] Minneapolis, MN. Exhibited: Minn. State A. Comm., 1914 (prize) [17]

McMILLAN, Laura B(rown) (Mrs.) [P,W,T] Kokomo, IN b. 23 Ap 1859, Malone, NY. Studied: John Herron IA; De Pauw Univ.; E. King; E. Sitsman; G. Innis, Jr. Member: A. Dept. Kokomo Women's C.; Kokomo AA; Ind. AC. Work: Tipton Pub. Lib.; Kokomo Women's C. House; YWCA Bldg. [33]

McMILLAN, L.L. [P] Alexandria, IN [13]

McMILLAN, Mary [Min.P,Dr] Syracuse, NY b. 29 Mr 1895, Ilion, NY d. ca. 1958. Studied: Syracuse Univ.; Smith Col.; M.R. Welch; H. Giles. Member: NAWA; ASMP; Pa. SMP; Lg. Am. Pen Women; Syracuse AA. Exhibited: ASMP, 1921–46; PAFA, 1930–41; Syracuse AA, 1926–46; NAWA, 1934 (prize); Pa. SMP, 1932 (med), 1936 (prize); Nat. Lg. Am. Pen W., 1932 (prize), 1933 (prize), 1934 (prize). Work: MMA; PMA; BM; PAFA [47]

McMILLEN, Jack [P,T,Li] East Portchester, CT b. 21 S 1910, Jericho, TX. Studied: Univ. Ky.; Univ. Ill.; Minneapolis Sch. A.; Univ. Mo.; ASL. Exhibited: WFNY 1939; Playhouse A. Gal., N.Y.; NY SFA; Albright A. Gal.; Georgetown Gal., Wash., D.C.; Contemp. A. Gal., NYC (one-man). Work: murals, Walter Reed Hospital; Presby. Church, Kirksville, Mo.; USPO, College Park, Ga.; Tuscumbia, Ala. WPA artist. [47]

McMILLEN, Mildred [B,En] Provincetown, MA b. 8 Je 1884, Chicago d. ca. 1940. Studied: AIC, 1906–12; Acad. Colarossi, Paris; NYC. Member: Provincetown Printers. Exhibited: Provincetown, AA, 1917–20. Work: Nat. Mus. Canada, Ottawa; NYPL [21]

McMORRIS, Leroy D(aniel) [P,I,E] NYC b. 1 Ap 1893, Sedalia, MO. Studied: Pennell; L. Gaspard; Bridgman; Wilimovsky; Patrick; Buehr. Member: Kansas City AA; L.C. Tiffany Fnd.; ASL; Kansas City AA [27]

McMULLEN, Blanche [Min.P] Grand Rapids, MI [17]

McMULLEN, E. Ormond [P,I,G,T] Bethel, CT b. 29 F 1888, Evert, MI. Studied: Grand Central A. Sch.; AIC; NAD; ASL. Member: Phila. WCC; Wash. WCC; AWCS; Springfield AL; SC; NYWCC. Exhibited: PAFA, 1936, 1938–45; CGA, 1938–40, 1942, 1943, 1945; AWCS, 1938–43, 1946; Springfield Mus. A., 1944–46; Hartford Atheneum 1944, 1945; Soc. Four A., Palm Beach, Fla., 1941; BMA, 1942; WFNY 1939; Jackson, Miss., 1942; AFA traveling exh., 1940; NYWCC, 1934, 1935, 1937, 1939; Wash. WCC, CGA, 1939 [47]

McMULLEN, Elizabeth M. (Mrs.) [P] Pittsburgh, PA. Member: Pittsburgh AA [21]

McMULLIN, Jeannette W. [P] Boston, MA b. Watertown, NY. Studied: Cooper Inst.; ASL [17]

McMUNIGLE, Mary G. [P] Pittsburgh, PA. Member: Pittsburgh AA [21]

McMURTRIE, Edith [P,T] Phila., PA b. 9 My 1883, Phila. d. ca. 1950. Studied: PAFA; Chase; Anschutz; Garber; Vonnoh. Member: Phila. Plastic C.; Phila. A. All.; Woodmere AA; Phila. A.T.A.; S.Indp.A. Exhibited: CGA; PAFA, 1929 (prize), 1930–38, 1943; Toledo Mus. A., 1938; Phila. A. All., 1944 (one-man); Phila. Plastic C., 1941 (prize); Woodmere A. Gal.; Bowdoin Col., 1945; Ogunquit A. Ctr., 1949. Work: PAFA. Position: T., Wm. Penn. H.S. [47]

McMURTY, Edward A. [S] Chicago, IL [19]

McNAIR, William [P] NYC/Bar Harbor, ME b.24 S 1867, Oil City. PS. Studied: G. deF. Brush, ASL. Member: AFA [29]

McNAMARA, A.L. (Mrs.) [P] Chicago, IL [24]

McNAMARA, A.M., Mrs. See Kempton, Martha Greta.

McNAMARA, Lena Brooke [I,Mur.P] Norfolk, VA b. 13 My 1891, Norfolk. Studied: Corcoran A. Sch.; E.E. Messer; R.N. Brooke; C.C. Critcher; PAFA; Breckenridge; C. Beaux; E. Carlson; C. Hawthorne. Member: Norfolk A. Corner; Norfolk S. Arts. Work: hotel, Virginia Beach; Crippled Children's Home, Richmond, Va.; Khedive Temple, Court House, both in Norfolk. Illustrator: "John Martin's Book for Children"; two small French picture books [40]

McNAMARA, Mary E. [P] Wash., D.C. Member: S. Wash. A. [29]

McNAMEE, Dorothy Swinburne (Mrs. Luke) [P] Wash., D.C. [25]

McNEALL, James Hector (Mrs.) [P] Devon, PA. Studied: PAFA [25]

McNEAR, Everett C. [Des,P] Evanston, IL b. 30 S 1904, Minneapolis, MN. Studied: Minneapolis Sch. A., with C. Booth; E. Kinzinger; L. Marcoussis. Member: Chicago AC; 27 Designers. Exhibited: AIC, 1935, 1936, 1939, 1940, 1942; SFMA, 1946 (one-man); Crocker A. Gal., 1946 (one-man); Rouillier Gal., 1944 (one-man); Wustum Mus. FA, 1945 (one-man); St. Paul Gal., 1943 (one-man); A. Chicago, 1945 (one-man). Illustrator: "Many a Green Isle," 1941 [47]

McNEELY, Perry [Ldscp.P] Los Angeles, CA b. 10 D 1886, Lebo, KS. Studied: self-taught. Member: Acad. Western P. (Pres.); Los Angeles AA. Exhibited: Glendale, Calif., 1926 (med); Pacific Southwest Expo, 1928 (prize); Los Angeles County Fair, 1929 (prize); H.S., Clearwater, Calif., 1937 (prize) [40]

McNEELY, Stephen [P,S] NYC b. 17 N 1909, East Orange, NJ. Studied: NAD; BAID. Exhibited: CGA, 1941; CI, 1941; PAFA, 1942; NAD, 1942 (prize); MMA (AV), 1943. Work: Newark Mus.; Newark Pub. Lib.; Caldwell (N.J.) Pub. Lib. [47]

McNEIL, George Joseph [P,T] Laramie, WY b. 22 F 1909, NYC. Studied: PIASch, 1927–29; ASL, 1930–31; Columbia; H. Hofmann. Member: CAA; Am. Abstract A.; Nat. Edu. Assn. Exhibited: MOMA, 1938; WFNY, 1939; BM, 1941; Am. Abstract A., 1944, 1946; Lyceum, Havana, 1941 (one-man); WMAA; SFMA. Work: Havana Nat. Mus.; Williamsburg Housing Project, N.Y. WPA artist, 1935–40. Position: T., Univ. Wyo. [47]

McNEILL, Stanley F. [P] NYC. Member: GFLA [27]

McNETT, William Brown [T,I,L,Gr,Por.P] Rutledge, PA b. 8 N 1896, Omaha, NB d. 25 Ja 1968, Los Angeles, CA. Studied: Johns Hopkins Med. Sch.; PAFA; Phila. Graphic Sketch C.; M. Brodel; R. Nuse; D. Garber; J. Enkeboll; Lasar; Raditz. Member: Assn. Medical Illus.; Am. Color Pr. S.; Phila. Alliance; Graphic Sketch Cl.; A. Union; F., Bryn Mawr A. Center. Exhibited: Phila. WCC, 1938, 1941 (prize); Phila. A. All.; AWCS, 1941; Wanamaker Exh., Phila.; Phila. Pr. C.; Am. Color Pr. S. Work: Davidson Col., N.C.; Flora MacDonald Col., Red Springs, N.C.; LOC; Am. Color Pr. S. Illustrator: "Neurology," by Gotten, 1941, "Fractures," by Bancroft, 1943, "Surgery," by Hill, 1946 (all textbooks); other med. books. Position: Dir., Dept. Medical A., Temple Univ.; Dir., Medical A., The Blakiston Co., Pub., Phila. [47]

McNULTY, Agnes Tait, Mrs. See Tait.

McNULTY, William Charles [P,E,T] NYC/Rockport, MA b. 28 Mr 1884, Ogden, UT d. 26 S 1963. Exhibited: AIC, 1936–46; MMA; WMAA; BMFA; Kraushaar; Kleeman; Assn. Am. A.; Macbeth Gal. Work: AGAA; Canajoharie Mus.; MMA; BMFA; WMAA; NYPL; LOC; Detroit Inst. A.; Newark Mus.; Fifty Prints of the Year, 1931, 1933; AIC; CGA. Position: T., ASL [47]

McNULTY, William, Mrs. See Brockman, Ann.

McPARLIN, Eleanor Beall [Min.P] Baltimore, MD [04]

McPEAK, William [P] Cincinnati, OH [17]

McPHARLIN, Paul [W,I,Des,Gr,C,T] NYC b. 22 D 1903, Detroit, MI d. 28 S 1948. Studied: G. Craig; J. Erskine; Columbia; Wayne Univ; Univ. Mich. Member: AIGA; Soc. Typographic A.; Puppeteers of Am.; Am. C. Des. Exhibited: AIC; Detroit Inst. A.; CM, 1936–40; Book Des. Exh., Evansville, Ind. & Racine, Wis. (one-man), 1941. Work: des., "The Raven and Other Poems," by Poe, "Satires and Bagatelles," by Franklin, 1936, 1937. Author/Illustrator: "A Repertory of Marionette Plays," 1929, "Puppets in America," 1936, "Paper Sculpture," 1945, other books. Contributor: Theatre Arts, Magazine of Art, American Artist, other magazines. Position: T. Wayne Univ., Detroit [47]

McPHERSON, J.C. [P] NYC. Member: S.Indp.A. [25]

McQUADE, Walter [En] NYC [17]

McQUAID, Mary C(ameron) [P,Li,T] NYC b. 21 N 1886, Jacksonville, FL. Studied: NAD; ASL; Cooper Union; Ettore Cadorin [33]

McQUAIDE, Lee F. [P] Pittsburgh, PA. Member: Pittsburgh AA. Exhibited: Pittsburgh AA, 1920 (prize) [25]

McQUINN, Robert [I] New Brighton, NY [19]

McRICKARD, James P. [P] Bayside, NY b. 7 N 1872. Studied: ASL; D. Volk; G. deF. Brush. Member: SC; AAPL [40]

McSNYDER, William [P] Madison, IN [06]

McTIGHE, Anne [P] Phila., PA. Exhibited: NAWPS, 1935–38 [40]

McVEIGH, Blanche [E,T] Ft. Worth, TX b. St. Charles, MO. Studied: St. Louis Sch. FA; AIC; PAFA; ASL; D. Garber; D. Reed; Wash. Univ. Member: Calif. Pr. S.; SAE; Chicago SE; Dallas Pr. C.; SSAL; Prairie PM; Artists G., Ft. Worth; Southern PM. Exhibited: AV, 1942; Buffalo Pr. C., 1938, 1939; Calif. Pr. S., 1940–44; CAFA, 1937–46, 1941 (prize); Chicago SE, 1938–45; Denver AM, 1943, 1945; WFNY, 1939; Northwest PM, 1940–42; NAD, 1943, 1944; Oakland A. Gal., 1938–45; Phila. Pr. C., 1936–45; LOC, 1943–46; CI, 1945; SSAL, 1945 (prize); Dallas Pr. C., 1941, 1942 (prize) 1944 (prize) 1945; Tex. General Exh., 1942–43, 1944 (prize), 1945 (prize); Tex. FAA, 1938, 1946 (prize); 100 Prints, Chicago, 1936 (prize), 1938 (prize); SAE, 1940 (prize), 1942 (prize), 1944 (prize), 1946 (prize). Work: Mus. FA, Houston; Ft. Worth AA; Okla. A&M Col.; Dallas Mus. FA; CM; CI; LOC; Univ. Tex.; Nat. Coll. FA, Smithsonian; Ft. Worth Pub. Lib. [47]

McVEY, Leroy V. [P] Kansas City, MO b. 14 F 1898, Ottawa, KS. Studied: AIC; Kansas City AI. Exhibited: Midwestern Exh., Kansas City AI, 1933 (med), 1935 (prize). Position: Newspaper Artist, Kansas City Star and Times [40]

McVEY, Leza S. (Mrs.) [S,C,T] Austin, TX b. 1 My 1907, Cleveland, OH. Studied: Cleveland Sch. A.; Colorado Springs FA Center; Research Studio, Maitland, Fla.; A. Blazys. Exhibited: Southwestern Gen. Exh., 1943–45; San Antonio, Tex., 1944; Houston MFA, 1938; Research Studio, Maitland, Fla. [47]

McVEY, William M. [S,T,L,P] Austin, TX b. 12 Jy 1905, Boston, MA. Studied: Rice Inst.; Cleveland Sch. A.; Despiau; H. Keller; F. Wilcox; Acad. Colarossi, Grande Chaumière, Acad. Scandinave, all in Paris. Member: Tex. S. Gr.; Seven Sculptors, Cleveland; Société des Artistes Scandinaves. Exhibited: Great Lakes Expo, Cleveland; Pomona Col., 1942 (prize); CMA, 1932 (prize), 1933, 1934; Houston MFA, 1929 (prize), 1936 (prize). Work: Houston MFA; CMA; Fed. Trade Comm., Wash., D.C.; San Jacinto Mon., Tex.; Mem. Mus., Austin; Texarkana, Tex.; Wade Park, Cleveland; Housing Project; Playground, Houston; Canton (Ohio) H.S.; Cleveland Mus. Hall; mon., Ozona, Tex. Contributor: Magazine of Art. Position: T., Univ. Tex., since 1939 [47]

McVICKAR, Harry Whitney [I,W] Southampton, NY. Member: Century; Lambs C. Contributor: Life. One of the founders of Vogue. Author/Illustrator: "Daisy Miller"

McVICKER, J. Jay [E] Wash., D.C. Member: SAE [47]

McWHINNEY, Harold [Dec] Eaton, OH b. 17 F 1908, Campbellstown, OH. Studied: McConaha; R. Moffett; J. King. Member: Richmond Palette C. Exhibited: Hoosier Salon, 1933 (prize); Richmond AA, 1934 (prize), 1939 (prize); John Herron AI, Ind., 1934, 1939 (prize) [40]

McWILLIAMS, Elizabeth [P] Chicago, IL [15]

MEAD, Alice [P] Upper Montclair, NJ [25]

MEAD, Ben Carlton [I,Mur.P] Amarillo, TX (1967) b. 1902, Bay City, TX. Studied: AIC, with J. Rozen, C. Schroeder. Work: mural; Panhandle Plains Hist. S. By 1935 he had illustrated 10 books with his southwestern subjects, and 7 more by 1967. [*]

MEAD, Elinor Gertrude [P] b. 1 My 1837, Brattleboro, VT d. 6 My 1910. Amateur artist. Sister of Larkin; wife of writer William Dean Howells. [*]

MEAD, Larkin Goldsmith [S] Florence, Italy b. 3 Ja 1835, Chesterfield, NH d. 15 O 1910. Studied: His career began as a boy in Brattleboro after he received publicity for his colassal snow sculpture of an angel; Brooklyn, with H.K. Brown, 1853–55; Florence, with H. Powers. Work: "Vermont" (1857), "Ethan Allen" (1876), in State House, Montpelier, Vt.; Soldier's Mon., St. Johnsbury, Vt.; Minn. Court House; Calif. State House, Sacramento; Agriculture Bldg., Columbian Expo, 1893; CGA. Position: A./Correspondent, Harper's, early in the Civil War [10]

MEAD, Nelson, Mrs. See Avery, Hope.

MEAD, Paul Edward [Por.P,I] Kenmore, NY b. 13 Ja 1910, Milwaukee, WI. Member: Buffalo AS; Guild of Allied A., Buffalo. Exhibited: Buffalo SA, 1935 (prize), 1937 (prize) [40]

MEAD, Roderick Fletcher [E,En,P,B,Li] Carlsbad, NM b. 25 Je 1900, South Orange, NJ. Studied: Yale; Grand Central A. Sch.; ASL; G. Luks; W.S. Hayter. Member: AWCS; Société des Sur Independents de Paris; Le Groupe des Artistes Anglais et Americain, Paris. Exhibited: AWCS, 1928–33; PAFA, 1928; AIC, 1929; SAE, 1941–45; NAD, 1945, 1946; Carnegie Inst., 1944, 1945; Mus. N.Mex., 1942, 1945; N.Mex. State Fair, 1944, 1945; Paris, France, 1934, 1939; Société des Beaux-Arts, Lorraine, France (med); Northwest PM, 1945–46 (prizes); LOC, 1946 (prize). Work: MMA; LOC; CI; Northwest PM; Princeton Univ. [47]

MEAD, William Rutherford [Arch] b. 20 Ag 1846, Brattleboro, VT d. 20 Je 1928, Paris, France. Studied: Norwich Univ., 1861; Amherst Col., 1867; NYC; Florence, Italy. Upon his return to NYC from Europe, became associated with Charles F. McKim; later joined by Stanford White, forming McKim, Mead and white. Member: NAD. Award: Acad. Arts and Letters, 1913 (gold, conferred upon an architect for the first time.) Work: see listing for McKim

MEADOWS, Dell (Mrs.) [P] Los Angeles, CA. Member: Calif. AC [25]

MEAGHER, M(arion) T. [P,S,T] NYC/Fisher's Island, NY b. NYC. Studied: NAD; Chase; Beckwith; R.S. Gifford; Paris; Antwerp. Position: Artist, AMNH; N.Y. Ophthalmic Col. [33]

MEAKIN, L(ewis) H(enry) [Ldscp.P,T] Cincinnati, OH b. ca. 1850, Newcastle, England (brought to U.S. as a child) d. 14 Ag 1917, Boston. Studied: Cincinnati Sch. Des.; Munich, 1882–86; Paris; Europe. Member: SWA (Pres.); Cincinnati AC; SC. Exhibited: Cincinnati AC 1902; St. Louis Expo, 1904 (med); Appalachian Expo, Knoxville, 1911 (med); Chicago, 1911 (prize). Work: Cincinnati Mus.; Indianapolis AA; AIC. Position: T., Cincinnati A. Acad.; Cur., Cincinnati Mus. [15]

MEANS, Charles W. [P] NYC. Member: Cleveland SA [27]

MEANS, Elliott [S,I] NYC b. 10 Mr 1905, Stamford, TX d. 1962. Studied: BMFA Sch. Exhibited: NAD, 1933, 1935–37, 1940, 1941, 1944; PAFA, 1935; Dance Intl., 1937; Arch. Lg., 1936; WFNY, 1939; Clay C., 1939. Work: S., Reliefs, Govt. Printing Office Bldg., Wash., D.C.; Welfare Island, N.Y.; USPO, Suffern, N.Y.; Dexter, Maine. Itinerant mural & sign painter on the Pacific Coast before attending BMFA Sch. and eventually becoming a sculptor and book illustrator. [47]

MEANS, Glenn [P] New Haven, CT. Member: NAWPS. Exhibited: NAWPS, 1935 (prize) [40]

MEANS, Mary Maud (Mrs.) [P] Santa Barbara, CA b. 1848, Marietta, OH. Studied: Florence; Paris [06]

MEARS, Helen F(arnsworth) [S] NYC b. 1876, Oshkosh, WI d. 17 F 1916. Studied: A. Saint-Gaudens, NYC; Paris. Member: NSS, 1907. Exhibited: Columbian Expo, Chicago, 1893 (prize); St. Louis Expo, 1904 (med); P.-P. Expo, San Fran., 1915. Work: MMA; Capitol, Wash., D.C. [15]

MEARS, Henrietta Dunn [P,E] St. Paul, MN/Provincetown, MA b. Milwaukee, WI. Studied: ASL; Hawthorne; Pape. Member: Copley S.; Provincetown AA; West Coast Arts; Berkeley Lg. FA. Exhibited: Minn. State Fair, 1927 (prize); St. Paul Inst., 1930 (prize) [33]

MEARS, William E. [I] Garden City, NY b. 1868, NYC d. 18 N 1945. Member: SC; A. Dir. C. Position: art ed./production mgr./illus., Harper's for more than 40 yrs

MECHAU, Frank Albert, Jr. [Mur.P,T] NYC/Redstone, CO b. 26 Ja 1903, Wakeeney, KS d. 9 Mr 1946, Denver. Studied: Denver Univ., 1923–24; AIC, 1924–25. Member: ANA, 1937; F., Guggenheim Fnd., 1934–36. Exhibited: Denver AM, 1933 (prize); AIC, 1935 (med); Kansas City AI, 1936 (prize); NA, 1938 (prize). Work: murals, FA Dept., Denver Pub. Lib.; USPO Dept. Bldg., Wash., D.C.; USPOs, Colorado Springs, Glenwood Springs, both in Colo.; mural, Ogalla, Nebr. and USPO in Court House, Ft. Worth, Tex.; fresco, Colorado Springs FA Center; MOMA; Detroit Inst. A. WPA artist. Positions: T., Colorado Springs FA Center (1937–38), Columbia (1939–43); traveled 20,000 miles as artist-correspondent for Life magazine during WWII [47]

MECHLIN, Leila [Cr,W,L] Wash., DC b. 29 My 1874, Wash., D.C. d. ca. 1950. Studied: Univ. Nebr. Member: AFA; Wash. SFA; Royal SA, London; Am. Assn. Univ. Women; NAC. Contributor: Architectural Record; American Review; The Century; Encyclopaedia Britannica; American Dictionary of Biography; others. Position: A. Critic, Evening & Sunday Star, Wash., D.C., 1900–46 [47]

MECKLEM, Austin Merrill [P,T] Woodstock, NY b. 17 D 1894, Colfax, WA d. 7 O 1951. Studied: Univ. Wash.; Calif. Sch. FA; ASL, with K.H. Miller; B. Robinson; San Fran. Sch. FA. Member: An Am. Group; Audubon A.; Woodstock AA; Am. S. PS&G; Am. A. Cong. Exhibited: WMAA, 1930–44; CGA, 1934; MOMA, 1934; AIC, MMA, 1941; Louisville Mus. A., 1928 (prize). Work: WMAA; Louisville Mus. A.; Binghamton Mus. A.; Ulster County Hist. S.; Recorder of Deeds Bldg., Wash., D.C.; N.Y State Armory, Kingston; USPO, Portland, Conn. [47]

MECKLEM, Marianne. See Appel.

MEDARY, Amie Hampton [Min.P,W,L] Little Compton, RI b. 24 Jy 1903, Groton, CT. Studied: BMFA Sch.; PAFA; A.M. Archambault. Member:

Intl. Lyceum Assn. Exhibited: Pa. SMP; ASMP, 1925–43; Little Compton; Boston, Mass.; Taunton, Mass. [47]

MEDAY, H. Augusta [P,E] NYC [10]

MEDDLEDETH, A.F. [P] Plainfield, NJ [17]

MEDELLIN, Octavio [P,S,T] San Antonio TX b. 23 My 1908, Mexico. Studied: San Antonio A. Sch. Member: Villita A. Gal., San Antonio. Exhibited: Tex. Cent., Dallas MFA, 1936; Witte Mem. Mus., San Antonia; NAD; WFNY, 1939. Work: Tech. Sch., San Antonio. Position: T., MA Sch, San Antonio [40]

MEDER, Ferdinand [Patron] East Orange, NJ b. 1857, Germany (came to U.S. in 1884) d. Summer 1922. Specialties: etchings and engravings of the old masters

MEEDER, Philip [En] NYC b. Alsace (came to the U.S. as a boy) d. 27 Je 1913. Partners with wood engraver Fred. Y. Chubb, under the firm of Meeder and Chubb. Specialty: wood engraving

MEEDS, Hollyday S. (Mrs.) [P] Wilmington, DE. Member: Wilmington SFA [25]

MEEKER, Mabel Aurelia [P] Bay City, MI [13]

MEEKS, Constance A. [P] Oakland, CA [13]

MEERT, Joseph John Paul [P] Kansas City MO b. 28 Ap 1905, Brussels, Belgium. Studied: T.H. Benton; B. Robinson; Kansas City AI; ASL; Europe. Member: Am. A. Cong. Exhibited: Kansas City AI, 1935 (prize), 1936 (prize), 1938 (prize); PAFA, 1950 (prize), 1953; Denver AM, 1936; WMAA, 1944, 1950–53; CGA, 1936–47; LOC, 1945, 1947 1950, 1956; BM, 1951–54. Work: USPOs, Marceline, Mt. Vernon, both in Mo., Spencer, Ind.; Kansas City AI. WPA artist. Position: T., Kansas City AI. [40]

MEESER, Lillian B. (Mrs. Spenser B.) [P,E,B] Millvale, PA/South Wellfleet, Cape Cod, MA b. Ridley Park, PA. Studied: PAFA; ASL; WMA; ASL. Member: Plastic C.; Phila. Alliance; North Shore AA; Provincetown AA; AFA; Detroit S. Women P. (founder). Exhibited: Plastic C., 1921 (prize), 1922 (med); PAFA, 1923 (prize). Work: Reading Mus., Pa.; State Col. Ar. Gal.; PAFA [40]

MEGARGEE, Lawrence Alonzo ("Lon") [I,P,G] Brooklyn, NY b. 10 Jy 1900, Phila., PA d. 1960 (probably Cottonwood, AZ). Studied: PAFA; NAD; ASL; PIASch; CUASch; Grand Central A. Sch. Exhibited: Tex. Cent. Expo, Dallas MFA, 1936; Ariz. PS, Phoenix, 1938; 48 States Comp., 1939; Grand Central A. Gal.; Cross Roads of Sport, NYC; Ackerman Gal., NYC; Harlow Gal., NYC. Illustrator: The Spur, Country Life, Sportsman magazines. Work: Mus. N.Mex.; Ariz. Capitol Bldg. (ca. 1911). Having worked as a cowboy, he often showed the funny side of cowboy life in his illustrations. [47]

MEGE, Violette (Clarisse) [P,S] NYC b. 19 Mr 1889, Algiers. Studied: Paris, with G. Rochegrosse, Ecole Nat. des Beaux-Arts; Académie Julian; J.P. Laurens; Humbert. Member: Société des Artistes Français; S.Indp.A.; F., French Gov. [25]

MEIERE, Hildreth [Mur.P,L] NYC b. NYC d. 2 My 1961. Studied: ASL; Calif. Sch. FA; BAID; Miller; DuMond; Peixotto; F. Van Sloan. Member: ANA; NSMP; Arch. Lg.; Mun. Ar. S.; S. Designer-Craftsmen; N.Y. A. Comm. Exhibited: Arch. Lg., 1928 (gold); NSMP. Work: Nebr. State Capitol; Nat. Acad. Sc., Wash., D.C.; St. Bartholomew Church, NYC; Cathedral, St. Louis; Irving Turst Co.; Rockefeller Center, NYC; Century of Progress, Chicago; WFNY, 1939; chapel, Univ. Chicago; Seminary, Northampton, Pa.; USPO, Logan Square Station, Chicago; churches, Mt. Kisco, N.Y.; Providence, R.I.; Beverly Farms, Mass.; Lexington, Ky.; New Haven, Conn.; Pikesville, Md.; Overbrook, Pa.; Sacred Heart, N.Y.; Tarrytown, N.Y.; Walker-Lespenard Bldg., NYC; Detroit, Mich.; church, Baltimore, Md.; Monastery, Union City, N.J.; Union Station, Kansas City; Bonomeo C., Newark. WPA artist. [47]

MEIERHANS, Joseph [P] Perkasie, PA b. 22 F 1890, Ober-Lunkhofen-Aargau, Switz. Studied: A.N. Lindenmuth; J. Sloan. Member: S.Indp.A.; ASL; Provincetown AA [33]

MEIGS, Anne Wilmot [P,I] Chicago, IL [13]

MEIKLE, William [Des] NYC. Specialty: glass design [10]

MEINSHAUSEN, George F.E. [En] Norwood, OH b. 6 Ja 855, Hanover, Germany. Studied: Cincinnati A. Acad. Exhibited: St. Louis Expo, 1904 (med). Work: Cincinnati AM; CI; LOC; Smithsonian; NYPL; Taft Mus., Cincinnati. Specialty: wood engraving [40]

MEISSNER, Alfred [Por.P,I] Chicago, IL b. 1877, Chicago. Studied: AIC. Member: Palette and Chisel C. [24]

MEISSNER, Leo J(ohn) [En,P,B] Yonkers, NY b. 28 Je 1895, Detroit, MI d. 1977. Studied: Detroit Sch. FA, J.P. Wicker; ASL. Member: ANA; Phila. Pr. C.; Albany Pr. C.; SC; An Am. Group; Prairie PM; Boston S.Indp.A.. Exhibited: 50 Prints of the Year, 1927–29, 1933; AIC; CMA; LOC, 1943 (prize), 1945 (prize); AV, 1943; AFA Traveling Exh.; CI, 1941, 1944, 1945; Intl. Pr. Exh., Warsaw, Poland; Smithsonian Inst.; Los Angeles Mus. A.; NAD; Southern PM, 1937 (prize), 1938 (prize); Prairie PM; Northwest PM; Detroit Inst. A., 1943 (prize), 1945 (prize); PAFA; Wichita, Kansas, 1937 (prize). Work: LOC; Currier Gal. A.; PMG; PMA; Arnot A. Gal., Elmira, N.Y.; Detroit Inst. A.; Joslyn Mem.; City Lib. Assn., Springfield, Mass.; NYPL; Baltimore Mus. Specialty: wood engraving. Position: A. Ed., Motor Boating, NYC, 1927 [47]

MEIXNER, Heinz [P] d. 22 D 1911, Milwaukee, WI. Scenic painter in NYC and Chicago.

MELCHER, Bertha Corbett (Mrs.) [I,Min.P] Topanga, CA b. 8 F 1872, Denver, CO. Studied: Volk, in Minneapolis; Pyle, in Drexel Inst. Specialty: children's books [21]

MELCHER, Betsy Flagg [Min.P] NYC b. 8 Ap 1900, Dongan Hills, NY. Studied: A. Hoen; C. Beaux; M.R. Welch. Member: ASMP (Pres.); Pa. SMP; Brooklyn SMP. Exhibited: CGA, 1937, 1943; ASMP, 1930–46; PAFA, 1931, 1932, 1933 (prize), 1934–36, 1937 (prize), 1938–43, 1944 (prize), 1945 (prize), 1946; NYC, 1942 (prize), 1943 (prize); Pa. SMP, 1933 (med) [47]

MELCHER, George Henry [P] Phila., PA [06]

MELCHERS, Corinne Lawton (Mrs. Gari) [P] Falmouth, VA b. 27 F 1880. Studied: G. Hitchcock; G. Melchers; Bouguereau. Member: AFA [40]

MELCHERS, J(ulius) Gari [P] NYC/Falmouth, VA b. 11 Ag 1860, Detroit, MI d. 30 N 1932. Studied: Düsseldorf Acad., 1877–80; Académie Julian, Paris, with Lefebvre, Boulanger, 1881. Member: ANA, 1904; NA, 1906; Paris SAP; Soc. Nat. des Beaux-Arts, Paris; Inter-Society of Artists, London; Munich Secession; Berlin R. Acad.; NIAL; New Soc. A.; NAC; AFA. Exhibited: Paris Salon, 1882, 1886 (honorable mention) [he and J.S. Sargent were the first two Americans to receive this award], 1889 (prize); Amsterdam, 1887 (med); Munich, 1888 (med); AIC, 1891 (prize); Berlin, 1891 (med); Phila. AC, 1892 (gold); Antwerp, 1894 (med); PAFA, 1896 (gold); Vienna, 1898 (med); Pan-Am. Expo, Buffalo, 1901 (gold); St. Louis Expo, 1904 (gold); CGA, 1910 (prize), 1928 (prize); Sequi-Centenn. Expo, Phila., 1926 (gold); CI, 1927 (prize); Md. Inst., 1931 (gold). Work: Luxembourg Mus., Paris; CGA; CI; PAFA; NGA; Detroit Inst. A.; AIC; MMA; Minneapolis Inst. A.; LOC; St. Louis Mus.; RISD; Toronto Mus.; Los Angeles Mus. A.; the largest coll. of his work is in Belmont, the Gari Melchers Mem. Gal., in Fredericksburg, Va. Awards: Knight of the Order of St. Michael of Bavaria; Chevalier of the Legion of Honor, 1895; Officer, 1904; Prussian Order of Red Eagle 1907; Inst. of France. Important expatriate artist who lived in the American colony at Egmond, Holland, 1884, along with G. Hitchcock, W. MacEwen. He taught at Weimar, Germany, 1909–14 before settling near Fredericksburg, Va. [31]

MELCHERS, Julius Theodore [S,T,Dec] Detroit, MI b. 1830, Soest, Prussia (came to U.S. after the 1848 Revolution; settled in Detroit, 1855) d. 1903. Specialty: wood carving. Position: T., many Detroit artists, including his son Gari. [*]

MELENEY, Harriet Edna [P] Chicago, IL [04]

MELICOV, Dina [S,P] NYC b. 12 Ja 1905, Russia. Studied: Iranian Inst.; Columbia; A. Bourdelle, Paris. Member: NAWA; S. Gld.; Am. Ar. Cong.; United Am. Ar. Exhibited: WFNY, 1939; PAFA, 1946; WMAA, 1936; BM; NAD; Argent Gal.; ACA Gal.; S. Gld.; NAWA (prize). Work: USPO, Northumberland, Pa. Position: T., Children's Workshop, N.Y. [47]

MELIK, Soss E. [Por.P] Kingston, NY b. 2 Ag 1913, Baku, Russia. Studied: C.C. Curran; H.W. Watrous; S.E. Dickinson; F. Zakharov; NAD. Work: Nat. Mus. of Armenia; private portraits [40]

MELIODON, Jules André [S,T] Phila., PA b. 1 Je 1867, Paris, France. Studied: Paris, with Falguière, Fremiet, Barrau, Messagé. Member: AAPL; Arch. Lg.; Soc. des Artistes Français; Soc. des Professeurs Français en Amerique; Alliance. Exhibited: Paris Salon, 1902; Master Craftsman, Phila. Bldg. Congress, 1932. Work: Paris Mus. Nat. Hist.; sculpture, Sorbonne, Paris; Bahai's Vase (with Tiffany and L. Bourgeois, arch.); mon., Bloomingdale, N.J.; Roxy Theatre, NYC; Admin. Bldg., Bd. of Ed., Phila.; busts, Phila. Med. Assn.; bust, Simon Gratz, City of Phila.; church, Phila. [40]

MELLEN, Frank [P] d. 7 N 1925, Greenwich, CT. Studied: BMFA Sch.

MELLINO, Gaetano [Por.P,Min.P,Dr] Brooklyn, NY b. 24 Jy 1882, Naples, Italy. Studied: Belle Arte di Napoli; Palizzo; Morello; Tedesco. Exhibited: Naples A. Gal., 1896 (prize), 1900 (prize). Contributor: articles and illus., Herald Tribune; Columbus; New York Times; Brooklyn Eagle [40]

MELLON, Andrew William [Patron] b. 24 Mr 1855, Pittsburgh, PA d. 26 Ag 1937, Southampton, NY. Secretary of the Treasury of the U.S., 1921–32; Ambassador to Great Britain, 1932–33; considered by many as the "world's greatest art collector." His many benefactions climaxed in his gift to the U.S. of the National Art Gallery and his magnificent collection of Old Masters.

MELLON, Eleanor M. [S] NYC b. 18 Ag 1894, Narberth, PA. Studied: ANA; NSS; Arch. Lg.; North Shore AA; NAC; V.D. Salvatore; E. McCartan; A.A. Weinman; R. Aitken; C. Grafly; H. Frishmuth. Member: NSS; NAWPS; Arch. Lg.; ANA, 1938; All.A.Am.; Mun. A. Soc. Exhibited: NSS, 1921, 1929, 1943; PAFA; NAD, 1927 (prize); AIC; All.A.Am.; NAWA, 1932; S. Wash. A., 1931 (med); AAPL, 1945 (med); North Shore AA; MMA, 1942; N.Y. Jr. Lg., 1942 (prize) [47]

MELLOR-GILL, Margaret Webster [Por.P,C,T,I] Phila., PA b. 13 Ag 1901, Phila. Studied: R. Meryman; C. Grafly; H. McCarter; A. Carles; H. Breckenridge; D. Garber; H. Sartain; C. Feurer. Member: Phila. Alliance; Phila. ACG; Boston SAC. Illustrator: Country Life, 1927–31. Specialty: japanning, as done in the 18th century [40]

MELOR, Margaret [P] Phila., PA [25]

MELOSH, Mildred E. (Mrs.) [P,W,L,T] NYC/Harrison, ME b. 8 Ag 1901, Jersey City. Studied: C. Lumsdon. Member: Salons of Am.; Jersey City WCC; S.Indp.A. [33]

MELROSE, Andrew W. [Ldscp.P] b. 1836 d. 23 F 1901, West New York, NJ. Studios in Hoboken and Guttenburg, N.J., during the 1870s–80s, but painted views from N.C. to New England, Ireland, the Tyrols, and Cornwall, England. Work: N.Y. Hist. S.; Oberlin Col. [*]

MELTON, Catherine Parker [P,S] Wash., D.C. b. Nashville, TN. Studied: Peabody Col.; Corcoran Sch. A.; H.B. Snell; W. Adams; J. Farnsworth; H. Breckenridge; C. Critcher. Member: Wash. AC; SSAL; S. Wash. A.; Sarasota AA. Exhibited: Lg. Am. Pen Women, 1941 (prize), 1943 (prize), 1944 (prize); Woodward-Lothrope, 1939 (prize); Washington, D.C., 1935 (prize); Wash. AC; S. Wash. A.; Nashville, Tenn.; Sarasota [47]

MELTON, Jesse J. (Mrs.) [P] Ft. Worth, TX [13]

MELTSNER, Paul R. [Li,Mur.P] NYC b. 29 D 1905, NYC. Studied: NAD. Member: S.Indp.A.; Mural P.; F., Tiffany Fnd. Work: BM; AIC; MOMA; Houston MFA; Dayton AI; State Mus., Biro-Bidjan, U.S.S.R.; Luxembourg Mus., Paris; BMFA; WMAA; NYPL; Dallas MFA; Detroit AI; M. Mod. Western A., Moscow, USSR. Illustrator: Coronet (1936), Bachelor (1937) [40]

MELTZER, Anna E(lkan) [P,T] NYC b. 6 Ag 1896, NYC. Studied: CUASch; ASL; A. Brook. Member: Audubon A.; NAWA; Staten Island Inst. A.&Sc.; AAPL. Exhibited: Audubon A., 1942 (med), 1944, 1945; NAWA, 1944–46; All.A.Am., 1944; Rockford AA (one-man); Massillon Mus. A. (one-man); Bloomington AA (one-man); Evansville, Ind. Mus. (one-man); Plainfield AA (one-man); Rundle Gal., Rochester, N.Y. (one-man); Cayuga Mus. Hist. & A. (one-man); Univ. Fla., 1944 (one-man), 1945 (one-man); Vendôme Gal., 1940, 1942; Newhouse Gal., 1945, 1946; Francis Taylor Gal., Los Angeles, 1947 [47]

MELTZER, Arthur [P,T,L] Langhorne, PA b. 31 Jy 1893, Minneapolis, MN. Studied: Minneapolis Sch. FA; PAFA; R. Koehler; J. Pearson; D. Garber. Member: Woodmere AA. Exhibited: CAFA, 1931 (prize); PAFA, 1921–46; AIC; CGA; Woodmere A. Gal.; Phila. Sketch C., 1924, 1927; Minn. State Fair, 1923; Phila. AC, 1926; New Haven PCC, 1931 (prize). Work: PAFA; Storrs Col., Conn.; Ill. Athletic C., Chicago; Columbus Gal. FA; Phila. A. All.; Carlisle AM, Pa.; Woodmere A. Gal. Position: T., Moore Inst., Phila. [47]

MELTZER, Arthur, Mrs. See van Roekens, Paulette.

MELTZER, Charlotte [P] NYC [15]

MELTZER, Doris (Mrs. Edward Rosen) [Ser,P,W,L,T] NYC b. 1 Ja 1908, Ellenville, NY. Studied: NYU; M. Kantor; W. Zorach. Member: Phila. Pr. C.; Am. Color Pr. S.; Nat. Serigraph S.; AL. Am. Exhibited: WFNY, 1939; Laguna Beach AA, 1943–46; Northwest PM, 1943, 1945; LOC, 1944, 1945; Newport AA, 1944, 1945; MET, 1942. Work: PMA; Am. Assn. Univ. Women; Office Inter-Am. Affairs; Wesleyan Univ.; Phillips Exeter Acad.; MET; SFMA; City Lib., Springfield, Mass.; LOC; U.S. State Dept. Position: Assoc. Ed., Serigraph Quarterly; Dir., Nat. Serigraph S. & Gal., NYC, 1945–46 [47]

MELVILL, Antonia (Mrs.) [P,T] Los Angeles, CA b. Berlin, Germany (came to America in 1894). Studied: W.P. Frith, in London; Heatherley Sch. A. Member: AFA; Los Angeles AA. Exhibited: GGE, 1939; State Fair, Sacramento, Calif., 1926 (prize), 1929 (prize). Work: Capitol, S.Dak.; Sacramento Pub. Lib.; Harvard Military Sch., Los Angeles; B'Nai Brith Temple, Los Angeles; Alhambra Theatre, Sacramento [40]

MELVILLE, Frank [P,E,T,S] Brooklyn, NY b. 28 D 1832, Brooklyn d. 1917, Chocorua, NH. Studied: H.K. Brown. Member: Calif. SE; Chicago SE. Work: LOC; NYPL; Brooklyn Inst. Mus.; Walker Gal., Liverpool, England. Specialty: watercolor [15]

MELVILLE, Marguerite Louise [P] Montclair, NJ b. 8 My 1912, Upper Montclair. Studied: Pembroke Col., Brown Univ.; RISD; ASL; F. Sisson; K. Nicolaides; J. Charlot. Member: N.J. WCS. Exhibited: AAPL, 1937 (med); Montclair AM; Newark Mus.; A. Center of the Oranges [47]

MELZER, William [P] Weehawken, NJ. Member: S.Indp.A. [25]

MELZIAN, Harley [P,Des,C] Los Angeles, CA b. 14 O 1911, Yankton, SD. Studied: Santa Ana Jr. Col. Member: Calif. WCS. Specialty: design for glass, metals, plastics, wood [40]

MENAGE, Bessie Marble [P,C] Chicago, IL b. 14 Jy 1877, Minneapolis, MN. Studied: L. Cushman; A. Covington. Associated with Univ. Chicago [10]

MENCONI, Frank G. [S,Des] b. 24 Ap 1884, Tuscany, Italy (came to U.S. in 1900) d. 24 Ap 1928, Union City, NJ. Work: des., Monumental Victory Arch (N.Y.), Boston Memorial to Mary Baker Eddy. Revived the ancient art known as "Graffiti;" a process of engraving on cement in color, which was used on several public buildings in Wash., D.C.

MENCONI, Raffaello E. [Arch-S] Hastings-on-Hudson, NY b. 1877, Italy (came to NYC in 1894; established studio there) d. 5 Mr 1942. Studied: Florence; Rome

MENDELOWITZ, Daniel Marcus [P,W,L,T] Palo Alto, CA b. 28 Ja 1905, Linton, ND. Studied: Stanford Univ.; ASL; Calif. Sch. FA. Member: Pacific AA; Calif. WCS. Exhibited: Santa Cruz (Calif.) A. Lg., 1935–44, 1945 (prize), 1946; CGA, 1941; AWCS, 1944–46; San Fran. AA, 1946; Mississippi AA, 1945; Gumps, San Fran., 1944 (one-man); Courvoisier Gal., San Fran., 1940 (one-man). Work: USPO, Oxnard, Calif. Author: "Challenge of Education," 1937, "Education in War Time and After," 1943. Contributor: Design magazine. Positions: T., San Jose State Col., Calif. (1927–34), Stanford Univ. (1934–46) [47]

MENDENHALL, Earl, Mrs. See Langley, Sarah.

MENDENHALL, Emma [P] Cincinnati, OH b. Cincinnati. Studied: Cincinnati A. Acad., with Nowottny, Duveneck; Académie Julian, Paris; summer sch., with Mrs. R.H. Nicholls, Snell, Woodbury. Member: AWCS; NAC; Wash. WCC [47]

MENDENHALL, Gertrude Emma [Por.P] Alliance, OH/Columbus, OH b. 2 My 1913. Studied: Ohio State Univ. Member: Columbus AL. Position: T., pub. sch., Alliance [40]

MENENDEZ, Arthur Middleton [Des,L] NYC b. 1 Jy 1876, NYC. Studied: Kline A. Sch., Brooklyn; Cooper Union. Specialty: designs for wallpaper, carpets, upholstery fabrics, chintzes [40]

MENGARINI, Fausta Vittoria [S,T] NYC/Rome, Italy b. 18 Ap 1893, Rome. Studied: Royal Acad. A., Rome, with E. Gjoia. Member: NAWPS. Exhibited: NAWPS, 1931 (prize); Intl. Fair, Tampa, Fla., 1931 (prize); Victory's Gal., Italy, 1935 (prize); Gov't. Rome, 1936 (prize). Work: War Memorial with figures, Palace of Justice, Royal Italian Gov't., Rome; Congregational Church, Montclair, N.J.; Monumental Lighthouse, Massaua, Eritrea, Africa (Royal Italian Gov't.); busts, H.M. King, Mussolini at Eastman Dental Clinic, Rome; Univ. Rome [40]

MENK, Oswen W., Mrs. See Cameron-Menk, Hazel.

MENKES, Sigmund Joseph [P,G,Dec] NYC b. 7 My 1896, Lwów, Poland. Studied: Nat. A. C. Sch., Lwów; Acad. FA, Cracow, Poland. Member: Société des Indp., Salon d'Automne, Soc. du Sal. des Tuilleries, all in Paris; Fed. Mod. P.&S. Exhibited: CGA, 1939, 1941 (prize); PAFA, 1945 (med); CI; Univ. Nebr.; CMA; Am. Univ., Wash., D.C.; State Univ. Iowa; Cranbrook Acad. A.; MMA; WMAA; Cornelius Sullivan Gal., N.Y. (one-man); Durand-Ruel Gal. (one-man); Assn. Am. A., 1936–44 (one-man); AIC, 1938. Work: MMA; Wichita AA; Cranbrook Acad. A.; Encyclopaedia Britannica Coll.; Abbott Laboratories Coll.; Musée du Jeu de Paume, Paris; Nat. Mus. Warsaw, Poland; Nat. Mus., Belgrade, Yugoslavia; Nat. Mus., Athens, Greece; Tel-Aviv, Palestine; Albright Gal., Buffalo [47]

MENNIE, Florence [P] Wilton, CT b. NYC. Studied: G. Bellows; L. Mora. Member: S. Indp. A.; Silvermine GA; Salons of Am. [29]

MENTE, Charles [P,I] Congers, NY b. 1857, NYC d. 8 D 1933. Studied: Gabl, Loefftz, both in Munich. Member: AWCS; Chicago WCC. Exhibited: Chicago SA, 1893 (prize); AC Phila., 1895 (gold); Atlanta Expo, 1895 (med); AWCS, 1904 (prize). Illustrator: Harpers [31]

MENTEL, Lillian A. [P,T] Cincinnati, OH b. 2 N 1882, Cincinnati. Studied: Cincinnati A. Acad.; PIASch. Member: Cincininati Women's AC [33]

MENZEL, Herman [P,T] Chicago, IL b. 19 O 1904, Chicago. Studied: W.B. Owen. Exhibited: Ar. Chicago Vicin. Ann., AIC, 1935, 1936, 1939 [40]

MENZLER-PEYTON, Bertha. See Peyton.

MERCER, Geneva [S,L] Boston, MA b. 27 Ja 1889, Jefferson, AL. Studied: Italy; G. Moretti. Member: Ala. Lg.; Copley S.; Inst. Mod. A., Boston. Exhibited: Phila. A. Week 1925 (med); San Remo, Itay, 1934 (prize); Mass. Horticultural Soc., 1941 (prize); NAD; PAFA; Assn. A. Pittsburgh; Copley Soc., Boston; Gore Mansion, Boston, 1942 (one-man). Work: Mus. FA, Montgomery, Ala.; Ala. Mem. Bldg.; Pub. Lib., Pittsburgh, Pa.; Osceola Sch., Pittsburgh; memorial, Bronxville, N.Y. [47]

MERCER, Henry Chapman [S,C,W,Cur] Doylestown, PA b. 24 Je 1856, Doylestown d. 9 Mr 1930. Studied: Harvard. Member: Daedalus A. & Cr., Phila.; Designers and Artisans C., Baltimore; Detroit A. & Cr.; Boston SAC; Bucks County Hist. Soc. (Pres., from 1910); Univ. Pa. Exhibited: Expo Historico-Americano, Madrid, 1892 (med); St. Louis Expo, 1904 (prize); Am. Inst. Architects, 1921 (med). He examined the artistic relics of Pennsylvania German settlers, and experimented upon and developed their processes of making and decorating pottery, which resulted in his Moravian Pottery and Tile Works. In 1899 he invented a new method of manufacturing tiles for mural decoration, and in 1902, a new process of making mosaics; in 1904 he invented a process for printing large designs in color on fabrics and paper. He had a collection of 24,000 utensils and implements illustrating the industrial history of the Colonial U.S. and built a Museum in 1916 in Doylestown to preserve and house the exhibition. He bequeathed this Museum, valued at $500,000 to the public, and "Fonthill" was left as a museum of ornamental tiles. [10]

MERCER, William Robert, Jr. [S] Doylestown, PA [10]

MEREDITH, Alice Adkins [B,C,Dec,I,L,P,S,T] Dallas, TX b. 10 O 1905, Dallas. Studied: Franklin Booth; Charles Livingston Bull; George S. Dutch; Pedro Lemos; Frank Reaugh; Pruett Carter; George Bridgman; Martha Simkins. Member: Frank Reaugh AC; Dallas AA; Klepper AC; Tex. FA Assn.; SSAL. Position: T., Art Dept., YWCA, Dallas [40]

MEREDITH, Dorothy L(aVerne) [P,C,T,Des,L] Milwaukee, WI b. 17 N 1906, Milwaukee. Studied: Layton Sch. A.; Milwaukee State T. Col.; Cranbrook Acad. A.; Z. Sepeshy; R. von Neumann; M. Nutting; Sinclair; E. Groom; C.R. Partridge; Ryōho Senda, in Tokyo; Peiping, China. Member: Wis. P. & S.; Wis. A. Fed.; Wis. Des.–Craftsmen (Pres.); Walrus C. Exhibited: Milwaukee AI, 1927 (prize), 1928–46; Wis. State Fair, 1929 (prize), Ann. C. Exh., AI, Milwaukee, 1938 (prize); AIC (prize); Madison Salon. Work: Cranbrook Acad. A.; Milwaukee AI; Nat. Soldiers Home, Wood, Wis.; Bay View H.S., South Division H.S., Milwaukee; Lake Bluff Sch., Shorewood, Wis. [47]

MEREY, Carl A. [P,Mus.Supv.,Edu,G] Denver, CO b. 21 D 1908, Denver. Studied: Univ. Denver. Member: Am. Oriental Soc. Positions: Asst. Cur., Japanese A. (1937–39); Supv. Edu., Denver A. Mus. (1940) [47]

MERIAN, L(ouis) H. [P,I,W] Kansas City, MO b. 2 Mr 1881, London, England. Studied: London; Paris. Member: Kokoon AC, Cleveland. Founder: "Cygnet," an art magazine. Compiler/Editor: Toronto of Today [24]

MERIDITH, Isaac Watt [P] Chicago, IL b. 28 Mr 1878, Frankfort, IN. Studied: W. Forsyth; C. Graf. Member: Hoosier Salon; All-Ill. SFA; South Side AA; Ridge A. Assn. Work: Board of Edu., Chicago; Field House, Chicago Pk. Bd.; Union Ch., St. Paul [40]

MERINGTON, Ruth [P,T] Newark, NJ b. London, England. Studied: NAD; ASL; E.M. Ward; B. Crane; B. Harrison; Académie Julian, Paris, with Constant [29]

MERKEL, Otto [P] Phila., PA [24]

MERLIER, Franz de [I,P] Traymore, PA b. 28 O 1873, Ghent, Belgium. Member: SI [10]

MERLIN, Maurice [P] Detroit, MI. Exhibited: San Fran. A. Assn., 1939; Ann., PAFA, 1939 [40]

MERMIN, Mildred Shire (Mrs.) [P] NYC b. 25 F 1907, NYC. Studied: Woodmere Acad.; ASL; NAD. Member: A. Lg. Am.; NAWA; New Haven PCC; Silvermine Gld. A. Exhibited: A. Lg. Am., 1945; NAWA, 1943, 1945, 1946; PAFA, 1929; AWCS, 1929; Silvermine Gld. A.; Montross Gal. [47]

MERO, Lee [I] Minneapolis, MN b. 30 My 1885, Ortonville, MN. Studied: R. Koehler, in Minneapolis; N.Y., with Henri. Member: Minneapolis SFA. Specialties: mottoes; greeting cards [31]

MERRELS, Gray Price (Mrs.) [Min.P] Hartford, CT/Branford, CT b. 1884, Topeka, KS. Studied: ASL; A. Beckington; L.C. Hills [40]

MERRIAM, Irma S. [P] Seattle, WA [25]

MERRICK, Arthur T. [I] NYC [21]

MERRICK, James Kirk [B,E,I,Por.P,Dr,L,T] Phila., PA b. 8 O 1905, Phila. Studied: PMSchIA; T. Oakley; H. Hensche. Member: Phila. A. All.; Phila. WCC; Woodmere AA; SC. Exhibited: Phila. A. All., 1936 (prize); Cape May AA, 1945 (prize); PAFA, 1935–45; Phila WCC, 1935–45; AIC, 1940; State Mus., Trenton, N.J.; SC; Herron AI; Woodmere AA; Lawrence Col.; Harcum Col.; State Mus., Harrisburg, Pa. Work: Phila. A. All.; Phila WCC; PMA; Cape May Col.; Phila. Pub. Sch. Position: T., PMSchIA, 1930– [47]

MERRICK, Joseph E. [P] Columbus, OH. Member: Columbus PPC [25]

MERRICK, Lulu [A.Cr] NYC b. 1878, Brooklyn, NY d. 12 Ap 1931. Positions: Critic, Morning Telegraph, The Spur. Was one of the first to advocate and direct traveling art exhibitions.

MERRICK, Richard L. [G,P,T,L,G] Coconut Grove, FL b. 28 N 1903, Coconut Grove. Studied: ASL, with Henri, Sloan, Luks, Pennell. Exhibited: MOMA, 1937; VMFA, 1945. Work: LOC; USPO, Miami. Position: T., Univ. Miami, 1944–[47]

MERRICK, William Marshall [I] Chicago, IL (1902) b. 1833, Wilbraham, MA. Illustrator: sketches made in Atchinson, Kans., published in Harper's, 1866 [*]

MERRIFIELD, Rube [I] Chicago, IL. Position: Staff, Four o'Clock [98]

MERRILD, Knud [P,B,S,D,W] Los Angeles, CA b. 10 My 1894, Odum, Denmark d. 1954, Copenhagen, Denmark. Studied: A. & Crafts Sch., Royal Acad. FA, Copenhagen. Member: Am. A. Cong.; AAPL; Calif. WCS. Exhibited: Intl. Exh., Paris, 1924 (prize); BM, 1936, 1939, 1943; Calif.-Pacific Expo, San Diego, 1935; MOMA, 1936, 1942; GGE, 1939; AIC, 1940; WMAA, 1941; AFA, 1942; Pasadena AI, 1932; Los Angeles Mus. A., 1934–44; Rose Gal., Los Angeles, 1935, 1936; Circle Gal., Hollywood, 1944; Mus. N.Mex., 1923 (one-man); Laguna Beach AA, 1935 (one-man); SFMA, 1937 (one-man). Work: MOMA; PMA; Los Angeles Mus. A.; San Diego FA Soc.; Pomona Gal., Calif.; A. & Crafts Mus., Copenhagen. Author: "A Poet and Two Painters" (memoir of D.H. Lawrence), 1938 [47]

MERRILEES, May S. [P] Brooklyn, NY [19]

MERRILL, Frank Thayer [I,P] Dorchester, MA b. 14 D 1848, Boston. Studied: BMFA. Member: BAC [10]

MERRILL, Hiram Campbell [P,En] Cambridge, MA b. 25 O 1866, Boston. Studied: ASL, with D. Volk, F. DuMond, H. Adams. Member: AWCS; Cambridge AA; NYWCC, 1914. Exhibited: Pan-Am. Expo, Buffalo, 1901 (med); St. Louis Expo, 1904 (prize); AFA; AIC; LOC; NYWCC; AWCS; Phila. WCC; Wash. WCC; Baltimore WCC. Work: CI; Boston Pub. Lib. Specialty: wood engraving [47]

MERRILL, Joseph [P] Brooklyn, NY [04]

MERRILL, Katherine [P,E,L] Sarasota, FL b. Milwaukee. Studied: AIC; Brangwyn, in London. Member: Chicago SE; Soc. Am. E.; Sarasota AA (Pres.). Exhibited: Fla. Fed. A., 1936 (prize), 1937 (prize). Work: LOC; Corcoran Gal.; N.Y. Pub. Lib.; AIC; Milwaukee AI; Newark Pub. Lib.; Springfield Pub. Lib.; Beloit Col., Beloit, Wis.; Hackley Gal. A., Muskegon, Mich.; Bibliothèque Nationale, Paris; bookplate coll., MMA; Widener Memorial Library, Harvard; Univ. Chicago; Gibbes Memorial Mus. A., Charleston, S.C.; N.Y. Botanical Gardens [40]

MERRILL, Nelle [P] Evansville, IN [24]

MERRILL, R.S. [P] Minneapolis, MN [17]

MERRIMAN, Helen Bigelow (Mrs. Daniel) [P,W] Boston, MA/Intervale, NH b. 14 Jy 1844, Boston d. 1933. Studied: W. Hunt. Member: Co-founder, with husband Daniel, of WMA (1896) and WMA Sch. (1898); AFA. Exhibited: Williams & Everett Gal., Boston, 1888. Author: "Study of Life and Works of J.F. Millet," 1882, "Concerning Portraits and Por-

traiture," 1891, "What Shall Make Us Whole?" 1888, "Religio Pictoris," 1899 [33]

MERRITT, Anna W. Lea (Mrs. Henry) [P,W] Andover, Hampshire, England b. 13 S 1844, Phila. d. 7 Ap 1930, London. Studied: London, with H. Merritt. Exhibited: Centenn. Expo, Phila., 1876 (prize); Paris Expo, 1889 (prize); Columbian Expo, Chicago, 1893 (medals); Atlanta Expo, 1895 (med); Pan-Am. Expo, Buffalo, 1901 (med). Work: "Love Locked Out," National Gallery of British Art, London; PAFA; Harvard; Oxford; St. Martin's Church, Wanersh, Guildford, England. Author: "Memoir of Henry Merritt," "A Hamlet in Old Hampshire," "An Artist's Garden." She relinquished her early art career for marriage, but after the death of her husband, an art critic and painting restorer, she resumed painting. Her career reached its peak when her painting "Love Locked Out" was purchased by the Tate Museum, London. [Anna W. Lea was listed as a miniature painter living in Paris, 1910; probably the same person.] [29]

MERRITT, Ingeborg Johnson [P] Townsend, MT b. 19 D 1888, Norway. Studied: AIC. Work: St. Paul's Church, Helena, Mont.; Vanderpoel A. Assn., Chicago [40]

MERRITT, Louisa P. [P] Minot, MA. Member: Copley S., 1897 [10]

MERRITT, Warren Chase [P,Dr] New Rochelle, NY b. 3 D 1897, Randsbrug, CA. Studied: Calif. Sch. FA. Exhibited: Ferargil Gal., N.Y., 1938 (one-man); San Fran. MA, 1939 (one-man). Work: Crown-Zellerback Bldg., San Fran.; Mamaroneck Pub. Lib.; Orienta Beach C., Mamaroneck; NAD [40]

MERYMAN, Richard S(umner) [P,T] Dublin, NH b. 4 Ap 1882, Boston. Studied: BMFA Sch.; Benson; Thayer; Tarbell. Member: Gld. Boston A.; SC. Exhibited: P.-P. Expo, 1915 (med); Sesqui-Centenn. Expo, Phila., 1926 (med); S. Wash. A., 1935 (prize); Gld. Boston A.; CGA; PAFA. Work: Pub. Lib., Wash., D.C.; Navy C., Wash., D.C.; Madison (Wis.) Hist. Soc.; Phillips Acad., Andover, Mass.; Groton (Mass.) Sch.; Mercersburg Acad., Pa.; Mercer Univ., Macon, Ga. Positions: T., Groton Sch., CGA [47]

MERSEREAU, Paul ("Paul Fontaine") [P,L] Shreveport, LA b. 2 D 1868, Dallas. Studied: Constant; Inness. Member: Am. APL; So. Nat. Acad. Work: Rogers Gallery, Laurel, Miss.; Helena Mus., Helena, Ark.; Shreve Memorial Library, Centenary College, Shreveport [33]

MERSFELDER, Jules R. [P] San Fran., CA b. California. Studied: A.H. Wyant; V. Williams. Member: Chicago Soc. A.; San Fran. Inst. A. Exhibited: AIC (prize); St. Louis Expo, 1904 (med) [10]

MERSFELDER, Lou (Mrs. Jules R.) [P] San Fran., CA b. Chicago. Studied: AIC. Member: Chicago SA; San Fran. Inst. A. Position: Associated with Press C., San Fran. [10]

MERTEN, John William (Jack) [C,Des,P,W] Cincinnati, OH b. 28 Ag 1898, Cincinnati. Studied: Harvard; Cincinnati A. Sch.; Univ. Cincinnati; W.E. Hentschel; R. Grooms; H. Nash. Member: Ceramic Gld., Cincinnati; Cincinnati Crafters Soc.; AFA; MacD. C. Exhibited: Syracuse Mus. FA; Butler AI, 1946; CM; Cincinnati Crafters; Ceramic Gld. Work: CM; included in "Eight More Harvard Poets" (1923) [47]

MERTENS, Francis William [P] NYC b. 31 My 1911, NYC [38]

MERTLER, Rudolph [P] NYC [25]

MERTON, Owen [P] Douglaston, NY b. 14 My 1887, Christchurch, New Zealand. D 1930, Middlesex Hospital, London. Studied: Paris, with Tudor-Hart. Work: National Gallery, New Zealand. Specialty: designs and color schemes for flower gardens [29]

MERWIN, Antoinette de Forrest (Mrs.) [P,T] Altadena, CA b. 27 Jy 1861, Cleveland. Studied: ASL; St. Paul Sch. FA, with B. Harwood; Merson; Courtois; Collin; J.M. Whistler. Member: Calif. AC; Pasadena SA; Pasadena FA Soc.; San Diego AG. Exhibited: Paris Salon, 1900 (prize). Work: Volendam Noord, Holland, owned by the Boston AC; Cuyamaca C., San Diego [40]

MESEROLE, W(illiam) Harrison [S] Brooklyn, NY b. 28 D 1893, Brooklyn. Studied: MacNeil [17]

MESIBOV, Hubert Bernard [E,P] NYC b. 29 D 1916, Phila. Studied: Phila. Graphic Sketch C.; PAFA; Barnes Fnd. Member: Lg. Present-Day A. Exhibited: PAFA, 1943; U.S. Nat. Mus., 1938; WFNY, 1939; State Mus., Harrisburg; CI, 1939; Phila. A. All., 1940, 1941, 1945. Work: PMA; Free Lib., Phila.; CI; Univ. Wyo.; USPO, Hubbard, Ohio. WPA artist. [47]

MESIC, Julian C. (Miss) [Des,C,P,W,Arch,S,L] Oakland, CA b. 20 Ag 1889, Colfax, WA. Studied: Calif. Col. A. & Crafts; Calif. Sch. FA. Member: Am. APL. Exhibited: AIA, de Young Mus., San Fran., 1929 (prize); Oakland A. Gal. Work: City Hall, Oakland; Univ. Calif.; City Planning Commission, Oakland; Regional Park Board, Oakland. Contributor: Architect & Engineer, California Arts–Architecture [47]

MESS, Evelynne Charlene (Mrs. George J.) [E,Li,P,C,I,T,Des] Indianapolis, IN b. 8 Ja 1903, Indianapolis. Studied: Herron AI; Butler Univ.; AIC; Ecole des Beaux-Arts, Fontainebleau, France; A. Strauss; Despujols; Forsyth; Stark; Adams; Benedictus; Ouvré. Member: Am. Color Pr. Soc.; Ind. AC; Ind. Soc. Pr. M.; Brown County AA; Ind. Fed. AC. Exhibited: Ind. State Fair, 1930 (prize); Ind. AC, 1936 (prize); Ind. Fed. AC, 1942 (prize); SAE, 1931, 1933–35; Los Angeles Mus. A., 1934, 1936; PAFA, 1934; Phila. SE, 1935; Phila. A. All., 1936; Am. Color Pr. Soc., 1945, 1946; Phila. Pr. C., 1946; Hoosier Salon, 1934, 1942, 1943, 1945, 1946; Ind. Soc. Pr. M., 1934–38, 1940, 1944–46; Herron AI, 1928, 1929, 1932–34, 1945; Brown County AA, 1943–46. Work: John Herron AI; Indianapolis Pub. Lib.; Graphic A. Studio, Chicago. Illustrator: "Old Fauntleroy Home," 1939 [47]

MESS, George Jo [E,Li,P,Des,L] Indianapolis, IN b. 30 Je 1898, Cincinnati d. 1962. Studied: Herron AI; Butler Univ.; Inst. Mod. Des., Chicago; France; A.W. Dow; A. Strauss; J. Despujols; M. Benedictus; G. Balande; W. Forsyth. Member: SAE; Chicago SE; Ind. SE; Ohio SE; Wash. WCC; Ind. AC; Brown County AA; Ind. Soc. PM; Phila. SE; Wash. WCC; AG, Louis Comfort Tiffany Fnd. Exhibited: Hoosier Salon, 1936 (prize), 1938 (prize), 1941 (prize), 1943–46 (prize); Herron AI, 1931 (prize); LOC, 1945 (prize); Ind. AC, 1944 (prize), 1945 (prize), 1946 (prize); Ind. State Fair, 1932 (prize), 1933 (prize), 1936 (prize); CI, 1930; SAE, 1935, 1937, 1939–46; Wash. WCC; MMA, 1943; PAFA, 1940, 1943–45; Herron AI; Hoosier Salon, 1936, 1938, 1940, 1942–46; Ind. Soc. Pr.M., 1936–46; Ohio Pr. M., 1940–46. Work: LOC; Herron AI; Grand Rapids A. Gal.; CMA; Indianapolis Pub. Sch.; Smithsonian. Illustrator: "Hoosier City," 1943, "Living in Indiana," 1946. Contributor: art magazines. Position: Staff Artist, Esquire [47]

MESS, Gordon Benjamin [P,Des,T] Indianapolis, IN b. 28 S 1900, Cincinnati d. 1 S 1959. Studied: Herron AI; Fontainebleau Sch. FA, France; W. Adams; A. Thieme; E. Gruppe; R. Coates; R.E. Selleck; A. Strauss; J. Despujols; G. Balande. Member: Ind. AC. Exhibited: Hoosier Salon, 1931 (prize), 1942 (prize), 1943 (prize); Richmond AA, 1931 (prize); Ind. State Fair, 1931 (prize); Ind. AC, 1938 (prize), 1941 (prize); PAFA; Herron AI; CM; Hoosier Salon; Richmond (Ind.) A. Gal.; Ball State T. Col.; Ind, Univ.; N.Dak. Col.; Dayton AI; Palace of Fontainebleau, France. Work: Indianapolis Pub. Sch.; Valparaiso Pub. Sch.; A. Assn., Richmond, Va. Position: Dir., Circle A. Acad., Indianapolis [47]

MESSER, Edmund C(larence) [Ldscp.P,T] Wash., D.C. b. 18 F 1842, Skowhegan, ME d. 9 F 1919, Menominee, WI. Studied: Paris, with Collin, Courtois, A. Morot. Member: S. Wash. A.; Wash. SFA. Work: Corcoran Gallery. Position: Principal, Corcoran Sch. A., 1892–1918 [17]

MESSER, Jeanette [P] Wash., D.C. d. 3 D 1917 Member: Wash. WCC. Sister of painter E.C. Messer. [17]

MESSERSCHMITT, Charles [P] Rochester, NY. Member: Rochester AC [25]

MESSICK, Benjamin Newton (Ben) [P,Li,T] Los Angeles, CA b. 9 Ja 1901, Stafford, MO. Studied: Chouinard AI; F.T. Chamberlin; C. Hinckle; P. Carter; Los Angeles Sch. A. Des. Member: Los Angeles A. Assn.; Calif. AC; SSAL; AFA. Exhibited: Los Angeles County Fair, 1925 (prize); PAFA, 1927 (prize); Albany Inst. Hist. & A., 1943; LOC, 1945; MMA (AV), 1942; CI, 1941; NAD, 1945; Stendahl Gal., Los Angeles, 1938–40; Los A. Mus. A., 1935 (one-man); Chouinard AI, 1941 (one-man); SFMA, 1942 (one-man); Springfield (Mo.) Mus. A., 1943 (one-man); Santa Barbara Mus. A., 1945 (one-man); U.S. Nat. Mus., 1944 (one-man); William Rockhill Nelson Gal. A., 1945 (one-man); Pasadena AI, 1946 (one-man). Work: Los Angeles Mus. A.; SFMA; U.S. Nat. Mus.; Smithsonian Inst.; Wiggins Trade Sch., Los Angeles; Calif. State Bldg., Los Angeles; Hall of Records, Los Angeles; Santa Barbara H.S. Position: T., Chouinard AI, Los Angeles, 1944–46 [47]

MESSICK, Turner B. [Comm.A,T] Denver, CO. Studied: Peabody Inst., Baltimore; Columbia; NAD; Henri; G. Bellows. Positions: T., Denver A. Sch., Santa Fe Sch. A. [40]

MESSINA, Joseph [P] NYC [24]

MESSINGER, Marion Gettelson [P,S,T] Chicago, IL b. 28 Je 1908. Studied: AIC (French Traveling Scholarship), with Lhote, 1927. Member: Chicago Ar. U. Work: Covenant C., Chicago. Position: T., Pub. Sch., Chicago [40]

MESSNER, Alfred John [Des,Mur.P] Calumet, MI b. 7 My 1909, Calumet. Studied: AIC, with E. Zettler. Work: Hall of Social Science, Century of Progress, Chicago; Council Social Agencies, Chicago [40]

MESSNER, Elmer R. [Car] Rochester, NY. Work: Huntington Library, San Marino, Calif. [40]

MESTCHERSKY, Boris [P] NYC. Work: USPO, Eaton Rapids, Mich. WPA artist. [40]

MESTLER, Ludwig [P,G,Arch] Cambridge, MA b. 25 Ag 1891, Vienna, Austria. Studied: K.K. Technische Nochschule, Vienna; State Acad. FA, Vienna; Univ. State N.Y. Exhibited: Int. E., Eng., AIC, 1936; Worcester AM, Mass., 1939 (one-man). Work: Addison Gal. Am. A., Andover; Worcester AM [40]

METCALF, Edwin [P,En] Norristown, PA b. 1848, England. Studied: England, with D. Kendal, F. Leighton; France, with C.E. Jacque. Member: AAS [10]

METCALF, Helen F. [P] NYC [10]

METCALF, Marie S. [P] East Orange, NJ. Member: Providence WCC [25]

METCALF, Robert Marion [Des,L,T,Mur.P,C] Yellow Springs, OH b. 23 D 1902, Springfield, OH. Studied: Columbus A. Sch.; Wittenberg Col.; PAFA; A.B. Carles; F. Wagner. Exhibited: PAFA, 1924. Work: coll. 10,000 color slides of European stained glass, Dayton AI; stained glass windows, St. James Chapel, Cathedral of St. John the Divine, NYC, St. Paul's Sch., Concord, N.H., Church of St. Johns in the Wilderness, Paul Smiths, N.Y. Specialty: stained glass. Positions: T., Dayton AI, Wittenberg Col. (Springfield), Antioch Col. (1945-) [47]

METCALF, Willard L(eroy) [Ldscp.P,T,I] NYC b. 1 Jy 1858, Lowell, MA d. 9 Mr 1925. Studied: G.L. Brown, Lowell Inst., both in Boston; Mass. Normal A. Sch.; BMFA Sch.; Académie Julian, Paris, with Boulanger, Lefebvre, 1883–89. Member: AWCS; Ten Am. P.; NIAL; Lg. AA. Exhibited: Paris Salon, 1888 (prize); Columbian Expo, Chicago, 1893 (med); SAA, 1896 (prize); Paris Expo, 1900 (prize); Pan-Am. Expo, Buffalo, 1901 (med); St. Louis Expo, 1904 (med); PAFA, 1907 (gold), 1911 (med), 1912 (med); Corcoran AG, 1907 (gold), 1923 (one-man); AIC, 1910 (med); Buenos Aires Expo, 1910 (gold); Milch Gal., NYC, 1925 (memorial). Work: CGA; Cincinnati Mus.; BMFA; Worcester (Mass.) A. Mus.; Nat. Gal.; PAFA; Detroit AI; AIC; Hackley A. Gal., Muskegon, Mich.; CI; St. Louis Mus.; Rochester Mem. Mus.; Albright Gal., Buffalo; New Orleans Mus.; MMA; New Britain (Conn.) Mus. A. Illustrator: of Zuni Indians, Harper's. Worked in the southwest, 1881–83. Received most acclaim for landscapes painted in Conn. at the Old Lyme colony (1905-), and winter scenes at Cornish (N.H.) colony (1909-)[24]

METCALFE, Howard Arlington [I,Li] Baltimore, MD b. 25 Ag 1893. Studied: Md. Inst.; Char. C.; PAFA. Work: Baltimore Nat. Bank; State of Md. War Mem. Bldg.; Woodrow Wilson Hotel, New Brunswick, N.J.; assistant to R. McGill Mackall on dec. for USPOs, Hillsdale, Baltimore, both in Md.; work owned by Franklin D. Roosevelt [40]

METCALFE, Louis R. [P] NYC [24]

METCALFE, N.W. [P] NYC [01]

METEYARD, Thomas B(uford) [I,P] Sussex, England b. 12 N 1865, Rock Island, IL d. 17 Mr 1928, Glion, Vaud, Switzerland. Studied: Harvard; Paris, with Bonnard, Monet. Member: St. John's Wood AC, London. Exhibited: Paris Salon; Soc. Am. A. World's Expo; St. Louis Expo; Intl. Exh., Paris (one-man); London (one-man). Illustrator: "Songs from Vagabondia." Specialty: Dec. Illus. [27]

METHENY, John Renwick [P,C,T] Wayne, MI b. 11 Mr 1881, U.S. Consulate, Latakia, Syria. Studied: A. Beaune; O. Fuchs. Member: Am. Oriental Soc. Exhibited: State Fair, Detroit, 1922 (med); A. Center, Beaver, Pa., 1937 (prize). Work: Barbour Intermediate Sch., Detroit; St. Paul's Inst., Tarsus, Turkey; C. Ft. McKinley, P.I. Author: articles on Near East archaeology [27]

METHENY, Sarah Fontaine (Mrs. W.A.) [P,T] Clarksville, AR/Hope, AR b. 11 F 1886, AR. Studied: Mrs. N.A. Emery. Position: Art Dir., College of the Ozarks [27]

METHFOSSEL, Herman [I] Staten Island, NY b. 1873, Stapleton, NY d. 17 D 1912, Great Kills. Studied: NAD. Positions: Staff, N.Y. World, New York Sun, New York Herald

METHVEN, H. Wallace [P,G,Dec] Chicago, IL b. 10 S 1875, Phila. Studied: H.F. Spread; K. Cox; Beckwith; Laurens; Delecluse [40]

METLAY, Harry [P] b. 4 Jy 1907 d. 1955, NYC. Studied: Parsons Sch. Des. Work: Mus. Non-Objective Art. WPA artist. [*]

METOUR, Eugene [P,E] Williamstown, MA b. Brittany d. Spring, 1929. Work: etchings depicted scenes in Annapolis, Baltimore, Pittsburgh. Positions: T., Univ. Pittsburgh, U.S. Naval Acad. [27]

METTLEN, Franke Wyman [P] Bloomfield, NE b. 3 Ap 1880, Mazomanie, WI. Studied: E.M. Hosteller; M. Snowden; L. Dow; D. Young. Exhibited: Nebr. Fed. Women's C. (prize) [40]

METZKES, F.W. [P] Pittsburgh, PA. Member: Pittsburgh AA [25]

METZL, Ervine [I,Car,Des] NYC b. 28 1899, Chicago. Studied: AIC; Acad., Munich. Member: Ar. Gld., N.Y.; SI; AIGA. Exhibited: A. Dir. C., NYC, 1932 (prize), 1935–36 (prize). Work: Kensington Mus., London. Contributor: American Artist, Art & Industry, other magazines [47]

METZLER, Karl Ernst [P,S,G] Baltimore, MD b. 15 Ag 1909, Lehe, Germany. Studied: Md. Inst. Member: Am. Ar. Cong.; Ar. U., Md. Exhibited: PMG; BMA (1938); WFNY, 1939. Work: Baltimore AM; PMG. Illustrator: "America Today," 1936 [40]

MEURER, Albert John Theodore (A.J. Ted) [G,I,P,L,B] Wash., D.C. b. 7 O 1887, Louisville, KY. Studied: R. Meryman; S.B. Baker; E. Weisz; Corcoran Sch. A.; D. Garber; R.C. Nuse; G. Harding; PAFA. Member: Wash. AC; Landscape C., Wash. Exhibited: Landscape C., Wash., 1938 (prize), 1939 (prize); S.Indp.A., 1933 (prize), 1934–46; Soc. Wash. A.; Wash. AC. Work: graphic analysis of international trade of U.S. Author/Illustrator: "Silhouettes." Work: Graphic Des., U.S. Tariff Comm., Wash., D.C., 1943- [47]

MEURER, Charles Alfred [P] Terrace Park, OH b. 15 Mr 1865, Germany d. 13 Mr 1955. Studied: Académie Julian, Paris; Cincinnati A. Acad; Bouguereau; Doucet; Duveneck. Member: Cincinnati AC. Exhibited: PAFA; Chicago Soc. FA; Paris; Cincinnati AM, 1939. Work: Melish Gal., Cincinnati; Park View Hotel, Cincinnati [47]

MEURER, Marjorie R. (Mrs. A.J. Ted) [Ldscp.P,B] Wash., D.C. b. 11 F 1900, Dover, MA d. 16 D 1940. Studied: D. Garber; G. Harding; PAFA, with R.C. Nuse; G.W. Jex. Exhibited: Nat. S.Indp.A., Wash., D.C., 1933 (prize) [40]

MEUTTMAN, William [P] Cincinnati, OH [13]

MEUX, Gwendolyn D. [P] Boulder, CO. Member: Boulder AA; Okla. AA. Exhibited: Kansas City AI, 1923 (med), 1929 (med); Denver Mus. Exh., 1928 (prize); Mid-West A. Exh., 1935 (prize) [40]

MEWETT, Alfred [P] Cleveland, OH. Position: Associated with Cleveland School of Art [25]

MEWHINNEY, Ella Koepke (Mrs.) [P] Holland, TX (1962) b. 21 Je 1891, Nelsonville, TX. Studied: Tex. Presbyterian Col., 1908; ASL, with Bridgman, 1913; Broadmoor Acad., Colorado Springs, with R. Davey, R. Reid, 1925. Member: SSAL; Tex. FA Assn. Exhibited: SSAL, 1928 (prize), 1931 (prize); San Antonio, 1929 (prize); Tex. Centenn.; Dallas Women's Forum, 1925. Work: Witte Mem. Mus. [47]

MEYENBERG, John C. [S,C] Cincinnati, OH (1904) b. 4 F 1860, Tell City, IN. Studied: Cincinnati A. Acad., with T.S. Noble; Beaux-Arts, Paris, with J. Thomas. Member: Cincinnati AC. Work: Fort Thomas, Ky.; Covington (Ky.) Carnegie Lib.; Linden Grove Cemetery; bust, Court House, Covington, Ky.; Lincoln Park, State of Ind.; Cincinnati Pub. Lib. [33]

MEYER, Alexander R. [Des,P] New Rochelle, NY b. 18 F 1878, Paris, France. Studied: Arts Decoratifs Sch., Paris. Specialty: designs for wallpaper, silks, cretonne [40]

MEYER, Alvin (William) (Carl) [S,T] Chicago, IL b. 31 D 1892, Bartlett, IL. Studied: Md. Inst.; PAFA; Am. Acad., Rome; C. Grafly; E. Keyser; H. Schuler. Awards: PAFA Scholarship; Rhinehart F.; Peabody Inst.; Prix de Rome, 1923. Work: Peabody Inst., Md. Inst., both in Baltimore; Chicago Daily News Bldg.; Chicago Bd. Trade; Ohio State Office Bldg., Columbus; Archives Bldg., Springfield, Ill.; Natural Hist. Bldg., Urbana, Ill. [47]

MEYER, Alys A. [P] Wash., D.C. [13]

MEYER, Christian [Ldscp.P] Brooklyn, N.Y. b. 1838, Germany (came to NYC as a young man) d. 15 Ap 1907. Exhibited: SAA; NAD. Actively painting after 1880.

MEYER, Enno [P,S,E,I] Milford, OH b. 16 Ag 1874, Cincinnati. Studied: Cincinnati A. Acad., with Duveneck. Member: Cincinnati AC [29]

MEYER, Ernest [P] Tylerville, CT b. 24 D 1863, Rothenburg, Germany. Studied: Chase; Twachtman; Ward; Beckwith; DuMond; Turner. Member: CAFA; SC [31]

MEYER, Felicia (Mrs. Reginald Marsh) [P] NYC b. 14 My 1913, NYC. Studied: ASL, with K. Nicolaides, K.H. Miller, G.P. DuBois. Exhibited: CGA, 1945; PAFA, 1946; WMAA, 1944; AIC; Pepsi-Cola, 1944. Work: WMAA; Detroit Inst. A.; AGAA; Wood Gal., Montpelier, Vt. [47]

MEYER, Frederick H. [T,Des,C] Oakland, CA b. 6 N 1872, Hamelin, Germany d. 1961. Studied: Royal A. Sch., Berlin; PMSchIA; Columbia; Univ. Cincinnati; San Jose State Teachers Col., Calif. Member: Am. Cer. Soc.; Pacific A. Assn. Exhibited: P.-P. Expo, 1915 (gold); St. Louis Expo, 1903, 1904; GGE, 1939. Contributor: School Arts, Sierra Educational News. Positions: Pres., Calif. Col. A.&Cr., Oakland, 1907-44 (founder); T., Univ. Calif [47]

MEYER, George [Por.P] Nashville, TN b. 1896, Chicago d. 26 D 1930, near Morocco, Ind. Studied: Chicago Acad. FA. Work: Tenn. State Capitol. Positions: T., Milwaukee AI, Watkins Inst. (Nashville)

MEYER, George [S,P,G] NYC b. 4 S 1889, Germany. Studied: Hamburg Sch. AC; Mark Hopkins Inst. FA. Member: United Am. Ar.; S. Gld. Exhibited: S. Gld., N.Y., 1938, 1939; PS Ann., PAFA, 1939 [40]

MEYER, George Berhnard [Min.P] Baltimore, MD. Member: Charcoal C. [29]

MEYER, George K. (Mrs.) [Patron] Dallas, TX d. 23 D 1932. Member: Dallas A. Assn. (Pres., for 25 years). Bequeathed her collection of 70 paintings to form nucleus of Dallas Mus. FA

MEYER, Grace Manton [P] Topeka, KS b. 27 Je 1914, Topeka. Studied: H. Breckenridge, in Gloucester; N.Y. Sch. F.&Appl. A., in Paris; Research Sch., Italy. Member: Kansas City SA. Work: sketches for Saratoga Springs Spa; Robinson's Shoe Store, Kansas City [40]

MEYER, Herbert [P] Dorset, VT b. 6 Mr 1882, NYC d. 1960. Studied: ASL, with Twachtman, DuMond. Member: ANA, 1939; NA; SC; NYWCC; AWCS. Work: AGAA; WMAA; MMA; Wood A. Gal., Montpelier; Canajoharie A. Gal.; Fleming Mus., Burlington; Fort Worth MA [47]

MEYER, Mary A. [P] Hartford, CT [19]

MEYER, Nellie Hertha [P,I] NYC b. 23 Ag 1881. Studied: Volk; Metcalf; Maynard; Twachtman; Clinedinst; Ochtman [08]

MEYER, Paul A(uberlin) [P] Cleveland, OH b. 5 Jy 1910, Cleveland. Studied: Cleveland Sch. A., with C.F. Gaertner. Exhibited: Cleveland Sch. A., 1931 (prize); Ann. Exh. Cleveland Ar.&Craftsmen, CMA, 1931 (prize), 1932 (prize), 1933 (prize) [40]

MEYER, William C. [P] Hazleton, PA b. 14 O 1903, Freeland, PA. Studied: Syracuse Univ.; PAFA; Univ. Pa. Member: AWCS; Central Inst. A.&Des., London. Exhibited: PAFA, 1938, 1939; Wanamaker Exh., Phila., 1934; Boyer Gal., Phila., 1934; AWCS, 1939; Roerich Gal., Phila., 1939 (one-man); AFA Traveling Exh., 1941; Peter Jones Gal., London, 1944 [47]

MEYERCORD, Grace E(linor) [Min.P] Germantown, PA b. 18 N 1900, Chicago. Studied: A.M. Archambault [25]

MEYEROWITZ, Jenny Delony Rice (Mrs. Paul A.) [Por.P.,Min.P,T,W] NYC b. 13 My 1866, Washington, AR. Studied: W.M. Chase; Cincinnati A. Acad.; St. Louis A. Sch.; Académie Julian, with Delance; Acad. Delecluse, Paris. Member: NAC; NAWPS; Brooklyn SE; AAPL; FA Cl., Ark. Work: Ark. Capitol; N.Y. Clearing House, Chemical Nat. Bank, both in NYC; Confederate Mus., Richmond, Va.; Tenn. Valley Hist. Mus., Tuscumbia, Ala.; Mus. FA, Little Rock, Ark. [40]

MEYEROWITZ, William [E,P] NYC (1977) b. 15 Jy 1898, Russia. Member: Audubon A.; NA (1959); SAE; Am. Color Pr. Soc.; S.Indp.A.; Gloucester SA; North Shore A.; CAFA; Salons of Am.; Phila. Pr. Cl.; Am. Ar. Cong. Exhibited: CAFA, 1923 (prize); North Shore AA, 1932 (prize), 1939 (prize); Am. Contemporary A. New England, 1944; Currier Gal. A., 1942; LOC, 1943, 1944; CGA, 1935, 1941, 1945; PAFA, 1935, 1936, 1940; WMA, 1935, 1937, 1939, 1945; AIC, 1935, 1936, 1940; WMAA, 1936; TMA; NAD; MMA; CI; Dayton AI; Am. Acad. A.&Letters; BMFA; BMA. Work: PMG; BM; U.S. Nat. Mus.; BMFA; Concord Mus. A.; Bibliothèque Nationale, Paris; Harvard Univ. Law Sch.; NYPL; Yale; CCNY; Univ. Pa.; J.B. Speed Mem. Mus.; Boston Univ.; Herron AI; Univ. Ky.; Harvard C.; Albany Inst. Hist.&A.; LOC; Currier Gal. A.; USPO, Clinton, Mass. WPA artist. [47]

MEYEROWITZ, William, Mrs. See Bernstein, Theresa.

MEYERS, Harry Morse [I] NYC. Member: GFLA [27]

MEYERS, Julius E. [P] Buffalo, NY. Member: Buffalo SA [17]

MEYERS, Lewis R. [P] Jersey City, NJ b. 1870, Jersey City. Studied: NAD [01]

MEYERS, O. Erwin [P] Chicago, IL Member: Chicago SA [27]

MEYERS, Ralph [P] Taos, NM [19]

MEYERSAHM, Exene R(eed) (Mrs.) [P] Providence, RI b. Northville, MI. Studied: RISD; BMFA; C. Hawthorne. Member: Providence AC; NAC; Springfield AL [33]

MEYLAN, Paul J(ulien) [I,P] NYC b. 17 My 1882, Canton of Vaud, Switzerland. Member: SI, 1907; AAS; Artists Gld. Illustrator: "Two Faces," "The Poor Lady," "Sarolta," "Come Out of the Kitchen,' "Ladies Must Live," "The Unexpected" [40]

MEYNELL, Louis [P,S] Chestnut Hill, MA b. 22 S 1868, Cherryfield, ME. Studied: O. Grundmann; F.H. Tompkins; BMFA Sch., 1888 [10]

MEYNER, Walter [P,S,W] NYC b. 12 F 1867, Phila. Studied: PAFA. Member: SC; S.Indp.A.; Allied AA [33]

MEYVIS, Almé Leon [P] East Rochester, NY b. 17 My 1877, St. Gilles-Waas, Belgium. Studied: Mechanic's Inst., Rochester; Royal Acad., The Hague. Member: Rochester AC; Arti et Amici, Amsterdam. Exhibited: Buffalo Soc. Artists, 1903 (prize); Ville de Paris, 1904 (med); Enghien-les-Bains, 1904 (med); Intl. Expo, Utrecht, Holland, 1909 (med). Work: Mod. Mus. The Hague, Holland; Sibley Hall Lib., Rochester [40]

MEYVIS, Frederick William [P] Rochester, NY [10]

MIAU, A. [P] Worcester, MA [24]

MICHAEL, D.D., Mrs. See Wolfe, Natalie.

MICHALOV, Ann [G,P,T] Chicago, IL b. 6 Je 1904, IL. Studied: AIC. Member: Chicago Soc. Ar. Exhibited: Great Lakes Exh., The Patteran, Buffalo, N.Y., 1938; Ar. Chicago Vicin., AIC, 1938, 1939; WFNY, 1939. Work: AIC. WPA artist. [40]

MICHELSON, Dorothy [P] Provincetown, MA b. 1 S 1906, Chicago. Studied: R. Moffett. Member: New England Soc. Contemp. A. [31]

MICHELSON, Eric Gustavus [P] Hollywood, CA. Member: Calif. AC [25]

MICHENER, Edward C. [P,I,Des] Camp Hill, PA b. 25 O 1913, Duncannon, PA. Studied: PMSchIA; T. Oakley; H.C. Pitz. Member: Harrisburg AA; Phila. Sketch C. Exhibited: Harrisburg AA, 1933-45, 1934 (prize), 1936 (prize), 1939 (prize). PAFA, 1936-38; Cumberland Valley A., 1942, 1943. Work: Pa. State Col. Illustrator: We the People magazine, 1936-37. Dir., Harrisburg A. Assn. Studios [47]

MICHNICK, David [S] NYC b. 4 O 1893, Gorenka, Ukraine. Studied: Beaux-Arts Inst. Des., N.Y. Member: S. Gld., N.Y. Exhibited: S. Gld., Brooklyn Mus.; WFNY, 1939. Work: Farragut Jr. H.S., NYC; Jackson H.S., NYC; Ft. Wadsworth, N.Y. [40]

MICKS, J(ay) Rumsey [I] NYC/Seneca Falls, NY b. 22 F 1886, Baltimore. Studied: H. McCarter. Illustrator: Everybody's, Scribner's, Harper's, Redbook [40]

MIDDLETON, Mary P. (Mrs. Laessle) [S] Germantown, PA [10]

MIDDLETON, Stanley (Grant) [P] NYC b. Brooklyn, NY. Studied: J. de la Chevreuse; Harpignies; Constant; Dagnan-Bouveret; Académie Julian, Paris. Member: Barnard C.; Lotos C.; SC. Exhibited: Pan-Am. Expo, Buffalo, 1901 (prize); Charleston Expo, 1902 (prize). Work: Crescent C., Brooklyn; AMNH; Nat. Gal.; West Point Lib.; Mem. Hall, West Point, N.Y.; Harvard; Houston; Princeton C.; Bronx Armory; Harvard C.; Brooklyn Mus., N.Y. [40]

MIDJO, Christian M. S. [P] Ithaca, NY [17]

MIELATZ, C(harles) F(rederick) William [E,T] NYC b. 24 My 1864, Breddin, Germany d. 2 Jy 1919. Studied: Chicago Sch. Des.; F. Rondel, in N.Y.; J.J. Calahan. Member: N.Y. Etching C.; ANA, 1906; AWCS; Am. Soc. P&G; Intl. Jury of Awards for etchings, St. Louis Expo, 1904. Work: NYPL; Parrish Mus. Prominent etcher of architectural subjects; active around Newport, R.I., through 1880s. Position: T., NAD [17]

MIELZINER, Jo [Stage Des,Mur.P,L,I] NYC b. 19 Mr 1901, Paris, France d. 1976. Studied: ASL; NAD; PAFA Scholarship, 1919-20. Member: Arch. Lg.; Scenic A. Un. Exhibited: MOMA; Mus. City of N.Y. Work: stage settings, Metropolitan Opera and Tudor's ballet, "Pillar of Fire," Ballet Theatre; 150 musical&dramatic productions, NYC, 1924-46. Commissioned by State Dept. to design setting for United Nations Conference, San Fran., 1945. Contributor: New York Times; Theatre Arts [47]

MIELZINER, Leo [P,S,I,Li,L,W] NYC/Head o'Pamet, North Truro, MA b. 8 D 1869, NYC d. 11 Ag 1935. Studied: Cincinnati A. Acad.; Ecole des Beaux-Arts, Acad. Julian, Acad. Colarossi, all in Paris; Kroyer, in Denmark. Member: Boston AC; Cincinnati AC; SC. Work: Kent Hall, Columbia; Jewish Theological Seminary, N.Y.; Hebrew Union Col., Cincinnati; Democratic Cl, N.Y.; Barnard Col.; Boston A. Mus.; Brooklyn A. Mus.; WMA; MMA; Cincinnati A. Mus.; NYPL [33]

MIERISCH, Dorothea [Dec,Li,P] NYC b. N.Y. Studied: S. Hirsch. Member: NAWPS. Exhibited: NAWPS, 1933 (prize); Montclair Mus., 1933 (med) [40]

MIFFLIN, LLoyd [Por.P] Norwood, Lancaster County, PA b. 1846 d. 16 Jy 1921. Published more than 500 sonnets; also lyricist

MIHALIK, Julius [Des,C,P,T] Cleveland, OH b. 1874, Budapest, Hungary d. 12 Ja 1943. Studied: E. Balli A. Sch., Budapest. Member: Boston SAC; Cleveland SA; P.-Et. Soc., Budapest; Art T. Gld., London. Work: MA, Municipal A. Gal., Cleveland. Co-author: "Art in Industry." Contributor: American Magazine of Art; European magazines; books on textile work; pageants. Position: T., Cleveland Col. [40]

MIHAS, Louis N. [P] Chicago, IL. Member: Chicago NJSA [25]

MIKELL, Minnie (Robertson) (Mrs. Alexander B.) [P,Des,C,T] Charleston, SC b. 18 D 1891, Charleston. Studied: A. Hutty; J. Pennell; E. Kinzinger; K. Ziolkowski; A. Webster. Member: Carolina AA, SSAL. Exhibited: NAWA; NAC; All.A.Am.; SSAL; Charleston Et. C.; Mississippi AA; Caroline AA. Illustrator: "Charleston Market" in "Two Hundred Years of Charleston Cooking." Position: T., Ashley Hall Sch. for Girls, Charleston, 1929-42 [47]

MIKKELSON, Gwendolen [S] Danbury, CT. Member: S.Indp.A. [25]

MILAM, Annie Nelson (Mrs.) [P] Ennis, TX b. 20 N 1870, Homer, LA d. 9 Ja 1934. Studied: J. Carlson. Member: El Paso AC; AFA. Exhibited: Southwestern Expo, El Paso, 1924 (prize) [33]

MILAM, Elizabeth Coffman [P,T] Ripon, CA/Stockton, CA b. 17 Je 1911, Spokane, WA. Studied: Col. of the Pacific; Univ. Calif. Member: Pacific Arts Assn. Illustrator: botanical sketches, "Economic Plants," 1934. Position: T., Ripon H.S. [40]

MILBANK, Marjorie R. (Mrs. Albert G.) [P] NYC/Huntington, NY b. 15 Je 1875, Lynn, MA. Member: NAWPS; S.Indp.A. [33]

MILBAUER, Mary, Mrs. See Van Blarcom.

MILBURN, Oliver [P,E] Los Angeles, CA b. 17 S 1883, Toronto. Studied: Los Angeles AI; Chouinard Sch. A. Member: Calif. AC; Laguna Beach AA; San Diego AG; Santa Monica AS; Calif. WCS [33]

MILEHAM, Christopher John, Mrs. See Durkee, Helen Winslow.

MILES, Emily H. [T,E] Denver, CO. Member: Denver AC [17]

MILES, Emily Winthrop (Mrs. C.L.) [S] Sharon, CT. Member: NSS. Exhibited: AIC, 1935; NAWA, 1935-39: WFNY, 1939 [47]

MILES, Eugene [P] Cleveland, OH. Member: Cleveland SA [27]

MILES, Harold Whiting [I,T,P] Roscoe, CA b. 2 S 1887, Des Moines, IA. Studied: Acad. Colarossi, Paris; Cumming A. Sch.; C.A. Cumming; J.F. Smith. Member: Calif.WCS; Motion Picture Lg. A. Dir. Exhibited: Calif. WCS, 1933 (prize). Work: West Des Moines H.S. Illustrator: "Girls of High Sierras," "Bride of the Rain God." Positions: A. Dir., Walt Disney Studio; T., Chouinard A. Inst. [47]

MILES, Helen Sonntag [Ldscp.P] Summit, NJ b. 3 O 1871, N.Y. [04]

MILES, John C. [P] Malden, MA. Member: Assn. Royal Canadian Acad.; Boston AC [06]

MILES, Maud Maple (Mrs.) [P,S,C,T] NYC b. 11 F 1871, Chariton, Iowa. Studied: AIC; N.Y., with A. Dow [10]

MILES, Samuel S. [P] Boston, MA [08]

MILES, Tracie E. (Mrs.) [C] Wakefield, MA b. 1 F 1895. Studied: Mrs. L.A. Chrimes. Member: Boston SAC. Specialty: needlework [40]

MILHAU, Zella de [E,I] NYC/Laffalot, Southampton, NY b. N.Y. Studied: A. Dow; E.N. Moran; ASL. Member: NAC [21]

MILHOLLEN, Hirst Dillon [E] Alexandria, VA b. 19 Mr 1906, Philomont, Va. Studied: Nat. Sch. F.&Appl. A., Wash., D.C. Member: Wash. SE (Pres.); Southern Pr.M. Work: fourteen etchings of Mexico, LOC [40]

MILHOUS, Katherine [Book Des.,I,W,Car,S] Phila., PA b. 27 N 1894, Phila. d. 1977. Studied: PMSchIA; PAFA, 1931; T. Oakley; W. Hancock; C. Grafly. Member: AIGA; PBC; Phila. WCC. Exhibited: AIGA (NY); Phila.; 1937 (prize); Phila. A. All.; Phila Plastic C.; WFNY, 1939. Author/Illus.: "Snow Over Bethlehem," "The First Christmas Crib," "Herodia, the Lovely Puppet," "Once on a Time," "Happily Ever After," "Lovina—Story of Pa. Country." Contributor: The Horn Book, others. Designer: books, Scribner's, 1944-46. WPA artist. [47]

MILIONE, Louis G., Sr. [S,T] Havertown, PA b. 22 F 1884, Padula, Italy d. 26 Mr 1955. Studied: Spring Garden Inst.; PMSchIA; PAFA, 1931 (Cresson traveling scholarship); C. Grafly; A. Calder; W. Chase; H. Deigendesch; Porter. Exhibited: PAFA, 1904 (prize), 1910-36; S. Soc., 1940-43; NAD, 1910-30; PMA; Rittenhouse AC. Work: Merion, Pa.; Laramie, Wyo.; Camden, N.J.; Phila. Acad. Music; Fairmount Park, Pa.; Phila. Municipal Court Bldg.; Germantown H.S.; Girard Col. Chapel, Phila.; Vicksburg, Miss.; Bryn Mawr, Church of the Reedemer [47]

MILLAR, Addison T(homas) [P,E] NYC/Norwalk, CT b. 4 O 1860, Warren, OH d. 8 S 1913 (in an automobile accident). Studied: N.Y., with Chase; Paris, with Benjamin-Constant, Boldini. Member: SC, 1897; Silvermine Group of Artists. Work: RISD; Mus. A., Detroit; NYPL; LOC; Detroit Mus. A.; Bibliothèque Nationale, Paris [13]

MILLAR, Anna K. [P] NYC [06]

MILLAR, Janie Craft (Mrs. Addison T.) [P] NYC b. 1861, Cortland, OH. Studied: A.T. Millar [10]

MILLARD, C. E. [P,I] NYC. Member: Ar. Gld. Illustrator: "The Prince of Wails," "California Fairy Tales," "The Tired Trolley Car" [40]

MILLARD, Elizabeth B(oynton) [P] Highland Park, IL b. Chicago. Studied: AIC; R. Clarkson, BMFA Sch.; E. Tarbell. Member: All-Ill. SFA; North Shore AL. Work: Highland Park Women's C. [33]

MILLBOURN, M(elville) Vaughn [Des,G,T] Chicago, IL b. 8 S 1893, Charlotte, MI. Studied: AIC. Member: A. Gld., Chicago; 27 Chicago Des.; Woodcut Soc. Exhibited: Northwest Pr.M., 1942, 1943; Phila. Pr. C., 1943, 1944; Wichita AA; Chicago A. Gld.; Soc. Typographic A. Position: T., Chicago Acad. FA, 1928- [47]

MILLER, Anna H(azzard) (Mrs. Edward J.) [P,T] Oklahoma City, OK b. 4 Je 1863, Minnesota. Studied: M. Braun; R. Davey; E. Lawson. Member: Okla. Art Lg.; Okla. State Ar. Assoc.; MacD. Cl. of All. Arts. Work: Univ. Okla. [40]

MILLER, Barse [P,Ldscp.P,Mur.P,T] La Canada, CA b. 24 Ja 1904, NYC d. 1973. Studied: NAD, with Snell; PAFA, with Breckenridge. Member: ANA; Phila. WCC; Fnd. Western A.; Calif. WC Soc.; Laguna Beach AA; AWCS. Exhibited: PAFA, 1936 (med); Los Angeles Mus. A., 1929 (gold,prize), 1932 (prize); Calif. WC Soc., 1933 (prize), 1935 (prize); Phila. WCC, 1938 (prize); Los Angeles County Fair, 1925 (prize), 1930 (prize), 1936 (prize); Ariz. State Fair, 1927 (prize); Rocky Mt. Exh. Mod. A., Logan, Utah, 1929 (prize); 48 Sts. Comp. (winner). Work: USPO, Island Pond, Vt.; San Diego FA Soc.; PAFA; Wood A. Gal., Montpelier, Vt.; Hackley A. Gal., Muskegon, Mich.; Los Angeles Mus. A.; Municipal Coll., Phoenix, Ariz.; Bentley Coll., Boston; H.S., Logan, Utah; Los Angeles Country Fair Assoc.; Dallas Mus. FA; Ford Motor Co., Dearborn, Mich.; Ebell Cl., 1935 (prize); Fnd. Western Art, Los Angeles; George Washington H.S., Los Angeles; Sommer and Kaufmann's, San Fran., 1930; murals, Southern Calif. Edison Co. Bldg. (Los Angeles, 1931), USPOs, Burbank (Calif.), Goose Creek (Tex.); Denver Mus.; Mus. A., Cranbrook, Mich.; Phila. WCC; high schools, San Pedro, Beverly Hills (both in Calif.), Furnace Creek Inn, Death Valley, Calif.; College Arch., Univ. Southern Calif.. Positions: T., PAFA (Chester Springs, 1939, 1940), Univ. Vt. (summer session) [47]

MILLER, Benjamin [E,Wood En,P] Cincinnati, OH b. 24 Jy 1877, Cincinnati. Studied: MIT; Cincinnati A. Sch., with Duveneck. Member: Cincinnati Prof. A. Exhibited: Tri-State Print Exh., 1945 (prize); Print Cl., Phila., 1929 (prize), 1935 (prize). Work: Bibliothèque Nationale, Paris; NYPL; Cincinnati Art Mus.; Minneapolis Inst. A.; published in "The Woodcut of Today at Home and Abroad," "La Gravure Sur Bois Moderne de L'Occident," "The New Woodcut," "Ohio Art and Artists" [47]

MILLER, Burr (Churchill) [S] NYC b. 3 Ap 1904, Wilkes-Barre, PA d. 10 O 1958, Brattleboro, VT Studied: Yale, with R. Eberhard; Bouchard, in Paris; J. de Creeft. Member: NSS; Fed. Mod. P.&S.; CAFA; Lyme AA; Arch. Lg. Exhibited: PAFA, 1930, 1946; NAD, 1931, 1932, 1935, 1936, 1939; S.Indp.A., 1938-42; GGE, 1939; WFNY, 1939; WMAA, 1940; CAFA, 1933, 1934, 1936, 1937; Anderson Gal., 1939 (one-man); Salon des Artistes, Paris, 1938 [47]

MILLER, Charles H(enry) [Ldscp.P,E,W,L] b. 20 Mr 1842, NYC d. 23 Ja 1922. Studied: NAD; Bavarian Acad., Munich, 1867-70; Adolph Lier, in Munich. Member: ANA, 1873; NA 1875; Century Assoc.; Lotos Cl.; Queensborough Soc. Appl. A.&Cr. (Pres.). Exhibited: Phila. Centenn., 1876 (gold); Boston (gold); New Orleans (gold). Work: MMA; Brooklyn Inst. Mus.; Republican Cl., Democratic Cl., both in NYC; RISD. Author: "Philosophy of Art in America" (under pseud. Carl De Muldor), 1885. First exhibited at NAD in 1860 but in 1863 became a physician; returned to painting in 1867. Best known for his Long Island scenes. [21]

MILLER, Clyde P. [C] Milton, NY/Penland, NC b. 20 Je 1899, Gerry, NY.

MILLER, Cora E. [Ldscp.P] Phila., PA b. Jenkintown, PA. Studied: Breckenridge; PAFA; F. Wagner. Member: Plastic Cl. [40]

MILLER, Courtney [P] Center, IN [24]

MILLER, Delle [P,C,T] Kansas City, MO b. Independence, KS d. 17 S 1932. Studied: Kansas City AI; A.W. Dow; Breckenridge; ASL. Member: North Shore AA; NAWPS; Western AA; Kansas City SA. Exhibited: Kansas City AI, 1922 (prize); Mo.-Kans. and Okla. Artists Expo, 1923 (prize); Kansas City Soc. A., 1928 (prize). Work: Kansas City Art Inst.; Greenwood Sch.; Kansas City Pub. Lib.; Pittsburgh, Kansas State Normal Sch.; Northwest Mo. State T. Col. [31]

MILLER, Donna (Mrs. Ernest W.) [Li,P,B] Milwaukee, WI b. 15 Jy 1885, Macon, MI. Studied: R. von Neumann; G. Sinclair; E. Groom. Member: Milwaukee Pr.M.; Wis. P&S; NAWA. Exhibited: Milwaukee AI, 1936, 1937 (prize), 1939, 1940 (prize), 1943 (prize), 1944, 1945, 1946 (prize); Wis. State Fair, 1941–44 (prizes). NYWCC, 1937, 1939; PAFA, 1936; Phila. A. All., 1937; Grand Rapids A. Gal., 1940; NAD, 1943; Albany Inst. Hist.&A., 1943; LOC, 1945; Renaissance Soc., Univ. Chicago, 1943; Detroit Inst. A., 1936, 1937; Madison, Wis., 1936, 1942, 1943, 1945; Wis. Pr. Exh., 1937 (prize) Work: prints, Wis. Ar. Calendar, 1937, 1938; Am. B. Calendar, 1939 [47]

MILLER, Doris Louise. See Johnson.

MILLER, Dorothy Canning [Mus.Cur,W] NYC b. Hopedale, MA. Studied: Smith; NYU. Editor: "New Horizons in American Art," 1936, "Charles Sheeler," 1939, "Romantic Painting in America," 1943, other books. Author: "Masters of Popular Painting," 1938. Contributor: Art News, Art in America. Position: Associated with MOMA, from 1934 [47]

MILLER, Dorothy McTaggart (Mrs.) [P] Worcester, MA [24]

MILLER, D. Roy [P,T,W] Chester Springs, PA b. 8 F 1891, Mechanicsburg, PA. Studied: PAFA. Member: Chester Country AA. Author: articles, Arts and Decoration, Magazine of Art, International Studio. Positions: Dir., PAFA (summer school, 1916–34), Painters' Farm Sch., Correlated Cultural A., Chester Springs [40]

MILLER, Earle [P,E,Li] Phila., PA b. 16 N 1907, Phila. Member: Phila . Alliance; Phila. Pr. Cl. [40]

MILLER, Edgar [C,Mur.P,S,P] Chicago, IL b. 1899. Exhibited: watercolors, AIC, 1934 (prize), 1935 (prize). Work: sculptures, Capitol, Bismarck, N.Dak.; Jane Addams Housing Proj., Chicago; murals, Grill, Eitel Field Bldg., Tavern, Univ. Clubs, all in Chicago; Nat. Acad.; Cliff Dwellers Cl.; Lib., Univ. Tenn.; Recreation Center Proj., Neenah, Wis; Chapel, Loyola Univ; La Salle Hotel, Chicago; wood carving/stained glass, North State Bldg., Chicago [40]

MILLER, Edith Maude [P] Oklahoma City, OK [19]

MILLER, Edward J. [P] Oklahoma City, OK. Member: Okla. AA [25]

MILLER, Eleazer Hutchinson [Por.P,E,I] Wash., D.C. b. 28 F 1831, Shepherdstown, WV d. 4 Ap 1921. Studied: Gibson; Healy. Member: Soc. Wash. A.; Wash. WCC. Work: CGA. His obituary states that he was the first artist of national reputation to make his home in Wash., D.C. [19]

MILLER, Ellen [P] Wash., D.C. [24]

MILLER, Emma D. [P] Phila., PA. Studied: PAFA [25]

MILLER, Evylena Nunn (Mrs.) [Ldscp.P,P,I,L,T] Los Angeles, CA b. 4 Jy 1888, Mayfield, KS. Studied: Pomona Col.; Univ. Calif.; ASL; abroad. Member: NAWA; Laguna Beach AA; Women P. of the West; Soc. for Sanity in Art; Los Angeles AA; Fnd. Western A.; Calif. AC. Exhibited: Calif. State Fair, 1925 (prize); Women's Cl., Hollywood, 1930 (prize); Festival All. A., 1934 (prize); Intl. Aeronautical A. Exh., Los Angeles Mus. A., 1937 (prize); NGA, 1928; Biltmore Salon; Ainslie Gal.; Kieritz Gal.; De Vannes Gal.; San Diego FA Soc.; Bowers Mem. Mus.; Pal. Leg. Honor; Wichita AC; Ebell Cl. (one-man); Long Beach Municipal A. Gal. Work: Hollywood Women's Cl.; Ferris Seminary, Yokohama; Women's Christian Col., Tokyo and Kobe; Chinese YMCA, San Fran.; First Presbyterian Church, Bowers Mem. Mus., both in Santa Ana, Calif. Illustrator: Pomona Col. publications. Author: "Travel Tree." [47]

MILLER, F.W. [S] NYC. Member: Lotos Cl. [13]

MILLER, Florence M. [P] Taos, NM. Exhibited: GGE, 1939 [40]

MILLER, Frances T. [Des] NYC b. 29 N 1893, NYC. Member: Soc. Des. Craftsmen; Mus. Mod. Art. Exhibited: textiles, Intl. Expo, Paris, 1937 (gold). Designer: rugs, textiles [40]

MILLER, Francis [P] b. 24 My 1885, Columbus, OH d. 4 F 1930, NYC. Studied: New York; Paris; Berlin

MILLER, Frank H. [P] Phila., PA [25]

MILLER, Fred, Jr. [B,W] St. Paul, MN b. 21 My 1912, St. Paul. Studied: Univ. Minn. Work: bookplates, Intl. Bookplate Soc. [40]

MILLER, George Charles [Li,L,T] NYC/Burlington, VT b. 17 Je 1894, NYC. Printer: books by Rockwell Kent, Wanda Gag, Nura Ulrich, others. Position: T., Wayman Adams Sch., N.Y. [40]

MILLER, George Washington [S] Andover, MA b. 14 N 1904. Studied: Grafly; F.W. Allen; Académie Julian, Paris, with P.F. Niclausse; H. Schwegerle [40]

MILLER, Harriette G. [P,S] Arlington, VT/Paris, France b. 6 Mr 1892, Cleveland, OH. Studied: Cleveland Sch. A.; P. Le Doux, in Paris. Member: NAWPS; Grand Central AG. Work: CGA; WMAA; Art Gal., Canajoharie, N.Y.; Wood Art Gal., Monteplier, Vt. [40]

MILLER, Helen Adele Lerch [S] Chicago, IL [19]

MILLER, Helen (Pendleton) [E] NYC b. 27 My 1888, St. Louis, MO d. 24 Je 1957, Port Washington, NY. Studied: N.Y. Sch. A.; ASL; K.H. Miller; H. Wickey. Member: SAE; NAWA; Calif. Pr.M.; PBC; AAPL. Exhibited: SAE, 1943 (prize); NAWA, 1945 (prize); NAD, 1936, PAFA, 1935, 1937, 1938, 1941–44; CGA, 1945; WFNY, 1939; NAWA, 1945, 1946; Phil. Pr. Cl, 1941–44, 1946; Southern Pr.M., 1942; Calif. Pr.M., 1940; Smithsonian Inst., 1943 (one-man); Mint Mus. A., 1946; Denver A. Mus., 1944; WMAA, 1938–40; Buffalo Pr. Cl., 1943; Albany Pr. Cl., 1945; Phila. A. All., 1940; Argent Gal., 1946 (one-man); New Haven PCC, 1946 (one-man); Intl. Expo, Paris, 1937. Work: NYPL; LOC [47]

MILLER, Helena Welsh [P] Phila., PA d. 3 D 1929, NYC. Studied: NAD; ASL. Member: NAWPS; C.L. Wolfe Art Cl. Specialty: flowers [01]

MILLER, Henry [Dealer] NYC d. 28 N 1924. Position: Vice-pres., William Macbeth Inc., art dealers

MILLER, Henry Arthur [Des,Mur.P,T] Brooklyn, NY b. 15 Ja 1897, Odessa, Russia. Studied: J.B. Whittaker; Adelphi Col.; M. Herman; Pratt Inst. Member: Brooklyn SA; SC. Position: Dir., Adv. A., Literary Digest [40]

MILLER, Hester [P] NYC/Woodstock, NY. Member: NAWPS [27]

MILLER, Iris (Marie) Andrews (Mrs. William N.) [P] Detroit, MI b. 28 Mr 1881, Ada, OH. Studied: Chase; Henri; Breckenridge; Mora. Member: NAWA; AFA; Detroit Soc. Women P.; NAC; AFA. Exhibited: Mich. A., Detroit Inst. A., 1923 (prize), 1924 (prize); Scarab Cl., 1929 (gold). Work: Detroit Inst. A.; San Diego FA Soc. [47]

MILLER, I(sabelle) Lazarus [E,P] Phila., PA b. 27 N 1907, Phila. Studied: PMSchIA; Graphic Sketch Cl.; E. Horter. Member: Phila. Pr. Cl.; Phila. A. All.; AAPL; SAE. Exhibited: Phila. Pr. Cl., 1935 (prize), 1936 (prize); PAFA, 1931, 1936, 1942; 100 Prints, 1942; NAD, 1936, 1943, 1944; AIC, 1938; CAFA, 1940; Grand Rapids A. Gal., 1940; SAE, 1940–45; AFA Traveling Exh., 1943–45; Southern Pr.M., annually; Northwest Pr.M., 1943; LOC, 1943; Denver A. Mus.; Buffalo Pr. Cl., 1940, 1943; Phila. A. All., annually; Phila. SE [47]

MILLER, Jane [I,Car] NYC/Carmel, NY. Exhibited: Md. Inst. [40]

MILLER, Jessie M. [P] St. Paul, MN [17]

MILLER, John Edward [Arch.,P,T] Cleveland, OH b. Cleveland. Studied: C. Broemel. Member: Wash. WCC; Hoosier Salon. Exhibited: Hoosier Salon, 1935 (prize). Position: T., Univ. Notre Dame [40]

MILLER, John R. [P] Indianapolis, IN [15]

MILLER, John Zollinger [P] Lancaster, PA b. 16 Je 1867, Lancaster, PA. Studied: J.F. Carlson; G. Wiggins. Member: Lancaster County A. Assn.; Am. Ar. Prof. Lg. Exhibited: Hotel Devon (one-man), Savoy Plaza (one-man), both in NYC; Lancaster County A. Assn. [40]

MILLER, J(oseph) Maxwell [S] Baltimore. MD b. 23 D 1877, Baltimore d. 20 F 1933. Studied: Md. Inst., Rinehart Sch. Sculpture, Charcoal Cl., all in Baltimore; Académie Julian, Paris, with Verlet. Exhibited: Md. Inst., 1897 (gold); Paris Salon, 1902 (prize); St. Louis Expo, 1904 (med); medals, P.-P. Expo, San Fran., 1915 (prize). Award: Officier d'Académie Français, 1912. Work: U.S. Naval Acad., Annapolis; Baltimore, Md.; PAFA; MMA; St. Louis Mus.; Peabody Inst., Walters Gal., both in Baltimore; monuments, Annapolis; Johns Hopkins Univ.; mon. to Confederate Women of

Md. Positions: Dir., Rinehart Sch., Md. Inst., Baltimore, since 1923; T., Corcoran Sch. Art [31]

MILLER, Juliet Scott [P,I,T] NYC b. 12 D 1898, Alexandria, VA. Studied: B. Robinson; Guy Pène DuBois; Minneapolis Sch. A. Member: ASL [31]

MILLER, Julius Anton [W,T] Meadville, PA b. 26 D 1906, Elgin, IL d. My 1953. Studied: Chicago Acad. FA; Univ. Wis.; Univ. Budapest. Member: Eastern AA; Am. Assn. Univ. Prof. Author: "Modern Hungarian Art," 1933. Positions: T., De Pauw Univ. (1934–35), Ill. State Normal Univ. (1935–37), Allegheny Col., Meadville, 1937– ; Shrivenham Am. Univ., England, 1945–46 [47]

MILLER, Kate Reno [P] Cincinnati, OH b. 1874, Illinois d. 23 N 1929. Studied: Cincinnati Art Acad.; Duveneck; Hawthorne. Member: Cincinnati Women's AC. Position: T., Cincinnati Art Acad., for 25 years [29]

MILLER, Kenneth Hayes [P,E,L,T] NYC b. 11 Mr 1876, Oneida, NY d. 1 Ja 1952. Studied: ASL, with Mowbray, Cox, DuMond; N.Y. Sch. A., with Chase; Europe. Member: Am. Soc. PS&G; SAE; Phila. SE; NA; NIAL. Exhibited: NAD, 1943 (med); AIC, 1946 (prize); Armory Show, NYC, 1913; nationally. Work: Los Angeles Mus.; MMA; CMA; WMAA; PMG; LOC; NYPL; VMFA; AGAA; MOMA. Positions: T., Chase Sch. A. (1900–11); ASL (1912–36). Important teacher of many urban realists, including Reginald Marsh, Isabelle Bishop, Edward Hopper, and George Bellows. [47]

MILLER, Kenneth Neils [I,Car,P,S] Racine, WI b. 19 O 1911, Humbolt City, IA. Studied: Layton Sch. A., Milwaukee. Studied: Women's Cl. Exh., Racine, 1939 (prize). Exhibited: Wis. PS Exh., Milwaukee AI, 1939; Madison Univ., 1939. WPA artist. [40]

MILLER, Lee [P] NYC [01]

MILLER, Leslie W(illiam) [P,T,W,L] Oak Bluffs, Martha's Vineyard, MA b. 5 Ag 1848, Brattleboro, Vt d. 7 Mr 1931. Studied: Mass. Normal A. Sch.; BMFA Sch.; Univ. Pa.; Temple Univ. Member: AC Phila.; Eastern A. T. Assoc.; T Sq. Cl.; Boston AC; Fairmount Park AA; AIA; Pa. Assoc. Master P.&Dec. Exhibited: Phila. A. Cl., 1920 (gold). Position: Dir., PMSchIA, 1880–1920 [29]

MILLER, Lilian May [B,P,L,W] Honolulu, HI b. Tokyo d. 13 Ja 1943, San Fran. Studied: T. Kano; B. Shimada. Exhibited: Honolulu PM, 1936 (prize). Work: British Mus., London; Smithsonian Inst.; Baltimore Mus. A.; Denver Pub. Lib.; AI, Chicago. Publication: "Grass Blades from a Cinnamon Garden," poems illus. with orig. block prints in color [40]

MILLER, Lola Sleeth [P,S,T] Laguna Beach, CA b. 24 O 1866, Groton, IA. Studied: Académie Julian, Paris; E. Carlsen; J.M. Whistler; D. Tilden. Member: A. Cl, Wash., D.C.; Soc. Wash. Ar.; A. Assn., Laguna Beach. Work CGA, D.A.R. Bldg., Cathedral Sch., all in Wash., D.C. [40]

MILLER, Marguerite C(uttino) [P,T] Charleston, SC b. 11 Je 1895, Charleston. Studied: PAFA. Member: SSAL; Sketch Cl. of Carolina AA [40]

MILLER, Mariema [Des,Li] Baconton, GA. Studied: Nat. Sch. F.&Appl. A., Wash., D.C.; E. Weisz; George Washington Univ.; B. Shute; R.S. Rogers; High Mus. Sch. Art. Member: High Mus. AL; Assn. Ga. A.; SSAL. Exhibited: High Mus. AL, 1936 (prize) [40]

MILLER, Marion [I] Chicago, IL b. St. Charles, IL. Studied: AIC [06]

MILLER, Mary G. [P,T] Shaker Heights, OH. Exhibited: WC annual, PAFA, 1934, 1935; Univ. Colo., 1937. Position: T., Hathaway Brown Sch. [40]

MILLER, M(aude) Alvera [P,C,T] Oakland, CA b. 31 Jy 1883, Skyland, CA. Studied: G. Leykauf. Member: San Fran. Soc. Women A. Exhibited: P.-P. Expo, San Fran., 1915 (med) [33]

MILLER, Mildred Bunting [P,B,E,T] Valley Center, CA b. 21 Je 1892, Phila. PA. Studied: PAFA; ASL; Anshutz; Vonnoh; Garber; Breckenridge; V. Oakley. Member: Friends A., Baltimore; Phila. Plastic Cl.; Phila. WCC; A. Un., Baltimore; Baltimore WCC. Exhibited: PAFA, 1920 (prize), 1931 (prize); Chester County AA, 1935 (prize); Phila. Plastic Cl., 1937 (med); CGA; NAD; BMA, 1941–44; AIC; Detroit Inst. A.; BM. Work: PAFA; Miss. AA, Jackson; Chester Country Hist. Soc. Contributor: art magazines. Position: T., Hannah More Acad. [47]

MILLER, Minnie M. [P] Germantown, PA. Studied: PAFA; Pa. Sch. Des. Member: Plastic Cl.; Phila. Alliance. Work: Reading (Pa.) Mus. [33]

MILLER, Murile [P] South Bend, IN [25]

MILLER, Oscar [P] Bristol Ferry, RI b. 1867, New York. Studied: Constant, Laurens, in Paris. Member: NYWCC [33]

MILLER, Philip [P,Ldscp.P,Dec,Car] Milwaukee, WI b. 15 Ap 1898, Milwaukee. Studied: Garber; Oberteuffer; Moriset, L'Fauconnier, in France. Exhibited: Mt. Mary's Col., 1931 (prize). Work: Mt. Mary's College; Milwaukee Jewish Center [40]

MILLER, Ralph C., Jr., Mrs. See Hagaman, Carol A.

MILLER, Ralph Davison [Ldscp.P] b. 1858, Cincinnati d. 14 D 1945, Los Angeles. Studied: self-taught; Bingham. Active in Cincinnati (1870s), Kansas City (1880), N.Mex. (1880s); settled in Los Angeles, 1890.

MILLER, Rebekah D. [P] London, England. Member: GFLA [27]

MILLER, Richard [P] Toledo, OH. Member: Artklan [25]

MILLER, Richard E. [P,I,Mur.P,L] Provincetown, MA b. 22 Mr 1875, St. Louis, MO d. 23 Ja 1943, St. Augustine, FL. Studied: St. Louis Sch. FA; Constant, Laurens, in Paris. Member: ANA, 1913; NA, 1915; SC. Exhibited: Paris Salon, 1900 (med), 1904 (med); Pan-Am. Expo, Buffalo, 1901 (med); St. Louis Expo, 1904 (med); Liège Expo, 1905 (med); PAFA, 1911 (gold); AIC, 1914 (gold); NAD, 1915 (prize); P.-P. Expo, San Fran., 1915 (med); Allied A. Exh., Brooklyn Mus., 1933 (gold). Award: Knight of the Legion of Honor, France, 1908. Work: Luxembourg Gal., Paris; MMA; Gal. Mod. Art, Rome; CGA; City A. Mus., St. Louis; Albright Gal.; PAFA; AIC; Detroit Inst.; Cincinnati Mus.; Queen City Art Cl., Cincinnati, CI; mural, Capitol, Jefferson City, Mo.; Royal Mus., Christiania (now Oslo); coll., King of Italy; Mus. FA, Antwerp; Mod. Gal. of the City of Venice; Musée du Petit Palais, Paris; Joslyn Mem., Omaha [40]

MILLER, Robert A. Darrah [P,G,Des] New Hope, PA b. 23 My 1905, Phila. Studied: PAFA. Member: New Hope AA. Exhibited: WMAA, 1934; New Hope AA; Newark AC. Work: Phila. MA; Univ. Pa.; Reading Mus.; murals, Stockton Hotel, NJ [40]

MILLER, Roy [P] Chila, NY. Member: Rochester AC [25]

MILLER, Ruth Blanchard [P,T] Pasadena, CA b. 17 Ja 1904, Chicago. Studied: Hawthorne; Pennell; Peitelson. Member: Calif. AC; ASL; Pasadena SA [31]

MILLER, Susan Barse (Mrs.) [P] Gloucester, MA b. Adrian, MI d. 10 Ja 1935. Studied: Acad. Grande Chaumière, Lhote, in Paris; NAD; PAFA; Breckenridge; W.M. Chase. Member: North Shore AA; Rockport AA; Boston S.Indp.A.. Exhibited: blockprint, Ariz. State Exh., 1932. Work: Los Angeles Mus.; Pasadena Mus. [33]

MILLER, Suzanne [P,Mur.P] Hollywood, CA b. Cortland, NY. Studied: J. Despujols. Member: Mural P. Exhibited: Arch. Lg., 1930 (prize). Work: murals: Jamaica (N.Y.) H.S., Long Beach (Calif.) Pub. Lib., South Gate (Calif.) Pub. Lib. [40]

MILLER, Viola [P] Paris, France/St. Louis, MO b. 1890, St. Louis. Studied: St. Louis Sch. FA; R. Miller; Paris [15]

MILLER, William [Wood En] NYC b. 3 D 1850, NYC d. 10 Ja 1923. Studied: Frank Leslie (pub. house); Germany. Exhibited: Columbian Expo, Chicago, 1893 (med); Pan-Am. Expo, Buffalo, 1901 (med). Work: U.S. Nat. Mus., Wash., D.C.; BMFA; NYPL; Springfield (Mass.) Mus.; CI [19]

MILLER, William B. [P] Brooklyn, NY [13]

MILLER, William C. [Patron] Charleston, SC b. 1858 d. 13 My 1927. Member: Carolina AA, 1925 (Pres.); (S.C.) Huguenot Soc. (Pres.) and SSAL (in both of which he played a prominent part)

MILLER, William Henry [Por.P,T] Denver, CO b. 25 N 1854, Phila. d. 1 Jy 1928. Studied: PAFA, with Eakins. Member: Phila. Sketch Cl. [27]

MILLER, William (J.?) [Min.P] b. ca. 1830s (Germany?) d. 27 Ap 1907, NYC. Active in Cincinnati and Indianapolis (1840s), later in NYC. (Groce and Wallace cite confusion over name and birthdate as unresolved.) [*]

MILLER, William Rickarby [Ldscp.P] NYC b. 20 My 1818, Staindrop, England (came to U.S. in 1844–45) d. Jy 1893. Studied: his father, Joseph. Exhibited: NAD, 1861–76. Specialty: watercolors. Work: N.Y. Hist. Soc. Known to be a prolific watercolorist. His "1,000 Gems" (American landscapes in pen & ink made since 1873) was never published. [*]

MILLES, (Vilhelm) Carl (Emil) [S,T] Bloomfield Hills, MI b. 1875, Lagga, Sweden d. 19 S 1955, Sweden. (Original surname: Anderson.) Studied: Stockholm Tech. Sch.; Ecole des Beaux-Arts, Paris. Member: NSS; NIAL. Exhibited: GGE, 1939 (prize). Work: WMA; Cranbrook Acad. A.; mon., City Hall, St. Paul, Minn.; fountains, St. Louis, Chicago; Diana Court, Chicago; AIC; mon., Wilmington, Del.; fountain, Chicago; Rockefeller Center, NYC; Northern Mus., Nat. Mus., Tech. Inst., Concert Hall, Teguer Mem., Enskilda Banken, Dramatic Theatre, all in Stockholm;

colossal mon. "Sten Sture," Uppsala; heroic figures, fountains, etc., Linköping, Hälsingborg, Saltsjöbaden, Göteborg, Halmstad, Köping, Westeras, public squares and parks, all in Sweden; Tate Gal., Swedenborg Mem., both in London; bronze doors, Finance Bldg., Harrisburg; Detroit AI. Positions: T., Royal Acad. Arts, Stockholm (1920–), Cranbrook Acad., A. (1929–) [47]

MILLESON, Hollis E. [P] Shelbyville, IN [24]

MILLESON, Royal H(ill) [Ldscp.P,W] Chicago, IL b. 23 N 1849, Batavia, OH. Member: Chicago SA; Boston AC. Work: Herron AI. Author: "The Artist's Point of View" [21]

MILLET, Clarence [P,E] New Orleans, LA b. 25 Mr 1897, Hahnville, LA d. 1959. Studied: Tulane Univ.; ASL, with Bridgman. Member: ANA, NOAA; Miss. AA; SSAL; New Orleans Art Lg.; New Orleans A.&Crafts Cl.; La. Soc. E. Exhibited: Miss. AA, 1925 (prizes), 1926 (prize) 1927 (gold), 1939 (prize); Miss. Fair Assn., 1928 (prize); Fort Worth AA, 1932 (prize); Mid-South Fair, 1932 (prize), 1936 (med); SSAL, 1922–27, 1945 (prize), 1929–46; Birmingham, Ala., 1945 (prize); La. State Exh., Shreveport, 1939 (prize); NOAA, 1925–40, 1941 (prize), 1942 (prize), 1943–46; La. A. Comm., Baton Rouge, 1946 (prize); NAD, 1943, 1945; WFNY, 1939; PAFA, 1927, 1928; AIC, 1929; SAE, 1941; Nat. Exh., Am. A., N.Y., 1937; New Orleans Art Lg., 1925–46; Miss. AA, 1922–46; Currier Gal. A. (one-man); Mus. FA, Houston; Delgado Mus. A.; Municipal A. Gal., Jackson, Miss.; State Exh. Bldg., Shreveport. Work: Municipal A. Gal., Belhaven Col., both in Jackson, Miss.; Warren Easton H.S., New Orleans; State Exh. Bldg., Shreveport; Univ. Southern Calif; A. Fnd., Corpus Christi, Tex.; Springville (Utah) AA; Miss. AA; La. State Gal.; City Hall, New Orleans; La. Polytechnic Inst., Ruston [47]

MILLET, Francis Davis [P,I] NYC/Wash., D.C. b. 3 N 1846, Mattapoisett, MA d. 15 Ap 1912 (went down with the Titanic; body recovered and interred at East Bridgewater, Mass.) Studied: Royal Acad. Arts, Antwerp, with Van Lerius, De Keyser, 1871–73; Rome; Venice. Member: ANA, 1881; NA, 1885; SAA, 1880; AWCS; Mural P.; BAC; A. Fund Soc.; Royal Inst. Painters in Oil, England; Century Assoc.; SI. Exhibited: Royal Acad., Antwerp, 1872 (med), 1873 (med); New Orleans Expo, 1886 (med); Paris Expo, 1889 (med); Columbian Expo, 1893, Chicago (med); Pan-Am., Buffalo, 1901 (gold); Phila. Centenn., 1876. Awards: Romanian Iron Cross; Order of Chevalier St. Anne and St. Stanislaus (Russian gov.). Work: MMA; Tate Gal., London; Un. Lg. Cl., NYC; murals, Custom House (Baltimore), Capitol (Minn.), Capitol (Wis.); Fed. Bldg. Cleveland; Essex County Court House, Jersey City; Hudson County Court House, Newark; church windows, Stockbridge and Cambridge, Mass.; des. murals, with J. LaFarge, Trinity Church, Boston. With W.M. Hunt and J. La Farge, he founded the BMFA School (1876); was special correspondent for the Daily News during the Russo-Turkish War (1877); illustrator for London Graphic (1878); with Poultney Bigelow, traveled 1700 miles down the Danube for Harper's Magazine (1891); war correspondent for New York Sun, London Times, and Harper's Weekly in the Philippines (1899); went on special U.S. gov. mission to Tokyo (1908). He was director of the American Academy at Rome; Secretary, American Federation of Arts. Co-author: with P. Bigelow, "From the Black Forest to the Black Sea" (1893) [10]

MILLET, Geraldine R. (Mme. François) [P] Barbizon, France b. America. Studied: A. Stevens, in Paris; Fontainebleau, with Baudoin [31]

MILLET, Louis J. [Mur.P,C,T] Chicago, IL b. New York d. 2 S 1923. Studied: Ecole des Beaux-Arts, Paris. Member: Chicago SA; Chicago Arch. Cl.; Municipal A. Lg., Chicago. Exhibited: Paris, 1889 (med), 1900 (med); Chicago, 1893 (med). Specialty: interior decorations [21]

MILLETT, G. Van [P] Kansas City, MO b. 5 Ap 1864, Kansas City. Studied: Royal Acad. FA, Munich, with Gysis, Loefftz. Member: Municipal Art Com., Kansas City. Exhibited: Munich Acad. (med). Work: Kansas City AI; Scottish Rite Temple, Chamber of Commerce, Pub. Lib., City Hall, all in Kansas City [40]

MILLET, Thalia W. See Malcolm.

MILLHOUSER, Harry L. [P] Chicago, IL [17]

MILLIER, Arthur [E,L,W] El Monte, CA b. 19 O 1893, Weston Super Mare, Somerset, England. Studied: Calif. Sch. FA. Member: Chicago SE; Calif. SE; Calif. AC. Exhibited: Calif. SE, 1922 (prize), 1928 (prize). Work: AIC; Los Angeles Mus. Hist. Sc.&Art; Los Angeles Pub. Lib.; LOC; Mus. FA, Dallas. Contributor: Magazine of Art, Christian Science Monitor. Position: Ed., "Art and Artists" page, Los Angeles Times [40]

MILLIGAN, Gladys [Por.P,T] Wash., D.C. b. 25 Je 1892, LaRue, OH. Studied: Western Col.; Westminster Col, New Wilmington, Pa.; PIASch; Fontainebleau, France; G. Luks; Lhote; H. Hofmann. Member: Studio Gld.; NAWA; Soc. Wash. A.; Wash. WCC; Wash. AC. Exhibited: NAWA; Denver Art Mus., 1929 (prize). Position: T., Nat. Cathedral Sch., Wash., D.C. [47]

MILLIKAN, Rhoda Houghton [P,T] b. D 1838, Marlboro, VT d. 2 O 1903, Indianapolis. Positions: T., Piqua (Ohio), Greenfield (Ind.) [*]

MILLIKEN, Robert McIntosh [P,T,Des] Sioux City, IA b. 26 O 1907, Buffalo. Studied: AIC; Otis A. Inst., Los Angeles; Univ. Akron; B. Anisfeld; N. Cikovsky; E. Vysekal. Exhibited: AIC; Iowa State Fair; Los Angeles MA. Position: T., Sioux City A. Center [40]

MILLIS, Charlotte (Melissa) [S,T,E] Chicago, IL b. 23 D 1906, Pal Alto, CA. Studied: Univ. Chicago; AIC; Univ. Oreg.; E. Zettler; A. Polasek. Member: Minn. Ar. Un.; Minn. AA; Minn. S. Group. Exhibited: Minneapolis Inst A., 1935 (prize), 1936 (prize), 1937 (prize), 1938 (prize), 1939, 1941 (prize), 1942, 1944 (prize); Minn. State Fair, 1939, 1942 (prize), 1944; Walker A. Center, 1944 (prize); AIC, 1935, 1946; WFNY, 1939; Oakland A. Gal., 1942; St. Paul Gal., 1941, 1945. Positions: T., Summit Sch., St. Paul (1935–45), Macalester Col. (1944–45) [47]

MILLMAN, Edward [P,Mur,P,Li,T,L] NYC b. 1 Ja 1907, Chicago, IL d. 11 F 1964, Woodstock, NY. Studied: AIC, with L. Kroll; Mexico; J. Norton. Member: Chicago SA; Am. A. Cong.; Chicago Ar. Un.; NSMP; F. Guggenheim Fnd., 1945. Exhibited: Times Herald A. Fair, Wash., D.C., 1945 (prize); AIC; WFNY, 1939; GGE, 1939; WMAA; MOMA; CGA; NGA; MMA; 48 Sts. Comp. (winner). Award: U.S. Navy citation for Combat A., 1945. Work: AIC; MOMA; U.S. Navy Mus., Annapolis, Md.; Nat. A. Soc.; murals, frescoes, USPOs, Moline (Ill.), Decatur (Ill.), St. Louis (Mo., in collaboration); murals, Century of Progress Expo, Chicago; Bd. Ed., Oak Park, Ill.; frescoes, Chicago City Hall, Flower H.S., Chicago. Author: "A Compilation of Technical Procedures & Materials for Fresco Painting," 1940 [47]

MILLONZI, Victor [P,T] Spring Valley, NY b. 17 D 1915, Buffalo. Studied: Univ. Buffalo; Albright Sch. A. Member: The Patteran; AWCS; Rockland County A. Center. Exhibited: Albright Sch. A., 1939 (prize); AWCS, 1942–44; Miss. AA, 1944, 1945; Acad. All. A., 1941; Pickwick Lib., Nyack (N.Y.), 1946; Albright A. Gal., 1940–46; NAC, 1946; Wawasee A. Gal., 1943; Am.-British A. Center, 1942; The Patteran, 1945, 1946; Jr. Lg., Buffalo, 1944; J.N. Adam Gal., Buffalo, 1942, 1945; Univ. Buffalo, 1942; Jersey City Mus., 1946. Position: T., Pearl River (N.Y.) H.S., 1945–46 [47]

MILLS, Charles E. [P] Dedham, MA [10]

MILLS, Clark [S] Wash., D.C. b. 13 D 1810, near Syracuse, NY d. 12 Ja 1883. Work: CGA. Early bronze founder best known for his equestrian statues of Jackson (the first large bronze statue cast in the U.S.) and Washington, in Wash., D.C., where he lived with his two sculptor sons Theodore and Theophilus, since 1850. [*]

MILLS, Dodie [S] NYC b. 2 N 1906, St. Louis, MO. Studied: ASL; C. Nielsen. Member: ASL.Exhibited: Morgan Gal.; Bonestell Gal.; Tricker Gal.; Roerich Mus. [47]

MILLS, Elizabeth [P] Hollywood, CA. Exhibited: WFNY, 1939 [40]

MILLS, Elsie [P] NYC. Member: Lg. AA [24]

MILLS, Helen E. [P] Phila., PA [19]

MILLS, Hugh Lauren [P,E,Li] NYC b. Omaha, NE. Studied: Univ. Nebr.; ASL; J.E. McBurney. Exhibited: NAD, 1928, 1929; NAC, 1927–30; CGA, 1941; Phila. A. All., 1938; SAE; Morgan Gal., 1938 (one-man); ACA Gal.; Tricker Gal.; Roerich Mus.; Baltimore MA; Los Angeles Mus. A. Work: BMA; MMA; Los Angeles Mus. A. [47]

MILLS, John Harrison [P,S,En,Ldscp.P,Por.P,I,T] Buffalo, NY b. 1842, near Buffalo d. 24 O 1916. Studied: W. Lautz, 1858; encouraged by L. Sellstedt and W.H. Beard. Member: NYWCC. Work: Albright Art Gal.; Pioneers' Mus., Colorado Springs. Illustrator: Leslie's (1873), Scribner's (1878), Cosmopolitan (1888). Active in Longs Peak, Colo. (1872), then in Denver; moved back to NYC (1883). [15]

MILLS, Knower [P] Windsor, CT [25]

MILLS, Lena [P] NYC [01]

MILLS, Loren Sturdevant (Sturdy) [S,C] Lincoln, NE b. 8 Ja 1915, Atkinson, NE. Studied: Minneapolis Sch. A.; Kansas City AI; Univ. Nebr. Member: Lincoln A. Group. Exhibited: Mo. State Fair, 1938, 1939 (prize), 1940, 1941; Syracuse Mus. FA, 1940; Minneapolis Inst. A., 1935; St. Paul A., 1935; Kansas City AI, 1938–40; William Rockhill Nelson Gal., 1941; Philbrook A. Center, 1940. Position: T., Kansas City AI, 1938–40 [47]

MILLS, Mariette (Mrs. Heyworth) [S] Morristown, NJ [10]

MILLS, Theodore Augustus [S] b. 1839 Charleston, SC d. D 1916, Pittsburgh. Studied: his father, Clark; Rome; Paris; Munich. Specialty: North American Indian groups. He made a life mask of Lincoln sixty days before the assassination. Active mainly in Wash., D.C., with his father.

MILLS, Theophilus [S] Wash., D.C. b. ca. 1842, Charleston, SC. Son of Clark [*]

MILLS, Thomas Henry [P,I,E,W] Ann Arbor, MI/Gloucester, MA b. Hartford, CT. Studied: K. Cox; W.M. Chase. Member: North Shore AA; AFA; Am. Ar. Prof. Lg.; Ann Arbor A. Assn. [47]

MILLS, Winifred H. (Mrs.) [W,T] Baton Rouge, LA b. 4 O 1885, Olean, NY. Studied: Cleveland Sch. A.; Columbia; NYU. Co-author: "Marionettes, Masks and Shadows" (1927), "the Story of Old Dolls, and How to Make New Ones" (1940), other books. Positions: T., Fairmount Training Sch., Cleveland (1916–33), La. State Univ. [47]

MILNE, David B. [P,I] NYC b. 8 Ja 1882, Paisley, Ontario, Canada. Studied: ASL, with DuMond, Reuterdahl, Bridgman. Member: NYWCC; Phila. WCC. Exhibited: P.-P. Expo, San Fran., 1915. Work: Canadian War Memorials Coll., Ottawa [29]

MILNE, May Frances [P] Boston Corners, Columbia County, NY b. 1 My 1894, Brooklyn, NY [21]

MILNOR, James Wilson [P,Des,Li,L,W,T] Buffalo, NY b. 21 S 1909, NY. Studied: Pratt Inst.; NYU; Univ. Buffalo. Member: EAA. Exhibited: Montclair Mus., 1933 (med), 1934 (prize). Positions: T., Univ. Buffalo (summers), Oyster Bay Pub. Sch. 40]

MILOVICH, Tanasko (Mr.) [P,C,Des,L] St. Louis, MO b. 27 Ja 1900, Fojnica, Yugoslavia. Studied: St. Louis Sch. FA; Washington Univ.; Acad. Moderne, with Jean Marechal, Acad. Colarossi, in Paris. Member: St. Louis A. Gld.; St. Louis Soc.Indp.A.; 2x4 Soc. Exhibited: St. Louis A. Gld., 1926 (prize), 1927 (prize) 1929 (prize), 1932 (prize), 1933 (prize), 1941 (prize), 1942 (prize), 1943 (prize), 1945 (prize), 1946 (prize); St. Louis S.Indp.A., 1939 (prize), 1942 (prize); CAM, 1942 (prize); Denver A. Mus., 1945 (prize); Critic's Choice, CM, 1945; Paris Salon, 1928, 1929; Salon d'Automne, 1928; Denver A. Mus., 1945; Pal. Leg. Honor, 1946; Wanamaker's Phila., 1930 (one-man); Newhouse Gal., St. Louis, Mo., 1931 (one-man); Wis. Soc. Appl. A., Milwaukee, 1936 (one-man); SAM, 1936 (one-man); Kansas City AI, 1939 (prize); Joslyn Mem., 1940; St. Louis A. Gld., 1943; Batik, 1933–34 (one-man); Mo. State Fair, 1926 (prize); Spring Salon, Paris, 1928 (prize). Work: CAM; City Lib., St. Louis; stained glass window, Ethical Soc., St. Louis; ten batiks for Stix-Baer-Fuller, 1931. Specialty: batiks. Position: T., St. Louis Sch. FA [47]

MILROY, Harry C. [S] Delphi, IN. Member: Ind. SS [25]

MILSK, Mark (Mrs. Edmond Imperato) [E,Li,T] San Fran., CA b. 15 N 1899, St. Paul, MN. Studied: Calif. Sch. FA; Chouinard AI; ASL. Member: Southern Pr.M. Soc.; Calif. SE. Exhibited: Syracuse, Ind., 1944 (prize); Calif. SE, 1942 (prize), 1943 (prize), 1945 (prize); Venice, Italy, 1940 (one-man); MMA, 1942; Gumps, San Fran., 1941 (one-man); Crocker A. Gal., Sacramento, 1941; de Young Mem. Mus., 1940; SFMA; Fnd. Western A., Los Angeles; Oakland A. Gal.; Southern Pr.M. Soc. Work: SFMA; State Lib., Sacramento [47]

MILSON, E(va) Grace [P,C,W,T,L] Angola, NY b. 8 D 1868, Buffalo d. 9 O 1944, Silver Creek, NY. Studied: Bischoff; Rose Clark; J.H. Mills; Europe. Member: Studio Gld.; Buffalo GA; Ogunquit A. Center; Palm Beach A. Center; Western N.Y. Fed. Women's Cl. Exhibited: Century of Progress Expo, 1933 (prize). Work: Town Cl., Unity Center, Albright A. Gal., all in Buffalo [40]

MINARD, Florence [P,I] Providence, RI. Member: Providence AC [25]

MINAZZOLI, Edward A. [S] Paris, France/West New York, NJ b. 16 Ag 1887, Momo, Italy. Studied: ASL; Niehaus; Fraser; Bartlett; Ecole des Beaux-Arts, Paris, with Antonin-Mercie. Member: Paris AAA; AFA; Soc. Med. Exhibited: Paris Salon, 1929 (prize), 1932 (med). Awards: Nicholas II, 1918 (gold); Chevalier order of Donilo, 1918; Chevalier of the Crown of Italy, 1922; Officier d'Académie, 1932. Work: Cathedral of Chatillon, Loire, France; Sainta Anne Church, Paris; mon., Gurnay sur Aronde, France; group, Fountain garden, Poughkeepsie, N.Y.; statue, West New York; New Canaan (Conn.) Pub. Lib. [40]

MINDELEFF, Julia F. (Mrs.) [P,W,T] Wash., D.C. b. N 1838, Petrograd, Russia. Studied: D. Begperchii [17]

MINDELEFF, Victor [P] Wash., D.C. [10]

MINER, Edward Herbert [P,I] Westbury, NY b. 23 Ja 1882, Sheridan, NY. Member: SC; NAC. Work: paintings of cattle, dogs, and horses, National Geographic Soc. (appearing first in its magazine and later in its books); equestrian portraits and paintings of hunting, polo, racing, other sporting subjects, in prominent collections, club houses, galleries [40]

MINER, Fred Roland [Ldscp.P,W,Photogr] Pasadena, CA? b. 28 O 1876, New London, CT. Studied: ASL; W. Wendt; J. Carlson. Member: Calif. AC; Laguna Beach AA; S.Indp.A. Exhibited: Panama-Calif. Expo, San Diego, 1915 (med). Work: Union Lg. Cl., Los Angeles; Glendale (Calif.) Sanitarium. Author: "Outdoor California," 1923. Settled in Calif., 1897; returned to N.Y. and Conn., 1911, 1916, 1921, 1925. [33]

MINER, Georgia Watson (Mrs. Lewis H.) [P,C,W,L,T] Springfield, IL/Old Mission, MI b. 4 Ap 1876, Springfield, IL d. ca. 1938. Studied: C.A. Herbert; Dawson-Watson.; M. Dibble; M. Middleton. Member: Chicago AG; Springfield AA. Exhibited: painting, ceramics, Ill. State Centenn., 1918 (medals). Work: Springfield AA [33]

MINER-COBURN, Jean P. [S] Chicago, IL b. Menasha, WI. Studied: AIC. Member: Palette Cl. [01]

MING, Marguerite [P] Phila., PA/Shelby, MS b. 21 Je 1911, Shelby. Studied: PAFA. Member: SSAL [40]

MINGHI, Charles [P] Chicago, IL b. 25 Mr 1872, Pescia, Italy. Studied: L. Lundmark [27]

MINGLE, Joseph F. [Ldscp.P,Mar.P] b. 13 Je 1839, Phila. d. 14 S 1903, Phila.

MINGO, Norman [I] Scarsdale, NY. Member: SI. Best known for his portraits of Alfred E. Neuman for MAD magazine. [47]

MINK, David D.C. [P,I] Evanston, IL b. 12 O 1913, East Liverpool, OH. Studied: Chicago Acad. FA; H. Keller; J. Farnsworth. Member: Chicago A. Gld. Exhibited: CMA, 1938 (prize), 1939 (prize); Butler AI, 1940 (prize); Chicago A. Dir. Cl., 1942 (med), 1943 (med), 1945 (med). Work: CMA; Butler AI [47]

MINKER, Gustave, Sr. [P] Belleville, NJ b. 18 My 1866, Germany. Studied: Westheld, in Germany; F.B. Williams; G. Cimiotte. Member: Newark AC; Art Center of the Oranges; Montclair AA; AFA [29]

MINNA, Wilhelmina Frances Allen [Des,T,C] Boston MA b. 2 My 1898, Franklin, NH. Studied: BMFA Sch., with H.H. Clark, G.J. Hunt. Exhibited: Phila. A. All.; Boston Soc. A.&Crafts; AGAA [47]

MINOR, Anne Rogers (Mrs. George Maynard) [P] Waterford, CT b. 7 Ap 1864, East Lyme, CT. Studied: R.C. Minor. Member: AFA; New Haven PCC; CAFA [33]

MINOR, Edna Valentine [C,T] NYC/New Canaan, CT b. 25 My 1878, NYC. Studied: E. Snow; G. Foldes; E. Gunter; A. Nott Shook. Member: N.Y. Soc. Craftsmen. Position: T., Craft Students League; Dir., Madison Ave. Weaving Centre, N.Y. [40]

MINOR, Robert Crannell [Ldscp.P] NYC/Watertown, CT b. 30 Ap 1839, NYC d. 3 Ag 1904. Studied: NYC, with A.C. Howland, for 2 yrs.; Barbizon, with Diaz (at Barbizon), Van Luppen (in Antwerp), Boulanger (in Paris), all during a 10-year period. Member: NA, 1897; SLP; SC, 1885; A. Fund. S. Exhibited: NAD; Paris Expo, 1900 (prize); Pan-Am. Expo, Buffalo, 1901 (med). Work: Lotos C. He was an important exponent of the American Barbizon school. One hundred andnine of his paintings were auctioned by Am. A. Gal., NYC in 1905 for $35,190. [04]

MINOR, Robert Crannell, Jr. [I] Paris, France/Waterford, CT. Member: SI, 1913. Son of Robert Sr. [17]

MINOTT, Joseph Otis [P] South Orange, NJ d. 14 My 1909, Paris. Lived abroad for some time. At the time of his death was arranging to paint the portraits of King Edward and Queen Alexandra. [01]

MINTZ, Harry S. [P,Li,T] Chicago, IL b. 27 S 1907, Ostrowiec, Poland. Studied: Warsaw Acad. FA, Poland; AIC. Member: Chicago SA; Am. A. Cong.; Around the Palette C., Chicago. Exhibited: AIC, 1934–36, 1937 (prize), 1938, 1939 (prize), 1940–44, 1945 (prize), 1946; Evanston, Ill., 1945 (prize); Pal. Leg. Honor, 1946 (med); Jewish Women's AC, Chicago, 1931 (prize); Covenant C., Chicago, 1936 (prize); Chicago SA, 1936 (prize); CM, 1934; VMFA, 1940, 1942, 1946; PAFA, 1940–42; CGA, 1939, 1941; AV, 1942; WFNY, 1939; Milwaukee AI, 1946. Work: Warsaw Mus. FA, Poland; Mod. Mus., Tel-Aviv, Palestine; Hackley A. Gal., Muskegon, Mich.; AIC [47]

MIRABEL, Eva [P] Taos, NM. Exhibited: First Nat. Exh. Am. Indian Painters, Philbrook A. Center, 1946 [47]

MIRABEL, Vincent [P,T] Taos, NM b. 1918, Taos d. 1945, Battle of the Bulge, WWII. Studied: Santa Fe Indian Sch. Work: St. Louis AM; M. Am. Indian; Univ. Okla. Regarded as a leading Taos Pueblo painter. [*]

MIRANDA, Fernando [S,I] NYC b. 3 Mr 1842, Valencia, Spain. Studied:

Madrid, with Piques; Paris, with Carpeaux. Member: NSS; Arch. Lg.; NAC; SI [08]

MIRKIL, Elise Maclay [P] Phila., PA Studied: PAFA [25]

MISE, R(oy) C(leveland) [P,T] Jenkintown, PA/Pipersville, PA b. 23 F 1885, Springfield, OH. Studied: Duveneck; Cincinnati A. Acad.; PAFA. Exhibited: PAFA, 1917, 1918 [19]

MISERENDINO, Vincenzo [P,S] NYC b. 29 Ja 1876, Italy (came to NYC at age 19) d. 27 D 1943. Studied: Palermo; Rome; Loiacolo. Work: large statue of Theodore Roosevelt [27]

MISH, Charlotte (Roberta) [P,S,I,W,C,T] Portland, OR b. 17 Ag 1903, Lebanon, PA. Studied: W.L. Judson; F. Tadema; ASL, with F. Vincent, DuMond; ASL; Univ. Southern Calif. Member: Portland AA; Oreg. SA. Work: Music Box Theatre, Blue Mouse Theatre, both in Seattle. Illustrator: national magazines; marine drawings, Portland Oregonian [40]

MITCHELL, Alfred R. [P,T] San Diego, CA b. 18 Je 1888, York, PA d. 1972. Studied: San Diego Acad. A., with Braun; PAFA, with Garber, J.T. Pearson; Europe, 1920; P. Hale, E. Blashfield. Member: San Diego A. Gld.; Laguna Beach AA; Contemporary A., San Diego. Exhibited: PAFA, 1920, 1927; P.-P. Expo, 1915 (med); San Diego A. Gld., 1926 (prize), 1927 (prize), 1931 (prize), 1937 (prize); Buck Hill AA, 1939 (prize); Wilmington, Del., 1920; GGE, 1939; Calif.-Pacific Expo, 1935, 1936; Laguna Beach AA; San Diego FA Soc.; La Jolla. Work: Reading Mus.; San Diego FA Soc.; Blanden Mem. Gal., Ft. Dodge, Iowa; Ohio Wesleyan Univ.; Hahneman Medical Col., Phila.; Univ. W.Va. [47]

MITCHELL, Arthur [P,] St. Louis MO b. 5 F 1864, Gillespie, IL. Studied: St. Louis Sch. FA. Member: 2x4 Soc.; St. Louis AG [33]

MITCHELL, Arthur [P,I,T] Trinidad, CO (1974) b. 1889, Trinidad, CO. Studied: Grand Central Sch. A., with H. Dunn, ca. 1919. Settled in Leonia, N.J., 1928, and produced 160 covers for Western magazines. Returned to Colo., 1946, teaching at Trinidad State Col. Founder: Baca House Pioneer Mus. [*]

MITCHELL, Bruce Handiside [Ldscp.P,E,W,T,L] Cornwall-on-Hudson, NY b. 27 Ja 1908, Tayport, Scotland d. 13 S 1963, Langhorne, PA. Studied: ASL, with G. Bridgman, E. Fitsch, H. Wickey, R. Lahey; S. Davis; T. Benton. Member: An Am. Group; A. Lg. Am.; Am. Ar. Cong.; Am. Watercolorists; Un. Am. Ar. Exhibited: WFNY, 1939; GGE, 1939; AV, 1942; CI, 1943–45; WMAA, 1932–46; AIC, 1934–40; BM; Rehn Gal., 1940, 1942 (one-man). Work: MMA; WMAA; PMG; Univ. Ariz.; USPO, Columbia, Pa. Contributor: Art Digest; "The Story of the Arizona Plan"; "Work for Artists." WPA artist. Positions: T., Univ. Ariz. Gal. Mod. Am. Painting (1941–43); A./War Correspondent, U.S. Engineers & Life magazine (1943–45); A. in Residence, Bucknell Univ., Lewisburg, Pa. (1947) [47]

MITCHELL, Charles D(avis) [I] Wallingford, PA b. 18 My 1885, Wilmington, DE. Member: Artists Gld., NYC; AC, Phila. Illustrator: Cosmopolitan, Delineator, Saturday Evening Post, Liberty [40]

MITCHELL, Eleanor B. (Mrs.) [P,T] San Anselmo, CA b. 19 S 1872, Pittsburgh. Studied: San Fran., with A. Mathews; Vitti Acad., with Collin, Merson; Paris, with Garrido. Member: San Fran. SA [19]

MITCHELL, Elmira [P] Peoria, IL [19]

MITCHELL, Eva B(lanche) [S] Riverside, IL b. 1 Ap 1872, Williamsport, PA. Studied: L. Taft [21]

MITCHELL, Frances [P] NYC [15]

MITCHELL, G(eorge) B(ertrand) [P] Rutherford, NJ b. 18 Ap 1872, East Bridgewater, MA d. 1966. Studied: Lowell Inst., Boston; Artists Artisans, NYC; Cowles A. Sch., Boston; Acad. Colarossi; Ecole des Beaux-Arts; Académie Julian, Paris, with Laurens, Constant. Member: AWCS; SC; Mystic AA; AAPL; Marine Hist. Assn. Exhibited: Paris Salon, 1890 (prize); AWCS, 1945, 1946; SC, 1945, 1946; Mystic AA, 1945. Work: Agricultural Dept., State of Conn.; Marine Hist. Assn., Stonington, Conn.; Lyman Allyn Mus. Specialty: Blackfoot Indians of the Canadian Rockies (1924–50) [47]

MITCHELL, George Harold [I] NYC b. 1880, La Grange, IL. Studied: Chase; AIC. Member: SI, 1914 [17]

MITCHELL, Gladys Vinson (Mrs.) [P,S] Oak Park, IL b. 1 My 1894, Albuquerque, NM. Studied: B. Gonzales; E.G. Eisenlohr. Member: Chicago AG. Exhibited: Women's Forum, Dallas AA, 1916 (med). Work: Mus. Santa Fe; Houston AL [24]

MITCHELL, Glen [P,I,T,L] NYC b. 9 Je 1894, New Richmond, IN d. 1972. Studied: AIC; Univ. Illinois; Grande Chaumière, Paris; Chicago Acad. FA; Spain; Italy; Egypt; Palestine. Member: Minn. Ar. Assn.; Minneapolis Soc. FA; Wash. WCC. Exhibited: AIC, 1919 (prize), 1920 (prize), 1921 (prize); Minn. AI, 1930 (prize), 1936 (prize); Corcoran Gal., 1939 (prize); Milwaukee Women's C., 1939 (prize); Hoosier Salon, 1940 (prize); MOMA; WMAA; PAFA; NAD; AIC; W.R. Nelson Gal.; SFMA; Oakland A. Gal. Work: First Methodist Episcopal Church, New Richmond, Ind.; Rotary C., Chicago. Position: T., Minneapolis Sch. A. [47]

MITCHELL, Guernsey [S] Rochester, NY b. New York d. 1 Ag 1921. Studied: Ecole des Beaux-Arts, Paris. Work: Univ. Rochester. Lived in Paris for 21 years. [10]

MITCHELL, Harriet Morgan (Mrs. Winthrop D.) [P] Worcester, MA [24]

MITCHELL, Harry C. [P] Yonkers, NY. Member: S.Indp.A. [24]

MITCHELL, James Murray [P,E,I] Queens Village, NY b. 9 N 1892, Edisto Island, SC. Member: SI [31]

MITCHELL, John Ames [I,P,Arch,W] NYC/Ridgefield, CT b. 17 Ja 1845, NYC d. 29 Je 1918, Ridgefield. Studied: Europe; Boston; Académie Julian, Paris; Ecole des Beaux-Arts. Exhibited: Paris Salon, 1880. Author/Illustrator: "Pandora's Box." Author: "Croquis de l'Exposition," "The Pines of Lory." Position: Founder/Ed., Life magazine [17]

MITCHELL, Laura M.D. (Mrs. Arthur A. Tennyson) [Min.P,L] Alhambra, CA b. Halifax, Nova Scotia. Studied: ASL, with L.F. Fuller, K. Cox, G. Bridgman; A. Beckington. Member: Calif. Soc. Min. P.; Women P. of the West. Exhibited: C.L. Wolfe Art Club, 1908 (prize); Pomona Fair, 1936 (prize); P.-P. Expo, 1915 (gold), 1916 (gold); Calif. Soc. Min. P., 1923 (prize), 1924 (prize), 1925 (prize), 1929 (prize); Pacific Southwest Expo, 1928 (gold); ASMP; Pa. Soc. Min. P.; Royal Soc. Min. P., London, 1929, 1937; Century of Progress, Chicago, 1933; CGA, 1938; P.&S. of Southern Calif.; Calif. AC; San Diego FA Soc.; Mission Inn, Riverside, Calif.; Los Angeles Mus. A.; Pasadena AI; Southwest Mus., Los Angeles. Work: Los Angeles Mus. Contributor: art magazines and newspapers [47]

MITCHELL, Mary [P] Wash., D.C. b. 11 D 1907, Cuba, NY. Studied: Baker; Merryman; Hawthorne; Luks. Member: Wash. SA [31]

MITCHELL, Neil Reid [Mar.P] Westport, CT b. 27 Ag 1858, NYC d. 28 Ja 1934, New Haven. Studied: NAD. Member: SC [10]

MITCHELL, Odessa [P] Indianapolis, IN [13]

MITCHELL, Sara Patterson Snowden (Mrs.) [P] Phila. b. Phila. Studied: PAFA; Acad. Viti, Paris. Member: Plastic C. [13]

MITCHELL, Sophie [P] Brooklyn, NY [01]

MITCHELL, Thomas John [P] Rochester, NY b. 22 F 1875, Rochester. Studied: Rochester A. Sch. Member: Rochester AC; Buffalo SA; Geneseeans; SC; Gloucester SA. Exhibited: Rochester A. Exh., Memo. A. Gal., 1929 (prize). Work: Memorial A. Gal., Rochester; Univ. C., Rochester; Iolo Sanitorium, Rochester. Visited Taos, 1930s [40]

MITCHELL, Wallace (MacMahon) [P,T] Bloomfield Hills, MI b. 9 O 1911, Detroit. Studied: Northwestern Univ.; Cranbrook Acad. A., with Z. Sepeshy; Columbia. Exhibited: Detroit Inst. A., 1945 (prize); AIC, 1938–41; Detroit Inst. A., annually; Albright A. Gal., 1939; Patteran, Buffalo, N.Y., 1938. Work: Cranbrook Acad. A. Mus.; Detroit Inst. A. Position: T., Cranbrook Acad. A. [47]

MITCHILL, Neil R. [P] Romford, CT. Member: SC [25]

MITIUS, Louis [Por.P] b. 1842 d. 28 D 1911, Cincinnati

MITTELL, Sybilla. See Weber.

MITTS, Harold Arthur [P,T] Columbus, OH b. 26 Ag 1902, Saginaw, MI. Studied: J. Norton; J.P. Wicker; G. Oberteuffer. Member: Columbus AL. Exhibited: Columbus Gal. FA, Columbus, 1934 (prize), 1935 (prize). Position: T., Ohio State Univ. [40]

MIX, Elena (Mrs. Alexander L.P. Johnson) [P] Raleigh, NC b. 19 Ag 1889, Nogales, AZ d. 21 O 1939. Studied: PAFA; D. Garber; H. McCarter; J.T. Pearson; C. Grafly; G.A. Bringas; Nat. Acad. of Mex. Member: N.C. Prof. Artists C. Work: Women's C., Raleigh [38]

MIX, Florence [Por.P,Ldscp.P,T] NYC b. 1881, Hartford d. O 1922, Glenwood, Long Island. Studied: Pratt Inst.; ASL. Positions: T., Girls' Sch. (Briarcliff Manor), Trinity Parish Sch. [19]

MIXTER, Felicie. See Howell.

MIYAMOTO, Kaname [P] NYC b. 3 F 1891, Japan. Studied: AIC; ASL. Exhibited: AIC; PAFA. Work: Honolulu Acad. A. [47]

MIYAZAKI, Schiro [P,B] Seattle, WA b. 24 My 1910, Japan. Studied: self-taught. Member: Northwest PM [33]

MIZEN, Frederic Kimball [P,I,Car,T] River Forest, IL b. 29 Ja 1888, Chicago d. 1964. Studied: J.F. Smith Acad., Chicago, with W. Ufer, 1904–06; AIC, with Clute, Vanderpoel; Taos, again with Ufer, 1935. Member: Soc. for Sanity in A.; Oak Park, River Forest A. Lg.; Chicago Gld. Ar. Work: adv., for U.S. Treasury, Coca-Cola, Gen. Tire. Illustrator: Saturday Evening Post, Cosmopolitan. Position: T., (founder) Mizen Acad. A., Chicago (1936), Taos (summers), Baylor Univ. (1952–60) [40]

MIZRAKJIAN, Artin [I,Por.P] Elmhurst, NY b. 27 Ap 1891, Armenia. Studied: ASL, with F. DuMond, G.B. Bridgeman; W. Adams [40]

MIZUNO, S. [P] Portland, OR [24]

MOCH, G(ladys) A(my) [P,E] NYC b. 1 N 1891, NYC. Studied: ASL [19]

MOCHARNIUK, Nicholas (Nimo) [S,C] NYC b. 11 My 1917, Phila., PA. Studied: Girard Col., Phila. Member: Lg. Present-Day A.; Woodstock AA. Exhibited: Marquie Gal., 1943–46; All.A.Am., 1945 (one-man); Audubon A., 1945 (one-man); Lg. Present-Day A., 1946 (one-man); Springfield (Mo.) Mus. A., 1945 (prize). Work: Springfield Mus. A. [47]

MOCHI, Ugo [Dec,Des,Dr,I,W,S,L] New Rochelle, NY b. 11 Mr 1890 d. 1977. Studied: DeCarolis, Rivalta, both in Florence; Berlin, with A.G. Koch, Meyerheim. Member: New Rochelle AA. Work: Windsor Castle Coll., England. Author: "L'Ombra delle Bestie" (Italy), "African Shadows." Illustrator: Woman's Home Companion [40]

MOCINE, Emily Rutherford (Mrs.) [C,L] Los Angeles, CA b. 11 Mr 1884, New Zealand. Studied: Tech. Col., Sydney, Australia; UCLA. Exhibited: Los Angeles Mus. A. (prize); Fnd. Western A. (prize); Alaska-Yukon-Pacific Expo, 1909 (med); Allied A. Exh., 1935 (prize); Los Angeles County Fair, 1935 (prize), 1937 (prize), 1938 (prize). Work: San Diego Expo, 1936. Specialty: woodcarving [47]

MOCINE, Ralph F. [P] Los Angeles, CA. Member: Calif. AC [25]

MOCK, George Andrew [P] Muncie, IN b. 18 My 1886, Muncie d. ca. 1958. Studied: AIC. Member: Hoosier Salon; Brown Co. AA. Exhibited: Hoosier Salon, 1934 (prize), 1937 (prize); Ind. Fed. C., 1942 (prize); Ind. Univ., 1945 (prize); Women's Cl., Indianapolis, 1946 (prize); Brown County AA, annually [47]

MOCK, Gladys [P,E] NYC b. NYC. Studied: ASL; K.H. Miller. Member: SAE; NAWA; Audubon S.; PBC; Am. Ar. Cong. Exhibited: CGA; PAFA; AIC; CI; NAD; SAE; NAWA, 1946 (prize); WFNY, 1939; Venice, Italy. Work: PAFA; Todd Mus., Kalamazoo, Mich.; LOC [47]

MODJESKA, Felicie M. (Mrs. Ralph) [S] Chicago, IL b. 2 F 1869, Cracow, Poland. Studied: Taft; Mulligan; Polasek [17]

MODJESKA, Marylka (Mrs. Sidney Pattison) [P,E,T] Tucson, AZ b. 22 Ja 1893, Chicago, IL. Studied: AIC; ASL; Académie Julian, Paris; G. Senseney; G. Degorce; G. Brandriff. Member: Laguna Beach AA; Palette & Brush C. Chicago SE; FAA, Tucson. Work: AIC. Position: T., Thomas Sch., Tucson [47]

MODRA, T(heodore) B. [P] Hollywood, CA b. 13 My 1873, Poland. d. N 1930. Studied: Henri; Colarossi Acad.; Groeber, in Munich. Member: NAD; MacD. C.; Calif. AC; Allied AA; S.Indp.A.; Calif. WCS; Los Angeles PSC; Artland C.; Laguna Beach AA. He lobbied successfully for an appropriation for a permanent art exhib. bldg. at Pomona for Los Angeles County Fair. [29]

MODRAKOWSKA, Eleanor [Por.P,E] NYC b. 29 Mr 1879, College Pt., NY. Studied: W. Chase; A. Azbe, in Munich. Member: SAE; Chicago SE; NAWA; Nassau County AL. Exhibited: NAD, 1936–42; NAWA; PAFA; MMA; Grand Central A. Gal.; NAC; Oakland A. Gal.; AIC; Nassau County AL; CAFA; Mineola Fair, 1940 (prize), 1942 (prize). Living in Chicago, 1913. [47]

MOE, George Eugene [P] Brooklyn, NY. Member: S.Indp.A. [25]

MOELLER, Elizabeth Anne [P,Mus.Dir,T,L] Davenport, IA b. 18 Ap 1906, Davenport. Studied: State Univ., Iowa; PAFA; C. Macartney; F. Speight; R.C. Nuse. Member: Iowa AG. Exhibited: Davenport Mus. A. Gal., 1931 (prize), 1934 (prize), 1936 (prize); Rockford AA, 1934. Work: Rock Island Pub. Sch. Position: Dir., Davenport Municipal A. Gal., since 1938 [47]

MOELLER, Gustave [P,T] Milwaukee, WI b. 22 Ap 1881, Wisconsin d. 11 F 1931. Studied: Paris; Milwaukee ASL; AIC; Royal Acad., Munich; NYC. Member: Wis. PS. Exhibited: Milwaukee AI, 1917; Wis. PS, 1922; Milwaukee AI, 1923 (med); Milwaukee Journal, 1926 (prize). Position: T., State T. Col., Milwaukee [29]

MOELLER, Henry Nicholas [P,S,I] NYC b. 5 Ja 1883, NYC. Studied: Hinton; Curran; MacNeil; Aitken. Work: mem. tablet, Havana, Cuba. [40]

MOELLER, Henry W. [P] NYC [25]

MOELLER, Leo [P] b. 1867, Hamburg, Germany. Studied: E.M. Ward, Will Low, both in NYC; Munich; H. Boisch, in Carlsruhe. Exhibited: NAD, 1897 (prize) [10]

MOELLER, Louis (Charles) [P] Weehawken, NJ b. 5 Ag 1855, NYC d. 11 N 1930. Studied: NAD, with Wilmarth; Diez, Duveneck, in Munich, 1873–82. Member: ANA, 1884; NA, 1894. Exhibited: NAD, 1893 (prize). Work: CGA; MMA; Oberlin Col. Specialty: genre painting [29]

MOELLER, Selma (M.D.) [Min.P] NYC b. 3 Ag 1880, NYC. Studied: ASL, with K. Cox, W. Chase, B. Harrison, DuMond; L.F. Fuller, A. Beckington. Exhibited: Phila. WCC; NAWA; SMP; Brooklyn SMP; P.-P. Expo, 1915 (med). Work: Ft. Riley, Kans; Ft. Benning, Ga.; Ft. Monmouth, N.J.; Ft. Sill, Okla.; Maxwell Field, Ala.; MIT [47]

MOEN, Ella C(harlotte) [P,T] Fresno, CA b. 18 Mr 1901, Bottineau, ND [29]

MOESSELL, Julius [P,Arch,E,W] Chicago, IL b. 10 O 1872, Munich, Germany. Studied: R. von Seitz. Member: Chicago Gal. Assn.; Chicago PS. Exhibited: AIC, 1934 (prize); Chicago Assn. PS, 1937 (prize). Work: Courthouse, Leipzig; Kurhouse, Kissingen; Court Theatre, Stuttgart; Kunstlerhouse, Munich; Jury Room, Nürnberg; murals, Field Mus. Nat. Hist., Chicago [40]

MOFFAT, Curtis [P,Photogr,Des,Dec,C] NYC b. 1887, NYC d. 1949, London, England. Studied: NYC, 1913–14; Paris. Exhibited: London galleries, 1925–30s; MOMA, 1937. Collaborator with Man Ray on Dada "rayographs" in Paris, 1923. He was an early experimenter with color photography; ran an avante-garde gallery in London; designed early tubular chairs. [17]

MOFFATT, A. [P] Worthington, MA [01]

MONFALCONE, Eugene D. [Mur.P] Richmond, VA b. Italy d. S 1922. Work: Fed. Reserve Bank of Richmond; Governor's Mansion, Richmond

MOFFETT, Anita [P] NYC. Member: GFLA; Wash. AC [29]

MOFFETT, Dorothy Gregory. See Gregory, Dorothy Lake.

MOFFETT, Mary Elvish Mantz (Mrs. Samuel E.) [P] b. 1863, Perry, IL d. 2 O 1940, Mt. Vernon, NY. Studied: Calif.; NYC

MOFFETT, Ross E. [P,E] Provincetown, MA b. 18 F 1888, Clearfield, IA. Studied: AIC; C. Hawthorne; ASL. Member: ANA, 1937; Mural P.; Am. Soc. PS&G; NA; Audubon A.; Mass. Archaeological S.; S. Am. Archaeology. Exhibited: CGA; PAFA; NAD, 1921 (prize); CI; Detroit Inst. A.; Albright A. Gal.; WMA; Springfield Mus. A.; Minneapolis Inst. A.; CAM; VMFA; Dayton AI; Louisville, Ky.; CMA; San Fran. AA, 1931 (med); AIC, 1918 (med), 1927 (gold). Work: PAFA; J.B. Speed Mem. Mus.; CGA; WMAA; Univ. Nebr.; Miami Univ.; murals, USPOs, Holyoke, Somerville, Revere, all in Mass.; Albright A. Gal., Buffalo; White House. Position: T., Miami Univ., Oxford, Ohio, 1932–33, 1935–36 [47]

MOHLTE, John Alfred [Por.P,Mur.P] NYC b. 2 Ap 1865, Sweden. Studied: NAD; Académie Julian, Paris; Constant; J.P. Laurens. Member: AAPL. Work: Shakespeare Shrine, Stratford-on-Avon, England. Specialty: ecclesiastical painting [40]

MOHN, N. Edward [P] St. Paul, MN [17]

MOHN, Sigvard M. [P,E] Babylon, NY b. 29 My 1891, Northfield, MN. Studied: St. Paul Inst. Sch. A.; PAFA; Grand Central Sch. A.; Académie Julian, Paris. Member: SC; Brooklyn SA; NAC. Work: N.Y. Homeopathic Medical Col.; Flower Hospital, N.Y. [47]

MOHOLY-NAGY, Laszlo [P,S,W,Photogr,T] Chicago, IL b. 1895, Borsod, Hungary d. 24 N 1946. Work: MOMA; Detroit Inst. A.; Mus. Non-Objective Painting, NYC; IMP. Prominent avante-garde artist; taught at Gropius' first Bauhaus in Weimar and Dessau, 1920s; left for London, 1935. One of the founders of the Inst. of Des., Chicago, 1939 ("Chicago Bauhaus"). Like Man Ray, created cameraless "photograms," 1920s.

MOHOR, Charlotte (Mrs. J.S.) [Min.P,E] Chicago, IL b. 17 Ap 1868, Paris. Studied: Stuttgart Royal Acad.; Tattori, in Florence; Henner, in Paris [06]

MOHR, Olga [P,Des] Cincinnati OH b. 20 Jy 1905, Little Rock, AR. Studied: Cincinnati A. Acad. Exhibited: Denver AM, 1936. Work: Cincinnati AM; mural, Linwood Sch., Cincinnati [40]

MOHRMANN, John Henry [Mar.P] b. 16 D 1857, San Fran. d. 17 Ja 1916, Alberta, Canada. Work: museums in Germany, Spain, Norway, England;

Mariners Mus.; Old Dartmouth Hist. S.; Peabody Mus., Salem, Mass.; San Fran. Pub. Lib. A seaman for 18 years, he painted ship portraits in collaboration with an Italian partner (since 1881). Settled in Alberta, 1913. [*]

MOILAN, Otto E. [P] Kansas City, MO b. Finland. Studied: Minn. Sch. A. Member: Kansas City SA. Work: Country Cl., Minneapolis; mural, Finnish Lutheran Church, Virginia, Minn.; St. Joseph's Church, Osseo, Minn. [40]

MOIR, Robert B. [G,P,S] Chicago, IL b. 12 Ja 1917, Chicago. Studied: AIC. Member: Ar. Un., Chicago. Exhibited: AIC. WPA artist. [40]

MOISE, Alice Leigh [C,P] New Orleans, LA b. 5 Ag 1905, New Orleans. Studied: Newcomb Col. Member: SSAL; NOAA [40]

MOKREYS, John [I] NYC [19]

MOLARSKY, Abram [P,T] Nutley, NJ b. 25 D 1883, Kiev, Russia. Studied: PAFA; Paris; W. Chase; C. Beaux. Member: Phila. A. Alliance. Exhibited: LOC, 1943; CGA, 1939, 1941, 1945; PAFA; CI; AIC; Milch Gal. (one-man); Newark AC, 1938 (prize) (one-man); Doll & Richards, Boston (one-man); Contemporary AC, 1936 (prize). Work: Pub. Sch., Court House, both in Newark. Position: T., Nutley (N.J.) H.S. [47]

MOLARSKY, Maurice [P,T] Phila., PA b. 25 My 1885, Kiev, Russia d. 1 Ja 1950. Studied: PMSchIA; Phila. A. All.; France; England. Member: F., PAFA; AAPL; Phila. A. All.; Allied AA. Exhibited: P.-P. Expo, 1915 (med); Sesqui-Centenn. Expo, Phila., 1926; Phila. Sketch C., 1932; Phila. AC, 1919 (gold). Work: Mt. Sinai Hospital, Jefferson Medical Col., Hahnemann Med. Col., City Hall, Pub. Lib., Aldine Trust Co., Atheneum Soc., all in Phila.; Evans Inst., Law Sch., Medical Sch., Univ. Pa.; Haverford Col., Pa.; Washington Col., Chestertown, Md.; State T. Col., West Chester, Pa.; Princeton; NAD; AAAL; Butler AI [47]

MOLARSKY, Sarah Shreve [P,T,I] Nutley, NJ b. 1879, White Hill, NJ. Studied: Swarthmore Col.; Drexel Inst., with H. Pyle; PAFA, with C. Beaux, W. Chase. Exhibited: CGA; PAFA; Montclair AM; Newark Mus.; Newark AC, 1941; CAM; Paper Mill Playhouse Gal., N.J., 1940. Illustrator: "A Knight of the West Side," "Carlotta of the Rancho." Position: T., South Orange-Maplewood Sch., N.J., 1942 [47]

MOLE, Hilma [P,E,B] Ogden, UT b. 5 D 1901, Croyden, UT. Studied: J.T. Harwood. Member: Utah A. Colony. Work: Smithfield Pub. Lib., Smithfield, Utah; Utah high schools [40]

MOLIN, C. Gunnar [P,S,E] Brooklyn, NY b. Stockholm, Sweden. Studied: ASL. Member: Scandinavian-Am. A.; AAPL [40]

MOLINA, Valentino [P] NYC. Member: SC [21]

MOLINARY, A. [Por.P] New Orleans, LA b. 1847, Gibraltar d. S 1915 [15]

MOLINARY, Marie Seebold (Mrs. Andrés) [P] New Orleans, LA b. 1876, New Orleans, LA. Studied: W. Chase; A. Molinary. Member: NOAA. Work: Delgado Mus. [40]

MOLIND, A. [Mus.Cur,P,T,Des] Phila., PA b. 1 Ap 1898, Norfolk, Va. Studied: Spring Garden Inst.; PMSchIA. Exhibited: PAFA, 1942. Positions: T., PMSchIA, La France AI; Cur., La France AI, Phila. [47]

MOLL, Aage (Peter Marinus) [P] Hartford, CT b. 9 F 1877, Ribe, Denmark. Studied: C.N. Flagg; J.G. McManus. Member: SC; CAFA; Scandinavian-Am. A. [40]

MOLLENHAUER, Frank [P,Dec] New Canaan, CT b. 28 N 1907, NYC. Studied: ASL. Member: Silvermine Gld. Ar., Norwalk, Conn. Exhibited: VMFA, 1938; WFNY, 1939; GGE, 1939 [40]

MOLLER, Hans [P,Des,T] NYC b. 20 Mr 1905, Wuppertal-Barmen, Germany. Studied: Germany. Exhibited: A. Dir. Cl., 1944 (prize); PAFA, 1944, 1946; AIC, 1943–46; VMFA, 1946; WMAA, 1946; Bonestell Gal., 1942, 1943; Chicago AC, 1945 (one-man); Univ. Mich., 1945 (one-man); Kleeman Gal., 1945 (one-man). Position: T., CUASch, NYC [47]

MOLLER, Olaf [Mur.P,Por.P,C,Des] Rupert, ID b. 21 My 1903, Copenhagen, Denmark. Studied: PAFA; D. Garber; A.B. Carles; N.C. Wyeth; H. Breckenridge; R. Meryman; R. Spencer; J.T. Pearson; G. Harding; H. McCarter; G. Oberteuffer; C. Lawless; P. Hale; H.R. Poore. Member: Rocky Mountain AA; Augustana Col. AA; Wash. Lndscp. Cl.; Teton AA. Exhibited: WNFY, 1939; PAFA, 1925 (prize), 1926 (prize); Springvile, Utah, 1933 (prize); Heyburn, Idaho, 1934 (prize), 1937 (prize). Work: Augustan Col., Rock Island, Ill.; Univ. Idaho; Boise A. Mus.; Carnegie Lib., Boise, Idaho; Twin Falls (Idaho) H.S. AA; Springville H.S. AA; Albion (Idaho) State Normal Sch. [47]

MOLLER, Robert [P] NYC [13]

MOLONY, Helen Wise (Mrs.) [P] b. 1859, Cincinnati d. 10 S 1934, North College Hill, OH. Exhibited: Cincinnati. Specialty: woodcarving

MOLYNEUX, Edward F(rank) [I] NYC b. 29 F 1896, London, England. Studied: PIASch. Member: SI; A. Dir. Cl. [33]

MOLZAHN, Johannes [P,Des,T,W,L] NYC b. 21 My 1892, Duisburg, Germany. Exhibited: Societé Anonyme, 1925–27; MOMA, 1931; traveling exh., "Abstract & Surrealist Art in America," 1944; WMA, 1945. Work: museums in Weimar, Essen, Breslau, all in Germany; Yale. Positions: T., Univ. Wash., Seattle (1923–41), Chicago (1943–44) [47]

MOMBERGER, William [Ldscp.P,Mar.P,Li,I] Morrisania, NY (1888) b. 7 Je 1829, Frankfort, Germany (came to U.S. in 1848). Illustrator: Duycinck's "Cyclopedia of American Literature," "Gallery of Am. Landscape Artists"; account of the post-Civil War Midwest, 1865 [*]

MOMMER, (Peter) Paul [P,W] NYC b. 21 F 1899, Bennevoi, Luxembourg. Member: Fed. Mod. P&S. Exhibited: CI, 1942–44; MOMA, WMAA, 1934, 1936, 1938; CGA, 1937; AIC, 1937; GGE, 1939; PAFA, 1933, 1934, 1938. Work: MMA. Author: "As I See It," 1938 [47]

MOMOSE, Senzaburo [E,P] NYC b. 14 My 1890 Naganoken, Japan [32]

MONAGHAN, Eileen. See Whitaker.

MONAGHAN, Gertrude [Arch,Des,P] Buck Hills Falls, PA/Nantucket, MA b. West Chester, PA. Studied: Phila. Sch. Des.; PAFA. Member: Nantucket AA; MacD. Colony. Exhibited: LOC, 1943; PAFA, 1910 (prize); Nantucket AA; Phila. AC; Phila. Pr. C.; Plastic C., Phila. Work: murals, Jacob Reed's Sons, Phila. [47]

MONAHAN, P.J. [I] Woodcliffe, NY. Member: SI, 1912 [25]

MONARD, Margaret [S] Plainfield, NJ [15]

MONCURE, Lisa Vance [P] Wash., D.C./Stafford County, VA b. 20 My 1886, Gallipolis, OH. Studied: PAFA, with H. Breckenridge, A. Carles, H. McCarter. Member: Soc. Wash. A.; SSAL. Work: PMG; Wash. Masonic Lodge, Alexandria, Va. [40]

MONGAN, Agnes [Mus.Cur,W] Somerville, MA b. 21 Ja 1905, Somerville. Studied: Bryn Mawr; Smith. Co-author: "Drawings in the Fogg Museum of Art," 3 vols., 1940. Editor: G.G. King's "Heart of Spain," 1941. Contributor: articles, American, English and French art periodicals. Position: Cur. Drawings, FMA [47]

MONGES, Henry B. [P] Berkeley, CA [15]

MONGULIAS, Joseph [P] NYC [19]

MONHOFF, Frederick [E,Li,L,T] Altadena, CA b. 23 N 1897, NYC. Studied: Univ. Calif. Member: Calif. Pr.M.; AIA; Chicago SE. Exhibited: San Fran., 1934 (med); BM; LOC; de Young Mem. Mus.; Los Angeles Mus. A. Position: T., Otis AI, Los Angeles, 1926 [47]

MONK, Gertrude [Des,P,S] Detroit, MI b. 2 Ag 1892, Alton, IL. Studied: Sch. FA, Detroit. Member: Detroit AC. Exhibited: Detroit AI, 1925 (gold). Work: St. Joseph's Church, St. Barnabas Church, both in Detroit; murals, Observatory Lodge, Ann Arbor, Mich. [40]

MONKS, Edward E. [I,W] Roslyn Estates, NY b. 6 Ja 1890, Cleveland, OH. Member: SI [40]

MONKS, J(ohn) A(ustin) S(ands) [P,E] Medfield, MA b. 7 N 1850, Cold Spring, NY d. Mr 1917, Chicago. Studied: etching, G.N. Cass; painting, G. Inness. Member: Boston AC; Copley S. 1892; N.Y. Etching C. Exhibited: SC, 1883; N.Y. Etching C., 1880s; AWCS. Work: "Sheep" (his best known painting), BMFA; Parrish Mus. Famous for his oils and etchings of sheep, which he also raised. He was called "The American Schenck and Jacque." [15]

MONKS, Robert Hatton [P] Paris, France b. Boston. [01]

MONNIER, France X. [S] Detroit, MI b. 1831, Belfort, France (came to U.S. just before the Civil War) d. 5 Ap 1912. Work: decorated interior of Commodore Vanderbilt's house in NYC

MONNIER, Maude Nottingham [P] Hartford, CT b. 13 Jy 1876, Abbotts, NY d. 22 F 1932. Member: New Haven PCC; Hartford AS; Hartford AC; Copley S.; North Shore AA; Springfield AL. Exhibited: Wadsworth Atheneum, 1932. Work: Dwight Sch., Hartford. Specialty: flowers, gardens

MONOCAL [P] Cuba. Exhibited: Paris Expo, 1900 [01]

MONRAD, Emily [P,L,T] Cooperstown, NY/Block Island, RI b. 30 Ja 1877, Sweden. Studied: V. Johansen, Royal A. Acad., Copenhagen; Paris. Member: New Haven PCC; Plainfield AA. Work: Hamilton Col. Position: T., Knox Sch. [40]

MONRAD, Margaret [S,G,T] Hamden, CT/Block Island, R.I. b. 10 Je 1878, New Zealand. Exhibited: Plainfield AA, 1939; Pub. Lib., New Haven, Conn. Author/Illustrator: "Marionettes, Handicrafts," 1929 [40]

MONRO, Clarence J. [Li,I,P] b. 1877, Orangeville, Ontario d. 22 S 1934, Mt. Vernon, NY. Illustrator: Saturday Evening Post, Ladies Home Journal, Good Housekeeping. Work: murals, Mem. H.S., Pelham, N.Y. Position: lithographer, Buffalo

MONROE, Albert A. [P] Brooklyn, NY. Exhibited: NAD, 1898 [98]

MONROE, G.R. [P] Toledo, OH. Member: Artklan [25]

MONROE, Laura Potter [P] Chicago, IL. Member: Chicago NJSA [25]

MONROE, M.B. [P] Phila., PA [06]

MONROE, Marion [P] Chicago, IL [25]

MONROE, Maxine [P] Worcester, MA [24]

MONSON, E. [P] NYC [17]

MONSON, (Edith) Dale [P] Hartford, CT b. New Haven, CT. Studied: ASL; Henri. Member: CAFA; Hartford Women P. [40]

MONTAGUE, Fannie S. See Moore, Mrs.

MONTAGUE, Hariotte Lee Taliaferro (Mrs. Jeffry) [P,T] Richmond, VA. Studied: G. deF. Brush; Twachtman; Munich, with A. Yank, Fehr, Hummel, Knurr; Simon, in Paris. Member: Richmond AC; San AA Lg. Work: Richmond AC; D.A.R. Hall, Wash., D.C.; Confederate Mus., State Lib., both in Richmond; Westmoreland (Va.) Court House [24]

MONTAGUE, Lilian Amy (Mrs.) [Ldscp.P,C] Lumberville, PA b. 27 N 1868, London, England. Studied: T. Anschutz; Breckenridge; Barlow; F. Andrews, in London. Specialty: weaving [40]

MONTAGUE, Ward [S,G] NYC b. Covelo, CA. Studied: Calif. Sch. FA, San Fran.; F. Leger; J. Charlot; E. Amero. Member: S. Gl., N.Y. Exhibited: S. Gl., 1938, 1939; BM, 1938; WFNY, 1939; Intl. Bldg., Rockefeller Center, 1939. Position: T., Universal Sch. Handicrafts, NYC [40]

MONTALBODDI, Raffaelo [P] Pasadena, CA [19]

MONTANA, Pietro [S,P] NYC b. 29 Je 1890, Alcamo, Italy. Studied: Brewster. Member: NSS; All.A.Am., 1938; Artists' Fellowship. Exhibited: NAD, 1931 (gold); All.A.Am., 1938 (prize). Work: S., mem., monuments, Brooklyn; East Providence, R.I.; St. John's Cemetery, N.Y.; Brookgreen Gardens, S.C.; Radio City, NYC; Fordham Univ.; mon., Heisser Square, NYC; Freedom Square, NYC; Highland Park, NYC; Ninth St. and Fifth Ave., NYC; Governor's Island, N.Y.; mem., Sicily, Italy; cemetery, Alliance, Ohio; mem., Mayaguez, Puerto Rico [47]

MONTGOMERY, Alfred [P] Lawndale, IL b. 1857, Lawndale d. 20 Ap 1922, Los Angeles, CA. Specialty: farm life [01]

MONTGOMERY, Carrie E. (Mrs. W.A.) [Ldscp.P,L] Cedar Rapids, IA b. 2 F 1878, Rockford, IL. Studied: AIC; A. Dornbrush; G. Wood. Member: Cedar Rapids AA [40]

MONTGOMERY, Carrie L(ewis) (Mrs. J.A.) [P] Birmingham, AL b. 2 D 1865, Montevallo, AL. Studied: NAD. Member: Birmingham AC; Ala. AL; SSAL. Exhibited: Ala. State Fair Exh. (prizes). Work: Birmingham Pub. Lib.; State Capitol, Ala. [33]

MONTGOMERY, Claude W. [E,Por.P] Peaks Island, ME b. 25 Ja 1912, Portland, ME. Studied: Portland Sch. A., with A. Bower; NAD, with L. Kroll, B. Geal; PIASch. Member: Portland SA. Exhibited: Radio City, NYC, 1935; NAD, 1936 (med), 1937, 1938; SAE, 1934, 1935; AWCS, 1942; Portland SA 1933-39, 1941-45; Intl. Expo, Paris, 1937 (med); Portland Mus. A., 1934 (prize); Paris Salon, 1937 (med). Work: Sweat Mem. Mus.; Colgate Univ. [47]

MONTGOMERY, Eloise [P] Mont Eagle, TN [15]

MONTGOMERY, Eugene Alexander [Por.P] Chicago, IL b. 23 Ag 1905. Studied: AIC, with G. Oberteuffer, B. Anisfeld, Van Pappelandam; F. Poole. Member: All-Ill. SFA. Illustrator: baby drawings, Carnation Milk Co.; Ladies Home Journal, Good Housekeeping, Woman's Home Companion [40]

MONTGOMERY, Lorin A.D. (Mr.) [P,T] Phila., PA b. 25 N 1904, Mason City, IL. Studied: Chouinard AI, with C. Hinkle; PAFA; Barnes Fnd.; Paris, France. Exhibited: CI, 1941; WFNY, 1939; CGA, 1936; Phila. A. All., Traveling Exh., 1934; PMA, 1935, 1938; PAFA, 1940; Carlen Gal.; Woodmere A. Gal., 1941-46; Phila. AC; Da Vinci All.; State Mus., Harrisburg, Pa., 1938; Germantown AL, 1938 (prize). Work: F. PAFA; Allentown Mus.; Temple Univ.; Bartram Radnor H.S., Pa.; Jefferson Hospital, Phila.; Carlisle Court House; Ft. Meade, Md. [47]

MONTGOMERY, Richard M. [S] NYC [17]

MONTGOMERY, W.H. [P] Allston, MA [24]

MONTIZAMBERT, Beatrice B(lanch) [P] NYC b. 24 F 1874, Quebec, Canada. Studied: Brangwyn; Levaun. Member: NAWPS [19]

MONTOYA, Alfredo [P] San Ildefonso Pueblo, NM b. before 1890, probably San Ildefonso Pueblo d. ca. 1915. The initiator of modern pueblo painting; his drawings of Indian life were exhibited in London. Work: Mus. Am. Indian; Mus. N.Mex. [*]

MONTOYA, Geronima Cruz (Po-tsu-nu) [P,T,L] Santa Fe, NM (1976) b. 22 S 1915, San Juan Pueblo, NM. Studied: Santa Fe Indian Sch, 1935; Claremont Col.; D. Dunn; K. Chapman; A. Martinez. Exhibited: Mus. N.Mex. Work: de Young Mus. A.; Mus. N.Mex.; Mus. Am. Indian. Position: T., Santa Fe Indian Sch., 1935-61 [47]

MONTMINY, Elizabeth Tracy, Mrs. See Tracy.

MONTRICHARD, Raymond Desmus [P] Los Angeles, CA b. 16 S 1887, Berkeley, CA. Member: Laguna Beach AA [33]

MONTROSS, N.E. [Patron,Dealer] NYC b. 1849 d. 10 D 1932. In 1914-15 he secured a large exhibition of works of Matisse for the Montross Galleries, which created a furor in the art world. In 1916-17 he brought together a large number of Cézannes, later followed by the finest collection of Van Goghs that ever came to this country. He instinctively recognized artistic ability, and his enthusiasm for the modern French masters never made him lose sight of American artists and their work.

MOODY, Frances J. [S] Abingdon, IL. Exhibited: Hoosier Sal, 1935, 1937, 1940 (prize) [40]

MOODY, Helen Wills. See Roark.

MOON, Anne Douglas See Peyton, Philip B., Mrs.

MOON, Carl [P,I,W,Photogr] Pasadena, CA b. 5 O 1879, Wilmington, OH d. 24 Je 1948. Studied: T. Moran; F. Sauerwein; L. Akin. Member: Pasadena AS. Work: 24 canvases of Indians, Huntington Lib.; AMNH; Southwest Mus., Los Angeles; Montclair Mus.; LOC. Illustrator: "Chi-Wee," "Runaway Papoose," many other Indian and Mexican stories for children. Author/Illustrator: "Flaming Arrow," "Painted Moccasin," "Tah-Kee"; numerous magazine stories. Like E.S. Curtis, Moon was an artistic photographer of Indians, making a large collection at his Albuquerque photography studio from 1904-07. [40]

MOORE, Aimee Osborne [P] NYC [08]

MOORE, Anita [P,T] Columbia, MO/Rolla, MO b. 4 Jy 1900, Cleveland, OK. Studied: J. Despujols; Lhote; J.S. Ankeney; Fontainebleau Sch. FA. Member: Assn. Okla. A.; AAPL. Exhibited: Okla. A. Exh., Tulsa, 1936 (med). Positions: T., Okla. Col. for Women, Univ. Mo. (Rolla summer session) [40]

MOORE, A(rthur) W. [P,T] Rochester NY b. 9 N 1840, Nottingham, England d. 15 Ap 1913. Studied: England, with Parker, Nottingham Art Sch. Member: Rochester AC; Central N.Y. AS [13]

MOORE, Benson B(ond) [P,T,E,I] Wash., D.C. b. 13 Ag 1882, Wash., D.C. Studied: Corcoran Sch. A. Member: S. Wash. A.; Wash. WCC; Wash. Landscape C.; AAPL; SSAL; Baltimore WCC; New Haven PCC Wash. SE; Wash. S. Min. PS & G; Royal S. PG & S, London; CAFA; Miss. AA. Work: LOC; White House, Wash., D.C.; Bibliothèque Nationale; NYPL; Univ. Wash.; Smithsonian Inst.; Houston MFA; Phila. A. All.; Wash. AC; Los Angeles Mus. A. Illustrator: syndicated nature article, "Nature's Children"; nature books [47]

MOORE, Bethnel Clark [P] NYC b. 15 Je 1902, Barbourville, KY. Studied: Louisville Sch. A.; NA. Member: C. Hawthorne. Member: Louisville AA; Tiffany Fnd. Schol., 1925. Exhibited: Wildenstein Gal., N.Y.; Creative A. Center, Charlottesville, VA; Louisville AA, 1925 (med); NA, 1927 (prize); Speed Mem. Mus., 1929 (prize). Work: Lib., William & Mary Col., Va.; Lib., Univ. Va.; State House, Frankfort, Ky. [40]

MOORE, Cecil Gresham [P,I,L,W,T] Rochester, NY/Kingston, Ontario. b. 12 Je 1880, Kingston. Studied: Rochester Athenaeum & Mech. Inst. Member: Rochester AC. Specialty: mural dec., theatrical and scenic productions [33]

MOORE, Charles Everett [Por.P] Edgewood, RI b. 1864, Taunton, MA. Studied: G.L. Brown; H. Breul. Member: Providence AC; Providence WCC. Work: Masonic Temple. Specialty: Biblical subjects [24]

MOORE, Charles Henry [P] Newark, NJ. Member: Lg. AA [24]

MOORE, Charles Herbert [Ldscp.P,Edu,W,Mus.Dir] b. 10 Ap 1840, NYC d. 17 F 1930, Hartley Wintney, Hampshire, England. Studied: NYC. Exhibited: NAD, 1858. Work: FMA; Princeton. Author: books on art and architecture, including "The Development and Character of Gothic Architecture" (1890), "Examples for Elementary Practice in Delineation," "Character of Renaissance Architecture," "Medieval Church Architecture of England." Contributor: "New Path" (Pre-Raphaelite journal). He was a noted follower of Ruskin. Positions: T., Harvard, 1871–1909; Dir., FMA, 1896–1909, after which he moved to England

MOORE, Charles W. [P] Pentwater, MI. Member: Chicago NJSA [25]

MOORE, Edwin A(ugustus) [P,E] Kensington, CT b. 24 Ag 1858, Hartford, CT. Studied: NAD; his father, N.A. Moore; Dresden [24]

MOORE, E. Bruce [S] NYC (Westport, CT, in 1940) b. 5 Ag 1905, Bern, KS. Studied: PAFA, with A. Laessle, Grafly (Traveling Scholarship, 1925, 1926). Member: Guggenheim F., 1929–31. NA; NSS. Exhibited: PAFA, 1929 (gold), 1930, 1940; WMAA, 1942; NAD, 1935 (prize), 1937 (prize); Meriden A. & Cr. Assn., 1940 (prize); M.R. Cromwell F., 1937–40 (prizes). Work: WMAA; Wichita A. Mus.; PAFA; Brookgreen Gardens, S.C.; Am. Acad., Rome [47]

MOORE, Ellen Maria [Min.P,T] Boothbay Harbor, ME b. 4 D 1861, Kensington, CT. Studied: ASL; De Camp; I.A. Josephi. Member: Copley S. [27]

MOORE, Frank Montague [P] Pasadena, CA b. 24 N 1877, Taunton, England. Studied: Royal Inst., Liverpool, England; Liverpool A. Sch.; H.W. Ranger. Member: Soc. for Sanity in Art; NYWCC; WCS; AFA. Exhibited: NAD; PAFA; CGA; NYWCC; Pan-P. Expo, 1915; Pasadena SA; Santa Cruz, Calif. 1944; Soc. for Sanity in Art, 1941–45; Calif. SA; Calif. State Fair; Palace Legion Honor, 1944 (med). Work: Honolulu Acad. A.; Auckland Mus. A., N. Zealand; USMC Headquarters, San Fran.; Huntington Hotel, Pasadena. Contributor: California Arts and Architecture, other mags. [47]

MOORE, Grace Cook (Mrs.) [P] Cincinnati, OH. Member: Cincinnati Women's AC [25]

MOORE, Guernsey [I] Swarthmore, PA b. 14 F 1874, Germantown, PA d. 6 Ja 1925, Phila., PA. Studied: PAFA. Member: SI, 1912. Position: Art Ed., Saturday Evening Post [24]

MOORE, H.W. [P] Hingham, MA. Member: Boston AC [27]

MOORE, Harry E. [P] Columbus, OH. Member: Columbus PPC [25]

MOORE, (Harry) Humphrey [P] Paris, France b. 1844, NYC d. 2 Ja 1926. Studied: Bail, in New Haven; S. Waugh, in Phila.; Ecole des Beaux-Arts, Paris, with Gérôme, Boulanger, Yvon. Member: Rochester AC [25]

MOORE, Henry Wadsworth [P,Arch,I,Car] Wash., D.C. b. 13 F 1879, BMFA Sch.; Académie Julian, Parker Acad., Ecole des Beaux-Arts, all in Paris. Exhibited: S. Wash. A., 1938 (prize), 1939, 1940; Wash. Ldscp. C., 1938 (prize). Work: murals, Adriance Mem. Lib., Poughkeepsie; Santa Barbara, Calif.; reredos, Nat. Cathedral, Wash., D.C.; Cleveland Park Church, Wash., D.C.; De Cordova Gal., Lincoln, Mass. [40]

MOORE, Herbert [P] Claymont, DE [13]

MOORE, John (Marcellus?) [P] Wichita Falls, TX (1948) b. 1865, near Ft. Worth, TX. Cowboy-artist who also was a Texas Ranger and Indian Scout. Encouraged by Remington; opened studio near Yellowstone, ca. 1885. Work: Ft. Worth A. Mus.; Santa Fe Railroad Coll. [*]

MOORE, John Wesley [P,T] Baltimore, MD b. 31 Ag 1912, New Park, PA. Member: Baltimore A. Union. Exhibited: Baltimore Mus. A.; Md. Inst.; B.&O. Exh.; WFNY, 1939. WPA artist. Position: T., WPA, Baltimore [40]

MOORE, Katherine Naomi [P] Dobbs Ferry, NY d. 14 Jy 1915

MOORE, Loraine (Elizabeth) [E,P] Oklahoma City, OK b. Oklahoma City. Studied: Okla. City Univ.; Okla. A.&M. Col.; D. Reed,; M. Hartwell. Member: NAWA; Oklahoma AA. Exhibited: SAE, 1938, 1940, 1941, 1944, 1945; Northwest PM, 1941, 1942, 1944 (prize), 1945, 1946; NAD, 1945, 1946; LOC, 1945, 1946; NAWA, 1946; Albany Pr. C., 1945, 1946; Kansas City AI, 1945, 1946; Tulsa AA, 1945, 1946; Okla. AA, 1940, 1941 (prize), 1942 (prize), 1944–46; Tulsa, Okla. (med); 100 Best Prints of the Year, 1941 (prize) [47]

MOORE, Lou Wall (Mrs.) [S] Chicago, IL. Member: Chicago SA. Exhibited: St. Louis Expo, 1904 (med) [21]

MOORE, Martha (Mrs. Charles H. Rathbone, Jr.) [S,G] NYC/Kensington, CT b. 30 D 1902, New Britain, CT. Studied: Grand Central A. Sch., N.Y.; ASL; Archipenko; H. Warneke. Member: NAC; Allied A. Am. Exhibited: NAC; Clay C., N.Y. Illustrator: "It's the Climate," 1936 [40]

MOORE, Martha Elizabeth (Mrs. Louis A. Burnett) [P,I,Des,T,E,Li] NYC b. 14 S 1913, Bayonne, N.J. Studied: ASL, with Bridgman, DuMond, Dickinson, Bouche; W. von Schlegell; K. Nicolaides. Exhibited: Portraits, Inc., 1946. Illustrator: Collier's (1936), Good Housekeeping (1937), Liberty (1939). Specialty: adv. design [47]

MOORE, Mary Ethelwyn [S,T] Cambridge, MA b. 24 Ap 1887, Taunton, MA. Studied: B.L. Pratt; C. Grafly; F.E. Elwell. Member: NAWPS Exhibited: PAFA, 1928 (prize); Phila. Alliance, 1928 (gold); Concord AA, 1928 (med); Boston Tercentennial Exh., 1930 (med). Position: T., Beaver Country Day Sch., Chestnut Hill, Mass. [40]

MOORE, May Virginia [P,T] Memphis, TN b. Brownsville, TN. Studied: Chase; Henri; Timmons; Miller; K. Cox; H. Breckenridge; N.Y. Sch. F.&Appl. A. Member: Western AA; Palette and Brush C. Position: Dir., Art, Memphis Sch. [31]

MOORE, Maude Isabell [S] Evanstown, IL [01]

MOORE, Nelson Augustus [Ldscp.P,Por.P] Kensington, CT b. 2 Ag 1824, Kensington d. 1902. Studied: NYC, with T. Cummings, D. Huntington. Work: CGA. Father of Edwin [*]

MOORE, Rufus Ellis [Patron,Arch] NYC b. 6 Mr 1840, Greenfield, MA d. 29 Mr 1918. Member: Am. Art A. (founder), directed the Christmas card and wallpaper exh., at the Am. A. Galleries which gave the first important stimulus to art industries in the U.S. Position: owner and publ., The American Churchman

MOORE, Ruth Huntington (Mrs.) [Por.P] NYC b. 1866, NYC d. 27 Je 1936, Raleigh, NC. Studied: NAD; PAFA; Paris, with MacMonnies, Collin, Hubbell, Whistler; M. Bohn, in Etaples. Exhibited: Paris Salon. Position: T., Pace College, NYC, 25 yrs. [10]

MOORE, Tom James [P,G] Hamilton, MT (1948) b. 22 F 1892, Dallas, TX. Studied: F. Duveneck, at Cincinnati A. Acad.; Luks; J. Sloan. Member: AAPL; AFA. Exhibited: WFNY, 1939. Position: Staff A., U.S. Public Health Service [40]

MOOREHOUSE-LELEN, Charlotte [E] Paris, France. b. NYC. Studied: Lelen, Paris [15]

MOORE-PARK, Carton [P,S,I,E,C,W,L,T] London, England b. 1879, Hebrides, New Brunswick. Studied: Glasgow Sch. A., with F. Newbery; Degas; Duran; Lieberman. Member: Intl. S. S., P. & Engravers; Pastel S.; Nat. S. Port. P., England; Aquarellists, Bruxelles. Exhibited: Glasgow Students C., 1897. Illustrator: "Alphabet of Animals," 1898; "Book of Birds," "Elfin Rhymes" [25]

MOORHOUSE, Major Lee [I] Pendleton, OR [10]

MOPOPE, Steven [P] Ft. Cobb, OK (1967) b. 14 Ag 1898, Ft. Cobb. Studied: Univ. Okla. A. Sch, with O.B. Jacoson; E. Makeir. Member: one of the "Five Kiowas" who attracted int'l. interest at the Prague Expo, 1928. Exhibited: Am. Indian Expo, Anadarko, 1965 (one-man). Work: WPA murals, Fed. Bldg., Muskogee; U.S. Field Artillery Mus., Ft. Sill; State Teacher's Colleges, Tahlequah, Weatherford, Okla.; First Nat. Bank, USPO, St. Patrick's Mission, Andarko, Okla. WPA artist. [40]

MOPP, Maximilian [P,I,Gr,W] NYC b. 1 Jy 1885, Vienna, Austria. Studied: Europe. Exhibited: AMC; Milwaukee AI; GGE, 1939; SAM; Nierendorf Gal., 1940; Europe; Vienna AS, 1925 (prize). Work: Albertina Mus., Vienna; State Gal., Prague; Nat. Gal., Berlin; MOMA. Contributor: art magazines in U.S. & abroad [47]

MORA, Domingo [S] Santa Clara, CA b. Spain d. 24 Jy 1911, San Fran.. Father of F. Luis and Joseph Mora. Member: NSS [10]

MORA, F(rancis) Luis [P,I,E,T] NYC b. 27 Jy 1874, Montivideo, Uruguay d. 5 Je 1940. Studied: BMFA Sch., with Benson, Tarbell; ASL, with Mowbray; his father, Domingo. Member: ANA, 1904; NA, 1906; Cer. S.; Arch. Lg., 1903; AWCS; NYWCC; SAE. Exhibited: Phila. AC, 1901 (gold); AAS, 1902 (gold); St. Louis Expo, 1904 (med) NAD, 1905 (prize), 1931 (prize); NYWCC, 1907; SC, 1908 (prize) 1910 (prize); P.-P. Expo, San Fran., 1915 (gold). Work: Lynn, Mass. Pub. Lib.; Oakland, Calif. Mus. A.; TMA; Newark Mus. Assn.; Butler AI; Lafayette, Ind.; Ft. Worth AA; Dallas AA; Muncie, Ind. Mus.; White House; Chamber of Commerce, Wash., D.C.; etchings, MMA; WPA murals, Town Hall C., NYC, USPOs, Catasauqua, Pa., Clarksville, Tenn. WPA artist. Position: T., Grand Central Sch. A. [40]

MORA, Jo(seph J.) [S,P,W] Pebble Beach, CA/Monterey, CA. b. 22 O 1876, Montevideo, Uruguay. Studied: Domingo Mora; J. DeCamp; J.C. Beckwith; ASL; Chase Sch. A.; Cowles A. Sch., Boston. Member: NSS;

Exhibited: GGE, 1939. Work: Cervantes monument, San Fran., Calif.; San Raphael; mem., Bohemian C., San Fran.; Mission, San Carlos, Carmel.; pediments, Don Lee Bldg., Stock Exchange, San Fran.; Pacific Mutual Bldg., Los Angeles; heroic figures, Scottish Rite Temple, San Jose; bronzes, Ponca City, Okla.; S. dec., Monterey County Courthouse, Salinas. Author/Illustrator: "Trail Dust and Saddle Leather," "Californios," "The Jo Mora Maps" [40]

MORAHAN, Eugene [S] Santa Monica, CA b. 29 Ag 1869, Brooklyn, NY. Studied: A. Saint-Gaudens. Member: NSS. Work: Newport, R.I.; Elks Mem., Buffalo; Soldiers and Sailors Mem., Carroll Park, Brooklyn; Cuddy Mem., St. Barnabas' Church, Bexhill, England; Gen. Sam Welch Mon., Buffalo; statue, Palisades Park, Santa Monica, Calif. [40]

MORAN, Allen C. [P] Wash., D.C. b. 30 Ap 1871, Wash., D.C. [17]

MORAN, Earl (Steffa) [I,P] Los Angeles, CA b. 8 D 1893, Belle Plain, IA. Studied: AIC; ASL; Grand Central A. Sch. Member: SI. Illustrator: adv., calendars [47]

MORAN, Edward [Mar.P] NYC b. 19 Ag 1829, Bolton, Lancashire, England (came to Md. in 1844) d. 9 Je 1901. Studied: Phila., with P. Weber, J. Hamilton; went to England with his brother for further study, 1862. Member: ANA (?); AWCS; Lotos C. Work: Phila. MA; MMA; BMFA; Denver AM. Best known for his seascapes showing Turner's influence. His 13 paintings of important epochs in U.S. marine history were widely exhibited. When they failed to bring the $40,000 he required, they were given to NYPL. The 1902 auction of 107 of his paintings at Fifth Ave. A. Gal. brought $16,505. His brothers were Thomas and Peter; his sons, Percy and Leon. [01]

MORAN, Edward [E,P] East Hampton, NY b. 14 Ap 1901, NYC. Exhibited: SAE, 1944; LOC, 1942, 1944; Albright A. Gal., 1943; Guild Hall, East Hampton, N.Y., 1932, 1933, 1943–46. Position: A. Dir., Guild Hall [47]

MORAN, (Edward) Percy [P,E] Easthampton, NY b. 29 Jy 1862, Phila., PA d. 25 Mr 1935, NYC. Studied: his father, Edward; PAFA with S.J. Ferris; NAD, NYC; Paris, London, 4 yrs. Member: AWCS. Exhibited: NAD, 1886 (prize); Am. A. Assn., NYC, 1888 (gold). Work: Wilstach Gal., Phila.; Masonic Hall, Chicago; Plymouth Mus.; Hamilton C., Brooklyn. Specialties: Colonial and historical subjects [33]

MORAN, Eliza Curtis [P] NYC [19]

MORAN, H. Marcus [P] Pittsburgh, PA. Member: Pittsburgh AA [24]

MORAN, Horace [Mur.P] NYC. Member: Arch. Lg., 1894; NAC [10]

MORAN, John [Ldscp.Photogr] b. 1831, Bolton, Lancashire, England (came to Md. in 1844) d. 1903. An important advocate of photography as art, his landscape photographs appeared as frontispieces in Wilson's "Philadelphia Photographer" from 1864–66. He also issued his own stereoviews, by at least 1866. Much of his work done in the Isthmus of Panama, 1870–71, was previously thought to be the work of T.H. O'Sullivan. Brother of Thomas, Edward, and Peter. [*]

MORAN, (John) Leon [P] Plainfield, NJ b. 4 O 1864, Phila., PA d. 4 Ag 1941. Studied: his father, Edward; NAD; France; England. Member: AWCS; Plainfield AA. Exhibited: Phila. AC, 1893 (gold); AAS, 1902 (gold) [40]

MORAN, Marie [P,E,T] NYC/Capri, Italy b. New Haven, CT. Studied: J.F. Weir; C. Hawthorne; S. Kendall; J. Pennell. Member: Whitney C.; GFLA [27]

MORAN, Mary Nimmo [Ldscp.P,E] Newark, NJ (during 1870s) b. 1842, Stathaven, Scotland (came to U.S. as a child) d. 24 S 1899. Studied: PAFA(?). Member: London Soc. E.&P., 1881; N.Y. Etching C., 1881. Exhibited: PAFA, 1870s; London; BMFA; NYC; 57 etchings at Union Lg. C., NYC, 1888, "Exh. of Work of the Women Etchers" (illustrated catalogue). Specialties: landscape; genre

MORAN, Paul Nimmo [P] NYC d. 26 My 1907, Los Angeles. Son of Thomas. Studied: Paris. Exhibited: AWCS; NAD. Member: SC, 1895. Active in the West, 1898. [04]

MORAN, Peter [P,E] Phila., PA b. 4 Mr 1841, Bolton, Lancashire, England (came to Md. in 1844) d. 10 N 1914. Studied: with his brothers, Thomas, Edward; London, 1863. Member: Phila. S. Etchers; A. Fund. S.; AC Phila.; Sketch C. Exhibited: etchings, Centenn. Expo, Phila., 1876 (med) [37 of the total of 209 in the expo were his; this led to his one-man exh. at NAD, 1877.]; AAS, 1902 (gold); Phila. AC, 1904. Work: Parrish AM; MMA; Amon Carter Mus.; NYPL; "Catalogue of Etched Work of Peter Moran," pub. Keppel, 1888. Specialties: landscapes; animals. Youngest of the Moran brothers, he went West before Thomas (N.Mex., 1864) and with him to the Tetons, 1879. In N.Mex. and Ariz., 1880s. His etchings were the first purchased by a major Am. publisher, 1877. His Irish wife, Emily Kelley, was also an artist. [13]

MORAN, Thomas [Ldscp.P,En,E,Li] Santa Barbara, CA b. 12 Ja 1837, Bolton, Lancashire, England (came to Md. in 1844) d. 26 Ag 1926. Studied: J. Hamilton, in Phila.; London; Paris; Italy. Member: ANA, 1881; NA, 1884; AWCS; PAFA; SC, 1888; Century Assn.; Lotos C.; A. Fund. S., Phila.; Painters of the West; S. P.&E., London. Exhibited: Centenn. Expo, Phila., 1876 (med); Pan-Am., Expo, Buffalo, 1901 (med); AAS, 1902, (gold). Work: Wistach Gal., Phila.; FA Acad., Buffalo; Capitol, Wash., D.C.; CI; MMA; Walker A. Gal.; most major museums. Best known of the prominent Moran family of painters, his fame was built upon his large majestic landscapes of the Far West and the Grand Canyon. He was with W.H. Jackson on the Hayden U.S. Geological Survey of Yellowstone, 1871; Yosemite, 1872; Grand Canyon, 1873; Tetons, 1879... traveling widely from 1881–1911. He signed his paintings with his monogram beginning in 1873 and applied his distinctive thumbprint by 1911. Mt. Moran bears his name. [25]

MORANG, Alfred (Gwynne) [P,E,L,W,T] Santa Fe, NM b. 13 Je 1901, Ellsworth, ME d. 1958. Studied: Fremond Univ.; H.B. Snell; C.S. Tyson. Member: Santa Fe P.&S.; N.Mex. AL. Exhibited: Mus. Non-Objective Painting, 1944, 1945; Phila. Pr. C., 1914; Univ. N.Mex. (one-man) / White Mem. Gal., Santa Fe (one-man); Mus. N.Mex. (one-man); Boston AC (one-man); N.Mex. State Fair, (prizes) 1941, 1943, 1944. Work: Mus. N.Mex.; Eastern N.Mex. Col.; Canyon Mus., Tex. Author: "Transcendental Painting," 1940. Illustrator: magazines, books. Position: T., Morang Sch. FA [47]

MORANG, Dorothy (Alden Clark) (Mrs. Alfred) [P,C,Mus.Cur] Santa Fe, NM (1966) b. 24 N 1906, Bridgton, ME. Studied: A. Morang; R. Jonson; E. Bistram. Member: Santa Fe P.&S.; N.Mex. AL. Exhibited: Mus. Non-Objective Painting, 1944, 1945; Sweat Mem. Mus., 1933, 1934; Mus. N.Mex., 1940–45; Univ. N.Mex., 1945; N.Mex. State Fair, 1943–45. Work: Canyon Mus., Texas. Contributor: "El Palacio" magazine. Position: Cur. Mus. N.Mex., since 1942 [47]

MORANGE, Edward A. [P] Bronxville, NY. Specialty: scenery [17]

MORANI, Salvatore [S] Phila., PA [19]

MORAS, Ferdinand [Li] Phila., PA b. 1821, Rhenish Prussia (came to Phila. in 1853) Active in Phila. until 1890s. [*]

MORE, Hermon [P,Mus.Cur] NYC/Woodstock, NY b. 15 Jy 1887, Medford, MA d. 1 D 1968, Long Branch, NJ. Studied: AIC; ASL. Member: Woodstock AA; Am. S. PS&G. Work: Davenport A. Gal., Davenport, Iowa; WMAA. Position: Cur., WMAA [40]

MOREAU, Edward Robert [P,T] Hartford, CT b. 20 Ja 1913, Springfield, MA. Studied: PIASch; YMCA Col., Springfield. Member: New Haven PCC. Illustrator: cover des., American Childhood, 1935–36, pub. Milton Bradley Co. Position: T., Weaver H.S., Hartford [40]

MOREDA, Armando [P] Brooklyn, NY [19]

MOREHOUSE, Vesta D. [P] Brooklyn, NY. Member: AWCS [47]

MOREL, May [I] New Orleans, LA. Position: associated with Daily Item, New Orleans [15]

MOREL, Vera [I] New Orleans, LA. Position: associated with Daily Item, New Orleans [15]

MORELAND, Francis A. [Mar.P] b. 1836 d. 1927. Work: Peabody Mus., Salem [*]

MORETTI, Giuseppe [S] Sylacauga, AL b. 3 F 1859, Siena, Italy (came to U.S. in 1888) d. 17 Ja 1935, San Remo, Italy. Studied: began at the age of nine, in Siena; Florence. Exhibited: Paris Expo, 1900 (med); Turin (med); St. Louis Expo, 1904 (med). Work: (a sponsor for Ala. marble) Highland Park, Pittsburgh; Panther Hollow Bridge, Pittsburgh; statue, Vanderbilt Univ., Nashville, Tenn.; statue, Birmingham, Ala.; Asbury Park, N.J.; mem., Methuen, Mass.; tablet, Shadyside Church, Pittsburgh; Albany, N.Y.; mem., Schenley Park, Pittsburgh; mem., Frederick, Md.; Endicott, N.Y.; mem., Canonsburg, Pa.; Harrisburg, Pa.; nat. mon., Battle of Nashville [25]

MOREY, Bertha Graves [P,Des,T,W] Ottumwa, IA b. 22 Jy 1881, Ottumwa, IA. Studied: AIC. Exhibited: A.All.Am., 1918 (prize) [40]

MOREY, Charles Rufus [Edu,W] Rome, Italy b. 20 N 1877, Hastings, MI. Studied: Univ. Mich.; Am. Sch. Classical Studies, Rome. Member: Mediaeval Acad. Am.; Acad. A. & Sc.; Archaeological Inst. Am.; CAA. Exhibited: Oberlin Col., 1932; Univ. Mich., 1938; Univ. Chicago, 1940; NYU, 1942. Author: "East Christian Paintings in the Freer Collection,"

1914, "Lost Mosaics and Frescoes of Rome," 1915, "The Miniatures of the Terence Mss.," 1931. Position: T., Princeton Univ., 1922-45 [47]

MOREY, Norman [P,I,Des] Milwaukee, WI b. 29 O 1901, Milwaukee, WI. Studied: G. Oberteuffer; G. Moeller; A. Miller; R. von Neumann. Exhibited: Milwaukee AI, 1937 (prize). Work: Milwaukee AI; Soldiers Home Hospital [40]

MORGAN, Adelaide Baker [P,C] Wash., D.C./Provincetown, MA b. Cleveland. Studied: G.E. Browne; M. Bohm, at Cleveland Sch. A. Member: Wash. A. Center; Cleveland AA [25]

MORGAN, Alexander C(onverse) [P] NYC/Lawrence, NY b. 1 Jy 1849, Sandusky, OH. Member: A. Fund S. (Pres.); Century A.; SC [33]

MORGAN, Annie Stephenson [P] Memphis, TN [24]

MORGAN, Arthur C. [S,P,Des,T,Mus.Dir,W,L] Shreveport, LA b. 3 Ag 1904, Ascension Parish, LA. Studied: BAID; G. Borglum; M. Korbel; E. McCarten. Member: AFA; Shreveport AC. Exhibited: La. State Univ., 1927 (one-man); Southwestern Inst. A., 1938 (one-man); La. State Exh., 1940 (one-man). Work: S., Centenary Col., St. Mark's Church, both in Shreveport, La.; USPO, Court House, both in Alexandria, La.; Terrebonne Parish Court House, Houma, La.; Southwestern Inst. A.; Gorham Co., NYC. Contributor: art reviews to newspapers. Positions: T., Centenary Col., Shreveport, 1928-33; Dir., Southwestern Inst. A., Shreveport, since 1933 [47]

MORGAN, Barbara [Photogr] Long Island, NY (1984) b. 1900, Buffalo, KS. Best known for her Martha Graham dance images, widely exhibited since 1935. Exhibited: IMP, 1955; Soc. Française de Photogr., 1964; Smithsonian, 1970; MOMA, 1972. Work: IMP; MOMA; LOC; MMA; PMA; Princeton; NPG [*]

MORGAN, Blanche (Mrs. Luther Curtis Losey) [Des,P,L] Seattle, WA b. 5 D 1912, Los Angeles. Studied: Univ. Wash. Member: NAWA; Northwest WCS; Northwest A.; Women P. Wash. Exhibited: NAWA; Oakland A. Gal.; SAM; Marshall Field Gal.; Studio Gal., Seattle; Tacoma AA; Frederick & Nelson Gal., Seattle; Women P. Wash. (prize). Work: SAM [47]

MORGAN, Charles L. [Arch,E,L,T,W] Stuart, FL b. 13 O 1890, Mt. Vernon, IL. Studied: Univ. Ill. Member: Chicago SE; AIA; AIC. Author: "Color Sketches, Spain, France, and England"; chalk talks, "Sketching for You," "Imagination, Sixth Sense," "A Century of Progress in Painting." Position: T., Kans. State College [40]

MORGAN, Charlotte Elizabeth Bodwell (Mrs.) [P,T] Carmel, CA b. California. Studied: Univ. Calif.; E. Carlsen; A. Jouillin; A. Hansen; P. Nahl; A. Matthews; Calif. Sch. FA. Member: Carmel AA. Exhibited: Oakland A. Gal.; Carmel A. Gal.; Sacramento. Exhibited: Oakland A. Gal.; Carmel A. Gal.; Sacramento [47]

MORGAN, Constance [P] NYC [08]

MORGAN, Dorothy [P] Brooklyn, NY [19]

MORGAN, Emmylou (Mrs. Ralph Depew) [P] Buffalo, NY b. 10 S 1891, Albany, NY d. 9 Mr 1932. Studied: U. Wilcox. Member: Buffalo SA; Guild Allied A.; NAC; AAPL. Exhibited: Albright A. Gal., 1927, 1928 (prize). Work: Albright A. Gal. [31]

MORGAN, Ernest [P] Chicago, IL [19]

MORGAN, Frances Mallory (Mrs. William A.) [S,T] Rye, NY b. Memphis, TN. Studied: Grand Central Sch. A.; PAFA; NAD; Archipenko; Hovannes. Member: S. Gld.; NAWA; Audubon A. Exhibited: PAFA, 1941, 1946; NAWA, 1934-40, 1941 (prize), 1942, 1943, 1944 (prize), 1945, 1946; WMAA, 1941; Riverside Mus.; CGA, 1942; S. Gld., 1939-46; Audubon A., 1946; Am. British A. Center; Arch. Lg., 1944; WFNY, 1939; NAC, 1933 (prize), 1934 (prize). Work: IBM Coll. Position: T., Halloran General Hospital, N.Y., 1943- [47]

MORGAN, Franklin Townsend [E,Li,P,Des,I,L,T,B,En] Lakeland, FL b. 27 D 1883, Brooklyn, NY. Studied: PIASch; ASL; Woodstock ASL; A. Dow; G. Bridgman; J.F. Carlsen; Pennel. Member: Phila. Sketch C.; Phila. Pr. C.; Phila. SE. Exhibited: Phila. Sketch C., 1929 (med); Phila. SE, 1932 (prize); SAE, 1935 (prize); Phila. PC, 1932. Work: LOC; NYPL; N.J. State Mus.; PMA; AIC; Cranbrook, Mich. Pub. Sch. Illustrator: "Clouds and the Weather." Positions: Associated with Virgin Island Project, T.R.A.P., 1936-37; A. Dir., Key West A. Center, Fla., 1935-41 [47]

MORGAN, George T. [S] Phila., PA [17]

MORGAN, Georgia Weston [P,T,L] Lynchburg, VA b. 18 D 1875, Floyd County, VA d. ca. 1955. Studied: Randolph-Macon Col. for Women; Académie Julian, Paris; PAFA; J. Carlson; D. Garber; J. Pearson; F. Wagner; H. Breckenridge; G. Harding; Harvard Summer Sch. A.; ASL; Beaux-Arts, Paris; Mme. La Farge, in Paris. Member: NAWA; SSAL; North Shore AA; Lynchburg AC; Studio G.; Lynchburg Sketch C.; VMFA; F., PAFA. Exhibited: NAWA, 1936-38; SSAL, 1927-30; North Shore AA, 1923, 1930, 1936; Norfolk Mus. A, 1943, 1946; Piedmont Festival, 1945, 1946; Mint Mus. A., 1943, 1946; VMFA, 1931, 1940 (one-man), 1945; Studio Gld., N.Y., 1928, 1939, 1940; Randolph-Macon Col. for Women, 1939 (one-man); Lynchburh Col., 1936, 1945 (one-man); Sesqui-Centenn. Exh., Lynchburg, 1936 (prize). Work: church, Lynchburg, Va.; Home Ec. Sch., Naruna, Va.; Randolph-Macon Col. for Women; Lynchburgh Col.; Jones Mem. Lib., Pub. Sch., Lynchburg, Va.; Vanderpoel Coll. Position: T., Lynchburg Col., 1917-45 [47]

MORGAN, Gladys B. (Mrs. Arthur C.) [P,En,T] Shreveport, LA b. 24 Mr 1899, Houma, LA. Studied: Randolph-Macon Col. for Women; Columbia; A.C. Morgan; W.H. Stevens. Exhibited: Mus. FA, Montgomery, Ala.; Old Capitol Mus., Baton Rouge; Delgado Mus. A. Positions: T., Centenary Col. (1928-33), Southwestern Inst. A., Shreveport, La. (since 1934) [47]

MORGAN, Helen [En] NYC b. Chicago, IL [15]

MORGAN, Helen Bosart (Mrs. J.W.) [S] Springfield, OH b. 17 O 1902, Springfield. Studied: Wittenberg Col.; Dayton AI. Member: NAWA; Dayton S. P&S; Springfield AA (founder). Exhibited: NAD, 1945; All.A.Am., 1944, 1945; NAWA, 1944, 1946; Miami Valley A., 1943-46; Butler AI, 1946; Springfield AA, 1946 [47]

MORGAN, Henry J. [P] Woodburn, D.C. [04]

MORGAN, Herbert A. [P,T] b. 22 Je 1857, NYC d. 29 D 1917. Studied: Gérôme, Ecole des Beaux-Arts, both in Paris. Member: SC, 1892; A. Fund S. Positions: T., ASL, MMA Mus. Sch. [17]

MORGAN, Isaac (Ike) [I] Brooklyn, NY b. 28 Je 1871, Grand Tower, IL d. 12 S 1913. Studied: St. Louis Sch. FA. Creator: "Kid of Many Colors." Living in Chicago, 1908. Positions: Staff, St. Louis Republic, Chicago and N.Y. newspapers [08]

MORGAN, J. Pierpont [Patron] b. 17 Ap 1837, Hartford, CT d. 31 Mr 1913, Rome, Italy. Studied: Goettingen Univ., Germany. On his return to the U.S. went into business in NYC, 1857. Was a major consolidator of the railroad, shipping and steel industries. A major collector and philanthropist, he was responsible for the Morgan Library in NYC.

MORGAN, John Hill [Patron,Mus.Cur] Farmington, CT b. 1875, NYC d. 16 Jy 1945. Specialty: early American art. Collected early Am. portraits; wrote extensively on the subject. Position: Hon. Cur., Am. Paintings, Yale Univ. A. Gal.

MORGAN, Junius Spencer [Patron] d. 18 Ag 1932, Valmont, Switzerland. Member: American Colony, Paris, 1910-32. Awards: Knight of the Legion of Honor; Order of the Crown of Italy. Princeton Univ. received his collection of engravings, etchings, rare editions of books, Greek terra cotta vases and a large coll. of poems by Virgil.

MORGAN, Lucy Calista [C,T] Penland, NC b. 20 S 1889, Franklin, NC. Studied: Central T. Col., Mt. Pleasant, Mich.; Univ. Chicago; E.F. Worst. Member: Southern Highlands Handicraft Gld.; Southern Highlands, Inc. Contributor: Practical Weaving Suggestions magazine. Positions: Dir., Penland Weavers & Potters, 1934-46; Founder/Dir., Penland Sch. Handicrafts, N.C., 1929-46 [47]

MORGAN, Lynn Thomas [I,E,Li,P] NYC b. 24 Ap 1889, Richmond, IN. Studied: John Herron AI; Cincinnati A. Acad.; ASL; W. Forsyth; Meakin; J. Hopkins; G. Bridgman. Member: SI [47]

MORGAN, M. [P] Pittsburgh, PA. Member: Pittsburgh AA [21]

MORGAN, M. De Neale [P,T,E,I] Carmel CA b. San Fran. Studied: Calif. Sch. FA, with V. Williams; A. Matthews, E. Carles, W. Keith; San Fran. AI; Chase. Member: Carmel AA. Exhibited: NYWCC; BM; NAWA; Laguna Beach AA; San Fran.; Oakland; Berkeley; Sacramento; Los Angeles. Work: San Fran. AA; Berkeley AL; Stanford Univ. A. Gal.; Univ. Tex.; Carmel A. Gal.; Mem. Mus., Los Angeles; Del Monte Gal.; Univ. Southern Calif.; Lindsay H.S.; Salinas H.S.; H.S., City Hall, Presidio, all in Monterey, Calif.; Sunset Sch., Carmel; Nordhoff Univ., Ventura; San Jose Sch. Dept. Illustrator: early Monterey, for Index of Am. Design [47]

MORGAN, Matthew [P,Li,Car] b. 1839, London d. 1890, NYC. Exhibited: Civil War panoramas, probably in NYC [*]

MORGAN, Maud Cabot (Mrs. Patrick) [P] NYC/Charlevoix, Quebec b. 1 Mr 1903, NYC. Studied: Académie Julian, Paris; ASL; H. Hofmann. Member: Collectors Am. A., Inc., NYC; Am. Fed. A. Exhibited: PAFA, 1937; Levy Gal., NYC, 1938; Grace Horne Gal., Boston, 1938. Work: MMA; WMAA [40]

MORGAN, Norma Townsend [P,C,T] Key West, FL/East Eddington, ME b. 11 F 1918, Moylan, Rose Valley, PA. Studied: F.T. Morgan; M. Watson. Member: Key West SA. Exhibited: Key West A. Center; Miami Beach A. Gal.; Fla. Bldg., WFNY, 1939. Position: T., Camp Baldy, Eddington, Maine [40]

MORGAN, Patrick [P] NYC/Charlevoix, Quebec, Canada b. 27 Mr 1904, NYC. Studied: Harvard; ASL; C. Hawthorne; H. Hofmann. Exhibited: Rehn Gal., NYC; PAFA, 1938; GGE, 1939. Exhibited: Wadsworth Athenaeum, Hartford [40]

MORGAN, Theophilous John [P,Dr,E,L,T,W] Silver Spring, MD b. 1 N 1872, Cincinnati, OH. Studied: Cincinnati Sch. A., with Lutz, Noble, Meakin, Nowottney, Rebisso, Duveneck. Member: S. Wash. A.; Wash. AC; NAC; Wash. WCC; San Diego AA; San Antonio AL; SSAL; Chicago Gal. Assn.; NYWCC; Beachcombers; San Antonio Palette Assn. Exhibited: Tex., 1928 (prize), 1929 (gold); Springville, Utah, 1930 (prize). Work: Univ. Ind.; Aurora, Ill. AA; Houston MFA; Delgado Mus. A.; Witte Mem. Mus.; Los Angeles Mus. A.; Springville AA; Highland Park SA, Dallas; Girl Scouts of America Barracks, San Antonio; Women's Bldg., Harlingen, Tex.; H.S., Salt Lake City; Women's Col. Ala.; Montgomery Mus. FA; L. Rosenwald Coll., Phila.; Highland Park SA [47]

MORGAN, Wallace [I] NYC d. 1948. Member: ANA; SI; NIAL; Century Assn.; AG. Positions: A., Am. Expeditionary Forces, France, WW I; Illus., Crowell Publ. Co., Cosmopolitan, Collier's [47]

MORGAN, William [Por.P] NYC b. 1826, London, England d. 1900. Studied: NAD, 1851; Le Havre, France. Member: ANA, 1862; A. Fund S.

MORGENROTH, Joseph G. [S] Buffalo, NY b. 27 My 1886, Germany. Studied: State Sch., Munich, with H. Wadere, B. Schmitt; Acad., Munich. Member: Buffalo SA. Exhibited: Buffalo SA, 1935 (prize). Work: Buffalo Mus. Sc.; General Electric Bldg., Syracuse; church, Munich. Position: Affiliated with Mus. Sc., Buffalo [40]

MORGENTHALER, Charles Albert [I,Des,S,C,P] St. Louis, MO b. 18 Je 1893, Hallsville, MO. Studied: St. Louis Sch. FA; AIC; F. Carpenter; E. Forsberg; J. Lacey. Member: Indp. A. St. Louis; St. Louis AL; Am.A.All. Exhibited: Kansas City AI, 1932; St. Louis AG; St. Louis AL; Indp. A., St. Louis, 1944–46; CAM, 1945, 1946 [47]

MORGERETH, Frank (H.) [P] Baltimore, MD b. 18 Ja 1899, Baltimore, MD. Studied: A. Gross. Member: A. Union, Baltimore; Am. Ar. Cong. Exhibited: Pal. Leg. Honor; PMG; Dallas MFA; Baltimore MA, 1937 (prize), 1938; WFNY, 1939. Work: Baltimore Mus. A.; Jr. Lg., Baltimore [40]

MORIES, Fred G. [I] Provincetown, MA [24]

MORIN, Harold N. [P] Minneapolis, MN b. 10 Ja 1900, Helsingborg, Sweden. Studied: Minneapolis Sch. A. [29]

MORITZ, T.E. [P] Chicago, IL [21]

MORLAN, Alice [P] NYC. Position: Affiliated with Carnegie Studios, NYC [01]

MORLAN, Dorothy [P] Indianapolis, IN. Studied: Herron AI, with Forsyth, Stark [25]

MORLEY, Eugene [P,Des,Dec,Li,T] NYC b. 10 N 1909. Member: Am. A. Cong.; N.Y. Artists U.; ASL. Work: murals, Williamsburg Housing Project, Brooklyn, N.Y. Positions: Assoc., Norman Bel Geddes, stage des.; T., Am. Artists Sch., NYC [40]

MORLEY, Helen Sewell Johnson [P,I,C,T] Wash., D.C. b. Cambridge, MD. Studied: I. Olinsky; C. Hawthorne; Corcoran Sch. A.; NAD. Member: AWCS; S. Wash. A. Work: PMG; Franklin Sch. Bldg.; WPA office, Wash., D.C. WPA artist. [40]

MORLEY, Hubert [E,P] Chicago, IL b. LaCrosse, WI. Studied: Chicago Acad. FA; AIC. Member: SAE; Chicago Gal. Assn.; Prairie PM. Exhibited: AIC, 1934 (prize); Tri-State Exh., Indianapolis, 1944 (prize). Work: AIC; Smithsonian Inst., Wash., D.C.; Ill. State A. Coll.; Bibliothèque Nationale, Paris [47]

MORLEY, Katherine Carol [P] Milwaukee, WI b. 1878 d. 1960. Studied: AIC; Whistler, in Paris [*]

MORLEY, Mary Cecilia [P,T] Watertown, NY b. 14 D 1900, Watertown. Studied: St. Lawrence Univ., Canton, N.Y.; Md. Inst.; Syracuse Univ.; NYU. Member: Saranac AL; Indp. A. Group. Exhibited: Acad. All. A., 1940–43; All.A.Am., 1941, 1943; Audubon A., 1944; Indp. A. Groups, 1944; Saranac AL, 1940, 1942–44; Watertown Pub. Lib., 1944 (one-man). Position: T., Jr. H.S., Watertown,, N.Y. [47]

MORLEY, Ruth Killick [S,C,T] NYC b. 8 Je 1888, London, England. Studied: J. Dampt; Bourdelle. Member: Alliance [33]

MORONEY, Frances Lea (Mrs.) [P] Phila., PA [17]

MOROSOFF, Vadim V(ladimirovich) [P] Brooklyn, NY b. 9 Ap 1874, Russia. Member: S.Indp.A. [29]

MORRELL, Edith Whitcomb [P] NYC. Studied: R. Miller, ASL. Member: NAWPS [21]

MORRELL, Mary Ogden [P] Knoxville, TN [13]

MORRILL, Grace [P] St. Louis, MO. Member: St. Louis AG [25]

MORRICE, James Wilson [P] Paris, France [01]

MORRIS, Adelaide (Mrs. Gardner) [P,Gr,C] Jamesville, NY b.11 Ja 1898, Brooklyn, NY. Studied: Women's Sch. App. Des.; ASL; Syracuse Univ.; J. Sloan; H. Sternberg. Member: S.Indp.A. Exhibited: CI, 1931; S.Indp.A., 1925–46; Contemporary A., 1937–40; Brooklyn SA, 1933–35; Finger Lakes Exh., Rochester, N.Y., 1943, 1946; Community A. Utica, N.Y., 1942, 1946; Syracuse AA, 1942–46; Syracuse PM, 1942–46, (prizes) 1942, 1943, 1945; Onandaga Hist. S., 1945 (prize). Work: Newark Mus. [47]

MORRIS, Adelaide [P,T] Los Angeles, CA b. 22 S 1881, Lineville, IA. Studied: Univ. Colo. Member: Pacific AA; Calif. A. Teachers A. Position: T., Univ. Calif, Los Angeles [40]

MORRIS, Alice [P,Li] San Fran., CA b. Wamesit, MA. Studied: Emory Univ.; NYU; Univ. Calif.; Calif. Col. A. & Crafts; M. Sterne. Member: Calif. WCS. Exhibited: Art in Nat. Defence travelling exh., 1942–46; Riverside Mus., 1940; SFMA, 1940–42; Los Angeles Mus. A.; San Diego FAS; San Bernardino, Calif., 1940–42 [47]

MORRIS, Benjamin Wistar [P,Arch] Mt. Kisco, NY b. 25 O 1870, Portland, OR. Studied: Sch. Arch., Columbia Univ.; Ecole des Beaux Arts, Paris. Member: Arch. Lg.; Am. Inst. Arch.; ANA, 1927. Exhibited: Arch. Lg.; Am. WCS, 1936. Work: Cunard Bldg., NYC; S.S. Queen Mary [40]

MORRIS, Carl A. [P,C,T] Portland, OR b. 12 My 1911, Yorba Linda, CA. Studied: AIC; Kunstgewerbeschule, Vienna; Acad., Vienna. Member: Am. Ar. Cong.; F., Fnd. des Etats Unis, Paris, 1935. Exhibited: WFNY 1939; GGE, 1939; AIC, 1942; SFMA, 1944–46; Palace Legion Honor, 1946; SAM, annually, 1940 (one-man); Portland AM, annually, 1946 (one-man); Spokane A. Center Work: SAM; Portland AM; Portland Pub. Lib.; Reed Col.; murals, USPO Eugene, Oreg. Position: Dir., WPA Gal., Seattle. WPA artist. [47]

MORRIS, Catherine Wharton. See Wright.

MORRIS, Charles K. [P,I] Chicago, IL [08]

MORRIS, Dudley (Henry) (Jr.) [P,Li,I,W,T] Princeton, NJ b. 26 Ap 1912, NYC d. 8 Ja 1966. Studied: Yale; ASL, with H. Wickey, A. Brook, C. Locke; G. Picken. Member: Am. A. Group. Exhibited: AIC, 1936; CI, 1936; WMAA, 1938; GGE, 1939; WFNY, 1939; CAM, 1937; RISD, 1937; W.R. Nelson Gal., 1938. Work: WMAA; AGAA. Author/Illustrator: juvenile books. Position: T., Lawrenceville Sch., N.J., 1936–43, since 1946 [47]

MORRIS, Elise H. [P] Phila., PA [06]

MORRIS, Ellwood [Ldscp.P] Richmond, IN b. 5 Je 1848, Richmond, IN d. 20 F 1940. Studied: self-taught. Member: Richmond AA. Work: Earlham Col., Masonic C., St. Mary's Sch., Richmond [40]

MORRIS, Florence (Mrs. R.E.) [P] Roswell, NM b. 5 Mr 1876, Nevada, MO. Studied: W.E. Rollins; A.J. Hammond; Paris; Antwerp; Florence. Member: AFA; N.Mex. Archaeological S.; BAC. Exhibited: Galerie d'Art du Montparnasse, Paris, 1930 (one-man); U.S.; Tri-State Fair, N.Mex., Tex., Okla., 1925 (prize). Work: Mus. A. & Archaeology, Santa Fe; portraits, Hos. N.Mex.; Crawford Hotel, Carlsbad; City Lib., Claremore, Okla.; Cottey Col., Mo.; Wesleyan Col., Iowa; U.S. Bldg., Sorbonne; Women's C. Bldg., Paris. [47]

MORRIS, George Ford [P,Gr,S,I] Shrewsbury, NJ b. St. Joseph, MA d. 1960. Studied: AIC; Académie Julian, Paris. Member: Am. Animal Ar. Assn. (Pres.); S. Am. Sporting A. Illustrator: Scribner's, Century. Specialty: painting famous horses, their owners & riders [47]

MORRIS, George L.K. [P,S,W,L,T,Des,Cr] NYC b. 14 N 1905, NYC d. 1975. Studied: Yale, 1928; ASL, with Sloan, K.H. Miller, 1929–30; Acad. Moderne, Paris, with Leger, Ozenfant, 1930. Member: Am. Abstract A., 1936 (founder); Fed. Mod. P&S. Exhibited: WMAA, 1938–46; PAFA, 1945, 1946; CI, 1944–46; Am. Abstract A., 1936–46; Fed. Mod. P.&S., 1941–46; VMFA, 1946; Berkshire Mus., 1933, 1966 (retrospective); Yale,

1935 (one-man); CGA, 1964 (retrospective); Riverside Mus., NYC; SFMA; WFNY, 1939; Nelson Gal., Kansas City. Contributor: articles on abstract art, Partisan Review. Positions: T., ASL (1945), St. John's Col., Annapolis (1960–61) [47]

MORRIS, George Spencer [P] Phila., PA. Studied: PAFA [21]

MORRIS, H.B. [P] Indianapolis, IN [24]

MORRIS, J. Craik, Jr. [Car,Ldscp.P,T,Dr] Wilmington, DE b. 8 Ag 1908, Memphis, TN. Member: Delaware AC; Wilmington SFA. Exhibited: AC Exh., 1930 (prize), 1935, 1939 (prize). Positions: A. Critic, Wilmington Evening Journal; T., St. Andrews Sch., Middletown, Del. [40]

MORRIS, J.H. [P] Morristown, NJ [06]

MORRIS, James Stovall [P,Dec] Santa Fe, NM b. 14 O 1898, Marshall, MO. Studied: Wash. & Jefferson Col.; Cincinnati A. Acad.; PAFA; ASL, with J. Sloan. Member: Santa Fe AA; Santa Fe P&S; Rio Grande Painters; Am. Ar. Cong. Exhibited: Univ. N.Mex.; Sequi-Centenn. Expo, Phila., 1926; WFNY, 1939; GGE, 1939; Denver AM, 1934, 1935; PMG, 1940; Oakland A. Gal., 1935, 1936; Santa Barbara Mus. A.; SFMA; San Diego FAS; Los Angeles Mus. A.; Springfield Mus.; U.S. Gov. Traveling Exh., 1940; N.Mex State Fair. Work: Santa Barbara Mus. A.; MMA; Lib. Color Slides; murals, Spanish-Am. Normal Sch., El Rito, N.Mex.; USNR Naval Construction Battalion, Aleutian Islands; Camp Parks, Calif. WPA artist. [47]

MORRIS, Louise [Mur.P,B,C] Cleveland, OH b. 14 Jy 1896, Alliance, OH. Studied: B. Robinson; G. Bridgman; F. Gruger; W. Reiss; H. Keller; F. Wilcox. Member: ASL; Cleveland Pr. C. Exhibited: CMA, 1932 (prize), 1934 (prize), 1935, 1936 (prize), 1939 (prize). Illustrator: "Los Pastores," by M.R. Van Stone, 1933. Work: Municipal Coll., Cleveland [40]

MORRIS, Nathalie [P] Phila., PA b. Phila. Studied: PAFA, with Anshutz [25]

MORRIS, Paul Winters [S] NYC/Bridgeport, CT b. 12 N 1865, DuQuoin, IL d. 16 N 1916. Studied: St. Gaudens, French, in NYC; Paris, with Injalbert, Rolard. Member: NAC; SC; NSS 1914; Arch. Lg. [15]

MORRIS, Raymond L. [P,Arch] Bloomington, IN b. 31 D 1897, Salem, IN. Studied: Herron AI, Indianapolis. Member: Bloomington AA (Pres.). Exhibited: Hoosier Salon. Work: mural, USPO, Knightstown, Ind. WPA artist. [40]

MORRIS, Robert C. [P] Anderson, IN b. 6 Ja 1896, Anderson. Studied: E.R. Sitzman, in Indianapolis; R. Byrum, in Anderson. Member: Anderson SA. Exhibited: Ind. State Fair, 1929 (prize), 1931 (prize); Anderson SA, 1932 (prize), 1934 (prize), 1935 (prize) [40]

MORRIS, Virginia Leigh [S,L] Norfolk, VA b. 16 O 1898, Norfolk. Studied: S. Borglum; H. Frishmuth; Yale. Member: Norfolk SA; S. Wash. A.; Wash. AC; SSAL. Exhibited: Norfolk SA, 1921 (prize), 1926 (prize) [40]

MORRIS, W.C. [I] NYC [19]

MORRIS, William Charles [Cart] Spokane, WA b. 6 Mr 1874, Salt Lake City, UT [13]

MORRIS, Wright [Photogr,W] b. 1910, NE. He is more widely known as a writer than a photographer, though his masterful combination of prose with photographs (e.g., "The Inhabitants," 1946) is unique. Work: MOMA; BMFA; Univ. Nebr.; SFMA. Position: T., Princeton, 1971–71 [*]

MORRISON, B.Y. [P] Wash., D.C. [19]

MORRISON, Carrie Trumpler [Min.P] Elkton, MD [13]

MORRISON, David H(erron) [P] NYC/Huntington, NY b. 15 N 1885, Rawalpindi, Punjab, India d. 4 S 1934. Studied: K.H. Miller; G.B. Bridgman. Member: ASL; Salons of Am. (Dir.); Am. Soc. PS&G. Exhibited: MMA; WMAA. Positions: T., A. Stevenson Sch., NYC; Dir., H.E. Field A. Fnd. [33]

MORRISON, Dorothy Marie [Des,E] Phila., PA b. 8 Je 1909. Studied: E. Horter, PMSchIA. Member: SAE; Southern PM S. Exhibited: Phila. Pr. C., 1935; Graphic Sketch C., 1935 (prize), 1937 (prize), 1939 (prize) [40]

MORRISON, L.G. [P] Seattle, WA [24]

MORRISON, Louise Gertrude [P] Bryn Mawr, PA b. Boston. Studied: Collin, Paris [15]

MORRISON, M.M. [P] Seattle, WA [21]

MORRISON, Mary Coples [S] Wash., D.C. b. 20 D 1908, Petersburg, VA. Studied: M. Miller; H. Schuler [33]

MORRISON, Nelson [P] Tacoma, WA. Member: Tacoma FAA [25]

MORRISON, R.B. [I] NYC [08]

MORRISON, R. Douglas, Mrs. See Black, Mary C.W.

MORRISON, Zaidee Lincoln [P,I] NYC b. 12 N 1872, Skowhegan, ME d. 29 Ag 1953. Studied: CUASch; NAD; ASL; F. DuMond; J.H. Twachtman; R.H. Nichols. Exhibited: NAD; North Shore AA; NYWCC; Ogunquit A. Center; Palm Beach AA; Portland Mus. A.; BM; NAWA; ASMP; Baltimore Min. P. S.; Grand Central A. Gal. Work: Mt. Holyoke Col.; History House, Skowhegan; Smithsonian Inst.; Boston Univ.; Municipal Gal., NYC; portraits [47]

MORROW, B(enjamin) F(rancis) [E,W] NYC b. 13 S 1891, NYC d. 27 O 1958, West Palm Beach, FL. Member: Haden Etching C. (Pres.); Am. Veterans SA; Am. Physicians AA. Exhibited: Am. Physicians AA, annually; Haden Etching C., annually; Am. Veterans SA, annually; NYC, 1936 (prize). Author: "Art of Aquatint," 1935. Contributor: Dun's Review, Avocations. Position: Ed., Fine Prints of the Year, 1935 [47]

MORROW, Julie. See De Forest.

MORROW, Nena. [P,I,W] Fayetteville, NC b. 1 F 1868, Haymount, NC. Studied: Cox; Beckwith; Brush; Browne; Carlson; Hawthorne; Brundage. Member: S.Indp.A. of NYC, Chicago, Buffalo and Wilkes-Barre [25]

MORSE, Anna G. [P,I,T] NYC b. Leominster, MA. Studied: Smith Col.; ASL; Académie Julian, Paris; K. Cox; J. Lefebvre; Robert-Fleury. Member: PBC; Lg. Am. Pen Women; C.L.W. Art C. Exhibited: PBC; Wolfe AC, 1910 (prize), 1920 (prize); Boston AC; Lg. Am. Pen Women, 1937 (prize); Wanamaker's, Phila., 1910 (prize). Position: T., Adelphi Acad. A., NYC, 1918–41 [47]

MORSE, Anne F. [P] Providence, RI. Member: Providence WCC [15]

MORSE, Anne Goddard [P,I] Providence, RI b. 17 Ja 1855, Providence d. ca. 1955. Studied: Mass. Normal A. Sch.; ASL; W. Eaton; stained glass, J. La Farge. Member: Providence WCC [40]

MORSE, Beryl [P] NYC [17]

MORSE, Edna [P] Montclair, NJ [01]

MORSE, Edward L(ind) [P,W] Pittsfield, MA b. 29 Mr 1857, Poughkeepsie, NY d. 9 Je 1923. Son of S.F.B. Morse. Studied: Germany, with Thumann, Gussow, Thedy; Paris, with Bouguereau, Ferrier. Author: "Samuel F.B. Morse, His Life and Letters" [21]

MORSE, Elizabeth Hubbard [P] Buffalo, NY. Assoc: Buffalo SA [17]

MORSE, Fannie S. Montague (Mrs. Joshua, Jr.) [P,I] Boston, MA b. 20 O 1867, Fair Haven, MA. Studied: BMFA Sch., with Benson, Tarbell; D.W. Tryon. Member: Copley S., 1891 [10]

MORSE, Glenn Tilley [P,C,W,L,J] Sarasota, FL/Newburyport, MA b. 30 Jy 1870, St. Louis, MO d. 23 Je 1950. Studied: Harvard; Ringling Sch. A.; W. Adams; H. Remson; M.F. Browne. Member: BAC; Copley S. (Pres.); Boston SAC; Sarasota AA; Business Men's AC, Boston; Merrimac Valley AA; Fla. Fed. A. Lectures: Wax Portraits; Modellers for Wedgewood; History of Spoons and Silver Marks; Sphragistics (especially seals of monarchs); Silhouettes as a Fine Art" [47]

MORSE, Howe Dorothy [Ldscp.P] Pawlet, VT b. 28 Ap 1900. Studied: BMFA Sch. [40]

MORSE, Irene Milner (Mrs. Norman K.) [P] Phila., PA/Avalon, NJ b. 16 Mr 1894, Phila. Studied: PAFA [33]

MORSE, Jean H. [P] Englewood, NJ/Cotuit, MA b. 7 S 1876, Derby, CT. Studied: Yale; Chase; Woodbury. Member: New Haven PCC; Northern Valley, N.J. AA; AFA [40]

MORSE, Jennie Greene (Mrs. Henry W.) [T,Des,P,C,W] Brooklyn, NY b. 19 Mr 1908, NYC. Studied: N.Y. Sch. Appl. Des. for Women; NYU; Berkshire Summer Sch. of A. Member: Salart C. Exhibited: MET, 1931; AMNH; Grand Central A. Gal. Contributor: articles, Annual of Am. Des., 1931; La Revue Moderne, 1932. Positions: T., N.Y. Evening Sch. Indst. A. (1929–43), Fashion Inst. Tech., NYC (from 1945) [47]

MORSE, John A. [P] West Detroit, MI [24]

MORSE, Lucy Gibbons (Mrs.) [I] b. 1840, NYC d. 15 Jy 1936, NYC. Her book of silhouettes was published when she was 80.

MORSE, Mamie Haile [P] Chicago, IL [13]

MORSE, Mary Minna [Ldscp.P,Mar.P] Boston, BA b. 30 Je 1859, Dorchester, MA. Studied: R. Turner; L. Ritter; G. Hitchcock, in Holland. Member: Boston WCC; Copley S. Specialty: watercolors [25]

MORSE, Pauline H(estia) [P] Worcester, MA b. Marlborough, MA. Studied: D. Ricci; Mumann; Rice; Snell. Member: S.Indp.A.; AFA; WMA [40]

MORSE, Ruth E(leanor) [P,T] Paris, France b. 12 Ap 1887, Watertown, MA. Studied: A.T. Hibbard. Member: Rockport AA [25]

MORSE, Sadie May [Edu,Des,C,P,L] Marblehead, MA b. 5 My 1873, Lexington, MA. Studied: Mass. Sch. A.; MIT; abroad. Member: Weavers Gld., Boston; Boston SAC (Master Craftsman); Marblehead AA; Professional Woman's C., Boston; AFA. Positions: T., Pub. Sch., Newburyport, Mass.; Occupational Therapist, 1940 [47]

MORSE, Vernon Jay [P,B,T] Sierra Madre, CA b. 9 S 1898, Benton Harbor, MI. Studied: S. Macky, C. Macky, at Calif. Sch. FA. Member: Laguna Beach AA; Calif. WCS. Exhibited: Intl. Exh., Los Angeles PM; Los Angeles County Fair (prize) [40]

MORSHEAD, A(rminell) [P,E] Blackheath, England. b. Devon, England. Studied: H. Tonks, Slade Sch., London; FA Dept., Univ. London. Member: New SA, London [25]

MORTELLITO, Domenico [Mur.P,Des,C.,L] NYC b. 1 S 1906. Studied: PIASch; Newark Sch. F.&Indst.A. Member: Mural P. Exhibited: WFNY, 1939; GGE, 1939. Work: Newark Pub. Sch. F.&Indst. A.; Newark City Railway Bldg.; USPO, Port Chester, N.Y.; Nat. Zoological Park, Harlem Housing Proj., Wash., D.C.; Morgan Lib. Annex, NYC; Capitol Theatre, Atlanta; Brooklyn Edison Co., NYC; St. Joseph's Chapel, Brentwood, N.Y.; Yale; Seaboard Air Line Railway; Atlantic Coast Line; Lerner Shop., NYC; Saks, Los Angeles Pub. Works A. Proj. Illustrator: book jackets, "Faith, Hope, No Charity," by Lane, 1936. Specialty: murals. WPA artist. Position: Des./Dir., Mortellito Studio, NYC. [40]

MORTELLITO, Jane Wasey, Mrs. See Wasey.

MORTIMER, Mary Eleanor [S] Tuxedo, Park, NY [19]

MORTIMER, Norman J. [S] New Hope, PA b. 16 My 1901, San Fran., CA [33]

MORTIMER, Stanley [P,Patron] NYC b. 1853, NYC d. 5 Ap 1932. Studied: Paris. Exhibited: Paris Salon. Although he turned from painting to sports he continued to build a large art collection.

MORTON, Christina (Mrs. Benjamin A.) [P] NYC b. Dardanelle, AK. Member: AFA; NAWA; All.A.Am.; MacDowell C. Work: Hispanic Mus., NYC. Illustrator: "The Veiled Empress," by B.A. Morton [47]

MORTON, Edward [P] Milwaukee, WI. Exhibited: PAFA, 1939; Madison, Wis. AA, 1938 (prize); Wis. Salon A., 1938 (prize). Work: USPO, Oconomowoc, Wis. WPA artist. [40]

MORTON, Helen [S] Wheaton, IL [17]

MORTON, John R. [P] Chicago, IL [15]

MORTON, Josephine A(mes) [P] Williamstown, MA b. 12 Mr 1854, Boston, MA. Studied: Eakins; Paris, with Laurens, Constant. Member: Newport AA; S.Indp.A. [25]

MORTON, Katherine Gibson [P,S] Madison, CT b. 14 N 1895, NYC. Studied: B. Robinson; J. Lie; J. Farnsworth. Exhibited: NAD, 1941; So. Vermont A., 1936–39; Norton Gal., West Palm Beach, Fla., 1944–46; Soc. Four A., 1943–46; Tricker Gal., 1939; Arden Gal., 1935 (one-man); Ferargil Gal., 1936 (one-man); Worth Ave. Gal., Palm Beach, 1943 (one-man). Work: S., Brookgreen Gardens, S.C. Illustrator: pamphlets, AMNH [47]

MORTON, Leonora [P] NYC [17]

MORTON, Ruth [P] Milwaukee, WI [24]

MOSBY, William Harry [P,Gr,I,T] Otummwa, IA b. 24 Ja 1898, Sioux City d. 19 D 1964, Wilmette, IL. Studied: Chicago Acad. A.; H. Richir; Pierre; Hoffman, Rubay; Hess; Acad. Royale des Beaux Arts, Brussels; AIC. Member: Beverly Hills AA; South Side AA; Chicago Gal. Assn.; Assn. Chicago P.&S.; CAA. Exhibited: U.S., abroad. Work: mural, St. Mathew's Episcopal Church, Chicago, Ill. Illustrator: for Chrysler; Mars Candy Co.; Goodrich Tires. Position: T., Am. Acad. A., Chicago [47]

MOSCA, August [P] Shelter Island, NY b. 23 Ag 1909, Naples, Italy. Studied: Yale; ASL. Exhibited: NAD, 1943; Mint Mus. A., 1946; Miss. AA, 1946; Irvington Pub. Lib., 1946; New Haven PCC, 1934; Palace Legion Honor, 1946 (med) [47]

MOSCHOWITZ, Paul [Por.P,T] NYC b. 4 Mr 1876, Giralt, Hungary d. 4 Ja 1942. Studied: ASL; Académie Julian. Member: SAA, 1901; ANA, 1906. Exhibited: St. Louis Expo, 1904 (med). Position: T., PIASch [47]

MOSCHEL, Mae C. [P] Cincinnati, OH. Member: Chicago NJSA [25]

MOSCON, Arthur [P] NYC. Member: S.Indp.A. [25]

MOSE, Carl C. [S,C,W,L,T] St. Louis, MO b. 17 F 1903, Copenhagen, Denmark d. 1973. Studied: AIC; ASL; BAID; L. Taft; A. Polasek; L. Lentelli. Member: St. Louis AG; S. Wash. A.; 2 x 4 C. Exhibited: AIC, 1918–38; NAD; Royal Acad., Copenhagen; Amsterdam; CGA (one-man); Minneapolis Inst. A. (one-man) (prize); S. Wash. A. (one-man), 1935 (prize); Chicago Gal. Assn. (one-man); PMG (one-man); St. Louis AG (one-man); Houston MFA (one-man); Salina, Kans. Comp. (prize); Twin Cities Exh., Minneapolis (prize); Kansas City AI, 1938 (prize), 1939 (prize). Work: CGA; Minn. State Hist. S.; S. figures, mon., Old Crossing State Park, Minn.; Ft. Sumter, N.C.; Meridian Hill Park, Wash., D.C.; Potomac Electric Power Co., Wash., D.C.; Wash. Cathedral; Hospital, St. Louis; Dept. Agriculture Bldg., Wash., D.C.; USPOs, Wellston, Mo., and at Court House, Salina, Kans.; Chicago YMCA; medal for Am. Med. Assn.; Emergency Hospital, Wash., D.C.; Faribault Lib., Minn.; Carleton Col., Northfield, Minn.; mon., Crookston, Minn.; Settlers Mon., Wash., D.C.; Noonday C., St. Louis; Wash. Univ.; Med. S. WPA artist. Position: T., Wash. Univ., St. Louis, from 1938 [47]

MOSE, Eric [P] Croton-on-Hudson, NY b. 27 S 1905, Copenhagen, Denmark. Studied: AIC; PAFA; Mexico. Member: NSMP; Mural AG, NYC. Exhibited: Knoedler Gal., Chicago, 1933(one-man); Minneapolis Inst. A., 1933 (one-man); Fed. A. Gal., NYC, 1936; Arch Lg., 1938 (prize); murals, WPA Bldg., WFNY, 1939. Work: WPA murals, Theatre & Pub. Market, Mexico City; Carleton Col., Northfield, Minn.; Samuel Gompers H.S., NYC; Lincoln Hospital, Bronx, N.Y.; Chase Hotel, St. Louis, Mo. [47]

MOSELEY, Helen E. [P] Grand Rapids, MI/Gloucester, MA b. 21 S 1883, Grand Rapids, MI. Studied: ASL; Breckenridge; Hawthorne. Member: NAWPS; North Shore AA [27]

MOSELEY, Nell [P] Ft. Worth, TX [25]

MOSELEY, Wendell [P,I] Elgin, IL [10]

MOSELSIO, Simon [S,P,T] Bennington, VT b. 17 D 1890, Russia d. ca. 1964. Studied: Kunstgewerbe Schule; Royal Acad., Berlin, with F. Koch, Koerte, Schaefer, Sekt, Virchow, Janensch, Galland, Gutknecht, Breuer. Member: NSS; Arch. Lg.; Yaddo Corp.; S. Des. Craftsmen. Exhibited: WFNY, 1939; WMAA, 1934, 1935, 1939, 1940–43, 1945, 1946; AIC; PAFA; Weyhe Gal. (one-man); Fleming Mus. A.; Salons of Am., 1925, 1926; N.Y. A. Center, 1926 (one-man); BM, 1930; Research Inst. Theatre, Saratoga Springs N.Y.; Buchholz Gal., 1941, 1943, 1945; Albany Inst. Hist. & A.; Yaddo; Saratoga Springs; Paris Intl. Expo (med). Work: S., WMAA; Univ. Ga.; Bennington Hist. Mus.; Weyhe Gal. Position: T., Bennington Col., from 1933 [47]

MOSENTHAL, Elizabeth [Des,Illuminator] d. 29 Jy 1921, Segovia, Spain. Member: N.Y.S. Craftsmen (Bd. Dir.). Position: N.Y. Sch. Appl. Des. for Women

MOSER, Artus Monroe [Mur.P,Por.P,W,E] Swannanoa, NC b. 14 S 1894, Hickory, NC. Studied: Univ. N.C.; Univ. Wis.; AIC; Grand Central A. Sch.; PAFA. Member: Asheville A. Gld.; Black Mountain AC; N.C. SA. Position: T., Lincoln Mem. Univ., Harrogate, Tenn., 1930–43 [47]

MOSER, Carl [P] Jersey City, NJ. Member: S.Indp.A. [25]

MOSER, Frank (H.) [P,Car,I,W] Hastings, NY b. 27 My 1886, Kansas d. 30 S 1964, Dobbs Ferry, NY. Studied: Cummings Sch. A., Des Moines, Iowa; ASL; NAD. Member: SC; Yonkers AA; Hudson Valley AA; Westchester AC Gld. Exhibited: All.A.Am., 1944; SC, 1940–46, 1944 (prize); Yonkers AA, 1940–46; Hudson Valley AA, 1940–46; NAC; NYWCC, 1937, 1939 [47]

MOSER, Gail R. [P] Jersey City, NJ [15]

MOSER, J(ames) H(enry) [Ldscp,P,I] Wash., D.C./West Cornwall, CT b. 1 Ja 1854, Whitby, Ontario d. 10 N 1913. Studied: J.H. Witt; C.H. Davis. Member: AWCS; NYWCC; Wash. WCC; S. Wash. A.; SC, 1908. Exhibited: Atlanta Expo, 1895 (med); Wash. WCC 1900 (prize), 1903 (prize); Charleston Expo, 1902 (med). Work: NGA; CGA. Illustrator: first pub. volume, "Uncle Remus," by J.C. Harris. Positions: T., CGA; Asst. Dir., Knoxville, Tenn. Expo, 1910 [13]

MOSER, John Henri [P,T] b. 1876, Wabern, Switzerland (came to Utah in 1888) d. 1951, Logan, UT. Studied: Brigham Young Univ., with A.B. Wright, 1905; Académie Julian, Paris, with Laurens, Simon, 1908–10. Specialty: bright impressionist landscapes [*]

MOSER, Martha Scoville (Mrs. James Henry) [P] d. 29 S 1941, White Plains, NY (formerly lived, Wash., D.C.) b. 1857

MOSES, Anna Mary Robertson (Grandma) [P] Eagle Bridge, NY b. 6 S 1860, Greenwich, NY d. 13 D 1961 (age 101). Studied: self-taught, beginning 1930s. Exhibited: Galerie St. Etienne, 1939; MOMA, 1939; Everhart Mus., 1943; Lawrence A. Mus., Williamstown, Mass., 1944; Smith Gal., Springfield, Mass., 1944; MMA, 1944; CI, 1945, 1946; Syracuse MFA, 1941 (prize). Work: Currier Gal. A.; Los Angeles Mus. A.; Pasadena AI; PMG; large coll., Bennington, Vt. Mus. Specialty: primitive painting. She made about 1600 paintings. [47]

MOSES, Thomas G. [Ldscp.P] Los Angeles, CA/Oak Park, IL b. 1856, Liverpool, England. Studied: AIC; R.M. Shurtleff. Member: Palette and Chisel C.; Calif. AC; Laguna Beach AA; SC; des., Scottish Rite stage-settings [33]

MOSES, Walter Farrington. See Farrington.

MOSHER, Evelyn Lurana [P] Worcester, MA [24]

MOSHER, Harris Peyton [E,B,C] Boston/Marblehead, MA b. 21 O 1867. Member: Marblehead AA; Boston AC; NY Physicians AC; Boston Physicians AC. Contributor: article, "The Turpentine Printing of Etchings," in Prints, 1934. Also a wood carver. [40]

MOSHIER, Elizabeth Alice [Edu,P,L] Utica, NY b. 24 D 1901, Utica, NY. Studied: Skidmore Col.; Columbia; Lhote Studio, Paris; Kunstgewerbe Schule, Vienna; Moholy-Nagy. Member: CAA; Am. Assn. Univ. Prof.; Am. Assn. Univ. Women. Exhibited: Albany Inst. Hist. & A.; Syracuse MFA; Rochester Mem. A. Gal.; Skidmore Col. Position: T., Skidmore Col., Saratoga Springs, N.Y., 1925–41 [47]

MOSKOVITZ, Harry S. [Por.P,E] Phila., PA b. 5 F 1894, Phila. d. 1 My 1956. Studied: Graphic Sketch C., Phila.; PMSchIA; Ecole des Beaux-Arts, Paris; Germany. Member: Graphic Sketch C. Exhibited: PAFA; Phila. A. All.; McClees Gal., Phila. Work: port., Capitol Bldg., Harrisburg, Pa.; Phillips Exeter Acad., Exeter, N.H.; prominent people [47]

MOSKOWITZ, Ira [E,Li] Santa Fe, NM b. 15 Mr 1912, Poland. Studied: ASL. Exhibited: MMA, 1941; NAD, 1946; CI, 1946; LOC, 1943, 1945, 1946; Los Angeles Mus. A., 1945; Albany Inst. Hist.&A.; Phila. Pr. C.; Laguna Beach AA; Springfield (Mo.) Mus. A.; Houston MFA (one-man); San Antonio Mus. A. (one-man) [47]

MOSKOWITZ, Shirley Edith (Mrs. Gruber) [P,T,I,Car,S,L] Oberlin, OH b. 4 Ag 1920, Houston, TX. Studied: Mus. A. Sch.; Houston; Rice Inst.; Oberlin Col.; C.B. Moody; R. Henry; Mrs. G.A. Volck; E. Langham; E.B. Bessell; B.J. Ploger; R. Joy. Member: Tex. FAA. Exhibited: Tex. General Exh., 1944, 1946; MFA Houston, 1936–46, 1945 (prize); Tex. FAA, 1945, 1946; Akron A. Exh., 1946. Positions: Art Ed., The Rice Owl, Rice Inst., Houston; T., Sidney Lanier H.S., Houston, Tex., 1943, Houston Col. for Negroes, 1944–45; L., pub. sch., Houston [47]

MOSLER, Gustave Henry [P] NYC/Margaretville, NY b. 16 Je 1875, Munich, Bavaria d. 17 Ag 1906, Margaretville. Studied: his father, Henry; Bonnât, Ecole des Beaux-Arts, both in Paris. Exhibited: Paris Salon, 1910 (med); St. Louis Expo, 1904 (med) [06]

MOSLER, Henry [P] NYC/Margaretville, NY b. 6 Je 1841, NYC (taken to Cincinnati in 1851) d. 21 Ap 1920, NYC. Studied: J.H. Beard, in Cincinnati, 1859–61; Düsseldorf, with Mücke, Kindler, 1863–65; Hébert, in Paris; Wagner, in Munich, 1874. Member: NAC; SC; A. Fund S.; Chevalier Legion of Honor, 1892; Officer d'Academie, 1892. Exhibited: Royal Acad., Munich, 1874 (med); Paris Salon, 1879, 1888 (med); Intl. Exh., Nice, 1884 (gold); Prize Fund Exh., NYC, 1885 (prize); Paris Expo, 1889 (med); Atlanta Expo, 1895 (gold); NAD, 1896 (prize); AC Phila., 1897 (gold); Charleston Expo, 1901 (gold); AAS, 1907 (gold). Work: "The Return," Luxembourg Mus., from the Salon of 1879, the first picture by an American purchased by the French Gov.; MMA; CGA; Cincinnati Mus.; TMA; PAFA. His studio was in Paris from 1877 until he returned to NYC, 1894. Position: Illus., Harper's, 1861–63 (with Army of the West) [19]

MOSLEY, Helen E. [P] Boston, MA b. 21 S 1883, Grand Rapids, MI d. 22 Ap 1928. Studied: AIC; R. Henri; H. Breckenridge; C. Hawthorne. Member: North Shore AA; NAWA. Exhibited: Scarab C., Detroit.

MOSLEY, Zack [I] Palm Beach, FL. Member: SI [47]

MOSMAN, Melzar Hunt [S,Des,C] Chicopee, MA b. 1845 d. 11 Ja 1926. Work: cast doors on the west wing of the Capitol, Wash., D.C.; Saint-Gaudens statue of Lincoln, London. Specialty: bronze founder

MOSMAN, Warren T. [S,T] Hopkins, MN b. 18 Jy 1908, Bridgeport, CT. Studied: Yale; Am. Acad., Rome. NSS. Exhibited: Minneapolis Inst. A.; WFNY, 1939. Award: Prix de Rome, 1931–34. Position: T., Minneapolis Sch. A. [47]

MOSS, Charles [P] NYC. Member: NYWCC [01]

MOSS, Charles E. [P] Ottawa, Canada b. Pawnee City, NE. Studied: Bonnât, Paris. Member: RCA [01]

MOSS, Frank [P] Wash., D.C. b. 9 My 1838, Phila., PA. Studied: Bonnât, in Paris. Member: Wash., WCC; Century Assoc., SC, 1894. Exhibited: NAD; PAFA, after 1860; Mass. Charitable Mech. Assoc., Boston (med) [10]

MOTE, Alden [Por.P,Ldscp.P] Richmond, IN b. 27 Ag 1840, West Milton, OH d. 13 Ja 1917. Studied: H.B. Hays; W.H. Hilliard. Member: Richmond AA; Richmond Sketch C. Work: Earlham Col., Richmond; Penn Col., Oskaloosa, Iowa; Reid Mem. Hospital, Richmond [10]

MOTE, Marcus [Por.P,Li,I,T,Photogr.] Richmond, IN b. 19 Je 1817, nr. West Milton, OH d. 26 F 1898. Active in Lebanon, Ohio until 1866 when he moved to Richmond. Painted panorama, "Uncle Tom's Cabin," 1853–54 and religious subjects. Uncle of Alden [*]

MOTHERWELL, Robert [P,G,W] NYC/East Hampton, NY b. 24 Ja 1915, Aberdeen, WA. Studied: Calif. Sch. FA, 1932; Hayter's Atelier 17, Paris, 1945; Stanford Univ.; Harvard; Columbia. Exhibited: PAFA, 1945; WMAA, 1945, 1946; SFMA, 1940, 1946 (one-man); Art of This Century, 1944 (one-man); Chicago AC, 1946 (one-man); Galerie Jeanne Bucher, Paris, 1946 (one-man). Work: MOMA; BMA; Norton Gal., West Palm Beach; Art in This Century; Galerie Jeanne Bucher; Kootz Gal., NYC; CMA; SFMA. Contributor: New Republic, Partisan Review, Design. Editor: "The Cubist Painter," 1944, "Plastic Art & Pure Plastic Art," 1945, "New Vision," 1946, "Dada Painters and Poets," 1951. Important abstract expressionist. Positions: T., Univ. Oreg., Eugene (1939–40), Black Mountain Col., N.C. (1945) [47]

MOTLEY, Archibald John, Jr. [P] Chicago, IL b. 7 O 1891, New Orleans. Studied: AIC; France; K. Buehr; A. Krehbiel. Member: Chicago AL; F., Guggenheim Fnd., 1929; Am. A. Cong. Exhibited: WMAA; Grand Central A. Gal.; Harmon Fnd.; 1928 (gold); Newark Mus., 1927 (prize); BMA; WFNY, 1939; AIC, 1925 (prize), 1933, 1934; Am.-Scandinavian Fnd.; New Gal., NYC (one-man); Atlanta Univ. (one-man). Work: painting, USPO, Wood River, Ill.; Nichols Sch., Evanston; State Hosp., Evansville; Pub. Lib., Ryerson Sch., Chicago. WPA artist. [47]

MOTLEY, Eleanor W. (Mrs. Thomas) [P] Boston, MA/Nahant, MA b. 16 D 1847, Boston. Studied: R. Turner. Member: Boston GA; Boston SWCP. Work: BMFA [40]

MOTLEY, Robert E. [P] Wash., D.C. Exhibited: S. Wash. A., 1933, 1934, 1936, 1937, 1939, 1940 [40]

MOTTETT, Jeanie Gallup (Mrs. Henry) [P] Great Neck, NY b. Providence, RI d. 30 O 1934, NYC. Studied: ASL; Chase; R.E. Miller; E.A. Webster. Member: NAWPS; Provincetown AA; AFA. Member: Officier d'Académie des Beaux-Arts, Paris, 1918; Officier d'Instruction Publique, 1929. Work: Musée du Luxembourg, Paris; BM. Position: Cur., Mus. French Art, NYC [33]

MOTTO, Joseph C. [S] Cleveland, OH b. 6 Mr 1892, Cleveland. Studied: Matzen; MacNeal; Heber. Member: Cleveland SA; Cleveland SS. Exhibited: CMA, 1922 (prize). Work: bust, City of Cleveland; Western Reserve Univ., Cleveland.; Cleveland Sch. A.; Hawken Sch., South Euclid [40]

MOTTS, Alicia Sundt (Mrs. Howard E.) [Por.P] NYC b. Oslo, Norway. Studied: AIC; John Huntington Polytechnic Inst.; G. Brockhurst, in London; G. Luks; J. Sloan; Archipenko; W. Adams. Member: NAWA; AAPL; Women's AC, Cleveland; Composers & Authors Assn. Am. Exhibited: AIC, 1936; CMA, 1937; Ogunquit A. Center, 1937; NAD, 1944, 1945 (prize); Butler AI, 1938–41, 1940 (prize); NAWA, 1945; CMA, 1929–43; Gage Gal., Cleveland, 1935 (one-man). Work: mural, Sch. of Nursing, Easton, Pa.; portrait commissions in NYC, Wash., D.C., Cleveland, London [47]

MOTT-SMITH, Harold M. [P] Maison Lafitte, Seine et Oise, France [06]

MOTT-SMITH, May [P,C,W,L] NYC b. 17 Mr 1879 Honolulu, HI d. 5 Je 1952. Studied: Paris, with S. Simpson. Member: A. Prof. A., Paris; Am. Numismatic Soc.; Women P.&S. Soc.; Lg. Am. Pen Women. Exhibited: All.A.Am.; AIC; PAFA; Boston SAC; XXI Gal., London, 1923–37; Artistes Français, Paris; P.-P. Expo, 1915 (med); Paris Salon (med); San Diego, Calif. (prize). Work: Hispanic Mus., NYC; med., Sculptors Lg., Los Angeles. Author/Illustrator: "Africa from Port to Port." Contributor: arch. and travel mags [47]

MOTZ, Grace Leslie [P,S] Ft. Wayne, IN b. 27 Ag 1911. Studied: Ft. Wayne A. Sch.; AIC; E. Zweybruck, in Vienna; G.G. Davisson; F. Chapin; L. Ritman; F. Stark. Member: Hoosier Salon; Ind. AC, Indianapolis. Exhibited: Hoosier Salon, 1938; Herron AI, 1938, 1939. Work: murals,

hotel, Ind.; Masonic Cathedral, Indianapolis; Masonic Temples, Evansville, Ft. Wayne, South Bend; St. Patricks Cathedral, Orcola, Ind. [40]

MOTZ, Ray Estep [P] Monessen, PA. Member: Pittsburgh AA. Exhibited: Pittsburgh AA, 1913 [19]

MOTZ, Ray Estep (Mrs.) [P,E,T] Monessen, PA/Shelburne Falls, MA b. 27 My 1875, Whitsett, PA d. 3 Mr 1930, Pittsburgh. Studied: CI; AIC; N.Y. Sch. F.&Appl. A. Member: Pittsburgh, AA. Exhibited: Pittsburgh AA, 1929 (prize) [29]

MOTZ-LOWDON, Elsie. See Lowdon.

MOUGEL, Max [E,S] NYC b. 21 Ap 1895, NYC. Exhibited: AMNH; SAE, 1936, 1938–40, 1944; CAFA, 1936; PAFA, 1936; Phila. Pr C., 1940; Alden Gal., 1940; LOC, 1944; CI, 1944; CGA, 1944–46; Nat. Maritime Exh., 1945. Work: BM; LOC. Illustrator: arch. & travel mag. [47]

MOULD, Ruth Greene (Mrs.) [P,C,T] Williamstown, VT b. 22 My 1894, Morrisville, VT. Studied: St. Paul AI; ASL, DuMond, Bishop, Soyer. Member: AAPL; Mid.-Vermont A.; Northern Vermont A. Exhibited: NAWA, 1938–40; AWCS, 1938; Fleming Mus. A., annually; Mid-Vermont A.; Ogunquit A. Center, 1946; CM, 1940; St. Paul AI (med). Work: Bennington, Vt. Mus.; Fleming Mus. A., Burlington, Vt. [47]

MOULTON, Claxton B. [P] Boston, MA [21]

MOULTON, Frank [P] South Boston, MA b. 22 S 1847, South Boston. Studied: G. Papperitz, Munich; I. Spiridon, Rome; Normal A. Sch., Boston [08]

MOULTON, Katherine [P] Minneapolis, MN [13]

MOULTON, Sue Buckingham (Mrs. Alston B.) [C,L,Dec,Des,Min.P] Phila., PA b. 20 Ja 1873, Hartford, CT. Studied: Hartford Atheneum; Corcoran Sch. A.; Andrews; Moser; Archambault; Frisbie. Member: Phila. A. All.; Philomusian C.; AAPL. Exhibited: Baltimore WCC; PAFA; Chicago Min. S.; ASMP. Work: Philomusian C.,; New Century C.. Illustrator: editions of Shakespeare, Dickens, Poe, Pepys [47]

MOUNIER, Louis [P,S,T] Vineland, NJ b. 21 D 1852, France. Studied: Sanzel, Paris (sculp.); F. Dondel, NYC (paint.) [10]

MOUNT, Cati [P,Des,C,L] NYC b. 23 D 1903, St. Louis, MO. Studied: AIC; J. Norton; J.T. Johnstone. Exhibited: 48 St. Comp. Work: Gen. Motors Futurama, WFNY, 1939. Position: Dir., Tony Sarg Marionette Workshop [40]

MOUNT, (Pauline) Ward [P,C,T] Jersey City, NJ b. Batavia, NY. Studied: ASL; NYU; A. Lucas; J. Pollia; F. Kimball. Member: P.&S. S., N. J.; Audubon A.; N.Y. S. Painters; Asbury Park SFA; AAPL; Acad. All. A.; All.A.Am.; A. Center of the Oranges. Exhibited: NAD, 1944; All.A.Am., 1939–45; Soc. P.&S. N.J., 1941–46, 1943 (prize); Audubon A., 1942–44; NSS, 1944–46; Acad. All. A., 1938–40; VMFA, 1940; Los An. Mus. A., 1945; Asbury Park SFA, 1941, 1942, 1946 (prize); AAPL, 1945; WFNY, 1939; N.J. State Mus., 1940; N.Y. S. Painters, 1940–43; N.J. A., 1945 (prize); Montclair A. Mus., 1944, 1945 (prize); A. Center of the Oranges, 1941, 1942; AAPL, 1941 (prize); Jersey City Mus., 1941 (prize). Work: Jersey City Mus.; White House, Wash., D.C.; Hotel Monmouth, Spring Lake, N.J.; State Capitol, N.Y.; Alford Hotel, East Orange, N.J.; Palm Beach Hotel; LOC. Positions: T., N.J. State T. Col., 1941–45; Dir., Ward Mount Art Classes, from 1939 [47]

MOUNTFORT, Arnold [P] NYC b. 21 Ja 1873, Eggbaston, England. Studied: Birmingham, Municipal Sch. Art, England [21]

MOUNTFORT, Julia Ann (Mrs. E.L.) [P,I,Dr,L,W] Damariscotta, ME b. 14 Ja 1888, Barford, Canada. Studied: Fox A. Sch.; AIC; Chicago Acad. FA; Sargent; Townsley. Member: Chicago SA; SSAL; South Shore A.; Chicago NJSA; All-Ill. SA; Lg. Am. Pen Women [47]

MOUZOFF, A. [P] NYC. Affiliated with Russian A. Lg., NYC [25]

MOWAT, H.J. [I] Montreal, Quebec. Member: SI, 1912; SC [31]

MOWBRAY, H(enry) Siddons [Mur.P] Wash., CT b. 5 Ag 1858, Alexandria, Egypt (came to U.S in 1859) d. 13 Ja 1928. Studied: U.S. Military Acad.; Bonnât, in Paris. Member: SAA, 1886; ANA, 1888; NA, 1891; CAFA; A. Fund. S.; Century A.; NIAL; Nat. Comm. FA. Exhibited: NAD, 1888 (prize); Atlanta (med); Boston (med); Chicago (med); Pan-Am. Expo, Buffalo, 1901 (gold). Work: Buffalo FA Acad.; NGA; Appellate Court, NYC; Univ. A. Lib., NYC; Morgan Lib., NYC; Gunn Mem. Lib., St. John's Episcopal Church, Washington Conn.; Fed. Court, Cleveland; homes of F.W. Vanderbilt, C.P. Huntington, J. Pierpont Morgan; Breckenridge Long Gal., St. Louis. Position: Dir., Am. Acad., Rome, 1903–04 [27]

MOWBRAY-CLARKE, John Frederick [S] Pomona, NY b. 4 Ag 1869, Jamaica. Studied: Lambeth Sch., London. Member: Am. P.S. Work: MET; Newark Mus.; British Mus., London [40]

MOWER, Martin [P,T] Rockport, MA b. 11 Ag 1870, Lynn, MA. Studied: Harvard. Work: Berkshire Mus., Pittsfield, Mass.; Isabella Stewart Gardner Mus., Boston; port., Harvard Business Sch.; Chilton C., Boston; Ch. St. John, Boston [40]

MOWRIS, C.C. (Mrs.) [P] South Lima, NY. Member: Rochester AC [25]

MOXOM, Jack [Arch,P,S,Li] San Fran., CA b. 7 Ag 1913, Calgary, Alberta. Studied: Calif. Sch. FA. Work: fountain, Golden Gate Park; Burke Hall, San Fran. State Col.; San Fran. AM. Position: T., Sacramento A. Center, Kremer Sch. [40]

MOYER, Jennie J. [P] Cincinnati, OH. Affiliated with Cincinnati A. Acad. [01]

MOYER, Miriam Finsterwald (Mrs. Elliott M.) [Dec,S,T] Wash., D.C. b. 27 Ag 1909 Marion, WI. Studied: Univ. Mich.; C. Angel; A. Fairbanks; H. Schuler. Position: Freelance Dec., Style Inc., Wash., D.C. [40]

MOYER, Virginia [P] Cincinnati, OH. Affiliated with Cincinnati A. Acad. [01]

MOYLAN, Lloyd [P,L,Mus.Cur] Gallup, NM (1948) b. 13 D 1893, St. Paul, MN. Studied: Minneapolis IA; ASL.; Broadmoor A. Acad., Colorado Springs. Exhibited: Univ. Colo. Mus., 1937. Work: Antlers Hotel, Cheyenne Sch, Ute Theatre, Colorado Springs; N.Mex. Normal Sch.; courtroom, Portales, N.Mex. Positions: T., Broadmoor AA, 1929–31; Cur., Mus. Navaho Ceremonial A., Santa Fe [40]

MOYNIHAN, Frederick [P,S] NYC b. 1843, Island of Guernsey d. 9 Ja 1910. Studied: Royal Acad. (life schol.) Member: NSS [13]

MOYNIHAN, H(elen) S. [P] Milwaukee, WI b. 13 Ap 1902, Marcus, IA. Studied: Chicago Acad. FA; H.R. Fischer; R. Von Neumann. Member: Wis. P.&S. Exhibited: AIC, 1943; Univ. Wis., 1940, 1941, 1943–45; Wis. State Fair, 1939–44; Wis. P.&S., 1940, 1941, 1943–46; Milwaukee AI, 1944 (prize) [47]

MOZLEY, Loren Norman [P,E,Li,Edu] Austin, TX b. 2 O 1905, Brookport, IL. Studied: Acad. Colarossi; Acad. Grande Chaumière; Univ. N.Mex. Member: Taos AA; SSAL; Tex. FAA; Taos Heptagon. Exhibited: Colo. Springs FA Center, 1938; Denver A. Mus., 1938; Tex. General Exh., 1941–46, 1942 (prize)Work: murals, Albuquerque Fed. Bldg.; USPO, Clinton, Okla.; Alvin, Tex.. Author: "Yankee Artist," monograph on John Marin, MOMA for Marin Exh., 1936). Positions: T., Univ. N.Mex. (1940), Univ. Tex. (1942–45) [47]

MRUK, W(ladyslaw E.) [P,Car] Buffalo, NY b. 12 Je 1895, Buffalo, NY d. 1942. Studied: Albright AI, ASL; Denver, with J.E. Thompson; again with Thompson, in NYC, 1926–28. Member: Los Cinco Pintores, Santa Fe, ca. 1921. Exhibited: N.Mex. Painters S., NYC, 1924; Mus. N.Mex., late 1920s. Work: Mus. N.Mex. [21]

MUCHA, Alphonse Maria [P,I,Photogr] NYC b. 24 Ag 1860, Ivancice, Moravia d. 14 Jy 1939, Prague. Studied: Ecole des Beaux-Arts, Prague; Munich Acad.; Paris, with Laurens, Boulanger, Lefebvre. Exhibited: Paris Salon, 1894 (prize); Paris Expo, 1900 (med). Leading Art Nouveau artist, famous for his posters of Sarah Bernhardt and Job cigarette papers during late 1890s. He settled in Paris, 1890; returned to Prague, 1910. Though not an American, he was included in the Am. Art Annual because he taught at N.Y. Sch. Appl. Des. for Women before returning to Prague. His estate coll. was given to Bibliothèque Forney, Paris, 1966. [10]

MUDGETT, Lucille (Mrs. H.M. Dingley, Jr.) [P,S] Auburn, ME b. 24 Ap 1911, Southern Pines, NC. Studied: Dallas AI; F.L. Klepper; J. McLean; N. Vayana. Member: Am. Fed. A.; N.C.A. Soc.; Palm Beach A. Center; Ogunquit A. Center. Exhibited: Palm Beach A. Center, 1935; Ogunquit A. Center, 1939 [40]

MUDGETT, Marcia [P] Wabash, IN [25]

MUEDEN, Mathilde. See Leisenring, L.M., Mrs.

MUELLER, Alexander [P,L,T] San Marino, CA b. 29 F 1872, Milwaukee, WI d. 16 Mr 1935. Studied: R. Lorenz, Milwaukee; M. Thedy, Weimar; C. Marr, Munich. Member: Wis. PS [33]

MUELLER, Augustus Max Johannes [S] Phila., PA b. 8 Je 1847, Meiningen, Germany. Studied: Royal Acad., Berlin; Royal Acad., Munich [10]

MUELLER, Carl [I,Car] Springfield, OH. Illustrator: Colliers, 1939 [40]

MUELLER, Ethel F. [P] Minneapolis, MN [24]

MUELLER, Hans Alexander [P] NYC. Exhibited: Vendôme Gal., NYC, 1940 (one-man) [40]

MUELLER, Herman Oscar [C] Yonkers, NY b. 2 Ag 1878, Neuhaus, Germany. Specialty: glass modeling. Position: associated with AMNH. [40]

MUELLER, Johanna [P] Phila., PA [06]

MUELLER, John Charles [I,C,D,W] Cincinnati, OH b. 3 N 1889, Cincinnati, OH. Studied: Nowottny; Duveneck; Meakin; Miller; Cincinnati A. Acad. Member: Cincinnati AC. [40]

MUELLER, Lola Pace (Mrs. Fred E.) [P,Li] San Antonio, TX b. 17 Ja 1889, Atlanta, GA. Studied: San Antonio AI; C. Rosen; M. Axley; J. Arpa; H.A. de Young. Member: San Antonio AL; SSAL; San Antonio PM; Palette & Chisel C.; Tex. FAA. Exhibited: LOC, 1943-45; CI; Albany Pr. C., 1945; SFMA; Witte Mem. Mus. (one-man); Women's C., Austin, Tex. (one-man); Fed. Women's C. (one-man); SSAL; Tex. FAA, 1940 (prize). Work: Witte Mem. Mus.; Fed. Women's C. [47]

MUELLER, Louis F. [P] Indianapolis, IN b. 29 Ap 1886, Indianapolis. Studied: Munich, with Zugel, Habermann, Marr. Member: Royal Bavarian Akademie, Munich [33]

MUELLER, Michael J. [P,D,T] Cable, WI b. 3 D 1893, Durand, WI d. Ja 1931, Bend, OR. Studied: S. Kendall; Winter; Savage; E.C. Taylor; Rittenburg; Bridgman; DuBois; Yale; Am. Acad. Rome. Exhibited: Northwest Ann., Seattle, 1930 (prize). Specialty: Northwest landscapes. Position: T., Univ. Oreg. [29]

MUELLER, Paul L. [P] Minneapolis, MN [24]

MUELLER, Rudolph C. [P] North Pelham, NY [06]

MUELLER-MUNK, Peter [C,Des,L,T] Pittsburgh, PA b. 25 Je 1904, Berlin, Germany. Studied: Berlin Acad. FA; Acad. F.&Appl. A., Berlin; W. Raemisch, in Berlin. Member: Am. A. Cong.; N.Y. Soc. Des.-Craftsmen; Pittsburgh AA; Am. Assn. Univ. Prof.; S. Indst. Des. Exhibited: GGE, 1939; Pittsburgh AA, 1937 (prize); MMA; Paris Salon, 1937; Detroit AI; Newark Mus.; CMA. Work: Detroit Inst. A.; Newark Mus.; Paris Expo, 1937. Contributor: articles, Creative Arts, Creative Design, Modern Plastics, Ceramic Age, Vogue; des. products, Revere Copper and Brass, Inc., Elgin Watch. Position: T., CI [40]

MUENCH, Agnes Lilienberg [P] Houston, TX b. 26 Je 1897. Studied: D. Garber; H. McCarter. Member: SSAL. Exhibited: SSAL, 1926 (prize), 1928 (prize), 1929 (prize) [40]

MUENCH, John D. [G,M,P,T] Lovell, ME b. 15 O 1914, Medford, MA. Studied: ASL. Exhibited: LOC, 1945; CI, 1945; NAD, 1946; Northwest Pr. M., 1946 [47]

MUENCH, Julian Rhodes [Mur.P,Por.P,S,C,W] Houston/La Porte, TX b. 2 Ap 1905, Sequin, TX. Studied: PAFA. Member: SSAL. Exhibited: SSAL, 1926 (prize), 1928 (prize); Tex. FAA, 1928 (prize); Houston MFA, 1931 (prize). Work: Houston MFA; Houston Pub. Lib.; Univ. Tex., Austin; North Tex. State T. Col., Denton; tablet, San Jacinto Mem. Mus.; Vet. Mem., San Jacinto Battleground, Tex. [40]

MUENDEL, George F. [P] Rowayton, CT b. 1871, Hoboken, NJ. Studied: Ochtman; ASL. Member: CAFA; Silvermine GA; AFA. Exhibited: CAFA, 1914 (prize) [33]

MUES, A. William [S] NYC b. 28 Ag 1877, Bremen, Germany d. 15 S 1946. Work: Statue, Erfurt; S. Zoological Gardens, Berlin, Germany; statues, Univ. Rochester, N.Y.; Busts, Grant's Tomb, NYC. Position: T., Berlin Acad. FA, 1912 [40]

MUHLENFELD, Otto [Mar.P] Baltimore, MD b. 25 Ap 1871, Baltimore d. 31 Mr 1907. Studied: Peale Mus., Baltimore. "Baltimore Port Painter," painted ship portraits, especially tugboats. His most productive year was 1898, although only 45 of his works had surfaced by 1985. [*]

MUHLHOFER, Elizabeth [Min.P] Wash., D.C. b. Maryland. Studied: Corcoran Sch., with Moser, Brooke, Messer. Member: Wash. WCC; S. Wash. A.; S. Min. PSG. Exhibited: S. Wash. A., 1930 (prize), 1937 (prize), 1938 (prize); Wash., WCC, CGA 1939 (prize) [40]

MUHR, Philip [P,T] Phila., PA b. 1860, Phila., or Germany. d. 2 F 1916. Studied: Paris, with Bonnât, Bouguereau; Munich. Member: Phila. Sketch C. [10]

MUHRMAN, H(enry) [P] London, England. b. 21 Ja 1854, Cincinnati. Studied: Munich Acad. FA. Member: AWCS; Intl. PS&G; London Pastel S.; Munich Secession; Berlin Secession. Exhibited: Munich Acad., 1877 (gold); Columbian Expo, Chicago, 1893 (med); Munich Expo, 1897 (gold); Intl. Expo, Dresden, 1901 (gold); St. Louis Expo, 1904 (gold); P.-P. Expo, San Fran, 1915 (med). Work: Munich Pinakothek; Dublin A. Gal.; Glasgow A. Gal.; Belfast A. Gal.; Chilian Nat. A. Gal.; RISD; Cincinnati Mus. [19]

MUKOYAMA, K. [P] Salt Lake City, UT. Affiliated with Univ. Utah. [15]

MULERTT, Carel Eugene [P] Katwijk, Holland b. 13 O 1869, Brunswick, Germany (settled in Cleveland). Studied: Paris, with Robert-Fleury, Lefebvre, Ferrier, Bouguereau [17]

MULFORD, Hunter P., Mrs. See Lent, Margarete.

MULFORD, Laura Lenore [P,T,W] Valley City, ND b. 24 O 1894, Stuart, NB. Studied: Park Col., Parkville, Mo.; Univ. Nebr.; Univ. Chicago; Columbia; Colorado Springs FA Center. Member: Nat. Edu. Assn.; Western AA; AAPL; Am. Assn. Univ. Women. Exhibited: Fargo FA C., 1939; Bismark FA C., 1946. Position: A. Dir., State T. Col., Valley City, N.Dak., 1938-46 [47]

MULFORD, M. [I] NYC. Position: Staff, Judge, 1898 [98]

MULFORD, Stockton [I,P] NYC. Member: GFLA. Illustrator: Zane Grey westerns [27]

MULHAUPT, Frederick J(ohn) [P] East Gloucester, MA b. 28 Mr 1871, Rockport, MO d. 10 Ja 1938. Studied: A. Acad., Kansas City; AIC; Paris. Member: ANA; Palette and Chisel C., Chicago; SC; Paris AAA; NAC; Allied AA; North Shore AA. Exhibited: SC (prize), 1921 (prize); Phila. Art Week, 1925 (med); All.A.Am., 1925, 1930 (prize); CAFA, 1927 (prize); NAC, 1929; Ogunquit A. Center, 1932 (prize); Rochester, N.H., 1934 (prize). Work: Herron AI; Mus. FA, Reading, Pa.; murals, Gloucester, Mass. Sch. [38]

MULLEN, Buell (Mrs. James Bernard) [Mur.P,Por.P] NYC b. 10 S 1901, Chicago, IL. Studied: Petrucci, Lipinsky, at British Acad., Rome; Cucquier, in Belgium; Tyler A. Sch., Chicago. Member: Chicago AC; All-Ill. SFA; North Shore AA; Chicago SA; Chicago NJSA. Exhibited: Smithsonian Inst. (one-man); All-Ill. SFA, 1934 (gold) (one-man); AIC; Knoedler Gal.; Ferargil Gal. (one-man); Findlay Gal. (one-man); Paris Salon; North Shore AA 1937 (prize). Work: LOC; U.S. Naval Acad.; Great Lakes Naval Training Station; Argentine & Brazilian Govts.; Church at Indiana Harbor; Hi-Hat Night Club, Chicago; murals, Mo. Pacific R.R., Burlington R.R.. Specialty: technique of painting on metallic surfaces [47]

MULLER, Alice Preston [P] Phila., PA [13]

MULLER, Dan [P,I,W] Port Washington, WI (1966) b. 1888, Choteau, MT. Author: "Horses," 1936, "Chico," 1938, "My Life with Buffalo Bill," 1948. He sold landscapes in Yellowstone, 1920; Chicago, 1930; Nevada, 1935, mostly to tourists. Traveled with the Buffalo Bill shows, 1911-12. He was Cody's adopted son. [*]

MULLER, Francis [Mar.P] Active 1890-1906. Work: Mariner's Mus. [*]

MULLER, George Frank [P] Paris, France b. 1866, Cincinnati, OH d. 4 Ag 1958, Orange, CT. Studied: Robert-Fleury [08]

MULLER, Helen Chance (Mrs. Eugene) [P] Merion, PA b. 19 Ja 1891, Phila., PA Studied: F. Cannon; E. Horter; E. Copeland. Member: Plastic C.; A. All.; Phila. WCC; Bryn Mawr A. Center; AWCS; Woodmere AA. Exhibited: Wash. WCC, 1933, 1934, 1936; PAFA, 1934, 1938, 1944; Wilmington SFA, 1935; NYWCC, 1934, 1936; AWCS, 1933, 1936, 1938, 1939, 1941, 1946; Phila. WCC, 1934, 1938 [47]

MULLER, Isador J. [Por.P] NYC b. 1876, Budapest, Hungary (came to U.S. in 1924) d. 20 Mr 1943. Work: portraits, U.S., Europe

MULLER, Olga Popoff (Mrs.) [S] Forest Hills,NY/Bridgehampton, NY b. 1 D 1883, NYC. Studied: Russia; Munich; Paris. Member: NAWPS. Exhibited: AIC, 1911; NAWPS, 1914 (prize), 1925; Paris Exh., Women's Works; P.-P. Expo, San Fran, 1915 (med). Work: St. Michael's Episcopal Church, Litchfield, Conn. [40]

MULLER, Richard A. [P,En,T] Brooklyn, NY b. 27 Mr 1850, Bavaria, Germany d. 17 N 1915. Studied: NAD, with J.G. Brown; CUASch, with C.A. Sommer. Exhibited: Pan-Am. Expo, Buffalo, 1901 (med); Berlin (prize); Vienna (prize). Member: S. Am. Wood Engravers Specialty: wood engraving [10]

MULLER, Theodor Carl [Des] New Milford, CT b. 30 Je 1904, NYC. Studied: MIT; H. Lever; B. Robinson; ASL. Member: Arch. Lg. Exhibited: packaging competition, 1936. Work: shop interior and furnishings, Elizabeth Hawes; interior and furnishings, Fine Arts Bldg., Vassar Col.; bronzes, Bank of Hawaii, Honolulu. Contributor: articles, Architectural Forum, 1929 [40]

MULLER-URI, Hildegarde (Petronella) (Bernhardina) [P,C,T,S,B,E] St. Augustine, FL b. 5 Jy 1894, NYC. Studied: Breckenridge, A. Sch.; ASL; DuMond; Olinsky; Adams; Lewis; G. Bridgman; H.H. Breckenridge. Member: Fla. Fed. A.; St. Augustine AC; SSAL; Ogunquit A. Center; Gloucester SA; Palm Beach A. Center. Exhibited: Gloucester SA; North Shore AA; Ogunquit A. Center, 1932 (prize); SSAL; Fla. Fed. A., 1934, 1936; S. Four A., Palm Beach; Palm Beach A. Center, 1934, 1935 (prizes); Fla. State Fair, 1925 (prize). Work: Bowery Savings Bank, NYC; Ghent, Belgium. Position: T., St. Augustine AC [47]

MULLER-URY, Adolph [Por.P] NYC b. 28 Mr 1868, Ticino, Switzerland (came to U.S. in (1888) Studied: Royal Acad., Munich; Ecole des Beaux-Arts, with Cabanel. Member: Lotos C. [33]

MULLETT, Suzanne (Mrs. Smith) [P,T,Des,W,I] Oakland, CA b. 31 Ag 1913, Wash., D.C. Studied: American Univ.; Corcoran Sch. A.; PMG Sch. A.; R. Lahey; C. Watkins; Colorado Springs FA Center. Member: Wash. AC; S. Wash. A.; Am. Assn. Univ. Women. Exhibited: Pal. Leg. Honor, 1946; Outdoor A. Fair, Wash., D.C., 1939; Nat. A. Week, Wash., D.C., 1941, 1942; PMG, 1936–44; NGA; S. Wash. A., annually; Wash. WCC; Pub. Lib., Wash., D.C.; BMA; Whyte Gal.; CGA; Georgetown Gal. Work: PMG. Author: "Arthur G. Dove," 1944. Positions: T., American Univ. (1939–44), Friend's Sch., Wash., D.C. [47]

MULLGARDT, Louis C(hristian) [P,W,L] San Fran., CA [19]

MULLIGAN, Charles J. [S,T] Chicago, IL b. 28 S 1866, Aughnachy, Ireland (came to U.S. as a youth) d. 25 Mr 1916. Studied: AIC, Taft; Ecole des Beaux-Arts, Paris, with Falguière. Member: Chicago SA; SWA; Palette and Chisel C. Exhibited: Chicago SA, 1908 (med). Work: AIC; statues, Supreme Court, Springfield, Ill.; Lincoln Statue, "The Rail-Splitter." Position: T., AIG [15]

MULLIGAN, George [S] Chicago, IL [19]

MULLIGAN, Ralph F(uller) [P] NYC. Studied: F. Luis Mora. Member: NAC [13]

MULLIKEN, Eleanor [S] Wash., D.C./Essex, NY b. 30 D 1910, NYC. Studied: Yale. Member: Arts C., Wash. Exhibited: S. Wash. A., 1937 [40]

MULLIKEN, Mary Augusta [P,L,W] Tientsin, China b. OH. Studied: W. Beck, Cincinnati; B. Harrison, Woodstock; Whistler, Paris. Member: AFA. Work: Lasell Jr. Col., Auburndale, Mass.; Nat. Acad. of A, Peking; Mus. FA, Tientsin; coll., Ex-Pres. Hsu Shih Chang,; Nat. Geographic S., Wash., D.C. Co-author: "The Buddhist Sculptures of the Yun Kang Caves," published by French Book Store, Peking. Contributor: articles, Studio, China Journal, West China Border [40]

MULLIN, Charles Edward [P,E,Ser,S,B,T] Orland Park, IL b. 6 Jy 1885, Chicago, IL. Studied: Chicago Acad. FA, with W.J. Reynolds; AIC. Member: South Side AA; Ridge AA, Chicago. Exhibited: NAD, 1944, 1945; LOC, 1944, 1945; Laguna Beach AA, 1945; Phila. Pr. C., 1946; Los Angeles Mus. A.; Kansas City AI; BMA; Springfield Mus. A.; AIC, 1920, 1928, 1929, 1930, 1932–34, 1937; Chicago, 1929 (prize), 1930 (prize) [47]

MULLIN, Willard [I,Car] Plandome, NY Member: Ar., Writers; SI. Work: Huntington, Lib., San Marino, Calif. Position: Staff, New York World-Telegram [47]

MULLINEUX, Mary [P,B,E,T] Phila., PA b. Phila. d. 1965. Studied: PAFA, with Breckenridge, Chase, Pearson; C. Beaux; McCarter. Member: Phila. Pr. C. [47]

MULLINS, Bert Rubin [Mur.P,Por.P] Disputanta, KY b. 29 Ap 1901, Disputanta. Studied: Berea Col.; F.W. Long; C.B. Clough; R. Miller; Provincetown, Mass.; Paris. Member: Louisville A. Center Exhibited: J.B. Speed Mem. Mus., 1937; Kentucky & Southern Ind. Exh., 1946; Union Col., Barboursville, Ky. (one-man); Berea Col. (one-man). Work: Eastern Col. Richmond, Ky.; Audubon Mem. Mus., Henderson, Ky.; Berea Col.; murals, churches, Ky., Ohio; Court House, Madisonville, Ky.; murals, USPO, Campbellsville, Ky.; Morganfield, Ky.; Louisville, Ky.; church, Mt. Vernon. WPA artist. [47]

MULLIS, Phyllis Haas [P,Des,I] Arlington, TX b. 9 My 1900, Sunbury, PA. Studied: Dallas AI; Southern Methodist Univ.; J. Knott; F. Spicuzza; G. Kadell; J. Eckford. Member: Frank Reagh AC. Exhibited: Dallas State Fair, 1925 (prize). Exhibited: Dallas MFA; Allied A. Exh., Dallas. Position: T., Southern Methodist Univ., 1930–32 [40]

MULRONEY, R(egina) W(inifred) [S,T,W] San Fran., CA b. 4 D 1895, NYC. Studied: ASL; San Fran. A. Sch. Member: NAWA; Lg. Am. Pen Women. Exhibited: Wolfe C., 1929 (prize); Lg. Am. Pen Women, 1934 (prize). Position: Dir., R.W. Mulroney Sch. A., San Fran. [47]

MULVANEY, John [P] NYC b. 1844, Ireland (came to U.S. in 1856) d. My 1906 (suicide: drowing). Studied: Düsseldorf; Munich, with Wagner, Piloty; De Keyser, in Antwerp. Best known as the first to paint "Custer's Last Rally" (11x20 ft.), exhibited in Kansas City, Boston, and NYC, 1881. Exhibited: Munich, ca. 1866 (med); NAD, 1876. Work: Cincinnati AM; Memphis Mus.

MUMFORD, Alice Turner. See Culin.

MUMFORD, Jane. See Pearson, Mrs.

MUMMERT, S(allie) B(lyth) [P] Ft. Worth, TX b. Cisco, TX. Studied: Aunspaugh A. Sch., Dallas. Member: S.Indp.A.; Ft. Worth AA. Exhibited: Women's Forum A. Exh., Tex. (med) [33]

MUNCY, P.W. [P] NYC [21]

MUNDHENK, August [S] Cincinnati, OH b. 1848 d. 1 Ap 1922. For over 30 yrs., he ran an art foundry in Cincinnati.

MUNDHENK, Oscar [S] Teaneck, NJ. Member: NSS [47]

MUNDT, Donald [B,E,Li,P,S,Dr] Chicago, IL b. 23 Jy 1911, Milwaukee, WI. Studied: AIC; self-taught. Illustrator, woodcuts, "My Mental Garden" by M. McAssen [40]

MUNDY, Ethel Frances [Min.S] Syracuse, NY b. Syracuse d. ca. 1964. Studied: ASL; Fontainebleau Sch. FA; A. Sacker; Twachtman; Beckwith. Member: NAWA; Royal SMP, London; S. Fontainebleau A.; Am. SM PS&G; Syracuse AA. Exhibited: NAWA; CI; CGA; Phila. WCC; Syracuse AA; Royal SMP, London; Syracuse MFA; Cayuga Mus. Hist. & A.; BM; Montclair A. Mus.; Denver A. Mus.; J.B. Speed Mem. Mus.; Louisville Mus. A. Work: Syracuse MFA; Frick Gal.; J.B. Speed Mem. Mus.; Louisville Mus. A. Specialty: wax portraits [47]

MUNDY, Johnson Marchant [S,Por.P] b. 13 My 1831, New Brunswick, NJ (or Geneva, NY) d. 1897, Tarrytown, NY. Studied: H.K. Brown (7-yr. apprenticeship). Active painting portraits in Rochester, N.Y., for 20 yrs., before moving to Tarrytown. Best known for his statue of Washington Irving. [*]

MUNDY, Louise Easterday [P,T] Lincoln, NE b. 9 My 1870, Nokomis, IL d. 6 My 1952. Studied: Univ. Nebr.; AIC; Chicago Acad. FA; Stout Inst. Member: Am. Assn. Univ. Prof.; Nebr. AA; Lincoln AG. Exhibited: Joslyn Mem., Omaha, 1938. Work: Univ. Nebr. Work: Lincoln, Nebr., Hastings Col., Nebr. Position: T., Univ. Nebr. [47]

MUNGER, Albert A. [Patron] Chicago, IL d. 26 Ag 1898. Left his art coll., valued at more than three hundred thousand dollars, to AIC.

MUNGER, Anne Wells (Mrs. W.L.C. [P,Dr,C,L] Pass Christian, MS b. 17 Jy 1862, Springfield, MA d. 11 Mr 1945. Studied: P. Hale; Woodbury, De Camp, in Boston; Brush, in NYC. Member: Provincetown AA; Gulf Coast AA; Miss. AA. Exhibited: Miss. AA, 1925 (prize); Gulf Coast AA, 1930, 1932 (prizes) [40]

MUNGER, E. Louise [P] Brooklyn, NY [08]

MUNGER, Caroline [Min.P] Madison, CT b. 15 My 1808, East Guilford, CT d. 4 Ja 1892 [*]

MUNGER, Clarissa [P] b. 20 My 1806, East Guilford, CT d. 14 D 1889. Flower painter; active, Andover, Mass.; NYC; Madison, Conn. Her work was well-known through reproductions. [*]

MUNGER, Gilbert Davis [Ldscp.P,En] b. 14 Ap 1837, Madison, CT d. 27 Ja 1903, Wash., D.C. Studied: New Haven. At 14 yrs old was in Wash., D.C. as an engraver; was employed by the Smithsonian; started the Bureau of Lithography in Wash. Spent two years with Prof. Louis Agassiz on special work in the Indian Ocean. After serving in Civil War he went to the Rocky Mountains, where he painted. His landscapes brought him a fortune from English collectors. He lived in Europe 17 yrs. His "Niagara Falls" was bought by the Prussian Gov. for $5,000. He was a friend of Sir John Millais, England, and had lived in Barbizon, France, returning to America in 1893.

MUNK, John [S] Brooklyn, NY. Member: NSS [10]

MUNN, Adelene [P] NYC [10]

MUNN, Charles Allen [Patron] NYC d. 3 Ap 1924. Positions: Pres., Munn & Co., Publishers; Ed., Scientific American; Chmn. publications, AFA

MUNN, George Frederick [P] NYC d. 10 F 1907

MUNN, Marguerite C(ampbell) [P,B,T] Wash., D.C. b. Wash., D.C.. Studied: H.B. Snell; R. Brackman; B. Lazzell. Member: S. Wash. A.; Wash. WCC; Wash. AC; NAWPS; NAC; SSAL. Exhibited: NAWPS. Position: T., Mt. Vernon Seminary, Wash., D.C. [40]

MUNRO, Albert A. [P,E,T] Springfield, NY b. 17 Ag 1868, Hoboken, NJ [25]

MUNRO, Norma Leslie [Por.P] NYC b. F 1884, NYC. Studied: G. Roussin, Paris. Exhibited: Versailles; Toulon (gold); Bordeaux (med); Cannes (gold) [19]

MUNRO, Ruth [P] Pittsburgh, PA. Member: Pittsburgh AA [21]

MUNRO, Thomas [Mus.Cur,W,L,T] Cleveland, OH. Studied: Amherst Col.; Columbia. Member: Am. Soc. Aesthetics; AFA; CAA; Edu. Research Assn. Author: "Primitive Negro Sculpture," 1926, "Great Pictures of Europe," 1930. Editor: "Art in American Life and Education," 1941. Positions: Cur. Edu., CMA, from 1931; T., Western Reserve Univ., Cleveland, 1931 [47]

MUNROE, Katherine [P,T] MacLean, VA/Provincetown, MA b. 12 Ag 1900, Phila. Studied: Corcoran Sch. A.; E.A. Webster. Member: SSAL; Provincetown AA. Position: T., Fairmount Sch. for Girls, Wash., D.C. [40]

MUNROE, Marjorie [P] NYC b. 21 S 1891, NYC. Studied: Du Mond. Member: NAWPS; C.L. Wolfe [40]

MUNROE, Sally C. (Mrs. Vernon) [Ldscp.P] NYC/Litchfield, CT b. 24 Ja 1881, NYC. Studied: Cox; Woodbury. Member: NAWPS [33]

MUNROE, Sarah Sewell [P] Litchfield, CT b. Brooklyn, NY. Studied: C. Hassam; Miller; Hawthorne. Member: S. Wash. A.; Wash. AC; Wash. WCC. Exhibited: Wash. WCC (prize); S. Wash. A., 1921 (prize), 1923 (med) [40]

MUNSELL, A(lbert) H(enry) [Por.P,T,W,L] Chestnut, Hill, MA b. 6 Ja 1858, Boston d. 28 Je 1918. Studied: Mass. Normal A. Sch.; Ecole des Beaux-Arts, Paris. Member: SC. Author: "Color Notation," "Color Balance." Inventor: Munsell color system. Position: T., Mass Normal A. Sch., from 1881 [17]

MUNSELL, Richard [P] Los Angeles, CA. Exhibited: Chouinard Inst., 1939; Acad. Western P., 1936 (prize); Santa Cruz, 1936 (prize), 1937 (prize) [40]

MUNSELL, W(illiam) A.O. [P,Arch] San Marino, CA b. 2 Mr 1866, Cold Water, OH. Member: AIA; S.Indp.A.; Laguna Beach AA; Allied Arch. Assn. Work: Los Angeles Mus.; Scottish Rite Cathedral, Los Angeles; San Marino City Hall; Soldiers Home, Calif. [40]

MUNSON, Alma [P] St. Paul, MN [19]

MUNSON, Walter [Car] New Haven, CT. Work: Huntington Lib., San Marino, Calif. Position: Staff, New Haven Register [40]

MUNSTERBERG, Selma Opler (Mrs. Hugo) [P] Cambridge, MA b. 1 Je 1867, Germany. Studied: Schüster, Freiberg, in Germany; Boston, with Carbee, Bixby. Member: Copley S., 1899. Exhibited: Rochester Fair, 1906 (prize) [13]

MUNTZ, Laura [P] NYC [06]

MUNZIG, George Chickering [Por.P] NYC b. 1859, Boston d. 5 Mr 1908. Studied: Brimmer A. Sch.; Paris. Work: portraits of many society people, Madame Melba, other artists

MURA, Frank [I,P] Brooklyn, NY b. 1861, Alsace (came to NYC as a child; became a citizen). Studied: Munich; The Hague. Exhibited: P.-P. Expo, San Fran., 1915 (med). Settled in England, 1891; living in England, 1915. [21]

MURANYI, Gustave [Por.P] NYC b. 1 Ag 1881, Temesvar, Hungary d. 3 D 1961. Studied: England [29]

MURATA, Yuki (Mrs.) [P] NYC [25]

MURCH, Frank J. [P] NYC. Member: GFLA [27]

MURCH, Walter Tandy [P,I] NYC b. 17 Ag 1907, Toronto, Ontario d. 11 d 1967. Studied: Ontario Col., 1925–27; ASL; A. Gorky. Exhibited: CGA, 1945; PAFA, 1945, 1946; AIC, 1945; Mortimer Brandt Gal., 1944, 1945; Wakefield Gal., 1941 (one-man); RISD, 1968 (retrospective). Work: PAFA. Illustrator: "Men and Machines," 1930, "Stars in Their Courses," 1932 [47]

MURCHISON, Ruth [P] Woodstock, NY. Member: GFLA [27]

MURDOCH, Ada Oliphant [P] NYC b. Edinburgh, Scotland. Member: Lg. of N.Y. Ar. [21]

MURDOCH, Dora Louise [P] Baltimore, MD b. 14 S 1857, New Haven, CT d. 28 Mr 1933, Baltimore. Studied: Paris, with Lucien Symon, Courtois, Rixen, Boutet de Monvel. Member: Friends of Art (founder); AWCS; NYWCC; Baltimore WCC (Pres.); AFA; Wash. WCC. Exhibited: Baltimore WCC, 1903 (prize); Peabody Inst., 1922 (prize) [31]

MURDOCH, Florence [C,Des,P,T,W,B] Cincinnati, OH b. 14 Je 1887, Lakewood, NY. Studied: Nowottny; Meakin; J. Carlson; W. Reiss; W. Watson; P. Ensign; S.T. Humphreys; E. Haswell. Member: AAPL; Cincinnati Woman's AC; Crafters Cl. Author/Illustrator: article, "Trailing the Bestiaries," American Magazine of Art, January, 1932 [47]

MURDOCH, Frank C. [P] Pittsburgh, PA. Member: Pittsburgh AA [21]

MURDOCH, Rowland R. [I] Pittsburgh, PA b. 1876, d. Mr 1917. Position: Field Illus. during the San Fran. earthquake, Russo-Japanese war.

MURDOCK, Cecil [P,C] Tuba City, AZ b. 6 O 1913, McLoud, OK. Studied: Wichita Univ.; Univ. Okla.; A. Nordmark; O. Jacobson. Exhibited: Philbrook A. Center, 1946 (prize); Palmer House, Chicago, 1939; Marshall Field Gal., 1930; U.S. Indian Service A.&Cr. Exh., Oklahoma City, 1939; Tulsa, 1940; Mus. Northern Ariz., 1946; Ariz. State Col., 1946. Work: Anadarko Indian Sch., Okla.; Mus. Northern Ariz.; Philbrook A. Center; Gilcrease Fnd.; Ft. Sill Indian Sch. [47]

MURDOCK, E(dwin) F(orrest) [P] NYC/ Branford, CT b. 28 Ap 1864, Wash., D.C. Studied: D.C. Peters. Member: Kit-Kat C. [25]

MURDOCK, Helen M. [P] Roxbury, MA [01]

MURDOCK, John [Por.P,Ldscp.P] b. 1835 d. 1924. Exhibited: PAFA, 1862 (a scene of Baltimore painted in conjunction with T.W. Richards). Active in St. Louis, 1854; San Fran., 1856. [*]

MURDOCK, Marguerita G. [Min.P] b. 1861, NYC d. 11 Jy 1943, Boston. Studied: Cowles A. Sch., Boston

MURDOCK, Mary Frances [P] Pittsburgh, PA. Member: Pittsburgh AA [21]

MURFEY, Charles Latham [Patron] b. 1850 d. 11 Ag 1936, Cleveland. Member: CMA (trustee); John Huntington Art and Polytechnic Trust, since 1903; Horace Kelly Art Fnd., since 1905

MURPHEY, Edith Blaisdell [P,Des,L,C,T] La Grange, IL b. Pittsburgh. Studied: Cincinnati A. Acad., with F. Duveneck; AIC, with A. Poole; Univ. Chicago; Columbia; C. Martin. Member: Provincetown Mod. A. Group; NAWA; Oak Park AA; Wash. WCC; Chicago Gal. A.; Provincetown AA; Oak Park-River Forest AL; All-Ill. SFA. Exhibited: Oak Park-Maywood AA; CM; AIC; Delphic Gal., N.Y.; Argent Gal. A.; Oak Park-River Forest AL, 1933–34, 1936 (prize). Work: Ill. Masonic Orphans Home; Vaughan Vet. Hospital, Hines, Ill.; murals, Lyons Township Jr. Col., La Grange, Ill.; stage and costume des., Chicago theatres. Positions: A. Dir., Lyons Township H.S. and Jr. Col., Vaughan Veterans Hospital [47]

MURPHEY, Mimi [S] Albuquerque, NM b. 13 Ja 1912, Dallas. Studied: Southern Methodist Univ.; Dallas AI; ASL; E.F. Shonnard, in N.Mex. Exhibited: Tex. All. A., 1931–33; BM, 1935; Tex. AL, 1935; N.J. State Mus., 1937, 1938; Coronado Centenn., 1939; SSAL, 1944 (prize), 1945 (prize), 1946 (prize); Tex. State Fair, Dallas, 1933 (prize); AAPL, 1937 (prize); N.Mex. State Fair, 1944 (prize). Contributor: article, Southeastern Arts Magazine, 1936 [47]

MURPHEY, Virginia A. [P] Chicago, IL b. New Castle, IN. Studied: AIC. Exhibited: Omaha Expo, 1898 [98]

MURPHY, Ada C(lifford) (Mrs. J. Francis) [P,I] Arkville, NY. Studied: CUASch.; D. Volk. Member: NAWPS; NAC. Exhibited: NAD, 1894 (prize); Pan-Am. Expo, Buffalo, 1901 (prize) [33]

MURPHY, Alice Harold [P,E,Li,T] NYC b. Springfield, MA. Studied: Parsons Sch. Des.; ASL; NAD; Grande Chaumière; C. Hawthorne; V. Vytlacil. Member: SAE; S. Wash. A.; NAWA; Rockport AA; Northwest Pr.M. Exhibited: WMAA, 1933; Marie Harriman Gal., 1934, 1935; BM, 1933, 1935; PAFA, 1928, 1935; Phila. WCC, 1934, 1935; AWCS, 1934, 1936; Wilmington SFA, 1934; CAA, 1934, 1936; AIC, 1937; CAFA, 1926, 1928; Phila. A. All., 1938, 1939, 1942; NAD, 1927, 1929, 1942–44, 1946; Phila. Pr. C., 1939, 1940, 1942, 1944–46; Buffalo Pr. C., 1938, 1943; Denver A. Mus., 1943; Mint Mus. A., 1943, 1946; Albany Inst. Hist.&A., 1943, 1945; Springfield Mus., 1943 (prize); Williams Col. (prize); Tiffany Fnd.; NAWA, 1946 (prize). Positions: T., NAD, Montclair Mus. Sch. (1944–45); ASL (1945–46) [47]

MURPHY, Caroline Boles [P] Winchester, MA [15]

MURPHY, Christopher, Jr. [P,E,Li,Des,I,T] Savannah, GA b. 28 D 1902, Savannah. Studied: ASL; DuMond; Bridgman; Pennell; Clark; Chadwick; BAID. Member: Savannah AC; Ga. AA; Tiffany G. Exhibited: SSAL, 1927 (prize), 1931 (prize). Work: Richard Arnold Sch., Savannah.

Illustrator: Country Life, American Architect, The Southern Architect; newspapers [47]

MURPHY, Ella [P] Dayton, OH. Member: Cincinnati Women's AC [21]

MURPHY, Emma J. [P] Brooklyn, NY. Member: S.Indp.A. [25]

MURPHY, Gerald [P] b. 1888, Boston d. 1964. Exhibited: Dallas MA, 1960; MOMA, 1974 (retrospective). Active, Europe, 1921. His abstract style similar to that of Stuart Davis. [*]

MURPHY, Gertrude Burgess [C,T] Pleasantville, NY b. 20 N 1899. Studied: C.F. Binns. Member: Am. Gld. Craftsmen; Westchester A.&Cr. Gld.; G. North Riding. Work: plate, WMAA [40]

MURPHY, Gladys Wilkins (Mrs. Herbert A.) [Pr.M,P,C,Des,T] Fall River, MA b. 15 Ap 1907, Providence, RI. Studied: RISD. Member: Providence AC; Providence WCC; Rockport AA; Fall River A. Gld.; Am. Color Pr. S.; Southern PM; Northwest PM. Exhibited: AWCS; NYWCC, 1937, 1940, 1942; SAE, 1937; NAD, 1937–43; LOC, 1943; Phila. Pr. C., 1937–42; Phila. A. All., 1935; Calif. PM, 1935–40; 50 Prints of the Year, 1933, 1934; BAC, 1935; Northwest PM; Wichita AA, 1937–39; Southern PM, 1936–42; Brown Univ., 1934, 1937, 1938; RISD; Rockport AA, 1935–46; Providence AC, 1928–46; Providence WCC, 1933–46; Newport AA, 1935–41; South County AA, 1933–38. Position: T., RISD, 1928–46 [47]

MURPHY, Harriet Anderson (Mrs. William D.) [Por.P] b. 1851, Liverpool, England d. 23 S 1935, NYC. Studied: self-taught. With her husband she painted portraits of many prominent people. Her portrait of McKinley hangs in the White House.

MURPHY, Harry (Daniel) [Car,L] La Jolla, CA b. 9 O 1880, Eureka, CA. Studied: self-taught. Work: Huntington Lib., San Marino, Calif. Position: Cart., Hearst newspapers, New York Herald, Philadelphia Inquirer, Portland Oregonian, Rocky Mountain News, Seattle Post Intelligencer, 1898–1940 [47]

MURPHY, Henry Cruse, Jr. [Mar.P,I,T] Cos Cob, CT b. 26 F 1886, Brooklyn, NY d. 1 Ja 1931. Studied: self-taught. Member: SC; Greenwich SA; AFA. Work: Nat. Mus. Illustrator: in color for reproduction purposes, cover des., for more than ten magazines [29]

MURPHY, Henry David [P,D] Providence, RI b. 14 Ag 1909, Natick, RI. Studied: LaCasse; Sherwood. Work: deYoung Mus., San Fran. WPA artist. [40]

MURPHY, Hermann Dudley [P,T] Lexington, MA b. 25 Ag 1867, Marlboro, MA d. 16 Ap 1945. Studied: BMFA Sch.; Laurens, in Paris. Member: ANA, 1930; NA, 1934; Copley S., 1886; Boston WCC; Boston SAC; Boston Gld. A.; NAC; Boston SWCP; Mass. State A. Comm.; PS Gal. Assn.; Pan-Am. Expo, Buffalo, 1901 (med); St. Louis Expo, 1904 (med); P.-P. Expo, San Fran., 1915 (meds); AIC, 1922 (prize); North Shore AA, 1931 (prize); Buck Hills, Pa., 1937 (prize). Work: AIC; Nashville AA; Albright A. Gal., Buffalo; Dallas MFA; CMA. Also noted as a designer of frames. Position: T., Harvard, 1931–37 [40]

MURPHY, J(ohn) Francis [Ldscp.P] NYC/ Arkville, NY b. 11 D 1853, Oswego, NY d. 29 Ja 1921. Member: ANA, 1885; NA, 1887; SAA, 1901; AWCS; SC; Rochester AC; Brooklyn AC, 1900; Lotos C. Exhibited: NAD, 1885 (prize), 1910 (gold); SAA, 1887 (prize), 1902 (prize); Columbian Expo, Chicago, 1893 (med); AWCS, 1894 (prize); AC Phila., 1899 (gold); Paris Expo, 1900; Pan-Am. Expo, 1901 (med); Charleston Expo, 1902 (gold); St. Louis Expo, 1904 (med); SC, 1911 (prize); P.-P. Expo, San Fran., 1915 (med). Work: CGA; Buffalo FA Acad.; WMA; NGA; AIC; MMA; CI; Montclair AM; Brooklyn Inst. Mus.; RISD. Leading tonalist of the American Barbizon; similar to G. Inness [19]

MURPHY, J. Francis (Mrs.). See Murphy, Ada.

MURPHY, John J.A. [P] NYC. Member: GFLA [27]

MURPHY, Joseph E. [P] Columbus, OH. Member: Columbus PPC [25]

MURPHY, L.M. [P] Los Angeles, CA. Member: Calif. AC [24]

MURPHY, Leo [P] Cincinnati, OH b. 12 D 1906, Springfield, OH. Studied: Cincinnati A. Acad. Member: Cincinnati Assn. Prof. Ar. Exhibited: Cincinnati Ar., Cincinnati AM, 1939; WFNY, 1939; Golden Gate Expo, 1939. Work: Lunken Airport, Cincinnati [40]

MURPHY, Lucile Desbouillons [P] East Savannah, GA [25]

MURPHY, Marjorie C. [P] Santa Barbara, CA. Member: Calif. AC [25]

MURPHY, M(ichael) [S] Chicago, IL b. 24 N 1867, Cork, Ireland. Studied: Royal College A., London. Member: Western Soc. Sculptors; Chicago SA. Work: Fourth Presbyterian Church, Chicago [25]

MURPHY, Mildred V. [P,E,I] Phila., PA b. 12 O 1907, Germantown, PA. Studied: PAFA, with H. McCarter; PMSchIA, with E. Horter; Barnes Fnd. Member: Phila. Print C.; A. Lg. Phila. [40]

MURPHY, Minnie B. Hall (Mrs. Edward Roberts) [P,S,W,L,T] Denver, CO b. 2 My 1863, Denver. Studied: ASL; AIC; Denver, with H. Read. Member: NAC; Denver AC [27]

MURPHY, M(innie) Lois [G,P,Des,I,E,En,B,Li] Brooklyn, NY b. 8 F 1901, Lyons, KS. Studied: Columbia; ASL; B. Robinson; K. Nicolaides; G. Grosz; Martin; Hoffman; Fitsch. Exhibited: PAFA, 1927 (gold), 1928, 1934; Wichita AA, 1932 (prize); BM, 1931; AIC, 1930, 1931; Los Angeles Mus. A., 1937; Northwest Pr.M., 1937; WFNY, 1939; John Herron AI, 1943; MOMA, 1936; Riverside Mus., 1934, 1935, 1937; S.Indp.A., 1929; Minneapolis Inst. A., 1930; Provincetown AA, 1930; Phillips Acad., Andover, Mass., 1932; Morton Gal., 1932. Work: WMAA; MMA; Brooklyn Pub. Lib.; Queens Pub. Lib.; Hunter Col.; Univ. Wis.; Syracuse Univ.; H.S., Flushing, Jamaica, Brooklyn, all in N.Y. [47]

MURPHY, Nelly Littlehale (Mrs. H. Dudley) [P] Lexington, MA b. 7 My 1867, Stockton, CA. Studied: J. De Camp; C.H. Walker. Member: AWCS; NYWCC; Copley S.; Boston SWCP; Boston GA; Grand Central AG. Exhibited: Boston AC, 1929 (prize). Work: BMFA [40]

MURPHY, Rowley Walter [P,C] Toronto, Ontario/Ulard's Island, Toronto b. 28 My 1891, Toronto d. 1975. Studied: PAFA [25]

MURPHY, William D. [Por.P,Photogr] b. 11 Mr 1834, Madison County, AL. Studied: Cumberland Univ.; Nashville, with W. Cooper. Together with his wife, Harriet, he painted portraits of prominent people in the early 20th century.

MURRAY, Albert K. [Por.P] White Plains, NY b. 29 D 1906, Emporia, KS. Studied: Syracuse Univ.; W. Adams; Mexico; Nat. Gal., London. Member: Newport AA; Soc. Four A., Palm Beach. Exhibited: Nat. Gal., London; Salon de la Marine, Paris; Melbourne, Sydney, both in Australia; CI; WMA; VMFA; CGA; PMA; U.S. Naval Acad.; NAD, 1941. Work: Syracuse Univ.; La Fayette Col.; U.S. Naval Acad.; Union C., N.Y. [47]

MURRAY, Alexander [I,W,L] Wilkes-Barre, PA b. 20 Jy 1888, Kingston, PA. Studied: PAFA; ASL; Columbia; C. Beaux; W. Chase. Author/Illustrator: "How to Draw", 1930, "How to Draw and Paint," 1946. Contributor: American Boy, Saturday Evening Post, School Arts [47]

MURRAY, Faith Cornish [P,T] Charleston, SC b. D 1897, Charleston, SC. Studied: Fairmount Col.; Monteagle, Tenn.; Columbia; G. Atkinson; A. Dow. Exhibited: WFNY, 1939; Augusta, Ga., 1940; Columbia, S.C., 1935–45; Gibbes A. Gal., 1935, 1939, 1940, 1944, 1945. Work: Gertrude Herbert Inst. A., Augusta, Ga.; Columbia (S.C.) A. Center [47]

MURRAY, Grace H. (Mrs. A. Gordon) [Min.P] NYC b. 9 N 1872, NYC d. 14 N 1944. Studied: Paris, with Bouguereau, G. Ferrier; ASL. Member: Am. Soc. Min. P.; Brooklyn Soc. Min. P.; P. Soc. Min. P. Exhibited: Baltimore WCC, 1930 (prize); Pa. Soc. Min. P., 1930 (prize). Work: Pa. Mus. A., Phila.; Brooklyn Mus. [40]

MURRAY, Harold Paul [Min.P,T] Westbury, NY b. 28 D 1900, NYC. Studied: ASL; PAFA; DuMond. Member: Nassau County A. Lg. Exhibited: NAD, 1931; Brooklyn Soc. Min. P., 1929; ASMP, 1930; WFNY, 1939; AWCS, 1926, NAC, 1932; Nassau County A. Lg., 1936–44. Position: T., Nassau Inst. A., Hempstead, N.Y. [47]

MURRAY, Hester Miller [Des,P,Dec] Wheaton, IL b. 12 S 1903, Idaho Falls, ID. Studied: AIC; E. Miller. Exhibited: NAWPS, 1936–38; Intl. WC Ann. AIC, 1939; 48 Sts. Comp., 1939. Work: Burlington Railroad; St. Thomas Aquinas Chapel, Chicago; St. Mary's Chapel, Evanston, Ill. Position: Staff, A. Dept., Murray Bros., Chicago [40]

MURRAY, Martin Joseph [P,T] Newport, RI b. 30 Ap 1908, Newport, RI. Studied: RISD; John Frazier Sch. P., Provincetown, Mass. Member: CAA; Phila. WCC. Exhibited: PAFA, annaully; Newport AA, annually; Butler AI, 1946; RISD, annually; Phila. WCC. Work: Brown Univ.; R.I. Pub. Sch.; murals, New England Steamship Co.; Viking Hotel, Newport, R.I. Position: T., Vt. Jr. Col. [47]

MURRAY, Samuel A. [S] Phila., PA b. 12 Je 1870, Phila. d. 3 N 1941. Studied: ASL of Phila., with T. Eakins, 1886 (with whom he later taught and became a close friend). Exhibited: Columbian Expo, Chicago, 1893 (prize); Phila. AC, 1894 (gold), 1897 (prize); Pan-Am. Expo, Buffalo, 1901 (prize); St. Louis Expo, 1904 (med). Work: Witherspoon Bldg., Phila.; Pa. State Mon., Gettysburg; Corby statue, Notre Dame Univ.; Jefferson Medical Col., Phila.; Bishop Shanahan Mem., St. Patrick's Cathedral; statue, Capitol Park, Harrisburg, Pa.; Deshong Mem., Chester, Pa.; statue, League Island Park, Phila.; MMA; WMAA; Pa. Mus. A., Univ. Pa., both in Phila. Position: T., Phila. Sch. Des. for Women (Moore Col.), 1890–1941 [40]

MURRAY, Waldo [P] London, England b. U.S. Studied: London, with Sargent. Exhibited: P.-P. Expo, San Fran., 1915 (gold) [17]

MURRAY, William J. [I] d. 11 Ag 1943 (in action—behind the enemy lines in Sicily). Position: Staff A., Philadelphia Evening Bulletin

MURRY, Jerre [P,G,T] Los Angeles, CA b. 22 My 1904, Columbia, MO. Studied: Detroit Acad. A. Exhibited: Intl. Expo, Paris, 1937; Los Angeles Mus. A.; mural, WFNY, 1939. Work: Los Angeles Water and Power Co. [40]

MURTON, Clarence C. [Des,I,L] Seattle, WA b. 17 F 1901, McMinnville, OR. Studied: Univ. Wash. Positions: A. Manager, Seattle Post-Intelligencer; T., Univ. Wash., Seattle [47]

MUSE, Isaac Lane [P,L,Ser,T,W] NYC b. 23 Je 1906, Maysville, KY. Studied: E. Taflinger; F. Schlemmer; R. Selfridge; NAD. Member: Ar. of Today; Audubon A.; Nat. Serigraph Soc.; Assoc. A. N.J. Exhibited: Ind. State Fair, 1932 (prize), 1933 (prize); Elisabet Ney Mus., 1943 (prize); San Diego FA Soc., 1941; AIC, 1941; Denver A. Mus., 1943; Albany Inst. Hist.&A., 1945; Ar. of Today, 1941–45; A. Gal., N.Y., 1943; Fitchburg A. Center, 1941; Nat. Serigraph Soc. Gal., 1947 (one-man). Work: MOMA; Newark Mus.; Albright A. Gal.; SFMA; State Mus., Iowa; Denver A. Mus.; Fitchburg A. Center. Position: T., Columbia (Summer) [47]

MUSGRAVE, Arthur Franklyn [P] Truro, MA b. 24 Jy 1876, Brighton, England. Studied: Newlyn Sch. A., Cornwall, with S. Forbes; Munich. Member: Nat. A. Cl.; Boston AC; Provincetown AA. Exhibited: Royal Acad., London; PAFA; CGA; PMG; Stuart Gal., Boston [47]

MUSGRAVE, Edith [P,W] Mt. Vernon, NY b. 25 D 1887, NYC. Studied: E.M. Ashe; Bridgman; J.C. Johansen; A. Bement; ASL [33]

MUSGRAVE, Helen Greene [P,T] Cambridge, MA/Truro, MA b. 6 Mr 1890, Cincinnati, OH. Studied: Cincinnati A. Acad.; Académie Julian, Paris; N.Y. Sch. F.&Appl. A. Member: Provincetown AA; NAC [40]

MUSGROVE, Louis [P] NYC b. 20 Ag 1893, New York. Studied: Volk; F.C. Jones; G. Giles. Member: Art Dir. Cl.; Inst. Graphic A. [29]

MUSICK, Archie L. [P,Mur.P,Li,T,W] Colorado Springs, CO b. 19 Ja 1902, Kirksville, MO. Studied: E. Lawson; R. Davey; Northeast Mo. State T. Col; T.H. Benton; S. Macdonald-Wright; B. Robinson. Member: Colorado Springs FA Center; MOMA. Exhibited: Denver Ann., Chappell House, 1928 (prize); Broadmoor A. Acad. Exh., 1928 (prize); Colo. State Fair, 1927 (prize), 1928 (prize), 1930 (prize); AIC, 1940; CI, 1941; PAFA, 1941; Los Angeles Mus. A., 1945; Santa Barbara Mus. A., 1945. Work: murals, USPOs, Red Cloud (Nebr.), Manitou Springs (Colo.), South Church, Moberly (Mo.), Municipal Auditorium, FA Center, Colorado Springs; Northeast Mo. State T. Col. Author/Illustrator: "Oil Painting for Beginners," 1930. Author: "Transplanting of Culture," Magazine of Art, March 1937. Positions: T., Cheyenne Mt. Sch. (Colorado Springs), Mo. Univ., 1946–47 [47]

MUSICK, W(illiam) E(arl) [P,I,T] Midlothian, IL b. 27 N 1896, Brashear, MO. Studied: AIC; PAFA; Chicago Acad. FA; J. Norton; Atl, Rivera, in Mexico; Univ. Ill. Member: Hoosier Salon; Nat. Assn. Art Ed.; Chicago ATA; Chicago T. Un. Exhibited: Hoosier Salon, Chicago, 1927 (prize). Work: frescoes, Long Sch.; St. Louis; Univ. Ill. Contributor: article, Design magazine. Position: T., Fenger H.S., Chicago [40]

MUSS-ARNOLT, Gustav [P] Tuckahoe, NY b. 1858 d. 9 F 1927, Avon, MA. Specialty: animals, esp. dogs

MUSSELMAN, M. Emma [P] Phila., PA b. 26 Ja 1880, Lancaster, PA. Studied: Chase; Beaux; Daingerfield; Snell [08]

MUSSELMAN-CARR, M(yra) V. [S] Woodstock, NY b. 27 N 1880, Georgetown, KY. Studied: Bourdelle; ASL; Cincinnati A. Sch. Member: Woodstock AA. Work: fountains, Kansas City (Mo.), Bronxville (N.Y.); Roslyn, N.Y.; tablet, Pittsburgh, Pa. [31]

MUSSER, B(yron) J. [I,E] Jackson Heights, NY b. 15 F 1885, Chicago, IL. Studied: Henri. Member: Art Dir. Cl. [31]

MUTH, Alice Lolita (Helen) [P,Ldscp.P,C] b. 27 F 1887, Cincinnati, OH. Studied: Zuloaga. Member: Artistes Française; C.L. Wolfe AC; MacD. Cl. Exhibited: C.L. Wolfe AC, (prize); Alliance (prize); Paris Salon Artistes Française, (med,prize) [33]

MUTH, John Haverstick [Des,I,P] Lititz, PA/Mt. Gretna, PA b. 19 D 1907, Lititz. Studied: N.Y. Sch. F.&Appl. A. Work: Moravian Church, Hotel General Sutter, both in Lititz. Specialty: screens for interiors [40]

MUTRUX, Louis [P] St. Louis, MO. Member: SWA [15]

MUTTON, Hilda [E] Hollywood, CA. Member: Calif. PM.; Calif. AC [25]

MUYBRIDGE, Eadweard [Photogr] b. 1830, Kingston, England (came to U.S. in 1852) d. 1904, Kingston. (Born Edward James Muggeridge.) Settled in San Fran., 1855. Exhibited: Stanford MA, 1972 (retrospective). Work: MMA; IMP; LOC; NYPL; PMA; most major museums. Important for producing 2,000 landscape photographs of Yosemite and the Far West (signed "Helios," ca. 1868–73) as well as his landmark studies of sequential motion begun in 1872, culminating in "Animal Locomotion" (Univ. Pa., 1884–85), being 11 folio volumes of 781 plates from 10,000 negatives. Photographing L. Stanford's horse in 1872, he proved that a galloping horse at one point has all four feet off the ground. In 1874 he shot and killed his wife's lover; then photographed in Central America and the Isthmus of Panama, 1875–76. He invented the precursor of the motion-picture projector, the "zoopraxiscope" (1879), and continued motion studies with Jules Marey in Paris (1881). He lectured widely (1880s, 1890s). Near the end of his life he is said to have been recreating a scale model of the Great Lakes in his backyard. The impact of his famous motion studies on artists worldwide is immeasurable. [*]

MYER, Marie Shields [P] Brooklyn, NY [08]

MYERS, Annie M. [P,T] Castile, NY b. 19 Ap 1858, Warsaw, NY. Studied: Perkins; Rondel; Kreydère, in Paris. Member: Rochester AC [33]

MYERS, C(harles) Stowe Daniel [P,Indst.Des,Arch] Altadena, CA b. 7 D 1906, Altoona, PA. Studied: Univ. Pa. Member: Soc. Indst. Engineers; AWCS. Exhibited: WFNY, 1939; AWCS, annually. Award: Naval Ordnance, 1945. Industrial des. in NYC and Los Angeles since 1934. [47]

MYERS, Datus E. [P] Santa Fe, NM b. Oregon. Studied: AIC, with Vanderpoel, Freer, Betts, C.F. Brown. Member: San Diego AG, 1924; Chicago SA. Work: USPO, Winnsboro, La. WPA artist. [40]

MYERS, David J. [P] Seattle, WA [24]

MYERS, Emmet E(dwin) [P,Mur.P,T,L] Huntington, WV b. 11 Ag 1868, Edinburgh, OH d. 2 Ap 1937. Studied: Cincinnati Art Acad. Member: Western AA; AFA. Work: murals, Huntington H.S.; Delphian Soc., Huntington. Position: T., Marshall Col., Huntington [38]

MYERS, Ethel H. Klink (Mrs. Jerome) [S,L,I,Car] Carmel, NY b. 23 Ag 1881, Brooklyn, NY d. 24 My 1960, Cornwall, NY. Studied: Hunter Col.; Columbia; W. Chase; Henri; K.H. Miller. Member: N.Y. Ceramic Soc. Exhibited: NAD; CGA; PAFA; AIC; WMAA; BM. Contributor: magazines, newspapers. Specialties: small sculpture; drawing [47]

MYERS, Florence [P] Germantown, PA [06]

MYERS, Frank Harmon [P,Mur.P,Ldscp.P,Mar.P,T] Pacific Grove, CA b. 23 F 1899, Cleves, OH d. 7 Mr 1956. Studied: Cincinnati A. Acad., with Duveneck, Wessel, Weiss; PAFA, with Garber, Breckenridge, Pearson; Fontainebleau, France, with Despujols, Gourguet. Member: Cincinnati AC; Carmel AA; Cincinnati Ass. Prof. A.; PAFA, 1928; CM, 1923–40; Chicago Gal. Assn.; Cincinnati AC; Carmel AA. Work: mural, Children's Hospital, Cincinnati; landscape, Cincinnati Women's Cl.; Univ. Cincinnati; Hughes H.S., Cincinnati; Miami Univ., Ohio; Mus. N.Mex. Position: T., A. Acad. Cincinnati, 1922–40 [47]

MYERS, Irwin [P] Chicago, IL [25]

MYERS, Jennie C(hace) [Min.P] Castile, NY b. 7 Ag 1861, Avon, NY d. 18 Ag 1934. Studied: G. Perkins; W.J. Whittemore; Ertz, in Paris. Member: Rochester AC. Work: Municipal Mus. Rochester [33]

MYERS, Jerome [P,E] Carmel, NY b. 20 Mr 1867, Petersburg, VA d. 19 Je 1940, NYC. Studied: CUASch; ASL, with G. deF. Brush, late 1880s. Member: ANA; NA, 1929; Am. Soc. PS&G. Exhibited: St. Louis Expo, 1904 (med); NAD, 1919 (prize), 1931 (prize), 1936 (prize), 1937 (prize), 1938 (med); Armory Show, NYC, 1913. Work: MMA; BM; AIC; Rochester Mus.; PMG; Los Angeles Mus. A.; Canajoharie (N.Y.) A. Gal.; Delgado Mus.; Newark Mus.; Milwaukee AI; CGA; NGA; WMAA. Specialty: New York street scenes [40]

MYERS, Lloyd B(urton) [P,I,G] San Fran., CA b. 19 F 1892, Sterling, IL d. ca. 1955. Studied: ASL. Member: SI; SC [47]

MYERS, Mary Shepherd Lukens (Mrs.) [P,L,T] Conshohocken, PA/Cape Neddick, ME b. 7 Jy 1878, Conshohocken. Studied: W.M. Chase; C. Beaux; Breckenridge; H. McCarter; PAFA. Member: Phila. Alliance; Ogunquit AA [33]

MYERS, O. Irwin [P,I] Chicago, IL b. 12 N 1888, Bananza, NE. Studied: AIC; Chicago Acad. FA. Member: Chicago SA; Chicago AG; Chicago AC [27]

MYERS, Sadie S. [Min.P] Cincinnati, OH [17]

MYERS, Texie [S,T] Marshall, TX b. 24 Ag 1900, Marshall [27]

MYERS, Willard [E,I,W] Phila., PA b. 17 O 1887, Phila. Studied: PMSchIA. Member: Phila. Sketch Cl.; AIGA. Exhibited: SAE, 1944; Phila. Pr. Cl., 1944, 1946; Phila. Sketch Cl., 1943–46. Author/Illustrator: "The Unbelievable City," 1926 [47]

MYERSON, M. [P] Brookline, MA. Member: AWCS [47]

MYGATT, Emily Tyers [P] NYC [10]

MYGATT, Nellie B. [Ldscp.P] b. 1861 d. 16 N 1936, New York

MYGATT, Robertson K. [P] NYC d. 16 D 1919. Member: SC; Ar. Fund Soc. Exhibited: St. Louis Expo, 1904 (med) [19]

MYKRANTZ, Elizabeth S. [P] Columbus, OH. Exhibited: Columbus A. Lg., 1937 (prize) [40]

MYLANDER, Mathilde M. [S] Baltimore, MD. Exhibited: Soc. Wash. Ar., 1939; WFNY, 1939 [40]

MYLER, Marshall [P] NYC. Exhibited: AIC, 1938; Am. WC Soc., 1938 [40]

MYRBACH, F. [I] NYC. Associated with "Century." [13]

MYRER, Angèle [E,P,B] b. 5 Je 1896, Chelsea, MA d. 1970. Studied: K. Knaths; B. Lazzell; Cranbrook Acad. Exhibited: Provincetown AA, 1938 [*]

MYRICK, Elizabeth [P] Chicago, IL. Member: Chicago NJSA [25]

MYRICK, Frank W. [P] Boston, MA. Member: Boston SWCP; Boston AC [10]

MYRICK, Katherine S. [P] Old Lyme, CT d. ca. 1950. Member: ASMP [47]

MYRICK, Ruth Kealing [P] Indianapolis, IN b. Indianapolis. Studied: L.M. King. Member: Ind. AA [25]

MYSLIVE, Frank Richard [P] Hammond, IN/Douglas, MI b. 5 N 1908. Member: Ind. Ar. Cl.; Polish A. Cl. Calumet Region; Douglas A. Soc. Work: St. Catherine's Hospital, East Chicago, Ind.; Calumet Orphan Home for Boys, Hammond; coll. in Warsaw, Poland [40]

Symbol of the National Academy of Design

NACHTRIEB, Michael Strieby [P] Wooster, OH b. 25 Ag 1835, Wooster d. 27 D 1916. Studied: NYC. Work: Wooster Col. Decorative and portrait painter active in Ohio and on Miss. River steamboats. [*]

NADEJEN, T. [I] NYC [24]

NADELMAN, Elie [S] Riverdale, NY b. 6 O 1885, Warsaw, Poland d. 28 D 1946. Work: BM; Detroit Inst. A.; RISD [40]

NADHERNEY, E.V. [I] NYC [01]

NAEGELE, Charles Frederick [Por.P] Marietta, GA b. 8 My 1857, Knoxville, TN d. 27 Ja 1944. Studied: W. Sartain; Chase; C.M. Collier. Member: A. Fund S.; SC, 1893; Lotos C. Exhibited: Mechanics Fair, Boston, 1900 (gold); Charleston Expo, 1902 (med). Work: NGA; portraits, Mem. Lib., City Hall, both in Watertown, N.Y.; Flower Hospital, Clearing House, both in NYC; Sch. Auditorium, State Capitol, both in Atlanta; State Capitol, Montgomery, Ala.; N.Y. Hist. Soc. Originator: new method of encouraging public collection of pictures; new method of indexing library, Salmagundi C. [40]

NAGEL, Eva M. See Wolf, Mrs.

NAGEL, Herman F. [P,T] Newark, NJ b. 1 D 1876, Newark. Studied: NAD. Member: SC [31]

NAGEL, Nellie Foster (Mrs. John G. Nagel) [P,T,L] Meriden, CT b. 23 Ap 1873, Meriden d. 20 Ap 1955. Studied: PIASch; NYU; Columbia; CCNY; H. Snell; A. Dow; G. Bridgman; A. Fisher; Member: NAWA; Brush & Palette C.; Meriden A.&Cr. S.; Wolfe AC. Exhibited: NAWA; All.A.Am.; Provincetown AA; Ogunquit A. Center; New Haven PCC; CAFA; Meriden A.&Cr. S., 1941 (prize), 1945 (prize); Argent Gal, NYC, 1939 (one-man). Work: church, Meriden [47]

NAGELVOORT, Betty (Mrs. Flint) [Des,C,En,P,B,Dr] Long Beach, CA b. 10 D 1909, Ann Arbor, MI. Studied: Univ. Wash.; Chouinard Sch.; Varney Serrao, in Rome; A. Center Sch., Los Angeles; H. Rhodes; W. Isaacs. Member: Calif. WCS; Prairie PM; Northwest PM. Exhibited: 50 Color Prints of the Year, 1933; GGE, 1939; Northwest PM; Prairie PM; Calif. WCS; Pomona Fair, 1932–38; Los Angeles Mus. A., 1940 (prize), 1941 (prize); Pomona Fair (prize); Work: des. of hand-blocked textiles, toys, children's furniture [47]

NAGLE, Edward P(ierce) [P] Charlottesville, VA/Georgetown, ME b. 1 Je 1893, Revere, MA [33]

NAGLE, Fred [P] Spuyten Duyvil, NY [21]

NAGLER, Edith (Kröger) [P,W] Huntington, MA b. 18 Je 1890, NYC. Studied: NAD; ASL; D. Volk; R. Henri; F. DuMond. Member: AWCS; AAPL; Springfield AL; Hudson Valley AA; CAFA. Exhibited: CGA; AIC; NAD; AWCS, 1923–46; PAFA; Springfield Mus. A.; BMA; New Haven PCC; AIC, 1927, 1934 (prize); Stockbridge, Mass., 1932 (prize); Bronx AG, 1931 (prize). Work: Wadsworth Atheneum, Hartford; Springfield Mus. A.; Highland Park Mus., Dallas, Tex. [47]

NAGLER, Fred [P,E] NYC/Huntington, MA b. 27 F 1891, Springfield, MA. Studied: ASL; W. Stock; R. Henri; F. DuMond. Exhibited: CGA, 1941 (prize); AIC; Albright A. Gal.; Detroit Inst. A.; PAFA; de Young Mem. Mus.; Dallas Mus. FA; NAD, 1923 (prize); WMAA; GGE, 1939; WFNY, 1939; VMFA, 1941 (prize); Springfield AL, 1935 (prize); New Haven PCC, 1928 (prize). Work: de Young Mem. Mus.; Springfield Mus. A.; AGAA; 50 Prints of the Year, 1932; "America Today"; "Art in America" [47]

NAGY, Frank [S] Astoria, NY b. 29 Mr 1897, Hungary. Studied: mostly self-taught; Strobl, in Budapest; Hansk, in Vienna [40]

NAHL, Charles Christian [P,En,Li,I,Photogr] San Fran., CA b. 13 O 1818, Cassel, Germany (came to NYC in 1849; Calif. in 1850) d. 1 Mr 1878 (typhoid). Studied: Paris, 1848. Exhibited: Paris, 1847–48. With his half-brother, Hugo, worked as photographer and commercial artist in San Francisco, 1850–67. Best known as painter of pioneer life in Calif.; most of his early work was destroyed by fire in Sacramento and later in the San Fran. fire. Work: BMFA; Amon Carter Mus.; BM; Stanford. Designer: the bear on the Calif. state flag [*]

NAHL, Hugo Wilhelm Arthur [P,En,I,Photogr] San Fran., CA b. 1820, Cassel, Germany d. 1 Ap 1889. Studied: Paris, 1848. Exhibited: San Fran. AA, 1870; Calif. State Fair, 1888 (med). Work: Oakland MA; Amon Carter Mus. Designer: Calif. state seal [*]

NAHL, Perham W. [P,S,L,T,E] Berkeley, CA b. 11 Ja 1869, San Fran. d. 9 Ap 1935. Studied: San Fran.; Paris; Munich. Member: Calif. SE; San Fran. AA. Exhibited: P.-P. Expo, 1915 (med); Calif. SE, 1926 (prize). Work: Palace FA, San Fran.; Municipal A. Gal., Oakland; Univ. Calif. Positions: T., Univ. Calif.; many study groups, Japan [33]

NAHL, Virgil [I] b. 1876, San Fran. d. 9 F 1930, San Fran. One of the best known newspaper artists in the West. Position: Staff, San Francisco Examiner, 32 yrs.

NAILOR, Gerald Lloyde [P,I] Penasco, NM b. 21 Ja 1917, Gallup, NM d. 12 Ag 1952. Studied: Albuquerque A. Sch.; Santa Fe Indian A. Sch.; O. Nordmark; K.M. Chapman. Member: Indian A. Colony, Santa Fe. Exhibited: Mus. N.Mex., Santa Fe, 1935, 1937; MOMA, 1936; Denver AM, 1936; WFNY, 1939. Work: murals, Court House (Window Rock, Ariz.), USPO, Mes Verde (Colo.); Dept. Interior Bldg., Wash., D.C.; Denver AM; Mus. Am. Indian. Illustrator: Jr. Red Cross magazine. WPA artist. [47]

NAKAGAWA, H. [P] Grundmann Studios, Boston, MA [01]

NAKAMIZO, Fugi [P,C,E,Li] NYC b. 17 Ja 1889, Fukuiken, Japan d. ca. 1950. Studied: ASL; CUASch; J. Pennell; W.D. Dodge; F. DuMond. Exhibited: PAFA, 1934; WFNY, 1939; NGA, 1941; NAD, 1946; Laguna Beach AA; CGA, 1943; LOC, 1945; SAE, 1945; CM; Everhart Mus.; Mus. FA, Houston; Norfolk Mus. FA; Portland (Oreg) Mus. A.; SFMA; Santa Barbara Mus. A.; SAM; CMA; WMAA; BM; Phila. Pr. C.; Honolulu Acad. A.; Ariz. State Fair, 1927 [47]

NAKAMURA, Kanzi [P] b. 1887, Nagasaki (came to U.S. in 1908) d. 7 Je 1932, Boston, MA. Work: BMFA; Fogg A. Mus.

NAKIAN, Reuben [S] NYC b. 10 Ag 1897, College Point, NY. Studied: P. Manship. Member: S. PS&G; F., Guggenheim Fnd., 1931. Work: MOMA; Newark Mus.; WMAA [40]

NANKIVELL, Edith (Mrs. Frank) [P] NYC [25]

NANKIVELL, Frank A(rthur) [P,Li,E] NYC/Walton, NY b. 16 N 1869, Maldon, Australia. Work: Mus. Am. Indian, NYC; Univ. Va., Charlottesville; State Hist. S., Mo., Columbus; BM; MMA; LOC; N.Y. Bar Assn.; Harvard Law Sch.; Duke Univ.; Brooklyn Pub. Lib. [40]

NANKWELL, Fred [I] NYC. Position: Staff, Truth, NYC [98]

NAPOLI, James [G] Cleveland, OH b. 8 Ap 1907, Cleveland, OH. Studied:

ASL, Cleveland; Huntington Inst.; Cleveland Sch. A. Work: MOMA; Cleveland Pub. Lib. [40]

NAPOLITANO, Giovanni [P] Los Angeles, CA. Studied: Acad. FA, Berlin; Kunstgewerbe Sch., Munich, Germany; Alfred Univ., N.Y.; F.T. Chamberlin. Work: Los Angeles Mus. Hist., Sc.&A. [40]

NAPOLITANO, Pasquale G. [P] Los Angeles, CA. Member: Calif. AC [27]

NAPPENBACH, Henry ("Nap") [I,Car,En,Ldscp.P] b. 1862, Bavaria d. 25 My 1931, NYC. Studied: Munich. Work: Oakland AM; Bohemian C., San Fran. Positions: Staff A., Hearst (1893), San Francisco Wasp; Hd., Color Dept., New York American, from 1918

NARAY, Aurel [P] Homestead, PA [24]

NARJOT, Ernest E. [Mur.P] San Fran., CA b. 1827, St. Malo, Brittany (came to San Fran. in 1849) d. 1898. Studied: Paris, 1843. Exhibited: San Fran. AA. Popular painter of genre, historical and military scenes, until his vision was impaired by paint dropping from the ceiling fresco of Stanford's tomb. Many of his works were lost in the 1906 fire. [*]

NASH, Anne Taylor (Mrs. E.S) [Por.P] Savannah, GA b. 29 Ja 1884, Pittsboro, NC. Studied: PAFA; Winthrop Col.; Rock Hill, S.C. Member: Carolina AA; SSAL; Savanahh AC. Work: Roper Hospital, Charleston; Hibernian S., Charleston; St. Andrews S., Charleston. [47]

NASH, Edgar S. [I] Phila., PA. Affiliated with The Beck Engraving Co., Phila. [21]

NASH, Flora [I] NYC. Member: SI; Artists Gld. [31]

NASH, Fred D. [I] Detroit, MI. Studied: Detroit A. Acad. Position: Staff, Detroit Journal [6]

NASH, Harold Siegrist [Edu,C,Des,W,L,T] Cincinnati, OH b. 8 N 1894, Buffalo, NY. Studied: N.Y. State Col. Ceramics, Alfred, N.Y.; C.F. Binns. Member: Am. Assn. Univ. Prof.; Am. Ceramic S.; Cincinnati Mus. Assn.; Cincinnati AC. Exhibited: Syracuse MFA; Alfred, 1940 (med); CM. Work: CM; IBM Coll. Contributor: Bulletin of Am. Ceramic S.; Design. Specialty: ceramics. Position: T., Univ. Cincinnati, from 1927 [47]

NASH, Isabel [Min.P] NYC. Studied: W. Whittemore [08]

NASH, Joseph Pfanner [P,Ser,T] Lake Forest, IL b. 16 Jy 1900, Dayton, OH d. ca. 1955. Studied: AIC; Univ. Ind.; Lake Forest Col.; G. Bellows; L. Seyffert; L. Ritman. Member: Chicago Assn. P.&S.; Chicago Gal. Assn; North Shore AL; Teton AA. Exhibited: AIC, 1934–36, 1942, 1945; Milwaukee AI, 1946; Rosenwald Mus. Sc. & Indst., 1943–45. Work: Northwestern Univ.; Lake Forest Col.; portraits of military personnel. Positions: T., Lake Forest Col. (1944–46), Bell Sch. (Lake Forest) [47]

NASH, Katherine (Mrs. Robert C.) [S,L] Excelsior, MN b. 20 My 1910, Minneapolis, MN. Studied: Univ. Minn.; Walker A. Center. Member: Minn. AA; Minn. S. Group (Vice-pres.) Exhibited: Minneapolis Inst. A., 1942, 1944 (prize) 1945; Minn. State Fair, 1941 (prize), 1942 (prize), 1944 (prize); Walker A. Center, 1940–42, 1944, 1945; Minneapolis Women's C., 1941, 1945; St. Paul Gal., 1945 [47]

NASH, Manley K. [P] St. Louis, MO [24]

NASH, Mildred Archer [S] Norwalk, CT [19]

NASH, Ray [Typ,Des,T] Hanover, NH b. 27 F 1905, Milwaukie, OR. Studied: Univ. Oreg.; Harvard Sch. FA; Univ. Brussels. Member: CAA; Bibliographical S. Am.; S. Printers, Boston; S. Typographic A., Chicago. Work: FMA; Dartmouth; typography des. for Economic Forum, Delphian Quarterly; books, Dartmouth publications; Boston & Maine Railroad; bookplates, inscriptins. Author: "Pioneer Printing at Dartmouth," 1941, "Some Early American Writing Books and Masters," 1943. Translator: "An Account of Calligraphy and Printing in the Sixteenth Century," 1940. Specialty: typographic design. Positions: T., New Sch. for Social Research, NYC (1932–37), Dartmouth (from 1937) [47]

NASH, Sarah E. [P] NYC. Member: Lg. AA [24]

NASH, Willard Ayer [P,E,Li,T] Hollywood, CA b. 29 1898, Phila. d. 1943. Studied: Detroit Sch., with J.P. Wicker. Member: Am. Ar. Cong. Exhibited: "The Modernist," Mus. N.Mex.; WMAA, 1932, 1935; San Fran. AA, 1931 (prize); Los Angeles AA, 1934 (prize); Los Angeles Mus. A., 1938 (prize). Work: Denver AM; Los Angeles Mus. A.; Univ. N.Mex.; Mus. N.Mex. Positions: T., Broadmoor AA (Colorado Springs), A. Center Sch. (Los Angeles), San Fran. Sch. A. [40]

NASON, Anna L. [P,T] Boxford, MA b. West Boxford, MA. Studied: P. Nordell; Mass. Sch. A. Member: BAC; Fitchburg A. Center. Position: T., H.S., Fitchburg, Mass. [40]

NASON, Gertrude [P,T] NYC/Lyme, CT b. 7 Ja 1890, Everett, MA d. ca. 1968. Studied: Mass. Sch. A., with J. De Camp; BMFA Sch., with E. Tarbell. Member: NAWA; Creative AA; NYSWA; PBC; Lyme AA; Brooklyn S. Mod. A. Exhibited: CGA, 1925, 1933, 1935, 1937; PAFA, 1925, 1932, 1934; NAD, 1933, 1935; CAM, 1934; Dayton AI, 1946; AFA Traveling Exh., 1933; Lyme A. Gal.; Lyman Allyn Mus., 1945; Copley S., 1945; Riverside Mus., 1942, 1944, 1946; Am.-British A. Ctr., 1943; All.A.Am., 1942; PBC, 1932 (prize), 1935 (prize), 1938 (prize), 1941 (prize), 1945 (prize); NAWA, 1939 (prize), 1945 (prize) [47]

NASON, L.M. [P] Worcester, MA [10]

NASON, Thomas W(illoughby) [En,B] Lyme, CT b. 7 Ja 1889, Dracut, MA d. 1971. Studied: Tufts Col. Member: NA; NIAL; SAE; SC; CAFA; Chicago SE; Lyme AA; ANA, 1936; Phila. SE. Exhibited: Phila. Pr. C., 1929 (prize), 1930 (prize), AIC, 1930 (prize); City of Warsaw, Poland, 1933; LOC, 1943 (prize), 1945 (prize); SAE, 1935 (prize), 1938 (prize), 1945 (prize); Woodcut S., Kansas City, 1937 (prize); Albany Pr. C., 1936; Northwest PM, 1932 (prize), 1933 (prize). Work: NYPL; BM; WMAA; AIC; SMA; AGAA; Smithsonian; BMFA; Boston Pub. Lib.; Victoria & Albert Mus., London; Bibliothèque Nationale, Paris; 50 Prints of the Year, 1926–27, 1931–33; Fine Prints of the Year, 1933–34, 1936; LOC. Specialty: wood engraving [47]

NAST, Cyril [P] NYC [24]

NAST, Thomas [I,Car] NYC b. 27 S 1840, Landou, Bavaria (came to NYC in 1946) d. 7 D 1902, Guayaquil, Ecuador (yellow fever). Studied: NYC, with T. Kaufmann, A. Fredericks; NAD. At the age of fifteen furnished sketches for Leslie's of a prize fight in Canada. Then in England he made sketches for the New York Illustrated News. His Civil War pictures produced for Harper's are among his most notable works (although he was involved in a bitter dispute with Alfred Waud who claimed Nast intercepted and signed the latter's drawings from the front lines.) He was the first to introduce caricature work into America, and his pictures of war scenes, of Andrew Johnson, and of the Tweed Ring had great influence on the politics of the time. He also painted in oil and watercolors. In 1902, he was appointed Consul-General to Ecuador. He created the Democratic donkey and Republican elephant symbols. He published Nast's Weekly, 1892–93. Folk etymology says that the term "nasty" comes from his biting satirical caricatures. Work: BMFA; MMA [01]

NAST, Thomas, Jr. [I] NYC [13]

NAT. See Tepper, Natalie.

NATHANS, Gwendolyn [P] NYC. Member: Lg. AA [24]

NATT, Phebe D. [P] NYC [01]

NATZLER, Gertrud [Cer,C] Los Angeles, CA b. 7 Ja 1908, Vienna, Austria d. 1971. Exhibited: Paris Salon, 1937; Syracuse MFA, 1939, 1940, 1941; GGE, 1939; SFMA (one-man); Los Angeles Mus. A. (one-man); San Diego FAS (one-man); Santa Barbara Mus. A. (one-man); Denver AM. Work: MOMA; Syracuse MFA; San Diego FAS; BMA; CM; PMA; Santa Barbara Mus. A.; SAM; Los Angeles Mus. A.; AIC; Walker A. Ctr. [47]

NATZLER, Otto [Cer,C] Los Angeles, CA b. 31 Ja 1908, Vienna. (Otto is listed at the same address and with the same data as Gertrud, except the birth date.) [47]

NAU, Carl W. [P] Emporia, KS [17]

NAUMAN, F(red) R(obert) [P,E] Glendale, MA b. 7 Ja 1892, St. Louis, MO. Exhibited: St. Louis AG, 1919 (prize) [33]

NAUMBURG, Nettie Goldsmith (Mrs.) [Patron] d. 6 Mr 1930, NYC. Bequeathed to the Fogg Museum of Harvard her art collection, including Rembrandt's "Portrait of an Old Man," El Greco's "Christ Driving the Money Changers Out of the Temple," and other works by the Old Masters. $100,000 was provided for transportation and building of three rooms at the Museum.

NAUMER, Helmuth [P] Santa Fe, NM b. 1 S 1907, Reutlingen, Germany. Studied: F. Wiggins; R. Weegman, Germany. Exhibited: Springville, Utah, 1941, 1946; Mus. N.Mex., Santa Fe, annually, 1945 (one-man), 1946 (one-man); N.Mex. State Fair, 1939 (prize). Work: N.Mex. Mus.; Univ. N.Mex.; Univ. Wyo.; Bandelier & White Sands nat. mon.; N.Mex.; Mus., Frijoles Canyon; State Univ., Laramie, Wyo.; Sch. Mines, Socorro, N.Mex.; Governor's Mansion, Santa Fe [47]

NAVE, Royston [P] Victoria, TX b. 5 N 1876, La Grange, TX. Studied: R. Henri. Member: SC. Work: State of Texas [31]

NAVIGATO, Rocco D. [P] Chicago, IL. Member: GFLA; Palette and Chisel C. [29]

NAYLOR, Alice [P,Li,T] San Antonio, TX b. Columbus, TX. Studied: Witte Mem. Mus. Sch. A.; San Antonio AI; C. Rosen; E. Ret; A. Dasburg. Member: San Antonio AL; Palette & Chisel C.; San Antonio PM; Tex. FAA; SSAL; NIAL; Mill Race A. Group. Exhibited: Critic's Choice, Cincinnati, 1945; Mus. N.Mex., 1945; Tex. General Exh., 1944, 1945; Tex. FAA, 1943–46; LOC, 1943; Austin, Tex., 1942; Witte Mem. Mus., 1945 (one-man); Tex. FAA, 1945 (one-man). Position: T., San Antonio AI, from 1943 [47]

NEAFIE, Edith S. [P,T] Newtown, CT b. 29 Ap 1884, Brooklyn, NY. Studied: PIASch; Grand Central Sch. A.; A. Fisher; L. Stevens. Member: Nat. A. Cl.; AAPL; NAWA; PBC. Exhibited: Nat. A. Cl., 1934, 1935; Am. WC Soc., 1937; NAWA, 1932, 1933, 1936–38; 1942, 1946; PBC, 1937–41, 1944–46; Wolfe AC, 1932 (prize) [47]

NEAL, David Dalhoff [Por.P,Hist.P] Munich, Germany b. 20 O 1838, Lowell, MA d. 2 My 1915. Studied: Munich Royal Acad., 1860s; Piloty, in Munich, 1869–76. Exhibited: Munich Royal Acad., 1876 (gold), the first American to win this award. Work: Cleveland Pub. Lib.; Royal Gal., Stuttgart. His "The First Meeting of Mary Stuart and Rizzio" (1876) was widely exhibited and reproduced. On his numerous visits to the U.S., he painted many portraits—among them Whitelaw Reid, Mark Hopkins, and several professors of Princeton Univ. [10]

NEAL, Grace Pruden (Mrs. Jesse H.) [S,P] Carmel, NY b. 11 My 1876, St. Paul, MN. Studied: St. Paul A. Sch.; AIC; ASL; Grande Chaumeire, Paris; K. Akerberg; Injalbert. Member: Carmel AA. Exhibited: Minn. State A. Soc., 1903 (prize), 1904 (prize), 1905 (prize); NAD, 1919–23, 1927; PAFA, 1914–17, 1920, 1922, 1924, 1927, 1929, 1930, 1945, 1946; CI, 1917; AIC, 1916, 1917, 1919, 1921, 1927; Arch. Lg., 1920, 1921, 1923; CGA, 1945, 1946; Smithsonian Inst., 1946; Phila. Plastic Cl.; Rochester Mem. A. Gal.; All.A.Am.; Putnam County AA; Newport AA; Albright A. Gal.; CAFA; Minn. State A. Soc.; Indianapolis AA. Work: mem., Cochran Park, St. Paul; bust, Gov. A.O. Eberhard, Minn.; bronze group, Thirty Cl., London [47]

NEAL, Mary Alley [P] NYC [01]

NEAL, Reginald H. [Edu,Li,P] Decatur, IL b. 20 My 1909, Leicester, England. Studied: Bradley Polytechnic Inst., Peoria, Ill.; Univ. Chicago; Yale; P.R. McIntosh; G. Wood. Member: Ill. Art Ed. Assn. Exhibited: AIC, 1935; PAFA, 1936, 1938, 1940; AV, 1942; Oakland A. Gal., 1936; Kearney Mem. Exh., Milwaukee, 1946; Decatur A. Center, 1943–45; Davenport Municipal A. Gal., 1940, 1942. Work: Davenport Municipal A. Gal.; LOC; Brigham Young Univ.; Queens Col., Kingston, Canada. Position: Dir. (1940–), T. (1944–), Decatur A. Center [47]

NEAL, Sue Rose [P] Grafton, PA b. Chaplin, KY. Studied: C. Walter. Member: Pittsburgh AA [25]

NEALE, Marguerite B. [P] Wash., D.C. Member: Wash. WCC [29]

NEALE, Sidnee Hubbard (Mrs. Russel) [I] NYC. Member: SI [47]

NEALL, Margaret Acton [P] Phila., PA. Studied: PAFA [25]

NEANDROSS, Leif [P] Ridgefield, NJ. Member: AWCS; NYWCC. Exhibited: NYWCC, 1937, 1939 [47]

NEANDROSS, Sigurd [S] Ridgefield, NJ b. 16 S 1871, Stavanger, Norway (came to NYC in 1881) d. 15 D 1958. Studied: Cooper Union evening classes; P.S. Kroyer, S. Sinding, in Copenhagen. Member: NSS. Exhibited: Arch. Lg., 1915 (prize) [40]

NEBEL, Berthold [S] Westport, CT b. 19 Ap 1889, Basel, Switzerland d. 1964. Studied: Mechanics Inst., with H.R. Ludeke; ASL, with J.E. Fraser. Member: ANA, 1932; NA, 1946; NSS. Exhibited: Va. War Mem. Comp., 1926 (prize); Arch. Lg.; NSS; Italy. Award: Prix de Rome, 1914–17. Work: U.S. Capitol; Conn. State Capitol; Brown Bros. Bank, NYC; bronze doors, Mus. Am. Indian, Geographical Soc. Am. Bldgs., Hispanic Mus., all in NYC. Living in Rome, 1933. [47]

NEDVED, Elizabeth Kimball (Mrs. Rudolph V.) [Arch.,P] Glencoe, IL b. 26 O 1897, Chicago, IL. Studied: Church Sch. A.; Armour Inst. Tech.; E. O'Hara. Member: Women's Arch. Cl., Chicago. Exhibited: Wash. WCC Ann., CGA, 1936, 1939 [40]

NEDWILL, Rose [P,E] NYC b. 10 Jy 1882, NYC. Studied: ASL, with Bridgman; H. Dunn; G.P. Ennis; D. Beard; R. Reid; C.G. Chapman. Member: Studio Gld., N.Y.; Bronx A. Gld.; Gotham Painters; North Shore AA; Gloucester SA [47]

NEEBE, Louis Alexander [P,L,T] Chicago, IL b. 18 Ag 1873, Phila., PA. Studied: C.F. Brown; W. Reynolds; F.F. Fursman; G. Senseney; W. Ufer. Member: Chicago SA; Chicago NJSA; S.Indp.A.; Business Men's Art Cl. [25]

NEEBE, Minnie Harms [P,C,L,T] Chicago, IL b. 25 D 1873, Chicago. Studied: AIC; Hawthorne; Browne; Webster; Reynolds; Ufer; Fursman; Senseney. Member: Chicago SA; Chicago NJSA; Chicago Municipal A. Lg. Work: Chicago public schools [25]

NEEDHAM, A(lfred) C(arter) [P] Manchester, MA b. 28 Ja 1872, Beechville, Canada. Member: Copley S.; Rockport AA; Gloucester North Shore AA [33]

NEEDHAM, Charles Austin [P,Ldscp.P,S,I,C] NYC b. 30 O 1844, Buffalo, NY d. 24 N 1923. Studied: A. Will; ASL. Member: NYWCC; AWCS; Lg. Am. Ar.; SC, 1903. Exhibited: Atlanta Expo, 1895 (med,prize); N.Y. State Fair, Syracuse, 1898 (prize); Paris Expo, 1900 (med); Charleston Expo, 1902 (med); St. Louis Expo, 1904 (med) [24]

NEEDHAM, Ray C(lay) [P] Richmond, IN b. 5 Ap 1893, Owosso, MI. Studied: E. Duffner; J.M. King; G.H. Baker. Member: Hoosier Salon; Richmond Palette Cl.; Richmond AA. Exhibited: Richmond AA, 1931 (prize). Work: Intermountain Union Col., Helena, Mont.; Masonic Home of Ind., Franklin; United Brethren Church, Richmond [40]

NEEL, Alice [Por.P] NYC b. 1900, Merion Square, PA d. 1984. Studied: Phila. Sch. Des. for Women, 1921–25. Exhibited: retrospective, Ga. Mus. A., 1975. After her WPA days, she developed an idiosyncratic style of portraiture. [*]

NEEL, Birdie M. [P] Pittsburgh, PA. Member: Pittsburgh AA [24]

NEEL, Frank [Min.P,Patron] b. 2 F 1874, Toledo, OH d. 29 Ja 1933, Toledo

NEELD, C(larence) E(llsworth) [P] Glen Ellyn, IL b. 7 My 1895, New Albany, IN. Studied: Menoir; C. Buck; J. Topping. Member: Hoosier A. Patrons A.; All-Ill. SFA [40]

NEELY, Anne Abercrombie (Mrs. Hugh) [P] Memphis, TN [24]

NEELY, Robert Walther [S,P] Minneapolis, MN/Grinnell, IA b. 7 Jy 1915, Grinnell. Exhibited: watercolor, Twin Cities Exh., Minneapolis Inst. A., 1936 (prize). Work: Minneapolis Inst. A. [40]

NEEVIL, Opal [P] Kansas City, MO [24]

NEFF, Earl J. [Mur.P,I] Fairview Village, OH b. 4 Ap 1902, Cleveland OH. Studied: Cleveland Sch. A.; H.G. Keller; Huntington Polytechnic Inst.; W. Sommer. Member: Cleveland PM. Exhibited: illus., Cleveland Mus. A., 1933 (prize), mural dec., 1935 (prize). Work: murals, Brotherhood of Locomotive Engineers (Cleveland), Techwood Homes (Atlanta, Ga.); Cleveland Pub. Lib.; Brownell Sch., Lakeview Terrace Nursery, both in Cleveland. Author: "Roly-Poly" books, 1935 [40]

NEGUELOUA, Francisca (Mrs. Wayland Fry) [P] New Orleans, LA. Exhibited: watercolor, PAFA, 1937. Work: USPO, Tallulah, La. WPA artist. [40]

NEHER, Fred [Car] Norwalk, CT b. 29 S 1903, Nappanee, IN. Studied: Chicago Acad. FA. Member: SI; A.&W. Soc.; Car. Soc. Illustrator: Judge, Collier's, Punch, Liberty, other magazines, "Chick Evans' Golf Book," "Ida Broke," and daily drawing "Life's Like That," for Bell Newspaper Syndicate. [47]

NEHLIG, Victor [P] NYC b. 1830, Paris, France (came to Cuba, ca. 1850; to NYC, ca. 1856) d. 1909. Studied: Cogniet, Abel de Pujol, in Paris. Member: ANA, 1863; NA, 1870. Exhibited: NA, 1871. Work: N.Y. Hist. Soc. [08]

NEIDIGH, Pansy Mills (Mrs.) [P,C,T,L] Richmond, IN b. 1 Ap 1907, New Ross, IN. Studied: Central Normal Col.; John Herron A. Sch.; Columbia. Member: NAC. Exhibited: Ind. State Exh. (prize); Butler AI (prize); NAC; Columbia Univ. Lib.; Hoosier Salon; Richmond AA. Contributor: Design, School Arts. Positions: T., Richmond Pub. Sch. (1938–46), Iowa State T. Col (1945–46) [47]

NEILL, Francis Isabel [P] NYC/Bailey's Island, ME b. 24 Jy 1871, Warren, PA. Studied: New York; Boston; Paris. Member: NAWPS; PBC [40]

NEILL, Jane Anderson [P] Trenton, NJ b. 11 S 1911, Trenton. Studied: PAFA, with G. Bradshaw; D. Garber; H. MacCarter; F. Speight; Breckenlidge; R. Nuse. Exhibited: Interstate Fair, 1931 (prize). Work: Grace Lutheran Church, Church of Saint Batholomew, both in Trenton; First Lutheran Church, Collingdale, Pa.; La France Inst., Phila.; PAFA [40]

NEILL, John R. [I] NYC. Studied: PAFA. Member: SC [31]

NEILSEN, M.P. [S] Westbury, NY [15]

NEILSON, Raymond P(erry) R(odgers) [P] NYC b. 5 D 1881, NYC d. 1 Mr 1964. Studied: ASL; BMFA Sch.; Académie Julian, Grande Chaumière,

Ecole des Beaux-Arts, all in Paris; Bridgman; R. Miller; L. Simon; Laurens. Member: ANA, 1925; NA, 1938; Century Assn.; SC; All.A.Am.; Audubon A.; CAFA. Exhibited: Paris Salon, 1914 (med); P.-P. Expo, 1915 (med); Currier Gal A., 1941 (prize); NAD, 1916-40, 1941 (prize), 1942-46; East Hampton Gld., 1942 (prize); All.A.Am., 1942 (prize); New Haven PCC, 1943 (prize); SC, 1944 (prize), 1945 (prize); CAFA, 1944 (prize); Albright A. Gal., 1921, 1922; AIC; CI; PAFA; CGA; WFNY, 1939; Portraits, Inc.; Century Assn.; AV, 1945; Currier Gal. A.; Ogunquit, Maine; Soc. for Sanity in Art. Work: Luxembourg Mus., Paris; NYPL; N.Y. Chamber of Commerce; N.Y. Clearing House; Amherst Col.; Univ. Va.; Univ. Louisville; F.D. Roosevelt Lib.; French Gov. [47]

NELAN, Charles [I,Car] NYC b. 1854, Akron, OH d. 7 D 1904, Cave Springs, GA. Position: Staff, New York Herald, 1898- [01]

NELKE, Dora Kaufman [Por.P] Phila., PA b. 22 Jy 1889, NYC. Studied: F. Wagner; U. Romano. Member: NAWA; Phila. Plastic Cl.; Phila. A. All. Exhibited: Phila. Plastic Cl., 1946 (prize); Woodmere A. Gal.; Phila. A. All. Work: Montgomery (Ala.) Mus. FA [47]

NELL, Antonia (Tony) (Miss) [P,S,I,T] NYC b. Wash., D.C. Studied: Denver Sch. A.; G. Bellows; W. Chase. Member: NAWA; NYWCC; Chicago WCC; Baltimore WCC. Exhibited: NYWCC (prize); Baltimore WCC, 1921 (prize); NAWA, 1935 (prize), 1936 (prize); AIC; NAD; WFNY, 1939; GGE, 1939; PAFA; abroad. Work: WMAA; Vassar Col.; MMA; Ellis Island, N.Y. Illustrator: national magazines [47]

NELL, William [P] Ventnor, NJ [24]

NELLY, George [En] Paris, France b. New York [08]

NELSON, Albert W. [P] Shrewsbury, MA [24]

NELSON, Bruce [P] Palo Alto, CA b. 13 Je 1888, Santa Clara, CA. Exhibited: P.-P. Expo, San Fran., 1915 (med). Work: San Fran. AI; Mem. Mus., San Fran. [17]

NELSON, Carl Gustaf (Simon) [P,Gr,T] Boston, MA b. 5 Ja 1898, Horby, Sweden. Studied: Chicago Acad. FA; ASL, with Nicolaides. Member: ASL; Tiffany Fnd.; Am. Ar. Cong.. Exhibited: CI, 1935-38; WMAA, 1934, 1936, 1938; AIC, 1936; PAFA, 1935; TMA, 1936; AFA Traveling Exh., 1937; Am. A. Cong.; WFNY, 1939; Colorado Springs FA Center, 1935, 1938; Macbeth Gal., 1931 (one-man), 1933 (one-man); Boris Mirski Gal., Boston, 1946; Iowa Traveling Exh., 1940. Work: Binghamton (N.Y.) Mus.; Dept. Labor Bldg., Wash., D.C.; Arnold Arboretum, Harvard; Am. Peoples Sch., N.Y. Positions: T., Am. Peoples Sch. (NYC), YWCA Workshop (Boston, 1946-) [47]

NELSON, Clara K. [P] Providence, RI. Member: Providence WCC [25]

NELSON, D. Earle [Des,I,Gr,P,Car] Moorestown, NJ b. 21 S 1902, Poughkeepsie, NY. Studied: PMSchIA; T. Oakley; J.R. Sinnock; H. Pullinger. Contributor: illus./car./dec./des., national magazines [47]

NELSON, Ernest O. [P] Wash., D.C. [01]

NELSON, G. Patrick [I] NYC. Member: SI; GFLA; SC [29]

NELSON, George Laurence [P,Por.P,Mur.P,Li] Kent, CT b. 26 S 1887, New Rochelle, NY d. 1978. Studied: NAD; ASL; Académie Julian, Paris, with Laurens. Member: All.A.Am.; ANA, 1929; NA, 1942; SC; AWCS; CAFA; NYWCC; Kent AA; NAC. Exhibited: NAD, 1921 (med); NAC, 1939 (med); CAFA, 1918 (prize), 1926 (prize), 1928, 1935 (prize); Meriden (Conn.) A.&Crafts Soc., 1945 (prize); Los Angeles Mus. A.; Toledo Mus. A.; Albright A. Gal.; Rochester Mem. A. Gal.; Montclair A. Mus.; AIC; John Herron AI; Tex. State Fair; Detroit Inst. A.; Md. Inst. Work: NAD; NAC; AAAL; portraits, N.Y. Hospital, Mt. Sinai Hospital, both in NYC; N.Y. Acad. Medicine; Reed Mem. Lib., Carmel, N.Y.; Univ. Buffalo; State Normal Sch., Plattsburg, N.Y.; Springfield (Ill.) AA; Canajoharie A. Gal; MMA; NYPL; CI; Bennington (Vt.) Hist. Soc.; Peace Palace, Geneva, Switzerland. Positions: T., CUASch (1915-23), NAD (1915-41) [47]

NELSON, Gertrude [S] Paris, France [13]

NELSON, Gertrude Wiser. See Butcher.

NELSON, Hans Peter [Indst.Des] Park Ridge, IL b. 30 Jy 1908, Chicago, IL. Studied: Ill. Inst. Tech.; Northwestern Univ.; C. McGowan; J. Stacey; E. Zettler. Member: ADI. Exhibited: Ill. Inst. Tech., 1933 (med); Century of Progress, Chicago, 1933, 1934; BM, 1945. Illustrator: Modern Plastics, Plastics. Positions: Des., Montgomery Ward & Co. (Chicago), Westclox Co. (Peru, Ill.) [47]

NELSON, Homer S. [P] Minneapolis, MN [17]

NELSON, Katherine [P] Murfreesboro, TN [15]

NELSON, Leonard L. [E,En,P] Phila., PA b. 5 Mr 1912, Camden, NJ. Studied: PAFA; Barnes Fnd.; PMSchIA. Member: Phila. Pr. Cl. Exhibited: PAFA, 1943, 1946; Phila. Pr. Cl., 1942-45, 1946 (one-man); Ragan Gal., Phila., 1942-44; Brandt Gal., 1944, 1945; Phila. A. All., 1944; PMA, 1946; BM, 1946. Work: PMA [47]

NELSON, Lucretia [P,T] Oakland, CA b. 19 F 1912, Nashua, NH. Studied: Univ. Calif.; Calif. Inst. Tech.; Taliesin. Member: San Fran. AA; San Fran. Soc. Women A. Exhibited: San Fran. Soc. Women A., 1944 (prize), annually; PAFA, 1938; San Fran. AA; Pal. Leg. Honor, 1945; Univ. Calif. A. Gal., 1942. Illustrator: "Textiles of the Guatamala Highlands," 1945. Position: T., Univ. Calif., 1938- [47]

NELSON, M. [P] NYC b. NYC [10]

NELSON, (Judith) Margaret [P] West Hartford, CT b. 16 Ag 1901, Klackeberga, Sweden. Studied: Conn. T. Col. Member: NAWA; CAFA; Hartford Soc. Women P.; Springfield A. Lg.; Gloucester SA; North Shore AA. Exhibited: NAD, 1933; All.A.Am., 1933-37; NAWA, 1934, 1935, 1938, 1939; North Shore AA, 1932, 1934, 1938; CAFA, 1929-46; New Haven PCC, 1930, 1933, 1936, 1938 [47]

NELSON, Mary Albert. See Albert.

NELSON, Patrick [I] NYC [10]

NELSON, Ralph Lewis [I,P,Mur.P,Car] Bethlehem, CT b. 1 F 1885, Coal City, IL. Studied: Des Moines Sch. A.; Cleveland Sch. A.; ASL; D. Cornwell; H. Dunn; W. Biggs. Member: Wilton Soc. Ar. Work: murals, schools in Wethersfield, Wallingford, New Canaan, East Hartford, Waterbury; Undercliff Sanatorium, Meriden, Conn. Illustrator: "Paddles" (1942), "Destination Tokio" (1943) [47]

NELSON, W(illiam) H(enry) de B(eauvoir) [P,W,L,T,Cr] Pelham Manor, NY b. 15 Ag 1861, London, England d. 27 S 1920. Studied: Reinhardt, in Dresden. Member: AWCS; SC. Work: Portland (Maine) Mus. Editor: International Studio [19]

NEMOEDE, Eda. See Casterton.

NEPOTE, Alexander [P,L,T] Oakland, CA (1976) b. 6 N 1913, Valley Home, CA. Studied: Calif. Col. A.&Crafts; Univ. Calif.; M. Sheets; Vytlacil. Member: Am. Soc. for Aesthetics; Calif. WC Soc.; San Fran. AA. Exhibited: Oakland A. Gal., 1940 (prize), 1941 (prize); Calif. State Fair, 1941 (prize); Santa Cruz A. Lg., 1938 (prize); Riverside Mus., 1944; United Nations Conference Exh., San Fran., 1945; SFMA, 1934-46. Work: MMA; Mills Col. Position: T., Calif. Col. A.&Crafts, Oakland, 1945- [47]

NERI, Bruno [S] Perth Amboy, NJ. Work: USPO, Cliffside Park, NJ. WPA artist. [40]

NESBART, Vincent [P] Pittsburgh, PA d. 1976. Member: Pittsburgh AA [25]

NESBIT, R.H. [P] NYC. Member: SC, 1908 [10]

NESBITT, Jackson Lee [P,E,I] Kansas City, MO b. 16 Je 1913, McAlester, OK. Studied: T.H. Benton; J.S. De Martelly. Exhibited: Kansas City AI, 1937 (prize), 1941 (prize); LOC, 1943 (prize), 1946 (prize); Philbrook A. Center, 1940; AIC, 1937; PAFA, 1941; LOC, 1943, 1946; Kansas City AI, 1937-41; CAM, 1941; Philbrook A. Center, 1940; Soc. Am. Graphic Ar., 1946 (prize). Work: Denver A. Mus.; LOC; Philbrook A. Center [47]

NESEMANN, Enno [P] Berkeley, CA b. 25 Ap 1861, Marysville, CA d. F 1949. Studied: A. Hart. Member: S.Indp.A.. Work: Sutter Fort Mus., Sacramento; Oakland A. Gal.; de Young Mem. Mus., San Fran. [47]

NESMITH, Joseph A. [P] Lowell, MA b. Lowell [13]

NESS, (Albert) Kenneth [P,T,Des] Chapel Hill, NC b. 21 Je 1903, Ignace, MI. Studied: Univ. Detroit; Detroit Sch. Appl. A.; Wicker Sch. FA; AIC; B. Anisfeld. Member: N.C. Chapter AIA. Exhibited: Johnson Gal., Chicago, 1932 (one-man); WMAA, 1933; AIC, 1934 (prize), 1935-40; GGE, 1939; Evanston A. Center, 1940; San Diego FA Soc., 1938; Pal. Leg. Honor, 1938; SAM, 1938; Dayton AI; Flint Inst. A., 1938; Grand Rapids A. Gal., 1938; Person Hall A. Gal., Chapel Hill, 1941 (one-man). Position: Resident A., Univ. N.C., 1941- [47]

NESS, Alfred [P] Minneapolis, MN [19]

NESSLER, Rosa C. [P] NYC. Member: NAWPS. Exhibited: Am. WC Soc., 1933, 1934, 1938; Argent Gal., 1937; NAWPS, 1935-38 [40]

NESTOR, Bernard D. [P] Seattle, WA b. 10 N 1903, Minnesota. Studied: Univ. Wash.; E. Renard, Leger, Ozanfant, in Paris. Position: Staff, Seattle AM [40]

NETTER, Frank H. [I] East Norwich, NY b. 28 Ap 1906, NYC. Studied: CCNY; NYU; NAD; ASL. Member: SI; SC; AMA; A. Gld; F., N.Y. Acad. Medicine. Exhibited: A. Gld., 1936 (one-man). Work: anatomical illus., medical paintings, Field Mus., Chicago; Ciba Series; Armour & Co. [47]

NETTLETON, Walter [Ldscp.P] Stockbridge, MA b. 19 Je 1861, New Haven, CT d. 28 Jy 1936, New Haven. Studied: Yale; ASL; Académie Julian, Paris, with Boulanger, Lefebvre; C. Duran; Harrison. Member: ANA, 1905; SSA, 1901; AFA; CAFA. Exhibited: Paris Salon, 1892 (prize); St. Louis Expo, 1904 (med); AAS, 1907 (gold); Buenos Aires and Santiago Expo, 1910 (med). Work: Yale Art Mus.; Mus. Art, New Britain, Conn.; Jackson Lib., Stockbridge, Mass.; Vassar Col. Art Gal.; BAC. A member of the advisory committee on art at the P.-P. Expo. Well known for his winter scenes and Breton subjects. [33]

NEUBAUER, Frederick August [Ldscp.P,I] Cincinnati, OH b. 1855, Cincinnati. Studied: Cincinnati Art Acad. Member: Cincinnati AC [24]

NEUFELD, Paula [P,Des,Gr,T] Kansas City, MO b. 1 F 1898, Berlin, Germany. Studied: Europe; Colorado Springs FA Center. Exhibited: AIC, 1937; Kansas City AI, 1942; W.R. Nelson Gal., 1942, 1945, 1946; CAM, 1945; Broadmoor Hotel, Colorado Springs (one-man); Denver A. Mus. Work: Bernheimer Mem., Kansas City, Mo.; Germany [47]

NEUFELD, Woldemar [P,Gr,T,I] NYC b. 10 N 1909, Waldheim, Russia. Studied: Ontario Col. A.; H. Keller; W. Eastman; F. Wilcox; Cleveland Sch. A.; Western Reserve Univ. Member: Am. Color Print Soc. Exhibited: Cleveland Sch. A., 1939 (prize); Am. Color Print Soc., 1946 (prize); CMA, 1936, 1937 (prize), 1938 (prize), 1939 (prize), 1940 (prize), 1941 (prize), 1942 (prize), 1943 (prize), 1944 (prize), 1945; 50 Prints of America, 1944 (prize); WFNY, 1939; VMFA, 1940; AIC, 1941, 1942; BM, 1942; LOC, 1942–46; Northwest Pr.M., 1946; Audubon A., 1945; NAD, 1946; Butler AI, 1938–45. Work: CMA; Dayton AI; NYPL. Illustrator: New Yorker, 1939. Position: A. Dir., East Side House Settlement, NYC, 1945– [47]

NEUHAUS, Eugen [P,W,L,T] Berkeley, CA b. 18 Ag 1879, Wuppertal, Germany. Studied: Royal A. Sch.,, Kassel, Germany; Inst. Appl. A., Berlin; C. Brunner; M. Koch; O. Eckmann. Member: Jury of Awards, P.-P. Expo, San Fran., 1915; San Fran. AA; Am. Soc. for Aesthetics. Exhibited: AIC, 1920–25; PAFA, 1921, 1922; San Fran. AA, annually; Pal. Leg. Honor, 1928, 1930 (one-man); Los Angeles Mus. A.; Oakland A. Gal.; Berkeley H.S. Author: "History and Ideals of American Art" (1931), "The Art of the Exposition," "Painters, Pictures and the People," "The Appreciation of Art," "William Keith, The Man and the Artist." Position: T., Univ. Calif., Berkeley, 1907– [47]

NEUHAUSER, Marguerite Phillips (Mrs. Roy L.) [P] Wash., D.C. b. North Arlington, VA. Studied: B. Perrie; G. Noyes; Corcoran Sch. A. Member: Soc. Wash. A.; Wash. AC; SSAL; North Shore AA [33]

NEUHEISEL, Cecilia [P,G,T] San Antonio, TX b. 24 My 1915, Montello, Wis. Studied: Mus. Sch., San Antonio; Univ. Mex. Studied: R. Staffel; R. Dugosh; H.L. McFee; C. Merida. Member: Southern Sts. A. Lg.; San Antonio A. Lg.; Bonner G. A. Soc. Exhibited: Witte Mus., 1938 (one-man); Southwest Tex. T. Col., San Marcos, 1939; Southern Sts. A. Lg. Traveling Exh., 1939. Positions: T., Witte Mus. A. Sch., Witte Mus. [40]

NEUMAN, Clyde James [P] Chicago, IL [06]

NEUMAN, Vincent Howard [Des,P] West Allis, WI b. 19 Mr 1916, West Allis. Studied: Layton Sch. A.; G.H. Baker; G. Sinclair; E. Groom. Member: Wis. P.&S. Exhibited: Wis. P.&S., 1940–42, 1943 (prize), 1944–46; Madison AA, 1941, 1942, 1943 (prize) 1944, 1945; AIC, 1944; Findlay Gal., Chicago, 1944, 1945. Positions: Indst. Des., Milwaukee Handycraft Project, 1940; Car., Badger Cartoon Co., 1942–46 [47]

NEUMANN, Gilbert F(ranz) [P,E,Mur.P,Dec,Des] San Antonio, TX b. 24 N 1906, San Antonio. Studied: J. Arpa. Member: Ar. Gld., San Antonio; Palette & Chisel Cl., San Antonio; Leon Springs A. Colony. Work: murals, City Hall, Green Memorial Hospital, both in San Antonio [40]

NEUMARK, Anne [P,Mur.P,Por.P,Dr] NYC b. 3 My 1906, Boston. Studied: Mass. Sch. A.; Designers' A. Sch., Boston. Exhibited: Boston AC; Gloucester SA. Work: E.A. Poe Shrine, Richmond, Va. [47]

NEUMEYER, Alfred [Edu,Mus.Dir,W,Hist.] Oakland, CA b. 7 Ja 1901, Munich, Germany d. 1973. Studied: Univ. Munich; Univ. Berlin. Author: "Dürer" (1929), "Josef Scharl" (1945). Contributor: Art Bulletin, College Art Journal, Magazine of Art, Pacific Art Review. Position: Dir., Mills Col. A. Gal. [47]

NEUSER, L.A.W. [Por.P,Ldscp.P,Dec] New Orleans b. 1837, Germany (came to New Orleans in 1855) d. 30 S 1902 [*]

NEUTRA, Richard Joseph [Arch,Des,W,L] Los Angeles, CA b. 8 Ap 1892 d. 1970. Studied: A. Loos; Univ. Vienna. Member: AIA. Exhibited: in collaboration with Erich Mendelsohn, Intl. Comp., Haifa, Palestine, 1922 (prize); House Beautiful Comp., 1934 (prize), 1936 (prize), 1937 (prize), 1938 (prize); Better Homes Comp., 1935 (gold,prizes); General Electric Comp., 1935 (prize). Work: Experimental Pub. Sch., Bd. Edu., Jr. H.S., all in Los Angeles; models of work, MOMA, Mus. Sc.&Indst., New York; RISD. Author: "How America Builds" (1927), "America, New Building in the World" (1929) [40]

NEUWIRTH, Morris [P,I] NYC (1977) b. 18 My 1912, NYC. Studied: NAD; Kroll; L. Ross. Member: A. Lg. Am. Exhibited: NAD, 1938; ACA Gal., 1937–41. Illustrator: Saturday Review of Literature, other magazines. WPA artist, 1935–40. [47]

NEVELL, Thomas George William [Indst.Des] Riverside, CT b. 16 S 1910, London, England. Studied: NYU; New Sch. Soc. Res. Member: ADI; Am. Soc. Mech. Engineers. Work: product des., leading industrial manufacturers [47]

NEVELSON, Louise [S] b. 1899, Kiev, Russia (came to Portland, Maine, in 1905). (Born Louise Berliowsky.) Studied: T. Bernstein, W. Meyerowitz, in NYC (1920); ASL, with K.H. Miller, Nicolaides (1929–33); H. Hofmann, in Munich (1931) and at ASL (1933). Work: MOMA; WMAA; other museums. Little of her sculpture from the 1930s survives. She is best known for her work after 1955, esp. assemblages of discarded objects painted black and other monochromes. [*]

NEVILLE, Katherine Young [P,T] Montgomery, AL/Camden, AL b. 21 F 1876, Camden. Studied: AIC; PAFA. Member: Ala. A. Lg.; Southern Sts. A. Lg. Exhibited: Nat. Exh. Am. A., Rockefeller Center, 1936; Ala. A. Lg., Huntingdon Col. Mus., 1937; MFA, Montgomery. Positions: T., Mus. FA Sch., Mildred Dean Sch., Montgomery [40]

NEVILLE, Mary [P] Wellborne, VA [13]

NEVILLE, Ralf [P] Kansas City, MO [10]

NEVIN, Blanche [S] b. 1838 d. 21 Ap 1925, Lancaster, PA

NEVIN, John Denison [P] New Hope, PA b. 15 Mr 1880, Easton, PA. Studied: self-taught. Exhibited: Flemington Fair, N.J. (prize) [40]

NEVIN, Josephine Welles (Mrs.) [S] b. Chicago, IL d. 31 O 1929, Saranac Lake, NY. Member: NAWPS; Darien G. Seven Arts. Specialty: portrait busts

NEW, E.H. [I] NYC [98]

NEW, George (Edward) [E,P,I,T] Milwaukee, WI b. 27 N 1894, Bethlehem, PA d. 1963. Studied: Univ. Paris; Ecole des Beaux-Arts; Am. Acad., Rome; J.S. Sargent; G. deF. Brush; J. Pennell. Member: Société des Beaux-Arts. Exhibited: SAE, 1943, 1945; LOC, 1943, 1945; Wis. Salon A.; Milwaukee AI, annually; Paris Salon, 1937 (prize); Wis. Salon A., 1943 (prize); Milwaukee AI, 1942 (prize), 1944 (prize). Work: MMA; LOC; Milwaukee AI; Kenosha Mus. A.; Bibliothèque Nationale; Victoria & Albert Mus., London. Position: T., Mount Mary Col., 1937–42; Univ. Wis., 1941–42; Marquette Univ., Milwaukee, 1942 [47]

NEWALL, Mildred Tilton (Mrs.) [I] NYC. Member: SI, 1913 [17]

NEWARK, Wilbur L. [P] Columbus, OH. Member: Columbus PPC [25]

NEWBERRY, Clare Turlay [W,I,P] NYC b. 10 Ap 1903, Enterprise, OR d. 1970. Studied: Univ. Oreg.; Portland Mus. A. Sch.; San Fran. Sch. FA; Grande Chaumière. Author/Illustrator: "Herbert the Lion," 1931, "Mittens," 1936, "Babette," 1937, "Pandora," 1944, "The Kittens' A B C," 1946; animal stories for children [47]

NEWBERRY, George H. [P] b. 1857, Brentwood, NY (settled in Argentina ca. 1877 as a dentist.) d. 1 F 1935, Buenos Aires. Best known for his paintings of Patagonia.

NEWBY, Ruby Warren (Mrs.) [P,E,Des,W,T,B,C,L] Redington, AZ b. 28 Jy 1886, Goff, KS. Studied: Southern Col., Lakeland, Fla.; Harvard. Member: AFA; Fla. Fed. A.; Orlando AA; Nat. Edu. Assn. Exhibited: SSAL, 1928; one-man exhibits: Winter Park, Fla.; Orlando AA, 1928; Weyhe Gal., 1940; Utah A. Ctr.; G.W.V. Smith Gal. A.; NYPL; Montclair AM; Berkshire Mus. A., 1941; Fla. Fed. A., 1929 (prize); Orange County Chamber of Commerce, 1928 (prize). Work: Yale A. Gal.; Société Anonyme; Orlando Pub. Lib.; AIC; Am. Lib. Color Slides; Utah A. Ctr.; G.W.V. Smith Gal. A.; Rollins Col., Winter Park. Lectures: Mayan Art [47]

NEWCASTLE, Lena May [P,C,T] NYC (lived in New Bedford, MA, 1920s) b. Pittsfield, MA. Studied: PIASch. Exhibited: Am. WCS, 1934; Argent Gal., NYC, 1935; NAWPS, 1936–38 [40]

NEWCOMB, Florence A. [P,T] Brooklyn, NY b. 1881, San Antonio, TX d. 15 Ap 1943. Studied: ASL; Columbia; NYU. Member: Sch. AL, NYC; Eastern AA; Nat. Edu. Assn. Positions: T., Washington Irving H.S., NYC (1910–28), Haaren H.S. (1928–43) [08]

NEWCOMB, Marie Guise [I] NYC b. NJ. Studied: Paris, with Schenck, Chialiva, E. Detaille. Specialty: horses. Traveled in Algeria as far south as the Sahara, studying the Arab and his horses. [01]

NEWCOMBE, Warren [P,Li,W] Los Angeles, CA b. 28 Ap 1894, Waltham, MA. Studied: Mass. Normal A. Sch., Boston; J. De Camp. Member: Acad. Motion Picture A.&Sc.; Fnd. Western A.; Am. Arts Fnd. Award: sound effects, Academy Award, "Thirty Seconds Over Tokyo," 1944. Exhibited: A. Center, NY, 1922 (one-man); Wilshre Gal., Los Angeles, 1929 (one-man); Stendahl Gal., Los Angeles, 1931 (one-man); Pasadena AI, 1932 (one-man); SFMA, 1933 (prize); UCLA, 1936 (one-man); Los Angeles Pub. Lib., 1938; Fnd. Western A., 1935–45; Mus. FA, Houston; San Antonio, Dallas, Ft. Worth, all in Tex.; CGA, 1931, 1935, 1937; SFMA, 1931, 1938, 1940; CM, 1931; San Diego FAS, 1931, 1934; S.Indp.A., 1933, 1934; Los Angeles AA, 1934, 1941, 1944; Colorado Springs FA Center, 1935–39; Denver AM, 1935; PAFA, 1936, 1937; John Herron AI, 1936; Crocker A. Gal., 1938; Currier Gal. A., 1939; Faulkner Mem. A. Gal., Santa Barbara, 1938, 1939 1940; GGE, 1939; Los Angeles Mus. A., 1933, 1934, 1938, 1942, 1944, 1945; Oakland A. Gal., 1943; Weyhe Gal., 1933–35. Work: Wood A. Gal., Montpelier, Vt.; Los Angeles Mus. A.; MMA; BMFA; PMA; PAFA. Illustrator: "Book on Warren Newcombe," by Merle Armitage, pub. E. Weyhe, NYC (one of "Fifty Books of Year 1932") [47]

NEWCOMER, Florence E. [P] Pittsburgh, PA. Member: Pittsburgh AA [24]

NEWELL, Clifton [Por.P,Mur.P,Li] NYC/Lakewood, OH b. O 1900, Cleveland, OH. Studied: Cleveland Sch. A.; ASL. Member: Cleveland PM. Exhibited: CMA, 1924 (prize), 1926 (prize), 1930 (prize) [40]

NEWELL, G(eorge) Glenn [P] Dover Plains, NY b. 1870, Berrigan County, MI d. 7 My 1947, Sharon, CT. Studied: NAD, with Ward; Columbia, with W.S. Robinson; Albion Col., Mich. Member: ANA; NA, 1937; SC; AWCS; NAD; Allied AA; Am. S. Animal PS; NWYCC; Lotos C.; Aquarellists; SPNY. Exhibited: SC, 1906 (prize); NAD, 1923 (prize); NAD, 1925 (prize); Allied AA, 1927 (gold); Am. S. Animal PS, 1929 (prize). Work: NGA; Detroit Inst. A.; Dallas AA; Butler Mus., Youngstown; T. Col., Kalamazoo, Mich.; Albion Col., Albion; Grand Central A. Gal.; NAC; Lotos C.; SC; NAD; Paramount Theatre, NYC; Paramount Theatre, Brooklyn; mural, USPO, Crawford, Nebr.; CGA. WPA artist. [40]

NEWELL, Gordon [S] Los Angeles, CA. Exhibited: Los Angeles Mus. A., 1930; WFNY, 1939 [40]

NEWELL, Hugh [P] Bloomfield, NJ b. 4 O 1830, Belfast, Ireland (came to U.S. ca. 1851; settled in Pittsburgh, then Baltimore) Studied: Antwerp Acad.; Couture, in Paris; South Kensington Mus., London. Member: AWCS. Exhibited: Md. Hist. S., 1853–58; PAFA; Wash. AA, 1857; NAD. Work: Peabody Inst., Baltimore. Specialties: portraits; genre. Position: T., Md. Inst., 4 yrs. [24]

NEWELL, James Michael [Mur.P] NYC b. 21 F 1900, Carnegie, PA. Studied: C.W. Hawthorne; P. Baudouin; L. Montagne St. Hubert. Member: Mural P.; Arch. Lg., 1936. Work: Community Hospital, Fontainebleau, France; fresco, Potomac Electric Power Co., Wash., D.C.; WPA murals, Childs H.S., NYC; Dept. Interior Bldg., Wash., D.C. Position: T., ASL [40]

NEWELL, Peter Sheaf Hersey [P,I,W,L] Leonia, NJ/Riverton, CT b. 5 Mr 1862, McDonough Co., IL d. 15 Ja 1924, Little Neck, NY. Studied: ASL. Member: SC. Work: Atlanta AM. Illustrator: Harper's, special edition of "Alice in Wonderland." Author: "Peter Newell's Pictures and Rhymes," "Topsys and Turveys," "The Rocket Book," "The Hole Book" [24]

NEWHALL, Adelaide May [P] Upper Montclair, NJ b. 22 Ja 1884, Worcester, MA d. 8 S 1960. Studied: Smith Col.; D. Tryon, C. Hawthorne; J. Farnsworth. Member: AAPL; Montclair AA; A. Center of the Oranges; Ridgewood AA; Provincetown AA. Exhibited: Montclair A. Mus., 1926, 1927, 1931, 1932, 1935, 1938, 1939, 1941, 1944, 1945; Newark AC; A. Center of the Oranges; Kresge Gal. (prize); Ridgewood AA [47]

NEWHALL, Donald Victor [P,I] NYC/Yarmouth, ME b. 7 F 1890, Richmond, Surrey, England. Studied: Académie Julian; PAFA [25]

NEWHALL, Elizabeth [P,I,E,Li,T] Gary, IN b. 25 N 1909, Philippine Islands. Studied: AIC; E. Giesbert; L. Ritman; L. Van Pappelendam; A. Philbrick. Member: Hoosier Salon; Ind. A.; Jr. Lg. Allied A., Gary; Chicago NJSA. Work: mural, Pub. Lib., Gary. Position: T., Pub. Schs., Gary [40]

NEWHALL, G.V. [P] NYC [25]

NEWHALL, Harriot B. [P,E,T] Provincetown, MA b. 23 Je 1874, Topeka, KS. Studied: Benson; Tarbell; Hawthorne. Member: Copley S.; Provincetown AA [33]

NEWHOUSE, Henry [P] Columbus, OH. Member: Columbus PPC [25]

NEWHOUSE, Mortimer Alfred [Dealer] b. 9 S 1850, NYC d. 18 Ap 1928. Studied: Germany. He published etchings and progressed into buying and selling art; established a business in St. Louis ca. 1898, which was the foundation of the Newhouse Galleries, Inc.

NEWKIRK, Newton [I] Boston, MA. Position: Staff, National Sportsman, Boston [13]

NEWLIN, Archie (Miss) [P] Phila., PA b. Phila. Studied: R. Vonnoh; M. Chase; PAFA; PMSchIA. Member: Plastic C. Exhibited: AAS, 1902. Specialties: watercolors; pastels [10]

NEWLIN, John North [Ldsp.P] Dover Plains, NY b. 16 My 1911, NYC. Member: SC; Allied AA; Dutchess County AA [40]

NEWLIN, Sara Julia. See Donald MacGregor, Mrs.

NEWMAN, Allen George [S] NYC/Kingston, NY b. 28 Ag 1875, NYC d. 2 F 1940. Studied: NAD; J.Q.A. Ward. Member: ANA, 1926; NSS, 1907; Beaux-Arts Inst.; NAC; Numismatic S.; AFA. Exhibited: NAC (prize). Work: Harriman Bank; H. Hudson Mem., gates, Squadron A, NYC; statue, Providence, R.I.; mon., mem., Atlanta, Ga.; statue, Montgomery, Ala.; mem., Scranton, Pa.; mem., Pittsburgh; Kochler Mem., West Point, N.Y. [38]

NEWMAN, Anna Mary [P,I,T] Richmond, IN b. Richmond, IN d. 15 Ag 1930. Studied: AIC; Sch. Appl. & Normal Art, Chicago; Overbeck Sch. Des. Pottery, Cambridge City, Ind. Member: Chicago ASL; Richmond AA; Ind. AC; Richmond AA; Ind. AC; Richmond Palette C.; AFA. Exhibited: Richmond AA, 1908 (prize); Ind. State Fair, 1914 (prize). Work: YMCA, Fort Wayne; Supreme Court, Indianapolis. Position: T., Ft. Wayne H.S. [29]

NEWMAN, Azadia [Por.P] Hollywood, CA/Houghton, ME b. Wash., D.C. Studied: Corcoran Sch.; Critcher Sch.; ASL; PAFA. Member: Wash. AC [40]

NEWMAN, Barnett [P,Li] b. 1905, NYC d. 1970. Studied: ASL, early 1920s, 1929–30. Work: MOMA, major museums of modern art. Important abstract expressionist. His vertical band paintings of the 1950s prefigured the minimalism of the 1960s. [*]

NEWMAN, Benjamin T. [P,T] Fryeburg, ME b. 5 N 1859, Bath, ME. Studied: Académie Julian, Paris, with Boulanger, Lefebvre [10]

NEWMAN, Carl [P] Huntington Valley, PA. Member: S.Indp.A.; Phila. AC. Exhibited: PAFA, 1921. Work: Herron AI, Indianapolis [25]

NEWMAN, Clara G. [P,T] Richmond, IN b. 10 S 1870, Brownsville, NE. Studied: J.E. Forkner; F. Mahony; Coats; J.M. King; R. Byram. Member: Hoosier Salon; Richmond AA; Ind. AC. Exhibited: Ind. State Fair, 1939 (prize) [40]

NEWMAN, E. Maude [P] Wash., D.C. [01]

NEWMAN, Elias [P,L,T] NYC b. 12 F 1903, Stashow, Poland. Studied: Edu. Alliance A. Sch.; NAD; Grande Chaumière. Member: S. Palestine Ar. and Sculp. Assn. Exhibited: Los Angeles Mus. A., 1944; Audubon A., 1045; Am.-British A. Center, 1944, 1945; A.Am.A., 1944; Montross Gal., 1934 (one-man); A. Center, NYC, 1935; BMA, 1934, 1940; Md. Inst., 1935, 1938; Tel-Aviv Mus., 1939; Maxwell Gal., San Fran., 1945; Modernage Gal., 1945. Work: BMA; SFMA; Denver A. Mus.; John Herron AI; Tel-Aviv Mus.; Jewish Theological Seminary, N.Y.; Cone Coll., Baltimore; MOMA; Norfolk Mus. A.&Sc.; Davenport Mun. A. Gal., Iowa. Author: "Art in Palestine," 1939. Positions: Am. Rep., Tel-Aviv Mus.; T., Edu. All. A. Sch., NYC; A. Dir., Palestine Pavilion, WFNY, 1939 [47]

NEWMAN, Ethel [P] Kodak, TN [13]

NEWMAN, George W. [P,I,Gr] Galveston, TX b. 22 My 1909, Galveston. Studied: AIC; Tex. A.&M. Col. Member: SSAL; Galveston AL. Exhibited: Tex. FAA; Houston MFA; SSAL, 1936 (prize); Galveston AL (prize). Work: Galveston AL. Illustrator: medical books. Positions: Staff A., Tex. State Med. Col., Univ. Tex.; T., Ball H.S., Galveston [47]

NEWMAN, Harry W. [P,L,T] NYC b. 26 Je 1873, London, England. Studied: Bridgman; Henri. Member: Bronx AG; SC. Exhibited: Bronx AG, 1931 (prize) [40]

NEWMAN, Henry [Por.P] Phila. b. 1843 d. 1921 [*]

NEWMAN, Henry Roderick [P,I] Florence, Italy b. ca. 1843 (or ca. 1833) Easton, NY d. 1917. Studied: Couture, in Paris, 1969. Lived in Italy and Egypt for over 50 years; most of his pictures were of Egypt. Traveled with Ruskin; made some of the drawings for "Stones of Venice."

NEWMAN, Hugh M. [T] d. 16 Jy 1937, Evanston, IL. Position: Dir., Chicago Acad. FA, 1931–37

NEWMAN, Hugo R.B. [P] NYC. Member: Chicago NJSA [25]

NEWMAN, Irene Hodes [P] NYC b. Cameron, MO. Member: Baltimore WCC; Springfield AL; AAPL. Exhibited: CGA, 1939; AWCS, 1939, 1941, 1942; Morton Gal., 1939, 1940; All.A.Am., 1939–42; BMA, 1939, 1940; AIC, 1940, 1941; Kansas City AI, 1940; BM, 1941; San Diego FAS, 1941; MMA, 1942; Audubon A., 1944; Springfield Mus. A., 1945; AAPL, 1945 [47]

NEWMAN, Isadora [P,S,I,C,W,L] NYC b. 23 Ap 1878, New Orleans, LA. Author: "Fairy Flowers" [29]

NEWMAN, Joseph [P,T] NYC b. 4 S 1890, NYC. Studied: PIASch; Adelphi Col.; Paris; Whittaker; Tiffany Fnd. Member: Allied AA; Tiffany Fnd.; NYWCC; SC; AWCS. Exhibited: Adelphi Col. (med); P&S S. (prize); SC, 1945 (prize). Work: BM; Newark Mus.; Tiffany Fnd. Position: T., Master Inst. United Arts, NYC [47]

NEWMAN, Maurice [Des,P,C] Rockport, MA b. 14 Ja 1898, Lithuania. Studied: Johannesburg Sch. A., So. Africa; BMFA Sch.; Vesper George Sch., Boston. Exhibited: Children's Mus., Boston; Essex Inst., Salem, Mass.; Mass. Bldg., WFNY, 1939. Specialty: diorama; min. models [40]

NEWMAN, Robert Loftin [P,Des] NYC b. 1827, Richmond, VA d. 31 Mr 1912. Studied: mostly self-taught; Couture, in Paris, 1850; influenced by the Barbizon Sch., through friendship with Millet. Work: MMA; BM. Specialties: mothers & children; biblical scenes. Stylistically similar to A.P. Ryder, he was called the "American Diaz." Served in the Confederate Army. Established his studio in NYC, 1867 (briefly moving to Nashville, 1872, where he tried unsuccessfully to open an art acad.). Back in NYC he designed stained glass for 5 yrs. for Francis Lathrop. [01]

NEWMAN, Salina [P] NYC [15]

NEWMAN, Sarah [P,S] NYC. Exhibited: Fed. A. Gal.; ACA Gal., NYC [40]

NEWMAN, W. (Mrs.) [P] Los Angeles, CA. Member: Calif. AC [25]

NEWMAN, Willie Betty (Mrs. J.W. Newman) [P] b. 1864, Murfreesboro, TN. Studied: Cincinnati A. Sch., with T.S. Noble; Paris, with Constant, Bouguereau, Bachet, Robert-Fleury, Laurens; Holland; Italy. Exhibited: Paris Salon, 1891, 1893, 1900 (prize); Nashville AA (gold); Tenn. State Fair, 1914 (prize), 1915, 1916, 1917. Work: Cincinnati Mus.; Nashville AA; Centenn. C., Nashville; Phila. AC; Vanderbilt Univ.; Univ. Miss.; Capitol, Wash., D.C. [33]

NEWTON, Alice [P] Manchester, VT. Member: NYSWA. Exhibited: NYSWA, 1936, 1939 [40]

NEWTON, Bessie E. [P] St. Paul, MN [19]

NEWTON, Clara C. [P] Cincinnati, OH. Member: Cincinnati Women's AC [25]

NEWTON, Edith [Li,Ldscp.P] Milford, CT. b. 7 Je 1878, Saginaw, MI. Studied: Corcoran Sch.; ASL. Exhibited: Northwest PM, 1935 (prize); NAWPS; LOC, 1946 (prize). Work: WMAA; MMA; Newark Lib.; SAM; LOC; NYPL [47]

NEWTON, Francis [P,Arch] East Hampton, NY b. 1872, Lake George, NY d. 27 S 1944. Studied: H. Pyle, in Wilmington, Del; R. Newton, Jr.; ASL; Chase Sch.; Columbia; Drexel Inst., Phila.; Colarossi Acad. Member: NSMP; Arch. Lg.; P.&S. Gal. Assn.; SC; Boston AC. Work: Univ. Ga., Augusta; G. Hall, East Hampton; Wilmington SFA [40]

NEWTON, Helen F. [P,W,T] New Haven, CT b. 17 Mr 1878, Woodbridge, CT. Studied: Mt. Holyoke Col.; H. Leith-Ross; C. Hawthorne. Member: CAFA; Bridgeport AL; New Haven PCC; Brush & Palette C.; Meriden A. & Cr. Assn.; Copley S.; Norwich AA. Exhibited: New Haven PCC, 1923–39, 1942–46; CAFA, 1924–28, 1931, 1932, 1937, 1938, 1941, 1942, 1944–46; SAM, 1929; Laguna Beach AA, 1929, 1930, 1934, 1935; Santa Cruz AL, 1930, 1935, 1936; Los Angeles Mus. A.; Pasadena AI; Stockbridge, Mass., 1931; Santa Barbara Mus. A., 1934–46; Williams Col., 1932; Mt. Holyoke Col., 1932; Springfield Mus. A., 1945; Bridgeport, Conn., 1941 (prize), 1942, 1944 (prize), 1945, 1946; Meriden, Conn., 1941–46; State Fed. Women's C., 1942 (prize). Position: T., Norwich (Conn.) Free Acad., 1940 [47]

NEWTON, Josephine Pitkin (Mrs. R.C.) [P] Scarsdale, NY. Member: NAWPS [33]

NEWTON, Marion Cleever Whiteside [P,C,Des,I] NYC b. 23 Mr 1902, Boston, MA. Studied: Radcliffe; Parsons Sch. Des.; Paris; I. Olinsky; L.F. Emmet; G. Bridgman. Exhibited: Salon des Artistes Français, Paris; NYWCC; New Haven PCC; Phila. WCC; Baltimore WCC; NAC. Work: MET; Mus. City of N.Y. [47]

NEWTON, Parker [P,Cr] NYC/Norfolk, CT d. 13 My 1928, Neuilly, France. Member: SC. Exhibited: NAD; CI. [21]

NEWTON, Richard, Jr. [P] NYC [21]

NEY, Elizabet (Mrs. Edmund Montgomery) [Por.S] Austin, TX b. 1830, Westphalia, Germany d. 30 Je 1907. Studied: Berlin; Munich; Christian Rauch, 1854–57. Exhibited: St. Louis Expo, 1904 (med). Work: Elizabet Ney Mus., Austin (founded, 1909). Among the great men who sat for Miss Ney were Von Humboldt, Von Liebig, Jacob Grimm, Schopenhauer, Joachim, Garibaldi and Bismark. She formed a band who came from Germany to Thomasville, Ga. to form a colony; when this was broken up in 1872 she bought a plantation in Texas. She executed the statues of Sam Houston and other noted Texans. [06]

NEY, Lloyd Raymond [P,L,T] New Hope, PA b. 8 Mr 1893, Friedenburg, PA. Studied: PAFA, with H. McCarter. [40]

NEYLAND, Harry [P,S] So. Dartmouth, MA b. 9 Ag 1877, KcKean, PA d. 23 O 1958. Studied: ASL; Paris. Member: Providence AC. Work: BAC; PIASch; New Bedford, Mass. Country C.; Mariners Mus., Newport News, Va.; Mystic Seaport Mus.; Kendall Whaling Mus. Illustrator: "Cap'n George Fred," 1929 [40]

NEYLAND, Watson [P] Liberty, TX b. 5 S 1898, Liberty. Studied: PAFA [33]

NICE, Blanch Heim [P] Houston, TX b. 15 D 1892, Houston, TX. Studied: St. Louis Sch. A. Member: SSAL. Exhibited: Tex. General Exh; Ar. Southeast Tex., 1938; Houston MFA, 1938, 1939; SSAL, 1938, 1939 [47]

NICE, Eugene [P] NYC b. 1841, Italy (came to U.S. in 1865) d. 13 N 1911

NICHOLLS, Burr H. [P] Lockport, NY b. D 1848, Lockport d. 12 My 1915, Stamford, CT. Studied: L.G. Sellstedt, Buffalo; Carolus-Duran, Paris. Work: PAFA; Peabody Inst., Baltimore; Buffalo FA Acad. [13]

NICHOLLS, Josephine (Lewis) (Mrs. Burr H.) [P,W,L] Buffalo, NY b. 26 S 1865, Hamilton, Ontario. Studied: S. Mowbray; G. Bridgman; L. Hitchcock. Member: Alliance; AAPL; Gld. Allied Arts; Buffalo SA; Lg. Am. Pen Women. Exhibited: Pan-Am. Expo, Buffalo, 1901 [40]

NICHOLLS, Rhoda Holmes (Mrs.) [P,I,W,T] Stamford, CT b. 28 Mr 1854, Conventry, England d. 7 S 1938. Studied: Bloomsbury Sch. A., London; Rome, with Cammerano, Vertunni. Member: AWCS; NYWCC; MacD. C.; Women's AA, Canada; SPNY; NAWPS. Exhibited: NYC (gold); Columbian Expo, Chicago 1893 (med); Atlanta Expo, 1895; Nashville Expo, 1897; Boston (med); Charlotte, N.C. (med); Pan-Am. Expo, Buffalo, 1901 (med); Charleston Expo, 1902 (med); St. Louis Expo, 1904 (med). Work: BAC; BMFA. Position: T., W.M. Chase's watercolor classes at Shinnecock, N.Y. (1890s), ASL [29]

NICHOLS, Audley Dean [Ldscp.P,Mur.P,] b. Pittsburgh. Studied: under his mother; ASL; MMA Sch. FA, with Blashfield, Cox, Mowbray; Europe. Active in El Paso, 1919–35. His aunt, Maria L. Nichols, was founder of Rookwood Pottery Co. [*]

NICHOLS, Carroll Leja [P] Brooklyn, NY/Boothbay Harbor, ME b. 1 My 1882. Studied: C. Yates; G.E. Browne. Member: SC; NAC [40]

NICHOLS, Dale (William) [P,Des,Li,I,W,L,T,B,Dr] Tucson, AZ b. 13 Jy 1904, David City, NE. Studied: Chicago Acad. FA; AIC; J. Binder, Vienna. Member: S. Typographic A.; Tucson Archaeological S.; All-Ill. SFA; Chicago GFLA. Exhibited: AIC, 1935 (prize), 1936, 1938, 1939 (prize); CI, 1937, 1946; Denver A. Mus., 1943; Century of Progress, Chicago, 1934; WFNY, 1939; GGE, 1939; Dallas Mus. FA, 1936; All-Ill. SFA, 1934 (prize). Work: MMA; AIC; Joslyn Mem.; Nebr. AA; Univ. Ariz.; Boys Town, Nebr.; mural, USPO, Morris, Ill.; Bauer and Black; des., illus., 2 booklets, "Wonder Library," Century of Progress Expo. Author: "A Philosophy of Esthetics," 1938. Illustrator: "Two Years Before the Mast," 1941, "A World History," 1910. Position: T., Univ. Ill., 1939–40; A. Ed., Encyclopaedia Britannica Publications, from 1945; Chm., Tucson Regional Plan, 1943–45 [47]

NICHOLS, David [En] Brooklyn, NY b. 1829, Newburgh, NY d. 1911. Specialty: wood engraving [*]

NICHOLS, De Lancey [P] Brooklyn, NY [01]

NICHOLS, De Owen, Jr. (Mrs.) See Roberts, Margaret.

NICHOLS, Edith L. [P,W,C,T,L] Brooklyn, NY b. Brooklyn. Studied: PIASch; Columbia; H.B. Snell; A. Fisher; C. Martin; E. Watson; W. Beck. Member: NAWA; Brooklyn SA; AAPL; Eastern AA; Nat. Assn. Women in Administration; Ixia S.; Nat. Assn. Art Ed. Exhibited: Brooklyn SA, 1920–40; NAWA, 1938–40; C.L. Wolfe C., 1936–38. Contributor: "School Arts." Position: A. Dir., NYC Pub. Sch. [47]

NICHOLS, Frederick B. [En] Bridgeport, CT b. 1824, Bridgeport d. after 1906. Worked as engraver for Smillie then started his own business and invented a relief engraving process in 1848. He published Nichol's Illustrated New York in 1846; stopped engraving after 1858. Was a mining engineer in Nova Scotia, 1865; returned to NYC, 1884. [*]

NICHOLS, George (Mrs.) [P] NYC. Member: Lg. AA [24]

NICHOLS, H(arley) D(e Witt) [Ldscp.P,I] Capistrano, CA b. 3 F 1859, Barton, WI. Studied: Hakel, Munich; ASL. Member: NYWCC; SC; Laguna Beach AA. Illustrator: "French and English Furniture," "Loves of Great Poets"; architecture illus., for books and mags., chiefly Harper's and Century when he lived in Brooklyn [40]

NICHOLS, (Henry) Hobart [Ldscp.P,I] Bronxville, NY/Oyster Bay, NY. b. 1 My 1869, Wash., D.C. d. 14 Ag 1962, NYC. Studied: H. Helmick, Wash., D.C. ASL; Académie Julian, Castelluccho, Paris. Member: ANA, 1912; NA, 1920 (Pres., 1939–49); S. Wash. A.; F. PAFA; Wash. WCC; NYWCC; SC; NAC; Allied AA; CAFA; North Shore AA; AWCS; NIAL; Paris Expo, 1900 (Asst. Dir.). Exhibited: Wash. WCC, 1901 (prize), 1904 (prize), 1906 (prize); S. Wash. A., 1902 (prize); SC, 1913 (prize), 1915 (prize), 1924 (prize), 1927 (prize), 1939 (prize); SAE, 1936 (prize); NAC, 1915 (med), 1920 (med); NAD, 1923 (prize), 1925 (prize), 1928 (prize), 1934 (prize), 1935 (prize); Century C., 1938 (prize). Work: NGA; AMNH; CGA; MMA; New Zealand AM. Position: Dir., Tiffany Fnd., Oyster Bay, 1940 [47]

NICHOLS, Hildegarde (Mrs. Hobart) [P] NYC. Member: NAWPS [25]

NICHOLS, J.J. [P] Newark, NJ [24]

NICHOLS, Jean Doornhein [P,T] Chicago, IL b. 27 Jy 1906, Holland, MI. Studied: AIC; Univ. Chicago; T. Col., Chicago; Lewis Inst. Member: Renaissance S., Univ. Chicago; Western AA; South Side AA; A. Educators Assn. Exhibited: PAFA, 1937; South Side AA, 1945, 1946. Position: T., Chicago Pub. Sch. [47]

NICHOLS, John (Crampton) [P,T,L] Woodstock, NY b. 31 My 1899, Maywood, IL. Studied: Amherst; AIC; ASL; Switzerland. Member: Woodstock AA. Exhibited: PAFA, 1942; MOMA, 1936; BMA, 1940; Woodstock AA, 1932–45, 1934 (prize); 67 Gal., 1945; Kelekian Gal., 1941; Mortimer Levitt Gal., 1946; Niveau Gal., 1946 [47]

NICHOLS, John Fountain [P,T,L] Chicago, IL b. 4 Je 1912, Chicago. Studied: AIC; Chicago Acad. FA; L. Cheskin. Member: South Side AA [40]

NICHOLS, John W. [E] NYC b. 1 Ag 1881, Keokuk, IA. Studied: C.A. Cumming; S.C. Carbee; E. Haskell [40]

NICHOLS, Juliette S. [P] NYC b. ca. 1870 d. ca. 1958. Studied: Paris. Member: Lg. AA. Exhibited: Provincetown AA, 1915 [24]

NICHOLS, Lila (Copeland) [P,T] Woodstock, NY b. 29 Ap 1912, Rochester, NY. Studied: ASL. Member: Woodstock AA. Exhibited: AIC, 1935, 1937 (med); GGE, 1939; Pepsi-Cola, 1946; Mortimer Levitt Gal., 1946; Woodstock AA, 1935–46 [47]

NICHOLS, Maria Longworth [Cer] b. 1849 d. 1932. Founder: Rookwood Pottery Co., Cincinnati, important for its role in the American art pottery movement. [*]

NICHOLS, Mary Plumb (Mrs.) [S] Denver, CO b. 15 Jy 1836, Vernon, OH. Studied: Preston Powers. Member: Denver AC. Exhibited: Columbian Expo, 1893 (med) [10]

NICHOLS, Melvin [P] NYC [01]

NICHOLS, Pegus Martin (Peggy) [Dec,Des,Por.P,W] Los Angeles, CA b. 22 Mr 1884, Atchison, KS. Studied: Chase; C. Beaux [40]

NICHOLS, Perry [P,C,Des,T] Dallas,TX b. 9 N 1911, Dallas. Exhibited: WFNY, 1939; Dallas All. A., 1932–34, 1940, 1941; SSAL, 1942 (prize); Dallas Mus. FA, 1940 (prize), 1944 (prize). Work: Dallas Mus. FA. Position: T., Hockaday Col., Dallas, 1944–46 [47]

NICHOLS, S.M. [P] Tarrytown, NY [04]

NICHOLS, Spencer Baird [P,T,L] Kent, CT b. 13 F 1875, Wash., D.C. d. 29 Ag 1950. Studied: Corcoran Sch. A.; ASL; Wash. ASL, with H. Helmick. Member: NAD; SC; AWCS; NA, 1933; Allied AA.; Arch. Lg.; Wash. WCC; S. Wash. A.; NYWCC; Grand Central AG. Exhibited: S. Wash., 1901 (prize); NAD, 1911–40, 1928 (prize), 1931 (prize), 1932 (prize); NYWCC, 1916–40. Work: House of Representatives, Wash., D.C.; Nat. Mus., Wash., D.C.; murals, Kent and Litchfield, Conn. H.S.; Presbyterian Church, NYC; Beloit, Wis. A. Gal; Joslyn Mem.; NAC. Illustrator: "The Happy Prince," 1923, "The Last Voyage," 1930, other books. T., Marot Jr. Col., Thompson, Conn., 1933–42 [47]

NICHOLS, Thomas W. [P] Newark, NJ [24]

NICHOLS, Wilbur D. [P] Los Angeles, CA. Member: Calif. AC [25]

NICHOLS, Wilhelmina (Mrs. Hobart) [P] West Bronxville, NY. Member: NAWPS; Exhibited: NA, 1937; NAWPS, 1936–38 [40]

NICHOLS, Alice B. [P,I] Milwaukee, WI b. 10 Ag 1898, Milwaukee. Studied: Chicago Acad. FA; Syracuse Col. Painting. Member: Milwaukee AS [17]

NICHOLSON, Delos Charles [P,I,L,T] Webster Groves, MO/Pelican, WI b. 10 My 1885, Edgerton, WI. Studied: W. Reynolds; J. Norton; E. Church. Member: 2 x 4 S., St. Louis. Position: T., St. Louis Sch. FA [40]

NICHOLSON, Douglas Cornwall [P,I] Berkeley, CA b. 8 S 1907, Omaha, NE. Studied: Univ. Calif.; H. Hofmann; W. Ryder; R. Boynton. Exhibited: SFMA, 1938; GGE, 1939. Work: PBA; WPA mural, USPO, Camas, Wash. Illustrator: U.S. War Dept., 1946 [47]

NICHOLSON, Edward (Horace) [P,Ser,T] Peoria, IL. b. 13 Je 1901, Lincoln, IL. Studied: Chicago Acad. A.; AIC; Grand Central Sch. A.; W. Adams. Member: Palette & Chisel Acad., Chicago; All-Ill. SFA; Peoria AL. Exhibited: All-Ill. SFA, 1939, 1940 (prize), 1944; Faulkner Mem. Mus., 1935, 1936; Santa Barbara AA, 1936–38; Hoosier Salon, 1941–43, 1944–46 (prizes); Oakland A. Gal., 1938, 1939, 1949; Peoria AL, 1941, 1946. Work: Ebell C., Long Beach, Calif.; Bradley Univ.; Peoria Pub. Lib. [47]

NICHOLSON, Elizabeth [Ldscp.P,Dec,T] b. 1833, Clinton County, OH (or Indianapolis) d. 26 Ap 1926, Indianapolis. Studied: McMickin Inst. Cincinnati, with Thomas Noble; Paris, with Henry Mosler, M. Revé; china painting, Phila. Positions: T., Ohio Female Col. (Col. Hill, Ohio), Kenwood Seminary (Chicago), privately (Indianapolis)

NICHOLSON, Emrich [P] Ventura, CA. Work: WPA mural, USPO, Vacaville, Calif. [40]

NICHOLSON, Frank S. [P] NYC. Member: GFLA [27]

NICHOLSON, George W. [P] Phila., PA b. 17 O 1832 d. 19 O 1912, Hammonton, NJ. Studied: Isabey, in Paris. Exhibited: AAS, 1902 (gold); PAFA, 1867 [10]

NICHOLSON, Isabel Ledcreigh (Mrs.) [P,S] Pebble Beach, CA b. St. Louis, MO. Studied: Lausanne, with Bohnen, Loup. Member: Carmel AA [40]

NICHOLSON, Leona (Mrs. Bentley) [Cer] New Orleans, LA b. St. Francisville, LA. Studied: Newcomb Sch. A.; Alfred Univ. Member: Boston SAC (Master Craftsman); Phila. ACG; NOACC; NOAA. Exhibited: NOAA (prize). Work: Delgado Mus. A.; Newcomb Col. A. Gal., New Orleans. Specialty: pottery [40]

NICHOLSON, William [I] Affiliated with R.H. Russell & Co., NYC [01]

NICHT, Edward W(illiam) [P] Syracuse, NY b. Auburn, NY. Studied: H.R. Poore; Leith-Ross. Exhibited: N.Y. State Fair, Syracuse, 1912 (prize) [40]

NICKAM, Charles W. [P] Indianapolis, IN b. 1844 d. 2 O 1913. He painted a portrait of A. Lincoln without knowing who was posing for him.

NICKELSEN, Ralf Edgar [P,Des] Auburndale, MA b. 2 F 1903, Hamburg, Germany. Studied: State A. Sch., Hamburg; ASL; BMFA Sch.; J.R. Nickelsen, in Hamburg. Exhibited: Fed. A. Gal., Boston, 1936; Abbott Acad., Andover, Mass., 1939. Work: WPA murals, Parcel Post Bldg., Worcester, Mass. [40]

NICKERSON, J(ennie) Ruth Greacen) [S] Scarsdale, NY b. 23 N 1905, Appleton, WI. Studied: NAD; BAID; S.A. Cashwan; H. Colby; R.I. Aitken; A. Ben-Shmuel. Member: ANA; NSS; NAWA; PBC; Scarsdale

AA; Westchester A. & Crafts G.; Grand Central A. Gal.; Guggenheim F., 1946. Exhibited: NAD, 1932, 1933 (med) 1937, 1945; PAFA, 1934; AAPL, 1937 (med); Montclair AM, 1939 (med); NAWA, 1946 (prize); Salons of Am., 1935; S.Indp.A., 1935; All.A.Am., 1934; WMAA, 1936; Roerich Mus.; BM; MMA, 1943. Work: Newark Mus.; Cedar Rapids AA; S., USPO, Leaksville, N.C.; S. group, Children's Lib., Brooklyn. [47]

NICKERSON, V.D. [Mar.P] (Cleveland ?) Active around Great Lakes, 1880–95. Work: Mariner's Mus.; Great Lakes Hist. S. [*]

NICKLES, Martha [P] Cincinnati, OH. Member: Cincinnati Woman's AC [25]

NICODEMUS, Chester Roland [S,C,T] Columbus, OH b. 17 Ag 1901, Barbarton, OH. Studied: Pa. State Col.; Cleveland Sch. A.; Univ. Dayton; Ohio State Univ.; H.N. Matzen. Member: NSS; Columbus AL. Exhibited: Syracuse MFA, 1933–38, 1940, 1941; Columbus AL, 1930–46, 1934 (prize), 1936 (prize). Work: Columbus Gal. FA. Position: T., Columbus A. Sch., 1930–43 [47]

NICODEMUS, Joan Bain See Bain.

NICOLAI, C.A. [P] Chicago, IL [25]

NICOLAIDES, Kimon [P,T] NYC/Lyme, NH b. 10 Je 1892, Wash., D.C. d. 18 Jy 1938. Studied: J. Sloan; K.H. Miller. Position: T., ASL; NY Sch. Appl.Des. Women [38]

NICOLAY, Helen [P] Wash., D.C./Holderness, NH b. 9 Mr 1866, Paris. Member: Wash. WCC [25]

NICOLET, Theophile [P] NYC [17]

NICOLL, J(ames) C(raig) [Mar.P,Et] NYC/Ogunquit, ME b. 22 N 1846, NYC d. 1918, Norwalk, CT. Studied: M.F.H. De Haas; K. Van Elten. Member: ANA, 1880; NA 1885; AWCS; A. Fund S.; NY Etching C., 1877; A. Aid S.; NY Municipal AS; Century Assn. Exhibited: NAD, 1867–1900; Mass. Charitable Mech. Assn., Boston, 1884 (med); New Orleans Expo, 1885 (med); Am. AA, NYC, 1888 (med); Paris Expo, 1889; Atlanta Expo, 1895 (med); Pan-Am. Expo, Buffalo, 1901 (med). Work: MET; BM [17]

NICOLOSI, Joseph [S,L] NYC b. 4 Ag 1893, Italy d. 13 Jy 1961, Los Angeles, CA. Studied: BAID, with S. Borglum; E. McCarten. Member: NSS; Arch. L.; Am. Veterans SA; AAPL. Exhibited: WFNY, 1939; NAD; PAFA; MET; NSS; Am. Veterans SA; BAID, 1915–1919 (med); A. Ctr., Oranges Exh., 1932, (prize). Work: s., busts, mem., Brookgreen Gardens, S.C.; Univ. Chicago; Phelps Mus., Caracas, Venezuela; Maracai, Venezuela; Mt. Tremper, N.Y.; Llewellyn Park, N.J.; Mellon Bank, Pittsburgh, Pa.; Nat. Palace, Guatamala City, Guatemala; Morristown, N.J.; City & County Bldg., Denver, Colo.; New Brighton, N.Y.; WPA mural, USPO, Mercersburgh, Pa.; Litiz, Pa.; Manhattan State Hospital; mem., Caltabellotta, Italy; NYC H. Schs.; CCNY. [47]

NICOLSON, Edith Reynaud (Mrs. H.W.) [I] Orange, NJ b. 24 S 1896, Mt. Vernon, NY. Studied: N.Y. Sch. Appl. Des. Women [25]

NIEDECKEN, George Mann [Mur.P,Arch,Dec] Milwaukee, WI b. 16 1878, Wilwaukee. Studied: AIC; Paris, with Mucha, Robert-Fleury, Laurens, Lefebvre [33]

NIEHAUS, Charles H(enry) [S] NYC/Grantwood, NJ b. 24 Ja 1855, Cincinnati, OH d. 19 Je 1935, Cliffside, NJ. Studied: McMicken Sch., Cincinnati; Royal Acad., Munich, 1877–81; Member: ANA, 1902; NA, 1906; Arch. Lg., 1895; NSS, 1893; NIAL. Exhibited: Pan-Am. Expo, Buffalo, 1901 (gold); Charleston Expo, 1902 (gold); St. Louis Expo, 1904 (gold). Work: statues, Wash., D.C.; Cincinnati; Astor Mem. doors, Trinity Church, NYC; MMA; Baltimore; Hoboken; Newark; Hackensack, N.J.; Capitol, Wash., D.C.; LOC. Specialties: port. statues; busts; monuments [33]

NIELSEN, Peter [P] Chicago, IL [17]

NIELSON, Harry A. [P] Pasadena, CA b. 25 S 1881, Slagelse, Denmark. Studied: AIC; Jean Manheim. Member: Calif. AC [24]

NIELSON, John [Por.P] Milwaukee, WI b. 1881 d. 1954. Studied: AIC; Wis. Sch. A. [25]

NIEMANN, Edmund E. [P,Dec] Jackson Heights, NY b. 27 O 1909, NYC. Studied: NA; ASL. Exhibited: PAFA, 1935; Contemporary A. Gal.; S.Indp.A. Position: Staff Artist, H. Niemann and Sons, Flushing, N.Y. [40]

NIEMEYER, John H(enry) [P,T,L] New Haven, CT b. 25 Je 1839, Bremen, Germany (came to Cincinnati in 1843) d. 7 D 1932. Studied: Ecole des Beaux-Arts, with Gérôme, Yvon; de la Chevreuse; Cornu, in Paris, 1866.

Member: SAA, 1882; ANA, 1906; Paris AA; CAFA; New Haven PCC. Exhibited: Pan-Am. Expo, Buffalo, 1901. In 1930 a retrospective exhibition of more than fifty of his paintings was held at Yale. Work: Smith Col.; Yale. Specialties: landscape painting; portraits. Among his pupils were A. Saint-Gaudens, F. Remington, Bela Pratt. Position: T., Yale, 1871–08 [31]

NIEPOLD, Frank [P,C] Wash., D.C. b . 1 Ja 1890, Frederick, MD. Studied: Corcoran Sch. Member: Wash. AC; Wash. Ldscp. C. [33]

NIEUWENHUIS, Celeste Withers [P] Hollywood, CA [24]

NIKOLAKI, Z.P. [E,I] NYC [21]

NILES, Helen J. [P] Toledo, OH [15]

NILES, Rosamond [E,P] Old Lyme, CT b. 5 N 1881, Portsmouth, NH d. ca. 1960. Studied: ASL; DuMond; Bridgman; Pennell; Paris, with Lhote; E. Leon. Member: NAWA; NAD; SSAL. Work: Witte Mem. Mus.; Randolph Aviation Field; Woodberry Forest Sch., Chatham Sch., both in Va.; Radcliffe Hicks Mem. Sch., Tolland, Conn. [47]

NILES, William J. [P] Bedford, MA. Member: Boston AC [08]

NILL, Mary [P] Greencastle, PA. Studied: PAFA [25]

NIMMO, Louise Everett [P] Los Angeles, CA b. 9 Ap 1899, Des Moines, IA. Studied: Grinnell Col.; Otis AI; Chouinard AI; Fontainebleau Sch. FA; Académie Julian; Fursman; C.W. Hawthorne; J.B. Wendt. Member: Calif. AC; Women P. of the West; Laguna Beach AA; S. for Sanity in A. Exhibited: Pacific-Southwest Expo, 1928 (prize), GGE, 1939; Los Angeles Mus. A.; Calif. AC; Women P. of the West; Laguna Beach AA, 1923 (prize), 1924–46; Beverly Hills Women's C., 1933 (prize); Calif. State Fair, 1936 (prize). Work: Opportunity Sch., Des Moines, Iowa; Beverly Hills Women's C.; Calif. AC; Los Angeles City Hall [47]

NIMO. See Mocharniuk, Nicholas.

NINAS, Jane [P] New Orleans, LA. Exhibited: WFNY, 1930 [40]

NINAS, Paul [P,G,Dec,T] New Orleans, LA b. 8 My 1903. Studied: Akademie der Beldenkunst, Vienna. Member: NOACC; SSAL; New Orleans AL. Exhibited: NOAC Gal.; WFNY, 1939. Work: WPA murals, USPO, Henderson, Texas. Position: Dir., New Orleans A. Sch. [40]

NISBET, C. Becheler (Mrs.) [P,I,Li] Devon, England b. 24 Ap 1902, East Hartford, CT. Studied: G. Inness, Jr.; Paris, with Despujols, Bartlett; Yale. Member: NAPWS. Exhibited: NAWPS, 1929–30 (prize), 1931 (prize). Work: murals, State Normal Sch., New Haven, Conn. [33]

NISBET, Robert H. [P,E,L] South Kent, CT b. 25 Ag 1879, Providence d. 19 Ap 1961. Studied: RISD; ASL; Europe; H. Snell; F. DuMond. Member: All.A.Am.; CAFA; NAC; Lotos C.; SC; Providence AC; SAE; A. Fund A.; A. Fellowship; Kent AA (Pres.). Phila. SE; AWCS; Arch. Lg., 1912; ANA, 1920, NA, 1928; AAPL; NYWCC; Intl. Jury, Italian Print Exh., 1931. Exhibited: Kent AA; CAFA, 1913 (prize); 1915 (prize); NAD, 1915 (prize); 1923 (prize) 1931 (prize); P.-P. Expo, 1915 (med); Calif. PM (prize); Los Angeles Mus. A., 1925 (prize); NAC, 1927 (med,prize); Living Am. Et., 1927–28; SAE, 1932 (prize). Work: RISD; Telfair Acad. A.; Butler AI; Conn. State Agricultural Col.; R.I. State Col.; NAC; Lotos C.; Sherman (Conn.) Lib.; MMA; NYPL; BM; Milwaukee AI; Detroit Inst. A.; Univ. Nebr.; Oberlin Col.; Art Council, N.Y.; Yale; Bibliothèque Nationale, Paris, NGA; LOC; Plantations C., Providence; Detroit Mus.; U.S. Nat. Mus.; Birmingham (Ala.) Pub. Lib. [47]

NISITA, Carlo Antonio [P,C,Gr,Des,T] East Aurora, NY b. 26 O 1895, Naples, Italy. Studied: Buffalo Sch. FA; Yale; ASL. Member: Buffalo Pr. C.; Buffalo SA. Exhibited: Denver AM, 1944; CGA, 1945; Albright A. Gal., 1934–46. Work: murals, Grosvenor Lib., St. Ann's Church, St. Francis Hospital, all in Buffalo, N.Y.; Gardenville, N.Y. Position: T., Pub. Sch., East Aurora, N.Y., 1934–46 [47]

NISWONGER, Ilse V. (Mrs.) [C,S] Westport, CT b. 26 Ja 1900, Metz, France. Studied: ASL; A. Archipenko; H. Hofmann; R. Belling; A. Lee; R. Laurent. Member: NAWA; NSS; N. Y. S. Craftsmen; N. Y. S. Ceramic A.; Silvermine AG; S.Indp.A.. Exhibited: Phila., 1946; SFMA, 1929; Silvermine AG; Westport, Conn.; Argent Gal.; Arden Gal.; Neumann Gal., Ferargil Gal., Lilienfeld Gal., all in NYC; Soap Sculpture Assn., 1932; NAWA, 1929, 1932, 1935 (prizes). Work: S., churches, Noroton, Westport, Fairfield, all in Conn.; Sydney, Australia [47]

NITZCHE, Elsa Koenig [Por.P] Phila., PA b. 24 Mr 1880, d. 18 Mr 1952. Studied: E. Daingerfield; D. Bouveret; PAFA. ; Phila. Sch. Des. for Women. Exhibited: Phila. AC; PAFA. Work: Univ. Pa.; Phila. AC; Nat. Mus., Wash., D.C.; Union Lg., Phila. Author/Illustrator: "Dickel and the Penguin" [47]

NITSCHE, Arik [I,Des] Ridgefield, CT b. 7 Jy 1908, Lausanne, Switz.

Studied: Europe. Exhibited: A. Dir. C. Exh., 1938–46. Illustrator: "French for the Modern World," 1946. Contributor: nat. mags. Positions: A. Dir., Air News, Air Tech (1943, 1944), Mademoiselle (1945) [47]

NIVEN, Frank R. [P,I,C] Rochester, NY b. 2 Mr 1888, Rochester, NY. Studied: S.C. Jones. Member: Rochester AC [25]

NIXON, Floyd S. [Car] Detroit, MI. Work: Huntington, Lib., San Marino, Calif. [40]

NIXON, Netta [P] Chicago, Il b. Ontario, Canada. Studied: AIC [04]

NIXON, William D. [P] Wash., D.C. [25]

NOBACK, Gustave Joseph [S,T,L] Forest Hills, NY b. 29 My 1890, NYC. Studied: Cornell Univ.; Univ. Minn.; W.C. Baker; H. Warneke; W. Williams. Member: NAC; AAPL. Exhibited: Arch. Lg., 1938; PAFA, 1940, 1942, 1946; NAD, 1945, 1946; All.A.Am., 1941–45; Clay C., 1934, 1935; Asbury Park SFA, 1939, 1940; Montclair A. Mus., 1945; NAC, 1944–46; Minneapolis S. Exh., 1945. Work: NYU; China Inst. Am. Position: T., Anatomy, NYU, 1924–45 [47]

NOBEL, Berthold [S] Rome, Italy. Studied: Am. Acad., Rome, 1914–17 [17]

NOBLE, Belden, Mrs. [P] Wash., D.C. [15]

NOBLE, Carl E. [I,Car,P] Great Neck, NY. Studied: BMFA Sch.; Grand Central A. Sch; Fenway Sch. Illus., Boston; ASL; J.S. Sargent; D. Cornwell; N. Rockwell. WPA artist. [40]

NOBLE, Ida S. (Mrs.) [P] Nashville, TN b. 25 F 1865, Beech Grove, TN. Studied: Bryson. Position: T., Lipscomb Col., Nashville [25]

NOBLE, John [P] NYC b. 15 Mr 1874, Wichita, KS d. 6 Ja 1935. Studied: Cincinnati Acad. FA; Paris, with Laurens, Académie Julian; Acad. des Beaux-Arts, Brussels. Member: ANA, 1924; NA, 1928; Paris Am. AA; S. Artists of Picardy; Independents of Paris; Allied Artists, London; CAFA; Provincetown AA; Grand Central A. Gal. (founder). Exhibited: SC, 1922 (prize); CGA, 1924 (prize); Atheneum, Hartford, Conn. (prize); NAD (prize). Work: Delgado Mus.; Acad. Des., R.I.; Dallas Mus.; Wichita Mus; CGA; Brooks Mem. Gal., Memphis; Milch Gal., NYC. He never used models nor painted with the object or scene before him, his theory being than an artist should be creative, not a copyist. Best known for his Brittany paintings and studies of the Am. buffalo. [33]

NOBLE, Mamie Jones (Mrs. J.V.) [P,C,W,L,T] Corsicana, TX b. Waxahahie, TX. Studied: AIC; R. Crosman; G. Oberteuffer; C. Kay-Scott; I.K. Manoir; A.A. Hills; J.B. Sloan. Member: SSAL; Dallas AA; Reaugh AC. Exhibited: Ft. Worth AC; Tex. Centenn. Exh.; Tex. Women's Col., Ft. Worth; Miss. State Fair, 1929 (prize) 1931 (prize); Fed. Women's C., Corsicana, 1937 (prize). Work: murals, Baptist Church, Itasca, Tex.; Mem. Church, Corsicana. Contributor: "The Outlook." Position: Dir., Tex. FAA, 1935–45 [47]

NOBLE, May [P] Chicago, IL [06]

NOBLE, Morton [P] Detroit, MI. Member: Cleveland SA [25]

NOBLE, Thomas Satterwhite [P] Cincinnati, OH b. 29 My 1835, Lexington, KY d. 27 Ap 1907, NYC. Studied: NYC, 1850s; Paris, with Couture; Munich. Member: Cincinnati AC (received several gold and silver medals). Served as a captain in Confederate Army; later, had studio in NYC until 1869. Position: T., Dir., Cincinnati A. Sch. (McMicken Univ.), 1869–04. [33]

NOBLE, W. Clark [P,S] Wash., D.C. b. 10 F 1858, Gardiner, ME d. 10 My 1938. Studied: London, with Pierce, Greenough, Taft. Member: NSS; NAC. Work: Mem., Newport, R.I.; mem., Church of Incarnation, NYC; bust, C. of C., NYC; Antietam, Md.; Bellefonte, Pa.; Church of St. Mary, Wash., D.C.; L'Enfant Mem., Sousa Mem., Wash., D.C.; Des. gold and silver money for Guatemala, 1925, Panama, 1930, 1931 [38]

NOBLE-IVES, Sarah [P] Middletown, CT [15]

NOCI, Arturo [P,I,T] NYC b. Rome, Italy. Studied: Inst. FA, Rome. Work: Rochester Mus.; Galleria d'Arte Moderna, Rome [33]

NOCQUET, Paul-Ange [P,S] NYC b. 1 Ap 1877, Brussels (came to NYC, 1903) d. 4 Ap 1906, NYC. Studied: Brussels, with J. Portaels, 1891; Lambeaux; Paris, with A. Mercié, Gérôme. Member: Soc. Nat des Beaux Arts, Paris; Soc. "Les Arts Réunis," Paris; Ste. Sillon, Brussels. Exhibited: Rome, 1900 (prize); Belgium, 1900 (prize); St. Louis Expo, 1904 (med); Salon of Champs de Mars, Paris, 1902. Work: Columbia Univ. His interest in ballooning dated from youth and the ascension made from NYC on 3 Ap 1906 proved conclusively his theories of the local winds and air currents. The balloon landed safely on the beach but the struggle across the water and mud between the sea and the village exhausted him and he died 4 Ap 1906. Within weeks a memorial exhibition was held in NYC. The Belgian Gov. ordered a set of casts of his works and several were purchased by the French Gov. [06]

NOECKER, J. Harold [P,Cart] Chicago, IL b. 3 O 1912, Urbana, IL. Studied: Univ. Ill.; Chicago Acad. A. Exhibited: VMFA, 1942, 1944; WFNY, 1939; Milwaukee AI, 1946; AIC, 1939–44, 1945; AIC, 1941, 1943 [47]

NOEL, Helen Jeanette (Mrs. Robert M. Shagarn) [Li,Por.P,Ldscp.P,Des,I] Chicago, IL b. 4 My 1912, Chicago. Studied: B. Anisfeld; L. Ritman; E. Giesbert; L. van Pappelendam; AIC. Member: S. Typographic Arts. Work: liths., Western Ill. State T. Col.; Cook County Hospital Nurses Home; Dwight Reformatory, Dwight, Ill.; YMCA Col., Chicago [40]

NOERDINGER, Jean Joseph [Mur.P] Chicago, IL b. 3 Ja 1895, Luxembourg, Europe. Studied: von Habermann, Royal Acad. FA, Munich. Member: All-Ill. SFA. Work: Courthouse, Sheboygan, Wis.; murals, Agri. Bldg., Century of Progress Expo; Our Lady of Sorrow Church, Chicago; Coll., Nancy, France; Coll., Grand Duchy, Luxembourg. Position: A. Dir., Mural Dec. Co., Chicago [40]

NOFZIGER, Ed(ward) (C.) [Car,I,W,G,P,L] Douglaston, NY b. 14 1⁄2 1913, Porterville, CA. Studied: UCLA; Columbia; ASL. Author/Illustrator: "Shorty," 1941, "Two Trees," 1944, "Spunky," 1946. Illustrator: Saturday Evening Post, Collier's, Esquire, Click. Position: Cart., U.S. Forest Service [47]

NOGA, François R.E. [E,Por.P] Chicago, IL b. 5 D 1892, Bohemia [40]

NOGUCHI, Isamu [S] NYC b. 17 N 1904, Los Angeles, CA. Studied: briefly with G. Borglum, 1922; da Vinci Sch. A., NYC; Paris, with Acad. Grande Chaumière, Acad. Colarossi, C. Brancusi, 1927–29; Peking, with Chi Phi Shi, 1930; pottery, Japan, 1930. Member: F., Guggenheim, 1927, 1928. Work: WMAA; Associated Press Bldg., Rockefeller Center; WPA sculpture, USPO, Haddon Heights, N.J.; Beinecke Lib., Yale, 1960–64; MOMA. Designer: sets for Martha Graham (1935); gardens for UNESCO, Paris (1956–58) [40]

NOHEIMER, Mathias John [P,I,Des,T] Cincinnati, OH b. 8 N 1909, Cincinnati OH. Studied: Univ. Cincinnati; A. Acad., Cincinnati. Member: Cincinnati Assn. Prof. A.; MacD. S. Exhibited: CM, 1932, 1934; SFMA, 1935; Cincinnati New Group, 1935, 1936; AIGA, 1935; Direct Mail Adv. Assn., 1944 (prize). Work: Reptile House, Tuberculosis Sanitorium, Children's Convalescent Home, all in Cincinnati; Levere Mem. Chapel, Evanston, Ill.; CM; Levere Mem. Temple. Illustrator: "Any Day Now," 1938, "A Baker's Dozen," 1939, "Ali Baba," 1943. Position: Ass. Dir., Studio Sch. A., Cincinnati [47]

NOHOWEL, M(argaret) Dressler [Por.P] Wash., D.C. b. 21 My 1888, Leipzig, Germany. Studied: ASL; R. Henri; W. Chase. Member: Wash. AC; S. des Beaux-Arts, Cannes. Exhibited: S. Wash. A.; CGA, 1939 [47]

NOLAN, Daniel J. [P,Patron] Everett, MA b. 1862, Boston d. 18 N 1920. For a number of years he was connected with Doll & Richards, Boston, and then with the Copley Gal. from 1908 [19]

NOLAN, Harry A. [P] Bloomington, IN [17]

NOLAN, Helen Esperance [P] St. Paul, MN [19]

NOLF, John Thomas [P,I,Car,L] Grand Detour, IL b. 23 Jy 1872, Allentown, PA d. ca. 1955. Studied: AIC; Smith A. Acad., Chicago; W. Reynolds; F. Smith; J. Vanderpoel; W. Ufer. Member: Chicago Gal. Assn.; Chicago P.&S.; Oak Park AL; Joliet AL; La Grange AL. Exhibited: AIC, 1924 (prize); PAFA; SFMA; NAD; Springville, Utah; Oak Park AA, 1928 (gold); Chicago Mun. AL, 1929 (prize). Work: Union Lg., Chicago; Chicago Pub. Sch. AS; Oak Park Pub. Schs.; Northwestern Univ.; H.S., Chicago; Lafayette AA, Ind.; Vanderpoel AA, Chicago. Position: monthly cart., Inland Printer, Chicago [47]

NOLL, Arthur Howard [En,C,W,L,T] Memphis, TN b. 4 F 1855, Caldwell, NJ. Exhibited: Am. Bookplate S., 1919 [21]

NOMURA, K(enjiro) [P] Seattle, WA b. 10 N 1896, Japan. Member: SAM; Group of 12, Seattle. Exhibited: SAM, 1932 (prize). Work: SAM [40]

NORBURY, Louise H. [P,T,L] NYC b. 18 Ag 1878, Hastings, NY d. 11 My 1952. Studied: PIASch; BM A. Sch; Pape; A. Brook; J. Farnsworth; A. Fisher; W. Adams; L. Hunt; Grand Central Sch. A.; Sch. Appl. Des.; NYU. Member: NAWA; Brooklyn SA; Wolfe AC; Brooklyn WCS; L.I. SA. Exhibited: AWCS; NAWA; BM; Bruce Mus. A.; Bridgewater County FAA (one-man); Studio G. (one-man); 8th St. Gal. (one-man); South Shore AA (one-man); Argent Gal. (one-man); Amherst Co. (one-man); WMA. Position: A. Supv., NYC Pub. Sch., 1912–40 [47]

NORCROSS, Eleanor [P,Patron] Paris, France b. Fitchburg, MA d. 18 O 1923, Fitchburg. Studied: Chase, in NYC; A. Stevens, in Paris [13]

NORCROSS, Emily Danforth [P,T] Cambridge, MA b. 1848, Cambridge, MA d. Mr 1909. Studied: Wm. M. Hunt, Boston, 1869; T. Couture, Villiers-le-Bel, 1875; Venice. Exhibited: J.E. Chase Gal., Boston, 1885. Position: T., BMFA Sch. (manager of painting sch., 1900–05)

NORCROSS, Grace [I,Dr,T] Glenside, PA b. 27 Ag 1899, Phila., PA. Studied: T. Oakley. Illustrator: "A Little Maid of Mohawk Valley," "Tuckaway House," "Ant Hills and Soap Bubbles," "The Story of Milk," and other children's books and magazines. Position: T., PMSchIA [40]

NORDBERG, C. A(lbert) [Mur.P,T] Evanston, IL b. 19 1895, Chicago, IL. Studied: R. Reid; J.F. Carlson; B. Sandzen; E. Warner. Member: Broadmoor A. Acad.; Colo. Springs FA Ctr.; Chicago SP; Denver SP; S. Am. P. Exhibited: North Shore AA, 1937 (prize). Work: murals, "Indians of Pike's Peak Region," "Towering Pine," Cheyenne Sch., Colorado Springs; Richmond, Ind.; Vanderpoel Mem. Coll.; Mission Covenanant Church, Evanston; dec., Children's Home, Princeton, Ill. [40]

NORDELL, Carl Johan David [P,Et] Westfield, NY b. 23 S 1885, Copenhagen, Denmark. Studied: BMFA Sch., with Tarbell; ASL, with Bridgman, DuMond; Académie Julian, with Laurens; RISD. Member: North Shore AA; SAE; Calif. PM; Chautauqua County SA; Boston WCC; SC. Exhibited: P.-P. Expo, 1915 (med); CGA, 1913 (prize); Swedish-Am. Exh., Chicago, 1917 (prize); SC, 1923 (prize) 1937 (prize), 1941 (prize); Nashville, Tenn., 1930 (prize); North Shore AA, 1928 (prize). Work: CMA; NYPL; LOC; Smithsonian Inst.; Dartmouth Col.; Wellesley Col.; Williams Col.; Hunter Col.; Bibliothèque Nationale; Oberlin Col.; Victoria & Albert Mus., London [47]

NORDELL, Emma Parker (Polly) (Mrs. Carl J.) [P,I,T,W] Boston, MA b. Gardner, MA d. ca. 1958. Studied: RISD, with S.R. Burleigh; S. Tolman; Chase Sch. A.; ASL, with DuMond, Henri; Acad. Grand Chaumière, with L. Simon, R. Ménard. Member: Providence WCC; Boston SWCP; NYWCC; Copley S.; Gld. Boston A.; Boston WCC; Phila. WCC. [47]

NORDERSCHER, Frank B. [P] St. Louis, MO [15]

NORFELDT, B(ror) J(ulius Olsson) [P,E,B,En,T] Lambertville, NJ b. 13 Ap 1878, Tulstorg, Scania, Sweden d. 21 Ap 1955, Henderson, TX. Studied: AIC, 1899; A. Herter, in NYC; Laurens, in Paris, 1900; F.M. Fletcher, Reading, England, 1900. Member: Taos SP; N.Mex. SP; Chicago SE; SAE. Exhibited: Milan, Italy, 1906 (med); P.-P. Expo, San Fran., 1915 (med); AIC, 1926 (med); Sesqui-Centenn. Expo, Phila., 1926 (med); Denver AM, 1936 (prize). Work: Sidney, Australia, MFA; AIC; NYPL; Toledo AM; Bibliothèque des Arts et Archeologie, Paris; Nat. Mus., Christiania, Norway; Detroit Inst. A.; Toronto AM; Mus. N.Mex.; Denver AM, Colorado; Minneapolis Inst. A.; Univ. Minn.; Wichita AM [47]

NORFELDT, B.J.O., Mrs. See Abbott, Emily.

NORDGREN, Oke G(ustaf) [P] Hempstead, NY b. 22 F 1907, Stockholm, Sweden. Studied: Corcoran Sch. A.; Webster Sch. A., Provincetown; R. Lahey; Stetson Univ., Fla; F., Tiffany Fnd., 1937–39, 1941. Member: S. Wash. A.; Gld. Wash. A.; Swedish Am. AA; Wash. Ldscp. C. Exhibited: VMFA, 1940; PAFA, 1941, 1942; Phila. A. All., 1940; NAD, 1941; Pepsi-Cola Traveling Exh., 1945 (prize), 1946; S. Wash. A., 1933–40, 1941 (prize), 1942 (med), 1943, 1944 (prize), 1945; PMG, 1939–43; Gld. Wash. A., 1943–45; Nat. Mus., Wash., D.C., 1939–41; Swedish-Am. Exh., Chicago, 1939 (prize), 1940 (prize); Two-Man Show, Wesley Hall, Wash., D.C., 1940. Position: Affiliated with Corcoran Sch. A., 1940 [47]

NORDHAUSEN, August Henry [P,T,S] NYC b. 25 Ja 1901, Hoboken, NJ. Studied: H. von Habermann; H. Giles; N.Y. Sch. F.&Appl. A.; Royal Acad., Kunstgewerbe Schule, Munich; F., Tiffany Fnd. Member: SC; All.A.Am.; A. Fellowship; Springfield AL; New Haven PCC; F., McD. Colony; F., Trask Fnd. Exhibited: AIC; PAFA; CGA; NAD; Glass Palace, Munich; All.A.Am.; AGAA; Springfield AL, 1930 (prize), 1931; New Haven PCC, 1931 (prize); All.A.Am., 1938 (med), 1940 (prize); SC, 1937 (prize) [47]

NORDLE, Anna Bates Robbins (Mrs. Leonard T.) [P,C,T] Hinsdale, IL/Mayland, TN b. 23 D 1891, Lemont, IL. Studied: E. Woodward [27]

NORDMARK, A. [P] Seattle, WA [21]

NORDMARK, C.J. [P] Duluth, MN [24]

NORDMARK, Olof E. (Olle) [P,Gr,I,T] Hopewell Junction, NY b. 21 My 1890, Dalecarlia, Sweden. Studied: Sweden. Member: Dutchess County AA. Work: First Swedish Baptist Church, NYC; Cathedral of Learning, Pittsburgh, PA; Swedish-Am. Hist. Mus., Phila. Position: T., U.S. Indian Service, 1938–44 [47]

NORDQUIST, Clyde [P,B] b. 1904, ND d. 5 O 1931, Ann Arbor, MI. Member: Scarab C. Exhibited: Detroit AI, 1929 (prize)

NORDSTROM, Carl H(arold) [P,E,B,L,T] Ipswich, MA b. 18 S 1876, Chelsea, MA. Studied: E. Pape; G.L. Noyes; C. Emerson; A. Spear; H. Brett. Member: BAC; Gloucester SA; North Shore AA. Position: Dir., Nordstrom Summer Sch. Art, East Gloucester, Mass. [40]

NORDSTROM, Evert [P] Seattle, WA [24]

NORDYKE, Micajah Thomas [P] Richmond, IN b. 9 Ap 1847, Richmond. Studied: McMicken A. Sch., with Duveneck, Farny [10]

NORLING, Ernest Ralph [I,P,W,L,T,E] Seattle, WA b. 26 S 1892, Pasco, WA. Studied: Whitman Col.; Chicago Acad. FA; AIC; Tiffany Fnd; F. Tadema. Member: Wash. State Press C.; Puget Sound Group P.; Pacific Northwest Acad. A. Exhibited: CGA, 1935; SAM. Work: SAM; White House, Wash., D.C.; WPA murals, USPOs, Bremerton, Prosser, both in Wash.; Bremerton Navy Yard Lib. Author: "Pencil Magic," 1935, "Perspective Made Easy," 1939. Illustrator: American Forest, Alaska Life; children's books; cartoon strip, Christian Science Monitor Position: A. Dir., Boeing Aircraft Prelim. Des. Unit, 1945 [47]

NORLING, Jo(sephine) (Stearns) [W] Seattle, WA b. 22 Jy 1895, Kalamo, MI. Studied: Univ. Wash. Author: "Pogo" series for children, including "Pogo's House," 1941, "Pogo's Fishing Trip," 1942 [47]

NORMAN, Da Loria (Mrs.) [Mur.P,Por.P,C] Lyme, CT b. 18 N 1872, Leavenworth, KS d. 14 Ag 1935, NYC. Studied: Europe. Member: NAWPS. Work: illuminations, NYPL; Teaneck (N.J.) Pub. Lib. Specialties: oil fresco; illuminations [33]

NORMAN, Geoffrey [Mur.P,Por.P] NYC b. 21 F 1899, London, England. Studied: NAD; Académie Julian; Italy. Member: Mural P. Work: Textile H.S., NYC. WPA artist. [40]

NORMAN, Mabel [P] Newport, RI. Exhibited: Newport AA, 1914 [15]

NORMAN, Maria [P,W] NYC b. Tilset, Germany. Studied: Europe. Member: NAWA; Lg. Present-Day A.; Springfield AL; Irvington AA. Exhibited: CGA, 1941; SFMA; Mint Mus. A.; Springfield A. Mus; Springfield AL, 1945 (prize); NAD; WFNY, 1939; Riverside Mus.; NYPL [47]

NORMAN, Vera Stone (Mrs.) [I] Chicago, IL b. Garden City, KS. Studied: AIC. Member: Cordon C. [25]

NORRIS, Ben [E,P,T] Honolulu, HI b. 6 S 1910, Redlands, CA. Studied: Pomona Col.; Sorbonne, Paris; S. Macdonald-Wright; F. Taubes; Otis AI; Harvard; Chouinard AI. Member: Calif. WCS; Phila. WCC; Honolulu AA; Honolulu PM; Laguna Beach AA. Exhibited: Calif. WCS, 1935–41; AIC, 1938–41; Phila. WCC, 1938–40; WFNY, 1939; AWCS, 1938, 1939; one-man exh.: Honolulu Acad. A., 1936, 1938 (prize), 1940, 1941 (prize), 1942, 1944 (prize); Honolulu PM, 1940 (prize); Oakland, 1936 (prize); Pal. Leg. Honor, 1945; Crocker A. Gal., Sacramento, 1946; Santa Barbara Mus. A., 1946; SAM, 1946; Pomona Col., 1935, 1946. Work: LOC; NYPL; Honolulu Acad. A.; Officers' C., Pearl Harbor; M. McInerny, Ltd., Honolulu; paintings on Army Aviation, Hawaii. Contributor: Life. Position: T., Univ. Hawaii, from 1937 [47]

NORRIS, Margaret Fernie [P] Brooklyn, NY. Member: NYWCC. Exhibited: Am. WCS-NYWCC, 1939 [40]

NORRIS, Marie de Jarnet [P] NYC. Member: S.Indp.A. [24]

NORRIS, S. Walter [Ldscp.P,W] Phila., PA b. 12 Ja 1868, Phila. Studied: Univ. Pa.; PMSchIA; PAFA; Legros, in Paris. Member: Phila. Sketch C.; Phila. Alliance; Phila. AC. Exhibited: PAFA, annually, 1930 (gold), 1933 (gold); Phila. AC, annually; NAD; CAM; WMAA; AIC; GGE, 1939; CGA; PMA; TMA; BM; Phila. A. All.; SAM; Decatur AI. Contributor: Century, Harper's, St. Nicholas [47]

NORRIS, W.J. [I,Des] Columbus, OH b. 20 Ag 1869, Chicago, IL. Member: Pen and Pencil C., Columbus AL [33]

NORRLANDER, G. [P] Minneapolis, MN [13]

NORSTAD, Magnus [P,E] Valhalla, NY b. 24 Je 1884, Norway. Studied: NAD. Member: AG. Exhibited: Minn. State A. Exh., 1914; St. Paul Inst., 1917 (prize). Work: St. Paul Inst. [38]

NORTH, Harold, Mrs. See Fowler, Mary Blackford.

NORTH, Lois [P,B] Orange, CT b. 21 My 1908, New Haven, CT. Studied: Yale. Member: New Haven PCC. Work: Yale Sch. FA, New Haven; Bethany, Conn. Pub. Sch. Illustrator: "Out of the Past of Greece and Rome," by M. Rostovtieff [40]

NORTH, Robert [P] Buffalo, NY. Exhibited: Buffalo SA, 1933, 1934; A. Western N.Y., 1934, 1935 (prize), 1936, 1938, 1939; Albright A. Gal. [40]

NORTHAM, Caroline A. [P] NYC b. 18 N 1872, Leavenworth, KS. Member: NAC [17]

NORTHCOTE, James [Ldscp.P] Brooklyn, NY b. 1822, Hammerston, England (came to NYC in 1858) d. 4 F 1904. Studied: NYC, with Philip Philips, Louis Haag, Stanfield. Exhibited: NAD, 1884–86. Work: scene painter, Drury Lane Theatre, Surrey Theatre for 8 yrs. He was in partnership with (his brother?) Henry.

NORTHCOTE, Stafford M(antle) [En] Brooklyn, NY b. 7 Jy 1869, Brooklyn. Studied: engraving, E. Heineman; drawing/painting, Brooklyn AI, with Boyle. Exhibited: Pan-Am. Expo, Buffalo, 1901; St. Louis Expo, 1904 (med). Specialty: wood engraving [33]

NORTON, Charles D. [Patron] NYC b. 1871, Oshkosh, WI d. 5 Mr 1923. Member/Trustee: MET, R. Sage Fnd., AFA, Am. Acad. in Rome

NORTON, Charles Eliot [W,Cr,T] Cambridge, MA b. 16 N 1827, Cambridge d. 21 O 1908. Studied: Harvard. Author: "The Portraits of Dante," "Historical Studies of Church Building in the Middle Ages," "Notes of Travel and Study in Italy." Traveled extensively in Europe and met John Ruskin, whose literary executor he later became. Position: T., Harvard, 1874–98

NORTON, Charles W. [Mar.P] Active around Great Lakes Region, 1870s–80s. Work: Great Lakes Hist. S.; Marine Hist. S., Detroit; Peabody Mus., Salem [*]

NORTON, Clara Mamre [P] Bristol, CT b. Burlington, CT. Studied: E. Tarbell; F.W. Benson; BMFA Sch. Member: Hartford Women P.; CAFA [40]

NORTON, Dora M. [P] Brooklyn, NY [01]

NORTON, Elizabeth [S,Gr,P] Palo Alto, CA b. 16 D 1887, Chicago, IL. Studied: AIC; ASL; NAD. Member: Calif. PM; Woodcut S.; AFA; Calif. SE. Exhibited: GGE, 1939; Calif. Min. Pr. S., 1941; Calif. State Lib., 1942 (one-man); Calif. PM, 1942; Calif. SE, 1942; NAD, 1942; Am. Color Pr. S., 1944; Wichita AA, 1946. Work: Detroit Athletic C.; Stanford Univ.; Calif. State Lib.; All Saints Church, Palo Alto; MET; AIC; LOC; Smithsonian; Hackley A. Gal.; FMA; Springfield, Mass., Pub. Lib.; NYPL; Children's Mus., Boston; Williams Col., Mass.; Ga. State Col.; Mass. State Col.; Yale [47]

NORTON, Ethel [E] San Fran., CA [24]

NORTON, Florence Edith [P] NYC b. 1 Jy 1879, Paris. Studied: W.E. Norton [10]

NORTON, Georgie Leighton (Miss) [T] d. 18 Ag 1923. Studied: Mass. Normal A. Sch. Position: Dir., Cleveland Sch. A., 1891–1918

NORTON, Gilbertine C. [P] Buffalo, NY [17]

NORTON, Grace Greenwood [I] NYC [01]

NORTON, Helen G(aylord) [Ldscp.P,Mar.P] Riverside, CA/Laguna Beach, CA b. 12 Ap 1882, Portsmouth, OH. Studied: Mills Col.; J. Manheim. Member: Laguna Beach AA; Calif. AC; Riverside AA. Exhibited: Riverside County Fair, 1914 (prize); Southern Calif. Fair, 1920 (prize); 1921 (prize), 1922 (prize), 1923 (prize) [40]

NORTON, James [P] Minneapolis, MN. Work: WPA mural, USPO, Morris, Minn. [40]

NORTON, John Warner [P] Chicago, IL b. 1876, Lockport d. 7 Ja 1934, Charleston, SC. Studied: AIC. Member: Chicago SA. Exhibited: AIC, 1926 (med); Arch. Lg., 1931 (gold); Century of Progress Expo, 1933. Work: Logan Archaeological Mus., Beloit, Wis.; Tavern C., Chicago; Bd. Trade Bldg., Chicago; Normal College, Chicago; Daily News Bldg., Chicago; murals, Court House, Birmingham, Ala.; murals, St. Paul City Hall and Court House, Minn.; AIC [33]

NORTON, Louis Doyle [P] Kennebunkport, ME b. 6 O 1867, Ashuelot, NH. Studied: RISD, with Juglars; Paris, with Benjamin-Constant, Lefebvre, Robert-Fleury, Chialva. Member: Providence AC [10]

NORTON, Ralph Hubbard (Mrs.) [Patron] West Palm Beach, FL b. 1881 d. 17 Mr 1947. Position: Co-owner, Norton Gal. & Sch. A., West Palm Beach

NORTON, S. Mary [P] d. 17 My 1922, Nutley, NJ. Studied: Paris. Exhibited: Paris Salon

NORTON, Walter Harold [P] Minneapolis, MN [17]

NORTON, William E(dward) [Mar.P] NYC b. 28 Je 1843, Boston, MA d. 25 F 1916. Studied: Lowell Inst., Boston; G. Inness; Paris, with de La Chevreuse, Vollon. Member: BAC; CAFA; SC, 1904; Blackheath AC, London. Exhibited: Boston (golds); Paris Salon, 1895; CAFA, 1905 (prize), 1914 (prize); Royal Acad., London; NAD; Columbian Expo, Chicago, 1893 [15]

NOSWORTHY, Florence England (Mrs. William A.) [I] Hampton, CT b. 1872, Milwaukee, WI d. 19 Mr 1936. Studied: Tarbell, at BMFA Sch.; K. Cox, at ASL. Member: Copley S.; Southern FA. Illustrator: "Great Musicians," "Miss Theodora," "Bunny Brown Books," "Tommy Tinker's Book," "Betty of Wye," "Land of Play"; covers; women's and children's mags. [33]

NOTMAN, Howard [P] Dongan Hills, NY/Keene Valley, NY b. 20 Ap 1881, Brooklyn. Studied: C. Herzberg; Brooklyn Polytech. Inst. Member: Brooklyn SA; AFA [40]

NOTTINGHAM, Mary Elizabeth (Mrs. Horace T. Day) [Ldscp.P,T] Staunton, VA b. 29 N 1907, Salisbury, CT d. 2 Ap 1956. Studied: Randolph Macon Woman's Col.; ASL, with H. Sloan, K.H. Miller, K. Nicolaides; McDowell Schol., ASL, 1932. Exhibited: CGA, 1934; Rockefeller Ctr., NYC, 1936; WMAA, 1938; G–R–D Gal., NYC, 1929–32; VMFA, 1934–37, 1939, 1940 (one-man), 1942, 1945; SSAL, 1935. Work: VMFA; Randolph-Macon Col.; Blackstone Col. for Girls; Winchester H.S. Positions: T., Mary Baldwin Col., Staunton, 1941–46; Super., Fed. A. Gal., Lynchburg [47]

NOTTINGHAM-MONNIER, Maud [P] Hartford, CT/Gloucester, MA b. 13 Jy 1876, Abbotts, NY. Studied: Griffin; Lavalley; Hibbard. Member: New Haven PCC; Hartford AS; Hartford AC; Hartford SWPS; Copley S.; North Shore AA; Gloucester SA; Springfield AL. Work: Dwight Sch., Hartford [31]

NOURSE, Elizabeth [P] Paris, France (with her sister Louise since 1887) b. 26 O 1859, Cincinnati d. 8 O 1938. Studied: Cincinnati Sch. Des. (McMicken Sch. A.), with W.H. Humphreys, T.S. Noble, B. Pitman (wood-carving), M. Eggers (china painting), L. Rebisso (sculpture), all 1874–81; ASL, with W. Sartain, 1882; again under T.S. Noble, 1885–86; Académie Julian, with Boulanger, Lefebvre, 1887; Henner; Carolus-Duran, 1887. Member: Ass., Soc. Nat. des Beaux-Arts, 1895, full member, 1901; Cincinnati Women's Pottery C., 1879; Lodge AL (Pres.), Paris, 1906–07; NAWPS, 1914; Am. Women's AA, Paris (Pres., 1899–00); MacD. S., Cincinnati, 1914; Phila. WCC, 1914. Exhibited: Cincinnati Indst. Exh., 1879, 1881–84, 1886; AWCS, 1884, 1886, 1911; Detroit A. Loan Exh., 1883; S. Nat. A. Français, 1888–89; S. Nat. Beaux-Arts, 1890–14, 1918–21; Royal Acad., London, 1889, 1892; Phila. AC, 1891; Royal S. British A., 1892; Walker AG, Liverpool, 1892; Munich Exh., 1892; Columbian Expo, Chicago, 1893 (med); Cincinnati AM (100 works in 1893, her only solo exh.; 9 other exh. after 1897); V.G. Fischer Gal., Wash., D.C. (her dealer, 1894–12); AIC, 1895–1914; PAFA (15 times from 1895); St. Louis Expo, 1895, 1904 (med); Copenhagen Inst. 1897; CI (7 times from 1897); Tenn. Centenn., Nashville, 1897 (gold); Inst. de Carthage, 1897 (med); Paris Expo, 1900 (med); Womans AC, NYC, 1902, 1904 (prize), 1911; Expo des Orientalistes, Paris, 1904, 1906; Union des Femmes PS, Paris, 1905, 1916; Amis des Arts, Nantes, 1905, 1908, 1911, 1912; Colonial Expo, Nugent, France 1905, (med); Lodge AL, Paris (5 times from 1906); CGA, 1907, 1910, 1911; S. Intl. WCP, Paris 1908, 1910; Intl. A. Union, 1909; Vienna Exh., 1910; S. Women A., Vienna, 1911; Rome Intl. Expo, 1911; Boston WCC, 1911; Herron AI, 1912; Anglo-Am. Expo, London, 1914; P.-P. Expo, San Fran., 1915 (gold); Luxembourg Mus., Paris 1919; Univ. Notre Dame, 1921 (med); Knoedler Gal., Paris, 1924; Cincinannati AM, 1983 (retrospective); NMAA, 1983 (retrospective). Work: Large coll., Cincinnati AM; NMAA; TMA; Detroit AI; Luxembourg Mus., Paris; AIC; Nat. Gal.; Adelaide MA, Australia; Newark Mus.; Univ. Minn.; Univ. Nebr.; Smith Col.; Univ. Wash., Seattle [38]

NOVAK, Louis [G,P,T] Cambridge, MA b. 13 O 1903, Zilina, Czechoslovakia. Studied: Mass. Sch. A.; BMFA Sch. Exhibited: LOC, 1943, 1946; NAD, 1943; Jordan Marsh Gal., 1946, Boston [47]

NOVANI, Cossado [S] NYC [21]

NOVANI, Guillo [S] NYC b. 11 Je 1889, Massa-Carrara, Italy. Studied: Acad. Massa-Carrara; BAID [29]

NOVELLI, James [S] NYC [25]

NOVELLI, R(udolfo) [P] Bronx, NY b. 28 D 1879, Italy. Studied: Peters. Position: Illus., Funk and Wagnalls Co., NYC [33]

NOVOTNY, Elmer Ladislaw [Por.P,T] Kent, OH b. 27 Jy 1909, Cleveland. Studied: Cleveland Sch. A.; Yale; Western Reserve Univ.; Kent Univ.; Slade Sch., London; Acad. Zagreb, Yugoslavia. Member: Cleveland SA;

Akron SA. Exhibited: CI, 1941; Milwaukee AI, 1945; Butler AI, 1940–45; Akron AI, 1946; CMA, 1929–45; 1930 (prize), 1937 (prize), 1938 (prize); Canton AI, 1944 (prize), 1945 (prize), 1946 (prize). Work: CMA; Cleveland Mun. Coll.; Coshocton Mus. Position: T., Cleveland Sch. A., Kent State Univ., 1938–44- [47]

NOWELL, Effie Alexander [P] Boston, MA b. Boston. Studied: Juglaris; H.R. Rice; L. Kronberg. Member: Copley S., 1892 [25]

NOWOTTNY, Vincent [P,T] Cincinnati, OH b. 1854, Cincinnati d. 30 Ag 1908, Alderson, WV (in a runaway accident). Studied: Loefftz, in Munich; Bouguereau, in Paris. Member: Cincinnati AC; SWA. Position: T., Cincinnati Acad. FA [08]

NOXON, Betty Lane See Lane.

NOXON, Grace P. [P,W,L,T] NYC b. Ossining, NY. Studied: Laurens; Ecole des Beaux-Arts; Chase, ASL; NY Sch. App. Des. Member: S.Indp.A. [27]

NOYES, Bertha [P] Wash., D.C. b. Wash., D.C. Member: Corcoran Sch.; C. Hawthorne; J. Farnsworth. Member: S. Wash. A.; Wash. WCC; NAWA; Newport AA; Providence AC; Wash. AC; South Co. AA; Arts Group, Wash. Exhibited: CGA (one-man); RISD (one-man); Newport AA (one-man); Wesleyan Univ., Delaware, Ohio (one-man); Currier Gal. (one-man); 33rd NAWA (one-man) [47]

NOYES, Ethel [P] Wash., D.C. [13]

NOYES, George L. [P] Pittsford, VT b. Canada. Studied: Paris, with Courtois, Rixen, Le Blanc, Delance. Member: BAC; Boston SWCP; Boston GA. Exhibited: Pan-P. Expo, San Fran., 1915 (med). Work: BMFA; Des Moines AM; Utah State Mus. [40]

NOYES, Helen Haskell (Mrs. Charles W.) [Bkbind] NYC b. Deer Isle, ME d. 12 Ag 1940. Studied: The Nordhoff Bindery, NYC; J. Domont, Paris. Member: Gd. Bookworkers. Work: books bound for American Soc. A. and Letters; Am. Sculp. S. [40]

NOYES, Henriette [P] NYCNYC b. 18 Mr 1890, Columbus, OH. Studied: ASL; Gontcharova, Paris. Exhibited: Minneapolis AI, 1933 (prize) [40]

NUDERSCHER, Frank [P,I] St. Louis, MO/Arcadia, MO b. 19 Jy 1880, St. Louis, MO d. 7 O 1959. Studied: England; Germany; France. Member: St. Louis AG; 2x4 S.; St. Louis AL; AAPL, Mo. (State Chairman); Mural P. Exhibited: St. Louis Salon, 1916 (prize), 1921 (prize); Chamber of Commerce, St. Louis, 1919 (prize), 1921 (prize), 1926 (prize). Work: Chamber of Commerce, St. Louis; Monday C., Webster Groves, Mo.; State Capitol, Mo; CAM; St. Louis Zoological Gardens; boardroom, M.C. Steinberg & Co., St. Louis; Second Nat. Bank, Indst. Bank and Trust, Children's War, Continental Life Ins. Bldg., Bd. of Ed., all in St. Louis; Governor's Mansion, Capitol, Jefferson City, Mo.; murals, Boatman's Nat. Bank, Northwestern Trust Co., both in St. Louis; Ohio Valley Nat. Bank, Henderson, Ky. Position: Supvr., WPA Project, St. Louis, 1936 [47]

NUGENT, A(rthur) W(illiam) [Cart,I,W] Newark, NJ b. 20 F 1891, Wallingford, CT d. 1975. Studied: Fawcett A. Sch., Newark; SI A. Sch., NYC. Member: SI. Author/Illustrator: children's puzzle and game books. Author/Cart./Pub.: "Circus of Fun Comics." Specialty: cartoon puzzles. Position: Cart., Assoc. Newspapers, from 1932 [47]

NUGENT, Meredith [I,W] Long Beach, CA b. 19 My 1860, London, England d. 29 Ag 1937. Studied: C. Beckwith, at ASL; T. Eakins, at PAFA; Académie Julian, with Boulanger, Lefebvre. Contributor: articles/illus., St. Nicholas, Harper's Young People, Ladies Home Journal, Woman's Home Companion, Pictorial Review, Century Publ.; educ. books and charts. Author/Illustrator: "New Games and Amusements." Illustrator: "Life of Darwin," "Life of Agassiz" [36]

NUHFER, Olive Harriette [P,Des,S,W,T] Pittsburgh, PA b. 16 Ag 1907, Pittsburgh. Studied: Univ. Okla.; CI; O. Jacobson; A. Kostellow; N. MacGilvary. Member: San Antonio AL; AAPL; Cordova C. Exhibited: Witte Mem. Mus.; Pittsburgh AA, 1936–40; CI. Work: WPA murals, USPO, Westerville, Ohio; altar mural, St. John's Episcopal Chapel, Norman, Okla.; Univ. Okla.; Pittsburgh Bd. Ed.; One Hundred Friends of Art, Pittsburgh; Juvenile Court, Pittsburgh; costumes for ballet "Persephone," CI, 1935 [47]

NUHN, Marjorie Ann [P] Cedar Falls, IA b. 31 O 1898, Cedar Falls. Studied: Chicago Acad. A.; AIC; G. Wood; A. Dornbush. Exhibited: Sioux City A. Ctr., 1945 (prize); Cedar Falls A. Gal., 1944 (prize), 1945 (prize); YMCA Exh., Waterloo, Iowa (prize); Taos A. Gal., N.Mex.; Mus., N.Mex., 1940 [47]

NUNAMAKER, K.R. [P] Center Bridge, PA/Glenside, PA [25]

NUNGESTER, Mildred Bernice [P] Decatur, AL b. 23 Ag 1912, Celina, OH. Studied: J.K. Fitzpatrick. Member: Ala. AL; SSAL. Exhibited: Montgomery, Ala. MFA, 1935 (prize); SSAL, 1938 (prize). Work: Leila Cantwell Seton Hall, Decatur; Montgomery MFA; Ala. Polytech. Inst., Auburn [40]

NUNN, Evylena [P,L] Los Angeles, CA b. 4 Jy 1888, Mayfield, KS. Studied: ASL; Berkshire Summer Sch. A.; A.A. Hills; Sch. A. and Des., Pomona Col.; Japan. Member: Calif. AC; Laguna AA; West Coast Arts. Position: A., Arrow-Bear Park Assn. [25]

NUNN, Frederic [P] Cape May Court House, NJ b. 18 Ag 1879, Phila., PA d. ca. 1960. Studied: PAFA, with Anshutz; Chase; C. Beaux; Grafly. Member: F., PAFA; AAPL; Phila. A. All.; Phila. WCC; Cape May County AL. Exhibited: PAFA, 1936 (prize); Cape May AL, 1944 (prize). Work: PMA; Los Angeles Mus. A.; Reading, Pa. Mus. A.; PAFA; City Hall, Cape May; Cape May Court House Lib.; Phila. WCC [47]

NUNO, Benito [P,T] NYC b. 21 Mr 1899, Madrid, Spain. Studied: Circulo Beaux A., Madrid; D. Rivera; Zuloaga, Spain. Member: Am. Co-op Group (pres.). Exhibited: Grand Central A. Gal.; Bonestell Gal., NYC. Work: mural, Church, St. Nicholas Ave., NYC; Apex Dec. Co., NYC; Venezian Gal., Italy [40]

NUPOK, Florence [P] St. Lawrence Island, AK. Exhibited: First Nat. Exh. Am. Indian Painters, Philbrook A. Ctr., 1946 (prize) [47]

NURA See Ulreich, Nura.

NURICK, Irving [I,E] NYC b. S 1896, NYC. Member: SI; AG. Illustrator: Cosmopolitan [47]

NUSBAUM, Esther Commons (Mrs.) [P] Richmond, IN b. 12 Ja 1907, Richmond, IN. Studied: Univ. Wis. Member: Ind. Artists C.; Hoosier Salon; Richmond Palette C. Exhibited: Hoosier Salon, annually, 1934 (prize); Ind. State Fair, 1934–35 (prizes); Richmond AA, annually. Work: Richmond, Ind. AA; Women's AL, Terre Haute, Ind. [47]

NUSE, Ellen Guthrie (Mrs. Roy C.) [P] Cincinnati, OH. Affiliated with Cincinnati A. Acad. [13]

NUSE, Oliver William [P,T] Phila., PA b. 20 Ja 1914, Oberlin, OH. Studied: PAFA, Cresson Sch., 1938; Univ. Pa. Exhibited: PAFA, 1939 (prize), 1943; Phila. Sketch C.; Friends Central Sch.; Woodmere A. Gal., 1945 (prize). Position: T., Penn Charter Sch., Phila., 1941–46 [47]

NUSE, Roy Cleveland [P,W,L,T] Rushland, PA b. 23 F 1885, Springfield, OH. Studied: Cincinnati Acad. A.; Oberlin Col.; PAFA; R. Duveneck. Exhibited: NAD; CGA; AIC; CM; TMA; A.; PAFA, annually; F., PAFA; Phila. Sketch C.; Phila. AC. Work: Jefferson Med. Col.; Hahnemann Med. Col., Phila; PAFA. Author: "Treatise on Pastel Painting," pub. F. Weber Co., Phila. Position: T., PAFA, 1925- [47]

NUTE, Jennie Evelyn [Min.P] Brookline, MA/Paris, France. Studied: Collin, in Paris. Member: Copley S., 1893 [04]

NUTTING, Myron Chester [Mur.P,Por.P,Dec,Dr,L,T] Hollywood, CA b. 18 O 1890, Panaca, NV. Studied: BMFA Sch.; ASL; Académie Julian; M. Denis; Lhote. Member: Wis. S. PS; Los Angeles AA; All. A. Los Angeles. Exhibited: PAFA; AIC; Los Angeles Mus. A.; San Diego FAS; SFMA; Societe des Artistes Française, Paris; Salon d'Automne; Salon des Tuileries, Paris. Work: murals, Mus. Natural Hist., Milwaukee; Wauwatosa H.S., Wis.; Beaver Dam H.S., Wis.; Chateau Baradieu, France [47]

NUTTING, Ruth F. [P] Wheaton, IL b. Randolph, VT. Studied: Jakobides, Munich [01]

NUTTING, Wallace [C,Ph,W,L] Framingham, MA b. 17 N 1861, Marlboro, MA. Member: Phila. ACG; MMA; Wadsworth Atheneum, Hartford. Author: "Old New England Pictures," "Furniture of the Pilgrim Century," "England Beautiful," "Virginia Beautiful," other books. Specialties: reproduction of early American furniture; wrought iron; cabinets; hand-colored photographs of New England [40]

NUYTTENS, J(osef) P(ierre) [P,E,I] NYC b. 7 Ag 1885, Antwerp, Holland. Studied: Antwerp RA; Ecole des Beaux-Arts, Paris; Ecole des Beaux-Arts, Brussels; AIC. Member: Cliff Dwellers, Chicago. Award: Chevalier of the Order of Leopold II. Work: AIC; White House, Wash., D.C.; Royal Palace, Brussels; State House, Springfield, Ill.; Vanderpoel AA Coll. [40]

NYE, Beatrice [P] Brooklyn, NY [13]

NYE, Edgar [P] Wash., D.C. b. 30 Ap 1879, Richmond, VA d. N 1943. Studied: Corcoran Sch.; J.N. Barlow, England. Member: S. Wash. A.;

Wash. WCC; Wash. Ldscp. C. Exhibited: S. Wash. A., 1926, 1927 (med), 1933 (med), 1937. Work: PMG; Plymouth Gal., England [40]

NYE, Elmer L(esley) [E,C] Santa Fe, NM b. 29 Je 1888, St. Paul, MN. Member: Minneapolis Attic C. Exhibited: Minn. SA (prize) [21]

NYE, Myra [P] Los Angeles, CA. Member: Calif. AC. Affiliated with Los Angeles Times [25]

NYE, Robert T. [P] Toledo, OH. Member: Artklan [25]

NYHOLM, Arvid Frederick [Por.P] Chicago, IL b. 12 Jy 1866, Stockholm, Sweden d. 14 N 1927. Studied: RA, Stockholm, with Zorn; Colarossi Acad. Member: Chicago Gal. Assn.; P.&S. Assn., Chicago; Chicago SA; Chicago WCC. Exhibited: Mun. AL, 1915 (prize), 1924 (prize); AIC, 1915 (prize); Chicago Gal. Assn., 1927 (prize). Work: NGA; West Point Acad.; Augustana Hospital, Chicago; Saddle and Sirloin C., Chicago [25]

NYHOLM, Greta [P] Chicago, IL. Member: Chicago NJSA [25]

NYME, Joseph Samuel [P,C,Des,S] Boston, MA b. 10 Ap 1908, Cleveland. Studied: Cleveland Sch. A.; H. Keller; F. Wilcox. Member: Un. Am. Ar.; Cleveland SFA; Cleveland Pr. C.; Cleveland AG. Exhibited: CM, 1940; CI; CMA, annually; Spokane, Wash., 1944 (prize); Butler AI, 1940 (prize); Contemp. A. Gal., NYC. WPA artist. [47]

NYQUIST, Earl B. [P,G,Dec] Wash., D.C. b. 18 Ja 1888, Sweden. Studied: Corcoran Sch.; AIC. Member: Ar. Un., Wash., D.C. Exhibited: The Bookshop, Wash., D.C.; Springfield (Mass.) MFA [40]

NYS, O(dilo) A(lbert) [P] NYC b. 5 Ja 1884, St. Nicholas, Belgium. Studied: E. Gruppe. Member: S.Indp.A. [25]

F. Luis Mora: *W. Elmer Schofield on the Way to Texas*. Private Collection

OAKES, Edward Everett [C] Wakefield, MA/North Woodstock, NH b. 5 Mr 1891, Boston. Studied: F.G. Hale; J.H. Shaw. Member: Boston SAC (Master Craftsman); Detroit SAC. Work: MMA; gold cross on cover, "Sermon on the Mount," Nat. Cathedral, Wash., D.C. Specialty: jewelry [40]

OAKES, Marcia. See Woodbury.

OAKES, W(ilbur) L. [P] Cleveland, OH b. 1 D 1876, Cleveland d. 11 O 1934. Studied: F.C. Gottwald; A.T. Hibbard, Rockport, Mass.; Cleveland Sch. A. Member: Cleveland SA [33]

OAKEY, Maria. See Dewing.

OAKLEY, Arthur [P] NYC b. NYC. Studied: Paris, with Bonnât, Bouguereau [08]

OAKLEY, George C. [P] Rochester, NY [13]

OAKLEY, Thornton [P,I,W,L,T,Arch] Villa Nova, PA b. 27 Mr 1881, Pittsburgh d. 1953. Studied: Univ. Pa; H. Pyle. Member: Pa. SMP; Wilmington SFA; Century Assn.; Phila. WCC (Pres.); F. PAFA (Dir.); Phila. Alliance; Phila. Pr. C.; Contemporary C., Phila.; Comm. of Artists (Chm.); Advisory Council A. Assns. Phila.; Sesqui-Centenn. Expo, 1926; Palmes d'Officier d'Academie, 1931. Exhibited: Univ. Pa., 1902 (med); P.-P. Expo, 1915 (med); Phila. WCC, 1914 (prize), 1935 (prize); Cape May, N.J., 1942 (prize); Sesqui-Centenn. Expo, 1926. Work: PMA; PAFA; Pa. Hist. Soc., Phila.; BM; NGA; LOC; Boston Pub. Lib.; NYPL; Phila. Free Lib.; Newark Lib.; Calif. State Lib.; Milwaukee AI; St. Louis Pub. Lib.; Seattle Pub. Lib.; British Mus., London; Musée de Lourdes, France; Musée de la Guerre, Paris; Luxembourg Mus., Paris; Nat. Lib., Brazil; murals, Franklin Inst., Phila.; made 48 paintings of "American Industries Geared for War," and others for Nat. Geographic Soc., 1942, 1943, 1945. Illustrator: books by Amy Oakley: "Hill Towns of the Pyrenees," 1923, "Cloud-lands of France," 1927, "Enchanted Brittany," 1930, "The Heart of Provence," 1936, "Scandinavia Beckons," 1938; by other authors: "Westward Ho!" 1920, "Autobiography of Benjamin Franklin," 1927, "Folk Tales of Brittany," 1929, "Six Historic Homesteads," 1935, "My Wondrous Land," 1937. Contributor: Harper's, Scribner's, Century, since 1904. Designer/Founder (1935): Oakley medal for Achievement in Creative Art at Shady Side Acad., Pittsburgh; Sch. IA, Phila.; Sch. FA, Univ. Pa. Positions: T., Univ. Pa. (1914–15),; PMSchIA (1914–1919; 1921–36) [47]

OAKLEY, Violet [Mur.P,S,I,W,C] Phila., PA b. 1874, Jersey City, NJ d. 26 F 1960. Studied: ASL; H. Pyle, at Drexel Inst.; PAFA, with J. De Camp, C. Beaux; Paris, with Aman-Jean, Collin, Lasar. Member: NA, 1929; Phila A. All.; AIA; Phila. WCC; NYWCC; Circulo de Bellas Artes, Madrid, Spain; Mural P.; AFA. Exhibited: NAD; Arch. Lg.; PAFA; CGA; Phila. A. All.; Woodmere A. Gal.; Yale; widely in Europe; St. Louis Expo, 1904 (med); PAFA, 1905 (gold); P.-P. Expo, San Fran., 1915 (med); Arch. Lg., 1916 (med). Work: All Angels Church, NYC; murals, Cuyahoga County Court House, Cleveland; USO Officers C., Phila.; PAFA; Victoria and Albert Mus., London; Vassar Col.; Fleischer Mem., Phila.; Lg. of Nations Lib.; Senate Chamber, Harrisburg, Pa.; 13 panels, Graphic Sketch C., Phila.; Hannah Penn House, Phila. Author/Illustrator: "The Holy Experiment," 1922, "Law Triumphant," 1932, other books [47]

OAKMAN, Arthur W. [P] Boston, MA b. 8 My 1910, Neponset, MA. Studied: BMFA Sch.; Mass. Sch. A. Work: PMG; WPA mural, Old Harbor Village Housing Proj. [40]

OBATA, Chiura [P] Berkeley, CA. Exhibited: PAFA, 1934–36; SFAA, 1939 [40]

OBERG, Folka [P] Minneapolis, MN [24]

OBERHARDT, William [Por.P,S,I,L] North Pelham, NY b. 22 S 1882, Guttenberg, NJ d. 22 Jy 1958. Studied: NAD, 1897–00; Munich, with Von Marr, Herterich, 1900–03; E. Ward; G. Maynard. Member: ANA; SI; A. Dir. C.; New Rochelle AA. Exhibited: NAD; WFNY, 1939; A. Dir. C., annually; SI. Work: NYPL; LOC; many portraits of prominent persons, including Pres. Harding, Thomas A. Edison, C.D. Gibson, Joseph Pennell [47]

OBERLAENDER, Gustave [Patron] b. 1867 d. 30 N 1936, Reading, PA. In 1931 he established the Oberlaender trust fund, with $1,000,000, to enable American men and women to make special studies in German-speaking countries with the aim of promoting good will between Germany and America.

OBERTAUFFER, Helen [P] NYC [21]

OBERTEUFFER, George [P] Gloucester, MA b. 1878, Phila., PA d. 1940. Studied: Chase; Anshutz. Member: ANA, 1937; NA, 1938; NAC; Salon d'Automne; Salon des Indépendants; Chicago Gal. A.; Chicago PS. Exhibited: Wis. PS, 1922 (gold); PAFA, 1922 (med); Chicago Gal. A., 1927 (prize); NAD, 1932 (prize). Work: BM; Nat. Gal., New South Wales; French Gov.; PMG; Grand Rapids Mus.; Milwaukee AI; Columbus (Ohio) AM. Position: T., PAFA, AIC, 1924–25 [40]

OBERTEUFFER, Henriette Amiard [P] Gloucester, MA b. 1878, Havre, France d. 1962. Studied: Laurens; Constant. Member: Salon d'Automne; Salon des Indépendants; Chicago Gal. A. Exhibited: Milwaukee AI (med); AIC, 1926 (prize), 1927 (med). Work: French Gov.; PMG; Minneapolis Inst. A.; WPA mural, USPO, Court House, Vicksburg, Miss. [40]

OBERTEUFFER, Karl (Amiard) [P,E,T] Gloucester, MA b. 9 Ag 1908, Croisic, France. Studied: AIC. Exhibited: AIC, 1927, 1928 (prize). Work: U.S. Navy Dept., Wash., D.C.; WPA mural, USPO, McKenzie, Tenn. Position: T., Vesper George Sch. A., Boston [40]

O'BRIEN, Catherine C. (Mrs.) [P] NYC/Southampton, NY b. NYC. Studied: Granbury; W. Shirlaw; A.W. Dow. Member: S.Indp.A. [33]

O'BRIEN, Daniel J. [P] Belvidere, IL b. Belvidere. Studied: J.W. Reynolds. Member: De Paul AL; Ill. Acad. FA [33]

O'BRIEN, John [S] Galveston, TX (since 1882) b. 1834, Ireland (came to NYC ca. 1859) d. 20 D 1904. Studied: Castini, in Rome, ca. 1853–59. Work: selected (1860) to execute a monumental statue of Commodore Perry in Cleveland

O'BRIEN, Michael Edward [P] Denver, CO b. 1854 d. 12 My 1936. Studied: self-taught. Exhibited: Denver AG, 1936. A bricklayer, he painted as a hobby.

O'BRIEN, Nell Pomeroy (Mrs. John A.) [Por.P,S,T] New Orleans, LA b. New Orleans. Studied: Tulane Univ.; ASL; New Orleans A. & Crafts Sch.; Fontainebleau Sch. FA; W. Adams. Member: SSAL; NOAA; New Orleans A. & Crafts S.; Le Petit Salon, New Orleans. Exhibited: SSAL; Delgado Mus. A., 1934 (prize), 1936 (prize), 1938, 1940 (prize), 1944–46 (prizes); Gresham Gal., New Orleans, 1938 (one-man); Old State Capital Mus., 1940 (one-man); Beaumont, Tex., 1941 (one-man); Galveston, Tex., 1941 (one-man); Lake Charles, La., 1941 (one-man). Work: Browning Lib., Waco, Tex.; La. State Mus.; New Orleans Assn. Commerce;

Women's C., Beaumont; Capitol, Baton Rouge, La.; Baylor Univ., Waco; Loyola Univ.; Civil Court Bldg., New Orleans. Position: T., Delgado Mus., New Orleans, 1942, 1944–45 [47]

O'BRIEN, Smith [P,E,Arch] San Fran., CA b. Cork, Ireland. Studied: Calif. Sch. FA; Lhote Acad., Paris. Member: Calif. SE; San Fran. AA; San Fran. Beaux-Art C. Exhibited: San Diego, 1927; Calif. SE, 1930 (prize) [33]

OBRIG, Clara [P,Patron] d. 22 O 1930, NYC. Work: MET; BM. Bequeathed $15,000 to NAD.

O'CALLAHAN, C(linton) C(lement) [P] Paris, France b. 19 F 1890, Hartford. Studied: C.N. Flagg; C. Guerin. Member: Paris AAA [29]

O'CALLAHAN, Kevin B. [Des,C,E,B,T] Buffalo, NY b. 14 F 1902, Buffalo, NY. Studied: Cornell; CI. Member: Buffalo Pr. C.; The Patteran. Exhibited: NAD, 1936–38, 1941, 1942, 1944, 1946; PAFA, 1936, 1938, 1940, 1941, 1943; Phila. Pr. C., 1937, 1938, 1940–44; SAE, 1937, 1940, 1942; Northwest PM., 1942–44; Denver AM, 1941, 1942; SFMA, 1941–43; LOC, 1943, 1944; Laguna Beach, Calif., 1943–45; Albright A. Gal., 1934, 1935, 1937–41, 1943–46. Work: LOC; Albright A. Gal.; Farnsworth Mus., Rockland, Maine. Position: T., Buffalo AI [47]

OCHTMAN, Dorothy (Mrs. W.A. Del Mar) [P] Greenwich, CT b. 8 My 1892, Riverside, CT d. 1971. Studied: NAD; Europe; L. Ochtman. Member: All.A.Am.; NAWA; Greenwich SA. Member: F., Guggenheim, 1927. ANA, 1929; PS Gallery Assn. Exhibited: NAD, 1921 (prize), 1924 (prize); Greenwich SA, 1928, 1929, 1930; Women's Arts and Indst., 1926, 1927 (prize); Fontainebleau Alumni Assn. Exh., NYC, 1937 (prize) [47]

OCHTMAN, Leonard [Ldscp.P,T] Cos Cob, CT (since 1891) b. 21 O 1854, Zonnemaire, Holland (settled at Albany, N.Y., 1866) d. 27 O 1934. Studied: briefly at ASL, 1879; mostly self-taught. Member: SAA, 1891; ANA, 1898; NA, 1904; AWCS; NYWCC; Brooklyn AC; A. Fund. S.; A. Aid. S.; SC, 1901; Lotos C.; NAC; NIAL; Greenwich SA (founder, 1912); AFA. Exhibited: Brooklyn AC, 1891 (prize); Columbian Expo, Chicago, 1893 (med); AC Phila., 1894 (gold); Pan-Am. Expo, Buffalo, 1901 (med); Charleston Expo, 1902 (med); SC, 1902 (prize), 1903 (prize), 1906 (prize), 1907 (prize); SAA, 1902 (prize); 1904 (prize); NAD, 1903 (gold); St. Louis Expo, 1904 (gold); S. Wash. A., 1905 (prize); Richmond (Ind.) AC, 1905 (prize); Knoxville Expo, 1911 (med); P.-P. Expo, San Fran., 1915; Greenwich SA Exh., 1929. Work: MET; CGA; CAM; Columbus (Ohio) Gal. A.; NGA; Brooklyn Inst. Mus.; Ft. Worth Mus. A.; Dallas AA; Hackley A. Gal., Muskegon, Mich.; Bruce Mus., Greenwich, Conn.; Butler AI, Youngstown; Albany Inst. Position: T., N.Y. Summer Sch., 1911 [33]

OCHTMAN, Mina Fonda (Mrs. Leonard) [P] Cos Cob, CT b. 28 Mr 1862, Laconia, NH d. Ap 1924. Studied: ASL; L. Ochtman. Member: AWCS; NAWPS; Chicago WCC; Greenwich SA [24]

O'CONNELL, George A. (Mrs.) (Francys Galvin) [P] Norfolk, VA/Virginia Beach b. 14 My 1913, Atlanta. Member: VMFA. Exhibited: Cavalier Hotel, Virginia Beach (one-man). Work: murals, U.S.S. Decatur [40]

O'CONNOR, Andrew, Sr. [S] b. 18 Ap 1846, Lanarkshire, Scotland (came to U.S. in 1851) d. 21 Jy 1924, Holden, MA. Studied: Rome; C.H. Hemenway. Work: fountain, Worcester, Mass.; mon., Spencer, Mass.; mem., Holyoke, Mass.; Antietam, Md.

O'CONNOR, Andrew, Jr. [S] Paxton, MA b. 7 Je 1874, Worcester, MA. Studied: his father; D.C. French, NYC. Member: ANA, 1919; NIAL. Exhibited: Pan-Am. Expo, Buffalo, 1901 (med); Paris Salon, 1906 (gold); Barcelona, Spain, 1907 (med). Work: Indianapolis AA; French Gov.; CGA; State House, Springfield, Ill.; Santa Fortunata, Springfield AA; St. Bartholomew's Church, NYC; Arlington; Tarrytown; St. Louis; Indianapolis; Washington; Worcester; Glen View, Ill.; Baltimore; The Hague; Boston; statues, Luxembourg; Musée des Arts Decoratif, Paris [29]

O'CONNOR, Henry M. [P,Et] NYC b. 5 Mr 1892, Brookline, MA. Studied: Mass. Normal A. Sch.; BMFA Sch.; Académie Julian; J. De Camp; F. Benson; A.H. Thayer. Member: SAE; SC; A. Fellowship. Exhibited: NAD, 1927; Chicago SE; Sesqui-Centenn. Expo, Phila., 1926 (med). Work: Capitol, Mass.; Jersey City Medical Center; Harvard; Newark Mus. [47]

O'CONNOR, John A. [S] NYC [04]

O'CONNOR, Katie C. [P] Indianapolis, IN [25]

O'CONNOR, Robert Barnard [Arch,Des] Mt. Kisco, NY b. Manhasset, NY. Studied: Princeton. Member: Arch. Lg.; BAID; AIA; Princeton Arch. Assn.; Am. Assn. Mus. Exhibited: Arch. Lg., 1934 (med). Work: Union Lg. C., NYC; First National Bank and Trust Co., Stamford, Conn.; Westchester County Office Bldg., White Plains; Westchester County Home, East View, N.Y.; Avery Mem. Mus., Hartford, Conn.; Berkshire Mus., Pittsfield, Mass.; interior architecture, first-class spaces, Cunard-White Star Liner, Queen Mary [40]

ODENHEIMER-FOWLER, Mary D. (Mrs. Frank) [Por.P] b. Phila., PA d. 4 Jy 1898. Studied: C. Duran; J.J. Henner. Exhibited: Phila. Expo; Chicago Expo; Tenn. Centenn. Expo, 1897. Contributor: articles, leading art magazines

ODOM, Minnie Rae [P] Parrish, AL b. Alabama. Studied: C.L. Hill. Member: Birmingham AC; Ala. AL; SSAL [33]

O'DONNELL, Agnes M. [P] NYC [25]

O'DONNELL, Charles [S] Lackawanna, NY/East Aurora, NY. Member: The Patteran. Exhibited: Albright A. Gal., 1936 (prize) [40]

O'DONOVAN, W(illiam) R(udolf) [P,S] NYC b. 28 Mr 1844, Preston County, VA d. 20 Ap 1920. Studied: self-taught. Member: NSS; Arch. Lg.; ANA, 1878. Member: NAD; Caracas, Venezuela; Newburgh, N.Y.; Trenton, N.J.; arch, Prospect Park, Brooklyn; Tarrytown, N.Y.; Charleston, S.C. [19]

OEHLER, Bernice Olivia [I,T,W,P] NYC b. Lake Mills, NY. Studied: Milwaukee-Downer Col.; AIC. Work: murals, Children's Mus., Brooklyn. Author/Illustrator: "The Boat with a Red Sail," "Figure Sketching," "A Series of Decorative Figures from the Dance," "How to Draw Children." Illustrator: series of Lincoln Sch. Readers; "Chico, the Circus Cherub," Stella May, "Fun in Bed for Children," "Now We are Growing Up." Position: A., for Ruth St. Denis [47]

OEHLER, Helen Gapen (Mrs. Arnold J.) [Ldscp.P,L,T] Westwood NJ b. 30 My 1893, Ottawa, IL. Studied: AIC; G.E. Browne. Member: All.A.Am.; AWCS; AAPL; NAWA; Audubon A.; Lg. Am. Pen Women; N.J. WCS; N.J. P.&S. S.; Ridgewood AA; NYC S.Indp.A.; Provincetown A. Exhibited: NAD, 1941, 1943; Salon d'Automne, 1938; Salon des Artistes Française, 1939; AFA Traveling Exh.; WFNY, 1939; Pepsi-Cola, 1945; Dayton AI; Newark Mus.; N.J. State Mus.; Montclair AM; Ridgewood AA, 1935, 1939 (prize) [47]

OENSLAGER, Donald (Mitchell) [Des,W,T,L] NYC b. 7 Mr 1902, Harrisburg, PA. Studied: Harvard. Member: AIA; Century Assn. Exhibited: Nat. Lib., Vienna; MOMA; Mus. City N.Y.; Marie Sterner Gal.; Am.-British A. Ctr.; BM; Pratt Inst.; FMA; PMSchIA. Designer: stage settings, Phila. Orchestra, Metropolitan Opera, Broadway productions, from 1925. Author: "Scenery, Then and Now," 1938, "Theatre of Bali," 1941. Positions: T., Yale; Advisory Bd., MOMA [47]

OERTEL, Johannes Adam Simon [Por.P,En,S,T,Dec] Vienna, VA b. 3 N 1823, Fürth, Bavaria (came to Newark in 1848). Studied: J.M. Enzing-Müller, in Munich. Work: ceiling dec., House of Representatives, 1857–58; Univ. of the South, Tenn.; Nat. Cathedral; many churches. Episcopalian priest (1871–95) in N.C., S.C., Wash., D.C., Tenn., Mo., Md. After retirement, painted religious subjects and series on the Redemption. His "Rock of Ages" was widely sold as a chromolithograph. [06]

OESTERMANN, Mildred (Caroline) [P,B] San Fran., CA b. 23 Ag 1899, San Fran. Studied: G.P. Albright; L.F. Randolph; C.L. Macky; E.S. Macky; R. Schaeffer. Member: Calif. SE [40]

OF, George F(erdinand) [P] NYC b. 16 O 1876, NYC. Studied: ASL; Weinhold, in Munich; Delecluse Acad., Paris [29]

OFFIN, Charles Z. [Cr,E,Li,L,T,W] NYC b. 5 F 1899, NYC. Studied: CCNY; Ecole des Beaux-Arts, Fontainebleau, France. Exhibited: Paris (one-man); Barcelona (one-man); NYC (one-man). Work: etchings, MMA; NYPL. Positions: T., CCNY, Brooklyn T. Assn.; Ed./Pub., Pictures on Exhibit magazine, 1937– [47]

OFFNER, Richard [Ed,W] NYC b. 30 Je 1889, Vienna, Austria. Studied: Harvard; Am. Acad., Rome; Univ. Vienna. Member: Sachs F., Harvard. Author: "Studies in Florentine Painting," 1927; "Works of Bernardo Daddi," 1930; "A Corpus of Florentine Painting," Sec. III, Vols. I–IV, 1930–34, Vol. V, 1946; other books. Position: T., NYU, 1923– [47]

OFFUTT, Lucy Lee [P] Friendship Heights, MD. Member: Wash. WCC [21]

OGDEN, Edith Hope [S] Boston, MA b. St. Paul, MN. Studied: ASL, with A. Saint-Gaudens. Work: prize design for bronze tablet for steamship "St. Paul" [10]

OGDEN, Ernest N. [P] Chatham, NY b. 1856 d. 24 N 1946

OGDEN, Helen Eastman. See Campbell, Mrs.

OGDEN, Henry Alexander [I] Englewood, NJ b. 17 Jy 1856, Phila., PA d. 15 Je 1936. Studied: Brooklyn Inst.; Brooklyn Acad. Des.; NAD; ASL. Member: SI, 1911. Author/Illustrator: "The Boy's Book of Famous Regiments," 1914, "Our Army," 1906, "Our Flag," 1917. Illustrator: for Leslie's great Western trip, 1877. He was regarded as the greatest living authority on colonial costumes, and was commissioned by the U.S. Gov. to make 71 color plates of Army uniforms representing every military period since the revolution. [33]

OGDEN, Lyman Garfield [P,I,C,Ldscp.Arch] Walton, NY b. 23 Mr 1882, Walton. Studied: T. Anshutz; Henri; H. Breckenridge [25]

OGILVIE, Clinton [Mar.P,Ldscp.P] NYC b. 1838, NYC d. 29 N 1900. Studied: J. Hart. Member: ANA, 1864. Member: Boston Athenaeum; PAFA, after 1860; NAD, 1861–1900; Brooklyn AA, 1863–86. Also painted landscapes, France and Switzerland. Work: Mystic Seaport Mus. [00]

OGLESBY, Margaret [P] NYC b. 1849 d. 12 N 1914

OGRIES, Valentine F. [P] NYC. Member: Pittsburgh AA [17]

O'HANLON, Richard Emmett [S,C,P,G,L] Mill Valley, CA b. 7 O 1906, Long Beach, CA. Studied: R. Stackpole; D. Rivera; Calif. Col. A. & Crafts; Calif. Sch. FA. Member: San Fran. AA; Marin SA. Exhibited: San Fran. AA, 1932, 1933, 1936, 1940 (prize), 1945; Calif. Sch. FA, 1933 (prize); Marin SA, 1946 (prize). Work: S. Univ., Calif.; SFMA; Tamalpais H.S. Calif.; USPO, Salinas, Calif.; Plaza, Mill Valley. Position: T., Calif. Col. A. & Crafts, Oakland, Calif. [47]

O'HARA, Bernard [P] NYC. Exhibited: Ar. Gal., NYC, 1940 [40]

O'HARA, Dorothea Warren (Mrs.) [Des,C,W,S] Darien, CT b. Malta Bend, MO. Studied: Royal Col. A., London, England.; Columbia; L. Day; C.F. Binns; Debschitz Sch. Des.; Kunstgewerbe, Munich; NY Sch. Clay Working; Alfred, N.Y. Member: NAC; PBC; Keramic Soc. & Des. Gld., N.Y.. Exhibited: Paris Salon; MET; Harlow Gal.; Grand Central A. Gal.; NAD; PBC; London; Stockholm; Tokyo; Pan-P. Exh, San Fran., 1915 (med); Syracuse, 1936. Work: MET; Cranbrook Acad. A.; Syracuse MFA; Litchfield Mus., Conn. Contributor: Ladies' Home Journal. Specialty: pottery [47]

O'HARA, Eliot [P,E,W,L,T] Wash., D.C./Goose Rocks Beach, ME b. 14 Je 1890, Waltham, MA d. 1969. Studied: Norwich Univ.; Europe; R.T. Hyde; C. Hopkinson. Member: ANA; AWCS; Phila. WCC; Baltimore WCC; Goose Rocks Beach WCC; Ogunquit WCC; Wash. WCC; Wash. AG; Palm Beach AL; S. Four A.; Palm Beach; Wash. Ldscp. Cl.; CI; AFA; Springfield AL; NYWCC; Ogunquit AA; North Shore AA; F., Guggenheim, 1928. Exhibited: Phila. WCC, 1938 (prize); PAFA; AWCS, 1931 (prize); Wash. WCC; AIC; AFA; BM; Springfield AL; Tucson WCC; WMAA; MMA; NAD; LOC; Gloucester SA; Butler AI; Dayton AI; Ind. A.; Wash. AG; Critic's Exh., Cincinnati; Palm Beach AL; New Haven PCC, 1931; Ogunquit A. (prize); Wash. Ldscp. C., 1945 (prize); S. Four A., 1945 (prize); Wash. AG (med). Work: Hispanic Mus., N.Y.; BM; Telfair Acad. A.; Carolina AA; San Diego FAS; Phila. WCC; John Herron AI; Mont. State Col.; Ind. Univ.; Joslyn Mem.; CAM; TMA; Norton Gal.; BAM; Brooks Mem. A. Gal.; Frances Shimer Col.; Farnsworth Mus.; Howard Univ.; LOC; Brick Store Mus.; Mappin A. Gal., Sheffield, England. Author: "Making Watercolor Behave," 1932, "Watercolor Fares Forth," 1938; other books. Contributor: American Artist. Position: Dir., The Watercolor Gal., Goose Rocks Beach, 1932–46 [47]

O'HARA, (James) Frederick [P,T,Li,B,W] Albuquerque, NM (living La Jolla, CA, 1976) b. 16 Ag 1904, Ottawa, Canada. Studied: Mass. Sch. A., 1922–26; BMFA Sch., 1926–29; Inst. Bellas Artes, Toledo, Spain, 1929–31. Exhibited: Tucson, Ariz., 1940 (prize); N.Mex. Fair, 1942–45 (prizes); PAFA, 1940, 1941; Denver AM, 1945; Chaffey Community A. Center, Ontario, Calif., 1944; Pepsi-Cola, 1946; Santa Barbara Mus. A., 1937, 1938. Work: prints, MMA; Mus. N.Mex.; Cincinnati MA; NGA; Norfolk Mus. A. & Sc.; Springfield Mus. A.; State Coll., Rabat, Morocco. Position: T. Univ. N.Mex., 1944–46 [47]

O'HARE, Berta Margoulies. See Margoulies.

OHAUS, Henry [P] Kansas City, MO [24]

O'HIGGINS, Paul Esteban [Mur.P,P,L] Mexico City, D.F. b. 1 Mr 1904, San Fran. Studied: USSR, 1931–32. Member: Lg. Revolutionary Ar. of Mex. Exhibited: ACA Gal., 1937. Work: Plaza, Mills Col. Mus., Calif.; murals/fresco, School of Zapata, Mex.; frescos, Abelardo R. Market; stairway, Galleries Graficos, Mexico City; murals, Sch., Michoacan, Mexico; lithographs, MMA [40]

OJA, Alexander [P,L,T,Dr] St. Paul, MN b. 26 F 1903, Buhl, MN. Studied: St. Paul Sch. A. Member: Minn. AA. Exhibited: WMAA, 1942; Minn. State Fair, 1932 (prize), 1941 (prize); Minneapolis AI, 1930, 1932 (prizes). Work: PMA. Positions: Des. of exhibits, St. Paul Science Mus., 1942– ; T., St. Paul Gal. & Sch. A., 1938 – [47]

O'KANE, Regina [Ldscp.P,T] Los Angeles, CA b. Newport, KY. Studied: A.W. Dow; ASL. Specialty: flowers [19]

OKANOFF, David [P] Chicago, IL [17]

O'KEEFFE, Ida Ten Eyck [P,T,E] NYC b. O 1899, Sun Prairie, WI. Studied: C. Martin; Columbia; L. Warner; Fogg AM, with R. Paine, Field; A. Vincent, Univ. Oreg. Member: NAWPS; SSAL; Southern PM S. Exhibited: SSAL, 1936; NAWPS, 1937 (prize). Author/Illustrator: "Forest Indians," 1934. Sister of Georgia. Position: T., Cortland State Normal Sch. [40]

O'KEEFFE, Georgia [P] NYC/Lake George, NY (living in Abiquiu, NM since 1946) b. 15 N 1887, Sun Prairie, WI. Studied: AIC, with Vanderpoel, 1904–05; ASL, with Wm. M. Chase; K. Cox; F. Mora, 1907–08; A.W. Dow, 1914–16 (her most important teacher) at Columbia. Exhibited: Stieglitz' "291" Gal., NYC 1916; his "American Place through the 1940s; numerous nat. exh., including retrospectives at AIC, 1943, 1966; MOMA, 1946. Position: T., Amarillo Texas, Pub. Sch., 1912–14; Univ. Va., 1913–16; West Texas St. Normal Col., 1916–18. Work: BMA; PMA; John Herron AI; Newark Mus.; MET; MOMA; WMAA; AIC; PMG; Detroit Inst. A.; Springfield, Mass. Mus. A.; CMA. Important modernist best known for her austere paintings of S.W. landscapes, found desert objects and flowers. Married A. Stieglitz, 1914. [47]

O'KEEFFE, Neil [I] New Rochelle, NY b. 19 Ap 1893, Creston, IA. Studied: Wash. Univ.; ASL; R. Henri; G. Bellows; G. Bridgman. Member: SI; New Rochelle AA; AAPL. Exhibited: SI, 1922–27; New Rochelle AA, 1925–27; A. Dir. C., Detroit, 1925 (med). Illustrator: "In the Court of King Arthur," Sam. E. Lowe, "American Fairy Tales," G. Brown, Colliers, American, New York Daily News. Position: A. Dir., American Weekly, NYC, 1945 [47]

O'KELLY, Aloysius [P] Brooklyn, NY b. 1853, Dublin, Ireland. Studied: Ecole des Beaux-Arts with Bonnât, Gérôme. Member: NYWCC [25]

O'KELLY, Stephen J. [S] b. 1851, Dublin, Ireland d. 21 O 1899

OKERBLOOM, Charles I., Jr. [P] Iowa City, IA. Exhibited: Kansas City AI, 1938, 1939 [40]

OLBRES, Zeigmund Anthony (Zigmont Olbrys) [P,S,Des] Clinton, MA b. 1 Ap 1915, Clinton, MA. Studied: Worcester A. Sch.; BMFA Sch. Work: murals, Casablanca, French Morocco; Caserta, Italy. Exhibited: WFNY, 1930; Army A. Exh., Algeria, North Africa [47]

OLCOTT, Harriet Mead [I] NYC b. Albany, NY. Studied: K.H. Miller [19]

OLCOTT, Lillia Morwick [P,W,C,T,L] Cortland, NY b. 18 Je 1879, Syracuse, NY. Studied: Syracuse Univ.; NYU; A. Robineau. Member: Lg. Am. Pen Women; AEA; Cortland AC. Exhibited: Cortland Pub. Lib.; Finger Lakes Exh.; Cortland County Exh. (one-man). Author: several art syllabi, N.Y. State Edu. Dept. Position: T., T. Col., Cortland, N.Y. [47]

OLD, Bert(rand) (E.) [P,T] Stillwater, MN b. 10 Jy 1904, St. Paul, MN. Studied: Minneapolis Inst. A.; St. Paul Sch. A.; C. Booth. Member: Minn. A. Council; United Am. Ar. Exhibited: AIC, 1942; Minn. State Fair, 1944; Minneapolis Inst. A., 1945; Walker A. Center, 1946 (one-man). Work: Lindbergh House, Little Falls, Minn.; Univ. Minn. WPA artist. Position: T., Walker A. Center [47]

OLDACH, Dorothy Maler [P,L,T,W] Lindon, NJ b. 8 N 1906, Phila. Studied: Univ. Pa.; Moore Inst., Phila.; NYU; Y. Abbott; S. Woodward; G.W. Dawson; Clements. Member: AAPL; Eastern AA; N.J. A. Edu. Assn.; Nat. Edu. Assn ; Salons of America. Exhibited: Assoc. Am. A., N.Y.; Linden, Nat. A. Week Exh. Author: "Monographs on Contemporary Artists." Position: T., Linden H.S. [47]

OLDFIELD, Harold [P] Des Moines, IA. WPA artist. [40]

OLDFIELD, Otis William [P,C,Des,Li,T] San Fran., CA b. 3 Jy 1890, Sacramento, CA. Studied: Best A. Sch., San Fran.; Académie Julian. Member: San Fran. AA. Exhibited: San Fran. AA, 1925 (med) 1935 (prize), 1939 (prize); Springville, Utah (prize); Fnd. Western A., 1934 (prize); Calif. State Fair, 1933 (prize); Salon des Indépendants, Salon d'Automne, Paris, 1912–24; one-man: San Fran., Los Angeles, Sacramento; Okla.; Tex. Position: T., Calif. Sch. FA, 1925–42 [47]

OLDS, Elizabeth [P,Li,Ser I,W,L] NYC b. 10 D 1897, Minneaplis, MN. Studied: Univ. Minn.; Minneapolis Sch. A.; ASL; G. Luks. Member: An Am. Group; A. Lg. Am.; Am. A. Cong; F., Guggenheim, 1926–27. Exhibited: Phila. Pr. C. 1937 (prize); Phila. A. All., 1938 (prize); PM

competition, "Artist as Reporter," 1940; Kansas City AI, 1933 (med). Work: Minneapolis AI; MET; MOMA; BM; PMA; NYPL; BMA; SAM; SFMA. Author/Illustrator: "The Big Fire," 1945, Jr. Literary G. selection [47]

OLDS, Ruth Reeves [P] NYC [19]

OLDS, Sara Whitney (Mrs. Robert Zoeller) [P,T,I] Mt. Sinai, NY b. 16 Ja 1899, Springfield, OH. Studied: CI; Pittsburgh AI. Member: Douglaston AL; Nassau County AL. Exhibited: Douglaston AL, 1930–46, 1945 (prize), 1946 (prize); Nassau County AL, 1944, 1945; Minneola Fair, 1944 (prize), 1945 (prize); Long Island Arts Festival, 1946; Patchogue, NY, 1943; 8th St. Gal., NYC, 1943. Work: portraits, Medical Mus., Wash., D.C.; Mason General Hospital; Station Hospital, Mitchell Field, N.Y. Illustrator: "Look Your Best," 1938, "Color and Design in Apparel," 1942 [47]

O'LEARY, Angela [Ldscp.P] Providence, RI b. 29 O 1879, Providence d. 2 O 1921. Studied: England; U.S. Member: Providence AC; Providence WCC. Specialty: watercolor [19]

O'LEARY, Samuel F. [P] Paris, France [10]

OLENCHAK, Thomas Richard [P,G,I,Cart] NYC b. 22 Mr 1907, Scranton, PA. Studied: Nat. Acad.; ASL. Member: Lackawanna A. All., Scranton; NYWCC. Exhibited: Everhart Mus., Scranton; Am. WCS-NYWCC, 1939 [40]

OLESEN, Olaf [P] NYC b. 12 F 1873, Denmark. Studied: AIC [24]

OLEY, Moses [Mur.P,Li,Por.P,T,Dr] NYC b. 1 My 1898, Lodz, Poland. Studied: Grande Chaumière, Paris; NAD; Corinth Sch. A., Berlin. Member: AAPL; Am. A. Cong.; Artists U. Exhibited: CGA, 1935, 1937; PAFA, 1934, 1935, 1938, 1942; AIC, 1935, 1938, 1940; VMFA, 1938, 1940; Toledo Mus., 1936; NAD, 1938, 1940; WMAA, 1938; Phila. A. All., 1937–39; Okla. A. Ctr., 1939–41; Am. A. Cong., 1937–41; GGE 1939; San Fran. AA, 1946; ACA Gal., 1934–46; Minneapolis Inst. A., 1935; Iowa State Univ.; W.R. Nelson Gal. A., 1935; Flint Inst. A., 1937; Grand Rapids A. Gal., 1937; Dayton AI, 1937; NAD, 1937. Work: Wood Gal. A., Montpelier, Vt.; Okla. Univ.; WPA murals, U.S. Treasury Dept., Wash., D.C.; Oneonta Hospital N.Y. [47]

OLINSKY, Ivan G. [Por.P,T] NYC/Old Lyme, CT b. 1878, Russia d. 11 F 1962. Studied: NAD; France; Italy. Member: AWCS; SC; NAD; All.A.Am.; Lotos C.; AFA; ANA, 1914; NA, 1919; Mural P.; AAS. Exhibited: NAD, 1914 (prize), 1929 (prize), 1931 (prize); SC, 1919 (prize), 1936 (prize); Lyme AA, 1922 (prize), 1926 (prize), 1930 (prize); NAC, 1931 (prize), 1935 (prize); Montclair AA, 1935 (prize); Allied AA, 1935 (gold). Work: Joslyn Mem.; Dallas MFA; Detroit Inst. A.; Butler AI; Norfolk AA; Montclair A. Mus.; Everhart Mus., Scranton, Pa.; Beach Mem. Coll., Storrs, Conn. [47]

OLINSKY, Tosca [P,T] NYC/Old Lyme, CT b. 11 Mr 1909, Florence, Italy. Member: ANA; AWCS; NAC; Lyme AA. Exhibited: NAD, 1937 (prize); All.A.Am., 1940 (prize); NAC, 1934, 1935, 1937 [47]

OLIS, Marcel [P] NYC [25]

OLIVER, Annie [P] NYC [01]

OLIVER, Dorothy Welch [P] Monterey, CA b. 6 Ag 1899, Monaca, PA. Studied: Haz; Curran; Chase; Robinson. Member: NY Studio C.; Whitney Studio C.; Laguna Beach AA; Calif. AC [25]

OLIVER, Edith Kemble [P] NYC [10]

OLIVER, Elisabeth Paxton (Mrs. Herbert D.) [P] Atlanta, GA b. 28 Ja 1894, Rockbridge County, VA. Studied: Md. Inst.; Europe; E. Browne. Member: NAWA; AAPL; SSAL; Georgia AA; Studio C., Atlanta; Atlanta AA. Exhibited: NAWA, 1935–46; SSAL, 1925–46; Georgia AA, 1925–46; High Mus. A., 1925–46; Salon des Artistes Français, Paris; Newhouse Gal. (one-man); Robert Vose Gal.; Atlanta AA; Argent Gal.; Assn. Ga. Ar., 1938; Atlanta Newspaper Assn. (prize). Work: High Mus. A.; Corpus Christi, Texas Mus. Position: T., High Mus. Sch. A. [47]

OLIVER, Ellis A. [P] Phila., PA [21]

OLIVER, Fred [P] Martinsville, IN [17]

OLIVER, Frederick W. [P] Newton Highlands, MA b. 4 S 1876, NYC. Studied: DeCamp; Major; S.C. Carbee; Hale. Member: Rockport AA; Copley S., Boston. Exhibited: Jordan Marsh, 1945; Rockport AA [47]

OLIVER, Jean Nutting [P,T,W] Boston, MA/Gloucester, MA b. Lynn, MA. Studied: BMFA Sch, with C.H. Woodbury, P. Hale. Member: Copley S.; Boston GA; Boston AC; Gloucester SA; North Shore AA; Rockport AA. Exhibited: PAFA, 1916 (prize); Boston Women Painters Exh., 1917 (prize) [40]

OLIVER, Louise (Mrs. F.L. Beebee) [P,I,Des,T] Glendale, CA b. 18 S 1912, Rialto, CA. Studied: Schuster; Shrader; S. MacDonald-Wright; Vysekal; R. Holmes; J. Redman; B. Okubo. Member: Calif. WCS. Exhibited: Calif. WCS, Los Angeles Mus., 1930 (prize) [40]

OLIVER, Myron Angelo [P,C] Monterey, CA b. 16 Je 1891, Fulton, KS. Studied: Stanford Univ.; Wm. Chase; F. du Mond; H.V. Poor; A. Hansen. Member: Carmel AA. Specialty: furniture des. [40]

OLIVER, T. Clark [Mar.P] d. 3 Mr 1893, Amesbury, MA. Studied: Wm. Bradford. Work: Kendall Whaling M.; works in chromolitho. by Prang & Co. [*]

OLMER, Henry [S] Willoughby, OH b. 30 N 1887, Czechoslovakia d. 27 D 1950. Studied: State A. Sch. for S.; Royal A. Acad., Czech. Work: Banks, Pub. Lib., Cleveland, Ohio WPA artist. [47]

OLMES, Mildred Young (Mrs. Hugh H.) [P,I,Des] West Chester, PA b. 12 F 1906, Oil City, PA. Studied: CI; A. Kostellow; A. Abels; R. Pougheon, Paris. Member: Chester County AA. Exhibited: CI, 1927 (prize); Paris Salon, 1931; AIC, 1934–36; Wichita Women Painters, 1937–39; Butler AI, 1936–46; Massillon Mus., 1941–45; Chester County AA, 1943–46; Canton AI, 1943, 1944, (prize), 1945 (prize) [47]

OLMSTEAD, Frederick Law [Ldscp.Arch] Waverly, MA b. 26 Ap 1822 d. 28 Ag 1903. Studied: Yale. Work: parks, Brooklyn; Boston; Montreal; Chicago and other cities; grounds and terraces, Capitol, Wash., D.C.; Columbian Expo, Chicago. Award: for his plans for Central Park, 1856. Positions: Ldscp. Arch./Superintendent, Central Park, 1857

OLMSTEAD, Harold L. [S,P] Buffalo, NY. Exhibited: Buffalo SA, 1933 (prize); Albright Gal., Buffalo, 1934, 1935, 1938, 1939 [40]

OLMSTEAD, Vincent H. [P] Hartford, CT. Member: CAFA [25]

OLMSTED, Anna Wetherill [Mus.Dir,W,L,Cr] Syracuse, NY b. Syracuse. Studied: Syracuse Univ. Member: AFA; AAMUs. Exhibited: PAFA, 1931; ASMP, 1931; Syracuse AA, annually. Contributor: Journal of Aesthetics, Design, Art News. Founded/Organized: Nat. Ceramic Exh., 1932. Assembled first exh. Contemporary Am. Ceramics for foreign mus. exh. Positions: A. Cr., Syracuse Post Standard, 1928–44; Dir., 1930– , Syracuse MFA; A. Cr., Syracuse Herald-Am., 1945 – [47]

OLMSTED, Harold S. [P] Buffalo, NY [17]

OLMSTED, M.B. [Min.P] Brooklyn [10]

OLNEY, Daniel Gillette [S] Wash., D.C. b. 24 Ag 1909, NYC. Work: Richmond Acad. FA; WPA murals, USPOs, Berryville, Ark., Marion, Va. [40]

OLSEN, Carl [Por.P] Chicago, IL b. 18 Je 1893, Wannas, Sweden. Studied: AIC; F. Poole; C. Scroeder; G. Oberteuffer; W. Reynolds; De Forest School; E. Forsberg. Member: All-Ill. SFA; Ill. Acad. FA; Swedish Am. AA; Chicago Business Men's AC; Northwest AL; ASL. Work: State Mus., Springfield, Ill.; Albany Park Lutheran Church, St. Stephen's Episcopal Church, Chicago, Ill.; Free Church, Aurora, Wis.; Utlandssvenska Mus., Gothenborg; Vaxsjo Mus., Sweden [40]

OLSEN, Chris E. H. [P,C,S,Mus.A,L,Des,Arch] Nyack, NY b. 8 Ap 1880, Copenhagen, Denmark. Studied: Allen's A. Sch., Perth Amboy, N.J.; Mechanics Inst.; P. Eggers. Member: Scandinavian-Am. A.; Rockland County Artist.; Studio G., NYC; Ridgewood AA. Exhibited: NAD, 1943; High Mus. A., 1933; Scandinavian-Am. A., 1935; AMNH, 1936; Staten Island Inst. A. & Sc., 1940; Arnot A. Gal., 1944; Mechanics Inst. (prize). Work: mural of undersea paintings, for Lambert, St. Louis, Mo.; undersea background, AMNH. Position: A., Modeler, AMNH, NYC, 1916– . [47]

OLSEN, Harry Emil [P,I,] Hollis, NY b. 20 S 1887, Brooklyn. Studied: Adelphi Col., Brooklyn. Member: SC; AWCS; All.A.Am.; Phila. WCC; Audubon A.; Brooklyn Modern P. Exhibited: AWCS, 1932 (prize), 1933–46; SC, 1932–46, 1937 (prize); All.A.Am., 1941 (prize), 1942–46; PAFA, 1939–41; Albany Inst. Hist. & A., 1940 (one-man); Barbizon Hotel, N.Y., 1945 (one-man). Position: T., Underwood & Underwood Ills. Studios, NYC [47]

OLSHANSKA, Stephanie (Mrs. R.S. Komarnitsky) [P,Des] Coraopolis Heights, PA b. 23 Mr 1900, Galicia, Western Ukraine. Studied: Europe; Columbia; G.E. Browne; F.W. Weber; F. Carpenter; R. & I. Teachers Seminary, Austria. Member: AAPL; Am. Assn. Univ. Women; Am. Lib. Color Slides; Montclair AA. Exhibited: Montclair AM; Newark Mus.; NAD; Detroit Inst. A., 1942; N.J. Women's C.; AFA traveling exh.,

1939; NAC; Provincetown AA; N.J. Gal. A., Newark, 1935 (prize). Work: Cliffside Park Women's C.; Am. Lib. Color Slides [47]

OLSON, Albert Byron [P] Denver, CO b. 3 My 1885, Montrose, CO d. 9 Mr 1940. Studied: PAFA, with Anshutz, McCarter. Member: Denver AM; Prairie WCC. Exhibited: Denver AM, 1935 (prize); Kansas City AI, 1937 (prize). Work: Denver AM; murals, St. Mark's Church, St. Andrew's Church, Ilyyria Lib., Denver, Colo. [40]

OLSON, Carl G(ustaf) T(heodore) [P,T] Belmont, MA b. 7 Je 1875, Sweden. Studied: P. Roos. Member: Copley S. Work: Bethlehem Church, Brooklyn.; Zion Church, Worcester, Mass.; mem. port., Augustam Church, Cambridge, Mass. [40]

OLSON, Chris [P,S] Eureka, WI b. 6 Ap 1905, Oshkosh, WI. Studied: G. Oberteuffer; J. Lutz; L. Turner; R. Stockton; D. Torbert; N.J. Behncke; E.J. Behncke. Work: Oshkosh Pub. Mus.; Oshkosh State T. Col.; Cormier Sch., Green Bay, Wis. [40]

OLSON, Florence [P] Kansas City, MO [24]

OLSON, Henry (W.) [P,L,T,W] Wash., D.C. b. 19 O 1902, Canton, OH. Studied: Columbus Sch. A.; Corcoran Sch. A.; Otterbein Col., Westerville, Ohio; Ohio State Univ. Member: Wash. Landscape C.; S. Wash. A.; Wash. WCC; Wash. AC; Am. Assn. Univ. Prof. Exhibited: Univ. Florence, Italy, 1945 (one-man); Wilston T. Col., 1946 (one-man); S. Wash. A.; Wash. Landscape C., 1941 (prize), 1944 (prize); Wash. WCC; Times-Herald Fair, Beaumont, Texas; Central Lib., Wash. D.C.; Wash. AC, 1944 (prize), 1945 (prize); Pa. State Teachers Col. Work: Dunbarton Col.; murals, Wilson T. Col. Author/Illustrator: monographs, "Biological Sciences." Position: T., Wilson T. Col., Wash., D.C., 1937– . [47]

OLSON, Herbert Vincent [P,I,S,Des,T,L] Glenview, IL b. 12 Jy 1905, Chicago, IL. Studied: AIC. Member: Phila. WCC. Exhibited: PAFA, 1942, 1943; AIC, 1939, 1940; Rockford, Ill., 1946; Bloomington, Ill., 1946; Racine, Wis., 1946; O'Brien Gal., Chicago (one-man); Findlay Gal., Chicago (one-man); Chicago Gal. Assn. (one-man); Swedish Am. Exh., Detroit, 1941 (prize), 1942 (prize); Chicago Free Lance A. Exh., 1939 (prize), 1940. Position: T., Chicago Professional Sch. A., 1938–40; Am. Acad. A., Chicago, Ill., 1940 [47]

OLSON, J. Olaf [Ldscp.P] NYC b. 1894, Buffalo, MN. Studied: G. Bellows; F. Tadema. Member: AWCS. Exhibited: AWCS, 1936, 1938, 1939; AIC, 1938 [47]

OLSON, J(oseph) Oliver [P] Seattle, WA [15]

OLSON, Ruth [P] Minneapolis, MN [17]

OLSON, Sigurd J. [P] Chicago, IL. Member: AG of Authors Lg. A. [25]

OLSSON, Axel Elias [S] b. 17 Ap 1857, Sweden. Studied: Stockholm Acad. FA [10]

OLSSON, Julius See Nordfeldt.

OLSTAD, Einar Hanson [P] ND (1951) b. 1876, Lillehammer, Norway (came to S.Dak. as a baby). Began painting western scenes of the N. Dak. Badlands at age 60. [*]

OLSTOWSKI, Franciszek [S] Matawan, NJ b. 25 Mr 1901, Zaborowo, Poland. Studied: his father. Member: NYPS; Buffalo SA; Chicago NJSA; S.Indp.A.; Chicago Polish AC. Work: Newspaper Men's C., NYC; Salesian Sch., New Rochelle, N.Y.; St. Mary's Church, NYC; Foreign Affairs Bldg., Warsaw; Theatre Lg., Buffalo; Gardner Dancing Sch., Toledo, Ohio; Courthouse, Hackensack, N.J.; Pub. Lib., Matawan [40]

OLYPHANT, Donald [B,Dr,Ldscp.P,T] Point Pleasant, PA b. 9 N 1896, NYC. Studied: P.A. Laurens. Member: AAPL; L'Amical de la Société des Artistes Françaises [40]

O'MALLEY, J.M. [P] Hollywood, CA. Member: AWCS [47]

O'MALLEY, Mary Holmes, Mrs. See Holmes.

O'MALLEY, Power See Power-O'Malley.

OMAN, Edwin [L,P,I,Des] NYC b. 25 Ag 1905, Chicago, IL. Studied: AIC; Am. Acad. A., Chicago. Member: AWCS; Polish AC; Lotos C. Exhibited: AWCS, annually; Polish AC (prize); Grand Central A. Gal.; Middlebury Col.; Currier Gal. A.; Sweat Mem. Mus.; G. Hall, East Hampton, N.Y.; Wash. AC; Davenport A. Gal.; Ill. State Mus.; Stendahl Gal., Los Angeles; Crocker A. Gal., Sacramento; Haggin Mem. Gal., Stockton, Calif.; Laguna Beach AA; San Diego FAS; Rollins Col., Winter Park, Fla. Illustrator: national magazines [47]

OMINSKY, Mrs. See Richardson, Rachel.

OMINSKY, Frank K. [G] NYC. Exhibited: Nat. Acad., 1937; CAFA, 1938; AIC, 1938 [40]

ONAGA, Yoshimatsu [P,S] Phila., PA b. 21 Ag 1890, Japan. Studied: PAFA; W.M. Chase. Exhibited: PAFA, 1921; Phila. Mus.; WFNY, 1939. Work: Phila. Mus. [40]

ONDERDONK, Eleanor [P,T] San Antonio, TX b. 25 O 1886. Studied: DuMond; Johansen; L. Fuller; A. Beckington; G. Bridgman; J.F. Carlson [29]

ONDERDONK, Julian [P] San Antonio, TX b. 30 Jy 1882 d. 27 O 1922. Studied: his father, Robert; Shinnecock, with Chase; ASL, with Henri, DuMond, 1901. Member: SC, 1913; Allied AA; Dallas A. Assn.; San Antonio A. Lg. Work: Dallas Art Assn.; San Antonio A. Lg.; Fort Worth Mus. A.; Houston FA [21]

ONDERDONK, Percy [P] Port Chester, NY b. 1878 d. 4 Je 1927

ONDERDONK, R(obert) J(enkins) [P] San Antonio, TX b. 16 Ja 1853, Baltimore d. 2 Jy 1917. Studied: NAD, with Wilmarth; ASL, with Shirlaw, Beckwith; NYC, with A.H. Wyant; Munich, with Chase. Work: Dallas A. Assn.; Waco (Tex.) A. Assn. Father of Julian. [15]

O'NEAL, William Bainter [B,P,I,Dec,Arch,T] Charlottesville, VA b. 21 Ag 1907, Zanesville, OH. Studied: CI; PAFA; Ohio State Univ. Work: Municipal Stadium, Zanesville. Contributor: weekly articles on art, Times Recorder. Positions: T., Zanesville AI, Univ. Va. [47]

O'NEIL, Agnes [S] Cincinnati, OH. Position: Affiliated with Art Acad. Cincinnati [01]

O'NEIL, John [P,T] Oklahoma City, OK b. 16 Je 1915, Kansas City. Studied: Univ. Okla., 1936-39; Colorado Springs FA Center, with B. Robinson, H.V. Poor; Taos SA, with E. Bisttram, 1942; Italy, 1951-52. Member: Okla. Ar. Exhibited: WFNY, 1939; CI, 1941; Colorado Springs FA Center, 1939, 1941; Denver A. Mus., 1940; internationally, winning 20 awards. Living in Houston, 1976. Positions: T., Univ. Okla., Norman, 1939–65, Rice Univ., 1965– [47]

O'NEIL, William J. [P] Cleveland, OH. Member: Cleveland SA [27]

O'NEILL, George Kerr [P] Phila., PA b. 1 Mr 1879. Studied: PAFA [21]

O'NEILL, R(aymond) E(dgar) [P,L,C,T] Trenton, NJ b. 8 Jy 1893, Trenton. Studied: A.W. Dow; Lachman; A. Zarrago; C.H. Martin. Member: S.Indp.A.; Trenton Alliance [25]

O'NEILL, Rose. See Wilson, Mrs.

O'NEILL, Thomas F. [P] South Portland, ME [24]

OPERTI, Albert (Jasper Ludwig Roccabigllera) [I,P,S] NYC b. 17 Mr 1852, Turin, Italy d. 29 O 1927. Studied: abroad. Member: Explorers C.; Palette C.; Tile C. Exhibited: U.S. Gov. exhibits, Chicago, San Fran. Expo. Work: Army and Navy Dept., Wash., D.C.; AMNH; Am. Geographic Soc., N.Y. Illustrator: books on arctic subjects. He made two voyages to the arctic regions with Rear Admiral Peary. Scenic Artist: NYC theatres [27]

OPLER, Hazal (Maybel) [P] Buffalo, NY b. 8 My 1910, Buffalo. Member: Buffalo SA [33]

OPPENHEIM, Adeline. See Guimard, Mrs.

OPPENHEIM, S. Edmund [I] NYC. Member: SI [47]

OPPENHEIMER, Henry [Patron] b. 1860 Wash., D.C. d. Spring 1932, London (where he lived most of his life.) His collection, rich in sculpture and faience of the Renaissance, and prints by old masters, unrivalled except by the great public galleries, was housed and displayed in Kensington Palace gardens. For many years he was active in the National Art Collections Fund.

OPPENHEIMER, Selma L. [P] Baltimore, MD b. 13 Ja 1898, Baltimore. Studied: Goucher Col.; Md. Inst.; H. Roben. Member: A. Un., Baltimore; Baltimore A. Gld.; AFA; NAWA. Exhibited: Md. Inst., 1933 (med); BMA, 1931–34, 1935, (prize) 1938 (prize) 1939–46; PAFA; VMFA; AIC; CGA; MCMA; PMG; Rockefeller Center, N.Y.; Friends of Art, Baltimore; Municipal Mus., Baltimore; Hagerstown, Md. Work: Pub. Sch., Baltimore [47]

OPPER, Frederick Burr [Car] New Rochelle, NY b. 2 Ja 1857, Madison, Lake County, Ohio. Work: "Puck" for eighteen years; comic strips; political cartoons. Illustrator: "Mark Twain," "Mr. Dooley." Position: Staff, Journal, since 1899 [32]

OPPER, John [P,Li,T] Laramie, WY b. 29 O 1908, Chicago. Studied:

Western Reserve Univ.; Columbia; H.Hofmann; Cleveland Sch. A.; AIC. Member: Am. Ar. Cong.; Un. Am. Ar. Exhibited: Pasadena AI, 1946; SFMA, 1945, 1946; AIC, 1940-42, 1944; MMA, 1941; SFMA, 1940 (one-man); Crocker A. Gal., 1940 (one-man); A. Gal., N.Y., 1941; Ten-Thirty Gal., Cleveland, 1946; Colorado Springs FA Center, 1946; NYWCC Ann., 1937; MFA, Springfield, Mass.; ACA Gal., N.Y. Work: Dept. Edu, Albany; Bureau Health Ed., Jefferson Sch., N.Y.; Pub. Lib., Brooklyn; State Normal Sch., Potsdam, N.Y. Position: T., Univ. Wyo., 1945- [47]

OPPER, Laura [Por.P] NYC d. 18 S 1924. Studied: NAD, with C. Beckwith, W.M. Chase; ASL; abroad. Member: NAWPS; ASL [01]

OPSTAD, Adolf [P] Chicago, IL [15]

OQWA PI, (Abel Sanchez) [P] Santa Fe, NM (1967) b. ca. 1899. Studied: Santa Fe Indian Sch. Member: San Ildefonso movement. Work: AMNH; BM; Denver AM; Mus. Am. Indian; Mus. N.Mex. [*]

ORB, Ovan (John Carbone) [S,P,L,T] Providence, RI b. 2 Mr 1911, Cranston, RI. Studied: RISD; BAID; L. Lentelli; E. McCartan; O. Zadkine. Member: R.I. Abstract A.; Providence AC; A.&W. Un., R.I. Exhibited: RISD, 1927, 1928 (prize), 1930-43; R.I. Col. Edu., 1940, 1941 (prize); Providence AC, 1937-41; Brown Univ., 1941; Contemp. A. Gal., 1944. Work: S., Technical H.S. Lib., Providence; Roger Williams Park, Jamestown, R.I.; RISD [47]

ORDE, Gertrude Cederstrom [P,I] Los Angeles, CA b. 6 Jy 1901 St. Louis. Studied: Minneapolis AI; Chicago Acad. FA; AIC; Otis AI, Los Angeles. Member: Women P. of the West; San Gabriel A. Gld.; Long Beach AA; Swedish Am. AA, Chicago. Exhibited: Long Beach AA, 1935 (prize); Fed. Women's C., A. Div., 1939 (prize); Ebell C., Mus. Hist. Science & A., both in Los Angeles. Specialty: child portraits [40]

ORDONEZ, Luisina [P] NYC b. Porto Rico. Studied: Univ. Porto Rico; Acad., San Fernando, Spain. Exhibited: Argent Gal., 1938 (one-man) [40]

ORDWAY, Alfred T. [P] Boston, MA b. 1819 d. 17 N 1897. Member: Boston AC (founder 1854; Pres. 1859); Boston PCC (founder); Boston Athenaeum. Exhibited: Boston Athenaeum 1855-64; AIC, 1898; Mechanics Fair, Boston, 1878. Position: Dir. Paintings, Boston Athenaeum, 1856-63)

ORDWAY, Frances Hunt Troop (Mrs. Samuel) [P,Patron] NYC b. 1860, NY d. 3 Jy 1933, East Hampton, Long Island. Studied: ASL; A. Stevens, in Paris. Member: NAWPS. Exhibited: NYC; Paris [21]

ORENTLICHERMAN, Isaac Henry [P] Brooklyn, NY b. 3 N 1895, Russia. Studied: W.S. Kendall; Paris, with Laurens, Lapparra. Member: Meriden SAC; S.Indp.A. [31]

ORGAN, Marjorie (Mrs. Robert Henri) [Car] NYC b. 3 D 1886, NYC. Studied: D. McCarthy; Henri. Member: S.Indp.A.; NYSWA. Cartoons: "Reggie and the Heavenly Twins," "The Man Haters' Club" [33]

ORLEMAN, Elsie Maria [P,S,E] Detroit, MI b. 28 F 1881, Chicago. Studied: W.M. Chase; K. Cox; R. Henri; DuMond [17]

ORLOFF, Gregory [P] Chicago, IL b. 17 Mr 1890, Russia. Studied: I. Olinsky; K. Buer; Korenev, in Russia; NAD; AIC. Member: Chicago SA; South Side AA. Work: State Mus., Springfield, Ill. [40]

ORLOFF, Lillian [P,E,Li] NYC b. 24 My 1908, Cleveland d. 6 Ag 1957. Studied: Baldwin-Wallace Col.; ASL. Member: S.Indp.A.; NYSWA; Woodstock AA. Exhibited: N.Y. FA Gal., 1944; Woodstock AA, 1936, 1946; NYSWA, 1942-46; Vendôme Gal., 1938; Schaeffer Gal., 1945; Galerie Neuf, 1946. Work: CMA [47]

ORME, Lydia Gardner (Mrs. James) [P] NYC d. 11 Je 1963. Exhibited: NYWCC, 1934, 1937; Grand Central Gal., 1935; NAWPS, 1935-38 [40]

ORMES, Manly D. (Mrs.) [Ldscp.P] Colorado Springs, CO (1923) b. ca. 1865, Phila. Studied: PAFA. Exhibited: Colo. Col., 1900 [*]

ORMOND, M. Georgia [S] Toledo, OH b. Sharon, PA. Studied: L. Taft; O. Patridge; H. MacNeil; G. Borglum. Member: NAWPS; Soc. Women Ar., Toledo. Exhibited: TMA; Cincinnati A. Acad.; NAWPS, 1935-38 [40]

ORMSBEE, Mary Catherine (Mrs.) [P] Poughkeepsie, NY b. 1854, Livingston, NY d. 2 My 1947 (age 93). Studied: NYC

ORNOFF, Nathan [P] NYC. Exhibited: Ann., PAFA, 1938; WFNY, 1939 [40]

ORNSTEIN, Jacob Arthur [P,W,L,T] Flushing, NY b. 7 Je 1907, Brooklyn, NY. Studied: Parsons Sch. Des.; NYU; M. Davidson. Member: A. T. Gld. Exhibited: All.A.Am., 1939; San Diego FA Soc., 1941; AWCS, 1942; Mississippi AA, 1942, 1943; Denver A. Mus., 1942; Elisabet Ney Mus., 1943; Newport AA, 1944; BM, 1941; Brooklyn SA, 1942. Author/Illustrator: "Lettering for Fun," 1939, "Paintbrush Fun for Home Decoration," 1944. Position: T., Andrew Jackson H.S., St. Albans, N.Y., 1935- [47]

O'ROURKE, Andrew P. [Por.P] b. 1894, Elizabeth, NJ d. 15 My 1935, Scotch Plains, NJ

ORR, Alfred Everitt [P,I] San Gabriel, CA b. 6 Ja 1886, NYC. Studied: ASL; Royal Acad., London; W.M. Chase; Hawthorne. Illustrator: poster, "For Home and Country," 5th Liberty Loan [27]

ORR, Carey [Car] Chicago, IL. Work: Huntington Lib., San Marino, Calif. [40]

ORR, Eleanor Mason (Mrs. James H.) [Min.P] Newton Centre, MA b. 15 Ag 1902, Newton Centre. Studied: BMFA Sch.; A.H. Jackson. Member: Copley S. Exhibited: PAFA, 1925, 1926, 1932, 1941; ASMP, 1926, 1935; Brooklyn Soc. Min. P., 1926, 1938; Grace Horne Gal., 1926; Newton Centre Women's C., 1925-28, 1932, 1934-36; Newtonville Lib., 1943 (one-man). Work: Marine Hospital, Brighton, Mass.; Union Service C., Boston; Cushing General Hospital, Framingham, Mass. Specialty: children [47]

ORR, Elliot [P] Chatham, MA b. 26 Je 1904, Flushing, NY. Studied: Ennis; Luks; Snell; Hawthorne. Exhibited: Baltimore, 1930 (prize); GGE, 1939; CGA, 1939. Work: BM; Macbeth Gal. [47]

ORR, Forrest (Walker) [P,Des,I] Winchester, MA b. 5 My 1895, Harpswell, ME. Studied: Portland (Maine) Mus. Sch. A.; ASL, with G. Bridgman, DuMond, H. Dunn. Member: Gld. Boston A.; Boston Soc. WC Painters; North Shore AA; Soc. Printers, Boston. Exhibited: Jordan Marsh Exh., 1945 (prize); North Shore AA, 1945 (prize), 1946; Soc. Boston WC Painters, 1944-46; Gld. Boston A., 1945 (one-man). Work: Kendall Whaling Mus. Illustrator: juvenile books; fiction; national magazines [47]

ORR, Frances (Morris) [P] Sewickley, PA/Great Barrington, MA b. 26 S 1880, Springfield, MO. Member: AA, Pittsburgh; New Haven PCC. Exhibited: AA, Pittsburgh; CI, 1922 (prize) [40]

ORR, G.F. [P] Syracuse, NY. Member: Chicago WCC [17]

ORR, J.B. (Mrs.) [P] Edgeworth, PA. Member: Pittsburgh AA [24]

ORR, J. Edward [P] Columbus, OH. Member: Pen and Pencil C., Columbus [25]

ORR, Louis [E,P] Paris, France b. 19 My 1879, Hartford, CT d. 1961. Studied: Paris, with W. Griffin, J.P. Laurens. Member: Legion of Honor. Work: State Bank, Hartford; 22 original pencil drawings, Rheims Cathedral; 11 etchings, Luxembourg, Paris; 10 etched copper plates, Louvre, Paris; 4 etchings, NYPL; 2 etchings, Oakland (Calif.) Mus.; etching, Strasbourg Mus.; 3 etchings of Rheims Cathedral, Nat. Am. Red Cross; set of etchings, Albright Art Gallery, Buffalo; etchings/drawings, Yale [40]

ORR, Margaret R. [P] Montclair, NJ [01]

ORR, Martha [I,Car] Chicago, IL. Creator: comic strip, "Apple Mary" [40]

ORR, Otis [P] Syracuse, NY [24]

ORRICK-SEMMES, A. Gertrude [P] Chicago, IL [10]

ORTGIES, John [Auctioneer] b. 1836, NY d. 15 O 1908, Ardsley, NY. Co-owner with Robert Sommerville of Fifth Avenue Art Galleries. He was connected with the American Art Assn. Some of the important art collections sold under his auspices were those of John Taylor Johnston, 1878; Daniel Cottier, 1878; John Wolfe, 1883; Albert Spencer, 1879 and 1888; J. Abner Harper, 1880 and 1890.

ORTH, J(ohn) W(illiam) [P] Kansas City, MO b. 26 Jy 1889, Markstft, Germany. Studied: H. von Habermann. Member: Kansas City SA. Work: Kunsthalls, Barmen, Germany [40]

ORTLIP, Aileen. See Shea.

ORTLIP, Aimee E. (Mrs. H.W.) [P,T,L] Fort Lee, NJ b. 21 Ap 1888, Phila. Studied: PAFA; W.M. Chase; S. Kendall; H. McCarter; C. Beaux. Member: AAPL. Exhibited: PAFA, 1909; Montclair Mus., 1934 (prize), 1937 (med); NAD; All.A.Am. [47]

ORTLIP, H. Willard [P,I,L] Fort Lee, NJ b. 28 Mr 1886, Norristown, PA; PAFA; W.M. Chase; S. Kendall; C. Beaux; H. McCarter. Member: All.A.Am.; SC; Am. Ar. Prof. Lg. Exhibited: PAFA, 1908, 1909; Montclair A. Mus., 1936 (med); All.A.Am., 1942, 1943; WFNY, 1939; SC, 1939; Women's C., Paterson, N.J., 1928 (med). Work: church murals, Buffalo, N.Y.; Johnson City, N.Y.; Camden, N.J.; Chester, Pa.; portraits, Nat. Bible Inst.; Chamber of Commerce, York, Pa.; Pub. Lib.,

York, Pa.; Women's C., Hackensack, N.J.; Hotel Huntington, Long Island, N.Y.; Beth Israel Hospital, Newark, N.J.; Littleton Mem. Lib., Plandome, N.Y.; Fort Lee H.S., N.J. [47]

ORTMAYER, Constance [S,T] Winter Park, FL b. 19 Jy 1902, NYC. Studied: Royal Acad. FA, Vienna, Austria. Member: NSS; NAWA. Exhibited: NAD, 1935 (prize); WMAA, 1940 (prize); PAFA, 1934, 1935; WMAA, 1940; Arch. Lg., 1937; BM, 1933; WFNY, 1939; NAWPS, 1935 (prize). Work: Brookgreen Gardens, S.C.; Am. Numismatic Soc., N.Y.; USPOs, Arcadia, Fla., Scottscoro, Ala. WPA artist. Position: T., Rollins Col., Winter Park, 1937– [47]

ORWIG, Louise [P,W] Des Moines, IA b. Mifflinburg, PA. Studied: W.M. Chase; H. McCarter; D. Garber. Member: Des Moines Assn. FA; Iowa AC. Exhibited: PAFA, 1911 (prize); 1919 (prize), 1920 (prize), 1921 (gold), 1923 (prize); Des Moines Women's C., 1927 (prize); Iowa AC, 1931 (prize); Iowa State Fair, 1934 (prize). Work: Hist. Soc., Iowa; Roosevelt H.S., Des Moines. Co-author: "Iowa Artists of First Hundred Years" [40]

OSBORN, C.M. [P] Cleveland, OH. Member: Associate, SWA [01]

OSBORN, Erel [P] Chicago, IL. Exhibited: Ar. Chicago, Vic. Ann., AIC, 1936, 1938. WPA artist. [40]

OSBORN, Frank C. [P] Manchester, VT b. 13 Je 1887, Altamont, NY. Studied: ASL. Originator: new technique, "Airbrush Print" [40]

OSBORN, Helen H. [P] Columbus, OH [13]

OSBORN, Roble (Mrs.) [P] Dobbs Ferry, NY. Member: S.Indp.A. [25]

OSBORN, Robert C. [Car] NYC b. 26 O 1904, Oshkosh, WI. Studied: Univ. Wis.; Yale; British Acad., Rome, 1928–29; Despiau; O. Friesz. Exhibited: Va. MFA, 1952; Wadsworth Atheneum, 1958; AFA, 1952–54; Berkshire Mus., 1967; cartoons: MOMA Traveling Exh., "If You Want to Build a House," "On Being a Cartoonist." Award: Legion of Merit, U.S. Navy, 1945. Author/Illustrator: "How to Catch Trout," 1939, "How to Ski," 1940, "Aye Aye, Sir," 1942, "Dilbert," 1943, "Osborn on Leisure," 1955, "The Vulgarians," 1960 [47]

OSBORN, William P(atten) [P,E] West New York, NJ b. 1 Ap 1902, NYC. Studied: ASL; G. Bridgman; DuMond; PAFA; D. Garber; Harding, Pearson; Garner. Member: Hudson Valley AA. Exhibited: PAFA, 1929, 1930. Work: Lib., N.Y. State Col. Forestry, Syracuse [40]

OSBORNE, Addis [P,G] Chicago, IL. Exhibited: Intl. E./En. Ann., AIC, 1938; 48 Sts. Comp., 1939 [40]

OSBORNE, Caroline M. [P] NYC [13]

OSBORNE, Joan [P] Montclair, NJ [24]

OSBORNE, Katherine (Mrs.) [C,Dec,L,W] Boston, MA b. New Haven, CT. Studied: Europe; Orient. Member: Copley S.; Royal Asiatic Soc., China. Work: sets of books to hold autographed letters of the Presidents of the United States. Specialty: Oriental bookmaking. Position: Dir., Boston Students Union [40]

OSBORNE, Lillie (Mrs. Lithgow) [S] Auburn, NY b. 8 Mr 1887, Aalholm, Denmark. Studied: Copenhagen; Rome; Paris. Specialty: portrait-statuettes of children and animals [33]

OSBORNE, Norman J.L. [P] Brooklyn, NY [17]

OSGOOD, Adelaide Harriett [china P] NYC b. 1842, Columbus, OH d. 26 N 1910. Founder: Osgood Art School, NYC, 1878 (the first school for decorative china painting)

OSGOOD, Anna Parkman [P] NYC [01]

OSGOOD, Harry Haviland [P,E] Chicago, IL b. S 1875, Illinois. Studied: AIC; Acad. Julian, Acad. Colarossi, both in Paris. Member: Chicago SA [25]

OSGOOD, I.J. [P] Toledo, OH. Member: Artklan [25]

OSGOOD, Julia [P,L] NYC d. 29 N 1908 (automobile accident)

OSGOOD, M.T. (Mrs. H.H.) [P] Atlanta, GA [17]

OSGOOD, Nellie Thorne (Mrs.) [P,T] Chicago, IL b. Je 1879, Michigan. Studied: AIC; Acad. Julian, Acad. Colarossi, both in Paris [21]

OSGOOD, Ruth [P] Wash., D.C. b. Minneapolis. Studied: Corcoran A. Sch.; ASL; Carlson; Henri; Hawthorne; Snell; O'Hara. Member: Wash. WCC; S. Wash. A. [40]

OSGOOD, Virginia M. [P,I,W,T,L] Los Angeles, CA/Laguna Beach, CA b. 2 Ap 1907, California. Studied: Otis AI; Chamberlin; Vysekal; Rich; Univ. Southern Calif. Member: Laguna Beach AA. Exhibited: Los Angeles, 1926 (med) [33]

O'SHAUGHNESSY, Betty [C,Des] San Fran., CA b. 19 Jy 1908, Mill Valley, CA. Studied: Calif. Sch. FA. Member: Nat. AAI; San Fran. Soc. Women Ar.; AFA. Exhibited: Laidlaw Co, Fourteenth Annual Comp., Alliance, 1929 (prize); San Fran. Soc. Women A., 1936 (prize) [40]

O'SHAUGHNESSY, Thomas A. [C,P,S,I,E,T] Chicago, IL b. Charlton County, MO. Studied: Maratta; Willits; Mucha; AIC; Paris; Dublin. Member: Municipal Art Comm., Chicago; De Paul Art Lg.; Liturgical A. Gld. Exhibited: Eucharistic Congress, Chicago (prize). Award: Palms of an Officer of the French Acad., 1936 (prize). Work: St. Patrick's Church; Elks Temple, New Orleans; St. James Episcopal Church, South Bend, Ind.; Springfield Cathedral; Church Extension Society; St. Procopius Monastery, Lisle, Ill.; Henry O. Shepherd School; Maloney Chapel, Spring Lake, N.J.; St. Mary's Church, Evanston, Ill.; St. Stephen's Episcopal Church, Chicago (place of honor, Hall of Religion, Century of Progress), Illinois Host House, Century of Progress Expo, St. Vincent's Chapel, Chicago; Shrine of St. Bride, Wexham, Wales; Million Unit Fellowship Movement Headquarters, Chicago. Lectures: Liturgical Art, Recovery of Pot Metal Glass for Windows. Specialties: stained glass, mosaics, metalwork [40]

O'SHEA, John [P] NYC/Carmel, CA. Member: AWCS [24]

OSHIVER, Harry James [P,Des] Phila., PA b. 14 F 1888, Moscow, Russia. Studied: Spring Garden Inst., Phila; PMSchIA; PAFA; J.F. Lewis. Exhibited: PAFA, 1924–25; Phila. Sketch C., 1930 (med). Work: Franklin Inst., Phila. [47]

OSK, Roselle H(ellenberg) [E,P,Car,Dec] NYC b. 27 F 1884, NYC d 4 My 1954. Studied: Hunter Col.; ASL; Grand Central A. Sch.; NAD; DuMond; Rheutedhal; K. Cox. Member: SAE; NAWA; CAFA; Prairie Pr.M. Chicago SE; AAPL. Exhibited: Phila. Pr. C., 1939 (prize); NAWA, 1940 (prize), 1946 (prize); Southern Pr.M., 1937 (prize); Mint Mus. A., 1945 (prize); Laguna Beach AA, 1945 (prize); presentation print, NAWA, 1946 (prize); SFMA, annually, 1938–46; AIC, annually, 1938–46; PAFA, annually, 1938–46; NAD, annually, 1938–46; Grand Central A. Gal., annually, 1938–46; SAM, annually, 1938–46; CGA, annually, 1938–46; Milch Gal., annually, 1938–46; 100 Selected Prints, 1937, 1938, 1944; Fine Prints of the Year, 1938. Work: MMA; LOC; NYPL; Smithsonian; CGA [47]

OSNIS, Benedict A. [P,T] Phila., PA b. 1872, Russia. Studied: PAFA. Member: AC Phila. [25]

OSNIS, Daisy Hartman (Mrs. Benedict) [P] Phila., PA Studied: PAFA [25]

OSTENDORF, Sister Camille [T,P,Des,Gr] Indianapolis, IN b. 19 Ja 1901, Vincennes, IN. Studied: St. Mary-of-the-Woods Col.; Northwestern Univ.; AIC; Am. Acad., Chicago; O. Gross. Member: Indianapolis AA; Hoosier Salon; Ind. AC. Exhibited: Hoosier Salon, 1935, 1940; John Herron AI, 1934, 1935, 1942; Ind. AC, 1935–39. Position: T., Ladywood Sch., Indianapolis [47]

OSTER, John [C,P,T,L] Jersey City, NJ b. 14 S 1873. Studied: NAD; ASL; D. Volk; G. Bridgman. Member: Jersey City Mus. Assn. Work: series stained glass windows, Harvard Mus.; Jersey City Medical Center [40]

OSTERHOLM, C. Adolph [Des.] Huntington, NY b. 5 Ag 1888, Brooklyn, NY. Studied: Columbia. Specialty: furniture [40]

OSTERTAG, Blanche [P,I] NYC b. St. Louis. Studied: Paris, with Collin, Laurens, Constant. Exhibited: St. Louis (prize). Work: murals, New Amsterdam Theatre, N.Y.; Northwest Railroad Station, Green Bay, Wis.: mosaics, Husser House, Chicago. Illustrator: "Old Songs for Young America" [13]

OSTERTAG, Edith D. [P] Brooklyn, NY. Exhibited: NYWCC, 1936, 1937; Am. WC Soc., NYWCC, 1939 [40]

OSTHAUS, Edmund H(enry) [P,T] Summit, NJ b. 5 Ag 1858, Hildesheim, Germany (came to U.S. in 1883) d. 30 Ja 1928 (at his hunting lodge near Marianna, Fla.). Studied: Josephinum Gymnasium, Hildesheim; Royal Acad. Düsseldorf, with A. Muller, P. Jansen, E.V. Gebhardt, E. Deger, C. Kroner. Member: Toledo Tile C. Work: TMA. Specialty: hunting dogs [24]

OSTHAUS, Marie Henrietta. See Griffith, Mrs.

OSTRANDER, William C(heesbrough) [P] NYC b. 5 Mr 1858, NYC. Studied: C. Hecker; Murphy; Scott; Venino. Member: SC, 1897; A. Fund S.; NYSC; Am. Inst. Graphic A. [33]

OSTRENGA, Leo Raymond [P,G] Milwaukee, WI b. 10 F 1906, Marinette,

WI. Studied: AIC. Exhibited: AIC, 1930 (prize); Astor Hotel, Milwaukee; WPA Gal., Wis. Position: T., Wis. A. Project [40]

OSTROM, Anna Sherwood (Mrs. Simon E.) [P,W] Brooklyn, NY b. 1866, Stonington, CT d. 2 My 1907

OSTROM, Cora Chambers [P] Eagle Pass, TX b. 2 S 1871, Harrison, AR. Studied: M. Brown; Wells; Arpa. Member: San Antonio AL; SSAL [33]

OSTROWSKI, Stanslaw K. [S] NYC b. 1881, Lemberg, Poland (came to NYC from France in 1940) d. 14 My 1947. Studied: Europe. Work: equestrian statue of the Polish hero, King Jagiello, which once stood in front of the Polish Pavilion at WFNY, 1939, and is now in Central Park, NYC

OSTROWSKI, S.L. [P] Toledo, OH. Member: Artklan [25]

OSTROWSKY, Abbo [E,P,T] Forest Hills, NY b. 23 O 1889, Elisabetgrad, Russia. Studied: NAD; CCNY; Russia; Turner; Maynard. Member: SAE; A. Lg. Am.; AAPL; Salons of Am.; Am. A. Cong. Exhibited: SAE, 1937 (prize); NAD; PAFA; AIC; Los Angeles AA; Mus. Western A., Moscow; SAE; Phila. Pr. C.; Phila. A. All.; BMA, 1931 (one-man); U.S. Nat. Mus., 1931 (one-man); Victoria & Albert Mus., London; Oslo Mus., Norway; Univ. Nebr.; NYPL. Position: Founder/Dir., Educational Alliance A. Sch., NYC, 1914– [47]

OSTROWSKY, Sam [P,T,L] Chicago, IL b. 5 My 1886, Russia. Studied: Kiev FA Sch.; Académie Julian, Paris, with Laurens. Member: Salon d'Automne, Salon des Tuileries, Salon des Indépendants, all in Paris; S.Indp.A. Exhibited: AIC, 1941 (prize); nationally; internationally. Work: Grenoble Mus., France; Biro-Bidjan Mus., Russia. Contributor: Esquire [47]

O'SULLIVAN, John F. [Mur.P] NYC. Member: Arch. Lg., 1899 [15]

O'SULLIVAN, Ruth [P] Newark, NJ [24]

O'SULLIVAN, Timothy H. [Photogr] b. 1840, NYC d. 1882. Important Civil War and U.S. Geological Survey photographer, 1867–75; worked for Matthew Brady in NYC, and Alexander Gardner during the Civil War. Work: LOC; N.Y. Hist. Soc.; AIC; IMP; NYPL; others [*]

OSVER, Arthur [P] Long Island City, NY b. 26 Jy 1912, Chicago. Studied: Northwestern Univ.; AIC; B. Anisfeld. Member: Audubon A. Exhibited: PAFA, 1940, 1944, 1946 (med); VMFA, 1944 (prize), 1946; Pepsi-Cola, 1944 (prize); Audubon A. (prize); Critic's Show, N.Y., 1946 (prize); AIC, 1938, 1939, 1942, 1943, 1945; CGE, 1939; CI, 1944–46; WMAA, 1944, 1945; Grand Central A. Gal., 1947 (one-man); Intl. WC Ann., 1935. Work: MOMA; Pepsi-Cola Coll.; PAFA [47]

OSVER, Arthur, Mrs. See Betsberg, Ernestine.

OSWALD, Frederick Charles [P,E] Chicago Heights, IL b. 21 N 1875, Chicago Heights. Studied: AIC. Position: T., AIC [10]

OSWALD, John Clyde [P] NYC [24]

OSWALD, Kalman [P] NYC. Member: S.Indp.A. [25]

OSWIECZYNSKI, Stanislaus Arthur [P,S,G,O,T] Bedford, OH b. 12 F 1915. Studied: Cleveland Sch. A.; Huntington Polytech. Inst. Member: Cleveland Soc. FA; United Am. Ar. Exhibited: Intl. E./En. Ann., AIC, 1938; WC Ann., Corcoran Gal., Wash., D.C., 1939; Cleveland MA. Work: Church of Holy Name, Cleveland; Elementary Sch., Cleveland Heights; Dayton AI. Position: T., Nat. Youth Administration, Cleveland [40]

OTIS, Amy [Por.P,L] Aurora, NY/Wilmington, NC b. Sherwood, Cayuga County, NY. Studied: Phila. Sch. Des.; PAFA; Colarossi Acad., Courtois, Garrido, all in Paris. Member: Phila. WCS; Phila. S. Min. P.; Plastic C. Work: Cornell; Columbia; Wheaton Col., Mass. [40]

OTIS, C.H. [P] Michigan City, IN [25]

OTIS, Elizabeth [P] Phila., PA [15]

OTIS, Fessenden Nott [Dr,T,W] b. 6 Mr 1825, Ballston Springs, NY d. 24 My 1900, New Orleans. Author: "Easy Lectures in Landscape," (5th ed., 1856), "Illustrated History of the Panama Railroad," 1861. Also a doctor, serving as police surgeon in NYC, 1861–71 [*]

OTIS, George Demont [P,E] Kentfield, CA b. 21 S 1879, Memphis. Studied: AIC; Chicago Acad. FA; CUASch; ASL; J. Carlson; R. Schmidt; Reynolds; Poole, Vanderpoel; R. Henri. Member: Chicago SA; Palette & Chisel C., Chicago; Soc. for Sanity in Art; Calif. AC; Los Angeles PS; Laguna Beach AA; Cliff Dwellers. Exhibited: Sacramento, Calif., 1925 (prize). Work: AIC; Hackley A. Gal.; other galleries & museums in U.S. and abroad [47]

OTIS, Marion [P] Atlanta, GA [13]

OTIS, Samuel Davis [C,Dec,Des,Dr,I,P,S] Norwalk, CT b. 4 Jy 1889, Sherwood, NY. Studied: H. McCarter. Member: Silvermine GA; Am. Gld. Craftsmen. Illustrator: "Cyrano de Bergerac," "Francesca da Rimini"; Harper's Bazaar [40]

O'TOOLE, Cathal Brendan (Mr.) [P,G,T] Nyack, NY b. 1903, Ireland. Studied: NAD. Member: NA; SC; NAA, 1939; Soc. Am. E. Exhibited: NAD, 1934 (prize), 1935 (prize); Tiffany Fnd. F., 1934 (prize). Position: T., Finch Jr. Col., N.Y. [47]

OTT, Peterpaul [S,C,G,L,T] Laguna Beach, CA b. 4 Je 1895, Pilsen, Czechoslovakia. Studied: Dresden, Germany; Emmerson Univ., Los Angeles; CUASch; Archipenko; Karl Albiker. Member: Laguna Beach AA; Chicago SA. Exhibited: Small Sculpture Comp., N.Y., 1930 (prize), 1931 (prize); Chicago A. Group, 1932 (prize); Evanston, Ill., 1934–36 (prize), 1938 (prize); AIC, 1934 (prize); Laguna Beach AA, 1943 (prize), 1944; Dresden Acad. A., Germany, 1919 (prize), 1920 (prize), 1921 (med); Kunstverein, Chemnitz, Saxony, 1922 (gold); Nat. Small Sculpture Comp., 1930 (prize), 1931 (prize); "90&9," Chicago; Women's C., Evanston, Ill., 1934 (prize), 1935 (prize), 1936 (prize), 1938 (prize); AIC, 1934 (med); Arch. Lg., 1928–30; S.Indp.A., 1929; Boston Arch. C., 1929; Ferargil Gal., 1929; Montclair A. Mus., 1929; NAD, 1929, 1930; NAD, 1929; Pal. Leg. Honor, 1929; CAA Traveling Exh., 1930; PAFA, 1929–33; AIC, 1931–40; Evanston Acad. FA, 1932 (one-man), 1933–40; Chicago SA, 1935–37, 1939, 1940; PMA, 1940; CI, 1940; Laguna Beach AA, 1941–46. Work: Greater N.Y. Savings Bank, Brooklyn; Massillon (Ohio) Mus.; Lane Tech. H.S. Lib., Chicago; U.S. Gov.; USPOs, Oak Park, Ill., Plano, Ill., and Kedzie-Grace Post Office (Chicago; aluminum relief); Regiment Hall, Pilsen, Czechoslovakia; Acad. A., Dresden; Church of the city of Pinow, Silesia; College of the City of Aue, Saxony; College of the City of Schneeberg, Saxony; Pilsen, Czechoslovakia (med); Schaffen and Koennen der Deutschen Frau, Chemnitz, Germany; Gorham Bronze Company Coll., NYC; Original Morris Plan Bank, Norfolk, Va.; St. George Playhouse, Brooklyn. WPA artist. Positions: Ott Studio, Evanston, Ill. (1940), Northwestern Univ. [47]

OTT, Ralph C. [P] Springfield, MO b. Springfield, MO. Studied: Constant; Laurens. Member: Phila. AC. Work: Capitol, Jefferson City, Mo.; Governor's Mansion, Jefferson City; Pub. Lib., Springfield; Art Mus., Springfield; City A. Mus., St. Louis; Masonic Temple, St. Louis; Chicago Theological Seminary [31]

OTTEN, Mitzi [P,C,Dec] NYC b. 28 N 1888, Vienna, Austria. Studied: J. Hoffmann; O. Straud, in Vienna. Exhibited: World's Fair, Paris, 1925; Milan, 1933; London, 1934; Vienna, 1934; Intl. Expo., Paris, 1937; Golden Gate Expo, 1939; Syracuse MFA; Denver AM [40]

OTTINGER, George M. [P] Salt Lake City, UT b. 1833, Bedford, PA d. 1917. Studied: R. Weir, in NYC, ca. 1853. Member: Utah SA; Desert Acad. FA (pres.) 1863. Exhibited: Centenn. Expo, Phila., 1876. In photography business of Savage & Ottinger; he tinted his partner's ambrotypes. [15]

OUDA, Ethel Annetta [P,T] Chicago, IL b. 14 Ja 1908, Chicago. Studied: Ruth Van Sickle Ford. Member: All-Ill. SFA. Position: T., Kelvyn Park H.S., Chicago [40]

OUDIN, Dorothy Savage (Mrs. C. Folger) [Mus.Dir,P] Cooperstown, NY b. 19 Jy 1898, Baltimore. Studied: PAFA; Garber; Carles; Hawthorne; Adams; Breckenridge. Member: Phila. Alliance; Cooperstown AA. Exhibited: PAFA, 1932 (med); Baltimore, 1924 (prize); NAD; AIC; Phila. AC; BMA; Baltimore Charcoal C.; Md. Inst.; Wash. AC (one-man); Schenectady Studio C. (one-man); Norfolk A. Corner (one-man). Work: WFNY, 1939. Position: Dir., Children's Mus., Cooperstown, N.Y. [47]

OUREN, Karl [P] Chicago, IL b. 5 F 1882, Fredrikshald, Norway d. 3 Ja 1943. Studied: Copenhagen; AIC; H. Larvin, at Palette and Chisel C., Chicago. Member: Northwest A. Lg.; Soc. for Sanity in Art; Chicago Gal. A. Exhibited: Palette and Chisel C., 1919 (gold); Chicago Gal. Assn., 1929–30 (prize); Norwegian Nat. Lg. (prize); Springfield, Ill. (prize). Work: Milwaukee AI; Hackley Gal., Muskegon, Mich.; Ill. State Mus., Springfield; A. Soc., Larvik, Norway [40]

OUTCAULT, Richard F(elton) [Car,I,P] Flushing, NY b. 14 Ja 1863, Lancaster, OH d. 25 S 1928. Studied: McMicken Univ., Cincinnati. In 1895 he launched in the New York Sunday World, "Hogan's Alley," the first full-page colored comic ever published; then followed it with "The Yellow Kid," in the New York Journal. In 1901 he created "Pore Lil Mose," and in 1902, his greatest triumph, "Buster Brown" (the original of which was his son, Richard F., Jr.); both were produced in the New York Herald. Position: Staff, New York Journal [27]

OUTERBRIDGE, Paul, Jr. [Photogr] b. 1896 d. 1958. Studied: Clarence White Sch. Photography, 1921. Illustrator: Vogue, Vanity Fair, Harper's Bazaar. Work: Laguna Beach MA; BMFA; CMA; LOC; MMA. Known for commercial still life and nudes in carbro process. Position: T., C. White Sch. Photography, ca. 1923 [*]

OVERBECK, Elizabeth Gray [C] Cambridge City, IN b. 21 O 1875 d. 1 D 1936. Studied: C.F. Binns; State Sch. Cer., Alfred, N.Y. Member: Am. Cer. Soc.; Cincinnati Women's AC. Exhibited: Ind. State Fair, 1920 (prize), 1928 (prize), 1929 (prize), 1932 (prize), 1933, 1934 (prize); Ind. Ar. Exh., 1929 (prize); Robineau Mem. Cer. Exh., 1934 (prize). Work: Herron AI, Indianapolis; A. Gal., Richmond, Ind.; Ball State T. Col., Muncie, Ind. In 1911 she established Overbeck Pottery with her sisters. Their craft work was in applied arts with glaze inlay and carving, entirely original as to form, glaze and decoration.

OVERBECK, Hannah Borger [P,C] Cambridge City, IN b. Cambridge City d. 28 Ag 1931. Member: Cincinnati Women's AC. Exhibited: Ind. State Fair, 1920–30 (prizes). Work: Herron AI. Co-founder of Overbeck Pottery. Sister of Mary and Elizabeth. [25]

OVERBECK, Margaret [P] Greencastle, IN [13]

OVERBECK, Mary Frances [C,P,Des] Cambridge City, IN b. 28 Ja 1878, Cambridge City d. 20 Mr 1956. Studied: Ind. State Normal Sch.; A.W. Dow. Member: Women's AC, Cincinnati; Am. Cer. Soc.; Palette C. Exhibited: Ind. State Fair, 1920 (prize), 1932 (prize), 1933 (prize), 1934 (prize), 1936 (prize), 1939 (prize); Ind. Ar. Exh., 1928 (prize), 1929 (prize); Robineau Mem. Cer. Exh., 1934 (prize); Ind. Fed. AC, 1936 (prize). Work: John Herron AI, Indianapolis; A. Gal., Richmond, Ind.; Ball State T. Col., Muncie, Ind. Contributor: Bulletin Am. Cer. Soc. Sister of Hannah and Elizabeth. Position: Operator/Owner, Overbeck Pottery [47]

OVERBY, Marion [S] Bloomfield Hills, MI. Work: USPO, Mason, Mich. WPA artist. Position: Affiliated with Cranbrook Acad. A., Bloomfield Hills [40]

OVERHARDT, William [P] NYC [15]

OVERLAND, Cora (Burus) [S] Boston, MA b. 6 N 1882, Boston. Studied: J. Wilson; C. Grafly. Member: Copley S.; Boston AC. Work: H.S., Braintree, Allston, Scituate, Abington, Harwichport, all in Mass.; many portraits and garden dec. [47]

OVERTON, Katherine [P] Laguna Beach, CA. Member: Calif. AC [25]

OVERTON, Nan [P] Fort Worth, TX [24]

OVIATE, Anna P. [P] Cleveland, OH [01]

OVRYN, Benjamin S. [P] Flushing, NY/Piermont, NY b. 3 O 1892, Russia. Studied: Ladisenski. Member: S.Indp.A.; Alliance; Salons of Am. [33]

OWEN, Charles H. (Mrs.) [P] Hartford, CT. Member: Hartford AS [25]

OWEN, Charles Kent [P] Chicago, IL [01]

OWEN, Clara B. [P] NYC [01]

OWEN, Esther S.D. (Mrs. Charles H.) [P] Hartford, CT b. 19 S 1843, Boston d. 20 S 1927. Studied: Votin; Geary; Tuckerman. Member: CAFA; Hartford ACS. Work: WMA [27]

OWEN, Michael G., Jr. [S,P,C,I] Greenbelt, MD b. 2 My 1915, Dallas. Studied: Dallas AI. Member: Soc. Wash. A. Exhibited: Dallas Mus. FA, 1937 (prize); Kansas City AI, 1938; Soc. Wash. A., 1944; Times-Herald Art Fair, 1944; BMA, 1945. Illustrator: U.S. Navy, WWII. Position: Des., Southern Potteries, Dallas [47]

OWEN, Robert Emmett [P] NYC b. 30 Ja 1878 d. 14 S 1957, New Rochelle, NY. Studied: Pape; Mulhaupt; Ochtman. Member: Greenwich SA. Exhibited: NAD; PAFA; CGA; AIC; CAFA. Work: Bruce Mem. Mus.; Pub. Lib., Greenwich, Conn. Illustrator: Scribner's, Harper's, Century [40]

OWEN, William B., Jr. [P] Chicago, IL. Member: Chicago NJSA [25]

OWENS, L.L. [P] Columbus, OH [13]

OWENS, R.W. (Mrs.) [P] Jeffersontown, KY. Member: Louisville AL [01]

OWINGS, Edna M. [P,T] Columbus, OH [10]

OWINGS, Thomas Bond [P] Baltimore, MD. Member: Baltimore WCC [29]

OWLER, Martha Tracy (Mrs.) [W,Cr] NYC b. 1853, Port Deposit, IN d. 3 O 1916. Positions: Staff, Leslie's, 1880s; Foreign Rep., Boston Herald, 1891; Staff, Fifth Ave. A. Gal. (auctioneers), 1904–16

OWLES, Alfred [P,I] Fairfax, CA b. 4 Jy 1898, Nottingham, England. Studied: Nottingham Sch. A. Exhibited: Gal. FA, San Diego; Gumps', San Fran. Specialty: airplanes [40]

OWSLEY, Leonora [P] Rydal, PA [17]

OZENFANT, Amedee J. [L,W,T,P] NYC b. 15 Ap 1886, Saint Quentin, France d. 4 My 1966, Cannes, France. Studied: France. Member: Fed. Mod. P., Authors & S. Exhibited: Legion d'Honneur, France, 1922; CI, 1935, 1936; WFNY, 1939. Work: MMA; AIC; SFMA; Luxembourg Mus., Paris; Providence, R.I.; Moscow; Phila. Contributor: "L'Encyc. Française," 1935, "L'Encyc. Photo. de L'Art," 1936, "Modern Art." Editor: "L'Esprit Nouveau." Positions: L, French Inst., Univ. Paris, 1936–38, Univ. Wash., 1938–39, New Sch. Soc. Res., N.Y., 1938–39, Univ. Mich., 1940, Yale, 1938–41, CUASch, 1939–40, Harvard, 1941; Hd., Ozenfant Sch. FA, NYC, 1939– [47]

OZIER, Ken(neth) (H.) [P,E,Li,Des,W,B,Dec] Cincinnati, OH b. 12 F 1905, Cincinnati. Studied: Univ. Cincinnati; Cincinnati A. Acad.; PAFA; George Washington Univ.; L. Kroll; B. Miller; H.H. Wessel; John E. Weis; Frank Meyers; George Harding; Roy C. Nuse; Francis Speight. Member: Cincinnati Prof. A.; Cincinnati Crafters; Cincinnati AC; Crafters Cl.; Ohio WCS. Exhibited: PAFA (prize); Wash., D.C. Open-Air Show, 1944 (prize); Los Angeles Mus. A., 1936; Northwest Pr.M., 1941; Southern Pr.M., 1935, 1941; AIC, 1939, 1940; Ohio Pr.M., 1935, 1941; Ohio WC Soc., 1935–39; PAFA, 1940; F., PAFA, 1931–40; Wash. WCC, 1942, 1943; PMG, 1942; CM, 1938–41; Wash., D.C. Open-Air A. Exh., 1944. Work: murals, Woodward H.S., Union Central Annex Bldg., Pub. Lib., Am. Red Cross, all in Cincinnati; etching, Old Kentucky Home Mus., Bardstown, Ky.; Univ. Cincinnati. Illustrator: "Primitive & Pioneer Sports," 1937 [47]

OZMUN, Donald, Mrs. See Little, Pauline Graff.

P

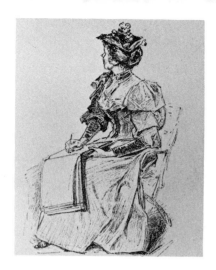

Victor Perard: *A Fair Artist*. From *The Illustrator* (1894)

PAAS, Emilie. See Van Der Paas.

PACELLI, Vincent [P] Brooklyn, NY. Exhibited: 48 Sts. Comp., 1939 [40]

PACH, Magda F. [P,Por.P,Li,Dr] NYC b. 29 Ja 1884, Dresden, Germany d. 9 N 1950. Studied: Nat. Acad., Mexico City; J. Marchand, in Paris; E. Stauffer. Member: S.Indp.A. (Dir.); N.Y. Soc. Women Ar. (Pres.)[47]

PACH, Walter [E,Mur.P,P,W,L,Cr] NYC b. 11 Jy 1883, NYC d. 27 N 1958. Studied: CCNY; Paris; W. Chase; R. Henri; L. Hunt. Member: S.Indp.A. Exhibited: U.S. Work: MMA; WMAA; BM; CMA; PMG; CI; Newark Mus.; The Louvre, Paris; mural, CCNY; NYPL. Contributor: articles, Scribner's, Century, Harper's, Gazette des Beaux Arts. Author: "The Masters of Modern Art," "Georges Seurat," "Modern Art in America," "Ananias or the False Artist," "R. Duchamp-Villon," "An Hour of Art," "Vincent van Gogh" (1936), "Queer Thing, Painting," "Ingres" (1939). Translator: "History of Art," by Elie Faure (5 vols., 1921–30), "The Journal of Eugene Delacroix" (1937). Positions: T.,Columbia, NYU; Dir., Masterpieces of Art, WFNY, 1939 [47]

PACHL, Delmar Max [S,Des,G,T] Arlington, TX/Kansas City, MO. Studied: W. Rosenbauer; T.H. Benton; J. deMartelly; J. Meert; R. Braught; M.W. Hammond. Member: Co-op Ar. Assn., Kansas City. Exhibited: sculpture, Kansas City AI, 1938 (prize). Position: T., North Tex. Agricultural Col. [40]

PACKARD, Alton [Car,L] b. 1870 d. 29 Ag 1929, Oklahoma City. Cartoonist/Artist: Minneapolis Journal, Chicago Times, other newspapers. Also a writer of songs.

PACKARD, Mabel [Min.P] South Pasadena, CA b. Iowa. Studied: AIC; Acad. Colarossi, Mme. La Forge, in Paris. Member: Chicago SA. Exhibited: St. Louis Expo, 1904 (med) [33]

PACKER, A.S. [I,Por.P] Mt. Vernon, NY b. 27 S 1907, Chicago. Studied: AIC; Acad. Julian, Acad. Colarossi, both in Paris. Member: SI. Illustrator: American Weekly [47]

PACKER, Clair Lange (Mr.) [I,Car,P,Des] San Antonio, TX b. 27 Ag 1901, Gueda Springs, KS. Studied: W.L. Evans Sch. Car.; H.A. DeYoung; Univ. N.Mex.; M. Sheets; B. Miller; J. Imhof; K. Adams. Member: Tex. FA Assn; SSAL. Exhibited: Houston MFA, 1939. Cartoonist: The Valley Morning Star [47]

PACKER, Francis H(erman) [S] Rockville Center, NY b. 1873, Munich, Germany d. 13 Jy 1957. Studied: P. Martiny. Work: statues, Raleigh, Wilmington, both in N.C.; equestrian, Milwaukee, Wis., Greensboro, N.C.; mem., Swope Park, Kansas City, Mo.; relief, Walt Whitman Bushwich H.S., Brooklyn, N.Y.; Congressional medal to Byrd Antarctic Expedition [40]

PACKER, Frederick L. [P,Car] NYC d. ca. 1958. Member: GFLA [27]

PACKMAN, Frank G. [P,I,E,L] Huntington Woods, MI b. 5 Je 1896, England. Studied: Detroit Sch. FA; P. Honoré; J.P. Wicker. Member: Scarab Cl., Detroit; Mich. Soc. A., Sc.&L. Exhibited: Scarab Cl., Detroit; Detroit Inst. A.; Univ. Mich. [47]

PADDEN, Peggy Emily [P] East Seattle, WA [24]

PADDOCK, Ethel Louise [P] NYC b. 19 Ap 1887, NYC. Studied: N.Y. Sch. A.; Henri; J. Sloan. Member: S.Indp.A.; NAWPS; PBC; NYSWA. Exhibited: PBC, 1934 (prize); NAWPS, 1929 (prize), 1932 (prize) [40]

PADDOCK, J(osephine) [P,Por.P,T,L,Des,W] NYC b. 18 Ap 1885, NYC. Studied: ASL; K. Cox; W. Chase; J. Alexander; Henri. Member: AWCS; All.A.Am.; CAFA; New Haven PCC; Springfield A. Lg.; North Shore AA; Gloucester SA; Soc. Wash. A. Exhibited: BM, 1935 (prize); New Haven PCC, 1935 (prize); CAFA, 1937 (prize); AWCS, 1946 (prize); CGA; PAFA; NAD; AIC; All.A.Am.; C.L. Wolfe AC, 1937 (prize). Contributor: article, Contemporary Club's "Club Dial" [47]

PADDOCK, Robert Rowe [Ldscp.P,Des] NYC b. 12 Ag 1914, Mansfield, OH. Studied: Cleveland Sch. A.; Western Reserve Univ. Exhibited: Detroit Ar. Market, 1939; CGA, 1937; Butler AI, 1937; CMA, 1934–37. Designer: theatrical prod., "Pinocchio," 1939 (ballet), "Robin Hood," 1940. Position: Theatrical Des., Junior Programs, Inc., NYC [47]

PADDOCK, Royce [P] NYC. Member: Lg. AA [24]

PADDOCK, Thelma [P,T] Los Angeles, CA b. 6 N 1898, Indiana. Studied: Otis AI; AIC; J.F. Smith. Member: ASL, Chicago; Southern Calif. AC [24]

PADDOCK, Willard D. [S,P,] South Kent, CT b. 23 O 1873, Brooklyn, NY d. 25 N 1956. Studied: PIASch; H. Adams; Courtois, Griardot, in Paris. Member: ANA; Century Assn.; NSS, 1915; A. Aid S. Work: New Milford (Conn.) H.S.; BM; Amherst Col.; Univ. Calif.; mem., Stratford, Conn. [47]

PADELFORD, Morgan [P,S,T] Pasadena, CA b. 10 O 1902, Seattle, WA. Studied: Hopkinson; Isaacs; H. Hoffman; A. Lhote. Member: Seattle AI; Northwest PM. Exhibited: oil, Northwest Ar. Exh., 1923 (prize). Work: bas-relief in cast stone, Chamber of Commerce Bldg.; Univ. Wash., Seattle. Position: Affiliated with Art Dept., Technicolor Motion Picture Corp. [40]

PAEFF, Bashka (Mrs. Waxman) [S,L,T] Cambridge, MA b. 12 Ag 1893, Minsk, Russia. Studied: BMFA Sch.; B. Pratt; N. Aronson, in Paris. Member: Gld. Botson A.; Boston Soc. A.&Crafts. Exhibited: Tercentenary Expo, Boston, 1933 (med). Work: State House (Boston); mem., Kittery (Maine); fountains, Westbrook (Maine), Ravina (Ill.), Stoughton (Mass.), Chestnut Hill (Mass.); Birmingham, Ala.; MIT; Harvard; busts, BMFA, Univ. Buenos Aires; bas-reliefs, Boston Psychopathic Hospital, Fernald State Sch., Waverly (Mass.), Rockefeller Inst. (N.Y.), Princeton Inst. (N.J.). Perkins Inst. for the Blind, Watertown (Mass.) [47]

PAGAN, Jack [P] Houston, TX. Exhibited: watercolor, SSAL, 1936 (prize) [40]

PAGE, Charles Jewett [P] Boston, MA [08]

PAGE, E.A. [P] Lynn, MA [08]

PAGE, Elizabeth Amie [P,Li, Des] Phila., PA b. 27 F 1908, Brookline, MA. Studied: ASL; BMFA Sch.; A. Brook. Member: Phila. A. All.; Phila. Pr. Cl. Exhibited: Phila. Pr. Cl., 1943 (prize); PAFA, 1938, 1939, 1943; NAD, 1943; LOC, 1943, 1944; Northwest Pr. M., 1944; Boston Indp. Exh., 1938; Phila. A. All., 1943 (one-man); Butler AI, 1939, 1940, 1944; NAWPS [47]

PAGE, Grover [Car,En] Louisville, KY b. 10 N 1892, Gastonia, NC d. 5 Ag 1958. Studied: AIC; Chicago Acad. FA. Member: SSAL; Southern Pr.M.; Ind. Pr. M.; Louisville AC; AFA; Louisville AA; Southern AA. Exhibited: SSAL, 1939 (prize), 1940 (prize). Work: Huntington Lib., San Marino, Calif.; Univ. Louisville. Positions: Editorial Car., Nashville Tennessean (1917–19), Courier-Journal, Louisville, (1919–) [47]

PAGE, Josephine [P] Wash., D.C. Studied: PAFA [25]

PAGE, Katherine S(tuart) [P,Min.P] Wash., D.C./Berryville, VA b. Cambridge, MD. Studied: Phila. Sch. Des. for Women; Margaretta Archambault. Member: Wash. Soc. Min.PS&G [40]

PAGE, Marie D(anforth) (Mrs. Calvin G.) [Por.P] Boston, MA b. Boston d. 3 Mr 1940. Studied: BMFA Sch. Member: ANA; Boston Gld. A. Exhibited: P.-P. Expo, San Fran., 1915 (med); PAFA, 1916 (prize); NAD, 1916 (prize), 1923 (prize), 1928 (prize); Duxbury AA, 1920 (prizes); Grand Central Gal., 1928 (prize); Newport AA, 1921 (prize); Sesqui-Centenn. Expo, Phila., 1926 (med); Springfield AA (prize). Work: portraits, Mt. Holyoke Col., Harvard Medical Sch., Peter Bent Brigham Hospital (Boston), Brooklyn, N.Y. Medical Soc., Lib. Sch., Univ. Wis.; Mus. and Art Gal., Reading, Pa.; Springfield (Ill.) AA; Art Mus., Montclair, N.J. [38]

PAGE, Walter Gilman [P,Por.P,W] Nantucket, MA b. 13 O 1862, Boston d. 24 Mr 1934. Studied: BMFA Sch.; Boulanger, Lefebvre, in Paris. Member: Portland SA; Springfield AS; AFA; Mass. State Art Commission; Boston Commission on Historic Sites. Exhibited: Paris Salon, three seasons; U.S. Work: TMA; Art Mus., Portland, Maine; portraits, Mass. State House, Portland (Maine) City Hall, Bowdoin Col., Maine Hist. Soc., Colby Col., Vt. State House, Worcester (Mass.) Pub. Lib., Fall River (Mass.) Publ Lib., Lowell (Mass.) City Hall, Dracut Pub. Lib., Tufts Col. Organizer: Public School Art Lg. [33]

PAGES, Jules [P,T] Paris, France b. 1867, San Fran. d. 22 My 1946, San Fran. Studied: Constant, Lefebvre, Robert-Fleury, in Paris. Member: Intl. Soc. Paris SP. Exhibited: Paris Salon, 1895 (prize), 1899 (med), 1905 (med). Award: Knight of the Legion of Honor, 1910. Work: Mus. Pau, France; Mus. Toulouse, France; Luxembourg, Paris; Golden Gate Park Mus. and Art Inst., San Fran.; Municipal Art Gal., Oakland, Calif. Position: T., Académie Julian, Paris (night class since 1902; life class since 1907) [40]

PAGET-FREDERICKS, Joseph Rous-Marten [I,W,Des,L,P,T] Berkeley, CA b. 22 D 1905, San Fran. d. 20 Ap 1963. Studied: Univ. Calif; Europe; L. Bakst; J.S. Sargent. Member: Los Angeles Mus. Assn.; Am. Soc. P.&S.; Grand Central A. Gal. Exhibited: Berlin, Germany, 1936 (prize); Stanford Univ., 1935 (prize); AIC; NYPL; Europe; South America. Work: Mills Col., Oakland, Calif.; Univ. Calif; collections in London, Paris, Rome, Venice. Author/Illustrator: "Green Pipes" (1929), "Anna Pavlova" (pub. in Paris), "Pavlova's Impressions," "Atlantis," "The Human Body in Rhythmic Action," "Red Roofs and Flowerpots," "Miss Pert's Christmas Tree," "The Paisley Unicorn," other books. Illustrator: "Selected Poems of Edna St. Vincent Millay" (1929), "The Macaroni Tree," (by Dora Amsden), other books. Positions: T., Calif. Col. A.&Crafts, Oakland, Fashion Art Sch., San Fran.; L., Univ. Calif. [47]

PAGON, Katharine Dunn (Mrs. William) [P] Baltimore, MD b. 25 D 1892, Phila. Studied: PAFA; Johns Hopkins Univ.; Columbia; Barnes Fnd.; Breckenridge. Member: Municipal A. Soc., Baltimore; NAWA; Friends of Art. Exhibited: NAWPS, 1936 (prize); Alumni, Springside, Phila., 1936 (gold), 1939 (gold); BMA; PAFA; NAD; CGA; PMG; Sweat Mem. Mus. Work: PAFA [47]

PAICE, Philip Stuart [P] Denver, CO [17]

PAIN, Louise (Carolyn) [S] Chicago, IL b. 14 Jy 1908, Chicago. Studied: E.R. Zettler. Exhibited: Ar. Chicago and Vicinity, AIC, 1933 (prize) [40]

PAIN, W. Boyse [P] Wash., D.C. [25]

PAINE, A.B. [I] NYC. Affiliated with R.H. Russel & Co., NYC [01]

PAINE, Joseph Polley [P,Li,En,E,Des,T] Austin, TX b. 25 Jy 1912, Llano, Tex. Studied: Tex. A.&I. Col.; ASL; San Antonio AI; Kansas City AI; Univ. Tex.; O'Hara Sch. Member: Bonner G. A. Cl. Exhibited: Oakland A. Gal., 1946; PAFA, 1938; San Fran. AA, 1938; San Antonio, Tex., 1946 [47]

PAINE, May [P] Charleston, SC b. 7 My 1873, Charleston. Studied: Leith-Ross; F. Chase; Gruppe; A. Hutty; I. Summers. Member: SSAL [33]

PAINE, Richard G. [S] East Falls Church, VA b. 15 F 1875, Charleston, SC. Studied: Amateis; Kemeys [21]

PAINE, Robert [S] San Fran., CA b. 1870, Valparaiso, IN d. 16 Ja 1946, Hollywood, CA. Studied: Chicago; ASL. Member: The Cornish (N.H.) Colony. Lived in West Hoboken, N.J. (1893-1914), then moved to San Fran. [15]

PAIPERT, Hannah [Por.P] Dorchester, MA/Sharon, MA b. 25 Ap 1911, Boston. Studied: R. Lahey [40]

PAIST, Henrietta Barclay [P] St. Paul, MN [15]

PALANCHIAN, Enid. See Bell.

PALANSKY, Abraham [P,S] Los Angeles, CA b. 1 Jy 1890, Lodz, Poland. Studied: AIC. Member: Los Angeles WC Soc.; NJSA, Chicago. Exhibited: AIC, 1940, 1941 (prize), 1942-44, 1945 (prize); Nat. A. Week, Chicago, 1940; Ill. State Mus., 1940; NJSA, Chicago, 1941, 1942; Los Angeles Mus. A., 1943, 1944 (one-man), 1945; Oakland A. Gal., 1944; SFMA, 1944; Riverside Mus., 1946 [47]

PALENSKE, Reinhold H. [E,P,I] Woodstock, IL b. 4 O 1884, Chicago d. 29 D 1954. Studied: AIC, with W. Reynolds. Member: Chicago SE. Exhibited: Chicago SE, 1945 (prize); Smithsonian Inst. (one-man); Municipal A. Gal., Oakland, Calif.; LOC. Work: LOC; NYPL; Royal Gal., London, England. Illustrator: The Spur, Washington Star, Chicago Daily News [47]

PALEOLOGUE, Jean [P] b. 1860, Romania (came to U.S. in 1900) d. 24 N 1942, Miami, FL. Studied: Paris

PALEY, Robert L. [I] Boston, MA (1923). Active in Colorado Springs, 1890s-1906. Illustrator: Saturday Evening Post; "Myths and Legends of Colorado," by. L.M. Smith, 1906 [*]

PALFREY, Elizabeth G.R. (Mrs.) [E] New Orleans, LA [19]

PALL, Augustin G. [Por.P,Mur.P] Chicago, IL b. 12 Jy 1882, Hungary. Studied: E. Ballo, A. von Wagner, F. von Stuck, in Munich; Lefebvre, in Paris. Work: murals, Church of St. Ignatius of Loyola, St. Sebastian Church, Solomon Temple, all in Chicago [24]

PALLADINO, Miles [P] Cleveland, OH b. 9 Ja 1908, Cleveland. Exhibited: CMA, 1933, 1939 [40]

PALLESER, Robert [E] Brooklyn, NY [27]

PALMEDO, Lillian Gaertner (Mrs. Harold B.) [P,Mur.P,I,Dec,Des] New Milford, CT b. 5 Jy 1906, NYC. Studied: Viennese Kunstgewebeschule and Acad., with J. Hofmann, F. Schmutzer. Member: Arch. Lg. Work: murals, Montmartre Cl., Palm Beach, Fla; Ziegfeld Theatre, Maritime Exchange Bldg., Hotel Essex, Hotel Taft, Plaza Hotel, Pennsylvania Hotel, Paradise Night Cl., all in NYC; American Asphalt Co., Chicago; Hotel Van Cleves, Dayton, Ohio; Standard Brands Pavilions, WFNY, 1939; Princeton Inn, N.J.; Regal Theatre, Phila.; dec. fabrics, Patio Room, Radio City, NYC; sketches for Ziegfeld Theatre and costumes for Metropolitan Opera productions, Vienna Mus. Theatre Coll. [40]

PALMER, A. Lucile [E,S,L,T] Reno, NV b. 20 Ap 1910, NYC. Studied: F.V. Guinzburg; E. Fraser; M. Young; G. Lober; H. Paul; A. Picirilli; E. Morahan; M. Gage; G. Luken. Member: AAPL; Art Centre of the Oranges; San Fran. Soc. Women A.; Santa Monica Art Soc. [38]

PALMER, Adaline Osburn [Min.P,Por.P,T] Rippon, VA b. 1817, Rippon d. 1906. Active in Fauquier County, Va., Mobile, Ala., and Richmond, Va. [*]

PALMER, Adelaide [P] Boston, MA/Piermont, NH b. Orford, NH. Studied: J.J. Enneking. Member: Copley S., 1893 [31]

PALMER, Allen Ingles [P,I,Car] Roanoke, VA b. 11 D 1910, Roanoke d. 1950. Studied: PMSch.A; G. Demetrios; W. Biggs; H. Hensche; Corcoran Sch. A. Member: AWCS; SC; Audubon A.; NYWCC; Beachcombers' Cl.; A. Assn., Provincetown. Exhibited: Roanoke, 1940 (prize); Roanoke A. All., 1941 (prize); AIC, 1940, 1945; Audubon A., 1945; AWCS, 1939-46; MMA, 1941; SC, 1942, 1946; VMFA; New Britain Mus.; NYWCC, 1937. Contributor: This Week, Rotarian [47]

PALMER, Arthur W. [P,Car,E,T] Woodacre, CA b. 27 N 1913, Chicago. Studied: Chouinard AI; F.T. Chamberlin. Member: Pasadena SA. Exhibited: Los Angeles AA, 1934 (prize); PAFA, 1933, 1935, 1936; Miss. AA, 1944; AWCS, 1944; Oakland A. Gal., 1944; San Francisco AA; Los Angeles County Fair, 1933; San Diego FA Soc., 1934; Los Angeles Mus. A., 1935; Pasadena SA, 1935, 1938; Portland (Oreg.) Mus. A., 1944. Position: Car., Walt Disney Productions Ltd., Hollywood [47]

PALMER, Delos, Jr. [P] NYC b. 1891 d. 4 My 1961, Stamford, Conn. [19]

PALMER, Elizabeth. See Bradfield, Mrs.

PALMER, Erastus Dow [S,T] Albany, NY (since 1846) b. 2 Ap 1817, Pompey, NY d. 9 Mr 1904. Studied: self-taught. Member: NA, 1849; NSS. Exhibited: Phila. Centenn. Expo, 1876 (med). At first an expert joiner and patternmaker, then a cameo cutter in Utica. His first important piece of sculpture, "The Infant Ceres," was exhibited at the National Academy of Design, in 1850. Work: Albany Inst. He made many ideal figures and, in 1874, executed the statue of Chancellor Robert R. Livingston, of New York, for the Capitol at Washington. Best known for his "White Captive," 1859 (at MMA).

PALMER, Frederick Woodbury [P] Phila., PA [04]

PALMER, Fredrikke S(chjöth) (Mrs.) [P] Honolulu, HI b. 26 My 1860, Drammen, Norway. Studied: K. Bergslien, in Christiania (now Oslo); C. Gussow, in Berlin. Member: New Haven PCC. Position: Staff Ar., Woman's Journal [29]

PALMER, George S. [Patron] b. ca. 1852 d. ca. 1930, Lake Wales, FL. For nearly half a century he had been a collector of Colonial art and antiques. In 1928 he donated what is known as the Palmer Collection of Americana to the Metropolitan Museum, New York.

PALMER, Hattie Virginia Young (Mrs. C.F.) [P,T] Houston, TX b. Ripley, OH. Studied: Cincinnati Art Acad. Member: Houston AL; Ind. AA; Ind. State Keramic Cl.; Tex. FAA; AAPL; SSAL [33]

PALMER, Herbert James [I] Westmont, NJ b. 22 Jy 1910, Phila. Studied: Phila. Public Indst. Art Sch. Position: affiliated with Public Ledger, Phila. [31]

PALMER, Hermione [I] Glendale, CA. Member: SI [47]

PALMER, Herman [P,S,I,E] NYC b. 17 Mr 1894, Farmingham, Utah. Studied: M. Young. Member: NYWCC. Illustrator: "Hidden Heroes of the Rockies" [29]

PALMER, Jessie (Mrs. Carl E.) [P,S,T] Dallas, TX b. 19 O 1882, Lawrence, TX. Studied: Dallas Tech. Col.; Broadmoor A. Acad.; J. Carlson; F. Reaugh; M. Simkins. Member: SSAL; Tex. FA Assn.; Amarillo AA; Reaugh AC; Dallas PB Women. Exhibited: Dallas Women's Forum, 1924 (med); Tex.-Okla. Fair, 1926 (prize), 1927 (prize); Tex. FAA, [Nashville, Tenn.] 1929 (prize), 1930–40; SSAL, 1928, 1934, 1944, 1945; Elisabet Ney Mus., 1935 (one-man); Tex. State Fair, 1934; Frank Reaugh A. Exh., 1925–46; Dallas AA, 1940. Work: Travis Sch., Dallas; Dallas Women's Forum. Position: Sec., Frank Reaugh AC, Dallas, 1944–46 [47]

PALMER, Julia B. [P] NYC [04]

PALMER, Lemuel [I,D,L] Springfield, MA b. 1 N 1893, Portland, ME. Studied: R. Andrews; Mass. Sch. A. Exhibited: Springfield A. Gld., 1927 (prize), 1928 (prize) [33]

PALMER, Lucie Mackay [P,L] NYC b. 23 My 1913, St. Louis, MO. Studied: BMFA Sch.; Washington Univ., St. Louis; ASL, with R. Soyer, J.M. Newell. Member: NAWA; St. Louis A. Gld. Exhibited: NAWA, 1944 (prize), 1945, 1946; AMNH, 1943 (one-man); Boston Mus. Nat. Hist., 1942; St. Louis A. Gld., 1934–46 [47]

PALMER, Lucile. See Wyman.

PALMER, Margaret Longyear [S,C,T] Grosse Pointe Farm, MI b. 19 Ag 1897, Detroit. Studied: J. Wilson. Member: Detroit SAC; Detroit Soc. Women P. Exhibited: Mich. State Fair, 1921 (prize); garden sculpture, Detroit, 1935 (prize) [40]

PALMER, Mildred Trumbull [Bookbinder,L] Cambridge, MA b. 11 F 1890, Cambridge. Studied: H. Noulac, E. Maylandor, in Paris. Member: Boston Soc. A.&Crafts; Book in Hand Gld., Boston [47]

PALMER, Minette D. (Mrs.) [P] Cincinnati, OH. Member: Cincinnati Women's AC [25]

PALMER, Pauline (Mrs. Albert E.) [P,Por.P] Chicago, IL/Provincetown, MA b. McHenry, IL d. 15 Ag 1938. Studied: AIC, with Chase, Miller, Hawthorne; Collin, Prinet, Courtois, Simon, in Paris. Member: Chicago PS; Chicago AC; Chicago Gal. Assn.; Grand Central Gal.; Nat. Pen Women's Lg. of Am.; Provincetown AA. Exhibited: St. Louis Expo, 1904 (med); AIC, 1907 (prizes), portrait (1914), 1916 (prizes), 1917 (prize) 1920 (prize); 1924 (prize), 1926 (prize), 1937 (prize); SWA, 1915 (prize); Chicago AG, 1915 (prize); Chicago SA, 1920 (med); Peoria, Ill., (med); NAWPS, 1924 (prize); Chicago Gal. Assn., 1928 (prize), 1929 (prize), 1931 (prize), 1936 (gold); Findley Gal., 1935 (med). Work: West End Women's Cl.; Municipal Art Lg. Coll.; AIC; Arché Cl., Chicago; Decatur (Ill.) Pub. Sch. Coll.; Muncie (Ind.) AA; Chicago Municipal Commission; Aurora (Ill.) A. Lg.; Aurora (Ill.) AA; Rockford (Ill.) AA; Springfield (Ill.) AA; Delgado Mus. A.; San Diego Gal. FA; Acad. FA, Elgin, Ill. [38]

PALMER, R. [P] NYC [15]

PALMER, Samuel M. [P] Phila., PA. Member: Phila. AC [25]

PALMER, Sarah [P] Phila., PA [06]

PALMER, Solveig [P] West Hempstead, NY b. 7 S 1894, Morris, MN. Studied: Barnard Col., ASL. Studied: G. Luks; J. Sloan. Member: NAWPS; ASL. Exhibited: Montross Gal., N.Y. [40]

PALMER, Walter L(aunt) [Ldscp.P] Albany, NY b. 1 Ag 1854, Albany d. 16 Ap 1932. Studied: F.E. Church; Carolus-Duran, in Paris. Member: ANA, 1887; NA, 1897; SAA, 1881; NYWCC; AWCS; SC, 1901; Pastel; Century Assoc.; AFA; Union Intl. des Beaux-Arts et des Lettres; N.Y. State Fine Arts Commission. Exhibited: NAD, 1887 (prize); Columbian Expo, Chicago, 1893 (med); Phila. AC, 1894 (gold); AWCS, 1895 (prize); Boston, 1895 (prize); Tenn. Centenn. Expo, Nashville, 1897 (prize); Paris Expo, 1900 (prize); watercolors, Pan.-Am. Expo, Buffalo (1901/med) Charleston Expo (1902/med), St. Louis Expo (1904/med); oil, St. Louis Expo, 1904 (med); Phila., 1907 (med); Buenos Aires Expo, 1910 (med); AIC, 1919 (prize); Wilmington, 1926 (prize), 1928 (prize). Work: Buffalo FA Acad.; Pub. Gal., Richmond, Ind.; Omaha (Nebr.) Art Soc.; Mem. Art Gal., Rochester, N.Y.; MMA; Art Mus., Youngstown, Ohio; BMFA. Son of Erastus. [31]

PALMER, William C. [Mur.P,L,T] Clinton, NY b. 20 Ja 1906, Des Moines, IA. Studied: ASL; Ecole des Beaux-Arts, Fontainebleau, France; K.H. Miller; B. Robinson; T. Benton; M. Baudouin. Member: Am. Soc. PS&G; Am. A. Cong; NSMP; Audubon Soc. Exhibited: Paris Salon, 1937 (gold); NAD, 1946 (prize); CGA; VMFA; CI; BM; AIC; TMA; WMAA; MOMA; Kansas City AI. Work: WMAA; AGAA; White House, Wash., D.C.; MMA; Cranbrook Acad. A.; Encyclopaedia Britannica Coll.; AAAL; murals, USPO Dept. Bldg. (Wash., D.C.), USPO (Arlington, Mass.), Queens General Hospital (Jamaica, N.Y.); Mus. City of N.Y. Contributor: American Artist. WPA artist. Positions: T., ASL; Dir., Munson-Williams-Proctor Inst., Utica, 1941– [47]

PALMERTON, Don F. [Mar.P,Ldscp.P] Hollywood, CA b. 12 Jy 1899, Chicago. Studied: J.C. Abbott; A.C.M. La Farge, M.E. Davis, in Paris. Member: Calif. AC [40]

PALMGREEN, Charles J. [P] Versailles, PA. Member: Pittsburgh AA [25]

PALMIE, Rosalie [P] Utica, NY b. Hamburg, Germany. Studied: Académie Julian, Paris, with Laurens, Constant; Berlin. Exhibited: Académie Julian (prize) [01]

PALOWETSKI, C(harles) E. [P] Paris, France b. 1 S 1885, New York. Studied: Bonnât, in Paris [15]

PALUMBO, Alphonse [P,S] NYC b. 14 N 1890, Raito, Italy. Studied: ASL; NAD; E. Speicher; F.L. Mora; DuMond. Member: A. Fellowship, Inc. Exhibited: All.A.Am.; NAD

PANCOAST, Henry B(oller), Jr. [P] Phila., PA b. 24 Je 1876, Phila. Studied: PAFA; Drexel Inst. Member: Phila. AC [25]

PANCOAST, Morris Hall [P,I,Car] Rockport, MA b. 27 Ap 1877, Salem, NJ. Studied: PAFA, with Anshutz; Académie Julian, Paris, with Laurens. Member: CAFA; SC; Phila. Sketch Cl. Exhibited: PAFA, 1924 (gold); CGA; NAD; Baltimore Charcoal Cl.; GGE, 1939; Gloucester SA; Rockport AA. Work: Williamsport (Pa.) Municipal A. Lg., PAFA; Reading (Pa.) Mus.; Williamsport Lib.; Speed Mem. Mus.; Mus. FA, Houston; Milwaukee AI

PANDICK, John [P] NYC [15]

PANDOLFINI, Joseph Paul [P,C,I] NYC b. 6 Je 1908, Italy. Studied: NAD, 1925–30; Royal Acad. FA, Italy, 1933. Exhibited: Musée du Jeu de Paume, Paris, 1938; AIC, 1939; MOMA; MMA; CGA; SFMA; WMAA, 1940; NAD, 1950. Work: Univ. Minn. Represented by Julien Levy Gal., NYC, 1934–36; Downtown Gal., 1937–40. Position: T., Brooklyn Mus. Sch., 1947–48 [47]

PANKE, Edith (Mrs. Felix Curt) [P] NYC. Exhibited: NAWPS, 1935–38 [40]

PANSING, Fred [Mar.P,Li,Photogr] b. 1854, Bremen, Germany (came to NYC ca. 1865) d. 1912, Jersey City. Member: Hoboken Sketch C. Work: Mariners' Mus.; Mystic Seaport Mus.; Peabody Mus., Salem. Was a sailor at age 16. Settled in Hoboken, N.J., 1872; then in Jersey City, 1890. Produced many ship portraits, which were published as chromolithographs for postcards, puzzles, and prints. Collaborated with Charles Parsons and Milton Burns. Most of his lithographs were made by Knapp & Co. and American Lithographic Co. [*]

PAOLO, C(artaino) S(ciarrino) [S] NYC/Boston, MA b. 29 Je 1882, Palermo, Italy. Studied: Am. Acad., Rome; FA Inst., Palermo. Work: busts, State House (Boston), Boston Cathedral; mem., Cathedral St. John the Divine, NYC; NYU; TMA; tablet, John Burroughs memorial field [21]

PAPASIAN, Jack (or Jacques) Charles [S,W] NYC b. 27 Je 1878, Olympia, Greece d. 1957. Studied: A.D. Zotto, in Venice; E. Ferrari, in Rome; Paris. Member: NSS. Work: Greek Government [47]

PAPE, Alice Monroe (Mrs. Eric) [P,I] Manchester-by-the-Sea, MA b.

Boston d. 17 My 1911. Studied: Bouguereau, Robert-Fleury, Lasar, in Paris; D. Bunker, G.H. Clements, in Boston. She played the piano and the double bass viol. Her sister was the wife of sculptor, George Grey Barnard. [10]

PAPE, Eric [P,I,T] Manchester-by-the-Sea, MA b. 17 O 1870, San Fran. d. 7 N 1938. Studied: E. Carlsen, in New York; Ecole des Beaux-Arts, Paris, with Gérôme, Constant, Lefebvre, Doucet, Delance. Member: United Arts Cl., Royal Soc. Arts, Atlantic Union, all of London; North British Acad.; Players Cl., NYC. Awards: medals and diplomas, various exh. Illustrator: "The Fair God," "The Scarlet Letter," "The Life of Napoleon Bonaparte," "Life of Mahomet," "Poetical Works of Madison Cawein." Contributor: portraits, "The Memoirs of Ellen Terry." Designer: mon., Stage Fort Park, Gloucester, commemorating founding of Mass. Bay Colony, 1623. Position: Dir., Eric Pape Sch. Art, 1898–1913 [38]

PAPE, George K. [P] Chicago, IL. Member: Chicago NJSA [25]

PAPE, Gretchen Anna (Mrs.) [P] Wilmette, IL b. 1866 d. 20 Ap 1947

PAPPAS, John L. [P] Detroit, MI b. 25 D 1898, Florina, Greece. Studied: J.P. Wicker. Member: Scarab Cl. Exhibited: watercolor, Mich. Ann. Exh., 1929 (prize); Mich. State Fair, 1930 (prize), 1932 (prize); Detroit AI, 1935 (prize); Scarab Cl., 1939 (gold). Work: Detroit Inst. A. [40]

PAPSDORF, Frederick [P] NYC b. 10 Je 1887, Dover, OH. Studied: Detroit Inst. A. Member: Progressive AC, Detroit. Work: CAM; PAFA; MOMA; Detroit Inst. A. [47]

PARADISE, Phil Herschel [P,Li,C,Des] Pasadena, CA b. 26 Ag 1905, Ontario, OR. Studied: Chouinard AI, 1927; F.T. Chamberlin; C. Hinkle; R. Lebrun; L. Kroll. Member: Calif. WC Soc.; Phila. WCC. Exhibited: GGE, 1939 (prize); Phila. WCC, 1943 (prize); AV, 1943 (prize); San Diego FA Soc., 1940 (prize); Pepsi-Cola, 1945 (prize); PAFA, 1941 (med); CI, 1943–45; CGA, 1942, 1944; AIC; PAFA; NAD; WMAA; SFMA; Los Angeles Mus. A.; San Diego FA Soc.; Denver A. Mus. Work: Cornell Univ.; San Diego FA Soc.; Univ. Calif.; Marine Hospital, Carville, La.; PAFA; Kansas State Univ.; Los Angeles County Fair. Illustrator: Fortune, other national magazines. Positions: T., Chouinard AI, 1936–40; Production Des., Motion Picture Studios, 1944–45 [47]

PARAMINO, John F. [S,W] Wellesley Hills, MA b. 25 D 1888, Boston. Studied: BMFA Sch. Member: Gld. Boston A.; Copley Soc. Exhibited: Mass. Horticultural Soc., 1929. Work: State House, Boston; Plymouth, Mass.; Hall of Fame, NYU; Boston Commons; Cambridge, Mass.; Boston Univ. Law Sch.; Harvard; Nantucket; U.S. Army; New Suffolk County Court House, Boston; Northampton, Mass.; Wellesley Col. Author: "Sculpture As A Medium of Expression," 1945 [47]

PARAVICINI, Lizette [P,C,T] Phila., PA b. 30 O 1889, Phila., PA. Studied: Univ. Pa.; PAFA; F. Linton; E. Horter; A. Carles. Member: A. All., Plastic Cl., WCC, A. T. Assn., all of Phila.; Woodmere AA. Exhibited: PAFA; Phila. WCC; Phila. Plastic Cl.; Woodmere A. Gal.; DaVinci All.; Phila. A. All. (one-man). Position: T., Kensington H.S., Phila., 1921– [47]

PARCELL, L. Evans [I] Washington, PA. Member: SI [31]

PARCELL, Malcolm Stephens [P,E] Washington, PA b. 1 Ja 1896, Claysville, PA. Studied: CI; Washington & Jefferson Col. Member: Pittsburgh AA. Exhibited: Assoc. A., 1918 (prize); NAD, 1919 (gold); AIC, 1924 (prize); nationally. Work: Butler AI; CI [47]

PARDI, Justin Anthony [P,T,L] Phila., PA b. 29 Ja 1898, Castelli, Italy d. 11 F 1951. Studied: BMFA Sch.; P. Hale; F. Bosley; McLellan. Member: Germantown AL; DaVinci All.; Phila. A. All.; Woodmere AA; Phila. Sketch Cl. Exhibited: DaVinci All., 1937–39, 1940 (med) 1941–44; PAFA, 1933–39. Work: Fitzgerald Mercy Hospital, Darby, Pa.; North & Co.; College Physicians, Phila. Positions: T., Business Men's A. Assn. (Phila.), PMSchIA (1927–32), PAFA (1932–39), Woodmere A. Gal. (1940) [47]

PAREDES, José M. [Mur.P,Por.P,S,C,L,W] St. Louis, MO b. 21 Jan 1912, Uruapan, Michoacán, Mexico. Studied: St. Louis AL; E. Siebert. Exhibited: sculpture, St. Louis AL (prize); Old Court House, 1931 (prize), 1932 [40]

PARIS, Walter [P,Arch] Wash., D.C. b. 28 F 1842, London, England (came to Colorado Springs, ca. 1872; became U.S. citizen, 1894) d. 26 N 1906. Studied: Royal Acad.; T.L. Rowbotham, Paul Naftel, Joseph Nash, in London (1870s). Founder/Member: Tile Cl., NYC, 1876. Work: CGA; Pioneers' Mus., Colorado Springs. Specialty: watercolors. Position: Arch., to British government in India, 1863–70. He made a large and remarkably fine series of flower studies from nature as aids to design. Also a violinist. [06]

PARIS, W(illiam) Francklyn [Mur.P,Arch,W,L] NYC b. New York. Studied: ASL; Académie Julian, Paris; Salvi, in Rome. Member: Arch. Lg., 1898–1933; Century Assn.; Mus. French Art; Artists' Fellowship; Société Histoire d'Art Française; Société Gens de Lettres de France; Royal Acad. A.&Sciences, Spain; MMA. Awards: Chevalier-Officer, Legion of Honor of France; Knight of the Crown of Belgium; Knight of the Crown of Italy, 1924; Knight of St. Michel; Hon. Knight of Malta. Work: Yale; Princeton; Oberlin Col.; Univ. Chicago; U.S. Supreme Court Bldg., Wash., D.C.; Senate, Mc. State Capitol; Detroit Pub. Lib.; Supreme Court, State Capitol, both in W.Va.; New York Life Insurance Bldg., NYC; Deanery, Cathedral of St. John the Divine, NYC; churches, Tulsa, Okla., Grand Rapids, Mich., Watertown, N.Y. Author: "Decorative Elements in Architecture" (pub. in London, 1917), "An Italian Temple to Arts and Letters" (Architectural Forum, 1925), "Personalities in American Art," "Rodin as a Symbolist," "Biography of Albert Besnard," "French Arts and Letters." Positions: U.S. Commissioner of Dec. Art., Paris Expo, 1900; Dir., WFNY, 1939 [40]

PARISH, A. Hutchinson (Mrs.) [P] Portland, OR [06]

PARISH, Betty Waldo (Mrs. Richard Comyn Eames) [P,B,E,En,Li] NYC b. 6 D 1910, Cologne Germany. Formerly Mrs. Whitney Darrow, Jr. Studied: Chicago Acad. A.; ASL; Académie Julian, Paris; Columbia; New Sch. Soc. Res.; Sternberg; Hayter; Sloan; Grand Central Sch. A. Member: SAE; NAWA; PBC; Dutchess County AA; Northwestern PM; NYWCC; Southern PM Soc.; FA Gld. N.Y. Exhibited: NAWA, 1937, 1938, 1939 (prize), 1940–45, 1946 (prize); SAE, 1940–42, 1943 (prize), 1944–46; PBC, 1944 (prize), LOC, 1941–46; NAD, 1941, 1945, 1946; PAFA, 1936; 1942, 1943; WFNY, 1939; AIC; Argent Gal.; Provincetown AA, 1939, 1940; Southern Pr.M.; Albany Inst. Hist.&A.; Dutchess County AA; Collectors of Am. A.; PBC. Work: MMA; SAM; LOC; AIC; Treasury Dept., Wash., D.C.; Collectors of Am. A. [47]

PARISH, W.D. [P] Providence, RI. Member: Providence WCC [19]

PARISH-WATSON, M. [Art Dealer] Fairfield, CT d. 21 F 1941. At his galleries in New York City he managed and displayed, from time to time, the William Randolph Hearst collection.

PARK, David [Mur.P,Fresco P,P,T,L] Berkeley, CA b. 17 Mr 1911, Boston. Member: San Fran. AA. Exhibited: San Fran. AA, 1935 (prize); AIC, 1936; Pal. Leg. Honor, 1946. Work: frescoes, John Muir Sch. (San Fran.), Cowell Mem. Hospital, Univ. Calif. (Berkeley). Positions: T., Winsor Sch. (Boston, 1936–41), Calif. Sch. FA (1944–) [47]

PARK, Edwin Avery [P,Arch,T] Bennington, VT b. 23 Je 1891, New Haven, CT. Member: Provincetown A. Assn. Author: "New Backgrounds for a New Age," 1926. Position: T., Bennington Col. [40]

PARK, Madeleine F. (Mrs. Harold H.) [S,L,W] Katonah, NY b. 19 Jy 1891, Mt. Kisco, NY d. 1960. Studied: ASL; A.P. Proctor; N. Los; L.T. Stevens; F.V. Guinzburg. Member: Art Workers' Cl. for Women; Chappaqua AG; NSS; NAWA; PBC; Soc. Medallists; AFA; Putnam County AA; Westchester A.&Crafts; N.Y. Zoological Soc.; All.A.Am.; Hudson Valley AA. Exhibited: Am. Women's Assn., 1933 (prize), 1940 (prize); PBC, 1938 (prize); Hudson Valley AA, 1944 (prize); Paris Salon; NAD; Arch. Lg.; PAFA; AIC; SFMA; WMAA; MMA; N.Y. Zoological Soc.; Brooks Mem. A. Gal. (one-man); Buie Mus., Oxford, Miss.; Miss. AA; Univ. Fla.; Converse Col.; Mint Mus.; J.B. Speed Mem. Mus.; Buffalo Mus. Science; Rochester Mem. A. Gal.; Erie A. Mus.; Utica Pub. Lib.; Cortland Free Lib.; Arnot A. Gal.; Ill. State Mus.; Wichita Mus. A.; Wustum Mus. FA; Kansas City Sate T. Col.; Univ. Wichita; Okla. A. Center; Massillon Mus. Specialty: wild and domestic animal sculptures [47]

PARK, Malcolm S. [Mur.P] Mt. Kisco, NY b. 13 O 1905, Helensburgh, Scotland. Studied: NAD; Ecole Americaine des Beaux Arts; Fontainebleau; Atelier des Fresques, Paris. Member: Princeton Arch. Assn.; Mural P. Exhibited: Fontainebleau Alumni Exh., 1934 (prize). Position: Indst. Des., Singer Mfg. Co., Elizabethport, N.J. [40]

PARK, Richard Henry [S] Florence, Italy (1890) b. 1832, NYC. Work: MMA [*]

PARKE, Jessie Burns [P,Por.P,E,C,I] Arlington, MA b. 2 D 1889, Paterson, NJ. Studied: N.Y. Sch. Appl. Des. for Women; BMFA Sch.; P. Hale; W. James; F.L. Bosley; M. Morgan, in Paterson. Member: Boston AC; Pa. Soc. Min. P. Exhibited: Pa. Soc. Min. P., 1945 (med), annually; PAFA; Albright A. Gal.; Boston AC; Ogunquit A. Center; Paris Salon, 1924; S.Indp.A.; Fed. Women's Cl., Mass.; Arlington (Mass.) Women's Cl. Work: portraits, Northwestern Univ.; South Boston H.S. [47]

PARKE, Nathaniel Ross [P,T] West Hartford, CT b. 20 O 1904, Williamsport, PA. Studied: Trintiy Col.; Yale. Member: New Haven PCC; Assn. Conn. A.; West Hartford A. Lg. Exhibited: BAID, 1927 (med,prize); All.A.Am., 1936; New Haven PCC, 1929; Williamsport A. Lg., 1929; Pa. State Col., 1936; Hartford Women's Cl., 1931; West Hartford A. Lg., 1935-41, 1945; CAFA, 1936; Indp. A. Conn., 1938. Work: Neuro-Psychiatric Inst. of Hartford Retreat; West Hartford Trust Co.; West Hartford A. Lg.; official bookplate, D.A.R. Position: T., West Hartford A. Lg. [47]

PARKER, Alfred [I] Westport, CT b. 16 O 1906, St. Louis, MO. Studied: Wash. Univ., St. Louis. Member: SI; AG. Exhibited: SI; New Rochelle Pub. Lib.; Lotos C. Illustrator: Ladies Home Journal, American, Cosmopolitan [47]

PARKER, A(nna) B(enedict) (Mrs. Neilson T.) [P] Woodstock, NY. Member: NAWPS; NAC [31]

PARKER, Charles S. [S,Por.P] Boston, MA b. 25 Ja 1870, NYC d. 3 Ag 1930. Studied: ASL; Paris, with Gérôme, Delance, Callot, Chapu, Puech. Member: NSS; Arch. Lg., 1898; NAC; BAC [10]

PARKER, Charles Stewart [Arch,P,T] Germantown, PA/New Hope, PA d. 3 Ja 1942. Studied: Pa. Sch. Indst. A.; Univ. Pa.; C. Woodbury. Member: Germantown AL; Am. Ar. Prof. Lg. Exhibited: Germantown AL, 1937; Phillips Mill, New Hope. Position: T., H.S., Phila., for 36 yrs. [40]

PARKER, Cora [P] Coral Gables, FL b. KY. Studied: Cincinnati A. Sch.; Académie Julian. Member: Greenwich SA. Work: Kansas City AC; Nebr. AA, Lincoln; Bruce Mus., Greenwich, Conn. [40]

PARKER, Cushman [I] Woodstock, NY/Onset, MA b. 28 Ap 1881, Boston, MA. Studied: Laurens; C. Marr. Member: SI; Artists' G. Illustrator: covers, The Saturday Evening Post, McCall's; Collier's [40]

PARKER, Dana (Mr.) [Cart] Port Washington, NY b. 1891 d. 22 Je 1933. Position: Cart., Miami Herald, San Francisco Chronicle

PARKER, Edythe Stoddard [S] Winnetka, IL b. Winnetka. Studied: AIC. Member: ASL, Chicago [10]

PARKER, Elizabeth [P,T] Beaufort, SC b. 12 Ag 1916, Edgefield, SC. Studied: M.H. Cabaniss; W.W. Thompson; Beaufort A. Sch. Member: Beaufort FAA; Carolina AA. Position: T. Beaufort A. Sch. [40]

PARKER, Emma Alice [P,I] Providence, RI b. 15 F 1876, Gardner, MA. Studied: S.R. Burleigh; Henri; F.V. DuMond; H.R. Poore. Member: Providence WCC [24]

PARKER, Ernest Lee [P,T] London, England [13]

PARKER, Frank F. [P] NYC [15]

PARKER, George Waller [P,C,Des,L,T,Dr,Dec] Summerville, SC b. 17 S 1888, Gouverneur, NY d. 1957. Studied: Brown Univ.; ASL; Grande Chaumière; Colarossi Acad. Member: SC; Portland SA; All.A.Am.; A. Fellowship; Audubon A.; Societé Coloniale des Artistes Française; FA Fed. N.Y.; AAPL; Grand Central A. Gal. Exhibited: Strasbourg (prize); NAD; PAFA; AIC; Kansas City AI; Springfield Mus. A.; Paris Salon; Rochester Mem. A. Gal.; one-man exh., NYC; Cincinnati; Cleveland; Chicago. Work: Rochester Mem. A. Gal.; Newark Mus.; Sweat Mem. Mus.; Lake Placid C., N.Y.; N.Y. Hist. S.; Saranac Lake Pub. Lib.; U.S. Navy Bldg., Wash., D.C.; Trudeau Sanitarium, Saranac Lake; BMA; Am. Ar Prof. Lg; Reception Hospital, Saranac Lake. Position: T., Nantucket, 1940 (summer school) [47]

PARKER, Gladys [I] NYC. Member: SI [47]

PARKER, Harry Hanley [Mur.P,S,Arch] Phila., PA b. 29 N 1869, Phila. d. 16 Mr 1917. Studied: PAFA. Member: Phila. Sketch C.; T Square C. Work: Calvary Methodist Episcopal Church, Phila. [15]

PARKER, Helen Stockton [P] Baltimore, MD. Member: Baltimore WCC [24]

PARKER, James K. [P] Evanston, IL [08]

PARKER, James K. [P] b. ca. 1880, HI (?) d. 1963, HI. Began painting at age 70 on his huge Hawaiian ranch. Specialty: primitive painting. (different from previous James K.) [*]

PARKER, John Adams [Ldscp.P] Adirondacks, NY b. 27 N 1827, NYC. Member: Brooklyn AA (founder); Brooklyn AC [06]

PARKER, John Clay [P] New Orleans, LA b. 1 F 1907, McComb, MI. Studied: Sch. Indst. A, NYC. Member: New Orleans AA. Exhibited: Miss. AA; New Orleans AA. Work: Masonic Temple, Wash., D.C.; Medical Sch., Tulane Univ.; Lib., Univ. Ala.; La. Supreme Court; Boston C., New Orleans; New Scottish Rite Bldg., Wash., D.C. [47]

PARKER, John E. [P] Phila., PA. Member: SC [21]

PARKER, John F. [P,S] NYC b. 10 My NYC, 1884. Studied: Henri, NYC; England; Paris, with Laurens, Steinlen. Member: Alliance; SC. Work: NGA; Valley Forge Mus. [25]

PARKER, John W. [Li] b. 1862 d. 26 Je 1930, NYC. Member: Poster Artists Assn. (Pres.)

PARKER, Lawton S. [Por.P,T] Pailly 'Oise, France (until 1942) b. 7 Ag 1868, Fairfield, MI d. 25 S 1954, Pasadena, CA. Studied: Académie Julian with Bouguereau, Robert-Fleury, 1889; Whistler, Paris; ASL, with H.S. Mowbray, Wm. M. Chase, 1897; Mur. P., with P. Besnard; Ecole des Beaux-Arts, with Gérôme, Laurens. Member: ANA 1916; Chicago SA; Paris AAA; NAC. Exhibited: Paris Salon, 1900, 1902 (med), 1913 (gold); St. Louis Expo, 1904 (med); Intl. Expo, Munich, 1905 (gold); CI, 1907; Chicago SA, 1908 (med); AIC; 1909 (prize); Pan-P. Expo, San Fran., 1915; NAD, 1909 (prize). Work: Chicago Univ.; U.S. Court of Appeals, Wash. D.C.; AIC; Los Angeles Mus. Position: T., St. Louis Sch. FA, 1892; Beloit Col, 1893; pres., N.Y. Sch. A., 1898–99; Dir., Parker Acad., Paris, 1900; T., AIC, 1902; pres., Chicago Acad. FA, 1903 [40]

PARKER, Lester Shepard [P,W,L] Jefferson City, MO b. 7 O 1860, Worcester, MA d. 25 Jy 1925, Rochester, MN. Studied: J. Ankeney; A. True; R. Miller; Colarossi Acad., Paris; J.G. Brown. He was largely instrumental in the movement to redecorate the Capitol at Jefferson City. [25]

PARKER, Lillian M. [P] Stroudwater, ME [24]

PARKER, Margaret R. [P] Indianapolis, IN [15]

PARKER, Mary Elizabeth [P] Phila, PA b. 19 Je 1881, Phila. Studied: Phila. Sch. Des. for Women, with H.B. Snell, B. Foster, E. Daingerfield, W. Sartain; PAFA [13]

PARKER, Nancy Wynne [En,Mur.P,Por.P] Swampscott, MA b. 15 D 1908, Swampscott, MA. Studied: ASL [40]

PARKER, Neilson R., Mrs. See Steele, Zulma.

PARKER, Paul [W,P,T] Vermillion, SD b. 7 Je 1905, La Grange, IL. Author: "The Modern Style in American Advertising Art," Parnassus, 1937; "The Iconography of Advertising Art," 1939. Position: T., Univ. S.Dak. [40]

PARKER, Phillips [P] San Diego, CA b. 1896 d. 4 F 1935, Granada, Spain

PARKER, Stephen Hills [Por.P] d. 17 My 1925, Florence, Italy. Studied: C. Duran, Paris

PARKER, Virginia [P] Charlottesville, VA. b. 19 Jy 1897, New Orleans, LA. Studied: PAFA, Cresson Traveling Schol., 1921. Exhibited: Morton Gal., N.Y., 1939 (one-man); BM, 1939. Contributor: Dial, 1927 [40]

PARKER, W.L. (Mrs.) [P] Boston, MA. Member: Boston WCC [24]

PARKER, Wentworth [P,E] Terre Haute, IN b. 11 O 1890, Terre Haute, IN. Studied: W. Forsyth [29]

PARKER, William Gordon [I] Arkansas City, KS b. 1875, Clifton, NJ. Studied: ASL [10]

PARKHOUSE, Stanley [I,Cart] NYC. Contributor: Cosmopolitan, 1939 [40]

PARKHURST, Anita (Mrs. Willcox) [P,I] NYC. b. 11 N 1892, Chicago. Studied: AIC. Member: Artists' G.; SI. Illustrator: covers, Saturday Eve. Post, Collier's [33]

PARKHURST, Anna M. [P] Wash., D.C. Member: S. Wash. A. [25]

PARKHURST, Burleigh [P,W,L] Amherst, MA b. Gloucester, MA. Studied: Sartain; Académie Julian. Member: Providence AC; Wash. SA; Wash. AC [27]

PARKHURST, C(lifford) E(ugene) [I] NYC/Vails Gate, NY b. 5 D 1885, Toledo. Studied: Vanderpoel; Freer; Armstrong. Member: Arch. Lg. Exhibited: AIC, 1906 [40]

PARKHURST, Henry Landon [P,T,Arch,Des] NYC b. 1867, Oswego, NY d. 31 Ja 1921. Studied: N.Y. Acad. FA. Member: N.Y. Sketch C. Position: T. of Arch., CUASch [10]

PARKHURST, Thomas Shrewsbery [Ldsp.P,I] Carmel, CA b. 1 Ag 1853, Manchester, England d. spring 1923. Studied: self-taught. Member: Toledo Tile C.; SC; NAC. Work: Toledo Mus.; Oakland AM; Lima, Ohio AL; Des Moines AC; Okla. AL [21]

PARKINSON, Donald B. [P] Los Angeles, CA. Member: Calif. AC [25]

PARKINSON, Grace Wells [P] Los Angeles, CA. Member: Calif. AC [25]

PARKINSON, Helen B. [P] Chicago, IL [17]

PARKINSON, William Jensen [P] Salt Lake City, UT b. 14 F 1899, Hyrum, UT. Studied: Univ. Utah, with A.B. Wright, 1924; R. Pearson, 1946. Member: Am. Ar. Cong.; Utah State Inst. FA. Exhibited: Utah State A. Center. Work: murals, McKinley Sch., Salt Lake City; Capitol, Utah; Hyrum City H.S.; Univ. C., Salt Lake City. Position: T., Utah State A. Center [40]

PARKMAN, Polly [P] NYC Studied: J. Farnsworth. Exhibited: CGA, 1939; Vendôme Gal., NYC, 1940 [40]

PARKS, Billie (Miss) [P] Chicago, IL. Member: GFLA [27]

PARKS, Robert Owen [P,T] Lafayette, IN b. 25 Ap 1916, Richmond, IN. Studied: Herron AI,; Cape Sch. A., Provincetown. Member: F., Tiffany Fnd., 1938. Exhibited: Tiffany Fnd., 1938; Cincinnati Mus., 1938. Position: T., Purdue Univ. [40]

PARLIN, Florence W. [P] Rochester, MN. Exhibited: AIC, 1935; PAFA, 1936; NAWPS, 1938; Kansas City AI, 1937–39 [40]

PARMELEE, Mathilde [S,T] Greenwich, CT b. 18 O 1909. Studied: Kunstgewerbe Schule, Munich; Alfred Univ., Syracuse. Exhibited: Syracuse Mus., 1937 (prize). Work: Syracuse Mus. [40]

PARMELEE, Olive Miriam Buchholz [P] Los Angeles, CA b. 21 Je 1913, Dubuque, IA. Studied: Univ. Ill.; ASL; PAFA. Member: NAWPS. Work: Univ. Ill. [40]

PARNELL, Eileen (Mrs. Gustav Bohland) [S] Miami Beach, FL b. Belfast, Ireland. Studied: Europe; America. Work: medal design, Fla. State Col. Women Alumnae Assn.; Garden S. [40]

PARNUM, Edward J. [Arch,B] Phila., PA b. 1 Ja 1901, Waco, TX. Studied: Univ. Pa.; Univ. Tex. Member: T Square C. [40]

PARR, Russell C. [P,T] NYC b. 28 Ag 1895, Evansville, WI. Studied: Grinnell Col.; Univ. Ill.; George Washington Univ.; Paris, with P. LeDoux, Dourananez; O. Gros; J. Butler. Member: SI; Wash. Ldscp. C.; Wash. AC. Work: Baltimore Pub. Lib. Position: Chief, Prof. Training, Veterans Admin., N.Y., 1944; WPA Dir./Advisor [47]

PARRISH, Anne L. Willcox (Mrs. Thomas) [Por.P,E,T] b. ca. 1850 (Phila.?). Work: Pioneers' Mus. Active Colo. Springs ca. 1880–1900s. [*]

PARRISH, Charles Louis [P,L] Oakland, CA (since 1865) b. ca. 1830, NYC d. 1902, NYC. Went to Calif., 1850 during gold rush. Specialty: views of Calif. towns [*]

PARRISH, Clara Weaver (Mrs. Wm. P.) [P,E,W] NYC b. Selma, AL d. 13 N 1925. Studied: ASL, with Chase, Mowbray, Cox, J.S. Weir; Paris, with Collin, Mucha, Courtois. Member: NYWCC; AWCS; NAWPS; NAC; Pen and Brush C.; SPNY; MacDowell C.; Lg. AA. Exhibited: NY Women's AC, 1902 (prize), 1913 (prize); Appalachian Expo, Knoxville, 1910 (med); P.-P. Expo, San Fran., 1915 (med); NAC, 1924 (prize); SSAL, 1925 [24]

PARRISH, Grace [P] St. Louis, MO. Member: St. Louis AG [25]

PARRISH, Mary E. [P] Newport, RI [19]

PARRISH, Maxfield [P,I] Windsor, VT b. 25 Jy 1870, Phila. d. 30 Mr 1966, Plainfield, NH. Studied: his father Stephen; Paris, 1884–86; arch., Haverford Col., 1888–91; PAFA, 1891–93; H. Pyle, at Drexel Inst. Member: SAA, 1897; Phila. WCC; ANA, 1905; NA, 1906; Cornish (N.H.) Colony, from 1898, where he designed and built his home "The Oaks." Exhibited: Paris Expo, 1900 (prize); Pan-Am. Expo, Buffalo, 1901 (med); Phila. WCC, 1908 (prize); Arch. Lg., 1917 (gold). Illustrator: covers for Collier's, 1903–10; Edison Mazda calendars, 1918–34 (1,500,000 printed in 1925); Brown & Bigelow calendars, 1936–62; children's books. Work: St. Louis AM. Important illustrator, best known for his unique style and for his "Maxfield Parrish blue," he mastered the mysterious effects of light and iridescent colors through a difficult glazing technique. He always worked from photographs rather than live models. His most famous painting, "Daybreak," sold millions as a print. [47]

PARRISH, Samuel Longstreth [Patron] b. 1849, Phila. d. 22 Ap 1932, NYC. Member: Parrish A. Mus., Southampton, N.Y. (founder); Century; Archaeological Inst. Am. Award: Italian Govt., Order of the Crown of Italy. He was one of the pioneer golf players of America.

PARRISH, Stephen [Et,P] Windsor, VT b. 9 Jy 1846, Phila., PA d. 15 My 1938. (father of Maxfield) Member: R. Soc. Painter-Etchers, London, 1881; N.Y. Etching C.; The Cornish, N.H. Colony. Exhibited: N.Y. Etching C.; Paris, 1885. Work: Toledo Mus. A.; CI; etching, Portfolio mag., 1885; Smithsonian [38]

PARRISH, Thomas [Ldscp.P,Por.P,I,E,T] Colorado Springs, CO (since 1870s) b. 1837, Phila. (brother of Stephen) d. 1899. Studied: Phila. Illustrator: "Legends & Myths of Pike's Peak Region." Specialty: watercolor [*]

PARRISH, Williamina [P] St. Louis, MO. Member: St. Louis AG [25]

PARROTT, William Samuel [Ldscp.P] b. 1844, MO (brought to OR, 1847, WA, 1859) d. My 1915, Goldendale, WA. Work: San Fran. MFA. Had a studio in Portland, Oreg. for 20 yrs.

PARSELL, Florence (Abbey) [P,I,T] Angola, IN b. 29 Ag 1892, Angola, IN. Studied: AIC. Member: Ind. AA [25]

PARSHALL, De Witt [Ldscp.P] Santa Barbara, CA b. 2 Ag 1864, Buffalo, NY d. 1956 (age 92). Studied: Hobart Col., 1885; Académie Julian, Paris, with Cormon, 1886–92; A. Harrison. Member: ANA, 1910; NA, 1917; Allied AA; SMPF West; Intl. S. AL; Lotos C.; Century Assn.; NAC; MacD. C.; Calif. AC; P. of the West. Exhibited: P. of the West, 1928 (gold); All-Calif. Exh., 1934 (prize). Work: MMA; TMA; Syracuse Mus.; WMA; Detroit Inst. A.; Hackley Gal., Muskegon, Mich.; FA Gal., San Diego; Los Angeles Mus. Hist., Sc.&A.; SAM [47]

PARSHALL, Douglas Ewell [P] Santa Barbara, CA (1976). Studied: his father De Witt. Member: ANA, 1927; Calif. AC; P. of the West. Exhibited: NAD, 1924 (prize), 1927 (prize); P. of the West, 1926 (gold); Los Angeles Mus. A., 1927. Work: Syracuse Mus. FA; NGA; Reading Pa. Mus.; Kansas City AI; San Diego FA Soc.; Detroit Inst. A. Position: T., Santa Barbara AI, from 1967 [47]

PARSON, George [P] Wash., D.C. Exhibited: Wash. WCC, 1898; Omaha Expo, 1898 [98]

PARSON, Lydia [P] Boston, MA [01]

PARSONS, Antoinette De Forest. See Merwin, T.D., Mrs.

PARSONS, Alfred [Ldscp.P] b. 1830, England d. 30 Ja 1920, Broadway, England. Lived for many years in America.

PARSONS, Arthur Jeffrey [Mus.Dir,Mus.Cur] b. 3 My 1856 d. 5 N 1915, Dublin, NH. Studied: Wash. SFA (Officer); AFA (Dir.). Positions: Cur. Prints, LOC, 1900–15; Dir., CGA

PARSONS, Audrey Buller, Mrs. See Buller.

PARSONS, Barbara [Por.P] New Britain, CT b. 11 Ag 1910, New Britain. Studied: Yale; New Britain AL; A. Brook; W. Adams; R. Brackman; R. Lahey. Member: CAFA; Hartford S. Women P.; Assn. Conn. A. Exhibited: New Haven PCC, 1932 [40]

PARSONS, Charles [Mar.P,Ldscp.P,Li,I] Boonton, NJ b. 8 My 1821, Rowland's Castle, Hampshire, England (came to NYC in 1830) d. 10 N 1910, Brooklyn, NY. Studied: NAD; apprenticed to Endicott & Co. (lithographers), working there until ca. 1861 (and making many prints for Currier & Ives). Member: ANA, 1862; AWCS. Exhibited: NAD, 1862–98. Work: Mystic Seaport Mus.; Peabody Mus., Salem; MIT. Position: Hd. A. Dept., Harper's, 1861–89, during which time he assembled one of the most talented teams of illustrators in publishing history, including Winslow Homer, E.A. Abbey, C.S. Reinhart, H. Pyle; M.J. Burns, and many others. Also among the first Americans to champion watercolor. [10]

PARSONS, Charles Richard [P,Li] b. 13 Mr 1844, Brooklyn, NY d. 1918 or 1920, England. Studied: his father Charles; worked at Endicott & Co. and Currier & Ives at same time as his father. Exhibited: NAD. Work: Mystic Seaport; Franklin Delano Roosevelt Mus. [*]

PARSONS, David Goode [S,T,P,I,L] Stoughton, WI b. 2 Mr 1911, Gary, IN. Studied: AIC; Univ. Wis. Member: Hoosier Salon; Wis. PS; Wis. A. Fed. Exhibited: Wis. Salon, 1934–41, 1938 (prize), 1943, 1944 (prize) 1945 (prize); Wis. PS, 1933, 1936–40, 1941 (prize); VMFA, 1943 (prize); Hoosier Salon, 1935, 1938, 1939 (prize); AIC, 1935–40, 1946; PAFA, 1940, 1946; WFNY, 1939; Grand Rapids A. Gal., 1939; CI, 1940; Univ. Wis., 1940 [47]

PARSONS, Edith Baretta Stevens (Mrs.) [S] NYC b. 4 Jy 1878, Houston, VA d. 1956. Studied: ASL, with French, Barnard. Member: NSS; NAWPS. Work: fountain, Memphis Pub. Park; Lib. Arts Bldg., St. Louis, Mo.; monu., St. Paul Mo.; MET; mem., Summit, N.J. [47]

PARSONS, Edward Roy [P] Columbus, OH. Member: Columbus PPC [25]

PARSONS, Ernestine [P,T,L] Colorado Springs, CO b. 20 S 1884,

Booneville, MO d. 30 Jy 1967. Studied: Colorado Col.; Columbia Univ., Broadmoor A. Acad.; ASL; Colorado Springs FA Ctr., with R. Davey, P. Burlin. Exhibited: CI, 1928; Albright A. Gal., 1927, 1930; Denver AM, 1933, 1942; Wooster Col. (one-man); Colorado Springs FA Ctr., 1944, 1945; Broadmoor A. Acad., 1927 (prize); Colorado State Fair, 1945. Work: Colorado Springs FA Ctr. Position: T., H.S., Colorado Springs [47]

PARSONS, Ethel M. See Paullin.

PARSONS, Frank Alvah [Edu,L,W] b. 1 Ap 1866, Chesterfield, MA d. 26 My 1930, NYC. Studied: Wesleyan; Columbia; France; England; Italy. Member: Knight of the Legion of Honor, 1927. Author: "Psychology of Dress," "Interior Decoration, Its Principles and Practice," "Art Appeal in Display Advertising." Lectured regularly at the Brooklyn Inst. of Fine Arts, MMA, and his school in Paris. Position: Pres., N.Y. Sch. Fine and Applied Arts, 1905–30 (the old Chase Sch. Art). He developed the School so that by 1927 it numbered 800 students. In 1921 he established a branch in Paris, where by 1927, pupils were registered from every state in the Union, Canada, and eighteen foreign countries.

PARSONS, George F. [P] San Fran., CA b. 2 N 1844, Appleton, OH. Studied: F. Fehr, P. Nouen, in Munich [04]

PARSONS, Isabella Hunner [Des,P] Baltimore, MD b. 12 N 1903, Baltimore. Member: Municipal A. Soc., Baltimore [40]

PARSONS, James Herbert [P,En,Medalist] b. 1831 d. 25 D 1905, West New Brighton, NY. Worked for Tiffany & Co. for 23 yrs, and won the Beaconsfield gold medal in 1880. He won medals for his employers at the Paris and Chicago expositions. One of his best works was the marriage certificate of the Duke of Marlborough and Miss Consuelo Vanderbilt.

PARSONS, Kitty (Mrs. Richard H. Recchia) [P,W] Rockport, MA b. Stratford, CT. Studied: PIASch; Columbia; Boston Univ.; Univ. Chicago; R.H. Recchia. Member: NAWA; Rockport AA; North Shore AA; Copley S., Boston; NOAA; Palm Beach AL; Springfield AL; Authors Lg. Am. Exhibited: NAWA, 1941, 1944; CGA, 1941; Portland SA, 1941, 1944; S.Indp.A.; Audubon A.; Springfield AL; Mint Mus. A.; Ala. WCS; Newport AA, 1944, 1945; Rockport AA; North Shore AA; CAFA; J.B. Speed Mem. Mus.; Palm Beach AL; Doll & Richards (one-man); Argent Gal. (one-man); Bennington Mus. (one-man); Whistler House, Lowell, Mass. (one-man); Winchester, Mass. (one-man) AA. Author: books of poetry [47]

PARSONS, Laura Starr (Mrs. Fitzgerald) [Min.P,Des] Nyack, NY b. 1 Je 1915, Rockford, IL. Studied: ASL; Mme. Brancour-Lenique, ca. 1908, Paris. Member: ASL; Young Am. Ar. Assn. Exhibited: Rockland Fnd.; Munic. Gal., NYC, 1938; Georgetown Gal., Wash., D.C., 1938, 1939; Young Am. Ar. Exh., R.H. Macy, N.Y., 1938, WFNY, 1939; ASL, 1939; Hudson River A., Nyack, N.Y., 1939 [47]

PARSONS, Lloyd Halman [P,Dr,Arch,B,E,Por.P] Little Compton, RI b. 2 F 1893, Montreal, Canada d. F 1968. Studied: McGill Univ.; ASL, with K.H. Miller; B. Robinson. Exhibited: CGA; AIC; NAD; PAFA; CI; WMAA. Work: WMAA [47]

PARSONS, Margaret H. [P] NYC. Member: NAWPS. Exhibited: NAWPS, 1935–36 [40]

PARSONS, Maude B. [P] Seattle, WA [21]

PARSONS, Orrin Sheldon [Por.P,Ldscp.P,Mus.Dir] Bronxville, NY b. 3 Ap 1866, NYC d. 24 S 1943, Santa Fe, NM. Active in Santa Fe since 1913. Studied: Chase, NAD; W. Low; E. Ward. Work: Mus. N.Mex.; Univ. N.Mex. Position: Successful NYC Port. P., 1895–1912; first Dir. of Mus. of N.Mex., 1918 [40]

PARSONS, Phillip N. [P] Chicago, IL. Member: S.Indp.A. [25]

PARSONS, Theophilus [P,W] Wash., D.C./Nonquit, MA b. 20 Je 1876, NYC. Studied: J. Carlson. Member: Wash. SA; Wash. AC [33]

PARSONS, Walter Edward [P] Provincetown, MA b. 11 N 1890, Troy, PA. Studied: Yale; CI; NAD; ASL; C. Hawthorne; H. Hofmann; I. Olinsky; Vytlacil; Schule für Bildende Kunst, Munich. Member: SC. Exhibited: VMFA, 1946; Provincetown AA, 1945, 1946 [47]

PARTEE, McCullough [Des,I,P,Car,T] Nashville, TN b. 19 F 1900, Nashville. Studied: Chicago Acad. FA; AIC; ASL; NAD; Grand Central Sch. A.; Hawthorne; Dunn; Carter; Pruett Carter; Reynolds; Bridgman. Exhibited: Tenn. A. Exh., 1929 (prize). Illustrator: Liberty, Colliers, Country Gentleman. Position: A. Ed., Southern Agriculturalist, Nashville, from 1935 [47]

PARTINGTON, Gertrude [P] San Fran., CA (living in Paris, 1908). Exhibited: P.-P. Expo, 1915 (med) [17]

PARTINGTON, Richard Langtry [Por.P] Phila., PA/San Fran., CA b. 7 D 1868, Stockport, England d. 3 Je 1919, Phila. Studied: his father, J.H. Partington; Beaux-Arts Inst., Antwerp; Sir H. Herkimer, London. Member: San Fran. AA; Phila. Alliance [27]

PARTON, Arthur [Ldscp.P] Yonkers, NY b. 26 Mr 1842, Hudson, NY d. 7 Mr 1914. Studied: W.T. Richards, in Phila. Member: ANA, 1871; NA, 1884; AWCS; A. Fund S. Exhibited: NYC, 1886 (gold); PAFA, 1889 (med); Paris Expo, 1889; NAD, 1896 (prize); St. Louis Expo, 1904 (med). Work: Brooklyn Inst. Mus.; Indianapolis AA; MMA [13]

PARTON, Ernest [Ldscp.P] London, England b. 17 Mr 1845, Hudson, NY. Member: A. Fund S.; Royal Inst. Painters, London. Exhibited: Paris Expo, 1889, 1900. Lived in England since 1873. [29]

PARTON, Henry Woodbridge [Ldscp.P,Mar.P] NYC b. 1858, Hudson, NY d. 1 Mr 1933. Member: NA, 1929; P.&S. Gal. Assn.; SC, 1889; Century Assn.; AFA; NAC. Exhibited: NAD, 1881–1900; Royal Acad., London; NAC, 1928 (prize), 1929 (prize). Work: Univ. Nebr.; Reading Mus., Pa. Position: for many years, designer of rugs, Yonkers [31]

PARTON, Hulda (Mrs. Daniel Day Walter, Jr.) [Por.P] Yonkers, NY b. Hudson, NY. Studied: ASL, with K. Cox; Blanche, in Paris; Sorolla, in Madrid. Work: Sherman Mem. Dispensary, Yonkers [15]

PARTRIDGE, Charlotte Russell [P,Mus.Dir,L,Cr,T] Thiensville, WI b. Minneapolis. Studied: Northern Ill. T. Col.; Emma M. Church Sch. A.; AIC; ASL; J. Carlson. Member: Oberlander F., 1936; CAA; AFA; AA Mus.; Wis. PS; Wis. Des.-Craftsmen; Nat. Edu. Assn.; Western AA; EAA; Wis. S. App. A. Awards: Carnegie Grant, 1940. Positions: T., Milwaukee-Downer Col. (1914–22); Dir., Layton Sch. A. (1920–), Layton A. Gal., Milwaukee (since 1922); WPA Dir. for Wis. [47]

PARTRIDGE, Imogene [P] Seattle, WA. Member: Seattle FAS [19]

PARTRIDGE, Mary Elizabeth (Mrs. Daniel, 3rd) [P,Des] Wash., D.C. b. 17 D 1910, Ossining, NY. Studied: Sarah Lawrence; PMG Sch. A. Exhibited: Studio House, 1938 (one-man); Jr. Lg. Gal., 1939 (one-man); PMG, 1940 (one-man); Phila. A. All. (one-man); Whyte Gal., Wash., D.C. (one-man). Work: PMG [47]

PARTRIDGE, Roi [E,T,L] Oakland, CA b. 14 O 1888, Centralia, WA d. 1984. Studied: NAD. Member: ANA; SAE; Chicago SE; Am. Assn. Univ. Prof.; Calif. SE. Exhibited: Alaska-Yukon-Pacific Expo, Seattle, 1909 (medals); NAD, 1910 (med); AIC, 1921 (med); Brooklyn, 1921 (prize); San Fran., 1921 (prize); Los Angeles, 1922 (prize), 1925 (prize), 1929 (gold); LOC, 1943 (prize). Work: LOC; Calif. State Lib.; WMA; NYPL; Walker A. Gal.; Liverpool, England; Toronto A. Gal.; de Young Mem. Mus.; SFMA; AIC; MOMA; Los Angeles Mus. A.; Honolulu Acad. A.; San Diego FA Soc.; Wells Col., N.Y.; BM; CI; NGA; Newark Pub. Lib.; TMA; Calif. State Lib., Sacramento; Milwaukee A. Gal.; Omaha AI; Haggin Mem. Mus., Stockton, Calif.; Crocker A. Gal., Sacramento; Nat. Coll. FA, Wash., D.C.; Mills Col.; Seattle Pub. Lib.; Univ. Nebr.; UCLA; Univ. Wash.; Scripps Col.; Prints of the Year, 1924–28, 1930–34. Illustrator: Creative Art, English Studio, Art and Archaeology, Prints, Aesthetic Judgement. Position: T., Mills Col., Oakland, from 1921 [47]

PARTRIDGE, W(illiam) H. [P] Wellesley Hills, MA b. 21 S 1858, Wheeling, WV. Studied: Mass. Sch. A.; BMFA Sch. Member: Boston AC; Springfield AI; Gloucester SA; Business Men's AC of Boston. Work: Lib., Wellesley, Mass. [40]

PARTRIDGE, William Ordway [S,W,T] NYC b. 11 Ap 1861, Paris d. 22 My 1930. Studied: Paris; Florence; Rome; NYC; he was a friend of Rodin, Bouguereau. Member: Arch. Lg.; Lotos C.; Royal SA, London; Cosmos C., Wash., D.C; AIA; SC, 1898; NSS. Work: statues, "Gen. Grant," Union Lg. C., "Alexander Hamilton" (both in Brooklyn), "Shakespeare" (Lincoln Park, Chicago), "Pocahontas" (Jamestown, Va.), "Nathan Hale" (St. Paul, Minn.), "S.J. Tilden," Riverside Drive, "Pieta," St. Patrick's Cathedral, both in NYC; font, Cathedral of St. Peter and St. Paul, Wash., D.C.; Schermerhorn Mem., Columbia; bust of Theodore Roosevelt, Republican C.; marble "Peace Head," MMA; CGA. Author: "Art for America," "The Song of Life of a Sculptor," "The Technique of Sculpture." Positions: Lecturer, Concord Sch. Philosophy and Stanford Univ.; T., George Washington Univ. [29]

PASAVANT, Frederick Joseph [P,I] NYC b. 1887, Brandon, VT d. 21 Ja 1919. Studied: ASL. Member: SI; Dutch Treat C.

PASCIN, Jules [P] Paris, France b. 1885, Widdin, Bulgaria d. 5 Je 1930. Studied: Vienna. Work: Detroit IA; Minneapolis IA. Specialty: his Mexican series of horses and riders is almost the only departure from his favorite theme: women, painted in rhythmic and delicate manner. Born

Julius Pincas, he later adopted the name under which all his paintings are known. In 1915 he became a citizen of U.S., living in Brooklyn. [29]

PASCOE, William [P] Detroit, MI [25]

PASKELL, William Frederick [Ldscp.P,Mar.P] Active around Cape Ann, Nantucket, 1930s b. Boston d. 1951. Studied: Juglaris; Paris, with F. de Blois [*]

PASQUELLE, Frances M.L. [P] Glenbrook, CT. Member: S.Indp.A. [25]

PASSAILAIGUE, Mary F. (Mrs. J.M.) [P] Columbus, GA. Studied: W. Adams. Exhibited: Atlanta AG, 1938; Assn. Ga. A., 1938; SSAL, Montgomery, Ala., 1938; San Antonio, Texas, 1939 [40]

PASTERNACKI, Vetold Henry [P] Detroit, MI b. 31 My 1896, Detroit, MI. Studied: John P. Wicker A. Sch., Detroit; Acad. Moderne, Paris.; Marchand; Dufresne. Member: Scarab C., Detroit. Exhibited: Salon d'Automne, Paris, 1929; AIC, 1938; Pepsi-Cola, 1946; Detroit Inst. A., 1930-45, 1943 (prize).; Detroit, 1932 (prize); Scarab C., 1932 (prize), 1935 (gold). Work: Wayne Univ.; Scarab C. [47]

PATAKY, Tibor [P] Orlando, FL. Exhibited: SSAL, 1938; WFNY, 1939 [40]

PATALANO, Frank Paul [Des,E,Por.P,B,Li,J] Providence, RI b. 4 Jy 1914, Providence. Studied: RISD. Specialty: gowns and jewelry [40]

PATEK, Joseph L. [P] Chicago, IL [15]

PATERSON, Grace [P] Phila., PA. Studied: PAFA [19]

PATERSON, Margaret [P] Boston, MA. Member: Women PS [15]

PATERSON, Zama Vanessa Helder See Helder.

PATIGAN, Haig [S] San Fran., CA b. 22 Ja 1876, Armenia. Studied: self-taught; criticism from Marquet, in Paris. Member: NSS; AIAL; S. Sanity in Art.; Société des Artistes Français; Jury of Awards, Pan-Pacific Expo, San Fran., 1915. Exhibited: S. Sanity in A. (prize); GGE 1939. Work: Bohemian C.; Pal. Leg. Honor, City Hall, Metropolitan Life Insurance Bldg., San Fran.; White House, D.C.; Seattle, Wash.; Mem. Mus., Civic Center, Olympic Country C., San Fran.; mon., Fresno, Calif.; San Fran. Pub. Lib. [47]

PATON, William Agnew [W] b. 20 Ap 1848, NYC d. 11 D 1918, NYC. Member: Union Lg. C., NAC; Century Assn.; Nassau C., Princeton. Author: "Down The Islands," 1887 (illus. by M.J. Burns).

PATRICK, James H. [P,Li,T,L] Los Angeles, CA b. 14 S 1911, Cranbrook, British Columbia Canada d. 8 D 1944. Studied: C. Hinkle; L. Murphy; R.T. Chamberlin; M. Sheets. Member: Calif. WCS; Fnd. Western A. Exhibited: Los Angeles County Fair, 1936 (prize), 1937 (prize); Calif. State Fair, 1938 (prize), 1939 (prize). Position: T., Chouinard AI, Los Angeles [40]

PATRICK, John Douglas [P] b. 1863, Hopewell, PA d. 19 Ja 1937. Studied: Académie Julian, Paris, with Lefebvre, Merson, Chatrain, Glaize, Fremut, Boulanger. Exhibited: Académie Julian (prizes); Paris Expo, 1889 (medal). Work: CAM. Positions: T., St. Louis Sch. FA, Kansas City AI

PATRICOLA, Philip [P] Buffalo, NY. Member: Buffalo SA [25]

PATTEE, Elmer Ellsworth [P,S] Paris, France. Affiliated with American Art Co., Paris [10]

PATTEE, Elsie Dodge [Min.P,I,L,P,T] Old Lyme, CT b. 4 S 1876, Chelsea, MA. Studied: Académie Julian, Paris. Member: Mystic AA; Brooklyn SMP; Am. SMP; Grand Central Gal. Assn. Exhibited: P.-P. Expo, 1915 (med); Brooklyn SMP, 1935 (med), 1939 (med); Calif. SMP, 1927 (prize), 1937 (prize); ASMP, 1930 (prize), 1936 (prize); Pa. SMP, 1935 (med), 1939 (prize); Concord AA, 1921; NAWPS, 1921. Work: MMA; BM; PMA. Illustrator: juvenile publications [47]

PATTEN, Frances M.E. [P] Rockville, Centre, NY [24]

PATTEN, Sarah E. [P] St. Paul, MN [15]

PATTEN, William [I,A.Ed] b. 27 N 1865, NYC d. 27 Jy 1936, Rhinebeck, NY. Studied: Paris. In 1932 he started in the LOC, the Cabinet of American Illustrators, "to preserve for posterity the work of outstanding American illustrators." Position: the youngest art editor, Harpers (at 23)

PATTERSON, Ambrose [P,T] Seattle, WA b. 29 Je 1877, Victoria, Australia. Member: Northwest PM; Seattle Art Mus.; Group of Twelve, Seattle. Exhibited: Seattle Art Mus., 1934 (prize). Work: Sydney; Adelaide; Canberra; Honolulu; Seattle; USPO, Mt. Vernon, Wash.; Nat. Gal., Sydney; Australian Commonwealth Government. WPA artist. Position: T., Univ. Wash., Seattle [47]

PATTERSON, Angelica Schuyler [P] Boston, MA b. 27 Je 1864, Jersey City, NJ. Studied: Cooper Union; New York, with D. Volk; Paris, with A. Stevens, Colin; Boston ,with A. Thayer. Member: Copley S., 1895. Specialty: church decorations [10]

PATTERSON, Anna Moore [P] Port Deposit, MD [08]

PATTERSON, C(harles) R(obert) [Mar.P] NYC b. 18 Jy 1878, England (settled in NYC in 1920s). Member: NAC; SC; Allied AA; AWCS; NYSP. Work: Royal Victoria Mus., Halifax; Butler Art Inst., Youngstown, Ohio; BMFA; Mus., Trenton (N.J.); U.S. Naval Acad., Annapolis. A sailor since age 13, he rounded Cape Horn 4 times. [47]

PATTERSON, Charles W. [P,T] Pittsburgh, PA b. 5 Ag 1870, Belle Vernon, PA d. 29 My 1938. Studied: PAFA. Member: Pittsburgh AA. Exhibited: Pittsburgh AA, 1914 (prize); Friends Pittsburgh Art, 1929 (prize); Pittsburgh AS, 1924 (prize). Work: 100 Friends of Art, Pittsburgh [31]

PATTERSON, Gertrude Hough [Por.P,T] Granby, CT b. 14 F 1882, Norwich, CT. Studied: PAFA; Yale; BMFA Sch.; R. Brackman; C. Woodbury; O. Dodge; E. Pape; A.V. Tack. Member: West Hartford A. Lg.; Hartford S. Women P.; Conn. Assn. A. Position: T., Sea Pines Sch., Brewster [47]

PATTERSON, Henry Stuart [P] NYC b. 5 Jy 1874, East Orange, NJ. Studied: R. Kent; F. Robinson; G.P. Ennis. Member: AWCS; SC; Century Assn.; Ramapo A.&Cr. Center. Exhibited: University C., N.Y., 1939 (prize) [47]

PATTERSON, Howard Ashman [P,Li] NYC b. 13 S 1891, Phila. Studied: PMSchIA; PAFA, with H. McCarter; ASL. Exhibited: PAFA; NAD; AIC; CI; Pal. Leg. Honor; CMA. Work: Luxembourg Mus., Paris; PAFA [47]

PATTERSON, James S [Wood En] b. 1832 d. 15 Ap 1916, Hackensack, NJ. Active in NYC from ca. 1858.

PATTERSON, Margaret (Jordan) [P,B] Boston, MA b. Soerabaija, Java. d. F 1950. Studied: Pratt Inst., with A. Dow; C.H. Woodbury, in Boston; Paris, with Castellucho, Augalada. Member: Boston SWCP; AFA; Copley S., 1900; Boston GA; Phila. WCC; Calif. PM; Providence WCC; Color Block PM. Exhibited: P.-P. Expo., San Fran., 1915 (prize); Phila. WCC, 1939 (med). Work: BMFA; Oakland (Calif.) Art Mus.; MMA; Univ. Calif.; Smith Col.; CMA; Mus.; Springfield (Mass.) Pub. Lib.; RISD; Victoria & Albert Mus., London; Print Coll., Mus., Genoa, Italy; LOC. Position: T., Dana Hall Sch., Wellesley, Mass. [40]

PATTERSON, Marion L(ois) [Edu,P] Vincennes, IN b. 3 N 1909, Knox County, IN. Studied: Ind. State T. Col.; Syracuse Univ. Member: NAWA; Ind. AC; Nat. Edu. Assn.; Ind. T. Assn.; Vincennes T. Fed. Exhibited: Hoosier Salon, 1942 (prize), 1943, 1944, 1946 (traveling exh.); AWCS, 1941; NAWA, 1943-45; Hoosier A. Gal. Mexican Exh., 1942; Ind. A., 1942, 1944, 1945; Syracuse Univ., 1942 (one-man); Vincennes Fortnightly C., 1946 (one-man). Position: T., Vincennes City Sch., 1937- [47]

PATTERSON, Martha [P,I,T] San Fran., CA b. Chicago. Studied: San Fran., with O. Kunath, W. Keith; ASL, with K. Volk, W.M. Chase, I.R. Wiles, C. Carleton. Member: San Fran. A. Assn. Exhibited: Mechanics' Inst. Exh. (prize); Calif. State Fair (prize) [01]

PATTERSON, Mary Frances [Des,Dec,Arch,C,L,T,W] Berkeley, CA b. 16 D 1872, Niagara Falls. Studied: T.H. Pond, H. Elliot, H.H. Clark, S. Burleigh, at RISD ; D. Ross, at Harvard; museum study, Spain, France, Italy, England. Member: Providence AC; Friends Far Eastern Art; Mus. Assn., San Fran.; Neddle and Bobbin C., N.Y.; Gld. Dec. A., Univ. Calif. Exhibited: St. Louis Expo, 1904 (prize); Better Homes Program, Berkeley, 1929 (prize). Contributor: articles on design, interior decoration, in edu. journals and magazines. Designed own home in Berkeley, which received hon. mention, permanent coll. of prize houses, Better Homes Headquarters, Wash., D.C., 1929. Position: T., Univ. Calif. [40]

PATTERSON, Nellie [P] Wash., D.C. b. Statesville, NC. Studied: C. Hawthorne; D. Garber; R. Miller. Member: Wash. WCC. Exhibited: Wash. WCC Ann., CGA, 1937, 1939 [40]

PATTERSON, Patty (Mrs. Frank Grass) [P,C,T,L,Des] Oklahoma City, OK b. 16 Ja 1909, Oklahoma City. Studied: Univ. Okla.; Ecole des Beaux-Arts, France; Fontainebleau Sch. FA; Taos Sch. A.; E. Bisttram. Member: Okla. AA; Okla. A. Lg.; MacD. C.; Applied AC. Exhibited: MacD. C., 1940 (prize), 1944 (prize); Okla. A. Lg., 1942 (prize); Fontainebleau Sch. FA; Arch. Lg.; MIT; Okla. AA, 1932-46; Tulsa AA; YWCA, Oklahoma City (one-man). Position: T., Oklahoma City Univ., 1934-[47]

PATTERSON, Rebecca Burd Peale [Min.P] Phila., PA b. Phila. Studied:

Pa. Mus.; Pa. Sch. Indst. A., Phila.; R. Van Trump; W.J. Whittemore, in N.Y.; A.M. Archambault. Member: Pa. Soc. Min. P. [40]

PATTERSON, Robert [I] NYC. Work: Cosmopolitan, 1939 [40]

PATTERSON, Russell [I] NYC b. 26 D 1896, Omaha, NE. Studied: Monet. Member: SI; Artists Gld.; Am. Inst. Dec.; Artists and Writers. Illustrator: American, Saturday Evening Post, Liberty [47]

PATTERSON, Viola (Mrs. Ambrose) [T,P] Seattle, WA b. 20 My 1898, Seattle. Studied: Univ. Wash.; Paris, with A. Archipenko; A. Ozenfant. Member: Seattle Art Mus.; Northwest PM; Group of Twelve, Seattle. Exhibited: Phoenix, Ariz., 1928 (prize); SAM, 1928, 1932. Position: T., Univ. Wash., 1940 [47]

PATTERSON, William Whitfield [P,Arch] Danville, VA/Goose Rocks Beach, ME b. 4 S 1914. Studied: E. O'Hara; Univ. Va. Member: Danville AC; Acad. Sc.&FA, Richmond, Va. [40]

PATTISON, A.M. Gould [P] St. Louis, MO [01]

PATTISON, Carrie A. [P] Indiana, PA b. 29 Jy 1877, Purchase Line, PA. Member: Pittsburgh AA; Allied Ar. Johnstown, Pa. Exhibited: Pittsburgh AA Exh., CI, 1935 (prize); Allied Ar. Johnstown, 1936 (prize), 1937 (prize). Work: One Hundred Friends of Pittsburgh Art Coll.; State Col., Pa. [40]

PATTISON, James William [P,W,L,T] Park Ridge, IL b. 14 Jy 1844, Boston d. 29 My 1915, Asheville, NC. Studied: N.Y., with J.M. Hart, Gifford Inness; Düsseldorf, with Flamm; Paris, with Chialiva. Member: Chicago SA; SWA; Chicago Municipal Art Lg.; Palette&Chisel C.; Attic C.; Cliff Dwellers; NAC. Exhibited: Mass. Charitable Mechanics' Assn., Boston, 1881 (med); St. Louis Expo, 1904 (med); Paris Salon; NAD; AWCS; PAFA; AIC. Work: AIC. Author: "Painters Since Leonardo." Editor: FA Journal, Chicago. Lecturer: AIC. Position: Dir., Sch. FA, Jacksonville, Ill., 1884-96 [13]

PATTISON, Robert J. [Ldscp.P,T] Brooklyn, NY b. 1838, NYC d. 13 S 1903. Studied: CCNY. Positions: T., CCNY, Brooklyn Boys' H.S. [01]

PATTISON, Sidney, Mrs. See Modjeska, Marylka.

PATTON, Alice Corson [P] Phila., PA. Work: TMA [15]

PATTON, Katharine [P] Phila., PA b. Phila. Studied: N.Y., with Cox, Hawthorne, Snell; PAFA; W.M. Chase; A. Robinson in Venice; F. Brangwyn, in London. Member: Phila. WCC; Phila. Alliance; AFA. Exhibited: Knoxville (Tenn.) Expo, 1913 (med); NAWPS, 1918 (prize); PAFA, 1921 (prize); Nat. A. Exh., Springville, Utah, 1926 (prize). Work: PAFA; Southern H.S., Phila.; Municipal Coll., Trenton, N.J.; Pa. State Col., State Col., Pa.; John Vanderpoel A. Assn., Chicago; Community Center, Camden, N.J. [40]

PATTON, Katherine Maxey [P] Wheaton, IL [19]

PATTON, M.C. (Mrs.) [P] Sacramento, CA. Member: Calif. AC [25]

PATTON, Marion [P] Brookline, MA. Studied: G.E. Browne. Member: Copley S.; Allied Ar. Am. Exhibited: Am. Ar. Group. Traveling Exh., Am. Fed. A., 1939, 1940 [40]

PATTON, Roy Edwin [P,E,L,T] Erie, PA b. 7 Ap 1878, Springfield, OH. Studied: Catlin; Ericson; Cross. Member: Erie AC; FA Palette C.; AAPL [40]

PATTY, William Arthur [P,T,En,L] North Hollywood, CA b. 17 Mr 1889, Hartford, CT d. 1961, Laguna Beach, CA. Studied: NAD; Académie Julian, Paris; C. Flagg; R. Brandegee; E. Ward. Member: Brooklyn SA; Brooklyn P.&S.; CAFA; All. A. Am.; Laguna Beach AA; Brooklyn WCC; Fifteen Gallery, N.Y. Exhibited: NAD; CGA; PAFA; CAFA; Wilmington Soc. FA; Witte Mem. Mus.; BM. Work: murals, Trinidad, B.W.I.; St. Petersburg, Fla.; Phoenix, Ariz.; Miami; Los Angeles [47]

PITZIG, Edna [P,T] Iowa City, IA b. LeMars, IA. Studied: Cumming; Bosley; Clark; Fontainebleau Sch. FA, with Gorguet. Member: Iowa AG; L.C. Tiffany Fnd.; Western AA. Exhibited: Iowa State Fair, 1925 (gold). Work: Montgomery (Ala.) Mus. FA. Position: T., Univ. Iowa [40]

PAUL. See Acruman, Paul.

PAUL, Andrew G. [P] Los Angeles, CA. Member: Calif. AC [25]

PAUL, Bernard Henry [C] Linthicum Heights, MD b. 22 Ap 1907, Baltimore. Studied: Md. Inst. Exhibited: Inst., 1929 (prize), 1933 (prize), 1937 (prize); Art Soc., Baltimore, 1928 (prize). Specialty: marionettes. Position: T., Md. Inst., 1929-42 [47]

PAUL, Charles R. [P,I,Des] Phila., PA b. 29 D 1888, Indiana, PA d. ca. 1945. Studied: W.M. Chase; T. Anschutz; H. McCarter [40]

PAUL, Gen NYC [25]

PAUL, William H., Jr. [I] Phila., PA b. 12 Ag 1880, Phila. Studied: PAFA [10]

PAULDING, John [S] Park Ridge, IL b. 5 Ap 1883, Dark County, OH d. 15 Ap 1935, Chicago. Studied: AIC; Europe. Member: Chicago Gal. A.; Cliff Dwellers; Chicago PS. Work: World War mem. in various American cities; McPherson, Kans., bronze equestrian statue of General James B. McPherson, unveiled in 1917 [33]

PAULEY, Floyd [B,Dr,I,Mur.P,Por.P] Milwaukee, WI/Herington, KS b. 10 Je 1909, Herington, KS d. 26 Ag 1935. Studied: G.V. Sinclair; M. Nutting; Layton Art Sch.; Osten; Sisson. Member: Daubers C.; Wis. P. Exhibited: Kans. State Free Fair, Topeka, 1932-33 (prize), 1934 (prize); Wis. P.&S. Exh., 1934 (prize); Intl. Watercolor Exh., Chicago, 1935 (prize). Work: Pub. Sch., Milwaukee [40]

PAULI, Corinne [I] Phila., PA. Studied: PAFA [25]

PAULIN, Elise [P] Tompkinsville, NY [15]

PAULIN, Telford. See Paullin, Telford.

PAULL, Grace [I,W,Li] NYC/Cold Brook, NY b. Cold Brook. Studied: PIASch; Grand Central A. Sch.; George Bridgman; Alexander Archipenko. Exhibited: PAFA; CGA; Munson-Williams-Proctor Inst. Author/Illustrator: "Raspberry Patch," other juvenile books. Illustrator: "Peter by the Sea," "Country Stop." Contributor: "Story Parade" [47]

PAULLIN, Ethel M. Parsons (Mrs. Telford) [Mur.P,Des] NYC b. Chardon, OH. Studied: BMFA Sch.; ASL. Member: NSMP. Work: St. Bartholomew's Church, Church of St. Vincent Ferrer, both in N.Y.; St. Stephen's Church, Stevens Point, Wis.; Fed. Bldg., Albany, N.Y.; triptychs, U.S. Army; U.S. Navy; Trinity Church, Roslyn, N.Y.; USPO, Albany, N.Y. Position: Des., handwoven tapestries and decorations, Herter Looms, NYC [47]

PAULLIN, Telford [I,P] NYC b. 1885, Le Mars, IA d. 4 Ap 1933. Studied: Chicago; J.M. Swan; F. Brangwyn, in London. Member: NSMP. Work: St. Vincent Ferrer's, NYC; Chapel St. Bartholomew's, NYC [21]

PAULUS, Christopher Daniel [S,P,I,C,T] Newton, KS b. 11 Ap 1848, Würtemberg, Germany. Studied: E. Kähnel, Dresden [08]

PAULUS, Francis Petrus [P,S,E,T] Detroit, MI b. 13 Mr 1862, Detroit, MI d. 3 F 1933. Studied: PAFA; Royal Acad., Munich, with Loefftz; Ecole des Beaux-Arts, Paris, with Bonnât. Member: Chicago SE; NAC; Scarab C.; La Gravure Originale en Noir; Société Intl. des Beaux-Arts et des Lettres. Work: Herron AI; Detroit AI; McGregor Lib., Highland Park, Mich.; NYPL; LOC; Oakland Mus.; Musée Moderne, Bruges; Royal Acad. FA, Munich. Positions: Asst. Dir., Detroit Acad. A. (1895-1903); Dir., Ann Arbor A. Sch. (1903-05), Bruges Sch. A. (1905-ca. 1908) [32]

PAUS, Herbert [P,I] Mamaroneck, NY b. 1880 d. 1 Je 1946. Member: GFLA. Work: many magazines; des., WWI posters [27]

PAUSAS, Francisco [P] NYC [15]

PAUSCH, Eduard Ludwig Albert [S] Buffalo, NY/Westerly, RI b. 30 S 1850, Copenhagen. Studied: C. Conrads; K. Gerhart, Hartford; D. Mora, NYC [10]

PAVAL, Philip Kran [C,P,S,L] Hollywood, CA b. 20 Ap 1890, Nykobing, Denmark. Studied: Denmark; Member: Calif. AC; P&S C., Los Angeles; Scandinavian-Am. AS; Am. Ar. Cong. Exhibited: Los Angeles Mus. A., 1935 (prize), 1937 (prize), 1941 (med); Hollywood Riviera Gal., 1937 (prize); Wichita AA, 1946 (prize); Calif. State Fair, 1935-39 (prizes); GGE, 1939; Santa Barbara Mus. A., 1945; Los Angeles Mus. A., 1937, 1943-45 (one-man); Dalzell Hatfield Gal., Los Angeles; Palace Legion Honor, 1938; PS C., Los Angeles, 1936 (prize); Pomona, Calif., 1934 (prize), 1935 (prize), 1936 (prize). Work: Lutheran Church, Los Angeles; Los Angeles Mus. A.; Philbrook A. Ctr.; MET; Presidential Palace, Quito, Ecuador; Devi Palace, Vizianagaram City, So. India [47]

PAVLOVICH, Edward [Por.P,Des] NYC b. 9 Jy 1915, NYC. Studied: H.E. Fritz; P. Moschowitz; W. Starkweather. Member: Kit Kat AC; Salart C. [40]

PAVON, José M. [E,Li] NYC b. Mexico City. Exhibited: AIC, 1931 (prize). Work: NYPL; AIC [32]

PAWLA, Frederick Alexander [P,Dec] Santa Barbara, CA b. 6 S 1877. Studied: Europe. Member: Royal A. Soc., New South Wales; Santa Barbara AS; San Diego AS. Work: War Dept., Wash., D.C.; murals, Dept. of Pub. Markets, NYC [40]

PAXON, Edgar Samuel [I,P] Missoula, MT (since 1905) b. 25 Ap 1852, East Hamburg, NY d. 1919. Studied: self-taught. Work: 8 murals, Missoula County Court House; 56 murals, Mont. Capitol; Univ. Mont.; Whitney Gal. Western A. After service as a scout in the Nez Percé war in Mont., 1877–78, he specialized in Indians and pioneer life. Best known for his 6' x 10' "Custer's Last Battle" which took many years to paint and was exhibited nationally. [19]

PAXSON, Ethel (Easton) (Mrs. Chester H. DuClos) [P,W,T] Essex, CT b. 23 Mr 1885, Meriden, CT d. 5 Jy 1982. (Formerly Mrs. Clement Esmond Paxson.) Studied: Lilla Yale; Corcoran A. Sch., with E. Messer, M. Mueden; PAFA, with W.M. Chase, C. Beaux, T. Anschutz, H. Breckenridge, H.R. Poore; R. Johonnot. Member: Am. WC Soc.; All. A. Am.; NAWA; A. Lg. Nassau County; Meriden A.&Crafts Assoc.; Catharine Lorillard Wolfe A. Cl.; New Haven PCC; Am. A. Prof. Lg. Exhibited: NAD; Am. WC Soc.; NAWA; CAFA; Meriden A.&Crafts Assoc.; A. Lg. Nassau County; Am. Ar. Prof. Lg.; Catharine Lorillard Wolfe A. Cl.; New Haven PCC; All.A.Am.; Long Island Univ.; Newhouse Gal.; Argent Gal.; Marquis Gal.; Marbella Gal., NYC. Work: MMA; New Britain Mus. Am. A.; Heckscher Mus., Huntington, N.Y.; Parrish A. Mus.; Southampton, N.Y.; Mattatuck Mus., Waterbury, Conn.; Meriden Hist. Soc.; Robert Hull Fleming Mus., Burlington, Vt.; Colby A. Mus.; Park Strathmore Gal., Rockford, Ill.; Marbella Gal.; Grand Central A. Gal.; Art Center, Florence Griswold Mus., both in Old Lyme, Conn.; Am. Embassy, Rio de Janeiro; Landmann Coll., São Paulo; Thomas Jefferson House, Brasilia. Contributor: articles, Woman's Home Companion, American Magazine. Writer/Illustrator: Brazilian American, Rio de Janeiro. Author: "Love Affair with Brazil," "Sonnets and Other Poems," other books. Positions: L. or Instr.; NAWA; Frick Mus.; Nassau Inst. A.; Am. Sch., Rio de Janeiro; Bell A. Lg. (1948–49); Creative Arts Sch., New York; Art Classes, Central Park (1944–45); artist's studio, Kew Gardens, N.Y.; "Highfields," Weston, Vt. (summers, 1936–41) [47]

PAXSON, Martha K.D. [Min.P] Phila., PA b. 1875, Phila. Studied: W. Sartain; Daingerfield [15]

PAXTON, Elizabeth Okie (Mrs.) [P] Newton, Centre, MA b. Providence, RI. Studied: W.M. Paxton. Member: Boston GA; North Shore AA. Exhibited: WFNY, 1939; P.-P. Expo, San Fran., 1915; North Shore AA, 1927 (prize); Jordan Marsh Gal., Boston, 1933 [40]

PAXTON, W.A. [P] Los Angeles, CA. Member: Calif. AC [25]

PAXTON, William M(cGregor) [P,T] Newton Centre, MA b. 22 Je 1869, Baltimore, MD d. 13 My 1941. Studied: Ecole des Beaux-Arts, Paris, with Gérôme; D.M. Bunker, at Cowles A. Sch., Boston. Member: ANA, 1917; NA, 1928; SC; NAC; Copley S., 1894; Boston GA; St. Botolph C., Boston; Phila. AC; Allied AA; AFA. Exhibited: Pan-Am. Expo, Buffalo, 1901; St. Louis Expo, 1904 (med); PAFA, 1915 (prize) 1921 (prize), 1928 (prize); P.-P. Expo, San Fran., 1915; CGA, 1919 (prize), 1935 (prize); Indianapolis MA, 1979 (retrospective). Work: PAFA; MMA; Army and Navy C.; CGA; BMFA; Cincinnati Mus.; Detroit Inst. A.; Wadsworth Atheneum, Hartford; Butler AI, Youngstown, Ohio. Position: T., BMFA Sch., 1906–13 [40]

PAYANT, Felix [W,L] Columbus, OH b. 10 Ap 1891, Faribault, MN. Studied: Univ. Minn.; PIASch; Columbia. Author: "Our Changing Art Education" (1935), "Design Technics," "Create Something." Positions: T., Ohio State Univ., Syracuse Univ.; Ed., Design [47]

PAYEN, Cecile E. [P] Chicago, IL b. Dubuque, IA. Studied: NYC; Paris. Exhibited: Columbian Expo, Chicago, 1893 (med) [01]

PAYNE, Amy Gertrude [Min.P] Phila., PA [10]

PAYNE, Arthur H. [P] Chicago, IL. Member: Chicago NJSA [25]

PAYNE, Charles Henry [Ldscp.P,Cr] Chicago, IL b. 27 N 1850 Newburyport, MA d. 1 Mr 1916. Member: Chicago SA; Chicago WCC. Position: Art Cr., Chicago Inter-Ocean [15]

PAYNE, Edgar Alwin [Ldscp.P,W] Los Angeles, CA b. 1 Mr 1882, Washburn, MO d. 8 Ap 1947. Studied: chiefly self-taught; AIC. Member: SC; Allied AA; Intl. S. AL; Calif. AC; Ten P. of Los Angeles; Laguna Beach AA; Chisel C., 1913. Exhibited: Sacramento State Fair, 1918 (gold); Sacramento, 1919 (med); AIC, 1920 (prize); Southwest Mus., 1921 (prize); Paris Salon, 1923; Los Angeles Mus. A., 1926 (gold,med). Work: murals, Empress Theatre, American Theatre, both in Chicago; Clay County Court House, Brazil, Ind.; Hendricks County Court House, Danville, Ind.; Queen Theatre, Houston; Nebr. AA, Lincoln; Peoria S. Allied A.; Herron AI; Mun. A. Commission; Janesville, Wis., AA; Southwest Mus., Los Angeles; NAD. Author: book on landscape painting. Specialty: Sierra Mountains [40]

PAYNE, Elsie Palmer (Mrs. Edgar A.) [P,T,L] Beverly Hills, CA b. 9 S 1884, San Antonio, TX. Studied: Best's A. Sch., San Fran.; Chicago Acad. FA. Member: Laguna Beach AA; Women P. of the West; Calif. AC; Calif. WCS; Soc. for Sanity in Art. Exhibited: Paris, 1925; NAWA, 1930; NAD, 1930; Calif. WCS; Riverside Mus., 1944; 1941–43; Laguna Beach AA; Ebell C., Los Angeles, 1932–1942, 1943 (prize); Los Angeles Mus. A., 1941, 1942 (prize), 1943, 1944 (prize); Calif. AC, 1943 (prize) [47]

PAYNE, Emma Lane (Mrs.) [P,T] Euclid, OH b. 5 My 1874, Canada. Studied: Cleveland Sch. A.; L. Ochtman. Member: Women's AC. Exhibited: Cleveland AM. Specialty: animal portraits [40]

PAYNE, George Kimpton [Des,P,Gr,S,C,I,B,En] Falls Church, VA b. 23 My 1911, Springville, NY. Studied: ASL, with G. Bridgman, A. Lewis, T. Benton; F.V. DuMond. Work: 200 animal drawings, U.S. Gov. Contributor: New Yorker. Position: Scientific Ar., Nat. Zoo. Park, Wash., D.C., 1936; Adv. A., 1937–43; USNR Terrain Map Model Maker, 1943–45; Supv. Displays, Woodward & Lothrop, Wash., D.C., from 1946 [47]

PAYNE, George Hardy [Des,C] Hawthorne, NJ b. 1872 d. 15 Ja 1927. Founder: Payne Studios, one of the largest designers of stained glass in the U.S.

PAYNE, Henry C. [P] Chicago, IL b. 1850, Newburyport, MA. Member: Chicago SA [15]

PAYNE, James [P] Phila., PA [04]

PAYNE, Jeanne. See Louis C. Johnson, Mrs.

PAYNE, John Barton [Patron] b. 26 Ja 1855, Prunytown, VA (now WV) d. 24 Ja 1935, Wash., D.C. The John Barton Payne Collection of Paintings presented to the Commonwealth of Virginia, consisting of fifty-one works by the Old Masters and "The Madonna of the Rappahannock" by Gari Melchers, is housed at Battle Abbey, Richmond. A contribution of one hundred thousand dollars from Judge Payne insured the building of the Va. State Mus. He restored the historic St. John's Church in Washington. Among his bequests was the Payne collection of etchings and twenty-five thousand dollars to the Univ. Va.

PAYNE, Paul T. (Mrs.) [S,L] Indianapolis, IN. Member: Ind. AC; F. PAFA; Ind. Fed. AC; Phila. A. All.; Indianapolis AA. Exhibited: Hoosier Salon, 1937 (prize); Inc. AC, 1938 (prize), 1939 (prize); Ind. Fed. AC, 1939 (prize) [40]

PAYNE, Pauline [P] Los Angeles, CA. Member: Calif. AC [25]

PAYNE, William H. [Cr] NYC b. 1834, Leicester, England (came to U.S. in 1853) d. 28 D 1905. Member: Union Lg. C. He was devoted to the advancement of American art.

PAYOR, Eugene [P,Des,Gr,W,I] NYC b. 28 Jy 1909, NYC. Studied: Univ. Calif.; ASL, with J.S. Curry, J. Charlot, R. Soyer. Exhibited: All.A.Am.; WMAA; Salons of Am.; VMFA; SFMA; Univ. Ga., 1944 (one-man). Position: T., Univ. Ga., 1943–45 [47]

PAZOLT, Alfred Joseph [P] Cornwall, England b. 1872, Boston, MA. Studied: P. Jansen, in Düsseldorf, Germany [13]

PEABODY, Amelia [S] Boston, MA b. 3 Jy 1890, Marblehead Neck, MA. Studied: BMFA Sch., with C. Grafly; Archipenko Sch. A. Member: Copley S., Boston; Boston S. Soc.; North Shore AA; Gld. Boston A.; NSS; NAWA; AAPL; Boston AC; AFA; Soc. Med. Exhibited: PAFA; WFNY, 1939; AIC, 1932; Boston S. Soc.; Jr. Lg. Nat Exh. (prize); Garden Cl. Am., (med). Work: BMFA; portrait heads [47]

PEABODY, Evelyn [P] Phila., PA. Affiliated with PAFA [25]

PEABODY, Grace Allen [P] NYC. S.Indp.A. [25]

PEABODY, Helen Lee (Mrs. Robert S.) [P] NYC b. 6 Je 1879, NYC. Studied: W. Chase; G deF. Brush. Member: NAWPS; AWCS. Exhibited: NAWPS, 1936, 1937, 1938; AWCS-NYWCC, 1939 [47]

PEABODY, L.L. (Mrs.) [Min.P] Quincy, MA [19]

PEABODY, Marian Lawrence [P,S] Boston, MA/Bar Harbor, ME b. 16 My 1875, Boston. Studied: Hale; Benson; Tarbell; Allen Recchia. Work: portrait head, Lawrence Col., Appleton, Wis.; Groton Sch., Groton, Mass.; Episcopal Theological Sch., Cambridge, Mass.; portrait, Univ. Kans., Lawrence [40]

PEABODY, Mary [P] Phila., PA [25]

PEABODY, Ruth (Eaton) [P,S] Laguna Beach, CA b. 1898, Highland Park, IL d. 1967. Studied: AIC; E. Colburn. Member: Calif. AC; San Diego AC; Laguna Beach AA. Exhibited: PAFA, 1931; AIC; Phila. A. All.; GGE, 1939; Crocker A. Gal., Sacramento; Oakland A. Gal.; Calif. AC;

Calif. State Fair; West Coast A., Los Angeles, 1926 (gold); Calif. State Fair, 1926 (prize), 1937 (prize); Laguna Beach AA, 1927 (prize), 1936 (prize), 1937 (prize); Riverside County Fair, 1928 (prize), 1930 (prize); San Diego FA Gal., 1928 (prize), 1929 (prize), 1931 (prize); Pasadena AI, 1930; Los Angeles County Fair, 1931 (prize). Work: San Diego FAS; Laguna Beach AA; mon., City of Laguna Beach; plaque, Anaheim H.S. [47]

PEABODY, William W. [C] Amesbury, MA b. 29 D 1873, Gardner, MA. Studied: T. Resterich. Member: Boston SAC (master craftsman); Phila. ACG. Position: In charge of Peabody Craft Shop, hand-made solid silver flat ware, Amesbury, Mass. [40]

PEACOCK, Claude [P,I] Montgomery, AL b. 18 Jy 1912, Selma, AL. Studied: Huntingdon Col., Montgomery, AL. Member: Ala. AL. Exhibited: Army A. Exh., Atlanta, Ga., 1945; Army A. Comp., Jefferson Barracks, Mo., 1942 (prize); Ala. AL, 1946 (prize). Work: Archives & History Dept., Ala.; WMAA; Montgomery Mus. FA; murals, Napier Field Army Air Base, Dothan, Ala. Illustrator: covers for American Druggist, Outdoorsman [47]

PEACOCK, Jean Eleanor (Mrs. William C. King) [P,Gr,T] Richmond, VA. b. Norfolk, VA. Studied: Columbia Univ., Va.; State T. Col., Farmville, Va.; ASL; E. O'Hara, G. Cox; H. Wickey; B. Makielski; C. Martin. Member: AAPL; NAWA; Va. All.A.; Richmond Acad. A.; SSAL; Southern PM Soc. Exhibited: NAWA, 1945, 1946; VMFA, 1945; Irene Leach Mem. Mus., 1945; Va. Intermont Col., 1945, 1946; SSAL, 1935 (prize). Position: T., Pub. Sch., Norfolk and Richmond, Va. [47]

PEACOCK, Jon (Edward) [Des,E,I] Hermosa Beach, CA b. 20 D 1908, NYC. Studied: G. Ennis; Arshile Gorky; F. Monhoff; C. Cartwright. Position: Set Des., 20th Century Fox [40]

PEACY, Jess Lawson (Mrs.) [S] NYC. Member: NSS [47]

PEALE, Mary Jane [P] b. 16 F 1827, NYC d. N 1902, Pottsville, PA. Studied: probably with her father Rubens Peale (1784–1865). Specialties: portraits; still-life [*]

PEALE, Rebecca Burd [Min.P] Holmesburg, PA [10]

PEANO, Felix [S] Hawthorne, CA b. 9 Je 1863, Parma, Italy. Studied: Tabacchi, Acad. FA, Turin. Work: interiors, Spreckels Theatre, San Diego; St. Vincent's Church, Los Angeles; Freeman Church, Inglewood; Quimby Bldg., Los Angeles; Catalina Island, Calif.; busts, arch. sculp., for many Calif. bldgs. [40]

PEAR, Charles [I] NYC. Position: staff, Illustrated American [98]

PEARCE, Charles Sprague [P] Paris, France/Auvers, France (since 1884) b. 13 O 1851, Boston, MA d. 8 My 1914. Studied: Bonnât, in Paris. Member: SAA, 1886; ANA, 1906; Paris SAP; SC, 1900; NIAL. Exhibited: Boston, 1878 (med); Paris Salon, 1881, 1883 (med); PAFA, 1881 (prize), 1885 (gold); Mechanic's Inst., Boston, 1884 (gold); Ghent, 1886 (gold); Munich, 1888 (gold); Berlin, 1891; San Fran., 1894 (gold); Atlanta Expo, 1895 (gold) Vienna Staats 1898 (gold); Pan-Am. Expo, Buffalo, 1901 (med). Awards: Chevalier of the Legion of Honor, France, 1894; Order of Leopold, Belgium, 1895; Order of the Red Eagle, Prussia, 1897; Order of Dannebrog, Denmark, 1899. Work: Buffalo FA Acad.; PAFA; AIC; MMA [13]

PEARCE, Edgar Lewis [P] Manasquan, NJ b. 26 Ap 1885, Phila., PA. Studied: PMSchIA; PAFA, with W. Chase, C. Beaux, J.A. Weir. Member: Union Intl. des Artes et Lettres, Paris; Manasquan River Group A. Exhibited: Spring Lake, N.J., 1945 (prize) [47]

PEARCE, Elizabeth J. [P] Baltimore, MD [25]

PEARCE, Fred E. [P] Chicago/Williamsburg, IN [10]

PEARCE, Glenn Stuart [P,Dr,T] Erie, PA b. 2 D 1909, Erie, PA. Studied: Ericson; Garber; Pearson; Harding; PAFA. Exhibited: Erie AC, 1929 (prize), 1930 (prize), 1931 [40]

PEARCE, W.H.S. [P] Newton, MA [01]

PEARMAN, Katharine K. (Mrs. Arthur) [P,L,T] Rockford, IL b. 11 F 1893, Beloit, WI d. 3 F 1961. Studied: H. Breckenridge; G. Wood; F. Chapin. Member: Chicago SA; Rockford AA; Chicago AC. Exhibited: NAD, 1944; Grand Rapids, Mich., 1940; PAFA, 1941; CGA, 1941; CI, 1941, 1943; Rockford AA, 1927-46 (prizes); AIC, 1929, 1932, 1935, 1940-43, 1945; Wis. Salon A., 1939, 1940, 1942 (prize), 1943 (prize), 1944-45; Milwaukee, Wis., 1946. Work: Burpee A. Gal., Rockford, Ill.; Univ. Wis.; Abbott Laboratories Coll.; mural, St. Paul's Chapel, Camp Grant, Ill. Position: T., Rockford Col., 1943-45 [47]

PEARSALL, A.B., Mrs. [P] NYC. Member: S.Indp.A. [24]

PEARSON, Albert R. [Por.P] Chicago, IL b. 22 F 1911. Studied: E. Giesbert; AIC; L. Ritman. Member: Chicago NJSA. Work: White House, Wash., D.C. [40]

PEARSON, Edwin [P,C,S,Des,T,Dec] Hyde Park, NY b. 20 D 1889, Yuma County, CO. Studied: Royal Acad. A., Munich; AIC, with H. Wolcott; H. Hahn. Exhibited: Swedish Am. A., Chicago; AIC; PAFA; NAD: Arch. Lg.; Milwaukee AI (one-man). Work: Sculpture, Nat. Mus., Munich; Nat. Lib., Weimar; Munich Theatre Mus. Positions: Dir./T., Arts & Crafts Gld., New York; Manager, San Jose Potteries, San Antonio, Tex., 1944-45 [47]

PEARSON, Eleanor Weare [P] East Gloucester, MA. Member: NAC [13]

PEARSON, Jane Mumford (Mrs.) [P] High Falls, NY b. Baltimore [24]

PEARSON, Joseph O. [P,En] d. 12 Jy 1917, Little Falls, NJ. Lived in Brooklyn, N.Y. for twenty years. Served in the Civil War. Specialty: music title pages

PEARSON, Joseph Thurman, Jr. [P,T] Huntington Valley, PA b. 6 F 1876, Germantown, PA d. 23 F 1951. Studied: PAFA, with Chase, J.A. Weir, 1897–1900. Member: ANA; NA, 1919; T Square Cl. Exhibited: PAFA, 1911 (med), 1916 (gold), 1917 (gold), 1933 (med); P.-P. Expo, 1915 (gold); Sesqui-Centenn. Expo, Phila., 1926 (gold); AIC, 1915 (med), 1918 (prize); NAD, 1911 (prize), 1915 (prize), 1918 (gold); CI, 1911 (med). Work: Univ. Cl., Phila.; PAFA. Position: T., PAFA (1909-22), (1924-37), (summers, 1929-35) [47]

PEARSON, Lawrence E. [P,I] Houston, TX b. 19 O 1900, Bay City, TX. Studied: MFA Sch., Houston. Studied: F. Browne; A. MacDonald. Member: Ar. Gal., Houston; Sketch Cl. Exhibited: Houston MFA. Position: P., Matteson Southwest Inc., Houston [40]

PEARSON, Marguerite S(tuber) [P] Rockport, MA b. 1 Ag 1898, Phila., PA d. 2 Ap 1978. Studied: BMFA Sch., W. James, H.H. Clark, F. Bosley; Rockport Summer Sch., with H. Leith-Ross, A.T. Hibbard. Member: Gld. Boston A.; All.A.Am.; North Shore AA; Rockport AA; AAPL; Phila. A. All., Sanity in Art; Ogunquit AA; SC; CAFA. Exhibited: NAC, 1966 (prize); AAPL (prize); SC, 1941 (gold); Rockport AA, many medals from 1944, 1964 (gold); North Shore AA, 1930 (prize); Springville, Utah, 1937 (prize); CGA, 1922, 1926, 1932, 1934; NAD, 1925–29, 1931, 1932, 1934; PAFA, 1924, 1926–29, 1931, 1933, 1935, 1936; Springville A. Gal., 1935–42, 1946; All.A.Am., 1925–46; New Haven PCC, 1932, 1938; CAFA, 1925–32; Jordan Marsh Gal., 1930–46; North Shore AA, 1926–46; Rockport AA, 1923–46. Work: Springville A. Gal.; New Haven Pub. Lib.; Beach Mem. A. Gal., Storrs, Conn.; Brigham Young Univ.; Mechanics Bldg., Boston; Episcopal Diocesan House, Boston; Somerville (Mass.) City Hall [47]

PEARSON, (Nils) Anton [C,Por.P,P,S] Lindsborg, KS. b. 23 My 1892, Lund, Sweden. Studied: Bethany Col., Sweden; B. Sandzen. Member: Smoky Hill AA. Contributor: Kansas magazine [47]

PEARSON, Ralph M. [E,L,W,Des,T,Cr] Nyack, NY b. 27 My 1883, Angus, IA d. 27 Ap 1958. Studied: AIC, with C.F. Browne, Vanderpoel. Member: Chicago SE; Am. A. Cong.; ASL, Chicago; Chicago SE; N.Y. SE; Calif. AC; Calif. PM; Calif. SE; Soc. Am. E.; Am. Soc. PS&G. Exhibited: Chicago SE, 1914 (prizes); Pan-Pacific Expo, 1915 (med); Am. Bookplate Soc., 1917 (med); Calif. Pr.M., 1922. Work: NYPL; LOC; Mechanics Inst., Rochester; AIC; Los Angeles Mus. A.; Univ. Chicago Lib.; Columbia; Newark Pub. Lib.; Am. Antiquarian Soc. Author: "Experiencing Pictures" (1932), "The New Art Education" (1941), "Fifty Prints of the Year" (for the American Inst. of Graphic Arts, 1927), other books, "Woodcuts" (Encyclopaedia Britannica, 1929). Positions: Dir., Design Workshop (School), New York and East Gloucester; A. Ed., Forum, 1936-40; Columnist, Art Digest, 1945, 1946 [47]

PEART, Caroline. See Brinton.

PEASE, Fred I. [P] Columbus, OH. Member: Columbus PPC [25]

PEASE, Lute (Lucius C.) [Car,Por.P,L,W] Maplewood, NJ b. 27 Mr 1869, Winnemucca, NV d. 1963 (age 94). Studied: self-taught; Malone (N.Y.) Acad., 1887. Member: AAPL; Art Center of the Oranges. Exhibited: NAD. Artist-correspondent and prospector in Alaska, 1897-01; U.S. Commissioner to Alaska, 1901-02; staff cartoonist, Portland Oregonian, 1902-05; editor/illustrator, Pacific Monthly, 1906-13; cartoonist, Newark Evening News, 1914-40s (awarded Pulitzer prize). Created approximately 70,000 cartoons. [40]

PEASE, Nell (Mrs. Lute C.) [I,Por.P] Maplewood, NJ (1963) b. 25 D 1883, Steubenville, OH. Studied: Corcoran Sch. A.; H. Helmick. Member: Art Center of the Oranges. Illustrator: Pacific Monthly, 1906-13 [40]

PEASLEY, Horatio N. [P] West Somerville, MA b. 10 F 1853, Milton, MA. Studied: J.J. Enneking, in Boston [10]

PECK, Anita Walbridge [C] Bronxville, NY/South Egremont, MA b. 14 N 1882, Brooklyn, NY. Studied: M. Robinson; V. Raffo; K. Illava; L. Jonas. Member: N.Y. Soc. Ceramic Arts; Westchester A.&Crafts [40]

PECK, Anna Gladys [I] NYC b. 21 Jy 1884, Monmouth Beach, NJ. Studied: Twachtman, Metcalf, Clinedinst, in New York. This is possibly Anne M. Peck, but only the birthdate is the same. (Error?) [17]

PECK, Anne Merriman (Mrs. Frank Fite) [I,Li,W,P] NYC b. 21 Jy 1884, Piermont, NY. Studied: R. Henri; I. Wiles; Hartford A. Sch.; N.Y. Sch. F.&Appl. A. Member: Am. A. Cong. Exhibited: Weyhe Gal., N.Y.; Tucson, Ariz. Work: Newark Mus. Author/Illustrator: "Roundabout South America" (1940), "Young Mexico" (1934), other books. Illustrator: "Steppin and Family" (1942). Position: Illus., Harper's [47]

PECK, Augustus [I,T] Proctor, VT b. 10 O 1906, Frederick, MD. Exhibited: drawing, CMA, 1931 (prize), illus., 1932 (prize) [32]

PECK, Clara Elsene [I,P,E] Brooklyn, NY b. 18 Ap 1883, Allegan, MI. Studied: Minneapolis Sch. FA; PAFA, with W. Chase. Member: NYWCC; AWCS; A. Gld.; SI; Women P.&S. Soc. Exhibited: AWCS Traveling Exh. of Illustrations.; N.Y. Women's PS, 1921 (prize), poster, 1922 (prize). Illustrator: children's and text books, covers and illus. for national magazines [47]

PECK, Edith Hogen [P,E,Li] Cleveland, OH b. 28 F 1884, Cleveland. Studied: Cleveland Sch. A.; H.G. Keller; F.N. Wilcox. Exhibited: CMA, 1941 (prize); PAFA, 1934, 1935, 1939; AWCS, 1946; Ohio Pr.M., 1941–46; NAD, 1942–46; LOC, 1942, 1943; SAE, 1943–46; Northwest Pr.M., 1945, 1946; Tri-State Pr.M., 1945, 1946; Phila. Pr. Cl., 1945; Laguna Beach Pr. Cl., 1945; Am. Color Pr. Soc., 1946; CMA, 1933–46; Butler AI, 1937, 1940, 1942, 1943, 1946. Work: CMA; Carville (La.) Mem. Hospital [47]

PECK, Esther [P] NYC. Member: Lg. of AA [24]

PECK, Glenna (Hughes) [Por.P,Des,Cer. S] Syracuse, NY/Moravia, NY b. Huntsburg, OH. Studied: N.Y. Sch. F.&Appl. A.; Syracuse Univ. Member: NAWA; Assoc. A. Syracuse. Exhibited: A. All., N.Y., 1931 (prize), 1932 (prize), Assoc. A. Syracuse, 1940 (prize), annually; Robineau Memorial Exh., Syracuse, 1934 (prize); Finger Lakes Exh., 1939; Syracuse Mus. FA, 1934; Bradenton (Fla.) AA, 1941 [47]

PECK, Grace Brownell [Ldscp.P,I] b. 1861, Moodus, CT d. 16 Ja 1931, Bristol, CT. Work: black-and-white sketches in magazines

PECK, Graham [I,P,W] Derby, CT b. 6 Ap 1914, Derby. Studied: Yale. Exhibited: Yale Gal. FA, 1939. Illustrator: "The Valley of the Larks," by Eric Purdon, 1939. Author/Illustrator: "Through China's Wall," 1940 [40]

PECK, Henry J(arvis) [P,I,W] Warren, RI b. 10 Je 1880, Galesburg, IL. Studied: E. Pape; H. Pyle; RISD. Member: Providence AC; Providence WCC; South County AA; North Shore AA [40]

PECK, James Edward [P,Des,I,G] East Cleveland, OH b. 7 N 1907, Pittsburgh. Studied: Cleveland Sch. A.; John Huntington Polytechnic Inst.; H.G. Keller; R. Stoll; C. Gaertner. Member: F., Guggenheim Fnd., 1942, 1945. Exhibited: CMA, 1931–38, 1939 (prize) 1940, 1941 (prize), 1942–44, 1945 (prize), 1946; PAFA, 1934, 1935, 1937; AWCS, 1934, 1935, 1946; AIC, 1933, 1934, 1939, 1943, 1946; Dayton AI, 1942 (one-man), 1943–45; Cleveland Sch. A., 1945; Cincinnati Mod. A. Soc., 1945; Little A. Center, Dayton, 1945; Ten-Thirty Gal., Cleveland, 1946; Butler AI, 1946. Work: CMA; Dayton AI; Carville (La.) Mem. Hospital; Cleveland AA; City of Cleveland [47]

PECK, Joseph A(lanson) [P] NYC/Middlebury, VT b. 2 My 1874, Augusta, ME. Member: SC [33]

PECK, Julia E. [P] Port Huron, MI. Member: S.Indp.A. [25]

PECK, Natalie [P] NYC b. 27 F 1886, Jersey City, NJ. Studied: K.H. Miller. Member: Salons of Am.; Springfield AA. Work: PAFA [29]

PECK, Orrin [Ldscp.P,Por.P] Pleasanton, CA b. 1860, Delaware County, NY d. 20 Ja 1921, Los Angeles. Studied: Gijsis, Loefftz, in Munich. Exhibited: Columbian Expo, Chicago, 1893 (gold). He painted several portraits of the Hearst family, and was in charge of the artistic work planned for W.R. Hearst's ranch in northern Calif. [17]

PECK, Stephen Rogers [P,T] Syracuse, NY b. 18 D 1912, Cortland, NY. Studied: Syracuse Univ.; Académie Julian, Paris. Exhibited: Syracuse Assoc. Ar., MFA, Syracuse. Position: T., Syracuse Univ. [40]

PECKHAM, Mary C. (Mrs. F.H.) [P] Providence, RI b. 26 O 1861, Providence, RI. Studied: M.C. Wheeler; R. Collin; A. Thayer. Member: Providence AC; Providence WCC; AFA; South County AA [40]

PECKWELL, Henry W. [Wood En] NYC b. 1854, New York. Exhibited: Pan-Am. Expo, Buffalo, 1901 (med) [06]

PECORINI, Margaret B. (Comtessa) [P,Por.P] NYC/Paris, France b. 18 Ag 1879, Phila. Studied Académie Julian, Paris. Member: Phila. Alliance. Work: BM. Specialty: child portraits [33]

PEDDLE, Caroline C. See Ball, Mrs.

PEDERSON, Andreas [P] Minneapolis, MN [24]

PEDERSEN, Robert Holm [P] Montclair, NJ b. 1 Je 1906, Hesselager, Denmark. Studied: self-taught; Denmark. Member: Art Center of the Oranges; Asbury Park Soc. FA; Am. Ar. Prof. Lg. Exhibited: Newark AC, 1936 (prize); N.J. Gal., 1936 (prize); Irvington (N.J.) Municipal Exh., 1938 (prize); PAFA, 1936–38; NAD, 1940; AIC, 1938; CAFA, 1938–41; Montclair A. Mus., 1936–40; Newark Mus., 1937, 1938 [47]

PEDERSON, Jörgen [P] Irvington, NJ b. 2 Jy 1876, Denmark d. 3 D 1926. Studied: W.M. Chase; Henri [25]

PEDRETTI, Humbert [P] Hollywood, CA [24]

PEBBLES, Frank (Francis) Marion [P,Por.P] Alameda, CA b. 16 O 1839, Wethersfield, NY d. 2 D 1928. Studied: NAD; Edwin White, in New York; G.P.A. Healy, in Chicago. Member: Chicago SA; Chicago Ar. Gld.; Chicago AD. Exhibited: San Fran., 1887 (med). He painted the first Pullman sleeper in Chicago, and in the fashion of the day painted the portraits of George Pullman and other railroad officials on engine headlights. Position: Master P., North Western Railroad. [27]

PEEBLES, Nelson Childs [P] Cincinnati, OH [10]

PEEBLES, Roy B. [P] Adams, MA b. 9 Ag 1899, Adams d. 17 N 1957. Studied: C. Cimiotti; E. Watson; W. Taylor; C. Balmer; N. MacGilvary; L. Blake; A. Bayard. Member: Pittsfield AL; Salons of Am.; Berkshire Business Men's A. Lg.; Deerfield Valley AA; Adams AA; AAPL. Exhibited: S. Indp.A., 1940; Williams Col.; Berkshire Mus.; Stockbridge AA; Deerfield Valley AA [47]

PEED, William B. [P,Ldscp.P] Indianapolis, IN. Exhibited: Hoosier Salon, Chicago, 1937 (prize), 1938 (prize) [40]

PEEKE, G. Wishaar [P] NYC [04]

PEERS, Florence Leif. See Leif.

PEERS, Frank W. [Mur.P,I,B,En,L,T,W] NYC b. 2 N 1891, Topeka, KS. Studied: J. Despujols; Fontainebleau. Work: dec. panels, Am. Pro-Cathedral, Paris; prints. NYPL. Illustrator: "June Goes Down Town," by H. Dietz (1925), "Midnight Court," by P. Arla (1926), "Sarah Simon," by H. Allen (1929), "Light from Arcturus," by M. Walker (1933) [40]

PEERS, Gordon Franklin [P,Mur.P,T,G] Cranston, RI b. 17 Mr 1909, Easton, PA. Studied: RISD; ASL; BAID; John R. Frazier. Member: Providence A. Cl.; Provincetown AA. Exhibited: Providence A. Cl., 1938; CI, 1942, 1943; VMFA, 1940; WFNY, 1939; GGE, 1939; Nat. Exh. Am. A., N.Y., 1936, 1938; Pepsi-Cola, 1946; Mus. RISD; Newport AA; WMA; Boston AC; Provincetown AA; Dept. Interior, Wash., D.C.; Univ. Ill.; Rockford (Ill.) AA. Work: RISD; mural, Viking Hotel, Newport. Position: T., RISD, 1934–36, 1938– [47]

PEERS, Marion [P] Topeka, KS. Position: T., Topeka H.S. [24]

PEET, Marguerite Munger [Por.P] Overland Park, KS b. 8 Je 1903. Studied: R. Davey; E. Lawson; T.H. Benton. Exhibited: Midwestern Exh., Kansas City, 1936 (prize); Jr. Lg. Exh., Kansas City, 1939 (prize); Jr. Lg. Regional Exh., Milwaukee, 1939 (prize) [40]

PEET, Martha Gertrude [C,J] Cambridge, MA b. 27 S 1880, Clinton, WI. Studied: BMFA Sch.; G. Hunt, in London; R. Robert, in Paris; H.H. Clark. Member: Springfield A. Lg.; Boston Soc. A.&Crafts. Exhibited: Portland (Maine) A.&Crafts (med); AIC, 1921 (prize), 1923 (prize), 1924 (prize), 1926 (prize); Boston Tercentenary Exh., 1930 (medals); Springfield A. Lg., 1936 (prize) 1938 (prize); jewelry, BMFA; Phila. A. All.; Dayton AI; SFMA; Handicraft Cl., Providence; Omaha Soc. FA; Columbus Gal. FA; Paris Salon 1938 [47]

PEETS, Elbert [P] Cleveland, OH [25]

PEETS, Orville Houghton [P,T,E,En,Li] Millsboro, DE/Woodstock, NY b. 13 Ag. 1884, Cleveland, OH d 17 Ap 1968. Studied: Académie Julian, Ecole des Beaux-Arts, Baschet, Laurens, in Paris. Member: Wilmington Soc. FA; Rehoboth (Del.) A. Lg.; Woodstock Ar. Assn.; Wilmington Pr. Cl. Exhibited: Intl. Pr. M. Exh., Los Angeles, 1931 (gold); intaglio,

CMA, 1932 (prize); Wilmington Soc. FA, 1942 (prize), 1943 (prize), 1944 (prize); Paris Salon, 1914 (prize). Work: Musée du Jeu de Paume, Paris; Hispanic Mus., N.Y.; Del. A. Center; State House, Dover, Del.; NYPL; LOC; Calif. State Lib.; Los Angeles Mus. A.; PMA; CMA; Wilmington Soc. FA. Position: T., Wilmington Acad. A. [47]

PEIRCE, Alzira [P,Li,Mur.P,T,S] NYC b. 31 Ja 1908, NYC. Studied: ASL, with B. Robinson; Bourdelle, in Paris. Member: NSMP; Fed. Mod. P.&S. Exhibited: PAFA; CI; AIC; Dallas Mus. FA; Pan-Am. Exh.; Fed. Mod. P.&S. Work: USPOs, Ellsworth, South Portland, both in Maine; Indian Mountain Sch., Lakeville, Conn. WPA artist. [47]

PEIRCE, Dorothy Rice (Mrs. Waldo) [P,S] NYC [24]

PEIRCE, Gerry [P,T,E,I] Tucson, AZ (1962) b. 3 Je 1900, Jamestown, NY. Studied: Cleveland Sch. A.; ASL. Member: Phila. Print Cl.; Chicago Gal. Assn.; Cleveland PM. Work: CMA; Denver AM; Ariz. State Mus., Tucson; Joslyn Mem., Omaha; Speed Mem. Mus. Author: "How Percival Caught the Tiger" (1936), "How Percival Caught the Python" (1937). Illustrator: "Plants of Sun and Sand" (1939) [40]

PEIRCE, H. Winthrop [P,I] West Newbury, MA b. 25 N 1850, Boston d. winter 1935–36. Studied: BMFA Sch., with Grundmann, Rimmer; Bouguereau, Robert-Fleury, in Paris. Member: Copley S., 1879; Boston SWCP; North Shore AA; Springfield AA. Work: John-Esther Gal., Andover; AGAA; Bowdoin Col.; Malden (Mass.) Pub. Lib.; Hist. Soc., Newburyport, Mass. [33]

PEIRCE, Margaret S. [P] Boston, MA [19]

PEIRCE, Sylvia (Margaret) Stiastny (Mrs.) [P,T] Lincoln, NE b. 30 Je 1906, Lincoln. Studied: T.E. Benson; H.J. Stellar; Univ. Nebr. [40]

PEIRCE, Thomas Mitchell [P,I] NYC b. 5 Ap 1865, Grand Rapids, MI [06]

PEIRCE, Waldo [P,I,Mur.P,W] Pomona, NY b. 17 D 1884, Bangor, ME. Studied: Harvard; Académie Julian, Paris; ASL. Member: Am. Soc. PS&G; Bangor SA; Salon d'Automne, Paris. Exhibited: Pomona, Calif., 1938 (prize); Pepsi-Cola, 1944 (prize); nationally. Work: MMA; WMAA; PAFA; BM; AGAA; Univ. Ariz.; State House, Augusta, Maine; Bangor (Maine) Pub. Lib.; murals, USPOs, Westbrooke (Maine) Troy (N.Y.), Peabody (Mass.). WPA artist. Illustrator: "Squawky and Bawky." [47]

PEIXOTTO, Ernest C(lifford) [Mur.P,I,P,W] NYC/Paris France b. 15 O 1869, San Fran. d. 6 D 1940, NYC. Studied: Constant, Lefebvre, Doucet, in Paris. Member: ANA, 1909; NIAL; Mural P.; Arch. Lg., 1911; SI, 1906; Century C.; MacD. Cl.; AIA; Beaux Arts Inst. Des.; AFA; NIAL; Société des Artistes Français; Art Commission, City of New York; Cornish (N.H.) Colony. Exhibited: Paris Salon, 1921 (prize). Awards: Chevalier of the Legion of Honor, 1921; Officer, 1924. Work: Nat. Gal., Wash., D.C.; Hispanic Soc. Am.; murals, Seaman's Bank, Bank of New York, Embassy Cl., all in NYC. Illustrator: "Life of Cromwell," by Roosevelt, "Wanderings," by Clayton Hamilton. Author: "By Italian Seas," "Romantic California," "Our Hispanic Southwest," "The American Front." Consultant: Mural Painting, Board of Design, WFNY, 1939. Positions: Official A., American Expeditionary Forces (1918); Dir., Atelier of Painting, A.E.F. Art Training Center, Bellevue, France (1919); Dir., Dept Mural P., Beaux Arts Inst., New York (1919–26); Chairman, American Committee, Fontainebleau Sch. FA [40]

PEIXOTTO, Florian [P] NYC [01]

PEIXOTTO, George Da Maduro [P,S] Crestwood, NY b. Cleveland d. 12 O 1937. Studied: Meissonier; Munkacsy. Exhibited: Royal Acad., Dresden (med); Acad. France. Work: Eastnor Castle, England; CGA; NGA; Widener Mem. Lib.; Harvard; Cleveland Chamber of Commerce; New Amsterdam Theatre, NYC [38]

PEIXOTTO, Mary H. (Mrs. Ernest) [P,W,L] NYC/Seine et Marne, France b. San Fran. Studied: San Fran. AA; Paris, with Delecluse. Member: NAWPS; MacD. C.; Legion of Honor, U.S.; Chevalier, Legion of Honor, 1934. Exhibited: Marie Sterne Gal., NYC; CGA, 1939; Grace Horne Gal., Boston, 1939. Work: Montclair AM; BM. Contributor: articles, American Magazine of Art, Scribner's, London Studio [40]

PELGRAM, Charles R. [I] NYC. Member: SI 1912 [13]

PELIKAN, Alfred George [Edu,W,L,P] Milwaukee, WI b. 5 Mr 1893, Breslau, Germany. Studied: CI; Columbia; ASL; England; H.S. Hubbell; Hawthorne; Bicknell; E. Savage; Columbia. Member: Wis. PS; Wis. Des.-Craftsman; Seven Arts S.; AAPL; Am. Inter-Prof. Inst.; Wis. SAC; Wis. Publicity A.; SAPP, A.; Western AA; Acad. Latine, Paris; F., Royal SA, London. Exhibited: Milwaukee Journal, 1931 (prize). Work: Kent Scientific Mus., South Sea Island. Author: "The Art of the Child," 1931, "The Graphic Aids" (series). Co-author: "Simple Metalwork," 1940. Contributor: School Arts, Design, Education, other magazines. Positions: Dir., Milwaukee AI, 1926–41; Dir. A. Edu., Milwaukee Pub. Sch., 1925–62 [47]

PELL, Ella Ferris [P,S,I] Beacon, NY b. 18 Ja 1846, St. Louis, MO. Studied: CUASch, with Rimmer; Paris, with Laurens, F. Humbert, G. St. Pierre. Work: "Salome," owned by BAC; "Andromeda," heroic statue [29]

PELL, Herbert, Mrs. See Bigelow, Olive.

PELL, Jacob [P,E] NYC/Marlboro, CT b. 24 Mr 1900, Russia. Studied: NAD, with L. Kroll; ASL, with J. Sloan. Member: Am. Ar. Cong.; Am. Watercolorists. Member: Nelson A. Gal., Kansas City; Nat. Training Sch., Wash., D.C.; Riverside Hospital, NYC [40]

PELLEGRINI, Ernest (G.) [S] East Boston, MA b. 18 Ag 1889 d. 24 Je 1955. Studied: Acad. Verona, Italy. Member: Boston Soc. S.; Copley S., Boston; North Shore AA; NSS. Exhibited: North Shore AA; PAFA; Copley S.; Detroit Inst. A. Work: Nat. Shrine of the Immaculate Conception, Wash., D.C.; churches, Cambridge, Boston, Brighton, Lenox, all in Mass.; NYC; Wash., D.C.; Chicago. Ill.; Portland, Maine; Miami, Fla.; New Milford, Conn.; Evanston, Ill.; Mattapan, Mass.; Concord, N.H. [47]

PELLEW, John C. [P] Astoria, NY b. 9 Ap 1903, Penzance, England. Exhibited: CGA 1935, 1936; CI, 1943–46; PAFA, 1936–38; BM, 1935, 1939, 1943; NAD, 1937, 1942, 1944; AIC, 1938, 1939, 1943; NYC (one-man), 1934, 1938, 1944. Work: MMA; BM; Newark Mus. [47]

PELLY, May G. [P] Phila., PA [08]

PELS, Albert [P,T,I] NYC (1977) b. 7 My 1910, Cincinnati, OH. Studied: Univ. Cincinnati; Cincinnati A. Acad.; ASL; BAID; Benton; Palmer; Brook. Member: NSMP; Artists U.; Progressive AA. Exhibited: WMAA, 1938, 1939, 1942, 1944; CI, 1941–45; NAD, 1938, 1940–42, 1945; PAFA 1937, 1943, 1944; CM, 1932–38, 1940, 1941, 1942 (one-man); Rochester Mem. A. Gal.; Nelson Gal.; Dayton AI; Riverside Mus.; Butler AII; CAFA; Massillon Mus. A.; CMA; SFMA; WFNY, 1939; VMFA; BAIC, 1936 (med); Parkersburg, W.Va., 1942 (prize). Work: Massillon Mus. A.; PMA; WPA murals, Wilmington, Del., and in USPOs, Normal, Ill., Wash., D.C. Position: T., CM Sch. [47]

PELTIER, Olive [S] Faribault, MN [15]

PELTON, Agnes [P] Cathedral City, CA. b. 22 Ag 1881, Stuttgart, Germany. Studied: PIASch, with A. Dow, W.L. Lathrop, H.E. Field; Rome. Member: NAWA; AAPL; Riverside, Calif. AA; Studio G., NYC; Transcendental P. Group, Santa Fe. Exhibited: NAWA, annually until 1932; Armory Exh., NYC, 1913; PAFA, 1930; Knoedler Gal., 1917; Mus. N.Mex., Santa Fe, 1933; BM, 1931; one man exh.: Montross Gal., 1929; Argent Gal., 1931; SFMA, 1943; Santa Barbara Mus. A., 1943; Crocker A. Gal., Sacramento, Calif.; Pomona Col. Work: San Diego FAS; Santa Barbara Mus. A.; H.L. Perry Mem. Lib.; First Nat. Bank, Louisville, Ga. Illustrator: "When I was a Little Girl," by Z. Gale, pub., Macmillan Co. [47]

PELZER, Mildred [P] Iowa City, IA. Work: WPA mural, USPO, Waverly, Iowa. [40]

PELZI, Robert [S] Chicago, IL d. 26 Ap 1931, IN (automobile accident). Exhibited: Ill. Acad. Show, 1931

PEMBER, Ada Humphrey [P] Janesville, WI/Stoughton, WI b. 3 O 1859, Shopiere, WI. Studied: W.M. Clute; F. Fursman. Member: Janesville AL; Wis. PS [25]

PEMBERTON, Mrs. Anita Le Roy [P] Phila., PA [17]

PEMBERTON, John P. [P,I,T,Des] New Orleans, LA b. 1873, New Orleans d. 27 D 1914, Perpignan, France (where he had lived since 1908). Studied: Tulane Univ.; Académie Julian, with Bouguereau, Ferrier. Position: T., Newcomb Col. [10]

PEMBROOK, Theodore Kenyon [Ldscp.P] NYC b. 1865, Elizabeth, NJ d. 22 S 1917 [15]

PEN, Rudolph T. [P,Li] Chicago, IL b. 1 Ja 1918, Chicago. Studied: AIC, traveling schol., 1943. Exhibited: NAD, 1945 (prize); LOC, 1946; CI, 1946; AIC, 1939–41, 1943–45; Milwaukee AI [47]

PENA, Tonita [P,T,Mur.P] Santa Fe, NM b. 1895, San Ildefonso Pueblo, NM d. 1949. Exhibited: First Nat. Exh. Am. Indian P., Philbrook A. Center, 1946. Work: AMNH; St. Louis AM; CG; Denver AM; Mus. Am. Indian; Mus. N.Mex. Specialty: watercolors of children and animals. She was the only successful Indian woman painter of the 1910s–20s. Position: T., Santa Fe Indian Sch., N.Mex. [47]

PENDERGAST, Molly Dennett (Mrs. E.P.) [P,T,I,W,L,Des] Sacramento,

CA b. 22 Mr 1908, Belmont, MA. Studied: Univ. Calif.; H. Hofmann. Member: Northern Calif. A.; San Fran. S. Women A. Exhibited: San Fran. AA, 1944–46; San Fran. S. Women A., 1944–46; Northern Calif. A.; City of Paris, San Fran., 1943 (one-man); Crocker A. Gal., 1946 (one-man); Univ. A. Gal., Berkeley. Position: WPA artist/dir.

PENDLETON, Constance [P,T,L] Bryn Athyn, PA b. Phila. Studied: Columbia; Europe; A. Carles; H. Breckenridge; A. Dow; W. Grauer. Member: NAWA; Phila. Plastic C.; Phila. A.T. Assn.; AFA; Eastern AA. Exhibited: A.All., Plastic C., Sketch C., all of Phila.; Argent Gal.; NAWPS, 1938. Position: T., Kensington H.S., Phila. [47]

PENDLETON, W(illiam) L(arned) Marcy [P] Bethel, CT b. 19 F 1865, Paris. Studied: C. Duran. Member: S.Indp.A.; Salons of America. Exhibited: Paris Salon, 1888 [33]

PENDRELL, William [P,I] Paris, France [10]

PENFIELD, Edward [P,I,W,T] Pelham Manor, NY b. 2 Je 1866, Brooklyn, NY d. 8 F 1925, Beacon, NY. Studied: ASL. Member: AWCS; GFLA; New Rochelle AA; SI, 1901; SC, 1905. Author/Illustrator: "Holland Sketches," "Spanish Sketches." Specialties: posters; adv. drawings; cover des. He was an early proponent of the Art Nouveau style. Position: A. Ed., Harper's, 1891–1901 [24]

PENFIELD, Florence Bentz (Mrs.) [P,T] Reading, PA b. 15 Ja 1895, Buffalo, NY. Studied: Univ. Buffalo; Buffalo Sch. FA; PAFA; F. Bach; Roy Nuse; F. Speight. Exhibited: Albright A. Gal., 1941 (prize); Parkersburg FA Center; Reading Pub. Mus. Work: Reading Pub. Mus. [47]

PENFIELD, George W. [I] NYC [01]

PENFOLD, Frank C. [P,T] Pont Avens, France b. Buffalo. Exhibited: Paris Salon, 1889; Pan-Am. Expo, Buffalo, 1901. Work: Buffalo FA Acad. [19]

PENGEOT, George J. [P] Buffalo, NY [17]

PENHALL, H.M. [P] His home was supposedly in San Fran. d. 23 Ja 1913, Palermo, Italy (suicide).

PENIC, Dujam [P] NYC [19]

PENMAN, Edith [P,C] NYC/Woodstock, NY b. London, England d. 14 Ja 1929. Studied: R.S. Gifford; H.B. Snell. Member: NAWPS; SPNY; NYWCC; Alliance; Allied AA; N.Y. S. Ceramic A. Specialties: flower pictures; pottery [27]

PENN, Jennie [P] Batavia, OH b. 11 Ja 1868, Batavia. Studied: Cincinnati A. Acad., with L.H. Meakin; V. Nowottny. Member: Cincinnati Women's AC. Exhibited: Cincinnati AM [10]

PENNELL, Elizabeth Robins (Mrs. Joseph) [W,Cr] NYC b. Phila., PA d. 8 F 1936, NYC. Mr. Pennell left his entire estate to his widow, with the provision that everything should pass to the Division of Prints of the Library of Congress, to be known as the Pennell Fund, to be applied to three ends: additions to the Whistler Collection; formation of the "J. and E.R. Pennell Collection," comprising manuscripts, drawings, books, etc.; and foundation of a Calcographic Museum, similar to that in the Louvre, Paris. Author: "The Life of Whistler," 1908, "Whistler Journal," 1921, (both with Joseph), "Whistler, the Friend," 1930, "The Life and Letters of Joseph Pennell," 1930

PENNELL, Joseph [I,Et,W,] NYC b. 4 Jy 1860, Phila., PA d. 23 Ap 1926. Studied: PAFA, 1878–80; Pa. Sch. Indst. A. Member: ANA, 1907; NA, 1909; NIAL; AAAL. 1922; Arch. Lg., 1894; Phila. SE; N.Y. SE; Intl. S. Painters, Sculp., Gravers, London; Royal Belgian Acad. Assn., 1914; Paris SAP; T Square C.; Societé des Peintres-Graveures Français, Paris; A. Workers Gld. London; Pa. Chapter AIA; Royal Inst. British Arch.; Chairman, Jury of Awards, St. Louis, 1905; Rome, 1911; San Fran., 1915; Commissioner, Milan, 1905; Leipsig, 1914. Exhibited: Paris Expo, 1889, 1900 (gold); Phila. AC, 1892 (med); Columbian Expo, Chicago, 1893 (med); Paris Salon, 1901; Pan-Am. Expo, Buffalo, 1901; Dresden, 1903 (gold); St. Louis Expo, 1904; Liège, 1905 (gold); Milan, 1906 (prize); Barcelona, 1907; Brussels, 1910; Amsterdam, 1912 (gold); Florence, 1915 (prize); P.-P. Expo, San Fran., 1915 (med); Concord AA, 1922; MMA, 1926 (mem. exh.). Work: Luxembourg Mus., Paris; Cabinet des Estampes, Paris; Uffizi Gal., Florence; Mod. Gal., Venice; Mod. Gal., Rome; British Mus., South Kensington Mus., both in London; LOC; AIC; BM; Berlin Gal.; Dresden Gal.; Munich Gal. Author: "Modern Illustration," "Life of James McNeill Whistler," and "The Whistler Journal," (with Mrs. Pennell), "The Graphic Art Series," "The Graphic Arts," Scammon lectures. Illustrator: Magazine of Art, Art Journal, Century. Wrote or illus. about 100 books [25]

PENNEY, James [P] NYC (1977) b. 6 S 1910, St. Joseph, MO. Studied: Univ. Kans.; ASL; A. Bloch; K. Mattern; Grosz. Member: NWMP; Audubon A. Exhibited: Kansas City AI, 1931 (med); CGA, 1936, 1939; AIC, 1939, 1943; BM, 1940–42; CI, 1942, 1943; MET (AV), 1942; TMA, 1944; Denver A. Mus., 1939; Audubon A., 1945; PAFA, 1940; WMAA, 1941; Hudson Walker Gal., 1938–40; Bonestell Gal., 1940; Marquie Gal., 1941; Kraushaar Gal. 1945, 1946; 8th St. Gal., 1935 (one-man). Work: WPA murals, Flushing, N.Y. High Sch. and USPO, Union Palmyra, Mo. Positions: T., Hunter Col., NYC (1941–42), Bennett Jr. Col., NYC (1945–46); Vice pres , ASL (1945, 1946) [47]

PENNEY, James, Mrs. See Avery, Frances

PENNIMAN, E. Louise [P] Phila., PA [15]

PENNIMAN, H(elen) A.F. [P,W] Baltimore, MD/Elkridge, MD b. 26 Mr 1882, NYC. Studied Twachtman; Beckwith; W.E. Whiteman; E.L. Bryant; Anshutz; Germany. Member: S.Indp.A. [25]

PENNIMAN, Leonora Naylor [P] Santa Cuz, CA/Brookdale, CA b. 2 Ap 1884, Minneapolis, Studied: E. Siboni. Member: Santa Cruz AL. Exhibited: Santa Cruz, 1928; Lg. Am. Pen Women, San Fran., 1931 (prize), 1935 (prize); Chicago, 1933; Santa Cruz County Fair, 1938 (prize), 1939 (prize). Work: Friendship House, Chicago [40]

PENNING, Tomas [S] Saugerties, NY b. 4 F 1905, Mellen, WI. Studied: Am. Acad. A.; E. Chassaing. Member: Sawkill PS [40]

PENNINGTON, Harper [I,P] b. 1855 d. 15 Mr 1920, Baltimore. Studied: Académie Julian. Member: Century A. [19]

PENNINGTON, Ruth Esther [C,B,T,P] Seattle, WA b. 4 Je 1905, Colorado Springs, CO. Studied: Univ. Wash.; Columbia; Univ. Oreg.; V. Vytlacil; E. Steinhof. Member: Northwest PM; Southern PM S.; Seattle AM. Exhibited: Northwest PM, Seattle AM, 1937 (prize) [40]

PENNOYER, Albert Sheldon [P,W] NYC b. 5 Ap 1888, Oakland, CA d. 17 Ag 1957, Madrid, Spain. Studied: Univ. Calif.; Ecole des Beaux-Arts; Grande Chaumière; H. Speed,in London; N. Los, in Rome; Académie Julian; Paris, with L. Simon, R. Ménard; Italy, with G. Casciaro, Carlandi; PAFA. Member: AWCS; Century Assn.; Kent (Conn.) AA. Exhibited: NAD; CGA; AWCS. Work: MMA. Author: "This Was California," 1938 [47]

PENNY, Carlton P. [P] NYC b. 20 Jy 1896, Metuchin, NJ. Studied: Columbia; Univ. Rochester; ASL; NYU. Member: SC; AAPL; Arch. Lg.; Audubon A.; Mun. A. Soc. Exhibited: NAD, 1945; Harvard, 1945; NAC, 1940, 1941; Arch Lg., 1943, 1944; Whistler Mus., 1945. Work: Harvard; Whistler Mus., Lowell, Mass. [47]

PENROD, Mabel Allen [P,T] Lansdowne, PA b. 24 Je 1889, Birmingham, MI. Studied: J.F. Copeland; Univ. Pa.; PMSchIA. Member: Wilmington SFA; Phila. Alliance. Exhibited: Wilmington SFA, 1934 (prize) [40]

PENROD, Viola D. [P] Dallas, TX [24]

PENROSE, Helen Stowe [P] Baltimore, MD. Member: Baltimore WCC [25]

PENT, Rose Marie (Mrs. Howard F.) [P] Jenkintown, PA b. St. Louis, MO d. 15 Jy 1954. Studied: PAFA; W. Chase; F. Wagner; H. Breckenridge. Member: Phila. A. All.; Phila. Plastic C.; Old York Road AG. Exhibited: PAFA; Phila. Plastic C.; Phila. A. All.; Phila. AC [47]

PEOPLES, Augusta H. (Mrs. R.E.) [P,T] Phila., PA b. 2 Ap 1896, Phila. Studied: Phila. Sch. Des. for Women; Spring Garden Inst.; PAFA. Member: Phila. A. All.; AAPL; Phila. Plastic C.; Germantown AL. Exhibited: PAFA, 1933–35; CGA, 1935–37, 1939; Phila. A. All., 1945 (45); Phila. Plastic C.; Phila. Sketch C.; Woodmere A. Gal.; Newman's Gal.; Bala Cynwyd Women's C., 1946 (one-man). Work: Moore Inst., Phila. [47]

PEPER, Meta A. [Min.P] NYC b. 21 Ja 1887, NY. Studied: Mrs. Ellis; A. Beckington [15]

PEPLOE, Fitzgerald Cornwall [S] b. 1861, England (came to U.S. in 1884) d. 30 Ja 1906, Purchase, NY. Studied: Paris; Rome. Work: statue, grounds of Mr. Chapman, at Dinard, Brittany; busts of women, in private art galleries of New York [04]

PEPPARD, Lorena [Ldscp.P,Min.P,S,T,W] Wooster, OH b. 28 D 1864 d. ca. 1939. Studied: Cincinnati A. Acad., with Nowottny, Noble, Duveneck; BMFA Sch., with W. Paxton, P. Hale. Member: Cincinnati Women's AC. Work: portraits, Ohio Supreme Court; Wayne County Court House; Pub. Lib., Wooster, Ohio. Contributor: articles, newspapers [38]

PEPPER, Charles Hovey [P] Brookline, MA b. 27 Ag 1864, Waterville, ME d. 25 Ag 1950. Studied: Colby Col, Waterville, Maine; ASL; Académie Julian; Chase, in NYC; Paris, with Laurens, Aman-Jean. Member: NYWCC; Copley S., 1900; Boston AC; New Haven PCC; The Fifteen

Gal. Work: BMFA; WMA; Newark Mus.; FMA; RISD; Mills Col., Oakland, Calif.; Colby Col. [47]

PEPPER, Stephen Coburn [Edu,W,L,Cr] Berkely, CA b. 29 Ap 1891, Newark, NJ. Studied: Harvard. Author: "Aesthetic Quality," 1938, "World Hypotheses," 1942, "The Basis of Criticism in the Arts," 1945, others. Contributor: Journal of Philosophy, College Art Journal, Parnassus. Position: T., Berkeley, Calif., 1919–46 [47]

PEPPER, Platt [Patron] Phila., PA b. 1837 d. 27 Ap 1907. One of the founders of PMSchIA. In 1878, headed a movement which led Congress to pass the act admitting free of duty works of art to be exhibited in museums and art galleries.

PERARD, Victor Seman [E,Li,I,L,T,W] NYC b. 16 Ja 1870, Paris, France. d. Jy 1957. Studied: NYU; ASL; NAD; Ecole des Beaux-Arts, Paris, with Gérôme. Member: SI; SC. Work: MMA; N.Y. Hist. S.; CAD; NYPL; Newark Pub. Lib.; LOC; NGA; Pittsfield Mus. A.; NYC Mus.; Vanderpoel AA, Chicago; Mariner's Mus., Newport News; War Ministry, Paris, France. Author: "Anatomy and Drawing," "Drawing Horses," "Faces and Expressions." Illustrator: many books. Contributor: national magazines. Position: T., Traphagen Sch. [47]

PERCH, John Dennis [Ldscp.P,T,W] East Haven, CT b. Olyphant, PA. Studied: Yale. Contributor: weekly art review, in New Haven Journal-Courier. Position: T., YWCA Sketch C., New Haven [40]

PERCIVAL, Olive [E] Los Angeles, CA [19]

PERCY, Isabelle Clark (Mrs. George Parsons West) [Edu,Des,Li,P,L] Sausalito, CA b. Alameda, CA. Studied: Hopkins AI, San Fran.; Columbia; Europe; A. Dow; F. Brangwyn; Snell. Member: San Fran. AA; Marin County SA. Exhibited: Paris Salon, 1911, 1912; P.-P. Expo, 1915 (med); House Beautiful Cover Comp., 1930; Calif. Bookplate Comps.; NYC; Boston; Cleveland; San Fran. Position: T., Calif. Col. A.&Cr. [47]

PERDUE, W.K. [P,C,W] Canton, OH b. 17 My 1884, Minerva, OH. Studied: Dr. Esenwein [29]

PEREIRA, Irene Rice [P,L] NYC b. 5 Ag 1907, Boston, MA d. 1971. Studied: Acad. Moderne, Paris; ASL, with Lahey, Matulka, 1927–30. Member: Am. Abstract A.; AL Am.; Audubon A. Exhibited: MOMA, 1944; WMAA, 1934, 1944, 1945, 1976 (retrospective); San Fran. Conference, 1945; Critics Choice, NYC, 1945; Cincinnati Mod. AS; MET; Pepsi-Cola, 1946 (prize). Work: MOMA; MET; Newark Mus.; Univ. Ariz.; Howard Univ.; PMG; Mus. Non-Objective Painting;WPA artist, 1935–39. [47]

PERENY, Andrew [Des,C] Westerville, OH b. 28 N 1908, NY. Studied: Ohio State Univ. Member: A. Ceramic S. Exhibited: Columbus AL, 1933 (prize). Contributor: article, "What Price Ceramics?," Design, 1937. Position: Pres., Pereny Pottery, Columbus [40]

PERENY, Madeline S. [P,Des] Wash., D.C./Woodstock, NY b. 1 S 1896, Hungary. Studied: Royal Acad. FA, Budapest; S. Hollosy, in Munich; K.H. Miller. Member: NAWPS. Exhibited: Argent Gal., NYC; NAWPS, 1939 (prize); Woodstock A. Gal. Work: City Hall, Budapest, Hungary. Illustrator: covers, New Yorker, 1929–31. Position: Des./Supv., animated cartoons., U.S. Gov. [40]

PERERA, Gino Lorenzo [P,S,E] Boston, MA b. 2 Ag 1872, Siena, Italy. Studied: Royal Acad., Rome; BMFA Sch.; H.D. Murphy; B. Harrison; Ochtman. Member: BAC (Pres.); St. Botolph C.; Copley S.; SC. Exhibited: PAFA; St. Botolph C.; Copley S.; BAC; Doll & Richards, Boston [47]

PERET, Marcelle [P,T] New Orleans, LA b. 14 My 1898, New Orleans. Studied: Newcomb Sch. A.; H. Breckenridge; Chouinard Sch. Member: SSAL; NOAA; New Orleans ACC. Position: T., Newman Sch., New Orleans [40]

PERETTI, Achille [P] b. Italy d. Summer 1923, Chicago. Lived in New Orleans for many years. Work: several churches, New Orleans

PERFILIEFF, Vladimir [P] Phila., PA b. 20 D 1895, Russia. Studied: PAFA, with Snell, Garber, Breckenridge, McCarter, Carrols, Pearson; Paris, with Schouhaieff, Lhote. Member: Phila. Alliance; Phila. Sketch C. [33]

PERIN, Bradford [P] Salisbury, CT [24]

PERINE, Eva (Mrs.) [P] Laguna Beach, CA. Member: Laguna Beach AA [25]

PERINI, Maxine Walker [P,Des,L,T,Mus.Dir] Abilene, TX b. 6 N 1911, Houston. Studied: Wellesley Col.; AIC; B. Anisfeld. Exhibited: AIC, 1936, 1937, 1941; Tex. Centenn. Exh., Dallas; Corpus Christi. Position: Dir., Abilene MFA [47]

PERKINS, Alexander Graves [Mar.P] Active in Newburyport, Mass., 1929–31. Work: Peabody Mus., Salem [*]

PERKINS, Edna L. [P] Kennebunk Beach, ME b. 29 Je 1907, Jersey City. Studied: ASL, with K.H. Miller. Member: NAWA; NYSWA; Assoc. A. N.J. Exhibited: PAFA; WFNY 1939; NYSWA, 1936, 1939; Montclair AM, 1944 (prize) [47]

PERKINS, Emily R. [P] Phila., PA [06]

PERKINS, Frederick Stanton [Por.P,Ldscp.P] Burlington, WI b. 6 D 1832, Trenton, NY d. 1899. Studied: NYC. Exhibited: NAD; PAFA, after 1855 [*]

PERKINS, Granville [P,I] NYC b. 16 O 1830, Baltimore. d. 18 Ap 1895. Studied: Phila., with J. Hamilton. Member: AWCS. Exhibited: NAD, 1862–89; PAFA, 1856. Work: Mystic Seaport Mus.; Peabody Mus., Salem, Mass. Illustrator: Harper's, Leslie's; "Beyond the Mississippi," 1867. Active in Baltimore, Richmond, Fla., Cuba, Phila., NYC [*]

PERKINS, Harley (Mr.) [P,W,L] Brookline, MA/Magnolia, MA b. 28 Ap 1883, Bakersfield, VT. Studied: Mass. Sch. A. Member: BMFA Sch. Exhibited: WFNY, 1939; AIC; BM; Doll & Richards, 1945, 1946 (one-man). Work: WMAA; mural, Ala. State Bldg., Montgomery. WPA artist/dir. [47]

PERKINS, John U(re) [P] Wash., D.C. b. 22 N 1875, Wash., D.C. Studied: Chase; Hawthorne; N. Brooke. Member: S. Wash. A. [27]

PERKINS, Katherine Lindsay [P] Topeka, KS [25]

PERKINS, Lucy Fitch (Mrs. Dwight H.) [I,W] Evanston, IL b. 12 Jy 1865, Maples, IN d. 18 Mr 1937, Pasadena, CA. Studied: BMFA Sch. Author/Illustrator: "A Book of Joys," "The Goose Girl," "The Dutch Twins," "The Scotch Twins," "Dandelion Classics," "Cornelia," other books for children [32]

PERKINS, Mary Smyth (Mrs. William F. Taylor) [P] Lumberville, PA b. 1875, Phila. d. 12 D 1931, Germantown, PA. Studied: PAFA; R. Henri; Phila. Sch. Des, with W. Sartain; Lawton Parker Sch., Cottet, Simon, all in Paris. Member: NAWPS. Exhibited: PAFA Sesqui-Centenn. Exh.; 1907 (prize); NAWA (prize). Work: port., City Hall, Phila. Specialty: hooked rugs in the form of wall panels [29]

PERKINS, Parker [Mar.P] Rockport, MA b. Lowell, MA. Studied: self-taught [24]

PERKINS, Sarah S. [P,C] Brookline, MA. Member: Copley S., 1899; Boston SAC [10]

PERKINS, Stella Mary (Mrs. J.V.) [P,I,W,L] Freeport, IL b. 12 My 1891, Winslow, ME. Studied: Rockford Col.; Univ. Wis.; M. Reitzel; F. Taubes; B. Dyer; Francis Shimer Sch. Member: Burpee AA; Daytona Beach A; All-Ill. SA; Rockford AA; AIC. Exhibited: AIC, 1938; Burpee A. Gal., 1935 (prize), 1940 (prize), 1941 (prize); Freeport Pub. Lib.; Freeport Hist. Mus.; CI; Colorado Springs FA Center; Denver AM. Work: Greenport Pub. Lib.; Freeport Hist. Mus. Illustrator: Better Homes and Gardens, 1939, 1940. Contributor: American Home, Parent Teachers, Junior Home [47]

PERKINS, Susan E.H. (Mrs.) [Patron] d. 29 Je 1929, Indianapolis, IN. Member: Women's AC (founder); Hoosier Salon Patrons Assn.; Ind. Federation of A. Clubs. For 30 yrs. she conducted a class in art history in her home.

PERKINS-RIPLEY, Lucy Fairfield [P,S] NYC b. Winona, MN d. ca. 1950. Studied: Paris, with Rodin, Despiau, Lhote; ASL; Saint-Gaudens. Member: NSS. Exhibited: NAWA, 1919 (prize); St. Louis Expo, 1904 (med). Work: WMA [47]

PERL, Esther [P] NYC [24]

PERL, Margaret Anneke [P] Monterey Park, CA b. Duluth, MN. Studied: AIC; Henri; Much; Freer; Scarbina; Smith; Slinkard; Goldbeck; N. Fechin. Member: Calif. AC; San Gabriel AG. Exhibited: AIC, 1940 (med) [47]

PERLE, Henry [P] Brooklyn, NY b. 24 F 1872, Germany. Studied: self-taught. Member: S.Indp.A. [27]

PERLIN, Bernard [P,I] NYC b. 21 N 1918, Richmond, VA. Studied: ASL. Work: murals, USPO, South Orange, N.J.; S.S. Pres. Hayes. Contributor: Life, Fortune. Style: "magic realist." WPA artist. [47]

PERNESSIN, Neomi [P] NYC [13]

PEROT, Annie Lovering [P] Phila, PA/East Gloucester, MA b. 20 O 1854, Phila. Studied: PAFA, with Breckenridge, Anshutz, Chase, McCarter, Wagner. Member: Phila. Alliance; Plastic C. [25]

PERRAULT, Marie (Mme.) [P] Detroit, MI [21]

PERRET, Ferdinand [P,Hist,Des,Gr,W,L,I,T] Los Angeles, CA b. 1 N 1888, Illzach, France d. 4 Ag 1960. Studied: J. Perret, in France; Folkwang Mus., with Rohlfs, Weiss, Germany; London Sch. A., with C.P. Townsley; W. Chase; Stickney Mem. Sch. FA, Pasadena; Summer Sch., Carmel, Calif. Member: Calif. AC; Los Angeles P&S C.; Santa Monica AA; Laguna Beach AA; Keith AA; AFA; Los Amigos Hist. S., Southern Calif.; Los Angeles AA. Exhibited: Pacific Intl. Expo, San Diego, 1935–36; Stickney Mem. Sch. FA; Los Angeles; Carmel, 1916. Work: Los Angeles Mus. A. Contributor: California Arts & Architecture. Author: "California Artist of the First One Hundred Years." Position: Founder/Owner/Dir., Ferdinand Perett Research Lib. A. & Affiliated Sciences, Los Angeles, from 1906 [47]

PERRETT, A. Louise [P,I,T] Boston, MA b. Chicago. Studied: AIC; H. Pyle; J. Carlson. Position: T., AIC [40]

PERRETT, Galen Joseph [P,E] Rockport, MA b. 14 S 1875, Chicago d. 12 Ag 1949. Studied: AIC; ASL; Académie Julian, Paris; Nat. Acad., Munich, Germany; Colarossi Acad., Paris. Member: SC; North Shore AA; Rockport AA. Work: Newark Mus.; Franklin (N.H.) Lib. [47]

PERRETT, Louise [P] Oak Park, IL [15]

PERRIE, Bertha E(versfield) [P,Min.P,T] Wash., D.C. d. 16 S 1921, Gloucester, MA. Member: Wash. WCC; S. Wash. A.; ASL; Pa. SMP. Exhibited: Wash. WCC, 1900 (prize), 1904 (prize). Position: T., CGA; private schools [19]

PERRINE, Van Dearing [P,W,L,T] Maplewood, NJ b. 10 S 1868, Garnett, KS d. 10 D 1955, Stamford, CT. Studied: CUASch; NAD; self-taught. Member: ANA; NA, 1931; Nat. AA; Millburn-Shore Hills AA; Am. Soc. PS & G. Exhibited: Charleston Expo, 1902 (med); P.-P. Expo, 1915 (med); NAD, 1930 (prize); CI, 1903; experiments with color music. Work: PMG; BM; CI; Newark Mus.; Montclair AM. Author: "Let the Child Draw" [47]

PERRING, Cornelia [P] Louisville, KY. Member: Louisville AL [01]

PERRY, Clara Fairfield (Mrs. Walter Scott Perry) [P] Stoneham, MA b. Brooklyn, NY d. 28 S 1941. Studied: W.S. Perry; H.B. Snell; E. Caser. Member: Meridian C.; Brooklyn SA; Brooklyn PS; Marblehead AA [40]

PERRY, Clara G(reenleaf) [P,S,L] Wash., D.C. Studied: Chavaniac-Lafayette, Haute Loire, France b. 22 Ag 1871, Long Branch, NJ. Studied: R. Henri. Member: Copley S.; NAWPS; Wash. AC [33]

PERRY, Emilie S. [S,I] Ann Arbor, MI b. 18 D 1873, New Ipswich, NH d. 16 Jy 1929. Studied: BMFA Sch.; Mass. Normal A. Sch.; M. Broedel. Member: Ann Arbor AA. Work: panel, The Women's C., Hollywood; Hollywood Lib.; Col. of Garvanza, Los Angeles [29]

PERRY, E(noch) Wood, Jr. [P] NYC b. 31 Jy 1831, Boston, MA d. 14 D 1915. Studied: Leutzé, in Düsseldorf, 1852–54; Couture, in Paris. Member: ANA 1868; NA, 1869; AWCS; A.Aid S.; Century Assoc.; U.S. Consul to Venice, 1856–58. Work: Buffalo FA Acad. Active in Europe, 1852–58; Phila. ca. 1860; Calif., Hawaii, Utah, 1862–66; opened studio, NYC, 1866. Specialty: genre [15]

PERRY, Frank Chester [Mar.P,Ldscp.P,T] Westerly, RI b. 26 Ag 1859, Swansea, MA [10]

PERRY, Glenn [P] Buffalo, NY b. 17 D 1880, Corning, NY. Member: The Patteran; Buffalo SA. Exhibited: Albright A. Gal.; Riverside Mus., NYC; Am. Fed. A., 1939 [40]

PERRY, James DeWolf, Mrs. See Weir, Edith.

PERRY, J(ames) R(aymond) [P] Chicago, IL b. 20 Ap 1863, Northfield, MA. Studied: self-taught. Member: South Side AA; All-Ill. SFA; AIC; AAPL. Exhibited: South Side AA, 1929 (prize). Work: Chicago pub. schs.; Harper Mem. Lib., Chicago Univ.; Beals Mem. Lib., Winchendon, Mass.; John H. Vanderpoel AA, Chicago [40]

PERRY, Lilla Cabot (Mrs. Thomas S.) [P,W] Boston, MA b. 1848, Boston d. 28 F 1933, Hancock, NH. Studied: Cowles A. Sch., with D.M. Bunker, R.W. Vonnoh, ca. 1885–88; Académie Julian; Colarossi Acad.; A. Stevens' Studio, Paris, 1888. Member: Boston GA; Allied AA, London; Société des Artistes Indépendants, Paris; Intl. S. AL; Women's Intl. AC, Paris, London; Nippon Bijitsu-in, Tokyo; Concord AA; CAFA. Exhibited: Paris Salon, 1889; Boston, 1892 (med); St. Louis Expo, 1904 (med); P.-P. Expo, San Fran., 1915 (med). Work: BMFA; NYPL; Am. Fed. Women's C., Wash., D.C.; Carolina AA, Charleston. Author: "The Heart of the Weed," "From the Garden of Hellas," "Impressions," "The Jar of Dreams." She began to study painting rather late (around age 30) and became more important for establishing cultural ties between the Boston painters and Giverny than for her own paintings. Her article "Reminiscences of Claude Monet from 1889–1909" (Am. Mag. of Art, Mr 1927) is based upon her stay at Giverny and is perhaps the most accurate account of Monet's method and nature of plein air painting. [27]

PERRY, Maeble C(laire) Mrs. Edwards) [S,P,Dec,Des,L,T] Chicago, IL b. 11 F 1902, Idaho. Studied: AIC, A. Polasek. Member: Chicago A. Gal.; AIC; Chicago PS. Exhibited: Alliance, 1931 (prize); Evanston Woman's C., 1933–34, 1936–37 (prizes); AIC, 1939 (prize). Work: AIC [40]

PERRY, Minnie Hall [P] Denver, CO [01]

PERRY, Raymond [P,I,Des,L,T,W] NYC b. 1886, Sterling, IL d. 15 N 1960. Studied: AIC. Member: AWCS; SC, 1908; NYWCC. Work: St. Andrew's Church, Pittsburgh; Mem. Lib., Hanover, Pa.; 7th Regiment Armory, Fraunces Tavern, both in NYC; Press C., Baltimore [47]

PERRY, Raymond W. [Edu,B,P,W] West Dennis, MA b. 28 Jy 1883, Natick, MA. Studied: Mass. Sch. A.; R.I. Col. Edu.; W.D. Hamilton; V. Preissig; A.K. Cross; Andrews. Member: Providence AC; Providence WCC; Cape Cod AC; EAA. Author/Illustrator: "Block Printing Craft," 1930, "Blackboard Illustration." Contributor: American Vocational Journal, School Shop mag. Position: State Supv., Indst. Edu, R.I. [47]

PERRY, R(oland) Hinton [Por.P,S] NYC/Richmond, MA b. 25 Ja 1870, NYC d. 27 O 1941. Studied: Paris, with Gérôme, Delance, Callot, Chapu, Puech, Ecole des Beaux-Arts, Académie Julian. Member: Grand Central A. Gal. Work: LOC; Buffalo Hist. Soc.; New Amsterdam Theatre, NYC; Capitol dome, Harrisburg, Pa.; Gettysburg; Ogdensburg; Louisville; Chattanooga; Conn. Ave. Bridge, Wash. D.C.; Syracuse, N.Y. [40]

PERRY, Shirley [P] NYC. Position: Affiliated with Carnegie Studios [01]

PERRY, Walter Scott [P,S,T,W,L] Brooklyn, NY/Stoneham, MA b. 1855, Stoneham, MA d. 22 Ag 1934. Studied: Langerfeldt; Higgins; P. Millet; Mass. Normal A. Sch.; Europe; Egypt; India; China; Japan. Member: NAD; Alliance; Eastern AA; Western AA; AFA; Rembrandt C.; Egypt Exploration Fund. Author: "Egypt, the Land of the Temple Builders," "With Azir Girges in Egypt," textbooks on art education. Positions: Supv., Dr./A.Edu., schools, Fall River, Mass., 1875–79, Worcester, Mass., 1979–87; Dir., PIASch 1887–28 [31]

PERRY, W(inifred) A(nnette) [P] Oakland, CA b. Wasepi, MI. Studied: San Fran. Sch. A.; W.V. Cahill; J. Rich [25]

PERSHING, Elizabeth Heifenstein [P] Phila., PA [13]

PERSHING, Louise [Mur.P,Por.P,L] Pittsburgh, PA b. 24 My 1904 Pittsburgh. Studied: PAFA; CI; Univ. Pittsburgh; A. Kostellow; G. Romanoglie. Member: NAWPL; Pittsburgh WC Soc.; Pittsburgh AA. Exhibited: Pittsburgh AA, 1931 (prize), 1932 (prize), 1940 (prize), 1943 (prize), 1946 (prize); NAWA, 1936 (prize); Wichita Mus., 1936 (prize); Ind. State T. Col., 1944 (prize); CI, 1931 (prize), 1932 (prize); NAWPS, 1936 (prize); CM, 1936–40; CGA, 1939; CI, 1937, 1942 (one-man), 1943–46; GGE, 1939; PAFA, 1936; VMFA, 1942; NAD, 1943; AIC, 1943, 1938, 1942; Springfield, Mass., 1944, 1945; Butler AI, 1936–1946; Contemp. A. Gal., 1944 (one-man). Work: Pittsburgh Pub. Sch.; Pa. State Col.; Ind. State T. Col.; murals, Dormont (Pa.) Pub. Sch. [47]

PERSONS, Geraldine [P] Worcester, MA. Member: NAWPS. Exhibited: Am. WCC, 1934, 1936–38; NAWPS, 1935, 1937, 1938 [40]

PERSONS, Simmons [P] NYC b. 5 D 1906, Norfolk, VA. Studied: ASL, with F. DuMond, G. Bridgman, K. Nicolaides. Exhibited: AIC, 1943, 1944; WMAA, 1938, 1939, 1941, 1945, 1946; PAFA, 1945; VMFA, 1941 [47]

PERVAULT, Ida Marie [P] Detroit, MI b. 1874, Detroit. Studied: Detroit Mus. A. Sch. Exhibited: Omaha Expo, 1898 [98]

PESCHERET, Leon R. [C,Dec,Des,E,I,L,T,W] Whitewater, WI b. 15 My 1892, London d. 1961. Studied: AIC; Royal Col. Engr., Kensington, England. Member: Soc. Am. E.; Chicago Soc. E. Exhibited: Chicago SE, 1935 (prize), 1936; Southern PM Soc., 1936 (prize), 1937 (prize). Work: Designs, interior, Mem. Union Bldg., Wis. Univ.; Kenyon College Union Bldg., Gambier, Ohio; Cabinet des Estampes, Brussels; Nat. Coll. FA, Wash., D.C.; NYPL. Illustrator: "The Spirit of Vienna," 1935 [40]

PESSEL, Esther [I,P,Dr] Phila., PA b. 11 My 1903, Phila. Studied: Phila. Sch. Des for Women; PAEA. Illustrator: daily newspapers [40]

PETER, George [Mur.P,Des] Milwaukee, WI b. 1860 d. 1943. Studied: Munich; Vienna. Work: painted panorama scene for film "Gone with the Wind" [*]

PETERDI, Gabor [P,G] b. 1915, near Budapest, Hungary (came to NYC in

1939). Studied: Hungarian Acad. FA, 1929; Acad. Belle A., Rome, 1930; Académie Julian, Paris, 1931; Acad. Scandinave, Paris, 1931; W.S. Hayter's Atelier 17, Paris 1933-39. Exhibited: BM, 1959 (restrospective). Author: "Printmaking," 1959 [*]

PETERS, Bernard E. [Mur.P,Des,T,W,L] St. Louis, MO b. 8 Ag 1893. Studied: England; France; St. Louis Univ.; Harvard; Univ. Mo.; F. Mulhaupt. Member: St. Louis Indst. AC; North Shore AA; St. Louis A. Gld.; 2 x 4 Soc., St. Louis. Exhibited: Mo. State Fair, 1933 (prize); PAFA; St. Louis A. Gld., annually; Barn Gal., 1946 (one-man); All-Mo. Ar. Exh. Position: T., Cleveland H.S., St. Louis [47]

PETERS, Betty [P] NYC [15]

PETERS, C. Merriman [I,P] NYC. Studied: Sacramento (Calif.) A. Sch. Specialty: comic subjects [06]

PETERS, Carl William [P] Fairport, NY b. 14 N 1897, Rochester, NY. Studied: C. Rosen; J. Carlson; H. Leith-Ross. Member: Rochester AC; Buffalo SA; Springfield AA; AFA. Exhibited: NAD, 1925 (prize), 1928 (prize), 1932 (prize); Univ. Rochester, 1924 (prize); Rochester AC, 1925 (med), 1927 (prize), 1928 (prize); Buffalo SA, 1927 (prize); CGA; PAFA. Work: Genesee Valley Trust Bldg.; Rochester (N.Y.) Acad. Medicine; Fairport (N.Y.) Pub. Lib. [47]

PETERS, Charles F. [I] Dover, NJ. Member: SI, 1911 [13]

PETERS, Charles Rollo [P] San Fran., CA b. 10 Ap 1862, California d. 1928. Studied: Calif. Sch. Des., with Williams, 1870s; San Fran., with J. Tavernier, 1885; Ecole des Beaux–Arts, with Gérôme; Paris, with Boulanger, Lefebvre. Member: Bohemian C., San Fran.; Lotos C.; Carmel Colony. Exhibited: Pan-Am. Expo, Buffalo, 1901 (med); St. Louis Expo, 1904 (med) [24]

PETERS, Constance [P] San Fran., CA [17]

PETERS, (Dewitt) Clinton [P,T,I] NYC b. 11 Je 1865, Baltimore. Studied: Ecole des Beaux-Arts, with Gérôme; Paris, with Lefebvre, Boulanger, Collin. Exhibited: Paris Expo, 1889 (med). Work: portraits, City Hall, Boys' School, both in Baltimore; Yale; Harvard; Rutgers Univ.. Hist. Soc. and H.S., Albany. Illustrator: "Tutti Fruitti," "Children of the Week," "Madame Daulnoy's Fairy Stories"; St. Nicholas, Harper's, Young People, Wide Awake, New York Life [40]

PETERS, Edith Macausland [P] Phila., PA. Studied: PAFA [10]

PETERS, G.W. [P] Leonia, NJ [01]

PETERS, Louis W. [S,Arch] NYC d. 9 D 1924. Work: sculptural des. for addition to Times Annex; carvings on several bldg. at West Point

PETERS, Maryella [P] NYC. Member: Lg. AA [24]

PETERS, Rollo [Scenic P.] NYC [17]

PETERSEN, Christian [S,T] Ames, IA b. 25 F 1885, Dybbol, North Slesvig, Denmark. Studied: Newark Tech. Sch.; ASL; RISD; H.H. Kitson. Member: Attleboro Chapter, AFA; Chicgo Gal. A.; East Orange AA. Work: New Bedford, Mass.; Newport, R.I.; St. John's Col., Brooklyn, N.Y.; state of Iowa; group of reliefs with Fountain, Dairy Industries Bldg.; relief and statue, Veterinary Quadrangle; reliefs on Gymnasium, several portrait busts, Iowa State Col.; Fountain of the Blue Heron, Decatur, Ill.; Bukh's Sch., Ollerup, Denmark. Position: T., Iowa State Col. [40]

PETERSEN, Eugen H. [P,Des,L,T] Manhasset, NY b. 16 F 1892, Bluefields, Nicaragua. Studied: PIASch; NYU; J. Carlson; G.E. Browne. Member: Brooklyn SA; Swedish-Am. Ar.; SC; PS. Position: T., PIASch., 1921- [47]

PETERSEN, Martin [P,E] NYC b. 23 N 1870, Denmark. Studied: NAD. Member: NYWCC; SC, 1906; ANA; AWCS; SAE. Exhibited: SAE (prize); LOC (prize); NAD, 1905 (prize); NYWCC, 1906 (prize); SC, 1907 (prize). Work: LOC; Pub. Lib., Newark, N.J.; BMFA [47]

PETERSHAM, Maud Fuller [I,W] Woodstock, NY b. 5 Ag 1889, Kingston, NY. Studied: Vassar; N.Y. Sch. F.&Appl. A. Award: Caldecott Medal, 1946. Co-author/Illustrator: "Miki," "Ark of Mother and Father Noah," "Bible Story Series," other children's books [47]

PETERSHAM, Miska [I,W] Woodstock, NY b. 20 S 1888, Torokszentmiklos, Hungary d. 15 My 1959, Alexandria, VA. Studied: Royal Acad., Budapest. Award: Caldecott Medal, 1946. Co-author/Illustrator (with Maud Petersham): children's books [47]

PETERSON, Elna Charlotte [P] Minneapolis, MN b. 6 O 1916 d. 4 F 1937.
Studied: Mitchell; Kopietz; Mosely; Winchell. Exhibited: Kansas City AI, 1935 (prize)

PETERSON, Elsa Kirpal (Mrs. R.M.T.) Flushing, NY b. 16 Je 1891, NYC. Studied: E.W. Burroughs; J.E. Fraser. Member: Alliance; ASL [33]

PETERSON, Eric A. [P] Tubercular Sanitorium, Columbus, OH. Member: Columbus PPC [25]

PETERSON, Jane (Mrs. M. Bernard Philipp) [P,Des] NYC/Ipswich, MA b. 1876, Elgin, IL d. 1965. Studied: PIASch, 1894; Sorolla, in Madrid; B. Harrison; DuMond; H.B. Snell; F. Brangwyn, in London; Lhote, in Paris; Blanche; Friesz. Member: AWCS; NAWA; Aududon A.; PBC; Wash. WCC; Phila. WCC; N.Y. Soc. P.; AFA; All. A. Am.; A. Lg. Am.; Miami A. Lg.; Soc. Four A., Palm Beach; NYWCC; NAWPS; CAFA; NAC; Hartford A; Fed. Française des Artistes, Paris. Exhibited: Girls AC, Paris, 1915 (prize); CAFA, 1916 (prize), 1917 (prize); NAWA, 1919 (prize), 1927 (prize); Fla. SA, 1938 (prize); Wash. WCC, 1940 (prize); CGA; NAD; PAFA; All.A.Am.; Phila WCC; AIC; AWCS; N.Y. Soc. P.; Soc. Four A.; Buffalo Mus. Sc.; Cayuga Mus. Hist.&A.; Chautauqua Women's C.; Binghamton Mus. A.; Arnot A. Gal.; Montclair A. Mus.; Rutgers; Princeton; Everhart Mus.; Mint Mus. A.; High Mus. A.; Chattanooga AA; Brooks Mem. A. Gal.; Speed Mem. Mus.; Butler AI; Ball State T. Col.; Fla. Fed. A., 1937 (prize); Kenosha Hist.&A. Mus. (one-man); Oshkosh Pub. Mus. (one-man); Wustum Mus. (one-man); Syracuse Mus. FA (one-man); Davenport Mun. A. Gal. (one-man); Springfield A. Mus. (one-man); Philbrook A. Center (one-man); Thayer Mus. (one-man); Wichita AA (one-man); Joslyn Mem. (one-man); Crocker A. Gal., Sacramento, Calif. (one-man); Haggin Mem. Gal., Stockton, Calif. (one-man); Santa Barbara Mus. A. (one-man); San Jose State Col. Work: BM; Grand Rapids AA; Boise City, Iowa A. Coll.; Sears A. Gal., Elgin, Ill.; Syracuse Mus. FA; Richmond (Ind.) A. Mus.; Frances Shimer Col.; Soc. Four A., Palm Beach; Wesleyan Col., Macon, Ga.; Wichita A. Mus.; Brooklyn Athletic C.; Pub. Sch., Evanston, Ill.; Country Club, Torrington, Conn.; YMCA, Elgin, Ill.; Boise Pub. Lib.; Rollins Col., Winter Park, Fla. [47]

PETERSON, Kay [E,P,Dr,T] Newton Lower Falls, MA b. 11 O 1902, Oak Hill, PA. Studied: Cleveland Sch. A. Member: Boston AC; Rockport AA. Positions: Dir., A. Dept., Lasell Jr. Col., Auburndale, Mass.; Hobby Studio, Newton Lower Falls [40]

PETERSON, Lily Blanche. See Rhome, Mrs.

PETERSON, Margaret [Dr] Berkeley, CA b. 1903, Seattle, WA. Exhibited: San Fran. Women A., 1936 (prize)l Illustrator: "The Man on the Flying Trapeze," 1934. Position: T., Univ. Calif. [40]

PETERSON, Roger Tory [I,W,L] Alexandria, VA (Old Lyme, CT, 1985) b. 28 Ag 1908, Jamestown, NY. Studied: ASL; NAD. Exhibited: nationally; Ornithologists Un., 1944 (prize); bird paintings, natural hist. mus. in Buffalo, Detroit, Los Angeles, Boston, New York, Toronto, Charlottevile (N.C.), Charleston (S.C.). Awards: Presidential Medal of Freedom, 1980; eleven honorary degrees. Best known as author/illus. of "A Field Guide to the Birds" (more than 3 million copies sold by 1985), a 31-vol. series of field guides first published in 1934; other natural hist. books. Contributor: Life. Positions: T., River Sch., Brookline, Mass., 3 years; Asst. Ed., Audubon, 1935-42 [47]

PETERSON, Vivian K. [P] Minneapolis, MN [24]

PETIGRU, Caroline (Mrs. William A. Carson) [Min.P,Por.P] Rome, Italy b. 24 My 1819, Charleston, SC d. 1893. Studied: Charleston. Active in NYC after 1860; in Rome since 1880s. [*]

PETO, John Frederick [P] Island Heights, NJ (from 1889) b. 1854, Phila. d. 1907. Studied: PAFA, 1878; influenced by W. Harnett. Exhibited: PAFA, 1880s. Work: BMFA, major mus. Important trompe l'oeil still life painter who received little recognition in his lifetime. By 1905 a Phila. dealer began forging the signature of the more famous William Harnett on many Peto paintings (although their styles differed greatly). [*]

PETOW, Edward T. [P] Providence, RI b. 3 O 1877, Russia. Studied: Acad. A., Odessa; Munich Acad. Member: Soc. A.&Letters, Geneva, Switzerland. Exhibited: Odessa (med); St. Petersburg (med). [10]

PETREMONT, Clarice Marie [P,C,Des,B,P,T] Shelton, CT b. Brooklyn, NY d. 22 O 1949. Studied: M. Fry; P. Cornoyer. Member: AAPL; Boston SAC; New Haven PCC; Bridgeport A. Lg. Position: T., Bridgeport A. Lg. [47]

PETRINA, Carlotta [P,Li,I] Brooklyn, NY b. 9 O 1901, Kingston, NY. Studied: Robinson; Bridgman; Miller; Savage. Member: Artists Gld.; SI. Exhibited: F., Guggenheim, 1933, 1935. Work: Fifth Ave. Lib., NYC; Brooklyn Mus. Illustrator: "South Wind," pub. Limited Editions Club; Milton's "Paradise Lost" [40]

PETRINA, John [P,I,Li,L,T,W] Roslyn, NY b. 20 Mr 1893, Venice, Italy (came to U.S. as a child) d. 14 Je 1935, Evanston, WY (automobile accident). Studied: Volk; Cox; Bridgman; Henry; Woodstock Colony. Member: Artists Gld. Exhibited: Paris Salons. Work: lithographs, Fifth Ave. Lib., NYC; Brooklyn Mus.; French Gov. Author/Illustrator: "Art Work, How Produced, How Reproduced." Illustrator: "Ports of France," "Trails of the Troubadours" pub. Century [33]

PETROFF, Gilmer [P,Dec,T] Taylors, SC b. 20 Mr 1913, Saranac Lake, NY. Studied: Yale; Univ. Wis.; E. Miller. Member: Phila. WCC; Atlanta AA; Greenville (S.C.) A. Lg.; Staten Island AA; Beach Combers C., Provincetown, Mass. Exhibited: PAFA, 1937, 1938; AIC, 1939; AWCS; Atlanta AA; Greenville (S.C.) A. Lg.; Mint Mus. A., 1946 (prize). Work: Saranac Lake AA; mural, Colonial Bldg. & Loan Assn., Staten Island, N.Y.; Dongan Hills, N.Y., Savings Bank; Staten Island Hist. Soc.; O'Hara Coll., Maine [47]

PETROVIC, Milan V. [P,E,T] Cincinnati, OH b. 28 Je 1893, Pancevo, Serbia. Studied: N. Kouznjezoff; E. Singer. Member: MacD. Soc., Cincinnati. Work: Hispanic Mus., Hispanic Society Am., N.Y. [40]

PETROVITS, Milan [P,Dr,I,T] Verona, PA b. 17 Ja 1892, Vienna, Austria. Studied: A.C. Sparks. Member: Pittsburgh AA. Exhibited: Pittsburgh AA, 1922 (prize), 1923 (prize), 1924 (prize), 1932 (prize); Pittsburgh A. Soc., 1938 (prize). Work: Public Sch. Coll., Pittsburgh. Position: T., AI Pittsburgh [40]

PETRYL, August [P] Chicago, IL [13]

PETRUCCELLI, Antonio [Des,I] Mt. Tabor, NJ b. 27 S 1907, Fort Lee, NJ. Studied: M.M. White. Exhibited: Corona Mundi, N.Y., 1925 (prize), 1926 (prize); Art Alliance of Am. for Intl. Press Exh., Cologne, 1927 (prize); Am. Soc. for Control of Cancer, 1928 (prize); Stehli Silk Corp., 1928 (prize); Johnson and Faulkner, N.Y., 1933 (prize); House Beautiful Cover Comp., 1928 (prize), 1929 (prize), 1931 (prize), 1933 (prize). Work: mural dec., Hotel Winslow, N.Y. Designer: covers, New Yorker, Collier's, Today, Fortune, 1932–37 [40]

PETRUCCI, Carlo Alberto [P] NYC [13]

PETRY, Victor [P,I,E,T] Douglaston, NY/Ogunquit, ME b. 9 O 1903, Phila. Studied: F. Waugh. Member: NYWCC; Seven Arts C. Work: Brooklyn Mus.; private collections [40]

PETT, Helen Bailey [S,T] Jackson, MI b. 26 My 1908, East Liverpool, OH. Studied: A.T. Fairbanks; Univ. Mich.; A. Laessle; PAFA. Member: AAPL. Work: medal for Mich. Horticultural Soc.; work reproduced in "American Magazine of Art" [40]

PETTE, John Phelps [P] NYC [08]

PETTERSON, John P. [Silversmith] Park Ridge, IL b. 15 My 1884, Gothenburg, Sweden d. 30 D 1949. Studied: Royal Sch. A.&Crafts; D. Anderson. Member: Boston Soc. A.&Crafts. Exhibited: AIC, 1922 (prize), 1923 (prize); Boston Soc. A.&Crafts, 1929 (prize), 1936 (prize); Paris Salon, 1937 (prize); Boston SAC, 1932 (prize), 1936 (med); MMA; SFMA; Joslyn Mem.; CMA; BMFA; AIC. Work: Passavant Hospital Mem. Fund Trophy, Chicago; Trophy, Lake Geneva, Wis.; sword presented to King of Italy by Italian War Veterans of Chicago, 1928 [47]

PETTINGELL, Lillian Annin (Mrs. C.K.) [P,T] La Crosse, WI b. 4 F 1871, LeRoy, NY. Studied: I.R. Wiles; L.M. Wiles; R.H. Nicholls, Chase Sch.; ASL [33]

PETTINGELL, Robert Clyde, Jr. [P] Wash., D.C. Exhibited: Wash. WCC, 1939; Am. Fed. A., 1939 [40]

PETTIT, Evelyn M. [P,T] Lisbon, OH b. 12 Je 1870, Lisbon, OH. Studied: Cleveland Sch. A.; A. Dow, PIASch. Position: T., N.Y. Sch. Decorative Appl. A. [06]

PETTIT, George W. [P] Phila., PA. Member: Phila. AC [10]

PETTIT, Grace [P] NYC. Exhibited: AIC, 1935; Kansas City AI, 1938; Contemp. A. Gal., NYC, 1938 [40]

PETTY, George [I,Cart] NYC. Contributor: Esquire, 1939 [40]

PETTY, Jessie W. [P,E,T] San Antonio, TX/Douglas, AZ b. Navasota, TX. Studied: Arpa; Gonzalez; de Young; Piazzoni. Member: SSAL; San Antonio AL; Palette and Chisel C.; Tex. FA [33]

PETZOLD, Adolph [P] Phila., PA [15]

PEUGEOT, George I(ra) [P,C] Buffalo, NY b. 26 N 1869, Buffalo. Studied: P. Gowans. Member: Buffalo SA [29]

PEW, Gertrude L. (Mrs. Frederic G. Robinson) [Min.P] NYC b. 25 Mr 1876, Niles, OH. Studied: E. Carlsen; L. Simon; Ménard. Work: War. Dept., Wash., D.C. [40]

PEYRAUD, Elizabeth K. (Mrs. F.C.) [P,I] Highland Park, IL b. Carbondale, IL. Studied: AIC; F.C. Peyraud. Member: Chicago PS; Chicago WCC; Cordon C.; Chicago Gal. Assn. [33]

PEYRAUD, Frank C. [P] Highland Park, IL b. 1858, Bulle, Switzerland. Studied: AIC; Ecole des Beaux-Arts, Paris; Bonnât; Friburg. Member: Chicago PSA; Chicago WCC; NAC. Exhibited: AIC, 1890 (prize), 1921 (prize); Chicago PS, 1935 (gold); Chicago SA (prize); P.-P. Expo, San Fran., 1915 (med); Hamilton C., Chicago, 1920 (med). Work: Union Lg. C., Chicago; AIC; fresco, Peoria Pub. Lib.; Mun. A. Coll., Phoenix, Ariz.; Friends Am. Art, Chicago; Mus., Bulle, Switzerland [40]

PEYTON, Alfred Conway [P,I,E] Gloucester, MA b. 9 N 1875, Dera Doon, British India (came to U.S. ca. 1906) d. 28 Ja 1936. Studied: South Kensington Sch., London, England. Member: AWCS; NYWCC; North Shore AA. Exhibited: Bombay (med); Madras (med). Work: Coll. Friends of Art. Illustrator: mags. in England, U.S. [32]

PEYTON, Ann Douglas Moon (Mrs. Philip B.) [P,I] Phila., PA b. 28 Je 1891, Charlottesville, VA. Studied: G. Bellows; R. Henri; W.M. Chase. Member: Richmond AC [25]

PEYTON, Bertha S.D. Menzler (Mrs. Alfred C.) [Ldscp.P,T,W] Gloucester, MA b. 25 Je 1871, Chicago d. ca. 1950. Member: North Shore AA (Dir.); NAWPS; NYWCC; AWCS; Allied AA; SPNY; Grand Central AG. Exhibited: AIC, 1903 (prize), 1909 (prize), 1910 (prize); NAWPS, 1926 (prize); North Shore AA, 1930 (prize); CGA; CI; PAFA; AWCS; Syracuse MFA; Detroit IA. Work: Union Lg. C., Chicago; Nike C., Klio C., West End Women's C., all in Chicago; Evanston Women's C.; BM; Chicago FA Bldg.; Addison Gilbert Hosp., Gloucester, Mass.; AFAA; BM. [47]

PEZET, A. Washington, Mrs. See Armstrong.

PEZZATI, Peter [P] Boston, MA. Exhibited: CGA, 1937; WFNY, 1939 [40]

PFALTZGRAF, R. [P] Columbus, OH. Member: Pen and Pencil C., Columbus [25]

PFEIFER, Clara Maria. See Garret, Mrs.

PFEIFER, Herman [P,I] NYC/Staten Island, NY b. 24 N 1879, Milwaukee d. 17 Ja 1931. Studied: Royal Acad., Munich; H. Pyle. Member: SI. Illustrator: Harper's, Century, McClure's, Ladies Home Journal, Good Housekeeping [40]

PFEIFFEN, Justus [P] NYC [15]

PFEIFFER, Fritz [P,T,L] Buffalo, NY/ Provincetown, MA b. 3 Je 1889, Gettysburg, PA d. 17 Je 1960. Studied: PAFA; R. Henri; Breckenridge; W. Chase; T. Anshutz. Member: Provincetown A.; Artist and Writers U., Provincetown; Am. A. Cong. Exhibited: Detroit IA, 1946; PAFA; AIC; Harvard, 1940 (one-man); Mich. State Normal Col., 1941 (one-man); Newhouse Gal. Work: Springfield Mus. A.; Falmouth, Mass. Pub. Lib.; stage sets, Provincetown Town Hall [47]

PFEIFFER, Heinrich H. (Harry R.) [P] St. Augustine, FL/Provincetown, MA b. 19 O 1874, Hanover, PA d. ca. 1960. Studied: ASL, with J. Carlson; PAFA, with H. Breckenridge, H. Carter; Charcoal C. Exhibited: CGA; PAFA; AIC [47]

PFEIFFER, Hope Voorhees (Mrs. Fritz) [P,Gr,T] Buffalo, NY/Provincetown, MA b. 28 Ja 1891, Coldwater, MI d. before 1970. Studied: Adrian Col.; Detroit Sch. Des.; F. Pfeiffer; B. Lazzell; E. Dickinson. Member: Provincetown AA. Exhibited: Detroit IA, 1946; Los Angeles Mus. A., 1932; PAFA, 1941; SAM, 1932; Wichita A. Mus., 1931; Mich. State Normal Col., 1941 (one-man); Adrian Col., Detroit, 1940 (one-man); Buffalo, N.Y., 1945 (one-man) [47]

PFEIL, G.H. [P] Phila., PA [06]

PFETSCH, Carl P. [Por.P] Indianapolis, IN b. 1817, Blankenberg, Germany (came to NYC ca. 1848) d. 1898. Active in NYC, ca. 1848–55; Cincinnati, 1856; New Albany, Ind., 1856–70; Indianapolis thereafter. [*]

PFINGSTEN, Clara Ella [B,C,S] Westport, CT b. 2 D 1897, Elberfeld, Germany. Studied: H. Heath. Affiliated with Art Extension Press, Westport, Conn. [40]

PFISTER, Jean Jacques (Mr.) [P,T,L] Coral Gables, FL b. 10 Jy 1878, Basle, Switzerland d. 7 Je 1949. Studied: Hopkins Sch. FA; ASL; W. Adams; Art Sch., Bremen, Germany. Member: AWCS; Laguna Beach AA; Carmel AA; New Rochelle AA; Palm Beach A. Lg.; NAC; SC; Blue Dome Fellowship. Exhibited: Palm Beach AL, 1938 (prize), 1940 (prize); Miami,

Fla., 1942 (prize). Work: Rollins Col., Winter Park, Fla.; Ohio Wesleyan Univ.; Vt. Hist. Mus., Old Bennington; Butterworth Hospital, Grand Rapids, Mich.; Normal Sch., Lander, Wyo.; Columbia Univ. Chapel; Palm Beach Women's C.; Elks Temple, Passaic, N.J.; Montanans, Inc., Helena, Mont.; State T. Col., Lander, Wyo.; Knowles Mem. Chapel, Winter Park, Fla.; Christian ScienceBldgs., WFNY (1939), GGE (1939). Illustrator: Amercan hist. textbooks [47]

PFLAGER, Dorothy Holloway (Mrs. Henry B.) [P] St. Louis, MO b. 26 N 1900, Los Angeles. Studied: Wellesley Col.; Wash. Univ. Member: St. Louis AG; St. Louis Studio Group. Exhibited: BMA, 1942. Exhibited: Baltimore WCC, 1942; Loring Andrews Gal., Cincinnati, 1945; CAM, 1945, 1946; St. Louis AG, 1946; St. Louis, 1944 (one-man) [47]

PFLAUMER, Paul Gottlieb, 2nd [P,I,C] Phila, PA b. 9 Ag 1907, Phila. Studied: T. Oakley; L. Spizziri,; J. Dull. Member: Phila. Alliance [40]

PFOHL, William F. [P] Winston-Salem, NC. Work: USPO, Wilmington, NC. WPA artist. [40]

PFRIEM, Bernard A. [P,T,Des] NYC b. 7 S 1914, Cleveland, OH. Studied: John Huntington Polytechnic Inst., Cleveland; Cleveland Sch. A., traveling schol. Exhibited: CI, 1942; CMA, 1938–40, 1943; Butler AI, 1939, 1940; Western Reserve Univ., 1940 (prize). Work: murals, Mexico City. Positions: Ed., Mexico Habla, (Spanish-English mag.), Mexico City, 1940–42; A. Dir., Grey Falcon Press; T., MOMA Edu. Program [47]

PHARES, Frank [P] Mt. Holly, NJ. Studied: PAFA [25]

PHELAN, Harold L(eo) [P,T] NYC b. 23 Jy 1881, NYC. Studied: H.W. Ranger [25]

PHELAN, Linn Lovejoy [C,S,Des,T,L] Alfred, NY b. 25 Ag 1906, Rochester, NY. Studied: Rochester Inst. Tech.; Ohio State Univ.; L.S. Backus; A.E. Baggs; F. Payant; F. Trautman. Member: N.H. Lg. A. & Crafts; Maine Craft Gld. Exhibited: Phila A. All., 1937–41, 1945, 1946; Syracuse MFA, 1932–36; N.Y. S. Ceramic A., 1934, 1936; N.Y. Decorators C., 1938; WMA, 1943; Rochester Mem. A. Gal., 1929, 1930, 1932, 1935, 1938; Bangor (Maine) SA, 1939, 1940; Boston SAC, 1938; Wichita AA, 1946; Dartmouth, 1945. Work: Cranbrook Acad. A.; Dartmouth, mem., YWCA, Lewiston, Maine. Contributor: Design Craft Horizons. Positions: Owner, Linwood Pottery, Saco, Maine, 1940–43; T., Sch. Am. Craftsmen, Alfred, N.Y (from 1944), Rowantrees Kiln, Blue Hill; Eastman Theatre [47]

PHELIPS, Emily Bancroft, Mrs. [P] Kimmswick, MO b. 1 Jy 1869, England. Studied: St. Louis Sch. FA; H. Breckenridge. Member: Artists G. Exhibited: Portland Expo, 1905; Sedalia, 1913 (gold), 1918 (gold) [31]

PHELPS, Adele C. [P] Laguna Beach, CA [25]

PHELPS, Dorothy [P] Highland Park, IL [27]

PHELPS, Edith Catlin (Mrs. Stowe) [P,E] Santa Barbara, CA b. 16 Ap 1875, NYC d. 8 Jy 1961. Studied: Académie Julian; C. Hawthorne. Member: CAFA; San Diego FAS. Exhibited: PAFA; CGA; AIC; GGE, 1939; Los Angeles Mus. A.; San Diego FAS, 1938 (prize); Sacramento State Fair, 1938 (prize), 1941 (prize); Oakland A. Gal.; Santa Cruz AL, 1935; Santa Barbara Mus. A., 1945 (one-man) [47]

PHELPS, Helen Watson [P] NYC b. 1864, Attleboro, MA d. 6 F 1944. Studied: Académie Julian, Collin, both in Paris. Member: NAWPS; Providence AC; SPNY; Yonkers AA; Newport AA; PBC; NAC. Exhibited: Pan-Am. Expo, Buffalo, 1901; N.Y. Women's AC, 1907 (prize), 1909 (prize); NAWPS, 1914 (prize), 1915 (prize) [40]

PHELPS, Sophia Throop [P] Chicago, IL b. 1875, Chicago. Studied: AIC [01]

PHELPS, W(illiam) P(helps) [P] Chesham, NH b. 6 Mr 1848, Dublin, NH. Studied: Lowell; Boston; Europe, with Velten, Meissner, Barth [17]

PHILBIN, Clara [S] Cincinnati, OH. Member: Cincinnati Woman's AC [27]

PHILBRICK, Allen Erskine [P,E,En,L,T] Winnetka, IL b. 19 N 1879, Utica, NY. Studied: AIC; Académie Julian, Ecole des Beaux-Arts, Laurens, all in Paris. Member: Chicago SE; Chicago PS. Exhibited: NAD, 1942–46; LOC, 1942–44, 1946; AIC, 1922 (prize), 1923 (prize); Evanston Women's C., 1937 (prize). Work: murals, Juvenile Court, Chicago; People's Trust & Savings Bank, Cedar Rapids, Iowa; Iowa State Hist. Mus.; Lake View H.S., Chicago; Univ. Iowa. Affiliated with AIC, 1940 [47]

PHILBRICK, Jane W. [P,T] Winnetka, IL/Wiscasset, ME b. 3 F 1911, Chicago, IL. Studied: AIC. Member: Wis. Fed. Ar. Exhibited: AIC, 1937; Milwaukee AI, Wiscasset AG. Position: T., Milwaukee-Downer Col. [40]

PHILBRICK, Margaret Elder [Et] Westwood, MA b. 4 Jy 1914, Northampton, MA. Studied: Mass. Sch. A. Member: SAE; Chicago SE. Work: LOC. Exhibited: SAE, annually; Chicago SE, annually; NAD, 1944, 1946; Northwest PM, 1946; Albany Pr. C., 1945; Buffalo Pr. C., 1940, 1943; LOC, 1944, 1945; CI, 1944 [47]

PHILBRICK, Mary [P] Grundman Studios, Boston, MA [01]

PHILBRICK, Otis [P,Li,T] Westwood, MA b. 21 O 1888, Mattapan, MA d. 1973. Studied: Mass. Sch. A. Member: Boston WC Painters. Exhibited: Nat. Mus., Wash., D.C., 1946 (one-man); NAD, 1943, 1944, 1946; Albany Pr. C., 1945; Buffalo Pr. C., 1940, 1943; LOC, 1943–46; CI, 1944, 1945; Boston WC Painters, annually; Jordan Marsh Gal. Position: T., Mass. Sch. A., Boston [47]

PHILIPP, M. Bernard, Mrs. See Jane Peterson.

PHILIPP, Robert [P] NYC b. 2 F 1895, NYC d. 22 N 1981. Studied: ASL, 1910–14, with DuMond, Bridgman; NAD, with Volk, C. Curran, Maynard, 1914–17. Member: ANA, 1934; NA, 1945; Lotos C., 1945; Intl. Soc. AL, 1959; F., Royal SA, 1965. Exhibited: NAD, 1922 (prize); AIC, 1936 (med); CGA, 1938 (med); CI, 1937 (prize). Work: BM; WMAA; Houston MFA. Positions: T., Am. Sch. A. (1940), Univ. Ill. (1941), ASL, NAD (from 1966) [47]

PHILIPS, Emily (Mrs.) [P] St. Louis, MO. Member: St. Louis AG [25]

PHILIPS, Katherine Elizabeth [P] Paris, France b. NYC [01]

PHILIPSE, Margaret G. [P] NYC [01]

PHILLIPS, Abraham [E] NYC [27]

PHILLIPS, Agda [P] Excelsior, MN [24]

PHILLIPS, Bert Greer [P,T,I] Taos, NM b. 15 Jy 1868, Hudson, NY d. 1956, San Diego, CA. Studied: NAD ca. 1889, ASL, ca. 1889; Académie Julian with Laurens, Constant. Member: Taos SA (founder, 1912); SC; Chicago Gal. A. Work: murals, Polk County Court House, San Marcos Hotel, Chandler, Ariz.; Capitol, Jefferson City, Mo.; Courthouse, Taos, Mus. N.Mex.; Philbrook A. Center. Specialty: Indian subjects [40]

PHILLIPS, Caroline King [Min.P] Boston, MA [24]

PHILLIPS, Claire Donner [P,E] Prescott, AZ (1962) b. 31 Ja 1887, Los Angeles. Studied: Stanford; Columbia, with A. Dow. Member: Calif. AC; Women P. of the West; Laguna Beach AA. Exhibited: Ariz. State Fair, 1928; Mus. Northern Ariz., 1930. Work: Prescott Ariz. Pub. Sch.; Ariz. Fed. Women's C. [47]

PHILLIPS, Clarence Coles [I] New Rochelle, NY b. 3 O 1880, Springfield, OH d. 12 Je 1927. Studied: Chase A. Sch. Member: New Rochelle AA. Member: GFLA; Author's Lg. America. Illustrator: Saturday Evening Post, Good Housekeeping, Ladies' Home Journal, Life, Liberty, McCall's, Woman's Home Companion [25]

PHILLIPS, Dorothy. See Sklar.

PHILLIPS, Duncan [Mus.Dir,W,L,Cr,P] Wash.,D.C. b. 26 Je 1886, Pittsburgh d. ca. 1968. Studied: Yale. Member: AFA; F., Berkeley Col., Yale; AA Mus; NGA, (trustee, member). Work: PMG. Author: "Collection in the Making," 1926, "The Artist Sees Differently," 1931, "The Leadership of Giorgione," 1937. Co-author: "Daumier," 1923. Editor/Contributor: PMG publications. Positions: Dir., PMG; Chm.-Com. for Mod. Am. Paintings, Tate Gal., London, 1946 [47]

PHILLIPS, Elizabeth Shannon [P] NYC b. 27 F 1911, Pittsburgh, PA. Studied: CI, Pittsburgh; ASL; Tiffany Fnd. Schol. Exhibited: CI; 48 Sts. Comp., 1939. Work: USPO, West Haven, Conn. WPA artist. [40]

PHILLIPS, Gertrude [P,T] NYC [10]

PHILLIPS, Grace H. [P] NYC. Member: S.Indp.A. [25]

PHILLIPS, Harriet S. [P,C] NYC/Hague-on-Lake George b. 1849, Rome, NY d. 30 Jy 1928. Studied: Fehr, Munich; Simon, Paris; NYC. Member: Kunstlerinen Verein, Munich; NAC; NYSC; SPNY; PBC; Mun. AC. Exhibited: NYC; Munich; Paris. Work: Univ. Akron [27]

PHILLIPS, Helen Elizabeth [S] San Fran., CA b. 3 Mr 1913, Fresno, CA. Studied: Calif. Sch. FA. Exhibited: SFMA, 1936 (prize). Work: St. Joseph's Church, Sacramento, Calif.; SFMA. Affiliated with San Fran. AA [40]

PHILLIPS, Holmead [P] NYC b. 2 O 1889, Shippensburg, PA. Work: Jeu de Paume Museum, Paris; BM [40]

PHILLIPS, J. Campbell [P] NYC b. 27 F 1873, NYC d. 24 S 1949. Studied: W. Chase; ASL; Clinedinst; Mowbray; MMA Sch. A. Member: AAPL; Lotos C.; Ar. Funds; Ar.of Carnegie Hall. Work: MMA; CMA; Albright

A. Gal.; High Mus. A.; U.S. Treasury Dept., Wash. D.C.; Capitols, Trenton (N.J.), Harrisburg (Pa.); Lotos C., N.Y.; NAD; Cornell; Colgate; CCNY; Phila. Bar Assn.; Supreme Court, Pa.; Nat. Democratic C., N.Y.; New York City Hall; DAR, Wash., D.C.; Acad. Medicine, NYC; Bronx County Court House, N.Y.; Real Estate Bd., NYC; N.Y. Supreme Court [47]

PHILLIPS, Jessie W. [P] Seattle, WA [24]

PHILLIPS, John E. [P] Chicago, IL. Member: Chicago PS [25]

PHILLIPS, J(ohn) H(enry) [E,T] Babylon, NY b. F 12 1876, Sun Prairie, WI. Member: SC. Exhibited: Chicago Arch. C., 1903. Work: Elizabethan Theater, Upper Montclair, N.J.; Babylon Theatre, Babylon, N.Y.; Ringling Mus., Sarasota, Fla. [27]

PHILLIPS, Josephine Neall [Min.P,P] Orange, N.J. Exhibited: Pa. SMP, PAFA, 1934, 1935, 1936; ASMP, 1938; Calif. SMP, 1938 [40]

PHILLIPS, Leonard H. [P] Columbus, OH. Member: Columbus PPC [25]

PHILLIPS, Marjorie (Mrs. Duncan) [Mus.Dir,P] Wash., D.C. b. 25 O 1895, Bourbon, IN. Studied: ASL, with B. Robinson, K.H. Miller; G. Beal. Member: S. Wash. A. Exhibited: CGA, 1925–1945; CI, 1934–46; AIC, 1931, 1940, 1941; WMA; MOMA, 1933; PAFA, 1944, 1945; WFNY, 1939; GGE, 1939; Tate Gal., London, 1946; Denver A. Mus., 1941; PMG, 1941; Kraushaar Gal., 1941 (one-man); Durand-Ruel Gal., 1941 (one-man); Santa Barbara Mus. A., 1945 (one-man). Work: BMFA; PMG; Yale Univ. Mus.; WMAA; WPA mural, USPO, Bridgeville, Pa. [47]

PHILLIPS, Patricia [P,E] NYC b. 1916, NYC d. 16 N 1946. Studied: Sarah Lawrence Col.; W.S. Hayter. Exhibited: Bonestell Gal., NYC; Pinacotheca Gal., NYC; Pal. Leg. Honor

PHILLIPS, Robert Francis [I] b. England d. 6 Je 1902, NYC (scarlet fever). Brother of Stephen, author and poet.

PHILLIPS, S. George [P] Phila., PA Studied: PAFA. Member: Phila. AC [25]

PHILLIPS, Sara J. [C,B] Tully, NY b. 5 F 1892, Brooklyn, NY. Member: PIASch; Columbia. Member: N.Y. Soc. Craftsmen [40]

PHILLIPS, W(alter) J(oseph) [P,B,E,C,W,T,L] Winnipeg, Canada (since 1913) b. 2 O 1884, Barton-on-Humber, England d. 1963, Calgary, Alberta. Studied: Birmingham A. Sch. with E.R. Taylor. Member: Calif. PM; Boston SAC. Exhibited: Los Angeles, 1926 (prize); Graphic Arts C., Toronto, 1926 (prize); Boston SAC (med). Work: Nat. Gal, Canada; AIC; Mus. N.Mex.; Toronto Gal.; British Mus.; Victoria and Albert Mus.; Los Angeles Mus. A.; Calif. State Lib. Author: "The Technique of the Color Wood-cut," "The Canadian Scene," "Essays in Wood." Positions: T., Univ. Wis., Univ. Alberta, Univ. Manitoba, Banff Sch. FA [31]

PHILLIPS, Walter Shelley [I,W] b. 1867 d. 1940. Illustrator: "Totem Tales," 1896. Active in Chicago before 1900. [*]

PHILLIPS, Wilber E(lmer) [P] Kansas City, MO/Bogard, MO b. 1 Mr 1907, Bogard. Studied: St. Louis Sch. FA; PAFA. Member: St. Louis AG. Exhibited: St. Louis AG, 1932 (prize); Mo. State Fair, 1934 (prize), 1935 (prize), 1937 (prize); Midwestern Ar., Kansas City AI, 1939 (prize). Work: Carrollton (Mo.) Baptist Church; Lib., Southeast H.S., Kansas City; Paseo H.S., Jackson County Court House, Detention Home, both in Kansas City [40]

PHILLIPS, Winifred Estelle [C,Des,P,T] Wauwatosa, WI b. 1 N 1880, Clay Banks, WI d. 1963. Studied: F. Fursman; G. Moeller; G. Oberteuffer; H.B. Snell; PIASch; AIC; Wis. Sch. A.; State Col., Milwaukee; State Sch. Cer., Alfred, N.Y. Member: Wis. A. Fed.; NAWPS; Milwaukee AI. Exhibited: Milwaukee AI (prize), 1936 (prize), 1937 (prize), 1938 (prize). Specialty: ceramics. Position: T., Milwaukee State T. Col. [40]

PHILPOT, Samuel H. [P,T,I] Baltimore, MD. Studied: Md. Inst.; ASL; PIASch; H. Roben; G. Bridgman; F. Goudy; A. Fisher. Exhibited: Md. Inst.; BMA; CGA; Ogunquit A. Ctr.; Hagerstown, Md. Work: Fed. Land Bank, Baltimore, Md. Position: T., Md. Inst. [47]

PHINNEY, Anita [P] Newport, RI. Member: Newport AA [25]

PHISTER, Jean Jacques [P,S] San Fran., CA b. 10 Jy 1878, Berne, Switz. [17]

PHOENIX, Bertha E. [P] Wash., D.C. [01]

PHOENIX, Florence Bingham (Mrs. Lauros Monroe) [Des,C] d. 12 Ja 1920. Studied: AIC

PHOENIX, Frank [P] Chicago, IL d. fall, 1924, Glendale, CA. Member: Chicago SA. Position: T., AIC [13]

PHOENIX, Lauros Monroe [Mur.P,Des,T] New Rochelle, NY b. 23 F 1885, Chicago. Studied: AIC; J. Vanderpoel; T.W. Stevens; L.W. Wilson; J.F. Carlson, at Woodstock Summer Sch. Member: NSMP; New Rochelle AA; ASL, Chicago. Work: St. Paul Hotel; murals, Lowrie Doctors' Bldg., St. Paul, Minn.; Donaldson Bldg., Elks C., Minneapolis, Minn. Position: T., NYU; Dir., N.Y.-Phoenix Sch. Des., NYC [47]

PIAI, Pietro [S] NYC b. 31 My 1857, Vittorio, Treviso, Italy. Studied: Vittorio, with Stella; Acad., Turin, with C. Tabacchi [04]

PIATTI, Emilio Fernando [S] Englewood, NJ b. 18 D 1859, NYC d. 22 Ag 1909. Studied: CUASch, with his father Patrizio; asst. to Saint-Gaudens. Work: mausoleum of George Wescott; statue of Gen. Spinola; bust of Bertha Galland [04]

PIATTI, Patrizio [S] NYC b. 1824, near Milan, Italy (came to NYC in 1850). Specialty: statuary. Father of Emilio. [04]

PIAZZONI, Gottardo F.P. [P,E,S,Dr,Dec,T,W] San Fran., CA b. 14 Ap 1872, Intragna, Switzerland. Studied: San Fran. AA Sch. FA; Académie Julian, Ecole des Beaux-Arts, both in Paris. Member: San Fran. AA; Calif. Soc. Mural A. Exhibited: San Fran. AA, 1919 (prize), 1924 (gold), 1927 (med); Ariz. State Fair, 1924 (prize); San Diego SFA, 1927 (prize). Work: The Walter Coll., San Fran. AA; Golden Gate Park Mus., San Fran.; Municipal Gal., Phoenix, Ariz.; Mills Col. A. Gal., Calif.: 5 murals, San Fran. Pub. Lib. [40]

PICCIRILLI, Attilio [S] NYC b. 16 My 1866, Massa, Italy (came to NYC in 1888) d. 8 O 1945 Studied: Academia San Luca, Rome. Member: ANA, 1909; NA, 1935; Arch. Lg., 1902; Allied AA. Exhibited: Pan-Am. Expo, Buffalo, 1901 (med); St. Louis Expo, 1904 (med); Paris Salon, 1912 (prize); P.-P. Expo, San Fran., 1915 (gold); PAFA, 1917 (gold); NAD, 1926 (gold); Grand Central Gal., N.Y., 1929 (prize). Work: "Maine Memorial," NYC; glass panel/entrance, Palazzo d'Italia; sculpture/glass panel/entrance, Intl. Bldg., Rockefeller Center, NYC; MacDonough Mon, New Orleans; FA Acad., Buffalo; bust of Jefferson, Va. Capitol; USPO Dept. Bldg, Wash., D.C.; USPO, Whitman, Mass. WPA artist. Son of Guiseppe. [40]

PICCIRILLI, Bruno [S,T] Poughkeepsie, NY b. 30 Mr 1903, NYC. Studied: NAD; BAID; Am. Acad., Rome. Member: NSS; Arch. Lg.; Dutchess County AA. Exhibited: San Fran., 1929; NAD, 1930–32; Arch. Lg., 1945; Albany Inst. Hist.&A., 1942, 1945. Work: Riverside Church, N.Y.; Brookgreen Gardens, S.C.; Mount Carmel Sch., Poughkeepsie; Wheaton Col.; USPO, Marion, N.C. WPA artist. Position: T., BAID [47]

PICCIRILLI, Ferruccio [S] NYC b. Massa, Italy (came to NYC in 1888). Son of Guiseppe. [25]

PICCIRILLI, Furio [S] NYC b. 14 My 1868, Massa, Italy d. 1949 (came to NYC in 1888). Studied: Acad. San Luca, Rome. Member: ANA; NA, 1936; Arch. Lg., 1914. Exhibited: Pan-Am. Expo, Buffalo, 1901 (prize); St. Louis Expo, 1904 (med); P.-P. Expo, 1915 (prize). Son of Guiseppe. [47]

PICCIRILLI, Guiseppe [S] NYC b. 1843 (came to NYC in 1888) d. 20 Ja 1910. Work: marble dec., new Customs House, N.Y.; Chamber of Commerce; County Court House; N.Y. Stock Exchange. With his six sons, all sculptors, he opened a studio adjoining his home.

PICCIRILLI, Horatio [S] NYC b. 1872, Massa Italy (came to NYC in 1888) d. 27 Je 1954, Riverdale, NY. Exhibited: NAD, 1926 (prize). Son of Guiseppe. [33]

PICCIRILLI, Maso [S] NYC b. Massa, Italy (came to NYC in 1888). Son of Guiseppe. [29]

PICCIRILLI, Orazio [S] NYC b. Massa, Italy (came to NYC in 1888). Son of Guiseppe. [29]

PICCIRILLI, Vivian Lush. See Lush.

PICCOLI, Girolamo [S] NYC b. 9 My 1902, Palermo, Sicily. Studied: Wis. Sch. A; F. Vittor; L. Taft. Member: Am. A. Cong. Exhibited: Milwaukee AI, 1922 (med); Wis. PS, 1924 (prize). Work: sculpture of the Eagles Club Bldg.; fountain, Lake Park, Milwaukee. WPA artist. [40]

PICKARD, Thomas W. [P] Columbus, OH. Member: Columbus PPC [25]

PICKEN, George Alexander [P,E,Li,T,L] NYC b. 26 O 1898, NYC. Studied: ASL; abroad. Member: An Am. Group; Am. Soc. PS&G.; Mural P.; Am. A. Cong. Exhibited: CGA, 1941, 1943 (prize), 1945; Herron AI, 1944, 1945; WMA, 1943; AIC, 1941–45; MMA, 1943; PAFA, 1944–45; WMAA, 1942–46; BM, 1944–46; CI, 1944–46; Iowa State Univ., 1946; VMFA, 1942, 1944, 1946; Berkshire Mus.; Marie Harriman Gal. (one-man); Frank Rehn Gal. (one-man). Work: CGA; WMAA; Newark Mus.; NYPL; Dartmouth; IBM Coll.; Univ. Ariz.; murals, USPO, Edward, N.Y.; Hudson Falls, N.Y.; Chardon, Ohio; Pub. Sch., Hawthorne, N.Y. [47]

PICKENS, (Lucien) Alton [P,En] NYC b. 19 Ja 1917, Seattle. Studied: Reed Col., Portland, Oreg.; Seattle AI; Portland (Oreg.) A. Mus. Sch.; L. Reynolds. Exhibited: MMA, 1942; MOMA, 1943; CAM, 1945; AIC, 1945; CI, 1945. Work: MOMA. Position: T., Univ. Ind., 1946-47 [47]

PICKERING, Hal [I] Salt Lake City, UT. Position: Affiliated with Deseret News [15]

PICKERING, James H. [Des] NYC b. 29 Ag 1904, Kansas City, MO. Studied: M. van der Rohe; H. Bayer; F. Reich, Berlin. Specialty: store interiors, displays, exhibitions [40]

PICKERING, S(imeon) Horace [P,Des,I,L,W] NYC b. 18 O 1894, Salt Lake City. Studied: AIC; Grand Central A. Sch.; W. Adams; D. Cornwell; Summer Sch. of P., Saugatuck, Mich. Member: S.Indp.A.; Am. Veterans Soc. A.; Acad. Allied A. Exhibited: S.Indp.A., 1927-46; Am. Veterans Soc. A., annually; AIC; Barbizon-Plaza A. Gal., N.Y.; Acad. Allied A., N.Y. Work: Nat. Park Service [47]

PICKETT, Frederick Augustus [Min.P] NYC d. 11 My 1904, Newport (R.I.) Hospital. Exhibited: PAFA, 1903 (last work publicly shown)

PICKETT, J.H.R. [P] Richmond, VA. Work: USPOs, Lewisburg, Tenn., Virginia Beach, Va. WPA artist. [40]

PICKETT, Joseph [Primitive P] New Hope, PA b. 1848, New Hope d. 1918. Work: MOMA; WMAA (few works survive) [*]

PICKHARDT, Carl E., Jr. [P,E,Li] Cambridge, MA b. 28 My 1908, Westwood, Mass. Studied: Harvard; C. Zimmerman. Exhibited: WMAA, 1936; Nat. Acad., 1936; McDonald Gal., N.Y., 1937; Inst. Mod. A., Boston, 1939; NAD, 1942 (prize). Work: BMFA; BM; LOC; NYPL; AGAA; PMA; FMA [47]

PICKNELL, George W. [Ldscp.P] Silvermine, CT b. 26 Je 1864, Springfield, VT d. 1 Ap 1943. Studied: Lefebvre; Constant. Member: SC; AFA; Springfield, Ill., AA. Exhibited: Bridgeport AL, 1934 (prize). Work: Detroit Inst. A.; New England Baptist Hosp., Boston; YMCA, Norwalk, Conn. [40]

PICKUP, Ernest A. [E,En,B] Nashville, TN b. 10 Ap 1887, Shelbyville, TN. Member: Woodcut Soc.; Southern Pr. M.; Studio C.; SSAL. Exhibited: Delgado Mus. A., 1937 (prize); SAE, 1937 (prize), AIC, 1937 (prize), 1938, 1939 (prize), 1940; PAFA, 1933-35; SAE Intl. Exh., 1937-39; Centenn. C., Nashville, 1939, 1945 (one-man). Work: Nashville Park Commission; Delgado Mus., New Orleans. Illustrator: "Man Upon Earth," 1945 (wood engravings) [47]

PIELKE, Rolfe [I] San Fran., CA [21]

PIERCE, A.A. (Mrs.) [P] Cincinnati, OH. Studied: BMFA. Member: Copley S., 1895; Cincinnati Women's A.C.; Cincinnati Women's Press C. Specialty: roses [10]

PIERCE, A.B., Jr. [P] Houston, TX. Exhibited: Houston Ar. Ann., Houston MFA, 1938, 1939 [40]

PIERCE, Anna Harriet [P,Dr,T] Southbury, CT b. 17 My 1880, Southbury. Studied: NAD; N.Y. Sch. A.; Yale; F.L. Mora; J.H. Niemeyer, F.C. Jones; G. Maynard; K.H. Miller; J.F. Weir; E.C. Taylor; Commonwealth Colony, Boothbay Harbor, Maine. Member: New Haven PCC; Brush&Palette C. Exhibited: Yale Sch. FA (prize); Brush&Palette C. (prize), 1927-36; CAFA, 1932, 1935; New Haven PCC, 1910-36 [47]

PIERCE, Charles F(ranklin) [Ldscp.P] Brookline, MA b. 26 Ap 1844, Sharon, NH d. 5 My 1920. Studied: Boston; Europe. Member: Boston AC; Boston SWCP; New Haven PCC [19]

PIERCE, Edgar A. (Mrs.) [P] Westboro, MA [24]

PIERCE, Elizabeth Raymond (Mrs. Vernon L.) [P] Bayside, NY b. Brooklyn, NY. Studied: ASL; J.S. Curry; R. Lahey; A. Goldthwaite. Member: Douglaston A. Lg. Exhibited: Douglaston A. Lg., 1946 (prize); BM, 1942, 1942; Studio Gal., 1945, 1946; Grant Studios, N.Y., 1937; ASL, 1939 [47]

PIERCE, Frances B. [Ldscp.P] Dunkirk, NY b. 20 Mr 1868, NJ. Studied: M. Walter; H.B. Snell; J. Lie; N. Fechin; S. Bredin. Member: Buffalo SA; Buffalo G. Allied A.; Nat. Lg. Am. Pen Women. Work: Pub. Sch., No. 19, Corona, N.Y. [40]

PIERCE, Glenn M. [I] Brooklyn, NY. Member: SI [33]

PIERCE, Harry [P] Hyde Park, MA. Member: Boston AC [25]

PIERCE, Herbert Stanton [P] South Orange, NJ b. 26 N 1916, East Orange. Studied: Newark Pub. Sch. Fine&Indus. A.; Grand Cen. Sch. A. Member: Am. Ar. Prof. Lg.; N.J. WC Soc.; Essex WCC. Exhibited: Newark AC, 1936 (prize); N.J. Gal., 1937 (prize); Asbury Park, Soc. A., 1938 (prize) [40]

PIERCE, J. Lee [P] Chicago, IL. Member: Chicago NJSA [25]

PIERCE, Kate F. [P] Weymouth, MA [01]

PIERCE, Lucy V. [P] Berkeley, CA [19]

PIERCE, Marion L. [P] Rumson, NJ. Member: AWCS [47]

PIERCE, Martha [P,T] Wayne, NE/Lincoln, NE b. 15 Ja 1873, Cumberland, WV. Studied: Chicago Acad. FA; J.W. Reynolds; J. Norton; L. Welson; C. Werntz; AIC; NYU, with J.P. Haney. Member: Nebr. Art. T. Assn.; Western AA; NAAE. Work: State T. Col., Wayne. Position: T., State T. Col., Wayne [40]

PIERCE, Mildred [P] Laguna Beach, CA [25]

PIERCE, Rowena Elizabeth [S] Providence, RI. Member: Providence AC [25]

PIERCE, William H.C. [D,T] San Diego, CA b. 23 Mr 1858, Hamilton, NY. Studied: Lowell Sch. Des.; MIT; Paris. Member: San Diego AG. Exhibited: Pan-Calif. Expo, San Diego, 1915 (med) [40]

PIERPONT, Clarence S. [P] Providence, RI. Member: Providence AC [25]

PIERSON, Alden [I] NYC b. 1874, Baltimore d. 3 My 1921. Member: SI, 1912. Position: A. Dir., American Magazine [19]

PIERSON, Elizabeth G. (Mrs.) [P] NYC. Exhibited: NAWPS, 1935-38 [40]

PIERSON, John C. [P] Hartford, CT. Member: CAFA [25]

PIERSON, John C. (Mrs.) [P] Hartford, CT. Member: Hartford AS [25]

PIERSON, N. [P] Alexandria, VA [04]

PIERSON, Susan E. [P] Wash., D.C. Member: Wash. WCC. Affiliated: Friends Sch., Wash. D.C. [06]

PIETERSZ, Bertus [P,W,T] Springfield, MA b. 13 S 1869, Amsterdam, Holland d. Jy 1938. Studied: Rotterdam, with H. W. Ranger. Member: AFA; Am. APL; Springfield AL. Work: Springfield, Mass., Art Mus. [38]

PIETERSZ, John C. [P] Springfield, MA [17]

PIETRO, Cartaino di Sciarrino [S] Pelham, NY b. 25 D 1886, Palermo, Italy d. 9 O 1918. Studied: Rome; mostly self-taught. Member: Boston AC. Exhibited: P.-P. Expo, San Fran., 1915 (prize). Work: busts, Am. Mus. Natural Hist., N.Y.; bust, Hamilton Col., Hamilton, Ohio; bust, Pan-Am. Union, Wash., D.C.; bust, Univ. Wis., Madison, Wis.; bust, Hague Peace Palace, Hague, Holland; bust, Memorial col., Phila.; marble fountain, Hackensack (N.J.) Court House. Founder/Director: Friends of Young Artists [17]

PIETRO, S.C. (Mrs.) [S] NYC [21]

PIETZ, Adam [S,En] Phila., PA b. 19 Jy 1873, Germany. Studied: PAFA; AIC; Germany. Member: Phila. Sketch C.; Phila. A. All. Work: Mem. Hall, Navy Yard, U.S. Mint, Univ. Pa., PAFA, Acad. Music, Sketch C., all in Phila.; Am. Numismatic Soc.; Nat. Mus., Wash., D.C.; AIC; Vanderpoel Coll.; British Mus., London; reverse, Congressional Med. Honor. Position: Asst. En., U.S. Mint, 1927-46 [47]

PIGOTT, Frank E. [P] NYC. Member: Rochester AC. Affiliated: Steck&Spelrein Lithographic Co., NYC [24]

PIKE, Charles J. [S,P] NYC. Member: Arch. Lg., 1902 [10]

PIKE, Harriet A. [P] Fryeburg, ME [24]

PIKE, John [P,I,Dec] Rutherfordton, NC/Old Lyme, CT b. 30 Je 1911, Boston. Studied: Charles Hawthorne; Richard Miller. Member: Provincetown A. Assn.; Old Lyme A. Assn.; NYWCC; Am. Ar. Group, Jamaica, B.W.I. Exhibited: Ferargil Gal., N.Y. (one-man); Grace Horne Gal., Boston (one-man); WC Ann., PAFA, Grand Cen. Sch.; Am. WCC-NYWCC, 1939 [47]

PILLARS, Charles Adrian [S,T] Sarasota, FL b. 4 Jy 1870, Rantoul, IL d. 21 Je 1937, Clifton, FL. Studied: AIC; Taft; French; Potter. Member: FA Soc., Jacksonville. Work: mem., Jacksonville; Bryan Mem., Battleship, Fla.; Mem. Flag Staff Standard, St. Augustine; statue, U.S. Capitol, Wash., D.C.; statue, Barnett Nat. Bank, Jacksonville. Position: T., Ringling Sch. A., Sarasota [33]

PILLIN, Polia [P] Santa Fe, NM b. 1905, Szenstochowa, Poland. Studied: Todros Geller. Exhibited: Oakland A. Gal.; Cincinnati AM; N.Mex. Mus., Santa Fe; WC Ann., San Fran. A. Assn., 1939 [40]

PILSBURY, Emma J. [P] NYC [06]

PIM, William Paul [Cart] Birmingham, AL b. 1 D 1885, Armstrong County, PA. Studied: Huntington Polytech. Inst. Member: Birmingham AC. Work: Huntington Lib., San Marino, Calif. Cartoonist: "Telling Tommy," educational newspaper strip [40]

PINCOVITZ, H.A. [P] Phila., PA Studied: PAFA [25]

PINE, Geri (Mrs. G.P. Werner) [P] NYC b. 17 My 1914, NYC. Studied: ASL, with J. Sloan. Member: Am. Ar. Cong.; Am. Contemp. Ar. Exhibited: WMAA, 1943; ACA Gal. (one-man), 1936, 1940, 1941; Bonestell Gal., 1945; BM, 1938; Parrish Mus. Work: Queens (N.Y.) Pub. Lib. WPA artist. [47]

PINE, Theodore E. [Por.P,En] b. 1828, NYC(?) d. 10 Je 1905, Ogdensburg, NY. Studied: under his father James (active NYC 1834–45); Paris; Rome; Munich, 1860. Active NYC, Chicago, St. Louis, Manitou Co., and Asheville N.C.

PINELES, Cipe (Miss) [P,I] Brooklyn, NY b. 23 Je 1908, Vienna, Austria. Studied: A. Fisher [29]

PINHEY, Robert Spottiswoode (Mrs.) [Ldscp.P] NYC b. NYC d. 2 F 1931, Geneva, Switzerland. Studied: Paris. Exhibited: Paris Salon. Active in Paris from the 1880s.

PINK, Harry [P] Chicago, IL. Exhibited: Ar. Chicago Vicinity Ann., 1934–38 [40]

PINKHAM, Marjorie Stafford [B,P,T] Saint Helens, OR b. 21 O 1909, Tarkio, MO. Studied: F.C. Trucksess; M.V. Sibell; V. True; F.H. Trucksess; Univ. Colo. Position: T., Cordova Indian Sch., Seward, Alaska [40]

PINNER, Philip [P,Des] San Fran., CA b. 13 Jy 1910, San Fran. Studied: Calif. Sch. FA; A. Center Sch., Los Angeles; Schaeffer Sch. Des., San Fran.; M. Dixon; J. Sinel. Member: San Fran. AA; United Am. Artists; San Fran. Ar. Coop. Exhibited: San Fran. AA, 1931, 1932, 1935, 1936, 1939, 1941, 1943–45; GGE, 1939; Pal. Leg. Honor, 1945, 1946; SFMA, 1945, 1946; Stanford Univ. A. Gal., 1946; SFMA Traveling Exh., 1944. Work: SFMA [47]

PINSON, Solomon M. [P] Phila., PA [25]

PINTNER, Dora [C,P,Des,L] Cambridge, MA b. Edinburgh, Scotland. Studied: Glasgow Col. A., Scotland; Radcliffe Col.; Boston Univ.; Coll. A., Edinburgh. Member: Copley S.; Cambridge AA; Pa. Soc. Min. P. Exhibited: PAFA, 1924–46; AIC; AWCS, 1933; Nat. Mus., Wash., D.C., 1943; CGA, 1944–46; ASMP, 1934, 1940, 1942,; Los Angeles County Fair, 1941; Portland SA, 1934–42; Boston AC, 1932, 1933, 1935; Copley S., 1937–46; Caif Soc. Min. P., 1937, 1938, 1941; Chicago Soc. Min. P., 1938, 1940, 1942; Contemp. New England A., 1942–46; Cambridge AA, 1944–46; Jordan Marsh Gal. Work: stained glass windows, Angell Mem. Hospital, Boston. Specialty: stained glass [47]

PINTO, Angelo [Mur.P,E,Dr,B] Phila., PA b. 27 S 1908, Casal Velino, Salerno, Italy. Member: Phila Pr. C.; Phila. A. All.; Phila. WCC; Un. Scenic Ar. Am. Exhibited: Barnes Fnd., Merion, Pa., 1931–33; Contemp. Am. P., Four AC, Palm Beach, Fla., 1937 (prize). Work: PAFA; Barnes Fnd.; MMA; NYPL; WMAA. Position: T., Barnes Fnd. [40]

PINTO, Biagio [Mur.P,Dr] NYC b. 6 O 1911, Phila. Exhibited: Barnes Fnd. Scholarship, Merion, Pa., 1932, 1933; Phila. AC, 1932 (prize). Work: PAFA; Pa. Mus. A.; Barnes Fnd., Merion; Mus. Allentown, Pa. [40]

PINTO, Salvatore [Mur.P,E,B,Dr] Phila., PA b. 4 Ja 1905, Casal Velino, Salerno, Italy. Member: United Scenic Ar. Am.; Phila. Pr. C. Exhibited: Barnes Fnd. Scholarship, Merion, Pa., 1931–33; Phila. Print C., 1932 (prize); Phila. AC, 1934 (gold). Work: MET; N.Y. Pub. Lib.; Whitney Mus. Am. A., N.Y.; Chicago AI; Barnes Fnd., Merion [40]

PIOTROWSKA, Irena Glebocka [W,I,Cr] NYC b. 18 S 1904, Poznań, Poland. Studied: Univ. Poznań; Ecole du Louvre, Paris; Columbia. Member: Am Soc. for Aesthetics; CAA; Polish Inst. A. &Sc. in Am.; Am. Soc. for Expansion of Polish Art Abroad; Kosciuszko Assn. Exhibited: Univ. Poznana, 1929 (med). Author: "Problems of Polish Contemporary Painting," 1935, "The Art of Poland," 1946. Co-author: "Poland," the United Nations series, 1945. Contributing Ed.: Encyclopedia of the Arts, 1945. Contributor: Journal Aesthetics & Art Criticism, Art & Industry, London, Liturgical Arts, other publications [47]

PIPER, George H. [P,S] Chicago, IL. Member: Chicago SA [06]

PIPER, Natt [P,Arch,B,W,T] Long Beach, CA b. 31 O 1886, Pueblo, CO. Studied: Fanshaw; Richter. Member: Los Angeles PS; AAPL; Long Beach AA; State Assn. Calif. Arch.; Santa Monica AA; Long Beach Arch. C.; Spectrum C. Exhibited: Southwest Expo, 1929 (med). Work: Ashton Coll. Wood-Engravings, Springfield, Mass.; NYPL; LOC. Illustrator: "American Architect," "California Arts and Architecture." Contributor: articles, "Pencil Points," "Arts and Decoration," "Architect and Engineer" [40]

PIPER, Van D. [P] NYC. Exhibited: NAD [98]

PIPPENGER, Robert [S,Des,C,T] New Hope, PA b. 26 Ap 1912, Nappanee, IN. Studied: John Herron A. Sch. Exhibited: Prix de Rome, 1938 (prize); Am. Acad., Rome (prize); Herron AI, 1938 (prize); Ind. State Fair; Grand Central A. Gal., 1937–39; PAFA, 1941; N.J. State Mus., Trenton, 1945. Work: sculpture, Plymouth (Ind.) Lib.; Brookgreen Gardens, S.C. [47]

PIPPIN, Horace [Primitive P] West Chester, PA b. 1888 d. 6 Jy 1946. Exhibited: Masters of Popular P., MOMA, 1938; Carlen Gal., Phila 1940 (one-man). Work: PMA; PAFA. Important Black primitive painter, whose serious work dates from 1930, and is rare. [40]

PIQUET, M.S. [P] NYC. Member: S.Indp.A. [25]

PIRSON, Elmer (William) [P,I] Buffalo, NY b. 26 Jy 1888. Studied: G. Bridgman; J.E. Fraser. Member: GFLA [27]

PIRSSON, J. Emily [P] Wyoming, NJ. Member: Lg. AA [24]

PISTEY, Joseph, Jr. [P] Bridgeport, CT. Work: USPO, Haynesville, La. WPA artist. [40]

PITCHER, Samuel H. [P] Worcester, MA [24]

PITFIELD, Florence Beatrice [P] Brooklyn, NY [13]

PITKIN, Caroline W. [P,C,T,S] NYC b. 12 Je 1858, NYC. Studied: Chase; DuMond; Harrison; Woodbury; Brenner. Member: PBC; Alliance; NAWPS [33]

PITKIN, Josephine [P] NYC [10]

PITMAN, Harriette Rice (Mrs. Stephen Minot Pitman) [P,T] Providence, RI b. Stetson, ME. Studied: Pratt Inst. Member: Providence WCC; Providence AC. Positions: Circuit Supv./T., Corning, Ithaca, Jamestown, all in N.Y., 1891–92; T., Providence Pub. Sch., 1894–1904, RISD Mus., 1926 [31]

PITMAN, Elizabeth S. [P] Wallingford, CT. Member: New Haven PCC [25]

PITMAN, Sophia L. [P,T] Providence, RI b. Providence. Member: Providence AC; Providence WCC; Copley S. [33]

PITMAN, Theodore B. [P,I,S] b. 1892 d. 1956. Studied: Harvard. Illustrator: "The Frontier Trail," 1923, "Firearms in the Custer Battle," 1953 [*]

PITMAN, Thomas [Mar.P,Sign P] b. 2 O 1853 d. 16 Ja 1911, Marblehead, MA. Work: Peabody Mus., Salem, Mass. [*]

PITTMAN, Hobson [P,B,T] Upper Darby, PA b. 14 Ja 1899, Tarboro, NC d. 1972. Studied: CI; Columbia; Pa. State Col.; Woodstock A. Sch., 1920; Europe, 1928; E. Walters; A. Heckman; D. Rosenthal. Member: Woodstock AA; Phila. WCC; Phila. A. All.; Audubon A. Exhibited: PAFA, annually, 1943 (prize), 1944 (med); CGA, 1935, 1937, 1939, 1941, 1943, 1945; VMFA, 1938, 1940 1942, 1944, 1946; AIC; WMA; Phila. WCC, annaully; CI, annually from 1940; CMA; Pal. Leg. Honor; Herron AI; Santa Barbara Mus. A.; MOMA; GGE, 1939; Paris; London; Venice. Work: PAFA; MMA; PMA; CMA; AGAA; BM; VMFA; Santa Barbara Mus. A.; WMAA; CI; Nebr. AA; Brooks Mem. A. Gal.; John Herron AI; Wilmington Soc. FA; Pa. State Col.; Encyclopaedia Britannica Coll.; IBM Coll.; PMG; Brooklyn Mus.; WMAA; MMA; Butler IA; N.C. Mus. A. (retrospective), 1963. Illustrator: Fortune. Position: T., Friends' Sch., Overbrook, Pa. [47]

PITTMAN, Kitty Butner (Mrs. James T.) [P,T,S] Atlanta, GA b. 20 D 1914, Phila. Studied: Oglethorpe Univ.; F. Zimmer; R. Dean; M. Seiglar. Member: Atlanta A. Exhibitors. Exhibited: SSAL, 1935–40; Assn. Georgia A., 1933–36, 1938, 1940; Atlanta Studio C., 1932–40; Atlanta AA, 1936, 1938; Atlanta A. Exhibitors, 1940–42; Chicago North Shore A. Lg., 1937 [47]

PITTS, Fred L. [P] Phila., PA b. 1842, MD. Studied: PAFA; McMicken Sch., Cincinnati. Position: affiliated with Phila. Sketch C. [17]

PITTS, Henry S. [P] Phila., PA. Member: Providence AC [17]

PITTS, Kate [P,E,I,Dr] NYC b. 14 O 1896, Aberdeen, MS. Studied: G.B. Bridgman; ASL; Studio Workshop, Boston and Rockport, Mass.; Lhote, in Paris. Member: A. All. Am.; Studio C. Exhibited: Studio C., 1922 (prize), 1923 (prize); watercolor, 1939 (prize). Illustrator: covers, Arts and Decoration, Oct. 1935, 1937 [40]

PITTS, Lendall [P] Paris, France. Member: Paris AAA [25]

PITZ, Henry Clarence [P,E,Li,I,W,T] Plymouth Meeting, PA b. 16 Je 1895, Phila. d. 1976. Studied: PMSchIA; Spring Garden Inst., Phila. Member: AWCS; Phila. A. All.; Phila. Sketch C.; Phila. Pr. C.; Audubon A.; A. Lg. Am.; Folio C.; Phila. WCC; Southern PM Soc. Exhibited: Los Angeles Mus. A., 1932 (med); PAFA, 1930–46, 1933 (gold); PMSchIA, 1934 (prize); Phila. A. All., 1941 (prize); Paris Salon, 1934 (prize); Phila. Pr. C., 1937 (prize); NAD; AIC; Stockholm, Sweden; PMA; AWCS, 1932 (prize), 1933–37, 1944; BM; BMA; Wilmington Soc. FA; WFNY, 1939; Ogunquit A. Center, 1932–32 (prize); Denver A. Mus., 1934 (prize); Southern PM Soc., 1937 (prize); Int. Expo, Paris, 1937 (med). Work: Los Angeles Mus. A.; LOC; NYPL; PMA; Denver A. Mus.; Allentown Mus.; Franklin Inst., Phila.; West Phila. H.S.; Woodrow Wilson Jr. H.S., Phila.; Miami Univ.; Vanderpoel Coll., Chicago; Artists Gld., Denver; Smithsonian; LOC; Century of Progress Expo, Chicago. Author: "Early American Costumes," 1930, "The Practice of Illustration," 1946; articles in London Studio, Sketch Book. Illustrator: "Master Skylark," "A Connecticut Yankee in King Arthur's Court," "Red Cross Knight," "Story of Rolf," "Westward Ho," "Robinson Crusoe," other books; Scribner's, Harper's, Cosmopolitan, Saturday Evening Post. Positions: T., PMSchIA (1934–46), PAFA (Summer session, 1938–), Univ. Pa. (1941) [47]

PITZ, Molly Wood (Mrs. Henry C.) [P,T,L] Plymouth Meeting, PA b. 12 My 1913, Ambler, PA. Studied: PMSchIA. Member: Phila. A. All.; Phila. WCC. Exhibited: Ann. Small Oil Exh., Phila. Sketch C., 1935 (prize), 1936–45; Woodmere A. Gal., 1943–46. Work: Pa. State Col. Position: T., Plymouth Meeting Friends' Sch., Pa. [47]

PIZZUTI, Michele [P] NYC b. 29 N 1882. Studied: D. Morelli. [29]

PLACE, Graham [I] Larchmont, NY. Member: SI [47]

PLACE, Vera Clark (Mrs.) [P] Minneapolis, MN 5 F 1890, Minneapolis. Studied: Minneapolis Sch. A.; Chase; Difner; R. Miller; A. de la Gandere. Member: Attic C., Minneapolis; Minneapolis SFA. Exhibited: Minn. State A. Exh. (prizes) [33]

PLAISTED, (Miss) Zelpha M. [P] Boston, MA b. Maine. Studied: Boston; England; Paris. Member: Copley S., 1891 [15]

PLAISTRIDGE, Philip [P,E] Winchester, NH [33]

PLANK, Esther Rae [P] NYC. Member: GFLA [27]

PLANK, G. Wolfe [I] Wyebrooke, PA [15]

PLANT, Olive [P] Wash., D.C. Member: S. Wash. A. [25]

PLANT, S. [P] NYC. Exhibited: AWCS, 1898 [98]

PLASCHKE, Paul A. [P,Car] Chicago, IL b. 2 F 1880, Berlin. Studied: CUASch; ASL; G. Luks. Member: Assn. Chicago PS. Exhibited: Richmond (Ind.) AA, 1917 (prize); Nashville AA, 1925 (prize); Hoosier Salon, 1929 (prize), 1934 (prize); Louisville AA, 1932 (prize); SSAL, 1936 (prize). Work: Attica (Ind.) Lib.; Lexington (Ky.) Lib.; Speed Mem. Mus., Children's Free Hosp., both in Louisville; Vanderpoel A. Assn. Illustrator: humorous drawings, Life, Puck, Judge, other magazines. Positions: Cart., Louisville Times; Chicago Herald American; Sunday Courier-Journal, 1913–36 [40]

PLATH, Karl [P,I,W] Chicago, IL b. Chicago. Studied: AIC; Acad. FA; Grant. Member: Chicago PS; All-Ill. Soc. FA; Chicago Gal. A. [33]

PLATT, Alethea Hill [Ldscp.P,Min.P] Sharon, CT b. 1861, Scarsdale, NY d. 24 My 1932, White Plains, NY. Studied: ASL; B. Foster; H.B. Snell; Délécluse Acad., Paris. Member: AFA; NYWCC; AWCS; NAWPS; NAC; Pen and Brush C.; SPNY; Yonkers AA; Allied AA; CAFA. Exhibited: N.Y. Women's AC, 1903 (prize); Minn. AA, Faribault, 1909 (prize); Nat. Lg. Art, Chap. Am. Pen Women, 1928 (prize). Work: Pub. Lib., Faribault, Minn.; Anderson (Ind.) A. Gal.; Court House, White Plains, N.Y.; Mus. St. Joseph, Mo.; Nat. Arts C., N.Y. [31]

PLATT, Charles Adams [P,Ldscp.Arch,E,W] NYC b. 16 O 1861, NYC d. 12 S 1933, Cornish, NH. Studied: NAD, 1879; ASL; Académie Julian, Paris, with Boulanger and Lefebvre, 1882–89; etching, S. Parrish, 1880. Member: SSA, 1888; ANA, 1897; NA, 1911; Am. Acad. AL; AWCS; N.Y. Etching C.; London Soc. P.&E.; AIA; Century; AFA; Am. Acad., Rome; Cornish (N.H.) Colony. Exhibited: SAA, 1894 (prize); Paris Expo, 1900 (med); Pan-Am. Expo, Buffalo, 1901 (med); Arch. Lg., 1913 (med); NAD, 1882–97; Paris Salon 1885–86. Work: AGAA; Albright-Knox, Buffalo; Montclair AM; Freer Gal.; CGA [31]

PLATT, Charles H., Jr. [P] Yonkers, NY [21]

PLATT, Eleanor (Mrs. Flavin) [S,T] Santa Barbara, CA b. 6 My 1910, Woodbridge, NJ. Studied: ASL; A. Lee. Member: NSS. Exhibited: Chaloner scholarship, 1939–41; Am. Acad. A.&Let., 1944 (prize); Guggenheim F., 1945. Work: BMFA; MMA; N.Y. Bar Assn.; Hebrew Univ., Jerusalem; Carnegie Corp.; Harvard Law Sch. Position: T., F. Indst. Sch. A., NYC [47]

PLATT, George W. [Por.P,Ldscp.P] Denver, CO b. 16 Jy 1839, Rochester, NY d. 16 S 1899. Studied: Univ. Rochester; PAFA, late 1860s; Italy; Munich. Member: Denver AC. Specialty: still life, ldscp., port. Active in Chicago 1880s before settling in Denver. With Powell's surveys in Colorado 1870s. [98]

PLATT, Harold [P] Brooklyn, NY [01]

PLATT, J.B. [P] NYC [19]

PLATT, Livingston [P] Brooklyn, NY [01]

PLATT, Martha A. [P,T] Boston, MA b. New Haven, CT. Studied: F.D. Williams. Member: Copley S. [10]

PLATT, Mary Cheney [Mur.P,Des,T] NYC b. 12 My 1893, NYC. Studied: Parsons Sch. Des.; N.Y. Sch. F&Appl. A.; G. Bridgman; ASL; NAD; C.W. Hawthorne; A. Crisp. Member: NAWA; NAWPS. Exhibited: NAWA, 1934–42, 1946; Montclair A. Mus., 1932; Contemp. A., 1933; Mun. A. Comm. Exh., 1936. Work: Russell Sage Fnd.; Spanish House, Columbia; General Fed. Women's Clubs. Position: T., Chapin Sch., NYC, 1935– [47]

PLAUCHE, Leda Hincks [P] New Orleans, LA b. 30 D 1887, New Orleans. Studied: G.L. Viavant; E. Woodward. Exhibited: Nat. Farm and Live Stock Show, New Orleans, 1916 (prize). Specialty: carnival and pageant costume design [21]

PLAVCAN, Catharine Burns (Mrs. Joseph M.) [Cr,T,P,L] Erie, PA b. 13 F 1906, Springfield, IL. Studied: Col. William&Mary; PAFA. Member: A. C., Erie. Exhibited: A. C., Erie, 1931 (prize); Indiana, Pa., 1943; Butler AI, 1943; ohio Valley Exh., Athens, Ohio, 1944. Position: T., Erie Day Sch., 1937–42; Erie Tech. H.S., 1946; Art Critic, Erie (Pa.) Dispatch-Herald, 1937–46 [47]

PLAVCAN, Joseph Michael [P,T,L,E] Erie, PA b. 19 Jy 1908, Braddock, PA. Studied: PAFA; Univ. Pittsburgh; Garber; Pearson, Jr.; Garner, Jr. Member: Am. Fed. T.; Am. Vocational Assn.; Erie AC. Exhibited: PAFA, Cresson traveling scholarship, 1928, 1929 (med), 1930, 1932–36, 1941; Soc. Wash. A., 1929 (med); CGA, 1931 (prize), 1933; Parkersburg FA Cen., 1943, 1944 (prize); CI, 1930, 1931, 1935, 1936; NAD, 1943, 1944; Pepsi-Cola, 1946; Indiana, Pa., 1943, 1944; Butler AI, 1938, 1939, 1942, 1944, 1945; Ohio Valley Exh., Athens, Ohio, 1943–45; Erie, Pa., 1928–43; AC of Erie, 1935 (prize). Work: Press C., Erie; Art C., Erie Women's Cl, Acad. H.S. Position: T., Erie Tech. H.S., 1932–46 [47]

PLEADWELL, Amy Margaret [P] Boston, MA/Paris, France b. Taunton, MA. Studied: Mass. Sch. A.; Grande Chaumière, Ecole Moderne, both in Paris. Member: NAWA; Copley S.; AFA; Lyceum C., Paris. Exhibited: numerous water color exh. [47]

PLEIMLING, Winnifred (Mrs. Harold O.) [P] Chicago, IL b. 28 Je 1899, Jackson, MI. Studied: AIC; F.V. Poole; G. Oberteuffer; L. Ritman. Member: Women A. Salon, Chicago; Chicago AC; Assn. Chicago P.–S.; Chicago SA; All-Ill. SA; FA Gld., Chicago; South Side AA; Chicago-N.J. Soc. Ar. Exhibited: South Side AA (prize); AIC, 1936, 1941, 1942, 1944; Ill. State Mus. [47]

PLEIN, Charles M. [P] b. Alsace-Lorraine d. Ja 1920, Omaha, NE. An authority on Indian history, he had a collection of rare Indian curios.

PLEISSNER, Ogden M. [P,E] NYC/Dubois, WY (1976) b. 29 Ap 1905, Brooklyn, NY d. 24 O 1983, London. Studied: ASL, with F.J. Boston; G. Bridgman; DuMond. Member: NA; SAE; Phila. WCC; All. A. Am.; AWCS; Baltimore WCC; SC; CAFA; Lyme AA; Audubon A.; Southern Vt. Ar. Exhibited: NAC, 1928–31 (prizes); SC, 1935 (prize), 1938 (prize), 1943 (prize); St. Botolph C., 1942 (prize); AWCS (prize); Audubon A., 1945 (prize); All.A.Am., 1938 (med), 1940 (prize), 1951 (prize); Baltimore WCC, 1949 (prize); CAFA, 1940 (prize), 1950 (prize); Concord AA, 1950 (prize); NAD, 1938 (prize), 1952 (prize). Work: MMA; WMAA; PMA; Minneapolis Inst. A.; Swope Gal. A.; New Britain Mus.; TMA; Canajoharie Mus.; NYPL; LOC; Reading Mus. A.; Univ. Nebr.; Univ. Idaho; BM; High Mus. A. Specialty: watercolor. Also active in Wyo. [47]

PLEUTHNER, Walter Karl [Des,Arch,P,L] Scarsdale, NY b. 24 Ja 1885, Buffalo, NY. Studied: ASL, Buffalo; NAD; DuMond; Mora. Member: Scarsdale AA; AIA; Arch. Lg.; Westchester Soc. Arch. [47]

PLIMPTON, William E. [P] NYC [01]

PLIMSOLL, Fanny G. [P] Paris, France [01]

PLOGER, Benjamin John [P,T] Houston, TX b. 21 S 1908, New Orleans. Studied: Acad. de la Grande Chaumière, Paris; Acad. Colarossi, Paris; De

L'Ecole la Fresque, Paris; W. Adams; E. Woodward. Member: SSAL; NOAA; NOAL; Houston Ar. Gal. Exhibited: P.W.A. exh., Delgado Mus. of Art, New Orleans, 1935 (prize); Houston artists exh., 1936 (prize). Work: Flowers Sch., New Orleans; U.S. Gov. Position: T., Mus. FA, Houston [40]

PLOTKIN, Edna. See Hibel.

PLOWMAN, George T(aylor) [I,E,W] Cambridge, MA b. 19 O 1869, Le Suer, MN d. 26 Mr 1932. Studied: Douglas Volk, in Minneapolis; Eric Pape, in Boston, 1910; F. Short at Royal College of Art, London, 1911-13. Member: Chicago SE; N.Y. SE; Boston SE; Calif. SE; Calif. PM; Soc. Am. E.; F., Royal Soc. Arts. Exhibited: P.-P. Expo, San Fran., 1915 (med). Work: etchings, BMFA; NYPL; LOC; British Mus.; South Kensington Mus.; Nat. Mus., Washington; Luxembourg Mus.; Neewark Pub. Lib.; Sacramento (Calif.) State Mus.; Albany A. Mus.; Southport Mus., England; MMA; Minneapolis Mus. A. Author: "Etchings and Other Graphic Arts," 1914, "Manual of Etching," 1924. Trained as an architect, he turned to etching at age 42 and was considered to have immortalized New England's covered bridges in his work. [31]

PLUMB, H(enry) G(rant) [P,T] NYC/Sherburne, NY b. 15 Ap 1847, Sherburne d. 29 Jy 1930, NYC. Studied: NAD; Ecole des Beaux-Arts, Paris, with Gérôme. Member: SC; A. Fund. S.; AFA. Exhibited: Paris Expo., 1889 (prize). Position: T., Cooper Union, 1882-1916 [29]

PLUMER, Nan D. [P] Boston, MA [06]

PLUMMER, Arrie Elizabeth (Mrs. L. L.) [P,T] Birmingham, AL b. 18 D 1884, LaGrange, GA. Studied: C. Hill; M. Armstrong; I. Lauder; S.W. Woodward; H. Leech; J.K. Fitzpatrick. Member: Birmingham AC; Ala. AL; Dixie Art Colony; SSAL; Sarasota AA. Work: Mus. FA, Montgomery; Pub. Sch., Birmingham; Seton Hall, Decatur, Ala. [40]

PLUMMER, Elmer [P,G,T] Hollywood, CA b. 6 N 1910, Redlands, CA. Studied: Chouinard Sch. A., Los Angeles; L. Murphy; M. Sheets; P. Carter; D. Alfaro; C. Hinkle; Siqueiros. Member: Calif. WCC. Exhibited: Los Angeles County Fair, 1932 (prize); Los Angeles AA., 1934 (prize); Calif. State Fair, 1938 (prize); WC Ann., PAFA, 1938; Int. WC Ann., AIC, 1939; GGE, 1939. Work: YMCA, Pasadena; Oxnard A. Assn., Calif.; FA Gal., San Diego; White House, Wash., D.C. Position: Artist, Walt Disney Studios [40]

PLUMMER, Ethel (Mrs. Frederick E. Humphreys) [P,I] NYC d. 31 O 1936, NYC. Member: SI

PLUMMER, Ethel M'Clellan (Mrs. Jacobsen) [P,I] NYC b. 30 Mr 1888, Brooklyn, NY. Studied: Henri; Mora. Member: SI. Illustrator: Vanity Fair, Vogue, Life, Woman's Home Companion, New York Tribune. Specialty: portrait sketches [38]

PLUNDER, Franz [P] NYC [25]

PLYMPTON, D. Della [P] Brooklyn, NY [15]

PNEUMAN, Mildred Young (Mrs. Fred A.) [P,Ser,B] Boulder, CO b. 15 S 1899, Oskaloosa, IA. Studied: Univ. Colo.; J. Rennell. Member: Boulder A. Gld.; AAPL; Hoosier Salon Assn.; Gary PPC. Exhibited: Gary Civic A. Fnd., 1937 (prize); Phila. Color Pr. Soc., 1945; Hoosier Salon, 1928-35; Denver A. Mus., 1944. Work: P.E.O. Mem. Lib., Mt. Pleasant, Iowa [47]

PODCHERNIKOFF, Alexis [P,G] San Fran., CA b. 11 D 1912, San Fran. Studied: Hopkins Sch. FA, San Fran.; A.M. Podchernikoff; O. de Perelmaof. WPA artist. [40]

PODOLSKY, Henry W. [S] Baltimore, MD [25]

POE, Elisabeth Ellicott [P,Cr] Wash., D.C. b. 27 Jy 1888, Phila. Studied: C.L. Watkins. Member: Wash. WCC. Exhibited: Syracuse Mus. FA (one-man); Wash. AC (one-man); CGA, 1938 (one-man); PMG, 1939 (one-man). Work: PMG; PAFA. Position: A. Cr., Washington Times-Herald [47]

POE, Hugh M. [P] b. 14 D 1902, Dallas, TX. Studied: R.L. Mason; Forsyth; C. Hawthorne. Member: Knoxville Sketch C.; Ind. AC; East Tenn. SFA; Hoosier Salon. Exhibited: Art Assn., Herron AI, 1923 (prize), 1924 (prize); Hoosier Salon, Marshall Field's, Chicago 1925 (prize). Work: Herron AI; Knoxville (Tenn.) Sketch C. [33]

POE, Lucy A. [P] NYC [06]

POEHLER, John [P] NYC. Work: USPO, Riverside, N.J.; WPA artist. [40]

POFFINBARGER, Paul [P] Des Moines, IA. WPA artist. [40]

POGANY, William Andrew ("Willy") [Des,P,I,Gr,S,L,E,C,W] NYC b. 24 Ag 1882, Szeged, Hungary d. 23 Ag 1955. Studied: Budapest, Hungary.
Member: Arch. Lg.; SC; Beaux-Art Inst. Exhibited: Pan-Pac. Expo., 1915 (gold); N.Y. Soc. Arch., 1923 (prize); Leipsig Expo. (gold); Budapest Expo. (gold). Work: Heckscher Children's Theatre, N.Y.; Niagara Falls Power Co.; W.R. Hearst's Wyntoon Village; Park Central Hotel, N.Y.; Hungarian National Gal., Budapest; Ritz Towers, N.Y.; St. George Hotel, Brooklyn. Author/Illustrator: books. Illustrator: American Weekly. Position: Motion Picture A. Dir., 1930-40 [47]

POGSON, Annie L. (Mrs.) [P] Los Angeles, CA. Member: Calif. AC [25]

POHL, Hugo David [P,E,T] San Antonio, TX b. 11 Mr 1878, Detroit d. 20 Jy 1960. Studied: J. Melchers (at age 11); Detroit Inst. A., with J. Gies; ASL; Académie Julian, with Laurens; Germany; Holland; Spain; Italy. Member: Tex. FAS; AAPL; Mural P.; Wash. A. Lg. Exhibited: NAD; SC, Detroit, Palette & Chisel C., Chicago. Work: San Antonio Auditorium; Intl. Harvester Co., Chicago; Union Pacific Railroad. Position: Dir., San Antonio Acad. A. [47]

POHL, LaVera Ann (Mrs. William) [P,W,L,Hist.] Milwaukee, WI b. 20 Ja 1901, Port Washington, WI. Studied: Univ. Bonn; Univ. Cologne, Germany; Wis. Sch. FA; Milwaukee State T. Col.; Milwaukee AI; Saugatuck Sch. P., Mich. Member: Wis. P.&S.; Wis. Designer-Craftsmen; CAA; AFA; Am. Assn. Univ. Women; NAWA; Wis. Pr. M. Exhibited: Wis. P.-S., 1918-41, 1942 (prize), 1943-46; NAWA, 1944, 1945; Milwaukee AI, 1946; Beloit Col., 1940, 1942, 1946; Col. Women's C., Milwaukee, 1940, 1946 (one-man); Argent Gal., 1945; Barbizon Plaza Gal., 1946. Work: Women's Army Corps med.; Milwaukee Univ. Grace Baptist Church. Author: "American Painting," 1938. Contributor: "Industrial Arts" Magazine, 1928-30 [47]

POHL, Lydia D. [P] Chicago, IL [15]

POHL, Minette T. See Teichmueller.

POILLON, Clara Louise (Mrs. Cornelius) [C] NYC b. 1851, NYC d. 23 Ag 1936. She specialed in creating colors and glazes for pottery, and conducted the Poillon pottery concern in Woodbridge, N.J., for more than twenty years, retiring in 1928. Her work was widely exhibited. She was a member of the American Ceramic Society, and was successful in reproducing the glaze and texture of Cretan ware of 2,200 B.C. in the MMA. [24]

POINCY, Paul [P] New Orleans, LA b. 11 Mr 1833, New Orleans d. 1909. Studied: Ecole des Beaux-Arts, Paris. Specialty: children's portraits. Served in the Confederate Army. Also active in AL. [*]

POINTER, Augusta L. [S] Lincoln Park, NJ b. 10 My 1898. Studied: H. Hering. Exhibited: Arch. Lg., 1928 (prize) [33]

POLAND, Lawrence [P] Cincinnati, OH. Member: Cincinnati AC [06]

POLAND, William Carey [Edu,W] b. 25 Ja 1846, Goffstown, NH d. 19 Mr 1929, Providence, RI. Studied: Brown; Berlin; Leipzig; France; Italy. Member: Providence AC. Author: several notable books on the history of art. Position: T., Brown Univ., 1892-1915

POLASEK, Albin [S,T] Chicago, IL b. 14 F 1879, Frenstat, Czechoslovakia. Studied: Am Acad., Rome; PAFA, with Grafly. Member: Arch. Lg.; Assn. Chicago P.&S.; Bohemian AC; AFA; ANA; NA, 1933; NSS, 1914; SW Soc.; Cliff Dwellers; Board of A. Advisors, State of Illinois. Exhibited: Prix de Rome, 1910 (prize); PAFA, 1914 (gold), 1925 (prize); AIC, 1917 (prize), 1922 (prize); Milwaukee AI, 1917 (med); Chicago SA, 1922 (prize); Chicago Gal. Assn., 1937 (prize); Paris Salon, 1913 (prize); P.-P. Expo, San Fran., 1915 (med); Assn. Chicago PS, 1933 (med). Work: MMA; PAFA; AIC; Detroit Inst. A.; Ball State T. Col., Muncie, Ind.; mem., Springfield, Ill.; Hartford, Conn.; Chicago; Vincennes, Ind.; mem., Prague, Czechoslovakia, 1928; bronze statues, mountain top in Frenstát pon Radhostem, Czechoslovakia. Award: Order of the White Lion, awarded by the Government. Positions: Hon. Prof., Am. Acad., Rome, 1930-31; T., AIC, 1940 [47]

POLELONEMA, Otis [P] Second Mesa, AZ (1967) b. 1902, Shungopovi, AZ. Studied: Santa Fe Indian Sch., 1914-20. Work: Denver AM; Mus. Am. Indian; Mus. N.Mex.; Philbrook A. Center. WPA artist. [*]

POLKINGHORN, George [P] Hollywood, CA b. 11 O 1898, Leadville, CO. Studied: Univ. Calif.; Otis AI. Member: Calif. AC. Exhibited: Calif. WCC; Laguna Beach AA; San Diego FA Soc.; Los Angeles Mus. A.; Santa Cruz A. Lg. [47]

POLGREEN, John [I,Car] NYC. Work: Red Book, 1939 [40]

POLITI, Leo [P,S,I,Car] Los Angeles, CA (1972) b. 21 N 1908. Studied: Milan (Italy) AI, 1924. Exhibited: AI, Milan, 1924; WC Ann. PAFA, 1937; PS Ann., AIC, 1937; Delphic Studios, N.Y. (one-man). Work: murals, theatre, Univ. Fresno (Calif.). Illustrator: "Little Pancho," 1938, Jack and Jill, weekly, 1939 [40]

POLK, Mary Alys [P,I,T] Indianapolis, IN b. 29 Ag 1902, Greenwood, IN. Studied: W. Forsyth. Member: Ind. AC. Exhibited: Hoosier Salon, 1927 (prize) [33]

POLKINGHORN, George [P] Los Angeles, CA b. 11 O 1898, Leadville, CO. Studied: Vysekal; Shrader. Member: Calif. AC; Calif. WCS [40]

POLKY, Olaf H. [P] Chicago, IL Member: Chicago NJSA [25]

POLLAK, Augusto [P] NYC [10]

POLLAK, Max [E,P] San Fran., CA b. 27 F 1886, Prague, Czechoslovakia. Studied: Vienna. Member; Chicago SE; Calif. SE. Exhibited: Chicago SE, 1942 (prize); Calif. SE, 1944 (prize), 1945 (prize); Cincinnati AM, 1939. Work: MMA; NYPL; Calif. State Lib.; SFMA; British Mus., London; Albertina Mus., Vienna; A. Mus., Prague; Mus. der Stadt Wien. Illustrator: "My City," 1929 [47]

POLLAK, Theresa [T,P,L,Gr,Dr] Richmond, VA b. 13 Ag 1899, Richmond. Studied: Westhampton Col.; Univ. Richmond; ASL; FMA; Harvard; Tucker; Miller; M. Weber; Bridgman; B. Robinson; Nicolaides. Member: Assn. Preservation Va. Antiquities; Richmond MFA. Exhibited: Tiffany Fnd., 1932; Carnegie F., 1933; Studio C., N.Y., 1926 (prize); Richmond A., 1931 (prize), 1938 (prize); VMFA, 1939 (prize); CGA, 1930; WMAA, 1932; BMFA, 1933; Rockefeller Center, N.Y., 1936, 1938; Oakland A. Gal., 1941–43; Richmond Women's C., 1928–30; Richmond Acad. A., 1931–38; VMFA, 1938, 1939, 1940 (one-man), 1941–46; Va.-Intermont Exh., 1944; Westhampton Col., 1940 (one-man); Univ. Va., 1940 (one-man); Randolph-Macon Col. for Women, 1940 (one-man); Farmville State T. Col., 1941 (one-man). Work: Richmond Sch. A.; VMFA. Position: T., Col. William & Mary, Richmond, Va., 1935–46 [47]

POLLARD, Alice Esther [P] St. Louis, MO b. Chillicothe, MO. Studied: St. Louis Sch. FA. Exhibited: St. Louis Expo, 1898 [98]

POLLARD, Henry (Mrs.) [P] Savannah, GA. Member: Savannah AA [25]

POLLET, Joseph [P,Gr,W,L,T] NYC b. 17 O 1897, Albbruck, Switzerland. d. 1979. Studied: Europe; ASL; J. Sloan; R. Henri. Member: S.Indp.A.; Woodstock AA; Am. Soc. P.S. & Gravers; Ind. Artists' C. Exhibited: Guggenheim F., 1929; Annual Intl. Exh. Contemp. Paintings, CI, 1929 (prize); CGA, 1926–36; PAFA, 1926–44; MOMO, 1930; CA, 1929–45; AIC, 1929–36; N.Y. Mun. Exh., 1933; VMFA; Newark Mus., 1944; WFNY, 1939; WMAA, 1923–46; numerous one-man exh., N.Y., 1923–. Work: Newark Mus.; WMAA; Los Angeles Mus. A.; Dartmouth; NYU; PMG; USPO, Pontotoc, Miss. WPA artist. Positions: T., NYU, 1946–47; Dir., Sawkill Sch. A., Woodstock, N.Y., 1937–42 [47]

POLLEY, Frederick [P,E,I,W,T,L] Indianapolis, IN b. 15 Ag 1875, Union City, IN d. ca. 1958. Studied: Ind. Univ.; Corcoran Sch. A.; J.R. Hopkins; Herron A. Inst., Indianapolis, with W. Forsyth. Member: Hoosier Salon; Brown Co. Art Gal. Assn.; Ind. AC; Ind. Soc. Pr. M.; Chicago SE; SC; New Orleans A. Lg. Exhibited: Hoosier Salon, 1925 (prize), 1926–29, 1930 (prize), 1931, 1932 (prize), 1933–35, 1936 (prize), 1937–41, 1942 (prize), 1943 (prize), 1944 (prize), 1945, 1946; Indiana Fed. A., 1945 (prize); Ind. AC, 1939 (prize), 1943 (prize), 1945 (prize); New Orleans A. Lg., 1943 (prize); John Herron A. Inst., 1934 (prize); LOC, 1944, 1945; CI, 1945; Delgado Mus. A., annually. Work: John Herron AI; Nat. Mus., Wash., D.C.; Iowa State Univ.; Univ. Pittsburgh; Pub. Schs., Indianapolis. Author/Illustrator: "Our America," "Historic Churches in America." Illustrator: "Indianapolis, Old and New," other books. Positions: Ed., Art feature, Indianapolis Sunday Star, since 1924; T., Arsenal Tech. Sch. [47]

POLLIA, Joseph P. [S] NYC b. 1893, Italy d. 1954. Studied: BMFA Sch. Member: NSS; Arch. Lg. Work: monuments: Santiago, Cuba; Greenfield, Mass.; Glencove, N.Y.; Tarrytown, N.Y.; Storm Lake, Iowa; Milford, Conn.; Manassas, Va.; Stoneham, Mass.; Richmond Hill, N.Y.; Jackson Mem. Position: Affiliated with Va. Mus. FA, 1940 [47]

POLLITZER, Anita L. [P] NYC [17]

POLLOCK, Charles Cecil [Li,Mur.P,T] East Lansing, MI b. 25 D 1902, Denver. Studied: Otis AI; ASL. Exhibited: AIC, 1937, 1942; SAE, 1937; SFMA, 1939; WFNY, 1939; Colorado Springs FA Center, 1937, 1938; PAFA, 1941; Detroit Inst. A., 1939, 1940, 1945. Work: murals, Mun. Water Plant, Lansing, Mich.; Mich. State Col., East Lansing; WMAA. Brother of Jackson. Position: T., Mich. State Col., East Lansing, 1942– [47]

POLLOCK, Courtnay [S] NYC [17]

POLLOCK, Jackson [P] East Hampton, NY b. 28 Ja 1912, Cody, WY d. 11 Ag 1956 (single-car crash). Studied: Los Angeles Manual A. Sch., 1925–27; ASL, with J. Sloan, R. Laurent, T.H. Benton, 1929–32. Exhibited: Art of This Century, 1943 (his first major exh., organized by Peggy Guggenheim); MMA (AV), 1943; Chicago (one-man); San Fran. (one-man); New York (one-man); Venice (one-man); Milan (one-man); Paris (one-man); Zurich (one-man), all in the 1950's; MOMA, 1967 (retrospective). Work: MOMA; SFMA; Univ. Iowa; Dallas MA; major museums; WPA artist, 1938–42. Important abstract expressionist famous for his "drip" action paintings made 1947–51. [47]

POLLOCK, James Arlin [P,C] Essex, CT b. 5 S 1898, Salt Lake City d. 5 Mr 1949. Studied: Univ. Pa.; J.G. McManus; G. Wiggins. Member: CAFA. Exhibited: NAD, 1943; CAFA, 1938–43; Lyme AA, 1939–43 [47]

POLLOCK, Mabel Clare Hillyer [P,B,T] Salem, MA b. 12 Ja 1884, Ashtabula, OH. Studied: Pratt Inst.; Henry Keller; Cleveland Sch. A. Specialty: block printing on textiles [40]

POLLOK, Merlin [P,G,T] Chicago, IL b. 3 Ja 1905, Manitowoc, WI. Studied: AIC; Ecole des Beaux-Arts, Fontainebleau Sch. FA, both in Paris. Exhibited: AIC, 1930; Fontainebleau Sch. FA, 1931. Work: murals, Lincoln H.S., Manitowoc; Tilden Tech. H.S., Chicago; Wright Jr. Col., Ill.; USPO, O'Fallon, Ill. WPA artist. Position: T., AIC [40]

POLONYI, John [P] NYC. Member: S.Indp.A. [25]

POLOS, Theodore C. [P,Li,T] Oakland, CA b. 16 F 1902, Mytelene, Greece. Studied: Calif. Col. A.Author&Crafts; Calif. Sch. FA; X.Martinez; C. Macky; S. Mackay. Member: A. Cen. San Fran.; San Fran. AA. Exhibited: San Fran. AA, 1937 (prize), 1938 (prize); SFMA, 1939 (prize); Rosenberg F., 1940; Richmond, Va., 1942 (med); MOMA, 1942; CI, 1943, 1944; AIC, 1943, 1945; CGA, VMFA, 1942; Fnd. Western A.; SFMA; Palace Legion Honor; Crocker A. Gal.; WFNY, 1939; GGE, 1939. Work: SFMA; VMFA; Crocker A. Gal. Positions: T., Acad. Advertising A. (San Fran.), Calif. Col. A.&Cr. [47]

POLOUSKY, Julie (Raymond) [P] Long Beach, CA b. 4 Ap 1908, Phila. Studied: ASL; N.Y. Evening Sch. Indst. A.; V. Helder; S.H. Harris; L. Barton. Member: Laguna Beach AA; Long Beach AA; Calif. WCC; Women Painters of the West. Exhibited: Long Beach AA, 1935 (prize), 1936, 1942–45 (prizes); Laguna Beach AA, 1944 (prize), 1946 (prize); Huntington Beach, Calif., 1945 (prize); Calif. WCC, 1945 (prize); Honolulu Acad. A., 1941; SFMA, 1946; Los Angeles Mus. A., 1945; Riverside Mus., 1946; Los Angeles Pub. Lib., 1946; Bakersfield, Calif., 1946. [47]

POLOWETSKI, C(harles) Ezekiel [P] NYC b. 1 S 1884, Russia. Studied: R. Blum; L. Bonnat. Member: Paris AAA; SC; Allied AA. Work: State Normal Sch., Brockport, N.Y.; Bezalel Col., Palestine; City Hall, Paterson, N.J.; Barnert Hospital, Paterson, N.J.; NYC Pub. Sch.; Summit Park Sanatorium, Pomona, N.Y.; Administration Bldg, Floyd Bennett Airport, N.Y. [40]

POMEROY, Elsie Lower (Mrs. Carl) [P,I,T] Mill Valley, CA b. New Castle, PA. Studied: Corcoran Sch. A.; P. Dike; M. Sheets; E. O'Hara. Member: Calif. WCS; Laguna Beach AA; Riverside FA Gld.; FA Soc., San Diego; Wash. WCC; Los Angeles AA. Exhibited: Los Angeles AA, Wash., D.C., 1935 (prize); Butler AI, 1942 (prize); Riverside (Calif.) FA Gld., 1946 (prize); AIC, 1938, 1939; GGE, 1939; AWCS, 1942; NGA, 1941; Chicago AC, 1943; Calif. WCC; Butler AI; Wash. WCC. Work: Los Angeles AA; Butler AI; Carville, La.; Riverside (Calif.) H.S. Illustrator: botanical illus. for U.S. Dept. Agriculture. Position: T., Riverside A. Cen. [47]

POMEROY, Florence W. (Mrs. Ralph B.) [P] West Orange, NJ/Isle-au-Haut, ME b. 9 Jy 1889, East Orange. Studied: Bellows; Johansen; A. Goldthwaite. Member: NAWA; NAWPS. Exhibited: NAD, 1942, 1944; NAWA, annually; Bonestell Gal., 1947 (one-man); 460 Park Ave., N.Y., 1942 [47]

POMEROY, Grace V. [P] NYC d. My 1906. Member: NYWCC [06]

POMEROY, Mrs. Laura Skeel [S] NYC b. 1833, NYC d. 23 Ag 1911. Work: bust of Matthew Vassar, Vassar College

POMEROY, Mary Agnes [P] NYC [01]

POMMER, Mildred Newell [P,G,Des,C,T,S] San Fran., CA b. 29 My 1893, Sibley, IA. Studied: Otis AI; Chouinard AI; Calif. Sch. FA; B. Bufano. Member: San Fran. AA; San Fran. Women A. Exhibited: San Fran AA, 1939 (prize); SFMA, 1943 (prize); San Fran. MA, 1939; San Fran. A. Assn., 1938, 1939; Wash. State Fair, Puyallup. Work: SFMA; Calif Hist. Soc.; Pal. Leg. Honor [47]

POND, Allen Bartlit [Arch,P] Chicago, IL [06]

POND, Dana [P] NYC d. 1962. Member: NA [47]

POND, Emma McHenry [P,T] Berkeley, CA b. San Fran. Studied: W. Keith. Member: San Fran. S. Women A. [33]

POND, George D. [P] Leonia, NJ [15]

POND, Harold Woodford [P,C,Des,T] East Orange, NJ b. 20 Je 1897, Appleton, WI. Studied: Lawrence Col., Appleton, WI; PIASch. Member: A. Center of the Oranges; AAPL; Irvington A. & Mus. Assn.; Millburn-Short Hills. A. Center. Exhibited: A. Center of the Oranges, 1945 (prize); PAFA, 1939; Irvington A. & Mus. Assn.; Millburn-Short Hills A. Center; Montclair A. Mus.; AAPL [47]

POND, Mabel E. Dickinson (Mrs.) [P] Spencer, MA [24]

POND, Theodore Hanford [P,C,W,L,T] Akron, OH b. 27 S 1873, Beirut, Syria d. 3 N 1933, near Kutztown, PA. Studied: Pratt Inst. Member: Boston SAC; Alliance; Am. Assn. Mus.; Assn. Art Mus. Dir.; AFA; College AA. Specialty: design of textiles, wall-paper, stained glass, silverware, jewelry. Positions: T., RISD, Md. Inst.; Dir., Dayton AI, Akron AI [31]

POND, Willi Baze (Mrs. Charles E.) [P,W,L,T] Spokane, WA b. 16 Mr 1896, Mason, TX d. 1947. Studied: Oklahoma Col. for Women; Am. Sch. Research, Santa Fe, N.Mex.; Broadmoor A. Acad.; K. Chapman; Norfeldt. Member: Okla. A. Lg.; Okla. AA. Exhibited: Denver A. Mus.; Colorado Springs FA Cen.; Okla. AA; Marshall Field; Anderson Gal., N.Y. Work: murals, Churstian & Baptist churches, Chickasha, Okla. Author: "The Rhythm of Colour"; "Six Great Moderns." Position: Dir., Indian A., Anadarko Reservation, 1922-27; Creative A., Women's C., Spokane, 1944-45 [47]

PONNET, Charles [P] Phila., PA [10]

PONSEN, Tunis [P,T,L] Chicago, IL b. 19 F 1891, The Netherlands. Studied: AIC; abroad; Buehr; Oberteuffer. Member: Chicago P.-S.; Chicago SA; Chicago Galleries Assn. Exhibited: AIC, 1927, 1928 (prize), 1929, 1930-35; Toledo Mus. A.; PAFA, 1931. Work: Hackley A. Gal.; Flint Inst. A.; City of Chicago Coll.; Chicago Pub. Sch.; Vanderpoel A. Assn.; Lib., Northwestern Univ. [47]

PONT, Charles Ernest [P,I,L,C,B,E,En,Li,W] NYC b. 6 Ja 1898, St. Julien, France. Studied: PIASch.; CUASch.; ASL. Member: AWCS; Soc. Typophiles; Southern Pr.M.; AI Graphic A. Exhibited: Southern Pr.M., 1941 (prize); SAE, 1937 (prize); Mineola Fair, 1934 (prize), 1935 (prize), 1936 (prize); Int. Wood Engr. Exh., Warsaw, 1937; NAD, 1933-40; MMA, 1941; AIC, 1936, 1937; PAFA, 1932, 1940; Warsaw, Poland, 1935; Phila. Pr. C., 1932, 1939; Phila. A. All., 1930, 1931; LOC, 1943; SFMA; WFNY, 1939; Southern Pr.M.; CAFA; AWCS; CMA. Work: LOC; MMA; Syracuse Mus. FA; NYPL; Newark Pub. Lib.; Peabody Mus.; Appalachian Mus., Mt. Airy, Ga.; Staten Island Inst. A. & Sc.; Pub. Lib., Hasbrouck Heights, N.J.; Pub. Lib., Mt. Vernon, N.Y. Illustrator: "Whalers of the Midnight Sun," "Head Wind," "Down East." Author/Illustrator: "Tabernacle Alphabet," 1946. Contributor: magazines, newspapers [47]

POOCK, Fritz [P,Des,Dr,E,I,L] Los Angeles, CA b. 20 F 1877 d. ca. 1945. Studied: Francisco del Marmol, in Granada, Spain; Germany. Member: Calif. AC. Work: Santa Maria H.S. Specialty: technical illus. [40]

POOKE, Marion Louise (Mme. Bernard S. Duits) [P,I,T] Paris, France b. Natick, MA. Studied: Mass. Normal A. Sch., Boston; BMFA Sch.; DeCamp; Tarbell; Benson; Woodbury. Member: CAFA. Exhibited: P.-P. Expo, San Fran., 1915 (med); CAFA, 1917 (prize); NAWPS, 1921 (prize). Positions: T., Abbot Acad. (Andover, Mass.), Walnut Hill Sch. (Natick, Mass., 1915-23) [31]

POOLE, Abram [P] Old Lyme, CT b. Ja 1883, Chicago d. 24 My 1961. Studied: Royal Acad., Munich, with Von Marr, 1905-12; Paris, with Simon, 1912-15. Member: Chicago SA; ANA, 1933; Nat. Acad., 1938. Exhibited: Paris Salon; CI; CGA, 1926 (prize); AIC, 1926 (prize); PAFA, 1930 (prize); NAD, 1938 (prize); Royal Acad., Munich (med); Concord, Mass., 1926 (med). Work: AIC; PAFA [47]

POOLE, Bert [Ldscp.P,I,W] East Milton, MA b. 28 D 1853, North Bridgewater (now Brockton), MA d. ca. 1939. Studied: T. Juglaris, in Boston. Member: Quincy AL; Am. APL. Work: Boston Pub. Lib.; City Hall, Boston; City Hall, Cambridge, Mass. Specialty: panoramas [33]

POOLE, Burnell [Mar.P] b. 1884 d. 22 F 1933, Englewood, NJ. Studied: MIT. Work: U.S. Naval Acad., Annapolis; official artist to the British fleet (WWI). An interesting commission received by the artist was for a painting of the old "Corsair" (the yacht of the late J.P. Morgan) which hangs in one of the cabins of the new "Corsair," owned by J.P. Morgan, Jr.

POOLE, Earl L(incoln) [P,S,G,I,L,E,T,Mus.Dir] West Reading, PA. b. 30 O 1891, Haddonfield, NJ d. 1972. Studied: PMSchIA; PAFA; Univ. Pa.; abroad. Member: Reading T. Assn.; Pa. State Edu. Assn.; Nat. Edu. Assn.; AA Mus.; Phila. Sketch C. Exhibited: PAFA; Univ. Mich.; LOC; Los Angeles Mus. A.; Harrisburg (Pa.) AA; CAM; AMNH. Work: Univ. Mich.; Reading Mus. Park, Reading, Pa. Illustrator: "Birds of Virginia," 1913, "Mammals of Eastern North America," 1943, other books. Positions: Dir. A. Edu., Reading Sch. District, 1916-39; Dir., 1939- [47]

POOLE, Eugene Alonzo [P] Pittsburgh, PA b. 16 F 1841, Pooleville, MD. Studied: PAFA; Bonnât, in Paris. Member: Pittsburgh AA [13]

POOLE, Frederic Victor [P,T,C,T] Chicago, IL b. 1865, Southampton, Hants, England d. 4 Jy 1936. Studied: London, with F. Brown. Member: Chicago SA; Chicago PS; Chicago Gal. A. Exhibited: AIC, 1928 (prize). Work: Toronto Univ. Position: T., AIC [33]

POOLE, (Horatio) Nelson [P,E,Li,T,I] San Fran., CA b. 16 Ja 1883, Haddonfield, NJ. Studied: PAFA. Member: Calif. SE; San Fran. AA; Chicago SE; Calif. Book Plate Soc. Exhibited: San Fran. AA, 1927 (prize); Calif. SE, 1927 (prize), 1929 (prize); GGE, 1939. Work: Honolulu Acad. A;.; Mills Col.; SFMA; murals, Roosevelt Jr. H.S., San Fran. Position: T., Calif. Sch. FA, 1927-42 [47]

POOLE, John [E] Honolulu, HI. Member: Calif. SE. Position: Affiliated with Star Bulletin [27]

POOR, Alfred Easton [P] NYC. Member: AWCS [47]

POOR, Charles H. [P] Wash., D.C. Member: Wash. SA; Wash. WCC. Exhibited: Wash. WCC, 1898; Wash. SA [98]

POOR, Henry Varnum [P,C,T] NYC b. 30 S 1888, Chapman, KS d. 1970. Studied: Stanford; Slade Sch., London, with W. Sickert; Académie Julian, Paris, with Laurens. Member: San Fran. AA. Exhibited: San Fran. AA, 1918 (prize); AIC, 1932 (prize); CI, 1934 (prize) Work: MMA; WMAA; PMG; SFMA; CGA; AGAA; BM; Newark Mus.; PMA; Kansas City AI; Los Angeles Mus. A.; Dallas Mus. FA; WMA; WPA frescoes; Dept. Justice, Interior Bldg., Wash., D.C.; Pa. State Col. Author/Illustrator: "Artist Sees Alaska," 1945. Positions: T., Skowhegan (Maine) Sch. A., Skowhegan Sch. P. & S., M. Hopkins AI (1917-19), Stanford, Columbia; also a potter, 1921-30 [47]

POOR, Henry Warren [P,L,W] Medford, MA b. 10 Ja 1863, Boston. Studied: Mass. Normal A. Sch.; Paris. Member: Boston AC [27]

POORE, Henry R(ankin) [P,I,W,T] Orange, NJ/Lyme, CT b. 21 Mr 1859, Newark, NJ d. 15 Ag 1940. Orange. Studied: PAFA, with Peter Moran; NAD; Paris, with Luminais, Bouguereau, 1883-85. Member: ANA, 1888; Phila. Sketch C.; AC Phila. SC; Lotos C.; Union Inter des Beaux-Arts et des Lettres; Phila. Alliance; Art Center of the Oranges; AAPL; NAC; Am. Soc. Animal P. & S.; AFA; Lyme AA. Exhibited: Am. AA, 1888; NAD, 1888 (prize); Pan-Am. Expo, Buffalo, 1901 (med); St. Louis Expo, 1904 (med); Am. A. Soc., Phila., 1906 (gold); Buenos Aires, 1910 (gold); P.-P. Expo, San Fran., 1915 (med). Work: FA Acad., Buffalo; City Mus. of St. Louis; A. Assn., Indianapolis; Worcester Mus.; Phila. A. C.; Rittenhouse Cl.; Madison A. Assn.; Tacoma AC; Mills Col. A. Gal., Calif.; Gov. purchase, Brazil; Nat. Mus., New Zealand. Author: "Pictorial Composition," "The Pictorial Figure," "The Conception of Art," "Art Principles in Pratice," "Modern Art: Why, What and How," "Thinking Straight on Modern Art." Position: T., PAFA, 1890s [40]

POPE, Alexander [P,Por.P,S] Brookline, MA/Hingham, MA b. 25 Mr 1849, Boston d. S 1924. Studied: W. Rimmer. Member: Copley S., 1893; Boston AC. Published: "Upland Game Birds and Water Fowl of the United States." Specialty: trompe l'oeil still life paintings and wooden models of animals and game birds. After 1912 he was chiefly a portrait painter. [24]

POPE, Arthur [P,T,L] Cambridge, MA. Position: T., Harvard [27]

POPE, Collett S. [P] Duluth, MN. Position: Affiliated with Duluth Acad. FA [24]

POPE, Louise [P] NYC [15]

POPE, Marion Holden (Mrs.) [P,E,Li,Por.P,Mur.P] Sacramento, CA b. San Fran. d. 21 Ag 1958. Studied: Mark Hopkins Sch. A.; A. Matthews; Whistler; Colarossi Acad. Member: Calif. SE; San Fran. AA; Northern Calif. AA; Kingsley AC, Sacramento; Laguna Beach AA. Exhibited: Mark Hopkins Sch. A. (med). Work: Calif. SE; LOC; SFMA; Crocker A. Gal.; SAM; mural dec., Carnegie Lib., Oakland, Calif.; portrait, Calif. State Capitol; Calif. State Lib. [47]

POPE, Sara Foster [P,I,C,T] Phila., PA b. 4 Jy 1880, Boston. Studied: Indst. Art Sch., Drexel Inst.; F. Lesshafft, in Phila. Member: Plastic Cl. [10]

POPE, Thomas Benjamin [P,Ldscp.P] Newburgh, NY d. 1891 (killed by a train at Fishkill, NY). Studied: Am. Inst., 1845, 1849. Specialties: fruit still life, landscapes, genre. Wounded while serving in the Union Army. [*]

POPE, William Frederick [P,S] Paris, France b. 1865, Fitchburg, MA d. 22 O 1906, Boston. Studied: Académie Julian, Ecole des Beaux-Arts, both in Paris. Exhibited: Paris Salon. Award: Grand Prix de Rome, Ecole des Beaux-Arts. Work: portrait in relief of Mrs. Mary Baker G. Eddy [06]

POPIEL, Antoni [P] Chicago, IL [10]

POPINI, Alexander [P,I] NYC. Member: SC [25]

POPKIN, Mark [P] NYC [06]

POPOFF, Andrew P. [P] Flushing, NY. Member: S.Indp.A. [25]

POPOFF, Olga. See Müller.

POPPE, Vera [P] NYC [19]

PORAY, Stan P(ociecha) [P,Des,C,I,L,T] Los Angeles, CA b. 10 Ap 1888, Kraków, Poland d. 18 O 1948. Studied: Acad. FA, Poland. Member: San Diego AS; Société des Artistes Polonais en France; Los Angeles AA; Calif. AC. Exhibited: Springville, Utah, 1929 (prize); Los Angeles Mus. A., 1938 (prize); GGE, 1939; Detroit Inst. A., 1945; SFMA; San Diego FA Soc.; Dallas Mus. FA; Salt Lake City AA; Calif. AC; Los Angeles P.&S. Cl.; Los Angeles AA. Work: Los Angeles Mus. A.; Good Samaritan Hospital, Bd. Edu., both in Los Angeles; Gardena (Calif.) H.S.; Radcliffe Col.; Polish Nat. All. Mus., Chicago; Polish Embassy, Wash., D.C.; IBM Coll.; Detroit Inst. A.; FMA [47]

PORSMAN, Frank Oscar [P,Dec,T] Worcester, MA b. 8 Ja 1905, Worcester d. ca. 1958. Studied: WMA Sch. Member: Wocester Gld. A.&Craftsmen. Exhibited: Critics Choice, CM, 1945; Nat. Gal., Ottawa, 1934, 1935; WMA, 1934, 1937, 1939. Work: Town Hall, Boylston, Mass. [40]

PORTANOVA, Giovanni B. [S,T] San Fran., CA b. 1 F 1875, Misilmeri, Palermo, Italy. Studied: Sch. FA, Palermo; Sch. FA, Rome; Inst. FA, Paris. Exhibited: Indst. AM, Rome, 1895 (prize); San Fran. Expo, 1915. Work: Bank of Am., San Fran.; Pantages, Fox theaters, San Fran. Position: T., Univ. Calif. [40]

PORTER, Benjamin Curtis [Por.P] NYC (since 1883) b. 29 Ag 1845, Melrose, MA d. 2 Ap 1908. Studied: W. Rimmer, A.H. Bicknell, in Boston; France. Exhibited: Paris Expo, 1900 (med); Pan-Am. Expo, Buffalo, 1901 (med); St. Louis Expo, 1904 (med). Member: NA, 1880; SAA, 1903; NSS; NAC; NIAL [08]

PORTER, Bruce [Mur.P,S,W,] San Fran., CA b. 23 F 1865, San Fran. Studied: England; France. Member: Am. PS. Award: Chevalier Legion of Honor, France. Work: Stevenson mem., San Fran.; stained glass/murals, churches and pub. bldgs. of Calif. Author: "The Arts in California" [40]

PORTER, Charles Ethen [P] Rockville, CT d. 6 Mr 1923. Member: CAFA [21]

PORTER, Doris Lucile (Mrs. Donald J. McLean) [P,Por.P,Ldscp.P,Mur.P,-T,L] Ann Arbor, MI b. 7 F 1898, Portsmouth, VA. Studied: Breckenridge; Cleveland Sch. A.; H. Hofmann, in Munich; PAFA; Wayne Univ.; Univ. Mich. Member: Norfolk A. Corner; Detroit Soc. Women P.; North Shore AA; Grosse Pointe A.; Ann Arbor AA; SSAL; Redford AC; AFA. Exhibited: CGA, 1939; NAD, 1934; PAFA, 1934; VMFA, 1934; Norfolk, Va., annually; Detroit Inst. A., 1939, 1941, 1943, 1946; Norfolk SA, landscapes, 1925 (prize), 1926 (prize), 1927 (prize), portrait/landscape, 1929 (prize); Grosse Pointe Ar., 1933 (prize), 1937 (prize), Argent Gal., 1939 (one-man); Mus. A.&Sciences, Norfolk, 1940. Work: portrait, Wythe House,, Williamsburg, Va.; Toledo Mus. A.; Univ. Mich.; Cranbrook Acad. A.; St. Mary's Hall, Burlington, Vt.; murals, PAFA, Ford Sch.; Highland Park, Mich.; Norfolk Col. Commerce; Wayne Univ. Positions: T., Mich. State Normal Col. (1939–41), Univ. Mich., Ann Arbor (1945) [47]

PORTER, Eliot [Photogr] b. 1901, Winnetka, IL. Studied: Harvard. Widely known for his bird and nature photographs, he was encouraged by Stieglitz, who exhibited his work at "American Place," 1938, 1939 [*]

PORTER, Elmer Johnson [C,P,Des,T] Cincinnati, OH b. 5 My 1907, Richmond, IN. Studied: AIC; Ohio State Univ.; Earlham Col.; Butler Univ. Member: Cincinnati Crafters; Western AA; Am. Soc. Bookplate Collectors & Des. Exhibited: Indianapolis AA, 1929 (prize); Hoosier Salon, 1939 (prize), 1940 (prize); Columbus A. Lg.; Richmond, Ind., 1929 (prize); Cincinnati; Ind. Exh.; Herron AI, 1929 (prize). Work: Richmond (Ind.) H.S. Coll.; murals, Shrine Temple dining-room, Cedar Rapids, Iowa. Position: T., Hughes H.S., Cincinnati [47]

PORTER, Frank [P] Kansas City, MO [17]

PORTER, Franklin [Silversmith] Danvers, MA b. 9 My 1869 d. ca. 1936. Studied: RISD. Work: eucharistic vessels, Chapel of the Resurrection, Nat. Cathedral, Wash., D.C.; sanctuary lamp, St. John's Church, Portsmouth, N.H. [35]

PORTER, George Taylor [P] Paris, France [04]

PORTER, James A. [P,Mur.P,W,T,L] Wash., D.C. b. 22 D 1905, Baltimore, MD. Studied: Howard Univ.; ASL; NYU; Paris; D. Romanovsky. Member: CAA; Am. A. Cong. Exhibited: Harmon Exh., 1933 (prize); AWCS, 1932; Nat. Exh. Negro Art, 1928–45; Dept. Labor Auditorium, 1942; Wash. WCC, 1926–28; A. Week Exh., 1942, 1945. Work: Hampton Inst.; Howard Univ.; murals, 12th Street Branch, YMCA, Wash., D.C.; Rankin Chapel, Wash., D.C. Author: "Modern Negro Art," 1943. Contributor: Magazine of Art, Art in America, Art Quarterly, Encyclopedia of the Arts. Position: T., Howard Univ., 1927–46 [47]

PORTER, James Tank [S,L] La Mesa, CA b. 17 O 1883, Tientsin, China. Studied: Pomona Col.; ASL; Bridgman; R. Aitken; G. Borglum. Member: San Diego FA Soc.; Spanish Village A. Center; San Diego A. Gld.; Contemporary A. San Diego. Exhibited: San Diego FA Soc., 1923, 1924 (prize), 1924–41; NAD; PAFA; GGE, 1939. Work: Beloit Col.; San Diego FA Soc.; Yale Univ. A. Gal.; Ellen B. Scripps Testimonial, La Jolla; portrait busts, Pomona Col., Methodist Episcopal Church of North China, Peking; bronze portrait relief, Mercy Hospital, San Diego [47]

PORTER, John L. [Patron] Pittsburgh, PA b. 1868, Meadville, PA d. 11 Ag 1937, Clifton Springs, NY. Member/Founder: One Hundred Friends of Pittsburgh Art, 1916; CI FA Committee. Position: Vice-President, CI

PORTER, L(aura) Schafer (Mrs.) [P,C,T] Gainesville, GA/Fort Edward, NY b. 16 O 1891, Fort Edward. Studied: N.Y. Sch. A.; ASL; Skidmore; Henri; Chase; Miller. Member: Southeastern AA; Ga. A.; AAPL; Phila. A.&Crafts Gld. Exhibited: NYWCC, 1939; Phila. A.&Crafts Gld., 1932, 1933; State Fairs. Work: Pittsburgh Lib.; Walter Reed Hospital, Wash., D.C. Position: T., Brenau Col. for Women [47]

PORTER, Love [P] NYC. Exhibited: NAWPS, 1935–38 [40]

PORTER, M(ary) K(ing) [Min.P] Wash., D.C./Charmain, PA b. 8 Je 1865, Batavia, IL d. 13 Ja 1938. Studied: Volk; ASL, Wash., D.C.; B. Perrie; Snell. Member: Wash. WCC; Wash. AC [38]

PORTER, Raymond A(verill) [S,T] Boston, MA b. 18 F 1883, Hermon, NY. Member: Boston SS; Cambridge AI. Work: Pres. Tyler Mem., Richmond, Va.; statue, Rutland, Vt.; Victory Mem., Salem, Mass.; mem., Commonwealth Armory, Boston; mem., Leominster, Mass.; mon., Somerville, Mass.; mon., State House, Boston. Position: T., Mass. Sch. A., Boston [40]

PORTER, Vernon Carroll [Mus. Dir,P,Des] Tompkins Corners, NY b. 6 Ag 1896, Cleveland. Studied: ASL; Grand Central Sch. A.; Mechanics Inst.; Brooklyn Polytechnic Inst. Member: AA Mus.; Am. FA Soc. Positions: Dir., Am. FA Soc. (1937–38), Riverside Mus. (1938– [47]

PORTER, Vernon, Mrs. See Beach, Beata.

PORTER, William Arnold [Dec,Ldscp.P,T] b. 28 N 1844, Worcester, England d. 17 O 1909. Studied: South Kensington Mus., London. Member: Phila. Sketch Cl.; Phila. SA; Phila. AC; Pen Cl. His first work on coming to New York was to decorate a service of china for Pres. Grant. Position: T., Spring Garden Inst., Phila., for more than 36 years [10]

PORTEUS, C.R. [Mur.P,S] Milwaukee, WI b. 1868 d. 1940. Studied: NYC. Sculpted all figures for French Pavillion at the St. Louis Centenn. [*]

PORTMANN, Frieda (Bertha) (Anne) [P,T,C,Des,W,B,S] Seattle, WA b. Tacoma Studied: Univ. Wash.; Oreg. State Col.; AIC; Univ. Chicago; Calif. Col. A.&Crafts; Cornish Sch. Member: NAWPS; Women P. of Wash.; Northwest Pr.M. Exhibited: Women P. of Wash., 1940 (prize), 1943 (prize), 1946 (prize); Puyallup (Wash.) Fair, 1946 (prize); Northwest Pr.M., 1936–46; NAWA, 1936–39; SAM, 1937–46. Work: Calif. Col. A.&Cr.; St. Joseph's Sch., Seattle. Contributor: educational magazines, newspapers. Postions: Ed., Seattle Assn. Classroom T. Bulletin; T., Seattle public schools, 1930– [47]

PORTNOFF, Alexander [S,P,T] Phila., PA b. 1887, Russia d. 30 D 1949. Studied: PAFA; C. Grafly. Member: NSS; Intl. Group. Exhibited: P.-P. Expo, San Fran., 1915 (prize). Work: Milwaukee AI; BM; PMA; Mus. Western A., Moscow [47]

POSEY, Leslie Thomas [S,C,T,Arch,Dec] Sarasota, FL b. 20 Ja 1900, Harshaw, WI. Studied: F. Koenig; PAFA; A. Laessle; C. Grafly; AIC; A. Polasek; Wis. Sch. F.&Appl. A. Member: Indianapolis Arch. Cl.; Sarasota AA; Hoosier Salon. Exhibited: Milwaukee AI, 1923 (med,prize); Hoosier Salon, 1930 (prize); Fla. Fed. A., 1940–44,1945 (prize); Sarasota AA, 1940–46; Ind. Arch. Assn., 1928 (med). Work: Walker Theater; Granada Theater; Brightwood Community Bldg., Indianapolis. Position: Dir., Posey-Harmes Sch. A., Sarasota, 1944–46 [47]

POST, Charles Johnson [Por.P,E,Car,L,W] Bayside, NY b. 27 Ag 1873. Studied: J.C. Beckwith; K. Cox. Illustrator: Harper's, American Legion Monthly, Century, Cosmopolitan, 1900–36 [40]

POST, Edwina M. [P] Member: Women's AC. Position: Affiliated with Carnegie Studios, NYC [01]

POST, George Booth [P,G,Mur.P,T,L] San Fran., CA b. 29 S 1906, California. Studied: Calif. Sch. FA. Member: San Fran. AA; Calif. WC Soc. Exhibited: watercolors, Oakland (1936, prize), San Fran. AA (1936, prize). Work: murals, Sonora (Calif.) H.S.; San Fran. Mus. A. [40]

POST, May Audubon [P,I] Phila., PA b. NYC d. 8 F 1929. Studied: PAFA, with Chase, Beaux, Grafly, Breckenridge; Drexel Inst., with H. Pyle; L. Simon, in Paris. Member: Phila. WCC; Plastic Cl.; S.Indp.A. Exhibited: Phila. AC, 1903 (gold) [27]

POST, Mildred Anderson (Mrs. Ambrose Kerigan, Jr.) [P,I] Wayne, PA b. 27 Ja 1892, Wayne d. Jy 1921. Studied: W. Everett; T. Oakley. Member: Phila. WCC [19]

POST, W(illiam) Merritt [Ldscp.P] Bantam, CT b. 11 D 1856, Brooklyn, NY d. 22 Mr 1935, New York. Studied: F. Johnson; ASL, with Beckwith. Member: ANA, 1910; AWCS; NYWCC; A. Fund S.; SC, 1900; CAFA; NYSP. Exhibited: NAD, 1910 (prize); Pan-Am. Expo, Buffalo, 1901 (prize). Work: Newark Mus. Assoc. [33]

POSTGATE, Margaret J. [P,S,Des,T,W] NYC b. Chicago, IL. Studied: AIC; ASL; R. Ryland; M. Young. Member: College AA; Ill. Acad. FA. Exhibited: Beaux Arts, 1924 (med); Nat. Small Sculpture Competition, 1924 (prize), 1927 (prize), 1928 (prize), NYC; Harper's Sketch Contest, 1931. Work: BM [40]

POTEAT, Ida I(sabella) [P,C,T] Raleigh, NC/Wake Forest, NC b. 15 D 1856, Yanceyville, NC. Studied: Mounier; Chase; Parsons. Position: Affiliated with Meredith Col., Raleigh [25]

PO-TSU-NU. See Montoya, Geronimina.

POTTENGER, Zeb [P] Richmond, IN [25]

POTTER, Agnes Squire [P,T] Chicago, IL b. 31 O 1892, London. Studied: N.Y. Sch. F.& Appl. A.; Minneapolis AI; Hawthorne; Breckenridge. Member: Chicago AC; Cordon C.; Chicago SA; Cor Ardens. Exhibited: AIC, 1922 (prize), 1929 (prize); Chicago W. Aid, 1932. Work: Chicago schools [40]

POTTER, Anne W. [P] Chicago, IL [13]

POTTER, Bertha Herbert (Mrs. Edward, Jr.) [P,G] Nashville, TN b. Nashville, Studied: Sch. A.& Appl. Des., NYC; Ringling Sch. A., Fla. Member: NAWPS; Boston AC; North Shore AA; SSAL; Nashville Studio C.; Sarasota AA. Work: portrait of Gov. Henry H. Horton for Tenn. [40]

POTTER, Bessie. See Vonnoh.

POTTER, Edna E. [P] Brooklyn, NY [24]

POTTER, E(dward) C(lark) [S] Greenwich, CT b. 26 N 1857, New London, CT d. Summer 1923, New London. Member: SAA, 1894; NSS, 1893; ANA, 1905, NA, 1906; Arch. Lg. 1898; NIAL. Exhibited: St. Louis Expo, 1904 (gold). Work: with D.C. French, "Gen. Grant," Fairmount Park, Phila. and "Washington," Paris, Chicago; LOC; Lansing, Mich.; Gettysburg; AIC; equestrian statue, Arlington Cemetery, Wash., D.C.; "Lions," NYPL; "Lions," Morgan Lib., NYC; Piedmont Park, Atlanta, Ga.; Brookline, Mass.; Mem., Greenwich, Conn. Specialty: animals [21]

POTTER, Gertrude B. [P] NYC [01]

POTTER, H(arry) S(pafford) [I,P] NYC b. 29 D 1873, Detroit, MI. Studied: Paris, with Constant, Laurens, L. Simon. Member: SI 1910 [40]

POTTER, Horace E. [Des,C,T] Gates Mills, OH b. 10 D 1873, Cleveland, OH. Studied: Cleveland Sch. A.; Cowles Sch. A.; Amy M. Sacker Sch. of Des.; England. Member: Cleveland SA. Exhibited: CMA, 1920 (prize), 1921 (prize); P.-P. Expo, 1915 (gold); AIC, 1917 (prize). Position: T., Historic Ornamentation, Cleveland Sch. A. [47]

POTTER, Lillian Brown [P,W,L] Caldwell, NJ b. 31 Ja 1892, NYC. Studied: G. Bridgman; A. Tucker; B. Robinson; D. Smith; ASL. Member: S.Indp.A. [25]

POTTER, Louis McClellan [S,Et] NYC b. 14 N 1873, Troy, NY d. 29 Ag 1912, Seattle, WA. Studied: Hartford, with C.M. & M. Flagg; Paris, with L.O. Merson, J. Dampt. Member: N.Y. Mun. AS. Award: Officier du Nicham Iftikar from Bey of Tunis, 1900. Work: des., mem. to Horace Wells, Hartford; busts, prominent persons. Specialty: Indian groups [10]

POTTER, M. Helen [P] Providence, RI. Member: Providence WCC [25]

POTTER, Martha J(ulia) [P,T] New Haven, CT b. 14 Ja 1864, Essex, CT. Studied: J.H. Niemeyer; J.F. Weir; A.W. Dow; M. Fry. Member: N.H. Paint and Clay C.; CAFA; AFA [33]

POTTER, Mary Knight [P,W] Boston, MA b. Boston. Studied: Metropolitan Mus. Sch.; ASL; Cowles A. Sch., Boston; Académie Julian. Member: Copley S. Author: "Love in Art," "Art of the Louvre," "Art of the Vatican," "Art of the Venice Academy" [21]

POTTER, Mathilde [P] Santa Barbara, CA/Phila., PA b. O 1880, Phila. Studied: D. Garber; V. Garber; Woodbury. Member: Plastic C.; Print C., Phila. [33]

POTTER, Muriel Melbourne (Mrs. E.M.) [P,I,Car] Brooklyn, NY b. 18 S 1903, Brooklyn, NY. Studied: ASL; N.Y. Sch. F.&Appl. A.; O'Hara Sch., Maine; PIASch. Member: NAWPS. Exhibited: NAWPS, 1937, 1938 [40]

POTTER, Nathan D(umont) [P,S] Lyme, CT b. 30 Ap 1893, Enfield, MA d. 29 N 1934. Studied: D.C. French; E.C. Potter. Work: WWI Mem. Column, Westfield, N.J.; equestrian statue, Colorado Springs; des., WWI medal for men of Greenwich, Conn. [33]

POTTER, Rose [P,I,T] Phila., PA [17]

POTTER, Ruth Morton [C,Des] New London, CR b. 1 F 1896, Enfield, MA. Studied: M.M. Atwater. Member: Boston SAC (Master Craftsman); Soc. Conn. C. Illustrator: Handicrafter [40]

POTTER, Ursula Yeaworth (Mrs. John M.) [P,T] Atlanta, GA b. York, PA. Studied: Md. Inst.; Johns Hopkins Univ. Member: SSAL; Southeastern AA (founder). Exhibited: High MA, Atlanta; SSAL, 1938. Position: Dir., Yeaworth-Potter A. Sch., Atlanta [40]

POTTER, V.G. [P] Camden, OH [06]

POTTER, William J. [P,T] Greenwich, CT/West Townshend, VT b. 14 Jy 1883, Bellefonte, PA d. 11 Jy 1964. Studied: PAFA; W. Sickert, London. Member: CAFA; SC. Exhibited: Allied AA, 1934. Work: Brooklyn Mus.; Hispanic Mus., NYC; Mem. A. Gal., Rochester, N.Y.; Herron AI; Sidney Australia Mus.; Cincinnati Mus.; Expo Park Mus., Los Angeles; Mus. Rouen, France; Museo Nacionale d'el Arte Modero, Madrid. Position: T., Broadmoor Acad. A., Colorado Springs, 1920s [40]

POTTERVELD, Burton Lee [Des,P,T] Milwaukee, WI b. 15 Mr 1908, Dubuque, Iowa. Studied: Layton Sch. A.; Univ. Dubuque; Univ. Wisconsin. Member: Wis. PS. Exhibited: AIC, 1931, 1937, 1938, 1939; Am. A., 1935; Wis. PS, 1932–46; Madison Salon, 1940–43. Work: Oshkosh State T. Col. Position: T., Layton Sch. A., Milwaukee[47]

POTTHAST, Edward H(enry) [P,I] NYC b. 11 Je 1857, Cincinnati d. 10 Mr 1927. Studied: Cincinnati Acad.; Antwerp; Munich; Paris. Member: SAA, 1902; ANA, 1899; NA, 1906; AWCS; NYWCC; SC, 1895; Lotos C.; Allied AA; Cincinnati AC; P&S Gal. Assn.; SPNY. Exhibited: NAD, 1899 (prize); AWCS, 1901 (prize), 1914 (prize); SC, 1904 (prizes), 1905 (prize); P.-P. Expo, San Fran., 1915 (med). Work: Cincinnati Mus.; Brooklyn Inst. Mus.; Hackley A. Gal., Muskegon, Mich.; AIC. Specialty: beach scenes [25]

POTTINGER, Zeb [P] Richmond, IN [24]

POTTS, W. Sherman [Por.P,Min.P] NYC/Noank, CT b. 29 Jy 1876 d. 17 Je 1930, Stonington, CT. Studied: C.N. Flagg, Hartford; PAFA; Paris with Laurens, Constant. Member: CAFA; ASMP; Mystic SA (pres.); American A. Prof. L. (founder). Exhibited: CAFA, 1929 (prize) [29]

POUCHER, Edward A. [P] NYC. Member: GFLA [27]

POUCHER, Elizabeth Morris [S,Li] Bronxville, NY b. Yonkers, NY. Studied: Vassar Col; NYU; Parsons Sch. Des.; Ecole Animalier, Paris; ASL; Archipenko; Lhote. Member: All.A.Am.; 15 Gal. Group. Exhibited: WMAA, 1940; All.A.Am., 1941–43; 1945; PAFA, 1942; MET (AV), 1942; NAD, 1944; Fifteen Gal., 1940, 1941; Bronxville Women's C., 1940; WFNY, 1939. Work: Mus. City of N.Y. Position: A. Staff, W.D. Teague Co., NYC, 1944–46 [47]

POUCHER, Emily Rollinson [P] Bronxville, NY. Exhibited: NAWPS, 1935–38 [40]

POUGIALIS, Constantine [P,T] Chicago, IL b. 29 N 1894, Corinth, Greece. Studied: AIC; France; G. Bellows. Exhibited: AIC; GGE, 1939; CGA; CI; PAFA; WFNY, 1939; WMAA; Rehn Gal.; MOMA; Univ. Minn. Work: Evanston (Ill.) Pub. Lib. Position: T., AIC, from 1938 [47]

POULL, Mary B. [P,T] Chicago, IL b. Port Wash., Wis. Studied: AIC; C.W. Hawthorne; J.C. Johansen; G. Oberteuffer; H. Luyten, in Belgium. Member: Chicago Women's Salon; AIC; North Shore AG. Exhibited: North Shore AG, 1935 (prize). Work: Gay and Sturgis, Houghton, Mich. [40]

POUPELET, Jane [S] Paris, France. Member: NAWPS [25]

POUSETTE-DART, Nathaniel J. [P,L,T,W] Valhalla, NY b. 7 S 1886, St. Maul, MN d. 17 O 1965. Studied: ASL; PAFA, 1909–10; W. Chase; R. Henri; H.R. Poore; St. Paul A. Sch.; MacNeil, in NYC; Anshutz. Mem-

ber: A. Dir. C.; Fed. Mod. P.&S.; Westchester A.&Cr. Gld.; Arch. Lg. ; Mural P. Exhibited: PAFA; WMAA; MMA; WFNY, 1930; Anderson Gal., NY, 1928; Pinacotheca, 1943; Am.-British A. Ctr., 1943; St. Paul Inst., 1915; Minn. State AS, 1913 (prize), 1914 (prize), 1916 (prize). Author: "Earnest Haskell, His Life and Work." Editor: "Distinguished American Artists" (series), pub. Frederic Stokes Co.; Art and Artists of Today mag. Position: T., N.Y. Sch. Appl. Des. Women [47]

POWELL, Arthur James Emery [P] Dover Plains, NY b. 11 D 1864, Vanwert, OH d. 15 Jy 1956, Poughkeepsie; Studied: San Fran. Sch. Des.; St. Louis Sch. FA; Académie Julian, with Toulouse, Ferrier. Member: ANA, 1921; NA, 1937; SC, 1904; Paris AA; A. Fund S.; Allied AA; NAC; NYWCC; Kent AA; Dutchess County AA. Exhibited: SC, 1913 (prize), 1929 (prize), 1931 (prize); NAD, 1921 (prize); NAD, 1930 (prize); New Rochelle, 1930. Work: Milwaukee AI; Boise, Idaho Lib.; NAC; mural, Dover Plains Methodist Episcopal Church; Bowen Hospital, Poughkeepsie [47]

POWELL, Caroline A(melia) [En] Boston, MA b. Dublin, Ireland d. 15 Ap 1935. Studied: W.J. Linton; T. Cole; CUASch; NAD. Member: S. Am. Wood Engravers. Exhibited: Columbian Expo, 1893 (med); Pan-Am. Expo, Buffalo, 1901 (med). Work: BMFA; NYPL; CI; Springfield Pub. Lib.; Santa Barbara, Calif. Pub. Lib.; New Bedford, Mass. Pub. Lib. Specialty: wood engraving [32]

POWELL, Doane [C,L,Cart,S] NYC b. 4 Mr 1881, Omaha, NE d. 28 Ag 1951. Studied: AIC; Académie Julian; Grande Chaumière; W.J. Reynolds. Member: SI. Exhibited: Arch. L.; Lotos C. (one-man). Specialty: portrait masks [47]

POWELL, Ella May [P] Chicago, IL b. Ap 1879, Davenport, IA. Studied: Paris, with Collin, Courtois [21]

POWELL, Fay Barnes (Mrs.) [P] Chicago, IL. Member: Chicago SA [27]

POWELL, Gabriel M. [P,C,Des] NYC. Studied: ASL; Acad. All. A.; Gregoriere. Member: A.Lg. Am.; S.Indp.A.; Un. Scenic A. Work: wall decorations, French Sch., N.Y. Exhibited: A. Lg. Am.; S.Indp.A.; Acad. All. A.; Vendôme Gal.; Barbizon-Plaza Gal. [47]

POWELL, J.S. [P] Logan, UT. Affiliated with Utah Agricultural Col. [15]

POWELL, Jennette M. [P,E,C,T] Norton, MA/Camp Hill, PA b. 1871, Kingston, Nova Scotia d. 6 Mr 1944, NYC. Studied: Columbia; Chase; Henri; Hawthorne; Parsons; Sandzen; Paris. Position: Iowa State Col.; Univ. Wash., Seattle [33]

POWELL, Leslie J. [Mur.P,Por.P,T,Des,S,Li] NYC b. 16 Mr 1906, Minneapolis, KS. Studied: Okla. Univ.; Chicago Acad. FA; ASL; New Orleans Sch. A. Member: Southwestern AA. Exhibited: Okla. A., 1946. Work: Univ. Ariz; H.S., New Orleans [47]

POWELL, Lucien Whiting [P] Round Hill, VA b. 13 D 1846, VA d. 27 S 1930, Wash., D.C. Studied: Phila., with T. Moran; PAFA; London Sch. A., with Fitz, ca. 1875; Rome; Venice; Paris with Bonnât. Member: S. Wash. A.; Wash. WCC. Work: CGA; NGA. Specialty: views of Venice and the Grand Canyon [29]

POWELL, Mary E. [P] Hempstead, NY [10]

POWELL, Ralph Williford [P] Hanford, CA b. 8 Ag 1908, Hanford. Studied: Calif. College FA, Oakland; Calif. Sch. FA, San Fran. Member: San Fran. AA. Work: CMA; San Fran. AA; Arnot Gal., Elmira, N.Y.; Ft. Dodge, IA, Fed. A. [40]

POWELL, William H. [Dealer] NYC b. 1865 d. 13 My 1916. A dealer well-known to artists of his day. He was once librarian of CUASch. Son of William, Sr. (1823–79, ANA)

POWER, Maurice J. [S,Foundry Owner] b. 18 O 1838, County Cork, Ireland (came to U.S. with his parents in 1841) d. 8 S 1902. Studied: learned the trade of stonecutting. In 1863 he established the National Fine Art Foundry, which cast many notable pieces of sculpture including battle monuments at Trenton and Monmouth, N.J., Albany and Buffalo, N.Y.

POWER, Tyrone [P] NYC [25]

POWER, Tyrone (Mrs.) [P] [25]

POWER-O'MALLEY, Michael Augustin [,E] Scarborough, NY b. 1878, County Waterford, Ireland d. 3 Jy 1946, NYC. Studied: W. Shirlaw; Henri; NAD. Exhibited: Aonach Sailteen, Dublin, 1924; San Antonio, Texas, 1927 (prize), 1929 (prize), Calif., 1928 (med). Work: PMG; LOC; Ft. Worth Mus. A.; Witte Mem. Mus., San Antonio, Texas; Mus. Modern Irish A.; Vassar College C., NYC; Mus. Assn., Jersey City, N.J.; murals, Sleepy Hollow C., Scarborough, Fleur de Le Chateau, Yonkers, N.Y.; "Contemporary Etching" for 1930–31 [40]

POWERS, Daniel W. [Patron] Rochester, NY b. 1818, Batavia, NY d. 11 D 1898. The Powers Art Gallery was known throughout the U.S., & Europe; besides containing the works of old masters, many celebrated American and European artists were represented

POWERS, John M. [I] NYC. Member: SI [33]

POWERS, Longworth [S] Florence, Italy b. 5 Je 1835, Cincinnati d. O 1904. Studied: his father, Hiram (1805–73) in Florence. [04]

POWERS, Marion (Mrs. W.A.B. Kirkpatrick) [P] Waldoboro, ME/Friendship, ME b. London, England of American parents. Studied: Garrido, Paris. Exhibited: PAFA, 1907 (prize); Buenos Aires Expo, 1910 (med); Pan-P. Expo, San Fran., 1915 (gold). Work: Luxembourg, Paris; Canadian Pacific Railway, Hotel Vancouver, B.C.; RISD [40]

POWERS, Mary (Swift) [P] Tenafly/Manchester, VT b. 7 S 1885, Leeds, MA d. N 1959, NYC. Studied: Framingham, Mass. Normal Sch. Member: Southern Vt. A. Exhibited: NAD; AWCS; AIC; Syracuse Mus. FA; Macbeth Gal.; Marie Sterner Gal. (one-man) Work: Williams Col.; Wood Gal. A., Montpelier, Vt.; WMAA; AAGA. [47]

POWERS, T.E. [P] Norwalk, CT d. 14 Ag 1939 [17]

POWRIE, Robert [S,P] b. 1843 d. 13 D 1922. Work: Mem., Gen. John Gibbons, Arlington Cemetery

PRAGER, G. Joseph [S] Amelia, OH b. 28 Mr 1907. Studied: C.J. Barnhorn; E. Bruce Haswell. Member: Cincinnati Assn. Prof. A.; Contemporary A.; Jewish AC. Exhibited: Cincinnati Women's C., 1930; Jewish AC, 1931–35 (prizes). Position: T., Cincinnati Col. [40]

PRAHAR, Renee (Irene) [S,T] NYC b. 9 O 1880, NYC. Studied: Bourdelle, Injalbert, Beaux-Arts, all in Paris. Member: NAWPS. Work: MMA [33]

PRANG, Louis [Wood En,Publisher,Li] Boston, MA b. 12 Mr 1824, Breslau, Germany (came to NYC in 1850; settled in Boston) d. 15 Je 1909, Los Angeles. Studied: self-taught. After partnership with J. Mayer (1856–60) opened his own lithographic firm in 1860, which became famous after the Civil War for its chromolithographic reproduction of famous paintings and his invention of the Christmas Card (1875). He also published popular drawing books. More than any other publisher he realized his great ambition of spreading art appreciation before the American public.

PRANKE, Earl Frederick [Des,I,P] Cleveland, OH b. 20 D 1914 Cleveland. Studied: Ohio Univ.; Cleveland Sch. A.; D. Boza. Exhibited: CMA, 1936–40. Position: A. Dir., Wolf Envelope Co., Cleveland, 1939–41, from 1946 [47]

PRASUHN, John G. [S] Indianapolis, IN b. 25 D 1877, near Versailles, OH. Studied: Mulligan; Taft; AIC. Member: Ind. AC; Indianapolis AA. Exhibited: Hoosier Salon, 1938 (prize). Work: Northern Ill. State Normal Sch., De Kalb; Field Mus. Nat. History; Lincoln Park, Chicago; lions, Columbus Mem. Fountain, Wash., D.C. Contributor: article "Cement," Scientific American, 1912. Associated with the Field Mus. Nat. History [40]

PRATHER, Ralph Carlyle [I,W] Phila., PA b. 4 N 1889, Franklin, PA. Illustrator: "Yellow Jacket," numerous children's stories, mag. covers, Nature, Boy's Life, Child Life, St. Nicholas [47]

PRATHER, Winifred Palmer (Mrs. Clark) [P] New Orleans, LA/Fort de France, Martinique b. 6 My 1912, Plainfield, NJ. Studied: Newcomb Col., La.; Grand Central A. Sch.; ASL. Member: NOAA. Exhibited: NOAA, 1938 (prize); Delgado AM; SSAL, Montgomery, 1938, San Antonio, 1939 [40]

PRATOR, Ernest [I] NYC. Position: Staff, Illustrated American [98]

PRATT, A.S. [P] Phillips, ME [15]

PRATT, Ann See Spencer.

PRATT, Bela L(yon) [S,T] Jamaica Plain, MA/North Haven, ME b. 11 D 1867, Norwich, CT d. 18 My 1917. Studied: Yale, with Niemeyer, Weir; ASL, Saint Gaudens, Elwell, Chase, Cox, NYC; Ecole des Beaux-Arts, Paris, with Falguière, Chapu. Member: NSS 1899; ANA 1900; Arch. L., 1911; Boston GA; NIAL; CAFA. Exhibited: Paris Salon, 1897; Pan-Am. Expo, Buffalo, 1901 (med); St. Louis Expo, 1904 (med); Pan-P. Expo, 1915 (gold). Work: Boston Pub. Lib.; LOC; Yale; State House, Boston; monu., Malden, Mass.; Andersonville, Ga.; St. Paul's Sch., Concord, N.H.; Brooklyn Inst. Mus. Position: T., BMFA Sch., 1893–17 [15]

PRATT, David (Foster) [P,C,Des] Holland, NY b. 11 Ja 1918, Ithaca, NY. Studied: Buffalo AI; W.B. Rowe; C. Bredemeier. Member: The Patteran. Exhibited: Albright A. Gal., 1939 (prize), 1940–46; Syracuse MFA, 1941 (prize); 20th Century C., 1940 (one-man) [47]

PRATT, Dudley [S,L,T] Seattle, WA b. 14 Je 1897, Paris, France d. 1975. Studied: Yale; BMFA Sch.; Grande Chaumière, Paris; E.A. Bourdelle; C. Grafly. Member: Pac. Northwest Acad. A. Exhibited: SAM, 1929-41, 1935 (one-man), 1936 (prize), 1939 (prize); Oakland A. Gal., 1940; WFNY 1939. Work: SAM; IBM Coll.; s., Civic Auditorium, Henry A. Gal., Doctors Hospital, Seattle, Wash.; Women's Gymnasium, Social Sc. Bldg., Univ. Wash.; Hoquiam, Wash., City Hall; Bellingham City Hall; Pub. Lib., Everett, Wash.; Seattle Surgical S., medals. Position: T., Univ. Wash. Seattle, 1925-432; Ed.-in-Chief, handbooks, from 1942, Boeing Aircraft Co., Seattle [47]

PRATT, Emmett A. [P] Hartford, CT [25]

PRATT, Frances (Mrs. Chris Ritter) [P] NYC b. 25 My 1913, Glen Ridge, NJ. Studied: N.Y. Sch. Appl. Des. for Women; ASL; R. Lahey; H. Hofmann. Member: NAWA; NYSWA. Exhibited: Layton A. Gal., 1941; Denver A. Mus., 1942; Mun. A. Gal., Jackson, Miss., 1943, 1946; AGAA, 1945; Mint Mus., 1946; Marquie Gal., 1943 (one-man); Am.-British A. Ctr., 1945 (one-man); NAWA, 1946 (prize). Position: T., YWCA, NYC [47]

PRATT, George Dupont [Patron] Glen Cove, NY b. Ag 1869, Brooklyn, NY (son of Charles M. who founded PIASch) d. 20 Ja 1935. Studied: Amherst Col., 1893. Member: MET (trustee); financed American Art Show, 1932, Intl. Art Exh., Venice; PIASch; Am. Fed. A.; Soc. Medalists (founder); Cosmos C.; Century

PRATT, Harry E(dward) [P,I,T] North Adams, MA/Jacksonville, VT b. 21 My 1885, North Adams [29]

PRATT, Helen L. (Mrs. Bela L.) [S] Jamaica Plain, MA b. 8 My 1870, Boston, MA. Studied: BMFA Sch. [17]

PRATT, Herbert William [P,Ser] NYC b. 26 F 1904, Leicester, England. Studied: NAD; ASL with J. Matulka, C. Hawthorne, H. Hofmann. Member: Nat. Serigraph S. Exhibited: NAD, 1928; Phila. WCC, 1929; Wilmington SFA, 1929; AWCS, 1928; Roerich Mus., 1933; SFMA, 1945; Oakland A. Gal., 1944; MOMA, 1940; BM, 1944, 1945; Intl. Pr. S., 1944; Rochester Pub. Lib., 1945 [47]

PRATT, John [P] Chicago, IL. Exhibited: AIC, 1936, 1937, 1939 [40]

PRATT, Julia D. [P,L] Buffalo, NY/North Collins, NY b. North Collins. Studied: O. Schneider, Buffalo FA Acad.; CUASch; NY Indst. A. Sch. Member: Buffalo Ind. A.; Buffalo Allied AA; Chicago NSA; S.Indp.A.; Buffalo SFA [33]

PRATT, Katharine [C,Des] Dedham, MA b. 3 Ag 1891, Boston, MA. Studied: BMFA Sch.; G.C. Gebelein. Member: Boston SAC. Exhibited: BMFA; Paris Salon, 1937; Boston SAC, 1932 (med); Tercentenary Exh., Boston, 1930 (med) [47]

PRATT, Lorus [Por.P,Ldscp.P,Mur.P] Salt Lake City, UT b. 1856, Salt Lake City d. ca. 1923. Studied: Deseret Univ. with Weggeland, Ottinger; NYC, 1876; Académie Julian with Constant, Doucet, ca. 1885. Work: LDS temples [15]

PRATT, M.S. [P] NYC. Member: Woman's AC [01]

PRATT, Philip H(enry) [Des,Dec,L,T] Brooklyn, NY b. 10 Ag 1888, Kansas City, MO. Studied: St. Louis Sch. FA; Phila. Indst. A. Sch.; South Kensington, London. Work: murals, Wis. State Capitol [40]

PRATT, Rosalind Clark [P] b. 1857 d. 28 My 1932, Branford, CT. Studied: NAD. Member: Am. Fed. A.; Nat. Edu. Assn.; Conn. Forest and Park Assn.; World Peace Lg.

PRATT, Ruth [P] Fenway Studios, Boston, MA [13]

PRATT, V(irginia) Claflin (Mrs. Dudley) [S,T] Seattle, WA/Deer Harbor, MA b. 1 Je 1902, Littleton, MA. Studied: C. Grafly; E.A. Bourdelle; BMFA Sch.; Grande Chaumière. Member: Pac. Northwest Acad. A. Exhibited: SAM; Northwest Ann., 1934 (prize). Work: numerous portrait heads. Position: T., Helen Bush Sch., Seattle [47]

PREBLE, Marie (Mrs.) [Min.P] Paris, France. b. Boston, MA. Studied: Mrs. Hortense Richards [04]

PRECHT, Fred A. [P] NYC [21]

PRECHT, Fritz [P] NYC [06]

PRELLWITZ, Edith Mitchill (Mrs. Henry) [P] Peconic, NY (from 1899) b. 28 Ja 1865, South Orange, NJ d. 18 Ag 1944, East Greenwich, RI. Studied: ASL with Brush, Cox; Académie Julian with Bouguereau, Robert-Fleury, Courtois. Member: SAA, 1898; ANA, 1906. Member: Cornish Colony, 1895-98. Exhibited: Paris Salon; NAD, 1894 (prize), 1929 (prize); SAA, 1895 (prize); Atlanta Expo, 1895 (med); Pan-Am. Expo, Buffalo 1901 (med). Work: mural, Universalist Church, Southold, N.Y. Contributor: article, "Tempest in Paint Pots," American Magazine of Art [40]

PRELLWITZ, Henry [P] Peconic, NY b. 13 N 1865, NYC d. 13 Mr 1940. Studied: P.T Dewing; ASL; Académie Julian. Member: SAA 1897; ANA 1906, NA 1912; Century Assn.; Cornish Colony. Exhibited: NAD 1893 (prize), 1907 (prize); Pan-Am. Expo, Buffalo, 1901 (med); St. Louis Expo, 1904 (med) [40]

PRENDERGAST, Charles E. [P,S,T] Westport, CT b. 27 My 1868, Boston, MA d. 20 Ag 1948. Member: Am. Soc. PS&G.; ANA, 1939. Work: PMG; AGAA; RISD; Barnes Fnd.; International House, N.Y. [47]

PRENDERGAST, James Donald [P,L,Des,Li,T] Ann Arbor, Mich. b. 17 O 1907, Chicago, IL. Studied: AIC; Univ. Chicago; UCLA; B. Anisfeld; E. Weston. Member: Laguna Beach AA; Calif. WCS; San Fran. AA; Audubon A.; CAA; Am. Assn. Univ. Prof. Exhibited: WFNY, 1939; GGE, 1939;; MMA; Univ. Ariz., 1943; SFMA, 1939-41, 1943; PAFA, 1939, 1942; AIC, 1933, 1935, 1942; BMA, 1939; CGA, 1941; VMFA, 1942; Audubon A., 1945; La Tausca Pearls Exh., 1946; San Diego FAS, 1940; Los Angeles Mus. A., 1938-40; Rockford AA, 1939. Work: Univ. Ariz. Positions: T., Univ. Southern Calif. (1937-40), New Orleans A. & Crafts Sch. (1940-42), Univ. Ariz. (1942-44), Univ. Mich. (from 1944) [47]

PRENDERGAST, James Donald, Mrs. See Ullrich, Beatrice.

PRENDERGAST, Maurice B(razil) [P,I,G] NYC b. O 1859, St. John's Newfoundland (came to Boston in 1861) d. 1 F 1924. Studied: Académie Julian, with Laurens, Acad. Colarossi, with Blanc, all in Paris, 1891-95; J.W. Morrice (Canadian). Member: NYWCC; Copley S., 1898; Boston WCC; Boston GA; Am. PS; S.Indp.A.; Lg. AA; New SA. Exhibited: Pan-Am. Expo, Buffalo, 1901 (med); Armory Show, 1913; with "The Eight" (although his work is neo-impressionist rather than "Ash Can"); Univ. Md., 1976 (retrospective). Work: MMA; WMAA; BMFA; PMG (also made over 200 monotypes, 1892-1905) [24]

PRENTIS, Edmund Astley [C] b. 1856, London, England (came to U.S., 1880) d. 15 D 1929, Long Island City, NY. Member: NY SAC (pres.) Specialty: illuminated Spanish leather

PRESCOTT, Katharine T. Hooper (Mrs. Harry L.) [S] NYC b. Biddeford, ME. Studied: E. Boyd, Boston; F.E. Elwell, NYC. Member: Copley S., 1893 [17]

PRESCOTT, Preston L. [S,T,Des] Ben Lomond, CA b. 10 Ag 1898, Ocheydan, IA. Studied: Minneapolis Inst. A.; Otis AI; ASL; G. Borglum; D. Edstrom; R. Aitken; J.B. Wendt. Member: Calif. AC; Laguna Beach AA. Exhibited: MET (AV), 1942; Los Angeles Mus. A., 1935 (prize), 1936 (prize), 1937; Calif. AC, 1935 (prize), 1936 (prize); Ebell Salon, 1935-37; Stendahl Gal., Los Angeles, 1937; Laguna Beach AA, 1936 (prize), 1937-38; Los Angeles C. of C., 1927-29 (prizes); Riviera Gal., Hollywood, 1936. Work: s. port., Calif. State Bldg., Los Angeles; mem., Arcadia, Calif; Fountain, Acacia Lodge, Ojai. Position: T., Sheriden Mem. Sch. A., Ben Lomond, Calif. [47]

PRESCOTT, William Linzee [P] NYC b. 1917, NYC. Studied: Chouinard AI; Galvan, Mexico. Exhibited: Morgan Gal., NYC, 1940 (one-man) [40]

PRESNAL, William Boleslaw [P,T] Rockport, MA b. 10 F 1910, New Bedford, MA. Member: Rockport AA; North Shore AA. Exhibited: Newport AA; North Shore AA; Rockport AA [40]

PRESSER, Josef [P,T,Gr,I,L] NYC b. Ap 18 1907, Lublin, Poland d. 14 Ap 1967, Paris, France. Studied: BMFA Sch.; Europe; B. Baker; H.H. Clark; P. Hale; W. James. Member: Phila. WCC; New Haven PCC. Exhibited: CI, 1941-46; AIC, 1938-46; PAFA, 1937-46; Contemp. A.; Assn. Am. A.; Weyhe Gal.; Nierndorf Gal.; MOMA; New Haven PCC, 1935 (prize), 1939 (prize); Toledo AA, 1944 (prize). Work: Royal Mus., Florence, Italy; MMA; PMA; AGAA; Syracuse Mus. FA; WMAA; Smith Col.; murals, Bristol, Pa.; USPO, Southern Pines, N.C.; Print C., Art Alliance, Phila.; BMFA; Allentown, Pa. Mus. Illustrator: jacket des., "Soul of the Sea," 1945 [47]

PRESSLER, Gene, Mr. [I] NYC [19]

PRESSOIR, Esther [P,E,B,L,T,C,Cart] NYC b. Phila., PA Studied: Hawthorne; K. Miller; Kuhn; B. Robinson; RISD; Kunstgewerbeschule, Munich. Member: Am. Craftsmen's Coop. Council; Calif. WCS; College AA. Exhibited: AIC; PAFA; Los Angeles Mus. A.; WFNY 1939; CAA; Rockefeller Ctr. (one-man). Work: PAFA; Los Angeles Mus. A. Contributor: Fiction Parade, New Yorker, Tomorrow. Illustrator: "Jews Are Like That." [47]

PRESTINI, James [C] Chicago, IL b. 13 Ja 1908, Waterford, CT. Studied: Yale; Univ. Stockholm; BAID. Exhibited: AGAA; Albany Inst. Hist. & A.; Albright A. Gal.; BMA; Butler AI; CMA; Dallas Mus. FA; Dayton AI;

Denver A. Mus.; de Young Mem. Mus.; Lyman Allyn Mus.; Milwaukee AI; MOMA; Neville Pub. Mus., Green Bay, Wis.; Portland Ore. A. Mus.; Russell Sage Fnd.; SFMA; Smithsonian Inst.; Joslyn Mem.; Toledo Mus. A.; Walker A. Ctr.; AIC; Phila. A. All.; Wash. County Mus. FA; MIT; Currier Gal. A.; many colleges & univs. Work: Albright A. Gal.; Ball State T. Col.; CMA; MOMA; Northwestern Univ.; Russell Sage Fnd.; Univ. Minn. Positions: T., North Texas State T. Col., 1942–43; Des. Consultant, MOMA, 1946 [47]

PRESTON, Alice Bolam (Mrs. Frank I.) [I,Des,C] Beverly Farms, MA b. 6 Mr 1889, Malden, MA d. 12 Ag 1958. Studied: Mass. Sch. A.; V. George; F.W. Howell; H. Snell; A.A. Munsell; A.K. Cross. Member: PBC; Copley S.; Rockport AA; Boston AC; North Shore AA; Gld. Beverly A.; Soc. for Preservation of New England Antiquities. Exhibited: Boston AC; Copley S.; PBC; Speed Mem. Mus.; Rockport AA; North Shore AA; House Beautiful Cover Comp., 1925–28 (prizes). Illustrator: "The Green Forest Fairy Boook" (1920), "Whistle for Good Fortune" (1940), "The Valley of Color Days," "Adventures in Mother Gooseland," "Peggy in her Blue Frock," "Humpty Dumpty House," pub. Houghton Mifflin. [47]

PRESTON, Alice M. [P] NYC. Member: Boston AC [06]

PRESTON, Alice Roberts (Mrs. Frank) [P] Auburndale, MA. Member: Concord AA [24]

PRESTON, Blanche (Mrs.) [P] New Orleans, LA [17]

PRESTON, Frank Loring [P] Auburndale, MA. Member: Concord AA [25]

PRESTON, James M. [I,P] Bellport, NY b. 1874 d. 15 Ja 1962, Southampton, NY. Member: GFLA [27]

PRESTON, Jessie Goodwin (Mrs.) [P] East Hartford, CT b. 9 S 1880, East Hartford, CT. Studied: W.M. Chase; Henri; W. Griffin. Member: CAFA; Hartford SWP; North Shore AA; New Haven PCC; Springfield AL. Exhibited: CAFA, 1924 [40]

PRESTON, Mary Wilson (Mrs. James M.) [I] NYC b. 11 Ag 1873, NYC. Studied: ASL; NAD; Whistler Sch., Paris. Member: SI, 1904. Exhibited: P.-P. Expo, San Fran., 1915 (med) [27]

PRESTON, William G. [P] Boston, MA. Member: Boston AC [10]

PRESTOPINO, Gregorio [P,T] Brooklyn, NY b. 21 Je 1907, NYC. Studied: NAD. Exhibited: WMAA, 1940, 1941, 1943–46; AIC, 1941, 1943; WFNY, 1939; CAM, 1945; GGE, 1939; PAFA, 1946 (med); Albright A. Gal., 1946; Pepsi-Cola, 1946 (prize); CGA, 1937; WMA, 1938. Work: WMAA; MOMA; Walker A. Ctr.; Rochester Mem. A. Gal.; U.S. State Dept. Position: T., Sch. for A. Studies, NYC [47]

PRETYMAN, William [P] Nantucket, MA [17]

PREU, John D. [Ldscp.P,C,T,B,I] Newington, CT b. 23 Jy 1913, Hartford, CT. Studied: PIASch; NYU; Dixon Sch. Metalcraft; Hartford A. Sch.; W. Starkweather; A. Fisher; A. Jones. Member: CAFA; New Haven PCC; Conn. WCS; Meriden A. & Crafts; West Hartford AL; Springfield AL. Exhibited: NYWCC, 1934–40; AWCS, 1935–40; All.A.Am., 1935; CAFA, 1936–46; Conn. WCS; AIC; Springfield AL, 1936–39; CAA Traveling Exh., 1935; New Haven PCC. Work: Biro-Bidjan Mus., Russia. Positions: T., Weaver H.S., Hartford, Conn. (1937–46), West Hartford AL (1937–46) [47]

PREUSSER, Robert Ormerod [P,T] Houston, TX b. 13 N 1919, Houston, TX. Studied: AIC; M. Davidson; Moholy-Nagy; R.J. Wolff. Exhibited: Nat. Exh. Am. A., N.Y., 1939; CI, 1941; AIC, 1942; VMFA, 1946; Houston MFA., 1940 (prize); San Antonio AL, 1941 (prize); Kansas City AI, 1936; Southeast Texas Exh., 1937–39; Texas General Exh., 1940–45; SSAL, 1941; Dallas MFA, 1938; Rockefeller Ctr., 1938. Work: Houston MFA [47]

PREVAL, Juanita [P] Milwaukee, WI [24]

PREVOT, M.J. [P] NYC [13]

PREYER, David C. [W] NYC b. 1862, Amsterdam, Holland (came to U.S. in 1883) d. 12 Ag 1913. Studied: New Brunswick Theological Seminary. Author: "The Art of the Netherlands," "The Art of the Berlin Galleries," "The Art of the Metropolitan Museum," "The Art of the Vienna Gallery." Position: Ed., Collector and Art Critic, from 1900–02

PREZZI, Wilma Maria [P] NYC b. 2 S 1915, Long Island City, NY d. ca. 1964. Studied: N.Y. State Edu. Dept.; Metropolitan A. Sch.; ASL. Member: Chinese A. Soc. Am. Exhibited: CI, 1946; All.A.Am., 1942–44; W.R. Nelson Gal. A., 1944 (one-man); Norfolk Mus. A. & Sc., 1945 (one-man); de Young Mem. Mus., 1945; Knoedler Gal., 1945; China Inst. in Am., 1947 (one-man). Work: Norfolk Mus. A. & Sc.; Hermitage Fnd., Norfolk, Va. Contributor: Asia magazine [47]

PRICE, Anna G. [P,T] Forest Hills, NY b. NYC. Studied: ASL; N.Y. Sch. A. Member: NAWPS; PBC[40]

PRICE, Charles Douglas [C,S,T] Newark, NJ b. 29 Mr 1906, Newark, NJ. Studied: PIASch; Cranbrook Acad. A.; W. Zorach; ASL. Work: Cranbrook Mus. Position: T., Cranbrook Acad. A. [40]

PRICE, Charles Matlack [P] NYC. Position: Staff, Arts and Decoration [24]

PRICE, Chester B. [I,E,Arch] Bronxville, NY b. 11 Je 1885, Kansas City, d. 1962. Studied: ASL; Wash. Univ., St. Louis; Royal Col. A., London, England; M. Osborne; R. Austin; Umbdenstock, in Paris; D. Barber, in NYC. Member: AIA; Arch. Lg.; SAE; Chicago SE; SC. Exhibited: Arch. Lg., 1915–37, 1928 (prize); NAD; SAE; WFNY, 1939; Chicago SE. Work: NYPL; Nat. Mus., Wash., D.C.; Univ. Nebr.; Fine Prints of the Year, 1931, 1932, 1935; Fifty Prints of the Year, 1933; Cranbrook Mus. Illustrator: article on architecture, Encyclopaedia Britannica, 14th ed. Co-author: "Portraits of Ten Country Houses Designed by Delano and Aldrich." Position: T., Columbia, 1942–44 [47]

PRICE, Clayton S. [P,I,Mur.P] Portland, OR b. 1874, Bedford, IA d. 1950. Studied: St. Louis Sch. FA, 1905. Exhibited: Portland AM, 1942 (retrospective); Seattle AM; Los Angeles AM; Baltimore AM; Detroit IA; Walker A. Ctr.; Calif. Palace of Legion of Honor; Santa Barbara MA, 1951–52; 48 States Comp., 1939. Work: Los Angeles MA; MET; MOMA; Portland AM; Detroit IA. Illustrator: Pacific Monthly, 1909. Specialty: Western scenes. Active in Wyo., 1888–ca. 1908 [40]

PRICE, Edith Ballinger [I,P,W] Newport, RI/Wakefield, RI b. 26 Ap 1897, New Brunswick, NJ. Studied: BMFA Sch.; NAD; ASL, with A. James; P.L. Hale; H. Sturtevant; G. Maynard; T. Fogarty. Member: Newport AA; So. County AA. Exhibited: Newport AA; South County AA. Author/Illustrator: "Garth Able Seaman," "Ship of Dreams," "A Citizen of Nowhere," "Lubber's Luck," also numerous short stories [47]

PRICE, Eleanore (Mrs. William F.) [P] Newport, RI. Member: Newport AA [25]

PRICE, Esther Prabel [Por.P] Chicago, IL b. 5 Mr 1904. Studied: AIC. Member: John H. Vanderpoel AA; Chicago NJSA. Position: T., Morgan Park Military Acad. [40]

PRICE, Eugenia [Min.P,P,T] San Antonio, TX b. 29 Ja 1865, Beaumont, TX d. fall 1923, Los Angeles. Studied: St. Louis Sch. FA; AIC; Académie Julian. Member: Chicago AC; Texas FAS; Chicago SMP; San Antonio AL; SSAL [21]

PRICE, Frank C. [P] Columbus, OH. Member: Columbus, PPC [25]

PRICE, Frederic Newlin [Mus.Dir,W,L] NYC b. 25 Ja 1884, Phila., PA d. 24 My 1963, Trenton, NJ. Studied: Swarthmore Col. Member: SC. Author: "Arthur B. Davies," 1930; "Albert P. Ryder," 1942; "Horatio Walker"; "Ernest Lawson"; others. Contributor: International Studio mag. Position: Dir., Benjamin West Mus., Swarthmore, Pa. [47]

PRICE, Garrett [I] Westport, CT. Member: SI [47]

PRICE, George [P,I,Cart] Tenafly, NJ b. 9 Jy 1901, Coytesville, NJ. Studied: G. (Pop) Hart. Illustrator: "The Strange Places," 1939; New Yorker, Collier's Weekly; Sat. Eve. Post [40]

PRICE, Gray. See Mrs. Merrels.

PRICE, Gwynne C. [P] Chicago, IL [01]

PRICE, Helen F. [P,W,L] Johnstown, PA b. 9 N 1893, Johnstown, PA. Member: All. A. Johnstown; NAWA; Pittsburgh AA. Exhibited: All.A.Am., 1936, 1937, 1939; Pittsburgh AA, annually; All. A. Johnstown, annually; Western Pa. Hist. S., 1940 (one-man). Work: Lutheran Col., Gettysburg, Pa. [47]

PRICE, Henry [S] London, England. Exhibited: St. Louis Expo, 1904 (med) [06]

PRICE, Irene Roberta [Por.P,T] Winston-Salem, NC b. 28 1900, Savannah, GA. Studied: Duke Univ.; Corcoran Sch. A.; C. Hawthorne; R. Brackman. Member: SSAL; AAPL; N.C. State AS. Exhibited: SSAL; Piedmont Festival A., 1944; N.C. Fed. Women's C., Charlotte, 1937. Work: City of New Bern, N.C.; Duke Univ.; Va. Military Inst.; many portraits [47]

PRICE, Lida Sarah [P] Paris, France b. IA. Studied: Paris, with R. Miller, Collin [08]

PRICE, M. Elizabeth [P,L,C] New Hope, PA b. Martinsburg, W.V. Studied: PMSchIA; PAFA; W. L. Lathrop; Breckenridge. Member: New Hope AA; PS; NAWPS; Ark. FAS; Phila. A. All.; The Ten. Exhibited: NAD,

1932–34; PAFA, 1932–43; CGA, 1933, 1935, 1937, 1939; Ferargil Gal. Work: Swarthmore Col.; Smith Col.; Dickinson Col. [47]

PRICE, Margaret Evans [I,W,P] East Aurora, NY b. 20 Mr 1888, Chicago, IL. Studied: Mass. Normal A. Sch.; J. De Camp; V. George; Major. Exhibited: Boston AC; Albright A. Gal. Author/Illustrator: "Legends of the Seven Seas," "Down Comes the Wilderness," "Enchantment Tales for Children," "Monkey-Do," 1935, other children's books. Illustrator: "Bounty of Earth," "West Indian Play Days." [47]

PRICE, Mary Roberts Ball (Mrs. Joseph) [P] Phila., PA. Studied: PAFA. Member: Plastic C. [25]

PRICE, Mary (Mrs. Chaarles Gray) [P] Chicago, IL. Member: Louisville AL [01]

PRICE, Norman (Mills) [I] NYC b. 16 Ap 1877, Brampton, Ontario d. 2 Ag 1951. Studied: Ontario Sch. A.; W. Cruikshank; Westminster Sch. A., Goldsmith's Inst., London; Académie Julian, with J.P. Laurens; R. Miller. Member: SI; AG. Exhibited: SI, 1921–46; Rockefeller Center, 1946 (prize). Illustrator: "The Lamb's Tales from Shakespeare" (1905), "The Rogue's Moon" (1929), "Leif Erikson the Lucky" (1939), other books; Cosmopolitan, American, Liberty [47]

PRICE, Rosalie Pettus (Mrs. William A.) [P] Birmingham, AL b. 19 N 1913, Birmingham, AL. Studied: Birmingham-Southern Col.; H. Elliot; A.L. Bairnsfather; W. Adams. Member: Calif. WCS; SSAL; Long Beach AA; Birmingham AC. Exhibited: Calif. WCS, 1945; Riverside Mus., 1946; SSAL, 1936, 1943, 1946; Birmingham AC, 1944 (prize), 1945 (prize); Long Beach AA, 1944, 1945; Los Angeles Nat. A. Week, 1945 [47]

PRICE, Samuel Woodson [Por.P] St. Louis, MO b. 5 Ag 1828, Nicholasville, KY d. 22 Ja 1918. Studied: Nicholasville, with W. Reading; Lexington, with O. Frazier, NYC. Wounded as a colonel in Union Army. Active in Lexington while also a postmaster, 1869–76; moved to Louisville, 1879; went blind, 1881; finally moved to St. Louis, 1906 [17]

PRICE, Susanna Martin [Min.P] Moylan, PA [15]

PRICE, Willard Bertram [P] Newark, NJ b. 1872, Newark. Studied: NAD; ASL; W.M. Chase [06]

PRICE, William Henry [Ldscp.P,Mar.P] Pasadena, CA b. F 1864, Pennsylvania. Studied: E. Forester. Member: Acad. Western P.; P.&S. C. Exhibited: Nat. PS Exh., Los Angeles Mus. A., 1931 (prize); Gardena A. Gal., 1933 (prize); Clearwater Gal., 1934 (prize); Calif. State Fair, Sacramento, 1934, 1935; Pasadena SA, 1936 (prize) Civic A. Exh., Pasadena, 1937 [40]

PRICHARD, J. Ambrose [P] Boston, MA. Member: Boston SWCP; Boston AC [04]

PRICHARD, Theodore Jan [Des,Arch,T] Moscow, Idaho b. 28 My 1902, Thief River Falls, MN. Studied: Univ. Minn.; Harvard; M. Arch. Member: AIA; Pacific AA. Exhibited: watercolor, Seattle AM; Boise (Idaho) AM. Position: T., Univ. Idaho [47]

PRICKETT, Rowland Pierson [P,W,T] Hampden, MA b. 31 My 1906, Springfield, MA. Studied: Cornell Univ.; Lumis A. Acad., with H.R. Lumis; PAFA. Member: SC; Springfield AG. Exhibited: Springfield AL, 1945, 1946; Springfield AG, 1945, 1946; Royal Inst., Jamaica, 1943, 1944; Westfield, Mass., Atheneum; BMFA, 1926 (prize). Work: CAFA; Travelers Ins. Co.; Jamaica. Position: Dir., Prickett Sch. Color [47]

PRIDE, Joy (Mrs. Tom Scott) [P,Gr,W] NYC b. Lexington, KY. Studied: Univ. Ky.; Académie Julian; ASL; Barnes Fnd.; S. Davis. Member: NAWA; PBC. Exhibited: CAA, 1931; CGA, 1933; NAWA, 1943–47; PBC, 1947; Speed Mem. Mus., 1929–33; Univ. Ky., 1932 (one-man); Circle Gal., Hollywood, Calif., 1943 [47]

PRIEBE, Karl [P] Milwaukee, WI b. 1 Jy 1914, Milwaukee, WI. Studied: Layton Sch. A.; AIC. Exhibited: Perls Gal., 1943 (one-man), 1944 (one-man), 1946 (one-man); AIC, 1936, 1938, 1939; Milwaukee AI, 1943–45 (prizes). Work: Layton Gal. A.; Milwaukee AI; Encyclopaedia Britannica Coll.; IBM Coll.; Reader's Digest Coll. Positions: Staff, Milwaukee Pub. Mus., 1938–42; Dir., Kalamazoo AI, 1944 [47]

PRIES, Lionel H. [P,E,L,T] Seattle, WA b. 2 Je 1897, San Fran. Studied: Univ. Calif.; Univ. Pa.; Cret; Dawson; Gumaer. Member: LeBrun F., 1922. Exhibited: Arch. Lg., 1921; Pal. Leg. Honor; SAM; Univ. Wash. Award: Prix de Rome, 1921. Work: mem., Univ. Calif. Position: Dir., SAM, 1929–30; T., Univ. Wash., Seattle, Wash. from 1928 [47]

PRIEST, Alan [Mus.Cur] NYC b. 31 Ja 1898, Fitchburg, MA d. 1968 Studied: Harvard. Member: Carnegie F., China, 1925; Sachs F., China, 1926–27. Author: "Chinese Sculpture in the Metropolitan Museum of Art," 1943, "Costumes from the Forbidden City" (monograph), 1945. Position: Cur., Far Eastern A., MMA [47]

PRIEST, Hartwell Wyse (Mrs.) [E,T] Summit, NJ/Pointe au Baril, Ontario b. 1 Ja 1901, Brandford, Canada. Studied: A. Lewis, ASL; Lhote, Paris. Member: Summit AA; NAWPS. Work: LOC. Illustrator: "The New Wood Cut," by M.C. Salaman [40]

PRIESTMAN, B. Walter [P] NYC b. Kewanee, IL. Studied: Chicago; Boston; NYC; Paris [04]

PRILIK, Charles Raphael [I,E,C] Gary, IN/Miller, IN b. 8 Jan. 1892, Odessa, Russia. Studied: Forsberg; Philbrick. Member: Gary AL [25]

PRIME, William Cowper [Edu,W] NYC b. 31 O 1825, Cambridge, NY d. 13 F 1905. Studied: Princeton, 1843. Member: Grolier C.; MET (trustee). Author: books dealing with art and travel. Position: T., Princeton

PRINCE, E.G. (Miss) [P] Weldon, PA [04]

PRINCE, Ethel [P] Wash., D.C. Member: S. Wash. A.; Wash AC [27]

PRINCE, William Meade [I,P,T,L] Chapel Hill, NC b. 9 Jy 1893, Roanoke, VA d. 10 N 1951. Studied: N.Y. Sch. F.&Appl. A. Member: SI; SC; N.C. State AS; A. & W. Assn.; Artists Gld. Exhibited: SI. Illustrator: Cosmopolitan, Collier's, Saturday Evening Post, American, other publications. Position: T., Univ. N.C., 1939–46 [47]

PRINDEVILLE, Mary [P] NYC/Chicago, IL [19]

PRIOR, Charles M. [P,E,Dec,T] NYC b. 15 D 1865, NYC. Studied: E.M. Ward, NAD. Member: Salons of Am.; EAA; AAPL; AFA [40]

PRIOR, Ruby. See Adair, Ruby.

PRISCILLA, Louis [I,Cart] NYC. Work: Collier's Weekly, 1937; New Yorker, 1939 [40]

PRITCHARD, J. Ambrose [Ldscp.P,Mar.P] Boston b. 11 Ap 1858, Boston d. 5 F 1905. Studied: Académie Julian with Boulanger, Lefebvre, Gérôme, 1882–89. Member: Boston AC; Boston SWCP

PRITCHETT, Eunice Clay (Mrs. John W. Squire) [P,Dr,L,T] Danville, VA b. Keeling, VA. Studied: B. Baker; J. Harding; R. Meryman; L. Stevens; J. Pearson; E. Nye; Garber; Nuse; O'Hara; Adams. Member: Danville AC; SSAL; Va. A. Alliance; Richmond Acad. Sc.&FA. Exhibited: Richmond Acad., 1936; Wash. SA; VMFA; Ogunquit A. Center. Work: Danville Mem. Hospital; Danville Armory; Averett Col.; Whitmell Farm Life Sch., Va.; Stuart (Va.) Courthouse [47]

PRIZER, Agnes I. [P] Dayton, KY. Member: Cincinnati Women's AC [25]

PRIZER, Tillie Neville [P] NYC. Studied: PAFA [25]

PRIZES, Charles, Mrs. [P] NYC. Member: NAWPS [19]

PROBERT, Sidney W. [P] Paterson, NJ b. 1865, Paterson, NJ d. 22 D 1919. Studied: Silver Lake A. Sch.; ASL; France; Italy. Member: SC; S.Indp.A. Work: Paterson Pub. Lib. Position: T., Pub. Sch., Paterson [19]

PROBST, Thorwald (A.) [P,I,T] Los Angeles, CA b. 18 Jy 1886, Warrensburg, MO. Studied: I. Olsen; V. Langer. Member: Calif. AC; Laguna Beach AA; Artland C. Illustrator: "Poems of California Missions" [33]

PROCTOR, A(lexander) Phimister [S,P] Seattle, WA b. 1862, Bozanquit, Ontario d. 5 S 1950, Palo Alto, CA. Studied: NAD, 1887; ASL, 1887; Académie Julian; Acad. Colarossi, with Puech, Injalbert, 1895. Member: ANA, 1901; NA, 1904; SAA, 1895; AWCS; Arch. Lg. 1899; NSS, 1893; NIAL; A. Aid S.; Century Assn.; NAC; Am. Soc. Animal P.&S. Exhibited: Columbian Expo, Chicago, 1893 (med); Paris Expo, 1900 (gold); St. Louis Expo, 1904 (gold), (med); Arch. Lg., 1911 (med); P.-P. Expo, San Fran., 1915 (gold). Work: Prospect Park, Brooklyn, N.Y.; MET; BM; Princeton; bridges, Wash., D.C.; CI; Univ. Oreg., Eugene; mon., Buffalo; statue, Portland, Oreg.; State House, Salem, Oreg.; Portland, Oreg.; Minot, N.Dak.; Civic Ctr., Denver; Lake George, N.Y.; Kansas City; mem., Wichita, Kans.; Pendleton, Oreg.; Dallas [47]

PROCTOR, Charles E. [P] NYC. Member: SC, 1891; A. Fund. S. Exhibited: NAD, 1897 (prize); Syracuse State Fair (prize); SC, 1900 (prize) [10]

PROCTOR, Ernest L. [P] Boston, MA [01]

PROCTOR, Gifford MacGregor [S] NYC/Wilton, CT b. 6 F 1912, NYC. Studied: Yale; A.P. Proctor. Member: Arch. Lg. Award: Prix de Rome, 1935. Exhibited: Arch. Lg., 1938; WFNY, 1939; 48 Sts. Comp., 1939. Work: USPO, New Orleans. WPA artist. [40]

PROCTOR, John A., Mrs. See Whiting, Gertrude.

PROCTOR, Romaine [P,T] Springfield, IL b. 12 Jy 1899, Birmingham, Ala. Studied: AIC; Chicago AFA. Member: Am. Bookplate S. [25]

PROEBSTING, Dewey [I,Car,P] b. 1898, Burlington, KS d. 1979, near Crystal Lake, IL. Designer: International Harvester logo during 1930s, as a commercial artist in Chicago. Creator: "Buckskin Lad" cartoon series for Chicago Sun. Specialties: country and farm life; cowboys and Indians [*]

PROETZ, Victor [P] St. Louis, MO [25]

PROHASKA, Ray [I,Car] NYC. Member: SI. Illustrator: Good Housekeeping, 1939 [47]

PROPER, Ida Sedgwick [P] NYC b. near Des Moines, IA. Studied: ASL; Thor, Munich; R. Miller, Paris. Member: SP. Work: N.J. State House; Iowa Hist. Gal. [17]

PROPHET, Nancy Elizabeth [S,T] Atlanta, GA b. 19 Mr 1890, Arctic Ctr., RI. Studied: RISD; Ecole des Beaux-Arts; Segoffio. Member: Newport AA; College AA. Exhibited: work of Negro Artists, 1929 (prize); Newport AA, 1932 (prize). Work: Mus., RISD; WMAA. Position: T., Atlanta Univ. [40]

PROSSER, Margaret (Mrs.) [P,T] Univ. Delaware, Newark, DE b. 26 Ja 1913, Vancouver, B.C., Canada. Studied: Univ. Wash.; Archipenko; Ozenfant. Member: Am. Assn. Univ. Prof. Exhibited: Wilmington SFA, 1942–45; Univ. Del., 1946 (one-man); Northwest Exh., 1938, 1941, 1943, 1945. Position: T., Univ. Delaware, 1942–46 [47]

PROTZ, W.F. [P] NYC [01]

PROTZMANN, George [P] NYC [21]

PROUT, George Morton [P,G,I] Columbus, IN b. 1 S 1913, St. Francisville, IL. Studied: Herron AI; PAFA. Member: Indianapolis AA; Ind. AC. Exhibited: Grand Central Gal., 1938; GGE 1939. Work: Herron AI [40]

PROW, Hallie P(ace) (Mrs.) [P] Bloomington, IN b. 25 Ap 1868, Salem, IN d. 11 D 1945. Studied: John Herron AI; L.O. Griffith; C. Graf; W. Forsyth. Member: Ind. AC; AAPL; Ind. A. Fed. Work: Salem, Ind. Pub. Lib. [40]

PRUCHA, Robert [P] Chicago, IL [19]

PRUSHECK, Harvey Gregory [P] Cleveland, OH b. 11 Mr 1887, Yugoslavia. Member: AAPL; Ill. Acad. FA; Chicago SA; AFA. Exhibited: AIC, 1930 (prize), 1932 (prize); Cleveland A. & Craftsmen, 1933. Work: Milwaukee AI; Pub. Libs., Chisholm, Minn., Boise, Idaho; Cleveland Pub. Libs.; Mun. A. Coll., Cleveland; CMA; Nat. Gal., Yugoslavia. Position: Dir., A.& Crafts, Div. Recreation, Cleveland [40]

PRUSS, Boris [P] Hammonton, NJ b. 1863, Wiikomir, Russia. Studied: Munich, with W. Diez; F. von Lenbach; Bonnât, Paris. Member: SC, 1900; Munich A.; Universal German AA; SC, 1900. Exhibited: Paris Salon; 1880 (med), 1881 (med), 1883(med), 1884, 1886 [04]

PRYCE, Al [P] Canton, OH. Member: Artklan. Affiliated with Canton Advertising [25]

PRYOR, Warrant [P] Rochester, NY. Member: Cleveland SA [27]

PRYOR, Yvonne L.D. [P] Chicago, IL. Exhibited: AIC, 1937, 1939 [40]

PSOTTA, Charles [P] Paris, France. Studied: Paris, with Laurens, Constant, A. Roll [01]

PUCCINELLI, Dorothy Wagner (Mrs.) [P,Dr,Mur.P] San Fran., CA b. 19 D 1901, San Antonio, TX. Studied: Calif. Sch. FA; R. Schaeffer; B. Bufano. Member: San Fran. AA; San Fran. Art Center; San Fran. Soc. Women A.; San Fran. Soc. Mural A. Exhibited: San Fran. Soc. Women A. (prize); Pal. Leg. Honor, 1932 (prize). Work: drawing, Pal. Leg. Honor; SFMA; Fleischbacker Mem. Mothers Home, San. Fran.; mural, USPO, Merced, Calif. [40]

PUCCINELLI, Raymond [S,Wood Carver,T,L] San Fran., CA b. 5 My 1904, San Fran. Studied: Univ. Calif.; Schaeffer Sch. Des., San Fran.; B. Schmitz; Calif. Sch. FA; B. Bufano. Member: NSS; San Fran. AA; Art Center San Fran. Exhibited: Oakland A. Gal., 1938 (prize), 1939, 1940, 1941 (prize), 1942 (prize); Los Angeles Mus. A., 1939 (prize); San Fran. AA, 1938 (prize); GGE, 1939; WMAA, 1940; PAFA, 1942; CM, 1941; NSS; Arch. Lg., 1941, 1945; WFNY, 1939; SFMA, 1936–46; San Diego Expo, 1935; Portland A. Mus., 1939; CGA, 1942; Pal. Leg. Honor, 1946 (one-man); Mills Col., 1945; Univ. Calif., 1945; de Young Mem. Mus., 1944; Santa Barbara Mus. A., 1946; Scripps Col., 1941; Crocker A. Gal., 1941; SFMA. Work: Phelan Bldg., San Jose; Pacific Nat. Bank Bldg., San Fran.; Mills Col. Art Gal.; Salinas (Calif.) Jr. Col.; wood panels, furniture, San Fran. Stock Exchange; Corpus Christi Church, Piedmont, Calif.; Marconi Mon., Telegraph Hill, San Fran.. Positions: T., Univ. Calif., Berkeley (1942–46), Mills Col. (1938–46) [47]

PUCKETT, Henry Frank [Por.P,B,T] Chicago, IL b. 10 Ag 1914, Chicago. Studied: W. Reynolds; A. Sterba. Member: Chicago NJSA; All.-Ill. Soc. FA; Hoosier Salon; Soc. Ar., Inc. Work: St. Procopius Abbey, Lisle, Ill.; Juvenile Court Bldg., Cook County, Ill.; state of Ill. Position: T., Austin Evening H.S., Chicago [40]

PUGH, Effie [P] Chicago, IL. Member: Chicago NJSA [25]

PUGH, Elizabeth Worthington (Mrs.) [P] Cincinnati, OH. Member: Cincinnati Women's AC [25]

PUGH, Mabel [P,Li,T,I,W,Dec] Raleigh, NC/Morrisville, NC b. Morrisville. Studied: ASL; PAFA; Columbia; N.C. State Col.; DuMond; Chapman; Hawthorne. Member: AAPL; N.C. State A. Soc.; NAWA; SSAL. Exhibited: N.C. State Fair, 1922 (prize); SSAL, 1930 (prize); Southern Pr.M. (prize); Mint Mus. A. (prize); Plastic Cl., Phila., 1926 (gold); N.C. State Fed. Women's Cl., 1937 (prize), 1938 (prize), 1939 (prize); NAD, 1932; LOC, 1943, 1944; NAWA, 1934, 1935 (prize), 1936–39; PAFA, 1933; Phila. Pr. Cl., 1929–31; Phila. WCC; AIC; WFNY, 1939; AAPL; N.C. Ar.; Kansas City AI. Work: LOC; N.C. State Garden Cl. Author/Illustrator: "Little Carolina Bluebonnet," 1933. Illustrator: Century Co., Thomas Crowell Co., Doubleday Doran, E.P. Dutton Co., Ginn Co. Position: T., Peace Col., Raleigh, 1936– [47]

PUGLIESE, Anthony [E,T,L] NYC b. 2 Je 1907, NYC. Studied: NYU. Work: NYU. Illustrator: Herald Tribune, Harper's, Redbook. Position: T., Brooklyn Col. [40]

PULFREY, Dorothy Ling [P] Sheffield, England b. 16 Ap 1901, Providence, R.I. Studied: J. Sharman; A. Heintzelman. Member: Providence WCC [33]

PULLINGER, Herbert [P,I,T,B,E,Li] Phila., PA b. 15 Ag 1878, Phila. Studied: PMSchIA; Drexel Inst.; PAFA, with McCarter, Anshutz. Member: Phila. Pr. Cl.; Phila. WCC; Phila. Sketch Cl. Exhibited: PAFA, 1925 (gold); Sesqui-Centenn. Expo, Phila., 1926 (med). Work: NYPL; Luxembourg Mus., Paris; Springfield (Mass.) Lib.; PAFA; PMA; CMA; Newark Mus.; LOC, Honolulu Acad. FA; Mus. Art, Toledo. Author/Illustrator: "Washington, the Nation's Capitol," 1921. Position: T., PMSchIA [47]

PULSIFER, J(anet) D. [P] Buffalo, NY/Scituate, MA b. Auburn, ME. Studied: ASL; Delance, Courtois, Aman Jean, in Paris [29]

PUMA, Fernando [P,T,W,L] NYC b. 14 F 1915, NYC. Studied: NYU; Columbia. Exhibited: Albany Inst. Hist.&A., 1943, 1944; Detroit Inst. A., 1944; Critics Show, N.Y., 1945; PMG; Adelphi Col.; Randolph-Macon Col.; Minneapolis Inst. A.; NYC (one-man); Santa Barbara Mus. A.; SFMA. Work: PMG; Randolph-Macon Col. [47]

PURCELL, Hazel [P] Alliance, OH [25]

PURCELL, John Wallace [S,C,T,W] Evanston, IL b. 3 Ja 1901, New Rochelle, NY. Studied: Cornell; AIC. Exhibited: AIC,1925–44; Evanston & North Shore A., 1933, 1934, 1935 (prize), 1936–38, 1939 (prize), 1940–46; WFNY, 1939. Work: AIC. Position: T., AIC (1925–44), Evanston (Ill.) A. Center (1944–46) [47]

PURDIE, Evelyn [Min.P] Cambridge, MA b. 31 D 1858, Smyrna, Asia Minor d. 1943. Studied: BMFA Sch., with Grundmann; Carolus-Duran, Henner, Mme. Debillemont-Chardon, in Paris. Member: Pa. Soc. Min. P.; Boston Gld. A. Exhibited: Pa. Soc. Min. P., 1929 (med) [40]

PURDY, Albert J. [Por.P] b. 1835 d. 5 Ag 1909, Ithaca, NY

PURDY, Earl [Mur.P,Arch,E] Larchmont, NY. Member: AIA. Work: murals, Hotel Washington, Washington, D.C.; etchings, Cushing Mem. Gal., Newport, R.I. [40]

PURDY, Maud H. [I,Min.P] Brooklyn, NY b. 29 N 1874, Phila. Studied: A. Cogswell; Whittaker. Member: Brooklyn AS. Illustrator: "Fundamentals of Botany," by Dr. Gager, other books. Position: Illus., Brooklyn (N.Y.) Botanical Gardens, 1911– [47]

PURDY, Robert Cleaver [P,Mur.P] Louisville, KY/Goose Rocks Beach, ME. Studied: Herron AI Sch. Exhibited: WC Ann., PAFA, 1938. Work: murals, USPOs, Princeton, Ky., New Albany, Miss. WPA artist. [40]

PURDY, W. Frank [Sculpture Expert] New Canaan, CT b. 1865 d. 23 D 1943. Member: Art All. Am.; Antique and Decorative Art Dealers Assn. Position: Hd., Sculpture Dept., Gorham Co.

PUREFOY, Heslope [Min.P] Asheville, NC b. 17 Je 1884, Chapel Hill, NC. Studied: A. Beckington; L.F. Fuller. Member: Pa. Soc. Min. P. [33]

PURRINGTON, Henry J. [Ship Carver] b. 1825, Mattapoisett, MA. Active in New Bedford, Mass., 1848–1900; still living in 1920s; also a musician and amateur doctor. [*]

PURSER, Mary May (Mrs. Stuart R.) [P,Des,Mur.P,T] Chattanooga, TN b. 9 D 1914, Chicago, IL. Studied: AIC; La. Col.; abroad; E. Zettler; M. Artingstall; N. Cikovsky. Exhibited: AIC, 1941; New Orleans AA, 1942; Delgado Mus. A. (one-man); Miss. AA (one-man). Work: mural, USPO, Clarksville, Ark. Positions: T., La. Col., 1940, Univ. Chattanooga, 1947 [47]

PURSER, Stuart R. [P,Mur.P,L,T] Chattanooga, TN b. 7 F 1907, Stamps, AR. Studied: La. Col.; AIC; A. Anisfeld; abroad. Member: SSAL. Exhibited: New Orleans AA (prize); Miss. AA, 1942 (prize); PAFA, 1946; AIC, 1936, 1938; WFNY, 1939. Work: murals, USPOs, Lelland (Miss.), Gretna (La.), Ferriday (La.), Carrollton (Ala.). WPA artist. Positions: T., La. Col., 1935-45, Univ. Chattanooga, 1946– [47]

PURSSELL, Marie Louise [P] NYC. Exhibited: NAWPS, 1935-38 [40]

PURVES, Austin, Jr. [Des,C,S,I,L,P,Mur.P,T] Litchfield, CT b. 31 D 1900, Chestnut Hill, PA. Studied: PAFA; Académie Julian, Paris; Am. Conservatory, Fontainebleau, France; D. Garber; P. Baudouin, in Paris. Member: Gld. of Louis Comfort Tiffany Fnd.; Arch. Lg.; NSMP; Century Assn. Exhibited: Arch. Lg., 1926 (prize). Work: Illuminated Litany Service, St. Paul's Church, Phila.; coats-of-arms, St. Michael's Church, Jersey City; reredos, St. Paul's Church, Duluth; mosaic ceiling, Bricken Bldg., N.Y.; mem., Wash., D.C.; fresco, St. Michael's Church, Torresdale, Pa.; S.S. America; murals, Folger Shakespeare Mem. Lib.; Nat. Mus., Wash., D.C. [47]

PURVIANCE, Cora Louise [P,T] Phila., PA b. 6 Ag 1904, Phila. Studied: Breckenridge; PAFA. Member: NAWPS. Exhibited: PAFA, 1930 (gold); Plastic Cl., 1931 (gold), 1932 (med) [40]

PURVIS, R. Murray [P] Boston, MA [[01]

PURVIS, William G. [P] Maywood, IL. Member: Chicago SA [21]

PUSHMAN, Hovsep [P] NYC b. 1877 d. F 1966. Studied: Lefebvre, Robert-Fleury, Dechenaud, in Paris. Member: Calif. AC; Paris AAA. Exhibited: Paris Salon, 1914 (med), 1921 (med); Calif. AC, 1918 (prize); Grand Central A. Gal., 1930 (prize). Work: Milwaukee AI; Layton Art Gal., Milwaukee; Minneapolis Art Mus.; Rockford (Ill.) Art Gld.; Norfolk (Va.) Art Assn.; University Cl., Milwaukee; Univ. Ill., Springfield; MMA; BMFA; Dallas A. Assn.; Amherst Col.; Montclair (N.J.) Art Mus.; Canajoharie A. Gal.; Detroit Inst. A. Best known for his still lifes of oriental objects. [40]

PUSTERLA, Attilio [Mur.P] Woodcliff, NJ b. 1862, Milan, Italy (came to U.S. in 1899) d. 1 My 1941. Work: murals: Lewis and Clark Mem. (Astoria, Wash.), Parliament Bldg. (Ottawa), N.Y. County Court House

PUTHUFF, Hanson (Duvall) [Ldscp.P,Por.P] La Crescenta, CA b. 21 Ag 1875, Waverly, MO d. 1972, Corona del Mar, CA. Studied: Univ. A. Sch., Denver, 1893. Member: Calif. AC; Laguna Beach AA; Los Angeles WC Soc.; Berkeley Lg. FA. Exhibited: Pan-Calif. Expo, San Diego, 1916 (2 medals); Calif. AC, 1916 (prize); State Fair, Sacramento, 1918 (gold), 1919 (med); Laguna Beach AA, 1920 (prize), 1921 (prize); Southwest Mus., Los Angeles, 1921 (prize); Springville, Utah, 1924 (prize), 1926 (prize), 1927 (prize), 1928 (prize); Painters of the West, 1925 (med), 1927 (gold), 1930 (med); Riverside, Calif., 1927 (prize); Pacific Southwest Expo, 1928 (med); Chicago Gal. Assn., 1930. Work: Municipal Coll., Denver; Los Angeles County Coll., Los Angeles Mus. A.; Municipal Art Gal., Phoenix; Los Angeles pub. schools [40]

PUTNAM, Arion [P] Los Angeles, CA. Member: Calif. AC [25]

PUTNAM, Arthur [S] Bohemian Cl., San Fran., CA/Paris, France b. 6 S 1873, Waveland, Miss. d. 27 My 1930, Ville Davray, near Paris. Studied: San Fran., with R. Schmidt; Chicago, with E. Kemeys (1897-98); bronze casting in Europe (1905). Member: NSS, 1913; Bohemian Cl. Exhibited: Rome, 1906; Paris, 1907. Work: groups of animal sculptures, Pal. Leg. Honor (San Fran.), San Diego FA Soc.; MMA; BMFA. Specialty: western animals, esp. mountain lions. Established foundry (1909), casting bronzes by the cire-perdue method (lost-wax process). [29]

PUTNAM, Brenda [S,W] NYC b. 3 Je 1890, Minneapolis, MN d. 1975. Studied: BMFA Sch.; ASL; M.E. Moore; B. Pratt; C. Grafly; J.E. Fraser. Member: ANA; NA, 1936; NSS; NAC; NIAL; NAWA. Exhibited: AIC, 1917 (prize); Arch. Lg., 1924 (prize); Grand Central Gal., 1930 (prize), 1939 (prize); NAD, 1922 (prize), 1929 (med), 1935 (gold); NAWA, 1923 (prize), 1928 (prize); PAFA, 1923 (med); extensively in U.S. Work: Dallas Mus. FA; NIAL; Hispanic Mus.; Folger Shakespeare Lib., Wash., D.C.; Norton Gal. A.; Brookgreen Gardens, S.C.; Lynchburg, Va.; West Palm Beach, Fla.; South Orange, N.J.; USPOs, Sloan Cloud, Minn., Caldwell, N.J.; Rock Creek Cemetery, Wash., D.C.; portrait bust of Harriet Beecher Stowe, Am. Hall of Fame. Author/Illustrator: "The Sculptor's Way," 1939. Had studio in New York. WPA artist. [47]

PUTNAM, Charlotte Ann [E] Bronxville, NY b. 20 My 1906, Red Wing, MN. Studied: ASL; H. Wickey. Exhibited: Nat. Jr. Lg. Exh., Cincinnati Mus., 1931 (prize); Nat. Jr. Lg. Exh., Los Angeles, 1932 (prize) [32]

PUTNAM, Elizabeth [P] Wash., D.C. [13]

PUTNAM, Marion. See Walton.

PUTNAM, Stephen G(reeley) [Wood En] Queens, NY b. 17 O 1852, Nashua, NH. Studied: Brooklyn Art Assn.; ASL; H.W. Herrick; F. French; E.J. Whitney. Exhibited: Paris Expo, 1889 (med), 1900 (med); Columbian Expo, Chicago, 1893 (med); Pan-Am. Expo, Buffalo, 1901 (med) [31]

PUTNAM, Wallace B. [P,W,I] NYC b. 1899, West Newton, MA. Studied: BMFA Sch. Exhibited: BM, 1926; MOMA; Bignou Gal., 1945 (one-man). Author/Illustrator: "Manhattan Manners" [47]

PUTZKI, Paul A. [P] Wash., D.C. b. 1858, Germany (came to U.S. in 1879) d. 25 F 1936. Taught watercolor and china painting in Chicago and Indianapolis prior to opening a studio in Wash., D.C., at the invitation of the wife of Pres. Harrison. [01]

PYE, Fred [P,T] Cincinnati, OH b. 1 D 1882, Hebden Bridge, Yorkshire, England. Studied: Acad. Julian, Acad. Colarossi, both in Paris. Member: SC; Cincinnati Men's AC; Cincinnati Prof. A. Exhibited: CM. Work: Luxembourg Mus., Paris; Mus. A., Edmonton, Alberta [47]

PYLE, Arnold [P] Cedar Rapids, IA. Exhibited: watercolor, Midwestern A. Exh., Kansas City AI, 1936 (prize) [40]

PYLE, Clifford C(olton) [P,I,B,C,Des,Dr,E,T,W] Oakland, CA b. 24 O 1894, MO. Studied: P. Lemos; L. Randolph; G. Albright; R. Schaeffer. Work: MMA. Author: "Leathercraft as a Hobby," 1939 [40]

PYLE, Ellen B.T. (Mrs.) [P,Por.P] b. 1881 d. 1 Ag 1936, Greenville, DE. Member: Wilmington Soc. FA. Specialty: child portraits

PYLE, Howard [I,P,W] Wilmington, DE/Chadds Ford b. 5 Mr 1853, Wilmington. d. 9 N 1911, Florence, Italy. Studied: Phila., with Van der Weilen, 1869-72. Member: ANA, 1905; NA, 1907; SC; 1876; NIAL; Century; Intl. Soc. SPG. Exhibited: Columbian Expo, Chicago, 1893 (med); Pan-Am. Expo, Buffalo, 1901 (gold); Paris Expo, 1900 (med). Work: Pyle Mem. Lib., Wilmington, Del. Author/Illustrator: 24 books, including "The Merry Adventures of Robin Hood" (1883), "Within the Capes," "Pepper & Salt," "The Wonder Clock" (1888), "The Rose of Paradise," "Twilight Land" (1895), "Stolen Treasure" (1907), "Otto of the Silver Hand." Illustrator: more than 100 books; every major magazine from 1876 on, including Scribner's, St. Nicholas, Harper's (in b&w from 1876-87). Specialty: pen-and-ink drawings. Had studio in New York (1876-80) and Wilmington (from 1880). Best known for his illus. of early Am. historical characters and events. Highly important and influential illustrator and teacher. He was the founder of the "Brandywine School" and is often referred to as the "Father of American Illustration." Among his many famous students were V. Oakley, N.C. Wyeth, M. Parrish, and H. Dunn. Positions: Drexel IA (1894-1900); Dir., Pyle Sch. A. (1900-06) [06]

PYLE, Katharine [Por.P,I,W] Wilmington, DE b. Wilmington d. ca. 1939. Studied: Women's Indst. Sch.; Drexel Inst., with H. Pyle; ASL. Member: Wilmington Soc. FA. Author: "Wonder Tales Retold," "Tales of Folk and Fairies," "Heroic Tales from Greek Mythology," "Heroic Tales from the Norse Mythology," "Charlemagne and His Knights," other books [38]

PYLE, Margery Kathleen [Ldscp.P,P] Wilmington, DE b. 6 Jy 1903, Wilmington. Studied: PAFA; Univ. Del.; D. Garber; R. Braught; F. Cannon; A. Doragh. Member: Wilmington A. Cl.; Studio Group of Wilmington; Wilmington Pr. Cl.; Wilmington Soc. FA; Rehoboth (Del.) A. Lg. Exhibited: Wilmington AC, 1934 (prize); Rehoboth A. Lg., 1937 (prize), 1939 (one-man); PAFA, 1936; Wilmington Soc. FA, annually [47]

PYLE, William Scott [P] NYC d. 13 F 1938. Member: SC [25]

PYLE, Walter, Jr. [P,Mur.P,I,T] Greenville, DE b. 25 Ja 1906, Wilmington. Studied: PMSchIA; PAFA. Member: Wilmington A. Cl. Exhibited: Wilmington Soc. FA, 1935 (prize), 1937 (prize), 1938 (prize); Wilmington A. Cl., 1937 (prize); WC Ann., PAFA, 1938. Work: murals, Special Sch. District, Georgetown, Del. Position: Del. State Supv., WPA [40]

PYLES, Virgil E. [I,P] NYC b. 23 D 1891, La Grange, KY. Studied: AIC; ASL; Grand Central A. Sch.; SI Sch. for Veterans. Member: Am. Veterans Soc. A. Exhibited: Lotos Cl.; Am. Veterans Soc. A. Illustrator: Ladies Home Journal, American, Adventure, other magazien [47]

PYNE, R. Lorrdine [P] NYC [06]

PYTLAK, Leonard [Ser,Li,P,T,L] NYC (1977) b. 3 Mr 1910, Newark, NJ. Studied: Newark Sch. F.&Indst. A.; ASL. Member: A. Lg. Am.; Nat.

Serigraph Soc. (founder); Audubon A.; Phila. Color Pr. Soc.; F., Guggenheim Fnd., 1941. Exhibited: MMA, 1942 (prize); AV, 1943 (prize); Phila. Pr. Cl. (prize); Phila. Color Pr. Soc. (prize); NAD, 1946 (prize); LOC, 1944, 1945, 1946 (prize); SAM. Work: MMA; BM; CI; Denver A. Mus.; SAM; BMFA; NYPL; PMA; Newark Lib.; MOMA; Contemporary A.; Nat. Serigraph Soc. [47]

Charles S. Reinhart: *Self-portrait sketch*. From *The Illustrator* (1894)

QUACKENBUSH, Ethel H. [P] NYC [19]

QUACKENBUSH, Grace M. [P] NYC [13]

QUALLEY, Lena [P] Hillsdale, MI b. Decorah, IA. Studied: AIC; Paris, with MacMonnies, de la Gandara, Simon, Dottet [10]

QUANCHI, Leo [P] Maywood, NJ b. 23 S 1892, NYC. Studied: CCNY; NAD; ASL; Parsons Sch. Des.; G. deF. Brush; F.C. Jones; D. Volk. Member: Audubon A.; A.Lg.Am.; Lg. Present-Day A.; S.Indp.A.; College AA; AAPL. Exhibited: NAD, annually; Pepsi-Cola, 1944, 1946; Montclair A. Mus., 1944 (prize), annually. Work: WMAA [47]

QUARTLEY, Arthur [Mar.P] NYC/Isle of Shoals, NH b. 24 My 1839, Paris, France (settled in Peekskill, NY ca. 1851) d. 19 My 1886. Studied: with his father Frederick W. (1808–74). Member: ANA 1879; NA 1886. Exhibited: NAD; Brooklyn AA, 1875–86. Work: Md. Hist. S.; NY Hist. S.; Peabody Mus., Salem, Mass. Began his career as engr. in Peekskill; a sign-painter in NYC; and in decorator firm of Emmart & Quartley, Baltimore, 1862–75. But he is best known as a marine painter, having opened his NYC studio, 1875. [*]

QUAT, Judith Gutman [P,G,T] Lewisburg, PA b. 1 Jy 1903, Radom, Poland. Studied: Hunter Col.; ASL; R. Laurent. Member: United Am. Ar.; Young Am. fA.; ASL. Exhibited: 8th St. Playhouse, NYC (one-man); ACA Gal., NYC, 1939, WFNY 1939. Work: Temple Rodeph Shalom, NYC; ASL [40]

QUATTROCCHI, Edmondo [S] Long Island City, NY d. 17 O 1966. Member: NSS [47]

QUEST, Charles F. [P,T,Et,Eng,S] St. Louis, MA/Webster Groves, MO. b. 6 Je 1904, Troy, NY. Studied: St. Louis Sch. FA, Wash. Univ.; Europe; Fred Carpenter; Edmund Wuerpel. Member: Mo. State T. Assn.; St. Louis AG. Exhibited: NGA; MOMA, 1933; CGA; CI; NAD; SFMA; CAM, 1932–46, 1944 (prize); AIC, 1942, 1942; WFNY 1939; Swope A. Gal.; SAM; Springfield Mus. A., 1945 (prize); Kansas City AI, 1932 (med); CAFA; Smith Col.; San Diego FAS; CM; CMA; LOC 1945, 1946; St. Louis AG, 1923 (prize), 1924, 1925 (prize), 1926, 1927 (prize), 1928, 1929, 1930 (prize), 1932 (prize)1933, 1937, 1942, 1945, 1946. Work: U.S. War Dept., Wash., D.C.; Univ. Wis.; Munson-Williams-Proctor Inst.; CAM; Springfield Mus. A.; LOC; Carpenter Branch Lib., St. Michael, St. George Episcopal Church, Trinity Church, Herzog Sch., all in St. Louis, St. Mary's Church, Helena, Ark.; Hotel Chase, St. Louis; Pub. Sch., University City, Mun. Auditorium, St. Louis. Position: T., St. Louis Pub. Sch., 1932–45; St. Louis Sch. FA, Wash. Univ., from 1945; 5 Arts Center, St. Louis [47]

QUEST, Dorothy (Johnson) (Mrs. Charles F.) [P,T,S,L] Webster Groves, MO. b. 28 F 1909, St. Louis. Studied: St. Louis Sch. FA.; Columbia; Europe; C.F. Quest; E. Wuerpel; F.G. Carpenter; G. Goetch. Member: St. Louis AG. Exhibited: CAM, 1932, 1934, 1938, 1939, 1940; St. Louis AG, 1935–1938, 1940, one-man: 1933, 1939, 1940, 1942, 1943, 1945. Work: assisted C.F. Quest, Helena, Ark., St. Louis, Mo., church murals. Position: T., Community Sch., Clayton, Mo., 1936–38; Sacred Heart Acad., St. Louis, 1939–41; Maryville Col., St. Louis, 1945 [47]

QUEST, E. Eloise [P] Brooklyn, NY/Columbus, OH [25]

QUIGLEY, Edward B. ("Quig") [P,I,S,Mur.P] Portland, OR (1968) b. 1895, Park River, ND Studied: AIC; Chicago Acad. FA. Specialty: animals and cowboy genre. Work: Merrihill MFA, Goldendale, Wash. [*]

QUIGLEY, Ellen Louise [P] Manchester, NH/East Gloucester, MA. Studied: E. Gruppe; Manchester Inst. of A. & Sc.; ASL. Member: North Shore AA; Gloucester SA; Merrimack Valley AA. Work: Tufts Col., Boston [40]

QUIMBY, Fred G. [Mar.P] Boston, MA b. 1863, Sandwich, NH d. 17 Je 1923, Arlington, MA. Member: Boston AC [21]

QUINAN, Henry B(rewerton) [Art.Dir] NYC b. 10 N 1876, Sitka, Alaska. Studied: Laurens, Paris. Member: SC; SI; Art Dir.; AFA. Position: A. Dir., Crowell Publishing Co. [31]

QUINAN, Henry R. [I] Glenbrook, CT. Member: SI [47]

QUINCY, C.B. [P] Norwood, OH. Member: Cincinnati AC [17]

QUINCY, Edmund [P,Dr] Boston, MA b. 15 My 1903, Biarritz, France. Studied: Harvard; A. Herter; G. Degorce; G. Noyes; F. Whiting. Member: Newport AA; Contemp. A. Exhibited: Salon d'Automne, 1928, 1929, 1935, 1936; Salon des Tuileries, 1938; PAFA, 1932, 1937 (prize), 1943, 1945; CGA, 1937, 1945; AIC, 1937, 1943; CI, 1941–45; WMA, 1936; Newport AA, 1941–45; Ogunquit A. Ctr., 1941; N.Y. State Exh., 1941; Springfield AL, 1929; Syracuse AA, 1940 (prize). Work: Musée de Grenoble, France; Univ. Ariz.; PAFA [47]

QUINLAN, Will J. [P] Yonkers, NY b. 29 Je 1877, Brooklyn, NY. Studied: J.B. Whittaker, Adelphi Col.; NAD, with Maynard, Ward. Member: SAE; Yonkers AA. Exhibited: SC, 1913 (prizes), 1914 (prize); Yonkers AA, 1932 (prize); Yonkers Mus. Sc. & A., 1939 Work: NYPL; Oakland Pub. Mus.; Yonkers Mus. Sc. & A. [40]

QUINN, Anne Kirby [P] Paris, France b. Hillsborough, OH. Studied: R. Miller, in Paris [15]

QUINN, Edmond T. [S,P] NYC b. 1868, Phila., PA d. 9 S 1929. Studied: Eakins, in Phila.; Injalbert, in Paris. Member: ANA; NSS, 1907; Arch. Lg., 1911; NIAL; Newport AA; New SA; Art Comm. Assn., N.Y. Exhibited: P.-P. Expo, 1915, San Fran. Work: Statue, Williamsport, Pa.; Brooklyn Inst A. & Sc.; King's Mountain Battle Mon., S.C.; E.A. Poe bust, Poe Park, Fordham, N.Y.; Pittsburgh Athletic C.; MET; Vicksburgh, Miss. Nat. Military Park; Gramercy Park, NYC; busts, BM; New Rochelle, N.Y.; bust, Hall of Fame; Gov. Venezuela [27]

QUINN, John [Patron] b. 1870, Tiflin, OH d. 29 Jy 1924, NYC. Member: MET. He conducted the campaign which resulted in the removal of all duty on modern works of art brought into this country, and was an organizer of the intl. exhibit of modern art (the Armory Show) held in 1913.

QUINN, John C. [P] St. Paul, MN [13]

QUINN, Robert Hayes [I,Gr] Mechanicville, NY b. 1 N 1902, Waterford, NY d. 3 S 1962, Biddeford, ME. Studied: Syracuse Univ.; PIASch. Exhibited: LOC, 1944, 1945; NAD, 1943–45; Albright A. Gal.; Hudson Valley A., Albany, Schenectady, Troy, N.Y. Contributor: Yankee, Trails. Position: Staff A., Trails mag., Esperance, N.Y. 1935–46 [47]

QUINN, Vincent Paul [P,Car] Chicago, IL b. 19 F 1911. Studied: AIC; Univ. Chicago. Work: Coll. Chicago Pub. Sch. AS [40]

QUINTANILLA, Luis [P,Gr,L] NYC b. 13 Je 1895, Santander, Spain. Studied: Jesuit Univ., Deusto, Spain; Gov. Traveling Fellowship, Italy. Exhibited: WFNY, 1939; Pierre Matisse Gal., 1934 (one-man); MOMA, 1938 (one-man); All.A.Am., 1939 (one-man); New Sch. Social Res.,

1940 (one-man); Knoedler Gal., 1944 (one-man) de Young Mem. Mus., 1944 (one-man); A. Am. Ar. Gal., 1939. Illustrator: "All the Brave," 1939, "Franco's Black Spain," 1945 "Gulliver's Travels," 1947, other books [47]

QUINTMAN, Myron [P,Et] Brooklyn, NY b. 8 Ag 1904, NYC. Studied: CUASch; Edu. All., NYC; Brooklyn A. Sch.; W. Auerbach-Levy. Exhibited: LOC, 1945, 1946; NAD, 1946; SAE, 1945; Laguna Beach AA, 1945; Newport AA, 1945; Northwest PM, 1946 [47]

QUINTON, W.W., Mrs. See Sage, Cornelia.

QUIRK, Francis Joseph [P,Des,T,W,L] Rydal, PA b. 3 Je 1907, Pawtucket, RI d. 1974. Studied: RISD; Univ. Pa.; J.R. Frazier; F. Sisson. Member: Phila. A. All.; Phila. AC; Am. Ar. Prof. Lg. Exhibited: PAFA; CGA; Buffalo; Portland, Maine; Providence, Newport, both in R.I.; RISD (prize); Providence AC (prize). Positions: T., Montgomery Sch. (1930–35; 1938–45), Ogontz Col., Pa. (1935–46); Mus. Dir. [47]

QUIRT, Walter W. [P,L,T] Milwaukee, WI b. 24 N 1902, Iron River d. 1968. Studied: Layton Sch. A., 1921–23. Member: An Am. Group; Am. A. Cong.; Artists Un. Exhibited: WPA, NYC, 1936. Specialty: social surrealism. Position: T., Layton Sch. A., 1924–29; Am. Artists Sch., NYC, 1940; Mich. State Col., 1940s; Univ. Minn., 1945–66 [47]

QUISTGAARD, Johann Waldemar de Rehling [Por.P] NYC b. 9 F 1877, Orsholtgaard, Denmark d. 12 D 1962, Copenhagen, Denmark. Studied: Denmark. Member: Chicago AC; N.Y. Genealogical & Biographical S.; SC. Exhibited: St. Louis World's Fair, 1904; Guild Hall A. Gal., London, 1907; Salon des Artistes Français, 1908, 1924–26; Royal Acad., Copenhagen, 1910; Royal Acad., London, 1908; Walker A. Gal., Liverpool, England, 1908, 1924; Ghent, Belgium, 1913; ASMP, 1912; Levy A. Gal., N.Y., 1921; Durand-Ruel, Paris, 1925, 1927 (one-man); Denver A. Mus., 1938; Women's C., Rockford, Ill., 1942; Chicago AC, 1943–46; Reinhardt A. Gal., 1914 (one-man); Rouillier Gal., Chicago, 1942 (one-man); A. Dir. C., 1944 (prize). Awards: Knight of Danneborg, Denmark, 1919; Chevalier, French Legion Honor, 1926. Work: Mus. of the Kings of Denmark, Copenhagen; Denver A. Mus.; St. John's Cathedral, Denver; Wash. Univ.; N.Y. Genealogical & Biographical S.; U.S. Dept. Agriculture; Smithsonian; U.S. Treasury Dept.; portraits of prominent persons [47]

Sketch of Carl Rungius by an unidentified artist. Private Collection

R

RAAB, Ada Dennett (Mrs. Sydney Victor) [P,W] NYC b. London, England d. 1950. Studied: London Univ.; F. Brown; W. Steer. Member: NAC; Wolfe AC. Work: Royal Acad., London [47]

RAAB, George [P,B,T,Mus.Cur] Decatur, Il b. 26 F 1866, Sheboygan, WI d. 24 S 1943, Milwaukee. Studied: R. Lorenz; Weimar Acad., Germany; Courtois, in Paris. Member: Wis. PS; Milwaukee AI (founder). Exhibited: Milwaukee AI, 1917. Work: St. Paul Inst.; Milwaukee AI. Position: Cur., Layton A. Gal., 1902–22 [40]

RAABE, Alfred [I] NYC b. 1872 d. 16 Ja 1913.

RABINO, Saul [P,G] Los Angeles, CA b. 8 Jy 1892, Odessa, Russia. Studied: Russian Imperial A. Sch.; Ecole des A. Decoratifs, Paris. Exhibited: Los Angeles Mus. Hist. Sc. A.; Laguna Beach AS; WFNY, 1939. Work: Los Angeles Pub. Lib. [40]

RABINOVITZ, Harold [P] NYC b. 1 F 1915, Springfield, MA. Studied: Yale. Member: Artists U. of Western Mass. Exhibited: Springfield AL, 1936 (prize) [40]

RABINOWITZ, Numa [P] Bronx, NY [25]

RABORG, Benjamin [Por.P,Ldscp.P] Active in San Fran., From ca. 1895. b. 1871, MO. d. 1918, killed by a cable car [*]

RABOY, Mac [P,G,C] NYC b. 9 Ap 1914, NYC. Studied: NY Sch. Indst. A.; PIASch. Member: United Am. A. Exhibited: AIC, 1937; NA, 1938; WFNY, 1939 [40]

RABUT, Paul [I,Des,P] NYC (Westport, CT, 1976) b. 6 Ap 1914, NYC. Studied: CCNY; NAD; ASL; J. Gottlieb; H. Dunn; L. Daniel. Member: SI. Exhibited: AIC, 1943; MET (AV), 1942; PAFA, 1941; SI, 1941–46; NAD, 1932 (med); A.Dir.Cl.; PMA; Springfield A. Mus.; 1943 (med), 1946 (med). Work: U.S. Army Medical Mus., Wash., D.C. Illustrator: nat. mags. [47]

RACHMIEL, Jean [P,E] NYC b. 10 My 1871, Haverstraw, NY. Studied: Brush, ASL; Paris, with Lefebvre, Laurens, Bonnât. Exhibited: Paris Salon, 1912 (med) [17]

RACHTOES, Matene (Mrs. Jo Cain) [P,Dec,Des,T,Li,L] Kingston, RI b. 13 Je 1905, Boston, MA. Studied: Mass. Normal A. Sch.; BMFA Sch.; Child Walker Sch. FA; Harvard Univ., F.; Fogg AM; F., Tiffany Fnd. Member: Conteporary A. Group; South County A.; Am. A. Cong. Exhibited: PMA; CGA; AIC; Providence Mus.; South County AA. Position: T., Mary Wheeler Sch., Providence, R.I. State Col. [47]

RACINE, Albert (Apowmuckon) [Woodcarver,P] Browning, MT (since 1961) b. 1907, Browning. Studied: W. Reiss; E.E. Hale, Jr.; A. Voision (French); C. Hutig (German); Puget Sound Col., ca. 1945. Blackfoot Indian painter from 1926; woodcarver from 1936. Work: Plains Indian Mus. [*]

RACKLEY, Mildred (Mrs. M.R. Simon) [Ser,P] Oakland, CA b. 13 O 1906, Carlsbad, NM. Studied: Univ. Tex.; N.Mex. Normal Univ.; Kunstgewerbe Schule, Hamburg, Germany; W. Ufer; G. Grosz. Member: Nat. Serigraph S. Work: MET; PMA; Springfield A. Mus.; Princeton Pr. C. Exhibited: Springfield AL, 1944–46; Denver AM; Newport AA, 1945, 1946; Laguna Beach AA, 1946; SAM; Mint Mus. A., 1946; MOMA, 1940; Nat. Serigraph S.; Oakland A. Gal.; AIC; Mus. N.Mex. [47]

RACKOW, Leo [I] NYC. Member: SI [47]

RACZ, André [E,Eng,P] NYC b. 21 N 1916, Cluj, Romania. Studied: Univ. Bucharest. Exhibited: Art of this Century, 1944; LOC, 1945, 1946; NAD, 1945; MOMA Traveling Exh., 1944–46; NYC, 1943 (one-man); Phila., 1945 (one-man). Author/Illustrator: books of engravings: "The Flowering Rock," 1943, "The Battle of Starfish," 1944, "Reign of Claws," 1945 [47]

RADBOURNE, William H. [Ldscp.P] b. 11 S 1838, Brooklyn (lived there until 1905) d. 23 Jy 1914, Orleans, NY

RADEKE, Eliza Green (Mrs.) [Edu,Patron] Providence, RI b. 1855, Augusta, GA d. 17 Mr 1931. Member: Bd. Dir., Am. Fed. Arts, since 1914. Her pictures, early Am. Furniture and a wide variety of objets d'art constitute an important part of the collections of the Eliza G. Radeke Mus., which was a gift to RISD. Position: Trustee, RISD (since 1889), Pres. (1913–31)

RADENKOVITCH, Yovan [Por.P,Mur.P,Arch,L,T,W] NYC/Gloucester, MA b. 11 My 1903. Work: BM; Yugoslav Legation, Wash., D.C.; SFMA; TMA. Contributor: articles on art to newspapers; Belgrade, Paris mags. [40]

RADER, Elaine Myers [P,B,T] Wichita, KS b. 13 N 1902, Ponca City, OK. Studied: Kopietz; Sandzen; Taft. Member: Wichita AG; Wichita AA; Kansas City AG [33]

RADER, Isaac [P] Detroit, MI b. 5 O 1906, Brooklyn, NY. Studied: Abramovsky; Kappes; Niles; Wicker; J. Marchand; Lhote. Member: Detroit AC. Exhibited: Toledo P., 1921 (prize); Detroit AI, 1926 (prize); TMA, 1930 [33]

RADER, Marcia A. [P,Dr,L,T,W] Sarasota, FA/Highlands, NC b. 6 O 1894, St. Louis, MO d. 6 N 1937. Studied: F. Oakes Sylvester; J.K. Wangelin; St. Louis Sch. FA. Member: Fla. Fed. Arts (pres.); AAPL; SSAL. Position: Art Ed., New State Course of Study for Florida; A. Dir., Sarasota H.S.; T., Ringling Jr. Col. [38]

RADFORD, Colin (Mrs.) [P] Seattle, WA [24]

RADITZ, Lazar [P] Phila., PA/Lincoln Univ., PA b. 15 Ap 1887, Dvinsk, Russia. Studied: W.M. Chase; Tarbell. Member: Phila. Alliance. Exhibited: Pan-P. Expo, San Fran., 1915 (med); NAD, 1918 (prize). Work: PAFA; Am. Philosophical S.; Dropsie Col.; Univ. Pa.; Baugh Inst. Anatomy; Acad. Nat. Sc.; Franklin Inst.; Col. Physicians; Temple Univ.; Free Lib.; Germantown Friends Sch.; Graphic Sketch C., Mercantile Lib., Phila.; Brown Univ.; Yale; State Capitol, Harrisburg; convent, Cornwalls Heights, Pa.; Rollins Col.; Fla. Position: T., Graphic Sketch C. [40]

RADITZ, Violetta C(onstance) [P] Phila., PA [25]

RADUE, Josephine Watt Lee (Mrs. Edward C.) [P] Wash., D.C./Blue Ridge Summit, PA b. 29 Mr 1910, Denver, CO. Studied: A. Otis; G.S. Foster. Member: So. County AA [40]

RAE, Frank B. [P] Cleveland, OH. Member: SC [25]

RAE, John [I,P,L,W] North Stonington, CT (1954) b. 4 Jy 1882, Jersey City, N.J. Studied: PIASch, 1900; ASL with H. Pyle, K. Cox, F.V. DuMond. Member: SI, 1912. Work: LOC. Author/Illustrator: "The Big Family," "The Pies and the Pirates," "Grasshopper Green and the Meadow Mice," "New Adventures of Alice," "Granny Goose," "Lucy Locket," "Why?" Illustrator: many books pub., Harper's, Macmillan, and others. Position: T., Cateau-Rose IA; Rollins Col. [40]

RAEMICH, Ruth (Mrs. Waldemar) [Enamel Painter] Providence, RI b. 7

Mr 1893, Berlin, Germany. Studied: Germany. Exhibited: CGA, 1943 (one-man); BMA, 1944; RISD, 1945; WMA; Syracuse MFA, 1941 (prize). Work: enamels: MET; RISD; IBM Coll. [47]

RAEMISCH, Waldemar [S,T] Providence, RI b. 19 Ag 1888, Berlin, Germany d. 16 Ap 1955. Exhibited: AIC, 1942; PAFA, 1946 (med); Phillips Acad., Andover, Mass., 1941; WMA, 1942; Buchholz Gal., 1941, 1945. Work: Cranbrook Acad. A.; FMA; Providence AM. Position: T., RISD, 1934– [47]

RAFFAELLI, Gino [P] Los Angeles, CA. Member: Calif. AC [25]

RAFFEL, Alvin R. [P] Dayton, OH b. 25 D 1905, Dayton. Studied: Chicago Acad. FA; AIC. Member: Dayton S. P.&S. Exhibited: Pepsi-Cola, 1945; CI, 1946; Dayton AI, 1933, 1935–43, 1945. Work: Dayton AI [47]

RAGAN, Henry, Mrs. See Waldvogel, Emma.

RAGAN, Leslie Darrell [I,P] NYC b. 29 N 1897, Woodbine, IA. Studied: Cumming Sch. A.; AIC; Chicago Acad. FA. Member: SC; Allied Ar. Am.; SI; A. Gld.; AAPL; A. Fellowship. Exhibited: Phila. A. All., 1940; AIC, 1940; WFNY, 1939; NAD; All.A. Am., 1939; Boston AC; SC; SI. Work: Posters, N.Y. Central R.R., Norfolk & Western R.R. [47]

RAHMING, Norris [P,E,L,T] Gambier, OH b. 1 My 1886, NYC d. Jy 1959. Studied: NAD; ASL; N.Y. Sch. A.; E. Carlsen; W. Chase; R. Henri; H.G. Keller. Member: CAA; Cleveland SA; Columbus AL. Exhibited: CMA, 1925, 1926 (prize), 1927 (prize), 1928 (prize), 1929 (prize), 1930–37; CGA; PAFA; CAM; Great Lakes Exh., 1937; Columbus AL, 1938, 1939. Work: CMA; Newark Mus.; City of Cleveland Coll.; Cleveland YMCA; Senate Office Bldg., Wash., D.C.; Am. Embassy, Paris; murals, USPO, Gambier (Ohio), Rocky River (Ohio) Pub. Lib.; Bd. Ed. Bldg., Cleveland. WPA muralist. Position: T., Kenyon Col., Gambier, from 1936 [47]

RAHN, A. Donald [P] Brooklyn, NY. Member: GFLA [27]

RAHN, Irving [P] Milwaukee, WI. Member: Wis. PS [25]

RAHTJEN, Fitzhugh [P] San Fran., CA [17]

RAIKEN, Leo [P] Brooklyn, NY. Exhibited: 48 States Comp., 1939 [40]

RAINE, Earle Thomas [P] Thiensville, WI b. 9 Ag 1911, Penns Grove, NJ. Studied: Layton Sch. A. Member: Wis. P.&S.; Wis. Ar. Fed. Exhibited: Grand Rapids A. Gal., 1940; PAFA, 1940, 1941, 1946; AIC, 1936, 1938–40; WFNY, 1939; Denver AM, 1936–38; CM, 1940, 1941; Wis. P.&S., 1935–42, 1946; Layton A. Gal., 1936, 1938, 1940, 1946, 1939 (one-man), 1944; Univ. Wis., 1935–40; 48 States Comp., 1939 Work: Layton A. Gal. WPA artist. [47]

RAINES, Minnie [P] Memphis, TN [25]

RAINEY, Robert E.L. (Réni) [P,Ser,Des,T] North Canton, OH b. 25 D 1914, Jackson, MS. Studied: Univ. Chicago; AIC; F. Chapin; B. Anisfeld. Member: Am. S. for Aesthetics; Vanguard PM Group. Exhibited: Northwest PM, 1945 (prize); Canton AI, 1946 (prize). Exhibited: AIC, 1938, 1940, 1942, 1944, 1946; Providence AC, 1945; Massillon Mus., 1945; Canton AI, 1946 (one-man). Work: SAM [47]

RAISBECK, J.J. [P] Swissvale, PA/Pittsburgh, PA. Member: Pittsburgh AA [25]

RAKEMAN, Carl [P,I,Dec,Des,E] Chevy Chase, MD b. 27 Ap 1878, Wash., D.C. Studied: Munich, Düsseldorf, Paris. Member: Ten Painters of Wash. Exhibited: CGA; S. Wash. A. Sesqui-Centennial Expo, 1926 (gold); General Motors Bldg., WFNY, 1939. Work: U.S. Capitol Bldg.; Hayes mem., Fremont, Ohio; Kenyon Col., Bambier, Ohio; U.S. Soldiers Home, Tenn.; State House, Columbus, Ohio; U.S. Court House, Dallas, Tex. [47]

RALEIGH, Charles Sidney [Mar.P] 1830, Gloucester, England d. 28 Mr 1925, Bourne, MA. Studied: self-taught. Work: Kendall Whaling Mus.; Mariner's Mus.; Mystic Seaport Mus.; Peabody Mus.; Old Dartmouth, Hist. Soc. A sailor since boyhood he settled in New Bedford, Mass. by 1870s; moved to Monument Beach, Mass., 1881. [*]

RALEIGH, Henry [E,I,Li] NYC b. 23 N 1880, Portland, OR. Studied: Hopkins Acad., San Fran. Member: Alliance; Artists G.; SC; SI; Coffee House C. Exhibited: SC, 1916 (prize); Ad. Art in America Comp., 1927 (gold). Illustrator: Saturday Evening Post, Cosmopolitan [40]

RALL, (Mrs.) [P] Los Angeles, CA. Member: Calif. AC. Affilated with Evening Express [25]

RALPH, Lester [P,E,I] NYC b. 19 Jy 1877, NYC d. 6 Ap 1927. Studied: ASL; Slade Sch., London; Académie Julian. Illustrator: "Eve's Diary," Mark Twain [25]

RALSTON, J(ames) K(enneth) [P,S,I,W] Billings, MT (1976) b. 31 Mr 1896, Choteau, MT. Studied: AIC, 1917, 1920. Exhibited: Yellowstone Gal., 1944; Billings, Mont., 1945 (one-man). Work: murals, Western Airlines, Billings; Cheyenne, Wyo.; Noble Hotel, Lander, Wyo.; Wort Hotel, Jackson, Wyo.; WPA murals, USPO, Sturgis, S.Dak., Sidney, Mont. Best known for his 4½' x 18' "After the [Custer] Battle," exhibited nationally and in Europe. [47]

RALSTON, Louis [Dealer] d. 28 Ag 1928, Point Pleasant Beach, NJ. Member: Lotos C.; Sons of the Am. Revolution. He had been an art dealer for thirty years, specializing in old masters, Barbizon and English paintings.

RAMBERG, Lucy Dodd (Mrs.) [P] d. 1929, Florence, Italy. Position: Hd., Lucy Dodd Sch. for American Girls

RAMBUSCH, Frode C.W. [P,Dec] b. 1860, Denmark (came to U.S., 1899) d. 19 O 1924, Brooklyn, NY. Work: Cathedrals in Baltimore, Md., Scranton, Pa., Erie, Pa., Buffalo, N.Y. Award: knighted by the King of Denmark, 1916

RAMEY, George [P] Atlanta, GA. Exhibited: SSAL, 1937, 1939; WFNY, 1939 [40]

RAMON, Adolpho [S] NYC. Studied: Mrs. H.P. Whitney [19]

RAMSAY, Milne [P] Atlantic City, NJ b. 1847 d. 16 Mr 1915, Phila. Studied: PAFA, before 1876. Specialties: still life; portraits [04]

RAMSAYE, Fern Forester (Mrs.) [I] b. 1889, Poplar Bluffs, AR d. 25 Ag 1931, South Norwalk, CT. Studied: St. Louis Sch. FA; Phila. Sch. FA; Art Inst., Versailles, France. Illustrator: adv. agencies, N.Y. magazines

RAMSDELL, Fred Winthrop [Ldscp.P,Por.P] Manistee, MI b. 1865 d. 27 My 1915. Studied: ASL, with C. Beckwith; Paris, with R. Collin. (After several years spent in France and Italy he returned to join the colony of painters at Lyme, Conn.)

RAMSDELL, Katherine [P] Woburn, MA [01

RAMSDELL, M. Louise (Lee) [P] Housatonic, MA b. Housatonic. Studied: Univ. Calif.; Smith Col.; ASL; Grand Central Sch. A.; Vienna; W. Adams; G. Luks. Member: All.A.Am.; NAWA; PBC; NAC; Pittsfield AL; Springfield AL. Exhibited: NAD, 1941, 1943; PBC, 1944 (prize); NAWA; All.A.Am., 1941–46; Portraits, Inc., 1942; St. Petersburg, Fla. AC, 1937 (prize); NAC, 1943–46; Pittsfield AL, 1934–46 [47]

RAMSEUR, Mary D. [P] Spartanburg, SC [24]

RAMSEY, Charles F. [P] New Hope, PA [13]

RAMSEY, Edith [S] Brooklyn, NY b. 2 O 1889, Ogden, UT. Studied: K.H. Gruppe. Member: NAWPS; Allied AA. Exhibited: Palm Beach A. Ctr., 1935 [40]

RAMSEY, Lewis A. [P,S] Hollywood, CA b. 24 Mr 1873, Bridgeport, IL. Studied: Utah, with J. Hafen; AIC, 1890; D. Volk; Académie Julian, with Laurens, Bouguereau, 1897–03. Member: Southern Calif. Artists. Work: murals, Latter Day Saints Temple, Hospital and State Capitol (Salt Lake City), Mun. A. Coll. (Ogden), Brigham Young Univ. (Provo), churches, all in Utah; Ohio State Univ., Columbus; Latter Day Saints Temple, Laie, Hawaii. Position: T., Latter Day Saints Univ., 1903–05 [40]

RAMUS, Charles Frederick [B,Dr,En,I,Li,P,L,T,W] Denver, CO b. 9 S 1902, Denver. Studied: J.E. Thompson; Denver Acad. Appl. A. Member: Cleveland PC. Work: CMA; Denver AM; Denver Pub. Lib.; Columbus Gal.; Allen Mem. AM, Oberlin Col.; CAM; Conn. Col.; Dayton AI; Cincinnati AM. Contributor: Rocky Mountain News, Cleveland Year Book [40]

RAMUS, Michael [P] San Fran., CA. Exhibited: 48 States Comp., 1939 [40]

RANCH, Mildred [P] Cincinatti, OH. Member: Cincinnati Women's AC [21]

RAND, Ellen G. Emmet (Mrs. William B.) [Por.P] NYC/Salisbury, CT b. 4 Mr 1876, San Fran. d. 18 D 1941. Studied: NYC; Paris. Member: NAD, 1926; NA, 1934; NAWPS; Portrait P. Exhibited: St. Louis Expo, 1904 (med); P.-P. Expo, San Fran., 1915; Buenos Aires Expo, 1910 (med); PAFA, 1922 (gold); NAWPS, 1927 (prize). Work: MET [40]

RAND, Helen [S,Dr,T] NYC b. 28 Ap 1895, NYC. Studied: S. Borglum, Bourdelle; R. Laurent. Work: Vassar Col. [40]

RAND, Henry A(sbury) [P] Holicong, PA b. 1 Ap 1886, Phila., PA. Studied: PAFA, with Chase, Anshutz, Breckenridge. Member: Phila. Sketch C. Work: PAFA [40]

RAND, Margaret A(rnold) [P,T] Cambridge, MA b. 21 O 1868, Dedham, MA d. 17 Mr 1930. Studied: E.D. Norcross, C. Goodyear, G.H. Smillie; H.W. Rice. Member: Copley S., 1894. Work: Boston AC [29]

RAND, Paul [Des,W,P,T] NYC b. 15 Ag 1914, NYC. Studied: PIASch; Parson Sch. Des.; ASL. Member: AIGA; A. Dir. C. Exhibited: AIGA, 1938 (prize), 1942; A. Dir. C., 1936–44, 1945 (med), 1946. Work: NYPL; MOMA. Author/Illustrator: "Thoughts on Design," 1946. Contributor: art mags./trade pub. Positions: A. Dir., Esquire, 1937–41; Wm. Weintraub Adv. Agency, from 1941; Book Des., leading publishers [47]

RANDALL, A.G. [P] Wash., D.C. Member: Wash. WCC. Exhibited: Wash. WCC, 1898 [98]

RANDALL, Asa Grant [P,B,T] Providence, RI/Boothbay Harbor, ME b. 1869, Waterboro, ME. Studied: H. Helmick; A. Dow; A.H. Munsell; PIASch. Member: Providence AC; Providence WCC; R.I. Assn. T. Drawing and Manual Arts; Quinsnicket P.; Commonwealth A. Colony, Boothbay Harbor, Maine (founder). Positions: T., Classical H.S. (Providence), A.K. Cross Sch. [40]

RANDALL, Byron [P,En,T] San Fran., CA b. 23 O 1918, Tacoma, WA. Studied: Salem Fed. A. Ctr., Ore.; C.V. Clear; L. Bunce. Member: San Fran. AG; San Fran. AA; Council All.A., Los Angeles. Exhibited: BMA, 1939; SFMA, 1946; Herron AI, 1946; Univ. Oregon, 1942; Los An. City Col., 1942; AC Cal., Los An., 1943, 1945; Raymond & Raymond Gal., San Fran., 1943, 1945; Little Gal., Los A. 1944; SAM, 1941; Whyte Gal., 1939. Work: SFMA; PMG [47]

RANDALL, D. Ernest [P,I] San Fran., CA b. 20 Je 1877, Rush Co., IN. Studied: AIC, with Vanderpoel, Hubble. Member: ASL, Chicago; Art Workers' G., St. Paul; Minn. State Art S. [24]

RANDALL, Darley, Mrs. See Talbot, Grace.

RANDALL, Eleanor Elizabeth [P,T] Boston, MA b. Holyoke, MA. Studied: Wheaton Col.; BMFA Sch.; Boston Univ. Member: CAA; Rockport AA; North Shore AA. Exhibited: Boston AC; Springfield AL; Rockport AA; North Shore AA; Jordan Marsh Gal. Positions: T., Wheaton Col., Norton, Mass., 1926–42; Div. Edu., BMFA, Boston [47]

RANDALL, Emma F. Leavitt [Por.P] Phila., PA b. Phila. Studied: PAFA, with W.M. Chase, W. Sartain [13]

RANDALL, George Archibald [G,L] Ventura, CA b. 2 D 1887, Berkeley, CA. Studied: Univ. Calif. Exhibited: Bachman Gal., Los Angeles, 1939. Illustrator: Spur, 1939. Specialty: horses [40]

RANDALL, James [P] Syracuse, NY [01]

RANDALL, L.C. [P] Columbus, OH. Member: Pen and Pencil C., Columbus [25]

RANDALL, Paul A. [Ldscp.P] Indianapolis, IN b. 29 S 1879, Warsaw, Poland d. 19 My 1933. Studied: W. Forsyth; C.A. Wheeler. Member: Indiana AC; Brown County Gal. Assn. [31]

RANDALL, Ruth Hunie (Mrs.) [T,C,W,S,L] DeWitt, NY b. 30 S 1896, Dayton, OH. Studied: Cleveland Sch. A.; Syracuse Univ.; F. Reeves; R. Obsieger; Vienna, Kunstgewerbeschule. Member: Am. Ceramic S.; L. Am. Pen Women; Syracuse AA; Syracuse Daubers. Exhibited: Syracuse MFA, 1932–42, 1937 (prize), 1938 (prize), 1939 (prize); Cranbrook Acad. A., 1946; WFNY, 1939; GGE, 1939; Paris Salon, 1937; MET; Phila. A. All., 1936 1942–45; Finger Lakes Exh., Rochester, Utica N.Y.; Youngstown, Ohio, Kansas City, Mo., ceramic exh., Scandinavian countries.; Syracuse AA, 1939 (prize); Robineau Mem. Exh., 1932. Work: IBM Coll.; Syracuse MFA; San Antonio Mus. A. Contributor: Craft Horizons & Design mags. Specialty: ceramics. Position: T., Syracuse Univ. [47]

RANDALL, Theodore Amossa [S,I] Brooklyn, NY b. 18 O 1914, Indianapolis, IN. Studied: Herron AI; Yale; Am. Acad., Rome. Exhibited: Yale; Grand Ctr. A. Gal.; Va. Bldg., WFNY, 1939 [40]

RANDOLPH, Grace Fitz See Fitz-Randolph.

RANDOLPH, Lee F. [P,E,L,T] San Fran., CA b. 3 Je 1880., Ravenna, OH. Studied: Cincinnati A. Acad.; ASL, with Cox; Paris, with Ecole des Beaux Arts, Académie Julian, Lhote. Member: San Fran. AA; Bohemian C.; Calif. S. E. Exhibited: Pan-P. Expo, San Fran., 1915 (med); San Fran AA, 1919 (med). Work: Luxembourg, Paris. Position: Dir., Calif. Sch. FA [40]

RANDOLPH, Mary [S] Chicago, IL [13]

RANGER, Henry W(ard) [Ldscp.P] NYC b. 29 Ja 1858, Syracuse, NY d. 7 N 1916. Studied: self-taught. Member: AWCS; ANA, 1901; NA, 1906; Lotos C; NAC; Rochester AC. Exhibited: Paris Expo, 1900 (med); Pan-Am. Expo, Buffalo, 1901 (med); Charleston Expo, 1902 (gold); AAS, 1907 (gold); NAD, 1887–95. Work: MMA; CGA; CI; TMA; Buffalo FA Acad.; NGA; PAFA; Brooklyn Inst. Mus.; Montclair AM, N.J. Important leader of the "tonalists" or "American Barbizon," he was also a great influence at Old Lyme colony, 1899–04 and in Noank, Conn., ca. 1902–14. Bequeathed his collection and $400,000 to NAD to buy paintings to be donated to U.S. museums. [15]

RANKEN, William B.E. [P] NYC [17]

RANKIN, Dorothy Taylor [P] Wash., D.C. [24]

RANKIN, Ellen Houser [S] Chicago, IL b. 1863, Atlanta, IL. Studied: AIC; Fehr Sch. Munich [01]

RANKIN, Myra Warner (Mrs. Leonard) [P,S,Des,C,I,B,T] New Hartford, CT b. 7 Je 1884, Roca, NE. Studied: AIC; W. Reiss; H. Riess; Univ. Nebr. Member: S. Conn. Craftsmen. Position: T., Hartford YWCA Craft Workshop [40]

RANN, Vollian Burr [P] Provincetown, MA b. 28 Ap 1897, Wilmington, NC d. 23 Ja 1956. Studied: Corcoran Sch. A.; NAD; Hawthorne. Member: Provincetown AA. Exhibited: CGA; PAFA, 1928, 1937; NAD, 1930, 1931; Phila. A. All.; All. A. Am.; Provincetown AA, 1923–46; Piedmont Festival, N.C.; Univ. Ill. [47]

RANNELLS, Will [I,P,T] Columbus, OH b. 21 Jy 1892, Caldwell, OH. Studied: Cincinnati A. Acad. Member: Artists G.; Columbus AL; Ohio WCS; NYWCC. Exhibited: Phila. WCC; AWCS. Author/Illustrator: "Animal Picture Story Book," pub. Saalfield Co., 1938. Illustrator: "Animals Baby Knows," 1938, "Farmyard Play Book," 1940; Life, Judge, McCalls, Country Gentleman, other magazines. Specialties: dog portraits; radio broadcasts. Position: T., Ohio State Univ. [47]

RANNEY, Glen Allison [P,T] Minneapolis, MN b. 4 S 1896, Hustler, WI d. 11 Ja 1959. Studied: Minneapolis Sch. A.; ASL; A. Angarola; R. Lahey; C. Booth; G. Luks. Member: Minn. AA. Exhibited: CM, 1937, 1938; PAFA, 1937, 1938, 1941; CGA, 1939; AIC, 1925, 1937, 1938; Kansas City AI, 1938–40; Davenport, Iowa, 1940; Minn. Inst. A., 1923 (prize), 1936–46, 1937 (prize), 1943 (prize); Minn. State Fair, 1923 (prize), 1936 (prize), 1937, 1938, 1939 (prize), 1940–42, 1943 (prize), 1944 (prize); ; Minneapolis Women's C., 1935 (prize), 1936–46; St. Paul A. Gal., 1940–46; No. 10 Gal., NYC, 1941 (one-man). Work: Minneapolis Inst. A.; Cape May Court House; Univ. Minn. U.S. Marine Hospital, Carville, La. WPA artist. [47]

RANNUS, A.W. [S] NYC. Member: S.Indp.A. [25]

RANSOM, Caroline L. Ormes [Por.P,Ldscp.P] Wash., D.C. b. 1838, Newark, OH d. 12 F 1910. Studied: Oberlin Col.; NYC, with A.B. Durand, Huntington; Munich, with Kaulbach. Member: D. Am. Rev. (founder); Classical C., Wash. Work: U.S. Capitol. Active in Sandusky, OH, 1858–60; Cleveland; NYC; finally settling in Wash., D.C. [*]

RANSOM, Fletcher C. [I] NYC. Member: SI 1903 [19]

RANSOM, Louis Liscolm [P] b. 23 Ja 1831, Salisbury Corner, NY d. ca. 1926, Cuyahoga Falls, OH. Studied: NYC, with P. Gray, 1851. Active in Rome, Lansingburg, and up-state N.Y., 1860s; Akron, OH, 1884. Best known for his "John Brown on His Way to the Scaffold." [*]

RANSOM, Ralph [P] St. Joseph, MI b. 5 F 1874, St. Joseph. Studied: AIC; Chicago A. Acad., with J.F. Smith; Acad. Delecluse, Paris [06]

RANSOM, William A. [Dealer,Patron] Los Angeles, CA b. 1856, Rochester, NY d. 17 O 1919

RANSON, Nancy Sussmann (Mrs.) [P] Brooklyn, NY b. 13 S 1905, NYC. Studied: PIASch.; N.Y. Sch. F.& Appl. A.; ASL; Laurent; Charlot; Brook. Member: NAWA; Brooklyn AS. Exhibited: AWCS, 1940, 1942, 1943; NAWA, 1943–46; Brooklyn SA, 1941–46; "Tomorrow's Masterpieces" Exh., 1943; Long Island A. Festival, 1946; Argent Gal.; Ferargil Gal. [47]

RAOUL, Margaret Lente (Mrs.) [B,Dr,L,T,W] Navesink, NJ b. 3 S 1892, Saratoga, NY. Studied: B. W. Clinedinst; F. Dielman; D. Rivera; A. Lewis. Illustrator: The London Mercury. Contributor: articles, American Magazine of Art, Parnassus, The Bookman [40]

RAPER, Edna [P] Pleasant Ridge, OH. Member: Cincinnati Women's AC [25]

RAPETTI, John [S] Weehawken, NJ b. 1862, Como, Italy d. 22 Je 1936. Studied: Milan; Paris, assisted Bartholdi casting the statue of Liberty. Work: busts, statues and mems. Came to U.S. in 1889 to assist W.O. Partridge on exhibits for the Columbian Expo, 1889.

RAPHAEL, Frances (Mrs. Nicholas D. Allen) [P] San Angelo, TX/Brooklyn, NY b. 3 My 1913, San Angelo, TX. Studied: X. Gonzalez; R. Staffel. Member: SSAL [40]

RAPHAEL, Joseph [P] San Fran., CA/Uccle, Belgium. b. 1872, Jackson, CA. Studied: San Fran. AA; Beaux-Arts, Académie Julian, Laurens, all in Paris. Exhibited: Paris Salon, 1915; P.-P. Expo, San Fran., 1915 (med); San Fran. AA (prize), 1918 (gold). Work: Golden Gate Park Mus.; San Fran. AA [40]

RAPHAEL, Samuel [P] NYC. Member: GFLA [27]

RAPP, Ebba [P] Seattle, WA. Exhibited: Women P., Wash., 1937 (prize); Northwest PM, Seattle AM, 1937; WFNY, 1939 [40]

RAPP, George [I] NYC. Member: SI

RAPP, Lois [Por.P,E,I,Dr,T] Norristown, PA b. 21 Mr 1907, Norristown. Studied: PMSchIA. Work: Phila. A. Alliance, 1937 [40]

RAPPAPORT, Maurice I. [P] NYC. S.Indp.A. [25]

RAPPLEYE, Eva [P,Des,T] Jersey City, NJ/Orr's Island, ME b. Interlaken, NY d. ca. 1955. Studied: MMA Sch.; ASL; K. Cox; B. Burroughs; G. Bridgman; G.P. Ennis; O. Julius. Member: PBC; Gotham Painters; Wolfe AC; Flower P. Gld. Exhibited: WFNY, 1939; PBC, 1944–46; Wolfe AC, 1944–46; Gotham Printers, 1944–46; Wolfe AC, 1936, 1937 [47]

RASARIO, Ada. See Cerere.

RASCHEN, Henry [P,T] Oakland, CA (from 1906) b. ca. 1854, Oldenburg, Germany (came to Ft. Ross, CA, 1868) d. ca. 1937. Studied: San Fran. AA, with V. Williams; Munich, with Loefftz, Striehuber, Barth, Dietz. Member: Bohemian C., San Fran. Exhibited: Munich Expo, 1898 (gold). Specialty: Indians (1883–90). Position: T., Munich, 1890–94 [*]

RASCHEN, Carl Martin [P,I,E,T] Rochester, NY b. 17 D 1882. Studied: Rochester Atheneum; G. Gaul; Mechanics Inst. Member: Rochester AC; Brush & Pencil C.; Beach Combers, N.J.; Woodstock AA. Work: Univ. Rochester. Illustrator: magazines, newpapers, books. [47]

RASCOVICH, Roberto Benjamine [P,Woodcarver] Chicago, IL b. 1857, Spalata, Dalmatia d. 29 O 1905. Studied: Imperial Acad., Vienna; Royal Acad., Venice; Ecole des Beaux-Arts, Paris; Rome. Member: Intl. S., Rome; WCS, Rome. Exhibited: Rome WCS (med); Chicago, 1897 (prize); Columbian Expo, 1893 (prize) [01]

RASKIN, Joseph [P,E,T,W] NYC b. 14 Ap 1897, Nogaisk, Russia. Studied: NAD. Member: Am. A. Cong.; F., Tiffany Fnd., 1921. Exhibited: A. Am., 1945; Tricker Gal., 1939; Schneider-Gabriel Gal., 1941; Steinway Hall, 1942; CGA; CI; PAFA; VMFA; NAD; SAE; Schervee Gal., Boston, 1927. Work: Dept. Labor Bldg., Wash., D.C.; Dartmouth Col. Lib. Author: "Portfolio of Etchings of Harvard University" [47]

RASKIN, Saul [Et,Li,P,Car,I,W,L,T] NYC b. 15 Ag 1878, Nogaisk, Russia. Member: AWCS; SAE; Audubon A.; NYWCC. Exhibited: AIC (prize); Phila. Pr. C. (prize); SAE (prize). Work: MET; BM; AIC; Pittsfield Mus. A.; CAM; VMFA; NYPL; LOC; Houston MFA; Brooks Mem. A. Gal.; Newark Mus., Lib.; Charleson Mus., S.C. Illustrator: "The Genesis," "The Book of Psalms," "The Hagadah." Author: "Palestine in Word and Picture." [47]

RASKO, Maxmilian Aurel Reinitz [Por.P,L,G,T] NYC b. 13 Je 1883, Budapest, Hungary d. 25 Ap 1961, Spring Valley, NY. Studied: RA, Munich, Germany; Académie Julian; Acad. FA, Rome; Royal Indst. Acad., Transylvania; Normal Sch., Budapest; RA, Dresden; Acad. FA, Vienna. Member: Audubon A.; AAPL; Am. Ar. Prof. Lg. Exhibited: Audubon A.; Budapest, 1903 (prize); Intl. Expo, Bordeaux, France, 1927 (prize). Work: Nat. Democratic C.; U.S. Treasury Dept., Wash. D.C.; The Vatican, Rome; private coll., Europe, America. Illustrator: "The Mysteries of the Rosary." [47]

RASMUSEN, Henry Neil [P,S,T,W,G] Austin, TX/Salt Lake City, UT b. 20 Ap 1909, Salt Lake City. Studied: AIC; Am. Acad. A., Chicago. Member: Utah State Inst. FA; Am. Ar. Cong. Exhibited: WFNY 1939; AIC, 1939, 1940; Am.A.Cong., 1939; Utah State A. Ctr., 1939, 1941; Denver A. Mus., 1940; Portland A. Mus.; San Diego FAS; Oakland A. Gal.; Santa Barbara Mus. A.; Kansas City AI; Utah State Fair, 1937 (prize). Work: Utah State Fair Assn.; Utah State Inst. FA; Brigham Young Univ.; Denver A. Mus.; IBM Coll.; murals, Utah State Capitol Bldg.; Utah State A. Ctr. Position: T., Utah State A. Ctr., 1940 [47]

RASMUSSEN, Bertrand [P] Brooklyn, NYC b. 8 O 1890, Arendal, Norway. Studied: Laurens, Paris. Member: Brooklyn WCC [25]

RATHBONE, Charles Horace, Jr. [P,E,T,W] NYC/Concarneau, France b. 25 N 1902, NYC d. 22 F 1936, FL. Studied: ASL; H. Lever. Member: NAC; "The Fifteen" (founder); SC; Artists Fellowship Assn.; Union Artistique de la Bretagne, France; Allied Artists of America. Work: BM; private colls., France, U.S. Author: "It's the Climate," 1936, illus. with linoleum cuts by his wife. [33]

RATHBONE, Charles H., Jr., Mrs. See Moore, Martha.

RATHBONE, Edith K. [S] NYC. Member: S.Indp.A. [24]

RATHBONE, Perry Townsend [Mus.Dir,Executive] NYC/Cambridge, MA (1985) b. 3 Jy 1911, Germantown, PA. Studied: Harvard. Member: Assn. A. Mus. Dir. Positions: Cur., Detroit AI, 1936–40; Sec., Dir., "Masterpieces of Art," WFNY 1939; Dir., CAM, St. Louis, Mo., 1940; Dir., BMFA; Exec. VP & Mus. Liason for Christies, 1985 [47]

RATHBONE, Richard Adams [P,L,T] New Haven, CT b. 6 N 1902, Parkersburg, WV. Studied: Yale; NY Sch. F.&Appl.A., Paris. Member: New Haven PCC; Parkersburg A. Ctr.; Assn. Conn. Ar. Work: Yale. Position: T., Yale [47]

RATHBUN, Helen R. [P] St. Louis, MO. Member: SWA [15]

RATHBUN, Richard [Mus.Dir,W] Wash., D.C. b. 25 Ja 1852, Buffalo, NY d. 16 Jy 1918. Studied: Cornell; Harvard, with Agassiz. Position: Dir., Nat. Mus., 1898–18

RATHBUN, Seward Humet [P,T,W,Arch] Wash., D.C. b. 18 Ja 1886, Wash., D.C. Studied: Harvard. Member: Wash. WCC; AWCS; AIA. Exhibited: AWCS; Wash. WCC, annually; Stanford Univ. (one-man). Author: "A Background to Architecture," 1926. Contributor: articles, Encyc. Social Sciences; "Pencil Points," Classic Art, Near Eastern [47]

RATKAI, George [P,I,Li] NYC b. 24 D 1907, Budapest, Hungary. Member: AL Am. Exhibited: Pepsi-Cola, 1945, 1946; Springfield Mus. A., 1946; Assn. Am. A., 1945, 1947; AL Am., 1944; Hungarian A. in Am., 1944. Work: Abbott Laboratories Coll. Illustrator: Collier's, Good Housekeeping [47]

RATKAI, Helen [P] NYC b. 5 Jy 1914, NYC. Studied: Y. Kuniyoshi, ASL. Member: AL Am. Exhibited: PAFA, 1942; SFMA, 1942; AV, 1942; MOMA, 1942; AIC, 1943; "Tomorrow's Masterpieces" Exh., 1943; Wildenstein Gal., 1941, 1942; Marquie Gal., 1943; Peiken Gal., 1944; Assn. Am. A., 1943–45; New-Age Gal., 1945, 1946; NYPL, 1944; Pepsi-Cola, 1946 [47]

RATLIFF, Blancho Cooley (Mrs. Walter B.) [P] Atlanta, GA b. 26 My 1896, Smithville, TX. Studied: O.B. Jacobson; D.B. Cockrell. Member: Les Beaux-Arts, Norman, Okla.; Ft. Worth Painter. Work: Univ. Okla. [33]

RATTERMAN, W.G. [P] NYC. Member: AG [31]

RATTI, Gino A. [S] b. 1882, Italy (came to U.S. ca. 1907) d. Ap 1937, Wash., D.C. Studied: stonecarving, Carrara, Italy. Work: figures on Supreme Court and Archives Bldgs., Wash., D.C.; Roosevelt Mem. Bldg., NYC; Michigan Ave. Bridge, Chicago.

RATTNER, Abraham [P] NYC b. 8 Jy 1895, Poughkeepsie, NY d. 1978. Studied: Corcorans Sch. A., 1914; PAFA, 1917, 1919; Ecole des Beaux-Arts, Académie Julian; Grande Chaumière. Exhibited: PAFA, 1941–44, 1945 (med), 1946; CI, 1943–46; CGA, 1943–46; AIC; BMFA; MOMA, 1945; WMAA; SFMA; Santa Barbara Mus. A.; Pepsi-Cola 1946 (prize); La Tausca Pearls Exh., 1947 (prize); Phila. A. All.; BMA; Pal. Leg. Honor; New Orleans A. & Crafts; Chicago AC; NGA; VMFA; CAM; Iowa State Univ.; Salon d'Automne, Salon des Tuileries, Salon des Indépendants, Paris; Univ. Ill., 1952 (retrospective); AFA Traveling Exh., 1960–61. Work: U.S. State Dept.; MOMA; WMAA; PAFA; Albright A. Gal.; AIC; BMA; Ft. Worth AA; Encyclopaedia Britannica Coll.; Pepsi-Cola Coll.; Clearwater A. Mus.; PMG. Active in Paris, 1918–40. Positions: T., Yale (1952–53), New Sch., NYC (1947–55), BM (1950–51), ASL (1954), PAFA (1954) [47]

RATZKA, Arthur L. [P] NYC b. 24 S 1869, Andrejova, Hungary. Studied: Acad. Vienna; Munich Acad.; S. Hollosi, Munich. Member: All.A.Am. Exhibited: NAD, 1930 (prize), 1931, 1945; All.A.Am., 1932–46 [47]

RATZKER, Max [S] NYC. Member: WFNY, 1939 [40]

RAU, V.B. [P] Brooklyn, NY/Provincetown, MA [25]

RAU, William [P,I] Kew Gardens, NY b. 1874, NYC. Studied: Chase; E.M. Ward; NAD. Member: Intl. SAL; AAPL; Nassau County SA. Work: Douglas Co. C.H., Omaha, Nebr.; St. Matthews' Church, Hoboken, N.J.; panels, Melrose Pub. Lib., NYC; High Bridge Pub. Lib., NYC; Patio Theatre, Brooklyn, NY; Keith Theatre, Richmond Hill, N.Y.; Pt. Wash. Theatre, Pt. Wash., N.Y.; Fantasy Theatre, Rockville Ctr., N.Y.; Bliss Theatre, Woodside, N.Y.; Bushrock Savings Bank, Brooklyn [40]

RAU, William H. [Photogr] Phila, PA b. 1855 d. 20 N 1920. Member: U.S. expedition which circled the earth in 1874 to observe the transit of Venus.

RAUCHFUSS, Marie. See McPherson, Mrs.

RAUGHT, John Willard [Ldscp.P] Dunmore, PA b. S 1857, Dunmore d. Ja 1931. Studied: NAD; Académie Julian. Member: SC, 1902; AFA. A memorial to him was established in the Everhart Mus., Scranton, Pa. [31]

RAUL, Harry Lewis [S,Mus.Cur,L,T,W,En,Des] Wash., D.C. b. Easton, PA. Studied: N.Y. Sch. A.; ASL; PAFA; W. Chase; F. DuMond; C. Grafly; F.E. Elwell. Member: AAPL; AA Mus.; Min. PS&G S., Wash., D.C.; A. Ctr. of the Oranges. Montclair AM; F., Royal SA, London, England. Exhibited: NAD; Arch. Lg.; CGA; P.-P. Expo, 1915; PAFA; Hispanic S., NYC; BMA; Montclair AM, 1931 (prize); Newark Mus.; Ferargil Gal.; Newark AC; A. Ctr. of the Oranges, 1930 (prize). Work: Intl. Mus., Asbury Park, N.J.; Montclair AM; U.S. Nat. Mus., Wash. D.C.; Lafayette Col., Easton, Pa.; West Chester, Pa.; Englewood, N.J.; Orange, N.J.; Yonkers, N.Y.; Jersey City; Morristown, N.J.; Berea Col., Ky.; Univ. of the South, Sewannee, Tenn.; Richmond, Va.; statue, Northampton Co., Pa.; portrait, Phila.; World War mon., Wilson Borough, Pa.; mem., Sea Girt, N.J.; War Mothers' Mem., Phila.; mem. tablets, First Congregational Church, Oak Park, Ill.; mem., Panzer Col., East Orange. Author: "The Celtic Cross for Modern Usage." Position: Cur., Mus. of U.S. Dept. Interior, Wash., D.C., from 1938 [47]

RAUL, Josephine Gesner (Mrs. Harry L.) [P,B,T] Orange, NJ/Groton, CT b. Linden, NJ. Studied: NAD; ASL; G.A. Thompson. Member: AAPL; A. Ctr. of the Oranges; NAWPS. Exhibited: NAWPS, 1930 (prize); Nat. Lg. Am. Pen Women, 1930 (prize); A. Ctr. of the Oranges, 1931 (prize); Kresge A. Exh., 1933 (prize) [40]

RAUL, Minnie Louise Briggs [E,W,I,L] Wah., D.C. b. Temple Hills, MD d. 7 F 1955. Studied: Hill Sch. A.; Corcoran Sch. A.; B.B. Moore; W. Mathews. Member: Wash. WCC; Wash. SE; Min. PS&G S.; Lg. Am. Pen Women. Exhibited: Contemp. C., Newark, N.J., 1941; Alexandria (Va.) Lib., 1942; Mem. Pier Gal., Bradenton, Fla., 1940; CGA, 1930–46; U.S. Nat. Mus., 1935, 1939 (prize), 1946; Lg. Am. Pen Women, 1930–46 (prizes) 1933, 1934, 1936, 1941; LOC; 1945; Wash. AC; Md. State Fair, 1941 (prize). Work: Johns Hopkins; Keats Mus., Wentworth House, London; Warm Springs, Ga. [47]

RAULSTON, Marion Churchill (Mrs. Burrell O.) [Por.P] Los Angeles, CA/La Jolla, CA b. 24 Mr 1886, Sunriver, MT d. 26 S 1955. Studied: PIASch; Otis AI; Skarbina, in Berlin. Member: Calif. AC; Women P. of the West; Los Angeles AA; NAWA; Council All. A.; Los Angeles; Laguna Beach AA. Exhibited: Los Angeles Mus. A., 1934 (prize), 1937 (prize), 1939 (prize); Women P. of the West (prize); one-man: Calif. AC; Stendahl Gal., Los Angeles; Los Angeles City Hall; Ebell C.; Hollywood Women's C.; Univ. Southern Calif. Work: Univ. Southern Calif.; Los Angeles AA [47]

RAUSCH, Stella Jane (Mrs. Henry G.) [P,Des,C,T] Cleveland, OH b. 12 S 1876, Monroe County, MI. Studied: Cleveland Sch. A.; Hawthorne; Johonnot. Member: Cleveland Women's AC. Exhibited: CMA (prize); Cleveland Sch. A. (prize). Work: Cleveland Pub. Lib.; Cleveland Hospital. WPA artist. [47]

RAUSCHNABEL, W.F. [P] San Fran., CA [17]

RAVELL, Henry [P] Laguna Beach, CA. Member: Laguna Beach AA [25]

RAVENEL, Pamela Vinton [Min.P,B,I,Dr] Woodstock, NY b. 28 Ja 1888, Boston, MA. Studied: Md. Inst.; Paris, with Collin, Courtois; E. Whiteman, in Baltimore. Member: Am. SMP; ASMP; Phila. Min. P. S.; SSAL; NOAA; New Orleans Min. P. S. Work: BM; CMA [47]

RAVENEL, William de Chastignier b. 25 Ag 1859 d. 8 O 1933. He assisted the American Red Cross in organizing its museum and was instrumental in establishing the headquarters of the American Association of Museums at the Smithsonian. Position: Dir., U.S. Nat. Mus., Wash., D.C.

RAVENOLD, Bruce [P] NYC [25]

RAVENSCROFT, Ellen [P,Li,C,T] NYC/Provincetown, MA b. 29 Ap 1876, Jackson, MI d. 9 Ja 1949. Studied: NAD; Chase Sch. A.; Castellucho, Paris. Member: NYSWA; Municipal A. Com. of 100, NYC; NYSWA; Provincetown AA; St. Louis AG. Exhibited: Wolfe AC, 1908 (prize), 1915 (prize); Kansas City AI, 1923 [47]

RAVESON, Sherman Harold [Des,P,I,W] Hastings, NY b. 11 Je 1907, New Haven, CT d. 1974. Studied: Cumberland Univ., Lebanon, Tenn.; ASL; V. Mundo. Member: AWCS. Exhibited: A.Dir.C., 1934 (med), 1939 (med); Nat. Adv. Award, 1941; CGA, 1935, 1939; PAFA, 1935–39; NAD, 1935, 1937, 1939; TMA, 1938; AWCS, 1934–45; CI, 1936; Iowa State Fair, 1936; Wash. State Fair, 1936; AIC, 1935, 1936, 1938–40; WFNY, 1939; Assn. Am. A., 1941 (one-man). Work: stage sets, "If Booth Had Missed," "That Is To Say," "Decision Reserved," "Dearly Beloved," "Show Business." Contributor: article, Literary America. Positions: A. Ed., Vanity Fair, 1929–34; A. Dir., Life, 1935, Esquire, 1936, Pettingell & Fenton, Inc., 1937–41 [47]

RAVLIN, Grace [P] Kaneville, IL b. 1885, Kaneville. Studied: Chase; Paris, with Simon, Ménard. Member: Associée Société Nationale des Beaux-Arts, Paris, 1912; Peintres Orientalistes Français; Sociétaire Salon d'Automne. Exhibited: Amis des Arts, Toulon, 1911 (med); AIC, 1918 (prizes), 1922 (prize). Work: AIC; Luxembourg, Paris; French Gov.; City of Chicago; Arché C., Chicago; Newark Mus.; Los Angeles Mus. A.; Vanderpoel AA Coll. [40]

RAWLINSON, Elaine [P] NYC b. 26 Ja 1911, NYC. Studied: NAD; PAFA Country Sch. Member: NAC; NAWPS. Award: winning design for 1-cent stamp, U.S. Gov. [40]

RAWLS, James [I] Falls Church, VA. Member: SI [47]

RAWSON, Albert Leighton [Ldscp.P,En,I,W] 15 O 1829, Chester, VT d. N 1902, NYC. After studying law, theology and art, he visited the Orient four times and traveled extensively in the U.S. and Central America. Exhibited: NAD, 1858. His publications, illustrated by himself, include a "Bible Dictionary," "Antiquities of the Orient," and dictionaries of Arabic, German, English and the Bedouin languages. He also executed more than 3,000 engravings.

RAWSON, Carl W(endell) [P] Minneapolis, MN b. 28 Ja 1884, Des Moines, IA. Studied: Cumming Art Sch.; NAD; Minneapolis Sch. A. Member: Minneapolis AS; Minn. State AS. Work: Minneapolis IA; Minneapolis Golf C. Gal.; Winona Country C.; Lib., Douglas Sch. and Northwestern Bank Bldg., Minneapolis; Capitol, Bismark, N.Dak.; State Hist. Dept., Lib., Des Moines, Iowa; Univ. Minn.; Pub. Lib., Mayo Clinic, Univ. C., Rochester, Minn.; Col. Surgeons, Chicago, Ill.; State Col., Ames, Iowa; Univ. Wis.; Minn. Hist. Bldg. [40]

RAWSTHORNE, J.W. [P] Pittsburgh, PA. Member: Pittsburgh AA [25]

RAY, Alice [P] Ft. Worth, TX [24]

RAY, Clary [I,P] Wash., D.C. b. 26 N 1865, Wash. D.C. Studied: Acad. Julian, Acad. Delecluse, both in Paris; ASL, Wash. D.C. [06]

RAY, Man [P,S,W,Ph] NYC b. 27 Ag 1890, Phila., PA d. 1976, Paris. (Born Emmanuel Radensky.) Studied: mostly self-taught; N.Y. Acad. A., 1908–12; Ferrer Sch., 1911. Member: Société Anonyme (the proto-Dada Group), NYC, 1920 and in Paris, 1921. Work: MOMA; RISD; Yale; AIC; IMP; NOMA; WMAA. Important surrealist painter and photographer; also worked in collage and constructions; many portraits of artists. After 1921 worked in Paris, moving to Hollywood in 1940, back to Paris, 1951. Inventor of "rayographs," cameraless light photos, 1921 [21]

RAY, Silvey Jackson [Cart] Kansas City, MO b. 15 Mr 1891, Chariton County, MO. Studied: F.R. Gruger, at ASL. Work: Huntington Lib., San Marino, Calif. Position: Cart., The Kansas City Star [40]

RAYMOND, Alexander Gillespie [Cart,I] Stamford, CT b. 2 O 1909 d. 6 S 1956. Studied: Grand Central Sch. A. Member: SI. Creator: "Flash Gordon," King Features Syndicate [47]

RAYMOND, Edith [G] Baltimore, MD. Exhibited: Md. Inst., 1940 (one-man) [40]

RAYMOND, Elizabeth [P,T] New Orleans, LA b. 5 N 1904, New Orleans. Studied: E. Woodward. Member: SSAL; Miss. AA; NOAA [33]

RAYMOND, Flora Andersen [P,I] Chicago, IL b. Pewaukee Lake, WI. Studied: AIC; Hyde Park Peoples Col.; E. Giesbert; F. Grant. Member: Lg. Am. Pen Women; All-Illinois AA; North Shore AA; South Side AA. Exhibited: AIC, 1937, 1942; Evanston Women's C.; Blackstone Lib., Chicago. Illustrator: books; book jackets [47]

RAYMOND, Frank Willoughby [E,P] Chicago, IL b. 1881, Dubuque, IA. Studied: AIC. Member: Calif. SE; Chicago SE; Palette and Chisel C.; Artists Gld.; Ill. Acad. FA; Chicago Gal. Assn. Work: AIC; TMA [40]

RAYMOND, Grace Russell [L,P,T] Winfield, KS b. 1 My 1876, Mt. Vernon, OH. Studied: Southwestern Col.; AIC; Corcoran Sch. A.; PAFA; H. Snell; G.E. Browne; N.Y. Sch. Appl. Des.; MMA Sch., NYC; London; Paris; Rome; Belgium; Mexico. Member: AFA; Wash. WCC. Position: T., Southwestern Col., Winfield 1930–45 [37]

RAYMOND, Julie E. [P] Laguna Beach, CA. Member: Laguna Beach AA [25]

RAYMOND, Kathryn Tileston [P] Boston, MA. Member: Boston A. Students Assn., 1884 [13]

RAYMOND, L(eone) Evelyn [S,L,T] Minneapolis, MN b. 20 Mr 1908, Duluth, MN. Studied: Minneapolis Sch. A.; Charles S. Wells. Member: Minn. AA; Minn. S. Group. Exhibited: Minn. State Fair, 1941 (prize), 1943 (prize), 1944 (prize); Minneapolis Inst. A., 1944 (prize); Walker A. Ctr., 1944 (prize), 1945 (prize). Work: stadium, International Falls, Minn. Position: T., Walker A. Ctr., Minneapolis, from 1938 [47]

RAYMONO, Antonin A. [P] NYC [15]

RAYMUNDO, Francisco V. [P,S,T] Attleboro MA b. 3 D 1897, Manila, Phillipines. Studied: Académie Julian; N.Y. Sch. F.&Appl. A.; ASL; Columbia. Exhibited: Attleboro Mus. A.&Hist., 1939 (prize); Boston S.Indp.A. Work: Attleboro Mus. A.&Hist.; Peoples Inst., Attleboro [40]

RAYNAUD, Louis [P,T] Chicago, IL b. 18 Je 1905, New Orleans, LA. Member: S. for Sanity in A. Exhibited: San Antonio AL, San Antonio, 1929 (prize); NOAL, 1933 (prize); NOAA, 1934 (prize). Work: WPA murals, USPOs, Bay St. Louis, Miss., Abbeville, La. [40]

RAYNER, Ada (Mrs. Hensche) [P] Provincetown, MA b. 9 F 1901 London, England. Studied: ASL; Cape Sch. A.; H. Hensche. Member: Provincetown AA. Exhibited: Provincetown AA; Miles Standish Gal., Boston [47]

RAYNES, Joseph F. [P] Boston, MA/West Wareham, MA b. 6 F 1876, Boston [25]

RAYNES, Sidney [P] Rockport, MA b. 25 D 1907, Melrose, MA. Studied: H.H. Breckenridge; ASL. Member: Am. Ar. Cong. Exhibited: Northwest PM, SAM, 1936 (prize) [40]

RAYNESS, Gerard (Mathiassen) [P,I,Des] Ames, IA b. 7 Mr 1898, Slater, IA d. 20 F 1946. Studied: C.A. Cumming. Member: Iowa AG. Exhibited: Iowa State Fair, 1931 (prize), 1932 (prize) [40]

RAYNESS, Velma Wallace [P,I,T] Ames, Iowa b. 31 O 1896, Davenport, IA. Studied: Cumming Sch. A. Member: Iowa AG. Exhibited: CGA, 1934; Joslyn Mem., 1939, 1946; Iowa Fed. Women's Cl., 1919–31 (prizes); Iowa State Fair, Des Moines, 1924–26 (prizes), 1935 (prize). Work: Collegiate Presbyterian Church, Ames, Iowa; U.S. Gov. Illustrator: "The Corn is Ripe," 1944 [47]

RAYNOR, E. Webster [P] NYC [01]

RAYNOR, Grace Horton [S] NYC b. 20 S 1884, NYC. Member: Art Workers C. Work: plaque, Pub. Lib., Glen Ridge, N.J.; fountain, Cherry Valley C., N.Y. Specialties: portraits; statuettes and heads [29]

REA, Dorothy (Mrs. Gardner) [P] Brook Haven, NY. Exhibited: NAWPS, 1935–38 [40]

REA, James Edward [Mur.P,Por.P,S,Des,L,T,I] St. Paul, MN b. 14 Ja 1910, Forsyth, MT. Studied: St. Paul Sch. A.; Am. Acad. A., Chicago; Univ. Minn. Member: Twin City Puppetry Gld. Exhibited: Minn. State Fair, 1933 (prize), 1934 (prize), 1935 (prize); Grumbacher Exh., 1935; Minneapolis Inst. A., 1932–42. Work: Custer State Park Mus., S.Dak.; Hotel Lenox, Duluth; Lowry Medical A. Bldg., Harding H.S., both in St. Paul [47]

REA, John L(owra) [P,S,W] Plattsburg, NY b. 29 Ja 1882, Beekmantown, NY. Studied: H.A. MacNeil; J.E. Fraser; DuMond. Member: Plattsburg AG. Work: tablet, George H. Hudson State Normal Sch., Plattsburg; figures, Miner Sch., Chazy, N.Y. Contributor: House Beautiful, House and Garden, American Home [40]

REA, Pauline DeVol [P,Des,I,E,T] San Diego, CA b. 7 O 1893, Chicago. Studied: Chicago Acad. FA; R. Schaeffer; C. Kay-Scott. Member: San Diego A. Gld.; La Jolla A. Center; San Diego Adv. Cl. Exhibited: San Diego FA Soc., 1941 (prize); AIC, 1918; Los Angeles; La Jolla A. Center; Laguna Beach AA; Cedar City, Utah. Work: San Diego FA Soc. Positions: Dir., San Diego Acad. FA (1921–41), La Jolla A. Center (1941– [47]

REA, Samuel [Patron] b. 21 S 1855, Hollidaysburg, PA d. 24 Mr 1929. Member: Patron, PMSchIA (1928)

READ, Adele von Helmold [P] Lansdowne, PA b. Phila. Studied: Chase; Anshutz; PAFA. Member: Phila. Alliance; Plasic Cl.; AFA. Exhibited: Boston AC, 1898 [40]

READ, E(lmer) J(oseph) [P] Palmyra, NY b. 19 Je 1862, Howard, Steuben County, NY. Studied: Syracuse, Univ.; Fremiet, in Paris [40]

READ, F.W. [I] Position: Associated with Munsey's Magazine [98]

READ, Frank E. [P,T,W] Seattle, WA b. 4 Ag 1862. Studied: W.M. Hunt. Member: Seattle FA Soc. [25]

READ, Henry [P,W,T,L,D] Denver, CO b. 16 N 1851, Twickenham, England d. 12 My 1935. Member: Nat. Acad. A.; Col. Chapter AIA; AFA, 1909. Work: Denver Mus. Position: Dir., Denver Students Sch. A. [29]

READE, Roma (Mabel Kelley Aubrey) [P,Mur.P,W,T] Pasadena, CA b. 2 Ag 1877, Skaneateles, NY d. 24 S 1958. Studied: Univ. Col., Toronto; Donalda-McGill Col., Montreal; Columbia. Member: Theatre A. Gld.; Westchester A. Gld.; Contemporary A. Cl.; Calif. AC; Glendale AA; Laguna Beach AA; New England Painters; Canadian A. Lg.. Exhibited: PAFA; WFNY, 1939; Pasadena SA; Pal. Leg. Honor; Paul Metcalfe Gal., Los Angeles. Work: murals, theatres and hospitals. Author: "Scene Painting and Art" [47]

READING, Alice [P] Wash., D.C. [19]

READIO, Wilfred A. [P,Li,T] Pittsburgh, PA b. 27 N 1895, Northampton, MA d. 17 F 1961. Studied: Carnegie Inst. Tech., with A.V. Churchill. Member: Assoc. A. Pittsburgh. Exhibited: Assoc. A. Pittsburgh, annually (1921 [prize], 1940 [prize]); Rocky Mountain Pr.M., 1935 (prize); SFMA, 1935; Cleveland Pr. Cl., 1935; Calif. Pr.M., 1935, 1936; Phila. Pr. Cl., 1934–45; Buffalo Pr. Cl., 1938–43; AIC, 1934, 1935, 1937, 1940; Wichita AA, 1934–38; Laguna Beach AA, 1945, 1946; LOC, 1944, 1945; Carnegie Inst. Tech., annually since 1934. Work: Pittsburgh Pub. Sch.; Latrobe (Pa.) H.S.; Carnegie Inst. Tech.; Pa. State Col. Position: T., Carnegie Inst. Tech., 1929– [47]

REAM, Carducius P(lantagenet) [P] Chicago, IL b. ca. 1836, Lancaster, OH d. 20 Je 1917. Studied: Europe; U.S. Member: Chicago Acad. Des. Work: AIC [15]

REAM, Vinnie. See Hoxie.

REAMER, Maude [P,T] Buffalo NY [21]

REARDON, M(ary) A. [P,E,Li,I,Mur.P] Quincy, MA b. 19 Jy 1912, Quincy. Studied: Radcliffe; Yale. Member: North Shore AA; Boston Liturgical A. Group. Exhibited: Northwest Pr.M., 1940; Inst. Mod. A., Boston; North Shore AA, 1940–46; Quincy, Mass. (one-man). Work: mural, Radcliffe; altar painting, St. John's Seminary, Boston; Maryknoll & Brookline Chapel, Boston; dec., St. Raphael's Hall, Newton, Mass.; tryptych, U.S.S. Wasp. Illustrator: "Snow Treasure," 1942, "They Came from Scotland," 1944, "Bird in Hand," 1945, other children's books [47]

REASER, Wilbur (Aaron) [Por.P,L] NYC b. 25 D 1860, Hicksville, OH d. 9 D 1942, Minneapolis. Studied: Mark Hopkins Inst., San Fran.; Constant, Lefebvre, in Paris. Member: San Fran. Art Assoc. Exhibited: Calif. Expo, 1894 (gold,medal); NAD, 1897. Work: Carnegie Gal., Pittsburgh; Art Gal., Des Moines; portraits, U.S. Senate Lobby (Wash., D.C.), Capitol (Montpelier, Vt.), Capitol (Charleston, W.Va.), State Hist. Soc. (Des Moines) [40]

REASONER, Gladys Thayer (Mrs. David) [P,T] Woodstock, NY b. 17 Jy 1886, Woodstock, CT. Studied: A.H. Thayer [25]

REAUGH, F(rank) [P,T] Oak Cliff, TX b. 29 D 1860, near Jacksonville, IL d. 1945, Dallas. Studied: St. Louis Sch. FA, 1883; Académie Julian, Paris, with Constant, Doucet, 1888–91. Member: Dallas Art Assoc.; AFA. Work: Dallas Art Assoc.; Dallas Pub. Lib.; Univ. Tex. Specialty: Tex. cattle and western landscapes. Epic cycle: "Twenty-four Hours with the Herd." Positions: Dir., Outdoor Summer Sketching Sch.; T., Baylor Univ. [40]

REAVIS, Esma Jacobs [P,C,T] Greenville, TX b. 26 F 1900, Corinth, MS. Studied: M. Simpkins; M. Marshall; Reaugh; Klepper. Member: SSAL; Reaugh AC, Dallas. Exhibited: Prof. Exh., Tex. State Fair, 1928 (prize), 1930 (prize); SSAL, 1931 (prize); Tex. Fed. Women's Cl., 1931 (prize); Frank Reaugh AC, 1932 (prize). Work: H.S., Greenville [40]

REAY, Martine R. [P,I] NYC b. 1871, New York. Studied: ASL [10]

REBAJES, Francisco [C,Des,T] NYC b. 6 F 1907, Puerto Plata, Dominican Republic. Studied: Dominican Rep.; Spain. Member: Soc. Des.-Craftsmen. Exhibited: Paris Salon, 1937 (med); MMA, 1937; BM, 1938. Work: WMAA. Position: Pres., Copper Craftsmen, Inc., NYC [47]

REBAY, Hilla (Baroness [Hildegard] von Ehrenwiesen) [P,W,L] Greens Farms, CT b. 31 My 1890, Strasbourg, Alsace d. 27 S 1967. Studied: Acadamies in Düsseldorf, Paris, Munich; G. Royer; J.P. Laurens; Laparra. Exhibited: WMA, 1928; Salon des Independents, Salon des Tuileries, Salon d'Automne, all in Paris; Munich; Berlin; GGE, 1939. Author: "Wassily Kandinsky," "Kandinsky Memorial," other books. Contributor: Southern Literary Digest, Carnegie Inst. Mag. Positions: Cur., Solomon

R. Guggenheim Fnd., 1937– ; Dir., Mus. Non-Objective Painting, 1939 [47]

REBECHINI, Guido [S] Chicago, IL [17]

REBECK, Steven Augustus [S] Cleveland Heights, OH b. 25 My 1891, Cleveland. Studied: Cleveland Sch. A.; K. Bitter; C. Heber. Member: NSS; Cleveland SA. Exhibited: CMA, 1922 (prize), 1923 (prize). Work: CMA; mem., Alliance, Ohio; Civil Court House, St. Louis [47]

REBER, Alfred A. [P] Dormont, PA. Member: Pittsburgh AA [24]

REBISSO, Louis T. [S] Cincinnati, OH b. 1837, Genoa, Italy (settled in Boston, 1857) d. 3 My 1899

RECCA, J. George [P] Elmhurst, NY b. 15 Ag 1899, Palermo, Italy. Studied: PIASch. Member: AWCS; SC; All.A.Am.; Brooklyn SA; NYWCC; N.Y. Soc. P.; Am. Ar. Prof. Lg.; Springfield (Mass.) A. Lg. Exhibited: Ogunquit A. Center, 1938 (prize), 1939 (prize); Exh. Religious Art, Grant Studios, Brooklyn, 1936 (prize); NAD, 1935, 1940, 1942; PAFA, 1940 [47]

RECCHIA, Richard H(enry) [S] Rockport, MA b. 20 N 1885, Quincy, MA. Studied: BMFA Sch.; Paris; Italy. Member: NSS; Copley S.; Boston SS (founder); Boston AC; Phila. Alliance; CAFA; NA; Gld. Boston A.; North Shore AA; Rockport AA; AAPL. Exhibited: BMFA Sch. (prize) (one-man exhibits); NSS, 1939 (prize), 1940-46; P.-P. Expo, 1915 (med); AIC; NAD, 1944 (prize), annually; CGA, 1928; Intl. Expo, auspices Italian Gov., Bologna, 1931 (gold,prize) Work: Harvard; Brown; Purdue; Boston State House; BMFA; Somerville Pub. Lib.; Malden H.S.; Red Cross Mus., Wash., D.C.; Buffalo Mus. A.&Sc.; Speed Mem. Mus.; Boston Psychoanalytical Inst.; Brookgreen Gardens, S.C.; mem., Northeaston, Mass.; equestrian statue, Manchester, N.H.; portrait tablet, Davenport Sch., Malden, Mass. [47]

RECCHIA, Richard H(enry), Mrs. See Parsons, Kitty.

RECKENDORF, J. Angelika [C,T] Pembroke, NC b. 12 Ag 1893, Freiburg, Germany. Studied: CI; Univ. N.C.; Europe, with H. Ehmke, H. Wolfflin. Member: CAA. Exhibited: N.C. Ar., 1940, 1944; Europe. Positions: T., Pembroke Col, 1942– , Univ. N.C., Chapel Hill, 1943–44 [47]

RECKHARD, Gardner Arnold [Ldscp.P] Poughkeepsie, NY b. 1858 Poughkeepsie d. 22 D 1908. Studied: New York. Member: Vassar A.&Crafts Soc. Position: A. Dir., Vassar Inst.

RECKLESS, Stanley L(awrence) [P,T] Los Angeles, CA b. 22 Ag 1892, Phila. Studied: PAFA; Académie Julian, Paris. Member: Graphic Sketch Cl., Phila.; Paris AAA. Exhibited: PAFA, 1916 (prize); La Fiesta, Los Angeles, 1930 (gold), 1932 (prize). Work: Wood Art Gal., Montpelier, Vt. Position: T., Art Center Sch., Los Angeles [40]

RECKNAGEL, John H., Jr. [P,T] Finistère, France b. 12 O 1870, Brooklyn, NY [10]

RECTOR, Anne [P] NYC [21]

REDDING, J.Y. [P] Brooklyn, NY [01]

REDDING, Kelly J. [Por.P,T] NYC b. NYC. Studied: NAD. Member: Allied AA; SC. Work: portrait of Lincoln, reproduced in Encyclopaedia Britannica. Position: T., Brooklyn, Col. [31]

REDDINGTON, George M. [P,Li,Ser] NYC b. 22 D 1905, Blue Rapids, KS. Studied: Univ. Kans.; Kansas City AI; ASL; Angarola; Kostellow; Barnet. Exhibited: Ft. Dix, N.J., 1945 (prize); Armed Services Exh., N.Y. Soc. A.&Crafts, 1945 (prize); LOC, 1943; Topeka, Kans., 1940; Okla. A. Center; Springfield Mus. A., 1940–43; Riverside Mus., 1945; NYC, 1938 (one-man), 1940 (one-man); ASL; Kansas City AI [47]

REDELL, Raymond [P] Wauwausota, WI. Exhibited: 48 Sts. Comp., 1939. Work: USPOs, Middlebury, Ind., Berlin, Wis. WPA artist. [40]

REDERER, Franz [P] Berkeley, CA b. 7 N 1899, Zurich, Switzerland. Exhibited: Caracas, Venezuela, 1940 (prize); Pal. Leg. Honor, 1946 (med); CGA, 1941; CI, 1944; AIC, 1940, 1942; BM, 1941; LOC, 1944; de Young Mem. Mus., 1943. Work: de Young Mem. Mus.; SFMA; Santa Barbara Mus. A.; SAM; Caracas Mus. A.; abroad [47]

REDERUS, S.F. [P,W,L] Dubuque, IA b. 29 Jy 1854, Netherlands. Studied: Bridgeport, Conn., with R. Wynkoop. Member: Milwaukee AI; Dubuque AS. Work: Presbyterian Church, Nortonville, Kans. [21]

REDETT, B(oyd) M(cCay) [P,Des] Toledo, OH/Fredericksburg, OH b. 16 F 1885, Fredericksburg [17]

REDFIELD, Alfred C. [P] Readville, MA [25]

REDFIELD, Edward W(illis) [Ldscp.P] New Hope, PA/Boothbay Harbor, ME b. 18 D 1869, Bridgeville, DE d. 19 O 1965 (age 96). Studied: PAFA; Bouguereau, Robert-Fleury, in Paris, 1886. Member: SAA, 1903; NA; AC Phila. Exhibited: (at the age of 7) study of a cow, Centennial Expo, Phila., 1876; AC Phila., 1896 (med); Paris Expo, 1900 (med); Pan-Am. Expo, Buffalo, 1901 (med); PAFA, 1903 (med), 1905 (gold), 1907 (gold), 1912 (prize), 1920 (prize);NAD, 1904 (prize), 1918 (prize), 1919 (prize), 1922 (prize), 1927 (med); SAA, 1904 (prize), 1906 (prize); St. Louis Expo, 1904 (med); CI, 1905 (med), 1914 (gold); CGA, 1907 (med,prize), 1908 (gold,prize); Paris Salon, 1908 (prize), 1909 (med); AIC, 1909 (med), 1913 (gold); Buenos Aires Expo, 1910 (gold); Wash. SA, 1913 (gold); P.-P. Expo, San Fran., 1915 (hors concours [jury of awards]); Wilmington Soc. FA, 1916, (prize); Calendar Comp., New York, 1926 (prize); Springfield AA, 1930 (prize); Newport AA, 1933 (prize); Buck Hill AA, 1936 (prize). Work: Luxembourg Mus., Paris; CGA; Cincinnati Mus.; CI; Boston Mus.; PAFA, Phila./New Hope; Brooklyn Art Inst., Indianapolis; Detroit Inst.; AIC; Buffalo FA Acad.; Minneapolis IA; RISD; MMA; Brooks Mem. Art Gal., Memphis; NGA; Cooke Coll., Honolulu; Telfair Acad. Savannah, Ga.; Delgado Mus.; Butler Art Inst.; Harrison Gal., Los Angeles Mus. A.; Boston Art Cl.; Kansas City Art Mus.; Dallas Pub. Art Gal.; Mem. Art Gal., Rochester; St. Louis Art Mus.; Grand Rapids Art Gal.; Assoc. FA, Des Moines; Phila. Art Cl.; Pub. Sch. Coll., Gary, Ind.; Nat. Gal., Buenos Aires, Argentina; Montclair (N.J.) Mus.; Pa. Mus. Art. Especially known for his Delaware River area winter scenes. Position: T., PAFA [47]

REDFIELD, Grace Chapman [P] Wilmette, Il. Member: Chicago WCC [24]

REDFIELD, Heloise Guillou [Min.P] Barnstable, MA/Wayne, PA b. 1883, Phila. Studied: PAFA, with Chase, C. Beaux, Mme. La Forge, Delecluse, in Paris. Member: Am. S. Min. P.; Pa. S. Min. P. Exhibited: Buffalo SA (prize); P.-P. Expo, San Fran., 1915 (med) [33]

REDFIELD, Mary Banister [P] Wash., D.C. b. 21 Ja 1883, Newark, NJ. Studied: ASL, with B. Harrison [17]

REDIN, Carl [P] Palomar Mountain, CA b. Sweden. Exhibited: Macbeth Gal., N.Y.; Broadmoor A. Acad,. Colorado Springs; Herron AI [40]

REDKA, Eugenia [P,T,Li,C,Des] Bronx, NY b. NYC. Studied: Hunter Col.; Columbia. Member: A. T. Assn.; Progressive Edu. Assn. Exhibited: Hunter Col. (prize); AIC, 1935, 1936; LOC, 1944; Phila. WCC, 1941; Wash. WCC, 1942; MMA (AV), 1942; Northwest Pr.M., 1944; 8th Street Gal., 1942. Positions: T., Col. of St. Rose, Albany (1933–36), H.S. Music & Art, NYC, 1936– [47]

REDMAN, Harry Newton [P,S,Li,Ser,T] b. D 1869, Mount Carmel, IL. Member: New England Mod. A. Soc.; Copley S. Exhibited: CI, 1928, 1930. Work: BMFA. Position: Affiliated with New England Conservatory of Music, Boston [47]

REDMAN, Joseph Hodgson [Car,I,W] Brooklyn, NY d. 15 D 1914. Illustrator: books, including one on Bermuda. Position: Car., Daily News. 16 yrs.; Hd. A. Dept., an evening paper, 10 yrs.

REDMOND, Frieda Voelter (Mrs. John J.) [P] NYC (Switzerland, 1915) b. Thun, Switzerland. Exhibited: Columbian Expo, Chicago, 1893 (med) [17]

REDMOND, Granville [P] b. 9 Mr 1871, Phila. Studied: Mathews; Joulin; Constant, Laurens, in Paris. Member: San Fran. AA; Calif. AC. Exhibited: San Fran. AA (gold,prize); Alaska-Yukon-Pacific Expo, Seattle, 1909 (med). Work: Capitol, Olympia, Wash.; Jonathan Cl., Los Angeles. Position: Affiliated with the Charlie Chaplin Film Co., Los Angeles [33]

REDMOND, James McKay [P,Li] Los Angeles, CA. Studied: S. Macdonald-Wright. Exhibited: Los Angeles PS, 1936 (prize). Work: murals, USPO, Compton, Calif.; Phineas Banning Jr. H.S., Wilmington, Calif; FA Gal., San Diego [40]

REDMOND, John J. [P] Gruvers, Switzerland b. Salem, MA. Studied: BMFA Sch. Member: NYWCC; SC, 1891 [25]

REDMOND, Lydia [P] Newport, RI. Member: Newport AA [25]

REDMOND, Margaret [C,Des,Dec,P] Boston, MA/Chesham, NH b. Phila. Studied: PAFA; J. Twachtman; L. Simon, R. Ménard, in Paris. Member: Copley S.; Boston SAC; Phila. WCC; Assn. Stained Glass of Am. Exhibited: Tercentenary FA Exh., Boston, 1930 (gold). Work: windows, Trinity Church (Boston), St. Paul's Church (Englewood, N.J.), Children's Room, Pub. Lib. (Englewood), St. Peter's Episcopal Church (Beverly, Mass.); stained glass medallion, Elliot Hospital (Keene, N.H.); St. Paul's Church, North Andover, Mass.; All Saints Church, Peterborough, N.H. [40]

REDNICK, Herman [P] Grantwood, NJ b. 9 Mr 1902, Phila. Studied: Hawthorne [31]

REDWOOD, Allen C. [I,W] Asheville, NC b. 1844 d. 26 D 1922. Work: Md. Hist. Soc. Author/Illustrator: article, Jackson's Foot-Cavalry at 2nd Bull Run, in "Battles and Leaders of the Civil War" (1884). A major in the Confederate Army. Important for his war illustrations from the Confederate side, which appeared in Leslie's, Harper's, and Century. After the war he opened a studio in Baltimore, later moving to NYC, Bayonne, N.J., and Port Conway, N.J. Known for his western illustrations during the 1890s. [*]

REE, Max Emil [Des,Car,Arch,I,A. Dir] Beverly Hills, CA b. Copenhagen, Denmark. Studied: Royal Univ., Copenhagen. Member: Un. Scenic A. Award: best art direction, "Cimarron," Acad. Motion Picture A.&Sc., 1931. Designer: costumes/stage sets for motion picture/stage productions, including productions of Max Reinhardt, MGM, Radio Pictures Studio, Von Stroheim, San Fran. Opera House. Did covers, caric., and illus. for The New Yorker, Theatre Magazine, other magazines [47]

REECE, Dora [P,Por.P] Phila., PA b. Philipsburg, PA. Studied: Phila. Sch. Des.; PAFA; Europe; Daingerfield; Snell; Seyffert; Breckenridge; Hale, Pearson; Garber. Member: Pa. Soc. Min. P.; Plastic Cl.; Phila. Alliance; AFA. Exhibited: Phila. Sch. Des. (prize); Rittenhouse Flower Market, Phila. (prize). Work: PMA; portrait, Mem. Lib., Philipsburg [47]

REED, Bertha M. [P] Worcester, MA [24]

REED, Burton I. [P] Position: Affiliated with St. Paul's Sch., Concord, N.H. [19]

REED, Chester A. [I] Worcester, MA [15]

REED, Doel (Mr.) [E,P,T,L] Stillwater, OK (Taos, NM, since 1959) b. 21 My 1894, Logansport, IN. Studied: Cincinnati A. Acad., with Meakin, Hopkins, Wessel, 1916–20; France; Mexico. Member: NA, 1952; SAE; Chicago SE; Phila. WCC; Audubon A.; Ind. Pr.M.; Prairie Pr.M.; Calif. Pr.M.; SSAL. Exhibited: Phila. Pr. Cl., 1940 (prize); Chicago SE, 1938 (prize); Currier Gal. A., 1942 (prize); Northwest Pr.M., 1942 (prize), 1944 (prize); Tulsa AA, 1935 (prize); Philbrook A. Center, 1944 (prize); Laguna Beach AA, 1944 (prize); SSAL, 1944 (prize); Oakland A. Gal., 1945 (prize); Kansas City AI, 1932 (med); SAE, 1930–46; "100 Etchings of the Year," 1932–44; NAD, 1934–46; CI, 1941; CGA, 1940; WMAA, 1942; Audubon A., 1945; AIC, 1934, 1937, 1939; "50 American Pr.," 1944; Albany Inst. Hist.&A., 1945; LOC, 1944–46; PAFA, 1944, 1945; Herron AI, 1943; MMA, 1942; Pasadena AI, 1946; Sweden, 1938; Paris Salon, 1937; Rome, Italy, 1937; Venice, Italy, 1940; London. Work: PMA; LOC; CI; SAM; Honolulu Acad. A.; NYPL; Philbrook A. Center; Mus. FA, Houston; Univ. Mont.; Univ. Tulsa; Grinnell Col.; Southern Methodist Univ.; Okla. A. Center; Okla. A. Lg.; murals, Okla. State Office Bldg., Oklahoma City. Author: "Doel Reed Makes an Aquatint," 1967. Position: T., Okla. A.&M. Col., 1942–59 [47]

REED, Earl H(owell) [E,W] Chicago, IL b. 5 Jy 1863, Geneva, IL d. Jy 1931. Studied: self-taught. Member: Chicago SA. Exhibited: memorial exh., Marshall Field Gal., Chicago. Work: TMA; LOC; AIC; NYPL; St. Louis Art Mus.; Milwaukee AI; Detroit AI. Author: "Etching: A Practical Treatise," "The Voices of the Dunes and Other Etchings," "The Dune Country," "Sketches in Jacobia," "Sketches in Duneland," "Tales of a Vanishing River," "The Silver Arrow." Became a prime mover in a campaign that resulted in the establishment of the Dunes State Park by the Ind. Legislature. [29]

REED, Earl Meusel [P,I,T] Casper, WY (Mills, WY, 1974) b. 12 Ap 1895, Milford, NE. Studied: Univ. Nebr.; AIC; PAFA, with Garber, Seyffert, G. Harding, 1923–25. Member: Swedish-Am. A. Soc.; Wyo. AA; Teton A. Exhibited: PAFA; Oakland A. Gal.; Milwaukee AI; Springville, Utah; Swedish-Am. Exh., Chicago; Kansas City AI; Univ. Nebr.; Denver A. Mus.; Joslyn Mem.; Harwood Gal., Taos. Work: Univ. Nebr.; Rawlins (Wyo.) Pub. Lib.; Queens Col., N.Y.; PAFA; Univ. Wyo.; USPO, Rawlins, Wyo. Positions: T., Natrona County H.S., Casper Jr. Col., 1940s–58 [47]

REED, Ed [I,Car] Des Moines, IA. Creator: cartoon, "Off the Record" [40]

REED, Eleanor [P] Haverford, PA b. 26 Jy 1913, Fort Sill, OK. Studied: Moore Inst., Phila. Member: Phila. A. All.; Provincetown AA; Am. Ar. Prof. Lg.; Key West Soc. Ar. Exhibited: PAFA, 1938, 1939; Wash. WCC, 1939 [40]

REED, Esther Silber [P,I,T] Pasadena, CA b. 1 My 1900, St. Louis. Studied: St. Louis Sch. FA; ASL; Breckenridge Sch. P. Member: St. Louis AG; St. Louis Indp. A. Exhibited: St. Louis AG, 1929 (prize), 1931 (prize). Work: St. Louis Post-Dispatch [40]

REED, Florence Robie [P,I,Car] West Acton, MA b. 2 Je 1915, Belmont, MA. Studied: ASL; Mass. Sch. A. Member: Boston Art Cl. Exhibited: Watertown Pub. Lib.; Boston Art Cl., 1938, 1939; Jordan Marsh Gal., 1938, 1943; Chatham, Mass., 1938, 1939; Dongan Hills, Staten Island, N.Y., 1940 (one-man); Vose Gal., 1941; Marblehead, Mass., 1941; South Yarmouth (Mass.) Lib., 1941 (one-man) [47]

REED, Grace Adelaide [P,T] Boston, MA b. 14 Jy 1874, Boston. Studied: Woodbury; Denman; Ross; Francis Hodgkins; Delecluse, Ménard, in Paris; Mass. Normal Art Sch. Member: Copley S.; AAPL [33]

REED, Grace Corbett (Mrs. Harold Whitman) [Weaver,T,L] Reading, MA b. Brattleboro, VT. Studied: M.M. Atwater. Member: Boston SAC; Weavers' Gld., Boston; Reading Soc. Craftsmen. Exhibited: Boston SAC, 1933 (med). Work: Raleigh Tavern (table linens), House of Burgesses (upholstery), both in Williamsburg, Va. Author: "Raised Weaving," "Luncheon Sets in Two-harness Weaving," both pub. The Handicrafter, 1928, 1930. Co-designer: Reed-Macomber Ad-A-Harness and Foldaway Looms. Position: T., Boston Sch. Occupational Therapy [40]

REED, Helen A. [P] Manchester, MA [19]

REED, Helen C. (Mrs.) [P] NYC. Member: Lg. AA [24]

REED, Lillian R. [P,T] Phila. PA b. Phila. Studied: PAFA; Phila. Sch. Des. for Women; Lathrop; Daingerfield. Member: Plastic Cl.; Phila. Art T. Assn.; Phila. Alliance. Exhibited: Plastic Cl. (gold) [40]

REED, Margaret W. (Mrs. David A.) [Por.P] b. 1892, Boston d. 1983, Norwich, VT. Studied: BMFA Sch., with J.S. Sargent, F. Benson, William Paxton. Specialty: children. Active in Boston, Cohasset, both in Mass.; Walpole, N.H.; Brevard, N.C. [*]

REED, Mary Taylor [P] Boston, MA [15]

REED, Myra [Por.P] Phila., PA b. 6 My 1905, Cincinnati. Member: Phila. A. All. Exhibited: Hotel Rittenhouse, Phila., 1937 [40]

REEDER, Dickson [P,E,En,Des,T] Fort Worth, TX b. 6 F 1913, Fort Worth. Studied: ASL; New Sch. Soc. Res.; Europe; W. Adams; W.S. Hayter. Exhibited: SSAL, 1934, 1938, 1939, 1944 (prize); CGA, 1939; Fort Worth AA, 1940 (prize), 1942 (prize), 1944 (prize), 1945 (prize); Tex. General Exh., 1945 (prize); Caller-Times Exh., Corpus Christi, 1945 (prize); Dallas Pr. Soc., 1945 (prize); CI; PAFA; Colorado Springs FA Center; Weyhe Gal.; AV; Pepsi-Cola. Work: Dallas Mus. FA; Fort Worth AA; Colorado Springs FA Center [47]

REEDER, Flora MacLean (Mrs. Harold L.) [P,T] Columbus, OH b. 8 Ag 1887, Saginaw, MI. Studied: Ohio State Univ.; Columbus A. Sch.; C. Hawthorne; J.R. Hopkins; M. Sterne; J. Frazier; E. Thurn. Member: Columbus Gal. FA; Columbus A. Lg. Exhibited: Ohio State Fair, 1924 (prize); Columbus A. Lg., 1925–36, 1937 (prize), 1938, 1939 (prize), 1940–46; Ohio State Journal, 1940 (prize); Everyman's Exh., Columbus, 1938 (prize); Ohio State Univ., 1928, 1929 [47]

REEDER, Lydia Morrow (Mrs. Charles Wells) [P] Columbus, OH b. 14 Ap 1885, Martinsville, OH. Studied: Ohio State Univ.; A. Schille; J.R. Hopkins; C.W. Hawthorne; L. Seyffert; L. Van Pappendam; AIC. Member: Columbus Art Lg.; Ohio WC Soc. Exhibited: Columbus Art Lg. Exh., 1935 (prizes) [40]

REEDU, Clarence M. [P] New Orleans, LA. Position: Affiliated with New Orleans Item [17]

REEDY, Leonard Howard [P] Chicago, IL b. 1899 d. 1956. Studied: AIC; Chicago Acad. FA. Specialties: Western scenes; cowboys [*]

REENTS, Henry A. [Ldscp.P] Michigan City, IN b. 25 Mr 1892, Chicago. Studied: AIC; A. Fleury; E.J.F. Timmons; C. Buhr. Member: Ind. A. Cl.; Hoosier Salon. Exhibited: Hoosier Salon, 1935–38. Work: high schools in Hartford, Mich., Rockford, Ill. [47]

REES, Lonnie [P,I] San Antonio, TX b. 8 N 1910, San Antonio. Studied: ASL; Nat. Acad. Member: SSAL; San Antonio A. Lg. Exhibited: SSAL, 1938, 1939 (prize); All Tex. Ann., Houston Mus. FA, 1940 (prize); Allied Ar. Am., 1937; Nat. Acad., 1938. Work: City Council Chamber, San Antonio. Illustrator: "The Texas Rangers," 1935 [40]

REES, Rosalie L. [P,En] NYC/Neponsit, NY b. 9 S 1897, NYC. Studied: NAD, with G. Maynard; Cooper Union, with J.C. Chase. Member: NAWPS; Am. Ar. Group. Designer: cover, Nature Magazine [40]

REESE, Charles Chandler [I,Car] b. 1862, Pittsburgh d. 3 Jy 1936, Glendale, CA. Affiliated with newspapers in New York, Pittsburgh, Phila.

REESE, Emily Shaw [P] NYC [19]

REESE, W.R. [P] St. Louis, MO [25]

REESE, Walter O. [P] Seattle, WA. Exhibited: Northwest Pr.M. Ann., SAM, 1937; WFNY, 1939 [40]

REESER, Lillian [P,C,T] Denver, CO b. 1876, Denver. Studied: BMFA; H. Rice, in Boston. Member: Artists Cl., Denver; Mineral Art Cl., Denver; Intl. Lg. of Mineral P. Exhibited: Omaha Expo, 1898 (prizes) [01]

REEVE, Myrtle A. [P] Jacksonville, FL [25]

REEVES, Joseph Mason, Jr. [Por.P,T] Los Angeles, CA b. 29 N 1898, Wash., D.C. d. 1973. Studied: Académie Julian; P.A. Laurens; E. Tarbell; Dechenaud; Royer; S. Meyer, in Rome. Member: Los Angeles AA; Calif. AC; P.&S. C., Los Angeles; S. for Sanity in Art; Bohemian C. Exhibited: Sacramento, Calif., 1927 (prize), 1931 (prize); Coronado, Calif., 1932; Santa Cruz, Calif., 1933; Los Angeles AA, 1934 (prize). Work: U.S. Navy Dept.; Univ. Calif.; Ebell C., Los Angeles; Serpell Col., Norfolk, Va.; Bohemian C. Position: T., The A. Ctr. Sch., Los Angeles [47]

REEVES, Ruth [Des,C,P,W,L,T] NYC b. 14 Jy 1892, Redlands, CA. Studied: PIASch; San Fran. Sch. Des.; ASL; Paris, with F. Leger; K.H. Miller. Member: AL Am.; Col. AA; F., Guggenheim, 1940–42; Carnegie Traveling F., 1934–35. Exhibited: Am. Des. Gal., 1929; BM, 1931; Minneapolis Inst. A.; MMA, 1929, 1931; BMFA, 1930, 1931; PMA, 1930; AIC, 1930; CAM, 1930; CI, 1930; Dayton AI, 1930; CM, 1930; BMA, 1930; TMA, 1930; CMA, 1931; Arch. Lg., 1931; State T. Col., Farmville, Va.; Univ. Chicago; Phila. A. All.; AGAA; Kansas City AI; Denver AM. Work: Radio City Hall, NYC; Children's Room, Mt. Vernon, NYPL; St. Albans (N.Y.) H.S.; textiles, Victoria & Albert Mus., London; CMA. Illustrator: "Daphnis and Chloe," pub. Limited Editions C., 1934. Specialty: hand-painted fabrics, hangings. Positions: Supt., "Index of American Design," for WPA; T., CUASch. [47]

REEVES, Walter Henry [P] NYC [15]

REEVS, George M. [Por.P] NYC b. 1864, Yonkers, NY d. 11 Ap 1930. Studied: Paris, with Constant, Laurens, Gérôme. Member: SC; A. Fund S. Exhibited: SC, 1906 (prize) [29]

REEVS, J. Graham [P] Shelter Island, NY. Member: SC [25]

REFREGIER, Anton [C,Mur.P,Car,Des,Li,T] Woodstock, NY (1977) b. Mr 1905, Moscow, Russia. Studied: RISD; H. Hofmann. Member: AL Am.; San Fran. AG. Exhibited: nationally. Work: Encyclopaedia Britannica Coll.; U.S. State Dept.; MET; MOMA; Walker A. Ctr.; Univ. Ariz.; WPA murals, USPO, San Fran.; Mus. Mod. Western A., Moscow, USSR. Position: T., Am. A. Sch., NYC [47]

REGESTER, Charlotte [C,P,S,T] NYC b. Baltimore, MD d. ca. 1964, Rockport, MA. Studied: Albright A. Sch.; ASL; Columbia; Greenwich House with R. Henri, M. Robinson, A. Piccirilli; R. Clark; U. Wilcox; Buffalo ASL. Member: NAWA; PBC; N.Y. Cer. S.; Clay C. Exhibited: NAWA, 1942 & prior; Argent Gal., 1943; PBC. Position: T., Todhunter Sch., NYC (1927–39), Dalton Sch., NYC (1939–46), Westchester Workshop A. & Crafts, White Plains, N.Y. (from 1946) [47]

REGISTER, Emmasita. See Corson, Mrs.

REHAG, Lawrence J. [Des,I,Car,T] Oakland, CA b. 11 D 1913, San Antonio, TX. Studied: Calif. Col. A.&Cr.; Prof. Ehmcke, in Munich. Exhibited: Calif. Col. A.&Cr., 1939. Position: Staff A., Velvetone Poster Co., San Fran.; Calif. Col. A.&Cr. [40]

REHBOCK, Lillian Fitch (Mrs. Ralph H.) [P,B] Seattle, WA b. 30 Ap 1907, Wilmette, IL. Studied: Northwestern Univ.; AIC; Univ. Wash. Member: Women P. of Wash.; Northwest PM [40]

REHLING, Zelda [P] Indianapolis, IN [10]

REHM, Wilhelmine [C,Des,L] Cincinnati, OH b. Cincinnati. Studied: Smith Col.; Sch. Appl. A., Univ. Cincinnati; A. Acad., Cincinnati. Member: Crafters Co.; Cincinnati Women's AC; Cincinnati Cer. Gld. Position: Dec., Rookwood Pottery, Cincinnati [40]

REHN, F.M.R. [P] NYC [24]

REHN, F(rank) K(nox) M(orton) [P] NYC b. 12 Ap 1848 Phila. d. 6 Jy 1914, Magnolia, MA. Studied: PAFA. Member: ANA, 1899; NA, 1908; SAA, 1903; AWCS; NYWCC; SC, 1883; Lotos C. Exhibited: NAD, 1879–81; St. Louis, 1882 (prize); Water Color Comp., NYC, 1885 (prize); Prize Fund Exh., NYC, 1886 (gold); Paris Expo, 1900; Pan-Am. Expo, Buffalo, 1901 (med); Charleston Expo, 1902 (med); St. Louis Expo, 1904 (med); SC, 1905 (prize), 1906 (prize); AAS, 1907 (gold). Work: Buffalo FA Acad.; Detroit Mus. [13]

REIBEL, Bertram [En,S,C,B] Chicago, IL b. 14 Je 1901, NYC. Studied: AIC; A. Archipenko. Member: Intl. PM; Northwest PM; Am.-Jewish AC; Am. A. Cong.; Southern PM S.; Chicago SA. Exhibited: NAD; Intl. PM; PAFA; MET; CM; Oakland A. Gal.; Northwest PM; AIC; Kansas City AI; Detroit Inst. A.; Southern PM [47]

REIBER, Cora Sarah (Mrs. Charles F. Rothweiler) [P,Des,L] Plainfield, NJ b. 28 D 1884, NYC. Studied: N.Y. Sch. Appl. Des. for Women; ASL; C. Leltrup; A. Mucha; J. Mayer. Work: mural, Wadsworth Ave. Baptist Church, NYC. Specialty: des. wallpaper and fabrics. Position: T., Traphagen Sch. Fashion [47]

REIBER, Richard Henry [Mur.P,Por.P,E,S,Des,L,T,Arch,I,W] Pittsburgh, PA b. 2 O 1912, Crafton, PA. Studied: Cornell; K. Washburn; A. Brauner; W. Stone. Member: Pittsburgh AA; Pittsburgh Arch. C.; Pittsburgh Pr. C. Position: T., Shady Side, Pittsburgh [47]

REICH, Jacques [Et] New Dorp, NY b. 10 Ag 1852, Hungary (came to U.S. in 1873) d. 8 Jy 1923, Dumraven, NY. Member: Budapest; Paris; NYC; PAFA. Member: Chicago SE; Calif. PM. Work: portraits of famous Americans; etchings, AIC; MET; NYPL; N.Y. State Lib.; Cornell. Illustrator: pen portraits, "Cyclopedia of Painters and Paintings" (pub. Scribner's), Appleton's "Cyclopedia of American Biography," Mace's "History of the United States," Cordy's "History of the United States" [21]

REICH, Jean Heyl [Cer,C] Cincinnati, OH b. Columbus, OH. Studied: Cincinnati A. Acad.; Univ. Cincinnati; H.S. Nash; H.H. Wessel; J. Hopkins. Member: Women's AC Crafters, Ceramic Gld., all of Cincinnati. Exhibited: Syracuse MFA, 1939–41, Traveling Exh., 1939–41; Women's AC, Cincinnati, 1939–45; Nat. A. Week, Wash., D.C., 1940; CM, 1939–42; NAC, 19040; Cincinnati Crafters, 1941; Ceramic Gld., 1943; CM, 1944 (one-man); Dayton AI, 1945 (one-man). Work: IBM Coll. [47]

REICHARD, Gustave [Dealer] Cedarhurst, NY b. 1843, Germany (came to NYC as young man) d. 4 Ja 1917. He was long prominent in NYC art life, being a close friend of Winslow Homer and other American artists.

REICHART, Joseph Francis [P] NYC. Member: S.Indp.A. [25]

REICHART, Donald [P,Des,T,B,L] Springfield, MA b. 10 N 1912, Chicago, IL. Studied: blockprints with E. Zweybruck, Vienna; O.E Smith. Member: Springfield AL; Artists U. of Western Mass.; CAFA; Am. Ar. Cong; Grand Central A. Gal.; Stockbridge AA. Exhibited: Springfield AL, 1937 (prize); Stockbridge AA, 1939 (prize). Work: Berkshire Mus., Pittsfield, Mass.; Springfield Mus. A.; G.W. Vincent Smith A. Mus.; Springfield, Mass. Pub. Lib.; Mt Hermon Sch., Northfield, Mass. Position: T., G.W.V. Smith A. Mus., Springfield [47]

REICHMANN, Josephine L. (Mrs.) [P] Chicago, IL b. 24 Mr 1864, Louisville, KY d. 1939. Studied: AIC; ASL. Member: Chicago SA; Chicago AC; North Shore AA; NAWPS; SSAL [38]

REICK, William A. [S] Wash., D.C. Member: NSS. Affiliated with War Dept., Wash., D.C. [47]

REID, Albert Turner [P,L,I,Cart,T,W] NYC b. 12 Ag 1873, Concordia, KS d. 26 N 1955. Studied: N.Y. Sch. of Art; ASL; L.C. Beckwith; W.A. Clark; Kansas State Univ. Member: AAPL; Cart. C.; AG; SI; FA Fed. of N.Y. Exhibited: P.-P. Expo, 1915 (prize). Work: Ft. Hays Kans. State Col.; State House, Topeka, Kans.; WPA murals, USPOs, Sabetha, Olathe, both in Kans., Sulphur, Okla.; des./builder, Kans. Semi-Centenn. Expo, Topeka, 1911; medal Wash. Bicentenn. Comm. Illustrator: national magazines; books; newspapers [47]

REID, Aurelia Wheeler [Min.P,C,S,W] San Pedro, CA b. Beekman County, NY. Studied: CUASch; Columbia; Univ. Calif., Los Angeles; Otis AI; Delecluse Acad., Paris; W. Metcalf; H.C. Christy. Member: Pa. SMP; Calif. SMP; Am. Assn. Univ. Women; W. Gld.; San Pedro A. Exhibited: CGA; Smithsonian Inst.; Los Angeles Mus. A.; San Diego FAS; San Pedro AA, 1939 (prize); Santa Barbara Mus. A.; Pasadena AI; Pomona, Calif.; San Pedro Writers G., 1936 (prize); Aeronautical Exh., 1939 (med). Work: S., Los Angeles Mus. A.; Calif. State Bldg., Los Angeles [47]

REID, C(elia) Cregor (Mrs. J.M.T.) [En,P,C,B] St. Augustine, FL b. Springfield, KY. Studied: Univ. Ky.; AIC; Md. Inst.; CI. Member: St. Augustine AC; SSAL; Lg. Am. Pen Women. Exhibited: NAD, 1943; WFNY 1939; Albright A. Gal., 1943; Phila. Pr. C., 1943; SSAL, 1933, 1937, 1940, 1943; St. Augustine AC, 1930–46. Work: Ill. State Mus. [47]

REID, Edith A. [P] Chicago, IL [17]

REID, Estelle Ray [P] Appleton, WI [04]

REID, H. Logan [P] NYC. Member: S.Indp.A. [21]

REID, J.B. [P] Rochester, NY [13]

REID, James Colbert [B,I] Trevose, PA b. 8 F 1907, Phila. Studied: Oakley; Pullinger; Pa. Mus. Sch. Indst. A. Member: Phila. Print C. Illustrator: "The Life of Christ," and "The Song of Solomon," in wood cuts; "Mijjkel Fonhus," "Miss Tiverton," "This Wooden Pig Went With Dora," and "Swords against Carthage," mystery books by S.S. Smith; "Ringtail," by A.C. Gall; "Pogo," by J. Berger; "Wonders of Water," by M.E. Baer; "Lost Island," by N. Burglon; "Not Really," by L. Frost [40]

REID, Janet Kellogg [P] Wilton, CT. Member: Allied A. Am.; Am. A. Prof. Lg.; Yonkers AA; AWCS. Exhibited: AIC; Nat. Acad. (prize); Paris Salon; AWCS-NYWCC, 1939; Milwaukee AI, 1929 (med) [40]

REID, Jean Arnot [Min.P,P] NYC/Monterey, MA b. 22 Jy 1882, Brooklyn, NY. Studied: R. Brandegee; Am. Sch. Min. Painting; ASL. Member: NAWPS; ASMP; Yonkers AA [47]

REID, M(arie) C(hristine) W(estfeldt) [P] NYC/South Bristol, ME b. NYC. Studied: J.A. Weir; D. Volk; G.W. Edwards; F.E. Elwell. Member: NAWPS; Salons Am. [40]

REID, Mary M. [P] Chicago, IL [19]

REID, O(liver) Richard [P,T] NYC b. 27 F 1898, Eaton, GA. Studied: D. Garber. Member: Salons Am. Exhibited: Harmon Fnd., NYC, 1928. Work: NYPL [40]

REID, Peggy [P,S] NYC/Skowhegan, ME b. 7 Je 1910, Liverpool, England. Studied: R.J. Kuhn [33]

REID, Robert [P,Mur.P,C,T] NYC/Broadmoor A. Acad., Colorado Springs, CO b. 29 Jy 1862, Stockbridge, MA d. 2 D 1929, Clifton Springs, NY. Studied: BMFA Sch., 1880–84; ASL, 1885, Académie Julian, with Boulanger, Lefebvre, 1885–89. Member: ANA, 1902; NA, 1906; Ten Am. P.; NIAL. Exhibited: Paris Salon, 1886–89; Pastelists, 1890; Columbian Expo, Chicago, 1893 (med); NAD, 1897 (prize), 1898 (prize); Paris Expo, 1900 (gold); Pan-Am. Expo, 1901 (med); St. Louis Expo, 1904 (med); CGA, 1909 (prize); P.-P. Expo, San Fran., 1915. Work: CGA; Albright A. Gal.; Brooklyn Inst. Mus.; MMA; Herron AI, Indianapolis, Nat. Gal. A.; Nebr. AA, Lincoln; AA, Richmond, Ind.; Cincinnati Mus.; Omaha Mus.; Detroit Inst. Arts; Minneapolis Inst. A.; Harrison Gal., Los Angeles Mus. A.; murals, Mass. State House, Boston; LOC; Appellate Court, NYC; Paulist Church, NYC; stained glass windows, H.H. Rogers Mem. Church, Fair Haven, Mass.; Central H.S., Springfield, Mass.; Ft. Worth, Mus.; Akron A. Gal. Position: T., BMFA Sch. (ass't) 1881–84; ASL, CUASch, 1890s; Broadmoor A. Acad. 1920–27 [27]

REID, Victor E. [P] Los Angeles, CA. Member: Calif. AC [25]

REIDY, Jeannette Sprague [P] Chicago, IL b. Iowa. Studied: AIC. Member: ASL, Chicago [08]

REIFF, Robert Frank [P] Rochester, NY b. 23 Ja 1918. Studied: Univ. Rochester; Colorado Springs FA Ctr.; B. Robinson; A. Dehn. Exhibited: NGA, 1942; MET (AV), 1942; Rochester Mem. A. Ga., 1936-46; Syracuse MFA, 1941; Grand Central A. Gal., 1941; Rochester Mem. A. Gal., 1941 (prize), 1945 (one-man) (prize); one man: de Young Mem. Mus., 1944; Rundel A. Gal., 1939; Santa Barbara Mus. A., 1944; Pasadena AI, 1944; Rochester Mem. A. Gal., 1945 [47]

REIFFEL, Charles [Ldscp.P] San Diego, CA (since 1925) b. 9 Ap 1862, Indianapolis, IN d. 1942. Studied: C. von Marr, Munich; mostly self-taught. Member: Allied AA; Contemporary; Intl. Soc. AL; Conn. SA; SC; CAFA; Buffalo SA; Silvermine GA; Wash. AC; North Shore AA; Hoosier Salon; Chicago Gal. A.; San Diego AG; Calif. AC; Laguna Beach AA. Exhibited: Buffalo SA, 1908 (prize); AIC, 1917 (med); CAFA, 1920; Intl. Expo, Pittsburgh, 1922; Hoosier Salon, 1925 (prize), 1926 (prize), 1927 (prize), 1928 (prize), 1931 (prize), 1938 (prize); Los Angeles Mus., 1926 (prize), 1929 (prize); San Diego FA Gal., 1926 (prize), 1927 (prize); Calif. AC, 1928 (gold); Sacramento AC, 1928 (prize), 1930 (prize); Phoenix, Ariz., 1928 (prize), 1930 (prize); Santa Cruz, 1929 (prize); John Herron AI, 1929 (prize); Richmond, Ind., AA, 1930 (prize); Painters of the West, 1930 (gold); Pasadena A. Gal., 1930 (prize); Los Angeles Exh., 1932 (prize). Work: CGA; San Diego FA Gal.; Santa Cruz AL; Mun. AC., Phoenix; Wood A. Gal., Montpelier, Vt.; Los Angeles Mus.; Herron AI; Admin. Bldg., San Diego [40]

REILLY, Frank Joseph [P,I,Tl] NYC. Studied: G. Bridgman; F. DuMond; D. Cornwell. Member: NSMP; SI. Position: T., Art Assocs., NYC [47]

REILLY, John G. [P] Cincinnati, OH. Member: Cincinnati AC [15]

REILLY, Paul H. [Por.P,Ldscp.P,I,Car] Pittsburgh, PA b. Pittsburgh d. 14 My 1944, Westport, CT. Studied: Pittsburgh. Member: Pittsburgh AA [19]

REIMANN, Carl [Mur.P,Dec,Des,I] Milwaukee, WI b. 13 Mr 1873, Milwaukee. Studied: R. Lorenz; M. Thedy, RA, Weimar, Germany. Work: Stained glass windows, St. John's Episcopal Church, Charlestown, W.Va.; Milwaukee AI [40]

REIMERS, Johannes [P] San Francisco, CA [19]

REIMS, Salvatore [S] NYC [21]

REIN, Harry R. [P,Gr,Cart,I,Des,L,Li] Pasadena, CA b. 13 F 1908, NYC. Studied: ASL. Member: Pasadena AA. Exhibited: MOMA, 1939; Laguna Beach AA, 1946. Work: MET; Greenpoint Hospital, Brooklyn. Contributor: cartoons, New Yorker [47]

REINA, Salvatore [S] NYC/South Beach, Staten Island, NY b. 8 Ap 1895, Girgenti, Italy. Studied: BAID: Member: Salons of Am.; Soc. Med.; Staten Is. AA. Exhibited: Staten Is. AI Soc., 1937, 1938; Studio G., Inc., NYC, 1939, 1940. Work: Lake View Cemetery, East Hampton, Conn.; Gate of Heavenly Rest Cemetery, N.Y. [40]

REINDEL, Edna [P] Santa Monica CA b. 19 F 1900, Detroit, MI. Studied: PIASch. Exhibited: WMAA, 1937, 1938, 1940; CI, 1937, 1938, 1944–46; AIC, 1934, 1945; A.Dir.C., 1935. Work: MET; WMAA; Ball State T. Col.; Canajoharie A. Gal.; Fairfield Court, Stamford, Conn.; Governor's House, St. Croix, Virgin Islands; WPA mural, USPO, Swainsboro, Ga. WPA artist. [47]

REINDEL, William George [P,E,En,L] Cleveland, OH b. 25 Jy 1871, Fraser, MI b. 16 D 1948. Studied: largely self-taught; America; Europe. Work: British Mus.; Victoria & Albert Mus., both in London; MMA; NYPL; Detroit Inst. A.; CMA; Butler AI [47]

REINDORF, Samuel [P,En,Li,I] NYC/Astoria, NY b. 1 S 1914, Warsaw, Poland. Studied: Am. A. Sch., NYC; H. Tschacbasov; S. Wilson; S. Baiserman. Member: A. Lg. Am. Exhibited: WFNY, 1939; Toronto A. Gal., 1935, 1937–39; Riverside Mus., 1945. Illustrator: "The Land of the Whip," 1939, "I Came Out Alive," 1941. Illustrator: New Masses mag. [47]

REINER, Joseph [S] Union Hill, NJ. Member: NSS. Exhibited: Garden C. Am., 1929 (prize) [31]

REINHARD, Albert Grantley [P,I] Brielle, NJ (formerly of Pittsburgh, PA) b. 1854 d. 14 S 1926. Studied: Munich; Venice; Paris [01]

REINHARDT, Ad F. [P,T,I,W] NYC b. 24 D 1913, Buffalo, NY d. 1967. Studied: NYC, with C. Holty, F. Criss, 1936; Columbia; NYU; NAD, with K. Anderson, 1936. Member: Am. Abstract A., 1937. Exhibited: BM, 1946 (one-man); Columbia, 1943. Work: PMA; CI; Mus. Living A.; MOMA. Illustrator: "The Good Man and His Good Wife," 1944, "Races of Mankind," 1944. Contributor: cartoons, Picture News, 1940s. Best known for his black paintings (5 ft.-sq.), from 1960 [47]

REINHARDT, Henry [Dealer] NYC b. 1858 d. 13 Ja 1921. He had galleries in Milwaukee, Chicago, NYC and Paris, and was instrumental in organizing and building some of the best-known art museums in the West. Through him the Toledo Museum of Art acquired the famous "Moonlight," by R.A. Blakelock. Member: Lotos C.

REINHART, Benjamin Franklin [P] b. 29 Ag 1829 near Waynesburg, PA d. 3 My 1885. Studied: Pittsburgh, ca. 1844; NAD, 1847–49; Düsseldorf; Paris; Rome, ca. 1850–53. Member: ANA, 1871. Work: CGA. Opened NYC studio, 1853. Active in Midwest and South; found success as portrait painter in London, England, 1861–68, thereafter settling in NYC. Uncle of Charles. [*]

REINHART, Charles Stanley [I,P] b. 16 My 1844, Pittsburgh, PA d. 30 Ag 1896, NYC. Studied: Paris, 1867; Royal Acad., Munich, with Streyhuber, Otto, 1868. Exhibited: Paris Expo, 1889 (med); PAFA, 1888 (gold). Work: CGA [*]

REINHART, Lester C. [Ldscp.P] Lancaster, PA b. 20 D 1908, Lower Lancaster County, PA. Studied: Wilmington Acad. A., Delaware. Member: Wilmington SFA; Wilmington AC; Chester County AA; Lancaster Sketch C. Work: bas-relief, Watt and Shand Bldg., Lancaster [40]

REINHART, Stewart [P,S,E] Mt. Kisco, NY b. 19 F 1897, Baltimore, MD. Studied: E. Berge; M. Miller [25]

REINIKE, Charles Henry [P,E,T] New Orleans, LA b. 25 Jy 1906, New Orleans. Studied: Gredhan A. Sch., New Orleans; Chicago Acad. FA. Member: NOAL; NOAA; SSAL. Exhibited: PAFA; NAD; Delgado Mus. A. (one-man); Mun. A. Gal., Jackson, Miss. (one-man); Eastman Mem. Mus., Laurel, Miss. (one-man); La. A. Comm. Gal., Women's C., Shreveport, La. (one-man); SSAL, 1936 (prize), 1940 (prize); NOAA, 1937 (prize), 1940 (prize), 1941 (prize), 1945 (prize); NOAL, 1941 (prize), 1945 (med); Mid-South Fair, Memphis (gold); Outdoor Show, New Orleans, 1941 (prize); High Mus., Atlanta, 1937 (prize). Work: Mint

Mus. A.; Mus. Sc. & Indst., Chicago. Position: Dir., Reinike Acad. A. [47]

REINKE, Ottilie [P] Milwaukee, WI. Member: Wis. PS [25]

REINSEL, Walter [Des,P,Et] Phila., PA b. 11 Ag 1905, Reading, PA. Studied: PAFA; Lhote, Paris; A. Carles. Member: Phila. Pr. C.; Phila. A. All.; F., PAFA. Exhibited: PAFA, 1939–45; Reading Mus. A., 1945; Phila. A. All., 1942 (one-man), 1946; Wanamaker Regional, Phila., 1934. Work: IBM Coll. Reading Mus. A. Specialty: layout design, typography. [47]

REISAPFEL, Berthold [P,Des] Chicago, IL b. 31 My 1911, Chicago, IL. Studied: AIC. Member: United Scenic A. Work: Theatrical Des., Chicago Opera; Lake Shore Theatre, Westford, Mass. [40]

REISINGER, Hugo [Patron,Dealer] b. 29 Ja 1856, Langenschwalbach, near Weisbaden, Germany (settled in NYC, 1890) d. 28 S 1914, Langenschwalbach, near Weisbaden, Germany. He arranged an exhibit of German art shown during 1908–09 at the MET, the Copley S., Boston and AIC. In 1910 he sent to Berlin and Munich a collection of about 200 paintings by American artists, some lent by the MET and PAFA, but most of them from his private collection. In 1914 he was appointed Honorary Commissioner to the Anglo-American Exposition in London and arranged the American art section and published its illustrated catalogue. He bequeathed $100,000 to Columbia, $50,000 to the MET, $50,000 to the Germanic Mus. at Harvard, and similar amounts to the art museums in Berlin and Munich.

REISMAN, Philip [P,T,E,I] NYC (1977) b. 18 Jy 1904, Warsaw, Poland. Studied: ASL, with G. Bridgman, W. Morgan, H. Wickey. Member: An Am. Group; A. Lg. Am.; Am. A. Cong. Exhibited: PAFA, 1946; MOMA, 1932; Nat. Print Exh.; Pepsi-Cola, 1944 (prize); NAD, 1956 (gold), 1968 (prize). Work: MMA; NYPL; MOMA; Bibliothèque Nationale, Paris; WPA mural, Bellevue Hospital, NYC. Position: T., Am. Artists Sch. [47]

REISNER, Irma (Victoria) (Mrs. Ferdinand Betzlmann) [Por.P] Wilmette, IL. b. 24 D 1889, Budapest, Hungary. Studied: Max Klinger; Liepzig; A. Tyler. Member: North Shore AL; Chicago NJSA; All-Ill. SFA; AAPL; AFA [33]

REISS, F(ritz) Winold [P,Mur.P,Des,Dec,T] NYC b. 16 S 1886, Karlsruhe, Germany d. 29 Ag 1953. Studied: Bavaria with his father; Munich Acad. with Von Stuck; Munich A. Sch. with Diez. Member: Arch. Lg.; AWCS; NSMP, SI. Exhibited: AWCS; AIC; NAD; Munich; Paris; Stockholm. Work: Dec., Apollo Theatre, South Sea Island Ballroom of Hotel Sherman, Chicago; Resturants Crillon, Robert, Bonaparte, Rumpelmeyer, Caprice, NYC; Tavern C., Chicago; Hotel St. George, Brooklyn; ten Longchamps Restaurants, NYC; Cincinnati Union Terminals; murals, Steuben Tavern; WFNY, Music Hall, 1939. collection of portraits of 81 Indians for Great Northern R.R., Minneapolis IA. Illustrator: "Blackfeet Indians," 1935. Position: T., mural painting, NYU [47]

REISS, Hans Egon Friederich [S,T] NYC b. 4 O 1885, Lahr, Baden, Germany. Studied: Acd. Bildenden Kuenste, Karlsruhe, Baden, Germany. Position: T., NYU, Winold Reiss A. Sch. [40]

REISS, Henriette [P,Des,S,L,T] NYC b. 5 My 1890, Liverpool, England. Studied: Switzerland; England; Schildknecht, Germany. Exhibited: MET; AIC; BMFA; BM; CMA; AFA; AMNH; Newark Mus.; PMA; CAM; CI; Dayton AI; CM; BMA; Am. Des. Gal.; Anderson Gal.; Grand Central A. Gal.; Rochester Mem. A. Gal., 1946; Am. Woman's Assn.; Toledo Mus. A. (one-man); CMA (one-man); Univ. Nebr. (one-man); Univ. Ky. (one-man); Univ. Del.; Hackley A. Gal.; Europe. Contributor: nat. mags. Position: T., Bd. Edu., NYC [47]

REISS, Lionel S. [P,Li,I,E] NYC b. 29 Ja 1894, Austria. Studied: self-taught. Member: AWCS; Audubon Soc.; A. Lg. Am. Exhibited: AIC; BM; CI, 1941; CM; Los Angeles Mus. A.; WMAA; PAFA; AWCS; NAD; MOMA, 1940 (prize); Am. A. Group (prize); Assn. Am. A., 1943 (prize). Work: Jewish Theological Inst., NYC; Sinai Ctr., Chicago; Columbia; BM. Illustrator: "A Golden Treasury of Jewish Literature" [47]

REISS, Louis H. [P,I,T] Newark, NJ b. 16 Mr 1873, Newark. Studied: J.W. Stimson; Diehl; Ward [10]

REISZ, Frank [P] Affilated: A. Acad., Cincinnati [17]

REITER, Freda Leibovitz (Mrs.) [P,Et,Li,L,I] Camden, NJ b. 21 S 1919, Phila., PA. Studied: Moore Inst. Des.; PAFA; Barnes Fnd.; San Carlos Acad., Mexico. Member: Phila. Pr. C. Exhibited: PAFA, 1936, 1938, 1941, 1942; NAD, 1941, 1944–46; CI, 1943; Carlen Gal., 1942 (one-man); Phila. Pr. C., 1944 (one-man); Graphic Sketch C., 1938 (prize), 1940 (prize). Work: LOC; CI [47]

REITZEL, Marques E. [P,E,Gr,L,T,I] San Jose, CA b. 13 Mr 1896, Fulton, IN. Studied: Seyffert; G. Bellows; J.A. St. John; Kroll; Hopkins; Ohio State Univ.; AIC; Cleveland Col., Western Reserve Univ.; C. Buehr; Foster. Member: Chicago SA; Chicago PS; Chicago Gal. A.; Hoosier Salon; Am. Coll. S. Print Collectors; Cliff Dwellers. Exhibited: CI, 1929; CGA, 1929; PAFA, 1928, 1929, 1931; AIC, 1927 (prize), 1928 (prize), 1929, 1931, 1934; CMA, 1931; Hoosier Salon, 1928, 1929 (prize), 1930, 1931, 1940, 1942, 1944, 1945; All-California Exh., 1940, 1941, 1944; Oakland A. Gal., 1941–43; Century of Progress, Chicago, 1934 (gold); GGE, 1939; San Jose AL, 1940 (prize), 1941 (prize); Chicago Gal. Assn., 1937 (prize), 1943 (prize). Work: Chicago Mun. Coll. for pub. schs.; Chicago Pub. Schs. AS; Hobart, Ind. H.S.; Rockford Col.; Dakota Boys' Sch.; H.S., Rockford, Ill., Lafayette, Ind.; AA, Belvidere Women's C.; Colorado State T. Col. Position: T., San Jose State Col. [47]

RELF, Clyde Eugenia [P] Seattle, WA [24]

RELYEA, Charles M. [I,P] Flushing, NY b. 23 Ap 1863, Albany, NY d. 17 Je 1932. Studied: PAFA, with T. Eakins; F.V. Du Mond, in NYC; Paris. Member: SC; Allied AA; Alliance; Player's C.; Artists Gld. [31]

REMAHL, Frederick [P,T] Chicago, IL b. 18 Je 1901, Sweden. Studied: Minneapolis Sch. A.; A. Angarola. Member: Chicago SA; AAPL. Work: Mus. Gothenburg, Sweden; Chicago Bd. Trade; twelve paintings, P.W.A.P., in State Inst., Ill. [40]

REMBERT, Catharine Philip (Mrs.) [Des,P,T] Columbia, SC b. 22 Ap 1905, Columbia. Studied: A. Dept., Univ. S.C.; Md. Inst.; A. Lhote, Paris. Member: Columbia AA; Columbia Sketch C.; SSAL; State Fair, 1931 (prize) 1932 (prize), 1936 (prizes). Specialty: lampshade and textile design, stagecraft. Position: T., Univ. S.C. [40]

REMBSKI, Stanislav [P,W,T,L] Baltimore, MD/Deer Island, ME b. 8 O 1896, Sochaczew, Poland. Studied: S. Lenc, Ecole des Beaux-Arts, Warsaw, Poland; RA, Berlin, Germany; E. Wolfsfeld, Berlin. Member: Am. Ar. Prof. Lg.; Charcoal C., Baltimore. Exhibited: Dudensing Gal.; Carnegie Hall Gal.; Newton Gal.; Chambers Gal., Baltimore, 1940. Work: murals, St. Bernard Sch., Gladstone, N.J.; port., Columbia Univ.; Kent Sch., Conn.; Adelphi Col.; Brooklyn Polytechnic Inst.; NAD; St. John's Hospital, Brooklyn; Mus. Osage Indian, Pawhuska, Okla.; Johns Hopkins Univ.; Goucher Col.; Loyola Col.; Bd. Edu., Baltimore; State House, Annapolis, Md.; Church of the Neighbor; Univ. N.C.; Beth Israel Hospital, Newark. Author: "Mysticism in Art," 1936; articles, "Art and Religion," "Reflections on Symbolism," New Church Messenger [47]

REMINGTON, Edith Liesee [P] Phila., PA [19]

REMINGTON, Elizabeth H. [P] b. 1825 d. 22 Ja 1917, Flushing, NY (age 92). Active in NYC, 1890s

REMINGTON, Frederic Sackrider [P,I,S,W] Ridgefield, CT b. 4 O 1861, Canton, NY d. 26 D 1909 (appendicitis). Studied: Yale A. Sch., 1878–79; ASL, ca. 1885; otherwise self-taught. Member: ANA, 1891; NIAL. Exhibited: Paris Expo, 1889, (med). Work: Amon Carter Mus.; Remington AM (Ogdensburg); NYPL; MET; AIC; major museums. Important painter of the vanishing West. He knew the Indian, the cowboy, the cavalryman and the Mexican vaquero and had killed bison, wolves, grizzlies and moose. Everything that happened on the plains or in the mining camps served him as subjects, and of all these he made permanent and faithful records. His first commission was for Harper's, in 1882, when he drew a picture of Geronimo's campaign. He made about fifteen bronzes (since 1895); 3,000 oil paintings, and wrote several books. One of his last sculptures was the cowboy statue erected in Fairmount Park, Phila. Since ca. 1886 he occupied a large studio which he had built at New Rochelle, N.Y., but sold it and moved to Ridgefield about six months before his death. [10]

REMINGTON, Schuyler [I] New Rochelle, NY. Member: New Rochelle AA [24]

REMINICK, Harry [S] Cleveland, OH b. 23 O 1913, Cleveland. Work: Valley View Housing Proj., Cleveland. Specialty: animals [40]

REMLINGER, Joseph J. [I] Trenton, NJ b. 29 Ag 1909, Trenton, NJ. Studied: Trenton Sch. Indst. A.; PAFA. Exhibited: PAFA, 1941; AIC, 1941; NAD, 1941–42; Montclair A. Mus., 1937–40; Kresge Exh., N.J., 1938–41; N.J. State Mus., Trenton, 1939–45; N.J. Gal., 1938 (prize), 1939 (prize), 1941 (prize) [47]

REMMEY, Paul Baker [P,I,T,L] Phila., PA b. 10 N 1903, Phila. d. ca. 1958. Studied: PMSchIA. Member: Phila. WCC; Phila. Sketch C.; Woodmere AA. Exhibited: PAFA, 1931, 1932, 1934–46; Phila. A. All., 1939–46; AIC, 1938, 1946; Woodmere A. Gal., 1940–46. Work: PMSchIA. Contributor: articles, mags.; Phila. Record; Phila. Inquirer [47]

REMMLEIN, Jules [S] Phila., PA [10]

REMQUIT, Carl [P] Brooklyn, NY [08]

REMSEN, Helen Q. [S,T] Sarasota, FL b. 9 Mr 1897, Algona, IA. Studied: Univ. Iowa; Northwestern Univ.; Grand Central Sch. A.; G. Lober; J. Hovannes. Exhibited: NAD, 1936; PAFA, 1937; All.A.Am., 1944; SSAL, 1944 (prize), 1945–46; S. Four A., 1942 (prize),1943–45; Norton Gal. A., 1944 (prize); Fla. Fed. A., 1939, 1941 (prize), 1942 (prize), 1943, 1944 (prize), 1945; Dallas MFA, 1944 (prize) [47]

REMSEN, Ira M. [P] NYC b. NYC. Studied: Paris, with B. Constant, Laurens. Member: Paris AAA; Mural P. [17]

RENAULT, Giorgio [S] Chicago, IL [17]

RENIER, Joseph Emilie [S,T] NYC b. 19 Ag 1887, Union City, NJ d. 8 O 1966. Studied: Am. Acad., Rome, F.A.A.R.; A. Weinman; V. Rousseau, Brussels. Member: ANA, 1937; NSS; Medallic AS; Arch. L.; New Haven PCC. Exhibited: PAFA; Newark Mus.; NAD; Arch. L.; NSS; Montclair A. Mus.; New Haven PCC, 1935; WFNY, 1939; Garden C. Am., 1928 (prize), 1929 (prize). Award: Prix de Rome. Work: Brookgreen Gardens, S.C.; Mattatuck Mus., Waterbury, Conn.; med., Medallic AS; S., State of Tex. Bldg., Dallas.; numerous port.; seven metopes, USPO Dept. Bldg., Wash., D.C. Position: T., Yale , 1927–41 [47]

RENNELL, J(ohn) W(atson) [P,S,I,L,T] Boulder, CO b. 28 Jy 1876, Foo Chow, China. Studied: PAFA; H. Pyle. Position: T., Univ. Colo. [25]

RENNER, Otto (Hermann) [P,E] Paso Robles, CA b. 19 N 1881, San Francisco, CA. Studied: C.H. Robinson; A. De Milhau; H. Wolf. [33]

RENNIE, Helen Sewell [P,Des,Cart,I,T] Arlington, VA b. Cambridge, MD. Studied: Corcoran A. Sch.; NAD. Member: AWCS; S. Wash. A. Work: PMG; mural, Roosevelt H.S., Wash., D.C. Exhibited: CGA, 1931, 1933; PAFA, 1934; MOMA, 1946 [47]

RENNINGER, Paul [P] Newark, NJ [04]

RENNINGER, Wilmer Brunner [P] b. 18 My 1909, Boyertown, PA d. 23 N 1935. Studied: T. Oakley; H. Pullinger. Work: Reading Mus.

RENOUARD, G. [G] NYC. Exhibited: AIC, 1936; CAFA, 1938; 15 Gal., NYC, 1940 (one-man)[40]

RENSHAWE, J.H. [P] Affilated with U.S. Geological Survey [13]

RENSIE, Florine (Mrs. William J. Eisner) [P] NYC b. 9 O 1883, Phila. ("Rensie" is Eisner spelled backward.) Studied: A. Brook; S. Laufman; G. Picken. Member: NAWA; Studio G. Exhibited: PAFA, 1937; CGA, 1941; VMFA, 1942; "Masterpieces of Tomorrow" Exh.; NAWA [47]

RENTSCHLER, Fred [P] Cleveland, OH [25]

RENWICK, Howard Crosby [I,P] NYC. Member: SI; Allied AA [47]

RENWICK, William Whetten [Arch,S,P] Short Hills, NJ b. 1864, Lenox, MA d. 15 Mr 1933. Member: SC; AIA, 1901; NSS. Work: Roman Catholic Church of All Saints, NYC; one of the towers of St. Patrick's Cathedral; pulpit, corner plot of Grace Episcopal Church, NYC. Specialty: ecclesiastical arch./des. Inventor: "fresco-relief" in mural dec. [25]

RENZETTI, Aurelius [S] Phila., PA. Studied: PAFA [25]

RESLER, George Earl [E] St. Paul, MN b. 12 N 1882, Waseca, MN. Member: Chicago SE. Exhibited: Minn. Art Comm., 1913 (prize), 1923 (prize), 1914 (prize); St. Paul Inst., 1918 (med). Work: AIC; Smithsonian Inst., Wash., D.C.; Mun. A. Gal., Tampa; St. Paul Inst. [40]

RESSINGER, Paul M. [P] Chicago, IL. Member: GFLA [27]

RET, Etienne (Mr.) [P,W,L] Hollywood, CA b. 6 Ja 1900, Bourbonnais, France. Studied: Ecole des Arts Decoratifs, Paris; M. Denis; G. Desvallieres. Exhibited: nationally. Work: de Young Mem. Mus.; Santa Barbara Mus. A.; Pasadena AI; San Diego FAS; Witte Mem. Mus.; State Mus., France; Encyc. Brit. Coll. Author: "Blindman's Bluff," 1929 [47]

RETHI, Lili (Elizabeth) [I,Li] NYC b. 19 N 1894, Vienna, Austria. Studied: Vienna; O. Friedrich; Von Larisch. Exhibited: Berlin; Vienna; Stockholm; Arch. L.; MET, 1942; Am. Soc. Civil Engineers, 1942. Work: murals, Construction companies, NYC. Illustrator: "U.S. Naval Dry Dock Constructions," 1941, 1943; "Builders for Battle (Pacific Naval Air Bases)," 1946, "Tanker Construction," 1946. Specialty: indst. illustrations [47]

RETTIG, John [P] Cincinnati, OH b. ca. 1860, Cincinnati, OH d. 2 My 1932. Studied: Cincinnati A. Sch., with Duveneck, Potthast; Paris, with Collin, Courtois, Prinet. Member: SC; Cincinnati AC; AFA. Much of his life was spent in Holland, among the fishing villages. He had also decorated and modeled Rookwood pottery. [31]

RETTIG, John (Mrs.) d. spring 1919, Cincinnati, OH. Member: Cincinnati Women's C. (head of art dept.); Cincinnati MacDowell S.

RETTIG, Martin [P] Cincinnati, OH b. Cincinnati. Studied: F. Duveneck. Member: Cincinnati AC [31]

RETZ, Philip [P,Arch,Des,C,T] Omaha, NE b. 24 S 1902, Berlin, CT. Studied: T.R. Kimball; A. Dunbier [40]

REUL, Alexander [S] b. 1874 d. 20 Ja 1937, White Plains, NY

REUSCH, Helen [P] Cambridge, MA [01]

REUSSWIG, William [I,W] NYC (1973) b. 1902, Somerville, NJ. Studied: Amherst; ASL. Member: SI. Illustrator: Collier's, True. Author/Illustrator: "A Picture Report of the Custer Fight" [47]

REUTERDAHL, Henry [P,I,W] Wash., D.C. b. 12 Ag 1871, Malmö, Sweden d. 20 D 1925. Studied: self-taught. Member: Arch. Lg., 1911; Assn. U.S. Naval Arch. Eng.; A. Fund S.; Mural P.; AG, Authors Lg. A. Exhibited: P.-P. Expo, San Fran., 1915 (med); Phila. WCC, 1919 (prize). Work: U.S. Naval Acad., Annapolis; Navy Dept., Wash., D.C.; Nat. Mus., Wash., D.C.; Naval War Col., Newport; TMA; Kalamazoo AA;; Culver Military Acad.; Capitol, Jefferson City, Mo. Specialty: naval, marine and indst. subjects. War correspondent during Spanish war and official artist, U.S. Navy during WWI, 1917–18 [25]

REVEREND, M.M. [P] Kansas City, MO [17]

REWALD, John [W,L] NYC b. 12 My 1912, Berlin, Germany. Studied: Univ. Hamburg; Univ. Frankfort; Sorbonne, Paris. Member: CAA. Author: "Cézanne et Zola," 1936, 1939; "Gauguin," 1938; "Georges Seurat," 1943; "The History of Impressionism," 1946. Ed.: Cézanne's "Letters," 1941; Gauguin's "Letters to Vollard and Fontainas," 1943; Pissarro's "Letters to His Son Lucien," 1943; Degas' "Works in Sculpture," 1944. Contributor: Art News, Gazette Des Beaux-Arts, Magazine of Art, Art in America [47]

REXACH, Alberto [P] NYC. Affiliated with Caldwell & Co. [24]

REXROTH, André, Mrs. [P] San Fran., CA b. 1902, Chicago, IL. Exhibited: Downtown Gal., NYC, 1937; AIC, 1938 [40]

REY, H(ans) A(ugusto) [I,W,Li,Car] NYC b. 16 S 1898, Hamburg, Germany. Studied: Univ. Munich; Univ. Hamburg. Member: AIGA. Author/Illustrator: "Curious George," 1941; "Cecily G.," 1942; "Look for the Letters," 1945, & numerous others, mainly for children. Illustrator: "Park Book," 1944; "Spotty," 1945; comic strip "Pretzel." Exhibited: 1946 Books by Offset Lithography Exh., NYC; 1946 Best Picture Books; AIGA, 1941 for "Curious George" [47]

REYAM, David [P,Des] Wilmington, DE b. 7 S 1864, NY d. 19 My 1943. Studied: NAD; Académie Julian, with Lefebvre, Bouguereau [40]

REYBURN, William F. [P] Wash., D.C. [01]

REYNARD, Grant (Tyson) [Et,Li,P,W,L,T] Leonia, NJ b. 20 O 1887, Grand Island, NE d. 13 Ag 1967, NYC. Studied: AIC; Chicago Acad. A.; H. Dunn, H. Wickey; M. Young. Member: SC; ANA; AWCS; SAE; Am. A. Group; Prairie PM; Am. Prof. Lg.; Phila. SE. Exhibited: WFNY, 1939; AGAA (one-man); LOC, 1944 (prize); AAPL, 1934 (prize); SC, 1939 (prize); Joslyn Mem.; Univ. Nebr.; Univ. Tulsa; AIC; PAFA; NAD; Kennedy & Co. (one-man); Clayton Gal. (one-man); Grand Central A. Gal.; (one-man); Assn. Am. A. (one-man); McD. C. (one-man); Bucknell Univ., 1946 (one-man). Work: Newark Mus.; FMA; Univ. Tulsa; MET; NYPL; LOC; AGAA; de Young Mem. Mus.; Univ. Nebr.; N.J. State Mus., Trenton; panels, Calvary Episcopal Church, N.Y.; St. John's Church, Leonia, N.J. Illustrator: "Rattling Home for Christmas," 1941 (Am. A. Group). Contributor: Scribner's, nat. mag. Positions: T., Millbrook Sch. (N.Y.), Palo Duro Sch. A., Canyon, Tex. [47]

REYNEAU, Paul O. (Mrs.) [P] Detroit, MI [21]

REYNOLDS, Alice [P] Albany, TX. Exhibited: 48 Sts. Comp., 1939 [40]

REYNOLDS, Alice M. [P] NYC b. Olcott, NY. Studied: ASL; Paris with Merson, Collin, Aman-Jean [08]

REYNOLDS, Clara W. (Mrs.) [Mur.P,Por.P,Des,Dec,B,Dr,I,E,T,W] Rutland, VT b. 14 N 1899, East Poultney, VT. Studied: Syracuse Univ.; Boston, with Vesper George Sch. A.; Fontainebleau Sch. FA. Member: Rutland AC (Dir.). Work: illumination, Rutland Pub. Lib. Position: T., Meldon Sch., Rutland [40]

REYNOLDS, Douglas Wolcott [P,L,S,T,E,En] Georgetown, TX b. 14 Je 1913, Columbus, GA. Studied: Ringling Sch. A.; Univ. Miami; Yale; J.B. Newman; J.W. Decker. Member: Fla. Fed. A.; Tex. FAA; F., Yale, 1941–42. Exhibited: Rome, Italy, 1941; Fla. Fed. A., 1934–36; Fla. State

Expo, 1930; New Haven, Conn., 1941, 1942, 1946 (one-man). Position: T., Southwestern Univ., Georgetown, Tex., from 1943 [47]

REYNOLDS, Edith [P] Wilkes-Barre, PA [19]

REYNOLDS, Elizabeth [P] Boston, MA [01]

REYNOLDS, Frances, Mrs. See Burr.

REYNOLDS, Frederick (Thomas) [E,C,L,T] NYC b. 19 F 1882, London. Studied: London. Member: SAE; SC [33]

REYNOLDS, George [P] Los Angeles, CA. Member: Calif. AC [25]

REYNOLDS, Harry Reuben [P,C,T] North Logan, UT b. 29 Ja 1898, Centerburg, OH. Studied: AIC; Univ. Iowa; Sandzen; B.J.O. Norfeldt; G. Wood; L. Randolph; O. Oldfield; R. Stackpole. Member: Utah AI. Exhibited: SFMA, 1931; Oakland A. Gal., 1929, 1932; Utah State Fair, 1936 (prize); Salt Lake City A. Ctr. (one-man); AIC, 1923 (med). Work: Bethany Col., Lindsborg, Kans.; Utah State Fair Coll.; Ogden Pub. Sch.; Branch Agriculture Col., Cedar City, Utah; Logan (Utah) H.S.; Polk Sch., Odgen. Position: T., Utah State Agriculture Col., from 1923 [47]

REYNOLDS, Helen Baker [C] San Fran., CA b. 15 Ag 1896, Ojai, CA. Studied: Calif. Sch. FA; R. Schaeffer Sch. Des.; Kunstgewerbe Schule, (Arts & Crafts Sch.) Vienna. Member: San Fran. AA; San Fran. S. Women A.; A. Ctr., San Fran. [40]

REYNOLDS, Joseph G., Jr. [Des,C,W,L,Cart] Belmont, MA b. 9 Ap 1886, Wickford, RI. Studied: RISD. Member: Mediaeval Acad. Am.; Copley Soc., Boston; Marblehead AA; Boston SAC (master craftsmen); AFA. Exhibited: Boston SAC, 1929 (med); Boston Tercentenary Expo, 1930 (gold); Paris Salon, 1937 (med). Work: stained glass windows: Princeton Chapel; churches in Pittsburgh, Pa.; Glens Falls, N.Y.; Mercersburg, PA; Belleau, France; Paris, France; Winston-Salem, N.C.; Litchfield, Conn.; Laconia, N.H.; Hudson Falls, N.Y.; Newport, R.I.; Wash., D.C.; also Wellesley Col.; Colorado Col.; Riverside Ch., NYC; Florence Nightingale Window, Nat. Cathedral; Cathedral of St. John the Divine; Church, Springfield, Ill. Contributor: articles, Cathedral Age, American Architect, Creative Design, Stained Glass Magazine [47]

REYNOLDS, Lloyd J. [P] Portland, OR. Exhibited: SAM, 1937, 1938 (prize) [40]

REYNOLDS, May E. [P] Put-In-Bay, OH [04]

REYNOLDS, Oakley [I] Rockville Center, NY. Member: SI [47]

REYNOLDS, Ralph William [Edu,P,E,Li] Indiana, PA. b. 10 N 1905, Albany, WI. Studied: AIC; Beloit Col.; State Univ., Iowa; G. Wood; J. Charlot; E. O'Hara. Member: Pittsburgh AA. Exhibited: Okla. A. Ctr., 1939; Phila A. All., 1939; Am. Color Pr. S., 1942; Iowa State Fair, 1939, 1940; Kansas City AI, 1940; Butler AI, 1941, 1942; Pittsburgh AA, 1942–46; Athens, Ohio, 1945, 1946; Parkersburg FA Ctr., 1945, 1946. Positions: T., Univ. S.Dak. (1940–41), State T. Col., Indiana, Pa. (from 1941) [47]

REYNOLDS, Richard [P] b. 1827, England (came to U.S. when a young man) d. Ja 1918, Cincinnati. A descendant of Sir Joshua Reynolds.

REYNOLDS, Virginia (Mrs.) [Min.P] Chicago, IL b. 1866, Chicago. Studied: C. Von Marr; Heterick, Munich; Lasar, Paris. Member: SBA; ASMP. Exhibited: Miniature Exh., NYC, 1896 [01]

REYNOLDS, Wellington Jarard [Por.P,T] Chicago, IL b. 9 Ap 1869, New Lenox, IL. Studied: Paris, with Laurens, Constant; RA, Munich; Académie Julian; Ecole des Beaux-Arts, Paris. Member: Societé des Artistes Français; Cliff Dwellers. Exhibited: Chicago, Ill., 1908 (med); Chicago SA, 1910 (med); Paris Salon, 1925 (med); Sesqui-Centenial Expo, Phila, 1926 (med); AIC, 1921 (prize). Work: Univ. Chicago; Piedmont Gal., Oakland, Calif.; Springfield MFA; City Mus., Laurel, Miss.; Univ. Ill.; Univ. Calif.; Golden Gate Park Mus., San Fran.; H.S., Riverside, Ill.; Hotel, Castle Park, Mich.; Lake Shore Athletic C., Chicago. Position: T., Chicago Acad. FA [47]

REYNOLDS, William H. (Mrs.) [P] Providence, RI. Member: Providence AC [25]

RHEAD, Frederick Hurten [Cer,C] East Liverpool, OH b. Hanley, Staffordshire, England. Studied: F.A. Rhead, Taxile Doat; L.V. Solon. Member: Arch. L.; A. Ceramic S. Exhibited: San Diego Expo, 1915 (gold), 1934 (med). Work: dec., theatres, hotels, etc., in collaboration with L.V. Solon. Contributor: articles on ceramics, Collier's Nat. Encyc. Author: "Studio Pottery," 1910. Positions: A. Dir., Homer Laughlin China C., Newell, W.Va.; T., W.Va. Univ. [40]

RHEAD, George W. [I] NYC. Affilated with R.H. Russell & Co., NYC [98]

RHEAD, Lois Whitcomb [S,C] East Liverpool, OH/Santa Barbara, CA. 16 Ja 1897, Chicago, IL. Studied: F.H. Rhead; L.V. Solon. Member: NAWPS; Amer. Cer. S. [29]

RHEAD, Louis [I,P,W] Amityville, NY b. 6 N 1857, Etruria, Staffordshire, England (came to U.S. in 1883) d. 29 Jy 1926. Studied: E.J. Poynter; A. Legros, in London. Member: Arch. Lg., 1902; NYWCC. Exhibited: Boston, 1895 (gold); Pan-Am. Expo, Buffalo, 1901; St. Louis Expo, 1904 (gold). Illustrator: Harpers' Juvenile Classics. Author/Illustrator: "Robin Hood"; several works on angling [25]

RHEAL, Ronda [P,Dr,I] Boston, MA b. 30 O 1891, Baltimore, MD d. ca. 1945. Member: Gloucester SA; Boston S.Indp.A. Illustrator: volume of Emerson's Essays, accepted by Harvard Univ. for Emerson Coll., Widener Lib. [40]

RHEEM, Royal Alexander [I] Minneapolis, MN b. 8 O 1883, Omaha, NE. Studied: Minneapolis Sch. A, with R. Koehler. Exhibited: Minn. State A.S. (prize) [10]

RHEIN, R(uth) V(an) W(yck) [P] NYC/Jamestown, RI b. 1 Je 1892, NYC. Studied: H.W. Ranger [17]

RHETT, Antoinette (Francesca) [E,P] Charleston, SC b. 7 O 1884, Baltimore, MD. Studied: A. Hutty. Member: Charleston EC; Car. AA; Miss. AA; Charleston Sketch C.; NOAA; SSAL. Exhibited: SSAL (prize); S.C. State Fair [40]

RHETT, Hannah McC(ord) [P,T] Brevard, N.C. b. 28 F 1871, Columbia, SC. Studied: ASL; Paris, with Collin, Laurens. Member: Carolina AA; S.Indp.A.; ASL. Exhibited: AAS (meds) [31]

RHIND, J(ohn) Massey [S] NYC b. 9 Jy 1860, Edinburgh, Scotland (came to U.S., 1889) d. 22 O 1936, London. Studied: his father, John Rhind, R.S.A.; Dalou, Paris. Member: NSS 1893; Arch. L., 1894; N.Y. Mun. AS; NAD; SC; Allied AA; Brooklyn SA; Royal Scotch Acad., 1933. Exhibited: St. Louis Expo, 1904 (gold). Work: Trinity Church, NYC; equestrian, "George Washington," Newark, N.J.; statues in Phila.; "Peter Stuyvesant," Jersey City; McKinley mem., Niles, OH; Butler AI; numerous decorations for fed. and mun. bldgs. His portrait bust of Carnegie is in many libraries. [33]

RHOADES, John Harsen [Patron] NYC d. 6 D 1906. Member: Soc. of Collectors (pres.) Had a notable collection of paintings by American artists.

RHOADES, K.N. [P] NYC [15]

RHOADS, Harry Davis [B,Des,Dr,E,En,I] Barberton, OH b. 7 Ja 1893, Phila., PA. Studied: H.G. Keller. Position: A. Dir., Firestone Tire Co., Akron, Ohio [40]

RHOADS, Katherine [P] Richmond, VA b. 25 Je 1895, Richmond, VA d. ca. 1938. Studied: G. Gieberich; A. Fletcher; J. Slavin. Member: Richmond Acad. A. [33]

RHODES, Charles Ward [P,T] d. 9 N 1905, Buffalo, NY (suicide?) Taught at St. Louis MFA; CI gallery business manager, 1902; moved to Boston, and finally to Buffalo.

RHODES, Daniel [C,P,T,Des,L] Menlo Park, CA b. 8 My 1911, IA. Studied: Univ. Chicago; Alfred Univ.; AIC; ASL; J.S. Curry; G. Wood. Member: Am. Cer. S.; Mun. A. Forum, Des Moines. Exhibited: AIC, 1938; SFMA, 1940; Pal. Leg. Honor, 1941 (one-man); Iowa State Fair Art Salon, 1938–40 (prizes). Work: cer., Walker A. Ctr.; WPA murals, USPOs, Glen Ellyn, Ill., Clayton, Mo., Marion, Iowa, Piggott, Ark., Storm Lake, Iowa.; Navy Bldg., Wash., D.C. Positions: T., A. Student's Workshop, Des Moines (1940), Stanford Univ., Palo Alto, Calif. (1946) [47]

RHODES, Ethel van Linschoten [C,T] Woodstock, VT b. 2 Ap 1882, Maidstone, England. Studied: Conn. Col., with O.W. Sherer, A. Watrous; W. Walden. Member: Boston SAC. Position: T., Vt. State Bd. Health [40]

RHODES, Helen N. [P,B,Li,I,T] Seattle, WA/Ellisport, WA b. Wilwaukee d. 16 Je 1938. Studied: A.W. Dow; NAD; Columbia. Member: Seattle Mus.; Northwest PM; Pacific AA. Exhibited: Seattle AI, 1923 (prize), 1924 (prize), 1925 (prize); Intl. Salon Water Colors, Provincial Exh., New Westminster, B.C., 1928 (med,prize), 1929 (med,prize); Northwest A. Annual Exh., Seattle, 1930 (prize), 1932; State Fair, 1932 (prize). Author: articles on university problems in design. Illustrator: "Paul Bunyan Comes West," pub. Houghton Mifflin. Position: T., Univ. Wash. [38]

RHODES, Naomi [Por.P] Lynn, MA b. 14 Je 1899, Lynn. Studied: Hale; James; Meryman; Tarbell. Member: Wash. AC [25]

RHOME, Lily Blanche Peterson (Mrs. Byron) [Min.P] Asbury Park, NJ. Exhibited: ASMP, 1938; Wash. SM PS&G, 1939 [40]

RIBA, Paul [P] Cleveland, OH b. 25 Ja 1912, Cleveland d. 1977. Studied: PAFA; Cleveland Sch. A. Work: Cleveland Pub. Lib.; WPA mural, Airport, Cleveland [40]

RIBAK, Louis [P] Taos, NM b. 3 D 1902, Russian Poland. Studied: PAFA with D. Garber; ASL, with J. Sloan; Edu. All. A. Sch.; NYC. Member: An. Am. Group; Am. Soc. PS&Gr; Am. Ar. Cong. Exhibited: CGA; PAFA; AIC; WFNY 1939; GGE, 1939; WMAA; WMA; Walker A. Ctr.; VMFA; MET; Springfield Mus. FA; BM; Newark Mus.; numerous traveling exh. Work: WMAA; Univ. Ariz.; Newark Mus.; BM; WPA mural, USPO, Albemarle, N.C. Position: T., Dir, Taos Valley A. Sc., 1959 [47]

RIBCOWSKY, Dey de [Mar.P] Los Angeles, CA b. 13 O 1880, Rustchuk, Bulgaria. Studied: Paris; Florence; Petrograd. Member: Newport AA; Buenos Aires SFA. Exhibited: Petrograd, 1902 (med); Uruguay Expo, Montevideo, 1908 (med); Rio de Janeiro Expo, 1909 (med); Odessa, 1909 (prize); Moscow, 1910 (prize); Sofia Nat. Gal., 1910 (prize). Work: Mus. Alexander III, Petrograd; Tretiacof Gallery, Moscow; Odessa Mus.; Uruguay Mus., Montivideo; Buenos Aires Mus.; Nat. Palace, Montevideo; Nat. Palace, Rio de Janeiro; Governor's Palace, Barbadoes; Manchester, N.H. Mem. Specialty: inventor of the Medium "Reflex." [25]

RICCI, Ulysses Anthony [S] NYC b. 2 My 1888, NYC d. 1960. Studied: CUASch; ASL; J.E. Fraser. Member: ANA; Am. Numismatic S.; Arch. L.; NSS; All.A.Am.; SC. Exhibited: PAFA; MET (AV), 1942; NAD; All.A.Am.; Arch. L.; SC. Exhibited: medals, Am. Numismatic S.; S., Plattsburgh N.Y.; Bowery Savings Bank; Rundel Mem. Lob.; Rochester Univ.; Arlington Mem.; Am. Pharmeceutical Bldg., Wash. D.C.; Dept. Commerce Bldg., Wash. D.C. [47]

RICCIARDI, Cesare A. [P] Phila., PA b. 8 Je 1892, Italy. Studied: PAFA. Member: Phila. Sketch C.; Phila. Alliance. Exhibited: Phila., 1916 (prize) [25]

RICCITELLI, D(omenico) [P] Providence, RI b. 29 Mr 1881, Italy. Studied: RISD [27]

RICE, Anne Estelle [I,P] Phila., PA b. 1879, Phila. [10]

RICE, Burton [P] Chicago, IL [15]

RICE, Charles H. [P] Sea Bright, NJ. Member: S.Indp.A. [25]

RICE, Dorothy. See Peirce.

RICE, Emma Duel [P] Wash., D.C. Member: Wash. WCC [25]

RICE, Franklin Albert [Min.P,Por.P] Cleveland, MO b. 30 J 1906, Cleveland, MO. Studied: A. Bloch; K. Mattern; R.J. Eastwood; Univ. Kans.. Position: staff, Thayer MA, Lawrence, Kans. [40]

RICE, Harold Randolph [T,Cr,Des,G,W,L] Phila., PA b. 22 My 1912, Salineville, OH. Studied: Univ. Cincinnati; Columbia. Member: Southwestern AA; SSAL; Birmingham A. Lg.; Ala. WCC; AFA; Ala. A. Lg. Exhibited: Columbia, 1943–44 (prize). Position: T., Univ. Cincinnati, 1934–43; Univ. Alabama, 1944–46; Dean, Moore Inst., A. Sc.&Indst., 1946– [47]

RICE, Henry W. [P,T] Watertown, MA b. Pownal, ME. Studied: R. Turner [25]

RICE, Kathryn Clark (Mrs.) [Des,C,P] Gambier, OH b. 18 Ja 1910, Frankfort, KY. Studied: Univ. Cincinnati; Cincinnati A. Acad; Ohio State Univ. Member: Columbus A. Lg. [40]

RICE, Lucy Wilson (Mrs. C.D.) [Por.P] Austin, TX b. 14 Mr 1874, Troy, AL. Studied: G.E. Browne; W. Adams; Grand Central Sch. A.; Acad. Colarossi, Grande Chaumière, Acad. Delécluse, all in Paris. Member: SSAL; Tex. FAA; Austin AL; AAPL. Work: portraits: State of Tex.; Univ. Tex.; Univ. Men's C., Austin; Baylor Univ.; Tex. Col. A.&Indst., Kingsville; Tex. Capitol; State Univ.; Federal Bldg., Austin; Pub. Lib., San Antonio; Theological Seminary, Rochester, N.Y.; Scottish Rite Dormitory, Univ. Tex.; Baylor College, Belton; State Teachers Col., San Marcos; Tex. Centenn. Expo, Dallas; Southwestern Univ., Georgetown, Tex.; Univ. Tex. Med. Sch., Galveston [40]

RICE, Maegeane Ruble [P,S,T,L] Muskogee, OK/Fayetteville, AR b. 11 Ja 1911. Studied: I. Gador; C. Batthyany; S. Pekary, in Budapest. Member: Ark. WCC. Exhibited: Assn. Okla. Ar., Oklahoma City, 1935 (prize), 1937 (prize); cer., Okla. State Fair, 1939 (prize). Work: Ark. State Lib. [40]

RICE, Marghuerite Smith (Mrs. Fred. Jonas Rice) [S] Buffalo, NY. b. 11 Je 1897, St. Paul. Studied: E. Pausch. Member: Buffalo SA; Gld. Allied A.; Lg. Am. P. Women. Work: port. bust, Bishop Charles Harry Brent, mem. in Philippines [40]

RICE, Mervyn A. [P] Wash., D.C. [25]

RICE, Myra M. [P] Newfane, NY. Member: Buffalo SA [25]

RICE, Nan (Mrs. Hugh) [P,L] Chicago, IL b. 9 My 1890, Winnipeg, Canada d. 7 D 1955, Stockton, CA. Studied: Winnipeg Sch. A.; Wesley Col., Winnipeg; AIC; Univ. Chicago. Member: Chicago SA; Chicago P.&S. Assn.; South Side AA; Ridge AA; All-Ill. Soc. FA; Hyde Park A. Center; Chicago AC. Exhibited: Wawasea A. Gal., Syracuse, Ind., 1944 (prize), 1945 (prize); All-Ill. Soc. FA, 1944 (prize); South Side A., 1942–45 (prizes); AIC, 1933, 1942,1944; Milwaukee AI, 1944. Work: Univ. Chicago; Vanderpoel Coll. [47]

RICE, Norman Lewis [T,G,P] Syracuse, NY b. 22 Jy 1905, Aurora, IL. Studied: Univ. Ill.; AIC. Member: Cliff Dwellers, Chicago. Positions: T., AIC (1930–42), USNR (1942–46), Syracuse Univ. (1946–) [47]

RICE, Richard Austin [Cur,T] Wash., D.C. b. 1846, Madison, CT d. 5 F 1925. Studied: Yale; Univ. Berlin; other foreign univ. and tech. sch. Positions: T., 1875–81, Univ. Vt., (1875–81), Williams Col. (for 25 years); Chief, Div. of Prints, LOC

RICE, Susanne C. [P] NYC [01]

RICE, William C(larke) [Mur.P,S,I,C,W,T] NYC/Center Lovell, ME b. 19 Ap 1875, Brooklyn, NY d. 13 F 1928. Studied: CCNY, 1897; G. deF. Brush; ASL. Member: N.Y. Arch. Lg.; Mural P. Work: murals: Pub. Sch., NYC; Jonas Bronck Sch.; Missouri Theatre, St. Louis; Nat. Gal., Wash.; 20-panel mural, Park Central Hotel, NYC. Position: T., NYC Pub. Sch. [27]

RICE, William M(orton) J(ackson) [Por.P] NYC b. 18 F 1854, Brooklyn, NY d. 13 O 1922. Studied: NYC, with Beckwith; Paris, with Carolus-Duran. Member: ANA, 1900; SAA; 1886; Century Assn.; Lg. of AA. Exhibited: Pan-Am. Expo, Buffalo, 1901 (med) [24]

RICE, William S(eltzer) [B,E,T,P,Des,I,W,L] Oakland, CA b. 23 Ja 1873, Manheim, PA d. 1963. Studied: PMSchIA; Col. A.&Crafts, Oakland; H. Pyle, at Drexel Inst. Member: Bay Region AA; Northwest PM; Calif. SE; Calif. Soc. Pr. M.; Prairie Pr. M. Exhibited: PMSchIA, 1904 (prize); Calif. SE, 1943 (prize), 1945 (prize); LOC; Phila. Pr. C., 1943, 1944, 1946; Calif. SE, annually since 1912. Work: prints, Calif. State Lib.; Oakland H.S.; Calif. Col. A.&Crafts.; Golden Gate Park Mus., San Fran. Author: "Block Printing in the School," "Block Prints-How to Make Them." Positiona: T., Fremont H.S. (1914–30), Castlemont H.S., Oakland, Calif. (1930-40), Univ. Calif. Extension Div.(1932–43)[47]

RICE-KELLER, Inez (Mrs.) [S,P,W] b. Kenosha Co., WI d. 3 S 1928, Mt. Vernon, NY. Studied: Md. AI; Paris; J. Dampt; M. Antokolski. Member: NAC. Exhibited: French Salon; London; N.Y.; Baltimore

RICE-MEYEROWITZ, Jenny. See Meyerowitz.

RICH, Frances L. [S] Santa Barbara, CA b. 8 Ja 1910, Spokane, WA. Studied: Smith Col.; BMFA Sch.; Cranbrook Acad. A.; M. Hoffman; C. Milles; A. Jacovleff. Exhibited: WFNY, 1939; Am. Acad. Des., N.Y., 1936; Cranbrook Acad. A., 1938, 1939; Santa Barbara Mus. A., 1941, 1942; Greek Theatre, Los Angeles, 1946. Work: Army-Navy Nurse Mon., Arlington National Cemetery; Purdue Univ.; Santa Barbara Mus. A.; Smith Col. [47]

RICH, George [P] Chicago, IL Member: Chicago NJSA [25]

RICH, James Rogers [Ldscp.P] Boston, MA b. 27 My 1847, Boston d. 17 Jy 1910. Studied: Harvard, 1870; chiefly self-taught. Exhibited: New Orleans Expo, 1885 (prize); Simla (India) FA Expo, 1902 (med). He traveled extensively in Europe, Egypt, the Orient and in India, where he lived seven years, returning to the U.S. ca. 1902. He was wealthy and his pictures were seldom for sale. [10]

RICH, John Hubbard [P,T] Hollywood, CA b. Boston d. ca. 1955. Studied: ASL; BMFA Sch.; Europe. Member: Calif. AC; Calif. WCC; Council All. A.; SC. Exhibited: BMFA, 1905–07 (Traveling Scholarship); San Diego Expo., 1915 (med); Calif. AC, 1916 (prize), 1917 (prize), 1919 (prize); Pan.-Calif. Expo., San Diego, 1916 (med); Los Angeles Mus., 1922 (prize); Phoenix, Ariz., 1928 (prize); Sacramento, Calif., 1928 (prize); FAS, San Diego, 1932 (prize); Santa Monica AA, 1932 (prize); Acad. FA, N.Y.; AIC; Pasadena AI; Laguna Beach AA; Fnd. Western A.; P.&S. C., Los Angeles; SC (prize). Work: Los Angeles Mus. A.; Utah State Inst. FA; Univ. C., San Diego; Fed. Bldg., Los Angeles; Good Samaritan Hospital, Los Angeles. Position: T., Otis AI, Los Angeles [47]

RICH, R.L. [I] NYC [19]

RICH, Waldo Leon [I] b. 1853, Schuylerville, NY d. 1 Ap 1930, Saratoga Springs, NY. Studied: Williams Col. Banking was his life work, but he did the illustrations for a limited edition of the "Arabian Nights Tales." He had collected a fine library, specializing in first editions of rare old books and had made notable collections of birds and butterflies.

RICHARD, Henri [P] Paterson, NJ. Member: S.Indp.A. [25]

RICHARD, Jacob [P,T] Chicago, IL b. 28 S 1883, Ukrania. Studied: H. Walcott. Member: Chicago SA; All-Ill. SFA; Ill. Acad. of FA; Assn. Chicago PS. Exhibited: AIC, 1912 (prize) 1917 (prize). Work: City of Chicago; Illinois State Mus., Springfield; John H. Vanderpoel A. Assn., Chicago. Position: T., Peoples Univ., Chicago [40]

RICHARD, Louis [Arch-S] West Nyack, NY b. 1869, France (came to U.S. in 1891) d. 12 Jy 1940. Work: mansions in N.Y. and Newport

RICHARDS, Anna M. [P] London, England b. 1870, Phila. Studied: S. Holloway, in London; J. La Farge, in Newport; Benjamin-Constant, in Paris. Exhibited: NAD, 1890 (prize) [10]

RICHARDS, Charles K. [P] Columbus, OH. Member: Columbus PPC [25]

RICHARDS, Charles Russell [Edu] NYC b. 30 Je 1865, Boston d. 21 F 1936. Studied: MIT. Member: French Legion of Honor. Exhibited: U.S. rep., Intl. Expo Mod. Dec. & Indst. A., Paris, 1925. Positions: Dir., Am. Assn. Mus., 1923–26; Dir., Gen. Edu. Board; Dir., Cooper Union, 1908–23; T., Pratt Inst., Brooklyn

RICHARDS, David [S] Utica, NY b. 1829, North Wales (settled in Utica, 1847) d. 28 N 1897. Studied: NYC for 7 yrs. Exhibited: NAD, 1859–60. Work: "President Grant," "General Harding," "The Confederate Soldier," at Savannah, Ga., are among his best. Other: also active in Chicago and Woodside, N.Y.

RICHARDS, E.M. [P] Newark, NJ. Member: SC, 1878 [10]

RICHARDS, E(lla) E. [Por.P] NYC b. Virginia. Studied: ASL; R. Collin; Lefebvre; R. Henry, Paris. Member: PBC. Exhibited: Omaha Expo, 1899 (med); Charleston Expo, 1902 (med) [40]

RICHARDS, Frederick De Bourg [Ldscp.P,E] Phila., PA b. 1822, Wilmington, DE d. 1903. Member: Artists' Fund Soc.; Phila. Soc. Artists; Phila. AC. Exhibited: PAFA, 1850; Brooklyn AA, 1875–76 [01]

RICHARDS, F(rederick) T(hompson) [Car,I,W] Phila., PA b. 27 My 1864, Phila d. 8 Jy 1921. Studied: PAFA, with Eakins, E.B. Bensell; ASL. Member: Phila. Sketch C.; Players C. Author: "Color Prints from Dickens," "The Blot Book." Positions: Staff, Life, since 1888; Cart. for New York Herald, Times, Philadelphia North American [19]

RICHARDS, George M(ather) [P,I] New Canaan, CT b. 3 S 1880, Darien, CT. Studied: D.J. Connah; R. Henri; E. Penfield. Member: SC; Silvermine Gld.; Arch. Lg. Illustrator: "The Golden Book" [33]

RICHARDS, Gertrude Lundborg [P] Richmond, NY [17]

RICHARDS, Harriet R(oosevelt) [P,I] New Haven, CT b. Hartford d. 1932. Studied: Yale; F. Benson, in Boston; H. Pyle, in Wilmington, Del. Member: New Haven PCC. Illustrator: holiday editions of books by Louisa M. Alcott and W.D. Howells [33]

RICHARDS, John [P] NYC [01]

RICHARDS, Lee Greene [Por.P,S,I] Salt Lake City, UT b. 27 Jy 1878, Salt Lake City d. 1950. Studied: Salt Lake City, with J.T. Harwood, ca. 1895; Acad. Julian, with Laurens, 1901; Ecole des Beaux-Arts, with Bonnât, 1902. Member: Salon d'Automne; Paris AAA; Utah SA; NAC. Exhibited: Paris Salon, 1904 (prize). Position: T., Univ. Utah, 1938–47. Popular Utah portrait painter, who was in Paris, 1901–04, 1908–09, 1920–23 [31]

RICHARDS, Lucy Currier (Mrs. F.P. Wilson) [S] Norwalk, CT b. Lawrence, MA. Studied: BMFA Sch; Kops, in Dresden; Eustritz, in Berlin; Académie Julian, Paris. Member: Copley S.; Boston GA; NAWPS; MacD. C. [33]

RICHARDS, Myra R. [S,P,T] Indianapolis, IN b. 31 Ja 1882, Indianapolis d. 28 D 1934, NYC. Studied: Herron A. Inst., with O. Adams, R. Schwartz, G.J. Zolnay; Paris. Member: Hoosier Salon. Work: statue, Greenfield, Ind.; bust, Indiana State Lib.; Columbus (Ind.) H.S.; fountain figures, Univ. Park, Indianapolis; group symbolic of women's achievement, presented by the Women's Press C. of Indiana to Turkey Run State Park. Position: T., John Herron AI [29]

RICHARDS, Thomas Addison [Ldscp.P,Por.P,I,W,T] NYC b. 3 D 1820, London (came to U.S., 1831; grew up in Hudson, N.Y. and Penfield, Ga.) d. 28 Je 1900, Annapolis, MD. Studied: NAD, 1844–46. Member: ANA, 1848; NA, 1851; AWCS; best known as a member of the Hudson River School. Author/Illustrator: a guide to flower painting (at age 18); an American travel book, 1857; many illustrated travel articles. Other: 100 of his works were sold at a NYC auction in 1871. Position: T., Charleston, S.C., 1843–44; CUASch (first director), 1858; N.Y. Univ. 1867–87 [98]

RICHARDS, Walter DuBois [I,Des] New Canaan, CT b. 18 S 1907, Penfield, OH. Studied: Cleveland Sch. A. Member: SI; Cleveland Pr.M.; Am. WCS. Exhibited: CMA, 1933–37 (prizes). Work: Cleveland Pub. Lib.; CMA. Affiliated with Charles E. Cooper Studios, N.Y. [47]

RICHARDS, William Trost [Mar.P,Ldscp.P] Newport, RI (since 1890) b. 14 N 1833, Phila. d. 8 N 1905. Studied: Phila., with Paul Weber, 1848; Florence, Rome, Paris, all during 1853–56. Member: AWCS; NA, 1871. Exhibited: Centenn. Exh., Phila, 1876 (med); PAFA, 1885 (med); Paris Expo, 1889 (med); NAD, 1861–99. From 1856 to 1867, he was best known for his landscapes and still-life paintings made near his Germantown, Pa., home. His summers at Newport (beginning 1874) turned his focus to marine painting, for which he is best known today. Later, he made frequent trips to Great Britain. [04]

RICHARDS, A.M. (Mrs.) [Ldscp.P] Boston, MA. Studied: ASL, with G. de Forest Brush and W.H. Foote; Boston, with L. Kronberg, S.C. Carbee. Member: Copley S., 1904 [10]

RICHARDSON, Benjamin J. [E,Photogr,P] Brooklyn, NY b. 1835, London (came to Brooklyn as a child) d. 28 F 1926 [06]

RICHARDSON, Catherine Priestly [P] Brookline, MA b. 22 N 1900, NYC. Studied: P.L. Hale. Member: NAWPS. Exhibited: Boston, 1921 (prize) [40]

RICHARDSON, Clara Virginia [P,E,T] Portland, ME b. 24 Ap 1855, Phila. Studied: Phila. Sch. Des. Women; Ferris; Moran; Daingerfield; Snell. Member: Plastic C.; Phila. Alliance [31]

RICHARDSON, Constance Coleman (Mrs. E.P.) [P] Detroit, MI b. 18 Ja 1905, Indianapolis. Studied: Vassar; PAFA. Exhibited: Mich. Ar. Ann., 1937 (prize); Detroit AI, 1938 (prize) 1945; AIC, 1940, 1941, 1945; CI, 1941, 1943–45; CGA, 1945; WMAA, 1944, 1945; PAFA, 1944, 1945; de Young Mem. Mus., 1943; Critics Choice, CM, 1945; Schaeffer Gal., N.Y., 1938; WFNY, 1939; Golden Gate Expo, 1939. Work: John Herron AI; Detroit Inst. A.; PAFA [47]

RICHARDSON, Earl [P] NYC b. 1912, NYC d. 18 D 1935. Studied: NAD. Member: Artists Union; Negro Artists Gld. Exhibited: NAD (prize); Harmon Foundation Exh. (prize). Work: painting and supervising a Negro hist. mural on a WPA project

RICHARDSON, E(dgar) P(reston) [Mus.Dir,W,L] Detroit, MI b. 2 D 1902, Glens Falls, NY d. 1985. Phila. Studied: Univ. Pa.; Williams Col.; PAFA. Author: "The Way of Western Art," 1939, "American Romantic Painting," 1944, Catalogue of Paintings in the Detroit AI, 1944. Positions: Dir., Detroit Inst. A.; Ed., The Art Quarterly [47]

RICHARDSON, Esther Ruble (Mrs.) [P,T,L] Lockport, IL b. 8 Je 1895, Nevada, MO. Studied: Univ. Chicago; AIC; Chicago Acad. FA; M. Sheets; F.M. Grant; W. Sargent. Member: Joliet A. Lg.; Illinois Edu. Assn.; All-Ill. SFA; Chicago Gal. Assn.; Hoosier Salon. Exhibited: Ill. Soc. FA, 1936 (gold); AIC, 1934–41; PAFA, 1935; Hoosier Salon, 1931–41 (including several one-man exh.); Chicago Gal. Assn. Work: Illinois Pub. Sch.; Pub. Lib., Iola, Kans. Position: T., Joliet H.S. & Jr. Col. [47]

RICHARDSON, Florence Wood [Potter] Columbus, OH. Exhibited: Columbus AL, 1937 (prize) [40]

RICHARDSON, Francis H(enry) [P] Ipswich, MA SA. 4 Jy 1859, Boston d. 18 Ap 1934. Studied: Académie Julian, Paris, with Boulanger, Lefebvre; Boston, with W.M. Hunt. Member: SC, 1901; Gloucester SA. Exhibited: Paris Salon, 1888–1900, 1899 (prize); AAS, 1902 (med). Work: BAC; Lasell Seminary, Auburndale, Mass.; Town Hall, Braintree, Mass.; Roxbury Latin Sch., Boston [33]

RICHARDSON, Frederick [I,P,T] NYC/Chicago, IL b. 26 O 1862, Chicago d. 14 Ja 1937, NYC. Studied: St. Louis Sch. FA; Paris, with Doucet and Lefebvre. Member: Century Assn.; SI, 1905; AFA; Cliff Dwellers, Chicago; MacD. C. Illustrator: books; magazines; Chicago Daily News [33]

RICHARDSON, Harold B. [P] Oak Park, IL [19]

RICHARDSON, Henry C. [P] NYC. Member: GFLA [27]

RICHARDSON, James B. [P] Wash., D.C. Member: S. Wash. A. [27]

RICHARDSON, John Frederick [P,T] 22 D 1906, Nashville, TN. Exhibited: SSAL, 1935 (prize). Work: PAFA. Position: T., Watkins Inst., Nashville [40]

RICHARDSON, Louis H. [P] NYC [17]

RICHARDSON, Margaret F. [Por.P] Boston, MA b. Winnetka, IL. Studied: J. DeCamp; E.L. Major; E.C. Tarbell. Exhibited: AIC, 1911 (prize); NAD, 1913 (prize). Work: portraits: MIT; Boston Univ.; Admin. Bldg., Boston; U.S.S. Phelps; T. Roosevelt Sch., Boston; Mechanic Arts H.S., Boston;

Boston Pub. Sch.; Am. Legion Post, Lynn, Mass.; Pub. Lib., Lawrence, Mass. [40]

RICHARDSON, Marion [P,Li,E] NYC/Adelynrood, South, Byfield, MA b. 24 Ja 1877, Brooklyn, NY. Studied: Chase; DuMond; Senseney. Member: Calif. P.M.; NAWPS; AFA. Work: mural block prints on linen, Mass. Gen. Hospital, Boston; Parish House, Grace Church, Amherst, Mass.; St. Anne's Church, Murray Bay, Quebec, Canada; St. Luke's Hospital, N.Y. [40]

RICHARDSON, Mary Curtis (Mrs.) [Woodcarver,Por.P] San Fran., CA b. 9 Ap 1848, NYC d. 1 N 1931. Studied: B. Irwin; V. Williams; CUASch; W. Sartain. Member: AFA. Exhibited: NAD, 1887 (prize); Calif. State Fair, 1887 (med), 1916 (prize), 1917 (prize) 1919 (prize); Indst. Expo, San Fran, 1893 (med); P.-P. Expo, San Fran., 1915 (med). Work: Golden Gate Park Mus., San Fran.; Music and Art Assn., Pasadena, Calif.; Pal. Leg. Honor; Stanford Univ. [29]

RICHARDSON, Mary N(eal) [Por.P] Boston, MA/Canton, ME b. 17 F 1859, Mt. Vernon, ME. Studied: BMFA Sch. Colarossi Acad., Paris; A. Koopman, Paris. Member: Copley S., 1897; AAPL. Work: Walker A. Gal., Bowdoin Col., Brunswick, Maine [33]

RICHARDSON, Rachel M. (Mrs. Frank K. Ominsky) [Mur.P,Textile Des] NYC b. 1896, London, England d. 23 O 1941. Studied: London; NYC

RICHARDSON, Rome K. [P,C] NYC b. 29 Ap 1877, Candor, Tioga Co., NY. Studied: Pratt Inst., Brooklyn; N.Y. Sch. A. Exhibited: book cover des., Pan-Am. Expo, Buffalo, 1901 (prize) [10]

RICHARDSON, Sarah [P] Phila., PA. Studied: PAFA [25]

RICHARDSON, Theodore J. [Ldscp.P] Netley Corners, MN b. 1855, Readfield, ME d. N 1914, Minneapolis. Studied: abroad, 1896–1902. Member: SC. Specialty: Alaskan scenery [13]

RICHARDSON, Theodore Scott [P] Chicago, IL [13]

RICHARDSON, V(olney) A(llan) [P,T] Houston, TX b. 14 F 1880, Attica, NY. Studied: Sch. FA, Albright A. Gal.; ASL; W.M. Chase; E. Dufner; F.V. DuMond; C.W. Hawthorne. Member: Buffalo SA. Exhibited: Albright A. Gal., Buffalo, 1927 (prize), 1931 (prize); Buffalo SA, 1935 (prize) [40]

RICHERT, Charles Henry [P,T] Arlington, MA b. 7 Jy 1880, Boston. Studied: Mass. Normal A. Sch.; J.De Camp, E.L. Major; R. Andrew. Member: Boston Soc. WC; Painters Gld., Boston A.; AWCS. Exhibited: BAID, 1919 (prize), 1920 (prize); PAFA; NAD; AIC; BMFA. Positions: T., Rindge Tech. Sch. (Cambridge, Mass.), Mass. Sch. A. [47]

RICHEY, Oakley E. [P,T,L,C,W] Indianapolis, IN b. 24 Mr 1902, Hancock County, IN. Studied: John Herron A. Sch.; Grand Central Sch. A.; ASL; DuMond; Purves; Pogany; S. Walker; G. Bridgman. Member: Nat. Edu. Assn.; Ind. State T. Assn.; Indianapolis Fed. Pub. Sch. T.; Indianapolis AA; Richmond AA; Hoosier Salon; Ind. Artists C.; Ind. Pr. M. Soc.; Portfolio C., Indianapolis. Exhibited: Indianapolis, 1935 (prize). Work: Richmond (Ind.) AA; Pub. Sch., Lafayette, Ind.; Pub. Sch., Connersville, Ind.; FERA Bldg., Indianapolis; writer and director of numerous pageants and masques. Positions: L., Ind. Univ. 1932– ; Dir., Ind. State Fair FA Exh. [47]

RICHMOND, Agnes M. [P] Brooklyn, NY b. Alton, IL. Studied: St. Louis Sch. FA; ASL. Member: All. A. Am.; 15 Gal. Group; NAWA; Brooklyn SA; Brooklyn PS. Exhibited: NAWA, 1911 (prize), 1922 (prize), 1933 (prize); New Rochelle, N.Y., 1932 (prize); CGA, PAFA, CI; NAD; Phila. WCC; Toronto; Montreal. Work: San Diego FA Soc. [47]

RICHMOND, Almond [P] Meadville, PA [21]

RICHMOND, Evelyn K. [P] Santa Barbara, CA b. 29 Ja 1872, Boston. Studied: H.B. Snell. Member: NAWA; Providence WCC; Santa Barbara A. Lg.; Calif. WC Soc. [47]

RICHMOND, Evelyn N. (Mrs. Harold A.) [P] Providence, RI. Member: Providence WCC [25]

RICHMOND, Gaylord D. [Des,C,T,Mur.P,Por.P] Woodbridge, CT b. 23 My 1903, Milan, MO. Studied: Otis AI; Yale; E.R. Shrader; E.C. Taylor; E. Savage. Member: Calif. AC; New Haven PCC; CAFA. Exhibited: New Haven PCC, 1931 (prize) 1938 (prize); Los Angeles AA, 1934 (prize); Calif. State Fair, 1934 (prize). Position: T., Yale, 1936–46; A. Dir., Allied Corp., 1942–46; Flintridge Sch., Pasadena, 1940 [47]

RICHMOND, R(obert) C. [P] Wash., D.C. b. 26 Je 1867, Baltimore [27]

RICHTER, Emil H. [P] Newton Centre, MA. Member: Boston AC [19]

RICHTER, George A. [P] Providence, RI [24]

RICHTER, George Martin [W,L] b. 1875, San Fran. d. 9 Je 1942, Norwalk, CT. Studied: Germany. Other: authority on Giorgione and Renaissance art

RICHTER, Giesela Marie Augusta [Mus.Cur,W,L,C] NYC b. 15 Ag 1882, London, England d. 1972. Studied: British Sch. Archaeology, Athens, Greece; Trinity Col., Dublin; Cambridge Univ., England. Member: F., Am. Numismatic Soc.; Archaeological Inst. Am. Exhibited: Am. Assn. Univ. Women, 1944. Author: "Animals in Greek Sculpture," 1930, "Handbook of the Etruscan Collection," 1940, "Attic Red-figured Vases, A Survey," 1946. Position: Cur., MET, 1906–72 [47]

RICHTER, Henry L. [P] Long Beach, CA b. 22 O 1871, Saxony. Studied: AIC; Munich. Member: Denver AA. Work: mural, Colorado State Normal Sch., Gunnison [21]

RICHTER, Julius [P,En,L] Buffalo, NY b. 19 D 1876, Allegheny, PA. Studied: V.A. Richardson; M.C. Green; E. Gruppe; J. Rummell. Member: Buffalo SA; Am. Physicians AA. Exhibited: Am. Physicians Exh., annually; Buffalo SA, annually; Albright A. Gal., 1946; City AM, St. Louis. Lecturer: Albright A. Sch., Buffalo, 1924–34 [47]

RICHTER, Lillian [P,Li,I,W,T] NYC b. 12 Ap 1915, Newport, RI. Studied: K. Nicolaides, E. Fitsch, G. Picken, at ASL. Exhibited: AIC; WFNY, 1939; ACA Gal.; G-R-D Gal.; Contemp. Women A., 1935–1939; PAFA 1940; CAFA, 1940. Position: T., Sch. for A. Studies, NYC, 1946 [47]

RICHTER, Louise C. (Mrs. William F.) [Indst.Des,T] Richmond Heights, MO b. 4 D 1918, Akron, OH. Studied: CI. Work: Univ. W.Va.; Granite City Steel Co., Granite City Ill.; designed Univ. medallion, Wash. Univ., St. Louis, Mo. Position: T., Washington Univ. Sch. FA, St. Louis, Mo., 1941– [47]

RICHTER, Mischa [P,I,Car,T] Darien, CT 12 Ag 1910, Russia. Studied: Boston MFA Sch.; Yale; Kozloff, Russia. Member: Boston S.Indp.Ar.; Am. Ar. Cong. Exhibited: Rockefeller Cen., N.Y.; A.C.A. Gal., N.Y. Work: mural, Burroughs Newsboys Fnd., Boston. Illustrator: Esquire, Collier's, Liberty, Saturday Evening Post, American Magazine [40]

RICHTER, Wilmer Siegfried [I,P,Des,Li,T] Havertown, PA b. 20 Ja 1891, Phila. Studied: PMSchIA; PAFA; W.H. Everett; D. Garber; J. Pearson; G. Oberteuffer. Member: Phila. Sketch C.; Phila. WCC. Work: Phila. Pub. Sch. [47]

RICKER, Grace [P] Milwaukee, WI [17]

RICKETSON, Walton [S] New Bedford, MA b. 27 My 1839, New Bedford. Member: New Bedford AC. Work: portrait busts of Louisa M. Alcott, Henry D. Thoreau, R.W. Emerson, others in pub. lib., New Bedford; Brown Univ.; Friends Acad., New Bedford; Concord (Mass.) Lib.; Gosnold Mem. Tower, Island of Cuttyhunk, Mass. Specialties: intaglios; bas-reliefs; busts [25]

RICKETTS, Agnes Fairlie [P,T] Jackson, MS b. Glasgow, Scotland. Studied: Wellesley Col.; Univ. Iowa; PAFA; Univ. Ga. Member: Miss. AA; SSAL. Exhibited: SSAL, 1945 (prize), 1946; Miss. AA, 1942, 1943; Delgado Mus. A., 1944–46 [47]

RICKEY, George Warren [S,P,W,T] Fennville, MI b. 6 Je 1907, South Bend, IN. Studied: Ruskin Sch., Oxford, Eng., 1928–29; Acad. Moderne, Paris, with Lhote, 1929–30. Member: United Am. Ar.; Am. Ar. Cong. Exhibited: Mich. Ar. ann., Detroit AI; Kalamazoo AI; Am. Ar. Cong. Work: USPO, Selinsgrove, Pa.; mural, Olivet Col., Mich. Best known for his kinetic sculpture after 1949, especially the wind-driven works after 1959. WPA artist. [40]

RICKLY, Jessie Beard [P,L,Car,T,B] Webster Groves, MO b. 5 O 1895, Leeper, MO. Studied: St. Louis Sch. FA; Harvard; C. Hawthorne; O. Berninghaus; E. Wuerpel. Member: SSAL; St. Louis A. Gld.; New Hats; Shikari. Exhibited: St. Louis A. Gld., 1927 (prize), 1931 (prize), 1932 (prize), 1945 (prize); Mo. State Fair, 1917 (prize), 1932 (prize); Kansas City AI, 1929, 1934 (med), 1940; CAM, 1928, 1939; SSAL, 1933, 1934. Work: Flynn Park Sch. & Jr. H.S., Univ. City, Mo.; Executive Mansion, Jefferson City, Mo. [47]

RICO, Dan [P,En,I,Li] NYC b. 26 S 1912, Rochester, NY. Studied: Cooper Union; N.Y. Evening Sch. Indst. A.; Am. Ar. Sch. Member: United Am. Ar.; Am. Ar. Cong. WPA artist. Contributor: The Nation, New Masses. Position: Affiliated with graphic art division Federal Art Project, N.Y. [40]

RIDABOCK, Ray(mond) (Budd) [P,T] Saranac Lake, NY b. 16 F 1904, Stamford, CT d. 1970. Studied: Williams Col.; A. Jones; A. diBonna. Member: AAPL; Silvermine Gld. A. Exhibited: Portland SA, 1943, 1946; New Haven PCC, 1943–45; Saranac Lake A. Lg., 1942–44; Irvington A. Mus. Assn., 1943; State T. Col., Pa., 1946; Mint Mus. A., 1946; Mid-Vt. A., 1943–45; Utica, N.Y., 1946; Lake Placid, N.Y., 1944, 1945 [47]

RIDDELL, Annette Irwin (Mrs.) [P] Laguna Beach, CA b. Oswego, NY. Studied: Vanderpoel; Freer; AIC; Collin; Courtois; Girardot; Académie Julian, Paris, with Royer, Prinet. Member: Laguna Beach AA; Alumni AIC [33]

RIDDELL, Annie [Min.P] Boston, MA [15]

RIDDELL, William Wallace [P] Laguna Beach, CA b. 21 Mr 1877, Chicago. Studied: AIC; Académie Julian, Paris, with Constant, Laurens. Member: Laguna Beach AA; Palette and Chisel Acad. FA, Chicago [47]

RIDDER, Arthur [P] Chicago, IL Member: Chicago SA [21]

RIDDLE, Alice (Mrs. Hans Kindler) [P,C,Li,T] Jessups, MD b. 3 O 1892, Germantown, PA. Studied: PAFA; Phila. Sch. Des. for Women; Académie Julian, Paris. Exhibited: PAFA; CGA; NAD; AIC; BMA; Paris (one-man); New York (one-man), Phila. (one-man); Baltimore (one-man); Phila. AC, 1933 (prize); Denver Mus. A., 1933 (prize). Work: PAFA; Baltimore Mun. Mus.; murals, West Phila. H.S.; WPA mural, USPO, Ware Shoals, S.C. [47]

RIDDLE, C.W. [P] Jamaica Plain, MA. Member: Boston AC [25]

RIDDLE, Mary Althea [S] Chicago, IL b. Chicago. Studied: AIC; Boston Sch. FA [17]

RIDDLE, Mary M. (Mrs. J.W.) [Mur.P,Por.P,L] Lawrenceburg, IN b. 17 Ap 1876, New Albany, IN. Studied: W. Chase; F. Duveneck. Member: Cincinnati Women's AC; Soc. of Western Aritsts; Ind. Fed. of C. (Art Dept.) Work: murals: Pub. Sch., Lawrenceburg [47]

RIDER, Arthur Grover [P,Des,G] Los Angeles, CA b. 21 Mr 1886, Chicago. Studied: Werntz Acad. FA, Valencia, Spain. Member: Chicago Gal. Assn.; Calif. AC; PS C., Los Angeles; Laguna Beach A. Assn. Exhibited: AIC, 1923 (prize); Calif. State Fair, Sacramento, 1936 (prize); Chicago Gal. Assn.; Laguna Beach AA; GGE, 1939. Position: Scenic-A., Metro-Goldwyn-Mayer and Twentieth Century-Fox Studios, Los Angeles [40]

RIDER, Charles Joseph [P,Des,L,T] San Pedro, CA b. 21 Ja 1880, Trenton, NJ. Studied: W.M. Chase; S. Macdonald-Wright. Member: Am. Soc. Bookplate Collectors & Des. [33]

RIDER, Henry Orne [P,T,L] Auburndale, MA b. 17 Je 1860, Salem, MA. Studied: D.W. Champney, at BMFA Sch.; M. Duval, at Ecole des Beaux-Arts; L. Boulanger, J. Lefebvre, at Académie Julian, Paris; L.G. Pelouse; L. Joubert; E. Petitjean, in Paris. Exhibited: Gloucester Soc. Ar., 1935, 1936; S.Indp.A., 1938. Work: dec., U.S. Destroyer "Phelps"; U.S. Destroyer "Charles V. Gridley"; mem., MacKay Jr. H.S., East Boston; Brookyn Inst. A.&Sc.; Bowdoin College; Harrison Gray Otis House, Univ. Women's Bldg., Boston; Va. Pub. Utilities Bldg., Alexandria; Fla. Power&Light Co., St. Petersburg; Seigle Bldg., Boston; H.S., Plymouth, Mass. [40]

RIDGELY, Frances Summers (Mrs. J.A.) [Mus.Cur,P,I,W,L] Springfield, IL b. 22 Ag 1892, Curran, IL. Studied: Syracuse Univ.; AIC. Exhibited: Sprinfield AA. Contributor: "Child Life." Position: Staff Artist, 1929–41; Cur.A., 1941– , Illinois State Mus., Springfield [47]

RIECKE, George [P] Brooklyn, NY b. 15 N 1848, Sheboygan, WI. Studied: CUASch [06]

RIEDY, Lorene M. [Des,Dec,P] Chicago, IL b. 14 F 1900, Lisle, IL. Studied: AIC; Sch. Applied A., Chicago; Am. Acad. A., Chicago. Member: All Ill. Soc. FA; Am. Des. Inst. Exhibited: Cook Co. Fair, Ill, 1935 (prize); Navy Pier [40]

RIEFSTAHL, Rudolf Meyer (Dr.) [Edu,W] NYC b. 1880, Germany d. 31 D 1936, NYC. Studied: Germany. Member: F., Guggenheim Fnd. Expert on Moslem art, antiquities of the Middle Ages. Led a number of expeditions into Asia Minor. Author: books on Islamic and Near Eastern art. Positions: T., NYU, for fifteen years; Advisor, Pa. Mus. A.

RIEGGER, Harold Eaton [C,T] Gridley, CA b. 21 Jy 1913, Ithaca, NY. Studied: N.Y. State Ceramic Col., Alfred Univ., Alfred, N.Y.; Ohio State Univ. Member: Am. Ceramic Soc.; Am. Craftsman's Cooperative Council. Exhibited: Syracuse Mus. FA, 1934–38, 1939 (prize), 1940–41; Robineau mem. exh., Syracuse, 1936 (prize); GGE, 1939; WFNY, 1939; WMAA, 1936; CAD; Phila. A. All., 1940 (one-man); European traveling exh. ceramics. Contributor: Craft Horizons. Position: T., PMSchIA, 1939–42; Oreg. Ceramic Studio, Portland, 1946– [47]

RIEKER, Albert George [S] New Orleans, LA b. 18 O 1889, Stuttgart, Germany d. 9 F 1959, Clermont Harbor, MI. Studied: Univ. Munich; Royal Acad. FA, Munich; Royal Acad. FA, Stuttgart. Member: New Orleans A. Lg.; NOAA. Exhibited: Stuttgart, 1910 (prize); Nuremberg, 1911 (prize); St. Württemberg, Stuttgart, 1921; NOAA, 1934 (prize), 1940 (prize), 1941 (prize); SSAL, 1938 (prize); La. State Exh., 1939 (prize); AIC, 1929; PAFA, 1939, 1930, 1937; New Orleans A. Lg. Work: mon./mem./figures, Vicksburg (Miss.) Nat. Park; State Capitol, Baton Rouge, La.; Jackson, Miss.; Mente Park; Masonic Temple, New Orleans; Temple, Sinai; bas-reliefs, Vacarro Mausoleum, Metairie Cemetery; First Nat. Bank, Port Arthur, Tex.; Miltenberger-Lapeyre Convalescent Home; Memorial Playground; busts, Touro Infirmary, New Orleans; Delgado Mus.; La. State Mus.; Elementary Sch., East Baton Rouge; Court House, St. Bernard, La. [47]

RIEPPEL, Ludwig [S] NYC b. 1861 d. 26 D 1960 (age 99) [21]

RIES, Gerta [P] Brooklyn, NY [25]

RIESENBERG, Sidney H. [P,I,T] Yonkers, NY (Hastings, NY, 1962) b. 12 D 1885, Chicago. Studied: AIC. Member: All.A.Am.; SC; Yonkers AA; Rockport AA. Exhibited: Yonkers AA, 1930 (prize); Westchester A. Gld., 1940 (prize), 1941 (prize); NAD, 1930, 1931, 1933, 1938, 1940, 1941; All.A.Am., 1936, 1938–45; WFNY, 1939; NYWCC, 1940, 1941; Montclair A. Mus.; Hudson Valley AA; New Rochelle AA; Rockport AA; Currier Gal. A. Work: Hudson River Mus.; Vanderpoel Coll.; Central Nat. Bank, Yonkers, N.Y. Illustrator: "With Whip and Spur," 1927, "Pioneers All," 1929. Contributor: Harper's, Collier's, Scribner's, Saturday Evening Post, other magazines [47]

RIESS, William [P] Indianapolis, IN b. 1856, Berlin (went to Indianapolis in 1884) d. 30 Mr 1919 (suddenly at his temporary studio in Chicago). Studied: Berlin A. Acad.; Von Werner. Exhibited: P.-P. Expo, San Fran., 1915 (gold,med). Work: John Herron AI, Indianapolis. Specialties: Western and Indian life [10]

RIFFLE, Elba Louisa (Mrs. Vernon) [P,S] Indianapolis, IN b. 3 Ja 1905, Winamac, IN. Studied: John Herron AI; Ind. Univ.; Purdue Univ.; M. Richards; Forsythe. Member: Hoosier Salon; Ind. AC. Exhibited: Northern Ind. A., 1931 (prize); Midwestern Exh., Wichita, Kan., 1932 (prize); Hoosier Salon, 1934 (prize); Ind. State Fair, 1930–32; 1934 (prize), 1935 (prize), 1938 (prize). Work: Christian Church, Winamac, Ind.; H.S., Winamac; Pub. Lib., Winamac; Pub. Lib., Tipton, Ind.; Ind. Univ.; Women's C. House, Clay City, Ind. [47]

RIGBY, F.G. [I] NYC [01]

RIGBY, Harroke B. [I] NYC [01]

RIGBY, Joseph P. [I] Member: Pittsburgh AA. Position: Affiliated with Press Publishing Co., Pittsburgh [21]

RIGGS, Robert [Li] Phila., PA b. 5 F 1896, Decatur, IL d. 1970. Member: NA; Phila. A. All.; Phila. WCC; ANA, 1938. Exhibited: Phila. WCC, 1932 (med); PAFA, 1934 (med); Phila. Pr.C., 1936 (prize), 1937 (prize), 1938 (prize); Century of Progress Expo, 1934 (prize). Work: Phila. WCC; AIC; BM; WMAA; NYPL; Dallas Mus. FA; LOC; Nat. Mus., Copenhagen, Denmark; Modern Art Gallery. Position: T., Phila. Mus. Sch. Indst. A. [47]

RIGHTER, Alice L. [P] Lincoln, NE b. Monroe, WI. Studied: AIC; ASL; DuMond; Castaign; Lasar; Dupré, in Paris [01]

RIGHTER, Mary L. [P] Lincoln, NE [01]

RIGNEY, Francis J(oseph) [Dr,I,W] NYC b. 20 Ja 1882, Waterford, Ireland. Studied: Metropolitan Sch. Art. Member: NAC. Work: WFNY, 1939. Illustrator: "The Clipper Ship," "Ships of the Seven Seas," "What's the Joke?," "Landlubbers Afloat," "Games and Game Leadership," "Elements of Social Science," "Johnny Round the World." Position: Art Ed., Boys' Life [40]

RIGOULOT, Helene [P] Elgin, IL [13]

RIGSBY, Clarence S. [Car,I] d. 25 My 1926, Seattle. He was the originator of the animated cartoon, and comic strip, including "Major Ozone" and "Ah Sid, the Chinese Kid." Position: Staff A., New York Herald, New York World, Brooklyn Eagle. Contributor: Life, Judge; Sam Lloyd Syndicate

RIIS, Anna M. [C,T] Cincinnati, OH b. Norway. Studied: Royal and Imperial Sch. for A. and Indst., Vienna; Royal A. Sch., Christiania. Member: Cincinnati Women's AC; Crafters; Cincinnati Ceramic C. Position: T., Cincinnati A. Acad. [31]

RIIS, Jacob August [Ph,W] NYC b. 1849 Ribe, Denmark, (came to NYC, 1870) d. 1914. America's earliest social reform photographer, he first illustrated slum conditions for NY Tribune, 1877–88. His influential books are: "How the Other Half Lives," 1890, "Children of the Poor," 1892, "Out of Mulberry St.," 1898, "The Making of an American," 1901, "Children of the Tenements," 1903. His work was continued by Jessie T. Beales and Lewis Hine. The three all had an influence on the "Ashcan school" of painters. [*]

RILEY, Agnes [P] NYC. Member: S.Indp.A. [25]

RILEY, Frank E. [P] Chicago, IL. Member: GFLA [27]

RILEY, Frank H. [P] Highland Park, IL b. 15 Je 1894, St. Joseph, MO. Studied: L. Ritman; J. Marchand; A. Lhote [33]

RILEY, Garada Clark [P] Highland Park, IL b. 22 Ap 1894, Chicago, IL. Studied: J. Marchand; Lhote; L. Kroll [33]

RILEY, Marguerite [P] Germantown, MD. Exhibited: 48 States Comp., 1939 [40]

RILEY, Mary G. [P] Wash., D.C. b. Wash., D.C. d. 1 F 1939. Studied: B. Harrison; H.B. Snell. Member: S. Wash. A.; NAWPS; Wash. AC; NAC; AFA; Wash. WCC; SSAL. Exhibited: S. Wash. A., 1923 (med), 1932 (med); NAC, 1928 (prize); NAWPS, 1930 (prize). Work: CGA [38]

RILEY, Maude Kemper [Cr,W,T,I] NYC b. 28 Ag 1902, Franklin, LA. Studied: Newcomb Col., Tulane Univ.; CUASch; E. Woodward; W.H. Stevens; W. Brewster. Positions: Ed. Asst./Illus.: Revue mag., 1937–38; A. Cr., Cue mag., from 1938; Assoc. Ed., Art Digest, 1943–45; Columnist, Progressive Architecture, 1945–46; Publisher & Ed., MKR's Art Weekly, from 1945 [47]

RILEY, Nicholas F. [I,Car,T] Brooklyn, NY b. 1900, Brooklyn, NY d. 1 My 1944. Studied: ASL; PIASch, 1921. Member: SI. Illustrator: Saturday Evening Post, 1939. Position: T., PIASch [40]

RIMANCCZY, A.W. [P] Cleveland Heights, OH. Member: Cleveland SA [27]

RIMMER, Caroline Hunt [S,W] Belmont, MA b. 10 O 1851, Randolph, MA. Studied: her father, Dr. William [13]

RIMMER, William [S,P,W,T] b. 20 F 1816, Liverpool, England (came to Nova Scotia, 1818; to Boston, 1826) d. 20 Ag 1879. Important romantic-baroque sculptor, painter, and influential teacher of many Boston artists. Work: BMFA; MMA. Author: "Elements of Design," "Art Anatomy." Settled in Randolph, Mass., 1845–55 making portraits. In East Milton, Mass., 1855–63, he was a doctor. By 1864–66 he was living in Chelsea, Mass. and lecturing on anatomy for artists in Boston and Lowell. After serving as dir. of CUASch, 1866–70, he reopened his school in Boston. He finally taught at BMFA Sch., 1876–79. Like William M. Hunt, he encouraged many women to pursue careers in art. He also lost most of his work in the Boston fire, 1872. [*]

RINDLAUB, M. Bruce Douglas (Mrs.) [Min.P] Fargo, ND [19]

RINDSKOPF, Alex C. [P] Chicago, IL. Member: GFLA [27]

RINDY, Dell Nichelson [P] Madison, WI b. 1889 d. 1962. Studied: AIC; Yankton Col., S.Dak. Member: Madison AG (Pres.) [24]

RINER, Florence See Furst.

RINES, Frank M. [P,T,G] Jamaica Plain, MA/Rockport, MA b. 3 Je 1892, Dover, NH. Studied: Eric Pape Sch. A., Boston; Mass. Sch. A. Member: Wash. WCC; North Shore AA; Copley S., Bsoton. Exhibited: Wash. WCC; North Shore AA, 1938–46; Copley S., 1946; Jordan Marsh Gal., 1932–46; Wash. WCS. Author/Illustrator: "Drawing in Lead Pencil," 1929; "Pencil Drawing," 1939. Position: T., Boston Univ., from 1939; Boston Ctr. Adult Edu., from 1937; Mass. Univ. Exten. from 1937 [47]

RING, Alice Blair [Min.P] Pomona, CA b. Knightville, MA. Studied: Paris, with Laurens, J. Dupré, J. Dupré, Hitchcock, Mme. La Forge, Melchers; ASL NYC; ASL Wash. D.C. Member: Cleveland Woman's AA; Laguna Beach AA; Calif. S. Min. P.; Women P. of the West; AFA. Exhibited: Pomona, 1922 (prize), 1936 (prize); Long Beach, Calif., 1928; Los Angeles Mus., 1936 [40]

RING, Elizabeth C. [P] Urbana, OH [01]

RINGELKE, H. [S] NYC [10]

RINGIUS, Carl [P,W,C,Des,B] Hartford, CT b. 3 D 1879, Bostad, Sweden d. 15 F 1950. Studied: Sweden; C.N. Flagg; R.B. Brandegee. Member: S. Graphic A., Stockholm, Sweden; Chicago AG; SC; Springfield AA; North Shore AA; New Haven PCC; Audubon A.; Conn. Lg. A. Students; Scandinavian-Am. A.; Swedish-Am. A.; Southern PM; Mid-Vermont A.; Gloucester SA; Ill. Acad. FA; AAPL; Hartford Salmagundians; Studio G. Exhibited: CAFA, 1935 (prize), 1941–46; Studio G., 1937 (prize); State of Conn., 1929 (med); North Shore AA, 1941–46; New Haven PCC, 1938 (prize), 1941–46, 1945 (prize); All. A. Am., 1944; Hartford Salmagundians, 1941–46; Mid-Vermont A., 1946; Scan.-Am Exh., Chicago, 1929 (prize). Work: Vanderpoel Coll.; Ill. State Mus.; A. Mus., Gothenburg, Sweden; Vexjo Mus., Sweden; Upsala Col., East Orange, N.J.; Springfield, Ill. AA. Author: "The Swedish People in Connecticut," (published for the Century of Progress Expo) Position: Dir., CAFA, from 1935

RINGIUS, Lisa (Mrs. Carl) [C] Hartford, CT b. Bergunda, Sweden. Studied: Sweden. Member: North Shore AA. Specialty: tapestry, weaving, needlework [40]

RINGLING, John [Patron] d. 2 D 1936, NYC. By his will he gave his entire estate to Florida, forming the John and Mable Ringling Mus. A. in Sarasota. His collection was strong in pre-1800 Italian art and Flemish and Dutch paintings, 1400–1900. They remain in his home "Ca'd'Zan" which reflected the opulent lifestyle of the 1920s.

RINGLING, John, Mrs. [Patron] b. OH d. 7 Je 1929, NYC. Her art collection consisted of many fine works secured during foreign travel. See John Ringling

RINGWALT, Katherine H. [P,T] Phila., PA. Studied: PAFA [25]

RION, Hanna (Mrs. Alpheus B. Hervey) [P,I,W] Bermuda/NYC b. 11 Jy 1875, Winnsborough, SC d. 5 My 1924. Studied: F. Ver Beck. Author: "Let's Make a Flower Garden," "The Garden in the Wilderness." [24]

RIORDAN, G.C. [P] Newport, KY. Member: Cincinnati AC [25]

RIORDAN, Roger [I,W,Cr] d. 26 N 1904, NYC. Contributor: leading American mags. Illustrator: Solomon's "Song of Songs." Positions: Art Ed., Harper's; Drama Cr., The Sun; Art Juror, Paris Expo, 1900; Ass. Chief, applied arts, Buffalo Expo, 1901

RIOS, John Fidel [L,W,T,Ser,Li,P] NYC b. 28 Je 1918, San Marcos, TX. Studied: Southwest Texas T. Col.; Univ. Texas; Columbia. Exhibited: CGA, 1944; LOC, 1945; CAFA, 1946; Mint Mus. A., 1946; ACA Gal., 1943; Southwest Texas T. Col. Mus., 1943, 1945; Intl. House, NYC, 1944; W.R. Nelson Gal., 1944. Position: T., The Tutoring Sch., NYC, 1944–45 [47]

RIPLEY, A(iden) Lassell [P,Et] Lexington, MA b. 31 D 1896, Wakefield, MA d. 29 Ag 1969, Lincoln, MA. Studied: Fenway Sch., 1917; BMFA Sch. Member: AAPL; Audubon A.; Gld. Boston A.; AWCS. Exhibited: PAFA, 1928, 1930, 1936, 1937, 1939, 1945; AWCS, 1939–46, 1945 (prize); AIC, 1927–45, 1928 (prize), 1936 (prize); Boston Tercentenary Exh. 1930 (med); Boston AC, 1929 (prize); NYWCC, 1933 (prize); Boston WCS, 1929 (prize); NAD, 1964 (prize); MET (AV), 1942; Baltimore WCC, 1940–42; TMA, 1938; N.J. State Mus., Trenton; WFNY, 1939; AGAA, 1939; WMA, 1940; BMFA, 1938; Currier Gal. A.; Boston SWCP; Gld. Boston A., 1942, retrospectives: 1972, 1974, 1975, 1978; DeCordova Mus., 1977. Work: AIC; BMFA; Davenport Mun. A. Gal.; murals, Winchester, Mass. Pub. Lib.; WPA mural, USPO, Lexington, Mass. Position: T., Harvard Sch. Arch., 1929 [47]

RIPLEY, Lucy P. See Perkins-Ripley.

RIPLEY, Robert [I] NYC d. ca. 1950. Member: SI [47]

RIPLEY, Thomas Emerson [P,W] Santa Barbara, CA b. 19 S 1865, Rutland, VT. Studied: Yale; B. Browne; R. Brown. Exhibited: Santa Barbara Mus. A. Author: "A Vermont Boyhood," 1937 [47]

RISEMAN, William [Mur.P,Des,Dec] Short Hills, NJ b. 7 D 1910, Boston, MA. Studied: Yale. Member: Mural P. Work: WPA murals, USPO, Lynn, Mass.; Lafayette Hotel, Brunswick Hotel, Boston; Lafayette Hotel, Portland, Maine [40]

RISHER, Anna Priscilla [P] La Crescenta, CA b. 2 N 1875, Dravosburgh, PA. Studied: A.A. Hills; D. Schuster. Member: Laguna Beach AA [40]

RISING, Dorothy Milne [P,W,T,B,C,I,L] Seattle, WA b. 13 S 1895, Tacoma, WA. Studied: PIASch; Cleveland Sch. A.; Univ. Wash.; H. Keller; R. Ensign. Member: Women P. of Wash.; Lg. Am. Pen Women; Northwest WCS; AAPL. Exhibited: Massillon Mus. A., 1945; Lg. Am. Pen Women, 1946; Northwest WCS, 1940–46; Women P. of Wash., 1941–46; Pacific Northwest Exh., Spokane, Wash., 1945, 1946 (prize); Studio Gal., 1944, 1945 (one-man), 1946; SAM, 1946 (one-man); Ferry Mus. A., Seattle, 1946 (one-man); Tacoma, 1945 (one-man); Pacific Coast Artists and Sculptors Assn., 1932 (prize), 1933 (prize), 1934 (prize); Western Wash. Fair, Puyallup, 1933–38 (prizes); Lg. Am. Pen Women, 1946 (prize). Contributor: articles, Design, School Arts, Christian Science Monitor, Handicrafter. Position: T., Broadway Evening Sch., Seattle [47]

RISLING, Jay [P] San Francisco, CA. Exhibited: San Fran. AA, 1935. Work: WPA mural, USPO, Guymon, Okla. [40]

RISQUE, Caroline Everett [S,T] St. Louis, MO/Santa Fe, NM b. 1886, St. Louis, MO. Studied: St. Louis Sch. FA, with Zolnay; F. Rhead, Laurent, at ASL; Colarossi Acad., Paris, with Injalbert, P. Bartlett. Member: St. Louis AG; Shikari; S.Indp.A. Exhibited: St. Louis AG, 1914 (prize), 1922 (prize), 1924 (prize). Work: Mus., New Orleans; St. Louis AG; Stone Group, Catholic Church, Helena, Ark.; St. Louis Medical S.; Dental Dept., Northwestern Univ. Medical Ctr. Position: Head., John Burroughs Country Day Sch.; T., Adult Study Ctr., St. Louis [40]

RISSER, J. Hemley [P] NYC [10]

RIST, Louis G. (Luigi) [G] Newark, NJ b. 26 Ja 1888, Newark, NJ d. 29 N 1959, Nottingham, PA. Studied: Newark Tech. Sch., with S. Skou. Member: Am. Color Pr. S. Exhibited: LOC; NAD; Phila. Pr. C.; Am. Color Pr. S., 1941 (prize); Northwest PM, 1946 (prize); Albany Pr. C.; Montclair A. Mus.; Irvington (N.J.) Lib.; Princeton Pr. C. Work: NYPL; MET; CM; Newark Lib.; Springfield A. Mus. [47]

RISWOLD, Gilbert P. [S] Oak Park, IL b. 23 Ja 1881, Sioux Falls, SD. Studied: L. Taft; C. Milligan. Work: Springfield, Ill.; Salt Lake City, Utah [24]

RITCHIE, Alexander Hay [Por.P,En] New Haven, CT b. 14 Ja 1822, Glasgow, Scotland (came to Canada in 1841) d. 19 S 1895. Studied: Edinburgh, with Sir William Allen. Member: NA, 1871. Settled in NYC ca. 1847. Became a successful engraver as well as painter. [*]

RITCHIE, Alexander [P] Hicksville, NY b. 19 F 1863. Studied: RISD. Member: Brooklyn SA [33]

RITCHIE, Andrew C. [Mus.Dir,L,W] Buffalo, NY b. 18 S 1907 Bellshill, Scotland. Studied: Univ. Pittsburgh; Univ. London. Author: "English Painters, Hogarth to Constable," 1942. Contributor: articles, The Art Bulletin, The Burlington Mag., Art News. Position: Dir., Albright A. Gal., Buffalo, N.Y., from 1942 [47]

RITCHIE, Mary D. Bladen (Mrs. George S.) [Ldscp.P] Phila., PA b. Phila. Member: Plastic C. [10]

RITER, Carl Frederick [P,T,L] Des Moines IA b. 28 My 1915, Carroll, IA. Studied: Univ. S.Dak.; Ohio Univ.; Univ. Iowa. Exhibited: Parkersburg FA Ctr., 1941, 1946; Joslyn Mem., 1945; Athens, Ohio; Gainesville, Fla.; Des Moines, Iowa. Position: T., Univ. Fla., Gainesville, 1944–45; Drake Univ., Des Moines, Iowa, from 1945 [47]

RITMAN, Louis [P,T] Chicago, IL b. 6 Ja 1889, Russia d. 1963. Studied: AIC; Ecole des Beaux-Arts, Paris; W. Chase; J. Vanderpoel; W.J. Reynolds. Member: ANA; Am. Soc. PS&G. Exhibited: Pan-Pacific Expo, 1915 (med); NAD, 1918 (prize) (med); AIC, 1930 (gold), 1932 (med), 1940 (med), 1941 (med); Chicago AG, 1915 (prize). Work: Chicago Mun. AL; Des Moines Gal. A.; PAFA. Position: T., AIC [47]

RITMAN, Maurice [P,W,L,T] Chicago, IL b. 11 O 1906, Chicago, IL; W. Reynolds; L. Ritman; AIC. Member: Chicago SA; Am. A. Cong. Exhibited: AIC, 1938 (prize), 1944 (prize). Position: A. Dir., Jewish Peoples Inst., Chicago [47]

RITSCHEL, William [Mar.P] NYC b. 11 Jy 1864, Nuremburg, Germany (came to U.S. in 1895) d. 1949. Studied: Munich, with F. Kaulbach, C. Raupp. Member: ANA, 1910, NA, 1914; NYWCC; AWCS; SC, 1901; A. Fund. S.; NAC; Kunstverein, Munich; Allied AA; Calif. WCS. Exhibited: SC; CA, Pittsburgh, 1912; NAD, 1913 (prize), 1921 (prize); NAC, 1914 (gold); Sacramento State Fair, 1916 (gold), 1936 (prize); Phila. AC, 1918 (gold); SC, 1923 (med); AIC, 1923 (prize); Santa Cruz (prize); Pomona, Calif., 1930 (prize); Dallas, Tex., 1930 (prize); Los Angeles, 1934 (prize); Springfield H.S. AA, 1935 (prize); Acad. West. P., 1936 (prize), 1937 (prize); Santa Cruz AL, 1936 (prize). Work: PAFA; Ft. Worth Mus.; AIC; Detroit AC; CAM; Smithsonian; Los Angeles Mus. A.; Albright A. Gal.; Minneapolis AM [47]

RITTASE, Roger M. [P] Wash., D.C. Member: S. Wash. A.; Wash. Ldscp. C. Exhibited: S. Wash. A., 1936 [40]

RITTENBERG, Henry R. [P,T] NYC b. 2 O 1879, Libau, Latvia. Studied: W.M. Chase, PAFA; Ludwig Heterich, Munich; Bavarian Acad., Germany. Member: BAID; P.&S. Assn.; AAPL; N.Y. Soc. Painters; Audubon A.; NA, 1927; Phila. AC; SC; NAC; Allied AA; Wash. AC; MacD. C.; Alliance; A. Fund S.; F., PAFA. Exhibited: NAD, 1920 (prize), 1926 (prize); AIC, 1925 (prize); NAC, 1938 (prize); AC Phila., 1906. Work: N.Y. Hist. S.; Columbia; Butler AI; Dept. Justice, Wash., D.C.; State Capitol, Harrisburg, Pa.; Univ. Pa.; Fed. Court, Phila.; Phila. Bar Assn.; Univ. Panama; Panama Republic; Jefferson Med. Col.; Univ. Va.; N.Y. Chamber of Commerce; N.Y. Acad. Med.; Franklin Marshall Col.; Skidmore Col.; College of Physicians, Union Lg.; Phila. AC; Hahnemann Col.; Poor Richard's C.; College of Pharmacy; Phila. Pub. Lib.; H.S., Phila.; N.Y. Produce Exchange; N.Y. County Bar Assn.; Masonic Lodge, St. Louis, Mo.; Nat. Arts C., Salmagundi C.; Pub. Lib., Greenville, S.C. Position: T., NA [47]

RITTER, Alice Bickley [P,T] Phila., PA. Studied: PAFA [25]

RITTER, Alonzo W. [P] Hagerstown, MD b. 7 Ja 1898, Hagerstown. Studied: D.M. Hyde. Member: Hagerstown SA. Exhibited: Cumberland Val. A., Hagerstown MFA, 1932, 1936 (prize). Work: murals, Jr. H.S., hotel, Hagerstown [40]

RITTER, A(nne) G(regory) [P,C,T] Denver, CO b. 11 Jy 1868, Plattsburgh, NY. (Previously Mrs. A. Van Briggle.) Studied: C.M. Dewey; R. Reid. Colarossi Acad., with Prinet, Girardot; Victoria Lyceum, Berlin. Member: Boston SAC; AFA; NSC; Women's AC, (N.Y.). Exhibited: St. Louis Expo, 1904 (med); Boston SAC, 1907 (prize). Work: Broadmoor A. Acad.; Denver AM Positions: Pres./Art Dir., Van Briggle Pottery Co. [31]

RITTER, Charles H. [P] Bloomingburg, NY [21]

RITTER, Chris [P,L] NYC b. 9 D 1908, Iola, KS. Studied: Univ. Kansas; ASL; Columbia; G. Grosz; M. Kantor. Exhibited: AIC, 1938, 1940, 1942–46; BM, 1939, 1941, 1943, 1945; CGA, 1938; PAFA, 1939; Denver AM, 1938–42; MET; CM; Oakland A. Gal.; Jackson (Miss.) Mus. FA; Kansas City AI; NGA, 1941, 1945. Work: BM; Univ. Ga. Mus.; U.S. Govt. Contributor: Display World mag. [47]

RITTER, Chris, Mrs. See Pratt, Frances.

RITTER, M. Antoinette [P,T] Baltimore, MD. Studied: Md. Inst., Baltimore; Johns Hopkins Univ. Exhibited: Friends of A., Baltimore (one-man); Baltimore MA, 1939 (prize); WFNY, 1939 [40]

RITTIS, J. Frank [P] Elgin, IL [13]

RITTMAN, L. [P] Paris, France. Member: Pairs AAA[15]

RITZ, Madeline Gateka [P,T] Brookings, SD b. 14 Jy 1903, Chickasha, OK. Studied: Okla. Col. for Women; Columbia; AIC; Univ. Iowa; Ohio State Univ.; J. Despujols; C. Martin; A. Strauss. Member: Am. Assn. Univ. Women; S.D. State Edu. Assn. Exhibited: Okla. AA. Position: T., S.Dak. State Col.; Okla. Col. for Women, 1940 [47]

RIVERA, Rolando [I] NYC. Member: SI [47]

RIVERS, Georgie Thurston (Mrs. William W.) [P,Des,B,T,L,W] Montgomery, AL b. 28 Ag 1878, Tunica, MS. Studied: G. Bridgman, ASL; AIC with E.P. Timmons, C. Wilson; W. Titze; H. Peterson; Huntingdon Coll.; Europe. Member: SSAL; Ala. AL; Miss. AA; NOAA. Exhibited: Jackson, Miss., 1926 (prize). Work: Montgomery FA, Ala. Contributor: articles, Art Digest, School Arts, Alabama newspapers. Position: T., Huntingdon Col. [40]

RIVERS, Jack Stuart [P] NYC [13]

RIVERS, Rosetta Raulston [P,B,C,Dr,L,T,W] Macon, GA. Studied: ASL; AIC; Hawthorne; E. Thurn; W. Woodbury; Modern A. Acad., Paris. Macon AA; Georgia AA; SSAL. Exhibited: Georgia AA, block printed wall drapery (prize). Position: T., Wesleyan Col. and Conservatory, Macon, Ga. [40]

RIX, Julian Walbridge [Ldscp.P,I,E] NYC b. 1851, Peacham, VT (came to San Fran. in 1855) d. 19 N 1903. Studied: self-taught. Member: SC, 1888; Bohemian C., San Fran.; Lotos C. Exhibited: NAD, 1884–86, 1891, 1894. Illustrator: "Picturesque California," 1888. Work: CGA; Minneapolis AM; TMA. Unknown outside of Calif. until he came to Paterson, N.J. (1888), then NYC. He was a "bohemian" and not in sympathy with art organizations; therefore, his work was not shown at the annual exhibitions, though he ranked among the best landscape painters of the day. [03]

ROACH, Mariana [C,Bookbinder] Dallas, TX b. 3 S 1908. Studied: Southern Meth. Univ.; E. Diehl; Gerlach, Columbia. Exhibited: Allied Arts exh., Dallas Mus. FA, 1933 (prize); Allied Arts craft exh., 1935 (prize). Illustrator: "Fine Bindings in Dallas," (S. Chokla, Publisher's Weekly, 1935.) Position: T., Dallas Evening Sch. [40]

ROARK, Helen Wills (Mrs. Aiden) [P,W,Des] San Francisco, CA b. 1906, Centerville, CA. Studied: Eugen Neuhaus, Univ. Calif.; Calif. Sch. FA. Author: "Tennis," "Fifteen-Thirty," (1928, 1937). Contributor: articles, Sat. Eve. Post; Cosmopolitan; Scribner's; Liberty; drawings, Sat. Eve. Post; Forum; Vanity Fair; London Sketch [40]

ROBB, Elizabeth B. [P] Emsworth, PA. Member: Pittsburgh AA; AFA. Exhibited: Pittsburgh AA, 1914 (prize), 1915 (prize) [33]

ROBB, Russell [P] Concord, MA. Member: Concoard AA [25]

ROBBINS, Douglas [P] NYC b. Springfield, OH [17]

ROBBINS, Frank G. [Mur.P,B,C,E,En] Louisville, KY b. 8 O 1886, Jefferson, CO, KY. Member: SSAL; Ky. Sketch C. [40]

ROBBINS, Franklin [I,Car,P,W] NYC b. 9 S 1917, Boston, MA. Studied: BMFA Sch.; NAD. Member: A.Lg.Am. Exhibited: NAD, 1936 (prize); 1937; Roerich Mus., 1945. Author/Illustrator: "Scorchy Smith" comic strip, 1939–44; "Johnny Hazard" comic strip, King Features Syndicate. Contributor: Life, Look, Cosmopolitan, other publications [47]

ROBBINS, Frederick Goodrich [Por.P,E,L,T,W] Westboro, MA b. 8 My

1893, Oak Park, IL. Studied: C.N. Werntz; S. Mackey; L. Randolph; H. McCarter; Breckenridge; Pierson; J. Laan, Amsterdam. Work: etchings, for Pres. Roosevelt, Queen of Holland and others [40]

ROBBINS, Horace Wolcott, Jr. [P] NYC b. 21 O 1842, Mobile, AL d. 14 D 1904. Studied: Newton Univ., Baltimore; Paris, 1865–67; NYC, J.M. Hart. Member: ANA, 1864; NA, 1878; AWCS; A. Fund S. (In 1890 he studied law at Columbia and was admitted to the bar in 1902); N.Y. Sch. Appl. Des. for Women (trustee); MET (fellow); Century; Lambs C. Traveled to Jamaica with F.E. Church, 1864; then France and Switzerland. Specialty: watercolor landscapes [04]

ROBBINS, Jennie [P] Louisville, KY. Member: Louisville AL [01]

ROBBINS, John C. [E] Farmington, CT [17]

ROBBINS, John Williams [L,P,W,E,] Boston, MA b. 16 F 1856, Windham, CT d. 1939. Studied: Mass. State Normal A. Sch.; Cowles A. Sch., Boston. Member: CAFA. Work: Windham Pub. Lib.; Otis House, Boston; AIC; NGA; Bibliothèque Nationale, Paris. . Specialty: inventor, brule print and mezzo brule etchings. Author: "The Witch of Tunthorne Gore," White Mts. Legends [38]

ROBBINS, Raymond Francis [P,T] Plainville, CT b. 20 Ja 1912, Boston, MA. Studied: Mass. Sch. A.; South Boston Sch. A.; G. Bjareby. Exhibited: VMFA, 1938; New Britain A. Mus., 1945; Ogunquit A. Ctr., 1938 [47]

ROBBINS, Richard Smith [P] Chicago, IL b. Solon, OH. Studied: Lefebvre, Constant, L. Doucet, at Académie Julian. Exhibited: Chicago A. Exh., 1898; Omaha Expo, 1898; Louisville A. Lg., 1898 [98]

ROBBINS, Theresa Reynolds [P] Boston, MA/Nantucket, MA b. 8 My 1893, Boston. Studied: P.L. Hale; R. Smith [31]

ROBBINS–LEE, Lucy [P] Paris, France b. NYC. Exhibited: Paris Salon, 1887 [04]

ROBERT [P,Des,Gr,S,C,T] b. 23 S 1909, NYC. Studied: L. Garfinkel; A. Jahr; S. DeG. Coster. Exhibited: AMNH, 1939; GGE, 1939; Vendôme Gal., 1938; Salons of Am., 1932; Weyhe Gal., 1943; 8th St. Playhouse, N.Y. (one-man). Work: Mun. Mus., Winston-Salem, N.C.; Carolyn Aid S., Savings Bank, Bronx, N.Y. [47]

ROBERT, C.E., Mrs. See McCullough, Lucerne.

ROBERTI, Romolo [P] Chicago, IL b. 18 O 1896, Montelanico, Italy. Studied: Cornell Univ.; AIC; A. Storba, A. Krehbiel. Member: Ill. Acad. FA; All-Ill. SA; Chicago SA. Exhibited: AIC, 1923, 1928, 1932, 1940; Findlay Gal. (one-man); Da Vinci A. Gal., NYC; Allerton, Harding, Barker Gal., Los Angeles, Calif. Work: State T. Col., Malcolm, Ill. Illustrator: "Art of To-Day," by J.Z. Jacobson [47]

ROBERTS, Alice Mumford. See Culin.

ROBERTS, Alice T. (Mrs. G.B.) [P] Phila., PA b. 1876, Phila. d. 23 Je 1955. Studied: H. McCarter. Member: Phila. Plastic C.; N.Y. Soc. Women A.; NAWPS. Exhibited: CGA; PAFA, 1936–46 (prize); Phila. Plastic C. (med); Woodmere A. Gal.; Hobson Pittman Gal., Toledo. Work: PAFA [47]

ROBERTS, Alton True (Mrs.) [P] Marquette, MI. Member: S. Detroit Women P. [25]

ROBERTS, Blanche Gilroy [S] Phila., PA/NYC b. 1871, Phila. [19]

ROBERTS, Dean (Mrs. Stanley H. Wolcott) [Dec,Des,Dr,E] Manhasset, NY b. 20 O 1899, Chelsea, MA. Studied: Corcoran Sch. A.; Calif. Art Sch. Member: Douglaston AL (Pres.) Illustrator: Herald Tribune. Work: Univ. Nebr. [40]

ROBERTS, Edith A. [C,Des,P] Woodstock, NY b. 8 Je 1887, Germantown, PA. Studied: N.Y. Sch. F.&Appl.A.; PAFA. Member: Boston SAC; Nat. AAI [40]

ROBERTS, Elizabeth [P] Wash., D.C. Member: S. Wash. A. Exhibited: S. Wash. A., 1936 [40]

ROBERTS, Elizabeth W(entworth) [P] Concord, MA/Hopkinton, NH/Coffen's Beach, West Gloucester, MA b. 10 Je 1871, Phila. d. 12 Mr 1927. Studied: Phila., with E. Bonsall, H.R. Poore; Paris, with Bouguereau, Robert-Fleury, Lefebvre, Merson. Member: Intl. SAL; Provincetown AA; Concord AA; NAWPS; North Shore AA; Alliance. Exhibited: PAFA, 1889 (prize); Paris Salon, 1892; Concord AA, 1922. Work: PAFA; Asllo San Giovanni, Bragora, Venice, Italy; Pub. Lib., Concord, Mass.; Fenway Court, Boston [25]

ROBERTS, George W. [P] Alden, NJ [17]

ROBERTS, Georgina Wooton [P,T] Hays, KS b. 6 Jy 1891, Auburn, Ind. Studied: De Pauw Univ.; AIC; Church Sch. A. Exhibited: Kansas-Okla.-Mo. Exh., 1923 (med) [25]

ROBERTS, Helen [P] Wash., D.C. [19]

ROBERTS, Herbert S., Mrs. See Howard, Edith.

ROBERTS, Hermine Matilda [G,P,T] Billings, MT b. 6 D 1892, Cleveland, OH. Studied: W. Forsyth ; E. Steinhof; Univ. Ind. Member: Southern PM; Ind. S. PM; Hoosier Salon. Author: course of art study for Jr. H.S., state of Mont., 1934. Position: T., Eastern Mont. State Normal Sch. [40]

ROBERTS, Howard [S] Bryn Mawr, PA b. 9 Ap 1843, Phila., PA d. Ap 1900, Paris. Studied: PAFA; Paris, Ecole des Beaux-Arts, with Dumont, Gumery. Exhibited: Centenn. Expo, Phila., 1876 (gold). Work: "Robert Fulton," Capitol, Wash., D.C.; PMA. Specialties: ideal figures; statuettes; busts; portraits [98]

ROBERTS, Jessie Macy [P] Cincinnati, OH. Exhibited: Cincinnati AM, 1934, 1936, 1939 [40]

ROBERTS, John Taylor [S] NYC b. 1878, Germantown, PA. Studied: C. Grafly [19]

ROBERTS, Josephine Seaman [P,W,L,T] Los Angeles/Idyllwild, CA b. Los Angeles, CA. Member: S. Calif. WCS; Calif. PS; Pac. AA [33]

ROBERTS, Louise Smith (Mrs. William A.) [I,Des] b. 1887, Phila., PA d. 2 D 1936, Fox Chase, PA. Studied: PMSchIA; ASL. Illustrator: Philadelphia Record (fifteen yrs.) Position: staff des., a number of women's mags.

ROBERTS, M.E. [P] NYC [01]

ROBERTS, Margaret Lee (Mrs. DeOwen Nichols, Jr.) [P,T] Norman, OK b. 19 Mr 1911 Oklahoma City, OK; Chouinard AI. Member: Assn. Okla. A.; Work: YWCA, Univ. Okla. [40]

ROBERTS, Marie C. [P] [13]

ROBERTS, Mary R. [P] Phila, PA [01]

ROBERTS, Maurine Hiatt (Mrs. Arthur K.) [P,I,C,T] Seattle, WA b. 29 Jy 1898, Kansas City, Mo. Member: Seattle FAS [25]

ROBERTS, Milnora, deB. [P] Seattle, WA [24]

ROBERTS, Nat., Mrs. See Wallace, Ethel.

ROBERTS, Norman L. [P] NYC b. 8 Ag 1896, Ironia, N.J. Studied: H.G. Keller. Work: Jr. Lg. C., Cleveland, Ohio; Cleveland, Ohio Pub. Lib. [29]

ROBERTS, Sarah Pickens [P] Chevy Chase, MD b. Louisville, KY. Studied: Corcoran Sch. A.; George Wash. Univ.; H.B. Snell; C. Critcher; Radcliffe Col. Position: T., Highland Hall [40]

ROBERTS, Spencer [P] Phila., PA. Member: AC Phila. [25]

ROBERTS, Sydney A. [I,G] Des Moines, IA b. 8 N 1900, FL. Studied: Cummings Sch. A., Des Moines. Member: Co-Op. Ar., State of Iowa. Exhibited: Iowa State Fair; Des Moines A. Gal. Specialty: cowboy subjects. WPA artist [40]

ROBERTS, Violet K(ent) (Mrs.) [P,I] Wash., D.C. b. 22 N 1880, The Dalles, OR d. ca. 1958. Studied: F. Benson; G. Eggers; Beck; Moschcowitz; Prellwitz; PIASch; BMFA Sch. Exhibited: Wash. WCC, 1945; Wash. Min. S., 1945; Wash. AC, 1946. Illustrator: "First Book of Religion." Position: Staff, CGA, from 1944 [47]

ROBERTSON, Ethel Burt [Min.P] Cincinnati, OH b. 13 D 1872, Cincinnati. Studied: Cincinnati A. Acad.; J.W. Dunsmore [08]

ROBERTSON, Fred E. [P] Savannah, NY b. 18 F 1878, NYC. Studied: Cornell Univ. Exhibited: Albright A. Gal.; Rochester Mem. A. Gal.; Saranac Lake AL; Auburn Mus.; State T. Col., Indiana, Pa.; Gal. St. Etienne, 1945 (one-man) [47]

ROBERTSON, H.O. [P,G] Dallas, TX. Member: Lone Star PM. Exhibited: WFNY, 1939; GGE, 1939; Dallas MFA, 1937 (prize). Illustrator: Ladies' Home Journal [40]

ROBERTSON, J. Milton [Cer] Dedham, MA b. 5 D 1890, Readville, MA. Studied: Hugh C. Robertson. Member: Boston SAC; Phila. ACG. Work: Dept. Agri., Quebec. Position: Super., Dedham Pottery, Dedham, Mass. Specialty: potter [40]

ROBERTSON, Jane Porter [P] Denver, CO. Member: Denver AA [19]

ROBERTSON, John Tazewell [P,G,T] NYC/Millington, NJ b. 8 Ag 1905, NYC. Studied: ASL; Tiffany Fnd., F., 1933. Exhibited: Corcoran Gal.,

Wash. D.C. Exhibited: CGA. Work: WPA murals: Hunt C., Omaha, Nebr.; USPO, Nashville (Ark.); Joslyn Mem., Omaha; McKinley H.S., Cedar Rapids, Iowa [40]

ROBERTSON, Madeleine Nixon [P,S,T,L] Phila., PA b. 14 Ag 1912, Vancouver, B.C., Canada. Studied: Moore Inst. Des. for Women; PAFA; Graphic Sketch C. Member: Ware F., 1943. Exhibited: Alum. Am. Acad., Rome, 1943 (prize); PAFA, annually; Moore Inst. Des. for Women; Phila. A. All. Work: Swedish Mus., Phila.; Phila. Sketch C.; Stevens Inst., Hoboken, N.J. [47]

ROBERTSON, Mittie Newton (Mrs. Jerome) [Des] NYC b. 14 O 1893, Grandview, TX. Studied: Schotz, in Dresden, Germany; D. Wier, NYC. Exhibited: All.A.Am., 1930 (prize). Specialty: textile des. [40]

ROBERTSON, Paul Chandler [P,I,Des,L,T] NYC b. 9 Mr 1902, St. Paul, MN d. 28 Mr 1961. Studied: Univ. Calif.; Calif. Sch. F. & Appl. A.; N.Y. Sch. F. & Appl. A. Member: NSMP. Exhibited: Anderson Gal.; Gal. Mus. French A., 1932; Kimball, Hubbard & Powell, 1933; Putnam County AA, 1936; Parsons Sch. Des., 1937; Decorators C., 1937–39; Decorators' War Relief Exh., 1941; Arch. L., 1946. Work: murals: Aluminum Corp.; Atlantic Rayon Co.; Cities Service Oil C.; Lord & Taylor, James McCreery, W. & J. Sloane, R.H. Macy, N.Y.; numerous hotels. Contributor: House Beautiful, House & Garden, New Yorker [47]

ROBERTSON, Persis W. (Mrs.) [Li,P] Des Moines, IA b. 10 My 1896, Des Moines. Studied: Wells Col., Columbia. Member: Audubon A. Exhibited: AIC, 1935, 1937, 1939; Northwest PM, 1937, 1939, 1940; Phila. Pr. C., 1936, 1937, 1939, 1940; Phila. A. All., 1936, 1939; Wash. WCC, 1939, 1940; Phila. WCC, 1940; Buffalo Pr. C., 1938, 1940; Boston S.Indp.A., 1941; Southern PM, 1938; Oakland A. Gal., 1938, 1939, 1941; Oakland A. Ctr., 1940, 1941; LOC, 1945; Audubon A., 1945; Joslyn Mem., 1936, 1938, 1940, 1941; Kansas City AI, 1936–41, 1940 (prize); Wichita, Kansas, 1938–40; Ferargil Gal., 1939 (one-man); Hanley Gal., Minneapolis, 1939 (one-man); Denver A. Mus., 1939 (one-man); W.R. Nelson Gal., 1940 (one-man); Seattle AM, 1937 [47]

ROBERTSON, Ralph F. [P] New Rochelle, NY. Member: New Rochelle AA [25]

ROBERTSON, Rhodes [E,T] Minneapolis, MN b. 27 S 1886, Somerville, MA [24]

ROBERTSON, Thomas Arthur [Por.P,Mur.P,Min.P,C] Little Rock, AR b. 19 Jy 1911, Little Rock. Studied: A.L. Brewer. Specialty: carved frames [40]

ROBERTSON, William [Cer,C] b. 29 Ag 1864, East Boston d. 17 Ja 1929, Dedham, MA. Member: Boston SAC. Exhibited: Paris Expo (prize); Buffalo Expo (prize); San Fran. Expo (prize). Work: BMFA; Isabella Stewart Gardner Mus., Boston. After mining in the West he returned to his father's pottery, known as the Chelsea Pottery Co. Upon the death of his father he changed the name to the Dedham Pottery, where the well-known blue and white crackle was made, with glaze in imitation of old Chinese pottery. The Twin Stars of Chelsea, vases glazed in rich ox-blood, are perhaps the most notable.

ROBESON, Edna Amelia [Min.P] Woodstock, NY b. 25 Ja 1887, Davenport, IA. Studied: F. Phoenix; ASL. Member: Pa. SMP [33]

ROBIN, Fanny [P] Phila., PA b. 28 Je 1888, Phila. Studied: Moore Inst. Des.; PAFA; Breckenridge; Snell; Horter. Member: in Phila., Plastic C. A. All., A. T. Assn. Exhibited: PAFA, 1936, 1939; Phila. A. All., 1943 (one-man); DaVinci All., 1942 (prize); Phila. Plastic C., 1943 (med) [47]

ROBINEAU, Adelaide (Mrs.) [C,T] d. 18 F 1929, Syracuse, NY. Position: T., Col. of FA, Syracuse Univ. Her porcelains won nat. and intl. awards.

ROBINS, Hugo [P] NYC [21]

ROBINS, Louisa W. (Mrs. Thomas) [P] Buffalo, NY b. 28 Ag 1898, Dedham, MA. Member: The Patteran. Exhibited: Ar. Western N.Y. (prize); Albright A. Gal., Buffalo, 1936 (prize), 1940 (prize). Work: MOMA; Albright A. Gal. [40]

ROBINS, Mary Ellis [P,T] Phila., PA b. 1 O 1860, Ashwood Plantation, MS. Studied: Phila. Sch. Des. for Women; PAFA. Member: Plastic C.; S. Arts & Letters [10]

ROBINS, Susan P.B. [P] Boston, MA b. 1849, Boston. Studied: J. Johnston; R. Turner; F. Crowninshield; BMFA Sch., with P. Hale. Member: Copley S., 1894 [25]

ROBINSON, Adah Matilda [P,Des,L,T] San Antonio, TX b. 13 Jy 1882, Richmond, IN. Studied: Earlham Col.; AIC; C. Hawthorne; G.E. Browne; J. Carlson; A. Woelfle. Member: San Antonio AL; Southwestern AA; Prairie PM; CAA. Work: Okla. City AL; Philbrook A. Ctr.; des. interior, First Christ Church, Tulsa, Okla.; mem. fountain, Tulsa. Methodist Church, Christian Science Church, Tulsa; Christian Science Church, Bartlesville, Okla.; Pub. Lib., Tulsa. Position: T., Tulsa Univ., 1927–45; Trinity Univ., San Antonio, from 1945 [47]

ROBINSON, Alexander Charles [P,T] Boston, MA/Paris, France b. 11 My 1867, Portsmouth, NH. Studied: Lowell Sch. Des.; Académie Julian, with Doucet, Constant. Member: NYWCC; Phila. WCC; Chicago WCC; AWCS; SC; Société Nationale des Aquarellistes; Société des Artistes Coloniale in Paris; Cercle d'Art, Tournai and Bruges, Belgium; United Arts C., London. Exhibited: P.-P. Expo, San Fran., 1915 (med). Work: TMA; Rockford (Ill.) AA; Miss. AA, Jackson; PAFA; Delgado Mus., New Orleans; Newcomb Gal., Tulane Univ.; D. Fitzgerald A. Gal., Brookline, Mass.; Museum d'Ixelles; Moscow, Russia; Glasgow, Dundee, both in Scotland; London, Manchester, both in England [40]

ROBINSON, Alice [P,L,T,W] Columbia, OH b. Westmoreland Co., PA. Studied: Miami Univ.; Columbia; C. Hawthorne; H.B. Snell; Cincinnati A. Acad.; ASL. Member: Coll. AA; Columbus Gal. FA; Friends of Art, Columbus; Ohio WCS. Position: T., Ohio State Univ. [40]

ROBINSON, Alonzo Clark [W,S] Paris, France b. 3 S 1876, Darien, CT. Member: SBA [31]

ROBINSON, Amy R. [P] Brooklandville, MD [25]

ROBINSON, Ann [P] Laguna Beach, CA. Member: Laguna Beach AA [25]

ROBINSON, Boardman [P,I,L,Cart,T] Colorado Springs, CO b. 6 S 1876, Somerset, Nova Scotia d. 5 S 1952. Studied: Mass. Normal A. Sch., with E.W. Hamilton, 1894–97; Acad. Julian, Acad. Colarossi, Ecole des Beaux-Arts, all 1898–99 and 1901–04. Member: SI; AIAL. Exhibited: Arch. Lg., 1930 (gold). Work: Rockefeller Ctr.; Dept. Justice, Wash., D.C.; MET; AIC; Los Angeles Mus.; Wichita Mus. A.; FMA; NYU; Denver AM; Univ. Ariz.; Colorado Springs FA Ctr. Illustrator: "Spoon River Anthology," "Moby Dick," "Cartoons of the War," pub. Dutton, 1915, "Rhymes of If and Why," by Betty Sage, pub. Duffield, "The War in Eastern Europe," by John Reed, "The Brothers Karamazov," "The Idiot." Positions: Dir., Colo. Springs FA Ctr., Fountain Valley Sch. (Colo. Springs); T., ASL, 1920–30 [47]

ROBINSON, Carrie B(rown) [P,C] Cleveland, OH/Gates Mill, OH b. 21 Ap 1867, Johnstown, PA. Studied: PAFA; Cleveland SA. Member: Womans AC, Cleveland [25]

ROBINSON, Charles Dorman [Ldscp.P,Mar.P] San Francisco, CA b. 1847, VT (or Monmouth, ME) d. 1933, San Rafael, CA. Studied: Wm. Bradford, 1862; G. Inness, M.F.H. de Haas, 1863; R. Gignoux, Cropsey, Newport, Vt., 1866–67; Paris, with Boudin, 1899–01. Exhibited: Mechanics Fair, San Fran., 1860 (prize); NGA, 1891. Work: CA Hist. S.; San Fran. Maritime Mus.; S. Calif. Pioneers; 84 works in British collections. Active in Vt., 1861–73; in Iowa, 1873–74; then settled in San Fran. After his 50 x 400 ft/50 ton painting of Yosemite was rejected by the Paris Expo, 1900, he cut it into pieces for sale. [17]

ROBINSON, Charles H(oxsey) [P,T] Morro Bay, CA b. 26 Ap 1862, Edwardsville, IL. Studied: J. Fry; C. Von Salza; E. Wuerpel. Member: Calif. WCS [33]

ROBINSON, Charles W. [P] Rochester, NY. Member: Rochester AC [25]

ROBINSON, David [P,I] Silvermine, CT b. 31 Jy 1886, Warsaw, Poland. Studied: America; France; Germany. Member: SI, 1910; SC; S.Indp.A.; Artists' G.; Silvermine GA; AFA [40]

ROBINSON, Delia Mary [P,E,T] Waterloo, NE b. Waterloo. Studied: Forsberg; E. Church, Chichester. Member: Laguna Beach AA; Omaha AG. Work: dec. study, Jr. H.S., Kearney; Masonic and Eastern Star Home, Plattsmouth, Nebr. [40]

ROBINSON, Dent [P] NYC [19]

ROBINSON, Edward [Mus.Dir] NYC b. 1858 d. 18 Ap 1931. Studied: Harvard, 1879; Europe, 1879–84. Member: American Acad., Rome (trustee); Am. Fed. A. (Dir.); Mus. City of N.Y. (trustee). Also selected and arranged collections in the Slater Mem. Mus., Springfield (Mass.) AM. Position: Dir., MET, 1910–31

ROBINSON, Florence V(incent) [P] NYC b. 18 N 1874, Boston, MA d. 30 Mr 1937. Studied: Vignal, in Paris. Member: Société des Aquarellists, Paris; AWCS. Work: Harvard; Cleveland Sch. A.; Gov. Coll., France; BMFA; Hispanic Mus., NYC; BM. Specialty: watercolor [38]

ROBINSON, Frederic G., Mrs. See Pew, Gertrude, L.

ROBINSON, H.L. [S,P] Columbus, OH. Member: Pen and Pencil C., Columbus [25]

ROBINSON, Hal [P] NYC [15]

ROBINSON, Harriette Wood [P] Auburn, ME [08]

ROBINSON, Helen Avery [S] NYC [24]

ROBINSON, Increase [P,L] Chicago, IL b. 2 Ap 1890, Chicago, IL. Member: Chicago SA; Chicago AC. Position: Asst. to Natl. Dir., WPA [38]

ROBINSON, Ione [P,W,I] NYC b. 3 O 1910, Portland, OR. Studied: Otis AI; PAFA. Member: Am. A. Cong.; F., Guggenheim, 1931. Exhibited: Marie Harriman Gal., 1931; Delphic Studios, 1931; PAFA, 1938; Los Angeles Mus. A., 1929; Julian Levy Gal., 1938; Univ. Mexico, 1938; Bonestell Gal., 1940; Bellas Artes, Mexico, 1944. Author: "A Wall to Paint On," 1946. Contributor: Sat. Review; Calif. Arts & Arch. Illustrator: "Impressions of South America," 1933. Work: National Palace, Mexico. [47]

ROBINSON, Irene Bowen (Mrs.) [I,P] Los Angeles, CA b. South Bend, WA. Studied: Drury Col.; Univ. Chicago; Broadmoor A. Acad.; J.F. Carlson; Otis AI. Member: Calif. WCS; Calif. AC; Laguna Beach AA. Exhibited: Los Angeles Mus. A., 1930-45, 1935 (prize);San Diego FAS, 1927 (prize); Calif. AC, 1931 (prize); Ebell Salon, 1934, 1942, 1945; Glendale AA, 1945 (prize). Illustrator: "At the Zoo," 1940; "Picture Book of Animal Babies," 1946; "The Forest and the People," 1946; "Ancient Animals," by W.W. Robinson (pub. Macmillan), "Animals in the Sun," "Lions," by W.W. Robinson (pub. Harpers) [47]

ROBINSON, James [Dealer] NYC b. NYC d. 25 Ap 1936. Head of the antique silver establishment on Fifth Avenue which bears his name today. An authority on old English silver, his hobby was the collection of china. He established offices in London, Palm Beach, Newport and Southampton.

ROBINSON, Jay (Thurston) [P,Des] NYC b. 1 Ag 1915, Detroit, MI. Studied: Yale; Cranbrook Acad. A., with Z. Sepeshy. Exhibited: NAD, 1945; Pepsi-Cola, 1944 (prize); Detroit AI, 1941, 1942; RKO Comp., 1944 (prize). Work: Cranbrook Acad. A.; U.S. Gov.; Pepsi-Cola Coll. [47]

ROBINSON, Jean A. [P] Charleston, SC [21]

ROBINSON, Kathleen. See Ingels.

ROBINSON, L.S. Mona [P] Paoli, PA [25]

ROBINSON, M.E. [P] Brooklyn, NY [01]

ROBINSON, Margaret Frances [Ldscp.P,Des] New Orleans, LA b. 1 Ja 1908, Hull, MA. Studied: W. Adams; R. Davey; L. Randolph. Member: NOAA; SSAL. Position: A. Dir., Civic Theatre Players, New Orleans. [40]

ROBINSON, Mary Turlay [P,L] NYC b. 7 S 1888, MA. Studied: Vassar; ASL; Fontainebleau Sch. FA; Dumond; Luks; Beaudoin; Despujols. Member: AFA; French Fresco S.; Officer of French Acad., 1933. Exhibited: NAWA, 1929-36; Am. Woman's Assn., 1932-38, 1937 (prize); Anderson Gal., 1930 (one-man); Nantucket AA, 1933-45; Bignou Gal., 1941, 1942; Salon d'Automne, 1925; Les Independents, Paris, France, 1926. Work: CUASch. Contributor: Magazine of Art [47]

ROBINSON, Mary Yandes [P] Indianapolis, IN. Associate: SWA [01]

ROBINSON, Maude [Cr,Cer,L,T] Sharon, CT b. 20 N 1880, Corning, NY. Studied: b. ASL; Newcomb Col.; N.Y. State Ceramic Sch.; C. Binns; A. Dow; J. Twachtman; J. Carlson; H.S. Mowbray; K. Cox; Newcomb Pottery; A. Baggs. Member: N.Y. Keramic S. Exhibited: MET; AIC; Sharon, Salisbury, Conn. Contributor: "Technique of Terra Cotta Sculpture," 13th Ed., Encyc. Brit.; chapter on pottery, "Careers for Women"; "Pottery and Porcelain," World Book Encyc. Position: Dir., Greenwich House Pottery, NYC; Consultant in Ceramic Technique, MET, NYC; A. Dir., Hartridge Sch., Plainfield, N.J. [47]

ROBINSON, May E. [T,W] b. Vincennes, IN d. 24 N 1928, Bloomington, IN. Studied: Pratt Inst.; St. Louis Sch. FA; John Herron A. Sch. Member: Allied Arts Section of Ind. Teachers Assn.; Ind. AC; Ind. Fed. AC (dir.). Positions: T., Washington (Ind.) Pub. Sch., Boothbay Studios (Boothbay Harbor, Maine)

ROBINSON, (Miss) [P] St. Joseph, MO [24]

ROBINSON, Nancy B(ell) [P,T] Phila., PA b. Big Cove, PA. Studied: PMSchIA. Member: Phila. Alliance; Plastic C. [33]

ROBINSON, Oliver D. [P] Rockville, Ctr., NY. Member: S.Indp.A. [25]

ROBINSON, Robert [I] NYC [19]

ROBINSON, Robert B. [P] NYC. Member: Lg. AA [24]

ROBINSON, Ruth C. See Treganza.

ROBINSON, Ruth Mae [P,Des,I] Upper Darby, PA b. 15 Ja 1910, Phila., PA. Studied: Moore Inst. Des. for Women; PAFA; E. Horter; U. Romano. Member: F., PAFA; A. All., Phila.; Plastic C., Phila.; WCC, Phila.; Bryn Mawr A. Ctr.; Chester AL. Exhibited: Phila. WCC, 1930-46; PAFA, 1940; GGE, 1939; Moore Inst. Des., 1930 (prize); AIC, 1936, 1937; Phila. Plastic C., 1932 (prize), 1941 (med); Cape May AL, 1940 (prize); Grand Central A. Gal.; Contemp. A. Gal.; Phila. A. All.; Mortimer Levitt Gal.; numerous exh. (one-man), Phila., N.Y. Work: Marine Hospital, Carville, La.; Ft. Knox, Ky.; Carnegie Corp. [47]

ROBINSON, Sarah Whitney [P] NYC [13]

ROBINSON, Theodore [P,T,Des] B. 3 Jy 1852, Irasburg, VT d. 2 Ap 1896, NYC (of asthma, and in poverty). Studied: AIC, 1970; NAD, 1874; Paris, with Carolus-Duran, Gérôme, 1876. Member: ASL (founder). Exhibited: NAD, 1881; SAA, 1888, 1890 (prize); BM, 1946 (retrospective); Baltimore Mus. A., 1973 (retrospective). Work: CGA; AGAA; Randolph-Macon Col. Designer: stained-glass and mosaics, 1879-ca. 1884. Important Impressionist active in France, 1876-92, mostly at Giverny; friend of Monet. Active in Greenwich, Conn., 1893-95 (Cos Cob, 1894). Biography: "Theodore Robinson, His Life & Art," by E. Clark. Positions: T., Brooklyn A. Sch. (1893-94), PAFA (from 1894) [*]

ROBINSON, (Virginia) Isabel [P,C,B,Des,E,T,W,Dr,L] Canyon, TX b. 16 N 1894, Eagle Ranch, MO. Studied: Kirksville (Mo.) State T. Col.; Univ. Mo.; Columbia; Otis AI; M. Sheets; Martin; Northrup; Allen Staples; Monhoff; Vysekal. Member: Tex. State T. Assn.; Assn. A. Instr., Tex.; NAAI; Col. AA; SSAL. Exhibited: SSAL; All. A. & Indst., NYC; Tex. Centenn. Exh.; Dallas, 1936; Dallas Mus. FA; Ft. Worth, Austin, San Antonio, Houston, all in Tex.; Mich. State Col., 1937 (one-man); Texas Fed. Women's C., 1946 (prize). Work: Columbia; Amarillo, Tex. Pub. Lib.; Hist. S. Mus., Canyon, Tex. Positions: T., Ohio State Univ. (1924-25), West Tex. State Col. (from 1927) [47]

ROBINSON, Walter Paul [P] Chicago, IL b. 29 O 1903. Studied: AIC. Member: Chicago NJSA; Chicago Artists U. Work: U.S. Govt. [40]

ROBINSON, Will(iam) S. [Ldscp.P,Mar.P] Old Lyme, CT (summers ca. 1905-20; permanently ca. 1921-37) b. 15 S 1861 East Gloucester, MA d. 11 Ja 1945, Biloxi, MS. Studied: Mass. Normal Art Sch., Boston; Académie Julian, with Constant, Lefebvre. Member: ANA, 1907; NA, 1911; AWCS 1897 (Pres., 1914-21); NYWCC, 1891; SC, 1896; Lotos C.; A. Fund S. 1889; NAD; Allied AA, 1919; Lyme AA (founder). Exhibited: Paris Expo, 1900; Pan-Am. Expo, Buffalo, 1901; SC, 1901 (prize), 1917 (prize), 1922 (prize); St. Louis Expo, 1904 (med); NAD, 1910 (prize), 1929 (prize); Buenos Aires Expo, 1910 (med); P.-P. Expo, San Fran., 1915 (med); Dallas Exh., 1915 (med); CGA, 1919 (prize); Lyme AA, 1925 (prize), 1927 (prize), 1928 (prize); Old Lyme AA, 1928 (prize). Work: CI; Dallas AM; NGA; CMA. Positions: T., in Boston (1880s), Md. Inst. (1885-89), Drexel AI (1890s), PAFA (1890s), Columbia (1890s), NAD (1920-34), Conn. Col. (1928-34) [40]

ROBINSON, W(illiam) T. [P] Malden, MA b. 17 S 1852, Somerville, MA. Studied: G.N. Cass, in Boston; Ecole des Beaux-Arts, Ecole de Medecine, both in Paris; Gobelin Tapestry Sch.; Bouguereau, Diogène Maillart. Member: NAD. Work: Henry Gal., Seattle; Roswell R. Robinson, Malden Pub. Lib. [40]

ROBISON, Ann(a) Dorothy [P,E,T] Los Angeles, CA b. Palmyra, IL. Studied: UCLA; Otis AI; J.H. Rich; P. Clemens. Exhibited: LOC, 1944; San Gabriel AG, 1942; Fnd. Western A.,1932-44; Pal. Leg. Honor, 1933. Position: T., Franklin H.S., Los Angeles, from 1931 [47]

ROBITSCHER, Bianca Bondi (Mrs.) [Wood Engr] b.1844, Dresden (came to U.S. in 1859) d. 21 D 1924, Elmhurst. Studied: CUASch. Position: T., CUASch

ROBSON, (Gerson) Adele May [Des] Springfield, PA b. 26 My 1908, Phila., PA. Studied: Phila. Sch. Des. for Women. Exhibited: Alliance, 1929 (prize). Work: mural: St. Joseph's Convent, Chestnut Hill, Phila. (in collaboration with Mrs. P.H. Bolano). Specialty: heraldic plaques and historical coats of arms [40]

ROBUS, Hugo [S,T,P] NYC b. 10 My 1885, Cleveland, OH d. 14 Ja 1964. Studied: Cleveland Sch. A., 1904-08; NAD, 1910-11; Bourdelle, at Grande Chaumière, 1912-14. Member: S. Gld.; An Am. Group. Exhibited: MET (AV), 1942 (prize); PAFA, 1941, 1945; WMAA, 1933-46; CI, 1941; WFNY, 1939; MOMA, 1939; S. Gld., annually; Bucholz Gal.; Grand Central A. Gal. Work: MET; MOMA; WMAA; IBM Coll.; Rockefeller Center, NYC; CGA [47]

ROBY, Helen E. [P] Meriden, CT [01]

ROCA, Stella McLennan [Por.P,Ldscp.P] Tucson, AZ b. Nebraska City, NE d. ca. 1955. Studied: AIC; J.C. Johannson. Member: Tucson FAA; Palette

& Brush C.; Nebr. AA; Lincoln AG. Exhibited: Phoenix Expo, 1923 (prize), 1926 (prize), 1931 (prize), 1932 (prize); Mus. Northern Ariz., 1933 (prize); Tucson, 1942 (prize). Work: Dept. Interior, Wash., D.C.; Union H.S., Yuma, Ariz.; Women's C., Tucson [47]

ROCHARD, Pierre [P,I,W,L,T] Salt Lake City, UT b. 10 Je 1869, Lyon, France. Studied: Paris, with Gérôme, Ecole des Beaux-Arts. Work: murals, frescoes: Metropolitan Opera House; Waldorf Astoria Hotel, NYC [19]

ROCHE, Leo Joseph [Cart] Kenmore, NY b. 20 F 1888, Ithaca, NY. Contributor: cartoons, Sat. Eve. Post; Collier's, etc. Position: Ed. Cart., Buffalo Courier-Express [47]

ROCHE, M. Paul [Mur.P,Et,Li,S,L] Baltimore, MD b. 22 Ja 1888 Cork, Ireland. Studied: St. John's Col.; PIASch; NAD, with Charles Hawthorne. Exhibited: NAD (prize); Brooklyn SE (prize); NAC (prize); AIC (prize). Work: BM; CMA; LOC: NYPL; murals: Wash. Col., Chesterton, Md.; Enoch Pratt Lib., Catholic Cathedral, St. Joseph's Church, all of Baltimore, Md.; AIC; Detroit AI [47]

ROCHELLE, Eugene [I] Flushing, Queens, NY b. 1876 d. 9 Mr 1914, NYC, suicide

ROCHON, (Marie) Louise See Mrs. Hoover.

ROCKMORE, M. Gladys [P] Chicago, IL. Member: AG of Authors Lg. A. [25]

ROCKWELL, Bertha [P] NYC b. 1874, Junction City, KS [10]

ROCKWELL, Cleveland [Mar.P] Portland, OR b. 1837, Youngstown, OH d. 1907. Studied: Troy (N.Y.) Polytechnic; Univ. N.Y. Work: Flavel Mus., Astoria, Oreg. Position: U.S. Geo Survey artist and mapmaker, surveying Oreg. coast from 1868 [06]

ROCKWELL, Edwin Amasa [W,Cr] Brooklyn, NY b. 1846 d. 8 Mr 1919. Position: art and musical ed., Brooklyn Eagle, twenty yrs.

ROCKWELL, Evelyn Enola [P] Kew Gardens, NY/Ogunquit, ME b. 4 Je 1887, Chicago, IL. Studied: PAFA; ASL; W.M. Chase; C. Beaux; C. Woodbury; E. G. Baker. Member: Queensborough SAC. Specialty: cosmic portraits [40]

ROCKWELL, Frederick (Frye) [P] Wiscasset, ME b. 12 Ja 1917, Brooklyn, NY. Studied: Columbia; NAD; Tiffany Fnd.; O. Malderelli; A. Blanch; G. Grosz; W. Zorach. Member: Audubon A. Work: U.S. Marine Hospital, Carville, La. Exhibited: WFNY 1939; AWCS, 1939, 1942, 1943; AIC, 1940, 1943, 1944; PAFA, 1943, 1946; NGA, 1941; WMAA, 1941; Portland Mus. A., 1944; Ogunquit A. Ctr., 1945; Audubon A., 1945; Morton Gal., 1941 (one-man), 1943 [47]

ROCKWELL, Fritz [P] NYC Exhibited: AWCS-NYWCC, 1939; WFNY, 1939 [40]

ROCKWELL, Lucy Twyman (Mrs. Frederick William) [C,L] Phila., PA b. Chicago, IL. Studied: Boston SAC; AIC; A. Colarossi, Paris. Member: Phila. A. All.; AC Gld., Phila. Exhibited: Phila. A. All.; Pan.-P. Expo, San Fran., 1915 (med); AC Gld., Phila.; Intl. Expo, Paris, 1937. Work: jeweled book, Nat. Cathedral, Wash., D.C. Specialty: jewelry [40]

ROCKWELL, Maxwell Warren [I] b. 1876 d. 17 O 1911, NYC. Contributor: Life; and other humorous publications

ROCKWELL, Norman Percevel [I] New Rochelle, NY/Arlington, VT (Stockbridge, MA since 1950s) b. 3 F 1894, NYC d. 1978, Stockbridge, MA. Studied: Chase Sch. A. ca. 1908; NAD, ca. 1909; ASL, with G. Bridgman, T. Fogarty, 1910. Frequently acclaimed as America's greatest illustrator, he created 322 covers for Sat. Eve. Post from 1916–63. His work also appeared in Brown & Bigelow calendars from 1924–76, as well as every major magazine. His illus. for "Tom Sawyer" and "Huckleberry Finn" became classics. His autobiography is "My Adventures as an Illustrator," 1960 [47]

ROCKWELL, Rena Victoria [Mar.P,L] Wilkinsburg, PA/S. Wellfleet, MA b. 9 Ag 1890. Studied: Bradley Polytech, Inst. Member: Pittsburgh AA; AAPL. Exhibited: Pittsburgh AA, 1937 (prize). Work: Forest Hills, Pa. pub. schs. [40]

ROCKWELL, Robert H. [S] b. 25 O 1886, Laurens, NY. Exhibited: small bronzes of animals, BM [29]

ROCLE, Margaret (K.) [P,G] Chula Vista, CA b. 6 Mr 1897, Watkins, NY. Studied: R. Henri; Bredin; Wiles. Member: San Diego FAS; San Fran. AA; Laguna Beach Progressives. Exhibited: Southern Calif. A., 1931; Santa Cruz Ann., 1932 (prize); San Diego Ann., 1933; San Diego AG, 1939 (prize). Work: BMA; FA Gal., San Diego [40]

ROCLE, Marius R(omain) [P,G,] Chula Vista, CA b. 6 Je 1897, Brussels, Belgium. Member: San Diego FAS; San Fran. AA; Laguna Beach Progressives. Exhibited: San Diego AG, 1931 (prize). Work: BMA; FA Gal., San Diego [40]

RODDY, Edith Jeannette [P,E,L,T] Sarasota, FL b. Meadville, PA d. ca. 1960. Studied: BMFA Sch.; Europe; C. Hawthorne; G.P. Ennis; Nat. Lg. Am. Pen Women; Syracuse AA; SSAL. Exhibited: Fla. AA; Sarasota AA; Clearwater AA, 1946 (prize); Palm Beach AL; Wash. WCC; Gulf Coast Group; Fla. Fed. A., 1938 (med). Work: Meadville (Pa.) AA. Contributor: Sch. Arts League, Design; covers for Literary Digest, Keramic Studio. Position: T. Ringling Sch. A., Sarasota, Fla. [47]

RODERICK, C(harles) E. D(uncan) [P] Allston, MA b. Nova Scotia. Studied: C.K. Fox. Member: Portland AS [25]

RODERICK, Harry T. [P] Columbus, OH. Member: Columbus PPC [25]

RODERICK, John M. [Mur.P,P,Dec,Des] Phila., PA b. 13 N 1878, Wilmington, DE. Member: Wilmington SFA. Work: PAFA; Wilmington SFA; mural dec., churches, Cambridge, Mass.; Easton, Md.; Wilmington, Del.; Pendleton, Oreg.; Collegeville, Pa.; Riverton, N.J.; Church, Ridgely, Md.; Sacred Heart Church, Delphi, Pa. [47]

RODERICK, L(ulu) Z(ita) (Mrs. H.P. Jeffries) [P,W,T,I] Sussex Corners, New Brunswickb. Nova Scotia. Studied: P. Moschowitz; PIASch. Member: Newport AA [25]

RODGERS, Isabel, Frances [P] Lumberville, PA b. 27 O 1890, Ft. Worth, TX. Studied: Moore Inst. Des. for Women; G.E. Browne. Member: All. Am. Am.; NAC; NAWPS. Exhibited: NAD, 1931, 1932, 1934, 1937, 1938; NAWA, 1937, 1938 [47]

RODGERS, M.C. [P] Pittsburgh, PA. Member: Pittsburgh AA [21]

RODGERS, Maria Sanchez [P] Santa Cruz, CA. Exhibited: Calif. Statewide Exh., Santa Cruz AL, 1937 (prize)[40]

RODINA, K. Michaloff [S] NYC [15]

RODMAN, H. Purcell [P] Alliance, OH. Exhibited: NYWCC, 1936, 1937; Wash. WCC, 1939; AWCS-NYWCC, 1939 [40]

ROE, Robert, Mrs. See Julie Stohr.

ROECKER, H(enry) Leon [P] Winthrop Harbor, IL b. Burlington, IL. Studied: Acad. Des., Chicago; Gysis, RA, Munich. Member: Chicago SA; Chicago WCC; Cliff Dwellers; Cor-Ardens. Exhibited: Munich, 1889; AIC, 1894 (prize), 1897 (prize), 1911 (prize); Chicago SA, 1909 (med) [33]

ROEDER, Elsa [I] Orange, NJ b. 1885, Baltimore, MD d. 20 Ap 1914. Studied: H. Pyle, Wilmington; E. Penfield; Sch. Indust. A., Phila. Member: Sketch C., Wilmington. Exhibited: Life Mag. contest, 1908 (prize); theatrical poster exh., (prize).

ROEDING, Frances [P] Berkeley, CA b. 23 Ag 1910, San Francisco, CA. Studied: Calif. Sch. FA, San Fran.; ASL. Member: San Fran. AAA; San Fran. SWA. Exhibited: San Fran. SWA, 1936 (prize); Women A., Wichita, Kans., 1938 (prize); Fnd. Western A., Los Angeles, 1938 (prize); All Calif. Exh., Los Angeles Mus. Hist., Sc.&A., 1930 (prize). Work: SFMA; Mills Col. Gal., Calif.; Los Angeles Mus. Hist., Sc.&A.; Oakland A. Gal. [40]

ROEHLK, Ernst [P] Chicago, IL. Member: Chicago SA [29]

ROEHRICH, P [Lucy Turner] St. Paul MN [24]

ROEN, Irma [P] Rock Island, IL. Member: NAWPS [25]

ROESCH, Kurt (Ferdinand) [P,E,En,T,I] Bronxville, NY b. 12 S 1905, Berlin, Germany. Studied: Acad. A., Berlin, with K. Hofer. Member: Am. A. Cong. Exhibited: CI, 1941–45; AIC; VMFA. Work: MET; MOMA; Univ. Minn. Illustrator: "The Metaphysical Poets," 1945; "Sonnets to Orpheus," 1944. Position: T., Sarah Lawrence Col., Bronxville, N.Y. [47]

ROETH, Esther [P] Chicago, IL [25]

ROGALL, Wilhelmine [P] NYC. Member: NAWPS [29]

ROGERS, A. Edith [P,T] Camden, NJ. Studied: PAFA [25]

ROGERS, A.H. [P] Phila., PA [06]

ROGERS, Adele (Mrs. Shrenk) [P,Des,E,I,T,Li] East Palatka, FL b. 7 Jy 1861, Mt. Vernon., NY. Studied: CUASch; W. Chase; C. Hawthorne; G. deForest Brush; D. Volk; R. Henri; G.E. Browne. Member: Provincetown AA; St. Augustine AC; PAFA. Exhibited: CUASch (prize) [47]

ROGERS, Annette Perkins [P] Boston, MA b. 1841, Boston d. 1920. Studied: W.M. Hunt, 1868; traveled Europe, 1881. Exhibited: Noyes & Blakeslee Gal., Boston. Specialties: landscapes; still-life [*]

ROGERS, Barksdale (Miss) [I,P] NYC b. Macon, GA. Studied: Steinlen, in Paris; Munich. Member: SI. Illustrator: Saturday Evening Post; Scribner's. Work: portrait masks [40]

ROGERS, Charles (A?) [Ldscp.P] b. ca. 1840, New Haven, CT d. 1913, Los Angeles, CA. Studied: NYC; Munich; Paris; Rome. Active San Fran. from 1860s; moved to Los Angeles after the 1906 fire destroyed his studio. [*]

ROGERS, Charles B. [P,Et,Li,L,T,C] Great Bend, KS b. 27 Ja 1911, Great Bend, KS. Studied: NAD; Bethany Col.; Tiffany Fnd. Member: SAE; Prairie PM; Calif. S. PM; Prairie WC Painters; Southern PM; Chicago NJSA; Northwest PM; S.Indp.A.; Progressive AA; F., Tiffany Fnd., 1937. Exhibited: NAD; Los Angeles Mus. A.; Phila. Pr. C.; NOAA; Oakland A. Gal.; SAE; Wash. WCC; Gumps, San Fran.; Wichita AA; WFNY 1939; Kansas City AI, 1928 (prize), 1939 (prize); Northwest PM; Ala. AA; CM; Alameda, Calif., 1945 (prize); Vendôme Gal. (one-man); Mus. N.Mex. (one-man); Thayer Mus. (one-man); Kansas State Agri. Col. (one-man); Bethany Col. 1941 (prize), 1943 (prize)(one-man); Univ. Okla. (one-man); Telenews Gal., San Fran. (one-man); Kansas State Fair, 1931–32 (prize), thirteen awards in four years; LOC, 1943 (prize). Work: Thayer Mus., Lawrence, Kansas; LOC; Kansas Univ.; Kansas State Women's C.; Smoky Hill, Kansas Col.; Hutchinson (Kansas) Jr. Col. [47]

ROGERS, Eleanor Gale (Mrs.) [P] Los Angeles, CA. Member: Calif. AC [25]

ROGERS, Elnora D. [P] New Haven, CT [17]

ROGERS, Frances [I,W] NYC/Bearsville, Ulster Co., NY b. Grand Rapids, MI. Studied: H. Pyle. Author/Illustrator: with Alice Beard, "Heels, Wheels, and Wire," "Fresh and Briny," "5000 Years of Glass," 1935 [40]

ROGERS, Franklin W. [P] Bingham, MA [15]

ROGERS, Gretchen W. [P] Boston, MA. Member: Boston GA. Exhibited: Pan.-P. Expo, San Fran., 1915 (med) [33]

ROGERS, Jane [P] NYC/Woodstock, NY b. 1 Ag 1896, NYC. Studied: S. Halpert; M. Weber. Member: NAWPS [40]

ROGERS, John [S] New Canaan, CT b. 30 O 1829, Salem, MA d. 26 Jy 1904. Studied: Paris; Rome, with Spencer, 1858; but mostly self-taught. Member: NA, 1863; NSS. Exhibited: Centenn. Expo, Phila., 1876 (29 works); Columbian Expo, Chicago 1893 (gold). Best known for his "Rogers Groups" (figural genre and literary sculpture groups), making more than 80 from 1849–94 in his NYC studio. [04]

ROGERS, John [P,I] Brooklyn, NY b. 9 D 1906, Brooklyn, NY. Studied: ASL. Member: AWCS; Brooklyn SA; Am. A. Group. Exhibited: AWCS, 1939–46, 1944 (med); BM, 1941; Brooklyn SA, 1940–46; A. Dir. C., 1938; Long Island A. Festival, 1945, 1946. Contributor: PM; New York Times; Today Mag. [47]

ROGERS, John A(rthur) [Arch,E,P,T] Daytona Beach, FL b. 12 Ap 1870, Louisville, KY d. 2 Je 1934. Studied: AIC; MIT; R. Seymour. Member: Am. Art. Prof. Lg.; Fla. Fed. A.; SSAL [33]

ROGERS, Katherine M. [Des,I,T] San Leandro, CA b. 1 Ag 1908, Pueblo, CO. Studied: Calif. Col A.&Crafts; J. Paget-Fredericks. Specialty: des. of theatrical costume, sets, posters [40]

ROGERS, Lanssat [P] New Castle, DE. Member: Wilmington, SFA [25]

ROGERS, Leore Corrin (Mrs.) [P] Buffalo, NY b. 23 Je 1897, Oconomowoc, WI. Studied: Mrs. W.E. Forbush; Mrs. H. Beecher. Member: Richmond AC; York, Pa. AC. Exhibited: York AC; Grand Central A. Gal., N.Y., 1939 [40]

ROGERS, Louise De Gignilliet [Por.P,E] Greenwich, CT b. Macon, GA. Studied: Steinlen, in Paris; R. Henri; Munich. Member: Brooklyn SE; Conn. SA. Work: port., Vice-pres. Marshall; W. Jennings Bryan; Senator Tillman [29]

ROGERS, Margaret [P,Des,C] Boston/Barnstable, MA b. Boston. Studied: A. Munsell; V. George; Mass. Sch. Art. Member: Boston SAC (master craftsman; Dean, Guild of Jewelers). Exhibited: Boston SAC (med); AIC (prize) [40]

ROGERS, Margaret Esther [P,T] Santa Cruz, CA b. 1 My 1872, Birmingham, England d. 15 Mr 1961. Studied: F.L. Heath, L.P. Latimer; A. Bower. Member: Santa Cruz AL (pres.); Women P. of the West. Exhibited: Santa Cruz AL; Oakland A. Gal.; Sacramento, Los Angeles; San Fran., Santa Cruz Statewide Exh., 1928 (prize), 1937 (prize), 1938 (prize); Calif. State Fair, Sacramento, 1934, 1936, 1937; GGE, 1939 [47]

ROGERS, Mary [P,S] NYC b. 7 My 1882, Pittsburgh, PA d. 26 Ag 1920. Studied: R. Henri; Paris, with Simon, Ménard. Member: S.Indp.A. (Dir.) [19]

ROGERS, Mary G. [P,W,L,T] NYC/Wequetonsing, MI. Studied: Chase; Despujols, France. Member: NAWPS; NAC; AWCS; PBC. Exhibited: NAD, PAFA, Pan.-Pac. Expo; NAWPS. Position: T. N.Y. Training Sch. for Teachers [40]

ROGERS, Meyric Reynold [Mus.Cur,W,L,Edu] Chicago, IL b. 8 Ja 1893, Birmingham, England d. 1972. Studied: Harvard. Author: "Carl Milles, Sculptor," 1940. Co-Author: "Handbook to the Pierpont Morgan Wing," MET, 1923; "Handbook to the Buckingham Medieval Collection," 1945. Positions: Asst. Cur., Decorative A. Dept., MET, 1917–23; T., Smith Col., 1923–26; Harvard Univ., 1927; Dir., BMA, 1928–29; Dir., CAM, 1929–39; Cur. Decorative A. & Indust. A., AIC, from 1939 [47]

ROGERS, O.A. [P] Los Angeles, CA. Member: Calif. AC [25]

ROGERS, Randolph [S] Rome, Italy b. 6 Jy 1825, Waterloo, NY d. 15 Ja 1892. Studied: Florence, Rome, 1848–53. Work: "Columbus" doors, U.S. Capitol (made in Rome, 1855); best known for his statue "Nydia." Specialty: Portrait busts and monuments. Univ. Mich. has most of his casts. [*]

ROGERS, Richard, Mrs. See Bean, Mary.

ROGERS, R(obert) B(ruce) [P,W,Eng,Li,I] NYC b. 13 Ap 1907, Girard, KS. Studied: ASL; G. Bridgman. Member: AFA; Newspaper G.; Provincetown AA; Am. A. Cong.; Beachcombers' C.; United American Artists. Exhibited: WFNY 1939; Phila. A. All., 1935; Am. A. Cong., 1936–40; Provincetown AA, 1933–37; FAP traveling exh., 1935–37; Grand Central A. Gal., 1936; Riverside Mus., 1941; A. Union, 1936 (prize). Work: Court House, USPO, Boston; Barnstable H.S., Hyannis; Pub. Sch., Falmouth; Pub. Sch., Eastham; Pub. Lib., Provincetown, Mass. [47]

ROGERS, Robert Stockton [P,Et,L,T] Atlanta, Ga b. 16 D 1896, Burrton, KS d. ca. 1960. Studied: AIC; Am. Acad. A., Chicago; A. Philbrick; H. Timmons; G. Oberteuffer; H.A. Oberteuffer; F. Young. Member: SSAL; Assn. Georgia A.; Artists' G., Atlanta. Exhibited: VMFA, 1938; MOMA, 1930; Phila. Pa., 1932; Rockefeller Ctr., 1932; SSAL, 1939 (prize); Assn. Georgia A.; IBM, 1941 (prize); High Mus. A., 1941 (prize). Work: Univ. Ga.; IBM coll. Position: Dir., High Mus., Sch. A., Atlanta, Ga. [47]

ROGERS, Roy D. [P] Seattle, WA [24]

ROGERS, S.D. [P] Memphis, TN [13]

ROGERS, W(illiam) A(llen) [I,W] Wash., D.C. b. 23 My 1854, Springfield, OH d. 20 O 1931. Studied: Worcester Polytechnic I. Member: SI; GFLA; SC, 1872 (founder). Work: LOC; Smithsonian. On staff of Harper's Weekly, Harper's magazine, Life, St. Nicholas, The Century, Washington Post, and New York Herald., the latter for 19 years (following T. Nast). He made many trips to the West from 1878–98. He was author of "World Worth While," "Danny's Partner," and "A Miracle Man." "America's Black and White Book" is one of his two volumes of cartoons. Because of one of his anti-German war cartoons he was decorated as Chevalier of the Legion of Honor, 1921. [39]

ROGERT, Alene (Mrs.) [P] Wyoming, OH. Exhibited: Ohio State Fair, 1935; PAFA, 1936; Cincinnati M., 1939 [40]

ROHDE, Gilbert [Des,C] NYC. Exhibited: MModA, Wash., D.C., 1939. Position: Head., WPA Program, N.Y. Des. Lab.; Des., modern furniture [40]

ROHDE, Peggy Ann (Mrs. Gilbert) [Des,C,W,T] Huntington, NY b. 11 My 1911, NYC. Studied: PIASch.; NYU; Columbia; Univ. Calif.; Univ. Wash. Member: Arch. L.; S. Indst. Des. Exhibited: NAD, 1940. Contributor: articles, Interiors, Home Furnishings [47]

ROHLAND, Caroline Speare [P,Li,E] Sierra Madre, CA b. 20 Ap 1885, Boston, MA. Studied: BMFA Sch.; ASL; Dasburg. Member: Woodstock AA. Exhibited: WMAA; VMFA, 1941; CGA; CI; LOC; NAD, 1945, 1946; Mus. N.Mex, 1944, 1945; N.Mex. State Fair. Work: WMAA; Honolulu Acad. A.; WPA murals, USPOs, Bunkie (La.), Sylvania (Ga.), Fulton (N.Y.). WPA artist. [47]

ROHLAND, H. Paul [P] Woodstock, NY. Member: Chicago NJSA [25]

ROHLAND, Paul [P,Ser] Sierra Madre, CA b. 11 Mr 1884, Richmond, VA d. 1953. Studied: ASL; Henri. Member: Woodstock AA. Exhibited: WMAA; VMFA; CGA; CI; PAFA; Mus. N.Mex.; Pasadena AI; Dallas Mus. FA, 1946. Work: WMAA; Syracuse Mus. FA; Davenport Mun. A. Gal.; Honolulu Acad. A.; Barnes Fnd.; WPA murals, USPO, Union, Pa.; Mus. N.Mex. [47]

ROHLFS, Charles [Des] b. NYC, 1853 d. 29 Je 1936, Buffalo, NY. In 1890 began manufacturing furniture, being credited with having originated

mission furniture. Member: Royal Society of Arts, London, the only American invited to exhibit furniture at an exhibition in Turin, Italy.

ROHL-SMITH, Carl [S] Wash., D.C. Studied: NSS [98]

ROHN, Ray [I,Car] Phila., PA b. 10 Jy 1888, Defiance, OH d. 8 Jy 1935. Member: SI. Illustrator: Harper's, Judge, Life. Position: Art Dept., Phila. Public Ledger [33]

ROHNSTOCK, J. Henry [C] West Somerville, MA/Scituate, MA b. 1879, Denmark. Member: Boston SAC (master craftsman). Exhibited: Tercentenary FA Exh., Boston (gold). Work: Riverside Church, NYC; Cathedral St. John the Divine, NYC; East Liberty Presbyterian Church, Pittsburgh, Pa.; Chapel of Colorado Col., Colorado Springs; Westminster Presbyterian Church, Springfield, Ill.; Princeton Univ. Chapel; Mercersburg Acad. Chapel, Pa.; Pres. Church, Glens Falls, N.Y.; National Cathedral, Wash., D.C.; Wellesley Col. Chapel; Am. Mem. Chapel, Belleau Wood, Belleau, France. Position: partner, Reynolds, Francis and Rohnstock, craftsmen in stained glass, Boston, Mass. [40]

ROHRBACH, Charles [P,C,Des] East Aurora, NY b. 9 Ja 1892, Berne, Switzerland. Studied: Switzerland; Fed. Sch. Commercial Des. Member: Buffalo SA; Buffalo AG; East Aurora Ar. Exhibited: Soc. for Sanity in A., 1937, 1938; Buffalo, Rochester, Auburn, Binghamton, East Aurora, N.Y. Buffalo SA, 1927 (prize), 1934 (prize), 1936 (prize), 1946 (med). Work: woodcarvings of figures, animals, furniture; modeling in clay. Position: Art Dir., Larkin Col, Inc. [47]

ROHRHEIMER, Louis [S] Cleveland, OH. Affiliated with Cleveland Sch. A. [04]

ROHRIG, Fritz [S] Glenmont, NY b. 25 Ag 1878 Benshausen, Germany. Studied: G.A. Sartorio, Rome, Italy; Acad., Weimar, Germany [40]

ROINE, J.E. [S] NYC. Member: NSS 1907. Work: MET [15]

ROLAND, Conrad [P] Norristown, PA [25]

ROLAND, Edward [P,S,T] Los Angeles, CA b. 21 Mr 1911, St. Louis, MO. Studied: Wash. Univ., St. Louis; A. Katchamakoff. Member: Calif. WCS; Correlated A. Group, Los Angeles. Exhibited: Los Angeles Mus. Hist. Sc. A.; Ebell C., Los Angeles. Author: "Science or Art," "Through the Looking Glass," 1939 [40]

ROLAND, Jay [P] NYC b. 28 S 1904, NYC d. 27 Ag 1960, Brewster, NY. Studied: NAD; ASL; Grand Central A. Sch. Member: AWCS; Audubon A.; Phila. WCC; Brooklyn SA; Arch. L. Exhibited: NYWCC, 1934–37; AWCS, 1933–46; AIC, 1935, 1941, 1946; BM, 1943; CAA, 1933, 1934, 1936; MET (AV), 1942; Phila. WCC, 1940–46; Audubon A., 1944, 1945; Brooklyn SA, 1941–46; Am.-British A. Ctr., 1942–44; Wash. WCC, 1942, 1943; NAD, 1943; Marie Sterner Gal., 1941 (one-man); Campbell-Ewald Co. Gal., 1941 (one-man). Work: BM [47]

ROLAND, Jay, Mrs. See Linton.

ROLANDO, Paolo Emilio (Paul E.) [P] NYC/North East, PA b. 7 N 1884, Rome, Italy. Studied: Mariani; Sartorio; PAFA; Corcoran Sch. A. Member: S. Wash. A. [40]

ROLANDO, Virginia Moorhead (Mrs. Paul E.) [P] NYC b. 4 O 1898, North East, PA. Studied: Corcoran Sch. A.; Otis AI; R. Shrader; L.G. Woodward; D. Woodward; L.C. Catlin. Member: S. Wash. A. Exhibited: CGA, 1933, 1934, 1936; Wash. AL, 1933; Erie Pub. Lib. (Pa.); Chautauqua, N.Y. Work: Presbyterian Home & Hospital, Cambridge Springs, Pa. [47]

ROLFE, Edmund [P,C] Shady, NY b. Ap 1877, Detroit, MI d. 30 Mr 1917 near Woodstock, NY in an automobile accident. Studied: AIC; ASL; CGA [15]

ROLFE, Mary See Allen, Mrs.

ROLLE, A.H.O. [P,G] Wash., D.C. b. 30 Mr 1875, MN. Studied: Corcoran Sch. A. Member: S. Wash. A.; Wash. Ldscp. C.; Wash. WCC. Work: LOC [40]

ROLLER, Janet Worsham (Mrs. S.K.) [P,I] NYC/Cobalt, CT b. Lynchburg, VA. Studied: CUASch; C. Hawthorne; R. Henri; K.H. Miller [40]

ROLLER, (Samuel) K. (Kay Roller) [P,T,I,L] Lynchburg, VA b. New Market, VA. Studied: Chicago Acad. A.; Univ. Va.; G.P. Ennis; Brooks; Corcoran Sch. A.; Henri; N.Y. Sch. A.; Otis A. Sch.; F. Grant. Member: AAPL; Lynchburg AC; Studio G. Exhibited: VMFA, 1942–44; Morton Gal., 1935 (one-man), 1936 (one-man); S. Four A., West Palm Beach, Fla., 1937 (one-man); Argent Gal., 1939 (one-man), 1940 (one-man); Lynchburg Woman's C., 1942 (one-man); Leach Mem., 1943 (one-man), 1944 (one-man). Work: N.Y. Hist. S.; Am. A. Group (one-man). Illustrator: McCall's; Pierce Lithographer Corp. [47]

ROLLINGS, A. Sydney [C,Des,T] Providence, RI b. 16 N 1880, Knoxville, TN. Studied: RISD. Member: Boston SAC. Specialty: jewelry. Position: T., RISD [40]

ROLLINS, Carl Purington [Des,C,L,T,W] Hamden, CT/Montague, MA b. 7 Ja 1880, West Newbury, MA. Studied: Harvard. Member: AIGA; Columbiad C., Conn.; Grolier C., NYC; Century Assn. Exhibited: "Fifty Books of the Year," annually; AI Graphic A., 1926 (med). Award: hon. degree, Yale, 1920. Contributor: Saturday Review, Dolphin, Print & other trade publications. Work: design books, Grolier C.; MET; Limited Editions C.; Yale Univ.; Yale Univ. Press; des./printer, "Anchors of Tradition," "Machu Picchu," "On the Duty of Civil Disobediance." Specialty: book design. Positions: Des., Yale Univ. Press, from 1918; Printer, Yale, from, 1920; Print Consultant, Rutgers Univ. [47]

ROLLINS, Helen A. Jordan (Mrs.) [C,P,I,T] Los Angeles, CA b. 4 Mr 1893, Hayward, CA. Studied: Los Angeles Sch. A. & Des.; J.E. McBurney; J.F. Smith; T Lukits. Work: Southwest Mus., Los Angeles; Pub. Sch., Los Angeles; mural, Edu. Bldg., San Diego [47]

ROLLINS, Josephine See Lutz.

ROLLINS, Warren Eliphalet [P,T] Paradise Valley, AZ/Baltimore, MD b. 8 Ag 1861, Carson City, NV d. 1962, Winslow, AZ. Studied: Calif. Sch. Des, with V. Williams. Member: early member of the Santa Fe Colony, 1915. Exhibited: Mus. N.Mex.; Md. Inst.; Calif. Sch. Des. (med). Work: Santa Fe Railroad; WPA murals, USPO, Gallup, N.Mex.; Harvey House, Gallup; Mus. N.Mex.; hotel, Arrowhead Springs, Calif.; Nat. Bank, Phoenix, Ariz.; Huntington Gal., Los Angeles. WPA artist. [47]

ROLLINSON, Charles [P] Elizabeth, NJ [19]

ROLLO, Jo(seph) [P] NYC/Woodstock, NY b. 27 F 1904, Ragusa, Italy. Studied: AIC; ASL; L. Kroll; J. Carroll; G. Luks. Work: WMAA; CAA. Exhibited: CGA, 1939; CI, 1929, 1931, 1936; AIC, 1930, 1934, 1936–38 [47]

ROLSHOVEN, Julius [P,T] NYC/Florence, Italy b. 28 O 1858, Detroit, OH d. 7 D 1930, NYC. Studied: CUASch, 1877; Hugo Crola, in Düsseldorf, 1878; Loefftz, in Munich, 1879; Duveneck, Florence; Paris, with Robert-Fleury, Bouguereau, 1882. Member: ANA; S. Nat. des Beaux-Arts, Paris; Secession, Munich; Detroit FAS; Intl. A. Congress; Paris SAL; Scarab C., Detroit; Foreign AC, Florence; Bene Merensa Societa di Belle Arte, Florence; Taos SA; NAC. Exhibited: Taos SA, 1922; Paris Expo, 1889 (med), 1900; Pan-Am. Expo, Buffalo, 1901 (med); medals, Munich, Berlin, Brussels, Chicago; St. Louis Expo, 1904 (med); Société Française, Paris. Work: Cincinnati Mus.; Detroit Inst.; Minneapolis Mus.; BM; Detroit Athletic C.; Bohemian C.; Union Lg. C., Chicago; Baltimore Mus.; Montclair Mus.; Mus. N.Mex. Position: T., life classes, 1890–1895, Paris; 1896–1902, London. Attendance was international. [29]

ROMAN, Amelie [P] New Orleans, LA [24]

ROMANACH, Leopoldo [P] NYC b. Cuba. Studied: F. Pardillo. Member: Associazione Artestica Internazionale di Roma. Exhibited: Paris Expo, 1900 (med) [01]

ROMANELLI, Carlo [S] Los Angeles, CA [24]

ROMANELLI, Frank [P,S,I] Buffalo, NY b. 20 F 1909, Italy. Studied: The Patteran. Exhibited: Albright A. Gal, Buffalo, 1938 (prize). Work: State T. Col., Buffalo; murals, Buffalo Marine Hospital; panels, City of Buffalo [40]

ROMANO, Emanuel Glicen [P,I,T,L] NYC b. 23 S 1901, Rome, Italy. Studied: Swizerland; E. Glicenstein. Member: A. Lg. Am. Exhibited: PAFA, 1945; AIC, 1940. Work: FMA; New London Mus.; mural, Klondike Bldg., Welfare Island, N.Y. Position: T., CCNY, 1944–45 [47]

ROMANO, Nicholas [P,S,C] Phila., PA b. 6 D 1889, Montoro, Italy d. 28 Ag 1941. Studied: A. Laessle. Member: DaVinci A. All. Exhibited: AIC, 1928. Work: PAFA; Phila. A. Alliance; Graphic Sketch C., Phila.; Albright Gal.; Rochester Mem. Gal.; Bok Vocational Sch., Phila. Position: T., Graphic Sketch C. [40]

ROMANO, Umberto [P,Et,S,T] NYC/Gloucester, MA b. 26 F 1905, Salerno, Italy. Studied: NAD. Member: Gloucester SA; North Shore AA; F., Tiffany Fnd., 1926. Exhibited: AIC, 1928, 1930 (prize); NAD (prize); Springfield AL, 1931 (prize), 1932 (prize); CAFA, 1931 (prize); North Shore (prize); Tiffany Fnd. (med); Springfield AL, 1930 (prize); Stockbridge, Mass, 1932 (prize). Work: FMA; WMA; Springfield Mus.; AGAA; RISD; Smith Col.; Goodyear Coll.; Encyclopaedia Britannica; San Diego FAS; BMA; murals, USPO, Springfield, Mass. Illustrator: Dante's "Divine Comedy," 1946. Position: T., WMA Sch. A., 1934–40 [47]

ROMANOWKSY, Dimitri [P] NYC [24]

ROMANS, Charles John [P,T] Jersey City, NJ b. 4 Mr 1893, NYC d. 1973.

Studied: State T. Col., Buffalo; NYU; NAD; G.E. Browne. Member: Provincetown AA; Gotham Painters; Audubon A.; P&S S. of N.J.; SC. Exhibited: NAD, 1941; AWCS, 1939; All.A.Am., 1938–46; Audubon A., 1944; Montclair A. Mus., 1937–46; Jersey City Mus., 1944 (prize), 1945, 1946; Am. Fed. A. Traveling Exh., 1939. Position: T., Jersey City Sch. System [47]

ROME, Richardson [B,Des,E,En,Li,L] Estes Park, CA b. 15 Ja 1902, Minneapolis, MN. Studied: E. Witter; S.C. Burton; Univ. Minn. Member: Phila. PC; Kansas City Woodcut S.; Northwest PM; Chicago Gal. A.; Am. S. Graphic A. Work: BM; MET; Kansas City AI; Denver AM; Atkins Gal., W.R. Nelson Gal., Kansas City. Author: "High Country," (book of woodcuts of the Colo. Rockies, Alden Galleries) [40]

ROME, Samuel [G,P,T] NYC b. 10 My 1914, NYC. Studied: MMA Sch.; ASL; NAD; NYU [40]

ROME, T. Herzl [P,S,L] Worcester, MA b. 29 D 1914, Worcester, MA. Exhibited: WMA, 1938; GGE, 1930; Salon des Surindependants, Paris [40]

ROMERO, Emilio [P] Guayama, Puerto Rico. Member: S.Indp.A. [21]

RONAY, Stephen R. [P,Cart,S,I,L] Port Wash., NY b. 27 F 1900, Hungary. Studied: Royal Acad. Des., Budapest; NAD. Member: Ar. Gld.; Ar. Un. Exhibited: Assn. Am. A.; Contemp. A. Gal.; Macbeth Gal.; MOMA; CGA [47]

RONDEL, Frederic [Ldscp.P] b. 1826 d. 1892. Member: ANA, 1861. Exhibited: NAD, PAFA, Boston Athenaeum, all 1855–70. Active in Boston, 1855–57; South Malden, Mass., 1858; NYC, 1859–61; Europe, 1862; back in NYC, 1868. Best remembered as a teacher of Winslow Homer in NYC, 1861. [*]

RONDELL, Lester [Des,P,L] NYC b. 8 F 1907, NYC. Studied: N.Y. Sch. F.& Appl. A.; K. Nicolaides, ASL. Member: A.Dir.C.; SI. Exhibited: PAFA, 1941; CI, 1945; Sch. A. Lg., 1925 (med); U.S. Treasury Dept., 1943 (prize); Pepsi-Cola, 1946 (prize) [47]

RONDONI, Romolo [S] NYC [24]

RONEY, Harold Arthur [P] San Antonio, TX b. 7 N 1899, Sullivan, IL. Studied: Chicago Acad. A.; AIC; H. Leith-Ross; J. Folinsbee; Aldrich; de Young; Schuman. Member: SSAL; Tex. FAA; Palette C., San Antonio; AAPL. Exhibited: South Bend, Ind., 1923 (prize); SSAL, 1929–1932, 1945; CAFA, 1937; Tex. FAA, 1929–33; San Antonio, 1944 (one-man), 1945; NOAA, 1928, 1929, 1931; New Hope, Pa., 1935, 1936; Phila., (one-man); Tex. Fed. WC, Lubbock, 1932. Work: Witte Mus.; Austin Pub. Lib.; South Bend Pub. Sch.; Southwest Tex. State T. Col.; Austin AL [47]

RONNEBECK, Arnold H. [S,Li,L,W,P,T] Denver, CO b. 8 My 1885, Nassau, Germany d. 14 N 1947. Studied: Paris, with Bourdelle, Maillol. Member: CAA. Exhibited: Kansas City, Mo., 1928 (med); City C., Denver, 1928 (prize); Kansas City AI, 1929 (gold). Work: Denver Nat. Bank, St. John's Cathedral, Hodges Mem., Church of the Ascension, all in Denver; Denver AM; WPA terra cotta relief, USPO, Longmont, Colo.; friezes of Indian Ceremonial Dances, La Fonda, Santa Fe. Position: T., Univ. Denver [47]

RONNEBECK, Arnold, Mrs. See Emerson, Louise.

RONSHEIN, John Noland [P,Des] b. 1920, Anderson, IN d. 15 Ag 1944, Italy (while in the Army Air forces). Studied: Corcoran A. Sch. Specialty: indst. design

RONZONE, Benjamin A. [P,W] b. 1849 d. 2 Ja 1927, Brooklyn, NY. Author: "The Marquis of Murray Hill," many short stories

ROOD, Henry, Jr. [P,I,T,L] Greesboro, NC b. 20 F 1902, Pleasantville, NY. Studied: ASL; NYU; J. Carlson; F. DuMond. Member: NAC; N.C. State AS. Work: Wake Forest Col., N.C.; Governor's Mansion, Raleigh, N.C. Illustrator: Forbes [47]

ROOD, John [S,P,W,L,T,Des] Athens, OH b. 22 F 1902, Athens, OH d. 1974. Studied: self-taught. Member: Columbus AL. Exhibited: Walker A. Ctr., 1945; Durand-Ruel Gal., 1944; numerous one-man exh., NYC. Work: Walker A. Ctr.; Cranbrook Mus.; Church of the Good Shepherd, Athens, Ohio. Author: "Wood Sculpture," 1940, "This, My Brother," 1935. Position: T., Univ. Minn. (1944–46), Ohio Univ., from 1946 [47]

ROOD, Roland [P] NYC [19]

ROOK, Edward F(rancis) [Ldscp.P] Old Lyme, CT (from 1903) b. 21 S 1870, NYC d. 25 O 1960 (age 90). Studied: Académie Julian, with Constant, Laurens, 1880s. Member: ANA, 1908; NA, 1924; Lotos C.; Lyme AA. Exhibited: Armory Show, 1913; PAFA, 1898 (gold); Pan-Am. Expo, Buffalo, 1901 (med); St. Louis Expo, 1904 (medals); CI, 1910 (med); Buenos Aires Expo, 1910 (med); P.-P. Expo, San Fran., 1915 (gold); CGA, 1919 (med) (prize); Lyme AA, 1929 (prize), 1938 (prize). Work: PAFA; Cincinnati Mus.; BAC; Lotos C.; Portland AM; CGA. His huge garage was the focal point of his house, although he never learned to drive. He drove rats crazy by placing plate glass over his garbage pail. He was a wealthy member of the colony at Old Lyme about whom stories abound. [47]

ROONEY, Helen [Por.P,Dr,T] Haddam, KS (summers) b. 21 My 1912. Studied: R. Sandzen; R.J. Eastwood; K. Mattern; A. Bloch; Univ. Kans. Member: Am. Ar. Prof. Lg. Exhibited: Kans. State Fair, Hutchinson, 1939 (prizes); Kans. Free Fair, Topeka, 1939 (prize). Work: Kans. State Fed. Women's C. Position: T., Pub. Sch., Dobbs Ferry, N.Y. [40]

ROOP, J.L. [S,I] Louisville, KY [10]

ROOS, Bernard L. [I] Chicago, IL [19]

ROOS, Peter [Ldscp.P,T] Cambridge, MA b. 22 F 1850, Sweden. Member: BAC. Exhibited: Boston, 1874 (med) [31]

ROOSEVELT, Samuel Montgomery [P] NYC/Skaneateles, NY b. 20 Jy 1863, New York d. 19 Ag 1920, Knickerbocker C., NYC. Studied: ASL; Académie Julian, with Laurens, Constant. Member: Port. P; A. Fund. S. Award: Chevalier Legion of Honor, 1904 [19]

ROOSEVELT, V.S. (Miss) [P] NYC. Member: Lg. AA [24]

ROOT, Franc. See E.A. McCreery, Mrs.

ROOT, Orville Hoyt [P] Paris, France [17]

ROOT, Robert Marshall [P,E,Dec,C] Shelbyville, IL b. 20 Mr 1863, Shelbyville d. ca. 1938. Studied: St. Louis Sch. FA; Académie Julian with Constant, Laurens, Lefebvre. Member: Brown County (Ind.) AA; Ind. A. Gal. Assn. Exhibited: State Centenn., Springfield, Ind. 1918. Work: painting, Springfield; Lt. Gov. office, Atty. General office, Springfield; Masonic Temple and Country C., Decatur; Macon Court House, Vandalina Court House, Shelbyville Court House; State T. Col., Charleston, Ill. [38]

ROPER, George (Mrs.) [P] Norfolk, VA. Member: Norfolk SA [25]

ROPER, M. Secor (Mrs. George W.) [P] Norfolk, VA/Charmian, PA b. 7 My 1886, Morristown, NJ. Studied: NAD; E. Carlsen; O. Miller. Member: Norfolk SA; Norfolk A. Corner; Studio G. [40]

ROPER, Murray J. [S,P] Yonkers, NY b. 2 F 1910, David City, NE. Studied: Univ. Nebr.; PAFA; ASL; BAID. Member: Putnam County AA. Exhibited: PAFA; Putnam County AA. Work: Nebr. State Mus., Lincoln. USPO, Harrison, NJ. WPA artist. [40]

ROPES, Andrew M. [P] b. 1830, Salem, MA d. 1913. Work: Peabody Mus., Salem [*]

ROPES, Phebe. See Coleman.

ROPP, Hubert [P,S,T] Lake Bluff, IL b. 15 Ap 1894, Pekin, IL. Studied: AIC; Europe. Member: Chicago AC; Chicago SA. Exhibited: AIC, 1933–39; CI; Boyer Gal., Phila.; Nat. Gal., Toronto; GGE, 1939. Position: Dean, AIC [47]

ROPP, Roy M. [P] Laguna Beach, CA b. 19 Je 1888, Butler County, KS. Member: AAPL; Laguna Beach AA; San Gabriel A. Gld.; Festival of Arts Assn., Laguna Beach; Los Angeles AA. Work: New Port Union H.S. Creator/Dir., annual Festival of Arts, Laguna Beach [47]

RORIMER, James J. [Mus. Cur] NYC b. 7 S 1905, Cleveland d. ca. 1968. Studied: Harvard. Member: AFA; Mediaeval Acad. Am.; Société Française d'Archeologie. Award: Chevalier French Legion Honor. Author: "The Cloisters—The Building and the Collection of Medieval Art" (1938), "Medieval Jewelry" (1944). Positions: Cur., MMA, since 1929, The Cloisters, 1938–68 [47]

RORIMER (OR RORHEIMER), Louis [S,Arch,C,L,T] Cleveland, OH b. 12 S 1872, Cleveland d. 30 N 1939. Studied: Puech, LeBlanc, Constant, in Paris; Widaman, Romeis, in Munich. Member: Cleveland SA; SC; Arts in Trade Cl.; Cleveland Arch. Cl. [31]

RORKE, Edward A. [Ldscp.P] Brooklyn, NY b. 1856 d. 30 D 1905. Although an amateur, he did win some recognition. [06]

ROSA, Guido [I] Mt. Vernon, NY b. 8 Ag 1890, New Jersey. Studied: E. Berta. Member: SC; Artists Gld.; AI Graphic A.; AFA. Exhibited: AI Graphic A., 1920 (med) [32]

ROSA, Lawrence [I,Des] Union City, NJ b. 10 Ag 1892, New Jersey. Data for "Studied," "Member," and "Exhibited" are identical to those listed for Guido. [29]

ROSAIES, E.O. [S] NYC [08]

ROSATTI, Ector F. [P] Springfield, MA [17]

ROSE, Adelaide E. [P] Chardonne-sur-Vevey, Switzerland [10]

ROSE, Augustus Foster [J,C,T] Providence, RI/Oquossoc, ME b. 4 Jy 1873, Hebron, Nova Scotia d. 20 Jy 1946. Studied: D. Ross; H.H. Clark; A. Fisher; C. Hanson; E. Schweitzer. Member: Boston SAC; Utopian Cl., Providence; Providence AC; Soc. Medalists; Eastern AA; AFA. Author: "Copper Work," "Art Metal Work," "The Metal Crafts," "Things In and About Metal." Co-author: "Jewelry Making and Design." Position: T., Providence Public Schools [40]

ROSE, Carl [I] Rowayton, CT. Member: SI [47]

ROSE, Daniel [P] Anacostia, D.C. Member: Wash. WCC [04]

ROSE, Ed [P] Dallas, TX [24]

ROSE, Elizabeth Agnes [P] Geneva, NY [13]

ROSE, Ethel Boardman (Mrs. Guy) [I,Por.P] Pasadena, CA b. Rochester, NY. Studied: ASL; Jean Paul Laurens, Girardot, in Paris. Member: Calif. WC Soc.; Pasadena Ar. Assn. Exhibited: Calif. WC Soc., 1935 (prize). Illustrator: fashions, Vogue, Harper's Bazaar, L'Art et La Mode (Paris), other magazines [47]

ROSE, George L. [P] Upper Montclair, NJ b. 8 O 1861, Newport, RI. Studied: J. La Farge. Member: Mural P. [33]

ROSE, Guy [P,I] b. 3 Mr 1867, San Gabriel, CA d. 17 N 1925 (Pasadena?). Studied: San Fran. A. Sch., with E. Carlsen, 1885; Académie Julian, Paris, with Lefebvre, Constant, Doucet, ca. 1886. Member: Calif. AC. Exhibited: Paris Salon, 1894 (prize); Atlanta Expo, 1895 (med); Pan-Am. Expo, Buffalo, 1901 (med); P.-P. Expo, San Fran., 1915 (med); Panama-Calif. Expo, San Diego, 1915 (med); Calif. AC, 1916; Calif. AC, 1919 (prize); landscape, Sacramento, 1920 (prize); Los Angeles AC, 1921 (prize). Work: Oakland AM; Los Angeles MA; San Diego MFA; CMA. Active in Giverny, France, 1900–14, Los Angeles, 1914–20. Position: T., PIASch, 1896–1900 [25]

ROSE, Iver [P,Li] NYC b. 17 Ap 1899 d. 1972. Member: Am. A. Cong. Work: Alice in Wonderland paintings, Chicago Pub. Lib. (various branches); Munroe (N.Y.) and Jefferson (N.Y.) high schools [40]

ROSE, Jack Manley [I] Position: Affiliated with Doubleday Page & Co., Garden City, NY [15]

ROSE, Leize (Mrs. Duncan M. Stewart) [P,Des,Dec] NYC/Purdy's, NY b. Fortress Monroe, VA. Member: Nat. Assn. Women PS; Grand Central A. Gal. Exhibited: GGE, 1939; WFNY, 1939. Work: Photographic tapestries, Gen. Electric Co., Western Union Co., N.Y.; mural, Municipal Bldg., N.Y. [40]

ROSE, (Ruth) Starr (Mrs. W.S.) [P,Li,L,T] Caldwell, NJ/Easton, MD b. 12 Jy 1887, Eau Claire, WI. Studied: ASL; H. Lever; V. Huntley; W. Palmer. Member: NAWPS. Exhibited: lith., N.J. State Exh., 1934 (prize); NYSWA, 1936 (prize); NAWPS, 1937 (prize) [40]

ROSE, William F. [I] NYC b. 16 S 1909, Pittsburgh. Studied: Univ. Pittsburgh; CI. Member: SI. Exhibited: SI, 1945, 1946. Contributor: This Week, Collier's, Today's Woman [47]

ROSELAND, Harry (Herman) [P] Brooklyn, NY b. 12 My 1866, Brooklyn d. 20 D 1950. Studied: T. Eakins; C. Beckwith; J.B. Whittaker, in Brooklyn. Member: Brooklyn AC; SC, 1896; Brooklyn PS; Brooklyn SA. Exhibited: Brooklyn AC, 1888 (gold); Boston, Mass., 1900 (med) 1904 (gold); Charleston Expo, 1902 (med); NAD, 1898 (prize); Brooklyn SA, 1930 (prize); AAS, 1902 (med), 1907 (gold); PAFA; SC; AIC; N.Y. Acad. All. A. Work: Brooklyn Inst. A.&Sc., Abraham Lincoln H.S., Plymouth Church, all in Brooklyn; Charleston A. Mus.; Huntington Lib., San Marino, Calif.; Huntington Art Mus.; Jackson Mus., Mich. [47]

ROSEN, Charles [Ldscp.P,P,I] Woodstock, NY b. 28 Ap 1878, Westmoreland County, PA d. Je 1950. Studied: NAD; N.Y. Sch. A., with Chase, DuMond, F.C. Jones; abroad. Member: ANA, 1912; NA, 1917; Am. Soc. PS&G; SC; NAC. Exhibited: NAD, 1910 (prize), 1912 (prize), 1916 (gold,prize); SC, 1914 (prize); CI, 1914 (prize); P.-P. Expo, San Fran., 1915 (med); Columbus, Ohio, 1924 (prize); CGA; AIC; PAFA, 1926 (gold); CAM; Herron AI; Columbus A. Lg., 1925 (prize). Work: Minneapolis Inst. A.; Duluth FA Assn.; Delgado Mus. A.; Butler AI; CAM; Univ. Mich.; WMAA; PMA; TMA; Columbus, Ohio; San Antonio, Tex.; Pa. State Col.; Dartmouth; murals, USPOs, Beacon (N.Y.), Palm Beach (Fla.), Poughkeepsie (N.Y.) [47]

ROSEN, Eduard, Mrs. See Meltzer, Doris.

ROSEN, Ernest T. [P] NYC [19]

ROSEN, Esther Yovits [P] NYC b. 3 Je 1916, Schenectady, NY. Studied: S. Brecher. Member: NAWA [47]

ROSENBAUER, W(illiam) Wallace [S,T,L] Johnson County, KS b. 12 Je 1900, Chambersburg, PA. Studied: Washington Univ., St. Louis; A. Archipenko. Member: Kansas City SA. Exhibited: Kansas City AI, 1925 (med), 1926 (med), 1927 (gold,prize), 1929 (med), 1935 (prize), 1936 (prize), 1939 (prize), 1940 (prize); CAM, 1929 (prize). Work: William Rockhill Nelson Gal. Position: Dir., Kansas City AI & Sch. Des. [47]

ROSENBAUM, Caroline [Por.P] Orlando, FL b. 2 F 1896, Bonham, TX. Studied: AIC. Member: NAWPS; S.Indp.A.; AAPL. Work: Jewish Children's Home, New Orleans; Chicago Home of Jewish Orphans, Home for Aged Jews, Convalescent Home for Women and Children, all in Chicago; National Hebrew Orphan Home, New York; Hebrew Union Col., Cincinnati; Hospital for Crippled Children, Galveston, Tex. [40]

ROSENBAUM, David Howell [P,T] Brigham, UT/Ogden, UT (1974) b. 20 My 1908, Brigham. Studied: Utah State Agriculture Col., with C. Fletcher, 1931; ASL, 1938; Am. A. Sch., NYC, with S. Wilson, M. Soyer, J. Liberte. Member: Utah State Inst. FA; Am. Ar. Cong. Exhibited: Am. Sch., N.Y. Work: Allocations, WPA, Utah. Position: T., Ogden A. Center [40]

ROSENBERG, H(enry) M. [P,T] Citronelle, AL b. 28 F 1858, New Brunswick NJ. Studied: F. Duveneck; Royal Acad., Munich; Florence; Venice. Member: SC; Nova Scotia SA. Position: Dir., Nova Scotia Col. A. [40]

ROSENBERG, Jakob [Mus.Cur,Edu] Arlington, MA b. 5 S 1893, Berlin, Germany. Studied: Univ. Munich; Bern; Zurich; Frankfort. Member: CAA. Author: "Drawings of Martin Schongauer" (1922), "Jacob van Ruisdael" (1928), "Lucas Cranach" (1932), other books. Position: T./Cur. Prints, FMA, 1939– [47]

ROSENBERG, James N. [P] NYC b. 20 N 1874, Allegheny City, PA. Member: NAC; S.Indp.A.; Wash. AC; AFA [33]

ROSENBERG, Louis Conrad [E,En,I,Arch] Portland, OR b. 6 My 1890, Portland. Studied: MIT; Royal Col A., London; Am. Acad., Rome. Member: ANA, 1932; NA, 1936; Phila. SE; F., Royal Soc. P.E.&En., London; SAE; Chicago SE; Southern Pr.M.; Prairie Pr.M.; Audubon A.; Am. Veterans Soc. A.; Cleveland SE; Phila. SE. Exhibited: Calif. Pr.M., 1924 (med); Chicago SE, 1925 (med), 1927 (med); AIC, 1923 (prize); Brooklyn SE, 1926 (prize); SAE, 1932 (prize), 1933–37, 1938 (prize), 1939–41; Albany Pr. Cl., 1945, 1946 (prize); NAD, 1930–41, 1945, 1946; AIC, 1932; Albany Inst. Hist.&A., 1945; Wichita AA, 1946; Am.-British Goodwill Exh., London, 1945. Work: Smithsonian Inst.; LOC; NYPL; Boston Pub. Lib.; BMFA; Albany Inst. Hist.&A.; British Mus.; Victoria & Albert Mus., both in London; Univ. Nebr.; Honolulu Acad. A.; CMA; Mont. State Col.; Slater Mem. Mus., Norwich, Conn.; AGAA; Howard Univ.; Royal Ins. Co., N.Y.; Cleveland Terminal Co.; Cincinnati Terminal Co.; Royal Acad. Arts, Stockholm; Fifty Prints of the Year, 1932, 1933, 1934, 1936. Author: "Davanzati Palace," 1922. Illustrator: "Bridges of France," 1924, other books. Position: Arch./Des., Stanton & Johnston, Portland, 1943– [47]

ROSENBERG, Manuel [I,Car,W,L,T] Cincinnati, OH b. 29 Ja 1897, New Orleans. Studied: Duveneck; Meakin; J. Maynard. Member: Commercial AC of Cincinnati; Western AA. Author: "Newspaper Art," "Practical Art," "Cartooning and Drawing," "The Art of Advertising" (with E. Walker Hartley, 1929). Positions: Art Ed., The Cincinnati Post; Chief A., The Scripps Howard League of Newspapers [31]

ROSENBERG, Mordecai [P] Chicago, IL [10]

ROSENBERG, Nelson Chidecker [P,T] Wash., D.C. b. 23 My 1908, Baltimore. Studied: ASL; Pratt Inst.; Nat. Acad; D. Rivera. Member: Ar. Un., Wash., D.C. Exhibited: Phillips Mem. Gal. (1939), Whyte Gal., Georgetown Gal., all in Wash., D.C.; BM. Work: Phillips Mem. Gal.; Allocations Gal., WPA, Wash. D.C.; murals, Roosevelt H.S., Wash. D.C. [40]

ROSENBERG, Rosa [P] Phila., PA. Studied: PAFA [24]

ROSENBERG, Samuel [Por.P,T] Pittsburgh, PA b. 28 Je 1896, Phila. d. 1972. Studied: CI; Collens; Sparks; Volk. Member: Assoc. A. Pittsburgh; Abstract Group, Pittsburgh; CAA; AFA. Exhibited: Assoc. A. Pittsburgh, 1917 (prize), 1920 (prize), 1945 (prize); Pittsburgh SA, 1928 (prize), 1929 (prize); CI, 1939, 1945; WFNY, 1939; GGE, 1939; Butler AI, 1939. Work: CI; Univ. Pittsburgh; Slippery Rock (Pa.) State Mus.; Pub. Sch., Court House, Chamber of Commerce, Pa. Col. for Women, all in Pittsburgh. Positions: T., Pa. Col. for Women, CI [40]

ROSENBERG, S(amuel) M(artin) [P] Springfield, MA/Congamond Lake,

CT b. 16 D 1893, Wash., D.C. Studied: H. Seldon. Member: Springfield A. Lg. Exhibited: Springfield A. Lg., 1927 (prize) [40]

ROSENBERG, Yetta (Mrs. David V.) [Cer,T] Cleveland, OH b. 19 Mr 1905, NYC. Studied: R. Aitken; W. Atchley; N.E. Dyer; Cleveland Sch. A. Member: Am. Ceramic Soc. Exhibited: CMA, 1938 (prize) [40]

ROSENBLATT, Alice [C,P,Des,T,L] Yonkers, NY b. NYC. Studied: Columbia; Grand Central Sch. A.; H.B. Snell; G. Bridgman; A. Woelfle; E. O'Hara; R. Brackman. Member: Eastern AA. Exhibited: PAFA; Barbizon Plaza, N.Y. Work: mural, Jr. H.S. #55, NYC; leather tooled and illuminated volumes, James Monroe H.S., Theodore Roosevelt H.S., NYC. Position: T., Theodore Roosevelt H.S. [47]

ROSENBORG, Ralph M. [P,B,Li,T] NYC b. 9 Je 1910, NYC. Studied: H. Reiss. Member: Am. Abstract A.; Southern PM Soc.; Scandinavian-Am. A. [40]

ROSENDAHL, Gertrude [Des,C] Brockton, MA. Studied: BMFA Sch.; New Sch. Des.; Boston Sch. Painting. Member: Boston SAC; Phila. ACG [40]

ROSENER, Hilda-Frank [S] San Fran., CA [01]

ROSENFELD, Edward [P] Baltimore, MD b. 22 Jy 1906, Baltimore. Studied: self-taught; Md. Inst. Member: Baltimore AA; Baltimore A. Un.; Baltimore A. Gld.; Wash. A. Gld. Exhibited: BMA, 1939, 1945 (prize); Little Gal., Wash., D.C., 1940; CGA; WFNY, 1939; GGE, 1939; Babcock Gal., N.Y.; Whyte Gal., 1945; CI, 1945; PMG, 1943 (one-man). Work: PMG; BMA; Babcock Gal., N.Y.; Cone Coll., Baltimore [47]

ROSENFELD, Paul [Cr,W] b. 1890, NYC d. 21 Jy 1946, NYC. Studied: Yale; Columbia. Contributor: Kenyon Review; Tomorrow; Commonweal, other magazines. Author: "Port of New York," books on art. Editor: "Alfred Stieglitz: A Collective Portrait"

ROSENFIELD, Hugo [P] NYC b. 1885, Minneapolis d. 25 O 1932. Studied: AIC; ASL; Paris. Brother of Lester. [21]

ROSENFIELD, Lester [P] NYC b. 1 F 1886, Minneapolis. Studied: AIC; ASL; Royal Acad., Munich. Brother of Hugo. [21]

ROSENGREN, Herbert [P,S,E] Rockford, IL/Cedar Rapids, IA b. 8 D 1908, Kewanee, IL. Member: Rockford AA; Iowa AC. Exhibited: etching/watercolor, Iowa State Fair, 1931 (prizes); sculpture, Iowa AC, 1931 (prize) [40]

ROSENKRANZ, Clarence C. [P,T] St. Paul, MN b. Hammondsport, NY. Studied: J.W. Stimson; W.M. Chase; W. Shirlaw. Member: Buffalo SA; Duluth AA; Minn. State AA. Exhibited: Buffalo FA Acad., 1909 (prize), 1911 (prize), 1912 (prize); Minn. Art Com., 1913 (prize). Work: Minn. Art Soc.; Hibbing, Minn. Pub. Lib.; Buhl, Minn. Pub. Lib. Position: T., Minn. Art Sch., St. Paul [40]

ROSENMEYER, B(ernard) J(acob) [Li,I,P] NYC b. New York. Studied: ASL, with Mowbray; Constant, Laurens, in Paris. Member: SI, 1902. Work: CI; NYPL; Butler AI; Poe Soc., Phila.; Mus. City of N.Y. [40]

ROSENQUIST, Fingal [S] Huntingdon Valley, PA. Exhibited: PAFA, 1933; WFNY, 1939 [40]

ROSENSON, Olga Lea [Por.P,E] Brooklyn, NY b. 10 S 1892, Brooklyn. Studied: DuMond; G. Luks; J. Pennell. Member: Brooklyn SA; NAWPS [40]

ROSENSTEIN, A. [S] NYC [21]

ROSENTAL, Sonia. See Brown, W.G., Mrs.

ROSENTHAL, Albert [P,E,Li] New Hope, PA b. 30 Ja 1863, Phila. d. D 1939. Studied: his father, Max; PAFA; Ecole des Beaux-Arts, Paris, with Gérôme; Munich. Member: SC; Phila. Alliance. Exhibited: St. Louis Expo, 1904 (med); P.-P. Expo, San Fran., 1915 (med). Work: BM; Butler AI; Los Angeles Mus. A.; Kansas City AI; Detroit AI; City Mus., St. Louis; Mus. FA, Dallas; Albright Art Gal.; Mus., Allentown, Pa.; H.S., New Hope, Pa.; RISD; Newport (R.I.) AA; Capitol, Supreme Court Bldg., both in Wash., D.C.; City Hall, Phila.; Capitol, Harrisburg, Pa. [38]

ROSENTHAL, Bernard J. [S] Los Angeles, CA b. 9 Ag 1914, Chicago, IL. Studied: Univ. Mich.; A. Archipenko; C. Milles. Exhibited: AIC, 1939-42; MMA (AV), 1942; Oakland A. Gal., 1941. Work: Ill. State Mus.; Mus. Sc.&Indst., Strauss Mem. Center, both in Chicago; USPO, Nokomis, Ill. [47]

ROSENTHAL, David [P,E,L] Cincinnati, OH b. 15 F 1876, Cincinnati d. 20 O 1949. Studied: Cincinnati Acad. A.; F. Duveneck; Meakin; Sharp; Nowotney; Azbe; G. Flad; Acad., Munich; Belle Arti, Rome. Exhibited: AIC; CM; Kuenstler Verein, Munich [47]

ROSENTHAL, Doris [P,Li,Dr] NYC b. Riverside, CA. Studied: T. Col., Los Angeles; Columbia; ASL; G. Bellows; J. Sloan. Member: Am. Soc. PS&G; Am. Art Cong.; F., Guggenheim Fnd., 1932, 1936. Exhibited: Northwest Pr.M. (prize); Mus. Mod. A., Paris, 1938; PAFA; WMA; VMFA; RISD; Dallas Mus. FA; GGE, 1939; AIC; Latin America Traveling Exh.; MMA; Dayton AI. Work: MMA: AGAA; MOMA; Colorado Springs FA Center; Rochester Mem. A. Gal.; TMA; Univ. Ariz.; LOC; San Diego FA Soc.; Davenport Municipal A. Gal. Author: The Prim-Art Series [47]

ROSENTHAL, Gertrude [W,L,Mus. Res. Dir] Baltimore, MD b. 19 My 1906, Mayen, Germany. Studied: Sorbonne, Paris; Univ. Cologne. Author: "French Sculpture in the Beginning of the 18th Century," 1933. Position: Dir. Res., BMA, 1945– [47]

ROSENTHAL, Louis Chatel [S] Baltimore, MD b. 20 F 1888, Russia. Studied: Md. Inst.; E. Keyser. Member: NSS; Royal Soc. Min. P.S.&G., London; Charcoal Cl., Baltimore. Exhibited: Pal. Leg. Honor, 1929; Phila. A. All., 1930; BMA, 1923; Royal Soc. Min. P.S.&G., London [47]

ROSENTHAL, Martin [P] NYC b. 20 Jy 1899, Woburn, MA. Studied: ASL, with J. Sloan, R. Henri, G. Luks, B. Robinson. Exhibited: BM; Springfield Mus. A.; Riverside Mus.; Contemporary A. Gal.; ACA Gal.; Morton Gal.; Montross Gal. (one-Man); Newark Mus., 1938 [47]

ROSENTHAL, Max [E,Li,En,Por.P] Phila., PA b. 23 N 1833, Turck, Russian Poland d. 8 Ag 1918. Studied: Carl Harnich, in Berlin; Martin Thumanger, in Paris, 1846 (age 13); Schussele, in Phila. Exhibited: St. Louis Expo, 1904 (med). Work: more than 500 portraits (prints) made with his son Albert, Smithsonian; CMA. He was also an artist who followed the Army of the Potomac, making sketches for the U.S. Military Commission. [17]

ROSENTHAL, Michael [P] Brooklyn, NY b. 10 My 1888 d. 3 N 1942. Studied: R. Henri. Member: Indp. Art Soc. Exhibited: Montross Gal., N.Y., 1938 [40]

ROSENTHAL, Mildred [P,T,W,L] San Fran., CA b. 18 O 1890, Panama. Studied: Calif. Sch. FA. Member: San Fran. AA; San Fran. Women Ar. Exhibited: San Fran. AA, 1939 (prize) [47]

ROSENTHAL, Rena [Dec,Des] NYC. Exhibited: Mus. Mod. A., Wash., D.C., 1939. Specialties: furniture, interor dec. [40]

ROSENTHAL, Sophie [S] NYC [15]

ROSENTHAL, Toby E. [P,T] Munich, Germany (1915) b. 15 Mr 1848, New Haven, CT d. autumn, 1917, Berlin. Studied: H. Bacon, F. Arriola, in San Fran.; Munich Acad., with Straehuber, Raupp, Piloty. Exhibited: Centenn. Expo, Phila., 1876 (med); Munich Expo (gold). Work: AIC; Mus., Leipzig, Germany; private collections. Award: Bavarian Order of St. Michael [17]

ROSENWEY, Paul [P] Phila., PA [17]

ROSEY, Alexander P. (Abraham Rosenstein) [S] NYC b. 4 Jy 1890, Baltimore. Studied: NAD; BAID. Exhibited: NAD (med); BAID (med); PAFA; AV; CGA; BMA [47]

ROSIN, Harry [S,T] New Hope, PA b. 21 D 1897, Phila., PA d. 1973. Studied: PMSchIA; PAFA; Paris. Exhibited: PAFA, 1933–38, 1939 (med), 1940 (med), 1941 (prize), 1942–46; World's Fair, Chicago, 1934; Tex. Centenn., 1936; GGE, 1939; WFNY, 1939; AIC, 1934–46; WMAA; CI; Mod. Am. A., Paris, 1932; Salon de L'Ouevre Unique, Paris, 1932. Work: PAFA; PMA; Papeete, Tahiti; mem., Fairmont Park, Phila.; L'Eglise de Julien, Trinidad [47]

ROSIN, T(heodore) L(avelle) [P,C] Wilmington, DE b. 17 Mr 1886, Wilmington. Studied: T. Anshutz; PAFA. Member: Wilmington Soc. FA [25]

ROSMER, Leo [P] NYC b. 19 Ap 1905, Vienna, Austria. Studied: Kunstgewerbe Sch., Vienna; Master Sch. Monumental Tech., Munich. Exhibited: Montross Gal., N.Y.; New Sch. Soc. Res.; watercolor, PAFA, 1938 [40]

ROSNER, Charles [Mar.P] b. 1894, Germany d. 3 Ap 1975, Bellport, NY. Work: Mystic Seaport Mus. A sailor in his youth; many of his works were later reproduced as chromolithos. [*]

ROSOL, John [Car] Phila., PA b. 14 Je 1911, Phila. Studied: PMSchIA. Cartoonist: Saturday Evening Post, Country Gentleman, Country Home, New York Journal [40]

ROSS, Adele [P] Chicago, IL [04]

ROSS, Alex [I] Wilton, CT b. 28 O 1909, Dunfermline, Scotland. Studied: CI, with R. Lepper. Member: SI; A.&W. Assn. Exhibited: A. Dir. Cl., 1941, 1943, 1945, 1946; Contemporary Am. Illus., 1946. Illustrator: "With Rifle and Plow," 1938, "Council Fires," 1940. Contributor: Saturday Evening Post, Good Housekeeping, Ladies Home Journal, Cosmopolitan [47]

ROSS, Barbara Ellis (Mrs. Robert T.) [P] Lincoln, NE b. 29 Ja 1909, Deadwood, SD. Studied: Univ. Nebr.; Exhibited: IBM (med); WFNY, 1939; SFMA, 1944; NAWA, 1945; Pasadena AI, 1946; CI; Lincoln, Nebr.; Omaha, Nebr.; Wichita, Kans. [47]

ROSS, C. Chandler [Por.P] Ridgefield, CT d. 7 Ja 1952. Studied: Académie Julian, Paris; Italy; Germany. Work: floral paintings reproduced and published by N.Y. Graphic Soc. Painted portraits of many prominent persons. [47]

ROSS, Charles B. [Ldscp.P,Por.P] b. 1878, Chicago d. 29 Ag 1933, Port Washington, NY. Studied: ASL, 1896; Chase Sch.; AIC. Known as an editor and advisor to the commercial art world.

ROSS, David P., Jr. [Des,Mus. Dir] Chicago, IL b. 21 F 1908, St. Louis. Studied: AIC; Univ. Kans., with B. Ray. Exhibited: South Side Community A. Center, 1939, 1941; Barnett Aden Gal., 1940; AIC, 1941; St. Louis Pub. Lib., 1930. Work: Howard Univ.; Douglas Pub. Sch., Chicago. Position: Dir., South Side Community A. Center, Chicago, 1939– [47]

ROSS, Denman W(aldo) [P,W,L,T] Cambridge, MA b. 10 Ja 1853, Cincinnati d. 12 S 1935, London, England (while on a visit). Member: Copley S., 1892; Boston SAC; AFA; Boston S. Arch.; Arch. C.; F., Am. Acad. A.&Sc., 1885; India Soc., London. Author: "A Theory of Pure Design" (1907), "On Drawing and Painting" (1912), "The Painter's Palette" (1919). Trustee: BMFA, to which he made gifts of more than 20,000 objects, including sculpture, painting, porcelains, ivories, and jewels. Founder: Ross Study Series at FMA, giving thousands of specimens that illustrated the history of design and technique. His collection of Peruvian textiles was given to the Peabody Mus. Nat. Hist., in Cambridge. Position: L., Harvard, since 1899 [31]

ROSS, Eva [P] NYC [15]

ROSS, Frederick Webb [P] Indianapolis, IN [15]

ROSS, Gordon [I] Montclair, NJ b. 1873 d. 26 D 1946, NYC [21]

ROSS, Herbert [P] Pewee Valley, KY [25]

ROSS, Isabel [P] Buffalo, NY b. Buffalo. Studied: ASL; Delecluse Acad., Paris [24]

ROSS, James [P,Arch] Yonkers, NY b. 1871, Williamsburg, VA d. 18 Jy 1944. Studied: Columbia. Member: Yonkers AA. Exhibited: Yonkers AA; Westchester A.&Crafts Gld.; (PAFA?, NAD?). Work: Hudson River Mus. Position: Arch., his firm of Ross & McNeal, NYC [25]

ROSS, Louis [Mur.P,P,C,E,En] NYC b. 21 Jy 1901 d. 3 Mr 1963. Studied: NAD; ASL, with K.H. Miller; B. Robinson. Member: NSMP; Arch. Lg.; Soc. Des.-Craftsmen. Exhibited: NSMP; Arch. Lg., 1941 (one-man). Work: mural, Bellevue Hospital, NYC; Manhattan Center; Am.-South African Steamship Lines; triptychs, Army & Navy chapels [47]

ROSS, Louise Pflasterer [S] Chicago, IL b. 4 D 1913, Cleveland. Studied: Univ. Chicago. Member: United Am. Ar. Exhibited: United Am. Ar. Gal., Chicago. Work: Lowell Sch., Oak Park, Ill. [40]

ROSS, Mabel [P] Springfield, MA b. 6 Jy 1906, Boston. Studied: M. Huse. Member: Ar. Gld., Springfield; Springfield Art Lg. [33]

ROSS, Mary Herrick [P] Oakland, CA [17]

ROSS, Pierre Sanford, 3rd [P,Li] Rumson, NJ b. 25 Ja 1907, Newark. Member: Am. Inst. Graphic Arts. Exhibited: WFNY, 1939; Am. Fed. A. Traveling Exh., 1940. Work: Fifty Prints of the Year, Newark Mus.; AGAA; SFMA; NYPL. Illustrator: Fortune [40]

ROSS, Raymond L. [P] Wash., D.C. b. 6 Ap 1880, Cattaraugus, NY. Member: Wash. WCC [40]

ROSS, Sue Robertson [P] Fort Worth, TX [19]

ROSS, Torrey [P] Chicago, IL. Member: Chicago SA [27]

ROSS, Y. [P] NYC. Member: S.Indp.A. [25]

ROSSE, Hermann [P,I,Arch,C,L,T] Pomona, NY/The Hague, Holland b. 1 Ja 1887, The Hague. Studied: Holland; Royal Col. Art, South Kensington, London; Stanford Univ. Member: Kunstkring of The Hague. Exhibited: P.-P. Expo, San Fran., 1915 (med). Work: dome of the Peace Palace, The Hague; mural dec., Salt Lake City Orpheum Theatre; Netherland Pavilion, Brussels; Victoria & Albert Mus., London. Designer: scenery for plays and motion pictures, including "Emperor Jones." Illustrator: "Wonder Tales from Windmill Lands," by F.J. Olcott. Position: T., Delft Univ., Holland [40]

ROSSEAU, Percival L(eonard) [P] Old Lyme, CT b. 21 S 1859, Point Coupeé Parish, LA d. D 1937. Studied: Lefebvre, H. Leon, Robert-Fleury, in Paris. Member: Lyme AA. Exhibited: Paris Salon, 1900 (prize), 1906 (med); Lyme AA, 1936 (prize) [38]

ROSSI, Lucius [I] Position: Affiliated with The Century Co., NYC [08]

ROSSIRE, Beatrice M. (Mrs.) [P] NYC. Member: NAWPS [25]

ROSSKAM, Edwin B. [P] Phila., PA [25]

ROST, Tom [P] Milwaukee, WI. Work: USPOs, Paoli, Ind., Elkhorn, Wis. WPA artist. [40]

ROST, W.C.F [P,T] Baltimore, MD. Member: Charcoal C. [17]

ROSTAD, Thorbjorg (Mrs. T.R. Freeland) [Des,P,L] Brooklyn, NY b. Oslo, Norway. Studied: Norway; Md. Inst.; Grand Central A. Sch.; E. Pape. Member: Norwegian A.&Crafts Cl., Brooklyn (Founder). Exhibited: BM; NAC; Vendôme Gal.; Grand Central Gal.; The Independents, N.Y.; Women's Intl. Expo, N.Y. Work: Norwegian Seamen's Center, Katonah, N.Y. [47]

ROSTON, Arnold [Des,P,W,L] Forest Hills, NY b. 29 Je 1913, Racine, WI. Studied: R. Soyer. Member: A. Dir. Cl.; F., Yaddo Fnd., 1939. Exhibited: Nat. Exh. Adv. A., 1944 (prize); MOMA, 1941 (prize); PAFA, 1938; WFNY, 1939; Contemporary A. Gal., 1936–40; Municipal A. Exh., N.Y. 1937, 1938; Montclair A. Mus., 1937. Work: MOMA. Contributor: American Printer. Positions: Des., Promotion Dept., New York Times; A. Dir., Mutual Broadcasting System, NYC, 1943– [47]

ROSZAK, Theodore J. [S,P,Des,Dec.Li,T,C,] NYC b. 1 My 1907, Poland. Studied: AIC, 1920s, NAD, 1920s; Columbia. Member: Am. Ar. Congress. Exhibited: World's Fair, Poznań, Poland, 1930 (med); AIC, 1929–31, 1933, 1934 (prize), 1938, 1941; WMAA, 1932, 1933, 1934 (prize), 1935–38, 1941–45, 1956 (retrospective); Minneapolis Inst. A., 1932–37; AGAA, 1932; Pal. Leg. Honor, 1932; Honolulu Acad. A., 1933; PAFA, 1936; Columbus Gal., FA, 1937; Roerich Mus., 1934, 1935; A. Gld., 1936; Julian Levy Gal., 1941; Robinson Gal., Chicago, 1932. Work: MOMA; WMAA; Univ. Ill.; Smith Col.; Nat. Coll. Position: T., Laboratory Sch. Indst. Des., N.Y. [47]

ROTAN, Walter [S] NYC b. 29 Mr 1912, Baltimore. Studied: Md. Inst.; PAFA; A. Laessle. Member: NSS. Exhibited: PAFA, 1935–38, 1940–45, 1946 (prize); NAD, 1936 (prize), 1942 (prize), 1944 (prize), 1945 (prize); AIC, 1936, 1938; PMA, 1940; CI, 1941; Chicago AC, 1943; MMA, 1943; WFNY, 1939; CM, 1938; WMAA, 1940; Audubon A., 1945; Phila. A. All., 1946; CAFA, 1938; Arch. Lg.; Springfield A. Lg.; NAC; New Haven PCC; Milch Gal.; Andre Seligmann Gal.; Arden Gal.; Ferargil Gal. Work: PAFA; Brookgreen Gardens, SC. Position: T., Taft Sch. Watertown, Conn., 1938– [47]

ROTENBERG, Harold [P,G,T] Boston, MA b. 12 Jy 1905, Attleboro, MA. Studied: BMFA Sch.; Académie Julian, Paris; Kunstgewerbe Acad., Vienna; Fogg Mus., Cambridge, Mass. Member: Boston AC; East Gloucester SA; North Shore AA; Rockport AA. Exhibited: Rockport AA (prize); North Shore AA (prize); PAFA; PMA; CGA; BMFA; Vose A. Gal.; Babcock Gal.; Grace Horne Gal.; Boston Pub. Lib. Work: Beth Israel Hospital; Boston AC; Hanover Inn, N.H.; Police Station, Rockport. Positions: T., BMFA Sch., Sch. Practical A., Boston [47]

ROTERS, Carl G. [P] NYC. Member: GFLA [27]

ROTH, Ernest David [E,P] NYC b. 17 Ja 1879, Stuttgart, Germany (came to NYC in 1884) d. 20 Ag 1964, Redding, CT. Studied: NAD; etching, with J.D. Smillie. Member: ANA; NA, 1928; NYWCC; SC; Chicago SE; N.Y. SE; Calif. SE; AWCS; Wash. WCC; Allied A.; Calif. PM. Exhibited: AIC, 1917 (prize); PAFA, 1930 (gold); Phila. Pr. Cl., 1934 (prize); SC, 1911 (prize), 1912 (prize), 1915 (prize), 1917 (prize), 1918 (prize); Chicago SE, 1914 (prize), 1936 (prize); Calif. PM, 1922 (prize); SAE, 1935 (prize); P.-P. Expo, 1915 (med); A. Fellowship, 1949 (med). Work: NYPL; BMFA; LOC; AIC; Newark (N.J.) Pub. Lib.; Minneapolis Inst. A.; Uffizi Gal., Florence, Italy. His printing press is at Silvermine Col. A., Conn. [47]

ROTH, Ernest (Mrs.) (Elizabeth Mackenzie) [P] NYC. Member: NAWPS [25]

ROTH, F(rederick) G(eorge) R(ichard) [S] Englewood, NJ b. 28 Ap 1872, Brooklyn, NY d. 21 My 1944. Studied: Hellmer, in Vienna; Meyerheim, in Berlin. Member: ANA, 1906; NA, 1906; Arch. Lg., 1902; NIAL; SAA,

1903; NSS, 1910; NAC; Am. Soc. PS&G. Exhibited: St. Louis Expo, 1904 (med); Buenos Aires Expo, 1910 (med); P.-P.. Expo, San Fran., 1915 (gold); NAD, 1924 (prize); NAC, 1924 (prize), 1928 (prize), 1931 (med). Work: MMA; Detroit IA; Cincinnati Mus.; Children's Mus., Boston; San Fran. Mus.; Mus., Newark, N.J.; equestrians, Washington, N.J., Morristown, N.J.; Baltimore mon., 18 animal tablets, mem. fountain, all in Central Park, NYC; 3 tablets, Prospect Park Zoo, Brooklyn; Bowdoin Col. Position: Chief S., Park Dept., NYC [40]

ROTH, George, Jr. [P] Cincinnati, OH. Exhibited: Ohio State Fair, 1935; Cincinnati Mus., 1939 [40]

ROTH, Herbert [Car,I] Larchmont, NY d. 27 O 1953, Scarsdale, NY. Member: SI, 1912 [40]

ROTH, James Buford [P,T,L] Kansas City, MO b. 11 My 1910, California, MO. Studied: Kansas City AI; Harvard; R.E. Braught; E. Lawson; L. Ney. Exhibited: Kansas City AI, 1932 (med), 1937 (prize); CAA, 1933 (prize). Position: Official Resident Restorer/T., W.R. Nelson Gal. A., Kansas City, 1935– [47]

ROTH, Julius J., Jr. [C,Des] NYC b. 8 My 1897, NYC. Specialty: mirror funiture, mirror wall treatments, flat and structural glass treatments [40]

ROTH, Robert [P] NYC. Member: GFLA [27]

ROTHBORT, Samuel [P,S,Dec] Brooklyn, NY b. 25 N 1882, Wolkovisk, Russia[n Poland]. Studied: self-taught. Member: Brooklyn Soc. Ar.; Soc. Indp. Ar.; Brooklyn WCC. Exhibited: Charles Barzansky Gal., N.Y.; Brooklyn and Long Island Stamp Exh., 1932 (ribbon), 1933 (ribbon) for painting of postage stamps; Nat. Stamp Exh., Rockefeller Center, 1934 (prize). Work: paintings, BM, U.S. Gov. [47]

ROTHERMEL, Peter Frederick [Por.P,Hist.P] Linfield, PA (since 1877) b. 8 Jy 1817, Nescopek, PA d. 15 Ag 1895. Studied: J.R. Smith; Bass Otis; PAFA. Work: PAFA. Active in Rome, 1856–58. Best known for his "Battle of Gettysburg" (which took 5 yrs. to complete), now in the Pa. State Capitol. Position: T./Dir., PAFA, 1847–55 [*]

ROTHERMEL, Vera G. [Des,Li,P] San Antonio, TX 29 S 1919, San Antonio. Studied: Witte Mem. Mus. Sch.; Univ. Mexico; San Antonio AI. Member: Tex. FA Assn.; Mill Race A. Exhibited: LOC, 1945; CI, 1945; SFMA, 1946; Laguna Beach AA, 1946; SAM, 1946; Mint Mus. A., 1946; Wichita AA, 1946; Witte Mem. Mus., 1945, 1946; Dallas Mus. FA, 1945; Texas General Exh., 1945; Tex. FA Assn., 1945 [47]

ROTHERY, Albert [P] Omaha, NE b. 8 O 1851, Matteawan, NY. Studied: F. Rondel, A Chatain, in New York. Member: SWA. Exhibited: Western AA (gold,prize) [15]

ROTHKO, Mark [P,W,L] NYC b. 25 S 1903, Dvinsk, Russia (came to Portland, Oreg. in 1913) d. 1970 (suicide). Born Marcus Rothkovich. Studied: ASL, with M. Weber, 1925. Member: Fed. Mod. P.&S. Exhibited: WMAA, 1946; PAFA, 1940; J.B. Neumann Gal., 1939 (one-man); Art of this Century, 1945; Mortimer Brandt Gal., 1946; SFMA, 1946. Work: Guggenheim Mus.; WMAA; MOMA; Vassar; Yale; Harvard. Important pioneer abstract expressionist best known for his large, bold paintings (two or three stacked rectangles) from the 1950s. His estate vs. Marlborough Gal. was one of the most highly publicized legal battles involving art in the 20th century. Position: T., Calif. Sch. FA (summers), 1947–49 [47]

ROTHLISBERGER, Jacob [P] Muncie, IN [15]

ROTHMAN, Henry L. [P,Des,E,Li] Phila., PA b. 18 F 1918, Phila. Studied: Barnes Fnd.; Graphic Sketch Cl., Phila.; PAFA; H. McCarter; G. Harding; J. Chapin. Exhibited: Graphic Sketch Cl., 1933 (prize); PAFA, 1938, 1939, 1941 (one-man). Work: PAFA; mural, Pine Camp, N.Y. [47]

ROTHSCHILD, Lincoln [P,S,W,L,T] NYC b. 9 Ag 1902, NYC. Studied: Columbia; ASL, with K.H. Miller. Member: CAA; Am. A. Cong. Author: "Sculpture Through the Ages," 1942, Sculpture, in World Book Encyclopedia. Contributor: Journal of Philosophy , Parnassus, Saturday Review of Literature. Positions: N.Y. Unit, Index of Am. Des. (WPA), 1938–40; T., Adelphi Col., Garden City, N.Y., 1946 [47]

ROTHSTEIN, Arthur [Photogr,T] New Rochelle, NY (1985) b. 1915. Studied: Columbia. Member/Founder: Am. Soc. Mag. Photogr. Work: LOC; IMP; MOMA; major museums. Important WPA photographer, during the Depression, for the Farm Security Administration. On the staff of Look, from 1940 (Dir. Photogr., 1969). Best known for his "Dust Storm, Cimarron County, Okla.," 1936, which became the most widely published image in books and magazines of that era. [*]

ROTHSTEIN, Charlotte [P,G,T] Chicago, IL b. 17 Ag 1912, Chicago. Studied: AIC; Acad. FA, Chicago. Studied: T. Geller; R. Weisenborn; A. Refregier. Member: Chicago Soc. Ar; United Am. Ar., Chicago; Am. Ar. Cong. Exhibited: AIC; GGE, 1939; WFNY, 1939. Work: AIC [40]

ROTHSTEIN, Elizabeth L. [P,T,Des] Albany, NY b. 3 S 1907, NYC. Studied: PAFA; ASL; Parsons Sch. Des.; NYU; F. Speight; G. Picken; E. Thurn; M. Davidson; H. Giles. Member: Albany A. Group. Exhibited: PAFA, 1929–32; AWCS, 1930–36; NAWA, 1934; A. of the Upper Hudson, 1943–46; Albany A. Group, 1946. Specialties: Adv. illus., commercial poster des. [47]

ROTHSTEIN, Theresa [P] Vancouver, WA b. 26 F 1893, Richmond, MN. Studied: C.L. Keller; Mus. Art Sch., Portland, Oreg.; Conservatory Music & Art, St. Paul, Minn. Member: AAPL; Oreg. SA. Exhibited: Oreg. SA, Portland, 1932, 1936, 1939; Salem, Oreg., 1935, 1936; AAPL, 1936. Work: Portland Women's Cl. [40]

ROTHWEILER, Charles F., Mrs. See Reiber, Cora.

ROTHWELL, Elizabeth L. [P] Pittsburgh, PA b. California, PA. Studied: Chase; C. Beaux. Member: Pittsburgh AA. Exhibited: Pittsburgh AA, 1915 (prize), 1918 (prize), 1928 (prize). Work: Hundred Friends of Art, Pittsburgh [40]

ROTHWELL, Violet H(amilton) (Mrs.) [P] NYC/Remsenburg, NY b. 27 Mr 1890, NYC. Studied: C. Lumsdon; Acad. de Passy, Paris [31]

ROTIER, Peter [Mur.P] Milwaukee, WI b. 5 N 1888, Baldwin, WI d. ca. 1964. Studied: ASL, Milwaukee; Milwaukee Normal A. Sch.; Chicago Acad. A.; ASL; Henri; DuMond; Milwaukee State T. Col. Member: AWCS; Wis. P.&S. Exhibited: Milwaukee AI, 1930 (prize), 1932 (prize), 1934 (prize); Milwaukee Journal, 1939 (prize); Wis. State Fair, 1942 (prize); AWCS, annually; Kansas City AI; AIC. Work: Milwaukee AI; USPO, West Bend, Wis. WPA muralist. [47]

ROUDEBUSH, John Heywood [S] NYC b. New York. Exhibited: Paris Salon, 1898 (prize); Paris Expo, 1900 (med); Pan-Am. Expo, Buffalo, 1901 (med) [10]

ROUGERON, M(arcel) J(ules) [Ldscp.P] NYC b. 6 O 1875, Paris, France. Studied: Académie Julian, Paris , École des Beaux-Arts; Gérôme; J.G. Vibert; L. Van den Bergh. Member: NAC; Wash. AC; AFA; SC; Lotos Cl.; AAPL; Montreal AC; Paris AAA; Société des Artistes Français; Société Royale Artistes Belges. Exhibited: Paris Salon, 1902 (prize); P.-P. Expo, San Fran., 1915. Work: BM; AIC; TMA; City Hall, New York; Art Mus., Montreal; W.R. Nelson Gal. Art; N.Y. Hist. Soc. Mus.; other collections. Awards: Officer d'Academie, 1900; Officer of Public Instruction (France), 1910; Chevalier of the Order of Leopold (Belgium), 1931; Chevalier of the Legion of Honor, 1935. Specialty: restoration of paintings. Son of J.J. Rougeron (1841–1880). [40]

ROULAND, Orlando [P,T] NYC/Marblehead, MA b. 21 D 1871, Pleasant Ridge, IL d. 26 Je 1945. Studied: M. Thedy, in Germany; Académie Julian, Paris, with Laurens, Constant. Member: ANA, 1936; SC, 1901; Paris AAA; Allied AA; AAPL; Lotos Cl.; North Shore AA; Springfield, AA; AFA. Exhibited: Duxbury AA, 1921 (prize). Work: Yale; Trinity Col., Cambridge Univ., England; Univ. Tex, State Capitol, both in Austin, Tex.; Hist. Soc., St. Paul, Minn.; Wheaton Col., Norton, Mass.; CI; Nat. Gal., Wash., D.C.; Engineers' Cl., Soc. Mining Engineers, Columbia, Lotos Cl., AAAL, all in NYC; City Cl., Boston; Montclair (N.J.) Mus. Art; Lexington (Ky.) Pub. Lib.; Amherst Col.; Art Cl., Erie, Pa.; Rollins Col., Winter Park, Fla.; Lafayette Col., Easton, Pa.; AMNH [40]

ROULLIER, Albert Edward [Dealer] b. 1858, Paris, France d. 19 Mr 1920, Chicago. Award: Officer of Public Instruction (France), in recognition of his efforts to promote friendship between the U.S. and France.

ROULLIER, Blanche [P] Paris, France b. San. Fran. Studied: Delance, in Paris [06]

ROUND, Irene Leslie [P,E,B] St. Paul, MN b. 27 Ag 1903, Pueblo, CO. Studied: C. Winholz; L. Bobleter; C. Haupers; St. Paul Sch. Art, with C. Booth. Member: Southern PM Soc.; Club Montparnasse, St. Paul. Work: Art Cl., Birmingham, Ala. [40]

ROUNDS, Glen H. [P,B,E,En,I] Rapid City, SD b. 4 Ap 1906, near Wall, SD. Studied: T.H. Benton; J. de Martelly. Exhibited: Kansas Artists Soc., Kansas City, 1934 (prize). Work: Jr. Col., Kansas City. Illustrator: Vanity Fair [40]

ROUNDTREE, Herman [I] South Kingston, RI b. 1878, Springfield, MO d. 8 D 1946. Illustrator: The Sportsman, Field and Stream. Specialty: animals in their native habitats

ROUSH, Louis L. [I] NYC [01]

ROUSSE, Charles [P] Phila., PA b. Scotland. Studied: South Kensington Sch., London [04]

ROUSSEAU, Angeline Marie [Por.P,B,T] Plymouth, MI b. 16 Ag 1912, Detroit, MI. Studied: Marygrove Col., Detroit. Member: Am. Fed. A. Exhibited: PAFA, 1937; AFA Traveling Exh.; Detroit Inst. A., 1933; AIC, 1936; Phila. A. All., 1939. Work: Am. Lib. Color Slides [47]

ROUSSEFF, W. Vladimir [P,Mur.P] Fish Creek, WI b. 24 My 1890, Silistria, Bulgaria. Studied: AIC. Exhibited: AIC, 1926 (prize), 1928 (prize), 1929 (med,prize), 1930 (prize). Work: AIC; Municipal Art Lg.; Swift Sch., Chicago; murals, Nichols Sch., Evanston (Ill.), USPOs, Iron Mountain (Mich.), Salem (Ill.). WPA muralist. [40]

ROUSSEVE, Ferdinand Lucien [Des,L,T] New Orleans, LA b. 18 Jy 1904, New Orleans. Studied: MIT; Univ. Chicago; Harvard. Member: CAA; Mediaeval Acad. Am. Position: T., Xavier Univ., New Orleans, 1934– [47]

ROUST, Helma (Mrs.) [P] NYC. Member: S.Indp.A. [25]

ROUYON, Adele [P] NJ/ME b. 1870, Brooklyn, NY. Studied: ASL, with Beckwith, 1888; Brooklyn Art Sch., 1890; PIASch, 1897–1906 [*]

ROVERSI, Luigi [W] b. 1860, Italy (came to U.S. ca. 1885) d. 5 Ja 1927, NYC. Studied: Royal Acad. FA, Bologna. Author: "Essays on Italian Art," "State and Church in Italy," "Ricordi Canavesani." Correspondent: Corriere d'America.

ROWAN, Edward Beatty [P,Mus. Cur,S,T,L,Cr] Falls Church, VA b. 1 Mr 1898, Chicago d. 30 Ag 1946. Studied: Miami Univ., Oxford, Ohio; Harvard. Exhibited: NGA; MOMA; South American Traveling Exh., U.S. State Dept.; Nat. Gal., Canada. Award: Carnegie Grant, 1928–34. Positions: Dir., Little Gal., Cedar Rapids, Iowa, 1928–34; PBA Chief, 1930s–40s [47]

ROWAN, George Miles [P] Silver Springs, MD [25]

ROWE, Clarence (Herbert) [I,E] Cos Cob, CT b. 11 My 1878, Phila. d. 17 Jy 1930. Studied: M. Bohm; PAFA; Bouguereau, Ferrier, in Paris. Member: SC; SI; Calif. PM; GFLA; NAC. Exhibited: U.S.; abroad [29]

ROWE, Frances Ely [P,Min.P] Maple Shade, NJ. Exhibited: PAFA, 1938; Wash. Soc. Min. PS&G, 1939 [40]

ROWE, Guy (Giro) [P,Des,Dr,L] NYC b. 20 Jy 1894, Salt Lake City, UT d. 25 Ag 1969, Long Island, NY. Studied: Detroit Sch. FA; J.P. Wicker. Member: Scarab Cl.; Art Dir. Cl., N.Y.; Detroit S.Indp.A. Exhibited: Detroit Inst. A.; Time (magazine) Traveling Exh., 1944–1946; BMA; Assoc. Am. A.; Georgetown Gal., Wash., D.C. Work: LOC. Illustrator: covers, Time. Lecture: Encaustic Printing and Painting [47]

ROWE, Guy, Mrs. See Finsterwald, Corinne.

ROWE, Helen Wright (Mrs. H.R.) [P,Des,E,B] Cuyahoga Falls, OH b. 20 My 1910, Pottsville, PA. Studied: Cleveland Sch. Art. Member: Ohio WCS; S.Indp.A. Exhibited: Akron Art Inst., 1929 (prize), 1930 (prize), 1931 (prize). Position: Product Des., B.F. Goodrich Co., Akron [40]

ROWE, J. Staples [Min.P,Por.P] NYC b. 1856 d. 1 N 1905. Studied: Boston. Member: Boston Art Cl.; Phila. Art Cl.; Orpheus Cl. Work: miniatures, Miss Helen Gould, President McKinley, J. Pierpont Morgan, other prominent persons [06]

ROWE, L. Earle [Edu,Mus.Cur] Providence, RI b. 19 Je 1882, Providence d. 17 F 1937. Studied: Brown; Am. Sch. Classical Studies, Athens, Greece, 1908–12. Member: Providence Art Cl.; Am. Fed. Arts; Eastern AA; Manual Training T.; Assoc. Mus. Dir. Member of the Harvard Egyptian expedition, Feb.–June, 1912. Positions: T., BMFA Sch., 1908–12, MIT; Dir., RISD, 1912, became Cur., 1928

ROWE, M.L. Arrington (Mrs.) [P] d. 23 Ja 1932, Canaan, CT. Member: Silvermine Gld. A.; PBC; NAC

ROWE, Mabel [P] St. Joseph, MO. Member: St. Joseph Art Lg. [25]

ROWE, William B. [Mur.P,Por.P,T,S,L,Dec,Arch] Buffalo, NY b. 25 My 1910, Chicago d. 22 Jy 1955, Taos. Studied: Cornell; Buffalo AI; E. Dickinson; W.K. Stone; W. Erich. Member: Artists' Cooperative Group, Buffalo; Buffalo Dec. AG; Mur.P.; The Patteran; Buffalo SA. Exhibited: Buffalo SA, 1935 (prize), Albright A. Gal., 1934–36, 1937 (prize), 1938–44; Arch. Comp., Seattle, Wash., 1932 (prize); MMA, 1938; Riverside Mus., 1937, 1941; GGE, 1939; CGA, 1935; Great Lakes Traveling Exh., 1937; Baltimore WCC, 1938; Kansas City AI, 1941; Rochester Mem. A. Gal., 1942; Syracuse Mus. FA, 1934. Work: Smithsonian Inst.; Rochester Mem. A. Gal.; murals, Bennett H.S., Marine Hospital, Hengerer Dept. Store, Garret Cl., all in Buffalo; Youngstown, N.Y; drawing, Citizen's Safe Deposit Co. Position: T./Pres., Buffalo AI, 1941–45 [47]

ROWE, Willie Lucille Reed (Miss) [E] Wash., D.C. b. 12 S 1914, Goliad, TX. Studied: Newcomb Col.; Tulane; Univ. Okla.; H. Leech; M. Pollak. Member: NOAA; SSAL; La. SE; Southern Pr.M. Exhibited: New Orleans Fiesta, 1938 (prize), 1939 (prize), 1940 (prize), 1941 (prize), 1943 (prize), 1944 (prize), 1946 (prize); La. State Fair, 1939 (prize); La. A. Comm., 1940 (prize); A. Outdoor Fair, Wash., D.C., 1946 (prize); NAD, 1943; LOC, 1943–45; CI, 1945; Northwest Pr.M., 1945; SSAL, 1940–46; NOAA, 1940–43, 1946; Caller-Times Exh., Corpus Christi, Tex., 1945, 1946. Work: Montgomery Mus. FA; Birmingham Pub. Lib.; Corpus Christi A. Fnd.; murals, Naval Officer Procurement Office, Radio Sch., Army Air Base, Intl. House, all in New Orleans [47]

ROWELL, Fanny Taylor (Mrs. Horace C. Wait) [P,T] NYC/Berryville, VA b. 11 My 1865, Princeton, NJ d. 22 Ap 1928. Studied: J.B. Whittaker, in Brooklyn, N.Y.; Colarossi Acad., in Paris; Trager, in Sèvres. Member: NAC; N.Y. Soc. C.; N.Y. Municipal AS; Arts Cl., Jersey City; Bridgeport AC; Jersey Keramic Cl.; Wash. AC. Exhibited: des. in pottery, Nat. Lg. Mineral P., 1898 (diamond medal).She taught the mountaineer white children arts and crafts near her summer home in Tamassee, S.C. [27]

ROWELL, Louis [Ldscp.P] b. 1873, New York d. Ag 1928, Asheville, NC. Painted in the Tryon Hills (N.C.), since ca. 1893.

ROWEN, George Miles [P] Silver Springs, MD. Member: Soc. Wash. A [27]

ROWLAND, Benjamin, Jr. [Edu.,W,P,L] Cambridge, MA b. 2 D 1904, Overbrook, PA d. 1972. Studied: Harvard. Member: Am. Oriental Soc.; Am. Archaeological Assn.; Am. Inst. for Iranian A. Author: "Jaume Huguet," 1932, "Wall-Paintings of India, Central Asia and Ceylon," 1938. Editor/Translator: "The Wall-Paintings of Horyuji," 1944. Contributor: Art Bulletin, Gazette des Beaux-Arts. Position: T., Harvard, 1930–40 [47]

ROWLAND, Earl [Mus.Dir,L,T,P,B,Dr] Stockton CA b. Trinidad, CO. Studied: AIC; Sch. Illus., Los Angeles. Member: AAPL; Calif. AC; Laguna Beach AA; Long Beach AA. Exhibited: Women's Cl., Phoenix, Ariz., 1923 (prize); Inglewood (Calif.) H.S. (prize). Work: San Diego FA Soc.; Bd. Edu., Pub. Lib., both in Los Angeles. Positions: T., Col. of the Pacific, Stockton, Univ. Redlands, Calif.; Dir., Pioneer Mus. & Haggin A. Gal., Stockton, 1937– [47]

ROWLAND, Edward B. [P] Paris, France b. U.S. Studied: Guillemet [13]

ROWLAND, Ruby [P,T,I] Hollywood, CA b. St. Mary's, KS. Studied: Kansas City AI. Exhibited: College AA (prize) [40]

ROWLAND, W.E. [P] Los Angeles, CA [29]

ROWLEY, Edward R., Mrs. See Horner, Blanch A.

ROWSE, Samuel Worcester [Por.P,En,Li] b. 29 Ja 1822, Bath, ME d. 24 My 1901, Morristown, NJ. Studied: apprenticed to wood engr. in Augusta, Maine; then in Boston for a litho. firm. Specialty: dainty crayon drawings of children. Settled in NYC, 1880; visited England, 1872.

ROYBAL, Tonita Cruz [C] Santa Fe, NM. Exhibited: the Exhibition of Inter-Tribal Arts. A full-blooded Tewa Indian, she was awarded many prizes for her pottery. [40]

ROYCE, Elizabeth Randolph (Mrs. Edward) [S] NYC/Ithaca, NY. Member: NAWPS [25]

ROYCE, Woodford [P] Woodstock, NY b. 27 N 1902, Willimantic, CT. Exhibited: Nat. Acad., 1933; CAFA, 1938 [40]

ROYER, Jacob S. [P,C] Dayton, OH b. 9 N 1883, Waynesboro, PA. Studied: Dayton AI; R. Oliver. Member: Dayton AG; AAPL. Work: Dayton AI [31]

ROYLA, Bonnie [P] Chicago, IL [10]

ROX, Henry [S,Des,I,T,L] South Hadley, MA b. 18 Mr 1899, Berlin, Germany. Studied: Univ. Berlin; Académie Julian, Paris; Kunstgewerbe Schule, Berlin. Exhibited: Springfield A. Lg., 1941, 1943 (prize); 1945; NAD, 1944, 1945; Nat. Exh. Adv. A., N.Y., 1943; New Haven PCC, 1946; Concord State Lib., 1945; abroad. Work: AGAA; Springfield Mus. A.; Mount Holyoke Col. Illustrator/Co-author: children's books. Position: L., Mount Holyoke Col., 1939– [47]

ROYER, Jacob S. [P,C] Dayton, OH b. 9 N 1883, Waynesboro, PA. Studied: Dayton AI; R. Oliver. Member: Dayton AG; AAPL. Work: Dayton AI [33]

ROYSHER, Hudson (Brisbine) [Des,C,T] Los Angeles, CA b. 21 N 1911, Cleveland, OH. Studied: Cleveland Sch. A.; Western Reserve Univ. Member: Cleveland SA; CAA. Exhibited: Cleveland Mus. A., 1933 (prize), 1934 (prize), 1936 (prize), 1940 (prize), 1941, 1946 (prize); Boston Soc. A.&Crafts, 1940; St. Paul Gal. A., 1942 (one-man); Los Angeles Mus. A., 1941 (one-man). Positions: Affiliated with Designers for Industry, Inc., Cleveland, Chicago, New York; T., Univ. Ill. (1937–39), Univ. Southern Calif. (1939–42), Chouinard AI [47]

RUBEN, Edward [P] b. 1895, Boston, MA d. 21 Ag 1934, Saranac Lake, NY. Position: T., PIASch

RUBENSTEIN, Leonard S. [Des,C,P] Buffalo, NY b. 22 S 1918, Rochester, NY. Studied: Alfred Univ.; Cleveland Sch. A.; Univ. Rochester; C.K. Nelson; M.L. Fosdick. Exhibited: Syracuse MFA, 1941; AIGA, 1940; Finger Lakes Exh., 1940 (prize), 1941; Albright A. Gal., 1939-41. Position: A.Dir., Landsheft, Inc., Buffalo, from 1946 [47]

RUBENSTEIN, Lewis [P,L,Li,T] Poughkeepsie, NY b. 15 D 1908, Buffalo, NY. Studied: Harvard, Traveling F., 1931-33; Paris, with Leger, Ozenfant, A. Marchand; Rome, with Galimberti; E. Ganso; Albright Gal. A. Sch. Exhibited: WMAA, 1941; Albany Inst. Hist.&A., 1936, 1945; AFA Traveling Exh., 1941; CGA, 1942, 1944; NAD, 1946; MOMA, 1934; Albright A. Gal, 1941, 1946; FMA, 1932, 1936, 1937; AGAA, 1935; Vassar Col., 1940, 1945; Wheaton Col., 1940; Wash. Pub. Lib., 1945; Wash. AC, 1945; Germanic Mus., Cambridge, Mass.; 48 States Comp., 1939. Exhibited: FMA; AGAA; Vassar; Albany Inst. Hist.&A.; murals, Johns Hopkins; USPOs, Wareham, Mass, Riverton, N.J.; Germanic Mus. Position: T., Vassar, from 1946 [47]

RUBIN, Hy [I,Car] NYC d. 17 My 1960. Contributor: illustrations, Good Housekeeping, 1939 [40]

RUBINS, David Kresz [S,Li,T] Indianapolis, IN b. 5 S 1902, Minneapolis, MN. Studied: Dartmouth Col.; BAID; Ecole des Beaux-Arts; Académie Julian; J.E. Fraser; Am. Acad. Rome, 1928. Member: Am. A. Cong. Exhibited: Arch. Lg., 1932 (prize); NAD, 1932; Ind. A., 1936, 1938, 1940, 1942, 1944, 1946. Work: Minneapolis Inst. A.; John Herron AI; Ind. Univ.; Archives Bldg., Wash., D.C.; USPO, Court House, Indianapolis, Ind. WPA artist. [47]

RUBINS, Harry W. [P,E,Dec] Minneapolis, MN b. 25 N 1865, Buffalo, NY d. 8 S 1934. Studied: AIC. Member: Chicago SE; Minneapolis SGA. Work: NYPL; Blake Sch. Lib., Minneapolis; St. Marks Church, Minneapolis; Nazareth Hall, St. Paul, Minn.; Northwestern Nat. Life Bldg., Minneapolis; Children's Hospital, Cincinnati [33]

RUBINS, Winfield [P] Minneapolis, MN b. 25 N 1865, Buffalo, NY. Studied: AIC. Member: Minneapolis SFA [10]

RUBITSCHUNG, François H. [S] NYC b. 12 F 1899, Germany. Studied: BAID; Columbia Univ. Member: United Am. A.; Nat. AS, NYC. Exhibited: Springfield MFA, Mass.; New Sch. Soc. Res., NYC; WFNY, 1939; Columbia, 1936 (prize). Work: Astoria Pub. Sch., N.Y. [40]

RUBY, Edna Browning [P,Des,L] Lafayette, IN b. Lafayette, IN. Studied: AIC; PMSchIA; PAFA; ASL. Member: F., Royal Acad., London; Nat. AAI; Intl. Soc. Ar. & Designers; Assoc. Des. of America & Europe; A. Dir. Cl.; Chicago AC Soc.; Indianapolis AA; Chicago Assn. A. & Indst.; Des. Assn., France; Ind. Fed. AC. Exhibited: P.-P. Expo, San Fran., 1915 (gold,medals); Assoc. Des., London, 1918 (gold); Krefeld, Germany, 1924 (med); Hoosier Salon, 1927; Salon des Indépendants, Paris, 1928 (prize). Work: ecclesiastical art, windows, mosaics, decorations, textiles, furniture, mems. Lectures: Creative Design; Textile, Origin and Development; The Carnival Boats of Venice; The Marquis de LaFayette Ancestral Homes, in France, others[40]

RUCKER, Maud [P] NYC. Member: Lg. AA [24]

RUCKMAN, Grace Merrill (Mrs.) [P] Chevy Chase, MD b. 12 My 1873, Buchanan, MI. Studied: Corcoran Gal. Sch.; H. Breckenridge; L. Stevens; M. Leisenring. Member: S. Wash. A. Exhibited: CGA, 1937 (med), 1938 (med); S. Wash. A., 1933-39 [40]

RUCKSTUHL, A.P. [P] NYC [15]

RUCKSTULL, F(rederic) Wellington [S,L,W] NYC b. 22 My 1853, Breitenbach, Alsace (brought to U.S. at age 1) d. 26 My 1942. Studied: Académie Julian, with Boulanger, Lefebvre; Rollins Acad., with Mercié. Member: NSS, 1893; Arch. Lg., 1894; NIAL; NAC; Sect., Committee on Dewey Arch, 1898; Chief of Sculpture, St. Louis Expo, 1904. Exhibited: Paris Salon, 1888; Columbian Expo, Chicago, 1893 (med). Work: MMA; Harrisburg, PA; Columbia, S.C.; Baltimore; Little Rock, Ark.; Columbia, S.C.; LOC; Capitol, Wash., D.C.; Appellate Court, NYC; Salisbury, N.C.; Jamaica, N.Y.; St. Louis; Petersburg, Va.; N.Y. Customs House; mon., Battlefield of Long Island; Stafford Springs, Conn. Author: "Great Works of Art and What Makes Them Great" [40]

RUDD, Emma (Mrs.) [P] Lyons, NY. Member: NAWPS [25]

RUDD, Tracy Porter [Des,C,I] Boston, MA b. Meran, Austria. Studied: Norwich A. Sch.; ASL; NAD. Member: Boston SAC. Illustrator: "The Beggars Vison," 1921, "The Ring of Love," 1923. Specialty: stained glass. Position: Charles J. Connick, Inc., Boston [47]

RUDDER, Stephen Wm. C. D(ouglas) [P,I,E,B,W,L] Salem, IN b. 12 My 1906, Salem d. 27 D 1932, Chicago, IL. Studied: AIC. Member: ASL of Chicago; Hoosier Salon; Ind. AA [32]

RUDDICK, Troy [P] Flushing, NY. Exhibited: Kansas City AI, 1934, 1939; WFNY, 1939 [40]

RUDELL, Peter Edward [Ldscp.P] NYC b. 1854, Preston, Ontario d. 20 Je 1899. Studied: A.H. Wyant. Exhibited: NAD, BAC, NYSF, St. Louis Expo, all in 1898 [98]

RUDERSDORF, Lillian C. [P] Chicago, IL. Exhibited: AIC, 1934-39 [40]

RUDERT, Anton [P] Newark, NJ [13]

RUDGE, William Edwin [Printer] Mt. Vernon, NY b. 23 N 1876, Brooklyn, NY d. 12 Je 1931. Member: AI Graphic A.; Grolier C.; Art in Trade C. Exhibited: AI Graphic A., (golds,medals); 2 Phila. exhs. (prizes); Institute Expo of Modern Decorative and Industrial Art at Paris, 1925. In April, 1931, he took over publication of the American Edition of the Studio of London under the name "Atelier." [25]

RUDIN, Paul [S] Towners, NY. Work: USPO, Dunn, N.C. WPA artist. [40]

RUDISILL, Margaret [P] b. 2 Jy 1857, Montgomery County d. 29 Je 1833, Indianapolis, IN. Studied: J. Cox (a pioneer Ind. artist); Académie Julian, 3 yrs. Exhibited: Paris Salon; Columbian Expo, Chicago, 1893; St. Louis Expo, 1904

RUDMORE, (Mrs.) [P] Ft. Worth, TX [24]

RUDOLPH, Alfred [C,Dr,E,Li] La Jolla, CA b. 21 S 1881, Alsace-Lorraine. Member: San Diego AG. Exhibited: San Diego FA Gal., 1933 (prize), 1934 (prize). Work: LOC; Smithsonian; San Diego FA Gal. [40]

RUDOLPH, Norman Guthrie [I,P] Jackson Heights, NY b. 10 N 1900, Phila. PA. Studied: T. Oakley; F. Wagner; D. Garber; P. Carter. Member: AWCS; SI; Phila. Sketch C.; SC; AG [47]

RUDOLPH, Pauline Dohn (Mrs.) [P] Winnteka, IL b. Chicago. Studied: PAFA; Paris, with Boulanger, Lefebvre, Lasar, Couture. Member: Palette C.; Cosmopolitan C., Chicago; Chicago SA. Exhibited: Chicago SA (prize) [33]

RUDULPH, Rella [P] Birmingham, AL b. 18 Ja 1906, Livingston, AL. Studied: A. Goldwaite; A.A. Andries; A. Brook. Member: Birmingham AC; Ala. AL; SSAL. Exhibited: Nat. Exh. Am. A., Rockefeller Center, NYC, 1938; SSAL, Atlanta, 1937, Montgomery, Ala., 1938. Work: Montgomery MFA [40]

RUDY, Charles [S,T] Ottsville, PA b. 14 N 1904, York, PA. Studied: PAFA, 1927-28; C. Grafly; A. Laessle. Member: F., Guggenheim Fnd., 1942; NSS; S. Gld.; AFA. Exhibited: PAFA, 1930, 1935 (med), 1946; WMAA, 1935, 1941-46; CI, 1938; AIC, 1932, 1943; Lincoln, Nebr., 1940; NAD, 1942; Trenton, N.J.; AFA Traveling Exh.; Am. Acad. A.&Let., 1944 (prize); WFNY, 1939. Work: Brookgreen Gardens, S.C.; Michigan State Col; PAFA; murals, USPO, Bronx, N.Y.; York, Pa. Pub. Schs. Position: T., CUASch [47]

RUDY, J. Horace [P] York, PA. Studied: PAFA [25]

RUDY, James F. [P] Los Angeles, CA. Member: Calif. AC [17]

RUDY, Mary Eleanor Robinson [P] Chicago, IL b. 29 My 1861, Burlington, IA. Studied: AIC; A.E. Brooks; Nyholm; G. Estebrook; Miss V. Phillips. Member: Arché C. [25]

RUEGG, Aimee. See Seyfort.

RUEGG, Verena [P,E,Li,B] Hollywood, CA b. 30 Ap 1905, San Fran., CA. Studied: Chouinard, Sch. A.; Otis AI. Member: Calif. AC. Exhibited: Calif. State Fair, 1932 (prize); Los Angeles Co. Fair, 1934 (prize), 1935 (prize), 1936 (prize) [40]

RUELLAN, Andrée (Miss) [P,Li,Dr] Woodstock, NY b. 6 Ap 1905, NYC. Studied: L. Lentelli; ASL; Europe; M. Sterne; C. Dufresne; Rome. Member: Woodstock AA; Phila. WCC; AM. S. PS&G. Exhibited: AIC, 1937, 1938, 1940, 1941, 1943; CI, 1930, 1938, 1939, 1940, 1943-45; CGA, 1939, 1941, 1943; CM, 1937, 1938, 1940; PAFA, 1934, 1935, 1939-44, 1945 (prize); VMFA, 1940, 1942, 1944, 1946; Toledo Mus. A., 1938, 1940, 1943; CAM, 1938, 1939, 1941, 1946; Detroit Inst. A., 1943; GGE, 1939; WMAA, 1934, 1937, 1938, 1940, 1942-45; MET (AV), 1943; Univ. Nebr., 1938, 1939, 1941; BM; Woodstock AA (prize); WMA, 1938 (prize). Work: MMA; FMA; W.R. Nelson Gal.; PMG; Springfield Mus. FA; Zanesville AI; Encyc. Brit.; IBM Coll.; PMA; Univ. Nebr.; LOC; WMAA; murals, USPOs, Emporia, Va, Lawrenceville, Ga.; Newark Pub. Lib.; Broadmoor A. Acad. [47]

RUF, Donald Louis [P] Chicago, IL b. 5 S 1906. Studied: A.W. Dunbier; J. Norton; Oberteuffer; AIC [40]

RUFFINI, Elise [L,Edu,P,C,W] NYC b. 7 S 1890, Austin, TX. Studied: Columbia. Co-Author, Co-Ed., "New Art Education Series," 1944. Position: T., Columbia, 1940-46 [47]

RUFFOLO, Gasper J. [P] Chicago, IL b. 22 Ap 1908, Chicago, IL. Studied: AIC; W.J. Reynolds; G. Oberteuffer; C. Pacioni. Member: Assn. Chicago P.&S.; SC; Chicago Gal. Assn.; All-Ill. SFA. Work: State House of Nebr., Lincoln; many portraits of prominent persons [47]

RUFINIA, Sister [P] Lafayette, IN. Exhibited: Hoosier Salon, 1933, 1935, 1937, 1938 (prize), 1940 (prize) [40]

RUGER, Julius [P] Brooklyn, NY b. 1841, Oldenburg, Germany (came to NYC as a youth and served in the Civil War) d. 23 Jy 1906 [01]

RUGGLES, Carl [P,T] Coral Gables, FL/Arlington, VT b. 11 Mr 1876, Marion, MA. Member: S. Vt. Ar. Exhibited: S. Vt. Ar., 1939; Detroit AI, 1938, 1939. Work: WMAA; Addison Gal., Andover, Mass.; BM; Detroit AI [40]

RUGGLES, Theo Alice See H.H. Kitson, Mrs.

RUHE, Miriam S. [P] Phila., PA b. Allentown, PA. Studied: E. Daingerfield; J. Sartain [01]

RUHL, John [S] NYC b. 14 Ap 1873, NYC. Studied: MET Sch. with J.W. Stimson, F.E. Elwell [13]

RUHLAND, Edwin [P] b. 1890, NYC d. 27 Mr 1922, Flushing, NY. Studied: NAD. Specialty: decorative borders. Position: staff, New York Review; Theatre Mag.

RUHLIN, Helena C. [P] Ft. Worth, TX [24]

RUHNKA, Roy [P] Wynnewood, Pa. Member: AWCS [47]

RULE, Fay Shelley (Mrs.) [Min.P] Chattanooga, TN b. 30 N 1889, Chattanoga. Studied: L.F. Fuller; M. Welch; A. Beckington; F.V. DuMond. Member: Chattanooga AA [40]

RULE, Lewis B. [P] Knoxville, TN [13]

RUMBOLD-KOHN, Estelle (Mrs.) [P] NYC. Exhibited: AIC, 1925 (prize) [31]

RUMCHISKY, Blanche [Min.P] Brooklyn, NY [25]

RUMLEY, Lucille [P,T] Hagerstown, IN b. 9 Ag 1901, Preble Co., OH. Studied: Hodgins; King; Wiggins. Exhibited: Richmond AA, 1932; CAFA, 1933 [40]

RUMMELL, John [P,W,L,T] Buffalo, NY b. 24 Ag 1861, Springville, NY. Studied: L.B.C. Josephs; J.F. Carlson; F.V. Du Mond; G. Bridgman. Member: Buffalo SA; AAPL. Exhibited: Buffalo SA, 1917, 1918, 1919, 1921 (prizes), 1934 (prize). Author: "Aims and Ideals of Representative American Painters" [40]

RUMMELL, Richard [P] Brooklyn, NY b. 1848 d. 4 Je 1924.

RUMMLER, Alexander J. [P] Glenbrook, CT b. 25 Jy 1867, Dubuque, IA. d. 1959. Studied: ASL; J.P. Laurens, at Académie Julian. Member: AAPL; SC; Silvermine GA. Exhibited: WFNY, 1939. Work: murals, St. John's Lodge, Norwalk, Conn.; 16 WPA murals, Norwalk H.S., 1937-41 [47]

RUMPH, Alice E(dith) [E,T] Birmingham, AL b. 6 My 1877, Rome, GA. Studied: Colarossi Acad., Paris, with McMonnies, Prinet; Chase; Hawthorne. Member: Chicago SE; SSAL. Exhibited: SSAL, 1939 (prize); WFNY 1939. Position: T., Miss Beard's Sch., Orange, N.J. [40]

RUMSEY, Charles Cary [S] Glen Head, NY b. 1879, Buffalo, NY d. 21 S 1922, Floral Park, NY (automobile accident). Studied: BMFA Sch.; Ecole des Beaux Arts, Paris. Member: Arch. Lg; New S. of Artists; NSS; BAID; S. Animal P. & Sculptors. Work: principally in bronze, statues of race horses. Also known as a polo player. [21]

RUMSEY, Evelyn [P] Buffalo, NY [21]

RUNDLE, Valiquette Morrsion [P] Lincoln, NE b. 5 D 1907, San Diego, CA. Studied: J. Norton; F.P. Glass; Heymann. Member: ASL, Chicago [33]

RUNDQUIST, Ethel Caroline [P,I,E] Minneapolis, MN b. Minneapolis, MN. Studied: AIC [17]

RUNGE, George [P] Minneapolis, MN. Exhibited: Twin Cities Exh., Minneapolis Inst. A., 1936 (prize) [40]

RUNGIUS, Carl [P,E] NYC/Banf, Alberta, Canada. b. 18 Ag 1869, Berlin, Germany (came to NYC in 1894) d. 1959 (age 90). Studied: P. Meyerheim, Berlin. Member: ANA, 1913; NA, 1920; SC; NAC. Exhibited: SC, 1922 (prize), 1923 (prize); NAD, 1925 (prize), 1926 (prize), 1929 (med). Work: NY Zoo. S.; Shelburne (Vt.) Mus.; Glenbow Fnd. has preserved his studio in the Rocky Mtns. as a museum. Specialty: western big game [47]

RUNQUIST, Albert Clarece [P] Portland, OR b. 25 O 1894, Aberdeen, WA. Studied: Univ. Oreg.; Portland A. Mus. Sch.; ASL. Member: Oreg. AG. Exhibited: WFNY 1939; Am. A. Cong., 1939; SFMA, 1940; Portland A. Mus., 1932, 1933, 1935, 1936, 1938, 1942, 1944, 1945. Work: Univ. Oreg. Lib.; murals, USPO, Sedro Wooley, Wash. [47]

RUNQUIST, Arthur [P,E,Li,T] Manzanita, OR b. 27 O 1891, South Bend, WA. Studied: Univ. Oreg.; ASL; Portland A. Mus. Sch. Member: Oreg. AG; Am. Ar. Cong. Exhibited: WFNY, 1939; GGE, 1939; Portland A. Mus., 1938 (prize), 1939; SAM. Work: Portland A. Mus.; murals, Univ. Oreg. Lib.; H.S. Pendleton, Oreg. [47]

RUNYON, S.D. [I] Millington, NJ [13]

RUPEL-WALL, Gertrude [S,C,W,L,T] Berkeley, CA b. Greenville, OH. Member: Am. Ceramic S.; San Fran. SWA; SFAA. Specialties: fountains; decorative tiles; pottery [31]

RUPERT, A.J. [P] Chicago, IL b. Ft. Plain, NY. Studied: RA, Munich [17]

RUPPRECHT, Edgar A. [P] Chicago, IL [21]

RUPPRECHT, George [I,Des] Woodhaven, NY b. 19 N 1901, Brooklyn, NY. Studied: PIASch. Member: SI; A. Gld. [47]

RUSACK, Emmy [P] Yonkers, NY [24]

RUSCH, Mabel [P] NYC [01]

RUSE, Margaret [P] Monessen, PA Member: Pittsburgh AA [21]

RUSH, Clara E. [P] Seattle, WA [24]

RUSH, Frank P. [P] Scottsdale, PA/Uniontown, PA [25]

RUSH, Olive [I,P] Santa Fe, NM b. 1873, Fairmount, IN d. 1966. Studied: Corcoran Sch. A.; ASL, with Twachtman, Mowbray; H. Pyle Sch.; Paris, with R. Miller. Exhibited: CGA; AIC; CI; Mus. N.Mex.; Richmond AA, 1919; Herron AI, 1919 (prize); Hoosier Salon, 1931 (prize); Denver, 1931; Nebr. AA (prize); Wilmington SFA (prize). Work: WMA; BM; PMG; John Herron AI; Wilmington SFA; Witte Mem. Mus.; Nebr. AA; murals, La Fonda Hotel & Pub. Lib, Santa Fe; WPA murals, USPOs, Florence, Colo., Pawhuska, Okla. Illustrator: Collier's, Scribner's. Specialties: women; children; frescos [47]

RUSHMORE, Alice [Min.P] Plainfield, NJ b. 1877, Westbury, NY. Studied: Mme. Debillemont-Chardon, Collin, both in Paris [10]

RUSHMORE, Delight [C] Madison, NJ b. 9 Ap 1912, Madison, NJ. Studied: M. Robinson. Member: NYSC. Specialties: pottery; original glazes [40]

RUSHTON, Desmond V. [P] Los Angeles, CA b. 22 Mr 1895, London, England. Studied: W. Orphen; J. Ward; G.L. Brockhurst. Member: Indp. A. of Los Angeles [25]

RUSK, Rogers D. [P,T,W] South Hadley, MA/McConnelsville, OH b. 17 N 1892. Studied: AIC; Cleveland Sch. A.; W. Adams. Member: Springfield AL; Holyoke AL; NYWCC. Exhibited: Springfield AL, 1935 (prize), 1936, 1937, 1939 (prize). Author: "Atoms, Men, and Stars," 1937. Position: T., Mt. Holyoke Col. [40]

RUSK, William Sener [Edu] Aurora, NY b. 29 S 1892, Baltimore, MD. Studied: Princeton; Johns Hopkins Univ. & abroad. Author: "William Henry Rinehart, Sculptor," 1939. Position: T., Wells Col., Aurora, N.Y. [47]

RUSS, Horace Alexander [P,T] Lake Shore, MS/New Orleans, LA b. 25 Ja 1887, Logtown, MS. Studied: Tulane Univ.; La. State Univ.; Columbia; PAFA. Member: SSAL; NOAA; NOAL; NOACC; La. State T. Assn., Pres. FA Dept. Position: T., Nicholls H.S., New Orleans. [47]

RUSSELL, Albert Cuyp [I,En] b. 1838, Boston, MA. D 1917, Roxbury, MA. He engraved the illustrations used in the Century Dictionary. His father, Moses B. Russell [ca. 1810-48] and mother were both Min. P. Specialty: wood engraving

RUSSELL, Alfred St. Louis, MO. Member: St. Louis AG [25]

RUSSELL, Andrew Joseph [Ph,Ldscp.P] b. 1830 d. 1902. A captain during Civil War, he is best known for documenting railroad construction and army fortifications, and views for Union-Pacific RR, 1868-69. Work: Boston Pub. Lib.; LOC; Mus N.Mex.; Natl. Archives; Oakland MA [*]

RUSSELL, Bruce Alexander [Cart] Los Angeles, CA b. 4 Ag 1903, Los Angeles, CA d. 18 D 1963. Studied: Univ. Calif., Los Angeles; Fed. Sch. Cart.; C.L. Bartholomew; W.L. Evans. Award: Pulitzer Prize, 1946. Work: FBI Coll.; Huntington Lib., San Marino, Calif.; Nat. Press C. Creator: comic strip "Rollo Rollingstone," Assoc. Press Feature Service, 1931–33. Positions: Sports Cart., Los Angeles Evening Herald, 1925–27; Staff Cart., 1927–34; Ed. Cart., Los Angeles Times, from 1934 [47]

RUSSELL, C.D. [I] NYC. Member: SI [47]

RUSSELL, Charles M(arion) [P,S,I,W] Great Falls, MT/Lake McDonald, MT b. 19 Mr 1864, St. Louis, MO d. 24 O 1926. Studied: self-taught. One of America's best-known artists of cowboys and Indians, he worked as a wrangler, 1879–92, and lived with the Blood Indians for 6 months in 1888. His first illus. for Harper's appeared in 1888. He began bronze sculpting in 1904. Work: Amon Carter Mus.; Mus. N.Mex.; Whitney G., Cody, Wyo.; Nat. Cowboy Hall of Fame; major museums [25]

RUSSELL, Dora. See Butcher.

RUSSELL, Edward John [Mar.P,Car,I] b. 1832, Isle of Wight, England (came to Canada ca. 1852; in Boston from 1882) d. 1 S 1906, Boston. Illustrator: London Illus. News, 1857–62, Canadian Illus. News, 1870; travel booklets for Boston and Providence steamship lines. Work: Mariner's Mus.; Mystic Seaport Mus.; Peabody Mus., Salem; Maine Maritime Mus.; Franklin Delano Roosevelt Mus. [*]

RUSSELL, Edward N. [Mar.P] Padanaram, MA (from 1892) b. 1852, West Tisbury, Martha's Vineyard, MA d. 5 My 1927. Studied: NYC. Exhibited: NAD, 1884. Work: Kendall Whaling Mus. Sailor aboard 3 whalers out of Edgartown in his youth. [*]

RUSSELL, Eva Webster (Mrs.) [P] Chicago, IL b. 22 S 1856. Studied: AIC, with Vanderpoel, M. Baker. Member: Chicago Mun. AL. Position: T., McKinley H.S. [10]

RUSSELL, Frank J. [P] Syracuse, NY [24]

RUSSELL, Grace L. [Mar.P] Scarsdale, NY/Rockport, MA b. Caldwell, N.J. Studied: A. Platt; U. Romano; C. Gruppe; P. Perkins. Member: Rockport AA; North Shore AA; Scarsdale AA; Studio G., N.Y.; Yonkers AA; Gloucester SA; Barnard C. Exhibited: North Shore AA; Yonkers AA; Rockport AA; All.A.Am.; Scarsdale AA [47]

RUSSELL, H.B. [P] Boston, MA. Member: Boston AC [31]

RUSSELL, James L. [P] New Albany, ID b. 10 O 1872, New Albany. Member: Louisville AL [25]

RUSSELL, Mark [P,Des,I,T,L] Worthington, OH b. 9 S 1880, Springfield, OH. Member: Ohio WCS; Columbus AL. Exhibited: Columbus AL; Ohio WCS; Ohio State Fair. Work: Last Judgement Window, Little Church Around the Corner, N.Y.; Le Veque Lincoln Tower, Columbus, Ohio. Illustrator: House Beautiful; Doubleday Doran, Garden Books. Position: T., Columbus Gal. FA, Ohio [47]

RUSSELL, Morgan [P,S] NYC b. 1886 d. 1953. Studied: ASL, with J.E. Fraser, 1906; R. Henri, A. Dasburg, 1907; Paris (under Matisse?) 1908; E. Tudor-Hart, 1911. Work: Los Angeles MA. Important modernist who began his abstract synchronist paintings (he called "Eidos") in 1913. His fellow synchronist was S. MacDonald-Wright. [15]

RUSSELL, Shirley (Marie) (Hopper) [P,T,E,B,Des] Honolulu, HI b. 16 My 1886, Del Rey, CA. Studied: Stanford Univ.; Univ. Calif.; Calif. Col. A. & Crafts; Paris, with Delecluse, Morisset, Lhote; Latimer; L. Walden; M. Sheets; Univ. Hawaii. Member: Honolulu AA; Honolulu SA; Lg. Am. Pen Women; Honolulu PM. Exhibited: Los Angeles Mus. A., 1937; Paris Salon, 1927; Oakland A. Gal., 1943–45; Pal. Leg. Honor, 1946; Honolulu Exh., annually; Honolulu Acad. A. (one-man), 1932 (prize), 1935 (prize), 1938 (prize), 1944 (prize), 1945 (prize). Work: Moana Hotel, Army Hospital, Monanaloa Gardens, Acad. A., Supreme Court, all of Honolulu. Position: T., McKinley H.S. [47]

RUSSELL, Virginia Hansford [P,S,T] Richmond, VA b. 23 Ja 1918, Richmond. Studied: Univ. Richmond. Exhibited: Richmond Acad. A.&Sc.; Univ. Richmond [40]

RUSSELL, Walter [P,S,W] NYC/Washington, CT b. 19 My 1871, Boston. Studied: Boston, with A. Munsell, E. Major; H. Pyle; Laurens, in Paris. Member: Spanish Acad. A.&Letters; Soc. A.&Sc. Exhibited: Turin Expo, Italy, 1900. Work: Dallas Mus. FA; bust of T. Edison; Mark Twain Mon./ Mem., Hannibal, Mo.; Mark Twain Mem., Victoria Embankment Gardens, London; Goodyear Mem., Akron. Author/Illustrator: "The Sea Children," "The Bending of the Twig," "The Age of Innocence," "The Universal One," "Salutation to the Day," "The New Electric Theory," "Russell Genero-Radiative Concept." Position: Art Ed., Collier's Weekly, 1897; War Correspondent, Colliers, Century [40]

RUSSELL, William George [Mar.P,Ldscp.P] Atlantic City, NJ b. 6 F 1860, Chatham, England. Studied: self-taught [06]

RUSSIN, Robert I. [S,I,T] NYC (Laramie, WY, 1976) b. 26 Ag 1914, NYC. Studied: CCNY; BAID, with Steinhof. Member: A. Lg. Am.; S. Gld.; Am. Ar. Cong. Exhibited: WFNY, 1939; GGE, 1939; WMAA, 1941; MMA, 1943; AIC, 1942; S. Gld., 1943–46; Assoc. Am. A. Work: U.S. Navy (Abbott Laboratories Coll.); Hyde Park Mem.; WPA sculpture, USPO, Evanston, Ill.; Conshocken, Pa. Positions: T., CUASch (1944–47), Univ. Wyo. (from 1947) [47]

RUSSMANN, Felix [P,Et,Li,T] Oak Park, IL b. 2 Ag 1888, NYC. Studied: NAD; Royal Acad., Munich; E. Carlsen. Member: Chicago SA; Chicago Gal. Assn.; Chicago NJSA. Exhibited: Albright A. Gal.; CGA; AIC; CI; John Herron AI; NAD, 1918 (prize); Chicago Gal., A., 1930 (prize). Work: Oberlin Col; Univ. Ky. [47]

RUSSO, Alexander Peter [P,I,Des] Atlantic City, NJ b. 11 Je 1922, Atlantic City, NJ. Studied: Studied: PIASch. Exhibited: Jackson, MS, 1946; PMG, 1945; Norfolk Mus. A. & Sc.,, 1943; Whyte Gal., 1945 (one-man); Swarthmore Col., 1946 (one-man); Salon de la Marine, Paris, 1945; CGA, 1946 (one-man). Work: Navy Dept., Wash., D.C. Illustrator: "To All Hands," 1944; "Art in the Armed Forces," 1944; "Many a Watchful Night," 1945 [47]

RUSSO, Sally. See Haley.

RUST, Edwin C. [S,L] Brooklyn, NY b. 5 D 1910, Hammonton, CA. Studied: Cornell; Yale; Archipenko; Milles. Member: NSS. Exhibited: WMAA, 1940; CI, 1940; PAFA, 1940; MMA (AV), 1942; VMFA, 1938. Work: Col. William and Mary. Position: T., Col. William and Mary [47]

RUTHRAUFF, Florence May Barlow (Mrs.) [W] Toledo, OH d. 22 Ja 1916. Most of her work was done in NYC.

RUTHRAUFF, Frederick Gray [P,W] Ogden, UT (since 1925) b. 6 Ag 1878, Findlay, OH d. 15 F 1932. Studied: W.V. Cahill; W.H. Clapp; H. Morrisett, Paris. Member: Berkeley LFA; Calif. AC; Odgen AS [31]

RUTHRAUFF, Herbert Haulman [P,Dec,T] Lansdale, PA b. 16 Jy 1894, Chambersburg, PA. Studied: self-taught. Work: Univ. Pa.; Pa. Dept. Welfare; PMA; Phila. Sketch C.; mural, Kirkbride Sch., Phila. Position: T., Lansdale Sketch C. [47]

RUTILI, Renzo R. [Des] Grand Rapids, MI b. 10 Ja 1901. Studied: CI. Specialty: furniture des. [40]

RUTKA, Dorothy [E,Por.P] Cleveland Heights, OH b. 26 Ag 1907. Studied: Cleveland Sch. A.; Huntington Polytech In. Member: Cleveland PM; Artists U. Exhibited: CMA, 1931, 1933 (prize), 1934–36. Work: Cleveland Bar Assn.; CMA [40]

RUTLAND, Emily [Li,P,D] Robstown, TX b. 5 Jy 1892, Lee County, TX. Studied: X. Gonzales; C. Kay-Scott. Member: SSAL; S. Tex. AL.; Texas FAA; Pr. Gl. Exhibited: Int. Pr. Exh., Austin, 1943; WMAA, 1942; Texas General Exh., 1943–45; Caller-Times Exh., Corpus Christi, Texas, 1944, 1945; Houston, 1937, 1939; Texas Women's Fed. C., Lubbock, 1931; SSAL, Nashville, 1935 [47]

RUTLEDGE, Ann [P] Long Beach, CA b. 26 Jy 1890, KS. Studied: V.H. Anderson; G.P.Ennis; C.W. Hawthorne. Member: Midwestern AA; Long Beach AA; Kansas AA [40]

RUTLEDGE, Bertha V. [P] Topeka, KS b. 28 Jy 1890, KS. Data for studied and member are identical to those for Ann. [38]

RUTMAN, Herman S. [Por.P,Des,T] Phila., PA b. 1 Je 1889, Kishineff, Romania. Studied: PMSchIA; PAFA; Temple Univ.; Barnes Fnd. Exhibited: NAD, 1940; Butler AI; Woodmere A. Gal.; YWHA, Phila., 1935 (prize). Work: City Hall, Phila.; des. for lithography. Originator: "Fabri-Graph" [47]

RUTT, Anna Hong (Mrs.) [P,L,T,W] Baton Rouge, LA b. 21 F 1894, Monona County. Studied: Otis AI; Calif. Sch. FA; Univ. Calif.; Los Angeles; Univ. Washington; Columbia. Baton Rouge AL. Exhibited: AIC; Los Angeles Mus. A.; Chicago Norske Klub, 1926 (prize), 1927 (prize); Calif. AC; La. A. Comm.; Los Angeles Mus. A, 1926 (prize); San Bernardino, Calif., 1926 (prize); Painters of the Northwest, 1925 (prize). Position: T., Northwestern Univ., Evanston, Ill., 1926–32 [47]

RUVOLO, Felix [P,Ser,T] Chicago, IL b. 28 Ap 1912, NYC. Studied: AIC. Exhibited: WMAA, 1944; VMFA, 1942, 1944 (prize), 1946; CI, 1941, 1943–45; PAFA, 1941, 1942, 1944; CGA, 1939, 1941, 1943; AIC, 1938–45, 1942 (prize), 1946 (prize); SFMA, 1942 (prize), 1944, 1945

(prize), 1946; Milwaukee AI, 1946 (med); San Fran, 1946 (med). Position: T., AIC, 1944-46 [47]

RUYL, Louis H. [I,E] NYC/ Hingham, MA b. 13, N 1870, Brooklyn, NY. Member: Artists Gld.; Stowaway C. Illustrator: "Cape Cod, Old and New," "Old Post Road, from Boston to Plymouth," "From Provincetown to Portsmouth." [31]

RUYNES [En] Paris, France b. NYC [08]

RUZICKA, Antonin Joseph [P,I,C,T] b. 1891, Racine, WI d. 10 O 1918, France (during WWI). Studied: AIC

RUZICKA, Rudolph [P,I,Des] Dobbs Ferry, NY b. 29 Je 1883, Bohemia. Studied: AIC; N.Y. Sch. A. Member: ANA; AIGA. Exhibited: AI Graphic A. (gold). Work: AIC; CI; MET; LOC; CMA; Brooklyn Mus. A.&Sc. Illustrator: Washington Irving's "Notes of Travel in Europe," Thoreau's "Walden," Oscar Wilde's "Happy Prince," Fables of La Fontaine [47]

RYAN, Angela (Mrs. William Fortune) [P] St. Paul, MN. Studied: ASL. Member: E. Kinzinger, Munich. Exhibited: St. Paul Sch. A., 1940 [40]

RYAN, Anne [G,P] NYC b. 20 Jy 1889, NJ d. 1954. Studied: Columbia; W.S. Hayter; L. Shanker. Member: Studio 17; Vanguard Pr. Group. Work: MET; MOMA; BM [47]

RYAN, Douglas [I] NYC [21]

RYAN, Edward [I] NYC. Related to Douglas Ryan [21]

RYAN, H. Calvin [P] Cleveland, OH. Member: Cleveland SA [27]

RYAN, Kathryn White (Mrs.) [P] NYC. Exhibited: Montross Gal., N.Y., 1937; NAC, 1935, 1939 [40]

RYAN, Sally [S] Redding, CT b. 13 Jy 1916, NYC. Studied: H. Miller, Montreal; J. Camus, Paris. Member: NSS. Exhibited: Paris Salon, 1934, 1935; RA, London, 1935; Royal Scottish Acad., 1935, 1936; Toronto A. Gal., 1933; Montreal A. Gal., 1933; WMAA; WFNY, 1939; CM; AIC; Delgado Mus.; Hartford Atheneum; SFMA; PMA, 1940; Independents, N.Y.; Cooling Gal., London, 1937 (one-man); Marie Sterner Gal., 1937 (one-man); Montreal AA, 1937 (one-man), 1941 (one-man); Wildenstein Gal., 1944 (one-man). Work: Tate Gal., London, Eng. [47]

RYAN, William Fortune [P,T] St. Paul, MN b. Milwaukee, WI. Studied: C. Booth; M. Weber; E. Kinzinger, Munich. Member: Minn. AA. Exhibited: Minneapolis IA; Kansas City AI, 1939; St. Paul Sch. A., 1940; Minn. State Fair, 1927 (prize), 1934 (prize), 1938 (prize); Minneapolis AA, 1927 (prize), 1938 (prize); SAM, 1934 (prize). Work: SAM; Mem. U., Iowa; Iowa State Col., Ames, Iowa. Position: T., St. Paul Sch. A. [40]

RYAN, William Lawrence [P,E,L] Richmond Hill, NY b. NYC. Studied: G.P. Ennis; O.H. Julius; L. DaVinci A. Sch.; NYU; CUAsch. Member: AAPL; A. Edu. Soc., NYU [40]

RYDEEN, Lloyd B. [P] St. Paul, MN [24]

RYDEN, Fleming [S] Chicago, IL b. 1869, Ringamala, Sweden. Studied: AIC; ASL [01]

RYDEN, Henning [S,D,P] NYC/Columbus, OH b. 21 Ja 1869, Sweden d. 27 F 1939. Studied: AIC; Berlin; London. Member: SC, 1908; Allied AA. Exhibited: P.-P. Expo, San Fran., 1915. Work: Am. Numismatic S. [38]

RYDER, Albert P(inkham) [P] NYC b. 19 Mr 1847, New Bedford, MA d. 28 Mr 1917, Elmhurst, NY. Studied: W.E. Marshall, ca. 1870; NAD, 1871. Member: ANA, 1902; NA, 1906; SAA, 1878 (founder); NIAL. Exhibited: NAD, 1880-95; Pan-Am. Expo, Buffalo, 1901 (med). Work: "Toilers of the Sea," MET; AIC; NGA; BMFA; Detroit AI; BM. One of America's greatest romantic painters. A recluse, he constantly reworked his oils, so only 165 are known. He lived to see his work included in the landmark Armory Show, 1913. Many forgeries of his work have been identified. [15]

RYDER, Chauncey F(oster) [P,E,Li] NYC/Wilton, NH b. 29 F 1868, Danbury, CT d. 18 My 1949. Studied: AIC; Académie Julian, with Laurens, Collin, 1901-03. Member: ANA, 1914; NA, 1920; AWCS; Allied AA; SC; NYWCC; NAC; SAE; Calif. PM; Chicago SE; AFA. Exhibited: Lyme AA, 1910-11; Paris Salon, 1903-06, 1907 (prize); P.-P. Expo, San Fran., 1915 (med); Baltimore WCC, 1920 (prize); Central State Fair, Aurora, 1922 (prize); SC (prize); Brooklyn SE (prize); NAC, 1930 (med,prize); AWCS, 1930 (prize); SAE, 1932 (prize); NAD, 1933 (prize); Intl. Expo, Paris, 1937 (gold); Soc. for Sanity in A., Chicago, 1939 (med,prize); AWCS-NYWCC, 1939 (prizes). Work: AIC; Delgado Mus.; Wash. State AA; CGA; Hackley A. Gal., Muskegon, Mich.; Nat Exh. Assn., Toronto; Denver AC; Engineer's C., NYC; Société des Amis des Arts, Douai, France; CAM, St. Louis; Butler AI, Youngstown, Ohio; Minneapolis Inst. A.; NGA; Wilmington SFA; Randolph-Macon Women's Col., Lynchburg, Va.; Quinnipiack C., New Haven, Conn.; Dayton Mus. A.; Macon Ga. AA; MET; Rochester Mem. Art Gal.; Springfield (Ill.) AA; Brooks Mem. A. Gal., Memphis; NYPL; AIC; Dept. Prints and Drawings, British Mus., London.; Dept. Engraving, Victoria and Albert Mus., South Kensington; Graphic A. Dept., Smithsonian Inst., Wash., D.C.; Print Dept., BM; Indianapolis AA; John Herron AI; Hartford (Conn.) Atheneum; New Britain AA; Univ. Ill., Urbana; Cabinet des Estampes, Bibliothèque Nationale, Paris; Newark Mus. A.; Syracuse MFA; New Haven PCC; Montclair AA, N.J.; Houston MFA; PAFA; Joslyn Mem., Omaha; Springville H.S., Utah; Pr. Dept., LOC; CMA [47]

RYDER, Henry Orne [P] Auburndale, MA b. 17 J 1860, Salem, MA. Studied: BMFA Sch.; Paris, with Boulanger, Lefebvre, P. Schmitt. Member: BAC [08]

RYDER, Jane G. [P,S,T] North Cambridge, MA [13]

RYDER, Marilla [P] Roxbury, MA [25]

RYDER, Platt Powell [Por.P] Brooklyn, NY b. 11 Je 1821, Brooklyn. d. 15 Jy 1896, Saratoga Springs, NY. Studied: Paris, London, 1869-70. Member: ANA 1868; Brooklyn Acad. Des. (founder). Exhibited: NA beginning 1850 [*]

RYDER, Worth [P,L,T] Berkeley, CA b. 10 N 1884, Kirkwood, IL. Studied: Univ. Calif.; ASL; RA, Munich, with M. Doerner, H. Hofmann. Member: San Fran. AA; Univ. Calif. AC & Faculty C.; Pacific AA. Exhibited: P.-P. Expo, San Fran., 1915 (med) (gold); San Fran. AA, annually; GGE, 1939. Work: SFMA; Calif. Acad. SC.; Piedmont, Calif. H.S. Position: T., Univ. Calif., from 1926 [47]

RYERSON, Margery Austen [P,E,Li,I,T,W] NYC b. 15 S 1886, Morristown, NJ. Studied: Vassar; Columbia; ASL, with Bridgman, Henri, Hawthorne. Member: ANA; SAE; Wash. WCC; Calif. PM; Grand Central A. Gal.; Allied AA; Provincetown AA; Phila. SE; Southern PMS; Chicago SE. Exhibited: NAD; PAFA; CGA; AIC; CAM; Phila. SE; Southern PM; Calif. PM; Phila. Pr. C.; All. A.Am.; NAC; Montclair A. Mus. (prize). Work: BM; Bibliothèque Nationale, Paris; CMA; Smithsonian; Roerich Mus., NYC. Position: Ed., Henri's "The Art Spirit," 1924; "Hawthorne on Painting," "Hints to Artist-Painters," by M. Fischer [47]

RYERSON, Martin Antoine [Patron] Chicago/Lake Geneva, WI b. 26 O 1856, Grand Rapids d. 11 Ag 1932. Member: AIC, 1887 (Pres., 1925-32). In his fifty years of collecting, he was among the first to envision the worth of the French Impressionists. The Ryerson Coll. now belongs to the AIC. In 1901 he presented the Institute with the 25,000-volume art library.

RYERSON, Mary McIlvaine [S] NYC/Provincetown, MA b. Phila., PA d. 19 Mr 1936. Studied: Saint-Gaudens, NAD; Solon Borglum; Fraser. Exhibited: NAD; PAFA [33]

RYLAND, L.H. (Mrs.) See Hamilton, Hildegarde.

RYLAND, Robert Knight [Mur.P,I] NYC/Russellville, KY b. 10 F 1873, Grenada, MS d. 9 N 1951. Studied: Bethel Col.; NAD; ASL; Am. Acad., Rome, schol.; 1903-05. Member: ANA; SC; ASMP; All.A.Am.; Mural P.; Brooklyn SA. Exhibited: NAD, 1924 (prize); CGA; CAM; AIC, 1926; BM; Brooklyn SA; SC. Work: Syracuse MFA; Washington Irving H.S., N.Y.; Supreme Court, N.Y.; Newark Mus. Illustrator: Everybody's, Delineator, McCall's [47]

RYMAN, C.M. [Min.P] Wilkes-Barre, PA [24]

RYON, James P. [P] NYC [21]

RYPSAM, Russell [P] NYC. Member: AWCS [47]

RYTHER, Martha [P] NYC [19]

S

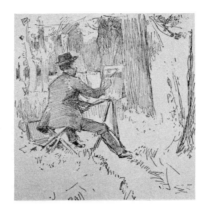

Albert Sterner: *With Pipe and Brush*. From *The Illustrator* (1893)

SAALBURG, Allen Russell [P,I] NYC b. 25 Je 1899, Rochelle, IL. Studied: ASL. Exhibited: WMAA; Kraushaar Gal.; AIC, 1939; murals, WFNY, 1939 [40]

SAARINEN, Eliel [Des,Arch] Bloomfield Hills, MI b. 1873, Helsingfors, Finland. Studied: Inst. Polytech, Helsingfors. Member: White Rose Order of Finland; Finnish Acad. A.; Imperial Acad. A., Russia; Royal Acad., Stockholm; Detroit Chap. AIA; Mich. S. Arch; Jury of Arch. Comp., Olympiad, Paris, 1924, Los Angeles, 1932; Colmubus Mem. Light-tower Comp., Santo Domingo. Exhibited: Arch. Lg., 1931 (gold); Nat. Comp., Smithsonian, 1939. Work: railway station, Keirkner Gal., associate on Nat. Mus., all in Helsingfors; town halls, in Lahti and Joensuu, Finland; Estobank, Reval, Estonia; Cranbrook Acad. A.; Cranbrook Sch. Boys, Kingswood Sch. for Girls, Bloomfield Hills, Mich. Position: Pres., Cranbrook Acad. A. [40]

SAARINEN, Lilian [S] NYC. Studied: H. Warneke; A. Stewart; B. Putnam; M. Grotell. Exhibited: Huntington, 1937 (prize); Wash., D.C. Art Fair, 1943 (prize). Work: USPOs, Carlisle, Ky., Bloomfield, Ind. [47]

SAARINEN, Loja (Mrs. Eliel) [S,Des] Bloomfield, MI b. Helsingfors, Finland. Studied: Helsingfors AI; Acad. Colarossi. Member: Decorators C., NYC; Detroit SAC; Helsingfors AS. Work: Cranbrook Acad. A.; Hudnut Salon, Yardley Shop, NYC; Chrysler Show Room, Detroit; Mendelssohn House, Bloomfield Hills, Mich. and Millbrook, N.Y. [40]

SABA, Rintaro [P] Westfield, NJ [17]

SABATINI, Raphael [P,S] Phila., PA b. 26 N 1898, Phila., PA. Studied: C. Grafly; E. Bourdelle; F. Leger. Work: PAFA; Phila. Mus. A.; Allentown Mus. Position: T., Temple Univ., Phila. [40]

SABER, Clifford [I,W,P,L] NYC b. 10 Jy 1914, Lawrence, MA. Member: SI. Exhibited: AWCS; CGA, 1944 (one-man); SI, 1943 (one-man). Contributor: National Advertising [47]

SABLE, Lawrence W. [P] Baltimore, MD [17]

SAC, Ollet [P,E,Li] New Orleans, LA b. 12 O 1900, Albuquerque, N.Mex. Studied: H.A. Nolan. Member: SSAL [33]

SACCARO, Giovanni [G,P] San Francisco, CA b. 2 S 1913, San Francisco, CA. Exhibited: SFMA, 1939 (one-man); AIC, 1939; Portland (Oreg.) Mus. A., 1939; Cincinnati Mus., 1939; Oakland A. Gal. [40]

SACHS, Carl I. [Por.P,Dr] Chicago, IL b. 24 Ap 1896. Work: State Capitol, Springfield [40]

SACHS, Joseph [P] Phila., PA b. 1 S 1887, Shavil, Russia. Studied: PAFA; Anshutz; Chase; Kendall. Member: Phila. Sketch C.; Phila. Alliance [24]

SACHS, Paul Joseph [Edu,W,L,Cr] Cambridge, MA b. 24 N 1878, NYC d. 19 F 1965. Studied: Harvard. Member: Archaeological Inst. Am. Author: "Focillon Memorial Volume of Gazette des Beaux-Arts". Co-author: "Drawings in the Fogg Museum," 1941. Position: Ass. Dir, FMA, 1915–44 [47]

SACHSE, Emma F. [P] Phila., PA. Studied: PAFA [25]

SACKER, Amy M. [Des,L,T] Boston, MA b. 17 Jy 1876, Boston. Studied: DeCamp; J.L. Smith; C.H. Walker; Rome. Member: Boston SAC; Copley S.; AFA. Exhibited: Pan-Am. Expo, Buffalo, 1901 (med); Boston SAC, 1930 (med). Illustrator: children's books. Position: Dir., Sacker Sch. of Design and Interior Dec., Boston [40]

SACKET, Laura Frances [B] Furlong, PA b. 23 Ap 1907, Syracuse, NY. Studied: PMSchIA. Member: Phila. Print C.; Phila. Alliance. Exhibited: Phila. Print C., 1936. Work: Royal Mus. Art, Ontario, Canada [40]

SACKETT, Clara E(lisabeth) [Por.P,T] NYC/Westfield, NY b. Westfield, NY. Studied: ASL; Paris, with Aman-Jean, Acad. Delecluse, Acad. Vitti. Member: Buffalo SA; Buffalo Gld. AA; Copley S.; Boston GA. Exhibited: Buffalo SA (prize). Work: Buffalo Hist. S. [40]

SACKETT, Edith S. [P] Providence, RI. Member: Woman's AC [01]

SACKETT, Richard R(oman) [Dr,L,P,W] Minneapolis, MN b. 21 O 1909, Bentonville, AR. Studied: Fed. Sch., Milwaukee AI. Exhibited: Minn. State Fair, 1932 (prize). Author: articles on Indian Lore, Minn. History. Position: Asst. State Dir., Hist. Records Survey [40]

SACKS, Joseph [P] Phila., PA b. 1 S 1887, Shavil, Russia. Studied: PAFA; Anshutz; Chase; Kendall. Member: Phila. Alliance. Exhibited: PAFA, 1932 (prize). Work: PAFA [40]

SACKS, Walter Thomas [Ldscp.P] Caledonia, NY b. 30 O 1901, Phila., PA. Member: S. Sanity A.; Rationalists. Exhibited: Rochester AC, 1938 (prize), 1939 (prize). Work: Bevier Fnd.; Rochester Athenaeum; Mechanics Inst., Rochester, NY [40]

SACKSTEDER, Aloys (Miss) [Cer,Des,S] Sandusky, OH b. 8 S 1911, Dayton, OH. Studied: Cleveland Sch. A.; Kent State Univ.; Ohio State Univ. Member: AL, Columbus, Ohio. Exhibited: Syracuse MFA, 1936–41; Paris Salon, 1937; GGE, 1939; Columbus AL, 1937–40; Pa. Exh., 1938; Columbus Gal. FA; NAC, 1940; Phila. A. All., 1937, 1939; Ohio-Pa. Exh., 1938. Position: T., Ind. State T. Col., 1938– [47]

SAECKER, Austin [P] Appleton, WI b. 13 F 1896, Appleton d. 1974. Studied: Wis. Sch. A.; A. Mueller; G. Moeller; F. Fursman; NAD; Paris; PAFA. Member: Wis. PS. Exhibited: Milwaukee AI, 1924 (med); Business Men's AC; Wis. PS, 1926 (prize), 1927 (prize). He became a hermit. [33]

SAEMONDSSON, Nina [S] Hollywood, CA. Exhibited: S. exh., Oakland A. Gal., 1938; WFNY, 1939 [40]

SAFFORD, Charles Putnam [P] San Diego, CA b. 18 N 1900, Logansport, IN. Studied: PIASch [40]

SAFFORD, Ruth Perkins [Ldscp.P] Wash., D.C. b. Boston, MA. Studied: Mass. Sch. A.; H.B. Snell; E.L. Major; J. De Camp; H. Breckenridge. Member: Gld. Boston A.; AWCS; Wash. WCC; Wash. AC; Copley S.; Boston AC; North Shore AA; NAWPS. Exhibited: Critics Choice, Cincinnati; New England Contemp. A.; AWCS; CGA. Work: portraits, Lee Mansion, Marblehead, Mass.; Arlington, Va.; U.S. Naval Acad., Annapolis [47]

SAGE, Cornelia Bentley (Mrs. W.W. Quinton) [Cr,Mus.Dir,P,W] Hollywood, CA b. 3 O 1876, Buffalo d. 17 My 1936. Studied: Buffalo ASL; ASL, NYC, with Twachtman, Beckwith, Wiles, Reid. Member: Buffalo SA; Calif. AC; Los Angeles AA; Natl. Advisory Committee, Sesqui-Centenn. Expo, Phila., 1926. Exhibited: NYWCC. Awards: Decoration of L'Officier de l'Instruction Publique, Paris, 1917; Decoration Palme d' Academique, 1917; Cross of the Legion of Honor, 1921; Sorolla Med., 1925. Positions: Dir., Pal. Leg. Honor (1924–30), Albright Gal. (1910–24) [33]

SAGE, Jane (Mrs. Cass Canfield) [S] NYC/Bedford, NY b. 29 Ap 1897 Syracuse, NY. Studied: J.E. Fraser; L.G. Fraser; F. Grimes; M. Young; A. Bourdelle; A. Salemme. Exhibited: Arch. Lg.; Weyhe Gal., NYC; WFNY, 1939 [40]

SAGE, Jennie A. [Min.P] Hackensack, NJ [19]

SAGE, Kay (Mrs. Yves Tanguy) [P] Woodbury, CT (since 1941) b. 25 Je 1898, Albany d. 1963. Exhibited: AIC, 1945 (prize), 1946–47; Corcoran, 1951 (prize); WMAA, 1946–51; CI, 1946–50; TMA, 1947–49; Pal. Leg. Honor, 1949–50; Univ. Ill., 1949, 1951; Herron AI, 1947, 1948, 1951; Los Angeles MA, 1951; BM, 1951; Detroit IA, 1952; Milan, Italy, 1936; SFMA, 1941; Cornell, 1977. Author: "Piove in Giardino," 1937 [*]

SAGE, Olive K. [P] Hartford, CT. Member: New Haven PCC [25]

SAGLE, Lawrence William [P] Baltimore, MD [25]

SAGUE, Julia [P] Poughkeepsie, NY [10]

SAHLER, Helen (Gertrude) [P,S,W] NYC b. Carmel, NY d. 3 D 1950. Studied: ASL; H. MacNeil; E. Yandell. Member: All.A.Am.; CAFA; North Shore AA; NAWA; N.Y. Mun. AS; Numismatic S.; AFA; Nat. AC. Exhibited: NAD, 1944, 1945 (prize) & prior; PAFA; Arch. L., 1945; NAWA, 1945; All.A.Am., 1945; AIC; CGA; Albright A. Gal.; CM; WFNY, 1939; Sesqui-Centenn. Expo, Phila. Work: Am. Numismatic S.; Macon Col. Lib.; Col. Physicians & Surgeons, NYC; church, Fall River, Mass.; Hackley Chapel, Tarrytown, N.Y.; Scarborough, N.Y. Contributor: The Outlook; International Book Review; American Review [47]

SAHULA-DYCKE, Ignatz [P,I,T] Dallas, TX b. 5 Jy 1900, Bohemia. Studied: Chicago Acad. FA. Member: Chicago A. Dir. C. Exhibited: AIC, 1926 (prize). Position: A. Dir., Tracy, Locke, Dawson, Dallas. Position: T., YMCA, Dallas [40]

SAID, Claus Milton [B,Car,Des,I,L,T,W] New Orleans, LA b. 27 My 1902, Memphis. Studied: C. Schroeder; P.B. Price; C. Ferring; F. Grant; C. Werntz; AIC; Chicago Acad. FA. Member: Tenn. SA (Pres.); AAPL; SSAL; Artist Gld. Memphis; Miss. AA. Creator: comics, "Inkid," "Buddy and Jazz" [40]

SAILORS, Robert D. [C,Des,Gr,Car,L,T] Cranbrook Acad. A., Bloomfield Hills, MI b. 23 My 1918, Grand Rapids, MI. Studied: Olivet Col.; AIC; Cranbrook Acad. A., 1944. Exhibited: La France Comp., Phila., 1945 (prize); Intl. Textile Exh., Greensboro, N.C., 1945 (prize); MOMA, 1944, 1945; AIC, 1944; AFA Traveling Exh., 1944; SFMA, 1945; MIT, 1946; Cornell Univ., 1945; Dallas Mus. FA, 1945; Detroit Inst. A., 1946; Wichita A. Mus., 1946; Royal Mus. A., Toronto, 1945; CM, 1946; Dayton AI, 1946; Univ. Minn., 1944; Olivet Col., 1944; Brooklyn Col., 1944; Sioux City, Iowa, 1946. Work: textiles/rugs, Weathersport A. Gal. and Cranbrook Acad. A. Position: T., Cranbrook Acad. A., from 1943 [47]

SAINT, Lawrence [P,W,I,C,L] Huntingdon Valley, PA b. 29 Ja 1885, Sharpsburg, PA d. 15 Je 1961. Studied: PAFA; W. Chase; C. Beaux; H.R. Poore; Kendall; J.H. Rudy. Member: F., Royal SA, London. Work: stained glass drawings, Victoria & Albert Mus., London; CI; NYPL; Free Lib., Phila.; CMA; stained glass windows, Wash. Cathedral, Wash. D.C.; five windows, Bryn Athyn Cathedral, Pa.; fifteen windows, Nat. Cathedral, Wash., D.C.; window, Riverside Cemetery, Norristown, Pa.; window, Episcopal Church, Hillsboro, N.C.; maker of medieval type glass-ware, White House, Wash., D.C.; work reproduced in 3-reel educational motion picture by MET. Author/Illustrator: "Lawrence Saint's Stained Glass Creed," "A Knight of the Cross," 1914, "Stained Glass of the Middle Ages in England & France," 1913. Contributor: trade publications; bulletins. [47]

SAINT, Louise [P] Paris, France [25]

SAINT CLAIR, Gordon [P] Chicago, IL. Member: Chicago SA [27]

SAINT CLAIR, Norman [Ldscp.P] Los Angeles, CA (since ca. 1897) b. 24 N 1863, England d. 6 Mr 1912, Pasadena, CA. Specialty: watercolor. Possibly the first painter in Laguna Beach, (1906) [10]

SAINT-GAUDENS, Annetta Johnson (Mrs. Louis) [S,C] Cocoanut Grove, FL/Cornish, NH b. 11 S 1869, Flint, OH d. 5 Ap 1943, Pomona, CA. Studied: Columbus A. Sch.; ASL, with Twachtman, Saint-Gaudens. Member: NAWPS; Columbus AL; NYSC; AAPL. Exhibited: NAWPS, 1913 (prize); Panama-Calif. Expo, San Diego, 1915 (med); P.-P. Expo, San Fran., 1915. Work: Columbus Gal. FA; Carpenter Hall Gal., Dartmouth. Position: Associated with Orchard Pottery, Cornish and Pelican Pottery, Cocoanut Grove [40]

SAINT-GAUDENS, Augusta Homer (Mrs. Augustus) [Patron] Died at her home "Aspet", Cornish, N.H., July 7, 1926. She had maintained her husband's studio since his death, and had secured replicas in bronze and plaster of practically all of his work, which with Aspet, all of its furnishings and the studios formed the Augustus Saint-Gaudens Memorial, incorporated in 1919.

SAINT-GAUDENS, Augustus [S] NYC/Cornish, NH b. 1 Mr 1848, Dublin, Ireland (brought to NYC when 6 months old) d. 3 Ag 1907, Cornish, NH. Studied: apprenticed to two NYC cameo-cutters, Avet (1861–64) and Jules le Brethon (1864–67); studied at CUASch, NAD, beginning 1864–67; Ecole des Beaux–Arts, Paris, with Jouffroy, 1867–70; in Florence and Rome, 1870–72. Member: SBA; Institute of France; NSS; NA, 1889; SA, 1877; Arch. Lg., 1902; Boston S. Arch.; Century; NIAL; Royal Acad., London. Exhibited: Paris Salon, 1880 (prize); Paris Expo, 1900 (prize); Pan-Am. Expo, Buffalo, 1901 (medals); St. Louis Expo, 1904 (gold). Work: Saint-Gaudens Nat. Historic Site, Cornish; Admiral Farragut statue in Central Park, NYC (his first public commission, 1881); equestrian statue of General Sherman, preceded by "Victory" in NYC, 1903; Shaw Mem. (a large bronze panel in high relief), Boston; "Samuel Chapin, Puritan," Springfield (Mass.) and Phila.; his strongest portrait statue, the "Lincoln," Chicago; In Rock Creek Cemetery, Wash., D.C., is one of his most impressive works, a bronze seated figure of a woman lost in thought. It is a memorial to Mrs. Hubert Adams, but bears no inscription. He also executed many small portrait medallions, plaques and busts; the coinage of eagles and double eagles is from his designs. A vast amount of his work was left unfinished at his death, but a large part of it had been carried far enough for it to be completed by those who had been working with him. His "infinite power for taking pains" is well illustrated from the fact that it took him twelve years to complete the Shaw Mem. Many of the pedestals and architectural bases of his monuments were designed by the late Stanford White. [04]

SAINT-GAUDENS, Carlota (Mrs. Homer) [Min.P] Pittsburgh, PA/Cornish, NH b. 11 O 1884, Rochester, NY d. 24 O 1927. Studied: PAFA; ASL, with Chase, Cox, Brush. Member: ASMP; Pa. SMP; NAC; Cornish (N.H.) Colony [25]

SAINT-GAUDENS, Homer [Mus.Dir,Edu,L] Pittsburgh, PA b. 28 S 1880, Roxbury, MA d. 8 D 1958. Studied: Harvard; abroad. Member: Am. Assn. Mus. Dir.; Cornish (N.H.) Colony. Awards: Order of the Crown of Italy, 1928; Chevalier Order of Leopold, 1929; Legion of Honor, 1933; Commander Hungarian Order of Merit, 1938; Hon. Foreign Corresponding Member of the Royal Acad., London, 1942. Author: "Reminiscences of Augustus Saint-Gaudens," 1909, "The American Artist and His Times," 1941. Position: Dir. FA, CI, from 1922 [47]

SAINT-GAUDENS, Louis [S] Cornish, NH b. 8 Ja 1854, NYC d. 8 Mr 1913. Studied: his brother, Augustus; Ecole des Beaux-Arts, Paris. Member: NSS; Cornish (N.H.) Colony. Exhibited: Pan-Am. Expo, Buffalo, 1901 (med). Work: "Lions," Boston Pub. Lib.; St. Louis Mus.; medal, MET [13]

SAINT-GAUDENS, Paul [C,S,W,L,T] Cornish, NH b. 15 Je 1900, Flint, OH. Studied: BMFA Sch.; A. Archipenko; C. Binns; F. Applegate; O.L. Bachelder. Member: Cornish (N.H.) Colony; Boston SAC; N.Y. Soc. Craftsmen; N.H. Lg. A. & Craftsmen; Phila. SAC. Exhibited: nat./intl. ceramic exhibits. Work: vases, St. Martin's Chapel, Denver; Newark Mus.; Denver A. Mus. Position: potter, Orchard Kilns, Cornish, N.H. [47]

ST. JOHN, J. Allen [P,I] Chicago, IL b. Chicago. Studied: ASL, with Mowbray, Chase, Beckwith, DuMond; J.P. Laurens, in Paris. Member: Chicago PS; Cliff Dwellers; Chicago Gal. A. Positions: T., AIC, Business Men's AC, Chicago [33]

ST. JOHN, Lola Alberta [P,C,Des] Albany, IN b. 16 Jy 1879, Albany. Studied: H.R. McGinnis; Cincinnati A. Acad., with Nowottny, Meakin; Indianapolis, with J.O. Adams, B. Steele. Member: Ind. Fed. AC; Muncie AA. Exhibited: Muncie AA (prize); Ind. State Fair, 1933 (prizes), 1934 (prizes), 1935 (prizes), 1937 (prizes). Work: Montpelier (Ind.) Lib.; Tipton AA. Specialty: china painting and des. [40]

ST. JOHN, Susan Hely (Mrs.) [P] b. 1833 d. 25 O 1913, Boston. Studied: G.P.A. Healy, Chicago

SAINT-LANNE, Louis [S] NYC b. 1871, France. Work: Fountain of the Seals/statue, NYC; equestrian statues, Charleston, Elkins, W.Va. [40]

ST. LEGER, Isabella Henrietta [P] NYC d. 21 D 1926 [21]

ST. PIERRE, Charles [P] Duluth, MN [17]

SAISETT, Ernest Pierre De [P] b. San Jose, CA d. D 1899, San Jose. Studied: Académie Julian with Lefebvre, Bouguereau, Constant

SAKIER, George [Des,P,W] NYC b. 24 D 1897, NYC. Studied: Columbia; PIASch. Member: F., Soc. Indst. Des. Exhibited: MET; MOMA; Phila.

A. All. (one-man); PMA; WMA; Century of Progress, Chicago; GGE, 1939; WFNY, 1939; Paris Salon. Contributor: articles, House and Garden, Advertising Arts. Specialty: des., Fostoria glassware [47]

SALA, Jeanne [P,L] Wilmington, DE b. 3 Jy 1899, Milan, Italy. Studied: Wilmington, A. Ctr.; PAFA, Europe; F. Bishop; N.C. Wyeth; E. O'Hara. Member: A. All., Plastic C., Pr. C., all in Phila.; Rehoboth AL; Wilmington A. Ctr.; Studio Group, Wilmington. Exhibited: Wilmington A. Ctr., 1941–45; PAFA, 1943–46; Studio Group, 1940–45; Woodmere A. Gal., 1945; Phila. Plastic C., 1946; Rehoboth AL, 1944. L: Correlation of Art & Music. [47]

SALEMME, Antonio [S,P,G,T] NYC b. 2 N 1892, Gaeta, Italy. Studied: A. Zanelli, in Rome; Boston; Paris. Member: BAID; F., Guggenheim, 1932, 1936. Exhibited: PAFA; AIC, 1930 (prize); WMAA; MET. Work: MET; Newark Mus.; Syracuse MFA [47]

SALERNO, Charles [S,T] NYC b. 21 Ag 1916, NYC. Studied: K. Nicolaides. Exhibited: PAFA, 1942; WMAA, 1946; Newport AA, 1944; Clay C., NYC, 1946; Weyhe Gal., 1946 (one-man); CM, 1946. Work: Providence (R.I.) Mus. A. Contributor: "G.I. Sketchbook" [47]

SALERNO, Vincent [I] NYC b. 10 F 1893, Sicily, Italy. Studied: A.S. Calder; F.C. Jones; NAD; BAID [31]

SALGANIK, Jassa [Por.P] NYC b. 1887, Kiev, Russia (came to U.S. in 1906) d. 31 Jy 1937. Studied: Kiev Conservatory; Md. Inst. Arts. Work: portraits, Pres. Taft, Charles Curtis, Cardinal Hayes, Cardinal Mundelein

SALIERES, Sylvain [T,S] b. Auch Gers, France (came to NYC in 1902) d. 28 F 1920. Studied: Ecole des Beaux-Arts, Paris. Exhibited: Paris Salon, (med). Award: Grand Prix de Rome. Work: sculpture, Grand Central Station, NYC. Position: T., CI, 1916–20

SALING, Henry (Frederick) [P] Hartford, CT/Lyme, CT b. 3 Mr 1901, Hartford. Studied: P.E. Saling; M. Jacobs; J.G. McManus. Member: CAFA; Springfield AL. Exhibited: Springfield AL, 1932 (prize) [40]

SALING, Paul E. [P] Hartford, CT/Lyme, CT b. 19 Jy 1876, Germany d. 6 Mr 1936. Studied: Germany; C.N.B. Flagg; A. Bunce; Conn. Lg. A. Students. Member: SC; CAFA; Conn. Lg. A. Students; Springfield AL; AFA. Exhibited: CAFA, 1915 (prize), 1934 (prize), 1935 (prize). Work: Storrs Col., Storrs, Conn.; East Hartford Trust Co.; Odd Fellows Temple, Hartford; Elks' Temple, New London, Conn. [33]

SALINGER, Flora [P] NYC [01]

SALISBURY, A(lta) W(est) (Mrs. William) [P,T] New Rochelle, NY b. 1879, Darnestown, MD d. 9 Ja 1933. Studied: Corcoran Sch. A.; C. Yates; L. Dabo; Fontainebleau Sch. FA; Dresden. Member: NAWPS; Brooklyn SA; Wolfe C.; New Rochelle AA; CAFA; Westchester ACG. Exhibited: New Rochelle AA (prize); Wolfe C. (prize); NAWPS, 1930 (med). Work: Ebell C., Los Angeles; Women's C., New Rochelle [31]

SALISBURY, Cornelius [P,T] b. 1882, Richfield, UT d. 1970, Salt Lake City. Studied: J.F. Carlson, 1904; Univ. Utah, 1905; Brigham Young Univ, 1907–8, with Eastmond; ASL, 1908; PIASch 1909–10; Corcoran Sch. A., 1916–18; Broadmoor A. Acad., 1927. Specialty: views in Salt Lake City and ghost towns [*]

SALISBURY, Dorothy [P] Maplewood, NJ. Member: AWCS [47]

SALISBURY, Eve [P,Dec,T] NYC b. 28 F 1914. Studied: Nat. Acad.; Grand Central Sch. A.; Roerich Acad. Exhibited: French Bldg., Rockefeller Center, N.Y., 1937. Work: USPO, Harrington, Del. Illustrator: Forum, 1935. WPA artist. [40]

SALISBURY, Laura Walker (Mrs. W.L.) [Por.P] Columbus, GA b. Georgia. Studied: W.M. Chase, N.Y. [06]

SALISBURY, Lee H(erbert) [P,I,E,W,L,T] Chicago, IL/Edgerton, WI b. 22 Ja 1888, Verdon, SD [25]

SALISBURY, Paul [P,I] b. ca. 1903, Richfield, UT. Studied: his uncle Cornelius Salisbury. Illustrator, Western subjects for magazines [*]

SALISBURY, Rosine Howard (Mrs. Cornelius) [P,T] b. 1887, New Brunswick, Canada d. 1975, Salt Lake City. Studied: Harwood, Richards, both in Utah; Univ. Utah, with Frazer, 1914; Calif., 1922, 1928 [*]

SALISKE, Helen V. (Mrs. James H.P. Conlon) [P] Branford, CT b. 21 Mr 1909, New Britain, CT. Studied: A.E. Jones; C.C. Vetter. Member: Hartford Soc. Women P.; Assn. Conn. Ar. Exhibited: Hartford Soc. Women P., 1937, 1939; CAFA [40]

SALKO, Samuel [P,Dec] Phila., PA b. 11 F 1888, Russia. Studied: PAFA, with D. Garber, P. Hale, R. Vonnoh. Member: Providence WCC; Springfield A. Lg.; Irvington A. & Mus. Assn.; Jackson (Miss.) AA. Exhibited: AWCS, 1944, 1945; PAFA, 1935, 1936, 1941; Phila. Sketch C., 1934; Butler AI, 1943, 1945, 1946; Baltimore WCC, 1939; Mint Mus. A., 1943–46; Saranac A. Lg., 1943, 1944; State T. Col., Indiana, Pa., 1944–46; Oakland A. Gal., 1941–43, 1945; Jackson AA, 1942, 1944–46; Providence WCC, 1943–46; Providence AC, 1943; Newport AA, 1944, 1945; Ohio Univ., 1946; CAFA, 1946; N.J. Soc. P.&S., 1945; Irvington A. & Mus. Assn., 1944–46; Montgomery (Ala.) WCC, 1944; Parkersburg FA Ctr., 1944–46; Woodmere A. Gal., 1945, 1946; Pacific Northwest Assn., 1946; Irvington (N.J.) Pub. Lib., 1944 (one-man); Cushing Mem., Newport, R.I., 1945 (one-man). Work: U.S. War Dept.; Univ. Pa. Hospital

SALLA, Salvatore [Por.P] Oak Park, IL b. 3 Ag 1903, Kosrowa, Persia. Studied: L. De Mango, in Constantinople [40]

SALLEY, Eleanor King (Mrs.) [P,Dr,I] Tallahassee, FL b. 5 Ap 1909, Marlow, OK. Studied: M. Avey. Member: Tallahassee AC; Fla. Fed. A.; SSAL; Pensacola AC. Exhibited: Pensacola AC, 1930 (prize); Gulf Coast AA, Biloxi, Miss., 1932 (prize); Montross Gal., N.Y., 1939 (one-man). Work: portraits, Pensacola A. Cl., Fla. Supreme Court, Capital City Bank, Capitol, Brevard Sch., all in Tallahassee; murals, Beach Casino, Pensacola Hospital, both in Pensacola; paintings, Tallahasee Women's C.; Women's C., Live Oak, Fla. Illustrator: maps; newspapers; school books [40]

SALMIG, Paul E. [P] Hartford, CT [19]

SALMON, Lionel E. [P] Tacoma, WA [25]

SALOOMEY, Mabel Kaiser [Des,P] Milford, CT b. 19 Ap 1908, Bridgeport, CT. Studied: Yale. Specialty: screen and textile design [40]

SALSBURY, Edith Colgate [Ldscp.P,Por.P] NYC b. 14 Ag 1907, Bedford, NY. Studied: ASL; J. Lie; Ecole des Beaux-Arts, Fontainebleau Sch. FA. Member: NAWPS; NAC [40]

SALTER, Stefan [Book Des.] Old Greenwich, CT b. 28 S 1907, Berlin. Studied: England; Germany. Exhibited: AIGA, 1945 (prize); "50 Books of the Year." Position: A. Dir., American Book-Stratford Press, 1937–43; Wolff Book Manufacturing Co., 1943– [47]

SALTONSTALL, Elizabeth [Li,P,T] Chestnut Hill, MA b. 26 Jy 1900, Chestnut Hill. Studied: BMFA Sch.; Lhote, in Paris; S. Wengenroth; F.S. Chase; P.L. Hale; H.H. Clark. Member: NAWA; Nantucket AA. Exhibited: LOC, 1944–46; NAD, 1944, 1946; NAWA, 1940–46; Jordan Marsh Gal.; Inst. Mod. A., Boston, 1943–45; Northwest Pr.M., 1945, 1946; Laguna Beach AA, 1945, 1946. Work: BMFA; LOC; Yale. Position: T., Milton Acad., 1928– [47]

SALTUS, J. Sanford [Patron] NYC b. 1853, New Haven, CT d. 24 Je 1922, London. Member: British Numismatic Soc. (Pres.); Am. Numismatic Soc. (Hon. Pres.); Legion of Honor of France; SC. He gave annually the Saltus medal for merit at the National Academy of Design, and gave rare books on costume to the library of the Salmagundi Club. He donated $25,000 to the fund for the erection of the Joan of Arc statue on Riverside Drive, and presented a replica of it to the city of Blois, France. He also gave a life-size statue of Joan of Arc to the Cathedral of St. John the Divine for the French Chapel. [21]

SALTZMAN, Mary P(eyton) E(skridge) [P] Wash., D.C./Hague, NY b. 28 Mr 1878, Ft. Leavenworth, KS. Member: Wash. AL; S.Indp.A., Wash. [33]

SALTZMAN, William [Mur.P,T,Des] Minneapolis, MN b. 9 Jy 1916, Minneapolis. Studied: Univ. Minn. Member: United Am. Ar. Exhibited: Minneapolis Inst. A., 1936 (prize); 1937–41; Minn. State Fair, 1936, 1937 (prize), 1940 (prize), 1941; Pal. Leg. Honor, 1946; St. Paul Gal. A., 1946; Minneapolis Women's C.; Walker A. Ctr., 1941 (one-man); St. Olaf Col., 1938 (one-man); Univ. Minn., 1939 (one-man). Work: murals, Univ. Minn.; paintings, Cummington Sch., Mass. Position: Asst. Dir., Univ. Minn. A. Gal., 1946– [47]

SALVATORE, Victor [S,P,T] NYC b. 7 Jy 1885, Italy d. 10 Ap 1965. Studied: C. Niehaus; A.P. Proctor. Member: NSS, 1913; A. Aid S.; Arch. Lg.; Century A. Exhibited: St. Louis Expo, 1904 (med); P.-P. Expo, San Fran., 1915 (med); NAD, 1919 (prize); AIC, 1919 (prize); Concord AA, 1920 (prize). Work: MET; Brooklyn Mus. A.; Mus. A., Portland, Oreg.; James Fenimore Cooper Hall of Fame, N.Y. [47]

SALZ, Helen (Mrs. Ansley K.) [P] San Fran., CA b. 30 N 1883, San Fran. Studied: Henri; G. Piazzoni. Member: San Fran. AA; San Fran. Soc. Women Ar. Exhibited: WC Ann., SFMA, 1939; Morton Gal., N.Y., 1939. Work: SFMA [40]

SALZBRENNER, Albert [P] Salt Lake City, UT [15]

SAMBUGNAC, Alexander [S,P] NYC b. 22 Ap 1888. Studied: F. von Stuck, in Munich; A. Bourdelle, in Paris. Member: NSS; Arch. Lg. Work: USPOs, Mount Pleasant (Pa.), Miami (Fla.), Rochester (Mich.); Courthouse, Miami; Mus. FA, Budapest; Cathedral, Vienna; Capitol, Havana. WPA artist. [40]

SAMERJAN, George E. [Des,P,T,L,S,I] Hollywood, CA b. 12 My 1915, Boston. Studied: Otis AI; Chouinard AI; A. Brook; W. Nash; B. Miller; S. Reckless. Member: Calif. WCC; A. Dir. C., Los Angeles; Aquarelle P.; San Diego FA Soc. Exhibited: AIGA, 1941 (prize); Los Angeles Adv. C., 1940 (prize); A. Fiesta, San Diego, 1938 (prize), 1939-42; Calif. WCC, 1938-42, 1943 (prize); Santa Cruz A. Lg., 1942 (prize); Oakland A. Gal., 1940 (med); Laguna Beach AA, 1939 (prize); NAD, 1941; VMFA, 1940, 1942, 1943; PAFA, 1938-40, 1943; AWCS, 1941, 1942; Denver A. Mus., 1941, 1942; San Fran. AA, 1940-42; Los Angeles Mus. A., 1939, 1941, 1942; New Haven PCC, 1941; Wash. WCC; CGA; Riverside Mus., 1938, 1939, 1941; Calif. State Fair, 1939-41; Santa Paula, Calif., 1942-45; Santa Barbara A. Mus.; Grand Central A. Gal.; SAM; Los Angeles AA; Santa Cruz A. Lg.; Calif. Inst. Tech.; Liège, Belgium; Paris, France. Work: San Diego FA Soc.; hospital, Lexington, Ky.; Am. Red Cross; murals, USPO, Maywood, Calexico, Culver City, all in Calif. WPA artist. Positions: A. Dir., Los Angeles Times, 1946-; T., Occidental Col., Calif. [47]

SAMMANN, Detlef [P] Pebble Beach, CA [17]

SAMMEL, Carrie E. [P] Moline, IL [15]

SAMMET, E.R. [P] Columbus, OH. Member: Columbus PPC [25]

SAMMONS, Frederick Harrington Cruikshank [P] Chicago, IL b. 1838, Bath, England d. S 1917. Studied: J. Gruder, in Dresden; J. Marshall, in Weimar. Member: Chicago SA. Official restorer of paintings for the Chicago AI. Godson of G. Cruikshank. [17]

SAMPLE, Paul Starrett [P,T] Norwich, VT b. 14 S 1896, Louisville, KY d. 1974. Studied: Dartmouth; Otis AI; J. Lie, 1926; F.T. Chamberlin. Member: AWCS; Calif. AC; ANA, 1937; NA, 1941; Calif. WCS. Exhibited: Los Angeles Mus. A., 1930 (prize), 1936 (prize); Calif. AC, 1930 (prize), 1931 (prize); NAD, 1931 (prize); Pasadena AI, 1932 (gold); Calif. State Fair, 1932 (prize); Santa Cruz A. Lg., 1933 (prize); PAFA, 1936 (gold). Work: MMA; BM; BMA; AIC; Springfield Mus. A.; Fnd. Western A., Los Angeles; White House, Wash. D.C.; Canajoharie (N.Y.) Lib.; San Diego FA Soc.; AGAA; Butler AI; Joslyn Mem.; Brooks Mem. A. Gal.; RISD Mus.; Univ. Nebr.; Swarthmore Col.; Williams Col.; Univ. Minn.; Univ. Southern Calif.; New Britain Mus. A.; Dartmouth. Positions: T., Univ. Southern Calif., 1926- , Dartmouth, 1938-62; War Art Correspondent, Life, 1942-45 [47]

SAMPSON, Alden [P,W] NYC b. 13 Mr 1853, Manchester, ME [21]

SAMPSON, Emma Speed (Mrs. Henry A.) [P] Louisville, KY b. Chatsworth, Crescent Hills, KY. Studied: ASL; Académie Julian, Paris, with Lefebvre, Constant [01]

SAMPSON, John H. [Des,Ldscp.P] Chicago, IL b. 15 Jy 1896, Rush County, IN. Member: Hoosier Salon. Designer: packages for merchandise and advertising [40]

SAMSTAG, Gordon [P,I,T] Bronxville, NY b. 21 Je 1906, NYC. Studied: NAD; Hawthorne; Neillson. Member: ANA, 1939; CAFA; Allied AA. Exhibited: NAD, 1931 (prize), 1936 (prize); PAFA, 1936 (prize); All.A.Am., 1936 (prize); Pulitzer traveling scholarship, 1938; Palm Beach AL, 1935 (prize); CAFA, 1936 (prize); CI; CGA. Work: TMA; USPOs, Scarsdale, N.Y., Reedsville, N.C. WPA artist. Position: T., NAD, 1940 [47]

SAMUEL, Helene [P] New Orleans, LA b. 6 N 1894, Superior, WI. Studied: Académie Julian, Paris; B. Karfiol; G.E. Browne. Member: A.C.C., New Orleans; SSAL. Exhibited: Shreveport AC, 1938 (prize); SSAL, Montgomery, Ala., 1938; Argent Gal., N.Y., 1939 (one-man). Work: Seaton Gld., Minneapolis [40]

SAMUEL, William M.G. [P] b. 1815, Missouri d. 1902, probably San Antonio, TX. Studied: self-taught. Work: Witte Mus., San Antonio. Specialties: painter of Tex. town views and notables at mid-century. Came to Texas late 1830s; later became a sheriff. [*]

SANBORN, C.T. [P] Brooklyn, NY. Member: S.Indp.A. [25]

SANBORN, Caroline V. (Mrs. Nestor) [P,T] Brooklyn, NY b. 1843 d. 29 O 1943. Taught art in her own studio and in private schools.

SANBORN, Earl Edward [P,T,Des] Annisquam, MA b. 21 My 1890, Lyme, NH d. 26 Jy 1937. Studied: BMFA Sch., with Burbank, Tarbell, Benson, Paxton. Member: Boston AC; Stained Glass Assn. of Am.; Rockport AA. Exhibited: Boston Tercentenary Exh., 1931 (gold). Award: BMFA traveling scholarship, 1914-16. Work: stained glass, National Cathedral, Wash., D.C.; Trinity Col., Chapel, Hartford, Conn.; Boston Col. Lib., Boston; St. Margaret's Convent, Boston [33]

SANBORN, Herbert James [Mur.P,Li,L] Arlington, VA b. 28 O 1907, Worcester, MA. Studied: NAD; Columbia; Univ. Chicago. Member: AA Mus.; Am. Assn. Adult Edu. Exhibited: Pulitzer Traveling F., 1929; W.Va. Artists, Parkersburg, 1940 (prize); Arch. Lg., 1931; Davenport Mun. A. Gal., 1933; Joslyn Mem., 1934; Parkersburg FA Ctr., 1940; Wickford (R.I.) AA, 1929. Work: Children's Orthopedic Hospital, Univ. Iowa. Illustrator/Editor: "Hill Towns of Spain" (ten lithographs), 1930. Positions: Dir., Davenport Mun. A. Gal. (1933-35), Mus. Oglebay Inst., Wheeling, W.Va. (1936-42); Consultant, LOC, 1946- [47]

SANBORN, Percy A. [Mar.P,T] b. 10 F 1849, Belfast, ME d. 23 N 1929. Studied: house dec., William Hall. Work: Mystic Seaport Mus.; Penobscot (Maine) Marine Mus. Illustrator: woodcuts, local newspaper [*]

SAND, Alice L. [P] NYC. Member: Lg. AA [24]

SAND, Henry A.L. [P] NYC. Member: Lg. AA [24]

SANDEFUR, John Courtney [E] Los Angeles, CA b. 26 My 1893, Indiana. Studied: A.E. Philbrick. Member: Chicago SE; Ill. Acad. FA. Exhibited: Hoosier Salon, Chicago, 1928 (prize) [32]

SANDERS, Adam Achod [S] Brooklyn, NY b. Je 1889, Sweden. Studied: BAID. Member: CCA; AFA; Brooklyn PSS; College AA. Work: Lincoln Mem. Coll., Wash., D.C.; Lib. of Friends of Music, N.Y. Designer: Schubert medal. Author: "The Theory of Altoform," 1945. Conductor: Metropolitan Opera House, N.Y. [47]

SANDERS, Bernard [E] NYC b. 9 O 1904, NYC. Studied: W.A. Levy. Work: Fifty Prints of the Year, 1931, 1932. Illustrator: "Maggie." Position: in charge of research in the drawings of the mentally ill, Bellevue Hospital, N.Y. [40]

SANDERS, Bertha D. [P] NYC b. Illinois. Studied: AIC; Cox, DuMond, in N.Y.; Merson, Collin, Julien Dupré, Aman-Jean, all in Paris [15]

SANDERS, H.M. [P] Indianapolis, IN [25]

SANDERS, Helen Fitzgerald [I] Butte, MT [13]

SANDERS, Herbert Harvey [C,Des,T] Alliance, OH b. 29 Ap 1909, New Waterford, OH. Studied: A.E. Baggs. Member: Columbus AL; San Diego AGL; Central Calif. Cer. C. Exhibited: Columbus Gal. FA, 1933 (prize), 1934 (prize), 1937 (prize); Robineau Mem. Exh., Syracuse Mus. FA, 1934 (prize), 1939 (prize); GGE, 1939. Work: Mus. FA, Syracuse. Contributor: Design. Position: T., San Jose State Col. [40]

SANDERS, Isaac [S] Bronx, NY [19]

SANDERS, S. Kent [P] Paris, France [10]

SANDERS, William Brownell [Patron] b. S 1854, Cleveland d. 25 Ja 1929, Boston. Member: Am. Fed. Arts; John Herron Art and Polytechnic Trust (trustee); Horace Kelley Art Fnd.; CMA (first Pres.)

SANDERSON, Bill (William Seymour) [Car] Mound City, IL b. 16 D 1913, Mound City. Studied: Chicago Acad. FA. Creator: comic strip "Pete Pentube," for RCA Radiotron Company. Cartoonist: Collier's; "Hooey"; "Illinois Central" [40]

SANDERSON, Charles Wesley [Ldscp.P] Boston, MA b. 1835, Brandon, VT d. 8 Mr 1905. Studied: J. Hope, in Vt.; S.L. Gerry, in Boston; Paris, with Boulanger, Oudinot; The Hague, with Van Borselen, Mesdag. Member: Boston AC [04]

SANDERSON, Henrietta [Por.P] West Caldwell, NJ b. 2 Ap 1909, Nashville, TN. Studied: G.E. Browne; M. Jacobs. Member: Allied AA; NAWPS [40]

SANDERSON, Raymond Phillips [S] Scottsdale, AZ b. 9 Jy 1908, Bowling Green, MO. Studied: AIC; Kansas City AI; R. Josset. Exhibited: WFNY, 1939; Denver A. Mus., 1939-42; Tempe (Ariz.) State T. Col., 1946 (one-man); Ariz. PS, 1938. Work: monument, Bisbee, Ariz.; carvings, U.S. Maritime Comm. vessels; Hotel Westward Ho, Hotel Adams, Phoenix, Ariz. [47]

SANDERSON, William [P,I,T,Des] Denver, CO (1969) b. 1905, Latvia (came to NYC in early 1920s). Studied: Berlin; NAD, 1923-28; ASL. Work: Denver AM. Positions: Staff A., PM Newspaper, NYC, 1938-42; T., Univ. Denver Sch. A., 1946 [*]

SANDFORD, Joseph E. [P] Brooklyn, NY. Member: GFLA [27]

SANDHAM, Henry [P,I] Boston, MA (1881–1901); London (1901–1912) b. 1842, Montreal, Quebec d. 6 Ja 1912, London. Studied: O.R. Jacobi; J.A. Frazer. Member: R. Canadian A. (charter member, 1879); Copley S., 1899; Boston AC. Exhibited: Phila. Centenn. Expo, 1876 (med); London 1886 (med); Boston, 1881 (med); Royal Acad. London; Salon Paris. Work: Natl. Gal., Canada. Illustrator: "Picturesque Canada," 1882; "Century," 1883; "Art Amateur," 1885; "Lenore," by E.A. Poe, 1886; "Ramona," by H.H. Jackson, 1886. [06]

SANDHAM, R.C.A. [I] Boston, MA. Position: Affiliated with Lamson, Wolffe & Co., Boston[98]

SANDONA, Matteo [P] San Fran., CA b. 15 Ap 1883, Schio, Italy. Studied: Acad. FA, Verona, Italy; Nani; Bianchi. Member: San Fran. AA; Bohemian C., San Fran.; AFA. Exhibited: Calif. State Fair, 1917 (med), 1926 (prize); Chicago Gal. Assn., 1926 (prize); Santa Cruz A. Lg., 1932 (prize); Lewis & Clark Expo, 1905 (med); NAD; Sesqui-Centenn. Expo, Phila., 1926; PAFA, 1926; AIC, 1927; Bay Region A. Assn., 1939 (prize); Jury of Awards, P.-P. Expo, 1915. Work: NGA; Pal. Leg. Honor; Mills Col.; Salt Lake City, Utah, H.S.; Springville (Utah) H.S.; Women's City C., San Fran.; portraits of several governors; plaque, Veterans War Mem., San Fran.; Golden Gate Park Mem. Mus., San Fran.; Punahou Col., Honolulu; Calif. Capitol, Sacramento; San Fran. Opera House; Hahemann Hospital, San Fran.; Bohemian C., San Fran. [47]

SANDOR. See Katz, A. Raymond.

SANDOR, Mathias [Por.P,Min.P,Ldscp.P] NYC b. 10 Jy 1857, Hungary (came to U.S. in 1881) d. 3 N 1920, NYC. Studied: ASL, 1885–86; Académie Julian, with Flameng and Ferrier, 1889–90. Member: SC, 1898; A. Fund. S. Specialty: well known for his Hopi Indian scenes at Taos [19]

SANDOW, Franz [S,I,Des] Berkeley, CA b. 24 D 1910, Hawaii. Studied: Univ. Calif. Member: United Am. Ar.; Am. Ar. Cong. Am. Ar. Prof. Lg. Exhibited: San Fran. MA; Oakland A. Gal. Work: relief, Labor Temple, Oakland; sculpture, Woodminster Amphitheater, Oakland [40]

SANDRECZKI, Otto [P] NYC [17]

SANDS, Anna M. [P] Wash., D.C. Member: Wash. WCC; S. Wash. A. [25]

SANDS, Ethel [P] London, England b. Newport, RI. Studied: Rolshoven; E. Carrière, in Paris [08]

SANDS, Gertrude Louis [G,Des] Berkeley, CA b. 15 S 1899, Cawker City, KS. Studied: AIC; Calif. Sch. FA; W. Gaw. Member: San Fran. A. Assn. Exhibited: San Fran. A. Assn., 1937; San Fran. MA; Pal. Leg. Honor [40]

SANDY, Percy T. [P] Taos, NM. Exhibited: First Nat. Exh. Am. Indian Painters, Philbrook A. Center, 1946 (prize) [47]

SANDZEN, (Sven) Birger [P,E,En,B,Li,Des,T,L] Lindsborg, KS b. 5 F 1871, Bildsberg, Sweden (came to Kansas in 1894) d. 19 Je 1954. Studied: Stockholm A. Lg., with Zorn, Bergh, Erlandsson; Paris, with Aman-Jean. Member: AWCS; Calif. WCS; Phila. WCC; Prairie Pr. M.; Chicago SE. Exhibited: Kansas City A., 1917 (prize); Phila. WCC, 1922 (prize); Taos SA, 1922. Work: LOC; AIC; BM; Yale Univ. A. Gal.; Mus. N.Mex., Santa Fe; British Mus., London; USPO, Lindsborg, Kans.; Sandzen Mem. Gal., Lindsborg. Author: "With Brush & Pencil." Specialty: Impressionist landscapes of the Rocky Mtns. WPA artist. Position: T., Bethany Col., Lindsborg, Kans. [47]

SANDZEN, Margaret (Mrs. Charles P. Greenough, III) [P,L,T] Lindsborg, KS b. 16 Je 1909, Lindsborg. Studied: Bethany Col.; Columbia; ASL; B. Sandzen; G. Bridgman; F. DuMond. Member: NAWA. Exhibited: Kans. State Fair, 1940 (prize); Rockefeller F., 1939–40 (prizes), 1940–41; NAWA, 1941 (prizes); Kansas City AI; Stockholm, Sweden; Dallas, 1936; Kansas City AI, 1933, 1935, 1939. Contributor: "Kansas." Position: T., Bethany Col., Lindsborg, 1934–37, 1942–46 [47]

SANELL, Louis [P] Kansas City, MO [21]

SANFORD, Edward Field, Jr. [Arch-S] Williamsburg, VA b. 6 Ap 1887, NYC. Studied: ASL; NAD; Académie Julian, Paris; Royal Acad., Munich. Work: Core Mem., Norfolk, Va.; Capitol, Sacramento, Calif.; finial figure/three colossal Gothic figures, Ala. Power Co. Bldg.; colossal figure, Yale Univ. Gymnasium; two colossal groups, Bronx County Court House, Francis P. Garvin Mausoleum (Woodlawn); animal frieze, N.Y. State Roosevelt Mem. Position: Dir., Dept. of Sculpture, Beaux-Arts Inst. Des., 1923–25 [40]

SANFORD, Isobel Brugess [P,Des] Burlingame, CA b. 22 D 1911, Edmonton, Alberta. Studied: Calif. Sch. FA; ASL, with M. Kantor; Parsons Sch. Des. Exhibited: NAD, 1946; Los Angeles Mus. A., 1945; AV War Posters Exh., 1942; San Fran. AA, 1935, 1936, 1940, 1941, 1944; Oakland A. Gal., 1942–44 [47]

SANFORD, John Williams, Jr. [P,G] Charlottesville, VA b. 10 Jy 1917, NYC. Studied: ASL; Grand Central Sch. A. Exhibited: Baylis Mus., Univ. Va.; Soc. Wash. Ar., Corcoran Gal., 1940 [40]

SANFORD, Marion [S] NYC b. 9 F 1902, Guelph, Ontario. Studied: PIASch; ASL; B. Putnam. Member: ANA; NSS; All.A.Am.; Arch. Lg.; NAWA; AAPL. Exhibited: NAD, 1943 (med); All.A.Am., 1945 (prize); AAPL, 1945 (prize); PBC, 1946 (prize); NAWPS, 1937 (prize); WFNY, 1939; WMAA, 1940; PAFA, 1943–46; NAD, 1938–46; All. A. Am., 1944, 1945; NAWA; Audubon A., 1945; Newport An., 1940. Work: PAFA; Brookgreen Gardens, S.C.; Warren (Pa.) Pub. Lib.; Trinity Mem. Church, Warren, Pa.; St. Mary's Chapel, Faribault, Minn.; USPO, Winder, Ga. Illustrator: "The Sculptor's Way," 1942. WPA artist. [47]

SANGER, Grace H.H. C(ochrane) [P,I] Ruxton, MD b. 15 Je 1881, Newark, NJ. Studied: H. Pyle; W.M. Chase; H. Breckenridge. Member: North Shore AA; Baltimore WCC; Baltimore Mun. A. Soc.; Baltimore Friends A. Work: McDonogh Sch., Md. Illustrator: "Eve Dorre" [40]

SANGER, I.J. [B,P,Des] NYC b. 8 Ja 1899, Port Republic, VA. Studied: A.W. Dow; Columbia. Exhibited: Phila. Print C., 1929 (prize), 1931 (prize); Fifty Prints of the Year, 1931; Fine Prints of the Year, 1936. Work: NYPL; Newark Pub. Lib., San Diego FA Gal. [40]

SANGER, William [P,G,E] NYC b. 10 Mr 1888, France (or 12 N 1875, Brooklyn, NY). Studied: CUASch; ASL; Artists & Artisans Inst., N.Y. Exhibited: Soc. Am. E., 1939. Work: Hispanic Mus.; WMAA; Newark Mus.; BM; MMA; entire cycle of figures of the Gate of Glory, Santiago Cathedral, Spain; Avery Library, Columbia [47]

SANGERNEBO, Alexander [S] Indianapolis, IN b. 1 My 1856, Esthonia, Russia d. 23 Ja 1930. Member: Ind. AC; Indianapolis Arch. C.; Indianapolis Athenaeum. Work: Indianapolis: Mural Temple; Lincoln Hotel; Union Station; Guarante Bldg.; Blind Institution; St. Joan of Arc Church; Ayres Bldg.; Ind. Nat. Guard Armory; Ind. Theatre; County Court House, Lebanon, Ind. [29]

SANGERNEBO, Emma Eyles (Mrs. Alexander) [S,P] Indianapolis, IN b. Pittsburgh. Studied: W. Forsyth. Member: Ind. AC; Nat. Lg. Am. Pen Women; AAPL. Work: Garfield Park, Washington H.S., Elizabeth Hitt Mem., Women's Dept. C., Loew's Theatre, all in Indianapolis; Union Bldg., Bloomington, Ind. [47]

SANGRÉE, Theodora (Mrs. Settele) [P,Li] Chappaqua, NY b. 9 Ja 1901, Harrisburg, PA. Studied: B. Robinson; K.H. Miller; T.H. Benton [40]

SANKEY, Clifford H., Mrs. See Jamison, Celia.

SANKOWSKY, Itzhak [P] Merion, PA b. 9 Mr 1908, Kishinew, Romania. Studied: Univ. Pennsylvania; Acad. Florence, Italy; A.B. Carles. Member: Phila. A. All. Exhibited: Wash. WCC, 1941; AIC, 1941; PAFA, 1940; Woodmere A. Gal., 1940, 1941; Y.M.H.A., Phila. 1939 [47]

SANON, John A. [P,T] Palo Alto, CA b. 1860 d. 25 Ag 1929. Member: Bohemian C. Position: Dean, San Fran. AI

SANTA EULALIA, Alexis (Count [of]) [P] Ashbourne, PA [13]

SANTEE, Ross [I,G,W] Phoenix, AZ (1936–41) b. 16 Ag 1889, Thornburg, IA d. 1965, Globe, AZ. Studied: AIC, ca. 1900–04; G. Bellows, 1908. Exhibited: Ariz. PS, 1938. Illustrator: "Powder River," 1938, "We Pointed Them North," 1939. Author/Illustrator: "Men and Horses," 1926, "Cowboy," 1928 [40]

SANTO, Pasquale (Patsy) (Mr.) [P] Bennington, VT b. 25 D 1893, Corsano, Italy. Exhibited: CI, 1943–45; PAFA, 1944; CGA, 1943, 1945; CAM, 1945; Stendahl Gal., Los Angeles, 1941; AGAA, 1943; TMA. 1943; Marie Harriman Gal., 1940–42; Macbeth Gal., 1944; MOMA, 1936, 1939, 1943; MMA, 1943; Albany Inst. Hist.&A., 1942, 1945; Pittsfield A. Lg., 1943; Williams Col., 1941; Bennington, Vt.; Manchester, Vt., 1938, 1939. Work: MOMA; WMAA; Univ. Ariz.; CI [47]

SAPP, Kitt George (Mr.) [P] Independence, MO b. 20 N 1887, Independence. Studied: Kansas City AI; Univ. Kansas City; Colorado Springs FA Ctr. Exhibited: Sedalia State Fair, 1939 (prize); Springfield, Mo., 1940 (prize); Joslyn Mem., 1945 (prize); Kansas City AI, 1938, 1939. Work: murals, Kansas City Stock Exchange [47]

SARDEAU, Helene (Mrs. George Biddle) [S] Croton-on-Hudson, NY b. 7 Jy 1899, Antwerp, Belgium d. 23 Mr 1968. Studied: ASL; N.Y. Sch. Am. S. Member: S. Gld. Exhibited: Arch. Lg., 1934 (prize), 1941; Salon d'Automne, Paris, 1928; PMA, 1934; GGE, 1939; WFNY, 1939; AIC, 1941; MOMA, 1940; AFA, 1940; PAFA, 1946; MMA, 1940; BM, 1940; CI, 1941; Arden Gal., 1923 (one-man); NAC (one-man); Ehrich Gal.,

1930 (one-man); Rome, Italy, 1932 (one-man); Julian Levy Gal., 1934 (one-man); Santa Barbara Mus. A., 1943 (one-man); Assoc. Am. A., 1944 (one-man); Carlen Gal., 1946 (one-man). Work: reliefs, Croton-on-Hudson H.S.; USPO, Greenfield, Mass.; Fairmount Park, Phila.; Nat. Lib., Rio de Janeiro; Supreme Court, Mexico City; WMAA; Y.M.H.A. Bldg., N.Y.; masks, Delphic Festival, Greece; USPO, Ossining, N.Y. [47]

SARFF, Walter Smith [P,Des,T,W] NYC b. 29 O 1905, Pekin, IL. Studied: Chicago Acad. A.; ASL; Grand Central A. Sch.; H. Ropp; Woodstock Sch. P. Member: Woodstock AA; Ulster County Ar. U. Exhibited: Woodstock AA, 1931 (prize), 1937 (prize); Nat. Acad. A., 1931 (traveling scholarship); Portland, Oreg., AM; 48 Sts. Comp., 1939; San Diego Expo, 1935; U.S. Nat. Mus., Wash. D.C.; CGA; Grand Central A. Gal.; WMA; Natural Hist. Bldg., Wash., D.C.; Denver A. Mus. Positions: Dir., Sawkill PS Gal., Woodstock; Pres., "Fashion Forecasts," NYC[47]

SARG, Mary [Por.P,T,I] New Hope, PA b. 24 Ap 1911, London. Studied: W. Reiss; ASL; Phoenix Art Inst.; N.Y. Sch. Applied Design for Women; J. Lie; G.W. Parker; Fontainebleau Sch. FA. Member: NAWPS. Illustrator: "Children's Corner," 1935, "Happy as Kings," 1936, "American Girl," 1935, "Today", 1935, 1936; Woman's Day, 1938, Junior Red Cross News, Mademoiselle, 1939. Position: T., Keramic Soc. & Des. Gld., N.Y. [40]

SARG, Tony [Des,Dec,Car,I,S,L,W] NYC/Nantucket, MA b. 24 Ap 1880, Guatemala d. 7 Mr 1942, NYC. Member: SC; SI. Author/Illustrator: "Book for Children," "Alphabet," "Marionette Book," "Trickbook." Illustrator: "Speaking of Operations," "Fiddle D.D." Creator: marionettes and the motion picture shadowgraph productions [40]

SARGEANT, Clara McClean [P] Cleveland, OH b. 24 Je 1889, Washington, IA. Studied: Cleveland Sch. A.; ASL; Corcoran Sch., Wash., D.C. Member: Women's AC, Cleveland. Exhibited: Cleveland Mus. A., 1922 (prize), 1924–28 (prizes) [29]

SARGEANT, Geneve Rixford [P,Li,T] San Fran., CA b. 14 Jy 1868, San Fran. Studied: AIC; Calif. Sch. FA; A. Lhote; O. Friesz, in Paris. Member: San Fran. AA; NYSWA; San Fran. Women A. Exhibited: San Fran. Women A. (prize), PAFA, 1941; numerous one-man exh., San Fran. Work: Mills Col.; de Young Mem. Mus.; Los Angeles AA; SFMA; Acad. Sc.&FA, Richmond, Va. [47]

SARGENT, Anita W. [P] Boston, MA/Bryn Mawr, PA b. 8 D 1876, Phila. Studied: W. Sartain; E. Daingerfield; E. Tarbell [10]

SARGENT, Florence Mary [P,I,C] London, England/Harlow-on-Thames, Bucks, England b. 21 Jy 1857, London. Studied: Paris, with Legros, Merson. Member: Arts and Crafts Soc.; N.Y. Women's AC. Exhibited: NAD, 1891 (prize) [10]

SARGENT, Irene [T,L,Cr,W] d. 14 S 1932, Syracuse, NY. Member: American Inst. Arch. & Allied Arts (the second woman to be elected an honorary member of the Inst.). Contributor: U.S., French, Italian publications. Position: T., Syracuse Univ., for 36 years

SARGENT, John S(inger) [Por.P,Mur.P] London, England b. 12 Ja 1856, Florence, Italy d. 15 Ap 1925. Studied: Acad. FA, Florence, 1871-72; Carolus Duran, in Paris. Member: ANA, 1891; NA, 1897; Mural P.; Port. P.; Copley S.; AIA; Paris SAP; Soc. Nat. des Beaux-Arts, Paris; Royal Acad., London (Assoc., 1894; R.A., 1897); Century Assn., N.Y.; NIAL; Phila. WCC; Berlin Acad.; Inst. de France, 1905. Exhibited: Paris Salon, 1878 (prize), 1881 (med); Paris Expo, 1889 (prize); Phila. AC, 1890 (med); Columbian Expo, Chicago, 1893 (med); PAFA, 1894 (gold), 1909 (gold); Pan-Am. Expo, Buffalo, 1901 (gold), 1903 (gold); Berlin, 1903 (gold); St. Louis Expo, 1904 (prize); Liège Expo, 1905 (gold); Venice, 1907 (gold); NIAL, 1914 (gold). Awards: Chevalier of the Legion of Honor, France, 1889; Order of Merit, Germany, 1909. Work: Boston Pub. Lib.; Luxembourg Mus., Paris; Tate Gal., London; Uffizi Gal., Florence, Italy; MMA; Buffalo FA Acad.; Boston Mus.; Worcester (Mass.) A. Mus.; PAFA; Brooklyn Inst. Mus.; Indianapolis AA; National Gal.; AIC; CGA. Important Impressionist and master of the bravura brush stroke, his work, along with Whistler's, was in greater demand by high society than that of any other American artist. [24]

SARGENT, M(argarett W.) [S] Wellesley, MA b. 31 Ag 1892, Wellesley. Studied: Woodbury; Borglum. Member: NAWPS [40]

SARGENT, Mary F. (Mrs. William Dunlap) [E,S,T,L,I] Westport, CT b. 4 Jy 1875, Somerset, PA. Studied: Pa. Col. for Women; ASL; Columbia; W.P. Robbins; P. Bornet; Inst. d'Esthetique Contemp., Paris; Cen. Sch. A., London. Member: PBC; CAFA; NAWA; Silvermine Gld. A. Exhibited: Pa. Col. for Women, 1895 (gold); SAE, 1942–44; LOC, 1944; NAD, 1943; NAWA, 1942, 1943; Silvermine Gld. A., 1940–43; CAFA, 1940–42, 1946; New England Pr. Assn., 1941; Soc. Liberal A., Omaha, Nebr., 1944; Morton Gal., 1939 (one-man); Studio Gld., 1940; PBC,
1944–46. Work: MMA; LOC; BM; Brooks Mem. A. Gal.; G.W.V. Smith A. Mus.; H.S., Somerset, Pa. Illustrator: House Beautiful [47]

SARGENT, Paul Turner [P] Charleston, IL b. 23 Jy 1880, Hutton, IL. Member: Brown County A. Gal. Assn.; Hoosier Salon. Work: Univ. Ind. Bloomington [40]

SARGENT, Richard [P] Crestwood, NY. Work: USPO, Morrilton, Ark. WPA artist. [40]

SARGENT, Walter [P,E,W] North Scituate, RI b. 7 My 1868, Worcester, MA d. 19 S 1927. Studied: Colarossi Acad., Delecluse Acad., both in Paris; L'hermitte, Paris; Delance, in Paris. Member: Copley S., 1896; Paris AAA; Chicago PS. Author: "How Children Learn to Draw," "Art Education in the United States," "The Enjoyment and Use of Color." Positions: T., Univ. Chicago, Boston Pub. Sch., AIC; State Supv. Drawing, for Mass. [25]

SARISKY, Michael A(loyisus) [P] Cleveland, OH b. 24 S 1906. Studied: H.G. Keller; H. Tonks; Slade Sch. Member: Cleveland SA. Exhibited: Ann. Exh. Work by Cleveland Artists and Craftsmen, CMA, 1931 (prize), 1932 (prize), 1933. Award: Prix de Rome, 1930, 1933. Work: USPO, Barnesville, Ohio. WPA artist. [40]

SARKA, Charles Nicolas [Mur.P,Dr,Dec] NYC/Canada Lake, NY b. 6 D 1879, Chicago. Member: AWCS. Exhibited: Arch. Lg., 1913 (prize); St. Louis Pageant, 1914 (prize). Work: mural, U.S. Gov., Wash., D.C.; Vanderpoel AA, Chicago [40]

SARKADI, Leo [P,E,W] NYC b. 24 My 1879, Budapest, Hungary d. 24 Mr 1947. Member: S.Indp.A.; Am. A. Cong.; Artists U. Work: Mount Morris Hospital; Folks Memorial Hospital, Oneonta; Brooklyn Technical H.S.; Summit Park Sanitorium, Pomona, N.Y.; Board Edu., Newark; Edgar Allen Poe Sch., Theodore Roosevelt H.S., Pub. Sch. 90, Pub. Sch. 165, Riverside Hospital, all in NYC; Newark Airport, N.J. [40]

SARKISIAN, Sarkis [P,Dr,T] Detroit, MI b. 15 My 1909, Smyrna, Asia Minor d. 1977. Studied: J.P. Wicker; J. Carroll. Member: Detroit Scarab C. Exhibited: Mich. Ar. Ann., 1937 (prize); Art Founders Soc., 1938 (prize); Detroit Inst. A. (prize); Am. Div. Golden Gate Expo, 1939. Work: murals, Julie Shop, Inc., Detroit; Fisher Bldg., Detroit; Detroit Inst. A. Position: T., Detroit Soc. A. Ctr. [40]

SARNOFF, Arthur [I] Great Neck, NY b. 30 D 1912, Brooklyn. Studied: Grand Central Sch. A.; N.Y. Sch. Indst. A.; H. Dunn. Member: SI. Exhibited: SI [47]

SARONY, Napoleon [Photogr,Li,Por.Dr] NYC b. 9 Mr 1821, Quebec (came to NYC ca. 1836) d. 9 N 1896. Member: Am. Photogr. Soc. (founder); SC 1871, (founder); Tile C. Exhibited: Centenn. Expo, Phila., 1876 (prize). Worked for Currier & Ives, early 1840s, before forming his own lith. firm, Sarony & Major, 1846. Opened his own photography studio in NYC, 1864, which quickly became the fashionable studio. An eccentric, Sarony's studio was a melange of ancient artifacts, stuffed alligators, and countless curiosities. He made portraits of thousands of celebrities, usually as cabinet cards. [In "The Fortunes of Oliver Horn" (F. Hopkinson Smith, 1902) Sarony is the character Julius Bianchi.] [*]

SARONY-LAMBERT, N. [P] NYC [19]

SARRE, Carmen G. [Por.P,L,T,Dec] New Orleans, LA b. 30 Je 1895, Antwerp, OH. Studied: Agnes Scott Col.; Univ. Michigan; N.Y. Sch. Des. for Women; PMG Sch.; L. Makielski; E.H. Barnes; J.C. Chase; C. Link; B. Crawford; S.F. Kimball. Member: NOAA; SSAL; New Orleans A. Cr. C. Exhibited: Wash. WCC, 1940–42; Chevy Chase Women's C., 1944 [47]

SARTAIN, Emily [P,Mezzotint En,T] Phila., PA b. Phila. d. 18 Je 1927. Studied: her father John Sartain; PAFA, with Schüssele; Luminais, in Paris. Member: Plastic C.; Lyceum C., London; Contemp. and New Century C., Phila. Served: Jury of Award, Columbian Expo, Chicago, 1892. Delegate: U.S. Gov. to Intl. Congress on Instruction in Drawing, Paris, 1900; Berne, Switzerland, 1904. Exhibited: Centenn. Expo, 1876 (prize); PAFA, 1881 (prize), 1883 (prize); Pan-Am. Expo, Buffalo, 1901 (prize). Position: T., Phila. Sch. Des. for Women [27]

SARTAIN, Harriet [Ldscp.P,T] Phila., PA b. Phila. Studied: Phila. Sch. Des. for Women; Teachers' Col., N.Y.. Member: Phila. Art Teachers A.; Eastern AA; Plastic C.; Phila. Alliance. Position: Dean, Phila. Sch. Design for Women [31]

SARTAIN, John [En,Por.P,Min.P] Phila., PA b. 24 O 1808, London (came to Phila. in 1830) d. 25 O 1897. Member: PAFA (Dir. for 23 yrs); A. Fund S. (Dir.); Phila. Sch. Des. for Women (Dir.). Position: A. Dir., Phila. Centenn. Expo, 1876. He introduced the mezzotint to U.S. His children, Samuel, Henry, Emily, and William were all artists. [97]

SARTAIN, Samuel [En,P] Phila., PA b. 8 O 1830, Phila. d. 20 D 1906. Studied: his father John; PAFA; France; Italy. Member: A. Fund S., Phila; Photographic Soc., Phila.; Franklin Inst. [06]

SARTAIN, William [P,T,W] NYC b. 21 N 1843, Phila. d. O 1924. Studied: PAFA; Bonnât, Ecole des Beaux-Arts, both in Paris; Italy; Spain. Member: ANA, 1880; SAA, 1877. Exhibited: Boston, 1881 (med); PAFA, 1887 (prize); Pan-Am. Expo, Buffalo, 1901 (med); Charleston Expo, 1902 (med); Buenos Aires Expo, 1910 (med). Work: CGA; National Gal.; MMA; Argentine Gov.; Luxembourg Gal., Paris; S.C. Art Assn.; Herron AI. Son of John. [24]

SARTELLE, Mildred E. [S] Wellesley, MA [25]

SASSE, Fred A. [P] St. Paul, MN. Work: United Engraving Co. [24]

SATER, Miles W. [P] Chicago, IL. Member: GFLA [27]

SATRE, August [P] Middle Village, NY b. 19 F 1876, Norway. Member: Providence WCC [29]

SATTERFIELD, Robert W. [P] Cleveland, OH. Member: Cleveland SA. Affiliated with: Newspaper Enterprise Assn., Cleveland [27]

SATTERLEE, Marion [I] NYC. Position: Affiliated with Scribner's Sons, NYC [98]

SATTERLEE, Walter [P,E,I] NYC b. 1844, Brooklyn, NY d. 28 My 1908. Studied: NAD; Columbia, 1863; E. White, in N.Y.; L. Bonnât, in Paris; Freeman, in Rome. Member: AWCS; Etching C., N.Y.; A. Aid S.; Century Assn. Exhibited: NAD, 1886 (prize); AAS, 1902 (med); ANA [08]

SATTERWHITE, Nell [P] Nashville, TN [15]

SATTIG, Violet Miller [P] East River, CT d. 18 S 1920. Member: New Haven PCC [19]

SAUER, LeRoy D. [E,I,L,B,T] Dayton, OH b. 17 F 1894, Dayton. Studied: Cincinnati Acad. A.; Cleveland Sch. A.; Western Reserve Univ.; H. Keller; F. Wilcox; E. Peixotto; Hopkins; Meakin; Wessel; Orr; Lachman. Member: Ind. Soc. Pr.M.; Dayton SE; Ohio Pr.M.; Fla. AA. Exhibited: Fla. AA, 1940 (prize); LOC, 1943 (prize); Dayton SE, 1921–45; Ohio Pr.M., 1928–45; NAD, 1943, 1944; LOC, 1943; Tri-State Exh., 1944, 1945. Work: LOC; Ohio Art and Artists; Dayton AI. Position: Dir., L.D. Sauer Studios, Dayton [47]

SAUERWEIN, Charles D. [Por.P,Genre P.] b. 1839 d. 1918, Red Bank, NJ. Studied: Europe, 1860s. Studio in Baltimore 1857–58; in Europe 1860–70; Baltimore 1870–80; Red Bank, N.J., 1880–1918. Father of Frank. [*]

SAUERWEIN, Frank Peters (or Paul Sauerwen) [P] Pasadena, CA/Taos, NM b. 22 Mr 1871, Baltimore (or Cantonsville, NJ) d. 14 Je 1910, Stamford, CT. Studied: his father, Charles; PAFA; AIC; PMSchIA. Member: Denver AC, 1891–ca. 1904. Work: Mus. N.Mex.; Southwest Mus.; Panhandle-Plains Hist. Soc. Specialties: western scenes; Indians [06]

SAUGSTAD, Eugenie de Land [P,C,I,T] Alexandria, VA b. Wash., D.C. Studied: George Washington Univ.; Drexel Inst.; Corcoran Sch. A.; E.F. Andrews; H. Pyle. Member: Lg. Am. Pen Women. Exhibited: Lg. Am. Pen Women; Alexandria (Va.) Pub. Lib. Work: ceiling mural, Eastern Star Temple, Wash., D.C.; Foundry Methodist Episcopal Church, Wash., D.C.; Presbyterian Church, Laurel, Md.; William and Mary Col., Williamsburg; Custom House, Yorktown; Masonic Lodge, Alexandria. Position: T., McKinley H.S., Wash., D.C. [47]

SAUGSTAD, Olaf [C,T] Alexandria, VA b. Vernon County, WI d. 19 Ag 1950, Annapolis, MD. Studied: Univ. Minn.; N.Y. Inst. A.&Artisans; Columbia. Member: N.Y. Gld. A.&Cr.; Handicraft Gld., Wash., D.C. Work: mem. tablet, Falls Church, Va.; Friendship House, Wash., D.C. Positions: T., McKinley H.S., Wash., D.C. (1911–38), Chevy Chase (Md.) Women's C. [47]

SAUL, (Saul Kovner) [E,Li,P] NYC b. 13 Ja 1904, Russia. Studied: NAD; I. Olinsky; C. Hawthorne; W. Auerbach–Levy. Member: SAE. Exhibited: PAFA, 1932 (gold); Morton Gal., 1943. Work: Brooklyn Col.; State T. Col., Indiana, Pa.; East N.Y. H.S.; Princeton Univ.; MMA; Montpelier (Vt.) Mus. A.; LOC [47]

SAUL, J.H. Louis [E,En] Astoria, NY d. 8 My 1925

SAUL, Maurice Bower [P] Moylan, PA/Long Lake, NY b. 6 O 1883, Phila. [33]

SAULNIER, James Philippe [Des,P,I] Somerville, MA b. 8 O 1899, South Hamilton, MA. Studied: Mass. Sch. A.; E.L. Major; R. Andrew; W. Hamilton. Member: Gld. Boston A.; North Shore AA. Exhibited: New England Contemp. A. Exh., 1942 (med), 1943 (med); AIC, 1927; NYWCC, 1927–33; Gld. Boston A.; North Shore AA; Grace Horne Gal.; Boston WCC; Nashua (N.H.) Lib. [47]

SAULTER, Leon [S] Los Angeles, CA b. 31 Mr 1908, Wilno, Poland. Member: Council All. A. Exhibited: Los Angeles Mus. A., annually; Contemp. A. Gal.; UCLA; Occidental Col. Work: Horace Mann Jr. H.S.; Sierra Bonita H.S.; mem., Hollywood Cemetery [47]

SAUNDERS, Albert Frederic [Des,C,L] Syracuse, NY b. 21 N 1877, Brooklyn, NY. Studied: Adelphi Col.; PIASch. Member: Assn. A. Syracuse. Exhibited: Syracuse Mus. FA, 1939–42, 1945, 1946. Position: Chief Des., Shiebler Co., 1904–07; A. Dir., Benedict Mfg. Co., Eaast Syracuse, N.Y., 1907–46. Specialty: silverware design [47]

SAUNDERS, Aulus Ward [P,T] Oswego, NY b. 22 S 1904, Perry, MO. Studied: Westminster Col., Fulton, Mo.; Washington Univ.; State Univ., Iowa; C. Cagle. Exhibited: Kansas City AI, 1935 (prize); CAM. Work: mural H.S., University City, Mo. Position: T., N.Y. State T. Col., Oswego, N.Y. [47]

SAUNDERS, Clara R(ossman) [P,T] Wash., D.C. b. Cincinnati d. 7 Ag 1951. Studied: Cincinnati A. Acad.; Corcoran Sch. A.; George Washington Univ.; Paris; W. Beck; C.W. Hawthorne; C. Guerin; E. Spiro; La Prade, Paris. Member: Wash. WCC; Soc. Wash. A.; SSAL; NAWA; Wash. AC. Exhibited: Soc. Wash. A., 1930 (prize), 1934 (prize); SSAL, 1930 (prize), 1935 (prize); Wash. WCC, annually, 1944 (prize); Women's C., Wash.,D.C., 1930 (prize), 1942 (prize), 1946 (prize); PAFA; Inst. House, N.Y., 1930 (one-man); Telfair Acad., 1945 (one-man) [47]

SAUNDERS, Elisabeth Hallowell (Mrs. Charles F.) [I,W,C] Phila., PA b. Alexandria, VA. Studied: H. Pyle; PMSchIA. Member: Plastic C. [10]

SAUNDERS, F.O., Mrs. See Eckert, Josephine.

SAUNDERS, Kendall [P] Westport, CT b. 23 S 1886, Templeton, MA. Studied: Académie Julian, with Laurens. Member: SC; Paris AAA; Union Internationale des Beaux-Arts et des Lettres [25]

SAUNDERS, L. Pearl [P,L,T,I] Jackson, TN b. Tennessee. Studied: ASL; W. Chase; C. Hawthorne; A. Lhote, in Paris; Académie Julian. Member: Nashville Studio C.; SSAL (State Chairman); NAWA; AAPL; Lg. Am. Pen. Women; NAWPS; Tenn. SA; Nashville Mus. Art. Exhibited: war poster, New Orleans, 1916 (prize); Southeastern Fair Assn. (prize); Tenn. State Fair (prize); Italy (prize); Nashville Mus. Art, 1928 (prize); Paris Salon; SSAL; NAWA. Work: Nashville Mus. A.; Centenn. C., Nashville; Women's C., Jackson, Tenn.; St. Luke's Episcopal Church, Jackson; Murfreesboro Women's C.; DAR, Wash., D.C.; Bank of Westminster, Paris. Author: "Make Your Own Posters." Positions: Dir., Sch. A.&Appl. Des. (Nashville), Summer Sch. A., Lake Junaluska (N.C.) [47]

SAUNDERS, Theodore (Raymond Vielant) [P,C,Des] Chicago, IL b. 26 Jy 1908, Denver. Studied: F.R. Cowles. Member: Chicago Assn. PS; Business Men's AC; South Side AA. Position: Stage manager/Designer, Little Ballet, Chicago [40]

SAUNDERS, Xantippe [P] Louisville, KY. Member: Louisville AL [01]

SAUSSY, Hattie [P,T] Savannah, GA b. 17 Mr 1890, Savannah d. 13 Ja 1978. Studied: M. Baldwin Seminary, Staunton, Va., 1906–07; N.Y. Sch. FA, 1908–09; NAD, 1911–12; ASL, with E. Speicher; DuMond; E. O'Hara; Bridgman, both in 1912; Paris, with E. A. Taylor, 1913–14; Telfair Acad., Savannah, with A. W. Blondheim, 1923; E.S. Shorter, F.S. Herring, in Brunsville, N.C., 1950–51. Member: Ga. AA, 1934 (Pres.). Exhibited: retrospectives: Hist. Savannah Fnd., 1982; R.M. Hicklin Gal., Spartanburg, S.C., 1983 [25]

SAUTER, Mary [P] Bridgeport, CT. Member: ASMP [47]

SAUTER, Willard J. [P,Ser,T,Des] Utica, NY b. 23 Jy 1912, Buffalo, NY. Studied: Sch. FA, Albright A. Gal.; State T. Col., N.Y.; M. Green; F.J. Bach; E. Zweybruck; Vienna. Member: Buffalo SA; Buffalo A. Council; Eastern AA. Exhibited: Albright A. Gal. 1940–45, 1946 (prize); Buffalo SA, 1933–39, 1940 (prize), 1941 (prize), 1942, 1943 (prize); 1944, 1945, 1946 (med); Adams Gal., Buffalo (one-man). Positions: T., Buffalo Pub. Sch. (1933–43; 1946), N.Y. State Inst. Appl. A.&Sc. (Utica), State T. Col. (Buffalo) [47]

SAVAFE, Dorothy Lyman [P] Baltimore, MD. Studied: PAFA [25]

SAVAGE, Augusta Christine [S] NYC b. Florida. Studied: Cooper Union; H. A. McNeil; F. Benneteau, Paris. Member: NAWPS. Work: NYPL (135th St) [40]

SAVAGE, Charles R. [Photogr] Salt Lake City, UT (since 1860) b. 1832,

England (came to NYC in 1856) d. 1909. Western photographer, perhaps best remembered for his view of the joining of the Union Pacific and Central Pacific railroads at Promontory Point, Utah. His firm, Savage&Ottinger, produced many views of the Rockies and Great Plains, often as stereoviews [*]

SAVAGE, Eugene Francis [P,T,S] New Haven, CT b. 1883, Covington, IN. Studied: CGA; AIC; Am. Acad. in Rome; Reynolds; Henderson. Member: ANA, 1924; NA, 1926; Century Assn.; Mural Ar. Gld.; NSMP. Exhibited: Arch. Lg., 1921 (gold); AIC, 1922 (gold), 1924 (prize); NAD, 1922 (prize), 1924 (gold); Grand Central Gal., 1929 (prize). Work: AIC; CAM; Los Angeles Mus. A.; Nebr. State Mus.; Herron AI; Oshkosh (Wis.) Pub. Mus.; murals, Yale; Columbia; USPO, Wash., D.C.; Greenwich House, NYC; Friday Morning C., Los Angeles; Central Centenn. Bldg., Dallas Expo, 1936; Communication Bldg., WFNY, 1939; Pa. Treasury, Harrisburg; fountain, Brooklyn. Author: report on art schools for Carnegie Corporation of N.Y.. Served on National Commission of FA. Position: T., Yale [47]

SAVAGE, Marguerite Downing (Mrs.) [P,I] Encino, CA/Prouts Neck, ME b. 6 S 1879, Bay Ridge, NY. Studied: U.S.; Europe; E.C. Messer; E.L. Morse; R. Miller. Member: Worcester GAC. Exhibited: WMA; Boston (one-man); Cleveland (one-man). Work: Hobart Col., Geneva, N.Y.; Stanford Univ.; Union Seminary, N.Y.; Worcester (Mass.) Polytechnic Inst.; Cornell. Illustrator: Harper's, 1902-11 [47]

SAVAGE, Thomas Michael [Mur.P] Fort Dodge, IA b. 4 O 1908, Fort Dodge. Studied: Grant Wood. Exhibited: Iowa State Fair Salon, 1934 (prize). Work: White House, Wash., D.C.; murals, USPOs, Jefferson, New Hampton, both in Iowa. WPA artist. [40]

SAVAGE, Trudi (Gertrude Fish Jones) [S] Clearwater, FL b. 28 S 1908, Roselle Park, NJ. Studied: Grand Central Sch. A.; PAFA; Clay C., N.Y. Member: Fla. Fed. A.; Clay C., N.Y. Exhibited: PAFA, 1930 (prize); NAD, 1937; Montclair A. Mus., 1937, 1938; Clearwater A. Mus., 1947 [47]

SAVAGE-JONES, James [S,C,Car] Clearwater, FL b. 22 Ag 1913, Kelty, Scotland. Member: Clay C., N.Y.; Fla. Fed. A. Exhibited: PAFA, 1938; Arch. Lg., 1936; CAFA, 1937; BM, 1936; Clearwater A. Mus., 1947 [47]

SAVELLI, Elena G. [P] Phila., PA [25]

SAVIER, Helen. See DuMond, F.V., Mrs.

SAVILLE, Bruce Wilder [S] Santa Fe, NM b. 16 My 1893, Quincy, MA d. 27 D 1938. Studied: Mass. Sch. Art, with Dallin; Mr. & Mrs. Kitson. Member: Boston AC; NSS. Work: Civil War and WWI memorials, Quincy, Mass.; Vicksburg (Miss.) National Park; Collingwood Mem., Kansas City; Potter Mem., Annapolis; Quincy H.S.; mem. tablet to Unknown Dead of World War, Quincy; Canadian Infantryman, St. John's; Victory figure, Chicopee, Mass.; Forrester Mem., Worcester, Mass.; Mem. of the 3 wars, Palmyra, Maine; Mem. to 104th Infantry, 26th Div., Westfield, Mass.; World War Mem., Upton, Mass.; World War Mem,. Ravenna, Ohio; Peace Mem., Civil War, State House grounds, Columbus, Mass; Mack Mem., Ohio State Univ.; three panels, Jeffrey Manufacturing Co. Office Bldg.; Ohio State World War Mem., Columbus; World War memorials at Glens Falls, N.Y.; Quincy, Mass.; mem., Wollaston, Mass.; mem., Toledo; mem. group, White Chapel, Memorial Park, Detroit; Am. trophy, James Gordon Bennett Balloon Races; fountain group, White Chapel Memorial Park, Detroit; mem., Worcester, Mass.; mem., City Hospital, Boston; mem., Boston Airport; War Memorial, National Cemetery, Santa Fe, N.Mex. [38]

SAVIOR, Sister Mary Divine [Des,P,C,G,T] Manchester, NH b. 17 Je 1899, Manchester. Studied: Beaux-Arts, Montreal, Quebec; Manchester Inst. A.&Sc.; C. Mailard; J. Chandler. Member: New Hampshire AA. Exhibited: Manchester Inst. A.&Sc., 1942 (prize); Ogunquit A. Center; Dartmouth; Women's C., Manchester, 1942 (one-man); Currier Gal. A. Work: design and decoration of churches, Troy, Walpole, West Swanzy, Salmon Falls, Charlestown, all in N.H.; des., Doucet Mon., Nashua, N.H. [47]

SAWE, Henry Leonard [P] Paris, France b. Chicago. Studied: Merson; Simon; Cottet, in Paris. Member: Paris AAA [08]

SAWITZKY, William [Cur] Stamford, CT b. 1880, Riga, Latvia (came to U.S. in 1912) d. 2 F 1947. Studied: Russia. An expert on early American paintings, he identified many works by Gilbert Stuart. Position: Advisory Curator, N.Y. Hist. Soc.

SAWRIE, Mary B. (Mrs.) [Min.P] Nashville, TN/Beersheeba, TN b. 22 S 1879, Nashville. Studied: AIC, with Vanderpoel; Chase; Arthur Dow; F.A. Parsons; Académie Julian, Paris [25]

SAWTELLE, A. Elizabeth [P] Wash., D.C./Ogunquit, ME. Studied: Sch. Des. for Women; Drexel Inst.; Corcoran Sch. A.; C. Woodbury; Ingram Summer Sch., Cornwall, England. Member: Wash. WCC; S. Wash. A.; Wash. Arts C.; Providence WCC [40]

SAWTELLE, Mary Berkeley (Mrs. Charles G.) [P] NYC b. 24 Ag 1872, Wash.,D.C. Studied: Corcoran Sch. A; Delecluse and Colarossi Academies, Paris; E. Scott, Paris; I. Wiles, N.Y.; C. Hawthorne, N.Y. Member: Wash. SA. Work: Delgado Mus., New Orleans [33]

SAWYER, Conway [S,T] Wilmington, DE b. 9 My 1902, NYC. Studied: Archipenko. Exhibited: Wilmington Soc. FA; Weyhe Gal., N.Y.; WFNY, 1939. Position: T., Wilmington Acad. A. [40]

SAWYER, Danton Winslow [P] Hamilton, MA b. 20 Ag 1910, Clinton, MA. Studied: Dartmouth; J. Orozco; B. Karfiol. Exhibited: WMA, 1938; CI, 1941; Inst. Mod. A., Boston; RISD. Work: Dartmouth; Wheaton Col. [47]

SAWYER, Edith [Min.P] NYC/Columbia, CT b. Coventry, CT. Studied: Adelphi Sch., ASL. Member: Pa. S. Min.P.; Brooklyn S. Min. P.; Brooklyn AG; New Haven PCC [33]

SAWYER, Edmund Joseph [P,I,W,L,Des,C] Bellingham, WA b. 1 Mr 1880, Detroit. Studied: Holmes Sch. I; Smiths A. Acad., Chicago. Member: Northwest Bird & Mammal Soc.; Agassiz Assn. Exhibited: Cornell; Rockefeller Center; 48 States Comp., 1939. Work: N.Y. State Mus.; Albright A. Gal.; Yellowstone Park Mus.; Bellingham (Wash.) Mus.; murals, USPO, Dennison, Ohio; WPA artist. Author/Illustrator: "Land Birds of Northern New York," 1925, "Game Birds and Others of the Northwest," 1945. Illustrator: "American Natural History," other bird books. Contributor: Nature, Bird-Lore, Field & Stream [47]

SAWYER, Edward W(arren) [S] Folkestone, England (or Toulon, France) b. 17 Mr 1876, Chicago d. 16 Jy 1932, Clos Vert La Palasse, Toulon, France. Studied: Verlet; Fremiet; Rodin, all in Paris. Exhibited: St. Louis Expo, 1904 (med); Intl. Expo, Ghent, 1913 (med); Salon des Artistes Français, 1914 (prize); P.-P. Expo., San Fran., 1915; Am. Numismatic Soc., 1931 (prize). Work: Luxembourg, Paris; Am. Numismatic Soc., N.Y.; U.S. Mint, Phila.; AIC; Mass. Hist. Soc.; Buffalo Bill Mus., Cody, Wyo. Specialty: medals [24]

SAWYER, Esther (Hoyt) (Mrs. Ansley W.) [P,G] Buffalo, NY b. Buffalo. Studied: Albright A. Sch.; ASL; C. Hawthorne; E. Dickinson. Member: The Patteran (Pres.); Nantucket AA; A. Collectors & A. Assn. Exhibited: 45 Group, 1945; The Patteran, 1943, 1944; Riverside Mus., 1941, 1942; Albright A. Gal.; Garret C., Buffalo, 1945 (one-man); Taylor Gal., Nantucket, Mass., 1945 (one-man) [47]

SAWYER, Grace M. [P] Worcester, MA [24]

SAWYER, Helen Alton (Mrs. Jerry Fransworth) [P,Li,W,T] North Truro, MA b. Wash., D.C. Studied: NAD; C. Hawthorne; Johansen; Sawyer. Member: ANA, 1937; Provincetown AA; Yonkers AA; Hudson Valley AA; NAC. Exhibited: Hudson Valley A. Inst., 1935 (prize), 1936 (prize); Fine Prints of the Year, 1937; AIC, 1936 (prize); nationally and internationally. Work: LOC; Toledo Mus. A.; WMAA; John Herron AI; PAFA; Vanderpoel Coll. Contributor: "Scribner's." Position: T., Fransworth Sch. A., North Truro, Mass. [47]

SAWYER, Lelia G. (Mrs. O.H.) [P] NYC. Exhibited: Fontainebleau Sch. FA, 1938 (prize); NAWPS, 1935-38; Studio Gld., N.Y., 1940 [40]

SAWYER, Myra L. [P] Salt Lake City, UT [15]

SAWYER, Natalie [P] NYC [01]

SAWYER, Phil(ip) (Ayer) [P,Li,Dec,L,E,T,C] Clearwater, FL b. Chicago d. 7 Mr 1949. Studied: AIC, with Vanderpoel; Purdue; Yale; Ecole des Beaux-Arts, with L. Bonnât. Member: Salon d'Automne, Paris; Artists' Union, N.Y. Work: Smithsonian Inst.; LOC; NYPL; mural, Gary Sch., Chicago. Position: T., Clearwater A. Mus. [47]

SAWYER, Wells M. [P] NYC b. 31 Ja 1863 d. ca. 1960. Studied: AIC; Corcoran Sch. A.; J.O. Anderson; J. Vanderpoel; Wash. ASL; H. Helmick. Member: Chicago SA; Soc. Wash. A.; Yonkers AA; AWCS; All.A.Am.; AFA; SC; Sarasota AA; Am. Ar. Prof. Lg. Exhibited: CGA, 1931 (one-man), 1938, 1939, 1942-45; AIC; Soc. Wash. A.; PAFA; NAD; All.A.Am.; AWCS, 1941-46; Provincetown AA; Sarasota AA; West Coast Group, 1944-46; Fla. Fed. A. Traveling Exh., 1944; NGA, 1931 (one-man); Milch Gal. (one-man); Ferargil Gal., 1936 (one-man); Univ. C. Salon, Mexico City, 1941 (one-man); abroad. Work: CGA; Vanderpoel Coll.; NCFA; State Dept., Wash., D.C.; Mus. City of N.Y.; Benjamin West Soc.; Hudson River Mus.; Smithsonian; Yonkers Mus. Sc.&A., N.Y.; LOC [47]

SAWYERS, Martha (Mrs. William Reusswig) [I,W] NYC. Member: SI [47]

SAWYIER, Paul [P] NYC [17]

SAX, Carol M. [Des,T] Lexington, KY. Member: Charcoal C. Position: Affiliated with Univ. Ky. [27]

SAXE, Carolyn N. [P,T,L] Lynbrook, NY/West Hurley, NY b. 14 Ag 1904, West Hurley. Studied: Univ. Buffalo; Parsons Sch. Des.; Columbia; C.J. Martin; B. Carter. Member: NAWA; EAA; Nassau County ATA. Exhibited: PAFA; Phila. A. All.; NYWCC; Argent Gal.; NAWA. Position: T., Pub. Sch., Lynbrook, N.Y., 1930–46 [47]

SAXON, Walter (Mrs.) [P] New Orleans, LA [15]

SAXTON, John G(ordon) [Ldscp.P] Seaford, NY b. 1860, Troy, NY. Studied: Lefebvre; Merson; Robert-Fleury all in Paris. Member: Lotos C. Exhibited: Paris Expo, 1900 (prize); Pan-Am. Expo, buffalo, 1901 (prize); St. Louis Expo, 1904 (med.) [33]

SAYEN, Henry Lyman [P,I,Mur.P] Phila., PA b. 25 Ap 1875, Phila. d. 28 Ap 1918. Studied: PAFA, 1899–ca. 1904; Paris, with Matisse, 1907–8. Member: Phila. Sketch C. Organizer: first exh. of Advanced Modern Art, with M.L. Schamberg in Phila., 1914. Work: Nat. Coll. [17]

SAYER, Edmund S(ears) [Mar.P,I,C,W,L] San Diego, CA b. 1 Mr 1878, Meadville, PA. Member: Spanish Village A. Assn., Las Surenos A. Assn., San Diego. Exhibited: Golden Gate Expo., 1939. Work: LOC; NYPL; album of 10 historical ships, text, poems and illustrations: U.S. Naval Acad., Annapolis, Md., Naval War College, Newport, R.I., Naval Records, U.S. Navy Dept., Wash., D.C. and N.Y. Hist. Lib.; President's Study, White House; rotunda, Navy Dept., Wash., D.C.; Naval Training Station, San Diego; San Diego Am. Legion Post [40]

SAYLES, M. [P] NYC [01]

SAYRE, Elizabeth Graves (Mrs.) [P,I,C] Wash., D.C. b. 13 Mr 1895, Fort Brady, MI. Studied: R.S. Bredin; H.B. Snell; H. Giles. Member: Wash. WCC. Exhibited: NAWPS, 1936, 1937; Soc. Wash. Ar., 1937–39 [40]

SAYRE, Fred Grayson [P] Glendale, CA (since 1924) b. 9 Ja 1879, Medoc, MO d. 31 D 1938. Specialty: Arizona desert scenes before 1922 [24]

SCALELLA, Jules [P,Des,T] Elkins Park, PA b. 31 Mr 1895, Phila. Studied: PMSchIA; Spring Garden Inst.; Phila. Graphic Sketch C.; A.J. Adolphe. Member: A. Dir. C., Phila.; Da Vinci All.; Phila. A. All.; Del. Co. AA. Exhibited: DaVinci All., 1943 (prize); PAFA, 1926–28, 1930, 1932, 1939, 1940; CAM, 1926, 1927; AIC, 1926; NAD, 1928; Phila. AC, 1927, 1928; Montclair A. Mus.; 1931; Woodmere A. Gal., 1941–46; Delaware County AA, 1929–32; Graphic Sketch C., Phila., 1929, 1931, 1932, 1944, 1945. Work: Allentown, Pa., Mus. [47]

SCAMMON, Charles Melville [Mar.Dr] Oakland, CA (since 1894) b. 28 My 1825, Pittston, ME d. 2 My 1911. Whaling Captain who was author and illustrator of "Marine Mammals of the Northwest Coast of North America and the American Whale Fishery," 1874. [*]

SCAMMON, L. N. [E] Fruitvale, CA. Member: Calif. SE [27]

SCANES, Ernest William [P,Li,Des,I] Detroit, MI b. 6 N 1909, Lorain, Ohio. Studied: Cranbrook Acad. A.; J.P. Wicker. Member: Scarab C. Exhibited: Detroit Inst. A., 1936 (prize) 1937 (prize), 1938–40, 1941 (prize), 1943–45; Milwaukee AI, 1944 (prize), 1945; WFNY, 1939 (prize); AIC, 1938, 1941; Albright A. Gal.; Butler AI, 1942; Great Lakes Exh., 1938. Work: Detroit Inst. A.; Milwaukee AI. Position: A. Dir., General Motors Corp., Detroit, 1945– [47]

SCAPICCHI, Erminio [P] Chicago, IL. Exhibited: Ar. Chicago Vicinity Ann. (1936),Intl. WC Ann. (1938), PS Ann. (1938), all at AIC [40]

SCARAVAGLIONE, Concetta Maria [S] NYC b. 9 Jy 1900, NYC. Studied: B. Robinson; R. Laurent. Member: NSS; S. Gld.; An Am. Group. Exhibited: PAFA, 1934 (gold); Fellow., Am. Acad., Rome, 1947; NAD (med). Work: WMAA; USPO Dept. Bldg., Fed. Trade Comm. Bldg., Wash.D.C.; Roerich Mus., N.Y. WPA artist. [47]

SCARBOROUGH, Alonzo [I] b. 1878 d. 25 O 1943, NYC

SCARLETT, Rolph [P] NYC. Exhibited: GGE, 1939 [40]

SCARPITTA, G. Salvatore Cartiano [L,S] Los Angeles, CA b. 28 F 1887, Palermo, Italy (settled in NY in 1910) d. 18 Ag 1948. Studied: Instituto di Belli Arti, Palermo; Rome. Member: NSS; Sculptors Gld.; Southern Calif.; N.Y. Arch. Lg.; FA Soc., San Diego (hon.); Milwaukee AI (hon.) Exhibited: NAD, 1914 (prize); N.Y. Arch. Lg., 1913 (prize); AIC, 1923 (prize), 1926 (prize); FA Gal., San Diego, 1933 (prize); Southern Calif. Chap. AIA, 1931 (prize); decorated by Japanese and Cuban governments. Work: Church of St. John the Evangelist, Los Angeles; Church of the Sacred Blood, Los Angeles; Los Angeles Stock Exchange Bldg.; State Mutual Bldg. and Loan Assn., Los Angeles; County Gen. Hospital, Los Angeles; FA Gal., San Diego; Pal. Leg. Honor, San Fran.; Milwaukee AI; life size statue of Marlene Dietrich for Paramount picture, "Song of Songs"; portrait of Mussolini for New Forum, Rome [40]

SCARR, Laura (Mrs.) [P] Hasbrouck Heights, NJ b. 1871 d. 4 Ja 1936. Exhibited: Montclair A. Mus.

SCARTH, Lorraine Alice (Mrs. Virgil) [P,Des] Enid, OK b. 11 D 1909, Dubuque, IA. Studied: Univ. Iowa; AIC. Member: Wichita AA; Prairie PM. Work: mural, Mus., Univ. Iowa, Iowa City [40]

SCHAAF, Anton [S] Brooklyn, NY b. 22 F 1869, WI. Studied: Shirlaw; Cox; Beckwith; Saint-Gaudens; Dewing; CUASch; Ward, NAD. Member: NSS; Arch. Lg. Work: war memorials and statues at: Vicksburg Nat'l Military Park; Glendale Mon., Ridgewood Mon., Brooklyn, NY; Shaw Mem., Woodlawn Cemetery, N.Y.; Tompkins Ave. Church, Central Cong. Church all in Brooklyn; Erriccon Mon., NYC; J. Temple Gwathmey, N.Y. Cotton Exchange; Prudential Life Insurance Co., Newark, N.J.; West Haven, Conn.; mem. ports., Todd Shipyards, N.Y.; Central Cong. Church, Brooklyn; Cornell Univ. [40]

SCHABELITZ, R(udolph) F(rederick) [I] NYC b. 10 Je 1884, Stapleton, NY. Studied: C. Marr, Munich. Member: SI; SC; Artists G. [33]

SCHACHT, Louise [P] NYC. Exhibited: Allied A. Am., 1934; NAWPS, 1935–38 [40]

SCHAEFER, Hans [S] NYC b. 13 F 1875, Sternberg, Czechoslovakia. Studied: Kunstgewerbeschule, Vienna, Austria [33]

SCHAEFER, Josephine Marie [P,T] Milwaukee, WI b. 12 My 1910, Milwaukee. Studied: Layton Sch. A.; AIC; L. Ritman. Member: Chicago AC; Wis. PS. Exhibited: AIC, 1935–46; Grand Rapids A. Gal., 1940; Wis. PS, 1936, 1939–41, 1944–46, 1945 (prize); Minneapolis Inst. A., 1942; Columbus A. Gal., 1942; Ill. State Mus., 1935–37, 1940; Rochester Mem. A. Gal., 1940, 1941; Kansas City AI, 1940; WMA, 1945; AGAA, 194 5; CMA, 1945; Springfield (MO.) A. Mus., 1945; Walker A. Center, 1945; Portland (Oreg.) A. Mus., 1945; Kalamazoo IA; Layton A. Gal. (one-man). Position: T., Layton Sch. A., Milwaukee [47]

SCHAEFER, Martha W. (Mrs.) [P] Cincinnati, OH. Member: Cincinnati Women AC [15]

SCHAEFER, Mathilde (Mrs. Davis) [S,C] Scottsdale, AZ b. 20 Mr 1909, NYC. Studied: R. Josset; W. Lemcke. Exhibited: AIC, 1933, 1935, 1938; WFNY 1939; SFMA, 1938–40; Denver AM, 1939; Santa Barbara Mus. A., 1942 (one-man); Mus. Northern Ariz., 1943 (one-man). Work: S., IBM Coll.; Mus. Northern Ariz.; Katherene Legge Mem., Hinsdale, Ill. [47]

SCHAEFER, Rockwell B. [P,L,T] NYC b. 26 D 1901, NYC. Studied: Columbia; ASL; BAID; F. Mechau. Member: Audubon A.; Am. Veterans SA (Pres.). Exhibited: All.A.Am., 1938, 1939, 1941, 1943; Audubon A., 1943–45; AWCS, 1942–45; Am. Veterans SA, 1941–45; Vendôme Gal., 1937, 1940 (prize), 1942; BM, 1941; Norwegian-Am. Relief Exh., 1940. Work: Scranton Mus. A. [47]

SCHAEFER, William G. [P] NYC. Member: SC; Wash. WCC [24]

SCHAEFFER, John Simon [P] Active in Brooklyn, NY, 1859–1901. Exhibited: NAD, 1859 [*]

SCHAEFFER, Mead [I] Arlington, VT b. 15 Jy 1898, Freedom Plains, NY. Studied: D. Cornwell. Member: SI. Illustrator: "Moby Dick," "Typee," "Omoo," all by Herman Melville; "Les Miserables," by Victor Hugo; "Wings of the Morning," by Louis Tracy; "Sans Famille," by Hector Malot; "King Arthur and His Knights"; "Jim Davis," by John Masefield; "The Wreck of the Grosvenor," by W. Clark Russell [47]

SCHAEFFER, Rudolph [Des,L,T] San Francisco, CA b. 26, Je 1886, Clare, MI. Studied: Europe; E. Batchelder; R. Johonnot. Member: SFAA; San Fran. Mun. Art Comm. Author: "Flower Arrangement Folio," 1935. Contributor: Homes of the West, Sunset, Better Homes & Gardens. Position: T., Stanford Univ., 1920–23; Calif. Sch. FA, San Fran, 1917–24; Dir., Schaeffer Sch. Des., San Fran., from 1926 [47]

SCHAEFFLER, Elizabeth [S] New Rochelle, NY b. 27 O 1907, Somerville, MA. Studied: PIASch; NAD; ASL; Clay C., N.Y.; M. Young. Member: Clay C.; New Rochelle AA; N.Y. S. Cer. A.; Westchester A.&Cr. Gld. Exhibited: New Rochelle AA, 1946 (prize); NSS, 1936–38; Clay C., N.Y.; N.Y. S. Cer. A. Work: mem., Church of the Highlands, White Plains, N.Y. [47]

SCHAETTLE, Louis [Mur.P,Dec] NYC b. Chicago d. 21 Je 1917. Member:

Arch. L. 1911. Work: decorations at Georgian Court. Redecorated the yacht of the Prince of Wales, King Edward VII [15]

SCHAFER, Frederick Ferdinand [Ldscp.P] Oakland, CA (1905-17) b. 1841, Germany (became citizen in San Fran., 1884) d. 1917. Member: San Fran. AA, 1880s [*]

SCHAFER, George L(eslie) [P,I] Wilmington, DE/Arden, DE b. 26 Ja 1895, Wilmington, DE. Studied: PAFA; Bellevue Art Training Center, Paris. Member: Wilmington SFA. Work: mural, Pa. Liquor Control Bldg., Phila. [40]

SCHAFER, Irene S. (Mrs.) [Li,Des,Dr] NYC b. Boston, MA. Member: NAAI. Exhibited: L.G. Hornby; J. Pennell [40]

SCHAFFER, L. Dorr [P] Santa Barbara, CA [17]

SCHAFFER, Myer [P,G,T,L] Los Angeles, CA b. 25 My 1912, NYC. Studied: Chouinard AI, Los Angeles; D.A. Siqueiros. Member: Am. Ar. Cong.; U. Fed. Ar. Exhibited: Los Angeles Mus. Hist. Sc. A.; Am. Ar. Cong. Work: murals, Los Angeles Tubercular San.; P., McKinley Jr. H.S., Pasadena; Dept. Natural Resources, Carpenteria, Calif. [40]

SCHALDACH, William J(oseph) [E,P,W,I] West Hartford, VT/(Tubac, AZ, 1964) b. 15 F 1896, Elkhart, IN. Studied: ASL; H. Wickey. Member: SAE; SC; Ind. S. Pr.M. Exhibited: NAD, 1935-44; PAFA, 1941; SAE, annually since 1928; Chicago SE, 1929, 1930; WFNY, 1939; MET (AV); Phila. Pr. C., 1930-36; Ind. S. PM, 1938-46; Southern PM, 1939, 1940; Currier Gal. A., 1939, 1940; J. Herron AI, 1946; Dartmouth, 1942, 1946. Author: "Carl Rungius, Big Game Painter," 1945. Author/Illustrator: "Fish," 1937, pub. Lippincott. Illustrator: "Coverts and Casts," 1943, "Upland Gunning," 1946, other books. Contributor: Esquire, Field and Stream, Print Collectors Quarterly, other magazines [47]

SCHALK, Edgar [P] Richmond, IN [06]

SCHALL, F(rederick) P(hilip) [P,I] NYC b. 13 Je 1877, Chicago, IL. Studied: Laurens, in Paris. Member: Kit Kat C. [24]

SCHALLINGER, Max [P,C,S,E] Baltimore, MD b. 26 S 1902, Ebensee, Austria d. 8 My 1955. Studied: Vienna, Austria. Member: Baltimore AG. Exhibited: PMG, 1944 (one-man); BMA, 1942 (one-man), 1945 (one-man). Work: PMG; BMA; Am. Univ., Wash., D.C. [47]

SCHAMBERG, Morton L(ivingston) [P,Ph,S] Phila., PA b. 15 O 1881, Phila. d. 1918. Studied: PAFA, with W.M. Chase, 1903-06. Member: S.Indp.A. Work: PMA. With his friend H.L. Sayen influenced by Synchronism, then Dada [17]

SCHANKER, Louis [Wook Block Pr.M,P,T,L] NYC b. 20 Jy 1903, NYC. Studied: ASL; CUASch; abroad. Member: Fed. Mod. P.&S.; Am. Ar. Cong; Am. Abstract A. Exhibited: VMFA; AIC; NAD; WMAA; Willard Gal.; Kleemann Gal.; Detroit Inst. A.; PMG; PMA; Phila. Pr. C.; Health Bldg., WFNY, 1939. Work: MET; CM; Munson-Williams-Proctor Inst.; BM; Detroit AI; Univ. Mich.; Wesleyan Col.; NYPL; PMG; WMAA; Wittenborn & Co., N.Y.; murals, Radio Station WNYC; Neponsit Beach Hospital, N.Y. Author "Line, Form, Color," portfolio with 5 color woodblock prints, 1944. Position: T., New Sch. Soc. Res., NYC [47]

SCHANZ, Elizabeth [P] Glen Ridge, NJ [25]

SCHANZENBACHER, Nellie [P] Louisville, KY b. Louisville, KY. Studied: ASL; W. Chase; R. Henri; F.L. Mora; E. Fitsch. Member: SSAL; Southern Ind. & Ky. A.; Speed Mem. Mus. Exhibited: Speed Mem. Mus., 1929 (prize); Ky. Fed. A., 1940 (prize); Women's C., Louisville, 1943 (prize), 1945 (prize); Journal & Louisville Times Exh., 1936 (prize). Work: State Lib., Frankfort, Ky.; St. Paul's Church, Louisville [47]

SCHAPIRO, Cecil [P,T,C] NYC b. NYC. Studied: Hunter Col.; Columbia. Member: Phila. WCC; N.Y. S. Cer. A. Exhibited: AWCS, 1936, 1939; Phila. WCC, 1939-46; All.A.Am., 1938-46; N.Y. S. Ceramic A., 1923-30. Position: T., N.Y. Bd. Edu., 1940 [47]

SCHAR, A(xel) E(ugene) [P] Duluth, MN b. 12 Ap 1887, Oslo, Norway. Studied: Fritz Thaulow. Member: Duluth AA [33]

SCHARDT, Bernard [G] NYC. Exhibited: Fed. A. Gal., N.Y., 1937; AIC, 1937, 1938 [40]

SCHARL, Josef [P,E,I] NYC b. 9 D 1896, Munich d. 1954. Studied: Sch. Decorators, Acad. FA, Munich, Germany. Member: Fed. Mod. P. & S. Award: Prix de Rome, 1930. Exhibited: CAM, 1944, 1946; VMFA, 1946; PAFA, 1946; Nuremburg, 1929 (prize); Munich, 1931 (prize); Essen, 1932 (prize); one-man: Nierendorf Gal., 1941, 1943-46; Pinacotheca, 1944, SFMA, 1944; Univ. Louisville, 1943; Munson-Williams-Proctor Gal., 1944; de Young Mem. Mus., 1945; Denver AM, 1945; Phila. A. All., 1946; Swarthmore Col., 1946. Illustrator: Grimm's "Fairy Tales," 1944; "Rock Crystal," 1945 [47]

SCHARLACK, Herman [Ldscp.P,E,L,W] NYC b. 2 D 1899, Newark, NJ. Studied: H. Boss; A. Goldwaite; W. Von Schlegell. Member: Bronx AG; Yosian FA C. [40]

SCHARY, Saul [P,I] NYC b. 3 N 1904, Newark, NJ. Studied: ASL; PAFA; Paris. Exhibited: WMAA, 1932, 1936, 1940, 1942-45; AIC, 1942; CI, 1943, 1944; PAFA; Pal. Leg. Honor; several one-man exh., N.Y.; Milch Gal., NYC, 1939 (one-man). Work: PAFA; Columbus Gal. FA, Ohio [47]

SCHATT, Roy [P,I,Car] Arlington, VA b. 21 N 1909, NYC. Studied: ASL; Grand Central Sch.; Corcoran Gal. Sch. Exhibited: 48 Sts. Comp., 1939. Position: Com. A., Warner Bros. Theatres, Wash., D.C. [40]

SCHATTENSTEIN, Nikol [Por.P] NYC b. 10 Ag 1877, Poniemon, Russia d. 1954. Studied: Vienna Akademie. Member: All.A.Am.; Kunstlerhaus, Vienna; Knight Cross of the Francis Josef Order. Exhibited: MET, 1942; AIC, 1943; Wildenstein Gal.; AFA, 1945-46; Intl. Expo, Vienna (gold); Nat. War Poster Comp., 1942 (prize); Paris (prize). Work: Nat. Mus., Krakow, Poland; Army Mus., Vienna; PMA; Court of Appeals, Albany, N.Y.; Supreme Court, Raleigh, N.C.; Court House, Winston-Salem, N.C.; NYU; Empire Theatre, NYC [47]

SCHATZ, Daniel Leon [Por.P,Mur.P] Chicago, IL b. 5 O 1908, Milwaukee, WI. Studied: G. Moeller; R. von Newmann; Milwaukee AI; Layton A. Sch.; AIC; S. Ostrowsky, Paris. Member: Around the Palette. Position: Bureau of Des., Montgomery, Ward, and Co., Chicago [40]

SCHAUER, Martha K. [P,T,L,W] Dayton, OH b. 13 F 1889, Troy, OH. Studied: PIASch; Wittenberg Col., Springfield, Ohio; Univ. Dayton; R. Johonnot; M. Langtry; O. Beck; A. Dow; C. Martin. Member: Ohio WCS; Dayton S. Painters; Am. Ar. Prof. Lg. Exhibited: Ohio WCS; Dayton AI, annually. Work: Dayton AI. Position: T., Stivers H.S., Dayton, from 1912 [47]

SCHAUFFLER, Margaret Reynolds [P,C,T] Oberlin, OH b. 4 Je 1896, Cleveland, OH. Studied: Oberlin Col.; Cleveland Sch. A.; Western Reserve Univ.; Breckenridge, Forrest. Member: AFA; CAA. Exhibited: CMA, 1922, 1937, 1940; Allen Mem. A. Mus., Oberlin Col., 1925, 1931, 1934, 1937, 1943, 1945. Position: T., Oberlin Col., from 1923 [47]

SCHAUS, Hermann [Dealer] NYC d. 9 F 1911. He had succeeded to the business established by his uncle, William Schaus, and many important paintings were handled by the firm.

SCHAUZ, Elzibeth [P] Caldwell, NJ [24]

SCHEFFEL, Herbert H. [P,Des,I] Clifton, NJ b. 6 Ja 1909, Clifton. Studied: Newark Sch. F. & Indst. A.; New Sch. Soc. Res.; H. Hensche; B. Gussow; A. di Benedetto. Member: AWCS; Wash. WCC; N.J. WCS. Exhibited: Calif., N.Y., Miss., Ill., N.J., Wash., D.C.; AAPL, 1936 (prize). Positions: Des., Glen Rock Puppeteers (1937, 1938), Pepper Puppeteers, Clifton, N.J. (1939) [47]

SCHEFFLER, Carl [P] Chicago, IL [13]

SCHEFFLER, Rudolf [P] Valley Cottage, NY b. 5 D 1884, Zwickau, Germany. Studied: Europe; Dresden Akademie; O. Gussman; C. Bantzer; H. Prell. Member: Brooklyn S. Mod. A.; Mural P. Award: Prix de Rome. Exhibited: PAFA; BM; Salons of Am.; Europe; Royal Acad., Dresden (gold). Work: New State Office Bldg., Columbus, Ohio; European galleries; German Govt.; mosaics, Cathedral of St. Louis; Churches in Detroit, Chicago, Los Angeles, New Orleans; New State Office Bldg., Columbus; WPA mural, USPO, Maumee, Ohio. WPA artist. [47]

SCHEIBE, Royal A. [S] Milwaukee, WI [24]

SCHEIBNER, Vira B. McIlrath (Mrs.) [P,T] St. Augustine, FL b. 12 Ag 1889, Cleveland, OH. Studied: Cleveland Sch. A.; PAFA,; J. Carlson; R. Spencer; England, with C. Rosen, E. Van Waeyenberge. Member: NAWPS. Exhibited: NAWA, 1927 (prize), 1928-32; PAFA, 1925-32 [47]

SCHEIER, Edwin [Cer,Des,T] Durham, NH b. 11 N 1910, NYC. Studied: ASL; Columbia. Member: Am. Ceramic S.; Am. Assn. Univ. Prof. Exhibited: WMA; BMA; CM; Syracuse MFA, 1940 (prize), 1941 (prize); Phila. A. All.; RISD. Work: CM; AIC; MOMA; Syracuse MFA. Positions: T., Univ. N. H., 1940-45; Hd., Cer. Section, Puerto Rico Development Co., 1945-46 [47]

SCHEIER, Mary (Mrs. Edwin) [Cer,Des] Durham, NH b. 9 My 1910, Salem, VA. Studied: ASL; Parsons Sch. Des. Exhibited: Syracuse MFA, 1940 (prize), 1941 (prize); WMA; BMA; CM; Phila. A. All.; R.I. Mus. A.; Currier Gal. A.; Univ. N.H.; VMFA. Work: AIC; Syracuse MFA; CM; MOMA; Univ. N.H. Positions: Cer. Des., Puerto Rico Dev. Co., San Juan, P.R.; T., RISD [47]

SCHEIN, Eugenie [P,T] NYC b. 3 My 1905, Austria. Studied: C.J. Martin, Hunter Col.; Columbia. Position: T., Hunter Col. [40]

SCHEINMAN, Hortense W. [P,S,T] Brooklyn, NY b. 26 Ap 1901, Baltimore, MD. Studied: Roben; Kaiser; Adams; Kroll [25]

SCHEIRER, George A. [Bookbinder,T] Wash., D.C. b. 14 Je 1895, Elmira, N.Y. d. 30 Je 1959. Studied: M. Lane. Member: Wash. AC; Wash. S. Min. PS&G; Boston SAC. Exhibited: CGA, 1936; Wash. AC, 1946; Phila. A. All., 1937; Wash. SAC, 1929; Pub. Lib., Wash., D.C., 1934; S. Min. PS&G, 1937–39, 1940, 1944, 1946. Position: T., The Rabbit Hutch Bindery, Wash., D.C., from 1935 [47]

SCHEIWE, Johannes [P] Ottumna, IA d. S 1915, Los Angeles, CA

SCHELER, Armin Alfred [S,T,Des,L] Baton Rouge, LA b. 20 My 1901, Sonneberg. Studied: K. Killer, at Sch. Appl. A.&Cr., Munich; Acad. FA, Munich, with Kurz and Hahn. Member: NSS; La. T. Assn.; NOAA; Soc. Des.-Craftsmen, NYC; New Rochelle AA. Exhibited: NAD; WMAA; PAFA; Paris Expo, 1936 (med), 1937; Delgado Mus. A., 1939 (prize), 1943–46; New Orleans SAC, 1946; WFNY, 1939; Switzerland, 1923 (prize); New Rochelle, 1938 (med). Work: Gov. Office Bldg., New Orleans; Gov. Printing Office, Wash., D.C.; USPOs, Evanston, (Ill.) Mattawan (N.J.). Contributor: Magazine of Art. WPA artist. [47]

SCHELL, Dorothy Root [P] Phila., PA. Member: Plastic C. [25]

SCHELL, Francis H. [I,P,Li] Germantown, PA b. 1834, PA d. 31 Mr 1909. Illustrator: "Beyond the Mississippi," 1867. During the Civil War he represented Leslie's at the front and after the war was in charge of Leslie's Art Dept. Later he formed a partnership with Thomas Hogan and for thirty years they worked together as illustrators.

SCHELL, Frank Cresson [I,W] Phila., PA b. 3 My 1857, Phila. d. 23 F 1942. Studied: T. Eakins; Anshutz. Member: Artists' Aid S.; F. PAFA; Phila. Alliance; Phila. Sketch C.; Fairmount Park AA; A. Fund S. Work: Mystic Seaport Mus.; Phila. Marine Mus.; Atwater Kent Mus., Phila. Illustrator: Harper's. Position: A. Ed., Leslie's and North American, 1903–25 [25]

SCHELL, Frederick B. [Mar.P] b. ca. 1838 d. 1905, Chicago. Exhibited: NAD, 1880 [*]

SCHELL, Gus G. [Scenic P.] Columbus, OH. Member: Pen and Pencil C., Columbus [25]

SCHELL, Susan Gertrude [P,T] Phila., PA Studied: State T. Col., West Chester, Pa.; PAFA. Member: NAWA; Phila. A. All.; Mystic AA; The Ten; Germantown AL. Exhibited: NAWA, 1934 (prize), 1936 (prize), 1940 (prize). Work: New Britain Mus.; State T. Col., Pa. Position: T., PMSchIA, 1930–46 [47]

SCHELLENGER, E.M. [P] NYC [01]

SCHELLIN, Robert [P,Gr,S,Dr,B,T] Milwaukee, IL b. 28 Jy 1910, Akron, OH. Studied: Milwaukee State T. Col.; Columbia; Univ. Wis.; H. Hofmann; F. Taubes; G. Moeller. Member: Wis. P&S; Wis. A. Fed. Exhibited: AIC, 1933 (med), 1944; AGAA, 1945; CMA, 1945; Walker A. Ctr., 1946; Milwaukee AI, 1933 (prize), 1936, 1939; Newark Mus., 1943; Portland A. Mus., 1946; Kalamazoo Inst. A., 1946; Wis. PS, 1930–46; Madison Salon, 1936, 1937, 1944, 1945; Wis. State Fair, 1943 (prize), 1944 (prize); Madison AA, 1945 (prize). Work: Milwaukee AI; Whitefish Bay (Wis.) Pub. Sch.; Milwaukee State T. Col.; Univ. Wis. Position: T., Jr. H.S., East Orange, 1940; Milwaukee State T. Col., from 1945 [47]

SCHEMPP, Theodore [P] Oberlin, OH [25]

SCHENCK, Albert F. [P] Phila., PA [06]

SCHENCK, C.C. [P] Phila., PA [13]

SCHENCK, Edwin [P] Baltimore, MD. Member: Charcoal C. [21]

SCHENCK, Phoebe Josephine [P] NYC/Cos Cob, CT b. 14 N 1883, Cleveland, OH. Studied: Cleveland, with Keller, Gottwald; DuMond, Henri, Chase, in NYC [15]

SCHENCK, Robert C. [P] Chicago, IL. Member: Chicago NJSA [25]

SCHETTER, Charlotte O. [P] Orange, N.J. [15]

SCHEU, Leonard [P,Li,T,I] Laguna Beach, CA b. 19 F 1904, San Fran., CA. Studied: Calif. Sch. FA; ASL. Member: Calif. WCS; Laguna Beach AA; San Diego AA; Aquarelle P. of Southern Calif.; San Diego AG. Exhibited: San Fran. AA, 1935; NYWCC, 1936; Laguna Beach AA, 1935–46; GGE, 1939; BM, 1941; Oakland A. Gal., 1938, 1945, 1946; Santa Cruz AL, 1935, 1938; Fnd. Western A., 1936, 1938, 1939; Santa Fe N.Mex., 1937; San Diego FAS, 1938; Calif. State Fair, 1938, 1940, 1941; San Diego AG, 1938, 1939; Bowers Mem. Mus., 1939; Aquarelle P. of Southern Calif., 1939; Santa Paula, Calif., 1941, 1942; Calif. WCS, 1943; Riverside Mus., 1946 [47]

SCHEUBER, Sylvia. See Fein.

SCHEUCH, Harry William [P,Li,Des,I,S,T] Edgewood, PA b. 5 Ap 1906, Elizabeth, NJ. Studied: CI; A. Kostellow; G. Romagnoli. Member: Pittsburgh AA. Exhibited: AIC, 1937, 1938; CI; Butler AI, 1942 (prize); Pepsi-Cola Exh., 1947; Pittsburgh AA, 1946 (prize). Work: Butler AI; Pa. State Col.; Pittsburgh Pub. Sch.; murals, City County Bldg., Pittsburgh; WPA mural, USPO, Scottdale, Pa.; 100 Friends of Pittsburgh Art. Position: Dir., Pittsburgh WPA [47]

SCHEUER, Suzanne [P] San Fran., CA. Work: USPOs, Caldwell, Eastland, both in Tex. WPA artist. [40]

SCHEUERLE, Joseph [P,I] b. 1873, Vienna, Austria (came to Cincinnati, 1882) d. 1948, So. Orange, NJ. Studied: Cincinnati AA. Member: Cincinnati AC. Work: Boileau Col., Birmingham, Mich. Painter of the Sioux Indian in 1909, the Crow and Blackfoot, 1910, the Cheyenne in 1911 and others. He was a friend of C.M. Russell, Gollings, and de Young. [04]

SCHEUKER, Harry [S] Paris, France [13]

SCHEUREN, E.F. [P] Cleveland, OH. Member: Cleveland SA [27]

SCHEVILL, W(illiam) V. [Por.P] Los Angeles, CA b. 2 Mr 1864, Cincinnati, OH. Studied: Munich, with Löefftz, Lindenschmitt, Gysis. Member: Century Assoc.; SC; St. Louis GA; AFA. Exhibited: St. Louis Expo, 1904 (med). Work: Cincinnati Mus.; portrait, Prince Henry of Prussia, Herron AI; Leipsic AM; portraits, Wash. Univ., St. Louis; War Dept., Wash., D.C.; St. Louis AM [40]

SCHEVLIN, Rubye Everts (Mrs.) [C,B,E,T] Wash., D.C. b. 26 My 1892, Anthon, IA. Studied: B.B. Morton; Chicago Acad. FA; G. Scheirer; J. Constable. Position: T., YWCA, Wash., D.C. [40]

SCHICK, Elma H. [P] Phila., PA [25]

SCHICK, Fred G(eorge) [P,I] Buffalo, NY b. 31 Ja 1893, Buffalo, NY. Studied: Wilcox; M.B. Cox. Member: Buffalo AC [25]

SCHICK, Paul Raymond [P,L] West Redding, CT b. 12 Ag 1888, Bellaire, OH. Member: SC. Exhibited: WFNY, 1939 (prize); GGE, 1939; SC, 1940–46; S. Four A.; Norton Gal.; Newport AA; Guild Hall, East Hampton, N.Y., 1940 (prize); Ball State T. Col. Work: Norton Gal., West Palm Beach, Fla.; murals, churches in Shreveport La.; Bosier City, La. [47]

SCHIER, Helwig, Jr. [Mur.P] NYC. Member: Arch. L., 1898 [10]

SCHIFF, Fredi [P] Columbus, OH b. 12 My 1915, Cincinnati, OH. Studied: Columbus A. Sch.; Gromaire, Paris; J. Smith. Member: Columbus AL; Am. Ar. Prof. Lg. Exhibited: Ohio WCS; Columbus AL, 1935 (prize), 1937 (prize), 1938 (prize). Work: Columbus A. Gal. [40]

SCHIFFER, Ethel Bennett (Mrs. W.B.) [P] New Haven, CT b. 10 Mr 1879, Brooklyn, NY. Studied: Yale; ASL. Member: New Haven PCC; NAWPS; New Haven BPC (Pres.); Springfield AL; CAFA. Exhibited: CAFA, 1932; New Haven PCC, 1937 (prize) [40]

SCHILDKNECHT, Edmund Gustav [P,E,L,T] Indianapolis, IN b. 9 Jy 1899, Chicago, IL. Studied: Wis. Sch. A.; PAFA; Académie Julian, Grande Chaumière, both in Paris; D. Garber; B. Oberteuffer. Member: Ind. S. PM; Ind. AC. Exhibited: CGA, 1930; AIC, 1928, 1929, 1931, 1934–36; PAFA, 1930–32, 1935, 1944; SAE, 1937, 1938, 1943; CM, 1931–34; Kansas City AI, 1935, 1936; John Herron AI, 1924–46, 1932 (prize), 1933 (prize), 1939 (prize); Hoosier Salon, 1943 (prize), 1944 (prize), 1946 (prize). Work: John Herron AI; 600 paintings at Univ. Maine, Orono. Position: T., Arsenal Tech. Sch., Indianapolis [47]

SCHILDKNECHT, Ruth Stebbins (Mrs. Edmund G.) [P,S,T] Indianapolis, IN b. Battle Creek, MI. Studied: AIC; Chicago Acad. FA; PAFA; A. Faggi. Member: Ind. Soc. PM. Exhibited: forty-fourth annual, NAWPS, 1935 (prize); Wichita AA, 1936 (prize) [40]

SCHILL, Alice E. [P] Richmond, IN. Exhibited: Hoosier Salon, 1934; Richmond AA, 1939 [40]

SCHILLE, Alice [P] Columbus, OH b. Columbus d. 6 N 1955. Studied: Columbus A. Sch.; ASL; N.Y. Sch. A., with Chase, Cox; Paris, with Prinet, Collin, Courtois, Colarossi Acad. Member: AWCS; NYWCC; Boston WCC; NAWPS; Chicago WCC; Phila. WCC. Exhibited: Wash., WCC, 1908 (prize); N.Y. Women's AC, 1908 (prize), 1909 (prize); SWA,

1913 (prize); P.-P. Expo, San Fran., 1915 (gold); AFA, 1915 (prize); Columbus AL, 1919 (prize), 1920 (prize); NAWPS, 1929 (prize); Women's Inst., Detroit, 1930 (prize). Work: Herron AI; Phila. AC; Columbus Gal. FA [47]

SCHILLING, Alexander [Ldscp.P,E] Leonia, N.J. b. Chicago. Studied: G.S. Collis. Member: AWCS; N.Y. Etching C.; SC, 1887. Exhibited: Phila. AC, 1901 (gold); St. Louis Expo, 1904 (med); SC, 1913 (prize). Work: MMA [25]

SCHILLING, Arthur O(scar) [P,I,Dr,L,W] Rochester, NY b. 14 My 1882, Germany. Studied: Chicago; Buffalo; Rochester; Munich, Germany. Member: Buffalo AC. Illustrator: "American Standard of Perfection on Poultry." Position: Official A., Am. Poultry Assn. [40]

SCHINASI, Leon [Patron] NYC b. 1890 d. 16 Ag 1930, Juan Iles Pins, France (while traveling). He was one of the foremost business magnates of America. His collection included "Madonna and Child," by Fillipo Lippi, purchased for $125,000. He also had a fine collection of rare tapestries.

SCHINDLER, Elsa [P,I,T] Phila., PA b. 27 D 1880, Phila. Studied: W.L. Lathrop; E. Daingerfield; H.B. Snell; Phila. Sch. Des. for Women, J. Sartain Fellowship [08]

SCHIWETZ, Edward M. [P,I] Houston, TX (College Station, TX, 1975) b. 1898, Cuero, TX. Studied: ASL; mostly self-taught. Exhibited: Houston A., 1933 (prize); SSAL, 1938 (prize); Houston MFA, 1938, 1939. Work: Dallas MFA; Houston MFA; Ft. Worth AA [40]

SCHLABACH, Barbara [P] Oklahoma City, OK. Member: Oklahoma AA [25]

SCHLADERMUNDT, Herman T. [Mur.P,C] Bronxville, NY b. 4 O 1863, Milwaukee, WI d. 26 Ja 1937, Kent, CT. Studied: Delecluse, in Paris; Académie Julian. Member: Arch. Lg., 1893; Mur. P.; Century Assn. Exhibited: Arch. Lg, 1898 (prize); Columbian Expo, Chicago, 1893 (med). Work: stained glass windows, Church, St. Augustine, Fla.; stained glass dome lights, Emigrants Bank, NYC; mosaic glass windows, House of Reps., Mo. Capitol, Jefferson City; USPO, Denver [33]

SCHLADITZ, Ernest [En] NYC b. 1862, Leipzig, Germany (of American parents). Studied: Europe. Exhibited: Boston; Phila.; Vienna; Columbian Expo, Chicago, 1893 (med); Paris Expo, 1900 (med); Pan-Am. Expo, Buffalo, 1901 (med). Specialty: wood engraving [13]

SCHLAFF, Herman [P,S] Phila., PA b. 19 D 1884, Odessa, Russia. Studied: Sch. FA, Odessa. Member: AFA [29]

SCHLAFFER, Lisa [P,Dr] NYC b. 24 N 1907, Brooklyn, NY. Studied: Pratt Inst.; Steris, in Paris. Member: NAWPS; S.Indp.A. [40]

SCHLAG, Felix Oskar [S] Owosso, MI b. 4 S 1891, Frankfurt, Germany. Studied: Kunstgewerbe Sch., Frankfurt; Acad., Munich, Germany. Exhibited: AIC, 1939; Detroit; NYC; abroad. Work: Champaign, Ill. Jr. H.S.; Bloom Township H.S., Chicago Heights; WPA work, USPO, White Hall, Ill.; des., Jefferson nickel, U.S. Mint, Wash., D.C., 1938; S., Franklin & Roosevelt H.S., NYC; Frankfurt AM, War Mem., Amberg, Germany; fountain, Frankfurt, Germany [47]

SCHLAIKJER, Jes Wilhelm [P,I,T] Wash., D.C. b. 22 S 1897, NYC. Studied: Ecole des Beaux-Arts, France; AIC; Forsberg; Cornwell; Dunn; R. Henri. Member: ANA, 1932; A. Gld.; Scandinavian-Am. A.; Grand Central A. Gal.; A. Fund S. Exhibited: NAD, 1926 (prize), 1928 (prize), 1932 (prize). Work: NAD; U.S. War Dept.; U.S. Naval Acad., Annapolis. Positions: Official A., U.S. War Dept., Wash., D.C., 1942–45; T., Newark Sch. F.&Indst. A. [47]

SCHLAPP, Charles W.L. [Por.P,Li,T,Dr] Rossmoyne, OH b. 20 D 1895, Cincinnati. Studied: Cincinnati A. Acad.; L.H. Meakin; J.R. Hopkins; H.H. Wessel; J.E. Weis. Member: Cincinnati AC; Cincinnati Professional A. Exhibited: PAFA, 1931; Butler AI, 1932; Ohio PM, 1938; CM, 1920–46; Cincinnati AC; Cincinnati Professional A. Position: T., Cincinnati A. Acad., from 1921 [47]

SCHLATER, Katherine [P,I,Li,B] Phila., PA b. Phila. Studied: PMSchIA; H. Breckenridge; R.M. Pearson; E. Horter. Member: Phila. A. All.; Phila. Pr. C.; AAPL; Plastic C. Exhibited: PAFA [47]

SCHLAZER, Michael [P,I,T,L] Brooklyn, NY b. 25 Ag 1910, Poland. Studied: AIC; Ostrowsky Ed. Alliance, N.Y. Exhibited: BM, 1939; MOMA; Mus. Non-Objective Painting, 1946; Contemporary A. Gal.; New Sch. Social Research; Exh. Am. A., N.Y., 1938. Work: Bd. Edu., N.Y.; Mus. Non-Objective Painting; P.S. #94, N.Y.; Ft. Hamilton H.S.; Jackson H.S., N.Y.; Newark (N.J.) Bd. Edu. [47]

SCHLEETER, Howard Behling [P,En,L,T] Albuquerque, NM (Santa Fe, 1963) b. 16 My 1903, Buffalo, NY. Member: N.Mex. AL. Exhibited: Phila. A. All., 1945 (one-man); de Young Mem. Mus., 1946; Kansas City AI, 1935–38; Cedar City (N.Mex) A. Exh., 1941–46; N.Mex. AL, 1939 (prize); N.Mex. State Fair, 1939 (prize). Work: Univ. N.Mex.; Mus. N.Mex.; Encyclopaedia Britannica Coll.; Research Studio, Maitland, Fla.; Cedar City Inst. Religion; N.Mex. AL; WPA murals, A.&M. Col., N.Mex.; Miners Hospital, Raton, N.Mex. Position: T., Univ. N.Mex., 1950–51, 1954 [47]

SCHLEGELL, Gustav von [P,T] St. Paul, MN b. 16 S 1877, St. Louis. Studied: R. Koehler, in Minneapolis; C. Marr, in Munich; Paris, with Laurent, Laurens. Member: 2x4 Soc. Work: St. Louis AG [33]

SCHLEIN, Charles [P,E,T] NYC b. 5 Ap 1900, Russia. Studied: L. Kroll. Member: Alliance [33]

SCHLEMMER, F(erdinand) Louis [P,T] Crawfordsville, IN/Provincetown, MA. b. 26 S 1893, Crawfordsville. Studied: Hawthorne; H.M. Walcott; AIC. Member: Ind. A. Soc.; Hoosier Salon. Exhibited: Ind. A., John Herron, 1927–31; Ind. State Fair, 1930 (prize); Richmond (Ind.) AA, 1929 (prize). Work: Miami Conservatory Art, Fla.; Wabash Col., Crawfordsville [40]

SCHLERETH, Hans [Por.P] Wash., D.C. b. 13 Je 1897, Bamberg, Bavaria. Studied: C. von Marr; Munich Acad. FA. Member: S. Wash. A.; Wash. AC. Exhibited: Univ. Munich, 1920 (med); S. Wash. A., 1934 (prize). Work: portraits, District Supreme Court, U.S. Labor Dept., Wash., D.C; Harvard Law Sch.; Franklin and Marshall Col., Lancaster, Pa.; Lafayette Col., Easton, Pa.; Wittenberg Col., Springfield, Ohio; portrait, State Capitol, Springfield, Ill. [40]

SCHLESINGER, Louis [S] NYC/Marlborough, NY b. 5 Ag 1874, Fischern-Karlsbad, Bohemia. Member: Arch. Lg., 1913 [27]

SCHLESSINGER, Alfred R. [I] NYC [01]

SCHLEY, M(athilde) G. [P,I,T,W] Milwaukee, WI/Beaver Dam, WI b. Horicon, WI d. 1941. Studied: R. Lorenz. Member: Salons of Am.; Chicago A.; S.Indp.A.. Work: Smithsonian; Newberry Lib., Chicago; NYPL; Harvard [40]

SCHLICHTING, H.C. [P] Darien, CT [25]

SCHMALZ, Arthur E. [P] Manchester, N.H. Work: USPO, Eastman, Ga. WPA artist. [40]

SCHMAND, J. Phillip [Por.P] NYC/Lyme, CT b. 24 F 1871, Germania, PA d. 7 Jy 1942. Studied: M. Cox; L. Hitchcock; H.S. Mowbray; Vonnoh; A.P. Lucas. Member: NAC; Wash. AC; SC; NAWPS; AAPL. Work: portraits of Blackstone, Pitt, Mansfield, John Marshall, at Lawyer's C., NYC; Green Free Lib., Wellsboro, Pa.; Nat. Cash Register Co., Dayton; Rochester (N.Y.) Consistory; Osage Inn, Essex, Conn. [40]

SCHMAUSS, Peter [P,I] NYC [17]

SCHMECKEBIER, Laurence E. [Edu,L] Cleveland, OH b. 1 Mr 1906, Chicago Heights, IL. Studied: Univ. Wis.; Univ. Marburg, Germany; Sorbonne, Paris; Univ. Munich, Germany; M. Doerner; H. Hofmann. Member: CAA; Minn. Hist. S.; Minneapolis SFA. Author: "A Handbook of Italian Renaissance Painting," 1938, "Modern Mexican Art," 1939, "Appreciation of Art," 1945. Contributor: art magazines & journals. Positions: T., Univ. Wis, 1931–38; Chm. Dept. FA, Univ. Minn., 1938–46; Dir., Cleveland Sch. A., from 1946 [47]

SCHMEDTGEN, William H(erman) [Car,I] Chicago, IL b. 18 My 1862, Chicago d. 29 D 1936. Studied: AIC. Specialty: outdoor sports. Position: Staff, Old Mail, The Record, The Record-Herald, The Daily News, all in Chicago, since 1883 [17]

SCHMID, Elsa [P,S] Rye, NY b. 22 Mr 1897, Stuttgart, Germany. Studied: ASL. Exhibited: MET; MOMA; WMAA. Work: Newark Mus.; FMA; Yale Univ. Chapel; Church of St. Brigid, Peapack, N.J. Contributor: articles, Commonweal, Liturgical Arts, Art News. Specialty: mosaics [47]

SCHMIDT, Albert Felix [P] NYC. Member: AWCS [47]

SCHMIDT, Albert H. [P] Santa Fe, NM b. 29 N 1885, Chicago, IL d. 1957. Studied: AIC; Académie Julian; Henri Martin. Member: Santa Fe A. Colony, after 1922. Exhibited: Vanderpoel AA, 1939; Mus. N.Mex., Santa Fe, 1940. Work: Field Mus., Chicago; Mus. N.Mex. [40]

SCHMIDT, Al(win) (E.) [I] Upper Montclair, N.J. b. 27 Je 1900, Des Peres, MO. Studied: St. Louis Sch. FA; F. Carpenter. Member: SI. Exhibited: Am. A. Exh., 1933, 1934; CAM, 1922; Mayfair A. Salon, St. Louis, 1933; St. Louis AG, 1933, 1934; CM, 1933; SI, 1944, 1945. Illustrator: Collier's, Redbook, Liberty [47]

SCHMIDT, Carl [P] San Bernardino, CA. Studied: AIC. Member: Laguna Beach AA; Los Angeles AA; San Bernardino County AA [40]

SCHMIDT, Carl [P,Et,Li,B] Cleveland, OH b. 26 Jy 1909, Cleveland. Studied: J. Huntington Polytechnic Inst.; Cleveland Sch. A. Member: Cleveland PM; Cleveland AC. Exhibited: Phila. WCC, 1935; AIC, 1936; Denver AM, 1935, 1936; Ohio PM, 1932–36; CMA, 1932 (prize), 1933–37. Work: CMA [47]

SCHMIDT, Carl Arthur [P,I,G] Chicago, IL b. 16 F 1890, Berlin, Germany. Studied: Berlin Acad.; Munich Acad.; Académie Julian; ASL; AIC. Member: Am. Fed. A.; Am. Ar. Prof. Lg.; S. Sanity in Art; All Ill. SFA. Exhibited: All Ill. SFA; Palette, Chisel Acad. FA, Chicago; Garfield Pk. M., Chicago [47]

SCHMIDT, Curt [P] NYC. Member: S.Indp.A. [24]

SCHMIDT, Eberhard Winter [P] Brooklyn, NY b. 16 Ja 1902, Bremerhaven, Germany. Member: Allied Ar. Am. Exhibited: Tricker Gal., NYC; Vendôme Gal., NYC; Allied Ar. Am., 1939 [40]

SCHMIDT, Felix [I] NYC. Member: SI [47]

SCHMIDT, Felix G. [P] Evanston, IL [19]

SCHMIDT, Karl [Ldscp.P] Ardmore, PA b. 11 Ja 1890, Worcester, MA d. 26 S 1962, Santa Clara County, CA. Studied: self-taught. Member: SC; Phila. Alliance [40]

SCHMIDT, Katherine [P] NYC b. 15 Ag 1898, Xenia, OH. Studied: K.H. Miller; J. Sloan; G. Bridgman; ASL. Member: Am. S. PS&G. Exhibited: WMAA (one-man); MET (one-man); Newark Mus. (one-man); Univ. Nebr. (one-man); CI, 1940. Work: MET [47]

SCHMIDT, Minna Moscherosch (Mrs.) [Des,W,L,T] Chicago, IL b. 18 Mr 1866, Sindelfingen, Germany. Studied: Kent Col. Member: AIC; Ill. SFA; Chicago Hist. S.; Chicago Press Assn.; Nat. Press Assn.; Lg. Am. Pen Women. Work: figurines: Trinity Col., Wash., D.C.; Chicago Hist. S.; Holy Family Acad., Chicago; Historic Figurines, Centennial Mus., Springfield, Ill. Author: "400 Outstanding Women of the World and Costumeology of Their Time." Position: T., Northwestern Univ. [47]

SCHMIDT, Oscar F. [I] NYC. Member: SI [47]

SCHMIDT, Otto [P,I,L,T,W] Phila., PA/Lindenwold, NJ b. Phila. d. 20 My 1940. Studied: PAFA, with Anshutz, Thouron, Chase; NAD, with E. Carlsen, H. Ward. Work: mural, Northeast H.S., Phila.; PAFA F. Coll.; John H. Vanderpoel AA, Chicago. Illustrator: Judge, Farm Journal, Saturday Evening Post; "A Bid for Liberty," "Tales of Pioneer Pittsburgh," "The Fishing Creek Confederacy," "3 Hikes thru Wissahickon," "Philadelphia Guide," "Pennsylvania," "Sea Transportation" [40]

SCHMIDT, Theodore B.W. [P] Monroe, WI [21]

SCHMIDT, W.B. [P] Evanston, IL [19]

SCHMITT, Albert F(elix) [P] Biarritz, France b. 14 Je 1873, Boston, MA. Studied: Mass. Normal A. Sch.; Cowles A. Sch.; BMFA Sch.; abroad. Member: Boston AC; Acad. d'Historie Intl., Paris, Decoration Etoile d'or et cravate; Grand Chevalier of the Order of the Holy Sepulchre, 1934. Work: CAM, St. Louis; Mus., RISD, BMFA; Musée du Ouvre, Paris; Musée de Pau, France; Musée de Lisbon, Portugal; Vatican, Rome [40]

SCHMITT, Carl [P,W,T] Norwalk, CT b. 6 My 1889, Warren, OH. Studied: Carlsen,NAD; S. Borglum; Florence, Italy. Work: Brady Mem. Chapel, Wernersville, Pa.; Oxford Univ., England; Pittsburgh Athletic C.; Mamaroneck (N.Y.) Theatre. Exhibited: CI; major exh. throughout U.S. [47]

SCHMITT, Henry [S] Buffalo, NY b. 8 Jy 1860, Mainz, Germany (came to U.S., 1884) d. 1 My 1921. Studied: Munich. Member: German S. Christian Arts, Munich; Buffalo SA. Work: Roman Catholic churches, Buffalo. Specialty: ecclesiastical subjects [10]

SCHMITT, Paul A. [Mur.P,B,C,Des] Oakland, CA b. 11 Mr 1893, Phila., PA. Studied: San Fran., Sch. FA; Calif. Sch. A. & Crafts. Member: Oakland AA; Bay Region AA. Exhibited: PS exh., Oakland A. Gal., 1935 (prize) [40]

SCHMITZ, Carl Ludwig [S,L,T] NYC b. 4 S 1900, Metz, France d. 13 My 1967. Studied: BAID; M. Dasio; J. Wackerle, State Sch. of App. Art; A. Hahn, State Acad. FA, Munich. Member: Guggenheim F., 1944; Grant, Am. Acad. A. and Letters; NSS; Arch. L.; Audubon A. Exhibited: PAFA, 1934–46, 1940 (med); WMAA, 1936, 1938–42, 1944; AIC, 1936–40; Syracuse MFA, 1938–41, 1946, 1939 (prize); CGA, 1936, 1939; S., WFNY, 1939; Audubon A., 1945; SFMA, 1935, 1936, 1941; NAD, 1934, 1935, 1932, 1944; Arch. L., 1936, 1942, 1944; NSS, 1940 (prize); AV, 1942 (prize); Our Lady of Victory Comp., 1945 (prize); Paris, France, 1937 (gold). Work: Syracuse MFA; IBM Coll.; N.Y. Mun. Coll.; Justice Bldg.; P.O. Dept. Bldg., Wash., D.C.; Fed. Bldg., Covington, Ky.; USPO, York, Pa.; des., Del. Tercentenary half-dollar & medal for City Planning.; Brooklyn Botanical Garden; Arch. L.; housing project, Metropolitan Life Ins. Co., the Bronx. Position: T., BAID, NYC [47]

SCHMITZ, Elizabeth T(erris) [P] Phila., PA b. Phila. Studied: PAFA. Member: Phila. Alliance; Phila. A. Week Assn. [25]

SCHMOHL, Fred C. [S] Los Angeles, CA b. 1847, Wurtemburg, Germany d. Summer, 1922. Work: statuary, World's Fair, Chicago; also designed sculpture for expositions at Seattle, San Fran. and San Diego

SCHMUCKER, Sam. L. [P] Phila., PA [01]

SCHMUTZER, Ferd [E] NYC [17]

SCHNAKENBERG, Henry Ernest [P] NYC b. 14 S 1892, New Brighton, NY d. 1970. Studied: Staten Island Acad.; K.H. Miller. Exhibited: nationally. Work: MET; WMAA; BM; Montclair AM; PAFA; Savannah (Ga.) Gal.; AGAA; Springfield (Mass.) Mus.; Wadsworth Atheneum; Fleming Mus.; Wood Mus., Montpelier, Vt.; Dartmouth Col. Gal.; Canajoharie (N.Y.) A. Gal.; AIC; Univ. Nebr.; Minneapolis Inst. A.; Pal. Leg. Honor; Dallas Mus. FA; WPA murals, USPO, Amsterdam (N.Y.), Ft. Lee, (N.J.); SFMA; Lawrence Mus., Williamstown, Mass.; Fleming M., Burlington, Vt. Contributor: articles/criticism, The Arts [47]

SCHNEEBERGER, J. [P] Chicago, IL [13]

SCHNEIDER, Arthur (same as Arthur E.?) [P,I] NYC. Member: AWCS; NYWCC. Exhibited: SC, 1906 (prize), 1907 (prize), 1912 (prize); AWCS, 1913 (prize) [25]

SCHNEIDER, Arthur E. [P,Et] Tampa, FL b. 1866, Madison, WI d. 7 F 1942. Studied: NYC; Europe. Studio in NYC, 1905–13, then in Cleveland

SCHNEIDER, Clara M. [P] Memphis, TN [13]

SCHNEIDER, Elsbeth [Por.P,En,T] Chico, CA b. 28 D 1904, Chicago, IL. Studied: Univ. Calif. Member: Lg. Am. Pen Women. Exhibited: Oakland A. Gal., 1940, 1941, 1943–45; Laguna Beach AA, 1944; Calif. SE, 1945; San Fran. AA, 1937; Lg. Am. Pen Women, 1935 (prize), 1937 (prize); Santa Cruz Ann., 1934, 1935. Position: T., Chico State Col., from 1926 [47]

SCHNEIDER, George W. [P,T,I] Madison, WI b. 12 Ja 1876, Youngstown, OH. Studied: AIC; Académie Julian with Laurens [08]

SCHNEIDER, Heinrich Rymer [P] Active Los Angeles, 1909–12, thereafter San Fran. b. 1883. Studied: Brussels; Paris; Florence; Rome. Member: Royal Acad. Belgium. Award: Prix de Rome (age 19). Work: busts/lions, for Hershey Arms, Los Angeles [*]

SCHNEIDER, Isobel (Mrs. Otto H.) [P] Ocean Beach, CA (since ca. 1924) b. 22 O 1880 (or 70), NY d. 18 Je 1962. Studied: M.B. Cox; L. Hitchcock; ASL, Buffalo; ASL; Z. Shanfield, Paris. Member: Buffalo SA; Contemp. Artists of San Diego; Los Surenos Art Ctr., San Diego. Exhibited: San Diego AG, 1936 (prize). Position: County Chairman, F.A., San Diego [40]

SCHNEIDER, Otto Henry [P,T] Ocean Beach, CA (since ca. 1924) b. 8 Ag 1865, Muscatine, IA d. 23 Ja 1950. Studied: AIC; ASL, Buffalo; ASL; Académie Julian, 1910–12. Member: Contemp. A. San Diego. Exhibited: Buffalo SA, 1912 (prize), 1917 (prize), 1922 (prize); Southern Calif. A., 1931. Position: T., Buffalo ASL, 1921–23; San Diego Acad. FA, 1925–50 [40]

SCHNEIDER, Otto J. [P,I,E] CHicago, IL b. 1875, Atlanta, IL d. 17 My 1946. Member: Chicago SE. Work: AIC; TMA; NYPL; Vanderpoel AA; Cleveland MA [40]

SCHNEIDER, Susan Hayward [P] Langhorne, PA b. 27 Je 1876, Pana, IL. Studied: Smith Col; PMSChIA; F. Wagner; W. Adams; Rittenberg; Voss, in Munich. Member: Phila. A. All.; AAPL; Plastic C.. Exhibited: Phila. AC, 1936–40; Ind. AC, 1936; PAFA, 1940; Reading Mus., 1940; New Century C., Phila. (one-man); Women's City C., Phila. (one-man); Plastic C., Phila. (one-man). Work: Langhorne (Pa.) Lib. [47]

SCHNEIDER, Theophile [P] Brooklyn, NY b. 3 D 1872, Freiburg, Germany. Studied: H. Boss; H. Hofmann; C. Hawthorne; G. Noyes; Monks; Davol. Member: Boston AC; SC; Brooklyn SA. Exhibited: PAFA; BM; Boston AC, 1924 (prize); NYWCC. Work: BM; Master Inst., N.Y.; Boston AC [47]

SCHNEIDER, William [I] NYC. Member: SI [47]

SCHNEIDER, William G. [P,I] NYC b. 1863, Monroe, WI d. 5 N 1912. Studied: Paris. Member: AWCS; SC, 1902; Players C., NYC [13]

SCHNEIDERHAHN, Maximilian [S] St. Louis, MO b. Germany (came to St. Louis in 1870) d. 25 N 1923. Studied: Munich Acad. FA. Work: executed commissions for many Roman Catholic churches

SCHNELLE, William G. [P,T] NYC/Rensselaerville, NY b. 29 Ja 1897, Brooklyn, NY. Studied: PIASch; ASL; W. Beck; H.B. Snell. Member: Soc. of the Five; NAC. Exhibited: NAC, 1931. Position: T., Washington Irving Evening H.S., NYC [40]

SCHNICKE, Harry [I,C] Cincinnati, OH b. 5 Mr 1871, Cincinnati. Studied: Cincinnati A. Acad, with Meakin, Sharp, Beck [10]

SCHNIDER, Elsa [P] Phila., PA [04]

SCHNIER, Jacques [S,T] San Fran., CA b. 25 D 1898, Romania. Studied: Stanford Univ.; Univ. Calif. Sch. FA. Member: San Fran. AA. Exhibited: San Fran. AA, 1928 (prize); Northwestern A. Exh., Seattle, 1928 (prize); San Fran., 1930 (prize); Los Angeles Mus. A., 1934 (prize); Oakland A. Gal., 1936 (prize). Work: playground fountain, San Fran.; mem., Calif. Sch. FA; half-dollar commemorating San Fran.-Oakland Bay Bridge, 1936; Mills College A. Gal., Commonwealth C., Calif.; San Fran. Mus. A., Tel-Aviv Mus., Palestine; Univ. Calif. A. Gal.; Calif. Hist. Soc.; bas reliefs/statues, GGE, 1939. Position: T., Univ. Calif., Berkeley [47]

SCHNIEWIND, Carl Oscar [Mus.Cur,W,L] Chicago, IL b. 22 S 1900, NYC d. 30 Ag 1957, Florence, Italy. Studied: Univ. Zurich; Univ. Berne, Switzer.; Univ. Heidelberg, Germany. Member: AA Mus.; Grolier C. Coauthor: "The First Century of Printmaking," 1941, "Posada, Printmaker to the Mexican People," 1944, "Drawings, Old and New," 1946. Positions: Cur., Prints/Drawings, BM (1935–40) and AIC [47]

SCHNITTMAN, Sacha S. [S,W,L] St. Louis, MO b. 1 S 1913, NYC. Studied: CUASch; NAD; BAID; Columbia; A. Piccirilli; R. Aitken; O. Brindesi. Member: NSS; S.Indp.A.; Russian S. Soc. Exhibited: All.A.Am., 1935, 1936; W.R. Nelson Gal., 1942; S.Indp.A., 1942 (prize), 1943–44; St. Louis AG, 1942; WMAA, 1943; Chicago AC, 1943; Kansas City AI, 1942 (prize); Pan-Am. Arch. S., 1933 (prize); Indp. A., St. Louis, 1941–43; SAM, 1942; CAM, 1942 (prize); Jr. Lg. Mo. Exh., 1942 (prize). Author/Illustrator: "Anatomy and Dissection for Artists," 1939, "Plastic Histology," 1940. Position: T., Univ. St. Louis [47]

SCHNITZLER, Max [P] NYC b. 12 My 1903, Bukowsko, Poland. Studied: Paris, with Leger, Ozenfant, Lhote. Exhibited: WMAA; CM; Denver AM; SAM; SFMA; Albright A. Gal.; Columbia (one-man); Zborowski Gal. (one-man); Contemp. A. Gal. (one-man); Pinacotheca (one-man) [47]

SCHOCH, Pearl [P] Brooklyn, NY b. 3 Jy 1894, NYC. Studied: PIASch; NYU; Columbia; A. Fischer; M. Davidson; C.J. Martin. Member: AWCS; NAWA. Exhibited: AWCS, 1939–46; BM; NAWA [47]

SCHOCK, William [E,Dec] Cleveland, OH b. 3 N 1913, Porto Alegre, Brazil. Studied: K. Kubinyi; H. Keller; R. Stoll; F. Wilcox. Exhibited: CMA, 1936 (prizes), 1939 (prize). Work: CMA [40]

SCHOEN, Eugene [Dec,Des,Arch] NYC b. 15 S 1880, NYC d. 16 Ag 1957. Studied: Columbia; W.R. Ware. Member: Am. Inst. Dec.; Arch. Lg. Exhibited: Arch. Lg., 1931 (gold). Work: PMA; interior arch. des. for: Stewart and Co., Stern Bros., R.H. Macy and Co.; Savoy-Plaza Hotel; Lincoln Hotel; NYC; Kaufmans, Pittsburgh; Jordan Marsh Co., Boston; casino, Rye, N.Y.; RKO Center Theatre; USSR Embassy, Wash., D.C.; Alfred Dunhill, London; Radio City, NYC; Boardwalk, Atlantic City, N.J.; Hotels Concourse Plaza, New Yorker. Consultant and architect to N.Y. State on Chicago World's Fair. Position: T., NYU [47]

SCHOEN, James D. [P] NYC. Member: S.Indp.A. [25]

SCHOENBORN, Annie M. [P] Wash., D.C. [01]

SCHOENFELD, Lucille [S] San Francisco, CA [21]

SCHOFER, Carl T. [P] Crafton, PA. Member: Pittsburgh AA [21]

SCHOFF, Stephen Alonzo [En] b. 16 Ja 1818, Danville, VT d. 6 My 1904, Norfolk, CT Studied: O. Pelton, in Boston, 1834–37; J. Andrews, 1837–39; Paris, ca. 1840–42. Member: ANA, 1844–84. Active in Boston 1850s–60s; Wash., D.C.; Newtonville AM; Brandon, Vt.; Norfolk, Conn. [*]

SCHOFIELD, Flora [P,S,B] Chicago, IL b. 6 Mr 1873, Chicago d. 1960. Studied: AIC; Paris, with Friez, Gleizes, Lhote; Provincetown, with C.W. Hawthorne, B.J.O. Nordfeldt, Wm. Zorach. Member: Chicago SA; Chicago AC; NYSWA; Cordon. Exhibited: Provincetown AA, 1916; Salon d'Automne, Salon des Indépendants, Paris, ca. 1925–35; AIC, 1929 (prize), 1931 (prize); Wichita Mus. A., 1939 (prize). Work: Detroit IA [47]

SCHOFIELD, Louise [Ldscp.P] d. 31 Mr 1912, NYC

SCHOFIELD, W(alter) Elmer [Ldscp.P] Phila., PA/Godolphin House, Breage, Cornwall, England b. 9 S 1869, Phila. d. 1 Mr 1944, Cornwall, England. Studied: PAFA; Paris, with Bouguereau, Ferrier, Doucet, Aman-Jean, Académie Julian, Ecole des Beaux-Arts. Member: SAA, 1904; ANA, 1902; NA, 1907; NIAL; Phila. AC; Century Assn.; NAC; SC; Royal Soc. British A.; Chelsea Arts C., London. Exhibited: Phila. AC, 1898 (prize); SAA, 1900 (prize); Paris Expo, 1900 (prize); NAD, 1901 (prize), 1911 (gold), 1920 (prize); Pan-Am. Expo., Buffalo, 1901; PAFA, 1930 (gold), 1914 (gold); CI, 1904 (med); St. Louis Expo, 1904 (med); NAC, 1913 (gold,prize); P.-P. Expo, San Fran., 1915 (med); AIC, 1921 (prize); Sesqui-Centenn. Expo, 1926 (med). Work: MMA; CGA; Cincinnati Mus.; CI; Albright A. Gal.; PAFA; Herron AI; Rochester; AIC; NAC; BM; Des Moines City Lib.; Harrison Gal., Los Angeles Mus. A.; Norfolk Mus. A., Va.; Luxembourg, Paris; State Mus., Uruguay; Buenos Aires [40]

SCHOFIELD, William B. See Scofield.

SCHOFLER, Raphael [P] Bronx, NY [15]

SCHOLL, Edward [I,Por.P,E] b. 1884 d. 13 My 1946, NYC. Studied: NAD; J.W. Alexander; etching, J. Smillie. Positions: Staff, New York World, Boston American, New York News

SCHOLZ, Lee, Mrs. See Kinney, Belle

SCHOLZ, Leopold F. [S] Boiceville, NY b. 1877 d. 13 My 1946. Work: USPOs, Angola (N.Y.), Chattanooga (Tenn.). WPA artist. [40]

SCHON, (Carl) Sigurd [P] NYC b. 24 S 1876, Kristiania, Norway [17]

SCHONBAUER, Henry [S] NYC b. 1 Mr 1895, Hungary. Studied: Acad. FA, Munich; Acad. FA, Budapest. Work: CCNY [40]

SCHONHARDT, Henri [S,P,T] Providence, RI b. 24 Ap 1877, Providence. Studied: Paris, at Académie Julian; Ecole des Arts Decoratifs; Ecole des Beaux-Arts; Ernest Dubois. Member: AAPL. Exhibited: Paris Salon, 1908 (prize). Work: St. Stephen's Church, Providence; City Hall Park, Providence; RISD; Bristol, R.I.; Little Compton, R.I.; Quidnessett, R.I.; R.I. State House, Providence [40]

SCHONNAGEL, Albert [P] NYC [01]

SCHOOK, Fred De Forest [P,T,I] Lombard, IL/Baileys Harbor, WI b. 1872, MI d. 15 O 1942. Studied: AIC; Paris, with Ménard, Simon; H.O. Tanner, Etaples, France. Member: Chicago SA; Chicago WCC; Chicago AG; Chicago PS; Cliff Dwellers. Work: Grand Rapids AM; Lombard, Ill. Pub. Lib.; Sturgeon Bay (Wis.) Hospital. Positions: T., AIC (30 yrs.), summer schools in the Dunes (Ind.), Baileys Harbor (Wis.), Peninsula AA, Door County (Wis.) [40]

SCHOOLCRAFT, C(ornelia) Cunningham (Mrs. James T.) [P,I,T,Dr,B,L] Dover, NH b. 2 D 1903, Savannah, GA. Studied: CUAsch; Grand Central Sch. A.; NAD; E. Roth; Berkshire Summer Sch. A. Member: AAPL; N.H. AA; Nat. Lg. Am. Pen Women. Exhibited: Wash. WCC, 1934; Contemporary Am. A., 1942; Lg. Am. Pen Women, 1932, 1933; SSAL, 1933–34; Georgia AA, 1929–35; New Hampshire AA, 1940–42; one-man exhs: Ga., Miss., La., Fla., 1927–42. Work: historical map of Ga., The Golden Isles of Ga.; Univ. N.H.; Union Col. Illustrator: "Thirteen Sonnets of Georgia," "Spaniard's Mark," "Death is a Little Man." Position: T., Univ. N.H., Durham, 1945–46 [47]

SCHOOLCRAFT, Freeman [S] Chicago, IL. Exhibited: AIC, 1938. Work: USPO, Peoria, Ill. WPA artist. [40]

SCHOOLEY, Elmer Wayne [P,E,Li,T,C] Silver City, N.Mex. b. 20 F 1916, Lawrence, KS. Studied: Univ. Colo.; Univ. Iowa. Member: Sr. AG. Exhibited: Denver AM, 1939; Kansas City AI, 1940. Position: T., State T. Col., Silver City, N.Mex., from 1946 [47]

SCHOONMAKER, Eugene Spalding [S] NYC b. 30 N 1898, NYC. Studied: L. Lentelli; H. McCarter; L. Lawrie; BAID. Member: Clay C., NYC. Work: S., Library, Univ. Cincinnati; Brookgreen Gardens, S.C.; mem., Yale. Exhibited: WFNY, 1939 [40]

SCHOONMAKER, Greta V. [S] NYC [17]

SCHOONMAKER, W(illiam) Powell [E,I] Phila., PA b. 14 N 1891, NYC. Studied: G.B. Bridgman, ASL. Member: Phila. Sketch C.; Phila. Print C.; Art Dir. C. Illustrator: Country Gentleman, Ladies Home Journal [40]

SCHOONOVER, Frank E(arle) [I,P,L,T,W,] Wilmington, DE/Bushkill, PA b. 19 Ag 1877, Oxford, NJ d. 1972. Studied: Drexel Inst., 1896-97, with Howard Pyle. Member: SI, 1905; F. PAFA; Wilmington SFA. Work: Brown Vocational Sch., Wilmington. Illustrator: Scribner's, Harper's, Century, Colliers, McClures. Specialties: Am. Indians; Canadian trappers. Position: T., Wilmington Acad. A.; started his own sch., 1942 [40]

SCHOONOVER, Margaret, Mrs. See Lefranc.

SCHORK, Joseph Carl [P] New Haven, CT. Exhibited: New Haven PPC, 1933; WFNY, 1939 [40]

SCHORR, Esther. See Brann.

SCHOULER, Willard C. [P] Arlington, MA b. 6 N 1852, Arlington. Studied: H. Day; W. Rimmer. Specialty: Western and Arabian scenes [29]

SCHRACK, Joseph Earl [P,T,W,L,Des,I] NYC b. 26 F 1890, Pottstown, PA d. 1973. Studied: AIC; ASL: John Herron AI; H. Hofmann, G. Inness, Jr.; Milwaukee State T. Col. Member: Audubon A. Exhibited: AIC, 1913 (prize); All.A.Am., 1945; Audubon A., 1944, 1945. Work: Gunther Fur Co., NYC. Illustrator: Century, Liberty, McCalls. Founder-Pres., Acad. Creative Arts, Roerich Mus., 1930-35 [47]

SCHRADER, Dorothy A.V. [P] Chicago, IL b. Chicago. Studied: AIC. Member: S.Indp.A. [25]

SCHRADER, Gustave [P] Woodstock, NY b. 15 My 1900, Elmhurst, NY. Studied: Woodstock Sch. Painting. Member: Woodstock AA. Exhibited: VMFA, 1938; CGA; Albany Inst. Hist. & A.; Woodstock AA; Woodstock PS [47]

SCHRAG, Karl [E,En,P,I,T] NYC b. 7 D 1912, Karlsruhe, Germany. Studied: Ecole des Beaux-Arts, Grande Chaumière, L. Simon, all in Paris; ASL; H. Sternberg. Member: A. Lg. Am.; SAE; S.Indp.A. Exhibited: WFNY, 1939; NYPL, 1945; WMAA, 1943; SFMA, 1941-45; MET (AV), 1942; S.Indp.A., 1940-44; LOC, 1944, 1945; CI, 1944, 1945; "100 Prints of the Year," "America at War," "50 American Prints" Traveling Exh.; Am.-British A. Ctr., 1943, 1944; Contemp. A., 1940-43; Kennedy & Co., 1944; Willard Gal., 1945; Phila. A. All., 1942-44; Phila. Pr. C., 1942, 1946; U.S. Nat Mus., 1945 (one-man). Work: LOC; U.S. Nat. Mus.; NYPL. Illustrator: "The Suicide Club," 1941, Limited Editions [47]

SCHRAM, Abraham John [P] Darby, PA b. 27 Jy 1891, Grand Rapids, MI. Studied: Corcoran A. Sch.; A. Sch., Chester Springs, Pa.; C. Hawthorne; L. Stevens. Member: S. Wash. A.; Wash. Landscape C. Exhibited: CGA; S. Wash. A.; Wash. Landscape C. [47]

SCHRECK, Horst [P] El Paso, TX (1935) b. 1885, Herisau, Switzerland. Studied: BAID, after WWI [*]

SCHRECKENGOST, Don [Des,S,P,C,T,L] East Liverpool, OH. b. 23 S 1911, Sebring, OH. Studied: Cleveland Sch. A.; A. Blazys; N.G. Keller; Western Reserve Univ.; Escuela de Bellas Artes, Mexico. Member: Am. Ceramic S.; U.S. Potters Assn.; Boston SAC; The Patteran; Cleveland SA; Ceramic Gld., Cleveland. Exhibited: St. Louis Am; CMA; Am. Ceramic S., 1946 (med); Syracuse MFA, 1941 (prize); Graphic A. Exh., N.Y., 1940 (prize); Albright A. Gal., 1938 (prize); Finger Lakes Exh., Rochester, N.Y., 1940 (prize). Work: Rochester Mem. A. Gal.; IBM Coll.; Universitaria de Bellas Artes, San Miguel, Mexico. Contributor: American Artist. Positions: T., Alfred Univ., 1935-45; A. Dir., Homer Laughlin China Co., Newell, W.Va. [47]

SCHRECKENGOST, Viktor [S,C,Des,T] Cleveland, OH/Sebring, OH b. 26 Je 1906, Sebring, OH. Studied: Cleveland Sch. A.; Kunstgewerbe Schule, Vienna, Austria; M. Powolny; Julius Mihalik. Member: Cleveland SA; Am. Ceramic S.; Arch. L.; U.S. Potters Assn.; ADI. Exhibited: Syracuse MFA, 1932-41, 1933 (prize), 1938 (prize); AIC; WFNY, 1939; Paris Salon, 1937; GGE, 1939; CMA, 1931 (prize), 1932 (prize), 1933, 1934 (prize), 1935, 1936-39 (prizes), 1940-42, 1946; Akron AI, 1931 (one-man); WMAA, 1937; CM, 1938, 1939, 1941; TMA, 1938, 1940; Cranbrook Acad. A., 1946; Alfred Univ., 1939 (med); many traveling exh., U.S. & abroad. Work: MET; WMAA; Syracuse MFA; Albright A. Gal.; CMA; Memphis Mus. A.; IBM Coll.; cab design, White Motor Co., Cleveland; dinnerware des., Am. Limoges China Co., Sebring; bronze tablet, Oberlin, Ohio; bronze tablet, Sebring Mem., Ohio; Miami, Fla., 1939. Contributor: Encyclopedia of the Arts, 1945. Positions: A. Dir./Des., Am. Limoges China Co. (1933-44), Salem China Co. (1936-46), Sebring Pottery Co.; T., Cleveland Sch. A. [47]

SCHREIBER, George L. [P,T] Santa Monica, CA b. NYC. Studied: ASL, with W. Sartain; Ecole des Beaux-Arts, Paris, with Gérôme, P.V. Galland. Member: Calif. AC [25]

SCHREIBER, Georges [P,Li,I,W,T] NYC b. 25 Ap 1904, Brussels, Belgium (came to NYC in 1928) d. 1977. Studied: Berlin, London, Rome, Paris, Florence, all 1922-28. Exhibited: CI, 1943-45; CGA, 1942, 1943, 1945; PAFA, AIC, 1932 (prize); WMAA; MET; MOMA, 1939 (prize); A. Dir. C., 1943 (prize). Work: MET; BM; WMAA; Swope A. Gal., Terre Haute; Davenport Mun. A. Gal.; Mus. City of N.Y.; Encyclopaedia Britannica Coll.; U.S. Navy Dept., series of marine & submarine paintings. Author/Illustrator: "Portraits and Self Portraits," 1936. Illustrator: "Little Man, What Now?," by Hans Fallada, other children's books. Contributor: national magazines. Position: T., New Sch. Soc. Res. [47]

SCHREIBER, Isabel [Mur.P,I,T] Atchison, KS b. 17 Ag 1902, Atchison, KS. Studied: Univ. Kans.; J.R. Frazier; A. Bloch; R. Eastwood. Member: Am. Assn. Univ. Women. Exhibited: PAFA; Kansas City AI; Young Gal., Chicago. Work: Kans. State Col.; mural backgrounds for bird exhibits, Dyche Mus., Lawrence, Kans.; murals, Atchison Pub. Sch.; Univ. Kans. [47]

SCHREIBER, John [I] NYC b. 1872 d. 3 Ag 1919 (of apoplexy). Position: Staff, Butterick Pub. Co.

SCHREYER, Claudius [P] Phila., PA b. 23 Ap 1864, Phila. Studied: PAFA; Paris, with Dagnan-Bouvert, Laurens. Exhibited: AAS, 1902 (med) [10]

SCHREYVOGEL, Charles [P,I,Li,S] Hoboken, NJ b. 4 Ja 1861, NYC d. 27 Ja 1912 (of blood poisoning from a chicken bone stuck in his gum). Studied: August Schwabe, in Newark; Munich, with C. Marr, Kirchbach, 1887-90. Member: ANA, 1901; SC, 1902. Exhibited: NAD, 1900 (prize); Paris Expo, 1900 (med); Pan-Am. Expo., Buffalo, 1901; St. Louis Expo, 1904 (med). Work: MET. Specialty: Western military life [10]

SCHRIEBER, E. [P] Toledo, OH. Member: Artklan [25]

SCHRODER, Arnold [P] San Fran., CA [17]

SCHRODER, Charles [P] Chicago, IL [15]

SCHROEDER, Charlotte D. (Mrs. H.W.) [P] Montclair, NJ b. 9 Ap 1893, Montclair. Studied: Montclair AM Sch; D. Prizer; C. Chapman; J.R. Koopman. Member: NAWA; West Essex AA. Exhibited: AWCS, 1940; Audubon A., 1945; NAWA, 1942-46; Newark AC, 1946; N.J. WCS, 1940-42; A. of Today, Newark, 1940; Montclair AM, 1933-41, 1943-45 [47]

SCHROEDER, Eric [Mus.Cur,P,L] Cambridge, MA b. 30 N 1904, Cheshire, England. Studied: Corpus Christi Col., Oxford Univ.; Harvard Grad. Sch. Exhibited: Today's A. Gal., Boston, 1945. Author: "Iranian Book Painting," 1940; "Persian Miniatures in the Fogg Museum," 1942. Co-Author: "Iranian & Islamic Art," 1941. Contributor: Encyc. of the Arts, Ars Islamica, Parnassus. Position: Keeper of Islamic A., FMA, from 1938 [47]

SCHROFF, Alfred Hermann [P,C,T] Carmel, CA b. 26 D 1863, Springfield, MA d. 16 Ap 1939. Studied: De Camp; Major; Chominski; Cowles A. Sch. Member: Boston AC; Boston Arch. C.; Laguna Beach AA; Pacific AA; Oakland AL; S. Oreg. A; Carmel AA; Copley S. Exhibited: Columbian Expo, Chicago, 1893 (med); Seattle, 1923 (prize); Springville, Utah, 1923 (prize); Diploma Beaux Arts, Fountainebleau, 1924; World's Columbian, Kingston, Jamaica (med). Position: T., Univ. Oreg.; Summer Sch., Univ. Calif. [38]

SCHROM, Archie Mark [Des] Wilmette, IL b. 27 Mr 1911, Santa Cruz, CA. Studied: AIC. Member: A. Dir. C., Chicago; S. Typographic A. Exhibited: AIC, 1946; A.Dir.C., Chicago, 1942 (med); S. Typographic A., 1944 (prize), 1946 (prize) [47]

SCHROTH, Dorothy L. [P,C] San Francisco, CA b. 9 My 1906, San Fran. Studied: M. Hartwell; R. Schaeffer; L. Lebaudt. Member: San Fran. S. Women A. [33]

SCHROTH, Marcella [P,T] Cincinnati, OH b. 8 F 1899, Cincinnati, OH. Studied: H. Allen; G.P. Ennis; F. Hopkins. Member: Three Arts; Cincinnati Woman's AC. Exhibited: Mid-Western A. Exh., Dayton, Ohio, 1934. Position: T., H.S., Cincinnati [40]

SCHUCKER, Charles [P,T] Brooklyn, NY b. 19 Ja 1908, Gap, PA. Studied: Md. Inst. Exhibited: MOMA; AIC; South Side Community A. Ctr., Chicago (one-man); Roullier Gal., Chicago; Bertha Schaeffer Gal., 1946; Niveau Gal., 1946; Macbeth Gal., 1946. Work: mural, Baltimore City Col. [47]

SCHUCKER, James [I] Quakertown, PA. Member: SI [47]

SCHUENEMANN, Mary B. [P,T] Phila., PA b. 5 S 1898, Phila., PA. Studied: Univ. Pa.; PMSchIA; E. Horter; E. Thurn. Member: A. All., Phila.; Plastic C.; Phila. WCC; Phila. A.T. Assn.; Eastern AA. Exhibited: PAFA, 1942-44; Phila. A. All., 1940 (one-man), 1943 (one-man); Plastic C., 1945 (med), 1946 (med). Work: Phila. Pub. Sch. Position: T., Pub. Sch., Phila. [47]

SCHULEIN, Julius W. [P,T] NYC b. 28 My 1881, Munich, Germany. Studied: Europe. Exhibited: WMAA, 1945; CI, 1945; Knoedler Gal., 1945 (one-man) [47]

SCHULENBERG, Adele (Mrs. Charles K. Gleeson) [S,C] Colchester, CT b. 18 Ja 1883, St. Louis, MO. Studied: G.J. Zolnay; St. Louis Sch. FA; Grafly; Berlin. Member: St. Louis AG [40]

SCHULER, Anne [P] NYC [13]

SCHULER, Eric [P] NYC [24]

SCHULER, H.J. [P] Toledo, OH. Member: Artklan [25]

SCHULER, Hans [S,P,T] Baltimore, MD b. 25 My 1874, Alsace-Lorraine, Germany. Studied: Verlet, in Paris; (Rinehart Scholarship, Paris, 1905). Member: NSS, 1908; Charcoal C. Exhibited: Paris Salon, 1901 (med); St. Louis Expo, 1904 (med); Arch. L., 1915 (prize). Work: Walters Gal., Baltimore; Johns Hopkins Mon., Baltimore; statue, Meridian Hill, Wash., D.C.; Martin Luther Mon., Marbury Mem., both in Baltimore. Position: Dir., Md. Inst. [40]

SCHULHOFF, Marjory, Mrs. See Collison.

SCHULHOFF, William [P] Phila., PA b. 1898 d. 2 Ag 1943. Studied: PAFA, Cresson Traveling Scholarship, 1924, 1925. Exhibited: NYC; Pittsburgh. Work: PMG [25]

SCHULL, Della F. [P] NYC [13]

SCHULLER, Jack Valentine [Des,E,I] Kansas City, MO b. 31 Ag 1912, Springfield, MO. Studied: J.S. de Martelly. Exhibited: Rocky Mountain PM Exh., Denver Mus., 1934 (prize). Work: Denver Mus. [40]

SCHULMAN, A.G. [Ldscp.P,T] NYC b. 5 Ja 1881, Königsberg, Germany (came to U.S. as a boy) d. 2 Je 1935 Phoenix, AZ. Studied: S.J. Woolf; NAD. Member: AAPL; Salons of Am. Positions: A. Ed., Encyclopedia Americana; T., CCNY [27]

SCHULTE, Antoinette [P] NYC b. NYC. Studied: ASL; Fontainebleau Sch. FA; L. Mezquita, Madrid. Exhibited: Salons Am., 1931 (prize); Salon des Tuileries, Salon d'Automne, Paris; extensively in U.S. Work: Benjamin West Mus., Swarthmore, Pa.; CGA; CM; Newark Mus.; BM; Montclair A. Mus.; MET; French Gov. Coll. [47]

SCHULTHEISS, Carl Max [E,En,I,P] Kew Gardens, NYC b. 4 Ag 1885, Nuremberg, Germany. Studied: Germany. Member: ANA; SAE; Audubon A. Exhibited: CI, 1914, 1944, 1945; AIC, 1938; NAD, 1940–46; CGA, 1946 (one-man); SAE, annually; LOC, 1943 (prize), 1944 (prize), 1945 (prize); Wichita, Kans., 1946 (prize); Laguna Beach AA, 1946 (prize). Work: LOC; NYPL. Contributor: Parnassus [47]

SHULTZ, Albert B. [I] b. 1868 d. 18 N 1913, NYC. Position: Staff, Puck, over 20 yrs.

SCHULTZ, George F. [Ldscp.P,Mar.P] Chicago, IL 17 Ap 1869, Chicago, IL. Exhibited: AIC, 1918 (prize). Work: Union Lg. C., Chicago; Cliff Dwellers, Chicago; Arché C., Chicago; City of Chicago Coll.; Mt. St. Claire Col., Clinton, Iowa; Muscatine, Iowa AA; Muskogee (Okla.) Pub. Lib. [33]

SCHULTZ, Harold A. [P,T,L] Urban, IL b. 6 Ja 1907, Grafton, WI. Studied: Layton Sch. A.; Northwestern Univ.; Sinclair; Quirt; Piccolli. Member: Chicago SA; Nat. Edu Assn. Exhibited: AIC, 1928–42; Chicago SA, 1931, 1932 (prize), 1933, 1934, 1935 (med.), 1936–42; BM, 1931; Ferargil Gal., 1940. Work: reproduced in "Art of Today" by Jacobson (Chicago, 1933). Positions: T., Francis W. Parker Sch., Chicago (1932–40), Univ. Ill. (from 1940) [47]

SCHULTZ, Harry [P] NYC b. 1 Ja 1900, Sebastopol, Russia. Studied: J. Sloan; K. Miller. Member: S.Indp.A.; Mus. Art Culture, Leningrad [31]

SCHULTZ, Isabelle. See Churchman.

SCHULTZ, L.L. (Barney) [Des,W,P] Bronxville, NY b. 11 O 1903 Elgin, IL. Studied: AIC. Member: SI. Contributor: Look [47]

SCHULTZ, Ralph T. [P] NYC. Member: SC [21]

SCHULTZ, Susette. See Keast.

SCHULTZ, Walter S., Mrs. [P] Hartford, CT. Member: Hartford AS [25]

SCHULTZE, Carl Emil ("Bunny") [Car,S] NYC b. 25 My 1866, Lexington, KY. Studied: Germany. Originator: "Foxy Grandpa" series in New York Herald and the American; The Nursery Prayer." Author: "Bunny's Blue Book" [13]

SCHULZ, Adolph R. [P] Delevan, WI [06]

SCHUMACHER, William Emile [P] Paris, France b. 1870, Boston. Studied: Paris [17]

SCHUMANN, Arno F. [P] Phila., PA b. 5 Ap 1891, Germany. Studied: PMSchIA. Member: Germantown AL. Exhibited: PAFA, 1939 [40]

SCHUMANN, Paul R. [Mar.P,Ldscp.P,T] Galveston, TX b. 13 D 1876, Germany (came to Galveston in 1881). Studied: Stockfeldt. Member: SSAL; Tex. FAA; NOAA Galveston AL; Springfield (Ill.) AA. Exhibited: Dallas, 1924 (gold); Nashville, 1925 (prize); Dallas Women's Forum, 1927 (prize); SSAL, 1929 (prize); West Tex. Fair, San Angelo (prize); Waco Cotton Palace, Waco, Tex. (prizes); Midwestern A. Exh., Kansas City AI, 1935 (prize); NOAA, 1935 (prize). Work: Dallas Woman's Forum, Art Dept.; Sch. of Painting, Ft. Worth; Rosenberg Lib., AL, Galveston; Springfield AA; Vanderpoel AA, Chicago. [40]

SCHUMO, Mabel [P] Phila., PA [19]

SCHUPBACH, Mae Allyn [P,B,Dr,T] Tulsa, OK b. 13 My 1895, Moberly, MO. Studied: J.F. Carlson; G. Wood; B. Sandzen; N.Y. Sch. F.&Appl. A. Member: Tulsa AA; Assn. Okla. A.; Prairie WCS; Painters and PMG, Tulsa; Ark. WCS. Exhibited: Tulsa AA, 1934 (prize). Position: Hd., Schupbach Sch. A. [40]

SCHUS, Adolph [Cart.,I] Harmon, NY b. 15 Je 1908, NYC. Studied: N.Y. Sch. F. & Appl. A. Member: Am. S. Magazine Cart. Contributor: illustrations: Collier's, etc. Position: Cartoon Ed., Pageant mag., 1945; A. Dir., The Boulevardier, Paris. [47]

SCHUSSELE, Cecelia Muringer (Mrs. Christian) [P] Phila. b. Besançon, France, 1841 (came to U.S. at an early age) d. 1916. Specialty: flowers, still life

SCHUSTER, Donna N. [P,T] Los Angeles, CA b. 26 Ja 1883, Milwaukee, WI d. 27 D 1953. Studied: Europe; AIC, Chase; Tarbell. Member: Calif. AC; Laguna Beach AA; S.Indp.A.; West Coast Arts; Calif. WCS (Pres.). Exhibited: Phoenix, Ariz., 1918 (prize), 1919 (prize), 1920 (prize); Calif. AC, 1921 (prize), 1931 (prize); Calif. WCS, 1926 (prize); Los Angeles County Fair, 1929 (prize), 1930 (prize); Orange County Fair, 1930 (prize); A. T. Assn., Los Angeles County, 1933 (prize); St. Paul Inst., 1915 (prize); Minn. State Art Exh., 1913 (gold), 1914 (prize); Pan-Calif. Expo, San Diego, 1915 (med); West Coast Arts, Inc., 1926 (prize), 1929 (prize); Riverside County Fair, 1930 (prize); Santa Cruz, 1931. Work: Calif. WCS. Position: T., Otis AI, Los Angeles, from 1932 [47]

SCHUSTER, Will [P] Santa Fe, NM. Affiliated with Santa Fe Mus. [27]

SCHUTZ, Anton (Joseph Friedrich) [W,Et] Scarsdale, NY b. 19 Ap 1894, Berndorf, Germany d. 19 O 1955. Studied: Univ. Munich; Royal Bavarian Acad. FA, with Groeber, P. von Halm; J. Pennell, ASL. Member: SAE; Chicago SE. Queens-Nassau Fair, Mineaola, 1932 (prize). Work: LOC; British Mus., London; Bibliothèque Nationale, Paris; BM; NYPL; AIC; CMA; St. Louis Pub. Lib.; Uffizi Gal., Florence. Contributor: etchings, Encyclopaedia Britannica, 14th ed. Position: Dir., N.Y. Graphic S. Author: "New York Etchings," 1939 [47]

SCHUYLER, Montgomery [W] New Rochelle, NY b. 19 Ag 1843, Ithaca, NY (came to NYC in 1865) d. 16 Jy 1914. Member: NIAL; Century. Author: "Westward the Course of Empires," "Studies in American Architecture." Contributor: Architectural Record. Positions: Ed., New York World; Staff, New York Times, 1883–1907

SCHUYLER, Remington [P,I,W,L] Buckingham, PA b. 8 Jy 1884, Buffalo, NY d. 19 O 1955. Studied: ASL, with Bridgman; Paris, with Laurens, E. Bashet, at Académie Julian; H. Pyle. Member: SI. Work: New Rochelle H.S., George Washington H.S., New Rochelle, N.Y.; Darien (Conn.) H.S.; Clyde Steamship Co. Author/Illustrator: "Art," 1944, "Sculpture," 1945. Illustrator: books for Boy Scouts of Am. [47]

SCHUYLER, Sophie N. [P] NYC b. St. Louis, MO. Studied: St. Louis Sch. FA [10]

SCHWAB, Edith Fisher (Mrs. C.) [P] New Haven, CT b. 28 Ja 1862, Cincinnati. Member: New Haven PCC [24]

SCHWAB, Eloisa [P] NYC b. 4 Jy 1894, Havana, Cuba. Studied: K.H. Miller, ASL; Académie Julian, Paris [33]

SCHWAB, Katherine Fisher [S] NYC b. 23 S 1898. Studied: Am. Sch. Sculpture; ASL. Member: New Haven PCC. Exhibited: S., New Haven PCC, from 1934 (prizes) [40]

SCHWABE, Henry August [Stained glass] South Orange, NJ b. 1842, Germany (came to U.S, in 1871) d. 8 F 1916. Studied: Stuttgart; Munich; Cologne; Chase, NAD. Work: des. windows for Chicago, Pittsburgh and Newark churches

SCHWACHA, George Jr. [P,T,L] Irvington, NJ b. 2 O 1908, Newark, NJ. Studied: A.W. Woelfle; J. Grabach; E. Dufner; A. Schweider. Member: AWCS; Audubon A.; Phila. WCC; Calif. WCS; New Haven PCC; CAFA; NOAA; Springfield AL. Exhibited: Mun. A. Exh., Irvington, 1936 (prize); N.J. Gal., 1937 (prize), 1939 (prize), 1940 (prize), 1942 (prize); A. Ctr. of the Oranges, 1937; AAPL, 1939; New Haven PCC, 1939 (prize), 1944 (prize); Asbury Park SFA, 1940 (prize); 1942 (prize); Newark AC, 1942 (prize); Mint Mus. A., 1943 (prize), 1946 (prize); Springfield AL, 1943 (prize); AWCS, 1944 (prize); Denver AM, 1944 (prize); Ala. WCS, 1944 (prize); N.J. P&S Soc., 1945 (prize); All.A.Am., 1945 (prize); Wash., WCC, 1946 (prize); CAFA, 1946 (prize); State A. Exh., Montclair, N.J., 1935 (med), 1937 (med); CM; CGA; Currier Gal. A.; Elgin Acad. A.; Delgado Mus. A.; NAD; NAC; Newark Mus.; N.J. State Mus., Trenton, PAFA; VMFA; AIC. Work: Albany Inst. Hist. & A.; Mint Mus. A.; AWCS; Elisabet Ney Mus.; Laguna Beach, Calif.; New Haven PCC; Montgomery FA; Newark Mus.; Women's C., Perth Amboy, Bloomfield, N.J.; Perth Amboy Pub. Lib. Contributed: articles, Irvington Herald, Newark Evening News [47]

SCHWAGER, John [P] Kansas City, MO [24]

SCHWALBACH, James Alfred [P,B,T] Milwaukee, WI b. 27 D 1912, South Germantown, WI. Studied: Univ. Wis. Member: Wis. PS. Position: T., Washington H.S., Milwaukee, WI [40]

SCHWALL, Kay Fuller (Mrs. E.E.) [P,T] New Concord, OH b. 31 O 1909, Dover, OH. Studied: Ohio Wesleyan Sch. FA; Ohio Wesleyan Univ.; Ohio State Univ. Member: Ohio WCS. Exhibited: Canton AI, 1942 (prize). Exhibited: PAFA, 1941; Ohio WCS, 1943-46; Ohio Valley Exh., Athens, 1946; TMA, 1942; Canton AI, 1942; Massillon Mus. A., 1945; Zanesville, Ohio, 1944, 1946. Position: T., Ohio Pub. Sch., 1936-42; Muskingum Col., New Concord, Ohio, 1942-44 [47]

SCHWANEKAMP, William J. [P,E,Dr,Des] Eggertsville/Cowlesville, NY b. 27 Ag 1893, Buffalo, NY. Studied: E. Fosbery; W. Paxton; P. Hale; W. James, BMFA Sch. Member: AAPL; Buffalo SA (Pres.); Artists G., Buffalo; Buffalo Print C.; Patteran S.; Northwest PM. Exhibited: Albright A. Gal., 1933, 1938 (prize); Western N.Y. Ann., 1935 (prize). Work: Albright A. Gal., Buffalo [40]

SCHWANKOVSKY, Frederick John de St. Vrain [P,T,L,W] Laguna Beach, CA b. 21 Ja 1885, Detroit, MI d. 14 F 1974, Humboldt Cnty., CA. Studied: Detroit Univ.; PAFA; ASL. Member: Laguna Beach AA; Am. Fed. T.; Calif. AC; Los Angeles AL; Calif. AT Assn. Exhibited: Laguna Beach AA, annually. Contributor: art reviews, newspapers. Positions: T., Manual Arts H.S., Los Angeles from 1919; Dir., Festival of Arts, Laguna Beach, Calif., 1946; T., Univ. So. Calif.; Whittier Eve. H.S., Los Angeles [47]

SCHWARCZ, Dorothea See Greenbaum.

SCHWARM, Wesley A. [Des,P] Brooklyn, NY b. Lafayette, IN. Studied: PIASch; R. Henri. Exhibited: Ind. A.; MacDowell C.; N.Y. Mun. Exh., 1938, 1939 Work: Jefferson, Ford & Washington Sch., Lafayette, Ind. [47]

SCHWARTZ, Alfred W. [P] NYC [06]

SCHWARTZ, Alvin Howard [P,I,T] Baltimore, MD b. 13 O 1916, Baltimore, MD Studied: NAD; Md. Inst.; NYU. Member: Md. A. Un.; Md. WCC; Baltimore Ar. Un.; Baltimore Munic. AS. Exhibited: Md. A. Un., 1939-41; BMA, 1939-41; Md. Inst. (one-man). Work: BMA; City of Baltimore, Sch. Bd. Coll.; Sinai Hospital, Baltimore; Jewish Edu. All., Baltimore; Forest Park H.S., Baltimore. Position: T., Night Sch., Md. Inst. [47]

SCHWARTZ, Andrew (Thomas) [Mur.P] Brooklyn, NY b. 20 Ja 1867, Louisville, KY d. 16 S 1942, Louisville, KY. Studied: Duveneck, Cincinnati; Cincinnati A. Acad.; Mowbray, ASL; Rome. Member: Louisville AA; AWCS; Circolo Artistica of Rome; Allied AA; SC; Fellow Am. Acad., Rome. Award: Lazarus schol. to Italy, 1899-02. Work: Dec.: Kansas City Life Insurance Co., Mo.; Baptist Church, S. Londonderry, Vt.; Cincinnati AM; Utica (N.Y.) Pub. Lib.; murals, Atkins Mus. FA, Kansas City; murals, County Courthouse, N.Y. [40]

SCHWARTZ, Elizabeth. See Neyland, Mrs. Charles.

SCHWARTZ, J. Charles [P] Columbus, OH. Member: Columbus PPC [25]

SCHWARTZ, Lester O. [P,T] Chicago, IL. Member: Ryerson Traveling F., AIC, 1937. Exhibited: AIC, 1936 (prize). Position: T., AIC [40]

SCHWARTZ, Manfred [P,T] NYC b. 11 N 1909, Lodz, Poland d. 1970. Studied: ASL. Member: Fed. Mod. P&S; Am. Ar. Cong. Exhibited: CI, 1943-45; WMAA, 1942, 1943, 1946; MET, 1942; VMFA, 1942, 1946; PAFA, 1940, 1942; AIC, 1942, 1944; BM, 1943, 1945; Wildenstein Gal.; Durand-Ruel Gal.; WFNY, 1939. Work: Brooklyn Col.; Univ. Minn.; NYPL [47]

SCHWARTZ, Marjorie Watson (Mrs. Merrill) [P,C,T] Memphis, TN b. 4 Ja 1905, Trenton, TN. Studied: State T. Col., Memphis; Newcomb Col., Tulane Univ. Member: AAPL. Exhibited: San Diego FAS, 1943; New Haven PCC, 1946; Miss. AA, 1946; Va.-Intermont Exh., 1946; Brooks Mem. A. Gal. (one-man). Position: T., Columbia Inst., Columbia, Tenn. [47]

SCHWARTZ, Rudolph [S] Indianapolis, IN b. Austria (came from Berlin to U.S.) d. 14 Ap 1912. Work: carved figures at the base of the Indiana Soldiers' Mon.; statue of H.S. Pingree, Detroit [04]

SCHWARTZ, Rudolph [E] Brooklyn, NY. b. 7 N 1899, Hungary. Studied: W.A. Levy; A.J. Bogdanove. Member: GFLA [27]

SCHWARTZ, Sadie O. [P] Cincinnati, OH. Exhibited: Cincinnati Expo, 1898 [04]

SCHWARTZ, William S. [P,Li,S] Chicago, IL b. 23 F 1896, Smorgon, Russia d. 1977. Studied: Vilna A.&Sc., Russia; AIC. Member: Phila. WCC. Exhibited: nationally/internationally; Detroit, 1925 (prize), 1926 (prize), 1936 (prize); AIC, 1927 (prize), 1928 (prize), 1930 (prize), 1936 (prize), 1945 (prize); Scarab C., Detroit, 1936 (prize); Monticello Col., Godfrey, Ill., 1939 (prize); Okla. City, 1942 (prize); Corpus Christi, Tex., 1945 (prize). Work: AIC; Encyclopaedia Britannica Coll.; Detroit IA; LOC; Dept. Labor, Wash., D.C.; Phila. A. All.; Dallas MFA; Madison AA; Monticello Col.; Oshkosh Pub. Lib.; Chicago Pub. Sch. Coll.; Univ. Ill.; Univ. Nebr.; Univ. Mo.; Univ. Wyo.; Univ. Minn.; Cincinnati Pub. Lib; Biro-Bidjan Mus., Russia; Tel-Aviv Mus., Palestine; Chicago, Glencoe, Davenport Pub. Libs; murals, USPOs, Fairfield, Eldorado, Pittsfield, all in Ill.; Cook County Nurses Home, Chicago; Univ. Wis.; Mun. Gal., Davenport, Iowa; Barrington (Ill.) Pub. Lib., Ill. State Normal Univ. WPA artist. [47]

SCHWARTZBURGER, C. [En] Brooklyn, NY b. 7 Jy 1850, Leipzig, Germany (came to NYC in 1874). Studied: Leipzig; Berlin. Exhibited: Pan-Am. Expo, Buffalo, 1901 [10]

SCHWARTZCHILD, Monroe M. [Patron] d. 18 N 1932, NYC. A major collector of the works and letters of George Cruikshank [1792-1878]. His collection ranked with those of Harvard and Princeton, and included many of the artist's illustrations for Dickens' works.

SCHWARTZKOPF, Earl C. [P,I,C] Toledo, OH b. 26 My 1888, OH. Member: Toledo Tile C. [24]

SCHWARZ, Amy [P] Phila., PA. Member: NAWPS [21]

SCHWARZ, Elizabeth [P] Phila., PA. Member: Women PS; NYWCC [15]

SCHWARZ, Felix Conrad [P,T,I,L,W] Enid, OK b. 13 Ap 1906, NYC. Studied: Corcoran Sch. A.; George Washington Univ.; Columbia; Europe; Grand Central Sch. A. Member: CAA; Western AA; S. Wash. A.; Okla. AA; Enid AL; Teaching F., George Washington Univ., 1926-27; Research F., Editorship, Columbia, 1939-41. Exhibited: CGA, 1927-35; PAFA, 1924-34; CI, 1930-34; Walker A. Ctr., 1934-39; Univ. Minn.; Univ. Ga., 1934-39; Phillips Univ.; Tricker Gal., N.Y., 1939 (one-man); S. Wash. A.; SSAL; Minn. A.; Va. A.; Enid AL; Okla. AA. Work: George Washington Univ.; Wash., D.C. Jr. H.S. Contributor: edu. and art mags. Position: T., Dir. Sch. A., Phillips Univ., Enid., Okla., from 1944 [47]

SCHWARZ, Frank (Henry) [P,Dr,C,Des,L,T,I] Croton, NY b. 21 Je 1894, NYC d. 5 S 1951. Studied: AIC; NAD; C. Hawthorne; H.M. Walcott. Member: ANA; NAD; NSMP; Royal SA, London, England; Arch. Lg. Awards: Prix de Rome, 1921. Guggenheim F., 1926; F., Royal SA, London, 1940. Exhibited: NAD, 1925-46; AIC; PAFA; CI; SC (prize); Tiffany Fnd., 1927 (med). Work: BM; Univ. Nebr.; Capitol, Oreg.; Family Relations Court, Phila.; churches: Montreal, Seattle; stone floor des., Mon., Harrodsburg, Ky. [47]

SCHWARZ, Franz J. [Cer,Min.P,T] b. 1845, Offenburg, Germany (came to U.S. in 1890) d. 2 Je 1930, Wash., D.C. Studied: Inst. Cer. A., Nuremburg, Bavaria. For three years he resided at the Castle of King Ludwig II of Bavaria, painting typical scenes from the Wagnerian operas on several sets of porcelains. From 1890 he maintained studios in Wash., D.C. and Chicago. Position: T., many of the royalty of Europe

SCHWARZ, Heinrich [Cur,W,L] Providence, RI b. 9 N 1894, Prague, Czechoslovakia d. 1974. Studied: Univ. Vienna. Author: "Amicis," Yearbook of the Austrian State Gallery, 1927; "D.O. Hill, Master of Photography," 1931, other books. Position: Cur., RISD, from 1943 [47]

SCHWARZ, Myrtle Cooper, Mrs. See Cooper.

SCHWARZ, S.L. [P] NYC [13]

SCHWARZ, William Tefft [P,I,T] Arlington, VT b. 27 Jy 1888, Syracuse, NY. Studied: Syracuse Univ.; C. Hawthorne; France; Spain. Work: Onon-

daga County Savings Bank, Syracuse; State House, Montpelier, Vt.; Shriner's Hospital, Phila.; hotels in Atlantic City, Phila., Utica, N.Y., Syracuse, Oswego, N.Y.; Fulton Nat. Bank, Lancaster, Pa.; Auditorium, Valley Forge, Pa.; mural for Girl Scout Hdqtrs.; Episcopal Acad., Overbrook, Pa.; restaurant, Phila.; Apollo Theatre, Atlantic City; Bennington Hist. Mus., Vt.; Engineer's C., NYC; Petroleum Bldg., WFNY, 1939. Contributor: illustrations, Sat. Eve. Post. Position: Hd., Art Unit, History of Surgery, WWI [47]

SCHWARZBURG, Nathaniel [P,L,T,G] Long Island City, NY b. 18 N 1896, NYC. Studied: CCNY; ASL; G. Bridgman; S. Skov. Member: A. Lg. A.; Am. Ar. Cong. Exhibited: Midtown Gal., 1934; Contemp. A., 1937; ACA Gal., 1941; Am. A. Cong., 1938, 1941; Vanderbilt Gal., 1944; Riverside Mus., 1945. Position: T., Seward Park H.S., N.Y. [47]

SCHWARZENBACH, Peter A. [I,C,T] NYC b. 22 Jy 1872, NYC. Studied: NAD; ASL. Specialty: decorative illus. [17]

SCHWARZOTT, Maximilian M. [S] NYC/Lew Beach, NY. Member: NSS, 1898. Exhibited: St. Louis Expo, 1904 (med) [17]

SCHWEBEL, Celia [P] Yorktown Heights, NY b. 14 F 1903, NYC. Studied: K.H. Miller, ASL. Member: NAWA. Exhibited: CAA; Whitney C.; Marie Harriman Gal.; NAWA; Woodstock Gal.; Assn.Am.A. (one-man); Theodore Kohn & Sons Gal. (one-man) [47]

SCHWEICKARDT, A. [S] NYC. Affilated with Gorham Co., NYC [13]

SCHWEIG, Aimee Gladstone (Mrs. Martin) [P,L] St. Louis, MO b. 31 Ja 1897, St. Louis. Studied: St. Louis Sch. FA, Wash. Univ.; C. Hawthorne; H. Hensche. Member: NAWA; St. Louis AG; Shikari; S.Indp.A.; Provincetown AA. Exhibited: MET (AV), 1942; CAM, 1945 (prize); Chicago, Ill.; Denver, Colo.; Davenport, Iowa; Kansas City, Mo. Work: Hamilton & Pershing Pub. Sch., St. Louis. Position: Co-Dir., Ste. Genevieve Summer Sch. of Art [47]

SCHWEIGARDT, Frederick William [S,L] San Francisco, CA b. 3 My 1885, Lorch, Germany. Studied: Stuttgart Acad.; Munich Acad.; Rodin, Paris. Member: San Diego FAS; Los Angeles AA. Exhibited: Pal. Leg. Honor, 1939; Paris Expo, 1913 (prize); Calif.-Pacific Intl. Expo, San Diego, 1935 (gold), 1936 (gold). Work: fountains, Hall Edu.; Balboa Park, San Diegop; Univ. Southern Calif.; Deutches M., Munich; N.Y. Mus. Sc.&Indst., Rockefeller Ctr.; port. busts, private coll. [40]

SCHWEINSBURG, Roland Arthur [Mur.P,I,L] Youngstown, OH b. 27 Jy 1898, Ellwood, City, PA. Studied: H. Keller; P. Travis; F. Wilcox; O. Ege; G. Shaw; M. Evans; H.T. Bailey. Member: Mahoning Soc. P.; Youngstown WCS; Buckeye AC. Exhibited: CMA, 1925 (prize). Work: murals, Children's Room, McMillan Pub. Lib., Youngstown; WPA murals, USPOs, East Liverpool (Ohio), Alexandria (Ind.), Eaton (Ohio); H.S., Struthers, Ohio; Carnegie Lib., E. Liverpool, Ohio. Illustrator: "The Roaring Loom," by E.H. Miller, 1935. [40]

SCHWEITZER, Gertrude [P] Hillside, NJ b. NYC. Studied: PIASch.; NAD; Académie Julian. Member: ANA; AWCS; Phila. WCC; Wash. WCC; N.J. WCS; Palm Beach AA. Exhibited: NAWA, 1933 (prize); A. Ctr. of the Oranges, 1935 (prize); Phila. WCC, 1936 (prize); Norton A. Gal., 1946 (prize); AAPL, 1934 (med); AWCS, 1933 (med); Montclair Art Mus. (med), 1935; PAFA, 1936 (prize). Work: BM; Toledo Mus. A.; Canajoharie A. Gal.; Hackley A. Gal.; Davenport Mun. A. Gal. [47]

SCHWEITZER, Moy J. [Min.P] Ampere, NJ b. 16 Mr 1872, England. Studied: ASL. Member: NSC; Gld. Book Workers [13]

SCHWEIZER, J. Otto [S] Phila., PA b. 27 Mr 1863, Zurich, Switzerland d. 1 D 1955 (age 92). Studied: A. Sch., Zurich; Royal Acad. FA, Dresden, with Schilling; Florence; Rome. Member: NSS. Work: Civil War statues, mem., busts, monuments: Phila.; Utica, N.Y.; Valley Forge Military Park, Pa.; Denver; Gettysburg, Pa.; Carlisle, Pa.; Union Lg., Phila.; Marietta, Ga.; Harrisburg, Pa.; Milwaukee; Fairmont Park, Phila.; Mexican War & WWI medals for Pa.; Am. Numismatic S.; reliefs in private residences [47]

SCHWERTFEGER, Ellen Newman [P,W,L,T] Galveston, TX b. 28 F 1918, Galveston. Studied: Univ. Tex.; AIC; Incarnate Word Col., San Antonio. Member: Galveston AL; Tex. State T. Assn. Work: Houston MFA, 1938–39; Tex. Edu. Exh., Dallas, 1937, 1938; Galveston AL, 1934–46; AIC, 1937 (prize). Author/Editor, "Hold a Candle to the Sun," 1938; "Galveston Community Book," 1945. Position: T., Galveston Pub. Sch. [47]

SCHWIEDER, Arthur I. [P,I,T] NYC b. 2 D 1884, Bolivar, MO. Studied: Drury Col., Springfield, Mo.; AIC. Exhibited: CI, 1945; PAFA, 1945. Positions: Illus., Doubleday, Doran, and Co.; Dir., Arthur Schwieder Group A.; NYC Dir., Schwieder Art Classes, NYC [47]

SCHWILL, William V. [Por.P] NYC b. 2 Mr 1864, Cincinnati. Studied: Europe. Member: SC, 1904. Exhibited: St. Louis Expo, 1904 (med) [06]

SCHWINN, Barbara E. (Mrs. L.B. Jordan) [I,L] NYC b. 30 O 1907, Jersey City. Studied: Parsons Sch. Des.; Grand Central A. Sch.; ASL; F.V. DuMond; L. Lucioni, others. Member: SI. Work: SI. Illustrator: nat. mags. [47]

SCHYE, Mildred Ruth [P,I] St. Paul, MN b. 15 D 1901, Chicago, IL. Studied: C. Booth; D. Albinson; C. Winholtz; H. Hofmann. Member: Minneapolis AI. Exhibited: Minn. State Fair; Portland, Oreg., AM [40]

SCIARRINO, Cartaino [S] NYC [13]

SCIBETTA, Angelo Charles [P,I,Dec] Buffalo, NY/Lancaster, PA b. 10 Je 1904, Italy. Studied: ASL; CUASch; NAD; BAID. Member: Tiffany Fnd.; ASL. Exhibited: Albright Gal., Buffalo. Work: murals, H.S., Hamburg, N.Y.; Buffalo Hist. S.; painting. YMCA, Buffalo [40]

SCOFIELD, Edna. See Halseth, Odd S., Mrs.

SCOFIELD, William B(acon) [W,S] Worcester, MA b. 8 F 1864, Hartford, CT d. 22 Ja 1930. Studied: G. Borglum. Member: AFA. Work: WMA. Author: "Verses," "Poems of the War," "A Forgotten Idyl," "Sketches in Verse and Clay." Position: City Ed., Worcester Evening Gazette [29]

SCOMA, Mario [S] Brooklyn, NY [15]

SCOTT, Anna Page [P,C,W,T,L] Dubuque, IA b. Dubuque d. 13 O 1925. Studied: Anshutz; A. Dow; AIC; PAFA; Colarossi Acad. Work: Carnegie Stout Pub. Lib., Dubuque. Author: "Art in its Relation to Industry" [24]

SCOTT, Benton F. [P] North Hollywood, CA b. 25 Je 1907, Los Angeles, CA. Studied: Europe; W. Foster. Member: Calif. AC; Los Angeles; Soc. for Sanity in Art. Exhibited: Palace Legion Honor, 1946; Santa Barbara Mus. A., 1944; Los Angeles Mus. A., 1939–45, 1943 (prize); Calif. AC, 1946 (prize) [47]

SCOTT, Bertha [Por.P,W,L] Frankfort, KY b. 25 Mr 1884, Frankfort d. 21 Ja 1965. Studied: A.K. Cross; A. Kauffman; G.A. Beneker. Member: Louisville AC; Louisville AA; SSAL. Work: ports., privately owned [47]

SCOTT, Catherine [P,Dr,L] Ottawa, KS b. 17 D 1900, Ottawa, KS. Studied: AIC. Member: AFA. Exhibited: Kansas City AI; Joslyn Mem. [47]

SCOTT, Charles T(homas) [P,S,C,T] Churchville, PA b. 4 D 1876, Chester Co., PA. Studied: PMSchIA. Member: Eastern A. T. Assn. Position: T., PMSchIA [21]

SCOTT, Charlotte Harrington [Mur.P,T,L,Dec,B,C] Worcester, MA b. 3 Je 1905, Holyoke, MA. Studied: WMA Sch.; Ecole Des Beaux-Arts, Fontainebleau, France; Clark Univ.; Copley A. Sch., Boston; Lhote, in Paris; H. Hofmann, in Munich. Member: Worcester Gld. A. & Craftsman (Pres.); Scituate AA. Exhibited: PAFA, 1931; WMA. Work: Princeton; Worcester City Hospital; Sherborne Reformatory, Framingham, Mass. Position: T., South H.S. & Worcester Jr. Col. [47]

SCOTT, C(harlotte) T. (Mrs. Hugh B.) [P] Wheeling, WV b. 19 Ag 1891, East Liverpool, OH. Studied: V.B. Evans. Member: AAPL. Exhibited: WFNY 1939; Parkersburg FA Ctr., 1941; Clarkesburg, W.Va., 1943; Intermont Col., 1946; Oglebay Park Mus., 1946 [47]

SCOTT, Clyde Eugene [P,Des,T,I] Los Angeles, CA b. 24 D 1884, Bedford, IA d. 6 O 1959. Studied: Boston A. Sch.; R. Andrews; E. Kingsbury; E.F. Brown. Member: Calif. AC; P.&S. C., Los Angeles; Laguna Beach AA; Santa Monica AA; S. Am. Illus.; Soc. Motion Picture Ar. Illus. Exhibited: Pan-Pacific Expo, 1915 (med); GGE 1939; Los Angeles Mus. A.; Haggin Mem. Gal.; Stanford Univ.; Pomona Col.; Santa Cruz AL; Oakland A. Gal. AC; San Gabriel A. Gal.; Los Angeles Pub. Lib.; Santa Monica Pub. Lib.; Palace Legion Honor; Glendale Col.; San Juan Capistrano; Los Angeles Co. Fair, Pomona; Acad. West. P., Los Angeles; Sacramento State Fair, 1931 (prize); Holly Riviera C., 1936 (prize); Gardena, Calif H.S., 1939 (prize); Laguna Beach AA, 1939 (prize); Calif. AC, 1940 (prize); P.&S. C., 1942 (prize), 1945 (prize); Ebell Salon, 1944 (prize); Chaffey Jr. Col., 1944 (prize); Clearwater H.S., 1945 (prize); Santa Monica AA, 1945 (prize). Work: Haggin Mem. Gal., Stockton, Calif.; Chaffey Jr. Col.; Santa Monica Mun. Coll.; Clearwater H.S., Gardena H.S., Calif. Position: A., special effects, 20th Century Fox Film Corp., from 1933 [47]

SCOTT, Colin (Alexander) [P,T] South Hadley, MA/Provincetown, MA b. 11 F 1861, Ottawa, Canada. Member: Providence AA [25]

SCOTT, David W. [P] NYC. Exhibited: NYWCC, 1937; AWCS, 1938; Phila. WCS, 1938; AWCS-NYWCC, 1939 [40]

SCOTT, Dorothy Carnine (Mrs. Ewing C.) [P,L] Syracuse, NY b. 30 Ja 1903, Hannaford, ND. Studied: Colo. Col.; Univ. Chicago; Colo. Springs

FA Ctr.; Robinson; Snell; Lockwood; E.H. Barrett; E. Clark; H.V. Poor. Member: Lynchburg AC; Syracuse AA; SSAL; Colo. Springs FA Ctr. Exhibited: Va. A. Exh., 1939 (prize); Lynchburg Civic AL, 1933–40, 1937 (prize); VMFA, 1932–45; Richmond Acad. A&Sc, 1938–40; Colo. Springs FA Ctr., 1934; Wash. WCC, 1934; SSAL, 1936–39; Va.-Intermont Col., 1944–46; Assn. A. Syracuse, 1946; Sweetbriar Col., 1938 (one-man), 1944 (one-man); Lynchburg A. Gal., 1938 (one-man); VMFA, 1944 (one-man). Work: Sweet Briar Col; Beth-el Hospital, Colo. Springs, Colo.; VMFA; John Wyatt Jr. Sch., Lynchburg [47]

SCOTT, Edith A. [P,T] Medford, MA b. Faulkner, MA. Studied: BMFA Sch., with Tarbell, Benson, Hale. Member: Copley S. [25]

SCOTT, E(mily) M(aria Spafard) (Mrs.) [P] NYC b. 27 Ag 1832, Springwater, NY d. 9 Ap 1915. Studied: NAD; ASL; Collin, Paris. Member: NYWCC; NYWAC; AWCS; PBC; NAC. Exhibited: Atlanta Expo, 1895 (med); Pan-Am. Expo, Buffalo, 1901; NYWAC, 1902 (prize). Work: MET; Brooklyn Mus. Specialty: flower painting [13]

SCOTT, Eric G(lidden) [P,E,T] Paris, France b. 5 Jy 1893, Bega, Australia. Studied: J. Asthon; H. Royer; J. Pages. Member: Chicago SE; Australian Painter-Etchers; Calif. SE. Work: AIC [33]

SCOTT, Frank Edwin [P] Paris, France (since 1895) b. 1862, Buffalo, NY d. 24 D 1929. Studied: Cabanel, at Ecole des Beaux-Arts. Member: Knight, Legion of Honor, Paris. Exhibited: Antwerp Expo, 1894 (med). Specialty: Paris street scenes [25]

SCOTT, Georgiana Helen [Min.P] New Rochelle, NY b. 1851, London, England (came to U.S., 1865) d. 27 Mr 1947. Studied: her father William W. Scott. Work: in N.Y. and Westchester County private collections.

SCOTT, Geraldine Armstrong [P,L] Kokomo, IN b. 1 O 1900, Elkhart, IN. Studied: Northwestern Univ.; N.Y. Sch. F.&Appl. A., in both NYC and Paris; E.R. Sitzman. Member: Kokomo AA (Dir.); Ind. AC; Three Arts C.; Ind. AL. Exhibited: Hoosier Salon; Ind. AC; South Bend, 1928 (prize); Northern Ind. AL (prize). Work: Butler Univ.; Carnegie Lib., Kokomo, Ind.; Carnegie Lib., Tipton, Ind.; Ind. Fed. C.; Northwestern Univ.; Noblesville (Ind.) H.S. [47]

SCOTT, Harold Winfield [I] Croton Falls, NY (1975) b. ca. 1898, Danbury, CT. Studied: PIASch, 1923. Illustrator: cowboys for Western mags. of 1930s–40s [*]

SCOTT, Howard [I] NYC. Member: SI [47]

SCOTT, James P(owell) [P,Li,I,T] Tucson, AZ (1974) b. 22 Ap 1909, Lexington, KY. Studied: AIC; Anisfeld; Ritman; Chapin; Oberteuffer. Member: Tucson Palette & Brush C.; Ariz. Soc. PS. Exhibited: AIC, 1930, 1931; Tucson FAA, 1936–41, 1938 (prize); NAD, 1946; Chicago Mun. AL, 1930 (prize). Illustrator: "Dusty Desert Tales," 1941. Position: T., Univ. Ariz. [47]

SCOTT, James [P,G] Milton, NY b. 3 S 1889, Racine, WI. Studied: ASL; Académie Julian; Acad. Colarossi; Acad. Grande Chaumière. Member: SC; AAPL. Exhibited: Pan-Pacific Expo, San Fran., 1915. Work: Am. Expeditionary Forces Univ., France [40]

SCOTT, Janet L. [P] Chicago, IL [19]

SCOTT, Jeannette [P,T] Skaneateles, NY b. 26 S 1864, Kincardine, Ontario, Canada d. 16 Ja 1937. Studied: PAFA; Phila. Sch. Des. for Women; Paris. Member: AFA. Work: Syracuse MFA. Position: T., Syracuse Univ., from 1895 [33]

SCOTT, John [I] NYC (Ridgefield, CT, 1975) b. 1907, Camden, NJ. Studied: Phila., 1923. Member: SI. Illustrator: Western mags. [47]

SCOTT, John G(reen) [I] Tamaque, PA b. 15 N 1887, Buck Mountain, PA. Studied: PMSchIA [25]

SCOTT, John White Allen [Por.P,Ldsop.P,Mar.P,Li,En] Cambridge, MA b. 1815, Dorchester, MA d. 4 Mr 1907, (92 yrs. old). Studied: liith., W.S. Pendleton, Boston. At his death, he was the oldest member of Boston AC. Exhibited: Boston AC; Boston Athenaeum. Work: Mass. State House, Boston. He had been a partner with Fitz Hugh Lane in a litho. firm until 1847. Later known for his landscapes of the White Mts. (N.H.) and Catskills (N.Y.)

SCOTT, Julian [P,I] Plainfield, NJ b.15 F 1846, Johnson, VT d. 4 Jy 1901. Studied: NAD, 1963–64; Leutze, 1864–68; Paris, 1866. Member: ANA, 1871; A. Fund. S. Work: Univ. Pa.; Smithsonian; Vt. State House; Union Lg. C., NYC. When the Civil War broke out he enlisted in the Third Vt. Regiment as a musician; later he was appointed to the staff of Gen. "Baldy" Smith. He was the first man to receive the Medal of Honor for bravery on the battlefield. [01]

SCOTT, Katharine H. [Por.P,Des,T,W] West Chester, PA b. Burlington, IA. Studied: AIC; Vanderpoel; Chase; Snow-Froelich Sch. Indst. A. Member: Chester County AA. Work: ports., Des Moines County Court House; Pub. Lib. and Merchants Nat. Bank, Burlington; Parson Col., Fairfield, Iowa; J.H. Vanderpoel AA, Chicago. Contributor: illus. articles, Industrial Art, Everyday Art, Art Activities [40]

SCOTT, Madeline [P] Knoxville, TN [13]

SCOTT, Mona Dugas [P] NYC b. Augusta, GA. Studied: L.F. Jones. Member: NAWPS [31]

SCOTT, Quincy [Cart] Portland, OR/Bainbridge Island, WA b. 1 S 1882, Columbus, OH. Studied: Cox; Bridges; Morgan; ASL; W.Q. Scott; Ohio State Univ. Work: Huntington Lib., San Marino, Calif.; Columbus Gal., FA, Ohio. Author/Illustrator: "Night Riders of Cave Knob," 1911. Illustrator: "Northwest Nature Trails," 1933. Position: Ed. Cart., The Oregonian, Portland [40]

SCOTT, R(alph) [P,Dr,T] Providence, RI/Rockport, MA b. 6 O 1896, Elliston, Newfoundland. Studied: J. DeCamp; E.L. Major; A.T. Hibbard; Mass. Sch. A.; Rockport summer sch. of Drawing and Painting; Darlington Tech. Col., Eng. Member: Providence AC; Providence WCC; Rockport AA. Work: Plantation Cl., Providence. Position: T., Providence Pub. Sch. [40]

SCOTT, Robert Gillam [Edu,P] New Orleans, LA b. 31 Ja 1907, St. Johns, MI. Studied: Harvard; Yale. Member: SSAL; Am. Assn. Univ. Prof. Exhibited: Texas General Exh., 1943–45; SSAL, 1945, 1946; Detroit Inst. A., 1945; Pepsi-Cola, 1946. Position: T. Newcomb Col., Tulane Univ., New Orleans [47]

SCOTT, Tom, Mrs. See Pride, Joy.

SCOTT, Townsend [P] Baltimore, MD [24]

SCOTT, Walt [P] Cleveland, OH [25]

SCOTT, William Edouard [P,I,Dec] Chicago, IL/Indianapolis, IN b. 11 Mr 1884, Indianapolis. Studied: AIC; Académie Julian; Colarossi Acad.; J. Vanderpoel; H.O. Tanner, in France. Member: Chicago AL; Rosenwald Fund F., 1931. Exhibited: Harmon Fnd. (gold); Chicago AL (prizes). Award: Legion of Honor, Government of Haiti. Work: murals: Evanston, Ill.; Herron AI, Indianapolis; Ft. Wayne (Ind.) Court House; Lafayette (Ind.) Court House; Springfield (Ill.) State House; schools, Inst. W.Va., Charleston; First Presbyterian Church, Chicago; Chicago Defender Newspaper Lobby; Binga State Bank, Chicago; Anthony Hotel, Ft. Wayne; Edwardsville, (Ill.) Nat. Bank; South Park Methodist Episcopal Church, Chicago; Paris Salon; RA, London; First Nat. Bank and H.S., Michigan City, Ind.; Peoples Finance Corp. Bank, St. Louis; Tuley Park, Davis Sq., Stanford Park Field-House, all in Chicago; murals, John Shoop Sch., Betsy Ross Jr. H.S., Chicago; Argentine Gov.; Port-Au-Prince, Haiti; Century of Progress Expo, Chicago; Cook County Juvenile Court, Chicago; YMCA, Indianapolis; 135th St. Branch, NYPL; 135th St. Branch, YMCA, NYC; Mun. Tuberculosis Sanitarium, Chicago; City Hospital, Indianapolis; murals, Pilgrim Baptist Church, Bethesda Baptist Church, Metropolitan Comm. Ctr., Chicago [40]

SCOTT, William J. [P] Hackettstown, NJ. Member: SC [25]

SCOTT, William Wallace [P] New Rochelle, NY (had been resident of NYC for 40 yrs.) b. 1822 d. 6 O 1905. Member: NAD; RA of Great Britain; AWCS [04]

SCOTTEN, S.C. [Patron] Chicago, IL b. 31 O 1851, Burlington, IA d. 6 Ag 1920. He owned what was said to be the fifth largest art collection in America

SCOVEL, Florence See Shinn, Mrs.

SCOVEL, Mary C. [P,T] Carmel, CA b. 1869 d. 18 O 1941. Positions: Hd., teacher training dept., AIC, until 1933; Pres., Western AA

SCRIBNER, Elizabeth (Mrs. Sidney Jones) [P] Pittsfield, MA b. 1874, Middleton, NY. Studied: W. Chase; Beckwith; Fabier; Gautier Sch. Member: NAC; C.L.W. Art C. [40]

SCRUGGS-CARRUTH, Margaret Ann (Mrs.) [E,T,I,W,L,C,B,Des,Dr] Dallas, TX/Indian River, MI. b. 187 F 1892, Dallas. Studied: Bryn Mawr Col.; Southern Methodist Univ.; F. Reaugh; R. Pearson. Member: Tex. FAA; Dallas AA; SSAL; AFA; AAPL; S. Medallists; Southern PM; Dallas Pr. S; Prairie PM; Calif. PM; Highland Park AA; Woodcut S.; Nat. Lg. Am. Pen. Women; Reaugh AC. Exhibited: WFNY, 1939; Ogunquit, Maine, 1931; Dallas All. A., 1932 (prize); Tex. Centenn. Expo, Dallas, 1936. Work: Elisabet Ney Mus., Tex. and Germany; CGA; Am. Embassy, Bucharest, Romania; Nat. Soc. DAR; Tex. Fed. Garden C. Illustrator:

"The Rainbow-Hued Trail," monthly page in Southern Home and Garden. Position: T., Southern Methodist Univ., Dallas [47]

SCRYMSER, Christabel [Min.P] Rockville Ctr., NY b. 12 My 1885, Brooklyn, NY. Studied: Whittaker; Twachtman; Metcalf; Beck; Fisher; CUASch; PIASch. Member: Brooklyn SMP; NAWPS; Pa. SMP [33]

SCUDDER, (Alice) Raymond [P,C] Pasadena, CA b. New Orleans, LA. Studied: Newcomb A. Sch.; N.Y. Sch. Appl. Des.; Chase; Mora. Member: New Orleans A. [33]

SCUDDER, Antoinette [P,W] Newark, NJ/Provincetown, MA b. 10 S 1888, Newark, NJ. Studied: Hawthorne. Member: NAWPS [25]

SCUDDER, Janet [S,P,W] NYC/Paris, France b. 27 O 1875, Terre Haute, IN. Studied: Rebisso, at Cincinnati A. Acad.; Taft, in Chicago; Macmonnies, in Paris. Member: ANA; NSS, 1904; NAWPS; NAC; AFA; Chevalier de la Legion d'Honneur, 1925. Exhibited: Columbian Expo, Chicago 1893 (med); Sun Dial Comp., NYC, 1898 (prize); St. Louis Expo, 1904 (med); Paris Salon, 1911 (prize); NAWPS, 1914 (prize); P.-P. Expo, San Fran, 1915 (med); Intl. Exp, Paris, 1937 (med). Work: seal, Assn. of the Bar, City of NYC; Brooklyn Inst. Mus.; fountains: MET, AIC, Peabody Inst., Baltimore, BM; pub. sch., Richmond, Ind.; Indianapolis AA; LOC; MET; Musée du Luxembourg, Paris; Ind. Centenn.; Minneapolis Inst.; RISD; Phillips AM, Bartlesville, Okla.; St. Bethesda on the Sea, Palm Beach, Fla. Fountains on many private estates. Author: "Modeling My Life." The first American woman to have sculpture bought for the Luxembourg, Paris. [40]

SCUDDER, Raymond [P] New Orleans, IN [15]

SCUDDER, Winthrop Saltonstall [Art Ed] NYC b. 1846 d. 14 Ag 1929. Studied: Harvard. Position: Art. Ed., Houghton Mifflin Co., for 40 yrs.

SCULL, Nina Woloshukova [P,L,T,Dec,Des] Phila., PA b. 28 O 1902, St. Petersburg, Russia. Studied: ASL; Corcoran Sch. A.; Columbia; W. Adams; G.E. Browne. Member: AFA; All.A.Am.; Provincetown AA; Pittsburgh AA. Exhibited: NAD, 1939-44; CI, 1936-46; AFA traveling exh., 1939; Ogunquit A. Ctr., 1940; PAFA, 1942-45; MET (AV), 1942; Montclair AM, 1942; Provincetown AA, 1940-44; Phila. Sketch C, 1945; Da Vinci All., 1943-45; Haverford Col., 1942; Norfolk Mus. A. & Sc., 1930; Pa. State T. Col., 1938, 1939; Pittsburgh AA, 1939; Newman Gal., Phila., 1939; Allied A. Am. Work: 100 Friends of Art, Pittsburgh; Imperial Gal., Phila.; Pub. Sch., Coll., Pittsburgh; Am. Legion, Somerset, Pa. Contributor: newspapers & mags. Position: Owner, Dir., Imperial A. Sch., Phila. [47]

SCULLY, Morrow Murtland (Mrs. Henry R.) [P] Pittsburgh, PA b. 3 S 1853 d. 4 Je 1932. Member: Pittsburgh AA. Studied: Pittsburgh Sch. Des. for Women [25]

SCUTT, Winifred [P,L,W] Colorado Springs, CO b. 15 My 1890, Long Island, NY. Studied: ASL; W. Adams; G. Bridgman; W. Woolsey. Member: PBC. Exhibited: PS of Southwest, 1943; Tucson, 1938; Women's C., El Paso, 1937; PBC, 1944; Mus. N.Mex., 1942 (one-man); Joseph Sartor Gal., Dallas, 1943 (one-man); Salon of Seven A., Jackson Heights, N.Y., 1937 (one-man); Studio C., 1937 (one-man); Chappell House, Denver (one-man). Work: portraits of prominent persons. Author/Illustrator: "The Children's Master," 1925 [47]

SEABORNE, William [S] NYC b. 1849 d. 11(?) Mr 1917

SEABURY, Roxoli, Mrs. [P,C,T] Colorado Springs, CO b. 6 Ja 1874. Studied: D.W. Ross; R. Reid; Knirr, Munich; Sch. Boston Mus.; AIC; PIASch. Affiliated with Broadmoor A. Acad. [25]

SEACORD, Alice N(icholson) (Mrs. Jay G.) [P] Chicago, IL b. 10 Ag 1888, Milwaukee, WI. Studied: Chicago Acad. FA; Syracuse Univ. College of F.A.; Milwaukee AL; Van Amburg Studio, Chicago. Member: All-Ill. SFA [40]

SEAFORD, John A. [P] Spiceland, IN [06]

SEAMANS, F.M. [P] Cleveland, OH [08]

SEARCY, Elisabeth [Et,Ldscp.P,E,W,Des,L] Memphis, TN b. Memphis, TN. Member: SSAL; Wash. AC. Exhibited: Arch. L.; Delgado Mus. A.; Brooks Mem. A. Gal.; numerous exh., N.Y. Gals.; Tenn. Artists, Nashville, (prize). Work: MET; Mus. City of N.Y.; LOC; Mus. A., Helena, Ark. Position: T., Whitworth Col., Brookhaven, Miss. [47]

SEARL, Leon A. [Cart] Flushing, NY b. 1882 d. 27 Ja 1919 Contributor: for the movies. Position: Art. Ed., Rocky Mountain News, Denver; Evening World; Evening Telegram, NYC

SEARLE, Alice T. [Min.P] NYC b. 8 F 1869, Troy, NY. Studied: ASL; Colarossi Acad.; Mme. Debillemont-Chardon, Paris. Member: Brooklyn AG. Exhibited: St. Louis Expo, 1904 (med) [25]

SEARLES, Stephen [S,P,T] Leonia, NJ b. 10 Je 1914, NYC. Studied: ASL; Grand Central A. Sch.; NAD; A. Lee; W. Hancock. Member: AAPL; AFA. Exhibited: CGA, 1943; Grand Central A. Gal., 1937, 1938; Montclair AM, 1938; Guild Hall, East Hampton, 1939 (prize); Ogunquit A. Ctr., 1938 (prize); Palace Legion Honor, 1945; Biarritz, France, 1946. Work: S., Biarritz, France; Army Med. Mus., Wash., D.C.; many portrait busts. Positions: Med. Illus., Army Med. Mus., Wash., D.C., 1942-43; A.Dir., Ninth Service Command, 1944-45; T., Biarritz American Univ., France, 1945-46 [47]

SEARLES, Victor A. [I] Boston [01]

SEARS, Caroline Page [P] Danvers, MA [06]

SEARS, Charles Payne [P] b. 1864, NYC d. 23 Je 1908, Atlantic Highlands, NJ. Exhibited: NAD, 1880

SEARS, Elinor Lathrop [Min.P,P,S,Dr,E,T] Lyme, CT b. 26 S 1902, Hartford. Studied: Hale; Logan; Mora; Miller; Calder. Member: AWCS; CAFA; Lyme AA. Work: Lyman Allyn Mus.; New London Hist. S. [47]

SEARS, John [I] Rochester, NY. Affiliated with Rochester Times [15]

SEARS, Mary Crease [Des,Bookbinder] Boston, MA b. Boston d. 22 My 1938. Studied: BMFA Sch.; J. Domont, in Paris; R. Cervi. Member: Copley S.; Boston SAC. Exhibited: St. Louis Expo, 1905 (gold); Boston SAC (med); Tercentenary FA Exh., Boston, 1930 (med). Work: books bound for: St. Clement's Church, Phila.; Grace Church, Colorado Springs; Gardner Mus., Boston; Harvard; Cathedral of St. John the Divine; Riverside Church, NYC; St. Martin's Church, Providence [38]

SEARS, Phillip Shelton [S] Brookline, MA b. 12 N 1867, Boston, MA d. 1953. Studied: BMFA Sch.; D.C. French. Member: NSS; Gld. Boston A.; North Shore AA; Copley S. Work: busts, mem., statues: State House, Boston; County Court House, N.Y.; Harvard Varsity C.; Harvard Medical Sch.; Am. Indian Mus., Harvard, Mass.; BMFA; White House [47]

SEARS, Sarah C(hoate) (Mrs. J. Montgomery) [P] Boston, MA b. 5 My 1858, Cambridge, MA d. 26 S 1935, West Goldsboro, ME. Studied: R. Turner; J. De Camp; D.M. Bunker; E.C. Tarbell. Member: NYWCC; Copley S., 1891; NAC; Phila. WCC; Boston WCC; Boston SAC. Exhibited: AWCS, 1893 (prize); Columbian Expo, Chicago, 1893 (med); Paris Expo, 1900 (prize); Pan-Am. Expo, Buffalo, 1901 (med); Charleston Expo, 1902 (med); St. Louis Expo, 1904 (med) [33]

SEARS, Taber [Mur.P] NYC b. 2 F 1870, Boston, MA. Studied: BMFA Sch.; NAD; E.M Ward; Académie Julian, with Merson. Member: SC; AWCS; All.A.Am.; AAPL; NYWCC; Arch. L. 1899; Mur. P.; NY Mun. AS; Century Assn.; A. Fellowship. Exhibited: NYWCC (prize); St. Louis Expo, 1904 (med); AWCS, 1926 (prize). Work: Rollins Col., Winter Park, Fla.; N.Y. City Hall; churches in Brooklyn, Los Angeles; NYC, Chapel of the Intercession, St. Thomas' Church, St. James' Church, First Presbyterian Church, NYC; Trinity Church, Buffalo, N.Y.; Choir Sch., NYC [47]

SEATON, C.H. [P] Glencarlyn, VA b. 25 Ag 1865, Monson, MA d. 8 F 1926. Studied: self-taught. Member: S. Wash. A.; Wash. Ldscp. C. [27]

SEATON, Walter Wallace [I] Woodstock, NY b. 22 Mr 1895, San Francisco, CA. Studied: Calif. Inst. Des., San Fran.; Univ. Calif.; ASL. Member: SI. Illustrator: Cosmpolitan, Sat. Eve. Post, Ladies Home Journal, Collier's [47]

SEAVER, Elizabeth [S,T] Cleveland, OH. Exhibited: CMA, 1934 (prize), 1936 (prize), 1939 (prize). Position: T., Cleveland MA [40]

SEAVER, Hugh D. [P] Cleveland, OH. Member: Cleveland SA [27]

SEAVEY, George W. [P] Boston, MA [15]

SEAVEY, Lilla B. [P] Denver, CO. Exhibited: NAD, 1898; Omaha Expo, 1898 [98]

SEAWELL, H(enry) W(ashington) [P,I,T] San Fran, CA b. San Fran. Studied: Paris, with Laurens, Constant. Member: Paris AAA; Bohemian C., San Fran.; Pac. AA, Calif. [33]

SEBERHAGEN, Ralph H. [P] NYC Exhibited: PAFA, 1934, 1935, 1938; AWCS-NYWCC, 1939 [40]

SEBOLD, Howard R. [P] Bronxville, NY. Exhibited: AWCS, 1936, 1937; NYWCC, 1936, 1937; AWCS-NYWCC, 1939 [40]

SEBRING, Frank A. [C] Sebring, OH d. 23 N 1936. One of the founders (1887) of the nationally known Potteries of Sebring, Ohio.

SECARNS, Robert [I] Brooklyn, NY. Affiliated with Brooklyn "Life" [98]

SECKAR, Alvena V(ajda) (Mrs. Bunin) [P,Des,I,W,L] NYC b. 1 Mr 1916, McMechen, W.Va. Studied: PMSchIA; NYU; E. Baum; S. Wilson. Member: CAA; F., Princeton, 1938; F., Inst. A. & Archeology, Paris, 1939. Exhibited: Miss. AA, 1946; Mint Mus. A., 1946; Allentown, Pa., 1938 (one-man); Univ. Pa., 1935–37; Webster Lib., 1945 (one-man); Parkersburg, W.Va., 1946. Contributor: L'udovy Dennik, (Slovanik newspaper) Pittsburgh. Position: Cur. Textiles, CUASch, 1941–42; Des., Saks Fifth Ave., NYC 1946 [47]

SECOR, David Pell [P,Cr,Patron] b. 1824, Brooklyn, NY d. 30 Mr 1909, Bridgeport, CT. He gave Stanford Univ. the Hervey herborium collection and the Bridgeport Scientific Society a collection of Indian relics.

SEDGEWICK, J.M. [P] Stockbridge, MA [06]

SEE, Ella E. [P,T] Rochester, NY. Member: Rochester AC [21]

SEEBERGER, Pauline Bridge (Mrs. Roy Vernon Sowers) [P,B,En] San Francisco, CA b. 12 Je 1897, Chicago, IL. Studied: Ecole Francais; J. Despujols, Rome; G. Rose, Calif.; Sch. Dec. Des., Boston [40]

SEEBOLD, Marie M. See Molinary, Mrs. A.

SEEBOLD, W.E. [Dealer] b. 1833, Hanover, Germany (came to U.S. as a young man) d. 25 Je 1921. He fought for the Confederacy during the Civil War. For over half a century he was a prominent dealer in New Orleans, and in his galleries were held exhibitions of work by all the local artists and by many visiting artists of note. He was the last survivor of the Art Union, the first association of artists in New Orleans. His son H.B. Seebold and his daughter, Mrs. Andres Molinary were both recognized painters.

SEEDS, Elise. See Armitage, Elise.

SEEGMULLER, Wilhelmina [Edu,W] Indianapolis, IN b. 1856, Fairview, Ontario d. 24 My 1913. Studied: PIASch, 1894–95. Author: "The Applied Arts Drawing Books," "Little Rhymes for Little Readers." Position: A. Dir., public schs., Indianapolis, 1895–1913

SEELY, Florence [P] NYC [01]

SEELY, Walter Frederick [P,L] Los Angeles, CA b. 7 D 1886, ME. Studied: C.T. Wilson. Member: Los Angeles PS [33]

SEEMAN, Erwin W., Mrs. See Huntoon, Mary.

SEEWALD, Margaret [E] Amarillo, TX b. 6 Je 1899, Amarillo. Studied: AIC; A. Philbrick. Member: SSAL; Texas FAA; Amarillo AA [40]

SEGAL, Dororthy (Mrs.) [P,Des,T] Hartford, CT b. 3 S 1900, Godlevo, Russia. Studied: BMFA Sch.; Boston Univ. Member: CAFA. Exhibited: PAFA; CGA; Mun. A. Comm., N.Y.; Jerome Stavola Gal., Hartford, Conn., 1933; Stuart A. Gal., Boston, 1945; Conn., 1932 (prize). Position: T., Randall Sch., Hartford, from 1944 [47]

SEGAL, Jacques H. [P,Arch,Des,Dr] Phila., PA b. 4 Jy 1905. Studied: Percy Ash; Pa. State Col. Member: Fed. A. Workers; Phila. City Planning Commision. Cover design, Penn State Players [40]

SEGAL, Ruth [P] Mt. Vernon, NY. Member: AWCS [47]

SEGALL, Julius G. [P] Milwaukee, WI b. 1860, Nankei, Prussia d. 20 Ja 1925. Studied: Munich; Karlsruhe. Exhibited: Acad. FA, Venice, 1887 (prize). Also a poet [10]

SEGUSO, Armand [I] Tuckahoe, NY. Member: SI [47]

SEGY, Ladislas [P,Des,W,L] NYC b. 10 F 1904, Budapest, Hungary. Studied: College de France. Member: A. Lg. Am. Exhibited: Wildenstein Gal., 1943; Pepsi-Cola, 1945; Finley Gal., 1937; Newhouse Gal., 1938; Decorator's C., 1938; Acad. All. A., 1939; Seligmann Gal., 1942, 1943; Gal. Mod. A., 1942; Am.-British A. Ctr., 1942, 1943 (one-man), 1944; A. Assn., 1942; Niveau Gal., 1943; Marquie Gal., 1943, 1944 (one-man); Peikin Gal., 1944; NYPL, 1944; A. Lg. Am., 1944; A. Hdqtrs., NYC, 1944 (one-man); Raymond Gal., 1941; Acquavella Gal., 1941. Work: PMG; BM; NYPL [47]

SEIBEL, Fred(erick) O(tto) [Cart] Richmond, VA b. 8 O 1886, Durhamville, NY d. 18 Je 1968. Studied: ASL. Member: Richmond Acad. A. Exhibited: 200 cartoons, VMFA, 1944 (one-man). Position: Cart., Richmond (Va.) Times-Dispatch [47]

SEIBERLING, Gertrude Penfield (Mrs. Frank A.) [P] Akron, OH b. 1866 d. 8 Ja 1946. Exhibited: Ohio State Fair, 1935; NAWPS, 1935–38 [40]

SEIBOLD, Macmillan [P] Rochester, NY [15]

SEIDEL, Emory P. [S,L] River Forest, IL b. 14 My 1881, Baltimore, MD. Studied: E Keyser; W.J. Reynolds. Member: Palette and Chisel Acad. FA; Assn. of Chicago PS; Cliff Dwellers; Palette, Oak Park and River Forest AL; Chicago Gal. Assn. Exhibited: Chicago Assn. PS, 1937 (prize). Work: fountain, Freeport (Ill.); mem., Chicago; bridge, Aurora (Ill.) [40]

SEIDENBERG, Janet [Min.P] Brooklyn, NY [15]

SEIDENBERG, Roderick [P] NYC [24]

SEIDENECK, George J(oseph) [P] Chicago, IL b. 4 F 1885, Chicago. Studied: W. Thor; von Marr. Member: Chicago AC; Chicago AG; Chicago SA; Chicago Palette and Chisel C. Work: portrait, Fed. Bldg., Chicago [21]

SEIELSTAD, Benjamin Goodwin [I,P] Inglewood, CA b. 23 D 1886, Lake Wilson, MN. Studied: ASL; J. Mannheim; R. Miller. Member: SI. Work: portraits of service-men, South Pacific area & U.S. Illustrator: Life, Fortune, Outdoor Life [47]

SEIFERT, Henry [Li] Milwaukee, WI b. 1824, Saxony (came to Milwaukee, 1852) d. 10 Mr 1911. Milwaukee's leading lithographer until 1898 [*]

SEIGLE, Ralph Cornell [P,Gr,Des,L,T] San Francisco, CA b. 18 S 1912, Jeffersonville, IN. Studied: Chouinard AI; M. Sheets; P. Dike; D. Graham. Member: Calif. AA. Exhibited: LOC, 1946; SFMA (one-man); Tucson AA (one-man); SAM; Santa Cruz AL; South American traveling exh.; de Young Mem. Mus. (one-man); Gumps, San Fran. (one-man) [47]

SEIPP, Alice [P,I,W,Dr,Des] NYC b. NYC. Studied: CUASch; ASL; D. Volk; B.W. Clinedinst; O. Linde; J. Peterson; Member: PBC; AWCS; NAWA; NYWCC. Exhibited: NAWA; AWCS; PAFA; CGA; Balt. WCC; Palm Beach A. Ctr., 1934. Author/Illustrator: textbooks for Woman's Inst. Domestic A. & Sc., (Scranton, Pa.) 1940 [47]

SEITHER, Anne Barber, Mrs. [P] Phila., PA b. Phila. Studied: PAFA; Phila. Sch. Des. Women, with E. Daingerfield; Colarossi Acad, Paris [15]

SEKANINA, Jaroslav [P] Chicago, IL [13]

SEKIDO, Yoshida [P,E] San Francisco, CA b. 21 Ja 1894, Tokyo, Japan. Studied: G.B. Bridgman; T. Seiho. Member: San Fran. AA. Exhibited: Vancouver, Canada, 1921 (prize); Santa Cruz AL, 1936 (prize). Work: Calif. Palace of Legion of Honor; SFMA; Mus. A., Murray Warner Mem. Coll. of Oriental Art, Univ. Oreg., Eugene; Art Mus., Toronto, Canada [40]

SELDEN, Dixie (Miss) [Por.P,Ldscp.P,I] Cincinnati, OH b. 1871, Cincinnati d. 16 N 1936. Studied: Cincinnati A. Acad, Duveneck; W.M. Chase; H.B. Snell. Member: Cincinnati Women's AC (Pres.); NAWPS; Cincinnati MacD. C.; NAC; Chicago Gal. Assn.; SSAL; Louisville AA. Exhibited: NAWPS, 1929 (prize) [33]

SELDEN, Henry Bill [P,E,T] New London, CT b. 24 Ja 1886, Erie, PA d. 25 Ja 1934. Studied: ASL; C. Woodbury; B. Harrison. Member: AWCS; NYWCC; Allied AA; A. Fund S.; CAFA; NAC; St. Botolph; SC; Lyme AA. Exhibited: CAFA, 1929 (prize), 1931 (prize). Work: Conn. Col. Position: T., Conn. Col. [33]

SELDON, Reeda (Mrs. Emrys Wynn Jones) [Por.P,B] Norwalk, CT b. 3 Ap 1905, NYC. Studied: E. Stange; NAD; BAID. Member: NAWPS [40]

SELFRIDGE, Reynolds L. [P,W,L,T] Indianapolis, IN b. 30 S 1898, Jasonville, IN. Studied: Hawthorne; Forsyth. Exhibited: John Herron AI, Indianapolis, 1926 (prize), 1928–29 (prize), 1930 (prize); Richmond, Ind., 1929 (prize) [40]

SELIGMAN, Alfred L. [S,Patron] NYC b. 29 Ja 1864, NYC d. 24 Je 1912. Studied: P. Nocquet. He befriended many struggling artists, particularly the sculptor Paul Nocquet; he was also the cellist and the moving spirit and financial backer of the Young Men's Symphony Orchestra, and owned a very valuable collection of stringed instruments. [10]

SELIGMANN, Arnold [Dealer] Paris b. 1870, France (came to NYC ca. 1900) d. 6 N 1932. Founder: firm of Arnold Seligmann, Rey and Co. Many art collections are today a witness to his unswerving integrity of taste and advice. He was one of the earliest dealers to recognize the importance of American museums and to foster their growth.

SELIGMANN, Kurt [P,G,I] NYC b. 20 Jy 1900, Basel, Switzerland d. 2 Ja 1961, Middletown, NY. Studied: Ecole des Beaux-Arts, Geneva; Italy; E. Buchner; E. Amman; Lhote. Exhibited: GGE, 1939; CI, 1946; Canadian Nat. Exh., 1939; WFNY, 1939; Paris (one-man); London (one-man); Rome (one-man); Tokyo (one-man); New York (one-man); Chicago (one-man). Work: Albright A. Gal.; Art of this Century; Smith Col.; NYPL; AIC; Palacio de' Bellas Artes, Mexico. Author: "A History of Western Magic," 1946. Illustrator: "Vagabondages Heraldiques," 1935, "Hommes et Metiers," 1936, "Oedipus," 1944 [47]

SELINGER, Emily H. McGary (Mrs. Jean P.) [P] Boston b. Wilmington, NC. Studied: A. Rocchi, Florence; M. Roosenboom, Holland. Exhibited: Mass. Charitable Mechanics Assn., Boston (med). Specialty: flowers [10]

SELINGER, Jean Paul [P] Boston b. 24 Je 1850 d. 11 S 1909. Studied: Munich Acad; W. Leibl; Lowell Inst., Boston. Member: B.A.C. Exhibited: Munich Expo. (prize); Mass. Charitable Mechanics Assn., Boston (med); Osborne Exhibition, N.Y., 1905 (prize). Specialty: figures [08]

SELLECK, Margaret [P,I,L,T] Des Plaines, IL b. 28 Ag 1892, Salt Lake City d. ca. 1960. Studied: AIC; D.C. Watson; R. Weisenborn; O. Gross; J. Hobby. Member: Ohio WCC; Northwest A. Lg.; All-Ill. Soc. FA. Exhibited: All-Ill. Soc. FA, 1934 (med); Ill. Fed. Women's C., Chicago, 1935 (prize); PAFA, 1941; CM, 1936; Allerton Gal., Chicago (one-man); Stevens Hotel, Chicago (one-man); Layton Gal. A., Milwaukee (one-man); Wis. Union, Univ. Wis. (one-man); Beloit Col. (one-man); Oshkosh A. Mus. (one-man). Illustrator: textbooks [47]

SELLERS, Mary (or Minnie) [P,G,T] Pittsburgh b. 23 N 1869, Pittsburgh. Studied: A. Robinson; A. Hennicott, Holland. Member: Associated Artists of Pittsburgh [40]

SELLSTEDT, Lars Gustaf [Mar.P,Ldscp.P,Port.P] Buffalo, NY b. 30 Ap 1819, Sundsvall, Sweden (settled in Buffalo 1845--after 15 years as a sailor) d. 4 Je 1911. Studied: self-taught. Member: ANA, 1871; N.A., 1874; NAD. Exhibited: NAD, 1851-99. Work: Albright A. Gal., Buffalo; portraits of Presidents Millard Fillmore and Grover Cleveland, and several mayors of Buffalo; founder of Buffalo FA Acad. Author: "From Forecastle to Academy," 1908 [10]

SELTZER, Olaf Carl [P,I,Min.P] b. 1877 (or 1881), Copenhagen (came to Great Falls, MT, age 14) d. 1957. Western painter, friend and stylistic follower of C.M. Russell. He produced over 2,500 paintings, but by the 1930s his vision weakened due to focusing on a commission of 100 Western miniatures. He had begun painting seriously ca. 1921. [*]

SELVAGE, Helen A. Coe [Min.P] Newark, NJ [17]

SEMMES, A. Gertrude O. [P] Chicago [13]

SEMON, John [P] Cleveland d. 17 D 1917. Member: Cleveland SA. Work: CMA [17]

SENAT, Prosper L. [P] Annisquam, MA b. 1852, Germantown, PA d. S 1925. Studied: Ecole des Beaux-Arts in Paris; E.L. Hampton, London; South Kensington Sch., London; Gerome. Member: SC; ACP; Phila. Soc. Artists; A. Fund S. Exhibited: Brussels expo., 1880; Naples Nat. Expo., 1889; Vienna National Exh., 1893; Columbian Expo., Chicago, 1893 (med); Atlanta Expo., 1895 (med) [21]

SENECAL, Ralph L. [P,I] Palmer, MA b. 3 Ag 1883, Bolton, Canada. Studied: NAD. Member: Springfield AC; Conn. SA; Springfield AL; CAFA [33]

SENN, Emil [P] NYC. Member: Bronx AG [25]

SENSENEY, George E. [E,B] Holyoke, MA/Ipswich, MA b. 11 O 1874, Whelling, WV d. 18 N 1943. Studied: Corcoran A. Sch, with H. Helmick; Laurens and Constant in Paris. Member: SC. Exhibited: P.-P. Expo., San Fran., 1915 (med). Work: LOC; South Kensington Mus., London. Specialty: design for industrial art [40]

SENTERI, Florio [P] Brooklyn, NY. Member: S.Indp.A. [21]

SENYARD, George [P] d. 18 Ja 1924, Olmstead Falls, OH. He toured the country with Lincoln, sketching him in the debates with Stephen A. Douglas over the slavery issue.

SEPESHY, Zoltan [L,P,T] Bloomfield Hills, MI b. 24 F 1898, Kassa, Hungary. Studied: Acad. FA&A. Instr., Budapest, Hungary; Paris; Prague; Royal Acad., Vienna. Member: Mich. Acad. Sc. AL; NSMP; AAPL; Scarab C., Detroit. Exhibited: Detroit Inst. A., 1925 (prize), 1930 (prize), 1936 (prize), 1938 (prize), 1940 (prize), 1945 (prize); The Patteran, 1939 (prize); IBM, 1940 (prize); Pepsi-Cola Comp., 1945 (prize); Am. Acad. A. &Let., 1946 (prize); PAFA, 1936-45, 1946 (med); CGA, 1936-46; AIC, 1936-46; WMAA, 1936-46; TMA, 1936-46; CI, 1938-46. Work: Detroit Inst. A.; AIC; Albright A. Gal.; Swope A. Gal.; Wichita A. Mus.; San Diego FA Soc.; CAM; Butler AI; Milwaukee AI; Grand Rapids A. Gal.; Flint Inst. A.; Univ. Ariz.; Encyclopaedia Britannica Coll.; IBM Coll.; Crambrook Acad. A. Mus.; McGregor Pub. Lib., Highland Park, Mich.; murals, General Motors Bldg., Detroit; Fordson H.S., Dearborn, Mich.; USPOs, Lincoln Park, Mich.; Nashville, Ind.; Rackham Fnd. Detroit; Royal Acad., Budapest. Author/Illustrator: "Tempera," 1946. Illustrator: Fortune. Position: T., Cranbrook Acad. A., Bloomfield Hills, Mich., 1932- [47]

SERBAROLI, Hector [Por.P,Dec,T] Los Angeles, CA b. 7 Ja 1886, Rome, Italy. Studied: Inst. San Michele, Rome; Acad. San Luca; C. Maccari, Lorretto, both in Italy. Member: San Fran. AA; Acad. West P.; PS C., Los Angeles; Circolo Artistico, Rome. Exhibited: PS C., 1938 (prize); P.-P. Expo. San Fran., 1915; West P. Ann., Los Angeles Mus. Hist., Sc.&A. Position: Sketch A., motion picture studios [40]

SERGEANT, Edgar [P] Nutley, NJ b. 25 N 1878, NYC. Studied: Columbia; ASL; Grand Central A. Sch.; F. DuMond; G. Beal; G.P. Ennis. Member: SC; AFA. Exhibited: NAD (prize); All. A. Am. (prize); Montclair A. Mus. (prize); Newark Mus. [47]

SERGEANT, Tacie N. [P] Nutley, NJ. Exhibited: N.J. State Exh., Montclair Mus., 1935 (med) [40]

SERGER, Frederick B. [P] NYC/Woodstock, NY b. 25 Ag 1889, Ivancice, Czechoslovakia d. 3 N 1965. Studied: Acad. A., Munich, Germany. Member: A. Lg. Am.; CAFA. Exhibited: CI, 1945; NAD, 1944; Santa Barbara Mus. A., 1944; La Tausca Pearls Comp., 1946; Springfield A&A; Hartford, Conn.; Salon d'Automne; de Young Mus. A., San Fran.; N.Mex. Mus. A.; PAFA; CGA; TMA; Delgado Mus. A., New Orleans; Mint Mus. A.; Sweat AM, Portland, Maine; Woodstock AA. Work: Mus. of City of Paris; Art Collectors & A. Assn., Buffalo [47]

SERISAWA, Sueo [P] NYC b. 10 Ap 1910, Yokohama, Japan. Studied: Otis AI; G. Barker. Exhibited: Fnd. Western A., 1940 (prize); Calif. State Fair, 1940 (prize); AIC; Los Angeles Mus. A.; San Diego FA Soc.; Denver A. Mus.; SFMA. Work: San Diego FA Soc.; Santa Barbara Mus. A.; Pasadena AI [47]

SERPELL, Susan Watkins (Mrs. Goldsborough) [P] Norfolk, VA b. 1875, California d. 18 Je 1913. Studied: ASL; Collin in Paris. Member: ANA, 1912. Exhibited: Paris Salon, 1899 (prize), 1901 (med); St. Louis Expo., 1904 (med); NAD, 1910 (prize) [13]

SERRA, Daniel (D. S. Badue) [P,W,T] Havana, Cuba b. 8 S 1914, Santiago de Cuba, Cuba. Studied: NAD; ASL; Columbia; Acad. Bellas Artes, Barcelona. Exhibited: John Wanamaker Comp., 1928 (prize); PAFA, 1941 (prize); AIC, 1938; All.A.Am., 1938; WFNY, 1939; CI, 1941; Acad. All. A., 1939; Spain; Cuba. Award: Guggenheim F., 1939, 1940. Position: T., Escuela Prov. de Artes Plásticas, Santiago de Cuba [47]

SERRAO, Luella Varney (Mrs.) [S] Cleveland b. 11 Ag 1865, Angola, NY. Work: Roman Catholic Cathedral, Odessa, Russia; Capitol, Minn.; Seaton Hall, Newark, N.J.; Cleveland Pub. Lib.; Catholic Cathedral, Cleveland [25]

SERRELL, Ottilie [P] Montvale, NJ [24]

SERTH, Arthur M. Sertich [P,C] Highland Park, MI b. 16 Ap 1898, Podlapac, Yugoslavia. Studied: Univ. Mich.; J.P. Wicker; W. Pascoe; others. Member: Scarab C., Detroit. Exhibited: Detroit Inst. A., 1922-25, 1926 (prize), 1927-46; Mich. State Fair, 1927 (prize), 1928 (prize), 1931 (prize), 1939 (prize); Scarab C.; numerous one-man and group exh. in Detroit; WFNY, 1939; Chicago World's Fair. Position: Ed. Asst./Supv., Aeronautical Charts, Army Map Service, 1942-45 [47]

SERVEN, Lydis M. [P] Wash., D.C./Warrenton, VA [25]

SERVER, J(ohn) William [P,T] Phila./Paris b. 21 My 1882, Phila. Studied: Deigendesch; W. Chase; Acad. Colarossi. Member: Phila. ASL; T Square C., Phila. [25]

SERWAZI, Albert B. [P] Phila. b. 20 Ag 1905, Phila. Exhibited: Da Vinci All., Warwick Gal., Phila., 1938 (gold); Sketch C., Phila., 1938; bien. Corcoran Gal., Wash., D.C., 1939. Work: PAFA; Whitney Mus. Am. A., N.Y. Partner: Central Studio A. Service, Phila. [40]

SESSIONS, Annamay Orton (Mrs. Frank M.) [P,C] Chicago b. 1855, Rome, NY d. 14 My 1947. She designed and painted the chinaware for President Taft. Mother of James.

SESSIONS, James Milton [Mar.P,I] Chicago b. 20 S 1882, Rome, NY d. 14 N 1962. Studied: AIC, 1903-06. Exhibited: MET; AIC; CMA; Milwaukee AM; Campanile Cal., Chicago, 1982. Work: Chicago Tribune Coll.; J.P. Speed Mus.; Great Lakes Naval Training Inst.; N.Y. Graphic S., "American Masters Coll."; Borg-Warner Coll., Chicago. A wheelsman aboard Great Lakes ships from 1906-14, he joined the Ill. Naval Reserve during World War I. He was a commercial illus., primarily with Vogue-Wright Studios in Chicago. In 1933 he began to focus on watercolor. During World War II he was a "brush reporter" of the Pacific Theatre. He also made a 60-painting documentary of jeeps in World War II action for Willys Overland Co. His World War II art was the subject of a book and was exhibited at the MET. Later he produced calendars for Brown & Bigelow Co., St. Paul. Many of his marine and hunting watercolors have been reproduced as prints by N.Y. Graphic Soc. Sessions was active around Rockport, Mass., Nova Scotia, the Caribbean, and the Southwest. Although a prolific painter in a

style similar to John Whorf and Ogden Pleissner, he destroyed much of his work. [*]

SESSLER, Alfred A. [P,Lith,T,L] Madison, WI b. 14 Ja 1909, Milwaukee d. S 1963. Studied: Layton Sch. A.; Univ. Wisconsin; Milwaukee State Teachers Col. Member: Milwaukee PM; Wis. Ar. Fed.; Wis. P&S.; Madison AA. Exhibited: Univ. Wisconsin, 1934 (prize), 1935 (prize), 1943 (prize), 1944 (prize); Milwaukee AI, 1935 (prize), 1937 (prize), 1938 (prize), 1942 (prize), 1945 (prize), 1946 (prize); Wis. State Fair, 1938 (prize), 1940-44 (prize); Madison A. Exh., 1946 (prize); Nat. Exh. Am. A., N.Y., 1936; CGA, 1936, 1937, 1939; AIC, 1936, 1938; Albright A. Gal., 1938; Am. FA Soc. Gal., 1938; WFNY, 1939; AFA traveling exh., 1940; CI, 1941; Inst. Mod. A., Boston, 1941; VMFA, 1942; Wis. P.&S., 1933-46; Wis. Salon A., 1935-46; Univ. Wisconsin, 1936, 1941, 1945 (one-man); wilwaukee AI, 1937-39; Wis. State Fair, 1938-44; Layton Gal., 1940, 1944 (one-man); Kansas City AI, 1939; Wustum Mus. FA, 1942; Milwaukee State T. Col., 1944 (one-man); Madison A. Exh., 1946; Milwaukee Pr. M. Ann., 1937 (prize); 48 States Comp., 1939. Work: Milwaukee AI; Univ. Wisconsin; murals USPO, Lowell, Mich.; Moriss, Minn. Editor: "The Wisconsin Artist." Position: T., Milwaukee State T. Col., 1945; Milwaukee AI, 1945-46; Univ. Wis., 1944-47 [47]

SESSLER, Stanley Sascha [P,E,L,T,Des] South Bend, IN b. 28 My 1905, St. Petersburg, Russia. Studied: Mass. Sch. of Art, with Major, Andrew, Woodbury, Hamilton. Member: Hoosier Salon; Ind. AC; A. of Northern Ind.; AAPL. Exhibited: Hoosier Salon, 1929-37, 1938 (prize), 1939-42; South Bend, Ind., 1942 (prize); Ind. AC, 1939-42; Northern Ind. A., 1929-46; Ogunquit A. Center, 1937, 1938; Palm Beach A. Center, 1937, 1938. Work: Wightman Gal., Notre Dame, Ind. Position: T., Univ. Notre Dame, Ind. 1928-46 [47]

SETON, Ernest Thompson [I,L,P,S,T,W] Santa Fe, NM b. 14 Ag 1860, South Sheilds, England (came to Canada ca. 1866) d. 23 O 1946. Studied: Toronto Col. I.; Royal Acad., London; Paris, 1890-96; Gérôme; Bouguerau; Ferrier; Mosler. Member: Nat. Inst. A. L. Exhibited: John Burroughs and Daniel G. Elliott medals, 1928. Author/Illustrator: "Art Anatomy of Animals," "Wild Animals I Have Known," "The Biography of a Grizzly," "Animal Heroes," "The Book of Woodcraft," "Lives of Game Animals," "Gospel of the Redman," "Great Historic Animals." Head of Boy Scout movement in America until 1915; chief of Woodcraft League of America; President, Seton Inst., Santa Fe, N.Mex.; Col. Indian Wisdom, Santa Fe (founder). Specialty: animals [40]

SETTANNI, Luigi [P,I] Phila. b. 17 Ag 1908, Torremaggiore, Italy. Studied: Oakley; Dull [38]

SETTELE, Theodora. See Sangrée.

SETTERBERG, Carl [P,I] NYC. Member: SI; AWCS [47]

SETTLEMYRE, Julius Lee, Jr. [P,L,T] Kings Mountain, NC b. 1 Ja 1916, Hickory, NC. Studied: George Washington Univ.; Corcoran Sch. A.; Paris; R. Lahey; C. Critcher. Member: Gaston A. Lg. Exhibited: Sorbonne Sch. FA, Paris, 1940; CGA, 1937, 1939; Nat. Mus., Wash., D.C., 1939; Mint Mus. A., 1940, 1943, 1946; Chapel Hill, N.C., 1943; MMA, 1942. Work: mural, Shakespeare Auditorium, Shelby, N.C. [47]

SEVERANCE, Clare M. (Mrs.) [C,Li] Madison, WI b. 16 D 1887, West Bend, WI d. ca. 1955. Studied: Univ. Wisc.; W.H. Varnum; R.M. Pearson. Member: Wis. Des.-Craftsmen; Boston Soc. A.&Crafts; Madison AA; Minn. S. Group. Exhibited: Milwaukee, 1928 (prize), 1930 (prize), 1939 (prize); Madison AA, 1944 (prize); Milwaukee AI, 1946 (prize); Nat. All. A.&Indst. 1933; Phila. A. All., 1937, 1944; Minn. S. Group, 1946; Wis. Salon A., 1940, 1942, 1943; Milwaukee Pr.M., 1940, 1942, 1944, 1946; Milwaukee Designer-Craftsmen, 1928, 1930, 1939, 1944, 1946 [47]

SEVERANCE, John L. [Patron] b. 8 My 1863, Cleveland d. 16 Ja 1936, Cleveland Heights, OH. President of Cleveland Mus. A., 1926-36. He donated his great collection of arms and armor in 1917; also he gave Severance Hall, the home of the Cleveland Symphony Orchestra.

SEVERANCE, Julia Gridley [S,E] San Diego, CA b. 11 Ja 1877, Oberlin, OH. Studied: AIC; Cleveland Sch. A.; ASL; Oberlin Col. Member: AAPL; San Diego A. Gld.; Cleveland Women's AC. Work: Oberlin Col.; LOC; St. Mary's Sch., Knoxville, Ill.; Allen Mem. Mus., Oberlin, Ohio [47]

SEVERIN, A.A. [P] Chicago, IL. Member: GFLA [27]

SEWALL, Alice Archer. See James, John H., Mrs.

SEWALL, Blanche Harding (Mrs. Cleveland) [P] Houston, TX b. 12 My 1889, Ft. Worth, TX. Studied: J.C. Tidden; F. Wagner. Member: Southern SAL [33]

SEWALL, Howard S. [P,G,T] Portland, OR b. 19 O 1899, Minneapolis.

Studied: Wash. Sch. A. (founder). Member: Am. Ar. Cong. Exhibited: Portland AM. Work: murals, Timberline Lodge, Mt. Hood, Ore.; H.S. Oregon City. Position: T., Salem A. Center [40]

SEWARD, Coy Avon [E,B,Lith,W,P] Wichita, KS b. 4 Mr 1884, Chase, KS d. 31 Ja 1939. Studied: Reid; Stone; Sandzen. Member: Wichita AA; Wichita AG; Calif. PM; Chicago SE; Prairie PM. Exhibited: Kansas City AI, 1924 (prize); Mid-West Artists, 1927 (med), 1928 (gold); Delta Phi Delta Graphic Arts, 1936 (prize). Work: Kans. Masonic Grand Lodge; Sedgwick Co. Historical Society; Los Angeles Mus. Hist. &A.; Springfield (Mass.) Pub. Lib.; Smoky Valley AC, Lindsborg, Kans.; H.S. Art C., Twentieth Century C., Univ. Wichita AA; Calif. State Lib.; Kans. Fed. Women's C.; Univ. Kans.; N.Mex. Fed. Women's C.; AIC; Vanderpoel Memorial H.S., Chicago; Mulvane A. Mus., Topeka, Kansas; Tulsa University; Univ. Oklahoma; Belhaven Col., Jackson, Miss.; Lawrence Col., Appleton, Wis.; Cleveland Mus. A.; Smithsonian; LOC; RISD; Bibliothèque Nationale, Paris; Honolulu Acad. A. Author: "Metal Plate Lithography for Artists." Contributor: articles in "Prints" and "The Palette" [38]

SEWELL, Alice [P,S,L,T] Portland, OR b. Hillsboro, OR. Studied: DuMond; A. Fairbanks; Voisin; E. Steinhof. Member: Oreg. SA. Exhibited: Oreg. SA Annual Exh., 1932 (prize), 1938 (prize); Carnegie F., Univ. Oregon, 1933. Work: sculpture, Sha Kung Sch., China; Pacific Univ., Forest Grove, Oreg.; mural Hillsboro H.S., Hillsboro. Position: T., Brandon Sch. Expression, Portland [40]

SEWELL, Amos [I] Westport, CT (1975) b. 7 Je 1901, San Fran. Studied: Calif. Sch. FA; ASL; Grand Central Sch. A. Member: SI; Gld. Freelance A. Exhibited: Annual exh. Am. Illustration; A. Dir. C., annually. Work: SI. Illustrator: national magazines [47]

SEWELL, Edith G. [P] NYC [01]

SEWELL, Helen Moore [I,W,P,E] NYC b. 27 Je 1896, Mare Island, CA d. 1957. Studied: Packer Inst.; PIASch; Archipenko; Charlot. Author/Illustrator: "Jimmy and Jemima," 1940, "Birthdays for Robin," 1944. Author: "A Round of Carols," "Ming and Mehitable," "Peggy and the Pony." Illustrator: "Jane Eyre," "A First Bible" [47]

SEWELL, (Lydia) A(manda) Brewster (Mrs. Robert V.V.) [P] Oyster Bay, NY b. 24 F 1859, North Elba, Essex County, NY d. 1926. Studied: ASL, with Chase; Académie Julian, with Robert-Fleury, Carolus-Duran. Member: ANA, 1903; NAWPS; Cosmopolitan C. Exhibited: NAD, 1888 (prize), 1903 (prize); Columbian Expo, Chicago, 1893 (med); Pan-Am. Expo, Buffalo, 1901 (med); Charleston Expo, 1902 (med); St. Louis Expo, 1904 (med) [27]

SEWELL, M. M. [P] Brooklyn, NY. Studied: F.D. Henwood [01]

SEWELL, Robert V(an) V(orst) [Mur.P] Oyster Bay, NY b. 1860, NYC d. 18 N 1924, Florence, Italy. Studied: Lefebvre and Boulanger in Paris. Member: ANA, 1901; N.Y. Arch. Lg., 1899; Mural P.; Century Assn.; Union Lg. C.; Lotos C. Exhibited: NAD, 1889 (prize); Boston, 1891 (med); Pan-Am. Expo., Buffalo, 1901 (med); St. Louis Expo., 1904 (med). Work: Georgian Court, Lakewood, N.J.; St. Regis Hotel, N.Y.; Sweat Mem., Portland, Maine [24]

SEXTON, E(mily) S(tryker) [P] Long Branch, NJ/Woodstock, NY b. 28 Je 1880, Long Branch d. 6 N 1948. Studied: N.J. State Normal Sch.; M. Field; C. Rosen; H. Giles; N.Y. Sch. F.&Appl. A.; Woodstock Sch. Mod. A. Member: AAPL; Asbury Pk. FA Soc. Exhibited: Traphagen Sch., 1925 (prize), 1926 (prize); CGA, 1936; NAD, 1936, 1939; PAFA, 1936, 1939, 1946; Asbury Park FA Assn.; Allenhurst AC; Montclair A. Mus., 1939-46 [47]

SEXTON, Frederick Lester [P] New Haven, CT b. 13 S 1889, Cheshire, CT. Studied: Yale Sch. FA; S. Kendall; J.F. Weir; E. Taylor; A.V. Tack. Member: SC; Lyme AA; New Haven PCC; Meriden A.&Crafts C.; CAFA. Exhibited: New Haven PCC (prize); Meriden A.&Crafts C., 1941 (prize); CAFA, 1937 (prize), 1938 (prize); Hartford, Conn., 1944 (prize); NAD; SC; Lyme AA; Lyman Allyn Mus.; Bridgeport AA; East Hampton (L.I.) AA. Award: Winchester Traveling F., Yale, 1915 [47]

SEXTON, Leo Lloyd [P,S] Hawaii b. 24 Mr 1912, Hilo, HI. Studied: BMFA Sch.; Slade Sch., London. Exhibited: BMFA Sch., 1935 (traveling scholarship); Royal Acad., London, 1938; Oakland A. Gal., Calif. 1939 [40]

SEYDEL, Victor L. A. [P] NYC/Terrace Park, OH. Member: Cincinnati AC; SC [25]

SEYFERT, Theodore H. [P] Phila. [04]

SEYFFERT, Helen F. (Mrs. Leopold G.) [P] Phila., PA. Studied: PAFA. Affiliated with AIC [25]

SEYFFERT, Leopold (Gould) [P] NYC/Easton, CT b. 6 Ja 1887, Calif. d. 13

Je 1956. Studied: PAFA; W. Chase. Member: Phila. Sketch C.; ANA, 1916; NA, 1925; Port. P.; AFA; Cliff Dwellers; Phila. AC; SC. Exhibited: Phila. AC, 1913 (gold); P.-P. Expo, 1915 (prize); PAFA, 1918 (gold), 1921 (gold); 1926 (gold), 1929 (prize); Chicago, 1923 (prize); Mun. A. Lg., Chicago; Sesqui-Centenn. Expo, Phila., 1926 (prize); NAD, 1916 (prize), 1917 (prize), 1918 (prize), 1921 (prize), 1923 (gold), 1924 (gold); CI (prize); nationally. Work: AIC; PAFA; Detroit Inst. A.; Rochester Mem. A. Gal.; CI; CGA; Los Angeles Mus. A.; BM; MET [47]

SEYFORT, Aimee (Mrs. Ruegg) [P,T] Binghamton, NY b. 8 My 1905, London. Studied: Paris. Exhibited: BM, 1926 (one-man); Roerich Mus., 1930 (one-man); Weyhe Gal., 1939 (one-man), 1941 (one-man); Am.-British A. Center, 1942 (one-man); Mus. N.Mex., Santa Fe, 1945 (one-man); N.Mex. A. Lg., 1946 (one-man); Amsterdam; Paris [47]

SEYLER, David Warren [C,Des,S,P,Li,L] Erlanger, KY b. 31 Jy 1917, Dayton, KY. Studied: Cincinnati A. Acad.; AIC; Univ. Chicago; W. Hentschel; F. Chapin; E. Zettler; others. Member: Mod. A. Soc., Crafters C., Cincinnati. Exhibited: Syracuse Mus. FA, 1938 (prize); AIC, 1938 (prize), 1939, 1944 (one-man) ; AIC, 1938 (prize); Univ. Chicago, 1938 ("Big 10 Exh."), 1939; Phila. A. All., 1939; Syracuse Mus. FA, 1938-41; WFNY, 1939; Loring Andrew Gal., Cincinnati, 1943 (one-man); CM, 1939-46. Work: Univ. Chicago; Syracuse Mus. FA; CM; murals, Philippine Island Base, U.S. Navy Great Lakes Naval Station. Positions: Sculptor/Des., Rookwood Pottery, Cincinnati, 1936-39; Art Dir., Kenton Hills Porcelains, Inc., Erlanger, Ky., 1940- [47]

SEYLER, Julius [P] St. Paul [15]

SEYMOUR, Cella B(urnham) [Port.P,I] NYC/Oakland, CA b. 15 D 1872, Buffalo, NY. Studied: Wm. Chase; Pratt Inst.; Paris; Holland. Illustrator: "Mexican Types." Specialty: portraits in pastel and red chalk [15]

SEYMOUR, Henry T. [P] South Orange, NJ [06]

SEYMOUR, Isabelle D. [P] Baltimore [25]

SEYMOUR, Ralph Fletcher [E,Des,I,W,P,T] Chicago b. 18 Mr 1876, Milan, IL. Studied: Cincinnati A. Acad; Nowottny; Meakin. Member: AIGA; Chicago SE; Cliff Dwellers; NAC. Exhibited: Knox Col., Galesburg, Ill. (prize); Hoosier Salon (prize); Chicago SE, 1934 (prize); Phila. Pr. C., 1936 (prize). Work: AIC; Sorbonne, Paris; AFA; Knox Col., Galesburg, Ill.; Newberry Lib., Chicago; NGA; Bibliotheque Nationale, Paris. Author/Illustrator: "Across the Gulf," "Some Went This Way." Illustrator/Designer: bookplates. Position: T., AIC, 1909-18; Supervisor of publications, Knox Col., Galesburg, 1936-37 [47]

SEYMOUR, Ralph Russell [P] Hartford, CT. Member: CAFA [25]

SEYMS, Katherine [P] Hartford, CT. Member: CAFA [25]

SHACKELFORD, Katharine Buzzell [P,T] La Canada, CA b. Ft. Benton, MT. Studied: Mont. State Col.; UCLA; N. Fechin. Member: Glendale AA; A. T. Assn.; Nat. Edu. Assn. Exhibited: Northern Mont. Fair, 1942 (prize); Glendale AA, 1932 (prize), 1943 (prize) [47]

SCHACKELFORD, Shelby [Pr.M,,I,P,W,T,E] Baltimore, MD b. 27 S 1899, Halifax, VA. Studied: Md. Inst.; R. Moffett; Paris, with M. Zorach, W. Zorach, O. Frieze, F. Leger. Member: A. Union; Baltimore AG; S.Indp.A.; Provincetown AA; Am. A. Cong.; NYSWA. Exhibited: Graphic Exh., N.Y., 1936; 50 Prints of the Year, 1930-32; BMA, 1944-46. Author/Illustrator: "Now for Creatures," 1934. Illustrator: "Time, Space and Atoms," 1932. Position: T., BMA, 1946 [47]

SHACKLETON, Charles [P] Cleveland, OH/Silvermine, Norwalk, CT b. Mineral Point, WI d. 2 Jy 1920, New Canaan, CT (on the golf links). Studied: Cleveland Sch. A., with F.C. Gottwald; Italy. Member: Cleveland SA; Cleveland EC; Cleveland AA; SC, 1904; NAC; S.Indp.A.; Wash. AC; Chicago AC; Conn. S.&P.; Silvermine Group; New Canaan S.; Provincetown AA. Work: CMA [19]

SHAEFER, William G. [P] New Rochelle, NY. Member: New Rochelle AA [24]

SHAFER, Claude [Cart] Cincinnati, OH b. 7 Ja 1878, Little Hocking, OH. Work: Princeton Univ. Lib.; Ohio State Univ. Lib.; Hist. S. Cincinnati; Huntington Lib., San Marino, Calif. Position: Ed. Cart., Cincinnati (Ohio) Times-Star [47]

SHAFER, L.A. [P,E,I] New Rochelle, NY b. 17 N 1866, Genesco, IL d. 19 Ap 1940. Member: SI 1911; New Rochelle AA. Illustrator: "The Shock of Battle," by Vaux, "The Road to Glory," by Powell, "Heading North," by Barbour; posters of the Great War; cover designs, American Legion Monthly, The Literary Digest [40]

SHAFFER, Carl [P,Gr,Des,I,L] Phila., PA b. 25 Mr 1904, Everett, PA. Studied: AIC; PAFA; A. Carles. Member: Phila. Pr. C. Exhibited: FMA, 1930, 1931; PAFA, 1924-27; AIC, 1937; in Phila.: Boyer Gal., Ragen Gal., A. All., Pr. C., Sketch C., Graphic Sketch C. Work: MET. Illustrator: "Southwest Passage," 1943, "What is Music?" 1944, Junior Science Series, 1944 [47]

SHAFFER, Lucy K. [P,T] Cincinnati, OH b. 5 O 1885, Cincinnati, OH. Studied: Cincinnati A. Acad.; N.Y. Sch. F. Appl. A.; O'Hara WC Sch. Member: Womens AC, Cincinnati. Exhibited: Womens AC [40]

SHAFFRAN, Jascha [Por.P,Min.P,Dr,T] Olive Branch, MS b. 15 S 1891, Irkutsk, Russia d. ca. 1955. Studied: NAD; ASL; C.C. Curran; L. Kroll; I. Olinsky. Member: AAPL. Exhibited: NAD; Brooks Mem. A. Gal.; Acad. All. A. Work: Univ. Tennessee Med. Sch.; Tenn. State Capitol; Southwestern Univ.; port. throughout the U.S. Position: T., Sch. FA, Memphis [47]

SHAGARN, Robert, Mrs. See Noel, Helen Jeannette

SHAHN, Ben [P,G,Ph] Hightstown, NJ b. 12 S 1898, Kovno, Lithuania (came to Brooklyn, NY, in 1906) d. 14 Mr 1969, NYC. Studied: NAD, 1919-22; NYU; CCNY; Acad. Grande Chaumière, Paris, 1925, 1927. Exhibited: MOMA, 1947 (retrospective); FMA, 1956 (retrospective); Sao Paulo Biennial, 1954 (prize); Venice Biennial, 1954. Work: Newark Mus.; WMAA; BMFA; MOMA; WPA murals, Comm. Bldg. (Hightstown, N.J.), Health & Edu. Bldg., Wash., D.C.; 3,000 photos at FMA; others at IMP; LOC; RISD. Important social realist who also produced photos for Farm Sec. Admin. (WPA), 1935-38 [40]

SHAINESS, Clara [S,P,Des,C] NYC b. 13 Ja 1898, Manchester, England. Studied: A. Goodelman. Member: NAWA; NYWSA; N.Y. Soc. Cer. A. Exhibited: Argent Gal.; Contemp. A.; ACA Gal.; J.B. Neumann Gal.; Bonestell Gal.; Norlyst Gal.; NAD; Audubon A.; WFNY, 1939 [47]

SHALER, Frederick [P,I] NYC b. 15 D 1880, Findlay, OH d. 27 D 1916, Taorima, Italy. Studied: Chase; DuMond [13]

SHALLENBERGER, Martin C. [P,L] Harrods Creek, KY b. 22 S 1912, San Fran., CA. Studied: CGA; ASL; NAD; U.S. Naval Acad.; Univ. Vienna. Member: AWCS. Exhibited: Joslyn Mem., 1939; Louisville, Ky., 1940, 1943; Ferargil Gal., 1946; Minneapolis, Minn., 1938; NYWCC, 1936, 1939; France; Germany [47]

SHANAHAN, Ray P. [I,Cart] b. 1892 d. 12 Ap 1935, Boston, MA. A newspaper artist widely known in Boston and N.Y.

SHAND, Helen [P] Naberth, PA. Studied: PAFA [25]

SHANDS, Anne T. [P] St. Louis, MO b. St. Louis. Studied: St. Louis Sch. FA. Member: St. Louis AG; St. Louis Assn. P.&S. [01]

SHANE, Frederick Emanuel [P,Li,Dr,T,L] Columbia, MO b. 2 F 1906, Kansas City, MO. Studied: Kansas City AI; R. Davey. Exhibited: AIC, 1940; CGA, 1941; PAFA; WFNY, 1939; WMAA, 1941; Pepsi-Cola, 1945; Denver AM; CAM, 1942 (prize), 1943 (prize); Springfield Mus. A. (prize); Assn. Am. A.; Los Angeles Mus. A., 1945; Mid-Western Exh., Kansas City, 1927 (med), 1936 (prize), 1937 (prize); St. Louis, 1929 (prize); Kansas City AI, 1939 (prize). Work: CAM; W.R. Nelson Gal.; Denver AM; Springfield (Mo.) Mus. A.; IBM Coll.; Abbott Laboratories Coll.; USPO, Eldon, Mo.; General Hospital, Bd. of Edu., both in Kansas City; mural, Independence, Mo.; U.S. Gov., Wash., D.C. Position: T., Univ. Mo. [47]

SHANE, Mildred Dora [P,T] Kansas City, MO. b. 11 Ag 1898, Kansas City. Studied: Wilimovsky; Frazier; Hawthorne [25]

SHANE, Rose M. [P] Nunda, N.J. [01]

SHANES, Helen Berry, Mrs. See Berry.

SHANFIELD, Zelda [Min.P] Paris, France [13]

SHANNON, Aileen Phillips (Mrs. Edmund G.) [P] Las Cruces, NM b. 12 Mr 1888, Gillsburg, MI. Studied: PAFA, 1944-46; Chicago Acad. FA; W. Chase; W. Adams; T. Hart, in Paris. Member: NAWA; SSAL; AAPL; Miss. AA; San Fran. AA. Exhibited: S. Wash. A., 1936; NAWA, 1942; Miss. AA; SSAL; Parkersburg FA Ctr.; Va.-Intermont Col., Santa Fe, N.Mex.; Fed. Sch., N.Mex., 1933 (prize) 1939 (prize); Women P. Am., Wichita, Kans., 1938; Rockefeller Ctr., N.Y., 1938. Work: Miss. AA; Rock Springs AA; N.Mex. State Col.; Brannigan Mem. Lib., Las Cruces, N.Mex.; 20th Century C., Clayton, N.Mex. [47]

SHANNON, Charles Eugene [P] Montgomery, AL b. 22 Je 1914, Montgomery. Studied: Emory Univ., Atlanta, Ga.; Cleveland Sch. A. Awards: Clevelands Sch. A., Traveling F., 1936; Rosenwald F., 1938-40. Exhibited: CMA, 1935, 1936 (prize); GGE, 1939 (prize); AIC, 1939; CAM, 1939; Clearwater Exh., 1939; CI, 1939; WMAA, 1939; Montgomery MFA, 1937 (one-man); Cleveland Sch. A., 1938; Jacques Seligmann Gal., 1938.

Work: mural, Ft. Belvoir, Va. Position: A. in Res., West G. a Col., 1941–42 [47]

SHANNON, Howard Johnson [I,W,P] Jamaica, NY b. 30 My 1876, Jamaica, NY. Studied: PIASch; H. Adams; F. DuMond. Member: Authors Lg. Am.; N.Y. Acad. Sc.; N.Y. Entomological S. Exhibited: BM, 1935; PIASch; Queensboro Lib.; Jamaica, Far Rockaway, both in N.Y. Author/Illustrator: "The Book of the Seashore," 1935; science articles in St. Nicholas, Harper's, Journal of the AMNH [47]

SHANNON, J(ames) J(ebusa) (Sir) [Por.P] London, England b. 3 F 1862, Auburn, NY (settled in England in 1878) d. 6 Mr 1923, London. Studied: South Kensington Sch. Member: New English AC; S. Port. P.; ARA, 1897; RA, 1909; ANA, 1908; knighted, 1922. Exhibited: Paris Expo, 1889 (gold), 1900 (med); Berlin (med); Vienna (med); Munich (med); CI, 1897 (med); PAFA, 1899 (prize); Pan-Am. Expo, Buffalo, 1901 (gold); St. Louis Expo, 1904 (gold); Intl. Expo, Venice, 1906 (gold); Barcelona, 1911 (med, prize). Work: CGA; CI; MET; Tate Gal., London [19]

SHANNON, Martha A. [P,L] Roxbury, MA. Studied: CUASch. Member: Copley S., 1896 [06]

SHANNON, William, Mrs. See Lenney, Annie.

SHAPIRO, Daniel [P,E,I] NYC b. 8 Ap 1920, NYC. Studied: CUASch; Columbia; L. Katz; M. Kantor. Exhibited: CUASch, 1940 (prize), 1941 (prize); Oakland A. Gal., 1944; LOC, 1945, 1946; Mun. A. Gal., Jackson, Miss., 1945, 1946; SAM, 1946; Brooklyn SA, 1942; "Art of the GI," Tribune A. Ctr., 1946. Work: CUASch; Howard Univ.; mural, Westover (Mass.) Service C. Illustrator: Fortune, 1946 [47]

SHAPIRO, Frank D. [P,C,T] Parkchester, NY b. 28 Jy 1914, NYC. Studied: NAD; CCNY. Exhibited: CGA, 1939; Syracuse MFA, 1941; Detroit AI. Work: WPA mural, USPO, Washington, N.J. [47]

SHAPIRO, Janice [P] NYC b. 21 D 1908, NYC. Studied: ASL; H. Wickey. Member: ASL. Exhibited: Nat. Acad.; Montross Gal., N.Y. Work: NYPL [40]

SHAPIRO, Lili [Cer,C,T] Boston, MA b. 30 Ja 1896, Boston. Studied: E. Brown; B.K. Brink; L. Beckerman; F. Allen. Member: Boston SAC (master craftsman). Exhibited: Int. Expo, Paris, 1937; Boston, 1937 (prize). Position: T., Paul Revere Pottery [40]

SHAPLEIGH, Frank Henry [Ldscp.P] Boston, MA/Jackson, NH/(winters in St. Augustine, FL after 1886) b. 7 Mr 1842, Boston d. 1906, Jackson, NH. Studied: Lowell Inst., Boston; Lambinet, in Paris, 1866. Member: Boston AC, 1876. Exhibited: NAD, 1866, 1869, 1870. Specialty: New England landscapes, esp. in the White Mtns. (N.H.) where he had his summer studio from 1876. [06]

SHARADIN, Henry William [P,C,I,L,T] Kutztown, PA b. 22 D 1872, Kutztown. Studied: PMSchIA; Am. Acad., Paris; Académie Julian; Tudor-Hart; Rome, with Bompianni, Nardi. Member: NAC; Lehigh A. Alliance, Allentown, Pa. Exhibited: NAC; N.Y. Soc. Keramic A.; Lehigh A. All.; Reading Mus. A.; Paris. Work: Reading Mus. A.; mural, State T. Col., Kutztown; numerous churches in Pa. Position: T., Kutztown State T. Col. 1907–16; 1926–39 [47]

SHARADY, H.M. [P] NYC [01]

SHARE, Henry Pruett [I,E,En] Flatbush, NY b. 1853, Los Angeles, CA d. 20 Je 1905. cousin of M.J. Burns. Position: Art. Ed., The New York World

SHARMAN, Florence M. [S] St. Louis, MO b. 27 Mr 1876, Bloomington, IL. Studied: St., Louis Sch. FA, with R.P. Bringhurst. Member: St. Louis AG [06]

SHARMAN, John [P,T] Belmont, MA. Member: Phila. AC; Boston GA; CAFA. Exhibited: CAFA, 1922 (prize). Position: T., Mass. Sch. A. [40]

SHARP, A.E., Mrs. See Custer, Bernardine.

SHARP, Bennis (Miss) [P] New Orleans, LA [15]

SHARP, Hill [Por.P,P,Li,T] Muncie, IN b. 22 F 1907, Pendleton County, KY. Studied: Ball State T. Col.; John Herron AI; G. Luks; G.P. Ennis; W. Adams; Académie Julian. Member: Ind. AC; Ind. PM. Exhibited: VMFA, 1939; All.A.Am., 1939; Phila. Pr. C., 1939; Southern PM, 1940 (prize); Hoosier Salon, 1928–46, prizes: 1928, 1929, 1934, 1936, 1938, 1939, 1941, 1943; Ind. A., 1929–46, 1939 (prize); Ind. AC, 1940–46, 1942 (prize), 1946 (prize); Ind. PM, 1945, 1946; Muncie AA, 1928 (prize), 1929 (prize), 1932 (prize); Indianapolis Star, 1936 (prize). Work: Am. Church, Paris; Univ. Wis.; Univ. C., Madison, Wis.; Court House, Baraboo, Wis.; Ind. Univ.; Ft. Wayne A. Mus.; Ball State T. Col. [47]

SHARP, John O. Robert [P] NYC. Work: USPO, Bloomfield, Iowa. WPPA artist. [40]

SHARP, J(oseph) H(enry) [P,I,T] Taos, NM/Pasadena, CA b. 27 S 1859, Bridgeport, OH d. 1953. Studied: McMicken Sch. Des., 1873; Cincinnati A. Acad.; C. Verlat, in Antwerp, 1881; von Marr, at Munich Acad., 1886; Duveneck, in Spain and Italy; Académie Julian, with Laurens, Constant, 1895–96. Member: Cincinnati AC; Calif. AC; SC; Taos SA; Calif. PM; AFA. Exhibited: Dept. Ethnology, Pan-Am. Expo, Buffalo, 1901 (med); Cincinnati AC, 1901 (prize); Pan.-Calif. Expo, San Diego, 1915 (gold), 1916 (gold); Calif. A. Exh.; Pasadena AI, 1930 (prize). Work: nearly 100 portraits of Indians, Univ. Calif.; 11 Indian portraits, 15 genre, Smithsonian; Butler Mus.; Mus., Santa Fe, N.Mex.; Houston MFA; Phillips Mus., Bartlesville, Okla.; Amon Carter Mus.; Wyo. State Gal.; Herron AI. Important painter of the Indian, he settled in Taos, 1912, and was considered the "father" of the colony there. [47]

SHARP, L.R. [P,I] NYC b. 14 Ap 1865, Boston, MA. Studied: W. Shirlaw; Wm. Sartain; E. Speicher. Work: G.H. Buck Coll. of American water colors. [13]

SHARP, Louis Hovey [Ldscp.P,I] Oak Park, IL b. 27 Jy 1875, Glencoe, IL d. 12 Je 1946, Pasadena. Studied: AIC; C.E. Boutwood; W.M. Chase; F. Duveneck. Exhibited: Taos & Pasadena, 1914–29. Settled in Pasadena, 1914; apparently spent years in Austria after 1929 [08]

SHARP, Marion Leale (Mrs. James R.) [P,Min.P] NYC b. NYC. Studied: ASL; L.F. Fuller. Member: Lg. Am. Pen Women. Exhibited: PAFA; Pa. SMP; BMA; Lg. Am. Pen Women, 1938 (prize), 1946 (prize); BM; Los Angeles Mus. A.; All.A.AM.; Paris Salon. [47]

SHARP, Minnie Lee [P] Houston, TX. Exhibited: SSAL, San Antonio, 1939; Houston MFA, 1939 [40]

SHARP, Theodora [Min.P] St. Davids, PA [19]

SHARP, William [E,Li,I] Forest Hills, NY b. 1900, England (came to NYC in 1934) d. 1961, NYC. Member: SAE [47]

SHARP, Will(iam) Alexander [P,Stained-glass Des,G] Los Angeles, CA (since 1907) b. 4 Je 1864, Taunton, England d. 26 Ag 1944, Alhambra, CA. Studied: Chicago Acad. FA. Member: Wash. WCC and S. Wash. A., until 1907; Calif. AC. Positions: T., Stetson Univ., Deland, Fla. (1890–1900s), Occidental Col. [21]

SHARPE, H. Percy [P] Seattle, WA [21]

SHARPE, Julia Graydon [Por.P,Ldscp.P,W] Indianapolis, IN/Harbor Springs, MI b. Indianapolis d. ca. 1938. Studied: ASL; W.M. Chase, at Ind. Sch. A.; J.O. Adams; W. Forsyth; H.S. Mowbray; Saint-Gaudens. Member: Ind. SA. Work: Indianapolis Univ. C.; Herron AI; MacD. C., NYC; Richmond (Ind.) AC; mem., Second Presbyterian Church, D.A.R. House, both in Indianapolis. Specialty: bookplates and des.. Writer of short stories. [38]

SHARPE, Matthew E. [P,T] Conshocken, PA b. 14 O 1902, Phila., PA. Studied: PMSchIA; PAFA; A.B. Carles; Barnes Fnd.; Merion, Pa.; Paris; Madrid. Exhibited: PAFA, 1940, 1945; WMAA, 1938; PMA, 1936–38; Graphic Sketch C., Phila.; Cheltenham A. Gal. Positions: T., Temple Univ., Miquon Sch., Stella Elkins Tyler Sch. FA, Phila. [47]

SHARPLESS, Ada May [S] Los Angeles, CA b. 16 Ag 1904, Hilo, HI. Studied: A. Bourdelle. Member: Calif. AC; Société des Artists Indépendants, Paris; Los Angeles AA. Exhibited: Calif. AC, 1929 (prize), 1930 (prize), 1931, 1932; Ebell Salon, 1933 (prize), 1934 (prize); Los Angeles County Fair, 1931 (prize), 1932 (prize), 1933 (prize); San Diego SFA, 1934 (prize); Riviera Gal., Hollywood, 1936 (prize). Work: Hist. Mus., Santa Ana, Calif.; New General Hospital, mon., Echo Park, both in Los Angeles; reliefs, Sierra Vista Sch., sculpture, Malibar Sch., Los Angeles; Los Angeles Mus. Hist., Sc.&A. [40]

SHARPLESS, Amy C. [P] Haverford, PA [13]

SHARPLESS, Helen Brinton [P] West Chester, PA [15]

SHARPLESS, Ida J. Seal (Mrs. Wallace) [P] Unionville, PA. Studied: PAFA [25]

SHARRARD, Alice B. [P,C] Louisville, KY b. Louisville, KY. Studied: Cincinnati A. Acad.; E. Biederman, Frieburg, Germany. Member: Louisville AL [04]

SHARRER, Honore Desmond [P] New Haven, CT/Coronado, CA Exhibited: GGE, 1939; 48 Sts. Comp., 1939 [40]

SHATTUCK, A(aron) D(raper) [Ldscp.P] Granby, CT (since 1868) b. 9 Mr 1832, Francestown, NH d. 30 Jy 1928. Studied: A. Ransom, Boston, 1851;

NAD. Member: ANA, 1856; NA, 1861. Work: Albright A. Gal. Specialty: New England landscapes, often of the White Mtns. (N.H.), or barnyard scenes of cattle and sheep on his farm in Granby. At the time of his death, he was the oldest member of NAD. Married Samuel Colman's sister. [27]

SHAVE, Rose M. [P,T] Nunda, NY b. 3 Ap 1848, Nunda. Studied: L.M. Wiles; I.R. Wiles; R.H. Nicholls, NYC; Académie Julian, with Robert-Fleury, Bouguereau. Position: T., summer sketching classes [10]

SHAVER, J(ames) R(obert) [P,I] NYC b. 27 Mr 1867, Reeds Creek, AR d. 23 D 1949. Studied: St. Louis Sch. FA; Drexel Inst.; F.O. Sylvester; P. Cornoyer; B.W. Clinedinst. Member: SC. Author/Illustrator: "Little Shavers," pen & ink drawings of children. Position: Contributor, Life, 28 yrs. Specialty: humorous drawings of children in pen and ink. [47]

SHAW, Alan W. [P,G,W] Miami, FL b. 15 O 1894, NYC. Member: Am. Ar. Prof. Lg. Exhibited: Nat. Exh. Am. A., NYC, 1937; VMFA, 1937; Audubon A., 1945; Contemporary A., 1943, 1944 (one-man); Morton Gal., 1941 (one-man); St. Petersburg AC, 1936 (prize); traveling exh., Fed. A. Proj., Fla., 1939 (one-man) Position: Dir., St. Petersburg A. Ctr. [47]

SHAW, Alice Harmon [P,Et] Cape Elizabeth, ME b. 11 Jy 1913, Portland, ME. Studied: Portland Sch. F. & Applied A.; A. Bower. Member: NAWA; Portland SA; Portland WCC. Exhibited: Farnsworth Gal., Rockland, Maine; Los Angeles Mus. A., 1937; San Diego FAS, 1941; Denver A. Mus., 1941; AWCS, 1939, 1941; NAWA, 1939, 1941–44; Portland WCC, 1942–45; Hayloft AC, Portland, 1935–46; Brick Store Mus., Kennebunk, Maine, 1941, 1942, 1946 [47]

SHAW, Charles Green [P,I,W,Des] NYC b. 1 My 1892, NYC d. 1974. Studied: Yale; Columbia. Member: Am. Abstract A.; Fed. Mod. P.&S. Exhibited: AIC, 1943; CI, 1945; WMAA, 1946; Chicago AC, 1938; SFMA, 1938; SAM, 1938; Am. Absract A., 1937–46; Fed. Mod. P.&S., 1942–46; Inst. Mod. A., Boston, 1945; Valentine Gal., 1934, 1938; Gal. Living Art, N.Y., 1938; Art of Tomorrow Mus., 1940; Passedoit Gal., 1945; Galerie Pierre, Paris, 1936; Mayor Gal., London, 1936; Berhskire Mus., 1940; 8 x 8 Exh., PMA, 1945. Author: "New York—Oddly Enough," 1938, "The Giant of Central–Park," 1940. Illustrator: "The Milk that Jack Drank," "Black and White," 1944. Contributor: nat. mags. Position: Advisory Bd., MOMA, 1936–41 [47]

SHAW, David [P] NYC Exhibited: NYWCC, 1937; Phila. WCC, 1938; AWCS-NYWCC, 1939 [40]

SHAW, Elsa Vick (Mrs. Glenn M.) [Mur.P,Des,C] Lakewood, OH b. 28 Ja 1891, Cleveland, OH. Studied: Cleveland Sch. A.; H. Keller; C. Hawthorne. Member: Clevleand Women's AC; CMA. Exhibited: CMA, 1923 (prize), 1927 (prize), 1929 (prize), 1931 (prize), 1932 (prize), 1934 (prize), 1937 (prize), 1944 (prize), 1945 (prize); Ohio WCS; Ten-Thirty Gals, Cleveland; Dayton AI, 1934 (prize). Work: murals, Severance Hall, Cleveland; S.S. President Polk [47]

SHAW, George Eleanor (Miss) [B,Des,T] Medford, MA. b. 26 Je 1890, Woburn, MA. Studied: E. Watson; J. DeCamp; C. Dallin; Munsell; Mass. Sch. A.; Harvard, Carnegie Grant, 1936. Position: T., H.S., Medford, Mass. [40]

SHAW, Glenn Moore [P,E,Des,T] Lakewood, OH b. 6 F 1891, Olmsted Falls, OH. Studied: Cleveland Sch. A.; H. Keller; C. Hawthorne. Member: Cleveland SA (Pres.); Ohio WCS (Pres.). Exhibited: CMA, 1921–46, prizes, 1921, 1924, 1925, 1926, 1928, 1931; Ohio WCS, 1928, 1931, 1932, 1934, 1937, 1938, 1940, 1941, 1946 (traveling exh.) Work: CMA; murals, Central Nat. Bank., Cleveland; Lincoln Nat. Bank, Ft. Wayne, Ind.; Old Nat. Bank, Lima, Ohio; Fed. Reserve Bank, Pittsburgh; Statler Hotels, Cleveland, Buffalo; Lakewood (Ohio) H.S.; S.S. America; USPOs, Canton, Warren, Perrysburg, all in Ohio. WPA artist. Positions: T., Cleveland Sch. A., Huntington Polytech. Inst. [47]

SHAW, H.J. [P] Columbus, OH. Member: Pen and Pencil C., Columbus [15]

SHAW, H(arriett) M(cCreary) (Mrs.) [Por.P,W,L,T] b. 17 Mr 1865, Fayetteville, AR d. 1934. Studied: Univ. A. Sch., Denver; M. Heurman; S. Richards, in Munich; C.P. Adams, in Denver. Member: AFA; Seattle FAS; Guggenheim F. Exhibited: St. Louis Expo, 1904 (gold) (med); Seattle Expo, (gold) (med). Work: William Woods Col. Author: "Outlines of American Painting" [38]

SHAW, Harry Hutchinson [Ldscp.P,Mur.P,I,L,T,B,Dr] Lafayette, LA b. 4 O 1897, Savannah, OH. Studied: Univ. Mich.; PAFA; Ohio State Univ.; G. Harding; J.R. Hopkins; Chester Springs (Pa.) Summer Sch. Member: Columbus AL. Exhibited: PAFA, 1926; Phila. WCC, 1925; Phila. AC, 1926; S.Indp.A., 1926; Butler AI; Columbus Gal. FA; CM; Massillon Mus. Award: F., Research Studio, Maitland, Fla., 1939. Illustrator: "Quest," 1934 (a book of block prints). Positions: T., Southwestern La. Inst., from 1942; Dir., Ohio River Sch. P. [47]

SHAW, Harry Hutchison, Mrs. See Allen, Margo.

SHAW, Robert [E] b. 10 Ja 1859, Wilmington, DE d. 18 Jy 1912, Wilmington. Member: Phila. Sketch C.; Phila. SE. Work: series of plates, N.Y. Hist. Soc. Specialty: hist. subjects

SHAW, Robert M. [Ldscp.P,C] Marion, IN b. 2 Jy 1915, Marion. Studied: H. Davisson; C. Bohm; G. Cleveland. Member: Brown County A. Gal. Assn. Exhibited: Hoosier Salon, 1937 (prize). Position: Mgr., Pioneer Gal., Marion [40]

SHAW, Russell H. [P] Providence, RI. Member: Providence AC [25]

SHAW, S. Van D. (Mrs.) [P] Chicago, IL. Member: Chicago SA [17]

SHAW, Samuel T. [Patron] NYC b. 1861 d. 10 F 1945. Awarded annual prize at NAD and SC; purchased work by American artists.

SHAW, Sarah Field (Mrs.) [P] Phila., PA b. Phila. Studied: Whistler [10]

SHAW, Sarah H. [P] Glenshaw, PA. Member: Pittsburgh AA [25]

SHAW, Stephen William [Por.P] San Francisco, CA b. 15 D 1817, Windsor, VT d. 12 F 1900. Studied: self-taught. Member: Mechanics Inst.; San Fran. AA. Work: He was the artist of the Masonic Order in Calif. since 1850, and painted over 200 portraits of its officers. In the Crocker collection there are 30 of his portraits of prominent pioneers of Calif. Position: Dir. & T., Boston Atheneum before 1849. He sailed to Calif. in 1849, via Cape Horn. He also was on the expedition that discoverd Humboldt Bay in New Guinea. [98]

SHAW, Sydney Dale [P,C] Mamaroneck, NY b. 16 Ag 1879, Walkley, England (came to NYC in 1892) d. 1946 (probably in Pasadena, CA). Studied: ASL; Acad. Colarossi, Ecole des Beaux-Arts, both in in Paris. Member: Calif. AC; AWCS; SC. Exhibited: Armory Show, 1913; Pan-Calif. Expo, San Diego, 1915 (med); Los Angeles, 1916; AWCS, NYC, 1917 (prize); SC, 1929 (prize) [40]

SHAW, Thomas B. [C,Des] Berkeley, CA b. 16 Jy 1914. Des. modern accessories, Amberg Hirth Studios, San Fran. [40]

SHAW, Thomas Mott [P] Concord, MA. Member: Concord AA [25]

SHAW, Vinnorma [P] Indianapolis, IN [17]

SHAW, Wilfred B. [E,I,W,Hist,L] Ann Arbor, MI b. 10 Ja 1881, Adrian, MI. Studied: Univ. Mich.; F. Holme Sch. Illus., Chicago. Member: Ann Arbor AA. Exhibited: Detroit; NYC; Ann Arbor; Toronto; Chicago; Wash., D.C.; Hackley A. Gal. (one-man). Author/Illustrator: "Short History of Univ. Mich.," 1937. Illustrator: Mich. Alum. Quarterly Review. Contributor: articles, "Rossetti," "Botticelli," "Relation of Modern American Art To That of China and Japan," in Craftsman; International Studio; Scribner's [47]

SHAW, William V. [Por.P] Jamaica, NY b. 1842 d. 29 D 1909

SHEA, Aileen Ortlip (Mrs. Alton J.) [Mur.P,Por.P] Houghton, NY b. 5 Ag 1911, Phila., PA. Studied: NAD; Sorbonne, Paris; G. Beal; L. Kroll; A. Covey; C.S. Chapman. Member: NAC. Award: Pulitzer traveling schol., 1935. Exhibited: Rochester-Finger Lakes Exh., 1946. Position: T., Houghton Col. [47]

SHEAD, Ralph [P] Jenks, OK [17]

SHEAFER, Frances B(urwell) (Mrs. Samuel Waxman) [P,L] Cambridge, MA/Greenbush, MA b. Pennsylvania d. 5 My 1938. Studied: PAFA; Phila. Sch. Des. for Women; W. Sartain. Member: Plastic C.; Scituate AA; AFA; Copley S. Exhibited: St. Louis Expo, 1904 (med); Horticultural S. Mass., 1931 (med). Specialty: botanical watercolors [40]

SHEAFER, Frank W. [P] Phila., PA b. 1 Ap 1867, Pottsville, PA. Studied: PAFA [24]

SHEAHAN, D.B. [S] NYC [10]

SHEAHAN, Joseph Gary [P] Chicago, IL. Member: Chicago NJSA [25]

SHEAN, Charles M. [Mur.P] NYC b. Brooklyn d. 7 O 1925. Studied: ASL; Cabenel, in Paris. Member: Mural P.; Arch. Lg., 1887; SC; Lg. Am. A. Exhibited: St. Louis Expo, 1904 (med). Work: Manhattan Hotel; Old Hotel Plaza; New York C.; stained glass window, St. John's Church, Larchmont; portrait of Lincoln, Capitol, Carson City, Nev. [24]

SHEAR, Fera Webber [Por.P] Berkeley, CA b. 20 Mr 1893, Eustace, FL. Studied: Cornell; NYU; Calif. Col. A.&Cr.; Calif. Sch. FA. Member: Calif. AC; Women P. of the West; Bay Region AA; Soc. for Sanity in Art; All Arts C., Berkeley, Calif. Exhibited: Springville, Utah, 1935–42, 1946; Oakland A. Gal., 1934 (prize), 1935–40; Gumps, San Fran., 1934; Mission Inn, Riverside, Calif., 1933–35; All Arts C., Berkeley, 1934–40; Berkeley

Women's City C., 1934 (one-man); Calif. State Fair, 1933-38; Bay Region AA, 1935-38; S. for Sanity in Art, 1939-42, 1945; GGE, 1939; Calif. State Fair, 1934 (prize) [47]

SHEARER, Christopher H. [Ldscp.P] Reading, PA b. 1840 d. 29 Ap 1926

SHEARN, Edith G. [P] NYC [04]

SHEBLE, Horace [E,P] Phila., PA b. 28 Ja 1869. Studied: self-taught. Specialty: stipple etching [40]

SCHECKELL, T.O. [P] Salt Lake City, UT [15]

SHEDY, Roy T. [Por.P] d. 27 My 1931, Ft. Smith, AR

SHEELER, Charles [P,Ph] Irvington, NY b. 16 Ja 1883, Phila., PA d. 7 My 1965. Studied: PMSchIA, 1900-03; PAFA with W.M. Chase, 1903-06 (and summer classes with Chase in Europe). Exhibited: one man exh.: FMA, 1934; MOMA, 1939; AGAA, 1947; Currier Gal. Am. A., 1948; Walker A. Ctr., 1952; traveling exh. in 1954-55 to: UCLA, PAFA, Ft. Worth AM, de Young MA, San Diego MA, and Munson-Williams-Proctor Inst. Work: BMFA; FMA; Columbus Gal. FA; WMA; Springfield Mus. A.; AIC; PAFA; MOMA; Newark Mus.; Santa Barbara Mus. A.; Univ. Nebr.; WMAA; Detroit AI; Pal. Leg. Honor; PMG; CMA. Important precisionist painter. He supported himself as a commercial photographer, 1912-45, until his paintings brought him success. The composition of some of his photographs are similar to his paintings. [47]

SHEERER, Mary G. [C,P,W] Cincinnati, OH/Ogunquit, ME b. Covington, KY. Studied: Cincinnati A. Acad; PAFA; ASL; D. Ross; A.W. Dow; F. Duveneck; H. Breckenridge. Member: NOAA; Cincinnati Women's AC; Cincinnati Crafters C. (Pres.); Cincinnati Mus. Assn.; F., A. Ceramic S.; Hoover Comm.; Am. Cer. Soc.; Intl. Expo Mod. Dec. & Indst. Art, Paris, 1925 (delegate). Contributor: articles, Journal of Am. Ceramic Society. Position: T., Newcomb Col., New Orleans [40]

SHEETS, Cree [P] Columbus, OH. Member: Columbus PPC [25]

SHEETS, Millard Owen [P,G,Des,T] Claremont, CA (Gualala, CA, 1976) b. 24 Je 1907, Pomona, CA. Studied: Chouinard AI, 1925-29. Member: Laguna Beach AA; Calif. WCS; NA, 1947. Exhibited: AIC, 1938 (prize); WFNY, 1939; Denver A. Mus.; Faulkner Mem. Gal.; Currier Gal. A.; BMFA; CGA; VMFA; WMAA; CI; CAM; Oakland A. Gal.; Albright A. Gal.; Kansas City AI; Nebr. AA; one-man exh.: Delgado Mus. A.; Brooks Mem. A. Gal.; Springfield A. Mus.; Rochester Mem. A. Gal.; High Mus. A.; Honolulu Acad. A.; Milch Gal.; Dalzell Hatfield Gal., Los Angeles; Calif. State Fair, 1930 (prize), 1932 (prize), 1933 (prize), 1938 (prize); Santa Cruz AL, 1931 (prize), 1932 (prize); Los Angeles Mus. A., 1932 (prize), 1945 (prize); P&S C., 1932 (prize); Los Angeles County Fair, 1928, (prize), 1930 (prize); Ariz. State Fair, 1928-30 (prize); San Antonio, 1929 (prize); Calif. WCS, 1927 (prize). Illustrator: "Sketches Abroad." Positions: T., Scripps Col., Claremont, Calif., 1932-35; A., Life mag., Burma-India Front [47]

SHEETS, Nan (Mrs. Fred C.) [P,W,Cr,L,T] Oklahoma City, OK (1976) b. 9 D 1889, Albany, IL. Studied: Valparaiso (Ind.) Univ.; J. Carlson; R. Reid; B. Sandzen; A. Thayer; E.L. Warner; N. Knopf; K.E. Cherry; H. Breckenridge. Member: Okla. AA; Okla. City AL; MacD. C.; North Shore AA; NAWPS; SSAL; AFA; Nat. Lg. Am. Pen Women. Exhibited: Broadmoor A. Acad., 1924 (prize); Kansas City AI, 1924 (prize); SSAL, 1929 (prize). Work: Kansas City AI; Springfield (Ill.) Mus. A.; Okla. Univ.; Vanderpoel Coll.; Dallas MFA. Contributor: weekly art feature, Daily Oklahoman, 1934-62. Position: T./Dir., Okla. A. Ctr., 1935-65 [47]

SHEETS, Willie A. [P] Ft. Worth, TX. Affiliated with Texas Women's Col., Ft. Worth [24]

SHEFFER, Glen C. [P,I] Chicago, IL b. 18 Ja 1881, Angola, IN d. 9 O 1948. Studied: Denison Univ.; AIC; Am. Acad. A., Chicago; H. Larvin, in Vienna; W.D. Goldbeck, in Chicago. Member: Palette & Chisel C., Chicago; Scarab C., Detroit; Cameo Salon, Chicago. Exhibited: Detroit Inst. A.; AIC; Ainslie Gal.; Chicago Gal. Assn.; numerous one-man exhibits; Palette and Chisel C., Chicago, 1946 (med). Work: Senn H.S., Chicago [47]

SHEFFERS, Peter Winthrop [P,L,G,T] Portland, OR b. 6 Ap 1893, San Antonio, TX d. 3 Ap 1949. Studied: RA, Berlin, Germany; A. Lecomte, in Paris; A. Jarosy, in London. Member: AAPL; Oreg. SA; Carmel AA; All-Ill. SFA; Am. Fed. A. Exhibited: All-Ill. SFA; Drake Hotel, Chicago (one-man). Work: Belle Keith A. Gal., Rockford, Ill.; Pub. Lib., Peoria, Ill. [47]

SHEFFIELD, Gloria Angela [S,P,C,T,B,L] Toledo, OH b. 2 My 1879, Charlotte, MI. Studied: S.L. Wise; Olivet Col.; AIC; L. Taft; J. Vanderpoel; D.C. French; C.J. Mulligan; W.M. Chase; Sch. of TMA. Exhibited: TMA, 1936 (prize). Work: Toledo Zoological S. [47]

SHELDEN, C.G. [P] Everitt, WA [24]

SHELDON, Charles Mills [I] London, England b. 24 Je 1866, Lawrenceburg, IN d. 15 Mr 1928. Studied: Académie Julian, with Constant, Lefebvre. Illustrator: Assoc. Press, "Pall Mall Budget." Covered world events for British illus. magazine, including the Spanish Am. War, South African War, and WWI [13]

SHELDON, George William [W] Summit, NJ b. 1843, Summerville, SC d. 28 Ja 1914. Studied: Princeton, 1863. Author: "American Painters," "Hours with Arts and Artists," "Artistic Homes," "Artistic Country Seats," "Recent Ideals of American Art," "Ideals of Life in France." Positions: T., Union Theological Seminary; Art Ed., New York Evening Post; Lit. Advisor, D. Appleton & Co., London, 1890-1900

SHELDON, Marshall H. [P] Pawtucket, RI. Member: Providence, WCC [25]

SHELDON, Mary A. [P,T] b. 1859 d. 8 D 1912, NYC. Studied: E. Graffet, in Paris; L.F. Day, in London. Positions: T., Normal Col., CUASch, Barnard Sch. [13]

SHELDON, R.V.A. [P] Paris, France. Member: Paris AA [25]

SHELDON, Rufus [P] Pittsfield, MA d. 28 Ja 1917. Member: SC 1897 [15]

SHELDON, Walter G. [P] Providence, RI. Member: Providence AC [25]

SHELLEY, Fay [P] Nashville, TN [15]

SHELTON, Alphonse Joseph [Mar.P] Southport, ME b. 11 F 1905, Liverpool, England. Studied: BMFA Sch.; L.P. Thompson; P. Hale; L. Stevens. Member: Gld. Boston A. Exhibited: S. Sanity in Art, 1941 (med) [47]

SHELTON, Frederick Davis [P,I] b. 1910, Columbia, CT d. 23 Mr 1943, Atlanta, GA. Studied: High Mus. A. Sch.; Corcoran A. Sch.; Paris. Position: Staff, Atlanta Journal

SHELTON, George F. [P] NYC. Member: AWCS [25]

SHELTON, W(illiam) H(enry) [P,I,W] NYC b. 4 S 1840, Allen's Hill, NY d. 4 O 1932. Studied: ASL. Member: SC. One of the founders of the Salmagundi Club, as librarian he (with Sandord Saltus) formed its famous collection. Illustrator: Harpers, Leslies, Century, New York Ledger. Author: "History of the Salmagundi Club," 1926. Position: Cur., Jumel Mansion, NYC (Washington's Hdqtrs.), 1908-16 [21]

SHENESHON, Clare [P,I,T] Minneapolis, MN b. 28 Jy 1895, Minneapolis. Studied: G. Luks; B. Robinson [25]

SHENTON, Edward [I,T,W] Westtown, PA b. 29 N 1895, Pottstown, PA. Studied: PMSchIA; PAFA. Studied: T. Oakley; H. McCarter; G. Harding. Exhibited: PAFA, 1922 (prize). Illustrator: Scribner's, Collier's, Cosmopolitan, Saturday Evening Post; "The Yearling," pub. Scribners, 1937, "Northern Lights," pub. Viking, 1939, "Face of a Nation," pub. Scribners, 1939. Position: T., PMSchIA [40]

SHEPARD, Augustus D., Jr., [Mur.P] NYC. Member: Arch. Lg., 1894. [10]

SHEPARD, C.E. [P] Kansas City, MO [17]

SHEPARD, Clare [P] Seattle, WA. Exhibited: P.-P. Expo, San Fran., 1915 (med) [15]

SHEPARD, Effie [P] New Orleans, LA [15]

SHEPARD, Elsie [P] NYC [24]

SHEPARD, Isabel Benson [P,G,C] Riverside, CA/Seattle, WA b. 2 D 1908, Spokane, WA. Studied: Univ. Wash.; A. Ctr., Riverside, Calif. Member: Riverside AG. Exhibited: Northwest PM, Seattle AM, 1937, 1938; Riverside AG, 1939 [40]

SHEPARD, Mary N. [P] NYC [15]

SHEPARD, Ralph [P] Hartford, CT [13]

SHEPHARD, Clarence [P,Arch] Kansas City, MO/Fryeburg, Maine/Bemis Point, NY b. 27 O 1869, Cortland, NY. Studied: Keith; Griffin. Member: Kansas City SA; Mid-Western A.; AIA; Arch. Lg. [33]

SHEPHARD, Elizabeth Hammond [P] Milwaukee, WI [24]

SHEPHARD, Minnie [P] San Fran., CA [19]

SHEPHERD, Charles [P] Brooklyn, NY b. 1844, Yorkshire, England (came to Brooklyn, NY, in 1869) d. 17 Ag 1924

SHEPHERD, Chester George [P,I] Chicago, IL b. 28 Ap 1894, Lathrop, MI. Studied: AIC. Member: Palette and Chisel C.; Assn. A. & Indst. [29]

SHEPHERD, George [P] Chicago, Il. Member: GFLA. Affiliated with Burleigh Withers Co., Chicago [27]

SHEPHERD, George B. [P] NYC [17]

SHEPHERD, J. Clinton [P,S,T,I] Palm Beach, FL (1962) b. 11 S 1888, Des Moines, IA. Studied: Univ. Mo.; Kansas City Sch. FA; AIC; BAID; W. Ufer; H. Dunn. Member: Palm Beach AL; S. Four A.; NSS. Exhibited: NAD; PAFA: Norton Gal.; Silvermine GA; Miami AL, 1940 (prize); Palm Beach AL, 1941 (prize). Work: John Herron AI; mem., Westport, Conn. Specialty: traditional Western. Position: Dir., Norton Sch. A., Palm Beach, Fla., 1941–46; Dean A., Barry Col., Miami [47]

SHEPHERD, Nina [P,E,T] Springfield, MO b. Des Moines, IA. Member: SSAL; Ozarks AA. Exhibited: St. Louis AL, Thumb-box Show, 1930–32 (prizes); Boston, 1938 (prize); Ozarks Empire Dist. Fair, 1939 (prize). Position: Hd., A. Dept., Bd. Edu., Springfield, Mo. [40]

SHEPLER, Dwight (Clark) [Por.P,Gr,W,T,I] Chestnut Hill, MA b. 11 Ag 1905, Everett, MA. Studied: BMFA Sch; Williams Col. Member: St. Botolph C., Boston; Am. A. Group; AAPL. Exhibited: PAFA, 1936; AIC, 1940; CGA, 1943; CI, 1944; BMFA, 1943; Minneapolis Inst. A., 1943; NGA, 1943–45; Salon de la Marine, Paris, 1945; MMA, 1945; Montclair A. Mus., 1941 (one-man); Philbrook A. Center, 1942; Boston (one-man); NYC (one-man); Chicago (one-man). Illustrator: "Many a Watchful Night," 1944, "The Navy at War," 1943. Contributor: illus., Country Life, Pageant, Life; illus. & articles, Boston Sunday Herald; covers, Sportsman, Time, 1936, 1937. Positions: Combat A., U.S. Navy, 1942–46; T., Professional Artists Sch., Boston [47]

SHEPLEY, Annie Barrows [P] Worcester, MA. Studied: H.S. Mowbray, in NYC; Paris, with Lefebvre, L. Simon. Member: NYWCC; NAC [08]

SHEPPARD, Ella W. See Gallagher, William, Mrs.

SHEPPARD, J. Warren [P,I] Brooklyn, NY/Lincoln Park, NJ b. 22 F 1882, Brooklyn, NY. Studied: his father Warren. Illustrator: Brooklyn Eagle, New York Herald Tribune, New York Sun; D. Appleton; Century, Scribner's [40]

SHEPPARD, Warren [P,I,W] Brooklyn, NY/Lincoln Park, NJ&Isle of Shoals, NH b. 10 Ap 1858, Greenwich, NJ d. 23 F 1937. Studied: Hertzberg; de Haas. Exhibited: Brooklyn AA, 1874–81; NAD, 1880–99; St. Louis Expo, 1904; Denver Expo, 1884 (gold). Work: Albright A. Gal.; TMA; Pub. Lib., Springfield (Mass.); AGAA; India House, NYC; Mystic Seaport Mus.; Peabody Mus., Salem. He was a navigator of racing yachts that he also designed. [33]

SHEPPARD, William H.C. [Por.P,Min.P,Ldscp.P,I,W,Li] Phila., PA b. 1 Ja 1871, Phila. Studied: Spring Garden Inst.; PAFA, 1895 (Cresson traveling schol.); Académie Julian, Ecole de Beaux-Arts, Bouguereau, Gérôme, all in Paris. Member: AAPL. Exhibited: Paris Salon; PAFA, 1896, 1900, 1930, 1932; AAPL, 1939, 1940; Currier Gal. A.; Cape May, N.J., 1946. Author/Illustrator: "Rambler Club Series" (15 books). Author: "Don Hale" stories (4 books) [47]

SHEPPARD, William Ludwell [I,S] b. 1833, Richmond, VA d. 27 Mr 1912, Richmond, VA. Studied: NYC and Paris, before 1860; P. Soyer, in London and Paris, 1877–78. Work: Soldiers' and Sailors' Monument, statue of Gen. A.P. Hill, Howitzer Mem. Hall, watercolors of Civil War, Confederate Mus., all in Richmond. Illustrator: Harper's, Leslie's, 1867–90; "Dombey and Son," by Dickens, 1873, "Picturesque America," 1872

SHERER, Renslow Parker [P,S] Highland Park, IL. b. 13 O 1888, Chicago. Studied: Univ. Chicago; R. Ingerle; G.H. Brandriff. Exhibited: AIC, 1937, 1939, 1940, 1944; Milwaukee AI [47]

SHERIDAN, Clare [S] NYC [25]

SHERIDAN, Frank J., Jr. [I,W] NYC/Sands Point, NY b. Dubuque, IA. Member: SI; Phila. Sketch C.; MMA [40]

SHERIDAN, John E. [I,P] NYC b. Tomah, WI. Member: SI, 1912. Illustrator: Saturday Evening Post [47]

SHERIDAN, Joseph Marsh [P,Gr,S,I,W,L,E,Li,T] New Wilmington, PA b. 11 Mr 1897, Quincy, IL. Studied: Beloit Col.; ASL; AIC; Univ. Calif.; Norton; Hofmann; Archipenko; E.D. Kinzinger. Member: San Fran. AA; San Diego AG; A. Cong.; A. Center, San Fran. Exhibited: Minneapolis Inst. A., 1929 (prize) 1931 (prize); European & Am. Abstractionists Exh., 1933; Oakland A. Gal., 1932–45; SFMA, 1932–45; AIC, 1931, 1933; many one-man exhibits in U.S. Work: SFMA; Berkeley (Calif.) Pub. Lib.; Oakland Pub. Lib; Univ. Calif.; Beloit Col.; Univ. Minn.; AF of L Bldg., San Fran.; Univ. Ariz.; Mills Col.; Westminster Col., Pa.; Oakland H.S.; Piedmont Cal. H.S. Illustrator: "Expressionism in Art, 1934. Positions: T., Univ. Minn., 1928–30, Univ. Ariz., 1944–45, Westminster Col., New Wilmington, Pa., 1945–46 [47]

SHERIDAN, Mark [Des,P] Savannah, GA b. 23 My 1884, Atlanta. Studied: Ga. Sch. Tech.; PMSchIA; PAFA. Member: NAC; Ga. AA; Savannah AC. Work: Telfair Acad. Exhibited: NAC, 1940, 1945; Ga. AA; Savannah AC; mural, Atlanta Theatre, Ga.; DeSoto Beach C., Savannah [47]

SHERIDAN, Max [I] NYC. Member: SI [47]

SHERIFF, Daisy [P] Pittsburgh, PA. Member: Pittsburgh AA [25]

SHERINYAN, Elizabeth [C,P,S,L,T,W] Worcester, MA b. 1877, Harpoot, Armenia. d. 25 Ja 1947. Studied: R. Martin; Marot; Hale; H.D. Murphy; Major; Greenwood; Cornoyer; WMA Sch.; Mass. Normal A. Sch.; Europe; Asia; Africa. Member: CAFA. Work: Monastery of S. Lazzari, Venice, Italy. Position: T., Pub. Sch., Worcester, Mass. [40]

SHERMAN, Beatrix [P] Chicago, IL [15]

SHERMAN, C.H. [P] NYC. Member: SC [25]

SHERMAN, Clifford C. [Car] b. 1878 d. 26 D 1920, Springfield, IL

SHERMAN, Edith Freeman (Mrs.) [S,W,C,T] Brookfield, IL b. 16 Je 1876, Chicago. Studied: L. Taft, at AIC [15]

SHERMAN, Edwin Allen [P] b. 25 Ag 1829, North Bridgewater, MA d. 17 Mr 1914, Oakland, CA. Gold-Rush amateur artist, 1849; settled in Sonoma, 1852, later in Oakland. [*]

SHERMAN, Effim H. [P,E,Li,T,I] NYC b. 8 Ag 1889, Romania. Studied: CUASch; NAD; E. Carlsen; D. Volk; G. deForest Brush. Member: SAE; CAFA. Exhibited: NAD, 1938–46; PAFA, 1937, 1938; AIC, 1938, 1939; Los Angeles Mus. A., 1938; SFMA, 1942, 1944, 1946; SAM, 1937–46; SAE, 1937–46, 1943 (prize); Phila. Pr. C.; Albany Inst. Hist.&A., 1943–45; CGA, 1938, 1939, 1940; WFNY, 1939; Southern PM; Nat. Exh. Am. A., NYC, 1936, 1938; Venice, Italy. Work: MMA; BM; PMA; AGAA; many H.S., NYC. [47]

SHERMAN, Ella Bennett (Mrs. John) [P] Rochester, NY/Wash., D.C. b. NYC. Studied: D. Volk; W.M. Chase; Henri. Member: Wash. WCC; Wash. SA [25]

SHERMAN, Florence Taylor Kushner [P,L] Miami, FL b. 20 S 1911, Boston. Studied: BMFA Sch.; P. Hale; F. Spaulding; B. Keyes. Member: Miami AL; Blue Dome F.; Fla. Fed. A. (Dir.); Copley S., Boston. Exhibited: Sarasota, Fla., 1936, 1937; Blue Dome F., 1941, 1945; Miami Beach A. Gal., 1941; Miami AL, 1940, 1941 (prize) 1942 (prize), 1944 (prize); Fed. A., 1937 (prize), 1938, 1940–46; Univ. Nebr., 1938; AAPL, 1941 (prize) 1943 (prize), 1944 (prize) [47]

SHERMAN, Frederic Fairchild [W,Patron] Westport, CT b. 1874, Peekskill, NY d. 23 O 1940. Position: Ed./Publ., Art in America, for 27 yrs.

SHERMAN, Gail. See Corbett, H.W., Mrs.

SHERMAN, Henry K. [Ldscp.P] Butler, PA b. 1 Ja 1870 d. 1 F 1946. Studied: C. Walter. Member: Pittsburgh AA; Butler County AA. Exhibited: Pittsburgh AA, 1936 (prize); Butler County AA, 1936 (prize), 1937 (prize). Work: 100 Friends of A., Pittsburgh [40]

SHERMAN, Heyman [P] NYC. Member: S.Indp.A. [25]

SHERMAN, Hoyt Leon [P,Des,E,Li,L,T] Columbus, OH b. 7 N 1903, Lafayette, AL. Studied: J.R. Hopkins; C. Rosen; Ohio State Univ. Exhibited: Columbus AL, 1937 (prize). Position: T., Ohio State Univ. [40]

SHERMAN, Irving Josef [I,P] NYC/Plainfield, NJ b. 22 My 1917, NYC. Studied: Pratt Inst., Brooklyn. Exhibited: Brooklyn WCC; FA Gal., NYC; Am. WCS-NYWCC, 1939. Illustrator: Mademoiselle, Pictorial Review [40]

SHERMAN, James Russell [P,Li,I] NYC b. 1 Ap 1907, Maxwell, IA. Studied: Kansas City AI; ASL. Exhibited: WFNY, 1939; LOC, 1943, 1945, 1946; AIC, 1939, 1940; PAFA, 1942; CI, 1943; Denver AM, 1940, 1942; Philbrook A. Center, 1945 (one-man); 8th St. Gal., 1938 (one-man); Weyhe Gal., NYC. Work: Philbrook A. Center; Logan County A. Mus., Colo.; murals, USPO, Loveland, Colo.; U.S. Army. Illustrator: "So You Think Its New," 1939, "City Government," 1941. Contributor: national magazines, newspapers. WPA artist. [47]

SHERMAN, Jessie (Gordan) [P,Des] Boston, MA b. Lenox, MA. Studied: V. George; W.B. Hazelton; U. Romano; New Sch. Design; H.E. Smith; P.M.M. Jones. Member: Boston SAC; Boston S.Indp.A. (Pres.); NAWPS; Fitzwilliam (N.H.) A. Center. Exhibited: Inst. Mod. A., Boston, 1941,

1944; NAWA, 1945; Jordan Marsh Gal., annually; Boston S.Indp.A., 1941; Fitzwilliam A. Center, 1939 (prize) [47]

SHERMAN, John [P,Des,T] Omaha, NE b. 26 Ap 1896, Brooklyn, NY. Studied: CI; ASL; Md. Inst.; J. Carlson. Member: Omaha AG. Exhibited: Joslyn Mem. (one-man). Work: Joslyn Mem.; Univ. Nebr.; Bethesda Chapel, Moorhead, IA [40]

SHERMAN, John K(urtz) [Cr] Minneapolis, MN b. 19 Ap 1898, Sioux City, IA. Studied: Univ. Minn. Position: A. Ed./Cr., Minneapolis Star-Journal & Tribune [47]

SHERMAN, Julia Munson (Mrs. Frederic F.) [C] Westport, CT b. 1875, Jersey City. Studied: L.C. Tiffany. Member: Boston SAC. Work: Walters A. Gal., Baltimore. Specialty: enamels; jewelry [40]

SHERMAN, Martha E. Coleman [P] Chicago, IL b. 1875, Henderson, KY. Studied: AIC [04]

SHERMAN, Stowell B(radford) [P,E] Providence, RI/Rockport, MA b. 22 Ja 1886, Providence. Studied: RISD. Member: Providence AC; Providence WCC [33]

SHERMUND, Barbara [I] NYC. Member: SI [47]

SHERRILL, Charles H. [Patron,W,L] b. 13 Ap 1867 d. 25 Je 1936, Paris. Wrote and lectured about stained glass. In 1923, as a member of the council of NYU, he reorganized the art department, inactive since 1872; it is now known as the School of Architecture and Allied Arts.

SHERRILL, Edgar B. [Printer] Boston, MA. Member: Boston SAC; S. Printers, Boston. Exhibited: AI Graphic A. Work: "Printing for Commerce." Position: Owner, Sherrill Press, Boston [32]

SHERWOOD, Anna K.K. (Mrs.) [Por.P] d. 2 Ap 1931, NYC. Studied: G. Luks. Also studied music with Edward MacDowell.

SHERWOOD, H.A. [P] Hartford, CT. Member: CAFA [25]

SHERWOOD, Mary Clare [P,T] Vicksburg, MS/Lyons, NY b. 18 My 1868, Lyons, NY d. 6 Ja 1943. Studied: ASL, with Weir, Chase, Cox, W. Long, A. Archipenko; Berlin, with C. Fehr, C. Hermanns; F.E. Scott, in Paris. Member: NAWPS; Miss. AA; SSAL. Exhibited: Miss. AA, 1931(gold), 1934 (gold), 1938 (prize); A. Exh., Women's Fed. C., Miss., 1933 (prize). Position: T., All Saints Col., Vicksburg [40]

SHERWOOD, Rosina Emmet (Mrs. Arthur M.) [P] NYC/Stockbridge, MA b. 13 D 1854, NYC d. 19 Ja 1948 (age 94). Studied: Académie Julian, Paris; Chase. Member: SAA, 1886; ANA, 1906; NYWCC; AWCS. Exhibited: Paris Expo, 1889 (med); Columbian Expo, 1893 (med); Pan-Am. Expo, 1901 (med); St. Louis Expo, 1904 (med) [47]

SHERWOOD, Ruth (Mrs. Albin Polasek) [S,T] Winter Park, FL/Chautauqua, NY b. Chicago d. 1953. Studied: Univ. Chicago; AIC; A. Polasek. Member: Chicago PS; Chicago Gal. Assn. Exhibited: Chicago AC; PAFA; NSS; Century of Progress, Chicago, 1933, 1934; SFMA; Wash., D.C.; Chicago Women's Aid (prize); Chicago Gal. Assn., 1928 (prize), 1930 (prize); AIC, 1921 (prize), 1922 (prize), 1929 (prize), 1930 (prize); Mun. AL, 1936 (prize); Assn. Chicago P.&S., 1939 (prize). Awards: Lathrop Foreign F., 1921; Adams Foreign F., 1921. Work: mem. tablets/busts/mem.: River Forest (Ill.) Women's C.; Portland Cement Assn.; Law Sch., Univ. Wis.; Univ. Chicago; Johns Hopkins Univ.; Lake Shore Bank medal for architecture; Sch. Religion; Globe C., Chautauqua, N.Y.; fountain, Kenilworth, Ill. [47]

SHERWOOD, Sherry (Mr.) [Des,P,S,C] Chicago, IL b. 5 Ja 1902, New Orleans d. ca. 1958. Studied: Md. Inst.; AIC; Chicago Acad. FA; J. McBurney; L. Taft. Exhibited: Century of Progress, Chicago, 1933, 1934; Atlantic City Auditorium; San Diego Expo; Tex. Centenn.; GGE, 1939. Work: WPA mural des., Chicago. Designer: scenery for N.Y. theatrical productions [47]

SHERWOOD, Walter J. [W,P] Wilmette, IL b. 15 Ag 1865, Wauseon, OH. Studied: AIC. Exhibited: AIC, 1940; Mun. A. Exh., Chicago; Ravinia (Ill.) Gal. Work: Ill. Athletic C., Chicago. Contributor: Magazine of Art, Athena. Positions: Author/Ed., Weekly News Letter, 1923–40; Manager, Printing/Publications, 1911–45, AIC [47]

SHERWOOD, William (Anderson) [E.P] Bruges, Belgium b. 13 F 1875, Baltimore, MD d. 1951. Member: Société Royale des Beaux-Arts Belge; Société Royale des Aqua-Fortistes de Belgique; Chicago SE; Calif. PM; AFA; Chevalier de l'Ordre de la Couronne (Belgique). Work: Etchings owned by Elisabeth, Dowager Queen of Belgium; etchings in Royal Lib., Brussels, Musée Plantin-Moretus, Antwerp, LOC, NGA; Cleveland Pub. Lib.; Detroit Pub. Lib.; Worcester Free Lib.; AIC; Calif. State Lib.; City Lib., Sacramento, Calif.; paintings, Musée Royal de L'Armée, Brussels [40]

SHEVEHON, Clare [P] Minneapolis, MN [25]

SHEWSBURY, Henrietta C. [P] Darby, PA [04]

SHIDELER, Paul [P,E] Indianapolis, IN b. 16 F 1888, Indianapolis. Studied: Forsyth; Coats [33]

SHIELDS, Beckwith A. [P] Boston, MA b. Cape Breton, Nova Scotia. Studied: L. Kromberg. Member: Copley S.; Boston AC [10]

SHIELDS, Blanche Cumming [P] Neenah, WI [17]

SHIELDS, Emma Barbee [Por.P] NYC d. 16 Ja 1912. She lived for many years in Texas and came to New York in 1893.

SHIELDS, Francis Bernard (Frank) [Li,Ser,P,I] Freeport, NY b. 2 Mr 1908, NYC. Studied: Columbia; NAD; ASL; Olinsky; Hawthorne; Nicolaides; D. Wortman. Exhibited: MMA (AV), 1943; LOC, 1941; Univ. Kans., 1939; Garden City, N.Y., 1943; Freeport Mem. Lib., 1939 (one-man), 1941–45; Weyhe Gal., WPA Gal., both in N.Y. Work: MMA; LOC; Univ. Kans.; N.Y. Pub. Sch. Illustrator: "A Collection of Animal Story Masterpieces," 1939, "Parade of Fairy Tales," 1945, "When Ships Were Ships." Contributor: Natural History, Boy's Life [47]

SHIELDS, Thomas W. [P] Brooklyn, NY b. 1849, St. Johns, New Brunswick d. 20 S 1920. Studied: NAD, with Wilmarth; Gérôme, Carolus-Duran, Lefebvre, in Paris. Work: Brooklyn Mus. A. [01]

SHIERER, Mary G. [P] New Orleans, LA. Position: Affiliated with Newcomb A. Sch. [15]

SHIFF, E. Madeline (Mrs. Wiltz) [P,C,Min.P] Woodstock, NY b. Denver. Studied: Adelphi Col.; ASL, with J.B. Whittaker, DuMond, W.M. Chase, H.E. Field. Member: Woodstock AA; Salons of Am.; Brooklyn Soc. Min. P. Exhibited: Baltimore, 1923 (prize). Work: WMAA [47]

SHILL, F. Hutton [P] Petro, AR 7 Je 1872, Omaha, NE. Studied: PAFA, with Anshutz, Chase, C. Beaux. Member: Phila. Sketch C. Award: PAFA, 1904, 1907 (traveling schols.) [19]

SHILLARD, Georgine Wetherell (Mrs. C. Smith) [P,T] Belleaire, FL b. 2 Mr 1874, Phila. d. 12 O 1955. Studied: PAFA; R. Henri; Whistler, Simon, Collet, in Paris. Member: Phila. Plastic C.; AFA; Fla. Fed. A.; NIAL; NAWA. Exhibited: Phila. Plastic C. (prize). Positions: T./Pres.: Clearwater A. Mus., Fla. [47]

SHILLING, Alexander [Ldscp.P,E] NYC (since 1885) b. 1860, Chicago d. 19 Ja 1937. Studied: G.S. Collis; H.A. Elkins, 1878. Member: AWCS; N.Y. Etching C.; SC; Century A.; Chicago AL (founder). Exhibited: Phila. AC, 1901 (gold); St. Louis Expo, 1904 (med); SC, 1913 (prize). Work: MMA; Print Coll., NYPL [33]

SHIMADA, Kainan T. [E] Los Angeles, CA [24]

SHIMIN, Symeon [P] NYC b. 1 N 1902, Astrakhan, Russia. Studied: CUASch; G. Luks. Member: A. Lg. Am. Exhibited: WMAA, 1940, 1941; CGA, 1940; AIC, 1940; Nat. Mus., Ottawa, 1940; U.S. Exh., Guatemala, 1941; 48 Sts. Comp., 1939. Work: murals, Dept. Justice, Wash., D.C.; USPO, Tonawanda, N.Y. WPA artist. [47]

SHIMIZU, Toshi [P] NYC. Member: S.Indp.A. [25]

SHIMOTORI, Show [P] NYC [19]

SHINDLER, William H. [I] NYC [01]

SHINN, Everett [P,Dec,Des,I,Dr,W] NYC b. 7 N 1876, Woodstown, NJ d. 3 My 1953. Studied: PAFA, 1893–97; Spring Garden Inst., Phila; Paris; London. Member: Cornish (N.H.) Colony; The Eight; ANA, 1935; NA, 1943. Exhibited: Charleston Expo (med); AIC, 1939 (prize). Work: MMA; AIC; mural, Council Chamber, City Hall, Trenton, N.J.; interior, Belasco Theatre, NYC. Illustrator: 28 books, 94 stories in Harper's, Delineator, McClure's, other magazines. Playwright: "More Sinned Against than Usual." Positions: A. Dir., Metro-Goldwyn-Mayer, other studios, 1917–23 [47]

SHINN, Florence Scovel ("Flossie") (Mrs. Everett) [I] NYC b. Camden, NJ d. 17 O 1940. Studied: PAFA. Work: LOC. Illustrator: "Lovey Mary," "Mrs. Wiggs of the Cabbage Patch," "Coniston." The first of four women married to Everett Shinn. (Shinn's mercurial temper resulted in four divorces.) After her divorce in the early 1920s she never returned to illustration, but wrote several popular books: "The Game of Life and How to Play It," 1925, "Your Word is Your Wand," 1928, "The Secret Door to Success," 1940 [21]

SHIPLEY, George Alfred [P,I] Flatbush, NY b. 13 N 1872. Studied: ASL [08]

SHIPPEN, Zoe (Mrs. Eugene Jewett) [P] Hartford, CT b. 12 N 1902.

Studied: L.P. Thompson; P. Hale; BMFA Sch.; W. Hazelton; J.P. Wicker; Sch. FA, Detroit. Specialty: red chalk and oil portraits [31]

SHIRAS, George E. [P] Los Gatos, CA. Member: Pittsburgh AA [21]

SHIRAS, O.C. [P] Cleveland, OH/Chicago, IL. Member: Cleveland SA [27]

SHIRE, Mildred [P] NYC b. 25 F 1907, NYC. Studied: Nat. Acad.; ASL. Member: MacDowell Col.; Silvermine Ar. Gld.; Am. Ar. Cong. Exhibited: Am. Ar. Cong., 1938, 1939; Am. FA Soc., 1938, 1939; Currier Gal., Manchester, N.H. [40]

SHIRK, Jeannette C(ampbell) [I,W] Glenshaw, PA b. 16 Ap 1898, Middletown, PA. Studied: E.F. Savage; C.J. Taylor; G. Sotter; Coll. FA, CI. Member: Pittsburgh AA. Exhibited: Pittsburgh AA, 1927 (prize). Author: "Bela the Juggler," 1936. Illustrator: "The Concert"; Millie Ruth Turner's books of nature verses [40]

SHIRLAW, Walter [Genre P.,Mur.P,Por.P,I,En,E] NYC b. 6 Ag 1838, Paisley, Scotland (came to NYC in 1841) d. 26 D 1909, Madrid, Spain. Studied: Munich Royal Acad., with Raab, Wagner, Ramberg, Lindenschmidt, 1870–77. Member: NA, 1888; SAA (founder; first Pres., 1875); Century Assn.; AWCS; Mural P.; A. Aid S.; AIC (founder), 1868. Exhibited: Royal Acad., Munich (med); Centenn. Expo, Phila., 1876 (med); Paris Expo, 1889 (prize); NAD, 1895 (prize); Pan-Am. Expo, Buffalo, 1901 (med); St. Louis Expo, 1904 (med); NAD; PAFA, beginning 1861; N.Y. Etching C., 1883. Illustrator: Harper's, Century. Position: T., ASL [08]

SHIRLEY, Alfaretta Donkersloot [C,S,T] Short Hills, NJ b. 2 Ag 1891, New Jersey. Studied: N.Y. Sch. F.&Appl. A.; Columbia; Alfred Univ., with C.F. Binns. Member: N.Y. Ceramic Soc.; Nat. Edu. Assn.; N.J. Edu. Assn.; Newark AC. Exhibited: Syracuse Mus. FA; Arch. Lg.; Montclair A. Mus.; Newark Mus.; N.Y. Ceramic Soc. Traveling Exh.; Rutgers. Positions: T., Newark Sch. F.&Indst. A., 1921–34, Barringer H.S., Newark, N.J., 1935– [47]

SHISLER, Clare Shepard [Min.P] Studied: C. Vanatta; L. Pettingill. Member: Calif. S. Min. P.; Pa. Soc. Min. P.; West Coast Arts, Inc. Exhibited: Yukon-Pacific Expo, 1909 (med); P.-P. Expo, San Fran., 1915 (med); Seattle FAS, 1913 (prize); West Coast Arts, Inc., 1923 (prize); Calif. S. Min. P., 1929 (prize) [29]

SHIVA, R(amon) [P,L] Santa Fe, NM b. 17 O 1893, Santander, Spain. Studied: AIC. Exhibited: AIC, 1921 (prize), 1923 (prize). Manufacturer: Shiva Artist Oil Colors [40]

SHIVELY, Douglas [Ldscp.P] Santa Paula, CA b. 10 Ap 1896, Santa Paula. Studied: Occidental Col., Los Angeles; Univ. Calif. Exhibited: Eisteddfod, Oxnard, Calif., 1930–32 (prize); Santa Cruz AL, 1935 (prize); Calif. AC (one-man) [47]

SHIVELY, Paul [P] NYC. Member: AWCS [47]

SHOEMAKER, Ann Green (Mrs.) [P] Doylestown, PA. Studied: PAFA [25]

SHOEMAKER, Edna. See Cooke.

SHOEMAKER, Vaughn Richard [Car,P,T] Chicago, IL b. 11 Ag 1902, Chicago. Studied: Chicago Acad. FA. Exhibited: O'Brien Gal., Chicago, 1935, 1936; Marshall Field, 1938, 1946. Awards: Pulitzer prize, 1938; National Headliners Award, 1942; National Safety Council Award, 1945. Author/Illustrator: six cartoon books. Positions: T., Chicago Acad. FA, 1927–42; Car., Chicago Daily News, 1922– [47]

SHOENFELT, Joseph Franklin [P,T] Oswego, NY b. 17 N 1918, Everett, PA d. 14 O 1968. Studied: State T. Col., Indiana, Pa.; Columbia. Exhibited: Harrisburg AA, 1941; All. A. Johnstown. Work: mural, State T. Col., Indiana, Pa. Position: T., State T. Col., Oswego [47]

SHOKLER, Harry [P,L,W,T,E,Ser] Brooklyn, NY/Londonderry, VT b. 25 Ap 1896, Cincinnati. Studied: H. Wessel; D. Garber; H. Giles. Member: Nat. Ser. Soc.; Am. Color Pr. Soc.; A. Lg. Am. Exhibited: NAD, 1943–46; LOC, 1944, 1945; SFMA, 1944; Northwest Pr.M., 1944, 1945. Work: MMA; Syracuse Mus. FA; PMA; Newark Mus.; CI; Munson-Williams-Proctor Inst.; Cincinnati Pub. Lib.; Princeton Pr. C.; LOC. Author: "Artists Manual for Silkscreen Printmaking," 1946. Position: T., BM Sch., Brooklyn [47]

SHOKLER, Morris [P] Cincinnati, OH [24]

SHOLL, Anna McClure [P,W] NYC b. 1868, Phila., PA d. 1 Ap 1956. Studied: Cornell; self-taught. Member: Studio Gld.; Staten Island Inst. A.&Sc.; NAC. Exhibited: NAC, annually; Staten Island Inst. A.&Sc.; N.Y. (one-man). Author/Editor: "Blue Blood and Red," 1915, "Fairy Tales of Weir," 1918, "Ancient Journey." Author: "The Law of Life," 1903, "The Greater Love," 1908. Contributor: national magazines [47]

SHONBORN, Lewis J. [P] Paris, France b. Iowa. Studied: Bonnât, in Paris [08]

SHONNARD, Eugenie F. [S] Santa Fe, NM (1976) b. 29 Ap 1886, Yonkers, NY. Studied: ASL, with J.E. Fraser; Bourdelle, Rodin, in Paris; N.Y. Sch. Appl. Des. for Women, with A. Mucha. Member: NSS; Salon d'Automne, Salon Nationale des Beaux-Arts, both in Paris. Exhibited: N.Mex. State Fair, 1940 (prize), 1941 (prize); Arch. Lg.; WFNY, 1939; WMAA, 1940; Paris, 1926 (one-man); Mus. N.Mex., 1927; MOMA, 1933. Work: Tingley Hospital for Crippled Children, Hot Springs, N.Mex.; Luxembourg Mus., Paris; MMA; CMA; Colorado Springs FA Center; Brookgreen Gardens, S.C.; Mus. N.Mex, Santa Fe; Sandia Sch., Albuquerque, N.Mex.; IBM Coll. Specialties: Pueblo Indians, designs and carves furniture, doors, bird cages executed in iron [47]

SHONTZ, Janet [P] Erdenheim, PA [19]

SHOPE, Henry B(rengie) [E,Arch] Paris, France b. 1 O 1862, Baltimore d. 21 S 1929, Bellevue, France. Studied: Preissig; W.R. Ware; R.M. Hunt; Satterlee. Member: Arch. Lg.; Chicago SE; Brooklyn SE; Calif. PM. Work: etchings, NYPL; U.S. National Mus. [27]

SHOPE, Irvin ("Shorty") [P] Helena, MT b. 1900 d. 1977. Studied: Grand Central Sch. A., with H. Dunn, 1935. Work: USPO, Webster, S.Dak. Specialty: cowboy artist. WPA artist. Friend of C.M. Russell and Will James. [40]

SHOPEN, Kenneth [P,E,T] Chicago, IL b. 11 S 1902, Elgin, IL d. 13 N 1967, Norwich, VT. Studied: Univ. Ill.; AIC. Exhibited: CGA; PAFA; AIC; CI; VMFA. Positions: T., AIC (1932–45); Biarritz Am. Univ., France (1945–46), Chicago Latin Sch. (1940) [47]

SHORE, Henrietta M. [P,L,W,T,Li] Carmel, CA b. Toronto d. 17 My 1963, San Jose, CA. Studied: N.Y. Sch. A.; ASL; London, England; Canada; Hayes Miller, in N.Y. Exhibited: P.-P. Expo, 1914, 1915 (med); San Fran. Soc. Women A., 1928 (prize); San Fran. AA, 1931 (prize); PAFA; CAM; AIC; Arch. Lg.; Erhich Gal., 1923; WMA, 1923; Minn. State Fair; Los Angeles Mus. A., (one-man), 1927; Pal. Leg. Honor, 1928, 1931; Kraushaar Gal., 1921 (one-man); de Young Mem. Mus., 1933 (one-man); Passedoit Gal., 1939 (one-man); London (one-man); Paris (one-man); Liverpool (one-man). Work: LOC; San Diego FA Soc.; Dallas Mus. FA; Univ. Wash.; Nat. Gal., Ottawa; murals, USPOs, Santa Cruz, Monterey, both in Calif.; Custom House, Monterey. WPA artist. [47]

SHOREY, George H. [P,E,T] Grantwood, NJ/Burnt Hills, NY b. Hoosick Falls, NY d. 20 Je 1944, Schenectady, NY. Studied: W. Shirlaw. Work: Soldiers bronze memorial tablet, Trinity Episcopal Church, Grantwood; Pr. Coll., LOC. Illustrator: "Cathedral of St. John the Divine," "New York Parks," "Old Kingston," other books. Position: T., Browning Sch., N.Y. [40]

SHOREY, Mary F. Jones (Mrs. George H.) [S,T] b. 1865 d. 26 S 1944, Schenectady, NY

SHORT, Jessie Francis [P] San Fran., CA [19]

SHORTER, Edward S(wift) [P,Des,Dr,T,W,L] Macon, GA b. 2 Jy 1900, Columbus, GA. Studied: Corcoran Sch. A.; Breckenridge Sch.; W.L. Stevens; W. Adams; M.F. Browne; E. Renard, in Paris. Member: North Shore AA; S. Wash. A.; Wash. Ldscp. C.; SSAL; S.Indp.A.; Wash. AC; Atlanta AA; AAPL; Chicago AL; Macon AA; Ga. SA. Exhibited: Southern Ar. Exh., Nashville, Tenn., 1926 (prize); Ga. Artists Exh., 1928 (prize), 1932 (prize), 1934 (prize), 1937 (prize); SSAL, 1934 (prize); Chattahoochee Valley Fair, 1938 (prize). Work: portraits, Baylor Univ., Tex.; Mercer Univ., Macon; Macon A. Assn.; Episcopal H.S., Alexandria Va.; MFA, Montgomery, Ala.; Wesleyan Col. Coll., Macon Ga. Contributor: various Ga. newspapers [40]

SHORTWELL, Frederic Valpey [P,I,E,L,T] Detroit, MI/Bay View, MI b. 22 S 1907, Detroit d. 2 Ag 1929. Studied: Berninghaus; Carpenter; Pennell; Dodge; Bridgman; Sepeschy. Member: Detroit SE; Scarab C. Work: murals, Lib. Fordson (Mich.) Sch.; General Motors Bldg., Detroit. Established the Frederick Valpey Shotwell Memorial Fund, set up to render aid in emergency to young artists of Detroit. [31]

SHOTWELL, Helen Harvey [P] NYC b. 21 Ap 1908, NYC. Studied: H.L. McFee; E. Scott. Member: NAWA; Woodstock AA; Royal Photographic Soc., London. Exhibited: Argent Gal., 1946 (one-man); Fitchburg A. Center; Carolina AA, 1946 (one-man); Woodstock, N.Y.; Dayton AI; Montclair A. Mus. Work: IBM Coll.; Fitchburg A. Mus.; China Inst., N.Y. [47]

SHOTWELL, Margaret [P] Paris, France b. NYC. Studied: E. Scott [15]

SHOULBERG, Harry [P,Ser,T] NYC (1977) b. 25 O 1903, Phila. Studied: Am. A. Sch.; J. Reed; S. Wilson; C. Holty; H. Glintenkamp. Member:

Nat. Ser. Soc.; A. Lg. Am.; United Am. Ar. Exhibited: Bronx House, N.Y., 1942 (prize); CGA, 1941; CI, 1945; LOC, 1945, 1946; San Fran. AA, 1946; SAM, 1944–46; NAD, 1946; Modernage Gal., 1945 (one-man). Work: MMA; Denver AM; SFMA; Baltimore MA; CI; Univ. Oreg.; Univ. Ariz.; N.J. State Col.; Butler AI; Wichita State Univ. [47]

SHOUSE, Helen Bigoney (Mrs.) [C,T,L] Appomatox, VA b. 26 Ag 1911, Rockville Centre, NY. Studied: PIASch; NYU; Columbia. Member: N.Y. Soc. Craftsmen. Exhibited: N.Y. Soc. Craftsmen, 1946. Position: T., Col. William & Mary, 1945– [47]

SHOVEN, Hazel Brayton [P] San Diego, CA b. 1 Jy 1884, Jackson, MI. Studied: A.W. Burnham; Johanson; AIC; Chicago Acad. FA; Schneider. Member: San Diego AG; La Jolla AG; Laguna Beach AA. Exhibited: Orange County Fair, Santa Ana, Calif., 1930 (prize); Los Angeles County Fair, 1931 (prize) [40]

SHOVER, Edna Mann [P,Des,I,W,T] Indianapolis, IN b. Indianapolis. Studied: PMSchIA; Faber; Deigendesch; T. Scott; P. Muhr; J.F. Copeland. Member: Indianapolis AA; Ind. AC; AFA. Exhibited: PMSchIA Alumni Assn. (gold). Author/Illustrator: "Art in Costume Design." [47]

SHOVER, Lucy M. [P] Indianapolis, IN [17]

SHOW, S. Van D. (Mrs.) [P] Chicago, IL. Member: Chicago WCC [17]

SHOWE, Lou Ellen, Mrs. See Chattin.

SHRADER, E(dwin) Roscoe [Ldscp.P,I,T] La Canada, CA b. 14 D 1879, Quincy, IL d. 18 Ja 1960. Studied: AIC, 1902–04; H. Pyle, 1904. Member: Calif. AC; Wilmington Soc. FA; Los Angeles Friends of A.; Southwestern Archaeological Fed. Exhibited: Calif. AC, 1930 (prize). Work: Los Angeles Mus. A.; Hollywood H.S. Active in Wilmington, Del., 1904–14; New Hope, Pa. colony 1914–17, Also a cellist. Position: T., Otis AI, 1917–48 [40]

SHRADY, Henry M(erwin) [S] Elmsford, NY b. 24 O 1871, NYC d. 12 Ap 1922. Studied: law, Columbia; self-taught in art. Member: ANA, 1909; NSS, 1902; Arch. Lg., 1902; NIAL. Exhibited: Pan-Am. Expo, Buffalo, 1901. Work: mon., Detroit; Charlottesville, Va.; Duluth, Minn.; Holland Soc.; equestrian statue of Washington, Williamsburg Bridge, Brooklyn; sculpted massive Grant Memorial in Wash., D.C. (approx. 252 ft. base), from 1902–22 [21]

SHRAMM (OR SCHRAMM), Paul H. [S,P,I,C,T] Buffalo, NY b. 22 D 1867, Heidenheim, Germany. Studied: Claudinso; Schrandolph; J. Grunenwald, in Stuttgart; MacNeil, at Pratt Inst.; Arangi. Member: N.Y. Soc. C.; Progredi AC. Specialty: jewelry. Active in NYC, 1906. [21]

SHROCK, John Granville [P,Li,Des,L,T] San Fran., CA b. 9 F 1910, Nappanee, IN. Studied: Albion Col.; ASL; Univ. Calif.; K. Nicolaides; W. Gregory. Member: San Fran. AA. Exhibited: Detroit Inst. A., 1933, 1941; SFMA, 1937–39, 1941, 1946; Pal. Leg. Honor, 1946; Olivet, Mich., 1941; Jackson, Miss., 1940. Work: Albion (Mich.) Col.. Positions: T., Albion Col., 1932–34, 1939–42; Washington State Col., 1936–37; U.S. Army, 1942–45 [47]

SHROPSHIRE, George E. [P] NYC. Member: GFLA [27]

SHRYOCK, Burnett Henry, Sr. [Por.P,Des,G,C,Li,T] Kansas City, MO b. 4 F 1904, Carbondale, IL d. 1971. Studied: C.E. Bradbury, Univ. Ill.; Am. Acad. Art, Chicago; E.V. Poole, AIC; Y. Kuniyoshi; E. Thurn; Columbia. Member: Soc. A.& Sc., N.Y. Exhibited: CAM, 1943 (prize), 1944, 1945; Ala. WC Exh., 1944 (prize); La Tausca Pearls Comp., 1946 (prize); AIC, 1936, 1938, 1944, 1946; Denver A. Mus., 1944, 1945; Kansas City AI, 1945; W.R. Nelson Gal., 1946 (one-man); Jackson, Miss., 1944 (one-man). Work: CAM; Southern Ill. Normal Univ.; Washington Park Race Track, Chicago; Presbyterian Ch., Carbondale. Positions: T., Southern Ill. Normal Univ., 1935–44, Univ. Kansas City, 1944– [47]

SHRYOCK, John Carter [G,W] Frostburg, MD. Studied: ASL. Exhibited: State T. Col., Frostburg [40]

SHRYOCK, Lucy W. [P] Pittsburgh, PA. Member: Pittsburgh AA [25]

SHUFF, Lily [P] Brooklyn, NY b. 12 My 1906, NYC. Studied: Hunter Col.; ASL; Brooklyn Acad. FA; J. Farnsworth; J. Corbino. Member: NAWA; A. Lg. Am.; Brooklyn SA; N.Y. Soc. Women A. Exhibited: NAD; BM; Riverside Mus.; NAC; Argent Gal.; Hofstra Col. FA Gal.; traveling exhibits, Phila., Kansas City, San Fran., Los Angeles [47]

SHUKOTOFF, Alice Zelma [P,Des,T] NYC b. 5 Jy 1911, Brooklyn, NY. Studied: NYU; CCNY; N.Y. Sch. F.&Appl. Art. [40]

SHULGOLD, William (Robert) [P,E,T] NYC b. Russia. Studied: Sparks; Sotter; Levy; Hawthorne. Member: Pittsburgh AA; Tiffany Fnd. Work: "Sketching" and "Self Portait," gift of "One Hundred Friends of Art" to Pittsburgh Pub. Sch. [40]

SHULKIN, Anatol [Mur.P,G,W,L,T] NYC b. 15 Ap 1899, Russia d. 22 N 1961. Studied: ASL; C. Curran; G. Bellows; NAD, with L. Kroll. Member: NSMP; Am. A. Cong. Exhibited: NAD, 1921; 48 Sts. Comp., 1939; CGA; PAFA; CM; CAM; R.I. Mus. A; CI; Am. A. Cong.; S.Indp.A.; Pepsi-Cola, 1942. Work: MMA; WMAA; murals, Barbizon-Plaza Hotel, N.Y.; USPO, Canajoharie, N.Y. Position: T., Newark Sch. F.&Indst. A. [47]

SHULL, Delia F. [P] NYC b. Albia, IA. Studied: Henri; Chase. Member: NAWPS [27]

SHULL, J(ames) Marion [P,I,Des,W] Chevy Chase, MD b. 23 Ja 1872, North Hampton, OH d. ca. 1950. Studied: ASL. Member: Wash. AC. Exhibited: CGA; PMG. Work: U.S. Dept. Agriculture, Bureau of Plant Industry. Author/Illustrator: "Rainbow Fragments. A Garden Book of the Iris," 1931. Contributor: Country Life, Ladies' Home Journal, Garden [47]

SHULMAN, Morris [P] NYC (1977). Studied: NAD; ASL; Hofman Sch. A. Exhibited: WFNY, 1939; ACA Gal., 1930s; Rehn Gal., 1950s; Graham Gal., 1960s, all in NYC; PAFA; MMA; CI; AIC; BM (prize); Springfield Mus. (prize). Positions: T., Sch. Visual A., NYC (1950–59), BMFA Sch. (1960–76), CUASch (1977) [40]

SHULTZ, George Leonard [Por.P] Webster Groves, MO b. 16 F 1895, St. Louis, MO. Studied: St. Louis Sch. FA; France; R. Bringhurst; R. Miller. Member: St. Louis A. Gld.; Am. A. All.; S.Indp.A. Exhibited: St. Louis A. Gld.; S.Indp.A.; Am. A. All.; CAM. Work: many portraits for private collections and business firms [47]

SHULTZ, Ralph T. [P] NYC. Member: SC [25]

SHULZ, Ada Walter (Mrs. Adolph) [P] Nashville, IN b. 21 O 1870, Terre Haute, IN d. 4 My 1928. Studied: AIC; Vitti Acad., Paris; Munich. Member: Chicago Cordon C.; Ind. AC; Chicago Gal. A.; Brown County Gal. Assn. (founder). Exhibited: AIC, 1917 (prize); Hoosier Salon, Chicago, 1925 (prize), 1926 (prize). Work: Milwaukee AI; Municipal A. Lg., Chicago Coll. Specialty: portrayals of child life [27]

SHULZ, Adolph Robert [Ldscp.P,T] Nashville, IN b. 12 Je 1869, Delavan, WI d. 1963. Studied: AIC; ASL; Académie Julian, Paris, with Lefebvre, Constant, Laurens; Munich. Member: Brown County Galleries Assn.; Chicago Galleries Assn.; Sarasota AA; Fla. Fed. Art. Exhibited: AIC, 1900 (prize), 1904 (prize), 1908 (prize); Milwaukee AI, 1918 (med); Brown County Galleries Assn., 1937 (prize); Hoosier Salon, 1936 (prize) [47]

SHULZ, Alberta Rehm [P] Nashville, IN b. 6 Jy 1892, Indianapolis. Studied: Butler Univ.; Univ. Tex.; Ind. Univ.; Herron AI; Ringling Sch. A.; A. Shulz; C.C. Bohm. Member: Brown County Galleries Assn.; Hoosier Salon; Sarasota AA. Exhibited: Hoosier Salon; Brown County Galleries Assn.; Swope A. Gal.; other exh. in Ind. and Fla. [47]

SHUMAN, Anna M. [P,T] Pittsburgh, PA/Provincetown, MA b. 26 F 1890, Pittsburgh d. 26 F 1919. Studied: Hawthorne; Dow. Member: Pittsburgh AA [19]

SHUMATE, Ella A. [P] Lebanon, IN/Kansas City, MO. Studied: E. Webster; Lhote, in Paris; Newland, Landsend, in England. Member: NAWPS; Hoosier Salon; Kansas City SA; Ind. Artists C. [40]

SHURTLEFF, Elizabeth [P] Boston, MA b. 3 S 1890, Concord, NH. Studied: P. Hale; Frank Benson. Work: murals, Raymond Whitcomb Co., Boston [31]

SHURTLEFF, Paul [P] NYC [15]

SHURTLEFF, R(oswell) M(orse) [Ldscp.P] NYC/Adirondacks b. 14 Je 1838, Rindge, NH d. 6 Ja 1915, NYC. Studied: Lowell Inst., Boston, 1858–59; NAD, 1860. Member: ANA, 1880; NA, 1890; AWCS; SC; 1888; A. Fund S.; Lotos C. Exhibited: Pan-Am. Expo, Bufflo, 1901 (med); St. Louis Expo, 1904 (med); AWCS, 1910 (prize); NAD, from 1872. Work: CGA; National Gal., Wash., D.C.; MMA. He was an architect in Manchester, N.H., 1857; a lithographer in Buffalo, 1858–59; went to Boston, 1859–60. He went to NYC in 1860, became an illustrator (and studied at the NAD). [13]

SHURTLIFF, Wilford Haskill [P,G,C,T] Salt Lake City, UT b. 28 Jy 1886, Ogden, UT. Studied: Univ. Chicago; AIC; Univ. Utah. WPA artist. Position: T., Utah State A. Center [40]

SHUSTER, Will(iam) Howard [P,E,I,S] Santa Fe, NM b. 26 N 1893, Phila. d. 1969, Albuquerque. Studied: Phila., with J.W. Server; Santa Fe, with J. Sloan, 1920. Member: Santa Fe P.&S.; Los Cinco Pintores; AAPL. Exhibited: N.Mex. State Fair (prize); Grand Junction, Colo. (prize); Sesqui-Centennial Expo, Phila., 1926; WFNY, 1939; GGE, 1939; Mus. N.Mex., Santa Fe, 1946 (one-man); numerous traveling exh. Work: Mus.

N.Mex., Santa Fe; Newark Mus.; BM; NYPL; sculpture, Spanish Am. Normal Sch., El Rito, N.Mex. Illustrator: "My Life on the Frontier," by Gov. M.A. Otero [47]

SHUTE, Augustus B. [P] Brookline, MA. Member: Boston AC [10]

SHUTE, Ben E. [Mus.Dir,T,L,Por.P] Atlanta, GA b. 13 Jy 1905, Altoona, WI. Studied: AIC; Chicago Acad. FA; H.A. Oberteuffer; G. Oberteuffer; A. Philbrick; C. Werntz. Member: SSAL; Assn. Ga. A.; Atlanta Ar. Gld. Exhibited: Pasadena AI, 1946; Assn. Am. A., 1945; AIC, 1929; Pal. Leg. Honor; Caller-Times Exh., Corpus Christi, Tex., 1945; Assn. Georgia A.; SSAL, 1930-38, 1939 (prize), 1940-46. Position: T., High Mus. A., Atlanta, 1928- [47]

SHUTTLEWORTH, Claire [P,T] Buffalo, NY/Chippawa, Ontario b. Buffalo d. 7 My 1930. Studied: Buffalo, ASL; DuMond; Bridgman; Merson, Collin, Leroy, in Paris. Member: Buffalo SA; NAWPS; Rockport AA; Buffalo GAA; AFA. Exhibited: Buffalo SA, 1910 (prize), 1929 (prize); Springville (Utah) H.S. A. Assn., 1927 (prize). Work: Arnot A. Gal., Elmira, N.Y.; Buffalo Hist. Soc. [29]

SIBBEL, Joseph [S] b. Germany d. 10 Jy 1907, NYC. Work: large statue of St. Patrick and subordinate statues, St. Partrick's Cathedral; death mask of Archbishop Corrigan

SIBELL, Muriel Vincent (Mrs. Wolle) [P,Li,T,I,W] Boulder, CO b. 3 Ap 1898, Brooklyn, NY d. 1977. Studied: N.Y. Sch. F.&Appl. A.; NYU; Univ. Colo.; F.W. Howell; ASL. Member: Boulder AG; NAWA; AFA; Am. Coll. S. PM; Topeka PM. Exhibited: Denver AM, 1928 (prize), 1929-44; Boulder AG, 1927-46; NAWPS, 1932 (prize), 1933-41; Kansas City AI, 1932-38, 1934 (prize), 1935 (prize); Joslyn Mem., 1932-40; Colo. State Fair, 1930 (prize), 1932 (prize). Work: Denver AM; Springfield (Mo.) AM; Mont. State Mus., Helena; Univ. Colo. Author/Illustrator: "Ghost Cities of Colorado," 1933, "Cloud Cities of Colorado," 1934. Contributor: illus., Theatre Arts Monthly, article, Design mag. Position: T., Tex. State Col. for Women (1920-23), N.Y. Sch. F.&Appl. A. (1923-26), Univ. Colo. (from 1926) [47]

SIBLEY, Ferol [P] Columbus, OH [19]

SIBLEY, Marguerite (Mrs. Will Lang) [S] Rockford, IL b. Butler, IN. Studied: Minneapolis Sch. A.; Rockford Col.; M. Reitzel; S. Beams. Member: Rockford AA; Winnebago County Hist. S. Exhibited: CGA, 1938, 1939, 1941-44, 1946; Burpee A. Gal., 1931, 1933-36, 1938, 1941-46; Beloit Col., 1940; Rockford Col., 1934, 1940; Burpee A. Gal., 1941 (one-man); Belle Keith Gal., Rockford, 1932, 1940. Work: Burpee A. Gal., Rockford, Ill.; Chicago Temple, Chicago, Ill.; Emanuel Episcopal Church, Rockford, Ill. [47]

SIBLEY, Mary Elizabeth [P] Chicago, IL [01]

SIBONI, Emma Benedikta [P] Wash., D.C. b. 29 S 1877, Sorö, Denmark. Studied: AIC; RA Acad., Copenhagen; Acad., Berlin. Exhibited: Wash. WCC, 1937; S. Wash. A., 1939; Wash. SM PS&G, 1937, 1939. Work: Huntington A. Gal., Los Angeles [40]

SICARD, Montgomery [Mar.P] b. 30 S 1836, NYC d. 14 S 1900 (Utica, NY?). Work: Mariner's Mus., Norfolk, Va. Position: career Navy officer [*]

SICHEL, Harold [I,Des] Oakland, CA b. 27 Jy 1881, Benicia, CA. Studied: A.F. Mathews, Calif. Sch. Des. Illustrator: "The Good Wolf," F.H. Burnett, 1908; "Shoe and Stocking Stories," E. Mardaunt, 1915; "The Truce of God," M.R. Rinehart, 1920; "Wonder Tales from Goblin Hills," F.J. Olcott, 1930; "The Story of Cotton," D. Searborough, 1933 [40]

SICHEL, Harold M. [P] NYC. Member: SC [21]

SICKELS, Noel Douglas [I,Cart] NYC (New Canaan, CT, 1966) b. 24 Ja 1910, Chillicothe, OH. Creator: "Scorchy Smith" for Assoc. Press. Illustrator: historical and Western fiction [40]

SICKMAN, Jessalee B(ane) [P,T] Wash., D.C. b. 17 Ag 1905, Denver, CO. Studied: Univ. Colo.; Goucher Col.; Corcoran Sch. A. Member: S. Wash. A. Exhibited: S. Wash. A.; Wash. (D.C.) Pub. Lib., 1941 (one-man); Corcoran Sch. A., 1941 (prize); Wash., D.C., 1945 (prize). Illustrator: Forum mag. Position: T., Corcoran Sch. A. [47]

SIDEBOTHAM, Mary H. [Min.P] Mascoma, NH [13]

SIDERIS, Alexander [P,Des] NYC b. 21 F 1895, Skopelos, Greece. Studied: ASL; Académie Julian; G. Bridgman; P. Laurence. Exhibited: NAD, 1938; All.A.Am., 1940-44; WFNY, 1939; S.Indp.A.; Oakland A. Gal.; Argent Gal., 1935 (one-man); Vendôme Gal.; Paris; Athens, Greece. Work: church, Pensacola, Fla. [47]

SIDLE, John W., Jr. [P] Phila., PA [19]

SIEBER, Edward G. [Ldscp.P] NYC b. 16 Ap 1862, Brooklyn, NY. Studied: NAD; Paris, with Flameng, Ferrier. Member: N.Y. Mun. AS; SC, 1899; Brooklyn AC. Exhibited: Brooklyn AC, 1887 (gold); Charleston Expo, 1902 (med). Specialty: cattle [08]

SIEBERN, E. [P] NYC [25]

SIEBERN, Emil [S] NYC b. 15 Ap 1888, NYC d. 14 Je 1942. Studied: CUAsch; ASL; NAD; Italy; France; Greece. Work: S., Hqtrs. Bldg., Bank of Montreal, Ottawa, Canada; stainless steel figures, Astoria Park, N.Y.; statues, William and Mary Col., Williamsburg, Va.; S., Central Park Zoo, NYC; Prospect Park Zoo, Brooklyn; port., Hall of Patriots, CCNY [40]

SIEBERNS, Caroline Lenore [P,Des] San Diego, CA b. 14 Ja 1911, Spring Valley, WI. Studied: Minneapolis Sch. A.; Columbia; B.J.O. Norfeldt; D. Kingman. Member: La Jolla A. Ctr. Exhibited: San Fran. AA, 1940; AWCS, 1941; Minneapolis Inst. A., 1935-37; San Diego AG, 1940-42, 1945, 1946; Denver A. Mus., 1945; San Diego FAS, 1940 (prize), 1941 (prize). Work: Acad. Holy Angels, Minneapolis, Minn.; mural, Hotel Bella Vista, Cuernavaca, Mexico [47]

SIEBERT, A.C. [P] St. Louis, MO [25]

SIEBERT (OR SIEBERN), Anne W.S. [Min.P] Columbus, OH. (Note: Street address is the same as that for E. Siebern.) [21]

SIEBERT, Edward S(eimar) [P,E,T] Rochester, NY b. 1 Jy 1856, Wash., D.C. d. 31 Ja 1944. Studied: Baur, Wiemar; C. Hoff, Karlsruhe; W. von Diez, Munich. Exhibited: Rochester, N.Y. (prize). Work: CGA [29]

SIEBOLD, Chester N. [P] Cleveland, OH. Member: Cleveland SA. Affiliated with Nat. Lamp Works, Cleveland [27]

SIEGEL, Adrian [P] Bearsville, NY b. 17 Jy 1898, NYC. Member: Phila. A. All.; Woodstock AA; AAPL. Exhibited: CGA, 1939; PAFA, 1941-45; AV, 1944; Friends' Exh., Phila., 1940-45; Phila. A. All., 1943 (one-man) [47]

SIEGEL, Leo Dink [I,Cart] NYC b. 30 Je 1910, Birmingham, AL. Studied: Univ. Ala.; NAD. Member: SI. Illustrator: Saturday Evening Post, Cosmopolitan, Good Housekeeping, Esquire [47]

SIEGER, Nicholas F. [P] Racine, WI b. 29 Mr 1910, Mineral Point, WI. Studied: Sister M. Sylvia, Racine; B.V. Shamberk. Exhibited: CGA, 1939. Work: St. John, Nep. Ch., Racine [40]

SIEGLER, Maurice [P,T] Atlanta, GA/NYC b. 7 Mr 1896, NYC. Studied: ASL; PAFA; Fontainebleau Sch. FA. Member: SSAL; Assn. Ga. Ar.; Tiffany Fnd. F. Exhibited: SSAL, 1938; San Antonio, Texas, 1939; WFNY, 1939. Work: Richmond Acad. A.&Sc.; Lib., State Capitol, Atlanta, Ga. Position: T., Ga. Sch. Tech., Atlanta [40]

SIEGRIEST, Louis B. [P,I,Des] San Francisco, CA b. 24 F 1899, Oakland, CA. Studied: Calif. Sch. FA; Calif. Sch. AC; F. van Sloan. Exhibited: posters, GGE, 1939. Position: A. Dir., C.R. Stuart, Inc. [40]

SIELKE, Leo, Jr. [P] b. 1880 d. Ag 1930. Member: S.Indp.A. Specialty: magazine cover designs, including portraits and landscapes.

SIEMS, Alice Lettig [S,Por.P] Chicago, IL/Pass-a-Grille, FL b. 12 D 1897. Studied: A. Polasek, AIC; Univ. Iowa; C.A. Cumming. Member: Assn. Chicago PS; AIC; Chicago Gal. Assn. Exhibited: Davenport (Iowa) Mun. Art Gal., 1931 (prize); Chicago Gal. Assn., 1931 (prize), 1932 (prize). Work: Univ. Chicago; Univ. Iowa; Univ. S.Dak. [40]

SIEMSEN, Frederick [P] NYC. Member: GFLA [27]

SIEVAN, Maurice [P,T] Flushing, NY (1974) b. 7 D 1898, Ukraine, Russia. Studied: NAD; L. Kroll; C. Hawthorne. Member: Fed. Mod. P.&S. Exhibited: Salon d'Automne, Paris, 1931; CGA, 1945; PAFA, 1944, 1946; CI, 1943-45; AIC, 1941; BM, 1941; MET (AV), 1942; VMFA, 1944; MOMA, 1943; WMAA, 1943; NAD, 1926, 1938, 1942-45; AWCS, 1941; Minn. State Fair, 1943; de Young Mem. Mus., 1943; G.W.V. Smith A. Mus., 1944; Tomorrow's Masterpieces Traveling Exh., 1943-44; Wadsworth Atheneum, 1944; Inst. Mod. A., Boston, 1945; Bucknell Univ., 1940; Riverside Mus., 1943; Wildenstein Gal., 1942-46; Midtown Gal., 1933-34; Contemporary A., 1939 (one-man), 1941 (prize); ACA Gal., 1938, 1946; Gal. Mod. A., 1944; Babcock Gal., 1943, 1944; Mortimer Brandt Gal., 1945 (one-man); Summit (N.J.) AA, 1945 (one-man). Positions: T., Summit AA, Summit, N.J. (1944-46), Queens Col. (1946-67) [47]

SIEVERS, Frederick William [S,C] Richmond, VA. b. 26 O 1872, Ft. Wayne, IN. Studied: Académie Julian; Ferrari, Royal Acad. FA, Rome. Member: VMFA. Exhibited: NSS; VMFA; Royal Acad. FA, Rome (prize). Work: mon./mem./statues: Abingdon, Va.; Gettysburg, Pa.; Richmond, Va.; Vicksburg, Miss.; State Capitol, Va.; Elmira, N.Y.; State Capitol,

Nashville, Tenn.; Confederate Mon. at Abingdon, Leesburg, Va.; tablet, Yorktown, Va. [47]

SIEVERS, Lucille Scott (Mrs.) [P] Delaware, OH. Member: S.Indp.A. [25]

SIEVERT, Emilie I. [P] Chicago, IL [06]

SIGSTEDT, Thorsten [Woodcarver] Bryn Athyn, PA. b. 22 N 1884, Stockholm, Sweden. Member: Phila. Alliance. Work: Royal Barge, King of Sweden; restoration of antique masterpieces, Swedish Acad. Antiquities; gothic carvings, Baltimore Protestant Cathedral; St. Michael Chapel, Torresdale, Pa.; Catholic Church, Saratoga Springs, N.Y.; St. Andrews Sch., Middletown, Del.; panel, Am.-Swedish Hist. M., Phila. Specialty: figure work [40]

SILBER, Esther. See Reed.

SILBERGER, Manuel G. [P] Cleveland, OH. Exhibited: Intl. Lith., En. Ann., AIC, 1937, 1938, 1939; 48 States Comp., 1939 [40]

SILBERMAN, Sarah G(ettleman) [S] Atlantic City, NJ b. 10 S 1909, Odessa, Russia. Studied: A. Laessle; W. Hancock; PAFA, 1931 (Cresson Traveling Sch.) [40]

SILBERT, Ben [Por.P,E] NYC b. 12 F 1893, Gorki, Russia. Studied: AIC. Work: AIC; Baltimore Mus. A.; BM; Milwaukee AI; etchings, Honolulu Acad. A.; Los Angeles Mus. of Hist., Sc. & A.; Mus. of Cahors, French Nat. Coll. Contributor: articles, illus. in French, German, American press. [40]

SILEIKA, Jonas [P,T] Lekeciaia, Lithuania b. 2 Jy 1883, Lithuania. Studied: AIC; Munich RA. Member: Am. Fed. A.; AS of Lithuania. Exhibited: AIC, 1920 (prize). Work: Gal. of Ciur Lionis, Kauna, Lithuania [29]

SILEIKIS, Michael Justin [P,W,L] Chicago, IL b. 15 O 1893, Lithuania. Studied: AIC; L. Seyffert; L. Kroll. Member: Hoosier Salon; All-Ill. Soc. FA. Exhibited: AIC, 1925 (prize); Hoosier Salon; All-Ill. Soc. FA. Position: A. Cr., Lithuanian Daily News, Chicago [47]

SILIGATO, Carlo [P] Wash., D.C. [17]

SILKE, Lucy S. [P,C,T] Chicago, IL b. Yonkers, NY. Studied: AIC; A.W. Dow, in NYC [08]

SILKOTCH, Mary Ellen [P,T] Dunellen, NJ b. 13 S 1911, NYC. Studied: Van Emburgh Sch. A., Plainfield, N.J.; J. Lie; S. Ivanowski. Member: AAPL; Plainfield AA; Westfield AA; Millburn-Short Hills AA; NAWA. Exhibited: All.A.Am., 1943, 1944; Audubon A., 1945; NAWA, 1944-46; Plainfield AA, 1936-38, 1942-46, 1944 (prize); Morton Gal., 1946; N.J. Gal., 1939; Newark Mus., 1942; Montclair A. Mus., 1942, 1944-46. Position: T., Van Emburgh Sch. A., Plainfield, N.J., from 1944 [47]

SILKS, Donald Kirk [P,T] NYC b. 9 Mr 1912, Kansas City, MO. Studied: Univ. Kans. Exhibited: Kansas City AI, 1939-41; 48 States Comp., 1939. Work: WPA mural, USPO, Augusta, Kans. Position: T., St. Joseph Jr. Col., Mo. [47]

SILL, Howard [P] Baltimore, MD [25]

SILLCOX, Luise M. [P] NYC. Member: GFLA [27]

SILSBEE, Martha [P] Dublin, NH b. N 1858, Salem, MA d. ca. 1929. Studied: BMFA Sch. Member: Boston WCC [27]

SILSBY, Clifford [Ldscp.P,Et] Los Angeles, CA (1984)/Nice, France b. 15 Ag 1896, New Haven. Studied: Laurens, Académie Julian, Ecole des Beaux-Arts, Dechenaud, Royer, L. Simon, J. Pages, all in Paris; J. Francis Smith. Member: S. Motion Picture A.&I. Exhibited: Paris Salon, 1923; Calif. PM, 1929, 1930, 1936; GGE, 1939; Los Angeles Mus. A., 1936 (one-man), 1940-45; Los Angeles P.&S., 1929, 1935-37, 1943; Oakland A. Gal., 1935, 1944; San Diego FA Soc., 1940; Santa Cruz AL, 1936; Santa Paula, Calif., 1941-43. Work: Los Angeles Mus. A. Specialty: motion pictures, Hollywood/NYC, from 1918. Adopted son of Wilson. [47]

SILSBY, Wilson [Et,Li,P,W,T] Los Angeles, CA b. 7 O 1883, Chicago, IL d. 17 Ja 1952. Studied: W. Chase; A. Thayer; F. Holmes. Exhibited: Salon d'Automne, 1922; Société des Artistes Français, Paris, 1923; PAFA, 1935; GGE, 1939; Columbus Gal. FA, 1939 (one-man); Gumps, San Fran., 1926 (one-man). Work: MET; LOC; Rockefeller Fnd., Paris; AIC; PAFA; BMFA; NYPL; PMA; CAM; Currier Gal. A.; BM; Crocker A. Gal.; W.R. Nelson Gal.; CM; CMA; Oakland A. Gal.; Mus. N.Mex.; Toledo Mus. A.; SAM; Denver AM; Springfield (Mass.) MFA; Ft. Worth Mus. A.; Brooklyn Pub. Lib.; H.H. de Young Mem. Mus., San Francisco; N.J. State Mus., Trenton; SFMA. Author/Illustrator: "Etching Methods and Materials," 1943. Inventor: "No ground" etching plate. Des. stage sets. Position: A. Dir., various motion picture companies [47]

SILVA, Francis Augustus [Mar.P] NYC b. 4 O 1835, NYC d. 31 Mr 1886. Member: AWCS, 1872. Exhibited: Am. Inst., 1848-50; NAD, 1868-86; Brooklyn AA, 1869-85. Work: Peabody Mus., Salem [*]

SILVA, William Posey [P] Carmel, CA b. 23 O 1859, Savannah, GA d. 10 F 1948. Studied: Chatham Acad., Savannah; Académie Julian, with Laurens, Royer; C. Ryder, in Etaples, France; A. Dow. Member: AAPL; SC; S. Wash. A.; Miss. AA; Calif. AC; Chattanooga AA; Paris AA; SSAL; NOAA; Carmel AA. Exhibited: PAFA; CGA; AIC; Peabody Inst.; Albright A. Gal.; Dodge City, Iowa, 1940 (prize); GGE, 1939 (prize); Delgado Mus. A.; SSAL, 1925 (prize), 1927 (prize), 1930 (prize), 1932-37; AFA Traveling Exh., 1926-28 (one-man); Carmel AA, 1946 (one-man); Ga.-Ala. Exh., Nashville, 1926 (prize); Miss. State Fair, 1926 (prize); Springville, Utah, 1927 (prize), 1929 (prize); San Antonio, 1928 (prize); Santa Cruz AL, 1930, 1931 (prize); Reaugh AC, 1932 (prize); NOAA, 1926 (prize), 1932 (prize); Miss. AA, 1932 (prize); Calif. State Fair, 1935 (prize); Knoxville, 1910 (med); Pan-Calif. Expo, San Diego, 1915 (med), 1916 (med); Miss. AA, 1916 (gold); Salon Artistes Français, Paris, 1922 (prize). Work: Blandon Mem. A. Gal., Ft. Dodge, Iowa; LOC; MET; Gibbes A. Gal.; Ft. Worth AA; Delgado Mus. A.; Palo Alto Pub. Lib.; Janesville (Wis.) AL; Miss. A. Gal., Jackson; Milwaukee AI; Kans. State T. Col., Emporia; French Gov. Coll.; Columbia (S.C.) Col.; Springville, Utah; Harrison Lib.; Carmel, Calif.; MFA, Houston; Los Angeles Mus. A.; many H.S.; Carnegie Pub. Lib., Chattanooga; 19th Century C., Huntington T., Savannah; Centenn. C., Nashville; Nashville AA; French Gov.; Cary AC, Jackson, Miss.; Tenn. Pen Women's C.; Women's C., Ft. Worth; White Lib., Marquette, Mich.; Pub. Lib., Birmingham; A. Appreciation C., Meridian, Miss.; Boise AA, Idaho; Mus. A., Montgomery, Ala.; Lib., Edgefield, S.C.; Women's C., Santa Monica [47]

SILVEIRA, Belle. See Gorski.

SILVER, Alice L. [P] Worcester, MA [24]

SILVER, Michael [I] NYC. Member: SI [47]

SILVER, Rose [P,I] Seattle, WA b. 8 My 1902, NYC. Studied: Univ. Wash.; R. Schaeffer. Member: Univ. Wash. AC. Illustrator: cover, Judge, 1922 (prize); New Yorker [33]

SILVERBERG, E. Myer [Por.P] NYC b. 10 My 1876, Russia. Studied: RA, Munich. Member: Pittsburgh AA. Work: H.S. and other pub. institutions, Pittsburgh [21]

SILVERCRUYS, Suzanne (Mrs. Edward F. Stevenson) [S,P,W,L] East Norwalk, CT b. 29 My 1898, Maeseyck, Belgium d. 1973. Studied: Belgium; England; Eberhardt, Yale. Member: NAWPS; PCC. Exhibited: CGA; Salon de Printemps, 1931; BAID, 1927 (prize). Awards: Order of Leopold; Officier d'Academie de France. Work: busts/plaques/mem., Louvain Lib.; Yale Sch. Medicine; Reconstruction Hospital, N.Y.; First Lutheran Church, New Haven, Conn.; Duell Award for N.Y Press Photogr. Assn.; Rumford (R.I) mem.; Gov. House, Ottawa, Canada; MET; Amelia Earhart Trophy for Zonta C.; busts of prominent people; New Haven Hospital [47]

SILVERMAN, Adolph [P] Brooklyn, NY. Member: S.Indp.A. [24]

SILVERMAN, Miles Mittenthal [P,T,Et,Li] Toledo, OH b. 26 S 1910, Flint, MI. Studied: Univ. Notre Dame; Univ. Mich.; Univ. Toledo; AIC; Toledo Mus. A. Member: Ohio WCS; Calif. WCS; Palette C., Toledo. Exhibited: S.Indp.A., 1942; Calif. WCS, 1938; Ohio WCS, 1937-45; Butler AI, 1936-46; TMA, 1934-43, 1944 (prize), 1945 (prize), 1946. Work: Jewish Fed. Bldg., Toledo [47]

SILVERS, Herbert (Ferber) [P,S] NYC b. 30 Ap 1906, NYC [33]

SILVETTE, Brooks (Johnson) (Mrs. Herbert) [P,T] University, VA b. 6 Ag 1906, Willoughby Beach, VA. Studied: P. Bornet. Affiliated with Univ. Va. [33]

SILVETTE, David [P] Richmond, VA. b. 28 My 1909. Studied: E.M. Silvette; Cecilia Beaux; Charles Hawthorne. Exhibited: CGA, 1933 (med) (prize). Work: Va. State Capitol; Richmond Acad. FA; CGA; WPA mural, USPO, New Bern, N.C. [40]

SILVETTE, Ellis M. [P,S] Richmond, VA b. 10 My 1876. Work: portraits, Confederate Mus., Richmond; Stevens Inst. Tech., Va.; Univ. Va.; State Chamber of Commerce, NYC [40]

SILVETTE, Marcia [P] Richmond, VA. Exhibited: NA, 1933, 1934; CGA, 1937, 1939 [40]

SILVIS, Caroline [P] Rosemont, PA [13]

SILVIS, Margaret [P] E. Downingtown, PA b. 6 D 1875, East Downingtown. Studied: Daingerfield; Chase [17]

SILVIUS, Paul T. [P] Los Angeles, CA b. 10 N 1899, Hampton, IA. Member: Laguna Beach AA [33]

SILZ, Arthur [P,T,I,Des] NYC b. 15 Ja 1901, Berlin, Germany. Studied: Berlin Acad.; ASL. Member: A. Lg. Am.; Am. Ar. Cong. Exhibited: VMFA, 1940, 1942; BM, 1941; MET, 1942; Pepsi-Cola Comp., 1946; Dallas MFA; Montclair AM; Brooks Mem. A. Gal.; Riverside Mus.; NAD; Hudson Walker Gal., 1938 (one-man); Wakefield Gal., 1943 (one-man); Worth Ave. Gal., Palm Beach, 1945 (one-man); Uptown Gal., NYC, (one-man). Illustrator: "Airplanes and How They Fly," 1943 [47]

SIMA. See Cohen, Esther.

SIMBOLI, Raymond [P] Pittsburgh, PA. Member: Pittsburgh AA [25]

SIMEON, Nicholas [P] NYC b. 27 Ag 1867, Zurich, Switzerland. Studied: Germany; Switzerland. Member: S.Indp.A.; Whitney Studio C. [24]

SIMKOVITCH, Simkha (Mr.) [P,T] Greenwich, CT b. 21 My 1893, Petrograd, Russia. Studied: RA Russia, Petrograd. Exhibited: First Soviet Gov., 1918 (prize); AID, 1932 (med,prize); WMA, 1933 (prize). Work: WWMA; Mus. of the Winter Palace, Petrograd; Mus. A., Petrograd; Krakow Mus., Poland; WPA murals, USPO, Beaufort, N.C., USPO and Court House, Jackson, Miss. Position: T., All Arts Studio, Greenwich, CT [40]

SIMKINS, Martha [P] Woodstock, NY b. TX. Studied: ASL; Chase. Member: NAWPS; PBC [33]

SIMMANG, Charles [C,En] San Antonio, TX b. 7 F 1874, Lee County, TX. Studied: C. Stubenrauch. Member: San Antonio AL; AFA. Work: Witte Mem. Mus., San Antonio. Specialty: steel relief engraving [40]

SIMMONS, Cordray [P] NYC b. 10 Jy 1888, Jersey City, NJ. Studied: Chase; Mora; Henri; Bellows; K.H. Miller; H.D. Webster; ASL. Member: Audubon A. Work: MET. Exhibited: AC, 1942; AIC, 1935, 1943; AFA Traveling Exh., 1931; PAFA, 1935; Ind. Univ., 1940; BM, 1930; WMAA, 1944 [47]

SIMMONS, Edward Emerson [Mur.P,C] NYC b. 27 O 1852, Concord, MA d. 17 N 1931, Baltimore. Studied: Paris, with Boulanger, Lefebvre. Member: Ten Am. P.; NIAL. Exhibited: Paris Salon, 1882; Paris Expo, 1889 (med); Pan-Am. Expo, Buffalo, 1901 (gold); Arch. Lg., 1912 (prize). Work: murals: Mass. State House, Boston; LOC; Criminal Court, NYC; Minn. State Capitol, St. Paul; Capitol, Pierre, S.Dak.; Court House, Mercer, Pa.; Astor Gallery, Astoria, N.Y.; Court House, Des Moines, Iowa; Appellate Court, N.Y.; Mem. Hall, Harvard Col. [29]

SIMMONS, F. Ronald [P] Providence, RI. Member: Providence WCC [24]

SIMMONS, Franklin [S] Rome, Italy (since 1867) b. 11 Ja 1839, Webster, ME d. 8 D 1913. Active in Maine, 1860–65, Wash., D.C., 1865–67, then settled in Rome. Studied: Boston, with J.A. Jackson, 1850s. Awards: Knighted by King Humber of Italy; the first American artist to receive the Cross of Caxilère. Work: equestrian, Portland, Maine; Providence; 15 mon., 100 busts in marble and numerous ideal statues; lg. coll. willed to Portland (Maine) SA [13]

SIMMONS, F(reeman) W(illis) [P] Cleveland, OH b. Fredonia, PA d. 3 O 1926. Studied: W.M. Chase; Lefebvre, Constant, in Paris. Member: Paris AAA; Cleveland SA. Work: port., CMA [25]

SIMMONS, George Harmon [P,I,Des] Rochester, NY b. 12 Je 1870, Phila. Studied: ASL; F.J. Boston, C. Hawthorne. Member: Rochester AC [10]

SIMMONS, Kate Cameron [P] Brooklyn, NY [13]

SIMMONS, M(arion) L(ouise) [P] Rumson, NJ b. 25 Jy 1903, Rumson, NJ. Studied: H.B. Snell; G.P. Ennis. Member: NAC; AWCS [40]

SIMMONS, William [Et,P,T] Baltimore, MD b. 4 Je 1884, Elché, Spain. Studied: Paris, with Académie Julian, Lefebvre, A. Harrison; E. Simmons, America. Member: SAE; Chicago SE; Calif. PM; Prairie PM. Exhibited: U.S. Nat. Mus., Wash., D.C., 1939. Work: NYPL; Smithsonian; LOC; Bibliothèque Nationale, Paris; Pub. Lib., Liverpool, England. Specialty: natural history [47]

SIMMONS, Will, Mrs. See Cerutti-Simmons.

SIMMS, Theodore Freeland [G,Des,P,D,T,L,B] Seattle, WA b. 14 Ja 1912, Arvada, CO. Studied: Univ. Southern Calif.; Chappell House, Denver; D. Lutz; Baldwin; M. Elrod; A. Montgomery; A. Jones; H. Harvey; M. Gniesen; G. Lukens. Member: Southern Calif. WCS; Scarab C. Exhibited: Denver AM, 1934, 1937; Chappell House, Denver, 1934 (one-man); Southern Calif. WCS, 1939. Work: Central City Opera House Assn., Denver. Position: T., Univ. Southern Calif. [47]

SIMON, Eugene J. [P] NYC/Woodstock, NY b. 8 My 1889, Hungary. Studied: K.H. Miller. Member: S.Indp.A.; Woodstock AA; Bronx AG [29]

SIMON, George Gardner [Ldscp.P] Ravenwood, IL. See Symons. Owing to his concern of anti-semitism he changed his name to Symons when he returned from England in 1908, settling in Brooklyn (the Ill. address was his parents'). Thus, his early paintings are signed "Simon." [08]

SIMON, Grant Miles [P,Arch,Li,I] Phila., PA b. 2 O 1887, Phila. Studied: PMSchIA; Univ. Pa; PAFA; Paris with Ecole des Beaux-Arts, Bernier. Member: AIA; AWCS; BAID. Exhibited: AWCS, 1943, 1945, 1946; NAD, 1945, 1946; LOC, 1941–43; Ferargil Gal., 1938. Work: LOC; Easton Pa. Court House. Contributor: Architectural Record [47]

SIMON, Howard [P,I,B,W] Stanfordville, NY b. 22 Jy 1903 NYC. Studied: NAD; Académie Julian. Member: AIGA; Calif. SE. Exhibited: 50 Prints of the Year; 50 Books of the Year; Victoria & Albert Mus., London; Intl. PM, Los Angeles, Calif. Work: MET; BMA; NYPL; Brooks Mem. A. Gal.; Mills Col.; Mus. of the Legion of Honor, San Fran., Calif.; Gramercy Park Hotel, NYC. Author: "500 Hundred Years of Art in Illustration." Illustrator: "History of California Pathfinders," "Ballads of Villon," "Robin of the Mountains," "Lost Corner," C.M. Simon; "Back Yonder." [47]

SIMON, Marie Ethalind [P] Phila., PA. Studied: PAFA [25]

SIMON, Mildred See Rackley.

SIMON, P. Marcius [P] NYC. Represented by S.P. Avery, Jr. [01]

SIMON, Sidney [P,T] NYC b. 21 My 1917, Pittsburgh, PA. Studied: Univ. Pa.; PAFA, Cresson Traveling F.; Barnes Fnd.; G. Harding. Member: Pittsburgh AA; Abbey F., 1940. Exhibited: NGA; MET, 1945; Pittsburgh AA, 1936–41, 1945; PAFA, 1946 (one-man); YMHA, Pittsburgh, 1946; CI, 1941 (prize), 1945 (prize). Work: U.S. War Dept., Wash. D.C. [47]

SIMONE, Edgardo G.F. [S,Des,T,W,L] Chicago, IL b. 20 Je 1890, Brindisi, Italy. Studied: Dorsi; Gemito; Inst. of Classics, Lecce, Ecole des Beaux Arts. all in Rome. Work: mon., Czar Alexander II, St. Petersburg, 1912 (award); Ipiranca mon., St. Paulo, Brazil, 1919 (award); war mon.: Ferrara, Monopoli; Brindisi; Sarno; Verona; Pianura; Avezzano; Majori; St. Bartolomeoin Bosco, Cerreto; Sannita; Marrara; St. Marzano sui Sarno; Minore; St. Pietro a Majella; Viggiano; St. Vito dei Normanni, Italy; Tampa, Fla.; religious mon.: Naples; Ravenna; Monopoli; St. Frances of Assisi, Sarno; Nocera Superiore; Benevento; Cathedral, Verona; mausoleum, Brindisi; Gattino maus., Torino; Naples; Caracas, Venezuela; Ferrara, Italy and St. Paulo, Brazil; busts: Queen Margherita of Italy; Senator Claude Kitchen, U.S. Capitol, Wash.; many notables. Lectures: Horticultural Bldg., Century of Progress, 1931 [40]

SIMONET, Sebastian [I,P,Li,Des,T,L,W] Stillwater, MN b. 19 O 1898, Stillwater, MN d. 6 O 1948. Studied: Minneapolis Sch. A.; ASL; NAD; Henri; B. Robinson. Exhibited: Minn. State Fair, 1921 (prize), 1928 (prize); N.Y. State Fair, 1922 (prize). Work: Stillwater (Minn.) H.S. Illustrator: U.S. Govt. publications; scientific illus., Univ. Calif., Div. War Research, U.S. Navy Radio & Sound Lab., San Diego, Calif., from 1944 [47]

SIMONS, Amory C(offin) [S] Santa Barbara, CA b. 1869, Charleston, SC. Studied: PAFA; Paris with Dampt, Puech. Member: AFA; Paris AA; NSS. Exhibited: Paris Expo, 1900; Pan-Am. Expo, Buffalo, 1901; St. Louis Expo, 1904 (med); Paris Salon, 1906; Pan-P. Expo, San Fran., 1915; NAD, 1922 (prize) [47]

SIMONS, Elvera H. (Mrs.) (El Vere) [Cer] San Fran., CA b. Omaha, NE. Studied: AIC; Mills Col; Univ. Calif.; Calif. Sch. Fa. Member: Assn. San Fran. Potters. Exhibited: Calif. Sch. FA, 1945, 1946; Mills Col., 1944. Author: "Colorology," 1929. Contributor: trade mags. [47]

SIMONS, George [P] b. 22 Ja 1834, Streeter, IL d. 1917, Long Beach, CA. Work: Council Bluffs Pub. Lib. Specialty: Western subjects; best known for "Kit Carson's Last Shot." One of the first artists to visit NE (1854); was a pioneer settler at Council Bluffs, Iowa where he was active into the 1890s.

SIMONS, James E., Mrs. See Hustead, Elvera C.

SIMONSON, Lee [Des,W,L] NYC b. 26 Je 1888, NYC. Studied: Harvard Univ. Member: Mun. AS (Dir.); Am. Nat. Theatre & Acad. (Dir.). Exhibited: Intl. Exh. Theatre A., MOMA, 1933; MET, 1945; WMA, 1940; WFNY, 1939. Author "The Stage is Set," 1932, "Part of a Lifetime," 1943 & others; articles in Atlantic Monthly, Creative Art, Harpers. Position: Ed., Creative Art, 1928–29; Consultant, Costume Exh., MET, 1944, 1945; theatre, Univ. Wis.; Univ. Ind., Hunter Col., NYC [47]

SIMONT, Joseph [I] NYC. Member: SI; Artists' G. Illustrator: Colliers, American [40]

SIMPKINS, Martha [P] Oak Cliff, TX [15]

SIMPSON, Bernard [P] Chicago, IL b. 1918, Cairo, IL. Studied: AIC; H. Wallace. Exhibited: AIC, 1940 [40]

SIMPSON, C. Helen. See Whittemore.

SIMPSON, Clara, Mrs. See Davidson.

SIMPSON, E.V. [P] Salt Lake City, UT [15]

SIMPSON, Edna Huestis (Mrs.) [Min.P] NYC b. 26 N 1882, Troy, NY. Studied: Emma Willard A. Sch.; Cornell Univ.; ASL. Member: Pa. SMP. Exhibited: Pan-Pacific Expo, 1915; Chicago World's Fair, 1933; ASMP; Pa. SMP, 1906–26. Work: portrait commissions [47]

SIMPSON, Frances [P] New Orleans, LA [15]

SIMPSON, Helen [P] NYC [10]

SIMPSON, Herbert [P] NYC [25]

SIMPSON, Lillian B. [P] Kansas City, MO [17]

SIMPSON, Margaret Spicer [Min.P] Paris, France. b. 1874, Wash., D.C. Studied: Knaus, in Berlin; Paris, with Boutet de Monvel, Carriére [01]

SIMPSON, Marian (Mrs. L.) [P] Berkeley, CA b. 12 Ja 1899, Kansas City. Studied: H.G. Keller. Member: C. Beaux Arts, San Fran. Exhibited: Cleveland Artists, 1923 (prize), 1924 (prize); San Fran., 1927; San Fran. AA, 1930 (prize). Work: Cleveland; Mills College Gal., Oakland, Calif.; YWCA, San Fran.; mosaic, Alameda County Courthouse, Oakland, Calif. [40]

SIMPSON, Marshall S. [P,L,T] Middletown, NJ b. 12 Ja 1900, Jersey City d. 29 N 1958. Studied: MIT; J. Sloan; M. Sterne; G. Pène du Bois; ASL. Member: N.J. AA; Artists of Today, Newark. Exhibited: Newark Mus.; Princeton Univ.; Montclair AM; Bonestell Gal. Work: PMA; Univ. Pa.; N.J. State Mus., Trenton. Position: Dir., FA Dept., Newark Sch. F. & Indst. A. [47]

SIMPSON, Martha [P] Hollywood, CA b. Chicago, IL. Studied: AIC; R. Davey; Paris, with Lhote, M. Blanchard. Member: NAWPS [40]

SIMPSON, Mary E. [P] Minneapolis, MN b. 26 D 1872, Englewood, IL. Member: Minneapolis Sch. FA, with R. Koehler. Member: Minn. SAC [17]

SIMPSON, Maxwell Stewart [Et,Li,P,I,T] Elizabeth, NJ b. 11 S 1896, Elizabeth, NJ. Studied: NAD; ASL; abroad. Member: New Jersey AA.; Mod. A., N.J. Exhibited: NAD, 1945; Los A. Mus. A., 1945; CI, 1941, 1943; AV, 1942; NGA, 1940; CGA, 1939; WFNY, 1939; WMAA, 1934; Artists of Today, Newark, 1946; GGE, 1939; Montclair A. Mus., 1944; Riverside Mus., 1944; Newark Mus., 1943; Summit (N.J.) AA, 1942. Work: Newark Mus.; NGA; NYPL; Newark Pub. Lib.; Pub. Lib., Elizabeth, N.J.; Mus., Briarcliff Sch, NYC. Illustrator: "Aucassin and Nicolete," Helen Gentry, selected by AIGA for "50 Books of the Year, 1936." Position: T., Sch. F. Indst. A., Newark, N.J. [47]

SIMPSON, Samuel [P,W,L,T] Tolland, CT b. 24 N 1868, Centerville, MI. Studied: ASL. Member: CAFA [25]

SIMPSON, Wallace [P,I] Fort Worth, TX (1935) b. 1880, Moweaqua, IL. Studied: F. Reaugh. Cowboy artist; illus. for Dallas News, Fort Worth Star-Telegram [*]

SIMPSON, William Marks [S,T] Baltimore, MD b. 24 Ag 1903, Norfolk, VA. Studied: J.M. Miller, H. Schuler; H. Adams; Rhinehart Sch. of Sculpture, Md. Inst.; Am. Acad., Rome. Member: Norfolk SA; Baltimore Mus.; Soc. Med. Exhibited: Norfolk SA, 1920 (prize), 1921 (prize); 1923 (prize), 1914 (prize); Am Acad. Rome Comp., 1920; Md. Inst., 1934 (med). Work: Va. Miltary Inst., Lexington; Villa Aurelia, Rome, Italy. Position: Dir., Rinehart Sch. of S., Md Inst. [40]

SIMS, Agnes C. [P] Santa Fe, NM b. 14 O 1910, Rosemont, PA. Studied: Phila. Sch. Des. for Women; PAFA. Exhibited: Palace Legion Honor, 1946; Mus. N.Mex., 1945 (one-man); Santa Barbara Mus. A., 1946 (one-man); SFMA, 1946 (one-man). Work: Taylor Mus., Colorado Springs, Colo. [47]

SIMS, Florence [Min.P] New Haven, CT b. 26 D 1891, Birmingham, Ala. Member: New Haven PCC; Pa. SMP; Yale Sch. FA, with Kendall, Taylor. Exhibited: PAFA, 1933–36, 1938, 1941, 1943, 1945; Smithsonian, 1944, 1945; ASMP, 1933, 1935–38, 1941; Calif. SMP, 1936, 1941 [47]

SIMS, Joseph Patterson [Li,Des,I,Arch] Phila., PA b. 6 Ja 1890, Phila., PA. Studied: Univ. Pa. Member: AIA; Phila. Print C. Exhibited: Southern PM, 1942 (prize). Work: State House, Phila.; LOC; pub. lib., in several cities. Author: with C. Willing, "Old Philadelphia Colonial Details," 1914. Specialty: dec., historical, and animal maps [47]

SIMS, Ralph [S] Delphi, Ind. Member: Ind. SS [25]

SINCLAIR, Archie [P,C] Portland, OR b. 19 F 1895, Pitlochry, Scotland. Studied: J.H. Dixon; C.L. Keller. Member: S.Indp.A.; Chicago NJSA; Salons of America. Work: Normal Sch., North Adams, Mass.; church dec. and stained glass windows [33]

SINCLAIR, Audrey [P,T] Bridgeport, CT b. 9 F 1910, Australia. Studied: St. Joseph Convent, Tech. Sch., Perth, Australia; Yale. Member: Am. Ar. Prof. Lg. Exhibited: Pub. Lib., Bridgeport; Reads Hall, Bridgeport [40]

SINCLAIR, Bernice [P,T] Ft. Wayne, IN b. 25 N 1888, Knox, IN. Studied: O. Stark; W. Forsyth. Position: T., North Side H.S., Ft. Wayne [40]

SINCLAIR, Ellen Chisholm (Mrs. Karl F. Mast) [P] Toledo, OH/Lake James, IN b. 6 S 1907, Phila., PA. Studied: PAFA; Acad. Colarossi, Paris. Member: Ind. Artists C. Work: Lambert Coll., PAFA [40]

SINCLAIR, Eva [P] Atlanta, IN [24]

SINCLAIR, Gerrit van W. [P,T] Milwaukee, WI b. 1 My 1890, Grand Haven, MI d. 23 D 1955. Studied: AIC, with Vanderpoel, Walcott & Norton. Member: Wis. PS; Wis. Fed. A.; Wis. PM. Exhibited: Salon d'Automne, Paris, 1929; Salon Printemps, Paris, 1930; PAFA, 1920, 1924–26, 1931, 1932; CGA, 1923, 1928, 931; CI, 1924–26; AIC, 1917, 1921, 1924, 1930, 1931, 1942; WFNY, 1939; NAD, 1926; NYWCC, 1926; BM, 1930; WMAA, 1933; Milwaukee AI, 1929–45. Work: Layton A. Gal.; Milwaukee AI; WPA mural, Wasau (Wis.) Fed. Bldg.; St. James Church, County Court House, Milwaukee; Sherman Park, Chicago, schs., Walworth, Shorewood, Port Wash., Wis. [47]

SINCLAIR, Marjorie [S] Paris, France b. U.S. Studied: Bourdelle, Paris [15]

SINDBERG, Lawrence Hansen [P,Des] Bozeman, MT b. 23 Mr 1902, Fredericia, Denmark. Studied: A. Acad., Denmark; AIC; W. Schwartz.; A. Angarola. Exhibited: AIC, 1929–32. Work: U.S. Govt.. Des. medals & silverware. Contributor: articles, Chicago Daily News; Fredericia S. Democrat [47]

SINDELAR, Charles J. [P] NYC [25]

SINDELAR, Thomas A. [I] NYC b. 3 F 1867. Studied: C. Hecker; A.M. Mucha. Member: SC, 1898; Lotos C.; A. Fund S. [21]

SINEL, Joseph [P] NYC. Member: GFLA [27]

SINGER, Burr (Mrs. Friedman) [P,Li] Los Angeles, CA b. 20 N 1912, St. Louis. Studied: St. Louis Sch. FA; AIC; ASL; W. Ufer. Member: Calif. WCS; Los Angeles AA; Council All. A.; Am. Ar. Cong. Exhibited: WFNY, 1939; GGE, 1939; AV, 1943; Denver A. Mus., 1943–46; Audubon A., 1945; Pepsi-Cola, 1944; Los Angeles Mus. A., 1940–45; Calif. WCS, 1940–45; Fnd. Western A., 1943–45; Kansas City AI, 1938, 1939; CAM, St. Louis. Work: Warren Flynn Sch., Clayton, Mo.; LOC [47]

SINGER, Clyde J. [Mur.P,Et,T] Youngstown, OH b. 20 O 1908, Malvern, OH. Studied: Columbus A. Sch.; ASL; J.S. Curry; K.H. Miller; A. Brook; T. Benton; Bridgman; Lahey; Olinsky; DuMond. Member: Columbus AL. Exhibited: PAFA, 1935–39, 1941; CM, 1935–38; NAD, 1936, 1938 (prize); Tex. Centenn., 1936; CI, 1936–39; WMAA, 1936, 1940; CGA, 1937, 1939; GGE, 1939; WFNY, 1939; VMFA, 1940, 1942; Pepsi-Cola, 1945; Butler AI, 1937–46, 1938 (prize), 1942 (prize); Columbus AL, 1936, 1937 (prize), 1938 (prize), 1939, 1941, 1946; AIC, 1935 (med), 1936–38; Portland AM, 1939 (prize); Columbus Gal. FA, 1946 (prize); Denver AM, 1935. Work: PAFA; Vanderpoel Coll.; Canton AI; Massillon Mus. A.; Columbus Gal. FA; Wadsworth Atheneum; Butler AI; mural, USPO, New Concord, Ohio. Positions: T., Ohio River Sch. P. (Marietta, Ohio), Butler AI (1940, 1941, 1946) [47]

SINGER, Malvin [I] Brooklyn, NY b. 25 N 1911. Studied: Brooklyn Col.; Grand Central A. Sch.; NAD. Illustrator: Redbook, Cosmopolitan, McCall's, Liberty [47]

SINGER, William Earl [P,L] Los Angeles, CA b. 10 Jy 1909, Chicago, IL. Studied: Univ. Chicago; AIC; C. Wilimovsky; J. Norton; Lhote, in Paris; Benedict. Member: Chicago SA; Calif. WCS; Beaux-Arts S., Paris; Am. A. Cong.; United Am. A. Exhibited: AIC, 1932–41; WFNY, 1939; GGE, 1939; Great Lakes Traveling Exh., 1939; Denver AM, 1938, 1939; Albright A. Gal., 1939; Toronto AM, 1938–39; AIC, 1940 (one-man); A. Fair, Chicago, 1933 (prize), 1932 (prize), 1940 (prize); Beaux-Arts S., Paris, 1934; Denver AM, 1938 (prize); Havana, 1946 (prize). Work: Grand Rapids A. Gal.; Ill. State Mus.; Univ. Mnn.; AIC; LOC; Univ. Ill.; U.S. Gov.; Libertyville (Ill.) Court House; Biro-Bidjan Mus., Russia; Osaka Mus., Japan; Mound City Pub. Lib.; Serge Coll., Brussels; French Consulate, Chicago; St. Paul's Col., Winnipeg, Canada; Bd. Edu., Chicago. Contributor: New Horizons in American A., MOMA; American Art Today, Nat AS [47]

SINGER, William H., Jr. [P] Olden, Nordfjord, Norway (since 1914) b. 5 Jy 1868, Pittsburgh d. 29 D 1943. Studied: Académie Julian, 1901. Member: ANA, 1917; NA, 1931; Pittsburgh AS; AFA; Allied AA; St. Lucas SA. Exhibited: PAFA, 1906-37; Wash. County MFA (Md.), 1981 (retrospective); P.-P. Expo, San Fran., 1915 (med); AIC, 1916. Award: Royal Order of St. Olaf, 1929. Work: Stedelijk, Amsterdam; Royal Mus., Antwerp; Musée du Luxembourg, Paris; CI; Milwaukee AI; Carnegie Pub. Lib., Ft. Worth; Delgado Mus.; Pinacothek Mus., Munich; MMA; BM; Brooks Mem. A. Gal., Memphis; City Mus. of the Hague, Holland; lg. coll. at Wash. County Mus. FA, Hagerstown, Md.; Curtis Inst., Phila.; Walker Gal. A., Brunswick, Maine; Sweat Mem. AM, Portland, Maine; PAFA; Nat. Gal., Oslo, Norway; Mus. des Beaux-Arts, Brussels, Belgium; Mus. des Beaux-Arts, Cairo; PIASch; MFA, Ghent, Belgium; Norwegian Legation, Wash., D.C.; Van Abbe Mus., Einhoven, Holland [40]

SINGER, Winnaretta [P] Paris, France b. 1865, Yonkers, NY. Studied: Barrias, in Paris [06]

SINGERMAN, Gertrude Sterne [P] NYC. Exhibited: Seattle SFA, 1922 [27]

SINGLETON, Esther [W] NYC b. Baltimore d. 2 Jy 1930, Stonington, CT. Member: Royal Society Arts, England; Colonial Dames of America. Author: fifty books: five dealing with antiques, thirteen on art. Position: Ed., The Antiquarian, since 1923.

SINNETTE, Margaret [P] West Cornwall, CT [10]

SINNICKSON, Mary H. [P] Phila., PA b. Phila. Studied: PAFA; Académie Julian. Member: Plastic C.; Baltimore WCC [13]

SINNOCK, J(ohn) R(ay) [S,P,Med,T] Phila., PA b. 8 Jy 1888, Raton, NM d. 14 My 1947, Staten Island, NY. Studied: PMSchIA. Member: Phila. Sketch C.; Phila. Alliance; NSS; AFA. Work: murals in several Phila pub. sch.; comm. coins for the Sesqui-Centenn. Expo, Phila., 1926; Cong. Med. Honor to T. Edison, 1928 and to E.N. Amundsen; port. medals from lives of presidents Coolidge, Hoover, FDR. Work: Luxembourg Mus., Paris; Nat. Mus., Wash., D.C.; Am. Numismatic Soc. M., N.Y. Position: Chief En./Medalist, U.S. Mint, Phila. [40]

SINZ, Walter A. [S,T] Univ. Heights, OH b. 13 Jy 1881, Cleveland. Studied: Paris, with Académie Julian, Landowski; Cleveland Sch. A.; H.N. Matzen. Member: Cleveland SA; NSS. Exhibited: WMAA, 1941; PAFA, 1935; CMA, annually, 1922 (prize), 1923 (prize), 1933 (prize), 1934 (prize), 1938 (prize), 1941 (prize), 1943 (prize). Work: CMA; Nat. Air Race trophies; Cleveland 125th Anniversary Med.; YMCA Fountain, Cleveland; Cleveland Flower Show Med.; S. group, St. Luke's Hospital, Cleveland; Mt. Union Col., Alliance, Ohio; Baptist Church, Shaker Heights, Ohio; Statler Hotel, Cleveland. Position: T., Cleveland Sch. A., from 1912 [47]

SIPLE, Ella Simons (Mrs. Walter H.) [W,L,Mus,Cur,C,T] Cambridge, MA b. 8 Ja 1889, Virden, IL. Studied: Wellesley Col.; Europe. Member: CAA; AA Mus. Contributor: Burlington mag.; News of Art in America; The Studio; WMA Bulletins. Positions: Hd. Edu. Dept. (1918-23), Cur. Decorative A., (1923-29), L. (1935-39), all at WMA; Special Ed., Webster's Dict., for tapestries, historical fabrics, costumes, 1927-31 [47]

SIPORIN, Mitchell [P,I] NYC b. 5 My 1910, NYC d. 1976. Studied: T. Geller; AIC. Member: Am. A. Cong.; United Am. Ar.; Guggenheim F., 1946. Exhibited: PAFA, 1946 (med); AIC, 1942 (prize). Work: AIC; MET; WMAA; MOMA; Wichita Mus. A.; Smith Col.; Univ. N.Mex.; Encyclopaedia Britannica Coll.; Univ. Ga.; WPA frescoes, USPOs, St. Louis, Mo., Decatur, Ill.; H.S., Chicago Heights, Ill.; Lane Tech. H.S., Chicago. Illustrator: Esquire, Ringmaster, New Masses [47]

SIPPLE, Carl [P,I] Phila., PA [04]

SISKIND, Aaron [Ph] Providence, RI (1985) b. 1903, NYC. Studied: CCNY, 1926. Member: Photo Lg., 1930. Exhibited: Photo Lg., NYC, 1941; MOMA, 1941, 1965; AIC, 1965; Denver AM, 1965; IMP, 1965; Santa Barbara AM, 1965; Brown Univ., 1975. Work: MOMA; IMP; Siskin archive at Ctr. Creative Ph., Tucson. Best known for his images of walls, signs, and graffiti, beginning 1943, which are closely related in spirit to the work of F. Kline and other abstract expressionists exploring shapes. Positions: T., Chicago Inst. Des. (1951-70), RISD (1971-76) [*]

SISSON, Frederick R. [P,Cr,T] Providence, RI/Falmouth, MA b. 5 S 1893, Providence d. 1962. Studied: RISD; BMFA Sch.; Grande Chaumière, Paris; A. Thayer, 1920-21. Member: Providence AC; Contemporary A., Providence. Exhibited: MET (AV); Providence AC; Brown Univ.; Contemporary A., Providence RISD; R.I. State Col.; Attleboro (Mass.) Mus., all in 1946. Positions: T., RISD, 1924-52; Cr., Providence Journal, 1932-50 [47]

SISSON, Nellie Stowell [P] Missoula, MT [19]

SISTER CAMILLE [P,Des,Dr,C,T] Indianapolis, IN/St. Marys-of-the-Wood, IN b. 19 Ja 1901, Vincennes, IN. Studied: Corcoran Sch. A.; AIC; Chicago Acad. FA; O. Gross; G. Mess. Member: Ind. Artists C. [38]

SISTER ESTHER [P,T,W] St. Marys-of-the-Wood, IN b. 17 My 1901, Clinton, IN. Studied: AIC; Syracuse Univ.; W. Forsyth; O. Gross; F. Foy. Member: Ind. Artists C. Exhibited: Hoosier Salon, 1937 (prize). Author: course of study for Jr. H.S., Diocese of Indianapolis, 1936. Illustrator: "A Bible History," Macdonald and Jackson [38]

SISTER MARY LAUREEN [P,Des,L,T] Holy Cross, IN b. 16 Je 1893, Ft. Wayne, IN. Studied: Univ. Chicago, AIC; Univ. Calif.; Notre Dame Univ. Member: Hoosier Salon. Exhibited: Hoosier Salon, 1937 (prize). Position: T., St. Mary's Col. [38]

SISTI, Anthony [P,E,Dr,T] Buffalo, NY b. 25 Ap 1901, NYC. Studied: F. Carena, Royal A. Acad, Florence; Paris; Munich; Vienna. Member: Buffalo SA; G. Allied Arts, Buffalo; The Patteran.; Basalica C. Exhibited: Albright A. Gal, 1930, 1932 (prize); Buffalo SA, 1934 (prize); Western N.Y. A., 1936 (prize), 1938 (prize). Work: Mussolini Gal., Rome; Buffalo City Hospital; mural, Univ. Buffalo; Albright A. Gal., Buffalo. Position: T., Buffalo AI [40]

SITER, Eliza Clayton [P] Phila., PA b. Phila. Studied: Eakins; Chase; Lasar, Paris. Member: Plastic C.; PAFA [10]

SITES, George [P] Brockton, MA [17]

SITTERLE, Harold F. [P] d. 28 D 1944, while in Govt. service. Exhibited: in Chicago

SITTIG, Augusta [P] Brooklyn, NY. Exhibited: Brooklyn Mus., 1934; NAWPS, 1935-38 [40]

SITTON, John Melza [Mur,P,Gr,Des,W,L,E] Lutherville, MD b. 9 Ja 1907, Forsyth, GA. Studied: Yale; ASL; NAD; Am. Acad., Rome; E. Savage; I. Olinsky. Member: All.A.Am.; NSMP; N.Y. Mun. A. Soc.; Audubon A.; Century Assn.; SC; Charcoal C., Baltimore; Grand Central AG; Ridgewood AA. Exhibited: NAD, 1932; WMAA, 1937; Pepsi-Cola, 1943; SSAL, 1943-46; All.A.Am., 1944; Audubon A., 1945; Mint Mus. A., 1943; Dayton AI, 1946; Century Assn., 1945; SC, 1943; Laguna Beach AA, 1943; High Mus., 1942 (one-man), 1946 (med); Dayton AI, 1933; Grand Central A. Gal., 1945; Telfair Acad., 1943; Clearwater A. Mus., 1943; Cornell, 1944. Work: Yale Univ. A. Gal.; AGAA; Mint Mus. A.; IBM Coll.; Bendix Radio Coll.; Tex. Tech. Col., Lubbock; Fed. Reserve Bank, Atlanta; Riverside Mem. Chapel, NYC; WPA mural, USPO, Clifton, N.J.; murals, WFNY, 1939; Elks War Mem., Chicago (asst. to E. Savage); Archives Bldg., Wash., D.C. (asst. to Barry Faulkner). Position: T., N.Y. Sch. Appl. Des. for Women (1940), Cornell (1941-44) [47]

SITZMAN, Edward R. [P,L,T] Indianaplis, IN b. 31 Mr 1874, Cincinnati, OH. Studied: Duveneck; H. Farney, Cincinnati A. Acad.; London; Munich. Member: Ind. AC; Indianapolis AA; Chicago Gal. Assn. Work: Cincinnati AM; pub. libs. & schs. of Ind. [40]

SKEELE, Anna Katharine [P,T] Monrovia, CA b. 12 Jy 1896, Wellington, OH d. 28 Je 1963, Pasadena, CA. Studied: Acad. FA, Florence, Italy; Lhote, Paris. Member: Laguna Beach AA; Calif. WCS; Council All. A., Los Angeles. Exhibited: San Diego FAS, 1930 (prize), 1933 (prize), 1938 (prize); Sacramento State Fair, 1930 (prize); Pomona County Fair, 1930 (prize), 1932 (prize), 1934 (prize); Los Angeles PS, 1931 (prize); Palace Legion Honor, 1946; Doheny Lib. Univ. Southern Calif. Position: T., Monrovia H.S.; Co-Owner and T., Pasadena Sch. FA, 1952-59 [47]

SKELLY, Gladys Gertrude [C] St. Louis, MO b. 13 F 1901, Mexico, MO. Studied: R. Barry; St. Louis Sch. FA. Member: NY Soc. Craftsmen; Boston SAC; St. Louis AG; Shikari; St. Louis S.Indp.A. Exhibited: SAM, 1941; de Young Mem. Mus., 1941; Philbrook A. Ctr., 1941; CAM, 1940-43; Houston MFA, 1941; Davenport A. Gal., 1941; Allen Mus., Oberlin, OH, 1942; Oshkosh Mus. A., 1942; Brooks Mem. A. Gal., 1942; Sedalia, Mo., 1932-33 (prizes); St. Louis, 1934 (prize); Paris Expo, 1937 [47]

SKELLY, Jerry [I] NYC. Member: SI [47]

SKELTON, Leslie J(ames) [Ldscp.P,I] Colorado Springs, CO (since 1890s) b. 27 Ap 1848, Montreal, Canada d. 10 Ja 1929. Studied: Iwill, Paris, ca. 1885. Member: Broadmoor A. Acad.; Colo. Springs AS. Work: Nat. A. Gal., Canada, Ottawa; Perkins A. Gal., Colorado Col.; Montreal AA. Popular Colorado painter whose landscapes were reproduced as post cards (about 5 million sold) [27]

SKELTON, Ralph Fisher [P,E] Chicago, IL/London, England b. 4 F 1899, Port Byron, IL. Studied: H. Tonks; W.W. Russell; Sir W. Orpen [29]

SKELTON, Robert Munshower [P,S,T] Forest Ave., Greensboro, NC b. Wellsboro, PA. Studied: State T. Col., Pa.; Columbia; A. Archipenko.

Member: Southeastern AA. Exhibited: Person Hall A. Gal., Chapel Hill, N.C.; VMFA. Position: T., Women's Col., Univ. N.C. [40]

SKEMP, Olive H. (Mrs.) [P] Scottsdale, Pa. Member: S.Indp.A. [25]

SKIDMORE, Lewis Palmer [Mus.Dir,P,E,I,L] Atlanta, GA b. 3 S 1877, Bridgeport, CT d. 10 Je 1955. Studied: J.H. Niemeyer, at Yale; Ecole des Beaux-Arts, Paris, with Laurens, Bouguereau, Bonnât. Member: Atlanta AA; SSAL; AAPL; Assn. Ga. A.; Brooklyn SA; Brooklyn WCC; New Haven PCC; Studio C., Atlanta; AAA, Paris. Exhibited: NAD, 1907, 1910, 1917; PAFA, 1919, 1910; Assn. Ga. A., 1931, 1933. Position: Dir., High Mus. A., from 1929 [47]

SKIDMORE, Thornton D. [I,Cart] Jackson Heights, NY b. 2 Je 1884, Brooklyn, NY. Studied: Eric Pape Sch. A.; H. Pyle. Member: SI. Illustrator: Cosmopolitan, Collier's, American, Woman's Home Companion [47]

SKILTON, John Davis, Jr. [P,Mus. Research Asst.] Fairfield, CT b. 28 F 1909, Cheshire, CT. Studied: Yale; Univ. Paris; NYU. Member: Rockefeller F., BM, 1935–36. Exhibited: WFNY, 1939. Position: Monument Specialist Officer, U.S. Army, 1945 [47]

SKINNER, Charles Everett [P] Minneapolis, MN [19]

SKINNER, C(harlotte) B. (Mrs. William Lyle) [P,E] Morro Bay, CA b. 1879, San Fran. Studied: Calif. Sch., FA; Mark Hopkins Inst. Art; A.F. Mathews; G. Piazzoni. Member: San Fran. Soc. Women A.; Los Angeles AA. Work: painting, gov. owned in Oreg. [40]

SKINNER, Dewitt A. [P] Rochester, NY b. 4 Ja 1880, Gates, NYC. Studied: A.L. Meyvis [21]

SKINNER, Frances Johnson [P,T] Houston, TX b. 22 O 1902, Dallas. Studied: BMFA Sch.; Chouinard AI; E. Spruce. Member: Tex. FA Assoc.; SSAL; NAWA. Exhibited: PAFA, 1938; Nat. Exh. Am. A., N.Y., 1938; Kansas City AI; Tex. Centenn.; SFMA; Dallas MFA, 1940 (prize), 1941 (prize); Houston MFA, 1943 (prize); Tex. FAA, 1943 (prize); NAWA, 1945 (prize); Tex. State Fair, 1931 (prize), 1932 (prize), 1933 (prize). Work: Dallas MFA; Dallas Pub. Sch. Coll.; Houston MFA. Position: T., Houston MFA [47]

SKINNER, Jessie R. [P] Madison, WI [24]

SKINNER, L.B. [P] Dunedin, FL [24]

SKINNER, Mary Colle [P] NYC [17]

SKINNER, Orin Ensign [C,Des,W,L] Newtonville, MA b. 5 N 1892, Sweden Valley, PA. Studied: H.J. Butler; F. von der Lancken; Member: Boston Arch. C.; Boston SAC. Positions: Ed. Manager, Stained Glass, publ. of the Stained Glass Assn. of America; Pres., Charles J. Connick, Stained Glass [47]

SKINNER, Rachel [P] Milwaukee, WI [24]

SKINNER, Thomas C. [P,Li,I] Newport News, VA b. 25 D 1888, Kuttawa, KY d. 10 Mr 1955. Studied: NAD; ASL; G. Bridgman; Henri; G. Luks. Work: murals, Mariners' Mus., Newport News, Va.; U.S. Naval Officer's C., Guantánamo, Cuba; LOC; Peabody Mus.; U.S. Naval Acad., Annapolis, Md.; MIT; India House, N.Y.; VMFA; Marine Mus., City of N.Y.; U.S. Merchant Marine Acad., Kings Point, N.Y.; murals, many steamships & U.S. Naval craft [47]

SKLAR, Dorothy (Mrs. Phillips) [P,T] Los Angeles, CA b. NYC. Studied: UCLA. Member: NAWA, NOOA; Springfield, Mass. AL; Calif. WCS; Laguna Beach AA; North Shore AA. Exhibited: Palace Legion Honor, 1945; Ala. WCS, 1944, 1945; Wawassee A. Mus., 1944, 1945; Newport, R.I., 1945; Delgado Mus. A., 1944–46; Gloucester, Mass., 1944–46; NAWA, 1946; Portland (Maine) AL, 1944–46; Jackson (Miss.) AA, 1944–46; Denver A. Mus., 1945; Oakland A. Gal., 1945; Laguna Beach AA, 1944–46; Santa Cruz AL, 1944, 1946; Santa Paula (Calif.) Chamber of Commerce, 1945; Springfield (Mass.) AL, 1945, 1946 [47]

SKLAR, George [S,Des,T,P] Phila., PA b. 24 Ag 1905, Phila., PA d. 6 Ja 1968. Studied: PMSchIA; Yale; BAID; Landowski. Member: Tiffany Fnd. F., 1929. Exhibited: PAFA, 1940; Ecole des Beaux-Arts, Paris, 1932 (prize). Specialty: animals. Positions: T., PMSchIA (1927–29), Yale (1935–37), Rutgers (1937–41) [47]

SKODIK, Antonin C. [C,S] NYC b. 2 S 1870, Modra, Moravia (came to U.S. in 1892). Studied: ASL, with Cox, Mowbray, Blum, Barnard, Bitter, Miss Lawrence. Member: NSS [10]

SKOLFIELD, Raymond White [P,Li] Brooklyn, NY/Portland, ME b. 17 S 1909, Portland. Studied: P. Hale; G. Demetrios; M. Young; G. Picken; G. Pene Du Bois. Member: ASL [40]

SKOLLE, John [P,T,L,I] Santa Fe, NM b. 7 F 1903, Plauen, Gemany. Studied: Acad. FA, Leipzig, Germany. Exhibited: MOMA, 1942; Palace Legion Honor, 1946 (med); Bonestell Gal. (one-man); Mus. N.Mex. (one-man); Univ. N.Mex. (one-man); Denver A. Mus., 1930 (prize). Work: Denver AM. Position: T., Brownmoor Sch., Phoenix, Ariz., from 1945 [47]

SKONVERE, Harold [P] Astoria, NY. Member: S.Indp.A. [25]

SKOOG, Karl F(rederick) [P,S] Boston, MA b. 3 N 1878, Sweden d. 1933. Studied: B.L. Pratt. Member: CAFA; Boston SS; Boston AC. Exhibited: Rochester, N.Y., 1908 (prize); SAA, 1912, 1918 (prize) 1920; CAFA, 1915, 1918, 1930 (prize); Swedish-Am. A., 1912, 1918 (prize), 1920, 1921 (prize). Work: bust, K. of P. Bldg., Brockton, Mass.; tablet, Home for Aged Swedish People, West Newton; mon., Forest Dale Cemetery; Elks Bldg., Malden, Mass.; medallion, R.W. Emerson, Mus. Numismatic S., NYC; mon., Cambridge, Mass.; mon., Cromwell, Conn.; hospital, Boston; mem., Cromwell Gardens, Cromwell, Conn.; Masonic Temple, Goshen, Ind.; John Morton Mem. Mus., Phila.; Vanderpoel Coll., Chicago [33]

SKOU, Sigurd [P,T] NYC/Concarneau, France b. Norway d. 18 O 1929 American Hospital, Paris. Studied: Zorn, in Stockholm; Krogh, in Paris. Member: Allied AA; NYWCC; AWCS; Aquarellists; CAFA; SC; Palette and Chisel; Paris AAA; Boston AC; NAC; Grand Central A. Gal. (founder). Exhibited: Norske C., Chicago, 1922 (prize), 1923 (prize), 1926 (prize); Norse Centenn., St. Paul, Minn., 1924 (gold); SC, 1926 (prize), 1929 (prize); All.A.Am., 1926 (gold); Baltimore WCS, 1927 (prize), 1928 (prize) [27]

SKOUGOR, Martha Gilbert [P] Brooklyn, NY/Neshantic, NJ b. 18 Mr 1885, Brooklyn, NY. Studied: F.V. Du Mond. Member: NAWPS; ASL [33]

SKRAINKA, Blanche [P] St. Louis, MO [25]

SKUPAS, Anthony J. See Cooper.

SLACK, Emma Patton [P] Minneapolis, MN [15]

SLADE, C. Arnold [P] Truro, MA b. 2 Ag 1882, Acushet, MA. Studied: F.V. Du Mond; Laurens; Schomer; Bachet. Member: Phila. AC; Paris AA; Allied A. of London; Grand Rapids AC; Springfield (Ill.) AC; New Bedford AA; Phila. Sketch C. Work: Springfield AC; Phila. AC; Attleboro (Mass.) Pub. Coll.; Gardner Mus., Boston; New Bedford (Mass.) Pub. Lib.; Milwaukee AI; Bethany Church, Phila.; Fitzgerald Gal., Brookline, Mass.; Paramont Theatre, NYC; John Wanamaker and Elkins Coll., Phila.; portraits. [40]

SLADE, Cora L. (Mrs. Abbott E.) [P] Fall River, MA d. ca. 1938. Studied: R.S. Dunning. Member: Provdence AC; Newport AA; Fall River AC [33]

SLADE, Emily [S,P] NYC. Member: NYWAC; Cornish (N.H.) Colony [04]

SLAFTER, Theodore S. [P] Member: Copley S., 1890; Boston AC [25]

SLATER, Edwin C. [P,W] Greenwich, CT b. 22 D 1884, N.J. Studied: PAFA with W. Chase, C. Beaux, T.P. Anshutz, H. Breckenridge; B. Harrison; C. Grafly; H.D. Murphy; H.R. Poore; G. Bridgman. Member: SC; Copley S. [40]

SLAVIN, John Daniel [Por.P,T] Wash., D.C. b. 31 Jy 1907, Wash., D.C. Studied: G. Wash. Univ.; Corcoran Sch. A.; ASL; E.C. Tarbell; B. Baker; R.S. Meryman; E. Weisz; M. Leisenring. Exhibited: Studio G., 1940; Blackston Col. for Girls; Norfolk Mus. A.; CGA, 1938; PAFA; CMA; Va. Lg. FA; U.S. Nat. Mus., Wash., D.C., 1940 (one-man); Anderson Gal., Richmond, 1933 (prize). Work: State Capitol, Richmond, Va.; Acad. Sc. & FA, Richmond; many portraits; Norfolk Mus. A. & Sc.; Medical Col., Va.; Hotel J. Marshall, Richmond; Chesapeake & Ohio R.R. Co., Cincinnati, Ohio; Parish Church, Williamsburg, Va. Illustrator: articles by T.B. Campbell [47]

SLAYMAKER, Elizabeth [P,I,T] Norfolk, VA b. Atlanta, GA. Studied: Paris with Vitti Acad., Académie Julian [08]

SLAYTON, Ronald Alfred [P,I,T] Burlington/Weston, VT b. 16 D 1910, Barre, VT. Studied: PIASch; Univ. Vt. Member: No. Vt. A.; Vt. AA; Burlington Comm. A. Council. Exhibited: So. Vt. A.; No. Vt. A.; WFNY, 1939. Position: T., Burlington Comm. A. Ctr. [40]

SLEE, W.F. [P] Dorchester, MA [08]

SLEETH, L. MacD. (Mrs. Francis V.) [P,S,T] Wash., D.C. b. 24 O 1864, Croton, IA. Studied: Whistler; MacMonnies; E. Carlsen. Member: San Fran. AA; Wash. WCC; S. Wash. A.; Wash. AC; Laguna Beach AA. Work: port. busts, CGA, Mem. Continental Hall, Cathedral Fnd. in Wash., D.C. [33]

SLEETH, R.L., Jr. [P] Pittsburgh, PA. Member: Pittsburgh AA [21]

SLICK, Margery Singley [P] Chicago, IL. Member: Chicago NJSA [25]

SLINKARD, Rex [P,T] Los Angeles b. 1887 d. 18 O 1918, NYC. Studied: R. Henri; USC; ASL of Los Angeles. Position: T., ASL of Los Angeles [*]

SLIVKA, David [S] San Francisco, CA b. 26 O 1913, Chicago. Studied: Calif. Sch. FA. Exhibited: WPA Sculpture: stone relief, pub. sch., San Fran.; USPO, Berkeley, Calif.; GGE, 1939 [40]

SLOAN, Blanding [P,S,E,Li,B,I,T] Cos Cob, CT b. 19 S 1886, Corsican, TX. Studied: B. Nordfeldt. Member: Chicago SE. Work: BM; Calif. Palace of the Legion of Honor. Illustrator: "Way Down South," C. Muse. [40]

SLOAN, Edna (Mrs.) [P] Salt Lake City, UT. Member: S. Utah Artists [01]

SLOAN, J(ames) Blanding [P,E,I,C,W,T] Corsicana, TX b. 19 S 1886, Corsicana. Studied: Chicago Acad. FA; B.J.O. Nordfeldt; G. Senseney. Member: Chicago SE [33]

SLOAN, John [P,E,I,T,W,Li] NYC/Santa Fe, NM b. 2 Ag 1871, Lock Haven, PA d. 1951. Studied: PAFA, with Anshutz, Henri, 1892. Member: S.Indp.A., (Pres., from 1918); AIAL; Taos SA. Exhibited: SAE, 1940 (prize); P.-P. Expo, San Fran., 1915 (med); Sesqui-Centenn. Expo, Phila., 1926 (gold); PAFA, 1931 (gold). Work: NYPL; Newark Pub. Lib.; CM; CI; MET; BM; Mus. N.Mex.; PMG; CGA; Pa. State Col.; Barnes Fnd.; Newark Mus.; Detroit Inst. A.; Los Angeles Mus. A.; San Diego FAS; AIC; WMAA; BMFA; AGAA; Wichita Mus. A.; PAFA; PMA; TMA; WPA murals, USPO, Bronxville, N.Y.; major coll.; John Sloan Trust, Wilmington, Del. Author: "Gist of Art," 1939. Illustrator: etchings and drawings for novels of Paul de Kock and Gaboriau; "Of Human Bondage," Ltd. Ed., 1938. One of the "black gang" in Phila. with Henri, Luks, Shinn and Glackens. By 1904 all five were in NYC and by 1908 they formed "The Eight," later known as the "Ashcan Group." Position: T., ASL, 1914–26, 1935–37 [47]

SLOAN, Junius R. [Ldscp.P,Por.P] b. 10 Mr 1827, Kingsville, OH d. Ag 1900, Redlands, CA. Work: Chicago Hist. S.; Minn. Hist. S. He was a Hudson River Valley School artist. Began as an itinerant painter active in Ohio, Pa. and N.Y., 1848–55; Princeton, Ill., 1855–57; NYC, 1857–58; Erie, Pa., 1958–63; Chicago, 1863–67; NYC and Hudson River Valley, 1867–73; Chicago, 1873–1900 [*]

SLOAN, Marianna [Ldscp.P,Mur.P] Phila., PA b. 21 S 1875, Lock Haven, PA d. 19 Mr 1954. Studied: Phila. Sch. Des. for Women; Henry; E. Daingerfield, Phila. Exhibited: St. Louis Expo, 1904 (med). Work: murals, Church of Annunciation, Phil.; St. Thomas Church, White Marsh, Pa.; St. John Baptist Church, Germantown, Pa.; St. Louis C.; PAFA [47]

SLOAN, Robert S. (Robert Sloan Smullyan) [P] NYC b. 5 D 1915, NYC. Studied: CCNY; NYU. Member: A. Gld. Exhibited: Nat. Soldier A. Exh., 1925; U.S. Nat. Mus., 1945; ASL, 1945; West Point. Work: U.S. Treasury Dept. Contributor: covers & port. to Time & Coronet mags. [47]

SLOANE, Eric [Ldscp.P,W] Santa Fe, NM/Warren, CT b. 27 F 1910, NYC d. 6 Mr 1985, NYC. Studied: ASL; Yale, 1929; NY Sch. FA, 1935. Best known for his series of more than 40 American books beginning 1954, especially that on barns. Also a meteorologist. His autobiography is "Eighty: An American Souvenir." [*]

SLOANE, Eunice [I] NYC. Member: SI [47]

SLOANE, George [P] Boston, MA. Member: Providence AC [25]

SLOANE, Marian Parkhurst (Mrs. George) [P] Boston, MA b. Salem, MA d. ca. 1955. Studied: BMFA Sch. Member: Gld. Boston A.; All.A.Am.; North Shore AA; Rockport AA; Copley S., Boston; NAWPS; CAFA; Grand Central Gal. Assn. Exhibited: CGA, 1928, 1932, 1939; PAFA, 1928, 1933, 1934; NAD, 1939; BMFA; Montclair A. Mus.; Currier Gal. A. [47]

SLOBE, Laura [P] Chicago, IL b. 17 N 1909, Pittsburgh, PA. Studied: AIC. Exhibited: AIC, 1932 (prize), 1933 (prize), 1934 (prize) [40]

SLOBE, Thelma [P] Chicago, IL b. NYC. Exhibited: AIC, 1940 (prize), 1943–45, 1946 (prize) (one-man); Am.-British A. Ctr., 1942; MET, 1942; PAFA, 1942, 1946; VMFA, 1946; Rundel Gal., Rochester, N.Y., 1944 (one-man) [47]

SLOBODKIN, Louis [S,W,I,L,T] NYC b. 19 F 1903, Albany, NY d. 1975. Studied: BAID. Member: An Am. Group; S. Gld.; AIGA; Albany A. Group; Rockport A. Group; NSS; Am. Ar. Cong.; Municipal AS. Exhibited: WMAA, 1935–44; PAFA, 1941–45; WFNY, 1939; AIC, 1939–43; MET, 1942; S. Gld., traveling exh.; An Am. Group, 1939–46; AIGA, 50 Best Books Exh., 1944; MET Ills. Exh., 1944; AV Goodwill Tour, Europe; AFA Traveling Exh., 20 Best Children's Books, 1944. Work: mem. tower, Phila. Interior Bldg., Wash., D.C.; WPA work, USPOs, Johnstown, Pa.; Madison Sq., NYC. Author: "Magic Michael," 1944; "Clear the Track," 1945; others. Illustrator: "Rufus M," 1943; "Many Moons," 1943; "Tom Sawyer," 1946; "Robin Hood," 1946; others. Contributor: Magazine of Art, Horn Book. Position: T., WPA, NYC, 1934–37; head of City A. Project for WPA, 1941–42 [47]

SLOBODKIN, Simon Harris [Cer.Des] NYC b. 17 Jy 1891, Boston, MA d. 4 F 1956. Studied: Harvard. Exhibited: MMA, 1934, 1940, WMA, 1933; Richmond Acad. A.&Sc., 1934; Indst. A. Expo, NYC, 1934; Paris Intl. Expo, 1937; MOMA, 1935 [47]

SLOBOKINA, Esphyr [P,I,W,S,Des,C] NYC b. 22 S 1914, Tcheliabinsk, Russia. Studied: NAD. Member: Am. Abstract A.; Fed. Mod. P.&S. Exhibited: Fed. Mod. P. & S.; Abstract A. Author/Illustrator: "The Little Fireman," "Hiding Places." [47]

SLOCUM, Annette M. (Mrs.) [S] NYC [24]

SLOCUM, Samuel Gifford [Arch,S] NYC/Saratoga Springs, NY b. 1854, Leroy, NY. Studied: Cornell Univ. Member: SC; AIA 1887 [08]

SLOHOTKIN, Louis [S] NYC [25]

SLOMAN, Joseph [P,C,Des,I] Union City, NJ b. 30 D 1883, Phila., PA. Studied: Drexel Inst.; H. Pyle; W. Chase; B.W. Clinedinst; C. Grayson. Exhibited: Phila. AC; AWCS; PAFA; NAD; Ft. Worth, TX; Marshall Field, Chicago (one-man); Drexel Inst., 1904 (prize). Work: Bordentown (N.J.) Hist. S. Mus.; mem., Snyder H.S., Jersey City, N.J.; mural, Gorham Silver Co., N.Y.; stained glass, Union City Pub. Lib., churches, Boston, NYC, Athens, Ga., Hoboken, N.J.; Church of St. John, West New York, N.J.; Hoboken Pub. Lib.; windows, Synagogue, Athens, Ga.; Hotel, Elizabeth, N.J.; Avenue U. Theatre, Bensonhurst, N.Y. Illustrator: "In Many Islands," "A Declaration of Dependence," "Alias Kitty Kasey" [47]

SLONIMSKY, Nicolas, Mrs. See Adlow, Dorothy.

SLOPER, Norma (Wright) [P] New Britain, CT b. 12 Ja 1892, New Haven, CT. Studied: A.E. Jones; L. Simon; R. Menard, Paris. Member: S. Conn. P.; CAFA. Exhibited: CAFA, 1922 [33]

SLOTNICK, Mack W. [Por.P,Dr,T] Plainfield, NY b. 1 D 1899, Russia. Studied: CUASch.; A&C G.; NAD. Member: Plainfield AA; Montclair AA; Orange AA [47]

SLUSSER, Jean Paul [Mus.Dir,P,W,L,T] Ann Arbor, MI b. 15 D 1886, Wauseon, OH. Studied: Univ. Mich.; BMFA Sch.; ASL; H. Hofmann; H. McFee; B. Shahn; J.F. Carlson. Exhibited: CGA, 1934; AIC; WMAA; BM; WFNY, 1939; Detroit Inst. A., 1926–46, prizes: 1924, 1928, 1931, 1937, 1945, Ann Arbor AA, 1926–46; Detroit Mus. A., 1931 (prize); Detroit SA, 1937 (prize). Work: IBM Coll.; Detroit Inst. A.; Ann Arbor AA; Univ. Mich.; WPA murals, USPO, Blissfield, Mich.; Detroit SAC. Author: "Bernard Karfiol," Am. A. Series, 1931. Contributor: art magazines. Position: T., Univ. Mich., 1926–45; Acting Dir., Mus. A., Univ. Mich, from 1946 [47]

SLUTZ, Helen Beatrice [Min.P] Dallas, TX b. 15 Ap 1886, Cleveland, OH. Studied: Cleveland Sch. A. Member: Calif. SMP (1920s). Exhibited: Theobald Gal., Chicago; Women's City C., Kansas City; Dallas Women's Expo [40]

SLY, Franklin [P] Seattle, WA [24]

SMALL, Eugene Walter [P] NYC b. 1871, NYC d. 7 My 1934 Studied: CCNY; NYU Law Sch. Exhibited: several one-man shows; Independent Artists, Rockefeller Ctr. He had been a lawyer & began painting ca. 1929

SMALL, F.W. [I] Brooklyn, NY [21]

SMALL, Frank O. [I,P] Boston, MA b. N 1860, Boston, MA. Studied: Paris, with Bouguereau, Robert-Fleury [17]

SMALL, Hazel [P,T] Denver, CO. Member: Denver AA [21]

SMALL, May. See Mott-Smith.

SMALLEY, Janet (Mrs. Alfred) [I,W] Swarthmore, PA b. 16 My 1893, Phila., PA d. ca. 1964. Studied: PAFA, 1915 (Cresson Traveling Schol.). Member: F., PAFA. Illustrator: "Biffy Buffalo," 1942, "A Grandma for Christmas," 1946, "Papa Was a Preacher," 1944. Contributor: Child Life, Jack and Jill. Author: children's books [47]

SMALLEY, Katherine [Ldscp.P] Settled in Colo. Springs, 1889; Living in Colo. City, 1924 b. ca. 1865, Waverly, IA. Studied: AIC with C. Corwin, 1884–85 [*]

SMART, Edmund Hodgson [Por.P] Los Angeles (since 1925) b. 12 Mr 1873, Ainwick, England (came to U.S. in 1916) d. 8 D 1942. Studied: Antwerp Acad.; Acad. Julian; Sir H. von Herkomer [*]

SMEDLEY, Will Larymore [P,C,Gr,Des,S,Arch,I,W,L] Chautauqua, NY b. 10 N 1871, Sandyville, OH d. ca. 1958. Studied: self-taught; Case Sch. Appl. Sc. Member: S. A.&Illus.; Cleveland SA; Nat. Craftsmen. Exhibited: NYC; Phila.; Cleveland; Chicago [47]

SMEDLEY, William T(homas) [P,I] NYC/Bronxville, NY b. 26 Mr 1858 d. 26 Mr 1920. Studied: PAFA; Laurens, in Paris. Member: ANA, 1897, NA, 1905; SAA, 1882; AWCS; Mural P.; NIAL, SI, 1901; Port. P.; A. Aid S.; Century Assn. Exhibited: AWCS, 1890 (prize); Paris Expo, 1900 (med); Pan-Am. Expo, Buffalo, 1901 (med); NAD, 1906 (prize), 1907 (prize), 1916 (prize). Work: NGA. Best known as illus. of beautiful women and the upper class of NYC. [19]

SMELTZER, Sterling [P] Charleston, WV. Work: WPA mural, Willoughby, OH [40]

SMERALDI, John D. [Mur.P,Furniture Des.] Los Angeles, CA b. 1868, Palermo, Sicily (came to U.S., 1889) d. 14 My 1947, Queens, NY. Work: hotels & private residences.

SMERTZ, Robert [P] Pittsburgh, PA. Member: Pittsburgh AA [25]

SMILEY, Helen A. [C,T,B,Des] Phila., PA b. 8 Jy 1896, Phila. Studied: Temple Univ.; Columbia; PMSchIA. Member: Phila. A. All.; Pa. Soc. Craftsmen. Exhibited: Phila. A. All., 1941 (prize), 1942–43. Specialty: jewelry, textile des., pottery [47]

SMILLIE, George F(rederick Cumming) [En] Wash., D.C. b. 22 N 1854, NYC. Studied: NAD; his uncle, James D. Smillie in Am. Bank Note Co. Work: the so-called "picture notes" ($2 and $5 silver certificates of 1895); back of $100 Fed. Reserve notes; large portraits of presidents Grant, McKinley, Roosevelt, Taft and Wilson. Position: Principal En., U.S. Bureau Engraving, 1894–22 [29]

SMILLIE, George H(enry) [Ldscp.P] Bronxville, NY b. 29 D 1840, NYC d. 10 N 1921. Studied: James M. Hart. Member: ANA, 1864, NA, 1882; AWCS; Century Assn.; Lotos C. Exhibited: N.Y. Etching C., 1884; SC, 1883; Am. Art Assn., N.Y., 1885 (prize); St. Louis Expo, 1904 (med); AAS, Phila., 1907 (med). Work: CGA, Wash., D.C.; Union Lg. C., Phila.; MMA; Lotos C., NYC; RISD; Erie, Pa., Pub. Lib. Son of James and brother of James D. [19]

SMILLIE, Helen (Nellie) Sheldon Jacobs (Mrs. George H.) [P] Bronxville, NY b. 14 S 1854, NYC d. 30 Jy 1926, NYC. Studied: J.O. Eaton; James D. Smillie. Member: AWCS [25]

SMILLIE, James David [P,E] NYC b. 16 Jy 1833, NYC d. 14 S 1909. Studied: steel engraving with his father James. Member: ANA, 1868, NA, 1876; AWCS (founder, 1866; Pres. 1873–79); Century; N.Y. Etching C. (founder, 1877). Exhibited: Centenn. Expo, Phila., 1876; Brooklyn AA; NAD, 1864–98. Work: BMFA; CGA; Amon Carter Mus.; Oakland MA; NYPL. Illustrator: "Picturesque America," 1972. He traveled widely, painting the Sierras, Adirondacks, Rocky, White and Catskill Mountains. Position: T., NAD, 1868 [08]

SMIT, Derk [Dec,L] Chicago, IL b. 29 Ja 1889, Netherlands. Studied: AIC; J. Allworthy; C. Buck. Member: All Ill. SFA; Beverly Sketch C.; S. Side AA; Ridge AA, Chicago. Exhibited: Navy Pier, Chicago, 1939; Palmer House, Auditorium Hotel, Chicago. Pres., D. Smit Interior Dec. Co., Chicago [40]

SMITH, A. Knight [Min.P] Phila., PA [24]

SMITH, Adelaine [P] Pittsburgh, PA d. 30 My 1907. Studied: Robert-Fleury, Académie Julian; ASL. Exhibited: Pittsburgh Exh. (prize); New Orleans Exh. (prize). She was also a composer.

SMITH, Albert Alexander [P,E,T] Paris, France. b. 17 S 1896, NYC. Studied: NAD. Exhibited: Harmon Fnd., 1930 (med); Tanner Lg. Exh., Wash., D.C., 1931 (gold) [33]

SMITH, Albert Delmont [Por.P,Mus.Dir] Huntington, NY b. 14 F 1886, NYC d. 2 O 1962. Studied: ASL; F. DuMond; W. Chase. Member: All.A.Am.; Chelsea AC, London; SC; Century. Exhibited: All.A.Am., 1940 (med). Work: TMA; CAM; Gallop A. Ctr.; Detroit Inst. A.; East Hampton, N.Y. Position: A. Dir., Heckscher A. Mus., Huntington, N.Y. [47]

SMITH, Albert E. [P,I] Cos Cob, CT b. Waterbury, CT. Studied: Yale. Member: SC [29]

SMITH, Alfred Aloysius ("Trader Horn") [P] b. ca. 1854 d. 1927. His autobiography, "Trader Horn," ed., E. Lewis, 1928, reveals that he taught painting to wealthy young women around Texas. [*]

SMITH, Alfred E(verett) [P] Nashua, NH b. 27 My 1863, Lynn, MA d. 9 Jy 1955 (age 92). Studied: BMFA Sch., with Crowninshield, Grundmann, Vonnoh; Académie Julian, with Boulanger, Lefebvre, Constant, Doucet. Member: North Shore AA; Gloucester SA. Exhibited: CI; PAFA; CGA; AIC; Boston AC; Gloucester SA; Rockport AA. Work: Harvard Dental Sch.; Wheaton Col.; Phillips Exeter Acad., N.H.; State Capitol, Concord, N.H., Augusta, Maine; State Lib., Concord, N.H.; Univ. N.H.; St. Paul's Sch., Concord; Bowdoin Col., Maine [47]

SMITH, Alfred H. [P] Wash., D.C.[13]

SMITH, Alice J. [P] NYC [01]

SIMPSON, Alice Mary [P] NYC/Gloucester, MA b. Newark, NJ d. 16 My 1934, NYC. Studied: ASL with Cox, Chase, Mowbray. In 1934, she was awarded the President's Medal, in recognition of her "forty years of unsparing devotion" to the Arch. Lg. [33]

SMITH, Alice R(avenel) Huger [P,W] Charleston, SC b. 14 Jy 1876, Charleston, SC. Member: SSAL; Carolina AA; AFA; NAWPS; NAC. Work: Delgado AM, New Orleans; Carolina AA; Brooklyn Inst. A. & Sc.; Albany Inst. History and A. Author/Illustrator: "The Dwelling Houses of Charleston," "The Life of Charles Fraser," "Twenty Drawings of the Pringle House," "A Carolina Rice Plantation of the Fifties." [40]

SMITH, Amanda Banks [P] b. 1846 d. Ap 1824, Greenwich, CT

SMITH, André. See Smith, J. Andre.

SMITH, Anita M(iller) [P,C] Woodstock, NY b. 20 O 1893, Torresdale, PA. Studied: J. Carlson; ASL. Member: NAWPS; Alliance; Woodstock AA. Work: PAFA [40]

SMITH, Anne Fry (Mrs. E.L.) [P] Oreland, PA b. 25 Ja 1890, Phila., PA. Studied: F. Wagner; Chester Springs Summer Sch. PAFA. Member: Phila. Alliance. Work: Pa. State Col. [40]

SMITH, Annie [P] Chickasha, OK [17]

SMITH, Annie H. Raeburn (Mrs.) [Min.P] Phila., PA [08]

SMITH, Archibald Cary [Mar.P] Bayonne, NJ b. 4 S 1837, NYC d. 8 D 1911. Studied: M.F. de Haas. Exhibited: NAD, 1865–81. A shipwright until the mid-1860s, he specialized in yacht portraits, 1867–77 but then gave up painting to design yachts. He was J.G. Tyler's teacher.

SMITH, Arthur B. [P] Cleveland, OH. Member: Cleveland SA [25]

SMITH, Barbara Baldwin. See Baldwin.

SMITH, Belle Patterson (Mrs. Myron) [P] Wash., D.C. Member: Wash. WCC [29]

SMITH, Benjamin F. [Li] b. 1830, So. Freedom, ME d. 1927, ME. Print publisher, with his three brothers, in Boston, NYC, 1848–57. In 1860 he was a banker in Omaha. [*]

SMITH, Bertha [P] Bladensburg, OH. Member: Cincinnati Women's AC [15]

SMITH, Brantley [P] Nashville, TN [25]

SMITH, C.J. [I] Phila., PA [25]

SMITH, C., Mrs. See Shillard.

SMITH, C.W. (Mrs.) [P] Glendale, CA [21]

SMITH, Calvin Rae [P] NYC b. 1850, NYC d. 8 Ag 1918, Brooklyn. Studied: NAD; Carolus-Duran; Ecole des Beaux-Arts, Paris. Member: SC, 1886. Position: T., CCNY [17]

SMITH, Carl. See Smith, Frederick Carl.

SMITH, Carl Rohl [S] b. Denmark (came to the U.S. in early 1880s) d. 22 Ag 1900, Copenhagen. Work: statue of Gen. Sherman, near Treasury Bldg., Wash., D.C.; Soldiers' Mon., Des Moines, Iowa; Massacre Mon., Chicago

SMITH, Cecil A. [P,I,S,T] Somers, MT (1976) b. 1910, Salt Lake City. Studied: NYC, with J. Carroll, M. Weber, Kuniyoshi. Illustrator: Sunset. Cowboy artist who found his subjects on his 89,000 acre ranch. [*]

SMITH, Cecelia (Frederick) [P,I,T] East Orange, NJ/Boothbay, Harbor, ME b. 14 S 1900, Atlanta, GA. Studied: I.W. Stroud [25]

SMITH, Charles L.A. [P] Los Angeles, CA b. 11 Ja 1871, NYC d. 28 N 1937. Studied: self-taught. Member: Boston AC; Calif. AC; Calif. WCC; Chicago SA; S. Western A. Work: Lawrence, Mass. AM [33]

SMITH, Charles Moore [P] Mt. Vernon, NY. Member: SC [21]

SMITH, Charles Timothy [P] Pittsburgh, PA b. 6 S 1897, Pittsburgh. Member: Pittsburgh AA [40]

SMITH, Charles (William) [En,Des,T,B] Bennington, VT/Charlottesville, VA b. 22 Je 1893, Lofton, VA. Studied: Univ. Va.; Yale; Corcoran Sch. A. Member: AIGA. Exhibited: Willard Gal., NYC (one-man); AIC (one-man); BMFA (one-man); VMFA (one-man); MOMA (one-man); Graphic Arts Leaders Exh., 1926. Work: FMA; MOMA; WMAA; AIC; SAM; PMG; SGA; CMA; VMFA; Hollins Col.; Portland (Oreg.) A. Mus.; Valentine Mus.; Mus. Non-Objective Painting; Yale; NYPL; Newark Mus.; 50 Prints of the Year, 1934; Springfield (Mass.) Pub. Lib.; William and Mary Col., Va. Author: "Old Virginia in Block Prints," one of 50 Books of the Year for 1929, "Old Charleston," 1934. Author/Illustrator: Linoleum Block Printing." Positions: T., Bennington Col.; Univ. Va. (Summer Quarter) [47]

SMITH, Clayton B. [P,C,L,T] Eden Park, RI b. 4 Ja 1899, New Bedford, MA. Member: Providence AC; R.I. Assn. T. of Drawing and Manual Arts [31]

SMITH, Clemie C. [P,C,T,W] Omaha, NE b. Tiskilwa, IL. Studied: S.K. Tracy; Univ. Nebr.; Omaha AI; A. Dunbier [33]

SMITH, Curtis Wager [P,I] Phila., PA [04]

SMITH, Dan [I,P,E] NYC b. 1865, Ivigut, Greenland (came to NYC as a boy) d. 10 D 1934. Studied: Public AI, Copenhagen, 1879; PAFA. Position: Staff A. for Leslie's, 1890–97; Hearst newspapers, after 1897; many covers for Sunday New York World mag. section; was artist-correspondent during Spanish Am. War.

SMITH, Dan Evans [T,Des,L,T,W] Chicago, IL b 20 Jy 1905, Aurora, IL. Studied: Un. Typothetae of Am. Sch. Printing; Univ. Wis.; Am. Acad. A., F. Young. Member: S. Typographic A.; A. Dir. C.; A. Gld., Chicago; Dayton A. Ctr. Exhibited: A. Dir. C., NYC, 1945 (med), A. Dir. C., Chicago, 1942–46 (med); Soc. Typographic A., 1939–46 (med); Mark Twain S. Work: Univ. Ill. Lib.; Chicago Pub. Lib.; Univ. Chicago. Author/Illustrator: "Graphic Arts A B C," "Square Serif," 1945. Position: T., Chicago A. Ctr. [47]

SMITH, Dan J. [P] Columbus, OH. Member: Columbus PPC [25]

SMITH, David [S] Brooklyn, NY b. 9 Mr 1906, Decatur, IN d. 24 My 1965, Albany, NY. Studied: Univ. Ohio; George Washington Univ.; ASL, with R. Lahey, J. Sloan, J. Matulka. Member: Am. Abstract A.; United Am. A.; Am. Ar. Cong. Exhibited: MOMA; BM; Denver AM; WFNY, 1939. Work: MOMA; Hirshhorn Mus.; AIC; BMFA; Dallas MA; Detroit IA; WMAA; Ind. Univ. Important sculptor known for his welding of cubist forms in series such as "Cubi," "Agricola," and "Tank Totems." [40]

SMITH, David, Mrs. See Dehner, Dorothy.

SMITH, David H. [P] b. 18 N 1844, Nauvoo, IL d. 27 Ag 1904, Elgin, IL. Amateur Morman painter of religious subjects; also a hymn writer [*]

SMITH, De Cost [P,I,W] Amenia, NY b. 1864, Skaneateles, NY d. 1939, Amenia, NY. Studied: McMullin Sch., NYC; ASL; Académie Julian. Member: SC, 1891. Exhibited: Paris Salon. Work: AMNH; Mus. Am. Indian. Co-Author/Illustrator: (with E.W. Deming) "Sketching Among the Sioux," 1893, "Sketching Among the Crow Indians," 1894, both articles for Outing Magazine [31]

SMITH, Dorman H(enry) [Cart,L] San Anselmo, CA b. 10 F 1892, Steubenville, OH d. 1 Mr 1956. Studied: self-taught. Member: Bohemian C., San Fran.; Marin Co. AA, Calif. Work: Bohemian C., San Fran.; Huntington Lib., San Marino, Calif.; Pa. His. S., Phila. Author: "101 Cartoons," compilation of work, 1936. Position: Cart., San Francisco Examiner and affiliates [40]

SMITH, Dorothy Alden [Book Des.] Phila., PA b. 1 Je 1918, Atlantic City, NJ. Studied: N.Y. Sch. F.&Appl. A.; Sch. Prof. A., N.Y. Member: Booksellers of Phila.; Women in Graphic A. Exhibited: 50 Best Books of the Year, 1945 (prize), 1946 (prize); Phila. Book Exh., 1946 (prize). Positions: A./Dir./Des., The Westminster Press. Phila., from 1944 [47]

SMITH, Duncan [P,T] NYC b. 21 O 1877, Charlottesville, VA d. 8 N 1934, Charlottesville. Studied: ASL, 1896; Am. Acad., Rome; Cox; Twachtman; DeCamp; Brush; Blum. Member: Arch. L.; Fifteen Gal. Exhibited: Fifteen Gal. Work: murals, NYC, other cities. Position: T., ASL [33]

SMITH, E. Bert [Cart] Denver, CO. Member: Denver AC Position: staff, Rocky Mountain News, Denver [06]

SMITH, E. Galusha (Mrs. William H.) [P,T] Peoria, IL b. 24 O 1849, Morris, IL. Studied: Chataine; M. Pullman; F.C. Peyraud. Member: Peoria AL; Peoria AA. Exhibited: Fine Arts Dept., National Implement Assn., 1920 (prize). Work: Shirley-Savoy Hotel, Denver [24]

SMITH, E(arl) Baldwin [Ed,W,L] Princeton, NJ b. 25 My 1888, Topsham, ME. Studied: PIASch.; Bowdoin; Princeton. Author, Ed. "Early Christian Iconography," 1918. Position: T., Princeton Univ., since 1916 [47]

SMITH, Edith T. [P] Wethersfield, CT. Exhibited: Springfield AL, 1936 [40]

SMITH, Edmund Revel [Ldscp.P] Skaneateles, NY (1859) b. 1829 d. 1911. Exhibited: NAD, 1859 [*]

SMITH, Edna Wybrant [P] Phila., PA [08]

SMITH, (Edward) Gregory [P] Old Lyme, CT b. 2 My 1880. Grand Rapids, MI b. 7 N 1961, Boiling Springs, PA. Studied: AIC. Member: Lyme AA (Pres.), 1934–58; CAFA, 1938 (prize); Allied AA; New S. Am. A. Exhibited: Lyme AA, (prizes) 1922, 1927, 1931, 1936; Lyme Hist. S., 1977 (retrospective). Work: Grand Rapids A. Gal.; Hackley A. Gal., Muskegon, Mich. An active member of the colony at Old Lyme since 1910, most of his work was destroyed in a 1925 fire. [40]

SMITH, E(dward) Herndon [P,S] Mobile, AL b. 9 Jy 1891, Mobile. Studied: Weir; Tack; Yale. Member: Brooklyn S. Modern A. [33]

SMITH, Edward R. [Lib,P,S] NYC b. 3 Ja 1854, Beyrout, Syria d. 21 Mr 1921, Stamford, CT. Studied: W. Rimmer; R. Duveneck. Member: Arch. Lg., 1910; N.Y. Mun. AS; Archaeological Inst. Am.; Am. Numismatic S.; Am. Lib. Assn. Position: Lib., Avery Library, Columbia Univ. [19]

SMITH, Edwin James [P] Omaha, NE b. 14 O 1899, Omaha. Studied: P. Dickinson [40]

SMITH, Eileen A. [P] Delaware, OH b. 29 S 1899, Hastings, NE. Member: Alliance [25]

SMITH, Eliza Lloyd [P] Wash., D.C./Bluemont, VA b. 21 Jy 1872, Urbana. OH. Studied: Corcoran A. Sch. Member: Wash. WCC [31]

SMITH, Elizabeth [P] Baltimore, MD. Member: Baltimore WCC [29]

SMITH, Ella B. [P] Boston, MA. Member: Chicago NJSA [25]

SMITH, Elma (Mrs.) [P] East Cleveland, OH. Member: Cleveland Woman's AC [25]

SMITH, E(lmer) Boyd [I] Wilton, CT (since early 1900s) b. 31 My 1860, St. John, New Brunswick d. 1943. Studied: Académie Julian, with Boulanger, Lefebvre. Member: Boston AC. Author/Illustrator: "The Story of Noah's Ark," "The Chicken World," "Pocahontas and Captain John Smith," "The Story of Our Country." Position: first Dir.of the Kansas City AA and Sch. Des. [33]

SMITH, Emily Guthrie (Mrs. Tolbert C.) [P] Fort Worth, TX b. 8 Jy 1909, Ft. Worth. Studied: Tex. State Col. for Women; Okla. Univ.; ASL; R. Brackman. Member: SSAL; Tex. FAA. Exhibited: VMFA, 1946; Oakland A. Gal., 1945; AWCS, 1946; Caller-Times Exh., Corpus Christi, Tex., 1945; SSAL, 1941–46; Tex. General Exh., 1942–46; Tex. FAA, 1943–46; Ft. Worth AA, 1940–45 [47]

SMITH, Emma J. (Mrs.) [P] Wash., D.C. Member: Wash. WCC [31]

SMITH, Ernest Browning [P] Los Angeles, CA (since 1895) b. 30 N 1866, Brimfield, MA d. 26 Ap 1951. Studied: self-taught. Member: Calif. AC; Laguna Beach AA. Exhibited: Sacramento State Fair, 1925 (prize); Pomona, Calif., 1925, 1928. Work: Los Angeles Mus. A.; SFMA. Played French horn in Los Angeles Symphony Orchestra, 1897–1911. [47]

SMITH, Erwin E. [S,Ph] b. 1888, Honey Grove, TX d. 1947 nr. Bonham, TX. Studied: L. Taft, Chicago; B. Pratt, Boston. Illustrator: "Life on the Texas Range," J.E. Haley, 1952; cowboy and pioneer scenes in many of G. Patullo's Western stories. [*]

SMITH, Ethel Amelia [P] Woodbury, NJ. Studied: PAFA [25]

SMITH, Ethel M. [P] Worcester, MA [25]

SMITH, Eunice Hatfield [Por.P] Poughkeepsie, NY b. 6 Je 1911, Mamaroneck, NJ. Studied: Syracuse Univ.; ASL. Member: Am. Assn. Univ. Women; Dutchess County AA. Exhibited: Dutchess County AA. Work: many portraits, U.S. & abroad [47]

SMITH, Eva F. [P] NYC [01]

SMITH, F(rancis) Drexel [P] Colorado Springs, CO b. 11 Je 1874, Chicago. Studied: AIC; Broadmoor A. Acad.; Vanderpoel; J. Carlson; E. Warner. Member: Denver AC; Miss. AA; Chicago Gal. Assn.; NOAA; Dubuque AA; Broadmoor A. Acad. (Pres.); Colorado Springs FA Ctr. (trustee). Exhibited: CI, 1924, 1929, 1930; NAD, 1922; PAFA, 1932–34; AIC, 1931;

Oakland A. Ga.; Portland (Oreg.) A. Mus.; New Haven, Conn.; Buffalo, N.Y.; Palm Beach, Fla.; Kansas City AI, 1924 (prize); SAM, 1929 (prize); NOAA, 1940 (prize); Seattle FA Soc., 1923; Buffalo SA, 1925 (prize); Denver AM, 1927 (prize), 1928 (prize) 1936 (prize); Colorado Springs, 1929 (prize), 1930 (prize), 1932 (prize); Miss. AA, 1932 (med). Work: Kansas City AI; Denver AM; Vanderpoel Coll.; Colorado Springs FA Ctr.; Dubuque AA; Mun. AC & Belhaven Col., Jackson, Miss.; Mus. FA, Montgomery, Ala.; Grinnell Col.; Miss. State Col. for Women [47]

SMITH, F. Stanley [P] North Shirley, MA. Member: Phila. WCC [31]

SMITH, Florence Sprague (Mrs. Jefferson R.) [S] St. Louis, MO b. 22 O 1888, Paulina, IA. Studied: ASL, with C. Mulligan, A. Polasek. Member: Indp. A. St. Louis. Exhibited: Iowa AC, 1932 (prize). Work: Des Moines Water Works; Pub. Lib., port. bust, Drake Univ. Chapel, all in Des Moines [40]

SMITH, F(rancis) Berkeley [I,Arch,W] Paris, France b. 24 Ag 1868, Astoria, NY d. Fall, 1931. Studied: Columbia. Author/Illustrator: "The Real Latin Quarter," "Budapest, the City of the Magyars"; mag. articles; short stories. Son of F. Hopkinson. Position: practicing arch. until 1896 [33]

SMITH, Frances S. (Mrs. George De Forest) [P] NYC. Member: NYWAC [04]

SMITH, F(rancis) Hopkinson [Ldsp.P,I,W,L] NYC b. 23 O 1838, Baltimore d. 1915. Studied: self-taught. Member: AWCS (Treas., 1873–78); Phila. AC; NIAL; SI, 1906; Cincinnati AC; Century Assn. Exhibited: Pan-Am. Expo, Buffalo, 1901 (med); Charleston Expo, 1902 (med); Phila. AC, 1902 (gold); AAS, 1902 (gold). Awards: Commander Order of the Mejidieh, 1898; Order of Osmanieh, 1900. Work: CGA; Albright A. Gal., Buffalo. Author: "Col. Carter of Cartersville," "Fortunes of Oliver Horn," "American Illustrators," 1894. After the Civil War he was a naval engineer with fellow artist J. Symington. They built the foundation for the Statue of Liberty and many breakwaters. [13]

SMITH, Francis S. (Mrs.) See Ingham-Smith, Elizabeth.

SMITH, Frank Hill [Dec,P] Boston, MA b. 1841, Boston d. 1904. Studied: architecture, with Hammatt Billings; Bonnât, Atelier Suisse, Paris; Italy. Member: Jury of Fine Arts, Centenn. Expo, Phila, 1876; BMFA Sch. (a director). Work: Opera House, Holyoke, Mass; public and private bldgs., Boston, Cambridge

SMITH, Frank Vining [Mar.P,W] Hingham, MA b. 25 Ag 1879, Whitman, MA d. 30 Jy 1967. Studied: BMFA Sch., with P. Hale, Benson, Tarbell; Central Ontario Sch. Des., Toronto; ASL. Exhibited: since 1922 (one-man); Jordan Marsh, Boston, 1939 (med), 1942 (med), 1945 (med), 1946 (med). Work: Kendall Whaling Mus.; Mariners Mus.; Mystic Seaport Mus.; Old Dartmouth Hist. Soc.; yacht clubs.: Grosse Pointe, Mich., New Bedford, Mass., Hingham, Marblehead, both in Mass.; Dartmouth Inst., New Bedford. Contributor: Yachting, Field & Stream, Outdoors [47]

SMITH, F(rederick) Carl [Por.P] Pasadena, CA (since 1917) b. 7 S 1868, Cincinnati d. 16 N 1955. Studied: Cincinnati A. Acad.; Académie Julian, with Bouguereau, Ferrier, Constant. Member: Laguna Beach AA; Calif. AC; Pasadena SA. Exhibited: AAS, 1902; Los Angeles Mus. A.; CGA; Paris Salon; Southwest Mus., Los Angeles, 1921 (prize). Work: Pub. Lib., Minneapolis; Continental Hall, Wash. D.C.; Allegheny (Pa.) Observatory; Capitol, Denver, Colo.; Capitol, Columbus, Ohio [47]

SMITH, Frederick W. [P] Kennebunkport, ME b. 21 My 1885, Malden, MA. Studied: E. O'Hara. Member: North Shore AA; Goose Rocks Beach AA [40]

SMITH, Gean [P,I] Galveston (since 1923) b. 1851, New York State d. 7 D 1928. His art training consisted of one lesson taken at the age of sixteen, costing one dollar. He maintained a studio in NYC (after moving from Chicago in 1885). His paintings comprise a pictorial record of the champion racing horses of America. He also painted dogs and western animals.

SMITH, George Ann [P] Wash., D.C. b. 1 Ag 1921, VA. Studied: Corcoran Gal. Sch., Wash., D.C. Exhibited: Smithsonian, 1937; Wash. WCC, 1939 [40]

SMITH, George Melville [P] Chicago, IL. Exhibited: AIC, 1933, 1937, 1938; 48 Sts. Comp., 1939. Work: WPA murals, USPOs, Elmhurst (Ill.), Park Ridge (Ill.), Crown Point (Ind.) [40]

SMITH, George N. [P] Oakland, CA [19]

SMITH, George Robert, Jr. [P] Bronx, NY b. S 1889, NYC. Studied: ASL; West End Sch. Art; G.E. Browne. Member: Provincetown AA; Cyasan A.; Bronx AG [31]

SMITH, George Walter Vincent [Patron] d. 28 Mr 1923. Position: Donor/ Dir., Springfield (Mass.) AM (1895)

SMITH, George W(ashington) [P,Arch] Santa Barbara, CA (since 1915) b. 22 F 1879, East Liberty, PA d. 16 Mr 1930, Montecito, CA. Studied: arch., Harvard, 1894–96; Ecole des Beaux-Arts, Paris, 1912–14; Rome. Member: Paris AAA; NAC; Calif. AC; AIA [29]

SMITH, Georgine. See Shillard.

SMITH, Gertrude Binney [Ldscp.P,Mar.P] Amesbury, MA b. 1873 d. 18 Je 1932, Beverly, MA. With several of her paintings under her arm, she was en route to an exhibition of the North Shore AA at East Gloucester, when she discovered she had taken the wrong train. With the train well underway, she is believed to have jumped off, and was instantly killed.

SMITH, Gertrude Roberts (Mrs.) [P,C,T] New Orleans, LA b. 11 My 1869, Cambridge, MA. Studied: Mass. Normal A. Sch.; Chase Sch.; Colarossi Acad., Paris. Member: SSAL; Boston ACS; NOAA; NOACC; Needle and Bobbin C. Exhibited: NOAA, Delgado AM (gold). Work: Newcomb Col. Position: T., Newcomb Col. [40]

SMITH, Gladys K. [B,Dr,S,T] Phila, PA/Avalon, NJ b. 30 Ap 1888, Phila. Studied: Phila. Sch. Des.; PAFA. Member: Plastic C.; Eastern AA. Work: Star Garden Rec. Ctr., Phila. Position: T., Shaw Jr. H.S., West Phila. [40]

SMITH, Gladys Nelson [P] Wash., D.C. Studied: S. Wash. A. Exhibited: S. Wash. A., 1936 (prize), 1939 (prize) [40]

SMITH, Grace P. [P,I] NYC b. Schenectady, NY. Member: AG [31]

SMITH, Gregory. See Smith, Edward Gregory.

SMITH, Guy [I] Yonkers, NY [19]

SMITH, H.E. [P,I] Paris, France. Position: staff, Harper's [13]

SMITH, Harriet E. [Dec] Montpelier, VT Studied: Yale; Metropolitan A. Sch. Member: Boston SAC. Specialty: dec.: trays, chairs, chests, antiques only [40]

SMITH, Harriet F(rances) [P,T] Allston, MA b. 28 Jy 1873, Worcester, MA d. 9 Je 1935. Studied: Mass. Normal A. Sch.; D. Ross; E.W.D. Hamilton; H.B. Snell; C.H. Woodbury; P. Hale. Member: Copley S.; EAA; NYWCC; AFA; Boston AC. Position: T., Boston Pub. Sch. [31]

SMITH, Harry Knox [C,P,Des] NYC b. 24 Ap 1879, Phila., PA. Studied: T. Anshutz, PAFA. Work: stained glass windows in many public bldgs. & churches; paintings in private coll. [47]

SMITH, Hassel Wendell, Jr. [P,T,Li] San Francisco, CA b. 24 Ap 1915, Sturgis, MI. Studied: Northwestern Univ.; Calif. Sch. FA; M. Sterne. Member: San Fra. AA; A. Gld; Rosenberg F. Exhibited: San Fran. AA, 1938–46, 1942 (prize); Palace Legion Honor. Position: T., San Fran. State T. Col., from 1945 [47]

SMITH, Helen Leon [P,C,Dec] Frederick, MD b. 21 Ja 1894, Frederick. Studied: C.Y. Turner. Member: Frederick AC. Work: murals: Court House, Masonic Temple, Frederick; Unionville Church, Burkettsville, Md.; church in Mt. Carmel, Md.; Frederick County Hospital [47]

SMITH, Helen Shelton [P] NYC [01]

SMITH, Helena Wood [P] Brooklyn, NY [04]

SMITH, Helene F. [S] NYC [15]

SMITH, Henry A. [P] NYC [10]

SMITH, Henry Pember [Ldscp.P] Asbury Park, NJ b. 20 F 1854, Waterford, CT d. 16 O 1907. Studied: self-taught. Member: AWCS; A. Fund S. Exhibited: NAD, 1977–99. Specialty: New England scenes; views of Venice [06]

SMITH, Henry T. [I] Upper Montclair, NJ b. 1866, Stoke-on-Trent, England (came to the U.S. as a child) d. 18 Ja 1947. Positions: staff, The Evening World, NYC, Dir., A. Dept., 1901–31

SMITH, Holmes [P,T,W,L] St. Louis, MO/Magog, Quebec, Canada b. 9 My 1863, Keighley, England d. ca. 1938. Member: St. Louis AG; 2x4 S.; Archaeological Inst. of Am.; St. Louis Chap. AIA [33]

SMITH, Hope [P] Providence, RI b. 10 My 1879, Providence. Studied: Woodbury; Chase; RISD; Paris. Member: Providence AC; South County AA. Work: RISD [40]

SMITH, Houghton Cranford [P] Taos, NM/NYC [25]

SMITH, Howard E. [P,Li,E] Carmel, CA b. 27 Ap 1885, West Windham, NH. Studied: ASL; BMFA Sch. (Paige Traveling Schol.); G. Bridgman; E.

Tarbell; H. Pyle. Member: ANA, 1921; Gld. Boston A.; North Shore AA; Carmel AA (Dir.); AAPL; AWCS; Rockport AA. Exhibited: CGA; Santa Cruz AL (prize); Oakland A. Gal.; P.-P. Expo, 1915 (med); AIC, 1923 (prize); Sacramento State Fair, 1942 (prize); Wilmington SFA (prize); PAFA (prize); AAPL (prize), 1945 (prize); NAD, 1917 (prize), 1921 (med), 1931 (prize). Work: PAFA; North Adams (Mass.) Pub. Lib.; Brown Univ.; State House, Boston; Rand Sch., N.Y.; Portia Law Sch., Latin Sch., both in Boston; De Cordova Mus., Lincoln, Mass.; U.S. Treasury Dept. [47]

SMITH, Ira [P] NYC. Member: AWCS [47]

SMITH, Ira J. [P] Pittsburgh, PA. Member: Pittsburgh AA [25]

SMITH, Irwin Elwood [P,B] Topeka, KS b. 14 F 1893, Labette, KS. Studied: Chicago Acad. FA; Washburn Univ.; G.M. Stone; C. Werntz; F.R. Southard; D.H. Overmeyer. Member: Topeka AG; Prairie WCA. Exhibited: Kansas City AI; Joslyn Mem.; Topeka AG; Prairie WC Exh.; Kansas Fair, 1934 (prize), 1936 (prize); Kansas A. Exh., Topeka, 1945 (prize). Work: Kansas Fed. Women's C.; Highland Park Jr. H.S., Boswell Jr. H.S., Topeka, Kansas; Stephenson Sch., Winfield, Kansas [47]

SMITH, Isabel E. (Mrs. F. Carl) [Min.P] Pasadena, CA b. 28 Ag 1843, Smith's Landing, OH d. 4 O 1938. Studied: Paris, with L'hermite; Delance, Callot. Member: Paris Woman's AC; Pasadena FAC [40]

SMITH, Ishmael [P,S,I] NYC b. 16 Jy 1886, Barcelona, Spain. Member: SC; Am. Soc. Book plate Collectors, and Des.; MOMA; S.Indp.A. Work: monu., Catalonia; port., Institute des estudies Catalans; port., Mus. Barcelona, Spain; British Mus., London; Hispanic Mus., NYC; Cleveland Mus.; Carmelite Fathers, Wash., D.C. [40]

SMITH, J. [S] NYC [19]

SMITH, J. Andre [P,E,T,W,Arch] Maitland, FL/Stony Creek, CT b. D 1880, Hong Kong d. 3 Mr 1959. Studied: Cornell Univ. Member: SAE. Exhibited: Fine Prints of the Year, 1931; Pan-Pacific Expo, 1915 (gold). Work: LOC; MET; BMFA; BMA; Honolulu Acad. A. Illustrator: "The Marne," "Art and the Subconscious." Position: Dir., Research Studio, Maitland, Fla.; official artist, A.E.F., France, 1919 [47]

SMITH, J.F. [P] Toledo, OH. Member: Artklan [25]

SMITH, J. Howard [P] Chicago, IL [10]

SMITH, Jack W(ilkinson) [P] Alhambra, CA (since 1906) b. 1873, Paterson, NJ d. 8 Ja 1949, Monterey Park, CA. Studied: Cincinnati A. Acad.; AIC. Member: Calif. AC; Calif. C.; Allied AA; SC; Laguna Beach AA. Exhibited: San Diego Expo, 1915 (med), 1916 (med); Sacramento Expo, 1917 (med), 1918 (med), 1919 (gold); Los Angeles Liberty Expo, 1918 (prize); Calif. AC, 1919 (prize); Phoenix, Ariz., Expo 1919 (prize), 1920 (prize); P. of the West, 1924 (gold), 1929 (gold), 1929 (prize). Work: Phoenix Municipal Coll. [40]

SMITH, Jacob Getlar [P,Dr,T] NYC b. 3 F 1898, NYC d. 28 O 1958. Studied: NAD. Member: NYWCC; An Am. Group; AWCS; NSMP; Guggenheim F., 1929. Exhibited: CI; PAFA; CGA; VMFA; WMAA; AIC, 1926 (prize), 1930 (prize). Work: WMAA; U.S. Dept. Labor; Mo. State T. Col.; murals, USPOs, Nyack, N.Y.; Salisbury, Md. Author: "Water-color Demonstrated," 1945. Contributor: Pictures on Exhibit, American Artist. [47]

SMITH, James Calvert [I] NYC. Member: SI; Artists G.; SC [31]

SMITH, Jaquelin Taliaferro [C,T] Arlington, VA b. 19 Ja 1908, Wash., D.C. Studied: Md. Inst. Member: Arts C. Wash. [40]

SMITH, Jerome Howard [I,Cart,P] b. ca. 1861, Pleasant Valley, IL d. 1941, Vancouver, British Columbia. Studied: Chicago, ca. 1884; Paris, 1890–92. Cartoonist: Chicago Rambler; Judge, NYC, 1887. Cowboy artist who turned to Western genre after his 1880s–90s career as a cart. and illus. [*]

SMITH, Jessie Sherwood [C,T] Hollywood, CA b. 12 F 1885, Vesper, WI. Studied: AIC; Calif. Col. A.&Cr.; Columbia; RISD; G. Lukins; E. Mayer; A.W. Dow; H.S. Dixon; A.F. Rose. Member: A. T. of Southern Calif.; Pacific AA. Exhibited: PAFA; AFA Exh., Paris Salon, 1937; GGE, 1939; Los Angeles County Fair, 1936 (prize). Specialties: jewelry; silver; coppersmithing. Positions: T., Los Angeles City H.S. (from 1923), Univ. Calif., 1945–46 [47]

SMITH, Jessie Willcox [P,I] Phila., PA b. 1863, Phila. d. 3 My 1935. Studied: PAFA; Drexel Inst., with H. Pyle. Member: Plastic C.; Phila. WCC; SI 1904; NYWCC; Phila. Alliance; AFA. Exhibited: Charleston Expo, 1902 (med); PAFA, 1903 (prize); St. Louis Expo, 1904; Phila. WCC, 1911 (prize); P.-P. Expo, San Fran., 1915 (med). Illustrator: "Child's Garden of Verses," R.L. Stevenson, "Water Babies," C. Kingsley; cover des., many mags. Specialty: children [33]

SMITH, John Bertie [P,W,T] Laramie, WY b. 5 Je 1908, Lamesa, TX. Studied: Baylor Univ.; Univ. Chicago; AIC; Columbia; J. Bakos; P. Mangravite. Member: CAA. Exhibited: Denver AM, 1938, 1939, 1941, 1943, 1945; SSAL, 1944, 1945; Colorado Springs FA Ctr., 1945. Work: Denver AM; Univ. Wyo.; Athens (Tex.) Pub. Lib. Contributor: Design, School Review. Position: T., Univ. Wyo., from 1939 [47]

SMITH, John C., Mrs. See Hatfield, Eunice.

SMITH, John E. [P] St. Paul, MN [17]

SMITH, J(ohn) Francis [P,T] Los Angeles, CA b. Chicago, IL. Studied: Gregori; Boulanger; Lefebvre, Constant. Member: Paris AAA; Chicago SA; Calif. AA. Position: T., Chicago AA; Académie Julian; Calif. Inst. A., Los Angeles; Smith A. Sch., Los Angeles [40]

SMITH, Joline Butler [P] Madison, CT. Member: CAFA; N.H. PCC [25]

SMITH, Joseph Lindon [P,S,Dec,C,L] Dublin, NH b. 11 O 1863, Pawtucket, RI. Studied: BMFA Sch., with Crowninshield, Grundmann; Académie Julian, with Boulanger, Lefebvre. Member: Mural P.; Boston SAC; Copley S., 1882; Century Assn. Exhibited: Phila. WCC, 1905 (prize). Work: murals, Boston Pub. Lib.; Horticultural Hall, Phila.; paintings, CGA; Smithsonian Inst.; AIC; BMFA; Gardner Mus., Boston; RISD; Dartmouth Col.; FMA; Harvard; Musée Guimet, Paris; Louvre Sch., Paris; studies from sculpture in: Italy, Egypt, Turkey, Mexico, Guatemala, Java, India, China, Sudan, Cambodia, Siam, Greece, Hondura, Yucatan, Japan, for museums. Lectures: on Persia; Egypt. Position: Honorary Cur., Egyptian Dept., BMFA; Harvard-Boston Mus. Expo, Pyramids, Egypt [40]

SMITH, Josephine [P] Madison, WI [25]

SMITH, Judson De Jonge [P,T] Woodstock, NY b. 14 Jy 1880, Grand Haven, MI d. 29 D 1962. Studied: J. LaFarge; J. Twachtman; Kenyon Cox. Member: Audubon S.; Woodstock AA; Am. S. PS&G; NSMP. Exhibited: CGA; PAFA; WMAA; CI, 1931; AIC, 1933 (prize); VMFA, 1944 (prize); Audubon A.; Detroit Inst. A., 1926 (gold) (prize), Asbury Park SFA, 1939 (gold). Work: Detroit Free Press; WMAA; Clinton Hotel, NYC; WPA murals, USPOs, Albion, N.Y., Kutztown, Pa. Positions: T., Univ. Tex., 1945; Dir., Woodstock (N.Y.) Sch. Painting [47]

SMITH, Katherine Adams [P] Paris, France [01]

SMITH, Katharine English [P] Wichita, KS b. 12 Mr 1899, Wichita. Studied: E.M. Church; B. Sandzen; C. Hawthorne; R. Reid; G.B. Bridgman. Member: Wichita AA; Smoky Hill AC [29]

SMITH, Kit Bellinger [P,Des] Rochester, NY [10]

SMITH, Lawrence Beall [P,Gr] Boston, MA b. Wash., D.C. Studied: Univ. Chicago; AIC; Thurn; Hopkinson; Zimmerman. Exhibited: AIC, 1940 (prize). Work: Herron AI; Harvard; AGAA; Swope A. Gal.; Univ. Minn. Position: T., Pub. Sch., Boston [47]

SMITH, Leon P. [P,L,T] NYC b. 20 My 1906, Chickasha, OK. Studied: Central State Col., Ada, Okla.; Columbia. Member: Guggenheim F., 1944; Nat. Edu. Assn. Exhibited: BM, 1942–44; AIC, 1943; WMAA, 1946; SFMA, 1944; Telfair Acad. A., 1941; MET, 1943; NY, 1941 (one-man), 1943 (one-man), 1946 (one-man). Work: Ind. Mus. Mod. A.; Univ. Ariz.; Univ. Ga. [47]

SMITH, Letta Crapo [P] Detroit, MI b. 4 Jy 1862, Flint, MI d. 17 Mr 1921. Studied: Chase, NYC; J. Rolshoven; G. Hitchcock; Académie Julian, Paris. Exhibited: St. Louis Expo, 1904 (med) [19]

SMITH, Leverett L. [P] Wheaton, IL [10]

SMITH, Leyland C(roft) [P,I,T] Opelika, Ala. b. 10 N 1910, Opelika. Studied: F.W. Applebee; R.H. Staples; S.W.J. VanSheck. Exhibited: Montgomery Mus. FA, 1932. Work: Ct. House, Opelika; Ala. Polytechnic Inst., Auburn [40]

SMITH, Lillian B. [P] Denver, CO [01]

SMITH, Linus Burr [P,Arch,Des,L,T] Lincoln, NB b. 8 Mr 1899, Minneapolis, KS. Studied: Kansas State Col.; Harvard Univ. Member: AIA (pres.); Neb. AA. Position: T., Univ. Nebr. [40]

SMITH, Louise J(ordan) [P,T] Lynchburg, VA/Flint Hill, VA b. 28 Mr 1873, Warrenton, VA d. 31 D 1928. Studied: J.H. Twachtman; J.A. Weir; Lefebvre; R. Fleury. Member: Va. Art Teachers' Assn.; NAD; Wolfe AC. Position: T., Randolph-Macon Women's Col., Lynchburg [27]

SMITH, Lucian E. [I,Arch] NYC [17]

SMITH, Lydia Dunham [P] Chicago, IL [10]

SMITH, Lyman [P] Sheridan, WY. Studied: Colo. Springs FA Ctr.; AIC.

Member: Colo. Springs FA Ctr.; A. Forum, Sheridan. Exhibited: Colo. Springs FA Ctr., 1935, 1936, 1937 [40]

SMITH, M.E. [P] Portland, OR. Exhibited: 48 States Comp., 1939 [40]

SMITH, Mabel Beatrice [Min.P] NYC b. Phila., PA. Studied: Phila. Sch. Des. Women; ASL; A. Beckington; M.R. Welch, Am. Sch. Min. Painting. Member: NAWPS [19]

SMITH, Marcella (Claudia Heber) [P,T] Wash., D.C. b. 6 Mr 1887, Molesey, Surrey, England. Studied: Delecluse, in Paris; F. Milner, at Royal British Acad., London; Corcoran Sch. A.; Phila. Sch. Des. Member: S. Wash. A. [33]

SMITH, Margaret L. [B] Pasadena, CA b. 9 F 1910, Guanapinto, Mexico. Member: Northwest PM [32]

SMITH, Margery Hoffman [Des,C,P,L] San Francisco, CA b. 30 Ag 1888, Portland, OR. Studied: Bryn Mawr Col., Portland A. Mus. Sch.; ASL; F.H. Wentz; K.H. Miller; A.B. Dow; H. Rosse. Member: San Fran. S. Women A.; Portland AA; Portland ACS. Exhibited: San Fran. Soc. Women A. Contributor: Design mag. Position: A. Dir., WPA, Oreg.; Bd. Member, SFMA, Portland AM. WPA artist. [47]

SMITH, Marie [P] NYC. Member: Bronx AG [27]

SMITH, Marrow Stuart (Mrs.) [P,T,L,W] Norfolk, VA/London Bridge, VA b. Staunton, VA. Studied: A. Dow; J. Carlson; G. Cox; G. Cootes; R.S. Bredin. Member: Norfolk A. Corner; Eastern AA; VMFA. Exhibited: Norfolk SA, 1927-38. Position: A. Dir., Norfolk Pub. Sch. [40]

SMITH, Marshall D. [P] Chicago, IL. Exhibited: AIC, 1933-39. WPA artist. [40]

SMITH, Mason, Mrs. [P] New Orleans, LA [01]

SMITH, May Mott. See Mott-Smith.

SMITH, Mildred R. See Martin.

SMITH, Minna Walker (Mrs.) [P] New Haven, CT b. 29 Mr 1883, New Haven. Studied: Yale. Member: AWCS; New Haven PCC; NYWCC. Exhibited: Ogunquit AC, 1932 (prize); New Haven PCC, 1933. Work: New Haven PCC [47]

SMITH, Miriam Tindall [P,C,S] Phila., PA. b. Norwood, PA. Studied: PMSchIA; A. Carles. Member: Phila. A. All. Exhibited: AIC, 1934-36; W.R. Nelson Gal., 1936; Minneapolis Inst. A., 1936; Dayton AI, 1936; PMA, 1935; PAFA, 1931, 1937; Woodmere A. Gal., 1941; Phila. A. All.; Frankford Hist. S.; Warwick Gal., Phila. (one-man); murals, masks, sculptures.; WFNY, 1939; PMSchIA, 1933 (med); Phila. Sketch C., 1940 (med). Work: murals, Lutheran Church, Norwood, Pa.; N.Y. Central & Santa Fe R.R.; Children's Ward, Univ. Pa. Hospital; Baptist Church, Shelby, N.C.; CGA; Phila., Mus.; Reading Mus. [47]

SMITH, Moore [P] Mt. Vernon, NY [13]

SMITH, Myrtis [P,T] Memphis, TN b. 4 S 1887, Kosciucsko, MS. Studied: Miss. State Col. for Women; AIC; N.Y. Sch. F.&Appl. A.; Tulane; G. Bellows; R. Reid. Member: Palette and Brush C., Memphis; SSAL; Western AA. Position: T., Snowden Jr. H.S., Memphis, TN [40]

SMITH, Myrtle Holm (Mrs. Clifford P.) [P,Dr] Brookline, MA b. 4 My 1875, Toledo, OH. Studied: Grinnell Col.; W. Reaser; G. Noyes; C. Woodbury. Member: North Shore AA; Mablehead AA. Exhibited: North Shore AA; Grace Horne Gal.; Dayton AI traveling exh.; Boston AC [47]

SMITH, Oliver Phelps [P,C,Dec,Des] Haddam, CT b. 18 D 1867, Hartford d. 10 Jy 1953. Studied: NAD; CUASch. Member: AWCS; NYWCC. Work: stained glass windows: Temple Beth-El, Detroit; Dix Mem. Chapel, Old Trinity Church, N.Y.; Mem. Chapel, Wesleyan Univ., Middletown, Conn.; heraldic windows, A.E.F. Mem. Chapel, Meuse-Argonne Cemetery, Romagne, France; glass mosaic ceiling, Woolworth Bldg., NYC [47]

SMITH, Owen E. [P] Hartford, CT. Member: CAFA [25]

SMITH, Pamela Colman [I] London b. 1878. Studied: PIASch, 1893-97; A.W. Dow; settled in London, 1899, befriending artists of the Irish Renaissance. Exhibited: first non-photographic artist to be exhibited at Stieglitz' Little Galleries of the Photo-Secession, 1907-09; retrospective held at Delaware AM, 1975. Work: published and edited "The Green Sheaf," London, 1903-04, with poems by W.B Yeats and others; designed the "Rider deck" of Tarot cards, 1909 [01]

SMITH, Patrick Knox [Commercial A] Minneapolis, MN b. 26 Jy 1907, Edinburgh, Scotland. Studied: Federal Sch., Inc. Exhibited: Minn. State Fair, 1931 (prize); North Mont. Fair, 1932 (prize). Position: Staff artist, Bureau of Engraving, Federal Schs. [40]

SMITH, Paul [Des,I,W] Fair Haven, NJ b. 18 Ja 1907, Worthington, MN. Studied: Univ. Minn. Member: SI; A. Dir. C. Exhibited: A. Dir. C., NYC, 1934 (med), 1935 (med), 1942 (med), 1945 (med); A. Dir. C., Chicago, 1930 (med), 1931 (med), 1932 (med), 1933 (med), 1935 (med); Adv. A. Exh., 1942 (med) [47]

SMITH, Paul H. [G,Arch] Fox Lake, IL b. 9 N 1894, Brooklyn, NY. Studied: PIASch. Member: Chicago SE; Prairie PM. Work: Smithsonian; Holabird and Root, Arch, Chicago [40]

SMITH, Paul Kauvar [P] Denver, CO (1973) b. 27 F 1893, Cape Girardeau, MO. Studied: St. Louis Sch. FA, Wash. Univ.; Denver A. Acad.; F.G. Carpenter; J.E. Thompson. Member: AAPL; Denver AG. Exhibited: Palace Legion Honor, 1946; Denver AM, 1923-45; Springville, Utah, 1946; Heyburn, Idaho, 1940-42, 1946; Kansas City AI, 1938, 1939, 1942; Joslyn Mus., 1939, 1943-45; Denver AG, 1934 (prize), 1935-45; WFNY, 1939; Denver AM, 1923-51, 1952 (one-man). Work: Heyburn (Idaho) Pub. Sch.; Denver AM [47]

SMITH, Paul Williamson [P,C,T] St. Davids, PA b. 8 Ag 1886, Phila., PA. Studied: PMSchIA; PAFA, Cresson traveling schol., 1908; W. Chase; C. Beaux. Member: Phila. A. All.; F., PAFA. Exhibited: Woodmere A. Gal.; Phila. A. All.; Warwick Gal., Phila.; PAFA [47]

SMITH, Ray Twitchell [Dr] Charleston, SC [24]

SMITH, R(obert) Harmer [P,Des,Arch] Jersey City, NJ 27 Jy 1906, Jersey City. Studied: PIASch; Yale; Watson; Yale; ASL. Exhibited: AWCS; Arch. L.; Jersey City Mus. Assn. Contributor: American Artist, Architectural Record; Pencil Points, 1937 [47]

SMITH, Robert M. [P] Columbus, OH. Member: Columbus PPC [25]

SMITH, Robin Artine [P,Des] Dallas, TX b. 18 Jy 1903, Warren, AR. Studied: AIC; Northwestern Univ.; H. Ropp; E. O'Hara. Member: Dallas AA; Tex. FAA; NAWA. Exhibited: AWCS, 1945; NAWA, 1945, 1946; SSAL, 1944, 1945; All. A., Dallas, 1943 (prize), 1944 (prize), 1945-46; Tex. General Exh., 1943-46; Reaugh C., 1943-45; Klepper C., 1943-45; Tex. FAA, 1945 (prize), 1946; Tex. A. Group, from 1945. Work: Dallas Mus. FA [47]

SMITH, Rosamond L. See Bouvé.

SMITH, Russell [Ldscp.P,Por.P] b. 26 Ap 1812, Glasgow, Scotland (came to Ind. County, PA, 1819) d. 8 N 1898 near Jenkintown, PA. Studied: Pittsburgh, with J.R. Lambdin ca. 1828-32. Member: PAFA (board); A. Fund S., 1936. Exhibited: PAFA, 1834, 1847-60; A. Fund S., 1935-45; Boston Athenaeum, 1842, 1852; Apollo Assn., Phila., 1838-40; Am. A. Union, 1838-45; Centenn. Exh., Phila., 1876; AIC, 1945; Baltimore MA, 1945; Univ. Pittsburgh, 1948; Vose Gal., Boston, 1977. Work: PAFA; Pa. Hist. S.; Oreg. Hist. S.; Carnegie Lib. Best known for his panoramas exhibited in Phila., Baltimore, Boston, Wash., D.C., 1850-51 [*]

SMITH, Russell Train [P,Arch,Des,L,T] Brookline, MA b. 14 Mr 1905, Concord, MA. Studied: Harvard. Member: Wash. WCC. Exhibited: Fitzwilliam A. Ctr., N.H., 1939 (prize). Positions: Dir., Fitzwilliam A. Ctr., N.H.; T., Univ. N.C., 1936-40; Hd., BMFA Sch., Boston, Mass., from 1940; T., Tufts Col., Medford, Mass., from 1943 [47]

SMITH, Sarah [P] Ft. Worth, TX. Exhibited: SSAL, Montgomery, Ala., 1938; San Antonio, TX, 1939 [40]

SMITH, Sarah J. [P] Hartford, CT [15]

SMITH, Sarah K. [P,Et,I,T,L] Wheaton, IL b. Rio Vista, CA. Studied: Wheaton Col.; AIC; BMFA Sch.; H. Pyle; W. Chase; Vanderpoel; Benson; Freer. Member: NAWA; Wilmington SFA; SSAL; Gulf Coast AA; NOAA. Exhibited: SSAL; Miss. AA (gold), 1939 ; Gulf Coast AA (prize). Work: Ruston (La.) Lib. Contributor: nat. mags. Position: T., Wheaton Col. Acad., Wheaton, Ill.; Gulf Park Col., 1940 [47]

SMITH, Sarah R. [P] NYC. Member: NAWPS [21]

SMITH, Sherman [P] Pittsburgh, PA. Member: Pittsburgh AA [25]

SMITH, Sibley [P] Wakefield, RI b. 26 Je 1908 NYC. Studied: Harvard; Yale. Exhibited: FAP, Wash., D.C., 1942; Inst. Mod. A., Boston, 1945; RISD, 1943-46; Tilden-Thurber Gal., Providence, 1942; Willard Gal., N.Y., 1945 (one-man); Pinacotheca; S. Four A., Palm Beach, Fla.; Boston AC. Work: RISD; Rochester Mem. A. Gal. [47]

SMITH, Sidney [Car] b. 13 F 1877, Bloomington, IL d. 20 O 1935, Harvard, IL (auto collision). Creator: comic strip "The Gumps," published in Europe, Hawaii, Canada, Australia, and the U.S. He produced "Old Doc Yak" and at least three other series of cartoon characters before "The Gumps" in 1917. In 1922, signed a $1,000,000 contract for "The Gumps" to

extend over a ten-year period, the largest figure ever guaranteed a similar feature at that time.

SMITH, Sidney Lawton [P,En,C] Boston, MA. Member: Boston SAC [10]

SMITH, Sidney Paul [Ldscp.P] Denver (1965) b. 1904, Salt Lake City. Studied: L. Squires; A.B. Wright; NAD, with Kroll, 1932–34. Specialty: watercolor [*]

SMITH, Stowell Le Cain, Mrs. See Fisher.

SMITH, Susan E. [P] Cambridge, MA. Member: Copley S., 1892 [10]

SMITH, Susanne F. [P] Boston, MA. Exhibited: BAC, 1898 [98]

SMITH, Suzanne, Mrs. See Mullett.

SMITH, Sydney [P] Buffalo, NY [17]

SMITH, Thomas Herbert [P] Wilton, CT b. 31 O 1877, NYC. Studied: G. Bellows. Member: NAC; Brooklyn SA; Silvermine GA; SC; New Rochelle AA; Group of Wilton A. Exhibited: Bridgeport AL, 1935 (prize). Work: Town Hall, Wilton, Conn. [40]

SMITH, Twigg [P] Honolulu, Hawaii b. 2 N 1882, Nelson, New Zealand. Studied: AIC; H.M. Walcott. Member: Hawaiian SA; Chicago ASL [25]

SMITH, Vernon B. [P] Orleans, MA b. 9 Ag 1894, Cortland, NY. Studied: H. Giles; R.S. Bredin. Exhibited: Contemporary New England Painters; Inst. Mod. A., Boston, 1939 [47]

SMITH, Violet Thompson (Mrs.) [Min.P] West Haddonfield, N.J. b. 28 Jy 1882, Annapolis, MD. Studied: Archambault. Member: Alliance [33]

SMITH, Virginia Jeffrey [P,T] Rochester, NY/Gloucester, MA b. Rochester, N.Y. Studied: Tryon; Breckenridge. Member: North Shore AA; Rochester AC [40]

SMITH, W. Eugene [Ph] b. 1918, Wichita, KS d. 1978 Tucson, AZ. Exhibited: MOMA; IMP: Univ. Oreg.; many others. Work: Smith archive at Ctr. Creative Photog., Tucson. Since 1936 an important photojournalist; best known for his moving photo-essays for Life such as "Spanish Village," "Country Doctor," "A Man of Mercy," "Minamata." [*]

SMITH, W. Harry [Mur.P,Et,Des] Cambridge, MA b. 23 D 1875, Devon, England d. 10 Jy 1951. Member: Copley S., Boston; Boston SAC; Boston S. WC Painters; Chicago SE. Exhibited: Chicago SE, 1925, 1946 (prize). Work: BMFA; FMA; MIT; NGA; AIC; Whistler House, Lowell, Mass. [47]

SMITH, W. Linford [P] Pittsburgh, PA/Miami, FL b. 31 D 1869, Pittsburgh, PA. Studied: C. Walters. Member: Pittsburgh AA [25]

SMITH, Wallace Herndon [P] Clayton, MO b. 9 My 1901, St. Louis, M. Studied: Princeton Univ.; Charousset; Hawthorne. Member: AIA. Exhibited: AG, St. Louis, Mo., 1929 (prize). Work: CAM [47]

SMITH, W(alter) Granville [P,I] NYC/Bellport, NY b. 26 Ja 1870, S. Granville, NY d. 1938. Studied: W. Satterlee; C. Beckwith; W. Metcalf; ASL; Europe. Member: ANA, 1908; NA, 1915; AWCS; SC, 1918; SPNY; Allied AA; Greenwich SA; NAC; AGA; Grand Central A. Gal. Exhibited: NAD, 1900 (prize), 1908 (gold), 1927 (prize), 1929 (prize), 1933 (prize); Charleston Expo, 1902 (med); AWCS, 1905 (prize), 1916 (prize); Worcester, 1906 (prize); CI, 1907; Buenos Aires Expo, 1910 (med); SC, 1911 (prize), 1913 (prize), 1918 (prize), 1922 (prize), 1925 (prize) (med), 1928 (prize). Work: Smithsonian; Butler AI; Toledo, Ohio; SC; NAC; Lotos C.; Fencers C. of NYC; Phila. AC [33]

SMITH, Walter W(ashington) [P,Des,C] Phila., PA b. 26 Ag 1892 or 1884, Clearfield, PA. Studied: CI; C.J. Taylor. Member: Germantown AL. Exhibited: Paris, France, 1923; CGA; St. Louis, Mo. Position: Dir., Display A. Shop, Phila. [47]

SMITH, Wilbur, Mrs. See MacKnight, Ninon.

SMITH, William Arthur [I,P,W] NYC b. 19 Ap 1918, Toledo, OH. Studied: T.J. Keane, Toledo; ASL; Grand Central Sch. A.; Ecole des Beaux-Arts, Paris; Acad. Grande Chaumière. Member: NA 1952; SI; AWCS; NA Western A. Exhibited: AWCS, 1942–44, 1946; A. Dir. C., 1943; SI 1944, 1946; MMA, 1943; Contemporary Am. Ills., 1946; Ohio State Exh., 1933; Calif. WCS, 1946; Phila. WCC, 1946; Toledo Mus. A., 1943 (one-man); SI, 1946 (one-man). Illustrator: "The Chinese Children Next Door," 1942; "The Water-Buffalo Children," 1943. Work: Chrysler Corp., war paintings coll. Specialty: watercolor [47]

SMITH, William Brooke [P] Phila., PA [06]

SMITH, William H. [P] Hartford, CT. Member: CAFA [25]

SMITH, William Harold [P,Des,T,L] Norman, OK b. 25 Mr 1900, Casteltown, ND. Studied: AIC; Univ. Wash. Work: Univ. Wash.; Northwest PM; Okla. City Pub. Sch. Exhibited: Chicago; NYC; Seattle; Kansas City; Tulsa; Oklahoma City. Position: T., Univ. Okla., from 1936 [47]

SMITH, William Mason (Mrs.) [D] New Orleans, LA [24]

SMITH, Wuanita [P,Et,B,I] Phila., PA b. 1 Ja 1866 d. 18 F 1959. Studied: Phila. Sch. Des. for Women; PAFA; ASL; H. Pyle; H. Breckenridge; R. Pearson; Paris. Member: Am. Color Pr. S.; Phila. Pr. C.; New Haven PCC; Bridgeport AA; NAC. Exhibited: Irvington (N.J.) AA (prize); Wilmington AA, 1934 (prize); Phila. PC, 1929 (prize), 1933 (prize); Miss. AA (med); New Haven PCC, 1936. Work: PAFA; LOC; Phila. Plastic C.; Phila. Sch. Des. for Women. Illustrator: "The Four Corner Series," "The Admiral's Granddaughter," "Grimms's Fairy Tales," "Gulliver's Travels," "Washington Square Classics," "Virginia Books" [47]

SMITH, Xanthus Russell [Mar.P,Ldscp.P,Por.P] Phila., PA/Casco Bay, ME b. 1839, Phila. d. 2 D 1929, Weldon (or Edgehill), PA. Studied: medicine, Univ. Pa., 1856–58; PAFA; Royal Acad., London. Exhibited: PAFA, 1856–58; Phila. AC; Mariner's Mus.; BMFA; Del. Hist. S.; Colby Col.; Union Lg. C., Phila. He served in the Navy during the Civil War, and later painted, on a large scale, the important naval engagements of the War. Illustrator: "Battles & Leaders of the Civil War," (1884). Son of Russell. [10]

SMITHBURN, Florence Bartley [P,E,Dr,T] NYC/Augusta, IN b. New Augusta. Studied: W. Forsyth; J. Herron A. Sch.; R. Lahey; H. Sternberg; G.P. Ennis. Member: Hoosier Salon; Ind. AA; NAWPS; ASL. Exhibited: Ind. State Fair, 1929 (prizes), 1930–34 (prizes); Hoosier Salon, Chicago, 1929 (prize); Ind. Artists' Exh., 1931 [40]

SMITHERS, Herbert H. [P] Buffalo, NY. Member: Chicago NJSA [25]

SMOKY, Lois [P] Virden, OK (1967) b. 1907. Member: one of the "Five Kiowas" at Univ. OK, 1927. Work: Although she stopped painting by the end of the 1920s, her work is in "Kiowa Indian Art," 1929, "Am. Indian Painters," 1950, both by Jacobson; Mus. Am. Indian; McNay AI, San Antonio [*]

SMOLEN, Francis (Frank) [P,I,Des,S,C,T,G] Sharon, PA b. 8 Ja 1900 Manor, PA. Studied: Fed. Sch., Inc.; CI; Bicknell; Redio; Ash. Member: Sharon AA (V.Pres.); Friends of Art, Youngstown, Ohio. Exhibited: Devoe & Reynolds Exh., 1940; Pittsbugh AA, 1928, 1931–34; Butler AI, 1935, 1936, 1938, 1941, 1943; Sharon AA, 1933–42, 1935 (prize), 1939 (prize), 1943 (prize), 1945. Work: WPA murals: Buhl Girls' C., Sharon, Pa.; Somerset H.S., Pa. [47]

SMOLIN, Nat [S,P,L,T,W] NYC b. 4 Jy 1890, NYC d. 25 O 1950. Studied: CCNY; J. Sloan; A. Bourdelle; C. Guerin. Member: AAPL. Exhibited: Am. Veterans SA; Indp. S.; Salon des Tuileries, annually; Salon d'Automne, annually; Colson & Leger, Paris. Work: Musée du Jeu de Paume, Musée de la Rochelle, France; BM; Sterling Mem. Lib., Yale; mon., Yale. Contributor: Revue de la Pensée Française [47]

SMONGESKI, Joseph L. [Book Des,P,Li,Ser] Quincy, MA b. 6 F 1914, Two Rivers, WI. Studied: Univ. Chicago; Univ. Wis.; AIC; L. Ritman. Member: Book Builders C., Boston. Exhibited: AIC, 1939; Madison Salon, 1938–40; Contemporary A. Gal., 1942; Elmira (N.Y.) A. Gal., 1945 (one-man) [47]

SMOOT, Margaret [S] Maitland, FL b. 29 Ag 1907, Lakeport, CA. Studied: C. Grafly; PAFA, 1930, 1931 (Cresson Traveling Schol.); A. Laessle [33]

SMUL, Ethel Lubell [P,Li,T,L] ,NYC b. 11 S 1897, NYC. Studied: ASL; Brackman; Olinsky; Robinson; von Schlegell. Member: NAWA; NYSWA; N.Y. T. Gld.; S.Indp.A. Exhibited: NAD, 1936; LOC, 1946; Argent Gal., 1934–46; FA Gal., N.Y.; Everhardt Mus.; Riverside Mus. Position: T., N.Y. Pub. Sch., from 1922 [47]

SMULLYAN, Robert. See Sloan.

SMUTNY, Joseph S. [Por.P] b. 1855, Bohemia (came to NYC ca. 1888) d. 15 Ja 1903. Studied: Vienna

SMYTH, Edmund R. [Des,P,W,I] Burbank, CA b. 6 N 1902, Toronto, Canada. Studied: AIC; Chicago Acad. FA; Grande Chaumière, Paris. Exhibited: Charney Gal., 1934; Allerton Gal., 1935; Davis Gal., 1935, 1936, all in Chicago; All-Ill. SFA, 1936; Chicago Jubilee Exh., 1937. Contributor: Saturday Evening Post [47]

SMYTH, Grace Allan, Jr. [S] Salem, VA b. 18 Je 1907, Blacksburg, VA. Studied: A. Laessle, at PAFA. Exhibited: PAFA, 1936 (prize) [47]

SMYTH, Nora. See Sweeney.

SMYTH, S(amuel) Gordon [E,B,I,P,T] Upper Darby, PA b. 21 N 1891,

Holmesburg, Phila. Member: A. T. Assn. of Phila.; Phila. SE. Exhibited: Calif. PM, 1936. Work: Franklin Inst., Phila. Position: T., Overbrook H.S., Phila. [47]

SMYTHE, Eugene Leslie [P] Providence, RI b. 1857, NYC d. 1932, Townshend, VT. Member: Providence, AC. Position: Staff, Tilden-Thurber Co., Providence [24]

SMYTHE, Lionel Percy [P] Pas-de-Calais, France [10]

SMYTHE, Margarita Pumpelly (Mrs. Henry L.) [P] Watertown, MS b. 6 Ag 1873, Newburgh, NY. Studied: Abbott H. Thayer. Member: Newport AA [25]

SMYTHE, Willard Grayson [Des,P,W,T] Chicago, IL b. 12 F 1906, Bellefontaine, OH. Studied: AIC. Member: 27 Chicago Des. Exhibited: Chicago Soc. Typographic A., 1929-44, 1931 (prize); AIGA, 1937 (prize); AIC, 1934-46; Nat. Advertising A. & Illus. Exh., 1940; Great Lakes Exh., 1939; Northern Miss. Valley A., 1943; A.Dir.C., Chicago, 1936-44; A.Dir.C., NYC, 1938. Work: Mem. Plaque, Santa Fe R.R. Position: T., AIC from 1928; A.Ed., Printing Art Quarterly, 1938-41 [47]

SNAER, Seymour [P] San Fran., CA. Member: San Fran. A. Assn. Exhibited: Oakland A. Gal., 1934; San Fran. A. Assn., 1939 [40]

SNAPP, Frank [I] NYC. Member: SI, 1910 [24]

SNARR, Mildred Ann [P] Cincinnati, OH [25]

SNEAD, Louise W(illis) (Mrs. Harry V.) [Min.P,Des,C,W,L] Norton, CT b. Charleston, S.C. Studied: Chase; ASL, with Theodora Thayer; Palestine; Egypt. Exhibited: Charleston Expo, 1902 (prize); Seal for a South Carolina city, 1915 (prize); Mineola, L.I., 1911 (prize), 1912 (prize). Work: Memorial Library, Shreveport (La.); D.A.R. Bldg., Charleston, S.C. Author/Illustrator: "History of Stamford, Connecticut"; "Silver and Gold," for Stamford Trust Co. Author/Producer: Oriental plays and pageants, designing the stage settings and costumes under the name of "Gulnare el Nahdir." [40]

SNEDECOR, Charles E. [Dealer] Sea Cliff, NY b. 1875 d. 4 Mr 1917. Head of the well-known art firm of Snedecor and Company, established by John Snedecor in NYC, 1852.

SNEDEKER, Virginia (Mrs. William L. Taylor) [P,C,I,G] Woodside, NY b. 25 N 1909, Brooklyn, NY. Studied: NAD; ASL; BAID; K.H. Miller; Nicolaides. Member: N.Y. Soc. Women A. Exhibited: Tiffany Fnd. F., 1931-32; Albright Gal., Buffalo; Contemporary A. Gal., N.Y. Work: Mus. City of N.Y.; mural, USPO, Audubon, Iowa. Contributor: New Yorker, 1934-39; Woman's Home Companion [47]

SNEDEN, Eleanor Antoinette (Mrs.) [S] Avon-by-the-Sea, N.J. b. 1876, NYC. Studied: Geneviève Granger, Paris. Specialty: portrait medallions [13]

SNELL, Carroll C(lifford) [Des,I,L] NYC/Wash., D.C. b. 15 Ag 1893, Medina, NY. Illustrator: leading publishers; posters; displays; design for Theatre Guild. Lecturer: Chromatics. Originator: Snell System of Color Harmony [47]

SNELL, Florence Francis (Mrs. Henry B.) [P] New Hope, PA b. 1850, London d. 20 Ja 1946. Studied: ASL. Member: NYWCC; AWCS; NAWPS; NAC. Exhibited: NAWPS, 1913 (prize), 1915 (prize); NAC (prize) [40]

SNELL, Henry B(ayley) [Mar.P,T] New Hope, PA b. 29 S 1858, Richmond, England d. 17 Ja 1943. Studied: ASL. Member: ANA, 1902; NA, 1906; NYWCC; AWCS; SAA, 1905; SC, 1903; Lotos C.; Fellowship PAFA, 1916; NAC; Allied AA. Exhibited: AC Phila., 1896 (gold), 1916 (prize); Nashville Expo, 1897 (prize); Paris Expo, 1900 (prize); Pan-Am. Expo, Buffalo, 1901 (med); St. Louis Expo, 1904 (med); Worcester Mus., 1905 (prize); NYWCC, 1905 (prize); P.-P. Expo, San Fran., 1915 (med), (gold); SC, 1918 (prize). Work: Albright A. Gal., Buffalo; Worcester Mus.; Herron AI, Indianapolis; MET. Position: Asst. Dir., FA, U.S. Comm., Paris Expo, 1900 [40]

SNELL, Lulu M. [P] Toledo, OH. Member: Chicago NJSA [25]

SNELL, Zulma M. [P] Toledo, OH b. Franklin, OH. Studied: Cincinnati A. Acad.; AIC. Member: Athena Soc., Toledo [17]

SNEPP, Hazel [P] Indianapolis, IN [17]

SNIDER, Lillian Bohl (Mrs. W.A.) [P,T, L] Albany, MO b. 2 Jy 1893 (or 1895), Kansas City d. ca.1955. Studied: Chicago Acad. FA; Kans. State T. Col.; Columbia; AIC; F.A. Parsons, in Paris; C. Martin; E. Bisttram. Member: Kans. State A. Assn.; St. Joseph A. Assn.; Western AA. Exhibited: Kansas City AI, 1937 (prize); 1938-40; Joslyn Mem., 1941, 1942; William R. Nelson Gal.; St. Joseph (Mo.) AA (one-man). Work: William R. Nelson Gal.; Joslyn Mem. [47]

SNIDER, Marguerite [P] Tacoma, WA. Member: Tacoma FAA [25]

SNIFF, John E. [P] Columbus, OH. Member: Columbus PPC [25]

SNODGRASS, Davis J. [P] Columbus, OH. Member: Columbus PPC [25]

SNOW, Charles H. [P] Marblehead, MA [25]

SNOW, E. E. [P] Salt Lake City, UT [15]

SNOW, Eben H. [I] Boston, MA b. 1870 d. 3 Ap 1945. Position: Staff, "Boston Globe" for 50 years

SNOW, Edith Huntington [Hand Weaver,T] NYC b. Lawrence, KS. Studied: Columbia; Univ. Kansas, Stanford; Mary Kissel; Vanner, Stockholm. Member: NYSC; Boston SAC; Needle and Bobbin C.; PBC [40]

SNOW, Edward Taylor [Ldscp.P] Phila., PA b. 13 Mr 1844, Phila. d. 26 S 1913. Studied: PAFA; Schüssele; France; Holland; Germany. Member: AC Phila. Exhibited: AAS, 1902 (gold). Art Commissioner at the Tennessee Centennial and Omaha Expositions [13]

SNOW, Laura E. [P] Phila., PA b. Phila. Studied: her father, Edward. Member: Plastic C. Exhibited: AAS, 1902 (gold); Charleston Expo, 1902 (med) [10]

SNOW, Mary R.B. (Mrs. Ralph D.) [P,G,T] Alexandria, VA b. 6 Mr 1908, Logan, UT. Studied: Corcoran Sch. A.; ASL; Otis AI; Univ. Utah; Grand Central Sch. A. Member: Wash. AC. Exhibited: CGA, 1937-39; Soc. Wash. A.; Wash. AC, 1945 (one-man); Salt Lake City, Utah. Work: Utah Pub. Sch. Coll. [47]

SNOW, Robert K. [Mar.P] Santa Barbara, CA d. Jy 1936 (while en route to Bar Harbor, Maine, for an exhibition of his paintings). Specialty: seascapes

SNOW-DAVIS. See Jessie Davis.

SNOWDEN, Chester Dixon [P,I,T] Houston, TX b. 8 O 1900, Elgin, TX. Studied: Univ. Texas; CUASch; ASL; B. Robinson; W.J. Duncan; H. Sternberg; Grand Central A. Sch.; Richard A. Sch., Los Angeles. Member: SSAL. Exhibited: Mus. FA, Houston, 1935-38, 1939 (prize), 1940-45, 1946 (prize); CGA, 1939; Southwest Texas Exh., 1946 and prior. Illustrator: "Shafts of Gold," 1938; "Children of Hawaii," 1939; "The Ape of Heaven"; "Half Dark Moon." [47]

SNOWDEN, Elsie Brooke [P] Wash., D.C./Ashton, MD b. 4 Mr 1887, Ashton. Studied: Corcoran Sch. A.; PAFA. Exhibited: PAFA, 1914 (Cresson Traveling Scholarship). Specialty: figure [33]

SNOWDEN, George Holburn [S] Los Angeles, CA b. 17 D 1902, Yonkers, NY. Studied: Yale; A.A. Weinman. Member: ANA, 1937; NA, 1941; NSS; Arch. Lg. Exhibited: New Haven PCC, 1926 (prize); BAID, 1926 (prize), 1935 (prize); WFNY, 1939. Award: Prix de Rome, 1927. Work: mem.&groups: Saratoga Springs, N.Y.; Armonk, N.Y.; Yale Mem., Pershing Hall, Paris. Position: T., Yale Sch. FA [47]

SNOWDEN, William Etsel, Jr. [Des,I,G,W] Atlanta, GA b. 29 My 1904, Elberton, GA. Studied: Georgia Sch. Tech.; Maryland Inst.; Federal Sch., Inc., Minneapolis. Member: Soc. Mem. Designers and Draftsmen; SSAL; Augusta AC; Assn. Georgia A.; Atlanta C. of Printing House Craftsmen; AIGA. Exhibited: Augusta AC, 1936 (prize); Printing House Craftsmen, 1945 (prize); Maryland Inst.; Assn. Georgia A., 1934-36, 1938; AIGA, 1945. Work: historical maps&brochures. Position: Partner, Snowden&Steward Advertising, Atlanta [47]

SNYDER, Annie F. [P] Rochester, NY. Member: Rochester AC [21]

SNYDER, C.B. [P] Brooklyn, NY [04]

SNYDER, C.F. [P] Paris, France. Member: Paris AAA [25]

SNYDER, Clarence W. [P] Phila., PA b. 10 Mr 1873. Member: PAFA; Drexel Inst.; Phila. AC [33]

SNYDER, Clifford [P] NYC [10]

SNYDER, Corydon Granger [I,Des,E,P,W,L,S] Chicago, IL b. 24 F 1879, Atchison, KS. Studied: AIC; Minneapolis Inst. A.; Toronto AI. Member: Chicago No-Jury Soc. A. Exhibited: Chicago No-Jury Soc. A., 1946. Work: Historical Soc., St. Paul, Minn. Author: "Instructions for Making Photo-Point Etching Prints." Position: T., Krompier Sch. Apparel Design, 1940 [47]

SNYDER, Jerome [P,T] NYC b. 20 Ap 1916, NYC. Member: A. Lg. Am. Exhibited: Biarritz, France, 1946 (one-man); ACA Gal., 1943, 1945; 48 States Comp., 1939. Work: murals: Soc. Security Bldg., Wash., D.C.;

USPO, Fenton, Mich. Illustrator: Portfolio #2, Black Sun Press, Paris. WPA artist. [47]

SNYDER, Seymour [I,Des] NYC b. 11 Ag 1897, Newark, NJ. Studied: Fawcett Sch. Indst. A.; ASL; Grand Central Sch. A. Illustrator: covers, House and Garden, American Home, McCall's; other magazines [47]

SNYDER, William Henry [Ldscp.P] Brooklyn, NY b. 1829, Brooklyn d. 4 O 1910. Studied: N.Y.; Paris. Member: Brooklyn A. C. Position: T., Brooklyn A. Sch. (manager) [01]

SOBERS, Rex Warren [S] Chicago, IL b. 6 S 1910, Bridgman, MI. Studied: Avard Fairbanks. Specialty: industrial and ceramic design [40]

SOBLE, John Jacob [P,T] Stroudsburg, PA/NYC b. 14 Ja 1893, Russia. Studied: NAD; C.C. Curran; L. Kroll; I. Olinsky; F.C. Jones. Member: All.A.Am. Exhibited: Ogunquit A. Center, 1935 (prize); NAD, 1935, 1929, 1932, 1936, 1938; PAFA, 1936, 1937; TMA, 1936, 1937; GGE, 1939; AIC, 1936; CI, 1941; CGA, 1937; VMFA, 1938; Pepsi-Cola, 1945. Work: TMA. Position: T., State T. Col., East Stroudsburg, Pa. [47]

SOCHA, John Martin [P,T] Minneapolis, MN b. 3 Mr 1913, St. Paul, MN. Studied: Minneapolis Sch. A.; Univ. Minn.; G. Mitchell; R. Brackman; Diego Rivera, in Mexico. Member: Minn. AA; Minn. Ar. Union; Montparnasse C., St. Paul. Exhibited: Minn. State Fair, 1940 (prize), 1941 (prize); Minneapolis Women's C., 1942 (prize); Minneapolis Inst. A., 1938–41, 1942 (prize), 1943–46; AIC, 1941, 1942; MMA, 1941, 1942; WMAA, 1942; NGA, 1940, 1942; Guatemala City, 1940; Mexico City, 1942; Walker A. Center, 1938, 1940; Davenport Mun. A. Gal., 1941; St. Paul A. Gal., 1938–42. Work: Univ. Nebr.; Minneapolis Inst. A.; Minneapolis Women's C.; Am. Red Cross, Wash. D.C.; murals, Winona (Minn.) State T. Col.; Univ. Minn.; Fed. Reserve Bank, Minneapolis; St. Luke's Cathedral, St. Paul. Positions: T., Minneapolis Sch. A. (1940), Univ. Minn. [47]

SOCHOR, Bozena (Miss) [P] Uniontown, PA b. 5 S 1901, Sonov, Czechoslovakia. Studied: Pa. State Col.; CI. Member: Uniontown AC; Assn. A. Pittsburgh. Exhibited: CI, 1945; Butler AI, 1944; Parkersburg FA Center, 1943–46; Ohio Univ., 1945; Uniontown AC, 1941–46 [47]

SODERBERG, George E. [E] Chicago, IL. Member: Chicago SE [27]

SODERBERG, Yngve Edward [E,Lith,P,Des] Mystic, CT b. 21 D 1896, Chicago d. 6 Ag 1971. Studied: AIC; ASL. Member: Chicago SE; SAE; Mystic AA. Exhibited: SAE, 1945 (prize); Chicago SE, 1936 (prize). Work: AIC; LOC; Smithsonian; USPO, Morrisville, Pa.; WPA artist [47]

SODERLIND, Nona Bymark [S] Minneapolis, MN/Marine on Saint Croix, MN b. 16 Jy 1900, St. Paul, MN. Studied: Minneapolis Sch. A.; C. Milles; Cranbrook Acad. of A. Member: Minnesota Artists Union. Exhibited: Minnesota State Fair, 1928 (prize), 1931 (prize); Minneapolis Inst. A., 1938 (prize), 1930 (prize), 1931 (prize). Work: relief, Farmer-Labor party; portrait, Am. Inst. Swedish Arts, Minneapolis [40]

SODERSTON, Herman [P] New Haven, CT b. 12 Jy 1862, Sweden d. 3 Jy 1926. Studied: Royal Acad. FA, Stockholm. Member: New Haven, PCC; CAFA. Work: Memorial Hall, Hartford; Sheffield Scientific Hall, New Haven, Conn. [25]

SOELLNER, Oscar Daniel [P,Des,E] Oak Park, IL/Grand Detour, IL b. 8 Ap 1890, Chicago. Member: Chicago Galleries Assn.; Assn. Chicago P. & S.; Palette&Chisel Acad. FA; Austin, Oak Park and River Forest AL; AFA; Am. APL; All-Ill. SA. Exhibited: Palette&Chisel Acad., Chicago, 1930 (prize); All-Ill Soc. FA, 1932 (gold); Springville, Utah, 1932 (prize); NAD; AIC, 1926–46; John Herron AI; Nebraska AA; Kansas City AI; Salt Lake City; Des Moines FA Assn. Work: mem./mon., Oglesby, Ill.; Pub. Sch., Oak Park and River Forest [47]

SOGLOW, Otto [Cart] NYC b. 23 D 1900, NYC d. 1975. Studied: ASL, with J. Sloan. Member: SI; Cartoonist Soc. Work: Baltimore Mus. Author/Illustrator: "Pretty Pictures"; "Everything's Rosey"; "Wasn't the Depression Terrible"; "The Little King." Illustrator: many books; "New Yorker," "Collier's," "Life"; cartoon strips, many newspapers by King Features Syndicate [47]

SOHON, Gustavus [Dr,Photogr] b. 10 D 1825, Tilsit, East Prusia (came to Brooklyn in 1842) d. 3 S 1903, Wash., D.C. Work: Nat. Mus. Bookbinder in Brooklyn, 1842–52; then became an expeditionary artist for the army in the Far West. His 1862 drawings of the Northwest were reproduced as lithos for the official report. Opened a photo studio in San Fran., 1863–65; then returned to Wash., D.C. [*]

SOHIER, Alice Ruggles [P] Concord, MA b. 21 O 1880, Quincy, MA. Studied: Buffalo; BMFA Sch., with Tarbell; Europe (as holder of Paige Traveling Scholarship). Member: Boston GA; Concord AA. Exhibited: P.-P. Expo, San Fran., 1915 (med). Work: State House, Boston; Episcopal Theological Sch., Cambridge; State Savings, Albany, N.Y.; Metropolitan Opera House, N.Y. [40]

SOHN, Frank [Des,C,P,G,L] Toledo, OH b. 24 Jy 1888, Columbus, IN. Studied: Univ. Ill.; A. Gunther; I. Manoir; A. Angarola; F. Grant; AIC. Member: Brown County (Ind.) A. Gal. Assn.; Toledo AC; Hoosier Salon. Exhibited: Toledo Mus. A., 1946 (prize); WMAA, 1933; MMA; AIC; Hoosier Salon. Work: glass murals, Toledo Pub. Lib.; numerous restaurants in Chicago&Detroit. Specialty: design products, bldgs., interiors, involving opaque structural glass and metal. Position: Des. Dir., Owens-Ford Glass Co., Toledo [47]

SOHNER, Theodore [P,T,L] Minneapolis, MN b. 18 Mr 1906, St. Paul, MN. Studied: Minneapolis Sch. A.; St. Paul Sch. A.; Paris, with Lhote; A. Angarola; C. Booth. Member: Minn. AA. Exhibited: Minneapolis Inst. A., 1942, 1943–45 (prizes); Minn. State Fair, 1942, 1944 (prize); Minneapolis Women's C., 1943, 1944, 1946 (prize). Work: Univ. Minn.; Minneapolis Inst. A. Position: T., Minneapolis Sch. A., 1945–46 [47]

SOKOLE, Miron [P,T,Lith] New Canaan, CT (1977) b. 20 N 1901, Odessa, Russia. Studied: CUASch; NAD. Member: Am. Ar. Cong. Exhibited: NAD (med); CGA, 1941, 1943; AIC, 1931, 1932, 1935, 1940, 1941, 1943, 1944; WMAA, 1939, 1943, 1945, 1946; BM, 1939, 1943; Dallas Mus. FA; Detroit Inst. A.; Pal. Leg. Honor; Rochester Mem. A. Gal.; Dayton AI; Milwaukee AI; Lehigh Univ.; Columbia; Albany Inst. Hist.&A.; Minneapolis Inst. A.; CM; Albright A. Gal.; PAFA, 1940–42; GGE, 1939; WFNY, 1939; Springfield Mus. A.; BMA; Columbus Gal. FA; CI, 1943–45; VMFA, 1944; Pepsi-Cola, 1944, 1945; MMA, 1942, 1944, 1945; Walker A. Center, 1944; G.R.D. Gal., 1930 (one-man); Cheshire Gal., 1932 (one-man); Midtown Gal., 1934 (one-man), 1935 (one-man), 1937 (one-man), 1939 (one-man), 1944 (one-man); Oklahoma City, 1938 (one-man). Work: WPA artist. Position: T., Am. Ar. Sch., N.Y., 1940 [47]

SOKOLOFSKY, Stephen G. [P,T] Phila., PA. Studied: PAFA [25]

SOKOLSKY, Sulamith [P] NYC b. 22 Jy 1889, NYC. Studied: CUASch; NAD [21]

SOLARI, Joseph [P] Kirkwood, MO. Member: St. Louis AG [27]

SOLARI, Mary [P,W] b. 1849 d. late in 1929, Memphis. Studied: Academy in Florence, Italy (first woman admitted)

SOLDWEDEL, Frederic [P,Arch] NYC b. 12 Ap 1886, NYC. Studied: England; Italy; Greece; France [40]

SOLLOM, Vincent P. [P] Pittsburgh, PA. Member: Pittsburgh AA. Affiliated with: CI, Pittsburgh [25]

SOLLOTT, Lillian [Por.P,I,L] Phila., PA b. Phila. Studied: PAFA; Phila. Sch. Des. Women; Barnes Found.; R.S. Bredin; G. Harding; H. Snell; H. McCarter [40]

SOLMON, Joseph [P] NYC (1977) b. 1909, NYC. Studied: ASL; NA; Columbia. Member: The 10, N.Y. Exhibited: The 10, 1938; Int. WC Ann., AIC, 1939; WFNY, 1939; Neumann-Willard Gal., N.Y., 1940; (retrospective) PMG, 1949; NIAL, 1961 (prize) [40]

SOLMANS, Alden [P] b. 1835 d. 29 Ap 1930, South Norwalk, CT. He was a well-known banker. At the age of 80 he took up the study of art and exhibited with much success towards the end of his life.

SOLOMON, Harry [P] NYC b. 5 Je 1873, San Fran. Studied: Paris. Member: SC. Work: Capitol Bldg, Des Moines; Morningside Univ., Sioux City [24]

SOLOMON, Maude Beatrice (Mrs. Joseph) [P,S] NYC b. Seattle, WA. Studied: PAFA; J.L. Tadd; H. Breckenridge. Illustrator: "Aristocrats of the North." [33]

SOLOMON, Mary C. [P] Brooklyn, NY [19]

SOLOMON, Mitzi [S,Des,T,L] NYC b. 1 Ja 1918, NYC. Studied: Columbia; ASL; O. Maldarelli; A. Goldthwaite. Member: S. Gld.; NAWA; N.Y. Soc. Women A.; Audubon A.; Springfield A. Lg. Exhibited: Smith A. Gal., Springfield, Mass., 1940 (prize), 1943 (prize), 1945 (prize); Irvington (N.J.) Pub. Lib., 1944 (prize); WMAA, 1945, 1946; AIC, 1942; CM, 1939, 1941; MMA (AV), 1942; Denver A. Mus., 1942–44; Mint Mus. A., 1945, 1946; NAWA, 1943–1946; CAFA, 1940; North Carolina A., 1943, 1944; Newport AA, 1944, 1945; Springfield A. Lg., 1941–44, 1946; Syracuse Mus. FA (one-man); Phila A. All. (one-man); de Young Mem. Mus. (one-man); Milwaukee AI (one-man); Brooks Mem. A. Gal. (one-man). [47]

SOLOMONS, Aline E. [P] Wash., D.C. b. NYC. Studied: Washington ASL [25]

SOLON, Harry [P] b. 5 Je 1873, San Fran. d. 5 Ag 1958, NYC. Studied: Calif. Sch. Design, San Fran.; AIC; Académie Julian, Paris; H. Royer; R.

Miller. Work: Capitol Bldg., Des Moines; Morningside Univ., Sioux City; portrait, Gen. José F. Uriburu, President of Argentina; portrait, Hon. Edwin Morgan, U.S. Ambassador to Rio de Janeiro; portrait Hon. Leland Harrison, U.S. Minister to Uruguay [33]

SOLON, Leon Victor [P,Des,W,I,L,C,Arch,Dec] Lakeland, FL b. 17 Ap 1872, Stoke-on-Trent, England. Studied: Royal Col. Art, London. Member: Hellenic Soc., London; A. Workers Gld., London; Royal Soc. British A.; Arch. Lg.; NSS; NSMP. Exhibited: Paris (med); AIA, 1928 (gold), 1931 (gold); Arch. Lg., 1932 (gold), 1936 (med); Am. Cer. S., 1935 (gold). Work: Barcelona Mus.; Victoria&Albert Mus., London; polychromatic dec., Fairmount Park Mus., Phila.; Rockefeller Center, N.Y. Author: "Architectural and Sculptural Polychromy" [47]

SOLOWEY, Ben [P] Bedminster, PA. Member: AWCS. Exhibited: PAFA, 1932, 1936, 1938; AWCS, 1934, 1936; AIC, 1936, 1937, 1939 [47]

SOMEREST, Frances M. [P] NYC. Member: S.Indp.A. [25]

SOMERVELL, W. Marbury [E] Seattle, WA [17]

SOMERVILLE, Howard [I] Brooklyn, NY. Affiliated with: Brooklyn "Life." [98]

SOMMER, A. Evelyn(Miss) [P,G,T] Baltimore b. Jersey City, NJ. Studied: Maryland Inst.; Johns Hopkins Univ.; Columbia; A. Heckman; E. Ganso. Member: CAA; AAPL; Nat. Edu. Assn.; Am. Ar. Cong. Exhibited: BMA, annually; Chesapeake C., Baltimore; Md. Inst., 1939. Position: T., Eastern H.S., Baltimore, 1932–46 [47]

SOMMER, Edwin G. [P,I,Des,C] Macedonia, OH b. 29 Je 1899, Roseville, NJ. Studied: W. Sommer. Exhibited: Cleveland Mus. A., 1923 (prizes), 1924 (prize). Work: Cleveland Mus. A.; Cleveland Pub. Sch. [40]

SOMMER, Emmy (Mrs.) [C,P,T] Woodside Park, MD b. 8 N 1878, Copenhagen, Denmark. Studied: Royal Danish A. Acad., Copenhagen; Manufacture Nationale des Gobelin, Paris. Exhibited: tapestries, Italy, France, Germany, England. Work: supervised restoration of 16th-century tapestries, Corcoran Gal. [40]

SOMMER, Frederick [Ph] Arizona (1985) b. 1905, Angri, Italy. Studied: landscape arch., Cornell, 1927. Exhibited: Santa Barbara Mus. A., 1946; Chicago Inst. Des., 1957; Pasadena A. Mus.; Phila. Col. A. Work: AIC; FMA; IMP; MOMA; Univ. N.Mex.; Ctr. Creative Photogr., Tucson. Surrealist, sometimes nightmarish, photographer of assemblages and collages, beginning 1935. [*]

SOMMER, Julius G. [P,I] NYC. Member: AI Graphic A. Position: Affiliated with "To-day's" magazine [25]

SOMMER, Verna Lee [P] NYC. Member: Lg. AA [24]

SOMMER, William [P,Dec,Dr] Macedonia, OH. b. 18 Ja 1867, Detroit. Studied: Acad. A., Munich, Germany; J. Melchers; L. Schmidt; J. Herterich in Munich. Member: Cleveland SA; Ko-Koon AC. Exhibited: AIC (prize); CMA, 1924 (prize), 1927 (prize), 1929 (prize), 1932 (prize), 1935 (prize), 1939 (prize), 1941 (prize), 1942 (prize), 1943 (prize), 1945 (prize); MOMA, 1933; WMAA, 1934, 1937; AFA Traveling Exh., 1934; CMA, 1922–46; Tate Mus., London, 1946; Butler AI; Akron AI; 1930 Gal., Cleveland, 1944–46. Work: CMA; AIC; Akron AI; Univ. Minn.; Oberlin Mus.; BM; City of Cleveland Coll.; murals, Cleveland Pub. Lib.; USPO, Geneva, Ohio. WPA artist. [47]

SOMMERS, Alice, Mrs. See Alice Decker.

SONED, Warren [P,Des,S] Brooklyn, NY b. 15 S 1911 d. 9 Jy 1966, Miami. Studied: FA Acad., Dusseldorf; Beaux-Arts Inst., Grande Chaumière, both in Paris. Member: Mural A. Gld.; S.Indp.A. Exhibited: Nat. Army Arts Exh., 1945 (prize); S.Indp.A. Work: USPO, Hapeville, Ga.; N.Y. Telephone Bldg.; Pildes Optical Co., N.Y.; Borden General Hospital, Chichasha, Okla.; Barbizon Sch. Fashion Modeling, N.Y.; numerous clubs. Designer: shows for Jewish Folk Art Theatre. WPA artist. [47]

SONDHEIMER, Rosalee [S] Memphis, TN b. 10 Ag 1910. Studied: G. Lober; Grand Central Sch. A.; L'Ecole d'Art; A. Archipenko. Member: NAWPS; Tenn. SA; Southern AA [40]

SONN, Albert H. [P,I] Newark, NJ b. 7 F 1867, Newark d. 23 S 1936, NYC. Studied: NAD; CUASch. Member: SC, 1900; AWCS; A. Fund S.; NYWCC; AFA; AAPL. Author: "Early American Wrought Iron." Position: Hd. A., Am. Lithograph Co. [33]

SONNECK, S. [P] NYC. Member: S.Indp.A. [21]

SONNENSCHEIN, Edward [Patron] b. 1881 d. 9 D 1935, Chicago. His famous collection of Chinese jade assembled during his travels made him recognized as one of the foremost authorities on his subject. Pieces from his collection were constantly on loan in museums and exhibitions.

SONNICHSEN, Yngvar [P,E,Des,T] Seattle, WA b. 9 Mr 1873, Oslo, Norway (came to Seattlein 1908) d. ca. 1939. Studied: Poytech. Inst., Oslo, Norway, 1894; Antwerp; Brussels; Académie Julian, with Bouguereau, Constant, 1895–99. Member: Seattle Mus.; Puget Sound Group. Exhibited: Intl. Exh., St. John, N.B., Canada, 1906 (prize); Northwest Ar. Annual Exh., Seattle, 1920 (prize). Work: dec., Norway Hall, Seattle; Mun. Galleries, Christiana, Arendal, Laurvik, all in Norway; Freemasons' Lodge, St. John, N.B.; Vanderpoel AA, Chicago; Norwegian C.; Brooklyn, N.Y.; Norwegian-Am. Hist. Mus., Decorah, Iowa; Tower Hotel, Bellingham; County Hospital, Seattle; Monroe Soldiers' Home, Orting; Seaman's Mission, Seattle. Contributor: articles on fine arts, Western Viking (Tacoma), Washington Post (Seattle). Specialty: landscapes of southeast Alaska [38]

SONNTAG, William Louis [Ldscp.P] NYC b. 2 Mr 1822, East Liberty, PA (now a part of the city of Pittsburgh) (Moved to Cincinnati where he began to paint in 1842.) d. 22 Ja 1900, NYC. Studied: mostly self-taught, but did study in Florence, Italy ca.1855–56. Member: ANA, 1860; NA, 1861; AWCS; A. Fund S. Exhibited: NAD; Phila. AC; AWCS; Omaha Expo, 1898. Work: Corcoran; Peabody Inst. [98]

SONNTAG, W. Louis, Jr. [P] NYC. Member: AWCS. Exhibited: AWCS, 1898 [98]

SOOK, Robert J. [S] Phila., PA [17]

SOODY, Louise Pinkney [P,Dec,L,W,T] Los Angeles, CA b. 19 Ag 1889, Blairstown, IA d. 26 D 1965, Torrance, CA. Studied: A.W. Dow. Member: Univ. Calif. AA; Calif. ATA; Calif. WCS; Pacific AA. Author: "Plan Your Own Home," 1940. Co-Author: "Early California Costumes," 1932. Position: T., UCLA [40]

SOPER, James. See Gardner-Soper.

SOPHER, Aaron [P,E,Cart,I] Baltimore, MD b. 16 D 1905, Baltimore d. 1972. Studied: Baltimore Polytechnic Inst.; Maryland Inst.; Alon Bement. Member: Baltimore A. Union; Baltimore A. Gld.; Am. A. Cong. Exhibited: BMA, 1934 (prize), 1940–42, 1943 (prize), 1944–45, 1946 (prize); Baltimore Evening Sun, 1931 (prize), 1933 (prize), 1943 (prize), 1945 (prize); Print C., 1936 (prize); NAD, 1945, 1946; WMAA, 1942; LOC, 1943, 1945; BM, 1941; CI, 1943; AIC, 1938, 1940, 1942; Albany Inst. Hist.&A., 1943, 1945. Work: PMG; BM; Dumbarton Oaks Coll.; BMA; Edward Bruce Mem. Coll.; Whitney Mus. Am. A. Illustrator: "Rivers of the Eastern Shore," 1944; Colliers; Life. Contributor: New Yorker; Baltimore Sunday Sun. Affiliated with: Boyer Galleries, N.Y. [47]

SOPHER, Bernhard D. [S] Hollywood, CA b. 15 Je 1879, Safed, Syria d. 1949. Studied: Royal Acad., Berlin&Royal Acad., Weimer, Germany, with P. Breuer, A. Brutt. Exhibited: Acad. Award, Berlin, 1905 (prize); San Diego FA Soc., 1937 (prize); SFMA, 1940, 1945 (prize); PAFA, 1944; Joslyn Mem., 1943; CAM, 1943; Mus. FA of Houston, 1943; Los Angeles Mus. A., 1937; de Young Mem. Mus., 1944. Work: Mills Col., Oakland, Calif.; many German museums. Aritcles: German and Californian newspapers [47]

SOPHIR, J., Mrs. See Young, Dorothy.

SORAVIA, Irene, Mrs. See Bianucci.

SORBY, J. Richard [P,T] Denver, CO b. 21 D 1911, Duluth, MN. Studied: Univ. Minn.; Colo. State Col. Edu.; AIC. Exhibited: NGA, 1941; Denver A. Mus., 1937, 1938, 1940, 1941, 1946; Joslyn Mem., 1941–43, 1945; PAFA, 1941; Kansas City AI, 1941. Work: Marine Hospital, Carville, La. Positions: T., Univ. Nebr. (1941–43), Univ. Denver (1943–) [47]

SORENSEN, Carl Sofus Wilhelm [S,P] Chicago, IL b. 25 S 1864, Denmark. Studied: Acad. FA, Copenhagen; P.S. Kroyer, Copenhagen [15]

SORENSEN, Olga [Min.P,P] NYC. Exhibited: Min. PSG Soc., Wash.,D.C., 1935; Am. Soc. Min. P., 1935; WFNY, 1939 [40]

SORENSON-DIEMAN, Clara L. See Dieman.

SORGMAN, Mayo [T,Des,P] Stamford, CT b. 29 Mr 1912, Brockton, MA. Studied: Mass. Sch. A.; NYU; Parsons Sch. Des. Member: Conn. WC Soc.; Rockport AA; Eastern AA. Exhibited: Audubon A.; CAM, 1944; W.R. Nelson Gal., 1944; Conn. WC Soc., 1941–45; Rockport AA, 1942; Springfield A. Lg., 1941. Position: T., Stamford H.S. [47]

SORINE, S(avely) [P] NYC/Paris, France b. 14 F 1884, Russia. Studied: St. Petersburg AFA. Work: H.R.H. The Duke of York; Luxembourg Museum, Paris [27]

SORKIN, Leon [P,T] Minneapolis, MN b. 27 Jy 1914, Phila. Studied:

Minneapolis Inst. A.; R. Brackman. Exhibited: Minn. State Fair, 1943; Minneapolis Inst. A., 1943-45; St. Paul A. Gal., 1945; Minneapolis Women's C., 1945. Work: Minneapolis Inst. A. Position: T., Walker A. Center Sch., Minneapolis [47]

SORKNER, E. [P] Seattle, WA. Member: Seattle FAS [15]

SORTER, Minnnie L. [P] Minneapolis, MN [17]

SORVER, G. P. [P] Phila., PA [06]

SORVINO, Gennaro [P] Brooklyn, NY [25]

SOTER, John [P] Seattle, WA [24]

SOTOMAYOR, Antonio [Car,P] San Fran., CA b. Bolivia, South America. Studied: Mark Hopkins A. Inst.; Sch. FA, La Paz. Member: San Fran. AA. Exhibited: GGE, 1939. Work: murals, Sonoma Mission Inn, Calif.; Sharon Bldg., San Fran.; Happy Valley Room, Palace Hotel, San Fran. Illustrator: "Guatemalan Tales," "Man in Nature," "Cartilla Mejicana," "Quetzal Quest" "San Francisco Chronicle" [40]

SOTTEK, Frank [P,I,E,C] Detroit, MI b. 10 O 1874, Toledo d. ca. 1938. Member: Toledo Indp. A. Exhibited: Toledo Fed. A. Societies, 1924 (prize) [38]

SOTTER, Alice Bennett (Mrs. George W.) [C,P,Des] Holicong, PA b. Pittsburgh. Studied: Pittsburgh Sch. Des. for Women; CI. Member: Phillips Mill Assn. Exhibited: Pittsburgh; Phila. Collaborator: with husband on stained glass and decorations [47]

SOTTER, Elizabeth [P] Pittsburgh, PA. Member: Pittsburgh AA [21]

SOTTER, George William [C,P] Holicong, PA b. 25 S 1879, Pittsburgh d. 6 My 1953. Studied: PAFA, with H. Keller, W. Chase, Anshutz, Redfield. Member: Liturgical A. Soc.; Assn. A. Pittsburgh; Stained Glass Assn. Am.; Alliance Phillips Mill Assn.; CAFA. Exhibited: San Fran., 1915 (med); Assn. A. Pitsburgh, 1917 (prize); Pittsburgh A. Soc., 1920 (prize); CAFA, 1921 (prize), 1923 (prize); PAFA, 1903-25; CI, 1903-25; AIC; Venice, Italy; Toledo, Ohio (one-man); Rochester, N.Y. (one-man); Pittsburgh, Reading, Pa. (one-man). Work: N.J. State Mus., Trenton; Reading Mus. A.; State Col., Pa.; stained glass: churches in NYC; Pittsburgh; St. Louis; St. Paul; Wheeling, W.Va.; Salt Lake City; Harrisburg, Pa.; Scranton, Pa.; Cleveland; Union City, N.J.; Doylestown, Pa.; Cincinnati; Los Angeles; Phila. [47]

SOUCHON, Marion [P] New Orleans, LA b. 9 O 1870, New Orleans. Member: SSAL; New Orleans AA; Mississippi AA. Exhibited: CGA, 1945; CI, 1941; SSAL; New Orleans AA; Mississippi AA [47]

SOUDEIKINE, Sergei Yurievich [Des,P,I,Cart,Dec] NYC/Woodstock, NY b. Mr 1886, near Smolensk, Russia d. 12 Ag 1946, Nyack, NY. Studied: Moscow PS Sch., Imperial Acad., St. Petersburg, Russia; Grand Chaumière, Paris. Member: Salon D'Automne; Diaghilev's World of A.; Russian A. Exhibited: Reinhardt Gal., N.Y. Work: Luxembourg Mus., Paris; Mus. Leningrad; MOMA; Mordsoff Gal., Girshman Gal., both in Moscow. Positions: Set Des., "Porgy and Bess" (Theater Gld.), "Chauve Souris"; A. Dir., Radio City Music Hall [40]

SOUDER, Mary Rinard [P] San Fran., CA [15]

SOULE, Claire F. [P] South Freeport, ME [24]

SOULE, Lucia A. [Des] Brookline, MA b. 6 Jy 1877, St. Albans, VT. Studied: Miss Sacker's School of Decorative Design, Boston. Member: Boston SAC (Master Craftsman) [40]

SOULE, Ruth Brooks (Mrs.) [Min.P] Brooklyn, NY [13]

SOULEN, Harvey H. [P] Minneapolis, MN [17]

SOULEN, Henry James [I] Phoenixville, PA/Oceanville, ME b. 12 Mr 1888, Milwaukee. Studied: ASL, Milwaukee; AIC; H. Pyle. Illustrator: Saturday Evening Post, Ladies' Home Journal, Country Gentleman [40]

SOUTER, Mary L. [P] Wash., D.C. [13]

SOUTHARD, Frank R. [P] Brooklyn, NY [15]

SOUTHER, John K. [P] Wash., D.C. b. 1870 (Erie, PA?) d. 5 D 1909 [10]

SOUTHER, Lyna Chase (Mrs. Latham T.) [P,W,W] Springfield, IL b. 14 O 1880, St. Louis. Studied: E. Wuerpel; B. Lovatt-Lorski; Klasstorner. Member: Springfield AA; Ill. Acad. FA [33]

SOUTHERLAND, Genevieve (Mrs. Robert H.) [P,T] Mobile, AL b. 22 My 1895, East Liberty, PA. Studied: ASL. Member: SSAL; Ala. A. Lg.; Mobile AA; Ala. WCC; Birmingham AC. Exhibited: Ala. WCC, 1944 (med); 1946 (prize); Ala. A. Lg., 1945 (prize); Mary Buie Mus., Oxford, Miss.; Tampa AI; Loren Rogers Mus., Laurel, Miss.; Miss. AA; Mobile Mus. A.; Studio Gld., N.Y., 1944, 1946; SSAL, 1945. Work: Montgomery Mus. FA [47]

SOUTHWELL, Owen J.T. [P] Urbana, IL. Affiliated with: Univ. Ill., Urbana [19]

SOUTHWICK, Albert A. [P] NYC. Member: SC [21]

SOUTHWICK, Elsie Whitmore [Min.P] NYC/Paris, France b. Providence, RI. Studied: Prinet, Dauchez, Mme. Chennevières, all in Paris. Work: Herron AI, Indianapolis [15]

SOUTHWICK, Jeanie Lea [P,W] Worcester, MA b. 1853, Worcester. Studied: ASL; BMFA Sch. Member: Boston AC; Corp. Worcester A. Mus. Exhibited: Coronation Ceremonies, Kyoto, Japan, 1915 (prize) [40]

SOUTHWICK, Katherine (Mrs. Burton Keeler) [P,I] Scarsdale, NY/Stevens Point, WI b. 9 Je 1887, Buxton, ME. Studied: Chicago Acad. FA; AIC; PAFA. Exhibited: PAFA, 1911-13 (Cresson Traveling Scholarship) [33]

SOUTHWICK, W. Hammersley [Mur.P,Min.P,Cart,Dec,I,T] NYC b. 25 D 1894. Work: over 6,000 drawings and color plates for Webster's New International Dictionary; magazine covers, "Home Decorations," "Yacht Decorations"; groups, models, backgrounds, Coral Reef Group, Rotifer Group, American Mus. Natural History, N.Y. Comics/Cartoons/Drawings: "New York Morning World and Evening World." Illustrator: "Seashore Book for Children." Position: Staff Artist, Am. Mus. Natural History, N.Y. [40]

SOUTHWORTH, F(red) W. [P] Tacoma, WA b. 7 F 1860, Ontario, Canada d. 24 Ap 1946. Studied: self-taught. Member: Tacoma FAA; North West AA; Chicago Brush and Palette C. Work: Ferry Mus., Tacoma; Scottish Rite Cathedral, Tacoma; YMCA/YWCA, Tacoma; Masonic and Shrine Temples, Tacoma; Women's C., Tacoma; Tacoma Pub. Sch.; Joselyn Memorial, Omaha, Neb.; Iowa Memorial Union, Univ. Iowa [40]

SOUTHWORTH, Helen McCorkle (Mrs.) [P] Phila., PA b. 11 Ja 1898, Detroit. Studied: J. Pardi; G. Wiggins. Member: AAPL; Woodmere A. Center; Bryn Mawr A. Center; Phila. A. All.; Phila. Plastic C.; Germantown A. Lg. Exhibited: Phila. Plastic C., 1944-46; Woodmere A. Center, 1942-46; Phila. A. All., 1944; Phila. Sketch C., 1940, 1944, 1945; Da Vinci All., 1940, 1943, 1944; Ogunquit A. Center, 1946; Bryn Mawr A. Center, 1946 (one-man); Scranton A. Lg., 1939 [47]

SOUVARINE, Joshua S. [P] Chicago, IL b. 1874, Naples [08]

SOVERNS, Louise. See Brann.

SOWERS, Roy Vernon, Mrs. See Seeberger, Pauline.

SOWINSKI, Jan [S,P] Long Island City, NY b. 2 O 1885, Opatow, Poland. Studied: BAID; Poland. Member: Modelers & Sculptors of Am. & Canada. Exhibited: BAID (prize). Work: theatre & church interiors; murals, St. Stephen's Church, Paterson, N.J.; Trinity Church, Utica, N.Y. [47]

SOYER, Isaac [P,Li] NYC b. 20 Ap 1907, Tombov, Russia. Studied: CUASch; BAID; NAD; Paris; Madrid. Member: Am. A. Cong. Exhibited: Albright A. Gal., 1944 (prize); Audubon A., 1945 (prize); WMAA; CGA; AIC; Milwaukee AI; GGE, 1939; CM; VMFA; Akron AI; Pal. Leg. Honor; Soc. Four A., Palm Beach, Fla.; Walker A. Center. Work: Whitney Mus. Am. Art; Albright A. Gal. Brother of Raphael and Moses. [47]

SOYER, Moses [P,T,Li] NYC b. 25 D 1899, Tombov, Russia (came to NYC in 1912) d. 1975. Studied: CUASch; NAD; BAID; Ed. Alliance; Ferrer Sch. All., 1916-20. Work: MMA; Newark Mus.; Swope A. Gal.; PMG; TMA; WMAA; USPO, Phila; Greenpoint Hospital, Brooklyn; prints, LOC. Twin of Raphael and brother of Isaac. Positions: T., Am. Ar. Sch.; New A. Sch., N.Y. [47]

SOYER, Raphael [P,Li,T] NYC (1982) b. 25 D 1899, Tombov, Russia (came to NYC in 1912). Studied: CUASch, 1914-17; NAD, 1918-22; ASL, with G.P. du Bois. Member: Am Soc. P.S. & G.; Am Ar. Cong.; Am. Group. Exhibited: Forty-fifth Ann. Exh. Am. Paintings and Sculpture, AIC, 1932 (prize); PAFA, 1934 (gold). Work: WMAA; PMG; MMA; BMA; NYPL; AGAA; Columbus Gal. FA; CGA; Buffalo AA; BM; WPA mural, USPO, Phila. Author: "A Painter's Pilgrimage," 1962, "Homage to Thomas Eakins," 1966, "Self-Revealment: A Memoir," 1969, "Dairy of an Artist," 1977. Twin of Moses and brother of Isaac. [47]

SPAAR, William, Jr. [I,Cart,P,W] East Orange, NJ b. 28 Ag 1896, Arlington, NJ. Studied: Fawcett Sch. A., Newark; N.Y. Univ. Work: Saturday Evening Post, Collier's; Liberty. Cartoon: King Features Syndicate [40]

SPACKMAN, Cyril (Saunders) [Min.P,P,S,E,En,Li,L,T,W] Surrey, England b. 15 Ag 1887, Cleveland. Studied: H.G. Keller, in Cleveland; Kings Col. Architectural Studio, London. Member: R.S.B.A.; R.S. Min. PSG; R.S. Antiquaries of Ireland; F.S. Antiquaries of Scotland; F.R.S.A.; Licentiate Royal Inst. British Arch.; Croydon Arts C.; Southeastern Soc. Arch.; AFA; Soc. Graphic A.; Cleveland SA; Chicago SE. Exhibited: Assn. Arch. & Surveyors (med). Work: CMA; AIC; Print Room, British Mus.; City of Hull Coll.; 13th-century church, Grosmont, Monmouthshire; Crucifix in stone, Sanctuary, William Lillico Memorial Church of All Saints, Selhurst, Surrey. Designer: med. of Masonic Million Mem. Position: A. Ed., "The Parthenon" [40]

SPACKMAN, Emily S. [P] NYC [24]

SPADER, W(illiam) E(dgar) [P,C,I] Jamaica, NY b. 14 Ap 1875, Brooklyn, NY. Studied: H.S. Mowbray; J.H. Boston. Member: Brooklyn PS; AWCS. Exhibited: AWCS, 1921-23, 1925-27, 1929, 1932, 1937-42, 1946; NAD; etc. Work: Mus. A., Fort Worth, Tex. [47]

SPAETH, Carola (Mrs.) [Por.P] Princeton, NJ b. 29 Ap 1883, Phila. Studied: PAFA; Graphic Sketch C., Phila. Member: Phila. Alliance. Specialty: children [33]

SPAETH, Marie Haughton (Mrs. J. Duncan) [P] Princeton, NJ/Chesham, NH b. Hanover, NH d. Spring 1937, Sarasota, FL. Studied: PAFA; Pa. Sch. Design; Spain; France; Italy. Member: NAWPS; Wolfe AC; AFA. Exhibited: Wolfe AC, 1932 (prize). Work: PAFA; Princeton Univ.; Proctor Foundation, Princeton, N.J.; Grace Erdman Memorial Hall, Occidental College, Calif. [33]

SPAFARD, Myra B. [P,T] Detroit, MI/Manchester, MI b. Manchester. Studied: ASL; Teachers' College; Mrs. E.M. Scott, N.Y. Member: NAWPS [31]

SPAGNA, Vincent [P] NYC b. 24 O 1898, Sicily, Italy. Studied: Conn. Lg. A. Students, Hartford. Exhibited: Pepsi-Cola, 1944 (prize); La Tausca Pearls Comp. (prize); CGA, 1939; PAFA; MMA; CI; Midtown Gal., N.Y., 1939. Work: AGAA; Pepsi-Cola Coll.; IBM Coll. [47]

SPALDING, Elisabeth [Ldscp.P] Denver, CO b. Erie, PA d. 1954. Studied: ASL; PAFA. Member: Wash. WCC; NYWCC; Am. A. Gl., Denver. Exhibited: Erie Art C., 1900 (prize); AIC, 1921 (prize); Colorado State Fair, 1930 (prize); Wash. WCC, 1931 (prize); Stockholm (one-man); Paris, 1932 (one-man). Work: Erie A. C.; WC. Coll., Denver A. Mus.; Children's Hospital, YWCA, Morey Jr. H.S., Girls Indust. Sch., St. Luke's Hospital, Denver [40]

SPALDING, Melvin P. [P] NYC [17]

SPALLER, Gertrude [P] Chicago, IL. Member: Chicago SA [25]

SPAMPINATO, Clemente [S] Sea Cliff, NY (1980) b. 1912, Italy (came to NYC in 1946). Studied: AFA; French Acad. Nude; Sch. Governatorate; Royal Sch. Medal, all in Rome. Member: NSS. Exhibited: Nat. A. Mus. of Sport, NYC, 1968; Rome, 1953. Work: Nat. A. Mus. of Sport; Rockwell Gal. Western A.; Delgado Mus.; Notre Dame; Okla. AC. Specialties: sports; Western subjects [*]

SPANUTH, Lillian. See Linding.

SPARHAWK-JONES, Elizabeth [P] Phila., PA. Studied: PAFA. Exhibited: PAFA, 1908 (prize), 1912 (prize); CI Pittsburgh, 1909 (prize); AIC, 1926 (prize). Work: AIC; PAFA [40]

SPARKS, Arthur Watson [P,T] Pittsburgh, PA b. 1871, Wash., D.C. d. 6 Ag 1919, Phila. Studied: Académie Julian, with Laurens; Ecole des Beaux-Arts, Paris; Cormon; Bouguereau; Thaulow; Mucha; Ferrier; Courtois. Member: Pittsburgh AA. Exhibited: Pittsburgh AA, 1913 (prize); P.-P. Expo, San Fran., 1915 (med); (retrospective) Westmoreland County Mus. A. (Pa.), 1963. Position: T., CI [19]

SPARKS, George S. [P] NYC [15]

SPARKS, H. L. [I] NYC. Member: SI [31]

SPARKS, Joseph [P,S,Lith,Des,B] Detroit, MI b. 23 D 1896, Jersey City. Studied: P. Ives; P. Honore; L. Kroll; AIC; Leger, Ozenfant, in Paris. Member: SC, Detroit; Michigan Acad. Sc. A.&Letters. Exhibited: Detroit Inst. A., annually; LOC, 1945; Ferargil Gal.; J.L. Hudson Co.; Univ. Mich.; Gordon Beer Gal., Detroit. Work: St. Michael's Church, Detroit; Detroit Inst. A.; Detroit Hist. Lib.; LOC; murals, Winterhalter Sch., Detroit; Maple Sch. Lib., Dearborn, Mich. Illustrator: "Letters to a Pagan," "The Pine Tree of Michigan" [47]

SPARKS, Will [P,E,W,T,L] San Fran., CA (since 1891) b. 7 F 1862, St. Louis. Studied: St. Louis Sch. FA; Académie Julian, Paris. Member: Bohemian C., San Fran.; AFA. Work: murals, Bohemian C.; Plaza Hotel, San Fran.; de Young Mem. Mus.; oils, Bohemian C.; Pal. Leg. Honor, San Fran.; FA Gal., San Diego; TMA; Minneapolis Inst. A.; City A. Mus., St. Louis [40]

SPARLING, John Edmond (Jack) [I,Cart,P,S] Elmhurst, NY b. 21 Je 1916, Winnipeg, Canada. Studied: A.&Crafts C., New Orleans; Corcoran Sch. A. Member: SI; Cartoonists Soc., N.Y. Exhibited: Treasury Dept. Citations, 1944, 1945. Work: Hyde Park Coll. Author/Creator/Producer: "Hap Hopper, Washington Correspondent," United Features Syndicate, 1939–43; "Claire Voyant," Chicago Sun&PM newspaper Syndicate, 1943–46. Position: Editorial Cart., New Orleans Item-Tribune, 1935–37; Washington Herald, 1937–39 [47]

SPARROW, Jack [P] NYC b. 25 Ap 1893, Edinburgh, Scotland. Studied: ASL; Henri; J. Sloan; G. Bellows. Exhibited: AIC; Arch. Lg.; BM; Salon d'Automne, Paris. Work: murals for mining companies; Trebor Co., Mariposa, Calif.; H.C. Dudley, Ontario; Duluth Minn.; Mexico [40]

SPARROW, Louise Kidder (Madame Paul E. H. Gripon) [S,W] Garonne, France b. 1 Ja 1884, Malden, MA. Studied: Europe; B. Pratt; F.W. Allen; E. Pape; H. Coleman; Bush-Brown; U. Dunbar. Member: Scarsdale AA; F., Royal Soc. A. Exhibited: Soc. Wash. A., 1930 (med); Diplome d'Honneur, Coloniale Internationale, Paris, 1931 (prize); CGA; NGA; Wash. AC (one-man); George Washington Univ. (one-man); Newport AA; Greenwich AA. Work: U.S. Naval Observatory, Wash., D.C.; Smithsonian Inst.; U.S. Nat. Mus.; George Washington Univ.; Cornell Univ.; Howard Univ.; Univ. Ala.; Montgomery Mus. FA; U.S. Military Acad., Md.; State Capitol, Helena, Mont.; South Church, Portsmouth, N.H.; Boston Authors C.; U.S. Senate, Wash. D.C.; Medical Soc., Denver; Bar Assn., Wash., D.C.; U.S. Merchant Marine Acad., Kings Point, N.Y.; N.Y. State Maritime Acad., Ft. Schuyler, N.Y.; Vassar Col.; Wayne Univ. Author: "The Last Cruise of the U.S.S. 'Tacoma' and 'Tankas'"; "Lyrics and Translations" (translation from Nico D. Horigoutchi) [47]

SPAULDING, Florence Louise [P,I,T] Brookline, MA b. 24 Ja 1899. Studied: Boston MFA Sch. Member: Copley Soc.; U. des Femmes PS, Paris. Specialty: medical illustrations [40]

SPAULDING, Grace (Mrs. A.M. John) [P,E] Houston, TX b. 10 F 1890, Battle Creek, MI. Member: Tiffany Foundation. Work: Houston Mus.; State Capitol, Oklahoma City [29]

SPAULDING, Henry P(lympton) [P] Brookline, MA b. 16 S 1868, Cambridge, MA. Studied: R. Turner; Blummers. Member: Copley S.; AFA [33]

SPAULDING, Warren (Dan) [P,Lith,I] Lincolnville, ME b. 7 O 1916, Boston. Studied: Mass. Sch. A. Exhibited: FAP, 1940 (prize); CM, 1940; LOC, 1946; NGA, 1941; CGA, 1940; Portland (Me.) SA, 1940; Asbury Park So. FA, 1940; Mint Mus. A., 1946; traveling exh. 1941–42. Work: Marine Hospital, Carville, La. Illustrator: children's stories; "World Horizons"; "Open Road for Boys"; magazines, 1938–39 [47]

SPEAKMAN, Anna W(eatherby Parry) (Mrs. T. Henry) [I] Stamford, CT b. Springfield, IL. Studied: PAFA. Member: Plastic C.; NAWPS; Phila. Alliance [33]

SPEAKMAN, Russel (Lindsay) (Mrs. Harold) [P] Redding Ridge, CT b. Topeka, KS. Studied: F.V. DuMond; J. James; AIC; Fontainebleau Sch. FA. Member: Mural P. Exhibited: Fontainebleau Sch. FA, ann. exh., 1932 (prize). Work: Fairy story panels, Children's Ward, Eye Inst., Columbia, Presbyterian Hospital, NYC [40]

SPEAR, Arthur P. [P] Brookline, MA/Friendship, ME b. 23 S 1879, Wash., D.C. d. 1959, Waban, MA. Studied: George Washington Univ.; ASL; Académie Julian, with Laurens. Member: ANA, 1920; St. Botolph C.; Allied AA; Gld Boston A. Exhibited: Pan-Am. Expo, 1915 (med); NAD, 1921 (prize) [47]

SPEARE, Caroline [P] Woodstock, NY. Member: Chicago NJSA [25]

SPEARS, Ethel [P,Li,Ser,I,T,C] Chicago, IL b. 5 O 1903, Chicago. Studied: AIC; A. Archipenko; J. Norton; H. Rosse. Member: NSMP; Chicago SA; A. Center, Chicago. Exhibited: AIC, 1946 (prize); Rogers Park Women's C., Chicago (prize); Chicago SA; San Diego FA Soc., 1944; La Jolla A. Center, 1944; New Trier H.S., Winnetka, Ill., 1945; Chicago Col. C., 1946; Oak Park Women's C., 1945; Chicago Women's C., 1945. Work: AIC; community houses, Chicago; Lowell School, Oak Park; Oakton School, Evanston, Ill; Crippled Children's Ward, Ill. Research Hospital; USPO, Hartford, Wis.; Pub. Lib., Rochelle, Ill. WPA artist. Position: T., AIC [15]

SPECK, Walter Edward [C,Lith,P,T] Detroit, MI b. 29 D 1895, Detroit. Studied: J.P. Wicker; Freisz, in Paris. Member: Scarab C. Exhibited: Scarab C., Detroit, 1931 (prize). Work: Pottery, Fisher Theatre, Detroit; water-

color, Detroit Inst. A.; State of Michigan. Position: Dir., Detroit Sch. A. [40]

SPEED, Rosalie [P,Des] Dallas, TX b. 27 N 1907, Dallas. Studied: Aunspaugh A. Sch., Dallas; Southern Methodist Univ.; Tex. State Col. for Women, Denton. Member: Tex. FA Assn.; SSAL; Dallas AL; Frank Reaugh AC, Dallas. Exhibited: Dallas Mus. FA, 1935 (prize), 1940 (prize), 1943 (prize); Tex. Centenn., 1936; SSAL, 1936; Art of the Americas, 1937; San Fran., 1938; Kansas City AI, 1938; Tex. FA Assn., 1943–46; Dallas All. A., 1935, 1940, 1943, 1946. Work: Dallas Mus. FA [47]

SPEED, Thelma Gladys [P,Des] Lynbrook, NY b. 3 D 1914, Bronx, NY. Studied: Pratt Inst., Brooklyn. Member: Nassau A. Lg., Hempstead, N.Y. Exhibited: Mineola Co. Fair, N.Y.; WC Exhib., Noank, Conn.; WFNY, 1939. Work: St. Andrews Textile Co., N.Y. [40]

SPEER, Anniola [P] Ft. Worth, TX [24]

SPEER, Will W. [P] Pittsburgh, PA. Member: Pittsburgh AA [25]

SPEICHER, Eugene E. [P] NYC b. 5 Ap 1883, Buffalo d. 1962. Studied: Albright A. Gal. Sch.; ASL; abroad. Member: ANA, 1912; NA, 1925; Port. P.; NAC; Boston AC; Cent. C.; Inst. A.&Letters; Contemporary; Am. Soc. PS&G. Exhibited: NAD, 1922 (prize), 1914 (prize), 1915 (prize); SC, 1913 (prize); P.-P. Expo, 1915 (med); VMFA, 1938 (prize); CI, 1922 (prize); PAFA, 1920 (gold), 1921 (med); 1922 (med), 1938 (prize); AIC, 1926 (gold); Corcoran C., 1928 (prize), 1935 (gold); Intl. Expo, Paris, 1937 (med). Work: MMA; Albright A. Gal.; CMA; CGA; Detroit Inst. A.; MOMA; WMAA; PMG; FMA; CI; TMA; A. Lg., Galveston, Tex.; Decatur (Ill.) Mus.; Minneapolis Mus.; Brooklyn Mus.; Worcester A. Mus.; Mus. FA, Des Moines, Iowa; BMFA; W.R. Nelson Mus. A., Kansas City; Los Angeles Mus. Hist., Sc.&A. [47]

SPEIDEN, Marion (Miss) [P] Louisville, KY. Member: Louisville A.L. [01]

SPEIGHT, Francis [P,T] Doylestown, PA b. 11 S 1896, Windsor, NC. Studied: Corcoran Sch. A.; PAFA. Member: NA, 1940 ; ANA, 1937. Exhibited: NAD, 1930 (prize), AIC, 1930 (prize); CGA, 1937 (med); PAFA, 1926 (gold), 1930 (prize), 1940 (prize); Soc. Wash. A., 1929 (prize); CAFA, 1932 (prize); Sketch C., Phila., 1938 (prize). Work: MMA; BMFA; Toronto Gal. A.; PAFA; Norton Gal. A.; Montpelier Mus. A.; Encyclopaedia Britannica Coll.; USPO, Gastonia, N.C. WPA artist. [47]

SPEIGHT, Francis, Mrs. See Blakeslee, Sarah.

SPEIR, Andrew H. [P] Baltimore, MD [25]

SPELLMAN, Coreen Mary [E,Lith,P,I,C,T,L] Denton, TX b. 17 Mr 1905, Forney, TX. Studied: Texas State Col. for Women; Columbia; ASL; Univ. Iowa; C. Martin; K.H. Miller; C. Locke; V. Vytlacil; W. Schumacker; E. O'Hara. Member: SSAL; Denton AL; Pr.M. Gld.; Nat. Women's T. Assn. Exhibited: West Texas A. Exh., 1940 (prize), 1942 (prize), 1945 (prize), 1946 (prize); Univ. Iowa, 1942 (prize); Texas Pr. Exh., 1942 (prize), 1943 (prize), 1945 (prize); Texas FA Assn., 1943 (prize), 1944 (prize); Texas General Exh., 1943 (prize); SSAL, 1944 (prize); Am. A. Cong., 1938; Nat. Exh. Am. A., N.Y., 1937; WFNY, 1939; Phila. A. All., 1939; WMAA, 1941; SAE, 1943; AFA Traveling Exh., 1944–45; Assn. Am. A., 1946; Caller-Times Exh., Corpus Christi, Texas, 1944, 1945; Denver A. Mus., 1944–46; Kansas City AI, 1936, 1937, 1942; Pr.M. Gld., 1940–46; Provincetown Gal., 1933; SSAL, 1932, 1936, 1937, 1944; Texas Centennial, 1936; Texas State Fair, 1938, 1939. Work: "Fifth Prints of the Year," 1932; Texas State College for Women; CI. Illustrator: "Dona Perfects," 1940; "El Mundo Espanol," 1942; "A Wedding in the Chapel." Position: T., Texas State T. Col. [47]

SPELMAN, John A. [P] Grand Marais, MN b. 30 S 1880, Owatonna, MN. Member: Assn. Chicago PS; Palette&Chisel Acad. FA; Oak Park and River Forest A. Lg.; Chicago Gal. A. Exhibited: AIC, 1926 (prize); Chicago Gal. A., 1927 (prize), 1928 (prize), 1929 (prize); Assn. Chicago PS (gold); Oak Park AL, 1930 (gold); Palette&Chisel Acad. FA, 1933 (gold). Work: Springfield A. Assn.; Chicago Athletic C.; Univ. Nebr.; State Mus., Springfield, Ill. [40]

SPENCELEY, J. Winfred [E,I] Boston, MA. Member: Boston SAC [01]

SPENCER, Ann Hunt (Mrs. Pratt) [P,T] NYC/Housatonic, MA b. 31 Ja 1914, Toronto, Ontario. Studied: NAD; J. Farnsworth; Sarah Lawrence Col., N.Y. Member: Nat. AC. Exhibited: NAC, 1937 (prize); Kosciuszko Fnd., 1937 (traveling scholarship), ; Kohn Gal., N.Y., 1938 (one-man). Work: Southington, Conn.; Kosciuszkco Fnd.; Univ. Plastic Corp., N.Y. WPA artist. [47]

SPENCER, Bertha Augusta [C,E,L,T,B] Carthage, MO b. Paxton, IL. Studied: Stout Inst., Menomonie, Wis.; Handicraft Gld., Minneapolis; Kans. State T. Col.; Columbia; C. Martin; L. Taft; J. Shapley; Europe. Member: Nat. Soc. Des.; Nat. Edu. Assn.; Kans. Fed. A.; Kans. State A. T. Assn. Exhibited: Miinneapolis (prize); ceramics and metalcraft, in many cities. Position: T., Kans. State T. Col., 1921– [47]

SPENCER, Clara Barton [P,Des,C] NYC b. Wash., D.C. Studied: Nat. Acad., Chicago; Am. Acad., Chicago. Exhibited: Delphic Studio, N.Y. (one-man); N.Y. Municipal Gal. (one-man) [40]

SPENCER, Edna Isbester [S,P,T] Waban, MA/Miami, FL b. 12 N 1883, St. John, New Brunswick. Studied: BMFA Sch.; ASL; B. Pratt, R. Aitken. Member: Miami A. Lg. Exhibited: Concord AA (prize); Miami A. Lg., 1940 (prize); Paris Salon, 1926 (prize); PAFA. Work: numerous portrait busts [47]

SPENCER, Elizabeth C. [P] Baltimore, MD/Westchester, NY. Member: NAWPS [25]

SPENCER, Frank B. [P] Rochester, NY [08]

SPENCER, Guy Raymond [Car] Omaha, NE b. 1 S 1878, Jasper County, MO. Positions: Staff, Omaha World-Herald (since 1899), Lincoln Commoner (1902–10) [21]

SPENCER, Henry Cecil [P,I,W,,T] Chicago, IL b. 3 Mr 1903, Mangum, OK. Studied: Baylor Univ.; Tex. Agricultural & Mechanical Col.; Ernest Blumenschein; ASL, with Romanovsky. Member: Am. Inst. Draftsmen; SSAL. Work: Baylor Univ., Waco, Tex. Author: "Technical Drawing," 1940, "The Blueprint Language," 1946. Positions: T., Ill. Inst. Technology (1941–), Tex. A.&M. Col. [47]

SPENCER, Howard Bonnell [P,I,T] NYC b. Plainfield, NJ. Studied: ASL; F. DuMond; A. Lucas; G.E. Browne; W. Kuhn. Member: All. A. Am.; SC, 1924; Barnard C.; Studio Gld.; Lime Rock AA; Yonkers AA; Ogunquit A. Center; A. Fellowship, Inc.; Provincetown AA; AAPL. Exhibited: NAD; AV. Work: Wesleyan Col., Macon, Ga. [47]

SPENCER, Hugh [I,L,Lith,Ph,W] Chester, CT b. 19 Jy 1887, St. Cloud, MN d. 1975. Studied: Chicago Sch. Appl.&Normal A.; ASL; N.Y. Evening Sch. Indst. A.; C. Chapman; A. Covey; H. Dunn. Member: Photographers Assn. Am.; Conn. Botanical Soc.; Phila. ACG. Author/Articles: "Nature"; "American Forests and Forest Life"; "Bird Lore"; "American Photography." Illustrator: books of Biology and Natural Science [47]

SPENCER, Irvin B. [P] Columbus, OH. Member: Columbus PPC [25]

SPENCER, Jean [P,W] NYC/Oak Park, IL b. 18 S 1904, Oak Park. Studied: Wellesley Col.; AIC; Grand Central Sch. A.; A. Woelfle; W. Adams; Traphagen Sch. Fashion, N.Y. Member: PBC; All. A. Am.; NAWA; Audubon A.; All-Ill. Soc. P.; Studio Gld., N.Y. Exhibited: Grand Central Sch. A. (med); All. A. Am.; All-Ill. Soc. Painters; NAC; PBC; Audubon A.; Manor House, N.Y., 1938 (one-man); Studio Gld., N.Y., 1938 (one-man); NAWPS, 1938–38. Exhibited: Work: Sioux Falls, S.Dak.; Trenton, N.J.; Court House, Chapel Hill, N.C. Author: "Fine and Industrial Arts" [47]

SPENCER, Jim-Edd [B,I,P] Independence, MO b. 6 Je 1905, Kansas City. Studied: Kansas City A. Inst.; Univ. Mo.; B. Sandzen; J.S. Ankeney. Member: Kansas City Soc. Ar. [40]

SPENCER, Joseph [P] Detroit, MI. Exhibited: Ann., PAFA, 1939; San Fran. A. Assn., 1939 [40]

SPENCER, Julia Selden (Mrs. R.P.) [P] Miami, FL (Deep River, CT, until 1925) b. Connecticut. Studied: ASL, with Seyffert; N.Y. Sch. F.&Appl. A., with Walter and Bredin; Breckenridge, in East Gloucester. Member: North Shore AA; Miami Beach AL [27]

SPENCER, Leontine G. [P,T] Brooklyn, NY b. 6 S 1882, NYC d. 24 Ag 1964. Studied: Columbia; Grand Central Sch. A.; G.P. Ennis; A. Woelfle. Member: AWCS. Exhibited: NAD, 1934; All.A.Am., 1933–37, 1940–42; AWCS, 1932, 1934; Rockefeller Center, N.Y., 1934; BM, 1939, 1940, 1943; Brooklyn P.&S., 1934, 1936; South Brooklyn Bd. Trade, 1939. Position: T., Thomas Jefferson H.S., Brooklyn [47]

SPENCER, Lilly (or Lillie) Martin (Mrs.) [Por.P,Genre P] NYC (since 1847) b. 26 N 1822, England (came to U.S. in 1830; to Marietta, Ohio, in 1833; Cincinnati, in 1841) d. 22 My 1902. Studied: Marietta, Ohio, with C. Sullivan, S. Bosworth; Cincinnati, with N. Longworthy, 1841. Member: NA (hon.). Exhibited: NAD; Phila. Centenn. Expo, 1876 (gold); Am. Art Union. Specialties: children; dogs

SPENCER, Margaret F(ulton) (Mrs. Robert) [P,Arch,Dec] Tucson, AZ/New Hope, PA b. 26 S 1882, Phila. Studied: Bryn Mawr Col.; MIT; N.Y. Sch. Des.; ASL; B. Harrison; H. Walker; R. Spencer. Member: AIA; AAPL; Union Des Femmes Peintres et Sculpteurs, Paris. Exhibited: annually, 1914– [sic]. Work: Simpson Coll., Phila. [47]

SPENCER, Margaret K. [P] South Orange, NJ [01]

SPENCER, Mary [P] Cincinnati, OH (since 1858) b. 1835, Springfield, OH d. 1923. Studied: C.T. Webber, in Cincinnati. Member: Cincinnati Women's AC. Work: Cincinnati Mus. [23]

SPENCER, Mary [P,T] Brooklyn, NY b. Fitchburg, MA. Studied: H. Adams; H.B. Snell; A. Dow; R. Miller. Member: NAWPS. Exhibited: NAWPS, 1936–38 [40]

SPENCER, Mary J. [P,Des,T,L] Riverside, IL b. 14 Ja 1900, Terre Haute, IN. Studied: Ind. State T. Col.; AIC; Chicago Acad. FA; Otis Art Inst. Member: Hoosier Salon; All-Ill. SFA; Ind. Ar. C.; Chicago SA; NAWPS; Exhibited: Hoosier Salon, 1934–39, 1940 (prize); NAWA, 1937, 1938; CAFA, 1939; AIC, 1936, 1939; S.C. AA, 1943, 1944. Position: T., Chicago Acad. FA [47]

SPENCER, Meade A(shley) [Arch,B,Des,Dr,E,I,P] Cleveland Heights, OH b. 8 Ap 1896, Sandusky. Studied: W. Felton Brown; MIT. Member: Cleveland PM; Cleveland Print C. Exhibited: Exhib. Cleveland A.&Craftsmen, Cleveland Mus., 1929 (prize), 1934 (prize). Work: Cleveland Print C. [40]

SPENCER, Niles [P] NYC/Provincetown, MA b. 16 My 1893, Pawtucket, RI d. 15 My 1952. Studied: RISD, 1913; ASL, with Bellows, Henri; France, Italy, 1921–22. Member: An Am. Group. Exhibited: CI, Pittsburgh, 1930 (prize); PAFA; WMAA; MOMA; AIC; Detroit Inst. A.; WMAA, 1965–66 (retrospective); Univ. Ky. (retrospective); Munson-Williams-Proctor Inst. (retrospective); Portland (Maine) Mus. A. (retrospective); Allentown A. Mus. (retrospective); Currier Gal. A. (retrospective); RISD. Work: Albright A. Gal.; PMG; WMAA; MOMA; MMA; Field Fnd.; Ann Arbor AA; Wichita Mus. A.; Providence Mus. A.; Columbus Gal. FA; mural, USPO, Aliquippa, Pa. [47]

SPENCER, Raymond M. [P] Columbus, OH. Member: Columbus PPC [25]

SPENCER, Robert [Ldscp.P] New Hope, Bucks County, PA b. 1 D 1879, Harvard, NE d. 11 Jy 1931. Studied: Chase; DuMond; Henri; Garber. Member: ANA, 1914; NA, 1920; SC; NAC; Century Assn. Exhibited: NAD, 1913 (prize), 1914 (gold), 1920 (prize), 1921 (prize), 1928 (gold); Phila AC, 1913 (prize), 1923 (prize), 1928 (gold); PAFA, 1914 (gold); Boston AC, 1915 (med); P.-P. Expo, San Fran., 1915 (gold); AIC, 1919 (med); CI, 1920 (prize), 1926 (prize); SC, 1921 (prize); Wilmington SFA, 1921 (prize); Sesqui-Centenn. Expo, Phila., 1926 (gold). Work: MMA; Boston AC; Detroit Inst. A.; AIC; National AC; CGA; Pittsburgh Athletic Assn.; Brooks Memorial A. Gal., Memphis, Tenn.; NAD; Union Lg. C., Chicago; Phila. AC; CI; Brooklyn Mus.; Newark Mus. Assn.; Albright A. Gal., Buffalo; Soc. FA, Wilmington, Del.; PMG [29]

SPENCER, W. Clyde [Car] NYC b. 1874, Peoria, IL d. 17 Jy 1915. Cartoonist: Denver Republican, 1895–1909; NYC papers, 1909–15

SPENNER, E. E. [P] Indianapolis, IN [25]

SPENS, Nathaniel [Primitive P,S,Dec] Mountainville, UT (since 1890) b. 1838, Edinburgh, Scotland (came to U.S. in 1862) d. 1916. Work: Latter Day Saints temples [*]

SPERLING, George J. [P] Pittsburgh, PA. Member: Pittsburgh AA [21]

SPERO, M.J. [I,P] NYC [24]

SPERRY, Edward Peck [P] NYC. Member: Mural P.; Arch. Lg. [13]

SPERRY, Keith (Mrs. Thomas K. Givens) [Des,Dec] Louisville, KY b. 15 Ja 1888, Louisville. Member: Louisville AC. Owner: Sideway Shop (designers and makers of furniture and ironwork) [40]

SPEYER, A. James [P] Pittsburgh, PA. Exhibited: Pittsburgh AA, 1936 (prize) [40]

SPICER-SIMSON, Margaret Schmidt (Mrs. T.) [Min.P] Cannondale, MA b. 6 Mr 1874, Wash., D.C. Studied: Knaus, in Berlin; Boutet de Monvel, Carrière, in Paris [17]

SPICER-SIMSON, Theodore [P,S] Paris, France/Cocoanut Grove, FL b. 25 Je 1871, Havre, France d. 1959, Miami. Studied: England; Germany; Ecole des Beaux-Arts, Paris. Member: Soc. Nationale des Beaux Arts, 1928; Century Assn.; NSS, 1911. Exhibited: Brussels Expo, 1911 (prize); Ghent Expo, 1915 (prize); P.-P. Expo, San Fran., 1915 (med). Work: MET; Numismatic Mus., N.Y.; AIC; Detroit Inst.; Minneapolis Mus. A.; City Mus. A., St. ouis; the Luxembourg, Paris; Victoria and Albert Mus., London; Holland; Belgium; Germany; Austria; Czechoslovakian Mus. [40]

SPICUZZA, Francesco J. [P] Milwaukee, WI b. 23 Jy 1883, Sicily d. 1962. Member: NYWCC; Wis. PS; Soc. A.&Science, N.Y. Exhibited: St. Paul Inst., 1915 (med), 1916 (prize), 1917 (med); Wis. PS, 1919 (prize); Milwaukee AI, 1922 (gold), 1927 (prize), 1930 (prize); 1932 (prize). Work: St. Paul Inst. A., St. Paul; Milwaukee AI. Position: T., Milwaukee AI [40]

SPIDELL, Enid Jean [P,T] New Rochelle, NY b. 5 Je 1905, Hampton, New Brunswick. Studied: N.Y. Sch. F.&Appl. A.; Parsons Sch. Des.; NYU; Columbia; G.P. Ennis. Member: AWCS; Springfield AA; New Rochelle AA; Wolfe AC; Studio Gld. Exhibited: AV-Am. A. Group Design Comp., 1943 (prize); Wolfe AC, 1937 (prize); PAFA; AWCS, 1937–45; Ogunquit AA, 1945; New Rochelle AA, 1940–45. Work: Pub. Lib., Eastport, Maine. Position: T., Pratt Inst., Brooklyn, N.Y. [47]

SPIEGEL, Charles, Jr. [P,E] Passaic, NJ d. 30 Ja 1905 (as he stepped from a train near his home). Specialty: watercolors

SPIEGEL, Doris [E,En,I,W] Bronx, NY b. 8 Je 1907, NYC. Studied: C. Balmer,in N.Y.; P. Chentoff, in Paris. Exhibited: NAD, 1939; AIC, 1935; SAE, 1936; LOC, 1945. Author/Illustrator: "Danny and Company 92," 1945. Illustrator: New Yorker, Forum, other magazines; "Paris to the Life," "Pif" [47]

SPIEGEL, Dorothy A. [P] Indianapolis, IN b. 8 D 1904, Shelbyville, IN. Studied: Ind. Univ.; John Herron AI; Butler Univ.; E. O'Hara; E. Bisttram; P. Hadley. Member: Indianapolis AA; Ar. C. Exhibited: Hoosier Salon, 1936 (prize); Ind. State Fair, 1941 (prize); Goose Rocks Beach, Maine, 1938 (med); Ind. Fed. AC Traveling Exh.; Ind. AC, 1937 (prize), 1938 (prize). Work: West Lafayette (Ind.) H.S.

SPIEGLE, Frederick M. [P,E] NYC b. 1863, NYC d. 29 D 1942. Studied: Paris. Exhibited: N.Y. Etching C., 1886. Represented by C. Klackner. Specialty: wildlife

SPIELBERGER, Morris [P] Chicago, IL. Member: Chicago SA [17]

SPIELMANN, Lucretia [P] Paris, France [10]

SPIERER, William McK. [Des,I,P,L] Flushing, NY b. 2 Ja 1913, NYC. Studied: ASL; NAD; Syracuse Univ.; DuMond; Boss; Bridgman. Member: AWCS; NAC. Exhibited: Editors & Publishers & Printers Assn., 1939 (prize), 1940 (prize); AWCS, 1929, 1946; NAD, 1931; PAFA, 1939. Camouflage expert, U.S. Army, WWII. [47]

SPIERS, Harry [P] Dedham, MA b. 15 O 1869, Selsea, Sussex, England. Studied: Académie Julian, Paris. Member: Boston SWCP. Work: BMFA; Historical Soc., Framingham, Mass.; Ontario Government Gallery, Toronto [40]

SPIERS, Richard N. [Stained Glass,Des] Brooklyn, NY b. 1873, London (came to U.S. in 1886) d. 29 My 1936. Work: stained glass windows, Riverside Church, St. Batholomew's Church, both in NYC

SPINETTA, Fred [P] NYC. Member: S.Indp.A. [21]

SPINGARN, Amy (Mrs. J.E.) [P] NYC/Amenia, NY b. 29 Ja 1883, NY. Studied: K.H. Miller. Member: S.Indp.A. [29]

SPINGLER, Oakley Austin [P] Providence, RI/Provincetown, MA b. 17 D 1908, Newport, RI. Studied: RISD; Provincetown Summer Sch. Member: Provincetown AC; Newport A. Assn. Exhibited: Provincetown AC; Newport A. Assn.; WFNY, 1939. Work: Newport Fire Dept.; R.I. State College; Ft. Adams, Newport [40]

SPIRO, Eugene [P,E,Li,T,I] NYC b. 18 Ap 1874, Breslau, Germany. Studied: A. Acads., Breslau, Munich, both in Germany; F. von Stuck. Exhibited: MOMA, 1942; St. Etienne Gal., N.Y., 1943 (one-man), 1945 (one-man). Award: Officier d'Academie des Beaux-Arts Française, Paris. Work: Archdiocese, Detroit; Musée du Jeu de Paume, Paris; numerous museums in Germany. Illustrator: "Antique Frescoes" (1922), "In Konzert" (1922) (lithographs of famous musicians) [47]

SPITZGLASS, Vicci [P] Chicago, IL b. 17 Ap 1901, Brooklyn. Studied: R. Weisenborn. Member: United Am. Artists. Exhibited: Ar. Un. Gal., Chicago; Chicago NJSA [40]

SPIVAK, H. David [P,I] Denver, CO b. 19 N 1893, Phila. d. ca.1938. Studied: Norton; Johansen; Henri. Member: Denver AG; Denver A. Mus. Exhibited: Colo. State Fair, 1921 (prize), 1929 (prize). Work: B.M.H. Synagogue, Denver [33]

SPIVAK, Max [Mur.P,C,Des] NYC b. 20 My 1906, Bregnun, Poland. Studied: CUASch; CCNY; Grand Central A. Sch.; ASL; Grande Chaumière, Paris. Member: S. Des.-Craftsmen; NSMP, 1969–70 (Pres.); Arch. Lg., 1966–68 (Vice-pres.). Exhibited: WFNY, 1939; GGE, 1939; MOMA, 1936; Bonestell Gal., 1945 (one-man); Mortimer Levitt Gal.; ACA Gal.; Contemp. A. Gal.; Valentine Gal., 1939; Arch. Lg., 1956 (med); WMAA; AIC; Newark Mus.; Denver A. Mus.; BMA. Work: BMA; Newark Mus.; H.S., Ft. Hamilton, N.Y.; Astoria (N.Y.) Pub. Lib.; Textile H.S., N.Y. Positions: T., PIASch (1960–70), Bard Col. (1959–62) [47]

SPIZZIRRI, Luigi [P,T] Phila., PA/Summerdale Park, Camden, NJ b. 23 O 1894, Spezzano, Grand Prov. of Cosenza, Italy. Studied: PAFA, with E. Carlsen; Vonnoh; Pearson; D. Garber; P. Hale; and W.M. Chase [33]

SPOERL, Christian George [P] Phila., PA [13]

SPOFFARD, E.W. [P] NYC. Member: GFLA [27]

SPOHN, Clay (Edgar) [P,T,G,Des] San Fran., CA b. 24 N 1898, San Fran. Studied: Berkeley Sch. A.&Crafts; Univ. Calif.; ASL; Acad. Moderne, Paris; Calif. Col. A.&Cr., Oakland; Mark Hopkins Inst. FA. Member: San Fran AA. Exhibited: San Fran. AA, 1929, 1939 (prize), 1945 (prize); Albert Bender Grant, San Fran, 1944–45 (prize); Pal. Leg. Honor, 1938, 1939, 1945, 1946; SFMA, 1938, 1939, 1942 (one-man), 1946. Work: Castro Valley (Calif.) Community Center; USPO, Montebello, Calif.; Los Gatos (Calif.) Union H.S.; Fire Dept., Carmel, Calif. WPA artist. Position: T., Calif. Sch. FA, 1945–46 [47]

SPONG, W.B. [P] Amityville, NY [08]

SPONGBERG, Grace [P,C,G] Chicago, IL b. 25 Ap 1906, Chicago. Studied: AIC; A. Krehbiel; F. Poole; F. Fursman; L. Ritman; E. Zoir. Member: Chicago SA; Swedish A., Chicago. Exhibited: Swedish-Am. Exh., Chicago, 1936 (prize); CM; PAFA; AIC; Joslyn Mem.; Chicago SA. Work: Bennett Sch., Byford Sch., Horace Mann Sch., all in Chicago; Mus. Vexio, Sweden [47]

SPOONER, Charles H. [Ldscp.P] Phila., PA b. 1836, Phila. d. 4 Mr 1901. Member: Artists' Fund So.; Phila. Sketch C.; Phila. AC; Phila. Soc. Artists. Exhibited: PAFA, 1863–67 [01]

SPOTH-BENSON, Eda [P,S] West Cornwall, CT b. 25 Mr 1898, Brooklyn, NY. Studied: Dabo; Eggleston. Member: Lime Rock (Conn.) A.; Brooklyn SA; Palm Beach AL. Exhibited: Lime Rock AA, 1929 (prize); Fla. Fed. A., Miami Beach, 1930–31 (prize) [33]

SPRADLING, Frank [I] Interlaken, NJ [21]

SPRAGUE, Amelia [P,T] Buffalo, NY [21]

SPRAGUE, Amelia Browne [P] b. 1870, Cincinnati. Studied: Cincinnati A. Acad.; Pratt Inst. Position: Dec., Rookwood Pottery, Cincinnati [04]

SPRAGUE, Curtiss [P] Nutley, NJ. Member: GFLA [27]

SPRAGUE, Elizabeth [P] Wichita, KS [15]

SPRAGUE, Elmer E. [P] Columbus, OH. Member: Columbus PPC [25]

SPRAGUE, Florence [S,T] Des Moines, IA b. Paullina, IA. Studied: C. Mulligan; A. Polasek. Member: Iowa AC; Des Moines Assn. FA; College AA. Work: Des Moines Water Works; Des Moines Pub. Lib. Position: T., Drake Univ. [33]

SPRAGUE, Harold Conger [P,T] Fanwood, NJ b. 19 Ag 1903, Ridgefield Park, NJ. Studied: ASL; J.F. Carlson; J.J. Newman. Member: SC; AAPL; Westfield AA; Plainfield AA. Exhibited: Plainfield AA, 1945 (prize); Spring Lake, N.J.; Westfield AA; Raritan Valley C.; Morton Gal., N.Y. [47]

SPRAGUE, Howard Freeman [Mar.P,I] b. 15 Ja 1871, Huron, OH d. 15 My 1899, Buffalo, NY of tuberculosis. Work: naval artist during Spanish-American War; Mariner's Mus.; Dossin Great Lakes Mus., Detroit [99]

SPRAGUE, Reynold (Marjorie Reynolds) [S,G,T] Sarasota, FL b. 19 Je 1914, White Plains, NY. Studied: Ringling Sch. A., Sarasota. Member: Sarasota AA; Fla. Fed. A.; SSAL; Exhibited: Denver AA, 1938; Ringling A. Mus., 1939; SSAL, San Antonio, 1939. Position: T., Sherman Reynolds Studios, Sarasota [40]

SPRAGUE, Robert B. [P,Des,L,T,W] Dayton, OH b. 12 Je 1904, Dayton. Member: Hoosier Salon; Richmond (Ind.) Palette C.; Am. APL; Taos AA. Exhibited: Exh. Mid-West Art., 1934 (prize). Position: Dir., Roswell Mus., N.Mex. [40]

SPRAGUE-SMITH, Isabelle Dwight (Mrs. Charles) [P,Des,L,T] Winter Park, FL b. 11 N 1861, Clinton, NY d. 28 D 1951. Studied: Dwight Sch. A.; ASL; Paris. Member: Fla. Hist. Soc.; Audubon Soc.; All. A. Florida. Position: Dir., MacD. Assn., Peterborough, N.H. [47]

SPRATT, Alberti (A.S. Lamb) [P,G,I] Monterey, CA b. 26 Ja 1893. Studied: Calif. Sch. Des.; College of Pacific, Stockton. Member: Carmel A. Assn.; Oakland A. Assn. Exhibited: Carmel A. Assn. Work: murals, Orinda Country C., Oakland. Specialty: horticultural illus. [40]

SPREAD, Anne [P] Chicago, IL b. Chicago. Studied: AIC; Bouguereau, Ferrier, in Paris. Member: ASL, Chicago [08]

SPREEN, Fred A. [P] Pittsburgh, PA. Member: Pittsburgh AA [25]

SPRENKLE, Arthur George [P,E,T] Los Angeles, CA b. 21 F 1881, Hanover, PA. Studied: PMSchIA. Member: Los Angeles AA; Calif. WCS; Calif. AC. Exhibited: Calif. AC, 1937 (prize). Positions: T., Chouinard AI; Affiliated with W.&J. Sloane, Beverly Hills, Calif. [40]

SPRETER, Roy Frederic [I,P,Des] NYC b. 2 Ag 1899, Chicago. Studied: AIC. Member: SI; A. Dir. C. [47]

SPRINCHORN, Carl [P] Mount Vernon, NY b. 13 My 1887, Broby, Sweden d. 1971. Studied: N.Y. Sch. A., with Henri. Member: Brooklyn S. Modern A.; S.Indp.A.; Salons of America. Exhibited: CGA, 1943; AIC, 1932, 1943; WMAA, 1936; Walker A. Center, 1943; Toledo Mus. A., 1943; CM, 1932; WMA (one-man); Chicago AC (one-man); Am.-Swedish Hist. Mus., Phila. 1942 (one-man); Summit (N.J.) AA, 1935 (one-man). Work: PMG; PMA; BM; Dayton AI; Mus. City of N.Y.; RISD; Macbeth Gal., NYC. Contributor: Dial [47]

SPRING, E.W. [P] Toledo, OH. Member: Artklan [25]

SPRING, Edward Adolphus [S,C,T,L] b. 1837, NYC. Studied: H.K. Brown; J.Q.A. Ward; W. Rimmer; England; France. Opened studio in Eagleswood, N.J., 1860s; by 1868 he was specializing in terra-cotta, and in 1877 established Eagleswood Art Pottery Co.

SPRINGER, Carl [P] Brevort, MI b. 4 N 1874, Fultonham, OH d. 12 Ag 1935, Delaware, OH. Member: ASL; Columbus Pen&Pencil C.; Columbus AL; SC. Exhibited: SC, Detroit, 1913 (prize), 1916 (prize); Ohio State Expo, 1920 (prize); Columbus A. Lg., 1920 (prize); 1924 (prize) 1926 (prize). Work: Gallery of FA, Columbus. Specialty: snow scenes [33]

SPRINGER, Charles H(enry) [P,C,T,S,I,D] Providence, RI b. 15 Jy 1857, Providence d. My 1920. Studied: ASL; H. Breul, in Providence; F.W. Freer, in N.Y. Member: Providence AC; RISD. Specialties: wood carving; furniture design [19]

SPRINGER, Eva [Min.P,G] Santa Fe, NM b. Cimarron, NM. Studied: Highlands Univ., Las Vegas; Columbia; Académie Julian; Grande Chaumiere, Paris; ASL; W.H. Foote; K.H. Miller; Delecluse and Mme. La Forge and F. Miller, Paris. Member: Brooklyn Soc. Min. P.; Pa. Soc. Min. P.; Wash. Soc. Min. P.; Wash. WCC; NAWPS; PBC; NAC. Exhibited: Académie Julian, Paris (prize); Grand Central A. Gal.; NCFA; Wash. WCC; Pa. Soc. Min. P.; PAFA; ASMP; Wash. Soc. Min. P. S.&G.; Mus. N.Mex., Santa Fe (one-man); Albuquerque, N.Mex. Work: Mus. N.Mex., Santa Fe; Pa. Soc. Min. P.; PMA [47]

SPRINGER, Frederick M. [P] Cincinnati, OH b. 5 F 1908, Bellevue, OH. Studied: Cincinnati A. Acad. Exhibited: Columbus AL, 1935 (prize), 1936 (prize). Work: Columbus Gallery of FA. Illustrator: "Patterns of Wolfpen," 1935 [40]

SPRINGWEILER, Erwin Frederick [S,C] Carinthia Heights, NY b. 10 Ja 1896, Pforzheim, Germany. Studied: Acad. FA, Munich, Germany; BAID; P. Manship, H. Haseltine; Artcrafts Sch., Pforzheim. Member: NSS. Exhibited: NSS, 1937 (prize), NAD, 1938 (prize); WFNY, 1939; NAD, 1937–46; PAFA, 1935–46; AIC; other major exh. Work: Wash., D.C. Zoo; medals, Soc. Medallists; USPO, Chester, Pa.; Highland Park, Detroit; Manchester, Ga.; metalwork: Williamsburg Savings Bank Bldg., Brooklyn; Pub. Lib., Jamaica, N.Y. WPA artist. [47]

SPROULL, M. Magdalen [P] Freeport, NY b. 16 F 1870, Rochester, NY. Studied: DuMond, in NYC; Flameng, Ferrier, Collin, all in Paris [13]

SPROUT, Donald A. [P] Phila., PA. Studied: PAFA [25]

SPRUANCE, Benton M. [Li,P,T] Germantown, PA b. 25 Je 1904, Phila. d. 6 D 1967. Studied: G. Harding; R. Nuse; Garber; Lhote. Member: Phila. Print C.; Am. Ar. Cong. Exhibited: Phila. Print C., 1929 (prize), 1932 (prize), 1929 (prize); WC Ann., 1937 (prize); PAFA, 1939 (med). Work: WMAA; Milwaukee AI; Seattle A. Mus.; NYPL; LOC; AGA. Positions: T., Beaver College (Jenkintown, Pa.), PMSchIA [40]

SPRUCE, Everett Franklin [P,Li,T] Austin, TX (1976) b. 25 D 1907, Faulkner County, AR. Studied: Dallas AI; O.H. Travis; T. Stell. Member: Tex. FA Assn.; Lone Star Pr.M. Exhibited: Tex. FA Assn., 1939–41, 1942 (prize), 1940–45; SFMA, 1940 (prize); WMA, 1945 (prize); Pepsi-Cola, 1946 (prize); CGA, 1939, 1941, 1943; PAFA, 1945; AIC, 1937, 1939–45; MOMA, 1942; Critics Choice, CM, 1944; Dallas Mus. FA, 1932–35, 1938–40 (prizes); Tex. General Exh., 1939–45; Tex. Centenn., Dallas, 1936; La Tausca Pearls Exh., 1947; Hudson Walker Gal., 1939 (one-man); Leavitt Gal., 1945 (one-man); Dallas Mus. FA, 1933 (one-man); Witte Mem. Mus., 1943 (one-man). Work: U.S. Dept. State, Wash., D.C.; Mus. FA, Houston; Dallas Mus. FA; PMG; Witte Mem. Mus.; MOMA; North Tex. State T. Col., Denton. Positions: T., Dallas Mus. Sch. (1936–40), Univ. Tex., Austin (1940–)[47]

SPRUNCK, Marian L. [P] Los Angeles, CA [24]

SPRUNGER, Arthur L. [P,En,C,T,Des] Goshen, IN b. 25 Ap 1897, Berne, IN. Studied: Goshen Col.; John Herron AI; AIC; W. Forsyth. Member: Hoosier Salon; Northern Ind. A. Lg.; Am. Ar. Prof. Lg.; Ind. Soc. Pr.M.; Elkhart County Ar. Lg. Exhibited: Hoosier Salon, 1928–30, 1931 (prize), 1934–40, 1943; Artists Lg. Northern Ind., 1920 (prize); Friends of Art, South Bend, 1929 (prize), 1932 (prize), 1933 (prize), 1934 (prize), 1937 (prize), 1939 (prize); Ind. State Fair, 1939 (prize); Elkhart County A. Lg., 1939 (prize); PAFA; Albright A. Gal.; SAM; Phila. WCC; Ind. Soc. Pr.M.; Ind. A. & Craftsmen; Indianapolis AA; Northern Ind. A. Lg. Position: T., Goshen Col., 1926– [47]

SPRUNK, Robert Godfrey [P,I] Ridgefield, N.J. b. 16 N 1862, Kroexen, Germany (came to Detroit in 1868) d. 9 Ap 1912. Studied: PAFA, with Eakins; Jakobides, in Munich; Paris, with Bouguereau, Robert-Fleury [10]

SPRY, Charles V. [P,Des] b. 1914 d. 5 Ag 1942, Pittsburgh, PA. Studied: CI. Member: Pittsburgh A. Comm.

SPURGEON, Sarah (Edna M.) [P,T] Ellensburg, WA b. 30 O 1903, Harlan, IA. Studied: Univ. Iowa; Harvard; Grand Central Sch. A.; Grant Wood; P. Sachs; C. Macartney; G. Oberteuffer. Member: Iowa AG; Women P. of Wash. Exhibited: Kansas City AI; Joslyn Mem.; Calif. SE; Des Moines A. Salon; SAM; Univ. Iowa, 1931 (prize); Iowa A. Salon, 1930 (prize), 1931 (prize). Work: Iowa Mem. Un., Iowa City. Position: T., Central Wash. Col., Ellensburgh, 1939–42, from 1944 [47]

SPURGEON, Joseph E. [Des,L] Chicago IL b. 22 O 1903. Studied: Cincinnati A. Acad. Member: Hoosier Salon. Exhibited: All-Am. Packaging Comp., 1935; Hoosier Salon, 1936 (prize); WC, 1939 (prize); Am. Management Assn., 1939 (prize); All. Am. Packaging Comp., 1939 (med). Work: package and product des. [40]

SQUIER, Donald Gordon [P,I] Melrose, MA b. 17 O 1895, Amherst, MA. Studied: BMFA Sch. with Tarbell, Hale; Europe. Exhibited: NAD; CGA; PAFA; Whistler House, Lowell, Mass.; Boston AC, 1935 (one-man); Copley S., Boston, 1934 (one-man); No. 10 Gal., 1936 (one-man). Work: many portraits of prominent people [47]

SQUIER, Frank [P] Brooklyn, NY. Member: B & W C.; SC 1893; NAC [01]

SQUIERS, David Ellicott [P,Et,T,L] Oxford, OH b. 8 Ag 1918, Dowagiac, MI. Studied: Western Mich. Col.; Kalamazoo Col.; Harvard; A. Burroughs; H. Rosenberg; A. Pope. Member: Am. Archaeological S.; AFA. Exhibited: Kalamazoo Inst. A., 1938 (prize); Cincinnati, OH. Work: mural, Kalamazoo Col. Position: T., Western Col., Oxford, Ohio from 1944 [47]

SQUIRE, Allan Taft [Des,P,W,L,T] Wash., D.C. b. 11 My 1904, New Haven, CT d. ca. 1950. Studied: Taft Sch., Watertown, Conn.; Yale; Am. Sch. Classical Studies, Athens, Greece. Member: AIA. Exhibited: PMG, 1939. Positions: Arch., FHA, until 1942; City Planning Commiesioner, Naval Govt., Guam, from 1945 [47]

SQUIRE, Dorothea (Mrs. Cram) [P,I,T] Richmond, VA b. 22 Mr 1901, Vaughan, NC. Studied: Richmond Sch. A., Col. William & Mary; Columbia; Ecole des Beaux-Arts, France. Member: CAA; Southeastern AA; Nat. Vocational Assn. Exhibited: BAID, 1928; Fed. A. traveling exh., 1940; CGA, 1942; PAFA, 1943; Richmond Acad. A. & Sc., 1941 (prize), 1942 (prize); VMFA, 1941 (prize); BMA, 1944 (prize), 1945 (prize); Butler AI; Wash. WCC, 1942 (prize), IBM, 1941 (prize). Work: IBM Coll.; frescoes, Col. William & Mary [47]

SQUIRE, Eunice. See Pritchett.

SQUIRE, Maude H(unt) [P,B,Dr,I] Vence, France b. 30 Ja 1873, Cincinnati, OH. d. ca. 1955. Studied: Cincinnati AC. Member: Société du Salon d'Autôme, Paris. Exhibited: P.-P. Expo, 1915; Provincetown AA, 1917–20. Work: Herron AI, Indianapolis; South Kensington Mus., London; CGA. Illustrator: "Child's Garden of Verse," R. Stevenson; "Greek Heroes," Kingsley; "Adventures of Ulysses," Kingsley; "When I was Little," E. Kelley; "Hindu Tales," T.P. Williston, 1917 [40]

SQUIRES, C. Clyde [I] NYC/Little Neck, NY b. 29 Ag 1883, Salt Lake City (cousin of Lawrence) d. 1970. Studied: NY Sch. A., 1901 with Henri, Miller, Du Mond, Mora, Pyle. Member: Artists G.; SI 1911. Illustrator: Life, 1906; later for Western Romances and other Western mags. Cousin of Lawrence. [33]

SQUIRES, Henry [Primitive Ldscp.P] Salt Lake City, UT b. 1850, Putney, Surrey, England (came to Salt Lake City, 1853) (Uncle of Lawrence and Clyde) d. 1928. Studied: Univ. Deseret, 1870. Work: Utah St. Capitol [*]

SQUIRES, Lawrence [P,E] Salt Lake City b. 14 Mr 1887 d. 18 Ja 1928. Studied: Mahonri Young, 1905; in Europe, 1907–10; ASL, with K.H. Miller, G. Bridgman, 1912–14. Work: Capitol, Utah; Denver AM [27]

STAATS, Teresa (Mrs.) [P,C,L,T] Bordentown, NJ b. 29 S 1896, Opelika, AL. Studied: Columbia Univ.; AIC; Univ. Chicago. Exhibited: N.J. State Mus., Trenton; Harmon Fnd., traveling exh.; Pyramid C., Phila.; Artists of Today Gal., Newark. Work: port., Carver Ctr., Trenton, N.J. Position: T., Manual Training Sch., Bordentown, N.J., from 1920 [47]

STACEY, Anna Lee (Mrs. John F.) [P] Pasadena, CA b. Glasgow, MO d. 4 Mr 1943. Member: Chicago PS; Chicago WCC. Exhibited: AIC, 1902 (prizes), 1907, 1921 (med); Chicago SA, 1912 (prize). Work: Chicago Woman's C.; Kenwood C., Chicago; Union Lg. C., Chicago; Chicago A. Commission purchase, 1914, 1924 [40]

STACEY, Dorothy Layman [P,Des,W,L,Dec] Des Moines, IA b. 30 S 1904, Des Moines. Studied: Des Moines Univ.; C.A. Cumming; A.M. Cumming. Member: Iowa AG; S. Sanity in Art. Exhibited: Grand Central A. Gal., 1935; Univ. Idaho, 1936; Denver AM, 1936; College AC, Santa Maria, Calif., 1936; Iowa AG, 1928–40; Iowa A. Salon, 1928–31 (golds), 1932–40; Univ. Iowa, 1928–37; Little Gal., Cedar Rapids, Iowa; Cornell Col., 1937; Blandon Mem. Gal., Ft. Dodge, Iowa, 1932; Des Moines Women's C., 1930 [47]

STACEY, J. George [P] Geneva, NY/Provincetown, MA b. 8 F 1863, Fayette, NY. Studied: ASL; C.W. Hawthorne; S.R. Knox. Member: Rochester AC; AAPL; Provincetown AA. Exhibited: Rochester, N.Y., 1927 (prize), 1928 (prize) [33]

STACEY, John F. [P,T] Pasadena, CA b. 1859, Biddeford, ME. Studied: Mass. Normal Sch., Boston; Boulanger, Paris with Académie Julian, Lefebvre. Member: Chicago PS; Pasadena SA. Exhibited: St. Louis Expo, 1904 (med); Field Exh., 1907 (prize); Buenos Aires, 1910 (med); AIC, 1911 (prize); 1924 (med); 1928 (prize); Chicago Gal. Assn., 1931 (prize); Chicago Assn. PS, 1937 (prize); Pasadena A. Exh., 1938 (prize). Work: MFA, Santiago, Chile; Union Lg. C., Chicago; Herron AI; Chicago A. Comm., 1922 [40]

STACEY, Lynn (Nelson) [P,Dec,Des,I,T] Des Moines, IA b. 24 My 1903, Wash., D.C. Studied: Univ. Iowa; Cummings Sch. A.; F. Jones; R. Neilson. Member: AAPL; Iowa AG; S. Sanity in Art. Exhibited: NAD, 1931; N.J. Sch. Indst. A., 1936; Mich. State Col., 1936; CGA, 1934; Duluth A. Ctr., 1936; Ill. State T. Col., 1936; Univ. N.D., 1936; Iowa A. Salon, 1928–40; Iowa AG, 1928–43; Des Moines Women's C., 1928 (prize), 1929 (med), 1934 (med). ; Iowa A. Salon (meds) 1927, 1928, 1930, 1931. Work: Univ. Iowa; Iowa State Col.; Des Moines Women's C.; Iowa AG; H.S., Iowa City. Related to Dorothy L. [47]

STACK, Charles J. [P] Pittsburgh, PA Member: Pittsburgh AA [21]

STACKPOLE, Alice [P] Boston, MA Member: Copley S. 1893 [06]

STACKPOLE, Ralph [S,E,C,T] San Fran., CA b. 1 My 1885, Williams, OR. Studied: R. Putnam; G. Piazonni; Ecole des Beaux-Arts, Paris. Member: Calif. SE. Exhibited: P.-P. Expo, San Fran., 1915; San Fran. AA, 1918; San Fran AA, 1920, (gold), 1935 (prize); S., GGE, 1939. Work: Univ. Calif.; Stanford Univ.; City Hall, Stock Exchange, both in San Fran.; murals, Coit Tower, George Washington H.S., both in San Fran.; Sacramento Jr. Col.; WPA mural, Dept. Interior, Wash., D.C. WPA artist. Position: T., Calif. Sch. FA [40]

STACY, William [P] d. 24 Ag 1919, Burlington, VT (suicide)

STADEKER, Claire Leo [P] b. 6 O 1886, NYC d. 6 Jy 1911

STADELMAN, Henryette Leech [P,T] Wilmington, DE b. 5 D 1891, Brownsville, PA. Studied: PAFA with H. Breckenridge, Hawthorne. Member: Plastic C.; Wilmington SFA; AFA [29]

STADLER, Al [P] Wash., D.C. b. 2 Ag 1914, NYC. Studied: Corcoran Sch. A.; N. Crandell. Member: D.C. Ar. Union.; United Am. A. Exhibited: New Sch. Social Research, N.Y., 1937; PMG, 1939; The Bookshop, Wash., D.C., 1939; Allocations Gal., Wash., D.C. 1938–40 [40]

STAEHLE, Albert [I] NYC b. 19 Ag 1899, Munich, Germany. Studied: ASL; Wicker Sch. FA, Detroit; Germany; C. Hawthorne. Member: SI. Exhibited: Outdoor Advertising Exh., 1937, 1942, 1946; A.Dir.C., N.Y., 1943; A.Dir.C., Phila., 1942; Kerwin Fulton med., 1938–40 [47]

STAFF, Jessie A. [S] NYC [15]

STAFFORD, B.E.D. [P] Pittsburgh, PA. Member: Pittsburgh AA [21]

STAFFORD, Clara B. [C,T] Manchester, VT b. 30 Je 1868, Manchester, VT. Studied: Columbia Univ. Member: Shuttlecraft G.; Weavers G., Boston [40]

STAFFORD, Marjorie. See Pinkham.

STAFFORD, Mary (Mrs. John R. Frazier) [Por.P] Providence, RI/Province-

town, MA b. 4 F 1895, Chicago, IL. Studied: AIC; Acad. Grande Chaumière; C.W. Hawthorne. Member: Providence AC. Exhibited: AIC, 1925 (prize), 1927 (prize) [40]

STAFFORD, P. S(cott) [P] NYC b. Brooklyn, NY. Studied: R. Henri. Member: PPC, Columbus, Ohio [24]

STAGG, Clarence Alfred [P] Nashville, TN b. 16 Ag 1902, Nashville. Studied: C.W. Hawthorne. Member: SSAL; Nashville Studio C. Exhibited: Nashville, 1927 (prize), 1928 (prize); SSAL, 1935 [40]

STAGG, Jessie A. (Mrs.) [C,S] Woodstock, NY b. 10 Ap 1891, Burnage, England d. 1958. Studied: ASL; British Acad.; Rome, Italy. Member: N.Y. S. Ceramic A.; Soc. Des.-Craftsmen; N.Y. S. Craftsmen; NSS; NAWPS (Pres.); AFA [47]

STAHL, Ben(jamin) (Albert) [P,I,L,Dr,T] Westport, CT b. 7 S 1910, Chicago, IL. Member: Westport, A; SI; A. & W. Gld. Exhibited: AIC, 1931–36; Chicago GFLA, 1937; Chicago Fed. Advertising C., 1939, 1941; A.Dir.C., Chicago, 1943, 1944. Illustrator: American Artist, Magazine World; Saturday Evening Post [47]

STAHL, Marie Louise [Por.P,B,Dr,T] Middletown, OH b. Cincinnati. Studied: Cincinnati A. Acad.; ASL; W. Chase; C. Hawthorne; L. Gaspard; E.A. Webster; M. Sterne. Member: Provincetown AA; Cincinnati Women's AC. Exhibited: CM; Dayton AI; Columbus AC; Albright A. Gal.; Provincetown AA; New Orleans; NYC. Work: Univ. Ohio, Athens; Christ Hospital, Cincinnati; H.S., Country C., both in Athens, Ohio. Position: T., Univ. Ohio (25 yrs) [47]

STAHLEY, Joseph [P,I,T] NYC (1948) b. ca. 1900, Rochester, NY Studied: AIC, ca. 1915; H. Dunn; D. Cornwell; N. Fechin. Specialty: Western subjects. Positions: A. Ed., Houghton-Mifflin, NYC; Rochester Inst. Tech.; set illus. for movie companies [*]

STAHR, Fred C. [Mur.P] Stapleton, NY b. 1878 d. 9 Mr 1946. Studied: Am. Acad. Rome; Lazarus schol., 1911–14. Member: Mural P. [25]

STAHR, Paul C. [I] NYC/Long Beach, NY b. 8 Ag 1883, NYC. Studied: J. Ward; NAD. Member: SI. Illustrator: Life, Collier's, American, Harper's Bazaar, Woman's Home Companion; "The Hornet," "The Mask," "The Seer." Specialty: flourescent painting [40]

STAHUNN, Mr. [P] Tacoma, WA. Member: Tacoma FAA. Position: Staff, Tacoma Engr. Co. [25]

STAIR, Ida M. (Mrs.) [P,I,S,T] Denver, CO b. 4 F 1857, Logansport, ID d. 27 Mr 1908. Studied: P. Powers; AIC, with Taft, Chase. Member: Denver AC. Exhibited: Omaha Expo, 1898 (med). Work: statues, parks, Denver. Position: T., Women's C., Denver [08]

STALEY, C(larence) W. [P] Martinsville, IN b. 19 Ja 1892, Sandborn, IN. Studied: J.O. Adams [17]

STALLMAN, Emma S. [C,T] Norristown, PA b. 6 N 1888, Chestnut Hill, Phila. d. 17 S 1959. Studied: Moore Inst. A.&Sc.; RISD. Member: Phila. A. All.; Phila. Plastic C.; Pa. Gld. Craftsmen. Exhibited: Phila. A. All.; Pa. Gld. Craftsmen; Phila. Plastic C.; Moore Inst. A.&Sc.; Md. Inst. Work: Mus. Northern Ariz., Flagstaff. Position: T., Phila. Sch. Occupational Therapy [47]

STALOFF, Edward [P,I,E] Mt. Vernon, NY b. 29 Mr 1893, Jersey City, NJ. Studied: Wickey; ASL. Exhibited: WFNY, 1939. Work: Fifty Prints of the Year; Am. Graphic A. Section, Paris Intl. Expo, 1937 [40]

STAMATO, Frank [P,S] Phila., PA b. 16 Ja 1897, Phila. Studied: PAFA; C. Grafly; A. Laessle; Lhote; 2 Cresson Traveling Schols. Member: Phila. Alliance; Da Vince AA; Graphic Sketch C. Exhibited: PAFA (prize). Work: Reading AM; Graphic Sketch C.; PAFA; Bd. Edu. Bldg., Phila.; Allentown (Pa.) Mus.; SFA, Wilmington, DE [40]

STAMBAUGH, Dean [P,T] Wash., D.C. b. 30 Je 1911, Galeton, PA. Studied: Edinboro (Pa.) State T. Col.; Pa. State Col.; H. Pittman. Exhibited: PAFA, 1940, 1944; CI, 1941; CGA, 1943, 1945; Butler AI, 1943. Position: T., St. Albans Sch., Wash., D.C. [47]

STAMOS, Theodoros [P] NYC b. 31 D 1922, NYC. Studied: Am. A. Sch., with S. Kennedy. Member: A. Lg. Am. Exhibited: CI, 1945; WMAA, 1945; PAFA, 1946; VMFA, 1946; Wakefield Gal., 1943 (one-man); Mortimer Brandt Gal., 1944, 1946 [47]

STAMPER, Mabelle Richardson (Mrs. W.Y.) [P] Mt.Adams, OH. Exhibited: Cincinnati AM, 1937, 1939; AIC, 1937 [40]

STAMPER, Willson Young [P] Mt. Adams, OH. Exhibited: Cincinnati AM, 1937, 1939; GGE, 1939 [40]

STANDING SOLDIER, Andrew [P,I] Wanblee, SD b. 1 F 1917, Hisle, SD. CGA, 1939; Pine Ridge, S.C., 1931 (prize); GGE, 1939 (prize). Work: WPA murals, USPO, Blackfoot, Idaho. Illustrator: "There Still Are Buffalos," "Pine Ridge Porcupine," 1943, other books [47]

STANFIELD, Marion. See Baar.

STANGE, Emile [P,T] North Hackensack, NJ b. 1 Jy 1863, Jersey City d. My 1943. Member: Allied AA; AAPL; SPNY [40]

STANGL, J.M. [Cer] Flemington, NJ b. 30 Jy 1888, Bavaria. Exhibited: P.-P. Expo, San Fran., 1915 (med); Sesqui-Centenn. Expo, Phila., 1926 (gold). Position: Dir., Fulper Pottery Co. [40]

STANISIA, Sister [P,T] Chicago, IL b. Chicago, IL. Member: AIC; Univ. Chicago; R. Clarkson; C. Hawthorne; von Zukotynski. Member: Renaissance S. of the Univ. Chicago; All-Ill. SFA; South Side AA; S. for Sanity in Art; Ridge AA. Exhibited: Warsaw World's Fair, 1932 (med); Century of Progress Expo, Chicago. Work: St. George H.S., Evanston, Ill.; murals, Cathedral, St. Paul, Minn.; Adrian Col., Mich.; Mt. Mary Col., Milwaukee, Wis.; St. Joseph's Hospital, St. Margaret's Church, Holy Cross Church, all in Chicago. Positions: T., Acad. of Our Lady, Chicago; Dir., FA Gl., Chicago [47]

STAN(ISZEWSKI), Walt(er) (P.) [I,Des,Cart,P,L,T] Wilmington, DE b. 9 S 1917, Wilmington, DE. Studied: PMSchIA; R. Riggs. Member: Am. AA; Phila. Graphic Sketch C.; Advertising Assn. Exhibited: PAFA, 1939; Pepsi-Cola, 1944; Delaware A. Ctr., 1941 (prize), 1942, 1944, 1945; PMSchIA (prize). Work: mural, New Castle Army Air Base, Del. [47]

STANLAWS, Penrhyn (Penrhyn Stanley Adamson) [P,I,E,W] NYC/Greenwich, CT b. 19 Mr 1877, Dundee, Scotland. Studied: Académie Julian, Paris, with Benjamin-Constant, Laurens. Work: Heckscher Park AM, Huntingon, N.Y. Author: plays: "The End of the Hunting," "Instinct"; movies: "The Little Minister," others [40]

STANLEY. See Twardowicz.

STANLEY, Blanche H. [P] Gloucester, MA [25]

STANLEY, Frederic [P,I] New Rochelle, NY [21]

STANLEY, George M. [S,T] Los Angeles, CA b. 26 Ap 1903, Acadia Parish, LA. Studied: Otis AI, Los Angeles. Member: Am. Ar. Cong. Exhibited: Los Angeles Mus., 1932; So. Calif. A., 1934 (prize). Work: Griffith Park Planetarium, Los Angeles; bas-reliefs, Bullocks Wilshire, Telephone Bldg., Los Angeles; granite figures, Hollywood Bowl; Scripps Col., Claremont. Position: T., Otis AI [40]

STANLEY, Jane C. [P] Ann Arbor/Charlevoix, MI b. 21 Jy 1863, Detroit. Studied: L.K. Harlow; H.H. Hallett; S.P.R. Triscott; L. Richmond, London. Member: Detroit S. Women PS; Ann Arbor AA; NAWPS [40]

STANLEY-BROWN, Rudolph [E,Arch] Cleveland Heights, OH b. 9 Ap 1889, Mentor, OH. Studied: Col. Sch. Arch.; Ecole des Beaux Arts, Paris. Member: AIA; S. of Beaux Arts Arch.; Cleveland PM; Cleveland Print C. Work: CMA; Yale [32]

STANNARD, Eva (Mrs.) [P] NYC b. Syracuse, NY. Studied: PIASch.; Buffalo FA Acad., W.A. Graves [25]

STANSFIELD, John Heber [Ldscp.P,Por.P] Mt. Pleasant, UT b. 1878, Mt. Pleasant d. 1953. Studied: self-taught, but influenced by meeting T. Moran in Calif. Work: Springville AG, Utah. Position: T., Snow Col., Utah (13 yrs.) [*]

STANSON, George C(urtin) (or Gjura Stojana) [P,S,] Los Angeles, CA/Santa Fe, NM (1975) b. 2 Ap 1885, Brisout, France (came to U.S, 1901; to Los Angeles ca. 1918) Member: Archaeological Inst. Am.; Calif. AC. Work: four murals, Biological Mus. of Univ. Calif., La Jolla; Golden Gate Park Mus., San Fran.; Mus. Archaeology, Santa Fe [21]

STANTON, Elizabath Cady (Mrs. W.H. Blake) [P,T,L] NYC/North Falmouth, MA/Nyack, NY b. 31 D 1894, NYC. Studied: ASL; Tiffany Fnd.; A. Sterner; F.L. Mora; G. Bridgman; C. Beaux. Member: NAWA; Tiffany Fnd.; Women's Faculty C., Columbia. Exhibited: NAD; PAFA; NAWA; AWCS; Tiffany Fnd.; Newport AA; Woodstock, N.Y.; Westport, Conn. Position: T., Horace Mann-Lincoln Sch., NYC, from 1946 [47]

STANTON, Gideon Townsend [P] New Orleans, LA/Bay St. Louis, MS b. 14 Jy 1885, Morris, MN. Studied: Rugby Acad., New Orleans; Baltimore Charcoal C.; S.E. Whiteman. Member: New Orleans A.&Cr. C.; NOAL; SSAL; NOAA; Am. Fed. A. Exhibited: S.Indp.A.; New Orleans A.&Cr. C.; NOAA, 1911 (prize), 1932 (med); NOAL, 1925 (prize), 1932 (prize) (prize) [47]

STANTON, Grace Harper (Mrs.) [Min.P] Garrison, NY b. 1872, NYC.

Studied: ASL; W. Whittemore, NYC; Paris, with Mme. Debillemont-Chardon, Bouguereau, Ferrer [08]

STANTON, John [P] San Fran., CA. Affiliated with San Fran. AI [17]

STANTON, Louise Parsons [P] Chicago, IL. Exhibited: AIC, 1935, 1939 [40]

STANTON, Lucy May [Por.P,Min.P,T] Athens, GA/Boston, MA b. 22 My 1875, Atlanta d. 19 Mr 1931. Studied: Colarossi Acad., L. Simon, E. Blanche, La Gandara, A. Koopman, all in Paris. Member: Pa. SMP; Am. SMP; NAWPS; Wash. WCC; G. Boston A.; Copley S.; Concord AA. Exhibited: Pa. SMP, PAFA, 1917 (med) Concord AA, 1923 (med), NAWPS, 1925. Work: Capitol, Wash., D.C.; miniature, Concord AA; miniature, Lincoln Mem. Mus., Milton, Mass.; miniature self-portrait, Phila. Mus. [29]

STANTON, Samuel Ward [Mar.P] NYC b. 8 Ja 1870, Newburgh, NY d. 15 Ap 1912 (on the Titanic). Studied: ASL, with Twachtman, Bridgman, DuMond; Lefebvre, at Acad. Julian. Exhibited: Columbian Expo, Chicago, 1893. An authority on the rendering of vessels of different types and periods; made murals for many streamers; assisted F.D. Millet in his decorations for the Baltimore Custom House. He had been to Spain to make studies for an Alhambra series of panels to decorate the S.S. Washington Irving of the Hudson River Day Line. Position: Publ., "American Steam Vessels," 1895; Nautical Mag.

STANWOOD, Gertrude. See Struven.

STAPLES, Clayton Henri [P,L,T] Wichita, KS/Gloucester, MA b. 4 F 1892, Osceola, WI. Studied: AIC. Member: AWCS; SC. Work: pub. schs., Winfield, Kans., Peoria, Ill.; Bloomington (Ill.) AA. Position: T., Univ. Wichita, from 1930 [47]

STAPLES, Edna Fisher Stout (Mrs. Arthur C.) [Ldscp.P,S,T] Phila., PA. Studied: Phila. Sch. Des., with E. Daingerfield, H.B. Snell, M. Sloan. Exhibited: Wanamaker Comp., 1904 (prize). Specialty: watercolor [10]

STAPLES, Frank A. [C,T,L] Concord, NH/Biddeford, ME d. 1 D 1900. Studied: Mass. Sch. A. Member: Lg. N.H. A. & Cr. Position: T., National Recreation Assn., NYC [40]

STAPLES, Roy Harvard [P,T] Auburn, AL b. 20 O 1905, Lynn, MA b. 20 Ag 1958. Studied: J. Sharman; C. Martin; E. O'Hara; Mass. Sch. A.; Ala. Polytechnic Inst., Auburn. Member: Ala. AL; SSAL. Exhibited: Ala. AL, Montgomery, 1934. Work: murals, Ala. Polytechnic Inst.; paintings, Montgomery MFA; Univ. Fla. Position: T., Ala. Polytechnic Inst. [40]

STAPLEY, M. [P] NYC b. 1872, NYC [04]

STAPPLES, E.S. [P] Wauseau, WI [01]

STARBUCK, Ellen [P] NYC [10]

STARIN, Arthur N. [P] Duluth, MN [15]

STARK, Forrest F. [P,S,T] Fort Wayne, IN b. 29 My 1903, Milwaukee, WI. Studied: Milwaukee State T. Col.; L. Kroll; C. Grafly; G. Harding; A. Laessle; G. Oberteuffer; B. Robinson; PAFA, 1927 (Cresson Traveling Schol.). Member: Ind. AC. Exhibited: PAFA, 1938; Ind. A.; Ft. Wayne A. Mus. Hoosier Salon, 1932 (prize); Milwaukee AI, 1933 (prize); John Herron AI, 1932 (prize). Work: Ft. Wayne A. Mus.; John Herron AI; relief, Forsyth Mem., Indianapolis. Position: T., Ft. Wayne A. Sch. [47]

STARK, Jack Gage [P] Santa Barbara, CA b. 1882, Jackson County, MO d. 2 D 1950. Studied: Paris, with J.E. Blanche, V.H. Millet, 1900. Exhibited: Paris, 1905; N.Mex., 1909-15; Los Angeles. Work: Santa Barbara Mus. A.; AIC [47]

STARK, Margaret [P] NYC b. 28 Mr 1915, Indianapolis, Ind. Studied: Ind. Univ.; Oberlin Col.; ASL; H. Hofmann. Exhibited: CI, 1944-46; Springfield (Mass.) Mus. FA, 1944; WMAA, 1944, 1945; Herron AI, 1944, 1945; Montclair AM, 1944; MOMA, 1944; Mod. A. Festival, Boston, 1945; Zanesville AI, 1945; 1030 Gal., Cleveland, 1945; BM, 1945; Philbrook A. Ctr., 1945; PAFA, 1944, 1945; Univ. Iowa, 1946; Perls Gal., 1944 (one-man); Passedoit Gal., 1946 (one-man) [47]

STARK, Melville F. [P,T] Zionsville, PA b. 29 S 1904, Honesdale, PA. Studied: East Stroudsburg, Pa. T. Col.; Univ. Pa.; Syracuse Univ.; W.E. Baum. Member: Lehigh A. All. Exhibited: PAFA; NAD; Phila. Sketch C.; Woodmere A. Gal.; Phila. A. All.; Reading A. Mus.; Scranton A. Mus.; Lehigh Univ.; Univ. Pa.; Allentown A. Mus. [47]

STARK, Otto [P,I,C] Indianapolis, IN b. 29 Ja 1859 d. 14 Ap 1926. Studied: Paris with Lefebvre, Boulanger, Cormon. Member: Intl. SAL; Hoosier Salon (founder); Ind. AC. Exhibited: Foulke prize, 1907; Herron AI, 1915 (prize); Hoosier Salon, 1925 (prize), 1926 (prize). Work: Herron AI,
Indianapolis; Cincinnati AM; City Hospital, Indianapolis; murals, pub. sch., Indianapolis; Ind. State House; Univ. Kans. [25]

STARKEY, Jo-Anita (Mrs.) [P,C,Des] Los Angeles, CA (1962) b. 1895, Gresham, NE. Studied: L. Barton; O. White; M. Wachtel. Exhibited: widely in Calif. [*]

STARKS, Chloe Lesley [P] Palo Alto, CA b. 17 D 1866, OH. Studied: Stanford; Corcoran Sch. A.; Colarossi Acad. [15]

STARKWEATHER, William (Edward) (Bloomfield) [P,W,L,T] Brooklyn, NY b. 16 My 1879, Edinburgh, Scotland d. 14 My 1969, New Haven, CT. Studied: ASL; Sorolla, in Madrid, Spain; Colarossi Acad.; Italy. Member: All.A.Am.; AWCS; Hispanic S. Am.; Phila. WCC; New Haven PCC; SC; NYWCC. Exhibited: Salon des Artistes Français, Paris, 1912-26; NAD, 1926-46; All.A.Am., 1915-46; WC Exh., NYC, 1925 (prize); Baltimore, 1926 (prize); PAFA, 1925 (gold), 1929 (prize); New Haven PCC, 1924. Work: MMA; BM; San Diego FAS for Women; Univ. Pa.; Randolph-Macon Col. for Women; Instituo de Valencia de Don Juan, Madrid. Author: "Drawings and Paintings by Francisco Goya in the Collection of Hispanic Society of America"; articles, Mentor mag. Position: T., Hunter Col., NYC, 1936-46 [47]

STARR, Eliza Allen [P,T,L,W,I] b. 29 Ag 1824, Deerfield, MA d. 7 S 1901, Durand, IL. Studied: C. Negus. Author/Illustrator: Catholic devotional books. Position: T., schools in Phila. and Brooklyn, 1854-56; Chicago, 1856-71 (when her studio was destroyed in the great fire of 1871); started art dept. at St. Mary's Acad., South Bend, Ind. [*]

STARR, Ida M.H. [P,W] Easton, MD b. 11 Jy 1859, Cincinnati, OH. Studied: Myra Edgerly; L. Adams; H. Schultze. Member: S.Indp.A. of NYC, Chicago, Buffalo [29]

STARR, Ivy Edmondson [Por.P] NYC/Cleveland, OH b. 20 F 1909, Cleveland, OH. Studied: H. Keller; L. Lucioni. Member: Cleveland PM; ASL [40]

STARR, Katharine Payne (Mrs. Frederick H.) [Min.P,L] Hollywood, CA b. 19 S 1869, Kansas City, MO. Studied: J. Telfer; E.S. Bush. Member: Calif. SMP. Exhibited: Calif. SMP, Los Angeles Mus. A., 1937 [40]

STARR, Lorraine Webster (Mrs.) [P,I,L,T,Min.P] Bozman, MD b. 24 Je 1887, Old Holderness, NH. Studied: Vassar Col.; BMFA Sch.; Am. Sch. Min. P.; M. Welch; E.D. Pattee; W. Paxton; P. Hale. Member: Baltimore WCC. Exhibited: PAFA; ASMP; Wash. WCC; Baltimore SCC; BMA; CI; Detroit Inst. A.; CAM; Memphis, Tenn. [47]

STARR, Louis [P] Dinard, France [25]

STARR, Maxwell B. [P,S,T] NYC b. 6 F 1901, Odessa, Russia. Studied: NAD; BAID; NYU; K. Cox; C.W. Hawthorne; I.G. Olinsky. Member: Arch. L.; NSMP; All.A.Am.; Am. Ar. Cong.; Mural AG. Exhibited: NAD, 1923 (med), 1924 (prize), 1926-32; PAFA, 1934, 1943; All.A.Am., 1941-45; AIC, 1925; WMAA, 1933, 1939; MOMA, 1939; BMFA, 1934; WFNY, 1939; Chaloner prize, 1922-24; BAID, 1922-24 (med). Work: Am. Mus. Numismatics; murals, U.S. Customs Office, NYC; Brooklyn Tech. H.S.; WPA murals, USPOs, Siler City (N.C.), Rockdale (Tex.). Position: T., Boys' C., NYC, 1940 [47]

STARR, Polly. See Thayer.

STARR, Sidney [Mur.P] NYC/Lawrence, NY b. 10 Je 1857, Kingston-on-Hull, Yorkshire, England d. 3 O 1925. Studied: Poynter; Legros. Exhibited: Universal Expo, Paris, 1889 (bronze). Work: murals, Grace Chapel, NYC; LOC [24]

STARRETT, Virginia Frances [P,I] b. 1901 d. Je 1931, Pasadena, CA. Member: Pasadena AI. Illustrator: excelled in imaginative illustrations, four books, edited by Hildegarde Hawthorne; "The Arabian Nights."

STARRETT, William K. [P] Forest Hills, NY. Member: GFLA [27]

STATE, Charles [I] NYC b. Montreal, Quebec. Studied: J.H. Walker, in Montreal. Member: S. Am. Wood En. Contributor: illus., Century [01]

STAUBEL, William [P] Rutherford, N.J. Member: S.Indp.A. [25]

STAUFFER, Edna Pennypacker [P,Gr,Li,I,T,L] NYC b. 12 O 1887, Chester County, PA d. 1956. Studied: Wells Col.; Columbia; PAFA; ASL; Chase; Pennell; McCarter; T. Anschutz; H. Breckenridge; NYU; Paris with Lhote, Acad. Moderne. Member: NAWA; PBC. Exhibited: NAWA, 1946; Albany Inst. Hist. & A., 1946; PBC, 1945 (prize); Phila. A. All., 1946; Mass. Fair, 1944, 1945; PAFA; Middlefield, Mass. Fair, 1944 (prize), 1945 (prize). Work: Whitney C.; MET. Position: T., Hunter Col., NYC [47]

STAVENITZ, Alexander Raoul [Et,Li,Des,P,T,L] NYC b. 31 My 1901, Kiev, Russia d. 11 F 1960, South Norwalk, CT. Studied: St. Louis Sch. FA,

Wash. Univ.; ASL. Member: Am. A. Cong.; Guggenheim F., 1931. Exhibited: Fifty Prints of the Year; Fine Prints of the Year. Work: NYPL; WMAA; Wesleyan; Mus. Modern Western A., Moscow. Position: Dir. Art Teaching Div., WPA, NYC [47]

STEA, Cesare [S,P] Long Island City, NY b. 17 Ag 1893, Bari, Italy d. 2 F 1960, Catham, NJ. Studied: NAD; CUASch; BAID; Grande Chaumiere, Paris; H. MacNeil; S. Calder; Italian-Am. AA; Victor Salvatore; Carle Heber; Anton Bourdelle. Member: NSS; S.Gld.; Am. Veterans A.S. Exhibited: Palace Legion Honor; Hispanic Mus.; WFNY, 1939; PAFA, 1944; BM, 1941; MET, 1942; WMAA, 1943; NAD, 1926 (prize); Montclair AM, 1933 (prize); P.-P. Expo, San Fran., 1915 (med); Nat. Defense Soc. (prize). Work: WMAA; Brooklyn Col.; Evander Childs H.S., NYC; Queensbridge Housing Project; U.S. Military Acad., West Point, N.Y.; WPA murals: USPO, Necomertoun (Ohio), Wyomissing (Pa.); Bowery Bay Water Treatment Plant, NYC. WPA artist. [47]

STEADMAN, Marcia Hunt (Mrs.) [P] Chattanooga, TN. Member: Cincinnati Women's AC [21]

STEARNS, Frederic Wainwright [E,I,B] Horseneck, MA b. 5 O 1903, Pittsburgh, PA. Studied: Saint-Gaudens; C. Grapin. Member: AIA; Phila. Chap., BAID; Phila. PC; T. Square C. Work: Fifty Prints of the Year, 1932; Pa. Athletic C., Phila. [40]

STEARNS, G. Douglas (Mrs.) [P] Brooklyn, NY. Member: B&W C. [01]

STEARNS, Junius Brutus [Por.P,Genre.P] Brooklyn, NY b. 2 Jy 1810, Arlington, VT d. 17 S 1885. Studied: NAD, ca. 1838; Paris, London, 1849–50. Member: ANA, 1848; NA, 1849. Exhibited: NAD; Apollo A. Work: BM; VMFA; Butler Inst. Am. A. [*]

STEARNS, Martha G. (Mrs. Foster) [C,L] Hancock, NH b. Amherst, MA. Member: N.Y. Needle & Bobbin C.; Boston SAC (master craftsman); N.H. Lg. A. & Cr. (council) [40]

STEARNS, Neilson (Mrs. Traphagen Stearns) [S] Brooklyn, NY. Member: NAWPS [25]

STEARNS, Robert L. [I] NYC [01]

STEBBING, John Noel, Jr. [P,G,S] Wash., D.C. b. 22 F 1906, Baltimore, MD. Studied: Md. Inst.; Corcoran Sch. A.; H. Podolsky. Member: S. Wash. E. Exhibited: CGA; U.S. Maritime Comm. [40]

STEBBINS, Roland Stewart [P,T,L] Madison, WI b. 22 My 1883, Boston d. 1974. Studied: Royal A. Acad., Munich, Germany; Grande Chaumière, Paris; PAFA; C. Chapman; H. Breckenridge; C. Hawthorne; Hachl; DeCamp; Dow; ASL; Columbia; Mass. Sch. A. Member: Boston AC; Copley S., Boston; North Shore AA; Madison AA; AFA; Wis. P. & S.; Wis. A. Fed. Exhibited: NAD, 1945; North Shore AA, Gloucester, Mass., annually; Boston AC; Copley S.; Madison AA, 1932 (prize) 1942 (prize), 1944 (prize), 1945 (prize), 1946; Madison Salon, 1944–46; Milwaukee P. & S., 1945, 1946; Grace Horne Gal., 1928 (one-man); Paris, France, 1928 (one-man); Wis. State Fair, 1944 (prize). Work: Univ. Wis.; City Lib., Madison; murals, Medical Sch., Madison; Med. Mem. Room, Memorial Union; Wis. State Hospital; Madison C., Madison, Wis. Position: T., Univ. Wis. [47]

STEBBINS, T.E., Mrs. See Flood, Mary.

STECHER, William Frederick [P,I,Gr,Des,T] East Milton, MA b. 2 Ap 1864, Boston, MA. Studied: Académie Julian; E. Knobel, W. Bouguereau; Acad. Colarossi, Paris; Acad. Dusseldorf, Germany. Member: S. WC P., Boston. Exhibited: Boston; Phila.; Chicago; St. Louis; Wash., D.C. Work: BMFA. Contributor: illus., Youth's Companion, St. Nicholas. Position: T. Scott Carbee Sch. A., Boston, 1940 [47]

STECHOW, Wolfgang [Edu] Oberlin, OH b. 5 Je 1896, Kiel, Germany d. 1975. Studied: Univ. Göttingen, Germany; Univ. Berlin. Author: "Apollo und Daphne," 1932, "Salomon van Ruysdael," 1938. Positions: T., Univ. Wis. (1936–40), Oberlin Col. (from 1940) [47]

STECK, Alden L. [P,T] Laurium, MI b. 15 N 1904, Calumet, MI. Exhibited: Grand Rapids A. Gal., 1942; AIC, 1938; CM; Kansas City AI, 1938, 1939; SFMA, 1938, 1940; Oakland A. Gal., 1938; 1941, 1944; AWCS, 1944; Acad. All. A., 1940; Miss. AA, 1943; Springfield A. Mus., 1945; Detroit AI, 1941, 1945; etc. [47]

STEDMAN, Esther [P] Santa Barbara, CA [19]

STEDMAN, Jeannette [Por.P] b. 1880 d. 8 Mr 1924, Chicago, IL. Studied: Paris

STEDMAN, Margaret Weir [Min.P,T] Haddonfield, NJ/Ocean City, NJ b. 10 S 1882. Studied: PIASch.; NYU; A.M. Archambault; L. Spizziri. Member: Pa. S. Min. P. [40]

STEDMAN, Myrtle Kelly (Mrs. Wilfred H.) [P] Santa Fe, NM b. 5 F 1908, Charleston, IL. Studied: F. Browne; W. Stedman. Member: Houston A. Gal.; Texas FAA. Exhibited: Houston MFA, 1933 [40]

STEDMAN, Wilfred Henry [P,S,Des,I,Arch,B,T] Santa Fe, NM b. 6 Jy 1892, Liverpool, England d. 17 N 1950. Studied: Minneapolis Inst. A.; SAL; Broadmoor A. Acad.; France; G. Goetch; L.M. Phoenix; H. Dunn; L. Mora; F.V. Du Mond; J.F. Carlson; B. Sandzen; R. Reid; C.S. Chapman. Member: Houston A. Gal.; Texas FAA. Exhibited: Glockner Sanatarium, Colo. Springs, Colo.; Church of Christ, Houston, Texas; James M. Lykes Shipping Co., Rice Inst., both in Houston; Catholic Tubercular Hospital, Colo. Springs, Colo.; N.Y. Engineering S. Author/Illustrator: "Santa Fe-Style Homes," 1936. Position: A.Ed., New Mexico Plan Book, 1939; New Mexico mag. [47]

STEEL, Rhys. See Caparn.

STEEL, Sophie B. [P] Mt. Airy, PA [06]

STEELE, Albert W(ilbur) [Cart] Denver, CO b. 18 Je 1862, Malden, IL. Position: Staff, Denver Post, since 1897 [13]

STEELE, Brandt Theodore [Des,C,Arch,L] Indianapolis, IN b. 16 N 1870, Battle Creek, MI. Studied: T.C. Steele; Aman-Jean, in Paris; Munich. Member: Ind. Ar. C.; Indianapolis AA; Indianapolis Arch. Assn.; Indianapolis Camera C. [40]

STEELE, Frederic Dorr [I,E] NYC b. 6 Ag 1873, Marquette, MI d. 5 Jy 1944. Studied: NAD; ASL. Member: SI, 1902. Exhibited: St. Louis Expo, 1904 (Med). Work: LOC. Illustrator: "The Return of Sherlock Holmes," and other tales by Doyle, books by R.H. Davis, Mark Twain, Myra Kelly, Gouverneur Morris, Mary Roberts Rinehart, Kipling, Conrad, Bennett, Tarkington [40]

STEELE, Helen McKay (Mrs. Brandt) [P,I,C] Boston, MA b. Indianapolis Studied: T.C. Steele; W. Forsyth; AIC. Member: Indianapolis AA [17]

STEELE, Ivy N. [I,S,Li,Dr] Chicago, IL b. 15 Ap 1908, St. Louis, MO. Studied: Wellesley Col. Member: AIC; Chicago NJSA [40]

STEELE, Juliette [P,Li,Des,T] San Fran., CA b. 21 Jy 1909, Union City, N.J. Studied: Calif. Sch. FA. Member: San Fran. AG; San Fran AA; San Fran. Women A. Exhibited: Pal. Leg. Honor, 1946; San Fran. AA, 1944–46; Oakland A. Gal., 1944; Laguna Beach AA, 1944; San Fran. Women A., 1945 [47]

STEELE, Margaret [P] Indianapolis, IN b. 7 Jy 1872, Battle Creek, MI. Studied: her father Theodore and brother Brandt [08]

STEELE, Marian Williams (Mrs. Chauncey D., Jr.) [P] Cambridge, MA b. 4 Ja 1916, Trenton, NJ. Studied: PAFA, Cresson traveling schol., 1936; Trenton Sch. Indst. A.; Barnes Fnd. Member: AAPL; Calif. AA; Laguna Beach AA; Rockport AA; North Shore AA. Exhibited: Los Angeles Mus. A., 1944; PAFA, 1933–1937 (prizes), 1939, 1943; AAPL, 1938–41; Rockport AA, 1942; Newark Mus., 1938; Long Beach AA, 1944 (prize); Santa Paula., Calif., 1944 (prize); Laguna Beach AA, 1933 (prize), 1934 (prize), 1935; Jordan-Marsh, Boston, 1946; AAPL, 1938 (prize), 1939 (prize) Work: port., N.J. State Hospital [47]

STEELE, T(heodore) C(lement) [Ldscp.P] Bloomington, IC b. 11 D 1847, Owen County, IN d. 24 Jy 1926. Studied: RA, Munich with Benczur, Loefftz, 5 yrs. Member: ANA 1914; Boston AC; Indianapolis AA; Ind. AC; member of jury for Paris Expo, 1900, St. Louis Expo, 1904, and Pan.-P. Expo, 1915; SWA (pres.). Exhibited: Paris Expo, 1900; SWA, 1910 (prize). Work: Cincinnati Mus.; Herron AI, Indianapolis; St. Louis Mus.; Richmond AA; Univ. Mo.; Christian Col., Columbia, Mo.; Ind. Univ.; Richmond (Ind.) Gal.; Boston AC; many clubs & univ. Position: T., Univ. Ind., 1918–26 [25]

STEELE, Thomas Sedgwick [P,I] Boston, MA b. 11 Je 1845, Hartford, CT d. 10 S 1903, Swampscott, MA. Studied: P. Marcius-Simons, in Paris. Member: SC, 1894; Boston AC. Author/Illustrator: books of travel. Specialties: fish; game; flowers [01]

STEELE, Viola [Min.P] NYC [15]

STEELE, Willard Karl [P,T] Jackson, MI b. 16 S 1910, Willard, OH. Studied: John Herron A. Sch. Member: Ind. Artists C. Exhibited: Hoosier Salon, 1930–35, 1936–39 (prizes), 1937–46; Ind. AC, 1936 (prize), 1938, 1941, 1942; Ind. A. (prize). Work: Northwestern Univ. Position: T., Wheaton Col., Ill., 1946– [47]

STEELE, Zulma (Mrs. Neilson T. Parker [P,C] Woodstock, NY (1902–67)b. 7 Jy 1881, Appleton, WI d. 1979, Westchester, NY. Studied: AIC; PIASch, 1890s; BMFA Sch.; ASL, with B. Harrison; A. Lhote. Member: NAWPS; Woodstock AA; Gld. Craftsmen. Exhibited: NAD; AIC; PAFA; BMFA; Baltimore MA; CI; Ohio Univ.; Ind. Univ. She was

among the first artists to live and work in the utopian colony, Byrdcliffe, near Woodstock. With Edna Walker she designed "mission oak" furniture on which she painted landscapes and leaf designs. She also made pottery called "Zedware," and designed books. [33]

STEENE, William [P,S] NYC/Great Barrington, MA b. 18 Ag 1888, Syracuse, NY d. 25 Mr 1965, Biloxi, MI. Studied: Henri; Jones; Cox; NAD; ASL; Chase; Paris, at Beaux-Arts, Académie Julian, Colarossi Acad. Member: Mural P.; Grand Central A. Gal.; Am. Fed. A.; CAFA; SSAL; SC. Work: City Hall, Galveston; Court House, Tulsa; Talequah, Okla.; Washington County Court House, Ark.; Univ. Ala.; Gov. Mansion, Hist. S., both in Jackson, Miss.; Ga. Military Acad., Atlanta; Masonic Hall, Greenville, Miss.; Macon, Ga.; Miss. AA; Asheville, N.C.; Winthrop Col., Rock Hill, S.C.; Central H.S., Charlotte, N.C.; Milledgeville, Ga.; Tift Col., Forsyth, Ga.; A.&M. Col., Starkville, Miss.; M.S.C.W., Columbus, Miss.; mural, H.S., Tulsa; Med. Center, NYC; NYU; Columbia; Duke Univ.; AIC; Supreme Courts, Ga., N.C.; Hercules Powder Co., Wilmington, Del.; murals, Hist. S., Raleigh, N.C.; Martha Wash., Jr. Col., Wash., D.C. [40]

STEENKS, Gerard L. [P] Brooklyn, NY [01]

STEENROD, Margaret. See Fetzer.

STEERE, Lora Woodhead [S] Hollywood, CA b. 13 Mr 1888, Los Angeles. Studied: Univ. Southern Calif.; Stanford; George Washington Univ.; A. Toft, Berlin; Calif. Sch. FA, with B. Pratt, Lentelli, R. Stackpole; Florence Wyle, in Toronto. Exhibited: AIC; PAFA; SFMA; Los Angeles Mus. A.; Mission Gal., Riverside, Calif., 1933 (one-man). Work: Los Angeles Mus. A.; Univ. Southern Calif.; Lincoln Mem. Univ., Harrogate, Tenn.; Jordan H.S., Los Angeles; Albert Wilson Hall, Los Angeles; Pearl Keller Sch. Dramatic Arts, Glendale, Calif. Position: T., Los Angeles H.S. [47]

STEES, Sevilla L. [P] Phila., PA b. Phila. Studied: PAFA; Women's Sch. Des. Member: Plastic C. [33]

STEFFEN, Bernard Joseph [P,Li] NYC b. 24 N 1907, KS. Studied: S. Macdonald-Wright; E. Lawson; B. Robinson; T.H. Benton. Member: Am. A. Cong. Exhibited: Mid-Western Exh., Kansas City AI, 1930–31 (meds). Work: WPA mural, USPO, Neodesha, Kans. [40]

STEGALL, Irma Matthews (Mrs. Charles W.) [P,L] Montgomery, AL b. 5 Ja 1888, Llano, TX. Studied: North Tex. State T. Col.; Dallas AI; M. Elliott; O. Travis. Member: Ala. AL; Tex. FAA; Ala. WCS; SSAL; Am. Assn. Univ. Women. Exhibited: Tex. FAA; SSAL; Ala. A. Lg.; Ala. WCS; Birmingham AL; Women's C., Montgomery (one-man); Montgomery Mus. FA (one-man); Carnegie Lib., Montgomery (one-man). Position: A. Dir., Am. Assn. Univ. Women (Montgomery Branch) 1944–46 [47]

STEGE, Wallace T. [S,P] Racine, WI. Exhibited: S. Milwaukee AI, 1936 (prize); AIC, 1939 [40]

STEGNER, Nicholas [P,C] Honesdale, PA b. 16 S 1882, Honesdale. Member: AAPL. Exhibited: Studio G., 1939 [47]

STEHL, Edward Richard [Mur.P] b. 1844 d. 5 Je 1919, Sea Cliff, NY

STEHLIN, Caroline [P] NYC [13]

STEICHEN, Eduard Jean (Edward, after WWI) [Photogr,P,Cur] NYC/Crecy-en-Brie, France. b. 1879, Luxembourg (came to Hancock, MI, in 1881; settled in Milwaukee in 1889) d. 1973. Member: Linked Ring, 1901; Photo-Secession, 1902 (founder); Salon d'Automne. Exhibited: Ph. S. of Germany, 1960 (prize); Royal Ph. S., London, 1961 (prize); Photo-Secession, 1906, 1908, 1909; MOMA, 1932, 1961. Award: Pres. Med. Freedom, 1963. Work: large coll. at MOMA; IMP; AIC; LOC; MET; NOMA; Royal Ph. S.; paintings: MET; TMA; murals, Luxembourg Mus., Paris. An important pictorialist of painterly style, he designed the covers for the Photo-Secession's "Camera Work." During WWI he was chief photographer for the Air Force and during WWII continued doing aerial photography for the Navy. He renounced painting in 1922 and burned all his canvases. From 1947 to 1962 he was photo cur. at MOMA. He organized the landmark exh. "Family of Man," which was seen in 69 countries from 1952 to 1955. [29]

STEIG, Joseph [P] NYC. Exhibited: Downtown Gal., NYC, 1937; M. Mod. A., Wash., D.C., 1938; AIC, 1937, 1939 [40]

STEIG, William [G,P] NYC. Exhibited: AWCS, 1933, 1936; AIC, 1936. Illustrator: cartoons, New Yorker; "About People," pub. Random House, 1939 [40]

STEIGER, Harwood [P,B,L,T] NYC/Edgartown, MA b. 2 Ja 1900, Macedon, NY. Studied: D. Garber, PAFA; H. Breckenridge. Exhibited: Mem. A. Gal., Rochester, 1928, 1929 (prize) 1930 (prize), 1931 (prize). Work: Mem. A. Gal., Rochester, N.Y.; Whitney Mus., NYC; WPA mural, USPO, Fort Payne AL. Position: T., Stieger Paint Group, Edgartown, Mass. [40]

STEIGNER, Adelaide [P] Newark, NJ [19]

STEIN, Annie [P] NYC b. 5 My 1879, NYC. Studied: ASL with G. Bridgman, R. Lahey, A. Brook; Thurn Sch., Gloucester, Mass. Member: NAWA; Bronx AL. Exhibited: Morton Gal., NYC, 1937; Pub. Lib., NYC, 1938; Studio G., 1938; Cornell Univ.; Yonkers, Mus.; ASL, 1939. Work: WPA mural, Marine Hospital, Carville, La. [47]

STEIN, B. [P] NYC b. NYC. Studied: W. Pach; J. Villon. Exhibited: S.Indp.A.; Vendome Gal., 1940; Theodore Kohn Gal., 1941; Mus. N.Mex., Santa Fe, 1941; Milwaukee AI, 1945 [47]

STEIN, Gertrude [Patron,W] b. 1874, Allegheny, PA d. 27 Jy 1946, Neuilly (Paris). From 1893–97 was a student at Radcliffe Col., where she was a pupil of William James & experimented with spontaneous automatic writing. Studied medicine for 4 years at Johns Hopkins Univ., spent a year in London, and in 1903 settled in Paris. Possessing an independent income, she became a patron of Picasso, Matisse, Braque, and other moderns, introducing them to the French and American public. Her first book, was "Three Lives," 1909. In most of her writings "she pushed abstraction to its farthest limits."

STEIN, Harve [I,P,T,Gr,L] Mystic, CT/Noank, CT. Studied: AIC; Académie Julian, Paris; H. Dunn. Member: SI; AWCS; Mystic AA; Providence AC. Exhibited: AIC, 1937; WFNY, 1939; AWCS, 1934–44; Mystic AA, 1934–45; PAFA, 1934–40; South County AA; Springfield AL. Position: T., RISD; Conn. Col., 1946 [47]

STEIN, Janet A. [Por.P] NYC. Studied: ASL; Woodstock Sch. A. Member: ASL [40]

STEIN, Modest [P] NYC. Member: GFLA [27]

STEINBERG, George [P] Chicago, IL. Member: Chicago SA [19]

STEINBERG, Isador N. [Des,I,Cart] NYC b. 14 Je 1900, Odessa, Russia. Studied: NYU; Grande Chaumière, Paris; ASL with Sloan, M. Weber. Exhibited: AIGA, 1941 (prize); "Fifty Books of the Year," 1939; Newark AC, 1935. Illustrator: "Tools of War," 1942; "Physical Training," 1945. Position: T., Columbia [47]

STEINBERG, Nathaniel P. [E,P,I] Chicago, IL b. 15 F 1895, Jerusalem, Palestine. Studied: AIC; A. Sterba; W. Reynolds; Seyffert; H. Walcott; G. Bellows. Member: Palette & Chisel Acad., Chicago North Shore AA; Chicago SE; Southern SE. Exhibited: Chicago SE, 1935 (prize); Paris Salon, 1937. Work: Fed. Court, Chicago; Smithsonian Inst.; Herzl H.S., Chicago; Four Arts, Palm Beach, Fla. [47]

STEINBERG, Saul [I,Car] NYC b. 15 Je 1914, Romania (came to NYC in 1942). Exhibited: WMAA, 1978. Work: Nat. Coll.; MOMA. Best known for his New Yorker covers, esp. his version of a New Yorker's myopic view of the U.S.; also illustrated for Fortune, Vogue, Town & Country, others. Author: 11 books including "All in Line," 1945 [47]

STEINER, Ralph [Ph] Thetford, VT (1985) b. 1899. Studied: Dartmouth; C.H. White Sch. Ph., NYC, 1921–22. Work: AIC; MET; MOMA; Princeton AM. Also a filmmaker. [*]

STEINER-PRAG, Hugo [I,G] b. 1880, Prague, Czech (came to U.S., 1941) d. 10 S 1945., NYC. Position: T., NYU

STEINFELS, Melville P. [P,Des,I,T,L] Adrian, MI b. 3 N 1910, Salt Lake City, UT. Studied: AIC; Chicago Sch. Des. Member: Catholic AA. Work: frescoes: St. Ignatius Auditorium, Chicago; Our Lady of Lourdes Church, Indianapolis; Loyola Univ., Chicago. Position: T., Siena Heights Col., Adrian, Mich. [47]

STEINHILBER, Walter [P] NYC. Member: GFLA [27]

STEININGER, Meta [P] NYC [13]

STEINITZ, Kate [P,W,L,Art Lib] Los Angeles, CA b. 2 Ag 1893, Beuthen, Germany. Studied: Paris, at Grande Chaumière, Sorbonne; Hanover, Berlin, both in Germany. Exhibited: WFNY, 1939; NYPL, 1937; Beekman Towers Hotel, 1942 (one-man). Work: Mus., Hanover, Germany; Societé Anonyme. Contributor: Art News, Magazine of Art. Position: Lib., Elmer Belt Lib. of Vinciana, Los Angeles, from 1945 [47]

STEINKE, Bettina (Mrs. Don Blair) [P,I] NYC (Santa Fe, 1976) b. 1913, Biddeford, ME. Studied: Fawcett A. Sch., Newark, NJ; CUASch.; Phoenix AI, NYC. Member: SI, 1941. Work: Nat. Cowboy Hall of Fame [47]

STEINKE, William (Bill) [I,Car] Irvington, NJ b. 25 N 1887, Slatington, PA. Studied: G. McManus; "Vet" Anderson. Member: Am. Assn. Cart. & Caric. [31]

STEINMETZ, E.M.A. [I] Phila., PA [13]

STEINVALOFF, Igor [P,T,W,L] NYC b. 26 My 1897, Brooklyn, NY. Studied: ASL. Member: S.Indp.A. [40]

STEKETEE, Helen [P] Grand Rapids, MI/Holland, MI b. 14 D 1882, Grand Rapids. Studied: M. Alten; H. Breckenridge; A. Krehbiel. Member: Detroit SWPS; NAWPS; Gloucester AA. Exhibited: Mich. Painters Exh., Detroit AI, 1931 [40]

STEKETEE, Sallie Hall (Mrs. Paul F.) [P] Grand Rapids, MI b. 11 S 1882, Brazil, IN. Studied: Cincinnati A. Acad. Member: NAWPS; Hoosier Salon. Exhibited: Hoosier Salon, Chicago, 1926 (prize), 1928 (prize), 1929 (prize), 1931 (prize). Work: Daughters of Ind., Chicago [40]

STELL, J.M., Jr. [P] San Antonio, TX. Exhibited: Allied A., Dallas, 1933; GGE, 1939; 49 States Comp., 1939. Work: WPA mural, USPO, Teague, Tex. [40]

STELLA, Joseph [P] NYC b. 13 Je 1880, Muro Lucano, Italy (came to NYC in 1896) d. 5 N 1946, Astoria, NY. Studied: ASL, 1897; N.Y. Sch. A., with Chase, 1898–1900, 1902; Florence, 1909. Member: Am. Soc. PS&G. Exhibited: CI, 1910 (one-man); Newark Mus., 1939 (one-man); MOMA, 1960 (one-man). Work: BM; WMAA; WMA; MET; MOMA; Newark Mus.; S. Anonyme; Yale. Contributor: articles, leading intl. art magazines; illus., Survey Graphic mag., 1905–08 [40]

STELLAR, Hermine [P,T] Chicago, IL b. Austria. Studied: AIC; Sorolla, Spain; G. Bellows; L. Wilson. Member: Chicago SA; AC, Chicago. Exhibited: Chicago AC; Chicago SA. Position: T., AIC; Univ. Nebr. [40]

STELLENWERF, Kenneth C. [P] Bay Shore, NY [25]

STELZNER, Raymond [P] Milwaukee, WI b. 1896, Germany. Studied: Wis. Sch. A.; ASL. Member: ASL (Pres.); Wis. PS [24]

STENBERY, Algot [P,T,I] NYC (1977) b. 24 Ap 1902, Cambridge, MA. Studied: Hartford A. Sch.; F. Bosley, at BMFA Sch.; Nicolaides, at ASL; A. Jones. Member: An Am. Group; ASL; Am. A. Cong; United Am. A. Exhibited: PAFA, 1939; WFNY, 1939; WMAA, 1945; Walker A. Gal., 1937 (one-man); SC; Arch. Lg. Work: MET; murals, Harlem Housing Project; USPO, Wayne, Mich. Positions: T., CUASch (1931–38), Am. A. Sch., NYC (1938–40) [47]

STENGEL, G.J. [P] Ridgefield, CT b. 26 S 1872, Newark, NJ d. 20 N 1937. Studied: ASL; Académie Julian. Member: SC; Yonkers AA; Allied AA; AFA; Silvermine G.; G. Am. P.; AAPL. Exhibited: Allied AA, 1930. Work: Mexican Gov., Pres. Palace, Chapultepec [38]

STENGEL, Hans [P,Caric,W,Cr] NYC b. F 1895, Sheboygan, WI d. 29 Ja 1928. Member: S.Indp.A. Work: caric., people in the theatrical world; magazines; newspapers. Position: Cr., New York Evening Journal [25]

STENSEN, Matthew Christopher [P] Richmond, CA b. 30 O 1870, Norway. Studied: Minn. Sch. A. Member: Bay Region AA. Exhibited: Minn. State Fair, 1920 (prize); Chicago Norwegian C. Exh., 1929 (prize); Santa Cruz AL, 1936 (prize). Work: East Bay AA, Oakland, Calif. [40]

STENSON, W.C. [P] Minneapolis, MN [25]

STENVALL, John F. [P,C,T,Gr,Car,B,Des,L,Dr] Chicago, IL b. 25 S 1907, Rawlins, WY. Studied: Univ. Nebr.; AIC. Member: Chicago SA; AL Chicago. Exhibited: MOMA, 1936, 1941; WFNY, 1939; Wichita A. Mus., 1934; Phila. SE, 1934; Univ. Minn. 1938; Phila. WCC, 1935; Rockefeller Ctr., 1936; BM, 1937; Musée du Jeu de Paume, Paris, 1938; CM, 1938; AIC, 1934–38, 1936 (prize) 1940, 1941, 1946; Chicago SA, 1934–41; Swedish-Am. A. Exh., Chicago, 1938; Chicago Graphic Group, 1937, 1938. Work: U.S. Gov. Position: T., New Trier H.S., Winnetka, Ill. [47]

STEPHAN, Elmer A. [I,T,Dr,L] Pittsburgh, PA b. 31 Ja 1892, Pittsburgh d. 3 My 1944. Studied: J. Greenwood; Univ. Pittsburgh. Member: AFA; EAA (Pres.) SA; SI. Illustrator: "Practical Art Drawing Books," "Let's Go Fishing"; illus. and ed., "Inspirational Art Books." Positions: T., Pittsburgh Pub. Sch. (1928–44), CI[40]

STEPHAN, John [P] Chicago, IL b. 4 Jy 1906, Maywood, IL. Exhibited: Chicago Artists, AIC, 1934 (prize) [40]

STEPHEN, Jessie [P,T] Wayne, NE/Delaware, OH b. 1 S 1891, Delaware, OH. Studied: Ohio State Univ.; J.R. Hopkins; G.B. Wiser. Position: T., State T. Col., Wayne, Nebr. [33]

STEPHENS, Alice Barber (Mrs. Charles H. Stephens) [I,P,T,Photogr,En] Moyland, PA b. 1 Jy 1858, near Salem, N.J. d. 14 Jy 1932. Studied: Eakins, PAFA; J. Dalziel, Phila. Sch. Des. for Women; Paris, at Académie Julian, Colarossi Acad. Member: Plastic C., 1897 (founder). Exhibited: Paris Salon, 1887; Columbian Expo, Chicago, 1893; Plastic C.; PAFA 1890 (prize); Atlanta Expo, 1895 (med); London, 1902 (gold) (for her illus. of Eliot's "Middlemarch"). Illustrator: books for Louisa May Alcott; Lucy Lillie; Arthur Conan Doyle; Harper's; Century; Scribners; Collier's. Position: T., Phila. Sch. Des. for Women (where she started the first life-drawing class just for women) [31]

STEPHENS, Charles Arthur Lloyd [P] Brooklyn, NY d. 13 Ap 1914 (committed suicide at home)

STEPHENS, Charles H. [I,T] Moylan, PA b. ca. 1855 d. 1 N 1931, Pittsburgh. Member: Phila. Sketch C. (Pres.); PAFA (Vice-pres.). Specialty: illustrations of Indians. Owned a collection of American Indian art distinguished for the beauty and rarity of its specimens; it was exhibited at the Univ. Pa. Mus. [31]

STEPHENS, C(lara) J(ane) [P,W] Portland, OR. Studied: K. Cox; W.M. Chase; F.V. DuMond. Member: S.Indp.A. Exhibited: Seattle FAS, 1920 (prize), 1925 (prize) [40]

STEPHENS, D(aniel) Owen [P] Pittsburgh, PA (Moylan, PA) b. 5 Ag 1893, Phila. d. 23 Je 1937, Balboa, Canal Zone (while en route home from Peru, where he had painted several pictures of the different stages of the eclipse of the sun, as a member of the Hayden Planetarium-Grace Eclipse Expedition). Studied: PAFA, with W. Lathrop, N.C. Wyeth. Member: Phila. Alliance [33]

STEPHENS, George Frank [S,C,T,L] Arden, DE b. 28 D 1859, Rahuway, NJ d. 16 Je 1935, Gilpin Point, near Denton, MD. Studied: PAFA. Member: Phila. Sketch C.; AC Phila.; NAC. He was co-founder of Arden and Ardentown, the single tax colonies near Wilmington, Del., and Gilpin Point. Positions: T., PAFA; Drexel Inst.; Spring Garden Inst., Phila. [31]

STEPHENS, Robert K. [P,T,C] Providence, RI/Provincetown, MA b. 21 My 1906, Scranton, PA. Studied: Syracuse Univ.; ASL; N.Y. Sch. F.&Appl. A.; RISD; J.R. Frazier. Member: Provincetown AA; Providence AC; R.I. WCC; Utopian C., Providence. Exhibited: Providence AC, 1938; Phila. WC Ann., 1938; AIC, 1939. Work: AMNH; Roger Williams Park Mus., Providence. Position: Dir., R.I. Lg. A.&Cr. [40]

STEPHENSON, Byron P. [Cr] NYC b. 1852, England (came to U.S. at an early age) d. 14 Ag 1915, New York Evening Post. Positions: New York Herald; Ed., Town Topics; critic, New York Evening Post

STEPHENSON, J.G. [P] Stamford, CT. Member: GFLA [27]

STEPHENSON, Robert S. [Arch,Mur,P] NYC [08]

STEPHEY, Eva [P] Los Angeles, CA. Member: Calif. AC [25]

STERBA, Antonin [Por.P,Et,T] Chicago, IL b. 11 F 1875, Hermanec, Czechoslovakia. Studied: AIC; Académie Julian, with Laurens, Constant; J.F. Smith. Member: Cliff Dwellers; Bohemian AC; Assn. Chicago P.&S.; Chicago Gal. Assn.; Chicago SE. Exhibited: CGA; AIC, 1938 (prize); PAFA; Bohemian AC, 1921 (gold), 1923 (med); Mun. AL, 1938 (prize); Chicago Gal. Assn., 1930 (prize). Work: Northwestern Univ.; De Pauw Univ.; Baylor Univ.; State Mus., Springfield (Ill.); NGA. Position: T., Am. Acad. A., Chicago [47]

STERCHI, Eda Elisabeth [P,B] Olney, IL b. Olney, IL. Studied: AIC; Grande Chaumière, L. Simon, both in Paris. Exhibited: Santa Barbara Mus. A.; Boston, Mass.; NYC; AIC (one-man) [47]

STERLING, Antoinette [S] Macdougal Alley, NYC. Lived with Alice Morgan Wright. [15]

STERLING, James Elias [P] NYC b. 25 Ag 1908 Reading, PA. Studied: M. Denis, in Paris; D. Frisia, in Milan. Exhibited: Ar. Gal., N.Y., 1937 [40]

STERLING, Lindsey Morris [S] NYC. Exhibited: P.-P. Expo, San Fran., 1915 [15]

STERLING, Lindsey Morris (Mrs.) [S,I] Edgewater, NJ/Essex County, NY b. 8 N 1876, Auch-Chunk, PA d. 23 Jy 1931, Englewood, NJ. Studied: G. Brewster; J. Fraser; Bourdelle, in Paris. Member: NSS; NAWPS; New Haven PCC; Allied AA.; Plainfield AA. Exhibited: P.-P. Expo, San Fran., 1915 (med); NAWPS, 1916, 1923; Newark AC, 1931 (med); New Haven PCC (prize). Specialties: bas-reliefs; small bronzes. Position: Staff A., AMNH, since 1901 [29]

STERLING, Ruth [P] NYC [01]

STERN, Caroline (Mrs.) [P] NYC b. 17 Je 1893, Germany. Studied: Académie Julian. Member: AWCS [47]

STERN, Ethel Louise [P,E,T] Buffalo, NY b. 5 D 1880, Buffalo, NY. Studied: ASL; Buffalo ASL [21]

STERN, Louise S. [P,E] NYC/West End, NJ b. 21 Ap 1901, Baltimore, MD [32]

STERN, Lucia [P,S,C] Milwaukee, WI b. 20 D 1900, Milwaukee. Studied: Columbia; Univ. Wis. Member: Springfield AL. Exhibited: AIC, 1944; Mus. Non-Objective P., 1944-46; Springfield AL, 1945, 1946; CMA; Detroit Inst. A., 1945 (one-man); Milwaukee AI, 1942 (one-man) [47]

STERN, Mildred B. See M.B. Miller, Mrs.

STERN, Sam Tilden [P,Des,Li,T,C] Brooklyn, NY b. 4 N 1909, NYC. Member: AG; Pittsburgh WCS. Exhibited: Midtown Gal., N.Y. (one-man); Marie Harriman Gal., NYC (one-man); Wunderly Gal., Pittsburgh (one-man). Work: murals, Warner and Enright Theatres, Pittsburgh. Specialties: fabric; glass; stage/movie set design. Position: Staff A., 20th Century Fox [40]

STERN, Sol J. [P] East Savannah, GA [25]

STERNBERG, Harry [P,Dr,T,E,Li,L] Glen Cove, NY b. 19 Jy 1904, NYC. Studied: ASL; H. Wickey. Member: AL Am.; Am. Ar. Cong.; United Am. Ar.; Guggenheim F., 1936. Exhibited: nationally. Work: MOMA; MET; WMAA; NYPL; LOC; FMA; PMA; CMA; Victoria & Albert Mus., London; Bibliothèque Nationale, Paris; de Young Mem. Mus., San Fran.; Pub. Lib., Newark; AGAA; 50 Fine Prints of the Year, 1931, 1933, 1934, 1938; WPA murals, USPOs, Chicago, Ill., Chester, Pa., Sellersville, Pa. Author/Illustrator: "Silk Screen Color Printing," 1945. Position: T., ASL & MOMA Veterans Ctr. [47]

STERNBERG, L.B. (Mrs.) [P] Buffalo, NY. Exhibited: Western N.Y. Artists, 1935 (prize), 1936 [40]

STERNE, Maurice [P,C,S,E,T] Mount Kisco, NY/Provincetown, MA b. 13 Jy 1878, Libau, Latvia (came to NYC in 1889) d. 23 Jy 1957. Studied: T. Eakins, NAD, 1894; CUASch; Italy; France; Bali, 1913-15. Member: ANA, 1935; NA, 1944; S. Gld.; NIAL, 1938. Exhibited: AIC, 1928 (prize); GGE, 1939 (prize); NAD (prize); PAFA (prize); CGA (med); first Am. artist given a one-man show at MOMA (1933). Work: MET; WMAA; MOMA; BM; BMFA; CMA; Detroit Inst. A.; San Diego FAS; AIC; RISD; AGAA; Yale; Kaiser Friedrich Mus., Berlin; Cologne Mus., Germany; Tate Gal., London; mon., Worcester, Mass.; Fairmount Park, Phila.; murals, Dept. Justice, Wash., D.C. [47]

STERNER, Albert [P,E,Li,L,W] NYC/Pittsfield, MA b. 8 Mr 1863, London, England (of Am. parents) d. 16 D 1946. Studied: Birmingham, England; Académie Julian, Paris, with Boulanger, Lefebvre, Gérôme. Member: ANA, 1910; NA, 1935; AWCS; NIAL; Am. S. PS&G; SAE. Exhibited: Paris Salon, 1891; Paris Expo, 1900 (med); Pan-Am. Expo, Buffalo, 1901 (med); Munich, 1905 (gold); NAD, 1935 (prize). Work: CI; MET; Toronto Mus.; BM; South Kensington Mus.; Victoria and Albert Mus., London; Kunstgewerbe Sch, Mus. Pinacothek, Munich; Kunstgewerbe Schule, Dresden; Royal Print Coll., Italy; Honolulu Acad. A.; NYPL; LOC; Speed Mem. Mus., Louisville, Ky.; Yale Univ. Lib.; Harvard C., Steinway Hall, NYC; portrait and dec., National Golf Links of America. Illustrator: "Ten Tales of François Coppée," "Prue and I," by G.W. Curtis, "Eleanor," "Marriage of William Ashe," "Fenwicks' Career," by Mrs. H. Ward; article, "The Cézanne Myth," Harper's (between 1893 and 1905); Prosper Merimee's "Carmen" (translated from original 36 drawings). Author: "Prints Without Ideas," "Odilon Redon"; article in Prints. [40]

STERNER, Harold [P] NYC b. 29 O 1895, Paris, France. Studied: St. George's Sch. Newport, R.I.; MIT. Exhibited: PAFA, 1943, 1944; CGA, 1943, 1944; AIC, 1943; WMAA, 1944, 1945; MET (AV), 1944; CAM, 1944; CI, 1946; Wakefield Gal., NYC 1940 (one-man). Work: BMFA [47]

STERNFELD, Edith A. [P,S,L,T,C] Grinnell, IA b. 26 S 1898, Chicago, IL. Studied: Northwestern Univ.; AIC; Univ. Iowa; Cranbrook Acad. A.; E. O'Hara; G. Wood; J. Charot; Layton Sch. A.; A. Angarola; R. Moffett, F.L. Allen.; B. Miller. Member: CAA; Iowa AG; Western AA; AAPL. Exhibited: AIC; Wis. P.&S.; AWCS; Phila. WCC; Baltimore WCC; Calif. WCS; Wash. WCC; Kansas City AI; Joslyn Mem., 1937 (prize), 1940 (prize); WFNY, 1939; Iowa WC Exh., 1945 (prize); Milwaukee AI, 1929-30 (prizes); Iowa AC, 1932; Iowa State Fair, 1932, 1933 (prize); Iowa A. Salon, 1939 (prize); All-Iowa Exh., 1937 (prize). Position: T., Grinnell Col., from 1930 [47]

STERNFELD, Harry [P] Pittsburgh, PA. Member: Pittsburgh AA [25]

STERNFELS, Edna [P] Mt. Vernon, NY. Member: S.Indp.A. [25]

STERRETT, Cliff [Car] Ogunquit, ME b. 12 D 1883, Fergus Falls, MN d. 29 D 1964, NYC. Studied: Chase Sch. A. Member: SI. Illustrator: "Polly and Her Pals," King Features syndicated cartoon [47]

STETCHER, Karl [Por.P,C] b. 1831, Germany (came to NYC as ayouth) d. Ja 1924, Wichita, KS

STETSON, Charles Walter [P,E] Rome, Italy b. 25 Mr 1858, Riverton Four Corners, RI d. 21 Jy 1911. Exhibited: N.Y. Etching C., 1886; PAFA; mus., Boston, Cincinnati; St. Louis [10]

STETSON, Katharine Beecher (Mrs. F. Tolles Chamberlain) [S,P,T] Pasadena, CA b. 23 My 1885, Providence d. 18 F 1979. Studied: Rome, with da Pozzo, Sabate, Noël, Breck; PAFA, with Chase, Kendall, Poore, Beaux; H.D. Murphy; B. Harrison; L. Ochtman; F.T. Chamberlin. Member: McD. Assn.; Pasadena SA. Exhibited: PAFA, 1912, 1914, 1915, 1916, 1919, 1926; NAD, 1914-16, 1919, 1925; Arch. Lg., 1915, 1917; AIC, 1915-17, 1926; Los Angeles Mus. A., 1921-26, 1925 (med); Pasadena SA, 1924-46, 1940 (prize); Los Angeles County Fair, 1927 (prize) [47]

STETTHEIMER, Florine [P,Des] NYC b. 1871, Rochester, NY d. 1948. Studied: ASL, with K. Cox; Paris, Rome, Munich, all 1906-14. Member: S.Indp.A. Work: PMA; Los Angeles Mus. A. Designer: stage sets for V. Thompson's "Four Saints in Three Acts," 1934 [29]

STEUART, Elizabeth Howard (Mrs. William D.) [P] Baltimore, MD [25]

STEUART, Emily Nourse [P,T] Wash., D.C. b. 13 Je 1893, Wash., D.C. Studied: George Washington Univ.; Columbia; H. Snell; G.P. Ennis; C. Martin. Member: Wash. AC; Wash. WCC; EAA; AFA; Twenty Women P. of Wash. Position: T., Western H.S., Wash., D.C. [47]

STEUART, LeConte [E,Li,B,P,T] Kaysville, UT b. 15 Ap 1891, Glenwood, UT. Studied: PAFA, with Carlson, Goetz, DuMond, Garber. Work: Springville (Utah) H.S.; Ogden City Coll., Utah; Utah State Coll., Salt Lake City [33]

STEUART, M. Louisa [P,T] Baltimore, MD/Cascade, P.O., MD b. Baltimore. Studied: H. Newell; J. Rolshoven; W. Chase; Courtois. Member: Baltimore WCC [33]

STEUART, Sarah R. [P] Montclair, NJ [06]

STEUVER, Celia M. [P,E] St. Louis, MO b. St. Louis. Studied: St. Louis Sch. FA; Ecole des Beaux-Arts, Paris; Germany; Vienna. Member: Albrecht Dürer Verein, Kunstler Genossenschaft, Vienna; Calif. PM; Calif. SE [25]

STEVEN, Francis Simpson [P] NYC [15]

STEVENS, Almira E. [P,T] Yonkers, NY b. 1861, NYC d. 3 Ag 1946. Studied: CUASch; Paris; Munich; Dresden. Specialties: watercolors; oils; dec. chinaware [24]

STEVENS, Angelina V. [Por.P] Springfield, MA/Rockport, MA b. Siena, Italy. Studied: E.L. Major; W.L. Stevens; Mass. Normal Sch.; Boston Univ.; Sch. FA, Florence, Italy. Member: Springfield AG [40]

STEVENS, Beatrice [P] Pomfret, CT b. S 1876, NYC [21]

STEVENS, Charles K. [I] NYC b. 1877 d. 7 F 1934. Studied: Chase A. Sch.; ASL. Specialty: brilliantly colored poster type of book jacket for more than 1,000 books, 1914-34

STEVENS, Clara Hatch (Mrs.) [P] Lake Bluff, IL b. 22 Ap 1854, Harrodsburg, KY. Studied: J.C. Beckwith; W. Chase; R.M. Shurtleff; Puvis de Chavannes. Member: All-Ill. SFA; North Shore AL. Work: frieze, Hall of Honor, Women's Bldg., World's Columbian Expo, Chicago, 1893; panel, Hall of Science, Century of Progress Expo, Chicago, 1933 [40]

STEVENS, Dorothy [E,P] Toronto, Ontario b. 1888, Toronto. Studied: Slade Sch., London. Member: Chicago SE. Exhibited: P.-P. Expo, San Fran., 1915 (med) [24]

STEVENS, Dwight Elton [Des,P,T] Stillwater, OK b. 1 My 1904, Sharon, OK. Studied: Okla. A.&M. Col.; Cincinnati A. Acad. Member: SSAL; AIA; Beaux-Arts S. Exhibited: Denver AM, 1943; Oakland A. Gal., 1943; AWCS, 1946; SSAL, 1946; Okla. A., 1944-46. Position: T., Okla. A.&M. Col. [47]

STEVENS, Edith. See Parsons, Mrs.

STEVENS, Edith Briscoe [P] Hartford, CT b. 1896, Phila. d. 31 Ag 1931, Gloucester, MA. Studied: A.E. Jones; H. Leith-Ross; G.E. Browne. Member: CAFA; New Haven PCC; Springfield AL; Gloucester SA; Rockport AA. Exhibited: New Haven PCC, 1931 (prize). Work: Beach Coll., Storrs, Conn. [29]

STEVENS, (Edward) Dalton [I] NYC b. 6 D 1878, Gouchland, County, VA d. Ag 1939. Studied: Vanderpoel, in Chicago; Chase Sch., NYC; Paris. Illustrator: "Mary Regan," by L. Scott, "The Crystal Stopper," by Leblanc, "Peter Rough"; Cosmopolitan, Redbook, McCall's, Liberty; covers for McFadden Pub. Co. [38]

STEVENS, Edward John, Jr. [P,E] Jersey City, NJ b. 4 F 1923, Jersey City. Studied: State T. Col., Newark, N.J.; Columbia. Exhibited: Pasadena AI, 1946; BM, 1945, 1946; WMAA; Soc. Four A., Palm Beach, Fla.; Phila. A. All., 1946; Weyhe Gal., 1944-47 [47]

STEVENS, Elizabeth T. [P] Hartford, CT. Member: Hartford AS [25]

STEVENS, Esther (Mrs. Walter T. Barney) [P] San Diego, CA b. 6 Ja 1885, Indianapolis. Studied: R. Henri; ASL. Member: San Diego AG. Exhibited: San Fran. AA, 1922 (gold) [24]

STEVENS, George W(ashington) [Mus.Dir,P,W,L] Toledo, OH b. 16 Ja 1866, Utica, NY d. 29 O 1926 Studied: J.F. Murphy, in NYC. Member: SC; Assn. Mus. Dir. (Pres.); Am. Fed. Photogr. Socs., (Pres., 1909-10); Nat. Inst. Social Sc.; Egypt Exploration S. (Hon. Sec.); Faculty of Arts, London (Vice-pres.) Author: "The King and the Harper and other Poems," "Things." Position: Dir., TMA, from 1903 [25]

STEVENS, Helen B. (Mrs. T.W.) [E] Santa Fe, NM b. 8 F 1878, Chicago. Studied: AIC; F. Brangwyn, in England. Member: Chicago SE; Pittsburgh AA. Exhibited: P.-P. Expo, San Fran., 1915 (med) Positions: T./Cur., AIC, 1909-12 [40]

STEVENS, John Calvin [Ldscp.P,Arch] Portland, ME b. 8 O 1855, Boston. Member: FAIA; Arch. Lg.; Maine Chap. AIA; Portland SA (Pres.); AFA [40]

STEVENS, Kelly Haygood [P,C,T] Mexia, TX (Austin, TX, 1962) Studied: TX Sch. for Deaf; Gallaudet Col., Wash., D.C.; Corcoran Sch. A., with Brooke, Messer; Trenton (N.J.) Sch. Indst. A., with McGinnis; Paris, with deaf painter J. Hanan (1920s), L. Biloul, H. Morisset (1933); Spain, with V. de Zubiaurre; N.Y. Sch. FA; La. State Univ. Member: SSAL; Tex. FAA; La. T. Assn. Exhibited: Dallas Mus. FA; Roerich Mus.; State A. Gal., Shreveport, La.; SSAL; Tex. FAA; Madrid; Brussels; Paris. Work: Position: T., N.J. Sch. for the Deaf (8 yrs.) [47]

STEVENS, Lawrence Tenney [S,P,L,T,E,C] Tulsa, OK b. 16 Jy 1896, Brighton, MA d. 1972. Studied: BMFA Sch.; Am. Acad., Rome; C. Grafly; B. Pratt. Member: NSS. Exhibited: PAFA, 1929; Arch. L., 1926; NAD, 1927, 1928; BMFA, 1926, 1931; Grand Central A. Gal.; Boston AC; Philbrook A. Ctr., 1944, 1946; Calif. State Fair, Pomona, 1934 (prize). Award: Prix de Rome, 1922. Work: Univ. Pa.; Brookgreen Gardens, S.C.; BM; Fairgrounds, Dallas; Pomona, Calif.; Scripps Col., Claremont. Specialty: western animals [47]

STEVENS, Louisa Bancroft [P,Des,C,Ldscp.Arch,L,T] Boston, MA b. 8 N 1872, Lawrence, MA. Studied: H.C. Walker; F. Benson; E. Tarbell; G. Lowell; E. André, Paris. Member: Boston SAC (master craftsman) [40]

STEVENS, Marian [P] Wash., D.C. Member: Wash. SA. Exhibited: NAWPS, 1935, 1937, 1938; Wash. WCC, 1933, 1939 [40]

STEVENS, Ruth Tunander (Mrs.) [En,C,T,B] Seattle, WA b. 25 Ap 1897, Calumet, MI. Studied: Univ. Wash.; A. Archipenko. Member: Northwest PM; Seattle Weavers Gld. Exhibited: Northwest PM, 1928-41; Seattle Weavers Gld. Positions: T., Seattle (Wash.) H.S. (1926-41), King's County (Wash.) "Federal Way Schools" (1943-46) [47]

STEVENS, Sarah E. [P] Roland Park, MD. Member: Baltimore WCC [25]

STEVENS, Stanford [P,W] Tucson, AZ b. 5 O 1897, St. Albans, VT. Studied: Harvard. Member: AWCS. Work: Wood Gal. A., Montpelier, Vt.; Rockland (Maine) A. Gal. Author: "Plants of Sun and Sand" [47]

STEVENS, Thomas Wood [Mur.P,E,W] Chicago, IL b. Daysville, IL. Studied: AIC; Armour Inst. Tech., Chicago; F. Brangwyn, in London; Sorolla, in Madrid. Position: Dir., Goodman Theater, AIC, 1924-30 [33]

STEVENS, Vera (Mrs. Anderson) [P,T] Waltham, MA b. 5 Ag 1895, Houstontown, PA. Studied: PMSchIA; G.E. Browne. Member: NAWA; CAFA; Provincetown AA; New Haven PCC; Boston AC. Exhibited: Paris Salon, 1929; CAFA; Springfield AL; New Haven PCC; NAD, NAWA, 1933 (prize); PAFA [47]

STEVENS, William C. [Ldscp.P] b. 1854, Barre, MA d. Fall, 1917. Work: WMA. Practised medicine until 1897, when he took up painting as a profession. [17]

STEVENS, W(illiam) D(odge) [I] NYC b. 13 S 1870, Tidioute, PA. Studied: AIC, with Vanderpoel, Grover; Paris. Member: AG [47]

STEVENS, Will Henry [P,Dr,T] New Orleans, LA b. 28 N 1881, Veray, IN. Studied: Cincinnati A. Acad.; J. Lie; A. Ryder; Nowottny; Duveneck; Meakin; Van Dearing Perrine, NYC. Member: F., Tiffany, 1932. Exhibited: Delgado Mus. A.; New Orleans A.&Cr. C.; Newcomb Col. A. Gal., 1945; Black Mountain Col., 1945; numerous traveling exh.; Richmond, Ind., 1914; SSAL, 1925. Work: BMFA; J.B. Speed Mem. Mus. A.; Univ. Okla.; galleries, Des Moines; Shreveport, La. Position: T., Stevens Sch. A., Gatlinburg, Tenn. (summers) [47]

STEVENS, W(illiam) Lester [P,T] Conway, MA/Rockport, MA. b. 1888, Rockport, MA d. 1969. Studied: P.S. Perkins, BMFA. Member: NA; AWCS; Rockport AA; Springfield (Mass.) AL; New Haven PCC; North Shore AA; Phila. WCC; Boston WCC; ANA, 1935; Boston Gld. A.; NYWCC. Exhibited: Wash. Ldscp. C., 1939 (prize); CGA, 1921 (prize); CAFA, 1924 (prize); NAD, 1927 (prize); AWCS, 1928 (prize); New Haven PCC, 1929 (prize), 1933 (prize); Springfield AL, 1925 (prize), 1932 (prize); Quincy, 1932 (med); Springville, Utah, 1931 (prize); Women's C., Mass., 1934 (prize), 1937 (prize), 1938 (prize); Meriden A.&Cr. Assn., 1938 (prize). Work: Boston AC; Birmingham (Ala.) Pub. Lib.; Gloucester (Mass.) H.S.: Rockport (Mass.) H.S.; Tewksbury (Mass.) State Sanitorium; Mint Mus. A.; WPA murals, USPOs, Dedham, Rockport, both in Mass.; Boston City C.; AM, Louisville, Ky.; Springville (Utah) AA; Wilson, Wolcott, Gavin schools, all in Boston; Mint Mus. A., Charlotte, N.C. [47]

STEVENS, William Oliver [P,I,W,L,T] Birmingham, MI b. 7 O 1878, Rangoon, Burma. Position: T., Cranbrook Sch., Birmingham [27]

STEVENSON, Amy Leanor [P,C,Des,I,Dec,L] NYC b. Quebec, Canada. Studied: CUASch; NAD; ASL; C. Hawthorne; E. Savage; R. Brackman; S. Skou; Ezra Winter. Member: A.All.Am.; Gotham Painters; F., Tiffany Fnd., 1923. Exhibited: A.All.Am., 1928 (prize); Arch. Lg.; S.Indp.A.; AWCS, 1946; WMA, 1946; Salons of Am.; Anderson Gal., N.Y.; Tiffany Fnd.; Nat. Rug Des. Comp. (prize) [47]

STEVENSON, Beulah [P,E,Li,T] Brooklyn, NY b. Brooklyn d. 17 Mr 1965. Studied: ASL; J. Sloan. Member: Fifteen Gal.; Am. Ar. Cong.; Fed. Mod. P.&S.; N.Y. Soc. Women A.; NAWA; Brooklyn SA; Creative A. Soc. Exhibited: BM (prize); NAWPS, 1930 (prize); Chicago; Wash., D.C.; Phila.; Paris; Fifteen Gal., N.Y., 1940 (one-man). Work: NYPL [47]

STEVENSON, Branson Graves [E,Li,P,C] Great Falls, MT (1976) b. 5 Ap 1901, Franklin County, GA. Studied: A. Sch., Instituto Nacional, Panama; R. Luiz. Member: SAE; Great Falls AA. Exhibited: SAE, 1943, 1944; NAD, 1944; LOC, 1944, 1945; CI, 1944, 1945; Los Angeles Mus. A., 1936; SAM; GGE, 1939. Also a potter. Position: T., Col. of Great Falls, 1963 [47]

STEVENSON, Claudia [Por.P,P,T] Cicero, IL/Rochester, IN b. Bolivar, IN. Studied: N.Y. Sch. F.&Appl. A.; Cape Cod Sch. P.; C. Hawthorne; W.J. Reynolds. Exhibited: CGA; NAD; AIC; Hoosier Salon. Positions: A. Dir., J. Sterling Morton H.S., Morton Jr. Col., Cicero, Ill., 1924-46 [47]

STEVENSON, Dorothea (Mrs. Richard R. Casady) [P,L,T] Oklahoma City, OK b. 23 F 1910, Dallas [Daughter of Edna?]. Studied: I. Annette; O.B. Jacobson; N. Sheets; E. Bisttram; M. Avey; Académie Julian, Paris; Univ. Okla.; Florentine Acad., Florence, Italy; R. Jonsen. Member: Okla. State AA; Women P. of the West. Exhibited: Okla. State AA, 1939 (prize), 1942 (prize); Kansas City AI, 1931, 1932; Rockefeller Center, N.Y., 1934; Albuquerque, N.Mex., 1940; Dallas Mus. FA, 1942; Philbrook A. Center, 1940; Los Angeles Mus. A., 1945, 1946; Oklahoma City (several one-man exh.). Work: Univ. Okla.; murals, Classen H.S., Wilson Elementary Sch., both in Oklahoma City. Positions: T., Univ. Oklahoma City, 1940-43, Univ. Southern Calif., 1945-46 [47]

STEVENSON, Edna Bradley [P,L,T] Oklahoma City, OK (1962) b. 8 F 1887, Hebron, NE [Mother of Dorothea?]. Studied: AIC, 1907; Académie Julian, Paris, 1936; Oklahoma City Univ., 1929; Florence, Italy; N. Sheets; M. Avey; E. Bisttram, in Taos, 1932-34; F. Becker; D. Donaldson. Member: Okla. State AA. Exhibited: Assn. Okla. A.; Okla. A. Center (one-man); Okla. State Fair; Santa Fe, N.Mex.; Harwood Gal., Taos. Position: Dir. A., Oklahoma City Univ., 1943-58 [47]

STEVENSON, Elaine Louise [C,T,P] Kalamazoo, MI b. 13 Ap 1891, Port Huron, MI. Studied: J. Norton; R. Quint; Western Mich. Col. Edu.; AIC; Ohio State Univ.; Cranbrook Acad. A.; Columbus Sch. A.; E.M. Church. Member: Kalamazoo AI. Exhibited: Mich. State Fair, Detroit, 1936 (prize); Kansas City AI; Norton Gal., West Palm Beach, Fla.; Mich.; Ohio. Position: T., Western Mich. Col. Edu., 1917- [47]

STEVENSON, Florence Ezzell [P,L] Chicago, IL b. Russellville, AL. Studied: Tuscaloosa (Ala.) Conservatory A. & Music; AIC; Chicago Acad. FA; C. Buehr; S. Davis. Member: AAPL; South Side AA; SSAL; All-Ill. Soc. FA; No-Jury Soc. A., Chicago; Lg. Am. Pen Women; Chicago Municipal A. Lg.; Ridge AA, Chicago; Vanderpoel AA. Exhibited: All-Ill. Soc. FA, 1936 (gold); South Side AA, 1939 (prize); Ill. Fed. Women's Cl., 1938 (prize), 1945 (prize); Lg. Am. Pen Women, 1941 (prize); AIC, 1937, 1938; The Parthenon, Nashville, Tenn.; Brooks Mem. A. Gal.; Smithsonian Inst.; Birmingham Pub. Lib., 1943 (one-man). Work: Rosewald Mus. Sc.&Indst, Morgan Park H.S., Vanderpoel Coll., all in Chicago; Hanover

Col., Ind.; Municipal Bldg., Russellville, Ala. Designer: covers, Literary Digest, La Revue Moderne (Paris), The Art World [47]

STEVENSON, Gordon [P,E] NYC b. 28 F 1892, Chicago, IL. Studied: Sorolla; AIC. Member: AWCS; Am. Veterans Soc. A. Exhibited: Olympic Exh., Berlin, 1936 (med); AIC; NAD. Work: BM [47]

STEVENSON, Horatio S. [P,T] Pittsburgh, PA b. New Castle, PA. Studied: NAD; Bouguereau, Robert-Fleury, in Paris. Member: Pittsburgh AS; Pittsburgh A. Assoc. Positions: Dir., Stevenson A. Sch.; summer sch. at Allegheny [10]

STEVENSON, Mary Anna [P] Phila., PA [17]

STEVENSON, Suzanne. See Silvercruys.

STEVENSON, Wendell Adam [P] Forest Park, IL b. 31 Ja 1915, Chicago. Studied: Flint (Mich.) Inst. A.; AIC. Work: Door County Hist. Soc., Wis.; Home for Incurables, Diversey Methodist Church, Chicago Community Methodist Church, Forest Park. Illustrator: "Variety of Verses," "Little Bits of Loveliness," "God, Flag, and Country," by F.L. Stevenson [47]

STEWART, Albert T. [S] Claremont, CA b. 9 Ap 1900, Kensington, England d. 1965. Member: NSS; Arch. Lg.; ANA, 1937; NA, 1945. Exhibited: NAD, 1927 (prize), 1931 (prize); Arch. Lg. (prize); PAFA (med). Work: MMA; Seamen's Inst., N.Y.; tablets, Williams Col., Williamstown, Mass., Amherst Col.; Buffalo City Hall; Baptistry door, St. Bartholomew's Church, N.Y.; mem. for Am. soldiers, Thiaucourt Cemetery, France; Auditorium, Kansas City; Court House, St. Paul, Minn.; pediment, Dept. Labor, Wash., D.C.; Court House, Mineola, N.Y.; U.S. Mint, San Fran.; medal for U.S. Navy for Nicaraguan campaign; panels, Home Owners Loan Corp. Bldg., Wash., D.C. WPA artist. [47]

STEWART, Catherine [P] Columbus, OH [25]

STEWART, David [P,T] Grafton, VT b. 27 N 1879, Glasgow, Scotland. Studied: ASL; NYU; H.S. Mowbray; DuMond; Columbia. Member: NYWCC; SC; Bronx A. Gld.; AAPL; Gotham Painters; Yonkers AA. Exhibited: AWCS; All.A.Am.; Brown A. Gld.; Yonkers AA; NAC, 1942; Gotham Painters; Audubon A.; NYWCC, 1936, 1937; Am. WC Soc.-NYWCC, 1939; SC; Bronx A. Gld. Position: T., Pub. Sch. Bd., N.Y., 1940 [47]

STEWART, Douglas [Mus.Dir] Pittsburgh, PA b. 1873, Pittsburgh d. My 1926. Position: Dir., Carnegie Mus., Pittsburgh

STEWART, Duncan, Mrs. See Rose, Leize.

STEWART, Edith Hoyt [P] Baltimore, MD b. Milford, MA. Studied: W.S. Robinson; H.B. Snell; W.L. Lathrop; C.Y. Turner [25]

STEWART, Esther L. [P,D] Vienna, VA b. 13 D 1895, Moorestown, NJ. Studied: Swarthmore Col.; PMSchIA; PAFA; Corcoran Sch. A. Exhibited: CGA; PMG; Whyte Gal.; Wash., D.C. Pub. Lib. Position: Trustee, Va. A. All., VMFA, Richmond, 1945, 1946 [47]

STEWART, Ethelyn Cosby [P,C,Des,Gr,Dec,Li,E] NYC b. 19 Ja 1900, Arlington, NJ. Studied: CUASch; W.E. Cox; E. Carlsen. Exhibited: NAD; PAFA. Work: PAFA; Smithsonian Inst. [47]

STEWART, Frances De F. (Mrs.) [P] NYC. Exhibited: Argent Gal., 1937 (one-man); NAWPS, 1935-38 [40]

STEWART, Grace Bliss (Mrs.) [P,W] NYC b. 18 Ap 1895, Atchison, KS. Studied: ASL; C. Hawthorne; H.B. Snell; F.L. Mora. Member: NAWA; PBC; AAPL; N.H. AA. Exhibited: All.A.Am., 1937; NAWA, 1930-46; Toronto, Ontario, 1937; North Shore AA; Gloucester AA; PBC; Dayton AI; Ogunquit A. Center; Salons of Am.; Palm Beach AA; Newport AA. Author: "In and Out of the Jungle," "Jumping into the Jungle," "The Good Fairy" (1930) [47]

STEWART, J.R. [P] Cleveland, OH. Member: Cleveland SA [27]

STEWART, Janet A. [E] Somerworth, NH [24]

STEWART, Jan(et) (Crouse) (Mrs. F.P.) [C,P,Des,T] Miami Beach, FL b. 15 Ag 1904, Mansfield, OH. Studied: PMSchIA; Chicago Acad. FA; S. Szukalski. Member: Hoosier Salon. Exhibited: Midland Acad., South Bend, Ind.; Hoosier Salon. Restorer of ceramics. [47]

STEWART, Jeanne M. [P] Chicago, IL b. 1868, Quincy, IL. Studied: AIC; J. Paterson, in Edinburgh, Scotland [08]

STEWART, Joseph Augustus Edward [Textile Des,P] Montclair, NJ b. 1864, Bristol, England (came to U.S. in 1875) d. 16 S 1943. Positions: Des., Pacific Mills, Converse & Co.

STEWART, Julius L. [P] Paris, France b. 6 S 1855, Phila., PA d. 1919. Studied: Paris, with E. Zamacois, F. Madrazo, Gérôme, 1880s. Member: Paris SAP; Soc. Nat. des Beaux-Arts, 1899. Exhibited: Paris Salon, 1885 (prize), 1890 (med); Berlin, 1891 (gold), 1895 (gold); Munich, 1897 (gold), 1901 (gold). Awards: Order of Leopold of Belgium, 1895; French Legion of Honor, 1895, Officer, 1901. Work: Essex Cl., Newark, N.J.; Buffalo Cl., N.Y. [17]

STEWART, LeConte [P,E,Li,L,T] Kaysville, UT (1974) b. 15 Ap 1891, Glenwood, UT. Studied: Univ. Utah; ASL, with Carlson, Goltz, DuMond, Blumenschein, Miller, 1911-13; PAFA, with Garber, Oberteuffer, Pearson. Member: Assoc. Utah A. Exhibited: Utah State Fair, 1915 (prize), 1937 (prize); Utah AI, 1916 (prize), 1941 (prize), 1938 (prize); Painters of the West, 1928; Colo. Graphic AC, 1938-40; Assoc. Utah A., 1945; Ogden Palette Cl., 1945 (one-man); Heyburn, Idaho, 1946; Boulder (Colo.) Women's Cl., 1946. Work: Utah State Coll.; Springville (Utah) H.S.; Ogden City Coll.; Univ. Utah; Ricks Col., Rexburg, Idaho; Heyburn (Idaho) Pub. Sch. Coll.; murals, Hotel Ben Lomond, Ogden; Latter Day Saints temples, Canada, Hawaii, Ariz. [47]

STEWART, Luella M. See Holden, Mrs.

STEWART, M. Louise [P] Baltimore, MD [25]

STEWART, Marie H. [P,Des,C,T,W] Indianapolis, IN b. 20 Ag 1887, Eaton, OH. Studied: PIASch; Butler Univ. Member: Ind. AC. Exhibited: Hoosier Salon, 1941, 1942 (prize), 1943, 1945; Ind. A., 1936-45; Herron AI; Award: for Lincoln tablet des., 1907. Contributor: Design. Position: Supv. A., Indianapolis Pub. Sch., 1918-40s [47]

STEWART, Marion Louise [P,Dec] East Aurora, NY b. Buffalo, NY. Studied: Radcliffe; Ecole des Beaux-Arts, Fontainebleau, France, with Guerin, Despujols; Columbia; ASL. Member: The Patteran. Exhibited: Albright A. Gal., 1938 (prize), 1939, 1940; WFNY, 1939; CI, 1941; Great Lakes Exh., 1939 [47]

STEWART, Robert B. [P] NYC/Phila., PA. Member: SI; Ar. Gld. [31]

STEWART, Robert W. [I] NYC [24]

STEWART, S. DeB. [P] Baltimore County, MD [13]

STEWART, Sarah Bartram [Min.P] Montclair, NJ [15]

STEWART, T.J., Mrs. See Horton, Dorothy.

STEWART, William Branks [Medical I,P,L,T] New Orleans, LA b. 26 Ag 1898, Airdrie, Scotland. Studied: Glasgow Sch. A.; D.F. Wilson; W.S. Shanks; J. Dunlop. Member: New Orleans A. Lg.; Assn. Medical Illus. Exhibited: Assn. Clinical Pathologists, Kansas City, 1936 (med), Chicago, 1944 (med); AMA, 1937 (med); New Orleans A. Lg., 1935-43, 1944 (med,prize), 1945 (prize); Delgado Mus. A., 1941 (one-man). Illustrator: "The Structure of the Human Body," 1945. Position: La. State Univ. Sch. Medicine, 1934- [47]

STEWART, William D. (Mrs.) [P] Roland Park, MD [17]

STEWART, William W. [P] Sèvres, France b. 1865, Phila. Studied: Gérôme, in Paris [01]

STEWART, Worth [P] Butte, MT [13]

STICK, Frank [I] Interlaken, NJ [19]

STICKLEY, Gustave [Furniture Des.] b. 1858, Osceola, WI d. 21 Ap 1942, Syracuse, NY. In 1884 he established a furniture factory in Binghamton, NY to carry out some of Ruskin's ideas. Position: Founder and ed., The Craftsman

STICKNEY, Lela Mabel (Mrs.) [C,Des,Dec] Arlington Heights, MA b. 13 My 1872, Chelsea, MA. Studied: D. Ross; F. Bischoff; M. Frye; S.W. Safford. Member: Boston SAC; Mineral AL; Professional Women's C., Boston. Exhibited: Ferargil Gal.; Anderson Gal.; Boston, Swampscott, Cambridge, Arlington, Lowell, all in Mass. [47]

STICKNEY, Lucy May [Min.P] Wash., D.C. [10]

STICKNEY, Mary West [P] Buffalo, NY [04]

STICKROTH, Harry I. [P,T] NYC d. O 1922, Chicago. Studied: Am. Acad., Rome; Lazarus schol. for mural painting, 1914-17. Work: mur. dec. (with B. Faulkner), Cunard Bldg., NYC. Position: T., AIC [17]

STIEGLITZ, Alfred [Photogr,Dealer,Patron,W] NYC b 1864, Hoboken, NJ (moved to NYC in 1871) d. 13 Jy 1946. Studied: CCNY; Berlin Polytechnic, 1881. Work: master set of all his images at NGA; his personal coll. at MET; IMP; AIC; BMFA; CMA; PMA; Univ. N.Mex.; MOMA; Princeton; papers at Yale. Became fascinated by the camera and developed from

an amateur to height of the profession, stressing photography as an art in itself. In 1890, began what he called the "battle of photography." Founder: Photo-Secession. Opened the Photo-Secession Little Gal. at 291 Fifth Ave. (1905-17) where, besides his own work, he discovered and championed some of the outstanding photographers of the day; edited Camera Notes and the quarterly Camera Work. After 3 years, Stieglitz began championing modern painters and sculptors, beginning with drawings by Rodin. In 1925 he established the Intimate Gal.; in 1929, opened his last gal., An American Place. A memorial exhibition at MOMA, in 1947, included photographs by Stieglitz and his collection of work by artists he had sponsored, such as Cézanne, Matisse, Picasso, and Americans, Marin, Demuth, Dove, Weber, Hartley, Walkowitz, and Georgia O'Keeffe (whom he married in 1924). His most famous image is "Steerage," 1907. More than 20 writers and artists contributed, in 1934, to "America and Alfred Stieglitz." In what is perhaps the best appraisal, the writer states, "A most incessant talker, [Stieglitz] raised his voice for more than half a century to proclaim his powers as a prophet, soothsayer and arbiter of all matters pertaining to the free spirit of mankind." [24]

STIEPEVICH, V.G. [P] Brooklyn, NY. Member: A. Fund S. [10]

STIERLIN, Margaret Emily [C,Des,S,T] Chicago, IL b. 28 D 1891, St. Louis, MO. Studied: Univ. Mo.; AIC, Am. traveling schol., 1932; E. Zettler. Member: Chicago AL; Chicago Potters Gld.; Indst. Des. Alliance, Chicago. Exhibited: AIC, 1935, 1936, 1940, 1941, 1943; Syracuse Mus. FA, 1940; Springfield, Mus. A., 1941. Specialty: scientific modeling, arch. modeling, stone and wood carving, toy des. Position: T., AIC, 1932-38; Hull House, Chicago, from 1939 [47]

STILES, Patti [P] NYC [25]

STILL, Clyfford [P,T,Li] b. 1904, Grandin, ND d. 1980. Studied: Spokane Univ., 1933. Exhibited: Art of This Century Gal., 1946; MET, 1979. Work: 31 paintings at Albright-Knox Gal., Buffalo; 28 at SFMA. Important abstract expressionist of the 1950s; his work of the 1940s was abstract biomorphism. Positions: T., Wash. State Univ.; Calif. Sch. FA, 1946-50 [47]

STILL, Roy [I] NYC [19]

STILLMAN, Ary [P] NYC b. 13 F 1891, Russia. Studied: AIC; NAD; ASL; Lhote, in Paris; Spain; Italy. Member: Fed. Mod. P.&S. S.Indp.A.. Exhibited: Salon des Beaux-Arts, 1926, 1927, 1933; Salon d'Automne, 1928; Salon des Tuileries, 1930, 1933; AIC, 1929, 1934; PAFA, 1929, 1934, 1937, 1946; CGA, 1939; CI, 1943, 1945; CAM, 1929 (one-man); Houston MFA, 1935; BM, 1944; Wadsworth Atheneum, 1944; Inst. Mod. A., Boston, 1945; Pal. Leg. Honor, 1937. Work: New Britain (Conn.) Mus. A.; Sioux City A. Ctr. [47]

STILLMAN, Effie [S] London, England/NYC b. London, England. Studied: C. Desvergnes, Paris [04]

STILLMAN, Lisa [S] b. U.S. (lived most of her life in London) d. 11 F 1946, London, England

STILLMAN, Marie [P] London, England [10]

STILLMAN, William James [Ldscp.P,W] b. 1 Je 1828, Schenectady, NY d. 6 Jy 1901, Surrey, England. Studied: Union Col., 1848; F.E. Church, 1848-49. Had studio in NYC, 1851-56. In 1855 founded art mag. Crayon. Painted in Cambridge, Mass., 1856-60. Am. Consul in Rome, 1861-65, then in Crete, 1965-68. Settled in England, 1868 but spent much time in Rome as correspondent to the London "Times." He wrote many books on art and archeology, including his "Autobiography of a Journalist," 1901 [*]

STILLSON, Blanche [P,T] Indianapolis, IN b. Indianapolis. Studied: Forsyth; Hawthorne. Member: Ind. Artists' C.; Hoosier Salon [33]

STILLWELL, John E. (Dr.) [Patron] b. 1853 d. 6 O 1930, NYC. His art coll. was the result of a series of trips to all parts of the world. In 1927 his coll., including works by Raphael, El Greco, Titian, Murillo and other masters, was sold and some of the best pieces are now in MMA.

STILLWELL, Sarah S. [I] Phila., PA b. Phila. Studied: H. Pyle. Exhibited: Pan-Am. Expo, Buffalo, 1901 (med) [10]

STILSON, Ethel M. [P] Cleveland, OH. Member: NAWPS; Cleveland Women's AC [29]

STILWELL, Wilbur Moore [T,Des,Gr,L,Mur.P,Car,W,I] Vermillion, SD b. 2 F 1908, Covington, IN d. 1974. Studied: Kansas City AI; Kans. State T. Col.; Univ. Iowa. Exhibited: PAFA, 1934; Kansas City AI, 1933 (prize), 1936 (prize), 1939; Kansas City A. Exh., Topeka, 1939 (prize), 1940, 1941 (prize); Mo. A., 1938; Okla. A. Exh., Tulsa, 1940 (prize); Sedalia, 1932 (prize); State Fair, Hutchinson, Kans., 1939 (prize). Work: Mus. Nat. Hist., Kansas Univ., Lawrence. Positions: T., Univ. S.Dak. (from 1941), Emporia Sch. A., Kans. (1940) [47]

STIMETS, Adelaide N. [P] Jersey City, NJ [01]

STIMMEL, George [P,Li,E,I,Des] Hackensack, NJ b. 14 Jy 1880 d. 30 My 1964. Studied: PIASch; Phila. AL; PAFA. Member: Scenic A. Un.; Hackensack AC; N.J. AA. Exhibited: SC. Work: set des., Metropolitan Opera [*]

STIMPSON, Helen Townsend [P] Hartford, CT b. 30 My 1886, Brooklyn, NY. Studied: NAD; CUASch; E. Carlsen; C. Hawthorne. Member: CAFA; Hartford SWP; North Shore AA.; Copley S.; Springfield AL. Exhibited: CAFA, 1923-46, 1932 (prize); New Haven PCC, 1925-46, 1941 (prize); Hartford SWP, 1928-46, 1940 (prize) [47]

STIMSON, Anna K(atherine) [S] Phila., PA/Bolton Landing, NY b. 14 N 1892, NYC. Studied: C. Grafly. Member: Phila. All.; Phila. WCC [33]

STIMSON, John Ward [P,I,T,W,L] Corona, CA b. 16 D 1850, Paterson, NJ d. 11 Je 1930. Studied: Yale, 1872; Ecole des Beaux-Arts, Paris, with Cabanel, Jaquesson de la Chevreuse; Italy (6 years); Belgium; Holland; England. Author: "The Gate Beautiful," "The Law of the Three Primaries," "Wandering Chords." Positions: T./Dir., MMA Sch., 5 yrs.; T., ASL, Artist-Artisan Inst., NYC (founder), Sch. F.&Indst. A., Trenton; Asst. Ed., Arena mag. [29]

STINCHFIELD, Estelle [Mur.P,Por.P,B,Dr,L,T] Greeley, CO b. 16 Je 1878, Brownville, CO. Studied: J.E. Thompson; Univ. Denver; Columbia; P. Tudor-Hart, London; Paris with Lhote, O. Friesz. Member: NAWPS. Work: mural, Colo. State Col of Edu. Position: T., Colorado State Col. [40]

STINEMETZ, Morgan [I] NYC [19]

STINSON, Charles A. [P] Phila., PA [24]

STINSON, Harry (Edward) [S,T,L] NYC b. 3 Ja 1898, Wayland, IA. Studied: Univ. Iowa; Cumming Sch. A., Des Moines; NAD; ASL; Aitkin; Hawthorne; Olinsky; Bridgman. Member: Iowa AG. Exhibited: NAD, 1929; PAFA, 1930, 1931; Kansas City AI, 1935 (prize); Nebr. AA, 1942; Clay C., N.Y., 1944-46; Iowa Exh., Chicago, 1937 (med). Work: mem., statues: Lake View, Council Bluffs, Iowa City, Iowa. Position: T., Univ. Iowa, 1921-40; Hunter Col., from 1940 [47]

STINSON, J. Whitla [P] NYC [19]

STIRLING, Dave [P,L,W] Estes Park, CO b. 24 Ja 1889, Corydon, IA. Studied: Chicago Acad. FA; Cumming A. Sch. Exhibited: Studio in the Woods, Rocky Mountain Nat. Park, 1922-46 (one-man); Youngs Gal., Chicago (one-man). Specialty: Rocky Mtn. subjects [47]

STIRLING, Glen [G,W,L] Hollywood, CA. Exhibited: Wash., WCC, 1938; Festival Allied A., Los Angeles (prize). Work: FA Gal., San Diego; Pub. Schs., Los Angeles; City Hall, Long Beach; cover, "Calif. Arts and Arch.," 1937 [40]

STIRNAMAN, Marilou (Mrs.) [Ldscp.P,T,P] Watsonville, CA b. 11 N 1907, Santa Clara, CA. Exhibited: Santa Cruz, 1935 [40]

STIRRETT, Wylie [Por.P] Los Angeles, CA b. 15 N 1915, Wash., D.C. Studied: J.F. Smith; S.L. Reckless; B. Miller; A. Ctr. Sch., Los Angeles. Member: Calif. WCS. Exhibited: Los Angeles Mus., 1935. Position: T., Hammond Hall, Los Angeles [40]

STITES, John Randolph [Por.P,Genre P,Ldscp.P] Active in Chicago, 1870-80; NYC, 1883-87 b. Buffalo, NY. Work: Chicago Hist. S. [*]

STITES, Raymond Somers [Edu,W,L] Yellow Springs, OH b. 19 Je 1899, Passaic, NJ d. 1974. Studied: Brown Univ.; RISD; Vienna. Author: "The Arts and Man," 1940. Position: T., Antioch Col., Yellow Springs, Ohio from 1930 [47]

STITT, Hobart D. [P] Pikesville, MD. b. 1880, Hot Springs, AR. Studied: St. Louis Acad. FA; PAFA; H. Pyle. Work: Wilmington SFA; Little Rock AM; Princeton. Specialty: Equestrian P. [40]

STIVERS, Harley Ennis [I] Scarsdale, NY/Belmar, NJ b. 25 N 1891, Nokomis, IL. Studied: AIC. Member: SI; Artists G. Illustrator: Saturday Evening Post, Ladies Home Journal, Cosmopolitan [40]

STOBIE, Charles S. [P] b. 1845, Baltimore, MD d. 1931, Chicago. Early Denver painter; he was also an Indian scout and buffalo hunter. Among his friends were Wm. Cody, Wild Bill Hickok, and F. Remington. Work: Colo. Hist. S. [*]

STOCKBRIDGE, Dana W. [P] Lowell, MA b. 29 Ja 1881, Haverhill, MA d. 24 N 1922. Studied: Harvard; Pape Sch. A. [21]

STOCKBURGER, William Harold [P,Des,T] NYC b. 24 S 1907. Studied: Univ. Detroit; ASL; J. Carroll. Member: North Shore AA. Exhibited: AWCS; VMFA; PAFA; Contemporary A. Gal.; SFMA; AIC; A. Market, Detroit; Ferargil Gal.; North Shore AA; NYWCC, 1937. Work: Montclair A. Mus. [47]

STOCKLIN, Grace Nina [P,Des,T] Chicago, IL b. 26 Jy 1913, Menominee, MI. Studied: AIC. Exhibited: AIC, 1939 (prize); Joslyn Mem., Omaha, Nebr. Position: T., AIC [40]

STOCKMAN, Helen Park (Mrs.) [P,S,T] Englewood, NJ b. 16 O 1896, Englewood. Studied: J. Lie; L. Mora; R. Henri. Member: Palisade AA [33]

STOCKTON, Francis Richard [En,I,W] NJ (until 1899) b. 5 Ap 1834, Phila. d. 20 Ap 1902 near Harper's Ferry, WV. Wood En. in Phila. & NYC, 1852–66; Asst. Ed., St Nicholas, 1873–81. Author of humorous novels including "Rudder Grange," and a well-known story, "The Lady or the Tiger?" [*]

STOCKWELL, Frances Taft [P] NYC b. 1865, Orange, NJ [06]

STODDARD, Alice Kent (Mrs. Joseph T. Pearson) [P] Phila., PA b. Watertown, CT. Studied: PAFA; Phila. Sch. Des. for Women. Member: ANA, 1938. Exhibited: PAFA, 1911 (prize), 1913 (prize), 1916 (prize), 1926 (prize); NAD, 1917 (med), 1928 (med); Phila. AC, 1913 (prize), 1916 (gold). Work: PAFA; Delgado Mus. A.; Reading (Pa.) Mus. [47]

STODDARD, B(eatrice) M(usetta) (Mrs.) [P,C,L,T] Indianapolis, IN/Nashville, IN b. Carson, IA. Studied: R. Johonnot, Maud Mason. Member: Ind. AC. Exhibited: Pan.-Pa. Expo, San Fran., 1915 [27]

STODDARD, Elizabeth M. (Mrs.) [P] Hartford, CT. Member: Hartford AS [29]

STODDARD, Frederick L(incoln) [Mur.P,I] Gloucester, MA b. Coaticook, Quebec, Canada d. 24 F 1940. Studied: St. Louis Sch. FA; Paris with Constant, Laurens. Member: North Shore AA; SC. Exhibited: St. Louis Expo, 1904 (med). Work: murals: City Hall, St. Louis; H.S., St. Louis; Hebrew Tech. Sch. for Girls, NYC; Eastern District H.S., NYC; Mem. Church, Baltimore, Md.; Sawyer Free Lib., Eastern Ave Sch., Forbes Sch., Gloucester [40]

STODDARD, Laura L. [P] Chicago, IL. Member: Chicago NJSA [25]

STODDARD, Musette Osler [P,C,T,L] Nashville, IN b. Carson, IA. Studied: AIC; R. Johonnot; C. Hawthorne; M. Mason. Member: Brown County A. Gal. Assn.; Ind. AC; Ind. Weaver's Gld.; Hoosier Salon; Ind. Keramic C. Exhibited: med., Pan-Pacific Expo., 1915. Position: T., Hilltop Sch., Nashville, Ind. [47]

STOERZER, Henry [P] Milwaukee, WI. Member: Wis. PS [25]

STOESSEL, Oskar [P,Et,T] NYC b. 17 Ag 1879, Neonkirchen, Austria. Studied: Europe. Member: AAPL. Exhibited: CGA (one-man); Harlow Gal. (one-man); Austria (med.) (prizes). Work: MET; British Mus.; Germany; Austria; Rumania. Contributor: Print Collector's Quarterly, London [47]

STOHR, Julia Collins (Mrs. Peter C.) [P] Lovell, ME b. 2 S 1866, Toledo, OH. Studied: CUASch; ASL with Beckwith, Chase, J.A. Weir, Freer, W.L. Lathrop; Paris. Member: A. Workers G., St. Paul; Minn. State S; Chicago WCC; NAWPS [33]

STOHR, Julie (Mrs. J.S. Roe) [P] Monterey, CA. b. 19 Mr 1895, St. Paul, MN. Studied: Paris with Simon, Menard; Henri; Bellows. Member: S.Indp.A. [31]

STOKES, Dudley R. [Mur.P,Por.P,Des] NYC/Provincetown, MA b. 9 D 1911, Phila. Studied: C.W. Hawthorne; G.B. Bridgman; F.V. DuMond. Member: Provincetown, AA [40]

STOKES, Frank W(ilbert) [P,I] NYC b. 27 N 1858, Nashville, TN. Studied: T. Eakins, PAFA; Paris, Ecole des Beaux-Arts, with Gérôme; Colarossi Acad., with Collin; Acad. Julian, with Boulanger, Lefebvre. Member: Peary Greenland Expedition, 1892, 1893–94; Swedish Antarctic Expedition, 1901–02; artist/member Amundsen-Ellsworth Expedition, 1926. Exhibited: Medaille d'Argent, Prix Alphonse de Montherot, Soc. de Geographie de Paris. Work: mural, AMNH; Société Geographie de Paris. Contributor: illus., Lippincotts', Scribner's, Century. Specialty: Arctic and Antarctic scenes [40]

STOLL, Frederick H. [S] Brooklyn, NY [25]

STOLL, John (Theodore) (Edward) [P,S,E,I,L] San Fran., CA b. 29 S 1898, Goettingen, Germany. Studied: Acad. FA, Dresden, Germany; Calif. Sch. FA. Member: San Fran. AA; Calif. SE. Exhibited: Intl. PM, Los Angeles, 1930–46; Calif. SE, 1924 (prize), 1936 (prize); Grand Central A. Gal., Phila.; Detroit Inst. A.; AIC; CAM; CMA; Honolulu Acad. A.; SAM; Boise, Idaho, 1938, 1942; Stanford Univ.; SFMA, 1941, 1942; Univ. Nev., 1943; Palacio des Bellas Artes, Mexico City; Madrid, Spain; Rome, Italy; GGE, 1939. Work: Pal. Leg. Honor; SFMA; Mills Col.; Oakland A. Gal.; Calif. Hist. S.; Buckingham Palace, London; mem./mural/sculpture, Sailors Union of the Pacific; Ashland Pub. Lib.; San Fran. Pub. Lib. [47]

STOLL, Rolf [P,L,T,Dr] East Cleveland, OH b. 11 N 1892, Heidelberg, Germany. Studied: Acad. FA, Karlsruhe; Acad. FA, Stuttgart, Germany; W. Truebner. Member: Cleveland Pr. C.; Cleveland SA. Exhibited: PAFA, 1933, 1937; CI, 1941; GGE, 1939; WFNY, 1939; AIC, 1940; CM, 1943; CMA, 1925–46 (prizes); Butler AI, 1932, 1934–37, 1942 (prize), 1943 (prize), 1944. Work: CMA; Columbus Gal. FA; Univ. Nebr.; Army Med. Lib., Wash. D.C.; Western Reserve Univ.; Mun. Coll., Case Sch. Appl. Sc., Fed. Reserve Bank, Bd. Edu. Bldg., all in Cleveland; WPA mural, USPO, East Palestine, Ohio; Dayton AI; TMA; Nebr. AA; Savings Bank, Buffalo; Med. Lib., Cleveland; Huntington Polytech Inst., Cleveland. Positions: T., Cleveland Sch. A. (from 1927), John Huntington Polytech. Inst., Cleveland (from 1928) [47]

STOLLER, Alexander [S] West Stockbridge, MA b. 1902, NYC. Studied: ASL. Member: NSS. Exhibited: WMAA, 1936; Delphic Studios, NYC, 1937 (one-man); WFNY, 1939 [47]

STOLLER, Helen Rubin [P,G,Des] NYC b. 2 F 1915, NYC. Studied: CUASch. Exhibited: 48 States Comp., 1939 [40]

STOLTENBERG, Hans John [P,T] Wauwatosa, WI b. 8 Ap 1880, Flensberg, Germany d. 1963 Studied: D.C. Watson. Exhibited: Milwaukee Journal Comp., 1918; Milwaukee AI, 1920, 1940. Work: Oshkosh Mus.; Madison Hist. Mus.; Carroll Col., Waukesha, Wis.; Vanderpoel Coll.; Concordia Col., Milwaukee; Mt. Mary Col., Milwaukee; H.S., Pub. Lib., Technical H.S., Masonic Temple, Wauwatosa, Wis.; Milwaukee AI; City Hall and H.S., Milwaukee; State Teachers Col., Whitewater, Wis. [47]

STONE, Alice Balch (Mrs. Robert B.) [P,S,C,] Jamaica Plain, MA/Chocorua, NH b. 12 Jy 1876, Swampscott, MA. Studied: C. Rimmer; W.D. Hamilton; J. Wilson. Member: Boston SAC; Boston AC; NAWPS. Work: pottery plaque, Jackson Mem. Bldg.; Boston Floating Hospital; Judge Baker Child Guidance Ctr., Boston [40]

STONE, Alice May [P] Baltimore, MD [25]

STONE, Alice Wadsworth (Mrs.) [P] Brooklyn, NY b. 1855, West Easton, NY d. 31 D 1917. Specialty: watercolor

STONE, Anna B. [P] Seattle, WA b. 8 Ja 1874, Dewitt, IA d. 1949. Studied: Scripps Col., Claremont, Calif.; Univ. Wash., with M. Sheets; P. Cafferman; Ella S. Bush; J.H. Rich; E. Tolknen. Member: Northwest WCS; Seattle AM; Women P. of Wash. (Pres.). Exhibited: Pal. Leg. Honor; SAM, 1929 (prize), 1939 (prize); State Fair, Puyallup, 1934 (prize), 1936 (prize); Women P. of the West, 1939 (prize) [47]

STONE, Arthur John [Silversmith] Gardner, MA b. 26 S 1847, Sheffield, England d. 6 F 1938. Studied: Sheffield Engr. Sch. Arts. Member: Boston SAC (master craftsman); Phila. ACG. Exhibited: Boston SAC, (med). Work: gold pyx-ciborium, Church of the Advent; Sarah Wyman Whitney chalice, Trinity Church, Boston; altar pieces, Chapel of St. Andrews, Church of St. James, Chicago; altar, Cranbrook Sch., Bloomfield Hills, Mich.; altar book, St. Stephens Church, Phila.; bowls, Yale; MET [38]

STONE, Beatrice (Mrs. J.C.) [S] NYC b. 10 D 1900, NYC. Studied: Smith Col; H. Warneke; O. Maldarelli; J. Loutchansky, in Paris. Member: NSS; All.A.Am.; NAWA; NYSWA. Exhibited: PAFA, 1938, 1940, 1942; NAD, 1940; AIC, 1942; Arch. L., 1944; CAFA; NYSWA, 1939; All. A., NYC; NAWA, 1942 (prize) [47]

STONE, Benjamin Bellows Grant [Ldscp.P,W] Catskill, NY (since 1865) b. 21 Ja 1829, Watertown, MA (now Belmont) d. 11 Ag 1906. Studied: B. Champney; J.F. Cropsey. Exhibited: NAD; Boston Athenaeum [*]

STONE, Cornelia Perrin [P] Newburyport, MA [19]

STONE, C. Sanpietro [P] Springfield, MA [19]

STONE, E. Bristol [P] Paris, France b. Phila. Studied: Chase; Paris, with Simon, Menard [13]

STONE, Edward L. [P] Roanoke, VA. Position: Staff, Stone Printing Co., Roanoke [25]

STONE, Ellen J. [P] NYC. Member: NYWAC; NAC [10]

STONE, Esther F. [P] Brooklyn, NY [01]

STONE, Frank F(rederick) [S] Los Angeles, CA b. 28 Mr 1860, London, England d. 13 Ag 1939. Studied: R. Belt. Member: Am. Numismatic S.

Exhibited: San Antonio State Fair (prize); Alaska-Yukon-Pacific Expo, 1909 (gold). Work: "Gladstone," from life, Treasury Office, "Cardinal Manning," Lambeth Palace, London; Mark Twain Medallion," Sacramento State Lib. [38]

STONE, George H. [P] Columbus, OH. Member: Columbus PPC [25]

STONE, George J. [P] NYC b. 1860 d. 8 D 1932, Pueblo, CO

STONE, George M. [P] Topeka, KS b. 1858, Topeka. Studied: Académie Julian, Boulanger, Lefebvre, Bonnât, all in Paris; H. Mosler, in NYC [25]

STONE, Helen [I,Des,P] NYC b. 31 O 1903, Englewood, NJ. Studied: N.Y. Sch. F.&Appl. A.; Paris. Exhibited: Delphic Studios, N.Y., 1932 (one-man); Fed. A. Exh., 1944. Illustrator: "Adventures of Waldo," 1945, "Plain Princess," 1945. Contributor: Horn Book [47]

STONE, Helen Loasley [P] Welland, Ontario. Member: Buffalo SA [25]

STONE, Iva Goldhamer [P,T] Cleveland, OH b. 2 Jy 1917, Cleveland. Studied: Cleveland Sch. A. Position: T., Cleveland Sch. A. [47]

STONE, Julia [P] NYC [10]

STONE, Leona [P] NYC. Member: SPNY; NAWPS [21]

STONE, Lewis Collins [P] St. Louis, MO. Studied: St. Louis Sch. FA; Baschet, Bouguereau, Laurens, all in Paris. Exhibited: St. Louis Expo, 1898 [98]

STONE, Louis K. [P,Des,T] Lambertville, NJ 22 Jy 1902, Findlay, OH. Studied: Cincinnati A. Acad.; ASL; PAFA; H. Hofmann, in Munich; Lhote, in Paris. Exhibited: WFNY, 1939; Am. A. Cong., 1937, 1938; Newark Mus.; Phila. A. All.; Woodstock, NY; Jacksonville, Fla.; Princeton, N.J.; New Hope, Pa. Work: murals, Fla. State Col. for Women, Tallahassee [47]

STONE, M. Bainbridge [P] Baltimore, MD. Member: Baltimore, WCC [29]

STONE, Madeline Masters (Mrs.) [S] Wash., D.C. d. 24 S 1932. Studied: G. Borglum; Bourdelle, in Paris. Work: bust of Lincoln as a youth; Am. Red Cross Headquarters

STONE, M(argaret) Anthony (Mrs. Harold R.) [P,Des,T,L] Larchmont, NY b. 30 Je 1910, West Barrington, RI. Studied: Vassar; A. Ctr. Sch., Los Angeles; A.M. Rindge; C.K. Chatterton; S. Reckless. Member: AAPL; NAWA. Exhibited: NAWA, 1940-45; NAD, 1943, 1945; San Fran.; Phila.; Wichita, Kans.; Portales, N.Mex.; Chicago; Los Angeles; Seattle, AAPL, Portland, Oreg., 1937 (prize) 1938 (prize) 1939 (prize); Rockefeller Center, NYC. Work: Lewis and Clark H.S., City Hall, both in Spokane, Wash. [47]

STONE, Marianna [P] Fort Washington, PA [10]

STONE, Marie W. [P] NYC d. Ja 1920, San Fran. Member: NAWPS; NYSP; NAC [19]

STONE, Maysie [S] NYC b. NYC. Studied: Cornell; Univ. Wis.; PAFA; C. Grafly; A. Laessle; Chester Springs Sch.; M. Ramos, in Paris. Member: AAPL. Exhibited: PAFA; NAD; Arch. L. [47]

STONE, Mildred B. [P] Houston, TX. Exhibited: S. Wash. A., 1937; MFA, Houston, 1938, 1939 [40]

STONE, Orrin F(urse) [P,Li,B] Pasadena, CA [33]

STONE, Pauline [P] East Orange, NJ [19]

STONE, Ruby [P,T,L] Houston, TX. b. 12 N 1900, Alexandria, LA. Studied: Dallas AI; SAL; Fontainebleau Sch. FA. Exhibited: Tex. Centenn., Dallas, 1936; MFA, Houston, 1939; Corcoran Gal., Wash., D.C. Work: murals, Highland Park Town Hall, Dallas; T. Col., Commerce, Tex. [40]

STONE, Seymour Millais [Por.P] NYC b. 11 Je 1877, Poland (came to U.S. at age 6). Studied: Académie Julian, Paris; AIC; ASL; Loeftz, Royal Acad., Munich; A. Zorn, in Sweden; Lefebvre, in Paris; J.S. Sargent, in London. Member: AAPL. Exhibited: CGA; AIC; Guild Hall, London, England. Award: Knight Commander of Merit of Konstantinian Order of St. George, Italy, 1921. Work: port., Peekskill Military Acad., N.Y.; Peekskill Lib.; Rollins Col.; Brown Univ.; Univ. Va.; Smithsonian; State House, Montgomery, Ala.; Army & Navy C., NYC; U.S. Military Acad., West Point, N.Y.; White House, Wash., D.C.; Republican C., NYC; Chicago; Ft. Worth C., Tex.; numerous portraits of royalty, painted in Europe [47]

STONE, Stanford Bryon [P,Des,I,T,L] Brooklyn, NY b. 17 Mr 1906, Denver. Studied: CCNY; ASL; B. Robinson; K. Nicolaides; G. Bridgman; DuMond. Member: NAD; Brooklyn SA; New Rochelle AA; AL Nassau; All.A.Am.; Yonkers Mus. Sc.&A. Exhibited: PAFA, 1932; NAD, 1934, 1935; Montross Gal., 1941 (one-man); Community Gal., 1939 (one-man); All.A.Am., 1932-36, 1938, 1939, 1941, 1943, 1944; Huntington Mus., 1941 (one-man); Neville Pub. Mus., 1942; Kenosha A. Mus., 1942; ASL, 1939. Work: port., 69th St. Armory, NYC. Illustrator: children's books. Positions: T., Hoboken Indst. Sch., 1939-46; Stone Atelier P. [47]

STONE, Vera. See Norman.

STONE, Viola Pratt (Mrs. Joseph H.) [P,S] Long Beach, CA b. 28 Ag 1872 d. 5 Ap 1958. Studied: Omaha, 1893; Kansas City AI, with J.L. Wallace, Edna Kelley, 1903-07; A. Blumberg; W.E. Schofield, 1935-37. Member: Long Beach AA. Exhibited: Long Beach AA, 1933 (prize); Ebell C., 1934 (prize), 1935 (prize) [47]

STONE, Walter King [P,I,Dec,L,T,W] Ithaca, NY b. 2 Mr 1875, Barnard NY. Studied: PIASch; A. Dow. Member: Iroquois AA. Work: Rochester Mem. Gal. Illustrator: "Log of the Sun," by W. Beebe, three books by W.P. Eaton. Position: T., Cornell [40]

STONE, William Ellsworth [P] Alliance, OH b. 20 Ja 1895, Limaville, OH. Studied: Youngstown Col.; C. Murhpy; L. Evans; C. Singer; G. De Armond. Member: Alliance AG; Ohio WCC; NYWCC. Exhibited: AWCS, 1939; Butler AI, 1941 (prize), 1944-46 (prizes); Parkersburg FA Center; Canton AI, 1943 (prize); Massillon, Ohio; Athens, Ohio; Canton, Ohio, 1928 (prize) [47]

STONEHILL, George [Mur.P] NYC b. 1888 d. 6 My 1943. Studied: AIC; Europe

STONEHILL, Mary (Mrs. George) [P,Des] NYC b. 23 O 1900, NYC d. 11 F 1951. Studied: Parsons Sch. Des.; ASL; Ecole des Beaux-Arts, Fontainebleau; Acad. Moderne, Paris. Member: NWMP; Arch. Lg.; Sch. AL, N.Y. Exhibited: La Tausca Pearls Traveling Exh., 1945-46; Arch. Lg.; Univ. Va. Illustrator: "Social Studies." Work: Univ. Va.; murals, Wash. Irving H.S., Seaman's Inst., Halloran Hospital, all in NYC [47]

STONER, Harry [P,S,I] NYC b. 21 Ja 1880, Springfield, OH. Member: SI; AG. Exhibited: AWCS; NAD; PAFA; Phila. WCC; CGA; Chicago WCC; Arch. Lg.; AIA; TMA; SI; AFA Traveling Exh. Work: glass mosaic curtain, National Theatre of Mexico, Mexico City [47]

STONER, John Lawrence [P,B] Point Loma, CA b. 17 Ja 1906. Studied: Otto H. Schneider; E. Devol. Member: San Diego AG. Exhibited: Ariz. A. Exh. Phoenix, 1931 (prize). Work: San Diego FA Soc.; Woodcut S., Kansas City [40]

STONER, Olive [P,T] Phila., PA b. Pleasantville, PA. Studied: PAFA, with Snell, Breckenridge, Garber, A.B. Carles, F. Wagner; Phila. Sch. Des. for Women. Member: Phila. Alliance; AG of Tiffany Fnd. [33]

STONEY, Eleanor E. [P] Pittsburgh, PA. Member: Pittsburgh, AA [25]

STONIER, Lucille Holderness (Mrs. Harold) [P,T] Asheville, NC b. 24 Ap 1886, Turkey Creek, TX. Studied: Col. Pacific, Stockton, Calif.; Chouinard AI; Parsons Sch. Des.; E. O'Hara, S.P. Wagner. Member: Lg. Am. Pen Women; Asheville (N.C.) AG; Black Mountain AC; Palm Beach AL; SSAL. Exhibited: Lg. Am. Pen Women, 1941 (prize) 1945, 1946; Norton Gal., 1942 (one-man); West Palm Beach AL, 1938, 1942, 1943, 1945, 1946; Asheville AG, 1936, 1940 (one-man); Palm Beach AL, 1938 (prize), 1944 (prize); Fla. State Fed., 1944 (prize). Work: Norton Gal., West Palm Beach; Veterans Hospital, Otean, N.C. Position: T., Polytechnic H.S., Los Angeles, Calif., 1914-31 [47]

STONOROV, Oskar [Arch,S] Charlestown, PA b. 2 D 1905. Studied: A. Maillol; V.A. Lurcat, in Paris; Ecole Polytech. Federale, Zurich, Switzerland. Exhibited: Soviet Palace Comp., Moscow, 1932 (prize). Work: PWA housing projects in Phila., Camden, N.J. Co-author: with W. Boesiger, "Le Corbusier, His Work up to 1929," 1929 [40]

STOOPENDALL, G. [I] NYC. Position: Staff, Truth, NYC [98]

STOOPS, Herbert Morton [I] NYC b. 1887, ID d. 19 My 1948, Mystic, CT. Studied: Utah State Col.; AIC, 1910s. Member: SI. Exhibited: NAD, 1940 (med). Western illustrator; worked for San Francisco Call, ca. 1910; Chicago Tribune, early 1910s; then settled in NYC after WWI. Sometimes signed his work as "Jeremy Cannon" or "Raymond Sisley." [47]

STORER, Charles [P] Providence, RI. Member: Boston AC [10]

STORER, Florence [I] Position: Staff, Youth's Companion, Boston [13]

STORK, Lisl (Mrs. C.W.) [P] Phila., PA b. 20 Ag 1888, Salzburg, Austria. Studied: H. McCarter [33]

STORM, Anna Alfrida [P,C,T] Evanston, IL/Greeley, CO b. 2 Jy 1896, Sweden. Studied: A.W. Dow. Member: Chicago SE; Chicago NJSA. Exhibited: Seattle FAS, 1923 (prize). Position: T., State T. Col., Greeley [33]

STORM, George [Por.P] b. 1830, Johnstown, PA d. 6 Jy 1913, Lancaster, PA. Work: portraits of many Pa. state officials. Most active in Harrisburg, Pa.

STORRS, Frances Hudson (Mrs. William M.) [P] Hartford, CT b. NYC. Studied: Chase; Hawthorne; Hale. Member: CAFA; North Shore AA; Hartford A. Cr. Soc. Work: Morgan Mem., Hartford [40]

STORRS, John [S,P,En] Chicago, IL (settled near Orleans, France, late 1930s) b. 29 Jy 1885, Chicago d. 1956, Orleans. Studied: Germany, 1907–08; Chicago Acad. FA, 1908–10, with L. Taft; Bartlett; Académie Julian, Paris; PAFA, 1910–12, with Grafly; Rodin, 1912–14, in Paris. Member: Société Anonyme; Chicago AC; Cliff Dwellers; Tavern C. Exhibited: Milwaukee AI, 1925 (one-man); Munic. Lib., Orleans, France, 1949 (one-man). Work: Los Angeles MA; WMAA [40]

STORY, Benjamin [I] NYC/Port Washington, NY d. 25 O 1927. Member: GFLA [27]

STORY, George H(enry) [P] NYC b. 22 Ja 1835, New Haven, CT d. 24 N 1923. Studied: Charles Hine, L. Bail, in New Haven; Europe. Member: ANA, 1875; Lotos C.; A. Fund S. Exhibited: Maine, 1859 (med); Centenn. Expo, Phila., 1876 (med). Work: MMA; NGA. Positions: Cur., MMA, 1889–1906, Acting Dir., 1904–05; Dir., Wadsworth Athenaeum, Hartford, 1899– [21]

STORY, Ina Perham [P] Mamaroneck, NY. Exhibited: San Fran. AA, 1939; Soc. Women A., San Fran., 1936 (prize) [40]

STORY, Julian [P] Phila., PA/Vallombrosa, Italy b. 8 S 1857, Walton-on-Thames, England d. 13 F 1919. Studied: Duveneck, in Florence; Paris, with Boulanger, Lefebvre. Member: ANA, 1906; SAA, 1892; Paris SAP; London S. Port. P.; Chevalier, Legion of Honor, 1901. Exhibited: Paris Salon, 1889 (med); Berlin, 1891 (gold); Paris Expo, 1900 (med); Pan-Am. Expo, Buffalo, 1901 (med); P.-P. Expo, San Fran., 1915 (med). Work: Minneapolis Inst.; CAM, St. Louis; Telfair Acad., Savannah, Ga.; Peabody Inst., Baltimore. Son of William W. [17]

STORY, Marion [Min.P] Port Chester, NY d. 22 Ag 1907 (suicide). Son of William W.

STORY, Thomas Waldo [S] Rome, Italy b. 1855, Barbarini Palace, Rome (son of William W.) d. 23 O 1915, NYC. Work: statue, House of Commons, London; bronze door, Morgan Lib., NYC; drinking fountain, Hopedale, Mass. [08]

STORY, William Wetmore [W,S] Rome, Italy (since 1856) b. 12 F 1819, Salem, MA d. 7 O 1895, Vallombosa, Italy. Studied: Harvard; sculpture, Italy, 1847. Work: Boston Pub. Lib.; MET; Smithsonian; Boston Athenaeum. Began career as a lawyer but turned to sculpture in 1856. Also well-known as a poet and essayist. His friend Henry James wrote his biography. Father of Julian, Marion, and Thomas. [*]

STOTESBURY, Helen (Mather) [P,T] NYC b. NYC. Studied: Grand Central Sch. A.; ASL; E. O'Hara; W. Adams. Member: NAWA; PBC; Rockport AA; N.H. AA.; Studio G; AAPL. Exhibited: PBC, 1936–46; NAWA, 1938–46; Rockport AA, 1934–37, 1939, 1942, 1943, 1945; Salons of Am.; 1936; All.A.Am., 1937, 1938, 1943; Portland SA, 1940; Wash. WCC, 1942; AWCS, 1946; Norton Gal., 1939 (one-man), 1944 (one-man); Argent Gal., 1942 (one-man) [47]

STOTLER, Charles C. [P] Wash., D.C. Member: S. Wash. A. [27]

STOTLER, Ilka Marie [P] Edgewood, PA/Wilkinsburg, PA. Member: Pittsburgh AA [25]

STOTTER, Charles C. [P] Wash., D.C. [19]

STOTTLEMEYER, Margaret A.R. [P] Wash., D.C. Studied: NA. Member: Wolfe AC. Exhibited: CGA, 1933. WPA artist. [40]

STOUFFER, J. Edgar [S] Baltimore, MD. Member: Charcoal C. Award: Rinehart Schol. to Paris, 1907–11 [33]

STOUT, Edna. See Staples, Mrs.

STOUT, George Leslie [Mus.Cons] Cambridge, MA b. 5 O 1897, Winterset, IA. Studied: Grinnell Col; Univ. Iowa; Harvard. Co-author: "Painting Materials, A Short Encyclopaedia," 1942. Editor: "Color and Light in Painting." Position: Hd. Dept. Conservation, FMA, from 1933 [47]

STOUT, Ida McClelland [S,T] Chicago, IL b. Decatur, IL d. 2 S 1827, Rome, Italy. Studied: AIC, with A. Polasek. Member: Chicago AG; MacD. C.; Chicago Gal. Assn. Work: Mary W. French Sch., Decatur, Ill.; Hillyer Gal., Smith Col.; Chicago Daily News Fresh Air Sanitarium for Children, Lincoln Park; mem. tablet., Englewood H.S., Chicago [27]

STOUT, Loren [I] b. 1891, Kansas City, MO d. 9 Jy 1942, NYC. Member: SI. Position: Staff, Kansas City Star

STOUT, Virginia Hollinger (Mrs.) [Min.P] Coronado, CA b. 5 F 1903, New Hope, PA. Studied: PAFA. Member: Pa. Soc. Min. P.; San Diego AG; Brooklyn S. Min. P. Exhibited: Pa. Soc. Min. P., 1938 (med); PAFA, 1938 (med). Work: PMA; U.S. District Court, Trenton, N.J. [47]

STOVER, Allan James [P,I] Corvallis, OR b. 9 O 1887, West Point, MS. Studied: Cleveland Sch. A. Work: dec., Masonic Temple, Corvallis. Illustrator: "Oregon's Commercial Forests" [40]

STOVER, Wallace [Por.P,I] Elkhart, IN b. 5 Ja 1903, Elkhart. Studied: Herron AI; W. Forsyth; C. Wheeler; P. Hadley; M. Richards. Member: Ind. AC; Hoosier Salon. Exhibited: Herron AI, 1925 (prize), 1927 (prize) [33]

STOW, Isabelle [P] Buffalo, NY [01]

STOWELL, M. Louise [P,I,C,T] Rochester, NY b. Rochester. Studied: ASL; A.W. Dow. Member: Rochester SAC; NYWCC. Specialty: water colors [31]

STOWELL, Royal [P] NYC. Member: Lg. AA [24]

STOWITTS, Hubert [Mur.P,Por.P,S,Des,L,W] Los Angeles, CA b. 26 Je 1892, Rushville, NE. Studied: self-taught. Work: portrait, Benito Mussolini, posed at Chighi Palace, Rome. Illustrator: with 60 color plates, "The Work of Stowitts for Fay-Yen-Fah." Affiliated with Pavlova Russian Ballet; Folies Bergere, Paris; M.G.M., Hollywood, etc. [40]

STOZANA, George [P] Hollywood, CA. See Stanson. [24]

STRAFER, Harriette R. [P] Cincinnati, OH b. 1873, Covington, KY. Studied: Cincinnati A. Acad.; Mrs. MacMonnies; Collin; Courtois, in Paris [13]

STRAHALM, Franz S. (Frank) [Ldscp.P,Mur.P,L,T] Dallas, TX b. 25 F 1879, Vienna, Austria (came to San Antonio in 1911) d. 3 Mr 1935. Studied: Vienna, with his father; Hamburg A. Sch.; Italy; France. Member: Alliance; SSAL. Work: mural, Mem. Lib., Shreveport, La.; Power and Light Co., Dallas; Little Rock AM; Ney Mus., Austin. Position: T./Founder, San Antonio Sch. Fine Painting, 1919 [33]

STRAHAN, Alfred W(infield) [P,I] Woodlawn, MD b. 24 Je 1886, Baltimore. Studied: S.E. Whiteman; H. Pennington. Member: Charcoal C. [40]

STRAIN, Daniel J. [Por.P] Boston, MA. Member: BAC [25]

STRAIN, Frances [P] Chicago, IL b. 11 N 1898, Chicago. Studied: AIC. Member: Un. Am. Ar.; Chicago SA; The Chicago Ten [40]

STRAIN, Oma (Miss) [P,T] San Jose, CA b. Crawfordsville, IA. Studied: State Univ. Iowa; G. Wood; A. Archipenko. Member: Cincinnati Women's AC; San Jose A. Lg. Exhibited: CM, 1943; Cincinnati Women's AC, 1942–44; Oakland A. Gal., 1944; Santa Cruz A. Lg., 1945; San Jose A. Lg., 1946. Contributor: Design. Positions: T., Drake Univ., Des Moines, Iowa, 1930–36; Norwood (Ohio) H.S., 1939–44; San Jose State Col., 1944– [47]

STRAIT, C. Barrett [P] Richmond, VA [19]

STRANAHAN, Clara C. Harrison (Mrs.) [W] Brooklyn, NY b. Westfield, MA, 1831 d. 22 Ja 1905. Founder/Trustee: Barnard College. Author: "History of French Painting," 1888

STRAND, Paul [Ph] France (since 1948) b. 1890, NYC d. 1976. Studied: Lewis Hine, 1909. Exhibited: Stieglitz' "291" Gal., 1916; Anderson Gal. NYC, 1925; Intimate Gal., NYC, 1929; Am. Place, 1945; MOMA, 1945, 1956; Kreis Mus., Germany, 1969; PMA, 1971. Work: Strand archive at Cen. Creative Ph., Tucson; lg. coll. at PMA; BMFA; MOMA; MET; Univ. N.Mex.; NOMA; Natl. Gal.; Yale; SFMA. Also filmmaker, producing "Manhatta" with C. Sheeler, 1921; and "The Wave" in Alvarado, Mexico, 1933. His books include: "Photographs of Mexico," 1920; "Time in New England," 1950; "La France de Profil," 1952; "Un Paese," 1954; "Tir A'Mhurain," 1962 [*]

STRANG, Allen John [Arch,Des] Madison, WI b. 31 D 1906, Richland Center, WI. Studied: G. Harding; H. Sternfeld; Univ. Pa. Member: Madison AA; Wis. Assn. Arch.; Madison Tech. C. Exhibited: traveling exhibs., MOMA; Am. Fed. A.; Univ. Pa., 1931 (prize). Contributor: drawings, Pencil Points, T-Square Club Journal, Architectural Forum, Architectural Record, House and Garden [40]

STRANG, Ray [R,I] Tucson, AZ (since ca. 1938) b. 1893, Sandoval, IL d. 1957. Studied: AIC, 1915 (wounded in WWI, then returned to AIC until 1920); ASL; SI Sch. Specialty: cowboy genre [*]

STRANSKY, Josef [Patron] NYC b. 1875, Czechoslovakia (came to NYC in 1911) d. 6 Mr 1936. After studying music in Leipzig and Vienna, he went to

Prague where he was conductor of the Royal Opera from 1898 to 1903. Subsequently he conducted orchestras in Hamburg, Berlin, and Dresden; he conducted the New York Philharmonic Orchestra from 1911 to 1923. He also studied art, and assembled one of the most comprehensive chronological collections of French art of the eighteenth, nineteenth and twentieth centuries now in existence. Associated with Wildenstein and Co., since 1924

STRATER, Henry [P] NYC/Ogunquit, ME b. 21 Ja 1896, Louisville, KY. Studied: C. Grafly; H.E. Field; Vuillard; M. Dennis; A. Carles; ASL; Madrid; Florence; Académie Julian, Paris; Grande Chaumière, Paris. Member: Sal. of Am.; Portland Soc. A.; Louisville AA; Ogunquit AA; Princeton Arch. Soc.; Players C.; Louisville AC; College AA. Work: paintings, Speed Mem. Mus.; Kentucky Mus.; Louisville, Ky.; Hamilton Easter Field Fnd., Coll., N.Y.; Montross Gal., NYC [40]

STRATHEARN, Robert P. (Bert) [P,E,Car] California (1968) b. ca. 1875 (Ventura County, CA?) Work: Natl. Cowboy Hall of Fame. Cartoonist: Los Angeles Times; Express. Specialty: cowboy genre [*]

STRATTON, Alza (Mrs. Hentschel) [Mur.P,Por.P,Des,E,I,L,T,W] Burlington, KY b. 2 Jy 1911, Lexington, KY. Studied: Univ. Kentucky; NAD; Cincinnati A. Acad., with W.E. Hentschel. Member: Cincinnati Women's AC; SSAL; AAPL; BPC.. Exhibited: Art Alliance, N.Y., 1930 (prize); CM; Syracuse Mus. FA, 1944. Work: IBM Coll.; mural, Guiguot Theatre, Iroquois Polo C., Lexington, Ky. Designer: stage sets; textiles; furniture. Position: T., Cincinnati A. Acad. [47]

STRATTON, Ernest Hapgood [P] Boston, MA [24]

STRATTON, F. [P] Indianapolis, IN. Affiliated with: Herron AI [25]

STRATTON, Grace Hall [C,Des,T] Boston, MA b. 7 Ag, 1877, Cambridge. Studied: BMFA Sch. Member: Boston Soc. A.&Cr. Specialty: needlework. Position: T., Boston Sch. Occupational Therapy, 1936– [47]

STRATTON, Howard Fremont [T] Phila., PA b. 1861, Salem, OH d. 22 Ja 1936. Studied: PMSchIA (member of the first class graduated). Position: T./Hd., A. Dept., PMSchIA, ca. 1880–1921

STRATTON, Mary Chase [C] Detroit, MI b. 15 Mr 1867, Hancock, MI. Studied: Univ. Mich.; Wayne Univ. Member: Detroit SAC; Boston SAC; Detroit Mus. Art Founders Soc. Exhibited: AIC, 1920 (prize). Work: mosaic/tile dec., Dudley Peter Allen Mem. A. Mus., Oberlin, Ohio; Shrine of the Immaculate Conception, St. Matthews Church, Wash., D.C.; St. Patrick's Church, Phila.; House of Hope Presbyterian Church, St. Paul; Union Cathedral, Detroit; Detroit AI; Cranbrook Mus., Bloomfield Hills, Mich.; Freer Gal., Wash., D.C.[40]

STRATTON, William Buck [Arch] Detroit, MI b. 16 F 1865, Ithaca, NY. Studied: Cornell Univ. Member: AIC; Detroit SAC; Detroit Mus. Art Founders Soc.; Scarab C. [40]

STRAUB, Elizabeth [S,T] NYC b. 10 My 1910. Member: Clay C. of N.Y. [40]

STRAUCHEN, Edmund R. [I] Cincinnati, OH b. 9 D 1910. Illustrator: Cincinnati Enquirer, Times-Star, Hygeia, Methodist Book Concern, The Arts, American Red Cross [40]

STRAUS, Ada Gutman [P] Baltimore, MD [25]

STRAUS, Gustav, Mrs. See Bloch, Julia.

STRAUS, Mitteldorfer [P,I,Dec,Des] Richmond, VA b. 21 Ja 1880, Richmond. Studied: ASL of Wash.; Europe; Africa. Member: AWCS; SI; NYWCC [47]

STRAUSS, Betty [P] NYC/Paris, France b. 10 Mr 1905, NYC. Studied: Columbia; L. Kroll, at NAD; ASL; Lhote, L. Gottlieb, both in Paris. Member: NAWPS; Intl. Assn. Women PS; Studio G. [40]

STRAUSS, Carl Sumner [E,I,P] Grisons, Switzerland b. 4 O 1873, Jamaica Plain, MA. Studied: Benson; Tarbell; Koehler; BMFA Sch. Member: Chicago SE; FA Soc., Florence, Italy. Exhibited: Black and White Intl. Exh., Florence, 1914 (prize). Work: etchings, Uffizi Gal., Florence; Dresden and Munich Cabinet of Prints; Nat. Gal. Modern A., Rome; Mun. A. Gal., Milan; Hamburg and Bremen Kunsthallen; Art Coll. of King of Italy; Kunsthaus, Zurich; Kunsthaus–Chur, Grisons; NGA. Illustrator: 20 colored etchings to be used as illus. for "The Marble Faun," pub. Limited Editions Club, N.Y. [40]

STRAUSS, Glenn Vernon [Ldscp.P] Crawfordsville, IN/Gibson City, IL b. 22 Je 1870, Baxton, IL. Studied: AIC [08]

STRAUSS, Malcolm A. [I,Por.P,W] NYC b. 1883, NYC d. 10 Ap 1936. Illustrator: covers for magazines; commercial adv. art. Author: books on fiction [01]

STRAUSS, Raphael [P] Cincinnati, OH b. Germany. Studied: Munich. Member: Cincinnati AC [01]

STRAUTIN, Wally [Port.P,Mur.P] NYC b. 27 S 1898. Studied: Cooper Union. Member: Un. Am. Ar.; S.Indp.A. [40]

STRAWBRIDGE, Anne West [P,W] Phila., PA b. 20 Mr 1883, Phila. Studied: W.M. Chase; PAFA. Member: Plastic C. Author: "Dawn After Danger," "The Black Swan," 1934, 1935 [40]

STRAWBRIDGE, Edward R(ichie) [P] Norristown, PA b. 22 N 1903, Phila. Studied: Univ. Va.; PMSchIA; T. Oakley; C. Hawthorne, at Cape Cod Sch. of A.; PAFA, Chester Springs; R. Miller. Member: Phila. A. All.; AWCS; SC; Phila. Sketch C.; Phila. WCC; Palo Alto AC; NYWCC; Germantown AL; Provincetown AA. Exhibited: PAFA, 1929, 1930, 1940, 1943; NAD, 1942; Buck Hill AA, 1936; Newport AA, 1933, 1934; Provincetown AA, 1939; Benjamin West Soc., 1936; Phila. A. All., 1937, 1944; McClees Gal., Phila., 1939. Work: Phila. WCC; Univ. Pa. [47]

STRAWBRIDGE, Margaret La Rue [P] Merion, PA/Cape Cod, MA b. 3 F 1919, Merion. Studied: G.T. Gemberling. Member: Phila. Print C. Exhibited: Phila. Print C., 1935 (prize), 1936 (prize), 1938 (prize) [40]

STRAYER, Paul [I] Illinois (1940s) b. 1885, Park Ridge, IL. Studied: AIC [*]

STREAN, Maria Judson (Mrs.) [Min.P] Pittsburgh, PA b. Washington, PA. Studied: ASL, with Cox, Weir; Paris, with Prinet, Dauchez. Member: ASMP; AWCS; Pa. Soc. Min. P.; All.A.Am.; NAWA; NYWCC. Exhibited: Pa. Soc. Min. P., 1921 (med); NAWA, 1930 (prize); ASMP, 1939 (prize); Pan-Am. Expo, Buffalo, 1901 (prize); Calif. S. Min. P., 1932 (prize). Work: MMA; BM; PMA; Swarthmore Col. [47]

STREAT, Thelma Johnson [Por.P,Des,G] San Fran., CA b. 29 Ag 1912, Yakima, WA. Studied: Portland AM. Member: San Fran. A. Assn. Exhibited: San Fran. AM. Work: WPA artist. [40]

STREATFEILD, Josephine [Por.P] NYC b. 31 My 1882, London. Studied: Slade Sch., London, with F. Brown. Member: Phila. PC; Soc. Women Artists, London; Alliance. Specialties: pastel and oil portraits; copies of old paintings [33]

STREATOR, Harold A. [P] Pasadena, CA (since ca.1919) b. 5 Ag 1861, Cleveland, OH d. 14 Jy 1926. Studied: ASL; BMFA Sch. Member: SC, 1906 [25]

STRECKER, Herman [S,W] b. 24 Mr 1836, Phila. d. 30 N 1901, Reading, PA. His first work as a sculptor was done when he was but twelve years old. One of his best known works was the Soldiers' Monument at Reading. He devoted his leisure to the study of zoology and butterflies, and published several works on the latter subject. His collection of butterflies numbered more than 300,000.

STREET, Agnes [P] Chicago, IL [17]

STREET, Frank [I,P,T] Leonia, NJ b. 1893 (Kansas City, MO?) d. 28 N1944, Englewood, NJ. Studied: ASL; H. Dunn Sch. Illus. (Leonia, NJ), with C. Chapman. Member: SI; SC [40]

STREET, Naomi Scudder [P,B,Dec,Des,T] Huntington, NY b. 18 N 1903, Huntington. Studied: ASL. Member: NAWPS; Brooklyn Soc. Modern Artists [40]

STREET, Sarah Wilson [P] Wilmington, DE b. 13 S 1912, Wilmington. Studied: Wilmington Acad.; Corcoran Sch. A.; Geo Wash. Univ.; Sarah Lawrence Col.; A. St. Lg.; G. Derujinsky; P. Mangravite. Member: AC., Wilmington. Exhibited: Wilmington Soc. FA (prize); Ann. PAFA, 1939; AC., Wilmington [40]

STREETER, Donald (Davis) [B,C,Dr,I,Lith] 21 N 1905, Vineland. Studied: Pa. Mus. Sch. of Indus. Art; PAFA; ASL. Member: Phila. Print C. Exhibited: Phila. Print C., 1932 (prize). Illustrator: "I'm Sorry if I have Offended," "Other Sob Ballads," by Clarence Knapp [40]

STREETER, Julia Allen (Mrs. George L.) [P] Baltimore, MD/Green Lake, NY b. 19 Je 1877, Detroit. Studied: Detroit Art Sch., with J. Gies and F.P. Paulus. Member: Baltimore WCC; Baltimore Indp. AA; Arundell C. Exhibited: Baltimore Charcoal C., 1924 [33]

STREETMAN, Christine Norman (Mrs. Sam, Jr.) [S,Dec,Des] Houston, TX b. 12 Ja 1903. Studied: MFA Sch., Rice Inst., Houston; N.Y. Sch. Interior Dec.; Texas State Col. for Women. Exhibited: Houston Ar. Exhib., 1938; So. Texas Ar. Exhib., MFA, Houston. Specialty: design ornaments [40]

STREETOR, W. Day [P] Oakwood, NY b. St. Louis, MO. Studied: St. Louis Sch. FA; Constant and Laurens, in Paris [01]

STREIGHT, Howard [Ldscp.P] d. O 1912, San Jose, CA. His best-known work is the "Cross on the Mountain."

STRENGELL, Marianne [Des,D,Dec,T] Bloomfield Hills, MI b. 24 My 1909. Studied: Atheneum, Helsingfors, Finland. Exhibited: Triennale, Milan, Italy, 1933 (gold); Cranbrook Mus.; traveling exhibs., Am. Fed. A. and MOMA. Work: Nat. Mus., Stockholm; City Hall, Helsingfors. Specialty: textile des. Position: T., Cranbrook Acad. A. [40]

STRETCH, Lillian R. [P] Seattle, WA [24]

STRICKLAND, Fred [P] Portland, OR [24]

STRICKLAND, Phyllis Alba [P] San Fran., CA b. 27 Jy 1915, Portland, OR. Studied: Chouinard AI; Am. Cent. Sch., Los Angeles; S. Bell; R. Munsell. Member: Laguna Beach A. Assn. Exhibited: PS Ann., Portland Mus., 1939; Laguna Beach A. Assn. [40]

STRIEBEL, John Henry [Cart,I] Woodstock, NY b. 14 S 1892. Studied: A. Dasburg; H.L. McFee. Illustrator: "Show Girl" (in Liberty); "Chicago Tribune"; "Dixie Dugan" (comic strip for McNaught Syndicate). Creator: Pantomime Strip, Syndicated by Associated Ed., Chicago [40]

STRIFFLER, Albert Christian [Ldscp.P] Brooklyn, NY b. 1861 d. 17 My 1918

STRIKER, Kenneth (Louis) [B,Adv,Des] Seattle, WA b. 16 S 1908, St. Louis, MO. Studied: Univ. Wash. Member: Northwest PM [32]

STRINGFIELD, Vivian F. [P,I,C,T] Los Angeles, CA b. 1882, California d. 25 O 1933. Studied: Hopkins AI; Pratt Inst.; D. Donaldson; R.H. Johonnot. Member: Southern Calif. Art Teachers Assn.; Boston SAC; Chicago AG. Exhibited: Pan.-Calif. Expo, San Diego, 1915 (med). Position: T., Pasadena, 1918 [33]

STROBEL, Oscar A. [P,I,Lith,E,Dec,W] Scottsdale, AZ b. 29 My 1891, Cincinnati d. 1967. Studied: Duveneck; Rabes; Henri; Herrman in Germany. Exhibited: Texas Expo, 1930 (prize). Work: Austin C., Security Trust Bank, Austin Texas; German Embassy, Wash. D.C.; Valley Bank&Trust Co., Phoenix, Ariz.; murals: Westward Ho Hotel, Phoenix, Ariz.; San Marcos Hotel, Chandler, Ariz. Position: T., Judson Sch., Phoenix, 1940 [47]

STRODE, Catherine (Mrs. Blakley) [P,I,T] Laguna Beach, CA b. Lewistown, IL. Studied: AIC; A.A. Hills. Member: Laguna Beach AA. Work: Laguna Beach Chamber of Commerce; Cal-Acres Co., Los Angeles; Laguna Beach Art Gallery [27]

STROHL, Clifford (Harrison) [P] Bethlehem, PA b. 8 O 1893, South Bethlehem. Studied: J. Dieudonne; O.G. Wales; PAFA [25]

STROM, Gustaf Adolf [P] Chicago, IL b. 1872, Sweden [13]

STROM, Nils [P] NYC b. 1 Ap 1905, Sweden. Studied: A St. Lg. Exhibited: Morgan Gal., N.Y., 1939; Vendome Gal., N.Y., 1940 (one-man). Work: "Commonsense," "The Nation" [40]

STROMSTED, Alf Jorgen [P,G] Summit, NJ b. 14 Jy 1898, Loedingen, Norway. Studied: Annot A. Sch., NYC; R. Jacobi; Norway. Member: Summit AA; Assn. A. NJ.; S.Indp.A., NYC (Dir., 1941-43). Exhibited: CGA, 1939, 1941; CI, 1944-46; PAFA, 1944, 1945; Pepsi-Cola, 1946; Portland (Oreg.) AM; BM; Montclair AM; Albright A. Gal.; Artists of Today, Newark, N.J.; Brazil; Contemp. A. Gal., N.Y., 1938 (one-man); Mun. A. Gal., N.Y.; Stauanger A. Soc., Norway. Work: PAFA [47]

STRONG, Charles R. [S] Cincinnati, OH [19]

STRONG, Constance Gill [P,T] Gary, IN b. 13 My 1900, NYC. Studied: Pratt Inst.; Univ. Pa. Member: Palette and Pencil C. Exhibited: Lake County Fair, Crown Point, Ind., 1926-28 (prizes) [33]

STRONG, Elizabeth [P] Carmel, CA b. 2 F 1855, Hartford, CT. Studied: N. Marche, Cabinel, Collin. Member: Carmel AA. Exhibited: Alaska-Yukon Expos., 1909 (med). Work: Dartmouth Art C.; Roxbury Hunting C., Boston; Electric C., NYC; Ebel C., Oakland, Calif. [40]

STRONG, Isobel. See Field.

STRONG, Joseph D. [P] San Fran., CA b. 1852, Bridgeport, CT d. 4 Ap 1900, San Fran. (Went to the Hawaiian Islands as a boy, then moved to San Francisco in 1859.) Studied: Calif. Sch. Des., with V. Williams (when it was started, 1871); Munich, with Piloty. Member: Bohemian C., San Fran. Exhibited: Royal Acad., Munich, mid-1870s (med). He lived in the South Sea Islands 1877-ca. 1898; and had married Robert Louis Stevenson's daughter, Isobel, also an artist.

STRONG, Peggy [P,T] Tacoma, WA b. 7 S 1912, Aberdeen, WA. Studied: Univ. Wash.; S. Sarkisian; F. Taubes. Member: Tacoma AA; Women Painters of Wash.; San Fran. Soc. Women A. Exhibited: SAM, 1936-37, 1938 (prize), 1939 (prize), 1940-47; Memphis, Tenn., 1939 (prize); U.S. Treasury Dept., 1940 (prize); Women Painters of Wash., 1942 (prize), 1943-45; West Seattle AC, 1945 (prize); Rockefeller Center, N.Y., 1938; Nat. Jr. Lg. Exh., 1939; GGE, 1939; VMFA, 1940; Tacoma AA, 1937; Oakland A. Gal., 1941; Everett, Wash., 1943; San Fran. AM; Cincinnati AM. Work: SAM; murals, Naval Officer's C., Dutch Harbor, Alaska; Tacoma Union Depot; USPO Wenatchee, Wash.; WPA artist [47]

STRONG, Ray Stanford [P] Berkeley, CA b. 3 Ja 1905, Corvallis, OR. Studied: F.V. DuMond; F. Van Sloun; M. Dixon; C.L. Kellar. Member: Palo Alto AC; Calif. S. Mural A.; ASL, San Fran.; ASL, N.Y. Exhibited: NAC, 1930 (prize), 1931 (prize). Work: mural, Keene Valley Congregational Church, N.Y.; Roosevelt Jr. H.S., San Jose, Calif.; White House, Wash., D.C.; USPO, San Gabriel, Calif.; Decatur, Texas; WPA artist. Position: Edu. Dir., No. Calif. Assn. Coops. [40]

STROTHMANN, Fred [I,Cart,P] NYC b. 23 S 1879, NYC d. My 1958. Studied: Carl Hecker A. Sch., N.Y.; Berlin Royal Acad.; Paris. Member: SI. Illustrator: books by Mark Twain, Carolyn Wells, Ellis P. Butler, Lucille Gulliver [47]

STROUD, Clara [Ldscp.P,C,Des,L,W,B,T] Herbertsville, NJ b. New Orleans. Studied: PIASch; R. Johonnet; J. Hambidge; H. Leech. Member: AAPL; AWCS; Manasquam River Group A.; NAWPS; Sarasota AA; NYWCC; Asbury Pk. SFA. Exhibited: AAPL, 1939 (prize) [47]

STROUD, Ida Wells (Mrs.) [P,T] Newark, NJ/Point Pleasant, NJ b. New Orleans. Studied: Pratt Inst.; ASL. Member: Am. Ar. Prof. Lg.; NYWCC; Newark AC; Essex Co. WCC. Exhibited: Newark Week Show, Kresge Dept. Store, 1939 (prize); Am. Ar. Prof. Lg., Springlake, N.J., 1939 (prize). Position: T., Newark Sch. F.&Indust. Art [40]

STROUD, Laura D. (Mrs.) [P] Phila., PA [01]

STRUBING, Louisa Hayes [P,S,C] Eggertsville, NY b. 15 Ja 1881, Buffalo. Studied: Buffalo Albright A. Sch.; R. Reid. Member: Buffalo SA; Buffalo GAA [33]

STRUBLE, Eva E. [T] b. Branchville, NJ d. 13 Jy 1932, Bloomfield, NJ. Director of Art, State Normal Sch., Newark

STRUCK, Herman [P,S] Mill Valley, CA b. 31 Mr 1887. Studied: Hopkins IA; AIC. Member: Marin Soc. Ar. Exhibited: Calif. State Fair, Sacramento, 1930 (prize); 48 States Comp., 1939. Work: murals, States Restaurant, San Fran. [40]

STRUDWICK, Clement [P] Hillsboro, NC b. 16 Ap 1900, Columbia, TN. Studied: ASL, with G. Luks; L.F. Biloulle in Paris. Member: Southern NAD; N.C. Prof. Artists' C. Exhibited: N.C. Fed. of Women's Clubs Exh., 1932 (prize) [40]

STRUNK, Herbert J(ulian) [S,P,G,Des,C,I,E,Car] Narrowsburg, NY b. 9 Ap 1891, Shakopee, MN d. ca. 1950. Studied: St. Paul AI; F.E. Triebel. Exhibited: St. Paul AI, 1912 (prize), 1915 (prize); Nassau County, N.Y., 1928 (prize); Rockefeller Center, NYC; Hispanic Mus.; Scranton AM; Am. A. Gal., 1932. Work: Eldred & Narrowsburg (N.Y.) Sch.; bronze mem, Court House, Monticello, N.Y. [47]

STRUNZ, William Frazee [Mur.P] Paris, France b. 26 Ja 1868, Tom's River, NJ. Studied: Ecole des Beaux-Arts, Acad. Julian, Colarossi Acad., all in Paris. Member: Lg. AA, Europe [08]

STRUPPECK, Julius [S,T] New Orleans, LA b. 29 My 1915, Grangeville, LA. Studied: Univ. Okla.; La. State Univ. Exhibited: AFA Traveling Exh., 1941. Work: Univ. Okla.; Marine Hospital, New Orleans; Court House, New Iberia; USPO, Many, La. Position: T., Newcomb Col., Tulane Univ., New Orleans [47]

STRUTHERS, Helen Von L. [P] Phila. PA [13]

STRUTHERS, Irva [Min.P] Phila. PA. Exhibited: A. A. S., 1902 (med) [04]

STRUVEN, Gertrude Stanwood (Mrs.) [P,E,T] Wilmette, IL (living in Lanesville, MA, 1927) b. 2 Mr 1874, West Newbury, MA. Studied: J. DeCamp; E. Major; W. Meyerowitz; T. Bernstein; C. Lasar, in Paris. Member: North Shore AA; Gloucester SA; S.Indp.A. [40]

STRYKER, Don [P] Grand Rapids, MI. Member: Grand Rapids AA; Lg. AA [24]

STUART, Alexander Charles [Mar.P] b. 2 Je 1831, Glasgow, Scotland (came to U.S. in 1861) d. 3 Ag 1898, Chester, PA. Began working for a shipbuilder in Wilmington, Del. Later active in Phila., Chester, Pa., and Eustis, Fla.

before returning to Chester. Work: Atwater Kent Mus., Phila.; Del. Hist. Soc.; BMFA; Mariner's Mus.; Mystic Seaport Mus.; Peabody Mus.; U.S. Naval Acad., Annapolis [*]

STUART, Catherine Baker [P,T] Columbus, OH b. 9 O 1905, Columbus. Studied: A. Schille; Ohio State Univ. Member: Columbus AL; Ohio WCS. Exhibited: Columbus AL, 1928 (prize) [40]

STUART, Donald R. [P] Brooklyn, NY [25]

STUART, Ellen [P] Paris, France [10]

STUART, Frederick T. [P,En] Boston, MA/Newton Centre, MA (since 1857) b. 1837 d. 8 O 1913. Member: Boston SWCP; Boston AC [13]

STUART, James E(verett) [P] San Fran., CA b. 24 Mr 1852, Dover, ME d. 1 Ja 1941. Studied: Sacramento, with Wood, 1868-73; San Fran. Sch. Des., with V. Williams, R.D. Yelland, Hill, and Keith, 1873-78; NYC. Member: Bohemian C.; San Fran. AA; Am. APL. Work: Kalamazoo (Mich.) Art Assn.; Joslyn Mem., Omaha; Reno Arts and Crafts C.; Oakdale Pub. Lib.; Los Angeles Mus. History, Science&A.; Los Angeles A. Assn.; Southwest Mus., Los Angeles; Municipal A. Comm., Los Angeles; Doheny Lib.; Univ. Southern Calif., Los Angeles; Calif. State Lib., Sacramento; Crocker Gal., Sacramento; de Young Mus., San Fran.; Golden Gate Park Mus., San Fran. Originator: new method of painting on aluminum and wood. He is said to have made 5,000 paintings. [40]

STUART, James Reeve [Por.P,T] Madison, WI (since 1872) b. 1834, Beaufort, SC d. D 1915. Studied: Univ. Va.; Harvard; Boston, with J. Ames; Royal Acad., Munich, 1860. Work: 35 port., Wis. Hist. Mus.; Capitol, Wis.; Univ. Wis. Positions: T., Milwaukee Col.; Univ. Wis.

STUART, Kenneth James [I,Des,T,L] Conshohocken, PA b. 21 S 1905, Milwaukee. Studied: PAFA, A.B. Carles; J. Pascin; H. McCarter; Acad. Colarossi, Paris. Member: SI; A. Dir. C., Phila. Exhibited: A. Dir. C., 1941 (prize). Work: LOC. Illustrator: Ladies Home Journal, Saturday Evening Post; Am. Telephone and Telegraph Co.; Ford Motor Co. Positions: A. Ed., Saturday Evening Post, Phila, 1943-; T., Moore Inst., Phila. Sch. Des. for Women, 1940- [47]

STUART, Luella M. [P] Syracuse, NY [01]

STUART, North [P] Wash., D.C. [13]

STUART, R. James [I] NYC [19]

STUBBS, Kenneth [P,T] Wash., D.C. b. 13 Jy 1907, GA. Studied: E. Weisz; M.M. Leisenring; R. Meryman; B. Baker; Corcoran Sch. Art; E. Webster, in Provincetown, Mass. Member: S. Wash. A.; Beachcombers, Provincetown. Exhibited: CGA, 1940 (one-man). Work: mural, Barber Sch., Highland Park, Mich. Position: T., Corcoran Sch. Art [40]

STUBBS, Mary H(elen) [P,I,C,T] Chicago, IL b. 31 O, 1867, Greenville, OH. Studied: Cincinnati A. Acad.; Académie Julian, Paris. Member: Cincinnati Women's AC; Cincinnati Ceramic C. Exhibited: Columbian Expo, Chicago, 1893 (prize) [33]

STUBBS, William Pierce [Mar.P] b. 1842, Bucksport, ME d. 15 My 1909, Medfield, MA. Exhibited: Intl. Mar. Exh., Boston, 1890. Work: Mariner's Mus.; Mystic Seaport Mus.; Peabody Mus.; Beverly Hist. Soc.; Phila. Mar. Mus.; Smithsonian. Son of a ship captain, he lived in Charlestown, Mass. with a studio in Boston ca.1876-94. In 1894 he was committed to Worcester St. Hospital. [*]

STUBER, Dedrick B(randes) [P] Los Angeles, CA (since 1925) b. 4 My 1878, New York d. 18 Ag 1954. Studied: Bridgman; J. Onderdonk; C. Peters; ASL. Member: Los Angeles PS; Laguna Beach AA; Glendale AA [40]

STUEBNER, Joseph A. [P] Evanston, IL [19]

STUEMPFIG, Walter, Jr. [P] Collegeville, PA b. 26 Ja 1914, Germantown, PA d. 1 D 1970, Ocean City, NJ. Studied: Univ. Pa.; PAFA, 1931-34 (Cresson Scholarship, 1934). Member: NIAL; Century; ANA, 1951; NA, 1953. Exhibited: PAFA; CGA, 1947 (prize); NAD, 1953 (prize); WMAA; Toronto AM, 1949; Walker A. Ctr., Minneapolis, 1954. Work: PAFA [40]

STUEVER, Celia M. [E.] St. Louis, MO b. St. Louis. Studied: St. Louis Sch. FA; Académie Julian, Paris, with Bouguereau and Ferrier; Vienna; Munich. Member: Chicago SE; Calif. SE; NYSE; Calif. PM. Work: City Art Mus., St. Louis; LOC; NYPL [32]

STUFFERS, Anthony [I] b. 1894, The Hague, Holland (brought to U.S. in 1900) d. F 1920, Chicago. Specialty: black and white illus.

STULL, George P. [P] Phila. PA [06]

STULL, Henry [P] New Rochelle, NY b. 1851, Canada (came to NYC when a young man) d. 18 Mr 1913. Work: Coney Island Jockey C. Position: staff, Leslie's Weekly. Specialty: race horses

STULTS, Elwin Martin, Jr. (Larry) [P,Des] Cabbage Key, FL b. 19 Jy 1899, Orwell, OH. Studied: AIC; CI; C.Hawthorne; E. Giesbert; F. Chapin. Member: A. Dir. C., Chicago; Pittsburgh AA. Exhibited: North Shore AA; Evanston (Ill.) A. Center; Massillon Mus. A.; Sarasota AA [47]

STUMAN, Jack Bates Huddleston [Des,Arch] Elberton, GA/Canton, GA b. 13 Jy 1908, Canton. Studied: Atelier, Ga. Marble Co.; Canton; Fincher Art Classes; London Art Sch., Cleveland. Member: Soc. Mem. Des. and Draftsmen of America. Exhibited: Soc. Mem. Des. and Draftsmen, Chicago, 936. Designer: public and private memorials. Contributor: design, "Art in Bronze and Stone," January 1937. Position: Des. Staff, Premier Studios [40]

STUMM, Maud [P,I,C] NYC b. northern Ohio. Studied: ASL, with K. Cox, H.S. Mowbray; O. Merson, in Paris [10]

STURDEVANT, Austa Densmore (Mrs.) [Por.P] Cragsmoor, NY b. 1855, Meadville, Blooming Valley, PA d. 19 D 1936, Kingston, NY. Studied: Allegheny Col.; MMA Sch. FA; ASL, with Mowbray, Beckwith; Collin, in Paris. Exhibited: Paris Salon, 1895 (prize); Columbian Expo, Chicago, 1893 [10]

STURGEON, Ruth (Barnett) [P,E,C,T] Council Bluffs, IA/Sterling, KS b. 21 O 1883, Sterling. Studied: L.C. Catlin; G. Senseney; H.B. Snell. Member: Western Arts Assn. [24]

STURGES, Dwight Case [E,Cart,I] Boston, MA b. 24 O 1874 d. 4 S 1940. Studied: Cowles Art Sch., Boston. Member: Chicago SE; Calif PM; AFA; Soc. Am. E. Exhibited: Chicago SE, 1915 (prize), 1926 (prize); P.-P. Expo, San Fran., 1915 (med); AIC, 1924 (prize); Calif. PM, 1927 (prize). Work: BMFA; AIC; Oakland (Calif.) Mus.; LOC; Nat. Gal.; NYPL; Toledo Mus. A.; Vanderpoel A. Assn., Chicago; Los Angeles Mus. [40]

STURGES, Katharine [P,I] Roslyn, NY. Member: Artists Gld. Illustrator: "Little Pictures of Japan," ed. O.K. Miller [33]

STURGES, Lee [E] Melrose Park, IL b. 13 Ag 1865. Studied: AIC; PAFA; Chicago Acad. Des. Member: SAE; Chicago SE (Pres.); AFA. Exhibited: AIC, 1923 (med). Work: AIC; Smithsonian; Calif. State Lib. [47]

STURGES, Lillian [P,I,W,T] Pittsburgh, PA b. Wilkes-Barre, PA. Studied: PMSchIA; CI; E.F. Savage, H.S. Hubbell; PAFA, at Chester Springs. Member: Nat. Edu. Assn.; Authors C.; Pittsburgh AA; Pittsburgh WCC. Exhibited: CI, 1920-46. Illustrator: "Treasury of Myths", "Bible A-B-C"; books of fairy tales. Author/Illustrator: "Runaway Toys" [47]

STURGIS, Annie A. [S] NYC [13]

STURGIS, D.N.B. [I,Arch] NYC [01]

STURGIS, Katharine [P] Cambridge, MA/West Dover, VT b. 17 O 1904, Long Island, NY. Studied: H. Giles; E. Horter [40]

STURGIS, Mabel R(ussell) [P,C] Boston, MA/Manchester, MA b. 17 Je 1865, Boston. Studied: BMFA Sch., with Woodbury. Member: Copley S.; AFA; North Shore AA [40]

STURM, Justin [S,W,P] Redding, CT/Westport, CT b. 21 Ap 1899, Nehawka, NE. Studied: Yale. Exhibited: Ferargil Gal., 1934; Karl Freund Gal., N.Y., 1938. Work: port. busts of prominent people. Author: "The Bad Samaritan," 1926. Contributor: Harper's, Collier's, Pictorial Review, Redbook [47]

STURM, William F. [Wood Engr] Hoboken, NJ (since 1877) b. NYC d. 11 Mr 1912

STURSBERG, Julie H. [P] NYC. Member: Lg. AA [24]

STURTEVANT, Edith Louise [P,T] Easton, PA b. 23 D 1888, Utica, NY. Studied: CI; NYU; PAFA, with McCarter, Breckenridge, Garber, J. Pearson. Member: Phila. Plastic C.; Nat. Edu. Assn.; Easton AG. Exhibited: PAFA (prize); CGA; BMA; Phila. Plastic C.; Phila AC. Work: PAFA; Easton Women's C. Position: A. Supv., Easton (Pa.) Sch. Dist., 1922 [47]

STURTEVANT, G. A. (Mrs) [P] San Fran., CA [13]

STURTEVANT, Helena [P] Newport, RI b. 9 Ag 1872, Middletown, RI d. 9 N 1946. Studied: BMFA Sch., with E. Tarbell; Colarossi Acad., Paris, with Blanche, L. Simon. Member: Newport AA; AFA; College AA; NAWPS; AAPL. Exhibited: WFNY, 1939; GGE, 1939. Work: etching, NYPL; altar piece, Berkeley Mem. Chapel, Newport, R.I. Sister of Louisa. Position: Dir., Sch. AA, Newport [40]

STURTEVANT, Louisa Clark [P,Des,T] Newport, RI b. 2 F 1870, Paris. Studied: BMFA Sch., with F. Benson, E. Tarbell; Simon, Collin, Blanche,

all in Paris. Member: AAPL; Newport AA. Exhibited: P.-P. Expo, 1915 (med); PAFA. Specialty: design of stained glass, textiles. Sister of Helena. Position: T., Newport AA [47]

STURTEVANT, Wallis Hall. See Ladd, Peter.

STUTZMAN, Vernon R. [P] Iowa City, IA b. 12 S 1902, Sharon Center, IA. Studied: State Univ., Iowa, with G. Wood, E. Ganso, F. McCray. Exhibited: CAFA, 1940, 1941; Grand Rapids A. Gal., 1940; Northwest Pr.M., 1945; Springfield A. Mus., Kansas City AI, 1938-41; All-Iowa Exh., 1940 (traveling exh.) [47]

STYKA, Adam [P,I] b. 1890, Kielce, Poland d. ca.1970 (NYC?). Studied: with his father Jan and his brother Thaddeus; Ecole des Beaux-Arts, Paris, 1908-12. Specialty: Western and Arab genre [*]

STYLES, George C(harles) [E,Arch,C] Bridgeport, CT b. 14 Je 1892. Studied: York Sch. Art, with R. Windass. Exhibited: King's prize in architecture, 1911; Assn Royal Col. A., 1914 (prize) [31]

STYLES, George William [P,En,B,C,L] Detroit, MI b. 11 N 1887, Sutton, England d. 20 O 1949. Studied: Sch. A.&Cr., London; Detroit Sch. Des.; G.E. Browne; P. Honore. Member: SC, Detroit; Mich. Acad. Sc., A.&Letters; AFA; Detroit Mus. A. Founders Soc. Exhibited: Detroit, 1921 (prize), 1927 (prize); Detroit Inst. A., 1915, 1920, 1921, 1925-29; Am. A. Exh., Detroit, 1926-29; Baltimore WCC; Detroit WCC, 1946. Work: Pub. Lib., Fordson H.S., both in Dearborn, Mich.; SC, Detroit; Souheastern H.S., Detroit; State of Mich., Lansing. Designer: medal, Detroit Board Edu. [47]

SUBA, Miklos [P] NYC b. 1880, Hungary (came to U.S., 1924) d. 18 Jy 1944. Studied: Europe

SUBA, Susanne (Mrs. McCracken) [I,Des,L] Chicago, IL b. 31 D 1913, Budapest, Hungary. Studied: PIASch. Member: AIGA; Soc. Typographic A., Chicago. Exhibited: BM, 1943 (prize); A.Dir.C., Chicago, 1945 (med), 1946 (med); A.Dir.C., NYC, 1946 (med); MOMA, 1946; AIC, 1942 (one-man); Raymond & Raymond Gal., San Fran., 1946 (one-man); Jr. Lg. Gal., Boston, 1939 (one-man); A-D Gal., NYC, 1940. Illustrator: "The Elegant Elephant," 1944; "This is On Me," 1942; "Spots by Suba," "The Lure of Mr. Lucas," 1935, "Life Without Principle," "Henry David Thoreau," 1936, "Stringe, The No-Tail Cat," 1938. Author/Illustrator: "My Paintbook." Contributor: Publishers' Weekly, A-D mag. [47]

SUCK, Adolph [P] Boston, MA. Member: Boston A. Students' Assn, 1897 [01]

SUDLER, A.E. [P] Baltimore, MD [25]

SUERTH, Ursula [P] Chicago, IL [19]

SUFFOLK, J.B. [P] Pittsburgh, PA. Member: Pittsburgh AA [17]

SUGIMOTO, Henry Yuzuru [Mur.P,Por.P,Gr,L] NYC (living in Hanford, CA, 1940) b. 12 Mr 1904, Los Angeles. Studied: Calif. Sch. FA; Calif. Col. A. & Crafts; Univ. Calif.; Segonzac; Acad. Colarossi, Paris. Member: San Fran. AA; Calif. WCS; Fnd. Western A.; Calif. Lg. Writers & Ar.; A. Ctr., San Fran. Exhibited: Salon d'Automne, Paris, 1931; Calif.-Pacific Expo, 1935; GGE, 1939; San Fran. AA; Los Angeles AA; San Fran. Lg. A., 1936; Fnd. Western A., 1937; Ark. State Exh., 1946; GGE, 1939 (med). Work: Pal. Leg. Honor; Hendrix Col., Ark.; Univ. Ark.; Calif. Col. A. & Crafts; Musée de Crécy, France; H.S., Pub. Lib., Hanford, Calif. Contributor: Japanese News mag. [47]

SUGLIO, Joseph [P] Buffalo, NY. Exhibited: Ar. Western N.Y., 1938, 1939; Albright A. Gal., Buffalo [40]

SUHR, Frederic [P,I,Des] NYC/Cambridge, MD b. 15 F 1889, Brooklyn, NY. Studied: ASL; PIASch; Bridgman; Fogarty; Dufner. Member: SC; SI; A. Dir. C. [47]

SUHR, William [P] NYC b. 31 My 1896, Kreutzberg, Germany. Studied: RA, Royal A.&Cr. Sch., Berlin; A.&Cr. Sch., Hanover. Exhibited: SFMA. Restorer: paintings for Detroit AI; CMA; TMA; de Young Mem. Mus., San Fran. [40]

SUINA, Theodore [P] Bernarlillo, NM. Exhibited: First Nat. Exh., Am. Indian Painters, Philbrook A. Ctr., 1946 [47]

SUKEY, Grover C. [S] Minneapolis, MN [15]

SULLIVAN, Alice Chase [P,I] Manhasset, NY b. 9 F 1887, NYC. Studied: W.M. Chase. Member: Douglaston AL. Exhibited: Douglaston AL, 8th St. Gal, NYC, 1940 [40]

SULLIVAN, Arthur B. [P] NYC. Member: SC; SI [29]

SULLIVAN, D. Frank [P,Des,T] Pittsburgh, PA/Trevett, ME b. 17 O 1892. Studied: Boston, with V. George, E.L. Major, R. Andrew. Member: Pittsburgh AA. Work: Brownsville, Pa.; Pittsburgh pub. schs. Position: H., Connelly Trade Sch., Pittsburgh [40]

SULLIVAN, Edmund J. [I] NYC. Position: Illus., Century Co., NYC [01]

SULLIVAN, Francis [Por.P] NYC d. Spring 1925

SULLIVAN, Hattie [P] Yonkers, NY [24]

SULLIVAN, James Amory [P,T] Boston, MA/Ashfield, MA b. 17 Ag 1875, Boston, MA. Studied: A. Harrison; Laurens, in Paris [25]

SULLIVAN, Lillie [I] d. 5 Jy 1903, Wash., D.C. Position: Chief Ills., entomology, Dept. of Agriculture, Wash., since 1880. Was considered the foremost illustrator of insects in the world.

SULLIVAN, Louise Karrer (Mrs. William) [P] Boston, MA b. 15 Mr 1876, Port Huron, MI. Studied: P.L. Hale BMFA Sch. Member: Copley S.; Rockport AA [33]

SULLIVAN, Margaret C. [P,T] Studied: PAFA [25]

SULLIVAN, Max William [C,T] Providence, RI b. 27 S 1909, Fremont, MI. Studied: Western State T. Col., Kalamazoo, Mich.; Harvard; A.N. Kirk; J. Enser. Member: Providence AC. Exhibited: Hackley A. Gal.; AGAA. Positions: T., Groton Sch., Mass., 1938-42; Dean, RISD, from 1945 [47]

SULLIVAN, Pat [Cart] NYC b. 2 F 1887, Sydney, Australia d. 16 F 1933. Studied: Pasquin, Sydney. He drew his first cartoons in London. Upon coming to NYC he created a comic strip for the "World," and afterwards joined the McClure Syndicate for which he originated "Sambo Johnson," "Old Pop Perkins," "Johnny Bostonbeans" and "Obliging Oliver." When the animated cartoon was introduced in motion pictures, he collaborated with Raoul Barre in a series on the adventures of "Sambo Johnson." He was the creator of the most popular animated cartoon, "Felix the Cat," which he put on the screen for Famous Players. [32]

SULLIVANT, T(homas) S(tarling) [I] Phila., PA/Jamestown, RI b. 4 N 1854, Columbus, OH. Studied: PAFA with Bensell, Moran. Member: SI; Phila. Sketch C. [25]

SULLY, Kate [P] Rochester, NY. Member: Rochester AC [29]

SUMAN, Lawrence [P,C] Sierra Madre, CA b. 30 Ja 1902, NYC. Studied: Syracuse Univ.; Corcoran Sch. A.; E. Tarbell; R. Munsell. Member: Calif. A. Potters Assn. Exhibited: Laguna Beach AA, 1942; Los Angeles Mus. A., 1941. Positions: Des., Walt Disney Productions, 1942-43; Owner, A.L. Suman Potteries, 1943-45 [47]

SUMBARDO, M.K. [P] Seattle, WA [24]

SUMM, Helmut [En,Ser,P,T,B] Elm Grove, WI b. 10 Mr 1908, Hamburg, Germany. Studied: Marquette Univ.; Roman; C. Peters; W.H. Varnum; R.S. Stebbins; H.W. Annen, Univ. Wis. Member: Wis. P& S.; Wis. PM; Wis. Edu. Assn.; Milwaukee PM. Exhibited: John Herron AI, 1946; LOC, 1944, 1945; Phila. Pr. C., 1945, 1946; Kearney Mem. Exh., 1946; Wis. PM, 1943-46; Wis. P. & S., annually; Wis. Salon, 1941, 1943; Milwaukee AI, 1945 (prize), 1946 (prize). Work: Milwaukee AI; mural, Mem. Service Inst., Madison. Illustrator: Wisconsin A. Calendar, 1936, 1937, 1938; Am. Blockprint Calendar, 1937. Position: T., Bay View H.S., Milwaukee [47]

SUMMA, Emily (Mrs.) E(mily) B. [P] St. Louis, MO b. 20 S 1875, Mannheim, Germany. Studied: St. Louis Sch. FA; Bissell; Dawson-Watson. Member: St. Louis AG; St. Louis AL. Exhibited: St. Louis AG Exh., 1917 (prize) [29]

SUMMERS, Dudley Gloyne [I] Woodstock, NY b. 12 O 1892, Birmingham, England d. 1975. Studied: ASL; Garden Sch. A., Boston; D.J. Connah; C. Chapman; G. Bridgman; F.R. Gruger. Member: SI. Exhibited: Montclair AM [47]

SUMMERS, Elizabeth F. [P,Li,T] Kansas City, MO b. 2 Je 1888, Moberly, MO. Studied: E. Lawson; J.D. Patrick; A. Kostellow; I. Summers. Member: Kansas City SA. Exhibited: Mo. State Fair, Sedalia, 1929 (prize); Midwest A. Exh., Kansas City AI, 1930 (med) [40]

SUMMERS, H.E. [P] Indianapolis, IN [13]

SUMMERS, Ivan F. [P,E] Woodstock, NY b. M. Vernon, IL d. 1964. Studied: ASL; St. Louis Sch. FA. Member: SC. Exhibited: St. Louis AG, 1916 (prize); ASL, 1916 (prize) [33]

SUMMERS, L.R. (Miss) [P] New Orleans, LA [01]

SUMMERS, William Henry [Cart] East Cleveland, OH b. 8 Jy 1897, Springarten, IL. Work: Huntington Lib., San Marino, Calif.; Univ. Ga.; Univ.

Ark.; Northwestern Univ.; Christian Brothers Univ., Ft. Worth, Texas; Columbus Gal. FA. Position: Cart., The Cleveland News [40]

SUMMERT, Herbert [I] Indianapolis, IN [08]

SUMMY, Katherine Strong [P,T] Wash., D.C./East Gloucester, MA b. 19 Ap 1888, Wash., D.C. Studied: George Washington Univ.; Columbia; E. Thurn; H. Hofmann. Member: Wash. AC; Wash. WCC. Exhibited: S. Wash. A., 1933–41; Wash. WCC, 1938–46. Position: T., Central H.S., Wash., D.C., from 1916 [47]

SUMNER, Amy (Draper) (Mrs.) [Min.P] NYC b. London, England. Studied: Westminster Sch. A., London. Member: Lyceum C., London [13]

SUMNER, Laura W.Y. (Mrs.) [P] Greenwich, CT/Raquette Lake, NY b. Middletown, CT. Studied: V.D. Perrine. Member: PBC; Palisade AA; Silvermine GA; S.Indp.A. [33]

SUND, Roland Wallace [Ldscp.P,B] Worcester, MA b. 24 Je 1913, Worcester. Studied: self-taught. Specialty: bookplates [40]

SUNDBERG, Anna M. [P] Chicago, IL [15]

SUNDBLOM, Haddon [I] Chicago, IL. Member: SI [47]

SURENDORF, Charles (Fredrick) [P,B,Cart,L,W] San Francisco, CA/Logansport, IN b. 9 N 1906, Richmond, IN. Studied: AIC; ASL; Ohio State Univ.; Mills Col. Member: Calif. SE; San Fran. AA; Ind. S. PM; Northwest PM. Exhibited: CGA, 1933; PAFA, 1937; CM, 1933, 1935, 1936; SFMA, 1936–46, 1937 (prize); AV, 1942; deYoung Mem. Mus., 1946; Los Angeles Mus. A., 1936; AIC, 1938, 1940; NAD, 1941, 1946; Albany Inst. Hist. & A., 1945; Phila. Pr. C., 1940, 1941 (prize), 1942 (prize), 1946; Northwest PM, 1938, 1941, 1942, 1944–46; John Herron AI, 1933 (prize), 1935 (prize), 1938 (prize), SAM, 1938 (prize), 1945 (prize); Calif. SE, 1938 (prize), 1941 (prize), 1942 (prize), 1944 (prize), 1945 (prize); GGE, 1939 (prize) 1946; Wichita AM, 1935–38, 1941; Phila. A. All., 1938; Tri-State Exh., Indianapolis, Ind., 1945 (prize); Ind. A., 1929–31 (prizes), 1933 (prize), 1934 (prize), 1940 (prize); Hoosier Salon, 1930 (prize); San Fran. AA, 1938 (prize); Richmond AA, 1938 (prize). Work: SFMA; Mills Col.; LOC; Wichita AM; Richmond (Ind.) AM; pub. sch., Indianapolis; lib., Logansport; Tahiti MA; Richmond (Ind.) A. Gal. Illustrator: "Mr. Pimney," 1945 [47]

SUSAN, Robert S. [P] Phila., PA b. 1888, Amsterdam, Holland. Studied: PMSchIA; Phila. Graphic Sketch C.; PAFA, 1911–13, Cresson traveling schol.; Spain; France. Member: Phila A. All.; Pen & Pencil C. Exhibited: PAFA, 1912 (prize), 1913 (prize), 1914 (prize), 1920 (med); San Fran., (med). Work: PAFA; Phila. Graphic Sketch C. [47]

SUSSMAN, Margaret [G,P,S,C] NYC b. 4 Ap 1912, NYC. Studied: Smith Col.; Grand Central A. Sch.; ASL; W. McNulty; G. Bridgman; W. Barnet. Member: NAC. Exhibited: NAC, 1940 (prize), 1945 (prize). Exhibited: NAD, 1943; Audubon A., 1945; All.A.Am., 1943, 1944; Phila. Pr. Cl., 1944; Veterans Exh., ASL, 1944; NAC, 1940, 1946; Contemporary A. Gal., 1943 [47]

SUSSMAN, Richard N. [P,Gr,Des] Richmond, CA b. 25 Je 1908, Minneapolis, MN d. 1971. Studied: Minneapolis Sch. A.; ASL; G. Grosz; H. Hofmann. Exhibited: PAFA, 1941; BM, 1940; MET (AV), 1942; AIC, 1943; Palace Legion Honor, 1946; de Young Mem. Mus., 1944; Uptown Gal., NYC, 1940 (one-man). Work: MET; stained glass windows for churches in many cities [47]

SUTCH, Marian [P] Pittsburgh, PA. Member: Pittsburgh AA [25]

SUTER, Walter Paul [Cer] Larchmont, NY b. 20 Je 1901, Basle, Switzerland. Studied: Sch. F. & Appl. A., Basle, Switzerland. Member: Am. Ceramic S.; Soc. Swiss PS&Arch. Exhibited: Robineau Mem. Exh., Syracuse Mus. FA, 1932 (prize). Work: terra cotta panels in Patio of the Detroit Inst. A.; Carillon Tower, Mountain Lake, Fla.; Hartford County Courthouse, Hartford, Conn.; Elevator Towers, Delaware River Bridge, Phila. Position: Affiliate, American Encaustic Tiling Company, NYC [40]

SUTHERLAND, Charles Vedder [P] Chicago, IL [17]

SUTHERLAND, Garnet [P] Indianapolis, IN [25]

SUTHERLAND, Minnie [P] Seattle, WA [21]

SUTO, Joseph [Metalwork,E,S,P] Cleveland, OH b. 1899, Hungary. Studied: A. Blazys; H.G. Keller. Member: Cleveland SA; Print C., Cleveland. Exhibited: CMA [40]

SUTRO, Florence Edith Clinton (Mrs. Theodore) [P,W] NYC b. 1 My 1865, England d. 27 Ap 1906. Exhibited: NAD. Author: "Women in Music." Also a musician

SUTTER, H.R. [P] Provincetown, MA [15]

SUTTON, Alice Marion (Mrs. George B. Bacon) [P,W] Cambridge, MA b. 23 Ap 1907, Cambridge, MA. Studied: Leith-Ross; Hibbard; BMFA Sch. Member: North Shore AA; Rockport AA. Contributor: article, American Magazine of Art, 1934 [40]

SUTTON, Bernice Perry (Mrs. Louis F.) [P] Akron, NY. Studied: CI; J. Smith. Member: The Patteran. Exhibited: Pittsburgh AA, 1936–45; The Patteran, 1942–46; Syracuse MFA, 1941–45 [47]

SUTTON, Cantey Venable [P] Raleigh, NC [25]

SUTTON, Frank (Mrs.) [P] Seattle, WA [21]

SUTTON, Frederick H. [P] Flushing, NY [10]

SUTTON, George Miksch [P,I,Mus.Cur,W,L] Ann Arbor, MI b. 16 My 1898, Lincoln, NE. Studied: Bethany Col.; Cornell; L.A. Fuertes. Member: Am. Ornithologist Un.; Cranbrook Inst. Sc.; Wilson Ornithologists S. Illustrator: "Birds of Florida," "American Bird Biographies," "Bird Lore." Position: Cur., Mus. Zoology, Univ. Mich. [47]

SUTTON, Harry, Jr. [P] Andover, MA b. 21 Ap 1897, Salem, MA. Studied: BMFA Sch.; Académie Julian. Member: Boston SWCP; Boston GA [40]

SUTTON, James F. [Dealer] Bedford Hills, NY b. 1843 d. 24 N 1915. One time a member of the firm of A.A. Vantine & Co., and one of the first Americans to visit China and bring back objects of art. In 1880 he founded the Kurtz Gal., which later became the auction house known as the American Art Assn.

SUTTON, Rachel McClelland (Mrs. W.S.) [P] Pittsburgh, PA b. 19 My 1887, Pittsburgh, PA. Studied: CI; ASL. Member: Pittsburgh AA; Pittsburgh WCS. Exhibited: CI, 1935–46; Pittsburgh AA, 1919–46; Butler AI; Ind., Pa., 1945; Pittsburgh WCS, 1945; Allegheny County Garden C., 1943 (prize); Pittsburgh SA, 1932 (prize). Work: Pittsburgh Pub. Sch. [47]

SUTTON, Ruth Haviland [Por.P,Li,B,T] Nantucket, MA b. 10 S 1898, Springfield, MA d. 23 N 1960. Studied: PMSchIA; Grand Central A. Sch.; ASL; J. Farnsworth; H.B. Snell. Member: CAFA; North Shore AA; NAWA; Nantucket AA; Springfield AG; Boston SAC. Exhibited: Springfield AL, 1926 (prize), 1927 (prize), 1928 (prize), 1928–35; NAWA, 1928, 1929, 1945, 1946; LOC, 1945, 1946; CI, 1945; NAD, 1927, 1945, 1946; CAFA, 1928–46; Northwest PM, 1944–46; Springfield AG, 1928–40; Jr. Lg., Springfield, 1931 (prize) in Worcester, Mass., 1931 (prize); Jr. Lg., Providence, 1932; Hartford, 1937. Work: Aston Col., Springfield; Springfield Mus. A.; LOC; Northampton (Mass.) Pub. Lib.; NYPL; Boston Pub. Lib.; Mus. Nat. His., Springfield; Springfield Pub. Lib. [47]

SUYDAM, E(dward) H(oward) [E,B,Li,I] Phila., PA b. 22 F 1885, Vineland, NJ d. 23 D 1940, Charlottesville, VA. Studied: Thornton Oakley, at PMSchIA. Member: Phila. WCC; Phila. Print C.; Phila. Sketch C.; SI; Calif. PM. Exhibited: Wanamaker Prize, 1916, 1917; PAFA (gold,prize). Work: NYPL; Calif. State Lib.; Royal Ontario Mus., Toronto. Illustrator: "Highlights of Manhattan," "Washington Past and Present," "Fabulous New Orleans," "Old Louisiana," "La Fitte the Pirate," "Chicago" "Nights Abroad"; Harpers, Forum, Country Life, other periodicals [40]

SUZUKI, Sakari [P,Des,T] NYC b. 10 O 1900, Iwateken, Japan. Studied: Calif. Sch. FA. Exhibited: CGA, 1934; Berkshire Mus.; ACA Calif., 1936 (one-man); CAA Exh.; N.J. Col. for Women, 1945; Am. A. Cong., 1936 (prize). Work: High Mus. A., Atlanta, Ga.; murals, Willard Parker Hospital, NYC [47]

SVENDSEN, Charles C. [P,E] Cincinnati, OH b. 7 D 1871, Cincinnati, OH. Studied: Cincinnati A. Acad.; Paris with Académie Julian, Bouguereau, Ferrier, Colarossi Acad. Member: AAPL; Scan.-Am. A. Exhibited: Detroit AI; CAM; AIC; PAFA; SAA; Palestine & Egypt; St. Louis Expo, 1904 (med). Work: Vanderpoel Coll.; mural, St. Xavier Church, Cincinnati [47]

SVENDSEN, Svend [Ldscp.P] Chicago, IL b. 21 Mr 1864, Christiania, Norway. Exhibited: Chicago, 1895 (prize); Nashville Expo, 1897 [15]

SVENSSON, C.W. [P] NYC. Member: GFLA [25]

SVOBODA, Josef Cestmir [P,Des,Li,L] Dallas, TX b. 28 Jy 1889, Smichov-Prague, Czechoslovakia. Studied: AIC; R. Clarkson; W. Ufer; C. Hawthorne; A. Sterba; H. Larwin. Member: Bohemian AC, Chicago; Taos SA; Dallas AA. Exhibited: AIC, 1921–30, 1932, 1933, 1935, 1936, 1938, 1941; Dallas MFA; Harwood Gal., Taos, N.Mex.; Santa Fe, N.Mex.; Ariz. State Exh., 1926 (prize); Bohemian AC, 1924. Work: Toman Pub. Lib., Chicago. Position: A. Dir., Herbert Rogers Co., Dallas [47]

SVOBODA, Vincent A. [P,Cart] Brooklyn, NY b. 27 Ag 1877, Prague, Czechoslovakia. d. 18 Mr 1961. Studied: C.Y. Turner; J.Q. Ward, NAD. Member: SC; All.A.Am.; Cart. C. Exhibited: NAD (prize); SC, 1935 (prize), 1937 (prize). Position: Ed. Cart., Brooklyn Eagle, from 1940 [47]

SWACEY, May Payne [P] Minneapolis, MN [17]

SWAIM, Curran [Por.P] b. 3 F 1826, Randolph County, NC d. 1 S 1897, Jasper County, MO. Active in South Bend, Ind., 1865–69; McHenry County, Ill., 1869–78 [*]

SWAIN, Alice Caven [P,T] Ronkonkoma, NY b. 8 S 1893. Studied: F. Duveneck; L.H. Meakin; D. Garber [40]

SWAIN, Corinne Rockwell [P] Phila., PA. Member: New Century C. [25]

SWAIN, Francis W(illiam) [P,E,I] Cincinnati, OH/San Fran., CA b. 24 Mr 1892, Oakland, CA d. 15 Mr 1937. Studied: San Francisco; Duveneck, in Cincinnati; PAFA; F.V. Sloun. Member: Cincinnati AC; Calif. SE. Work: dec., Westwood Sch., Cincinnati [31]

SWAIN, Jerre (Mrs. Saint E.) [P,T] Houston, TX b. 21 My 1913, Yoakum, TX. Studied: Mary Hardin-Baylor Col., Belton, Tex.; E. Bisttram. Member: Tex. FAA; Houston AA. Exhibited: Houston Gal. AA (one-man); Houston MFA; Elisabet Ney Mus. A.; Little Theatre & Jr. Lg. of Houston [47]

SWAIN, P(hilip) S(tarbuck) [Mar.P,T] NYC b. 1 Ap 1838, Nantucket, MA [21]

SWAIN, Ruth Newton [Por.P,Dr,S,T] Los Angeles, CA b. 19 O 1907, Los Angeles, CA. Studied: S.Z. Reckless; M. Sheets; J. Charlot; L. Katz; M. Gage. Member: Calif. AC. Exhibited: Los Angeles Col. Fair, Pomono, 1934 [40]

SWAIN, W. [P] Tacoma, WA. Member: Tacoma FAA [25]

SWAINE, P.S. [P] Nantucket, MA [15]

SWALLEY, John F. [P,E] Toledo, OH b. 5 S 1887, Toledo. Studied: A.W. Dow; W. Darling; E. Dean; I. Abramovsky; K. Kappes. Member: Toledo Print C.; Artklan-Toledo; Ohio WCS. Position: Pres., The Publisher Press Co., Inc., Toledo [40]

SWALLOW, W(illiam) W(eldon) [S,P,T] Allentown, PA b. 30 S 1912, Clark's Green, PA. Studied: PMSchIA; Univ. Pa. Member: Audubon A.; Lehigh Valley A. All. Exhibited: PAFA, 1941–45; NAD, 1943–45; Audubon A., 1945 (prize); Syracuse MFA, 1940 (prize), 1941 (prize); Wichita AA, 1946; Lackawanna County AA, 1940–45; Lehigh Valley AA, 1940–46; Lehigh Univ., 1940–46; PMSchIA, 1935 (prize); AV, 1942 (prize); NSS, 1946 (prize). Work: MET; Allentown AM; IBM Coll. Position: Dir. A., South Whitehall Sch., Allentown, 1936–46 [47]

SWAN, Emma Levinia [P,T] Providence, RI b. 24 F 1853, Providence d. 27 Jy 1927. Studied: A.H. Thayer. Member: Providence AC. Work: many New England coll.; Providence AC. [27]

SWAN, Florence (Wellington) [D,T] Boston, MA b. 13 Jy 1876, Cambridge, MA. Studied: A.M. Sacker. Member: Boston SAC (master). Work: mem. tablets,, Beneficent Congreg. Church, Providence; St. James' Church, Salem [31]

SWAN, Joe [P,T] Minneapolis, MN b. 13 Ap 1914, N.Dak. Member: Un. Am. A. Exhibited: Univ. Minn.; Minn. State Fair; Hanley Gal., Minneapolis; Twin City Exh., Minneapolis, 1939 (prize). Work: mural, State Normal Sch.; altarpiece, Methodist Ch., Madison, S.Dak. Position: T., Walker A. Gal., Minneapolis [40]

SWAN, John M. [P] London, England [04]

SWAN, Lillian G. [P] St. Paul, MN [17]

SWAN, Lucille [P] Chicago, IL [13]

SWAN, Mary Ferris [P] Shanghai, China [19]

SWAN, Paul [P,S] NYC/Paris b. 5 Je 1899 (or 1884), Ashland, IL d. 1 F 1972, Bedford Hills, NY. Studied: Lorado Taft; J. Vanderpoel; NYC; Paris. Also a dancer in movies. [25]

SWAN, Walter Buckingham [P,W,L] Omaha, NE b. 13 Jy 1871, Boston, MA. Studied: Creighton Univ., Omaha, Nebr.; Sargent; Colcord; Kingsbury; BMFA Sch.; Lowell Sch. of Des. (MIT), Boston; Paris; London. Member: North Shore AA; Gloucester SA; Ogunquit A. Cent.; Springfield AL; S.Indp.A.. Exhibited: U.S. Nat. Mus., Wash., D.C., 1943 (75 watercolors sponsored by Mexican Ambassador. Exhibited in many cities of the U.S. under the auspices of Pan-American Union) [47]

SWANN, James [E,I,L] Chicago, IL b. 31 Jy 1905, Merkel, TX. Studied: Sul Ross State T. Col., Alpine, Tex. Member: SAE; Chicago SE; Calif. PM; Prairie PM; PM Soc. Calif. Exhibited: SAE; NAD; CI; LOC; other major print exh.; Chicago SE, 1940 (prize); Calif. PM, 1943 (prize); SSAL, 1936 (prize); Paris Salon, 1937 (med). Work: Smithsonian; AIC; NYPL; Los Angeles Mus. A.; Dallas MFA; Ill. State Lib.; Newark Mus.; Pub. Lib., Sherman, Tex. Contributor: American Artist; Chicago Tribune [47]

SWANN, Lilian [S] NYC. Member: NAWPS. Exhibited: NA, 1937; NAWPS, 1937, 1938; WFNY, 1939 [40]

SWANN, Samuel Donovan (Don) [E,W] Baltimore, MD b. 22 F 1889, Fernandina, FL. Studied: St. Johns Col., Annapolis, Md. Member: Etchcrafters AG (Dir.); SAE; Baltimore WCC; AAPL. Work: Nat. Cathedral; MET; J.P. Morgan Lib.; BMA; VFMA; LOC; Enoch Pratt Lib., Baltimore; Princeton Univ. Lib.; U.S. Naval Acad., Annapolis; Sweet Briar Col., Va.; Randolph-Macon Col., Lynchburg. Co-author/Illustrator: "Colonial and Historic Homes of Maryland," (100 etchings), 1938 [47]

SWANSON, Bennet A. [P,Li,T] St. Paul, MN b. 26 Ap 1900, Winthrop, MN. Studied: St. Paul Inst. A.; ASL; Paris, with Lhote, Stockhold, Galanesse. Exhibited: AIC, 1942; Paris Salon, 1927; Milwaukee, 1944; Minn. State Exh., 1920, 1922–26, 1933 (prizes), 1936 (prize); Minneapolis Inst. A., 1923; Twin City Exh., 1926 (prize), 1934 (prize). Work: Walker A. Ctr.; Minneaplis Inst. A.; Nat. Red Cross, Wash., D.C.; mural, Field House, Ft. Snelling, Minn.; hospitals/schools/pub. bldgs., throughout U.S. Positions: T., Art Crafts Center, St. Paul; A., General Outdoor Advertising Co., Minneapolis [47]

SWANSON, Eric Hjalmar [Mar.P] San Fran., CA (since 1930) b. 1882, Sweden d. 17 O 1960. Studied: self-taught. Also a longshoreman. [*]

SWANSON, George Alan [P,I,W] Bloomfield, NJ b. 27 D 1908, Hoboken, NJ. Studied: Newark Sch. F.&Indst. A.; W. Barnet; J.H. Duncan. Member: N.J. AA; N.Y. Zoological S. Exhibited: Montclair AM, 1938, 1939; Artists of Today, 1942, 1944; Newark Mus., 1944; Riverside Mus., 1945; Caracas, Venezuela, 1944, 1945. Work: Newark Mus.; Dance Archives, MOMA. Author/Illustrator: "Weird Dwellers of the Deep," Popular Science, 1944; "Jungle Studio," Animal Kingdom mag., 1946. Positions: Staff A., Dept. Tropical Research, N.Y. Zoological S., 1934–46; Staff A., several scientific expeditions to the Pacific, Mexico, West Indies [47]

SWANSON, Jonathan M. [P,S] NYC b. 21 Jy 1888, Chicago, IL. Studied: AIC, with J. Vanderpoel. Member: N.Y. Numismatic C. Work: portraits of ten club presidents and the King of Italy, Numismatic C., NYC; three portrait medals, French Mint Exh.; numerous others [40]

SWANSON, William [P] North Branch, MN [17]

SWANTEES, Ethel Lucile [P,E,Li,T] NYC/Alfred, NY b. 2 N 1896, Madison, WI. Studied: ASL, with J. Sloan, H. Wickey. Member: S.Indp.A.. Exhibited: CGA, 1937; Dallas MFA; MET (AV), 1942; NAD, 1939, 1945; Mattatuck Mus., 1943 (one-man), 1946; Modernage Gal., 1945 (prize). Position: T., Westover Sch., Middlebury, Conn., from 1941 [47]

SWARS, Ethel. See Maxon.

SWARTZ, Harold [S,Li,W,L,T] Los Angeles, CA (since 1923) b. 7 Ap 1887, San Marcial, N.Mex. Studied: Berlin; Paris. Member: Sculptors Gld., Southern Calif.; Calif. AC; Calif. PS; Municipal A. Comm. Exhibited: Arcadia Exh., 1923 (prize); Pomona Expo, 1923 (prize); Pacific Southwest Expo, 1928 (gold); Calif. AC, 1932 (prize). Work: Los Angeles Mus. A. Positions: T., Otis AI, Chouinard AI, both in Los Angeles [40]

SWARZ, Sahl [S,P,T] NYC b. 4 My 1912, NYC. Studied: ASL. Member: CAFA; Clay C., NYC. Exhibited: Syracuse MFA, 1938, 1940; CAFA, 1938; PAFA, 1946; Clay C., 1934–46; BM, 1936; Berkshire Mus., 1941; Rochester Mem. A. Gal., 1940; Springfield Mus. A., 1936; Lyman Allyn Mus., 1939; Plainfield (N.J.) AA, 1943; Newark Mus., 1944. Work: Brookgreen Gardens, S.C.; Court House, USPO: Statesville, N.C., Linden, N.J. Position: Asst. Dir., T., Clay C. Sculpture Ctr., NYC 1931–46 [47]

SWAY, Albert [P,Et,Li,I,Cart,T] Cincinnati, OH b. 6 Ag 1913, Cincinnati, OH. Studied: Cincinnati A. Acad.; ASL. Member: Cincinnati Assn. Prof. A.; Cincinnati AC; SAE. Exhibited: AIC, 1936, 1938; CGA, 1939; PAFA, 1936; GGE, 1939; Paris Salon, 1937; Stockholm, Sweden, 1937–38; WFNY, 1939; SAE; LOC, 1944, 1945. Contributor: cartoons in Saturday Review; New Yorker [47]

SWAYNE, H(ugh) N(elson) [P,E,T] Hickman, KY b. 22 Jy 1903, Hickman. Studied: W.H. Stevens; C.M. Saz; G.P. Ennis; J. Costigan. Member: Louisville AA; SSAL; Natchitoches A. Colony. Exhibited: Louisville AA, 1928 (prize); Baton Rouge, 1929 (prize) [33]

SWAYNE, William Marshall [Por.S] Active in Wash., D.C., 1859–62; then returned to Chester County, PA b. 1 D 1828, Pennsbury, PA d. 1918, Chester, County, PA. [*]

SWEENEY, Dan [I] b. 1880, Sacramento, CA d. 1958 (NYC?) Illustrator:

San Fran. Chronicle, Overland Monthly, Colliers, theatre and travel posters. Specialty: western and marine subjects [*]

SWEENEY, James Johnson [W,Hist,Cr,L] NYC b. 30 My 1900, Brooklyn, NY. Studied: Georgetown Univ., Wash., D.C.; Jesus Col., Cambridge, England; Sorbonne, Paris, France; Univ. Siena, Italy. Member: Royal Soc. Antiquaries of Ireland (Dublin); La Société de l'Histoire de L'Art Francais, La Société des Africanistes (Paris); Century Assn.; Grolier C. Ed., "African Negro Art," 1935; "Three Young Rats," 1944. Author: "Alexander Calder," 1943; "Stuart Davis," 1945; "Marc Chagall," 1946; "Georgia O'Keefe," 1946. Position: Assoc. Ed., Transition, 1935–38; Visiting L., NYU, 1935–40; Dir., P. & S., MOMA, 1945–46 [47]

SWEENEY, Joseph Henry [P,Des] Milwaukee, WI b. 5 Jy 1908, Elkins, WV. Studied: AIC. Exhibited: Wis. Memo. Union, Madison, 1935. Position: Indst. Des., Des., Kirby, Cogeshall, Steinau Co., Milwaukee [40]

SWEENEY, Mary B. [P] Phila., PA [25]

SWEENEY, Nora (Mrs. Samuel Gordon Smyth) [I,P] Upper Darby, PA b. 17 Je 1897, Phila., PA. Studied: W.H. Everett; E. Horter. Exhibited: PAFA. Illustrator: juvenile subjects [40]

SWEENEY, Sarah Catherine [P,W,L,T] NYC b. 27 F 1876, Nashville, TN. Studied: C.C. Cooper; Volk; Metcalf; Hawthorne; Chase; Twachtman; Maynard [25]

SWEENEY, William K. [P,I] Baltimore, MD. Member: Charcoal C. [25]

SWEENY, Robert O. [P] Active in MN ca. 1852; possibly Phila., 1860 b. 1831 d. 1902. Work: MN Hist. S. [*]

SWEET, Frederick Arnold [Mus.Cur,W] Chicago, IL b. 20 Je 1903, Sargentville, ME. Studied: Harvard Univ. Member: Chicago AC. Author: "The Hudson River School and the Early American Landscape Tradition," 1945; "Early American Room," 1936. Editor: "George Bellows," 1946. Contributor: The Art Quarterly; Art News; Antiques. Position: Cur., Renaissance A., BM, 1932–36; Dir., Portland, Maine A. Mus., 1936–39; Asst. Cur., P. & S. AIC, Chicago, from 1939 [47]

SWENGEL, Faye (Mrs. Badura) [P] New Hope, PA b. 28 O 1904, Johnstown, PA. Studied: PAFA; Barnes Fnd.; D. Garber; A.B. Carles. Exhibited: CGA, 1932–40; CM; PAFA, 1940–46; NAD; VMFA; MET, 1943; AIC, 1943 [47]

SWENSON, Carl Edgar [P,Des,I] Rockford, IL b. 20 O 1897, Fairdale, IL. Member: Rockford AA. Exhibited: Rockford AA Annual Exh., 1935 (prize), 1936 (prize). Position: Asst. A. Dir., H.H. Monk and Assoc., Rockford, Ill. [40]

SWENSON, Gottfrida [P] Duluth, MN b. 19 Je 1882, Sweden. Studied: K. Heldner; Delecluse, Paris. Member: Duluth AS. Exhibited: Duluth AS; Arrowhead Exh., (prizes) [33]

SWENSON, Howard William [S,Des,Gr] Rockford, IL b. 30 Je 1901, Rockford d. 12 N 1960. Studied: Corcoran Sch.; O. Nordmark. Member: Rockford AA; Potters Gld.; Greater Chicago; Ar.U.; Swedish-Am AA, Chicago. Exhibited: S. Wash. A.; CGA; Phila. Pr. C.; Rockport AA; Md. Inst. Work: LOC. WPA artist. [47]

SWENSON, Olé (Valerie K.) [P] Long Island City, NY b. 11 Ap 1907, Kansas City, MO. Studied: A. Bloch. Member: MacDowell S.; Swedish-Am. AA. Position: Asst. Ed., The Prof. A. Quarterly [40]

SWERDLOFF, Sam [P] (NYC ?) 1977 b. WI. Studied: Colt Sch. A., Madison, Wis.; Univ. Wis. Member: Artists Union of Baltimore (founder); Am. A. Cong. Exhibited: WPA Exh. at CGA, 1934. Work: WPA murals, Baltimore, NYC [*]

SWETT, Alice A. [Ldscp.P] Allston, MA. Member: Copley S. 1897 [13]

SWETT, Ruth Doris [E] Southern Pines, NC/Winter Park, FL/Deer Isle, ME b. 11 Ja 1901, Southern Pines, NC. Studied: Chouinard AI; W. McNulty; F. Nankivell; M. Ryerson; G. Bridgman; ASL; E.O. Verner. Member: N.C. SA; Wash. WCC; Orlando SA; Rockport AA; AFA; SSAL; Allied A., Winter Park; Southern PM. Exhibited: SAE, 1936; Wash. WCC, 1939; NGA, 1936; Intl. PM, Calif., 1936; Southern PM; Fla. Fed. A., 1939 (med); Rockport AA. Work: St. Mary's Sch., Raleigh, N.C.; etching, published as frontispiece, "Beech Mountain Folk Songs." [47]

SWETT, William Otis, Jr. [Mar.P,Ldscp.P] Dover Plains, NY/Ogunquit, ME b. 5 My 1859, Worcester, MA d. ca 1938. Studied: Whistler; H.G. Dearth; Munich; Paris; Belgium; Holland. Member: SC, 1903; Chicago AG; S.Indp.A. [38]

SWEZEY, Agnes [P] NYC [25]

SWIFT, Clement Nye [P] NYC b. 25 O 1846, Acushnet, MA d. 29 Mr 1918. Studied: France (living at Avon, 1870–71). Exhibited: Paris Salon; NAD, 1877–96. Work: Kendall Whaling Mus. Specialties: animals; marine [01]

SWIFT, Dick [P,E,Li,I,T] Los Angeles, CA b. 29 N 1918, Long Beach, CA. Studied: Los Angeles City Col.; Chouinard AI; ASL; H.L. McFee; W. Barnet; J. Corbino. Exhibited: AIC, 1944 & traveling exh.; Minneapolis Inst. A.; Rochester Mem. A. Gal.; CI; CM; Dayton AU; CAM; Soc. Liberal A. Omaha; NAD, 1944–46; SAM, 1945; Laguna Beach AA, 1943–45; Los Angeles Mus. A., 1944; Ebell C., 1941 (prize); Long Beach AA, 1942 (prize), 1943 (prize); Contemp. A. Gal., 1945 (one-man) (prize). Work: mural, Indst. Des. & Builders, Los Angeles [47]

SWIFT, Florence Alstin [Mur.P,C,Des] Berkeley, CA b. 30 S 1890, San Fran. Studied: Hans Hofmann Sch. A.; V. Vytlacil; Univ. Calif.; Calif. Sch. FA; Calif. Col. Arts & Crafts. Member: San Fran. AA; All.A.Am.; San Fran. Soc. Women A.; Am. Abstract A. Exhibited: SFMA (one-man); Pal. Leg. Honor; GGE, 1939; All.A.Am.; San Fran. AA, 1920 (med); San Fran. Soc. Women A., (med); Sacramento State Fair, 1927. Work: Mills Col.; SFMA; mosaic, Art Bldg., Univ. Calif., Berkeley. Specialty: mosaics [47]

SWIFT, Emma. See McRae.

SWIFT, Ivan [P,Arch,C,L,W] Detroit, MI/Harbour Springs, MI b. 24 Je 1873, Wayne, MI d. 5 O 1945. Studied: AIC; Freer; Von Sulza; Ochtman; Chase. Member: NAC; PS; Mich. Acad. Sc., A.&L. Exhibited: S. Art, Poetry & Music, Detroit, 1936 (prize); Mich. Art, 1937 (prize). Work: Detroit Lib.; 20th Century C., Lockmoor C., Detroit; Univ. Nebr.; Mich. Fair Gal.; Harbor Springs H.S.; Mich. State Lib.; Delgado Mus., New Orleans; Harbor Springs Pub. Lib.; Detroit Inst. A.; Vanderpoel AA. Author: "Fagots of Cedar," "The Blue Crane and Shore Songs," "Nine Lives in Letters" [40]

SWIFT, Margaret G. [P,T] Phila., PA b. Ap 1874, Phila. PA. Studied: PAFA; PMSchIA; W.C. Chase; C. Beaux; H. Breckenridge; C. Schuyler; E. Horter. Member: Phila. A. All. Work: PAFA; Royal Gal., Oslo; Luxembourg Mus., Paris [40]

SWIFT, Samuel [Cr] b. 1873, Newark, NJ d. 21 Jy 1941, NY Hospital. Studied: Univ. Pa., 1894. Member: MacDowell C. Position: Art Critic, New York Evening Mail, from 1896–1907

SWIFT, S(tephen Ted) [I,E] Palo Alto, CA. Studied: P.J. Lemos; L.P. Latimer; Calif. Sch. Arts and Crafts. Specialty: wood block printing, etching. Position: Staff A., School Arts mag. [31]

SWIGART, Ednah Knox [P] Sheffield, IL [13]

SWIGGETT, Grace Kiess (Mrs.) [P,I,B,C,L,T,W] Wash., D.C. b. Cincinnati, OH. Studied: Ind. Univ. Columbia; Cincinnati Univ. Chicago Univ.; R. Johonnot; J.P. Haney; L.H. Meakin; V. Nowottny; W.O. Beck; F. Duveneck; O. Humann; A. Dow. Member: Women's AC of Cincinnati; S. Wash. Artists. Exhibited: Women's AC of Cincinnati, 1929 [33]

SWIGGETT, Jean (Mr.) [P,Gr,Des,T] San Diego, CA b. 6 Ja 1910, Franklin, IN. Studied: Chouinard AI; San Diego State Col.; Univ. Southern Calif. Member: All.A. Council, San Diego. Exhibited: GGE, 1939; Los Angeles Mus. A., 1935–41, 1946; SAM, 1941; San Diego FAS, 1937–39; SFMA, 1936, 1938; Wichita AM; Calif. State Fair, Sacramento, 1938 (prize); Los Angeles County Fair, Pomona, 1938 (prizes). Work: San Diego FAS; murals, S.S. Pres. Adams, S.S. Pres. Jackson; WPA mural, USPO, Franklin, Ind.; Univ. Southern Calif.; Polytech. H.S., Long Beach. Positions: T., Univ. Southern Calif. (1940–41), Wash. State Col. (1941–42), San Diego State Col. (from 1946) [47]

SWINBURNE, A.T. (Mrs. Henry H.) [P] NYC. Member: NY Women's AC [04]

SWINDELL, Bertha [Min.P] Baltimore, MD b. 2 D 1874, Baltimore d. 30 Ap 1951. Studied: Bryn Mawr Col.; Drexel Inst.; PAFA; C. Hawthorne; Chase; Bridgman; Breckenridge; La Forge, Académie Julian; S. Forbes, England; R. Miller. Member: Baltimore WCC; Pa. Soc. Min. P. Exhibited: Enoch Pratt Lib., Baltimore; BMA; PAFA; N.Y. Acad. FA; Smithsonian Inst. [47]

SWING, David Carrick [Ldscp.P,T] Phoenix, AZ (since 1917). b. 1864, Cincinnati d. 1945. Exhibited: GGE. Work: Phoenix Pub. Lib.; Phoenix Masonic Temple. Position: Dir., Los Angeles En. Co., 1905–14; T., Phoenix Jr. Col. [*]

SWING, Jeannette [P] Cincinnati, OH b. 15 D 1868, Cincinnati, OH. Studied: Cincinnati AA. Member: Cincinnati Women's AC [19]

SWINNNERTON, James [I,Car,Ldscp.P] West Hollywood, CA b. 13 N 1875, Eureka, CA d. 5 S 1974, Palm Springs, CA. Studied: San Fran. A.

Sch., with W. R. Keith and E. Carlsen. Member: Calif. AC; Bohemian C. Exhibited: All-Calif. Exhib., 1934. His cartoon for Hearst newspapers was among the first. In NYC he created "Little Jimmy" and "Little Tiger." In 1903 he moved to Colton, Calif., to recover from tuberculosis, and became best known for his desert landscapes. By the 1930s–40s he was drawing "Canyon Kiddies" for Good Housekeeping, and animation cartoons for Warner Brothers Studios [40]

SWINSBURNE, Anna T. (Mrs. Henry H.) [P] NYC. Member: Women's AC [01]

SWINTON, Alfred [P,I,Wood En] Hackensack, NJ b. 1826, England (active in NYC by 1851) d. 3 O 1920. Position: Staff, Harpers. Best known for Civil War subjects

SWINTON, Marion [P] NYC/Hackensack, NJ b. NYC. Studied: Chase [17]

SWISHER, Allan [Por.P] NYC/Paris, France b. 2 O 1888, Kansas. Studied: H.M. Walcott; J.P. Laurens, in Paris [40]

SWISHER, Amy Margaret [C,B,E,Ser,Des,T,L] Oxford, OH b. 14 Ag 1881, Groveport, OH. Studied: Ohio Wesleyan Univ.; H. Hofmann; E. Ulbricht, Columbia, with A.W. Dow, C.J. Martin, A. Heckman. Member: Ohio Edu. Assn.; Nat. Edu. Assn.; Women's AC, Cincinnati; Oxford AC; AFA; Western AA. Exhibited: Cincinnati Women's AC, 1936 (prize). Position: T., Miami Univ., Oxford, 1920– [47]

SWISHER, P. M. [I] Phila., PA [21]

SWITZER, George [Indus.Des,L] NYC b. 6 Mr 1900, Plymouth, IN. Studied: J. Norton; Univ. Ill.; Chicago Acad. FA; AIC. Member: AI Graphic A.; A. Dir. C., N.Y.; Soc. Typog. A.; Nat. A. Soc. Work: indst. des., Jormel&Co., IBM, Johnson&Johnson, Eagle Pencil Co., Westinghouse, Studebaker, Rolls Royce, DuPont [40]

SWITZER, Patty [Min.P] Hollywood, CA. Studied: Am. Sch. Min. P., with M. Welch and E.D. Pattee; CUASch [27]

SWOPE, Emma Ludwig (Mrs.) [C,Des,T] Freeville, NY b. 17 Mr 1891, Spillville, IA. Studied: AIC; Washington State Col., Pullman, Wash.; Columbia; R. Pearson; N.Y. Sch. F&Appl. A.; Europe. Member: N.Y. Soc. Craftsmen. Exhibited: N.Y. Soc. Craftsmen, 1941. Owner/Manager: Des.&Crafts Workshop [47]

SWOPE, H. Vance [P] NYC/Ogunquit, ME b. 4 Mr 1879 (or 1877) d. 10 Ag 1926. Studied: Cincinnati A. Acad, 1890–96; NAD; Académie Julian, with Constant. Member: Gld. Am. P.; AWCS; SC; N.Y. Arch. Lg.; Allied AA. Work: Pub. Lib., Seymour, Ind. [25]

SWOPE, Kate F. (Mrs.) [P] NYC b. Louisville, KY. Studied: NAD. Member: Louisville AL. Exhibited: SSAL, 1895 (gold); Louisville AL, 1897 (prize) [25]

SWOPE, Virginia Vance [P] NYC/Leonardo, NJ b. Louisville, KY. Studied: DuMond; Mora; Carlson; Penfield; Bridgman [25]

SWORD, James B(rade) [Por.P,Ldscp.P] Phila. PA b. 11 O 1839, Phila. d. 1 D 1915. Studied: W.T. Richards; PAFA. Member: Phila. A. Fund S.; Phila. SA (Pres.); AC Phila. (founder). Exhibited: New Orleans Expo, 1885 (med); AAS, 1902 (gold), 1903 (gold). Work: Univ. Pa.; Capitol, Wash., D.C. [15]

SYKES, Annie G. (Mrs.) [P] Cincinnati, OH b. Brookline, MA d. 31 Mr 1931. Studied: BMFA Sch.; Cincinnati A. Acad, with Duveneck. Member: Cincinnati Women's AC; NAWPS [29]

SYKES, Charles Henry [Cart] Cynwyd, PA b. 12 N 1882, Athens, AL d. 19 D 1942. Studied: B.W. Clinedist at Drexel Inst., Phila. Member: Phila. Sketch C. Cartoonist: "Evening Public Ledger," Phila., 1914–42 [31]

SYKES, (William) Maltby [P,Lith,L,T] Auburn, AL b. 13 D 1911, Aberdeen, MS. Studied: ASL; A. Bairnsfather; W. Adams; D. Rivera; G.C. Miller. Member: SSAL; Ala. WCC; CAA; Southeastern AA; Birmingham AC; AFA; SC. Exhibited: Ala. A. Lg., 1934–43, 1944 (prize), 1945 (prize); New Orleans AA, 1937 (prize), 1945 (prize); Ala. State Fair, 1939 (prize), 1941 (prize); Birmingham AC, 1939–40, 1941 (prize), 1942 (prize), 1943; Mint Mus. A., 1944, 1945 (prize); SSAL, 1934, 1935, 1937, 1939–44, 1945 (prize); Ala. WCC, 1941 (prize), 1943 (prize); Phila. WCC, 1938; Wash. WCC, 1944; AWCS, 1945; CI, 1946; LOC, 1945; Phila. Pr. C., 1945; Northwest Pr.M., 1945, 1946; NAD, 1946; Albany Pr. C., 1945; Ala. WCC, 1942–45; Miss. AA, 1943–46. Position: T., Polytechnic Inst., Auburn, 1942, 1943, 1946– [47]

SYKES, S. D. Gilchrist [P] Providence, RI b. Cheshire, England. Studied: BMFA Sch. Member: Copley S.; North Shore AA [40]

SYLVESTER, F(rederick) O(akes) [Mur.P,Ldscp.P,T] St. Louis, MO/Elsah, IL b. 8 O 1869, Brockton, MA d. 2 Mr 1915, Brockton. Studied: Mass. Normal A. Sch., Boston. Member: SEA; St. Louis AG; 2 x 4 Soc. Exhibited: Portland Expo, 1905 (med); St. Louis Expo, 1904 (med); SWA Chicago, 1906 (prize). Work: mural, Central H.S., St. Louis; Central H.S., Decatur, Ill.; Noonday C., St. Louis. Author: "The Great River" (poems and pictures). Positions: T., Newcomb Col., New Orleans (1891–92), Central H.S., St. Louis (1892–1913) [13]

SYLVESTER, Harry E(lliott) [P,Wood En] Topsfield, MA b. 10 Ap 1860, North Easton, MA d. 22 F 1921, Boston. Studied: J.A. Fraser; C. Hassam; engraving, with G.E. Johnson. Member: Boston AC. Work: CI [19]

SYLVESTER, Ida Pond (Mrs.) [P] Passaic, NJ b. NYC d. 18 Ja 1935. Studied: Snell; Graecen; Ennis. Member: NAWPS; AWCS [33]

SYLVESTER, Lucille [P,G,I] NYC b. 24 Je 1909, Russia. Studied: ASL; Académie Julian, Paris; G. Bridgman; J. Adler. Member: NAWA; Audubon A. Exhibited: Municipal Gal., N.Y., 1936; Hammer Gal., 1939 (one-man); NAD, 1944; NAWA, 1941, 1942, 1944, 1946; Audubon A., 1944, 1945; All. A. Am., 1938, 1940, 1942, 1944; Studio Gld.; Vendome Gal.; Decorators C.; Argent Gal.; N.J. Col. for Women. Illustrator: juvenile books [47]

SYMINGTON, James [P] NYC b. 1841, Baltimore, MD. Studied: NAD; ASL. Member: AWCS; Arch. Lg., 1893; SC, 1888 [17]

SYMMERS, Agnes Louise (Mrs. James K.) [Ldscp.P,W] University, VA b. 23 Je 1887, University. Studied: ASL; F.V. DuMond; Henri; Lhote. Member: PBC; NAC; SSAL; Albemarle AL. Author: "Beyond the Serpentine Wall," 1936 (brochure); "Letters of a Javanese Princess," 1922 (translated from Dutch) [40]

SYMMES, Adelaide Fisher (Mrs. Roscoe M.) [P] Boston, MA b. Framingham, MA. Studied: Cowles Sch. A., Boston [13]

SYMMONDS, Albert [P] Fullerton, CA b. 22 Ja 1902, Riceville, PA. Member: Calif. WCS [40]

SYMON, Abigail (Gail) [P,T] Norwalk, CT b. Boston. Studied: NAD; L. Kroll; I. Olinsky; G. Beal. Member: Audubon A.; Silvermine Gld. A. Exhibited: Silvermine Gld. A., 1929–44, 1945 (prize), 1946; Audubon A., 1945; Montross Gal., 1938 (one-man), 1941; Riverside Mus., 1938, 1941, 1946; AGAA, 1945; Babcock Gal., 1942; Argent Gal., 1944; Macbeth Gal., 1945 [47]

SYMONS, (George) Gardner [Ldscp.P] NYC/Colrain, MA b. 1863, Chicago d. 18 Ja 1930, Hillside, NJ. Studied: AIC; Paris; Munich; London, 1900s. Member: ANA, 1910; NA, 1911; Royal Soc. British Artists; Union Inter des Beaux-Arts et des Lettres; SC, 1900; NAC (life); Chicago SA; Century Assn.; Calif. AC; Inst. Arts&Letters; Chicago Gal. A.; AFA. Exhibited: NAD, 1909 (prize), 1919 (prize); SC, 1910 (prize); Buenos Aires Expo, 1910 (med); NAC, 1912 (gold); Corcoran, 1912 (med). Work: MET; CGA; Cincinnati Mus. A.; TMA; AIC; City A. Mus., St. Louis; Dallas AA; Brooklyn Inst. Mus.; Minneapolis Inst. A.; CI; Fort Worth Mus.; Butler AI; Los Angeles Mus. A.; NAC; Des Moines A. Assn.; Lincoln AA, Nebr.; Cedar Rapids AA, Iowa; Mus. A., Erie, Pa.; Rochelle AA, Ind.; Union Lg. C., Chicago; Hyde Park A. Assn., Chicago. Came to Calif. with his friend W. Wendt in 1896; studio in Montecito, near Laguna Beach. Most of career spent in the East, based in NYC. He is best known for his snow scenes in Berkshire Mtns., Mass. See also Simon, George Gardner (for explanation of name change). [29]

SZABO, Laszlo [Port.P,T,L] Buffalo, NY b. 18 Ag 1895, Budapest, Hungary. Studied: Royal Acad. A., Budapest; Académie Julian; Ecole des Beaux-Arts, Paris; ASL. Member: Buffalo SA; Gld. All. A. Exhibited: All. A., 1940 (gold), 1944 (prize); Buffalo SA, 1943 (prize), 1946 (prize); Buffalo SA, annually; Gld. All. A. Work: Erie County Hall, Buffalo; N.Y. State Historical Assn., Ticonderoga [47]

SZANTO, Louis P. [Mur.P,E,I,Dec] NYC b. 8 O 1889, Vacz, Hungary d. 15 Mr 1965. Studied: Acad. A., Budapest, Hungary; Munich; Académie Julian, Paris. Member: Royal Acad. Soc., Budapest; A. C., Budapest; Mural P. Gld.; Soc. Mur. P. Exhibited: Century of Progress, Chicago, 1934; WFNY, 1939, Europe. Work: Hungarian Mus. A.; murals, Bellevue Hosp., NYC; St. Clement Pope Church, Poughkeepsie, N.Y.; Worcester Acad., Mass.; State Mus., Des Moines, Iowa; Univ. Del. [47]

SZATON, John J. [S] Chicago, IL b. 18 N 1907, Ludlow, MA. Studied: Chicago Acad. FA; Chicago Sch. S.; AIC; E. Chassaing; L. Taft. Exhibited: AIC, 1935; PAFA, 1940; NAD, 1941; CM, 1941; AV, 1942; Polish AC, Chicago, 1942; Soc. for Sanity in Art, 1940. Work: panels/plaques/dec., Recreation Bldg., Hammond, Ind.; Pilsudski plaque, Springfield, Mass.; Lincoln Mem., Vincennes, Ind.; Northwest Armory, Chicago [47]

SZEKESSY, Curt [E] NYC. Member: Brooklyn SE [27]

SZUCS, Victor [P,G] NYC. Exhibited: Ann., Nat. Acad., 1937; 48 States Comp., 1939 [40]

SZUKALSKI, Stanislaus [S] Chicago, IL. Exhibited: AIC, 1916 (prize) [17]

SZYK, Arthur [I] New Canaan, CT b. 3 Je 1894, Lodz, Poland d. 13 S 1951. Studied: Acad. FA, Kraków; Sch. FA, Paris. Exhibited: Poland (prize); George Washington Med.for U.S. Award: Officer of Palms, France. Illustrator: "Song of Songs," 1917, "Temptation of St. Anthony," 1924, "George Washington and His Times," 1931, "Rubaiyat," 1939, "Hagadah," 1941, "New Order," 1942 [47]

SZYNALIK, John J. [P] Chicago, IL. Exhibited: Ar. Chicago Vicinity Exh., AIC, 1937 [40]

T

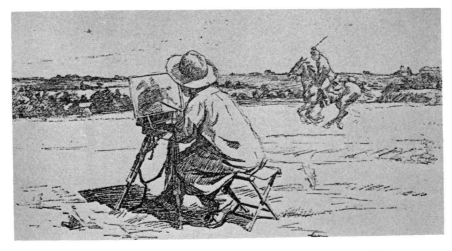

William T. Trego: *Self-portrait, studying a horse in action.* From *The Illustrator* (1893)

TAAKE, Daisy [S,I,P,T] St. Louis, MO b. 21 Mr 1886, St. Louis. Studied: AIC; St. Louis Sch. FA; L. Taft. Exhibited: St. Louis Art League Fountain Comp.; Century of Progress, 1934; WFNY, 1939. Position: T., Soldan H.S., Evening, St. Louis [40]

TABARY, Céline Marie [P,Des,I,T] Wash., D.C. b. 29 Jy 1908, Vermelles, France. Studied: France. Member: Société des Artistes Lillois. Exhibited: U.S. Nat. Mus., Wash., D.C., 1940, 1944 (prize), 1946; Salon des Artistes Française, Paris, 1938, 1939; Am.-British A. Center, 1944; Inst. Mod. A., Boston, 1944; NAD, 1945; PMG, 1940, 1945, 1946; CGA, 1940, 1944, 1945; Wash., D.C. Pub. Lib., 1946; Whyte Gal., 1941–44; Barnett Aden Gal., 1943–46; Howard Univ., 1941–42; numerous exh. in France. Work: Barnett Aden Gal., Wash., D.C.; Palais National, Haiti. Position: T., Howard Univ., 1945–46 [47]

TABB, Gladys Clark (Mrs.) [P,T] Oakland, CA b. Gilroy, CA. Studied: Stanford Univ.; Columbia; Calif. Col. A. & Crafts; A. Bement; A. Dow; F. Taubes. Member: Lg. Am. Pen Women. Exhibited: Palace Legion Honor, 1946; Oakland A. Gal., 1941, 1943, 1945; San Fran. AA, 1943; GGE, 1939; Santa Cruz A. Lg., 1938 [47]

TABER, Dorothea [P] Worcester, MA [24]

TABER, E. M. [P] NYC [98]

TABER, Isaiah West [Ldscp.P,Por.P,Ph] b. 1830, New Bedford, MA d. 1916, San Fran. First went to San Fran. during the gold rush; later was one of the first to open a photo gallery in Syracuse, N.Y. Joined Bradley & Rulofson Gal. in San Fran., 1864–71. Opened his own photo gal. in San Fran., 1871; became prominent for both portraits and landscapes. Named Commissioner to Yosemite Valley, 1888. Lost 30 tons of portrait negatives and 20 tons of landscape negatives in the San Fran. Fire, 1906. Later printed C.E. Watkins' negatives. [*]

TABER, J. W. [I] NYC. Member: SC [01]

TABER, Sarah A. See Coffin.

TABLER, Hazel (Mrs.) [P] Osceola, IA. Exhibited: Iowa A. Salon, 1934; Iowa Ar. Exh., Mt. Vernon, 1938 [40]

TABOR, Robert Byron [Mur.P,Por.P,P,I] Independence, IA b. 12 F 1882, Independence. Member: Nat. A. Gld., Chicago. Exhibited: Iowa Art Salon, 1934 (prize); Nat. Exh. Am. A., N.Y., 1936; MOMA, 1934; CGA, 1934; AFA; Colorado Springs FA Center, 1940, 1941. Work: White House, Wash., D.C.; murals, hotels in Des Moines; USPO, Independence; U.S. Gov. WPA artist. [47]

TACCARD, Patrick [P] Liberty, NY b. 23 My 1879, NYC. Exhibited: Orange County. Agriculture Soc., 1938 (prize); Walker Gal., N.Y., 1929; Am. P. Today, Albright Gal., 1939 [40]

TACK, Augustus Vincent [P,T] NYC/Deerfield, MA b. 9 N 1870, Pittsburgh. Studied: Mowbray, La Farge, both in N.Y.; Merson, in Paris. Member: ASL, N.Y. (life); CAFA; New Haven PCC; Century Assn.; Intl. Soc. AL; Arch. Lg., 1900. Exhibited: SAA, 1889 (prize); Boston AC; PAFA, 1898. Work: MET; PMG (large coll.); Legislative Chamber, New Parliament Bldgs., Winnipeg; CMA; A. Mus.; Newark Mus.; Speed Mem. Mus., Louisville, Ky.; Paulist Church, NYC; Chapel of The Cenacle Convent, Newport, R.I.; St. James Church, South Deerfield, Mass.; dec., Governor's Reception Room, Nebr. State Capitol, Lincoln [40]

TADAMA, F(okko) [P,T] Seattle, WA b. 16 My 1871, Bandar, India. Studied: Amsterdam Acad. FA. Member: Seattle FA Soc. Exhibited: Amsterdam, 1898 (prize). Work: SFMA; New Royal Theatre, Victoria, B.C.; Press C., Seattle; Indst. Exh. Bldg., Seattle [25]

TADD, Edith J. See Little, Mrs.

TADD, J. Liberty [P,T,L] Phila., PA b. 1863, England. Member: AC Phila. Position: Principal, Public Industrial A. Sch. Phila., where he introduced ambidextrous drawing [15]

TADEMA, F. [P] Seattle, WA. Member: Seattle FAS [15]

TAFFS, C. H. [I] NYC. Member: SI; Artists Gld. [33]

TAFLINGER, Elmer E. [P] Indianapolis, IN b. 3 Mr 1891, Indianapolis. Studied: ASL; G. Bridgman. Exhibited: Ind. Painters, 1930 (prize) [40]

TAFLINGER, Ethel Cline (Mrs. Emil) [I,W] Paris, IL/Crooked Lake, Angola, IN b. 3 Je 1894, Paris, IL. Studied: AIC. Illustrator: Child Life, Youth, Wee Wisdom [32]

TAFT, Charles Phelps [Patron] Cincinnati, OH b. 21 D 1843, Cincinnati d. 31 D 1929. Member: Cincinnati Mus. Assn., 1887 (trustee), 1914–27 (Pres.). His collection of paintings and porcelains and his gift of $1,000,000 formed the nucleus of the Cincinnati A. Mus.

TAFT, Lorado Zadoc [S,W,L] Chicago, IL/Oregon, IL b. 29 Ap 1860, Elmwood, IL d. 30 O 1936. Studied: Univ. Ill. (where his father was prof. of geology) 1880; Ecole des Beaux–Arts, Paris, with Dumon, Bonnassieux, Thomas. Member: NSS, 1893; ANA, 1909; NA, 1911; Nat. Acad. AL; Chicago PS; AFA; AIA (hon.), 1907; Ill. State Art Comm.; Nat. Comm. FA, 1925–29. Exhibited: Columbian Expo, Chicago, 1893 (med); Pan-Am. Expo, Buffalo, 1901 (med); St. Louis Expo, 1904 (med); P.-P. Expo, San Fran., 1915 (med). Work: AIC; mon., Seattle, Wash.; fountain, Paducah, Ky.; Bloomington, Ill.; Wash., D.C.; Chicago; Denver; Danville, Ill.: Ogle County Soldier's Mem., Oregon, Ill.; Urbana, Ill.; Elmwood, Ill; Univ. Ill.; Muskegon, Mich.; Sand Springs, Okla; Mem. to Victor Lawson, Chicago; pylons (main entrance) La. Capitol, Baton Rouge. Author: "History of American Sculpture," 1903, "Modern Tendencies in Sculpture." Positions: T., AIC (1886–1906); L., AIC (1886–1929), Univ. Chicago, Univ. Ill. [33]

TAGAWA, Bunji [P,I] Brooklyn, NY b. 13 Ag 1904, Tokyo, Japan. Illustrator: "Chiyo's Return" [40]

TAGGART, Edwin Lynn [P,S,E,I] San Mateo, CA/Richmond, IN b. 23 Ap 1905, Richmond, IN. Studied: R.L. Coates; F.F. Brown; B. Waite; Calif. Sch. A.&Cr. Member: Ind. AC; Junior AA. Exhibited: Wayne County Fair (5 prizes). Award: U.C.T. Art Med., 1925. Work: murals, Morton H.S., Richmond, Ind. [33]

TAGGART, George Henry [Por.P] Port Washington, NY b. 12 Mr 1865, Watertown, NY. Studied: Académie Julian, Paris, with Bouguereau, Ferrier, Lefebvre. Member: Soc. Intl. des Beaux-Arts et des Lettres; Buffalo SA; S.Indp.A.. Exhibited: Utah State Exh. (prize); Expo Toulouse, France (prize); Salon d'Automne, Paris (prize). Work: Palace of Governor, City of Mexico; Brigham Young Univ.; Capitol, Salt Lake City; City Hall, Watertown, N.Y.; Tusculum Col., Greenville, Tenn.; Welch Mem. Lib., Baltimore; Royal Palace, Berlin (private coll.); Chemists C., N.Y. [47]

TAGGART, Lucy M. [P] Indianapolis, IN/Gloucester, MA b. Indianapolis. Studied: Forsyth; Chase; Hawthorne; Europe. Member: NAC (life); Art Workers' C. for Women; North Shore AA; NAWPS; Grand Central AG; AFA. Work: John Herron A. Mus., Indianapolis [40]

TAGGART, Mildred Hardy (Mrs.) [Por,P,I,Des,B] Chevy Chase, MD b. 8 Ag 1896, Corsicana, TX. Studied: Corcoran Sch. A., with Messer; ASL, with G. Bellows, Henri, F.V. DuMond; Abbott Sch. F&Com. A., with S.B. Chase, H. Inden. Articles: Art Digest; Washington Star, 1937 [40]

TAGGART, Richard (T.) [P,W,T] Altadena, CA b. 11 My 1904, Indianapolis. Studied: P. Hadley; J. Mannheim; A. Clark. Member: Pasadena SA; P.&S. C., Los Angeles; Calif. AC; Carmel AA; Laguna Beach AA. Exhibited: GGE, 1939; Pasadena SA; Calif. AC; Carmel AA; Laguna Beach AA; John Herron AI; Purdue Univ.; Univ. Southern Calif.; Stanford Univ. (one-man); Pomona Col. (one-man); Nicholson's Gal., Pasadena (one-man); Stendahl Gal., Los Angeles; Calif. State Fair, 1934 (prize), 1939 (prize). Work: Pomona Col., Claremont, Calif. Specialty: Mt. Wilson Observatory, 1944–. Position: T., Pomona Col., 1940–41 [47]

TAGUE, Robert Bruce [Mur.P,Arch,T] Chicago, IL b. 15 S 1912. Studied: Chicago Sch. Des.; Armour Inst. Tech. Member: SC; Assn. Am. Inst. Arch. Work: mural, in collaboraton with R.J. Schwab, WGN Studio Bldg., Chicago. Position: T., Sch. Des., Chicago [40]

TAINTOR, Daisy Josephine (Mrs.) [P,B,Des] NYC b. Ft. Wayne, IN. Studied: Cincinnati A. Acad.; John Herron AI Sch.; PMSchIA; F.A. Parsons. Member: Nat. AAI [33]

TAINTOR, Musier (Mrs. Lawrence Lee) [P] Charlottesville, VA b. 6 Mr 1909, NYC. Studied: ASL. Exhibited: Boston Ar. Group show, 1938; WC Exhib., Va. MFA, 1937, 1939; Bayly Mus., Charlottesville, 1937, 1939 [40]

TAIPALE, Teppo [P,G] Madison, WI b. 11 O 1906, Kenosha, WI. Studied: AIC; Layton A. Gal. Sch., Milwaukee. Exhibited: Wis. Sal. A., Wis. Univ., Madison, 1938 [40]

TAIT, Agnes (Mrs. McNulty) [Por.P,Mur.P,Li] Santa Fe, NM (1962) b. 14 Je 1897, NYC. Studied: NAD. Member: NAWPS. Exhibited: WFNY, 1939; 48 Sts. Comp., 1939; Ferargil Gal., N.Y.; nationally. Active in NYC, 1931–39; Providence, R.I., 1940s; then settled in Santa Fe. Work: NYPL; MMA; LOC; Mus. N.Mex; murals, Bellevue Hospital, NYC; USPO, Laurinsburg, N.C. Illustrator: "Peter and Penny of the Island," 1941. WPA artist. [47]

TAIT, Arthur Fitzwilliam [P] Yonkers, NY/Adirondacks, NY (Long Lake) b. 5 Ag 1819, Livesey Hall, near Liverpool, England (came to NYC in 1850) d. 28 Ap 1905. Studied: Royal Inst., Manchester, England; mostly self-taught. Exhibited: NAD; Phila. AC, 1898; Brooklyn AA. Work: Corcoran; Denver AM; Amon Carter Mus.; BM; Yale. Specialties: farm animals; sporting scenes. Many of his paintings were made as lithos by Currier & Ives, beginning 1852. He frequently collaborated on paintings with J.M. Hart. He also made a series on Indians and Western life with L. Maurer. [04]

TAIT, John Robinson [Ldscp.P] Baltimore, MD (since 1876) b. 14 Ja 1834, Cincinnati d. 29 Jy 1909. Studied: A. Weber, in Düsseldorf; A. Lier, H. Baisch, in Munich (all 1859–71). Member: Charcoal C. Exhibited: Cincinnati Indst. Expo, 1871 (med), 1872 (med). Work: Peabody Inst., Baltimore [08]

TAIT, Katharine. See Lamb.

TAIT, Nina Stirling (Mrs.) [P] NYC [13]

TAKIS, Nicholas [P,Des,T] NYC b. 22 Ag 1903, NYC d. Mr 1965. Studied: ASL; N.Y. Sch. A.; N.Y. Evening Sch. Indst. A. Member: Audubon A. Exhibited: CM, 1939; Audubon A., 1945; Salons of Am.; Valentine Gal. Work: Ind. State T. Col.; Maitland Gal., Fla.; Brooklyn Pub. Lib.; Ind. Mus. Mod. A. [47]

TAKSA, Desha A. Milcinovic [P,Ser,Des,S,T] NYC b. 3 Mr 1914, Zagreb, Yugoslavia. Studied: Acad. Zagreb, with I. Mestrovic. Member: AAPL; Greenwich SA. Exhibited: AAPL, 1940–42; A. Dir. C. Traveling Exhb., 1930–36; Arden Gal., 1943; Dance Intl., N.Y., 1940; Witte Mem. Mus., 1944 (one-man); Kansas City, Mo.; Oakland A. Gal., 1943; Dallas Mus. FA, 1944; LOC, 1946; Morgan Lib., New Haven, Conn., 1946; Greenwich, Conn., 1946. Work: Greenwich Lib.; Witte Mem. Mus., San Antonio. Illustrator: "Adventures in Monochrome" [47]

TALBERT, Zel E. [P] West Elkton, OH b. 14 Jy 1869 [06]

TALBOT, Catherine P. [P] Portland, OR [98]

TALBOT, Cornelia Brackenridge (Mrs. M. W.) [P] Norfolk, VA b. 30 D 1888, Natrona, PA d. 24 Mr 1925, Natrona. Studied: PAFA; H. Breckenridge; Carnegie Tech. Inst. Exhibited: Pittsburgh AA, 1916 (prize) [24]

TALBOT, Grace Helen [S] Syosset, NY b. 3 S 1901, North Billerica, MA. Studied: H.W. Frishmuth. Member: NSS; NAWA. Exhibited: Arch. L., 1922 (prize); NAWA, 1925 (med) [47]

TALBOT, Henry S. [P] Boston, MA. Member: Boston AC. Work: Minneapolis Inst. A. [25]

TALBOT, Jarold Dean [P,T,L] Peoria, IL b. 28 Ag 1907, Solano, NM. Studied: Drake Univ.; Cumming Sch. A.; Grand Central Sch. A.; Tiffany Fnd.; I. Olinsky. Member: Peoria A. Lg. Exhibited: Iowa State Fair, 1936 (prize), 1940 (prize); Cornell Col., Mt. Vernon, Iowa, 1940 (prize); All-Iowa Exh., Chicago, 1937 (prize); Carson Pirie Scott Co., Chicago, 1937 (prize); 48 States Comp., 1939; Nat. Exh. Am. A., N.Y., 1937; NAD, 1938; CGA, 1940; Kansas City AI, 1942; Joslyn Mem., 1936. Work: panels, Iowa State Hist. Bldg. Positions: T., Grand Central Sch. A. (1930s), Ottumwa A. Center (1939–42), Bradley Polytechnic Inst., Peoria, Ill.; WPA Supv., Des Moines, Iowa [47]

TALBOT, Sophia Davis [P,L,T] Mattoon, IL b. 13 Ap 1888, Boone County, IA. Studied: State Univ. Iowa; Cumming Sch. A. Member: AAPL; Soc. for Sanity in Art; A. Gld. of Eastern Ill.; All-Ill. Soc. FA. Exhibited: Wawasee A. Gal., 1942 (prize), 1943; Women Painters of Am., Wichita, Kans., 1938; Denver A. Mus., 1941; All-Ill. Soc. FA, 1939–41; Central Ill. A., 1943, 1944; Drake Hotel, Chicago, 1942 (one-man); Eastern Ill. T. Col., 1942 (one-man); Matoon, Ill., 1942 (one-man). Work: Hawthorne Sch., Lincoln Sch., both in Mattoon, Ill.; mural, Nat. Bank of Mattoon. Position: T., Univ. Iowa, 1940 [47]

TALBOTT, Katharine [S] Berkeley, CA b. 18 Ja 1908, Wash., D.C. Studied: H.P. Camden; A. Fairbanks; R. Laurent. Exhibited: Exh. of Oreg. Artists, Sculptors and Designers, Portland Mus. Art, 1932 (prize) [40]

TALCOTT, Allen Butler [Ldscp.P] NYC/Old Lyme, CT b. 8 Ap 1867, Hartford, CT d. 1 Je 1908, Old Lyme. Studied: Trinity Col., 1890; ASL; Paris, with Laurens, Benjamin-Constant. Member: SC, 1901. Exhibited: NAD, 1898; St. Louis Expo, 1904 (med) [08]

TALCOTT, Dudley Vaill [S,I,W,P] Farmington, CT b. 9 Je 1899, Hartford, CT. Exhibited: AIC, 1940; Dudensing Gal., 1947; MOMA, 1930; WMAA, 1937; Grace Horne Gal., Boston; Phillips Acad., Andover. Author/Illustrator: "Noravind," 1929; "Report of the Company," 1936 [47]

TALCOTT, Sarah W(hiting) [P] Elmwood, CT b. 21 Ap 1852, West Hartford, CT d. 21 Jy 1936. Studied: N.Y., with Chase, Cox; Paris, with Bouguereau, Robert-Fleury. Member: CAFA; Hartford AC [38]

TALFOURD, Florence L. [P] Roselle, NJ [98]

TALIAFERRO, Elizabeth Stewart (Mrs. W.F.) [P] Nuttall, Gloucester County, VA b. 18 Ja 1869, Newark, NJ. Studied: ASL. Member: SSAL. Exhibited: SSAL, Montgomery, Ala., 1938 [40]

TALIAFERRO, Lucene. See Goodenow.

TALLANT, Richard H. [Ldscp.P,I] Devil's Gulch, Estes Park, CO (since 1891) b. 1853, Zanesville, OH d. 1934. Studied: self-taught. Member: Denver AC, 1886–87 [*]

TALLMADGE, Thomas Eddy [E] Evanston, IL b. 24 Ap 1876, Wash., D.C. Studied: MIT. Member: Cliff Dwellers; Chicago SE; NAD; AIC Alumni; F., AIA; Plan Comm., City of Evanston; Governing Life Member AIC. Work: Cliff Dwellers C., Chicago. Author: "Story of Architecture in America," "Story of England's Architecture." Positions: Chairman, Bd. Art Advisors, State of Ill.; Advisory Comm. of Architects, Restoration of Williamsburg, Va.; Dir., Historical Am. Bldg. Survey [40]

TALLMAN, M(artha) G(riffith) (Mrs. Walter B.) [P] NYC/Kent, CT b. 22 S 1859, Llanidloes, North Wales d. 12 My 1930, NYC. Studied: F.S. Church; NAD; ASL; Mrs. Coman; J. Peterson. Member: Pen and Brush C.; NYWCC; NAWPS; AFA [29]

TALLON, William John [S,I,P,L] Chicago, IL/Manchester, CT b. 22 Ap 1917, Manchester. Studied: Univ. Chicago. Exhibited: Ar. Chicago, Vicin. Ann., AIC, 1939; Big 10 Traveling Exhib., 1939 [40]

TAM, Reuben [P,G,T] NYC b. 17 Ja 1916, Kappa, Kauai, HI. Studied: Univ. Hawaii; Calif. Sch. FA; Columbia; New Sch. Soc. Research. Member: Honolulu AA; Honolulu Pr.M.; Nat. Serigraph Soc. Exhibited: GGE, 1939 (prize); IBM Coll. (prize); Honolulu AA, 1939 (prize), 1941 (prize); Honolulu Pr.M., 1940 (prize); Nat. Exh. Am. A., 1938; VMFA, 1940, 1946; PAFA, 1945, 1946; CI, 1944, 1945; Los Angeles Mus. A., 1945; Albright A. Gal., 1946; WFNY, 1939; Pal. Leg. Honor, 1940 (one-man); Crocker A. Gal., 1940 (one-man); Downtown Gal., N.Y., 1945 (one-man). Work: IBM Coll.; Honolulu Acad. A.; Massillon Mus. A.; NYPL [47]

TAMOTZU, Chuzo [P] NYC (from 1948 he lived in John Sloan's old studio

in Santa Fe, N.Mex.) b. 19 F 1891, Kagoshima, Japan (came to NYC in 1920) d. 1975, Santa Fe. Studied: self-taught. Member: A. Equity (founder); Am. A. Cong. Exhibited: WPA Art Exh., Parsons Sch. Des., NYC, 1977. Work: Field Fnd., NYC; Berkshire Mus., Pittsfield, Mass. [40]

TANAKA, Yasushi [P,T] Seattle, WA b. Japan. Member: Seattle FAS [24]

TANBERG, Ella Hotelling (Mrs.) [P] Hollywood, CA/Laguna Beach, CA b. Janesville, WI d. 6 Ap 1928. Member: West Coast Arts Inc.; Janesville AL; Chicago AC; Calif. AC; Laguna Beach AA. Work: Janesville A. Lg. [27]

TANDLER, Rudolph (Frederick) [P,Lith,T] The Principia College, Elsah, IL/Woodstock, NY b. 22 Mr 1887, Grand Rapids, MI. Studied: G. Bellows; J. Sloan; A. Dasburg. Member: S.Indp.A., S. Louis; New Hats; St. Louis AG; Woodstock AA. Exhibited: Detroit AI, 1930 (gold); City Mus. St. Louis (prize). Position: T., Principia College [40]

TANEJI, Moichiro Tsuchiya [P] NYC b. 14 Ja 1891, Ogaki City, Japan. Studied: Japan. Member: Penquins [21]

TANNAHILL, Mary H. [Min.P] NYC/Provincetown, MA b. Warrenton, NC. Studied: N.Y., with Weir, Twachtman, Cox, Mowbray. Member: Pa. S. Min. P.; NAWPS; Provincetown AA; NYSWA. Exhibited: NAWPS, 1914 (prize), 1932 (prize); NYWCC, 1898. Work: Newark (N.J.) Mus.; Bibliothèque Nationale, Paris [40]

TANNAHILL, Sallie B. [B,I,L,T,W] NYC b. 25 O 1881, NYC d. 29 Ja 1947, Youngstown (Ohio) Hospital. Studied: A.W. Dow; V. Preissig. Author: "Ps and Qs," "Fine Arts for Public School Administrators." Position: T., Columbia, for 35 years [40]

TANNAR, Harold D. [P,T] East Orange, NJ. Member: A. Center of the Oranges. Exhibited: N.J. State Exh., Montclair Mus., 1936 (prize). Position: T., Adult Edu., East Orange [40]

TANNER, H(enry) O(ssawa) [P] Paris, France/Trépied, par Etaples, Calais, France b. 21 Je 1859, Pittsburgh d. 25 My 1937. Studied: PAFA, with Eakins, 1880–82; Paris, with Laurens, Constant, 1891. Member: ANA, 1909; NA, 1927 (the first Black artist to be elected); Paris SAP; Soc. International de Peinture et Sculpture. Exhibited: Paris Salon, 1896 (prize), 1897 (prize), 1900 (med), 1906 (med); Paris Expo, 1900 (med); Pan-Am. Expo, Buffalo, 1901 (med); St. Louis Expo, 1904 (med); AIC, 1906 (prize); P.-P. Expo, San Fran., 1915 (gold); Grand Central Gal., 1930 (prize). Work: Luxembourg Mus., Paris; CI; PAFA; AIC; Wilstach Coll., Phila; Hackley A. Gal., Muskegon, Mich.; Des Moines Assn. FA; Los Angeles Mus. A.; Mus. African A. (lg. coll.), Fred Douglass Inst, Wash., D.C. Specialty: Biblical subjects. He was one of the first Negro artists to achieve fame, attaining national eminence as a painter when his "Rising of Lazarus" was purchased by the French gov. in 1897 for the Luxembourg Mus. His choice of religious subjects was a reflection of early training, for his father was a Bishop of the African Methodist Episcopal Church. [33]

TANNER, W. Charles [P] St. Charles, IL [13]

TANNING, Dorothea (Mrs. Max Ernst) [P,S] Paris, France (since 1950s) b. 1913, Galesburg, IL. Studied: AIC, 1933. Exhibited: J. Levy Gal., NYC, 1942. A surrealist. She and Max Ernst lived in NYC and Ariz. before settling in Paris. [*]

TAPLEY, J.J. Wooding [P] Belfast, ME [15]

TAPP, Marjoire D. [P] Shawnee, OK. Member: Okla. AA [27]

TAPPAN, Roger [P] Boston, MA. Member: B. A. Students' Assn., 1898; Boston AC. Exhibited: PAFA, 1898 [98]

TAPPAN, William Henry [Engr,Dr,W] Manchester, MA (since 1876) b. 30 O 1821, Manchester d. 22 Ja 1907. Work: Wis. Hist. Soc.; Amon Carter Mus. Made topographical drawings on Agassiz' expedition to Lake Superior, 1848; in Oreg., 1849; in Clark County, Wash., 1850–76; then returned to his hometown, whose history he wrote. [*]

TARBELL, Edmund C(harles) [P,T] New Castle, NH/Boston, MA (winters) b. 26 Ap 1862, West Groton, MA d. 1 Ag 1938. Studied: Boston Normal A. Sch.; BMFA Sch., with O. Grundmann, 1879; Académie Julian, with Boulanger, Lefebvre; W.T. Dannat, in Paris, all 1883–88. Member: ANA, 1904, NA, 1906; Boston GA; Ten Am. Painters; U.S. Public A. Lg., 1896; National A. Comm., Wash., D.C. Exhibited: NAD, 1890 (med), 1894 (prize), 1908 (med), 1929 (med); SAA, 1893 (prize); PAFA, 1895 (gold,prize), 1896 (prize), 1908 (med), 1911 (med); AC Phila., 1895 (gold); Tenn. Expo, Nashville, 1897 (prize); WMA, 1900 (prize), 1904 (prize); Boston Charitable Mechanics' Assn. (med); Paris Expo, 1900 (med); CI, 1901 (prize), 1904 (prize), 1909 (prize), 1928–29 (prize); AIC, 1907 (prize); CGA, 1910 (prize); P.-P. Expo, San Fran., 1915 (prize); Newport AA, 1935 (prize); St. Botophe C., Boston, 1898 (one-man); mem. exh., BMFA, 1938. Work: CGA; Cincinnati Mus. A.; RISD; BMFA; WMA; PAFA; Wilstach Coll., Phila.; FA Acad., Buffalo; War Dept., Wash., D.C.; Butler AI; Mass. Senate Chamber, State House, Boston; Smith Col. He was considered the leader of the Boston Impressionists, and his numerous devout students were called "Tarbellites." Positions: T., BMFA Sch. (1889–1913), Corcoran Sch. A. (1917–22) [38]

TARKINGTON, Booth [I,W] Richmond, IN b. 29 Jy 1869, Indiana d. 1946. Studied: Princeton, 1893. An illustrator, although best known for his many novels, including "The Gentleman from Indiana," 1899; "The Two Vanrevels," 1902; "Alice Adams," and many others, including one on collecting art. [08]

TARLETON, Mary Lightfoot (Mrs. Bernhard Knollenberg) [S] New Haven, CT b. 9 Je 1904, Great Neck, NY. Studied: M. Young. Member: Am. Ar. Cong.; S. Gld. Exhibited: S. Gld., N.Y., 1938, 1939; WFNY, 1939 [40]

TARLETON, Mary Livingston [Ldscp.P,Min.P] Great Neck, NY b. Stamford, CT. Studied: Hassam; C.W. Hawthorne; W.M. Chase; ASL. Member: NAWPS [31]

TARR, A.R. [P] Phila. PA [06]

TASKEY, Harry Le Roy [I,B,T] NYC/Milford, NJ b. 12 Je 1892, Rockford, IN. Studied: ASL; Grande Chaumière, Paris; Sloan; Bridgman; Von Schlegell; H. Lever; H. Boss; B. Robinson; H. Sternberg. Member: Am. Veterans Soc. A.; Phila. SE; Ind. Soc. PM. Exhibited: BM, 1931, 1935; AIC, 1931, 1935; NAD, 1935; Tex. Centenn. Expo, 1936; PAFA, 1935; Syracuse Mus. FA, 1934; CGA, 1934; Phila. A. All., 1932; LOC, 1932; Am. Pr.M., 1932; WMAA, 1938; Am. Veterans Soc. A., 1945. Work: MMA; NYPL; Syracuse Mus. FA; Montgomery Mus. FA; Mus. City of N.Y.; John Herron AI; Wilmington Soc. FA [47]

TATE, Sally [I,P,L] NYC b. 6 Je 1908, Sewickly, PA. Studied: Vesper George Sch. A.; Parsons Sch. Des.; B. Keyes; H. Moore; J. Pillon. Member: PBC. Exhibited: children's illus., Springfield Lib. Author/Illustrator: "The Furry Bear," "The Wooly Lamb," other children's stories. Illustrator: textbooks [47]

TATLOCK, Anne Fisher [S,Por.P] Boston, MA b. 27 S 1916, Petersham, MA. Studied: A. Iacovleff; J. Sharman; BMFA Sch. Exhibited: Assn. Jr. Lgs. Am. Exhib., 1939 (prize) [40]

TATRO, Amy [Mur.P,Dec,T] Hartford, CT b. 2 Ap 1906, Hartford. Studied: Yale, with E.C. Taylor, E. Savage; M. Kantor; ASL. Position: T., MacMurray Col., Jacksonville, Ill. [40]

TATTI, Benedict [S,T] NYC b. 1 My 1917, NYC. Studied: ASL; Slobodkin; W. Zorach. Member: Brooklyn SA. Exhibited: Brooklyn SA, 1943, 1944 (prize), 1945–46; Soldier A. Exh., NGA, 1945 (prize); MMA (AV), 1942; Tribune A. Gal., 1946 (one-man) [47]

TATUM, V(ictor) Holt [B] Cincinnati, OH b. 6 Mr 1894, Cincinnati. Studied: C.W. Boebinger [32]

TAUBE, Walter [P] Minneapolis, MN [24]

TAUBER, James [Des] NYC b. 1876 d. 13 F 1912. Designer: floats for the Hudson–Fulton celebration; original scenery for the Hippodrome pageant

TAUBES, Frederic [P,E,T,Li,W,L,Cr] NYC b. 15 Ap 1900, Lwów, Poland (or Lemberg, Austria). Studied: Munich A. Acad., with F. von Stuck; M. Doerner; Bauhaus, in Weimar, with J. Itten; Acad. Vienna; schools in Florence; Paris. Exhibited: CI, 1936–46; CGA, 1936–46; PAFA, 1935–44; VMFA, 1938–46; AIC, 1935–46. Work: SFMA; W.M.R. Nelson Gal.; MMA; San Diego FA Soc.; Santa Barbara Mus. A.; de Young Mem. Mus.; High Mus. A.; Mills Col., Oakland, Calif.; A. Assn., Bloomington, Ill. Author: "The Technique of Oil Painting," 1941, "You Don't Know What You Like," 1942, other books. Contributor: American Artist, Taubes Page. Positions: T., Univ. Ill. (1940–41), Mills Col., (1938), Univ. Hawaii (1939), CUASch (1943), Univ. Wis. (1945) [47]

TAUCH, Waldine [P,S,T] San Antonio, TX b. 28 Ja 1892, Schulenburg, TX. Studied: P. Cappini. Member: NAWA; SSAL; NAWPS; Soc. Western Sculptors; AAPL. Exhibited: SFMA; NAD; NAWA. Work: Witte Mem. Mus.; Wesleyan Col., Macon, Ga.; mon., City Hall Square, San Antonio; Canton, Tex.; Gonzales, Tex.; Bedford, Ind.; Richmond, Ky.; mem., Winchester, Ky.; George Washington Jr. H.S., Mount Vernon. Positions: T., Trinity Univ. (San Antonio), Acad. A. (San Antonio) [47]

TAUSEND, Henry C. [P] Niles, MI [15]

TAUSEND, Henry E. [P] Norwood, OH [13]

TAUSZKY, D(avid) Anthony [Por.P] Altadena, CA b. 4 S 1878, Cincinnati d. 26 F 1972, Pasadena, CA. Studied: ASL, with Blum; Académie Julian, Paris, with Laurens, Constant. Member: SC, 1907; CAFA; Allied AA; Laguna Beach AA; Southern Calif. PS; Pasadena SA; Grand Central AG. Exhibited: Pasadena AI, 1928 (prize); Santa Ana, 1928 (prize); Allied AA, 1929 (prize); SC, 1929 (prize); CAFA, 1931 (prize); Civic Art Exh., Pasadena, 1937 (prize). Work: Criminal Court, Vienna; portraits, Wingate Sch., Haaren H.S., both in NYC; Denver AM; Mutual Fire Insurance Bldg., Hartford, Conn. [40]

TAVERNIER, Jules [P,I] b. 1844, Paris (came to NYC ca. 1871) d. 1889 Honolulu (alcoholism). Studied: Paris, with F. Barries. Member: Bohemian C., San Fran., 1874. Exhibited: Paris Salon, 1865–70. Illustrator: New York Graphic, Harper's. Teamed with P. Frenzeny on Western sketching tour for Harper's; settled in San Fran., 1874–84. Perhaps San Francisco's most popular "bohemian"; constant debts forced him to leave. [*]

TAVSHANJIAN, Artemis (Mrs. Charles A. Karagheusian) [P,Min.P] NYC b. 18 Je 1904, Englewood, NJ. Studied: M.R. Welch; R.G. Eberhard. Member: ASMP; NAWA. Exhibited: NAWA, 1933 (prize); Grand Central Gal., 1933 (prize), 1939 (prize). Work: Wellesley Col. [47]

TAYLOR, Alice Bemis (Mrs. F.M.P.) [Patron] Colorado Springs, CO b. 22 Je 1942. She was responsible for having the Colorado Springs FA Center built. It opened in 1936.

TAYLOR, Anna Heyward [P,C,Dec,B] Charleston, SC b. 13 N 1879, Columbia SC d. 1956. Studied: S.C. Col. for Women; Univ. S.C.; W. Chase; C. Hawthorne; DuMond; W. Lathrop; Nordfeldt; Meijer. Member: N.Y. Soc. Craftsmen; SSAL; Carolina AA; NAWA; Phila. Pr. Cl.; Am. Color Pr. Soc. Exhibited: WFNY, 1939; Phila. Pr. Cl., 1937 (prize); PAFA; NAD; SSAL. Work: IBM Coll.; PMA; FMA; Berkshire Mus. A., Pittsfield, Mass.; Charleston Mus. A.; des./textiles, AMNH; Brooklyn (N.Y.) Botanic Gardens Coll. Specialties: textiles; screens [47]

TAYLOR, Beatrice M. [P] Pittsburgh, PA. Member: Pittsburgh AA [21]

TAYLOR, Benjamin John [P,Des] Fairfield, IA b. 3 Ap 1908, Fairfield. Exhibited: Iowa A. Sal., 1928 (prize), 1929, 1937. Position: Staff, Fairfield Daily Ledger [40]

TAYLOR, Bertha Fanning [P,L,W,T,Cr,Mus.Cur] Norfolk, VA/NYC b. 30 Jy 1888, NYC. Studied: CUASch; Sorbonne, Univ. de Montpellier, Ecole du Louvre, all in Paris; M. Denis; G. Desvallieres. Member: CAA; PBC; Pan-Am. Women's Assn. Exhibited: Paris Salon, 1937 (med); PBC 1942 (med), 1944, 1945; Société National des Beaux-Arts, Salon d'Automne, Salon des Tuileries, Salon des Artistes Indépendants, Musée du Jeu de Paume, all in Paris; Ferargil Gal., 1940; Garden City Community Cl., 1941 (one-man); Harlow Gal., 1944; Sharon Conn., 1941 (one-man). Work: triptych, Chapel Benmoreel Protestant Church, Norfolk; many portraits. Positions: L., Louvre Mus., Paris, 1930–39; A. Cr., New York Herald-Tribune's Paris Edition, 1930–32, 1932–39; Cur., The Hermitage Fnd. Mus., Norfolk [47]

TAYLOR, Bessie Barrington [P] Bradenton, FL/Andalusia, AL b. 9 D 1895, Rutledge, AL. Studied: Univ. Ala.; Ala. State T. Col.; Ringling Sch. A. Member: SSAL; A. Lg., Manatee County, Bradenton. Exhibited: SSAL, Montgomery, Ala., 1938. Work: Benjamin Mus., Ellenton, Fla. [40]

TAYLOR, Carol [S] NYC b. 17 Ag 1888, NYC. Studied: ASL; P. Hamon; P. Landowski, in Paris; A. Archipenko, G. Rossi, in Italy. Member: NAWPS [40]

TAYLOR, Cecelia Evans [S] Williamsville, NY b. 23 Jy 1897, Chicago. Studied: A. Lee. Member: Buffalo SA; The Patteran. Exhibited: Albright A. Gal., 1932 (prize), 1933 (prize); Ar. Western N.Y. Exh., 1937 (prize) [40]

TAYLOR, Charles Andrew [P,E] Phila., PA b. 15 D 1910, Phila. Studied: Graphic Sketch C. Member: DaVinci All.; Phila. A. All; Phila. WC Cl.; Pen & Pencil Cl. Exhibited: CI, 1941, 1942; PAFA, 1930, 1933, 1939; CGA, 1939; Phila. WC Cl., 1929–42; AIC, 1941. Work: Graphic Sketch Cl., Phila.; U.S.S. Saratoga [47]

TAYLOR, Charles Jay [I,P,Ldscp.P,T] Pittsburgh, PA b. 11 Ag 1855, New York d. 18 Ja 1929. Studied: ASL; NAD; E. Johnson, in NYC; London; Paris. Member: SI, 1910; Pittsburgh AA; Pittsburgh Arch. Cl.; The Players; Phila. AC; SC. Exhibited: drawing, Pan-Am. Expo, Buffalo, 1901 (prize); P.-P. Expo, San Fran., 1915 (med, hors concours [jury of awards]); Sesqui-Centenn. Expo, Phila., 1926 (med). Work: CI. Illustrator: "The Taylor-Made Girl," "Short Sixes," by H.C. Bunner, "England," other books. Position: T., Carnegie Technical Schools, Pittsburgh, 1911–29 [27]

TAYLOR, Charles M., Jr. [P] Phila., PA. Studied: PAFA [25]

TAYLOR, Cora Blin (or Bliss) [P,L,T] Saugatuck, MI b. 14 Ap 1895, Cincinnati. Studied: AIC; ASL; L. Seyffert; L. Kroll; C. Hawthorne; Lhote. Member: Chicago Gal. A. Exhibited: AIC, 1925 (prizes), 1930 (prize); Detroit Inst. A.; AIC; Minneapolis Inst. A. Work: Chicago Pub. Sch.; FA Bldg. Assoc., Chicago. Position: Dir., Taylor Art Sch. [47]

TAYLOR, Edgar Dorsey [P,T] Berkeley, CA b. 15 Jy 1904, Grass Valley, CA. Studied: Univ. Calif. Member: San Fran. AA. Exhibited: San Fran. AA, 1936, 1937 (med), 1938, 1939, 1943–46; Tex. FA Assn., 1942 (prize), 1944 (prize); SFMA, 1945, 1946; AFA Traveling Exh., 1940; CI Traveling Exh., 1940; GGE, 1939; Tex. General Exh., 1941–43. Position: T., Univ. Calif., Berkeley, 1945–46 [47]

TAYLOR, Edgar J. [P,I] Westbrook, CT b. 22 Ag 1862, Brooklyn, NY. Studied: NAD; ASL, with Beckwith; Brooklyn A. Gld., with Eakins. Member: Brooklyn AC; CAFA; S.Indp.A.; AAPL [31]

TAYLOR, Edith Belle (Mrs. W.M.) [P] Columbus, OH. Exhibited: WC Ann., PAFA, 1936; Butler AI, 1939 [40]

TAYLOR, Edward DeWitt [P,E,Des] San Fran., CA b. 17 Je 1871. Studied: A. Hansen; G. Piazzoni. Member: Calif. SE; San Fran. AA; Am. Inst. GA. Exhibited: print, Calif. Soc. E., 1937 (prize). Work: SFMA. Designer: books. Position: Des., Taylor and Taylor, printers, San Fran. [40]

TAYLOR, Edwin C(assius) [P,T] New Haven, CT/Liberty, ME b. 10 Mr 1874, Detroit d. 27 N 1935. Studied: ASL; Kenyon Cox. Member: New Haven PCC. Work: dec., (with K. Cox) LOC. Many of his students won the Fellowship of the American Academy in Rome. Position: T., Yale, 1908–35 [33]

TAYLOR, Elizabeth Shuff [P] New Berlin, IL/Provincetown, MA. Member: Chicago SA; S.Indp.A.; Provincetown Printers. Work: Detroit Inst. [33]

TAYLOR, Elizabeth V. [Min.P] Cambridge, MA b. New Jersey. Studied: BMFA Sch., with Tarbell, De Camp. Member: Boston A. Students' Assoc., 1887; Copley S., 1887. Exhibited: Poland Springs Art Gal., 1898; PAFA, 1898; Phila. AC, 1898; BMFA (prize); Nashville Expo, 1897 (med) [10]

TAYLOR, Elizabeth Wheeler [S,P] Scranton, PA b. 12 Jy 1905, Scranton. Studied: Mt. Holyoke Col.; Yale; PAFA; Fontainebleau Sch., France; P.P. Jennewein. Member: Lackawanna County AA. Position: Dir., Everhart Mus. Hist., Sc.&A., Scranton [40]

TAYLOR, Emily (Heyward) Drayton (Mrs. J.M.) [Min.P,P] Phila., PA b. 14 Ap 1860, Phila. d. 19 Je 1952 (age 92). Studied: C. Ferrère, in Paris; PAFA. Member: Pa. Soc. Min. P.; Plastic C.; Alliance; AFA. Exhibited: Phila. WCC, 1898; Earl's Court Expo, London, 1900 (gold); for services on Jury, Charleston Expo, 1902 (gold); P.-P. Expo, San Fran., 1915 (med); PAFA, 1919 (med), 1920 (prize), 1924 (prize). Co-author: with Miss Wharton, "Heirlooms in Miniature." Work: portraits, Pres. and Mrs. McKinley; Dr. S. Weir Mitchell, George Hamilton, Cardinal Mercier [40]

TAYLOR, Ethel C. [P] NYC/Schroon Lake, NY b. Taylor's-on-Schroon, NY. Studied: K.H. Miller. Member: Artists Gld. Illustrator: Vanity Fair, Vogue, Town and Country, Scribner's, Harper's, Theatre, New York Times, New York Sun, New York Herald Tribune [40]

TAYLOR, Farwell M. [P] San Fran., CA b. 19 O 1905, Oklahoma. Studied: Calif. Sch. FA; P.L. Labaudt. Exhibited: Intl. WC Ann., AIC, 1938; San Fran. AA, 1937–39 [40]

TAYLOR, Frances [P] Brooklyn, NY [19]

TAYLOR, Francis Henry [Mus.Dir,Cr,W,L] NYC/Stonington, CT b. 23 Ap 1903, Phila. d. 22 N 1957, Worcester, MA. Studied: Univ. Pa.; Tufts; Amherst; Yale; Europe. Member: Am. Acad. A.&Sc., Boston. Awards: Carnegie F., Princeton Univ., 1926–27; F., Guggenheim Fnd., 1931; Commander Royal Order of Vasa (Sweden); Chevalier Order of the Crown (Belgium); Commander Order of Merit (Ecuador). Positions: Cur., Mediaeval A., PMA, 1927–31; Dir., WMA, 1931–40, MMA, 1940– ; Chm., Advisory Comm., Walters A. Gal., Baltimore, 1934–44; Regional Dir., New England States, WPA, 1933–34, Nat. Council for A. Week, 1940 [47]

TAYLOR, Frank H(amilton) [I] Phila., PA b. 21 Ap 1846. Member: Phila. Sketch C. [13]

TAYLOR, Frank J. [P] NYC. Member: S.Indp.A. [21]

TAYLOR, F(rank) Walter [I] Phila., PA/Frontenac, Jefferson County, NY b. 8 Mr 1874, Phila. d. Summer 1921. Studied: PAFA; Paris. Member: SI, 1905; Phila. WCC. Exhibited: P.-P. Expo, San Fran., 1915. Illustrator: "Fisherman's Luck," by H. Van Dyck, "Marriage à la Mode," by Mrs. Humphry Ward, "The Iron Woman," by M. Deland [19]

TAYLOR, Grace Martin [B,T] Morgantown, WV/Provincetown, MA b. Morgantown, 1903. Studied: PAFA, with Breckenridge, A.B. Carles, Garber, H. McCarter; B. Lazzell; F. Pfeiffer; H. Hofmann [*]

TAYLOR, Harriet Ward Foote (Mrs. Herbert A.) [Des] Cleveland, OH/Little Compton, RI b. 11 S 1874, Guilford, CT. Studied: M. Ware; Hartford Art Sch. Member: Boston SAC; N.Y. Needle and Bobbin Cl.; Tex. AC of Cleveland. Specialty: embroideries [40]

TAYLOR, Helen Campbell [P] Chicago, IL b. 7 F 1900, Chicago. Studied: W. Reynolds; G. Oberteuffer; H. Amiard Oberteuffer. Exhibited: Ar. Chicago Vicinity Ann., AIC, 1936, 1938, 1939 [40]

TAYLOR, Helen J(ackson) [P] Barrington, IL b. 14 Ap 1903, Kenilworth, IL. Studied: AIC. Exhibited: Ar. Chicago Vicinity Ann., AIC, 1929. Work: Joseph Sears Pub. Sch., Kenilworth [40]

TAYLOR, Helena M. [P] Phila., PA. Studied: PAFA [21]

TAYLOR, Henry Fitch [P] Cornish, NH b. 15 S 1853, Cincinnati d. 10 S 1925, Plainfield, NH. Studied: Académie Julian, Paris, with Boulanger, Lefebvre, 1880s. Member: SAA, 1891; NAC; Am. PS. Exhibited: Phila.; London; Paris; Rome; Chicago; San Fran.; Armory Show, 1913. Author: "The Taylor System of Organized Color" [25]

TAYLOR, Henry Weston [I,T,Des] Chester, PA b. 11 My 1881, Chester. Studied: PAFA, with McCarter, Breckenridge; Drexel Inst. Member: Phila. AC. Illustrator: Saturday Evening Post, Cosmopolitan, Good Housekeeping [47]

TAYLOR, Henry White [P,T,I] Clearwater, FL/Quakertown, PA b. 22 Ag 1899, Otisville, NY d. 3 O 1943, Atlanta, GA. Studied: Mass. Sch. A.; PAFA; H. Breckenridge, in East Gloucester, Mass. Member: AAPL; Phila. Alliance; Fla. Fed. A. Exhibited: Chester County AA, 1934 (prize), 1935 (prize). Position: Dir., AM, Mus. Sch. A., Clearwater [40]

TAYLOR, Hilda Grossman [I] Riverdale, NY. Member: SI [27]

TAYLOR, Horace [P,I] NYC b. 1864 d. 18 S 1921, Swamp Lake, WI. Illustrator: newspapers. Specialty: watercolors [08]

TAYLOR, Ida C. [Por.P,P] Le Roy, NY b. Le Roy. Studied: W.M. Hunt; Académie Julian, Paris. Member: Rochester AC. Work: portraits, Hist. Mus., Buffalo; Episcopal Church, Masonic Temple, both in Le Roy; De Veaux Sch., Niagara Falls, N.Y.; Alpha Chapter House, Trinity Col., Hartford [40]

TAYLOR, James Earl [P,I] b. 12 D 1839, Cincinnati d. 22 Je 1901, NYC. Studied: Univ. Notre Dame, 1855. In 1867 he went with the Peace Commission to the Indians, and the pictures he sent from the West gained for him the name of "The Indian Artist." Position: A./Correspondent, Leslie's, 1863-83, covering the Civil War and, later, the Great Plains. From 1883 he devoted his time to illustrating for various magazines and painting in watercolor.

TAYLOR, James Earl [P,E] Boonton, NJ b. 17 D 1899, Greenfield, IN. Studied: Wittenberg Col.; Ohio State Univ.; Cincinnati AA. Member: Cincinnati AA. Exhibited: SAM, 1942; Butler AI, 1940, 1943; Hoosier Salon, 1940; CM, 1939-42 [47]

TAYLOR, James William, Jr. [P] South Bend, IN b. 8 Jy 1902, South Bend. Studied: Dartmouth. Exhibited: Hoosier Salon, 1940-42, 1943 (prize), 1944-46; John Herron AI, 1942, 1943, 1945, 1946; Butler AI, 1943, 1944; AIC, 1942-44 [47]

TAYLOR, Jean [P] San Fran., CA. Exhibited: 48 Sts. Comp., 1939 [40]

TAYLOR, John C.E. [P,Dr,T] West Hartford, CT b. 22 O 1902, New Haven, CT. Studied: Yale; Académie Julian, Paris; W. Griffin. Member: Gloucester SA; Rockport AA; North Shore AA; CAFA; Springfield A. Lg.; SC. Exhibited: Springfield AL, 1935 (prize); Palm Beach A. Center, 1935 (prize); Hartford, Conn., 1935 (prize); CGA, 1935, 1939; Pepsi-Cola, 1946; AV, 1942; Gloucester, Mass.; San Fran.; Charlotte, N.C.; Boston. Positions: T., Lawrenceville (N.J.) School (1940), Trinity Col., Hartford

TAYLOR, John H. [P] Norwalk, CT/NYC. Member: S.Indp.A. [25]

TAYLOR, John K.M. [P] Wash., D.C. Exhibited: Wash. WCC, 1933, 1934, 1937, 1939 [40]

TAYLOR, John W(illiams) [P,Li,E] Woodstock, NY b. 12 O 1897, Baltimore.
Studied: ASL; J.F. Smith; S. MacDonald-Wright; B. Robinson. Member: Woodstock AA. Exhibited: Baltimore WCC, 1939 (prize); VMFA, 1946 (med,prize); CI, 1941, 1943-45; MMA (AV), 1942; PAFA, 1942; NAD, 1945; John Herron AI, 1945, 1946; TMA, 1945; Univ. Nebr., 1945; AIC, 1934-37, 1941, 1942; BM, 1945; WMAA, 1938, 1939, 1943; WMA, 1940. Work: VMFA; MMA: WMAA; Muskegon (Mich.) Mus.; Canajoharie (N.Y.) Mus. A.; murals, USPO, Richfield Springs, N.Y.; Pub. Lib., Newark, N.J. Represented by Macbeth Gal., NYC [47]

TAYLOR, Joseph Richard [S,P,L,T] Norman, OK b. 1 F 1907, Wilbur, WA. Studied: Univ. Wash.; Columbia. Member: Assn. Okla. A. Exhibited: SAM, 1932 (prize); IBM (prize); Kansas City AI, 1932 (med), 1934 (med), 1935 (prize); Univ. Nebr., 1940 (med); PAFA, 1934, 1936-38; WFNY, 1939; AV, 1944; Oakland A. Gal., 1945. Work: Fuller A. Gal., Seattle; Univ. Nebr.; IBM Coll.; Okla. State Capitol Office Bldg.; Univ. Okla. Position: T., Univ. Okla., Norman [47]

TAYLOR, Katherine [P] Wash., D.C. [08]

TAYLOR, Katrina V.H. See Van Hook.

TAYLOR, Lawrence Newbold [B,I] Haverford, PA/Glen Moore, PA b. 26 Ap 1903, Haverford, PA. Studied: PMSchIA. Member: Phila. Sketch Cl.; Print Cl.; Phila. Alliance; Wayne Art Center. Illustrator: "To the South Seas," by Gifford Pinchot [40]

TAYLOR, Loron A. [Car] b. 1900 d. 2 Ap 1932, Cleveland, OH. Position: comic-strip work, a feature service newspaper association

TAYLOR, Margaretta Bonsall [Ldscp.P,I] Phila., PA b. 2 Ja 1880, Phila. Studied: PAFA, with W.M. Chase, C. Beaux; Ferraris Studio, Rome. Specialty: watercolors [08]

TAYLOR, Marie Carr [P] St. Louis, MO b. 22 F 1904, St. Louis. Studied: St. Louis Sch. FA; J. Farnsworth. Member: S.Indp.A., St. Louis. Exhibited: St. Louis AG Exh., City Art Mus., 1933 (prize) [40]

TAYLOR, Mary Perkins. See Perkins, Mary Smyth.

TAYLOR, Minnie C. [P] San Fran., CA [15]

TAYLOR, P(aul) F(orrester) [P,Arch] Phila., PA b. 19 D 1898, Phila. Studied: G.W. Dawson. Member: Phila. WCC; Phila. Alliance; AIA [33]

TAYLOR, Prentiss [P,Li,L,T] Arlington, VA b. 13 D 1907, Wash., D.C. Studied: ASL; C. Hawthorne; C. Locke; A. Goldthwaite. Member: A. Gld., Wash., D.C.; Wash. SE; Wash. WCC; Wash. Ldscp Cl. Exhibited: Greater Wash. Indp. Exh., 1935 (prize); VMFA, 1943 (prize); LOC, 1943 (prize); WMAA, 1945; Irene Leach Mem., 1945, 1946; AIC, 1933, and later; PAFA; Phila. Pr. Cl.; Phila. A. All.; A. Gld., Wash., D.C., 1942, 1944, 1946. Work: BMFA; AGAA; Wadsworth Atheneum, Hartford; NYPL; MMA; WMAA; PMA; BMA; PMG; LOC; VMFA; Norfolk Mus. A.&Sc.; Gibbes Mem. A. Gal.; SAM. Illustrator: "Scottsboro Limited," "The Negro Mother" [47]

TAYLOR, R. [P] Wash., D.C. [19]

TAYLOR, R.B. [P] Toledo, OH. Member: Artklan [25]

TAYLOR, Ralph [P,T] Phila., PA b. 18 Ja 1897, Russia. Studied: Graphic Sketch Cl.; PAFA, with H. McCarter; abroad. Member: Phila. Graphic Sketch Cl.; All.A.Am.. Work: PAFA; La France AI; Graphic Sketch Cl. Exhibited: CGA; NAD; PAFA; Rochester Mem. A. Gal.; All.A.Am., 1944; Phila. AC, 1928; Bower Gal., N.Y., 1930 (one-man); Woodmere A. Gal.; Graphic Sketch Cl.; State T. Col., Indiana, Pa. [47]

TAYLOR, Renwick [P] Brooklyn, NY b. 24 Ag 1898. Exhibited: Nat. Gal., Wash., D.C., 1930 (prize). Award: Pulitzer traveling scholarship, 1925. Work: dec., Foxwood Sch., Flushing, N.Y. [33]

TAYLOR, Richard [Car] Bethel, CT b. 18 S 1902, Fort William, Canada. Studied: Ontario Col. A.; Los Angeles Sch. A.&Des. Cartoonist: New Yorker, Saturday Evening Post, Collier's [40]

TAYLOR, R(olla) S. [Ldscp.P,E,T] San Antonio, TX b. 1874, Galveston, TX. Studied: San Antonio A. Lg.; J. Arpa; San Fran., with A.W. Best; F. Fursman, in Mich.; J. Onderdonk. Member: Tex. FAA; Chicago NJSA; San Antonio A. Lg.; San Antonio AG; AFA [40]

TAYLOR, Roy W. [Car] Wash., D.C. b. 1882 d. 21 O 1914. Positions: Car., Philadelphia North American; Staff, New York World, Chicago Tribune

TAYLOR, Ruth P(ermelia) [P,En,T] Brooklyn, NY b. 21 Mr 1900, Winsted, CT. Studied: PIASch; ASL; J. Freeman; G. Bridgeman; K. Nicolaides. Member: NAWA; Brooklyn SA. Exhibited: NAWA, 1935, 1937, 1938, 1941, 1942, 1944-46; NYWCC, 1936; AWCS, 1937; LOC, 1944; BM, 1941-46; Fifteen Gal., 1940 (one-man); Argent Gal., 1937-46; Newark

A. Sch., 1938–45. Positions: T., PIASch (1925–), Newark A. Sch. (1926–45) [47]

TAYLOR, Sarah C. [P,T] Phila., PA. Studied: PAFA [25]

TAYLOR, Thomas [P,Dec] Brooklyn, NY b. 1854, Scotland d. Je 1915. Position: T., Pratt Inst.

TAYLOR, Virginia. See Snedeker.

TAYLOR, Walter [I] Phila., PA b. 8 Mr 1874, Phila. Studied: PAFA; Europe. Member: SI [08]

TAYLOR, William Francis [P,I,Li] Lumberville, Bucks County, PA b. 26 Mr 1883, Hamilton, Ontario. Member: SC; Asbury Park Soc. FA. Exhibited: Province of Ontario, 1902 (med); SC, 1924 (prize), 1927 (prize), 1932 (prize); Phila. AC, 1924 (prize). Work: Phila. Art Alliance [40]

TAYLOR, W(illiam) L(add) [I,P] Wellesley, MA b. 10 D 1854, Grafton, MA d. 26 D 1926. Studied: ASL; Boulanger, Lefebvre, both in Paris. Member: SI, 1905; Copley S., 1907. Exhibited: Armory Show, 1913. Work: Kendall Whaling Mus. Series of illustrations: "The 19th Century in New England," "The Pioneer West," "Pictures from the Psalms," "Pictures from the Old Testament," "Our Home and Country." Also a popular illustrator for Ladies Home Journal, where his pictures were reproduced as prints and mass-distributed. Specialty: biblical subjects [25]

TAYLOR, William Lindsay [P,S] Woodside, NY b. 8 Ag 1907, Paisley, Scotland. Studied: ASL; BAID; Nicolaides; Miller; Sloan; Tiffany Fnd., Oyster Bay, NY. Exhibited: PAFA, 1934–41; VMFA, 1939, 1940; GGE, 1939; AV, 1942; Pepsi-Cola, 1945; Arch. Lg., 1936; ASL. Work: ASL; mural, St. Zephrin Church, La Tuque, Quebec [47]

TAYLOR, William N(icholson) [P,Arch] NYC b. 22 Ja 1882, Cincinnati. Studied: L. Bernier. Member: Mural P.; NSS; BAID; Beaux-Arts Architects; Société des Architects Français; Lyme AA [33]

TAYLOR, Will(iam) S. [Mur.P,T] Providence, RI/Lyme, CT b. 27 N 1882, Ansonia, CT. Member: AIA; Mural P.; SC; Allied AA; CAFA; Providence AC; Lyme AA. Work: sixteen panels relating to early life of Alaskan and British Columbian Indians, and three murals showing development of man through material culture, J.P. Morgan Mem. Hall, AMNH; murals, City Park Chapel (Brooklyn, N.Y.), Providence Street Jr. H.S. (Worcester, Mass.). Position: T., Brown Univ. [40]

TAYLOR, William Watts [C,Patron] Cincinnati, OH b. 1846 d. 12 N 1913. Member: Cincinnati Mus. Assn. Award: honorary degree, Harvard. Position: Pres., Rookwood Pottery Co.

TAYLOR, Wynne Byard (Mrs. Edward J.) [S] South Londonderry, VT b. 1904, NYC. Studied: Bourdelle; Archipenko; Laurent. Member: NAWPS [40]

TEAGUE, Donald [P,I] Encino, CA (1980) b. 27 N 1897, Broookyn, NY. Studied: ASL, 1916–17 with DuMond, Bridgman; London, with N. Wilkinson, 1918; again at ASL, with D. Cornwell, 1919–20. Member: NA, 1948; AWCS; Audubon A.; All.A.Am. Exhibited: MET; BM; AIC; TMA; CAFA; Stendahl Gal., Los Angeles, 1944 (one-man); NAD, 1932 (prize); New Rochelle AA, 1935 (prize); SC, 1936 (prize), 1939 (prize); AWCS, 1944 (prize). Illustrator: Collier's, Saturday Evening Post [47]

TEAGUE, Walter Dorwin [I,Adv.A,Des] River House, NY/Annandale, NJ b. 18 D 1883, Decatur, IN d. 5 D 1960, Flemington, NJ. Studied: G. Bridgman. Member: SI, 1913; Arch. Lg.; Grolier C.; Bd. Design, WFNY, 1939. Author: "Design This Day." Positions: Des., Kodak Co., Ford Motor Co., A.B. Dick Co., others [40]

TEAL, W.P. [P] Cincinnati, OH [17]

TEALE, E.G. [I] NYC [19]

TEALL, Gardner [P,I] NYC/Brewster, MA [10]

TEASDEL, Mary [P,T] Salt Lake City, UT b. 1863, Salt Lake City d. 11 Ap 1937, Los Angeles. Studied: Univ. Deseret, 1886; Harwood, 1891; G. DeF. Brush, ASL, 1897; Paris, with Simon, Constant, Collin, Garrido, Whistler, 1900–03. Member: Utah SA; Women P. of the West; Calif. AC. Work: Carnegie Pub. Lib.; Univ. Utah; Utah Capitol. She was the first woman artist from Utah to gain recognition. Specialty: watercolor [21]

TEDFORD, Elsie Mae (Ford) [P] Columbus, NM b. 1 N 1901, Abington, MA. Studied: ASL; Tiffany Fnd., 1929; H. Lever; K.H. Miller; K. Nicolaides. Exhibited: NAD, 1931, 1933; G-R-D Gal., 1933, 1934; Studio Gld.; Albion (Mich.) Col. [47]

TEED, D(ouglas) Arthur [P] Detroit, MI b. 21 F 1863, Utica, NY. Studied: Paris; London; Rome. Exhibited: Intl. Expo, Rome, 1911. Work: East Aurora, NY; Canton, Ohio [25]

TEEGEN, Otto [Des,Arch,W,T] NYC b. 19 Ag 1899, Davenport, IA. Studied: Harvard. Member: BAID. Award: Harvard Traveling F., 1925–27. Work: Asst. to Joseph Urban, des. of exterior color and lighting for Century of Progress Expo, Chicago, 1933. Contributor: articles, Architecture. Position: Dir. Arch., BAID [40]

TEEL, Lewis Woods [P,I] El Paso, TX (1948) b. 1883, Clarksville, TX. Specialties: Southwestern desert; portraits [*]

TEESDALE, Christopher H. [P] Cleburne, TX b. 6 Ap 1886, Eltham, England. Member: Tex. FAA; Cleburne AA. Work: port., Cleburne Pub. Sch., Masonic Temple, Cleburne; Ft. Worth Pub. Sch. [40]

TEE-VAN, Helen Damrosch (Mrs. John) [P,C,Des,I,W] NYC b. 26 My 1893, NYC d. 1976. Studied: N.Y. Sch. Display; G. DeF. Brush; J. Lie. Member: Soc. Women Geographers. Exhibited: NAD, 1917; CAM, 1917; CM, 1917; Los Angeles Mus. A., 1926; AMNH, 1925; PAFA, 1923; Gibbes Mem. A. Gal., 1935; Buffalo Mus. Sc., 1935; Berkshire Mus., 1936; Ainslie Gal., 1927; Warren Cox Gal., 1931; Argent Gal., 1941. Work: Berkshire Mus.; Bronx Zoo, N.Y.; color plates of flora and fauna of British Guiana, for Tropical Research Station, N.Y. Zoological S., the Arcturus, Haitian and Bermuda Oceanographic Expeditions under W. Beebe, 1922, 1924, 1925, 1927, 1929–33. Author/Illustrator: "Red Howling Monkey." Illustrator: Encyclopaedia Brittanica; Collier's Encyclopedia; books by Dr. Beebe; children's books [47]

TEFFT, Charles (or Carl) Eugene [S,T,L] Guilford, ME b. 22 S 1874, Brewer, ME d. ca. 1950. Studied: Artist-Artisan Inst.; Blankenship; Ruckstuhl. Member: NSS. Exhibited: NAD; NSS; Arch. L. Work: fountain, Bronx Mus.; AMNH, Statuary Hall, Wash., D.C.; statue, Bangor, Maine; mon., Ft. Lee, N.J. [47]

TEICHERT, Minerva Kohlhepp [Mur.P,W,T] Cokeville, WY (1974) b. 28 Ag 1889, Ogden, UT. Studied: Mark Hopkins AI, San Fran.; AIC, with Vanderpoel, 1912; Sterba; ASL, with Henri, K.H. Miller, Bridgman, 1914–17. Member: Utah AI. Work: State Capitol, Wyo.; Cokeville H.S., Wyo., South H.S., Salt Lake City; LDS Temple, Manti, Utah [40]

TEICHMAN, Sabina [P] NYC Exhibited: AWCS, 1934, 1936; AWCS-NYWCC, 1939 [40]

TEICHMUELLER, Minnette (Mrs. Pohl) [P] San Antonio, TX b. 26 Ja 1872, La Grange, TX. Studied: Sam Houston Normal Sch.; San Antonio Acad. A.; H.D. Pohl. Work: White House, Wash., D.C.; WPA mural, USPO, Smithville, Tex.. Position: T., San Antonio Acad. A. [47]

TEICHNER, Joseph [P] Fieldston, NY b. 18 F 1888, Gyoma, Hungary. Studied: J. Carlson; NAD. Member: Brooklyn SA; Allied AA [40]

TEIGEN, Peter [P,Arch] Cambridge, MA b. 28 Ag 1895, Minneapolis d. Summer 1936, Glenveigh Castle, County Donegal, Ireland. Studied: D. Ross; Jacovleff; Schoukhaieff; Harvard; Univ. Minn., 1915. Positions: T., Princeton Univ. (1928–36), Smith Col. [25]

TELIEZ, J. [P] NYC [13]

TELLANDER, A. Frederic [P] Evanston, IL b. 4 N 1878, Paxton, IL. Studied: Rome; Paris. Member: Assn. Chicago PS; Chicago Gal. Assn. Exhibited: Englewood Women's C., 1921 (prize); AIC, 1923 (prize); FA Bldg., 1927 (prize); Mun. AL, 1927 (prize); Assn. Chicago PS, 1926 (gold); Chicago Gal. Assn., 1926–32. Work: Lawrence Col., Beloit Col.; Ill. Athletic C., Union Lg. C., Chicago; Chicago Mun. Comm. [40]

TELLING, Elisabeth [P,E,L] Guilford, CT b. 14 Jy 1882, Milwaukee. Studied: Smith Col.; W.P. Henderson; G. Senseney; H.E. Field; H. Heymann, in Munich. Member: Chicago AC; Chicago SE. Exhibited: all one-man: AIC, 1922, 1937; Milwaukee AI, 1923, 1924; Marie Sterner Gal., 1933, 1937; Rouillier Gal., Chicago, 1933; Courvoisier Gal., San Fran., 1936; Gibbes A. Gal., 1937; CGA, 1937; Northwestern Univ. Lib., 1937; Univ. Mich., 1937 (group exh.) Work: Calif. State Lib., Pasadena; Calif. PM; Tulane Univ.; Bishop A. Gal., Honolulu [47]

TEMPLE, C.M. [P] Salt Lake City, UT [15]

TEMPLE, Harry C. [P] Member: GFLA [27]

TEMPLE, Samuel, Mrs. See Anderson.

TEMPLE, William [P] Phila., PA. Work: PAFA, 1936 (prize) [40]

TEMPLEMAN, Albin Frederick [P,T] Oakland, CA b. 19 Ag 1911, Sacramento, CA. Studied: Univ. Calif.; H. Hofmann. Exhibited: San Fran. AA, 1937–46; Sacramento, Calif.; Oakland A. Gal. Work: SFMA [47]

TENER, George E. (Mrs.) [P] Sewickley, PA. Member: Pittsburgh AA [21]

TEN EYCK, John (Adams) [P,E,T] Stamford, CT/Westerly, RI b. 28 O

1893, Bridgeport, CT d. 21 O 1932. Studied: N.Y. Sch. F.&Appl. A.; ASL; L. Mora; K.H. Miller; J. Pennell; C. Hawthorne; B.J.O. Nordfeldt. Member: SI, 1922; SC, 1926; Société des Artistes Indp., Paris; S.Indp.A., 1918; Arch. Lg., 1928; Brooklyn S. Mod. A. Position: T., Kihn-Ten Eyck Art Sch., Stamford, Conn. [31]

TENGGREN, Gustaf Adolf [P,G,I] Chicago, IL/Woodstock, NY b. 3 N 1896, Magra, Sweden. Studied: Slojdforening Sch.; Voland A. Sch., Sweden. Exhibited: Los Angeles County Fair, 1939; 48 Sts. Comp., 1939. Illustrator: "Ring of the Niebelung," 1932, "Saldom and Golden Cheese," 1935. Position: A. Dir., Walt Disney Studios, Hollywood [40]

TENKACS, John [P] Cleveland, OH b. 30 My 1883, Hungary. Studied: Royal Hungarian Acad. FA; Cleveland Sch. A. WPA artist. [40]

TENNANT, Allie Victoria [S] Dallas, TX b. St. Louis. Studied: ASL, with G. Bridgman, E. McCartan. Member: NSS; Dallas AA; SSAL. Exhibited: PAFA, 1935; AIC, 1935; Kansas City AI, 1935; Tex. Centenn., 1936; Arch. L., 1938; WFNY, 1939; Nat. Exh. Am. A., NYC, 1939; WMAA, 1940; NSS, 1940; CI, 1941; Dallas AA, 1936 (prize); SSAL, 1932 (prize), 1933 (prize), 1936 (prize); Nashville AA, 1927 (prize); Dallas Pub. A. Gal., 1928 (prize), 1929 (prize), 1930 (prize), 1932 (prize). Work: State of Tex. Bldg., Dallas; Brookgreen Gardens, S.C.; Hocakaday Sch., Southwest Medical Col., Aquarium, MFA, Women's C., all in Dallas; mem., Corsicana, Bonham, Tex.; WPA murals, USPO, Electra, Tex.; Baylor Univ., Dallas; Centenn. Expo, Dallas; Maple Lawn Sch. [47]

TENNENT, Madge [P] Honolulu, HI. Exhibited: GGE, 1939 [40]

TENNEY, Adna [Por.P,Min.P] b. 26 F 1810, Hanover, NH d. 17 Ag 1900, Oberlin, OH. Studied: Francis Alexander, in Boston, 1844. Work: Dartmouth; N.H. State House, Concord. Itinerant painter in N.H.; NYC; Baltimore; along the Miss. River, ca. 1856; Winona, Minn.; Oberlin, Ohio [*]

TENNEY, Alice [Mur.P,Li,L] Crystal Bay, MN b. 21 F 1912, Minneapolis. Studied: ASL. Work: murals, Hotel Nicollet; Westminster Presbyterian Church, Minneapolis [40]

TENNEY, Burdell [P] Phoenix, AZ. Exhibited: Ariz. PS, Phoenix, 1938; Nat. Exh. Am. A., Rockefeller Ctr., NYC, 1938 [40]

TENNYSON, Arthur A., Mrs. See Mitchell, Laura.

TEPPER, Natalie Arras (Nat) [P,Des,L,T] Woodstock, NY b. 14 Jy 1895, NYC d. 28 O 1950. Studied: N.Y. Sch. F.&Appl. A.; G. Wiggins; E. Pape; R. Laurent; A. Heckman; J. Koopman; J. McManus; H. Troendle, in Switzerland; Munich. Member: AFA; NAWA; Woodstock AA; Studio Gld. Exhibited: NAWA, 1938-46; Albany Regional Exh., annually; All.A.Am.; CGA; AFA Traveling Exh., 1936; Brooklyn SA; WFNY, 1939; GGE, 1939; Canada. Work: Ft. Hamilton & Lincoln H.S., NYC; Am. Lib. Color Slides. Position: T., Ft. Hamilton H.S. & Lincoln H.S., NYC [47]

TEPPER, Saul [I] NYC b. 25 D 1899, New York. Studied: Dodge; Lawlor; Dunn. Member: SI; AG. Illustrator: McCall's, Delineator, Cosmopolitan, American, Saturday Evening Post [47]

TERA, George Sugimori [P] NYC b. 19 S 1887, Japan. Studied: F.V. Dumond; H. Read [24]

TERADA, Edward Takeo [Por.P,Mur.P,Min.P,S,B,Des,Dr,E,Li,T] San Fran., CA b. 27 Ap 1908, Chico, CA. Studied: Calif. Sch. FA; O. Oldfield; S. Yoshida, in Japan. Member: San Fran. AA; A. Ctr., Calif.; S. Mural Ar.; Japanese Ar. of San Fran.; Los Angeles AA. Exhibited: Calif. State Fair, 1928 (prize); Am. Legion, 1928 (prize). Work: fresco, Coit Mem. Tower, San Fran. Contributor: weekly woodblock prints, Hokubei Asahi Daily News [40]

TERESA [P] Santa Fe, NM b. Nervi, Italy. Exhibited: Santa Barbara Mus. A., 1946; Mus. N.Mex., Santa Fe, 1942-46; Univ. Denver, 1938 [47]

TERMOHLEN, Karl E. [P] Maywood, IL b. 1863, Copenhagen, Denmark [08]

TERRELL, Allen Townsend [P,S,T] NYC b. 2 N 1897, Riverhead, NY. Studied: Columbia; ASL; Académie Julian, Ecole des Beaux-Arts, both in Paris; Fontainebleau Sch. FA; C. Despiau. Member: NAC; AWCS; AAPL. Exhibited: Salon d'Automne, 1931; NAD, 1932-34, 1937; PAFA, 1933, 1934, 1936; AWCS, 1942-45; Dec. C., N.Y., 1939 (one-man); Stendahl Gal., 1944 (one-man); Pasadena AI, 1944 (one-man); Village A. Ctr., 1943 (prize); Arch. L., 1939 (prize); NYC, 1941 (prize); IBM, 1945 (prize). Work: York C., NYC; IBM Coll.; murals, S.S. America; Aluminum Corp. Am., Garwood, N.J. Designer: Vermilye med., Franklin Inst., Phila. Position: T., Parsons Sch. Des., 1944, 1946 [47]

TERRELL, Elizabeth [P] Woodstock, NY b. 23 O 1908, Toledo. Studied: Ringling Sch. A.; ASL. Member: An Am. Group; Woodstock AA. Exhibited: BM, 1941, 1945; AIC, 1940, 1941; WMAA, 1938, 1944, 1945; MOMA; PAFA, 1939; AV, 1943; Univ. Ariz., 1943; VMFA, 1946; Univ. Iowa, 1945; PMG, 1936; WFNY, 1939; 48 Sts. Comp., 1939 (prize). Work: MMA; Newark Mus.; Univ. Ariz.; Edward Bruce Mem. Coll.; murals, USPOs, Conyers, Ga., Starke, Fla. WPA artist. [47]

TERRIBERRY, W.S. [P] NYC [13]

TERRIZZI, Anthony T. [S] NYC. Exhibited: Arch. L., 1915 (prize) [15]

TERRY, Duncan Niles [C,Des] Bryn Mawr, PA b. 6 N 1909, Bath, ME. Studied: BMFA Sch.; Central Sch. A. & Crafts, London, England; Acad. Moderne, Paris; H.H. Clark; F. Leger; BMFA Sch. Traveling Schol. Member: Phila. A. All.; Stained Glass Assn. Am. Exhibited: Dartmouth Col.; Gibbes Mem. A. Gal.; Tricker Gal., NYC; Woodmere A. Gal.; Phila. A. All.; London. Work: glass murals/panels, hotels in Baltimore, Phila.; Bryn Mawr Col. [47]

TERRY, Eliphalet [Ldscp.P,Animal P] b. 2 Jy 1826, Hartford, CT d. 1896, probably NYC. Studied: Rome, with his cousin Luther Terry [1813-69], 1846-47. Exhibited: NAD; Am. A. Union, 1850s. Went to Yellowstone with W.J. Hays, 1860 [*]

TERRY, John Coleman [Car] b. My 1880 d. 27 F 1934, Coral Gables, FL. Studied: M. Hopkins AI. Illustrator: 1900, San Francisco Call, 1900; active with his brother Paul in the early animated cartoon films and helped him institute "Terry Toons" for the motion pictures, 1912. Creator: "Scorchy Smith," boy aviator strip

TERWILLIGER, Edwin [P] Chicago, IL b. 21 S 1872, Mason, MI. Member: Palette and Chisel Acad. FA; Chicago SE [40]

TERWILLIGER, R.L. [P] Chicago, IL [19]

TESAR, Joseph [I] Rockville Center, NY. Member: SI [47]

TESTER, Jefferson [P] New Rochelle, NY b. 3 Je 1900, Mountain City, TN. Studied: AIC. Exhibited: WMA, 1945; AIC, 1945; Critics Choice Exh., 1945; CI, 1945; NAD, 1945 [47]

TEVIS, Edwin Enos [I,T] NYC/Westport, CT b. 31 Ja 1898, Toledo. Studied: AIC; ASL [40]

TEW, Marguerite R. [S] Los Angeles, CA b. 6 Ja 1886, Magdalena, NM. Studied: PMSchIA; PAFA, Grafly, Cresson European Schol., 1913. Member: Calif. AC, 1917. Exhibited: Calif. AC, 1924 (prize). Work: Mayan ornament, South West Mus., Los Angeles [40]

TEWKSBURY, Fanny W(allace) [P,T] Newton, MA b. Boston, MA. Studied: Sch. Des., MIT, R. Turner, all in Boston. Member: NYWCC; Phila. WCC; N.Y. Women's AC. Exhibited: PAFA, 1898 [33]

TEYRAL, Hazel Janicki (Mrs. John) [P,T] Lakewood, OH b. 9 F 1918, London. Studied: Cleveland Sch. A.; H.G. Keller; K. McLeary. Member: Prof. Women's AC, Cleveland. Exhibited: AV, 1944; Butler AI, 1943, 1945; Kearney Mem. Exh., Milwaukee AI, 1946; VMFA, 1946; CMA, 1932-46; 1030 Gal., Cleveland, 1945 (one-man). Work: CMA; mural, USO Lounge, Cleveland. Position: T., Cleveland Sch. A., 1943 [47]

TEYRAL, John [Des,T,P] Lakewood, OH b. 10 Je 1912, Yaroslav, Russia. Studied: Cleveland Sch. A.; BMFA Sch.; H.G. Keller; A. Jacovleff. Member: Cleveland SA. Exhibited: CI, 1941; BMFA, 1942; Butler AI, 1943-45 (prize); Milwaukee AI, 1946; VMFA, 1946; CMA, 1932-42, 1943 (prize), 1944, 1945 (prize), 1946 (prize); 1030 Gal., Cleveland, 1945 (one-man). Work: Butler AI; CMA; City of Cleveland Coll. Positions: T., BMFA Sch. (1936-37), Cleveland Sch. A. (1939-41), U.S. Army (1942-43) [47]

THACHER, Amy C. [P] Yarmouthport, MA. Member: N.Y. Women's AC. Exhibited: NAD, 1898 [13]

THACHER, Elizabeth [P] Brookline, MA b. 13 F 1899, Brookline. Studied: Boston, with L. Thompson; P. Hale; W. James; F. Bosley [40]

THAIN, Howard A. [P] NYC b. 16 N 1891, Dallas. Studied: S. Ostrowsky; A. Sterba; F.V. DuMond; R. Henri; V. Anspaugh; F. deF. Schook; J. Hambridge; ASL. Member: S.Indp.A.; Bronx AG; SSAL [33]

THAL, J. [P] Toledo, OH. Member: Artklan [25]

THAL, Sam(uel) [E,S,P] Boston, MA b. 4 My 1903, NYC d. ca. 1964. Studied: ASL; NAD; Beaux-Arts Acad.; BMFA Sch. Member: SAE; Boston Arch. C. Exhibited: Doll & Richards, Boston; Rockport AA; Inst. Mod. A., Boston; SAE; LOC; CAFA, 1943 (prize); SAE, 1941-43 (prizes); LOC, 1945 (prize). Work: BMFA; LOC; CAFA; CI; Cincinnati

Bell Telephone Bldg.; Harvard Med. Sch.; Rindge Tech. Sch., Cambridge, Mass.; East Boston Airport; Harvard Univ. Dormitory [47]

THALHEIMER, Fannie B. [P] Baltimore, MD [25]

THALINGER, E. Oscar [P] Chesterfield, MO b. 20 Mr 1885, Alsace-Lorraine. Studied: St. Louis Sch. FA, Wash. Univ.; Gruber, Munich. Member: St. Louis AG; 2x4 Soc.; Group 15. Work: CAM. Position: Registrar, CAM, St. Louis, from 1914 [47]

THALINGER, Frederic Jean [S] Croton-on-Hudson, NY b. 28 Ag 1915, St. Louis, MO. Studied: Antioch Col.; Wash. Univ.; AIC; G. Wood. Member: Traveling F., Wash. Univ., St. Louis, 1939. Exhibited: Kansas City AI, 1937; AIC, 1940, 1941; CAM, 1943; Syracuse MFA, 1937 (prize); New-Age Gal., NYC, 1946; Beaux-Arts Exh., 1939 (prize). Work: Syracuse MFA; Ill. State Mus.; Antioch Col., Yellow Springs, Ohio; s., USPO, Jenkins, Ky.; Francis Cabrini Housing Project, Chicago, Ill. [47]

THALLON, Florence N. [P] Boston, MA [06]

THARIN, Selma [P] Charleston, SC [25]

THARP, Rose B. [P] Jacksonville, FL [25]

THARSILLA, Sister M. [P,T] San Antonio, TX b. 19 Ap 1912, Westphalia, TX. Studied: Our Lady of the Lake Col.; Columbia; AIC, with C. Pougialis, R. Lifvendahl. Work: Witte Mem. Mus., 1943, 1944; Tex. General Exh., 1945–46. Position: T., Our Lady of the Lake Col., San Antonio, from 1932 [47]

THATCHER, Earl [I] NYC. Illustrator: Harper's [01]

THATCHER, Edward W. [P] Columbus, OH. Member: Columbus PPC [25]

THATER, Marie Louise [I] Chicago, IL. Studied: PAFA [25]

THAW, A. Blair [P] Wash., D.C. [25]

THAW, Florence (Mrs. Alexander Blair) [Por.P] Wash., D.C./North Hampton, NH b. 17 F 1864, NYC d. 5 Mr 1940. Studied: A. Thayer; B. Harrison; Académie Julian. Member: Wash. SA; N.Y. Cosmopolitan C.; Wash. AC [38]

THAYER, Abbott H(anderson) [P] Monadnock, (Dublin) NH b. 12 Ag 1849, Boston, MA d. 29 My 1921 (died of a stroke, although he had committed himself to a hospital in 1918 because of his suicidal impulses.) Studied: H.D. Morse, 1865; Brooklyn A. Sch., with J.B. Whittaker, 1867; NAD, with Wilmarth, 1868; Ecole des Beaux-Arts, Paris, with Gérôme, Lehmann, 1875. Member: ANA, 1898; NA, 1901; SAA, 1879; NIAL; Società delle Belle Arti Denominata de San Luca, Rome; NSMP; A. Fund S. Exhibited: Brooklyn Acad. Des., 1868 (gold); Mass. Charitable Mech. Assn. (gold); PAFA, 1891 (gold); PAFA (prize); Paris Expo, 1889 (med); Columbian Expo, Chicago, 1893 (med); NAD, 1898 (prize); Paris Expo, 1900 (gold). Work: murals, Bowdoin; paintings: MMA; BMFA; Smith Col.; Cincinnati Mus. A.; NGA; WMA. Discoverer of the laws of concealing coloration in the animal kingdom, which were adapted for camouflage during WWI, and known as "Thayer's Law." [19]

THAYER, Albert R. [P] Boston, MA [13]

THAYER, Alice Bemis (Mrs. Charles P.) [Ldscp.P,Mar.P] Evanston, IL b. 1864, Boston. Studied: Cowles' A. Sch., Boston, with R. Turner, A.W. Buhler; Colarossi Acad., Paris. Member: Chicago WCC [17]

THAYER, Charles S. (Mrs.) [P] Hartford, CT. Member: Hartford AS [25]

THAYER, Emma Beach (Mrs. Abbott H.) [P] Monadnock, NH b. 1850 d. 1 Mr 1924. Specialty: flower studies in oil and pastel [24]

THAYER, Emma Homan (Mrs. Elmer A.) [P,I] Denver (since 1882) b. 14 F 1842, NYC. Studied: NAD; ASL, with Chase, Church. Exhibited: NAD. Author/Illustrator: "Wild Flowers of Colorado," 1885, "Wild Flowers of the Pacific Coast," 1887 [06]

THAYER, Ethel R(andolph) [P] Boston, MA/Hingham, MA b. 8 N 1904, Boston. Studied: P. Hale. Member: Boston GA; NAWPS. Exhibited: NAD, 1929 (prize) [33]

THAYER, Florence E. [P] Worcester, MA [24]

THAYER, Gerald H(anderson) [P,W,L,T] Monadnock, NH b. 5 S 1883, Cornwall, NY. Studied: A.H. Thayer. Work: MMA; BM. Author: "Concealing Coloration in the Animal Kingdom," "The Nature-Camouflage Book," "The Seven Parsons and the Small Iguanodon" [27]

THAYER, Gladys. See Reasoner, David, Mrs.

THAYER, Grace [P] Boston, MA b. Boston. Studied: BMFA Sch.; Mme. H. Richard, Paris. Member: Copley S., 1885 [25]

THAYER, Harriet Barnes (Mrs.) [P] Wash., D.C [25]

THAYER, Polly (Mrs. Starr) [Por.P] Boston, MA b. 8 N 1904, Boston, MA. Studied: P. Hale, BMFA Sch.; H. Wickey, ASL. Member: Boston FA; Boston AC; NAWPS. Exhibited: NAD, 1929 (prize); Boston Tercentenary Exh. (med). Work: PAFA; BMFA; Springfield A. Mus. [47]

THAYER, Raymond L. [P] NYC b. 16 N 1886, Sewickley, PA d. 15 N 1955. Studied: K.H. Miller. Member: AG; SI; AWCS [33]

THAYER, Theodora W. [Min.P,T] NYC b. 1868, Milton, MA d. 6 Ag 1905. Studied: DeCamp, in Boston. Member: ASMP; Copley S., 1894. Exhibited: Pan-Am. Expo, Buffalo, 1901 (med); SAA, 1898 [04]

THECLA, Julia [P,S,Des,Li] Chicago, IL b. IL. Studied: AIC; E. Forsberg. Member: Chicago AC; Women Ar. Salon, Chicago; Chicago NJSA (Dir.). Exhibited: MOMA, 1943; Art of This Century, 1942–45; AIC, 1931–33, 1935–37, 1940, 1942–1945; SFMA, 1945 [45]

THEIS, Gladys Huling (Mrs. [S] Albuquerque, NM b. 24 Ag 1903, Bartlesville, OK. Studied: Okla. A. & M. Col.; Cincinnati A. Sch.; Corcoran Sch. A.; Paris; Malfrey; Despiau; C.J. Barnhorn; M. Miller. Exhibited: S. Wash. A., 1931, 1932; N.Mex. AL, 1937; Albuquerque, N.Mex., 1937 (one-man); Southwestern A. Exh., 1940 [47]

THEISS, J(ohn) W(illiam) [P,W] (Living in Los Angeles but listed Springfield, OH address.) b. 20 S 1863, Zelionople, PA. Studied: San Fran., with L.P. Latimer, A. Anderson. Member: Springfield AL. Specialty: watercolor [33]

THEOBALD, Elisabeth Sturtevant (Mrs. Samuel) [S,P] NYC b. 6 Jy 1876, Cleveland d. 4 Ja 1939. Studied: Chase; Mora; Hawthorne; F.C. Gottwald; H. Matzen. Member: NAWPS; Studio G. [38]

THEOBALD, R.C. [P] Los Angeles, CA. Member: Calif. AC [19]

THEOBALD, Samuel, Jr. [P,E,T] NYC b. 23 O 1872, Baltimore. Studied: Johns Hopkins Univ.; NAD; A. Castaigne. Exhibited: CGA; Albright A. Gal.; Los Angeles Mus. A.; NAD [47]

THEODORE, Pan [S,T] NYC b. 5 F 1905, Lemnos, Greece. Studied: DaVinci A. Sch.; BAID; ASL. Exhibited: PAFA, 1942; NAD, 1944; S.Indp.A., 1943. Work: numerous portrait busts [47]

THERIAT, Charles J(ames) [P] Melun, Seine-et-Marne, France b. 4 Ja 1860, NYC. Studied: Paris, with Lefebvre, Boulanger. Member: Paris SAP. Exhibited: Paris Expo, 1889, 1900; Pan-Am. Expo, Buffalo, 1901 (med); Paris Salon 1896 [13]

THETFORD, William E. [P,Patron] Brooklyn NY b. 1813, London (came to NYC in 1836) d. 23 N 1903

THEUERKAUFF, (Carl) R(udolph) [P] Rochester, NY b. 4 My 1875, Germany d. 24 Je 1926. Studied: self-taught. Member: SC; Rochester AC; Geneseeans [25]

THEVENAZ, Paul [P] b. 22 F 1891, Geneva, Switzerland (came to U.S. in 1917) d. 6 Jy 1921, Greenwich Hospital, NYC. Served in the American Army during WWI.

THEW, (R.) Garret [P,S] Westport, CT b. 13 O 1892, Sharon, CT. Studied: E. Penfield; J. Carlson; W. Biggs. Member: AG. Work: Newark Mus. [33]

THIEDE, Henry A. [I] Evanston, IL b. 27 O 1871, Germany. Member: Palette and Chisel C. Exhibited: Palette and Chisel C., 1929 (prize) [33]

THIEM, Herman C. [P,Arch,I] Rochester, NY b. 21 N 1870. Studied: Mechanics' Inst.; S. Jones; C. Raschen. Member: Rochester AC; Picture Painters' C. [33]

THIEME, Anthony [P,Des,T] Rockport, MA/Riviera b. 20 F 1888, Rotterdam, Holland (came to NYC in 1920s) d. 7 D 1954. Studied: Royal Acad., Holland; Germany; G. Hacker; Garlobini, Guardaciona, Mancini, in Italy. Member: AWCS; SC; CAFA; Boston AC; Providence WCC; Boston SAC; North Shore AA; Springfield AL; Rockport AA; NYWCC; AAPL; Gloucester SA; Phila. Alliance; Phila. PC; NAC. Exhibited: NAD, 1930–34; AIC, 1930; PAFA, 1929–31; CGA, 1932; CAM, 1933; Los Angeles Mus. A., 1930, 1931 (prize); Albright A. Gal., 1932; Detroit Inst. A., 1931; SC, 1929 (prize), 1931 (prize); Springville, Utah, 1928 (prize), 1931 (prize); Gloucester AA, 1928 (prize); Springfield AL, 1927 (prize), 1928 (prize); North Shore AA, 1930 (prize); CAFA, 1930 (prize); Jordan Marsh Exh., 1944 (med); NYWCC, 1930 (prize); Tercentenary Exh., Boston, 1930; Ogunquit A. Ctr., 1930; New Haven PCC, 1931 (prize); Wash. WCC, 1931 (prize); Los Angeles Mus. A., 1930, 1931 (prize); Buck Hill Falls AA, Pa., 1938 (prize). Work: BMFA; Pittsfield (Mass.) Mus. A.; Albany Inst. Hist. & A.; Dayton AI; City of New Haven Coll.; Coll., Springville, Utah; Univ. Iowa; MMA; Los Angeles Mus. Hist., Sc.&A.; Beach Coll.,

Storrs, Conn.; Montclair AM; SAM; AM, New Britain, Conn. Position: Dir., Thieme Sch. A., Rockport, Mass. [47]

THIESSEN, (Charles) Leonard (Jr.) [Cr,S,Gr,P] Omaha, NE b. 3 My 1901, Omaha, NE. Studied: Univ. Nebr.; Sch. Royal Acad., Stockholm, Sweden. Work: Nebr. AA; AG, Lincoln, Nebr.; Alfred East Mem. Gal., Kettering, Northants, England. Positions: State Dir., Iowa, WPA, 1941–42; A. Cr., Omaha World-Herald, from 1938 [47]

THOBURN, Jean [P,I,S,C,T] Pittsburgh, PA b. 27 N 1887, Calcutta, India. Studied: Goucher Col.; Columbia; N.Y. Sch. F.&Appl. A.; A. Dow; B. Miller; CI. Member: Pittsburgh WCS; Pittsburgh AA. Exhibited: PAFA, 1937, 1939; Pittsburgh AA, 1926, 1936–43, 1944 (prize); Pittsburgh WCS, 1945; Ogunquit A. Ctr., 1939. Work: 100 Friends of Art, Pittsburgh. Illustrator: children's stories. Position: T., Peabody H.S., Pittsburgh, from 1911 [47]

THOELE, Lillian (Caroline) (Anne) [P,I,Des] St. Louis, MO b. 12 Ag 1894, St. Louis. Studied: St. Louis Sch. FA; PAFA; Chester Springs Summer Sch.; Summer Sch., Saugatuck, Mich. Member: St. Louis AG; St. Louis Adv. C.; S.Indp.A., St. Louis; Ar. U.; Eight WP, St. Louis. Exhibited: CAM, 1918–46; St. Louis AG, 1918–46; Mo. State Fair; St. Louis Pub. Lib., 1939. Work: murals, Am. Youth Fnd. Camps, Shelby, Mich., New Ossipee, N.H.; Gundlach Pub. Sch.; St. James Church, German General Orphans Home, Crippled Children's Home, Custom House, all in St. Louis. Illustrator: textbooks; children's stories [47]

THOENER, Charles H. [Ldscp.P] Yonkers, NY b. 1844 d. 22 My 1924. Represented by M. Knoedler & Co., NYC, for 30 yrs.

THOL, Henry [Car] Brooklyn, NY b. 1896 d. 28 Jy 1944. Studied: CUASch. Position: Cart., Bell Newspaper Syndicate and Consolidated News Features, 1924–44

THOLENARR, Theo [S] NYC [04]

THOLEY, Charles P. [Li,Por.P] d. 1898. Active in Phila., by 1860. Specialty: pastel portraits (later) [*]

THOM, James Crawford [Por.P,Ldscp.P,Genre P] b. 1835, NYC d. 16 F 1898, Atlantic Highlands, NJ. Exhibited: NAD, from 1857; Royal Acad., London 1867–73 (when his address was Brentford, England); Boston Athenaeum; PAFA. Son of James [1799–1850]

THOMA, Eva [P] Norman, OK [17]

THOMAN, Josef [P] NYC [13]

THOMAS, Alice B. [P] Los Angeles, CA [24]

THOMAS, Allan F. [Des,Li,I,P,B] Stevens Point, WI b. 15 F 1902, Jackson, MI. Studied: PAFA, 1925, 1927 (Cresson Traveling Schol.); G. Harding; D. Garber; H. McCarter; England; France. Exhibited: Phila WCC, 1926–28, 1929 (gold), 1930, 1932; AIC, 1929, 1930, 1933; Detroit Inst. A., 1934–36; Arch. L., 1939; FAP, Wash., D.C., 1937–41; PAFA, 1926 (prize). Work: PAFA; murals, Upjohn Sch., Kalamazoo, Mich.; St. John's Church, Radio Station WIBM, Jackson H.S., all in Jackson, Mich.; WPA murals, USPOs, Crystal Falls, Clare, both in Mich., Wabasha, Minn.; Hackley Hospital, Muskegon, Mich.; State Prison, So. Mich. [47]

THOMAS, Byron [Li,P,T] NYC b. 28 Jy 1902, Baltimore, MD. Studied: ASL. Exhibited: PAFA, 1941–43, 1945; Carnegie Inst., 1943–45; AIC, 1942–44; MET, 1943; AIC, 1937 (prize). Work: MOMA; Herron AI; AIC; IBM Coll. Position: Illustrator, Life mag; War Correspondent, Life, 1943–44; T., CUASch, 1932–46

THOMAS, C.B. [P] NYC. Member: Mural P. [29]

THOMAS, (Conrad) Arthur [Mur.P] Pelham, NY b. 28 Ap 1858, Dresden, Germany (came to the U.S., 1892) d. Je 1932. Studied: Hofman; Grosse; Schilling. Member: AFA; New Rochelle AA. Work: murals, City Hall, St. Louis; Court House, Auburn, Ind.; Sinton Hotel, Cincinnati, Ohio; murals, Court House, South Bend, Ind.; Seelbach Hotel, Louisville, Ky.; Raddison Hotel, Louisville, Ky.; Sts. Peter and Paul Cathedral, Phila. [31]

THOMAS, D.F. [Min.P] Baldwin Park, CA b. Aix-la-Chapelle, France d. Je 1924. Studied: his father, Dusseldorf Acad.; Brussels; Rome. Member: Calif. S. Min. P. Exhibited: San Diego Expo, 1915 (gold), 1916 (med); NAD, 1898, SAA, 1898, SL, 1898 [25]

THOMAS, Dora [P] NYC [13]

THOMAS, Elizabeth Haynes [P] Provincetown, MA b. Phila. Studied: PAFA; Paris. Exhibited: PAFA, (prize); Phila. AC, 1898 [25]

THOMAS, Elizabeth R. (Mrs. Edward) [Por.P] NYC. Member: N.Y. Women's AC [21]

THOMAS, Ella [P] NYC [98]

THOMAS, Ellen [P] Augusta, GA b. 14 Mr 1895, Augusta. Studied: A.K. Cross. Member: SSAL; Assn. Ga. A. Exhibited: Assn. Ga. A., 1938; SSAL, Montgomery, Ala., 1938; San Antonio, Tex., 1939. Exhibited: Montgomery MFA [40]

THOMAS, Emma Warfield [P,T] Phila., PA b. Phila. Studied: PAFA, with Beaux, W.M. Chase, T.P. Anshutz, C. Grafly, H.H. Breckenridge. Member: Phila. A. All.; Phila. Plastic C. Work: PAFA. Author, Ed., "Fragments—A Journal for Artists." [47]

THOMAS, Estelle L. [P,I,T] Pittsburgh, PA b. NYC. Studied: Pittsburgh Sch. Des. for Women; Univ. Pittsburgh; CI; Parsons Sch. Des.; C. Hawthorne; J. Sloan; H. Keller; M. Borgard; N.Y. Sch. F.&Appl. A. Member: Pittsburgh AA; Pittsburgh WCS; Pittsburgh AA, 1910–46; Pittsburgh WCS, 1945, 1946; Pittsbrugh A. & Crafts Ctr. Position: T., Pittsburgh Pub. Sch., 1910–46 [47]

THOMAS, Florence Todd (Mrs. T.D.) [I] Cleveland, OH b. 3 Je 1909, Peoria, IL. Studied: Cleveland Sch. A. Exhibited: CMA, 1936 (prize) [40]

THOMAS, G.W. [P] NYC. Member: GFLA [27]

THOMAS, George R. [T,Des,P,Li,L] Durham, NH b. 8 D 1906, Portsmouth, VA. Studied: Univ. N.C.; CI; Columbia. Member: AIA; N.H. S. Arch.; N.H. AA. Position: T., Univ. N.H., Durham [47]

THOMAS, Georgia Seaver [P] Los Angeles, CA. Member: Calif. AC [25]

THOMAS, Glenn [I] NYC. Member: SI [47]

THOMAS, Grace Thornton (Mrs.) [Cer,T] Altadena, CA b. 19 Ap 1880, Genoa, NE. Studied: Md. Inst.; Newark Sch. F.&Indst. A.; Greenwich House, NYC; M. Mason. Member: San Diego FAS; San Diego AG [40]

THOMAS, Henry Atwell [Li,Por.P] Brooklyn, NY b. 1834, NYC d. 12 N 1904. Exhibited: AWCS. A pioneer in the lithographic business; known for his theatrical portraits. Brother-in-law of N. Sarony.

THOMAS, Henry Wilson [S] d. 21 Je 1930, Florence, Italy. (Had been a resident of New Rochelle, N.Y.) Position: Ed., N.Y. newspapers.

THOMAS, Howard [T,P,En,Li,B] Athens, GA b. 30 Mr 1899, Mt. Pleasant, OH. Studied: AIC; G. Bellows; L. Seyffert; J. Binder; R. Davey. Member: Assn. Ga. A.; SSAL; Southeastern AA; CAA; Wis. PS (Pres.); Wis. A. Fed. Exhibited: AIC, 1935–42; Wis. PS, 1927–42; Phila. WCC, 1938, 1939, 1941; CGA, 1945; SSAL, 1945, 1946; Assn. Ga. A., 1945 (prize); Wis. Salon, 1934–37, 1938 (prize), 1939, 1941 (prize); Milwaukee AI, 1926 (prize), 1930 (prize), 1933, 1936 (med). Work: Milwaukee AI; Marine Hospital, Carville, La.; Univ. Wis.; Univ. N.C.; Univ. Ga.; Agnes Scott Col.; Bay View H.S., Milwaukee; Milwaukee Pub. Sch.; State T. Col., Milwaukee. Contributor: American Artist. Positions: Dir. A. Edu., Milwaukee State T. Col., 1930–42; T., Women's Col. Univ. N.C. (1943), Agnes Scott Col. (1943–45), Univ. Ga., Athens (from 1945) [47]

THOMAS, Howard Ormsby [P,Gr,Des,C] Chicago, IL b. 30 S 1908, Chicago d. 1971. Studied: AIC. Exhibited: PAFA, 1941; ASMP, 1942; Elgin Acad. A. Gal., 1941; AIC, 1940–42; Springfield Mus. A., 1940, 1941 [47]

THOMAS, Lenore [S] Accokek, MD b. 1 N 1909, Chicago. Studied: AIC. Member: Am. A. Cong; Ar. Union. Work: carving in limestone, Resettlement Comm., Hightstown, N.J.; Sch., Town Ctr., Greenbelt, Community, Berwyn, Md.; USPOs, Fredonia, Kans., Covington, Va. WPA artist. [40]

THOMAS, Marjorie Helen [P] Scottsdale, AZ (1948) b. 26 Jy 1885, Newton Center, MA. Studied: BMFA Sch., with Tarbell; Benson; R. Hale; Louis Kronberg; J.P. Wicker. Member: Phoenix FA; Ariz. AG. Exhibited: PAFA, 1924 [40]

THOMAS, Mary (Alice) Leath [P,C,T] Athens, GA b. 25 F 1905, Hazelhurst, GA d. 3 My 1959. Studied: Ga. State Col. for Women; Duke Univ.; Women's Col., Univ. N.C. Member: Assn. Ga. A.; SSAL; Southeastern AA. Exhibited: PAFA, 1941; Mint Mus. A., 1942, 1943; ACA Gal., N.Y., 1943; N.C. Ar., 1940, 1941 (prize), 1942 (prize), 1943, 1944; Piedmont Festival, Winston-Salem, N.C., 1943; SSAL, 1941, 1942 (prize), 1943, 1945, 1946 (prize); Assn. Ga. A., 1945. Work: Albemarle, N.C. Pub. Sch.; Fed. Women's C., Cary, N.C.; Univ. Ga. Position: T., Woman's Col., Univ. N.C., 1938–44; Stephens Col., Columbia, Mo., 1944–45; Univ. Ga, from 1945 [47]

THOMAS, Norman Millet [Mur.P,E] Portland, ME/Long Island, ME b. 21 N 1915. Studied: A. Bower; Portland Sch. F.&Appl. A.; NA. Member: Portland SA; SC. Exhibited: 48 States Comp., 1939. Award: Pulitzer F., NA, 1938, 1939 [40]

THOMAS, Paul K.M. [Por.P,S,W,L,T,I] New Rochelle, NY b. 31 Ja 1875, Phila. Studied: PAFA; C. Beaux; W. Chase; C. Grafly. Member: AAPL; Lotos C. Exhibited: St. Louis Expo, 1904 (med). Work: port., Bryn Mawr Col.; Univ. Chicago; Williams Col.; Western Reserve Univ.; Yale; Smith Col.; Univ. Pa.; Tokyo; Madrid; Rome [47]

THOMAS, Richard S. [S] Bordentown, NJ/Seaside Park, NJ b. 4 S 1872, Phila., PA. Studied: A. Zeller; C. Grafly; E. Maene. Member: Trenton AC; Mem. Craftsmen Am. Position: Senior partner, Thomas and Bowker Memorial Granite Works, Bordentown [40]

THOMAS, Roland [P] Independence, MO b. 31 Jy 1883, Kansas City, MO. Studied: W. Chase; R. Henri; F.V. DuMond. Member: Kansas City AG; Am. Artists, Munich. Exhibited: Mo. State Art Exh., 1912 (prize). Work: Elverhoj A. Gal., Milton, N.Y.; American AC, Munich; murals, Curtiss Bldg.; murals, Hudson Brace Motor Co., Kansas City, Mo. [25]

THOMAS, Ruth [P,Cr] Newport, RI b. 10 O 1893, Wash., D.C. Studied: Corcoran Sch. A.; C. Beaux; Winold Reiss; A. Sterner; J. Elliott; H. Sturtevant. Member: Newport AA, 1925–46; NAWA, 1930–32, 1933 (prize), 1934; Vose Gal., Boston (one-man); Argent Gal. (one-man); Jr. Lg., Baltimore, Md. (one-man); Palm Beach A. Ctr., 1934 [47]

THOMAS, Ruth. See Felker.

THOMAS, Steffen Wolfgang George [S,G,L] Atlanta, GA b. 7 Ja 1906, Fuerth, GA. Studied: Zink Sch. FA, Nuremburg, Acad. FA; Univ. Bavaria, Munich, Germany. Member: SSAL; Atlanta AA. Exhibited: High MA, Atlanta, 1939 (one-man). Work: City of Fuerth, Bavaria; Univ. Ala.; State T. Col., Jacksonville, Ala.; Emory Univ.; Berry Schools, Atlanta; Pub. Lib., Atlanta; Scott Col.; State Capitol, Ga.; Am. Col. of Surgeons, Chicago; Women's Better Govt. Lg., Atlanta; Tuskegee Inst., Ala.; Atlanta Univ.; Ga. Am. Legion, Atlanta; Edinborough Univ., Scotland. Position: State Supr., NYA, Ga. [40]

THOMAS, Stephen Seymour [Por.P] La Crescenta, CA (lived in Paris, 1888–1914; NYC, 1914–19; then settled in CA) b. 20 Ag 1868, San Augustine, TX d. 29 F 1956. Studied: ASL, 1885–88; W.M.Chase; C. Beckwith; Acad. Julian, with Lefebvre, Constant, 1888–91; Ecole des Beaux-Arts, Paris. Member: Los Angeles AA; Paris S. Am. P.; Pasadena AS. Exhibited: PAFA, 1898; Paris Salon, 1898, 1901 (gold), 1904 (prize); Paris Expo, 1900 (med); Munich, 1901 (gold); Pan-Am. Expo, Buffalo (med); Chevalier Legion of Honor, 1905. Work: MMA; Albright Gal.; Buffalo Mus. A.; Chamber of Commerce, N.Y. Life Bldg., Courtroom, Hall of Records, all in NYC; John Herron AI; Houston MFA; Winona (Minn.) Mus.; Los Angeles Mus. Hist., Sc.&A.; Athenaeum, Pasadena; State House, Trenton, N.J.; MIT; port. Woodrow Wilson, White House; Nat. Liberal C., London; Univ. Calif.; Trinity Col.; Syracuse Univ.; Nat. Acad. Sc., Wash. D.C.; Chamber of Commerce, Cleveland; Am. Col. Surgeons, Chicago; Morrison Lib., Univ. Calif.; Huntington Mem. Hospital, Pasadena; Good Samaritan Hospital, Los Angeles [40]

THOMAS, Susan Spencer [P] Represented by: Haseltine Gal., Phila. [13]

THOMAS, Vernon (Mrs.) [P,I,E] Chicago, IL b. 12 S 1894, Evanston, IL. Studied: R. Clarkson; C. Hawthorne; W.J. Reynolds. Member: NAC; Chicago SE; Cordon C. Work: City of Chicago Coll. Specialty: children [40]

THOMAS, Winfield Scott [Por.P,W] Haverhill, MA b. 15 Ja 1900, Haverhill, MA. Studied: R.W. Broderick; W.M. Chase; BMFA Sch., with L.P. Thompson, P.L. Hale, B. Keyes. Member: Merrimack Valley AA; Boston S.Indp.A.; Ogunquit A. Ctr. Work: Andover (Mass.) Jr. H.S.; Haverhill (Mass.) H.S.; Haverhill Pub. Lib.; 175 water colors of old Haverhill houses [47]

THOMASON, Francis Q. [P] Paris, France (1915) b. Van Buren, AR. Studied: NYC; Paris. Exhibited: St. Louis Expo, 1904 (med); Intl. AL, Paris, 1908 (prize). Work: St. Louis C. [17]

THOMASON, John William, Jr. [I,W] b. 1893, Huntsville, TX d. 12 Mr 1944, San Diego. Studied: Southwestern Univ., 1909–10; Houston Normal Inst., 1910–11; Univ. Tex., 1912–13; ASL, 1913–15. Author/Illustrator: "Fix Bayonets," 1925; books on the Texas Rangers, Davy Crockett, Custer

THOMPKINS, Clementina [P] b. 1848, Georgetown, D.C. d. 9 N 1931, NYC. Studied: Peabody A. Inst., Baltimore; Brussels; Paris, with Bonnât. Exhibited: Paris Salon; CGA; Centenn. Expo, Phila., 1876 (med). Work: Boys' C. NYC

THOMPSON, Agnes J. [P] St. Louis, MO [01]

THOMPSON, Alan [P,I,Des] Alexandria, VA b. 9 Je 1908, South Shields, England. Studied: CI; Pittsburgh AI; A. Kostellow; C. Carter. Member: Pittsburgh AA. Exhibited: CI, 1941; Pittsburgh AA, 1939–40 1941 (prize); Butler AI, 1939, 1940 (prize); Parkersburg FA Ctr., 1940. Work: Pittsburgh Faculty C.; Pittsburgh Pub. Sch.; mural, USPO, Pittsburgh, Pa. Position: Illus., New Yorker Studio, Wash., D.C. from 1946 [47]

THOMPSON, Alfred Wordsworth [Ldscp.P,Por.P] b. 26 My 1840, Baltimore d. 28 Ag 1896, Summit, NJ. Studied: Baltimore; Paris, with Gleyke, 1861–62; E. Lambinet, A. Passi, 1862–68. Studio in NYC from 1868. Member: NA, 1875; SAA, 1877 (founder-member). Exhibited: NAD, 1867–96 [*]

THOMPSON, Bertha [C,J] Woodstock, NJ b. England. Studied: A.W. Dow; G. Gebelin; T. Christiansen. Member: Boston SAC (master craftsman) [40]

THOMPSON, C. Mortimer [P] Knoxville, TN [13]

THOMPSON, Clara A. [P] Hartford, CT. Member: CAFA [17]

THOMPSON, Dorothea. See Litzinger.

THOMPSON, Edith Blight (Mrs.) [P] London, England b. 27 Ap 1884, Phila. Studied: F.V. DuMond; L. Mora. Member: Newport AA. Exhibited: Paris Salon, 1927 (prize). Specialty: interiors [33]

THOMPSON, Edmund Burke [Publisher] Windham, CT b. 7 S 1897, NYC. Studied: Columbia. Member: AI Graphic A. Exhibited: MOMA, 1932 (prize). Work: "Fifty Books of the Year," 1932, 1934, 1935, 1936, 1937. Printing/publishing activities under name of Hawthorn House. [40]

THOMPSON, Eleanor Shepherd (Mrs.) [Edu,Des,C,W,Gr,P,L] Elmhurst, NY b. Tillsonburg, Ontario. Studied: Univ. Toronto; Ontario Col. A.; Parsons Sch. Des.; Univ. Paris, France; Columbia; N.Y. Sch. F.&Appl. A. Member: St. John's (Newfoundland) AC; NAWA; Univ. Women's C., St. John's, Newfoundland; AFA. Exhibited: NAWA; Ontario SA; N.Y. S. Craftsmen. Author: "Training Girls for Art Vocations," 1935, "Textile Design," 1939. Contributor: Toronto State Weekly. Positions: A. Dir., Gov. Normal Sch., Toronto; T., Okla. A. & M. Col.; A. Supv./Consultant, Nat. Handicrafts Proj., Gov. Newfoundland [47]

THOMPSON, Ellen Kendall Baker (Mrs. Harry Thompson) [P] Puteaux, Seine, France/Buffalo, NY b. Fairfield, NY d. 4 D 1913, England. Studied: Paris, with C. Muller; P. Soyer; H. Thompson. Exhibited: Paris Salon, since 1879; Munich; Berlin; St. Petersburg; NYC; Phila.; Chicago; Detroit; Pan-Am. Expo, Buffalo, 1901 [08]

THOMPSON, Ernest Seton [P,I] NYCb. 14 Ag 1860, South Shields, England. Studied: Paris, with Gérôme, Bouguereau, Ferrier [01]

THOMPSON, Ernest Thorne [E,Li,P,T,I] New Rochelle, NY b. 8 N 1897, St. John, New Brunswick. Studied: Mass. Sch. Art, with Major, Hamilton, Andrew; BMFA Sch., with Bosley; Europe. Member: AAPL; Chicago SE; Ind. S. PM; Southern PM; New Rochelle AA; SI. Exhibited: Chicago, 1927 (prizes); Fifty Prints of the Year, 1928 (prize); Cunningham prize, 1929; New Rochelle, N.Y. 1937 (prize), 1940 (prize), 1946 (prize); 100 Prints of the Year, 1940; Bibliothèque Nationale, Paris; Victoria & Albert Mus., London, 1928. Work: Bibliothèque Nationale; NYPL; U.S. Nat. Mus.; Univ. Notre Dame; mural, St. Patrick's Church, McHenry, Ill.; Oliver Hotel, South Bend, Ind.; Nat. Coll. FA (Smithsonian). Position: T., Col. New Rochelle, N.Y., from 1929 [47]

THOMPSON, (F.) Ray(mond) (Jr.) [Car,T] Wyncote, PA b. 9 Jy 1905, Phila. Studied: Temple Univ.; PAFA; Spring Garden Inst., Phila.; Graphic Sketch C.; PMSchIA. Position: Car., "Myra North," comic strip, N.E.A. Service, 1934–39; comic panel, "Homer the Ghost," N.Y. Herald-Tribune Syndicate [47]

THOMPSON, F(loyd) Leslie [E,Des,L,T,I] Glen Allyn, IL b. 26 Je 1889, Chicago, IL. Studied: G. Senseney; B. Jacques; De Forest Shook; Saugatuck Sch. A. Member: A. Gld., Chicago; Austin, Oak Park & River Forest AL; Calif. PM; Am. Color Pr. Soc.; Chicago SE. Exhibited: Southern PM S.; Chicago SE, Calif. PM, Am. Color Pr. S., annually. Work: AIC; Smithsonian Inst.; Nat. Coll. FA (Smithsonian) [47]

THOMPSON, Frances L. [P] Wash., D.C. [04]

THOMPSON, Francis Alpheus [P] b. 1838, ME d. 1905 (CA?). Work: Santa Barbara Hist. S. [*]

THOMPSON, Fred [E] Waltham, MA [19]

THOMPSON, Fred D. [P] Providence, RI. Member: Providence WCC [29]

THOMPSON, Frederic Louis [P,S] NYC/Chilmark, MA b. 5 N 1868, Middleboro, MA. Studied: G.H. McCord; Salvatore Bilotti. Member: SC; Soc. des Beaux-Arts [25]

THOMPSON, Frederick [P,T] NYC b. 16 O 1904 d. 26 Je 1956, Hollis, NY. Studied: N.Y. Sch. Des.; ASL; D.J. Connah; F.V. DuMond. Member:

AAPL. Exhibited: NAD, 1941; CGA, 1943, 1945; Albany Mus. Hist. & A., 1941; All. A. Am., 1942; Berkshire Mus., 1941 (one-man); NYU, 1943 (one-man) [47]

THOMPSON, Gabriel [P] Paris, France [10]

THOMPSON, G(eorge) A(lbert) [P,T] Mystic, CT b. 1 Jy 1868, New Haven, CT d. 18 Mr 1938. Studied: Yale; J. La Farge; Paris with Merson, Blanc, Courtois, Girardot. Member: New Haven PCC (pres., 1905); Mystic AA; CAFA. Exhibited: NAD, 1898; SAA, 1898; New Haven PCC, 1924 (prize); CAFA, 1928 (prize). Work: National Gal., Uruguay, S.A. Position: T., Yale [38]

THOMPSON, Georgette Rosamond [P,Des,I,C,T] New Orleans, LA b. 13 S 1905, New Orleans. Studied: Newcomb Col., Tulane Univ.; Chicago Acad. FA; ASL; W. Stevens; R.V.S. Ford; Woodward; Werntz; G.D. Smith. Member: NOAA; SSAL. Exhibited: S.Indp.A., 1939; Chicago NJSA, 1928; NOAA, 1927-46, 1933 (prize); SSAL, 1927-40, 1930 (prize); Delgado Mus., 1930 (prize). Work: New Orleans Assn. Commerce; La. Col., Pineville, La. [47]

THOMPSON, Gilbert [P] Wash., D.C. [10]

THOMPSON, Hannah [P,C,E,T] Pasadena, CA b. 27 D 1888, Phila., PA. Studied: W.M. Chase. Member: Calif. AC; Calif. SE [27]

THOMPSON, Harriette K. [Min.P] Hartford, CT [24]

THOMPSON, Harry [P] Buffalo, NY b. London. Exhibited: Paris Salon, 1882 (prize), 1884 (med); Paris Expo, 1889, (med) [10]

THOMPSON, Harry Ives [Por.P,T] West Haven, CT b. 31 Ja 1840, West Haven, CT d. 1906. Studied: B.H. Coe, 1861. Position: T., New Haven, 1864-67 [*]

THOMPSON, Helen Foht [P] Poland, OH b. 26 Mr 1900, Cleveland, OH. Studied: Elmira Col., N.Y.; Youngstown Col., Ohio; C. Singer. Member: Friends Am. A. Exhibited: Parkersburg FA Ctr., 1942-46; Bridgeport, Conn., 1942; Ohio Valley Exh., Athens, Ohio, 1944, 1946; Massillon Mus., 1942-44, 1946; State T. Col., Indiana, Pa., 1946; Butler AI, 1941, 1943-46 [47]

THOMPSON, Helen Lathrop (Mrs. Laurence M.) [P] Mendham, NJ b. 24 Ap 1889, Wilkes-Barre, PA. Studied: Wilkes-Barre Inst.; Vassar Col.; Corcoran Sch. A. Member: Lg. Am. Pen Women; Nat. S. Pastellists; Wash. S. FA. Exhibited: Women's Univ. C., Phila., 1939 (one-man); Alexandria, Va., 1944 (one-man) (prize); Binghamton, N.Y. (one-man); Wash., D.C. (one-man) [47]

THOMPSON, Helen S. (Mrs. Henry S.) [P] Concord, MA. Member: Concord AA [25]

THOMPSON, Herbert E. [Mus.Cons] Waltham, MA b. 1877, Lexington, MA d. 5 Ag 1932. Restorer of paintings: BMFA; CGA; Freer A. Gal., Wash., D.C.; Nat. Gal. A., Ottawa, Canada; Gardner Mus., Boston.

THOMPSON, Hiram H. [Mur.P,Por.P] NYC b. 18 F 1885, Cincinnati, OH. Studied: AIC; Chicago Acad. FA; W. Ufer. Member: Palette and Chisel Acad. FA. Member: Palette and Chisel Acad. FA. Exhibited: Davenport Mun. Art Gal., 1930 (prize). Work: mural, Am. Commercial Bank, Davenport, Iowa; Davenport Mun. Art Gal. [40]

THOMPSON, J. Woodman [P] Pittsburgh, PA. Member: Pittsburgh AA [21]

THOMPSON, Janet Reid [P] Wausau, WI [24]

THOMPSON, John Edward [P,Des,T] Denver, CO b. 3 Ja 1882, Buffalo, NY d. 23 My 1945. Studied: L.W. Hitchcock, ASL, Buffalo; ASL; Paris, with Laurens, Blanche, Cottet, Tudor-Hart. Member: Denver AG; Denver A. Mus. Exhibited: WFNY, 1939; Denver C., 1929 (prize). Work: Nat. Bank Bldg., Polo C., St. Martin's Chapel, Art Mus., all in Denver; CGA. Position: T., Univ. Denver [40]

THOMPSON, Juliet H. [Por.P] NYC b. NYC d. 4 D 1956. Studied: Corcoran A. Sch.; ASL, Wash.; K.H. Miller; Académie Julian. Member: N.Y. Women's AC; N.Y. Mun. AS; NAC; S. Wash. A.; Wash. WCC; S.Indp.A.. Exhibited: Brown-Bigelow Comp., 1925 (prize) [33]

THOMPSON, Kate E. [P,Arch,T,W] Pompton Plains, NJ b. 8 Je 1872, near Middletown, Orange County, NY. Studied: ASL, with K.H. Miller, G. Bridgman. Member: AAPL. Work: mural, Office Dir. Pub. Health [40]

THOMPSON, Kenneth W. [I,P] NYC b. 26 Ap 1907, NYC. Studied: E. Pape; H. Ballinger; G.P. Ennis; W. Adams. Member: AWCS; SI; AG. Exhibited: AWCS, 1936, 1937, 1938

THOMPSON, Launt [S] b. 8 F 1833, Abbeyleix, Ireland (came to Albany, 1847) d. 26 S 1894, Middletown, NY. Studied: E.D. Palmer, Albany, 1848-57. Member: NA, 1862. Successful sculptor of portraits and ideal figures; active in NYC from 1857, except for stay in Italy, 1875-81 [*]

THOMPSON, Laura Jones (Mrs. Richard H.) [P,T] Winnetka, IL b. 18 Ag 1899, Muncie, IN. Studied: Northwestern Univ.; Columbia; AIC; G. Buehr; C. Longabaugh. Member: Muncie AA; North Shore AA; All-Ill. SFA; Hoosier Salon. Exhibited: CGA, 1943; Denver AM, 1936; Hoosier Salon, 1940-46; Evanston Women's C., 1940, 1941 (prize), 1942 (prize), 1943-46; Stevens Hotel (one-man), Drake Hotel (one-man), Chicago; Winnetka Community House, annually; Winnetka Women's C., 1940-46. Work: Winnetka Women's C., 1940-46 [47]

THOMPSON, Leslie Prince [P,T,Arch] Newton Ctr., MA b. 2 Mr 1880, Medford, MA d. 1963. Studied: Mass. Normal Sch.; BMFA Sch.; E.L. Major; E.C. Tarbell; BMFA, 1904 (Paige Traveling Schol.). Member: Boston AG; St. Botolph C.; NA, 1937; Newport AA. Exhibited: nationally; St. Louis Expo, 1904 (med); P.-P. Expo, 1915 (med); Sesqui-Centenn. Expo, Phila., 1926 (med); NAD, 1911 (prize); Newport AA, 1914 (prize); PAFA, 1919 (gold), 1927 (prize); Boston AC, 1928 (prize) [47]

THOMPSON, Lorin Hartwell, Jr. [Mur.P,Dec,E,I,Li,T] Pittsburgh, PA b. 19 Mr 1911, Pittsburgh. Studied: A. Kostellow; N. MacGilvary; S. Rosenberg; E. Warner; E.M. Ashe; CI. Member: Pittsburgh AA. Exhibited: 48 Sts. Comp., 1939 (prize). Work: WPA murals, USPOs, Altoona, Pa., Mercer, Pa., Pascagoula, Miss.; murals, Aluminum Co. of Am.; Mellon Inst., Pittsburgh; H.S. Somerset, Pa.; Duquesne C., Pittsburgh. Position: T., Ad-Art Studio Sch., Pittsburgh [47]

THOMPSON, Louise Guthrie [P,T] Los Angeles, CA b. 12 D 1902, OK. Studied: UCLA. Member: Calif. WCS; Calif. Art T. Assn. [33]

THOMPSON, Margaret A. Howard [S] Wash., D.C. Exhibited: S. Wash. A., 1937, 1938, 1940; Wash. S. Min. PS&G, 1939 [40]

THOMPSON, Margaret Whitney (Mrs. Randall) [S] Wellesley Hills, MA b. 12 F 1900, Chicago. Studied: PAFA; C. Grafly; Schoukieff, in Paris. Member: Phila. Alliance [31]

THOMPSON, Marvin Francis [P,B,E] Chicago, IL b. 14 Mr 1895, Rushville, IL. Studied: Chicago Acad. FA; L. Ritman; D. Viciji. Work: "Hunters," Pere Marquette Hotel, Peoria, Ill. Specialty: Southwest [40]

THOMPSON, Mary. See Tyson.

THOMPSON, Mills [Mur.P,W] Saranac Lake, NY b. 2 F 1875, Wash., D.C. Studied: Corcoran A. Sch.; ASL of Wash., D.C.; ASL. Member: S. Wash. A.; Wash. WCC; WC Phila. [33]

THOMPSON, Myra [P,S] Spring Hill, TN b. 23 N 1860, Manry County, TN. Studied: A. St. Gaudens; French; Injalbert; Eakins. Member: S.Indp.A. [25]

THOMPSON, Nellie Louis [Min.P,S] Boston, MA b. Jamaica Plain, Boston. Studied: Sir J. Linton; South Kensington Sch., London, with A. Williams, Miss B. Hughes, London; Cowles A. Sch., Boston, with De Camp; H.B. Snell. J. Wilson; R.N. Burnham; B. Pratt; C. Dallin. Member: Copley S., 1893; MacD. C. (allied member); North Shore AA; Gloucester SA; Boston SS [33]

THOMPSON, Paul Leland [P,C] Wash., D.C. b. 20 My 1911, Buffalo, Iowa. Member: S. Wash. A.; Ldscp. C. Wash. Exhibited: CGA, 1945; Honolulu Acad. A., 1936 (prize); SAM, 1939; S. Wash. A., 1944-46; Ldscp. C., Wash., 1945 (prize), 1946; Intl. Gal., Wash., D.C., 1946 (one-man); Wash. Pub. Lib., 1946 [47]

THOMPSON, Ralston Carlton [P,T] Springfield, OH b. 28 Mr 1904, Ironton, OH. Studied: Wittenberg Col.; Dayton AI; Chicago Acad. FA; Ohio State Univ.; Columbia. Member: Archaeological Inst. Am.; CAA. Exhibited: AIC, 1943, 1946; Los Angeles Mus. A., 1945; VMFA, 1946; NAD, 1945; Pepsi-Cola, 1946; Denver AM, 1944; Newport AA, 1944; Oakland A. Gal., 1945; Columbus Gal. FA, 1937-39; Dayton AI, 1944-44, 1945 (prize); Butler AI, 1944-45, 1946 (prize); Ohio Valley Exh., Athens, 1944, 1945 (prize), 1946 (prize); Springfield AA, 1946 (prize). Work: Butler AI; mural, Ohio Steel Co., Lima. Positions: T., Ohio State Univ. (1935-41), Wittenberg Col., Springfield, Ohio (from 1941) [47]

THOMPSON, Rodney [I] NYC. Member: SI, 1912 [13]

THOMPSON, Seymour [P] NYC. Member: SI [47]

THOMPSON, Thomas Hiram [P] Mullan, ID b. 27 S 1876, San Fran., CA. Studied: self-taught. Member: Spokane AL. Exhibited: Interstate A. Exh., Spokane, 1902 (gold), 1903 (gold) [08]

THOMPSON, Victor King [S,Arch] Columbus, OH b. 18 Je 1913, Colum-

bus, OH. Studied: E. Frey; Ohio State Univ. Member: Columbus AL. Exhibited: Columbus Gal. FA, 1937 (prize) [40]

THOMPSON, Walter W(hitcomb) [P,L,T] Mayesville, SC b. 10 Ja 1882, Palatka, FL d. 29 Ap 1948. Studied: Univ. Fla.; W.T. Robinson; C.W. Reed; V. George; New Sch. Des., Boston; J. Enneking. Member: North Shore AA; AAPL; Sumter (S.C.) AA; Ga. AA; Savannah AC; Beaufort FAA (Pres.); Carolina AA. Exhibited: Telfair Acad. A., 1935–37, 1939; Savannah AC; Coker Col., Hartsville, S.C., 1935, 1939–41; Gibbes A. Gal., 1937, 1939; North Shore AA, 1943–46; Mint Mus. A., 1942, 1944–46; Macbeth Gal.; Ainslie Gal.; Milch Gal. Work: Lander Col., Greenwood, S.C. Positions: Co-founder/Dir., Beaufort Art Colony, Beaufort, S.C.; Dir., Beaufort A. Sch.; T., Beaufort Pub. Sch. [47]

THOMPSON, William Norman [P,Li,Des,I] Wash., D.C. b. 13 N 1913, Wash., D.C. Studied: Abbott Sch. Des., Wash., D.C.; NAD; Corcoran Sch. A. Member: Wash AG. Exhibited: Wash. AG, 1944–46; 48 States Comp., 1939. Illustrator: "Right of Fair Trial," 1942. Position: A. Dir., U.S. Office Edu., 1936–43 [47]

THOMPSON, Winifred Dorothy Gilliland [P,Des,B,C,T] Albuquerque, NM b. 21 D 1906, Memphis d. 5 O 1945, Camp Adair Army Hospital, OR. Studied: G. Cassidy; N. Hogner; K. Adams; R. Jonson; F. Parsons; E. Steinhof. Member: AL of N.Mex.; Albuquerque AG. Exhibited: Albuquerque, 1934 (prize), 1935 (prize); AL of N.Mex., 1936 (prizes); Prof. Ar. Exh., State Fair, N.Mex., 1939 (prizes) [40]

THOMPSON, Woodman [P,D] NYC b. 19 N 1889, Pittsburgh. Studied: A.W. Sparks; G. Sotter; R. Holmes. Member: Pittsburgh AA. Founder: Dept. Stagecraft, CI. Specialties: set des.; mural paintings [40]

THOMS, Herbert [E] New Haven/Old Lyme, CT b. 5 Ja 1885, Waterbury, CT. Member: New Haven PCC; SC. Exhibited: WFNY, 1939 Work: New Haven PCC; Paris Expo, 1937 [40]

THOMSEN, Sandor Von Colditz [S] Chicago, IL b. 1879, Chicago d. 7 D 1914. Studied: L. Taft. Also a lawyer

THOMSON, Adele U(nderwood) (Mrs.) [P,T] Corpus Christi, TX b. 28 Ap 1887, Grosbeck, TX. Studied: AIC; Newcomb Col.; Tulane Univ.; E.A. Holmes; W. Stevens; X. Gonzales. Member: SSAL; Lg. Am. Pen Women; Texas FAA; Corpus Christi A. Fnd.; South Texas AL. Exhibited: NGA, 1946; Lg. Am. Pen Women; Caller-Times Exh., Corpus Christi; SSAL; Tex. FAA; Corpus Christi A. Fnd, 1945 (prize), 1946 (prize) [47]

THOMSON, Frances Louise [P,L,T] b. 22 F 1870, Hagerstown, MD. Studied: ASL; Md. Inst.; J.P. Laurens, at Académie Julian. Member: Wash. SA; Wash. WCC. Work: Md. Hist. Soc., Baltimore [29]

THOMSON, George [P] Ontario, Canada b. 10 F 1868, Claremont, Ontario. Studied: F.V. DuMond; W.L. Lathrop; H.R. Poore. Member: CAFA; New Haven PCC. Exhibited: CAFA, 1915 (prize) [33]

THOMSON, H(enry) G(rinnell) [P] Wilton, CT b. 24 N 1850, NYC d. ca. 1939. Studied: NAD; ASL; W.M. Chase. Member: S.Indp.A.; SC; Silvermine GA; AFA; AAPL. Exhibited: AWCS, 1898; SAA, 1898 [38]

THOMSON, Josephine N. (Mrs. J.C.) [P] NYC b. 1872, Indianapolis d. 28 O 1928. Studied: Acad. Colarossi. Member: PBC; NAWPS; Allied AA; NYWAC [27]

THOMSON, Rodney [I,E] NYC b. 2 O 1878, San Francisco, CA. Studied: Partington Sch. Illus. Member: Chicago SE; Artists G. [32]

THOMSON, Sarah K. [P] Ossining, NY [04]

THOMSON, William [P] NYC. Exhibited: NAD, 1898; NYWCC, 1898 [01]

THOMSON, W(illiam) T. [Por.P,I,C] Phila., PA b. 5 O 1858, Phila. Studied: PAFA. Member: AC Phila.; Phila. Sketch C.; AAS; Phila. AA. Exhibited: AAS, 1902 (med); Omaha Expo, 1898 [40]

THON, William [P,E,C] Port Clyde, ME b. 8 Ag 1906, NYC. Member: SC; Brooklyn SA; Brooklyn PS; All.A.Am.; F., Am. Acad., Rome, 1947. Exhibited: CGA, 1938–46; PAFA, 1939–46; VMFA, 1939–46; AIC, 1940–46; WMAA, 1941–46; Kansas City AI, 1942–46; Albright A. Gal., 1944–46; Pepsi–Cola Exh., 1944–46; BM, 1942 (prize), 1945 (prize); NAD, 1944 (prize), SC, 1942 (prize). Work: Bloomington (Ill.) AA; Swope A. Gal.; Farnsworth Gal., Rockland, Maine [47]

THORBERG, Trygve [S] Brooklyn, NY [17]

THOREK, Max (Dr.) [Photogr] Chicago, IL b. 10 Mr 1880, Hungary. Member: F., Royal Photogr. S., Great Britain; Fort Dearborn Camera C.; Chicago Camera C.; Pictorial Photogr. Am. Awards: 31 first prizes, 20 second prizes, 12 third prizes, 6 fourth prizes, 7 fifth prizes, 1 gold, 11 silver, 4 bronze, 45 hon. mentions, 25 certificates of merit, all during the year 1929. Most of his collection was destroyed in a fire. [30]

THORNBERRY, Bernice [P] Chicago, IL. Member: Chicago NJSA [25]

THORNBURGH, F.K. [P] NYC. Member: GFLA [27]

THORNDIKE, Charles Hall [Ldscp.P] Paris, France b. 10 D 1875, Paris to American parents. Member: Laurens, Paris. Member: Paris AAA; Assn. Salon d'Automne; French Acad., (officer) [21]

THORNDIKE, Charles J. (Chuck) [I,W,Cart,L,T,Des] Miami, FL b. 20 Ja 1897, Seattle, WA. Studied: Univ. Wash.; Univ. Calif. Author: "The Art of Cartooning," 1937; "Seeing America, the Easy Way," 1940; "Life Drawing and Anatomy," 1941; "Drawing for Money," 1941. Co-Author: "It's Fun to Draw"; "Jr.'s Fun to Draw." Contributor: "The Artist," London, England; Professional Arts Monthly. Position: A. Dir., General Motors Corp., 1928–31 [47]

THORNDIKE, Willis Hale [Car] b. 8 F 1872, Stockton, CA d. 18 Mr 1940. Studied: San Fran. AI; ASL; Académie Julian, with Laurens, Constant. Positions: Staff, San Francisco Chronicle (1890s), then New York Herald, Baltimore Sun [13]

THORNE, Anna Louise [P,E,L,B] Toledo, OH b. 21 D 1866, Toledo. Studied: AIC; Chicago Acad. FA; ASL; W. Chase; N. Los; Delacluse, M. Castelucho, Lhote, all in Paris. Member: Ohio Women A.; Detroit Women PS; Toledo Women AS; Mich. Acad. Sc., A.&L. Exhibited: Detroit, (one-man); TMA. Work: Toledo Zoo; mural, Toledo Pub. Lib. [47]

THORNE, Diana [I,W] NYC b. 7 O 1895, Winnipeg, Canada. Studied: W. Strang. Member: Chicago SE; Calif. PM; NAWPS. Author/Illustrator: "The Dog Basket," "The Human Comedy," "Your Dogs and Mine," "Wild Animals," "Tails Up," "Polo", 1936 "Cats as Cats Can," 1937 "Kiki the Kitten." Illustrator: "Igloo," by J. Waldo, "A Mile of Freedom," by Helen Train Hilles, "Rrou," Maurice Genevoix [40]

THORNE, Thomas [Mur.P,E,I,L,T] Williamsburg, VA (was living in Guilford, CT, 1940) b. 5 O 1909, Lewiston ME. Studied: Portland Sch. F. & Appl A.; Yale; ASL, with R. Marsh; A. Bower; Savage. Member: Am. Assn. Univ. Prof.; Virginia A. All.; Boston AC; Gloucester SA; Boston S.Indp.A. Exhibited: PAFA, 1930; NYWCC, 1937; VMFA, 1945; Boston S.Indp.A., 1935–38 Work: Hobart Col., Geneva, N.Y.; murals, H.S., General Hospital, Portland, Maine; St. Lawrence Church, Portland. Position: T., William & Mary Col., Williamsburg, Va., from 1943 [47]

THORNE, William [P] Delavan, WI b. 1864, Delavan, WI d. 10 Ja 1956 (age 92). Studied: Paris with Constant, Lefebvre, Laurens. Member: ANA, 1902; NA, 1913; SAA, 1893. Exhibited: NAD, 1888 (med); Paris Salon, 1891 (prize); Pan-Am. Expo, Buffalo, 1901 (med). Work: CGA [47]

THORNSCHEIN, Isidor [Por.P] NYC b. 1886 d. 14 Ap 1947.

THORNTON, Alice Green [P,B,Li,L,T] Edmond, OK b. 27 Ap 1903, Shawnee, OK. Studied: J. Martin; A. Young; Cox; Upjohn; B. Boas; Columbia. Member: Provincetown AA; Okla. AA; Mid-Western AA; Edmond AL. Exhibited: Annual Mid-Western Exh., Kansas City AI, 1932 (prize). Position: T., Central State T. Col., Edmond, Okla. [40]

THORNTON, Amy G. [P] Brooklyn, NY b. 1845 d. 26 Ag 1913

THORNTON, Anna Foster (Mrs. Harrison R.) [P,B,I] Alexandria, VA b. 21 N 1905, Baltimore. Studied: Md. Inst.; ASL; Md. Inst, 1930 (traveling schol.). Member: Baltimore AA; Baltimore WCC [47]

THORNTON, (Eugene Von Note) 'Gene [I] Kansas City, MO b. 28 Jy 1898, Hamilton, MO. Studied: C. Wilimovsky; L. L Balcom. Member: Kansas City SA. Contributor: illus./ed. features, Foreign Service mag., Household mag., The Rotarian; advertising illus. [40]

THORNTON, Henry LaVerne [S] Hammond, IN b. 13 Ja 1906, Herrin, IL. Studied: R. Josset; J. Martin. Member: Hoosier Salon; Hammond Lg. PS. Position: Tech. Dir., Hammond Community Theatre [40]

THORNTON, Margaret Jane [I,Por,P,Dec] Grove City, OH b. 25 S 1913, Grove City. Studied: A. Schille, M. Russell, Columbus A. Sch. Member: Columbus AL. Exhibited: Ohio State Fair, 1938 (prize), 1939 (prizes). Position: T., Columbus A. Sch. Display A., the Maramor, Columbus [40]

THORP, Earl Norwell [S] Danbury, CT d. 28 F 1951. Member: NSS. Work: USPO, Wrightsville, Ga. WPA artist. [47]

THORP, Hattie E. See Ullrich.

THORP, William (Mrs.) [P] Meadville, PA [19]

THORPE, Dorothy Carpenter [C,Des] Glendale, CA b. 5 Ja 1901, Salt Lake City, UT. Studied: Latter Day Saints Univ., Salt Lake City; Univ. Utah. Exhibited: glassware, Mus. Mod. A., Wash., D.C.; Marshall Field, Chicago; Assistance Lg., Hollywood, 1939 (prize). Work: CI. Designer: table ensembles, linen, glassware [47]

THORPE, Edward [E] East Orange, NJ [10]

THORPE, Everett Clark [Por.P,Mur.P,I,T,Car] Logan, UT (1976) b. 22 Ag 1907, Providence Cache, UT. Studied: Utah State Col.; Otis AI; O. Oldfield; R.M. Pearson; R. Stackpole; Syracuse Univ.; H. Hofmann Sch. A.; Grosz; Nordfeldt, Sepeshy; Zerbe. Member: Am. Assn. Univ. Prof.; Ogden AG; Logan A. Group. Exhibited: Utah State Inst. FA, 1946 (prize); CGA, 1941; Nat. A. Week, Wash., D.C., 1938, 1939; Denver AM; Utah A. Ctr., 1938-45; Utah Univ., 1938-46. Work: Utah State Inst. FA; Logan City Sch. Coll.; Cache County & Tremontan Sch. Coll.; Utah Capitol; USPO, Provo, Utah. Position: T., Utah State Col., Logan, from 1944 [47]

THORPE, Freeman [Por.P] b. 1844 d. 20 O 1922, Hubert, Minn. Work: portraits, gov. officials, Wash., D.C.

THORPE, Jayta Pauline (Polly Thorpe) [Textile Des] Stamford, CT b. 5 F 1912. Studied: G. Wiggins; N.Y. Sch. Appl. Des. for Women. Member: Springfield, AL; Lyme AA [40]

THORSEN, Lars [P] Noank, CT b. 30 N 1876, Norway d. 1952. Member: CAGA; Mystic AA; SC. Exhibited: CAGA, 1937 (prize). Work: Beach Coll., Storrs, Conn.; NYC; New Haven and Hartford Railway Co.; murals, Mariner's Savings Bank, New London, Conn.; A. Mus., Norway; Dayton AI; Mystic Seaport Mus. [40]

THORSON, Louise [P] NYC. Member: Lg. AA [24]

THORWARD, Clara Schafer (Mrs.) [P,C,E,T] South Orange, NJ b. South Bend, IN. Studied: AIC; Cleveland Sch. A.; ASL; H. Hofmann; H.G. Keller; Thurn Sch. Mod. A. Member: Sarasota SAC. Exhibited: CMA, 1925 (prize), 1926 (prize); AL of Northern Ind., 1932; Montclair AM, 1939; Ringling AM, Sarasota, Fla., 1939; Hoosier Salon; Lock Gal., Sarasota, 1939 (one-man); AL of Northern Ind., 1938; Morton Gal., N.Y. 1940; Plaza Hotel, N.Y., 1940; Witte Mem. Mus., 1944; Palace FA, Mexico City, D.F., 1946 [47]

THOURON, Henry Joseph [Mur.P,T] b. 1851, Phila. d. 12 D 1915, Rome, Italy. Studied: PAFA; Rome; Paris, with Bonnât. Member: AC Phila.; Phila. WCC; Arch. Lg., 1903; U.S. Public AL, 1897; PAFA F., 1909-15 (Pres.) Exhibited: PAFA, 1901 (med). Work: Cathedral of St. Paul and St. Peter, Phila.; holy water fonts of green bronze, St. Patrick's Church. Position: T., PAFA [15]

THRASH, Dox [P,E,Li,W,L,Des,S] Phila., PA b. 22 Mr 1892, Griffin, GA. Studied: AIC; Phila. Graphic Sketch C.; H.M. Norton; E. Horter. Member: Phila. Pr. C. Exhibited: WFNY, 1939; PMA; Phila. A. All., 1942 (one-man) Work: LOC; BMA; Lincoln Univ.; PMA; Bryn Mawr Col.; West Chester (Pa.) MFA; NYPL; U.S. Gov. Contributor: Magazine of Art, Art Digest [47]

THRASHER, Harry Dickinson [S] Baltic, CT b. 24 My 1883, Plainfield, NH d. 11 Ag 1918, France during WWI. Studied: A. Saint-Gaudens; Am. Acad., Rome, schol., 1911-14. Member: Mural P.; NSS 1917 [17]

THRASHER, Leslie [P,I] NYC/Setauket, NY b. 15 S 1889, WV d. 2 D 1936, of smoke inhalation after fire destroyed his summer home at Setauket. Studied: PAFA with Pyle, Chase, Anshutz. Member: SC. Became a commercial artist at seventeen; best known by his many cover pictures, full of character and homely American humor. [33]

THRESHER, Brainard B. [P,C] Dayton, OH. Member: SWA (assoc.) [08]

THROCKMORTON, Cleon (Francis) [P,L] NYC b. 3 O 1897, Atlantic City. Member: Wash. AC; Guggenheim F., 1935. Work: scenic designs for "Emperor Jones," "Desire Under the Elms," "The Verge," "Patience," "Wings of Chance," "All God's Chillun Got Wings," "Criminal at Large," "House of Connelly," "In Abraham's Bosom (Pulitzer prize), "Alien Corn," "Porgy" [40]

THRUSH, Helen Alverda [P,T] Phila., PA b. 15 D 1903. Studied: PMSchIA; Univ. Pa.; Columbia; Barnes Fnd., Merion, Pa. Member: Southeastern AA. Contributor: School Arts; Design mag. Position: T., Univ. N.C. [40]

THULIN, Emil O. [P] Chicago, IL [24]

THULIN, Walfred [C] Belmont, MA/Stonington, ME b. 20 Ap 1878, Sweden. Member: Boston SAC; Copley S. Exhibited: Boston SAC, 1919 (med). Specialty: carved and gilded mirrors and picture frames [40]

THULSTRUP. See de Thulstrup.

THUM, Patty P(rather) [Ldscp.P,I,W] Louisville, KY b. 1853, Louisville d. 28 S 1926. Studied: H.V. Ingen, Vassar Col; ASL with Chase, Mowbray, Wiles; MET Sch. FA. Member: Louisville AC. Exhibited: Columbian Exp, Chicago, 1893. Exhibited: NYSF, 1898; S. Ldscp. P., 1898. Work: Louisville Pub. Lib. [25]

THUM, William M. [P] Louisville, KY. Member: Louisville AL [98]

THURBER, Alice Hagerman (Mrs. Thomas L.) [P,C,T] Birmingham, MI b. 21 Je 1871, Birmingham, MI. Studied: J. Gies; Detroit Commercial A. Sch.; AIC with St. Pierre; F. Fursman; W.W. Kreghbeil; F.L. Allen. Member: Detroit S. Women PS; Chicago NJSA; Detroit S.Indp.A. Exhibited: Mich. Inst. A., State Fair, 1915 (prizes); 1916 (prizes), 1928 (prize); 1935 (prize). Work: Comm. House, Birmingham, Mich.; P., Mich. Lg. House, Univ. Mich., Ann Arbor [40]

THURBER, Caroline (Nehleton) (Mrs. Dexter) [Por.P] Brookline, MA b. Oberlin, OH. Studied: Italy; Benjamin-Constant, in Paris; Germany; England. Member: Copley S.; Boston AG. Exhibited: NAD, 1898. Work: portraits: Smith Col.; Mt. Holyoke Col.; Oberlin Col.; Boston Univ.; Supreme Courts, Iowa, R.I. Specialty: portraits of many distinguished authors and educators [40]

THURBER, Edna [P] b. 1887 d. 1981. Member: Woodstock art colony [*]

THURBER, James Grover [I,Car,W] NYC b. 1894, Columbus, OH d. 1961. Studied: Ohio State Univ. Illustrator: Columbus Dispatch, Paris Tribune, New YorkEvening Post; New Yorker [40]

THURBER, Rosemary [P,I] Birmingham, MI b. 1 My 1898. Studied: R. Herzberg; W. Sesser; K. Conover; K.H. Miller; F.V. DuMond; W.J. Duncan; ASL. Member: Detroit S. Women PS; Three AC, NYC; Detroit A. Market; Mich. AA. Exhibited: Three AC Gal., 1930 (prize); Detroit AI, 1935 (prize) [40]

THURLO, Frank [P] b. 1828, Newburyport, MA d. 25 D 1913. Specialty: painting views on Plum Island

THURLOW, Helen [P,I,E,En,Des] NYC/Norwalk, CT b. 15 Jy 1889, Lancaster, PA. Studied: PAFA (2 Cresson traveling schols). Member: SI; AG. Work: Lancaster Pub. Lib.; Muhlenberg Col., Allentown, Pa. [47]

THURMOND, Ethel Dora [P,T] Victoria, TX b. 15 Je 1905, Victoria. Studied: Univ. Tex.; Sul Ross State T. Col., Alpine Tex.; Univ. Colo.; X. Gonzales; P. Ninas; J. Woeltz. Member: Tex. FAA; SSAL; Victoria AL. Exhibited: SSAL, 1938, 1939; Caller-Times Exh., Corpus Christi, 1944, 1945; Tex. FAA; 1935; Southeast Tex. Exh., 1937–39; Tex. General Exh., 1940, 1945; Tex.-Okla. Exh., 1941; Houston MFA, 1938. Work: mural, H.S., Victoria. Position: T., Victoria Jr. Col. [47]

THURN, Dorothy Maria [P,I,W] Providence, RI b. 8 Mr 1907, Providence, RI. Studied: RISD; J. Goss. Member: Providence WCC. Work: WMA [40]

THURN, Ernest [P,W,L,T,Li] Boston, MA b. 23 Jy 1889, Chicago. Studied: H. Hofmann; Royal Acad. FA, Munich; Paris, with Lhote, Acad. Julian. Member: Gloucester AA. Positions: T., Erskine Sch., Boston; Dir., Thurn Sch. Mod. A., Boston & Gloucester, Mass. [47]

THURSTON, Charles W. [P,I] Paris, France/Somerville, MA [10]

THURSTON, Elmer M. [P] Rochester, NY. Member: Rochester AC [17]

THURSTON, Florence [P] Minneapolis, MN [17]

THURSTON, George A. [P] Rochester, NY [24]

THURSTON, Jane McDuffie (Mrs. Carl) [P,E] Pasadena, CA b. 9 Ja 1887, Ripon, WI. Studied: AIC, 1910-12; J. Mannheim; R. Miller; C.P. Townsley. Member: Pasadena SA; Calif. WCS. Exhibited: Los Angeles Mus. A., 1945, 1946; Calif. WCS, 1946; Pasadena SA, 1946; Pomona (Calif.) Col., 1946; Women P. of the West, 1922 (prize); West Coast Arts, 1923 (prize); Calif. AC, 1925 (prize). Work: Pasadena AI. Also a filmmaker on art, 1950s. [47]

THURSTON, John K. [P] Gloucester, MA b. 1865, Gloucester. Member: Boston AC [10]

THWAITES, Charles Winstanley [P,Li,T] Milwaukee, WI b. 12 Mr 1904, Milwaukee. Studied: Univ. Wis.; Layton Sch. A. Exhibited: CI, 1941, 1945; CGA, 1939, 1941; VMFA, 1946; MMA (AV), 1942; AIC, 1930-32, 1936, 1937, 1940-42, 1945; PAFA, 1936, 1938; Pepsi-Cola, 1946; SFMA, 1946; Contemp. A. Gal., 1944 (one-man); Milwaukee, 1944; Kearney Mem. Exh., 1946; Milwaukee AI, 1927–46, prizes: 1933, 1936, 1939, 1941, 1943, 1944; Univ. Wis., 1936-38, 1945; 48 Stts. Comp., 1939 (prize); Pal. Leg. Honor, 1946; Wis. PS, 1933 (prize), 1936 (prize). Work: Univ. Wis.; Marquette Univ.; Milwaukee Fed. Court; Milwaukee County Court; WPA

murals, USPOs, Greenville (Mich.), Plymouth, Chilton (both in Wis.), Windom (Minn.) [47]

THWING, J. Franklin [P] Chicago, IL [06]

THWING, Leroy L. [P] Allston, MA. Work: Index Am. Des., WPA [40]

TIBBETS, Marion [P] Seattle, WA. Member: Seattle FAS [21]

TIBBETTS, Frank E. [P] Columbus, OH. Member: Columbus PPC [25]

TIBBITTS, Armand [P] Buffalo, NY [17]

TIBBLES, Yosette La Flesche (Mrs. Thomas H.) [P,I,T] b. 1854, Bellevue, NE d. 1903, Lincoln, NE. Studied: N.J.; Univ. Nebr., Omaha. Indian painter; she was an interpreter for the Ponca Indians until 1882. [*]

TIBBS, Charlotte Eliza [P,Des] Biloxi, MS b. 2 O 1877, Buffalo, NY. Studied: F.A Parsons; J.C. Johansen; C.W. Hawthorne; P. de Lemos; M. Alton. Member: SSAL; Gulf Coast AA; NOAA. Work: Biloxi Pub. Schs. [40]

TICE, Clara [P] Brooklyn, NY [24]

TICE, Tempe [P] Indianapolis, IN [17]

TIDBALL, John Caldwell [Dr] b. 25 Ja 1825, Ohio County, VA (now WV) d. 15 My 1906, prob. Montclair, NJ. Studied: West Point, 1848. Work: topographical sketches from Lt. Whipple. Survey of 35th parallel (1853–54) in Okla. Hist. S. He rose to Brig. Gen. during Civil War. [*]

TIDDEN, Agnes Lilienberg [P] Houston, TX [25]

TIDDEN, John C(lark) [P,I,T] NYC (living Houston, TX, 1931) b. 10 F 1889, Yonkers, NY. Studied: PAFA, Cresson Schol. Member: SSAL; SI. Exhibited: PAFA, 1914 (prize). Work: Univ. C., Houston; Univ. Pa. [47]

TIEL, Ella Sheldon (Mrs.) [P] London, England/Phila., PA. Studied: PAFA [25]

TIEMANN, A. [P] Milwaukee, WI [17]

TIFFANY, Lillian [P,E] New City, NY b. 10 Ap 1900, Wash., DC. Studied: G.B. Bridgman; L. Kroll; R.P.R. Neilson; A.S. Covey. Member: Studio G. Illustrator: American Kennel Gazette; Spur mag. Specialty: dogs [40]

TIFFANY, Louis C(omfort) [P,C] NYC/Oyster Bay, NY b. 18 F 1848, NYC d. 17 Ja 1933. Studied: G. Inness, S. Colman, in NYC; L. Bailey, in Paris. Member: ANA, 1871; NA, 1880; SAA; AWCS; Arch. L., 1889; Century A.; N.Y. SFA; N.Y. Mun. AS; AIGA; NSS; AFA; Société Nationale des Beaux-Arts; Imperial Soc. FA, Japan; Chevalier Legion of Honor, France, 1900. Exhibited: Paris Expo, 1900 (gold); Dresden Expo, 1901 (gold); Turin Expo, Dec. A., 1901; St. Louis Expo, 1904; P.-P. Expo, San Fran., 1915 (gold); Sesqui-Centenn. Expo, Phila., 1926 (gold). Specialty: Oriental scenes. He was the son of the founder of the well-known jewelry firm of Tiffany and Co. of which he was himself a vice-president and director. He was also president and art director of the Tiffany Studios, which produced the Tiffany Favrile glass he originated. In 1918 he established the Louis Comfort Tiffany Fnd. for art students at Oyster Bay, Long Island, and deeded to it his art collections, Gallery, Chapel, country estate and $1 million. [31]

TIFFANY, Marguerite Bristol [P,T,C,L] Paterson, NJ b. Syracuse, NY. Studied: Syracuse Univ.; Columbia; Parsons Sch. Des.; E. Walters; W. Zorach. Member: N.J. AA; AAPL. Exhibited: Montclair AM, 1933–35, 1937; Paterson (N.J.) AA, 1934, 1936, 1946; Englewood (N.J.) AA; America House, N.Y., 1941, 1942. Author: "Industrial Arts Cooperative Service" (pamphlet), 1935. Position: T., State T. Col., Paterson, from 1927 [47]

TIFFANY, William Shaw [P,I] NYC b. 1824 d. 28 S 1907. Studied: Harvard, 1845; Paris, with Ary Sheffer, Couture, Troyon, Benjamin-Constant. Was a friend of William Morris Hunt. Returning to America in 1854 he settled in Baltimore. Exhibited: Md. Hist. S., 1856–93. Work: Mem. Hall, Harvard; illus., Tennyson's "May Queen"

TILDEN, Alice Foster [P,E,T] Boston/Rockport, MA b. Brookline, MA. Studied: BMFA Sch.; W.M. Chase. Member: Copley S.; Rockport AA; Boston AC; North Shore AA. Exhibited: Lg. Am. Pen Women Exh., Wash., D.C., 1934 (prize), 1936 (prize) [40]

TILDEN, Anna M(eyer) [S] Oak Park, IL b. 9 Jy 1897, Chicago, IL. Studied: A. Polasek; L. Taft. Member: Chicago PS; Chicago Gal. Assn.; Austin Oak Park, River Forest AL. Work: World War Mem., River Forest, Ill. [40]

TILDEN, Douglas [S,T,W] Oakland, CA b. 1 My 1860, Chico, CA d. 6 Ag 1935. Studied: NAD, with Ward, Flagg; Gotham Students' Lg., with Mowbray; Choppin, in Paris. Member: NSS; NAC; San Fran. AA, 1904. Exhibited: Paris Salon, 1890 (prize), 1892; Chicago Expo, 1893; Paris Expo, 1900 (med); Alaska-Yukon-Pacific Expo, Seattle, 1909 (gold). Work: AIC; Golden Gate Park, San Fran.; Portland, Oreg.; Los Angeles; San Fran. Position: T., Hopkins AI, from 1894–1900 [25]

TILDEN, George T. [P] Boston, MA. Member: Boston AC [08]

TILDESLEY, Florence K. [P] Brooklyn, NY. Member: Brooklyn SA [27]

TILL, Harry [P] Phila., PA. Member: Phila. AA [17]

TILLERY, Mary [P,T] Raleigh, NC b. Scotland Neck, NC. Studied: Meredith Col.; N.Y. Sch. F.&Appl.A., Paris; PAFA Country Sch.; Breckenridge Sch. P. Member: SSAL; N.C. Professional Artist's C. Position: T., Meredith Col., Raleigh, N.C. [33]

TILLINGHAST, Archie Chapman [P,Des,T] Westerly, RI b. 8 Je 1909, Stonington, CT. Studied: Newark Sch. F. & Indst. A. Exhibited: Lyman Allyn Mus. A.; Montclair AM; Newark Mus.; MOMA; Mystic (Conn.) AC. WPA artist. [47]

TILLINGHAST, Mary Elizabeth [C,P] NYC b. NYC d. 15 D 1912. Studied: John La Farge (assisted him with his windows), in NYC; Paris, with Carolus-Duran, Henner. Member: NAC. Exhibited: NAD, 1898; Columbian Expo, Chicago, 1893 (med); Charleston Expo, 1902 (gold,med). Work: stained window, Home for Friendless Children; window, Grace Church; N.Y. Hist. S. Bldg.; new Allegheny Observatory; Hotel Savoy. Was the first to realize the difference that the electric lighting of churches was destined to make in the spectacular effect of window designs [10]

TILLMAN, Ruth [P] Lakewood, OH. Member: Cleveland Women's AC [27]

TILLOTSON, Alexander [P,Mus.Dir,T,L] Topeka, KS b. 9 Jy 1897, Waupun, WI. Studied: Milwaukee Sch. F. & Appl. A.; ASL; Milwaukee State T. Col.; Columbia; K.H. Miller; M. Sterne; A. Dasburg; Max Weber. Member: Great Plains Mus. Assn.; Wis. PS; Kans. State Fed. A.; CAA; Wis. Ar. Fed. Exhibited: PAFA, 1932, 1933, 1935, 1936; CGA, 1933, 1935; Exh. Am. A., NYC, 1936; AIC, 1936, 1940; WFNY, 1939; Milwaukee AI, 1927 (prize), 1928–34, 1935 (prize), 1936–38, 1940 (prize); Univ. Minn., 1938; Univ. Chicago, 1944; Springfield (Mo.) Mus. A., 1946. Work: Milwaukee AI. Positions: T., Milwaukee Secondary Sch., 1926–43; Dir., Layton Sch. A. (Milwaukee), Mulvane AM, Washburn Mun. Univ., Topeka, Kans. (from 1945)[47]

TILT, Maude [S] Chicago, IL [01]

TILTON, Florence. See Ahlfeld.

TILTON, Olive (Mrs. Bigelow) [P] NYC/Hull's Cove, ME b. 12 My 1886. Studied: Paris, with Collin, Delecluse; Munich; London [21]

TILTON, Paul H. [P] Princeton, NY [01]

TIMBREL, Clarence O. [P] Des Moines, IA b. 24 O 1869, Mahuska Co., IA. Studied: G. Nollen. Exhibited: Iowa A. Salon, Des Moines, 1938 [40]

TIMKEN, Georgia. See Fry, John H., Mrs.

TIMMERMAN, P.F. [S] Minneapolis, MN [15]

TIMMERMAN, Walter [P] Kansas City, Kansas [17]

TIMMINS, H.A., Mrs. [P] Chicago, IL [10]

TIMMINS, Harry L. [I,T] Encino, CA b. 20 N 1887, Wilsonville, NE. Studied: AIC. Member: SI; GFLA; SC. Illustrator: "The Chicago," 1942 (Rivers of America Series); Ladies' Home Journal, Cosmopolitan, Collier's, MacLean's; This Week [47]

TIMMONS, Edward J. Finley [P,L,T] Chicago, IL b. 1882, Janesville, WI. Studied: AIC; R. Clarkson; Sorolla, Spain; England; Holland, with Melchers; France; Italy. Member: Chicago ASL; Chicago PS; Ill. Acad. FA. Exhibited: Mun. AL, AIC, 1929 (prize). Work: Univ. Chicago; Univ. Ark.; Univ. Ill.; Beloit Col.; Capitol, Des Moines, Iowa; Janesville AL, San Diego Gal. FA, Nat. Bank of Mattoon (Ill.); Mt. Clair (Ill.) Community House; Capitol, Cheyenne, Wyo.; Visitation Col., Dubuque, Iowa; Louis Berghoff Coll., Wilmette, Ill.; Santa Fe Railroad; Polytechnique Inst., Blacksburg, Va.; Meyer Mem., Michael Reese Hospital, Mun. A. Coll., Bell Sch., Chicago. Lectures: The Great Architectural Painters Throughout the Ages [40]

TIMOTHY, David [P] Knoxville, PA. Member: Pittsburgh AA [24]

TINDALE, Edward H. [P] Brockton, MA/S. Hanover, MA b. 21 Mr 1879, Hanson, MA. Studied: Munich Acad. with C. Marr, H. von Hayeck, Loeftz [29]

TINGLE, Minnie (Mrs.) [P] Los Angeles, CA. Member: Calif. AC [25]

TINGLER, Chester J. [P,Dec,Des] Coral Gables, FL b. 13 Je 1886, Buffalo, NY. Studied: ASL. Member: AFA; AAPL; Am. Ar. Cong.; Miami AL. Exhibited: VMFA; WFNY, 1939; Wash. A. Gal., Miami Beach; Worth Ave. Gal., Palm Beach; Century of Progress, Chicago, 1933 (prize). Work: WPA mural, USPO, Sylvester, Ga.; hotels and schs., Miami [47]

TINGLEY, Blanche [P] San Fran., CA [15]

TINKEY, John [Wood En] Westfield, NJ b. NYC. Studied: J.D. Felter, in NYC. Member: S. Am. Wood Engravers. Exhibited: Columbian Expo, Chicago, 1893, (med); Pan-Am. Expo, Buffalo, 1901 [13]

TINNE, Margaret S. [P] Cincinnati, OH. Exhibited: Cincinnati Woman's AC, 1934; Cincinnati AM, 1939 [40]

TINTNER, Leontine. See Camprubi.

TISCH, Annette Pauline [P] NYC/Truro, MA b. NYC. Member: NAWPS; AWCS [33]

TISCH, William [P] NYC [19]

TISCHLER, Marian Clara [P] Cincinnati, OH. Member: Cincinnati Women's AC [27]

TISCHLER, Victor [P,Li,I,T,C] Mamaroneck, NY b. 24 Je 1890, Vienna, Austria d. 1951, France. Studied: Beaux-Arts Acad., Vienna. Exhibited: Paris, 1936 (prize), 1938 (prize), Vienna, 1934, (prize); CI, 1943, 1945; WMAA, 1945; CMA, 1945; Pepsi-Cola, 1946; Kansas City AI, 1946; numerous one-man exh., U.S., abroad. Work: de Young Mem. Mus.; Santa Barbara Mus. A.; Stendahl Gal., Los Angeles; NYPL; Passedoit Gal., NYC; Europe [47]

TISHLER, Harold [Craftsman,T] Jackson Heights, NY b. 15 D 1895, Russia. Studied: Kunstgewerbeschule, Vienna, with M. Powolny, J. Hoffman. Member: N.Y. Soc. Craftsmen. Exhibited: MMA; BM; Roerich Mus.; Syracuse Mus. FA; VMFA; Phila. A. All.; N.Y. Soc. Craftsmen; N.Y. Soc. Cer. Arts; Intl. Expo, Paris, 1937 (gold,med) [47]

TITCOMB, M(ary) Bradish [P,I] Boston, MA b. NH d. S 1927, Marblehead, MA. Studied: BMFA Sch., with Tarbell, Benson, Hale. Member: Copley S., 1895; NYWCC; NAWPS; CAFA; North Shore AA. Exhibited: CAFA, 1917. Work: White House, D.C. [27]

TITCOMB, Virginia Chandler (Mrs. John Abbot) [S] Brooklyn, NY b. Otterville, IL. Specialty: bas-reliefs [06]

TITLOW, Harriet W(oodfin) [P] Jersey City, NJ b. Hampton, VA. Studied: Henri. Member: NAWPS; N.Y. Soc. Women A. [33]

TITSWORTH, Julia [P] Bronxville, NY b. 1878, Westfield, MA. Studied: AIC; R. Collin, in Paris. Member: NAWPS; AFA [29]

TITTLE, Walter Ernest [P,E,W] Danbury, CT b. 9 O 1883, Springfield, OH. Studied: N.Y. Sch. A., with Chase, Henri, Mora. Member: SAE; Chicago SE; Calif. PM; AAPL; Royal SA, London. Exhibited: NAD; Royal Acad., London; CGA, 1936; PAFA; LOC (one-man); AIC (one-man); CGA (one-man); U.S. Nat. Mus., 1943 (one-man), 1946 (one-man); NAC, 1931 (prize); Chicago SE, 1934 (prize); Calif. PM, 1932 (med). Work: Nat. Port. Gal., British Mus., Victoria & Albert Mus., all in London; Johns Hopkins Univ.; Masonic Temple, Springfield, Ohio; U.S. Nat. Mus.; LOC; BM; CI; AIC; Boston Pub. Lib.; NYPL; CMA; Columbus Gal. FA; TMA; Calif. State Lib.; Fitzwilliam Mus., Cambridge; Univ. Va.; Lib., Arlington, Mass. Author/Illustrator: "Colonial Holidays," "The First Nantucket Tea Party." Contributor: articles, Century, Scribner's; Illustrated London News [47]

TITUS, Aimé Baxter (Mr.) [P,T,I] San Diego, CA b. 5 Ap 1883, Cincinnati, OH. Studied: ASL, with Harrison, Mora, Bridgman, DuMond, Chase; San Fran. Inst. Member: San Diego FAS (Dir.). Exhibited: P.-P. Expo, San Fran., 1915 (med) [33]

TITUS, Millard W. [Ldscp.P,Des,Dec] Chicago, IL b. 2 Ja 1890, Dallas. Member: All-Ill. SFA. Exhibited: All-Ill. SFA, 1936 (prize) [40]

TOASPERN, Otto [P,I] NYC b. 26 Mr 1863, Brooklyn, NY. Studied: Royal Acad. FA, Munich, with Gysis, Nauen [10]

TOBERENTZ, Robert [S] NYC [01]

TOBEY, A.S. [P] Hartford, CT. Exhibited: 48 Sts. Comp., USPO Sta., East Hartford, Conn. 1939 (prize) [40]

TOBEY, Edward, Mrs. See McCartney, Edith.

TOBEY, Mark [P] b. 1890, Centerville, WI d. 1976. Lived in Seattle, Paris, NYC, and Chicago, 1931-38; Seattle, 1938-60; Basel, Switzerland, from 1960. Studied: briefly at AIC; briefly with Teng Kuei, in Seattle, 1923-24; calligraphy in Japan, 1934. Exhibited: Portland (Oreg.) AM, 1939 (prize); WFNY, 1939; MOMA, 1962 (retrospective). Work: MOMA. Important modernist whose Baha'i religious beliefs and studies in oriental calligraphy influenced his abstract "white writing" painting technique of tangled linear strokes. [40]

TOBIAS, Abraham Joel [P,Li,T,L,Des,I] Arlington, VA b. 21 N 1913, Rochester, NY. Studied: Rutgers Univ.; CUASch; ASL. Member: Am. Ar. Cong. Exhibited: MOMA, 1939; BM, 1937-39; SFMA, 1941; ACA Gal., 1936; Delphic Studios, 1935-37; New Sch. Soc. Research (one-man); Everhart Mus., 1939 (one-man); Howard Univ., 1938 (one-man). Work: BM; Los Angeles Mus. A.; Howard Univ. Gal. A.; NYPL; Rochester Pub. Lib.; murals, Midwood H.S., N.Y.; USPO, Clarendon, Ark. Positions: A. Dir., U.S. Army Air Forces, Intelligence Div. (1944), Metropolitan Opera Gld. (1946); T., Howard Univ., Wash., D.C. (1943-46) [47]

TOBIN, George Timothy [I,E,P,T] New Rochelle, NY b. 26 Jy 1864, Waybridge, VT d. 5 My 1956 (age 92). Studied: ASL, with G. deF. Brush. Member: SI; AAPL; New Rochelle AA. Exhibited: NYWCC; PAFA; New Rochelle AA, 1915-46. Work: FMA; Smithsonian; Daniel Webster Sch., New Rochelle, N.Y.; port. of prominent men. Illustrator: "Bible Stories," 1922, "Wind Blown Stories," 1930, "The Blue Highway," 1932 [47]

TOBRINER, Haidee [P] San Fran., CA [13]

TOCH, Maximilian [Paint Expert] b. 1865 d. 28 My 1946, NYC. A recognized chemist who lectured at NAD on "Paint, Paintings and Restoration," and published books on these subjects.

TODAHL, J(ohn O.) [P,I] Milford, CT b. 21 S 1884, Crookeston, MN. Studied: AG of Authors Lg. A. Work: CGA. Illustrator: "Cruise of the Cuttlefish," Scribner's [25]

TODD, Albert M. [Patron] b. 3 Je 1850, Nottawa, MI. A founder of three art museums, he began early in life to collect rare books and eventually owned 10,000 rare books and many valuable illuminated manuscripts. He purchased works of art on his first trip to Europe (1875). Most of his works of art have been given to educational institutions in Kalamazoo.

TODD, Anne Ophelia [Des,Mur.P,T] NYC b. 17 S 1907, Denver, CO. Studied: CI; ASL; BAID. Member: A. Des. Group. Exhibited: F., Tiffany Fnd., 1928, 1929, 1931. Position: T., Manhattanville Col., NYC [40]

TODD, Bianca [Mur.P] NYC b. NYC. Studied: Europe; ASL with K.H. Miller; W. Kuhn. Member: NSMP; NAWA; East Hampton Gld.; NAWPS; AFA; Munic. AS. Exhibited: Santa Barbara, Calif., 1933 (prize), NAWA, 1937 (prize); Argent Gal., 1939 (one-man). Work: Collaborated with Fred W. Ross on murals, Courthouse, Terre Haute, Ind. Position: Dir., Argent Gal., NYC [47]

TODD, C(harles) Stewart [P,Des,C] Cincinnati, OH b. 16 D 1886, Owensboro, KY. Studied: Cincinnati A. Acad.; W. Snell; A. Herter. Member: Boston SAC; Cincinnati Professional A.; Cincinnati MacDowell S. Exhibited: CM, 1914-46; Cincinnati Professional A., 1934-46; Closson Gal., 1920 (one-man), 1922 (one-man); Loring Andrews Gal., Cincinnati, 1940 (one-man); AIC (one-man). Specialty: batik. [47]

TODD, Edwin [S,P,T,L] Parkville, MO b. 26 D 1913, Sedalia, MO. Studied: Univ. Iowa; Columbia. Exhibited: Kansas City AI, 1939. Position: T., Park Col. [40]

TODD, Frances Carroll [P] Charlottesville, VA b. NYC Studied: Corcoran Sch. A.; Phila. Sch. Des., with H.B. Snell; Univ. W.Va., with E. Clark; Webster Art Sch., Provincetown, Mass.; H. Breckenridge; C.C. Critcher; E. Graecen; G.P. Ennis; Grand Central Sch. A.; Yard Sch. FA, Wash. Member: S. Wash. A.; Wash. AC. Exhibited: Univ. Va.; CGA, 1946; VMFA, 1945 [47]

TODD, H. Stanley [Por.P] NYC b. 1872 d. 21 Ap 1941, Northport, NY. Member: SC, 1900. Exhibited: NAD, 1898; Pan-Am. Expo, Buffalo, 1901 (prize); St. Louis Expo, 1904 (med) [10]

TODD, Marie Childs [Woodcarving,P,T] Indianapolis, IN b. Indianapolis. Member: Ind. Artists C.; Hoosier Salon, Chicago; John Herron AA. Work: three paintings in Pub. Sch., Indianapolis. Position: T., Shortridge H.S., Indianapolis [40]

TODD, Marjorie [S] Toledo, OH. Exhibited: TMA, 1936 (prize) [40]

TODD, Nell Margaret [P,T] Minneapolis, MN b. 19 Ja 1882, Minneapolis. Studied: R. Koehler, Minneapolis; Henri; Dow. Member: Minneapolis SFA; Attic C. [17]

TODD, Thomas [Printer] Boston, MA. Member: Boston SAC [32]

TODHUNTER, Francis [Dr,E,I,P] San Francisco/Mill Valley, CA b. 29 Jy 1884, San Fran. Studied: NAD; Calif. Sch. FA; F. Van Sloun. Member:

Calif. SE; San Fran. AA; Bohemian C. Exhibited: Bay Region AI, 1938 (prize). Position: A. Dir., McCann-Erickson Inc., San Fran. [40]

TODTLEBEN, Richard [P] Chicago, IL [13]

TOEPFERT, O.A. [P] Cincinnati, OH [13]

TOERRING, Helene [P.C,Des] Phila., PA/Brant Beach, NJ b. Davenport, IA. Studied: AIC; ASL; PAFA. Member: Phila. A. All. Exhibited: Los Angeles Mus. Hist., Sc., A.; PAFA [40]

TOFEL, Jennings [P,I,W] NYC b. 18 O 1891, Poland d. 7 S 1959. Studied: CCNY. Exhibited: U.S.; abroad. Work: WMAA. Author: "B. Kopman," (monograph), two monographs for Société Anonyme, article in American Caravan, essay in "America and Alfred Stieglitz." [47]

TOFFT, Carle Eugene [S] NYC b. 22 S 1874, Brewer, ME. Studied: Blankenship; Ruckstuhl. Member: NSS [04]

TOH-YAH. See Nailor, Gerald.

TOJETTI, Edward [P] b. 1852, Rome, Italy d. 27 N 1930, San Francisco. Work: murals, old St. Ignatius' Church and College; des. San Fran. Diamond Palace. All were destroyed by the fire of 1906.

TOJETTI, Virgillo [Genre P.,Mur.P] b. 15 Mr 1851, Rome d. 26 Mr 1901, NYC. Studied: his father; Paris with Bouguereau, Gérôme. Work: murals, NYC residence of Charles T. Yerkes; Savoy Hotel; Hoffman House

TOKITA, Kamekichi [P] Seattle, WA b. 1897, Japan. Exhibited: Seattle AM, 1934, 1938 [40]

TOKSVIG, Harald [P] NYC [21]

TOLEGIAN, Manuel J. [Mur.P] Sherman Oaks, CA b. 18 O 1911, Fresno, CA. Studied: ASL; J. Sloan; T. Benton; J.S. Curry; G. Grosz. Exhibited: CGA, 1939, 1941, 1943; PAFA, 1938; WMAA, 1937, 1940, 1941; CI, 1939; GGE, 1939; WFNY, 1939; AIC, 1938, 1943; SFMA, 1941; Ferargil Gal., 1936–39; Palace Legion Honor; Crocker A. Gal.; San Diego FAS; Assn. Am. A., 1941. Illustrator: "The Dove Brings Peace," 1944; "Dinner at Omar Khayyam's," 1944. Work: Univ. Ariz.; Palace Legion Honor; Crocker A. Gal.; PMG; Pub. Lib., Chico, Calif. [47]

TOLMAN, Emile Ferdinand [P] Paris, France b. Boston, MA [13]

TOLMAN, George R. [P,Arch,I] Boston, MA b. Boston. Exhibited: Boston AC, 1898. Specialty: watercolors [01]

TOLMAN, Nelly McKenzie (Mrs. Ruel P.) [Min.P] Wash., D.C. b. Salisbury, N.C. Studied: Corcoran Sch. A. Member: Pa. Soc. Min. P.; Wash., S. Min. PS&G. Exhibited: AAPL (prizes); Wash. Soc. Min. PS&G. Work: NCFA [47]

TOLMAN, Robert [Por.P,T] NYC b. 1886, Boston. Studied: Acad. Julian, with Laurens; Colarossi Acad.; A. Gilbert; Bridgman; Johansen [40]

TOLMAN, Ruel Pardee [Mus.Dir,P,E,W] Wash., D.C. b. 26 Mr 1878, Brookfield, VT. Studied: Univ. Calif.; Corcoran Sch. A.; ASL; NAD. Member: Intl. Assn. Printing House Craftsmen (hon.); Chicago SE. Work: Amherst Wilder Charity, St. Paul, Minn.; U.S. Nat. Mus. Contributor: articles for Antiques mag., incl. "American Miniatures and Graphic Arts," "E.G. Malbone, Miniature P." Positions: Dir., NGA, 1932–37; NCFA, 1937–46; Cur., Div. Graphic A., U.S. Nat. Mus., 1946; Dir., NCFA, from 1946 [47]

TOLMAN, Stacy [Por.P,T] Pawtucket, RI b. Ja 1860, Concord, MA d. 20 F 1935. Studied: O. Grundman, in Boston; Paris, with Boulanger, Lefebvre, Cabanel. Member: Providence AC; Providence WCC; Boston AC. Position: T., RISD [33]

TOLPO, Carle (Axel) (Edward) [Por.P] Chicago, IL b. 22 D 1901, Ludington, MI. Studied: Augustana Col., Rock Island, Ill.; Univ. Chicago; AIC; F.O. Salisbury, in London. Member: All-Ill. SFA. Exhibited: Swedish-Am. Exh., 1939, 1946; Chicago Lake Shore C., 1943; Ill. State Mus., 1944 (one-man); All-Ill. SFA, 1938 (one-man), 1939 (one-man) 1941 (one-man), 1942 (one-man). Work: Augustana Col.; Augustana Hospital; Swedish-Am. Hist. Mus., Phila.; Mun. Court, Chicago; Inst. Med., John Marshall Law Sch., Chicago; Ill. Capitol; Chicago City Opera Co. [47]

TOLSON, Magdalena Welty (Mrs. Norman) [P,C,T] Ft. Wayne, IN/Lake George, MI b. 15 F 1888, Berne, IN. Studied: AIC. Exhibited: Kansas City AI, 1922 (prize). Work: Kansas City AI [40]

TOLSON, Norman [P,E,I,Des,T] Ft. Wayne, IN/Lake George, Clare County, MI b. 25 Mr 1883, Distington, Cumberland, England. Studied: A. von Jank, in Munich; AIC; London Art Sch. Member: Kansas City AS; Ill. SFA; South Side AS; AIC. Exhibited: AIC, 1917 (prize); Kansas City AI, 1921 (prize), 1924 (prize), All-Ill. SFA, 1929 (prize); Wash. Bi-Centenn. Ill. Comm. Award, 1933 (gold). Work: panels, La Salle Hotel, murals, Stevens Hotel, Pub. Sch., Chicago; Country C., Lake Geneva, Wis. Positions: T., Layton Sch. A. (Milwaukee), Beloit Col. (Wis.) [40]

TOMAJAU, William Hurant [P] Worcester, MA [24]

TOMANEK, Joseph [P] Chicago, IL b. 16 Ap 1889, Straznice, Czechoslovakia. Studied: A.H. Krehbiel; A. Sterba; K.A. Buehr; AIC; Hynais, in Prague. Member: Bohemian AC, Chicago; Assn. Chicago PS; Palette and Chisel Acad. FA; Chicago Gal. Assn.; All-Ill. SFA; Austin-Oak Park-River Forest AL. Exhibited: Bohemian AC, 1920; Chicago Gal. Assn., 1939 (prize); Palette and Chisel Acad. FA, 1939 (gold). Work: John Vanderpoel AA, Chicago [40]

TOMASO, Rico [P,I] NYC b. 21 F 1898, Chicago, IL. Studied: D. Cornwell; H. Dunn; J.W. Reynolds. Member: SI. Illustrator: "Son of the Gods," by Rex Beach, "The Parrot," by Walter Duranty, and "Tagoti," Cynthia Stockley [40]

TOMEI, Lucille V. [S,P,T] Pittsburgh, PA b. 11 My 1904, St. Joseph, MO. Studied: Univ. Kansas; Kansas City AI; Univ. Pittsburgh; C. Sasportas; J. Heidner; G. Gray. Member: Pittsburgh AA. Exhibited: Kansas City AI, 1937 (prize), 1938 (prize), 1939; Contemporary Am. A., Topeka, 1939. Work: Immaculata H.S., Ft. Leavenworth Mus., Ft. Levenworth, Kansas; Churchill Country C., Cathedral of Learning, Pittsburgh, Pa.; Kansas Hist. Mus.; Max Adkins Studios, Pittsburgh, Pa. Position: T., St. Mary's Col., Leavenworth [47]

TOMKINS, Margaret [P,T] North Seattle, WA b. 11 S 1916. Studied: Univ. So. Calif.; P. Sample; D. Lutz; D. Prendergast. Member: Los Angeles Mus. Hist., Sc., A.; Monticello Col., Ill., 1939; WFNY, 1939; San Fran. MA, 1939. Position: T., Sch. A., Univ. Wash. [40]

TOMLIN, Bradley Walker [P] NYC/Woodstock, NY b. 19 Ag 1899, Syracuse d. 11 My 1953. Studied: Syracuse Univ., 1921; Jeannette Scott; Acad. Colarossi; Grande Chaumière, 1923–24. Member: Fed. Mod. PS; Woodstock AA; Hiram Gee F., Syracuse Univ. Exhibited: nationally; Montross Gal., 1924 (one-man), 1927 (one-man); Rehn Gal., 1931 (one-man), 1942; Hofstra Univ., 1975 (retrospective). Work: MET; WMAA; BM; PAFA; PMG; AGAA; Cranbrook Acad. A.; MOMA; Newark Mus.; Baltimore MA. Specialty: lyric abstract expressionism [47]

TOMLINSON, Anna C. [P] Roxbury, MA [19]

TOMLINSON, Dorothea (Mrs. Gulaelma Dorothea Tomlinson Marquis) [P,Des,L,Li,T] Fairfield, IA b. 16 Je 1898, Fairfield. Studied: Cumming Sch. A.; Stone City Summer Sch., Iowa. Member: Iowa AC. Exhibited: CGA, 1939; Joslyn Mem., 1932; AFA Traveling Exh., 1938, 1939; Iowa AC, 1931–35, 1933 (prize); Iowa A. Salon, 1931–41; Des Moines WC Exh., 1932–35, 1937, 1939–41; Des Moines Women's C. (prize); Mid-Winter Exh., 1920 (prize), 1933 (prize), 1937 (prize); Iowa State Fair, since 1912 (prizes). Work: Iowa State Col.; Ames (Iowa) Women's C.; Charles City (Iowa) Women's C.; Congressional Bldg., Wash., D.C.; WPA murals, USPOs, Hoisington, Kans., Mt. Pleasant, Iowa. Author: "Before the Railroad," 1937. Position: T., Parsons Col., Fairfield, Iowa, from 1944 [47]

TOMLINSON, Florence Kidder (Mrs. E.B.) [Por.P,Mur.P,En,T,I,B,Des] Madison, WI b. 10 Ja 1896, Chicago, IL d. 1979. Studied: Colt Sch. A., Madison; Univ. Wis. O. Hagen; F. Taubes. Member: Wis. P.&S.; Lg. Am. Pen Women; Madison AG; Madison AA; All-Ill. SFA. Exhibited: LOC, 1944, 1945; Milwaukee AI, 1940, 1942–45; Laguna Beach AA, 1945; NAD, 1942, 1943; Albright A. Gal., 1943; Northwest PM, 1946; Madison A. Salon, 1940–43, 1945; Wis. Mem. Union, 1929 (prize); Madison, Wis., 1941 (prize), 1942 (prize); Wis. State Fair, 1938 (prize), 1942 (prize) 1943 (prize), 1944 (prize); Madison AG, 1944 (prize), 1945 (prize), 1946 (prize). Work: Milwaukee AI. Illustrator: Nature, House and Garden, School Arts, Country Life in America. Position: T., Madison Evening Vocational Sch. [47]

TOMLINSON, Henry W(elling) [P] Salisbury, CT b. 18 S 1875, Baltimore. Studied: E.S. Whiteman, Baltimore; ASL, with Cox and Brush [31]

TOMMASINI, Joseph [P] Kansas City, MO [24]

TOMPKINS, Alan [P,T,I,L,Des] Stratford, CT b. 29 O 1907, New Rochelle, NY. Studied: Columbia; Yale. Member: Winchester Traveling G., 1933–34. Exhibited: AIC, 1936; L.D.M. Sweat Mem. Mus., 1943; mural sketches & traveling exh., U.S. & abroad; PAFA, 1939; Herron AI, Indianapolis. Work: WPA murals, USPOs, Martinsville, North Manchester, Indianapolis, all in Ind.; Boone, N.C.; General Electric Co., Bridgeport, Conn.; Columbia Univ., NYC. Positions: T., John Herron AI (1934–38), CUASch (1938–43), Columbia (from 1946) [47]

TOMPKINS, Frances L(ouise) [P] Brooklyn, NY b. 21 S 1877, Newark, NJ.

Studied: ASL, with Henri, J. Sloan, K.H. Miller, M. Weber. Member: S.Indp.A. [25]

TOMPKINS, F(rank) H(ector) [P] Brookline, MA b. 13 My 1847, Hector, NY d. 11 Jy 1922. Studied: ASL; Cincinnati Sch. Des.; Royal Acad., Munich, with Loefftz. Member: Boston AC; Copley S. Exhibited: Mass. Charitable Mechanics' Assn. (gold). Work: Boston AC; PAFA; BMFA [21]

TOMPKINS, Helen [P,T] NYC/Palenville, NY b. 31 Jy 1883, Westfield, NJ. Studied: NAD; NYU Sch. Arch. [40]

TOMPKINS, Laurence [S,P] NYC b. 18 F 1897, Atlanta, GA. Studied: BAID; ASL; Slade Sch., London; Grande Chaumière, Paris; D. Edstrom. Member: NSS. Exhibited: Royal Acad., London; Paris Salon, 1924; PAFA; NAD; Reinhardt Gal., NYC, 1938 (one-man); Carstairs Gal., NYC, 1939 (one-man); WFNY, 1939 (one-man). Work: monuments, Augusta, Ocella, Atlanta, all in Ga.; Luxembourg Mus., Paris [47]

TOMPKINS, Marjorie J. [P] Nyack, NY [24]

TOMPKINS, Van Veet [P] NYC. Member: S.Indp.A. [25]

TONETTI, F(rancois) M(ichel) L(ouis) [S] NYC b. 7 Ap 1863 (came to U.S. in 1899) d. 2 My 1920. Studied: Ecole des Beaux-Arts, with Falguière; Paris, with Noël, MacMonnies. Member: NSS; Arch. Lg.; 1901. Exhibited: Paris Salon, 1892 (prize); St. Louis Expo, 1904 (med). Work: bust, Luxembourg, Paris; fountain, Chicago World's Fair, 1893; Brooklyn Arch; N.Y. Custom House; NYPL; collaborated with St. Gaudens at LOC; a figure symbolizing the "Battle of the Marne" [19]

TONETTI, Mary Lawrence (Mrs. F. Michel) [S] NYC b. 1868 d. 14 Mr 1945 [17]

TONEY, Anthony [P,T,W] NYC (1977) b. 28 Je 1913, Gloversville, NY. Studied: Syracuse Univ.; Ecole des Beaux-Arts; Académie Grande Chaumière, 1937–38. Member: AL Am.; United Am. Ar.; NSMP; A. Equity; Audubon A.; NA, 1971. Exhibited: Pinacotheca; Mortimer Brandt Gal.; CGA; AIC; MOMA; Mortimer Levitt Gal.; Wakefield Gal., 1941 (one-man); Santa Barbara Mus. A., 1944 (one-man); ACA Gal., NYC, from 1952 (prizes); NAD (prizes); NIAL (prizes); Audubon A. (prize). Work: mural, Gloversville (N.Y.) H.S. WPA muralist, NYC, 1940–41. [47]

TONK, Ernest [P,I,W,Mur.P] Garden Grove, CA (1968) b. 1889. Cowboy artist active in Calif. and Wash. [*]

TONKIN, John Carter [C,T] Durham, NH b. 11 N 1879, Mullicahill, NJ. Member: Boston SAC; NH Lg. A. & Crafts. Work: Univ. N.H. Position: T., Univ. N.H. [47]

TONKIN, L(inley) M(ansen) (Mrs.) [P,E,Li,L,W] Taos, NM/ Denison, TX b. Sherman, TX. Studied: ASL; J. Carlson; I. Wiles; C. Carleton. Member: Assn. Okla. A.; SSAL; Chicago SE; Calif. PM. Work: Tex. Tech. Col., Lubbock [33]

TONSBERG, Gertrude Martin [P] Boston, MA/East Gloucester, MA b. 3 F 1903, Boston. Studied: Mass. Sch. A.; BMFA Sch. Member: North Shore AA; Rockport AA; Gloucester SA; Boston AC; S.Indp.A. Exhibited: Springfield AL, 1935. Work: Woodrow Wilson Jr. H.S., Jeremiah Burke Sch., both in Boston; Worcester AM. Position: Tech. Dir., Hatfield's Color Shop, Boston [40]

TOOKER, Marion Farwell [P] Paris, France/Chicago, IL b. 22 N 1882, Chicago. Studied: Du Mond; Mora; R. Miller, Paris. Member: Women's Intl. S., Paris, London [13]

TOOMBS, Adelaide Althin [S,C,L,T] Roxbury, MA b. 8 My 1915, Boston, MA. Studied: Mass. Sch. A.; MIT; C. Dallin; R. Porter. Member: Copley S.; Boston SAC. Exhibited: PAFA, 1941; NAD, 1942; CGA, 1942; Copley S., Boston, 1941; Boston AC, 1942; Mass. Sch. A., 1936 (med) [47]

TOOMEY, R.W. [P] Columbus, OH b. 16 N 1882, Columbus. Member: Columbus PPC [25]

TOOR, Nishan [S,Des] Altadena, CA. b. 16 F 1888, Armenia. Member: Pasadena SA. Exhibited: GGE, 1939; WFNY, 1939; FA Gal., San Diego; Los Angeles Mus. Hist., Sc.&A.; Pasadena Jr. Chamber of Commerce, 1936 (prize); Pasadena, 1937 (prize); Los Angeles Mus. Hist., Sc.&A., 1937 (prize); Pasadena Playhouse, 1939 (med). Work: war mem., Paris; Pau AM, France [40]

TOPANELIAN, Fanny N. (Mrs. Edward) [P] Worcester, MA [24]

TOPCHEVSY, Morris [P,E,L,W] Chicago, IL b. 15 O 1899, Bialistock, Poland d. ca. 1950. Studied: San Carlos Acad., Mexico; A.H. Krehbiel; AIC. Member: AL, Chicago; Am. A. Cong.; Chicago Artists Univ.; Chicago SA. Exhibited: AIC, 1941–46; NAD, 1942. Work: murals, Abraham Lincoln Ctr., Chicago; Holmes Sch., Oak Park, Ill. Author: "America Today," 1937. Position: A. Dir., Lincoln Ctr., Chicago [47]

TOPP, Esther (Mrs. James G. Edmonds) [P,T] Pittsburgh, PA b. 17 N 1893, Pittsburgh d. 18 Jy 1954. Studied: Cornell Univ.; CI. Member: Pittsburgh AA; Pittsburgh WCS. Exhibited: CI, 1933, 1940–46; Pittsburgh AA, 1921–46, 1923 (prize), 1924, 1926 (prize), 1929 (prize), 1930 (prize), 1945 (prize); Chicago Gal. Assn., 1927 (prize); Hoosier Salon, 1938 (prize); Work: Pittsburgh Pub. Sch.; Pa. State Col.; mural, Mary Biesecker Pub. Lib., Somerset, Pa. Position: T., CI, since 1921 [47]

TOPPING, James [Ldscp.P,Li] Oak Park, IL b. 25 F 1879, Cleator Moor, Cumberland, England d. 24 Jy 1949. Studied: AIC; England. Member: Chicago Gal. Assn.; Palette & Chisel Acad., Chicago; Ill. Acad. FA; Chicago P.&S.; Brown County AA; Austin, Oak Park & River Forest AL; Chicago Lith. C.; Hoosier Salon. Exhibited: PAFA; Nat. Exh. Am. A., NYC, 1936; Joslyn Mem.; AIC, 1924 (prize), 1925–31, 1926 (prize), 1929 (prize); Chicago Gal. Assn., 1927 (prize); Hoosier Salon, 1938 (prize), 1940 (prize); Brown County AA; Nashville, Ind; Min. AL, Chicago, 1923 (prize); Palette and Chisel Acad., 1924 (gold), 1927 (med); Assoc. Chicago P&S, 1942 (med); Oak Park AL, 1930 (med); Business Men's AC, Chicago, 1929; Hummell Mem. Prize, 1940. Work: State Mus., Springfield, Ill.; Joslyn Mem.; Oak Park C.; Chicago Pub. Sch.; Palette & Chisel Acad. FA, Chicago; Chicago Gal. Assn.; H.S., Kenilworth, Ill. [47]

TORAN, Alfonso T. [Mur.P,Dec,Des,L,W,T] Bronx, NY b. 17 My 1896, Naples, Italy. Hills. Studied: Italy. Exhibited: WMAA. Awards received in Italy, France and U.S. Work: murals, Hotels Delmonico, Pierre, New Yorker, Waldorf-Astoria. Position: Dir., Creative Studios of Art & Decoration, NYC, from 1935 [47]

TORGERSON, William [Mar.P] active Chicago 1873–90. Work: portraits of Cunard Steamship Co. ocean liners in BMFA and Chicago Hist. S. [*]

TORRANCE, H.C. [P] Pittsburgh, PA. Member: Pittsburgh AA [21]

TORRES, Garcia J. [P] NYC. Member: S.Indp.A. [21]

TORREY, Charles [Mar.P] b. 1859, Boston d. 1921, Brookline, MA. Work: Peabody Mus., Salem, Mass. (amateur) [*]

TORREY, Elliot (Bouton) [P] San Diego, CA (since 1923) b. East Hardwick, VT d. 10 Mr 1949. Studied: Bowdoin Col., 1890; Florence; Paris. Member: San Diego FAS. Exhibited: BAC, 1898. Work: AIC; CMA; Akron AI; San Diego Fine Arts Mus. Specialties: children; seascapes [40]

TORREY, Eugene [P] Los Angeles (1890s–26) Exhibited: Paris, 1886. Specialties: Calif. missions, 1890's; military subjects, after 1910 [*]

TORREY, Franklin [S] Florence, Italy (since ca. 1860) b. 25 O 1830, Scituate, MA d. 16 N 1912. He studied in Rome, was American Consul General at Genoa, and at one time proprietor of the Carrara Marble Works. The American Church in Florence was built under his supervision.

TORREY, Fred M. [S,P] Chicago, IL b. 29 Jy 1884, Fairmont, W.V. Studied: C.J. Mulligan. Member: Chicago S. P.&S. Exhibited: PAFA; Dayton AI; WFNY, 1939; AIC; Chicago World's Fair. Work: S./med./mem./busts, Chautauqua, N.Y.; Westley Hospital, Chicago; Haines County Court House, Jackson, Miss.; La. State Medical Sch., New Orleans; Capitol, Baton Rouge, La.; Univ. Chicago; Brown Univ.; Northwestern Univ.; Swedish Hall of Fame, Phila.; Pub. Sch., Bloomington, Ill.; Paradise Theatre, 124th Field Artillery Bldg., both in Chicago; Haish Lib., DeKalb, Ill.; Schs., Charleston, Ill.; bronze doors, Highland Park Pub. Lib., Mich.; mem. tablets, Ontario, Canada; busts, Houston; port. statue, Winchester, Ill.; equestrian statues, Springfield, Ill.; Mun. mem., Topeka, Kans.; Am.-Swedish Hist. M., Phila. [47]

TORREY, George Burroughs [Por.P] NYC b. 1863, NYC d. 14 Ap 1942, Honolulu, HI. Studied: NYC; Paris. Award: Order of the Savior, 1904, by the King of Greece. Exhibited: NAD, 1898 [17]

TORREY, Hiram Dwight [P] active in Milwaukee, 1851; in Reading, PA, 1853–62. b. 24 Je 1820, New Lebanon, NY d. 11 Ag 1900, Delanco, NJ. Exhibited: PAFA, 1855. Specialties: ldscps.; still life [*]

TORREY, Mabel Landrum [S,T] Chicago, IL b. 23 Je 1886, Sterling, CO. Studied: State T. Col., Greeley, Colo.; AIC; C.J. Mulligan. Member: Chicago Gal. Assn. Exhibited: Chicago Gal. Asn., 1930 (prize); AIC. Work: statues, reliefs, mem., etc., Wash. Park, Denver; Omaha Children's Lib.; Proctor's Hospital, Cincinnati, Ohio; Univ. Chicago Nursery Sch.; State Normal Col., Greeley; many portraits of children; fountain, Wellsboro, Pa.; South Bend, (Ind.) Lib. [47]

TOTH, Steven Jr. [Des,P] Alhambra, CA b. 29 D 1907, Phila., PA. Studied: Cleveland Sch. A.; H.G. Keller; S. Vago; R.E. Wilhelm, J.F. Faysash. Member: Akron SA. Exhibited: Akron AI, 1930–40; Butler AI, 1937, 1939. Work: mural, Akron (Ohio) Armory [47]

TOTTEN, George Oakley, Jr. [P] Wash., D.C. [01]

TOTTEN, Vicken von Post (Mrs. George O.) [S,P,I,L] Wash., D.C. b. Sweden. Studied: Académié of Beaux-Arts, Stockholm. Member: Grand Central A. Gal.; Women's Soc. PS, Stockholm. Work: Metropolitan Church of Immaculate Conception, Wash., D.C.; A. Industry M., Copenhagen; Nat. M., Stockholm; WPA murals, USPOs, Waterbury, Conn., Spencer, W.Va.; Fed. Bldg., Newark, N.J. [40]

TOULMIN, Ashby [P] University, LA. Exhibited: 48 States Comp., 1939. Position: Affiliated with Dept. FA, Univ. La. [40]

TOUSEY, T. Sanford [I,W] active NYC, 1924-48. Art Editor/Illustrator: children's books [*]

TOUSEY, Maude [I] Boston, MA [10]

TOWENE, Charles H. [I] New Rochelle, NY. Member: New Rochelle, AA [25]

TOWLE, Edith [P] Chicago, IL [13]

TOWLE, H. Ledyard [Mur.P,Por.P,T] NYC b. 30 Ag 1890, Brooklyn, NY. Studied: Adelphi Col.; Pratt Inst.; ASL, with Du Mond, Chase. Member: SC; Allied AA; CAFA; S.Indp.A.; NAC. Exhibited: Yonkers Expo, 1913 (med). Work: Mun. Bldg., NYC; Ohio Wesleyan Univ. Positions: T., N.Y. Evening Sch. Indst. A., Fawcett Sch. Indst. A. (Newark, N.J.) [19]

TOWNA, Arthur [I] Illustrator: Judge, NYC [98]

TOWNE, Constance (Gibbons) (Mrs. F.T.) [Por.P,S] Norton, CT b. 9 S 1868, Wilmington, DE [17]

TOWNE, L. Benson [P] Cincinnati, OH [19]

TOWNER, Flora L. [P] Albany, NY b. Exhibited: PAFA, 1898 [01]

TOWNER, Xarifa (Miss) [P] Los Angeles, CA. Member: Calif. AC [17]

TOWNLEY, Clifford [P] Leonia, NJ. Member: SC [25]

TOWNLEY, Frances Brown (Mrs.) [P] Englewood, NJ b. 10 Mr 1908, Waterbury, CT. Studied: Yale; PAFA. Member: Phila. Alliance; New Haven PCC; New Haven BPC; Boston AC; NAWPS. Exhibited: Waterbury Annual, 1934 (prize). Work: St. Thomas Church, New Haven [40]

TOWNSEND, Ernest Nathaniel [P,T,I] NYC b. 26 Je 1893, NYC d. 16 O 1945. Studied: P. Cornoyer; G. Maynard; C.Y. Turner; T. Fogarty. Member: SC; Yonkers AA; Allied AA; AAPL; AWCS Artists' F. Exhibited: SC, 1938 (prize). Work: N.Y. Hist. Soc. [40]

TOWNSEND, Ethel Hore (Mrs. John) [Min.P,C] Glen Ridge, NJ b. 26 S 1876, Staten Island, NY. Studied: H.B. Snell; Orlando Rouland, NYC. Member: NYWCC; Artists F.; Art Ctr. of the Oranges [40]

TOWNSEND, Eugene Coe [Des,S] Jacksonville, FL b. 18 O 1915, Mechanicsburg, IL. Studied: Rollins Col., Fla.; J.E. Davis. Exhibited: 4 A. Soc., Palm Beach; Allied AS, Winter Park, Fla. Work: 4 A. Soc., Palm Beach. Position: Supv. WPA Fla. [40]

TOWNSEND, Frances [Ldscp.P,T] Yakima, WA b. 27 Mr 1863, Wash., D.C. Studied: R. Harshe; M. de Neal Morgan; A. Patterson. Member: Seattle FAS [24]

TOWNSEND, Frances B. (Miss) [P] Arlington Heights, MA b. Boston d. 5 D 1916. Studied: Florence, Italy; J. Dupré, in Paris; BMFA Sch. Member: Boston WCC; Copley S., 1880. Exhibited: Mass. Charitable Mechanics Centenn., 1895 (med); Atlanta Expo, 1895 (gold); Boston AC, 1898; Poland Springs A. Gal., 1898; AIC, 1898. Specialty: animals [17]

TOWNSEND, James Bliss [Cr] NYC b. 1855, NYC d. 10 Mr 1921. Positions: Ed., American Art News; Cr., New York World, New York Herald

TOWNSEND, Harry E(verett) [P,I,E,B,En,Dec] Norwalk, CT b. 10 Mr 1879, Wyoming, IL d. 25 Jy 1941. Studied: AIC; H. Pyle; NAD; Paris; London. Member: Conn. AA; Westport A.; Darien G. of Seven A.; SC; Silvermine GA; SC. Exhibited: SC, 1920 (prize). Work: War College; Smithsonian; MET; NYPL; murals, H.S., East and West Norwalk, Conn.; City Hall, Norwalk Position: A., with the A.E.F. during WWI [40]

TOWNSEND, Helen Elizabeth [P,T] Wash., D.C. b. 4 N 1893, Effingham, IL. Studied: Despujols; Strauss; Ballande; Fontainebleau Sch. FA. Member: Wash. SA; Wash. AC; SSAL. Position: T., MacFarland Jr. H.S. [40]

TOWNSEND, Horace [Cr,W] NYC b. 1859, Claughton, England d. 9 My 1922, NYC. Author: several plays and books; catalogues for the Am. Art Assn. Positions: Staff, New York Tribune, 1883-1900; later, London correspondent, New York Herald; later, Chicago Record, Philadelphia Record, The Public Ledger

TOWNSEND, Lee [P] Westport, CT b. 7 Ag 1895, Wyoming, IL d. 21 Ja 1965, Milford, NJ. Studied: H. Dunn; AIC. Exhibited: Mus. Mod. Art, Wash., D.C., 1937 [40]

TOWNSEND, Ruth [P] NYC [19]

TOWNSEND, Sarah Gore Flint (Mrs.) [C,Cur] Boston b. 1874, Arequipa, Peru d. 4 S 1924. Member: Boston SAC (master craftsman), 1901. Position: Cur. Textiles, BMFA for 18 years

TOWNSHEND, Henry H. [P] New Haven, CT [17]

TOWNSLEY, C(hannel) P(ickering) [P,T] care of Frank Brangwyn, London, England/Los Angeles, CA b. 20 Ja 1867, Sedalia, MO d. 2 D 1921, London. Studied: Acad. Julian, Acad. Delacluse, both in Paris; Chase, in NYC. Member: SC; Calif. AC. Positions: T./Manager, Chase's Shinnecock Sch. and some of his European classes; T., Stickney A. Sch., Pasadena (1914-18), Otis AI (1918-21), London Sch. A. [21]

TOY, Ruby Shuler [P] Wash., D.C. Exhibited: S. Wash. A., 1937-39 [40]

TOZZER, A. Clare [P] Cincinnati, OH. Member: Cincinnati Women's AC [27]

TRABOLD, A. [I] Hoboken, NJ [01]

TRACY, Charles D. [P] NYC [13]

TRACY, Elizabeth (Mrs. Montminy) [P] Austin, TX b. 5 Je 1911, Boston, MA. Studied: Radcliffe. Member: Guggenheim F., 1941. Exhibited: PMG, 1936; GGE, 1939; WMA, 1938; Pal. Leg. Honor, 1946; NAD, 1946; Dallas Mus. FA, 1944-45, 1945-46; Arch. Lg., 1938; CGA, 1939; Abbot Acad. Gal., Andover, Mass., 1939. Work: murals, Mun. Bldg., Saugus, Mass.; City Hall, Medford, Mass.; Salinas y Rochay Cia, Dept. Store, Mexico City; WPA mural, USPOs, Milton, Mass., Downers Grove, Ill.; Kennebunkport, Maine [47]

TRACY, Glen [P,I,T] Cincinnati, OH b. 24 Ja 1883, Hudson, MI. Studied: Nowottny; Meakin; Duveneck. Member: Cincinnati AC. Exhibited: Detroit AI, 1924 (prizes). Work: Detroit Inst. A.; CMA. Position: T., Ctr. Acad. Commercial A., Cincinnati [40]

TRACY, Henry Prevost [I] NYC b. b. 1888 d. 19 F 1919, Denver, CO. Specialty: posters

TRACY, Henry R. [P] Boston, MA b. 1833, Oxford, NY. Studied: Boston [06]

TRACY, Lois Bartlett (Mrs.) [Ldscp.P,W,T,L] Laconia, NH b. Jackson, MI. Studied: S. Parsons; J.J. Pfister; H. Leech; Rollins Col.; Mich. State Col.; Ringling Sch. A.; E. Lawson; H. Hofmann.; S. Woodward. Member: Gulf Coast Group; N.H. AA; PBC; Fla. AA; Four A. Soc., Palm Beach. Exhibited: AFA, traveling exh., 1937, 1938, 1942-46; Nat. Exh. Am. A., N.Y., 1938; SSAL, 1935, 1936; Great Lakes Expo; State Lib., Concord, N.H., 1940; Studio Gld., 1936; Norlyst Gal., 1945; Fla. Fed. A., 1933-35 (prizes); Sarasota AA, 1937 (prize), 1938 (prize); Clearwater Mus. A., 1946 (prize); WFNY, 1939 (med); Allied Arts, Winter Park, Fla., 1929 (prize), 1930 (prize); Ringling Mus., 1931 (prize), 1938 (prize); Central Fla. Expo, 1932 (prize); Miami Women's C., 1938 (prize). Work: Fla. State Bldg., Great Lakes Expo, 1936 [47]

TRADER, Effie Corwin [Min.P] Cincinnati, OH b. Xenia, OH. Studied: Duveneck; Cincinnati A. Acad.; L.T. Dubé, in Paris. Member: Cincinnati Women's AC; Cincinnati MacD. C.; Nat. Lg. Am. Pen W. [40]

TRAHER, William Henry [Mur.P,I,Des,Gr,Li,B] Denver, CO b. 6 Ap 1908, Rock Springs, WY. Studied: Yale; NAD; L. Kroll; A. Covey; C.S. Chapman. Member: Denver AG. Exhibited: Nat. Exh. Am., 1936; MOMA, 1936; AIC, 1935; Denver AM, 1935 (one-man), 1935 (one-man), 1936; 48 States Comp., 1939; Rocky Mtn. PM, 1936 (prize). Work: Iowa State Univ.; Denver A. Mus.; Colo. State Hist. Soc.; Rocky Mtn. Nat. Park; WPA murals, Cole Jr. H.S., Denver; Williams Field, Ariz.; USPO, DeWitt, Ark. Illustrator: "Stars and Men," 1939 [47]

TRAIN, H. Scott [I] Astoria, NY. Member: SI [40]

TRAJAN, T. [S] NYC. Member: Sculptors Gld. Exhibited: Mus. Mod. A., Wash., D.C., 1938; Sculptors Gld., NYC, 1938-40 [40]

TRANQUILLITSKY, Vasily Georgievich [P,Des,T] San Francisco, CA b. 24 Mr 1888, Russia. Studied: Imperial Russian Sch. A., Kiev; Krizitski, Russia. Member: Northwest FAS. Exhibited: Seattle AM; Fed. A. Gal., San Fran.; murals, Calif. Bldg., GGE, 1939. Work: murals, Merchants Exchange, Seattle [40]

TRANTHAM, H(arrell) E. [P] Abilene, TX b. 19 Ap 1900, Abilene. Member: Texas FAA; SSAL; Bd. Dir., Abilene MFA, 1945-46. Exhibited: Intl. Print Exh., 1943; Kansas City AI; Texas General Exh., 1940-46;

Texas FAA, 1940-46; SSAL, 1940-46; Ft. Worth Pub. Gal., 1940 (prize), 1942 (prize), 1945 (prize). Work: Ft. Worth Pub. A. Gal. [47]

TRANTHAM, Ruth N. (Mrs. Harrell E.) [P] Abilene, TX b. 22 Jy 1903, Caps, TX. Member: SSAL; Texas FAA; Abilene Creative AC. Exhibited: Texas General Exh., 1943-45; regularly in Texas local & regional exh.; Ft. Worth, Tex., 1944 (prizes); Abilene, Tex., 1945 (prize); Fed. C., San Antonio, Tex., 1946 (prize) [47]

TRAPHAGEN, Ethel (Mrs. William R. Leigh) [Des,T,I,W,L] NYC b. 10 O 1882, NYC d. 29 Ap 1963. Studied: CUASch; NAD; ASL; N.Y. Sch. F.& Appl. A.; Paris, France. Member: Am. Women's Assn.; Nat. All. A. & Indst. Exhibited: New York Times Comp., 1913 (prize); CUASch (med). Author: "Costume Design and Illustration," 1918, "Fashion Work As a Career," Book of Knowledge Annual, 1942. Pub. & Ed., "Fashion Digest." Positions: T, CUASch, Brooklyn T. Assn., NYU; Founder, Dir., Traphagen Sch. Fashion, NYC [47]

TRAPHAGEN, Neilson [P] Brooklyn, NY [24]

TRAPIER, Pierre (Pinckney) (Alston) [P,Gr,I,W] Wash., D.C. b. 6 Mr 1897, Wash., D.C. d. 9 Ap 1957. Studied: George Wash., Univ.; Mahoney Sch. A., Wash., D.C.; Corcoran Sch. A.; Académie Julian, Paris. Exhibited: Rockefeller Ctr., NYC, CGA, 1937 (one-man); AFA; Santa Barbara Mus. A.; Charleston, S.C.; abroad. Work: series of paintings of great cities of U.S. and Europe [47]

TRASHER, Harry D. [S] NYC. Studied: Am. Acad., Rome, 1911-14 [15]

TRASK, John E.D. [P,T] b. 1871, Brooklyn, NY d. 16 Ap 1926, Phila. Member: Phila. AC; T-Square C.; Sesqui-Centenn. Expo (Dir. FA); PAFA (Dir.); U.S. Comm. General, Intl. FA Expos in Buenos Aires (Argentina), Santiago (Chile), both in 1910; P.-P. Expo, San Fran., 1915 (Dir.) [21]

TRASK, Mary Chumar (Mrs. G.G.) [P] NYC/Newburgh, NY [15]

TRAUBEL, (Morris or Martin) H. [Li] b. 1820, Frankfort, Germany (came to Phila. ca. 1850) d. 1897, Phila. (suicide). Position: Head of lithography firm bearing his name, Phila., 1850-69 [*]

TRAVER, C(harles) Warde [P,W,L,T] NYC/Wuanita Hot Springs, CO b. 10 O 1880 or 1889, Ann Arbor, MI. Studied: Royal Acad., Munich, with Von Marr; Millet; Snell [27]

TRAVER, Geo(rge) A. [P] NYC b. 30 Mr 1864, Corning, NY d. 2 Mr 1928. Studied: Weir; Dewing; Mowbray. Member: SC. Exhibited: Milwaukee AI, 1928; Art Ctr., NYC; AWCS, 1898. Work: BM [27]

TRAVER, Marion Gray [P] NYC b. 3 Je 1892, Elmhurst, NY. Studied: G.A. Traver. Member: All.A.Am.; NAWA; PBC; C.L. Wolfe AC; Three Arts C. Exhibited: NAD, 1930, 1931 (prize), 1932, 1935, 1936; CGA, 1933; NAWA, 1925-46, 1930 (prize), 1934 (prize), 1938-41 (prizes); All.A.Am., 1929-46, 1931 (prize), 1942 (prize); Intl. AC, London, 1931; BM; Montclair A. Mus.; Milwaukee AI; Dayton AI; Grand Rapids A. Mus.; WFNY, 1939; AFA Traveling Exh.; Staten Island Inst. A.&Sc.; Columbia Univ.; Union Lg. C., NYC; Argent Gal.; War Workers Jury, 1943 (prize); Wolfe AC, 1926-28 (prizes); Women's A. & Indst., 1928 (med) [47]

TRAVIS, Diane [P] Houston, TX b. 5 Ag 1892, NYC. Studied: H. Giles; A. Stillman. Member: SSAL; Okla. Northwest AA; NOAA. Exhibited: Okla. Northwest AA, 1931 (prize); PAFA, 1932 (prize); Dallas Fair, 1935 (prize) [40]

TRAVIS, Kathryne Hail [P,T] Beverly Hills, CA b. 6 F 1894, Ozark, AR d. 1972. Studied: AIC; Chicago Acad. FA; Cincinnati AM. Member: SSAL; Highland Park SA; Dallas MFA. Exhibited: Parkland Hospital, Jr. H.S.; Highland Park, all in Dallas; H.S., Bonham, Tex. [40]

TRAVIS, Olin Herman [P,Li,I,E] Dallas, TX (1976) b. 15 N 1888, Dallas. Studied: AIC, 1904-14; Clarkson; Norton; Walcott; Sorolla; C.F. Browne. Member: Chicago SA; Tex. FAA; Highland Park AA; SSAL; San Antonio AI (Dir.); Dallas AI (Founder; Dir., 1926-44). Exhibited: Rockefeller Ctr.; GGE, 1939; Tex. Centenn.; one-man exhibits: Chicago, San Antonio, Denver, Dallas; SSAL, 1930 (prize), 1932 (prize). Work: Dallas Mus. FA; Elisabet Ney Mus.; Highland Park Mus.; Hall of State, Dallas; Love Field Airport, Tex. [47]

TRAVIS, Paul Bough [P,E,Li,T,L] Cleveland Heights, OH b. 2 Ja 1891, Wellsville, OH. Studied: Cleveland Sch. A.; H.G. Keller. Member: Am. Soc. for Aesthetics; Cleveland Soc. for Aesthetics (Pres., 1946); Cleveland Mus. Natural Hist.; African Expedition. Exhibited: BM, 1931, 1935; MOMA; AIC, 1931, 1932, 1938; GGE, 1939; PAFA, 1930, 1932, 1934; CI, 1931, 1932; CGA, 1930, 1932; Pasadena AI, 1946; Butler AI, 1936-46; CMA, 1920, 1921 (prize), 1922-29, 1930 (prize), 1931 (prizes), 1932-37, 1938 (prize), 1939 (prize), 1940 (prize), 1941-46; Butler AI, 1940 (prize); Cleveland AA, 1921 (prize), 1922 (prize), 1925 (prize), 1928 (prize), 1929 (prize), 1930 (prize), 1931 (prize), 1934 (prize), 1936 (prize). Work: CMA; Butler AI; Ohio WCS; BM; Cleveland Mus. Natural Hist.; Univ. Utah; NYPL. Position: T., Cleveland Sch. A., from 1920 [47]

TRAVIS, Stuart [Dec,C,I,T] Andover, MA b. 1868 d. 25 D 1942. Position: T., Phillips Acad., Andover, 12 yrs.

TRAVIS, William D.T. [P,I] b. 1839 d. 24 Jy 1916, Burlington, NJ. A Civil War artist, he made a series of 35 views of the Army of the Cumberland. Also painted religious subjects.

TREADWELL, Grace A. (Mrs. Abbot) [P] NYC b. 13 Jy 1893, West Chop, MA. Studied: BMFA Sch.; ASL; Grande Chaumière, Paris. Member: PBC; NAWA. Exhibited: BM; High Mus. A.; PBC, 1946 (prize). Work: Albright A. Gal.; murals, St. Luke's Church, Smithport, Pa.; Madonna, St. Mark's Church, N.Y.; p., First Presb. Church, N.Y. [47]

TREADWELL, Helen [P,Des,Mur.P] Greens Farms, CT b. 27 Jy 1902, Chihuahua, Mexico. Studied: Vassar Col.; Sorbonne, Paris. Member: NSMP; Arch. L. Exhibited: Arthur Newton Gal., 1934; Rockefeller Ctr., N.Y.; Arch. L., 1946; murals, Mun. Bldg., Chile, 1936. Work: Murals: mun. Bldgs., Chile; Hotels Waldorf-Astoria, New Yorker, Beekman, Delmonico, Astor, all in NYC; Belvue-Stratford, Phila.; Hotel Utah, Salt Lake City, Utah [47]

TREADWELL, S.L. [E] St. Paul, MN [19]

TREASE, Sherman [Ldscp.P,E,W] San Diego, CA (since late 1920s) b. 22 Mr 1889 d. 26 Jy 1941. Studied: Sch. App. Art, Battle Creek, Mich.; A.H. Knott. Member: FAS, San Diego; San Diego AG; Spanish Village A. Ctr., San Diego (pres.) Exhibited: Joplin (Mo.) AL, 1921 (prize). Illustrator: "Square Riggers Before the Wind," 1939 [40]

TREAT, Alice E. [P] Minneapolis, MN [13]

TREBILCOCK, Paul [P] NYC b. 13 F 1902, Chicago, IL. Studied: Univ. Ill.; AIC; Europe; Seyffert. Member: ANA, 1932; Chelsea AC, London; Cliff Dwellers; Chicago AC. Exhibited: ASL, Chicago, 1923 (prizes); AIC, 1925 (prize), 1926 (prize), 1928 (prize), 1937 (prize), 1929 (gold); Chicago Gal. Assn., 1926 (med); NAD, 1931 (med); Newport AA, 1931 (med). Work: AIC; Albright A. Gal.; Cranbrook Mus.; portraits; Univ. Ill.; Univ. Chicago; Northwestern Univ.; Johns Hopkins Univ.; Columbia; Univ. Rochester; The Waldorf-Astoria, NYC; Joslyn Mem., Omaha, Nebr. Contributor: American Artist [47]

TREBILCOCK, Amaylia. See Castaldo.

TREFETHEN, Jessie Bryan [P,T,E,L] Oberlin, OH b. Portland, ME. Studied: Mt. Holyoke Col.; PAFA, with Garber, J. Pearson, E. Carlsen, H. McCarter; Europe, 1915. Exhibited: PAFA, annually; Sweat Mem. Mus.; Allen A. Mus., Oberlin Col., 1941 (prize), 1942 (prize), 1944 (prize), 1945 (prize). Positions: T., Knox Sch., Cooperstown, N.Y. (1923-26), Oberlin Col. (from 1926) [47]

TREGANZA, Ruth Robinson (Mrs.) [P,Arch,D,T] NYC b. 30 Mr 1877, Elmira, NY. Studied: J.M. Hewlett; L.C. Tiffany; A.W. Dow; H.W. Corbett. Member: NAWPS; AFA. Position: T., Columbia T. Col. [31]

TREGO, Edward Comly [P] Bryn Athyn, PA [17]

TREGO, William T. [P] North Wales, PA b. 1859, Yardley, PA d. 24 Je 1909, North Wales. Studied: PAFA; Paris. Exhibited: AAS, 1902 (med); PAFA (prize); Paris Salon, 1888 [08]

TREIDLER, Adolph [I] NYC. Member: SI [47]

TREIMAN, Jocye Wahl [P] Winnetka, IL b. 29 My 1922, Evanston, IL. Studied: Stephens Col.; State Univ. Iowa. Exhibited: VMFA, 1946; AIC, 1946; Oakland A. Gal., 1943; Denver AM, 1944; AIC, 1945, 1946; John Snowden Gal., 1946 (one-man) [47]

TREMAINE, Edna A. [P] Boston, MA. Affiliated with Mass. Normal A. Sch., Boston [21]

TREMEAR, Charles H. [Daguerreotypist] b. 1866, d. 20 Jy 1943, Detroit, MI. Operated the tintype and daguerreotype studio at Henry Ford's Greenfield Village, 1929-43.

TRENCH, Isabel [P] New Brighton, NY [17]

TRENCHARD, Edward [Mar.P] West Islip, NY b. 17 Ag 1850, Phila. d. Summer, 1922. Studied: Phila., with E. Moran; NYC; Europe. Exhibited: NAD, 1874-78

TRENHOLM, George Francis [Des,Typog] Wellesley Farms, MA b. 23 O 1886, Cambridge, MA. Studied: Mass. Sch. A.; C. Heil; H. Jahn; V. Preissig. Member: Stowaways; Artists G.; Typophiles and S. of Printers.

Award: Book Type Face, Nat. Bd. on Printing Type Faces, 1935. Designer: Trenholm Old Style, cursive and bold type faces for Barnhart Brothers and Spindler, Chicago; Nova type face, Intertype Corp., Brooklyn [40]

TRENKAMP, Henry, Jr. [P] Cleveland, OH [25]

TRENT, Victor Pedrotti [P,Des,Dec] White Plains, NY b. 9 F 1891, Austria. Studied: K.B. Loomis. Work: murals, Fulton Sch., Mt. Vernon; Battle Hill Sch., White Plains; Pocantico Hills Sch., Tarrytown, N.Y. Affiliated with WPA, N.Y. [40]

TRENTHAM, Eugene [P,T] Austin, TX b. 23 S 1912, Gatlinburg, TN. Studied: C.M. Kassler. Exhibited: Denver Pub. Sch.; Denver A. Mus., 1936, 1938; Tex. Guggenheim F., 1939; CGA, 1937-41; GGE, 1939; WFNY, 1939; PMG, 1936; MOMA, 1941; CI, 1949; PAFA, 1942; MMA (AV), 1942; WMAA, 1942; AIC, 1943; AGAA. Work: Denver A. Mus.; West Denver H.S.; Colorado H.S., Wheatridge, Colo.; St. Vincent's Hospital, Santa Fe, N.Mex; City Court House, Pueblo, Colo.; murals, East Denver H.S.; USPO, O'Neill, Nebr.; WPA artist. Position: T., Univ. Tex., 1940- [47]

TRESSLER, Anne K. (Mrs.) [C,Ser,W,T] Madison, WI b. 22 S 1910, Rockford, IL. Studied: Univ. Wis.; Columbia. Author/Editor: "Norwegian Design in Wisconsin," 1946. Position: Dir., Union Workshop, Univ. Wis., 1943-46 [47]

TREVITTE, Laura M. [P] NYC [19]

TREVITTS, Joseph [P,T] Manistee, MI b. 8 Ap 1890, Ashland, PA. Studied: H. Breckenridge; C. Beaux; J.T. Pearson, Jr.; D. Garber; P. Hale; E. Carlsen; R. Vonnoh; J.A. Weir; T. Anshutz; PAFA; E. Peixotto; R.F. Logan; A. Zorroga; B. Nandin; J. Blanche, in Paris, 1913. Member: Mich. Acad. Sc. A.&Letters; Scarab C. Work: Reading (Pa.) Pub. Mus.; Pub. Sch., Pub. Lib., Masonic Temple, Mission Covenant Church, all in Manistee, Mich. [47]

TREVOR, Doris E. (Mrs. B.C.) [P,G,T,L] Jacksonville, FL b. 15 Ag 1909, Havre de Grace, MD. Studied: La France Sch. A., Phila.; Moore Inst.; Phila. Sch. Des. for Women. Member: St. Augustine AC. Exhibited: Fla. Fed. A. (traveling); Jacksonville A. Center; Va. MFA, 1939. Work: Pub. Lib., Jacksonville. Position: T., Jacksonville A. Center [40]

TRIBBLE, Dagmar Haggstrom [P] South Orange, NJ. Member: AWCS [47]

TRIBE, George J. [P] Worcester, MA [24]

TRICCA, M(arco) Aurelio [P,S] NYC b. 12 Mr 1880, Alanno, Italy (came to U.S. in 1912) d. Je 1969. Studied: Sch. Liberal A., Rome, 1900s. Exhibited: CGA, 1935; AIC, 1935, 1938; PAFA, 1933, 1937; Mortimore Brandt Gal., 1944; BM; Whitney Studio C. (one-man); WMAA (one-man); Contemp. A., 1940 (one-man); Long Island Univ. (retrospective, 1973, one-man); Univ. of Minn. (one-man). Work: AIC; WMAA; Wadsworth Athenaeum; Butler IA; Neuberger Mus., Purchase, N.Y. Stopped painting in 1944; became reclusive. Resumed painting in 1954. [47]

TRICKER, Florence [P,S,T] NYC b. Phila. Studied: Phila. Sch. Des for Women; E. Daingerfield; H.B. Snell; D. Garber; C. Grafly; S. Murray; A. Laessle. Member: Phila. Alliance; Plastic C. Exhibited: Graphic Sketch C. (gold); Plastic C. (med,prizes); Tampa AI, 1927 (prize). Work: Graphic Sketch C. Owner/Director: Tricker Galleries of Ecclesiastical A. [40]

TRIDLER, Avis [P,S,L,E,C] San Fran., CA b. 12 D 1908, Madison, WI. Studied: Labandt; Boynton; Stackpole; DuMond. Member: San Fran. Women A.; San Fran. FAC [31]

TRIEBEL, C.E. [S] NYC. Member: NSS; Arch. Lg., 1902 [04]

TRIEBEL, F(rederic) Ernst [P,S] College Point, NY b. 29 D 1865, Peoria, IL. Studied: A. Rivalta. Member: Academicien of Merit, Roman Royal Acad., San Luca, Rome; NSS. Exhibited: Museo Nazionale di Antropologia, Florence, 1891 (med). Work: Soldiers' Mon., Peoria, Ill.; Iowa State Mon., Shiloh, Tenn.; Miss. State Mon., Vicksburg; Robert G. Ingersoll statue, Peoria; statues of late Senators Shoup and Rice, Statuary Hall, Wash., D.C.; Otto Pastor Mon., Petrograd, Russia; bronze, Imperial Mus., Japan; Dante medal, Sons of Italy; Dante plaque; various H.S. and Pub. Libs. Position: Superintendent of Sculpture/Secretary for Intl. Jury on Awards, Columbian Expo, Chicago, 1893 [40]

TRIFYLLIS, Demetrius [P] NYC [21]

TRIGGS, Floyd W(ilding) [Car,W] Darien, CT b. 1 Mr 1872, Winnebago, IL d. 25 Ag 1919, Stamford, CT. Studied: AIC. Cartoonist: Christian Science Monitor [21]

TRIMBLE, Corinne C. [S] Norwood, OH [01]

TRIMM, Adon [P] Jamestown, NY b. 20 F 1897, Grand Valley, PA d. 31 O 1959, Buffalo, NY. Member: Soc. for Sanity in Art, Chicago. Exhibited: Albright A. Gal., 1933, 1934; Soc. for Sanity in Art, 1941; Chautauqua, N.Y., 1940-42 (one-man); Jamestown, N.Y., 1941, 1942. Work: Capitol, Albany, N.Y. [47]

TRIMM, George Lee [P,I,T] Syracuse, NY b. 30 Je 1912, Jamestown, NY. Studied: Syracuse Univ. Exhibited: Syracuse, N.Y., 1946 (one-man). Work: St. Lawrence Univ.; Ohio State Univ.; U.S. War Dept., Wash. D.C.; Engineer Corps., Wash., D.C.; murals, Ft. Belvoir, Va.; Waldes Kohinoor, Inc., Long Island City, N.Y.; Le Moyne Univ., Memphis. Position: T., 6th Army Univ., Osaka & Kyoto, Japan, 1945 [47]

TRIMM, Lee S. [P] Syracuse, NY b. 15 Ap 1879, Ft. Larned, KS. Studied: De Forest Carr. Member: Soc. for Sanity in Art, Chicago; Jamestown Sketch C. (founder). Exhibited: Soc. for Sanity in Art, 1941; Utica Lib., 1938-40 (one-man); Daytona Beach, Fla., 1941; Assn. A. Syracuse, 1937; Jamestown, N.Y. Work: portraits, Syracuse Univ.; Gettysburg Acad.; Puerto Rico Missionary Col.; many libraries [47]

TRIPLETT, Beryl May [T,P] Fayette, MO b. 12 Ag 1894, Mendota, MO. Studied: Northeast Mo. State T. Col.; Mo. Univ.; Columbia; Univ. Colo.; H.L. McFee; M. Sheets. Member: Western AA; Mo. State T. Assn. Position: T., Central Col., Fayette, Mo., 1927- [47]

TRIPLETT, Margaret Lauren [P,T] Norwichtown, CT b. 30 D 1905, Vermillion, SD. Studied: State Univ. Iowa; BMFA Sch.; Yale; G. Wood; ASL; Thurn Sch. Mod. A., Boston. Member: EAA; Nat. Edu. Assn.; Conn. State T. Assn.; Norwich AA; Meriden A.&Cr. Exhibited: AWCS, 1940; CM, 1940; New Haven PCC, 1939; Clay C., 1939; Portland Mus. A., 1939; Iowa A. Salon, 1932-34, 1938; Joslyn Mem., 1933, 1938; CAFA, 1937, 1938; Conn. WCC, 1939, 1940. Positions: T., Norwich A. Sch., 1929-; Dir., 1943- [47]

TRIPP, B. Wilson [P] Providence, RI. Member: Providence AC [27]

TRISCOTT, S(amuel) P(eter) R(olt) [Mar.P,T] Monhegan, ME b. 4 Ja 1846, Gosport, England (came to U.S. in 1871) d. 15 Ap 1925. Studied: Philip Mitchell, Royal Inst. P. in Water Colors, both in London. Member: Boston AC; Boston SWCP. Exhibited: AWCS, 1898; PAFA, 1898. Work: BMFA. Specialty: watercolor [24]

TRISSEL, Lawrence E. [P,Des,I] Indianapolis, IN b. 27 Ja 1917, Anderson, IN. Studied: John Herron AI; E. O'Hara; F. Chapin; M. Kahn. Exhibited: BAID, 1938 (med); Ind. AC, 1941 (prize), 1944 (prize); Ohio Valley Exh., 1944 (prize); Ind. State Fair, 1941 (prize); Hoosier Salon, 1946 (prize); CM, 1940; CI, 1941; Oakland A. Gal., 1940, 1944; PAFA, 1941; VMFA, 1946; Butler AI, 1944. Work: U.S. Gov. [47]

TRIVELLA, Ralph Herman [Ceramic Des,Potter,T] Proctorsville, VT b. 30 N 1908, Columbus. Studied: Ohio State Univ.; A.E. Baggs. Member: Columbus AL; Ohio WCS. Exhibited: Nat. Des. Contest, 1928 (prize). Positions: T., Columbus Pub. Sch.; Fletcher Farm, Proctorsville [40]

TRNKA, Alois, Mrs. See Kindlund, A.B.W.

TRNKA, Anna Belle Wing (Mrs.) [Min.P,P] Buffalo, NY b. 18 F 1876, Buffalo d. 1922. Studied: L.W. Hitchcock; G. Bridgman. Member: Buffalo Soc. Ar.; N.Y. Soc. Craftsmen. Exhibited: Pan-Am. Expo, Buffalo, 1901 (prize); St. Louis Expo, 1904 (med); P.-P. Expo, San Fran., 1915 (med)

TROBAUGH, Roy (B.) [P] Delphi, IN b. 21 Ja 1878, Delphi. Studied: ASL; J.H. Twachtman. Member: Ind. AC [29]

TROCCOLI, Giovanni Battista [P,C] Newton Center, MA b. 15 O 1882, Lauropoli, Italy d. 21 F 1940. Studied: D. Ross; Académie Julian. Member: Copley S.; Boston SAC; Boston GA; AFA. Exhibited: CI, 1911 (prize); AIC, 1913 (med); P.-P. Expo, San Fran., 1915 (gold); NAD, 1922 (prize); Tercentenary Hall, Boston, 1930 (prize). Work: Detroit AI; BMFA [38]

TROEBER, Carl [P] Newark, NJ [24]

TROEGER, Elizabeth [P] Hinsdale, IL b. McGregor, IA. Studied: Paris, with Merson, Collin. Exhibited: NAD; PAFA; AIC [01]

TROGDON, Doran S. [P] Phila., PA [24]

TROMKA, Abram [P,E,Ser] Jersey City, NJ b. 1 My 1896, Poland d. Je 1954. Studied: G. Bellows; R. Henri. Member: A. Lg. Am.; Assn. A. N.J.; Brooklyn SA; Am. Ar. Cong. Exhibited: BM, 1946 (prize); Long Island A. Festival (prize); PAFA, 1932; John Herron AI, 1938; Am. A. Cong., 1938, 1939; BM, 1933, 1935, 1937, 1942; WMAA, 1938; AIC, 1938, 1942; AWCS, 1941-44; CI, 1941, 1944, 1945; VMFA, 1944; MMA, 1943; de Young Mem. Mus., 1943; Albright A. Gal., 1942; CAA Traveling Exh., 1937; Riverside Mus., 1943, 1945; LOC, 1944, 1945; 100 Prints of the Year, 1944, 1945; Los Angeles Mus. A., 1945; NAD, 1945, 1946; Albany Inst. Hist.&A., 1945; Butler AI, 1944; Phila. A. All., 1944; Springfield (Mass.)

Mus. A., 1937; George Walter Vincent Smith Mus. A., 1938; traveling exh. silk screen prints, U.S.S.R.; BM, 1932 (one-man); ACA Gal., 1933-61. Work: Boston Pub. Lib.; MMA; Newark Pub. Lib.; Iowa State Col.; CAM; CI; BM; U.S. State Dept., Wash., D.C. Illustrator: "House on Henry Street," 1915 [47]

TROMMER, Marie [P,W] Brooklyn, NY b. Kremenchug, Russia. Studied: CUASch; D. Volk; W. Adams; S. Halpert; C. Curran. Member: Brooklyn S. Modern A.; Brooklyn WCC. Exhibited: S.Indp.A.; All. A. Am.; Salons of Am.; Brooklyn Soc. Mod. A.; Brooklyn WCC, 1936 (one-man). Work: Corona Mundi, N.Y.; Biro-Bidjan Mus., Russia; N.Y. Pub. Lib.; LOC. Author/Illustrator: "America in My Russian Childhood," 1941; others. Translator: "Russian Essays, Sketches & Poems," 1943. Contributor: articles, Jewish publications [47]

TROTH, Celeste Heckscher [Por.P,I] Phila., PA b. 19 Jy 1888, Ambler, PA. Studied: PAFA; Rome, with S. Pozza; C. Ricciardi. Member: Phila. A. All. Exhibited: PAFA; Woodmere A. Gal.; Warwick Gal., A. All., Cosmopolitan C., all in Phila.; Douthitt Gal., N.Y., 1941 (one-man). Work: Protestant Episcopal Church, Roxborough, Pa.; Acad. Music, Phila.; Woodmere A. Gal., Chestnut Hill, Pa. [47]

TROTH, Emma [Min.P,I,T] Phila., PA b. 5 Mr 1869, Phila. Studied: Hovendon; Vonnoh; Pyle; PAFA [25]

TROTH, Henry [Photogr] Phila., PA b. 1860 d. 25 Ap 1945. A founder of the Photographic Salon, ca. 1900. Awards: 30 medals worldwide.

TROTTA, Giuseppe [P] Flushing, NY [27]

TROTTA, Joseph H. [P] Flushing, NY [17]

TROTTER, Anna M. [P] NYC [15]

TROTTER, Mary K. [P] Paris, France b. Phila. Studied: T. Eakins. Exhibited: Phila. WCC; SAA; Boston AC; St. Louis Expo, 1898; AIC; NYSF; PAFA, 1882 (prize) [01]

TROTTER, Newbold Hough [P] Phila., PA (or Cheyney, PA) b. 1827, Phila. d. 21 F 1898, Altantic City, NJ. Studied: PAFA; The Hague, with T. van Starkenborg; mostly self-taught. Member: A. Fund S.; Phila. SA. Exhibited: PAFA, from 1858; NAD, 1874–75; Boston Athenaeum; Phila. AC, 1898; "A Wounded Buffalo Pursued by Prairie Wolves," Phila. Centenn. Exh., 1876. Work: War Dept.; Penn. RR; Smithsonian. Specialties: ldscps.; animals. He apparently traveled in the West; also made a trip to North Africa [98]

TROUBETZKOY, Paul [S] Paris, France/Lago Maggiore, Italy b. 16 F 1866, Lago Maggiore d. F 1938. Studied: Italy; Russia; France. Exhibited: Paris Expo, 1900 (prize). Work: Luxembourg, Paris; National Gal., Rome; National Gal., Venice; Mus. of Alexander III, Petrograd; Treliakofsky Gal., Moscow; Nat. Gal., Berlin; Royal Gal., Dresden; Leipzig Gal.; AIC; Detroit Inst.; TMA; Buffalo FA Acad.; Golden Gate Park Mus.; Mus. Buenos Aires; Brera Mus., Milan [38]

TROUBETZKOY, Pierre [Por.P] Cobham, Albemarle County, VA b. 19 Ap 1864, Milan, Italy (came to U.S. in 1896) d. 25 Ag 1936, Charlottesville, VA. Studied: Ranzoni; Cremona. Member: S. Wash. A. Work: portraits, Nat. Gal. (Edinburgh), Nat. Portrait Gal., London; Town Hall of Dover; Inst. de Valencia de Don Juan, Madrid; Univ. Va., Charlottesville. Married Amélie Rives, the author; they made their home in Wash., D.C., NYC and Albermarle County, Va. [33]

TROUK, Adell Henry [T] b. 1855, Vienna, Austria d. 20 Ja 1934, New Haven, CT. Positions: T., Vienna, Russia, Brazil, Europe; established a fine arts school in NYC, 1920

TROUNSTINE, Syl. F. [P] Cincinnati, OH. Member: Cincinnati AC [24]

TROUT, (Elizabeth) Dorothy Burt [P,I,T] Wash., D.C. b. 3 Je 1896, Fort Robinson, NE. Studied: E.C. Messer; B. Perrie; C. Critcher; H. Giles; C.W. Hawthorne; E.A. Webster. Member: S. Wash. A.; Provincetown AA [33]

TROWBRIDGE, Alexander B. [Ldscp.P,Arch,L,W] Winter Park, FL b. 3 S 1868, Detroit. Studied: Cornell; Ecole des Beaux-Arts, Paris, with M. Lambert. Member: Arch. Lg.; Soc. Beaux-Arts Arch.; AFA. Contributor: "Planning and Building the City of Washington" [40]

TROWBRIDGE, Gail [P,Li,T] Provincetown, MA b. 6 N 1900, Marseilles, IL. Studied: Columbia. Member: NAWA; N.Y. Soc. Women A.; Assn. A. N.J.; Provincetown AA; Artists of Today, Newark, N.J. Exhibited: NAWA, 1940 (prize); Argent Gal., 1945 (prize); Women's Intl. AC, England, 1946; NAWA, 1938–46; MMA, 1942; Newark Mus.; N.Y. Soc. Women A., 1945, 1946; Riverside Mus., 1944; Wash. AC, 1945 (one-man); Artists of Today, Newark (one-man). Position: T., Elementary Sch., Millburn, N.J., 1930-45 [47]

TROWBRIDGE, Helen F(ox) [S] Glen Ridge, NJ b. 19 S 1882, NY [17]

TROWBRIDGE, Irene Underwood (Mrs. Miles C.) [P,C,G,T] Chevy Chase, MD/Sherwood Forest, MD b. 4 Ap 1898, Pittsburg, KS. Studied: AIC. Member: Am Ar. Prof. Lg. (D.C. director). Exhibited: Fed. Women's C., Md., 1936 (prize); Wash., D.C., 1938 (prize); Soc. Wash. A., 1939; Md. Inst., 1939; Intl. House, Wash., D.C., 1939 (one-man). Work: Fed. Women's C., Wash., D.C. [47]

TROWBRIDGE, Lucy Parkman [P] NYC. Exhibited: SAA, 1898; Soc. Beaux-Arts, Paris, 1898 [01]

TROWBRIDGE, V.S., Mrs. See Funsch, Edith.

TROWBRIDGE, Vaughan [E,P] Paris, France/NYC b. 3 D 1869, NYC. Studied: Brush, J.H. Boston, in N.Y.; Paris, with Constant, Laurens. Illustrator: "Paris and the Social Revolution." Specialty: street scenes in aquatint [17]

TROY, Adrian [En,P,I,L] Chicago, IL b. 20 F 1901, Hull, England. Member: Am. A. Cong.; Chicago Soc. Ar. Exhibited: WFNY, 1939; LOC; SFMA, 1941, 1944, 1946; WMAA, 1942; PMG; AIC, 1938. Work: CI; AIC; Evansville State Hospital; Univ. Ill.; Chicago Normal Col. [47]

TROY, Lota Lee [C,Des,T] New Orleans, LA/Greensboro, NC b. 14 N 1874, Guilford County, NC. Studied: A.W. Dow; AIC; J. Mason; W. Roach. Member: NOAA; SSAL; Southeastern AA; Gld. Bookworkers, N.Y. Position: Dir., Sch. A., Newcomb College [40]

TRUAX, Sarah Elizabeth [P,Min.P,T] San Diego, CA (since 1917) b. Marble Rock, IA d. 26 S 1959. Studied: AIC, 1907-09; H. Pyle; A. Mucha; J. Sorolla. Member: San Diego A. Gld.; La Jolla AA; Baltimore WCC; Women P. of the West; Calif. Soc. Min. P. Exhibited: P.-P. Expo, 1915 (prize); Los Angeles County Fair, 1928 (prize); GGE, 1939; Calif.-Pacific Intl. Expo, 1935; PAFA, 1927–30, 1932; Brooks Mem. A. Gal.; Detroit Soc. A.&Cr., 1928, 1929; Los Angeles Soc. Min. P.; Grand Central A. Gal., 1930; Okla. Col. for Women; Ft. Worth Mus. A.; Witte Mem. Mus.; Pacific Southwest Exh., Long Beach, Calif.; BMA; San Diego FA Soc., 1926–39, 1945, 1946; Sacramento (Calif.) State Fair, 1930, 1936 (prize); Phoenix (Ariz.) State Fair, 1932; La Jolla AA. Work: San Diego FA Soc.; Women's C., Lidgerwood, N.Dak.; First Unitarian Church, San Diego. Position: T., San Diego AG, 1925–29 [47]

TRUBACH, Ernest Sergei [P,G,W,L,T] NYC b. 17 F 1907, Russia. Studied: NAD. Member: Rockport A. Group; Am. Ar. Cong.; United Am. Ar.; Allied Ar. Am. Exhibited: NAD, 1928 (prize), 1930 (prize), 1929 (Mooney Traveling F.), 1929 (med); CI, 1938; PAFA, 1938, 1946; CGA, 1939; WFNY, 1939; GGE, 1939; VMFA, 1946; Nierendorf Gal., 1946; ACA Gal., 1946; Art of This Century, 1946. Work: Biro-Bidjan Mus., Russia; Fed. Bldgs., Wash., D.C.; Mt. Morris Hospital, N.Y.; Port Chester (N.Y.) Jr. H.S.; Theodore Roosevelt H.S., N.Y.; Barnard Col. [47]

TRUBEE, John [P,T] NYC b. 31 Ja 1895, Buffalo, NY. Studied: Lafayette Col.; ASL; Henri; Paris, with Leger, Rodin, Ozenfant, Marchand. Exhibited: NAD, 1938; AFA Traveling Exh. [47]

TRUCKSESS, F(rederick) C(lement) [P,T] Boulder, CO b. 16 Ag 1895, Brownsburg, IN. Studied: E.C. Taylor; E. Savage; W. Forsyth. Member: Boulder AG; Prospectors. Exhibited: Ind. State Fair, 1922 (prize); Denver A. Mus., 1933 (prize). Work: Jefferson Sch., La Fayette, Ind.; stage curtain and mural, Univ. Colo. [40]

TRUCKSESS, Frances. See Hoar.

TRUE, Allen Tupper [P,I,Dec] Denver, CO b. 30 My 1881, Colorado Springs d. 1955. Studied: Univ. Denver; CGA Sch.; H. Pyle, 1902-08; F. Brangwyn, in London, 1910s; France, 1924. Member: Denver AA; Mural P.; Arch. Lg.; F., Royal Soc. A., England. Work: dec. (assisted F. Brangwyn), P.-P. Expo, 1915; dome of Mo. Capitol; murals, Wyo. Capitol; Mont. Nat. Bank, Billings; Pub. Lib., Greek Theatre, Civic Center, Voorhees Mem. Arch, Colorado Nat. Bank, Mountain States Telephone Bldg., all in Denver; pendentives in dome, Mo. Capitol, Jefferson City; Taylor Day Nursery, Colorado Springs; Indian pottery des. applied to barrel vault ceiling, U.S. Nat. Bank Bldg., Denver; color consultant, Power Plant, Boulder Dam; murals, Brown Palace Hotel, Denver. Illustrator: Harper's, Collier's, Saturday Evening Post; "Song of the Indian Wars" [40]

TRUE, Dorothy [P] NYC [17]

TRUE, George A. [E,P] Detroit, MI b. 1863, Funchal, Madeira. Studied: Western Reserve Sch. Des., Cleveland. Exhibited: AIC, 1898 [19]

TRUE, Grace H(opkins) (Mrs. E.D.A.) [P] Melbourne City, FL b. 2 My 1870, Frankfort, MI. Studied: J.P. Wicker; F. Fursman. Member: Orlando AA; SSAL; Detroit S. Women P., 1925. Exhibited: Tampa Fed. A., 1930 (prize); Orlando Fair, 1939 (prize) [40]

TRUE, Lilian Crawford (Mrs. John P.) [I] Waban, MA b. Boston. Studied: Cowles A. Sch., Boston, with T. Juglaris [08]

TRUE, Virginia [P,T] Ithaca, NY b. St. Louis. Studied: John Herron AI; Cornell Univ.; W. Forsyth; D. Garber; R.S. Meryman; H. Breckenridge; C. Grafly. Member: NAWA; Prospectors. Exhibited: Denver AM, 1932 (prize), 1933 (prize); Kansas City AI, 1935 (prize); Rochester Mem. A. Gal., 1939 (prize); Annual Colo. Artists Exh., 1932–33 (prize); AWCS; NAWA; CI; Cornell Univ. Work: Univ. Colo.; State Col. Agriculture, Ft. Collins, Colo.; Cornell Univ. Positions: T., Herron AI (1926–28), Univ. Colo. (1929–36), Cornell Univ. (1936–) [47]

TRUEBLOOD, Stella [P] St. Louis, MO. Member: St. Louis AG [27]

TRUEMAN, A.S. [P] NYC. Member: GFLA [27]

TRUESDELL, Edith P(ark) [P,B,T] Brookvale, CO/Carmel Valley, 1979 b. 15 F 1888, Derby, CT. Studied: BMFA Sch., with Tarbell, Benson, Hale, Bosley. Exhibited: Laguna Beach Anniversary Exh., 1924 (prize); Los Angeles County Exh., Pomona, 1928 (prize); Calif. AC, Los Angeles, 1930 (gold); Los Angeles Fiesta Exh., 1931 (prize); Calif. WCS, 1934 (prize). Work: Denver A. Mus. Positions: T., Waynflete Sch. (Portland, Maine), YWCA Workshops (Boston) [40]

TRUESDELL, Gaylord Sangston [P] Paris, France b. 10 Je 1850, Waukegan, IL d. 13 Je 1899. Studied: PAFA; Paris, with Morot, Cormon. Exhibited: Paris Expo, 1889 (med); Salon de Champs Elysees, Paris, 1892 (med); PAFA; AIC; Omaha Expo. Specialty: sheep [98]

TRUEWORTHY, Jessie (Jay) [Por.P,Min.P] Pasadena, CA b. Lowell, MA. Studied: Pasadena AI; V. George; M. Welch; E. Hansen; A. Woelever; E.S. Bush. Member: Laguna Beach AA; Calif. Soc. Min. P.; Pa. Soc. Min. P.; Pasadena AA. Exhibited: Calif. Soc. Min. P., 1940 (prize); Ebell C., Los Angeles, 1944 (prize); PAFA, 1941–45; CGA, 1939, 1941; Chicago Centenn.; Grand Central A. Gal.; Brooklyn Soc. Min. P.; Smithsonian; Los Angeles Mus. A., 1935 (prize). Work: Los Angeles Mus. A. [47]

TRUEX, Van Day [P] NYC. Exhibited: Carstairs Gal., N.Y., 1939 (one-man). Position: T., N.Y. Sch. F.&Appl. A. [40]

TRUITT, Una B. (Mrs. J.J.) [P,W,L,T] Houston, TX b. 17 S 1896, Joaquin, TX. Studied: Houston Univ.; Mrs. J.O. Mills; P. Tate. Member: Assn. A. Houston; Houston Ar. C. Exhibited: local and state exh., 1932–46; Dallas MFA, 1938; Houston MFA, 1938, 1939. Work: Nacogdoches Col. FA, Tex.. Positions: T., Supv. A., Houston City Sch., 1925–38; Supv. A. for Crippled Children, Houston, 1928–46 [47]

TRULLINGER, John Henry [P] Paris, France [10]

TRUMAN, Edith S. [I] NYC b. NYC. Studied: K. Cox; W.A. Clark; H. Pyle [08]

TRUMAN, Ella S. [P] New Haven, CT. Member: S.Indp.A. [27]

TRUMBULL, Edward [P] Pittsburgh, PA. Member: Pittsburgh AA. Position: Affliated with CI [15]

TRUMBULL, Gordon [P] Hartford, CT b. 1841, Stonington, CT d. 28 D 1903. Studied: F.S. Jewett, Hartford; James Hart, NYC. Specialty: fish

TRUMP, Rachel Bulley (Mrs. Charles C.) [Por.P,L] Merion, PA b. 3 My 1890, Canton, OH. Studied: Syracuse Univ. Member: Phila. A. All.; Phila. Plastic C.; NAWPS. Exhibited: Phila. Plastic C., 1938 (gold); Woodmere A. Gal., 1943 (prize); NAWA; Phila. A. All.; N.Y. State Fair Grounds. Work: Circuit Court, Richmond, Va.; Haverford (Pa.) Sch.; Haverford Friends Sch.; Women's Medical Col., Phila. [47]

TRUMPLER, Carrie E. [P] Phila., PA [04]

TRUMPORE, William L. [P] b. 1867 d. 21 D 1917, Jersey City, NJ. Work: White House. Specialty: floral scenes

TRUNK, Herman, Jr. [P] Brooklyn, NY b. 31 O 1899, NYC. Studied: CUASch; PIASch; ASL; H.L. McFee; H. Lever. Member: Brooklyn Soc. Modern A.; Am. Veterans Soc. A. Work: WMAA [47]

TRUSLOW, Neal A. [P] NYC [15]

TRYON, Benjamin F. [Ldscp.P] b. 1824, NYC d. 1896. Active mostly in Boston. Studied: R. Bengough; J.H. Cafferty [*]

TRYON, D(wight) W(illiam) [Ldscp.P,T] NYC/South Dartmouth, MA (since 1883) b. 13 Ag 1849, Hartford, CT d. 1 Jy 1925, South Dartmouth. Studied: Ecole des Beaux-Arts, Paris; J. de la Chevreuse; briefly with C.F. Daubigny, A. Guillemet, H. Harpignes, all 1876–81. Member: ANA, 1890; NA, 1891; SAA, 1882; AWCS; NIAL. Exhibited: Mech. Fair, Boston, 1882 (med); Am. Art Assn., NYC, 1886 (gold) 1887 (gold); NAD, 1887 (prize), 1888 (prize); AIC, 1888 (prize); Chicago Interstate Expo, 1889 (prize); SAA, 1889 (prize); Munich Expo, 1892 (gold); Columbian Expo, Chicago, 1893 (med); Cleveland Interstate Expo, 1895 (prize); Tenn. Centenn., Nashville, 1897 (prize); CI, 1898 (gold), 1899 (med); Pan-Am. Expo, Buffalo, 1901 (gold); St. Louis Expo, 1904 (gold); P.-P. Expo, San Fran., 1915 (med); PAFA, 1898; Univ. Conn., 1971 (retrospective). Work: Freer Gal., Wash., D.C.; CGA; MMA; TMA; WMA; PAFA; Herron AI; Detroit AI; A. Mus., Montclair; Hackley A. Gal., Muskegon, Mich.; RISD; Butler AI; Tryon G. (now Smith Col., Mass.), was given by the artist. Important Tonalist (and Quietist), whose landscapes are subtle and lyrical. Position: T., Smith Col., 1885–1923 [24]

TSATOKE, Monroe [P] b. 1904, Saddle Mountain, OK d. 1937, OK. Studied: self-taught; some lessons from Mrs. Susie Peters; Mrs. Willie Baze Lane; Miss Mahier, at Univ. Okla. Member: One of the "Five Kiowas" at Univ. Okla. who won international acclaim by 1928 and about whom Dr. Jacobson (Univ. Okla.) wrote a book in 1929. Work: M. Am. Indian; Mus. N.Mex.; Philbrook A. Center [*]

TSCHACBASOV, Nahum [P,T] NYC b. 30 Ag 1899, Baku, Russia. Studied: Lewis Inst.; Armour Inst. Tech.; Paris; L. Gottlieb. Member: Am. A. Cong.; United Am. Ar.; An Am. Group. Exhibited: CI, 1944, 1945; AIC, 1944, 1945; PAFA, 1940, 1944–46; CGA, 1945; MOMA, 1945; WMAA, 1937–39, 1945; MVFA, 1944–46; Walker A. Center, 1945, 1946; MMA, 1944, 1946; "Galerie Zak," Paris, 1934 (one-man); Gal. Secession, 1935 (one-man); ACA Gal., 1936, 1938, 1940, 1942, 1946 (one-man); Univ. Tex., 1946 (one-man); New Orleans A.&Cr. C. (one-man); Vigeveno Gal., Los Angeles (one-man); 1030 Gal., Cleveland. Position: T., Am. Ar. Sch., N.Y. [47]

TSCHAEGLE, Robert [S,Cur,T,W,L] Indianapolis, IN b. 17 Ja 1904, Indianapolis. Studied: AIC; Univ. Chicago; Univ. London; L. Taft. Member: CAA. Exhibited: AIC; Hoosier Salon; John Herron AI; NAD. Positions: T., Univ. Mo., 1935–36; Asst. Cur., Herron A. Mus., 1937–41 [47]

TSCHUDI, Rudolf [P,T] Cincinnati, OH b. 27 Ap 1855, Glarus, Switzerland d. 23 Jy 1923. Studied: H. Ruch,t Glarus. Member: Cincinnati AC. Exhibited: Ohio Mechanics Inst., 1874 (prize); St. Louis Expo, 1904 (med). Work: Evanston School, Cincinnati; A. Mus., Glarus, Switzerland [21]

TSCHUDY, H(erbert) B(olivar) [P,W] NYC b. 28 D 1874, Plattsburg, OH d. 15 Ap 1946. Studied: ASL. Member: Fifteen Gal., N.Y.; AWCS; Phila. WCC; Brooklyn S. Modern A. Work: Brooklyn Mus.; State Mus., Santa Fe, N. Mex.; Aquarium, AMNH; Pub. Lib., Yellow Springs, Ohio; Antioch Col., Ohio; Nat. Mus., Warsaw, Poland; Nat. Mus., Sofia, Bulgaria [40]

TSISETE, Percy [P] Santa Fe, NM. Exhibited: First Nat. Exh., Am. Indian P., Philbrook A. Center, 1946. Affiliated with Santa Fe Indian School [47]

TUBBY, Joseph [Ldscp.P,Por.P] b. 25 Ag 1821, Tottenham, England (settled in Kingston, NY, 1832) d. 6 Ag 1896, Montclair, NJ. Studied: Black (in Kingston?). Exhibited: NAD, 1851–60. A close friend of Jervis McEntee, he lived in Brooklyn and N.J., 1890–96. [*]

TUBBY, Josiah Thomas [P,E,Arch] Portland, ME b. 2 Je 1875, Brooklyn, NY. Studied: Columbia; Ecole des Beaux-Arts, Paris; A. Bower; C.H. Woodbury; G.B. Bridgman. Member: SC; State of Maine A. Comm. (Chm.); AIA; Portland SA; Hayloft AC. Exhibited: SC; Portland SA; Brick Store Mus., Kennebunk, Maine [47]

TUBESING, Walter [P] Minneapolis, MN [24]

TUCCIARONE, Wilma McLean [C,Des] Hempstead, NY b. Hempstead. Studied: N.Y. State Col. Cer., Alfred Univ.; C. Binns; M. Fosdick; C. Nelson. Member: EAA; Nassau County A. Lg. Position: T., Hempstead H.S., 1935 [47]

TUCKER, Alice. See De Haas.

TUCKER, Allen [P,Arch,W,L,T] NYC/Castine, ME b. 29 Je 1866, Brooklyn, NY d. 26 Ja 1939. Studied: Columbia; ASL; J. Twachtman. Member: (founder) AAPS (which organized the Armory Show, 1913). Exhibited: Paris Salon; NYC; Phila. Work: RISD; Brooklyn Mus.; MET; Albright Gal., Buffalo; PMG; WMAA. Author: "Design and the Idea," "There and Here." Position: T., ASL [38]

TUCKER, Cornelia [S] Sugar Loaf, NY b. 21 Jy 1897, Loudonville, NY. Studied: Grafly, at PAFA [33]

TUCKER, Peri [I,W,P] Akron, OH b. 25 Jy 1911, Kashau, Austria-Hungary. Studied: Columbus Sch. A.; R.E. Wilhelm; E.C.V. Swearingen. Member: Akron Women's A. Lg. Exhibited: Ohio WCS, 1943; Canton, Ohio, 1944–46; Akron, Ohio, 1940–46; Massillon, Ohio, 1944, 1946. Illustrator: "Big Times Coloring Book," 1941, "The Quiz Kids," 1941; other books for children. Position: Art Columnist, Akron Beacon-Journal [47]

TUCKERMAN, Lilia (McCauley) (Mrs. Wolcott) [P] Carpinteria, CA (1962) b. 15 Jy 1882, Minneapolis. Studied: Corcoran Sch. A., with G.S. Noyes, C.H. Woodbury, DeWitt Parshall. Member: NAWA; NAC; Soc. Wash. A.; Boston AC; Calif. AC; San Diego A. Gld. Exhibited: NAD, 1930; Women's Intl. Exh., London, 1930; NAWA, 1931, 1933, 1935, 1937-39, 1941; NAC, 1928, 1929, 1931, 1933-37, 1940, 1945; Soc. Wash. A., 1923-26, 1928, 1929, 1931, 1934-37; Ogunquit, Maine, 1933, 1934, 1935 (prize), 1937-40, 1945; Santa Barbara Mus. A., 1944; Argent Gal., 1938 (one-man). Work: mural, St. Paul Church; triptych, Trinity Episcopal Church, Santa Barbara; backgrounds for animal groups, Santa Barbara Mus. Natural Hist. Mus. [47]

TUCKERMAN, Stephen Salisbury [Mar.P,Ldscp.P] Standeford, England (since 1872) b. 8 D 1830, Boston d. Mr 1904. Studied: Brimingham, England; W.M. Hunt, in Boston; Paris, 1860. Exhibited: Centenn. Expo, Phila., 1876. Work: Bostonian S., Old St. House. Position: T., Dir, New England Sch. Des., Boston, 1861-64

TUDOR, Rosamond [Por.P,E,T,L] Redding, CT b. 20 Je 1878, Bourne, MA d. 26 Je 1949. Studied: BMFA Sch., with Benson, Tarbell; Hawthorne; Bicknell. Member: AAPL; Bridgeport AA; Redding AA (Pres.) Exhibited: Bridgeport AA, 1942 (prize); Guatemala City, Guatemala, 1941. Work: Zahm Mem. Lib., Notre Dame Univ., Ind. Position: Dir., Migratory A. Gld.; Norton Sch., Claremont, Calif., 1945- [47]

TUDOR, Tasha (Mrs. Thomas L. McCready, Jr.) [I,W] Webster, NH b. 28 Ag 1915, Boston. Studied: BMFA Sch. Author/Illustrator: "Alexander the Gander," 1939, "Snow before Christmas" 1941, "The White Goose," 1943, other books. Illustrator: "Mother Goose," 1944, "Andersen's Fairy Tales," 1945 [47]

TUFTS, Florence Ingalsbe [P] Berkeley, CA. Exhibited: WC Ann., San Fran. A. Assn., 1937 (prize), 1939; Oakland A. Gal., 1934 [40]

TUFTS, Marion [S] Chicago, IL. Exhibited: Ar. Chicago Vicin. Ann., AIC, 1933, 1935, 1936, 1939 [40]

TUKE, Gladys [S,C,T] White Sulphur Springs, WV b. 19 N 1899, Linwood, WV. Studied: Corcoran Sch. A.; PAFA; A. Laessle; M. Miller. Member: Phila. A. All. Exhibited: PAFA; Woodmere A. Gal, 1941 (prize). Specialty: sculpture of horses. Positions: T., White Sulphur Springs Art Colony; YWCA, Germantown, Pa., 1940 [47]

TULK, Alfred James [Mur.P] Stamford, CT b. 3 O 1899, London. Studied: Oberlin Col.; Yale; NAD; ASL. Member: NSMP; Arch. Lg.; AIGA. Exhibited: BAID, 1922 (med). Work: murals in many banks, restaurants, hotels, churches [47]

TULLIDGE, John [P,Mur.P,T] Salt Lake City, UT b. 1836, Weymouth, England (came to Salt Lake City in 1863) d. 1899. Member: Soc. Utah Ar. Work: Latter Day Saints temples, theatre. Position: T., Deseret Acad. FA, 1863- [98]

TULLOCH, W(illiam) A(lexander) [P,I,L,T] NYC b. 3 Ja 1887, Venezuela, South America. Studied: W. Turner; Grand Central Sch. Prof. Illus. Member: Salons of Am.; S.Indp.A. [40]

TULLY, Sydney Strickland (Miss) [S,P] Toronto, Ontario b. Mr 1860, Toronto. Studied: Legros, in London; Paris, with Constant, Robert-Fleury, Courtois; Lazar, in England; Shinnecock, with W.M. Chase. Member: Assn. RCA; OSA; '91 Club, London [01]

TUNIS, Edwin (Burdett) [P,Des,E,I,En] Reisterstown, MD b. 8 D 1897, Cold Spring Harbor, NY d. 1973. Studied: Md. Inst.; C.Y. Turner; J. Lauber; H. Breckenridge. Member: Baltimore WCC. Exhibited: WFNY, 1939. Work: murals, Hicks & Co., McCormick & Co., both in Baltimore; Aberdeen Proving Ground. Illustrator: "Eat, Drink, and Be Merry in Maryland," 1932, "You'll Find It in Maryland," 1945, "Seventeen." Contributor: House Beautiful, Better Homes and Gardens [47]

TUPPER, Alexander Garfield [W] NYC/Gloucester, MA b. Gloucester d. ca. 1950. Studied: J.H. Twachtman; F. Duveneck. Member: NAC; North Shore AA; Gloucester SA [47]

TUPPER, Luella [P] Oak Park, IL b. Morris, IL. Studied: PIASch; W.M. Clute, in Chicago; Marshall Fry, H.B. Snell, both in N.Y. [13]

TURCAS, Ella Dallett (Mrs. Jules) [P] NYC b. NYC. Studied: Chase. Member: N.Y. Women's AC. Exhibited: SAA, 1898; PAFA, 1898; St. Louis Expo, 1898 [113]

TURCAS, Jules [Ldscp.P] NYC b. Cuba, 1854. Member: Lotos C.; SC, 1908; Allied AA; Century. Exhibited: NAD, 1898; SAA, 1898; PAFA; Pan-Am. Expo, Buffalo, 1901 (med); AAS, 1902 (med); St. Louis Expo, 1904 (med) [15]

TURCK, Ethel Ellis de (Mrs. A. Eugene Beimers) [P] Phila., PA. Studied: PAFA. Member: NAWPS; Plastic C. [27]

TURE, N.A. Responsible during the last half of the 19th century for great movement for artists to paint outdoors "en plein air," particularly during the peak of the Hudson River School through the era of Impressionism. When Utah artist Henry Culmer was asked who was his greatest teacher, he replied: "N. A. Ture."

TURINI, Giovanni [S] b. 23 My 1841, Italy d. 27 Ag 1899. Work: statue of Garibaldi, Wash. Square, NYC

TURKENTON, Netta Craig [Por.P,T] Wash., D.C. Studied: Corcoran Sch. A.; PAFA, with W.M. Chase. Member: Soc. Wash. A.; AFA. Exhibited: PAFA; Baltimore Charcoal C.; AFA Traveling Exh.; Soc. Wash. A. [47]

TURLE, Sarah A. [Min.P] Duluth, MN b. 21 Ap 1868, Mauch Chunk, PA. Studied: C. Beaux; E.D. Pattee; L.F. Fuller [25]

TURLE, Walter [P] Duluth, MN [17]

TURMAN, William Thomas [P,T,Car] Terre Haute, IN b. 10 Je 1867, Graysville. Studied: Union Christian Col.; AIC; PAFA; J.F. Smith; A. Brook; D. Garber; Chicago Acad. FA; A. Sterba; A.T. Van Laer. Member: Ind. AC; Western AA; PBC, Terre Haute. Exhibited: Hosier Salon, 1921-31, 1932 (prize), 1933-46; Ind. AC, 1939-45; Swope A. Gal., 1943-46; Ind. State T. Col. Work: Ind. State T. Col.; Pub. Sch., Columbia City, Terre Haute, Jasonville, Harrison Township; Pub. Lib., Thorntown, Ind.; Pub. Lib., Merom, Ind. [47]

TURNBULL, Gale [P,E] Los Angeles, CA b. 19 D 1889, Long Island City, NY. Studied: Guerin; Preissig; Lasar. Member: Am. Ceramic Soc.; Paris Groupe PSA. Work: Luxembourg Mus., Paris; Brooklyn Mus., N.Y. Position: A. Dir., Vernon Kilns, Los Angeles [40]

TURNBULL, Grace Hill [S,P,W] Baltimore, MD b. 1880, Baltimore d. 1976. Studied: Md. Inst.; ASL; PAFA; C. Beaux; E. Keyser. Member: NAWA. Exhibited: Paris, 1914 (prize); BMA, 1926, 1929, 1930, 1931, 1933, 1937 (prize), 1938, 1940-43, 1944 (prize) 1945-46; NAWA, 1931, 1932 (prize), 1933-36, 1939, 1941, 1942, 1944, 1946 (prize); NSS, 1908, 1916, 1943; PAFA, 1908, 1909, 1912, 1915, 1920, 1933-35, 1942, 1946; CGA, 1941; AIC, 1912, 1915, 1916, 1920, 1936, 1941; NAD; MMA (AV), 1942; Arch. Lg., 1921, 1933, 1937; Tex. Centenn., 1936; WFNY, 1939; P.-P. Expo, 1915; Salon des Beaux-Arts, Paris, 1914; Md. Inst., 1909, 1910, 1920, 1932 (prize), 1938-40, 1945; Phila. 1932 (prize). Work: MMA; BMA; mem., Eastern H.S., Baltimore. Author: "Tongues of Fire," 1929, "The Essence of Plotinus," 1935 [47]

TURNBULL, James Baare [P,G] Croton-on-Hudson, NY b. 1909, St. Louis d. 1976. Studied: St. Louis Sch. FA; PAFA. Member: Am. Ar. Cong. Exhibited: 48 Sts. Comp., USPO, Purcell, Okla. Work: WMAA; Springfield Mus.; Univ. Ariz.; PMG; La. Marine Hospital; mural, USPO, Fredericktown, Jackson, both in Mo. WPA artist. Position: A./Correspondent, Abbott Laboratories [47]

TURNBULL, Ruth [S] Hollywood, CA b. 25 Ja 1912, New City (N.Y.?). Studied: E. Buchanan [29]

TURNER, Alice. See Culin.

TURNER, Alfred M. [P,T] NYC b. 28 Ag 1851, England (came to NYC in 1892) d. 27 Jy 1932, West New Brighton, N.Y. Studied: his father Edward. Member: AWCS. Exhibited: NAD, 1880-94. Work: NYU; FDR Mus., Hyde Park, N.Y. Position: T., CUASch, for 12 years [29]

TURNER, August D. [P] Albany, NY/Etaples Pas-de-Calais, France d. 8 Ap 1919. Exhibited: Paris Salon. Work: Imperial Palace, Petrograd (during the Czar's reign) [10]

TURNER, Charles H. [P] Boston, MA b. 7 Ag 1848, Newburyport, MA. Studied: O. Grundmann, in Boston. Member: Unity AC; Boston AC (Pres.) [10]

TURNER, C(harles) Y(ardley) [Mur.P,I,T] Wash., D.C./Baltimore, MD/NYC b. 25 N 1850, Baltimore d. 1 Ja 1919, NYC. Studied: Md. Inst., Baltimore, 1870; NAD; ASL, 1872-78; Paris, 1878-81. Member: ANA, 1883; NA, 1886; AWCS; Mural P.; Arch. Lg., 1896; ASL (founder); A. Aid S.; Century Assn.; SC; Charcoal C. Exhibited: NAD, 1884 (prize); Pan-Am. Expo, Buffalo, 1901 (med); St. Louis Expo, 1904 (med); Arch. Lg., 1912 (med). Work: Court House, Baltimore; Hudson County Court House, Jersey City; Essex County Court House, Newark; Hotel Raleigh, Wash., D.C.; Mahoning County Court House, Youngstown, Ohio; Appellate Court, NYC; St. Andrew's Methodist Episcopal Church, NYC; De Witt Clinton H.S., NYC; Manhattan Hotel, NYC; Hotel Martinique, NYC; Hotel Waldorf-Astoria, NYC; MET; Brooklyn Inst. Mus. Position: T., ASL, 1881-84 [17]

TURNER, Dorothy Ling (Pulfrey) [P,Dr] Lancashire, England b. 6 Ap 1901, Providence, RI. Studied: J. Sharman; A. Heintzelman. Member: St. Helens AC [40]

TURNER, Emery S. b. 1841 d. 11 O 1921, Saranac Lake, NY. Head of Anderson Art Galleries. Served in the Civil War.

TURNER, Frances Lee (Mrs. E.K.) [P,T] Atlanta, Ga. b. 5 N 1875, Bridgeport, AL. Studied: Corcoran A. Sch.; ASL; K. Cox; G.E. Browne; D. Garber; G.P. Ennis; W. Stevens; R.H. Nicholls. Member: Ga. AA; Atlanta AA; Atlanta AG; Riverside (Calif.) A. Assn. Exhibited: Atlanta AA, 1923 (prize). Work: White House. Contributor: Atlanta Journal. Position: T., Emory Univ. [40]

TURNER, Helen Maria [P,Min.P] New Orleans, LA (lived in NYC since 1895; summers at Cragsmoor, NY, 1906–26) b. 13 N 1858, Louisville, KY d. 31 Ja 1958 (age 99). Studied: New Orleans AA, with A. Molinary, B.A. Wickstrom, late 1880s-early 90s; ASL, with K. Cox, S.D. Volk, 1895–99; CUASch, 1898–1901, 1904–05, with S.D. Volk; Columbia, 1899–1900; W.M. Chase, in Europe, 1904, 1905, 1911. Member: ANA, 1913; NA, 1921; NYWCC; NAC; AAPL; SSAL; NOACC; NOAA; AWCS. Exhibited: N.Y. Women's AC, 1912 (prize); NAWPS (prize); NAD, 1913 (prize), 1921 (prize), 1927 (prize); AIC, 1913 (prize); NAC, 1922 (prize), 1927 (gold); NYWCC, 1897; PAFA, 1898; SAA (Min. P.), 1900; Pa. Soc. Min. P.; first one-woman show, Milch Gal., NYC, 1917; Grand Central AG; Corcoran, 1917; St. Louis AM, 1917; Cragsmoor Lib. (retrospective); Akron AM (retrospective); Jersey City Mus. (retrospective); Owensboro MFA, Ky., 1983–84 (retrospective). Work: MMA; CGA; Detroit Inst.; Nat. AC; PMG; Houston A. Mus.; Norfolk Mus., Va.; Newark A. Mus.; Highland Park Soc. Arts, Dallas; Montclair A. Mus.; Jersey City Mus.; N.Y. Hist. Soc.; Sweet Briar Col.; Rockford AA; Zigler Mus.; Detroit IA; NOMA; Syracuse; Akron A. Mus.; High Mus.; Speed Mus.; Tweed Mus., Duluth; Brooks G., Memphis; Montgomery MFA. Position: T., YMCA A. Sch., NYC, 1902–19

TURNER, Ila. See McAfee.

TURNER, Jean (Leavitt) (Mrs. LeRoy C.) [P,I,S,T,L] San Fran., CA b. 5 Mr 1895, NYC. Studied: PIASch; CUASch; E. Traphagen. Member: AAPL; Lg. Am. Pen Women. Exhibited: Pal. Leg. Honor, 1938–39; AAPL, 1940–46; Lg. Am. Pen Women, 1940, 1941. Specialty: children's books. Position: Dir., Jean Turner A. Center [47]

TURNER, John [P] Boston, MA. Member: Chicago NJSA [25]

TURNER, LeRoy [Mur.P,Des,Dr,T] Stillwater, MN b. 1 N 1905, Sherwood, ND. Studied: C. Booth; St. Paul Sch. Art; Univ. Minn.; E. Kinzinger, in Munich, Germany. Work: mural, Central H.S., St. Paul. Position: T., Stillwater A. Colony, Minn. [40]

TURNER, Leslie [I] Wichita Falls, TX/Tobe, CO b. 25 D 1900, Cisco, TX. Illustrator: Saturday Evening Post, Ladies' Home Journal, Pictorial Review [40]

TURNER, Lottie B. [P,T] NYC/Saginaw, MI. Studied: PIASch; Beck; Prellwitz; Paddock; Johonnot; Collins; Haney; Snell; Watson [21]

TURNER, Marian Jane [P] Chester, PA b. 20 S 1908, Chester. Studied: Phila. Sch. Des. for Women; PAFA. Member: Phila. Alliance; Plastic C. Work: Phila. Alliance; PAFA [40]

TURNER, Matilda Hutchinson [Min.P] Phila., PA b. Jerseyville, IL. Studied: Drexel Inst., with Steinmetz; PAFA, with H. Breckenridge, W.M. Chase, C. Beaux, S. Kendall, M. Archambault. Member: Pa. Soc. Min. P.; Phila. Plastic C. Exhibited: PAFA, 1925–33, 1935, 1937, 1939, 1940, 1942, 1944, 1945; BM, 1928, 1929; ASMP, 1929, 1932; Baltimore WCC, 1930; Century of Progress, Chicago, 1933; Calif. Soc. Min. P., 1937, 1944; Smithsonian, 1944, 1945 [47]

TURNER, Raymond [S] NYC (1977) b. 25 My 1903, Milwaukee. Studied: Milwaukee AI; Wis. Normal Sch.; Layton Sch. A.; CUASch; BAID. Member: NSS; East Hampton Gld. Exhibited: Detroit Inst. A., 1927 (prize); NAD, 1932, 1933, 1935; PAFA, 1936, 1940; WFNY, 1939; Salon d'Automne, Paris, 1928. Work: "Four Freedoms," Rockefeller Plaza, NYC; schools in NYC and Brooklyn [40]

TURNER, Richard Sydney [Car] Newburgh, NY b. 1873 d. 10 Ag 1919. He was cartoonist for Poughkeepsie Evening Star, Newburgh News, Union, and American.

TURNER, Ross (Sterling) [P,I,C,T,W] Salem, MA/Wilton, Hillsboro County, NH b. 29 Je 1847, Westport, Essex County, NY d. 12 F 1915, Nassau in the Bahamas. Studied: F. Currier, in Munich, 1876. Member: NYWCC; AWCS; Boston WCC; Copley S., 1891. Exhibited: Pan-Am. Expo, Buffalo, 1901 (med); AWCS, 1908 (prize); NAD, 1886; Boston AC; PAFA. Work: Peabody Mus., Salem. Author: "Art for the Eye—School Room Decoration." Specialties: watercolors; illuminating of manuscripts. Positions: T., Mass. Normal A. Sch. (1909–), MIT [19]

TURNER, Shirley [Min.P,C,T] NYC b. NYC. Studied: Constant, Lefebvre, in Paris; A. Dow, in N.Y. Member: Brooklyn AC. Exhibited: SAA, 1898; PAFA, 1898; Louisville AL, 1898 [13]

TURNER, William Greene [S,Medallist] Newport, RI b. 1832 d. 22 D 1917. Work: Commodore Oliver Hazard Perry statue, Newport

TURNEY, Ester [P] Norman, OK [17]

TURNEY, Olive [P] Pittsburgh, PA/Scalp Level, PA b. 4 Ag 1847, Pittsburgh d. ca. 1939. Studied: Pittsburgh Sch. Des. for Women. Member: Am. APL. Exhibited: 1872 (gold) [33]

TURNEY, Winthrop Duthie [P] Brooklyn, NY b. 8 D 1884, NYC. Studied: ASL; G. DeF. Brush; DuMond; L. Loeb. Member: Fifteen Gal. Group; All. A. Am.; Brooklyn SA; A. Fellowship; Brooklyn S. Mod. A.; Brooklyn PS. Exhibited: All.A.Am., 1944 (prize); PAFA; AWCS, 1937, 1940, 1944–46; NAD, 1944–45, 1946; Newark Mus.; Milwaukee AI; WMAA, 1929; MOMA [47]

TURNEY, Withrop D., Mrs. See Richmond, Agnes.

TURNURE, Arthur [P,Pub] NYC b. 1857, NYC d. 13 Ap 1906. Studied: Princeton, 1876. Member: Arch. Lg., 1887; (founder) Grolier C., NYC, ca. 1890. Began the paper known as "The Art Age," which he let die to begin "The Art Interchange." Later became art director for Harper's, where he arranged a richly illustrated edition of Lew Wallace's "Ben Hur." [06]

TURRELL, Charles James [Min.P] Ridgefield, CT b. 1845, London (came to U.S. as a young man) d. 13 Ap 1932, White Plains, NY. Exhibited: Royal Acad., for 58 years. Work: portraits, Queen Victoria, Queen Mary, Queen Alexandra, Queen Maud of Norway, Gladstone and others, executed on his frequent visits to England. [25]

TURVEY, Esther [P] Norman, OK [19]

TURZAK, Charles [P,Car,I,Des,B,C] Chicago, IL b. 20 Ag 1899, Streator, IL. Studied: AIC. Exhibited: AIC, 1940 (prize). Work: LOC; murals, USPOs, Chicago, Lemont, both in Ill. Illustrator/Publisher: "Abraham Lincoln—Biography in Woodcuts," 1933; "Benjamin Franklin—Biography in Woodcuts," 1935. WPA artist. Position: A. Dir., "Hygeia," 1942– [47]

TUTHILL, Corinne [Mur,P,Por,P,B,Des,C,T] Florence, AL b. 11 O 1891, Laurenceburg, IN. Studied: Columbia. Exhibited: Provincetown, Mass.; Wash., D.C.; Morton Gal.; SSAL. Award: Schol., Harvard, 1942. Contributor: articles, School Arts, Design. Position: T., State T. Col., Florence, 1933– [47]

TUTHILL, M.E. [P] Brooklyn, NY [17]

TUTHILL, Margaret H. [P] Chicago, IL [17]

TUTTLE, Adrianna [Min.P] Newark, NJ b. 6 F 1870, Madison, NJ. Studied: Chase. Member: Pa. S. Min. P.; NAWPS; Am. S. Min. P. [40]

TUTTLE, Charles M. [P] Woodstock, NY [25]

TUTTLE, (Henry) Emerson [Cur,T,E,En] New Haven, CT/Nantucket, MA b. 10 D 1890, Lake Forest, IL d. 8 Mr 1946. Member: Soc. Am. E.; Chicago SE. Work: AIC; British Mus.; London; Memorial A. Gal., Rochester, N.Y.; Bibliothèque Nationale, Paris; Mus. FA, Yale. Specialty: etchings of birds. Positions: T./Curator, Gal. FA, Yale, 1930 [40]

TUTTLE, Helen Norris [P,T] Bryn Mawr, PA b. 26 S 1906, Croton-on-Hudson, NY. Studied: Bryn Mawr Col.; Univ. Pa; T. Benton; E. Forbes; J. Albers.; B. Robinson; Lhote. Member: Phila. A. All.; AAPL. Exhibited: PAFA, 1932, 1935, 1936; Phila. AC, 1937; Bryn Mawr A. Center, 1938, 1944 (one-man); Phila. A. All., 1939; Haverford Col., 1940. Position: Supv. A., Pub. Sch., Landale, Pa., 1941–45 [47]

TUTTLE, Isabelle Hollister (Mrs. Henry) [P] New Haven, CT/Nantucket, MA b. 2 Je 1895. Studied: F. Chase; G. Wiggins; Yale. Member: New Haven PCC; NAWPS; CAFA. Exhibited: NAWPS, 1931 (prize); CAFA, 1934 (prize) [40]

TUTTLE, Macowin [P,I,En,T,W,L] NYC b. 3 N 1861, Muncie, IN d. 26 Mr 1935, Buck Hill Falls, Pa. Studied: W.M. Chase; Duveneck; Laurens, at Académie Julian, Paris. Member: NAC; SC; Paris AAA. Work: MET; Mus. City of N.Y.; NGA; LOC; Yale. Specialty: engravings on wood direct from nature [33]

TUTTLE, Mary McArthur T(hompson) (Mrs. H.) [P,I,W] Hillsboro, OH b. 5 N 1849. Studied: McMickin A. Sch., Cincinnati, with T.S. Noble; Graef, in Berlin; Seitz, in Munich. Work: port., Cornell Univ.; Crusade

Mem. Room, Hillsboro. Author: "Historical Chart of the Schools of Painting" [15]

TUTTLE, Mildred Jordan (Mrs.) [Min.P,E,T,P] Clinton, CT b. 26 F 1874. Studied: Yale; W.M. Chase. Member: New Haven PCC; Pa. S. Min. P. Work: Yale [33]

TUTTLE, Plymmon Carl [Des,E,Li,P] NYC b. 5 Jy 1914, Cleveland. Studied: Cleveland Sch. A.; Huntington Polytechnic Inst.; Corcoran Sch. A.; O Egge; F. Wilcox, P. Travis; R. Lahey. Exhibited: Wash. WCC, 1945, 1946. Positions: A./Des., Reserve Lithograph Co., Cleveland, 1933–42; A., Coast & Geodetic Survey, Wash., D.C., 1942–44 [47]

TUTTLE, Ruel Crompton [Por.P,Mur.P] Greenfield, MA b. 24 S 1866, Windsor. Studied: ASL, with Mowbray, J.A. Weir; MIT. Member: CAFA; Wash. WCC; NYWCC; AWCS; Hartford AS. Work: Lib,. Trinity Col., Hunt Mem., First Methodist Episcopal Church, Town and Country Club, Wadsworth Atheneum, all in Hartford, Conn.; John Fitch Sch., Windsor, Conn. [40]

TUTTLE, Walter (Ernest) [I,P] NYC/Springfield, OH b. 9 O 1883, Springfield. Studied: Chase; Henri; Mora. Author/Illustrator: "The First Nantucket Tea Party" [13]

TWACHTMAN, J(ohn) Alden [P] Greenwich, CT b. 5 Mr 1882, Cincinnati. Studied: his father, John H.; Niemeyer; Bonnât, in Paris [17]

TWACHTMAN, John Henry [Ldscp.P,E,T] Greenwich, CT (since 1888) b. 4 Ag 1853, Cincinnati d. 8 Ag 1902, Gloucester, MA. Studied: Ohio Mechanics Inst.; McMicken Sch. Des., Cincinnati, with Duveneck, 1871; Royal Acad., Munich, with Loefftz, 1875–77; went to Venice with Duveneck and W.M. Chase, 1877; Académie Julian, 1883, with Boulanger and Lefebvre. Member: SAA, 1879; Am. AC, Munich; Ten Am. P.; N.Y. Et. C.; Tile C.; Player's C. Exhibited: SAA, 1888 (prize); Columbian Expo, Chicago, 1893 (med); PAFA, 1895 (gold); CI, 1899 (prize); NAD; Cincinnati AM, 1966 (retrospective). Work: MMA; Mus. N.Mex.; BM; AIC; PAFA; Smith Col. Mus. A.; Cincinnati A. Mus.; WMAA; many major museums. Illustrator: Scribner's, 1888–93. Important Impressionist. His early style reflected the influence of Duveneck and the Munich school, while his residence in Paris (1883–85) saw the evolution of a more abstract Whistlerian style. Upon settling in Greenwich on his 17–acre farm, maturity saw his palette become lighter, expressing poetic and subtle nuances of tone. His Gloucester period saw the reintroduction of black in his paintings. American Art Gal., NYC auctioned 98 of his paintings in 1903 for $16,610. Position: T., summer classes at Cos Cob, Conn., 1890– ; Gloucester, 1900–02 [01]

TWARDOWICZ, Stanley John [P,Li,T] Detroit, MI b. 8 Jy 1917, Detroit. Studied: Meizinger A. Sch.; AIC; F. de Erdely; F. Chapin; D. Lutz. Member: Scarab C., Detroit. Exhibited: Detroit Inst. A., 1942, 1943 (prize), 1944, 1945 (prize), 1946; Pal. Leg. Honor, 1946; Milwaukee AI, 1944, 1946; Scarab C., 1944, 1945; J. L. Hudson Gal., Detroit, 1946; Kalamazoo AI, 1946 [47]

TWARDZIK, Henryk F. [P,C,T] Boston, MA/Rockport, MA b. 5 S 1900, Oswiencium, Poland. Studied: Connick; Connoli; Hopkinson; Wilcox; Albright Sch. FA. Member: New England Soc. Contemp. A.; Buffalo SA. Exhibited: Spring Exh., Buffalo, 1928 (prize). Work: Nat., Mus., Poland [33]

TWEEDY, Richard [P] NYC. Studied: Mowbray and Chase. Member: Paris AAA [10]

TWICHELL, Gertrude Stevens [W,C] Boston, MA/Fitchburg, MA b. Fitchburg. Studied: RISD; Sch. Appl. A.&Cr., Boston; Mass. Sch. A. Member: Boston SAC (Master Craftsman). Exhibited: Intl. Expo, Paris, 1937; Am. Fed. A. (traveling), 1937, 1938. Contributor: articles, Industrial Arts, Handicrafter. Specialties: metal work; enameling [40]

TWIGGS, Russell Gould [P,Li] Pittsburgh, PA b. 29 Ap 1898, Sandusky, OH. Studied: CI. Member: Assn. A. Pittsburgh; Abstract Group, Pittsburgh, 1942. Exhibited: CI, 1942–45; PAFA, 1946; AIC, 1939, 1946; SFMA, 1937; San Diego FA Soc., 1941; Assn. A. Pittsburgh, 1942–45; Abstract Group, 1945, 1946; San Fran. A. Assn., 1934 [47]

TWIGG-SMITH, W. [P,I] Honlulu, HI b. 2 N 1883, Nelson, New Zealand. Studied: AIC; H.M. Walcott. Member: Hawaiian SA; Chicago ASL. Work: Univ. Hawaii; Honolulu Acad. A. Illustrator: for Hawaiian Sugar Planters Assn. [40]

TWINING, Yvonne [P] Boston, MA/Berkshire County, MA b. 5 D 1907, NYC. Studied: NAD; ASL; Tiffany Fnd.; C. Hawthorne Sch., Provincetown, Mass. Exhibited: Stockbridge AA, 1935 (prize); WFNY, 1939. WPA artist. [40]

TWITCHELL, Asa Weston [Por.P] b. 1 Ja 1820, Swanzey, NH d. 26 Ap 1904, Slingerlands, NY. Exhibited: NAD; Am. A. Union. Active around Albany, N.Y. [*]

TWORKOV, Jack [P,T] NYC b. 15 Ag 1900, Biala, Poland (came to NYC, 1913). Studied: Columbia; NAD; ASL, 1923–26. Exhibited: PAFA, 1942; AIC, 1942; NGA, 1941; WMAA, 1941; ACA Gal., 1940 (one-man); MOMA, 1964 (retrospective). Work: WPA artist, 1934–41 (example in Marine Hospital, Carville, Iowa); modern works at MOMA; CMA [47]

TWYMAN, Joseph [Arch,P,T,C] Chicago, IL b. 8 O 1842, Ramsgate, England d. 1904, Chicago. Studied: London, with Pugin, Christopher, Dresser, William Morris. Member: South Park Improvement; Workshop Assn.; Chicago Arch. C.; Morris Soc. [04]

TYERS, Emily [P] NYC. Exhibited: Boston AC, 1898 [01]

TYLER, Alice Kellogg (Mrs.) [P,T] Chicago, IL (many summers spent in Europe) d. 14 F 1900. Studied: one of the first pupils at the AIC. Member: SAA, 1891; SWA. Exhibited: Chicago Ar. Assn. (prize); NYWCC, 1898; PAFA, 1898. Position: T., AIC [98]

TYLER, Bayard H(enry) [Port.P] Yonkers, NY/Catskill, NY b. 22 Ap 1855, Oneida, Madison County, NY d. 6 Je 1931, Yonkers. Studied: Syracuse Univ.; ASL; NAD; T. Kaufman. Member: Lotos C.; SC; Yonkers AA; NYWCC. Exhibited: Wash. SA, 1913 (prize); Yonkers AA, 1927 (prize). Work: CGA; State Coll., Albany, N.Y.; Banking Dept., Albany; Insurance Underwriters, N.Y.; Aetna Insurance Co., N.Y.; North River Insurance Co., N.Y.; Standard C., Chicago; Holden Mem., Clinton, Mass.; Hackley Mem. Sch., Tarrytown; Albright Mem. Lib., Scranton; Wells Col., Aurora; Twenty-second Regiment Armory, N.Y.; Women's Col., New London [29]

TYLER, Carolyn D. [Min.P] Chicago, IL b. Chicago. Studied: AIC, with Mrs. V. Reynolds; ASL, Chicago. Member: Chicago SA; Chicago WCC; Chicago S. Min. P.; Chicago AC; Cordon [40]

TYLER, Charles H. [Patron] d. 7 D 1931. He left his large collection of furniture, silver, books and prints to Boston Museum of Fine Arts.

TYLER, Ernest F(ranklin) [P,Arch,D] NYC/Cooperstown, NY b. 13 Ap 1879, New Haven, CT. Studied: Yale; Columbia. Member: Soc. Beaux-Arts, Arch.; Arch. Lg.; Century A.; Nat. Soc. Mural P. Exhibited: Arch. Lg., 1937 (one-man); WFNY, 1939. Work: dec., Am. Telephone & Telegraph Bldg.; Equitable Life Assurance Soc., Riverside Church, both in NYC; Essex County Court House; Essex County Hall of Records, Newark; Masonic Temple, Scranton; Trinity Cathedral, Pittsburgh; Worcester (Mass.) War Mem.; Woolsey Hall, Yale; Christ Church, Greenwich, Conn.; Baltimore Trust Co., Bank Bldg., Baltimore; U.S. Supreme Court Bldg. (two rooms); Old Trinity Church, Collegiate Church, St. Nicholas N.Y.; Christ Church, Cooperstown, N.Y.; portrait, AGAA; (in association with E.W. Jenney) Sun Life Assurance Soc., Montreal; Woolworth Bldg., N.Y.; Wis. State Capitol; Union Central Life Bldg., Cincinnati; Hibernia Bank and Trust Co., New Orleans; Houses of Parliament, Ottawa, Canada; Seamen's Bank for Savings, N.Y.; First Nat. Bank, Jersey City; Standard Oil Co. Bldg., N.Y.; New Palmer House Hotel, Chicago; New Aeolian Co. Bldg., N.Y.; Nat. Acad. Sciences Bldg., Wash.; War Mem. Bldg., Nashville; Union Planters Bank, Memphis; Columbia Univ., dining hall; Cathedral St. John, N.Y. [40]

TYLER, Hugh C. [P] Knoxville, TN [24]

TYLER, James G(ale) [Mar.P,I,W] Greenwich, CT b. 15 F 1855, Oswego, NY d. 29 Ja 1931, Pelham, NY. Studied: A.C. Smith. Member: Brooklyn AC; SC, 1893; A. Fund. S.; Greenwich SA. Exhibited: NAD, 1880–99. Work: CGA; Tokyo Mus.; Wadsworth Atheneum, Hartford; Omaha, Nebr.; Mariner's Mus. He painted pictures of every America's Cup race since 1900. In 1930, at age 75, he went to the races off Newport and made his characteristic vivid portrayals of the Shamrock and Enterprise, which were later shown at the Union League Club. [29]

TYLER, Margaret Yard [P,T,W,Li] Wash., D.C. b. 10 Ap 1903, NYC. Studied: Corcoran Sch.; PAFA; M. Sterne. Member: S. Wash. A. Exhibited: Indp. Ar. Exh., Wash., D.C., 1936 (prize). Position: Dir., Yard Sch. FA, Wash., D.C. [40]

TYLER, Owen (Mrs.) [P] Louisville, KY. Member: Cincinnati Women's AC [15]

TYLOR, Stella Elmendorf (Mrs.) [S] Madison, WI. Member: Wis. PS [27]

TYNG, Griswold [Des,I,T,G,P,L,W] Jamaica Plain, MA/Orleans, MA b. 13 Ag 1883, Dorchester, MA. Studied: Mass. Sch. A.; H. Pyle; J. De Camp. Member: Assn. A. & D. of New England. Work: public relations posters and related material for Liberty Loan and the Boston Common Tercentenary. Author: "History of the Engraving Processes," 1941. Specialty: educational publicity [47]

TYNG, Lucien Hamilton (Mrs.) [P,Patron] NYC b. 30 O 1874, NYC d. 22 F 1933, Nassau. Her New York studio had been the center of an indoor art market where she and her husband, with the aid of a committee, offered opportunity to struggling artists to dispose of their work through private and auction sales.

TYNG, Margaret Fuller (Mrs. Griswold Tyng) [P] Jamaica Plains, MA. Member: Boston GA [29]

TYRE, Philip Scott [P,E,Arch] Phila., PA b. 14 Jy 1881, Wilmington, DE d. 25 Ag 1937. Studied: PAFA, with Anshutz, H.R. Poore. Member: Phila. AC; AFA; Union Lg.; Am. Soc. Civil Engineers [33]

TYRSON, Peter [P,S,C] Madison, CT/Friendship Island, ME b. 25 O 1853, Goteborg, Sweden (came to U.S. in 1890s) d. 27 O 1950. Studied: NAD; ASL; W.M. Chase; A. Zorn; Académie Julian, 1870s [33]

TYSON, Carroll Sargent, Jr. [P] Phila., PA b. 23 N 1877, Phila. d. 19 Mr 1956. Studied: PAFA, with Chase, Anshutz, Beaux; C. Marr, W. Thor, in Munich. Member: NA; Phila. AC; S.Indp.A.. Exhibited: PAFA, 1915 (gold); P.-P. Expo, 1915 (med); Phila. AC, 1930 (gold); Wildenstein Gal., 1938, 1946 (one-man). Work: Phila. AC; PMA; Pa. State Col. [47]

TYSON, Dorsey Potter [E] NYC b. Maryland. Work: Grand Central A. Gal. Specialty: colored Oriental etchings [40]

TYSON, (Mrs. George) [P] Boston, MA. Member: Boston WCC [29]

TYSON, Mary (Mrs. Thompson) [P] NYC b. 2 N 1909, Sewanee, TN. Studied: Grand Central Sch. A.; G.P. Ennis; H. Hildebrandt; W. Adams; E. Greacen; E. Pape. Member: AWCS. Exhibited: Baltimore WCC, 1930; AGAA, 1935; BM, 1935, 1937; Phila. WCC, 1934, 1936; AWCS, 1936–40, 1943, 1944; Montross Gal.; Contemporary A.; Morton Gal.; Harlow Gal. [47]

TYTUS, Robb de Peyster [I] Tyringham, MA b. Asheville, NC d. 14 Ag 1913, Saranac Lake, NY. Studied: Yale, 1897. While traveling in the East he made sketches for American magazines; later he became interested in archaeology, and with Percy E. Newbury, the English archaeologist, made numerous excavations. He was twice elected to the Mass. House of Representatives.

U

Symbol of the Washington Watercolor Club

UBALDI, Mario Carmelo [S,Des,T] Chicago, IL b. 16 Jy 1912, Monarch, WY. Studied: Indst. Mus. A., Rome; AIC. Member: United Am. Ar., Chicago. Exhibited: AIC, 1937–42, 1943 (med), 1944 (prize), 1945; WFNY, 1939; CGA; Univ. Chicago, 1942; Marc Gal., New Orleans, 1940 (one-man). Position: T., AIC [47]

UERKVITZ, Herta (E.W.E.) [P,W] Everett, WA b. 1 Mr 1894, WI. Work: Seattle FA [21]

UEYAMA, Tokio [P] Los Angeles, CA b. 22 S 1890, Wakayama, Japan. Studied: PAFA. Work: State Col., Pa. [31]

UFER, Walter [P] Taos, NM (since 1914) b. 22 Jy 1876, Louisville, KY d. 2 Ag 1936, Santa Fe. Studied: Royal Appl. A. Sch., Dresden, 1894–96; Royal Acad., Dresden, 1897–98; AIC; J. Francis Smith A. Sch., Chicago, 1901–03; W. Thor, Munich, 1911–13. Member: ANA, 1920; NA, 1926; Chicago SA; SC; Taos SA, 1913; Boston AC (hon.); NAC (life); Allied AA; F., Royal SA; CAFA; N.Mex. P.; Modern SA, Los Angeles. Exhibited: AIC, 1916 (prize), 1923 (gold); NAD, 1918 (prize), 1921 (prize), 1926 (gold,prize); Ill. P., 1918 (prize); Intl. Exh., CI, 1920 (prize); CAFA, 1922 (prize); Phila. AC, 1922 (gold); PAFA, 1923 (gold); Ky. Painters, Nashville, 1925 (prize); Corcoran, 1923 (one-man). Work: AIC; Springfield (Ill.) State House; Brooklyn Inst. A.&Sciences; PAFA; Md. Inst., Baltimore; Harrison Coll., Mus. History, Science & Art, Los Angeles; Chicago Municipal Coll.; Corcoran Gal.; Tulsa, Okla. A. Assn.; Rockford (Ill.) A. Assn.; Joliet A. Assn.; Union Lg. C., Chicago; Nat. AC, N.Y.; Wichita (Kans.) A. Assn.; Dubuque, Iowa A. Assn.; MMA; Houston Mus. FA [33]

UFER, Walter, Mrs. See Frederiksen, Mary.

UHL, Grace E. [P] Paris, France b. Shenandoah, IA. Studied: R. Mille, L. Simon, both in Paris; ASL; J.L. Wallace [13]

UHL, S. Jerome, Sr. [P] Cincinnati, OH b. 1842, Holmes County, OH. Studied: Augusta Emile, Carolus-Duran, Puvis de Chavannes, both in Paris. Member: S. Wash. A.; Wash. WCC. Exhibited: NAD, 1898; Paris Salon. Work: Wash., D.C.; State Bldg., Columbus, Ohio [08]

UHLE, Bernhard [P] Phila., PA. Member: Phila. AC [25]

UHLER, Anne. See Abbott.

UHLER, Ruth Pershing [P,T,L] Houston, TX/Santa Fe, NM b. 21 Mr 1898, Gordon, PA d. ca. 1968. Studied: Phila. Sch. Des. for Women; J. Charlot; L. Seyffert; H.B. Snell. Member: Houston Artists' Gal.; SSAL. Exhibited: Mus. FA, Houston, 1931 (prize). Work: Mus. FA, Houston; Houston Pub. Lib. Position: T., Mus. Sch. A., Houston [47]

ULBER, Althea [P,Des,C,T,S,G] La Crescenta, CA b. 28 Jy 1898, Los Angeles; F.T. Chamberlain; S.McD. Wright; H. Hofmann, in Munich; Binder, in Vienna. Member: NSMP. Exhibited: Los Angeles Mus. A. (prize). Work: Los Angeles Mus. A.; H.S., Los Angeles; fabric design, Johnson & Faulkner, Arthur H. Lee, N.Y. Position: T., (Children's) Chouinard AI, Los Angeles, 1921–41 [47]

ULBRICHT, Elsa Emilie [T,C,Des,Li,P,L] Milwaukee, WI b. 18 Mr 1885, Milwaukee d. 1980. Studied: Wis. Sch. A.; PIASch; Milwaukee State T. Col.; A. Mueller; F. Chapin; W.M. Clute; F. Fursman; S. Sorenson; E.G. Starr; G. Senseney. Member: Wis. P.&S.; Wis. Des.–Craftsmen; Western AA; Milwaukee AI; Milwaukee PM. Exhibited: Wis. Union, Madison (prize); Milwaukee AI, 1925 (prize), 1926 (prize), 1930 (prize), 1936 (prize); Wis. Salon, 1938 (prize); Wis. Des.–Craftsmen. Work: Univ. Minn.; Milwaukee AI; Wis. Artists Blockprint Calendar. Contributor: Design magazine; articles on weaving and marionettes. Position: T., Milwaukee State T. Col., 1911– [47]

ULEN, Jean Grigor (Mrs. Paul) [E,P,T] Lakewood, OH/Frankfort, MI b. 19 D 1900, Cleveland. Studied: Cleveland Sch. A.; H. Tonks, at Slade Sch., London; Univ. London. Member: Cleveland PM. Exhibited: Cleveland Mus. Art, 1925 (prize), 1926 (prize), 1930 (prize), 1931 (prize), 1933 (prize), 1936 (prize); May Show, Cleveland Mus. Art, 1937 (prize), 1938 (prize). Work: Cleveland Mus. Art. Position: T., West Tech. H.S., Cleveland [40]

ULEN, Paul V. [P,E,W] Lakewood, OH/Frankfort, MI b. 7 Jy 1894, Frankfort. Studied: Cleveland Sch. A.; H. Tonks, Slade Sch., London; Univ. London; Cent. Sch. Arts and Crafts, Sir J. Cass Sch., London. Member: Cleveland PM. Exhibited: Cleveland Mus. A., 1930 (prize), 1932 (prize), 1933 (prize); May Show, Cleveland Mus. A., 1937 (prize). Work: Cleveland Mus. A.; Werner Coll., City of Cleveland. Co-author: "Making Prints." Position: T., West Tech., H.S., Cleveland [40]

ULKE, Henry [Por.P] Wash., D.C. b. 29 Ja 1821, Frankenstein, Germany (came to NYC in 1849) d. 17 F 1910. Studied: Berlin. Work: White House; War Dept.; portraits of gov. officials, including Pres. Grant; Lincoln's Cabinet

ULLMAN, Alice Woods (Mrs. Eugene P.) [I,P] Provincetown, MA b. Goshen, IN. Member: NAWPS; NAC [25]

ULLMAN, Eugene Paul [P,L] Westport, CT b. 27 Mr 1877, NYC. Studied: NAD; W. Chase; Whistler. Member: Lotos C.; Salon des Jeunes (hon.); Salon des Beaux-Arts, Paris; Am. A. Assn., Paris; Paris Soc. Am. P.&S. (Chm.); Salon des Indépendants, Paris; New Soc. A.; SC, 1902. Exhibited: St. Louis World's Fair, 1924 (med); Orleans, France, 1925 (med); WMA, 1906 (prize); St. Louis Expo, 1904 (med); PAFA, 1906 (gold), 1943, 1944; P.-P. Expo, San Fran., 1915 (med); John Herron AI (prize); CI, 1943–45; CGA, 1943. Work: French Gov. Coll.; BM; Herron AI [47]

ULLMAN, Jane F. [Cer-S] Beverly Hills, CA. Exhibited: Los Angeles PS Exh., 1936 (prize) [44]

ULLMAN, Paul [P] b. 1906, Paris, France (of American parents) d. 25 Ag 1944 (fighting in France in WWII). He had spent most of his life in France.

ULLMARK, Andrew V. [P] Chicago, IL b. 1865, Sweden. Studied: AIC [08]

ULLRICH, Albert H. [P] Wilmette, IL b. 24 1869, Berlin. Studied: AIC, with C.E. Boutwood; F. Freer; G. Melchers; Duveneck; Rome; Munich; Paris. Member: Palette & Chisel Acad.; Galleries Assn., Chicago; Cliff Dwellers; Tavern C., Chicago; Chicago P.&S. Exhibited: Chicago AC; Cliff Dwellers; Chicago Gal. Assn.; Palette & Chisel Acad. [47]

ULLRICH, B(eatrice) (Mrs. J.D. Prendergast) [P,Li,Des] Ann Arbor, MI b. 26 Ag 1907, Evanston, IL. Studied: Northwestern Univ.; AIC, with B. Anisfeld; F. Chapin; K. Blackshear; E. Zettler. Member: Laguna Beach A. Assn.; San Fran. AA; Calif. WCS. Exhibited: Laguna Beach AA, 1938 (prize); MMA; Univ. Ariz., 1943; CI, 1941, 1943, 1944; GGE, 1939; WFNY, 1939; AIC, 1937–39; PAFA, 1938; SFMA, 1938–41; CGA, 1939; SAM, 1940; Portland A. Mus., 1939; BMA, 1939; Denver A. Mus., 1940; Albright A. Gal., 1940; Montalvo Fnd., 1940; Central Am. Traveling Exh., 1940; Riverside Mus., 1940; San Diego FA Soc., 1940; Detroit Inst.

A., 1944; Delgado Mus. A., 1940–42; SFMA, 1940 (one-man); G. Place Gal., Wash., D.C., 1944 (one-man); Oakland A. Gal., 1938; Los Angeles County Fair., Pomona, 1938, 1939. Work: Univ. Ariz. [47]

ULLRICH, E.W. [P] New Orleans, LA [15]

ULLRICH, Hattie Edsall Thorp (Mrs. Albert H.) [P] Chicago, IL b. 20 Ag 1870, Evanston, IL. Studied: AIC, with C.E. Boutwood, J.H. Vanderpoel [10]

ULM, John Louis (Dink) [I, Car] McKeesport, PA b. 18 S 1907, McKeesport. Studied: Am. Sch. A. Exhibited: WFNY, 1939 (prize); "PT" Boat insignia, U.S. Navy. Work: Huntington Lib., San Marino, Calif. Position: Staff A., Daily News, McKeesport, 10 years [47]

ULMAN, Elinor [I,P,Car] Wash., D.C./Oquossoc, ME b. 21 F 1910, Baltimore. Studied: Iowa State Col.; M. Sterne; O. Coubine. Member: Baltimore Artists U.; Am. A. Cong. Illustrator: U.S. Dept. Agriculture bulletins [47]

ULMANN, Doris [Por.Photogr,T] NYC b. 1884, NYC. Studied: Sch. Ethical Culture; Columbia; White Sch. Photogr., 1914. Work: large coll. prints and negatives, Univ. Oreg.; IMP; LOC; Univ. N.Mex.; Berea Col., Ky. Author/Illustrator: "Roll, Jordan, Roll." Internationally known portrait photographer who is best remembered for her pictorial documentation of rural life of the poor in Appalachia and the Deep South, 1920s–30s. Position: T., Columbia

ULMSCHNEIDER, Frank J. [P] Shore Wood, WI. Member: Wis. PS [27]

ULP, Clifford (McCormick) [P,I,W,L,T,Dec] Rochester, NY b. 23 Ag 1885, Olean, NY d. 22 Ja 1957. Studied: Rochester Inst. Tech.; ASL; E. Gruppe; C. Woodbury; W. Chase; F.W. Taylor. Member: Eastern AA; Rochester AC; Iroquois AA; Memorial A. Gal.; Rationalists. Exhibited: Rochester AC, 1920–37, 1938 (prize), 1939–45; Rationalists, 1938–45; Finger Lakes Exh., 1942–43; Elmira, N.Y.; Cortland, N.Y.; Auburn, N.Y.; Geneva, N.Y. Work: NGA; Rochester Dental Dispensary; St. Monica's Church, Rochester; National Gal. Author: "Models in Motion," 1931, "If Your Are Considering Applied Art," 1935; articles, Art Digest (magazine). Illustrator: Saturday Evening Post, Country Gentleman. Position: Dir., Dept. Appl. A., Rochester Inst. Tech., 1921– [47]

ULREICH, Eduard Buk ("Buk") [P,S,Des,I] NYC (San Fran., CA, 1962) b. 1889, Güns, Austria-Hungary. Studied: Kansas City AI; PAFA; Mlle. Blumberg. Exhibited: A. Dir. C., 1927 (prize), 1932 (med); Anderson Gal., N.Y. (one-man); Dudensing Gal., 1930; Phila. A. All., 1937; Bonestell Gal., 1941; Paris; Vienna. Work: wall hangings, Chicago Temple Bldg.; marble mosaic, Century of Progress Expo, Chicago; mural, Radio City Music Hall; USPOs, Tallahassee, Fla., Columbia, Mo., New Rockford, N.Dak. WPA artist. [47]

ULREICH, Nura Woodson (Mrs. Edward B.) [Li,T,I] NYC b. Kansas City, MO d. 25 O 1950. Studied: Kansas City AI; ASL; Chicago Acad. FA; J. Sloan; F.R. Gruger. Exhibited: PAFA; AIC; CGA. Work: Walker A. Center; San Diego FA Soc.; BMA; AIC. Author/Illustrator: "The Buttermilk Tree," "The Mitty Children Fix Things," "Nura's Garden of Betty and Booth"; other children's books [47]

ULRICH, Charles Frederic [P] NYC b. 18 O 1858, NYC d. 15 My 1908, Berlin. Studied: NAD; Loefftz, Lindenschmidt, both in Munich, early 1880s. Member: ANA, 1883; SC, 1884; Pastelists; SAA. Exhibited: NAD (first recipient of the Clarke prize [1884] for "The Land of Promise"); Am. A. Assn., N.Y., 1886 (prize); Paris Expo, 1889 (prize); Columbian Expo, Chicago, 1893 (med). Work: MET; Nat. Gal.; Corcoran [08]

ULRICH, Edward [P] Phila., PA [15]

ULRICH, Fred J. [P] Irvington, NJ. Exhibited: AWCS, 1898 [01]

ULRICH, Louis W. [P] Irvington, NJ. Exhibited: NAD, 1898; AWCS, 1898; ACP, 1898 [01]

ULRICH, Vic [P] Chicago, IL b. Chicago. Studied: AIC; Munich. Exhibited: AIC, 1898 [01]

UMBSTAETTER, Nelly Littlehale [P] Boston, MA [17]

UMLAUF, Charles [S] Austin, TX b. 17 Jy 1911, South Haven, MI. Studied: Chicago Sch. S.; AIC. Exhibited: San Fran., 1941 (prize); IBM, 1941 (prize); Tex. General Exh., 1941, 1942, 1943 (prize), 1944, 1945, 1946 (prize); AIC, 1937 (prize), 1938 (prize), 1941, 1942, 1944; WFNY, 1939; AV, 1942; WMAA, 1946; CGA, 1945; Denver; Los Angeles; San Fran. Work: Cook County Hospital, Chicago; Witte Mem. Mus.; Lane Tech. H.S., Chicago; USPOs, Morton, Ill.; Paulding, Ohio. WPA artist. [47]

UNDERHILL, Ada [P] Glen Ridge, NJ [24]

UNDERHILL, Georgia E. [P] Brooklyn, NY. Exhibited: NAD, 1898 [01]

UNDERHILL, Katharine [S] NYC/South Ashfield, MA b. 3 Mr 1892, NYC. Studied: E. Norton [17]

UNDERWOOD, Addie [P] Lawrence, KS [17]

UNDERWOOD, Clarence F(rederick) [I,P] NYC b. 1871, Jamestown, NY d. 11 Je 1929. Studied: ASL; Académie Julian, Paris, with Constant, Laurens, Bouguereau. Member: SI, 1910. Position: Staff, New York Press [27]

UNDERWOOD, Elisabeth Kendall [S,P] South Salem, NY b. 22 S 1896, Gerrish Island, ME d. 1976. Studied: Yale. Exhibited: AWCS; NAD; New Haven PCC [47]

UNDERWOOD, Ethel B. [Min. P] NYC [08]

UNDERWOOD, (George) (Claude) Leon [P,S,I,E,W,L] London, England b. 25 D 1890, London. Exhibited: CI, 1923 (prize). Work: Manchester A. Gal., England; The Whitworth A. Gal., Manchester; British Mus., London; Victoria and Albert Mus., London. Illustrator: "The Music from Behind the Moon," by James Branch Cabell, pub. John Day Co.; wood engravings and verses for "Animalia" [25]

UNDERWOOD, Mary Stanton [Por.P] Wausau, WI b. Glens Falls, NY. Studied: AIC; Chase, DuMond, both in N.Y. [08]

UNDERWOOD-FITCH, Alice (Mrs.) [Min.P] Paris, France [10]

UNITT, Edward G. [Scenic P] NYC. Member: Artists Aid Soc. [27]

UNSWORTH, Edna Ganzhorn [P,T] Long Beach, CA b. 26 My 1890, Baltimore. Studied: Md. Inst.; PAFA; C. Beaux. Member: Long Beach AA; Laguna Beach AA; Calif. AC. Exhibited: Ariz. State Fair, 1929 (prize); Calif. Artists' Exh., Pasadena, 1930 (prize) [33]

UNVER, George [Por.P] Kansas City, MO. Exhibited: Kansas City AI, 1923 (med) [31]

UPDEGRAFF, Sallie Bell [C,P] Wash., D.C. b. 15 Ap 1864, Belmont County, OH. Studied: John Herron AI Sch. Exhibited: Ind. State Fair, 1921 (prize); Fed. WC Exh., Wash., 1934 (prize). Work: "Ceramic Studio" [40]

UPDIKE, Daniel Berkeley [Typogr] Boston b. 1860 d. 28 D 1941. Member: AIGA (hon.) Exhibited: AIGA (gold). Position: Hd., Merrymount Press (which he founded in 1893)

UPHAM, B.C. [I] NYC. Affiliated with Cooper Union A. Sch., N.Y. [98]

UPHAM, W.H. [I] Boston, MA. Position: Illus., National Magazine, Boston [98]

UPJOHN, Anna Milo [P] New Milford, CT b. Dover NJ. Studied: Casteluccio, in Paris. Member: NAWPS. Exhibited: NAWPS, 1938, 1936, 1937, 1938; Studio Gld., N.Y. (one-man) [40]

UPJOHN, Everard Miller [T,W,L] NYC b. 6 N 1903, Scranton, PA. Studied: Harvard. Member: Athenaeum, N.Y. Author: "Richard Upjohn, Architect and Churchman," 1939. Positions: T., Univ. Minn. (1929–35), Columbia (1935–) [47]

UPJOHN, Millie [Caric] NYC [08]

UNTHANK, Alice Gertrude [P,C,T,L,W,G] Superior, WI b. Economy, IN. Studied: Earlham Col.; Univ. Nebr.; Univ. Chicago; P. de Lemos; J.E. Bundy; M. Walter; C.C. Rosencrantz; K. Heldner; O. Frieze; E. Scott, in Paris. Member: CAA; Western AA; Nat. Edu. Assn.; Superior AA; Superior A. Center; Hoosier Salon; Arrowhead AA; AAPL; AFA. Exhibited: Arrowhead Exh., Duluth, Minn., 1928 (prize); Am. Lib. Color Slides, 1940 (prize); West Duluth, Minn., 1929 (prize); Hoosier Salon; Ind. Traveling Exh., 1929–30; Nat. A. Week, Superior, 1940, 1941; Douglas County Hist. Mus., Superior, 1945 (one-man). Work: Carroll Col., Waukesha, Wis. Contributor: School Arts, Design. Positions: T., Superior State T. Col., 1923–; Nat. Edu. Assn., A. Edu. Comm. Col. A. Faculties, 1940–42 [47]

UPSHUR, Martha R(obinson) (Mrs. Francis W.) [P] Richmond, VA b. 15 O 1885, Richmond, VA. Studied: T. Pollak. Member: NAWPS; Richmond Acad. Exhibited: Richmond Acad., 1937 (prize). Work: William and Mary Col., Richmond Div., Va.; Med. Col. Va., Richmond [40]

UPTEGROVE, Sister M. Irena [P,I,L,T] St. Joseph, MN b. 13 F 1898, Melrose, MN. Studied: Univ. Minn.; Col. St. Benedict; Univ. Mich.; Minneapolis Inst. A.; AIC. Member: CAA; Western AA; Catholic AA. Exhibited: Catholic AA; Univ. Minn. Work: Col. of St. Benedict, St.

Joseph. Illustrator: "The Man Who Made the Secret Doors," 1946; other books. Position: T., Col. St. Benedict, St. Joseph [47]

UPTON, Ethelwyn [P] NYC d. Spring, 1921. Member: NAWPS [19]

UPTON, Florence K. [P,I] London, England b. NYC d. 16 O 1922. Studied: his father at NAD; K. Cox; R. Collin, in Paris; G. Hitchcock, in Holland. Member: Soc. Nat. des Beaux-Arts, Paris. Exhibited: Intl. Expo, Nantes, 1905 (med). Illustrator/Creator: "Golliwogg" series of children's books [21]

URBACH, Amelia [P] San Antonio, TX b. Norfolk, VA. Member: Tex. FA Assn. Exhibited: AIC, 1940; Tex. Panorama (AFA), 1943; Tex. General Exh., 1940-46; Tex. FA Assn., 1943-46; All. A. Dallas, 1937-40; San Antonio, 1942-46. Work: Dallas Mus. FA [47]

URBAN, Joseph [Scenic Des,I,Arch] NYC b. 26 My 1872, Vienna (came to U.S. in 1911) d. 10 Jy 1933. Studied: Imperial and Royal Acad. FA, Vienna; Polytechnicum, Vienna; Baron Carl Hasenauer. Awards: Kaiser Prize, for illustration of Edgar Allan Poe's "The Mask of the Red Death," 1897; Austrian State Grand medal (for other illustrations); St. Louis Expo, 1901 (gold), designed the Austrian pavilions; Architectural League, N.Y., 1933 (gold), stage settings for religious pageant. Work: Boston Opera House (Dir.), 1911; Ziegfeld productions, N.Y.; designed interior of municipal bldg., Vienna; Czar Bridge, Leningrad; Palace of Khedive, Egypt; Schloss of Count Carl Esterhazy near Pressburg Hungary; des. many bldg. in U.S.; color treatment for entire Century of Progress Expo, Chicago. His mastery of materials, forms and colors made him internationally recognized as the greatest scenic designer.

URBAN, Robert [T,P] Cambridge, MA b. 1915 d. 6 Mr 1947. Studied: Princeton. Position: T., Harvard

URIBE, G(ustavo) Arcila [P,S] Chicago, IL b. 2 Mr 1895, Bogota, Columbia. Studied: S. Cuellar; F.A. Cano; E. Zerda; D. Cortes. Member: Nat. Cir. Bellas Artes, Bogotá. Exhibited: AIC, 1922 (prize) [25]

URICH, Louis J. [P,Des,S,T] Elmhurst, NY b. 4 Jy 1879, Paterson, NJ. Studied: ASL; CUASch; BAID. Exhibited: NAD, 1914 (prize). Position: T., NYC H.S. [40]

URNER, Joseph (Walker) [S,P,E] Frederick, MD b. 16 Ja 1898, Frederick. Studied: Baltimore Polytechnic Inst.; Md. Inst.; E. Cadorin; D. Williams. Member: SSAL. Exhibited: Cumberland Valley A., annually, 1939 (prize). Work: Ala. Mon., Gettysburg, Pa.; Taney Mon., Frederick, Md.; Cedar Lawn Mem.; presentation portrait, Gen. A.A. Vandergrift, USMC [47]

URSULESCU, Michael Marius [P,Li,C,T] Evanston, IL b. 17 S 1913, Echka, Yugoslavia. Studied: AIC. Exhibited: AIC, 1938-40, 1941 (prize), 1942, 1943 (prize), 1944-46; Detroit Inst. A., 1942 (prize); VMFA, 1944; Pepsi-Cola, 1946; Detroit Inst. A., 1937-39, 1942, 1944, 1945. Award: Chicago, 1935 (traveling scholarship). Work: Detroit Inst. A. [47]

USHER, Leila [S,P] NYC b. 26 Ag 1859, Onalaska, WI d. 30 Jy 1955 (age 95). Studied: G.T. Brewster, in Cambridge; ASL, with A. Saint-Gaudens; H.H. Kitson, in Boston; Paris. Member: AAPL; AFA. Exhibited: Atlanta Expo, 1895 (prize); P.-P. Expo, 1915 (prize). Work: Harvard; Johns Hopkins Univ.; Bryn Mawr Col.; Rochester Univ.; Bowdoin Col.; Tuskegee & Hampton Univ.; Royal Danish Mint & Metal Coll.; FMA; Nat. Mus., Wash., D.C.; Smithsonian; Arlington Nat. Cemetery; Grand Canyon; Agassiz Mus., Cambridge [47]

USHER, Ruby W(alker) [Min.P,P,E,I] Hollywood, CA b. 20 Ap 1889, Fairmont, NE d. 1957. Studied: Chicago Acad. A.; CI; Am. Sch. Min. P.; Grand Central Sch. A. Member: Women P. of the West; Calif. AC; ASMP; AAPL; Calif. Soc. Min. P.; Soc. for Sanity in Art. Exhibited: Calif. State Fair, 1937-41 (prizes); Women P. of the West, 1940 (prize), 1942 (prize), 1944 (prize), 1946 (prize); Los Angeles Mus. A., 1940 (med), 1943 (prize); Calif. Soc. Min. P., 1938 (prize), 1944 (prize); Palace Legion Honor, 1944 (prize); SFMA, 1945 (prize); N.J. Pr. Exh., 1933 (prize); Ebell C., Los Angeles; PAFA; Oakland A. Gal. Work: PAFA [47]

USRY, Katherine Bartlett (Mrs.) [P,G,T] Columbus, OH Studied: AIC; Columbia; Berkshire Summer Sch.; N.Y. Sch. F.&Appl. Des. for Women; Ohio State Univ.; H.B. Snell; Venice. Member: Ohio WCS; Cincinnati AC; NAWPS; Columbus A. Lg. Exhibited: Ohio State Univ., 1939 (one-man); NAWPS, 1937, 1938. Position: Art Dir., South H.S., Columbus [40]

USUI, Bumpei [P] NYC. Exhibited: Ann. AIC, 1938; Ann. PAFA, 1938; Fed. A. Proj., Wash., D.C., 1938 [40]

UTPATEL, Frank Albert Bernhardt [P,I,B] Mazomanie, WI b. 4 Mr 1905, Waukegan, IL. Studied: Milwaukee AI; AIC; J.S. Curry; Layton Sch. A., Milwaukee. Member: Soc. Am. Pr. M.; Soc. Wis. P., Pr. M. Exhibited: Milwaukee AI, 1939 (prize), 1940 (prize); SAM, 1941 (prize), 1942; Wis. State Fair, 1940 (prize), 1941 (prize); Wis. Salon, 1940 (prize); Madison A. Exh., 1940 (prize), 1941 (prize); CMA, 1935; Am. A. Gal., 1939; AIC, 1940; Layton A. Gal., 1940 (one-man); Meuer's A. Gal., 1940; Wis. Mem. Un., 1938-41; CAFA, 1941; PAFA, 1941, 1945; WMAA, 1942, 1943; LOC, 1944, 1946; CI, 1944; Laguna Beach AA, 1944. Work: Milwaukee AI; Univ. Wis. Illustrator: "Village Day," 1946, "Lives Around Us," 1942; other books. Contributor: wood engravings, American Mercury, Tomorrow, Outdoors [47]

Symbol of the No-Jury Society of Artists

VAGANOV, Benjamin G. [P,C,W,L,T] San Diego, CA b. 8 O 1896, Archangel, Russia. Studied: Russia. Member: San Diego A. Ctr.; Escondido AS; AAPL. Exhibited: GGE, 1939; Am. Veterans SA, 1944, 1945; San Fran. AA, 1943; Oakland A. Gal., 1944, 1945; Southern Calif. A. Exh., 1940; San Diego FAS, 1940–42 (prizes). Work: San Diego FAS; Carnegie Lib., Escondido, Calif.; mural, House of Pacific Relations, San Diego; dioramas, San Diego County Visual Edu. [47]

VAGIS, Polygnotos George [S] Hicksville, NY b. 14 Ja 1894, Thasos, Greece d. 14 Ap 1965. Studied: BAID; self-taught. Member: Fed. Mod. PS; Sculpture G.; Am. Ar. Cong. Exhibited: Chicago World's Fair, 1934; Nat. Exh. Am. A., N.Y., 1934; CGA, 1934, 1937; Mus. Mod. A. Gal., Wash., D.C., 1938; WFNY, 1939; CI, 1940; BMFA, 1944; Wadsworth Atheneum, 1945; P.&S. Gal., 1932 (one-man); BM, 1933; Sculpture G., 1938–42; Buchholz Gal., 1945; Wildenstein Gal., 1945; Kraushaar Gal., 1933 (one-man); Valentine Gal., 1938 (one-man); Hugo A. Gal., 1946. Work: BM; WMAA; ASL; TMA. Contributor: articles/illus., Trend, Review Du Vrai et Du Beau, Creative Art, L'Illustration [47]

VAGO, Sandor [P,T,L] Cleveland Heights, OH b. 8 Ag 1887, Hungary. Studied: Royal Acad., Budapest; Royal Acad., Munich. Member: Nat. Salon, Budapest (founder); Royal AA, Budapest (founder); Royal Acad., Budapest (founder); Cleveland SA; AAPL. Exhibited: CMA, 1924–26 (prizes); CGA; PAFA; Newark Mus., 1926 (prize); Albright A. Gal.; Budapest, 1913 (prize); Rochester Mem. A. Gal.; All.A.Am.; Cleveland AG (prize). Work: Bluffton Col.; Univ. Dayton; Fed. Circuit Court, Cincinnati; City Hall, Pub. Lib., stores, all in Cleveland; Cleveland Plain Dealer; Cleveland Hermit C.; Cleveland Mid-Day C.; CMA; Nat. Salon, Budapest; Case Sch. Applied Sc., Cleveland [47]

VAIKSNORAS, Anthony, Jr. [P,Des,I] Cleveland, OH b. 5 S 1918, Du Bois, PA. Studied: Cleveland Sch. A. Member: Cleveland SA. Exhibited: CI, 1941; VMFA, 1946; CMA, 1946 (prize); Butler AI; Norfolk Mus. A. & Sc.; Milwaukee AI, 1946; Eldorado Pencil Comp., 1939 (prize); Strathmore Comp., 1939 (prize). Work: CMA. Illustrator: "Art in the Armed Forces," "To All Hands an Amphibious Adventure," 1943 [47]

VAIL, Eugene Lawrence [P] Paris, France b. 29 S 1857, Saint-Servan, France (of American father) d. 28 D 1934. Studied: ASL, with Beckwith, Chase; Ecole des Beaux-Arts, Paris, with Cabanel, Dagnan-Bouvert, Collin. Member: Soc. Nat. des Beaux-Arts; Paris SAP; Société de Peintres et Sculpteurs; Providence AC; Leg. of Honor, 1894. Exhibited: Paris Salon, 1886 (prize), 1888 (med); Paris Expo, 1889 (gold); Berlin (prize); Munich (med); Antwerp (med); St. Louis Expo, 1904 (med); Liège Expo, 1905 (med). Work: CGA; RISD; Luxembourg Mus.; several European mus. [25]

VAIL, Robert D. [P] Columbus, OH. Member: Columbus PPC [25]

VAIL, Robert William Glenrole [Mus.Dir,W] NYC b. 26 Mr 1890, Victor, NY. Studied: Cornell; Lib. Sch. NYPL; Columbia; Univ. Minn. Author: many monographs. Positions: Ed., Sabin's Dictionary of Books on America; Librarian, N.Y. State Lib., 1940–44; Dir., N.Y. Hist. S., from 1944 [47]

VAILLANT, Louis D(avid) [Mur.P] NYC/Wash., CT b. 14 D 1875, Cleveland, OH d. 7 F 1944. Studied: Mowbray, ASL. Member: Arch. L., 1902; Mural P. Exhibited: NAD, 1910 (prize). Work: stained glass windows, Meeting House, Ethical Culture Sch., NYC; First Nat. Bank, Titusville, Pa. [40]

VALENCIA, Manuel [P] b. 1856, California d. 6 Jy 1935, Sacramento, CA. Work: Bohemian C; Huntington A. Gal., San Marino, Calif. Active mostly in San Fran.

VALENKAMPH, Theodore Victor Carl [Mar.P] Gloucester (since 1899) b. 1868, Stockholm, Sweden d. Mr 1924, Gloucester, MA. Member: Boston AC [10]

VALENTA, Yaroslav Henry [P,G] Brooklyn, NY b. 23 My 1899, Czechoslovakia. Studied: Portland (Oreg.) AM Sch. Member: Am. Ar. Cong.; United Am. Ar. Exhibited: Fed. A. Gal., NYC; Am. Ar. Cong. WPA artist. [40]

VALENTE, Alfred [P] Chicago, IL. Member: Chicago NJSA [25]

VALENTEE, Edward N. [P] Baltimore, MD Member: Baltimore WCC [25]

VALENTI, Angelo [P,Des,Dec,I] NYC b. Massarosa, Tuscany, Italy. Studied: self-taught. Member: AIGA. Work: illus./woodcuts, "Leaves of Grass," by Walt Whitman, pub. Grabhorn Press; 35 other books; hand illuminations, Golden Cross Press, Bronxville, N.Y. [40]

VALENTI, Paul [E,W,L,T] St. Louis, MO b. 16 Ja 1887, NYC. Studied: C. Boito; L. Beltrami; G. Moretti. Member: AIA; St. Louis AG. Exhibited: Intl. Comp. for Des. of Royal Palace, Sofia, Bulgaria, 1913 (prize) [27]

VALENTIEN, Albert R. [P,Cer] San Diego, CA (since 1908) b. 11 My 1862, Cincinnati, OH d. 5 Ag 1925. Studied: Cincinnati A. Acad., with Nobel, Duveneck. Member: Cincinnati AC; San Diego AG; Jury of Awards, Pan-Calif. Expo, San Diego, 1916. Exhibited: Cincinnati Expo, 1898; SWA; Omaha Expo, 1898. Work: 50 paintings of wild flowers (made 1908–18) in State Lib., Calif., Sacramento. Position: Staff, Wheatley Potters, Cincinnati; Rookwood Potteries, 1881–1905 (after which he began painting wild-flowers) [24]

VALENTIEN, Anna Marie (Mrs. A.R.) [P,S,T] San Diego, CA (since 1908) b. 27 F 1862, Cincinnati, OH d. 25 Ag 1947. Studied: Cincinnati AA, with Rebisso, 1893–97; Paris, with Rodin, Injalbert, Bourdelle, 1899–00. Member: AGFAS, San Diego; La Jolla AA. Exhibited: Atlanta Expo, 1895 (gold); Pan-Calif. Expo, San Diego, 1915 (gold), 1916 (golds); Sacramento State Fair, 1919 (prize); Acad. FA, San Diego, 1931 (med). Positions: Staff, Rookwood Potteries, Cincinnati, 1884–1905; T., San Diego Normal Sch. (1914–16), H.S. (1917–38) [47]

VALENTINE, Edward Virginius [S] Richmond, VA b. 12 N 1838, Richmond d. 19 O 1930. Studied: W.J. Hubbard, 1850s; Paris, with Jouffroy, Couture, 1859–60; Rome, 1861; Bonanti, in Italy; A. Kiss, in Berlin, 1861–65. Work: statues, Mem. Chapel, Lexington, Va.; Richmond; Fredericksburgh, Va.; New Orleans; U.S. Capitol, Wash., D.C. While in Berlin he received four photographs of Gen. Robert E. Lee, from which he modeled a statuette which was sold in Liverpool for the benefit of the Southern cause. In 1865 he opened a studio in Richmond. His most famous work is the recumbent statue of General Lee in the Lee Mem. Chapel at Lexington, Va., although some critics have pronounced his "Andromache and Astyanax" in the Valentine Mus., at Richmond, his masterpiece. Some of his most characteristic works were studies of negro life made just after the Civil War and sold in Northern cities. Position: Pres. Valentine Mus., Richmond, Va. [29]

VALENTINE, D'Alton [I,E,T] NYC b. 6 Je 1889, Cleveland d. 13 Ja 1936. Studied: Ufer; J.W. Reynolds. Member: SI; AG; Players; SC; Dutch Treat C. [31]

VALENTINE, Deane (Mrs.) [P] Minneapolis, MN [24]

VALENTINE, Francis Barker [P,Des,I,T] Hamburg, NY b. 20 S 1897, Buffalo, NY. Studied: Albright A. Sch.; Yale; PAFA; D. Garber. S. Kendall. Member: The Patteran; Buffalo SA; Commercial AG, Buffalo. Exhibited: Riverside Mus.; Albright A. Gal., annually, 1945 (prize); Great Lakes Traveling Exh. Work: IBM office, YMCA, both in Buffalo. Positions: Illus./layouts, Dunlop Tire & Rubber Co.; T., Albright A. Sch., Buffalo, N.Y., from 1932 [47]

VALENTINE, Jane H. [P] Phila., PA b. Ag 1866, Bellefonte, PA. Studied: W.M. Chase; C. Beaux. Member: Phila. Alliance; Phila. Print C. Work: Albright A. Gal., Buffalo [38]

VALENTINE, Josephine [P] St. Louis, MO [25]

VALENTINE, Marion Kissinger (Mrs. Hans G.) [Mur.P,C,Des,T] Milwaukee, WI b. 14 F 1901, Milwaukee. Studied: Layton Sch. A. Member: Wis. S. Appl. A. (Pres.); Wis. PS. Exhibited: Milwaukee AI, 1930–35 (prizes). Position: T., Layton Sch. Art [40]

VALENTINE, Robert [P,I] Bellefonte, PA b. 23 Ja 1879, Bellefonte. Studied: Anshutz; Carlson; Hale; Wear; Vonna [31]

VALENTINER, W(illiam) R(einhold) [Mus.Dir-Consultant,W] Los Angeles, CA b. 2 My 1880, Karlsruhe, Germany d. 6 S 1958. Studied: Univ. Leipzig; Univ. Heidelberg. Author: "Rembrandt und seine Umgebung," 1905, "The Art of the Low Countries," 1914, "Frans Hals," 1923, "Pieter de Hooch," 1930, "Origins of Modern Sculpture," 1945, other books. Co-author: "Catalogue Raisonné of the Works of the Most Important Dutch Painters of the 17th Century," Vol. I. Positions: Ed., "Art in America" (1913–31), Art Quarterly (1938–45); Dir./Consultant, Los Angeles Mus. A.[47]

VALERIO, Silvio B. [P,C] NYC b. 17 Jy 1897, Boston. Studied: ASL; Grand Central Sch. A., with A. Woelfle; H. Nichols. Member: SC; Allied Ar. Am.; Ar. Fellowship. Exhibited: SC, 1935 (prize); Allied AA (prize). Work: Vanderpoel AA, Chicago [40]

VALK, Ella Snowden [Min.P] NYC. Member: NAWPS [27]

VALLE, Maude Richmond Fiorentino [P,I,W,T] Denver, CO. Studied: ASL, with Cox, Chase, Brush, Beckwith; Académie Julian, with Lefebvre, Constant, Beaury-Sorel; Acad. Delecluse, with Delance, Callot. Member: Denver AG [40]

VALLINDER, W. [P] Minneapolis, MN [24]

VAN AALTEN, Jacques [P,T,L] Detroit, MI b. 12 Ap 1907, Antwerp, Belgium. Studied: NAD; ASL. Member: NSMP. Exhibited: NAD; WMAA; BAID; Arch. L.; S.Indp.A.; Detroit IA; Suydam med., NYC, 1930. Work: Textile H.S., NYC; numerous portraits [47]

VANACORE, Frank [P,G] Phila., PA b. 27 O 1907, Phila. Studied: Barnes Fnd., Merion, Pa. Exhibited: Ann., PAFA, 1938; Pr. C., Phila.; Butler AI, Youngstown, Ohio [40]

VAN ALLEN, Gertrude Enders [P,C,T] Port Washington, NY b. 15 O 1897, Brooklyn, NY. Studied: CUASch; PIASch; NYU; G.L. Nelson; R. Pearson; A. Fisher; L. Skidmore; W. Taylor; H. Reiss. Member: NAWA; Nassau AL [47]

VAN ALSTINE, Mary J. (Mrs. Leslie H.) [P,T] Whittier, CA b. 1878, Chicago. Studied: Boothbay Harbor Col.; Otis AI; Brackman; Wood; Cross. Member: Iowa AC. Exhibited: Iowa A. Salon, 1934; Iowa AC, 1935; Joslyn Mem.; Iowa A. Exh., Mt. Vernon, 1938 [47]

VAN ARSDALE, Arthur [P] Edmond, OK. Member: Okla. AA [27]

VAN ARSDALE, Ruth [I] NYC [19]

VAN ASDALE, Walter [I] NYC [19]

VAN BENSCHOTEN, Clare D. [P,G] NYC. Member: AWCS; NAWA. Exhibited: AWCS, 1934, 1936, 1938; NAWA, 1935–38 [47]

VAN BENTHUYSEN, Will [I] NYC b. 1883, Leavenworth, KS d. 8 Mr 1929. Work: series of illustrated stories on animals at the Bronx Zoo, in New York World. Specialty: wild animal life. Position: Staff, New York World, 26 yrs.

VAN BLARCOM, Mary (Mrs. Milbauer) [P,Ser,C] Point Pleasant Beach, NJ b. 25 Ap 1913, Newark, NJ. Studied: Wellesley Col. Member: Nat. Serigraph S.; NAWA; Artists of Today; Am. Color Pr. S.; Assoc. A. N.J. (Dir.). Exhibited: Elisabet Ney Mus., 1943; Independents, 1942–44; Laguna Beach AA, 1945, 1946; NAWA, 1945, 1946 (prize); Montclair A. Mus., 1941–45; Northwest PM, 1944, 1946; Mint Mus. A., 1946; LOC, 1946; Artists of Today, 1942–46. Work: Newark Pub. Lib.; U.S. Govt.; AA Univ. Women; State of New York [47]

VAN BLITZ, Samuel E. [S,Arch] Paterson, NJ b. 1865, Utrecht, Holland d. 1 Je 1934. Had lived in France, England, and Palestine. Position: repair and restoring art objects, MET

VAN BOSKERCK, Robert Ward [Ldscp.P] NYC b. 15 Ja 1855, Hoboken, NJ d. 24 Ap 1932. Studied: R.S. Gifford; A.H. Wyant. Member: ANA, 1897; NA, 1907; SAA, 1887. Exhibited: Pan-Am. Expo, Buffalo, 1901; St. Louis Expo, 1904 (med); NAD, 1880; AWCS, 1898; CI, 1898; SL, 1898. Work: Union Lg., Lotos C., Fencers' C., both in NYC; Layton A. Gal., Milwaukee; Hamilton C., Brooklyn; Mappin A. Gal., England [31]

VAN BRIGGLE, Anne. See Ritter.

VAN BRIGGLE, Artus [P,C] Colorado Springs, CO d. 4 Jy 1904. Studied: Frank Duveneck; Paris, with Benjamin-Constant, Laurens. Member: Cincinnati AC; Assoc. Soc. Western A. Exhibited: St. Louis Expo, 1904 (med); Paris Salon, 1903; Cincinnati Expo, 1898. Positions: Staff, Rockwood Pottery, Cincinnati; moved to Colo. and established Van Briggle Pottery [04]

VAN BRUNT, Jessie [Des,C] Brooklyn, NY b. 1863 d. 28 F 1947. Studied: J. La Farge. Work: gave stained glass windows to churches throughout the world. Specialty: des. stained glass windows. Positions: A. Dir., Packer Collegiate Inst.; active in N.Y. Sch. Appl. Des.

VAN BUREN, A.A. [P] Member: Louisville AL. Position: Staff, D.H. Baldwin & Co., Louisville, Ky. [01]

VAN BUREN, Raeburn [I,Cart,L] Great Neck, NY b. 12 Ja 1891, Pueblo, CO. Studied: ASL. Member: Cart. S.; SI; A.&W. S. Exhibited: SI. Illustrator: "Stag at Eve," "Star of the North"; Saturday Evening Post, New Yorker, Life, Esquire [47]

VAN BUREN, Stanbery [P] Columbus, OH b. Zanesville, OH. Studied: Lahaye, in Paris; Twachtman, in NYC [17]

VAN BUSKIRK, Karl [Por.P] b. 1887, Cincinnati, OH d. 3 Ja 1930, NYC. Studied: Duveneck, in Cincinnati. Work: Treasury Bldg., Wash., D.C. Position: Staff A., New York newspaper, Mexican border, 1916 [13]

VANCE, Fred Nelson [Ldscp.P,Mur.P] Indianapolis, IN b. 1880, Crawfordsville, IN d. 21 S 1926. Studied: Smith Acad., Chicago; Laurens, Gèrôme, Max Bohm, Académie Julian, Colarossi Acad., Vitti Acad., all in Paris; E. Vedder, in Rome. Member: Brown County A. Gal. Assn.; Hoosier Salon; Indianapolis Circle Français (Pres.); Paris AAA; Ind. AC [25]

VANCE, Mae H. [P,Des,I,C] Wash., D.C. b. Ohio. Studied: Cleveland Sch. A.; Corcoran Sch. A. Member: Lg. Am. Pen Women. Exhibited: Indp. A., Wash., D.C.; Lg. Am. Pen Women. Illustrator: birthplaces of U.S. presidents [47]

VAN CLEEF, Augustus D. [P,E,Cr,W] NYC. b. 1851, Millstone, NJ d. 14 F 1918. Exhibited: NAD, 1877–82. Had studio in same bldg. with S. Colman and J. & G. Smillie, 1880s. For several years he was art critic for the New York Herald; for about 3 years he was asst. editor of American Art News. At one time he was librarian for Knoedler & Co.

VAN CLEVE, Helen Mann (Mrs. Eric) [P,S,W,Des] Pacific Palisades, CA b. 5 Je 1891, Milwaukee. Studied: Univ. Calif.; BMFA Sch.; Grande Chaumière, Paris; B. Pratt; E. Withrow; C. Boon; AIC. Member: S. for Sanity in Art. Exhibited: Santa Barbara Mus. A., 1940, 1944, 1945; Pal. Leg. Honor, 1940–45; Laguna Beach AA, 1944; San Diego FAS, 1932; Montclair AM, 1934; Kennebunk Village, 1934; Gumps, San Fran.; Rockefeller Ctr., NYC, 1934. Work: Pal. Leg. Honor; San Diego Pub. Lib. Author/Illustrator: children's books [47]

VAN CLEVE, Kate [C,T,W,L] Brookline, MA b. 24 Mr 1881, Chicago. Studied: Mich. Normal Cl.; PIASch. Member: Boston Weavers G. (Dir.); Textile Weavers G.; Boston SAC. Author: "Handloom Weaving for Amateurs," 1937. Co-author: "Garden Studio Notebook of Handloom Weaving," 1932, "The Weaver's Quarterly," 1932–43. Positions: T., Garden Studio (Brookline), Boston Sch. Occupational Therapy [47]

VAN CORTLANDT, Katherine Gibson (Mrs. Augustus) [Por.P,S] Mt. Kisco, NY/Brandon, VT b. 14 N 1895, NYC. Studied: H.V. Poor; J. Lie; V. Chernoff. Member: NAWPS; MOMA. Work: dec., ballroom, Porcupine Club, Nassau, B.W.I.; Wood Art Gal., Montpelier, Vt.; Brookgreen Gardens., S.C. [40]

VAN COTT, Dewey [P,T] Mt. Vernon, NY b. 12 My 1898, Salt Lake City, UT d. 21 S 1932. Studied: AIC; Chicago Acad. FA; Yale; Académie Julian, Paris. Exhibited: Beaux-Arts Inst. (meds). Positions: Dir., Springfield AI; A. Dir., New Britain (Conn.) Schs., 1924; Dir., Mt. Vernon, from 1930

VAN COTT, Fern H. (Mrs. Dewey) [P,C] Salt Lake City, UT b. 6 F 1899. Studied: D. Van Cott. Member: Springfield P. Work: Springfield AI [33]

VAN COTT, Herman [P,Dec] NYC b. 4 Mr 1901, Albany, NY. Studied: Chicago Acad. FA; AIC; Yale. Member: Arch. L; Nat. S. Mur. P.; Mural P. Gld. Exhibited: NYWCC, 1938; murals, Operations Bldg., Court of States, WFNY, 1939 [40]

VAN COURT, Franklin (F. Van Court Brown) [P] Chicago, IL b. 26 Ag 1903 Chicago. Studied: AIC; NAD; C.W. Hawthorne; F.M. Grant; R. Henri; A. Angarola. Member: Chicago SA. Exhibited: Union L., Chicago, 1929 (prize); Chicago SA, 1931 (med) [49]

VAN DELFT, John H. [Por.P] Brooklyn, NY d. 28 My 1913

VAN DEN BERGHEN, Albert Louis [S] b. 8 S 1850, Vilvorde, Belgium (of Am. descent; came to U.S. in 1876). Studied: Brussels; NYC; Chicago [08]

VAN DEN HENGEL, Walter [P] Phila., PA [25]

VANDERCOOK, Margaret Metzger (Mrs. John W.) [S] NYC b. 7 Ap 1899, NYC d. 5 Ap 1936, Kingston, Ontario. Studied: Wellesley Col.; G. Lober, in NYC; A. Rousaud, in Paris. Member: NAWPS. With her husband she traveled widely through the jungles of Africa, South America and remote South Sea Islands, making portraits of the natives. [33]

VAN DEREK, Anton [P,Des,C,T] Provincetown, MA b. 9 Ja 1902, Chicago, IL. Member: Provincetown AA; Eastern AA; Beachcombers C. Specialty: metal work. Position: Dir., Child-Walker Sch. Des. [40]

VANDERHOOF, Charles A. [P,E,I,T,W] NYC d. 8 Ap 1918, Locust Point, NJ. Illustrator: Harper's, 1881. Position: T., CUASch, late 1880s [10]

VANDERHOOF, Elizabeth [P] NYC [10]

VAN DERLIP, John Russell [Patron] Minneapolis, MN d. 23 Mr 1935. Member: Minneapolis AI (founder/Pres.); AFA (Dir.) The growth of Minneapolis AI had been attributed largely to his efforts and generosity.

VANDER MARK, Parthenia [Des,T] Woodbury, NJ b. Phila. Studied: Columbia. Member: A. Group, Nat. Ed. Assn. Work: series block prints, Gloucester County (N.J.) historic points, 1932. Position: T., State T. Col., N.J. [40]

VAN DER PAAS, Emilie [P,S,Des,Dec] NYC/Bermuda b. 18 My 1906, City Island, NY. Studied: F. MacMonnies; P. Manship; Florence; Paris. Work: paintings of tropical marine life for William Beebe, Bermuda Biological Station, 1932; paintings, Bermuda shore fishes for L. Mowbray, Curator, Bermuda Gov. Aquarium; paintings of marine life, Yale; Princeton Univ.; Miami Univ., Ohio; fish paintings, Bank of Bermuda, Hamilton; black and white drawings, S. Beaux Arts Arch., N.Y. [40]

VANDERPOEL, Emily Noyes (Mrs. John A.) [Weaving,P,W] NYC/Litchfield, CT b. NYC. Studied: R.S. Gifford; W. Sartain. Member: NYWCC; N.Y. Soc. Craftsmen; AWCS; AFA; Women's AC. Exhibited: Columbian Expo, Chicago 1893 (med). Work: Nat. Mus., Wash., D.C. Author: "Color Problems," "Chronicles of a Pioneer School," "More Chronicles of a Pioneer School," "American Lace and Lace Makers" [38]

VANDERPOEL, John H. [P,T,Mur.P] Chicago, IL b. 15 N 1857, Haarlemmer-Meer, Holland (came to U.S. in 1868) d. 2 My 1911, St. Louis. Studied: Turner Hall; old Chicago Acad. Des.; AIC, with J.F. Gookins, L. Earle, H.F. Spread; Paris, with Boulanger, Lefebvre, 1886. Member: Chicago SA (Pres.); Soc. Western A; NYWCC; AAC. Exhibited: Chicago Artists Exh., 1898; St. Louis Expo, 1904 (med). Specialty: mural dec. Author: "The Human Figure" (a standard work in art instruction). At the age of fourteen he suffered a fall in a gymnasium which made him a cripple for life, and when he was about thirty-five he lost the sight of one eye. Positions: T., AIC (over 30 yrs.), People's Inst., St. Louis [10]

VANDERPOEL, Matilda [P,T] Chicago, IL/Gold Hill, CO b. Holland. Studied: AIC [33]

VAN DER POEL, Priscilla Paine (Mrs.) [P,Car,L,T] Northampton, MA b. 9 Ap 1907, Brooklyn, NY. Studied: Smith Col.; ASL; Italy; F. DuMond; G. Bridgman; S. Whiton. Member: CAA. Exhibited: Studio C., Northampton, 1936-45. Position: T., Smith Col., Northampton, 1935- [47]

VANDERPOOL, Madeleine McAlpin [S] Princeton, NJ b. 22 D 1912, Morristown, NJ. Studied: M. Hernandez, in Paris; R. Davis; G.K. Hamlin. Member: NAWPS; Morristown AA. Exhibited: NA, 1935, 1936; NAWPS, 1937, 1938 [40]

VAN DER VEER, Mary [P] Amsterdam, NY b. 9 S 1865, Amsterdam, NY. Studied: Phila. A. Sch.; R.H. Nicholls; Chase; PAFA; NAD; Whistler, in Paris. Member: NYWCC; NAWPS. Exhibited: WCC, 1898; PAFA, 1898; Louisville AL, 1898; St. Louis Expo, 1904 (med); NAD, 1898, 1911 (prize) [40]

VAN DER VELDE, Hanny (Mrs. A.W.) [P] Royal Oak, MI/Melbourne Beach, FL b. 19 S 1883, Rotterdam, Holland. Studied: Rotterdam Acad. FA. Member: NAWPS; Detroit Soc. Woman P. Exhibited: Rotterdam, 1910 (prize); Detroit, 1910-24 (prizes); Mich. State Show, 1926 (prizes); Detroit AI, 1927 (prize). Work: Detroit AI; Grand Rapids AA; Vanderpoel AA, Chicago, IL [40]

VAN DER WESTHUYZEN, J.M. [P] Chicago, IL. Member: Chicago NJSA [25]

VAN DER WEYDEN, Harry [P] Rye, Sussex, England b. 1868, Boston, MA. Studied: Slade Sch., London; Paris, with Laurens, Lefebvre, Constant; Fred Brown, in London. Member: Paris SAP; Paris AAA; Inst. Oil P., London. Exhibited: SBA, 1898; Paris Salon, 1891 (gold); Intl. Expo, Antwerp, 1894 (med); Atlanta Expo, 1895 (gold); Paris Expo, 1900 (med); Munich, 1901 (gold); Vienna, 1902 (gold); Liège Expo, 1905 (med). Award: Slade schol., London, 1887; Work: AIC; French Gov., 1906, 1908 [31]

VAN DER WOERD, Bart [Dec,Des,Arch,T,W] NYC b. Deventer, Holland. Studied: Sch. Higher Arch., Amsterdam; Middelbare Technische Sch., Utrecht, Holland. Member: Arch. L; NAAI. Work: modern rugs, textiles, furniture, lamps, glassware; modern arch. and interiors [40]

VAN DER ZEE, James [Ph] Harlem, NYC (studio since 1916) b. 1886, NYC d. ca. 1980. Studied: self-taught. Exhibited: "Harlem On My Mind," MET, 1969. Work: Van Der Zee Inst. (auspices of MET); NOMA. Documenter of Harlem life since 1920s. [*]

VANDIVER, Mabel [P] Norman, OK. Member: Okla. AA [27]

VAN DOREN, Harold (Livingston) [Des,P,W,L] Ardmore, PA b. 2 Mr 1895, Chicago, IL d. 3 F 1957. Studied: Williams Col.; Grande Chaumière, Paris; Bridgman; Sterne; Rosen. Member: S. Indst. Des. Exhibited: Am. Acad. Des., 1927; TMA, 1932; Friends Am. A., Paris, 1924; Nat. All. A. & Indst., 1932 (prize); Mod. Plastics Comp., 1936 (prize), 1941 (prize); Lord & Taylor Am. Des., 1941 (prize). Author: "Industrial Design, A Practical Guide," 1940. Translator: Vollard's "Cezanne—An Intimate Record," 1923, Vollard's "Renoir—An Intimate Record," 1925; articles, Saturday Evening Post, The Arts, Machine Design [47]

VAN DORSSEN, G. [P] NYC. Member: S.Indp.A. [24]

VAN DRESSER, William [Por.P,E,I] Boca Raton, FL b. 28 O 1871, Memphis d. 1950. Studied: F.L. Mora; D. Connah; A. Dow; G. Bridgman; W.A. Clark. Member: S. Four A., Palm Beach, Fla.; Grand Central AA; AAPL; SSAL. Exhibited: S. Four A., 1936-46; Palm Beach AL, 1940-46; Grand Central A. Gal. (one-man). Work: portraits of prominent persons. Position: T., ASL, 1943-45 [47]

VAN DROSKEY, M. (Mrs.) [E] NYC [24]

VAN DUZEE, Kate Keith [P,C,Dr] Dubuque, IA b. 18 S 1874, Dubuque. Studied: Dow; Monks; Woodbury; J. Johansen; A.J. Dornbush. Member: Dubuque AA. Exhibited: Iowa State Fair, medals, 1917-20, 1922, 1923, 1929, 1930, 1936; Iowa State Fed. Women's C., 1931 (med); Dubuque AA, 1934 (prize). Work: Dububque Pub. Lib. [47]

VAN DYKE, Ella [P,T] Schenectady, NY b. 9 F 1910, Schenectady. Studied: Skidmore; Columbia; Ecole des Beaux-Arts, Fontainebleau, France; C.J. Martin; C. Lemeunier. Member: NAWA; Am. Assn. Univ. Prof.; Am. Assn. Univ. Women; Detroit S. Women PS. Exhibited: PAFA, 1934; AIC, 1935; NAWA, 1935, 1944, 1945; Albany Inst. Hist.&A., 1935, 1945, 1946; Schenectady Mus. A., 1945, 1946. Positions: T., Albion Col., Mich. (1936-39), Univ. Conn. (1939-43) [47]

VAN DYKE, John Charles [Cr,W,T,L] New Brunswick, NJ b. 21 Ap 1856 d. 5 D 1932, NYC. Member: NIAL, since 1908. In 1923 Dr. Van Dyke published a large volume entitled "Rembrandt and His School." It was a controversial work attempting to show that the tendency to attribute to the great painter a vast number of pictures differing in style was a mistake. He charged that only a possible fifty of nearly a thousand pictures attributed to Rembrandt were really the work of the Dutch master. The book called forth a storm of comment, criticism and protest on both sides of the Atlantic. He also edited the autobiography of Andrew Carnegie and wrote many essays on natural history, literature and genealogy. His works make up 35 volumes.

VAN EK, Eve Drewelowe [P,Des,C] Boulder, CO b. 15 Ap 1903, New Hampton, IA. Studied: Univ. Iowa; C.A. Cumming. Member: NAWA; Boulder A. Gld.; Prairie WC Assn. Exhibited: Nat. Exh. Am. A., NYC, 1938; WFNY, 1939; PAFA, 1936; AIC, 1939; NAWA, 1939-44, 1946; Denver AM, 1926, 1931, 1932 (prize), 1933, 1936, 1938, 1941, 1945; Univ.

Colo., 1937; Cornell Univ., 1942; Univ. Okla., 1935; Kansas City AI, 1935, 1937, 1940, 1942; Joslyn Mem., 1934, 1936-39, 1942, 1944; Boulder AG, 1925-46; Prairie WC Assn., 1936-46; Colo. State Fair, 1931 (prize), 1932 (prize). Work: Univ. Iowa; Univ. Col.; Crippled Children's Sch., Jamestown, N.Dak.; H.S., Agricultural Col., Cedar City, Utah [47]

VAN ELTON, Hendrik. See Kruseman van Elton.

VAN ELTON, Elizabeth F. Kruseman. See Duprez, Mrs. [25]

VAN EMPEL, Jan [P,W] Franconia, NH b. Amsterdam, Holland. Studied: R. Henri; R. Kryzanowsky. Work: St. Peter's Church, Seward, Alaska; Canadian Nat. Railroad [29]

VAN EVEREN, Jay [P] NYC. Member: Mural P. [29]

VAN GORDER, Luther Emerson [P,I] Toledo, OH b. 22 F 1861, Pittsburgh, PA d. 1 F 1931. Studied: Chase; C.Y. Turner; Carolus-Duran, Ecole des Beaux-Arts, Paris; London. Member: NYWCC; Toledo Tile C. Exhibited: NAD; AWCS; SAA; Boston AC; Phila. AC; all 1898; Paris Salon. Work: Mus. Art, Toledo. Specialty: Paris street scenes and landscapes [24]

VAN GUNTEN, Adele [Min.P] Germantown, PA [06]

VAN HOOK, Katrina (Mrs. Taylor) [Cr,T,L] Wash., D.C. b. 26 Mr 1912, NYC. Studied: Smith Col.; Radcliffe Col.; Univ. Paris. Contributor: Magazine of Art, Gazette des Beaux-Arts. Positions: T., Smith Col., 1938-40; Mus. Aide, 1941-43; Supv. Edu., 1943-45, NGA, Wash., D.C.; A. Cr., Washington Post, 1945-46 [47]

VAN HOOK, Nell [P,S,T] Atlanta, GA b. 29 O 1897, VA. Studied: NAD; ASL; Calder; Rittenberg. Member: SSAL; Ga. State AL; Ga. Prof. AL; Nat. Lg. Am. Pen W.; AFA. Exhibited: Atlanta AA, 1928 (prize); C.L. Wolfe AC, 1935 (prize). Work: Erskin Col., Due West, S.C.; Peachtree Christian Church; Westminster Presbyterian Church, Atlanta, Ga.; Gibney Fnd.; Columbia; Mem. A. Gal., Rochester [40]

VAN HOUTEN, Raymond F. [P] Cincinnati, OH. Position: staff, Rookwood Pottery, Cincinnati [13]

VAN INGEN, Henry A. [P,T] Poughkeepsie, NY b. 12 N 1833, Holland d. 17 N 1899. Member: AWCS. Exhibited: NAD; AWCS. Position: T., Vassar Col. [98]

VAN INGEN, Josephine K. [P] Poughkeepsie, N.Y. Exhibited: NAD, 1898; PAFA, 1898 [01]

VAN INGEN, W(illiam) B(rantley) [Mur.P] NYC b. 30 Ag 1858, Phila. Studied: PAFA, with Schuessele, Eakins; La Farge; Bonnât, in Paris. Member: Arch. Lg., 1889; Mural P.; AC Phila.; NAC; Lotos C.; A. Aid S.; A. Fund S. Exhibited: SAA, 1898; Pan-Am. Expo, Buffalo, 1901 (prize). Work: eight panels in U.S. Court House, Chicago; U.S. Courthouse, Indianapolis; U.S. Mint, Phila.; Capitol, Harrisburg, Pa.; Capitol, Trenton, N.J.; LOC; Admin. Bldg., Panama Canal Zone, 1914-15; murals, N.Y. State Col., Albany [40]

VAN KOERT, John Owen [P,E,Des,B,Li,T] Milwaukee, WI b. 30 Jy 1912, Minneapolis. Studied: Univ. Wis.; Milwaukee State T. Col.; Columbia. Exhibited: Milwaukee AI, 1937 (prize). Work: Milwaukee AI; USPO, Neillsville, Wis. WPA artist. Position: T., Univ. Wis. [40]

VAN LAER, Alexander T(heobald) [Ldscp.P,T,W,I,L] b. 9 F 1857, Auburn, NY d. 12 Mr 1920, Indianapolis. Studied: NAD; R.S. Gifford; G. Poggenbeek, in Holland. Member: ANA, 1901; NA, 1909; AWCS; NYWCC; CAFA; A. Fund S.; NAC; SC, 1892; Lotos C.; Soc. P. of N.Y; Rembrandt C.; Jury of Awards, St. Louis Expo, 1904. Exhibited: Charleston Expo, 1902; (med); St. Louis Expo, 1898, 1904 (gold); NAD, 1898. Work: Lotos C.; Brooklyn Inst. Mus.; NGA; NAC; Montclair Mus., N.J.; Herron AI, Indianapolis [19]

VAN LAER, Belle [Min.P] Johnsville, PA b. 19 S 1862, Phila. Studied: Phila. Sch. Des. for Women, with S.J. Ferris, J.L.G. Ferris, H. Faber, L. Faber. Member: Plastic C. [25]

VAN LESHOUT, Alexander J. [E,T] Louisville, KY b. 16 My 1868, Harvard, IL d. 24 My 1930, My. Studied: ASL; AIC; C. Beckwith; F. Freer; J.H. Vanderpoel; Holland; Paris. Member: SSAL; Chicago SE; Louisville AA. Position: Dir. Louisville Sch. A., Conservatory of Music [29]

VAN LEYDEN, Ernst Oscar Mauritz [P,S] Los Angeles, CA b. 16 My 1892, Rotterdam, Holland. Exhibited: VMFA, 1946; Pepsi-Cola, 1946; Santa Barbara Mus. A.; San Diego FAS; Syracuse MFA; SFMA; Europe; Expo, Brussels (med); Paris Expo, (med); Amsterdam Expo, (med); The Hague Expo, (med); Venice, Italy, 1932 (prize); Los Angeles Mus. A. (prize). Work: Tate Gal., London; museums throughout Europe [47]

VAN LEYDEN, Karin Elizabeth (Mrs. Ernst) [P,Des,I] Los Angeles, CA b. 23 Jy 1906, Charlottenburg, Germany. Member: Royal S. Mural P., Great Britain. Exhibited: Marie Sterner Gal. 1938; Nierendorf Gal., 1940; Wildenstein Gal., 1941; Carroll Carstairs Gal., 1944; Bonestell Gal., 1946; Syracuse MFA, 1941; San Diego FAS; Santa Barbara Mus. A.; Los Angeles Mus. A.; SFMA; Europe. Work: museums in Europe [47]

VAN LOAN, Dorothy (Leffingwell) [P,Li] Phila., PA b. Lockport, NY. Studied: PMSchIA; PAFA, 1927-28 (Cresson traveling schol.); Phila. Graphic Sketch C. Member: Phila. Pr. C. Exhibited: Watkins Gal., Phila., 1935; Marie Sterner Gal., 1937, 1939 (one-man); Phila. A. All., 1936 (gold), 1945 (one-man); NAD, 1943, 1945; PAFA, 1932, 1933, 1935, 1940-45; CI, 1941-42, 1945-46; Ragan Gal., Phila., 1941-43; Phila. Graphic Sketch C., 1935 (gold), 1944, 1945; PMA, 1946; F., PAFA, 1927-46; Woodmere A. Gal., 1941-45; Gimbel Gal., 1937 (one-man); Phila. Pr. C., 1944 (prize); PAFA, 1927 (prize), 1928 (prize), 1935 (prize); An American Place, NYC. Work: PMA; PAFA; Phila. A. Alliance; La France AI, Phila. [47]

VAN LOON, Hendrik Willem [W,I] Old Greenwich, CT b. 1882, Netherlands (came to U.S.in 1902) d. 11 Mr 1944. Author/Illustrator: books on history and biography

VAN MILLETT, George [P,Cur] Kansas City, MO b. 1864, Kansas City b. 1952. Studied: Munich. Position: Cur., William Rockhill Nelson Mus., 1920s [*]

VANN, Esse Ball (Mrs.) [P,T] Richmond Beach, WA b. 21 S 1878, Lafayette, IN. Studied: Univ. Southern Calif.; E. Forkner; E.P. Ziegler. Member: Hoosier Salon; Women P. of the West; Laguna Beach AA; Women A. Wash. (pres.) [40]

VANN, Loli (Mrs. Oscar Van Young) [P] Los Angeles, CA b. 7 Ja 1913, Chicago. Studied: AIC; S. Ostrowsky. Member: Calif. WCS; Council All. A., Los Angeles; Los Angeles AA. Exhibited: AIC, 1938, 1941, 1942, 1945; CI, 1946; Pepsi-Cola, 1946; Pal. Leg. Honor, 1946; SFMA, 1944; Santa Barbara Mus. A., 1944; Denver A. Mus., 1943; Chaffey Col., Ontario, Calif., 1945; Oakland A. Gal., 1945; Los Angeles Mus. A., 1941, 1943, 1944 (prize), 1945; Fnd. Western A., 1942-45; Los Angeles AA, 1944-46; Pasadena AI, 1945; Laguna Beach AA, 1945 [47]

VANN AUSDALL, Wealtha Barr [Por.P,Li,L,T] Oil City, PA b. Franklin, PA. Studied: W. Barr; W.F. Bates; Moore Inst.; Phila. Sch. Des. for Women; Graphic Sketch C.; P.H. Balano. Member: Phila. Print C.; Plastic C.; Phila. AG. Exhibited: WFNY, 1939. Work: Drake Mem. Mus., Titusville, Pa.; Mun. Coll., Oil City, Pa.; Graphic Sketch C., Phila. [40]

VAN NESS, Beatrice. See Whitney.

VAN NESS, C.W. [P] St. Paul, MN [24]

VAN NESS, Frank Lewis [Por.P,I] Chicago, IL b. 29 S 1866, Paw-Paw, MI. Studied: G.P.A. Healy. Exhibited: Art Loan Exh., Detroit, 1885 (med) [10]

VAN NORMAN, Evelyn [P] New Rochelle, NY b. 7 F 1900, Hamilton, Ontario, Canada. Studied: ASL. Member: Alliance Française. Exhibited: AIC, 1930 (gold); WFNY, 1939 [40]

VAN ORDER, Grace Howard [P,I,T] Baltimore, MD b. 16 F 1905, Baltimore. Studied: Md. Inst.; PAFA, Chester Springs Summer Sch. Member: AAPL. Exhibited: Md. Inst.; Baltimore MA; AAPL. Position: T. Park Sch., Baltimore [40]

VAN ORMAN, John A. [I] NYC. Member: SI [47]

VAN ORNUM, Willard [P] Earlville, IL [15]

VAN PAPPELENDAM, Laura [P] Chicago, IL b. Donnelson, Lee County, IA. Studied: AIC; Sorolla; G. Bellows; N. Roerich. Member: Chicago SA; Chicago Gal. A.; Ill. Acad. FA. Exhibited: AIC, 1932 (prize), 1933 (prize). Work: Vanderpoel AA Coll., Chicago [40]

VAN PARNEGH, Clara W. [P] NYC [04]

VAN PELT, Ellen Warren [P] Univ. Park, CO [01]

VAN PELT, John V. [Arch,P] NYC [06]

VAN PELT, Margaret V. [P] New Haven, CT. Member: AWCS [47]

VAN RAALTE, David [P,Des,G] Bronx, NY/Lake Peekskill, NY b. 24 S 1909, NYC. Studied: Jacobs; MMA Sch., NYC; H. Hofmann. Member: Salon Am.; S.Indp.A. Exhibited: Fed. A. Proj. Gal., NYC; GGE, 1939. Work: Munic. Mus., Winston-Salem, N.C. WPA artist. [40]

VAN RENSSELAER, Mariana Griswold (Mrs. Schuyler) [W] NYC b.

1851, NYC d. 20 Ja 1934. Studied: Columbia, 1910 (hon. degree). Member: AIA; Am. S. Ldscp. Arch. Exhibited: AAAL, 1923 (gold). Author: an authoritative biography of Henry H. Richardson, 1888; "English Cathedrals," "Six Portraits," "Art Out of Doors," "History of the City of New York in the Seventeenth Century," 1909

VAN REUTH, Edward Felix Charles [P] Baltimore, MD b. Holland d. Mr 1925

VAN ROEKENS, Paulette (Mrs. Arthur Meltzer) [P,T] Langhorne, PA b. 1 Ja 1896, Chateau Thierry, France. Studied: PAFA; Moore Inst.; S. Murray; H.B. Snell; C. Grafly; G. Seyffert; J. Pearson. Member: NAWPS. Exhibited: PAFA, 1918, 1920–30, 1928 (prize), 1937, 1939; CI, 1922–24; AIC, 1921, 1923, 1925, 1927–30; CGA, 1921, 1923, 1926, 1933, 1937, 1939, 1943; Montclair A. Mus.; Mint Mus. A.; Woodmere A. Gal., 1946 (prize); Phila. AC; Columbus Gal. FA, 1930; Mystic AA; Boston AC; Newport AA; NAWPS (prize); Phila. Plastic C., 1920 (gold); Phila. Sketch C., 1923 (gold). Work: PAFA; Phila. Graphic Sketch C.; F. PAFA; Pa. State Col.; Reading Mus. A.; Woodmere A. Gal.; Phila. Sch. Des. Position: T., Moore Inst. [47]

VAN ROSEN, Robert [P,Des,L] NYC b. 6 F 1904, Kiev, Russia (came to NYC in 1923) d. 17 N 1966. Studied: Master Inst. Un. A., NYC; Russia. Work: Queens Col.; WPA work, 1937–39 at Univ. Minn. Designer: theatrical productions. Lectures: Art; Theatre; Stagecraft. Positions: Cur., Roerich Mus., NYC, 1926–28; A. Dir., IBM Corp. (1940–42), Makowsky Corp., NYC (from 1943) [47]

VAN RYDER, Jack [E,P,W] Tucson, AZ b. 7 Je 1898, Continental, AZ d. 1968. Studied: C.M. Russel, in Mont. Member: SI. Work: Guild Hall, East Hampton, N.Y. Contributor: Literary Digest. Illustrator: "Dust of the Desert." Specialty: Ariz. ranch life [40]

VAN RYN, Agnes. See Lowrie.

VAN RYZEN, Paul [P] Duluth, MN [25]

VAN SANTVOORD, Anna T. [P] NYC [15]

VAN SCRIVEN, Pearl Aiman (Mrs. Lloyd) [P,T] Chestnut Hill, PA b. 3 O 1896, Phila. Studied: Moore Inst.; PAFA; L. Seyffert; V. Oakley; H. Snell. Member: Phila. Plastic C.; Lg. Am. Pen Women; NAWA. Exhibited: Germantown AL, 1937; NAWPS, 1936, 1937, 1938; Chestnut Hill (med); Phila. Plastic C. (med); PAFA (prize); NAD; CGA. Work: Allentown Mus.; Rochester Mem. A. Gal.; Ogontz Jr. Col.; Univ. Pa. Position: Vice-pres., Woodmere A. Gal., Phila., 1946 [47]

VAN SHECK, Sidney W. Jirousek [P,Li,T] Birmingham, AL b. Prague, Czech. Studied: Julian Acad.; L'Ecole des Beaux-Arts, Paris. Member: Boston S.Indp.A.; Ala. AL; Birmingham AC; SSAL; NSMP. Exhibited: Am. Adv. Dir., 1939 (prize). Work: H. Burroughs Newsboy Fnd.; portraits of Pres. and Mrs. T.G. Masaryk, Prague; Richmond Theatre, North Adams, Mass.; Capitol, Little Rock, Ark.; Woodlaw Auditorium, Birmingham [40]

VAN SLOUN, Frank J. [P,E,T] San Francisco, CA b. St. Paul, MN. Exhibited: Pan-P. Expo, San Fran., 1915 (med) [33]

VAN SLYCK, Wilma Lucile [P] Cincinnati, OH b. 8 Jy 1898, Cincinnati. Studied: H.H. Wessel; J.R. Hopkins; J.E. Weis; Hawthorne; I.C. Olinsky. Member: Cincinnati AC. Work: Circ. Gal., Dayton AI [33]

VAN SOELEN, Theodore [P,W,Li,I] Santa Fe, NM (since 1922)/2nd studio in Cornwall, CT by 1930s. b. 15 F 1890, St. Paul, MN d. 14 My 1964. Studied: St. Paul AI, 1908–11; PAFA. Member: ANA, 1933; NA, 1940; Century Assn. Exhibited: CI; PAFA, 1931 (prize); MMA; MOMA; SFMA; Los Angeles Mus. A.; San Diego FAS; CGA; AIC; NAD, 1927 (prize), 1930 (prize); N.Mex. State Fair, 1944 (prize), 1945 (prize); Sesqui-Centenn. Expo, Phila., 1926 (prize). Work: PAFA; NAD; Mus. N.Mex.; Pub. Sch., Phila. and Denver; WPA murals: Grant County Court House, Silver City, N.Mex., USPOs, Portales, (N.Mex.), Waureka (Okla.), Livingston (Tex.). Contributor: Field & Stream [47]

VAN STOCKUM, Hilda (Mrs. Marlin) [W,I,P,Li] Quebec, Canada b. 9 F 1908, Rotterdam, Holland. Studied: Europe; Corcoran Sch. Art; Nat. Sch. Art, Dublin, Ireland; Rijks Akad. van Beelende Kunsten, Amsterdam. Member: Children's Book Gld. Exhibited: CGA, 1937. Author/Illustrator: "Kersti & St. Nicholas," 1940, "Pegeen," 1941, "Gerrit and the Organ," 1943, "A Day on Skates," 1934, "The Cottage at Bantry Bay," "Francie on the Run," 1938, 1939. Illustrator: "Tilio, A Boy of Papua," 1937. Contributor: The Horn Book. Work: Rijks Akademie coll., Amsterdam [47]

VAN SWEARINGEN, Eleanore Maria (Mrs. E.K.) [Printmaker,Des,C,T] Wash., D.C. b. 29 My 1904, Luzon, Philippines. Studied: Bryn Mawr Col.; Stanford Univ. Member: Hololulu PM. Exhibited: Honolulu AA, 1940, 1946; Phila. Pr.C., 1946; Oakland A. Gal., 1935, 1936; Honolulu PM, 1940–42, 1945; Northwest PM, 1939; Phila. A. All., 1938; Denver A. Mus., 1940; Sydney, Australia, A. Mus., 1942 [47]

VANT, Margaret Whitmore [C] Brighton, MA b. 20 My 1905. Studied: Mass. Sch. A.; G.J. Hunt. Member: Boston SAC (Master Craftsman). Specialty: jewelry [40]

VAN TRUMP, Rebecca N. [Por.P,Min.P] Paris, France b. PA. Studied: PAFA; Acad. Julian, Paris. Exhibited: Phila. AC, 1898; Columbian Expo, Chicago, 1893 [17]

VAN TYNE, Peter [P] Lambertville, NJ b. 24 O 1857, Flemington, NJ. Studied: ASL; PAFA. Exhibited: Trenton Fair, 1925 (prize), 1926 (prize) [40]

VAN VALKENBURGH, Peter [P,Li,T,W] Piedmont, CA b. 4 D 1870, Greenbush, WI d. 25 Ag 1955. Studied: Chicago Acad. A.; AIC; F. Smith; J. Vanderpoel. Member: Calif. Writers C. Exhibited: Oakland A. Gal. (one-man); SFMA (one-man); Claremont (Calif.) A. Gal. (one-man); Faculty C. & Lib., Univ. Calif. (one-man); Stanford Univ. (one-man); Paul Elder Gal., San Fran. (one-man); Iowa State Col., Ames, 1939; Bureau of Reclamation, Denver, 1939. Work: port., Acad. Sc., N.Y.; Stanford Univ.; Univ. Calif.; Calif. Inst. Technology; Calif. Acad. Sc., San Fran.; Oakland Pub. Lib.; Iowa State Col.; Bureau of Reclamation, Denver; UCLA [47]

VAN VEEN, Pieter (J.L.) [P] NYC/Paris, France. b. 11 O 1875, The Hague, Holland. Studied: Holland; France. Member: SC; NAC; N.Y. Mun. AS; Allied AA. Exhibited: France, Cross of Legion of Honor, 1929. Work: Butler AI; Coll. H.M. Queen of Belgium; Seattle AM; H.C. Henry Coll., Wash. Univ., Seattle [40]

VAN VEEN, Stuyvesant [P,Gr,I,W,L,Car,T] Cincinnati, OH (1977) b. 12 S 1910, NYC. Studied: PAFA; NAD; ASL; N.Y. Sch. Indst. A.; Columbia; D. Garber; T. Benton. Member: NSMP; Mural AG; Am. A. Cong.; A. Lg. Am. Exhibited: CI, 1929; AIC, 1930–35, 1939, 1941, 1943, 1946; MOMA, 1934, 1937, 1939; WMAA, 1935–37, 1939, 1940; CGA, 1935, 1936, 1939, 1941; PAFA, 1927, 1936, 1939, 1940, 1941, 1943; BMFA, 1929, 1936; BM, 1929, 1936; CAM, 1929, 1936, 1939, 1943; Minn. Inst. A., 1929, 1936, 1939; Syracuse MFA, 1939; NGA, 1942, 1944; McD. C., 1936 (prize); Ohio Valley Exh., Athens, Ohio, 1945 (prize), 1946 (prize); Wright Field Army A., 1945 (prize); State Wide Army A. Comp., 1945 (prize). Work: Walker A. Ctr.; N.Y. Hist S.; Ohio Univ.; N.J. State Mus., Trenton; MMA; Frick Coll.; WPA murals: Riverside Mem. Chapel, N.Y., Mackley Mem. Pub. Lib., Juniata Park, Pa.; USPO, Pittsburgh; Fordham Hospital; Trafford City, Pa.; Seagram Corp.; Juvenile & Domestic Relations Court, Phila. Illustrator: "The Fairy Fleet"; literary satires, Nation, New Masses magazines. Position: T., CUNY, until 1973 [47]

VAN-VLECK, Natalie [P] NYC. Member: S.Indp.A. [25]

VAN VOAST, Virginia Remsen [P,E,C] Cincinnati, OH b. 10 Ap 1871, Columbia, SC. Studied: Cincinnati A. Acad.; H. Sharp; G.P. Ennis; A. Thieme. Exhibited: Member: Cincinnati Women's AC; Cincinnati Prof. A. Exhibited: Phila. WCC, 1934; Ohio PM, 1937; Cincinnati Mus., 1939 [47]

VAN VOORHEES, Linn [I] NYC b. Atlanta, GA. Member: SI [47]

VAN VORST, Garrett W. [P] NYC. Member: SC [25]

VAN VORST, Marie [P,W] Rome, Italy (since 1916) b. 1867, NYC d. 16 D 1936, Florence, Italy. A writer of novels, she turned to painting when she was 53, and in less than a year turned out more than fifty pictures.

VAN WAGENEN, Elizabeth Vass [P,T] Danville, VA b. 11 Ag 1895, Savannah, GA d. ca. 1955. Studied: ASL; E.A. Webster; H.L. McFee; D. Garber; J.T. Pearson; K.H. Miller; G. Bridgman. Member: SSAL; Va.A.All.; AFA; Danville AC. Exhibited: VMFA; Va. A. Exh., N.Y., 1937. Position: T., Stratford Col., Danville, Va. [47]

VAN WART, Ames [S] NYC/Nevilly (Paris), France b. NYC d. 1927, Paris. Studied: Hiram Powers. Member: Century Assn. Exhibited: Paris Salon, 1904–05. Work: MET [25]

VAN WERVEKE, George [I] NYC. Member: SI; Artists G. [33]

VAN WESTRUM, Anni Baldaugh (Mrs.) [P] Corona, CA b. Ag 1886, Holland. Studied: Trendsen Holland; Jaschke, Vienna; von Kunowsky, Munich; Ecole des Beaux-Arts, Paris. Member: Calif. Min. S.; CAFA. Exhibited: Los Angeles, 1922 (gold) [25]

VAN WILLIS, Edmund. See Willis.

VAN WINKLE, Evelyn [Min.P,Des,G] White Plains, NY b. 10 S 1885.

Studied: D. Volk; Gifford; J. Twachtman. Member: Westchester ACG; Studio G.; Ten Talents G. A.&C. (pres.) [40]

VAN WOLF, Henry [S] Van Nuys, CA b. 14 Ap 1898, Regensburg, Bavaria. Studied: Europe. Member: AAPL; Calif. AC; San Fernando Valley AC. Exhibited: BM, 1932; All.A.Am., 1936, 1937; Arch. L., 1937; Springfield Mus. A., 1938; Calif. AC, 1944–46; Los Angeles,1945. Work: WPA work, USPO, Fairport, N.Y.; Bethlehem Steel Co., N.Y. WPA artist. [47]

VAN WYCK, Matilda. See Browne.

VAN YOUNG, Oscar [P,Li,T] Los Angeles, CA b. 15 Ap 1906, Vienna, Austria. Studied: Acad. FA, Odessa, Russia; T. Geller; E. Armin; S. Ostrowsky. Member: Calif. WCS; Council All. A., Los Angeles; Chicago SA; Am. Ar. Cong.; United Am. Ar., Chicago. Exhibited: AIC, 1937–39, 1942, 1945, 1946; GGE, 1939; Pepsi-Cola, 1945, 1946; NAD; VMFA, 1946; Pal. Leg. Honor, 1946; San Fran. AA, 1941, 1942, 1944, 1945; CGA, 1941; Oakland A. Gal., 1943, 1945; Santa Barbara Mus. A., 1944; Denver A. Mus., 1943, 1945; San Diego FAS, 1941; Los Angeles Mus. A., 1941, 1942 (one-man), 1943UN–45; Vigeveno Gal., 1942 (one-man); SFMA, 1943 (one-man); Pasadena AI, 1945 (one-man); Santa Barbara Mus. A., 1946 (one-man); Dayton AI, 1937; Kansas City AI, 1938; Calif. WC, 1943 [47]

VAN YOUNG, Loli. See Vann.

VAN ZANDT, Hilda (Mrs.) [P,T] San Pedro, CA b. 18 Je 1892, Henry, IL d. 31 Jy 1965, Long Beach, CA. Studied: UCLA. Member: Calif. AC; Calif. WCS; Women P. of the West. Work: Women's C., Baldwin, Calif. [40]

VAN ZANDT, Origen A. [P] NYC. Exhibited: Phila. AC, 1898 [01]

VARADAY, Frederic [I] NYC. Member: SI [47]

VARECK, A.M. [P] Yonkers, NY. Exhibited: NYWCC, 1898 [01]

VARGA, Margit [W,P] Brewster, NY b. 5 My 1908, NYC. Studied: ASL, with B. Robinson, R. Laurent. Exhibited: RISD, 1938; GGE, 1939; Cranbrook Acad. A., 1940; Dallas Mus. FA; Central Ill. Expo, 1939; VMFA; CI; Pepsi-Cola; AIC, 1937; PAFA, 1938; CGA, 1939; BM; Cincinnati AM. Author: "Waldo Peirce," 1941, "Carol Brant," 1945; articles, Magazine of Art, Studio Publications. Co-author: "Modern American Painting," 1939. Position: Assoc. Ed., Life, NYC, from 1936 [47]

VARGISH, Andrew [P,T,Des,I,Et,L] Poultney, VT b. 11 O 1905, St. Thomas, Austria-Hungary. Studied: Univ. Chicago; Columbia. Member: SAE; Chicago SE. Exhibited: SAE, annually, 1929 (prize); Chicago SE; PAFA; Southern Vermont A.; Pittsburgh SE, 1930 (prize). Work: LOC; NYPL; NGA. Illustrator: "Eleven Times Ourselves," F. Baer; "Sonnets from the Portuguese." Author/Illustrator: poems, "I Importune God." Position: Dir., Dept. A., Green Mountain Jr. Col., Poultney, Vt., from 1937 [47]

VARIAN, Dorothy [P,Des] Bearsville, NY b. 26 Ap 1895, NYC. Studied: CUASch; ASL; Paris; J. Sloan. Member: Woodstock AA; Am. Soc. PS&G. Exhibited: CI, 1931, 1937, 1939, 1940, 1942–45; CGA, 1935, 1937, 1939, 1941, 1943; PAFA, 1940, 1942–45; VMFA, 1938, 1940; AIC, 1941; CAM, 1938, 1945; WMAA, 1933–35, 1937–41, 1943–46; WMA, 1938; NAD, 1945; Pepsi-Cola, 1944; Woodstock AA, annually. [47]

VARIAN, George Edmund [I] Brooklyn, NY b. 16 O 1865, Liverpool, England (came to U.S. as a boy). Studied: Brooklyn AG; ASL. Member: SC. 1905; Brooklyn AC. Exhibited: Paris Salon, 1907. Illustrator: "Seen in Germany," by R.S. Baker, "The Tragedy of Pelée," by G. Kennan, for McClure's, 1902; he witnessed the destruction of St. Pierre on Martinique. [19]

VARIAN, Lester [Li] Denver, CO. Exhibited: 47 prints of Colo. scenes under WPA, Denver AM, 1934 [40]

VARNUM, William H(arrison) [P,W,T,C] Madison, WI/Monhegan, ME b. 27 Ja 1878, Cambridge, MA d. 4 Jy 1946. Studied: De Camp; Major; Woodbury; Mass. Sch. Art. Member: Western AA; Wis. PS. Author: "Industrial Arts Design," "Pewter Design and Construction," "Art in Commemorative Design," "Creative Design in Furniture." Position: T., Univ. Wis. [40]

VASGERDSIAN, Haroutin [P,G,T,L] Cambridge, MA b. 5 Ja 1906, Armenia. Studied: Mass. Normal A. Sch.; Copley S. Member: Bay State AG. Exhibited: Boston AC. Work: Armenian Apostolic Church, Boston [40]

VASSOS, John [Des,P,I,L,W] Norwalk, CT b. 23 O 1898. Studied: J. Sloan; J.S. Sargent. Member: Silvermine AG; Am. Ar. Cong.; Am. Des. Indst. Work: murals, radio station WCAU, Phila.; Athens Mus., Greece. Contributor: articles, Esquire, American Monthly. Illustrator: Woman's Home Companion, American, Forum, Esquire, New Yorker [40]

VAUDRONS, John C. [P] NYC [06]

VAUGHAN, Agnes L. (Mrs.) [P,T] NYC d. 11 Ap 1919. Position: T., MET

VAUGHAN, David Alfred [P,Car,L,T] Costa Mesa, CA b. 3 D 1891, Selma, AL. Studied: Columbia; ASL; K.H. Miller; R. Henri. Exhibited: Paris Salon; AIC, 1945; Pal. Leg. Honor, 1946; Los Angeles Mus. A., 1942; Cedar City, Utah, 1945, 1946; San Diego FAS, 1941 (one-man), 1944 (one-man), 1946 (one-man); Pasadena AI, 1944 (one-man); Santa Barbara Mus. A., 1945 (one-man); Palos Verdes Estates (Calif.) A. Gal., 1946; La Jolla A. Ctr., 1946 (one-man); Laguna Beach AA, 1944 (one-man), 1945 [47]

VAUGHAN, Lester Howard [C] Taunton, MA b. 6 N 1889, Taunton, MA. Member: Boston SAC; Phila. ACG. Exhibited: Boston SAC (med); AIC (prize). Specialty: metalwork [47]

VAUGHAN, S. Edson [Por.P] Santa Barbara, CA b. 24 Mr 1901, Chula Vista, CA. Studied: F.M. Fletcher; C.O. Borg; S. Meyer; W. Adams. C.C. Cooper. Member: SC. Exhibited: Santa Cruz AL, 1935 (prize); Pasadena, 1933 (prize); Acad. Western P., Los Angeles Mus. A., 1935 (prize) [47]

VAUGHAN, W.S. [P] Watertown, MA [19]

VAUGHT, Larken [P,Des,T] Whittier, CA b. 3 D 1904, Centerville, IA. Studied: A. Hills; D. Dowiatt; F. Schwankovsky; G.K. Brandriff. Member: Laguna Beach AA; Whittier AA. Exhibited: Laguna Beach A. Gal.; Whittier A. Gal.; Whittier AA, 1939 (prize), 1945 (prize). Position: Cur., Whittier A. Gal. [47]

VAUTRINOT, Madolin [P] Egg Harbor, NJ b. 7 Je 1913, Egg Harbor, NJ. Studied: CI; Country Sch., PAFA. Member: Pittsburgh AA. Exhibited: Pittsburgh AA, 1935 (prize), 1936 (prize). Work: murals, Republic Oil Co., Pittsburgh; Seaview Golf C., Seaview, N.J.; Atlantic City pub. schs.; Coll., 100 Friends of Art, Pittsburgh [40]

VAVAK, Joseph [P] Chicago, IL b. 4 My 1899, Vienna, Austria. Studied: AIC; ASL; Lhote Studio. Member: Chicago SA; Artists U. Chicago. Exhibited: Chicago SA, 1935 (gold). Work: schs. and other pub. inst., Chicago and vicinity [40]

VAVRA, Frank J. [P,Dec,C] Bailey, CO (since 1928) b. 19 Mr 1898, St. Paul, NE d. 1967, Denver. Studied: G.W. Eggers, Denver Acad.; J. Thompson; R.A. Graham; Giverny with Monet during WWI Member: Denver AG. Exhibited: Ann., Denver AM, 1936; Kansas City AI, 1935, 1939. Work: State Capitols, Denver, Colo., Cheyenne, Wyo.; Denver AM. Position: T., Univ. Denver [40]

VAVRA, Kathleen H. [P,Des] Bailey, CO. Member: Denver AG. Exhibited: Denver AM, 1936 (prize) [40]

VAWTER, John William [P,I,E] Nashville, IN b. 13 Ap 1871, Boone County, VA d. 11 F 1941. Member: Hoosier Salon; Chicago Gal. Assn.; Brown Co. A. Gal. Assn. Exhibited: Marshall Field Gal., 1925 (prize); Hoosier Salon, 1935 (prizes); Nashville Gal., 1935 (prize). Illustrator: the Riley Series of books [40]

VAWTER, Mary H(owey) Murray [Por.P,Ldscp.P,W] Nashville, IN b. 30 Je 1871, Baltimore d. ca. 1950. Studied: ASL; S.N. Randolph; S.E. Whiteman; I. Wiles; T.C. Corner; L. Kroeger; Md. Inst.; Charcoal C., Baltimore. Exhibited: Independents, 1931; Ind. A.; J.B. Speed Mem. Mus.; Hoosier Salon; Pub. Lib., Mathews, Va. Work: Nashville Pub. Lib.; Court House, Franklin, Ind. [47]

VAYANA, Nunzio [P,I,L] Ogunquit, ME b. 28 Ag 1887, Castelvetrano, Italy. Studied: Grosso; Morelli; Pisani. Exhibited: Venice AC, 1921 (prize); CAFA, 1924 (prize); I.E., Rome, 1925 (prize). Position: Dir., The Art Center, Ogunquit [40]

VECCHIO, Louis [P,S,T] NYC b. 24 Ag 1879, NYC. Member: W. Shirlaw; NAD [13]

VEDDER, Elihu [P,S,I,W,Mur.P] Rome, Italy (since 1866)/Isle of Capri b. 26 F 1836, NYC d. 29 Ja 1923. Studied: T.H. Matteson, in Sherburne, N.Y.; Picot, in Paris, 1856; Florence, with R. Bonaiuti. Member: ANA, 1863; NA, 1865; SAA, 1880; Mural P.; Century; Tile C., 1861–65; NIAL. Exhibited: Venice Biennale, 1867; PAFA, 1898; Paris Expo, 1889 (prize); Pan-Am. Expo, Buffalo, 1901 (med). Work: MET; LOC; Bowdoin Col.; CI; BMFA; AIC; Brooklyn Inst. Mus.; RISD. Illustrator: "The Rubaiyat of Omar Khayam," 1884. Author: "The Digressions of V.," 1910, "Moods in Verse," 1914, "Doubt and Other Things," 1923. Symbolist painter best known for his "Questioner of the Sphinx" (1863, BMFA) and "The Lair of the Sea Serpent" (1864–65, MMA). [21]

VEDDER, Eva Roos (Mrs. Simon H.) [P] London, England [13]

VEDDER, Simon Harmon [P,I] NYC b. 9 O 1866, Amsterdam, NY. Studied: MET Sch., NYC; Académie Julian with Bouguereau, Robert-Fleury; Ecole des Beaux-Arts, with Gérôme; Glaize. Exhibited: Paris Salon 1899 (prize); Crystal Palace, London (med) [19]

VEENFLIET, Richard [P] Chicago, IL. Member: Cincinnati Art C. Position: Strobridge Lithographic Co., Cincinnati [15]

VELONIS, Anthony [P,Des,C,T] Ridgefield, NJ b. 20 O 1911, NYC. Studied: College FA, NYU. Member: Un. Am. Ar. Exhibited: WFNY, 1939; NAS. Author: "Technique of Silk Screen Process," 1939. Position: T., Am. Ar. Sch., NYC [40]

VELSEY, Seth M. [S,P,T,Des] Dayton, OH b. 26 S 1903, Logansport, IN d. 12 Ap 1967. Studied: Univ. Ill.; AIC; A. Polasek; L. Taft. Exhibited: Hoosier Salon, 1928 (prize); Ind. A., 1931 (prize); Hickox prize, 1934; Paris Salon, 1937 (med). Work: Dayton AI; Wright Field, Dayton; St. Peter's Church, Chillicothe, Ohio; WPA reliefs, USPO, Pomeroy, Ohio [47]

VENANZI, Carlo Gino [P,E] Kansas City, MO b. 6 S 1875, Assisi, Italy. Studied: FA Institutes of Siena, Florence, Rome. Member: Academie Belle Arti, Perugia [21]

VENNING, Frank L. [P] Chicago, IL [17]

VENTRE, Lucian J. (Mrs.) [P] Dubuque, IA. Member: Dubuque AA [24]

VER BECK, Hanna. See Rion.

VERBECK, George J. [E] Chicago, IL b. 1 Je 1858, Belmont County, OH. Specialty: animals [10]

VER BECK, William Francis (Frank) [I,W] Hockley, Essex, England b. 1858, Belmont County, OH d. 13 Jy 1933. Studied: NYC. His children's stories with illustrations, especially his representations of comic animals, won for him a wide and appreciative public. He collaborated with Albert Bigelow Paine on "The Dumpies and the Arkansas Bear," published in 1896, and "The Arkansas Bear Complete," issued thirty-three years later. Other works include the Ver Beck Bear stories, Little Black Sambo series, "The Little Cat Who Journeyed to St. Ives," "The Donkey Child." Designer: Ver Beck earthenware models [31]

VERBEEK, Gustave [P,E,I] NYC b. 29 Ag 1867, Nagasaki, Japan. Studied: Constant; Laurens; Girardot; Blanc; Brush; early training in Japan. Working as an illustrator in Phila., 1901 [25]

VER BRYCK, William [Por.P] active NYC from 1851; settled in Milwaukee, 1881 b. 1823, NYC d. 21 Je 1899. Studied: NAD

VERHEYDEN, Francois (Isidore) [P,E,T] Provincetown, MA b. 8 Ap 1880, Hoeylaert, Belgium. Studied: Royal Acad. Brussels [29]

VERMILYE, (Anna) Josephine [E,B,P] Westfield, NJ b. Mt. Vernon, NY d. 3 Je 1940. Studied: J.F. Carlson; G. Bridgman; J.C. Johansen; Henri; B.J. Nordfeldt; A. Lewis. Member: AFA; NAWPS; Plainfield AA; Westfield AA; Phila. Print C. Exhibited: NAWPS, 1931 (med) [40]

VERMORCKEN, F.M. [P] NYC b. 1862, Brussels, Belgium. Studied: Paris, with Carolus-Duran, Cabanel. Member: Phila. AC [06]

VERMOSKIE, Charles [Ldscp.P,Por.P,T] Stoughton, MA b. 4 Mr 1904, Boston. Studied: F.M. Lamb; Boston Sch. Des. Work: Stoughton Pub. Lib.; St. Peters Church, South Boston, Mass. [40]

VERN. See Wiman, Vern.

VERNAM, W.B. [P] Brooklyn, NY. Member: Brooklyn SA [27]

VERNER, Elizabeth O'Neill [E,P,W,L] Charleston, SC b. 21 D 1883, Charleston, SC. Studied: PAFA; Central Sch. A., London; Seiho Sch., Japan. Member: Charleston EC; SSAL; Carolina AA; Chicago SE; Miss. AA; NOAA; Wash. WCC. Exhibited: Chicago SE; Phila. A. All.; SAE; Calif. PM; Kennedy & Co. (one-man); Doll & Richards, Boston (one-man). Work: MMA; LOC; BMFA; Honolulu Acad. A.; High Mus. A.; Hispanic Mus.; FMA; Harvard; Charleston Mus.; Chicago SE; Montgomery (Ala.) Lib. Author: "Prints and Impressions of Charleston," 1939, "Mellowed by Time," 1941. Illustrator: "Charleston Edition of Porgy," "Southern Exposure," by P.M. Wilson, "The Carolina Low Country," "French and American Culture," by H.M. Jones [47]

VERNIER, Racine [P] Cedar Rapids, IA. b. 7 Ap 1898, Butler, IN. Studied: D. Seabury. Exhibited: Iowa A. Salon, 1934, 1935, 1936; All States Exh., Rockefeller Ctr., NYC, 1938. Work: WPA murals: Agriculture Bldg., State Fair Grounds, Iowa; Index Am. Des. [40]

VERNON, Arthur G. [P] NYC. Member: Calif. AC [17]

VERNON, Cora Louise [P] NYC [17]

VERNON, Elba. See Riffle.

VERRECCHIA, Alfeo [Li,P,Des] Providence, RI b. 16 Je 1911, Providence. Studied: RISD; Provincetown Sch. A.; J.R. Frazier. Member: Contemp. A., Providence. Exhibited: AFA Traveling Exh.; NAD, 1943; MMA (AV); Providence AC, 1943 (prize); LOC, 1943 (prize). Work: LOC [47]

VERREES, J. Paul [P,I] Scherpenberg, Westmalle, Belgium b. 24 My 1889, Turnhout, Belgium. Studied: J. de Vriendt; F. Lauwers; Royal Acad. FA, Antwerp; Higher Inst. FA, Belgium. Member: Brooklyn SE; Chicago SE. Exhibited: AIC, 1921 (med). Work: AIC; State Lib., Calif.; NYPL; Smithsonian Inst., Wash., D.C.; BMFA [29]

VERRIER, James [P] Arlington, NJ [25]

VERSCHAEREN, Barth [P] NYC. Member: S.Indp.A. [24]

VERSEN, Kurt [Des] Tenafly, NJ b. 21 Ap 1901. Studied: Polytech Sch., Charlottenburg, Germany. Member: Nat. AAI; Soc. Des. C. Exhibited: lighting displays: WFNY, 1939; GGE, 1939; U.S. Pavilion, Paris Expo, 1937; Intl. Expo, Paris, 1937 (med). Work: lighting systems: Wadsworth Atheneum; Spring (Mass.) Mus. FA; Cincinnati Mus.; WMAA, NYC; San Diego Expo, 1935. [40]

VER STEEG, Florence B(iddle) [P] St. Louis, MO b. 17 O 1871, St. Louis, MO. Studied: St. Louis Sch. FA; R. Miller; H. Breckenridge. Member: St. Louis AG; North Shore AA; Boston AC; All-Ill. SFA; S.Indp.A., St. Louis. Exhibited: Kansas City AI, 1923 (prize); St. Louis AL, 1928 (prize); Mo. Artists, 1929 (prize); All-Ill. SFA (gold), 1935. Work: House of Detention, St. Louis [40]

VERTES, Marcel [P,I] NYC b. 10 Ag 1895, Ujpest, Hungary d. 31 O 1961, Paris, France. Studied: Académie Julian. Member: AL Am.; Scenic A.; Knight of Leg. of Honor. Work: MOMA; Luxembourg Mus. A., Paris; murals: Dallas; Plaza Hotel, NYC. Author/Illustrator: "The Stronger Sex," "Art and Fashion." Contributor: Vogue, Harper's Bazaar [47]

VERY, Marjorie [P] Westwood, MA [25]

VESCE, Francesco [S] Brooklyn, NY [25]

VESCIA, L.F. [S] NYC [10]

VETTER, Cornelia Cowles (Mrs.) [P] Cheshire, CT b. 20 F 1881, Hartford, CT. Studied: PIASch; ASL, with R. Henri; Spain and Paris, with Anglada-Camarasa. Member: CAFA; New Haven PCC. Exhibited: Stockbridge, Mass.; Springfield, Mass.; NYC; Hartford, Conn.; CAFA, 1930 (prize); New Haven PCC, 1932 (prize). Work: Juvenile Court, Hartford [47]

VETTER, George Jacob [P,Des,B,C] Elmira, NY b. 5 Ja 1912. Studied: H. Kelsey. Member: Elmira Sketch C.; Elmira AS. Specialty: wood engraver [40]

VEVANZI, Carlo Gino [P] Kansas City, MO [17]

VEZIN, Charles [P,W] NYC/Old LYme, CT b. 9 Ap 1858, Phila., PA d. 13 Mr 1942, Coral Gables, FL. Studied: ASL, with DuMond, Chase, G.E. Browne, J. Carlson, F.L. Mora; H. M. Turner; G.M. Bruestle. Member: SC. 1902; Brooklyn SA (Pres.); Brooklyn PS; NAC; Century Assn.; Lyme AA; SPNY; Allied AA; NYWCC; Yonkers AA; ASL (Pres.) 1911–15; SC, 1902 (Pres., 1914); Deutsch Verien. Exhibited: S. Wash. A., 1914 (prize); CAFA, 1925 (prize); Lyme AA, 1927 (prize); Hudson Valley AA (prize); Palm Beach A. Ctr., 1935 (prize); Allied AA, 1935 (prize). Work: High Mus., Atlanta; Montclair (N.J.) Mus. [40]

VHAY, John D. (Mrs.) [P] Pontiac, MI [21]

VIAGGIO, Pietro [P] NYC [25]

VIANCO, Ruth Hastings [P,I,C,T] Rochester, NY b. 23 Ag 1897, Rochester. Studied: Mechanics Inst. Member: Rochester AC. Exhibited: Rochester AC, 1917 (prize), 1918 (prize). Specialty: watercolor [27]

VIANDEN, Heinrich [Ldscp.P,T] Milwaukee, WI b. 1814, Popplesdorf, Germany (came to Milwaukee in 1849) d. 1899. Studied: Munich; Antwerp. A leading painter in Wis. and teacher of many of the best-known Wis. artists of the late 19th century. [*]

VIAVANT, George [P] New Orleans, LA b. New Orleans d. 1925. Studied: Parelli, Southern Union. Exhibited: New Orleans Cotton Centenn. Expo, 1884 (prize). Work: La. State Mus. Specialty: watercolors of local fauna [*]

VIBBERTS, Eunice Walker (Mrs. Gerald) [P,T] Greenwich, CT b. 8 Ag

1899, New Albany, IN. Studied: PIASch; ASL; Beaux-Arts, Fontainebleau, France; A. Fisher; F.V. DuMond; J. Despujols. Member: NAWA; Greenwich SA; Scarsdale AA; Westchester A. & Crafts G; Louisville AA; Westchester AA. Exhibited: CGA; NAWA, 1925-27, 1929-32, 1934, 1936-38, 1940-44, 1946; Scarsdale AA, 1929-45, 1941 (prize), 1943 (prize); Greenwich SA, 1943, 1944, 1945 (prize) 1946; Baekland prize, 1943. Position: T., Adult Ed., Rye, N.Y., 1940 [47]

VIBBERTS, Grace Chamberlain (Mrs. Frank G.) [P] New Britain, CT d. 4 F 1945. Member: NAWPS; Hartford S. Women P. Exhibited: NAWPS, 1935-36; CAFA, 1933, 1938 [40]

VICE, Herman Stoddar [P,I] Chicago, IL b. 21 Je 1884, Jefferson, IN. Studied: Chicago Acad. FA. Member: South Side AA [40]

VICKERS, S(quire) J(oseph) [P,Arch,W] Grandview-on-Hudson, NY b. 18 My 1872, Middlefield, NY. Studied: Cornell. Member: Arch. Lg. [27]

VICKERY, John [I,Des,P] NYC b. 31 Ja 1906, Victoria, Australia. Studied: Nat. Gal. A. Sch., Melbourne, Australia. Member: Victorian AS; New Melbourne AC; Chelsea AC, London, England; SI. Exhibited: A. Dir. C., NYC, 1937, 1941, 1942; A. Dir. C., Phila., 1943; Outdoor Adv. A., Chicago, Ill. Work: Nat. Gal., Melbourne [47]

VICTOR, Sophie [P] Detroit, MI [25]

VIDAR, Frede [Mur.P,Min.P,Por.P] Montclair, NJ b. 6 Je 1911, Denmark. Studied: Royal Acad., Denmark; Calif. Sch. FA; Ecole des Beaux-Arts, Académie Julian, both in Paris; Acad. FA, Munich, Germany. Member: Am. Acad., Rome; San Fran. AA; NSMP; N.J. AA; Calif. S. Mural A. Awards: Chaloner F., 1932, 1935, 1936, 1937; Guggenheim F., 1946. Exhibited: 48 Sts. Comp., 1939. Work: MOMA; Nat. Mus., Copenhagen; Pal. Leg. Honor; Newark Mus.; Pasadena AI [47]

VIELE, Sheldon K. [P] Buffalo, NY [17]

VIERRA, Carlos [Ldscp.P,Mur.P,Ph] Santa Fe, NM (since 1904) b. 1876, Moslanding, CA d. 1937. Studied: San Fran., with G. Piazzoi. Work: Mus. N.Mex.; murals, Santa Fe AM. He was a marine painter in NYC, 1901-03. [19]

VIERTEL, Paul A. [P] Columbus, OH. Member: Columbus PPC [25]

VIETT, E.T. [S] Charleston, SC [04]

VIGNA, Gloriano [P,S,I,Arch,W,T] Paterson, NJ b. 20 Ag 1900, Paterson. Studied: Bridgman; Du Mond; F. Vigna, in Turin, Italy. Decorator: to the King and Queen of Italy [33]

VILLA, Hernando Gonzallo [P,I,T,Mur.P] Los Angeles, CA b. 1 O 1881, Los Angeles d. 7 My 1952. Studied: Los Angeles Sch. FA, 1905; England & Germany, 1906. Exhibited: San Fran. mural, P.-P. Expo, 1915 (gold). Illustrator: West Coast mag.; Los Angeles Town Talks, Santa Fe RR for 40 yrs. Work: murals in Los Angeles and Phoenix. Specialty: scenes of the Old West and Indians [*]

VILLANI, James A. [P] St. Albans, NY. Member: AWCS. Exhibited: NYWCC, 1937; AWCS-NYWCC, 1939 [47]

VILLENEUVE, Nicholas [I,Cart] Boise, ID. Work: Huntington Lib., San Marino, Calif; Carnegie Lib., Boise. Position: Illus., Cart, Idaho Daily Statesman [40]

VILLERE, Elizabeth. See Forsyth.

VILLON, Jacques [P] NYC (care of Walter Pach). Member: S.Indp.A. [25]

VINCENT, Ada S. (Mrs. John W.) [P] Roland Park, MD. Member: Baltimore WCC [25]

VINCENT, Andrew McDuffie [P,T] Eugene, OR b. 14 My 1898, Hutchinson, KS. Studied: AIC; Member: Am. Assn. Univ. Prof.; AAPL. Exhibited: GGE, 1939; SAM; Portland A. Mus.; San Fran., Calif.; Mills Col., Denver, Colo.; Chicago, Ill.; Eugene, Ore.; AIC, 1928 (prize). Work: SAM; WPA murals, USPOs Toppenish (Wash.), Salem (Oreg.). Position: T., Univ. Oreg. [47]

VINCENT, Harriet S. [P] NYC [15]

VINCENT, H(arry) A(iken) [Mar.P] Boston, MA b. 14 F 1864, Chicago d. 27 S 1931. Studied: self-taught. Member: ANA; SC; Allied AA; NYWCC; North Shore AA. Exhibited: SC, 1907 (prize), 1916 (prize), 1918 (prize), 1925 (prize); NYWCC (prizes). Work: Butler AI; Ill. State Univ. [29]

VINMAR, Charles [P] NYC. Member: S.Indp.A. [25]

VINSON, L.C. [P] Cleveland, OH. Member: Cleveland SA. Position: Affiliated with Gage Gal., Cleveland [27]

VINSON, Lyle [P] Newark, NJ [15]

VINSON, Marjorie Green (Mrs. Fleming G.) [P] d. 25 My 1946, Savannah, GA. Member: SSAL

VINTON, Frederick Porter [Por.P] Boston, MA b. 29 Ja 1846, Bangor, ME d. 19 My 1911. Studied: Boston, with W.M. Hunt; Lowell AI, wih W. Rimmer; Paris, briefly with Bonnât, 1874; Munich, with Piloty; Royal Acad., Munich, with Mauger, W. Diez, 1874; first Am. to study with Laurens, 1875; returned to Boston, 1879. Member: NA, 1891; SAA, 1880; NIAL. Exhibited: Paris Salon, 1890 (prize); Columbian Expo, Chicago, 1893 (gold); Atlanta Expo, 1895; Paris Expo, 1900 (med); Pan-Am. Expo, Buffalo, 1901 (gold); St. Louis Expo, 1904 (gold); BMFA, 1911 (mem. exh.)

VINTON, L(illian) Hazlehurst [P] NYC/Essex, NY b. 5 Je 1881, Boston, MA. Studied: S. Simi, Florence; Paris with R. Collin, Courtois, R. Miller; Woodbury [25]

VINTON-BROWN, Pamela (Mrs.) [Min.P,P] Woodstock, NY b. 28 Ja 1888, Boston, MA. Studied: Paris with Collin, Courtois; E. Whiteman, Baltimore. Member: AMSP. Exhibited: Exh. Am. Woman's Work, Paris, 1914 (prize); Baltimore WCC, 1920 (prize). Work: CMA; BM. Listed in 1917 as Mrs. Vinton-Strunz in Roland Park, Md. [40]

VINTON-STRUNZ, Pamela. See Vinton-Brown.

VINTROUX, Kendall [Cart] Charleston, WV. Work: Huntington Lib., San Marino, Calif. Affiliated with Charleston Gazette [40]

VIRGIN, Norman L. [P,I] Virginia, IL [19]

VIRRICK, William E. [P] NYC [19]

VIRTUE, R.A. [P] Chicago, IL [10]

VISMOR, Dorothy Anita Perkins (Mrs.) [P,E,T] Atlanta, GA b. 31 D 1911, Crown King, AZ. Studied: High Mus. Sch. Art, Atlanta. Member: SSAL; Assn. Ga. A.; Atlanta AG; Atlanta AA. Exhibited: High Mus., 1935 (prize), 1937 (prize); All-Atlanta A. Exh., 1937 (prize); YWCA, 1936 (one-man); Carnegie Lib., Atlanta, 1937 (one-man) [40]

VISTYN, James [Ldscp.P] Cleveland, OH b. 14 Ap 1891, Cleveland, OH. Studied: Cleveland Sch. A.; H.G. Keller; W.J. Eastman; F.C. Gottwald; Berkshire Summer Sch. A., Monterey, Mass. Member: Springfield AL; S.Indp.A. Exhibited: Springfield AL, 1933 (prize), 1936 (prize) [47]

VITACCO, Alice (L. Alice Wilson) [P,I,Des,Dec] Westport, CT b. 30 N 1909, Mineola, NY. Studied: L.V. Solon; N.Y. Sch. Appl. Des. for Women; Univ. Mexico; W. Reiss; K. Nicolaides; L. Bernhard. Member: NAWA; Salons Am. Exhibited: Lexington Gal., N.Y., 1929, 1939 (prize); Wolfe Mem. prize, 1931; NAWA, 1936 (prize). Illustrator: "Mexican Popular Arts," 1939 [47]

VITOUSEK, Juanita Judy (Mrs. R.A.) [P] Honolulu, HI b. 22 My 1892, Portland, OR. Studied: Millard Sheets, at Univ. Calif. Member: AWCS; Honolulu AA. Exhibited: Honolulu AS, 1934 (prize); Honolulu Acad. A., 1937 (prize), 1938 (prize); PAFA; Riverside Mus.; Calif. WCS; Honolulu AA [47]

VITTOR, Frank [S] NYC b. 6 Ja 1888, Italy. Studied: Bistolfi. Member: Acad. Brera, Milan, Italy; Wash. AC. Work: bust, Pres. Wilson, White House; Pittsburgh Chamber of Commerce [19]

VITTORI, Enrico [S] Indianapolis, IN [19]

VIVASH, Ruth. See Athey.

VIVIAN, Calthea (Campbell) [P,E,T] Berkeley, CA b. ca. 1870, Fayette, MO. Studied: Crocker AI, San Fran.; A. Mathews, Mark Hopkins AI, San Fran.; Paris, at Lasar Acad., Colarossi Acad. Member: San Fran. AA; San Fran. SE; Laguna Beach AA; Calif. AA; Calif. AC. Work: Palace FA, San Fran.; Ark. Auditorium Gal. [33]

VIVIAN, G. [P] NYC b. Venice, Italy. Studied: Royal Acad. FA, Venice [06]

VIVIANO, Emanuel [S,P] Chicago, IL. Exhibited: AIC, 1935, 1938; Chicago Ar. Ann., 1936, 1938; WFNY, 1939 [40]

VIVIEN, Arthur S. [P] New Orleans, LA [17]

VOELCKER, Rudolph A. [S] Newark, NJ b. 10 Mr 1873. Member: AAPL; A. Ctr. of the Oranges. Exhibited: Newark AC, 1937 (prize); Kresge Gal., Newark, 1937 (prize), 1938 (prize); A. Ctr. of the Oranges, 1939 (prize) [40]

VOGEL, Donald S. [P,L,T,E] Dallas, TX. b. 20 O 1917, Milwaukee, WI. Studied: Corcoran Sch. A.; AIC. Member: "The Eight"; P. of Tex. Exhibited: CI, 1941; NGA, 1941; AV, 1942; PAFA, 1941; Oakland A.

Gal., 1941, 1942; SFMA, 1941, 1942; CM, 1941; AIC, 1940; Tex. General Exh., 1941-42, 1943 (prize), 1944 (prize), 1945; Dallas All. A., 1941-45 (prize); Am. Acad., Rome, 1941 (prize). Work: Dallas Mus. FA [47]

VOGEL, Joseph [Mur.P,Lith,Des,L] NYC b. 22 Ap 1911, Austria. Studied: NAD, with L. Kroll. Member: NSMP; Mural AG; Union Am. Ar. Exhibited: WFNY, 1939 [40]

VOGEL, Valentine [P,T,G] Cedar Hill, MO b. 19 Ap 1906, St. Louis. Studied: K. Cherry; Wash. Univ.; NAD; Grande Chaumière; Am. Acad., Rome; C.W. Hawthorne; A. Angarola; Lhote. Member: St. Louis S.Indp.A.; Lg. Am. Pen Women; St. Louis AL; Am. C., Paris. Exhibited: St. Louis AG, 1929 (med), 1930 (prize); St. Louis AL (prizes); Kansas City AI, 1939 (med); St. Louis Post-Dispatch, 1931 (prize); St. Louis Little Theatre, 1931 (prize); YMHA, 1944 (prize). Work: murals: Crunden Lib., St. Louis; St. Louis City Hospital; Md. Sch., Clayton, Mo.; Belvue Sch., Univ. City, Mo.; Pub. Lib., Sikestone, Mo.; YMHA; University City H.S., St. Louis. Position: T., YMHA, St. Louis [47]

VOGELGESANG, Shepard [Des,Dec,L] Whitefield, N.H. b. 9 F 1901, San Francisco, CA. Studied: MIT; Staats Kunstgewerbe Schule, Vienna; J. Hofmann. Member: Chicago AC; BAID; Artists U. Chicago; Am. Fed. A. Work: stage settings: Avery Mem., Hartford, Conn.; Univ. Chicago; des., interior color & mural projects, Century of Progress, 1933; Chief Des., Com. FA, GGE, 1939; Des., exhibits, WFNY, 1939. Contributor: Architectural Record, Architectural Forum, Magazine of Art [47]

VOGNILD, Enoch M. [P] Chicago, IL b. 8 Ap 1880 Chicago d. 18 Ag 1928, Woodstock, NY. Studied: AIC, with Johansen, Vanderpoel; Woodbury, in Ogunquit, Maine; Paris, at Acad. Julian, Acad. Delecluse. Member: ASL, Chicago; Round Table; Chicago AC; Chicago AG; Chicago SA. Exhibited: Mun. AL, 1906 (prize); Norwegian C., 1925 (prize) [27]

VOGNILD, Edna (Mrs. Ted) [Por.P,L] Chicago, IL b. 23 N 1881. Studied: AIC; C. Hawthorne; J. Johansen; H.B. Snell; Acad. Colarossi; Bileul Acad., Paris. Member: All-Ill. SFA; Northwest AL; S. Sanity A.; Munic. AL. Exhibited: All-Ill. SFA, 1937 (prize) (gold) [47]

VOGT, L(ouis) C(harles) [P] Cincinnati, OH b. 29 Jy 1864, Cincinnati. Studied: H.S. Mowbray; F. Duveneck. Member: Cincinnati AC. Work: Cincinnati Mus. [24]

VOIGHT, Charles A. [I,Cart] NYC/Pelham Manor, NY b. 1888 d. 10 F 1947. Member: SI 1913; New Rochelle AA. Drew comic feature "Betty" for New York Tribune syndicate, 1919-42 [27]

VOIGTLANDER, Katherine [P,T] Kansas City, MO b. 19 Ap 1917, Camden, NJ. Studied: Univ. Pa.; Kansas City AI; PAFA, Cresson Schol., 1938; Univ. Kansas City; T. Benton; G. Harding; F. Speight. Member: F., PAFA. Exhibited: Kansas City AI, 1931, 1936; Denver, Colo., 1939; Phila. AC, 1938; Women Painters of Am., 1936 (prize); Cumberland Valley Exh., 1944 (prize), 1945-46; PAFA, 1940 (prize). Position: T., Wilson Col., Chambersburg, Pa., from 1943; Wash., County Mus., Hagerstown, Md., from 1946 [47]

VOLCK, Adalbert John [P,S,C,Caric] Baltimore, MD (since 1850s) b. 14 Ap 1828, Augsburg, Germany (came to U.S. in 1848) d. 26 Mr 1912. Studied: Nurnburg; Munich. As a Confederate during the Civil War he signed his caricatures "V. Blada." He was also a dentist while prominent in art circles of Baltimore. Brother of Frederick. [*]

VOLCK, Fannie (Mrs.) [P] Houston, TX [13]

VOLCK, Frederick [S] b. 1833, Bavaria d. 1891, probably Baltimore. Work: Peabody Inst., Baltimore. Said to have designed the Confederate 10 cent stamp bearing port. of Jefferson Davis. Active in Baltimore after 1865. Brother of Adalbert. [*]

VOLCK, G.A. (Mrs.) [P] Houston, TX. Member: Houston AL [25]

VOLCK, Hans H. [P] Cleveland, OH [25]

VOLEM, Franc. See Guglielmi

VOLK, Leonard Wells [S] Chicago, IL b. 7 N 1828, Wells, NY d. 19 Ag 1895, Osceola, WI. Studied: St. Louis; Rome, 1855-57. Best known for his statue of relative Stephen A. Douglas and port. bust of A. Lincoln. He was the only sculptor to make life casts of Lincoln's face and hands. Father of Stephen. [*]

VOLK, (Stephen A.) Douglas [P,T,L,W,I] NYC/Centre Lovell, ME. b. 23 F 1856, Pittsfield, MA d. 7 F 1935, Fryeburg, ME. Studied: St. Luke Acad., Rome, 1870; Paris, with Gérôme, 1873-78. Member: ANA, 1898; NA, 1899; SAA, 1880; NAC; A. Fund S.; A. Aid S.; Port. P.; Arch. Lg., 1912; Century Assn.; Intl. SAL; Mural P.; SI; Wash. AC; AFA. Exhibited: Louisville AL, 1898; St. Louis Expo, 1898, 1904 (med); Paris Salon, 1875-78; Phila. Centenn., 1876; Columbian Expo, Chicago 1893 (med); SAA, 1899 (prize), 1903 (prize); Colonial Exh., Boston, 1899 (prize); Pan-Am. Expo, Buffalo, 1901 (med); Charleston Expo, 1902 (med); Carolina AA, 1907 (gold); NAD, 1910 (gold,prize), 1915 (prize); NAC, 1915 (gold); P.-P. Expo, San Fran., 1915 (gold); PAFA, 1916 (gold). Award: Officer of the Order of Leopold II, 1921. Work: murals des., Capitol, St. Paul, Minn.; CI; MMA; CGA; NGA; Pittsfield (Mass.) Mus.; Des Moines (Iowa) Courthouse, 1913; Montclair (N.J.) Mus.; Rochester Mem. A. Gal.; NAD; Hackley A. Gal., Muskegon, MI; Omaha A. Gal.; NGA; Albright Gal., Buffalo; Portland (Maine) Mem. Art. Mus.; West Point. Organizer: handicraft movement at Centre Lovell. Positions: T., NAD; CUASch.; Dir., Minneapolis Sch. FA, 1886-93 [33]

VOLK, Victor [P,B,W] Milwaukee, WI b. 21 Jy 1906, Milwaukee. Studied: G. Moeller. Member: Wis. PS. Exhibited: Wis. Salon, 1934 (prize); Wis. PS, 1936 (prize). Work: gov.-owned high schools (WPA work). [40]

VOLKERT, Clara Maude [P] Cincinnati, OH b. 3 N 1883, Cincinnati d. 9 O 1936. Studied: Cincinnati A. Acad. with Duveneck, Nowottny, Meakin, Beck; ASL, with Mowbray. Member: Cincinnati Women's AC. Exhibited: Cincinnati Women's AC [13]

VOLKERT, Edward Charles [Ldscp.P] Lyme, CT b. 19 S 1871, Cincinnati d. 4 Mr 1935. Studied: F. Duveneck, in Cincinnati; ASL. Member: ANA; NYWCC; AWCS; Alled AA; SC; Union Int. des Beaux-Arts et des Lettres; Cincinnati MacD. S.; Am. Soc. Animal PS; NAC; CAFA; AFA. Exhibited: PAFA, 1898; NYWCC, 1919 (prize); CAFA, 1925 (prize), 1929 (prize); PAFA, 1898; New Haven PCC, 1930 (prize); Lyme AA, 1932 (prize). Specialty: watercolors of cattle, rural scenes [33]

VOLKMAR, Charles [P,S,Et,C,T,Cer] Metuchen, NJ b. 21 Ag 1841, Baltimore d. 6 F 1914. Studied: Paris, sculpture with Barye, painting with Harpignies. Member: Arch. Lg., 1890; SC, 1880; NAC. Exhibited: AWCS, 1898. At first a landscape and animal painter, he later became chiefly a potter. [13]

VOLKMAR, Leon [Cer,P,L,T] Bedford, NY b. 25 F 1879, Paris, France (of Am. parents) d. 30 O 1959. Studied: NAD; C. Volkmar. Member: N.Y. Cer. S. (Hon. Pres.) SA. Exhibited: AIC (med); Greenwich (Conn.) Paris Salon, 1937 (med). Work: AIC; Detroit Inst. A.; Cranbrook Acad. A.; BMFA; BMA; BM; Newark Mus.; MMA. Position: T., Westchester Workshop, West Co. Ctr., White Plains, N.Y., 1940 [47]

VOLL, Joseph A. [P] Pittsburgh, PA. Member: Pittsburgh AA [21]

VOLLMER, Clarence C. [P] Chicago, IL. Member: GFLA [27]

VOLLMER, Grace Libby [P] Laguna Beach, CA b. 12 S 1889, Hopkinton, MA. Studied: E. Vysekal; E.R. Shrader; H. Hofmann. Member: Laguna Beach AA. Exhibited: Orange Co., Calif. Fair, 1927 (prize); Laguna Beach AA, 1935 (prize); 1936 (prize) [40]

VOLPE, Anton [S] Phila., PA b. 1853 d. 26 My 1910, NYC.

VOLZ, Gertrude (G.V. Crosby) [P,S] NYC b. 27 O 1898 NYC. Studied: ASL [33]

VOLZ, Herman [P,Li,C] Los Angeles, CA b. 25 D 1904, Zurich, Switzerland. Studied: Commercial A. Sch., Zurich; Acad. FA, Vienna. Member: Council All. A., Los Angeles. Exhibited: Paris Salon, 1937; LOC, 1945; SFMA, 1937-41; Crocker A. Gal., 1942 (one-man); Nat. Exh., Berlin, Germany, 1927 (prize); San Fran. AA, 1937 (prize); Riverside Mus. Work: SFMA; mosaic murals, San Fran. Jr. Col. [47]

VON ALLESCH, Marianna [C,Des,T,Mur.P,L] NYC b. Ingolstadt, Germany. Studied: Europe, with A. Niemayer, B. Paul; Royal Acad., Berlin. Exhibited: WFNY, 1939; GGE, 1939; extensively in Europe; Gov. Acad., Berlin (med); Musée des Arts Decoratifs (prize); Salon d'Automne, Paris (prize); Italy (prize); Japan (prize). Work: Detroit Inst. A.; Minneapolis IA; AIC. Industrialized Glass Industry (6,000 Glass Blowers) for German Gov., Thuringen. Creator: Pulaski Modern Furniture [47]

VON ALT, Joseph [P] Bloomfield, NJ b. 1874, NYC. Studied: NAD. Member: Country Sketch C. [08]

VON AUW, Emilie [P,C,Des,E,S,L] Albuquerque, NM b. 1 S 1901, Flushing, NY. Studied: N.Y. Sch. F.& Appl. A.; Columbia; Ecole des Beaux-Arts, Paris; Germany; Holland; Italy. Member: N.Mex. AL; Clay C., NYC. Exhibited: Brooklyn SA; Clay C., NYC: Albuquerque A.; N.Mex. AL; Univ. N.Mex.; Mus. N.Mex., Santa Fe. Positions: Dir., Studio Workshop, Albuquerque; T., Univ. N.Mex., 1940-45 [47]

VON BELFORT, Charles [B,I] Los Angeles, CA b. 10 Ja 1906, NYC. Studied: J.F. Smith; F. Geritz [40]

VON BERG, Capt. Charles L. [Ldscp.P,Genre P] b. 1835, Bavaria, Germany (came to NYC in 1854) d. 1918, probably Colorado. Civil War and Indian

scout. Hunting scout for Grand Duke Alexis of Russia, 1872 in Colo. and Nebr. Work: Denver Pub. Lib. [*]

VON DACHENHAUSEN, Friedrich W(ilhelm) [P,Des,T] Wash., D.C. b. 25 D 1904, Wash., D.C. Studied: A. Ianelli; F. Poole; F. Spieler; Hermann; Rosse; C. Robinson; J. Reynolds; AIC; Nat. Sch. F.&Appl. A. Member: Soc. Min. PS&G, Wash., D.C. Work: altar cards, Nat. Cathedral, Wash., D.C. [40]

VON DER LANCKEN, Frank [P,L,T,S] Tulsa, OK. b. 10 S 1872, Brooklyn, NY d. Ja 1950. Studied: PIASch, with H. Adams; ASL, with Mowbray; Académie Julian, with Constant, Laurens. Member: SC; Tulsa AG; Assn. Okla. A.; Philbrook M., Tulsa; P. & PMG. Exhibited: NAD; SAA, 1898; Arch. L.; Boston WCC; PAFA; CM; Pal. Leg. Honor, 1946; Rochester Mem. A. Gal.; Kent AA; Tulsa AA; Okla. A. Ctr.; AFA, 1938; Syracuse MFA (one-man); PIASch (one-man); Highland Park Gal., Dallas (one-man); Philbrook A. Ctr. (one-man); Chautauqua, N.Y. (one-man); Okla. State Exh., 1943 (prize); Ky. State Exh., 1925 (med); Rochester Expo, 1926 (med); PAFA, 1937 (gold); Okla. AL, 1945 (med); Ky. Fed. Women's C., 1925 (med). Work: PAFA; SC; Univ. Rochester Lib.; Univ. C., Rochester; Univ. C., Tulsa; Hist. Bldg., Oklahoma City; Panhandle Bank, Amarillo, Tex.; Pub. Lib., Tulsa; Rochester Inst. Tech.; Tulsa Central H.S. Positions: T., Rochester Inst. Tech., 1904–24; Dir., Sch. A. & Crafts, Chautauqua Inst., 1921–36; Univ. Tulsa, Okla., 1935–45 [47]

VON DER LANCKEN, Giulia [Des,P,T] Tulsa, OK/New Milford, CT. b. Florence, Italy. Studied: NYU; Tulsa Univ.; G. Fattori; A. Burchi; A. Zochhi, Royal Acad. FA, Florence, Italy; Mechanics Inst., Rochester, N.Y. Member: Southwest AA. Exhibited: Okla. Ar., Tulsa AA (prize). Position: Ed. Staff, The Tulsa Teacher [40]

VON DRAGE, Ilse [C] NYC b. 30 S 1907. Studied: State Sch., Munich; F. Schmidt. Specialties: goldsmithing; enameling. Position: T., Crafts Students' League [40]

VONDROUS, John C. [P,I,E] East Islip, NY/Prague, Czechoslovakia b. 24 Ja 1884, Bohemia, Europe. Studied: NAD, with E.M. Ward, G. Maynard, F.C. Jones, J.D. Smillie. Member: S.V.U. Manes; Graphic Arts S.; "Hollar," of Prague; Chicago SE; Calif. PM. Exhibited: P.-P. Expo, San Fran., 1915 (med); Chicago SE, 1917 (prize), 1918 (prize), 1919 (prize); Sesqui-Centenn. Expo, Phila., 1926 (med). Work: Modern Gal., Prague; AIC; NYPL; Fogg Mus.; LOC; Victoria & Albert Mus., British Mus., both in London; Kupferstich Kabinett, Berlin [31]

VEN EHRENWIESEN, Hildegard. See Rebay.

VON EISENBARTH, August [P,Des] Bronxville, NY b. 15 1897, Hungary. Studied: Royal Hungarian Acad.; ASL. Member: Nat. Salon, Budapest; AWCS. Work: Nat. Salon, Budapest; AWCS; NYWCC. Specialties: watercolors; adv. and textile des. [40]

VON ERFFA, Helmut [P,W,L,T] New Brunswick, NJ b. 1 Mr 1900, Lueneburg, Germany. Studied: Harvard; Princeton; Germany, with J. Itten; P. Klee. Member: CAA; Am. Oriental S.; Am. Arch. S. Exhibited: Swarthmore Women's C., 1945; Wadsworth Atheneum, 1930; PMA, 1946. Work: Wadsworth Atheneum. Contributor: FMA Bulletin, College Art Journal, Ars Islamica, etc. Positions: T., Harvard Univ., 1930–32; Bryn Mawr Col., 1935–36; Northwestern Univ., 1938–43; Swarthmore Col., 1943–46; Rutgers Univ., from 1946 [47]

VON FALKENSTEIN, Clare [P] San Francisco, CA. Exhibited: SFMA, 1937, 1939; Oakland A. Gal., 1938 (prize) [40]

VON FRANKENBERG, Arthur [P] NYC Member: GFLA [27]

VON GLEHN, Jane Emmet (Mrs. W.G.) [P] NYC [13]

VON GLEHN, W.G. [P] NYC [13]

VON GOTTSCHALCK, O.H. [P,I] Hackensack, NJ. Studied: RISD; ASL. Member: SC, 1903 [21]

VON GROSCHWITZ, T.F. Gustave [Mus.Dir,L,T,W] NYC b. 16 Ap 1906, NYC. Studied: Columbia; NYU. Member: SAE; Am. Nat. Comm. Engraving; F., CAA, 1945–46. Contributor: Prints, Print Collector's Quarterly, Art Bulletin. Position: Cur. Prints, T., Wesleyan Univ. [47]

VON HELMOLD, Adele. See Read.

VON HOFSTEN, H(ugo Olof) [I,P] Winnetka, IL b. 20 Je 1865, Sweden. Studied: Royal Acad., Stockholm with M.E. Wingé, O. Aborelius, A. Larson. Member: Forestry Painters of Chicago (organizer). Exhibited: Swedish Am. Artists, 1919 (prize) [31]

VON JOST, Alexander [Por.P,E] Richmond, VA b. 24 Ja 1889, Laurence, MA d. 11 Ja 1968. Studied: Johns Hopkins Univ.; Md. Inst. Exhibited: S.C. State Fair, 1927 (prize); Richmond Acad. A.&Sc., 1933 (prize). Work: Hanover County Court House, Va.; Confederate Mus., Richmond, Va.; Supreme Court, William & Mary Col., Williamsburg, Va.; Richard Cimbal Lib., Phila. Pa.; Blues Armory, Richmond, Va. [47]

VON LEHMDEN, Ralph [P,Des] Larchmont, NY b. 17 S 1908, Cleveland, OH. Studied: Cleveland Sch. A.; Western Reserve Univ.; Grand Central Sch. A. Member: Chicago AC. Exhibited: AIC, 1940 (prize); CI, 1941; CMA; Butler AI; Kansas City AI; Milch Gal., NYC. Position: Adver. Des., Chicago Tribune, 1929–42; freelance, from 1946 [47]

VON LOSSBERG, Victor F. [C] NYC b. Baltic Provinces, Russia. Studied: Germany, with Olbrich, Darmstadt; Paris, with Rémil, Ecole des Arts et Metiers. Member: Arch. Lg.; Alliance; Art-in-Trades C. Exhibited: AIA, 1926 (med); Arch. L., 1931 (med). Specialties: metalwork; enamels. Positions: Pres./Des., Edward F. Caldwell & Co., Inc. [40]

VON MANIKOWSKI, Boles [P,Des,S,L] Corning, NY b. 11 S 1892, Kempen, Germany. Studied: ASL; L. Hofstrup; S. Moldovan; F. Carder; Baer, Germany; AIC; E. Anderson. Exhibited: S.Indp.A., 1936; Cayuga Mus. Hist.&A., 1940, 1941; Blue Ridge, N.C., 1942 [47]

VON MARR, Carl [P,I,T] Munich, Bavaria b. 14 F 1858, Milwaukee, WI d. 10 Jy 1936. Studied: Weimar Acad., with Schaus; Berlin Acad., with Gussow; Munich, with Seitz, Gabriel Max, Lindenschmit; H. Vianden; Acad. of Athens. Member: NIAL. Exhibited: Prize Fund Exh., NYC, 1886 (gold); Vienna, 1893 (med), 1894 (med); Berlin, 1891 (gold); Munich, 1889 (med), 1893 (med); Dresden (med); Madrid, 1892 (med); Salzburg (med); Barcelona (med); Antwerp (med); Budapest (med); Liège, 1905 (med); Anvers, 1894 (med). Work: TMA; MMA; Königsburg; Breslau; Munich; Budapest. He was one of the American-born artists who reached the top in German art. He resided in Munich most of his life, where he had been a professor at the Bavarian Acad. Arts since 1893. [33]

VON MEYER, Michael [S,T] San Fran., CA b. 10 Je 1894, Russia. Studied: Calif. Sch. FA, San Fran. Member: San Fran. AA. Exhibited: Oakland A. Gal., CGA, 1936; WMAA, 1936; Calif. AA; Pal. Leg. Honor; de Young Mem. Mus.; GGE, 1939; San Fran. AA, 1926 (prize), 1934 (med); Women's AA, 1926 (prize); Oakland A. Gal. (med). Work: SFMA; Pal. Leg. Honor; Univ. Calif. Hospital; San Fran. City Hall; House Office Bldg., Wash., D.C.; USPO, Santa Clara, Calif.; Fleishhacker Playground, San Fran.; statue, Art Comm., San Fran.; Stanford Univ. Hospital. Contributor: Asia, Art News, Pencil Points [47]

VON MIKLOS, Josephine [Indst.Des,W,L] New Canaan, CT b. 5 My 1900, Vienna, Austria. Studied: Univ. Vienna. Member: Arch. L.; Fashion Group; ADI. Exhibited: Arch. L., 1944; All-America Package Comp., 1941 (prize). Work: des. for leading cosmetic manufacturers. Author/Illustrator: "I Took a War Job," 1943. Contributor: Modern Packaging, Modern Plastics [47]

VON MINCKWITZ, Katharine [P,G,S,T] NYC b. 10 My 1907, NYC. Studied: J. Sloan; H. Sternberg [40]

VON NESSEN, Walter [Des] NYC b. 12 D 1889, Iserlohn, Germany. Studied: B. Paul; Grenander. Member: Nat. AAI. Position: Associate, Nessen Studio, Chase Brass and Copper Co., A.H. Heisey & Co. [40]

VON NEUMANN, Robert [P,L,T,B,En,Li] Milwaukee, WI b. 10 S 1888, Rostock, Germany d. 1976. Studied: Royal Acad., Berlin; F. Bunke, in Weimar; Kunstgewerbe Mus., Berlin, with E. Doepler; M. Kock; H. Hofmann, in Munich. Member: SAE; Chicago SE; Wis. P&S; Milwaukee PM; Southern PMS; Rockport AA. Exhibited: NAD; CGA; WFNY, 1939; GGE, 1939; CI; Minneapolis Inst. A.; Madison Salon; Milwaukee Journal, 1933 (prize); Madison AA, 1934 (prize); AIC, 1936 (prize); Palm Beach, Fla., 1937 (prize); Milwaukee AI, 1938 (prize), 1941 (med); SAE, 1942 (prize); LOC, 1943 (prize); PAFA, 1944 (prize); Herron AI (prize); Wis. State Fair, 1930 (prize); Wis. PS, 1934 (prize). Work: Univ. Wis.; Milwaukee AI; AIGA; LOC; Berlin, Germany; Milwaukee State T. Col.; Four Arts S., Palm Beach. Positions: T., Milwaukee State T. Col. (1940), AIC [47]

VONNOH, Bessie (Onahotema) Potter (Mrs. Robert W.) [S,P] NYC/Lyme, CT b. 17 Ag 1872, St. Louis d. 1954. Studied: AIC, with L. Taft, ca. 1890. Member: ANA, 1906; NA, 1921; NSS, 1898; Port. P.; Allied AA; NAC; NIAL; SAA. Exhibited: Columbian Expo, Chicago, 1893; Nashville Expo, 1897, (prize); Paris Expo, 1900 (med); Pan-Am. Expo, Buffalo, 1901 (prize); St. Louis Expo, 1904 (gold); Panama-Pacific Expo, San Fran., 1915 (med); NAD, 1921 (gold). Work: MMA; AIC; Brooklyn Inst. Mus.; CI; CGA; Phila. Acad.; Newark Mus.; Cincinnati Mus.; Detroit Inst.; Roosevelt Mem. Bird Fountain, Oyster Bay, N.Y.; mem., Central Park. In 1948 she married Dr. Edward Keyes, but he died within a year. [47]

VONNOH, Robert William [P,T] NYC/Grez-sur-Loing, France/Lyme, CT b. 17 S 1858, Hartford, CT d. 28 D 1933, Riviera art colony, Nice, France.

Studied: Mass. Normal A. Sch., Boston, 1875–77; Académie Julian, with Boulanger, Lefebvre, 1881–83; Paris again, 1887–91, influenced by Bastien-Lepage and Monet. Member: ANA, 1900; NA, 1906; SAA, 1892; NAC; Arch. Lg.; Port. P.; Lotos C.; SC, 1904; F., PAFA; Allied AA; Munich Secession; CAFA; Gamut C. of Los Angeles; Paris AAA; L.C. Tiffany Fnd.; Lyme AA. Exhibited: PAFA; SAA; St. Louis Expo, 1898; Cincinnati Expo, 1898; Mass. Charitable Mechanics Assn., Boston, 1884 (gold); Paris Salon, 1889 (prize); Paris Expo, 1889 (med), 1900 (med); Pan-Am. Expo, Buffalo, 1901 (med); Charleston, 1902 (gold); NAD, 1904 (prize); P.-P. Expo, 1915 (gold); CGA, 1920 (prize); Newport AA, 1920 (prize). Work: PAFA; College of Physicians, Phila.; Buffalo C., N.Y.; Union Lg. Cl., Phila.; Dept. Justice, Wash., D.C.; Post Office Dept., Wash., D.C.; Am. Philosophical S., Col. of Physicians, both in Phila.; Brown Univ.; Mass. Hist. Soc., Boston; W. Wilson's family, White House; MMA; Butler AI; BM; Harrison Gal., Los Angeles Mus. A.; Capitol, Hartford, Conn.; Ft. Worth (Tex.) Mus.; County Court House, Bel Air, Md.; CMA. Among his students were Henri, W. Glackens, M. Parrish, E. Redfield. Positions: T., Mass. Normal A. Sch., Roxbury Eve. Sch., Thayer Acad., all in Boston (1879–81), East Boston Evening Sch. and Cowles A. Sch. (1883–85), BMFA Sch. (1885–87), PAFA (1891–96 and 1918–20) [27]

VON PRIBOSIC, Viktor [P,G,Des] Los Angeles, CA b. 23 Mr 1909, Cleveland. Member: Los Angeles GAA. Exhibited: Woodcut Exh., Los Angeles Mus. A., 1937 (one-man); G., Borden's Gal., Los Angeles, 1939 (one-man); GA, Los Angeles County Fair, Pomona, 1935 (prize), 1936 (prize). Work: FA Gal., San Diego. Specialties: modern furniture des.; interior dec. [40]

VON RECKLINGHAUSEN, M. [P] NYC. Member: S.Indp.A. [24]

VON RIEGEN, William [Car,I] Weehawken, NJ b. NYC. Studied: ASL. Exhibited: Bredemeier Gal., Buffalo; Keppel Gal., NYC; ASL. Contributor: New Yorker, 1939 [40]

VON RIPPER, Rudolph Charles [P,I] New Canaan, CT b. 29 Ja 1905. Studied: A. Acad., Düsseldorf, Germany; Paris. Award: Guggenheim F., 1945. Work: Univ. Chicago Lib.; MOMA; BM; NYPL; Courtauld Coll., London; mural, William Beaumont Gen. Hospital, El Paso. Author/Illustrator: "Ecraser L'Infame," 1938, "The Soul and Body of John Brown," 1941. Illustrator: Time, Fortune [47]

VON RUEMELIN, Adolph G.W. See Wolter.

VON RYDINGSVARD, Karl [S,C] NYC/Brunswick, ME. Member: Arch. Lg., 1904. Specialty: wood carving [10]

VON SALTZA, Charles Frederick [Por.P,T] NYC b. 29 O 1858, Sorby, Sweden (came to the U.S. in 1891) d. 10 D 1905. Studied: Acads. Stockholm, Antwerp, Brussels; L. Bonnât, in Paris. Member: Assn. Swedish A.; St. Louis AG; St. Louis Assn. P.&S.; SWA. Exhibited: St. Louis Expo, 1898; SWA, 1898. Positions: T., St. Louis Sch. FA, Columbia T. Col. (1899), AIC [06]

VON SALTZA, Philip [P,T] North Castine, ME b. 9 Mr 1885, Stockholm, Sweden. Studied: ASL; H.E. Field Studio, Ogunquit, Maine. Exhibited: 48 Sts. Comp., 1939 (prize); Macbeth Gal., N.Y., 1938; WFNY, 1939; AIC, 1939. Work: murals, USPOs, St. Albans, Vt., Schuyler, Nebr., Milford, N.H. WPA artist. [40]

VON SCHLEGELL, Gustav William [P,T] Harrison, NY b. 1884, St. Louis. Studied: Univ. Minn.; Europe. Member: Soc. PS&G. Exhibited: Mun. Exh., N.Y., 1934; PAFA, 1934. Work: CAM; PMG. Position: T., Ogunquit Sch., summers [47]

VON SCHMIDT, Harold [I,P,L,T] Westport, CT (1976) b. 19 My 1893, Alameda, CA. Studied: Calif. Col. A.&Cr., 1912–13; Grand Central A. Sch., with H. Dunn, 1924; W. Ryder; M. Dixon; San Fran. AI, 1915–18. Member: AAPL; SI; AG. Exhibited: SI; Westport A. Group. Work: Calif. State Capitol; Mont. Hist. S.; West Point Mus.; Air Force Acad. Mus.; Nat. Cowboy Hall of Fame. Illustrator: "Death Comes to the Archbishop," "December Night," "Homespun"; Saturday Evening Post, for 20 years. Position: T./Founder, Famous Artists Sch., Westport, Conn. [47]

VON SCHNEIDAU, Christian [P,S,E,I,L,T] Los Angeles, CA b. 24 Mr 1893, Smoland, Sweden (came to Minn. in 1906) d. 6 Ja 1976, Orange, CA. Studied: J.W. Reynolds; K. Buerh; H.M. Walcott; C.W. Hawthorne; R. Miller; M. Bohm; G.E. Browne; H. Pushman. Member: Scandinavian-Am. AS of the West (Pres.); Soc. for Sanity in A. Exhibited: AIC, 1915 (prize), 1916 (prize); Minn. State Fair, 1916 (prize); Swedish-Am. Exh., Chicago, 1917 (prize), 1919 (prize); Calif. State Fair, 1919 (gold), 1920 (med), 1925 (prize), 1926 (prize), 1929; Southwest Mus., 1921 (prize); Expo, Park Mus., 1921 (prize), 1924 (prize); John Morton Mem. Hall Comp., 1928 (prize); Creative AC, Calif., 1931 (prize); Scandinavian-Am. S. of the West, Los Angeles Mus. A., 1939 (prize). Work: murals, Forum Theatre, Southwest Baptist Church, Calif. Lutheran Hospital, Angelical Lutheran Church, all in Los Angeles; Swedish C., Chicago; 3 murals, John Morton Mem. Mus., Phila.; gift to Crown Prince of Sweden; dec., Columbia Studios, Los Angeles. Position: Dir., C. von Schneidau Sch. FA, Los Angeles, from 1920 [47]

VON SCHOLLEY, Ruth [P] Boston, MA [25]

VON SCHWANENFLOEGEL, Hugo [P] Lawrence, NY [24]

VON SODAL, L.E. [P] Affiliated with A.&Crafts C., Meriden, Conn. [15]

VON VOIGTLANDER, Katherine [P] Kansas City, MO b. 19 Ap 1917, Camden, NJ. Studied: Kansas City AI; PAFA, 1938. Exhibited: Phila. AC, 1937; Denver AM, 1939; Women P. Am., Wichita AM, 1936 (prize) [40]

VON WESTRUM, Anni. See Baldaugh.

VON WICHT, John G.F. [P,C,S] Brooklyn, NY b. 3 F 1888, Malente-Holstein, Germany d. 1970. Studied: Germany. Member: Abstract A. Am.; S. Des.-Craftsman; NSMP; Scenic A. Un. Exhibited: BM, 1924, 1925, 1939, 1943; MMA, 1941; WMAA, 1941, 1947; AIC, 1947; PS. Fed. Bldgs, 1936; 48 States Comp., 1939; GGE, 1939; Brooklyn SA, 1945 (prize); Berlin Acad. (prizes). Work: BM; Nat. Gal., Berlin, Germany; murals/mosaics, Carville, La.; Fed. Court House, Knoxville, Tenn.; Court Room Bldg., Dept. Health, N.Y.; Radio Station WNYC, N.Y.; Pennsylvania R.R. Station, Trenton; Christ Church, N.Y.; murals, USPO, Brewton, Ala. WPA artist. [47]

VON WREDE, Ella [S] Paris, France b. 1860, NYC. Studied: Schlüter, Dresden [01]

VOORHEES, Clark G(reenwood) [Ldscp.P,E] Old Lyme, CT (since 1904)/Somerset, Bermuda (since 1919) b. 29 My 1871, NYC d. 17 Jy 1933, Old Lyme, Conn. Studied: chemistry, Yale; Columbia; I. Wiles, in NYC, 1894; Académie Julian, Paris, with Constant, Laurens, 1896. Member: Lyme AA; CAFA; Century; Mass. AA; Stockbridge AA; Grand Central AA, 1923 (founder). Exhibited: St. Louis Expo, 1904; NAD, regularly from 1901, 1906 (prize); Lyme AA, 1923 (prize); AIC; CI; Brit. Commonwealth Expo, 1925. First artist to discover Old Lyme (1896); settled there (1904). His work ranged from Tonalism to Impressionism. [31]

VOORHEES, Henriette Aimee Le Prince (Mrs.) [C,L,T] NYC b. Leeds, England. Studied: Mme. Le Prince, W.C.B. Upjohn; A. Bement; C.C. Curran; C.F. Binns. Member: N.Y. S. Craftsmen; N.Y. Soc. Cer. Arts; Phila. ACG; Boston SAC. Exhibited: WFNY, 1939. Work: Newark (N.J.) Mus.; Litchfield (Conn.) Mus.; YMCA, NYC; Phila.; Lecturer: Montclair AM, Princeton Women's C.; Am. Women's Assn. Specialties: pottery; modeling. Positions: Partner/Dir., Inwood Pottery Studios; T., Westchester County Workshop; NYU (extension) [40]

VOORHEES, Hope Hazard [P,S,B,T] Detroit, MI/Provincetown, MA b. 28 Ja 1891, Coldwater, MI. Studied: Detroit Sch. Des.; Dickenson; Kolski; Roerich Inst. Member: Detroit S. Women PS; Provincetown AA. Position: T., Grosse Pointe Country Day Sch., Mich. [40]

VOORHEES, Louis F. [P,Arch,T] High Point, NC b. 14 N 1892, Adrian, MI. Studied: Univ. Mich.; H. Breckenridge. Member: AIA; N.C. Professional AC; North Shore AA [40]

VORIS, Mark [P,En,Des,L,T] Tucson, AZ b. 20 S 1907 Franklin, IN d. 1974. Studied: Franklin Col.; Univ. Ariz.; P. Dougherty. Member: Tucson Ad C.; Ariz. P.&S.; Palette & Brush C., Tucson; Tucson FAA; Tucson WCC. Exhibited: Rockefeller Ctr., 1938; Ariz. State Fair, 1931 (prize). Position: T., Univ. Ariz., from 1946 [47]

VORIS, Millie Roesgen [P,W,L,T] Columbus, IN b. 23 Ag 1859, Dudley Town, IN. Studied: A. Berger; T.C. Steele; J. Cox; W. Chase; L.C. Palmer; L. Griffin; Prof. Berger, in Berlin. Member: NIAL; Chicago AC; Chicago AA; AFA; Palette C., Chicago; Ind. AA; Chicago PC. Exhibited: Hoosier Salon; Chicago World's Fair (prize); Columbian Expo, Chicago, 1893 (prize); Pettis Gal., Indianapolis; John Herron AI; Ind. AA. Work: Berlin A. Mus. Author: "Newspaper Jimmy" [47]

VORST, Joseph Paul [Por.P,Mur.P,B,I,Li,T] Overland, MO b. 19 Je 1897, Essen, Germany. Studied: Folkwang Acad., Essen; Acad. FA, Berlin, with M. Slerogt, M. Liebermann. Member: Am. A. Cong. Exhibited: GGE, 1939; WFNY, 1939; AIC, 1937 (prize); CGA; VMFA; WMAA; W.R. Nelson Gal.; CAM, 1933 (prize), 1945 (prize); Kansas City AI, 1938 (prize); St. Louis AG, 1930 (prize), 1933 (prize); 48 Sts. Comp., 1939 (winner). Work: Davenport Mun. A. Gal.; Princeton Univ.; CI; CAM; Springfield Mus. A.; murals, USPOs, Betheney, Vandalia (both in Mo.), Paris (Ark). Author/Illustrator: articles, "The Volcano"; litho., "The Fietemann"; woodcuts, "The Death Dance" (Kunstanstalt Ruhrland). Illustrator: Esquire. Position: Thomas Jefferson Col., St. Louis [47]

VOS, Hubert [P] NYC/Newport, RI b. 17 F 1855, Maastricht, Holland (came to U.S. in 1892 to act as Art Commissioner for Holland at the Columbian Expo, Chicago, 1893) d. 8 Ja 1935. Studied: Acad. FA, Brussels; Cormon, in Paris. Exhibited: Paris, Amsterdam, Munich, Dresden, Brussels (gold medals). Work: Luxembourg Mus., Paris. Specialties: aboriginal races; portraits; interiors; still lifes of Chinese porcelains. He was the first westerner to paint the portrait of the Dowager Empress Tzu Hsi of China. [33]

VOS, Marius [P] NYC. Member: SC [21]

VOSBURGH, Edna H. [P] Paris, France b. Chicago. Studied: R. Miller, in Paris [08]

VOSBURGH, R.G. [I] NYC [15]

VOSE, Adairene. See Congdon, Thomas, Mrs.

VOSE, Seth Morton [Dealer] Providence, RI b. 5 Ag 1831, Stoughton, MA d. 2 Ap 1910. At nineteen years of age he purchased the Westminster Art Gallery in Providence; later, a branch store was opened in Boston, where it remains a family business today. In 1852 Seth made the first importation to America of paintings by Corot, thus introducing the Barbizon painters to this country.

VOSS, D.R. [P] NYC Exhibited: NAD, 1898 [01]

VOSS, Elsa Horne (Mrs.) [S] Westbury, NY. Member: NAWPS [25]

VOUTE, Kathleen [P,Des,I] Montclair, NJ b. Montclair. Studied: ASL; Grand Central Sch. A.; G.P. Ennis; H. Turner; E. Greacen; G. Bridgman; H.B. Snell. Member: AWCS; N.J. WCS; Wash. WCC; AAPL. Exhibited: AWCS, 1928–36, 1939, 1940; Wash. WCC, 1936, 1941; PAFA, 1928, 1931; Montclair AM, 1930–41; N.J. WC Soc., 1939–42; AAPL, 1931 (med), 1939 (med); Montclair AA, 1932 (prize). Illustrator: "Runaway Cousins," 1936, "Quinito en España," 1940, other children's books [47]

VOZECH, Anthony [S,T,L] Toledo, OH b. 11 Je 1895. Studied: A. Polasek; Indst. A. Sch., Prague, Czechoslovakia. Member: Bohemian C., Chicago. Exhibited: TMA, 1936 (prize), 1937 (prize), 1938 (prize), 1939 (prize). Work: Thayer Mus. A., Univ. Kansas; Univ. Southern Calif.; Kingswood, Mansfield, Ohio; Bohemian Nat. Cemetery, Chicago; Toledo Pub. Lib. [40]

VREELAND, Elizabeth L. Wilder (Mrs. Frederick K.) [P] Montclair, NJ b. 24 Ja 1896, Poona, India. Studied: NYC; London; Paris; Norway [25]

VREELAND, Francis William [P] Hollywood, CA (since 1920s) b. 10 Mr 1879, Seward, NE d. 4 S 1954. Studied: O.W. Beck; V. Nowottny; G. Bridgman; Académie Julian. Member: Mural P.; Arch. Lg.; Calif. AC; Artists Council, Los Angeles; Okla. AL; ACS, Southern Calif.; Art and Edu. Comm., Los Angeles Chamber of Commerce; Ch. Art Comm., Hollywood. Position: Staff, Rookwood Potteries, Cincinnati, early 1900s [40]

VROMAN, Adam Clark [Photogr] Pasadena, CA (since 1892) b. 1856, La Salle, IL d. 1916. Work: large coll. vintage platinum prints at Pasadena Pub. Lib.; Nat. Hist. Mus., Los Angeles; Southwest Mus., Los Angeles, all documenting Southwest Indian life, 1895–1904 [*]

V'SOSKE, Stanislav [C,Des] Grand Rapids, MI b. 11 O 1899, Grand Rapids. Studie: PAFA, with D. Garber; Oberteuffer; Henri; Bellows; Detroit Acad. FA, with Wecker, Count Kryizanowski. Member: S. Des.-Craftsmen. Exhibited: MMA; Mus. Mod. A., Wash., D.C.; Dayton AI; Colorado Springs FA Center; Lord & Taylor, 1937 (prize); ADI medal, 1941. Work: MOMA. Position: Des./Manufacturer, V'soske Hand Tufted Rugs [47]

VUCHINICH, Vuk [P,S,E] NYC/Santa Barbara, CA b. 9 D 1901, Nikshitch, Montenegro, Yugoslavia. Studied: Univ. Serbia; I. Městrović; BAID, with R. Aitken; NAD, with C. Curran; F.C. Jones. Member: NSS; Kit Kat C. [40]

VUILLEMENOT, Fred A. [Des,P,S,I,Dec] Toledo, OH b. 17 D 1890, Ronchamps, France d. 26 F 1952. Studied: Ecole des Beaux-Arts, Ronbiax, Paris, France; Ecole des Arts Decoratifs, Paris; Lemaire; David; Rouard; E. Deully. Member: Toledo Fed. A. Exhibited: Salon des Artistes Français, 1912; Paris & Lille, France, 1910–14 (med); TMA (prize). Work: Gravereaux Mus., France, 1912 [47]

VUKOVIC, Marko [P,G] Saugerties, NY b. 7 Ap 1892, Liska, Yugoslavia. Studied: self-taught. Member: Woodstock AA. Exhibited: Newark Mus., 1930; WMAA, 1933; Yonkers Mus., 1940; PAFA, 1941; Syracuse Mus. FA, 1941; Albany Inst. Hist.&A., 1941, 1946; Rochester Mem. A. Gal, 1942; Cornell, 1942; NAD, 1942. Work: Willard Parker Hospital, East Harlem Health Center, NYC; Newark Bd. Edu. [47]

VUKOVICH, Marion [P] NYC [19]

VYSEKAL, Edouard A(ntonin) [P,T] Los Angeles, CA b. 17 Mr 1890, Kutna Hora, Czechoslovakia (came to U.S. as a boy) d. 2 D 1939. Studied: AIC, with Vanderpoel; H.M. Walcott; S.M. Wright; M. Russell. Member: Calif. AC; Laguna Beach AA; Calif. WCS. Exhibited: Calif. PS, 1922 (prize); Calif. AC, 1922 (prize), 1923 (prize), 1924 (prize), 1926 (gold); Western Painters A., 1924 (prize); S. Western A., 1925 (med); PS S., 1927 (prize); Calif. WCS, 1927 (prize), 1932 (prize); Pomona WCS 1927 (prize); PS, West, 1927 (prize); Santa Cruz, 1927 (prize), 1929 (prize), 1935 (prize); San Diego Annual, 1929 (prize); Los Angeles AA, 1932 (prize), 1934 (prize); Oakland, 1936. Work: Barbara Worth Hotel, El Centro, Calif.; Mission Inn, H.S., both in Riverside, Calif. Position: T., Otis AI, Los Angeles, 1922–39 [38]

VYSEKAL, Luvan Buchanan (Mrs. E.A.) [P] Los Angeles, CA (since 1914) b. Lemars, Iowa d. 11 Ja 1954. Studied: AIC, with Vanderpoel, Walcott, Norton, 1910–14; S. Macdonald Wright. Exhibited: Los Angeles A. Mus., 1924 (prize); Arcadia, Calif., 1923 (prize); Riverside, Calif., 1929 (prize); Pomona, Calif., 1924 (prize), 1928 (prize); Santa Cruz, Calif., 1929 (prize); Laguna Beach, Calif., 1929 (prize); Fed. Women's C., 1924 (prize); Hollywood C., 1927 (prize); Calif. PS, 1932 (prize); Ebell C., 1934 (prize). Work: Kans. State Agricultural Cl., Kans. State Capitol [47]

VYTLACIL, Elizabeth Foster (Mrs. Vaclav) [P,T] Paris, France b. 5 Mr 1899, St. Paul, MN. Studied: Minneapolis Inst. A.; Lhote, in Paris; Munich, with H. Hoffman, C. Von Marr. Exhibited: Minn. State Fair (prize); Minn. State AS (prize) [33]

VYTLACIL, Vaclav [P,L,T] Rockland County, NY b. 1 N 1892, NYC. Studied: AIC; ASL; H. Hoffman; Royal Acad., Munich. Member: Am. Abstract A.; Am. A. Cong. Exhibited: AIC, 1913 (prize); France, 1936 (gold). Work: Milwaukee AI; Municipal Coll., Chicago; Mus. Dessau, Munich. Co-author: "Egg Tempera Painting," pub. Oxford Univ. Press. Positions: T., ASL, Florence Cane Sch. Art, Dalton Sch., all in NYC [40]

VYTLACIL, William [P] Mt. Lebanon, NYC. Member: Chicago WCC. Exhibited: AIC, 1913 [21]

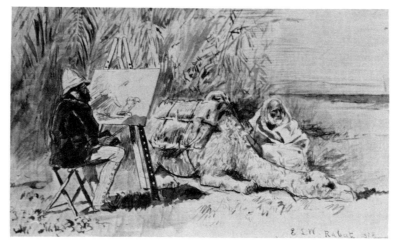

Edwin Lord Weeks: *Self-portrait, painting an uncooperative camel in Rabat, Morocco, 1878.* Private Collection

W

WAANO-GANO, Joe [P,Des,I,W,L] Los Angeles, CA (1946) b. 3 Mr 1906, Salt Lake City, UT. Studied: Los Angeles Acad. FA; Christian von Schneidau A. Sch., 1924–28. Member: Calif. AC; Soc. PS; San Fernando Valley AC; Soc. PS; San Fernando Valley AC. Exhibited: Greek Theatre, Los Angeles; Calif. AC, 1946; Los Angeles Mus. A., 1946; Los Angeles City Hall, 1946; Kern County (Calif.) Fair, 1929 (prize); Gardena (Calif.) H.S., 1946 (prize); Chicago, 1933 (med). Work: Gardena H.S. Coll.; murals, Los Angeles General Hospital; Sherman Indian Inst., Riverside, Calif.; Western Air Lines Offices, San Fran.; Rapid City, S.Dak. Lectures: Art of the American Indian. Designer: Indian motifs for textiles [47]

WACHTEL, Elmer [Ldscp.P,I,C,T] Pasadena, CA (since 1882) b. 21 Ja 1864, Baltimore d. 31 Ag 1929, Guadalajara, Mexico. Studied: briefly, ASL; criticism from W.M. Chase; London. Member: Ten P. of Los Angeles. In 1888 he was first violin for the Los Angeles Philharmonic Orchestra. [27]

WACHTEL, Marion Kavanaugh (Mrs. Elmer) [Ldscp.P,T] Pasadena, CA b. 10 Je 1876, Milwaukee, WI d. 22 My 1954. Studied: AIC; Chase. Member: Pasadena SA; Pasadena Soc. P.; Aquarelle P. Exhibited: Pasadena SA, 1942 (prize), 1944 (prize). Work: Vanderpoel Coll.; Fremont H.S., Los Angeles; Gardena H.S. (Calif.); State Bldg., Los Angeles; Cedar Rapids (Iowa) A. Mus.; Calif. C.; Friday Morning C., Los Angeles; Women's C., Hollywood; Vanderpoel A. Assn., Chicago. Specialty: watercolor; oils only after her husband's death. Position: T., AIC, 1900s–04 [47]

WACK, Ethel Barksdale (Mrs. J. De B.) [P] NYC/Westport, NY b. 26 Ag 1898, Wilmington, DE. Studied: I. Olinsky; V.W. Garber. Member: S.Indp.A.; Wilmington SFA [25]

WACK, Henry Wellington [P,W,L,Des,] Covina, CA b. 21 D 1875, Baltimore d. ca. 1955. Studied: L. Dabo; N.R. Brewer; H.S. Hubbell; F. Spenlove-Spenlove (London). Member: AAPL; Authors C., NYC & London; F. Royal Geographical S., London; Brooklyn SA; PS; Lime Rock AA; SSAL. Work: Newark Mus.; High Mus. A.; Delgado Mus. A.; PAFA; Lincoln Mem. Univ., Harrogate, Tenn.; Mary Washington Col., Univ. Va.; Hickory Mus. A.; Vanderpoel Coll.; Covina Pub. Lib.; Salisbury (Conn.) Pub. Lib.; San Antonio; Ft. Worth; Elks C., St. Paul, Minn.; Whistler House, Lowell, Mass.; Lib. Colla., Birmingham, Ala.; Antioch Col., Ohio; Roerich Mus., NYC; NYPL; permanent exh., Catskill Mountain cabin of John Burroughs. Author: camping and outdoor life books. Position: Founder/1st Ed., Field & Stream [47]

WACKERMAN, Dorothy. See Hutton.

WADDELL, Martha E. [P,W,G] Youngstown, OH b. 27 F 1907, Ontario, Canada. Studied: Butler AI. Member: NAWPS; Cleveland A. Ctr.; Columbus AL; Youngstown Alliance [40]

WADE, Caroline D. [P] Elmhurst, IL b. 25 Ap 1857, Chicago. Studied: AIC; Courtois, in Paris. Member: AFA; Chicago SA; SWA [31]

WADE, Claire E. (Mrs.) [P,T] Kew Gardens, NY b. 18 Ja 1899, Ossining, NY. Studied: NYU; J. Farnsworth. Member: NAWA. Exhibited: NAWA, 1943–46; All.A.Am., 1943, 1944; AWCS, 1943; Brooklyn SA, 1945–46; Sarasota SA, 1942; Farnsworth Sch., Sarasota (prize) [47]

WADE, Jean (Elizabeth) [P,I] Bridgeport, CT. b. 17 Mr 1910, Bridgeport, CT. Studied: Yale. Member: NAWA; Audubon A.; Silvermine GA; Bridgeport AL; Lg. Am. Pen Women. Exhibited: Audubon A., 1945; NAWA, 1945, 1946; New Haven PCC, 1945; Bridgeport AL, 1945, 1946; Silvermine GA, 1945, 1946; CAA, 1931 (prize); Bridgeport AL, 1945 (prize) [47]

WADE, Jeptha Homer [Patron] b. 1857, Cleveland, OH d. 6 Mr 1926, Thomasville, GA. Gave the land on which the Cleveland Museum is built; also the donor of the J.H. Wade Purchase Fund; gave to the General Endowment Fund about $1,500,000 as well as several hundred works of art.

WADE, Robert [P,T] Bradford, (Haverhill), MA b. 30 O 1882, Haverhill, MA. Studied: Eric Pape Sch. A. Work: altar panels, St. Mary of Redford, Detroit; St. James Church, Woonsocket, R.I.; murals, Boston Univ. Sch. Theology; Shove Mem. Chapel, Colorado Col., Colorado Springs; Emanuel Church, Newport, R.I.; Lincoln Sch., La Junta, Colo. Positions: T., Pueblo Jr. Col., Colo. (1937–38), Bradford Jr. Col., Mass. (from 1939) [47]

WADMAN, Lolita Katherine (Mrs. David Granahan) [P,I] London, KY b. 3 Mr 1908, Minneapolis. Studied: Europe; G. Mitchell, Minneapolis Sch. A. Exhibited: Minneapolis Inst. A., 1930–35; Minn. State Fair, 1931, 1932, 1933 (prize), 1934, 1935, 1936 (prize). Illustrator: "Upper Mississippi," 1936, "Finlandia," 1939, "Who Wants an Apple," 1941, "The American People" [47]

WADSWORTH, Adelaide E. [P] Boston, MA b. 29 O 1844 d. Ag 1928. Studied: W.M. Hunt; F. Duveneck; J. Twachtman; C.H. Woodbury; A. Dow. Member: Copley S., 1894. Exhibited: Boston AC; St. Botolph C.; NAD; Boston galleries, all 1876–95 [27]

WADSWORTH, Frank Russell [P] Chicago, IL b. 1874, Chicago d. 9 O 1905, Madrid, Spain (while studying in W.M. Chase's summer class). Studied: Chase, in NYC; AIC. Member: Chicago SA; Mun. AL of Chicago. Exhibited: SAA, 1898; AIC, 1898, 1904 (prize) [04]

WADSWORTH, Grace [P,T] NYC b. 1879, Plainfield, NJ. Studied: Twachtman; Metcalf; Dow; Dielman [10]

WADSWORTH, Lillian (Mrs.) [P] Westport, CT b. 30 Mr 1887. Studied: J.E. Fraser; S. Brown; Annot. Member: NYSWA [40]

WADSWORTH, Lucy G. [P] Boston, MA. Exhibited: Boston AC, 1898 [01]

WADSWORTH, Myrta M. (Mrs.) [P] Winter Park, FL/Rochester, NY b. 9 N 1859, Wyoming, NY. Studied: L.M. Wiles; I. Wiles. Member: Rochester AC [25]

WADSWORTH, Wedworth [Ldscp.P,I,W] Durham, CT b. 22 Je 1846, Buffalo, NY d. 22 O 1927. Member: NYWCC; SC, 1890; Brooklyn AC. Author/Illustrator: "Leaves from an Artist's Field Book." Illustrator: "The Song of the Brook," "A Winter's Walk with Cowper," "Under the Greenwood Tree with Shakespeare," "Through Wood and Field with Tennyson," "An Artist's Year" [25]

WAGENHALS, Katherine H. [P] San Diego, CA b. 2 Ag 1883, Ebensburg, PA. Studied: Smith College; ASL; Acad. Moderne, Paris. Exhibited: Arch. Lg.; Herron AI, 1916 (prize). Work: "The Visitor," Herron AI. Position: Staff, Herter Looms, NYC, 1900s [24]

WAGER-SMITH, Curtis (Miss) [Por.P,I,W] Willow Grove, PA b. Binghamton, NY. Studied: E. Sartain; Phila., with A.B. Stephens, H. McCarter. Member: Plastic C.; SAL; City Parks Assn.; Women's Press Assn. Exhibited: Dallas Expo, 1890 (med). Illustrator: "Rhymes for Wee Sweethearts," "Story Without an End," other children's books [33]

WAGGONER, Elizabeth [P,C,W] Hollywood, CA (1932) Studied: AIC, 5 yrs. Member: Calif. AC. Positions: T., AIC, before 1908; crafts at USC Col. FA, 1908–10; Hollywood Polytech. H.S., from 1910 [25]

WAGNER, A. [P] Toledo, OH. Member: Artklan [25]

WAGNER, Blanche Collet [L,P,C,W] San Marino, CA b. 26 O 1873, Grenoble. France d. ca. 1958. Studied: C. Peters, in NYC; H. Gazan, in Paris; A. Grosso, in Seville, Spain. Member: Los Angeles AA; Lg. Am. Pen Women; Calif. AC; Women P. of the West; San Gabriel AG. Exhibited: Southwest Mus., Los Angeles; Santa Ana (Calif.) Mus., 1935, 1936; Lg. Am. Pen Women, 1939 (prize); San Fran., 1939 (prize); Los Angeles, 1946 (prize). Translator: "Streets of Mexico," 1937. Author/Illustrator: "Tales of Mayaland," 1937 [47]

WAGNER, Edward Q. [S,P] b. 1855 d. Spring, 1922, Detroit. Work: sculptural work on the St. Louis Fair Bldgs., 1904. He spent five years executing work for the Brazilian Gov., Rio de Janeiro.

WAGNER, Frank Hugh [P,S,I] Chicago, IL b. 4 Ja 1870, Milton, Wayne Co., Ind. Studied: AIC, with Freer, Vanderpoel, Von Salza. Member: Hoosier Salon. Work: St. Joseph's Chapel, West Pullman, Ill.; Chapel Hall, Danville, Ind. [40]

WAGNER, Fred [P,T] Phila., PA b. 20 D 1864, Valley Forge, Pa d. 14 Ja 1940. Studied: PAFA, with Eakins. Member: Phila. Sketch C.; Phila. WCC. Exhibited: PAFA, 1914 (prize); CI, 1922 (prize). Work: PAFA; Phila. AC; Reading AM; CMA [38]

WAGNER, George [S,C] Vincennes, France. Studied: Dumont, in Paris. Specialty: statuettes of silver, gold, ivory, and precious stones [08]

WAGNER, Jacob [P] Boston, MA b. Bavaria, Germany d. F 1899. Studied: Lowell Inst., Boston, but principally self-taught. Member: Boston AC [98]

WAGNER, Lee A. [P] NYC [19]

WAGNER, Mary North [P,L,W] Chicago, IL/Saugatuck, MI/Milford, IN b. 24 D 1875, Milford, IN. Studied: J. Vanderpoel; F. Freer; W.M. Chase; F. Richardson; AIC. Member: Hoosier Salon. Author/Illustrator: "The Adventures of Jimmy Carrot," 1911. Illustrator: "The Second Brownie Book," by A.B. Benson [40]

WAGNER, May W. [P] Rockport, MA b. Chicago. Exhibited: Alled Ar. Am.; Sweat Mem. Mus., Portland, Maine; Butler AI, Youngstown, Ohio; Nat. Acad. [40]

WAGNER, Robert Leicester ("Rob") [P,I,W] Beverly Hills, CA d. 20 Jy 1942, Santa Barbara, CA. Studied: Académie Julian; Acad. Delecluse, both in Paris. Member: Calif. AC. Exhibited: Alaska-Yukon-Pacific Expo, Seattle, 1909 (med); P.-P.Expo, San Fran., 1915 (med). Contributor: articles/illus., Saturday Evening Post, Collier's, Liberty. Editor: Rob Wagner's Script. Also motion picture director. [40]

WAGNER, Rosa [P] Rockville, MD. Member: Wash. WCC [29]

WAGNER, S. Peter [P,E,T] Rockville, MD b. 19 My 1878, Rockville. Studied: ASL; Corcoran Sch. A.; Grande Chaumière, Paris; P. Pascall. Member: S. Wash. A.; SSAL; Ldscp. C.; Wash. WCC; AWCS; SC; S. Four A., Palm Beach, Fla.; St. Petersburg AC; Baltimore WCC; Pensacola AC; Wash. AC; AFA. Exhibited: Fla. Fed. A., 1928 (prize), 1931 (prize), 1932 (prize); Ldscp. C., Wash., D.C, 1943 (med), 1945 (med); Tampa AI, 1928 (prize) Position: Dir., St. Petersburg Winter Sch. A., 1938–44 [47]

WAGONER, Harry B. [Ldscp.P,S] Altadena, CA/Chicago, IL b. 5 N 1889, Rochester, IN d. 9 Ap 1950, Phoenix, AZ. Studied: H. Pollock; Paris. Member: Pasadena SP; Hoosier Salon; Intl. S. SPG. Specialty: desert ldscp., since late 1920s [33]

WAHL, Bernhard O. [P] Brooklyn, NY b. 8 N 1888, Lardal, Norway. Member: Norwegian A.&Cr. C., Brooklyn, N.Y.; Brooklyn SA. Exhibited: BM, 1943–46; Vendôme Gal.; Staten Island Inst. A.&Sc. [47]

WAHL, Theodore [Li,P] NYC b. 18 D 1904, Dillon, KS. Studied: K. Mattern; A. Bloch; Univ. Kans.; L. Nye; R. Braught, at Kansas City AI; B. Brown. Exhibited: Kansas City AI, 1933 (gold). Position: Hd. printer of lith., WPA, NYC [40]

WAINWRIGHT, Christine H. [P] Seattle, WA [24]

WAINWRIGHT, Jeannette Harvey [P] Indianapolis, IN [24]

WAINWRIGHT, S.H., Jr. [I] Greenwich, CT. Member: Greenwich SA [25]

WAIT, Blanche E. [P] Cincinnati, OH b. 20 D 1895 d. 6 N 1934. Member: Cincinnati Women's AC [19]

WAIT, Carrie Stow (Mrs. Horace C.) [Ldscp.P,I,W] NYC b. 9 Jy 1851, New Haven, CT. Studied: R.H. Nicholls, in NYC; A. Nugenholtz, in Holland. Specialty: watercolors [08]

WAIT, Erskine L. [P] d. 9 Mr 1898, Rahway, NJ. Member: Brooklyn AC

WAIT, Lizzie F. [P,C,T] Kingston, NY b. Boston. Studied: BMFA Sch., with Tarbell, De Camp, Major, Benson. Member: Copley S., 1887 [10]

WAITE, Charles W. [P] Cincinnati, OH. Studied: Ohio Mechanics' Inst.; Duveneck. Member: Cincinnati AC [29]

WAITE, Clara Turnbull [P] Baltimore, MD. Member: Baltimore WCC [25]

WAITE, Emily Burling [P,E,W,L] Worcester, MA b. 12 Jy 1887, Worcester. Studied: WMA Sch.; ASL; BMFA Sch.; F.L. Mora; F. DuMond; P. Hale; ASL; England; France; Belgium; Holland; Germany; Austria; Italy; Spain. Member: North Shore AA; Newport AA; Worcester Gld. A. & Craftsmen; SAE; Chicago SE; Boston SAC; Lg. Am. Pen Women; Wash. WCC. Exhibited: CGA; PAFA; NAD; SAE, 1946; Chicago SE, 1945; Worcester County A., 1945; North Shore AA, 1946; Newport AA, 1946; Boston SAC; P.-P. Expo, 1915 (med); Lg. Am. Pen Women (prize). Work: Clark Univ., Worcester; Tufts Col., Medford, Mass.; BMFA; MMA; FMA; Episcopal Theological Sch., Cambridge, Mass.; WMA; Worcester City Hall [47]

WAITE, William J. [P] Worcester, MA [24]

WAITT, M(arian) P(arkhurst) (Mrs. George Sloane) [P] Boston, MA b. Salem, MA. Studied: BMFA Sch.; Boston, with Juglaris, Gallison, L. Kronberg. Member: Copley S., 1904; NAWPS [25]

WAKEFIELD, Ruth. See Cravath.

WAKEMAN, Marion D. Freeman (Mrs. Seth) [P,E] Northampton, MA/Martha's Vineyard, MA b. 5 D 1891, Montclair, NJ d. 22 S 1953. Studied: Smith Col., with Tryon; Switzerland; ASL, with DuMond, Luks; Pennell; Hawthorne. Member: NAWA, annually, 1942 (prize); NAD; Arch. L.; PAFA; Montclair AM; Smith Col., 1938 (one-man). Illustrator: "The Curious Lobster," 1937, "The Curious Lobster's Island," 1939 [47]

WAKEMAN, R(obert) C(arlton) [S] Norwalk, CT b. 26 O 1889, Norwalk. Studied: L. Lawrie; Yale; BAID. Member: NSS; NAC; Silvermine GA. Exhibited: Nat. Aeronautic Assn., Wash., D.C. (prize); Brown and Bigelow med. Work: Southern Sch. Photog., McMinnville, Tenn.; Dotha Stone Prineo Mem., Norwalk Pub. Lib., Masonic Temple, all in Norwalk; H.S., New Canaan, Conn.; U.S. Naval Acad., Annapolis, Md.; Bok Singing Tower, Mountain Lake, Fla. Work: Dept. Justice Bldg., Wash., D.C. WPA artist. [40]

WAKEN, Mabel (J.) [P] Chicago, IL/East Gloucester, MA b. 13 Mr 1879, Chicago. Studied: C. Hawthorne; H. Breckenridge; R. Davey. Member: Chicago AC; Wash. AC [33]

WALBURNE, Rand [P] Knoxville, TN [13]

WALCOFF, Muriel [P] NYC. Exhibited: PAFA, 1936; WFNY, 1939 [40]

WALCOT, William E. [E] NYC. Member: Calif. PM [25]

WALCOTT, Anabel Havens ("Belle") (Mrs. Harry M.) [P] Coronado, CA (living in Rutherford, NJ], 1940) b. 21 S 1870, Franklin County, OH. Studied: ASL; Chase Sch. A.; Whistler; Colarossi Acad.; Holland. Exhibited: PAFA; AIC; Paris Salon; St. Louis Expo; NAD, 1903 (prize). Work: St. Louis C. [47]

WALCOTT, H(arry) M(ills) [P,T] Transbay, Coronado, CA (living in Rutherford, NJ], 1940) b. 16 Jy 1870, Torrington, CT d. 4 N 1944. Studied: NAD; Académie Julian, Paris, with Constant, Laurens. Member: ANA, 1903. Exhibited: Paris Salon, 1897 (prize); Pan.-Am. Expo, Buffalo, 1901 (med); SAA, 1902; NAD, 1903 (prize), 1904 (prize); CI, 1904 (prize); St. Louis Expo, 1904 (med); P.-P. Expo, San Fran., 1915 (med). Work: Richmond (Ind.) AA; Erie (Pa.) AA; Ohio State Univ., Columbus, Ohio Wesleyan Univ., Delaware; H.C. Frick Col. [40]

WALCOTT, Helen (Breese) [P] Westport, CT b. 20 Ag 1894, Rochester, NY. Studied: C.W. Hawthorne; E. Dickinson; J. Fraser [25]

WALDECK, C(arl) G(ustave) [P] Kirkwood, MO b. 13 Mr 1866, St. Charles, MO d. 17 F 1930. Studied: Paris, with Constant, Laurens. Member: St. Louis AG; 2 x 4 S.; Officier d'Académie, Paris, 1904.Exhibited: St. Louis Expo, 1904 (med); Lewis & Clarke Expo, Portland, Oreg., 1905 (med); Mo. State Expo, 1913 (gold); St. Louis AG, 1914 (prize), 1923 (prize); Soc. Western Artists, Indianapolis, 1914 (prize); St. Louis AL, 1915 (prize); CAM, St. Louis, 1923 (prize) [29]

WALDECK, Nina V. [P,I,E,T] Olmsted Falls, OH b. 26 Ja 1868, Cleveland, OH d. 21 Mr 1943. Studied: Chase; M. Bohm; Académie Julian. Member:

Orlando AA; Cleveland Women's AC. Work: Portrait, Women's C., Cleveland; Ursuline Acad., Cleveland [40]

WALDEN, Dorothy DeLand (Mrs. Louis H.) [C] Norwichtown, CT b. 21 Jy 1893, Ovid, NY. Studied: Rochester (N.Y.) Athenaeum, Mechanics Inst.; Alfred Univ.; Cornell Univ.; Mt. Holyoke Col. Member: Norwich AA; S. Conn. Craftsmen. Contributor: articles, "Weaving in the Summer Camp," Handicrafter, May, June, 1930 [40]

WALDEN, Lionel [Mar.P] Honolulu, HI b. 22 My 1861, Norwich, CT d. 12 Jy 1933, Chantilly, France. Studied: Carolus-Duran, in Paris. Member: AFA; NIAL; Paris SAP; Soc. Intl. de Peinture et Sculpture, Paris. Exhibited: Crystal Palace Exh., London (med); Paris Salon, 1899 (prize), 1903 (med); Paris Expo, 1900 (med); St. Louis Expo, 1904 (med); P.-P. Expo, San Fran., 1915 (med). Work: Wilstach Coll., Phila.; Luxembourg Gal., Paris; Cardiff Mus., Wales.; Honolulu Acad. A. [31]

WALDEN, Louis Hart [C,T] Norwichtown, CT b. 26 F 1890, Scotland, CT. Member: Norwich AA; S. Conn. Craftsmen. Positions: T., Norwich Free Acad., Walden Sch. Handweaving, Norwichtown [40]

WALDO, E(ugene) L(oren) [P,E,Li] Ponca City, OK b. 21 S 1870, NYC. Studied: B. Sandzen [33]

WALDO, George B. [P] NYC. Exhibited: SAA, 1898 [98]

WALDO, Ruth M(artindale) [P] Plainfield, NJ b. 18 Ja 1890, Bridgeport, CT. Studied: J. Lie; F.V. DuMond; C. Hawthorne. Member: Plainfield, AA [33]

WALDRON, Anne A. [P] New Brunswick, NJ d. ca. 1955. Member: Plastic C.; AWCS. Exhibited: AWCS, 1934, 1936, 1938, 1939; Fontainebleau Alumni, 1935 [47]

WALDVOGEL, Emma (Mrs. Henry Ragan) [Des] Asilomar, CA b. Schaffhansen, Switzerland. Studied: Kunstschule für Damen, Zurich, Switzerland. Contributor: House Beautiful [40]

WALES, George Canning [Mar.E,P,Li] Brookline, MA b. 23 D 1868 d. 1940. Studied: arch., MIT, 1885–88; etching, W. Paxton, 1917. Member: SAE; Boston GA. Exhibited: Goodspeed's Boston, 1921. Work: etchings, LOC; Nat. Mus.; NYPL; Peabody Mus., Salem; Old Dartmouth His. Soc.; British Mus., Victoria and Albert Mus., both in London; Marine Mus., Boston; Mus., Stavanger, Norway; Kendall Whaling Mus.; Mystic Seaport Mus. Author/Illustrator: "Etchings and Lithographs of American Ships," "History of American Sailing Ships" [40]

WALES, Orlando G. [P,T] Allentown, PA b. Phila. Studied: PAFA; W.M. Chase; A. Mucha. Member: SC, 1908 [33]

WALES, Susan M(akepeace) L(arkin) [Ldscp.P] Boston, MA b. 24 Jy 1839, Boston d. 11 S 1927. Studied: W.M. Hunt; BMFA Sch.; Paris, with Carolus-Duran; V. Poveda, in Rome; Blommers, in Holland. Member: Boston WCC; Copley S. [27]

WALGREN, Anders Gustave [P] Rockford, IL. Member: Palette and Chisel C., Chicago [10]

WALINSKA, Rosa Newman [S,W,L] NYC b. 25 D 1890 Russia. Studied: ASL; R. Laurent; A. Archipenko. Member: NAWA; AAPL; Lg. Present-Day A. Exhibited: WFNY, 1939; Independents; Am.-British A. Ctr.; NAWA; Riverside Mus.; New Sch. Social Research; Gld. A. Gal.; Anderson Gal.; Delphic A. Gal., 1939 (one-man). Work: plaque, Women's Peace S., N.Y.; mem., Lynn, Mass. Author: "Ink and Clay," 1942 [47]

WALKER, A(lanson) B(urton) [Cart,I] Milford, CT b. 19 N 1878, Binghamton, NY d. 22 Ja 1947. Studied: K. Cox.; J. Burroughs; C. Curran; F.V. DuMond. Member: SI. Contributor: illus./cartoons, Life, Judge, Harper's, Scribner's, Century, The American Golfer, St. Nicholas; book jackets for Harper's, Dodd Mead & Co., D. Appleton-Century, Payson & Clarke [40]

WALKER, Alice J. [P] New Haven, CT. Member: New Haven PCC [25]

WALKER, Angie [P] Cambridge, MA. Exhibited: Boston AC, 1898 [98]

WALKER, Anne [P] Baltimore, MD [25]

WALKER, C. Bertram [P] Paris, France [10]

WALKER, Charles Alvah [P,E] Boston, MA/Brookline, MA b. 1848, London, NH d. 11 Ap 1920. Studied: self-taught. Member: Boston AC; London Print Sellers Assn.; Copley S., 1905. Developed the Monotype Process. While engaged in scientific research work at the Peabody Acad. Science at Salem he developed a talent for both wood and steel engraving. Two of his plates after Mauve and Daubigny received honorable mention at the Paris Salon, 1893. [19]

WALKER, Charles Howard [Arch,I,C,L] Boston, MA b. 9 Ja 1857, Boston, MA. Member: Boston SA; AIA 1891; Copley S. 1903; Boston SAC (master craftsman); NAC; Printer's S., Boston. Exhibited: PAFA (gold); Arch.-in-Chief, Omaha Expo (gold); Cincinnati Mechanics' Assn. (med); St. Louis Expo, 1904 (prize). Position: Dir., Dept. Des., BMFA [10]

WALKER, Dugald Stewart [I,P,L] NYC b. Richmond, VA d. 26 F 1937. Studied: Richmond, with A. Fletcher, H. Taliaferro Montague; G. Cootes, Summer Sch., Univ. Va.; N.Y. Sch. Art; ASL. Illustrator: "Hans Anderson's Fairy Tales," "Stories for Pictures," "The Gentlest Giant" [33]

WALKER, E. Mildred [P] NYC [13]

WALKER, Ernest [P] Phila., PA. Exhibited: PAFA, 1938; AIC, 1939; WFNY, 1939. Affiliated with Phila. WCC [40]

WALKER, F.R. [P] Cleveland, OH. Member: Cleveland SA [29]

WALKER, Ferdinand G(raham) [P] New Albany, IN b. 16 F 1859, Mitchell, IN d. 11 Je 1927. Studied: Académie Colarossi, Dagnan-Bouvert, Puvis de Chavannes, Blanche, Merson, all in Paris. Member: S. Ind. A.; Louisville AA; Chicago AG; S.Indp.A.; Chicago NJSA; SSAL; Hoosier Salon. Work: Ky. State Hist. S. Coll.; Univ. Ky., Lexington; Berea Col.; Agricultural Col., Mich.; Lincoln Inst., Simpsonville, Ky.; Ky. State Coll., Frankfort; State House, Indianapolis; Jefferson Davis Mem., Fairview, Ky.; Pub. Libs., Louisville, Lexington, both in Ky., New Albany, Ind.; Evansville Col., Greenbrier Col., both in W.Va.; Courier Journal Bldg., Univ. Louisville; pub. gal., New Albany, Ind., Lexington, Ky.; murals, St. Peter's Church, Louisville [25]

WALKER, Frances Antill L. [Min.P] Brooklyn, NY b. 1872 d. 16 Ja 1916 [13]

WALKER, Frank [P,Arch] Morristown, NJ [04]

WALKER, George W. [P,Car] Cleveland, OH b. 1895 d. 29 Jy 1930, Middletown, NY. Member: Cleveland SA. Creator: "Jazzbo Jones," "Things That Never Happen" [29]

WALKER, Gene Alden [P,I] Warren, PA. Studied: PIASch; NAD; C. Hawthorne; J. Farnsworth. Member: NAC; NAWA; PBC; SSAL. Exhibited: NAD, 1942–45, NAD, 1943 (prize); PBC, 1945, 1946; Newport AA, 1944, 1945; Phila. WCC, 1933; Butler AI, 1945; AAPL, 1945; NAC, 1944, 1945; NAWA, 1935–39, 1942, 1943 (prize), 1944, 1945, 1946 (prize); CI, 1945, 1946; Bridgeport, Conn., 1942 (prize), 1945 (prize); SSAL, 1938; All.A.Am., 1944 (med). Work: Montgomery Mus. FA. Illustrator: "Range Plant Handbook," pub. U.S. Dept. Agri., 1937 [47]

WALKER, H.L. [P] NYC. Affiliated with Walker Engraving Co., NYC [24]

WALKER, Harold E. [P] Toledo, OH b. 6 N 1890, Scotch Ridge, OH. Studied: A. Whiting; K. Kappes; F. Trautman; W.M. Darling; R. Moffett. Member: Toledo Artklan; Beachcombers. Exhibited: Toledo Mus. A., 1922 (prize), 1923 (prize). Work: Vanderpoel AA, Chicago [40]

WALKER, Helen. See Boyd.

WALKER, H(enry) O(liver) [P,Mur.P] Belmont, MA b. 14 My 1843, Boston, MA d. 14 Ja 1929. Studied: Bonnât, in Paris. Member: Cornish (N.H.) Colony; AFA; ANA, 1894; NA, 1902; SAA, 1887; Mural P.; NIAL; Century Assn. Exhibited: Columbian Expo, Chicago 1893 (med); SAA, 1894 (med); NAD, 1895 (prize); Pan-Am. Expo, Buffalo, 1901 (med); St. Louis Expo, 1904 (med); Charleston Expo, 1902 (gold); Worcester, 1907 (prize). Work: mural paintings: LOC; Mass. State House, Boston; Appellate Court, NYC; Minn. State Capitol, St. Paul; Newark, N.J.; paintings: NGA; MET [25]

WALKER, Hobart Alexander [P] Maplewood, NJ b. 1 N 1869, Brooklyn, NY. Exhibited: AWCS, 1936, 1938; AWCS-NYWCC, 1939 [40]

WALKER, Horatio [P] Ile d'Orleans, Quebec, Canada. b. 1858, Listowel, Ontario (came to NYC in 1885) d. 27 S 1938. Member: ANA, 1890; NA, 1891; SAA, 1887; NIAL; Royal Inst. P. in Water Colors, England; AWCS; SC; A. Fund S.; A. Aid A.; Rochester AC; NAC. Exhibited: Am. Art Gal., NYC, 1887 (gold); AWCS, 1888 (prize), 1920 (prize); Paris Expo, 1889 (med); Columbian Expo, 1893 (gold); Pan-Am. Expo, 1901 (gold); Charleston Expo, 1902 (gold), St. Louis Expo, 1904 (golds); PAFA, 1906 (gold); Worcester, 1907 (prize); P.-P. Expo, San Fran., 1915 (gold). Work: MMA; CGA; CAM, St. Louis; Albright A. Gal.; NGA; CI [38]

WALKER, Hudson D. [Mus.Assoc] Forest Hills, NY b. 17 Je 1907, Minneapolis, MN d. 1976. Studied: Univ. Minn.; FMA. Positions: Dir., Marsden Hartley Exh., MOMA, 1944; Selected Annual Exh., Contemporary Am. Paintings, Walker A. Ctr., Minneapolis, 1943, 1944, 1946; Pres., AFA, from 1945 [47]

WALKER, James [P] b. 1819, Northamptonshire, England (settled near

Albany, NY, in 1824) d. 1889, Watsonville, CA. Only Am. painter active during the Mexican War during the seige of Mexico City. Best known as a military painter, he opened his NYC studio in 1850; then moved to San Fran. in early 1870s. [*]

WALKER, Jessie A. (Mrs.) [E] Loubet, France. Member: Chicago SE; Brooklyn AC [25]

WALKER, John [Mus.Cur;W,L] Wash., D.C. b. 24 D 1906, Pittsburgh. Studied: Harvard. Co-author: "Great American Paintings from Smibert to Bellows," 1943, "Masterpieces of Painting from the National Gallery of Art," 1944. Positions: Assoc. in charge, Dept. FA, Am. Acad. in Rome, 1935–39; Chief Cur., NGA, from 1939 [47]

WALKER, John Law [P,E,En,C,T] Burbank, CA b. 19 S 1899, Glasgow, Scotland. Studied: L. Murphy; M. Sheets; F.T. Chamberlin; C. Hinkle. Member: Calif. WCS; Los Angeles AA; Santa Monica AA. Exhibited: Pomona Fair, 1932 (prize); Pasadena AI, 1933 (prize); Calif. WCS, 1934 (prize); Santa Cruz AL, 1934 (prize), 1937 (prize); Calif. State Fair, 1934 (prize); Southern Calif. Festival All. A., 1934 (prize). Work: WPA murals, USPOs, South Pasadena, Calif., Lockhart, Tex. Position: T., Jr. Col., Glendale, Calif., 1940 [47]

WALKER, John P. [P] Richmond, VA b. 1855 d. Ag 1932. He had painted every Virginia Governor during the last half century.

WALKER, Lissa Bell [Mur.P] Boston, MA b. Forney, TX. Studied: N.Y. Sch. F.&Appl. A.; F. Reaugh; M. Hagendorn; H.R. Poore; E. Albert. Member: NAC; Dallas AA; Reaugh AC. Exhibited: Mass. Horticultural S. (med). Work: murals, Monticello Hotel, Charlottesville, Va. [47]

WALKER, Lydia LeBaron (Mrs. William H.P.) [Dec,Des,W,C] Boston, MA b. 3 Mr 1869, Mattapoisett, MA d. 27 Ap 1958. Studied: A. Cummings. Member: Boston Author's C.; PBC; Copley S., Boston. Work: Index Am. Des. Author: "Homecraft Rugs," 1929. Contributor: Woman's Home Companion [47]

WALKER, M. Mulford (Mrs.) [P] NYC [08]

WALKER, M. Topping [P] NYC. Exhibited: NAD, 1898 [98]

WALKER, Margaret (Beverley) Moore [Por.P] Greenville, SC b. 2 O 1883, Darlington, SC. Studied: Converse Col.; CUASch; C. Hawthorne; R. Miller; B. Burroughs; W. Thor, in Munich; H. Hensche. Member: SSAL; Carolina AA; FA Lg. of the Carolinas (Pres.). Exhibited: SSAL, 1928–41; Nat. Exh., Am. A., NYC, 1936–38; FA Lg. of the Carolinas. Work: port., Fed. Court, City Hall, S.C. Soc., all in Charleston; Supreme Court, Univ. S.C., both in Columbia; Clemson Col.; Furman Univ., Greenville, S.C.; Davidson Col., N.C. Positions: Founder/Dir., Greenville Sch. A. [47]

WALKER, Margaret McKee [P,Des,L] Wilmette, IL b. 12 S 1912. Studied: Northwestern Univ.; ASL, with G. Grosz; AIC; Lhote. Exhibited: AIC, 1934, 1935, 1936, 1938; Salon des Tuileries, Paris, 1939. Work: Patten Gymnasium, Northwestern Univ. [40]

WALKER, Marian D. Bausman (Mrs. Otis L.) [S] Casper, WY b. 21 Je 1889, Minneapolis. Studied: Minneapolis. Member: Minneapolis SFA. Exhibited: Minn. State Art S., 1914 (prize) [33]

WALKER, Marian Blakeslee [P,L] Kansas City, MO b. 29 Ja 1898, Rock Island, IL. Studied: Kansas City AI, with A. Angorola, I. Summers; E. Kopietz, AIC. Member: Kansas City AI; Kansas City SA. Exhibited: Mo. State Fair, Sedalia, 1930 (prize); Kansas City AI, 1931 (prize). Work: Scarritt Sch., Kansas City [40]

WALKER, Mary Evangeline (Mrs. Harold A. Landy) [P,L,T,I] Boston, MA/Manomet, MA b. 16 F 1894, New Bedford, MA. Studied: N.Y. Sch. Des. for Women; BMFA Sch.; A. Sterner; P. Hale. Member: Boston AC; Copley S., Boston; Newport AA. Exhibited: Boston AC, annually. Work: Boston AC; port., Veteran's Bldg., Court House, Customs House, Pub. Works Bldg., Suffolk County Court, all in Boston; Radcliffe Col.; City Hall, Medford, Mass.; Masonic Hall, Batavia, N.Y.; H.S., Revere, Mass.; Jefferson C., Cambridge, Mass.; Am. Legion Post, Dorchester, Mass.; Fed. Bldg., Boston; Latin Sch., Boston. Illustrator: "Homecraft Rugs," 1929. Positions: Dir., "The Studio Group," Boston, Mass.; Member, A. Comm., City of Boston, from 1942 [47]

WALKER, Myrtle Van Leuven [P] Crystal, MI b. Summer, MI [08]

WALKER, Nellie Verne [S] Chicago, IL b. 8 d 1874, Red Oak, IA. Studied: AIC, with L. Taft. Member: NSS, 1911; Chicago SA; Soc. Women Sc.; Chicago PS. Exhibited: Mun. A. Lg., Chicago, 1907 (prize); AIC, 1908 (prize), 1911 (prize). Work: mem./statues/groups: Capitol, Wash., D.C.; AIC; Colorado Springs; Keokuk, Iowa; Marmette, Wis.; Cadillac, Mich.; panels, State Col., Ames, Iowa; Roger Sullivan Jr. H.S., Chicago [47]

WALKER, Ryan [Cart] NYC b. 26 D 1870, Springfield, KY d. Summer, 1932, Moscow, Russia. Studied: ASL. Contributor: Life; Judge. After being a socialist for many years, he had become a communist and was visiting Russia as the guest of the Soviet Gov. when he dies. He was an active member of the John Reed Club in NYC. Positions: Cart., Kansas City Times, 1895; later for the St. Louis Republic, Boston Globe, New York Call [15]

WALKER, Sophia A. [P,S,E,C,W,L,T] NYC/Palatine Bridge, NY b. 22 Je 1855, Rockland, MA d. 29 O 1943. Studied: Lefebvre, in Paris; NYC, with Mowbray, Chase. Member: NAC. Work: State Normal Sch. Bridgewater, Mass. [21]

WALKER, Stuart [P] Albuquerque, NM. Exhibited: GGE, 1939; WFNY, 1939 [40]

WALKER, Sybil (Mrs. A.S.) [P,Des,Dec] NYC b. 1882, NYC. Studied: N.Y. Sch. Appl. Des. for Women. Member: NAWA. Exhibited: Detroit Inst. A.; AIC; St. Louis World's Fair; Marie Sterner Gal.; Knoedler Gal.; Parrish Mus., Southampton, N.Y.; AFA Traveling Exh. Work: BM; Tate Gal., London, England [47]

WALKER, Thomas B. [Patron] b. 1 F 1840, Xenia, OH d. 28 Jy 1928, Minneapolis. He was a pioneer in the midwest and won great wealth as a lumberman. Utilizing his fortune to advance the cause of art, as well as religion and charity, he enabled Minneapolis to establish one of the largest private art collections of the U.S. by building the Walker Art Galleries, to which he gave 8,000 pieces estimated to be worth $5,000,000 (in 1928). The Minneapolis Pub. Lib. and its museum also owe their origin to him.

WALKER, T. Dart [Por.P,Mar.P] d. 21 Jy 1914, NYC

WALKER, Wilhelmina [P] NYC. Exhibited: Boston AC [98]

WALKER, William Aiken [Genre P., Por.P] Charleston, SC b. 1838, Charleston, SC d. 3 Ja 1921. Studied: Düsseldorf, Germany, 1850s; mostly self-taught. Exhibited: Charleston, 1850 (age 12). Best known for his post-Civil War genre paintings of Blacks and southern plantation life. Two of his La. and Fla. views were lithographed by Currier & Ives in 1884. Also painted fish and game; turned to landscapes after 1890. [*]

WALKER, William H(enry) [Car,Por.P,Ldscp.P] Flushing, NY/Duxbury, MA b. 13 F 1871, Pittston, PA d. 18 Ja 1938. Studied: ASL. Contributor: Life, 1898–24. Specialty: satirical/political cartoons [38]

WALKINSHAW, Jeanie Walter (Mrs. Robert) [P,I] Seattle, WA b. Baltimore. Studied: E. Whiteman; R. Menard; L. Simon, in Paris; R. Henri, in NYC; Charcoal C., Baltimore. Member: Women P. of Wash.; Nat. Lg. Am. Pen Women; Pac.-Northwest Acad. A. Work: Temple of Justice, Olympia, Wash.; Univ. Wash., Seattle. Illustrator: "On Puget Sound," 1929 [47]

WALKLEY, David Birdsey [P] Hartford, CT/Rock Creek, OH b. 2 Mr 1849, Rome, OH d. 23 Mr 1934, Rock Creek, OH. Studied: PAFA, 1867–71; Acad. Julian, with Boulanger, Lefebvre, 1878; Acad. Mosler, 1878; ASL, with W.M. Chase, 1885. Member: SC, 1903; SAA. Exhibited: NAD; PAFA; Phila. AC; Columbian Expo, Chicago, 1893; AIC; CGA. Among the first artist-residents at Mystic, Conn., ca. 1902–ca. 1915. Positions: T. Pittsburgh Sch. Des. (1879–84), ASL (late 1880s) [25]

WALKLEY, Winfield Ralph [P,Ser] Merrick, NY b. 19 F 1909, Brooklyn, NY d. 1954. Studied: PIASch, 1929–30; ASL, with J.S. Curry, M. Kantor, H. Wickey, 1935–37. Member: Am. A. Congress. Exhibited: FAP traveling exh.; T.R.A.P. Traveling Exh.; Rockefeller Ctr., NYC, 1938; Ferargil Gal., 1936; ACA Gal., 1938; A. Cong., 1938, 1939. Work: WPA mural, USPO, Greer, S.C. [47]

WALKOWITZ, Abraham [P,E,I,Li] Brooklyn, NY b. 28 Mr 1880, Tuiemen, Siberia, Russia (came to NYC in 1889) d. 27 Ja 1965. Studied: NAD, with Ward, Maynard, F.C. Jones, 1894, 1898; Acad. Julian, with Laurens, 1906. Member: Am. A. Cong.; Am. S. PS&G; S.Indp.A. (Dir.); People's AG, 1915 (founding member). Exhibited: Stieglitz' Little Gal., 1912; Armory Show, 1913; Forum Exh., NYC, 1916. Work: BM; MET; AGAA; PMA; Kalamazoo Inst. A.; LOC; NYPL; WMAA; BMFA; Newark Mus.; Columbus Gal. FA; PMG; MOMA; Biro-Bidjan Mus., U.S.S.R. Author: "Isadora Duncan" (of whom he made thousands of drawings); "From the Objective to the Non-Objective," 1945 [47]

WALL, A. Bryan [P] Pittsburgh, PA b. Allegheny City, PA d. ca. 1938. Studied: his father, A. Wall. Member: CI; Pittsburgh SA; AC Phila. Exhibited: AAS, 1907 (gold) [33]

WALL, Alfred S. [Ldscp.P] Pittsburgh, PA b. 1809, England (settled in Pittsburgh, 1840s) d. 6 Je 1896. Exhibited: Pittsburgh AA, 1859–60;

PAFA, 1867. Member: CI (trustee). His brother William Coventry Wall [1810–86] was also a painter.

WALL, Bernhardt [C,E,W,T] Lime Rock, CT (1940)/Sierra Madre, CA (1953) b. 30 D 1872, Buffalo, NY d. ca. 1955. Studied: J.F. Brown; H. Reuterdahl; W. Auerbach-Levy. Member: Sierra Madre A. Gld.; Tex. State Hist. S.; Mo. State Hist. S. Exhibited: Laguna Beach AA, 1945, 1946; Chicago SE. Work: Grosvenor Lib., Buffalo, N.Y.; N.Y. Hist. S.; Lincoln Lib., Shippensburg, Pa.; Lincoln Mem. Univ.; Allegheny Col.; Harvard; Univ. Chicago; Univ. Ind.; Univ. Mich.; Ill. State S.; Brown Univ.; British Mus.; Columbia Univ.; Univ. Calif.; Yale; LOC; Scripps Col.; Southwest Mus., Los Angeles; Princeton; Los Angeles Pub. Lib.; Newark Pub. Lib. Specialties: pictorial biographies; prints; etching; bookbinding. Author/Illustrator/Editor: "Abraham Lincoln" (85 volumes etchings), 1931–42; "Thomas Jefferson" (13 volumes etchings), 1933–37; "The Odyssey of the Etcher of Books," 1945 [47]

WALL, Gertrude Rupel (Mrs.) [C,P,Gr,T,W,L,Des,S] San Fran., CA b. 9 F 1881 (or 1886), Greenville, OH. Studied: Denison Univ.; Oberlin Col.; Chicago Acad. FA; Herron AI; W. Chase. Member: San Fran. SWA; Am. Ceramic S.; Marin A. Soc.; San Fran. Assn. Potters; Bay Region AA. Exhibited: Syracuse MFA; SFMA; Palace Legion Honor; Auburn, N.Y., 1938; Haggin A. Gal., Stockton, Calif. (one-man); de Young Mem. Mus., 1945 (one-man); Oakland A. Gal., 1944 (one-man). Position: T., Univ. Calif., Extension Div. [47]

WALL, Hermann C. [I,P] Wilmington, DE b. 22 S 1875, Stettin, Germany. Studied: H. Pyle. Member: SI 1912. Exhibited: Woman's Home Companion cover contest, 1907 (prize); Strathmore Wash Drawing contest, 1908 (prize) [19]

WALL, W.G. [P] NYC [08]

WALLACE, Amy [P] Minneapolis, MN [24]

WALLACE, Carleton (Mrs.) [P] Minneapolis, MN [21]

WALLACE, Ethel A. (Mrs. Nat Roberts) [P,Des,Dec] New Hope, PA b. Chesterfield, NJ. Studied: PAFA; W. Lothrop; F. Ramsey. Member: Phila. Alliance. Work: private port. commissions [40]

WALLACE, Frederick E(llwood) [Por.P,T] Boston, MA b. 19 O 1893, Haverhill, MA d. 9 My 1958. Studied: Mass. Normal A. Sch.; Académie Julian; E.L. Major; J. De Camp. Member: Gld. Boston A.; Rockport AA; North Shore AA; Am. Veterans SA. Exhibited: New England Contemporary A., 1944 (prize); Rockport AA; North Shore AA. Work: Mass. State House; Dartmouth Col.; N.H. State T. Col; Boston City C.; Bridgewater Normal Sch.; Brooklyn Tech. H.S. [47]

WALLACE, Georgia Burns [P] Washington, CT [15]

WALLACE, J.W. [P] Knoxville, TN [13]

WALLACE, J(ohn) Laurie [P,S,T] Omaha, NE b. 29 Jy 1864 Garvagh, Ireland. Studied: T. Eakins. Member: Omaha AG (Pres.). Work: Univ. Nebr., Pub. Lib., Masonic Hall, All Saints Church, Clarkson Hospital, Federal Court, Trinity Cathedral, Creighton Medical Sch., Nebr. Methodist Episcopal Hospital, Joslyn Mem., all in Omaha; Press C., Chicago; NYC Athletic C. [40]

WALLACE, Lew(is) [P,W] b. 10 Ap 1827, Brookville, IN d. 15 F 1905, Crawfordsville, IN. Amateur painter best known as the author of "Ben Hur," 1880. He was a Civil War general, Gov. of N.Mex., 1878–81, and minister to Turkey, 1881–85. As a youth he was assistant to painter Jacob Cox and resumed painting and writing later in life. [*]

WALLACE, Lillie T. (Mrs. Fred A.) [P,C] Andover, MA b. Manchester, England. Studied: Cornoyer; Mulhaupt. Member: North Shore AA; Rockport AA; Boston SAC [31]

WALLACE, Lucy (Mrs. Lagerberg) [P,C,Des,T] Wading River, NY b. 1884, Montclair, NJ. Studied: N.Y. Sch. F.&Appl. A.; ASL; K.H. Miller; J.R. Koopman. Member: Boston SAC. Exhibited: CGA; CAM; AWCS; Montclair AM; Phila. WCC; Paris Salon; New Haven PCC, 1923 (prize) [47]

WALLACE, Robert R. [P] Minneapolis, MN [17]

WALLACE, Thomas J. [S] Schenectady, NY b. 10 Mr 1851, Schenectady. Studied: Plassmann; Elwell [10]

WALLER, Frank [P,Arch] Morristown, NJ b. 12 Je 1842, NYC d. 9 Mr 1923. Studied: Chase; J.G. Chapman, Rome. Member: Arch. Lg., 1887; NAC; founder & pres., ASL [21]

WALLER, Harold B. (Mrs.) [P] Dallas, TX [24]

WALLER, Johannes O. [P] Evanston, IL b. 1903, Munich, Germany (came to Chicago in 1929) d. 12 F 1945. Work: murals/portraits for Levere Mem. Temple, nat. headquarters of Sigma Alpha Epsilon

WALLER, Robert [P] San Fran., CA b. 29 S 1909, Anaheim, CA. Studied: P. Sample. Exhibited: San Fran. AA, 1937, 1939 [40]

WALLEY, Abigail B.P. [Ldscp.P] Brookline, MA b. Boston. Studied: Sanderson; Langerfeldt; Bensa; Rice. Member: AFA. Specialty: gardens in watercolors and pastels [31]

WALLEY, John Edwin [Mur.P] Chicago, IL/Cody, WY b. 2 F 1910, Sheridan, WY. Studied: Chicago Acad. FA; Goodman Theatre of AIC; H. Ropp's Sch. Art. Member: Wyo. AA. Work: murals, Univ. Wyo., Pub. Lib., Cody [40]

WALLIN, Carl E. [Por.P,Mur.P] Chicago, IL b. 22 Mr 1879, Sweden. Studied: AIC; Reed's A. Sch., Denver. Member: Chicago AA; All-Ill. FA; Swedish Ar. Chicago; Chicago Gal. A. Exhibited: Swedish Am. Artists' Assn., 1925 (prize), 1928 (prize), 1929 (prize); Swedish Ar. Chicago, 1928 (prize). Work: St. Adelbert's Church, Whiting, Ind.; Gothenburg Mus. (Sweden) [40]

WALLING, Anna M. [C,P,Des,W,L,T,B,Dec] Middletown, NY b. 25 D 1881, Warwick, NY. Studied: Europe; M. Fry; A. Heckman; A. Dow; G. Cornell; W. Reiss; D.W. O'Hara; M. Mason. Member: N.Y. Keramic S.; N.Y. Craftsman's C.; Des. G., N.Y. Exhibited: MET; AMNH; Craftsmen's C.; N.Y. Keramic S. Contributor: Keramic Studio [47]

WALLING, Dow [I] Pelham Manor, NY. Member: SI [47]

WALLIS, Frank [P] NYC Exhibited: N.J. State Exh., Montclair AA, 1938; AIC, 1937, 1938; AWCS-NYWCC, 1939 [40]

WALLIS, Mary Burton [P,G] Scarsdale, NY b. 26 S 1916, Dubuque, IA. Studied: ASL. Member: Young Am. Ar.; NAWPS. Exhibited: Contemp. A. Gal., N.Y.; FA Gal., NYC [40]

WALMSLEY, Lucy [P] Noroton Heights, CT [19]

WALP, M. Vignes (Mrs.) [P] Long Beach CA. Member: Calif. PM [25]

WALSER, Floyd N. [E,Ldscp.P,T] Framingham, MA b. 29 Ja 1888, Winchester, TX. Studied: BMFA Sch.; Plowman; Spaulding; Kitson. Member: Southern PM; Framingham AL. Exhibited: SAE; CMA; Southern PM Traveling Exh. [47]

WALSH, Clara A. [P] Lincoln, NB [04]

WALSH, Elizabeth Morse [P] Lowell, MA b. Lowell, MA. Studied: BMFA Sch. Member: Concord AA [25]

WALSH, Madge [E] Chicago, IL [19]

WALSH, Noemi M. [C,T] Richmond Heights, MO b. 3 Jy 1896, St. Louis. Studied: Wash., Univ., St. Louis. Exhibited: St. Louis AG; Noonan-Kocian Gal.; CAM. Work: commissions in jewelry & silversmithing, including Chancellor's medallion, Wash., Univ.; pins, Alton Mem. Hospital, St. Louis. Positions T., Wash. Univ., St. Louis (1928–46), Univ. Col., St. Louis (1942–46) [47]

WALSH, Richard M.L. [P] NYC b. NYC. Studied: ASL. Member: NAC [10]

WALSH, W. Campbell [P] Astoria, NY b. 22 O 1905, PA. Studied: PAFA, with D. Garber, J.T. Pearson; PMSchIA. Member: Artists U.; S.Indp.A. [40]

WALTEMATH, William [P] Rockville Center, NYC. Exhibited: Walker Gal., NYC, 1937, 1939; PAFA, 1939 [40]

WALTENSPERGER, Charles E. [P,I] Detroit, MI b. 10 Ap 1871, Detroit d. 12 D 1931. Studied: Europe, 2 yrs. Specialty: Dutch interiors. Illustrator: books by "M. Quad"; Detroit Free Press [25]

WALTER, Christ [P] Plimpton, OH [04]

WALTER, Christian J. [P] Pittsburgh, PA/ Ligonier, PA b. 11 F 1872, Pittsburgh d. 25 F 1938. Member: Pittsburgh AA. Exhibited: Pittsburgh AA, 1913 (prize), 1915 (prize), 1921 (prize), 1927 (prize); CI, 1937 (prize). Work: St. Petersburg permanent coll. (Fla.); John Vanderpoel AA, Chicago; Pa. State Col.; coll., 100 Friends of Art [38]

WALTER, Edgar [S] San Fran. CA. Studied: Perrin, in Paris. Member: NSS, 1911. Exhibited: Paris Salon, 1901 (prize); P.-P. Expo, San Fran., 1915 (prize). Work: MMA; fountain, NYC, 1914; TMA [24]

WALTER, George M. [P] Columbus, OH. Member: Columbus PPC [25]

WALTER, Hulda. See Parton.

WALTER, J.W. [P] Wilkinsburg, PA. Member: Pittsbrugh AA [21]

WALTER, Jeanie. See Walkinshaw.

WALTER, Joseph [P,S] Brooklyn, NY b. 5 Jy 1865, Galtuer, Austria. Studied: Loefftz; S. Herterich; J. Hackl, in Munich; Gripenkerl, in Vienna. Member: Dubuque AA. Exhibited: WFNY, 1939. Work: murals, Catholic Church, Madison, Nebr.; six murals, Peter and Paul's Church, Petersburg, Iowa; St. Joseph's Church, Peoria, Ill.; St. Patrick Church, Dubuque, four paintings, Church, Sherrills, mural, Holy Ghost Church, Dubuque; painting, St. Mary's Church, Remsen; St. Joseph's Church, Garnavillo, Iowa; St. Joseph's Convent, St. Joseph, Minn.; WPA S., USPO, Fairfield, Maine [40]

WALTER, L. [P] NYC [10]

WALTER, Louise Cameron [Min.P] Pittsburgh, PA b. Pittsburgh. Studied: Paris, with Mme. Laforge, Rénard [10]

WALTER, Martha [P] Melrose Park, PA b. Phila., PA. Studied: W.M. Chase, PAFA; Académie Julian (1903), Académie Grande Chaumière, both in Paris. Exhibited: PAFA, 1909, (prize); NAWPS, 1915 (prize); F. PAFA, 1923 (gold). Work: TMA; PAFA; Norfolk SA; F., PAFA; Milwaukee AI; Little Gal., Cedar Rapids, Iowa; AIC; Luxembourg Mus., Paris. Traveled to Italy, Holland, Spain and Germany. [40]

WALTER, Otis W. [P] Pittsburgh, PA. Member: Pittsburgh AA [21]

WALTER, Solly [I,L] b. 1846, Vienna, Austria (came to U.S. in 1878; settled in San Fran. in 1883) d. 26 F 1900, Honolulu, HI. Member: San Fran. AA; Bohemian C. Position: T./Founder, sch. of drawing in San Fran.

WALTER, Valerie Harrisse [Por.S] Baltimore, MD b. Baltimore. Studied: E. Keyser; A. Lukeman; Mrs. Lefebvre's Sch. Member: Wash. AC; SSAL. Exhibited: NSS; NAD; Paris Salon; CGA; BMA; PAFA; Detroit Inst. A.; SFMA. Work: CGA; Aeronautical Ministry, Rome, Italy [47]

WALTER, William Francis [P,Car,Des] Wash., D.C. b. 2 Ja 1904, Wash., D.C. d. 1977. Studied: Corcoran Sch. A.; C. Hawthorne; W.L. Stevens; R. Meryman; B. Baker. Member: Wash. AC; SSAL; S. Wash. A.; Ldscp. C., Wash., D.C. Exhibited: Ldscp. C., Wash., D.C., 1939, 1941 (prizes); U.S. Nat. Mus., 1939 [47]

WALTERS, C.A. [P] Portland, OR [15]

WALTERS, Carl [Cer.S,C,P] Woodstock, NY b. 19 Je 1883, Ft. Madison, IA d. N 1955. Studied: Minneapolis, Sch. A.; R. Henri. Member: Woodstock AA; Am. S. PS&G; Guggenheim F., 1935–36. Exhibited: Copenhagen, Denmark, 1927; Stockholm, Sweden, 1928; WMAA, 1929–45; AIC, 1932–45; PAFA, 1938–45; Musée du Jeu de Paume, Paris, 1938; Syracuse Mus. FA Traveling Exh. to Denmark, Sweden, Finland, 1937; MET (AV), 1940 (prize). Work: MOMA; WMAA; MET; AIC; Davenport Mun. A. Gal.; CM; PMG; Minneapolis Inst. A.; Portland (Oreg.) Mus. A.; N.Y. State Col. Cer., Alfred Univ.; Detroit Inst. A. [47]

WALTERS, Emile [Ldscp.P,T] Poughkeepsie, NY (1970) b. 31 Ja 1893, Winnipeg, Ontario (came to U.S. in 1898) d. Studied: AIC; PAFA; Tiffany Fnd. Member: SC; Pittsburgh AA; Phila. AC. Exhibited: AIC, 1918 (prize), 1919 (prize), 1921 (prize); NAD, 1924 (prize); Nat. Art Exh., Springville, Utah, 1926 (prize), 1927 (prize). Award: dec., Order of the Falcon, King Christian of Denmark, 1939. Work: Smithsonian; Phila. AC; 100 Friends of Art, Pittsburgh; Mus. FA, Houston; Heckscher MFA; Mus. A., Saskatoon, Canada; FMA; Mus. Rouen, France; BM; SAM; Vanderpoel Col.; Winnipeg Mus. FA; Luxembourg Mus., Paris; Mun. Gal. Mod. A., Dublin, Ireland; Nat. Mus., Helsinki, Finland; Mus. Iceland, Reykjavik; Pomona Col., Claremont, Calif.; Pal. Leg. Honor; Newark Mus.; Los Angeles Mus. A.; Fleming Mus.; Mus. N.Mex.; Springfield, Ill. Later specialized in views of Iceland, Greenland, and the Arctic regions. Position: T., Pa. State Col. (summer session) [47]

WALTERS, Emrys L. [P] Columbus, OH. Member: Columbus PPC [24]

WALTERS, Henry [Patron] NYC b. 26 S 1848, Baltimore, MD d. 30 N 1931. The Walters Art Gallery, his large three-story private gallery adjoining his Baltimore residence, has long been famous. For many years pilgrimages have been made to it on certain days during the first four months of the year, and the admission fees have been given to charity. The paintings in the collection number seven hundred and fifty items, including old masters and the Massaranti collection purchased in 1902 and brought to this country from Italy on a specially chartered steamship. It is said that the Egyptian section cannot be duplicated in a private collection and the jades and watches form an important group. Of the sculpture a replica of Rodin's "The Thinker" is the most notable. He bequeathed the Walters Art Gal. and the house adjoining with its entire contents to the City of Baltimore, as well as one-quarter of his $10,000,000 estate. He also willed $188,888 to the MET, of which he was a vice-president and a director.

WALTHER, Charles H. [P,T] Baltimore, MD/Middletown, MD b. 10 F 1879, Baltimore d. 11 My 1937. Studied: Md. Inst.; Paris, with Blanche, Simon, Laurens, Cottet. Member: Charcoal C.; Baltimore Mus. A.; Baltimore S.Indp.A. Work: Cone Coll., Baltimore; H.S., Baltimore; PMG [38]

WALTHER, Frederich W. [P] Phila., PA b. 24 S 1895, Württemberg, Germany. Studied: Pforzheim, Stuttgart, Strassbourg, Germany. Member: ASMP; AAPL [47]

WALTMANN, Harry Franklin [P] Dover Plains, NY b. 16 Ap 1871, Ohio d. 23 Ja 1951. Studied: Constant, Laurens, in Paris. Member: ANA, 1917; SC, 1897; Allied AA; NAC. Exhibited: SC, 1916 (prize); NAC, 1927 (prize); Stockbridge AA, 1938 (prize). Work: Butler AI [47]

WALTON, Edward Austin [Des,P,T,L] Phila., PA b. 11 Jy 1896, Haddonfield, NJ. Studied: PMSchIA; Phila. Sketch C. Member: Phila. WCC. Exhibited: PAFA, 1933–38, 1944. Specialty: furniture des. Position: T., PMSchIA [47]

WALTON, Florence L. [P] West Orange, NJ b. 9 Jy 1889, East Orange, NJ. Studied: G. Bellows; J. Johansen; B.J.O. Nordfeldt; H. Boss. Member: S.Indp.A.; NYSC [25]

WALTON, Frederick C. [P] Chicago, IL [10]

WALTON, Katherine [Por.P] d. 15 F 1928, Annapolis, MD. Restored some of the old paintings at the U.S. Naval Acad.

WALTON, Marion (Mrs. Putnam) [S] NYC b. 19 N 1899, New Rochelle, NY. Studied: Bryn Mawr Col.; ASL; Grande Chaumière, Paris; M. Young; A. Bourdelle; G. Borglum. Member: S. Gld.; Fed. Mod. P.&S.; Am. A. Cong. Exhibited: WMAA; PAFA; MET (AV); AIC; CI; Weyhe Gal., 1934 (one-man); Dallas Mus. FA; Los Angeles Mus. A.; SFMA; WFNY, 1939. Work: Univ. Nebr.; relief, USPO, Pittston, Pa. Contributor: Magazine of Art [47]

WALTON, William [P,C,W] NYC b. 10 N 1843, Phila. d. 13 N 1915 (drowned). Studied: PAFA; NAD, NYC; Carolus-Duran, in Paris. Member: Arch. Lg., 1888; Am. Fine Arts; NAC; Century. Work: Calvary Church, NYC; Grace Church, Newark, NJ. Author: "Art and Architecture, World's Columbian Exposition, 1893." Specialty: designs for stained glass [15]

WALTRIP, Mildred [Mur.P,G,Des,I] NYC (Chicago, IL in 1940) b. 4 O 1911, Nebo, KY. Studied: AIC; Northwestern Univ.; Moholy-Nagy; A. Archipenko; Fernand Leger. Exhibited: AIC, 1935; Phila. A. All.; Los Angeles Mus. A. Work: murals: Oak Park (Ill.) Pub. Sch.; Chicago Park Bd., Adminstration Bldg., Cook County Hospital, Chicago; Scott Field, Belleville, Ill. Illustrator: "Guide Book to Cairo, Illinois," 1939. Position: Comm. A., Grey Advertising Agency, NYC [47]

WALZ, John [S] Savannah, GA b. 31 Ag 1844, Württemberg, Germany (came to U.S., 1859). Studied: Aimé Millet, Paris; Tilgner, Vienna [10]

WAMALINK, H.J. [P] Cleveland, OH. Member: Cleveland SA [29]

WAMSLEY, Frank C. [S] Hollywood, CA b. 12 S 1879, Locust Hill, MO. Studied: AIC, with C.J. Mulligan, A. Polasek; BAID; S. Borglum; J. Gregory; E. McCarten. Member: Artland C.; PS of Los Angeles. Work: Hackley A. Gal., Muskegon, Mich.; Hollywood Crematory; mem. tablet, Covina, Calif. Specialties: fountains; garden figures [33]

WAMSLEY, Lillian Barlow (Mrs.) [C,S,T,Des,B,L] NYC b. Ft. Worth, TX. Studied: Columbia; A.W. Heckman; H. Reiss; M. Robinson; C. Upjohn. Member: N.Y. Keramic S. & Des. Gld.; N.Y. Soc. Ceramic A. Exhibited: WFNY, 1939; Boston SAC, 1940; N.Y. Keramic S., 1920–40, 1931 (prize); N.Y. Ceramic A., 1920–40; Okla. A. Exh., 1923 (prize); Mus. Nat. Hist., 1931 (prize) Contributor: Keramic Studio. Position: Owner/Dir., Pottery and Sculpture Studios, NYC, from 1939 [47]

WAMSLEY, Margaret. See Cole, Mrs.

WANAMAKER, Lewis Rodman [Patron] b. Phila., 1863 d. 9 Mr 1928, Atlantic City, N.J. Studied: Princeton. He aided the flights made by Lieutenant Commander Byrd to the North Pole and France, and he also sponsored three expeditions under the authority of the U.S. Bureau of Indian Affairs into the Indian Country. His lifelong interest in art brought him recognition as a connoisseur. Aside from his private collection of art treasures, there were many examples of the work of great painters in his NYC and Phila. stores. One of his principal gifts was that of an art collection to Princeton. The Paris AAA elected him president, and partly through his patronage, the American Art Students C. in Paris was founded. He was decorated as Commander of the Royal Victorian Order of Great Britain, Grand Officer of the Order of the Crown (Italy), Officer of the Order of St. Sava (Serbia), and member of Order of the Liberator

(Venezuela). He was a member of the MMA, the Sulgrave Inst., Wash., D.C. and numerous other organizations and clubs in this country and abroad.

WANDS, Alfred James [P,Li,T,L] Denver, CO b. 19 F 1904, Cleveland. Studied: Cleveland Sch. A.; Académie Julian; John Huntington Inst.; Western Reserve Univ.; F.N. Wilcox; H.G. Keller. Member: Denver AG; Ohio WCS; Chicago Gal. Assn.; AAPL; Cleveland SA. Exhibited: CI, 1928; PAFA, 1924, 1926, 1928, 1932, 1934; WFNY, 1939; AIC, 1934; CGA, 1935; CMA, 1923–30 (prizes), 1931–37, 1939, 1940; Kansas City AI, 1930–33, 1934 (med); Denver AM, 1931–1945, 1932 (prize), 1946 (prize); Paris Salon, 1936 (prize); Pal. Leg. Honor, 1932 (prize); Chaloner prize, NYC, 1926. Work: BM; CMA; Pal. Leg. Honor; Cleveland Pub. Sch.; Denver Pub. Sch.; Denver AM; murals, Col. Women's Col.; Methodist Church, Sterling, Colo.; Kansas City AI; Denver Univ. Position: T., Colo. Women's Col., Denver [47]

WANG, E.O. [P] Brooklyn, NY. Member: S.Indp.A. [25]

WANGELIN, Josie Kircher [Ldscp.P,B,C,Des,T] St. Louis, MO b. Belleville, IL. Studied: St. Louis Sch. FA; PIASch; AIC; K. Cherry; D. Mulholland; F.B. Nuderscher; G. Goetsch. Member: St. Louis A. Ctr. Exhibited: Civic Lg. Art Exh., St. Louis. Work: decoration in handwrought silver for Children of the American Loyalty League. Specialty: handwrought jewelry [40]

WANKER, Maude Walling (Mrs. C.C.) [P,T,L] Wecoma, OR (1962) b. 22 O 1882, Portland, OR. Studied: Univ. Oreg.; AIC; Portland Mus. Art Sch.; C. Stevens; J. Stewart. Member: AAPL; S. Oreg. A. Exhibited: SAM, 1933–38; Portland A. Mus., annually. Work: Oreg. Hist. S.; Oreg. State Capitol; Portland Women's C. Positions: T., Lincoln County A. Ctr., DeLake, Oreg.; Coquille Valley AA [47]

WANN, Marion [P,T] Oklahoma City, OK. Member: Okla. AA. Position: T., H.S., Oklahoma City [27]

WARBURTON, James [En] b. 1827 d. 15 Jy 1898, Pawtucket, RI. At the time of his death one of the oldest engravers in the U.S.

WARD, Albert Prentiss [P,S,I] Rochester, NY. Studied: S.S. Thomas; Whistler [10]

WARD, Bernard Evans [P] OH/FL b. 1857, London, England. Exhibited: Royal Acad. Arts (gold); Fla. Fed. A., annually. Work: He came to Cleveland (1913) and painted portraits of Cleveland residents.

WARD, C.M. [P] Boston, MA. Member: Boston AC [25]

WARD, Charles S. [Ldscp.P] b. 1 F 1850, Geneva, IL d. 24 My 1937, Montecito, CA. Active in Los Angeles, 1892–1915. Specialty: pastel [*]

WARD, Charles W. [Mur.P,T] Carversville, PA b. 24 Ja 1900, Trenton, NJ. Studied: Sch. Indst. A., Trenton; PAFA, 1930 (Cresson traveling schol.). Work: F., PAFA; Everhart Mus.; WPA murals, USPOs, Trenton (N.J.), Roanoke Rapids (N.C.) [47]

WARD, Clarence [Edu,Mus.Dir,W,L,Des] Oberlin, OH b. 11 Mr 1884, Brooklyn, NY. Studied: Princeton. Author: "Mediaeval Church Vaulting," 1915. Position: Dir., Oberlin Col. Mus., from 1916 [47]

WARD, Edgar Melville [Ldscp.P,Genre P,T] NYC b. 24 F 1849, Urbana, OH d. 15 My 1915. Studied: his brother J.Q.A. Ward; Miami Univ.; NAD, 1870–71; Ecole des Beaux-Arts, Paris, with A. Cabanel, 1872–74. Member: ANA, 1875; NA, 1883; Century. Work: MMA; Nat. Gal.; Luxembourg Mus., Paris [10]

WARD, Edgar Melville [P,T] Kingston, NY b. 19 F 1887, France. Studied: E. Carlsen; G.W. Maynard; E.M. Ward; F. Jones. Exhibited: Albany Inst. Hist.&A.; Woodstock AA Gal. Work: murals, Wells Col., N.Y.; Refectory, Jones Beach, N.Y.; painting, H.S., Albany; Bd. Edu., Newark, N.J. [40]

WARD, Edith Barry [P] Wash., D.C. Member: Wash. WCC. Exhibited: Wash. SA, Wash. WCC, 1898 [98]

WARD, Edmund F. [P,I,T] White Plains, NY (1976) b. 3 Ja 1892, White Plains. Studied: ASL, with E. Dufner, G. Bridgman, T. Fogarty, 1910–12. Member: SI; SC; GFLA. Exhibited: AIC, 1925 (prize). Work: WPA mural, Fed. Bldg., White Plains, N.Y. Illustrator: national magazines; books. Position: T., ASL, 1924–25 [47]

WARD, Elsie. See Hering, Henry, Mrs.

WARD, Franklin T. [P] Boston, MA [15]

WARD, Harold L. (Mrs.) [P] Orchard Lake, MI. Member: Detroit S. Women P. [25]

WARD, Heber Arden (Mrs.) [P] Denver, CO. Member: Denver AA [25]

WARD, Herbert T. [S] b. 1862 d. 2 Ag 1919, Neuilly, France. He was also an explorer.

WARD, Hilda [P] Roslyn, NY. Member: NYWCC [25]

WARD, Irene Stephenson (Mrs. H.W.) [L,P] Oakman, AL b. 18 Jy 1894, Oakman. Studied: Miss. State Col.; Oakman Col. Member: Birmingham AC; Ala. AL; SSAL. Exhibited: VMFA, 1938 (prize); S.Indp.A., 1943 (prize); Montgomery, Ala., 1938–46 (prizes); Fed. Women's C., 1939 (prize); Ala. AL, 1938–46; Birmingham AL, 1938–46; Toledo, 1946; Jasper (AL) AC. Work: MA, Decatur, Ala.; H.S., Oakman [47]

WARD, Irving [Por.P,Ldscp.P] Baltimore, MD d. 17 Ap 1924. Member: Charcoal C. (charter member) [24]

WARD, J. Stephen [P] Jacksonville, OR b. Ap 1876, St. Joseph, MO. Studied: N. Brewer; M. Braun. Member: Calif. AC; Artland C.; Los Angeles PS; Glendale AA; Oreg. SA. Exhibited: State Fair, Phoenix, Ariz., 1923 (prize); Witte Mem. Mus., San Antonio, 1929 (prize); Oreg. State Fair, 1930 (prize). Work: H.S., Hollywood, Calif.; Clubb Coll., Kaw City, Okla. [33]

WARD, Jean S. [P] Los Angeles, CA b. 27 Jy 1868, WI. Studied: U.S.; Europe [25]

WARD, John Quincy Adams [S] NYC b. 29 Je 1830, Urbana, OH d. 1 My 1910. Studied: Brooklyn, with H.K. Brown, 1849–56 (with whom he cast the statue of Washington at Union Square.) Work: equestrian statues of Sheridan and Hancock in Phila.; statue of the "Indian Hunter," "The Pilgrim" and Shakespeare, in Central Park, and Henry Ward Beecher in Borough Hall Park, Brooklyn; also statues of Commodore Perry at Newport, R.I., and Israel Putnam at Hartford, Conn. He opened his NYC studio in 1861 and was considered America's "sculptor laureate" and "dean of American sculptors." Brother of Edgar. [10]

WARD, John R. [Cart] El Paso, TX. Work: Huntington Lib., San Marino, Calif. Position: Cart., El Paso Times [40]

WARD, John (Talbot) (Jr.) [P] Phila., PA b. 14 My 1915, Wilkes-Barre, PA. Studied: PAFA; Cresson traveling schol., 1936, 1937. Member: Phila. Pr. C.; Am. Fed. A; F., PAFA. Exhibited: CM, 1938; PAFA; Phila. A. All.; Phila. Sketch C.; Woodmere A. Gal. Work: mural, Christ Church, Stuart Manor, N.Y.; decorations, St. Mary's Church, Burlington, N.J.; St. Paul's Church, Westfield, N.J. Position: A. Dir., St. Mary's Hall, Burlington, N.J. [47]

WARD, Lynd (Kendall) [Li,I,P,E] Leonia, NJ b. 26 Je 1905, Chicago. Studied: Columbia; State Acad. Graphic A., Leipzig, Germany. Member: ANA; A.Lg.Am.; Am. A. Cong. Exhibited: Am. A. Cong.; WFNY, 1939; NAD; John Herron AI; LOC. Work: LOC; Newark Mus. Author/Illustrator: novels in woodcuts: "Madman's Drum," 1930, "Song Without Words," 1936; "Vertigo," 1937; articles, Horn Book [47]

WARD, Mabel Raymond (Mrs.) [P,T,E] NYC/Summit, NJ b. 1874, NYC. Studied: Henri; Chase. Member: ASL; A. Workers C.; Calif. SE; Chicago SE. Work: NYPL [17]

WARD, Mary Trenwith Duffy [Por.P,I,Dr,T] Wash., D.C./New Bern, NC b. 29 O 1908. Studied: M. Ashton; A. Bessimer; F. Hamoney; Breckenridge. Member: Wash. S. Comm. Ar. Position: T., Columbia Tech. Inst., Wash., D.C. [40]

WARD, Nina B. [P] Phila., PA b. Rome, GA. Studied: St. Louis Sch. FA; N.Y. Sch. A.; PAFA, Cresson European schol., 1908, 1911. Exhibited: PAFA, 1912 (prize); 1914 (prize) [21]

WARD, Phillips [I] Staten Island, NY [08]

WARD, Prentiss [P] Rochester, NY [08]

WARD, Richard, Jr. [I,Car,S,C] NYC b. 30 Ap 1896, NYC. Studied: Margate Col., England; BAID. Member: SI [47]

WARD, Ruth Porter [P] Wash., D.C. b. Statesville, NC d. 23 Jy 1936. Studied: Tarbell; Meryman; Baker; Breckenridge; Tiffany. Member: S. Wash. A.; Artists Group; L.C. Tiffany Fnd. Exhibited: S. Wash. A., 1932 (prize) [38]

WARD, Sarah G. [P] Evanston, IL. Exhibited: SWA, 1898 [01]

WARD, William de Lancey [P] Paris, France b. NYC. Studied: Paris, with Bonnât, Roll, Bordes [10]

WARD, Winifred [S,W] Phila., PA b. 20 Ja 1889, Cleveland, OH. Studied: C. Grafly. Member: Plastic C.; NAWPS; S.Indp.A. [21]

WARDEN, Ben W. [P] Columbus, OH. Member: Columbus PPC [25]

WARDEN, William F(rancis) [P] Paris, France b. 2 Je 1872, Bath, ME. Studied: Paris, with Comèrre, Constant, Robert-Fleury. Member: Cercle de l'Union Artistique, Paris; Paris AAA [13]

WARDIN, Frances Mitchell [P] Topeka, KS b. 19 Ja 1888, Topeka. Studied: R. Henri, in NYC [15]

WARDMAN, John W(illiam) [P,I,B] Los Angeles, CA b. 7 S 1906, Leeds, England. Studied: J.P. Wicker. Exhibited: Mich. State Fair, 1929 (prizes). Work: bookplates, Intl. Bookplate Assn.; Los Angeles Mus. Hist., Sc.&A.; Southwest Mus.; Mun. Art Comm., Los Angeles [40]

WARDWELL, James H. [P] Woodstock, NY [13]

WARE, Ellen Paine (Mrs. J.W.) [P] Memphis, TN b. 12 N 1859, Jacksonport, AR. Studied: St. Louis Sch. A.; Cincinnati Sch. Des. Member: Memphis AA. Exhibited: Memphis AA, 1920 (prize), 1921 (prize) [31]

WARE, Florence Ellen [P,I,W,L,T] Salt Lake City, UT b. 6 My 1891, Salt Lake City d. 1971. Studied: Univ. Utah; Provincetown, with C. Hawthorne; Hills; AIC; Calif. Sch. A.&Cr. Member: Utah AI; Laguna Beach AA; SAC, N.Y. Exhibited: Utah AI, 1928 (prize); Springville, Utah, 1931 (prize); Utah State Fair, 1939 (prize). Work: WPA murals, Laramie (Wyo.) H.S., Appleton (Wis.) H.S.; Utah State Fair Assn.; port. sketch, Utah AI; H.S.; Whitman Col., Walla Walla, Wash.; Stewart Sch., Univ. Utah; Ladies Literary C., Salt Lake City; murals, Sch., Rowland Hall Chapel, Port Pub. Co., Pub. Lib., all in Salt Lake City; H.S., Richmond, Utah; Univ. Utah. Position: T., Univ. Utah, 1918–40s [40]

WAREHAM, John Hamilton D(ee) [P,C] Cincinnati, OH b. Grand Ledge, MI. Studied: Duveneck; Meakin. Member: Cincinnati Mun. AS; Cincinnati AC; MacD. C.; Cincinnati Mus. Assn. Exhibited: St. Louis Expo, 1904 (med); dec., Ft. Pitt Hotel, Pittsburgh; Seelbach Hotel, Louisville, Hotel Sinton, Cincinnati. Position: Pres., Rookwood Pottery Co., 1940 [40]

WARFIELD, Majel [P,I] New Orleans, LA b. 10 Mr 1905, New Orleans. Studied: F. Grant. Member: NOAA; SSAL [33]

WARGHY, Armand [P,E] Chicago, IL [21]

WARHANIK, Elizabeth C. (Mrs. C.A. Warhanik) [P] Seattle, WA b. 29 F 1880, Phila. Studied: P. Gustin; E. Forkner; C. Woodbury. Member: Seattle A. Mus.; Women P. Wash. Exhibited: Northwest Artists, Seattle, 1917 (prize); Univ. Wash., 1930 (prize); Women P. Wash., 1937–39 (prizes) [40]

WARING, Amalia V. [Min.P] Paris, France [10]

WARING, E.B. (Miss) [P] Newport, RI b. Chappaqua, NY. Studied: A.H. Thayer. Member: Newport AA [25]

WARING, James D. [P] Montclair, NJ [24]

WARING, Laura Wheeler [Por.P,I,T] Phila., PA b. Hartford, CT d. 3 F 1949. Studied: Chase; Boutet de Monvel; Prinet; McCarter; Violet Oakley; PAFA, Cresson Traveling Sch. Exhibited: Harmon Fnd., 1928 (gold); Exh. Colored Artists, 1919 (prize); PAFA; AWCS; AIC; CGA; Detroit Inst. A. Work: portraits; Cheyney State T. Col.; U.S. Armory, NYC. Contributor: School Arts [47]

WARING, Leila [Min.P] Charleston, SC. Member: SSAL; Carolina AA; AFA [33]

WARKANY, Josef [E] Cincinnati, OH b. 25 Mr 1902, Vienna, Austria. Exhibited: Intl. Etching & Engraving Exh., 1938; LOC, 1945; SAE, 1945; Ohio PM., 1938, 1944; CM, 139, 1944 (one-man); Am. Physicians' AA, 1938–41 (prizes) [47]

WARLOW, C. Joseph [P] Phila., PA Studied: PAFA [21]

WARNACUT, Crewes [P,E] Inwood, IN b. 1 Je 1900, Osman, IL. Studied: W. Forsyth; C. Hawthorne. Member: All-Ill. SFA; Hoosier Salon; Lg. Northern Ind. Exhibited: All-Ill. SFA, 1929 (prize); Lg. Northern Ind., 1929 (prize) [33]

WARNEKE, Heinz [S,T] Wash., D.C./East Haddam, CT b. 30 Je 1895. Studied: Acad. FA, Berlin. Member: ANA, 1939; Am. Soc. PS&G; Salon des Tuileries; NSS; CAFA; MOMA. Exhibited: Salon des Tuileries, Paris, 1926 (prize); St. Louis AG, 1924 (prize), 1925 (prize); AIC, 1930 (med); PAFA, 1935 (gold); CAFA, 1935 (prize); Wash. AA, 1943 (med). Work: Brookgreen Gardens, S.C.; Univ. Nebr.; AIC; AGAA; CGA; MOMA; BM; Masonic Temple, Ft. Scott, Kans.; Medical Soc., YMCA, City Hall, all in St. Louis; Harlem Housing Proj., NYC; Zoological Gardens, Wash., D.C.; Fairmount Park, Phila.; WPA statue, Post Office Dept. Bldg., Wash., D.C.; Dept. Interior Bldg. Position: T., CGA, from 1942–46 [47]

WARNER, Alice. See Burgess.

WARNER, Anne Dickie [Por.P] Wilmington, DE. Studied: PAFA, with J.T. Pearson, Jr., D. Garber, H. Breckenridge, Cresson Schol., 1936; C. Hawthorne. Member: Wilmington SFA; Wilmington AC. Position: Affiliated with Cranbrook Acad., Bloomfield Hills, Mich. [40]

WARNER, (E.) Victor B(ell) [P,Li] NYC/Provincetown, MA b. 21 Ag 1908, Ipswich, England. Studied: T. Benton; R. Moffett; J. Bowes.; ASL [33]

WARNER, Earl A. [I,T] b. 1883 d. 19 Jy 1918, Battle Creek MI. Position: T., Peabody T. Col., Nashville, Tenn.

WARNER, Everett Longley [Ldscp.P,E,L,T,W] Westmoreland, NH b. 16 Jy 1877, Vinton, IA d. 1963. Studied: ASL; Wash., D.C. ASL; Académie Julian, Paris. Member: NA, 1938; ANA, 1913; AWCS; NAC; Wash. WCC; S. Wash. A.; Pittsburgh AA; Paris AAA. Exhibited: Wash. WCC, 1902 (prize); PAFA, 1908 (med); Buenos Aires Expo, 1910 (med); NAD, 1912, 1937 (prize); SC, 1913 (prize); S. Wash. A., 1913 (med); SC, 1914 (prize); P.-P. Expo, San Fran., 1915 (med); CAFA, 1917 (prize); AIC, 1919 (prize); Lyme AA, 1924 (prize), 1937 (prize); Pittsburgh AA, 1934 (prize). Work: CGA; PAFA; Erie Pub. Lib.; PAFA; MFA, Syracuse, NY; TMA; RISD; CAM, St. Louis; NAC; AIC; Gibbes Art Gal., Charleston, S.C.; Okla. AL, Oklahoma City. A studio fire destroyed much of his work in 1972. Position: T., CI, 1924–42. [47]

WARNER, Helene [S] Chicago, IL. Exhibited: AIC, 1936; WFNY, 1939 [40]

WARNER, Isabel Anna (Mrs. Willis) [P] Gilmore City, IA b. 1 N 1884, Lee, IL. Studied: Mrs. L.H. Van Alstine. Member: Ft. Dodge AG. Exhibited: Blanden Gal., Ft. Dodge, Iowa; Iowa Fed. Women's C., Sioux City; Iowa Ar. Exh., Mt. Vernon, 1938 [40]

WARNER, Landgon [Mus.Cur,Edu] Cambridge, MA b. 1 Ag 1881, Cambridge d. Je 1955. Studied: Harvard. Author: "Japanese Sculpture of the Suiko Period," 1923, "Craft of the Japanese Sculptor." Position: Cur., FMA [47]

WARNER, Margaret [I,W] Wash., D.C. b. 5 D 1892, Mabbettsville, NY. Studied: Corcoran Sch. A.; Abbott Sch. A., Wash., D.C.; N.Y. Sch. F.&Appl.A.; Berkshire Summer Sch. A. [31]

WARNER, Mary E. [P] Phila., PA [04]

WARNER, Mary Loring (Mrs.) [P] Middletown, CT b. 2 S 1860, Sheffield, MA. Studied: F. de Haven; C.W. Eaton. Member: CAFA; New Haven PCC [40]

WARNER, May [P] Seattle, WA [25]

WARNER, Myra [I,P] Rochester, MN b. Roca, NE. Studied: AIC; Univ. Nebr.; M. Broedl. Specialty: medical illus. [25]

WARNER, Myrtle L(ouise) [P,S,I,T] Sterling, MA/Cliff Island, ME b. 25 Je 1890, Worcester, MA [25]

WARNER, Nell Walker (Mrs. Emil Shostrom) [P] La Crescenta, CA b. 1 Ap 1891, Nebraska d. 30 N 1970, Monterey County, CA. Studied: P. Lauritz; Los Angeles Sch. Art & Des., 1916; F. Werner, N. Fechin, 1923–25. Member: Calif. AC; Glendale AA; Women P. of the West; Calif. WCS; Laguna Beach AA; Artland C. Exhibited: Calif. Eisteddfod, 1925 (gold); Southern Calif. Fair, 1925 (prize); Phoenix, 1929 (prize); Tex. State Exh., 1929 (prize); Sacramento State Exh., 1929 (prize); Santa Cruz Annual, 1930 (prize); Calif. State Annual, 1931 (prize); Phoenix, Ariz., Annual, 1931 (prize); Ebell C. (prizes); Los Angeles Mus. A., 1933 (prize); Beverley Hills, Calif., 1933 (prize); Calif. AC, Los Angeles Mus. A., 1936 (prize). Work: Mun. A. Gal., Phoenix; Los Angeles Mus. A. Specialties: flowers; landscape [40]

WARNER, Olin Levi [S,Medalist] NYC (since 1872) b. 1844, Suffield, CT d. 1896. Studied: Ecole des Beaux-Arts, Paris, with Jouffroy, 1869–72. Work: MMA; Corcoran. Exhibited: Columbian Expo, Chicago, 1893. Successful by 1876, he died in an accident before he could complete his bronze doors for LOC. He had designed the Columbian half-dollar in 1893, and greatly popularized the bas-relief portrait. [*]

WARREN, Asa Coolidge [I,En,Ldscp.P] NYC b. 25 Mr 1819, Boston d. 22 N 1904. He came to NYC in 1863 and became a steel engraver; later entered the Gov. engraving depart. at Wash., D.C. He illustrated the first edition of Whittier's Poems. He lost the use of his right eye in 1897 and then turned to landscape painting. Son of Asa, Sr. [Min.P; active Boston, 1840s]

WARREN, Charles Bradley [S] Pittsburgh, PA b. 19 D 1903, Pittsburgh.

Studied: CI; BAID. Member: Arch. L.; Pittsburgh AA; S. Sculptors, Pittsburgh. Exhibited: Pittsburgh AA, 1930-41, 1936 (prize), 1937 (prize); Arch. L., 1940-42; S. Sculptors, Pittsburgh; CI, 1936 (prize), 1941 (prize); Work: Dept. Justice, Raleigh, N.C.; County Bldg., High Point, N.C.; Stevens Sch., Pittsburgh; Stephen Foster Mem.; St. Athanasius Church, West View, Pa.; Kaufmann tablet, Pittsburgh; aluminum spandrel, Scott Township H.S., Pa.; stone panels, Prospect H.S.; medallion, Farmers Bank; Soldiers' Mem., Allegheny Cemetery, Pittsburgh; mem., Republic, Pa. Specialties: arch. S.; medals [47]

WARREN, Constance Whitney [S] Paris, France (since 1911) b. 1888, NYC d. 1848. Exhibited: Paris Salon, regularly. Work: MET; Okla. State Capitol. Specialty: bronzes of cowboys, horses and dogs [*]

WARREN, Dudley Thompson [S] Roanoke, VA b. 17 F 1890, East Orange, N.J. Member: Richmond Acad. Arts. Work: "Age of Endearment," Church Home of the City of Baltimore [40]

WARREN, Edward Perry [Patron] London, England b. Portland, ME d. 29 D 1928, London. He acted as collector for the Sch. of Classical Art at RISD, and the collection of Greek Art in the BMFA is due chiefly to him. He made many gifts to museums, including the University of Leipzig, and Bowdoin Col. He bequeathed $65,000 for the establishment of a Greek lectureship at Corpus Christi, Oxford.

WARREN, Edward Vance [P] Brooklyn, NY [25]

WARREN, Elisabeth Boardman (Mrs. Tod Lindenmuth) [Painter,E,I] St. Augustine, FL/Rockport, MA b. 28 Ag 1886, Bridgeport, CT. Studied: Mass. Sch. A.; Vesper George Sch. A.; W.H. Bicknell, in Providence; C. Simpson, in England. Member: St. Augustine AC; Rockport AA; Palm Beach AL; Provincetown AA; Southern PM S.; SSAL. Exhibited: SAE; Chicago SE; Calif. PM; Southern PM; Phila. Pr. C.; Phila. A. All.; St. Augustine AA; Rockport AA; Fla. Fed. A., 1937 (prize); Palm Beach AL; Soc. Four A., Palm Beach. Illustrator: children's books [47]

WARREN, F.A. [P] Snow Hill, MD. Member: Pittsburgh AA [21]

WARREN, Fanny L. [P] NYC [19]

WARREN, Ferdinand E. [P] Brooklyn, NY b. 1 Ag 1899, Independence, MO. Member: ANA; AWCS; SC; AAPL; Allied AA. Exhibited: Kansas City AI, 1923 (med); NAD, 1935 (prize); All.A.Am., 1939 (prize). Work: MET [47]

WARREN, Frank C. [P] NYC [15]

WARREN, Garnet [I] b. 1873, England (came to U.S. in 1900) d. 27 My 1937, Hackensack, NJ. Positions: Cart./Writer, New York Evening Telegram and New York Herald

WARREN, Harold B(roadfield) [Ldscp.P,I,C] Cambridge, MA b. 16 O 1859, Manchester, England (came to U.S., 1876) d. 23 N 1934. Studied: Harvard, with C.E. Norton, C.H. Moore; BMFA Sch. Member: Copley S., 1891; Boston S. Arch.; Boston SWCP; Boston SAC (Master). Work: BMFA; CMA. Specialty: watercolor. Position: T., Harvard, 1912-30 [33]

WARREN, Harold Edmond [Des,B,P] Oakland, CA b. 18 Mr 1914, Alameda, CA. Studied: Calif. Sch. FA; ASL. Member: Bay Region AA. Specialty: fabric des. [40]

WARREN, Helen [P] Wash., D.C. [19]

WARREN, Leonard D. [Cart] Westmont, NJ b. 27 D 1906, Wilmington, DE. Position: Cart., Philadelphia Record, 1927-46 [47]

WARREN, Lloyd NYC b. 1867 d. 25 O 1922 (killed in a fall from a window of his N.Y. apartment). Studied: Paris. He was one of the chief movers of the plan of the Beaux-Arts Society which established the atelier system of art training in America. He established the Paris Prize, the most important architectural competition. Position: Dir., BAID

WARREN, Masgood A. Wilbert [S,P] Studied: ASL, 1932-35; NYU, 1935-39; Temple Univ., Phila., 1961. Exhibited: NAD; NAC; AWCS; Allied A. Work: busts/portraits of famous people. Active 1977. WPA artist. [*]

WARREN, Roberta Frances [P] Chicago, IL [17]

WARREN, Sylvanna [P,S,W] NYC/Weston, CT b. 24 Ag 1899, Southington, CT. Studied: Dickinson; DuMond; Fogarty; Gruger; Sentilli; Calder. Member: NAC; NAWPS [31]

WARRICK, Meta Vaux. See Fuller.

WARSAGER, Hyman J. [E,En,Li,P,I] NYC b. 23 Je 1909, NYC. Studied: Hartford A. Sch.; MMA; PIASch; Grand Central Sch. A.; Am. Artists Sch. Member: United Am. Ar. Exhibited: San Fran. AA, 1938 (prize). Work: BM; San Fran. AA; Wesleyan Univ., Middletown, Conn. Contributor: New Masses [40]

WARSAW, Albert Taylor [P,Des,Li,I,Com.A] Flushing, NY b. 6 O 1899, NYC. Studied: NAD; ASL; BAID. Exhibited: AWCS; Phila. WCC; PAFA [47]

WARSHAWSKY, Abraham (or Abel) George [P] Paris, France b. 28 D 1883, Sharon, PA d. 30 My 1962, Monterey, CA. Studied: NYC, with Mowbray, Loeb. Member: Nouvelle Salon, Paris; Exhibited: Raleigh Hotel, Wash., D.C., 1938; Reinhardt Gal., 1938. Award: Chevalier of the Legion of Honor of France. Work: murals, Rorheimer Studio, Brooks Studio, both in Cleveland; CMA; Minneapolis AI; drawings, AIC; Luxembouurg Mus., Petit Palais, both in Paris; paintings, TMA; Canajoharie A. Gal., N.Y.; Los Angeles Mus. Hist., Sc.&A.; CGA; Sweat Mem. Mus. [40]

WARSHAWSKY, Alexander [P] Paris, France b. 29 Mr 1887, Cleveland. Studied: NAD. Member: Paris AA; Group X.Y.Z., Paris. CMA; Los Angeles Mus. A. [40]

WARTHEN, Ferol Sibley [P,B] Wash., D.C./Provincetown, MA b. 22 My 1890. Studied: Columbus Sch. A.; ASL, 1911-13; W.M. Chase; K.H. Miller; K. Knaths, 1939-49; B. Lazzell [*]

WARTHOE, Christian [S,W,T] Chicago, IL b. 15 Je 1892, Salten, Denmark. Studied: Minneapolis Sch. A.; ASL; BAIC. Member: NSS; Am. Veterans SA. Exhibited: Am. Veterans SA, 1939-42; NSS, 1941; NAD, 1942, 1943; S. Gld., 1942. Work: mem., Chicago. Contributor: Danish American Press [47]

WARTS, F.M. [P] NYC [15]

WARWICK, Edward [P,En,W,L,B,Edu] Phila, PA b. 10 D 1881, Phila. Studied: Univ. Pa.; PMSchIA; J.F. Copeland; C.T. Scott. Member: Phila. A. All.; Phila. WCC; Phila. Sketch C.; Phila. PC; Arms and Armours C., NYC; Phila. AC. Exhibited: PAFA, annually; Phila. WCC; Phila. Sketch C.; Phila. PC. Co-author: "Early American Costume." Position: T., PMSchIA, 1932-47 [47]

WARWICK, Ethel Herrick (Mrs. Edward) [P] Phila., PA b. NYC. Studied: Moore Inst. Des.; PAFA; F. Wagner; H. Breckenridge; H.B. Snell; E. Horter; E. O'Hara. Member: Plastics C., A. All., WCC, all of Phila. Exhibited: PAFA, annually; Woodmere A. Gal.; Phila. Plastic C. (prizes). Work: Pa. State Col.; portrait commissions [47]

WASEY, Jane (Mrs. Mortellito) [S] NYC b. 28 Je 1912, Chicago. Studied: Paris, with J. Bertran; P. Landowski; NYC, with Moselsio; J. Flanagan, H. Warneke. Exhibited: AIC, 1938; PAFA, 1938-40, 1946; Newark Mus., 1934; WMAA, 1935-46; Montross Gal., 1933 (prize). Work: WMAA [47]

WASHBURN, Cadwallader [P,E,W] Brunswick, ME b. 1866, Minneapolis d. 21 D 1965 (age 99). Studied: arch., MIT; Sorolla, in Spain; Besnard, in Paris; ASL, with Mowbray, Chase; also with Chase, in Shinnecock, N.Y. Member: NAC; AFA; Wash. AC. Exhibited: Paris Salon, 1896-04; Paris AAA (prize); P.-P. Expo, 1915 (gold). Work: Luxembourg Mus., Bibliothèque Nationale, Paris; Victoria & Albert Mus., British Mus., London; Rijks Mus., Amsterdam [47]

WASHBURN, Chester Austin, Jr. [P,Des,G,L] Albuquerque, NM b. 1 O 1914, Albuquerque. Member: N.Mex. AL. Exhibited: Univ. N.Mex.; Mus. N.Mex. [40]

WASHBURN, Huldah M. Tracy (Mrs. Charles H.) [C] Taunton, MA b. 10 Jy 1864, Raynham, MA. Studied: H. Sandham; L.A. Chrimes. Member: Boston SAC (Master Craftsman); Women's Edu. and Industrial Union. Specialty: needlework [40]

WASHBURN, Jeanette [P,C,T] Jacksonville, FL b. 25 S 1905, Susquehanna, PA. Studied: Fla. State Women's Col.; Syracuse Univ.; ASL; K.H. Miller. Member: Palm Beach AL; Jacksonville AC. Exhibited: Butler AI, 1941; PBA, 1941; Norton Gal. A.; Tampa AI; State Circuit Exh., for Army & Navy C., 1941, 1942; Blue Ridge, N.C., 1941; Jacksonville, AC, 1946. Position: A. & Crafts Specialist, Am. Red. Cross, assigned to U.S. Army Hospitals, 1944-46 [47]

WASHBURN, Jessie M. [P] Laguna Beach, CA (1932). Studied: Paris with Auburtin. Member: Laguna Beach AA [25]

WASHBURN, Kenneth (Leland) [P,S,T] Ithaca, NY b. 23 Ja 1904, Franklinville, NY. Studied: Cornell. Member: AWCS; Iroquois Assn.; Springfield (Ill.) AA. Exhibited: Tex. Centenn., 1934; WFNY, 1939; NAD, 1942-44; AWCS, 1942-45; PAFA, 1940, 1941, 1946; Rochester Mem. A. Gal., 1943-46; Finger Lakes Exh., 1941-46; Cortland County (N.Y.) State Exh., 1945 (prize); Finger Lakes Exh., Auburn, N.Y. 1944 (prize).

Work: Springfield (Ill.) Mus. A.; Binghamton (N.Y.) Mus. A.; IBM Coll.; WPA murals/plaque, USPOs, Binghamton, N.Y., Moravia, N.Y.; mem., Ten Broeck Acad., Franklinville. Illustrator: "Distant Wonder," by Schwab, 1936. Position: T., Cornell, from 1928 [47]

WASHBURN, Louese Bunnell (Mrs. Clayton) [P,Gr,Des,C,W,L] Jacksonville, FL b. 17 Ja 1875, Dimock, PA d. 3 Je 1959. Studied: PIASch; Broadmoor A. Acad.; Colorado Springs FA Ctr.; R. Moffett; H.V. Poor; A. Dow; B. Robinson; W. Lockwood. Member: Palm Beach AL; Jacksonville AC; St. Augustine AC; NAWPS. Exhibited: FAP, 1941; Argent Gal., 1939, 1940; Univ. Alaska, 1935; Blue Ridge, N.C., 1941; Tampa AI, 1924 (prize), 1941; Univ. Fla., 1930; Jacksonville Pub. Lib., 1935; Jacksonville AC, 1928 (prize); Fla. Fed. A., 1929 (prize), 1931 (prize), 1933 (prize), 1934 (prize); IBM purchase prize, 1941. Work: St. Luke's Hospital, Jacksonville; Hope Haven Hospital for Crippled Children, Fla.; Thornwell Orphanage, Clinton, N.C.; Univ. Alaska [47]

WASHBURN, Mary N(ightingale) [P] Greenfield, MA b. 1861, Greenfield, MA d. 13 O 1932. Studied: Smith Col., with D.W. Tryon; H.G. Dearth; ASL. Member: Springfield AL; NAWPS. Exhibited: NAD [31]

WASHBURN, Mary S. [S] Berkeley, CA b. Star City, IN. Studied: AIC; E. Sawyer, in Paris. Exhibited: P.-P. Expo, San Fran., 1915 (med). Work: Milroy Park, Rensselaer, Ind.; medal, CI; mem.. Logansport, Ind.; mon./ Waite Mem., Rock Creek, Wash., D.C.; character sketch medallions, Berkeley Lg. FA; bust, Medical Lib., Chicago [29]

WASHBURN, Miriam [P] Worcester, MA [24]

WASHBURN, Roy E(ngler) [P] Evanston, IL b. 10 Ja 1895, Vandalia, IL. Studied: Duveneck; Meakin; J.R. Hopkins. Member: Cleveland SA [31]

WASHINGTON, Elizabeth Fisher [Ldscp.P,Min.P] Phila., PA b. Siegfried's Bridge, PA. Studied: PMSchIA; PAFA, with Breckenridge, F. Wagner. Member: Phila. A. All.; Phila. Pr. C.; Pa. Soc. Min. P.; AWCS. Exhibited: PAFA, 1912 (prize), 1917 (prize), 1918-42, 1934 (prize), 1944; CI, 1920-22; CAM; CGA; NAD, 1930; P.-P. Expo, 1915; Woodmere A. Gal., 1941-45; Cape May, N.J., 1939-45; Phila. A. All.; Plastic C.; Phila. Sketch C.; AFA; Springville, Utah, 1927 (prize). Work: PAFA; Springville (Utah) H.S. Coll.; Mun. Coll., Trenton, N.J.; Smith Col.; New Century C., Phila.; Pierce Business Col., Phila.; Boyertown (Pa.) Gal.; PMA; Allentown (Pa.) Gal.; Phila. Civic C.; Oak Lane Review C., Phila.; Women's C., West Chester, Pa. [47]

WASKOWSKY, Michaill [P] Chicago, IL. Exhibited: AIC, 1938, 1939 [40]

WASSON, George Savary [Mar.P] Kittery Point, ME (since 1885) b. 27 Ag 1855, Groveland, MA d. 1926. Studied: Royal Acad., Württemberg, Germany. Work: Mystic Seaport Mus.; Peabody Mus., Salem [10]

WATANABE, Torajiro [P] NYC/Woodstock, NY (Los Angeles since late 1920s) b. 9 Jy 1886, Fukushima, Japan. Studied: H. Read; C. Rosen. Member: Japanese AS; Woodstock AA [25]

WATERBORY, Laura Prather (Mrs. George) [Min. P] Corona, Riverside County, Calif. [24]

WATERBURY, Edwin M. [P] Chicago, IL b. Albion, IA. Studied: ASL; W.M. Chase. Exhibited: AIC, 1898 [01]

WATERBURY, Florance [Ldscp.P] Convent Station, NJ/Provincetown, MA b. 26 Mr 1883, NYC. Studied: C.W. Hawthorne; G. Noel; C. Beaux; Rome; Peking. Member: NAWPS; Provincetown AA [40]

WATERMAN, Hazel G. [P] Madison, WI b. 10 F 1896 Sumner, IA. Studied: A.N. Colt. Member: Madison AG; Wis. Commercial AG. Work: Burlington Hist. S.; Mount Mary College, Milwaukee [40]

WATERMAN, Marcus [P] Brescia, Lombardy, Italy b. 1 S 1834, Providence, RI d. 2 Ap 1914, Moderno, Italy. Studied: Brown Univ., 1850s. Member: AWCS; Boston PCC; ANA, 1861. Exhibited: NAD. His studio was in NYC, 1857-74; then moved to Boston but traveled frequently to Vt. and Cape Cod, and twice to N. Africa. In 1900 he settled in Italy. [13]

WATERMAN, Myron A. [Cart,S] Kansas City, KS b. 28 O 1855, Westville, NY d. 20 D 1937. [38]

WATEROUS, H.L. [P] Cleveland, OH. Member: Cleveland SA [27]

WATERS, B.M. [I] Brooklyn, NY. Position: Illus., Brooklyn Life [98]

WATERS, George Fite [S,T] Paris/Hossegor, France b. 6 O 1894, San Fran., CA d. 14 D 1961, Greenwich, CT. Studied: Elwell, at ASL; Rodin, in Paris; Italy; London. Member: Soc. des Artistes Landais; Soc. Moderne. Exhibited: Salon des Artistes Français, 1932 (prize). Work: Dublin AG; Eastman Sch. Mus.; Rochester, N.Y.; Ottawa Nat. Gal.; Portland, Oreg.; NYU; St. Dustan's, London; John Brown Mem. Park, Osawatomie, Kans.; Osso Films, Inc.; Stratford-on-Avon, England; bust, French Gov. [40]

WATERS, George W. [Ldscp.P,Por.P,I,T] Elmira, NY b. 1832, Coventry, NY d. 1912. Studied: NYC; Dresden; Munich. Member: B.&W. C. Position: T., Elmira, Col. [98]

WATERS, Herbert Ogden [P,B,L] Warner, NH b. 15 N 1903, Swatow, China. Member: Southern PM S.; Gloucester SA; Merrimack Valley AA. Exhibited: WFNY, 1939. Work: Nashua (N.H.) Pub. Lib.; bookplate, N.H. State Lib.; woodcuts, Yankee mag., 1936-37. Illustrator: "New England Years," 1939. WPA artist. [40]

WATERS, John [P,I,T] NYC b. 27 My 1883, Augusta, GA. Studied: Chicago Acad. FA; ASL; Phoenix AI, N.Y. Exhibited: NAC; New Rochelle AA. Work: Ill. Cunard Line; Curtiss Flying Service. Position: T., Phoenix AI [40]

WATERS, Julia I. [P] Baltimore, MD. Member: Baltimore WCC [27]

WATERS, R. Kinsman [P,C,T] Columbus, OH b. 21 Jy 1887, Columbus. Exhibited: AWCS, 1936; Wash. WCC, 1939 [40]

WATERSTON, Alicia. See Atkinson.

WATKINS, Carleton E. [Ldscp.Ph] b. 1829, Oneonta, NY d. 1916. Studied: with daguerreotypist Robert Vance. Exhibited: "Era of Exploration" Exh., MET, 1975. Work: MET; Amon Carter Mus.; Boston Pub. Lib.; IMP; LOC: Univ. N.Mex.; NYPL; Oakland MA; Stanford; UCLA. Important early western landscape photographer best known for his "mammoth" views of Yosemite, 1861-70s and Oregon coast, ca. 1868. He also made stereoviews, which are rare. About 60 of his 115 large landscape views are known. Most of his work was lost in the San Fran. fire, 1906. Many of his negatives were later printed by I.W. Taber. [*]

WATKINS, Catherine W. (Mrs.) [P,L,W] Los Angeles, CA b. Hamilton, Ontario. Studied: AIC; Paris, with Dauchez, Simon, Ménard, Miller; Brangwyn, in London; Sorolla, in Madrid. Member: NAWPS; Intl. A. Un.; Am. Women's AA, Paris. Lectures: Adventures in North China; Idling in Japan; Studio Life in Paris [40]

WATKINS, Charles Law [P,T,W] Bethesda, MD/Chatham, MA b. 11 F 1886, Peckville, PA d. 2 Mr 1945, New Haven, CT. Member: S. Wash. A. Exhibited: S. Wash. A., 1937 (med). Contributor: article, Magazine of Art, 1935. Positions: Assoc. Dir., PMG; Dir., PMG A. Sch.; T., Hood Col., Frederick, Md. [40]

WATKINS, Frances Emma [Mus.Cur] Los Angeles, CA b. 27 D 1899, Denver. Studied: Univ. Denver; Univ. Southern Calif. Author: "The Navaho," 1943, "Hopi Toys," 1946. Contributor: California Folklore Journal, Desert mag., Westways. Position: Asst. Cur., Southwest Mus., Los Angeles, from 1929 [47]

WATKINS, Franklin Chenault [P,T] Plymouth Meeting, PA b. 30 D 1894, NYC d. 1972. Studied: Univ. Va.; Univ. Pa.; PAFA, 1913-18. Member: ANA, 1951; NA, 1957; NIAL. Exhibited: CI, 1931 (prize); AIC, 1938 (prize); GGE, 1939 (prize); Paris Salon, 1937 (med); CGA, 1939; (med); PAFA, 1941 (prize), 1942 (med), 1944 (prize); NAD, 1927; MOMA, 1950 (retrospective). Work: PAFA; WMAA; PMA; MOMA; CGA; PMG; Smith Col.; Courtauld Inst., London; murals, Rodin Mus., Paris; Detroit IA; Albright-Knox AG, Buffalo. Positions: T., Tyler Sch. A. (1940-43), PAFA (from 1943) [47]

WATKINS, Gertrude May [P,S,T,L,W] Chicago, IL/Momence, IL b. 30 Ag 1890, Frankton, IN. Studied: AIC; L. Van Pappelendam; P. de Lemos; A.W. Dow; A. Freman. Member: Hoosier Salon; South Side AA; Western AA. Position: T., Chicago H.S. [40]

WATKINS, Mary Bradley [P] Wash., D.C. b. 8 Ag 1911, Wash., D.C. Studied: PMG Sch. A. Exhibited: CGA, 1937; Soc. Wash. A., 1936-44; BMA, 1937, 1938; Bignou Gal., 1939; Critics Choice, CM, 1945; Soc. Four A., 1945; PMG, 1936-46; A. Gld. Wash., 1941-46. [47]

WATKINS, Mary Wilson. See Preston.

WATKINS, Mildred [P] Cleveland, OH b. 21 Jy 1882. Studied: Cleveland Sch. A.; L.H. Martin. Member: Boston SAC; Cleveland Women's AC. Specialties: jewelry; silverware [27]

WATKINS, Susan. See Serpell, Goldsborough, Mrs.

WATKINS, William Reginald [Des,Por.P,Min.P,Li,T] Baltimore, MD b. 11 N 1890, Manchester, England. Studied: Md. Inst.; C.W. Turner; M. Miller; H. Schule; E. Berge. Member: Beaux-Arts C.; Baltimore WCC; AAPL. Exhibited: PAFA, 1930; BMA, 1927-33; Peabody Gal., 1916-24; Mun. Mus., Baltimore, 1941-45; Md. Inst. (one-man); Charcoal C., Baltimore (one-man). Work: Md. Jockey C.; murals, Owens-Ill. Corp

Wash., D.C.; mem., Univ. Md. Positions: T., Md. Inst.; Beaux-Arts Sch. A. [47]

WATKINSON, Helen (Louise) [P,I,C,T] NYC b. Hartford, CT. Studied: A.W. Dow; M. Fry; H. Snell; W. Schumacher. Member: Lyceum C., Paris [17]

WATMOUGH, Marjorie Ellen [P] Phila., PA b. 26 My 1884, Cleveland. Studied: PAFA, with Anschutz, Breckenridge. Member: Plastic C. [10]

WATROUS, Elizabeth Snowden Nichols (Mrs. H.W.) [P,W] NYC b. N 1858, NYC d. 4 O 1921. Studied: Paris, with Henner, Carolus-Duran. Member: N.Y. Women's AC (Pres., 1911-12); Pen and Brush C.; SPNY; NAWPS. Author: two novels, "Ti," and "It" [19]

WATROUS, Harry W(illson) [P] NYC/Lake George, NY b. 17 S 1857, San Fran. d. 10 My 1940. Studied: Acad. Julian, with Boulanger, Lefebvre; Bonnât, 1881. Member: ANA, 1894; NA, 1895; NAD (Pres. 1933-34); SAA 1905; A. Aid S.; Lotos C.; Century Assn.; NAC; SC; SPNY; AFA; Tiffany Fnd. (Pres.). Exhibited: Pan-Am. Expo, Buffalo, 1901 (med); St. Louis Expo, 1904 (gold); NAC, 1931 (med); PAFA, 1934 (prize). Exhibited: NAD, 1886, 1889-91, 1894-16, 1918-41, medals in 1894, 1829, 1931 and 1934 (gold). Work: MET; Montpelier (Vt.) Mus.; CAM, St. Louis; Buffalo FA Acad.; BM; Ft. Worth Mus.; CGA [40]

WATROUS, James Scales [Mur.P,T] Madison, WI b. 3 Ag 1908, Winfield, KS. Studied: Univ. Wis. Member: Madison AA; Wis. PS. Exhibited: PAFA, 1939, 1940; CI, 1941; Milwaukee AI, 1937 (prize), 1941 (prize), 1942 (prize); Wis. Salon Art, 1935 (prize), 1936 (prize). Work: Milwaukee AI; Univ. Wis.; WPA murals, Wis. Union, Fed. Bldg. (Park Falls, Wis.), USPOs, Park Falls (Wis.), Grand Rapids (Minn). Position: T., Univ. Wis., from 1939 [47]

WATROUS, Mary E. [P] Laguna Beach, CA. Member: Calif. AC [25]

WATSON, Adele [Mur.P] NYC b. 30 Ap 1873, Toledo, OH d. 23 Mr 1947, Pasadena, CA. Studied: ASL; R. Collin, Paris. Member: AAPL [40]

WATSON, Agnes M. [I,T,P] Phila., PA b. Phila. Studied: PMSchIA; H. Pyle. Member: Plastic C. [21]

WATSON, Aldren A. [P,B,Dr] Brooklyn, NY/Monterey, MA b. 10 My 1917, Brooklyn, NY. Member: AFA. Work: 50 Color Prints, 1932 [40]

WATSON, Amelia Montague [P,I] Windsor Hill, CT b. 2 Mr 1856, Windsor Hill d. 20 Ja 1934, Orlando, FL. Illustrator: cover, frontispiece, "The Carolina Mountains," by M. W. Morley; Thoreau's "Cape Cod," "Thousand Mile Walk to the Gulf," John Muir. Specialty: Southern scenery [33]

WATSON, Anna M. [Min.P] NYC. Studied: Paris [13]

WATSON, Charles A. [Mar.P] Baltimore, MD b. 16 N 1857, Baltimore d. 23 O 1923, Easton, MD. Studied: A. Castaigne; E.S. Whiteman; D. Woodward. Member: Baltimore WCC; Charcoal C. (founder) [24]

WATSON, Dawson. See Dawson-Watson.

WATSON, Dudley Crafts [P,T,W,L] Highland Park, IL b. 28 Ap 1885, Lake Geneva, WI d. 1972. Studied: AIC; Beloit Col.; Sir A. East, in London; Sorolla. Member: Chicago AC; Cliff Dwellers C. Exhibited: AIC, annually, 1911 (prize), 1926 (prize); Grand Central A. Gal.; Milwaukee AI, 1923 (prize); Wis. PS, 1922 (prize); ASL, Chicago, 1908 (prize). Award: Gov. Ecuador, 1946. Work: Burlington (Iowa) Pub. Lib.; Milwaukee AI; Layton Gal. A.; IBM Coll.; H.S., Chicago; H.S., Milwaukee; H.S., La Mars, Iowa; Milwaukee Yacht Cl. Author: "Nineteenth Century Painting," 1931, "Twentieth Century Painting," 1932. Originator: Music-Picture Symphonies. Positions: A. Ed., Milwaukee Journal; Dir., Milwaukee AI, 1914-24; Edu. Dir., Minneapolis AI, 1922-23; Radio Commentator, WGN, Chicago; Lecturer, AIC, 1926 [47]

WATSON, Elizabeth H. [P] Philadelphia, PA. Studied: PAFA. Exhibited: PAFA, 1896 (prize) [33]

WATSON, Elizabeth V(ila) (Taylor) (Mrs.) [Por.P] Plymouth, MA b. N.J. Studied: BMFA Sch., with Tarbell, DeCamp. Member: Boston AC; Copley S. Exhibited: Circuit Court, Boston; port. commissions. Exhibited: Springfield AC; Vose Gal., Boston; Boston AC; Copley S. [47]

WATSON, Ella (Mrs.) [Ldscp.P] b. 1850, Worcester, MA d. 23 Mr 1917, Somerville, MA. Member: Boston SAC

WATSON, Ernest W. [B,I,P,W] NYC/Monterey, MA b. Conway, MA. Studied: Mass. Sch. A.; PIASch; ASL. Member: Prairie PM; Rochester Pr. C. Work: Smithsonian; NYPL; BM; LOC; Rochester Mem. A. Gal.; Los Angeles Mus. Hist., Sc.&A.; Columbus Gal. FA; Baltimore MA. Positions: Founder/Dir., Berkshire Summer Sch. A.; Ed., American Artist [40]

WATSON, Eva Auld (Mrs.) [B,P] Brooklyn, NY/Monterey, MA b. TX. Studied: M.O. Leiser, Pittsburgh Sch. Des.; PIASch. Member: AFA; Calif. PM. Exhibited: P.-P. Expo, San Fran., 1915 (prize). Work: Los Angeles Mus. A. Author: "Coptic Textile Motifs" [40]

WATSON, Harry, Jr. [P] NYC. Member: S.Indp.A. [25]

WATSON, Henry S(umner) [I] NYC b. 1 Ag 1868, Bordentown, NJ d. 15 N 1933. Studied: PAFA, with Eakins; Acad. Julian, with Laurens. Member: SI, 1904. Specialty: hunting scenes. Illustrator: Outing mag. Position: Ed., Field and Stream [31]

WATSON, Horace [E] Berkeley, CA. Member: Calif. SE [27]

WATSON, Jean [P] Phila., PA b. Phila., PA Studied: PAFA; E. Horter. Member: Phila. A. all.; Plastic C. Exhibited: PAFA, 1935, 1937, 1939, 1940, 1943 (prize), 1944-46; CGA, 1937, 1939, 1941; VMFA, 1938, 1940; WFNY, 1939; GGE, 1939; AIC, 1940; CI, 1941; CM, 1939, 1941; NAD, 1938, 1941, 1945; MET (AV), 1942; Audubon A., 1945; Lilienfeld Gal., 1940 (one-man); 48 Sts. Comp., 1939; Phila. Plastic C., 1935 (gold); 1938 (med); Phila. Sketch C., 1937 (med). Work: Woodmere A. Gal., Phila. Work: WPA murals, USPOs, Stoughton, Mass., Madison, N.C. [47]

WATSON, Jesse Nelson [P,E] Glendale, CA b. 13 Ja 1870, Pontiac, IL. Studied: self-taught. Member: P&S C.; S. Sanity in Art; Acad. Western P.; Pasadena SA; 2x4 S., St. Louis; Long Beach AA; Santa Monica AA; Calif. WCS. Exhibited: St. Louis, 1943; Los Angeles Mus. A.; SFMA; Oakland A. Gal.; Pasadena SA; Santa Paula, Gardena, Glendale, San Pedro, all in Calif. [47]

WATSON, Nan (Mrs. Forbes) [P] Wash., D.C./Harbor Springs, MI b. Edinburgh, Scotland. Studied: Girardot; Prinet; Chase. Work: WMAA; PMA; MET [40]

WATSON, Rhea D. [Min.P] Phila., PA b. 1874, Phila. Studied: PAFA, with T. Anshutz, Breckenridge. Member: Plastic C. [10]

WATSON, Ruth Crawford (Mrs.) [P] Decatur, AL b. 8 F 1892, Decatur d. 16 My 1936. Studied: Colarossi Acad., Paris; Rome. Member: Birmingham AC; Ala. AL; SSAL. Work: Old State Banking Building, Decatur; Montgomery Mus. FA, Ala. [33]

WATSON, Sue E. [S] Pittsburgh, PA [19]

WATT, B(arbara) Hunter [P,E,T,I,W,L,Des] Wellesley Hills, MA b. Wellesley. Studied: Mass. Sch. A; New Sch. Des., Boston; V. George; R. Andrew; E. Major; W.B. Hazelton; A.H. Munsel; J. De Camp; D.J. Connah. Member: Wellesley SA; Copley S., Boston. Work: murals, Twentieth Century Assn., Boston; Mass. A. Sch.; Pub. Lib., Wellesley, Mass. Contributor: illus./covers, House Beautiful. Specialty: garden subjects [47]

WATT, William Godfrey [P] Longmeadow, MA b. 2 Ap 1885, NYC. Studied: W.L. Stevens; A.T. Hibbard; R. Wolcott; H. Loomis. Member: SC, 1903; Springfield AL; Deerfield Valley AA; Bridgeport AL; Am. Veterans SA; Rockport AA; North Shore AA. Exhibited: Bridgeport AA, 1945 (prize); Am. Veterans SA, 1940, 1945; Chicago, Ill., 1945; San Fran., 1946; Springfield, Mass.; Hartford, Conn.; Westfield, Mass. [47]

WATTERNS, Susan [P] Paris, France [10]

WATT, Francis S. [P,I] Wash., D.C. b. 28 My 1899, Scranton, PA. Studied: E.H. Nye; B. Baker. Member: Wash. SA [27]

WATT, William Clothier [P,Dr] Carmel Highlands, CA b. 4 Ag 1869, Phila. Studied: PAFA, with R. Vonnah, T. Anshutz. Member: Phila. WCS; Phila. Sketch C.; Calif. WCS; Carmel AA. Exhibited: Santa Cruz AL, 1936 [40]

WATTSON, A. Francis [P] NYC. Exhibited: NAD, 1898 [98]

WAUD, Alfred Rudolph [I,P,Photogr] Orange, NJ b. 2 O 1828, London, England (came to NYC in 1850) d. 6 Ap 1891, Marietta, GA. Work: 1,200 drawings, Hist. New Orleans Coll.; 1,150 in LOC; Chicago Hist. S.; Mo. Hist. S.; BMFA; Am. Heritage Pub. Co. Special artist-correspondent during Civil War for New York Illustrated News (1860-62) and Harpers (1862-90). The most prolific of all the Civil War illustrators. After the war he documented reconstruction in the South and recorded Indians and pioneer life as far west as the Rockies. Brother of William. [*]

WAUD, William [I,Arch,W] b. ca. 1830, London, England (came to NYC ca. 1856) d. 10 N 1878, Jersey City. Work: LOC; Hist. New Orleans Coll. Illustrator: Leslie's (1860-64), Harpers (1865). In England he assisted Paxton in designing the Crystal Palace. He also documented Farragut's siege of New Orleans, 1862. Brother of Alfred. [*]

WAUGH, Coulton [P,Car,W,Li,En,I] Newburgh, NY b. 10 Mr 1896, Cornwall, England d. 1973. Studied: ASL; G. Bridgman; F. DuMond; D. Volk; F.J. Waugh. Member: Am. Ar. Cong.; Provincetown AA. Exhibited: NAD; PAFA; CI, 1939, 1943, 1944, 1946; GGE, 1939; Provincetown AA, 1925-43; Hudson Walker Gal., N.Y., 1938 (one-man). Work: N.Y. Bd. Edu.; Nat. Bank, Providence, R.I.; Peabody Mus., Salem, Mass.; Mem. Hall, Plymouth, Mass.; Nat. Geo. S.; 321 libraries. Contributor: Yachting, Fortune; marine drawings/maps, American Sketch, Harpers [47]

WAUGH, Frderick J(udd) [Mar.P,I] Kent, CT (since 1915)/Provincetown, MA (since 1927) b. 13 S 1861, Bordentown, NJ d. 10 S 1940. Studied: PAFA; Académie Julian, 1882-83. Member: RA of the West of England, Bristol; ANA, 1909; NA, 1911; SC, 1908; Lotos C.; NAC; CAFA; F., PAFA; Boston AC; Wash. AC; North Shore AA; AFA. Exhibited: PAFA, 1881-85; NAD, 1884, 1886, 1891, 1910 (prize), 1929 (prize), 1935 (prize); Royal Acad., London, 1899-06; Buenos Aires Expo, 1910 (gold); Boston AC, (prize); AIC, 1912 (med); CAFA, 1915 (prize); P.-P., 1915 (med); Phila. AC, 1924 (gold) CI, 1934-38 (prize); Buck Hill Falls AA, 1935 (prize). Work: MET; AIC; TMA; NGA; Brooklyn Inst. Mus.; Montclair (N.J.) AM; PAFA; Butler AI; Bristol (England) Acad.; Walker A. Gal., Liverpool; Durban A. Gal., South Africa; Dallas AA; Austin AL; CAM, St. Louis; Currier Gal., Manchester, N.H. Author: "The Clan of the Munes." Illustrator: London Graphic, London Daily Mail. Son of S.B. Waugh, port. painter. [40]

WAUGH, Ida [P,I] Montclair, NJ b. Phila. d. 25 Ja 1919. Studied: her father Sam. B. Waugh; PAFA; Paris, with Lefebvre, Constant, Callot, Delance. Exhibited: NAD, 1896 (prize). Work: PAFA. Illustrator: books for children. Sister of Frederick. [17]

WAUGH, Sidney Biehler [S,Des] NYC b. 17 Ja 1904, Amherst, MA d. 1963. Studied: Amherst, MIT, 1920-23; Rome, 1924; Ecole Beaux-Arts, Paris, with H. Bouchard, 1925-28; Rome, 1929-32. Member: NSS; NIAL; ANA, 1936; NA, 1938. Exhibited: Paris Salon, 1928 (med), 1929 (med). Award: Prix de Rome, 1929. Work: MET; Victoria & Albert Mus., London; CMA; TMA; AIC; Herron AI; mon., Richmond, Tex.; Corning Bldg., N.Y.; Smith Col.; Buhl Planetarium, Pittsburgh, Pa.; Fed. Trade Comm. Bldg., Wash., D.C.; Dept. Justice Bldg., Wash., D.C. Author: "The Art of Glassmaking," 1938. WPA artist. Position: T., Dir., Rinehart Sch. Sculpture, Baltimore [47]

WAXMAN, Bashka. See Paeff.

WAXMAN, Frances. See Sheafer.

WAY, C. Granville [P] Boston, MA. Member: Boston AC [13]

WAY, Edna (Martha) [P,Des,T,L] Athens, OH b. 5 Ja 1897, Manchester, VT. Studied: Columbia; C. Martin; N.Y. Sch. F.& Appl. A., Paris. Member: NAWA; Ohio WCS; Columbus AL; Studio G. Exhibited: NAWA, 1937-46; PAFA, 1936-38, 1941-44; AWCS, 1936-39; Studio G., 1938-40; Southern Vt. A.; Ohio WCS; Springfield AL; Butler AI; CM. Position: T., Ohio Univ., from 1926 [47]

WAY, George Brevitt [Ldscp.P] Baltimore, MD b. 29 O 1854, Baltimore. Studied: Paris [04]

WAYBRIGHT, Marianna [P] Dayton, OH [10]

WAYCOTT, Hedley William [P,C] Peoria, IL b. 9 F 1865, Corsham, Wiltshire, England d. 21 F 1938. Member: All-Ill. SFA; Peoria AI. Work: Bradley Polytechnic Inst.; Sch., Pub. Lib., both in Peoria [38]

WAYMAN, Nelson P. [P] Pittsburgh, PA. Member: Pittsburgh AA [21]

WEADELL, (Miss) [I] Chicago, IL. Illustrator: "Four o'Clock"[98]

WEARING, Dorothy Compton [P] Chicago, IL b. 12 Ag 1917, Edgewater, AL. Studied: Birmingham Southern Col.; UCLA. Exhibited: AIC, 1941, 1942; SSAL, 1938; San Antonio, Tex., 1939 [47]

WEARSTLER, Albert M. [P,Cr,W] Youngstown, OH b. 5 Je 1893, Marlboro, OH d. 3 Mr 1955. Studied: Cincinnati A. Acad. Member: Ohio WCC; Buckeye AC, Youngstown. Exhibited: AWCS, 1944-46; Ohio WCC, 1938-46; Massillon, Ohio, 1941-46; Butler AI, 1936-38, 1940-42, 1944, 1945; Ohio Valley A., Athens, Ohio, 1944-46; Portland, Maine, 1942, 1946; Parkersburg (W.Va.) FA Center, 1941-46. Work: Butler AI. Position: Art Cr., Youngstown Vindicator, 1942-45 [47]

WEATHERBY, Evelyn Mae (Mrs.) [P,E,Li,B,T] Jacksonville, FL b. 2 O 1897, NYC. Studied: Cooper Union; ASL; K. Kappes; I. Abramofsky. Member: NAWPS; Ohio WCS; Toledo Women's AL; Toledo S.Indp.A.; SSAL. Exhibited: TMA, 1937 (prize); Fla. Fed. A., 1939 (prize). Position: T., Civic AI, Jacksonville [40]

WEATHERLY, Newton [P] Geneva, NY. Member: Rochester AC [25]

WEAVER, Ann Vaughan [S,T] West Palm Beach, FL b. Selma, AL. Studied: NAD; ASL; CUASch; C. Keck; L. Kroll; J. Hovannes. Exhibited: Soc. Four A., Palm Beach, 1943, 1944 (prize), 1945 (prize); Norton Gal., 1943-45 (prizes), 1946; MOMA, 1930; NSS, 1940, 1941; Seligmann Gal., N.Y., 1934; Clay C., N.Y., 1939 [47]

WEAVER, Beulah Barnes [P,S,T] Wash., D.C. b. 8 Jy 1882, Wash., D.C. Studied: ASL; Corcoran Sch. A.; P. Mangravite; K. Knaths. Member: Soc. Wash. A.; Twenty Women P. of Wash. Exhibited: CGA (prize); Wash. Women's C. (prize); Indp. A. Exh., Wash., D.C. (prize); S. Wash. A., 1935 (prize); PMG; Anderson Gal., N.Y.; Richmond, Va.; CGA; NGA. Work: PMG. Positions: Dir./T., Madeira Sch., Greenway, Va., 1947– [47]

WEAVER, B. Maie [P,T] New Hartford, CT b. 12 D 1875, New Hartford. Studied: Mass. Sch. A.; Académie Julian, Paris; Grande Chaumiere, Paris; R. Turner; G. Collins; Mme. La Forge; M. Simone. Member: Springfield AL; Holyoke AL; N.Y. Keramic C. Exhibited: Académie Julian (prize); St. Petersburg, Fla.; Springfield (Mass.) Mus. A.; Sarasota, Fla.; Paris Salon. Work: State Lib., Hartford, Conn. Position: T., Holyoke, Mass. [47]

WEAVER, Clara. See Parrish, W.P., Mrs.

WEAVER, Emma M(atern) (Mrs.) [P] Greencastle, IN b. 10 My 1862, Sandusky, OH. Studied: Cincinnati AA; ASL; Güssow, in Berlin [13]

WEAVER, Florence M. [P,Dec] Des Moines, IA b. 13 My 1879, Iowa Falls, IA. Studied: A. Acad., Munich; AIC; E. O'Hara. Member: Iowa AC. Exhibited: O'Hara Gal., Goose Rocks Beach, Maine, 1938; Iowa AC, 1934, 1935 [47]

WEAVER, Grover O(pdycke) [P] Paris, France b. Montpelier, OH. Studied: AIC; Guerin; Colarossi, in Paris; Delecluse Acad., Paris. Member: Paris AAA [27]

WEAVER, Inez Belva (Mrs. H.H.) [P,L,T] Stromsburg, NE b. 3 My 1872, Marshall County, IA. Studied: E. Hornburger; L.W. Johnson. Member: Central Nebr. Ar. Gld. Exhibited: Iowa State Fair, Des Moines, 1887 (prize); Nebr. State Fair, Lincoln, 1923 (prize) [33]

WEAVER, Jay [P] NYC. Member: AWCS [47]

WEAVER, Margarita (Weigle) (Mrs. John) [P] Brandon, VT. Studied: Forsyth, in Indianapolis; Paris, with L. Simon, H. Morriset, Bourdelle. Member: Hoosier Salon; Chicago AC. Exhibited: Hoosier Artists, Marshall Field's, 1925 (prize) [33]

WEAVER, Martha Tibbals (Mrs. Arthur F.) [C] Cleveland, OH b. 8 My 1859, Cleveland. Studied: F. Thompkins; I. Wiles; J. De Camp; M. Fry; A.W. Dow; C.F. Binns; Cleveland Sch. A. Member: Am. Ceramic Soc.; Cleveland Women's AC; AFA. Specialty: ceramics [40]

WEAVER, Robert E(dward) [P] Peru, IN b. 15 N 1914, Peru, IN. Studied: John Herron A. Sch. Exhibited: NAD, 1938 (prize); Am. Acad., Rome, 1937 (prize); CGA, 1940; PAFA, 1941; GGE, 1939; Hoosier Salon, 1940; Ind. A., 1946; AIC, 1938. Work: Nat. Cash Register Corp. Coll.; murals, Indianapolis Methodist Hospital; Naval Air Station, Alameda, Calif. [47]

WEBB, A.C. [P] NYC b. 1 Ap 1888, Nashville, TN. Studied: AIC, ASL. Member: BAID; Paris AAA; Chicago SE. Exhibited: Mun. Arts in Arch., N.Y., 1917 (prize). Work: etchings, owned by City of Paris; French Gov. Represented by: Kennedy & Co., NYC [40]

WEBB, Aileen O. [P] NYC. Member: AWCS [47]

WEBB, Albert J(ames) [P,E,Li] Brooklyn, NY b. 25 Jy 1891, NYC. Studied: ASL. Work: MMA; CCNY; Brooklyn Mus. [40]

WEBB, Charles A. [P] Saranac Lake, NY. Member: NYWCC [24]

WEBB, Edith Buckland (Mrs.) [P,W] b. 11 D 1877, Bountiful, UT d. 28 O 1959, Los Angeles. Active in Calif. by 1901. Author: "Indian Life at the Old Missions" [*]

WEBB, Edna Dell. See Hinkelman.

WEBB, Elizabeth Holden [C] Mystic, CT b. Geneva, Switzerland. Studied: E. Johnston, in England. Member: Mystic AA; NAC. Work: illuminated baptismal service book, Cathedral of St. John the Divine; St. George's Mortuary Chapel, Stuyvesant Sq., NYC; Memorial Houses, Vassar Col., Poughkeepsie, N.Y.; Webster Mem. Chapel, Newport, R.I. Specialties: illuminating; lettering [40]

WEBB, Garl [P] Indianapolis, IN b. 3 F 1908, Peru, IN. Studied: Art Sch. John Herron. Member: Ind. Artists' C. Exhibited: Ind. Artists' C., Indianapolis, 1935 (prize), 1936 (prize) [40]

WEBB, Grace (Agnes) (Parker) [P,W,L] Burlington, VT b. 24 Ag 1898, Vergennes, VT. Studied: PIASch; Univ. Vt.; Univ. Calif.; Simmons Col.; B. Miller; P. Sample; R. Brandt. Member: Phila. WCC; NAWA; Santa Barbara (Calif.) AA; Lg. Vt. Writers; Northern Vt. AA; Vt. Hist. Soc. Exhibited: PAFA, 1940-44; NAWA, 1944, 1946; AWCS, 1943; Soc. for Sanity in Art, Boston, 1941; High Mus. A., 1944; Northern Vt. A., annually; Phila. WCC, 1944-46. Fleming Mus. A., Burlington [47]

WEBB, Herbert C. [P] Seattle, WA [24]

WEBB, J(acob) Louis [P] NYC b. 1856 d. 1928. Member: SAA, 1888; ANA, 1906 [27]

WEBB, James Elwood [G,P,L] Los Angeles, CA/Hermosa Beach, CA b. Hamorton, Chester County, PA. Studied: W.E. Schofield; N. Fechin; P. Lauritz; J.W. Smith; E. Payne. Member: PSC, Los Angeles. Exhibited: PSC, Los Angeles (traveling). Work: Univ. Southern Calif. Specialty: bookplates [40]

WEBB, Margaret Ely [Des,P,I,En,T] Santa Barbara, CA b. 27 Mr 1877, Urbana, IL d. 12 Ja 1965. Studied: ASL; CUASch; K. Cox; A. Dow; G. Bridgman; J. Twachtman; J. Alden Weir. Member: Boston Soc. A. & Cr.; Calif. Bookplate Soc.; Am. Soc. Bookplate Collectors & Des. Exhibited: Am. Bookplate Soc., 1924 (prize), 1925 (prize); Soc. Women P. & S.; Oakland A. Gal.; Boston AC; Copley S.; Faulkner Mem. Gal., Santa Barbara. Work: bookplates, Am. Antiquarian Soc.; Huntington Lib.; Liverpool (England) Pub. Lib.; British Mus., London. Illustrator: "The House of Prayer," "Aldine First Reader," "Under Greek Skies," other books [47]

WEBB, Paul [Car] New Canaan, CT b. 20 S 1902, Towanda, PA. Studied: PMSchIA; PAFA. Member: SI; Cart. Soc. Author: "Comin' Round the Mountain," 1938, "Keep 'Em Flyin'," 1942. Cartoonist: Esquire, Life, Collier's, Saturday Evening Post; comic strip, "The Mountain Boys" [47]

WEBB, Robert Jr. [P] Methuen, MA [19]

WEBB, Thomas [P] NYC. Member: GFLA [27]

WEBB, Todd [Ph] Bath, ME (1985) b. 15 S 1905, Detroit. Studied: Ansel Adams; largely self-taught. Exhibited: Guggenheim F., 1953, 1956; Mus. City of N.Y., 1946 (one-man); ACM, 1965. Work: Smithsonian; Columbus Mus. A., Ga.; AIC; Univ. Louisville; WMA; BMA; Univ. Mich.; Newark Mus.; MOMA; NYPL; IMP; PMA; ACM. Specialty: Best known for his post-WWII scenes of NYC and Paris, ghost towns of the Old West; frequent trips to France and England [*]

WEBB, Vonna Owings (Mrs.) [Ldscp.P,Mar.P] b. 1876, Sunshine, CO d. 1964, Manhattan Beach, CA. Position: T., Ind./Mont., early 1900s [*]

WEBBER, Charles T. [Por.P,Ldscp.P,S,T] Cincinnati, OH (since 1858) b. 31 D 1825, Cayuga Lake, NY d. 1911. Member: Cincinnati Sketch C., 1860 (founder); McMicken Sch. A., 1869 (founder); Cincinnati AC, 1890 (founder) [10]

WEBBER, Frederick W. [Cur,W] b. 1847 d. F 1922 (automobile accident). Position: Cur., Herkscher Park Art Mus., Huntington, N.Y.

WEBBER, Wesley [Mar.P] Boston, MA b. 5 My 1839, Gardiner, ME d. 3 N 1914, Wollaston, MA. Exhibited: Mechanics Inst., Boston, 1882-83; NAD, 1890; Brooklyn Acad., 1891. Work: Peabody Mus., Salem. Served in the Civil War and was present at Lee's surrender. From sketches made at the time, he later executed illustrations which were shown at the Boston Art Club and brought him his first public recognition. He had a studio in Boston, 1870-89; in New York by 1892.

WEBER, Albert L. [P] Columbus, OH. Member: Columbus PPC [25]

WEBER, Alfons [S,C] Chicago, IL b. 12 S 1882. Studied: A. Sch., Nuremberg; State Sch., Munich. Work: woodcarvings, Century of Progress Expo, Chicago; GGE, 1939; AIC; Hist. Soc. Mus., Chicago. Designer: furniture [40]

WEBER, August James [P] Marietta, OH b. 21 O 1889, Marietta. Studied: F. Duveneck; L.H. Meakin; H.H. Wessel [40]

WEBER, C. Phillip [P] Germantown, PA b. 28 Je 1849, Darmstadt, Germany. Studied: Kreling, in Nuremburg; P. Weber, in Munich. Member: Phila. A. Fund S. Exhibited: London, 1873 (med); Sydney, Australia (med); Melbourne, Australia (med); AAS, 1902 (prize) [06]

WEBER, Carl [Ldscp.P] Phila., PA b. 18 O 1850, Phila. d. 24 Ja 1921. Studied: his father Paul; Becker, in Frankfort; Steinle, in Vienna; Raupp, in Munich; Paris. Member: Phila. A. Fund S.; AAS; Phila. AC. Exhibited: London, 1873 (med); Columbian Expo, Chicago, 1893 (prize); Atlanta Expo, 1859 (prize); AAS, 1902 (gold) [19]

WEBER, Carrie May [P] Toledo, OH. Exhibited: Ohio WCC; Ohio State Fair; Boston S.Indp.A.; TMA, 1936, 1940 [40]

WEBER, Elsa [E] NYC b. Columbia, SC. Studied: F.T. Weber [40]

WEBER, Fred W. [P,W,L,Cr] Phila., PA b. 1 D 1890, Phila. Studied: Temple Univ.; Drexel Inst.; E. Horter; P. Martell. Member: Sketch C., Phila.; AC, Phila.; A. All., Phila.; Pen & Pencil C. Exhibited: PAFA; Sketch C., Phila; AC, Phila.; A. All., Phila.; Woodmere A. Gal.; Univ. Puerto Rico (one-man). Work: mural, Franklin Inst., Phila. Author: "Artists' Pigments," 1923. Contributor: Art Digest, Encyclopaedia Britannica. Positions: Bd. Gov., PMSchIA, PMA; A. Ed./Cr., Philadelphia Record, 1947- [47]

WEBER, Frederick T(heodore) [E,P,S,W] NYC b. 9 Mr 1883, Columbia, SC. d. 1 Ja 1956. Studied: Académie Julian, Paris, with Laurens; P. Richer; Ecole des Beaux-Arts, Paris; Muller-Schoenfeld, in Berlin. Member: SAE; AWCS; NAC; Phila. SE; NYWCC; New Haven PCC. Exhibited: CGA; NAD; Soc. Wash. A.; Peabody Inst.; CAM; Detroit Inst. A.; PAFA; New Haven PCC; AIC; AWCS; Wash. WCC; Baltimore WCC; Phila. WCC; Phila. Pr. C.; U.S. Nat. Mus., 1930 (one-man); High Mus., 1931 (one-man); Columbia AA, 1931 (one-man). Work: MMA; BM; LOC; U.S. Nat. Mus.; NYPL; Bibliotheque Nationale, Paris; Mus. City of N.Y.; Winthrop Col., S.C.; Univ. S.C.; City Hall, Charleston, S.C.; Univ. Vt.; Va. House, Richmond. Contributor: Encyclopaedia Britannica, 14th edition [47]

WEBER, Kem [Des,C,T] b. 14 N 1889, Berlin (came to San Fran. ca. 1913) d. 31 Ja 1963, Santa Barbara, CA. Studied: Berlin Acad. Appl. A., 1908-12. Position: T., Los Angeles A. Center, 1931-41 [*]

WEBER, Lou K. [P,T] Dayton, OH b. 2 Ag 1886 d. 20 My 1947 Studied: Univ. Chicago; Columbia. Exhibited: Women's Nat. Expo, Cincinnati, 1934 (prize). Contributor: articles, Design. Position: T., Oakwood H.S. [40]

WEBER, Max [P,W,T] Great Neck, NY b. 18 Ap 1881, Bialystok, Russia (came to Brooklyn in 1891) d. 4 O 1961. Studied: PIASch, with A. Dow, 1898-1900; Académie Julian, Paris, with Laurens 1905-06; Grande Chaumiere, 1906-07; Acad. Colarossi, 1906-07; helped organize class under Matisse 1907-08; again Acad. Colarossi, 1908. Member: Soc. Am. PS&G; Am. A. Cong. (Chmn.), 1937). Exhibited: AIC, 1928 (gold), 1941 (prize); La Tausca Pearls Comp., 1928 (prize); Pepsi-Cola Comp., 1945 (prize), 1946 (prize); CGA, 1941 (prize); PAFA, 1941 (prize); Salon des Indépendants, 1906-07; Salon d'Automne 1907-09; retrospectives: MOMA, 1930, Santa Barbara Mus. A., 1947; WMAA, 1949; Walker A. Center, 1949; PIASch, 1959; Newark Mus., 1959; AAAL, 1962; Boston Univ., 1962; Univ. Calif., Santa Barbara, 1968. Work: MMA; WMAA; MOMA; Jewish Theological Seminary of Am. AIC; Los Angeles Mus. A.; Pal. Leg. Honor; Santa Barbara Mus. A.; Wichita A. Mus.; Newark Mus.; Walker A. Center; Univ. Nebr.; BM; CMA; PMG; Nat. Gal.; Vassar; Brandeis. Author: "Essays on Art," 1916, "Primitives," 1926, "Cubist Poems." Positions: T., Minn. Normal Sch., Duluth, 1903-05; White Sch. Photogr., NYC, 1914-18 [47]

WEBER, Paul [Ldscp.P,Por.P] b. 1823, Darmstadt, Germany (came to Phila. in 1848) d. 1916, Phila. Studied: Frankfort, Germany. Exhibited: PAFA, from 1849; Wash. AA, 1857, 1859. Work: CGA. Position: T., Phila. (one of his students was Edward Moran) He returned to Darmstadt as court painter in 1860 but later returned to Phila. [*]

WEBER, Rosa [P] Fort Wayne, IN [17]

WEBER, Rudolph [I,T] b. 1858, Switzerland (came to U.S. in 1888) d. 8 Je 1933, NY. Illustrator: scientific books. Position: T., Princeton Univ.

WEBER, Sarah S. Stilwell (Mrs.) [I] Phila., PA d. 4 Ap 1939 [25]

WEBER, Sybilla Mittell [P,E] NYC b. 30 My 1892, NY d. 31 Jy 1957. Studied: A. Purtscher, in Munich; Pennell, in N.Y. Member: SAE; Wash. WCC. Exhibited: Phila. Print C., 1937 (prize). Work: Westminster Kennel C., N.Y.; BM; Berlin Mus.; New Pinakothek, Munich; LOC; Smithsonian; Pa. Mus. A.; Honolulu Acad. A. [47]

WEBER, William [P,T] Kansas City, MO b. 1865, Germany (came to U.S. as a child) d. 1905. Studied: Royal Acad., Berlin. Position: T., Kansas City Central H.S.

WEBER-DITZLER, Charlotte [I] NYC b. 5 Mr 1877, Phila. Studied: Munich, with Schmidt, Fehr [13]

WEBERG, John [P] Pittsburgh, PA. Member: Pittsburgh AA [21]

WEBSTER, Bernice M. [P] Croton Falls, NY b. 13 D 1895, Northfield, MA. Studied: Mass. Sch. A.; Columbia; H.B. Snell; A. Woelffle. Member:

NAC. Exhibited: All.A.Am., 1941; NAC, 1931-45; Vendôme Gal., 1941; Tomorrow's Masterpieces, 1943; Northfield, Mass., 1931 (one-man) [47]

WEBSTER, E. Ambrose [P,T,L] Provincetown, MA b. 31 Ja 1869, Chelsea, MA d. 1935, Ja. Studied: BMFA Sch., with Benson, Tarbell; Paris, with Laurens, Benjamin-Constant, A. Gleizes. Member: Provincetown AA. Author: Booklet on Color. Lectures: Modern Art. Positions: Dir./T., Webster A. Sch., Provincetown [33]

WEBSTER, Ethel Felder [P] Westport, CT [15]

WEBSTER, Frederick Rice [S] Evanston, IL b. 12 N 1869, Grand Rapids, MI. Studied: RA, Munich. Member: Chicago WCC; Chicago SA [19]

WEBSTER, H. Daniel [S] Westport, CT b. 21 Ap 1880, Frankville, IA d. 1912. Studied: ASL, with Barnard, MacNeil, F.C. Jones, DuMond. Member: Silvermine Group. Work: statues, near Saugatuck, Conn.; State Capitol, Pierre, S.Dak.; bronze doors, American National Bank Bldg., Austin, Tex. [13]

WEBSTER, Harold Tucker [Car] Stamford, CT/Meddybemps, ME b. 21 S 1885, Parkersburg, WV d. 23 S 1952. Member: SI; Dutch Treat C. Author/Illustrator: "Our Boyhood Thrills and other Cartoons," "Boys and Folks," "Our Boyhood Ambitions," "The Thrill That Comes Once in a Lifetime," "Life's Darkest Moment," "The Beginning of a Beautiful Friendship," "How to Torture Your Wife"; cartoon, "The Timid Soul." Work: Huntington, Lib., San Marino, Calif. [47]

WEBSTER, Herman Armour [E,P] Paris, France b. 6 Ap 1878, NYC. Studied: Yale; Laurens, in Paris. Member: Royal S. Painters & Etchers, London; SAE; Société Nationale des Beaux-Arts, France; London AC; Paris AA; Chelsea AC; "Societé des Amis des Vieux Moulins" (organization for the preservation of old windmills in France) (founder); Legion d'Honneur, France; Paris Salon, 1937. Exhibited: NAD; Royal Acad., London; Venice, Italy; SAE; Salon des Beaux-Arts; Chicago; Pittsburgh; San Fran.; Wash., D.C.; P.-P. Expo, 1915 (gold); SAE, 1932 (prize), 1934 (prize); Brooklyn SE, 1930 (prize). Work: AIC; LOC; FMA; NYPL; Yale; Bibliothèque Nationale, Paris; Victoria & Albert Mus., London; Luxembourg, Paris; South Kensington, London; British Mus.; Darmstadt; MET; Prints of the Year, 1932, 1933, 1934 [47]

WEBSTER, Hutton, Jr. [E,P,I,W,T,L] Tucson, AZ b. 11 F 1910, Lincoln, NE d. 30 Ja 1956. Studied: Univ. Nebr.; Princeton. Member: Southern PM; SAE; Calif. PM; Calif. SE; F., Tiffany Fnd., 1932. Exhibited: CI; NAD; Univ. Nebr.; regional exhibits; 100 Prints of the Year, 1941. Award: Pulitzer Prize, 1933. Work: MET; LOC; Princeton; Stamford Univ.; NGA; NYPL; Joslyn Mem.; Univ. Nebr. [47]

WEBSTER, Margaret Leverich [P,C,T] Elizabeth, NJ b. 9 F 1906, Belleville, NJ. Studied: Newark A. Sch.; A. Fisher. Member: NAWPS. Exhibited: NAWPS, 1929 (prize), 1936-38 [40]

WEBSTER, Mary H(ortense) [S,P] Chicago, IL b. Oberlin, OH. Studied: Cincinnati A. Acad., with Barnhorn, Nowottny; Paris, with Injalbert, Verlet, Waldmann; Hitchcock, in Holland; Hawthorne, in Provincetown; L. Taft, AIC [33]

WEBSTER, Stokely [Por.P,Des] Hempstead, NY b. 23 Ag 1912, Evanston, IL. Studied: Yale; Univ. Chicago; Columbia; NAD; W. Adams; L. Parker, in Paris. Member: Chicago AC; Allied Ar. Am., N.Y. Exhibited: CGA; AIC; NAD, 1941 (prize); O'Toole Gal., N.Y. 1940 (one-man); Rouillier Gal., Chicago, 1940 (one-man) [47]

WECHSLER, Henry B. [P] NYC. Member: SC 1898. Exhibited: NAD; NYSF [13]

WEDDA, John A. [Des,P,I,T] Larchmont, NY b. 4 N 1911, Milwaukee, WI. Studied: R.O. Bennett. Member: A. Dir. C.; Adcraft C., Detroit. Exhibited: AIC, 1942-46; WMAA, 1943-45; Detroit Inst. A., 1936, 1938-45, 1943 (prize); A. Dir. C., 1945, 1946. Contributor: Pageant, Seventeen [47]

WEDDELL, Iris [E] Hinsdale, IL. Member: Chicago SE [27]

WEDDERSPOON, Richard G. [P,T] Syracuse, NY b. 15 O 1890, Red Bank, NJ. Studied: CI; Corcoran Sch. A.; PAFA, with Garber, H. McCarter. Member: Chicago AC; Syracuse SA. Exhibited: CGA; PAFA, 1917 (prize); Peabody Inst., Baltimore; AIC, 1922 (prize); Syracuse MFA, 1926 (prize), 1927-46, 1937 (prize), 1944 (prize). Work: Chicago Mun. Coll.; Vanderpoel Coll.; De Pauw Univ. Position: T., Syracuse Univ., from 1923 [47]

WEDDIGE, Emil [P,Li,T,Des,L] Ann Arbor, MI b. 23 D 1907, Ontario, Canada. Studied: Mich. State Normal Col.; Univ. Mich., with M. Kantor, E. Ganso; J.P. Slusser. Member: Scarab C. Exhibited: NAD, 1945; CI, 1945; TMA, 1946; VMFA, 1945; Assn. Am. A.; Alger House, Detroit; Ann Arbor A.; Detroit AI, 1937 (prize); Butler AI; Woodstock (N.Y.) Gal.; Akron AI; San Fran. AA; SFMA, 1939; WFNY, 1939. Work: Univ. Mich.; Detroit AI. Position: T., Univ. Mich. [47]

WEDEPOHL, Theodor [P] NYC b. 1863, Exter, Westphalia, Germany d. 28 Mr 1931. Studied: Imperial Acad., Berlin; Munich; Paris; Rome. Exhibited: Imperial Acad., Berlin (prizes). Work: portraits of many notables; his landscapes included some of the first ever painted in Iceland.

WEDIN, Elof [P] Minneapolis, MN b. 28 Je 1901, Sweden. Studied: AIC; Minneapolis AI. Exhibited: Los Angeles Mus. A., 1945; Tex. Centenn., 1936; GGE, 1930; Minneapolis IA, 1937 (prize). Work: Minneapolis IA; Univ. Minn.; Minneapolis Women's C.; WPA murals, USPOs, Litchfield, Minn., Mobridge, S.Dak. [47]

WEDO, Georgette [P,Gr,T] Sausalito, CA b. 19 My 1911, Italy. Exhibited: SFMA, 1943, 1945, 1946; SAE, 1944; LOC, 1946; Oakland A. Gal., 1942-44; de Young Mem. Mus., 1945; Crocker A. Gal., Sacramento, Calif., 1944; Paul Elder Gal., San Fran.; Col. Puget Sound, Tacoma, Wash., 1944; Calif. SE (prize). Position: T., Good Samaritan Comm. Ctr., San Fran., from 1945 [47]

WEDOW, Rudolph [P] Williamsville, NY b. 1906 d. 12 D 1965, Clinton, NY. Exhibited: Buffalo SA, 1937; Albright A. Gal., Buffalo [40]

WEED, Clive R. [P,I,Car] Phila., PA/NYC b. 1884 d. 28 D 1936, NYC. Studied: PAFA, with Anshutz. Illustrator: newspapers & magazines, Phila. & New York [19]

WEED, Helen Tott [P] Brooklyn, NY [15]

WEED, Raphael A. [Patron,P] b. NYC d. 16 N 1931, NYC. Studied: D. Volk; K. Cox. Member: NAC; Mun. AS, NYC; Player's C. Lived mostly in Newburgh and Wilton, N.Y. In 1929 presented to the N.Y. Hist. Soc. a collection of rare theatrical photographs.

WEEDELL, Hazel (Elizabeth) (Mrs. Gustav F. Goetsch) [P,E,C,T] Glendale, MO b. 26 Ja 1892, Tacoma, WA. Studied: G.F. Goetsche; R. Koehler; E. Batchelder; Minn. Sch. A. Member: St. Louis AG [31]

WEEDEN, Eleanor Revere [Por.P] NYC b. 11 D 1898, Colchester, CT. Studied: Wheaton Col.; BMFA Sch.; Fenway Sch. Illus.; ASL; Paris. Member: All.A.Am. Exhibited: All.A.Am.; Portraits, Inc., NYC. Work: many commissions [47]

WEEDER, F. Ellsworth [P] Phila., PA [10]

WEEDEN, Howard (Miss) [P,I] Huntsville, AL b. Huntsville AL. Specialty: Southern subjects [08]

WEEGEE, (Arthur Fellig) [Ph] NYC b. 1899 Zloczew, Poland (came to NYC in 1909) d. 1968. Work: large coll., Ctr. for Creative Photogr., Tucson; MET; MOMA; IMP. Epitome of the cigar-chewing news photographer, he recorded NYC crime, disasters and street life of the 1940s. His book "Naked City" inspired a movie and TV series of the same name. [*]

WEEKS, Edwin Lord [P,I] Paris, France b. 1849, Boston, MA d. 16 N 1903, Paris. Studied: Ecole des Beaux-Arts, Gérôme, Bonnât, all in Paris. Exhibited: Paris Salon, 1884 (prize), 1889 (med); Paris Expo, 1889 (gold); Phila. AC, 1891 (gold); Berlin Intl. Expo, 1891 (prize); London Expo, 1896 (med); Dresden, 1897 (med); Munich, 1897 (med); Pan-Am. Expo, Paris, Buffalo, 1901 (med). Awards: Chevalier of the Legion of Honor, France, 1896; Officer of the Order of St. Michael of Bavaria. Member: SC, 1897; Secession, Munich; Paris SAP; Boston AC. He traveled extensively in Egypt, Jerusalem, Damascus and Tangiers. Specialty: North African orientalist genre. A group of 277 of his paintings was sold at the Am. A. Gal., NYC, 1905, for $47,500. [03]

WEEKS, Leo Rosco [I,P] Chicago, IL b. 23 Je 1903 La Crosse, IN d. 1977. Studied: Am. Acad. A., Chicago; G. Sheffer. Member: Hoosier Salon; All-Ill. SFA; Wawasee A. Gal.; Palette & Chisel Acad. FA, Chicago. Exhibited: Hoosier Salon; Palette & Chisel Acad., 1943 (prize), 1944 (prize); All-Ill. SFA, 1946 (prize); Wawasee A. Gal. Illustrator: "Penny Wise," 1942; children's books [47]

WEEKS, Lore Lucile [P] Chicago, IL [04]

WEEKS, William [S,Arch] b. 11 Ap 1813, Martha's Vineyard, MA d. 8 Mr 1900, Los Angeles. Work: Morman Church, Salt Lake City (arch. dir.). arch. and ornamental carver for Mormon Temple, Nauvoo, Ill., 1840s; traveled to Utah, 1847, then settled in Calif. [*]

WEGER, Marie [P] Mt. Vernon, NY b. 24 D 1882, Murten, Switzerland. Studied: Munich, with P. Nauen; W. von Dietz. Member: All.A.Am.; Beaux-Arts S., Munich & Paris; Queensboro SAC. Exhibited: BM; All.A.Am.; AAPL; Queensboro SAC; Tricker Gal.; extensively in Europe [47]

WEGGELAND, Daniel F. [P] Salt Lake City, UT [15]

WEGGELAND, Danquart Anthon [Por.P,Ldscp.P,T] Salt Lake City (since 1862) b. 1827, Christiansand, Norway (came to NYC in 1861) d. 1918. Studied: Royal Acad., Copenhagen, 1848; Ldscp. P. in Norway, 1849; NAD, with D. Huntington, G.P.A. Healy, 1861. Exhibited: Centenn. Expo, Phila., 1876; Columbian Expo, Chicago, 1893. Work: Brigham Young Univ.; Springville AM; Latter Day Saints temples. Position: T./ Founder: Deseret Acad. FA, 1863 [*]

WEHLE, Fannie [P] Louisville, KY. Member: Louisville A.L. [04]

WEHN, James A. [S,T] Seattle, WA/Crescent Beach, WA b. Indianapolis. Studied: R.N. Nichols. Member: Am. Numismatic S. Work: mon., Seattle; relief, Court House, Chehalis, Wash.; medallions, Univ. Wash., Yesler Lib., Garden C., Northern Life Tower; Zeta Psi Fraternity, Seattle; seals of U.S./stone eagles, USPO, Longview, Wash.; bust, Skagway, Alaska; medallions, Sitka Nat. Park, Richardon Highway, Alaska; seal, City of Seattle; mon., Univ. Wash. campus; bust, Harbor View Hospital, Seattle; medallions, Columbus Hospital, Seattle [40]

WEHR, Paul Adam [I,Des,P,Gr] Indianapolis, IN b. 16 My 1914, Mt. Vernon, IN d. 1973. Studied: Herron AI. Exhibited: PAFA, 1940, 1943; Adv. A. Exh., N.Y., 1945; Ind. A., 1937, 1942 (prize), 1943, 1944 (prize); Ind. AC, 1944; Ind. State Fair, 1936, 1940 (prize), 1941 (prize); Hoosier Salon, 1943 (prize), 1944 (prize); A. Dir. C., Chicago, 1945 (prize). Work: Herron AI. Illustrator: Collier's, Coronet, Red Book. Position: T., John Herron AI, 1937–45 [47]

WEHRSCHMIDT, Daniel A. [P,E] London, England. Exhibited: P.-P. Expo, San Fran., 1915 (medals); St. Louis Expo, 1904 (medals for paintings and mezzotints) [17]

WEIDENAAR, Reynold H(enry) [E,I,L] Grand Rapids, MI b. 17 N 1915, Grand Rapids. Studied: Kansas City AI; W. Rosenbauer; J. Meert; M. Hammon. Member: SAE; Chicago SE; Wash. SE; Calif. SE; CAFA; AAPL; Wash. WCC; Bridgeport AL; North Shore AA; Gloucester AA; New Orleans AA; Carmel AA; Springfield AL; Inst. Mod. A., Boston; Palm Beach AL; Wash. AC; Guggenheim F., 1944. Exhibited: SAE, 1942 (prize), 1945 (prize); LOC, 1944 (prize); P&S Soc., N.J., 1945 (prize); Wash. WCC, 1946; New Orleans AA, 1945 (prize), 1946 (prize); NAD, 1946; Detroit Inst. A., 1943; Irvington A. & Mus. Assn., 1943; CAFA, 1943. Work: LOC; U.S. Nat. Mus.; Honolulu Acad.; Detroit Inst. A.; CAFA; Wadsworth Atheneum; W.R. Nelson Gal.; Hackley A. Gal.; PMA; Grand Rapids A. Gal. Illustrator: "The Street," 1945, "The March of Truth," 1944, other books [47]

WEIDHAAS, Ted [Des,Dec] NYC. Work: contour curtain, Radio City Music Hall, NYC; decorative masks, theatre sets, metal murals [40]

WEIDNER, Carl A. [Min.P] NYC b. 14 Mr 1865, Hoboken, NJ. Studied: NAD; ASL; P. Nauen, in Munich. Exhibited: Pan-Am. Expo, Buffalo, 1901 (prize) [10]

WEIDNER, Doris Kunzie [P,E,Li] Christiana, PA b. 17 Jy 1910. Studied: Barnes Fnd.; PAFA. Exhibited: PAFA, 1938–43, 1944 (prize), 1945, 1946 (prize); Okla. Lithograph Exh., 1941 (prize); NAD; VMFA; Phila. Pr. C.; Woodmere A. Gal.; Newark Mus.; Asbury Park, N.J.; MET (AV), 1945. Work: Woodmere A. Gal.; PAFA; LOC [47]

WEIDNER, Roswell Theodore [P,Li,T] Christiana, PA b. 18 S 1911, Reading, PA. Studied: Barnes Fnd.; PAFA, Cresson Schol., 1936. Member: Phila. Pr. C. Exhibited: PAFA, 1935–46; CGA; AIC; CI; WFNY, 1939; NAD; MET (AV); Phila. PC; Woodmere A. Gal.; Phila. A. All.; Phila. Sketch C. (prize); Reading Mus. A. Work: Pub. Lib., Phila., Reading Mus. A.; MET; LOC; PAFA; Pa. State Col.; PMA. Position: T., PAFA [47]

WEIFFENBACH, Elizabeth [P,T] Buffalo, NY [21]

WEIGLEY, M.W. [P] Paris, France. Exhibited: Phila. AC, 1898 [01]

WEIL, Arthur [A] Evanston, IL b. 8 Je 1883, Strassbourg, France. Studied: Italy. Work: Canadian Gov. [19]

WEIL, Carrie H. (Mrs.) [S] NYC b. 17 Ag 1888, NYC. Studied: P. Hamaan, NYC; Landowski, Paris. Member: NAWPS. Specialty: portrait busts [33]

WEIL, Josephine Marie [P] NYC [19]

WEIL, Otilda [P] NYC [13]

WEILAND, James G. [Por.P] Lyme, CT b. 30 N 1872, Toledo, OH. Studied: NAD; ASL; Royal Acad., Munich; Acad. Delecluse, Acad. Colarossi, both in Paris. Exhibited: NAD; All.A.Am.; Brooklyn SA; Lyme AA. Work: Conn. State Capitol; U.S. Nat. Mus.; Conn. State Lib.; Conn. Supreme Court; Court Houses at New London, Putnam, Willimantic, Bridgeport, Hartford, all in Conn.; Cleveland Pub. Lib.; Western Reserve Univ.; Granby (Conn.) Lib. [47]

WEILL, Edmond [P,E,Li] Brewster, NY b. 29 Jy 1877. Studied: NAD, with E.M. Ward. Member: SC; Brooklyn SA; Putnam County AA; Brooklyn PS; Brooklyn WCC; AWCS. Exhibited: CI; CGA; PAFA; AIC; BMFA; WMA. Work: BM; CCNY; Middletown Lib. [47]

WEILLER, Lee Green (Mrs. Eugene W.) [P] Elkins Park, PA b. 15 Ag 1901, London, England. Studied: Moore AI; PAFA; H.B. Snell; R.S. Bredin. Member: Phila. A. All. Exhibited: CGA, 1937; Phila. A. All.; Phila. Sketch C.; Woodmere A. Gal.; AFA Traveling Exh., 1937. Work: Cheltenham Township, England [47]

WEIMER, B. [P,Des,] Akron, OH b. 22 S 1890. Exhibited: Akron AI, 1924 (prize). Position: A. Dir., Indst. Des., Miller Rubber Co., Akron [40]

WEIMER, Charles Perry [I,W,L] NYC b. 1 S 1904, Elkins, WV. Studied: Univ. Pittsburgh; CI; AIC; Pittsburgh; H. Dunn. Member: SI; Ar. Gld., N.Y.; Chatham AC; A. Center of the Oranges, N.J. Exhibited: Montclair AM; Ar. Gld., NYC; A. Dir. C.; SI. Contributor: Professional Art Quarterly; photo mags. Illustrator: movies on 20 Latin American countries [47]

WEIN, Albert W. [S] NYC b. 27 Jy 1915, NYC. Studied: Md. Inst.; NAD; Grand Central Sch. A.; BAID; Am. Acad., Rome, 1940, 1947. Member: NSS. Exhibited: NAD, 1940–42; MET (AV), 1944; Arch. L., 1942–46, 1944 (prize); WMAA, 1945; Mun. A. Gal., 1938; NSS, 1942 (prize), 1946 (prize); Atlantic Terra Cotta Comp., 1934 (prize); Metropolitan Life Insurance Comp., 1938 (prize). Work: Gramercy Park Mem. Chapel, N.Y.; USPO, Frankfort, N.Y. [47]

WEINBERG, E(milie) Sievert (Mrs.) [P] Berkeley, CA b. Chicago, IL. Studied: AIC; W.M. Chase; H. Hormann; Univ. Calif. Member: San Fran. S. Women A.; Mural S. Calif.; San Fran. AA. Work: Fresco, Univ. Elementary Sch., Berkeley; Vanderpoel AA, Chicago; Mills Col., Calif. [40]

WEINBERG, Hortense [P,S] Baltimore, MD [25]

WEINBERG, Louis [C,Des,T] Tulsa, OK b. 19 Je 1918, Troy, KS d. ca. 1959. Studied: Univ. Kans. Member: Am. Cer. S. Position: T., Univ. Tulsa [47]

WEINBERG, Mark [P] NYC. Member: Bronx AG [27]

WEINCEK, Alicia [P] NYC. Work: WPA mural, USPO, Mooresville, N.C. [40]

WEINDORF, Arthur [E,P,I,Car,W] Long Island City, NY b. 25 My 1885, Long Island City. Member: S.Indp.A. Exhibited: LOC, 1943; NAD, 1944, 1945; Phila. Pr. C., 1942, 1943; Wash. WCC, 1942; Brooklyn SA, 1944; Oakland A. Gal., 1943; Portland SA, 1941, 1942; Bridgeport AL, 1942; Irvington A. & Mus. Assn., 1942 [47]

WEINER, A(braham)S. [P,Des] Santa Monica, CA b. 30 Mr 1897, Vinnitza, Russia. Studied: Univ. Mich.; Studio Sch. A., Chicago; A. Archipenko; J. Norton. Member: Calif. WCS; Los Angeles AA. Exhibited: Pepsi-Cola, 1946; Chaffey Col., 1945; Denver AM, 1944, 1945; Oakland A. Gal., 1944–46; Santa Barbara Mus. A., 1944; AIC, 1931, 1934; Los Angeles Mus. A., 1944, 1945 (one-man), 1946; UCLA, 1943 (one-man); SFMA, 1943 (one-man); Santa Barbara Mus. A., 1946 (one-man); Du Page County (Ill.) A., 1935 (prize); Glendale (Calif.) AA, 1945 (prize) [47]

WEINER, Edwin M.R. [Por.P,L,T] Beloit, WI b. 9 S 1883, Kingston, NY. Studied: Cornell; ASL; W. Adams; G. Bridgman. Member: Rockford AL; Beloit AL; Chicago Gal. Assn. Exhibited: Chicago Gal. Assn., 1942 (prize), 1943–46; Rockford AL, 1936–46; Beloit AL, annually; Davenport Mun. A. Gal.; Evansville, (Ind.) Mun. Gal.; Tulsa, Okla. Position: T., Beloit Col. [47]

WEINER, Egon [S,C,L,T] Chicago, IL b. 24 Jy 1906, Vienna, Austria. Studied: Sch. A. & Crafts, Acad. Plastic A., both in Vienna; E. Steinhof; J. Huelnner; A. Hanak. Exhibited: AIC, 1940, 1942–46; PAFA, 1941; Oakland A. Gal., 1942, 1945 (med) 1946; Newport AA, 1945; Univ. Chicago, 1943, 1945; Pokrass Gal., Chicago, 1943 (one-man); Intl. Exh. A.&Cr., Paris, 1925 (prize); Vienna, 1932–34 (prize). Position: T., AIC, 1947 [47]

WEINER, Isadore [P,G,T] Chicago, IL b. 11 S 1910, Chicago. Studied: AIC. Member: United Am. Ar. Exhibited: Fed. A. Gal., Chicago, 1939; AIC, 1939. Position: T., Hull House, Chicago [40]

WEINER, Louis [P] Chicago, IL b. 28 My 1892, Vinnitza, Russia. Studied: Reynolds; Higgins; Poole; Norton; Krehbiel. Member: Palette & Chisel C.; Chicago Acad. FA; Chicago SA; Around the Palette; Am. A. Cong.; Chicago Artists U. [40]

WEINERT, Albert [S] NYC, 1904 b. 13 Je 1863, Leipzig, Germany. Studied: Ecole des Beaux-Arts, Brussels. Member: NSS, 1909; S.Indp.A. Exhibited: arch. sculpture, P.-P. Expo, San Fran. Work: Lake George, N.Y.; Toledo; Baltimore; Hall of Records, NYC; Detroit; tablets, Sons of the Revolution, Soc. Colonial Wars; arch. sculpture, LOC [33]

WEINGAERTNER, Hans [P] Lynhurst, NJ b. 11 S 1896, Kraiburg, Germany d. 1970. Studied: Royal Acad., Munich; L. Klein; M. Hyman; A. Jank. Member: N.J. AA; Mod. Ar., N.J.; S.Indp.A.; New Haven PCC. Exhibited: S.Indp.A., 1929–40; BM, 1932; AIC, 1936; traveling exh., 1936–37; CGA, 1939; Newark Mus., 1940, 1944; CI, 1941; VMFA, 1946; New Haven PCC, 1934–39; Montclair AM, 1938, 1939; N.J. State Mus., Trenton, 1939; Pa. State T. Col., 1944, 1946. Work: Newark Mus. [47]

WEINIK, Sam(uel) [P,B] NYC b. 17 S 1890, Newark, N.J. Member: Cyasan Artists [33]

WEINMAN, Adolph A(lexander) [S,Medalist] Forest Hills, NY b. 11 D 1870, Karlsruhe, Germany (came to America in 1880) d. 8 Ag 1952. Studied: CUASch; ASL, 1889; Saint-Gaudens; P. Martiny; assistant to Niehaus, Warner and French. Member: SAA, 1903; ANA, 1906; NA, 1911; NSS, 1900; Arch. Lg. 1902; NIAL; AAAL, 1932; Century Assn.; Am. Numismatic S.; AFA; Intl. Jury for Sculpture, P.-P. Expo, San Fran., 1915; NYC Art Comm., 1924–27; Nat. Comm. FA, 1929–33. Exhibited: Pan-Am. Expo, Buffalo, 1901 (prize); St. Louis Expo, 1904 (med); Brussels Expo, 1910 (med); Arch. Lg., 1913 (gold); Am. Numismatic S., 1920 (med); PAFA, 1924 (gold); AIC, 1930 (med). Work: memorials, Hodgenville, Ky., Madison, Wis.; Detroit; MET; Brooklyn Inst. Mus.; CI; Kansas City Mus.; NYC; Houston MFA; Mo. State Capitol Grounds; pediment, Wis. State Capitol; frieze, Elks Nat. Mem. Hdq. Bldg., Chicago; all sculpture, Pennsylvania Station; tower/façade, Mun. Bldg., NYC; des., "Liberty" half-dollar and "Mercury" dime; Victory button, U.S. Army and Navy; statue/monumental frieze, La. State Capitol; designed all sculpture for new P.O. Dept. Bldg; U.S. Supreme Court Room; pediment, Archives Bldg., Wash., D.C.; bronze doors, Am. Acad. A.&Letters Bldg., NYC [47]

WEINMAN, Howard [S] Garden City, NY. Member: NSS [47]

WEINMAN, Robert Alexander [S,P] Forest Hills, NY b. 19 My 1915, NYC. Studied: NAD. Exhibited: NAD, 1937, 1938; PAFA, 1939; Albany Inst. Hist. & A., 1939; NAC, 1941. Work: Brookgreen Gardens, S.C.; Our Lady Queen of Martyrs Church, N.Y. [47]

WEINMANN, Albert [S] b. 1860 d. 21 Jy 1931, East Rockaway, NY

WEINRICH, Agnes [P,E,B] Provincetown, MA b. 16 Jy 1873, Burlington, IA d. 17 Ap 1946. Studied: AIC; ASL. Member: N.Y. Soc. Women A.; New England S. Contemp. A.; Provincetown AA. Exhibited: Provincetown AA, 1915. Work: PMG. Sister-in-law of Karl Knaths. [40]

WEINRICH, Leo L. [P] Bound Brook, NJ [15]

WEINSTEIN, Sylvie L. [C] Brooklyn, NY b. NYC. Member: Am. G. Craftsmen. Exhibited: Syracuse Mus., 1932 (prize). Work: Paris Expo, 1937; Phila. AI [40]

WEINSTOCK, Carol [P,G,T] NYC b. 29 O 1914, NYC d. 1971. Studied: ASL. Member: United Am. Ar. Exhibited: WFNY, 1939; GGE, 1939; ACA Gal., NYC, 1939; MOMA (one-man); Smithsonian (one-man); Nat. Gal.; AIC; PAFA; MMA; WMAA. Work: Univ. Minn.; Pub. Lib., Brooklyn; Queen's Col., NYC; PMA. Specialty: gouaches, 1930s; collages, 1960s–70 [40]

WEIR, Dorothy (Mrs. Mahonri Young) [P,B] NYC/Ridgefield, CT. b. 18 Je 1890, NYC d. 28 My 1947. Studied: her father Julian; NAD; ASL. Member: NAWPS. Exhibited: NAWPS, BM, 1928 (med); Stockbridge AA, 1929 (prize). Publisher: her father's letters [40]

WEIR, Edith Dean (Mrs. James De Wolf Perry) [Min.P,W] Providence, RI/Princeton, MA b. 17 Ag 1875, New Haven, CT d. 24 F 1955. Studied: Yale, with her father John F. Weir; A. Herter; L.F. Fuller. Member: Providence AC. Work: St. Paul's Church, New Haven, Conn.; Christ Church, West Haven, Conn. Author: "Under Four Tudors," 1940 [47]

WEIR, Irene [P,E,W,L] NYC/Katonah, NY b. 1862 d. 22 Mr 1944, Yorktown Heights, NY. Studied: J.A. Weir; J. Pennell; Yale; ASL; Paris, with Colarossi Acad., Ecole des Beaux-Arts; Fontainebleau Sch. FA. Member: NYWC; NAWPS; Salon of Am.; Coll. AA; SAE. Work: Houston MFA; Univ. Ga.; Rollins Col.; West Point. Author: "Greek Painters," articles, Art Digest [40]

WEIR, John F(erguson) [P,S,T,L,W] Providence, RI b. 28 Ag 1841, West Point, NY d. 8 Ap 1926. Studied: his father Robert W., at West Point; NAD. Member: ANA, 1864; NA, 1866; CAFA; Century Assn.; Providence AC; New Haven PCC (founder). Work: MET; statues, Yale; fountain, New Haven Green; portraits, Yale; Putnam Hist. S., Cold Springs, N.Y. Author: "John Trumbull and His Works." While he achieved fame in the 1860s for his dynamic industrial interior scenes, his importance lies more in his role as an influential teacher. He was also overshadowed later by his famous Impressionist brother, Julian. Positions: A. Commissioner, Centenn. Expo, Phila., 1876; Dir., Yale Sch. FA 1869–1913 [24]

WEIR, J(ulian) Alden [P,E,T] NYC/Windham and Branchville, CT (since 1882) b. 30 Ag 1852, West Point, NY d. 9 D 1919, NYC. Studied: his father Robert; NAD, 1868–73; Ecole des Beaux-Arts, Paris, with Gérôme, 1873. Member: Cornish (N.H.) Colony; AAPS (elected Pres. 1913 but resigned due to the anti-NA stance of the AAPS); ANA, 1885; NA, 1886 (Pres. 1915–17); AWCS; Ten Am. P.; N.Y. Etching C.; CAFA; Lotos C.; A. Aid. S.; Century Assn.; NIAL. Exhibited: Paris Salon, 1882 (prize); Paris Expo, 1889 (med), 1900 (med); Am. A. Assn., 1889 (prize); CI, 1897 (med); St. Louis Expo, 1904 (gold) (med); Pan-Am. Expo, Buffalo, 1901 (med); NAD, 1906 (gold); PAFA, 1910 (prize), 1913 (med); AIC, 1912 (med); Armory Show, 1913; CGA, 1914 (gold) (prize); P.-P. Expo, San Fran., 1915 (prize). Work: MET; AIC; Albright A. Gal., Buffalo; RISD; WMA; NGA; PAFA; Brooklyn Inst.; CI; CGA; Montclair AM, N.J.; 47 etchings, Cincinnati Mus.; Luxembourg Mus., Paris. Positions: T., summer classes at Cos Cob, Conn. (with Twachtman), 1892–93; ASL and CUASch, 1877–98; summer classes at Branchville, Conn., 1897–1901 [15]

WEIR, Lillian [P] NYC b. 23 Mr 1883, Ft. Wadsworth, NY. Studied: Ida Stroud; D. Volk [15]

WEIR, Robert Walter [Ldscp.P,Por.P,Genre P.,I] NYC b. 18 Je 1803, NYC d. 1 My 1889. Studied: J.W. Jarvis; R. Cox, ca. 1820–21; Am. Acad. FA, ca. 1821; Florence, 1824–27, with P. Benvenuti. Member: NA, 1829; early member of the Hudson River School. Exhibited: West Point Mus., 1976 (retrospective). Work: MMA; BMFA; Capitol, Wash., D.C.; West Point Mus.; NGA; NYC Hall; N.Y. Hist. Soc. Father of Robert, Jr., Julian and John. [*]

WEIR, Robert Walter, Jr. [I] b. 12 Ja 1836, West Point, NY d. 1905, Montclair, NJ. At age 19 he ran away to become a sailor on a whaler for 3 yrs., then joined the Navy during the Civil War. His illustrations appeared in Harper's, in 1864. He later became a construction engineer. Son of Robert, Sr. [*]

WEIR, William (Joseph) [P,I,E] Chicago, IL b. 8 Je 1884, Ballina, Ireland. Studied: AIC; Chicago Acad. FA; Académie Julian, Paris. Member: Chicago Palette and Chisel Acad. FA. Work: State Mus., Springfield, Ill. 40]

WEIS, Bernard J(ackson) [P,I,C] Homsestead, PA b. 27 D 1898, McKeesport, PA. Studied: C.J. Taylor. Member: Pittsburgh AA [25]

WEIS, Fred [P] Houston, TX [24]

WEIS, John E(llsworth) [P,T] Cincinnati, OH b. 11 S 1892, Higginsport, OH. Studied: Duveneck; Meakin; Hopkins; Wessel. Member: Cincinnati AC; Cincinnati MacD. C.; Jafa Soc. Position: T., A. Acad., Cincinnati [40]

WEIS, S(amuel) W(ashington) [P] Chicago, IL/Glencoe, IL b. 8 Ag 1870, Natchez, MS. Member: NOAA; SC; Business Men's AC, Chicago; Palette & Chisel C., Chicago; North Shore AL, Winnetka [27]

WEISBRODT, H.W. [En] b. 1856 d. 6 S 1827, Cincinnati

WEISBROOK, Frank S. [P] Davenport, IA. Exhibited: St. Paul Inst., 1918 (med) [31]

WEISE, Charles [Min.P] Baltimore, MD [10]

WEISE, Paul [P] Dallas, TX [24]

WEISEL, Deborah Delp [P,Li,W,E,L] Springfield, MO/Moorestown, NJ b. Doylestown, PA d. 16 D 1951. Studied: PMSchIA; PAFA; Columbia; H. Breckenridge; C. Martin; De Voll. Member: AFA; AA Mus.; SSAL; Ozark AA; Mo. State T. Assn.; Friends of Art, Springfield; Western AA; Springfield Art Comm. Exhibited: Springfield A. Mus.; Ozark AA; SSAL. Position: T., Southwest Mo. State Col., 1921– [47]

WEISENBERG, Helen Mills [P] Phila., PA. Member: New Century C.; Plastic C., Phila., 1924 [25]

WEISENBORN, Rudolph [P] Chicago, IL b. 1881, Chicago. Exhibited: Fed. A. Project, AIC, 1938; "Half Century Am. P." Exh., AIC, 1939 [40]

WEISENBURG, George W. [P] Oak Park, IL [19]

WEISENBURG, Helen M(ills) [P] Baltimore, MD. Studied: Phila. Sch. Indst. Art; PAFA, with Breckenridge. Member: Plastic C.; Phila. Alliance; Baltimore Friends of A. Exhibited: PAFA, 1927 (prize); Plastic C., Phila., 1929 (gold) [33]

WEISENBURGER, S. [P] Indianapolis, IN [13]

WEISGARD, Leonard [I,Des,L] Danbury, CT b. 13 D 1916, New Haven, CT. Studied: PIASch; A. Brodovitch. Exhibited: 50 Best Books of the Year, 1942–45 (prize); MOMA; MMA; many libraries. Work: MOMA Children's Coll. Author: "Water Carrier's Secret"; children's books, 1936–46. Contributor: New Yorker, American Home, Ladies Home Journal, other magazines [47]

WIESMAN, Joseph [Li,Des,P] Los Angeles, CA b. 17 F 1907, Schenectady, NY. Studied: Chouinard AI; Los Angeles A. Center Sch.; B. Miller; M. Sheets; C. Hinkle; Murphy; S. Reckless. Member: Los Angeles AA; P.&S. C., Los Angeles; Calif. WCS; Laguna Beach AA. Exhibited: Calif. State Fair, 1932–35, 1936 (prize), 1938 (prize), 1939 (prize); Santa Cruz, Calif., 1933 (prize), 1934–38, 1946; Laguna Beach AA, 1936 (prize); Santa Barbara Mus. A., 1944; PAFA, 1936–37; Laguna Beach AA, 1938; Los Angeles Mus. A., 1930, 1932, 1933, 1937–39; San Diego FA Soc., 1931, 1933, 1940; Oakland A. Gal., 1933, 1936–38; Los Angeles AA, 1945, 1946; Los Angeles County Fair, 1929–31, 1936, 1938; GGE, 1939; Santa Paula, Calif., 1945. Work: Manual Arts H.S., Metropolitan H.S., Los Angeles; Los Angeles AA [47]

WIESMAN, Robert R. [P] Chicago, IL. Member: Chicago NJSA [25]

WEISMANN, Barbara Warren (Mrs.) [Des,G,T] St. Paul, MN b. 29 Jy 1915, Milwaukee. Studied: Milwaukee State T. Col. Exhibited: Milwaukee AI, 1935 (prize), 1936 (prize); Wis. Sal. A., Univ. Wis.; WPA Exh. (traveling), Minn. Position: T., Univ. Minn. [40]

WEISMANN, Donald LeRoy [P,T,L,B] Wauwatosa, WI b. 12 O 1914, Milwaukee. Studied: Milwaukee State T. Col.; Univ. Wis.; Harvard; St. Louis Univ.; Univ. Minn. Member: Wis. Soc. Appl. A.; Minn. Ar. Soc.; Am. Assn. Univ. Prof.; Nat. Edu. Assn.; Wis. P.&S. Assn. Exhibited: Wis. P.&S., 1934 (prize); Wis. Salon A., 1939 (prize); Harvard, 1941 (prize); AIC, 1938–40; Milwaukee AI; Wis. Mem. Un. Gal.; Dayton AI; Monte Carlo Gal., Jalisco, Mex., 1946; Rockefeller Center, N.Y., 1935; Wis. Sal. A., 1938, 1939. Work: Wis. Ar. Calendar, 1937. Position: T., Ill. State Normal Univ., Normal [47]

WEISS, Bernard. See Weis.

WEISS, Julius [P,G] Boston, MA b. 17 Ap 1912, Portland, ME. Studied: H. Giles; C. Hopkinson. Member: Ar. Un., Boston. Exhibited: Provincetown AA; Springfield, Mass., MFA; Fed. A. Proj. Exh. (traveling), Mass. [40]

WEISS, Mary L. (Mrs. William H.) [P] East Gloucester, MA b. Mauch Chunk, PA. Studied: PAFA, with Chase. Member: Plastic C.; NAWPS [25]

WEISS, Ray (Miss) [P,E,L] New Haven, CT b. New Haven. Studied: E. Leon; PIASch. Member: New Haven PCC; Phila. Print C.; AAPL. Exhibited: Salon Société des Artistes Français, 1930 (prize); New Haven PCC, 1932 (prize). Work: etching, British Mus., London; Bibliothèque Nationale, Paris; MET, 1932 [40]

WEISS, Samuel A. [Ldscp.P] NYC b. 19 Mr 1874, Warsaw, Poland (came to U.S. in 1886). Studied: NAD; H. Mosler [17]

WEISS, William Lentz [P] East Gloucester, MA. Member: SC [25]

WEISSBUCH, Oscar [P,G,T,L,B,E] Utica, NY b. 15 S 1904, NYC d. 17 My 1948. Studied: ASL; BAID; E.C. Taylor; E. Savage; D. Keller; L. York; Yale. Exhibited: MOMA, 1936; WFNY, 1939; MMA (AV), 1942; CI, 1941; Phila. Pr. C., 1938, 1940, 1942, 1946; BM, 1940; British Mus., London, 1937; SFMA; Los Angeles Mus. A.; Albright A. Gal., 1943; LOC, 1944, 1945; Yale, Mus. FA (one-man); Fine Prints of the Year, 1937; 60 Prints of the Year, 1942–42; 100 Am. Block Prints, 1941–42; Norway; Sweden; Denmark. Work: Wesleyan Univ.; Albright A. Gal.; Yale; Princeton; LOC; Queensboro Pub. Lib.; Brooklyn Pub. Lib.; Hunter Col.; State Dept. of Insurance, N.Y.; Washington Irving H.S., N.Y.; La. State Univ.; Univ. Wis.; Rochester Pub. Lib.; M. Proctor Inst.; Queens Col.; Westminster Church, Buffalo; Post Graduate Hospital, U.S. Naval Hospital, N.Y.; Univ. Minn. Positions: T., Munson-Williams-Proctor Inst., Utica, N.Y. (1941–), Mod. Painters Group, Cooperstown, N.Y. (1945–) [47]

WEISSER, Fred W. (Mrs.) [P] New Braunfels, TX b. 5 O 1890, Guadalupe County, TX. Studied: Col. Indst. A., Tex.; Southwestern Univ., Georgetown, Tex.; M. Stanford; J.E. Jenkins; R.J. Onderdonk. Member: SSAL; San Antonio A. Lg. Exhibited: Hays County, Tex., Fairs, 1922–24 (prizes); Edgar B. Davis Exh., San Antonio, 1929 (prize); Tex. Fed. Women's C., 1931 (prize); San Antonio A. Lg., 1927–29; SSAL, 1929–35; Tex. A. 1926–34, 1942; San Antonio A., 1927, 1931, 1933, 1934; San Marcos, Tex., 1921 [47]

WEISSLER, William, Jr. [P] Cincinnati, OH. Member: Duveneck Soc. [25]

WEISZ, Eugen [P] Wash., D.C. b. Hungary. Studied: Corcoran Sch. A.; PAFA; Albright Sch. FA. Member: S. Wash. A. Exhibited: S. Wash. A., 1927 (med). Position: T., Corcoran Sch. A. [40]

WEISZ, George Gilbert, Jr. [Li,Ser,P,E] Seville, OH b. 6 Jy 1921, Leroy, OH. Studied: Miami Univ., Oxford, Ohio; E.L. Fulwider. Exhibited: LOC, 1943, 1946; Elisabet Ney Mus., 1942; Okla. A. Center, 1942; Wichita, Kans., 1945; Providence, R.I., 1946; Northwest Pr.M., 1946; Mint Mus. A.; Laguna Beach AA, 1946; Butler AI, 1946; Parkersburg FA Center, 1946; Akron AI, 1946; Massillon Mus., 1945 (one-man); North Canton Little Gal., 1945 (one-man). Work: Elisabet Ney Mus., Austin, Tex.. Position: T., Akron AI, 1946– [47]

WEITENKAMPF, Frank [Cur,W] NYC b. 1866 d. 1962. Author: "American Graphic Art," 1924, "Manhattan Kaleidoscope," 1927. Important curator of prints at NYPL. [*]

WELBORN, C. W. [P] Oklahoma City, OK [19]

WELCH, Katherine G. [P] Spring Station, KY. Member: NAWPS [27]

WELCH, Mabel R. [Min.P] NYC/North Wilbraham, MA b. New Haven, CT d. 1 Ja 1959. Studied: ASL, with Cox, Reid; Paris, with Garrido, Lasar, Scott, Van der Weyden, Courtois. Member: ASMP; NAWA; Brooklyn Soc. Min. P.; Pa. Soc. Min. P.; Grand Central AG. Exhibited: P.-P. Expo, 1915 (med); Pa. Soc. Min. P., 1920 (med); ASMP, 1935 (med), 1940 (med); Calif. Soc. Min. P., 1937 (med); Brooklyn Soc. Min. P., 1933 (prize); NAWA, 1938 (prize); PAFA, 1938 (prize). Work: BM; PMA; CGA [47]

WELCH, Thaddeus [Ldscp.P] Santa Barbara, CA (since 1905) b. 14 Jy 1844, IN d. 19 D 1919. Studied: worked for a printer in Portland, Oreg., 1863; San Fran., 1866; Royal Acad., Munich, 1874 (where he befriended Twachtman, Chase, and Duveneck); Paris, 1878–81. Exhibited: Bohemian C., San Fran. Work: Pal. Leg. Honor; Oakland Mus. A.; San Diego AG; some works made as chromolithos by Prang in Boston. Welch worked in NYC and Boston during 1880s; traveled to the Southwest 1888–89; Australia, 1889; finally settling in Calif., 1892. [*]

WELD, Virginia Lloyd [P] Cedar Rapids, IA b. 1915, Cedar Rapids. Studied: Coe Col., Iowa; Univ. Iowa; M. Cone. Exhibited: Coe Col. Lib.; Iowa Ar. Exh., Mt. Vernon, 1938. Affiliated with D.C. Cook Pub. Co., Elgin, Ill. [40]

WELDON, C(harles) D(ater) [I,P] NYC b. 1855, Ohio d. 9 Ag 1935, East Orange, NJ. Studied: W. Shirlaw, in N.Y.; Munkacsy, in Paris. Member: ANA, 1889; NA, 1897; AWCS; Century Assn. Exhibited: Charleston Expo, 1902 (med). Specialty: Japanese motifs. He spent several years in Japan illustrating books. [33]

WELDON, Walter A. [Des,L,C] Baltimore, MD b. 4 My 1890, Rochester, NY. Studied: Johns Hopkins Univ. Member: Am. Cer. Soc. Exhibited: Syracuse Mus. FA; ceramic exhibits in U.S. Work: high-fire porcelain; Chinese art in porcelain. Contributor: Am. Ceramic Soc. Bulletin. Position: Cer. Engineer, Locke Insulator Corp., Baltimore [47]

WELLA, H. Emily (Mrs.) [P,T] Rochester, NY b. 31 My 1846, Delaware, OH d. Winter, 1925. Member: Rochester AC [24]

WELLENS, Helen Miller (Mrs. Jules C.) [Por.P,I,T] Ardmore, PA b. Phila. Studied: her father H. Miller; PAFA, with W.M. Chase. Exhibited: PAFA, 1901 (prize) [10]

WELLER, Allen Stuart [T,W,L] Columbia, MO b. 1 F 1907, Chicago. Studied: Univ. Chicago; Princeton. Author: "Francesco di Giorgio," 1943. Contributor: Art Digest, Art in America, Magazine of Art. Positions: T., Univ. Mo. (1929–43; 1946–), U.S. Army Air Force (1942–45) [47]

WELLER, Carl F. [P] Wash., D.C. b. 29 Jy 1853, Stockholm, Sweden d. S 1920. Studied: Royal Acad. A., Stockholm; Kensington A. Sch., London. Member: S. Wash. A.; Wash. WCC; Wash. SFA [19]

WELLER, Paul [P,Li,I] NYC b. 20 D 1912, Boston. Studied: NAD; Am. Ar. Cong. Member: A. Lg. Am.; United Am. Ar. (Vice-pres.). Exhibited: AIC, 1936; PAFA, 1936; MOMA, 1939; Phila. A. All.; WFNY, 1939. Work: MMA; Springfield (Mass.) Mus. A.; mural, USPO, Baldwinsville, N.Y. WPA artist [47]

WELLING, Gertrude Nott [P] NYC [19]

WELLINGTON, Frank H. [I] Passaic, NJ. Exhibited: Pan-Am. Expo, Buffalo, 1901 (med). Specialty: wood engraving [10]

WELLINGTON, John L. [P] Cumberland, MD. Exhibited: PAFA, 1938; Am. WCC, 1938; Wash. WCC, 1936–39 [40]

WELLS, Alice Rushmore (Mrs. Henry C.) [P,Min.P] Plainfield, NJ b. 21

My 1877. Studied: ASL; R. Collin; Mme. Debillemont-Chardin. Member: NAWPS [40]

WELLS, Alma (Mrs. Horace C. Levinson) [P] Chicago, IL/Kennebunk, ME b. 15 O 1899. Studied: J. Norton; H. de Waroquier, in Paris. Member: Arts C., Chicago. Exhibited: A. Ctr., Ogunquit, Maine, 1935 (prize) [40]

WELLS, Amy Watson [P,Des,L,T] Trenton, NJ b. 21 D 1898, Lynchburg, VA. Studied: Sch. Indst. A., Trenton; PAFA; Columbia; Chicago Sch. Des.; H. Hofmann; C. Hawthorne. Member: Morrisville-Trenton A. Group; SSAL. Exhibited: Montclair AM, 1945; Morrisville-Trenton A. Group, 1945; Contemp. C., Trenton, 1946 (one-man). Work: Longfellow Sch., Phila.; IBM Coll.; Capitol, Trenton, N.J. Position: T., Sch. Indst. A., Trenton, from 1930 [47]

WELLS, Benjamin B. [P] Hackensack, NJ. Member: SC [25]

WELLS, Cady [P] Santa Fe, NM b. 15 N 1904, Southbridge, MA d. 1954. Studied: Harvard; Univ. Ariz.; A. Dashburg, 1932. Member: AFA; Springfield (Mass.) AL; San Diego AG. Exhibited: San Diego AF, 1936 (prize); State Fair, N.Mex., 1939 (prize); Rio Grande P., Santa Fe, 1934; Heptagon G., Taos, 1934; Mus. N.Mex., 1956 (retrospective); Univ. N.Mex., 1967 (retrospective). Work: FMA; Avery Mem., Hartford, Conn.; San Diego AG; AIC; Mus. N.Mex.; Amon Carter Mus. Specialties: watercolors; gouache abstractions [47]

WELLS, Carrie Carter (Mrs. Charles J.) [P] Mattituck, NY. Member: NAWPS [24]

WELLS, Charles S. [S,T] Minneapolis, MN b. 24 Je 1872, Glasgow, Scotland. Studied: K. Bitter; A. Saint-Gaudens; G.G. Barnard. Work: fountain, Gateway Park, Minneapolis; Anna T. Lincoln Mem., Northfield, Minn. [40]

WELLS, Eloise Long [S,G,Des] St. Louis, MO b. 3 My 1875, Alton, IL. Studied: St. Louis Sch. FA; Chouinard AI. Member: St. Louis Ar. Gld.; AC, Chicago. Exhibited: Kansas City AI, 1923 (gold) [40]

WELLS, Emily (Mrs.) [P] Rochester, NY. Member: Rochester AC [21]

WELLS, F. Marion [S] San Fran., CA b. 1848 d. 22 Jy 1903. Member: Bohemian C., San Fran. (founder). Work: Statue of Liberty on City Hall, San Fran.; Marshall Mon. at Coloma

WELLS, James Lesesne [Li,En,P,I,T] Wash., D.C. b. 2 N 1902, Atlanta. Studied: Lincoln Univ.; Columbia; NAD; Nankivell. Member: AFA. Exhibited: Harmon Fnd., 1931 (gold), 1933 (prize); NAD, 1946; LOC, 1944, 1946; Phila. Pr. C., 1943-46; Dillard Univ., New Orleans, 1941; Albany Inst. Hist. & A., 1945; PMG, 1945; Intl. Pr. Soc., 1944; Newport AA, 1944; Howard Univ., 1945. Work: PMG; Valentine Mus. A., Richmond, Va.; Thayer Mus., Univ. Kans.; Hampton Inst.; Howard Univ. Gal. A.; Lincoln Univ. Illustrator: "Plays and Pageants from the Life of the Negro." Position: T., Howard Univ., Wash., D.C., 1929- [47]

WELLS, Jane McClintock (Mrs. F.H.) [B,Des] Smithfield, VA b. 11 My 1903, Charleston, SC. Studied: A. Hutty; A.H. Smith; BMFA Sch. Author/Illustrator: "Collecting Ship Models in China," in the Mariner, 1930; "Chinese Lines of Communication," 1934 [40]

WELLS, Lucy D. (Mrs. William A.) [P,T] Seattle, WA b. 4 S 1881, Chicago. Studied: AIC; Vanderpoel; R. Clarkson; R. Davey; E. Lawson. Member: Seattle AM; NAWPS; Pacific Coast PS and Writers. Exhibited: Pacific Coast PS and Writers, 1936 (prize) [40]

WELLS, Newton A(lonzo) [P,S,I,Arch,C,T] Urbana, IL b. 9 Ap 1852, Lisbon, St. Lawrence County, NY. Studied: Constant, Laurens, both in Paris. Member: Mur. P., 1905; Arch. Lg. Am. (Vice-pres.); Chicago SE; Paris AAA. Work: mural dec., Univ. Ill. Lib.; Sangamon County Court House, Springfield, Ill.; Colonial Theater, Boston; Englewood H.S., Chicago. Position: T., Univ. Ill., 1899- [21]

WELLS, Rhea [P] NYC. Member: GFLA [27]

WELLS, Sabina E. [P] Charleston, SC [13]

WELLSTOOD, William [Ldscp.En,E] NYC b. 19 D 1819, Edinburgh, Scotland (came to NYC, 1830) d. 19 S 1900. Worked for NYC publishers. His brother John [1813-93] and son James [1855-80] were also engravers. [*]

WELMHURST, O. [I] NYC. Position: Illus., Appleton & Co. [10]

WELP, George L. [I,Art Dir] Flushing, NY b. 30 Mr 1890, Brooklyn, NY. Studied: ASL; PIASch; W. Biggs. Member: SI; SC; A. Dir. C. [29]

WELPLEY, Charles [P,E] Wash., D.C. b. 11 Je 1902, Wash., D.C. Studied: B. Baker; D. Garber [29]

WELSCH, Paul [P] Paris, France b. 26 Jy 1889, Strasbourg. Studied: M. Denis; C. Guerin; B. Naudin, in Paris. Work: AIC; Musée de Mulhouse, Musée de Chateau des Rohans, both in Strasbourg [33]

WELSH, (Horace) Devitt [I,E,P,B,Dr,L] NYC b. 2 Mr 1888, Phila. d. 11 Jy 1942. Studied: T. Anshutz; W.M. Chase; J. Pennell. Member: Phila. Sketch C.; F., PAFA; Phila. WCC; Phila. Art Week Assn.; Soc. Allied A. Work: Widener Coll., Phila.; etching of White House for Pres. Wilson; Elkins Coll., Phila.; LOC; Free Lib., Phila.; NYPL; British Mus. Position: Asst. Sect., Div. Pictorial Publicity, WWII; Chmn., Joseph Pennell Mem. Exh., Phila., 1926 [40]

WELSH, Herbert [P] Germantown, PA b. 4 D 1851. Studied: PAFA; Bonnât, in Paris; F.A. Ortmanns, at Fontainebleau Sch. FA; O. Carlandi, in Rome [25]

WELSH, Roscoe [P] Chicago, IL b. 17 Je 1895, Laclede, MO. Studied: E. Califano [24]

WELSH, William P. [P,I] Chicago, IL b. 20 S 1889, Lexington, KY. Studied: M. Kinkead; Delecluse, Baschet, Royer, in Paris; DuMond, in N.Y. Member: SI. Exhibited: H.P. Whitney Mural Comp., 1910 (prize); First Intl. Water Color Exh., 1921 (prize); Tribune Mural Comp., 1922 (prize); Inst. Poster Comp., Chicago World's Fair poster (prize); Ann. Exh. Adv. Art for black and white drawing, 1930 (med); Poster N.Y., 1931 (prize); Chicago Soc. Typogr. Arts, 1936 (med). Work: AIC; mural dec., Men's Café, Palmer House Hotel, Chicago. Illustrator: covers, Woman's Home Companion [40]

WELTY, Magdalena [P] Fort Wayne, IN [13]

WEMMELL, Charles W. [P,Patron] Brooklyn b. 1839, Brooklyn, NY d. 31 Mr 1916. Served in the Civil War

WENBAN, S.L. [E] Rockville, CT [17]

WENCK, Paul [P,I,G] New Rochelle, NY b. 13 Ja 1892, Berlin, Germany. Studied: Berlin, with Hancke, Boese, Friederich, Herwarth, Schaeffer. Member: Artists G.; German A. Union, Berlin [40]

WENDEL, Theodore [Ldscp.P] Ipswich MA b. 1859, Cincinnati d. 1932, Ipswich. Studied: McMicken Sch. A. (where he formed friendship with J. DeCamp, ca. 1876); became one of the "Duveneck Boys" in Munich, Florence, and Venice, 1878-80; at Giverny, summers of 1886-87 (where his work was praised by Monet). Member: Boston GA. Exhibited: PAFA, 1909 (med); P.-P. Expo, San Fran., 1915 (med). Work: Cincinnati Mus.; PAFA. Joined a circus as an acrobat (age 15-17). Became one of Boston's most successful landscape painter but illness forced him to stop painting in 1917. [29]

WENDT, Julia M. Bracken (Mrs. William) [S,P] Los Angeles, CA/Laguna Beach, CA b. 10 Je 1871, Apple River, IL d. 22 Je 1942. Studied: AIC, with Taft, 1887-92. Member: Chicago SA; Chicago Mun. AL; Los Angeles FA; Calif. AC; NAC; Three Arts C., Los Angeles; Laguna Beach AA. Exhibited: Chicago, 1898 (prize); Chicago Mun. AL, 1905 (prize); Pan.-Calif. Expo, San Diego, 1915 (gold); Calif. AC, 1918 (gold). Work: Columbian Expo, 1893; Los Angeles Mus. A. Position: T., Otis AI (7 yrs.) [40]

WENDT, William [Ldscp.P] Los Angeles, CA/Laguna Beach, CA (since 1906) b. 20 F 1865, North Germany d. 29 D 1946. Studied: AIC; mostly self-taught. Member: ANA, 1912; Chicago SA; NAC; Calif. Laguna Beach AA; AFA. Exhibited: Chicago, 1893 (prize); AIC, 1897 (prize), 1904 (prize), 1910 (prize), 1913 (prize), 1922 (prize); Pan-Am. Expo, Buffalo, 1901 (med); St. Louis Expo, 1904 (med); Chicago SA, 1905 (prize); Wednesday C., St. Louis, 1910 (med); SWA, 1912 (prize); P.-P. Expo, San Fran., 1915 (med); San Diego Expo, 1915 (prize); Calif. AC, 1916 (prize); Pan.-Am. Exh., Los Angeles, 1925 (prize); Pacific Southwest Expo, Long Beach, 1928 (gold,prize); Pasadena AI, 1930 (prize). Work: Cincinnati Mus.; AIC; Herron AI; H.S., Richmond, Ind.; Cliff Dwellers C., Chicago; Des Moines Assn. FA; Univ. C., Seattle; Los Angeles MA [40]

WENG, Siegfried R. [B,L,T] Dayton, OH b. 20 My 1904. Studied: Univ. Chicago; AIC; FMA. Positions: Lecture Assist., L. Taft; Dir., Dayton AI [40]

WENGENROTH, Isablle S. (Mrs. F.W.) [C,Des] Bayport, NY b. 29 Je 1875, Toledo. Studied: W. Reiss; A. Heckman; J. Carlson; G.P. Ennis. Member: Keramic S., NYC; Design G., NYC; Baltimore WCC; NAWPS. Specialty: textiles [40]

WENGENROTH, Stow [Li] NYC b. Jy 1906, Brooklyn, NY d. 1978. Studied: ASL; Grand Central A. Sch.; ASL, with W. Adams, G.P. Ennis, J. Carlson, G. Bridgman, 1923-27. Member: NIAL; Providence WCC; CAFA; SC; Prairie PM; ANA, 1938; NA, 1941; Phila. WCC. Exhibited: Phila. Pr. C., 1934 (prize), 1935 (prize) 1937 (prize), 1939 (prize); SC, 1937 (prize); AV, 1942 (prize); Northwest PM, 1943 (prize); CAFA, 1943 (prize),

1946 (prize); Mint Mus. A., 1944 (prize); Phila. WCC, 1933 (gold), 1943 (gold); Audubon A., 1945 (gold); NAC, 1933 (prize). Work: Syracuse Mus. FA; BMA; AGAA; LOC: NYPL; WMAA; Denver AM; Milwaukee AI; Los Angeles MA; SAM; FMA; BMFA; PAFA; MET; CI; Albany Inst. Hist. & A.; large coll., Boston Pub. Lib. Author: "Making a Lithograph," 1936 [47]

WENGER, John [P,D] NYC b. 16 Je 1891, Russia. Studied: NAD; Russia; Imperial A. Sch., Odessa. Member: Audubon A.; AWCS; Un. Scenic A.; SC; Arch. Lg., NYWCC. Exhibited: CGA, 1935; PAFA (prize); NAD; AIC; AWCS; Audubon A., 1945; Ferargil Gal., 1925 (one-man); Montross Gal., 1931–34 (one-man); Grand Central A. Gal., 1929 (one-man), 1935 (one-man), 1938 (one-man), 1940 (one-man), 1944 (one-man); Staten Island Inst., 1945 (one-man); Sesqui-Centenn. Expo, Phila., 1926 (prize). Work: Tel-Aviv Mus., Palestine; Mus. City of N.Y. Designer: stage productions; scenic des. for movie "Paramount on Parade." Position: A. Dir., Roxy Theatre, NYC [47]

WENIGER, Maria P. [S] NYC. Member: S.Indp.A. [25]

WENTLAND, Frank A. [P,E,L,T] Michigan City, IN b. 28 Ag 1897, Rolling Prairie, IN. Studied: A.C. Winn; A.H. Krehbiel. Member: Hoosier Salon; La Porte Brush and Palette C.; Mich. City AL [40]

WENTWORTH, Adelaide E. [E,C,T,L] Cincinnati, OH/Kittery Depot, ME b. Wakefield, NH. Studied: D.W. Ross; W.S. Robinson; A. Dow. Member: Cincinnati Women's AC; Crafters C. [31]

WENTWORTH, Almond Hart (Mr.) [P,T] St. Petersburg, FL/East Lebanon, ME b. 5 Ag 1872, Milton Mills, NH d. 26 Jy 1953. Studied: Cowles A. Sch., Boston; ASL, with Buffalo; D. Ross; Harvard. Member: EAA; CAFA; New Haven PCC; St. Petersburg AC. Exhibited: New Haven PCC, 1941–40; St Petersburg AC, 1944, 1945 (prize), 1946; Bridgeport AL. Position: Dir., A. Edu., Pub. Sch., New Haven, Conn., 1904–40 [47]

WENTWORTH, Catherine (Mrs.) [P] Paris, France. Studied: Paris, with Bouguereau, Robert-Fleury [15]

WENTWORTH, Cecile De (Mrs.) [P] Paris, France/NYC b. NYC. Studied: Sacred Heart Convent; Paris, with Cabanel, Detaille. Exhibited: Tours (gold); Lyon (gold); Turin (gold); Paris Salon, 1891 (prize); Paris Expo, 1900 (med). Award: Chevalier of the Legion of Honor, France, 1901; Officier of Public Instruction in France; Order of Holy Sepulchre from Pope Leo XIII [10]

WENTWORTH, (Daniel) F. [P] New Milford, CT d. 31 My 1934. Studied: Munich; largely self-taught. Member: CAFA. Exhibited: Brooklyn AC; AWCS; CAFA, 1922 (prize). Work: Storrs Col., Conn. [33]

WENTWORTH, Harriet Marshall (Mrs. Robert S.) [Min.P,Por,P] Mamaroneck, NY b. 7 S 1896, New Hope, PA. Studied: PAFA; Grande Chaumière; D. Garber; W. Lathrop; A.M. Archambault; C. Beaux; F.L. Mora; A. Favori. Exhibited: PAFA, 1933, 1934, 1942; Smithsonian. Work: PAFA; Smithsonian [47]

WENTZ, Henry Frederick [P,C,L,T] Portland, OR/Nehalem, OR b. The Dalles, OR. Studied: ASL. Work: Portland AA [40]

WENZELL, A(lbert) B(eck) [I,P] Englewood, NJ b. 1864, Detroit d. 4 Mr 1917 (pneumonia). Studied: Munich, with Strahüber, Loefftz; Paris, with Boulanger, Lefebvre. Member: Arch. Lg., 1913; Mural P. Exhibited: Pan-Am. Expo, Buffalo, 1901 (med); St. Louis Expo, 1904. Work: New Amsterdam Theatre, NYC. Author: "Vanity Fair," "The Passing Show" [15]

WERBE, Anna Lavick (Mrs. David B.) [P,I,L,T,Des] Detroit, MI b. Chicago. Studied: AIC, with Vanderpoel, F. Freer; M. Baker. Member: Detroit FA All. Exhibited: Los Angeles Mus. A.; Detroit AI; Grand Central A. Gal.; PAFA; AIC; Scarab C.; Mich. State Fair, 1934 (gold). Position: Founder/Dir., Jewish Community Center A. Sch. [47]

WERHEIM, Roland [P] NYC. Exhibited: GGE, 1939 [40]

WERNER, Frank A. [P] Chicago, IL. Member: Chicago SA [21]

WERNER, Fritz [Por.P] NYC b. 7 Ap 1898, Vienna, Austria. Studied: H. Tichy, in Vienna; H. von Haberman, in Munich; German Nat. Acad. Exhibited: Austrian Nat. Acad., 1920–21 (prize) [40]

WERNER, Geraldine. See Pine, Geri.

WERNER, Nat [S,L] NYC b. 8 D 1910, NYC. Studied: CCNY; ASL; R. Laurent; Columbia. Member: S. Gld.; Am. A. Cong. Exhibited: WMAA, 1936–46; PAFA, 1942, 1943, 1945, 1946; AIC, 1942, 1943; MET, 1941; MOMA; ACA Gal., 1938, 1941, 1942, 1944 (all one-man exh.). Work: Lyman Allyn Mus.; James Madison H.S., N.Y.; N.Y. Engineering C.; USPO, Fowler Ind. WPA artist. [47]

WERNER, Simon [P] NYC [10]

WERNTZ, Carl N. [P,I,T] Chicago, IL b. 9 Jy 1874, Sterling, IL d. 27 O 1944, Mexico City. Studied: J.H. Vanderpoel; R. Freer; L. Parker; J. Pratt; O. Lowell; A. Mucha; R. Reid; R. Miller, Paris; O. Carlandi, Rome; Japan, with S. Mizuno, K. Kawatika. Member: AFA; Western AA; Arts C., Chicago. Contributor: covers/illus., Red Book, Life, Century, Harper's, New York Times, Art and Archeology, Asia; Illustrated London News, Japan Travel Bulletin; B.P. Australian Quarterly. Positions: Cart., Chicago Record; Founder/Dir./Pres., Chicago Acad. FA [40]

WESCHLER, Anita [S,W,L] NYC b. NYC. Studied: N.Y. Sch. F.&Appl. A.; ASL; PAFA; A. Laessle; W. Zorach. Member: NAWA; Fed. Mod. P.&S.; S. Gld.; S.Indp.A.; Am. Ar. Cong. Exhibited: WMAA; MOMA; BM; AIC; PAFA; PMA; CI; AFA traveling exh.; SFMA; Weyhe Gal., 1937 (one-man), 1940 (one-man); Hudson Park Branch, NYPL, 1938 (one-man); Robinson Gal., 1940 (one-man); Montclair AM, 1935 (med); S. Wash. A., 1936 (med); SFMA, 1938 (med); Friends Am. A., Grand Rapids, 1940 (prize). Work: WPA work, USPO, Elkin, N.C.; numerous portraits. Contributor: Magazine of Art. Author: "Nightshade" [47]

WESCOTT, Alison Farmer (Mrs. Paul) [P] West Chester, PA/Friendship Island, ME b. 1909, NYC d. 1973. Studied: ASL, with Grosz; A. Brook; P. Bacon, 1927; PAFA; Europe, 1932. Member: Chester AA; PAFA; MET. Exhibited: PAFA; Phila. AA; Nat. Drawing Biennials; Wilmington SFA; Chester AA (mem. exh., 1974); Farnsworth AM, 1960. Specialty: drawings [*]

WESCOTT, Harold (George) [Des,Dec,P,B,C,T,L] Milwaukee, WI b. 1 D 1911. Studied: H. Thomas; R. von Neumann; F.L. Wright; Milwaukee State T. Col. Member: Milwaukee PM; Wis. S. Appl. A. Exhibited: Wis. Salon Art, Madison, 1936 (prize); Wis. PS, 1936. Work: Milwaukee AI. Specialties: des. furniture, interiors; typographical layouts. Position: T., Milwaukee State T. Col. [40]

WESCOTT, Paul [P,Des,T] Pottstown, PA/Friendship Island, ME b. 12 Ap 1904, Milwaukee d. 1970. Studied: AIC; PAFA, 1930. Member: Chester County AA; S. Wash. A. Exhibited: PAFA, 1928–45, 1932 (prize), 1944 (prize); MET (AV), 1942; NAD, 1936, 1938, 1940–44; Chester County AA, 1930–45, 1941 (prize); Phila. Sketch C., 1933 (prize), 1934 (prize), 1935 (prize), 1936–45; Woodmere A. Gal., 1940–45; Butler AI, 1941–45; F. Pafa, 1941, 1945; Phila. AC, 1937 (prize). Work: PAFA; Reading Mus.; Scranton Mus.; Farnsworth MA, Rockland, Maine. Position: T., The Hill Sch., Pottstown, Pa., 1932–46 [47]

WESCOTT, Sue May [P] Denver, CO b. 14 Ja 1893, Sabinal, TX. Studied: PAFA; Denver Mus. Sch. [25]

WESCOTT, William [S] NYC. Member: NSS [47]

WESSEL, Bessie Hoover (Mrs.) [P] Cincinnati, OH b. 7 Ja 1889, Brookville, IN. Studied: Cincinnati A. Acad.; F. Duveneck. Exhibited: CM, 1939, 1944; Cincinnati Prof. A., annually; Women's AC, annually, 1937 (prize), 1939 (prize), 1940 (prize); Hoosier Salon, annually, 1944 (prize), 1945 (prize); Ohio State Fair, 1934, 1935 [47]

WESSEL, Herman Henry [P,T,E] Cincinnati, OH b. 16 Ja 1878, Vincennes, IN. Studied: Cincinnati A. Acad., with Duveneck; Académie Julian, with J.P. Laurens. Member: Cincinnati AC; Cinncinnati Prof. A. Exhibited: S. Western A., 1915 (prize); Atlanta, 1920 (prize); Columbus, 1922 (prize). Work: CM; WPA murals: Scioto County Courthouse; Fed. Reserve Bank, Holmes Hospital, H.S., all in Cincinnati; Ohio State Office Bldg., Columbus; USPO, Springfield, Ohio. Position: T., Cincinnati A. Acad. [47]

WESSELHOEFT, Mary Fraser [C,Des,P,L] Santa Barbara, CA (since late 1920s) b. 15 F 1873 d. 23 Mr 1971. Studied: BMFA Sch., with D. Ross, C.H. Woodbury; von Habermann, in Munich. Member: Copley S., 1892; Am. Ar. Cong. Exhibited: Calif. WCS, Los Angeles. Work: stained glass window, Grace Church, Kansas City; rose window, Unitarian Church, Santa Barbara; Nat. Hist. Mus.; FMA. [40]

WESSELS, Glen Anthony [Mur.P,Des,Dec,E,Dr,L,T,W] Berkeley, CA b. 15 D 1895, Capetown, South Africa. Studied: Calif. Col. A. & Crafts; Univ. Calif.; H. Hofmann, in Germany; Lhote, in Paris. Member: San Fran. AA. Exhibited: Oakland A., 1935; San Fran. AA, 1935–46; Santa Barbara Mus. A., 1946 (one-man); SAM (prize). Work: SFMA; Univ. Calif.; SAM; Wash. State Col.; murals, Laguna Honda Home for the Aged, San Fran. Translator: articles for H. Hofmann. Position: A. Ed., San Francisco Argonaut; T., Calif. Col. A. & Crafts, 1930–40; Mills Col., Oakland, Cal., 1932; Wash., State Col., 1940–46; Univ. Calif., Berkeley, from 1946. [47]

WESSER, Ethelyn H. [P] Brooklyn, NY [21]

WESSON, Grace E. [P,I] Orange, NJ [24]

WEST, Bernice (Mrs. Robert A. Beyers) [S,L] Bronxville, NY b. 26 Ap 1906, NYC. Studied: A. Archipenko; E. Amateis; W. Zorach; W. Reiss; Lu Duble. Member: NAWA; SSAL; CAFA; Southern Vt. A.; Studio G.; AL, Mt. Dora, Fla. Exhibited: NAD, 1941; CAFA, 1941–46, 1943 (med); Mint Mus. A., 1940, 1941, 1945, 1946; Southern Vt. A., 1938–40; SSAL, 1938–41, 1940 (med); Conn. A. Market, 1932–35; Mt. Dora AL, 1935–40; Contemp. A., 1931 (one-man); Midtown Gal., 1932 (one-man); Ferargil Gal., 1933; NAWA, 1932 (med); City Gardens C., N.Y., 1932 (med). Work: mon., Silver Springs, Fla.; Wadsworth Atheneum; Mint Mus. A.; Swarthmore Col.; garden sculpture, Rockefeller Ctr., NYC; bronze plaque, Venice, Nokomis Bank, Fla. [47]

WEST, Charles Massey, Jr. [P,T,S] Centreville, MD b. 5 D 1907, Centreville. Studied: PAFA, 1934 (Cresson schol.); Univ. Iowa; Herron AI. Member: Wilmington SFA. Exhibited: CGA, 1941, 1943; AIC, 1942; PAFA, 1941; BMA, 1941; Del. A., 1939–46; CM, 1942; Hoosier Salon, 1942 (prize), Del. A., 1942 (prize), 1943 (prize); Ind. AA, 1940 (prize), 1941 (prize). Position: T., Herron AI, 1939–43 [47]

WEST, Clifford Bateman [P,T,L] Bloomfield Hills, MI b. 4 Jy 1916, Cleveland. Studied: Cleveland Sch. A.; Adams State T. Col., Alamosa, Colo.; Colorado Springs FA Ctr.; Cranbrook Acad. A.; B. Robinson; A. Blanch. Exhibited: AIC, 1937, 1939, 1943–45; MET (AV), 1942; Detroit AI, 1937, 1938, 1940–45; CMA, 1934, 1937; Butler AI, 1938, 1943, 1946; Denver AM, 1937, 1939, 1943, 1946; Milwaukee AI, 1946; Flint AI (prize). Award: Prix de Rome, 1939. Position: T., Cranbrook Acad. A. [47]

WEST, Fannie A. [P] d. Phila., PA., 8 Ap 1925

WEST, Gladys (M.G.) [P,T] Phila., PA b. 24 Ag 1897, Phila. Studied: PAFA, with Breckenridge, Hale, Merriman, Pearson, Vonnoh. Member: Phila. Alliance. Work: St. Michael and All Angels, Phila.; Church of the Nativity, Phila.; Oak Lane Review C., Phila. [40]

WEST, Harold Edward [P,C,B] Santa Fe, NM (1962) b. 16 O 1902, Honey Grove, TX. Exhibited: Mus., N.Mex.; WFNY, 1939; AIC. Work: Mus. N.Mex. Author/Illustrator: "Cowboy Calendar," from 1939 (hand blocked prints) [47]

WEST, Helen [P] NYC [15]

WEST, Isabelle. See Percy.

WEST, James G. [P] Cleveland, OH. Member: Cleveland SA [27]

WEST, Jean Dayton (Mrs. Leonard A.) [Por.P,E,Dr,T] Langley Field, VA b. 17 Mr 1894, Salt Lake City, UT. Studied: State Univ., Iowa; NAD; C. Hawthorne; C.A. Cumming. Member: Iowa AG. Exhibited: Iowa State Fair, 1918 (gold), 1920 (gold); Des Moines Women's C., 1931 (gold), 1934 (med.) 1935 (med). Work: St. John's Pub. Hospital, St. John, N.B., Canada; Lamoni (Iowa) Col. Illustrator: "Sign Posts to Music," by A. West, pub. Carl Fisher [47]

WEST, Levon [E,P,Ph,W,T] NYC/Mayville, ND b. 3 F 1900, Centerville, SD d. 1968. Studied: J. Pennell, 1925–26; Univ. Minn., 1920–24; ASL, 1925. Member: SAE; AIGA; Print Col. C. Exhibited: Phila., 1928 (prize). Work: Phila. Mus.; NYPL; BM; Hispanic Mus., NYC; Havemeyer Col., MET; BMFA; Univ. Minn. A. Gal.; Inst. Geographical Expo, Harvard; Honolulu Acad. A.; "Prints of the Year," 1931, 1933, 1934. Illustrator: "Vivid Spain," 1926; "Bald-Headed Aft," 1928; "Masters of Etching," No. 24, 1930; "Catalogue of the Etchings of Levon West," 1930, "Making an Etching," "How-to-Do-it," 1932. Represented by: Kennedy Gal., NYC. As a photographer, he used the name was "Ivan Dmitri." [40]

WEST, Louise [P,T] Baltimore, MD/Gloucester, MA b. Baltimore. Studied: H. Snell; F. Brangwyn [25]

WEST, Margaret W. [P] Chicago, IL b. Peoria, Ill. Studied: Académie Julian. Exhibited: AIC [01]

WEST, Maud S. (Mrs.) [P] Houston, TX. Member: Southwest A., Houston; SSAL; Tex. FAA. Exhibited: Ar. S.E. Tex., 1938; Houston Ar. Ann., 1939; Houston MFA [40]

WEST, Peter B. [Ldscp.P] Albion, NY b. 1837, Bedford, England (came to U.S. in 1863) d. 3 O 1913. Exhibited: Phila. Centenn., 1875 (prize); Columbian Expo, Chicago, 1893 (prize)

WEST, Russell W. [P] Boston, MA b. 25 Ja 1910, Haverhill, MA. Studied: E.L. Major; Mass. Sch. A.; N.Y. Sch. F.&Appl. A., Paris [40]

WEST, Sarah Jesse [P,T] Lake Erie, OH b. Toledo. Studied: ASL; Delecluse Acad., Paris. Work: TMA. Position: T., TMA, summer sch. at Put-in-Bay Island, Lake Erie [19]

WEST, Sophie (Mrs. [Ldscp.P] b. 1825, Paris, France (came to the U.S. in 1845) d. 12 My 1914, Pittsburgh

WEST, Walter Richard [P,C,T,L] Phoenix, AZ (Lawrence, KS, 1976) b. 8 S 1912, Darlington, OK Studied: Bacone Col., Muskogee, Okla., 1938; Univ. Okla., 1941; Univ. Redlands, Calif. Exhibited: Kansas City, 1937 (prize); Tulsa, 1938; Dept. Interior, Wash., D.C., 1940; Chappell A. Gal., 1941; Am. Indian A. Exh., Philbrook A. Ctr., 1946 (prize). Work: W.R. Nelson Gal.; U.S. Dept. Interior, Wash., D.C.; Chappell A. Gal., Pasadena, Calif.; Phoenix Indian H.S.: USPO, Okemah, Okla.; Bacone Col. Illustrator: book jacket, "The Cheyenne Way," 1941. A Cheyenne Indian. Position: T., Phoenix Indian Sch., 1941–46; Bacone Col., from 1947 [47]

WESTBROOK, Clara [P] Brooklyn, NY [10]

WESTBROOK, Lloyd Leonard [P] Olmstead Falls, OH b. 28 Ap 1903, Olmstead Falls. Studied: Cleveland Sch. A.; H. Keller; F.N. Wilcox. Exhibited: CI, 1941; VMFA, 1946; CMA, 1946; Cleveland Artists and Craftsmen Ann., CMA, 1932 (prize), 1933 (prize), 1934 (prize) 1935 (prize), 1939 (prize). Work: CMA [47]

WESTCOTT, George [I] Waterville, NY. Member: SI [47]

WESTERBERG, John [P] Rockport, MA [13]

WESTERFIELD, J(oseph) Mont [P,I] Louisville, KY b. 6 O 1885, Hartford, KY. Studied: F.G. Walker; P.A. Plasohke. Member: Louisville AL [15]

WESTERLIND, A. [P] Chicago, IL. Member: Chicago NJSA [25]

WESTERMAN, Harry James [Cart,P,I,T,W] Columbus, OH b. 8 Ag 1877, Parkersburg, WV d. 27 Je 1945. Studied: Columbus A. Sch. Member: Columbus Pen & Brush C.; Lg. Columbus Ar.; S.Indp.A.; Chicago NJSA; Lg. Amer. A. Position: Cart., Ohio State Journal, Columbus [40]

WESTERMEIER, Clifford Peter [P,Des,L,Dec,T] Boulder, CO b. 4 Mr 1910, Buffalo, NY. Studied: Buffalo Sch. FA; PIASch; N.Y. Sch. F.&Appl. A.; Univ. Buffalo; Univ. Colo. Member: Buffalo SA. Exhibited: Albright A. Gal., 1937–43; AWCS, 1939; Syracuse MFA, 1941; Paris; London; The Patteran, 1939 (prize), 1940 (prize); Ar. Western N.Y. Ann., 1939 (prize); Boulder, Colo. Work: Albright A. Gal. Contributor: Encyc. Brit. Positions: T., Buffalo Sch. FA (1935–44), Univ. Buffalo (1935–44), Univ. Colo. (1944–46), St. Louis Univ. & Maryville Col., St. Louis (from 1946) [47]

WESTFALL, Tulita Gertrude Bennett [Mur.P,Dr,E] Monterey, CA b. 15 S 1894, Monterey. Studied: H.V. Poor; F. Van Sloun; P.J. de Lemos; R. Schaeffer; L. Randolph; E.A. Vysekal; Calif. Sch. FA; Otis AI, Los Angeles. Member: Carmel AA; Monterey A.A. Exhibited: Calif. State Fair, Sacramento, 1926 (prize); Calif. State-Wide Exh., Santa Cruz, 1931 (prize). Work: Pub. Lib., Grammar Sch., both in Monterey [40]

WESTFELDT, Patrick McLosksy [P] Asheville, NC (lived mostly in New Orleans) b. 25 My 1854, NYC d. 2 Je 1907. Studied: Carl Hecker; William Prettyman, in NYC. Member: NOAA [04]

WESTON, Edward [Photogr] Carmel, CA (since 1928) b. 1886, Highland Park, IL (came to Calif. in 1906) d. 1958. Studied: self-taught. Award: Guggenheim F., 1937–38. Exhibited: MOMA, 1946 (retrospective); Paris, 1950 (retrospective). Work: MOMA; MET: AIC; IMP: Amon Carter Mus.; Univ. N.Mex.; NOMA; Oakland MA; major mus. worldwide. Master of "straight" photography, renowned for both his originality of vision and ultimate craftsmanship, Best known for nudes and for still-life studies, such as "Pepper No. 30," 1930. [The best source on his life is his journals, "The Daybooks," ed. N. Newhall (Vol. 1., 1961; Vol. 2, 1966)][*]

WESTON, Frances M. [P] Haddonfield, NJ [24]

WESTON, Harold [P] Alexandria, VA b. 14 F 1894, Merion, PA d. 1972. Member: Am. A. Cong. Exhibited: GGE, 1939 (prize). Work: Rochester Mem. A. Gal.; PAFA; PMG; Yale; SFMA; Columbia Univ. Lib. [47]

WESTON, Harry Alan [P,T] NYC/Oakdale, NY b. 11 D 1885, Springfield, IL d. 26 Mr 1931. Studied: AIC; Grand Central Sch. A.; G.E. Browne; A. Mucha. Member: SC; AWCS; NYWCC; AAPL; Allied Artists of America. Exhibited: SC, NYC, 1928; AWCS, NYWCC, 1929 [29]

WESTON, James L. [P] Roxbury, MA [01]

WESTON, Morris [P,S,W,T] NYC/Essex, CT b. 19 N 1859, Boston, MA [27]

WESTOVER, Russell Channing (Russ) [Cart,L] New Rochelle, NY b. 3 Ag 1886, Los Angeles. Studied: Mark Hopkins AI. Exhibited: Emil Alvin Hartman Sch. Des., NYC (med). Work: Huntington Lib., San Marino, Calif. Creator/Cartoonist: "Tillie the Toiler" and "The Van Swagger" for King Features Syndicate, since 1921 [40]

WETHERALD, Harry H. [P,Des,I] Providence, RI b. 3 Ap 1903, Providence d. 4 Je 1955. Studied: RISD; NAD; C.W. Hawthorne; J.R. Frazier.

Member: Providence AC; Providence WCC; Boston A. Dir. C. Exhibited: Phila. WCC; AIC; BMA; AFA Traveling Exh., 1924–27 [47]

WETHERBEE, Alice Ney [S] Paris, France b. NYC. Studied: Larroux, in Paris [10]

WETHERBEE, Frank Irving [P] Boston, MA b. Hyde Park, MA, 1869 [04]

WETHERBEE, George [P] London, England b. 1851, Cincinnati, OH. Studied: Royal Acad., London; Antwerp. Member: Royal Inst. Painters in Water Color; Royal Inst. Painters in Oil. Exhibited: St. Louis Expo, 1904 (med); Chicago; Paris. Work: Albright Art Gal., Buffalo [21]

WETHERBY, Isaac Augustus [Por.P,Photogr] b. 6 D 1819, Providence, RI d. 23 F 1904. Active Norway, Maine, 1834; Boston, 1835–46; Milton, Mass., 1848–54; opened daguerrotype studio in Iowa, 1854, then Rockford, Ill., until 1857. Finally settled in Iowa City; active until 1874. [*]

WETHERILL, E(lisha) Kent K(ane) [P,E] NYC/Phoenicia, NY b. 1 S 1874, Phila. d. 9 Mr 1929, Aberdeen, N.C. (result of injuries received in WWI). Studied: Univ. Pa; PAFA, with Anshutz; Paris, with Whistler, Laurens. Member: ANA, 1927; Sketch C.; SC; Allied AA; Brooklyn SE. Exhibited: P.-P. Expo, San Fran., 1915; Sesqui-Centenn. Expo, Phila., 1926 (med). Work: Phila., AC; Luxembourg Mus., Paris [27]

WETHERILL, Isabelle M. [P] Phila., PA [01]

WETHERILL, Roy [T,P] Kansas City, MO b. 11 My 1880, New Brunswick, NJ. Studied: C.A. Willimovsky; R.L. Lambdin; N. Tolson. Position: T., Kansas City AI [25]

WETHEY, Harold Edwin [Edu,L,W] Ann Arbor, MI b. 10 Ap 1902, Port Byron, NY. Studied: Cornell; Harvard. Member: Hispanic S. Am. F., Rockefeller Fnd., 1944–45; Sheldon F., Harvard Univ., 1932–33. Author: "Gil de Siloe and His School," 1936. Positions: T., Bryn Mawr Col. (1934–38), Washington Univ., St. Louis (1938–40), Univ. Mich. (from 1940) [47]

WETMORE, Mary Minerva [P] Champaign, IL b. Canfield, OH. Studied: Cleveland A. Sch.; ASL, with W.M. Chase, Fox, Mowbray; Phila. Sch. Des. for Women.; Hopkins AI; Acad. Julian, with Laurens, Constant, Collin; Acad. Colarossi, with Courtois; W.M. Chase summer classes in Madrid, 1905 and Carmel, Calif., 1914. Member: Chicago SA; Chicago AC; Paris Women's AA; N.Y. Women's AC [33]

WETTERAU, Margaret Chaplin [P] Chicago, IL [17]

WETERRAU, Rudolf [Des,P] Bronxville, NY b. 25 My 1891, Nashville, TN. Studied: ASL; SI; A. Dir. C. [47]

WETZEL, George J(ulius) [P] Douglastown, NY b. 8 F 1870, NYC d. ca. 1936. Studied: ASL, with Mowbray; Beckwith; Cox; Chase. Member: SC, 1898; Nat. FAS; AFA; Nassau County AL. Exhibited: Phila. AC (prize); SC (prize) [35]

WEYAND, Edith. See Crockett.

WEYGOLD, Frederick P. [P,W] b. 1870, St. Charles, MO d. 7 Ag 1941, Louisville, KY. Studied: PAFA; Europe. Specialty: painting and writing about Am. Indian life, especially the Sioux

WEYL, Lillian [P,T] Indianapolis, IN b. 28 My 1874, Franklin, IN. Studied: PIASch; W. Sargent; A.W. Dow; A. Hibbard; G. Wiggins; G.E. Browne. Member: Western AA; Friends A., Nelson Gal.; Kansas City AI. Position: Dir. A., Public Schs., Kansas City [40]

WEYL, Max [Ldscp.P] Wash., D.C. b. 1 D 1837, Wurtemberg, Germany (came to Wash., D.C, 1853) d. 6 Jy 1914. Studied: Europe. Member: S. Wash. A. Exhibited: S. Wash. A., 1901 (prize), 1904 (prize). Work: CGA; NGA; Cosmos C., Wash., D.C; Albright-Knox AG, Buffalo [13]

WEYRICH, Joseph Lewis [P] Baltimore, MD [17]

WEYSS, John E. [Dr] b. ca. 1820 d. 24 Je 1903, Wash., D.C. Position: Topogr. A., Western U.S. Geological Surveys, beginning with Emory Mexican Boundary Survey, 1849–55, through Wheeler Survey, 1889 [*]

WHALEN, John W(illiam) [P,I,T] Pittsfield, MA/Madrid, NY b. 25 F 1891, Worcester, MA. Studied: Boston, with E. Pape, Chase, Emerson, H. Brett, A. Spear. Member: Pittsfield AL [25]

WHALEY, E(dna) Reed (Mrs.M.S.) [P,T,W] Columbia, SC b. 31 Mr 1884, New Orleans. Studied: Newcomb Sch. A. Member: AAPL; SSAL; Columbia (S.C.) AA. Exhibited: Columbia AA, 1924 (prize); SSAL, 1921 (prize). Work: Vanderpoel Coll. Illustrator: "The Old Types Pass," by M.S. Whaley [47]

WHARTON, Carol Forbes (Mrs. James P.) [Min.P,W] Baltimore, MD b. 2 O 1907, Baltimore d. 30 Je 1958. Studied: Bryn Mawr Col.; Corcoran Sch. A.; Md. Inst.; Peabody Inst.; Nat. Sch. F.&Appl. A., Wash., D.C. Positions: Columnist/Feature Writer/A. Cr., Baltimore Sun [47]

WHARTON, Elizabeth [P] NYC. Member: NAWPS. Exhibited: Argent Gal. 1940 (one-man) [40]

WHARTON, James P. [Por.P,E,I,Li,L,T] Columbus, GA/Fort Benning, GA b. 18 Ap 1893, Waterloo, SC d. 5 Jy 1963. Studied: Kroll, Md. Inst.; Duke Univ.; Ecole des Beaux-Arts, Dijon, France. Member: SSAL; Assn. Ga. A. Exhibited: SSAL, High Mus., Atlanta, 1937 (prize). Work: Lib., Fort Benning. Illustrator: feature page, "It Happened in Georgia," Sunday Magazine Section, Atlanta Journal, from 1936. Position: Hd., Columbus Sch. A., Ga. [40]

WHEAT, John Potter [P,T] Darien, CT b. 22 Ap 1920, NYC. Studied: Yale. Member: NSMP. Exhibited: MET (AV), 1942; NAD, 1943; AIC, 1943; NWMP, 1944 (prize); NAD, 1946 (prize). Work: murals, Mamaroneck Jr. H.S., N.Y.; Emmanuel Women's C., San Fran. [47]

WHEATER, J.H. [I] Leonia, NJ [19]

WHEATLEY, T(homas) J(efferson) [P,C] Cincinnati, OH b. 22 N 1853, Cincinnati. Studied: T.C. Lindsay; C. Arter. Member: Cincinnati AC; Cincinnati A. & Crafts C.; NSC (Ceramic G.). Specialty: pottery [13]

WHEATON, Francis [P,T] Suffern, NY b. 18 S 1849, Valparaiso, Chile. Studied: AIC; NAD. Member: Copley S., 1891. Specialty: sheep [13]

WHEDON, Harriet (Fielding) [P] NYC b. Middletown, CT. Studied: Calif. Sch. FA; O. Oldfield; R. Boynton. Member: San Fran. AA; San Fran. A. Ctr.; Fnd. Western A., Los Angeles. Exhibited: Santa Barbara Mus. A.; Los Angeles Mus. A. Ctr.; Pal. Leg. Honor; SFMA, 1939 (one-man); GGE, 1939; Fnd. Western A., Los Angeles [47]

WHEELAN, Albertine Randall [P,I,C] Paris, France b. 27 My 1863, San Fran. Studied: V. Williams; San Fran. Sch. Des. Member: AFA. Designer: character and costume sketches for C. Belasco; bookplates; stained glass windows. Orginator: newspaper cartoon "The Dumbunnies" [29]

WHEELER, Candace Thurber (Mrs.) [Des,W] b. 1828 d. 5 Ag 1923. Member: S. Dec. Arts; Associated Artists. Author: books on household art. Position: Dir., Women's Bldg., Chicago Expo, 1893

WHEELER, Charles H. [C.Des,L] Longmeadow, MA b. 5 Ag 1865, New Haven, CT. Studied: J. Niemeyer, at Yale. Member: Springfield AL; Springfield AG. Exhibited: Springfield MFA, 1929 (prize), 1937 (prize). Work: des./execution, special lighting fixtures, railings etc., St. Peter's Episcopal Church, Springfield; Chapel, South Kent Sch. for Boys, South Kent, Conn.; art metal work [40]

WHEELER, Cleora Clark [Des,En,P,W] St. Paul, MN b. Austin, MN. Studied: Univ. Minn.; N.Y. Sch. F.&Appl. A.; J. Gauthier. Member: Am. S. Bookplate Collectors & Des.; Lg. Am. Pen Women; Bookplate Assn. Intl. Exhibited: Am. Bookplate S., 1916–25; Avery Lib., Columbia, 1916–25; Grolier C., NYC, 1916–25; Bookplate Assn. Intl. 1926, 1931–36; Lg. Am. Pen Women, 1936, 1938, 1940, 1942 (prize), 1944, 1946; U.S. Nat Mus., 1946; Minn. State A. Soc., 1913 (prize); St. Paul Inst.; Minneapolis Inst. A., 1922, 1923; St. Paul Pub. Lib., 1937 (one-man); Paul Elder Gal., San Fran., 1926 (one-man); Univ. Minn., 1937 (prize). Work: LOC; Yale C., NYC; Minn. State Hist. S.; Minneapolis Inst. A.; Univ. Minn. Lib.; Brown Univ. Lib.; Pub. Libs., St. Paul, Minneapolis, Los Angeles; Am. Lib., Paris; Am. Assn. Univ. Women, Wash., D.C., Am. S. Bookplate Collectors and Des.; Bookplate Assn. Intl.; Hist. S., St. Paul, Minn.; bookplate reproduced in "The Book of Artist's Own Bookplates," by R.T. Saunders [47]

WHEELER, Clifton A. [P,T] Indianapolis, IN b. 4 S 1883, Hadley, IN d. 10 My 1953. Studied: Columbia; Butler Univ.; W. Forsyth; W. Chase; R. Henri; Europe. Member: Ind. AC. Exhibited: AWCS; PAFA; GGE, 1939; WFNY, 1939; VMFA, 1938; annually in local & regional exh.; Richmond (Ind.), 1917 (prize); Herron AI, 1921 (prize), 1923 (prize); Ind. AA, 1924 (prize); Franklin Col., 1926 (prize); Rector Mem. prize, 1927, 1932; Ind. Univ., 1928 (prize). Work: John Herron AI; Swope A. Gal.; Purdue Univ.; De Pauw Univ.; Ind. Univ.; Ball State Col.; murals, Indianapolis City Hospital, Arsenal Tech. H.S., Nancy Hanks Hall, Indianapolis; Thorntown (Ind.) Pub. Lib.; Mooresville (Ind.); Pub. Lib.; Rose Polytechnic Inst., Terre Haute; Syracuse (Ind.) Pub. Lib.; St. Joseph's Convent, Tipton, Ind.; Circle Theatre, schools, all in Indianapolis. Position: T., Shortridge H.S., Indianapolis [47]

WHEELER, Dilah Drake (Mrs. Clifton) [P] Indianapolis, IN [24]

WHEELER, Dora. See Keith.

WHEELER, E. Kathleen [S] Hillside, WI [24]

WHEELER, Frances [P] Wash., D.C. b. 5 Mr 1879, Charlottesville, VA. Member: New Haven PCC; Wash. AC; S. Wash. A.; Wash. WCC [40]

WHEELER, Helen Cecil [P] Newark, NJ/Edgartown, MA b. 10 S 1877, Newark, NJ. Studied: J.C. Johansen; ASL [25]

WHEELER, Hughlette ("Tex") [S] b. ca. 1900, TX d. 1955, Christmas, FL. Studied: Chicago. Active in Alhambra, Calif., 1930s; Santa Monica, Calif., 1940s. Sculptor of Western subjects whose work is rare. He was a friend of C.M. Russell, E. Borein, D. Cornwell, and took over F.T. Johnson's studio, 1939. [*]

WHEELER, Janet D. [Por.P] Long Beach, CA b. Detroit. Studied: PAFA; Bouguereau; Courtois, in Paris. Member: Plastic C.; Phila. Alliance; AFA. Exhibited: PAFA (prize), 1901 (prize); Phila. AC, 1902 (prize); St. Louis Expo, 1904 (med) [40]

WHEELER, Kathleen (Mrs. W.R.H. Crump) [S] Chevy Chase, MD b. 15 O 1884, Reading, England d. 1977. Studied: E. Moore; Slade Sch., London, England. Member: S. Wash. A.; Phila. Alliance. Exhibited: AIC (prize); S. Wash. A. (prize). Work: Harvey's Mus., St. John's Wood, London; Hackley A. Gal., Muskegon, Mich.; Canadian Pacific RR, London [47]

WHEELER, Laura [Por.P,I,C,T] Cheyney, PA/Brooklyn, NY b. Hartford, CT. Studied: M.W. Chase; H. McCarter; V. Oakley. Illustrator: "The Shadow," "The Upward Path" [29]

WHEELER, Mary C. [P] Providence, RI d. Mr 1920. Member: Providence AC [19]

WHEELER, Nina Barr [P] NYC. Studied: Fontainebleau Sch. FA, France. Exhibited: Fontainebleau Alumni, 1935, 1936; NAWPS, 1935–38; 48 States Comp., 1939 [40]

WHEELER, Ralph D. [P] Chicago, IL [19]

WHEELER, Ralph Loring [C] Newton Centre, MA b. 3 My 1895, Allston, MA. Studied: BMFA. Member: Boston SAC. Specialty: dyeing [40]

WHEELER, Zona Lorraine [P,Des,E,En,Li] Wichita, KS b. 15 F 1913, Lindsborg, KS. Studied: Bethany Col.; Am. Acad. A., Chicago; B. Sandzen. Member: Wichita AG; Wichita AA; Prairie WCC. Exhibited: CGA, 1934; Phila. Pr. C., 1935; SFMA, 1946; Rocky Mountain PM, 1935; Okla. A. Ctr., 1940; Kansas City AI, 1935; Kansas City AI, 1935, 1938, 1939; Joslyn Mem., 1936–39; Topeka AG, 1939–41; Wichita AG, 1937–46; Kans. Fair, 1938, 1939 (prize); Wichita 20th Century C., 1937–46; Kans. Fed. A. Traveling Exh.; Wichita Women Artists, 1936 (prize). Work: Woodcut S., Kansas City [47]

WHEELOCK, Adelaide [P] Minneapolis, MN [17]

WHEELOCK, Ellen [P] St. Paul, MN [17]

WHEELOCK, J. Adams [I] Brooklyn, NY. Member: B.&W. C. [98]

WHEELOCK, Lila Audubon (Mrs. Howard) [S] NYC. Exhibited: NAWPS [21]

WHEELOCK, Warren (Frank) [P,S,C,T,W] NYC b. 15 Ja 1880 d. 8 Jy 1960, Albuquerque, NM. Studied: PIASch. Member: S. Gld.; An Am. Group; Am. A. Cong; Am. Abstract A.; S.Indp.A. Exhibited: Musée de la Paume, Paris, 1938; MOMA, 1939; CI, 1941; PMA, 1940; PAFA, 1932, 1934, 1944–46; AIC, 1942; Denver AM, 1941; WMAA, 1932–46; BM, 1938; MET (AV), 1942; S. Gld., annually; Pan-Am. Exh., Los Angeles, 1925 (prize). Work: WMAA, AIC, IBM Coll.; Corporation of Glasgow, Scotland; Bartlett H.S., Webster, Mass.; Los Angeles MA. Contributor: American Artist. Positions: T., PIASch (1905–10), CUASch (1940–45) [47]

WHEELRIGHT, Louise [P] Boston, MA [19]

WHEELWRIGHT, Edward [P] b. 1824 d. 1900. Exhibited: Boston Athenaeum, 1859 [*]

WHEELWRIGHT, Elizabeth S. [T,En,P,I,C] Chesham, N.H. b. 11 O 1915, Boston. Studied: Child-Walker Sch. A.; Italy; E. O'Hara. Member: N.H. AA; Copley S., Boston. Exhibited: Boston AC; Boston S.Indp.A.; Southern PM; New England Pr. Assn.; N.H. AA. Position: T, Cambridge Sch., Belmont Day Sch., Mass. [47]

WHEELWRIGHT, Ellen duPont (Mrs. Robert) [P,S] North Haven, ME b. 23 D 1889. Studied: H. Breckenridge; C. Hawthorne; R. Bridgeman; C. Sawyer. Member: Wilmington SFA; Phlia. WCS. Exhibited: PAFA, 1938, 1939; A. Ctr., Wilmington [40]

WHEETE, Glenn [B] Tulsa, OK b. 2 Mr 1884, Carthage, MO. Member: Prairie PM; Calif. PM Soc.; Soc. E.; Canadian S. GA; Woodcut S.; Color Block PM. Exhibited: Intl. PM Exh., Los Angeles, 1934 (med); Midwestern A., Kansas City AI, 1937 (prize) [40]

WHEETE, Treva [G,S] Tulsa, OK b. 8 Je 1890, Colorado Springs. Member: Prairie PM; Calif. PM, Soc. E.; Canadian S. GA; Woodcut S.; Color Block PM. Exhibited: Intl. PM Exh., Los Angeles, 1934 (med), 1936 (prize) [40]

WHELAN, Blanche [P] Los Angeles, CA b. Los Angeles. Studied: Stanford Univ.; Los Angeles Sch. A. & Des.; ASL; B. Robinson; N. Haz. Member: Calif. AC; Laguna Beach AA; Women P. of the West. Exhibited: Ariz. State Fair, 1931 (prize) [47]

WHELAN, Henry, Jr. [Patron] Devon, Clovelydale, PA d. 17 My 1907. Patron of the musical, pictorial and plastic arts. Position: Pres., PAFA

WHERRY, Elizabeth F. [P] Phila., PA [25]

WHETSEL, Gertrude P. (Mrs.) [P] Los Angeles, CA b. 21 S 1886, McCune, KS. Studied: C.L. Keller. Member: Oreg. AS. Exhibited: Oreg. State Fair, 1922 (prizes) [33]

WHINSTON, Charlotte (Mrs. Charles N.) [S,P,Gr] Mt. Vernon, NY b. NYC. Studied: N.Y. Sch. F. & Appl. A.; NAD; CUASch; ASL; G. Luks; G. Maynard. Member: S.Indp.A.; Yonkers AA; Westchester A. & Crafts G., NAWA; PBC. Exhibited: S.Indp.A.; Yonkers AA; Westchester A. & Crafts Gld.; NAD, 1917 (med); CUASch, 1917 (prize) [47]

WHIPPLE, C(harles) Ayer [Por.P,Mur.P] NYC b. 22 F 1859, Southboro, MA d. 3 My 1928, Wash., D.C. Studied: Paris, with Bouguereau; Robert-Fleury, Ferrier. Work: Republican C., NYC; State Dept., War Dept., Post Office Dept., Navy Dept., all in Wash., D.C.; West Point, N.Y.; State Hist. Bldg., Des Moines; Ottawa, Canada. He was engaged in retouching the famous Burmidi paintings at the Capitol, 1921–28. [17]

WHIPPLE, Dorothy Wieland [P,T] Toledo, OH b. 31 Ag 1906, Sandusky, OH. Studied: Cleveland Sch. A. Member: Toledo Women's AL; Western AA. Contributor: article, "Clay Modeling Stimulates Visual Senses," Design mag., 1937 [40]

WHIPPLE, Elsie R. [P] Pittsburgh, PA. Member: Pittsburgh AA [21]

WHIPPLE, Seth Arca [Mar.P] b. 1856, New Baltimore, MI d. 10 O 1901, Detroit. Work: Dossin Great Lakes Mus., Belle Isle, Mich. Specialty: ship portrait painter, active around Great Lakes Region [*]

WHISH, Lilian J. [P] Albany, NY. Member: New Haven PPC [25]

WHISLER, Howard F(rank) [P] NYC b. 25 Ja 1886, New Brighton, PA. Studied: ASL; PAFA, with Breckenridge, McCarter, Cresson European Sch., 1910–12. Member: Arch. Lg.; North Shore AA. [33]

WHISHNER, G. Arthur [P] Columbus, OH. Member: Columbus PPC [25]

WHISTLER, James Abbott McNeill [P,E,Li,W,T] London, England (since 1859) b. 10 Jy 1834, Lowell, MA d. 17 Jy 1903. Studied: probably received early training from his father, George Washington Whistler [1800–49] who had taught drawing at West Point [1821–22]; Imperial Acad. FA, St. Petersburg, Russia, 1845; Pomfret, Conn., 1849–51; West Point, 1851–54 (flunked out); Paris, under Gleyre, 1855. Member: Officer, Legion of Honor; Acad. St. Luke, Rome; Royal Acad. Bavaria; S. British A., 1884 (Pres. 1886; resigned after dispute, 1888); Intl. S. PS&G, London (Pres./founder) 1898; Royal Acad., Dresden; RSA; S. Natl. Beaux-Arts, Paris. Exhibited: Paris Salon 1883 (med), 1889 (gold), 1900 (med); Munich Intl. Expo, 1892 (med); PAFA, 1894 (gold); many others. In 1863 his "Symphony in White" was refused at the Paris Salon but was hung at the Salon des Refusées, where it created a sensation. Work: MMA; Tate; Louvre; Natl. Gal.; AIC; PMA; Detroit IA; Glasgow AM; major mus. Opened Acad. Carmen in Paris, 1889 (briefly called "Acad. Whistler") and enlisted the help of his friend F. MacMonnies. The new school immediately drew hundreds of students away from the other schools in Paris. Whistler's diminishing appearances resulted in the school closing in 1901. Among his leading American students were F. Frieseke and H.S. Hubbell. Often considered the greatest artist of the 19th century, although he would have extended the time period to all of history. Witty and caustic, his fascinating personality kept him constantly before the public. In 1878 he sued John Ruskin for libeling his work. Whistler won the case—and one farthing—then went bankrupt. Ruskin had a mental breakdown. The pervasive and lasting influence of Whistler cannot be overemphasized... even the artistic way in which exhibitions are hung today owes a debt to this exacting master. He is also ranked with Rembrandt as the greatest of etchers, and his "Nocturne" lithographs are among the best the medium has ever offered. [The major sources on his life and work are his own "The Gentle Art of Making Enemies," (1890); E.P. & J. Pennell's "Life of James McNeill Whistler" (1908) and "Whistler Journal" (1921).] [01]

WHISTLER, Joseph Swift [C] Lenox, MA b. 1860, Baltimore d. 28 N 1905. Studied: Harvard; abroad. Nephew of James McNeill Whistler.

WHITAKER, Eileen Monoghan (Mrs. Frederic) [P] La Jolla, CA (1976) b. 1911, Holyoke, MA. Studied: Mass. Col. A., Boston. Member: ANA, 1957. Work: Okla. Mus. A.; High Mus. A., Atlanta; Norfolk, A. Mus. Specialty: watercolor [*]

WHITAKER, Ethel [P] Winthrop, MA b. 6 N 1877, Southbridge, MA. Studied: BMFA; A. Graves; A. Palmer [01]

WHITAKER, Frederic [P,W] Cranston, RI (La Jolla, 1976) b. 9 Ja 1891, Providence, Studied: RISD, with Cyrus Farnum, 1907–11. Member: NA, 1951; AWCS; SC; All.A.Am.; Audubon A.; Providence AC; Wash. WCC; Providence WCC; South County AA. Exhibited: PAFA, 1946; NAD, 1946; AWCS, annually; All.A.Am., annually, 1944 (prize); Wash. WCC, 1942 (prize); annually; Audubon A., annually; Oakland A. Gal., 1942–44 (prizes); SC, 1944 (prize); Bridgeport, Conn., 1944 (prize); Gloucester, Mass., 1944 (prize); Parkersburgh (W.Va.) FA Ctr., 1945 (prize). Work: Cayuga Mus. Hist. & A.; Neilson Mus., Pocatello, Idaho; Lawrence Gal., Atchison, Kans.; Providence AC; IBM Coll. Contributor/Editor: Am. Artist. Author: illus. autobiography, 1976. Specialty: watercolor [47]

WHITAKER, George William [Ldscp.P,Mar.P] Providence, RI b. 1841, Fall River, MA d. 6 Mr 1916. Member: Providence AC; Providence WCC (founder). Work: RISD. Had been called the "Dean of Providence artists." [15]

WHITAKER, John [P] Phila., PA [04]

WHITAKER, Lawrence Leroy [P] Windber, PA b. 26 Jy 1889, Reynoldsville, PA. Studied: E. Walters. Member: All. A. Johnstown; Pittsburgh AA. Exhibited: All.A.Am.; Ind. State T. Col.; PMG; Pa. State Col.; CI, 1939 (prize), 1943 (prize); All. A. Johnstown, 1933–36 (prizes), 1938 (prize); Butler AI, Youngstown, Ohio. Work: PMG; Pa. State Col.; Ind. State T. Col.; Pittsburgh Pub. Sch.; Somerset Pub. Sch. [47]

WHITAKER, Stella Trowbridge (Mrs.) [P] Cambridge, MA. Member: S.Indp.A. [24]

WHITCOMB, Jon [I] Darien, CT. b. Weatherford, OK. Studied: Ohio Wesleyan Univ.; Ohio State Univ. Exhibited: A. Dir. C., 1946; SI, 1946. Illustrator: Collier's, Ladies Home Journal, Cosmopolitan [47]

WHITE, Agnes [Por.P] Marietta, OH b. 8 Ja 1897 Columbus, OH. Studied: Columbus A. Sch.; PAFA; Ecole des Beaux-Arts; Fontainebleau Sch. FA. Member: NIAL; Soc. Four A., Palm Beach, Fla.; Columbus AL. Exhibited: AWCS, 1941; Soc. Four A., 1942–45; Columbus Gal. FA, 1941–46 [47]

WHITE, Alden [E] New Bedford, MA b. 11 Ap 1861, Acushnet, MA. Studied: V. Preissig; Haskell. Member: Chicago SE [31]

WHITE, Ambrosia Chuse (Mrs. John C.) [P,T,W] Madison, WI b. 3 D 1894, Belleville, IL. Studied: Notre Dame Acad.; St. Louis Sch. FA; Univ. Wis.; F. Taubes; Wash. Univ., St. Louis. Member: Madison AG; All-Ill. SFA; Soc. for Sanity in A., Chicago. Exhibited: St. Louis A. Gld., 1935; All-Ill. SFA, 1936–38; Milwaukee AI, 1938; Wis. Salon A., 1943; Madison AG, 1935–46. Positions: T., H.S., Beloit, Wis., 1945–46; Pub. Sch., Belleville, Ill. [47]

WHITE, Belle Cady [P,Dr,T] Brooklyn, NY/Chatham Ctr., NY b. Chatham, NY d. 26 F 1945, Hudson, NY. Studied: PIASch; Snell; Woodbury; Hawthorne. Member: AAPL; AWCS; Brooklyn WCC. Exhibited: Brooklyn SA, 1932 (prize). Work: Rollins Col., Fla.; pub. schs., St. Louis. Author/Illustrator: article "Everyday Art." Position: T., PIASch [40]

WHITE, Charles Henry [I] NYC. Exhibited: St. Louis Expo, 1904 (med) [10]

WHITE, Charles (Wilbert) [P,Lith,T] NYC b. 2 Ap 1918, Chicago, IL. Studied: AIC; ASL; H. Sternberg; B. Dyer; G. Neal. Member: A. Lg. Am.; Assn. War Veteran A. Am.; Rosenberg F., 1942, 1944. Exhibited: AIC, 1942; LOC, 1941; Atlanta Univ., 1942–45 1946 (prize); SFMA, 1946; ACA Gal., 1942; BMFA, 1943; BM; Smith Col., 1943; Edward Alford award, 1946. Work: Hampton Inst.; Newark Mus.; Howard Univ.; Atlanta Univ.; Barnett Aden Gal.; mural, Assoc. Negro Press; Chicago Pub. Lib. Positions: A. in Residence, Howard Univ., Wash., D.C., 1945; T., George Washington Carver Sch., NYC, 1943–45 [47]

WHITE, Clarence Hudson, Sr. [Ph,T] NYC/ Canaan, CT b. 1871, Carlisle, OH b. 8 Jy 1925, Mexico City. Studied: self-taught. Member: Photo-Secession, 1902; Pictorial Ph. Am. (first Pres., 1916); N.Y. Camera C.; Vienna Camera C. Exhibited: 1st Phila. Salon, 1898; Boston; Dresden; Paris; NYC; Vienna; MOMA, 1971 (retrospective); Glasgow Expo (med); Turin Expo. Work: mostly platinum prints at MOMA; IMP; MET; LOC; Royal Ph. S; CMA; large coll. at Princeton AM. Important leader of the Pictorialist movement; highly influential teacher. His platinum prints show the influence of Whistler, the Impressionists, and Japanese prints. Positions: T., Columbia, 1907–14; Founder/Dir., Clarence H. White Sch. Ph., 1914; Brooklyn AI; Summer Sch. Ph., Seguinland, Maine.

WHITE, Clarence Hudson, 2nd [Ph] NYC b. 14 Ja 1907. Member: Pictorial Photographers of Am. Son of Clarence, Sr. [30]

WHITE, (Clarence) Scott [Ldscp.P] Belmont, MA b. 14 Mr 1872, Boston, MA. Studied: C.H. Woodbury. Member: Copley S., Boston; Boston S. WC Painters; Odd Brushes; Boston AC. Exhibited: BMFA; Boston S. WC Painters. Specialty: watercolor [47]

WHITE, Constance [P] Wash., DC [10]

WHITE, Edith (Mrs.) [Ldscp.P,Floral P] Pasadena, CA (since 1893) b. near Decorak, IA d. Ja 1946, Berkeley, CA (?) Studied: Mills Col.; San Fran. Sch. Des., ca. late 1870s; ASL, 1892 [*]

WHITE, Elizabeth [Min.P] Atlantic City, NJ [25]

WHITE, Elizabeth [E,P,I,T,L] Sumter, SC b. Sumter. Studied: Columbia; PAFA; W. Adams. Member: Carolina A.; SSAL; MacD. Col. Assn.; Tiffany Fnd. Exhibited: SSAL, Houston, 1926 (prize); Venice, Italy, 1940; Smithsonian, 1939 (one-man); WFNY, 1939. Illustrator: "Crossin' Over," 1938 [47]

WHITE, Emily H. [Min.P] Laguna Beach, CA b. 4 F 1862, Norris, IL d. 1 My 1924. Studied: AIC, with J. Guerin; Ogunquit, Maine, with C.H. Woodbury. Member: Laguna Beach AA. Sister of Nona. [24]

WHITE, Emma Chandler (Mrs.) [C] Saltville, VA b. 23 S 1868, Pomfret, VT. Member: Boston SAC (Master Craftsman). Specialty: weaving [40]

WHITE, Emma Locke Reinhard (Mrs. F.W.) [P] Staten Island, NY/Kent Hollow, New Preston, CT b. 21 N 1871, New Brighton, NY d. 7 S 1953. Studied: ASL, with Mowbray, Cox, Chase, Twachtman, Brandegee. Member: AAPL; NAWA; Staten Island Inst. A.&Sc.; Kent AA. Exhibited: Staten Island Mus. A.&Sc., 1943 (one-man) [47]

WHITE, Frances (Mrs.) [P,I,C] NYC [13]

WHITE, Francis Robert [P,G,T,L] Sioux City, IA/Clearlake, IA b. 19 Ap 1907, Oskaloosa, IA. Studied: PAFA; ASL; K. Cherry. Member: Am. Ar. Cong.; F., Guggenheim, 1930. Exhibited: WMAA; Iowa A. Salon, Des Moines; WFNY, 1939; Kansas City AI, 1936 (prize). Work: WMAA; Univ. Ill.; AIC Lib.; Little Gal., Cedar Rapids; WPA murals, USPO, Missouri Valley, Iowa; Post Office at Courthouse, Cedar Rapids. Specialty: stained glass. Position: Dir., Little Gal., Cedar Rapids [40]

WHITE, Frank M. [P] Phila., PA [08]

WHITE, George Fleming [P] Des Moines, IA b. 1 Je 1868, Des Moines. Studied: ASL; Munich, with A. Azbe, R. Frank [25]

WHITE, George Gorgas [I,Wood En] NYC b. ca. 1835, Phila. d. 24 F 1898. Studied: Phila., with J. Cassin, late 1850s. A Quaker, he came to NYC during the Civil War as an illustrator of war articles. He contributed illustrations to almost all the leading magazines for over a quarter of a century. Also illus. "Beyond the Mississippi," 1867

WHITE, George Merwangee [Mar.P] Salem, MA b. 8 O 1849, Salem d. 23 Mr 1915. Work: Peabody Mus., Salem; Lynn (Mass.) Hist. S. [*]

WHITE, H.P. [P] Brookline, MA [01]

WHITE, H(élène) Maynard [S,Por.P] Phila., PA/Bar Harbor, ME b. 26 My 1870, Baltimore. Studied: PAFA, with Moran, Chase, C. Beaux, Grafly; Paris. Member: Plastic C.; Lyceum C.; Intl. S. Exhibited: St. Louis Expo, 1904 (prize); Intl. S. (med); AC Phila. (prize); Calif. med). Work: Roosevelt, Ariz.; Union Nat. Bank; Univ. Pa.; Bethany Col. Church; Mohican Lodge, Red Bank, N.J.; San Fran.; murals, St. Andrew's, Phila. [17]

WHITE, Henry Cooke [P,W,T,E] Waterford, CT (since 1914) b. 15 S 1861, Hartford, CT d. 28 S 1952. Studied: D.W. Tryon, 1875, 1880s; ASL, with K. Cox; G. DeF. Brush, 1884–86. Member: NYWCC; CAFA, 1919 (founder); Lyman Allyn Mus., New London, Conn. (trustee). Exhibited: NAD; PAFA; AIC; AWCS; CAFA; The Pastellists; Hartford; Springfield; Lyman Allyn Mus., 1954 (mem. exh.). Work: PMG; Wadsworth Atheneum. Author: "Life and Art of Dwight William Tryon," 1930. Contributor: Art in America. Position: T., Hartford AS, 1897 [47]

WHITE, Inez Mary Platfoot [P,L] Omaha, NE b. 2 D 1889, Ogden, UT. Studied: A. Dunbier. Member: Nebr. A.; Omaha AC; Omaha AG; Friends of A. Exhibited: Joslyn Mem.; Nebr. A. Work: Windsor Sch., Field Sch., Our Lady of Lourdes Sch., all in Omaha [47]

WHITE, J(acob) C(aupel) [Des,P,E,I,L,T] Oakdale, NY b. 1 O 1895, NYC. Studied: NAD; Académie Julian; F., Tiffany Fnd. 1920; Member: Adv. Cl., NYC. Exhibited: NAD; Salon de Tunis; Tiffany Fnd. Work: Tiffany Fnd. Position: A. Dir., Outdoor Adv., NYC, 1942-44 [47]

WHITE, Jane Felix (Mrs. Clarence H. White) [Ph] b. 1872 d. 18 Ap 1943, Ardmore, Ohio. Following her husband's death in 1925 she continued until 1940 the Clarence White Sch. of Photography, NYC.

WHITE, Jessie Aline (Mrs. George R. Angell) [P,W,C] Fort Worth, TX b. Wessington, SD. Studied: Minneapolis Sch. A.; AIC; ASL. Member: Dallas AA; Tex. FAA; SSAL. Exhibited: Allied Arts Exh., Dallas, 1930 (prizes), 1931 (prize); SSAL, 1937 (prize) [40]

WHITE, Juliet M. See Gross, Mrs.

WHITE, Juliet Von O. [P] Phila., PA [04]

WHITE, Lucy Schwab [P] New Haven, CT. Member: New Haven PCC [25]

WHITE, Mable Dunn (Mrs. Edgar R.) [P] Greenville, SC b. 28 Ja 1902, Charlotte, NC. Studied: Greenville Col. for Women. Member: SSAL; AAPL; FA Lg. of the Carolinas. Exhibited: Nat. Exh. Am. A., NYC, 1941; SSAL, 1941, 1943; Mint Mus. A. (prize); Gibbes A. Gal.; Blue Ridge Al; Greenville Civic A. Gal., 1942 (one-man); Asheville (N.C.) Civic A. Gal., 1942 (one-man) [47]

WHITE, Margaret Wood (Mrs. Victor G.) [Por.P] Woodmere, NY b. 4 Mr 1893, Chicago. Studied: Bridgman; Blumenschein; Johansen; Paris, with Bileul, Humbert. Work: portrait, Pres. F.D. Roosevelt [40]

WHITE, Marie [Dec] Kansas City, MO b. 17 S 1903. Studied: Kansas City AI [40]

WHITE, Mary [I,C] Brooklyn, NY b. 4 Je 1869, Cambridge, MA. Studied: CUASch; ASL [08]

WHITE, Mary Jane [P,L,T] Columbia City, IN b. 27 Je 1907, Columbia City. Studied: R.E. Burke; H. Engel; C.B. Taylor; C.C. Bohm; AIC. Member: Midland AS; Ind. Artists; Hoosier Salon; Western AA; AAPL. Exhibited: Midland Acad., South Bend, Ind. 1934 (prize), 1936 (prize), 1938 (prize). Work: St. Mary's Acad., South Bend; Spink-Wawasee Hotel, Wawasee, Ind. Position: FA Dir., Plymouth City Sch., Ind. [40]

WHITE, Mazie J(ulia Barkley) (Mrs.) [P,E,B] Clifton, NJ b. 9 Ap 1871, Ft. Scott, KS d. 5 S 1934. Studied: C.G. Martin; G.J. Cox; A.R. Young; E. Graecen; W. Adams. Member: N.J. Chapter, AAPL [33]

WHITE, Minor [Ph,T,Cr,W] Cambridge, MA b. 9 Jy 1908, Minneapolis d. 24 Je 1976. Studied: Univ. Minn., 1928-33; Columbia, 1944. Member: S. Ph. Edu. 1962. Exhibited: MOMA, 1941; Portland AM, 1942; IMP, 1959; PMA, 1970 (traveling exh.); SFMA, 1948; Photogr. Lg., NYC, 1950. Founder.Editor: Aperture mag., 1952-76. Influential teacher and critic. [His life in photography is best recorded in his "Mirrors, Messages, Manifestations," 1969.] Positions: T., Portland, Oreg., 1937; La Grande A. Ctr., Oreg. (WPA), 1940-41; Calif. Sch. FA., 1946-53; Rochester Inst. Tech., 1955-60; MIT, 1965-75. [*]

WHITE, Nelson Cooke [P,W] Waterford, CT b. 11 Je 1900, Waterford. Studied: NAD; his father Henry C. Member: CAFA. Exhibited: NAD; AWCS. Author: "The Life and Art of J. Frank Currier," 1936. Contributor: Art in America, Art & Archaeology. Positions: Trustee, Lyman Allyn Mus., New London, Wadsworth Atheneum, Hartford [47]

WHITE, Nona L. [P,L,W,Cr] Pasadena, CA b. 4 O 1859, IL d. 11 Mr 1937. Studied: AIC. Member: Pasadena SA; Laguna Beach AA; Women P. of the West. Sister of Emily. Position: A. Cr., Los Angeles Evening News [33]

WHITE, Orrin A(ugustine) [Ldscp.P] Pasadena, CA (since 1923) b. 5 D 1883, Hanover, IL d. 28 Ap 1969. Studied: Phila. Sch. Appl. A., 1906. Member: Calif. AC. Exhibited: Panama-Calif. Expo, San Diego, 1915; Calif. AC, 1921. Work: Los Angeles MA; State Mus., Springfield, Ill.; Montclair Mus.; CMA [40]

WHITE, Owen Sheppard [P,T] Mayaguez, Puerto Rico/Petoskey, MI b. 6 D 1893, Chicago. Studied: Amherst; CI; Columbia; ASL; Ecole des Beaux-A., Fontainebleau, France; Cape Cod Sch. A., Mass. Exhibited: All.A.Am., 1938, 1939; WFNY, 1939; Newton Gal., N.Y. 1939 (one-man) [40]

WHITE, Peter W. [I] Rochester, NY. Member: Rochester AC [17]

WHITE, Theo [Li,E,I,Dr,Arch,W,L] Ardmore, PA b. 26 N 1902, Norfolk, VA. Studied: Univ. Pa. Work: series of lithographs, Williamsburg, Va.; drawings and lithographs, Boulder Dam; Richmond Mus. Author/Illustrator: "Colonial Mansions of Fairmount Park," "Richmond, Twelve Lithographs of the City on the James" [40]

WHITE, (Thomas) Gilbert [P,Dec,L,T,W] Paris/ Les Andelys, France b. 18 Jy 1877, Grand Haven, MI d. 17 F 1939. Studied: Twachtman; Académie Julian, with Constant, Laurens; Beaux-Arts; Whistler; MacMonnies. Member: AAPL (Pres. European Chap.); Societé Internationale; Anglo-Am. Group of Paris. Awards: Commander de la Legion d'Honneur; Officer de l'Academie; Order of the Purple Heart. Work: murals, Capitol, Ky.; Federal Bldg., Gadsen, Ala.; Capitol, Utah; County Court House, New Haven, Conn.; Peninsula C., Grand Rapids, Mich.; portrait, Pan-Am. Bldg., Wash., D.C.; murals, Capitol, Okla.; McAlpin Hotel, NYC; Agri. Bldg., Wash., D.C.; Locust C., Phila.; Houston Mus.; Brooklyn Mus.; City of Paris Mus.; Luxembourg Gal.; Gallerie du Journal, Paris; Univ. C.; Carnegie Fnd., Paris; Musée de St. Quentin; drawings, Univ. Utah; Univ. Okla., Norman; drawings, CGA [38]

WHITE, Vera [P,Li,Des] Ardmore, PA/Downingtown, PA b. St. Louis. Member: Phila. A. All.; Phila. WCC; Chester County AA. Exhibited: Chester County AA (prize); PAFA; WMAA; AIC; Phila. Pr. C.; LOC; Phila. A. All.; Edward Side Gal., McClees Gal., Carlen Gal., all in Phila.; Honolulu Acad. FA; Honolulu Acad. A.; Reid & Lefevre Gal., London; Galleries, NYC, (one-man): Ferargil, Marie Sterner, Durand-Ruel, Seligmann. [47]

WHITE, Victor (Gerald) [P] Cedarhurst, NY b. 27 F 1891, Ireland d. Ap 1954. Studied: ASL, with Bellows, Henri, W.M. Chase; Acad. Julian; Laurens; Grande Chaumière; Paris, with L. Simon, Billoul. Member: Mural P. Residential; Portraits, Inc.; Arch. Lg., 1945. Work: murals, Waldorf-Astoria Hotel, ITT Bldg., both in NYC; Grumman Corp.; WPA mural, USPO, Rockville Ctr., N.Y.; frieze, Theatre Guild, N.Y. [47]

WHITE, Walter Charles Louis [P,L,T] St. Albans, NY/Woodstock, NY b. Sheffield, England d. ca. 1964. Studied: Columbia; PIASch; Carlson; Dow; Hawthorne. Member: SC; AWCS; New Haven AA; Miss. AA; AL Nassau County; NYWCC; AAPL; Long Island Soc. Arch (hon.). Exhibited: WFNY, 1939; Sesqui-Centenn. Expo, Phila., 1926; Wash. WCC; BM; TMA; AWCS; AFA Traveling Exh.; SC; New Haven Paint & Clay C.; Miss. AA, 1926 (gold); AL Nassau County, 1929 (prize). Work: Vanderpoel Coll.; John Adams H.S., St. Albans, N.Y. [47]

WHITE, William Davidson [Mur.P,I,Dr] Wilmington, DE b. 22 Jy 1896, Wilmington. Studied: PAFA. Exhibited: Wilmington SFA, 1932 (prize). Work: CGA; Pa. Mus. A.; Univ. Pa.; Wilmington SFA; Harlan Sch., Wilmington; WPA mural, USPO, Dover, Del. [40]

WHITE BEAR, (or Oswald Fredericks) [P,C,T] Oraibi, AZ (1968) Studied: Bacone Col., 1933-37; self-taught. Work: Mus. Am. Indian. Position: T., N.J. YMCA, 15 years [*]

WHITEHAN, (Edna) May [P,I] Takoma Park, MD b. 16 Ja 1887, Scribner, NE. Studied: Univ. Nebr., with S. Hayden, Seymour; AIC. Member: Lincoln AC. Exhibited: Nebr. State Fair (prizes) [25]

WHITEHEAD, Edith H. [P] Wash., D.C [25]

WHITEHEAD, Florence [P] Phila., PA [17]

WHITEHEAD, Margaret Van Cortlandt [P] Rye, NY. Member: NAWPS. Exhibited: NAWPS, 1936-38; Pittsburgh AA, 1912 (prize) [40]

WHITEHEAD, Ralph Radcliff [C,W] Woodstock, NY b. 1854, Yorkshire, England (came to U.S. in 1892) d. 23 F 1929, Santa Barbara, CA (an earlier obit says he died with the sinking of the steamer "Vestris" off the Va. coast). Studied: Balliol Col., Oxford, England. Member/Founder: "Byrdcliffe," the Utopian arts-and-crafts settlement in Woodstock, a colony intended to foster the ideals of John Ruskin and William Morris. Author: "Grass of the Desert," "Dante's Vita Nuova." Specialty: pottery

WHITEHEAD, Walter [P,I] Dare, VA b. 2 S 1874, Chicago d. 31 Ja 1956. Studied: AIC; H. Pyle. Member: SI, 1911; A. Dir. C.; SC. Position: T., Chicago Acad. FA [47]

WHITEHEAD, Walter Muir [W,Lib,Cur] North Andover, MA b. 28 S., 1905, Cambridge, MA. Studied: Harvard; Univ. London. Author: "Spanish Romanesque Architecture of the Eleventh Century," 1941; "New England Blockaded in 1814," 1939. Positions: Assist. Dir., Peabody Mus., 1936-46; Lib., Boston Atheneum, from 1946 [47]

WHITEHOUSE, James Horton [J,En] Brooklyn, NY b. 28 O 1833, Staffordshire, England (came to NYC in 1857) d. 29 N 1902. He was a member of the firm of Tiffany & Co., NYC, and an authority on art and engraving on precious metals. Some of his most notable works are the William Cullen Bryant silver vase, presented to the poet in 1874, and now in the MMA; the silver casket presented to the late Bishop Horatio Potter, in 1879, and the Third Seal of the United States Gov., now in use at Wash., D.C.

WHITEHURST, Camelia [Por.P] Baltimore, MD b. 9 Ap 1871, Baltimore d.

23 Je 1936. Studied: PAFA, with Chase, Beaux. Member: SSAL; NAWPS; Grand Central A. Gal.; North Shore AA; Springfield AL; S. Wash. A. Exhibited: All Southern Exh., Charleston, S.C., 1921 (prize); NAWPS, 1920 (prize), 1923 (prize); Memphis, 1922 (prize); New Orleans, 1923 (prize); Wash. SA, 1925 (med), 1929 (prize); Springfield, Mass., 1929 (prize); Jackson, Miss., 1929 (gold). Work: Delgado Mus., New Orleans; Baltimore Friends of Art [33]

WHITELAW, Norma [Min.P] NYC [17]

WHITELAW, Robert N.S. [Et] Charleston, SC [25]

WHITELEY, Rose (Mrs.) [P] Salt Lake City, UT [15]

WHITEMAN, Leona. See Curtis.

WHITEMAN, S(amuel) Edwin [Ldscp.P,T] Baltimore, MD b. 1860, Phila. d. 27 O 1922. Studied: Ecole des Beaux-Arts, with Boulanger, Constant, Lefebvre. Member: Charcoal C. Exhibited: Paris Expo, 1889 (prize). Positions: Dir./T., Charcoal C., 25 yrs.; T., John Hopkins Univ. [21]

WHITENER, Paul (Austin) W(ayne) [Mus.Dir,P,T,L] Hickory, NC b. 1 S 1911, Lincoln County, NC d. My 1959. Studied: Duke Univ.; Ringling Sch. A.; W. Conrow; D. Blake; F. Herring. Member: AAPL; N.C. State AS. Exhibited: Mint Mus. A., 1944; Hickory Mus. A., 1943–46; SSAL, 1942, Duke Univ., 1945 (one-man). Work: Duke Univ.; Lenoir Rhyne Col., Hickory, N.C.; Hickory Mus. A.; port. commissions. Positions: Dir., Hickory Mus. A., from 1943; T., Hickory H.S., 1945–46 [47]

WHITESIDE, Frank Reed [Ldscp.P,T] Phila., PA/Ogunquit, ME b. 20 Ag 1866, Phila. d. 19 S 1929, Phila. (mysteriously shot down on the threshold of his home when he responded to a ring of the doorbell). Studied: PAFA; Paris, with Laurens, Constant. Member: Phila. Sketch C.; F., PAFA (board); Phila. WCC; Phila. Alliance. Exhibited: Phila. Sketch C. 1929 (memorial); Phoenix AM (retrospective) 1971 [27]

WHITESIDE, Henryette Stadelman (listed as **Henry Leech Whiteside** in 1933 edition) [P] Wilmington, DE b. 5 D 1891, Brownsville, PA. Studied: Italy, with Donati; PAFA, with Anschutz, H. Breckenridge, C. Hawthorne. Member: Phila. WCC; Phila. A. All.; Wilmington SFA. Exhibited: PAFA; NAD; AIC; WFNY, 1939; Del. A. Ctr.; Univ. Del., 1938. Work: State House, Dover, Del.; Wilmington SFA. Position: Founder/Dir., Wilmington Acad. A., until merged with Del. A. Ctr., 1942 [47]

WHITFIELD, Emma M(orehead) [Por.P,T] Richmond, VA b. 5 D 1874, Greensboro, NC d. 6 My 1932. Studied: ASL; R. Collin, in Paris. Work: portraits, State Lib., Richmond, Va.; Univ. Richmond, Va.; Carnegie Lib., Greensboro, N.C.; Capitols, Raleigh, N.C., Jackson, Miss.; Guildford County Court House, Greensboro; Confederate Battle Abbey, Confederate Mem. Mus., Executive Mansion, all in Richmond; Women's C., Raleigh; Miss. Col., Clinton; port., Boy's Indst. Sch., Birmingham, Ala. [31]

WHITFORD, William Garrison [C,W,T] Olympia Fields, IL b. 12 D 1886, Nile, NY. Studied: AIC; C.F. Binns, Alfred Univ.; H.F. Staley, Iowa State Col. Member: Am. Ceramic Soc.; Western AA. Work: set of dishes, Univ. Chicago. Author: "Introduction to Art," 1937. Illustrator: "Robert and Peggie in a Century of Progress," the Chicago Tribune. Contributor: Design mag. Positions: Advis. Ed., School Arts mag.; T., Md. Inst. (1911–13), Univ. Chicago (from 1913) [47]

WHITIES-SANNER, Glenna [P] Findlay, OH b. 13 Ag 1888, Kalida, OH. Studied: L. Pescheret; Mrs. V. Whities. Member: Ohio WCS; Toledo AC. Exhibited: TMA, 1943, 1944; Taft Mus., Cincinnati; Ohio WCS Traveling Exh., 1943, 1943; Findlay, Ohio, 1943; Kent State Univ.; Dayton AI; CMA; Butler AI; Columbus Gal. FA; Ohio Univ.; Canton AI [47]

WHITING, Almon Clark [P,Et] NYC b. 5 Mr 1878, Worcester, MA. Studied: Mass. Normal Sch.; Académie Julian, with Laurens, Constant, Whistler. Member: Paris AA; SC; Tile C., Toledo; SWA. Work: TMA. Position: Founder/Dir., TMA, 1901–03 [47]

WHITING, Florence Standish [Mur.P,E,Dec] Phila., PA/Wildwood, NJ b. 1888, Phila. d. 5 F 1847. Studied: PAFA, with E. Horter, H. McCarter; Cresson traveling schol., 1918–19. Member: Phila. Alliance; Plastic C. Exhibited: GGE, 1939; Plastic C. 1931 (gold). Work: murals, Brègy Sch., Phila.; PAFA; FA Bldg., Univ. Pa.; Allentown Mus. [40]

WHITING, Frank [E] Cooperstown, NY. Member: SAE [47]

WHITING, Gertrude [C] NYC b. NYC. Studied: Institut Neuchatelois des Dentelles. Member: Needle and Bobbin C. (founder); NYSC; Boston SAC (Master Craftsman); Embroiderers G., London; Les Amis du Louvre, Paris; Paris Chap. AFA; Hon. F., MMA. Work: Indexed sampler 145 lace grounds, MMA; made 100 models of original stitches based on native des. for 130 East Indian schools. Author: "A Lace Guide for Makers and Collectors," "The Spinster," "Tools and Toys of Stitchery." Position: Lacemaker to Indian Gov. and United British and inter-denominational Am. Missions. Specialty: lace making [40]

WHITING, Gertrude (Mrs. John A. Proctor) [Por.P] NYC b. 3 Jy 1898, Milwaukee. Studied: BMFA Sch., with P. Hale; ASL; W. Adams. Member: All.A.Am.; CAFA; AAPL; Soc. for Sanity in Art, Chicago; Marblehead AA; North Shore AA. Exhibited: NAD; All.A.Am.; Palm Beach A. Ctr.; Oakland A. Gal.; New Haven PCC; Montclair A. Mus.; Ogunquit A. Ctr., 1937; North Shore AA; Argent Gal., 1936 (one-man). Work: Univ. Ga.; Princeton Univ. [47]

WHITING, Giles [P,C] NYC b. 21 Je 1873, NYC d. 27 Ap 1937. Studied: Columbia, 1895 (Arch. sch.). Member: A. Aid S.; N.Y. Mun. AS; Arch. Lg., 1899; SCUA, 1895 (charter); Japan Soc. of London; Art-in-Trades C.; Artists Fellowship; Am. Acad., Rome. Award: Friedsam medal for promotion of art in industry [13]

WHITING, John Downes [P,W,I,L] New Haven, CT b. 20 Jy 1884, Ridgefield, CT. Studied: C.S. Carbee; L. Hitchcock; Yale, with J.H. Niemeyer, G.A. Thompson. Member: New Haven PCC; CAFA; Rockport AA; Meriden A.&Cr. S. Exhibited: New Haven PCC; Rockport AA; CAFA; Conn. WCS; Meriden A.&Cr. S. Work: Nat. Lib., Color Slides, Wash., D.C.; Mun. Coll., New Haven; State Armory; Stephen's Col., Columbuia, Mo. Author/Illustrator: "Practical Illustration," 1920; "Fighters," pub. Bobbs-Merrill, "S.O.S.," "the Trail of Fire," pub. Bobbs [47]

WHITING, Lillian V. [P] Laguna Beach, CA [24]

WHITING, Mildred Ruth [I,Des,T] Lincoln, NE b. Seattle, WA. Studied: Univ. Nebr.; Univ. Minn. Member: Western AA; A. Gld. of Eastern Ill.; AAPL; Lincoln AG. Exhibited: All-Ill. SFA, 1942, 1943; AG, Eastern Ill.; Nebr. State Fair, 1929 (prize), 1930 (prize); Bus. Prof. Women's C., Lincoln, 1932 (prize); Eastern Ill. State T. Col., 1939; Lincoln AG, 1939; All-State Exh., Lincoln, 1939. Position: Eastern Ill. State T. Col., from 1936 [47]

WHITLOCK, France J(eanette) [P,C,T] Los Angeles, CA b. 12 D 1870, Warren, IL. Studied: Dow; C. Martin. Member: Calif. AC. Position: T., Normal Sch., Fresno, Calif. [25]

WHITLOCK, Mary Ursula [Min.P] Riverside, CA (living in Brooklyn, NY, 1904) b. Great Barrington, MA d. 7 D 1944. Studied: J.A. Weir; ASL; Académie Julian. Member: Calif. S. Min. P.; Pa. S. Min. P.; Riverside AA. Work: White House; Los Angeles Mus. Hist., Sc.&A. Friend of Cecilia Beaux. [40]

WHITMAN, Thelma. See Grosvenor.

WHITMAN, Charles Thomas, 3rd [I] Phila., PA b. 23 F 1913, Phila. Studied: PMSchIA. Member: Phila. Alliance; Phila. Sketch C.; Phila. WCC. Work: Roosevelt Jr. H.S., Phila. [40]

WHITMAN, John Franklin, Jr. [I,Des] Lebanon, PA b. 27 Ag 1896, Phila. Studied: Univ. Pa.; PAFA, with McCarter; Ecole des Beaux-Arts, Fontainebleau, France; Despujols; Carlu. Exhibited: A. Dir. C., 1928; Mod. Packaging Exh., 1937. Position: A. Dir./Illus., Winston Co., Publishers [47]

WHITMAN, John Pratt [P,G,L] Tamworth, NH b. 28 Mr 1871, Louisville, KY. Studied: Mass. Sch. A. Exhibited: Grace Horne Gal., Boston; Currier Gal. A., Manchester, N.H.; AGAA; Argent Gal., 1940 (one-man). Work: "Utopia Dawns," Utopia Pub. Co., Boston [40]

WHITMAN, Paul [E,Li,P] Pebble Beach, CA b. 23 Ap 1887 of 1897, Denver. Studied: Wash. Univ., St. Louis; A. Hansen. Member: Carmel AA; Lithogr. Technical Fnd.; Intl. S. Etchers, Los Angeles, 1928 (prize). Work: Stanford Univ.; Del Monte (Calif.) Hotel; Calif. State Lib. Position: T., Douglas Sch., Pebble Beach [47]

WHITMAN, Sarah de St. Prix Wyman (Mrs. Henry) [P,W,C] Boston, MA b. Baltimore, 1842 d. Jy 1904. Studied: W.M. Hunt; Villiers-le-Bel, with Couture. Member: Committee Mem., BMFA Sch., 1885–04; SAA, 1880; U.S. Pub. AL, 1897; Copley S. (hon. member). Exhibited: Pan-Am. Expo, 1901 (med); widely in Boston galleries, incl. Boston AC and St. Botolph Cl.; NAD; Columbian Expo, (med), Chicago, 1893. Work: BMFA (her legatee); "Brooks Mem. Window" at Trinity Church, Boston, 1895. Author: tribute to William M. Hunt in International Review, 1879; "The Making of Pictures. Twelve Short Talks with Young People," 1886; "Robert Browning in his Relation to the Art of Painting," 1889; article, "Stained Glass" for Handicraft (Boston SAC, 1903) [04]

WHITMER, Helen Crozier (Mrs.) [P,L,T] La Grangeville, NY b. 6 Ja 1870, Darby, PA. Studied: Phila. Sch. Des. for Women; Breckenridge; Anshutz;

Henri; Thouron; Vonnoh. Member: Pittsburgh AA; Dutchess County AA. Exhibited: PAFA; Pittsburgh AA; Dutchess County AA [47]

WHITMIRE, La Von [P,G,T] Indianapolis, IN b. Hendricks County, IN. Studied: W. Forsyth; F. Fursman; E. O'Hara; F. Chapin. Member: Ind. Ar. C.; Prattlers C., Indianapolis; Western AA. Exhibited: Herron AI, 1937 (prize), 1939, 1939. Work: Herron AI. Position: T. Wash., H.S., Indianapolis [40]

WHITMORE, Charlotte [P] NYC Studied: CUASch; G.H. Smillie [01]

WHITMORE, Coby [I] NYC. Member: SI [47]

WHITMORE, Olive [P] NYC [19]

WHITMORE, Robert Houston [P,E,En,C,I,B,T] Yellow Springs, OH b. 22 F 1890, Dayton, OH. Studied: AIC; Cincinnati A. Acad.; H.M. Walcott; James R. Hopkins. Member: Dayton A., P.&S.; Dayton SE. Exhibited: NAD, 1944; LOC, 1904; Phila. Pr. C., 1945; Ohio Pr. Traveling Exh., 1935–39; Dayton AI, 1936–40; Butler AI, 1942; Dayton SE, 1921–42; AIC, 1915 (prize), 1921 (prize); Intl. PM, 1924 (prize); ASL, Chicago, 1920 (prize). Work: Los Angeles MA; Dayton AI; Steele H.S., Normal Sch., both in Dayton; Coshocton (Ohio) Pub. Lib.; Antioch Col., Yellow Springs, OH; Vanderpoel Coll.; Dayton Mus.; Pub. Lib., Lima, Ohio. Position: T., Antioch Col., from 1925 [47]

WHITMORE, William R. [P] Springfield, MA [01]

WHITNEY, Anne [S] Boston, MA (since ca. 1871) b. 2 S 1821, Watertown, MA d. 23 Ja 1915 (age 93). Studied: briefly under W. Rimmer, 1862; Munich; Paris; Rome, 1867–ca.1871. Member: White Marmorean Flock, Rome. Work: statues: Samuel Adams for Capitol, Wash., D.C.; Adams Square, Boston; Wellesley Col.; "Leif Eriksen," in Boston and Milwaukee; others in Albany, St. Louis, and Newton, Mass.; Calla Fountain, Franklin Park, Phila.; Smith Col.; BMFA [08]

WHITNEY, Beatrice (Mrs. Van Ness) [P] Brookline, MA b. 24 My 1888, Chelsea, MA. Studied: Tarbell; Benson; Hale; Pratt. Exhibited: NAD, 1914 (prize); P.-P. Expo, San Fran., 1915 (med) [33]

WHITNEY, Charles Frederick [Dr,L,T] Danvers, MA/Tamworth, NH b. 18 Je 1858, Pittston, ME. Studied: Mass. Sch. Art; BMFA Sch. Author: "Blackboard Sketching," "Blackboard Drawing," "Indian Designs and Symbols," "Chalk Talks for the Teacher." Position: T., The Wheelock Sch., Boston [40]

WHITNEY, Daniel Webster [P] Catonsville, MD b. 3 My 1896, Catonsville. Studied: C.Y. Turner; D. Garber; H. Breckenridge; J. Pearson [31]

WHITNEY, Douglas B. [P] NYC [15]

WHITNEY, Elwood [I] NYC. Member: SI [47]

WHITNEY, Frank [P,S,I] Hubbardwoods, IL b. 7 Ap 1860, Rochester, MN. Studied: Académie Julian, with Puech, Bouguereau, Ferrier. Specialty: animals [10]

WHITNEY, George Gillett [P] Westtown, PA [24]

WHITNEY, Gertrude V(anderbilt) (Mrs. Harry P.) [S] NYC/ Old Westbury, NY b. 1878, NYC d. 18 Ap 1942. Studied: J.E. Fraser; A. O'Connor. Member: NAWPS; NSS; Port. P.; Newport AA; New S. A.; NAC. Exhibited: Paris Salon, 1913 (prize); NAWPS, 1914 (prize); P.-P. Expo, San Fran., 1915 (med); Am. Art Dealers Assn., 1932 (med). Award: Grand, Order of King Alfonso II of Spain. Work: fountain, McGill Univ., Montreal; Titanic Memorial statue, Wash., D.C. Founded: Whitney Mus. of Modern American Art (WMAA) [40]

WHITNEY, Helen Reed (Mrs. P.R.) [P,Des] Evanston, IL b. 1 Jy 1878, Brookline, MA. Studied: BMFA Sch., with F. Wagner, P. Hale, F.W. Benson, E.C. Tarbell. Member: Plastic C.; Phila. Alliance; Phila. WCC; Phila. Print C. Exhibited: Wanamaker Exh., 1915 (prize); Newtown Sq., Pa., 1935 (prize). Work: Women's C., Media, Pa.; Pa. State Col. [47]

WHITNEY, Isabel Lydia [Mur.P,Des] NYC b. Brooklyn, NY d. 2 F 1962. Studied: A. Dow; H. Pyle; H. Lever. Member: Brooklyn WCC; NAD; Brooklyn S. Mod. A.; Fifteen Gal. Work: BM. Specialty: watercolors [40]

WHITNEY, Josepha [P,T] New Haven, CT/Woodstock, NY b. 27 S 1872, Wash., D.C. Studied: Messer; Chase; Ennis. Member: New Haven PCC; NAWPS; AWCS [40]

WHITNEY, Katharine [P] Minneapolis, MN [15]

WHITNEY, Margaret. See Thompson.

WHITNEY, Marjorie Faye [C,Des,Dec,T] Lawrence, KS b. 23 S 1903, Salina, KS. Studied: Kans. Wesleyan Univ.; Univ. Kans.; Calif. Col. A. & Crafts; F.G. Hale; R. Ketcham; G. Lukens; H. Dixon. Member: CAA; Western AA; Kans. Fed. A.; Kans. A. T. Assn.; MacD. Assn. Work: Bell Mem. Hospital, Kansas City; Gage Park Sch., Topeka; Watkins Mem. Hospital and Pinckey Sch., Lawrence, Kans. Illustrator: "Boys of the Bible." Position: T., 1928–46; Dir., Des. Dept., Univ. Kans., from 1940 [47]

WHITNEY, Philip Richardson [P,C,T,Arch] Swarthmore, PA b. 31 D 1878, Council Bluffs d. ca. 1960. Studied: MIT; F. Wagner. Member: Phila. AC; Phila. WCC. Exhibited: PAFA; Phila. WCC; Baltimore WCC; Phila. AC. Work: Pa. State Col. Position: T., Univ. Pa., until 1936 [47]

WHITON, S.J. [P] Hingham, MA [01]

WHITSIT, Elon [P] NYC [13]

WHITSIT, Jesse [P] NYC b. 11 My 1874, Decatur, IL [21]

WHITTAKER, John B. [P,S,I] Brooklyn, NY. Member: SC 1897. Position: A. Dir., Adelphi Col. [10]

WHITTAKER, Mary Wood (Mrs.) [P,T] Brooklyn, NY d. 10 Jy 1926 [24]

WHITTEKER, Lilian E. [P] Cincinnati, OH. Member: Cincinnati Women's AC [27]

WHITTEMORE, Charles E. [I] NYC [04]

WHITTEMORE, Charles E. (Mrs.) [P] NYC [01]

WHITTEMORE, Frances D(avis) (Mrs. L. D.) [P,W,L,T] Topeka, KS b. Decatur, IL. Studied: ASL, with J.A. Weir; K. Cox; W. Shirlaw; AIC. Member: Topeka AG; Kans. State Fed. Art. Author: George Washington in Sculpture," pub. Marshall Jones Co., 1933 [40]

WHITTEMORE, Grace Conner (Mrs. George A.) [P] East Orange, NJ b. 29 O 1876, Columbia County, PA. Studied: Phila. Sch. Des. for Women; PAFA; Daingerfield; Snell. Member: Essex WCC; A. Ctr. of the Oranges; Bloomfield AL. Exhibited: A. Ctr. of the Oranges; Essex WCC; Montclair AM, 1936; Women's C., Orange, N.J. (prize); N.J. State Fed. Women's C., 1942 (prize), 1943 (prize) [47]

WHITTEMORE, Helen Simpson (Mrs. William J.) [P] East Hampton, NY b. Horsham, England d. ca. 1958. Studied: Chase; Colin; Merson; Garrido, in Paris. Member: NYWCC; NAWPS; Allied AA. Work: Guild Hall, East Hampton, N.Y. [47]

WHITTEMORE, Margaret Evelyn [I,B,W] Topeka, KS b. Topeka. Studied: Washburn Col., Topeka; AIC. Work: Univ. Kans., Lawrence; Clay Ctr. Lib., Wichita Pub. Lib.; Kans. State Hist. S., Pub. Lib., both in Topeka. Illustrator: "Adventures in Thrift," 1946; woodcuts, "Trees," pub. Bruce Humphries; "Bird Notes," by H.L. Rhodes, 1932. Author/Illustrator: "Sketchbook of Kansas Landmarks," 1936. Contributor: Christian Science Monitor [47]

WHITTEMORE, William J(ohn) [P,Min.P,T] East Hampton, NY (since 1895) b. 26 Mr 1860, NYC d. 7 F 1955 (age 95). Studied: NAD, with W.M. Hart, L. Wilmarth, 1882–86; ASL, with J.C. Beckwith, 1885; Acad. Julian, with Constant, Lefebvre, late 1880s. Member: ANA, 1897; AWCS; NYWCC; Am. S. Min. P.; SC, 1890; Lotos C.; Calif. S. Min. P.; Brooklyn AC; Allied AA; SPNY; Century Assn. Exhibited: Paris Expo, 1889 (med); Atlanta Expo, 1895 (med); Charleston Expo, 1902 (med); NAD, 1917 (prize); AWCS, 1927 (prize); SC, 1927 (prize); Baltimore, 1928 (prize); Pa. S. Min. P., 1934 (prize); Calif. S. Min. P., 1942 (prize). Work: Boston AC; Detroit C.; State House, Montpelier, Vt.; Columbia Univ.; Lotos C., NYC; Franklin Inst., Phila.; State House, Trenton, N.J.; Guild Hall, East Hampton, N.Y. [47]

WHITTLESEY, Caroline H. [P] Cleveland, OH. Exhibited: NYWCC, 1898 [01]

WHITTLETON, Anna Goodheart. See Howland.

WHITTREDGE, (Thomas) Worthington [Ldscp.P] Summit, NJ b. 22 My 1820, Springfield, OH d. 25 F 1910. Studied: Cincinnati, 1838–39; Düsseldorf, with A. Achenbach, 1849–54; London; Paris; Antwerp; Rome, 1856–59. Member: NA, 1861 (Pres., 1874–77); A. Fund S.; Century Assn. Exhibited: Centenn. Expo, Phila., 1876 (med); Paris Expo, 1889 (prize); Pan-Am. Expo, Buffalo, 1901 (med); St. Louis Expo, 1904 (med); Exh. of 125 paintings, Century Assn., 1904. Work: WMA; Cincinnati AM; BM; MET; Newark Mus. A friend of Bierstadt and Leutze in Düsseldorf, he was Leutze's model for his famous "Washington Crossing the Delaware." Best known for his New England landscapes. He was in the Rockies in 1866, and again in 1870 with friends S.R. Gifford and J.F. Kesnett. He made a third trip, to the Platte River region of Colorado, in 1877. He was in Mexico in 1893, and again in 1896 with F.S. Church. He finished his autobiography in 1905. [10]

WHITWELL, Mary Hubbard [P] b. 1847, Boston d. 1908, probably Boston. Studied: W.M. Hunt, early 1870s; Couture, in Paris, ca. 1877; Académie Julian, 1885 [*]

WHORF, John [P] Provincetown, MA b. 10 Ja 1903 d. 13 F 1959. Studied: BMFA Sch.; M. Bohm; C. Hawthorne; Miller; Acad. Colarossi, Paris. Member: ANA; AWCS; Fla. WCS. Exhibited: AWCS; PAFA; Milch Ga., N.Y.; AIC, 1939 (prize), 1943 (prize). Work: BM; WMAA; Herron AI; BMFA; Amherst Col.; TMA; MMA; Montclair Mus.; AIC; RISD; CAM; Univ. Ill.; New Britain Mus. A.; W. Nelson Gal., Kansas City [47]

WHYTE, James [P] NYC. Member: S.Indp.A. [25]

WHYTE, Martha A. [P,I] Phila., PA b. Phila. Member: Plastic C. [10]

WIBOLTT, (Jack) Aage Christian [Por.P,Mur.P] Los Angeles, CA (1948) b. 10 N 1894, Denmark. Studied: Royal Acad., Copenhagen. Member: Am. Ar. Cong. Exhibited: WFNY, 1939 Work: Fox Theatre, Los Angeles; Los Angeles Jr. Col. [40]

WICHERTS, Arend, Jr. [Ldscp.P] Chicago, IL b. 23 D 1876, Matteson, IL. Studied: AIC; R.S. Robbins [04]

WICKARD, J. Murray [P] Indianapolis, IN [25]

WICKENDEN, Robert J. [Por.P,Ldscp.P] Quebec, Canada b. Rochester, England (came to U.S. at age 13) d. 28 N 1931, Brooklyn, NY. Work: two portraits of King Edward VII, Parliament Building, Ottawa, Ontario, Halifax, N.S. Specialty: Montreal snow scenes [01]

WICKER, Mary H. (Mrs.) [P,S] Chicago, IL b. Chicago. Studied: Académie Julian, Paris; Brangwyn; Hawthorne; Pushman; Gaspard; Browne; Szukalski. Member: NAC; AAPL; Chicago PS; Chicago AC; Hoosier Salon. Exhibited: AIC, 1923, 1924 [40]

WICKERSHAM, Marguerite H. [P] Phila., PA [08]

WICKES, William Jarvis [P,S] Saginaw, MI b. 26 My 1897, Saginaw. Studied: AIC. Member: Alliance [33]

WICKEY, Harry [E,T,Li] Cornwall Landing, NY b. 14 O 1892, Stryker, OH. Member: NA; ANA, 1939; Am. Soc. PS&G; F., Guggenheim Fnd., 1939, 1940. Exhibited: SC, 1925 (prize); SAE, 1934 (prize); Sesqui-Centenn. Expo, Phila., 1926 (prize); Chicago SE (prize). Work: MMA; AIC; Newark Mus.; BMFA; WMAA; AGAA; NYPL; LOC; Fifty Prints of the Year, 1933, 1938; Fine Prints of the Year, 1934 [47]

WICKEY, Maria Rother (Mrs. Harry) [P] Cornwall Landing, NY b. 9 Ap 1897, Warsaw, Poland. Studied: NAD, with F.C. Jones; ASL; G. Bellows; G. Bridgman; A. Covey. Work: murals, Manhattan Trade Sch., NYC. Position: T., ASL [40]

WICKHAM, Julie M. [P] Long Island, NY. Member: NAWPS. Exhibited: NAWPS, 1935–38 [40]

WICKISER, Ralph Lewanda [Ser,T,Li,P] Baton Rouge, LA b. 20 Mr 1910, Greenup, IL. Studied: AIC; Eastern Ill. State T. Col.; Peabody Col. Member: Am. Soc. for Aesthetics; F., Tiffany Fnd., 1934. Exhibited: Assn. Am. A., 1944, 1946; Wash. WCC, 1943, 1944; LOC, 1946; SFMA, 1941–43, 1946; La. Exh., 1946; New Orleans, 1946 (prize). Author: "An Introduction to Art Activities," 1941. Contributing Ed.: Dictionary of Fine Arts. Position: T., La. State Univ., from 1941 [47]

WICKS, Heppie En Earl [Por.P,L,T] Leroy, NY b. Leroy. Studied: L.M. Wiles; I.R. Wiles; C.Y. Turner; C. Beaux; Académie Julian, Ecole des Beaux-Arts, both in Paris [33]

WICKS, Katharine. See Gibson.

WICKSON, Guest [P,T] Berkeley, CA b. 6 F 1888, Berkeley. Member: San Fran. AA [25]

WICKSTROM, Axel [P] Duluth, MN [17]

WICKWIRE, Jere Raymond [P] NYC b. 3 Jy 1883, Cortland, NY. Studied: W.M. Chase. Member: ANA, 1936; All.A.Am. Exhibited: Allied AA, 1934 (prize). Work: Vassar Col. [47]

WIDEMAN, Florice (Florence P.) [C,Des,T,E] Palo Alto, CA b. 26 Ag 1893, Scranton, PA. Studied: Calif. Sch. FA; ASL; Parsons Sch. A.; F. Van Sloun; E. Scott, in Paris. Member: Calif. WCS; San Fran. Women A.; Palo Alto AC. Exhibited: Riverside Mus. A. Illustrator: articles for New York Times, New York Herald Tribune. Positions: Des., modern pottery, Amberg Hirth Studios, San Fran.; T., Palo Alto Pub. Sch. [47]

WIDENER, Peter A.B. [Patron] Elkins Park, PA b. 13 N 1834, Phila. d. 6 N 1915. His collection included such masterpieces as the "Cowper Madonna" by Raphael, "The Mill" by Rembrandt, the "Moresini" helmet and valuable pieces of Chinese porcelain. He had made a fortune in the meat business before entering politics in Phila.

WIDFORSS, G(unnar Mauritz) [P] San Fran., CA/studio on the rim of Grand Canyon b. 21 O 1879, Stockholm, Sweden (settled in Calif. in 1921) d. 2 D 1934, Grand Canyon, AZ. Studied: Stockholm Inst. Tech., 1896–1900. Member: Calif. WCS; Scandinavian-Am. A. Exhibited: Calif. WCS, 1928 (prize); Calif. State Fair, 1930 (prize); Mus. Northern Ariz., 1969 (retrospective). Work: Nat. Mus. Illustrator: "Songs of Yosemite," 1923. Specialty: views of the Grand Canyon, since 1922 [33]

WIDLIZKA, Leopold [P] NYC [24]

WIDNEY, G(ustavus) C. [I,P] Chalfont, PA b. 27 N 1871, Polo, IL. Studied: AIC, with Von Saltza; Académie Julian, with Constant, Laurens. Member: Chicago SA; SI, 1911; Nat. Press C., Wash., D.C. [13]

WIDSTROM, Edward Frederick [S,C] Meriden, CT b. 1 N 1903, Wallingford, CT. Studied: ASL; A. Lee; W. Zorach. Member: CAFA; New Haven PCC; Meriden A. & Cr. Assn. Exhibited: NAD, 1940; PAFA, 1939; Fairmont Park, Phila. 1940; CAFA, 1934–46; New Haven PCC, 1939–46; Meriden A. & Cr. Assn., 1937 (prize), 1939 (prize), 1946 (prize). Position: Staff, International Silver Co., Meriden [47]

WIEBKING, Edward [P] Cincinnati, OH [15]

WIECHMANN, Margaret H(elen) [S] Wainscott, NY b. 29 S 1886, NYC. Studied: A. Proctor: ASL; NAD. Specialty: small bronzes of animals [21]

WIECZOREK, Max [P] Pasadena, CA b. 22 N 1863, Breslau, Germany d. 25 S 1955 (age 92). Studied: Italy; Germany; F. Keller; M. Thedy. Member: Calif. AC; Laguna Beach AA; Calif. WCS; AWCS; P. of the West; Chicago Gal. Assn.; Intl. Bookplate A.; AFA; Fnd. Western A. (Pres.); NYWCC; Painters and Sculptors C.; Artland C. Exhibited: Panama-Calif. Expo, 1915 (med); Calif. AC, 1918 (med), 1920 (med); Ariz. State Fair, 1920 (med), 1922 (med); Laguna Beach AA, 1920 (prize); Calif. WCS, 1923 (prize); Intl. Bookplate A., 1926 (prize); Calif. State Fair, 1927 (prize); Pacific Southwest Expo, Long Beach, 1928 (gold). Work: Chaffey H.S., Ontario, Calif.; Engineer's C., NYC; Denishawn Sch., N.Y.; Los Angeles Mus. A.; Virgil Jr. H.S., City Hall, both in Los Angeles; Los Angeles Athletic C. [47]

WIEDERSEIM, Grace. See Drayton.

WIEDHOPF, Etta L.W. [P] NYC. Member: S.Indp.A. [25]

WIEGAND, Gustave Adolph [P] Summit, NJ b. 2 O 1870, Bremen, Germany. Studied: Royal Acad., Dresden, with E. Bracht; Chase, in NYC. Member: NAC; All.A.Am.; NYWCC; SC. Exhibited: St. Louis Expo, 1904 (med); Allied AA, 1937 (prize); NAD, 1905 (prize); World's Fair, St. Louis (med). Work: BM; NAC; Newark Mus. [47]

WIEGAND, Henry H. [Patron] b. 1861 d. 17 N 1943, Baltimore, MD. Trustee of the BMA, and its secretary for many years.

WIEGHARDT, Paul [P] Chicago, IL b. 26 Ag 1897, Germany d. 1969. Studied: Sch. FA, Cologne, Germany, with Klee; Acad. FA, Dresden, Germany. Exhibited: PAFA, 1945, 1946; AIC, 1946; Salon des Indépendants, Salon d'Automne, Salon des Tuileries, Paris Salon, all in Paris; Knoedler Gal. (one-man); PMG (one-man); St. Paul Gal. A. (one-man); Berkshire Mus. (one-man); Springfield (Mass.) Mus. A. (one-man). Work: Albright A. Gal.; Barnes Fnd.; Berkshire Mus.; PMG; Rosenwald Coll.; Smith Col.; Northampton (Mass.) Mus. A. [47]

WIEGHORST, Olaf [P,I,S] El Cajon, CA (1975) b. 1899, Jutland, Denmark (came to NYC in 1918). Studied: probably with his father, who was an illustrator and engraver. Work: Amon Carter M.; Nat. Cowboy Hall of Fame. Cowboy artist who worked on a ranch in Ariz. before becoming a mounted policeman in NYC, 1925–44. Moved to El Cajon in 1945 and by the 1950s was well known for his specialty, horses. [*]

WIEHLE, Paul [S] NYC. Member: Arch. Lg., 1901 [04]

WIELAND, Frederick [Stained Glass Des] b. 14 Mr 1889, Wurzburg, Germany. Studied: frescoe painting, N.Y. Trade Sch.; NAD; ASL; SI Sch. Active in San Diego, from 1923. [*]

WIENER, Paul Lester [Des,Dec,Arch,L] NYC b. 2 My 1895. Studied: Art schools in Leipzig. Contributor: Architectural Forum, Architectural Record, Arts and Decoration, Spur, House and Garden, American Architect. Specialties: Industrial designs and models; architectural designs, modern interiors and exteriors [40]

WIENER, Rosalie Roos (Mrs. A. Lee) [C] New Orleans, LA. Studied: E. Woodward; M.W. Butler; W. Stevens; X. Gonzales; Newcomb Col. Member: SSAL. Exhibited: Newcomb Col., 1930 (prize), (Master Craftsman) 1930; NOAA, 1933 (prize); SSAL, 1936 (prize) [40]

WIENS, Aurelia M. [P] Milwaukee, WI [24]

WIER, Gordon D. (Don) [Des,P,T,I] Stratford, CT b. 14 Je 1903, Orchard Lake, MI. Studied: Univ. Mich. Chicago Acad. FA; Grand Central Sch. A.; J.S. Williams. Exhibited: Baltimore, 1929; Decorators Cl., 1942; D.M. Read Co., Bridgeport, Conn., 1941–43 (one-man). Illustrator: "Adventures par la Lecture," 1932, "The Victors," 1933. Positions: T., Grand Central Sch. A., 1927–35; Des., Steuben Glass, Inc. [47]

WIER, Mattie [P] Houston, TX. Exhibited: Houston MFA, 1938, 1939 [40]

WIESE, Kurt [I] Frenchtown, N.J. b. 22 Ap 1887, Minden, Germany. Exhibited: Intl. Expo, Paris, 1937 (prize). Author/Illustrator: "Karoo the Kangaroo," "Wallie the Walrus," "The Parrot Dealer," "Chinese Ink Stick," "Liang and Lo." Illustrator: "Bambi," "Life Story of a Little Monkey," "Bong Kwei," "The Adventures of Mario," "Jungle Book," "Young Fu" [40]

WIESELTHIER, Vally (Miss) [Des,Dr,S,T,C] NYC b. 25 My 1895, Vienna, Austria d. 1 S 1945. Studied: Vienna, with J. Hoffman, Hafnermeister. Exhibited: Expo des Arts Decoratifs, Paris, 1925 (med); Barcelona (prize). Work: MMA; Cincinnati Mus.; Vienna Mus. A.; Grassi Mus., Liepzig. Contributor: Am. and European magazines, papers. Position: Affiliated with General Ceramics Co., N.Y. [40]

WIESEN, George William, Jr. [I,P,L,T] Home, PA b. 22 F 1918, Phila. Studied: Ind. State T. Col., Indiana, Pa. Exhibited: Ind. State T. Col., Pa. [40]

WIESSLER, William [P,T] Cincinnati, OH b. 14 Je 1887, Cincinnati. Studied: F. Duveneck; L.H. Meakin; V. Nowottny. Position: T., Ohio Mechanics Inst. [40]

WIGAND, Adeline Albright (Mrs. Otto) [Por.P] Staten Island, NY/Wilmington, NY b. Madison, NJ d. 30 Mr 1944. Studied: W.M. Chase; Robert-Fleury; Académie Julian, Paris, with Bouguereau. Member: NAWPS; SPNY; Staten Island Inst. A.&Sc.; Staten Island AA. Exhibited: N.Y. Women's AC, 1905 (prize), 1908 (prize); NAD, 1909 (prize); NAC, 1910 (prize), 1912 (prize); NAWPS, 1920 (prize). Work: RISD; Little Gal., Cedar Rapids, Iowa; Staten Island Inst. A.&Sc. [40]

WIGAND, Otto Charles [P] Staten Island, NY/Wilmington, NY b. 8 Je 1856, NYC d. 17 Jy 1944. Studied: ASL; Académie Julian, Paris, with Boulanger, Lefebvre. Member: SC, 1899; NYWCC; S.I. Inst. A.&Sc.; Staten Island AA (Pres.). Work: Boston AC [40]

WIGGAM, W.M. [P] Toledo, OH. Member: Artklan [25]

WIGGINS, Carleton [Ldscp.P] Old Lyme, CT (since 1915) b. 4 Mr 1848, Turner's, Orange County, NY d. 12 Je 1932. Studied: NAD, with G. Inness, 1870; Carmeincke, in Brooklyn; Paris, 1880–81. Member: ANA, 1890; NA, 1906; SAA, 1887; AWCS; SC, 1898; Lotos C; Brooklyn AC; A. Fund. S.; A. Aid S.; Am. Soc. Animal P.&S.; CAFA; Lyme AA; AFA. Exhibited: Prize Fund Exh. NYC, 1894 (gold); Pan-Am. Expo, Buffalo (med), 1901; Paris Salon, 1881; Royal Acad., London. Work: NGA; MMA; Lotos Cl., NYC; Hamilton C., Brooklyn; CGA; NGA; Brooklyn Inst. Mus.; AIC; Newark Mus. Specialty: landscapes with cattle. Father of Guy. [31]

WIGGINS, George E.C. [I,T] Phila., PA. Exhibited: PAFA, 1938. Position: T., PAFA [40]

WIGGINS, Guy C. [P,T] NYC (until 1920s)/Lyme, CT (1905–37)/Essex, CT (1937–62) b. 23 F 1883, Brooklyn, NY d. 25 Ap 1962, St. Augustine, FL. Studied: with his father Carleton; NAD; W.M. Chase; R. Henri. Member: ANA, 1916; NA, 1935; SC, 1907; CAFA (Pres. 1927–30s); Lotos C.; NAD; Lyme AA; Kit Kat C.; New Haven PCC; NAC. Exhibited: CAFA, 1916 (prize), 1918 (prize), 1926 (prize), 1931 (prize), 1933 (prize); RISD, 1922 (prize); New Rochelle Soc., 1929 (prize); New Haven PCC, 1930 (prize); Lotos C., 1938 (prize); SC, 1916 (prize), 1919 (prize). Work: MMA; NGA; Brooklyn Inst. Mus.; Hackley Art Gal., Muskegon, Mich.; AIC; Dallas Art Assn.; Lincoln (Nebr.) AA; Newark (N.J.) Mus.; Lotos Cl.; NAC; Wadsworth Athenaeum; Beach Mem. Gal., Storrs, Conn.; Detroit Athletic C.; Denton College, Tex.; Cincinnati C., Cincinnati, Ohio; New Britain (Conn.) Inst.; Heckscher Park Art Mus., Huntington, N.Y.; Syracuse MFA; Reading Mus.; City Coll., Richmond, Ind.; Amherst Col.; Univ. Nebr. A. Gal. Work: Position: Dir., Guy Wiggins Art Sch., Essex, Conn. [47]

WIGGINS, John Gregory [C] Pomfret, CT/North Belgrade, ME b. 17 N 1890, Chattanooga, TN. Member: Boston SAC. Work: St. Paul's Sch., Concord, N.H.; Trinity Col. Chapel, Hartford, Conn.; anthropological models, Peabody Mus., Andover, Mass.; models, Marine Room, BMFA. Specialties: woodcarving; models [40]

WIGGINS, Myra Albert [P,Des,W,T,Photogr] Seattle, WA b. 15 D 1869, Salem, OR d. 14 Ja 1956. Studied: Willamette Univ., Salem, Oreg.; Mills Col.; ASL; W. Chase; K. Cox; G. deF. Brush; W. Metcalf; J.H. Twachtman; F.V. Dumond; N.Y. Sch. A. Member: NAWA; AAPL; AFA; Women P. of Wash.; Am. A. Group; Lg. Am. Pen Women; Pacific Coast Assn. P.&S. Exhibited: SAM; Vancouver (B.C.) A. Gal.; AIC, 1933 (prize); New Orleans, La.; Albright A. Gal.; Lg. Am. Pen Women, 1939 (prize); Rochester Mem. A. Gal.; Portland (Oreg.) A. Mus.; Spokane, Wash.; San Fran.; Phila.; Alaska; Argent Gal., 1946 (one-man); numerous salons in Europe. Work: State Lib., Pub. Lib., both in Olympia, Wash.; YMCA, YWCA, both in Yakima, Wash. [47]

WIGGINS, Sidney Miller [Dec,Des,P] Yonkers, NY b. New Haven, NY. Studied: R. Henri; E.J. Sloane. Member: SC; Yonkers AA; NYWCC; AWCS; Allied AA [40]

WIGGLESWORTH, Frank [P,S] Boston, MA b. 7 F 1893. Studied: C. Grafly. Member: Boston SS; Boston AC; North Shore AA; Gloucester SA [33]

WIGHT, Moses [Por.P,Genre P] Paris, France b. 2 Ap 1827, Boston d. 1895. Studied: Europe; Rome, 1851–54. Work: Am. Antiquarian S. His studio was in Boston, 1854–73; then settled in Paris, where he specialized in interior scenes. [*]

WIGHTMAN, Francis P. [P] Baltimore, MD [13]

WIGLE, Arch P. [P] Detroit, MI [24]

WIKEN, Dick [S,C,Des,W,T,L] Milwaukee, WI b. 11 Ap 1913, Milwaukee, WI. Studied: Univ. Wis.; mostly self-taught. Member: Wis. P.&S. Exhibited: Wis. P.&S., 1934, 1935 (med) 1937, 1939–41; Madison Salon A., 1935 (prize), 1937 (prize), 1939, 1940; Wash., D.C., 1936, 1937; Rockefeller Center, N.Y., 1934, 1938; WFNY, 1939; PAFA, 1940; Miss. Valley A., 1941; AIC, 1941; Syracuse Mus. FA, 1939; Nat. Exh. Am. A., N.Y., 1937, 1938; Milwaukee AI, 1934 (prize), 1935 (med). Work: Pub. Sch., Milwaukee; Soldier's Field, Administration Bldg., both in Chicago. Specialties: woodcarving; ceramics [47]

WIKSTROM, Bror Anders [P] b. ca. 1839, Stora Lassana, Sweden d. 27 Ap 1909, NYC. Studied: Acad., Stockholm; E. Perseus. Member: NOAA. Designed floats used in the Mardis Gras carnivals for about 35 years. [08]

WILBER, Ruth [P] Chicago, IL b. 1915, Lake Forest, IL. Studied: AIC. Exhibited: AIC, 1940 (prize) [40]

WILBERFORCE, T.C. [P] Glen Ridge, NJ [01]

WILBERG, Theodore L. [P] Cincinnati, OH. Member: SWA [15]

WILBUR, Dorothy Thornton [P,I,S] Wash., D.C. b. Fincastle, VA. Studied: F. Fursman; J. Golz; A. Schille. Exhibited: Minnesota SA, 1924 (prize). Illustrator: "Stars" [47]

WILBUR, Eleanore E. [P] Boston, MA b. 1844 d. 12 D 1912, Cambridge, MA [01]

WILBUR, Ernest C. [Cart] Oak Park, IL [19]

WILBUR, Lawrence L. [I] NYC. Exhibited: National Preparedness, 1917, best Army poster (prize) [17]

WILBUR, Lawrence Nelson [P,E,Li] NYC b. 21 D 1897, Whitman, MA. Studied: Mass. Normal A. Sch.; Otis AI; Grand Central Sch. A.; N.C. Wyeth. Member: SAE; AWCS; SC; Chicago SE; All.A.Am. Exhibited: AWCS, 1943 (prize); SC, 1942 (prize), 1943 (prize); NAD, 1941, 1943; SAE; Chicago SE; All.A.Am., annually; Argent Gal., 1938 (one-man); Am. WCC, 1936, 1937, 1938; PAFA, 1938; Am. WCC, NYWCC, 1939. Work: LOC; NGA; PMA [47]

WILBUR, Margaret Craven [S] NYC b. Detroit. Studied: Detroit Sch. FA; A. Polasek; AIC. Member: NAWPS. Affiliated with Phoenix AI [40]

WILBY, Margaret Crowninshield [Por.P] Detroit, MI b. 3 Ja 1890, Detroit. Studied: AIC; ASL; Ontario Col. A.; E. O'Hara; J.P. Wicker; J.H. Vanderpoel; C.W. Hawthorne; A. Tucker; T.H. Benton. Member: Deerfield Valley (Mass.) AA; Detroit Soc. Women P.; NAWA. Exhibited: NAWA, 1932–34, 1939, 1940; Detroit Inst. A., 1939, 1942, 1943; Detroit Women P.; Detroit WCC, 1946; Rockport AA, 1931; Gloucester AA, 1934; Deerfield Valley AA, 1933, 1934, 1937, 1938 [47]

WILBY, Martha [P] Cincinnati, OH. Affiliated with Art Acad. Cincinnati [10]

WILCOCKS, Edna Marrett [P,T,W] Altadena, CA b. 11 My 1887, Portland, ME. Studied: Vassar; BMFA Sch., with F. Benson, E. Tarbell, P. Hale; ASL; Pratt; Harrison. Member: Women P. of the West. Exhibited: Women P. of the West, 1933–46; Pasadena SA, 1930–34. Work: Court House,

Wilkes-Barre, Pa.; Bowdoin Col.; Court House, Edmonton, Alberta. Position: T., Flintridge Sch. for Girls, Pasadena [47]

WILCOTT, Frank [P] Chicago, IL [08]

WILCOX, Beatrice C. [P] Chicago, IL b. Geneva, IL. Studied: AIC. Member: SWA [01]

WILCOX, Frank Nelson [P,E,I,L,W,T] East Cleveland, OH (1962) b. 3 O 1887, Cleveland. Studied: H.G. Keller; F.C. Gottwald. Member: Cleveland SA. Exhibited: Cleveland, 1920 (med); CMA Ann., 1932 (prize). Work: CMA; Brooklyn Mus.; TMA; San Diego Gal. FA. Author/Illustrator: "Ohio Indian Trails." Position: T., Cleveland Sch. A.; John Huntington Polytechnic Inst. [40]

WILCOX, John A.J. [P,I] Boston, MA. Member: Boston AC [10]

WILCOX, Harriet E. [P] Cincinnati, OH [10]

WILCOX, Lois [Mur.P,Li,C,T,W] Wellesley, MA b. 11 Ja 1889, Pittsburgh. Studied: ASL, with F.V. DuMond; BMFA Sch., with P. Hale; W. Metcalf; C. Hawthorne; Rome, with Galemberti, Venturini-Papari. Exhibited: Arch. L.; Fifty Prints of the Year, 1939; NAD; CGA, 1935, 1937; Century of Progress, Chicago; many nat. exh. lithographs. Contributor: Magazine of Art. Position: T., Sweet Briar Col., Va., 1933–39 [47]

WILCOX, Ray [P,I,W] Tenafly, NJ b. 9 D 1883, Elmira, NY. Studied: Rochester Athenaeum; ASL; Colarossi Acad., Paris. Member: SC; AAPL. Exhibited: Kresge Gal., Newark, 1933 (prize), AAPL, 1935 (med); Montclair AA, 1936 (med); SC, 1936 (med); nat./state exhibits. Author/Illustrator: "Feathers in a Dark Sky," 1941 [47]

WILCOX, Ruth (Mrs. Dawes) [P] Closter, NJ b. 4 Ag 1908, NYC. Studied: ASL; N.Y. Sch. F.&Appl. A.; PAFA; Académie Julian, Paris. Member: NAWA; AAPL. Exhibited: NAWA, 1932 (prize), 1933, 1934 (prize), 1935–46; NAD, 1931-33, 1934 (prize); Ridgewood (N.J.) AA, 1935 (prize); Wichita AM, 1937 (prize); Montclair AM, 1936 (med), 1939 (med); PAFA; CI, 1941; CAFA, 1934; Montclair AM, 1933–46; Rochester, Poughkeepsie, both in N.Y.; Jersey City, Newark, Hackensack, Trenton, all in N.J. Work: Maugham Sch., Tenafly, N.J.; Grammar Sch., Leonia, N.J.; Palisades Interstate Park Comm. [47]

WILCOX, Ruth Turner (Mrs. Ray) [P,I,L] Tenafly, NJ b. 29 Ap 1888, NYC. Studied: Académie Julian, Paris; Munich. Member: NAWA; AAPL. Exhibited: NAWA; Wichita Mus. A.; Delgado Mus. A.; Montclair AM; N.J. State Exh., Montclair, 1934 (prize). Author/Illustrator: "The Mode in Costume," 1942, "The Mode in Hats and Headdress," 1945 [47]

WILCOX, Urquhart [P,T] Buffalo, NY b. 1876, New Haven, CT d. 16 My 1941. Studied: ASL, Buffalo. Exhibited: Buffalo SA, 1906 (prize), 1911 (prize), 1913 (prize). Work: Albright A. Gal., Buffalo. Position: Dir., Sch. FA, Albright A. Gal. [40]

WILDE, Ida M. [Min.P] Brooklyn, NY. Exhibited: Brooklyn Soc. Min. P., 1934, 1935; Pa. Soc. Min. P., PAFA, 1934, 1935, 1939; Wash. Soc. Min. P. S.&G., 1939 [40]

WILDE, Lois (Lois W. Hartshorne) [Por.P] Minneapolis, MN b. 17 D 1902, Minneapolis. Studied: C. Booth; Angorola; A. Kanoldt; Lhote, in Paris. Member: Minn. A. Un. Exhibited: Minn. State Fair, 1936 (prize) [40]

WILDEN, Jim [S] NYC [17]

WILDEN, Spence [I,Indst.Des] b. 1906 d. 31 O 1945, New Rochelle, NY. Studied: ASL. Member: SI. Position: A. Ed., Woman's Home Companion, 1945

WILDENRATH, Jean A(lida) [P,S] NYC b. 3 N 1892, Denmark. Studied: G.F. Morris; J. Dupont; Cooper Union; NAD [33]

WILDENSTEIN, Nathan [Dealer] b. 1852 d. 24 Ap 1934, Paris. Founder: Wildlenstein and Co., N.Y., 1903, a branch of his Paris firm.

WILDER, Arthur B. [Ldscp.P] Woodstock, VT b. 23 Ap 1857, Poultney, VT. Studied: ASL; Brooklyn A. Gld. Sch.; T. Eakins. Member: AFA; Mid. Vt. Ar. Assn., Rutland. Work: murals, Woodstock Inn, Vt. [40]

WILDER, Bert (Gil Parché) [P,E,T] NYC/Homer, NY b. 17 S 1883, Taunton, MA. Studied: Cooper Union; Académie Julian; Mass. Sch. A.; BMFA Sch. Member: Kit Kat C. Exhibited: Puerto Rico, 1933 (prize) [40]

WILDER, H. S. [P] Newton, MA. Member: Boston AC [25]

WILDER, Herbert Merrill [I] NYC/Hinsdale, NH b. 26 S 1864, Hinsdale. Studied: T. Juglaris, in Boston. Specialty: comic subjects [10]

WILDER, Louise (Hibbard) (Mrs. Bert) [S,E,T] NYC/Homer, NY b. 15 O 1898, Utica, NY. Studied: G.T. Brewster. Member: NAWPS; Soc. Med. Exhibited: Nat. Garden Show, N.Y., 1929 (prize). Work: Court House, Newark; mem. fountain, Home for Indigent Aged, Wash., D.C. [40]

WILDER, Mitchell Armitage [Mus.Dir] Colorado Springs, CO b. 19 Ag 1913, Colorado Springs. Studied: McGill Univ., Montreal; Univ. Calif. Position: Asst. Ed., Santos' "Religious Folk Art of New Mexico"; Dir., Taylor Mus., Colorado Springs FA Center [47]

WILDER, Ralph (Everett) [Caric] Morgan Park, IL b. 23 F 1875, Worcester, MA. Studied: AIC; Chicago Acad. FA. Position: Staff, Chicago Record-Herald, since 1903 [21]

WILDER, Tom Milton [P,B] Ravinia, IL b. 3 Mr 1876, Coldwater, MI. Studied: AIC. Member: North Shore AL; Lake County AL; Southern Pr.M. Soc. Exhibited: Southern Pr.M. Soc., 1937 (prize) [40]

WILDHACK, Robert J. [I,P] La Crescenta, CA b. 27 Ag 1881, Pekin, IL. Studied: R. Henri, N.Y.; O. Stark, Indianapolis. Member: SI, 1910; SC; Artists Gld. Specialties: posters; humorous line drawings [31]

WILDMAN, Caroline Lax [P] Bellaire, TX b. Hull, England d. 1 D 1949. Exhibited: Mus. FA, Houston, 1938, 1939, 1944 (prize); SSAL, 1938; San Antonio, Tex., 1939 [47]

WILDMAN, Mary Frances [E] Palo Alto, CA b. 10 O 1899, Indianapolis. Studied: Stanford Univ. Member: Calif. SE; Palo Alto AC. Exhibited: PAFA, 1928–31; Phila. Pr. C.; Calif. SE, 1926–32; Palo Alto AC, 1929, 1930 [47]

WILENCHICK, Clement [P] NYC b. 28 O 1900, NYC. Studied: A.B. Carles; H. McCarter [25]

WILES, Bertha Harris [Edu,W] Chicago, IL b. 17 D 1896, Sedalia, MO. Studied: Univ. Ill.; Univ. Wis.; Am. Acad., Rome; Radcliffe Col. Member: CAA. Awards: Carnegie F., 1927, 1928; traveling sch., 1929; Am. Council Learned Soc. grant, 1931; Sachs F., Harvard Univ., 1936. Author: "Fountains of Florentine Sculptors," 1933. Positions: T., Radcliffe (1930–35), Univ. Chicago (1940–) [47]

WILES, Gladys Lee (Mrs. W.R. Jepson) [P] Peconic, NY b. NYC. Studied: K. Cox; W.M. Chase; Johansen; Wiles. Member: ANA, 1934; NAWPS; Allied AA; NYSP; AAPL. Exhibited: NAWA, 1919 (med) [47]

WILES, Irving R(amsay) [Por.P,I,T] Peconic, NY b. 8 Ap 1861, Utica, NY d. 8 Ap 1948. Studied: his father L.M. Wiles; W.M. Chase; J.C. Beckwith, at ASL, 1880–82; Carolus-Duran, in Paris, 1882. Member: ANA, 1889; NA, 1897; SAA, 1887; AWCS; NIAL; All. AA; Paris AAA; AAPL; A. Fund S.; Por. P.; Pastelists; Arch. L., 1897; NYWCC, 1904. Exhibited: NAD, 1897–1900; Knoedler Gal., NYC, 1900s (first one-man show); NAD, 1886 (prize), 1889 (prize), 1913 (prize), 1919 (prize), 1931 (prize), 1936 (prize); Paris Expo, 1889 (prize), 1900 (med); Col. Expo, Chicago, 1893 (med); AWCS, 1897 (prize); Tenn. Centenn., Nashville, 1897 (med); SAA, 1900 (med); Pan-Am. Expo., Buffalo, 1901 (prize); S. Wash. A., 1901 (prize); St. Louis Expo., 1904 (gold); Appalachian Expo, Knoxville, 1910 (med); Buenos Aires Expo, 1910 (gold); P.-P. Expo, San Fran., 1915 (gold); Newport AA, 1917 (prize); Duxbury AA, 1921 (prize); PAFA, 1922 (prize). Work: Hotel Martinique, N.Y.; City Hall, Brooklyn; CGA, NGA; West Point Military Acad.; MMA; Butler AI; Univ. Berlin, Germany; State Dept., Wash., D.C.; Chase Bank; Banker's Club, N.Y.; Columbia Univ.; Lotos C. Illustrator: Harpers, Scribner's, Century, 1880s. Positions: T., ASL, 1890s-1900s; Chase Sch. A.; Wiles Summer Sch., Peconic, 1890s [47]

WILES, Lemuel Maynard [Ldscp.P,T] NYC (since 1864) b. 21 O 1826, Perry, NY d. 28 Ja 1905. Studied: N.Y. State Normal Col., 1847; Ingham Univ., LeRoy, N.Y., 1848; Albany Acad., with W.M. Hart, from 1848; NYC, with J.F. Cropsey, early 1850s. Work: Perry (N.Y.) Pub. Lib.; Ingham, Univ., N.Y. Father of Irving. Position: Dir., Col. FA, Ingham; Dir., A. Dept., Univ. Nashville; T., Wash., D.C., Albany, N.Y.; Dir., summer sch., Silver Lake

WILEY, Catherine [P] Knoxville, TN [25]

WILEY, Frederick J. [P] NYC. Member: Century Assn.; Lotos C.; Mural P. Exhibited: St. Louis Expo, 1904 (med) [33]

WILEY, Hedwig [P,T] Phila., PA b. Phila. Studied: PAFA, with W.M. Chase; Univ. Pa.; C. Beaux; H. Snell; Dow; Breckenridge. Member: Plastic C.; A. All., Phila.; Pr. C., Phila; AFA. Exhibited: PAFA; Phila. AC; Phila. Pr. C.; Phila. Plastic C. [47]

WILEY, Lucia [Mur.P] Minneapolis, MN/Camp Danworthy, Walker, MN b. Tallamook, OR. Studied: Univ. Oreg. Member: Mur. P.; Minn. Artists Assn. Work: Univ. Oreg. Eugene; Miller Vocational H.S., Minneapolis, Armory, Minneapolis; Seattle AM; USPO, Intl. Falls, Long Prairie, Minn. WPA artist. [40]

WILFORD, Loran Frederick [P,T,I] Stamford, CT b. 13 S 1892, Wamego, KS d. 1972. Studied: Kansas City AI; C. Wilimovsky; G.P. Ennis. Member: S.Indp.A.; Artists Gld.; Salons of Am.; NYWCC; AWCS (life); SC; N.Y. AG. Exhibited: AWCS, 1929 (prize), 1932 (prize); Phila. WCC, 1931 (prize); SC, 1930 (prize); Audubon A., 1945 (prize); Calif. P.M., 1922 (prize); Kansas City AI, 1922 (med); NYWCC, 1929 (prize); Fla. Fed. A., Miami, 1937 (prize); CI, 1946; CGA; NAD; PAFA; GGE, 1939. Work: TMA; NYPL; Holmes Pub. Sch., Darien, Conn. [47]

WILHELM, Adolph L. [P] St. Paul, MN [24]

WILHELM, Arthur Wayne [Ldscp.P,Li] NYC b. 13 Ap 1901, Marion, OH. Studied: B. Robinson; C. Rosen; C. Hawthorne; W. Von Schlegell; R. Reid; Matulka. Member: Woodstock AA [40]

WILHELM, E(duard) Paul [Mur.P,T] Dayton, OH b. 7 My 1905, Königsberg, East Prussia, Germany. Studied: State Art Sch., Königsberg. Work: Dayton AI. Position: T., U.S. Indst. Reformatory, Chillicothe, Ohio [40]

WILHELM, R(oy) (E.) [P,Des,B,I] Cuyahoga Falls, OH b. 19 F 1895, Mt. Vernon, OH d. 8 Je 1954. Studied: John Huntington IA, Cleveland; J. Carlson; E. Novotny; H. Keller; Cleveland Sch. A.; S. Vago; E. Gruppe. Member: Akron SA; North Shore AA; Buffalo SA; Ohio WCC. Exhibited: Canton AI, 1945, 1946; Akron AI, 1946. Work: Ohio Bell Telephone Co. Coll.; Akron AI; Ohio Fed. Women's C. [47]

WILIMOVSKY, Charles A. [E,En,P,T,B] Chicago, IL b. 10 S 1885, Chicago. Studied: AIC, with J.C. Johansen, W.M. Chase; Académie Julian, Paris. Member: Chicago SE; Prairie Pr.M.; SAE; Chicago SA. Exhibited: Kansas City AI, 1916 (prize), 1920 (prize), 1923 (prize); AIC 1924 (prize), 1929 (prize), 1937 (prize); Univ. Okla. (med); Okla. Artists, 1917 (med); nationally; Paris, Brussels; Florence; Rome. Work: Kansas City AI; AIC; Springfield (Mass.) Pub. Lib.; Honolulu Acad. A.; Mod. Gal., Prague; Lindsborg (Kans.) Univ.; Kansas City C.; City of Chicago Coll.; Cedar Rapids A.; Bibliothèque Nationale, Paris. Positions: T., AIC; Am. A. Acad. [47]

WILKE, William H(ancock) [Des,E,I,T,B] Berkeley, CA b. San Fran. Studied: Mark Hopkins IA; Académie Julian, with Laurens, Blanche; A.F. Mathews. Member: Calif. SE; San Fran. Fed. Arts. Exhibited: P.-P. Expo, San Fran., 1915 (gold). Work: "Fifty Best Books," Am. Inst. Graphic A.; etchings in privately printed books [47]

WILKES, Susan H. [P] White Bluff, TN [15]

WILKEVICH, Eleanor (Mrs. Proto A.) [P,T] San Diego, CA b. 2 Ag 1910, NYC. Studied: Grand Central Sch. A.; ASL; G.P Ennis; H.B. Snell; A. Hibbard. Member: San Deigo AG; La Jolla AG; La Jolla A. Lib. Assn. Exhibited: San Diego FA Soc., 1943 (prize), 1946 (prize); GGE, 1939; La Jolla A. Center (one-man); Laguna Beach AA (one-man); Admiral Hotel Gal., San Diego; La Jolla AG (one-man); San Diego AG (one-man); Cedar City, Utah (one-man) [47]

WILKIE, Robert D. [P,I,T] Boston and Roxbury, MA, 1856–1902 b. F 1828, Halifax, Nova Scotia d. 1903, Swampscott, MA. Illustrator: "Gleason's Pictorial Drawing Room Companion," 1850s; Leslie's, 1863–65. Exhibited: Vose Gal., Boston, 1948 (rediscovery) [*]

WILKIN, Mildred Pierce (Mrs.) [P,T] Corona, CA b. 23 N 1896, Kansas. Studied: Los Angeles State Normal Sch.; Columbia; UCLA; Calif. Sch. FA; A.A. Hills. Member: Calif. WCS. Exhibited: Calif. WCS, 1925–32, 1936; Laguna Beach AA, 1925–32; Ontario, Calif., 1941, 1945 [47]

WILKINS, Elizabeth Waller [P,Des,I,T,Dec] Phila., PA (living in Wytheville, VA, 1940) b. 29 Jy 1903, Wheeling, WV. Studied: Detroit Sch. FA; PMSchIA; J.P. Wicker; J.J. Dull. Member: SSAL; Detroit Ar. Market. Exhibited: Times-Herald A. Fair, Wash., D.C., 1946 (prize) [47]

WILKINS, Emma Cheves [P,T] East Savannah, GA b. 10 D 1871, Savannah. Studied: Telfair Acad., Savannah, with C.L. Brandt; Colarossi Acad., Paris, with Courtois, Girardot. Position: Principal, A. Sch., Savannah [25]

WILKINS, Gladys M(arguerite) [B,C,Des,E,P,T] Providence, RI/Broadway, Rockport, MA b. 15 Ap 1907, Providence. Studied: RISD. Member: Providence WCC; South County AA; Providence AC; AAPL; Rockport AA; AM. Fed. A.; Southern Pr. M. Soc. Position: T., RISD [40]

WILKINS, Margaret [P] Newton Center, MA [19]

WILKINS, Ralph Brooks [P,Des] NYC b. San Jose, CA. Studied: Calif. Sch. FA. Exhibited: best non-fiction book jacket of year, "The American Adventure," Muzzey, 1928 (prize). Designer: book jackets, Harper's, Scribner's, Dodd Mead, Morrow, Appleton-Century, Farrar and Rinehart[40]

WILKINSON, Edith L. [P] Affiliated with Lovell Studio, Provincetown, MA [24]

WILKINSON, Edward [P,S,Arch,Dec,T,W] Garden Villas, TX/Houston, TX b. 22 Ja 1889, Manchester, England. Studied: J. Chillman; J.C. Tidden; Rice Inst. Work: hist. dioramas for mus. in Houston and Huntsville, Tex.; Capitol, Tex.; Houston Pub. Lib. Articles: "Texas Historical Buildings," Tex. papers and "Journal" [40]

WILKINSON, F.A. [P] Surrey, England [10]

WILKINSON, Fritz [I,Car] NYC. Illustrator: New Yorker, 1939 [40]

WILKINSON, Jack [P,T] Euguene, OR b. 2 Jy 1913, Berkeley, CA d. 1973. Studied: Univ. Oreg.; Calif. Sch. FA; Paris; M. Sterne. Member: San Fran. AA; Oreg. Gld. P.&S. Exhibited: 48 States Comp., 1940 (prize); San Fran., 1937 (prize); Portland A. Mus., 1945 (one-man). Work: SFMA; Univ. Oreg.; Eagles Lodge, Eugene, Oreg.; USPO, Burns, Oreg. WPA artist. Position: T., Univ. Oreg., 1941– [47]

WILKINSON, R. [P] Newburgh, NY [13]

WILKINSON, Rhoda [P] NYC [13]

WILKINSON, Ruth Lucille [P] Des Moines, IA b. 18 My 1902, Des Moines. Studied: C.A. Cumming; C.W. Hawthorne. Member: Iowa AG. Work: Iowa Memorial Union, Iowa City [40]

WILKINSON, Tom [P,I] NYC. Member: GFLA [27]

WILL, August [P,I] Jersey City, NJ b. 1834 d. 24 Ja 1910 [01]

WILL, Blanca [S,P,T] Winslow, AR b. 7 Jy 1881, Rochester, NY. Studied: Rochester Mechanics Inst.; Grande Chaumiere, Paris; H. Adams; J. Fraser; G.G. Barnard; D.W. Tryon; J. Alexander; Tyrohn, in Karisruhe; Luhrig, in Dresden; Castellucho, in Paris; H. Hofmann. Exhibited: Rochester Mem. A. Gal., 1932 (prize), 1933 (prize); Rochester, 1934 (prize); N.Mex. State Fair, 1938-40 (prize); NAD; PAFA; traveling exh. bronzes, U.S. and Canada; Coronado, Calif.; Univ. N.Mex.; Albuquerque, N.Mex.; Mus. N.Mex., Santa Fe (one-man); Rochester, N.Y. (one-man). Work: Rochester Mem. A. Gal.; Univ. Ark.; sculptured busts; oil portraits; Univ. Rochester; New Sch. Soc. Res. Position: T., Memorial A. Gal., Rochester [47]

WILL, John M. [Por.Dr,Ldscp.Dr,Des] Jersey City, NJ b. 1834, Weimar, Germany (came to NYC before 1855) d. 29 Ja 1910 [*]

WILLARD, Archibald M. [P] Cleveland, OH b. 22 (or 26) Ag 1836, Bedford, OH d. 11 O 1918. Work: Abbot Hall, Marblehead, Mass. His best known painting is "The Spirit of '76."

WILLARD, Frank Henry [Car] Tampa, FL b. 21 S 1893 d. Ja 1958. Studied: Chicago Acad. FA. Work: 238 newspapers; 7 books; reproductions of strips, "The Plushbottom Twins," "Moon and Kayo." Creator: "Moon Mullins." Affiliated with Chicago-Tribune, New York News Syndicate [40]

WILLARD, Howard W. [Li,I] NYC b. 8 S 1894, Danville, IL d. 1960. Studied: ASL. Member: Artists Gld. Exhibited: Fifty Best Books of the Year, 1931. Illustrator: "The Silverado Squatters," "The Colophon," 1931. Specialty: lithographs of Chinese [40]

WILLARD, L. L. (Miss) [P,W,T] Salt Lake City, UT b. 29 S 1839 [17]

WILLARD, Marie T. [P] NYC [25]

WILLARD, Rodlow [Cart,I,Des,W] NYC b. 7 S 1906, Rochester, NY. Studied: Univ. Calif. Member: A. Gld. Exhibited: Cart. Gld. Traveling Exh., 1938–40. Illustrator: "Word Magic," 1939; "Hungry Hill," 1943. Position: Staff Cart., Digest magazine, "Review of Reviews," 1936–37 [47]

WILLARD, Theodora [P] Cambridge, MA b. Boston. Studied: A.F. Graves; A.W. Bühler. Member: Copley S., 1892 [25]

WILLARD, William [Por.P] Sturbridge, MA b. 24 Mr 1819, Sturbridge, MA d. 1 N 1904. Exhibited: Boston Athenaeum. Work: Am. Antiquarian S. Active in Boston, 1850s. [*]

WILLCOX, Anita. See Parkhurst.

WILLCOX, Arthur V. [P] Glendalough House, County Galway, Ireland. Member: Phila. AC [25]

WILLCOX, James M. [P] Lisnabrucka Recess, County Galway, Ireland [25]

WILLCOX, W. H. [P,I] Germantown, PA b. 1831, NY. Studied: J.L. Williams; PAFA. Member: A. Fund S. [17]

WILLET, Anne Lee (Mrs. William) [C,Dec,Des,P,T,L,W] Phila., PA b. 1867, Bristol, PA d. 18 Ja 1943 (visiting in Atlanta, GA). Studied: PAFA; Anshutz; Richardson; W. Willet. Member: Stained Glass Assn. Am.;

MacD. C. Work: stained glass windows, Cadet Chapel, U.S. Military Acad.; Chicago Theological Seminary; all windows, including Hilton Devotional Chapel, Journeys of the Pilgrims, Students' Lounge, Graham Taylor Chapel Lib. and Hall, First Presbyterian Church, Church of the Atonement, Col. of Surgeons, Chicago; Grosse Point Mem. Presbyterian Church, Mich.; Blessed Sacrament Church, Jefferson Ave. Presbyterian Church, Metropolitan Methodist Church, Detroit; St. Columbia's Protestant Episcopal Church, Wash., D.C.; Greenwood Cemetery Chapel, Brooklyn, N.Y.; St. Paul's Cathedral, Calvary Protestant Episcopal Church, Pittsburgh; DuPont mem. front windows, St. John's Episcopal Cathedral, Wilmington, Del.; sanctuary window, St. John's Protestant Episcopal Church, Locust Valley, N.Y.; All Saints' Chapel, Univ. Tex., Austin; Colonial Dames, Whitefield Mem., Bethesda, at Savannah, Ga.; Church of the Resurrection, Rye, N.Y.; Princeton Graduate Col.; Harrison Mems., Holy Trinity, Calvary Protestant Episcopal Church, Phila.; Trowbridge Mems., Santa Fe, N.Mex.; Wilson Mem., St. Gabriel's, Calif.; sanctuary window, Church St. John the Lateral, Locust Valley; Trinity Cathedral, Cleveland; Garford, Abbe Mems., St. Andrews Church, Elyria, Ohio; St. James Methodist Episcopal Church, Phila.; St. Nathaniel's Church, Phila.; Church of Nativity, Fox Chase, Pa.; Trinity Episcopal Church, Miami; Potter Mem., Jamestown, R.I.; Pardee Mem., Lake Placid, N.Y.; Chichester Mem., Leesburgh, Va.; Page Mem., Fredericksburg, Va. Articles: "Art and Archaeology" [40]

WILLET, Henry Lee [C,L] Ambler, PA b. 7 D 1899, Pittsburgh. Studied: Princeton; Univ. Pa.; Europe; W. Willet. Member: AFA; AIA; Arch. L.; Stained Glass Assn. Am. (Nat. Pres., 1942–44); Fairmount Park AA; T. Square C.; Phila. All.; Pa. Mus. A.; Medieval Acad. Am. Exhibited: leading galleries in U.S. Work: stained glass windows for churches and chapels: Nat. Cathedral, Wash., D.C.; West Point; Randolph Field, San Antonio, Tex.; Chicago Theological Seminary; Northwestern Univ.; Berea, Ky.; Wilmington, Del.; Longport, N.J.; Muskegon, Mich.; Columbia, S.C.; Grosse Pointe, Mich.; Buffalo, N.Y.; Pittsburgh; Ardmore, Pa.; Atlanta; Baltimore; Palmer, Mass.; Jackson, Miss.; Winter Park, Fla.; San Juan, Puerto Rico; Pelham, N.Y.; many others; great west window, St. Mary's Sch., Glens Falls; St. Paul's Episcopal Cathedral, Detroit; Chancel rose; Martin Luther Church, Youngstown; epic windows, McCartney Lib., Geneva Col., Beaver Falls, Pa.; Valley Forge Military Acad.; Trinity Episcopal Church, Swarthmore, Pa.; St. Peter's Episcopal Church, Phoenixville, Pa.; First Unitarian Church, New Orleans; Presbyterian Church, Rye, N.Y.; Christ Episcopal Church, Greensburg, Pa.; St. Paul's Episcopal Cathedral, Erie, Pa. [47]

WILLET, William [Mur.P,C,L,W] Phila., PA b. 1 N 1868, NYC d. 29 Mr 1921. Mechanics' and Tradesmen's Inst., N.Y.; Van Kirk; Chase; J. La Farge; France; England; Whittaker. Member: Mur. P.; Arch. Lg., 1910; Boston SAC; St. Dunstan's C., Boston; Phila. Alliance. Work: stained glass windows, churches at: West Point Military Acad.; Proctor Hall, Post Graduate Col., Princeton; Trinity Cathedral, Cleveland; St. John's Church, Locust Valley; St. Paul's Cathedral, Pittsburgh; Calvary Church, Germantown; St. Alvernia's Convent, Presbyterian Hospital Chapel, Third Presbyterian Church, all in Pittsburgh; Greenwood Cemetery Chapel, N.Y.; Trinity Church, Syracuse; St. Paul's Church, Halifax, Nova Scotia. Author: "Stained Glass in Our Churches" [19]

WILLETS, Anita [P,I,C,T] Chicago, IL b. 22 Ag 1880, Brooklyn, NY. Studied: AIC, with Vanderpoel, F. Freer; F.V. DuMond; W.M. Chase. Member: ASL, Chicago (Sec. 1903) [08]

WILLETT, Arthur Reginald [Mur.P,Dec] NYC b. 1868, England. Studied: E.H. Blashfield; H.S. Mowbray; F. Lathrop; London. Member: Mural P.; Arch. Lg.; A. Fellowship. Capitol, St. Paul, Minn.; Courthouse, Youngstown, Ohio; Foreign Relations Committee Room, U.S. Capitol [40]

WILLETT, J(aques I.) [P] NYC b. 1882, Petrograd, Russia d. 19 My 1958. Studied: Imperial Acad. Art, Petrograd; Munich; Paris. Member: Allied AA; Brooklyn SA; PS; Salons of AM.; S.Indp.A.; Contemporary A. Work: Newark Mus.; Univ. N.C., Chicago; Acad. Allied A., N.Y. [40]

WILLEY, Edith M(aring) (Mrs. N.C.) [P,E,W,T] North Seattle, WA/ Union, WA b. 4 Je 1891, Seattle. Studied: E.P. Ziegler; P. Camfferman; E. Forkner; C.C. Maring; L. Annin; A.C. Foresman. Member: Pacific Coast P.S.&W.; Lg. Am. Pen Women; Women P. of Wash. Work: Law Lib., Capitol, Olympia, Wash.; John Hay Sch., King County Court House, Seattle [47]

WILLIAM, Meyvis Frederick [P] Rochester, NY [10]

WILLIAMS, Abigail Osgood [P,T] Salem, MA b. O 1823, Boston d. 26 Ap 1913. Studied: Rome, 1860–61. Sister of Mary E. Position: T., Salem sch. [*]

WILLIAMS, Ada G. (Mrs.) [P] Cincinnati, OH. Member: Cincinnati Women's AC [24]

WILLIAMS, Adele [P] Richmond, VA. Member: AWCS; NYWCC. Exhibited: Pittsburgh AA, 1912 (prize); NAWA, 1936–38 [47]

WILLIAMS, Alice L. [P] Phila., PA. Exhibited: Intl. WC Ann., AIC, 1934, 1939 [40]

WILLIAMS, Alyn (Mr.) [Min.P,W,L,T] Wash., D.C./Barrack's Hill, Plimpton, Sussex, England b. 29 Ag 1865, Wrexham, Wales d. 1955. Studied: Slade Sch. A., London; Paris, with Laurens, Constant. Member: Royal Brit. Colonial Soc. Artists; Royal Soc. Min. PS&G (Pres.); Imperial AL; Min. PS&G Soc., Wash., D.C.; Royal Cambrian Acad., Wales; AFA. Exhibited: Royal Acad., London; New WCS, London; Paris Salon; most active exhibiting in U.S., 1890–1914. Work: miniatures of King Edward VII, and Queen Alexandra in Guildhall (London) Art Gal.; Queen Mary; in Rome of Pope, Cardinal Garquet, Cardinal Archbishop Bourrie, Premier Mussolini; H.R.H. Princess Marie Jose of Belgium; Cardinal Gibbons; Pres. Taft, Pres. Coolidge, in Smithsonian. One of the most successful miniature painters at turn-of-the-century. [33]

WILLIAMS, Ann [P,T] Memphis, TN/Clinton, KY b. 8 Mr 1906, Clinton, KY. Studied: Univ. Ky.; Univ. Wis., with W.H. Varnum, Zozzora; Chicago Acad. FA. Member: Tenn. SA; Palette and Brush C., Memphis; Western AA; SSAL. Position: A. Dir., Messick H.S., Memphis; T., Memphis Acad. A. [40]

WILLIAMS, Arthur S. (Mrs.) (Marie K. Berger) [Por.P,Mur.P] NYC b. 25 Je 1906, Gretna, VA. Studied: H.B. Snell; L. Kroll; E.C. Clark; C.C. Curran. Member: Lynchburg C.; Va. Art Alliance; SSAL; Artists Gld., Lynchburg. Work: Campbell County Board Edu. [40]

WILLIAMS, Berkeley, Jr. [P] Richmond, VA/Eccleston, MD b. 18 Jy 1904, Richmond, VA. Studied: PAFA; B. Grigoriev. Member: SSAL [40]

WILLIAMS, C. D. [I] Englewood, NJ. Member: SI [47]

WILLIAMS, C. Louise [P] Hartford, CT [01]

WILLIAMS, Caroline Greene (Mrs.) [P,E] East Cleveland, OH. b. 9 My 1855, Fulton, NY. Studied: Cleveland Sch. A., with H. Keller; C. Yates; C. McChesney; M. Jacobs. Member: Cleveland Women's AC [31]

WILLIAMS, Charles D. [I] New Rochelle, NY b. 12 Ag 1880, NYC. Member: SI; Artists Gld. [33]

WILLIAMS, Charles Sneed [P] Louisville, KY b. 24 My 1882, Evansville, IN. Studied: Allan Fraser A. Col., Arbroath, Scotland; G. Harcourt, in London. Member: Chicago Assn. P.&S.; Cercle de L'Union Artistique, Paris; Louisville AA (hon. life); AIC (life); Hoosier Salon; Chicago Gal. A. Exhibited: Hoosier Salon, 1935 (prize), 1938 (prize); SSAL, 1936 (prize); Paris Salon; Royal Soc. Por. P., London; Glasgow Inst.; Belfast (Ireland) AM; NAD; PAFA; CGA; NGA; AIC; Paris (one-man); London (one-man); NYC (one-man); Chicago (one-man). Work: U.S. Capitol; Ky. State Capitol; Am. Col. Surgeons; Confederate Mus., Richmond, Va.; Ky. State Hist. Soc.; Speed Mem. Mus., Louisville, Ky.; Northwestern Univ., Evanston, Ill.; Vanderpoel AA, Chicago; Am. Legion Auxiliary Headquarters, Indianapolis; Royal Ophthalmic Hospital, London; Shomberg House, London [47]

WILLIAMS, C(harles) Warner [S,L] Chicago, IL b. 23 Ap 1903, Henderson, KY. Studied: Polasek; Zettler; Ianelli; AIC; Herron AI. Member: Chicago AA; Hoosier Salon; All-Ill. SFA; Chicago AC; Assn. Chicago PS; Chicago Gal. Assn. Exhibited: Hoosier Salon, Chicago, 1928 (prize), 1930 (prize), 1931 (prize), 1932 (prize); North Shore AA, 1937 (prize), 1938 (prize); AIC, 1939 (prize). Work: Court House, Frankfort, Ind.; Berea Col., Ky.; Logansport (Ind.) Pub. Sch.; Bradwell Sch., Chicago; Spaulding Sch., Chicago; City Church, Gary, Ind.; Riley Children's Hospital, Indianapolis; Court of States, Century of Progress Expo, Chicago; Kalamazoo (Mich.) Pub. Lib.; Ball State T. Col., Muncie, Ind.; Three Arts C., Chicago [40]

WILLIAMS, Clara. See Peck.

WILLIAMS, Delarue [P] Brooklyn, NY [01]

WILLIAMS, Dwight [Ldscp.P,T] Cazenovia, NY b. 25 Ap 1856, Camillus, Onondaga County, NY d. 12 Mr 1932. Studied: J.C. Perry. Member: AFA; Central N.Y. Soc. Artists. Work: Phillips Mem. Gal., Wash., D.C. Restorer of Old Master paintings. Positions: T., Utica Seminary; Dir. A., Norfolk Col, 1889–1892; National Park Sch., Wash., 1894–1898 [31]

WILLIAMS, Edward K. [P] Nashville, IN b. 5 Je 1870, Greensburg, PA. Studied: AIC. Member: Chicago Gal. Assn.; Ind. AC; Brown County AA; Hoosier Salon; Chicago SA. Exhibited: AIC, 1928 (prize); Hoosier Salon, 1930 (prize), 1932 (prize), 1934 (prize), 1937 (prize), 1938 (prize), 1940 (prize), 1941 (prize); Brown County AA, 1939 (prize); Ind. AC, 1939 (prize), 1940 (prize), 1941 (prize); Chicago Gal. Assn., 1940 (prize) [47]

WILLIAMS, Eleanor Palmer (Mrs. Carroll R.) [P] Rye, NY b. Baltimore. Studied: PMSchIA; Md. Inst., Baltimore; G.H. Smillie; B.W. Clinedinst; H. Newell; M. Lippincott, in Phila. Member: Phila. WCC (life); Plastic C. (life); Phila. All. (life); Phila. Print C. Work: Phila. WCC [40]

WILLIAMS, E(merson) Stewart [P,Arch,T] Annadale-on-Hudson, NY/ Dayton, OH b. 15 N 1909. Studied: C. Midjo; G. Harding; P.P. Cret; Cornell; Univ. Pa. Member: Dutchess County AA. Exhibited: Am. Acad., Rome, 1934 (prize); Am. WCC, 1938 (prize). Work: Cornell. Position: T., Bard Col. [40]

WILLIAMS, Esther [P,Des,Dec] Lime Springs, IA b. 18 Ja 1901, Lime Springs. Studied: Cumming Sch. A., Des Moines. Member: Am. Ar. Prof. Lg. Exhibited: Plastic A., Iowa State Fair, 1936 (gold); Centenn. Iowa Fair, Marshalltown, 1936 (prize); Iowa Fed. Women's C. (traveling), 1936, 1937; Am. Fed. A. (traveling), 1937, 1938 [40]

WILLIAMS, Esther Baldwin (Mrs. Oliver H.) [P,Li] Boston, MA b. 19 F 1907, Boston. Studied: BMFA Sch.; Lhote. Member: Rockport AA; Copley S., 1899; N.Y. Women's AC. Exhibited: PAFA, 1927, 1932–34, 1935 (prize), 1936, 1937, 1938, 1941, 1943, 1945; NIAL, 1944 (prize); MMA (AV), 1942; CGA, 1930, 1932, 1937, 1939, 1941, 1943, 1945; AIC, 1935, 1937, 1938 (prize), 1940–43, 1945; WMAA, 1933, 1936, 1938, 1940–46; Dallas Mus. FA, 1933, 1940, 1942; WMA, 1935 (prize), 1936, 1938, 1945; CI, 1936, 1939, 1940, 1943–46; VMFA, 1938, 1940, 1942, 1944, 1946; GGE, 1939; WFNY, 1939; TMA, 1940–45; de Young Mem. Mus., 1943; PMG, 1942; CM, 1940, 1941; NIAL, 1944; Kraushaar Gal., 1941, 1944. Work: PAFA; WMAA; WMA; BMFA; AGAA [47]

WILLIAMS, Florence White [P,I,W,L,T] Greenfield, MA b. Putney, VT d. 17 My 1953. Studied: Chicago Acad. FA; AIC; H.B. Snell; J.F. Carlson; A. Aldrich; F. Grant; K. Krafft. Member: Deerfield Valley AA; Assn. Chicago P.&S.; South Side AA, Chicago; Chicago Gal. Assn.; Ill. Acad. FA; AFA. Exhibited: Ill. Fed. Women's C. (prize); ASL, 1924 (prize); Boston Line Greeting Card Contest, Boston (prize); Chicago Gal., 1927 (prize); All-Ill. SFA, 1932 (med); AIC; CGA; Baltimore WCC; Detroit Inst. A.; Milwaukee AI. Work: Commission for Encouragement of Local Art; Chicago, Pub. Sch. Illustrator: children's books and magazines [47]

WILLIAMS, Frederic A(llen) [S,L,W,T] NYC/Taos, NM b. 10 Ap 1898, West Newton, MA d. 6 D 1958. Studied: Columbia; NAD; BAID; R. Aitken. Member: AAPL; Am. Veterans Soc. A. (Pres.) Exhibited: NAD, 1922 (prize), 1926, 1928, 1931, 1933, 1935, 1936, 1942–44; BAID, 1921 (prize); PAFA, 1926, 1927; Arch. L., 1929, 1936; NSS, 1929; Am. Veterans Soc. A., 1938–45; A. of the Southwest, Santa Fe, N.Mex., 1926–45; BM, 1930; Jersey City Mus.; MMA, 1942. Work: Arkell Mus., Canajoharie, N.Y.; Columbia Dental Col., Medical Center, N.Y.; Am. Acad. A. & Letters; Heye Fnd., N.Y.; Historic Arts Gal.; Town Hall, Friedrichshafen, Germany. Articles: "Weavings of the American Indians," Tex-Style magazine. Specialties: Indians; life in the Southwest [47]

WILLIAMS, F(rederick) Ballard [Ldscp.P] Glen Ridge, NJ (since 1885) b. 21 O 1871, Brooklyn d. 11 D 1956. Studied: Cooper Union; J.W. Stimson; NAD, with C.Y. Turner, W.H. Gibson, E.M. Ward; England; France. Member: ANA, 1907; NA, 1909; NYWCC; Lotos C.; SC, 1898 (Pres., 1914–19); NAC; Montclair AA (Pres., 1924–25); AAPL. Exhibited: Pan-Am. Expo, Buffalo, 1901 (med); SC, 1907 (prize); NAD, 1909 (gold); AAPL (gold). Work: NGA; MMA; Albright A. Gal., Buffalo; Brooklyn Inst. Mus.; Montclair AM; Hackley A. Gal., Muskegon, Mich.; City AM, St. Louis; Dallas Art Assn.; Lotos C.; Quinnipiack C., New Haven; NAC; Milwaukee AI Coll.; AIC; Grand Rapids AA; Los Angeles MA; New Britain (Conn.) AA; Engineers Cl., N.Y.; Nat. Gal., Lima, Peru; Drexel Inst., Phila. [47]

WILLIAMS, Frederick Dickinson [Por.P,Ldscp.P,T] Brookline, MA b. 1829, Boston d. 27 Ja 1915. Studied: Harvard, 1850; trip to Paris, mid-1870s

WILLIAMS, Gaar B. [Car,I] Glencoe, IL b. 12 D 1880, Richmond, IN d. 15 Je 1935, Chicago. Studied: Cincinnati A. Sch.; AIC. Illustrator: "Indianapolis News," 1919. Cartoon strips: "Just Plain Folks"; for 14 years his cartoons were distributed by the Chicago Tribune-New York News Syndicate [25]

WILLIAMS, Garth Montgomery [I,S,P,Car,Des] NYC b. 16 Ap 1912, NYC. Studied: Westminster Sch. A.; Royal Col., London. Exhibited: Prix de Rome, 1936; British Royal Acad., 1933–35, 1938; Am.-British A. Ctr., 1942. Illustrator: "Stuart Little," 1945, "Eastward to Eden," 1945, "In Our Town," 1946; others. Cartoonist: New Yorker, Tomorrow [47]

WILLIAMS, George Alfred [P,I,C] Kennebunkport, ME b. 8 Jy 1875, Newark, NJ d. 29 F 1932. Studied: Chase; Cox. Member: N.Y. Soc. Keramic A. Exhibited: P.-P. Expo, San Fran., 1915 (med). Work: AIC; Newark Mus. Illustrator: Dickens' characters [31]

WILLIAMS, Gluyas [I,Car,W] West Newton, MA/Deer Isle, ME b. 23 Jy 1888, San Fran. Studied: Harvard. Exhibited: BMFA, 1946. Work: LOC. Author: "The Gluyas Williams Book," 1929, "Fellow Citizens," 1940. Illustrator: "Daily Except Sunday," 1938, "People of Note," 1940, "A Tourist in Spite of Himself." Contributor: New Yorker [47]

WILLIAMS, H.D. [I] NYC [19]

WILLIAMS, Helen F. [T,C,Cer] Syracuse, NY b. 13 O 1907, Syracuse. Studied: Syracuse Univ. Member: Assn. A. Syracuse; Lg. Am. Pen Women. Exhibited: Assn. A. Syracuse, 1937 (prize), 1946 (prize); Syracuse Mus. FA, 1932–41; WFNY, 1939; Paris Salon, 1937; BMA, 1944; Lg. Am. Pen Women, 1946. Work: IBM Corp. Mus., Endicott, N.Y. Position: T., Univ. Syracuse [47]

WILLIAMS, Helen P. [P] Hastings-on-Hudson, NY. Exhibited: Am. WCC, 1938; NYWCC, 1939 [40]

WILLIAMS, Henrietta [P] Crafton, PA. Member: Pittsburgh AA [25]

WILLIAMS, Henry Dudley [Dealer] Boston d. 1 Ja 1907. Studied: Brown Univ. Member: Bostonian Soc.; Brown Univ. C.; Boston AC. Position: Hd., firm of Williams & Everett Gallery

WILLIAMS, Hermann Warner, Jr. [Mus.Asst.Dir,W] Wash., D.C. b. 2 N 1908, Boston d. 1975. Studied: Harvard; Univ. London; NYU. Co-author: "William Sidney Mount, 1807-1868," 1944. Contributor: Burlington Magazine; MMA Bulletin & art magazines. Positions: Asst. Cur., Renaissance Art, BM (1936), Painting, MMA (1936–46), Dir., CGA (1946) [47]

WILLIAMS, Howe [P] Tempe, AZ b. Massillon, OH. Studied: Univ. Mich.; W. Shirlaw; A. Hibbard. Member: Phoenix FA Assn. Exhibited: Ariz. State Fair, 1926 (prize), 1930 (prize); Mus. Northern Ariz., 1932 (prize). Work: Mus. N.Mex., Santa Fe; Municipal Coll., Phoenix [40]

WILLIAMS, Irving Stanley [Port.P,I] Buffalo, NY b. 13 Mr 1893, Buffalo. Studied: Albright A. Gal.; BMFA Sch.; Paris. Member: Buffalo SFA; Patteran AC; Prof. Artists' Gld. [40]

WILLIAMS, Isaac L. [Ldscp.P,Por.P] Phila., PA b. 24 Je 1817, Phila. d. 23 Ap 1895. Studied: Phila., with J.R. Smith, J. Neagle. Member: A. Fund S., 1860 (later, Pres.) Exhibited: Phila., from 1837 [*]

WILLIAMS, J.A. [I] NYC [08]

WILLIAMS, J.L.S. [P] Rutherford, NJ [10]

WILLIAMS, James Robert [P,S,Car] Prescott, AZ (since 1931) b. 30 Mr 1888, Halifax, Nova Scotia d. 1957, probably San Marino, CA. Studied: Mt. Union Col., Alliance, Ohio. Cowboy-cartoonist who had a 45,000 acre cattle ranch. Best known for his cartoon "Out Our Way," which appeared in more than 700 papers since 1922. [40]

WILLIAMS, John Alonzo [P,I] NYC b. 23 Mr 1869, Sheboygan, WI. Studied: ASL; MMA Sch. Member: ANA; SC; AWCS; SI; AAPL; A. Gld.; NYWCC; Artists Fund Soc. Exhibited: SC, 1937 (prize), 1939 (prize); AWCS-NYWCC (prize) [47]

WILLIAMS, John Scott [Mur.P,T,C] NYC b. 18 Ag 1897, Liverpool, England. Studied: AIC. Member: NA; AWCS; NSMP; SC; Arch. Lg.; ANA, 1935; NA, 1937; NYWCC. Exhibited: AIC, 1924 (prize); AWCS, 1925 (prize), 1927 (prize); SC, 1928 (prize); WFNY, 1939. Work: AIC; Indianapolis; Johns Hopkins Univ.; USPO, Newcastle, Del.; four murals and five stained glass windows, Ind. State Lib. and Hist. Bldg., Indianapolis. WPA artist. Position: T., NYU [47]

WILLIAMS, (John) Nelson [P] NYC b. 18 Ap 1912, Brazil, IN. Studied: John Herron AI; De Pauw Univ.; Corcoran Sch. A.; ASL. Exhibited: Jackson, Miss., 1945 (prize), 1946 (prize); Herron AI, 1944 (prize); AWCS, 1945; Albany Inst. Hist. & A., 1945; SFMA, 1945; Butler AI, 1946; Portland SA, 1946; Rockport AA, 1942; Soc. Wash. A., 1937 [47]

WILLIAMS, Julia Tochie [P] Dawson, GA b. 14 D 1887, Americus, GA d. My 1948. Studied: Wesleyan Col., Macon, Ga.; Daytona Beach A. Sch.; E. Wilkins; Mrs. J.A. Varnedo. Member: Atlanta AA; Assn. Georgia A. Exhibited: High Mus. A., 1944–46; Assn. Georgia A.; Bristol, Va., 1946 [47]

WILLIAMS, Kate A. [P] NYC d. 8 Ag 1939. Member: NAWPS; Wash. WCC; AWCS; NAC; Am. APL; AFA [33]

WILLIAMS, Katherine [P] Glastonbury, CT. Member: CAFA [25]

WILLIAMS, Keith Shaw [P,E,T] NYC b. 7 O 1905, Marquette, MI d. 10 F 1951. Studied: NAD; PAFA; I. Olinsky; D. Garber; C. Hawthorne. Member: SC; SAE; AWCS; All.A.Am.; Chicago SE; A. Fellowship; ANA, 1939; NA, 1942. Exhibited: NAD, 1935 (prize); SC, 1936–40 (prize); LOC, 1946 (prize); All.A.Am., 1938 (med), 1940 (med); Montclair AM, 1941 (med); AAPL, 1941 (med); NAC, 1928 (prize); Junior A., 1930

(prize), 1931 (prize), 1932 (prize). Work: N.Y. Hist. Soc.; NAD; SC; LOC; Rollins Mus. Lib.; Cornell C., NYC. Position: T., Grand Central Sch. A. [47]

WILLIAMS, L(awrence) S. [P] Tenafly, NJ b. 24 Jy 1878, Columbus. Studied: C. Beckwith; W.M. Chase; F.V. DuMond. Member: SC [33]

WILLIAMS, Leah Frazer (Mrs. Ramond H.) [C] Lubock, TX b. 1 D 1903, Beaver, UT. Studied: Univ. Utah; M. Frazer; J.T. Harwood. Member: Lincoln Artists Gld.; Utah Art Gld.; Nebr. AA [40]

WILLIAMS, Lois Katherine [Port.P] NYC b. 10 Ap 1901, Morristown, NJ. Studied: R.P.R. Neilson; E.E. Rand. Member: NAWA. Exhibited: NAD, 1934; PAFA, 1936; NAWA; All.A.Am., 1935–40; Ferargil Gal., 1933, 1935, 1937, 1940 (all one-man). Work: portrait commissions [47]

WILLIAMS, Louis Sheppard [Wood En] Wash., D.C. b. 8 Jy 1865, Bridgeton, NJ. Studied: H. Simon; H. Helmick. Position: In charge of illustrations, U.S. Dept. Agriculture [17]

WILLIAMS, Louise A. [S] Augusta, GA [10]

WILLIAMS, Louise H(ouston) [P,Li,B,Dr,T] Anacortes, WA b. 9 Ap 1883, Garnett, KS. Studied: R. Davey; Kansas City AI; Kans. Univ. Member: Pacific Coast Artists; Am. Soc. A.&Sc. Positions: T., Union Jr. Col., Mount Vernon; Private Sch., Anacortes [40]

WILLIAMS, Lucy O. [P,T] Forrest City, AR b. 27 S 1875, Forrest City. Studied: ASL; AIC; J.H. Twachtman; D. Volk; W.M. Chase; R. Reid. Member: Ark. WCC. Work: Forrest City Pub. Sch.; Courthouse, Forrest City [40]

WILLIAMS, Marian E. [P] Trenton, NJ. Award: PAFA, 1936 (schol.) [40]

WILLIAMS, Mary Elizabeth [P,T] Salem, MA b. 1825, Boston d. 15 S 1902. Studied: Rome, 1860–61. Sister of Abigail. Position: T., Salem Pub. Sch. [*]

WILLIAMS, Mary Rogers [P,T] Northampton, MA b. Hartford, CT d. 17 S 1907, Florence, Italy. Studied: J.W. Champney; W.M. Chase; D.W. Tryon. Member: N.Y. Women's AC. Position: T., Smith College [04]

WILLIAMS, Max [Dealer] b. 1874 d. 5 D 1927, NYC. For forty years he had been a collector of prints, and since 1905 had made a specialty of gathering fine examples of ship models. He secured the figurehead of the frigate Constitution, a likeness of Andrew Jackson. In 1926 his collection of naval and marine prints, paintings and relics was sold for $19,235.

WILLIAMS, May [P,C,T] Pittsburgh, PA b. Pittsburgh. Studied: Carnegie Col. FA, Pittsburgh; N.Y. Sch. F.&Appl. A.; Ecole des Beaux-Arts; Fontainebleau Sch. FA. Member: Assn. A. Pittsburgh; Pa. Craftsmen Gld.; AFA; Pittsburgh A. Center. Work: CI; Pittsburgh A. Center. Position: T., Ellis Sch., Pittsburgh [47]

WILLIAMS, Mildred Emerson [Por.P,Li] Detroit, MI b. 9 Ag 1892, Detroit. Studied: PAFA; ASL; H. McCarter; R. Henri; C. Locke; G. Luks; Paris. Member: Detroit Soc. Women Painters. Exhibited: PAFA, 1925, 1926, 1928 (prize); Detroit Inst. A., 1934 (prize), 1936 (prize), 1939 (prize), 1940 (prize); AIC, 1935; CGA, 1936; AFA Traveling Exh.; CI, 1941; AIGA, 1935. Work: NYPL; PAFA; Detroit Inst. A. [47]

WILLIAMS, Milton (Franklin) [P,Des] Seattle, WA b. 29 Ja 1914, Burlingame, CA. Studied: Calif. Sch. FA; M. Sandona. Exhibited: Santa Cruz A. Gal., 1936 (prize); Oakland A. Gal.; Calif. State Fair; Little Gal., Seattle, 1946; Univ. Wash., 1943; SAM, 1942, 1943 [47]

WILLIAMS, Nelly Miller [P] Fort McPherson, GA [25]

WILLIAMS, Olga C. [P,C,T] Hot Springs, AR b. 18 Ja 1898, Sweetwater, TN. Studied: I.J. Crawley; M.C. Forbes; C. Hill; A. Montgomery; I. Coulter [25]

WILLIAMS, Otey [P] Phila., PA [24]

WILLIAMS, Otis [P] NYC [17]

WILLIAMS, Patricia Gertrude [P] Oakland, CA b. 10 Ja 1910. Studied: Univ. Calif. Member: San Fran. AA; San Fran. S. Women A. [40]

WILLIAMS, Pauline Bliss [Min.P,I,Des,L] Springfield, MA b. 12 Jy 1888, Springfield. Studied: ASL; Henri Sch. A.; F. DuMond; F.L. Mora; G. Bellows; H. Miller. Member: NAWA; North Shore AA; Springfield A. Gld.; Springfield A. Lg.; Pa. Soc. Min. P.; Gloucester SA; Brooklyn S. Min. P.; AAPL; Boston AC. Exhibited: Springfield, 1926 (prize), 1928 (prize); AIC, 1941 (prize); Pa. Soc. Min. P.; NSMP; North Shore AA; Brooklyn Soc. Min. P.; NAWPS, 1926 (prize); Springfield AG, 1932 (prize). Work: Shriner's Hospital, Springfield [47]

WILLIAMS, Ramond Hendry [P,S,L,W,T] Lubbock, TX b. 31 O 1900, Ogden, UT. Studied: M. Frazer; C.J. Martin; W. Varnum; A. Archipenko; AIC; Univ. Chicago. Member: Utah AG; Lincoln AG. Exhibited: Delta Phi Delta Nat. Exh., Kansas City, 1936 (prize). Work: Logan Jr. H.S.; Logan H.S.; Joslyn Mem., Omaha, Nebr. Contributor: articles, Design, 1933, 1935, 1938. Position: T., Tex. Tech. Col. [40]

WILLIAMS, Reed [E] Los Angeles, CA b. Pittsburgh. Member: Los Angeles Print Makers [24]

WILLIAMS, Robert F. [P] Staten Island, NY [08]

WILLIAMS, Robert T. [P] Chicago, IL. Member: Chicago NJSA

WILLIAMS, Ruth Moore [P,E] NYC b. 14 My 1911, NYC. Studied: C.S. Chapman; I. Olinsky; K. Anderson; NAD. Member: NAC. Exhibited: NAC, 1934 (prize), 1937 (prize) [40]

WILLIAMS, Virgil [Ldscp.P,Genre P,Por.P,Dec] San Fran., CA b. 1830, Taunton, MA (or Dixfield, ME) d. 18 D 1886, near Mt. St. Helena. Studied: Paris; Rome, 1853–60. Work: Oakland A. Mus. Lived in Boston, 1860–62; San Fran., 1865–71; settled in San Fran., 1871. Founder: (with W. Keith, W. Hahn and T. Hill) San Fran. Sch. Des., 1874. His wife was the daughter of painter William Page [1811–1885]; they were close friends of Robert Louis Stevenson. Position: T., Harvard, 1865 [*]

WILLIAMS, W.N. (Mrs.) [P] Pittsburgh, PA. Member: Pittsburgh AA [21]

WILLIAMS, Walter Reid [S] Chicago, IL b. 23 N 1885. Studied: C. Muklligan; B. Pratt; P. Bartlett, Mercié, in Paris. Work: Women's Athletic C., Chicago. Position: Dir., Clay Arts Studio, Ridge Park Field House, Chicago [40]

WILLIAMS, W.S. [I] NYC [19]

WILLIAMS, Warner [S,Des,L,P,T] Culver, IN b. 23 Ap 1903, Henderson, KY. Studied: Berea Col.; Herron AI; AIC. Member: Chicago AC; Chicago AA; Hoosier Salon. Exhibited: AIC, 1941 (prize); Herron AI, 1925 (prize); Hoosier Salon, 1928 (prize), 1930 (prize), 1931 (prize), 1932 (prize), 1937 (prize), 1942 (prize); North Shore AA, 1939 (prize); City of Chicago, 1938 (prize); Century of Progress, Chicago, 1932. Work: memorials and bas-reliefs: Court House, Frankfort, Ky.; Berea Col.; Ind. Univ.; City Church, Gary, Ind.; Purdue Univ.; Bradwell Sch., Chicago; Francis Parker Sch.; Univ. Pittsburgh. Contributor: Design magazine. Position: T., Culver Military Acad., 1940– [47]

WILLIAMS, Watkins [P] Chicago, IL [13]

WILLIAMS, Wayland Wells [P] New Haven, CT/Salisbury, CT b. 16 Ag 1888, New Haven d. 6 My 1945. Studied: I. Weir; Yale. Member: New Haven PCC. Author: "The Whirligig of Time," "Goshen Street," "The Seafarers." Position: State Dir., WPA, Conn. [40]

WILLIAMS, Wheeler [S,P,W,L,T,Arch] NYC b. 3 N 1897, Chicago d. 1972. Studied: Yale; Harvard; J. Wilson, in Boston; Ecole des Beaux-Arts, with J. Coutan. Member: NA; NSS; Arch. Lg.; Audubon A.; FA Fed. N.Y. (Pres.); Municipal A. Soc., N.Y.; Am. Veterans Soc.; N.Y. Soc. Ceramic A.; ANA, 1939; BAID. Exhibited: NAD, 1936 (prize); Salon des Artistes Français, 1923–27; Salon d'Automne, Paris, 1937 (med); PAFA; AIC; WFNY, 1939; GGE, 1939; Pal. Leg. Honor; NSS; Ferargil Gal. (one-man); Arden Gal., Guild Hall, East Hampton, N.Y. (one-man); Soc. Four A. (one-man). Work: San Diego FA Soc.; Brookgreen Gardens, S.C.; Four A. Gal., Palm Beach, Fla.; Norton Gal. A., West Palm Beach, Fla.; AIC; Hackley A. Gal.; many architectural and monumental works throughout U.S., South Africa, Canada; Michigan Ave. Bridge, Chicago; Grosse Point Yacht C., Detroit; Dept. Interstate Commerce Bldg., Wash., D.C.; Regents Park, London; USPOs, Canal St. Station (NYC), Bay Shore (N.Y.); Reader's Digest Tower, Pleasantville, N.Y. Specialty: garden sculpture. WPA artist. Position: T., BAID [47]

WILLIAMSON, Ada C. [P,I] Ogunquit, ME b. 15 S 1880, Camden, NJ d. 31 O 1958. Studied: Drexel Inst.; PAFA; W. Chase; C. Beaux. Member: Phila. Pr. C.; Phila. A. All.; Ogunquit AA. Exhibited: PAFA, 1922 (gold), 1941–44, 1945 (prize); Cosmopolitan C., 1945 (prize); Phila. Plastic C., 1913 (gold) [47]

WILLIAMSON, A.W. (Mrs.) [P] Cincinnati, OH. Member: Cincinnati Women's AC [27]

WILLIAMSON, Clarissa [P,T] Logansport, IN. Position: Art Supervisor, Pub. Sch., Logansport [24]

WILLIAMSON, Curtis [P] care of Robert Henri, NYC [08]

WILLIAMSON, Edward L. (Mrs.) [P] Carmel, CA. Member: Women PS [15]

WILLIAMSON, Elizabeth Dorothy (Mrs. Ten Broeck Williamson IV) [S,C] Old Albuquerque, NM b. 20 D 1907, Portland, OR. Studied: Mus. Sch., Portland; Otis A. Inst.; R. Allen. Member: N.Mex. AA. Work: Los Angeles Mus. Hist., Sc.&A.; State Expo Bldg., Los Angeles. Specialty: diorama sculpture. Position: T., State Vocational Edu., Old Albuquerque [40]

WILLIAMSON, Elizabeth M. [P] Richmond, VA [13]

WILLIAMSON, Frank [P] NYC [01]

WILLIAMSON, H.G. [P] Baltimore, MD. Member: SI, 1910; SC, 1905 [25]

WILLIAMSON, Howard [I] NYC. Member: SI [47]

WILLIAMSON, J. Maynard, Jr. [P,I] Pittsburgh, PA b. 7 Je 1892, Pittsburgh. Studied: F.V. DuMond. Member: Pittsburgh AA. Exhibited: Pittsburgh AA, 1911 (prize) [21]

WILLIAMSON, James W. [I] Greenwich, CT b. 2 S 1899, Omaha, NE. Studied: Yale. Member: SI. Exhibited: A. Dir. C. (med). Illustrator: Saturday Evening Post, Life, Look, Woman's Home Companion [47]

WILLIAMSON, John [Ldscp.P] b. 1826, near Glasgow, Scotland (came to Brooklyn in 1831) d. 1885, Glenwood, NY. Member: Brooklyn AA. Exhibited: NAD, from 1850. Hudson River Sch. painter; also active in New England [*]

WILLIAMSON, Mabel [P,I] NYC b. 31 Ja 1875, Cincinnati, OH. Studied: Hopkins IA [04]

WILLIAMSON, Margaret T. [P] Pittsburgh, PA. Member: Pittsburgh AA [21]

WILLIAMSON, Paul Broadwell [P] San Fran., CA b. 11 Ja 1895, NYC. Studied: Ohio Mechanics Inst., Cincinnati; F. Duveneck. Member: AAPL; Am. Veterans Soc. A. Exhibited: Smithsonian, 1940; Mus. N.Mex., Santa Fe, 1941; Am. Veterans Soc. A., 1941–43, 1946; Springfield Mus. A., 1945; Soc. for Sanity in Art, 1940; Army-Navy Exh., San Fran., 1942; AAPL, 1943, 1946. Work: St. Mary's Col., Moraga, Calif.; Univ. C., San Fran. Author: "El Camino Real" [47]

WILLIAMSON, Shirley (Mrs. Edward L.) [C,Des,T] Palo Alto, CA b. NYC. Studied: ASL; A.W. Dow; W.M. Chase; Paris, with Constant, Rodin. Member: Palo Alto AC; N.Y. Women's AC, 1904. Exhibited: Golden Gate Expo, 1939. Position: T., Palo Alto H.S. [40]

WILLING, J(ohn) Thomson [P,C,W,L] Germantown, PA/Henryville, PA b. 5 Ag 1860, Toronto, Ontario. Studied: Ontario Sch. A. Member: AIGA; Royal Canadian Acad.; A. Dir. C.; SI; SC 1897. Specialty: designs for bookplates. Positions: Art Manager, The North American (since 1900); Ed., Gravure Service Corporation [27]

WILLING, Jessie. See Gillespie.

WILLIS, Albert Paul [Ldscp.P,T] Phila., PA/Casco Bay, ME. b. 15 N 1867, Phila., PA. Studied: PMSchIA; F.V. DuMond. Member: Phila. WCC; Phila. Sketch C.; Providence WCC [33]

WILLIS, Alice M. [P] St. Louis, MO b. 24 Ag 1888, St. Louis. Studied: R.H. Nicholls; Member: St. Louis AG. Specialty: watercolors [17]

WILLIS, Edmund Aylburton (a.k.a. **A. Van Willis**) [Ldscp.P] Brooklyn, NY b. 12 O 1808, Bristol, England (came to NYC ca. 1852) d. 3 F 1899. Exhibited: NAD, early 1850s

WILLIS, Eola [P,C,W,L] Charleston, SC b. Dalton, GA. Studied: ASL, with Mrs. J.S.D. Smillie, Chase; Paris. Member: Carolina AA; S. for Preservation of Old Bldgs. (Historian). Exhibited: Charleston Expo, 1902 (prize). Work: Gibbes Mem. A. Gal., Charleston. Author: "The Charleston Stage in the XVIII Century," "Henrietta Johnston, First Woman Painter in America" [40]

WILLIS, Katherine [P] Omaha, NE [01]

WILLIS, Patty [P,L,Des,Li,C,B,S] Charlestown, WV b. 20 S 1879, Summit Point, WV. Studied: AIC; PIASch; Académie Moderne, Paris, with F. Leger. Exhibited: CI, 1925; CGA, 1923, 1931; All. A. W.Va., 1937, 1945; Cumberland Valley A., 1935–46; Nat. Exh. Am. A., N.Y., 1936, 1938; Wash. County MFA, Hagerstown, Md. (prize). Work: Charlestown (W.Va.) H.S. [47]

WILLIS, R(alph) T(roth) [Mur.P,S,I,E] Encinitas, CA b. 1 Mr 1876, Leesylvania, Freestone Point, VA. Studied: Corcoran Sch. A.; ASL; Académie Julian, Paris. Member: Mural P.; Calif. AC. Work: 22nd Regiment Armory, NYC; LOC; Pomona (Calif.) Bldg. & Loan Assn.; Angeles Temple, Los Angeles; Brock Jewelry Store, Los Angeles [40]

WILLIS, Thomas [Mar.P] b. 1850, CT d. 1912, NYC. Work: Mariner's Mus.; Mystic Seaport Mus.; Peabody Mus., Salem. He used silk or satin for the sails in his ship paintings. [*]

WILLISON, Gertrude [P,C] NYC [10]

WILLITS, Alice [P,I,C] Friendwood, TX b. 1885, IL. Studied: Cincinnati A. Acad. Member: Cincinnati Women's AC [10]

WILLMAN, Joseph G. [P] Phila., PA [01]

WILLMARTH, Arthur F. [I,Cart] Denver, CO. Member: Denver AC. Position: Cart., Denver Republican [98]

WILLMARTH, Elizabeth J. [P] Chicago, IL [01]

WILLMARTH, Kenneth L. [P,I] Omaha, NE. Exhibited: Nebr. A., Omaha, 1932; Kansas City AI, 1939 [40]

WILLMARTH, William A. [Des] Omaha, NE b. 20 N 1898, Chicago, IL. Studied: Chicago Acad. FA; Armour Inst., Chicago. Member: Omaha AG [40]

WILLNER, William Ewart [P,Des,Arch,E,W] Atlanta, GA b. 15 My 1898, Duluth, MN. Studied: P.P. Cret; Univ. Minn.; Univ. Pa.; ASL, with W. von Schlegell. Member: AWCS; Brooklyn SA; Ga. A. Exhibited: PAFA; AWCS; BM; AIC; High Mus.; Ga. A. [47]

WILLOUGHBY, Alice Estelle [P] Wash., D.C. b. Groton, NY d. 28 O 1924. Studied: Wash. AL; Corcoran A. Sch. Member: Wash. WCC; Wash. AC [24]

WILLS, Mary Motz (Mrs.) [P] Abilene, TX b. Wytheville, VA. Studied: W.M. Chase; J.Twachtmann; ASL; Phila.; Boston. Member: SSAL. Exhibited: AMNH. Work: 350 Tex. wildflowers in watercolor, Univ. Tex., Austin [40]

WILLSIE, Addie G. [P] Kansas City, MO [24]

WILLSON, Edith Derry [P,E] Los Angeles, CA b. 20 Ja 1899, Denver, CO. Studied: J. Pennell; ASL. Member: Chicago SE; N.Y. Soc. Women PS. Work: Nat. Gal., Munich; Cincinnati Lib.; Los Angeles Lib.; CMA; AIC; Detroit Mus. A. [31]

WILLSON, James Mallory [P,E] Palm Beach, FL b. 28 D 1890, Kissimmee. Studied: Rollins Col.; NAD; ASL, with Henri, Bridgman, Johansen, Maynard, Fogarty. Member: S. Four A., Palm Beach, Fla. Exhibited: S. Four A., 1941 (prize); SAE, 1940, 1945; AV, 1942; NAD, 1944–46; LOC, 1943, 1945; S. Four A., 1939, 1946; Palm Beach AL, 1939, 1946; Norton Gal., 1944, 1945. Work: LOC. Position: T., Norton Sch. A., West Palm Beach, Fla., from 1946 [47]

WILLSON, Martha B. See Day.

WILLSON, Rosalie A. [P] NYC. Member: NAWPS [27]

WILMARTH, Euphemia B. [Ldscp.P] New Rochelle, NY b. ca. 1856 d. 21 Jy 1906, Pasadena, CA (she had gone to Calif. to study the landscape)

WILMARTH, L(emuel) E(verett) [Genre P,T] NYC b. 11 N 1835, Attleboro, MA d. 27 Jy 1918. Studied: PAFA; Royal Acad., Munich, with Kaulbach, 1859–62; École des Beaux-Arts, Paris, with Gérôme, 1863–67. Member: ANA, 1871; NA, 1873; A. Aid S. Positions: Dir., Brooklyn Acad. A. Sch. (1868–70), NAD Sch. (1870–90) [17]

WILMER, George [P] Los Angeles, CA. Exhibited: 48 Sts. Comp., 1939 [40]

WILMES, Frank [P,C] Cincinnati, OH b. 4 O 1858, Cincinnati. Studied: L.H. Meakin; V. Nowottny; F. Duveneck. Member: Cincinnati AC [33]

WILMETH, Hal T. [P] Lincoln, NE. Exhibited: Kansas City AI, 1938, 1939 [40]

WILMOT, Alta E. [Min.P,T] NYC b. Ann Arbor, MI. Studied: J.A. Weir; Paris with G. Courtois, Prinet. Member: SPNY; P.S. Min. P.; AFA [29]

WILSHIRE, Florence L.B. [P] New Haven, CT. Member: New Haven PCC [29]

WILSON, Albert [Shipcarver] Newburyport, MA b. 29 Je 1828 d. 26 N 1893. Brother of James. Son of Joseph [1779–1857]. [*]

WILSON, Alice. See Vitacco.

WILSON, Anna Keene (Mrs. Edward C.) [P] Baltimore, MD [25]

WILSON, Ashton (Miss) [P] NYC/White Sulphur Springs, WV b. 1 Ap 1880, Charleston, WV. Studied: Chase; Hawthorne; Beaux; Twachtman; Borglum; F. Howell; ASL; Acad. Colarossi, Paris. Member: NAWPS; PBC. Work: Capitol, W.Va.; Wash., D.C. Illustrator: "Gardens of Virginia" [40]

WILSON, Beatrice Hope [P] NYC. Member: S.Indp.A. [25]

WILSON, Ben [P,T,L] Long Island City, NY b. 23 Je 1913, Phila. Studied: CCNY; NAD; K. Anderson; L. Kroll; G. Eggers. Member: A. Lg. Am.; S.Indp.A.; Hetero A. Group. Exhibited: Audubon A., 1945; PAFA, 1946; Pepsi-Cola, 1946; Norlyst Gal., 1945; Riverside Mus., 1942; Am.-British A. Ctr., 1943; S.Indp.A., 1944; CCNY, 1933 (prize); NAD, 1932 (med) [47]

WILSON, Charles [P] NYC. Member: S.Indp.A.; Bronx AG [27]

WILSON, Charles Banks [Por.P,Li,I,W] Miami, OK (1976) b. 6 Ag 1918, Miami, OK. Studied: AIC; F. Chapin; L. Ritman; B. Anisfeld; H. Ropp. Exhibited: AV, 1944, 1945; NAD, 1942–46; LOC, 1943–46; SFMA, 1943–46; SAM, 1943–46; Philbrook A. Ctr., 1944–46; Arkansas Exh., 1946 (prize); BM, 1944 (prize); Okla. A., 1945 (prize); NGA, 1946 (prize). Work: MMA; CGA; Smithsonian Inst.; LOC; Philbrook A. Ctr.; Gilcrease Fnd. Author: "Indians of Eastern Oklahoma." Illustrator: "Northwest Voyage," 1944, "Henry's Lincoln," 1945; 26 other books. Position: T., Northeast Okla. Col., for 15 yrs. [47]

WILSON, Charles J.A. [E,P,I] Newtonville, MA b. 23 Je 1880, Glasgow, Scotland (brought to Duluth, MN, 1881; in Newton, MA, by 1890s) d. 1965. Studied: self-taught. Exhibited: PAFA, 1929; Intl. PM, 1930; Currier Gal. A., 1932; Lyman Allyn Mus., 1934; SAE, 1931; LOC, 1943, 1944. Work: Marine Mus., Boston; New Haven R.R.; U.S. Coast Guard Acad., New London, Conn.; Mun. Mus., Baltimore; U.S. Naval Acad.; Peabody Mus., Salem, Mass.; Mariner's Mus., Newport News, Va.; MIT. Signed his etchings with monogram "W" over an anchor. [47]

WILSON, Charles Theller [P] b. 1885 d. 3 Ja 1920, NYC. Specialty: Calif. redwoods

WILSON, Claggett [P] Boston, MA b. 3 Ag 1887, Washington, D.C. Studied: ASL; Académie Julian; F.L. Mora; R. Miller; Laurens, in Paris. Member: S.Indp.A.; Salons of Am. Work: BM; MET [40]

WILSON, Clara Powers [P,S] Chicago, IL [19]

WILSON, Della Ford [Edu,C,W] Madison, WI b. 31 Mr 1888, Hartsell, AL. Studied: J. Milliken Univ.; Peoples Univ., St. Louis, with F. Rhead; Alfred Univ., with C.F. Binns; Columbia. Member: Nat. Edu. Assn.; Wis. T. Assn.; Western AA; Lg. Am. Pen Women; Madison AA. Exhibited: Wis. Salon A., 1942; Madison AA, 1941. Author/Illustrator: "Primary Industrial Arts," 1927–35. Position: T., Univ. Wis., from 1915 [47]

WILSON, Donna A. [P] Lorton, NE [01]

WILSON, Douglas [P,G] Chicago, IL. Exhibited: Intl. WC Ann., 1937, 1938; Intl. Li.-En. Ann., 1937, 1938; Ar. Chicago, Vicin., 1938; Fed. A. Project Exh., 1938, all at AIC [40]

WILSON, Edgar [P] Phila., PA [25]

WILSON, Edward A. [E,Des,B,I,Li,P] Truro, MA b. 4 Mr 1886, Glasgow, Scotland. Studied: AIC; H. Pyle. Member: SI, 1912; SC; Artists G.; AI Graphic A.; Players C. Exhibited: A. Dir. C., NYC, 1926 (med), 1930 (med); SC, 1926 (prize), 1942 (prize); Bookplate Intl., Los Angeles, 1923; Phila. Pr. C., 1936 (prize). Work: LOC; NYPL; MET; Princeton Pr. C. Illustrator: "The Hunting of the Snark," 1932, "A Shropshire Lad," 1935, "The Tempest," 1944, "Jane Eyre," 1944, "Westward Ho!," 1946, "Robinson Crusoe," "The Last of the Mohicans," "The Man Without a Country," "Green Mansions." Contributor: Fortune, Saturday Evening Post, Collier's [47]

WILSON, Ellen Louise Axon (Mrs. Woodrow) [P] b. Savannah, GA d. 6 Ag 1914, White House, Wash., D.C. Studied: Women's Col., Rome; ASL. Member: NAWA. Exhibited: NAD. Wife of the president of the U.S.

WILSON, Ellis [P,I] NYC b. 30 Ap 1900, Mayfield, KY. Studied: Ky. State Col.; AIC; X. Barile. Member: United Am. A. Exhibited: Negro Expo, 1940; Caresse Crosby Gal., Barnett Aden Gal., both in Wash., D.C.; WFNY, 1939; Downtown Gal., Contemporary A. Gal., Intl. Pr. Gal., Vendôme Gal., all in NYC; Harmon Fnd. Traveling Exh.; Mechanics' Inst., NYC (prize); AIC, 1923 (prize); Atlanta Univ., 1946 (prize). Awards: Guggenheim F., 1944, 1945 [47]

WILSON, Eloise H. [B] Edgewood, MD. Exhibited: Northwest PM, 1936 [40]

WILSON, Emily L(oyd) [P] Beach Haven, NJ/St. Augustine, FL b. 2 N 1868, Altoona, PA. Studied: Phila. Sch. Des. for Women; W. Sartain. Member: Plastic C. Work: St. Augustine Hist. Soc. Mus. [31]

WILSON, Estol [P] Hastings, NY [19]

WILSON, Floyd [P] Portland, OR. Affiliated with Portland Pub. Lib. [15]

WILSON, Francis Vaux [I] Old Lyme, CT b. Nov 1874, Phila., PA d. 17 Ap 1938. Studied: PAFA; Henri. Member: Phila. AC; Salma C. [31]

WILSON, Frederick [P,I,C] NYC b. 3 N 1858, Great Britain. Studied: C. Wilson, in England. Member: Arch. Lg., 1911; AC Phila. Exhibited: Paris, 1900 (gold). Work: murals/stained glass: Cuyahoga County Court House, Cleveland, OH; St. Clement's Church, Phila.; Manchester Cathedral, England; cartoons/mosaic, Cleveland; cartoons, Staten Island, N.Y.; U.S. Naval Acad., Annapolis [21]

WILSON, Frederick Francis [Cart] San Diego, CA b. 4 My 1901, Aurora, MO. Studied: W.L. Evans Sch. of Cartooning, Cleveland. Work: Huntington Lib., A. Gal., San Marino, Calif.; Franklin Inst., Phila. Position: Staff Cart., San Diego Union-Tribune [40]

WILSON, Gilbert Brown [P,S,I] Terre Haute, IN b. 4 Mr 1907, Terre Haute. Studied: W.T. Turman; E. Savage; E.A. Forsberg; AIC; Ind. State T. Col.; Yale. Member: Am. A. Cong.; A. Lg. Am. Exhibited: Hoosier Salon, 1929 (prize), 1933 (prize); BAID, 1930 (prize); Ind. State Kiwanis (prize). Work: murals, Woodrow Wilson Jr. H.S., Terre Haute, Ind.; Ind. State T. Col.; Antioch Col., Yellow Springs, Ohio; Hotel, Lake Wawasee, Ind. [47]

WILSON, Grace (Mrs.) [P] Pittsburgh, PA. Member: Pittsburgh AA [25]

WILSON, Harriet [P] West Orange, N.J. Member: AWCS. Exhibited: AWCS, 1934, 1936, 1939. Illustrator: covers, Design, 1936 [47]

WILSON, Helen [P,T] Lincoln, NE b. 26 O 1884, Lincoln, NE d. 1974. Studied: AIC; C.W. Hawthorne; H. Breckenridge; D. Garber; W. Adams; Fontainebleau Sch. FA. Member: Lincoln AG. Position: T., H.S., Lincoln, Nebr. [40]

WILSON, Henrietta [P,T] Norwood, OH b. Cincinnati, OH. Studied: Cincinnati A. Acad. Member: Cincinnati Women's AC (Pres., 1902); Crafters C.; Ohio-born Women P. Position: T., Cincinnati A. Acad. [40]

WILSON, Howell [P] Phila., PA b. Phila. Studied: PAFA; London. Member: Phila. AC [08]

WILSON, J. Coggeshall [P] NYC b. NYC. Exhibited: Paris Salon, 1902 (prize) [04]

WILSON, James Warner [Shipcarver] Newburyport, MA b. 2 Jy 1825, Newburyport d. 19 O 1893. Brother of Albert. [*]

WILSON, Jean Douglas [P] Bronxville, NY [25]

WILSON, John A(lbert) [S] Boston, MA b. 10 Ap 1878, New Glasgow, Nova Scotia. Studied: H.H. Kitson; B.L. Pratt [13]

WILSON, John Woodrow [P,Li,T] Roxbury, MA b. 14 Ap 1922, Roxbury. Studied: BMFA Sch. Exhibited: Atlanta Univ., 1943–46; CI, 1944, 1945; "The Negro Artist comes of Age" Exh., 1945; LOC, 1945, 1946; Smith Col., 1941; Wellesley Col., 1943; Springfield AM, 1945, 1946; BMFA Sch. (prize); Inst. Mod. A., Boston, 1943 (prize), 1945 (prize); Pepsi-Cola, 1946 (prize). Work: Smith Col. Mus.; Atlanta Univ.; MOMA; Howard Univ. Positions: T., Samuel Adams Sch.; Boris Mirski Gal., Boston [47]

WILSON, Joseph Miller [P,Arch] Phila., PA [04]

WILSON, Josephine Davis [P] West Phila., PA [04]

WILSON, Kate [P,T,S] Norwood, OH b. Cincinnati. Studied: Louis Rebisso, Cincinnati A. Acad. Member: Cincinnati Women's AC [31]

WILSON, Louis W. [P] Chicago, IL. Member: Chicago SA [10]

WILSON, Lucy Adams (Mrs.) [P] Miami, FL/Asheville, NC b. 1855, Warren, OH. Studied: Herron AI, Indianapolis; ASL; W. Forsyth; T.C. Steele. Member: Miami AL; Am. Fed. A. Work: Herron AI; Zion Park Inn., Asheville, N.C. [40]

WILSON, Maude [P] Chicago, IL b. Chicago. Studied: AIC [01]

WILSON, Melba Z. [P] Los Angeles, CA. Member: Calif. AC [25]

WILSON, Melva Beatrice [S,Mur.P,L] NYC/Hempstead, NY b. 1866, Madison, IN d. 2 Je 1921, NYC. Studied: Cincinnati A. Acad., with Nobel, Nowottny, Rebisso; Rodin, in Paris. Work: Farley Mem. Chapel, Calvary Cemetery, N.Y.; St. Louis Cathedral. Specialty: decorative religious subjects. Also a poet. [08]

WILSON, Mortimer, Jr. [I,Car] NYC. Member: SI. Contributor: illus., Good Housekeeping, 1939 [47]

WILSON, Nelson (D.) [P,Des,T] Evansville, IN b. 28 Ja 1880, Leopold, IN. Studied: Chicago Acad. FA. Exhibited: Hoosier Salon, 1929, 1946 (prize); John Herron AI, 1926–28; Evansville A. Mus., 1930 (one-man). Work:

Culver Grade Sch., Bosse H.S., Evansville, Ind.; State House, Indianapolis; murals, Vanderburg County Coliseum, Evansville, Ind. [47]

WILSON, Norman Badgley [P,En] Indianapolis, IN b. 1 D 1906, Arcadia, IN. Member: Indianapolis AA; Ind. Soc. Pr. M. Exhibited: PAFA, 1937; Butler AI, 1945, 1946; Tri-State Pr. Exh., 1944, 1945; Milwaukee AI, 1946; Herron AI, 1937, 1939, 1942, 1944–46 [47]

WILSON, Robert Burns [Por.P,Mar.P] NYC b. 1851, Parker, PA d. 31 Mr 1916, Brooklyn. Exhibited: SSAL, at Henderson, Ky., ca. 1900 (med). Specialty: animals. He settled in Frankfort, Ky. remaining there for nearly 30 yrs. Studio mate of J.W. Alexander. [15]

WILSON, Rose Cecil O'Neil (Mrs.) [I,Des,W] Saugatuck, CT b. 1875, Wilkes-Barre, MA d. 6 Ap 1944 at her home near Springfield, MO. Member: S. Des Beaux-Arts, Paris; SI, 1912; Artists G. Her most famous success was the Kewpie Doll. [33]

WILSON, Sarah C. [Min.P] Beaver, PA. Member: Pittsburgh AA [25]

WILSON, Scott [Des,P] NYC b. 19 Mr 1903, Vigau, Luzon, Philippines. Studied: Harvard. Member: ADI; Arch. L. Author/Illustrator: "Tommy Tomato and the Vegets," 1936, "Tommy Tomato Saves the Garden," 1937. Specialty: design of textiles, wallpaper, furniture, lighting fixtures. Position: Partner, Scott Wilson & Fritz Foord, Indst. Designers [47]

WILSON, Sol [P,Ser,T] NYC b. 11 Ag 1896, Vilno, Poland d. 1974. Studied: CUASch.; NAD; BAID; G. Bellows; R. Henri; G. Olinsky; G. Maynard. Member: An Am. Group; AL Am.; Nat. Ser. S.; Boston AC; Am. A. Cong. Exhibited: NAD, 1938, 1940, 1945, 1946; AIC, 1935, 1943, 1945; VMFA, 1942, 1944, 1946; Critics Choice, N.Y., 1945; Nebr. AA, 1945, 1946; LOC, 1944; Univ. Iowa, 1945, 1946; CAM, 1939; WFNY, 1939; Am. Red Cross, 1942 (prize); AV, 1943 (prize); Pepsi-Cola, 1944 (prize). Work: Telfair Acad.; Lincoln H.S., N.Y.; Brooklyn Col.; BM; Am. Red Cross; LOC; BMA; SAM; CAM; USPO, Delmar, N.Y.; Westhampton, N.Y.; Biro-Bidjan Mus., U.S.S.R. [47]

WILSON, Sophie (Mrs. Wins) [Por.P,B,I,Dr] Richmond, VA b. 29 My 1887, Falls Church, Va. Studied: PMSchIA; Corcoran Sch. A.; Berkshire Summer Sch. A. Member: Richmond Acad. A.; VMFA. Illustrator: cover drawings, Etude, Country Life, Peoples Popular mag. [40]

WILSON, Susan Colston [P] Saranac Lake, NY. Affiliated with American Red Cross [25]

WILSON, Vaux [I] Elmhurst, NY [21]

WILSON, W. Reynolds, Jr. [Por.P] Phila., PA b. Phila., PA, 1899 d. 7 Mr 1934. Studied: Académie Julian; Grand Central A. Sch., NYC; PAFA. Member: Phila. AC; Phila. Sketch C.

WILSON, William J. [P,E] Long Beach, CA b. 1 N 1884, Toledo, OH. Member: Long Beach AA (Pres.); Los Angeles PS (Dir.); Laguna Beach AA; Spectrum C. Exhibited: Spectrum C., Long Beach, 1932 (prize), 1933 (prize). Work: Bilge C., San Pedro, Calif. [40]

WILSTACH, George L. [P,Des,C] Lafayette, IN/Gloucester, MA b. 1892. Studied: AIC; ASL. Member: Hoosier Salon; Ind. Ar. C.; North Shore AA. Work: Lafayette AM, Ind. Position: Des./Manufacturer, hand-carved picture frames [40]

WILTON, Anna. See Keener.

WILTZ, Arnold [P,En] Woodstock, NY b. 18 Je 1889, Berlin, Germany d. 13 Mr 1937. Studied: self-taught. Member: Brooklyn S. Modern A.; Woodstock AA. Work: Cincinnati Mus.; Helena Rubenstein Col., Paris, France; PMG; WMAA [33]

WILTZ, Madeline. See Shiff, E. Madeline.

WILWERDING, Walter Joseph [I,P,L,T,W,Ph] Old Greenwich, CT (Minneapolis, 1966) b. 13 F 1891, Winona, MN. Studied: Minneapolis Sch. A., with R. Koehler; G. Doetsch, E.M. Dawes, 1919–15; M. Phoenix; M. Cheney. Work: Explorers C., Chicago. Illustrator: "True Bear Stories," J. Miller; "King of the Grizzlies," A. Richardson, "Under Western Heavens," Olai Aslagsson; "Indian Moons," Winona Blanche Allen. Author/Illustrator: "Jangwa, The Story of a Jungle Prince," "Keema of the Monkey People," "Punda, the Tiger-Horse." Position: T., Minneapolis Sch. A., 1926–32; 1941–61. [40]

WIMAN, Vern (Miss) [Caric,I,E,P] San Francisco, CA b. San Fran. Studied: Calif. Sch. FA; M. Sterne; Schaeffer Sch. Des. Exhibited: Calif. Sch. FA, 1938 (prize), 1939 (prize). Exhibited: CI, 1944; W.R. Nelson Gal., 1944; CAM, 1944; Portland AM, 1939, 1944; CM, 1944; SFMA, 1940, 1941, 1944–46; de Young Mem. Mus., 1943; Calif. SE, 1945; Dorian A. Gal., 1945; Raymond Gal., 1945, 1946; Workshop Gal., 1945. Work: Portland AM. Position: Caric., San Francisco Chronicle, from 1939 [47]

WINANS, Walter [P,S,I] Kent, England/Brussels, Belgium b. 5 Ap 1852, St. Petersburg, Russia (of Am. parents) d. 12 Ag 1920. Studied: Volkoff; Paul; Geroges; Corboult. Member: Peintres et Sculpteurs du Cheval; Allied AA. Work: Marble Palace, St. Petersburg; Hartsfeld House, London. Award: Chevalier of the Imperial Russian Order of St. Stanislaus. Also a noted Am. sportsman. [13]

WINCHELL, Elizabeth Burt (Mrs. John P.) [P,C,Des,T,G,L] Freeport, ME b. 20 Je 1890 Brooklyn, NY. Studied: E. Daingerfield; D. Garber; W.W. Gilcrist, Jr.; H. Sartain; Moore Inst. Des., Phila.; PAFA; PMSchIA; H. Snell; S. Murray. Member: Freeport AC; Maine Craft Gld.; Haylofters, Portland, Maine; AAPL. Exhibited: PAFA; BM; Portland SA; Freeport AC, 1940–46; Providence, R.I; Wanamaker Exh., Phila., 1910–11 (prize); Flower Show Exh., Phila., 1911 (prize), 1928 (prize); C.L. Wolfe AC, NYC, 1928 (prize). Position: T., Bailey Sch., Bath, Maine, 1939–46 [47]

WINCHELL, Fannie [P] Laguna Beach, CA. Member: Laguna Beach AA [25]

WINCHELL, Paul [G,I,T] Minneapolis, MN. Studied: AIC; L. Kroll; B. Anisfeld; D. Garber; C. Woodbury; G. Oberteuffer; E. Forsberg. Exhibited: Midwestern Ar. Ann., Kansas City AI, 1938. Position: T., Minneapolis Sch. A. [40]

WINCHELL, Ward [P] Los Angeles, CA. Member: Calif. AC [25]

WINCKLER-SCHMIDT, Adele (Mrs.) [Min.P] London, England b. St. Louis. Studied: St. Louis Sch. A. Exhibited: St. Louis Expo, 1904 (med) [13]

WINDETT, Villette [P] Chicago, IL [04]

WINDHAM, Edmund [P] Brooklyn, NY [01]

WINDISCH, Marion L(inda) (Mrs. Alden Cody Bentley) [S] NYC b. 20 Je 1904, Cincinnati. Studied: C.J. Barnhorn; E. McCartan. Exhibited: Three AC (prizes); Women's City C., Cincinnati (prize) [33]

WINEBRENNER, Harry Fielding [S,P,W,L,T,C] Chatsworth, CA b. 4 Ja 1885, Summersville, WV d. 8 O 1969. Studied: Univ. Chicago; AIC; British Acad., Rome, Italy; Taft; Mulligan; Sciortino. Member: Calif. AC; S. Sanity in Art; S. Gld., So. Calif. Work: Okla. City, Okla.; Venice (Calif.) H.S. Author/Illustrator: "Practical Art Education." Position: T., Venice (Calif.) H.S., 1917–45 [47]

WINEGAR, A.L. [P] New Haven, CT [04]

WINEGAR, Anna [P] Bronxville, NY. Member: NAWPS [27]

WINEGAR, Samuel P. [Mar.P] New Bedford, MA (1900) b. 1845, New Bedford, MA. Work: Kendall Whaling Mus. A sailor who, by 1881, was listed as an artist. [*]

WING, Anna. See Kindlund.

WING, Florence Foster (Mrs.) [Des] Newton Centre, MA b. 18 O 1874, Roxbury, MA. Studied: BMFA Sch. Member: Copley S.; Boston SAC. Exhibited: BMFA (prize). Work: Bookplate. BMFA Lib.; Elmwood Pub. Lib., Providence, RI. Specialty: bookplates [40]

WING, Francis Marion [Cart,T] Minneapolis, MN b. 24 Jy 1873, Elmwood, IL. Studied: Grinnell Col., Iowa. Author: "The Fotygraft Album," 1917; "Yesterdays," 1930. Positions: Cart., Minneapolis Journal (1900), Chicago Tribune Syndicate; T., Fed. Sch., Minneapolis [40]

WING, G.F., Jr. [P] NYC [04]

WINGATE, Arline (Mrs. Clifford Hollander) [S,L,T] NYC b. 18 O 1906, NYC. Studied: A. Faggi; J. Hovannes; A. Archipenko; Smith Col. Member: Fed. Mod. P. & S.; NAWA; N.Y. Soc. Women AC. Exhibited: NAD, 1939; GGE, 1939; NAWA, 1941–46; PAFA, 1940, 1943, 46; BM, 1944; Wadsworth Atheneum, 1944; Smith Col., 1942; WMAA, 1940–42; 1945; AIC, 1942; WFNY, 1939; Riverside Mus., 1938, 1941; Midtown Gal., 1938–46; Durand-Ruel Gal., 1944; Wildenstein Gal., 1941–46; Clay C., 1938; N.Y. Soc. Women AC, 1939 [47]

WINGATE, Carl [P,I,E,W] Milton, MA/Marblehead, MA b. 9 D 1876. Studied: W. Shirlaw. Work: 14 drypoints of ships, Mus., City of N.Y. [40]

WINGERD, Loreen [G,C,T] Indianapolis, IN b. 2 Ag 1902. Studied: W. Forsyth; J. Herron AI. Member: Ind. Artists C.; Ind. S. PM [40]

WINGERT, Edward Oswald [P,S] Phila., PA b. 29 F, 1864. Studied: PAFA, with Anshütz, Hovenden, Porter. Member: AAPL. Exhibited: Spring Garden Inst. (medals). Work: Graphic Sketch C., Phila.; Youngstown AI [40]

WINGERT, Paul Stover [Edu,W,L] NYC b. 13 N 1900, Waynesboro, PA d.

1974. Studied: Columbia; Univ. London; Sorbonne; Paris. Co-author: "The Sculpture of W. Zorach," 1938, "An Outline Guide to the Art of the South Pacific," 1946, "Arts of the South Seas," 1946. Positions: Cur. FA & Archaeology (1834–42), T. (from 1942), both at Columbia [47]

WINHOLTZ, Caleb [P] St. Paul, MN [19]

WINKEL, Nina [S] NYC b. 21 My 1905, Borken, Germany. Studied: Germany. Member: Clay C. S. Ctr. Exhibited: NAD, 1943, 1945 (med); PAFA, 1946; Nebr. AA, 1946; Clay C., Gal., 1944 (one-man); Newark Mus., 1944 [47]

WINKLE, Emma Skudler (Mrs. Vernon M.) [P,C,Des,I,L,T,B,Cer] Lincoln, NE b. 27 Je 1902, Stuart, NE. Studied: Univ. Nebr.; Columbia; J. Upjohn; H. Church; Mrs. H.M. Brock; H. Stellar; L. Mundy; Paul Grummann. Member: Lincoln AG; Topeka AG; Am. Assn. Univ. Women; Nebr. AA. Exhibited: Lincoln AG, 1924–45; Topeka AG, 1945; Lincoln State Fair; Univ. Nebr., 1922–40. Member: Nebr. Fed. A. Illustrator: "In-Service Education of Elementary Teachers," 1942; "In-Service Education of Teachers & Rural Community Building," 1940. Position: T., Univ. Nebr., 1921–32 [47]

WINKLER, Agnes Clark (Mrs. G.A.M.) [P,W] Chicago, IL b. 8 Ap 1864, (or 1893) Cincinnati d. 15 Ja 1945. Studied: L. Lundmark; E. James; F. Timmons; AIC. Member: All-Ill. SFA; Hoosier Salon; Cincinnati Women's AC; Chicago NJSA. Contributor: Paris magazines [40]

WINKLER, John W. [E,P] Berkeley, CA Member: NA; Chicago SE; ANA, 1936; Am. Soc. E.; Société des Graveurs in Noir, Paris. Exhibited: Chicago SE, 1918 (prize); Calif. SE, 1919 (prize); SAE, 1937 (prize); Concord AA, 1920 (prize). Work: AIC; NYPL; Luxembourg Mus., Paris [47]

WINKS, Lucile Condit [P,Li,B,Dr] Salisbury, NC/Columbia Univ., NYC b. 29 Je 1907, Des Moines. Studied: B. Sandzen; A. Shannon; M. Whittemore; C. Henkle; A. Young. Member: Lg. Am. Pen Women; N.C. Prof. AC [40]

WINN, James Buchanan, Jr. [Mur.P,Dec] Dallas/Wimberley, TX b. 1 Mr 1905, Celina, TX. Studied: O.E. Berninghaus; F. Carpenter, Wash. Univ.; Académie Julian. Work: bas relief, City Park, murals, Tex. State Bldg., Village Theatre, Burrus Mills, Power and Light Bldg., all in Dallas; ceiling and dec., Univ. Tex., Austin; dec., Blackstone Hotel, Ft. Worth; State Mem., Gonzales; bas-reliefs, Ripley Fnd.; dec., River Oaks Theatre, Houston; murals, Med. A. Bldg., dec., Hillcrest Mausoleum, both in Dallas [40]

WINN, James H. [J,C,Des,En,S,L,T,W] Pasadena, CA. b. 10 S 1866, Newburyport, MA. Studied: H. Resterich; E. Rose; C. Mulligan. Exhibited: AIC, 1910 (prize); Women's Conservation Expo, Knoxville, Tenn., 1913 (gold,prize); Calif. State Fair, Pomona, 1931 (prize). Author: articles, Christian Science Monitor, Motif [40]

WINNER, Margaret F. [Por.P,Min.P] Phila., PA b. 21 O 1866, Phila. d. 21 D 1937. Studied: PAFA; H. Pyle. Member: Phila. Alliance. Work: Dickinson Col., Carlisle, Pa.; County Medical S., Phila. [38]

WINNEWISSER, Emma Louise [P] Boston, MA b. Bellows Falls, VT. Studied: A.W. Bühler, in Boston [04]

WINSEY, A. Reid [P,I,Car,W,L,T] Greencastle, IN b. 6 Je 1905, Appleton, WI. Studied: Univ. Wis.; Yale; Am. Acad. A., Chicago; E. Taflinger; T.H. Benton. Member: Hoosier Salon; Ind. AC; Ind. Fed. AC; Chicago SE. Exhibited: Wis. Salon. Work: Layton A. Gal.; Wis. General Hospital, Madison; A. Edu. Bldg., Madison; Atwater Training Sch., New Haven, Conn. Author/Illustrator: "Off Limits," 1946. Illustrator: "Skohby the Snow Dog," 1946. Position: T., De Pauw Univ., Greencastle, Ind., 1935– [47]

WINSHIP, Florence Sarah [I,W,Des] Chicago, IL b. Elkhart, IN. Studied: Chicago Acad. FA; AIC. Illustrator: "The A-B-C Book," 1940, "Sounding Rhymes," 1942, "Sir Gruff," 1946, "Woofus," 1944, "Animal A-B-C," 1945. Author/Illustrator: "Counting Rhymes," 1941, "Fuzzy Wuzzy Puppy," 1946, other children's books [47]

WINSLOW, Earle B. [I,Li,P] Woodstock, NY b. F 21 1884, Northville, MI. Studied: Sch. FA, Detroit; AIC; ASL. Member: SI; AG (Pres., 1940–44); SC. Exhibited: Intl. WCS, 1928–40; CAA; SI, 1931–45; PAFA, 1919, 190; Macbeth Gal. (one-man). Illustrator: "Robbins' Journal," 1931; "Gospel of St. Mark," 1932, "Fire Fighters," 1939; children's books [47]

WINSLOW, Edward Lee [Ldscp.P] Indianapolis, IN b. 28 Je 1871, Tescola, IL. Member: Ind. Artists C.; Hoosier Sal. Work: Shortridge H.S., Indianapolis [40]

WINSLOW, Eleanor C.A. (Mrs.) [P] NYC b. 1877, Norwich, CT. Studied: ASL; Whistler, in Paris. Member: CAFA; NAWPS; Norwich AA. Exhibited: NAD, 1907 (prize) [40]

WINSLOW, Henry [P,E,Cr] London, England b. 13 Jy 1874, Boston d. 1950s. Studied: Whistler, in Paris. Member: Chicago SE; AIGA. Exhibited: Paris Salon; Royal Acad., London. Work: British Mus., London; Bibliothèque Nationale, Paris; NYPL; London Port Authority. Author: "The Etching of Landscapes," Chicago SE, 1914. He was the first artist to produce etchings in Cos Cob, Conn. (1906) [40]

WINSLOW, Leo [P] Logansport, IN [25]

WINSLOW, Leon Loyal [T,W] Baltimore, MD b. Brockport, NY. Studied: PIASch. Member: AFA. Author: "Organization of Art," "Elementary Industrial Arts," "Essentials of Design" [31]

WINSLOW, Marcella. See Comes.

WINSLOW, Morton G. [P] Exhibited: Great Lakes Exh., The Patteran, Buffalo, 1938; AIC, 1939; WFNY, 1939 [40]

WINSTANLEY, John Breyfogle [P,W,L] Largo, FL b. 23 O 1874, Louisville, KY d. 5 D 1947. Studied: Purdue Univ.; Univ. Pa.; PAFA; W.M. Chase. Member: NYWCC. Exhibited: P.-P. Exh., 1915. Work: Rochester Mem. A. Gal. Author: "The Black Mirror: 1903–12." Contributor: International Studio [47]

WINTER, Alice Beach (Mrs. Charles A.) [P,S,I,T] East Gloucester, MA b. 22 Mr 1877, Greenridge, MO. Studied: St. Louis Sch. FA; ASL; G. de Forest Brush; J. De Camp; J. Fry; C. Von Saltza; J. Twachtman. Member: North Shore AA; Gloucester SA. Exhibited: NAD, AIC; CI; CAM; Los Angeles Mus. A.; NAWA; St. Louis Sch. FA, 1894–97. Contributor: illus./covers, Delineator. Specialty: children [47]

WINTER, Andrew [P] Monhegan Island, ME (NYC in 1940) b. 7 Ap 1893, Sindi, Estonia d. 27 O 1958, Brookline, MA. Studied: NAD; Cape Cod Sch. A.; Tiffany Fnd.; Am. Acad, Rome; NAD, Mooney traveling schol., 1925. Member: AWCS; NAC; SC; A. Fellowship; Tiffany Fnd.; ANA, NA, 1938; Allied AA; AAPL. Exhibited: PAFA; AIC; CGA; VMFA; CI; AFA Traveling Exh.; GGE, 1939; WFNY, 1939; AV; Pepsi-Cola; Montclair AM; Herron AI; TMA; NAD, 1924 (med), 1931 (med), 1935 (med), 1940–42 (prizes); NAC, 1931 (prize); Allied AA, 1933 (prize), 1939 (prize); SC, 1934 (prize), 1937 (prize), 1938 (prize) 1940 (prize), 1941 (prize), 1942 (prize), 1945 (prize); Buck Hills Falls, Pa., 1940 (prize); Currier Gal., 1941 (prize). Work: Marine Mus., Newport News, Va.; NAD; PAFA; Cranbrook Acad. A.; Winchester (Mass.) Pub. Lib.; Buck Hills Falls; Wake Forest (Ill.) Col.; NAC; IBM Coll.; High Mus. A.; Hickory (N.C) Mus.; Claremont H.S., N.C.; Rochester Mem. A. Gal.; WPA mural, USPO, Wolfeboro. N.H. [47]

WINTER, Charles Allan [P,I,Dec,Dr,L,T] East Gloucester, MA b. 26 O 1869, Cincinnati d. 23 S 1942. Studied: Cincinnati A. Acad., with Nobel, Nowottny; Académie Julian, Paris, with Bouguereau, Ferrier, 1894; Rome. Work: murals, City Hall, H.S., both in Gloucester, Mass.; Univ. Wyo. Contributor: illus./covers, Elbert Hubbard's "Little Sermons" in Cosmopolitan and Hearst's mag.; illus./covers, Collier's; American Bank Note Co. [40]

WINTER, Clark [S,T,Li,L] NYC b. 4 Ap 1907, Cambridge, MA. Studied: Harvard; ASL; Cranbrook Acad. A.; R. Laurent; W. Zorach. Exhibited: Fontainebleau Sch. Alumni Assn., 1943 (prize); PAFA, 1942; S.Indp.A., 1942, 1943; Vendôme Gal., 1943. Position: T., PIASch, 1945–47 [47]

WINTER, Ezra (Augustus) [P,I] Falls Village, CT b. 10 Mr 1886, Manistee, MI d. 7 Ap 1949. Studied: Chicago Acad. FA; Am. Acad, Rome, schol, 1911–14. Member: NSMP; SC; AFA; Arch. L.; Am. Acad. A.&Let.; ANA, 1924; NA, 1928; Players C. Exhibited: Arch. L., 1922 (med); N.Y. S. Arch., 1923 (gold). Work: Cunard Bldg., N.Y.; Cornell; N.Y. Cotton Exchange; Nat. Chamber of Commerce, Wash., D.C.; Union Trust Bldg., Detroit; Music Hall, Rockefeller Ctr.; Kilburn Hall, Eastman Theatre, Rochester, N.Y.; Pub. Lib., Birmingham, Ala.; Savings Bank, Rochester, N.Y.; Industrial Trust Bldg., Providence, R.I.; stained glass window, Straus Bank, Chicago; N.Y. Life Bldg., Restaurant, NYC; Bank of Manhattan Trust Co.; George Rogers Clark Mem., Vincennes, Ind. [47]

WINTER, H. Edward [C,Des] Cleveland, OH b. 14 O 1908, Pasadena, CA. Studied: Cleveland Sch. A.; Kunstgewerbe Schule, Vienna, Austria. Member: Cleveland SC; NYSC. Exhibited: CMA, 1933 (prize), 1934 (prize), 1936 (prize); Robineau Mem. Ceramic Exh., Syracuse Mus., N.Y., 1934 (prize), 1936 (prize); Canadian Nat. Exh., 1933 (prizes); Nat. Ceramic Exh., Syracuse MFA, 1937 (prize), 1938 (prize). Work: 25 porcelain enamel murals, for the Ferro Enamel Corp., Cleveland; CMA, Am. Ceramic Tour of Europe, 1937 [40]

WINTER, Lumen Martin [P,I,Des,L,T,Car] Cincinnati, OH b. 12 D 1908,

Ellery, IL. Studied: Cleveland Sch. A.; NAD; Grand Central Sch. A.; BAID; Olinsky; Biggs; Pape; Grand Rapids, Mich. Jr. Col. Member: Cincinnati Prof. A.; Cincinnati AC; A. Dir. C., Chicago; A. Gld., N.Y.; Am. Fed. A. Exhibited: Salon of Am., 1933; Asbury Park SA, 1939, 1940; AV, 1943; Butler AI, 1943, 1944; CM, 1937–46, 1944 (prize); Ohio WCS, 1944, 1945; Cincinnati Prof. A., 1943–45; Grand Rapids A. Gal., 1929–31; Cincinnati AC, 1937–45; Hackley A. Gal., 1929 (one-man); Grand Rapids Pub. Lib., 1932; Brown Gal., Cincinnati, 1940; Detroit AI; Grand Central A. Gal.; Hotel Gibson, Cincinnati (one-man). Work: Union H.S., Jr. Col., both in Grand Rapids, Mich.; Univ. Cincinnati; Friar's C., Cincinnati; murals, Fed. Bldg., Fremont, Mich.; Hutchinson, Kans.; WPA murals: USPOs, Fremont, Mich., Wellston PS, St. Louis. Co-author: "Epics of Flight," 1932, "Can It Be Done?," 1933. Contributor: covers, Liberty, 1935 [47]

WINTER, Mary Taylor [P] NYC b. 28 Mr 1895. Studied: NAD, with C.W. Hawthorne, I. Olinsky; Tiffany Fnd.; Cape Cod Sch. A.; Iowa Univ. [40]

WINTER, Milo Kendall, Jr. [P,Des,T] Chicago, IL/Goose Rock Beach, ME b. 31 Jy 1913, Chicago d. 15 Ag 1956. Studied: AIC; Cranbrook Acad.; E. O'Hara. Exhibited: AIC, 1939; PAFA; Am. Fed. A., 1938, 1939 (traveling). Work: CAM. Positions: T., RISD; O'Hara WC Sch. (summer) [40]

WINTER, Raymond [P] Fairhaven, PA. Member: Pittsburgh AA [25]

WINTERBURN, Phyllis [P,T,Des,B] Sausalito, CA b. San Fran. Studied: Calif. Sch. FA; Schaeffer Sch. Des.; Univ. Calif.; Dominican Col. Member: San Fran. S. Women A.; Marin SA; San Fran. AA; Work: SFMA; Marin AA; Pal. Leg. Honor. Position: T., Katharine Branson Sch., Ross, Calif. [40]

WINTERHALDER, Erwin [S] San Francisco, CA [17]

WINTERICH, Joseph [S] Cleveland, OH b. 1861, Neuweid, Germany (came to U.S. in 1907). d. 16 N 1932, Coblenz, Germany. Work: church dec., St. Ignatius, St. Cyril, St. Methodine & Our Lady of Good Counsel, all in Cleveland. In 1920, he joined his son in church furnishing & dec. firm in Cleveland.

WINTERMOTE, Mamie W. (Mrs.) [Por.P] Hollywood, CA b. 3 O 1885, Liberty, MA. Studied: Kansas City AI; R. Davey; N. Facine. Member: Calif. AC; Women P. of the West [40]

WINTERS, Denny (Denny Winters Cherry) [P,Li,Des,C,S,B] Woodstock, NY b. 17 Mr 1907, Grand Rapids, MI. Studied: AIC; Chicago Acad. FA; Weisenborn. Member: Los Angeles WCS. Exhibited: MOMA; AIC, 1936, 1937, 1945; PAFA, 1940, 1941; SFMA, 1939–42, 1943 (prize), 1941 (prize); CI, 1945, 1946; Colorado Springs FA Ctr., 1943; Los Angeles Mus. A., 1939–45, 1944 (one-man); Perls Gal., 1942; Levitt Gal., 1945 (one-man); Denver A. Mus., 1941 (prize). Work: dioramas, Century of Progress, sponsored by Univ. Chicago [47]

WINTERS, Ellen [P,S] NYC. Member: NAWA. Exhibited: NAWA, 1935–38 [40]

WINTERS, Helen H. [P] Newark, NJ [15]

WINTERS, John (Richard) [S,B] Chicago, IL b. 12 My 1904, Omaha. Studied: Chicago Acad. FA; AIC; F. Poole; J. Allen St. John. Exhibited: CGA, 1934; Denver AM; Wichita A; Kans. State Col; Tulsa AA; Topeka AG; Salina (Kans.) AA; AIC, 1935, 1936, 1938, 1940, 1944; Springfield (Mass.) Mus. A., 1938; Little Gal., Chicago; Carson Pirie Scott Co., Chicago; Chicago Women's C., 1938. Work: murals: Stienmetz H.S., Chicago; Northwest Airlines, Seattle; Cook County Hospital, Ill.; Hatch Sch., Oak Park, Ill.; Brookfield (Ill.) Zoo.; WPA mural, USPO, Petersburg, Ill. [47]

WINTERS, Paul Vinal [S,P,Dec,Des,T] Norwood, MA b. 8 S 1906, Lowell, MA. Studied: Mass. State Sch. A.; R.A. Porter; L. Toschi; C. Dallin. Member: Boston AC. Exhibited: Robbins Mem. Town Hall, Arlington, Mass., 1932; Pub. Lib., Children's Mus., Boston; Peabody Mus., Cambridge. Work: statue, Monohoi, Pa.; bust, Boston Pub. Lib.; Pub. Lib., Children's Mus., Boston. Position: T., Dorchester House [47]

WINTHROP, Emily [S] NYC. Member: NAWPS [27]

WINTHROP, Grenville L. [Patron] NYC b. 1865 d. 19 Ja 1943. His collections, left to Harvard, included early American portraits, drawings by English and French artists, and Chinese sculpture.

WINTRINGHAM, Frances M. [P] NYC b. 15 Mr 1884, Brooklyn, NY. Studied: ASL, with G. Bellows; K.H. Miller; R. Henri; J. Sloan; C. Hawthorne. Member: S.Indp.A.; Lg. AA; Whitney Studio C. [33]

WINZENRIED, Henry E. [P,Li,I,Des,B] NYC/Woodstock, NY b. 24 Mr 1892, Toledo. Studied: J.F. Carlson; Southern Pr.M. Soc. [47]

WIRE, Melville T(homas) [P] Albany, OR b. 24 S 1877, Austin, IL. Studied: M.C. Le Gall; Mrs. E. Cline-Smith. Member: Oreg. SA. Exhibited: Oreg. SA, 1931 (prize) [33]

WIREMAN, Eugenie M. [P,I] Phila., PA b. Phila. Studied: PAFA; H. Pyle. Member: Phila. Alliance [33]

WIRES, Alden Choate (Mrs.) [P] Rockport, MA b. 16 F 1903, Oswego, NY. Member: Tiffany Fnd.; Rockport AA [33]

WIRES, Hazel Kitts [P,Des] Haworth, NJ b. 16 F 1903, Oswego, NY. Studied: Corcoran Sch. A.; A.T. Hibbard; R. Hammond; H. Breckenridge; S.B. Baker; W.L. Stevens. Member: North Shore AA; Ridgewood AA; S. Wash. A.; AAPL. Exhibited: S. Wash. A., 1937 (med). Position: T., Englewood A. Gal., N.J., from 1943 [47]

WIRTH, Anna M(aria) Barbara [I,P,W] Altadena, CA b. 12 N 1868, Johnstown, PA d. ca. 1938. Studied: PAFA; Phila. Sch. Des. for Women. Illustrator: "Progressive Pennsylvania," by J.M. Swank. Author/Illustrator: "The King's Jester." Contributor: articles, Los Angeles Saturday Night; poems, Davis Anthologies [38]

WIRTZ, Carel [S] NYC [17]

WIRTZ, William [Por,P,S,Li,L,T] Baltimore, MD b. 9 My 1888, The Hague, Holland (came to Baltimore in 1912) d. 20 Ap 1935. Studied: F. Jansen; W.A. van Konijnenburg, in The Hague; Düsseldorf [27]

WISE, Ethel Brand (Mrs. L.E.) [S] Syracuse, NY b. 9 Mr 1888, NYC d. 14 Ag 1933. Studied: J.E. Fraser; H. Trasher; A. Lee. Member: Syracuse AA; Syracuse ACG. Work: mem., Masonic Temple, Syracuse; mem., Wichita Falls, Tex.; Univ. Mo., Columbia; St. Johns Military Acad., Manlius; Central H.S.; Marshall Mem. Home, Syracuse; Macon, Ga. [31]

WISE, Florence B(aran) (Mrs.) [P,I] Cranston, RI b. 27 Ja 1881, Farmingdale, NY. Studied: NAD, with F.C. Jones, G.W. Maynard, G. Bridgman; RISD. Member: Providence WCC. Work: Ambassador Hotel, Chicago; Vacation Home for Crippled Children, Spring Valley, N.Y.; R.I. Post 23, Providence; Temple Beth-El, Providence. Illustrator: covers for periodicals [40]

WISE, Louise Waterman (Mrs. Stephen S.) [Por.P,S,W] b. NYC d. 10 D 1947. Studied: ASL, with K. Cox, R. Henri, K.H. Miller, G. Bellows. Exhibited: PAFA; CGA; NAWA. Work: Columbia, Tel-Aviv Mus., Palestine. Translator: works from French [47]

WISE, Sarah Green (Mrs.) [S] NYC d. 11 My 1919. Studied: Rodin

WISE, Vera [P,Li,T] El Paso, TX b. Iola, KS. Studied: Willamette Univ., Salem, Oreg.; Chicago Acad. FA; Kansas City AI. Member: NAWA; SSAL; Tex. FAA. Exhibited: AWCS, 1937, 1939; NAWA, 1938, 1942, 1943, 1945; CM, 1935; Jackson, Miss., 1943; SSAL, 1943, 1945; Wash. WCC, 1942; Tex. FAA, 1943, 1946; West Tex. A. Exh., 1942–46; Tex. Pr. Exh., 1945; Denver AM, 1934–37, 1943, 1944; Kansas City AI, 1933, 1935, 1939; Ft. Worth 1942 (prize); Abilene, Tex., 1946 (prize). Position: T., Col. Mines, El Paso, 1939–46 [47]

WISE, William G. [P] Phila, PA. Studied: PAFA [25]

WISELTIER, Joseph [P,C,T] West Hartford, CT b. 6 O 1887, Paris, France d. Fall, 1933. Studied: Dow; Bement; Snell. Member: Alliance; EAA (Pres.); Conn. AA; Hartford ACC; AFA; AAPL. Exhibited: Hartford; NYC. T., State Dir., A. Edu., Conn. [31]

WISELY, John Henry [S,T,C] Champaign, IL b. 11 S 1908, Woodward, OK. Studied: Kansas City AI; W. Rosenbauer; R. Braught; M. Hammond. Exhibited: GGE, 1939; Kansas City AI, 1936–1940, 1941 (prize); St. Louis, 1939; Tulsa, 1938, 1939; St. Joseph, Mo., 1938, 1939; Mo. State Fair, 1936–40; San Fran. A. Ctr., 1940 (prize); WFNY, 1939. Work: IBM Coll. [47]

WISEMAN, Robert Cummings [P,E,Arch] NYC b. 28 Je 1891, Springfield, OH. Studied: Kenyon Col., Gambler, Ohio; MIT; Columbia. Member: AIA. Exhibited: Hudson River AA, 1940; Springfield AA, 1945; ACA Gal., 1938; Barzansky Gal., 1943 (one-man). Work: Mus., City of N.Y. [47]

WISER, Guy Brown [P,I,W,T] Los Angeles, CA b. 10 F 1895, Marion, IN. Studied: Despujols; Gorguet; H.H. Breckenridge; C. Hawthorne; J.R. Hopkins. Member: Hoosier A. Patrons Assn.; Columbus AL; AAPL. Exhibited: PAFA, 1927 (prize); Northern Ind. AL, 1927 (prize); Hoosier Salon, Chicago, 1927 (prize), 1929 (prize), 1930 (prize), 1931 (prize), 1932 (prize), 1933 (prize), 1934 (prize); Richmond (Ind.) AA, 1928 (prize); Columbus AL, 1929 (prize); Herron AI, 1930 (prize). Work: Muskingum Col., New Concord, Ohio; Hospital and Law College, Ohio State Univ. Illustrator: "Rambles in Europe," pub. American Book Co., "Prose and

Poetry," pub. L.W. Singer Co., "Ourselves and the World," pub. Whittlesey House [40]

WISH, Oliver P.T. [Cur,Photogr] Portland, ME b. 4 Jy 1860, Portland d. 2 F 1932. Member: Portland Camera C.; Portland SA. Position: Curator: Sweat Mem. AM, Portland

WISMER, Frances Lee [P,I,B] Seattle, WA b. 19 Je 1906, Pana, IL. Studied: W. Isaacs; A. Patterson; H. Rhodes; Univ. Wash. Member: Northwest PM. Exhibited: Northwest PM, Seattle, 1929 (prize); SAM, 1935 (prize) [40]

WISNIEWSKA, Benedicta [P] Buffalo, NY. Exhibited: Great Lakes Exh., The Patteran, 1938; Albright A. Gal., 1938-40 [40]

WISSLER, Jessie Louisa [P] Thurmont, MD b. Duncannon, PA. Studied: Phila. Sch. Des. for Women; Drexel Inst. Specialty: watercolors [08]

WITHAM, Marie Alis [P] Cincinnati, OH [19]

WITHENBURG, Virginia Thomas (Mrs.) [P] Glendale, OH. Member: Cincinnati Women's AC [27]

WITHERS, Celeste [P] Los Angeles, CA. Member: Calif. AC [19]

WITHERS, George (K., Jr.) [P,I] Kansas City, MO b. 20 D 1911, Wichita, KS. Studied: A. Bloch; R.J. Eastwood; K. Mattern [33]

WITHERS, Loris Alvin [Mur.P,C,T,Dec,Des] Port Washington, NY. Studied: CI; ASL; NAD; R. Miller; Grande Chaumière, Delecluse Acad., Casteluchio, Morisset, all in Paris. Member: SC. Exhibited: Arch. L.; Salon des Tuileries, Paris; SC. Work: Church of the Holy Family, Columbus, Ga. Positions: Des., stained glass, Heinigke & Smith, NYC, 1916-32; T., Hunter Col. (1926-33), Brooklyn Col. (1933-43) [47]

WITHERSPOON, M(ary) Eleanor [Min.P,P] Ft. Worth, TX b. 23 Mr 1906, Gainesville, TX. Member: Brooklyn S. Min. P. [33]

WITHERSTINE, Donald F. [E,P] Provincetown, MA b. 9 F 1896, Herkimer, NY d. 1961. Studied: AIC; PAFA; G.E. Browne. Work: Peoria (Ill.) AI; Bloomington (Ill.) AA; Univ. Ill.; wood blockprint selected by Allied Artists of Am. as society's gift to its members, Christmas, 1933 [40]

WITHINGTON, Elizabeth R. [P] Rockport, MA. Member: AWCS. Exhibited: AWCS, 1933, 1934, 1936-39; AIC, 1936 [47]

WITHROW, Eva Almond [Por.P,Genre P] b. 1858, Santa Clara, CA d. 1928, San Diego. Painted portraits of prominent San Franciscans and Londoners. [*]

WITKOWSKI, Karl [Por.P] Newark, NJ b. 1860, Austria d. 17 My 1910. Studied: Czartkow, AA with Matejko. Work: Newark Pub. Lib.

WITMAN, Mabel Foote [P] Wash., D.C. [25]

WITT, John Henry (or Harrison) [Por.P] NYC (since 1879) b. 18 My 1840, Dublin, IN d. 13 S 1901. Studied: Cincinnati, with J.O. Eaton, 1858. Member: ANA, 1885; A. Fund S. His studio was in Columbus, Ohio, 1862-ca. 79, where he painted prominent people. [01]

WITTENBER, Jan [P] Chicago, IL Member: Chicago NJSA [25]

WITTER, Ella M. [P] Minneapolis, MN [24]

WITTERS, Nell [P,C,I,E,Des] NYC b. Grand Rapids, MI. Studied: AIC; PAFA; J.C. Johansen; ASL; Columbia; E. O'Hara; G.E. Browne. Member: NAWA; PBC; Wolfe AC; 8th St. AA, NYC. Exhibited: Wolfe AC, 1935 (prize); AIC, 1919 (prize); Alliance, 1919 (prize); NAWPS, 1933 (prize); PBC, 1937 (prize) [47]

WITTMACK, Edgar Franklin [P] NYC b. 1894, NYC d. 26 Ap 1956. Member: SI. Illustrator: cover of Saturday Evening Post, 1930s [47]

WITTMER, Henry [P] Pittsburgh, PA. Member: Pittsburgh AA [21]

WITTRUP, John Severin [P] Chicago, IL b. Mr 1872, Stavanger, Norway. Studied: AIC; W. Clute; C. Bothwood. Member: A. Gld.; S. for Sanity in Art; Ill. SA; Chicago P.&S. S. Exhibited: Chicago P.&S. S.; A. Gld. (one-man); Babcock Gal. (one-man); Findlay Gal., Chicago; Johannesburg, South Africa, 1936, 1938 (one-man); BM; Paris Salon, 1937; AIC, 1942 [47]

WIX, Otto [P] NYC [01]

WOBORIL, Peter P. [P] Milwaukee, WI [24]

WOELFFER, Emerson S. [P,S,G,L] Chicago, IL b. 27 Jy 1914, Chicago, IL. Studied: AIC. Member: Un. Am. Ar. Exhibited: Intl. WC Ann., 1936, Intl. Lith., Wood En. Ann., 1937, 1938, PS Ann., 1937, 1938, Ar. Chicago, Vicin. Ann., 1936-39, AIC, PS Ann., PAFA 1939 [40]

WOELFLE, Arthur W. [P,L,T] NYC b. 17 D 1873, Trenton, NJ d. 6 Mr 1936, Brooklyn, NY. Studied: ASL, with Mowbray, Beckwith, Cox, Twachtman; NAD, with W. Low, C.Y. Turner; Paris; Munich, with C. Marr, Diez. Member: ANA, 1929; NAC; SC 1902; Artists G.; Grand Central A. Gal.; Allied AA; AFA. Exhibited: Munich, 1897 (prize); Allied AA, 1928 (med); Brooklyn Inst. schol.; Montclair A. Mus., N.J., 1934 (prize); NAC, 1935 (med). Work: murals/portraits, Court House, Youngstown, Ohio; Court House, Coshocton, Ohio; murals, AC Gal., Erie, Pa. Positions: T., Kingsley Sch.; Mechanics Inst.; Castle Sch.; Grand Central Sch. A., 1928-36 [33]

WOELTZ, Julius [P,T] New Orleans, LA b. 7 Jy 1911, San Antonio, TX. Studied: AIC. Member: AC Cl., New Orleans. Exhibited: WFNY, 1939; Miss. AA, Jackson, 1935 (prize); AC Cl., New Orleans, 1936 (prize). Work: WPA murals, USPO, Elgin, Amarillo, Tex. Position: T., New Orleans A. Sch. [40]

WOELTZ, Russell [P] Chicago, IL. Exhibited: Ar. Chicago, Vicin., 1937, 1938 (prize), Fed. A. Project, 1938, AIC [40]

WOHLBERG, Meg [I] NYC. Member: SI [47]

WOICESKE, Elizabeth Bush (Mrs.) [P,S,B,Des,T] Woodstock, NY b. Phila., PA. Studied: St. Louis Sch. FA; J. Banks. Specialty: flowers [40]

WOICESKE, R(onau) W(illiam) [E,P,Des,T] NYC b. 27 O 1887, Bloomington, Il. d. 21 Jy 1953. Studied: St. Louis Sch. FA; J. Carlson. Member: SAE; Calif. Pr. C.; Phila. Pr. C.; Chicago SE; CAFA. Exhibited: SAE; Calif. Pr. C.; Phila. Pr. C.; Chicago SE; CI; several one-man exh., NYC; Southern PM, 1936 (prize); St. Louis AL (prize). Work: Los Angeles Mus. A.; LOC; NYPL; stained glass windows & murals in many churches; Contemporary Prints of the Year, 1931; Fifty Prints of the Year, 1933; Fine Prints of the Year, 1935; Nat. Gal. [47]

WOKAL, Louis Edwin [Des,C] College Point, NY b. 25 My 1914, Astoria, NY. Member: Un. Scenic A. Work: models/ dioramas, WFNY, 1939; N.Y. Mus. Sc.&Indst. Position: modelmaker, J.C. Stark Indst. Models, NYC [47]

WOLCHONOK, Louis [P,E,Des,T,W,L] NYC b. 12 Ja 1898, NYC. Studied: CUASch; NAD; CCNY; Académie Julian; Brooklyn Acad. FA. Member: SAE; NYSC. Exhibited: WMAA, 1934; AIC, 1930-32; NAD; PAFA; Los Angeles MA; Tate Gal., London; Milch Gal. (one-man); ACA Gal. (one-man); Newhouse Gal. (one-man); Ainslie Gal. (one-man). Work: CMA; Univ. Nebr.; Bibliothèque Nationale, Paris. Contributor: articles, Creative Design, 1934. Position: T., YWCA, NYC, from 1932 [47]

WOLCOTT, Frank [P,S,E,C] Chicago, IL b. McLeansboro, IL. Studied: AIC [25]

WOLCOTT, Helen [P] Provincetown, MA [25]

WOLCOTT, John Gilmore (Fra Angelo Bomberto) [Por.P,Car,L,T,W] Lowell, MA/Gloucester, MA b. 31 Ja 1891, Cambridge, MA. Studied: Harvard; D. Ross; C. Woodbury; W. Churchill. Member: NSMP; AAPL (Mass. State Chm., 1941-46); Lowell AA (Pres., 1944-46); St. Botolph's C., Boston; Whistler G., Boston. Exhibited: WFNY, 1939; numerous regional exh. Work: Whistler Mus., Lowell, Mass.; murals, Park Square Bldg., Boston; H.S., Gardner, Mass. Author/Illustrator: "Fra Angelo Bomberto in the Underworld of Art," 1946. Positions: T., Greenhalge Sch., Lowell; Mgr., Nat. Masters Studios [47]

WOLCOTT, Katherine [P] Chicago, IL b. 8 Ap 1880, CHicago. Studied: AIC; Acad. FA, Chicago; V. Reynolds; L. Parker; H.B. Snell; F. Grant; O. White; Mme. La Forge, Paris. Member: Assn. Chicago PS; Chicago AC; The Cordon; Chicago Gal. Assn.; North Shore AL; South Side AA [40]

WOLCOTT, Marion Post [Ph] b. 1910. Studied: NYU; Univ. Vienna. Work: LOC; Univ. Minn.; MET; SFMA. Position: WPA photographer for the Farm Security Admin., 1938-43 [*]

WOLCOTT, Roger Augustus [Des,P,C,S,T] Agawam, MA b. 25 Ag 1909, Amherst, MA. Studied: Mass. Col. A.; N.Y. Sch. F.& Appl. A.; R. Andrew; J. Cowell; E. Major. Member: Rockport AA; Springfield AG; A. Univ. Western Mass. Work: Springfield Mus. Natural Hist. Position: T., Springfield, Mus. FA, 1933-40 [47]

WOLCOTT, Stanley, Mrs. See Roberts, Dean.

WOLDEN, Matt [P] Duluth, MN [24]

WOLEVER, Adeleine [P,I,T] Boston, MA b. 8 Ap 1886, Belleville, Ontario, Canada. Studied: Tarbell; Benson; Hale; Paxton; Woodbury; Noyes. Work: theatre drawings in the Boston Transcript [21]

WOLINS, Joseph [P] b. 1915, Atlantic City, NJ. Studied: H. Fritz; NAD, with L. Kroll, 1931-35. Exhibited: WFNY, 1939; TMA; PAFA; CGA;

Univ. Ill; WMAA; Butler AI; Smithsonian; Audubon A., 1976 (prize); NIAL, 1976 (prize); Am. S. Contemp. A., 1976 (prize). Work: MMA; St. Joseph's Univ., Mo.; Fiske Univ. AL; Butler AI; WPA murals, NYC, 1935-41 [*]

WOLF, Amanda [S] Cincinnati, OH. Exhibited: Cincinnati AM, 1937, 1939 [40]

WOLF, Ben [P,Cr,I,T] Wellfleet, MA b. 17 O 1914, Phila., PA. Studied: C.H. Nordstrom; J.A. Pardi; H. Hofmann. Member: Phila. A. All.; Provincetown AA. Exhibited: Phila. A. All.; Phila. Pr. C.; Grace Horne Gal., Boston; Arch. L., 1944; Provincetown AA. Illustrator: "Memoirs of C.N. Buck," 1941, "The King of the Golden River," 1945. Contributor: Art in the Armed Forces, 1944; G.I. Sketchbook, 1944; Life mag. Positions: Assoc. Ed./Cr./Columnist, Art Digest, NYC; T., Wellfleet Sch. A., Mass.; U.S. Coast Guard Combat A., 1942-44 [47]

WOLF, Eva M. Nagel (Mrs. Addison) [P,I,C] Phila., PA b. 10 O 1880, Chicago, IL. Studied: Md. Inst.; PAFA [24]

WOLF, Fay Miller [P] Woodmere, NY. Member: S.Indp.A. [25]

WOLF, Hamilton (Achille) [P,T,L] Oakland, CA b. NYC d. 2 My 1967. Studied: NAD; Columbia; ASL, with W.M. Chase, R. Henri; Acad. Colarossi. Member: San Fran. AA. Exhibited: SFNY, 1939; GGE, 1939; CI, 1941; de Young Mem. Mus., 1943; Pal. Leg. Honor, 1945, 1946; San Fran. AA; Stanford Univ.; Fnd, Western A., Los Angeles; Seattle AS, 1917 (prize); Oakland A. Gal., 1929 (prize); Calif. State Exh., 1930 (prize), 1934 (prize), 1940 (prize); Pomona, Calif., 1938 (prize); San Fran. AA, 1939 (prize), 1944 (prize). Work: mural, Shell Lab., Oakland; Huntington Lib., San Marino. Positions: T., Los Angeles Sch. A., 1911-16; Univ. Wash; Univ. Calif., 1929-38; Calif. Col. A. & Crafts, Oakland, from 1929; Acad. Adv. A., San Fran., from 1935 [47]

WOLF, Henry [Wood En] NYC b. 3 Ag 1852, Eckwersheim, Alsace (came to NYC in 1871) d. 18 Mr 1916. Studied: J. Levy, in Strasbourg. Member: ANA, 1905; NA, 1908; Int. Soc. of S.P.&G.; Lotos C.; Union Intl. des Beaux-Arts et des Lettres, Paris; Jury, Paris Expo, 1889, 1900; Jury Selection and Awards, Pan-Am. Expo, Buffalo, 1901; Jury of Awards, St. Louis Expo, 1904. Exhibited: Paris Salon, 1888 (prize), 1895 (gold); Paris Expo, 1889 (prize), 1900 (med); Columbian Expo, Chicago, 1893 (med); Rouen Expo, 1903 (med); St. Louis , 1904 (prize); P.-P. Expo, San Fran., 1915 (prize). Work: series for Century; portraits, Harper's; LOC; NYPL. With T. Cole and W.J. Linton formed the great triumvirate of American wood engravers. [15]

WOLF, Leon [P] NYC [15]

WOLF, Max (Dr.) [P,E] NYC/Millwood, NY b. 22 O 1885, Vienna, Austria. Member: Physicians AC; Am. Bookplate S. [29]

WOLF, Peggy (Pegot) [S] Exhibited: Chicago, 1935; WFNY, 1939. Active Chicago, 1935; Calif., 1939; NYC, 1948. [40]

WOLFE, Ada A. [P,T] Minneapolis, MN b. Oakland, CA. Studied: Minneapolis Sch. FA; N.Y. Sch. A., with Chase. Exhibited: Minn. State Art S., 1914 (prize). Position: T., Minneapolis Sch. FA [33]

WOLFE, Ann (Mrs. Graubard) [S] Wash., D.C b. 14 N 1905, Poland. Studied: Hunter Col.; Paris, with Despiau. Member: AG, Wash. Exhibited: All.A.Am., 1936; AGAA, 1942; AG, Wash., 1942-45; S. Wash. A., 1944, 1945 (prize); WMA, 1939 (one-man), 1940, 1946; Grace Horne Gal., 1940; Whyte Gal., 1946. Work: Mus. Western A., Moscow, Russia. Contributor: Worcester (Mass.) Telegram-Gazette; art book reviews [47]

WOLFE, Byron B. [P,I] b. 1904, Parsons, KS d. 1973, Colorado Springs. Studied: Univ. Kans. Illustrator: covers, Western, Western Horseman, Kansas Historical Society. Work: Whitney G., Cody, Wyo.; Mont. Hist. S.; W.R. Nelson Gal., Kansas City [*]

WOLFE, George E. [I] NYC [21]

WOLFE, Karl [Por.P,C] Jackson, MI b. 25 Ja 1904, Brookhaven, MS. Studied: AIC, traveling schol., 1929. Member: SSAL; NOAL; NOAA; Chicago Gal. A.; Miss. AA. Exhibited: Miss. AA, 1932 (med); SSAL, 1933 (prize), 1934 (prize); Nashville Mus., 1935 (gold); Atlanta 1937 (prize). Work: Montgomery Mus., Ala.; Hall of Fame, Governor's Mansion, Jackson, Miss.; USPO, Louisville, Miss. Specialty: woodcarver. WPA artist. [40]

WOLFE, Meyer [P,Li,I] NYC/Frenchtown, NJ b. 10 S 1897, Louisville, KY. Studied: Chicago Acad. A., with DeVoe; ASL, with J. Sloan; Académie Julian, with Laurens. Work: Univ. Minn. (WFNY purchase) [40]

WOLFE, Natalie (Mrs. D.D. Michel) [S] San Fran., CA b. 16 Mr 1896, San Fran. d. ca. 1938. Studied: Ferrea; Calif. Sch. FA. Member: Nat. Lg. Am. Pen Women (FA dept.). Work: bust, San Fran. Mem. Mus.; portrait, Masonic Home, Dacota, Calif.; portrait reliefs, Hadassah S., George Washington H.S., San Fran. [38]

WOLFF, Adolf [S] NYC b. 1 Mr 1887, Brussels, Belgium. Studied: Nat. Acad.; Royal Acad., Brussels. Member: S. Gld.; Am. Ar. Cong. Exhibited: S. Gld., 1938, 1939; BM; Am. Ar. Cong.; Musée Moderne, Brussels (prize) [40]

WOLFF, Gustave [P] NYC b. 28 Mr 1863, Germany (brought to U.S. when 3 yrs. old). Studied: St. Louis Sch. FA, with P. Cornoyer; Europe. Member: Buffalo SA. Exhibited: Portland, Oreg., 1905; Competitive Exh., St. Louis, 1906; SWA, 1907 (med). Work: CAM [40]

WOLFF, Isabel. See Bishop.

WOLFF, Otto [P,I,C,W,L,T] Chicago, IL b. 30 Jy 1858, Cologne, Germany. Studied: Paris. Member: Chicago SA; Chicago AC. Exhibited: Paris Salon, 1888 (prize) [24]

WOLFF, Robert Jay [P,Des,S,W,L,T] NYC (Chicago, IL, 1940) b. 27 Jy 1905, Chicago, IL d. 1978, New Preston, CT. Studied: Yale; Paris, with Georges Mouveau. Member: Am.A. Cong.; Un. Am. Ar.; Am. Abstract A. Exhibited: AIC, 1934, 1935 (one-man), 1938, 1946; Am. Abstract A., 1938, 1945; Quest & Kuh Gal., Chicago (one-man); Reinhardt Gal., NYC (one-man), Nierendorf, NYC Gal. (one-man); Kleeman Gal., NYC (one-man); Denver, San Fran., Cincinnati, Topeka. Author/Illustrator: "Elements of Design," 1945. Contributor: Kenyon Review. Positions: Dean/Hd., Painting & S. Dept., Inst. Des., Chicago, 1939-42; Prof. Des., Brooklyn Col., N.Y., from 1946 [47]

WOLFF, Solomon [P] NYC b. 1841, Mobile, AL (settled in NYC, ca. 1844) d. 27 My 1911. Studied: CCNY; Free Acad., 1859. Position: T., CCNY, 1860-1903

WOLFROM, Philip H. [P] NYC [04]

WOLFS, Wilma Diena [S,P,Gr,I,L,T] Lakewood, OH b. Cleveland. Studied: Western Reserve Univ.; Cleveland Sch. A., traveling schol., 1928; Univ. Minn.; Radcliffe; NYU; Univ. PA; Keller, R. Stoll, L. Simon, F. Humbert, Prinet, Baudoin, Ducos de la Haille, Laguillermie, Ecole des Beaux-Arts, all in Paris; Hans Hofmann.; W. Eastman; Univ. Chicago. Member: Am. Assn. Univ. Women; Ohio WCS; Ark. WCS; S.Indp.A.; N.H. A.&Crafts S. Exhibited: CGA; CMA; Butler AI; Wichita AM; Philbrook A. Ctr.; Studio Gld.; Univ. Ark.; Brooks Gal., Cleveland; Akron AI; Columbus Gal. FA; Dayton AI; Massillon Mus.; Ohio Univ.; Zanesville AI; TMA; MFA, Little Rock, 1939 (prize); Ark. WCS, 1938 (med). Work: Univ. Ark.; Hendrix Col., Conway, Ark.; S., Catholic Church, Winter Park, Fla.; Research Studio, Maitland, Fla. Positions: T., Hendrix Col., Conway, Ark., 1936-37; State T. Col., Keene, N.H., 1937-38; MacMurray Col., Jacksonville, Ill., 1938-39; Fla. State Col. for Women, 1939-40 [47]

WOLFSON, Henry Abraham [Por.P] NYC b. 11 Je 1891, Leningrad, Russia. Member: NAD [40]

WOLFSON, Irving [P,E,T] NYC b. 10 D 1899 [29]

WOLFSON, William [Li,P,Des,E,W] Forest Hills, NY b. 26 O 1894, Pittsburgh. Studied: CI; NAD; ASL; A.W. Sparks; G.W. Maynard; DuMond. Exhibited: 50 Prints of the Year, 1928-29, 1931. Work: Bibliothèque Nationale, Paris; NYPL. Author/Illustrator: "Going Places," 1940. Contributor: Readers Digest, Coronet [47]

WOLINSKY, Joseph [P] Sydney, Australia b. 13 Jy 1873. Studied: Royal Art Soc., New South Wales; Colarossi, in Paris. Member: Royal AS, New South Wales. Work: Nat. Art Gal., New South Wales [27]

WOLKIN, Harry [P] Pittsburgh, PA. Member: Pittsburgh AA [25]

WOLLE, Muriel. See Sibell.

WOLTER, Adolph G. (Adolph Gustave Wolter von Ruemelin) [S,C,T,L] Indianapolis, IN b. 7 S 1903, Reutlingen, Germany. Studied: Herron AI; Germany; D.K. Rubins. Member: Ind. AC (Dir.) Exhibited: Nat. Exh. Am. A., NYC, 1938; Ind. State Fair, 1935 (prize), 1936, 1937-40 (prizes); Herron AI, 1938 (prize), 1943, 1945; Hoosier Salon, 1946 (prize). Work: S., Ind. State Lib.; Indianapolis; Washington Park Cemetery, Indianapolis; Indianapolis Star. Position: Gal. Asst., Herron AI, 1945-46 [47]

WOLTER, H.J. [P] Amersfoort, Holland [01]

WOLTZ, George W. [P] NYC. Member: SC [25]

WOMRATH, A(ndrew) K(ay) [P,I,D] Kent, CT b. 25 O 1869, Frankford, Phila. Studied: ASL, with Twachtman, J.A. Weir; Paris, with Grasset,

Merson; Westminster Sch. A., London. Member: Arch. Lg., 1902; NAC [33]

WONDENBERG, C.M.I. [P] Paterson, NJ [24]

WONSETLER, John Charles [Mur.P,Des,Dec] NYC b. 25 Ag 1900, Camden, NJ. Studied: PMSchIA; T. Oakley. Exhibited: Phila. A. All., 1930, 1939; Wanamaker Gal., Phila., 1929; PMSchIA, 1925 (prize), 1931 (one-man). Work: murals, Franklin & Marshall Col., Lancaster, Pa.; murals for theatres: Colonel Drake Theatre, Oil City, Pa.; Holmes Theatre, Holmesburgh, Pa.; Hotel Warwick, Forum Theatre, Apollo Theatre, and Iris Theatre, Phila., Pa.; Embassy Theatre, Reading, Pa.; Norris Theatre, Norristown, Pa.; Collingswood Theatre, Collingswood, N.J.; Reed Theatre, Alexandria, Va.; Rivoli Theatre, Wilmington, Del.; St. John's Church, Tamaqua, Pa.; Church of St. Mary Magdalene de Pazzi, Phila.; Hotel Belvedere, Baltimore, Md.; theatre, York, Pa.; Tyson, Byrd Theaters, Phila. [47]

WOOD, Alma [P] NYC [15]

WOOD, Annie A. (Nan) (Mrs. Chas. M.) [P] Tucson, AZ b. 11 F 1874, Dayton, OH. Studied: ASL; Lhote, in Paris. Member: Palette & Brush C., Tucson; Tucson AA. Work: Dayton AI [40]

WOOD, Beatrice (Beato) [C,Por.P,L] North Hollywood, CA b. San Francisco. Studied: Univ. Southern Calif.; France; Shipley; Finch; G. Lukens. Exhibited: MET; Syracuse MFA; San Diego FAS. Work: San Diego FAS. Specialty: ceramic sculpture [47]

WOOD, Charles Erskine Scott [P] Portland, OR b. 1852, Erie, PA [13]

WOOD, E. Shotwell [P,T,L] Mill Valley, CA b. 30 Jy 1887, San Fran. Studied: Calif. Sch. FA; Ecole des Beaux-Arts, Fontainebleau, France; Lhote, P. Beaudoin, J. Despujols. Member: Calif. Soc. Women A.; Marin SA (Pres., 1937-38, 1944-45); Calif. S. Mural P. Exhibited: WMAA, 1920; Salon des Indépendants, Paris, 1928; San Fran. Soc. Women A., 1934-45 (prizes); Marin SA, 1937-45 (prizes); Calif. State Fair, 1939 (prize). Work: Fontainebleau, France; San Fran.; San Mateo, Calif. [47]

WOOD, Edith Longstreth (Mrs. William S.) [P,Li] Phila., PA b. Phila. Studied: Bryn Mawr Col.; PAFA, Cresson traveling schol.; England; H. Breckenridge; Scandinavian Art Acad., Paris; H. Hoffman. Member: F., PAFA; Phila. A. All.; Phila. Pr. C.; Plastic C.; North Shore AA; Phila. WCC. Exhibited: NAD; PAFA, 1932-46; Phila. Plastic C., 1933 (med). Work: PAFA; La France IA Gal., Phila.; Phila. A. All. [47]

WOOD, Ella Miriam [P] New Orleans, LA b. 18 F 1888, Birmingham, Ala. Studied: Newcomb Col.; PAFA, with H. McCarter; C. Hawthorne; D. Garber. Member: New Orleans AA; New Orleans A.&Cr. C. Exhibited: Delgado MA; New Orleans A.&Cr. C.; La. State Exh., Baton Rouge; Newcomb A. Sch. (prize). Work: mural/altarpiece, St. Augustine Church, New Orleans; port., Newcomb Col., Charity Hospital, both in New Orleans [47]

WOOD, Eloise [E,T,L,Des] Geneva, NY b. 7 S 1897, Geneva, NY. Studied: Albright A. Sch.; ASL; W. Smith Col., Geneva, N.Y.; Columbia; H. Wickey; A. Lewis; C. Locke. Member: Am. Assn. Univ. Prof. Exhibited: Phila. SE, 1931; NAC, 1930; Brooklyn SE, 1931; Chicago SE, 1931; Calif. PM, 1931; Phila. Pr. C., 1931; Kennedy Gal., N.Y., 1932 (one-man). Work: MET. Position: T., Hobart & William Smith Col., Geneva, N.Y. [47]

WOOD, Ethelwyn A. [P] Lake Worth, FL b. 10 Ja 1902, Germantown, PA. Studied: Pa. Sch. Indst. A.; PAFA. Member: West Palm Beach AL. Work: painting, F., PAFA [33]

WOOD, Franklin T. [P,E,T] Rutland, VT b. 9 O 1887, Hyde Park, MA d. 22 My 1945. Studied: Cowles A. Sch.; ASL; abroad. Member: Chicago SE; SAE. Exhibited: P.-P. Expo, San Fran., 1915 (med). Work: AIC; BMFA; LOC; Smithsonian [40]

WOOD, George Albert [P] b. 1845 d. 1910. Exhibited: Barridoff Gal., Portland, Maine, 1984. Active in Maine. [*]

WOOD, George Bacon, Jr. [Ldscp.P,Genre P] Staten Island, NY b. 6 Ja 1832, Phila. Studied: PAFA, with C. Schussele. Member: Phila. Sketch C.; A. Fund S. Phila. Exhibited: PAFA. Active in Germantown, Pa., during the 1850s. Also known as a silhouettist. [10]

WOOD, Grace Mosher [P] Paris, France. Exhibited: SBA [01]

WOOD, Grant [P,T,G] Iowa City, IA b. 13 F 1892, Anamosa, IA d. 12 F 1942. Studied: Minneapolis Sch. Des., with E. Batchelder, summers 1910-11; Iowa State Univ.; AIC; Académie Julian, Paris, 1923. Member: Mural P. Exhibited: AIC, 1930 (med). Work: Cedar Rapids (Iowa) AA; Cincinnati AM; Amon Carter Mus.; Mem. Bldg., Cedar Rapids; "American Gothic," AIC; Nebr. AA, Lincoln; Omaha (Iowa) AI; Dubuque (Iowa) AA; WMAA. Illstrator: "Main Street," by Sinclair Lewis. Positions: T., Stone City A. Sch. (founder) 1932; Univ. Iowa, from ca. 1933; WPA Dir. for Iowa, 1933-34 [40]

WOOD, Gretchen Kratzer (Mrs. L.R.) [P,Dec] San Juan, Puerto Rico b. Clearfield, PA. Studied: PMSchIA; ASL; A. Sotomayor, in Madrid; E. Pape; C. Beaux. Member: Studio G.; AAPL (Chmn., Puerto Rico). Exhibited: Indp. A. Exh., N.Y., 1938; Studio G. Work: Washington Col., Chestertown, Md.; Polytech Inst., San German, P.R.; murals, Hotel Candado, San Juan, P.R. [40]

WOOD, Harrie (Morgan) [P,I] NYC/Bethel, CT b. 28 Ap 1902, Rushford, NY. Studied: PIASch; ASL. Member: NWCC; AWCS; Mystic AA. Work: Lyman Allyn Mus., New London, Conn. Illustrator: "The Boy Who Was," "Made in America," "Something Perfectly Silly," "Lucian Goes A-Voyaging," "Made in England," 1932 [40]

WOOD, Harry [Car,I] Kansas City, MO b. 1871 d. 14 My 1943. Creator: comic strip "The Intellectual Pup," run in the Kansas City Star since 1907

WOOD, James L. [P,T,L] Phila., PA b. Phila. Studied: T. Eakins, in Phila.; Gérôme, in Paris. Position: T., Drexel Inst., Phila. [04]

WOOD, Jessie Porter [P,I,C,T] Wash., D.C. b. 27 F 1863, Syracuse, NY. Studied: J.C. Beckwith; G. deF. Brush; W. Shirlaw; J.W. Stimson [25]

WOOD, John Z. [P] Rochester, NY [08]

WOOD, Julia Smith (Mrs. Richmond) [P] New Bedford, MA b. 27 Ja 1890. Studied: Swain Sch. Des. Member: Boston AC; Providence AC [40]

WOOD, Justin [P] Cleveland, OH. Member: Cleveland SA [27]

WOOD, Katharine Marie [Min.P,P] Staten Island, NY b. 15 F 1910. Studied: Sch. Appl. Des. for Women, N.Y.; ASL; E.D. Pattee; A. Schweider. Exhibited: ASMP, 1938; Pa. S. Min. P., PAFA, 1938 [40]

WOOD, Katheryn Leone [Min.P,Por.P,W] Los Angeles, CA b. Kalamazoo, MI d. ca. 1936. Studied: R. Freer; Lawton Parker. Member: AFA. Work: miniature of Mrs. J.C. Burrows, Continental Mem. Hall, Wash., D.C.; U.S. District Court, Cincinnati, Ohio [35]

WOOD, Lillian Lee [Por.P] Richmond, VA b. 18 D 1906, Richmond, VA. Studied: Sweet Briar Col.; ASL, with K.H. Miller; K. Nicolaides; D. Romanovsky. Member: VMFA; Acad. Sc.&FA, Richmond. Exhibited: VMFA; Richmond Acad. A., 1932 (prize); Va. Mechanics Inst., 1932 (prize). Work: Richmond (Va.) Armory [47]

WOOD, M. Louise. See Wright.

WOOD, Margaret (Mrs. Victor G. White) [P] Woodmere, NY b. 4 Mr 1893, Chicago. Studied: Biloul; Humbert; R. Miller; Johansen; Bridgman; Speicher. Work: portrait, Pres. F.D. Roosevelt, Harvard C., NYC [38]

WOOD, Mary Earl [P] Boston, MA b. Lowell, MA. Studied: BMFA Sch., with Tarbell, Benson, De Camp. Member: Copley S. [33]

WOOD, Nan (Mrs. Charles M.) [P] Tucson, AZ b. 11 F 1874, Dayton, OH. Studied: ASL; Lhote, in Paris Member: Tucson AA; Palette & Brush C., Tucson. Exhibited: State Mus., Tucson, 1943-46; Boston AC. Work: Dayton AI [47]

WOOD, Norma Lynn [P] Houston, TX. Exhibited: MFA, Houston, 1938, 1939 [40]

WOOD, Norman (Mrs.) [P] Knoxville, TN [13]

WOOD, Ogden [Ldscp.P] Paris, France b. 1851, NYC d. 13 S 1912. Studied: E. Van Marcke. Exhibited: St. Louis Expo, 1904 (med). Member: A. Fund S. [10]

WOOD, Robert [Ldscp.P] Texas b. 1889 d. 1979 [*]

WOOD, Robert W. [P] Baltimore, MD [17]

WOOD, Stacy H. [P] NYC [17]

WOOD, Stan [P] Cleveland, OH. Member: Cleveland SA [27]

WOOD, Stanley [P,Li] Carmel, CA b. 12 S 1894, Bordentown, NJ. Exhibited: San Fran. AA, 1924 (gold), 1930 (prize); Santa Cruz, 1928 (prize). Work: BM; Mills College A. Gal., Oakland, Calif. [40]

WOOD, Thomas Waterman [Por.P,Genre P,E,I] NYC (since 1852) b. 12 N 1823, Montpelier, VT d. 14 Ap 1903. Studied: Boston, with Chester Harding, 1846-47; Düsseldorf, with Hans Gude, 1858-60; London. Member: ANA, 1869; NA, 1871 (Pres., 1890-1900); AWCS (Pres., 1878-87); N.Y. Etching C. (founder); NAC; A. Aid. S. (founder-Pres., 1869-03); Century. Work: more than 200 oils/watercolors, Wood A. Gal., Montpelier, Vt. [01]

WOOD, Virginia Hargraves [P] NYC/Leeton Forest, Warrenton, VA b. Wash., D.C. Studied: CUASch; Yale. Member: Nat. Soc. Mural P. Exhibited: Nat. Assn. Women PS, 1935–38; Liturgical A. Soc., N.Y., 1937 (prize). Work: WPA murals, Fed. Court Room, Scranton, Pa.; Liturgical A. Soc., N.Y.; USPO, Farrell, Pa. [40]

WOOD, W. Homer [Min.P] Yeadon, Delaware County, PA [04]

WOOD, Waddy B. [P,Arch] Wash., D.C. [21]

WOOD, Wallace [Patron] b. 1850, Jamestown, NY d. 16 D 1916, NYC. Studied: abroad. While in Europe he made a collection of pictures, costumes, and other objects illustrating the history of civilization, which is now at NYU. He was for many years holder of the Samuel F.B. Morse Chair of Art at NYU.

WOOD, William D. [P] d. 10 O 1915, Albany, NY (automobile accident). Position: Hd. Dec., N.Y. Central's car shops, West Albany, N.Y.

WOOD, W(illiam) R(euben) C(lark) [Ldscp.P] Baltimore, MD/Prudence Island, RI b. 15 Ap 1875, Wash., D.C. d. 30 Ap 1915. Studied: S.E. Whiteman, in Baltimore. Member: Charcoal C., Baltimore; Baltimore WCC (Pres.); Baltimore Mun. AC [17]

WOOD, William S. [P] Phila., PA. Studied: PAFA [21]

WOOD, Worden [Mar.I] Illustrator: Yachting, 1927. Work: Mystic Seaport Mus.; Peabody Mus., Salem. Active 1912–37. [*]

WOODAMS, Helen Chase [S,P] Rochester, NY b. 31 My 1899, Rochester, NY. Studied: ASL; AIC; Académie Julian. Exhibited: WFNY, 1939; MOMA; Finger Lakes Exh., Rochester, NY; Albright A. Gal., 1939 (prize) [40]

WOODARD, A. [P] Toledo, OH. Member: Artklan [25]

WOODARD, Lee L. [Des] Owosso, MI b. 21 Je 1884, Owosso. Studied: AIC; Kirkpatrick Sch. Furniture Des., Grand Rapids, Mich. Designer: furniture, for Marshall Field & Co., Carson, Pirie, Scott, Chicago; W.& J. Sloane, Wanamaker's, Lord and Taylor, Macy's, NYC; Lammert's, St. Louis. Position: Des., Woodard Furniture Co., L.J. Woodard Sons' Wrought Iron Furniture Co., Owosso, Mich. [40]

WOODARD, Leroy Reynolds [Por.P,E] Randolph, NH b. 16 Ap 1903, Brockton, MA. Studied: BMFA Sch. [40]

WOODBERRY, Robert [P,I,T] Somerville, MA b. 1874, Centreville, MA. Studied: W.D. Hamilton, Boston; Académie Julian, Paris, with Constant, Laurens [08]

WOODBURN, Thomas [P] Wash., D.C. Work: recruiting posters, U.S. Army [40]

WOODBURY, C.O. [I] NYC [19]

WOODBURY, Charles H(erbert) [Mar.P,E,T,W] Boston, MA/Ogunquit, ME b. 14 Jy 1864, Lynn, MA d. 22 Ja 1940, Jamaica Plain (Boston), MA. Studied: MIT, 1882–86; Académie Julian, with Boulanger, Lefebvre, 1890. Member: SAA, 1899; ANA, 1906; NA 1907; Boston SWCP; NYWCC; Boston GA; Ogunquit AA. Exhibited: Boston AC, 1884 (prize), 1895 (prize); Atlanta Expo, 1895 (gold); Tenn. Centenn., Nashville, 1897 (prize); Mechanics' Fair, Boston (medals); Paris Expo, 1900 (med); Pan-Am. Expo, Buffalo, 1901 (med); WMA, 1903 (prize), 1907 (prize); St. Louis Expo, 1904 (med); CI, 1905 (prize); Buenos Aires Expo, 1910 (med); AWCS, 1911 (prize); W.A. Clark Prize, 1914; Corcoran med., 1914; P.-P. Expo, San Fran., 1915 (medals); PAFA, 1924 (gold); Brooklyn, 1931 (prize); NAD, 1932 (prize); SAE, 1933 (prize). Work: AGAA; AIC; Berkshire Athenaeum; Boston Pub. Lib.; CI; St. Louis AM; CGA; Danforth MA; Detroit IA; FMA; Gardner Mus., Boston; Herron AI; Joslyn AM, Omaha; MET; BMFA; RISD; Utah Coll.; Telfair Acad., Savannah; WMA; Colby Col.; Ogunquit MA; Portland (Maine) MA; SFMA; Peabody Mus., Salem; Wellesley Col. Illustrator: Century and Harper's, 1888–89. Positions: T., Worcester AA (1895), Ogunquit (summers, 1898–1917), Wellesley Col. (1899–06; 1913–14), Pine Hill Sch. (1907–10) [38]

WOODBURY, J.C. [P] Providence, RI. Member: Providence WCC [29]

WOODBURY, Marcia Oakes (Mrs. Charles H.) [P] Boston, MA/Ogunquit, ME b. 20 Je 1865, Berwick, ME d. 7 N 1913. Studied: Lasar, in Paris. Member: N.Y. Women's AC; NYWCC; Boston WCC. Exhibited: Mechanics' Fair, Boston (med); Boston AC (prize); Atlanta Expo, 1895; Tenn. Centenn., Nashville, 1897 [13]

WOODCOCK, Hartwell L. [P,C] Belfast, ME b. 20 N 1852, Scarsmour, ME d. 14 D 1929. Studied: F.E. Wright, in Boston; Colarossi Acad., Paris. Exhibited: Portland SA, 1885 (med). Specialty: scenery of Maine coast, oil and watercolors [08]

WOODHOUSE, Betty. See Burroughs.

WOODHOUSE, John [P] Phila., PA [04]

WOODING, J.J. [P] Belfast, ME [10]

WOODING, Jennie James [P] NYC [01]

WOODMAN, Edith. See Burroughs.

WOODMAN, Edwin Wright [P] Chicago, IL [10]

WOODMAN, Florence [P] Chicago, IL [21]

WOODRING, Gaye [P] Chicago, IL. Member: GFLA [27]

WOODROFFE, Eleanor G. [P] Niantic, CT/NYC. Member: NAWPS [29]

WOODROFFE, Louise M. [P,T] Urbana, IL b. Champaign, IL. Studied: Univ. Ill.; Syracuse Univ.; H. Breckenridge. Member: NAWA; North Shore AA. Position: T., Univ. Ill. [47]

WOODRUFF, B.D. [P] Toledo, OH. Member: Artklan [25]

WOODRUFF, Bessie Hadley [P] Jersey City, NJ [13]

WOODRUFF, Claude Wallace [I,P] Pittsburgh, PA b. 17 F 1884, Hamilton, MI. Studied: G. Bridgman; T. Fogarty; E. Penfield; C.B. Falls, C. Rosen. Member: SI. Illustrator: children's books, pub. Harpers; Author/Illustrator: "The Life of Shep, the Farmer's Dog." Position: T., Pittsburgh AI [40]

WOODRUFF, Corice (Mrs. Henry S.) [P,S] Minneapolis, MN b. 26 D 1878, Ansonia, CT. Studied: Minneapolis Sch. FA, with R. Koehler; K. Akerberg; ASL. Member: AG, Chicago; Attic C. Exhibited: Minn. State Art S. (prize), 1914 (prize); St. Paul, 1916 (prize). Specialties: small sculpture; bas-relief portraits; portrait busts [33]

WOODRUFF, Fannie P. [P] Boston, MA [01]

WOODRUFF, Hale Aspacio [P,Mur.P,B,T,L] NYC b. 26 Ag 1900, Cairo, IL. Studied: J. Herron AI; Paris, with H.O. Tanner, 1931; FMA Sch.; Acad. Scandinave; Acad. Moderne; fresco painting, with Diego Rivera, Mexico City, 1936. Exhibited: VMFA, 1944; Assn. Ga. A., 1938; Studio M, Harlem, 1979 (retrospective); WFNY, 1939; Harmon Fnd., 1926 (prize); Diamond Jubilee Expo, Chicago, 1940; High Mus. A., 1940. Work: Newark Mus.; Howard Univ.; Atlanta Univ.; murals, Talladega Col., Ala.; Howard H.S., Atlanta; murals, Atlanta Sch. Soc. Work. Lectures "The Negro as Artist." Positions: T., Atlanta Univ. (1931–45), NYU (1945–) 1945 [47]

WOODRUFF, John Kellogg [P,S,Gr,T] Nyack, NY b. 6 S 1879, Bridgeport, CT d. 14 Je 1956. Studied: Yale; Artist-Artisan Inst., N.Y.; Columbia; J. Niemeyer; W. Shirlaw; A. Dow; C.J. Martin; W.S. Robinson; Curran. Member: S.Indp.A.; Salons of Am. Exhibited: Marie Sterner Gal., Babcock Gal., Dudensing Gal., Argent Gal., Findlay Gal. (all one-man); BM. Work: BM [47]

WOODRUFF, Julia S. [P] Seattle, WA [21]

WOODRUFF, Linda [P] Paris, France b. Bridgeton, NJ. Exhibited: SBA, 1898 [98]

WOODS, Alice. See Ullman.

WOODS, Beatrice [Por.P,Dr] Cincinnati, OH b. 25 Jy 1895, Cincinnati. Studied: Cincinnati A. Acad.; Slade Sch., London; Royal Acad., London. Member: Women's AC, Cincinnati; Cincinnati MacD. S.; Cincinnati Print and Drawing Circle; Cincinnati Assn. Prof. A.; AFA; Nat. AC; Studio G.; NAWPS. Specialty: medical illus. [40]

WOODS, Lily Lewis (Mrs.) [P] Cambridge, MA. Member: Cincinnati Women's AC [17]

WOODS, Lilla Sorrenson (Mrs. E.B. Woods) [P] Hanover, NH b. 27 Ap 1872, Portage, WI. Studied: L. Ely; AIC; Corcoran Sch. A.; H.T. Hammond; Miss Hawley, in Rijsvard, Holland; Académie Julian, Paris, with Laurens. Member: Gloucester SA 40]

WOODS, Studman [P] Tacoma, WA. Member: Tacoma FAA. Affiliated with Tacoma Engraving Co. [25]

WOODSIDE, Anna Jeannette [P,C,Et,T] Pittsburgh, PA b. 12 N 1880, Pittsburgh. Studied: Pittsburgh Sch. Des. for Women; C. Walter; H. Keller; J. Lie; F. Clayter; C. Hawthorne. Member: AFA; AAPL; Pittsburgh AA. Exhibited: Pittsburgh AA, 1927 (prize); Russell Mem. prize, 1930. Position: T., Schenley H.S., Pittsburgh (retired 1942) [47]

WOODSON, Marie L. [P,C,T] Denver, CO b. 9 S 1875, Selma, AL. Studied: AIC; Ochtman; N.Y. Sch. F.&Appl. A. Member: Denver AA; Art Comm., City and County of Denver. Exhibited: Denver (prize). Work: murals, Denver Pub. Lib. Illustrator: "Tunes for Tiny Tots," by A. Freneauff. Position: Dir. A. Edu., Denver Pub. Schs. [40]

WOODSON, Max Russell [P] Guilford, CT [17]

WOODWARD, Anna [P,W,] Pittsburgh, PA/Paris, France. b. Pittsburgh. Studied: Académie Julian, Paris, with Robert-Fleury, Lefebvre, Bouguereau; G. Hitchcock, Holland. Member: Pittsburgh AA; Femmes Peintres et Sculpteurs [10]

WOODWARD, David Acheson [Por.P] Baltimore (since 1849) b. 1823 d. 1909. Exhibited: A. Fund S., 1842. Work: Princeton [*]

WOODWARD, Dewing (Miss) [P,W,L,I,T] Miami, FL (living in Provincetown, MA, 1901) b. 6 Je 1856, Williamsport, PA. Studied: PAFA; Académie Julian, with Robert-Fleury, Lefebvre; Paris, with Deschamps, J. Blanche, Raffaelli. Member: Blue Dome F.; Baltimore WCC, 1901; Soc. des Femmes P.&S., Paris. Exhibited: Miami Women's C. (prize); Dade County War Mem. Assn. (prize); Lg. Am. Pen Women, 1936 (prize); Académie Julian, 1894 (prize); Marseilles, 1897 (gold); Nantes, 1904 (med). Work: Univ. Miami; Académie Julian, Paris; Women's C., Miami; City Hall, Coral Gables, Fla.; State Col. for Women, Tallahassee; Sub-Treasury, Wash., D.C.; District Court, Pennsacola; BMA; Deschanel Coll., Paris [47]

WOODWARD, Ellsworth [P,E,L,I,T] New Orleans, LA b. 14 Jy 1861, Bristol County, MA d. 28 F 1939. Studied: RISD; C. Marr, in Munich. Member: NOAA (Pres.); SSAL (Pres.); Providence AC (hon.); Round Table C. Exhibited: NOAA (gold), 1935 (prize); Miss. AA (gold); Boston SAC (med); SSAL (prize). Work: Mun. Court House, Delgado Mus. A., Newcomb Col. A. Gal., all in New Orleans; Jackson AA, Miss.; Charleston Mus., S.C.; BM; MFA, Houston. Position: Pres. Bd. of Administrators, Delgado Mus. [38]

WOODWARD, Ethel Willcox (Mrs. H.E.) [P] Penns Grove, NJ b. 28 D 1888, Andover, MA. Studied: P. Hale; WMA Sch. [40]

WOODWARD, Helen M. [P,Des] Indianapolis, IN b. 28 Jy 1902, Orange County, IN. Studied: J. Herron AI; Butler Univ.; Ind. Univ.; C. Hawthorne; E. O'Hara; W. Adams; Cape Cod Sch. P.; R. Miller. Member: Ind. AC; Contemp. C., Indianapolis; Hoosier Salon. Exhibited: Hoosier Salon, 1928 (prize), 1929 (prize); Herron AI, 1939 (prize); Ind. AC (prize); Ball State Col., Muncie, Ind. (one-man); Ind. Univ. (one-man); H. Lieber Gal., Ind. (one-man). Work: Riley Sch., Bedford H.S., Ind. [47]

WOODWARD, Hildegard H. [P] Boston, MA [25]

WOODWARD, John Douglas [P,I] New Rochelle, NY b. 1848, Middlesex County, VA d. 5 Je 1924. Studied: Cincinnati, with F.C. Welsch. Member: SI; New Rochelle AA. Illustrator: Hayden's U.S. Geological Survey Report, 1872 [24]

WOODWARD, Lella Grace [P,T] Forest Glen, MD b. 2 My 1858, Coldwater, MI. Studied: Boston; Chicago; England; Holland; Rome; Venice; DuMond; Merson, Collin, Whistler, all in Paris [29]

WOODWARD, Mabel May [P] Providence, RI/Ogunquit, ME b. 28 S 1877, Providence d. 14 Ag 1945. Studied: Chase; DuMond; Cox, at ASL. Member: Providence AC; Providence WCC; South County AA; Ogunquit AA. Exhibited: Providence AC, 1939 (one-man). Work: Providence AC [40]

WOODWARD, Robert Strong [P] Buckland, MA b. 11 My 1885, Northampton, MA d. ca. 1960. Studied: BMFA Sch.; E. Tarbell; P. Hale; mostly self-taught. Member: SC; Boston AC; Gld. Boston A.; Springfield (Mass.) A. Lg.; Pittsfield (Mass.) AL; AFA; NYWCC; Deerfield Valley AA; Grand Central AG. Exhibited: CI; CGA; AIC; PAFA; BMFA; WFNY, 1939; GGE, 1939; Deerfield Valley AA; Williston Acad.; NAD, 1919 (prize); Springfield AL, 1927 (prize), 1932 (med); Albany Inst. Hist. & A., 1937 (prize); Tercentenary Expo, Boston, 1930 (gold); Boston AC, 1932 (med); Concord AA, 1920 (prize). Work: Springfield A. Mus.; Canajoharie A. Gal.; Syracuse MFA; Williston Acad., Easthampton, Mass.; Stockbridge Pub. Lib.; Yale; Pasadena AI; San Diego FA Soc.; Northfield (Mass.) Seminary; Mount Holyoke Col.; Putnam Mem. Hospital, Bennington, Vt.; Lib., Northampton. Mass.; Mass. State Col., Amherst; H.S., Gardner, Mass. [47]

WOODWARD, Stanley [P,I,E,T] Rockport, MA b. 11 D 1890, Malden, MA d. 1970. Studied: Eric Pape Sch. A.; BMFA Sch.; PAFA. Member: Gld. Boston A.; All.A.Am.; Audubon A.; AWCS; Phila. WCC; Wash. WCC; Boston S. WC Painters; SAE; North Shore AA (Pres.); Rockport AA; SC; Springfield AL; Chicago SE; NYWCC; Grand Central AG. Exhibited: NAD, 1925 (prize); AWCS, 1927; Baltimore WCC, 1927; Springfield AL, 1928; Stockbridge AA, 1931; New Haven PPC, 1940; Wash. WCC, 1940; North Shore AA; Boston Tercentenary Expo, 1930 (gold); Concord AA, 1919 (prize). Work: BMFA; Bowdoin Col.; Univ. Mich.; Ft. Worth AM; Ball State T. Col.; Mem. Gal., New Haven; Wellesley Hills Lib.; Vanderpoel Coll.; Concord AA; St. Mark's Sch., Southboro; BM; Converse Mem Gal., Malden, Mass. Contributor: American Artist. Position: T., Ringling A. Sch., Sarasota, 1937–38 [47]

WOODWARD, William [P,T,E,Arch] Biloxi, MS b. 1 My 1859, Sekonk, MA d. 17 N 1939. Studied: RISD; Mass. Normal A. Sch., Boston; Boulanger, in Paris. Member: La. Chapter AIA; NOAA; AIA, 1897; SSAL; Gulf Coast AA; Miss. AA; AFA; Laguna Beach AA. Exhibited: Gulf Coast AA, 1927 (gold), 1929 (gold); Miss. Fed. Women's C., 1931 (prize); NOAA, 1932 (prize), 1936 (prize); SSAL, 1936 (prize). Work: NOAA; Delgado AM; United Fruit Co.; Tulane Univ.; High Mus., Atlanta; Rogers A. Gal., Laurel, Miss. Position: T., Tulane Univ. [38]

WOODWARD, William, Mrs. [P] New Orleans, LA [15]

WOODWELL, Elizabeth [P] Pittsburgh, PA. Member: Pittsburgh AA [21]

WOODWELL, Joseph (or James) R. [P] Pittsburgh, PA b. 1843, Pittsburgh d. 30 My 1911. Studied: Paris and Munich, early 1860s–66. Exhibited: Pittsburgh; Wash., D.C.; NYC; Paris; St. Louis Expo (med), 1904. Position: Chmn., FA Comm., CI [10]

WOODWELL, W.E. [P] Pittsburgh, PA. Member: Pittsburgh AA [21]

WOODY, Solomon [Por.P,Ldscp.P] Fountain City, IN b. 11 Mr 1828, near Fountain City, IN d. 30 N 1901. Studied: Cincinnati, 1840s briefly. Amateur painter who ran a general store. [*]

WOODY, Stacy H. [I] b. 1887 d. 7 Je 1942, Mt. Vernon, NY. Studied: PIASch; AIC. Member: New Rochelle AA

WOOLDRIDGE, Julia [P,T] Richmond, VA. Studied: M. de Tarnovsky; Dow. Position: Supervisor A., Pub. Sch., Richmond [17]

WOOLEY, Fred Henry Curtis [P,Des] Malden, MA b. 1861 d. 18 O 1936

WOOLF, Michael Angelo [I,Genre P,Wood En] NYC b. 1837, London, England (brought to U.S. ca. 1838) d. 4 Mr 1899. Studied: Paris; Munich. Specialty: children of the slums in comic vein [98]

WOOLF, Samuel Johnson [Gr,W,I,Por.P] NYC b. 12 F 1880, NYC d. 3 D 1948. Studied: CCNY; ASL; NAD, with Cox, Brush. Exhibited: NAD, 1904 (prize); St. Louis Expo, 1904 (prize); Paris Salon, 1937 (prize); PAFA; CI; CGA; Mus. City of N.Y., 1946; Appalachian Expo, Knoxville, 1910 (med). Work: U.S. Capitol, Wash., D.C.; MET; NYPL; CCNY; Brook C.; Normal Col.; Catholic C., NYC; Hunter Col., NYC; Univ. Mich. Author/Illustrator: "Drawn from Life," 1932, "Here Am I," 1942. Author: "A Short History of Art," articles, New York Times Mag., Personality Interviews [47]

WOOLFE, Annette (Mrs.) [P] NYC. Member: NAWA. Exhibited: NAWA, 1935, 1937, 1938 [40]

WOOLFOD, Eva Marshall (Mrs.) [P] Paris, France. Studied: Paris, with Collin; J. Adler [04]

WOOLLETT, Anna Pell (Mrs. Sidney) [S,P] Jamaica Plain, MA b. Newport, RI. Studied: BMFA Sch., with B. Pratt [13]

WOOLLETT, Sidney W. [S] Jamaica Plain, MA [17]

WOOLLEY, A.B. [P] Avalon, PA. Member: Pittsburgh AA [25]

WOOLLEY, Virginia [P,E,T] Laguna Beach, CA (since ca. 1925) b. 27 Ag 1884, Selma, AL d. 15 F 1971. Studied: J. Blanche; L. Simon; R. Miller; F.W. Freer. Member: SSAL; Laguna Beach AA [40]

WOOLRYCH, Bertha Hewit (Mrs. F. Humphry W.) [P,I] St. Louis, MO b. 1868, Ohio d. 1937. Studied: St. Louis Sch. FA; Paris, with Morot, Collin, Courtois. Member: St. Louis AG; St. Louis A. Students Assn. Exhibited: Lewis and Clark Expo, Portland, 1905 (med); St. Louis Sch. FA (gold,med); St. Louis District, Gen. Fed. Women's C. (med) [38]

WOOLRYCH, F. Humphry W. [P,I] St. Louis, MO b. 1868, Sydney, Australia. Studied: Royal Acad., Berlin; Ecole des Beaux-Arts, Colarossi Acad., Collin, Courtois, Puvis de Chavannes, all in Paris. Member: Hellas AC, Berlin; St. Louis AG; 2x4 Soc. Work: St. Louis Pub. Lib.; Mus. Nat. Resources, Univ. Mo.; Columbia, Mo.; murals, Leschen Rope Co., Mo.; Athletic Assn. Bldg., Delmar Baptist Church, both in St. Louis; Capitol, Jefferson City, Mo.; Capitol, Montgomery, Ala. [40]

WOOLSEY, C(arl) E. [P] Martinsville, IN b. 24 Ap 1902, Chicago Heights, IL. Studied: self-taught. Exhibited: Hoosier Salon, 1928 (prize), 1929

(prize), 1935 (prize), 1937; Block Mem. prize, 1937; NAD, 1931 (prize). Work: Kokomo, Ind. AA [40]

WOOLSEY, Wood W. [P] Stroudsburg, PA b. 29 Je 1899, Danville, IL. Studied: self-taught. Exhibited: NAD, 1930, 1932, 1934; Hoosier Salon, 1931 (prize), 1932 (prize); Phoenix AA, 1932 (prize); Evansville AI, 1935 (prize). Work: Fed. Women's C., Kokomo, Ind.; Mus. FA, Evansville, Ind.; Lafayette (Ind.) AI; Danville, Ill.; Terre Haute, Evansville, Columbus, Ind., H.S. [47]

WOOLTIDGE, Powhattan [P] Louisville, KY. Member: Louisville AL [01]

WOOTON, Clarence [P,Dec,T] Norfolk, VA b. 14 My 1904, Dry Hill, KY. Studied: Detroit City Col.; E. Lawson; G. Ignon. Member: Spectrum C., Long Beach, Calif.; Prof. AG, Norfolk. Exhibited: Irene Leach Mem. Mus., Norfolk, 1944, 1945; VMFA, 1945; Pepsi-Cola, 1945; Pub. Libs., Miami Beach, Coral Gables, Fla.; Univ. Ky, 1940 (prize). Work: Collins Mem. Lib., Miami Beach. Position: T., Miami Beach A. Ctr. [47]

WORCESTER, Albert [P,E] Detroit, MI b. 4 Ja 1878, West Campton, N.H.. Studied: Merson; Laurens, in Paris [21]

WORDEN, Laicita Warburton (Mrs. Kenneth Gregg) [P,S,I] Greenwich, CT/Phila., PA b. 25 S 1892, Phila. Studied: PAFA [25]

WORDEN, Sara. See Lloyd, Hinton S., Mrs.

WORES, Theodore [Ldscp.P, Por.P,I,T] San Fran., CA b. 1 Ag 1860, San Fran. d. 1939. Studied: Munich, with A. Wagner, Duveneck. Member: Century Assn. Exhibited: Alaska-Yukon Expo, 1909 (gold). Work: Los Angeles MA. Position: T., San Fran. AI, 1907–12. Among the first Americans painting in Japan, 1880s–90s. [33]

WORK, J. Clark [I] Westport, CT. Member: SI [47]

WORKMAN, David Tice [Mur.P] Excelsior, MN b. 18 O 1884, Wahpeton, ND. Studied: Hamline Univ., St. Paul, Minn.; BMFA Sch., with P. Hale, F. Benson; England; H. Pyle. Work: murals, Pub. Lib., Hibbing, Minn.; Marshall Auditorium, Roosevelt Auditorium, Central Lutheran Church, St. James' Church, St. Mary's Hospital, all in St. Louis; Pub. Lib., Ely, Minn.; Franklin Auditorium, Mankato, Minn. [47]

WORKS, Katherine S. [P] San Anselmo, CA. Work: WPA mural, USPO, Woodland, Calif. [40]

WORMAN, Eugenia A. [P] Seattle, WA. Exhibited: Seattle SFA, 1922 (prize) [24]

WORMS, Edward J. [En] Paris, France b. NYC. Studied: Gérôme [13]

WORMS, Ferdinand [Mar.P] b. 1859 d. S 1939 [*]

WORRALL, Henry [I,P] Topeka, KS (since 1868) b. 14 Ap 1825, Liverpool, England (came to Buffalo, 1835; later to Cincinnati) d. 20 Je 1902. Studied: self-taught. Illustrator: Western history, Harper's and Leslie's, 1877–93; books on Western history. Also a musician. [*]

WORRALL, Rachel [Min.P] NYC [10]

WORSHAM, Janet [P] Lynchburg, VA [17]

WORST, Edward F. [C,L,T,W] Lockport, IL b. Lockport, IL. Studied: Lowell Textile Inst.; Chicago Normal Sch.; Germany; Sweden. Author: "Foot Power Loom Weaving," "How to Weave Linen." Position: T., Edward F. Worst Craft House, Penland, N.C. [40]

WORSWICK, Lloyd [S,C,T] NYC/Washington, NY b. 30 My 1899, Albany. Studied: Urich; Cedarstrom; Brewster; Olinsky; Weinman; Bufano [33]

WORTH, Thomas [Genre P,Car] b. 12 F 1834, NYC d. 29 D 1917, Staten Island, NY. Exhibited: NAD, 1874. His comic work lithographed by Currier and Ives was very popular. Also made racing scenes. Lived at Islip, Long Island until late in life. [*]

WORTHINGTON, Beatrice Maude [S] Boston, MA [15]

WORTHINGTON, Mary E. [P] Denver, CO b. Holyoke, MA. Studied: Paris, with Constant, Laurens, DuMond; H. Read, at Denver AM [31]

WORTHINGTON , Pearl. See Hill.

WORTHINGTON, Virginia Lewis [P,C] San Antonio, TX. Studied: Newcomb Col., New Orleans. Member: SSAL. Exhibited: SSAL, Montgomery, Ala., 1938; Southeastern Tex. AA, 1938; Cincinnati AM, 1939 [40]

WORTHLEY, Caroline Bonsall (Mrs. Irving T.) [P,C] Phoenixville, PA b. 25 D 1880, Cincinnati, d. ca. 1940. Studied: Cincinnati A. Acad.; PMSchIA; F. Wagner; J.F. Copeland; PAFA (Chester Springs Summer Sch.); Chautauqua Summer Sch. Appl. Arts [40]

WORTMAN, Denys [Car,I] Martha's Vineyard, MA b. 1 My 1887, Saugerties, NY d. 20 S 1958. Studied: Rutgers; N.Y. Sch. F.&Appl. A.; K.H. Miller; R. Henri. Member: ANA; NIAL; SI (Pres.). Exhibited: Armory Show, 1913. Work: complete file of proof, MET and NYPL. Author: "Metropolitan Movies," ca. 1927, "Mopey Dick and the Duke," ca. 1952. Specialty: life among NYC's lower classes. Position: Car., New York World-Telegram and United Features Syndicated Papers, from 1924 [47]

WOSE, Beatrice Ely [P,T] Syracuse, NY b. 8 Jy 1908, Syracuse. Studied: Syracuse Univ.; G.B. Luks. Member: Syracuse AA. Exhibited: GGE, 1939; Finger Lakes Exh., Rochester, N.Y., 1939–44; Syracuse MFA, 1933–46. Work: Syracuse MFA. Position: T., Syracuse Univ., from 1943 [47]

WOSTREY, Carlo [Mur.P] B. 1865, Italy (came to NYC ca. 1920) d. 25 D 1930, Los Angeles. Work: murals, Church of St. Vincent, Trieste; Church of Madonna of Loudres, NYC; St. Andrews Church, Pasadena [*]

WOY, Leota [P,I] Laguna Beach, CA b. 3 Jy 1868, New Castle, IN d. 23 Ja 1962, Glendale, CA. Studied: self-taught.; Cory Sch. Indst. A., NYC. Member: Denver AC; Ex-Libris S., Berlin. Specialty: bookplates [25]

WOZECH, Anthony. See Vozech

WRAAI, Gustav [Mur.P] NYC [13]

WRAGG, Eleanor T. [P,Min.P] Stoney Creek, CT. Member: Carolina AA [25]

WRAY, Henry Russell [P,E,W] NYC/Colorado Springs, CO b. 3 O 1864, Phila. d. 29 Jy 1927, Colorado. Member: SC; Players C. [27]

WRENN, Charles L(ewis) [Por.P,I] NYC/Norwalk, CT b. 18 S 1880, Cincinnati. Studied: W. Chase; ASL. Member: SI; SC [33]

WRENN, Elizabeth J(encks) [S] Baltimore, MD/Wellfleet, MA b. 8 D 1892, Newburgh, NY. Studied: A. Eberle; ASL; Md. Inst., Baltimore; G. Bridgman; M. Young; A. Dazzi, in Rome. Member: Mun. A. Soc., Baltimore; Baltimore Ar. Un.; AAPL. Exhibited: WFNY, 1939. Work: City Hall, Baltimore [40]

WRENN, Harold Holmes [P,T,Dr,Arch] Baltimore, MD b. 27 Ap 1887, Norfolk, VA. Studied: Norfolk Acad., Va.; Univ. Va.; Columbia. Member: AFA; AG, Baltimore (Pres.); Baltimore A. Un.; Provincetown AA; Mun. AS, Baltimore; BMA; Charcoal C. Exhibited: CGA, 1935; AFA Traveling Exh., 1935; WFNY, 1939; GGE, 1939; MOMA; VMFA, 1939 (prize); Pepsi-Cola Traveling Exh., 1945; Phila. A. All.; BMA, 1939 (prize); Mun. Mus., Baltimore, 1943 (prize). Work: Phila. A. All.; Norfolk Mus. A.&Sc.; VMFA; BMA; Mun. Mus., Baltimore [47]

WRIGHT, Alice Morgan [S] Albany, NY b. 10 O 1881, Albany, NY. (lived with Antoinette Sterling in NYC, 1915) Studied: Smith Col.; ASL; Ecole des Beaux-Arts, Paris; Injalbert; G. Borglum; J.E. Fraser; H. MacNeil. Member: NSS; NAWA; Am. Assn. Univ. Women. Exhibited: PAFA; AIC; S.Indp.A.; NAWA; Paris Salon; Salon d'Automne, Salon des Beaux-Arts, Paris; NAD (prize); NAWPS, 1920 (prize); NAC, 1923 (prize). Work: NGA; Folger Shakespeare Mus., Wash., D.C.; Newark Mus.; Smith Col.; Bleecker Lib., Albany; Brookgreen Gardens, S.C. Work: Mt. Pleasant H.S., Brooklyn, NY. Contributor: Harpers', Bookman. [47]

WRIGHT, Alma Brockerman (Mr.) [P,T] Dordogne, France b. 22 N 1875, Salt Lake City d. 1952. Studied: LDS Col., 1892–95; Univ. Utah, with Haag, Harwood, 1895–96; Laurens, Acad. Julian, Acad. Colarossi, Ecole des Beaux-Arts, Bonnât, all in Paris, 1902–04. Member: S. Utah Artists; Paris AAA; Laguna Beach AA; AAPL. Exhibited: Utah AI, 1904 (prize), 1905 (med). Work: murals, LDS Temples, Honolulu and Cardston, Alberta; Senate Chamber, Utah Capitol; Mormon Temple, Mesa Ariz., in collaboration with the sculptor. Position: T., Utah colleges (incl. Univ. Utah), 1896–37 [47]

WRIGHT, Angie Weaver (Mrs.) [Por.P,Des,Dec,T,L] Honolulu, HI b. 12 F 1890, Leesburg, OH. Studied: Corcoran Sch. Member: S. Wash. A.; Columbus AL; Hudson Highlands AA; Honolulu Assn. A.; Am. Lg. Pen Women. Work: dec., Cadet Gymnasium, U.S. Military Acad.; stage settings, West Point Players, 1935–37. Position: T., YWCA, Honolulu [40]

WRIGHT, Bertha Eugenie Stevens (Mrs. Lawrence W.) [P] Merrick, NY b. Astoria, NY. Studied: self-taught. Member: AAPL [40]

WRIGHT, Catharine Wharton Morris (Mrs.) [P,W] Wyncote, PA b. 26 Ja 1899, Phila. Studied: Moore Inst. Des. for Women; H.B. Snell; L. Seyffert. Member: ANA; AWCS; Phila. WCC; Baltimore WCC; Wash. WCC; All.A.Am.; Audubon A.; Phila. S. Min. P.; CAFA; Phila. A. All.; Newport AA; Authors Lg. Am.; NYWCC. Exhibited: PAFA, 1918–46, 1933 (prize); CGA, 1921–41; NAD, 1930–45, 1933 (prize); AIC, 1921–42; CI; All.A.Am., 1938–45, 1941 (prize); Audubon A., 1945; Newport AA, 1918–46, 1933 (prize); Woodmere A. Gal., 1941–46; Phila. A. All.,

1918–46; Springside (Pa.) Sch., 1937 (med), 1940 (med); Phila. AC, 1924 (prize). Work: PAFA; Allentown Mus.; Moore Inst. Des. for Women; Woodmere A. Gal.; Univ. Pa.; Pa. State Col.; PMA. Contributor: Scribner's, Story Parade. Author: "The Simple Nun." [47]

WRIGHT, Charles H. [P,I] NYC b. 20 N 1870, Knightstown, IN. Studied: ASL. Member: SI, 1914; SC; NYWCC; New Rochelle AA [40]

WRIGHT, Charles Lennox [P,I,T] Bayside, NY/West Rockaway, NY b. 28 My 1876, Boston. Studied: ASL; Dagnan-Bouveret, in Paris [25]

WRIGHT, Chester [I] NYC [19]

WRIGHT, Christina [P] b. 1886 d. 17 Ap 1917 (drowned in North River)

WRIGHT, Edna D. [P] Norfolk, VA. Studied: PAFA, 1936, 1937 (Cresson traveling schol.) [40]

WRIGHT, Elva M. [P,T] Long Branch, NJ b. 19 Mr 1886, New Haven, CT. Studied: Columbia; ASL; H.L. McFee; Y. Kuniyoshi. Member: NAWA; AAPL. Exhibited: NAWA, 1938, 1939, 1941–46; AAPL, 1937–40, 1942 (prize), 1943–46; Asbury Park SFA, 1938, 1939 (prize), 1940, 1946; N.J. A. Gal., Newark, 1938 (prize), 1940 (prize) [47]

WRIGHT, Emma R. [P] New Haven, CT. Member: New Haven PCC [25]

WRIGHT, F.E. [Por.P] Boston, MA b. 1849, South Weymouth, MA. Studied: Paris, with Bonnât, Chapu, Boulanger, Lefebvre [*]

WRIGHT, F. Harriman [P] NYC [24]

WRIGHT, Frances Pepper [P,G] Phila., PA/Kittery Point, ME b. 2 Jy 1915, Phila. Studied: PAFA; J.J. Capolino. Member: Plastic C., Phila. Exhibited: PAFA, 1937 [40]

WRIGHT, Frank Lloyd [Arch,Des] b. 1869, Richland Center, Wis. d. 1959. Internationally influential for his "Prairie Houses," built 1900–10, which were analogous to cubism in painting and also reflected a Japanese influence. Designer: total living environment, including furniture, stained glass windows, and fabrics [*]

WRIGHT, Fred W. [Por.P] NYC/Cambridge, MD b. 12 O 1880, Crawfordsville, IN. Studied: Académie Julian, P. Marcel-Baronneau, both in Paris; J.O. Adams; ASL; R. Reid, NYC. Member: SC. Work: Capitol, Albany, N.Y.; Nat. Democratic C., Union C., Catholic C., Columbia Univ., all in NYC; Hill Reference Lib., St. Paul, Minn.; Col. Indst. A., Denton, Tex.; N.Y. County Lawyers' Assn., Hospital, both in Haverstraw, N.Y.; Law School, Albany [40]

WRIGHT, Fredda Burwell (Mrs. William) [P,S,T] Topeka, KS b. 11 Je 1904, Orleans, NE. Studied: ASL; M. Huntoon; L.T. Hull. Exhibited: Women P. Am., Wichita AM; Midwestern A. Ann., Kansas City AI. Position: T., Topeka Community A. Ctr. WPA artist. [40]

WRIGHT, Frederick William [E,P,C] Freeport, NY b. 28 Mr 1867, Napanee, Ontario d. 13 Ja 1946. Studied: Montreal AA. Member: SAE; Nassau County AL; Ind. Soc. PM; S.Indp.A.; Salons of Am. [40]

WRIGHT, George Hand [P,I,E] Westport, CT b. 6 Ag 1872, Fox Chase, Phila. d. 14 Mr 1951. Studied: Spring Garden Inst.; PAFA. Member: SC; SAE; Westport A.; NA (Elect, 1936); SI, 1901; Dutch Treat C. Exhibited: NAD; LOC: AIC; CI; SC; Grand Central A. Gal.; Harlow Gal.; Ferargil Gal. [47]

WRIGHT, Gladys Yoakum [P] Fort Worth, TX [19]

WRIGHT, Grace Latimer [P] Brooklyn, NY [15]

WRIGHT, Grant [P,I] Weehawken, NJ b. 1 S 1865, Decatur, MI d. 20 O 1935. Studied: NAD; E. Ward. Member: Bronx Artists Gld. (founder); N.J. Art Group. Work: Mus. City of N.Y. Illustrated: "Yazzo Valley Tales," by E.F. Younger [33]

WRIGHT, H.B. [P] Portville, NY [08]

WRIGHT, Helen [Lib,W] Wash., D.C. b. Columbus, OH d. 23 Ja 1935. Member: Ohio State Archaeological S.; Arts C., Archaeological S., Literary S., Am. Fed. A., all in Wash., D.C. Author: biographical sketches of artists in the "Dictionary of American Biography." Contributor: American Art News. Position: Staff, LOC, for 30 yrs.

WRIGHT, Helen Elizabeth. See Rowe.

WRIGHT, J. Dunbar [P] NYC b. 1862 d. 5 O 1917 Port Jervis, NY. Member: SC [15]

WRIGHT, James [P] NYC [17]

WRIGHT, James Couper [P,T,Des,C] Los Angeles, CA b. 21 Mr 1906, Kirkwall, Orkney Islands, Scotland. Studied: Edinburgh Col. A., Scotland, traveling schol.; Mills Col., Oakland; Germany; France; Austria; London; England. Member: Calif. WCS; Los Angeles AA; AFA. Exhibited: AIC, 1936–38; Phila. WCC, 1936–38; Calif. WCS, 1931 (prize), 1932–46, 1937 (prize); San Fran. AA, 1937–44; Oakland A. Gal., 1938–45, 1942 (prize); San Diego FA Soc., 1934 (prize); Denver, 1941 (prize); Santa Cruz, 1944; Los Angeles AA, 1934 (prize); Calif. State Fair, 1935 (prize), 1936 (prize). Work: SFMA; Santa Barbara MA; Los Angeles MA; San Diego FA Soc.; Intl. Exh. Hygiene, Dresden, Germany, 1930. Specialty: stained glass. Position: T., Univ. Ga., 1939–41 [47]

WRIGHT, Jennie E. (Mrs.) [P] Portland, OR [04]

WRIGHT, John [P] London, England. Member: Concord AA [27]

WRIGHT, Jud [Car] Los Angeles, CA [19]

WRIGHT, M. Louise (Mrs. John) [P,I,T] London, England b. 1875, Phila. Studied: PAFA; Whistler, Académie Julian, both in Paris; F.W. Jackson, in England. Member: Phila. WCC; NYWCC; Concord AA. Exhibited: St. Louis Expo, 1904 (med); PAFA (prize) [33]

WRIGHT, Margaret Hardon (Mrs. James H.) [E] Newton, MA b. 28 Mr 1869, Newton d. 12 Ja 1936. Studied: MIT; Wellesley; W.H.W. Bicknell; Paris, with Merson, Cavaille-Call. Member: Chicago SE; Copley S.; Boston SE; AAPL. Work: NYPL; LOC; M. Carnavalet, Paris. Specialties: bookplates; etchings; Christmas cards [27]

WRIGHT, Marian [P] NYC [25]

WRIGHT, Marsham E(lwin) [P,C,B,I] South Minneapolis, MN b. 27 Mr 1891, Sidcup, Kent, England. Studied: L.A. Henkora; C. Booth; Minneapolis Sch. Art. Member: AAPL. Exhibited: Minneapolis Inst. A., 1929 (prize), 1931 (prize); Minn. State Fair, 1931 (prize), 1932 (prize) [40]

WRIGHT, Mary Catherine [P] NYC [01]

WRIGHT, Mildred G. [P] Long Branch, NJ b. 10 Jy 1888, New Haven, CT. Studied: Cape Ann A. Sch.; Woodstock Sch. Painting; C. Rosen; J. Smith. Member: NAWA; AAPL; Asbury Park Soc. FA. Exhibited: NAWA, 1938–46; AAPL, 1939–46; Spring Lake, N.J., 1940–46; Asbury Park Soc. FA, 1938–40; Asbury Park Women's C., 1940; Long Branch Women's C., 1939–42; Long Branch T. Assn., 1944; N.J. A. Gal., Newark, 1939 (prize), 1942 (prize) [47]

WRIGHT, Miriam Noel [S,W] d. 3 Ja 1930, Milwaukee, WI

WRIGHT, Nellie B. [P] Portville, NY [01]

WRIGHT, Norman B. [P] Chicago, IL. Exhibited: AIC, 1937 (prize) [40]

WRIGHT, Pauline [P] New Orleans, LA. Affiliated with Newcomb Sch. A., New Orleans [17]

WRIGHT, (Philip) Cameron [I,Des] Jackson Heights, NY b. 11 Je 1901, Phila. Studied: M. Herman; Pratt Inst.; W. de Leftwich Dodge; G.B. Bridgman; ASL; E. Arcioni, at British Acad. A., Rome. Member: Artists G. Illustrator: "Two Fables," by C. Morley; book jackets, Century Co., Longmans, Green & Co., Bobbs Merrill; covers, Country Life, 1925, Christmas 1926; "Plymouth, 1620," by W.P. Eaton, "Stonewall," by J.D. Adams, "Lucinda," "The Boy Who Had No Birthday," by M.L. Hunt; children's books, pub. William Morrow, H.C. Kinsey, Harcourt Brace and Co., and Random House, 1937. Specialty: children's books [40]

WRIGHT, Redmond Stephens [Por.P,Mur.P,E] NYC b. 13 My 1903, Chicago. Studied: Harvard; AIC; E. Leon, in Paris. Member: SAE; Chicago AC; Société Intl. de la Gravure Originale en Noir. Work: LOC; mural of Red Cross history presented at Conference to the Japanese Red Cross in Tokyo, 1934 [47]

WRIGHT, Rufus [P,Li,T] b. 1832, Cleveland, OH. Studied: NAD; G.A. Baker, in NYC. Exhibited: NAD. Work: Oakland MA; Chicago Hist. Soc. His 1859 lithograph of Davenport, Iowa (printed by Sarony) indicates he went West. Probably in San Fran., 1880s. Position: T., Brooklyn Acad. Des., 1866–72 [*]

WRIGHT, Russel [Des,Dec] NYC b. 3 Ap 1905, Lebanon, OH d. 1976. Studied: K.H. Miller; Lentelli, at ASL; Columbia. Work: des. for house furnishings, e.g., furniture, wallpaper, textiles, metal ware, pianos, radios, for leading manufacturers. Designer: Focal Food & Fashion Exhibits, WFNY, 1939. Wright's modern indst. des. for furniture and household objects is the hallmark of middle-class consumerism in the 1940s–50s. [40]

WRIGHT, Sara Greene [S] NYC b. 1875, Chicago, IL. Studied: AIC; Paris, with F.M. Charpentier, F. MacMonnies [04]

WRIGHT, Sarah Jane [P] Wash., D.C. [19]

WRIGHT, W. Lloyd [P] NYC. Member: SI [31]

WRIGHT, William [P] Pittsburgh, PA. Member: Pittsburgh AA [21]

WRIGHT, William B. [P] NYC [15]

WRIGLEY, Viola Blackman (Mrs. Roy F.) [P,Li] White Plains, NY b. 27 D 1892, Kendallville, IN. Studied: Oberlin Col.; Univ. Kans.; Columbia; C. Martin; H.B. Snell; Grand Central A. Sch. Member: NAWA; Hudson Valley A. Gld.; Westchester AG; Chappaqua G. Exhibited: NAWA; Westchester AG; Toronto, 1941 [47]

WUERMER, Carl [Ldscp.P,E] Woodstock, NY b. 3 Ag 1900, Munich, Germany d. 1983. Studied: AIC; ASL; W.J. Reynolds. Member: A. Fellowship, Inc.; Allied AA; Springfield AL; Ill. Acad. FA; Grand Central Gal.; CAFA. Exhibited: AIC, 1926 (prize), 1927 (prize); NAD, 1928 (prize); Springfield (Mass.) AL, 1928 (prize); Buck Hill Falls (Pa.) AA, 1943 (prize); Anderson Gal., Chicago, 1925 (one-man), 1926 (one-man); Grand Central A. Gal., 1929 (prize), 1930 (one-man), 1934 (one-man), 1938 (one-man), 1943 (one-man), 1945 (prize); O'Brien A. Gal., Chicago, 1931 (one-man). Work: Amherst Col. Became U.S. citizen. [47]

WUERPEL, Edmund Henry [P,T,W,L] Clayton, MO b. 13 My 1866, St. Louis d. 24 F 1958 (age 92). Studied: Wash. Univ., St. Louis; Doucet, Whistler, Académie Julian, and Ecole des Beaux-Arts, with Bouguereau, Gérôme, Robert-Fleury, Ferrier, Aman-Jean, all in Paris. Member: St. Louis AL; St. Louis AG; 2 x 4 Soc., St. Louis; Paris AAA. Exhibited: CGA; CI; PAFA; P.-P. Expo, 1915 hor concours; CAM; 2 x 4 Soc.; Chicago; Portland; St. Louis AG (prize); St. Louis AL (prize); Nashville Expo, 1897 (med); St. Louis Expo, 1904, hors concours; Lewis and Clarke Expo, Portland, Oreg., 1905 (med); Buenos Aires, Expo, 1910 (prize). Work: murals, Capitol, Mo.; Church of Unity, St. Louis; CAM; Pub. Lib., St. Louis; Herron AI, Indianapolis; Mo. Athletic C. and Lib.; Buenos Aires Mus.; Sch. of Orthodontia, Pasadena; Burroughs Sch., St. Louis. Positions: Dean Emeritus, Wash. Univ., St. Louis; Acting Dir./Dean, St. Louis Sch. FA [47]

WUERTZ, Emil H. (or Wuerst) [S,T] b. 1856, St. Albans, VT (or Germany) d. 4 Jy 1898 (went down with the "Bourgogne" off Nova Scotia). Studied: Paris, with Rodin, Chapu, Mercie. Exhibited: World's Columbian Expo, 1893 (med); Tenn. Centenn. Expo, 1897 (med); NSS, 1898. Position: T., AIC

WUHL, Edna Dell [P] Troy, NY [21]

WULF, Lloyd William [P,G,T] San Fran., CA b. 2 S 1913, Avoca, NE. Studied: Univ. Nebr.; Calif. Sch. FA. Exhibited: Intl. Lith., Wood En., AIC, 1937; SFMA, 1937 (prize). Work: SFMA [40]

WULFF, Timothy Milton [P] San Fran., CA b. 13 O 1890, San Fran. Studied: F. Van Sloun. Member: San Fran. AA. Work: Palace FA, San Fran. [33]

WUNDERLY, August [P] Pittsburgh, PA. Member: Pittsburgh AA [21]

WURTELO, Isobel Keil [P] Rochester, MN [19]

WURTH, Herman [S] NYC b. NYC. Studied: Paris, with Falguière, Mercié [13]

WURTZ, Edith M.B. [P] Englewood, NJ [24]

WYAND, Edith V. See Cockcroft.

WYANT, Alexander Helwig [Ldscp.P] NYC (since ca. 1866) b. 11 Ja 1836, Evans Creek, OH d. 29 N 1892. Studied: NAD; Karlsruhe, Germany, with F. Gude, 1865–66. Member: NA, 1869. Exhibited: NAD, 1865–92; Univ. Utah, 1968 (retrospective). Work: BM; Montclair M.; MMA; TMA. He learned to paint with his left hand after a paralytic stroke in 1873. Best known for his peaceful landscapes painted during his summers at Keene Valley, N.H. (1873–89) and Arkville in the Catskills, N.Y. (after 1889) [*]

WYANT, Arabella L. (Mrs. Alexander H.) [P] NYC/Arkville, NY d. 27 O 1919. Studied: her husband. Member: NAWPS; NAC [15]

WYATT, A.C. [Ldscp.P] Montecito, CA b. England d. 8 F 1933. Exhibited: Royal WCS (golds); Royal Intl. Horticultural Exh., London, 1912 (prize). Painted in the New England states, S.C., Hawaii

WYATT, Mary Lyttleton [Min.P] Paris, France. b. Baltimore. Studied: Paris, with Mme. Debillemont-Chardon, Collin [10]

WYCKOFF, Joseph [P,T] NYC b. 9 Jy 1883, Ottawa, KS. Studied: AIC; PAFA; J. Hambridge; H. Giles; ASL; N.Y. Sch. F.&Appl. A. Member: AAPL [33]

WYCKOFF, Maud E. [P] Broooklyn, NY [13]

WCYKOFF, Marjorie Annable [S] Buffalo, NY b. 23 S 1904, Montreal, Quebec. Studied: A. Lee [33]

WYCKOFF, Sylvia Spencer [P,T] East Syracuse, NY b. 14 N 1915, Pittsburgh, PA. Studied: Syracuse Univ. Member: NAWA; Syracuse AA; Eight Syracuse Watercolorists; EAA. Exhibited: NAWA; Eight Syracuse Watercolorists, 1943–46; Daubers C.; Onondaga Hist. Soc.; Syracuse AA, 1943 (prize); Syracuse AA, 1943 (prize). Position: T., Syracuse Univ., from 1942 [47]

WYER, Raymond [P,W,L] Worcester, MA b. London, England. Studied: London; Brussels; Academie Delecluse, Bouguereau, Benjamin-Constant, all in Paris. Member: Artists' S., London; Langham C., London; Archaeological Inst. Am.; Am. Assn. Mus.; NAC; St. Botolph C.; Boston; F., Royal S. Arts, London. Positions: Dir., Hackley Gal., Muskegon (1912–16), WMA (1918) [21]

WYETH, Andrew Newell [P] Chadds Ford, PA/Port Clyde, ME (1985) b. 12 Jy 1917, Chadds Ford. Studied: his father N.C. Wyeth. Member: NA, 1945; Audubon A. (Dir.); Phila. WCC (Dir.); AWCS. Exhibited: Macbeth Gal., NYC, 1937 (his first one-man exh.); AIC (one-man); MOMA; Traveling Exh. to England; PAFA, 1947; Traveling Exh. to PAFA, Baltimore, NYC, Chicago, 1966; de Young MA, 1973; first living American to receive a retrospective at MMA, 1976; Wilmington (Del.) Mus. (prize); Butler AI (prize); AAAL, 1947 (prize); AWCS, 1952 (prize). Award: Art in America mag., 1958. Work: MMA; BMFA; AIC; Canajoharie A. Gal.; Univ. Nebr.; AGA; New Britain Mus.; Butler AI; Wilmington Mus. A.; Lincoln Mus., England; mural, Delaware Trust Bank, Wilmington. Author: "The Nub," "The Smugglers' Sloop," 1935. Specialties: watercolor; egg tempera. Internationally recognized by early 1940s for paintings such as "Christina's World" (1948, MOMA); his has been a household name since the 1950s. His watercolor style has attracted countless followers. [47]

WYETH, Caroline [P] Chadds Ford, PA/Port Clyde, ME b. 26 O 1909, Chadds Ford. Studied: N.C. Wyeth. Member: Wilmington SFA; Chester County AA; Phila. A. All. Exhibited: Wilmington Soc. FA, 1932 (prize), 1937 (prize) [40]

WYETH, Henriette (Mrs. Peter Hurd) [Por.P,Mur.P] Chadds Ford, PA/San Patricio, NM (1980) b. 22 O 1907, Wilmington, DE. Studied: her father N.C. Wyeth; Mass. Normal A. Sch., Boston, with R. Andrew; PAFA, with H. McCarter, A.B. Carles. Member: Wilmington Soc. FA; Chester County AA; ANA, 1974. Exhibited: Wilmington Soc. FA, 1933–36 (prizes); Chester County AA, 1934 (prize); PAFA, 1937 (prize). Work: Wilmington Soc. FA; Roswell MA; Lubbock MA; Tex. Tech. Univ. Sister of Andrew. [40]

WYETH, John Allan [P] NYC. Exhibited: CI, 1938; CGA, 1939; PAFA, 1939; GGE 1939 [40]

WYETH, Newell Convers [P,I,Mur.P,Dec,T] Chadds Ford, PA/Port Clyde, ME b. 22 O 1882, Needham, MA d. 19 O 1945 (in a railroad accident near his home in Chadds Ford). Studied: Mechanics A. Sch., Boston, 1899; Mass. Normal A. Sch., with R. Andrew; Eric Pape Sch. A., Boston, with G.L. Noyes, C.W. Reed; H. Pyle, 1902–11. Member: SI, 1912; Wilmington Soc. FA; Phila. All.; Chester County AA; NA, 1941. Exhibited: Phila. WCC, 1910 (prize); P.-P. Expo, San Fran., 1915 (gold); Wash. SA, 1931 (med); CGA, 1932 (prize); Macbeth Gal., N.Y., 1939 (one-man) Work: murals, Capitol, Mo.; Hotel Traymore, Atlantic City; Reading Mus. FA; Fed. Reserve Bank, First Nat. Bank, both in Boston; NYPL; Franklin Savings Bank, NYC; First Mechanics Bank, NYC; First Mechanics Nat. Bank, Trenton; Roosevelt Hotel dining room, NYC; Penn Mutual Life Insurance Bldg., Phila.; Wilmington Savings Fund Soc., Del.; altar in Chapel of the Holy Spirit, Nat. Cathedral, Wash., D.C. One of Pyle's leading students, he produced more than 3,000 illus. for hundreds of articles, numerous posters, and more than 100 books. His best-known book illustrations include "Treasure Island," "Kidnapped," "Black Arrow," all by R.L. Stevenson; "Deerslayer," "Last of the Mohicans," both by James Fenimore Cooper; "Robin Hood"; "Robinson Crusoe," by D. Defoe; "Drums," by J. Boyd.

WYHOFF, Julius [P] Yonkers, NY. Work: WPA mural, USPO, Mt. Gilead, OH [40]

WYKES, Frederic Kirtland [P,I,T] Grand Rapids, MI b. 23 Jy 1905, Grand Rapids. Studied: Stetson Univ.; Univ. Mich.; AIC; F. Fursman; J.P. Slusser. Work: IBM Coll.; mural, Orthopedic Sch., Grand Rapids. Illustrator: "Wings in the Sun," "History of Allegan County, Michigan." [47]

WYLE, Florence [P] Oak Park, IL [10]

WYLIE, Marion. See Stirrett, Wylie.

WYLIE, Samuel B. [P] Woodstock, NY b. 1900 d. 1957. Studied: ASL. Member: SC [21]

WYMAN, Florence. See Ivins.

WYMAN, Lois Palmer (Mrs.) [P] Cincinnati, OH. Exhibited: NAWPS, 1935–38. Member: NAWA [40]

WYMAN, Lucile Palmer [E,S,L,T] Gardnerville, NV b. 20 Ap 1910, NYC. Studied: F.V. Guinzburg; E. Fraser; M. Young; G. Lober; H. Raul; A. Piccirilli; E. Morahan; M. Gage; G. Luken. Member: AAPL; Art Ctr. of the Oranges; San Fran. S. Women A.; Santa Monica AS [40]

WYNNE, Evelyn B. [P,Min.P,E,T] Chevy Chase, MD b. 22 Ag 1895, NYC. Studied: ASL; Royal Col. Engraving, London; Univ. Mich.; Corcoran A. Sch.; M. Osborn; A. Fairbanks; E. Weiss. Member: Lg. Am. Pen Women. Exhibited: LOC, 1943; Wash. SE, 1944–46; Wash. SMP, 1946; S. Wash. A., 1946; Corcoran A. Sch., 1942 (prize) [47]

WYNNE, Madeline Yale (Mrs.) [P,C] Chicago, IL/Deerfield, MA b. 25 S 1847, Newport, NY. Studied: BMFA Sch.; G. Fuller. Member: Copley S., 1879; Chicago A.&Cr. Soc.; Deerfield A.&Cr. Soc. Specialty: metal work [10]

XCERON, Jean [P] NYC b. 24 F 1890, Isari, Greece d. 1967. Studied: Corcoran Sch. A.; Ecole des Beaux-Arts. Member: Am. Abstract A.; Fed. Mod. P.&S.; S.Indp.A. Exhibited: GGE, 1939; CI, 1942–44; Palace Legion Honor, 1945; Fed. Mod. P.&S., 1945; New Orleans A.&Crafts C., 1931; Nierendorf Gal., 1938; Galerie Dalmau, Barcelona, Spain; Galerie Pierre, Paris, 1934; São Paolo, Brazil, 1939. Work: MOMA; PMG; Mus. Non-Objective Painting; Cahiers d'Art, Paris; murals, Assembly Room Chapel, Riker's Island, N.Y. Affiliated with Cahiers d'Art, Paris, 1940 [47]

Symbol of the Whitney Museum of American Art, used during the 1940s

Symbol of the American Watercolor Society

Y

YAEGER, Edgar Louis [P] Detroit, MI b. 26 Ag 1904, Detroit. Studied: Univ. Detroit; Univ. Mich.; Wayne Univ.; J.P. Wicker; Lhote, M. Gromaire, O. Friesz, all in Paris. Member: Scarab C., Detroit; Wayne Univ. AC. Exhibited: Detroit Inst. A., 1932 (prize), 1939 (prize); AIC; CI; PAFA; CGA; CAA; MOMA; Angell Mus., Ann Arbor, Mich. (one-man); Weyhe Gal., N.Y. (one-man). Award: Anna Scripps Whitcomb traveling scholarship, 1934. Work: Detroit Inst. A.; murals, Receiving Hospital, U.S. Naval Armory, Detroit; Ford Sch., Highland Park, Mich.; Grosse Pointe Pub. Lib.; City of Detroit Pub. Lighting Comm.; Univ. Mich. [47]

YAEGER, William L. [P] Phila., PA. Member: Phila. AA [25]

YAFFEE, Edith Widing (Mrs. Herman) [Por.P] Wash., D.C. b. 16 Ja 1895, Helsingfors, Finland d. 6 F 1961, Freeport, ME. Studied: W. Paxton; P. Hale; PAFA. Exhibited: Chaloner Paris-Am., 1920 (prize). Award: European traveling scholarship, PAFA, 1921 [33]

YAFFEE, Herman A. [P] Cousins Island, ME b. 20 Je 1897. Studied: BMFA Sch.; PAFA; Paris; Spain [29]

YAGHJIAN, Edmund [Por.P,T,L,W] Columbia, SC b. 16 F 1903, Armenia. Studied: RISD; ASL; J.R. Frazier; I.G. Olinsky; W. Von Schlegell; S. Davis. Member: AFA; Southeastern AA. Exhibited: CGA, 1936, 1939, 1945; PAFA, 1934, 1936, 1939, 1941, 1943; NAD, 1934, 1936; MMA (AV), 1942; Pepsi-Cola, 1944; WMAA, 1936, 1939, 1942; GGE, 1939; CI, 1936, 1941, 1945; several one-man shows. Work: NYPL; Duke Univ.; Ossining (N.Y.) Mus.; Montpelier (Vt.) Mus.; numerous H.S. and hospitals; NYU; Jr. H.S. 93, Beth El Hospital, both in NYC; Commerce Bldg., Wash., D.C.; Newark Edu. Bldg.; Mt. Morris Hospital, Farm Colony Hospital, N.Y. Positions: T., Univ. S.C. (from 1946), ASL [47]

YALE, (Charlotte) Lilla [P,T] Meriden, CT b. 14 Mr 1855, Meriden d. 1929. Studied: D.F. Wentworth, in Hartford; G. deF. Brush; ASL; W.M. Chase, R.H. Nicholls, both in Shinnecock, Long Island. Member: Meriden A.&Cr. Assn. [27]

YALE, Leroy Milton (Dr.) [Painter-etcher] b. 12 F 1841, Holmes' Hole (now Vineyard Haven, MA) d. 12 S 1906. Member: NYEC (a founder). Work: Print Dept., NYPL has selection of his best work, with a manuscript catalogue of his etchings as well as original plates and tools illustrating the technique of the art. He made several hundred etchings.

YAMA, Sudzuki Shinjiro [B,Dec,L] Syracuse, NY b. 10 Mr 1884, Japan. Work: Mus. FA, Syracuse [40]

YAMANAKA, Sadajiro [Patron] b. 1866, Japan (came to U.S. ca. 1896) d. Fall, 1936. Opened N.Y. branch of his firm. Oriental and occidental circles knew him as one of the foremost connoisseurs of Asiatic art. The governments of Japan, France, and Germany conferred honors upon him.

YAMPOLSKY, Oscar [P,S,T] Chicago, IL b. 1892 d. 17 Mr 1944. Studied: AIC; Europe. Position: T., Fort Wayne (Ind.) A. Sch.; Wash. State Col. [17]

YANDELL, Charles R. [P,C] NYC. Member: NAC [01]

YANDELL, Enid [S,T] Boston, MA/Edgartown, MA b. 6 O 1870, Louisville, KY d. 12 Je 1934. Studied: Cincinnati A. Sch.; P. Martiny, in N.Y.; MacMonnies, Rodin, both in Paris. Member: NSS, 1898; N.Y. Mun. AS; NYWCC; Boston SS. Exhibited: Columbian Expo, Chicago, 1893 (med); Tenn. Expo, Nashville, 1897 (med); Pan-Am. Expo, Buffalo, 1901 (prize); St. Louis Expo, 1904 (med); Officier de l'Academie, French Government, 1906. Work: fountain, Providence; Col. Physicians and Surgeons, N.Y.; mem., Albany, N.Y.; fountain/mon., Louisville, Ky.; fountain, Watch Hill, R.I. Organizer: Branstock Summer Sch. A., Edgartown, 1907 [33]

YARBROUGH, Vivian Sloan [P] Ft. Worth, TX b. 20 F 1893, Whitesboro, TX. Studied: R.Davey; E. Lawson; J. Sloan. Member: S.Indp.A.; SSAL; Tex. FA Assn. [33]

YARD, Margaret. See Tyler.

YARDLEY, Caroline S. [Min.P] St. Paul, MN. Member: Pa. S. Min. P. [10]

YARDLEY, Ralph O. [Car] Stockton, CA b. 2 S 1878, Stockton. Studied: Mark Hopkins AI. Work: Huntington Lib., San Marino, Calif. Position: Staff Car., Stockton Record [47]

YARROW, William H.K. [P,W] Redding Ridge, CT b. 24 S 1891, Glenside, PA d. 21 Ap 1941, NYC. Studied: PAFA; Acad. Grand Chaumière, Colarossi, both in Paris. Member: Arch. Lg. Exhibited: P.-P. Expo., 1915 (med); Phila. AC, 1916 (gold); Ferargil Gal., N.Y., 1938. Work: PAFA; WMAA; Phila. AC. Author: "Robert Henri," 1921. Editor: American Art Library [40]

YATER, George David [P,Des,W] Provincetown, MA b. 30 N 1910, Madison, IN. Studied: Herron AI; Cape Sch. A.; H. Hensch; W. Forsyth; E. Dickinson. Member: Phila. WCC; Provincetown AA; Indianapolis AA. Exhibited: NAD, 1934, 1940; AWCS, 1938, 1945; PAFA, 1934, 1937, 1939, 1943–45; WFNY, 1939; Currier Gal. A., Manchester, N.H., 1940; Univ. Ill., 1939; Inst. Mod. A., Boston, 1939; Paper Mill Playhouse, Millburn, N.J., 1939; Provincetown AA, 1934–46; Ind. A., 1931–46; Hoosier Salon, 1931 (prize), 1932, 1934, 1936 (prize), 1940, 1941, 1945, 1946 (prize); Hanover Col., Ind., 1939 (one-man). Contributor: Rudder, Motor Boating, Yachting [47]

YATES, Cullen [Ldscp.P] Shawnee-on-Delaware, Monroe County, PA b. 24 Ja 1866, Bryan, OH d. 1 Jy 1945. Studied: NAD, Chase, Ochtman, all in N.Y.; Ecole des Beaux-Arts, Colarossi Acad., both in Paris; Académie Julian, Paris, with Laurens, Constant. Member: ANA, 1908; NA, 1919; AWCS; NYWCC; Lotos C.; SC, 1899; NAC (life); Allied AA; SPNY; N.Y. Century A. Exhibited: St. Louis Expo, 1904 (med); SC, 1907 (prize), 1921 (prize); NAC, 1932 (med). Work: NGA; City A. Mus., St. Louis; Seattle Gal.; Brooklyn Inst. Mus.; Montclair AM, N.J.; Butler AI; Seattle AM; Nat. AC; Lotos C.; Newark AM [40]

YATES, Edna Roylance [B,E,Wood En,Li,T,L] NYC/LaGrangeville, NY b. 24 Ja 1906, NYC. Studied: A. Gorky; A. Lewis; H. Wickey. Member: AA of Syracuse. Exhibited: Syracuse Mus. FA, 1937 (prize). Position: Dir., Adults & Children's Sch. AC, N.Y. [40]

YATES, Elizabeth M. [P,T] Buffalo, NY b. 13 My 1888, Stoke-on-Trent, Staffordshire, England. Studied: PIASch. Member: Buffalo GAA [31]

YATES, Ida Perry [Mus.Cur,C] Wash., D.C. b. 29 Ap 1876, Charles Town, WV. Position: Cur., Textile Mus., Wash., D.C., 1929– [47]

YATES, Julie Chamberlain (Mrs.) [S] Governor's Island, NY d. 4 N 1929. Studied: Rodin. Member: NAC, 1920

YATES, Julie T. [S] NYC [Same as Julie C.?] [17]

YATES, Ruth [S,T] NYC b. 31 D 1896, Greenville, OH. Studied: Cincinnati A. Acad.; Grand Central A. Sch.; Académie Julian, Paris; P. Landowski; J. de Creeft. Member: NSS; NAWA; PBC; Hudson Valley AA; West-

chester A. & Cr. Gld. Exhibited: NAWA, 1931, 1932, 1938, 1939 (prize), 1945, 1946; PBC, 1945 (prize), 1946; NAD, 1931; PAFA, 1942, 1943; N.Y., 1939 (one-man). Work: Brookgreen Gardens, S.C. Position: T., Westchester Workshop, White Plains, N.Y. [47]

YEAGER, Charles George [C,B,P,T] Indianapolis, IN b. 26 Jy 1910, Morgan County, IN. Studied: J.M. Thompson; O. Richey; W. Forsyth; P. Hadley; A. Heckman; C. Martin; W. McBride; C. Wheeler; A. Young. Member: Ind. AC; Ind. Soc. PM. Exhibited: Ind. Artists' Exh., 1929 (prize); Ind. State Fair, 1937 (prize); Hoosier Salon, 1937 (prize). Work: Ind. Univ. Position: T., Emmerich H.S., Indianapolis [40]

YEATS, John [Por. P,W] NYC b. 1839, Ireland d. 3 F 1922. Member: S. Indp. A.; Hibernian Acad. Author: "Essays, Irish and American." Father of poet William Butler Yeats and of artist Jack B. Yeats. [17]

YELLAND, Raymond Dabb [Ldscp. P] Oakland, CA b. 1848, London (came to U.S. in 1851) d. 27 Jy 1900. Studied: NAD, with W. Page, L.E. Wilmarth, J.R. Brevoort; Paris, with Merson. Member: San Fran. AA, 1874. Exhibited: NAD, 1882–88. Work: Chicago Hist. S. Position: Asst. Dir., Calif. Sch. Des., 1877 [98]

YELLENTI, Nicholas [P] NYC (Old Lyme, CT, in 1924) b. 7 Jy 1894, Pittsburgh. Studied: Swain Sch. Des., with C. Riddell, I. Caliga, P. Little. Member: SC. Exhibited: Toledo Fed. A. Exh., 1920 (prize), 1921 (prize) [40]

YELLIN, Samuel [C,T] Wynnewood, PA b. 2 Mr 1885, Poland d. 3 O 1940, NYC. Studied: PMSchIA; Europe. Member: AIA; Arch. Lg.; Arch. C., Chicago; Boston SAC; Phila. Alliance; Am. Assn. Mus.; Fairmount Park AA; Phila. Sketch C.; T. Square; Medieval Acad. of Am.; AFA; Am. Inst. Iranian A. & Archaeology; BAID; Royal Soc. A., London; Armor & Arms Soc. Exhibited: Art Exh., Phila. 1916 (prize); AIC, 1918 (med); AIA, 1920 (med); Arch. Lg., 1922 (gold); PMSchIA, 1930 (prize). Award: Phila. Civic Book Award, 1925. Work: Harkness Mem. Quadrangle, Yale; Carillon Tower, Mountain Lake, Fla.; National Cathedral, Wash., D.C.; Cathedral of St. John the Divine, Fed. Reserve Bank, Equitable Trust Co., Central Savings Bank, J.P. Morgan Lib., Columbia, Jewish Theological Seminary, St. Thomas Church, all in NYC; Goodhart Hall, Bryn Mawr Col., Pa.; Wash. Mem. Chapel, Valley Forge, Pa.; Princeton Univ. Chapel; Hall of Fame, NYU; Sterling Mem. Lib., Yale; McKinlock Mem., Northwestern; Harvard; Seattle AM; AIC; Ohio State Univ., Columbus; Oberlin Col.; St. George's Chapel, Newport, R.I.; Grace Cathedral, San Fran.; Cloisters, MMA; Univ. Pittsburgh. Contributor: articles, Encyclopaedia Britannica. Specialty: metalwork. Position: Advisor in Metalwork, Phila. MA [40]

YENS (ALSO JENS), Karl (Julius Heinrich) [Mur. P,Por. P,I,E,T] Laguna Beach, CA b. 11 Ja 1868, Altona, Germany d. 13 Ap 1945. Studied: M. Koch, in Berlin; Constant, Laurens, both in Paris. Member: Laguna Beach AA; AAPL; Los Angeles AA (hon. life); Acad. West P.; Calif. AC; Calif. WCC; Long Beach AA; San Diego FAS; Intl. Bookplate Assn.; Scandinavian-Am. A. Soc. of West. Exhibited: Pan.-Calif. Intl. Expo, San Diego, 1915 (med); Calif. AC, 1919 (prize); Laguna Beach AA, 1921 (prize), 1922 (prize), 1924 (med), 1925 (prize), 1927 (prize), 1935 (prize); Calif. WCS, 1922 (prize); Southern Calif. Fair, Riverside, 1922 (prize), 1928 (prize); Southwest Mus., 1922 (prize); Los Angeles P&S, 1923 (prize), 1928 (med); Ariz. State Fair, Phoenix, 1923 (prize), 1927 (prize), 1928 (prize); Orange County Fair, Calif., 1923 (prize), 1925 (prize), 1927 (prize); Los Angeles County Fair, 1924 (prize), 1928 (prize); Artists Southern Calif., San Diego, 1926 (prize); Biltmore Salon, Los Angeles, 1926 (med); Intl. Bookplate Assn., 1927 (prize); Sacramento State Fair, 1927 (prize), 1934 (prize); FA Gal., San Diego, 1928 (prize); Pacific Southwest Expo, Long Beach, 1928 (gold); Second Ann. Statewide Art Exh., Santa Cruz, 1929 (prize); Ann. Exh., Springville, Utah, 1931 (prize); Calif. State Fair, Sacramento, 1935 (prize); Laguna Beach AA, 1935 (prize); Aeronautical Art Exh., T.W.A., 1937 (prize); Scandinavian-Am. Soc. of West, 1938 (prize). Work: City Hall, Altona, Germany; Country Club House, Brookline, Mass.; Duquesne C., Pittsburgh; Astor Theatre, NYC; Los Angeles MA; Calif. State Expo Bldg, Los Angeles; UCLA; Clearwater H.S.; Laguna Beach H.S.; FA Gal., San Diego; San Pedro H.S.; U.S.S. California; John H. Vanderpoel AA, Chicago; Bowers Mem. Mus., Santa Ana [40]

YEOMANS, Walter Curtis [E,I] Cornwall Bridge, CT b. 17 My 1882, Avon, IL. Studied: Univ. Ill.; Fursman; Senseney; Bicknell; AIC. Member: Chicago SE [47]

YERKES, Charles T. [Patron] NYC b. 25 Je 1837, Phila. d. 29 D 1905. Urban transportation magnate who was on the board of directors of the Worlds Columbian Expo, Chicago, 1893, to which he loaned his collection of paintings.

YERKES, David Norton [Des,P,Arch] Wash., D.C. b. 5 N 1911, Cambridge, MA. Studied: Harvard; Yale. Member: AIA. Exhibited: Wash. WCC, CGA, 1939; Smithsonian [40]

YERKES, Mary Agnes [P] Oak Park, IL [17]

YERUSHALMY, David [S] Chicago, IL b. 15 O 1893, Jerusalem, Palestine. Studied: Franz-Barwig, J. Mullner, F. Zelzny, all in Vienna. Member: Around the Palette; All-Ill. SFA. Exhibited: Ann. Exh. Artists Chicago Vicinity, AIC, 1931 (prize) [33]

YETO, Genjiro. See Katoaka.

YEWELL, George Henry [Por. P,Genre P,E] NYC/Lake George, NY b. 20 Ja 1830, Havre-de-Grace, MD d. 26 S 1923, Lake George, NY. Studied: NAD, with T. Hicks, 1851–56; Paris, with T. Couture, 1856; settled in Rome until 1878, when he returned to NYC. Member: ANA, 1862; NA, 1880; A. Fund S.; Century. Exhibited: NYEC, 1888. Work: MMA; Louisville, Ky., A. Gal.; Wadsworth Atheneum, Hartford; Hist. Dept., Des Moines; Acad. Med., NYC; Presbyterian Bldg., NYC [04]

YOCHIM, Louise Dunn [P,C,G,T] Chicago, IL b. 18 Jy 1909, Sitomir, Russia. Studied: AIC; Univ. Chicago. Member: A. Lg. Chicago; Am.-Jewish AC; Chicago NJSA. Exhibited: AIC, 1935–37, 1941, 1942, 1944; Detroit Inst. A., 1945; Chicago FA Gal., 1945; Univ. Chicago, 1946; Omaha, Nebr., 1936; Sioux City, Iowa, 1935; Chicago NJSA, 1934. Position: T., Chicago H.S., 1938–46 [47]

YOCHIM, Maurice [P,G,T] Chicago, IL b. 17 Ap 1908, Russia. Studied: AIC. Member: Around the Palette, Chicago (Pres.); Chicago NJSA. Exhibited: Chicago NJSA, 1934; Ar. Chicago Vicin. Ann., AIC, 1936. Position: T., Waller H.S., Chicago [40]

YOFFE, Vladimir [S] NYC. Work: USPO, Derry, N.H. WPA artist [40]

YOHN, F(rederick) C(offay) [I] Norwalk, CT b. 8 F 1875, Indianapolis d. 5 Je 1933. Studied: Indianapolis A. Sch.; ASL, with Mowbray. Member: SI, 1901; Artists Gld.; SC, 1901. Work: 100 drawings, LOC; Ind. Hist. Soc.; Mass. Hist. Soc. He was prominent for a generation as an illustrator of books and magazines, noted especially for his spirited battle scenes. He illustrated a series of frontier sketches by Theodore Roosevelt; General Funston's "Memoirs of Two Wars"; John Lodge's "Story of the Revolution"; he drew extensively for Scribner's and Collier's. In 1930 he was commissioned to paint several large historical canvases for the Mass. Bay Tercentenary. [31]

YONAN, Solomon D. [P] Chicago, IL b. 22 O 1911, Persia. Studied: AIC. Exhibited: AIC, 1931 (prize) [40]

YONKERS, Richard [P,L] Grand Rapids, MI b. 22 Ja 1919, Grand Rapids. Studied: Grand Rapids A. Gal. Sch.; Cranbrook Acad. A. Exhibited: Detroit Inst. A., 1944 (prize), 1945. Work: Grand Rapids A. Gal.; Detroit Inst. A. Positions: Dir., Grand Rapids A. Gal., 1946– ; Artist-in-Residence, Hope Col., Holland, Mich., 1945 [47]

YORK, John Devereux [P] Chicago, IL b. 1865, Nashville, TN. Studied: Ecole des Beaux-Arts, Paris, with R. Collin. Exhibited: Tokyo, Japan, 1901 (prize) [08]

YORK (OR YORKE), William G. [Mar. P] Active Brooklyn, N.Y., 1872–81. Work: Mystic Seaport Mus.; N.Y. Hist. Soc.; Peabody Mus., Salem; Sailors' Snug Harbor, Staten Island, N.Y. [*]

YOSHIDA, Hiroshi [P] Boston, MA [01]

YOST, Eunice Fite (Mrs. F.) [P] Ann Arbor, MI. Affiliated with Univ. Mich. [27]

YOST, Frederick J. [Mur. P,Li,L,T] Youngstown, OH b. 6 N 1888, Berne, Switzerland d. 1968. Studied: Mt. Union Col., Alliance, Ohio; ASL; H. Boss; J. Sloan; R. Henri; R. Lahey. Member: Ohio WCS (Pres.). Exhibited: Massillon Mus., 1944 (prize); Ohio WCS, 1944 (prize); Indianapolis, 1944 (prize); Tri-State Pr.M., 1945 (prize); Butler AI, 1946 (prize); Youngstown Pub. Schools, 1946 (prize); MMA (AV); AIC; many nat. print exh. Work: Massillon Mus.; Youngstown Pub. Sch. Coll.; Butler AI; Akron AI; Kennedy & Co., N.Y.; Beaver Col., Jenkintown, Pa.; Block Gal., Indianapolis; Prospect Park, N.Y.; Rockefeller Center; Radio City, N.Y.; Brooklyn Zoological Park. Affiliated with NYC Park Dept. Mural Projects. Position: T., Butler AI; Akron AI [47]

YOST, Philipp Ross [T,Des,P,W] Columbus, OH b. 11 Mr 1914, Auburn, NB. Studied: Cleveland Sch. A.; AIC; Univ. Kans. Member: The Patteran. Exhibited: Kansas City AI, 1931, 1934 (prize), 1935–36; Albright A. Gal., 1936 (prize), 1937–41; Great Lakes Exh., 1939. Work: Patteran Soc., Buffalo. Positions: T., Albright A. Gal. (1936–42), Univ. England (1942–45); Ed. Asst., Design (from 1945) [47]

YOUNG, Aretta [P,T,W] b. 1864, Idaho d. Mr 1923, Provo, UT. Studied: Columbia, with A.W. Dow. Position: T., Brigham Young Univ.

YOUNG, Arthur (Art) [Car,W] Bethel, CT b. 14 Ja 1866, Orangeville, IL d. 29 D 1943, NYC. Studied: Vanderpoel, at AIC; ASL; Académie Julian, Paris, with Bouguereau. Member: Am. A. Cong. Exhibited: Armory Show, 1913. Author: "Trees at Night," "On My Way," "Art Young's Inferno," "The Best of Art Young," "Art Young, His Life and Times." Illustrator: Saturday Evening Post, Collier's, Life, New Yorker, New Masses, The Nation. Specialty: radical socialist cartoons [40]

YOUNG, Arthur Raymond [E,Li,P,L,W,T] NYC b. 10 Jy 1895, NYC. Studied: NAD; ASL; G. Bellows. Exhibited: BM; Weyhe Gal. (one-man); Daniels Gal. (one-man); Pan-Hellenic Engineers C. (one-man). Work: British Mus., London; Fifty Prints of the Year, 1929, 1931. Position: T., Columbia, from 1927 [47]

YOUNG, August [Por.P,Ldscp.P] Brooklyn, NY (since 1860) b. 8 Jy 1837, Germany (or NYC?) d. 6 N 1913. Studied: NAD; J.B. Stearns; T. Kaufman; Berlin and Paris, 1853–56; watercolor, J.B. Wandesforde, in NYC, 1856

YOUNG, C.L.V. [P] Syracuse, NY [24]

YOUNG, C(harles) Jac [E,P] Wehawken Heights, NJ b. 21 D 1880, Bavaria d. 4 Mr 1940. Studied: NAD, with E.M. Ward, C.Y. Turner; Henri. Member: SAE; Chicago CE. Exhibited: Brooklyn SE, 1928 (prize); Paterson, N.J., 1928, 1930 (prize); Newark AC, 1931 (prize), 1933 (prize), 1935 (prize); Northern N.J. Artists, Newark, 1932 (prize), 1933 (prize); Montclair AA, 1922 (prize), 1933 (prize); Phila. Pr. C., 1933 (prize); Contemp. C., Newark, 1934 (prize), 1935 (prize); N.J. Gal., 1934 (prize), 1935 (prize); Yonkers AA, 1928 (prize); SAE, 1929 (prize); SC, 1929 (prize); Albany Pr. C., 1935 (prize). Work: Los Angeles MA; Newark Pub. Lib.; Toronto A. Gal., Ontario; NYPL; etchings, Univ. Nebr.; Peoria (Ill.) AI; Milwaukee AI; CGA; Hackley Gal. Art, Muskegon, Mich.; LOC; Phila. Pr. C.; Smithsonian; SAE; Chicago SE; Honolulu Acad. A.; Mus. Sc.&A., Yonkers, N.Y.; AIC; BM; AGAA; Andover (Mass.); Am. Fed. Labor, Wash., D.C.; Pub. Lib., Hasbrouck Heights, N.J.; Bd. Edu., Kearney, N.J.; Dept. Pub. Instruction, Hunterdon County, N.J.; etchings, Albany Inst. Hist.&A. [38]

YOUNG, Charles Morris [Ldscp.P,E] Radnor, PA b. 23 S 1869, Gettysburg, PA d. 14 N 1964 (age 95). Studied: PAFA; Colarossi Acad., Paris. Member: ANA; Phila. AC. Exhibited: PAFA (prize), 1921 (gold) 1925 (prize); Pan-Am. Expo, Buffalo, 1901 (prize); St. Louis Expo, 1904 (med); Phila. AC, 1908 (gold); CI, 1910 (prize); Buenos Aires Expo, 1910 (med); P.-P. Expo, San Fran., 1915 (gold); Amsterdam, Holland, 1929 (gold). Work: PAFA; CGA; Boston AC; St. Louis AC; Budapest Nat. Gal.; Albright A. Gal., Buffalo; Rochester A. Gal.; Nat. Gal., Santiago, Chile; Reading AM; Pa. Mus., Phila. [47]

YOUNG, Chick (Murat Bernard Young) [I,Car] NYC b. 1901. Creator: comic strip "Blondie" [40]

YOUNG, Clara Huntington [S] Los Gatos, CA b. 2 F 1878, Oneonta, NY. Studied: Arturo Dazzi, in Rome. Member: NAWPS. Work: Huntington Lib. and A. Gal., San Marino, Calif.; Berkeley Women's C. [40]

YOUNG, Dorothy O. (Mrs. Jack J. Sophir) [S,P,T,C] University City, MO b. 22 Je 1903 (or 1906), St. Louis. Studied: St. Louis Sch. FA; ASL; E. Wuerpel; Leo Lentelli; G. Bridgman; Victor S. Holm. Member: St. Louis AG; S.Indp.A., St. Louis. Exhibited: St. Louis AG, 1925 (prize), 1926–46; Kansas City AI, 1928–32, 1935; St. Louis AL, 1924–30, 1931 (prize), 1933–34; Joslyn Mem., 1939, 1941, 1944; Springfield A. Mus., 1943; CAM, 1939–46; S.Indp.A., St. Louis, 1937 (prize), 1940 (prize), 1943 (prize), 1944 (prize), 1945 (prize). Work: Rockwoods (Mo.) Mus.; Jackson Park Sch., St. Louis [47]

YOUNG, Eleanor R. [P,Dr] NYC b. 24 Ap 1908, Red Bluff, CA. Studied: ASL; Archipenko. Member: NAWPS [40]

YOUNG, Eliza Middleton Coxe (Mrs. C.M.) [P] Jenkinstown, PA b. 1875, Phila. Studied: PAFA [19]

YOUNG, Ellsworth [P] Oak Park, IL b. 8 Jy 1866. Studied: AIC. Member: Chicago PS; Chicago Gal. A.; Austin, Oak Park, River Forest AL; All-Ill. SFA. Work: State Mus., Springfield, Ill.; Tolleston Pub. Sch., Gary, Ind.; Ill. State T. Col., H.S., both in Bloomington, Ill. [40]

YOUNG, Elmer E. [P] Minneapolis, MN. Member: AWCS [47]

YOUNG, Esther Chistensen (Mrs. Charles J. Young) [I,Dr,C,W] Van Hornesville, NY b. Milwaukee, WI. Studied: Groom; Aiken; Sinclair; Milwuakee-Downer Col.; ASL. Exhibited: Wis. PS, 1924 (prize); Women's Arts and Industries Expo, N.Y., 1925 (prize) [40]

YOUNG, Eva H. [Min.P] NYC [19]

YOUNG, (F.) Cliff(ord) [I,W,P,T] NYC b. 27 D 1905, New Waterford, OH. Studied: Pittsburgh AI; C. Schroeder; L. Kroll; H. Dunn; G. Oberteuffer; J. Norton. Member: SI; NAC; Arch. Lg. Exhibited: NAC, 1933 (prize), 1934 (prize), 1936 (prize). Author/Illustrator: "Figure Drawing Without a Model," 1946. Position: T., Central Park Sch. A., N.Y. [47]

YOUNG, Florence [P,E,T] Alhambra, CA. Studied: AIC; ASL. Member: Women P. of the West; S. for Sanity in Art. Exhibited: Los Angeles MA, 1943 (prize); GGE, 1939; Los Angeles Pub. Lib.; Ebell C., Los Angeles; Santa Paula, San Diego, both in Calif. [47]

YOUNG, Frances Price [P,T] Hibbing, MI b. 3 O 1901, Winterset, IA. Studied: Hawthorne; Cumming; Miller. Member: Iowa AG. Exhibited: Iowa State Fair, Des Moines, 1927 (prize); Arrowhead A. Exh., Duluth, Minn., 1931 (prize) [40]

YOUNG, Frank Herman [Des,W,T] Chicago, IL b. 11 D 1888, Nebraska City, NE. Studied: AIC. Member: A. Dir. C., Chicago; SI; Chicago GFLA. Author: "Advertising Layout," 1928, "Modern Advertising Art," 1931, "Technique of Advertising Layout," 1935. Positions: Founder/Pres., Young and Timmins Ad. Studios, Chicago; Pres., Dir., Am. Acad. A., Chicago [47]

YOUNG, Gladys G. [P,G] NYC b. 11 Je 1897 (or 1889), Vevey, Switzerland. Studied: ASL; Paris, with A. Lhote. Member: Audubon A.; N.Y. Soc. Women A. (Pres.). Exhibited: CGA, 1941; Gal. 460 Park Ave., NYC, 1941 (one-man); Ferargil Gal., 1945 (one-man); Riverside Mus., NYC, 1938; Provincetown AA, 1937, 1938; Shaw Gal., NYC, 1939 [47]

YOUNG, Grace S. [Cer,Batik,P] Brooklyn, NY/Orient, NY b. 29 My 1874, Brooklyn. Studied: A. Heckman; W. Reiss; G. Cornell; K. Williams; V. Raffo; Sally Stevens; Maude Robinson. Member: NYSC; Keramic S. and Des. G., NYC. Exhibited: Keramic S. and Des. G., 1930 (prize) [40]

YOUNG, Harvey B. (or Harvey Otis) [Ldscp.P,T] b. 1840, Post Mills, VT d. 14 My 1901, Colorado Springs. Studied: Munich; Académie Julian; Carolus-Duran, 1870s. Exhibited: Paris Salon, 1878. In 1859 he was a prospector and artist in Colo., Calif., Nev., and Oreg. Most of his career was spent in Calif. After serving in the Civil War he had a studio in San Fran., 1866–69; in Paris and NYC, 1869–79; in Manitou Springs, Colo., 1879–98; finally settled in Colorado Springs

YOUNG, Helen [P] Mt. Vernon, NY b. 26 Mr 1888, South Otselic, NY. Studied: C.J. Martin. Member: N.Y. Soc. Women A. Exhibited: NAWPS, 1933 (prize), 1936, 1937; N.Y. Soc. Women A., 1939; A. Center, NYC, 1923 (prize). Work: City Hall, Dinan, France [40]

YOUNG, James Harvey [Por.P] Boston, MA b. 14 Je 1830, Salem, MA d. 1918, Brookline, MA. Member: Boston AC. Work: Am. Antiquarians; Essex Inst., Salem [17]

YOUNG, John C. [P,B,C] Honolulu, HI b. Mr 1909. Member: Assn. Honolulu Ar.; Calif. WCS. Exhibited: Honolulu Acad. A., 1938 (prize) (med), 1939 (prize); GGE, 1939; Am. A. Exh., Rockefeller Ctr., NYC. Work: Honolulu Acad. A. [40]

YOUNG, John H. [Des] North Pelham, NY b. 1858, Grand Rapids, MI d. 4 Ja 1944. Work: scenic work in Chicago, NYC. (Brother of Louis C.?)

YOUNG, Kathryn I. [C,T,L,W] Hartsdale, NY b. 25 O 1902, Babylon, NY. Studied: N.Y. Sch. F.&Appl. A.; Columbia. Member: EAA; Westchester A.&Cr. Gld.; Chappaqua A.&Cr. Gld. Position: Dir., Westchester Workshop, County Ctr., White Plains, N.Y. [40]

YOUNG, Louis C. [Scenic P.] Pelham, NY b. 1864, Grand Rapids, MI d. 31 Jy 1915. (Brother of John H.?)

YOUNG, Mahonri MacKintosh [P,W,S,E,T] NYC/Ridgefield, CT b. 9 Ag 1877, Salt Lake City, UT d. 2 N 1957, Norwalk, CT. Studied: Salt Lake City, with J.T. Harwood, 1897; ASL, 1899–00; Paris: Académie Julian, Colarossi, Acad. Delecluse with Laurens, Verlet, 1901–05. Member: ANA, 1912; NA, 1923; NSS, 1910; New Soc. A.; NAC; Am. Soc. PS&G; SAE; NIAL. Exhibited: Paris AAA (prize); NAD, 1911 (prize), 1932 (prize); P.-P. Expo, San Fran., 1915 (prize); Olympic Games, Los Angeles, 1932 (med); Armory Show, 1913; AGAA, 1940 (retrospective). Work: large coll., Brigham Young Univ.; MET; Hopi, Navaho and Apache groups, AMNH; Newark Mus.; NYPL; Salt Lake City; Peabody Inst., Baltimore; RISD; Salt Lake City, AI; LDS Gymnasium, Salt Lake City; CMA; AGAA; BM; Los Angeles Mus. Hist., Sc.&A.; mon, Protestant Cathedral, Paris. Author: article, "Modeling," Encyclopaedia Britannica. Position: T., ASL; Am. Sch. Sculpture, NYC, 1905 [47]

YOUNG, Dorothy. See Weir.

YOUNG, Mary L(ouise) [P] Worcester, MA b. St. Louis. Studied: Twachtman. Member: Greenwich SA [25]

YOUNG, Mattie [P] San Fran., CA [15]

YOUNG, Maybelle [P,T] Jackson Heights, NY b. 22 Ag 1891, Charleston, SC. Studied: NAD; ASL; PIASch; Grand Central A. Sch. Member: NAWA; Gotham Painters; Wolfe AC. Exhibited: NAWA, 1939, 1944; Gotham Painters, 1943-45; Phila. WCC, 1938; AWCS, 1938; Town Hall C., NYC. Position: T., Newtown H.S., Elmhurst, N.Y. [47]

YOUNG, Myrtle M. [P] San Fran., CA [24]

YOUNG, N.M. [P] NYC [19]

YOUNG, Richard Carr [P,I,C,T] Chicago, IL b. 29 S Chicago [25]

YOUNG, Rose [P] Phila., PA [15]

YOUNG, Susanne B. (Mrs. Benjamin Swan Young) [P,Dec] Oyster Bay, NY b. 28 D 1891, NYC. Studied: Alexander; G. deF. Brush. Work: frieze, Club Royal, NYC [40]

YOUNG, Thomas A. [Ldscp.P] Flatbush, NY (since ca. 1863) b. 1837, London, England (came to NYC before 1863) d. 14 N 1913

YOUNG, Walter N. [I,Des,T] Goldens Bridge, NY b. 20 F 1906, Brooklyn, NY. Studied: PIASch. Exhibited: A. Dir. C. Illustrator: McCall's, House and Garden, other magazines. Position: T., PIASch, 1936-42 [47]

YOUNG, William Crawford [I] Norwalk, CT b. 26 Mr 1886, Cannonsburg, MI. Studied: AIC; Chicago A. Acad. Member: Silvermine GA. Position: Staff, Judge, King Features Syndicate [40]

YOUNGERMAN, Reyna Ullman [P,L,T] New Haven, CT b. 26 Je 1902, New Haven. Studied: Yale; ASL; W. Adams; A. Brook; J. Farnsworth. Member: CAFA; NAWA; New Haven PCC; Brush & Palette C.; Meriden SA; Conn. WCS; F., Tiffany Fnd., 1926-27. Exhibited: New Haven PCC, 1942 (prize); NAWA, 1932-46; BMFA; Morgan Mem.; Avery Mus.; Yale Gal. FA; NAD; CAFA; Brush & Palette C.; Copley S., Boston; Meriden SA, 1934 (prize), 1945 (prize), 1946 (prize). Work: Tiffany Fnd.; Superior Court, New Haven. Position: Hd. A. Dept., New Haven Col., 1940 [47]

YOUNG-HUNTER, Eva Hatfield [P] NYC [24]

YOUNG-HUNTER, John [Por.P] Taos, NM (since 1942) b. 29 O 1874 (first came to U.S. in 1913) d. 9 Ag 1955. Studied: Royal Acad. Sch. and Univ. London, with his father Colin Hunter, Alma-Tadema, W. Orchadson, J.S. Sargent. Member: All.A.Am.; AWCS; CAFA; SC; Chelsea A., London. Exhibited: Royal Acad. A., London, 1900-13; NAD; All.A.Am.; AIC; Kansas City AI; Oklahoma City; Mus. N.Mex.; Harwood Fnd., Taos, 1956 (retrospective); Paris Salon, 1910 (prize), 1914 (med); Hartford, 1925 (prize); Allied AA, 1933 (gold); Oakland Ann., 1937 (prize). Work: Nat. Gal., London; Luxembourg Mus., Paris; WMA; Oberlin, Ohio; Princeton; Harvard; Johns Hopkins; Texas Tech. Univ.; Dayton AI; Walker A. Gal., Liverpool, England; A. Mus., Wellington, New Zealand; Gov. House, Ottawa, Canada; A. Mus., Dundee, Scotland [47]

YOUNGLOVE, Mary Golden [Min.P,C,T] Chicago, IL b. Chicago. Studied: AIC, with F. Freer, Johansen. Member: ASL, Chicago; Lake View AC, Chicago [15]

YOUNGLOVE, Ruth Ann (Mrs. Benjamin Rhees Loxley) [C,P,T,L,B] Pasadena, CA b. 14 F 1909, Chicago, IL. Studied: UCLA; O. White; Bessie Hazen; Helen Chandler; B. Whitice. Member: Calif. WCS; Pasadena SA; Laguna Beach AA; Los Angeles AA. Exhibited: Pasadena SA; Laguna Beach AA; Los Angeles County Fair, 1936-41 (prizes) [47]

YOUNGS, M.B. [P] Seattle, WA [24]

YOUNKIN, William LeFevre [Arch,P] Lincoln, NE b. 20 N 1885, Iowa City. Studied: M. Braun; Columbia Sch. Arch. Member: Lincoln Artists G.; Nebr. AIA; AAPL [40]

YOVITS, Esther [P,T] NYC b. 3 Je 1916. Studied: S. Brecher. Member: NAWPS; PS&G, NYC. Exhibited: Ann., PAFA, 1938; NAD, 1938; Argent Gal., NYC; Contemp. A. Gal., NYC [40]

YOW, Rose Law [P] Seattle, WA [24]

YPHANTIS, George [P,T,G] Berkeley, CA. Studied: Univ. Toronto; Yale. Exhibited: GGE, 1939; PAFA, 1942; Mont. State Univ. (one-man); Univ. British Columbia (one-man); Seattle AM (one-man). Positions: T., Mont. State Univ. (1934-42), Calif. Col. A.&Cr. (from 1946) [47]

YUDITSKY, Cornelia R. [P,Des,T] Wash., D.C. b. 21 Ap 1895. Studied: Calif. Sch. FA, C.; Corcoran Gal. Sch.; Univ. Utah; Grace Cornell; John Butler. Member: AC, Wash. D.C. Exhibited: S. Wash A., Corcoran Gal., 1939; Allocations Gal., WPA, Wash., D.C., 1939. Position: T., Jewish Community Ctr., Wash., D.C. [40]

YUTZEY, Marvin Glen [Des,C,L] Moundsville, WV b. 25 My 1912, Canton, OH. Studied: Cleveland Sch. A. Member: ADI; Am. Ceramic S. Exhibited: CMA, 1933, 1934. Specialty: pressed glass. Positions: Des./Dir., Fostoria Glass Co., Moundsville, W.Va., from 1936 [47]

Symbol of the Allied Artists of America

Z

ZABOLY, Bela (Pal) (Mr.) [P,I,E] Cleveland, OH b. 4 My 1910, Cleveland. Exhibited: Ann. Exh. Work by Cleveland A. & Craftsmen, 1932. Work: CMA [40]

ZABRISKIE, William B. [P] Hackensack, NJ b. 1840 d. 1 My 1933. Active in NYC in his youth.

ZACCONE, Fabian F. [Mur.P,Por.P,I,Li,T] West New York, NJ b. 3 S 1910, Valsini, Italy. Studied: PIASch; NYU; Da Vinci A. Sch. Member: Salons of Am.; S.Indp.A.; N.J. A. Group. Exhibited: LOC; Riverside Mus.; Artists of Today, 1943, 1944 (one-man); Montclair AM, 1934 (med), 1936 (med), 1939 (med); N.J. A. Group, Newark, 1934 (prize); N.J. Gal., Newark, 1938 (prize); WFNY, 1939. Work: mural, Pub. Lib., West New York. Illustrator: "Behold Your King," 1946. Position: T., Mem. H.S., West N.Y., 1940 [47]

ZACHINNI, Hugo [P,L,T,W] Tampa, FL b. Peru, South America. Studied: Francesco Michetti. Work: Cathedral, Alexandria, Egypt; des./arch., Temple of Music, Tampa, Fla. Affiliated with Ringling Brothers Barnum & Bailey Circus. Position: Dir., Art and Nature Inst., Tampa [40]

ZADIG, Bertram [I,B] NYC b. Budapest, Hungary, 29 S 1904. Member: SI. Work: NYPL. Illustrator: "Critical Woodcuts," Stuart P. Sherman; "Hunger Fighters," Paul de Kruif; "Twelve Portraits of the French Revolution," Henri Beraud; "The History of the American Nation," Mason W. West [47]

ZAHN, Otto [C,Bookbinder] Wash., D.C. b. 6 Mr 1906, Arnstadt, Thuringia, Germany. Studied: Otto Dorfner, in Weimar, Germany. Position: Bookbinder, Bliss Lib., Wash., D.C. [40]

ZAIKINE, Eugene A. [P,S,Dec] NYC b. 12 Ja 1908, Russia. Studied: NAD; ASL; Grand Central A. Gal. Member: Mural Ar. Gld.; S.Indp.A. Exhibited: Cooperstown AA, N.Y.; murals, WFNY, 1939. Work: Russian Greek Catholic Cathedral of Transfiguration, Brooklyn; Sts. Peter and Paul Church, Granville, N.Y.; Half Moon Hotel, Brooklyn; Mayflower Hotel, Plymouth, Mass. [40]

ZAISS, Leonard [P,S] b. 1892 d. 26 N 1933, Harrison, NY

ZAK, Karel J. [P] Elgin, IL [13]

ZAKHAROFF, Feodor [P] NYC b. 1882, Russia. Studied: Moscow Sch. Painting, Sculpture and Arch. Exhibited: PAFA, 1928 (prize); CGA, 1937 (prize). Work: museums in Russia [40]

ZAKHEIM, Bernard Baruch [Mur.P,S,C,Des,T] Sebastopol, CA b. 4 Ap 1898, Warsaw, Poland. Studied: San Fran. Sch. FA; Art Acad., Warsaw; Politechnicum, Danzig, Germany; Mexico; France. Member: Am. A. Cong.; San Fran. AA; Ar. Un. Exhibited: San Diego Traveling Exh., 1940; U.S. Treasury Dept., 1940; SFMA, annually; GGE, 1939; Pal. Leg. Honor; San Fran., AA, 1935 (med). Work: SFMA; Coit Mem. Tower, Jewish Community Ctr., Univ. Calif. Medical Sch., Univ. Calif. Hospital, all in San Fran.; WPA murals, USPO, Mineola, Tex. Position: T., San Fran. Pub. Sch. [47]

ZANDER, Jack [I] Long Island City, NY. Member: SI [47]

ZANETTA, Clotilda [P] Cincinnati, OH. Associated with A. Acad., Cincinnati [25]

ZANG, John J. [Ldscp.P] Active in Calif., 1883; also painted along Hudson River. Work: Wadsworth Atheneum, Hartford [*]

ZARING, Louise E(leanor) (Mrs.) [P,S,C] Greencastle, IN b. Cincinnati. Studied: Paris, with Merson; J. Twachtman; MacMonnies; L.R. Garrido; C. Hawthorne; ASL. Member: Paris Women's AA; Provincetown AA; ASL; Wash. AC; Ind. Soc. S; North Shore AA. Exhibited: Richmond AA, 1900, 1919 [33]

ZARINI, E. Mazzoni [E] Niccolo, Florence, Italy. Member: Chicago SE [27]

ZARSKY, Ernest [P,Li,En] Cleveland, OH b. 19 S 1864, Germany. Studied: F.C. Gottwalt; H. Keller; H.R. Poore; Cleveland Sch. Art. Member: Cleveland SA [40]

ZAUNER, Leslie [I] Rochelle, NY b. 7 Ap 1890, Perry, TX [29]

ZECKWER, Emilie [P] Phila., PA [13]

ZEELER, Arthur [P] St. Louis, MO [15]

ZEIDLER, Avis [P,S,Dr,Des] San Fran., CA b. 12 D 1908, Madison, WI. Studied: Labault; Boynton; Stackpole; E. Neuhaus; DuMond [40]

ZEIGLER, E.P. [P] Cordova, AK [19]

ZEIGLER, Lee Woodward [P,I,L] New Windsor-on-Hudson, NY b. 6 My 1868, Baltimore d. 16 Je 1952. Studied: Md. Inst.; self-taught. Member: Hudson Highland AA; AFA; Mural P.; Medieval Acad. Am.; F., Royal SA, London. Exhibited: St. Paul Inst., 1915 (gold); Md. Inst., 1925 (med). Work: Md. Inst.; St. Paul (Minn.) Inst.; Church of St. John, NYC; St. Thomas Church, New Windsor; St. Paul Pub. Lib.; Trinity Church, Ft. Wayne, Ind.; St. James-by-the-Sea, Monticito, Calif.; Chapel of the Transfiguration, Glendale, Ohio; St. Michael's Church, Church of St. Mary Magdelen, both in NYC; Calvary Church, Cincinnati; equestrian portrait, Gen. Anthony Wayne, Stony Point Mus., N.Y.; portrait of Washington, West Point. Illustrator: de luxe editions of Kingsley, Gauthier, Balzac [40]

ZEIL, William Francis Von [Edu,P,Gr,W] Phila., PA b. 11 Jy 1914, Harrisburg, PA. Studied: Villanova Col.; Webster Col., St. Louis Univ.; C. Shaffer; M. Blackburn. Member: Phila. Pr. C.; Phila. A. All.; Mediaval Acad. Am. Exhibited: Villanova Col., 1934 (med); Phila. Pr. C., 1945, 1946; Phila. A. All., 1944, 1945; Phila. Sketch C., 1943; Ragan Gal., 1943. Author: "The Development of Christian Symbolism in Western Art," 1945. Position: T., Girard Col., Phila. [47]

ZEISEL, Eva S. [Des,T,L] NYC b. 13 N 1906, Budapest, Hungary. Studied: Acad. FA, Budapest. Exhibited: Paris Salon, 1937; WFNY, 1939; MOMA, 1936 (one-man), 1944; Phila., 1926. Position: T., PIASch, from 1939 [47]

ZEITLIN, Alexander [S] NYC b. 28 Jy 1872, Tiflis, Russia. Studied: Falquiere, Beaux-Arts, Paris. Member: Alliance; PS; Brooklyn SA. Work: statue, La Valence, France; R. Hudnut's mon., Woodlawn Cemetery, N.Y.; G. Backer's mon., Betholom Fields Cemetery, Brooklyn [33]

ZELENKA, Maxine [P] St. Louis, IL b. 21 Ag 1915, Chicago. Studied: Univ. Ill.; AIC; NAD; C. Pugialis. Exhibited: AIC, 1939; Vendôme Gal., NYC; Indp. Ar. Exh., NYC [47]

ZELL, Ernest N(egley) [P] Columbus, OH b. 16 O 1874, Dayton, OH. Studied: Columbus A. Sch.; Cincinnati A. Acad.; Shinnecock Summer Sch.; Ohio State Univ., Columbus; Chase, in Holland. Member: Columbus AL. Position: Dir. A., Sch. for the Deaf, Columbus [33]

ZELLER, Arthur [P] St. Louis, MO. Member: St. Louis AG [27]

ZELLER, August [S,T] Pittsburgh, PA b. 7 Mr 1863, Bordentown, NJ d. 11 Ja 1918. Studied: Franklin Inst.; PAFA, with Eakins; Ecole des Beaux-Arts, Paris, with Thomas; Paris, with Rodin. Member: Pittsburgh AA. Work: Episcopal Church, Fox Chase, Pa.; Schuylkill Co. military mon., Pottsville, Pa. Position: T., Architectural Sculpture, CI [17]

ZELLNER, Minna Weiss (Mrs. Carl Sina Zellner) [E,T] Phila., PA b. New Haven, CT. Studied: E. Horter; Leon, in Paris. Member: Phila. Print C.; Phila. Alliance; Phila. Art T. Assn.; New Haven PCC; AAPL; Société de la Gravure Originale en Noir, Paris. Work: etching, British Mus.; Chicago Lib.; Newark Mus.; Univ. Nebr.; NYPL; MET; dry point, Bibliothèque Nationale, Paris [40]

ZENNER, Rose [P] Cincinnati, OH. Member: Cincinnati Women's AC [29]

ZENSKY, J. [P] NYC. Member: S.Indp.A. [21]

ZERBE, Karl [P] Boston, MA b. 1903, Berlin, Germany d. 1972. Studied: Acad., Munich. Exhibited: Intl. WC Ann., AIC, 1937, 1938, 1939; MOMA, 1938; GGE, 1939. Work: FMA; MFA, Boston; Nat. Gal., Berlin. Position: T., BMFA Sch. [40]

ZEREGA, Andrea Pietro [Por.P,Li,T,P] Wash., D.C. b. 21 O 1917, De Zerega, Italy. Studied: Corcoran Sch. A.; Tiffany Fnd.; Italy; R. Lahey; H. Nichols. Member: A. Gld. Wash.; Soc. Wash. A.; Wash. WCC; SSAL; Landscape C., Wash. Exhibited: Tiffany Fnd., 1938; Times-Herald Exh., 1943 (prize); Landscape C., Wash., 1944 (prize), 1945 (med), 1946 (prize); Soc. Wash. A., 1936–39, 1940 (prize), 1941, 1942 (prize), 1943, 1944 (prize), 1945; CGA, 1939, 1941, 1942 (one-man), 1943; PAFA, CI, 1941; NAD; MMA; VMFA, 1942; PMG; Ferargil Gal.; Wash. AC; Univ. Ky.; BMA; U.S. Nat. Mus.; Catholic Univ. Am.; Wash. Pub. Lib., 1941 (one-man). Work: PMG; Tiffany Fnd. [47]

ZETTERLUND, John [P] Berkeley, CA [17]

ZETTLER, Emil Robert [S,Des,T] Deerfield, IL b. 30 Mr 1878, Karlsruhe, Baden d. 10 Ja 1946, Chicago. Studied: AIC; Royal Acad., Berlin; Académie Julian. Exhibited: AIC, 1912 (prize), 1915 (med), 1916 (gold), 1917 (med), 1921 (prize), 1925 (gold); Chicago SA, 1915 (med); P.-P. Expo, San Fran., 1915 (med). Work: Mun. A. Coll., Chicago; BM; des./executed official medal, Century of Progress Expo, 1933; Gov. Bldg., Chicago. Position: T., Indst. A., AIC [40]

ZIEG, Elsa Anshutz [P] Pittsburgh, PA. Member: Pittsburgh AA [25]

ZIEGLER, Eustace Paul [P,E,L,T] Seattle, WA b. 24 Jy 1881, Detroit. Studied: Detroit Sch. FA; Yale, with Ida M. Perrault. Member: Puget Sound Group P.; Pacific Northwest Acad. Exhibited: Ann. Northwest Ar. Exh., 1926 (prize), 1927 (prize) 1929 (prize), 1931 (prize), 1932 (prize), 1934 (prize). Work: Alaska Steamship Offices; Olympic Hotel, Pub. Lib., Steamship, Alaska; Seattle AM; Broadway H.S., Seattle; Capitol, Wash.; Dayton Clinic, Ohio; Pub. Lib., Jersey City Art Mus.; Baranof Hotel, Juneau [40]

ZIEGLER, Henry [E,I] Richmond, NY b. 10 F 1889, Sherman, TX. Studied: J. Pennell; W.R. Leigh. Member: ASL. Illustrator: "Cowboy Stuff"; de luxe edition illus. with fifty original etchings owned by various pub. lib. [32]

ZIEGLER, Matthew E. [P] Genevieve, MO b. 4 F 1897. Studied: AIC. Exhibited: 48 States Comp., 1939 (prize); Ar. Gld., City AM, St. Louis. Work: USPO, Flandreau, S.Dak. WPA artist. [40]

ZIEGLER, Samuel P. [P,Li,E,T] Fort Worth, TX b. 4 Ja 1882, Lancaster, PA d. 1967. Studied: PAFA, with Chase, Anshutz, Breckenridge; Tex. Christian Univ. Member: AFA; AAPL; SSAL; Tex. FA Assn.; Ft. Worth AA. Exhibited: Dallas, 1924 (med); SSAL, annually in regional and local exh., 1929 (prize). Work: Carnegie Lib., Ft. Worth; Univ. C.; Tex. Christian Univ.; Ft. Worth MA; Stirling & Polytechnic H.S., Ft. Worth. Position: T., Tex. Christian Univ., 1919– [47]

ZIGROSSER, Carl [Mus.Cur,W,Cr] Phila., PA b. 28 S 1891, Indianapolis d. 1975. Studied: Columbia. Member: Phila. A. All.; Phila. Pr. C. Awards: Guggenheim F., 1939, 1940. Author/Editor: "Twelve Prints by Contemporary American Artists," 1919; "The Artist in America," 1942; "Kaethe Kollwitz," 1946; other books. Contributor: Print Collector's Quarterly, Creative Art; other publications. Positions: Dir., Weyhe Gal., NYC, 1919–40; Cur., Prints & Drawings, PMA, 1941– [47]

ZILLIG, Fritz [P] Chicago, IL [15]

ZILVE, Alida [S] Brooklyn, NY b. Amsterdam, Holland d. 14 N 1935. Studied: A.G. Newman; E. Stetson; Crawford. Work: bas-reliefs: Seaman's Savings Bank, N.Y.; YMCA, Little Falls, N.Y.; Canastota Mem. Hospital, N.Y.; Macon, Ga.; YWCA, Bayonne, N.J.; Independence Mem. Bldg., United Daughters of the Confederacy, Independence, Mo.; Elks C., Paterson, N.J.; Roselle H.S., N.J.; Hempstead, N.Y.; Elizabeth (N.J.) Jr. H.S.; Vocational Sch., Perth Amboy, N.J. [33]

ZILZER, Gyula (Mr.) [P,E,I,Des,Li] Hollywood, CA b. 3 F 1898, Budapest, Hungary d. 1969. Studied: Hungarian Acad. A.; Decorative A. Sch., Hans Hofmann, both in Munich; Acad. Moderne, Paris. Member: Am. A. Cong.; Soc. de Salon d'Automne, Paris; Soc. de Salon des Indépendants, Paris; Soc. de Salon de l'Araigné, Paris. Exhibited: Int. Expo, Bordeaux, 1927 (prize); de Young Mem. Mus., 1944 (one-man); Los Angeles AM, 1943 (one-man); San Diego FA Soc., 1943 (one-man); Assn. Am. A., 1937 (one-man); Mellon Gal., Phila. 1933 (one-man); New Sch. Soc. Res., 1932 (one-man); AIC, 1932, 1937; London, 1931; Amsterdam, 1931; Moscow, 1927; Paris, 1926. Work: Graphische Cabinet, Munich; Nat. MA, Budapest; Mus. Mod. A., Rotterdam; Luxembourg Mus., Bibliothèque Nationale, both in Paris; Mus. Western A., Moscow; British Mus., London; MMA; NYPL. Illustrator: Poe's "The Black Cat," 1927; "Gas Attack," a portfolio of lithographs, 1932. Contributor: U.S. & European Production; numerous films, including "Sahara," 1943, "The Short and Happy Life of Francis Macomber," 1946 [47]

ZIM, Marco [E,P] NYC b. 9 Ja 1880, Moscow, Russia. Studied: ASL, with G.G. Barnard; NAD, with Ward, Maynard; Ecole des Beaux-Arts, Paris, with Bonnât. Member: SAE. Work: LOC; NYPL; AIC [47]

ZIMBEAUX, Frank Ignatius Seraphic [P] Salt Lake City (since 1924) b. 1861, Pittsburgh d. 1935. Studied: London; Paris. Specialty: romantic landscapes and figures. Raised in Europe. [*]

ZIMM, Bruno Louis [S,Arch] Woodstock, NY b. 29 D 1876, NYC d. 21 N 1943. Studied: J.Q.A. Ward; A. Saint-Guadens; K. Bitter. Member: NSS. Exhibited: Arch. Lg., 1913 (prize); Paris Expo, 1900 (med). Work: Slocum Mem. and Mem. Fountain, N.Y.; Finnegan Mem., Houston; mem., Wichita; sculpture, A. Bldg., San Fran.; bust, Baylor Col., Belton, Texas; Seaboard Nat. Bank, NYC; First Nat. Bank, Jersey City; statue, St. Louis; sculptures, St. Pancras Church and St. Thomas Church, Brooklyn; St. Clement's Church, Phila. [40]

ZIMMELE, Margaret Scully (Mrs. Harry B. Zimmele) [P,I,T] Wash., D.C./Berkshire Heights, Great Barrington, MA b. 1 S 1872, Pittsburgh. Studied: Chase; Shirlaw; Whittemore; Lathrop; Carlson; Hawthorne. Member: S. Wash. A.; Pittsburgh AA; Wash. AC; Nat. Lg. Am. Pen Women [40]

ZIMMER, Marion Bruce (Mrs. Gerald H. Zimmer) [Por.P,T] Syracuse, NY/Amber, NY b. 29 S 1903, Battle Creek, MI. Studied: Syracuse Univ. Member: AA of Syracuse; NAWPS; Nat. Lg. Am. Pen Women. Exhibited: Syracuse Mus., 1935 (prize), 1936 (prize); Lg. Am. Pen Women, 1936 (prize); Syracuse MFA, 1938 (prize). Position: T., Syracuse Univ. [40]

ZIMMERMAN, Carl John [Mur.P,Por.P] Loveland, OH b. 13 S 1900, Indianapolis. Studied: Herron AI; Chicago Acad. FA; Cincinnati A. Acad.; J. Marchand, in Paris; J. Weis; Audubon Tylor; William Forsyth. Member: Cincinnati AC; Prof. A., Cincinnati; MacD. Soc., Cincinnati. Work: murals: Cathedral of St. Monica, Cincinnati; St. Paul's Church, Marty, S.Dak.; SS. Peter & Paul Church, Norwood, Ohio; Cincinnati C. Position: T., Cincinnati A. Acad., 1940 [47]

ZIMMERMAN, Carolyn (Mrs. Carl Zimmerman) [S] Loveland, OH b. 25 N 1903, Walton, IN. Studied: W. Forsyth; M.R. Richards; W. Hentschell; C.J. Barnhorn; Cincinnati A. Acad.; Antoine Bourdelle, Madame Levy-Ginsborg, both in Paris. Member: Women's AC of Cincinnati; MacD. Soc.; Cincinnati Crafters Co.; Cincinnati Assn. Prof. Ar.; Cincinnati Cer. Gld. [40]

ZIMMERMAN, Elinor Carr [Min.P] NYC b. 14 D 1878, St. Louis. Studied: Wash. Univ.; Mabel R. Welch; Wayman Adams; Gertrude Whiting; A.M. Archambault; PAFA. Member: Pa. Soc. Min. P.; AAPL; Phila. Plastic C. Exhibited: PAFA, 1936–45; AAPL, 1945; Asbury Park, N.J. (one-man); exh. of miniatures, Chicago; Los Angeles; Wash., D.C.; NYC. Work: Phila. Mus. A. [47]

ZIMMERMAN, Eugene ("Zim") [Caric] Elmira, NY b. 25 My 1862, Basel, Switzerland d. 26 Mr 1935. Author: "This and That about Caricature," "Cartoons and Caricatures," "Home Spun Philosophy." Illustrator: books and articles for Bill Nye and James Whitcomb Riley. Position: Staff, Puck (since 1882), Judge (1884–1913); Dir., Correspondence Sch. of Caricature, Cartooning and Comic Art [27]

ZIMMERMAN, Frederick A. [P,S,T] Pasadena, CA b. 7 O 1886, Canton, OH d. 27 N 1974, Arcadia, CA. Studied: Univ. Southern Calif.; V. Brenner. Member: Pasadena SA (Pres., 1946–47); Scarab C.; Calif. AC; Laguna Beach AA; Southern Calif. SAC; AFA; AAPL. Exhibited: Pasadena AI, 1931 (prize); Pasadena SA, annually; Los Angeles Mus. A.;

Sacramento State Fair; San Diego FA Soc.; Detroit Inst. A. Work: John Muir Pub. Sch., Seattle; Pasadena Pub. Lib. [47]

ZIMMERMAN, Herman [P] NYC. Work: WPA murals, USPOs, Wilmington, Del., Tipp City, Ohio [40]

ZIMMERMAN, Jane [Por.P] Frederick, MD b. 20 Mr 1871, Frederick d. ca. 1955. Studied: CUASch; NAD; Chase Sch. A.; ASL; F. Luis Mora; R. Henri; C.Y. Turner; Hood Col. Exhibited: CUASch, 1898 (med); BMA; Md. Inst.; Hagerstown Mus. A. Work: Lee Hospital, Frederick; Lee Hotel, Frederick [47]

ZIMMERMAN, L(illian) H(ortense) [S] Milwaukee, WI b. Milwaukee. Studied: AIC; ASL. Member: Wisc. PS. Exhibited: Milwaukee AI, 1924 (med,prize) [33]

ZIMMERMAN, Marco. See Zim.

ZIMMERMAN, M(ason) W. [P,B] Rydal, PA b. 4 Ag 1860, Phila. Studied: Académie Julian, Paris; J.W. Little. Member: Phila. WCC; Phila. Sketch C.; Phila. Alliance; AWCS; Wash. WCC; Baltimore WCC; Phila. SE. Exhibited: PAFA, 1920 (gold); Sesqui-Centenn., Phila., 1926 (med); Phila. Print C., 1931 (prize) [40]

ZIMMERMAN, Walter [S,T] Oak Park, IL b. Switzerland (came to U.S. as a young man) d. 30 Ja 1937, Vincennes, IN. Position: Associate of L. Taft at AIC for 25 years

ZIMMERMAN, William Albert [C] Brookline, Delaware County, PA b. 23 N 1888, Lehighton, PA. Studied: PMSchIA. Member: T Square C. Designer/Partner: "The Iron-Craftsmen," Phila. Specialty: metalwork [40]

ZIMNERER, Frank J. [P,Des,T] Lincoln, NE b. Nebraska City. Studied: AIC; Paris. Specialty: stage design. Position: T., Univ. Nebr., Lincoln [27]

ZINGALE, Santos [P,T,B] Madison, WI b. 17 Ap 1908, Milwaukee. Studied: Milwaukee State T. Col.; Univ. Wis.; G. Moeller; R. Von Neuman; H. Thomas. Member: Wis. PS. Exhibited: Madison Salon, 1937 (prize), 1938-41, 1942 (prize), 1943-46; Wis. PS, 1931-34, 1935 (prize), 1936, 1937 (prize), 1938-43; Wis. State Fair, 1929 (prize), 1930 (prize); Wis. Salon Art, Madison, 1935 (prize). Work: murals, Henry Mitchell H.S., Racine, Wis.; Univ. Wis.; USPO, Sturgeon Bay, Wis.; Milwaukee State T. Col. WPA artist. Positions: T., Layton Sch. A.; Univ. Wis., 1946- [47]

ZINSER, Frank [P] Cincinnati, OH. Member: Cincinnati AC [27]

ZINSER, Paul R. [P,S,I,C] Chicago, IL b. 4 Ap 1885, Wildbad, Germany. Studied: J.H. Adam. Member: Cincinnati AC. Work: Cincinnati AM [24]

ZINSSER, Handforth [P,S] Boston, MA/Dover, MA. Studied: ASL; MIT; G. Demetrois; Kunstgewerbe Schule, Vienna [40]

ZIOLKOWSKI, Korczak [S,P,Arch] Hartford, CT b. 6 S 1908, Boston. Member: NSS. Exhibited: CAFA, 1938, 1939; New Haven PCC, 1938; Symphony Hall, Boston, 1938; Romanian Pavilion Contemp A., WFNY, 1939 (prize). Work: SFMA; Symphony Hall, Boston; Vassar Col. Position: Asst. S., Mt. Rushmore Mem., Black Hills [47]

ZIPIN, Martin Jack [P,G,T] Phila., PA b. 10 Je 1920, Phila. Studied: Graphic Sketch C., Phila.; Tyler Sch. FA, Phila; M.B. Gottlieb; F. Watkins; E. Horter; F. Fincke; M. Sharpe. Member: Graphic Sketch C. Exhibited: Graphic Sketch C., 1936 (prize,med); WC Ann. PAFA, 1938. Work: Graphic Sketch C. [40]

ZIRNBAUER, Franz (Seraph) [P,T] Paris, France/Carthage, MO b. 10 O 1860, Pittsburgh. Studied: Laurens, Blanche, R.E. Miller, Gervaix, all in Paris; London; Dublin [21]

ZIROLI, Angelo Gerardo [S] Wyandotte, MI b. 10 Ag 1899, Montenegro, Italy d. 15 N 1948. Studied: AIC; Italy; A. Polasek; A. Sterba; V. Gigliotti. Member: Chicago Gal. A.; Ill. Acad. FA; All-Ill. SFA; Soc. Med. Exhibited: AIC, 1923 (prize), 1924 (prize); Soc. Wash. A., 1928 (prize); NAD, 1931 (prize), 1935, 1940; PAFA, 1929-31, 1941; Chicago Gal. Assn.; Detroit IA, 1941. Work: mem., Randhill Park Cemetery, Arlington Heights, Ill.; mem., East Chicago. Author: "The Life of a Chicago Sculptor" [47]

ZIROLI, Nicola Victor [P,T,E,Li] Urbana, IL b. 8 My 1908, Montenegro, Italy. Studied: Ritman, Oberteuffer, at AIC. Member: Phila. WCC. Exhibited: Soc. Wash. A., 1934 (prize); AIC, 1936, 1937, 1938 (prize), 1939 (prize); San Fran. AA, 1939 (med); Springfield (Mo.) AM, 1945 (prize), 1946 (prize); Decatur (Ill.) A. Center, 1945 (prize); Ohio Univ., 1946 (prize); Mint Mus. A., 1946 (prize); CI, 1942, 1944; CGA, 1931, 1933, 1937, 1939, 1941, 1943; PAFA, 1934, 1935, 1938, 1942-44; NAD, 1932, 1934, 1940, 1941, 1944; SFMA, 1935, 1937-44; VMFA, 1938, 1940, 1942, 1946; Pal. Leg. Honor, 1946; CM, 1933, 1939, 1940; WMAA, 1938; Los Angeles Mus. A., 1945; Albright A. Gal.; Kansas City AI; Oakland A. Gal., 1938, 1941; Denver AM, 1938; Rochester Mem. A. Gal.; TMA; CMA; Detroit Inst. A.; MMA [47]

ZISKA, Baroness Helene F. [I,S] Valley Stream, NY b. 27 D 1893, NYC. Studied: Acad. Munich; Acad. Vienna; Creighton Univ. Member: Nassau County AL. Work: restoration drawing of Baluchitherium (largest fossil mammal found), AMNH. Illustrator: "From Fish to Men," "Man's Place Among the Anthropoids," "Fish Skulls," "Surgery," "Garden Cinderellas," "Scientific Results of the Cruises of the Yacht 'Eagle'." Position: Scientific Illus., Dept. Comparative Anatomy, AMNH [40]

ZOELLER, Robert (Fredric) [P] Mt. Sinai, NY b. 19 Jy 1894, Pittsburgh. Studied: Corcoran Sch. A.; CI; A. Lg. Pittsburgh; G. Grant. Member: Douglaston A. Lg.; Am. Veterans Soc. A. Exhibited: Douglaston A. Lg., 1930-37, 1938-40 (prize), 1941-44, 1945 (prize), 1946; Mineola Fair, 1944 (prize); Grand Central A. Gal., 1940; Am. Inst. Sporting A., NYC, 1940, 1941; Chicago, 1940, 1941; Am. Veterans Soc. A., 1938-45; Long Island A. Festival, 1946; 8th St. Gal., N.Y., 1940 [47]

ZOELLER, Sara. See Olds.

ZOELLNER, Louis [Cameo carver] b. 1852, Idar, Germany d. 17 N 1934, Brooklyn, NY. In 1868 he studied cameo carving under German masters in Berlin, and soon developed a special technique. (The region of Berkenfold, Germany, had been for centuries the source of semi-precious stones used by cameo artists for their carvings.) He served in the Franco-Prussian War, at its close he sailed for N.Y., arriving in 1871. For fifty years, Zoellner was recognized as an outstanding exponent of his art and was reputed to be the last notable cameo carver in the U.S. He did cameos of William Cullen Bryant, Henry W. Longfellow, Peter Cooper, Commodore Cornelius Vanderbilt, President and Mrs. Hayes, Edwin Booth, Robert Louis Stevenson and President James A. Garfield. He spent three to five years on some of the more delicate cameos. His largest pieces were "Caesar," "Paris and Helen of Troy," "Mount Olympus" and "Venus Festival," said to be the largest carved in modern times by a cameo master.

ZOELLNER, Richard [Mur.P,Por.P,B,Dr,T] Cincinnati, OH b. 30 Je 1908, Portsmouth, OH. Studied: Cincinnati A. Acad.; Tiffany Fnd. Member: Nat. Soc. Mur. P. Work: murals, Univ. Sch., Cincinnati; U.S. Gov.; Reptile House, Zoo, Cincinnati, Community Bldg., Greenhills, Cincinnati; USPO, Hamilton, Ohio; Portsmouth, Ohio; Cleveland; Medina, Ohio; Georgetown, Ohio; oil paintings, Gov. House, Charlotte Amalie, Virgin Islands. WPA artist. [40]

ZOELLNER, Richard Charles [P,Li,I,L,T] Tuscaloosa, AL b. 30 Je 1908, Portsmouth, OH. Studied: Cincinnati A. Acad.; Tiffany Fnd. Member: SSAL; Ala. AL; Birmingham AC. Exhibited: Ind. Soc. Pr.M., 1944 (prize); Northwest Pr.M., 1945 (prize); Ala. AL, 1945 (prize); Ala. WCS, 1946 (prize); Birmingham AC (prize); LOC, 1943, 1945; PAFA, 1942; AIC, 1941, 1942; WFNY, 1939; SAM, 1944; SFMA, 1944; Dayton AI, 1942, 1943; CM, 1941-43; Intermont Col., W.Va., 1944; SSAL, 1945; others. Work: LOC; La. Polytechnic Inst.; SAM; Gov. House, Virgin Islands; murals, USPOs, Portsmouth, Georgetown, Medina, Cleveland; Mannington, W.Va. WPA artist. Position: T., Univ. Ala. [47]

ZOGBAUM, R(ufus) F(airchild) [Naval P,I] NYC b. 28 Ag 1849, Charleston, SC d. 22 O 1925. Studied: Univ. Heidelberg; ASL, 1878-79; Paris, with Bonnât, 1880-82. Member: AWCS; Century Assn. Exhibited: Columbian Expo, Chicago, 1893 (med); Brooklyn AA; Avery Gal., NYC, 1889. Work: murals: State Capitol, St. Paul; Federal Bldg., Cleveland; Woolworth Bldg.; portraits, Naval War Col., Newport; Williams Col., Williamstown, Mass.; Flower Hospital, N.Y. Illustrator: "Horse, Foot and Dragoons," "All Hands," "Ships and Sailors"; Harper's, Scribners. The leading artist-correspondent during the Spanish-American War in the Caribbean. Specialty: military [24]

ZOLL, Victor Hugo [P] Paris, France [08]

ZOLLER, Edwin W. [P] Du Bois, PA. Member: Assoc. Ar. Pittsburgh; AFA; DuBois Civic A. Soc. Exhibited: Pittsburgh AA, 1937 (prize). Work: Coll., 100 Friends Pittsburgh. Position: T., Pa. State Col. [40]

ZOLNAY, George Julian [S,T] NYC b. 4 Jy 1863 (came to U.S. in 1892). Studied: Imperial Acad. FA, Vienna; Nat. Acad., Bucharest; E. Hellmer; C. Kundmann. Member: NAC; St. Louis AG; Wash. AC; Union Intl. des Arts et Sciences, Paris; S. Wash. A.; Circolo Artistico, Rome; Tineremia Romana, Bucharest; Arch. Lg., 1900; SWA; Chmn., Mo. Comm. to Portland Expo. Exhibited: Portland Expo, 1904 (gold), 1905 (gold); Vienna Acad. (prize). Award: Order "Bene Merenti," by King of Romania. Work: mon, St. Louis; Richmond, Va.; Nashville, Tenn.; Savannah, Ga.; Owensboro, Ky.; Univ. Va., Charlottesville; City Gates,

University City, Mo.; U.S. Customs House, San Fran.; New Bedford, Mass.; statue, U.S. Capitol; Bucharest Royal Inst.; City AM, St. Louis; Herron AI. Positions: T., St. Louis Sch. FA, pre-1940; Cur. S., St. Louis AM, pre-1940 [40]

ZOOK, Gertrude [P,T] Ft. Wayne, IN. Studied: Columbia; AIC; Ind. Univ. Member: Hoosier Salon; Western AA. Position: T., North Side H.S., Ft. Wayne, Ind. [40]

ZORACH, Marguerite Thompson (Mrs. William) [P,C] Brooklyn, NY/Robinhood, ME b. 25 S 1887, Santa Rosa, CA d. 27 Je 1968. Studied: Grande Chaumière, Paris, with F. Auburtin; La Palette, J.D. Fergusson, both in Paris, 1908–12. Member: Am. Soc. PS&G. Exhibited: S.Indp.A., Paris, 1911; Salon d'Automne, 1911; Armory Show, 1913; Forum Exh., NYC, 1916 (only woman to exhibit); Nat. Coll., 1973; P.-P. Expo, San Fran., 1915 (med); AIC, 1920 (med). Work: MMA; WMAA; MOMA; Newark Mus.; BM; murals, USPOs, Peterborough, N.H., Ripley, Tenn. WPA artist. [47]

ZORACH, William [S,P,W,T,L] Brooklyn, NY/Robinhood, ME b. 28 F 1887, Eurburick-Kovno, Lithunania (came to U.S. in 1891) d. 15 N 1966, Bath, ME. Studied: Cleveland Sch. A., 1902–05; ASL, 1908–09; NAD, 1908–09; La Pallette Sch., Paris, 1908–09. Member: Am. Soc. PS&G; Am. Soc. S.; Cornish (N.H.) Colony. Exhibited: AIC, 1931 (prize), 1932 (prize), 1938 (one-man); Arch. Lg., 1937 (prize); Salon d'Automne, 1911; Armory Show, 1913; Dayton AI, 1922 (one-man); Univ. Rochester, 1924 (one-man), 1941 (one-man); Dallas MFA, 1945 (one-man); McNay AI, 1956 (one-man); Bowdoin Col. Mus. A., 1958 (one-man); retrospective, 1959–60, traveling to WMAA; Lowe A. Center; Columbus Gal. FA; Cincinnati Contemp. A. Center; Pal. Leg. Honor, 1946. Work: MMA; MOMA; Berkshire Mus.; Newark Mus.; WMAA; Wichita AM; Norton Gal. A.; Swope A. Gal.; Munson-Williams-Proctor Inst.; BMFA; BM; CMA; Los Angeles Mus. A.; WMAA; AIC; PMG; WPA statue, USPO Bldg., Wash., D.C. Contributor: Magazine of Art, Creative Arts, National Encyclopaedia. Position: T., ASL, 1929– [47]

ZORNES, (James) Milford [Mur.P,Por.P,Ldscp.P,I,T,L,] Nipomo, CA b. 25 Ja 1908, Camargo, OK. Studied: Pomona Col.; Otis AI; F. Tolles Chamberlin; Millard Sheets. Member: Calif. WCS; Southern Pr. C.; San Diego FA Soc.; Laguna Beach AA; Riverside AA. Exhibited: Los Angeles County Fair, 1933 (prize), 1936 (prize); Calif. WCS, 1935 (prize); Beverly Hills H.S., 1939 (prize); MMA, 1941 (prize); Allied Services Exh., Bombay, India, 1944 (prize); Pomona Col., 1946 (prize); AWCS; CGA; AIC; GGE, 1939; Riverside Mus., 1938; Fnd. Western A.; Los Angeles Mus. A.; SFMA, 1946; San Diego FA Soc., 1934 (prize); Denver AM; Santa Barbara Mus. A. Work: Los Angeles Mus. A.; San Diego FA Soc.; Butler AI; White House Coll.; Glendale (Calif.) H.S.; U.S. War Dept.; USPO, El Campo, Tex. WPA artist. Position: T., Polytechnic Jr. H.S., Pasadena, 1940 [47]

ZORTHIAN, Jirayr H(amparzoom) [P,C] Altadena, CA (New Haven, CT, in 1940) b. 14 Ap 1912, Kutahia, Armenia. Studied: Yale; Italy. Member: AAPL. Exhibited: New Haven PCC, 1936, 1938–41; BMA, 1943–45; Washington County Mus. FA, 1945. Work: murals, State Capitol, Nashville, Tenn.; United Illuminating Co., New Haven; New Plaza Hotel, Harrisburg, Pa.; Camp Ritchie, Md.; USPO, St. Johnsville, N.Y. Contributor: Pencil Points, Life, G.I. Sketch Book. WPA artist. [47]

ZOZZORA, Frank [P,I,L,T,W] Madison, WI/New London, CT b. 20 Ag 1902, Sassano, Italy. Studied: E. Savage; F. Bicknell; C.J. Taylor; E.M. Ashe; T.W. Stevens. Member: Wis. PS; Madison AA [33]

ZSISSLY. See Albright, Malvin.

ZSOLDOS, Julius [P] NYC [04]

ZUCKER, Jacques [P,W] NYC (1977) b. Je 1900, Radom, Poland. Studied: Académie Julian, Grande Chaumière, both in Paris. Member: Fed. Mod. P.&S. Exhibited: MMA; CI; PAFA; AIC; Smith Col.; Springfield Mus. A.; Inst. Mod. A., Boston; WMA; WMAA; BM; Assn. Am. A., 1940, 1944; Bignou Gal., 1946; Wadsworth Atheneum; Yale Univ.; Dudensing Gal.; Ferargil Gal.; Reinhardt Gal.; Wildenstein Gal.; Paris. Contributor: articles, L'Art Vivant (Paris), Esquire. WPA artist. [47]

ZUELECH, C(larence Edward) [E,I] Cleveland, OH b. 20 F 1904, Cleveland. Studied: Keller. Member: Cleveland PM. Exhibited: CMA, 1932 (prize); 48 Sts. Comp., 1939. Work: Cleveland Print C.; CMA [40]

ZUPPKE, Robert C. [P] Chicago, IL [15]

ZYLINSKI, Andrew [P,T] Ebenezer, NY b. 29 My 1869, Zaile, Lithuania. Studied: Wojciech; Gerson; Warsaw (Poland) Sch. Des. Member: St. Louis AL. Work: Delgado AM; Commercial C., Hannibal, Mo. [21]